NEW YORK 2000

Architecture and Urbanism Between the Bicentennial and the Millennium

NEW YORK 2000

Architecture and Urbanism Between the Bicentennial and the Millennium

ROBERT A. M. STERN, DAVID FISHMAN, AND JACOB TILOVE

THE MONACELLI PRESS

PREVIOUS PAGES View to the south of Times Square during
New Year's celebration, 2000. Tannenbaum. AT

First published in the United States of America in 2006 by
The Monacelli Press, Inc.
611 Broadway, New York, New York 10012

Library of Congress Cataloging-in-Publication Data

Stern, Robert A. M.
New York 2000 : architecture and urbanism between the
Bicentennial and the Millennium / Robert A.M. Stern, David
Fishman, and Jacob Tilove.
 p. cm.
Includes bibliographical references and index.
ISBN 1-58093-177-4 (hardcover)
1. City planning--New York (State)--New York. 2. Urban renewal--
New York (State)--New York. I. Fishman, David. II. Tilove, Jacob. III.
Title.
HT168.N5S74 2006
307.1'21609747--dc22

 2006019842

Designed by Abigail Sturges

Printed and bound in China

ACKNOWLEDGMENTS

New York 2000 would not have been possible without the help of many people. Regretfully, limitations of space prevent us from thanking everyone involved, but we would like, first and foremost, to give special thanks to our colleague Anita Franchetti, whose able assistance during the later stages of the book in finding, obtaining, and organizing the artwork was essential. We also owe a debt of gratitude to the research assistants who helped during the course of writing the book: Jennifer Bleich, Tamarah Bossewitch, Kate Buckner, Andrew Cocke, Alexis Fischoff, Vernon Gibbs II, Jennifer Goold, Eva Hagberg, John Harwood, Margo Klein, Adam Kleinman, Kate Lemos, Marisha Pessl, Alexa Pinard, Ashley Reis, Andrea Ruedy, Erin Rulli, Sarah Schleuning, Adam Sokol, Regan Tuder, and Anne Walker. In addition, we would also like to thank Jonathan Grzywacz for his efforts in preparing photography. As always, the facilities and staff at Columbia University's libraries were a constant and indispensable resource. Christopher Gray at the Office for Metropolitan History and the Rev. James Parks Morton generously shared their knowledge with us.

The book would not be what it is without the many talented photographers whose work is represented here. Special thanks are due to Norman McGrath and his studio manager, Anna Mogyorósy; Ellen Oster, Erica Stoller, and the staff at ESTO Photographic Services; Michael Moran and his studio manager, Jessika Creedon; Paul Warchol and his staff; Allan Tannenbaum; Stan Ries; Elliott Kaufman; and Camilo Vergara. We are also greatly indebted to the individuals and institutions who helped us find photographs and gave us permission to use them, particularly Richard Haas, Phyllis Cohen of the Municipal Art Society, and George Klein and his assistant, Beverly Keitz.

While we are unable to individually note all of the architects and the members of their firms who assisted us, we would be remiss not to make specific mention of Elizabeth Kubany of Skidmore, Owings & Merrill; Carol Giffen of Swanke Hayden Connell Architects; Der Scutt; Eli Attia; Mig Halpine of Cesar Pelli's office; Catherine H. Chase of Kevin Roche John Dinkeloo and Associates; Frederic Schwartz; Jamie Schwartz of Gwathmey Siegel & Associates Architects; Shannon Rossetti of H3 Hardy Collaboration Architects; Jane L. Wechsler of Cooper, Robertson & Partners; Grace Bak of Davis Brody Bond; Tod Williams and Billie Tsien as well as Brent Buck from their office; and Keith Palmer of Murphy/Jahn.

Finally, *New York 2000* could never have been completed without the guidance of the many people involved in its production. Abigail Sturges designed the book and B. Webb Eaken helped put her refined scheme on paper. Elizabeth White orchestrated the complex production of the book with great aplomb, assisted by John Gregory, Stacee Lawrence, and Lara Stelmaszyk. We are particularly grateful to our editor, Elizabeth Kugler. Finally, the support and vision of our publisher, Gianfranco Monacelli, was indispensable in bringing *New York 2000* to fruition.

CONTENTS

PREFACE

New York 2000 is the fifth and last in a series chronicling architecture and urbanism from the time of the Civil War, when the modern metropolis began to take shape, until the beginning of the twenty-first century when, with the September 11, 2001, attack on the World Trade Center, its fate was cast upon the stage of world history in a totally unprecedented way.

Although various teams of authors have been responsible for the books in the series, the methodology has remained consistent from the start, attempting to be faithful to the spirit of the times chronicled and avoiding as much as possible the imposition of a contemporary perspective on historical events.[1] There is, however, a significant difference between *New York 2000* and its predecessor volumes: its subject is the recent past. Nonetheless, despite the temptation to play critic, we have kept the authorial tone down, preferring to let the city tell its own story through the journalism of the day and through the statements of the various architects and urbanists and the professional critics who have contributed so much to the discourse.

New York 1960, covering the years between World War II and the nation's bicentennial, documented a city skidding into diminution as it was being virtually subsumed by its region, the so-called East Coast Megalopolis, its prestige threatened by the growth of other American urban powerhouses such as Los Angeles and the Bay Region of San Francisco, not to mention the new cities of the Sun Belt, especially Houston and Phoenix.

New York 2000 tells a different tale—one of rebounding fortunes—reflecting the city's role as the world's financial and media capital. As well, *New York 2000* is a story of recaptured glory, with the city counteracting the suburbanizing trend of the post–World War II era by capitalizing on its heady mix of history, culture, and social diversity to convey a special aura

of hypermodernity. As a consequence, many suburbanites as well as hinterland Americans and foreign tourists rekindled a love for New York that had been almost extinguished in the dreary years of the late 1960s and 1970s when the city was nearly bankrupt and almost unbridled lawlessness prevailed in its streets. Additionally, hordes of immigrants poured into the city, especially from Asia and Latin America, choosing to settle there and raise families side by side with very many young native-born Americans who, in the postwar years, would typically have chosen the suburbs. As a result, the city dramatically increased in population, contradicting the wisdom of generations of demographers. In 1960 New York was home to 7,781,984 people; by 1980 that number had declined by over 700,000. But by 2000 the city's population had soared to 8,008,278, the highest it had ever been.[2] As we write, New York is not only more populous but also more cosmopolitan than it has ever been, even in the heyday of immigration between the Civil and First World Wars.

New York 1960 documented a city scrambling to compete with suburban patterns of land use and lifestyle, struggling to adapt a nineteenth-century urban plan to the demands of the automobile which, combined with the proliferation of electronic communication, permitted the middle class to leave its center, withdrawing into suburban homes for entertainment and increasingly for work. To meet the challenges of suburbia and the demographic changes brought on by a rapidly growing African American and Hispanic population, post–World War II New York undertook massive programs of urban reconstruction. This so-called "slum" clearance, legislated with massive federal funds as "urban renewal," devastated community life. Similarly, the construction of a vast network of highways that made it easy for suburbanites to come to the city center for work and leisure, also made it easier for those suburbanites to leave at day's end, abandoning the center. The failure to real-ize Westway, a seemingly enlightened project combining highway construction and urban redevelopment, came largely as the result of the public's desire to break with the catastrophic, suburbanizing highway-scale redevelopments of the postwar era and reclaim the city's traditional model of piecemeal, block-by-block growth and change.

Why 2000? Each of the books in this series covers a period of about thirty years' duration, traditionally the measure of a generation. But until this one, each in the series had as its focus a strategic date falling near the midpoint of the era considered. If we had followed this pattern, this volume would be *New York 1990*, and that would have made considerable sense, marking a lull between the 1980s cycle of economic boom and another even more heady era that crashed to a close in 2000. But we have not. Instead, we named it *New York 2000* for reasons having as much to do with the millennium as a point of closure as with its sense of new beginnings. But the millennium proved to be of little consequence compared to the fatal day of September 11, 2001, about which we briefly comment in the Afterword.

A note on the photography

While the previous books in the series were illustrated with black-and-white photographs, *New York 2000* reflects contemporary developments in the field that made inexpensive color film widely available and therefore standard.

INTRODUCTION

PREVIOUS PAGES View from Jersey City, New Jersey, of lower Manhattan skyline during blackout, July 14, 1977. Tannenbaum. AT

ABOVE Looting in Bedford-Stuyvesant, Brooklyn, during blackout, July 14, 1977. Dukos. NYT

It may be romantic to search for the salves of society's ills in slow-moving rustic surroundings, or among innocent, unspoiled provincials, if such exist, but it is a waste of time. Does anyone suppose that, in real life, answers to any of the great questions that worry us today are going to come out of homogeneous settlements?

Dull, inert cities, it is true, do contain the seeds of their own destruction and little else. But lively, diverse, intense cities contain the seeds of their own regeneration, with energy enough to carry over for problems and needs outside themselves.

Jane Jacobs
The Death and Life of Great American Cities
(New York: Random House, 1961), 448.

THE FALL AND RISE OF THE PUBLIC REALM

Blackout

At 9:34 on the evening of July 13, 1977, lightning struck a Consolidated Edison transmission line in northern Westchester County, causing a massive power failure affecting all five boroughs of the city as well as parts of Westchester County.[1] Although it was reminiscent of the last major power outage in the city, the November 1965 blackout that struck at the height of the evening rush hour and lasted thirteen hours, this time the reaction in the city was decidedly different. Whereas the earlier blackout was a time of remarkable civic calm, with civilians rushing to the aid of the police and other emergency workers, the summertime blackout of 1977 quickly degenerated into lawlessness. As Lawrence Van Gelder reported in the *New York Times* on July 14 in a special edition of the newspaper printed at satellite facilities in New Jersey, "Within minutes after the power failed last night, police radios around the city began to crackle with reports of crime."[2] To help quell the rioting, looting, and arson, Mayor Abraham Beame asked Governor Hugh Carey to call in state troopers. But by the time full power was restored twenty-five hours later, the results were grim, with more than 3,000 arrested and property damage estimated in excess of $300 million.

Lost as well was the returning pride of New Yorkers generated by the previous summer's success stories: the popular celebration of the nation's bicentennial with the parade of Tall Ships in the harbor and Hudson River and the hosting of the Democratic National Convention two weeks later without incident.[3] Coming at a time when the city was still trying to emerge from the hangover created by the fiscal crisis of 1975 that brought it close to bankruptcy and forced it to cede significant financial autonomy to the Municipal Assistance Corporation, a public finance corporation created by the state legislature to monitor the city's finances as well as borrow money on its behalf, the blackout depressed even the most boosterish New Yorkers.[4] As the editors of the *New York Times* put it: "So more than bankruptcy ails us after all. More than mismanagement. More than the colors of our skins, the

tones of our accents. The lightning can strike and when it does it is the human condition that is exposed as more faulty even than our machines. . . . We must begin to understand that at least in some measure, these scars are self-inflicted. We did not spend enough of our ingenuity and our affluence to solve the problems the riots of the 60's made evident; we continued the overload. It is a sad but profoundly important lesson for New York—and for the nation."[5]

The blackout was but the most visible and destructive of a series of disasters that frayed the nerves of New Yorkers in 1977. On the night of February 18, two powerful bomb explosions damaged the Chrysler and Gulf & Western buildings.[6] The first bomb went off just before midnight at the Gulf & Western Building, largely empty except for the building's management staff and late diners at its rooftop restaurant, the Top of the Park. A few minutes later, the second explosion ripped through the Texaco Touring Center on the ground floor of the Chrysler Building, shattering windows as high as the fourth floor. The bombs were soon determined to be the work of a Puerto Rican pro-independence group, Fuerzas Armadas de Liberación Nacional Puertorriqueña (FALN), which had claimed credit for at least thirty previous bombings in the city during the last two and a half years, including one at Fraunces Tavern in 1975 that killed four people and injured fifty-three others. The FALN continued its deadly handiwork throughout the year, including an August 3rd blast at Mobil's midtown headquarters that killed one and injured seven others.[7] Additional bomb threats that day, which came only three weeks after the blackout, resulted in the evacuation of over 100,000 people in a dozen midtown and downtown office buildings, including both towers of the World Trade Center. The evacuations were estimated to have cost millions in lost worker time, overtime payments, and

added security expenses in addition to the untold psychological impact.

Another catastrophe occurred just two months before the blackout, on May 16, 1977.[8] At the height of the evening rush hour, five people were killed as a thirty-passenger helicopter idling on the roof of the Pan Am Building keeled over when its landing gear collapsed, snapping off a large rotor blade that plunged into the street fifty-nine stories below. Four of the dead were on the helipad, while the fifth was a pedestrian walking on Madison Avenue and Forty-third Street, a city block away. Five more people were seriously injured. Regularly scheduled helicopter service to the roof of the Pan Am Building, which had operated for twenty-six months between 1965 and 1968 until it was stopped because of operating losses, had only resumed in February 1977 after the Board of Estimate unanimously approved the measure over the objections of community and environmental groups, who worried about noise pollution. Service was permanently terminated as a result of the crash.

Adding to the skittishness of New Yorkers was a spree of murders committed by a deranged serial killer, David Berkowitz, the self-styled Son of Sam, who terrified the city and dominated the tabloids for a year beginning in July 1976, further cementing the city's reputation as a dangerous, out-of-control place.[9] Until his apprehension in August 1977, Berkowitz, a postal worker who grew up in the Bronx but lived in Yonkers, shot and killed five young women and one young man, capturing the public's morbid fascination by leaving notes at the scene of his seemingly random crimes as well as sending letters to local newspapers. Berkowitz believed that he was being commanded to kill by an "evil" Labrador retriever owned by a "high demon" called "Sam" who was actually a neighbor named Sam Carr. At the height of the hysteria, the police revealed that they were receiving four tips a minute from people offering information on the puzzling case, which was ultimately solved when police tracked down Berkowitz through a parking ticket he received at the scene of his last crime in the Bath Beach section of Brooklyn.

Out of the Ashes

The beginnings of the city's turnaround would only come with a change in administration. In November 1977 Congressman Edward I. Koch was elected New York's 105th mayor, having defeated a deeply weakened Abraham Beame in a tight Democratic primary that also featured five other candidates, including Mario Cuomo, who forced a runoff election.[10] Koch would also defeat Cuomo in a surprisingly close general election in which the current Secretary of State ran on the Liberal line. The abrasive and outspoken Koch, famous for his trademark greeting "How'm I doin'?" was in most ways the opposite of the urbane, photogenic John V. Lindsay, a liberal Republican, who, before his election as mayor in 1965, had also represented the same "silk-stocking" congressional district. Koch, initially a leading reform Democrat but later viewed as one of the party's more conservative members, accused Lindsay of fiscally irresponsible decisions that helped pave the way for the city's current difficulties.

Koch inherited a city with deep problems. The *New York Times* political reporter Frank Lynn pointed out that the mayoral campaign "was played out against the backdrop of some of the city's most troubled times. . . . Even before the fiscal crisis, the storm signals were flying. The city had lost 600,000

Wreckage of New York Airways helicopter atop Pan Am Building, May 16, 1977. View to the south showing Empire State Building in distance. Morris. NYT

View to the southwest from Tiffany and 165th Streets, South Bronx, 1982.
Vergara. CV

jobs—most of them for unskilled workers—in the last five years. Its population had declined by 442,000 since 1970. But even that figure masked a more serious situation—the loss of many more middle-income residents and their replacement, at least in part, by poor migrants from the South and the Caribbean, eroding the tax base and adding to the cost of municipal services. Vast and growing areas—the South Bronx and the East New York, Brownsville, and Bushwick sections of Brooklyn—took on the look of bombed-out Berlin and war-torn cities. The housing stock declined at a precipitous rate, with little replacement during a decade of Republican administrations in Washington and tight money in Albany and New York. The city's physical plant—streets, schools and other facilities—deteriorated because capital funds, as well as book-keeping gimmicks, had been used since the Lindsay administration to balance the city's operating budget."[11] Another symbol of the city's decline was corporate flight: 50 of the nation's 500 largest corporations had left the city since 1960, and office building construction had ground to a virtual halt. The deterioration was more than physical. In the wake of the fiscal crisis, even the future expectations of once confident and optimistic New Yorkers were diminished. As Fred Ferretti, a columnist for the *New York Times*, put it: "New York will be forced to be a much smaller apple."[12] In a poll of Democratic voters taken in August 1977, only a third of those surveyed rated the city as an excellent or good place to live.

Koch's first order of business was to institute a dramatic series of budget-cutting measures as well as to secure federal loan guarantees that were being opposed by a hostile Congress. His efforts were rewarded in August 1978 when, before a cheering crowd of 5,000 people gathered in front of City Hall, President Jimmy Carter signed the loan guarantee bill that closed the long, dramatic effort of the city to stave off bankruptcy.[13] The $1.65 billion bill guaranteed pension-fund loans expected to provide the base for $4.5 billion of long-term loans that the city was expected to need between 1978 and 1982. Half the money would be used to restructure the city's $12 billion debt, with the remainder going to long-deferred capital projects, including street rebuilding and bridge and subway repair. Contingent on the plan's success was the commitment of pension funds, banks, and other financial institutions to lend the city $2.55 billion and the risky business of successfully marketing $1 billion in city bonds. The federal money was to be paid out in fixed amounts over the four-year period, by which time the city was required to be operating with a balanced budget. While the federal loan marked a big step toward municipal solvency, the battle for stability was not yet over, with large deficits in current operations suggesting that more expense cutting was still likely.

Koch's commitment to fiscal responsibility was tested in an eleven-day transit strike in 1980 that recalled the strike that greeted John Lindsay in his first days as mayor in 1966.[14]

In that earlier strike, Lindsay's capitulation to the Transit Workers Union, with huge wage settlements and generous provisions for early retirement, greatly raised operating costs and set the city on the road to financial recklessness, which would ultimately lead to the fiscal crisis. In the 1980 strike, Koch did not have direct control over the negotiations (beginning in 1968 the Metropolitan Transportation Authority, or MTA, oversaw labor negotiations), but his voice was nonetheless important. His very public urging against concessions that would threaten the city's financial stability—as well as his outspoken support of the heavy fines levied against the union and its members because the work action was deemed illegal—helped set the stage for the hard line he would take in his contract dealings with the municipal unions under his direct control. Criticizing the ultimate deal worked out between the MTA and the union, Koch warned that city workers, including policemen, firefighters, hospital and sanitation workers, and teachers, could not expect the same kind of settlement, one that was deemed relatively modest by most impartial observers. "I believe that kind of settlement would put us into bankruptcy," Koch thundered. "We're not going into bankruptcy, and we're not going to pay it."[15]

Koch's policy of fiscal restraint was applauded by the editors of the *New York Times* in December 1980. Noting the pressures placed on the mayor to increase spending as the city's finances began to improve, they warned that the city "needs to stick to Mayor Koch's announced priority: to use the money first to rebuild the city's basic plant, rather than on less basic though socially desirable structures. . . . The city has been given one reprieve from the fatal mistake of trying to answer all demands at once. There will be no second reprieve."[16] Two months later, in February 1981, the fiscal outlook had so improved that the city was able to enter the bond market for the first time since 1974, selling $100 million in short-term notes backed only by anticipated tax revenues.[17] And when the city ended its 1981 fiscal year on June 30, Koch was able to report a true budgetary surplus according to generally accepted accounting principles, the first genuine budget surplus since the 1960s.[18] Riding the crest of these economic successes, Koch would easily win reelection in the fall of 1981, running on both the Democratic and Republican Party lines. The city's economy, long dependent on the ups and downs of Wall Street, would receive an additional boost with the beginning of a prolonged and significant rise in the stock market beginning in the summer of 1982.

In addition to Koch's success in getting the city's financial house in order, he also embarked on a series of measures to improve daily life as well as the image of the city at large. One of the more modest but nonetheless highly publicized of these measures was the passage, on August 1, 1978, of Section 1310 of the New York State Health Law, known as the Canine Litter Law, but more popularly referred to as the "Pooper-Scooper Law," requiring dog owners in cities with a population of over 400,000, meaning New York City and Buffalo, "to pick up or pay up," as the *New York Times* put it.[19] Not all of Koch's "cosmetic" measures were so well received. In 1983 the mayor was widely derided for his plan to place decorative vinyl decals depicting flowerpots, curtains, and shades over the windows of abandoned, city-owned buildings, primarily in the South Bronx, in the hope of boosting morale in blighted neighborhoods until more money became available for genuine renovation and rehabilitation (see The Bronx).

On a more substantive level, New York's tourist trade, reinvigorated by the 1976 bicentennial celebrations, continued to grow.[20] With 16.7 million visitors to the city in 1977 and about 17 million estimated for 1978, hotels were typically 90 percent occupied, a remarkable increase over the low of 62.5 percent reported in 1971 and 66.2 percent in 1975. There were many reasons to explain the turnaround, including the positive effect of the state-sponsored "I Love New York" advertising campaign with its memorable song composed by Steve Karmen and iconic and widely imitated logo designed by Milton Glaser. But the devaluation of the dollar played an equal, if not greater, role. For most Europeans, New York, already the best-known city in America, became more affordable. Europeans and Japanese quickly adopted it as their principal destination, giving rise to a general feeling that, as one hotel executive put it, "our hard times are behind us."[21] In July 1978 the popular "I Love New York" campaign, hitherto confined to the Northeast, was taken to a national audience and by the end of the year, the State Department of Commerce could report that the $14.7 million spent on advertising over the last sixteen months had reaped $287 million in tourist dollars.

In addition to the beefed-up tourist trade, foreign investment in the city also rose, attributable in part to the weak dollar but also to the sense that New York was one of the world's most interesting cities in which to work and live.[22] While some lamented the overcrowded subways, the maddening delays on commuter trains, and the rush-rush service in restaurants, they found much to praise, not least the city's vast pool of talent and, as was the case in the tourist boom, its relatively low prices (given prevailing monetary exchange rates) compared with Paris, London, or Tokyo. While English and French businesses were attracted to the city in significant numbers, it was the rising presence of the Japanese, a decade-long trend, that made the greatest impression. The Koch administration actively courted foreign investment, with the mayor and senior staff members hosting the leaders of major foreign corporations in the hope of landing new business. The trend continued into the late 1980s, culminating in the era's most dramatic example of foreign investment in the city when Japan's Mitsubishi Estate Company bought controlling interest in Rockefeller Center in October 1989.

Given the admonition by Mayor Koch that municipal dollars were precious and to be prioritized for only the most

"I Love New York" logo. Milton Glaser, 1976. NYSDED

important public projects, a new type of private, self-help organization, the Business Improvement District (BID), entered the scene to provide the kind of amenities—additional security, sidewalk cleaning, graffiti removal, improved streetlights, landscaping, and information kiosks—that people felt were not being adequately provided by the city.[23] The immediate predecessor to the BIDs was the Bryant Park Restoration Corporation, dedicated to improving conditions in the troubled midtown park, a private group set up in 1980 with the financial aid of the Rockefeller Brothers Fund. The creation of the BIDs, which were to be funded by a special assessment paid by property owners within the district, was not without controversy. Some felt that the new entity represented an inappropriate ceding of government authority to private organizations. Although enabling legislation was passed at the end of 1981 allowing BIDs, court challenges to the new law delayed the creation of the city's first BID, located in the Fourteenth Street-Union Square area, until 1984. Their full impact would not be felt until the 1990s, however, when they proliferated throughout Manhattan and began to be formed in the outer boroughs. The founding of the crime-fighting, beret-wearing Guardian Angels in 1979 by Curtis Sliwa was an even more controversial attempt at privatizing a traditional municipal service, in this case the police.[24] Although some praised the group for its subway and street patrols, others, most notably a vocal Mayor Koch, felt that it was a vigilante organization more appropriate for the Wild West.

The pickup in the local economy was vastly stimulated by the significant increase in numbers of young people electing to live in the city, especially on Manhattan Island and in historic portions of Brooklyn. According to the editors of the *New York Times*, the trend involved "young urban residents choosing to

Delirious New York. Rem Koolhaas, 1978. Cover illustration by Madelon Vriesendorp. OMA

stay put just as much as suburbanites moving back. The post–World War II birth-boom babies are now causing a boom in new households. Higher divorce rates are creating two households where there would have been one. Zooming housing costs in the suburbs spur the search for convenience and bargains in the cities. Urban cultural riches have special appeal for the young and childless." In an editorial titled the "Victims of Urban Revival," the *Times*'s editors offered a curious caution that would become an increasingly widespread litany among politicians and planners in the 1980s: "For the migrants to move in means someone else is pushed out. And, too often, the someone else is poor, or black, or elderly, or politically powerless."[25] The *Times*'s concern failed to consider the development of new housing on the many open sites that existed even in Manhattan, not to mention new landfill, as at Battery Park City. The most significant demographic development was not the so-called postwar baby boomers but the continuation of a trend in which the city's population became more diverse and less white, with new immigrants arriving from Europe, Africa, the Caribbean, and especially Asia.[26]

The improving image of the city and the renewed enthusiasm for city life was brilliantly reflected by the publication in 1978 of Dutch screenwriter-turned-architect Rem Koolhaas's *Delirious New York: A Retroactive Manifesto for Manhattan*, a paean to the city that, according to Ada Louise Huxtable, celebrated Manhattan's "'culture of congestion,' a process of creative chaos and calculated instability in which builders camouflage their wildest fantasies with profit-and-loss accounting." Describing the book as "equally full of splendid, off-beat insights and self-indulgent opacities," Huxtable declared it "this year's most imaginative and provocative book about Manhattan."[27] Koolhaas's self-proclaimed ghostwritten biography of the city, graced by a memorable cover of a seemingly postcoital Chrysler Building and Empire State Building, painted by Koolhaas's wife, Madelon Vriesendorp, was excerpted in several publications and quickly became a cult classic. When it was reissued in 1994, Herbert Muschamp described *Delirious New York* as an "ecstatic love poem to Manhattan that challenged conventional thinking in urban design. While planners and urban designers struggled to bring logic, sanity and order to the built environment, Mr. Koolhaas argued that the glory of the city lies in the exceptional, the excessive, the extreme."[28] An even more unusual and abstract use of the city was found in Bernard Tschumi's 1981 book, *The Manhattan Transcripts*, in which the architect chose to locate a series of fictional projects in various Manhattan locations.[29]

Midtown Building Boom

The most dramatic and visible sign of the renewed economy was a significant, sustained building boom that began in Koch's first term in office. In rapid succession, beginning in spring 1978, plans were released for new midtown headquarters for such corporate giants as AT&T, IBM, and Philip Morris, as well as prominent mixed-use skyscrapers such as Trump Tower. As Ada Louise Huxtable put it in March 1978, "After a long, cold winter, there are signs of spring in New York. Trees and real estate are about to burst into bloom."[30] The new building activity included not only office towers but apartment houses as well, aided by the J-51 tax incentive program.[31] Previously confined to the improvement of rent-controlled apartments, the twenty-one-year-old J-51 program was extended in 1976 to encompass rent-stabilized apartments,

View to the northwest showing construction of AT&T Building (Philip Johnson and John Burgee, 1984), left, Trump Tower (Der Scutt, 1983), center, and IBM Building (Edward Larrabee Barnes Associates, 1983) right, c. 1981. Ries. SRP

cooperative and condominium units, as well as new dwellings created through the conversion of hotels, office buildings, factories, and other nonresidential properties. In return for physical improvements, J-51 provided a twelve-year real estate tax exemption as well as real estate tax deductions proportionate to the cost of those improvements. The boom in new apartments was accompanied by a distinct change in the character of the product. Most of the new buildings were built not as rental units characteristic of the comparatively few new buildings of the early and mid-1970s but as condominiums, with an increase in larger units aimed at family living.

The pace of the boom was staggering. In July 1979 Paul Goldberger observed, "With astonishing suddenness, building is booming again in midtown. It is going ahead so rapidly now that most planners agree that the most urgent problem today is not encouraging growth but controlling it. The city may now be on the verge of becoming too built-up." But, as Goldberger went on to note, it was not the city as a whole, or even Manhattan, but only one concentrated area in that borough which was experiencing the boom: "The desirable area for construction is not expanding, as it has in previous booms. Instead builders are erecting new towers almost exclusively within the square bounded by 40th and 60th Streets and Third Avenue and the Avenue of the Americas."[32] Writing a month

after Goldberger, Ada Louise Huxtable was even more emphatic: "Real estate men are apparently as forgetful of recent recessions and over-building as young lovers are of the last heartbreak as they plunge into new romance. . . . In . . . New York, zoning restrictions are being stretched and manipulated to their absolute limits to accommodate these behemoths. As the new landmarks rise from 40th to 49th Streets this year, not only will the skyline be radically altered, but the effect on the scale, circulation, character and amenity of the city will become apparent."[33]

The explanation for this higher concentration lay in the inherent conservativeness of lending institutions as well as, according to Goldberger, in "the desire by foreign-based companies, which now make up a large percentage of the commercial rental market, to be at one of the best addresses."[34] As a result of this concentrated boom, the City Planning Commission, which had for years encouraged development with offers of extra space bonuses in exchange for public amenities that were frequently deemed to be of dubious value by the public, began to rethink its position. Robert F. Wagner Jr., chairman of the commission, believed the excessive development was "a threat to the special character and ambiance of certain of [Manhattan's] avenues, streets and places, which are a hallmark of its unique and urbane quality."[35]

The development frenzy seemed counterintuitive, given the Federal Reserve Board's moves to tighten credit in late 1979, pushing construction financing charges to between 16 and 18 percent and commercial mortgage financing to about 12 percent. But the city's major developers pressed on with their plans, encouraged by the strong demand for office space. For developers, the situation was tricky and fraught with peril. As Carter B. Horsley, perhaps the *New York Times's* most astute real estate writer at the time, put it in January 1980: "In Manhattan's office market, there is hardly any space available and rents are climbing," a situation that last existed at the end of the 1960s, when "the city's building community began a construction boom that significantly changed the skyline, but then an economic downturn caught committed developers without tenants. At the end of the 70's, the conditions are ripe for another boom, and for another economic downturn. But history, many real estate owners and brokers, maintain, does not always repeat itself."[36]

The city's rapidly changing skyline was clearly capturing the public's attention. In February 1981 the Museum of Modern Art sponsored a symposium, "New York: Building Again," featuring seven prominent architects who had major skyscrapers under construction: Philip Johnson (AT&T Building); Edward Larrabee Barnes (IBM Building); I. M. Pei (499 Park Avenue); Der Scutt (Trump Tower); Eli Attia (101 Park Avenue); Raul de Armas of Skidmore, Owings & Merrill (780 Third Avenue); and Cesar Pelli (MoMA Tower).[37] In order to address concerns that development activity was too heavily concentrated on the east side of midtown, the city created the Special Midtown Zoning District in 1982. The new measure in effect shifted development to the West Side by allowing the construction in West Midtown of buildings 20 percent larger than permitted under zoning. The law also included a sunset clause that ended its benefits in May 1988, a provision that motivated developers to act quickly. Not everyone applauded the move. As City Planning Commissioner Martin Gallent put it: "They're now going to do [on the West Side] what they shouldn't have done on the East Side in the first place."[38]

Local Law 10

Coupled with the rise in construction activity was the acknowledgment, after a fatal accident, that greater oversight was needed over the condition of the city's building stock. Traditionally spring was a particularly hazardous time of year for pedestrians, who were in danger of being hit by pieces of masonry loosened as a result of postwinter thaw. While contractors specializing in restoration regularly issued dire warnings of dangerous conditions to the public, Acting Buildings Commissioner Irving Minkin discounted such remarks in April 1978 as "gratuitous hogwash."[39] One year later, on May 16, 1979, a Barnard College freshman, Grace Gold, was killed by masonry falling from the seventh floor of 601 West 115th Street, an apartment building owned by Columbia University.[40] Triggered in part by Ms. Gold's death and by injuries sustained by a fifteen-year-old girl, Christina Martinez, when a piece of granite facing fell from the facade of Gimbels department store on East Eighty-sixth Street a few weeks later on June 25, the City Council passed Local Law 10 in February 1980.[41] The new law required inspections of the exterior walls of all buildings over six stories by a licensed engineer or architect every five years. Any unsafe conditions were to be immediately reported to the Buildings Department and promptly repaired by the owners. The measure was only the second of its kind in the country, following a similar law enacted in Chicago in 1978. Although applauded by local politicians as an important safety tool, Local Law 10 aroused some concern among preservationists, who feared the potential loss of many robustly ornamented facades that failed inspection. Writing three years after the passage of the law, Paul Goldberger noted that Local Law 10 had no "provision . . . to encourage preservation of ornament, especially where a building's facade is in bad shape, and there is certainly no financial incentive for preservation and restoration. . . . So a long-term result of what Local Law 10 may do, unfortunately, may not be to end a tragedy but to compound it—and turn the private loss that has already been suffered in the case of an unnecessary death into a public loss in the form of a diminished city."[42] While many buildings were stripped of ornament to expeditiously meet the requirements of Local Law 10, perhaps none was more prominent than that of the Mayflower Hotel (Emery Roth, 1926), 15 Central Park West, a modestly ornamented Georgian-esque red brick design that was scraped clean and reduced to the status of a brick box.[43]

Greed Is Good?

After leading the nation in liberal welfare spending in the 1960s, in the 1980s New York became the epicenter of what has come to be referred to as "The Greed Decade." Between 1982, when the bull market on Wall Street began, and the stock market crash of October 19, 1987, when the Dow Jones Industrial Average lost 508 points, falling 22.6 percent, the nation enjoyed one of the biggest economic booms in its history.[44] President Ronald Reagan, who served from 1981 until 1989, presided over and in many ways set the tone for what the left-leaning social commentator Marshall Berman called the "long Scrooge Christmas of the 1980s."[45] During his tenure Reagan vastly reduced the federal government's support of social programs in cities. New York was particularly hard hit, denied funding for many vital programs and services, including subsidized housing, health care, welfare, and job training, upon which it had come to rely. As Joelle Attinger,

Mayflower Hotel (Emery Roth, 1926), 15 Central Park West. View in the course of reconstruction after Local Law 10 required removal of potentially dangerous ornamental elements, 1982. View to the northwest. Hausner. NYT

writing in *Time* magazine, put it: "If during the city's close brush with bankruptcy during the 1970s Gerald Ford was willing to let New York drop dead, the Reagan Administration seemed eager to bury it."[46] The president's defense of First Lady Nancy Reagan's purchase in 1981 of a $209,508 set of china for the White House, a rather lavish expense at a time when a record number of Americans lived below the poverty line, was a poignant precursor to the excesses that came to typify the 1980s boom.[47] In New York especially, the 1980s were years of great wealth and great poverty existing side by side, a time when compassion was out, conspicuous consumption was de rigueur, and when the journey for power and wealth blinded those who embarked on it to the people who fell to the bottom along the way.

The decade witnessed the emergence of the "service economy," a term that in many ways was a misleading catchall, as Gus Tyler cautioned in the fall 1987 issue of the Socialist quarterly, *Dissent*: "This service sector . . . means many things . . . [and] like many economic concepts, is . . . an invention of pundits. It includes brain surgeons and the brainless, airline pilots and dishwashers, stockbrokers and stockboys. It includes blue-collar people who wrap and tote; white-collar people who sell, type, file; no-collar people who handle fast food, sweep floors, or see to it that you don't shoplift."[48] By 1986, 85 percent of all jobs in the city were in the service sector—as compared with the national statistic of 75 percent—up from 81 percent in 1976. Between 1977 and 1984, the number of stockbrokers and dealers in New York increased from 56,000 to 99,000. During the 1980s, 350 foreign and many out-of-state financial institutions opened regional operations in New York.[49] Of the 600,000 jobs in finance and business services that existed in New York in 1986, 184,000 had been created since 1977. By the middle of the 1980s, the outer boroughs joined Manhattan in benefiting from these figures: of the 130,000 new private-sector jobs created in 1984 and 1985, two-thirds were located in the outer boroughs.[50] At the same time, manufacturing, which had been declining in New York since the middle of the century, began to do so at a much greater rate. Between 1976 and 1986 the percentage of manufacturing jobs in New York City fell from 16.8 to 11, threatening to leave many unskilled laborers, the majority of whom were black and Hispanic, without employment.

Chief among the participants in the service economy were the youngest members of the baby boom generation, who began to flock to the city. In 1979 Blake Fleetwood, writing in the *New York Times Magazine*, described the emergence of a "New Elite" in an American "Urban Renaissance" and particularly in New York, where "the evidence of the late 70's suggests that the New York of the 80's and 90's will no longer be a magnet for the poor and the homeless but a city primarily for the ambitious and educated. . . . New York may never woo back the middle class that fled to the suburbs after the Second World War, but it seems to be attracting a new professional upper class."[51] Fleetwood's observation was seconded by Roger Starr, who pointed out that, "The people who are moving in are . . . young lawyers, architects, doctors, people in the investment community."[52] This burgeoning sector would come to be known as "yuppies," the term, short for "young urban professionals," first used in the popular press in 1984 to describe the important role of young voters in the presidential election, especially those who supported Senator Gary Hart in his failed bid for the Democratic presidential nomination.[53]

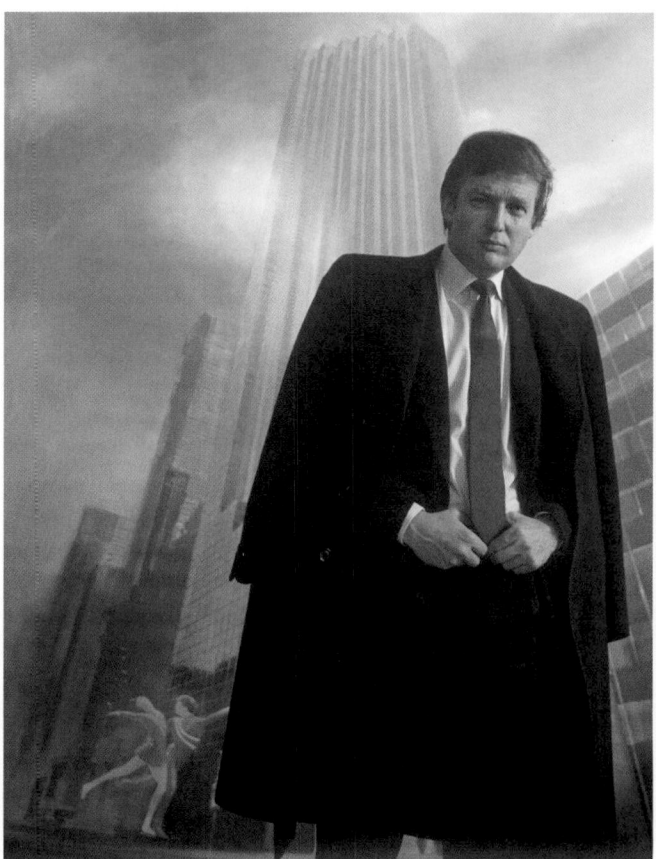

Donald Trump, 1988. H. Benson. BEN

The yuppies were particularly drawn to the potential riches of a manic Wall Street, transforming the rather buttoned-down, staid character of the nation's financial center into a frenzied landscape of acquisitiveness. Tom Wolfe, describing the bond trading room of Pierce & Pierce, a fictional investment banking firm in his bestselling 1987 novel, *Bonfire of the Vanities*, wrote: "It was a vast space . . . an oppressive space with a ferocious glare, writhing silhouettes, and the roar. . . . It was the sound of well-educated young white men baying for money on the bond market."[54] In September 1984 a new magazine, *Manhattan, inc.*, debuted, devoted to New York's powerful and power hungry: "For the business of New York is, in a word, power—economic, political, social, and cultural," the premier issue stated. "Our readers and subjects were to be one and the same— Manhattan-based men and women who operate on a grand scale, sophisticated achievers whose actions are worth watching and weighing."[55]

Little in New York during the 1980s was as exalted as "the deal," and the most successful deal-makers were elevated to celebrity status. In the real estate realm, the developer Donald J. Trump rose to the top as a deal-maker, celebrating his business acumen in the first of a series of self-congratulatory books he was to write, *The Art of the Deal* (1987).[56] Trump's penchant for making money was matched only by his flair in spending it. His purchase in October 1987—after the market crash—of what he called "the ultimate toy," a 286-foot yacht originally built for a Saudi arms dealer complete with gold-plated doorknobs, window frames, and faucets, was one of the era's most egregious examples of conspicuous consumption.[57]

Studio 54, 254 West Fifty-fourth Street. Experience Space, 1977.
Tannenbaum. AT

On Wall Street, "the deal" was perhaps best—and most disastrously—exemplified by Ivan F. Boesky, the arbitrageur who traveled by stretch limousine, helicopter, and private jet, reportedly slept only two to three hours each night, and proclaimed to an audience of graduating business students, "Greed is all right, by the way. I think greed is healthy. You can feel greedy and still feel good about yourself."[58]

Oliver Stone's commentary on the era, the well-timed 1987 film, *Wall Street*, was set in 1985 and featured the iconic character Gordon Gekko, a corporate raider who ruthlessly wrecked companies simply because they were "wreckable" and who made a killing trading on inside information, stating, "If you're not inside, you're outside." Though Gekko was a composite of many Wall Street players, his famous speech to shareholders was inspired by Boesky: "The point is, ladies and gentlemen, that greed, for lack of a better word, is good. Greed is right. Greed works. Greed clarifies, cuts through and captures the essence of the evolutionary spirit."[59] The possibility of achieving such wealth and power, even, as in the case of Gordon Gekko, at the expense of the lives and livelihoods of the working class, was so tantalizing that for many who saw the film, the mantra "greed is good" became the unintended moral of the story.

In 1986 Boesky was charged with conspiring to falsify records connected with insider trading and was convicted the following year in perhaps the highest-profile case within the industry, calling into question the ethics of the day. In his late forties, Boesky was one of the oldest among the group of Wall Street cowboys who would be charged with criminal offenses. In May 1986, thirty-three-year-old Dennis B. Levine was arrested for insider trading and within two months, five other investment bankers and lawyers had been implicated in the growing investigation, all but one (who was thirty-seven) being younger than thirty-four. In a separate insider trading scandal during the same period, the *New York Times* noted that all five men charged were younger than thirty.[60] As author Pete Hamill observed in 1988: "The new crowd seemed to be its own generation, well suited to an age of vehemence. . . . Say what you will about the rich men of the robber-baron era, they left behind Carnegie Hall, the Metropolitan Museum, the New York Public Library, the Frick, schools and hospitals and architecture. This bunch seems destined to leave behind nothing except some repossessed BMWs."[61]

The nouveaux riches may not have been supporting cul-

tural institutions but they were having fun. Nightlife enjoyed a renaissance. Following on the heels of the wildly successful Studio 54, opened by Ian Schrager and Steve Rubell in 1977 but shut down because of bookkeeping irregularities in 1978 (it was reopened in 1981 by Mark Fleishman), new clubs like Xenon (1978), Regine's (1978), and the Palladium (1985) proliferated (see Interiors). A steady stream of expensive, high-design restaurants also opened as the experience of dining out was elevated to an evening's entertainment. Notable among the many hot spots were the Odeon (1981), Gotham (1984), America (1985), and Positano (1985) (see Interiors).

The dark side of the city's good-time image was documented in a series of morality plays, like *Bonfire of the Vanities* (a brilliantly successful novel of 1987, released as a dismal film in 1990), *Wall Street*, and Jay McInerney's best-selling 1984 novel, *Bright Lights, Big City* (released as a film in 1988), whose protagonist, an earnest but misguided twenty-four-year-old recently abandoned by his fashion model wife and fired from his job at a prominent *New Yorker*-like magazine because of his propensity for cocaine and the high life, ultimately found himself on the streets of Tribeca at dawn, bleeding from the nose after an all-night party, trading his sunglasses for a bag of bread, and left to embark on a soul-searching reevaluation of his priorities, a situation that might be compared to that of the city itself in the wake of the economic collapse of 1987.[62]

Homesteading and Homelessness

By the mid-1980s, 23.9 percent of New Yorkers were living below the poverty line, the figure having risen from 15 percent in 1975. In 1985 New York's unemployment rate was 8.1 percent, but it was distributed unevenly, with the rate for whites at 7.2 percent; for blacks, 11.5 percent; and for Hispanics, 13.4 percent.[63] As Gus Tyler noted in 1987, New York's economy was "divided into three parts: upper, lower, and under. The first two—upper and lower—are old hat, retailored now to fit the service economy. The third—the underground economy—has moved from being a pest to a pestilence." The three parts, according to Tyler, fed upon and supported one another. "The affluent—whether businesses or individuals—provide a market for the service economy. Those who serve in restaurants, cafés, hospitals, homes, offices, beauty parlors, warehouses, and department stores at very modest pay make life more comfortable for those they serve. Those who in a past era might have been employed in semi- and unskilled jobs at a livable wage turn to a parasitic existence, preying on the affluent, less affluent, and even the nonaffluent. . . . Much of the underground economy is outrightly illegal, simply criminal: burglary, mugging, trafficking in drugs, shoplifting, arson, hijacking, robbery, pilferage."[64]

Gentrification, the process by which neighborhoods were revitalized by affluent newcomers often resulting in the displacement of lower-income residents, was a major phenomenon of the period. It came in many forms. At its worst it was a violent process, such as on Manhattan's Upper West Side during the late 1970s and early 1980s, when a high concentration of single-room-occupancy (SRO) hotels were renovated into housing for the upper middle class as a result of the extension of the J-51 tax abatement program, leaving many of the city's poor literally homeless. In May 1982, columnist Sidney Schanberg devoted a five-part series in the *New York Times* to exploring this process at one typical SRO, the Arvia,

605 West 112th Street, where, in an effort to drive out the building's ninety residents (after four months only fifteen were left), "a tenant had his ribs broken by the barrel of a rifle wielded by one of the musclemen apparently hired to empty the place . . . [and] the brother of a former tenant leader was murdered when another of the musclemen . . . emerged from the owners' office with a powerful .357 magnum revolver and shot him down."[65] Schanberg described the helplessness of those being displaced and the inability of the legal system to punish the owners or their henchmen: "Not only have the assaults on their basic tenancy rights been ignored, but the process of casting them out became such an applauded civic virtue at City Hall and elsewhere that it was given an upstanding name: gentrification. After all, political leaders told us, neighborhoods were being improved. And indeed they were. There is just one nagging thought—the throwaway people have no place to go. . . . Some are now part of the city's growing population of nomadic, homeless people."[66]

Gentrification was a "natural process," the result of improved economic factors stimulating private investment in neighborhoods with unrealized potential. But it had not been part of the city's evolution for so long that its arrival, after decades of slum clearance and social engineering, came as a wrenching shock to the system. In Brooklyn's Park Slope, gentrification began in the 1970s when the existing stock of brownstones which had become rooming houses were gradually bought up by young urbanites who converted them into one- and two-family residences.[67] Between 1970 and 1980, the number of homeowners in Park Slope increased by nearly 9 percent even though the number of housing units shrank by 5 percent (1,200 units) and the population by 21 percent. The renaming of areas by real estate brokers to disassociate improving neighborhoods from the negative connotations that their historic names sometimes carried with them was not uncommon and had been part of the process of gentrification since the 1960s, when the northeast quadrant of Red Hook, Brooklyn, became Carroll Gardens and Cobble Hill, and Manhattan's Hell's Kitchen became Clinton, to name three notable examples. In some cases, gentrification was the result of landlords simply raising rents so much that long-term residents could no longer afford to stay. Most gentrifying areas had begun as middle- and upper-middle-class neighborhoods with exceptional housing stock. But gentrification was also taking place in what had traditionally been working-class neighborhoods such as the Lower East Side of Manhattan, where tenements prevailed. In cases like the East Village (née Lower East Side), gentrification was the complex consequence of many factors and it came improbably, after long periods of neglect and abandonment, a condition that itself attracted the artists whose presence in turn brought in young professionals able to pay skyrocketing rents which in turn encouraged the city to auction off properties in the neighborhood to whichever developers would pay the highest price.[68]

By far the worst plague of the 1980s was homelessness. Though gentrification was often and rightly cited as a cause of homelessness, driving the poor from rooming houses and single-room-occupancy hotels, it was only one among many factors contributing to its epidemic rise during the decade. Urban planner Peter Salins pointed out, "There have been many more people pushed out by abandonment than have ever been moved out by so-called gentrification."[69] But an even more significant cause of homelessness was the deinstitutionalization,

beginning in the 1950s, of patients from state psychiatric hospitals.[70] Their discharge, based on the false assumption that there would be an adequate network of community services to help them, left many people on the streets, adding an unpredictable and often dangerous element to the homeless population. By the mid-1970s, alcoholism, the traditional affliction of the homeless, was rivaled by severe psychiatric disorders among homeless persons treated in the city's shelters. That the very term "homeless," as the writer and editor Norman Podhoretz pointed out, was used more and more often to describe people who were formerly derided as bums, hobos, beggars, and drunks, "exculpates them as victims of heartless government policies."[71] Mortimer Zuckerman completed the thought, stating: "The word *homeless* implies society's responsibility" whereas the old terms suggested "individual responsibility."[72]

Exploding in number, the homeless, previously concentrated on and near the Bowery, began during the 1970s to spread to all quarters of the city, visible on the streets, in parks, in doorways, on sidewalks, and in subway, bus, and train stations, most notably in and beneath Grand Central Terminal, where, as the *New York Times* reported in November 1977, despite denials by senior officials in charge of policing the terminal, an exclusively male colony of homeless people ranging in age from seventeen to seventy made their homes in the little-known network of steam tunnels that extended as much as six levels below Park Avenue, from the terminal to the Waldorf-Astoria Hotel.[73] The men, who panhandled on the streets during daylight hours, slept on newspapers and strips of cardboard in cubicles formed by structural steel columns and cooked their food in tins on the hot metal pipes. The tunnels, long known to the city's derelicts, could be entered at a number of different points, through service doors of the various hotels and office buildings above.

The precise number of homeless was contested through the 1980s, with advocates for the homeless and the city offering conflicting figures.[74] In 1981 the Community Service Society, a 132-year-old nonprofit social agency, reported that there were 36,000 homeless people in the city, a statistic that made the front page of the *New York Times*.[75] Mayor Koch publicly argued the number but could only state: "We don't know how many there are," going on to rather hyperbolically promise: "If they're out there and they come in for a bed and there are 36,000 of them, then we will provide 36,000 beds."[76] In fact, the city was required to do so. In 1981, in response to a class

Homeless in Grand Central Terminal, 1985. Tannenbaum. AT

Rows of beds for homeless men in a Brooklyn armory, 1987. Tannenbaum. AT

action suit brought by a young Wall Street lawyer on behalf of six homeless men two years earlier, the city entered into a consent decree that required it to provide adequate shelter for any homeless man who applied.[77] But the exact definition of adequate shelter and the location of these shelters would be contested. While all acknowledged that the optimal shelters were small ones within neighborhoods where homelessness occurred, these facilities were almost always opposed by local residents, resulting in the use of larger, more cost effective, but relatively remote facilities like the 450-bed shelter on Wards Island, which was doubled in size in 1981. By 1983, the city could house 6,500 homeless in eighteen shelters—up from the 1978 figure of 2,000 beds in three shelters. To cope with the growing population, the city began to house the homeless in armories and gymnasiums. The state also built two 196-bed residences (1984-85) for mentally ill homeless people on the grounds of the Creedmoore Psychiatric Center, 80–45 Winchester Boulevard, in Oakland Gardens, Queens.[78] In 1985 the Bellevue Psychiatric Center became the city's largest men's homeless shelter. For many homeless, however, especially those with mental illness, the shelters were degrading and dangerous, leaving them vulnerable to assault by their peers. Yet others abused the shelters as permanent housing, with a 1984 survey indicating the average stay to be more than a year.

All the while, the city took criticism for concentrating on the symptomatic relief, as it were, of sheltering the homeless and not on preventive measures that would help reduce their number—namely, more affordable housing. In 1984 the city spent more than ever on providing food and shelter for the homeless but to no avail. By January 1988 there were an estimated 5,200 homeless families (17,800 individuals) in New York. In August of that year, the crisis came to a head during the Tompkins Square Riots, an explosive clash between policemen and protestors catalyzed by issues of homelessness and gentrification (see East Village).

Beneath the Glitter

While ever-present urban ailments such as homelessness and gentrification continued to get worse, the city faced two new challenges that brutally tore apart its social fabric: the disease AIDS and the drug crack. AIDS, first detected in New York in 1981, was by 1985 the leading cause of death among New Yorkers aged twenty-five to forty-four, with homicide the leader for those aged twenty to twenty-four. By 1987 AIDS had

taken over as the single leading cause of death among New Yorkers under forty, with more than 25 percent of the 10,000 reported AIDS cases nationwide occurring in New York City.[79] The growth of the disease was feared to be exponential. Crack, the cheap, potent, and powerfully addictive form of cocaine, hit the streets of the Bronx in 1984, though the Drug Enforcement Agency estimated that three-quarters of the early New York City-area crack users were "white professionals or middle-class youngsters from Long Island, suburban New Jersey, or upper-class Westchester County" who had previously been cocaine users.[80] By the time it received local media attention in 1985, the drug had spread throughout the city, becoming an epidemic of vast proportions in poor neighborhoods. In 1988 crack was determined to be a pervasive presence throughout New York's homeless shelters and was also discovered to be an endemic problem among children under sixteen in the underclass. It was determined to have played a role in at least 38 percent of the 1,867 homicides that took place in 1988 and resulted in a surge of prisoners entering the increasingly overcrowded correction system, also bogging down the criminal justice system. Between the time when crack first appeared and 1989, when it peaked, New York City's jail population rose from 9,815 to more than 17,500.

The coexistence of such extreme prosperity and poverty was disturbing, to say the least. In an essay comparing the New York of 1968 with that of 1988, Pete Hamill wrote:

> Twenty years later, glittering new towers reach for the sky and the streets are filled with beggars. Twenty years later, uncountable millions flow through the city's restaurants, shops, art galleries, and theaters while men and women sleep under the rusting skeleton of the West Side Highway. Twenty years later, stretch limousines are double-parked every night on the avenues of the East Side while children play with crack vials in the forbidding corridors of the Holland Hotel. Twenty years later, Manhattan has become in too many respects the place predicted by the Cassandras of the sixties: the habitation of the rich and the very poor.[81]

Irving Howe was similarly dismayed by "the signs of social and economic polarization. . . . Those sleek, dark-curtained limos driving through streets in which thousands of people are homeless on winter nights; Madison Avenue below 96th Street and Madison Avenue above; the glitz of midtown contrasted with the devastation of large sweeps of Brooklyn and the Bronx—a few of the signs." Worse, for Howe, was a disheartening public apathy toward it all: "One rarely hears any longer expressions of social dismay or anger or even guilt. If the developers tighten their grip on Manhattan, driving out small storekeepers and booksellers and offbeat movie houses, and the city, dispensing tax breaks and helpful indifference, acquiesces with at best a weary version of the 'drip-down' argument—why that's the way things are, the way they've always been." Howe concluded, "What made New York a place one loved—its diversities, its unconventionalities—is being swept away by the forces of money, the developers and the foreign investors, the corporations with their sleek facades."[82]

In February 1984, Mayor Koch, responding to *New York Daily News* editor James G. Wieghart's persistent demands to know what the city's vision was as it moved toward the twenty-first century, appointed a Commission on the Year 2000, chaired by the president of the Board of Education and

Crack is Wack, mural on the wall of a handball court at 128th Street and Harlem River Drive, East Harlem. Keith Haring, 1986. EKH

former deputy mayor, Robert F. Wagner Jr., to prepare a plan for the city's future that examined subjects such as education, economic development, housing, transportation, health care, capital needs, poverty, crime, the environment, and neighborhood preservation.[83] The last time a similar project was undertaken was in 1969-70, when the City Planning Commission released its master plan for New York.[84] Though optimistically entitled *New York Ascendant*, the 185-page report, released in June 1987, made clear, as the editors of the *New York Times* put it, "that the ascent will be more like a mountain climber with a heavy pack than the carefree flight of a balloon."[85] According to Ada Louise Huxtable, the report could "hardly be called upbeat," having "come to the appalling conclusion that New York is no longer the city of opportunity. . . . Today a record 25 percent of the city's population, unemployed or poorly employed, lives below the poverty line. That figure, still rising, is the highest in the city's history. New York's burgeoning prosperity, its aggressive affluence, has not touched one-quarter of its people. . . . The commission has found a city more divided than it ever was before, divided ultimately by class rather than by race, divided by immovable and unyielding barriers. What is gone is the vaunted upward mobility that was a tenet of the American, and New York, way of life—the ability to move out and up, to become part of the mainstream."[86]

Indeed, the report found that "changes are needed in a host of areas—housing, transportation, education, health care—but reform is particularly needed in the area of poverty," which threatened to create a permanent underclass that could undermine New York's well-being, leaving "a city in which peace and social harmony may not be possible."[87] Some of the report's recommendations were aimed at solving that problem, such as the need to overhaul the public education system, but the report also addressed a wide spectrum of other issues: it identified a dire need for more affordable housing; it recommended alternatives to prison such as house arrest; it called for tolls to be collected at the four East River bridges to discourage unnecessary automobile traffic; and it advocated the appointment of a special prosecutor to eliminate corruption in the construction industry. Published as the city's—and nation's—economy was about to be plunged into deep recession, *New York Ascendant* was largely ignored.

The transformation of New York's social condition was paralleled by that of its urban condition. Continuing the boom

that had begun in the late 1970s, over 50 million square feet of new office space and 106,000 units of new housing were built in the city during the 1980s. Municipal construction also tripled since the mid-1970s. During the 1980s, the construction industry was second only to business services in the speed of its growth. To meet the demand, construction workers were regularly imported from the suburbs as well as from the South and the Midwest and earnings among those in the industry nearly doubled between 1980 and 1988.[88] In the residential realm, luxury condominiums were the hot product. A November 30, 1985, deadline to qualify for 421a tax abatements, reducing property taxes for ten years on new buildings below Ninety-sixth Street, led to a frenzy of construction. In 1986 the Real Estate Board of New York estimated that there were 20,000 new apartment units under development, more than the total of the previous five years. That year, 11,341 apartments were completed and in 1987, 12,388 more came to market. In 1988, however, only 4,510 apartments were under development.[89] At its peak, the residential market was so competitive that developers went to great lengths of gimmickry in selling their wares. In addition to the full-page advertisements for new apartment buildings that dominated the *New York Times*'s Sunday real estate section, Ian Bruce Eichner, a newcomer to the field of property development, took the unusual step of running television ads for his building, Cityspire (see 6½ Avenue), which featured the fading top model Lauren Hutton and the 1940s movie star Van Johnson but were solely intended to create hype: "We didn't even tell people it was a building," he stated.[90]

After the Boom

In addition to the expiration of the 421a tax abatements in 1985, the tapering off of residential construction resulted from a lack of available sites in top neighborhoods leading to a market of greatly increased land prices. Construction prices, which skyrocketed by about 50 percent between 1984 and 1988, also had a cooling effect and little new came on-line until the late 1990s. The office boom lasted a bit longer, although the financial district felt the effects of a flooded market early on as a result of the October 1987 stock market crash. Adding insult to the injured downtown market, as David Dunlap reported, "The 90's began on the surprising note of Drexel's collapse," referring to the downfall of the investment banking firm Drexel Burnham Lambert, which led to its abandonment of 1.4 million square feet of downtown office space.[91] In 1990 the Real Estate Board of New York reported that, for the first time since 1982, no new office buildings would open downtown, while the Julien J. Studley brokerage firm reported that in the same year no new office buildings were expected to break ground downtown.

By this time, the situation was no better in West Midtown, where the bulk of midtown development was occurring because of the creation of the 1982 Special Midtown Zoning District. A late surge in construction had begun in 1988 as developers rushed to complete foundations in order to take advantage of the 20 percent height or density bonus that expired in May of that year. As these buildings were breaking ground, 14 percent of midtown's 225 million square feet of office space was vacant—the highest vacancy rate in almost a decade.[92] A 1988 report issued by Cushman & Wakefield warned, "Unless the financial markets settle, the flurry of buildings arriving on the market in the next two years will

Americas Tower, 1177 Sixth Avenue, between West Forty-fifth and West Forty-sixth Streets. View to the northwest of unfinished building, 1990. Krulwich. NYT

find a thinner tenant market than was anticipated just six months ago."[93] Such proved to be the case. By December 1989, eleven more office buildings had come on line containing 6 million square feet, and the vacancy rate in West Midtown had risen to about 16 percent. Only half the space in the new crop of towers was filled. Referring to buildings that had been rushed to construction before the 1988 deadline, the *New York Times* reported in July 1990 that "so many new towers are rising on the West Side of Manhattan that it is hard to believe the boom is over."[94] But indeed it was. Among the most visible signs of disaster were 1585 Broadway, 750 Seventh Avenue, and 1540 Broadway, a trio of Times Square buildings completed in 1990 that each went bankrupt within three years of completion for a lack of tenantry. The amount of vacant office space in midtown Manhattan in 1990 amounted to more than the total combined office space in Portland, Oregon, Seattle, Washington, and Tampa, Florida. Work on the Americas Tower, on Sixth Avenue between Forty-fifth and Forty-sixth Streets, was halted in 1989 when its consortium of developers was unable to obtain additional funding and began to battle among themselves for control of the project. The building wasn't completed until 1994, all the while standing, as David Dunlap put it, as "a three dimensional symbol of the end of the 1980's building boom."[95]

Most observers welcomed the slowdown with open arms. Architects, critics, and community groups alike seemed to have been caught off guard not only by the rapid pace of development and its sheer volume, both of which were deemed detrimental to the city, but by the inability of regular citizens to have any say whatsoever in the process. A new relationship had been forged between the city and the development community that virtually ignored the public. And zoning, meant to control development for the benefit of the public realm, had become a negotiable menu of bonuses and add-ons in which variances could be purchased from the city if the price was right. Ada Louise Huxtable sounded the alarm in March 1987:

> What is new and notable in New York City's unprecedented building boom is that all previous legal, moral and esthetic restraints have been thrown to the winds, or more accurately, to the developers, in grateful consideration of contributions to the tax base and the political purse. . . . This reorientation of priorities has created a climate in which zoning controls developed and tested over 70 years no longer have credibility or support; their exploitation is active policy. The city is wide open. Greed has never been so chic. The public interest has never been so passé. . . . The city is now selling itself to the highest bidder.[96]

Each major development proposed, according to Huxtable, like the redevelopment of the Coliseum site and Philip Johnson and John Burgee's proposal for Times Square,

> runs a predictable course in a familiar, almost ritual drama. First, there is the announcement of a scheme so overdone or grotesque that there is an immediate outcry. The plan is then withdrawn for redesign and/or renegotiation. This leads to the reduction of a few of the excesses that were bargaining chips in the first place, so the developer still gets essentially what he wanted. These modifications are accepted as a compromise, which they are not. Public hearings follow in which community boards (advisory), public interest groups (honorary), and private citizens (powerless) make their opinions known. There may be lawsuits to stop the project and a few red herrings to divert attention from any real issues involved. If the opposition seems strong, a builder or client will announce that he is going to another city. That sets the stage for capitulation; after some political posturing at the Board of Estimate, the project is approved.[97]

Paul Goldberger, writing two months later, picked up on Huxtable's concerns:

> Once, there was a time when the city of New York saw its responsibility for physical planning as a simple mandate: to limit growth. The idea was not to restrict it unreasonably, or to meddle excessively with the forces of capitalism, but to guarantee that those qualities of urban living that are of public benefit, such as light, air, sunshine and a sense of comfortable scale, did not disappear. It was implicitly understood that the private sector, acting on its own, had little incentive to preserve these things, and that it was the responsibility of the city to do so instead. That is the premise on which zoning laws are based: that for the common good the city has the right to limit what an individual owner may do on his land . . . The city is no longer our protector, but a full-fledged participant in the orgy of Manhattan real-estate development. This is the sad truth—that the municipal Government, which at its best should be a moral force for good development, has shown so little interest in anything except accommodation. It is not the job of private developers to set limits; it is their job to

FACING PAGE Midtown Manhattan, looking southwest from about East Sixtieth Street and Lexington Avenue, 2000. Goldberg. ESTO

make money. It is the function of the city to represent the public interest and forge into the building process the values that matter, which often means drawing the line. And that is just what the city has chosen not to do.[98]

Density and scale aside, many critics were less than thrilled by the architectural quality of what was being built. Huxtable specifically cited the Equitable Center, Fifty-third at Third, the AT&T Building, E. F. Hutton, and 60 Wall Street as examples of the "'signature building,' a postmodernist phenomenon that combines marketing and consumerism in a way that would have baffled Bernini but is thoroughly understood by the modern entrepreneur."[99] Rem Koolhaas would later write that in this era's "state of narcissism, Manhattan's architects and developers begin to clone and rip off the most obvious features of the city's pre-WWII architecture. Boxes sprout spires; art deco becomes the new new. A tectonic pornography—over dimensioned displays of excitement, each relentlessly pursuing its own release, an architecture of money shots."[100]

Architect Paul Byard, in his capacity as vice president for architecture at the Architectural League, wrote an op-ed column in the New York Times in February 1987 bemoaning these "disquieting times for architects of New York," arguing that the debasement of civic values in the boom years affected the city's architecture as well, reversing a long-standing commitment of architects to civic concerns. "The curious, conflicted historicism of much of our new work, our confused search for validation in publicity and chic, our exceptional readiness to promote and decorate projects that by ordinary standards should not be built at all—these seem signs of a pervasive trouble. They are symptoms of an unconcealable underlying lack of principle and purpose that is close to embarrassing." Byard attributed this problem at least in part to the economic doldrums, as well as "the end of an important 50-year cycle in the history of building in America and in New York." He noted that New York architects from "the early 1930's to the present decade" were asked to design major civic buildings, housing for middle-income families, schools, parks, parkways, pools, and a host of other reformist buildings. "It was work that was shot through with important questions of moral and social principles that enriched our work and demanded conviction." But, Byard complained, "no one is asking us to do any work like this today. . . . Except for some institutional work, virtually the entire province of new design has been left to corporations indulging their wealth in headquarter monuments of little perceivable social utility." The remedy, Byard believed, was to "focus again on the real questions we ought to be asking: What do we truly want to build and why? What kind of city do we want and why?"[101]

Writing in the New Republic, Herbert Muschamp thoughtfully responded to Byard's op-ed piece, likening architects to "Satan's decorators, hired flunkies retained to outfit this hell with a bit of dash. And the truth is that what may be most embarrassing by today's standards is not the architects' lack of principle; it is their lack of whatever black magic it takes to transmute unprincipled behavior into The Art of the Deal." Although Muschamp "didn't doubt Byard's sincerity," he was "skeptical about the power of his argument to affect the status quo, particularly since his view of the problem rested on a dubious historical premise. Yes, 50 years ago New York did lead the way in the use of architecture for socially progressive ends. And yes, at about the same time American architects

embraced the Modern movement's idealistic program of architecture and urban design. But these two developments do not belong to a single history; they arose from separate visions, each unfolding according to its own internal logic. The first vision was predominantly social, a vision in which 'reformist buildings' were among a range of means employed toward the end of New Deal social reform. The second was a predominantly architectural vision, in which architectural reform was less a means than an end in itself."[102]

Spinning out of Control

Edward Koch easily won reelection in the fall of 1985, capturing an impressive 78 percent of the vote. But his popularity did not endure. The beginning of his downfall could be dated to an incident that greeted his third term in office. On January 9, 1986, Queens Borough President Donald Manes was found bleeding in his car on Grand Central Parkway following a suicide attempt. In the following weeks and months, an extensive and deep-rooted network of corruption and kickbacks among numerous government officials at various levels was discovered.[103] Manes succeeded in a second suicide attempt on March 13, 1986. During the following year, corruption was uncovered in the city's Parking Violations Bureau, Housing Authority, Department of Environmental Protection, General Services Administration, Board of Estimate, and Taxi Commission and by 1987 six of Koch's appointed officials were in jail and nearly 250 lower-level bureaucrats sentenced. As investigative reporters Jack Newfield and Wayne Barrett put it in their book exhaustively chronicling the scandals, New York had turned into a "City for Sale."[104] Although Koch was never personally implicated in any of the financial skulduggery, his reputation as the city's leader was severely compromised.

In addition to the municipal corruption scandals, Koch's reputation was also damaged by several ugly incidents that served to raise racial tensions significantly. On December 20, 1986, in the predominantly white, middle-class Howard Beach section of Queens, Michael Griffith, a twenty-three-year-old African American man, along with his stepfather and a friend, was attacked by a mob of a dozen bat-wielding white teenagers who reportedly taunted them with racial slurs.[105] After the beating, Griffith was chased onto Shore Parkway, where he was hit by a car and killed. Black leaders seized on the assault as evidence of a pervasive problem in the city and not an example of an isolated attack. In August 1989 another African American, sixteen-year-old Yusuf Hawkins, was killed in a racially motivated attack in a predominately white area, in this case the Bensonhurst section of Brooklyn.[106] Visiting the mostly Italian neighborhood in the hope of buying a used car, Hawkins was set upon by an estimated mob of ten to thirty white teenagers before being shot twice in the chest.

Racial tensions and corruption scandals were joined by budget shortfalls. Koch's 1988 budget called for reduced services, higher taxes, and a freeze on city hiring. Jittery New Yorkers were also concerned about the economic fallout from the October 1987 stock market crash. Amid unraveling nerves, the media began to demonize New York in a manner that recalled the situation in the mid-1970s. The April 11, 1988, cover of the New Republic read "NYC, RIP." The issue featured "Rotting Apple," a story by Howard Kurtz, the New York bureau chief of the Washington Post, who had grown up in the city but only recently returned from a decade's residence in Washington: "Now, in the wake of Black Monday,

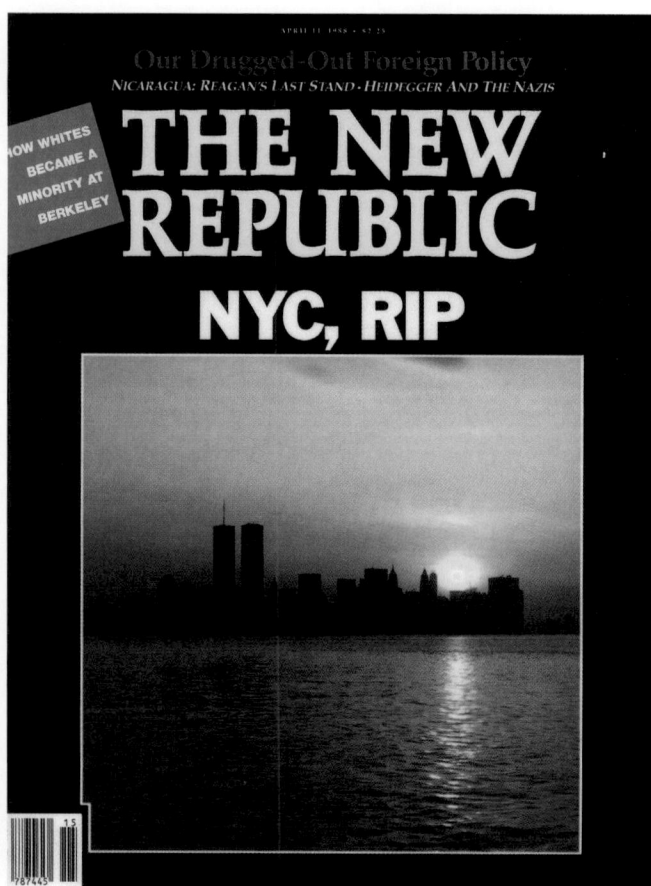

The New Republic, April 11, 1988. SG

the party is clearly over. . . . The fiscal horizon suddenly looks cloudy because New York's economy is more dependent on Wall Street than anyone previously realized." For Kurtz, although New York's "raw magnetism and ethnic diversity make Washington look as bland as white bread . . . the sad truth is that our most fabled metropolis has become an increasingly intolerable place to live, at least as life is normally defined by people beyond the Hudson River." Relating the story of a recent Friday evening subway commuting snafu that stranded 100,000 straphangers, including Kurtz, for several hours, the reporter noted that had this happened in Washington, the incident "almost surely would have made the front page of the . . . *Washington Post*. But the fiasco (which turned out to have been caused by a track fire allegedly set by disgruntled transit workers) rated only a three-inch blurb on page B2 of the next day's *New York Times*. It was, quite simply, not news. How is it possible that a city of such tremendous wealth and energy can, for all but the most fabulously well-to-do, make daily existence so awful?"[107]

Despite the aggravations of urban life, the city continued to be celebrated for its diversity and eccentricities. In 1988 William H. Whyte, a former journalist best known for his study of corporate culture, *The Organization Man* (1956), published *City: Rediscovering the Center*, an in-depth study and ultimately a celebration of the street, which he called "the river of life of the city, the place where we come together, the pathway to the center. It is the primary place." Whyte, who conducted the original studies that ultimately led to the renovation and restoration of Bryant Park, appreciated "the irregu-

lars" on the street: "handbill passers, pushcart food vendors, merchandise vendors, messengers, entertainers, palmists, solicitors for religious causes, blood pressure takers. Then there are the odd people: Moondog, Mr. Magoo, Mr. Paranoid, Captain Horrible, Aztec Priestess, Gracious Lady, Tambourine Woman. Whatever the fantasies they have been acting out they make a beneficent presence on the street."[108]

After twelve years in office, Koch had so outworn his welcome that a revisionist history of his administration seemed to be setting in, with some commentators repressing any memory of Koch's earlier popularity as well as the triumphs of his first two terms in office, including his stewardship of the city out of the fiscal crisis. In 1989 Marshall Berman blamed "the demagogic genius of the man himself: his aggressive bluster and meanness, his cosiness with the city's winners and contempt for its losers, his flair for pouring oil on the fire of every stored-up race and class hate, his ability to lower the level of political discourse to primitive eruptions of fear and rage."[109]

Clearly ready for a change, New Yorkers elected former city clerk and Manhattan Borough President David N. Dinkins as mayor in November 1989, the first African American to hold the job. Dinkins defeated Koch in the Democratic primary and narrowly beat his Republican opponent, Rudolph W. Giuliani, in the general election, winning 90 percent of the black vote, 73 percent of all Hispanics but only 27 percent of the white vote. Unfortunately for Dinkins, the economic decline that began in Koch's third term only worsened. Faced with a $1.8 billion deficit, Dinkins, after only three days in office, delayed the hiring of 1,800 police officers, ordered $200 million in spending cuts, and raised the possibility of tax increases. In addition to a declining economy, crime in the city also took a turn for the worse. In 1990 a record number of murders were committed in the city, with 2,262 homicides, or about six killings each day.[111] Robberies and subway crime also rose. One particularly prominent tragedy that received national attention was the September 3, 1990, murder of twenty-two-year-old tourist Brian Watkins, visiting from Provo, Utah, to see the U.S. Tennis Open.[112] Watkins was stabbed to death in a midtown subway station as he defended his father and mother from a group of muggers. Four days later, the *New York Post* captured the feelings of many frustrated New Yorkers in a memorable headline that ran across the entire front page in two-inch-high block letters: "Dave, Do Something!"[113] *People* magazine put the Watkins story on its cover and reporter Tom Morganthau wrote in *Newsweek* magazine that "news of yet another spectacularly senseless crime seemed to put the whole city on edge. . . . It was every tourist's nightmare—and it was New York's latest nightmare, too." Morganthau concluded that the murder has "already become a symbol of the Dinkins administration's inability to control crime."[114] Or, as Joelle Attinger put it in a *Time* magazine cover story entitled "The Decline of New York": "Outside the city [the Watkins murder] confirmed what most Americans already believed: New York is an exciting but dangerous place. Among New Yorkers it reinforced the spreading conviction that the city has spun out of control."[115]

Although partially elected in the hope that he would bring racial harmony to the city, Dinkins, who repeatedly referred to New York as a "gorgeous mosaic," presided over a city that continued to be ethnically polarized, with two major incidents setting the turbulent tone. The first was the so-called

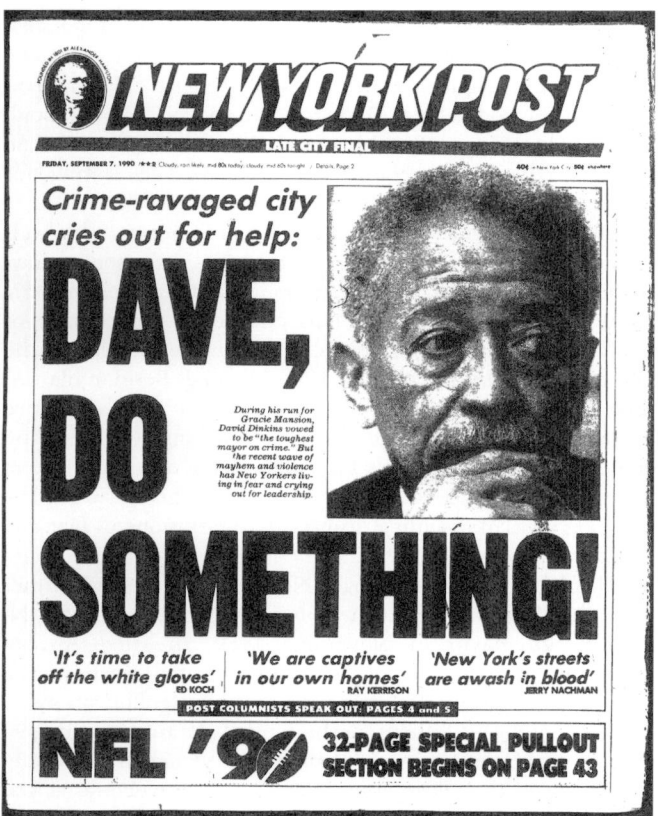

New York Post, September 7, 1990. NYP

Korean Boycott.[116] In January 1990 a Haitian immigrant got into an argument with the Korean owners of a grocery and produce store in the Flatbush section of Brooklyn that quickly escalated into an ugly fight between black residents and two local Korean-owned delis, resulting in a boycott of both stores, with demonstrators outside the shops successfully convincing shoppers to stay away. Recent Korean immigrants controlled over 1,500 grocery stores and 500 fish markets throughout the city, and the confrontation threatened to extend beyond the borders of Flatbush. The boycott lasted for nearly a year and Dinkins was widely criticized for his inability to bring the two sides together. The other nationally publicized racial incident was deadly. On August 19, 1991, in the Crown Heights section of Brooklyn, a car in the entourage of the Lubavitcher Grand Rabbi ran a red light and went out of control, hitting and killing seven-year-old Gavin Cato, the son of a Guyanese immigrant.[117] Tensions were already high between the neighborhood's two dominant groups, Hasidic Jews and blacks, many immigrants from the Caribbean. Four days of rioting quickly ensued after a rumor circulated in the community that a Hasidic ambulance crew had come to the accident scene but tended only to an injured Hasid and ignored the dying child. Sixty-six civilians and 173 police were injured, and, most consequentially, there were two murders. A twenty-nine-year-old visiting rabbinical student from Australia named Yankel Rosenbaum was surrounded by a mob chanting anti-Semitic remarks before being stabbed by sixteen-year-old Lemrick Nelson. And in a case of mistaken identity, sixty-seven-year-old Anthony Graziosi, who sported a full beard and was wearing dark clothing reminiscent of the garb favored by ultra-Orthodox Jews, was dragged from his car and stabbed to

death. Again, Mayor Dinkins was lambasted for his lack of action and ineffective leadership.

New York was particularly hard hit by the recession of the early 1990s, with the city accounting for nearly 25 percent of all the jobs lost nationally. With the end of the eight-year economic boom, many believed that the recent strides in attracting the young and middle class to the city were in danger of being lost. Worries over rampant crime were joined by concerns about basic quality-of-life issues as budget cuts reduced basic services such as library hours and street cleaning.[118] Dinkins's few initiatives, such as raising taxes, also backfired. As the situation continued to deteriorate and Dinkins did little to inspire confidence that he would be able to lead the city out of its troubles, people began to take it upon themselves to find their own solutions. On November 26, 1990, *New York* magazine's cover read "How to Save New York."[119] Inside, thirty-nine personalities, businessmen, politicians, and intellectuals offered advice. The issue came fifteen years to the week after *New York* had published a special issue timed to the fiscal crisis headlined "We've Got to Help Ourselves!" While columnist Bob Herbert believed that a reduction in crime rates was critical, cartoonist and writer Jules Feiffer recommended legalizing drugs, and sociologist Herbert Gans argued for more unskilled and semiskilled jobs. One month later, the *New York Times* entered the fray with a series of eleven editorials entitled "To Restore New York City," suggesting specific steps that should be taken to bring the city back to health, addressing issues like crime, sanitation, homelessness, summons collection, and improving facilities for the mentally ill.[120] A poll taken by the *Times* at the end of 1991 only confirmed the worst: 58 percent of city residents predicted that the city would be a worse place to live in the next ten to fifteen years, the highest level of dissatisfaction registered since the question was first asked in 1973. And 60 percent of those polled said that, if they were able to, they would leave the city. Only one person seemed to be taking the decline in stride. Ed Koch commented on the downturn with his characteristic caustic wit: "The people threw me out and the people must be punished."[121]

Although Dinkins's calm demeanor and civility were acknowledged, the public was, as Kent Barwick, president of the Municipal Art Society, put it, "hungry for leadership. Today many have the feeling, 'I don't know who's in charge here.'"[122] In his defense, Dinkins had the added challenge of

"I'm afraid I wasn't watching my speed, Officer—we're fleeing from New York."

trying to govern in a dramatically altered political environment. On August 27, 1990, the Board of Estimate was abolished, replaced by a new arrangement that distributed the board's formidable power between the mayor and an expanded, more unwieldy, and suddenly potent City Council.[123] The previous March, the United States Supreme Court had unanimously ruled the Board of Estimate, whose origins dated back to the creation of the modern city in 1898, unconstitutional. Since five of its eight members were borough presidents (the others were the mayor, the comptroller, and the president of the City Council, all elected in citywide contests) and because the boroughs differed so dramatically in population, the composition of the board was deemed in violation of the principle of one person, one vote.

Attack on the Trade Center: 1993

The city's image and reputation suffered an additional setback at 12:18 P.M., on February 26, 1993, a wintry day with light snow flurries, when a car bomb placed on the second level of the four-level underground parking garage beneath the World Trade Center complex exploded, killing six and injuring more than 650 others.[124] Robert D. McFadden, writing in the next day's issue of the *New York Times*, described the blast as possessing the "force of a small earthquake . . . , collapsing walls and floors, igniting fires and plunging the city's largest building complex into a maelstrom of smoke, darkness and fearful chaos." He added that the explosion, which "was felt throughout the Wall Street area and a mile away on Ellis and Liberty Islands in New York Harbor, also knocked out the police command and operations centers for the towers, which officials said rendered the office complex's evacuation plans useless."[125] Mayor Dinkins was not in the city at the time of the incident. He was visiting Japan for the purpose of attracting new business, ironically trying to convince the Japanese that New York was not a dangerous place. The event captured the city's and the nation's attention for the next several weeks, dominating the local newspapers and the national news magazines.

Minoru Yamasaki's twin towers weathered the bombing remarkably well, encouraging Joe Mysak, in his 1997 history of the Port Authority, to contend that

> few buildings would have survived the blast endured by the World Trade Center. The design, unlike in most skyscrapers, makes use of hundreds of columns to form the tower perimeters. Groups of columns, in turn, converge into 'super' box columns of high-strength structural steel, which descend into bedrock. These columns are strengthened further by diagonal beams that brace the building from windsway. So resilient is this design, it deflected the bomb's force even at ground zero. While the parking garage floors around the super columns collapsed and fell into a crater five floors deep, even the super column six feet from the bomb sustained little damage.[126]

Remarkably, only a week after the explosion, one-third of the Trade Center was back open, including many concourse retailers. Tenants in Two World Trade Center returned to their offices on March 18, 1993, and the north tower was open by the end of the month. The parking garage where the blast originated was back in business in September, with the addition of a concrete-reinforced crash barrier that prevented cars from entering until after they had been inspected. The Vista Hotel, with more extensive structural damage, remained shuttered for more than twenty months because its owners decided to use the tragedy as an occasion to extensively renovate the facility. In the same vein, the operators of Windows on the World, the bar and restaurant on the 106th and 107th floors of One World Trade Center, decided to close the Warren Platner–designed space, although it suffered no damage beyond a layer of dust, to make way for a new restaurant and bar designed by Hugh Hardy.

Six days after the attack, Mohammed A. Salameh, an illegal Palestinian immigrant living in Jersey City, was arrested for the bombing. Salameh, a follower of Sheik Omar Abdul Rahman, a blind Islamic cleric tied to the assassination of Egyptian president Anwar el-Sadat, was traced to the crime when he tried to retrieve the rental deposit left on the van that carried the explosive device. Three other conspirators were quickly picked up. The four defendants were found guilty on all counts in March 1994 after a five-month trial. Perhaps it was the resiliency of the Trade Center buildings themselves and their quick reopening, or perhaps wishful thinking that the bombing was an aberration, an isolated incident of madness instead of the beginning of a terror campaign on American soil, or maybe it was simply the unprecedented nature of the second tragedy eight years later, but the city and the nation at large, though forewarned, were not prepared for the horror of the Trade Center's ultimate collapse on September 11, 2001.

Getting the City's House Back in Order

In November 1993, David Dinkins was narrowly defeated in his bid for reelection by Rudolph W. Giuliani, the man he had beat four years earlier.[127] Campaigning on a platform of fiscal responsibility as well as a commitment to quality-of-life concerns, including a significant reduction of the record-setting crime rates, Giuliani, the former United States Attorney for the Southern District of New York best known for his prominent convictions of organized crime figures and white-collar criminals, captured 50.7 percent of the vote, which, like the 1989 contest between the same candidates, was again divided along racial lines, with Dinkins getting more than 90 percent of the black vote and Giuliani taking over 75 percent of the white vote. The forty-nine-year-old Giuliani, who became the city's first Republican mayor in twenty-eight years, benefited from the endorsement of two prominent Democrats, former Mayors Ed Koch and Robert F. Wagner Jr. The key factor in the election was the high turnout of voters in the city's most Republican borough, Staten Island, who were motivated to go to the polls in greater numbers because of a nonbinding referendum on the borough's possible secession from the city, which was approved by 65 percent of Staten Islanders.

The 1993 election also featured the successful passage of a referendum that limited city officials, including the mayor, comptroller, public advocate, borough presidents, and City Council members, to two consecutive four-year terms.[128] The term limits agreement, which reflected a national trend against incumbents and career politicians, was supported by cosmetics heir and one-time candidate for mayor Ronald S. Lauder, who spent more than $1 million in promoting it. Not surprisingly, the referendum was opposed by most of the political establishment. The editors of the *New York Times* also weighed in against term limits, which they feared would wreak havoc: "The timing is terrible. City officials and Council members have not yet had a full cycle of experience in their new roles under the revised City Charter. The new Charter eliminated the formerly dominant Board of Estimate,

greatly enhanced the Council's power and created a new bipolar mayor-Council relationship. To make another radical change this soon is an invitation to sloppy government."[129]

Despite his narrow victory, Giuliani seized on the results "as a mandate," according to his most objective biographer, political reporter Andrew Kirtzman, "not just to govern New York City but to save it. He was about to usher New York into a new, unromantic era."[130] In the wake of Dinkins's timidity to lead, Giuliani sensed that New Yorkers wanted an activist mayor who would decisively deal with problems. As Giuliani himself put it in his inaugural address: "The era of fear has had a long enough reign. The period of doubt has run its course. As of this moment the expressions of cynicism—New York is not governable, New York is not manageable, New York is not worth it—all of these I declare politically incorrect."[131]

Giuliani took control of a city that, as Fred Siegel, a former editor of the *City Journal* and a professor of history at Cooper Union, put it, "stood on the edge of social and economic breakdown," with an unemployment rate that, at 13.4 percent, was one of the nation's highest and nearly double the national average.[132] Faced with a budget deficit of $2.2 billion, the mayor first tightened the city's fiscal belt, proposing $1.2 billion in spending cuts, the elimination of 15,000 municipal jobs, and substantial increases in worker productivity.[133] Although Giuliani inherited a city with serious economic problems, he was fortunate to take office at the conclusion of a recession. A task force from the outgoing Dinkins administration recommended raising taxes to meet expenses, but Giuliani took the opposite tack, first cutting property taxes for co-op and condominium owners and then lowering the hotel occupancy tax, the unincorporated business tax, and the commercial rent tax. On a far more controversial level, Giuliani began a reform of the city's welfare system in 1995, earning him the wrath of many who deemed the measures at best insensitive and possibly inhumane.[134] In addition to more carefully checking the eligibility of potential welfare recipients, who numbered 1.1 million in 1993, the city instituted a comprehensive workfare program, assigning those on Home Relief menial jobs in city offices, hospital wards, and parks. By the time President Clinton signed national welfare reform legislation in 1996, the city's workfare program was the largest in the country and more than 125,000 people had passed through it. The editors of the *New York Daily News* heartily endorsed the plan: "A quiet revolution is taking shape in the city's parks, courthouses and vacant lots. Thousands of people on welfare are working for several hours a day to make those places more usable and enjoyable for all New Yorkers. They are doing something else, too: They are changing forever the face and nature of welfare in New York City. Savor the moment: something badly broken is being fixed."[135] In two years' time, Giuliani's new measures reduced the welfare rolls by 250,000, saving the city, the state, and the federal government some $475 million in annual expenses.

In addition to fiscal austerity measures and tax cutting, Giuliani's other major move was a full frontal assault on crime. The groundbreaking strategy, devised in concert with Police Commissioner William J. Bratton and Deputy Commissioner Jack Maple, relied heavily on computer statistics to more effectively track crime rates among seventy-six widely scattered police precincts.[136] With the use of these so-called Comstat numbers, police brass were not only able to more closely monitor evolving crime patterns but also to demand an unprecedented level of accountability from individual precinct commanders. Another aspect of the new strategy was a "zero tolerance" policy whereby even minor violations and nuisance crimes were treated with the utmost attention. In essence a variation on political scientist James Q. Wilson's "broken windows" theory that posited that an unrepaired window only invited the destruction of all the others near it, the zero tolerance approach not only had the benefit of demonstrating to New Yorkers that the police were carefully watching the streets but also, according to Bratton, would also help reduce more serious crime. Referring to the new crackdown on subway turnstile jumpers, Bratton pointed out that more than 5 percent of those caught were carrying dangerous weapons and an even larger percentage were wanted for felonies.

The most celebrated example of the zero tolerance campaign was Giuliani's effort to eliminate the "squeegee man" problem.[137] At innumerable intersections throughout the city, especially at major bridge and tunnel entrances and exits, a wave of squeegee men had appeared. Often homeless and disheveled in appearance and wielding filthy rags or discarded newspapers, they would approach a car stuck in traffic or at a red light and ask—others would describe it more as a demand—that the car owner offer a tip for the "service" of having his or her windshield cleaned. In addition to the fact that the windshields often ended up dirtier after the alleged cleaning, many people felt threatened and intimidated by the squeegee men, who presented an awful image of the city, especially to out-of-towners visiting New York for the first time on pleasure or business. Although the squeegee men seemed to have overrun the city, it turned out there were only about 200 of them, many with criminal records and a history of drug or alcohol abuse. After finding an existing statute that prohibited approaching a driver for the purpose of washing a windshield, undercover cops and uniformed officers went after the squeegee men. If they continued to ply their trade after a warning, the police issued summonses. The most persistent offenders were eventually arrested and given a day in jail. Norman Siegel, head of the New York Civil Liberties Union, strongly protested the strategy, but Giuliani was not deterred. The campaign against the squeegee men was so successful that in May 1996 *New York Daily News* reporter Michael Daly could pen a tongue-in-cheek column about a rare sighting: "One after another, the motorists peered through their windshields to behold a species of urban life widely believed to be extinct. The species was Homo Squigiorum, the once-ubiquitous Squeegee Man. They are now as scarce as reindeer, and the motorists who passed along W. 33d St. late Friday afternoon no doubt thought they had seen the last of them."[138] Other violators of nuisance misdemeanors that the police targeted included aggressive panhandlers, street prostitutes, and illegal street vendors who clogged crowded city sidewalks.

Giuliani and Bratton's crime-fighting campaign quickly produced dramatic results on all types of lawbreaking in the city, including the most serious offences.[139] In 1996 the overall crime rate fell for a third consecutive year and was 39 percent lower than in 1993, the last year of Dinkins's mayoralty. The number of homicides in 1996 dropped to 985, the lowest since 1968 and down from 2,005 in 1992. Major felonies, including assault, auto theft, burglary, grand larceny, and rape also had sharp declines. Even notoriously dangerous neighborhoods, such as the Brownsville section of Brooklyn, saw significant drops in the crime rate. As Fred Siegel pointed out:

"Across America, crime dropped 5 percent between 1993 and 1996; in New York City, it fell 35 percent—which is to say that New York alone accounted for one third of the national drop."[140] The Giuliani administration also had success in combating organized crime, with highly publicized cases involving the construction industry, trash hauling, and the Fulton Fish Market that led to racketeering convictions. Although some naysayers pointed to such factors as a diminishing of the crack epidemic, an aging population, and the additional cops hired under Dinkins's Safe Streets, Safe City program as a way to explain the drop in crime, most observers credited Giuliani and Bratton with a job well done.

The results of Giuliani's "tough love" approach were widely appreciated and extensively reported in a rash of articles: in *New York* ("The Suddenly Safer City"), *Business Week* ("A Safer New York City"), *Maclean's* ("Why the Big Apple Feels Safer"), and *Time* ("Safe? You Bet Your Life"). The January 15, 1996, issue of *Time* featured a cover story, "One Good Apple," that applauded the Giuliani-Bratton strategy. The magazine placed Bratton on the cover, setting off a fierce battle of egos between the mayor, who didn't enjoy sharing center stage, and his police commissioner, who left the department two months later, at the end of March 1996.[141] Although Bratton's deputy, Jack Maple, soon followed, the policies that they had established remained in place and crime rates continued to plummet. In 1998 the city ended the year with only 620 homicides, fewer murders than were recorded in the city of Chicago, whose population was dwarfed by New York's by over four and a half million people. Of the 200 United States cities with populations of 200,000 or more, New York City ranked 163rd in per-capita crime in 1998.

Giuliani's commitment to quality-of-life issues also included two cleanup campaigns, one of which was literal. In 1994 the city brought back street cleaning on Wednesdays and Saturdays, a casualty of Dinkins's budget cuts three years earlier.[142] The Sanitation Department also instituted productivity reforms, cutting the time it took to clean a residential street from three hours in 1993 to ninety minutes in 1996 and reduced by half the amount of time needed for commercial areas. The far more significant cleanup, which would ultimately help lead to a reinvigorated Times Square and Forty-second Street, was the attempt to reduce the number of sex-related businesses in the city through zoning reform.[143] At the end of 1993, before Giuliani took office, 177 sex-oriented businesses were in operation in the city, a 35 percent rise from the 131 counted in 1984. Video stores and peep shows had tripled and topless bars had increased by 26 percent but the number of theaters showing pornographic films had fallen by more than 50 percent, testament to the growing popularity of home video. In September 1994 Giuliani proposed comprehensive changes to existing zoning regulations to prohibit adult video stores, topless bars, and theaters showing X-rated movies from operating within 500 feet of residences, houses of worship, schools, or one another. Later refinements to the zoning, which were adopted by the City Council in October 1995, included the so-called 60–40 provision, which limited to 40 percent the space in a store or club devoted to adult entertainment. The editors of the *New York Times* endorsed this "reasonable" measure, calling it "a realistic attempt to limit the harm done to neighborhoods by pornography shops without denying customers reasonable access to X-rated materials or trespassing on the rights of affected businesses."[144]

View to the southeast of West Forty-second Street between Eighth Avenue and Broadway, 1997. Aaron. ESTO

Although the plan was extensively challenged in the courts by First Amendment activists such as the New York Civil Liberties Union, as well as by a coalition of owners of adult operations, in January 1999, the legality of the new zoning was upheld by the United States Supreme Court. The sex shops and clubs, however, proved remarkably resilient. Exploiting the 60–40 provision, many were able to remain open. In January 2001, despite the very public cleanup around Times Square, a total of 142 adult businesses remained open throughout the five boroughs, only two less than in 1998.

Brighter Lights, Bigger City

In October 1996 the *New York Times* reported that "the economy of New York City, which has foundered since the recession of the early 1990's, has begun to crawl back toward prosperity, largely because of rising profits on Wall Street."[145] As the Dow Jones Industrial Average climbed to ever greater heights, the city took in hundreds of millions more in taxes than projected. Although the unemployment rate was 9.9 percent—the highest of the twenty largest urban centers in the United States—44,500 new jobs were created in 1996, the greatest increase since the 1980s. In all, the private sector created about 141,000 new jobs since the end of the recession but the government had shed 60,000 positions, leaving the municipal bureaucracy leaner and municipal finances rosier. Nonetheless, the city had not recovered the 361,000 jobs lost during the recession, nor had the financial services sector quite regained the health it enjoyed during the 1980s, despite Wall Street's boom. Other sectors of the economy, however, picked up unexpectedly, including manufacturing, which, after years of decline, was making a surprise comeback. In the Bronx, the Bathgate Industrial Park, begun in the 1980s, reached full capacity with the construction of a tenth building beginning in 1994, by which time the complex employed nearly 1,500 workers. Joseph Rose, director of the City Planning Commission, noted in 1996, "For the first time, we're seeing across-the-board growth in trucking, warehousing, retail, wholesale trade and air transportation. The gains are modest but they represent an end to what had been long years of decline."[146]

Signs of renewal could be seen throughout the city. The creation of Empowerment Zones by the federal government in December 1994 helped some of New York's troubled neighborhoods regain their health, providing $300 million in development funds and $250 million in tax incentives to be spent over ten years in areas including parts of the Bronx and Upper Manhattan, but most dramatically affecting Harlem, where, although progress was delayed until 1996, 125th Street underwent a remarkable revitalization during the late 1990s. The South Bronx overcame its reputation as an area of urban blight as neighborhoods of litter-strewn lots and abandoned houses were reclaimed.[147] At the city's core, the rebirth of Times Square and Forty-second Street was the most obvious symbol of New York's ability to turn itself around. In December 1996, *New York Times* reporter Andrew Jacobs wrote, "This was the year the glare of the Great White Way became blinding. As the Walt Disney Company and other purveyors of wholesome entertainment rushed in for a chunk of the new Times Square, the once-pervasive sign of sleaze nearly disappeared. Once a textbook case for urban decay, Times Square has become a paradigm of inner-city renewal. . . . Camera-toting tourists have replaced the pimps, hucksters and three-card monte deal-

ers on the neighborhood's sidewalks."[148] James Traub, another *New York Times* reporter who would later go on to publish a book about Times Square, gave the lion's share of credit to Mayor Giuliani: "This new Times Square is the emblem of Giuliani's safe, clean, family-friendly New York."[149]

With reduced crime and an improved image came an increase in tourism.[150] In 1996, 30.3 million visitors came to New York, the highest ever in a year, more than half of them domestic vacationers. Hotel occupancy rates were at 86 percent, the highest figure in sixteen years. The 1996–97 Broadway theater season grossed a record $499 million, compared with $239 million five years earlier. Two hundred seventy-six new restaurants opened in 1997, and museums reported soaring attendances.

While visitors experienced the improved city for themselves, New York's improving image was also projected to the world by a steadily increasing number of films shot in the city, films that in 1996 alone generated $2.57 billion in economic activity for New York. Television churned out one popular New York show after another—among them *Seinfeld* (1990–98), *Law and Order* (1990–), *Friends* (1994–2004), and *Spin City* (1996–2002)—all portraying not only an exciting and glamorous city, but a livable one. As Richard Parsons, president of the media giant Time Warner, put it at the end of 1997: "There's been a complete turnaround in the mood of New York. People's confidence is restored, and that's had a big impact on business."[151]

The real estate market also crept back to life. Residential rents increased sharply in 1996 and co-op and condo prices began to rise after years of stagnation.[152] That year, vacancy rates in midtown office buildings fell to 11.8 percent, down from 17.2 percent in 1992, while the vacancy rate in the perennially troubled lower Manhattan business district fell to 15.2 percent from 20.2 percent in the same period. The commercial market revived during the mid- to late-1990s with the construction of new office buildings and hotels as retailers enjoyed heavy traffic.[153] Between 1992 and 1997, the number of available stores for rent declined from 3,300 to 1,700. Aside from newly vitalized retail areas like 125th Street and Times Square, New York's old retail strongholds were also revived. Between 1992 and 1997, the average rent per square foot on Madison Avenue rose from $250 to $450. In 1996 Fifty-seventh Street was hopping, with plans in place for new "theme" stores as well as glamorous fashion emporia such as that of Chanel, which was completing construction of an office building between Fifth and Madison Avenues, and LVMH, beginning construction of its own building next door.

The "New Media"

The most unexpected boon to New York's economy during the 1990s was the so-called new-media industry, which took root in 1995 and developed into the city's fastest-growing economic sector.[154] The term "new media," according to the accounting firm Coopers Lybrand, which undertook several early studies of the emerging industry, could be applied to any business combining "elements of computing technology, telecommunications and content to create products and services which can be used interactively."[155] For a time, the explosive growth of new-media companies, not only in New York but also in San Francisco, Austin, Texas, and the Virginia suburbs of Washington, D.C., was so enrapturing that it seemed it would render obsolete the ballyhooed service economy of the

1980s, with information and ideas taking precedence over hamburger flipping and stock trading.

In New York, the new media arrived late but took hold in a unique way. Between 1995 and 2000, jobs in the new-media industry grew from 27,000 to 138,000, making it a bigger employer than the banking, construction, legal services, or apparel industries. Part of the reason this technological industry took the city by surprise was that the development of computers, software, and high-technology products was traditionally confined to the West Coast, particularly the region south of San Francisco known as Silicon Valley. It wasn't until the emergence of the World Wide Web during the second half of the 1990s that New York's pool of creative talent, working in fields like advertising, publishing, finance, and graphic design, was called upon to come up with content that could bring to life the technologies developed in Silicon Valley. As Ian Fisher put it in the New York Times: "If San Francisco is home to techies who dream up the codes that make the World Wide Web work, New York is becoming the acknowledged new home for those who create the pictures, the stories, the advertising copy that makes someone actually want to call up a home page or buy a CD-ROM."[156]

In 1993 Robert Stein moved Voyager, his multimedia publishing company, from Santa Monica, California, to SoHo in what was considered to be a strong vote of confidence for New York. An even bigger moment arrived in 1995, when four of the nation's largest online computer service companies, Prodigy Services Company, Delphi, America Online, and CompuServe, announced that they would open offices in New York. Writing about Prodigy's move in the New York Times, Jacques Steinberg noted that lower Manhattan "is fast becoming a national center of the fledgling multimedia industry."[157]

As the World Wide Web exploded in popularity in 1995, a year during which the number of Web sites doubled every fifty-three days, applications to New York University's Interactive Telecommunications program quintupled, and the New York Times estimated that 100 new-media companies had opened in lower Manhattan in the previous eighteen months. Janet Allon, a reporter, described the atmosphere: "This world has a gold-rush feel, replete with the desperate to succeed, the entrepreneurs, the schemers, and the hangers on, the people who show up at the parties, carry copies of [the magazine] Wired around but never actually go on line, the corporate recruiters hungry to land the digitally gifted who will usher their company into the new media age."[158]

The city was optimistic about the new media's power and potential influence. Clay Lifflander, president of the New York City Economic Development Corporation, estimated in 1995 that "it is already a $1 billion industry, and that will probably grow to around $2 billion within the next five years."[159] In fact, Coopers Lybrand, in a study commissioned in 1996 by the Empire State Development Corporation, found that the size of the new-media industry had more than doubled between 1993 and 1996, by which time it was a $3.8 billion industry with more than 4,200 companies, mostly small entrepreneurial firms which, taken together, employed 18,000 workers in Manhattan—more than its "old-media" counterparts such as the television, newspaper, and book publishing industries.[160]

Most of the new-media action was taking place in "Silicon Alley," a name reportedly coined to describe not so much a geographical location like its California progenitor, but a kind of business.[161] In an attempt to map Silicon Alley, Coopers Lybrand defined it as including those new-media companies located below Forty-first Street in Manhattan. The loft spaces of Tribeca and SoHo were the most popular locations for new-media companies early on, but by the late 1990s Silicon Alley firms generally clustered on or near Broadway in the Flatiron district and in the financial district, where they could take advantage of extraordinary infrastructure set in place to benefit the financial services industry. That so many companies in an emerging industry, let alone the high-tech industry, conglomerated near one another put the lie to old fears that technology would contribute to the decentralization of business districts.

The Internet boom was wildly entrepreneurial in spirit. Start-up companies typically had ten to twenty employees, most of whom were part of a generation younger than their yuppie counterparts in the 1980s. Populated by recent college graduates and others who were simply disenchanted by their chosen fields which often had little or nothing to do with technology per se, the typical Silicon Alley firm rewarded notoriously long work hours with a laid back work environment, frequent parties, and, as the industry grew, the promise of stock options that could lead to untold wealth.[162] Yet the early days of the Internet boom were not about reaping financial gains—in 1996 the average new-media salary was $31,500, as compared to $62,500 in advertising—but about taking part in something historical, in which the impact of the work seemed palpable on a global scale.

If Silicon Alley thrived on the creation of virtual realms, it had a very real impact on New York real estate. The wave of start-up companies almost single-handedly revived the decimated downtown office market. In 1996 Carl Weisbrod, president of the Alliance for Downtown New York, commented: "There is no denying the financial industry's loss of jobs since the 1987 stock market crash. But Wall Street is in the midst of a transformation that will place it at the forefront of the information revolution, just as lower Manhattan as a neighborhood will emerge as New York's most exciting area."[163] The lower Manhattan office vacancy rate in 1995 was 20 percent, a figure that by 2000 was reduced to 8.9 percent. The most important building in the new-media industry was the thirty-story, 400,000-square-foot 55 Broad Street (Emery Roth & Sons, 1967), previously headquarters of the disgraced Drexel Burnham Lambert, which in 1990 left the building vacant to stand for five years as a symbol of Wall Street's busted "old" economy. In 1995 Rudin Management purchased 55 Broad Street and hired Fox & Fowle to renovate it with up-to-date telecommunications equipment, reopening it the following year as the New York Information Technology Center.[164] The new facility, benefiting from real estate and rental tax abatements, provided spaces for high-tech businesses of all sizes. It was a raging success, attracting tenants like the California-based Sun Microsystems and Cornell University, which planned to use its space to create virtual-reality environments and demonstrate the uses of the supercomputer to Wall Street. The firm N2K Inc. (for Need to Know), the center's first tenant, doubled its space within a year and doubled it again in 1997 to occupy 40,000 square feet. Seeking to leverage the success of the New York Information Technology Center, in February 1997 Mayor Giuliani announced the Plug 'n' Go program, sponsored by the New York City Economic Development Corporation and the Alliance for Downtown

New York, in which six downtown office building owners agreed to provide state-of-the-art wiring, below-market rents (less than half the going midtown rate), and flexible short-term leases to start-up companies.[165] As Carl Weisbrod explained, "The concept is to fill a niche by developing a Levittown for cyberspace. These are starter homes for young companies."[166] The program included a well-funded marketing campaign to attract companies that wouldn't otherwise have considered entering the Manhattan market. After the first successful year, during which 120,000 square feet of space was offered and fully leased, additional buildings joined the program. By December 1998, Plug 'n' Go had placed 171 new-media companies into roughly 400,000 square feet downtown.[167]

Numerous other downtown buildings were adapted to the new economy, including 75 Broad Street (Louis S. Weeks, 1930), whose owners initially intended to convert the former office building for residential and hotel use but instead leased the floors to telecommunications firms, installing "generator farms" on the seventeenth and eighteenth floors to provide backup power for the building's tenants and using one of the elevator shafts to provide additional riser lines for power and communications cables.[168] The AT&T Building (Voorhees, Gmelin & Walker, 1932), 32 Sixth Avenue, was renamed the New York Global Connectivity Center in 2000 when Fox & Fowle renovated it to provide space for "telcos, dot-coms and major corporations that want to have a new media presence," according to William C. Rudin, whose family had purchased

32 Sixth Avenue, between Walker and Lispenard Streets. Renovation as New York Global Connectivity Center by Fox & Fowle, 2000. View to the southeast. Gordon. FXF

the building after their success at 55 Broad Street. The modernized building featured two 150-foot antenna masts, ten cooling units, and fourteen emergency generators on its roof as well as eleven more generators and fourteen cooling units on the fifteenth floor.[169] To ventilate the equipment, about half the windows were replaced by louvers which, because the building was a designated landmark, were recessed behind frames reproducing the original six-over-six sash.

Outside the financial district, the Flatiron district was home to the city's densest concentration of new-media firms. In 1998 the online advertising company DoubleClick officially recognized the neighborhood's premier industry by erecting a north-facing billboard on the roof of a building on the southeast corner of Twenty-second Street and Broadway that proclaimed, "DoubleClick Welcomes You to Silicon Alley." DoubleClick was one of the industry's stalwart companies. Founded in January 1996, it grew from 13 to 171 employees by the end of 1997. It went public with an initial public stock offering in February 1998 and by the close of 1999 had 1,300 employees and was headquartered in 300,000 square feet on the top floors of the Westyard Distribution Center (Davis, Brody & Associates, 1970), 450 West Thirty-third Street, where it built a rooftop basketball court for its employees' use.

The Internet bubble continued to expand as venture capitalists entered the picture, in 1997 pouring $240 million into New York's new-media companies, as compared with $49.5 million in 1995.[170] At first this infusion of cash was refreshing, but by 1999 the situation seemed to have spun out of control, with venture capitalists, eager to thrust money upon young entrepreneurs in ever more risky situations, encouraging thirty-seven New York City Internet companies to go public in fifty-two weeks, raising $3.5 billion. Not since the stock market boom of the 1920s had the nation, but especially New York, enjoyed such heady and reckless times. One venture capitalist warned: "The rate of company creation going on is unsustainable. . . . People are forming companies for the wrong reasons. They aren't passionate about their ideas. They just want to be millionaires like all their friends, and there is so much capital in New York that anybody can start a company today."[171] At the same time, as another observer warned, "even the biggest and most established" companies "are swimming in red ink with no clear way to profits in sight. Some companies are so small and unproven that in earlier days they would have hardly qualified for a bank loan, never mind a stock offering."[172]

The downturn began in early 2000. The Nasdaq, on which the majority of technology stocks were listed, topped out at 5,048.62 on March 10. Then on April 14 it declined by 9.7 percent. By October, Silicon Alley companies had laid off about 3,000 people and had given up almost 1 million square feet of office space; the Nasdaq had plunged 38 percent from its high and Silicon Alley stocks in particular had lost 53 percent of their value. The decline continued into 2001, with the Nasdaq ending the year at 1,950.40. Soon enough, the newspapers were filled with accounts of company after company going out of business. Those that survived laid off employees who were once millionaires on paper but were now worth nothing and unemployed. Even DoubleClick felt the heat. By 2003 it had laid off over 1,000 employees and left its offices and rooftop basketball court, which were taken over by an "old-media" company, the Associated Press. DoubleClick had already removed the billboard welcoming New York to Silicon Alley

View to the south showing "DoubleClick Welcomes you to Silicon Alley" billboard (1998–2002) on the southeast corner of East Twenty-second Street and Broadway. Dallal. TD

in March 2002, stating "we are putting our ad dollars into more strategic media allocations."[173] One observer felt that the billboard's symbolic removal "represents that the stupidity is over."[174] The very term Silicon Alley, according to a broker at Cushman & Wakefield, had long before become anathema: "I can't remember the last time I heard the term used. It's lost its cachet completely."[175]

Emperor Giuliani?

Despite an easy victory over Manhattan Borough President Ruth Messinger in his 1997 bid for a second term, making him only the second Republican to win reelection as mayor since La Guardia, Giuliani's star began to dim. Many who tolerated or even applauded his various quality-of-life campaigns began to believe that he was going too far and that his police department had become too aggressive.[176] The mayor was also less able to bully his opponents—his preferred management style—because of the new term limits law that effectively rendered him a lame duck on the first day of his second term. Some of the complaints were relatively minor: Giuliani was criticized for banning the traditional Lunar New Year and July 4 fireworks displays in Chinatown, for cracking down on jaywalking (the fine was increased from $2 to $50), and for placing metal barriers on ten midtown intersections to improve traffic flow.[177] As Fred Siegel put it: "Giuliani went into his final four years with more than adequate confidence and his eyes elsewhere. . . . In the absence of a full-scale agenda, he began to press too hard on quality-of-life issues."[178] Giuliani

was charged with promoting censorship when he threatened to withdraw city funding from the Brooklyn Museum because of its 1999 "Sensation" show that featured Chris Ofili's painting of the Virgin Mary, a canvas decorated with elephant dung.[179] Giuliani was also accused of trying to criminalize homelessness when in November 1999 he ordered the police to arrest any homeless person who refused to move or accept a ride to a shelter.[180] The criticism grew louder when he attempted to evict shelter residents who turned down job offers and, if they were parents, to take their children away on grounds of negligence, a move that the State Supreme Court did not allow.

Giuliani's great success in reducing crime rates also came under renewed scrutiny, especially after a series of horrific incidents involving charges of racism against the police. On August 9, 1997, Haitian immigrant Abner Louima was brutally sodomized with a broken broomstick in the bathroom of Brooklyn's 70th precinct by several cops.[181] Eighteen months later, on February 4, 1999, West African immigrant Amadou Diallo was fatally shot in the South Bronx by four white plainclothes officers from the controversial Special Street Crimes Unit.[182] The unarmed Diallo, mistaken for a suspected rapist who the police thought was reaching for a gun, was shot at forty-one times and hit by nineteen bullets, provoking outrage throughout the city. Although Giuliani publicly regretted the accident (the police officers were eventually acquitted of all charges, including second-degree murder), he strongly defended the aggressive practices of the Special Street Crimes

Unit, noting that they were responsible for seizing 40 percent of all illegal guns in the city. The unit had for some time been under fire from community and civil rights activists, who argued that officers in the group had repeatedly targeted and frisked minorities without cause. On March 16, 2000, Haitian immigrant Patrick Dorismond became the fourth unarmed civilian killed by the police in the last thirteen months.[183] Defenders of the police pointed to the fact that in the last year of the Dinkins administration officers had fired 212 times but in 1999, under Giuliani, they had only squeezed off seventy-one shots (and forty-one of those were aimed at Diallo). In addition, the number of people killed by the police dropped from a high of forty-one under Dinkins to only eleven in 1999. Still, the damage was done and there was a growing sense that Giuliani and large parts of the police force were at best insensitive to minorities, if not actually racist.

Giuliani's standing was also weakened by several events beyond his control, including three prominent accidents in relatively quick succession involving the construction trades or building failures. On December 7, 1997, just as the Christmas shopping season was swinging into full gear, a section of bricks at the thirty-third floor on the south wall of the thirty-nine-story 540 Madison Avenue (Kahn & Jacobs, 1970), southwest corner of Fifty-fifth Street, separated from the rest of the wall and showered down to the sidewalk and street below, causing only minor injuries but requiring the evacuation of numerous nearby buildings and the closing of Madison Avenue between Fifty-third and Fifty-fifth Streets to traffic for six days.[184] After a thorough inspection of the facade, it was determined that all of the brick on the south facade would need to be replaced. That the building was owned by Harry Macklowe, infamous for his part in the illegal demolition of several single-room-occupancy hotels on West Forty-fourth Street, did not help (see Times Square). On April 13, 1998, in a fortunately empty section of Yankee Stadium's upper deck, a 500-pound concrete and steel beam collapsed, and three months later, on July 22, there was a fatal scaffolding accident at the construction site of the Condé Nast Building in Times Square.

In part due to his lame-duck status, Giuliani decided to challenge First Lady Hillary Rodham Clinton for the senate seat held by Daniel Patrick Moynihan, who was retiring. But the mayor's personal life interfered before he could secure the Republican nomination. Not only did Giuliani announce that he had prostate cancer, but he also initiated divorce proceedings against his wife, both compromising his political chances.[185] Then, on June 11, 2000, at the conclusion of the Puerto Rican Day Parade, the city's much-admired reputation for civic order, which Giuliani had worked so hard to cultivate, faltered when mayhem erupted in and around Central Park.[186] Fifty or more sexual assaults were reported as drunken youths sprayed women with water, tore off their clothes, and groped them. Some of the violence was caught on amateur videotapes that also showed police officers standing around in seeming disinterest.

The difficulties Giuliani encountered in his second term led to a round of harsh assessments that emphasized his darker side, although most critics continued to acknowledge his earlier successes. "He was not the most likable fellow around," wrote New York Times reporter Clyde Haberman. "He governed by fear and he obsessively–critics would say dictatorially–hoarded information that should have been in the public

domain. Disagree with him, even mildly, and he would denounce you as politically corrupt, intellectually dishonest or plain evil. He played fast and loose with the First Amendment so often that the courts had to rein him in time and again. Still, his record was generally sterling."[187] Or, as fellow Times reporter James Traub put it: "The Mayor has a passion for suppressing the bad but not for cultivating the good."[188] Giuliani's reputation, however, was ultimately defined, not just in New York but in the nation at large, if not the world, by the courageous manner in which he led a frightened city in the days and weeks following the 9/11 attack when he earned the widely circulated title of "America's Mayor."

TOWARD A LIVABLE CITY

While the city had always suffered from varying degrees of housing shortages, the housing crisis that began during the 1970s was both physically and psychologically devastating. The wave of abandonment that swept through formerly thriving neighborhoods, particularly in Upper Manhattan, the South Bronx, and parts of Brooklyn—Bedford-Stuyvesant, Brownsville, East New York, and Coney Island—was extreme. By the end of the 1970s, about 30,000 apartments per year were being lost to the market as building owners, in the face of increasing expenses, especially for fuel, were unable, largely because of rent regulations, to achieve sufficient income to maintain their properties. When the owners walked away, the city was forced to take over, thereby making New York its own largest single landlord. The problem was exacerbated by the fact that so much of the middle class, "the backbone of the city," continued to flee to the suburbs, leaving behind enclaves for the rich, mostly in Manhattan, and many formerly diverse neighborhoods now home only to the poor.[1] Efforts to stem the middle-class exodus by providing better housing were hampered by the need to increase city support of low-income housing as the federal funds that traditionally paid for it were gradually but steadily withdrawn during the eight-year Reagan presidency, when the portion of funding earmarked for New York fell from nearly $3 billion to under $1 billion. At the same time, the city was also forced to cope with an unprecedented surge in homelessness.

For the first half of the 1980s, the city government, led by Mayor Koch, virtually ignored the crisis, blinded to all but the high-paced production of market-rate housing fueled by the booming economy. But after 1986, by which time municipal finances were stabilized, the Koch administration began to confront the housing crisis, initiating a series of proposals that over the next ten to fifteen years would lead to the rehabilitation of nearly the entire stock of city-owned apartments, to the transfer of their ownership back to the private sector, and, with the private sector as a partner, to the realization of new middle-income and affordable housing on the vast acreage of abandoned, "bombed-out" sites.

The housing proposed by the Koch administration differed dramatically in form from the high-rise public housing projects of midcentury. The towers in the park, or "red-brick beehives" as Lewis Mumford referred to them, once held in high regard, began to be discredited in the 1950s when, it was argued, they had replaced one kind of slum with another.[2] In their place, alternate strategies were pursued, including low-rise, high-density prototypes that proved relatively unsuccessful when

attempted during the 1970s but would meet with better results in later efforts during the 1990s. But the vast majority of affordable housing that was built during the last quarter of the twentieth century was low-rise and low-density, consisting primarily of the types of one-, two-, and three-family houses that had historically constituted the city's bread-and-butter accommodation but had been disparaged by housing reformers such as Mumford and Clarence Stein in the 1920s.[3]

Despite the collapse of federal support for low-income accommodation and the demise of the Mitchell-Lama program in the mid-1970s, which had enabled the construction of about 139,000 middle-class apartments over more than fifteen years, during the 1980s the thrust of the city's housing program was directed toward the middle class. This effort was for a short time supported by the federal government's Section 235 subsidy program, which encouraged the construction of new moderate- and middle-income housing by lowering builders' mortgage interest rates (as had the Mitchell-Lama program) so that the price of housing could be brought to an affordable level. Unlike Mitchell-Lama, which encouraged the construction of large, high-rise apartment buildings, the Section 235 program specifically called for owner-occupied two- and three-story houses.

To encourage private developers to take advantage of the federal subsidies and overcome high construction costs and the red-lining of areas by banks—issues that had discouraged most builders from even contemplating the construction of middle-class housing—New York City planned to complement Section 235 funds with incentives that would make the houses more salable, such as property tax abatements and grants of up to $15,000 for potential homeowners. The city's ability to donate vast acreage at little or no cost was also crucial to the program, virtually guaranteeing that much of the new housing would be built in blighted neighborhoods—many of them dormant urban renewal areas where large tracts of city-owned land had been cleared but never built upon. In these areas, the city could also assist developers in preparing sites while expediting the often tangled process of installing sidewalks, sewers, streets, and lights. Reporting on the Section 235 program in 1980, Alan S. Oser cautioned, "What remains to be seen is whether the small home builders will overcome their long-standing trepidation about bureaucracy in the building process, whether they will hesitate because of site condition problems to move into locations of previous demolition or whether they will share the official optimism about the possible speed of production and marketability in chosen locations."[4]

On February 12, 1981, Mayor Koch announced the city's selection of developers to build 2,200 moderately priced, primarily single-family rowhouses in ten impoverished neighborhoods using Section 235 funds.[5] The first 173 houses were to be built in the Carroll Gardens section of Brooklyn. Other neighborhoods slated to receive the houses were: East New York, Bedford-Stuyvesant, Brownsville, Bushwick, Coney Island, and Prospect Heights in Brooklyn; the St. Nicholas Park Urban Renewal Area in Manhattan; South Jamaica, Queens; and the South Bronx.

The promise of Section 235 proved short-lived. In June 1981, the Reagan administration soured its prospects by halting the allotment of new funds and amending the Housing Act to require current developers of Section 235 houses to have firm commitments for the sale of all planned units by March 31, 1982, or lose the subsidies. The requirement meant that developers already wary of the task at hand now faced the additional challenge of selling houses before construction had even begun.

By August 1981 Koch was decidedly solemn in tone as he held a press conference describing the city's housing problems in light of the increasing federal cutbacks, among the most recent being the beginning of the phase-out of Section 8 subsidies for low-income renters. In his comments, Koch identified decreasing federal funding as the prime problem for low-income New Yorkers but stated, "It certainly does concern me that there are not adequate apartments, not only for the poor, but for the middle-class."[6] Koch stated that there was little the city could do, apart from trying to use whatever federal funds were available and offering property tax abatements to developers who were willing to build. But he also noted that rising interest rates were working against the prospects of more new house construction, both in New York and elsewhere in the country.

In December 1981 the *New York Times* reported that several of the developers designated to build the Section 235 housing were not convinced they would be able to go forward, in part because of the requirement to sell the houses before the federal deadline (which was ultimately extended), but also because of another bureaucratic concern in which the Federal Housing Administration, required to appraise the proposed houses, was assigning them values well below the selling prices, making it unlikely that local lenders would offer mortgages for the homes. This problem pointed to a basic lack of cooperation among city and federal agencies that plagued numerous efforts to create housing in an era of constantly shifting economic conditions.

While many of the projects eventually went forward with or without Section 235 subsidies, some homeowners were less than satisfied with the final product, as was the case with the Mermaid Neptune Development Corporation's 448 houses designed by the firm of Scully Thoresen and Linard on three sites in Coney Island called Saltaire Gardens, Bayview Gardens, and Botticelli Gardens.[7] Saltaire Gardens, completed on September 7, 1983, consisted of seventy-two two-story red brick and beige aluminum-siding-clad houses set back from West Twenty-second Street between Neptune and Mermaid Avenues with driveways in front and rear yards. But the following July, when Mayor Koch dedicated the 180 homes of Bayview Gardens, situated on five blocks of West Thirty-seventh Street, between Bayview and Canal Avenues, residents of Saltaire were in attendance with placards protesting the water leaks, buckling walls, and inadequate insulation in their homes. Though the major problems were corrected, the issue highlighted the fact that New York's construction industry seemed to have lost the knack of building single-family rowhouses. From the point of view of aesthetics and urbanism, the new houses were also fairly deficient, representing little more in quality than the shoddy rows of houses on the site that had been torn down two decades before.

Among the other Section 235 projects to be completed were Beyer Blinder Belle's 200 two- and three-story houses in the South Bronx's Crotona-Mapes section, completed in 1985, located mostly between East 181st and 182nd Streets, just west of Richard Meier's Twin Parks Northeast.[8] Richard Plunz, associate professor of architecture at Columbia, called

I. BAYVIEW GARDENS
2. BOTTICELLI GARDENS
3. SALTAIRE GARDENS

Bayview Gardens, Botticelli Gardens, and Saltaire Gardens, Coney Island, Brooklyn. Scully Thoresen and Linard, 1983. Site plan. TLAP

Bayview Gardens, bounded by Bayview, Canal, Maple, and Sea Gate Avenues, West Thirty-sixth and West Thirty-seventh Streets, Coney Island, Brooklyn. Scully Thoresen and Linard, 1983. View to the northwest. TLAP

Saltaire Gardens, bounded by Neptune and Mermaid Avenues, West Thirtieth and West Thirty-second Streets, Coney Island, Brooklyn. Scully Thoresen and Linard, 1983. View to the southeast. TLAP

the houses "an extreme reaction to the failure of the experimentation at Twin Parks Northeast. They are also a pragmatic expression of the reduction in resources for social housing in recent years."[9]

Koch's program to build middle-income housing was complemented by private sector initiatives, most notably by the New York City Housing Partnership (NYCHP), a task force of the nonprofit civic group the New York City Partnership, formed by David Rockefeller in 1981 with the goal of building 5,000 homes and rehabilitating 25,000 apartments for the middle class by the end of the 1980s.[10] The Housing Partnership included representatives of business and financial institutions, developers, lawyers, architects, planners, organized labor groups, and neighborhood housing development corporations. Its projects were underwritten privately but relied on the same kinds of city and state assistance provided to Section 235 developers: tax abatements, city-donated land, and state-issued low-interest mortgages. The NYCHP benefited from a well-structured public-private partnership. Its operating subsidiary, the Housing Partnership Development

Corporation, was chaired by Virgil Conway, chairman of the Seaman's Bank for Savings, and Anthony B. Gliedman, the city's Commissioner of Housing Preservation and Development, encouraging a process by which the city chose the development sites and the partnership determined the feasibility and type of new construction.

The partnership's first project was a collection of seventeen two-family rowhouses built on two Prospect Avenue sites in the Windsor Terrace section of Brooklyn. Ground was broken for the houses in December 1983. Designed by the Brooklyn-based Saltini Ferrara Associates, the twenty-two-by-forty-four-foot three-story houses were to be occupied by the owner and one tenant family. Not all of NYCHP's projects were low-rise: the two-building 599-unit Towers on the Park (1987) (see Central Harlem) on Frederick Douglass Circle at the northwest corner of Central Park rose twenty stories. Of all the private sector efforts to build subsidized housing, NYCHP was the most prolific, helping to realize more than 20,000 homes and apartments in the five boroughs over twenty years, though not without facing a good bit of criticism at times, aimed mostly at its unwavering dedication to the needs of the middle class.

The Nehemiah Plan

The challenge of providing decent housing for low-income New Yorkers was also taken on by private groups, the most innovative and influential of which was East Brooklyn Churches (EBC), a group formed in 1978 by a coalition of thirty-six churches whose leaders realized that in order to keep their congregations from fleeing the devastated area they would have to build housing themselves.[11] EBC's plans were inspired by the writings of I. D. Robbins, a developer turned civic activist and a former president of the City Club who used a weekly public affairs column in the *Daily News* during the late 1970s to tout what he felt to be the ultimate solution to the housing crisis: the single-family rowhouse. In an October 7, 1979, article, "For the $12,000-a-Year Income: Blueprint for a One-Family House," Robbins wrote: "We have come full cycle in house-building. We went from the single-family house to the small multi-family tenement, to the six-story elevator building, to the 32-story apartment house and large project. Now, both the high cost of construction and the social frictions of high-density communities suggest that we go back to where we started—and take another, and more respectful look at the two-story, single-family row house. . . . What our city needs now is new homes and a way to build on the hundreds of acres of city-owned vacant or abandoned sites. We need a model or prototype which, with variations, can be produced efficiently by the average builder. . . . The use of a prototype, though varied in styling to avoid the cookie cutter effect, means that economies can be built into the design. Greater labor efficiency through repetitive procedures and assurance of steady work plus lower material and component costs through large purchases of standard items become likely."[12] Robbins included in his column plans for a typical house designed by Robert Clothier with two-bedroom units measuring eighteen by thirty feet and three-bedroom units eighteen by thirty-two feet. Robbins's vision was grand: "row housing can be built wherever as much as a 200-foot block front is available," he explained, "each development ought to be as large as possible."[13]

Robbins was deeply committed to the ideal of homeowner-

New York City Housing Partnership houses, site bounded by Prospect and Eleventh Avenues, Eighteenth and Vanderbilt Streets, Windsor Terrace, Brooklyn. Saltini Ferrara Associates, c. 1984. HPDC

ship for low-income families: "A family should feel it has its own house, take pride in it and be responsible for utilities and total maintenance just as if it were a house in the suburbs. . . . We have never yet tried on a big scale to encourage lower income families to treat low-cost housing as their own. Ownership could encourage responsible community leadership. It would also be a challenge—and an invitation—to join the mainstream of American life."[14]

In his column, Robbins specifically called upon Mayor Koch to establish programs that would put his theories into practice. But it was East Brooklyn Churches that actually did so when, in June 1982, the group announced the Nehemiah Plan, an ambitious program to build 5,000 single-family rowhouses in Ocean Hill, Brownsville, and East New York, according to Robbins's model. EBC would raise funds for the project and Robbins would serve as developer. The plan was named for the biblical prophet sent by the king of Persia to rebuild Jerusalem in 420 B.C. after the Babylonian captivity. The goal was to build the first 1,000 Nehemiah Homes in a single year on a twenty-one-block site in Brownsville bounded by Livonia, Linden, and Van Sinderen Avenues, and Chester Street, adjacent to the Van Dyck Houses (Isadore and Zachary Rosenfield, 1955), a massive housing project, with the next 4,000 homes intended to be completed by 1987.[15]

As Robbins had forecasted, the viability of the Nehemiah Plan depended on a confluence of physical and economic conditions. While construction would be financed through

BELOW Nehemiah Homes, Brownsville, Brooklyn. James D. Robinson, 1984. View of houses on Riverdale Avenue, 2003. Vergara. CV

ABOVE Nehemiah Homes, Brownsville, Brooklyn. James D. Robinson, 1984. View to the southeast from Livonia Avenue and Mother Gaston Boulevard, 2003. Vergara. CV

interest-free loans from East Brooklyn Churches, to keep costs down Robbins required vast tracts of vacant land in order to achieve economies of scale by building rows of twenty-eight attached houses all at once. This would require only one connection to the city's sewers for each row of houses, instead of twenty-eight individual connections, a money-saving variation that initially proved to be a sticking point for the city but which was, years later, written into the building code. Another key to success was keeping "soft costs" such as legal, architectural, and financing charges, at about 6 percent of the total cost as compared to the usual of about 35 percent. The plan depended on and received the city's support. In 1982 the Koch administration agreed to transfer the land required for the first 1,000 houses for $1 per parcel and agreed to subsidize the first 1,000 homebuyers with $10,000 no-interest loans that were not due until the owners resold the houses. The city

also provided twenty-year tax abatements. According to Deputy Mayor Robert F. Wagner Jr., the agreement to subsidize the Nehemiah Plan was the first of its kind in the city's history.[16] In June 1983, Governor Cuomo announced that the state would also provide low-interest mortgages through the sale of tax-exempt bonds.

Ground was broken for the 1,000 Nehemiah Homes in Brownsville on October 31, 1982, in a ceremony attended by 5,600 onlookers and presided over by Mayor Koch. The two-story two- and three-bedroom homes, designed by James D. Robinson (Robinson would be replaced as Nehemiah's architect in 1984 by James T. Martino), were eighteen feet wide and thirty-two feet deep, situated on 18-by-100-foot plots providing a driveway and patch of lawn in the front and a yard in the rear. The houses were identical in elevation (except for an intermittent reversal in plan that produced mirror-image facades) and stepped forward and back from the street in an effort to provide some visual relief. The architecture offered little of interest. Richard Plunz compared the houses, with their banal brick facades and tiny windows, to nineteenth-century mill housing. "At the level of the individual house, the spatial standards are reasonable," Plunz wrote. "At the collective level, however, the design conception is primitive and, in its own way, as reductive as the 'tower in the park.' The configuration is a horizontal barracks rather than vertical, with a density of only 14.6 dwellings per acre."[17]

Aesthetics aside, the houses succeeded in their mission: they were built for half the cost-per-square-foot of other contemporary government-subsidized single-family houses and

Nehemiah Homes, site bounded by East 161st Street and Prospect, Westchester, and St. Ann's Avenues, Melrose, Bronx. James T. Martino, 1993. View to the southeast from East 156th Street and St. Ann's Avenue. Moran. MM

sold for less than any other new housing in the city. As well, roughly 40 percent of the first 1,000 residents came from nearby public housing projects and could now call themselves homeowners. But Robbins's vision of lining the city's vacant blocks with Nehemiah houses began to run into trouble when, as large tracts of vacant land became scarce, he called for the demolition of sound buildings in order to clear sites for more houses. The very idea, harkening back to the slum clearance policies of previous decades, was objectionable to community members and politicians alike. But Robbins was steadfast, stating, "I never rehabbed a building in my life. I don't believe in it."[18] More significantly, as the 1980s marched on and the housing crisis worsened, the very idea of building single- instead of multi-family housing was considered a wasteful use of land, and the Nehemiah Plan stumbled.

By 1987 more than 1,200 Nehemiah Homes had been built, but new ones planned for Spring Creek in Brooklyn and the Arverne section of Queens were stalled because, as Robbins put it, "the city has simply not made enough cleared land available to us."[19] In 1992-93, Robbins, working with the South Bronx Churches, a coalition of forty Protestant and Roman Catholic congregations, built 224 single-family and 288 two- and three-family Nehemiah Homes on a largely vacant Melrose site bounded by East 161st Street and Prospect, Westchester, and St. Ann's Avenues in the Bronx.[20] The new buildings represented the first Nehemiah development built outside Brooklyn and the first departure from the single-family house model. Bradford McKee, writing in *Architecture*, denounced the failure to develop the large site

adequately, criticizing the "low-cost, low-value, Faux-Tudor townhouses stacked for two or three families, raising the density ante [over the notably suburban Charlotte Gardens (see The Bronx)] only nominally."[21] I. D. Robbins, naturally, was more enthusiastic: "This is Tudor City north. What you have is a little community here."[22]

In 1993 East Brooklyn Congregations (the word *congregations* replaced churches when two synagogues joined the group) dropped Robbins as their developer in part because of his refusal to leave sound buildings in place and in part because, as Robert Neuwirth wrote in *Metropolis* in 1995, "the idea of a Nehemiah New York—a sprawling city of identical single-family rowhouses—is aggressively antiurban. The earliest Nehemiah developments, now a decade old, still seem like enclaves; the life within them has not spilled over into surrounding neighborhoods. Efforts to develop grocery stores and other amenities have been largely fruitless. And the obsession with building only for homeowners has excluded all but the upper reaches of the low-income market. . . . In some cases Robbins and his church allies actually seemed to despise the communities they were battling to rebuild."[23]

But Nehemiah continued with its mission, even expanding to build housing in cities around the nation. In 1997 it used modular construction in the development of New Nehemiah, a group of 645 houses located throughout the blocks bounded by Linden Boulevard, Junius Street, Sutter Avenue, and Pennsylvania Avenue, between neighborhoods of original Nehemiah houses. Prefabricated in a Brooklyn Navy Yard factory and completed in phases, the houses, trucked to the site in two pieces—one module each for the first and second floors—were 20

percent larger and built to a higher standard of quality than the earlier Nehemiah houses.[24] They were also more attractive, with brick covering the first floor and aluminum siding above. Nehemiah also called for modular construction in its development of a neighborhood in the Spring Creek section of Brooklyn (see Brooklyn), which began construction in 2004.

The Infill Solution

In contrast to the large-scale approach typical of the city's construction of affordable public housing in the 1930s and 1940s, and its urban renewal efforts of the 1950s and 1960s, the idea of adopting incremental infill construction as public policy seemed almost revolutionary. But in so many outer borough neighborhoods as well as in areas of Manhattan such as Harlem, where block after block of sound housing was pockmarked with rubble-strewn lots, infill housing construction held great promise. As Peter Marcuse observed in 1988, infill housing represented "the opposite of 'slum clearance' and displacement. It represents integration of buildings—and their residents—into the existing social fabric, not their separation and exclusion."[25]

Infill housing was the subject of several studies and design competitions during the 1980s. In December 1983 the Minority Students and Faculty Organization of the Columbia University Graduate School of Architecture, Planning and Preservation invited community activists and housing practitioners to participate in a two-day charrette examining the problem of affordable housing in Harlem.[26] The project, led by Ghislaine Hermanuz, director of the school's Community Design Workshop, focused on two study areas in Harlem in which 70 percent of the land was owned by the city. The western site, bounded by 117th Street, Adam Clayton Powell Jr. Boulevard, 124th Street, and Manhattan Avenue, was occupied primarily by abandoned buildings interspersed by vacant lots while the eastern site, bounded by Lexington and Fifth Avenues, 117th and 124th Streets, featured large parcels of vacant land. Proposing a mix of infill housing and rehabilitation for the western site and larger-scale new construction for the eastern site, the plan, which was published in 1985 as *A Housing Platform for Harlem*, stressed that the area's "very desirable" residential scale be retained. The plan also urged that "semi-public spaces, such as stairs and stairwells, roofs, alleys and hallways . . . be activated to become points of gathering, interaction and work, not places perceived as dangerous and wasteful." Mixed-use buildings were encouraged, combining single-room-occupancy units, family-sized apartments, retail spaces, and work spaces to help the buildings "generate economic activities."[27]

In the western study area, prototypes were developed for traditional townhouses with stoops on the side streets and midrise elevator apartment buildings on the avenues. The planners proposed that old-law tenements be renovated by private developers into market-rate lofts, or, if rehabilitation was too expensive, be demolished. New-law tenements were to be renovated as small apartments for low-income or homeless families. In the eastern study area, the planners called for courtyard apartment buildings to fill the large vacant lots. Commercial functions could be placed along the avenues on

RIGHT Inner City Infill proposal, various sites bounded by Lenox Avenue and Adam Clayton Powell Jr. Boulevard, 115th Street and the midblock between 117th and 118th Streets, Manhattan. David Bergman, 1985. Axonometric, view to the northwest. DBA

BELOW Inner City Infill proposal, various sites bounded by Lenox Avenue and Adam Clayton Powell Jr. Boulevard, 115th Street and the midblock between 117th and 118th Streets, Manhattan. Secundino Fernandez, 1985. Site plan. RTUF

the first few floors, situated back to back with residential units facing the courtyard. In this situation, party walls, which contained utility cores, would now run parallel to the avenues rather than perpendicular.

As Columbia released its study in 1985, the Architecture, Planning and Design Program of the New York State Council on the Arts (NYSCA) sponsored a two-stage national design competition, *Inner City Infill*, that was intended to "achieve excellence in the design of new and rehabilitated housing, and to meet the changing social needs of the existing inner-city community."[28] The program identified five separate sites on a two-and-a-half-block area in Harlem between Lenox Avenue and Adam Clayton Powell Jr. Boulevard, 115th Street and the midblock between 117th and 118th Streets. The sites, all city-owned and ranging in size from 12,500 to 65,500 square feet, contained a typical mix of vacant lots and run-down buildings. With the exception of four rowhouses on 117th Street that, according to the program, were to be retained, the rest of the buildings were to give way to "new construction which, while exhibiting a sympathy for extant streetwall configurations and a respect for characteristic period features, must establish a distinct identity of its own."[29] Bordering one of the sites was the palazzo-like apartment house Graham Court (Clinton & Russell, 1901), east blockfront of Adam Clayton Powell Jr. Boulevard between 116th and 117th Streets.[30] Entrants, required to provide 420 units of new and rehabilitated housing, 33,000 square feet of commercial space, and 7,000 square feet of space for community facilities, were also asked to "work within the existing *social* context, without promoting gentrification or massive displacement."[31]

The competition drew seventy-four proposals. While some architects devised small, twenty- to twenty-five-foot-wide prototype buildings that could be repeated on various individual sites, others proposed clearing large parcels to create sites that could accommodate midrise elevator buildings, which were thought to be more profitable to private developers. Some designers closed off the block interiors to become private yards and gardens while others opened them as shared public space, among them Secundino Fernandez, whose proposal connecting 115th and 117th Streets featured a large midblock public square. Sergei Bischak's proposed through-block passage provided small-scale commercial spaces to allow for a marketplace. While many entrants proposed contextual designs employing the ornament and massing of neighboring buildings, others broke out of the mold with setbacks above the streetwall. David Bergman proposed a prototype four-story rowhouse featuring recessed bays and stone bases that could be repeated along a block, but employed a freer hand in designing playful volumetric additions set back above the fourth floor and rising to varying heights to give the area a distinct identity.

In her overview of the competition, Ghislaine Hermanuz found that not enough of the proposals dealt sufficiently with identifying "design features expressive of Harlem's specificity as a black community, beyond the ubiquitous stoops and the stereotypical basketball courts." Most submissions did not take into consideration units capable of "housing intergenerational family groups; single young adults sharing larger accommodations; allowances for economic activities, from child care to catering; the designation of open spaces for activities such as street vending and market-style commerce; mixing rather than segregating the different age groups and economic groups; collective rather than individual control of

Inner City Infill proposal, various sites bounded by Lenox Avenue and Adam Clayton Powell Jr. Boulevard, 115th Street and the midblock between 117th and 118th Streets, Manhattan. Adele Naude Santos Architects, 1985. Model, view to the northwest. ANS

the semi-public spaces; [and] institutional spaces closely knitted into the residential fabric."[32]

The best schemes, which addressed many of the issues Hermanuz raised in her critique, were selected for a second stage of the competition: the Oakhattan Group, comprised of Michael Pyatok & Associates of Oakland, California, working with William Vitto & Ira Oaklander, of New York, were awarded first place; Stephen Campbell, of New York, working with Mark Nielsen, of Boston, received second place; and the Philadelphia-based firms Adele Naude Santos Architects, third place, and Stoner Duncan Architects, honorable mention. Campbell and Nielsen, naming their proposal Philip A. Payton Place in honor of the co-founder of the Afro-American Realty Company, the first to rent housing to blacks in Harlem, called for rows of five-story owner-occupied townhouses with facades that could be left bare or augmented with bay windows and other ornamental options chosen by the owners. Adele Naude Santos proposed traditional five-story apartment buildings, decorating them with bow fronts and stoops and occasionally dormers and barrel-vaulted roofs as well as pedestrian mews situated at right angles to the street, extending into the midblocks, which were to be developed with parking lots and a complex system of open spaces.

The Oakhattan Group's winning proposal would house 600 families in a combination of six-story buildings fronting the streets and three- and four-story townhouses extending perpendicularly into the midblock behind them. The six-story buildings were smartly planned as a hybrid, with the first three floors intended for private ownership by families and the upper three floors intended as rental apartments for individuals or couples with no children, mostly expected to be elderly. The separation allowed for active street life that did not impinge on individual privacy. The family units were entered from stoops, eliminating the need for children to use elevators, a problem in high-rise housing projects. Those living on the upper three floors would come through a double-height open-air passageway leading from locked doors along the street to elevators located in the rear courtyard. A bedroom and bathroom, somewhat isolated from the unit as a whole, would allow residents to take in tenants if need be.

The townhouses within the block provided community meeting areas, terraces, and shared yards that fostered interaction

West 117th Street

West 116th Street

West 115th Street

Rear Yard, Aerial, Sites A & B

Section Through Site D, Looking North

Inner City Infill proposal, various sites bounded by Lenox Avenue and Adam Clayton Powell Jr. Boulevard, 115th Street and the mid-block between 117th and 118th Streets, Manhattan. Oakhattan Group, 1985. PA

between residents. The open spaces were semipublic, with each one available for use by a maximum of thirty families. Joanna Wissinger, writing in *Progressive Architecture*, praised the design's "series of separate enclaves emphasizing economic and social issues over rhetorical gestures."[33] While the complex's proportions, massing, and lines of articulation were designed to recall the neighboring buildings, construction was to be of concrete block finished in a variety of colors and textures. A recurring tile motif would run along the tops of the buildings to give the development an iconic identity.

For Richard Plunz, the Inner City Infill program, more so than the many earlier housing competitions in New York, moved "discourse closer than previously toward exploration of direct design responses to social imperatives. . . . 'Contextualism' continued to be important, focused on reconstruction of existing community fabric." But, he continued, "the outlook of the program and its submissions could not help but be overshadowed by the diminished resources for building housing for poverty level families; . . . By official estimate, the population of New York City considered poverty level constitutes fully one quarter of the total, and has increased by ten percent since 1970."[34]

Despite plans to build the winning scheme, the necessary financial and political support, as Plunz suggested, was not there. Portions of the site were eventually developed in the late 1990s. In 1998 the Center for Community Enrichment, a three-story red and beige brick building, 125 West 115th Street, was built by the Canaan Baptist Church, becoming home the following year to the state's first charter school, the for-profit Sisulu Children's Academy.[35] A large portion of the competition site, on both sides of 117th Street, was developed in 2000 as Shabazz Gardens (see Central Harlem).

In June 1987 the Architectural League of New York, partnering with the city's Department of Housing Preservation and Development, took the discourse on infill housing further with a competition, *Vacant Lots: A Study Project in Infill Housing in New York*, in which architects, designers, and students were invited to propose plans for low- and moderate-income housing on ten sites—three each in the Bronx, Brooklyn, and Queens and one in Manhattan.[36] The competition drew seventy submissions and the results, exhibited between October and November 1987, revealed occasional artistry. The sites ran the gamut of shape and size, from an 80-by-100-foot site in Ocean Hill-Brownsville, Brooklyn, close to several blocks of Nehemiah houses, to a 40-by-195-foot site in Corona, Queens, to a long and narrow 33-by-200-foot site in the South Bronx. In his review of the competition, Roy Strickland, an architect on the faculty at Columbia, praised the program for reintroducing "housing as a subject of serious discussion and research by a larger circle of architects." But he also stated that Vacant Lots was not "an unqualified success," calling "some of the projects . . . hardly better than the contractor-built standard." Others, he continued, dealt with site constraints that "led several architects to re-create the problems of light, air, and privacy against which housing reformers struggled throughout the 19th Century."[37]

The Manhattan site, 511 West 133rd Street, between Broadway and Amsterdam Avenue, a 50-by-100-foot lot situated between tenements and facing south to the Manhattanville Houses (William Lescaze, 1961), provoked the widest range of solutions, though most of the nine schemes proposed prototypical designs applicable to other locations

Vacant Lots proposal for 511 West 133rd Street, between Broadway and Amsterdam Avenue, Manhattan. Samuel Haffey, 1987. Rendering of view to the northwest. VL

and provided flexible plans that could accommodate, through simple reconfiguration, single-room-occupancy units, large family-size apartments, and anything in between.[38] Samuel Haffey intended for half the tenants in his project to be homeless or underprivileged and the other half to be students and young people who couldn't afford market-supplied housing. All would be offered residences for a period of five years, then asked to move on. Apartments were situated in a U-shaped building surrounding a courtyard, the fourth side of which, facing south, would be enclosed by a monumental facade rising two stories above the buildings. Paul Goldberger felt the front facade, serving "as an enclosure and gateway toward the street," gave the "modest, amiable structures behind a kind of public grandeur . . . tying them in visually to the large tenements on either side." He found Haffey's proposal "particularly impressive in the way in which its physical design literally expresses one aspect of its social goal. The architects here have intentionally exaggerated the distinction between the public face of their building and its private innards to make the point that, in their view, the construction and maintenance of the facade should be the city's responsibility."[39]

Marion Weiss and Michael Manfredi, pursuing a highly keyed Modernism, proposed a six-story building that maintained the streetwall but rose to nine stories at the rear of the site. A courtyard separated the two elements, which were linked by a narrow circulation stack. The units would be flexible, loftlike spaces and the plan was organized to be easily repeated along a block either in the same form or in a mirror image to enclose a double-sized courtyard. Retail space was provided at ground level. Scott Marble also proposed a Modernist design forming a courtyard between two buildings, as did the Smith & Thompson team, which additionally picked up on the ideas put forth by the 1985 Columbia study, providing workshop spaces at the rear of the site that would

TOP AND MIDDLE Vacant Lots proposal for 511 West 133rd Street, between Broadway and Amsterdam Avenue, Manhattan. Marion Weiss and Michael Manfredi, 1987. Section and plan. VL

ABOVE Vacant Lots proposal for 511 West 133rd Street, between Broadway and Amsterdam Avenue, Manhattan. Smith & Thompson, 1987. Section. VL

LEFT Vacant Lots proposal for 3215 106th Street and 3214 107th Street, Corona, Queens. Donna Selene Seftel and Peter Lynch, 1987. Axonometric and section. VL

BELOW Vacant Lots proposal for 3215 106th Street and 3214 107th Street, Corona, Queens. Breslin/Mosseri, 1987. Axonometric. VL

inject economic activity into the project. The Smith & Thompson proposal called for masonry bearing walls that were relatively inexpensive and could be built by semiskilled laborers, an element also specified by Gruzen Samton Steinglass, which broke the streetwall with a set-back five-story building designed to maximize site coverage, eliminating the need for an elevator and therefore increasing the net rentable area. The Boxer Group also focused on flexible apartment layouts and the provision of a courtyard, but its scheme fell short urbanistically, with its slablike six-story apartment house sited perpendicularly to the street so that a broad wall of east-facing windows overlooked a courtyard and playground separated from the sidewalk by a high wall. Roy Strickland felt the Boxer Group's proposal had "one of the clearest and most rational plans . . . rich in its possibility for shared living environments" but felt it was the "right building in the wrong location . . . it does not belong in its mid-block location but on a street corner."[40]

Tod Williams and Billie Tsien's proposal was the most eye-catching and the only one in the competition to call for a high-rise solution. Their somewhat arty design called for an attached pair of slender thirty-five-foot-diameter twelve-story cylindrical towers elevated on stilts above the rooflines of the neighboring buildings. Though the tower approach at first glance seemed distinctly opposed to prevailing community sensibilities, Williams and Tsien saw their design as a "reaction to the vast and dangerous housing blocks" of the Manhattanville Houses. At ground level, open spaces used as parks and community gathering areas would complement low-scale buildings for commercial or community use. Interestingly, though Williams and Tsien sought to keep the vacant lots vacant, they also specified that the open spaces in the Manhattanville Houses across the street be filled in with "a one to two story base of commercial and community activity. The roofs of these low buildings would be planted with private gardens for Manhattanville residents. Certain block-through paths running north and south would remain at grade for public use. It is important to break down and reintegrate the superblock into the city fabric."[41]

For the outer borough sites, where the neighborhoods were less densely built out with rowhouses and occasional tenements and apartment houses, most architects responded to the low scale and density in kind. On a narrow, sloping through-block site at 3215 106th Street and 3214 107th Street in Corona, Queens, the firm of Breslin/Mosseri proposed a three-story house at each end separated by a shared courtyard crossed by clotheslines. Shared garages and community rooms were located on the houses' first floors and above, bedrooms could be easily reconfigured to form eight one-bedroom units or four two-bedroom suites to accommodate the needs of the area's many newly arrived immigrants. For Roy Strickland, the project's "barrel roofs and inflected walls" made it "among the most elegant projects in the program."[42] On the same site, Donna Selene Seftel and Peter Lynch divided the parcel longitudinally, placing four evenly spaced small houses on a plinth covering half the site. The houses each contained a two-bedroom apartment encased in a glass-and-steel volume that

cantilevered off the plinth halfway over the lower half of the site and supported a small one-bedroom apartment within a two-story masonry shell above.

Richard Plunz's team, working on a through-block site at 446–448 East 144th Street and 447–449 East 143rd Street in the South Bronx, arranged a network of apartments, stairs, balconies, and common open spaces in a two- and three-story U-shaped plan that could be rotated to allow a large courtyard to face the street, become a sideyard, or adjoin the courtyard of an adjacent building to provide open space on the block interior. In each case, the outdoor area would be overlooked by balconies and terraces, allowing parents easy supervision of their children. On a site in Arverne, Queens, McDonough/ Nouri Associates envisioned an inventive, detached two-family house formed, in plan, as a pair of sheared, overlapping boxes whose party wall was parallel to the street so that one residence faced the front and the other a rear yard. For the same site, James Tice proposed to take advantage of the interstitial space between two detached houses, transforming it

into "a suitable shared space rather than a dead zone," by situating the entry points to the residences on the sides of the houses.[43]

Voorsanger & Mills's proposal for a corner site at Aldus and Faile Streets in the Morrisania section of the Bronx was, for Paul Goldberger, the "most inventive, sociologically if not architecturally," of the competition, calling for a form of cooperative ownership in which one could purchase a bedroom and bathroom suite in a three-bedroom apartment that would carry with it a one-third stake in the living room and kitchen. "It is an intriguing notion economically," Goldberger wrote, "for it opens up the possibility of housing ownership to people of very modest means, although the social complications of such partly communal living could be horrendous."[44] Other proposals for the same site displayed varying approaches to context. Nancy Hitchcock and William Leggio sought to blend in with the surroundings, proposing a stretch of four-story buildings set back from the sidewalk to align with neighboring rowhouses along Faile Street but stepping the height up to six stories to meet the height of the apartment houses along Aldus Street. On the same site, Paul Rosenblatt, offering an early example of the Deconstructivism that would dominate late 1980s aesthetics, designed a jarring four-story jumble of angular planes meant to represent "the fragmented reality" of Morrisania and its residents.[45]

As Paul Goldberger noted, however, many architects viewed their rather depressed sites more optimistically. He cited Thomas Wittrock's "amiable, colorful, squat masonry building" for a site in the Morris Heights section of the Bronx; it does not "imitate the buildings around it but looks as if it would be exceptionally comfortable among them." Goldberger also pointed to Saunders/Heidel's proposal for a "little complex of three buildings with pitched roofs . . . where the inventive landscaping" transformed a Corona, Queens, site "into a tiny village." Goldberger stated: "In these projects . . . the existing neighborhood is seen neither as a blight to be ignored nor as a challenge to be risen above. It is, rather, a world to be acknowledged and, for all that is awful about it, a world to be respected. Admitting reality is the key, and knowing that there need not be any contradiction between idealism

and realism. All of these projects are idealistic–it is just that some deal in a utopia that is not ever attainable, while others deal in dreams that are connected to the world as it is. They are the ones that hold the true promise."[46]

Perhaps the most socially aware of all of the Vacant Lots proposals was that of Gustavo Bonevardi and Lee Ledbetter, architectural interns, for a prototype residence for people with AIDS. Although it was proposed for a South Bronx site, the architects felt that small, vacant lots throughout the city could accommodate these buildings, especially ones in residential neighborhoods where AIDS patients lived, sparing them the unpleasantness of being sent off to a hospital and encouraging the integration of "AIDS patients back into their communities." The design was one of the competition's more realistic proposals, prepared with the help of Linda Baldwin, a planner, Morgan Hare, an architect, and James Lay, a clinical psychologist. The scheme proposed low-cost building materials and methods. On a through-block site, two identical buildings would rise along the street walls separated by a midblock garden. Each building would feature two "conceptually independent units": a rear section whose "height could be changed as zoning would allow" containing eight to twelve single rooms with balconies overlooking the garden, and a front, "contextual/public" section that would house less private spaces, such

as shared living rooms and nurses' offices, and whose "facade would adapt to the texture of the surrounding buildings." The garden was intended to bring the "two buildings together and provide a contemplative and nurturing environment."[47]

In a passionate essay describing Bonevardi and Ledbetter's project, Herbert Muschamp described the design as "rational, modular, crisply Modern." He continued:

Those whose lives have been affected by this disease live in a separate world, a world that is collapsing, while the world outside, the world now called euphemistically 'the general population,' a world to which one belonged only yesterday, goes about its business. To inhabit this separate world, to live behind this wall, is to witness one's suffering converted into issues, one's hope for survival into the material that furnishes the others with their posters, their news, their columns, their opinion polls. The strength of Bonevardi and Ledbetter's design lay in symbolically breaking through this thickening wall of stigma, reminding us, as Poe did, of the moral doom invited by those who imagine themselves protected by such walls. The architects offered their response on a practical, not a metaphorical, level; yet the breached wall can stand as a metaphor for what the 'Vacant Lots' show achieved. The architects of all the projects were saying that they too are trapped by the walls of privilege they have been designing, walled up alive by their own projections of Top Dog values.[48]

Vacant Lots proposal for 446 and 448 East 144th Street, 447 and 449 East 143rd Street, Mott Haven, Bronx. Gustavo Bonevardi and Lee Ledbetter with Linda Baldwin, Morgan Hare, and James Lay, 1987. VL

More Strategies, Some Progress

By the mid-1980s, the efforts of the public and private sectors to increase the housing supply had proven to be meager in comparison to the astronomical demand for dwellings.[49] Public policy relied on private developers acting at their own initiative to take advantage of various incentives, both existing and new. One existing incentive, the 421a tax abatement, which delayed city real estate taxes for ten years, allowing housing developers to lower their carrying charges and consequently their prices, was modified to encourage low-income housing as a by-product of market-rate housing. In 1985 the 421a abatements were eliminated for developments in Manhattan between Fourteenth and Ninety-sixth Streets because of the number of high-priced apartments being unnecessarily subsidized by it. However, under new rules, developers in the excluded area of Manhattan could still receive the tax abatements if they agreed to build or even rehabilitate low-income apartments on-site or elsewhere. In fact, the low-income housing could be built by an entirely different developer and sold to the market-rate developer, an indirect subsidy that turned the tax abatements into commodities.

The first beneficiary of the tax abatement transfer was Spring Creek Gardens (1990) (see Brooklyn), a planned 765-unit low-income housing development occupying a 7.8-acre site of flat, vacant land in Brooklyn, close to the Queens border.[50] The developers of Spring Creek Gardens received tax benefits for more than 3,000 Manhattan apartments, some of which were sold to Zeckendorf Properties, which applied them to the Belaire (see Upper East Side) on East Seventy-second Street. Another pair of projects linked by the 421a abatements was the low-income thirty-eight-unit Davidson Court in the Mariners Harbor section of Staten Island, which provided abatements for the 202-unit Alexandria on Broadway and Seventy-second Street in Manhattan (see Upper West Side).[51] The cross-subsidy of the 421a plan was criticized by those who felt it encouraged economic segregation—relegating the poor to the outer boroughs. But the complaint did not register with Mayor Koch, who had made his position clear in 1984: "We're not catering to the poor anymore . . . there are four other boroughs they can live in. They don't have to live in Manhattan."[52]

There were some exceptions, however, such as the buildings constructed under the city's "80/20" self-subsidy program, also initiated in 1985 after three years during which the average rent in New York had increased by 35 percent, leaving nearly half of all renters devoting more than 30 percent of their incomes to rent, with 29 percent spending more than 50 percent.[53] In so-called 80/20 buildings, developers were given lower-cost financing from the city in return for setting aside 20 percent of a building's units for low-income tenants who would pay no more than 30 percent of their income in rent. The remaining 80 percent of the apartments were rented at market rates that were high enough to subsidize the low-income units. The plan was essentially an effort to fill the void left by the Section 8 program that would have subsidized the low-income units. The first 80/20 project was the Westmont (see Upper West Side), on Columbus Avenue between Ninety-fifth and Ninety-sixth Streets in the West Side Urban Renewal Area. Because they depended on achieving market rents, most 80/20 projects were built in Manhattan.

While these incentives catalyzed the construction of new low-income housing, they did not take advantage of the one resource that could significantly help the housing crisis—the city's languishing stock of nearly 6,000 vacant buildings and 17,000 vacant lots. With mounting pressure to take bold steps, in January 1985 both Mayor Koch and Governor Cuomo announced plans for new housing initiatives in their respective State of the City and State of the State addresses.[54] Koch called for the construction or renovation of 100,000 apartments for the poor, lower, and middle classes in five years, with new construction to be predominantly low-rise and built in designated fifteen- to twenty-five-square-block districts, stressing that the city could not build the housing alone. To encourage the private sector, the city would turn to its old bag of tricks, providing land, offering tax abatements, reducing builders' interest rates, and making new efforts to ease zoning and underwrite financing. But the mayor also offered new ideas for raising capital, including the use of city income from the World Trade Center, which would require the Port Authority to either sell it (so that it would be put on the tax rolls) or increase the Port Authority's payments to the city in lieu of taxes. Cuomo was more innovative in his plan to leverage funds from the Battery Park City Authority for the construction of 15,000 low- and moderate-income apartments in New York City. The idea to use the funds originated with BPCA president Meyer S. Frucher when it became clear that the original plans to include low-income housing in Battery Park City were falling by the wayside but that the highly profitable development could spawn affordable housing elsewhere in the city. Koch welcomed the idea and together, the mayor and governor developed it into the Housing New York program, announcing in May 1985 an agreement wherein 75,000 apartments would be renovated or built with the Battery Park City Authority funds.

The editors of the *New York Times* were underwhelmed by the initiative, accusing the mayor and governor of focusing too much on how to raise capital and not enough on the type of housing that would be built and the many costs it would incur after its completion: "Perilously the Governor and Mayor forget that housing costs do not end when the first occupants move in. . . . If costs rise faster than rents, if tenants prove destructive, if unanticipated defects require expensive repairs or if tenant leaders go on rent strikes, taxpayers would inherit large deficits."[55] Koch and Cuomo defended their plans by noting that "city and state taxpayers will have absolutely no legal or moral obligation to pay debt service on such bonds as are issued to finance the program. . . . To chide us for ignoring the long-term costs and the political and social realities of any public housing program is to mischaracterize our proposals. We both know from personal experience the financial costs that a poorly planned housing program can have. We also know that there is a desperate need for more housing and that the loss of nearly all Federal support for housing compels us to look for new techniques to meet the need."[56]

In November 1985 Mayor Koch asked thirty-four of the city's developers and real estate executives for advice on how to facilitate the construction of unsubsidized affordable housing.[57] The developers responded that city approval processes needed to be streamlined, that zoning should be changed to allow for new types of housing, and that the building code, which was rife with archaic restrictions that drove up costs, needed to be revamped. If the city were to streamline the building process, the developers promised to build 3,000 units of housing on a nonprofit basis. In March 1986 the developers officially released their recommendations and on April 16, 1986, the recently formed Mayor's Panel on Affordable

Housing issued a report that incorporated many of the developers' recommendations as well as new ones.

Far and away the boldest proposal made by the mayor's panel called for the rezoning of roughly 45 percent of the city to allow for what the mayor described as "large-scale, moderate-income housing."[58] The zoning, affecting only the outer boroughs and covering most of Staten Island, a broad patch of southern Brooklyn, and various swaths of Queens, the eastern Bronx, and parts of Riverdale, was specifically aimed at allowing three- and four-family homes to be built where lower densities were presently called for and to also encourage a return to the construction of six-story apartment houses. Among nearly thirty other proposals were the establishment of a housing trust fund with money from an increased hotel tax and a recording tax on co-op mortgages, the waiving of taxes on building materials for builders, and, as the developers had suggested, the liberalization of the building code to allow for less expensive materials such as lighter electric cable and copper, instead of brass, piping. The panel also called for the kinds of shared water and sewer connections that I. D. Robbins had employed in the Nehemiah Homes. In specific response to the request by developers for a more efficient building process, the panel also proposed an Office of Housing Coordination, which was created in May 1986.[59] Another of the panel's proposals— to allow architects and engineers to certify that their own work was being built to code rather than requiring the six city inspections and approvals currently necessary—was met with considerable opposition from the American Institute of Architects, which felt that "such work seriously increases the architect or engineer's professional liability" and that it also presented conflicts of interest with contractors, who would pressure them to certify the work.[60] Nonetheless, self-certification was adopted in 1995.

The editors of the *New York Times* were kind in their response to the panel's "boldly ordinary housing plan," stating that it uncovered what "other observers have failed to see. The most successful housing program in New York, and other large cities as well, is that carpenter's cliché, the three-family frame house. This kind of home calls on no federal or state subsidy, no high technology, no inspired architecture. Yet it provides acceptable affordable homes for thousands of families of modest income. A city with a vacancy rate of less than 2 percent should encourage building many more of them." The "recommendation on small homes," they concluded, "promises a real breakthrough. By turning to the conventional, the Mayor's housing panel has actually showed daring."[61]

A Ten-Year Plan for Housing

On April 30, 1986, Koch announced a ten-year plan to build or rehabilitate 252,000 apartments for low-, moderate-, and middle-income New Yorkers.[62] The plan called for a total of $4.2 billion to be spent on housing, a sum that, according to national housing experts, made it the most ambitious municipal housing program in the country. Included was the Housing New York program, approved by the state legislature that year to provide $400 million in bonds backed by the Battery Park City Authority's surplus commercial rent. The ten-year plan also called for the creation of a housing trust fund and, for the first time, set aside a significant amount of the city's capital budget to be spent on housing. An array of new initiatives involving the public and private sectors and rehabilitated and new housing were aimed at attacking the housing shortage on all fronts so that in some cases the city would sell vacant buildings to private developers for rehabilitation while in other cases it would hire contractors itself and turn the rehabilitated buildings over to nonprofit organizations for operation. The city also devised new methods of providing financing, such as allowing public employees to use their pension funds to back mortgages, an opportunity which 4,000 people took advantage of by 1989.

The emphasis of the ten-year plan was on rehabilitating the city's housing stock for the middle class. The first phase of the plan, announced in December 1986 and called the Vacant Buildings program, was aimed at creating 3,395 units in abandoned buildings which would be sold to developers for $1 and renovated for middle-income renters, upsetting advocates of low-income housing. Their concerns would be at least partially addressed in the second phase, which called for contractors to renovate 1,801 apartments in fifty-eight abandoned buildings with 75 percent of the units to go to homeless and low-income families. In 1987 the first rehabilitations under the Housing New York program got under way as 1,825 dilapidated apartments in Harlem and the South Bronx were renovated for homeless, low-, and moderate-income families. The Harlem site included forty-eight buildings bounded by 139th Street, 147th Street, Lenox Avenue, and Adam Clayton Powell Boulevard, and the South Bronx site included fourteen buildings bounded by 170th Street, 174th Street, Walton Avenue, and Townsend Avenue.

In May 1988 the ten-year plan was expanded by $900 million, making it a $5.1 billion program. Among the new funds were an additional $600 million from the Battery Park City Authority. With the extra funding, the city was quite ambitious, calling for the rehabilitation of every abandoned apartment building it owned, thus raising the total number of scheduled rehabilitations to 49,000 apartments as compared to the 29,000 initially outlined. It also provided for the renovation of 32,000 more apartments that the city expected to take over during the coming decade and included plans to renovate 36,000 occupied city-owned apartments—an important step to halt the processes of abandonment—which would continue to be owned and operated by the city. Compared to the $25 million spent by the city on housing in 1985, in the 1988 fiscal year the city expected to spend $410 million of its capital budget on housing and the following year expected to spend $640 million.

There were few visible signs of progress during the plan's first years, during which time the mayor received more than his fair share of criticism. By 1988, however, a noticeable amount of work was taking place in the city's vacant buildings and in 1989 the results really began to show, with rehabilitated apartments constituting two of every three units added to the housing supply and a total of 26,352 units of new or rehabilitated housing under way. Observing a flurry of construction in January 1989, Jack Rosenthal rhapsodized in the *New York Times*: "It's a stunning sight up here atop an abandoned brick apartment house in the Bronx, a sight that offers a glimpse into one of the great construction projects in the history of cities. . . . Masons erect a new parapet on this building. Roofers scramble about on the next one. One over, workers stagger under sheets of plywood. Dust billows from a two-story mountain of refuse. Gut rehab, it's called. . . . When has any city anywhere undertaken such a monumental task? It's a 20th-century equivalent of the pyramids."[63]

By 1991, the plan had begun to prove itself, leading Roger Starr to observe: "The program has been around long enough to permit two tentative conclusions: The city has found a way to fix buildings. Just as important, it has found ways to make the fixes last. . . . The idea of using public money to reclaim once-useful apartment houses from devastation is hardly new. What's different about the present program is the city's emphasis on maintenance and tenant cooperation." Starr described the city's "four-part attack on decay. Three of the four approaches rely on private groups—cooperative, nonprofit and for-profit enterprises—which acquire title and manage the buildings after restoration. The fourth approach involves city ownership and management. It's by far the largest component of the anti-decay program: the city is responsible for more than 30,000 of the 50,000 apartments already renovated." Noting the often poor conditions of city-owned buildings and the problem that "many tenants simply don't trust their new municipal owners," Starr found it "encouraging that the city now seems to be moving more quickly to take prompt corrective action when tenants complain."[64]

Others saw things differently. Camilo José Vergara, a photographer who documented changes in the city's most ravaged areas, criticized the government's ability to maintain its rehabilitated buildings and articulated a view held by many that even if the ten-year plan was producing new housing, it was doing very little to provide the kinds of supportive social services necessary to sustain a healthy neighborhood: "Workers spoke to me with pride about what they were doing, yet they often made the point that soon after people moved in, the newly renovated buildings would look just like those in the decrepit neighborhoods surrounding them. Optimistic accounts of the plan in the media and the high hopes of officials and advocates contrasted with the opinions of most of those who lived and worked within the reconstructed blocks." The plan's "most troubling flaws," he felt, were "the lack of effective programs designed to deal with the severe drug infestation and crime that exists in the areas where the rebuilding is concentrated . . . and the extreme poverty of the neighborhoods chosen for the bulk of homeless housing and shelters. . . . From the start, the ten-year plan has been characterized by speed, expedience, and lack of vision." He contended that the program lacked "the following essentials for creating stable communities: neighborhoods and buildings where working families are dominant, small shelters located evenly throughout the five boroughs, social services, and an effective police presence."[65]

The ten-year plan slowed as the city slipped into a recession during the early 1990s, significantly curtailing public and private spending on housing.[66] The Housing New York program, which had funded the rehabilitation of over 1,100 apartments, was sidelined in 1990 when the newly elected Mayor Dinkins used $200 million raised for the program to close a city budget shortfall. As housing production for all sectors of the population decelerated, overcrowding became as severe as it had ever been, and it was not only the poor who found themselves doubled and tripled up in apartments. When asked in September 1990 how pervasive overcrowding had become, Columbia urban planning professor Peter Marcuse commented, "I can tell you that it goes right through tenured college professors," referring to his own living situation in which he shared a small apartment with his daughter and her foster child.[67] According to the New York Times, a typical overcrowded apartment was populated either by young couples living with parents, single mothers living with parents, or recent immigrants living with extended families. By the close of 1992, the number of families on the waiting list for New York City Housing Authority apartments had grown to a record level, with an estimated twenty-year wait for an apartment. Making matters worse was the practice, initiated by Koch in 1988 under pressure from the federal government, of moving the homeless from welfare hotels into the housing projects, where they were prioritized for housing over existing applicants on the waiting list.[68] Between 1988 and 1992, more than 8,000 homeless families were moved into the projects. As this strategy proved to be ill-conceived, Dinkins called for the reopening of the welfare hotels as "Tier II" facilities that provided not just single rooms, but family-sized apartments with private bathrooms and kitchens in buildings with support services like health care and day care.[69] The attractiveness of these facilities and other Tier II projects such as the transitional housing being built in the outer boroughs (see below) led to a new problem in which families living in overcrowded apartments began to "go homeless" so they could be prioritized for housing.

The market for luxury housing also dried up in the early 1990s, with Peter Salins stating: "When you have a slowdown in production for the middle class, in the long run that means less choice and lower quality and higher prices for the poor."[70] Programs like 421a and 80/20, in which the production of low-income housing relied on a demand for market-rate housing, virtually ground to a halt. Yet the falloff in market-rate housing, widely viewed as a symbol of the city's declining fortunes, also highlighted the success of the ten-year plan, then it its sixth year, which had rehabilitated 43,000 apartments.[71]

Although community groups supported the overall direction of the ten-year plan and were relieved that Dinkins intended to continue with it, they had serious qualms about the production of so much middle-class housing. Not surprisingly, the New York City Housing Partnership, the city's leading builder of such housing, came under heavy fire. As its critics saw it, not only was the partnership accepting substantial city subsidies while ignoring the blaring need for low-income housing, it was using up the city's prime building sites while doing so.[72] Even worse than the city's emphasis on building for the middle class, argued Margaret Mittlebach, a writer, was the fact that community groups—the people who knew the most about what was needed in their neighborhoods—had no say in what got built, where it got built, and for whom: "Local critics . . . have never really warmed up to the agency's top-down planning style or their commandeering of government subsidies that they say might be better spent elsewhere."[73]

Dinkins himself had criticized the ten-year plan in his capacity as Manhattan borough president, and as mayor sought to respond to these issues, shifting the plan's emphasis away from the middle class and toward housing for the homeless and low- and moderate-income families. All buildings renovated under the Vacant Buildings program were now required to set aside 20 percent of their units for low-income residents, with the other apartments made more affordable by direct rent subsidies. Dinkins also responded to concerns that too many rehabilitated buildings were being turned over to private, for-profit owners by eliminating the Private Ownership Management Program, known as POMP. As well, several of the major construction projects initiated by Koch

HELP I, 515 Blake Avenue, block bounded by Hinsdale Street and Blake, Sutter, and Snediker Avenues, East New York, Brooklyn. Cooper, Robertson & Partners, 1988. View to the southeast. Pottle. ESTO

were either put to rest or modified to include more low-income housing and a greater level of community involvement in the planning process. The Melrose Commons (see The Bronx) development in the South Bronx exemplified the transition during the early 1990s from top-down planning to a collaborative process that included community groups.

When Rudolph Giuliani became mayor in 1994 the city was beginning to emerge from the recession. There were two years left in the ten-year plan, but spending on housing had been cut significantly, with the capital budget for the Department of Housing Preservation and Development having decreased in four of the previous six years. Mayor Giuliani committed, on paper at least, to renew the program for another ten years with a budget of $4.2 billion, but the city's still shaky economy raised doubts as to whether or not the funds would be available. As it turned out, between 1992 and 2001, city spending on housing dropped by roughly 65 percent.

The ten-year plan could be judged a success. By 1995, as it drew to a close, the initiative had produced more than 50,000 units of new housing, more than the total of all other municipal efforts in the nation combined during the same period.[74] The plan had also rehabilitated 3,000 abandoned apartment buildings and led to the construction of 12,000 one-, two-, and three-family houses, built on vacant lots and sold to families. Including the renovation of occupied city-owned buildings, the ten-year plan produced more than 141,000 units of housing. The Bronx was the prime recipient, receiving 36 percent of the total number of units, while Manhattan received 33 percent, Brooklyn 25 percent, Queens 5 percent, and Staten Island 1 percent.[75]

Housing the Homeless

By the mid-1980s the city's housing and homelessness crises had melded into one as the desperate need to produce low-, moderate-, and middle-income housing was rivaled, if not partially eclipsed, by the need to provide what was in essence no-income housing for the homeless. Constant efforts to shelter the homeless in welfare hotels and in converted armories and gymnasiums were not only unable to meet the demand for beds, but also proved expensive and unsatisfactory. City-sponsored programs to rehabilitate vacant buildings for homeless individuals and families were relatively successful, but the process was slow and the number of units available was not sufficient to significantly reduce the homeless population. In 1986 new strides were made toward housing the homeless when Andrew Cuomo, an attorney and son of Governor Mario Cuomo, formed Housing Enterprise for the Less Privileged (HELP), a private nonprofit group that developed "transitional housing," also known as Tier II housing, to provide not only shelter for the homeless, but also the job training and social services necessary to help individuals and families make the transition to self-sufficiency.[76] By 2004 HELP had built fourteen facilities in the New York metropolitan area on land donated by the city. The accommodations, operated by the Red Cross, were mostly provided at no rent to homeless families, who could stay for up to thirteen months.

HELP's first building, HELP I, designed by Cooper, Robertson & Partners, opened in 1988 at 515 Blake Avenue in East New York, Brooklyn.[77] Organized as two parallel three-story residential buildings constructed of twelve-by-forty-foot stackable prefabricated concrete modules and separated by a

courtyard with a playground and grass lawn, HELP I had at one end of its courtyard a one-story entrance wing providing 12,500 square feet of community and day care facilities as well as space for social services provided by seventeen in-house social workers. The complex's 200 units, able to accommodate 800 residents, were entered from open-air courtyard-facing corridors similar to those of typical motels while the street facades featured windows but no entrances. Paul Goldberger, reviewing the building as it neared completion, noted that "the presence of a great deal of concrete" made the buildings "somewhat rough and hard-edged in appearance" but felt that the complex was "so well planned that it comes off in the end as welcoming more than harsh." He noted the presence of "tiny hints of a cornice, not so much to confer luxury as to lessen the possibility that the place will look like a barracks" and found the 390-square-foot apartments, each containing a bedroom, bathroom, living room, and kitchenette, to be "small," but, in feel, "considerably larger than they are. Every unit runs all the way through the residential wing from the courtyard to the street side, so there is ventilation and sunlight everywhere, and it is possible to supervise children playing outside from every unit." Though Goldberger stated that "in general, turning away from the street is a bad idea," he felt that the particular nature of transitional housing—"part conventional housing, part shelter,"—made it necessary "for the privacy and security of the complex and its residents to take precedence over other factors. Since the forms of the buildings are lined up right along the street, and not set back, they do their urbanistic duty visually—it is only in terms of actual access to the street that they hold back."[78]

HELP I was followed by two facilities based on its design but carried out by Castro-Blanco, Piscioneri & Associates: HELP Bronx Crotona (1991), 785 Crotona Park North, on the block bounded by Crotona Avenue, Clinton Avenue, Fairmount Place, and East 176th Street,[79] providing housing for ninety-six families with roughly 30 percent of the residents also employed at the facility; and HELP Bronx Morris (1992) (see The Bronx), 285 East 171st Street, located on a site bounded by Morris Avenue, College Avenue, East 171st and East 172nd Streets.[80] A fourth facility, HELP Homes (Cooper, Robertson & Partners), completed in 1992 in East New York, Brooklyn, across the street from HELP I, marked a new direction for the organization in that it provided permanent, not transitional, housing for seventy-seven homeless families, seventy-two low-income families, and 184 individual adults.[81] The four-story 192,000-square-foot building hugged the perimeter of the entire block bounded by Snediker Avenue on the west, Blake Avenue on the north, Hinsdale Avenue on the east, and Dumont Avenue on the south, enclosing a 1.1-acre landscaped courtyard. The facility's corner entrance was marked by a dramatically shaped pitch-roofed octagonal tower and provided access to an adjacent 16,000-square-foot community center containing day care, medical care, and counseling facilities as well as administrative offices. The entire complex was clad in brick and stucco and employed cast-stone lintels and occasional decorative colored tiles. Alternating sections of flat and gabled roofs enlivened the massing. Like its predecessor, all of the apartments—ranging in size from 575-square-foot one bedrooms to 1,225-square-foot four bedrooms—were entered from outdoor courtyard-facing corridors, eliminating the need for potentially dangerous interior double-loaded halls and resulting in a building that was only thirty-two feet deep.

Surprising many with her September 30, 2004, *Wall Street Journal* assessment, Eve Kahn found it difficult to "find nice or even noncommital things to say about what HELP is up to." She determined that the group's strategy was to "isolate the homeless in one-block-square temporary or permanent housing" and was dissatisfied that the "long interior balconies permit constant surveillance of tenant comings and goings. . . . Sidewalk-hugging outside walls, bereft of entrances or large windows, are good places to get mugged and often end in pointed towers reminiscent of prison lookouts." Kahn concluded: "Not only does the design send clear messages to residents and pedestrians that we are not safe in each other's presence, but the workmanship tends to be horrific: the stucco-slathered balconies could be Howard Johnson motel rejects."[82] Conrad Levenson, an architect specializing in affordable housing, agreed, characterizing HELP's facilities as "concentration camps for families," while another architect, Tony Schuman, called them "social and neighborhood disasters."[83] HELP expanded its programs to provide, among other services, housing for victims of domestic violence, growing into a national organization, HELP USA, that operated twenty transitional housing facilities in five cities around the country. The transitional housing developed for the Brooklyn and Bronx sites gave way to new forms, at times responding to more urban sites as in the Genesis Apartments (1995), 113 East Thirteenth Street, in Manhattan, where Cooper, Robertson & Partners adroitly inserted a twelve-story building into a vacant through-block site (see Union Square).

In October 1986, the city followed in HELP's footsteps by announcing its own plan to permanently replace sixty-three welfare hotels, which housed 3,800 families, with twenty purpose-built transitional housing facilities–four in each of the boroughs–over two years. Staten Island was later taken off the list because it had agreed to host a new jail, and the intended number of shelters was whittled first to seventeen and then to eleven as critics fought hard against the projects. Despite the controversy, the city moved forward, hiring the unlikely firm of Skidmore, Owings & Merrill to prepare designs for two transitional housing prototypes—one to accommodate 100 families and the other 200 single adults—each of which could be modified for construction on a variety of sites.[84] The Skidmore firm's selection was in part a product of its offer to complete the work at cost and its ability to work on all eleven planned buildings at once. Not all were pleased by the choice. Conrad Levenson later commented: "Asking SOM to design homeless shelters is like asking me to design the World Trade Center."[85]

SOM's family housing prototype, a 70,000-square-foot reinforced concrete structure, featured red brick–clad residential wings housing twenty-five families each, arranged in an H-plan around a central building providing space for community use and social services. The central building and the connecting portions of the residential wings were topped by green hipped roofs with cupolas allowing light to enter brightly colored corridors. A landscaped entrance and a play area occupied the two street-facing courtyards, offering a distinct and welcome contrast to the Cooper, Robertson designs for HELP, where courtyards were shielded from the street. The units— seventy 275-square-foot rooms for single mothers with one or two children and thirty 550-square-foot suites for larger families—featured small cooking areas near the entrances and private baths with polished stainless-steel mirrors to prevent breakage. The apartments, along with a social worker's office

ABOVE HELP Homes, 330 Hinsdale Street, block bounded by Hinsdale Street, Dumont, Snediker, and Blake Avenues, East New York, Brooklyn. Cooper, Robertson & Partners, 1992. View to the northeast. Mauss. ESTO

RIGHT HELP Homes, 330 Hinsdale Street, block bounded by Hinsdale Street, Dumont, Snediker, and Blake Avenues, East New York, Brooklyn. Cooper, Robertson & Partners, 1992. Site plan. CRP

and two common living rooms—one for television and one for quieter activities—were arranged around a central space lit by clerestory windows and glassed-in light wells. Not long after completion, however, many of the living rooms were converted into apartments to meet additional demand.

For the singles housing, SOM's prototype called for a long, narrow building set against the street wall with space for gardens provided in the rear. Groups of eight single rooms were situated around central double-height living rooms and kitchens that interlocked with one another on different floors. Each set of eight rooms was expressed as a group on the red or buff brick exteriors, where casement windows were capped by bold black steel lintels. The stacked living rooms and kitchens were set behind three- or four-story-high black aluminum-trimmed curtain walls divided into two-by-four-foot white-mullioned win-

dows rising above the cornice line to give the long facades a rhythm and distinction on the street. In all, ten of the SOM designs were constructed. The family housing facilities were built at 346 Powers Avenue (1989) in the Mott Haven section of the Bronx; 10875 Avenue D (1989) in Brooklyn; 691 East 138th Street (1989) in the Bronx; 1381 East New York Boulevard (1990) in Queens; 1675 Broadway (1990) in Brooklyn; and on 134th Street (1992) in Queens. The singles housing facilities were built at 50 West Mt. Eden Avenue (1990) in the Soundview section of the Bronx; 381 East New York Avenue (1990) in Brooklyn; 22 East 119th Street (1992) in Manhattan; and 1150 Commonwealth Avenue (1993) in the Bronx.

The Skidmore-designed buildings were almost twice as expensive to build as Cooper, Robertson's, and the difference in quality showed. Eve Kahn felt SOM's transitional housing

stood "worlds above the . . . aloof, disturbing shelters that H.E.L.P. . . . has erected in and around New York," calling the buildings "sensible, dignified and predominantly modernist" and noting that neither the family nor singles model "screams 'shelter' or 'homeless'; if you walked toward them, you would know you were approaching something unusual and well-built but would be hard pressed to guess what went on inside." Of the singles housing, Kahn wrote, "These buildings don't make the modernist mistake of offending any neighbor," remarking that the curtain walls punctuating the facade created the "illusion of townhouse rows minus a few front doors." Likewise, the family housing "tries to fade into context. . . . The footprints vary greatly among the . . . sites, sometimes reduced to a J, an L or a mere dash."[86]

Paul Goldberger, reviewing SOM's designs before construction began, found the work to be "more ambitious architecturally" and "a bit closer to permanent housing than" Cooper, Robertson's HELP I in "external appearance if not" in the interior layouts, which he felt were "not quite as good" as Cooper's since the SOM buildings "would not have through ventilation." He acknowledged, however, that the SOM layouts did "allow for more flexibility, since rooms can be merged into adjoining units." For Goldberger, the SOM prototype for family housing was "impressive . . . at once sensible and humane." But, he continued, "the design for singles, which is in effect a latter-day version of a single-room-occupancy hotel, is better still—a design that brings considerable architectural sensitivity and invention to what could be dismissed as the most banal of problems." Considering both the Cooper, Robertson and SOM designs together, Goldberger wrote: "Perhaps the most important thing of all about these new buildings is that they can provide permanent social services right on the premises, something that is nearly impossible to do in rehabilitated housing, and which is not done at all in the welfare hotels." While Goldberger found the accommodations to be "bare bones" and "small," he believed they offered "a testament to the possibility of decent city living for people who have known mainly frustration and denial."[87]

A specialized type of homeless housing emerged during the late 1980s to provide care for people with AIDS, the

devastating and debilitating disease that reached epidemic proportions in the 1980s. The housing, which took the form of both rehabilitated and new buildings, like transitional housing for the homeless, provided not only shelter but social and medical services. The concept was a hard sell. As one homeless person with AIDS stated, the general perception of the government's stance was: "Why waste money? Why should congress, the state or city donate millions of dollars to dead people? Well, if you have that attitude you might as well build a big crematorium eight blocks long. They're killing people with words."[88] But Gustavo Bonevardi and Lee Ledbetter broke the ground when they gave architectural expression to the special demands of AIDS patients in their 1987 submission to the Vacant Lots competition (see above). In October 1988, the Koch administration announced a plan to provide, by 1991, 840 beds for homeless people with AIDS and their relatives in converted buildings on eight sites in Manhattan, Brooklyn, and the Bronx.[89] Up to that point, only seventy-four nonhospital beds were set aside for homeless people with AIDS, the majority of them located in one

facility: Bailey House, on Christopher Street in the West Village, which had opened in 1986 with funds from the city, the state, and private sources.[90] The proposed facilities faced the same kinds of opposition as the transitional housing projects, with many communities adamantly opposed to welcoming such residents. However, several of the projects were able to go forward, including the gut renovation of Woodycrest Mansion, the Beaux-Arts, mansarded, stone, terra-cotta, and gray brick–clad former American Female Guardian Society and Home for the Friendless (William B. Tuthill, 1902), 936 Woodycrest Avenue in the Bronx, originally built as a home for 120 neglected children. Completed in 1991, the conversion, carried out by the architect Donald Sclare and sponsored by two nonprofit groups, Housing and Services, Inc., and the Highbridge Community Life Center, provided ninety-nine beds for children, individuals, and families with AIDS in a mix of forty-two one- and two-bedroom apartments on six residential floors.[91] The 65,000-square-foot Highbridge-Woodycrest Center also provided lounges, a dining room, a nursing center, and a nursery. The building

741–749 East Ninth Street, northwest corner of Avenue D. Johnson/Wanzenberg, 1997. View to the northwest. Freeman. AWA

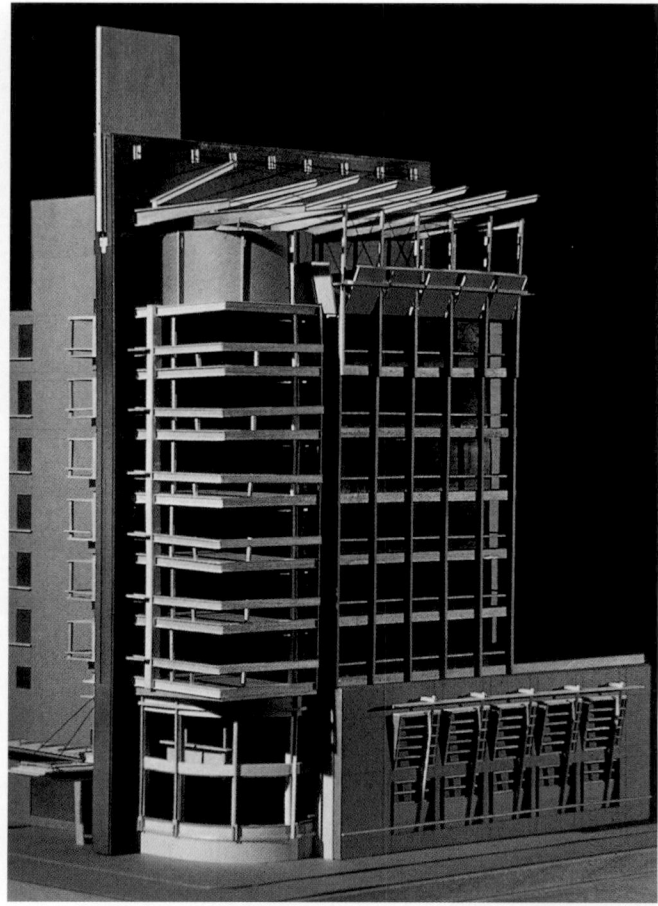

Proposed Claremont Park Family Care Center, northwest corner of Second Avenue and Mt. Eden Parkway, Bronx. Perkins & Will, Kohn Pedersen Fox, and Swanke Hayden Connell, 1992. Model, view to the northwest. PER.

itself was treated with kid gloves even though the Landmarks Preservation Commission held several hearings on the structure but did not designate it.

Housing and Services, Inc., also transformed the former Speyer School (Edgar H. Josselyn, 1902), 516 West 126th Street, between Amsterdam Avenue and Old Broadway, originally built as a facility for Teachers College, into a forty-bed residence for homeless people with AIDS.[92] Garrison McNeil served as architect for the renovation, which was completed in June 1992. Of greater impact was Rivington House, 45 Rivington Street, southeast corner of Forsyth Street, completed in 1994 as the largest specialized AIDS residence in the state and perhaps the nation. The facility occupied the former Public School 20 (C. B. J. Snyder, 1898), which Davis, Brody & Associates and Perkins & Will renovated to provide an outpatient clinic and 219 beds, including forty-five beds for patients with tuberculosis.[93] The U-shaped building's courtyard was filled in and its rooftop gymnasium converted into a penthouse providing various types of therapy. The ground floor accommodated a gift shop, a dental and ophthalmological suite, meditation and meeting rooms, and an outpatient unit. Patients were housed on the second through fifth floors, and a basement level provided radiology equipment, a pharmacy, a cafeteria, and kitchens. To alleviate as much as possible the institutional nature of the facility, the designers called for indigo, tangerine, and yellow walls in the entry vestibules to patient rooms.

Several purpose-built facilities were also undertaken for AIDS patients. Housing Works, a nonprofit agency formed in 1990 to assist homeless people with AIDS, commissioned the firm of Johnson/Wanzenberg to design a five-story brick-clad residence with terra-cotta trim at 741-749 East Ninth Street (1997), corner of Avenue D, that provided thirty-six furnished efficiency apartments with a day treatment center.[94] Jed Johnson designed the interiors while his partner, Alan Wanzenberg, took on the architectural job of shaping a double-height sun-filled atrium, a room on each residential floor to accommodate family members of dying residents, and, on the ground floor, dining and smoking rooms, a patio garden, and a restaurant that was to accept food stamps. Housing Works also hired the Pratt Planning and Architectural Collaborative to design a programmatically similar thirty-six unit residence at 2626 Pitkin Avenue, at Fountain Avenue in East New York, Brooklyn.[95] One notable project that did not go forward was the Claremont Park Family Care Center, a 52,517-square-foot ground-up outpatient clinic for children with AIDS collaboratively designed on a pro bono basis by Perkins & Will, Kohn Pedersen Fox, and Swanke Hayden Connell.[96] The nine-story building, proposed for the northwest corner of Second Avenue and Mt. Eden Parkway across from Claremont Park in the Bronx, was to feature acute and nonacute clinics organized in a bipartite plan, with the nonacute services—counseling and child care facilities, conference rooms, classrooms, and

administrative offices—located along the street facades and occupying a glass-enclosed corner tower, while the medical facilities were to be situated deeper within the building for more privacy.

Cleaning House

The ten-year plan had demonstrated that the city could successfully rehabilitate buildings and get them back into the hands of the private sector. But by 1994 the city still remained in control of 4,823 buildings (1,862 vacant and 2,961 occupied) containing 43,884 apartments as well as 11,000 vacant lots, acquired through seizure for nonpayment of taxes.[97] The editors of the New York Times pointed out that even though the average tax delinquency on a foreclosed building was only $36,000, the city spent an average of $2.2 million per building to operate, manage, and eventually prepare it for sale: "Once acquired," they noted, "a building remains in city possession for an average of 19 years before it is rehabilitated and sold."[98]

The city's so-called in rem properties were the little-discussed stepchildren of the housing crisis, presenting even greater challenges than the abandoned buildings. As the New York Times's Shawn G. Kennedy explained, "Unlike the big, vacant multifamily apartment buildings that the city successfully recycled in the late 1980s, the vast majority of what the city now owns is much less attractive to potential owners. Many are small buildings, which cost more to administer than larger ones because owners do not get the same economies of scale that landlords of large buildings do. In many cases, they are occupied, which makes renovations much more complicated, and many of the tenants are very poor" and would "have trouble paying the rents new owners would need to recover their investments."[99] The challenge of turning the rehabilitation of these small, scattered buildings into a profitable endeavor for the private sector was met by Mayor Giuliani's Housing Preservation and Development commissioner, Deborah C. Wright, who proposed to bundle small abandoned buildings together with nearby occupied city-owned buildings and sell the packages to single owners so that any loss taken on rehabilitating the vacant buildings could be offset by the occupied buildings, which were in many cases already operating profitably. Along the way, the city would provide grants and loans to the new owners, many of whom, it was hoped, would be nonprofit organizations.

As part of the effort, Mayor Giuliani announced the Neighborhood Entrepreneurs Plan calling for the sale of 250 small city-owned buildings containing 2,500 apartments. One thousand units were to go to nonprofit community groups, 500 would be converted to tenant-run cooperatives, and the remaining 1,000 were taken over by the New York City Housing Partnership, which would turn the leases over to "local entrepreneurs" for a three-year period during which time the entrepreneurs would be trained to manage the buildings. If they successfully completed the training, they would be eligible to buy the building at the end of the three years.

Mayor Giuliani also launched a campaign to prevent future cycles of abandonment and foreclosure, an especially important effort at a time when one such cycle seemed to be forming as the number of buildings in default increased sharply from 13,737 in 1989 to 18,003 in 1993 and the number of owners paying off taxes in order to be removed from the tax-arrears

list declined from 12,472 in 1989 to 5,691 in 1993. Under the new system, instead of the city seizing buildings for nonpayment of taxes, an "early warning system" would identify buildings that were threatened with foreclosure. Whenever possible, the landlords would be given financial advice and even loans to maintain their tenants' services. But if they could not do so, new owners would be sought and would receive loans and grants to operate the buildings. The city would take ownership only as a last resort.

Between 1994 and 2001, the city sold 1,102 vacant apartment buildings, which were renovated by new owners, and itself renovated and sold 1,617 occupied apartment buildings, leaving it in possession of only 2,104 vacant and occupied apartment buildings. By 2003, New York City owned fewer than 800 apartment buildings containing 4,000 units.[100] According to a report by the city's Independent Budget Office, the entire inventory was expected to be sold off by 2011.

Housing and Gardens

Despite the Giuliani administration's considerable accomplishments in housing development, the public focused on its one misstep: the decision to reclaim community gardens as sites for new housing. Soon after taking office in 1994, Mayor Giuliani called for an inventory to be taken of the 11,000 vacant lots owned by the city in an effort to bring as many of them as possible back into use and onto the city's tax rolls. The Department of Housing Preservation and Development determined that 3,000 lots were suitable for new housing. Among these were 300 community gardens, small patches of often lushly planted green space tended by local citizens who had created them on formerly vacant and often dangerous lots.

Some of the first community gardens were established by the Green Guerillas, a group formed in 1973. Tom Fox, one of its founding members, later commented: "We did not have any permits. We cut fences open with wire cutters, and took sledgehammers to sidewalks to plant trees. It was a reaction to government apathy."[101] In 1978 the city recognized the value of these initiatives when, funded with federal antipoverty grants, it formed Greenthumb, an agency offering gardeners yearly leases on the vacant lots at no charge with the understanding that the gardens were to be temporary and could be demolished whenever the city was able to find other uses for the sites. The program was quite popular. By the late 1990s, a total of 750 gardens were handled by Greenthumb.

Mayor Giuliani's 1997 proposal to do away with community gardens unleashed a firestorm of criticism, catching the administration completely off guard.[102] Candlelight vigils were held, letters flooded into the New York Times in protest, and in April 1997 members of a new group, the New York City Coalition for the Preservation of Gardens, some dressed as ladybugs and tomatoes, rallied at City Hall. But the Giuliani administration was not to be swayed. Plans for twenty gardens giving way to 800 units of housing were well under way and Deputy Mayor Fran Reiter stated: "The bottom line is, we're going to build wherever we can, whenever we can. Do we sacrifice gardens to build housing? You're damn right we do."[103] Reiter's bluster fell on deaf ears as garden advocates argued that they not only had beautified decrepit lots but had also made streets safer, brought neighbors together, and in many cases simply provided much

needed therapy for residents of the city's most distraught communities. But the mayor remained convinced that the gardens were temporary and that if one was lost for housing, another garden could be started on another lot. More than two dozen gardens were bulldozed between 1995 and 1998. In May 1998, the Department of Housing Preservation and Development took over the entire stock of 741 community gardens from the Department of Citywide Administrative Services, adding 400 parcels to the ones it already controlled. Within six months about twenty gardens were destroyed and fifty-eight more were scheduled for elimination. The losses compounded the growing perception that the Giuliani administration was callous. In January 1999, the situation went from bad to worse when the city announced it would auction off 112 gardens as part of a larger auction of 700 city-owned lots. In an attempt to cash in on the booming real estate market, redevelopment would not be limited to low-income housing or even housing at all, but instead the gardens would be sold to the highest bidder for any use allowed by zoning. In some cases, the plan negated hard-fought agreements like one in Brooklyn, where the city government and Community Board 6 had agreed to allow a garden's redevelopment as a hospice for developmentally disabled teens. Another of the to-be-auctioned gardens was the so-called Garden of Eden, a twenty-five-by-eighty-three-foot garden in Queens that had been featured in a 1996 article in *National Geographic* celebrating Earth Day. Andrew Stone, director of the New York chapter of the Trust for Public Land, a nonprofit land conservation group, was shocked: "It's unbelievable. That garden is a source of stability for a neighborhood that has experienced a lot of problems. It's a model for a small community garden that functions as a community center. They run a children's program there every summer."[104]

Early in 1999 opposition to Mayor Giuliani's plan intensified, with the Brooklyn, Bronx, Queens, and Manhattan borough presidents speaking out against it and the City Council promising to block it if local feedback was not taken into consideration. As well, state legislators sought to introduce a bill that would allow nonprofits to buy gardens with state funds. The editors of the *New York Times* accused the mayor of announcing the plan during the winter because that was when the gardens looked their worst and were "empty of the noisy eco-protestors who would certainly be there in high summer." They criticized the city's "abysmally secretive" process "even by this administration's standards" and concluded, "Selling off the surplus lots may be fiscally prudent for City Hall, but bulldozing a working garden is an act of neighborhood violence."[105] Despite a sit-in at City Hall on February 24, 1999, and numerous protests around the city, Mayor Giuliani continued to hold his ground, sounding almost Koch-like when he dismissively told the gardeners: "This is a free-market economy. Welcome to the era after communism."[106] In mid-April, as the auction grew nearer, the Trust for Public Land, supported by twenty-five donors, offered to buy 165 community gardens, including all of those to be auctioned, for $2 million but the offer, well below the expected auction proceeds, was rejected by the city as being bad for the taxpayers. The offer's denial set off a new wave of letters to the *New York Times* criticizing the mayor, with the editors themselves weighing in against him.

A week before the auction, a coalition comprised of the Green Guerillas, community boards, gardeners, and a group

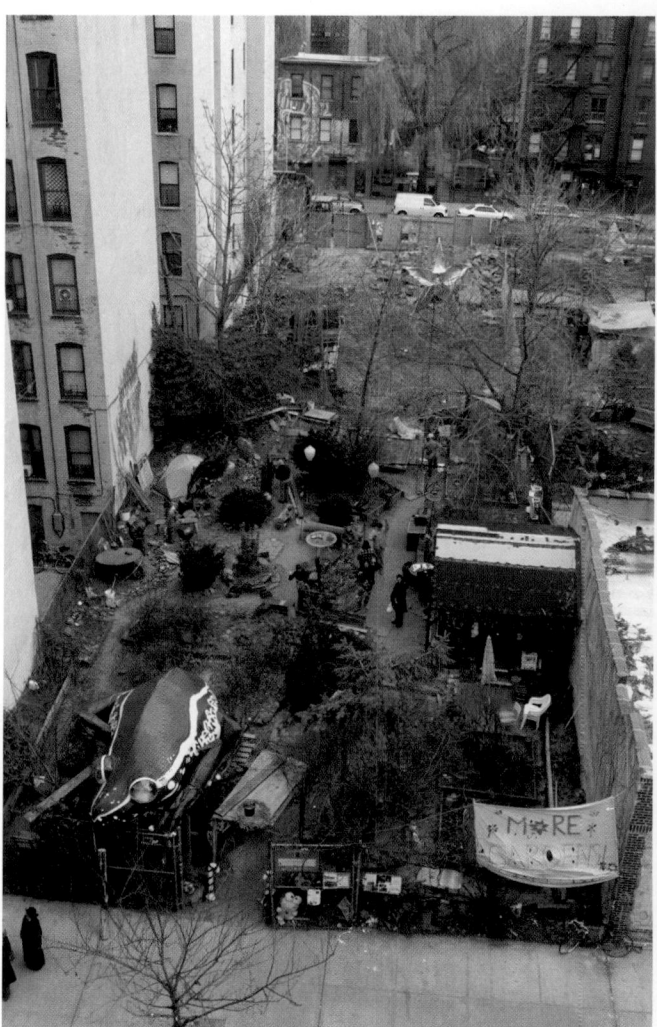

Jardín de la Esperanza, southwest corner of East Eighth Street and Avenue C extending south to East Seventh Street. View to the north, 1999. Maisel. NYDN

of elected officials including Bronx Borough President Fernando Ferrer and Brooklyn Borough President Howard Golden filed suit against the city, claiming that it hadn't followed City Charter requirements to take into consideration the sale's potential impact on communities. Days later, another suit was filed by the New York City Environmental Justice Alliance claiming that because the gardens to be auctioned were primarily in neighborhoods with heavy concentrations of minorities, the sale would violate the civil rights of these New Yorkers who "have dramatically less access to green recreation space than its white residents" by lowering their quality of life.[107] On May 10, three days before the auction, a third lawsuit was filed in the State Supreme Court in Brooklyn by State Attorney General Eliot Spitzer, who charged that the sale violated state laws because adequate environmental reviews were not performed. Additionally, Spitzer contended that many of the lots had been gardens for so long that they were considered to be parkland according to state law and thus the sale required state legislative approval.

Spitzer's lawsuit broke the mayor's resolve. The day before the scheduled auction he was reported to be negotiating the sale of sixty-three of the gardens to the Trust for Public Land,

contingent, however, on the administration's demand that "all the lawsuits go away," a condition over which the Trust had no power.[108] The same day, the public-spirited musical entertainer Bette Midler and her private conservation group, the New York Restoration Project, stepped in to buy fifty-one of the gardens and contribute significant funds to allow the Trust for Public Land to purchase additional gardens so that, between the two groups, all 112 parcels scheduled for sale could be taken off the auction block.[109] The city had been particularly receptive to the deal, given the decision by a Supreme Court judge in Brooklyn to temporarily bar the auction pending further environmental review. In addition, the city received market rate for the cumulative eleven acres of land and the agreement stated that if the lots were ever used for anything other than gardens, ownership would revert to the city.

Despite the fact that some community gardens were saved, roughly 600 others faced an undetermined fate. Moreover, some observers felt that the method of saving the gardens set a bad precedent for future negotiations. John D. Echeverria, director of the Environmental Policy Project at Georgetown University Law Center, commented that Mayor Giuliani's "extortionate demand that private parties pay the city not to destroy" the gardens "will make it more difficult to save hundreds of other community gardens across the city. . . . Preservation of publicly owned urban green space should be recognized as a legitimate function of government, not left to the serendipitous intervention of one generous movie star."[110]

The battle to save community gardens was indeed not over. In a highly protested act, the city destroyed the twenty-two-year-old Jardín de la Esperanza on the southwest corner of Eighth Street and Avenue C in the East Village in February 2000 (see East Village). Following the demolition, a court order was issued barring the sale of any remaining gardens to developers. In July 2001, a Brooklyn judge denied the Giuliani administration's move to have the court order lifted.[111] Mayor Bloomberg took office with a goal of settling the numerous lawsuits leftover from the Giuliani administration and, early in his term, began negotiations with Eliot Spitzer to end the acrimonious battle over the gardens by earmarking some of the remaining community gardens for redevelopment with low-income housing and allowing others to remain intact.[112] In September 2002 Bloomberg and Spitzer announced an agreement to protect nearly 500 remaining community gardens and build 3,000 units of low-income housing on the sites of about 200 others in what the mayor called a "practical compromise in a complex world."[113] Of the protected gardens, 200 were to be owned and operated by the city, primarily the Parks Department and the Department of Education, and 200 others were to be given to the Parks Department or transferred to nonprofit groups for a nominal fee. The gardens slated for development would have to undergo a public review process. Pleased that "the effort to pit open space against housing," which had "always had a ring of unfairness to it, since it required those in need of open space to make way for those in need of four walls and a roof" was over, the editors of the New York Times concluded, "while the details of the proposed compromise haven't been worked out, and fresh problems could always bring back the protestors in sunflower suits, community gardeners are already looking forward to the day when they don't have to worry about a bulldozer idling just around the corner."[114]

DIGGING IN

Throughout much of the city's history, even in the best of times, neglect of infrastructure—the physical plant, including roads, tunnels, bridges, and facilities and rolling stock for mass transit—was characteristic. But the situation in the late 1970s, coming on the heels of the fiscal crisis and after decades of decay, was particularly bad, and the new Koch administration pledged to reverse the trend.[1] In an eighty-six-page report released in March 1978, the City Planning Commission recommended that the amount of money to be spent on capital improvements in the next three years be doubled over what had been spent in the previous three, with the highest priority placed on bridge repair and street reconstruction. But twenty-one months later, in December 1979, Edward M. Kresky, an investment banker and vice chairman of the Municipal Assistance Corporation, complained in an op-ed article in the New York Times that scant progress had been made, writing that the "city each month falls further behind in its program to rebuild its infrastructure, particularly streets and bridges, sewer and water systems."[2]

Despite municipal reluctance to commit scarce funds to keep up infrastructure, the public works picture did improve and several prominent and controversial projects managed to move forward after long delays. Although the grandiose plan for Westway (see On the Waterfront), which would have created a ten-lane expressway set far enough back from the pierhead line to create up to 700 new acres of land capable of housing 85,000 families, was finally put to rest in 1985 after a bitter, more-than-decade-long fight, the badly deteriorated West Side Highway was eventually replaced with a new surface boulevard, the construction of which also led to a major new amenity, the Hudson River Park. In 1986, after two decades of opposition and delay, the immense North River Water Pollution Control Plant, capable of processing 170 million gallons of effluent each day, was opened in West Harlem on the Hudson River waterfront between 137th and 145th Streets (see West Harlem).

Slaking the City's Thirst

The Third Water Tunnel was the era's largest infrastructure project, and indeed the largest public works project in the city's history.[3] Another holdover from previous years, the tunnel was first proposed in 1954 in response to increasing demand for water but also to flaws discovered in the bronze valves in City Tunnels 1 and 2, completed in 1917 and 1936, respectively; these flaws made it virtually impossible to turn off the water at incremental locations to make repairs or inspect for potential catastrophic failures. Without a new backup water tunnel in place, conditions in the two existing tunnels would only continue to deteriorate.

The Croton water system, first established in 1842, a landmark in the history of infrastructure, was supplemented in 1915 by the Ashokan system, which drew water from a vast upstate watershed to slake the city's enormous thirst. Primarily through the force of gravity, the water reached the Hillview reservoir in Yonkers before Tunnels 1 and 2 routed the water to the city's extensive distribution system. The Third Water Tunnel would also connect with the Hillview reservoir. The undertaking, staggering in its complexity and size, was most often compared to the building of the Brooklyn Bridge with the caveat that almost no one would actually see the results and that many New Yorkers would even be

View of the Third Water Tunnel under construction in the Bronx, 1983.
Tannenbaum. AT

unaware of its construction. Designed to be constructed in four stages and not to be completed until 2020, the twenty-four-foot-diameter Third Water Tunnel, significantly larger than the two existing conduits and planned to include stronger stainless-steel valves, would reach depths of 800 feet and travel about sixty miles from the Yonkers reservoir through the Bronx and down to the southern tip of Manhattan before continuing to Brooklyn, Queens, and Staten Island.

Construction on the new tunnel began in 1970 but progress was quickly stymied, first by lawsuits over unrealistic cost estimates and then by the city's fiscal crisis, which halted construction in 1974. Work resumed on a very minimal basis in 1977 but it was not until February 1983 that the project got back on track when the city announced that four companies had been selected after a competitive bidding process to complete excavation work for phase one of the tunnel. Although the Third Water Tunnel did not generate anywhere near the kind of rancor associated with Westway or the North River Water Pollution Control Plant, some parts of its route were protested, producing minor delays in a construction process that, considering the project's inherent complexity, was efficient.

Only one aspect of the mammoth project captured the public's interest: the extremely hazardous working conditions of the tunnel workers popularly known as sandhogs, a nickname that dated back to the construction of the Brooklyn Bridge and referred to the soft soil the workers encountered after their

deep excavations. They were often romanticized in the press for their devotion to duty and camaraderie, especially after a serious accident or fatality. The dangers to sandhogs could come from a variety of sources, including cave-ins, floodings, dynamite accidents, and even falling icicles or dropped tools turned into deadly projectiles as they hurtled down the deep shafts. If a sandhog was lucky enough to avoid a catastrophic accident, the continued exposure to poisonous air thick with silica dust and intense levels of noise could wreak havoc.

In February 1997 the Brooklyn section of the Third Water Tunnel was connected to Queens and eighteen months later, in August 1998, the city announced that water from the new conduit would finally begin to flow to city faucets. Although it had originally been thought that the entire project would need to be finished before turning on the water, engineers determined that the completed phase one could safely be used. In a ceremony held at the Central Park Reservoir to celebrate the accomplishment, Mayor Giuliani read the names of the twenty-four people who had lost their lives during the tunnel's construction but also optimistically noted that work was on schedule for completion by 2020.

(Re)building Bridges

The deteriorated state of the city's bridges was also deemed a priority of the new Koch administration in 1978 when it was revealed that a total of 168 bridges were in "fair" condition

and needed "major rehabilitation," including the four major spans over the lower East River—the Brooklyn, Manhattan, Williamsburg, and Queensboro Bridges.[4] Engineers from the Department of Transportation determined that no bridge was considered unsafe, but they would not vouch for their future integrity if repairs were not soon begun. In March 1979, Mayor Koch announced that $244 million, including $195 million from the federal government, had been allocated to rehabilitate 126 of the city's bridges over the next four years, with a third of the money reserved for repair work on the major East River crossings in the worst shape. Despite some progress in the effort to repair the city's bridges, the battle to keep them in shape seemed to be a losing one, especially after cutbacks in federal aid during the Reagan administration.[5] Calvin Sims reported in the *New York Times* in September 1990 that the most recent engineering study had found 56 percent of the city's 842 bridges to be "'structurally deficient'—no longer strong enough to carry the loads for which they were designed," a figure that had jumped 14 percent over the previous year's analysis.[6]

The worst of the lot was the Williamsburg Bridge (Leffert L. Buck, 1903), spanning the East River from Delancey and Clinton Streets in Manhattan to Washington Plaza in Brooklyn, a 1,600-foot steel suspension bridge, the city's second East River crossing, initially designed not only to carry pedestrians and horse-drawn vehicles but also trains and trolleys, and now subjected to the ceaseless pounding of automobiles and trucks.[7] On April 10, 1988, the Department of Transportation reduced vehicular traffic in half when it closed the bridge's outer roadways after inspectors found cracks and a large hole in the bridge's main crossbeam near the

Manhattan side.[8] Subway service was also halted in both directions. Two days later, after further inspections revealed additional flaws, the bridge was indefinitely closed to all traffic, inconveniencing some 240,000 daily commuters. City officials, long aware of serious maintenance problems, including frayed and corroded cable wires, promised to reopen it within two or three weeks.

In some ways the timing was fortuitous: a technical advisory committee was soon to report to Mayor Koch and Governor Cuomo about whether it would be more prudent to repair the Williamsburg Bridge or replace it, with the editors of the *New York Times* declaring the bridge "a hopeless lemon that ought to be replaced, not rebuilt."[9] Despite the *Times*'s advice, two months later, in June 1988, the advisory group recommended that the bridge be extensively rehabilitated. Before its decision was released, however, the committee received and exhibited twenty-five replacement schemes solicited from engineering and architecture firms. I. M. Pei, working with three Swiss engineering concerns, proposed a cable stay span south of the existing bridge that featured prominent, clothespinlike towers. Skidmore, Owings & Merrill's plan would build new reinforced-concrete towers around the existing Williamsburg Bridge towers, placing a triple-decked, steel-truss roadbed just above the present roadway, which could be used as a work platform until the new bridge was completed. The Ehrenkrantz Group & Eckstut, collaborating with the engineers Andrews & Clark, called for a single central tower accommodating two decks with subway service shifted to a new, separate tunnel. The most unusual submission came from the team of DRC Consultants, Parsons Brinckerhoff Quade & Douglas, and Der Scutt: they proposed to house a

Proposed Williamsburg Bridge. I. M. Pei & Partners, 1988. Rendering of view to the southwest. PCFP

ABOVE Proposed Williamsburg Bridge. Ehrenkrantz Group & Eckstut and Andrews & Clark, 1988. EEKA

BELOW Proposed Williamsburg Bridge. Der Scutt, DRC Consultants, and Parsons Brinckerhoff Quade & Douglas, 1988. Rendering of view to the southwest. DSA

View of Hell Gate Bridge (Henry Hornbostel and Gustav Lindenthal, 1916) after repainted using color scheme devised by Donald Kaufman and Taffy Dahl, 1992. Roca/NYDN. NYDN

museum and a restaurant, reached by glass elevators, in the two towers of the new bridge, which would be sheathed in cinnamon-colored reflective panels. The bridge also featured six lanes for vehicular traffic, three subway train tracks, and a central, twenty-eight-foot-wide pedestrian walk.

Six weeks after its closing, on May 26, 1988, two lanes of the Williamsburg Bridge were reopened. But it would take a total of three and a half months before complete service was restored. The editors of the *New York Times* applauded the effort: "From the day the bridge closed, some 140 engineers, iron workers, painters and laborers toiled 12 hours a day, seven days a week, hammering in 150 tons of new steel, adding 15,000 bolts and riveting 21 one-ton floor beams to the superstructure."[10] Despite the heroics, the repairs were essentially a stopgap measure, and beginning in 1995 the Williamsburg Bridge underwent an even more extensive renovation that was for the most part completed in time to celebrate its 100th anniversary in 2003.[11] The new work, undertaken by Parsons Brinckerhoff working with Beyer Blinder Belle, included replacing the cable suspension system, rebuilding approaches on both sides of the bridge, rehabilitating the towers, and providing new underpinnings for the subway tracks and a new pedestrian walkway and bicycle path.

Although it did not generate the kind of drama associated with the rehabilitation of the Williamsburg Bridge, the resolution of structural problems at the Manhattan Bridge (Leon Morsieff and Carrère & Hastings, 1910), connecting Manhattan's Canal Street with Brooklyn's Flatbush Avenue Extension, was also deemed a priority, with work beginning in earnest on the long-term project in 1982.[12] The renewal effort required a three-year closure of the two Brooklyn-bound upper lanes and more than a decade of interruptions on express subway service, which was finally restored on February 22, 2004.

In 1991 the issue of bridge color arose after Senator Daniel Patrick Moynihan secured federal funds for the first repainting of the seventy-five-year-old steel-arch Hell Gate Bridge (Henry Hornbostel and Gustav Lindenthal) that carried inter-city rail service over the East River between Ward's Island and Queens.[13] Acting on instructions from Moynihan, the Municipal Art Society set up a color selection committee that included Donald Kaufman and Taffy Dahl, a husband-and-wife team of color specialists, architects David Childs and Billie Tsien, minimalist painter Robert Ryman, and the society's president, Kent Barwick. Taking inspiration from a shade of red found in a tie worn by Ryman, Kaufman and Dahl created "Hell Gate Red," said to be "a deep, cool red, a color that creates a sharp silhouette from a distance and complements the surrounding landscape, recalls the traditional color of the Pennsylvania Railroad, and also inhibits rust."[14] Although there was some nervousness at the painting party inaugurating the project when the first dabs splashed by the Senator and Mayor Dinkins looked a tad too pink, Kaufman explained that the sample was not quite Hell Gate Red: "We have to use a latex paint for this ceremony, because if we had used a real

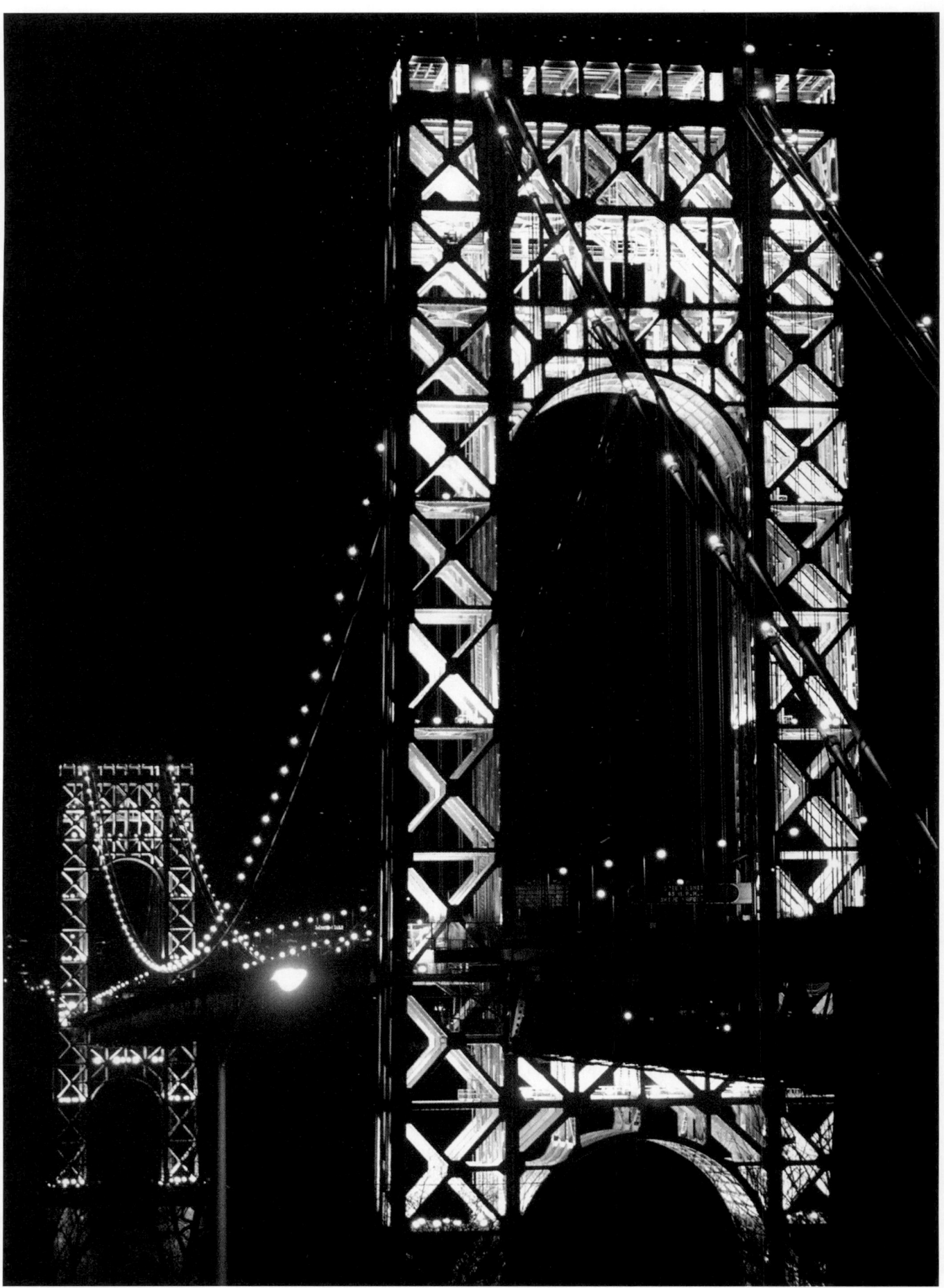

bridge paint the fumes would have knocked out half the Democratic leadership of the city. But the pigment is about right, and, with the proper base, it will look–dignified."[15]

Although unrelated to any repair effort or structural improvements, the innovative lighting scheme created in 2000 for the George Washington Bridge brought new life and welcome attention to Othmar Hermann Ammann's 1931 masterpiece.[16] Domingo Gonzalez Associates' design strikingly lit the bridge's two 604-foot-tall latticed towers with 688 1,000-watt and 72 150-watt metal halide fixtures that complemented the existing necklace of light stretched along the cables. The effect was spectacular, rendering the towers crystalline, as Stephen Napolitano, general manager of the bridge for the Port Authority, put it.[17] Hendrik Hertzberg, who normally wrote about politics for the *New Yorker*, remarked that the "very beautiful" bridge had always been overshadowed by the attention lavished on the Brooklyn Bridge, but he thought things would change due to the publicity generated by the "breathtaking glow" emanating from the towers.[18] Although the Port Authority originally intended for the tower lighting to be used only on holidays and special occasions, after the September 11 tragedy, the agency decided to keep the lights on for longer periods of time.

While most energy was devoted to bridge repair and rejuvenation, Lee Harris Pomeroy, working with the engineers Ammann & Whitney, added a new, albeit modest bridge to the lower Manhattan streetscape with the completion in 1989 of the eighty-five-foot-long, eight-foot-wide Trinity Place Pedestrian Bridge linking the rear of Trinity Church with the second floor of its parish house across the street, a response to safety concerns after a congregation member was struck by a truck crossing Trinity Place.[19] Inspired by the wrought-iron fencing surrounding the church as well as another lower Manhattan pedestrian bridge, the cast-iron Loew Bridge (Ritch & Griffiths, 1866-67), which spanned Broadway at Fulton Street but was taken down after only one year's service, Pomeroy's design for the thirty-ton steel bridge included ornamental iron railings decorated with bronze medallions displaying Trinity's coat of arms.[20] After approval from the Landmarks Preservation Commission, the lacy structure was fabricated in one piece in Pittsburgh and delivered to the site for installation sixteen feet above the street.

Getting to the Plane on Time

With clogged highways and crowded bridge and tunnel crossings, and with the heavy traffic often further congested by necessary but disruptive repair service, a long-standing complaint from New Yorkers and visitors alike was the inability to travel efficiently from Manhattan to any of the area's major airports, especially the relatively far-flung John F. Kennedy Airport. The idea of a rail link between midtown Manhattan and Kennedy Airport had a long history, dating back to the original planning of the Van Wyck Expressway in the mid-1940s, when Robert Moses refused to consider it.[21] In 1968 the idea was resurrected when the Port Authority announced plans for a high-speed connection. Two years later, the Port Authority pledged to include a link to Newark Airport in the new system but nothing came of the plans.[22] With no real

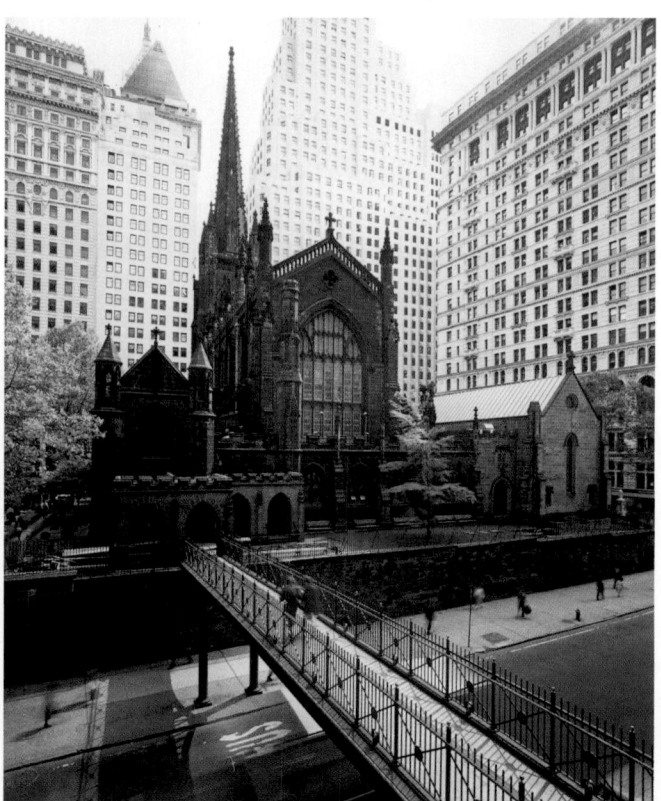

Trinity Place Pedestrian Bridge, spanning Trinity Place between Rector and Thames Streets. Lee Harris Pomeroy and Ammann & Whitney, 1989. View to the southeast. Zimmermann. LHP

progress on the Port Authority's part, in 1978 the Metropolitan Transportation Authority inaugurated its "train to the plane" as a compromise measure.[23] At a time when the subway fare was fifty cents, travelers paid $3.50 for one-way eight-stop express service from the Sixth Avenue and Fifty-seventh Street subway station to Howard Beach; there, they boarded buses to the various airport terminals. The total travel time on the three-car trains, equipped with baggage areas and running on twenty-minute headways, was estimated at about one and a quarter hours. Reaction to the service, officially known as the JFK Express, which after two years in operation was averaging about 1.3 million passengers a year, including many airport employees, was generally positive, although some passengers carrying heavy loads complained about steep stairs in the subway stations. Despite the favorable response, the Metropolitan Transportation Authority terminated the JFK Express in April 1990, after a dozen years in service, citing mounting losses and relatively low ridership.[24] At the same time, the MTA proposed a new light-rail line that would instead link the central terminals of Kennedy and La Guardia Airports using the rights-of-way along the Van Wyck Expressway and the Grand Central Parkway. The rail line would have connected to the Long Island Rail Road and the city subway system in Queens, with stations in Jamaica and at Shea Stadium. Although it remained unrealized, the plan formed the basis of what was eventually built.

In 1992 the Port Authority revived its rail-link plans with a scheme that would connect both La Guardia and Kennedy Airports with a new terminal at First Avenue and Fifty-ninth Street in Manhattan, a twenty-mile route beginning on the

FACING PAGE View of George Washington Bridge (Othmar Hermann Ammann, 1931) showing new lighting designed by Domingo Gonzalez Associates, 2000. Gordon/NYDN. NYDN

AirTrain JFK, Jamaica Terminal. Voorsanger Architects, 2003. View to the southwest. PANY

AirTrain JFK, Jamaica Terminal. Voorsanger Architects, 2003. PANY

outer roadways of the Queensboro Bridge and traveling almost entirely along public rights-of-way.[25] The plan would also include a monorail system at Newark that would connect with Amtrak's Northeast Corridor line, creating a link between the New Jersey airport and New York's Pennsylvania Station. Although the editors of the New York Times praised the initiative as "exciting" and the idea of "off-highway mass transit" as the "right concept," they objected to the new terminal next to the Queensboro Bridge, believing that a "better system would feed into midtown Manhattan, specifically into Penn Station, a nexus of railways and subways."[26] While plans for Newark's monorail continued to develop, the Port

Authority, citing rising costs, dropped its ambitious rail-link scheme in June 1995, a move that Senator Moynihan strongly criticized, noting, "We are the only major city in the developed world without a rail link to its airports."[27] The Port Authority did provide a very modest mass-transit option to Kennedy in 1995 when it added free shuttle bus service from the subway station at Howard Beach to air terminals at Kennedy.[28]

In April 1996 the Port Authority released plans for AirTrain, a much reduced scheme that would provide a mass-transit connection only between Manhattan and Kennedy Airport, abandoning the effort to link Kennedy and La Guardia Airports as well as the provision for a new Manhattan terminal.[29] AirTrain's 8.4-mile light-rail line would run from the Jamaica station of the Long Island Rail Road on an elevated track fifty feet above the median of the Van Wyck Expressway and connect to the airport's nine passenger terminals as well as employee and long-term parking lots and rental car areas. A second elevated line would connect the Howard Beach subway station with the same airport facilities. According to Port Authority officials, the plan represented the twenty-second attempt in thirty years to improve access to the area's airports. More modest than previous plans, AirTrain was still estimated to cost over $1 billion. Nonetheless, despite the fact that it was not the one-seat ride to midtown Manhattan that many had clamored for, the proposal was welcomed as a realistic alternative to cars and taxis, reducing travel time in half from midtown, with the Port Authority estimating that the entire trip from Penn Station would take about one hour.

Predictably, as disputes over issues such as funding, perceived misplaced priorities, and details of the plan and its route slowed progress on the Kennedy rail link, the monorail system at Newark, dubbed AirTrain Newark, made significant headway. Opening in October 2001 it connected the airport's three major terminals and remote parking areas with a new station on the Northeast Corridor line where travelers could catch Amtrak regional service or New Jersey commuter trains to Penn Station in New York. Finally, in the summer of 1999, construction began on AirTrain JFK and by the end of the year dramatically proportioned, funnel-shaped concrete support columns began to take shape along the Van Wyck Expressway's central median. In contrast to the difficulties encountered in trying to get the massive project started, the complex engineering challenge experienced relatively few glitches and the project suffered only one notable delay when, on September 27, 2002, a solitary motorman on a test drive was killed after his train derailed and hit the guideway retaining wall. Investigators determined that the three-car train failed to negotiate a curve because the driver was going far too fast, a situation exacerbated by sixteen 2,000-pound unsecured concrete blocks placed in the sixty-foot-long cars to simulate live loads.

The AirRail Transit Consortium, a group consisting of Slattery Skanska and Bombardier Transportation, was responsible for the job, while the station at Howard Beach was the work of the Port Authority's in-house architecture department under the direction of Robert Davidson. The new facility at Jamaica, designed by Voorsanger Architects, featured a glass-walled and vaulted platform connected to a granite-clad lobby and a sixty-foot-high atrium and mezzanine bridge with a moving walkway that led to connections to the Long Island Rail Road station and the subway. The lobby was located in the seven-story reflective-glass-clad Vertical Circulation Building, which also housed offices and a two-story control center for the railroad. The most striking feature of the work at Jamaica was the 263-foot-long, 72-foot-high arch spanning the Long Island Rail Road's platforms. Service on AirTrain JFK was inaugurated by Governor Pataki and Mayor Bloomberg on December 17, 2003, in a maiden voyage that was slightly marred when the steel doors on the computer-operated train closed a bit too quickly on Bloomberg, causing him to stumble. Fortunately for the mayor, Pataki was on hand to catch him. Bloomberg quickly recovered, announcing that "the ride was great."[30]

Getting the Subways Back on Track

The dilapidated state of the 722-mile subway system was the most prominent example of the city's failure to maintain its infrastructure. In 1976 Ethan C. Eldon, Commissioner of the New York City Department of Air Resources, but writing for the Op-Ed page of the New York Times as a private citizen, declared that the subway system, "once considered the best in the world, has become the noisiest, dirtiest and most rapidly deteriorating of them all." Noting that "the viability of the economy of this city is tied directly to its mass-transit system," Eldon called for a change in the system's leadership before sinking ridership levels "reached the point where all those who can afford alternate means of transportation have done so."[31]

Coupled to the subway system's physical deterioration was an overall decline in service, with a total of 855 runs dropped between the beginning of 1975 and August 1976.[32] Public dis-

satisfaction was at an all-time high. In a letter to the editors of the New York Times, Stanley Turkel, former president of the City Club, wrote, "If one were commissioned and paid to recommend the administrative steps necessary to destroy the New York subway system over a period of time . . . one possible schedule" would go like this: "(1) Raise the fare; (2) reduce the number of riders; (3) cut the service frequency; (4) keep trains dirty, with malfunctioning lights and doors; (5) don't renovate stations. And then to be certain that even tourists and visitors have problems, keep the number of system maps to a minimum, make signs confusing and teach employees to be rude and unresponsive."[33] Turkel claimed that this was exactly what the current leadership was doing and pointed to an alarming statistic: in 1976 the subway system served 400 million fewer riders per year than a decade earlier but employed 10 percent more workers.

Straphanger anger seemed to crystalize over the design of the subway map. The existing official map, designed by Massimo Vignelli in 1972, was positively baffling to visitors and vexing to locals, one of whom, George Weller, a painter, poet, and child psychologist originally from Kentucky, set out to do something about it, publishing his own map in 1977 which appeared with a cautionary note: "If you are confused ask somebody. New Yorkers are very helpful. However, the first person you ask will give you the wrong answer. So ask loudly enough that others will overhear and make corrections. New Yorkers love to correct each other."[34] Weller printed up 10,000 copies of his map, which not only included the various subway routes but noted major thoroughfares, connecting commuter rail lines, and popular destinations like Yankee Stadium.

One year later, in 1978, the Transit Authority decided to replace Vignelli's abstract, Mondrianesque version with a new map, designed by John Tauranac and Michael Hertz, which was a more realistic version, showing the routes in relation to major streets, parks, and neighborhoods.[35] In place of Vignelli's multicolored map, Tauranac and Hertz delineated all subway routes in one color. Commenting on the new map, Paul Goldberger praised its clarity, which emphasized information over graphics, noting that it was "not the object worthy of framing that Mr. Vignelli's map was, but . . . it is likely to provide the best combination of information and good looks that we can expect."[36] One understandable dissenter from the good reviews was Massimo Vignelli, an internationally honored graphic designer who was harsh in his assessment: "This new map is a tremendous step backwards. It's a return to the Middle Ages by an agrarian mind." Defending "the beauty" of his map as "totally accidental," Vignelli disagreed "completely about its functionalism. The entire world uses schematic maps—Berlin, Tokyo, Paris—every major city. London has used them since 1933. They're much easier to grasp."[37]

Enjoying a much longer shelf life than Vignelli's version, Tauranac and Hertz's design (although multiple colors were introduced to represent the different routes) remained in service for two decades until 1998, when the Metropolitan Transportation Authority released a new map designed by Michael Hertz Associates without Tauranac's input.[38] The changes in the design were evolutionary rather than revolutionary and mostly centered around a desire to include much more information, including a depiction of the entire MTA system. Printed on thicker stock that allowed for richer

colors, the new map, 85 percent larger than the 1979 version, included not only the subway system but also bus connections at major subway stations, the Staten Island Rapid Transit line, and, on the reverse, the Metro-North and Long Island railroad systems, Long Island and Westchester County bus lines, the nine toll bridges and tunnels under the authority's control, and ferry connections to such distant points as the central Jersey shore. Philip Nobel believed that too many details were included, complaining about the information "bubbles which hover over every free area like a plague of computer help balloons."[39]

The transit system needed much more than a new map to get it back on track. Physical improvements were slow in coming. Under the leadership of Phyllis Cerf Wagner, wife of former mayor Robert Wagner and head of the MTA's aesthetics committee, a program called Operation Facelift was launched in 1978; it involved the repainting of eighty-four stations and some minor renovation.[40] The work was done by the Transit Authority's in-house design staff under the direction of architect Paul Katz. Paul Goldberger found the initial results of the program "highly encouraging," although he reflected the general wisdom that "there is no public environment in the United States as squalid as the New York City subway. It is dirty, cramped, smelly, noisy and altogether lacking in amenities as basic as a place to sit down." Goldberger was impressed with the repainting of the West Fourth Street station, where the typical silver and blue palette was replaced with a combination of beige and green: "The colors are handsome in themselves, they go together well, and they make for a warmer, brighter place overall."[41] Sometimes the results were a bit jarring, as in the case of Heins & La Farge's historic Wall Street station (1905) in which the original oak and bronze change booth on the downtown platform was lovingly restored while the yellowed white tiles that originally lined the walls were replaced with rather flashy ultramarine blue glazed brick. Soon enough, however, Operation Facelift became shrouded in controversy when it was discovered that the money for the beautification program did not come out of the authority's regular maintenance budget, as first reported, but instead was diverted from funds reserved for subway car inspections.

Something of a turnaround seemed possible in 1979 when it was reported that additional funding from a combination of federal grants and Port Authority dollars would soon become available for partial rehabilitation as well as more extensive renovation of some of the system's 456 stations.[42] With the promise of outside funding, the MTA optimistically announced a plan to rework fourteen stations, including those at Herald Square and Grand Central, addressing not only aesthetics but such issues as platform layout, passenger circulation, and lighting, as well as temperature and noise control. Although she was relieved that something might soon be done to improve the "sordid stations," Ada Louise Huxtable objected to the MTA's piecemeal approach: "Spot beautification is not subway redesign."[43]

The system's rolling stock was in no better condition than its stations and in June 1979, as the problems with Operation Facelift were surfacing, reports that 293 new R-46 subway cars were defective was front-page news.[44] There were allegations of bribery among transit officials, who were accused of accepting substandard equipment—in this case, the cast-steel undercarriages, which required extensive repair. The MTA was

dealt an additional blow by an eleven-day transit strike in April 1980. The new Reagan administration's reluctance to provide more federal aid for mass transit also took its toll, and the MTA was forced to raise fares for the first time in five years, with increases in 1980 and 1981.[45] As the city's fortunes began to show real signs of recovery, including a return to the capital markets in February 1981 and a budgetary surplus for the fiscal year ending in June, the health of the subway system remained a sticking point. Although hardly seen as a panacea, in June 1981 the state legislature passed a bill granting the MTA the authority to issue $5.6 billion in bonds to help finance capital improvements to be made over the next five years.

In 1982, in one of the first steps of its new spending program, the MTA announced a station renovation plan that would create four model "culture stations" designed to promote and complement nearby cultural institutions, an idea inspired by the Louvre station in the Paris Metro, where reproductions from the museum's collections were displayed in vitrines.[46] In New York, the designers of the reworked stations were selected with the help of the Municipal Art Society, which also sponsored an exhibition of the planned schemes. For the Eastern Parkway station near the Brooklyn Museum, the Brooklyn Botanic Garden, and the Brooklyn Public Library, exhibition designer Edwin Schlossberg and the graphic design firm Two Twelve Associates proposed colorful platform-level signs that would flash different images identifying the three separate institutions.[47] The plan remained on the drawing boards, however, a fate that also befell another of the planned culture stations, Richard Dattner's renovation of the Lincoln Center station, which called for television monitors placed throughout the station that would be linked to a closed-circuit network, allowing straphangers to view live performances or excerpts from previous concerts.[48]

Four years after the program was initiated, in 1986, the first "culture station" was completed at the Fifth Avenue and Fifty-third Street station, serving several museums, including the Museum of Modern Art, the Museum of Broadcasting, the American Craft Museum, and the Museum of American Folk Art, as well as the Urban Center and the Donnell branch of the New York Public Library.[49] Designed by Lee Harris Pomeroy in association with the graphic design firm Pentagram, the refurbished station was given bright red and white tiles as well as a gleaming vaulted aluminum ceiling backed by fiberglass batting to muffle train noise. The highlight of the redesign, seventy-five backlit glass boxes for the display of color transparencies, illustrated objects from the various museums' collections. The display ran the full 400-foot length of the platform.

The fourth of the planned culture stations, Prentice and Chan, Ohlhausen's renovation of the Astor Place station serving Cooper Union and the Public Theater, was also completed in 1986.[50] Although designated a landmark in 1979 along with eleven other stations designed by Heins & La Farge for the first subway line, built by the Interborough Rapid Transit Company in 1904, the Astor Place station was in hideous shape; its principal architectural feature, an elaborate cast-iron and glass entrance kiosk, typical of many provided by the subway's original developers, had been removed in the 1950s. Although they considered a modern design, the architects decided instead on a faithful reproduction of the kiosk, recreated from period photographs and original drawings and

Fifth Avenue and Fifty-third Street subway station. Lee Harris Pomeroy in association with Pentagram, 1986. Lieberman. LHP

Kiosk, Astor Place subway station. Prentice and Chan, Ohlhausen, 1986. ODA

fabricated by Robinson Iron at its foundry in Alabama. At the platform level the architects stripped away the shiny ceramic white wall tiles installed in the 1950s, replacing them with a combination of new ceramic tile and glazed white and iron-spot brick. They also removed the ceramic tile added to the station's original cast-iron columns. The decorative terra-cotta beaver plaques, symbols of the source of John Jacob Astor's original fortune, were restored. Collaborating on the project was graphic designer Milton Glaser, who provided colorful abstract porcelain-enamel murals.

At the end of 1986, *New York Times* reporter James Brooke assessed the success of the MTA's five-year capital improvement plan, noting that substantial progress had been made, including 1,300 new subway cars added to the 6,200-car fleet and an increase in the maintenance budget for track work.[51] Derailments now averaged one every 180 days, as opposed to the rate of one every 18 days that prevailed four years earlier. In addition to the two completed culture stations, the MTA had earmarked more than $250 million for the rehabilitation of fifty-six stations, with the design work to be done by the Transit Authority's in-house staff. But by the end of 1986, only six restorations had been completed. In one area, however, success was both more visible and surprising. In 1989 David L. Gunn, president of the Transit Authority, declared that the scourge of graffiti had finally been conquered by a zero-toler-ance policy begun in 1984. More than 1,000 people were hired specifically to clean the graffiti and any "marked" car was ordered out of service within twenty-four hours, depriving the graffiti artist of seeing his creation. Even the normally critical Gene Russianoff, of the Straphangers Campaign, was forced to admit that this was "a major achievement."[52]

It was not until the 1990s that the pace of station renovation began to pick up, although it never achieved the optimistic goals of the MTA's five-year capital improvement plan.[53] Many of the station renovations included specially commissioned works of art, a consequence of the ambitious and successful Arts for Transit program begun in 1985 to expand the amount and improve the quality of public art in the subways.[54] On renovations with construction costs of $20 million or less, 1 percent of the budget would be set aside for the art program, a percentage that would be sliced in half for

more expensive rehabilitation efforts. The Arts for Transit program also included a music component, encouraging street musicians to register with the MTA and play at sanctioned times and in designated places.

Much of the new art consisted of modest though welcome decorative embellishments, such as Liliana Porter's ceramic mosaic mural *Alice the Way Out* (1994), a whimsical depiction of characters from *Alice in Wonderland* for the Fiftieth Street station on the Broadway line, or various mosaics designed in collaboration with students from local public schools, including Lee Brozgold's *Greenwich Village Murals* (1994) for the Christopher Street station. A more unusual effort was Michelle Greene's *Railrider's Throne* (1991), an oversized welded steel chair placed for view and use on the downtown platform of the station at 116th Street and Broadway. Although one straphanger described the piece as "a psychedelic electric chair," Greene stated that her intention was to "make something whimsical that would make people feel special, kind of less alienated." She also noted that "I wanted something that people can't destroy, so I built it like a tank."[55]

Some of the subway art came from established members of the New York art scene. One of the most ambitious projects was Elizabeth Murray's *Blooming* (1998), a colorful Italian glass mosaic mural that spanned more than 120 feet along four walls lining the mezzanine between the Lexington Avenue station of the N and R line and the Fifty-ninth Street station of the 4 and 5 line.[56] Using shapes inspired by the monumental subway graffiti of the 1970s, Murray included pink and green trees, sunbursts, pairs of red high heels, and immense yellow coffee cups spewing steam and purple coffee. For the renovation of the Yankee Stadium station (2002) at 161st Street and River Avenue, two artists, Helene Brandt and Vito Acconci, each contributed major pieces. Brandt's thirty-eight-by-seven-foot glass, stone, and marble mosaic mural, *Room of Tranquility*, attempted to create the illusion of a view from outside the station.[57] Acconci's *Wall-Slide*, dispersed throughout the station, was designed with the help of the architect John di Domenico. One particularly memorable part along the platform used fragments from the station's own tile work to create sculptural seating that seemed to peel away from the walls.

Wall-Slide, River Avenue and East 161st Street subway station, Bronx. Vito Acconci and John di Domenico, 2002. ACC

Framing Union Square, Union Square subway station. Mary Miss, 1996. Zimmerman. LHP

Conceptual artist Mary Miss collaborated with Lee Harris Pomeroy, who was responsible for the extensive renovation between 1995 and 2001 of the Union Square station, the city's third busiest, serving three subway lines.[58] While Pomeroy sought to rationalize the existing mazelike mess that resulted from the connection of three separate subway stations built at different times, Miss decided to preserve and display various parts of the construction that would otherwise be destroyed in the modernization effort. Her *Framing Union Square* celebrated the history of the station with 125 separate elements, including restored fragments as well as text panels dedicated to Heins & La Farge. According to Karrie Jacobs, Miss was "acting as a sort of postmodern graffiti artist, tagging the seamless new surfaces with bold references to the station's old ornamentation and infrastructure."[59]

Times Square, the subway's busiest and most troubled transportation hub, encompassed four stations as well as a dreary block-long passageway to a fifth. Not only a symbol of the system's deterioration but also a prominent reminder of the neighborhood's steep decline, it was what most visitors and natives alike had in mind when they denigrated the subway system as confusing, dirty, and dangerous. A comprehensive renovation plan for the complex, including new entrances, a reorganization of platforms and ramps, a new mezzanine to ease congestion, as well as increased retail space, was tied to the fate of the area's redevelopment efforts, specifically the ambitious plan introduced in the early 1980s for four new office towers that were key to reviving Forty-second Street's theater block (see Forty-second Street). Robert Kiley, chairman of the MTA, saw the Forty-second Street project as a golden opportunity to fix the troubled station, with the towers' private developers agreeing to bear $91 million of the renovation costs. At the other end of the theater block, the Forty-second Street and Eighth Avenue station was being renovated by John Carl Warnecke. Writing in October 1986, as the work neared completion, Paul Goldberger found that "from an esthetic standpoint the station will be every bit as harsh and institutional as it was before the first penny was spent. . . . The floor will be covered in mud-brown quarry tiles in two colors, arranged in a pattern that is supposed to reflect the layout of the station in some way. It is virtually impossible to make sense of, however, particularly when heavy crowds make it hard even to see it." He also regretted that "the low ceiling remains, and so does the glaring fluorescent lighting. The entire decrepit platform level, where most riders spend most of their time, is being left untouched."[60]

As predicted by Robert Kiley, meaningful change was linked to the larger success of Forty-second Street's renewal, a process that would not begin until the 1990s.[61] But by the time the project did get under way the deal was revised, with the developers of the office towers excused from the majority of the subway rehabilitation effort but instead agreeing to pay for new entrances at their individual building sites. As Lynne Sagalyn succinctly put it, "The public sector had gambled on private development to deliver the funds for a high-priority public benefit—and lost."[62] Although work on a revised set of rehabilitation plans for the Times Square subway station complex began in 1993, and some work was completed by 1997, including a new entrance distinguished by an eye-catching undulating canopy on the south side of Forty-second Street between Broadway and Seventh Avenue designed by Fox & Fowle, it was not until 1998 that the MTA released its three-phase plan, which was not expected to be completed until 2010.

William Nicholas Bodouva + Associates was hired to do the work with the goal of easing the station's congestion, increasing security, and making the train platforms accessible to handicapped riders. One of the major complaints about the massive complex was that it was simply too confusing. As a remedy, the architects proposed an oval "ring of light," as Christine Bodouva put it, to "cut through all the different levels, so you'll always be able to identify where you are."[63] In addition to widening corridors and adding staircases to improve sight lines and pedestrian flow, the architects' plans included the restoration of historic mosaics, new bright white tile walls, and nonslip granite floors to replace the filthy, gum-plated concrete floors. Phase one of the renovation, which included enlarging the mezzanine under Seventh Avenue between Forty-first and Forty-second Streets, reconstruction of the platforms for the Seventh Avenue trains, two new elevators, as well as new walls, floors, and ceilings throughout the station, was completed in September 2002.

The renovation of the Times Square subway station complex, benefitting greatly from the Arts for Transit program,

included a glass mosaic mural, *The Return of Spring* (2001), by realist painter Jack Beal placed on a wall between the uptown and downtown platforms of the Seventh Avenue line, and Jacob Lawrence's six-by-thirty-six-foot mural made of colorful Murano glass, *New York in Transit* (1997), a semi-abstract work depicting straphangers as well as city scenes as seen from the windows of an elevated train, installed in November 2001 in the station's Broadway mezzanine, a year after the death of the prominent African-American artist.[64] The highlight of the new art, however, was Roy Lichtenstein's *Times Square Mural*, a piece originally commissioned in 1990 and fabricated in 1994 but not installed until 2002, five years after the artist's death.[65] Located near the entrance at Broadway and Forty-second Street in the mezzanine between the Grand Central shuttle and the IRT platforms, the six-foot-high, fifty-three-foot-long porcelain-enamel-on-steel mural included many of the Pop artist's signature themes, including comic-book characters and images from science fiction, such as Buck Rogers and a spaceship. The mural also included a depiction of the original 1904 terra-cotta plaque of the number 42 designed by Grueby Faience as well as references to the 1939 and 1964 World's Fairs.

Another long-troubled station was finally improved when Richard Dattner finished work on one of the city's busiest and most physically constrained, that at Broadway and Seventy-second Street, not only renovating the existing station kiosk (Heins & La Farge, 1904) but designing a new one (2002) just to the north across Seventy-second Street in an enlarged Verdi Square Park, a project partly funded by and tied to Donald Trump's Riverside South development (see Upper West Side).[66] Providing four additional stairways as well as elevator access to the subway, Dattner's busily detailed exposed-steel-and-glass station kiosk was designed, in the architect's words, as a "contemporary version of the original building."[67] James Gardner's cranky assessment found it "brighter, more spa-

cious, and more convenient" than Heins & La Farge's original but essentially "mediocre": "Contextualism is surely a good idea in these circumstances. And yet there is hardly a perfect fit between the two buildings, which seem not so much to clash as to miss one another."[68]

Kiss + Cathcart, a firm known for its dedication to environmental issues and use of solar power, completed the first phase of its reconstruction of Coney Island's Stillwell Avenue Terminal, the largest aboveground station in the system, in May 2004 after three years of work.[69] The highlight of the renovation was a stunning glass-and-steel shed spanning four train platforms and topped by semi-transparent photovoltaic modules capable of producing 250,000 kilowatt hours per year, or about 15 percent of the station's electrical power needs. Brooklyn resident Mozell Hill enthused that "it's really modern. It's a 21st-century design in the middle of Coney Island."[70]

The MTA also embraced high technology with its new R-142 subway cars that debuted with a thirty-day test run in July 2000.[71] Designed by Masamichi Udagawa and Sigi Moeslinger of Antenna Design and manufactured by Kawasaki Rail Car and Bombardier, the stainless-steel trains featured computerized LED signs flashing the time and next stop as well as automated announcements to supplement the intercom system that in previous train models was perennially criticized for delivering garbled, if not totally incomprehensible, messages from the conductor. The new cars, complete with indirect lighting, were also quieter, with more efficient brakes, better soundproofing, and rubber floors. Walls and ceilings were made of melamine, said to be more resistant to scratching, and the doors were widened from fifty to fifty-four inches to ease congestion. Slanted metal bars placed at the ends of the bench seating near the doors were designed to thwart muggers from grabbing a purse or necklace and quickly exiting. Not everyone, however, was pleased with the high-

RIGHT Kiosk, West Seventy-second Street and Broadway subway station. Richard Dattner, 2002. View to the north showing renovated kiosk (Heins & La Farge, 1904) in foreground and new kiosk in center. RDPA

BELOW *Times Square Mural*, Times Square subway station. Roy Lichtenstein, 1990 (fabricated in 1994 and installed in 2002). O'Shields. ERC

Stillwell Avenue Terminal, Coney Island. Kiss + Cathcart, 2004. View to the west. Friedberg. KCA

tech trains. Subway aficionado Stan Fischler complained that the operator's space in the new cars was not limited to a corner but instead stretched to the entire width of the car, rendering the front windows inaccessible to passengers.[72]

Another talisman from the system's past departed at midnight on April 12, 2003, when the last token was sold a year before the subway celebrated its centennial.[73] Three weeks later, on May 4, when the transit fare rose from $1.50 to $2.00, the token was no longer accepted for use, ending a fifty-year run that began in 1953 and included five different token models. The token's fate had been sealed almost a decade earlier, in 1994, when New York's subway became one of the last systems in the country to introduce fare cards.[74] Dubbed the MetroCard, the thin blue and yellow credit-card-size plastic device was cheaper to produce than tokens and could also be programmed to offer discounts and allow transfers. The MTA also pointed to significant savings because tokens would no longer have to be emptied from the turnstiles and delivered to token booths.

Toward More Livable Streets

There was perhaps no more vexing quality-of-life problem in the city, especially in lower Manhattan and midtown, than the dearth of public toilets. Even the modest facilities that existed were often out of service. In 1978, of the 744 public comfort stations located in the city's parks, only 445 were usable. One step taken to address the problem was the granting of bonuses allowing additional square feet for those developers who included street-level public toilets in their new office buildings.[75] The measure produced only modest results and the problem of public urination persisted, leading the editors of the New York Times to complain in 1986 that "the sight of somebody looking nervously over one shoulder while wetting a wall or a parked car has become common. . . . But it's hard to exhort people to use proper facilities; there aren't

any. . . . Six years ago, the subway system boasted 708 public restrooms. Today there are only 103, deterioration and danger having padlocked the others. Facilities in many of the public library's smaller branches have been closed for similar reasons."[76]

In November 1990, the editors of the Times, citing a recent class-action lawsuit against the city and the Metropolitan Transportation Authority by four homeless people who alleged that the lack of public toilets represented a public nuisance, argued that the time had come to adopt the kind of sturdy public toilets used in several European cities.[77] And in 1991 the J. M. Kaplan Fund, which provided money for the renovation of the Carrère & Hastings-designed rest-room buildings in Bryant Park (see Fifth Avenue), organized the Public Toilets Working Group, promoting a demonstration plan by JCDecaux, a French company that operated 4,000 public toilet kiosks in more than 700 European cities.[78] According to the plan, the city would pay about $10,000 to install five coin-operated, self-cleaning kiosks, one of which would be oversized to provide access for the handicapped. The units would be connected to sewer lines. In exchange for the right to sell advertising space on the facilities, JCDecaux offered to provide and maintain the kiosks at no charge. The experiment, planned to last four months, after which time the French company would add an additional ninety-five kiosks if the city was satisfied with the service, was stymied by two factors: a state law prohibiting pay toilets (Decaux insisted on a small charge, citing its experience in London, where free units were vandalized); and a federal law that required that each unit be large enough to accommodate a wheelchair (Decaux believed that the handicap-accessible kiosks at 30 square feet, as opposed to only 8.5 square feet for the regular units, were far too bulky to be successfully placed in large numbers on the city's crowded sidewalks and also noted that they were more likely to be used by prostitutes or drug users).

In 1992 a compromise was worked out: the state legislature passed a city-sponsored bill temporarily allowing pay toilets, and the federal government, over the continued objection of advocates for the handicapped, approved the installation of three pairs of public toilet facilities, one for the handicapped entered with a special magnetic card and the other open to all for the price of a quarter.

On June 30, 1992, the test of Decaux's public toilets began with the opening of facilities in City Hall Park across from the Tweed Courthouse, on West Thirty-fourth Street near Macy's, and on 125th Street between Frederick Douglass and Adam Clayton Powell Boulevards near the Harlem State Office Building. Although the large concrete handicap units failed to make much of an aesthetic impression, a writer for the *New Yorker*'s "Talk of the Town" column praised the standard kiosk as a "strikingly elegant fifteen-foot tower."[79] As a safety measure, the doors of the coin-operated kiosk opened after fifteen minutes, while the handicap unit allowed a thirty-minute stay. The editors of the *New York Times* were impressed with the new public toilets, enthusiastically describing a test run:

> You put your quarter in the slot, go inside and the big curved door slides shut behind you. The place is no bigger than the restroom on an airplane, yet it feels roomier and has a lot more style. That's because of the ingenious design. Only a small toilet bowl protrudes from the wall. There's no need for a sink; you wash your hands by sticking them into a rectangle under a big round mirror. In a few seconds they are bathed in warm, soapy water, then cool clear water, then warm air. When you leave, the door slides shut behind you and the unit locks for 55 seconds while water cleans the floor and the toilet bowl folds into the wall. When it opens again for the next person, it is spotless.[80]

As planned, the demonstration project concluded after four months at the end of October 1992.[81] Despite the success of the trial, which resulted in almost no vandalism and served over 40,000 customers, prospects for a permanent solution did not look bright, with plenty of bureaucratic red tape still ahead, including a permanent waiving of the state ban on pay toilets as well as continued protests from advocates for the disabled who believed that any plan that included toilets inaccessible to the handicapped was a violation of the Americans with Disabilities Act. Although Mayor Dinkins had pledged to install another ninety-five kiosks, no progress was made after the Decaux facilities were removed. In July 1994, the Parks Department in the new Giuliani administration instituted another public toilet demonstration, this time using a drab, utilitarian design from a German company, Wall City Design. Although this experiment with just one public toilet in City Hall Park was also deemed a success, the inability to move forward with a comprehensive solution left New Yorkers in much the same state as they were before any of the tests began, except they now had firsthand knowledge about how much better the situation could be.

On April 14, 1995, the Giuliani administration, in an attempt to tidy up the cacophony that was the city's streetscape, solicited proposals for a coordinated set of street furniture to be provided by a single vendor.[82] Issued through the Department of Transportation, the twenty-year contract would allow one company to design and build up to 3,500 bus-stop shelters, 500 newsstands, 100 automatic self-cleaning toilets, and an unspecified number of loosely defined "public

service structures," kiosks that could grow as high as sixteen feet and provide substantial advertising space. The unusual length of the contract was deemed necessary to attract vendors who would need plenty of time to recoup substantial initial investments. Kent L. Barwick, president of the Municipal Art Society, applauded the idea, stating that it would "put a little order into what has been chaos."[83] But not everyone supported the initiative, officially known as the Coordinated Street Furniture Franchise, including newspaper owners and newsstand operators who worried that a new arrangement would result in significantly fewer venues to sell their wares. Timothy Mennel, in a letter to the editors of the *New York Times*, found the prospect "aesthetically distressing. . . . A preponderance of generic fixtures numbs urban vitality and promotes only the most corporate conception of civic well-being." Mennel contended that "what makes New York one of few remaining interesting American cities is precisely its lack of standardization, its energetic clash of designs and intents. Contra the Giuliani administration, New York—especially midtown—needs *more* street-level diversity, not less."[84]

Four companies responded to the city's request for proposals, including the British firm Adshel, Transportation Displays, a division of CBS, and the two concerns that had previously provided public toilets on an experimental basis, Decaux and Wall City Design. The companies enlisted a surprising number of prominent architects for their submissions, although the designs were officially kept under wraps as full-size models were produced. Adshel hired Richard Meier, who came up with two different lines, the more severe Metropolis, which Philip Nobel described as "a somewhat hunkering

View to the northeast along West Thirty-fourth Street showing public toilet installation by JCDecaux, 1992. JCD

Adshel, proposed Coordinated Street Furniture. Newsstand, Metropolis line. Richard Meier & Partners, 1997. Prototype. ADSHEL

JCDecaux, proposed Coordinated Street Furniture. Newsstand. Vignelli Associates, 1997. Prototype. VIG

Adshel, proposed Coordinated Street Furniture. Bus shelter, New Amsterdam line. Richard Meier & Partners, 1997. Prototype. ADSHEL

JCDecaux, proposed Coordinated Street Furniture. Newsstand. Robert A. M. Stern Architects, 1997. Prototype. RAMSA

meditation on New York industrial typology in battleship gray aluminum and tempered glass,"[85] and the black New Amsterdam line, designed, according to Meier, to "complement historical contexts, adding to their richness and appeal."[86] Wall City Design turned to German architect Josef Paul Kleihues, who responded with a spare but sturdy-looking bus shelter in steel and glass. Decaux employed a full stable of leading architects and designers: James Stewart Polshek, who in 1971 had designed an arc-shaped bus shelter that was realized at many locations in the city, produced a more linear, industrial-strength version for the 1990s; Gwathmey Siegel, which employed its characteristic crisp and spare vocabulary; Massimo Vignelli, who responded with designs perhaps impractically finished in white; and Robert A. M. Stern, who was inspired by the industrial classicism of the city's street furniture from the early twentieth century, including Heins & La Farge's subway kiosks.[87] Decaux also commissioned Peter Eisenman, who, not surprisingly, seemed more interested in challenging the streetscape than providing a user-friendly amenity, proposing a slanting, twisting bus-stop shelter that, according to the architect, was "a spatial object . . . intended to cause people to look at it and comment on bus shelters. We want people to be more aware of their physical environment, not less aware."[88]

Although public interest in street furniture was increased by an exhibition sponsored by the Municipal Art Society, "21st Century Streetscape," which ran from June to September 1997 and featured futuristic as well as actual designs from around the world, in June 1998 Mayor Giuliani canceled the project, claiming that the massive long-term proposal was too susceptible to "being corrupted" after several newspaper articles raised the issue of potential conflicts of interest arising from a connection between Adshel and a lobbying group closely associated with senior members of his administration.[89]

As the city dithered, several Business Improvement Districts partly took up the slack, most notably the Grand Central Partnership, which throughout the 1990s installed hundreds of benches, bicycle racks, newspaper vending boxes, information kiosks, and planters. In 2001 another BID, the 34th Street Partnership, installed coin-operated self-cleaning public toilets at Herald and Greeley Squares.[90] Purchased at a cost of $350,000 each from Adshel, the two handicap-accessible facilities cost a quarter to use and were modeled on existing toilets in France and England. But the municipal government made no progress on any comprehensive or even small-scale plan and the most significant news on the public toilet front was the September 2001 opening on Broadway of *Urinetown,* a surprising musical hit about an unidentified American city held hostage by an unscrupulous corporation

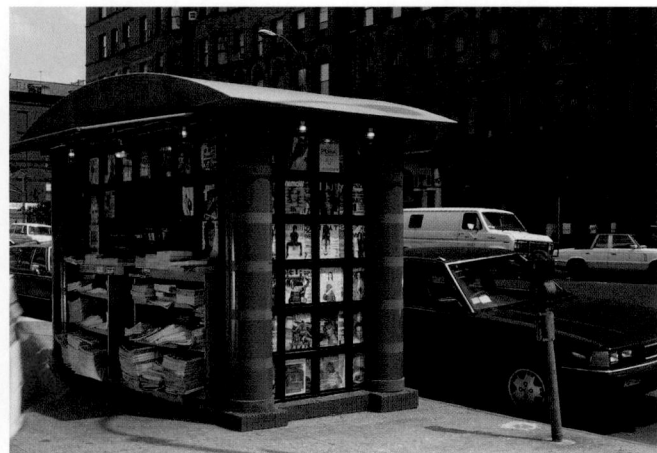

Newsstand, northeast corner of Columbus Avenue and West Eighty-first Street. Wayne Turett, 1984. View to the southwest. TCA

Prototypical newsstand competition, Public Art Fund. Dan Graham in collaboration with Tod Williams Billie Tsien & Associates, 1988. Model. Moran. TWBTA

Prototypical newsstand competition, Public Art Fund. Patsy Norvell and Frances Halsband, 1988. Model. KHA

Newsstand. Patsy Norvell and Frances Halsband, 1994. KHA

that controlled all of the town's public pay toilets.[91] In August 2002, however, the Bloomberg administration announced its desire to restart Giuliani's aborted effort and again proposed the idea of a single vendor armed with a twenty-year contract to provide newsstands, bus shelters, and public toilets.[92] But another three years passed before the city announced, in September 2005, that it had reached an agreement with Cemusa to provide street furniture designed by Nicholas Grimshaw & Associates.

One of the difficulties in realizing the ideal of a comprehensive program of street furniture was the fact that the city's newsstands were privately owned by individual vendors, many of them disabled war veterans and other handicapped people. The typical newsstand was a rather ramshackle shed-like wood or metal structure that not only dispensed newspapers and magazines but also candies, nonalcoholic drinks, and in some cases ice cream. Occasionally, efforts were made to spruce up individual newsstands, as in 1984 when architect Wayne Turett completed work on what the editors of the *AIA Guide* described as "the world's smallest Po Mo palazzo," located on the northeast corner of Columbus Avenue and Eighty-first Street.[93] Turett designed and built the seventy-two-square-foot newsstand using red stucco columns to carry a gray arched fiberglass roof. Gridded glass and anodized aluminum walls doubled as magazine display space. "People love

the design," Turett stated. "Some think it's Chinese-looking. The Greek florist said it looked like a Greek temple."[94]

In 1988 three artist-architect teams submitted schemes for a prototypical newsstand as part of an invited competition sponsored by the Public Art Fund at the suggestion of the city's Art Commission.[95] Artist Andrea Blum, working with architects Kenneth Kaplan and Ted Krueger, proposed a severe design with a square grid for the display of newspapers as well as a news ticker and a digital weather display. Dan Graham, in collaboration with Billie Tsien and Tod Williams, produced an open design with a dramatically cantilevered roof. The winning scheme, the work of artist Patsy Norvell and architect Frances Halsband, called for a seventy-two-square-foot steel-framed hipped roof pavilion. As Halsband explained, "The current newsstands are painted plywood with huge metal gates, little sheds with protective armor. We decided to build the whole thing out of protective armor: perforated steel."[96] In 1994 eight of the Norvell-Halsband designs were placed along Sixth and Seventh Avenues between Fourteenth and Fifty-fifth Streets, but plans for their future proliferation were abandoned after the estimated cost of $20,000 per unit proved optimistic. The actual price tag—$33,000—was deemed too expensive for newsstand operators, who would have to buy the six-by-twelve-by-nine-foot stands from the city.

ON THE WATERFRONT

By the late 1970s there was widespread agreement that the future of New York's waterfront would not be tied to its industrial past. Although once a commercial maritime powerhouse, New York's commercial waterfront began to wane beginning in the 1950s as the traditional system of longshoremen directly unloading freight from "great bulk" docks was replaced by a new system in which truck-sized containers were off-loaded by massive cranes requiring large industrial yards, which were located at the Port Newark/Elizabeth Marine Terminal on Newark Bay, with its more convenient access to rail, truck, and air freight service. Although more modest container ports were built in Brooklyn and Staten Island, Port Newark quickly became the leading container ship facility on the Eastern Seaboard. New York's waterfront, an underutilized 578-mile-long asset, was cut off from the majority of its residents in all five boroughs by highways, dilapidated piers, underutilized if not abandoned industrial sites, and by the undesirability of the polluted water itself.

While the fiscal crisis generally tended to paralyze the city's ability to plan for the future, the waterfront seemed a notable exception, gaining considerable attention from city officials and outside groups. Fundamental was the dramatic improvement in the quality of the water in New York's rivers and harbor as the city complied with the federal mandates of the Clean Water Act of 1972. Additionally, as the long-planned Battery Park City at last moved forward, a significant and highly visible stretch of waterfront was transformed into a premier asset, strategically located opposite New Jersey's Hudson River shoreline, especially that in Jersey City, where rapid development challenged the city to move ahead if it intended to maintain its status as an office center. Beginning in the late 1960s the city had embarked on a comprehensive plan for the Manhattan waterfront, initially called Wateredge but soon retitled Westway, a project combining highway construction with the possibility of creating as much as 700 acres of land along the Hudson River.

Westway

The early story of Westway, perhaps the grandest infrastructure project ever conceived for Manhattan, was introduced in *New York 1960*.[1] Principally justified as a replacement for the deteriorating West Side Highway but more fundamentally conceived as a way of stimulating the redevelopment of the abandoned piers and upland warehouses and manufacturing areas that were no longer economically viable, Westway was initiated in 1971 by Samuel Ratensky, a veteran civil servant specializing in housing and redevelopment, and Craig Whitaker, a young architect specializing in urban design. They saw it as an opportunity to take advantage of federal funds for interstate highway construction, a program that was expected to be eliminated in 1990, and thereby transform Manhattan's West Side by constructing a major eight- or ten-lane expressway set back 100 feet from the pierhead line, so that in some areas it would be more than 1,000 feet from the existing shoreline, creating the possibility for between 650 and 700 acres of new land capable of housing between 75,000 and 85,000 families.

Westway proved to be highly controversial, rekindling the anti-big-project spirit of the 1960s best articulated by Jane Jacobs in her 1961 book, *The Death and Life of Great American Cities*,[2] and by suspicions of any and all highway projects that were fueled by the negative portrait of Robert Moses's career painted by Robert Caro in his widely read and discussed Pulitzer Prize-winning biography, published in 1974.[3] So powerful was the opposition to Westway that even a compromise plan calling for a six-lane interstate highway buried under landfill was opposed by leading civic groups including, to many people's surprise, the venerable Regional Plan Association, for almost its entire history a proponent of big infrastructure projects. The RPA called for a four-lane surface boulevard below Twenty-third Street and six lanes, also at grade, north of Forty-second Street, leaving only a short stretch underground. With many civic groups challenging Westway in the courts, there was a growing call for the project's abandonment and for the trade-in of the federal funds for mass transit, an option that had been made possible in 1974 during the Ford administration in an effort to give local communities greater control over their transportation systems.

As Westway's destiny unfolded, the fate of the West Side (or more properly Miller) Highway was also being sealed of its own accord. On December 15, 1973, a section of the highway between Little West Twelfth and Gansevoort Streets collapsed, propelling a truck and a car to the street below. A short time before, $1 million had been allocated to provide stop-gap maintenance for the forty-year-old elevated road, but the situation was so serious that by June 1974 the road south of Forty-sixth street was closed and in September 1976 its demolition begun, denying many residents the use of a new recreational asset—since its closure to automobiles it had become a popular bikeway and promenade.[4]

On January 4, 1977, Westway won its final go-ahead from the federal government.[5] But federal approval only seemed to redouble the efforts of civic groups to fight the road. Aside from an almost innate prejudice against large-scale projects and real estate development, there was, as Paul Goldberger observed, the problem that "no one yet knows what all of these vast changes are going to end up looking like. The West Side Highway Project, the special city and state planning agency that created the present scheme, has deliberately prepared no more than a loose outline."[6] Ada Louise Huxtable, opining on the underlying mood that fired so much of the opposition, pointed out, "New Yorkers have . . . been burned too many times—too often lied to and co-opted in the name of some greater good. They are partisan, protective and paranoid." But Huxtable added that the skepticism of New Yorkers to Westway reflected a national trend: "People, cities and countryside have been ravaged by expressways. Mother wisdom says resist; the evil that we have is better than the evil to come." Against this background, she continued, "it is hard to sell New Yorkers on Westway. They are skilled street fighters who love the game. They also have a secret pleasure (which I share) in the perverse wonder of silent bicycles and quiet strolls on the wrecked highway turned into an inadvertent and rather absurd promenade with superb river view."[7]

The charms of ruins notwithstanding, Huxtable did not align herself with the growing number of Westway opponents. Her support for the highway was, like that of the editorial board of the *Times* itself, wholehearted: Westway "is an opportunity to do something extraordinarily constructive and creative—*provided that it is done well*." Huxtable pointed to the single most important objection by local community groups—the fear of untrammeled real estate speculation, which she argued "must be controlled, or the creative chance

LEFT Proposed Westway, Battery to Forty-second Street, 1977. Rendering of view to the north. NYT

BELOW Proposed Westway, Battery to Forty-second Street, 1977. Rendering by Bernard Paquer of view to the northeast. NYT

will be lost and neighborhood damage guaranteed. Land values will zoom on the West Side, adjacent to parks and river and the areas of new construction. Zoning restrictions must set appropriate building, or non-building patterns for both the new land and the bordering neighborhoods."[8] Barry Benepe, an urban planner, was quick to question Huxtable's arguments, which he felt "wistfully and too optimistically accepted the 'beautiful picture book' aspect of a partially depressed and covered highway."[9]

Westway's real problems began in February 1977 when the Federal Environmental Protection Agency, in an advisory report submitted to the Secretary of Transportation, branded the project "environmentally unsatisfactory" because it would increase already unhealthy levels of air pollution.[10] In his first campaign for mayor in October 1977, Edward I. Koch called for a transit fund trade-in, labeling Westway a "disaster" that would "never be built."[11] A few months later, in December, New York State's Environmental Commissioner, Peter A. A. Berle, denied the project an air quality permit vital to the project's progress.[12]

Jane Jacobs, who had moved to Toronto in 1969 in order to protest America's involvement in the Vietnam War, joined the

Westway (Schematic section at West 12th Street)

Park Proposed street West St.

3 lanes southbound Vent 3 lanes northbound LANDFILL EXISTING LAND

Vollmer Associates Proposal (Schematic section at West 12th Street)

Promenade 3 lanes southbound 3 lanes northbound West St.

Hudson River

EXISTING LAND

Proposed Westway, 1977 (top) and alternate proposal by Vollmer Associates, 1980 (bottom). Sections. NYT

attack on Westway. As she saw it, Westway was but another manifestation of the piecemeal approach Robert Moses used to realize grand ideas: "He would build a bridge without saying there must be a highway at either end." According to Jacobs, if Westway were to be built, then the Lower Manhattan Expressway, which she had successfully opposed, "will be revived." Jacobs was highly skeptical of Westway's promise of new parks and housing: "The grandiose land-development scheme is a red herring to sell the project. Instead of talking about the highway, proponents keep trying to talk about the landfill and what will be built on it, and they hope that nobody asks the questions: 'All right, if the landfill and parks and apartment houses are so great and the city really will have money to run these parks and the people of New York really do have enough income to fill up this many more apartments and so on, then why not do it on its own?'"[13]

Despite the rising tide of objections, Westway continued to move forward. In February 1978, the state's Department of Transportation selected the firms of Venturi & Rauch, architects, and Clarke & Rapuano, landscape architects, as project designers. The choice was surprising, given that Robert Venturi and his partner, Denise Scott Brown, had a reputation for working with community groups opposing urban highway projects, leading Venturi to wryly observe that "the good guys and the bad guys get so mixed up these days that you often find yourself on the opposite side of the fence from where you'd expect." In a fleet-footed bit of rationalization, Venturi argued, "This is still very much a job involving planning for neighborhoods," but he was probably closer to reality when he added that he saw his firm's job "as mediating between" community needs "and the needs of engineers."[15]

As design work proceeded, the project seemed to become more and more of a political football, if not a joke. In May 1978, Edward Koch, who had become the mayor, seemed to reverse his opposition at the behest of Governor Hugh Carey, who was seeking reelection. What Koch had previously described as a "boondoggle and environmental disaster," he now was prepared to support, in return, it appeared, for

Carey's endorsement of plans for a new convention center as well as some commitments to transit funding and a pledge to keep Radio City Music Hall open. Despite Koch's endorsement, the economic benefit of the project was challenged and the clamor for a mass-transit trade-in became increasingly vocal.[16]

By December 1980, however, with Governor Carey safely back in Albany and the convention center project secure—ground had been broken six months earlier—Mayor Koch backed off, proposing a possible alternative plan for Westway's implementation.[17] The plan, produced in a short time by Vollmer Associates but based on the River Road proposal of the architects Paul Willen and John Belle, called for a six-lane surface boulevard on existing land, leaving more than $1 billion in federal highway trade-in funds for the city's ailing transit system, which Koch said was "falling apart."[18] In February 1981, President Ronald Reagan, encouraged by Alfonse D'Amato, senator from New York, made it clear through his Secretary of Transportation that the Westway project, so long associated with politicians from the Democratic party, would have the support of the new Republican administration.[19] A month later Westway seemed to be making some headway on the environmental front when three federal environmental agencies dropped their objections to the project.[20]

With Washington's blessing, Governor Carey notified community boards that the state and federal governments intended to begin land acquisition for the road.[21] Senator Daniel Patrick Moynihan, who had grown up in the Hell's Kitchen neighborhood that Westway bordered and had jumped off its docks to swim in the Hudson, and later had worked on those docks, believed in the project because, as George F. Will put it, he wanted to show that New York still had the capacity to do big things. According to Will, Moynihan, out to disprove that the city's capacity to build big had "virtually vanished," was "provoked by that argument, not because it is groundless but because it is somewhat true, because repeating it may make it truer, and because it will be repeated until refuted by a big, splashy counterexample, like Westway."[22]

Senator Moynihan's support notwithstanding, the debate over the transit trade-in continued.[23] In May 1981 groups opposed to Westway sued in Federal District Court to stop the project, arguing that the Army Corps of Engineers' recently issued environmental permit for the highway was based "on improper political considerations" and failed to fully consider its impact on air, water, and wildlife, while neglecting to study alternatives to the $1.7 billion highway project.[24]

The fight against Westway really heated up on June 6, 1981, when Sydney H. Schanberg, a newly minted *New York Times* Op-Ed columnist covering metropolitan subjects, who as a reporter for the *Times* had won a Pulitzer Prize for his coverage of the Vietnam War, embarked on the first of what would become a series of twenty-one signed editorials opposing Westway. His tirades would only conclude on July 27, 1985, when he was relieved of his columnist position, reportedly because of his crusade against the project as well as his public criticism of the *Times*'s news coverage of it and its favorable editorial stance to the road.[25] In his first blast, Schanberg wrote that the "fight for and against Westway" had "gone on so long that it" had "come to resemble nothing so much as an ideological war, the urban equivalent of doves versus hawks on Vietnam." As Schanberg put it, Westway's supporters saw it as "a rare chance for New York to raise a phoenix from the ashes of the fiscal debacle, to regain our self-esteem and credibility, to prove that we can overcome the defeatists among us, emerge from the age of doubt and do things in a big way again. The opponents," he continued, regard it as "an outrageous misuse of public funds . . . , a grab by real-estate builders to fatten their coffers, a turning away from the more critical need of saving the city's mass transit system from collapse." Schanberg, who was convinced that Westway was unaffordable, came down firmly on the side of the straphangers.[26]

On July 31, 1981, as the controversy raged, Governor Carey and Mayor Koch agreed on a plan for Westway, resolving ten years of wrangling between the city and state. The agreement, which adopted Westway as "the official policy" for replacing the West Side Highway, was reached just three days before a crucial deadline for securing federal site acquisition funds. The crux of the nine-page "memorandum of understanding" was the provision that should the federal government not finance landfill parklands and other "amenities," then the mayor, who professed that his "own personal preference is not Westway," could seek a trade-in of the federal highway funds for mass transit dollars.[27] With this accord behind them, officials began to map out the project's ten-year construction schedule, consisting of the landfill and the road building but not including, until the end of that time period, the construction of the parks.[28] Meanwhile, demolition of the remaining 2.3 miles of the West Side Highway south of Jane Street began in late August 1981.[29] In February 1982, as demolition proceeded, an eighty-foot section of the highway collapsed near Canal Street, injuring three workers.[30]

On Labor Day, September 7, 1981, "in a ceremony embroidered with economic significance and political nuance," as Clyde Haberman reported, President Reagan went to Gracie Mansion "to present a stage-prop check" for $85 million, constituting a down payment on the $2.3 billion that Westway was now expected to cost.[31] The message was clear: the Republican president was courting organized labor by providing money for a substantial number of construction jobs. Not surprisingly, environmentalists pressed on with their opposition, with experts contending in court that Westway could not go forward "without risking serious consequences to important aquatic resources."[32] In particular, environmentalists feared that the landfilling would significantly change the area of the lower Hudson River, which provided food and protection for striped bass and other species.

On December 13, 1981, Federal Judge Thomas P. Griesa dismissed all objections to the highway except for one—the suit concerning the fate of the fish. The suit seemed to pose no real threat to the project, at least according to John Marino, the state's Assistant Transit Commissioner for New York City, who, when asked about it, stated: "When was the last time you had striped bass from the Hudson? That's our comment on it. I don't expect that in the end this will be a serious issue. The way is clear for Westway. It's a go-ahead."[33] As the case was being deliberated by Judge Griesa, Sydney Schanberg kept hammering away at Westway.[34] The issue was whether or not there was enough money available from Washington to pay for the project as envisioned, especially given drastic cutbacks in spending for urban aid. Carol Bellamy, president of the City Council, was also a relentless opponent.[35] But the editors of the *Times* remained steadfast in their support, despite the decision of leaders in the state legislature to halt financing until the federal government agreed in advance to pay its share even if the highway were never completed, a seemingly ridiculous demand crafted in anticipation of what most believed would be Koch's successful candidacy for governor in November 1982, which would leave Bellamy, automatically elevated to the position of mayor, likely to halt the project.[36] Koch was defeated in the primary by Mario Cuomo.

On March 31, 1982, Judge Griesa, in a ninety-four-page decision, barred Westway's 200-acre landfill until its environmental impact could be evaluated. The judge also said that another hearing would be necessary to determine whether the federal government should be prevented from expending funds for Westway because it had failed to consider "the impact of Westway on fishing resources."[37] At a second hearing in early April, Judge Griesa required the Corps of Engineers to submit a supplemental impact statement on natural "Hudson River fisheries" as well as cost estimates on the entire Westway project. Pending the preparation of the two studies, on April 14, Judge Griesa issued an eight-page order prohibiting all "activities relating to Westway that affect the waters or bed of the Hudson River," thereby preventing the demolition of some piers, which had been slated to begin in May.[38]

Sydney Schanberg was exuberant, calling attention to attempts by politicians and other Westway advocates to dismiss the court decision as a "technical hitch": "Anyone who has read the solid, meticulously documented ruling . . . knows that it has as much to do with a 'procedural error' as Watergate had to do with a 'third-rate burglary.' What the Federal district judge says throughout the 94 pages of his decision is that the Corps of Engineers, in collusion with New York State officials, primarily the Transportation Department, sought to suppress, withhold and cover up strong data about Westway's environmental impact on fish resources."[39] In late June, Schanberg returned to the topic of Westway, reporting on what he called "the second stage of the Westway cover-up trial" which "produced testimony showing that the concealment and distortion of crucial evidence was far more pervasive

and serious than anyone had earlier imagined." Schanberg was referring to the three-week trial that had been ignored by the *New York Times* and the city's other daily newspapers but which "revealed that officials for state and Federal agencies . . . promoting [the] $4 billion superhighway boondoggle told untruths under oath in order to hide information damaging to the approval of the project."[40]

On June 30, 1982, Judge Griesa blocked all federal funds for the Westway project, ruling that various agencies involved had colluded in holding back crucial information.[41] Even the editors of the *New York Times* were forced to temper their normally pro-Westway stance: "A decade of disgraceful obstruction of Manhattan's Westway has been made more disgraceful still by the conduct of the highway's boosters." But with the late 1983 deadline for the transit trade-in fast approaching, the editors, more or less conceding defeat for the project, admonished that "the great danger now is that New York will get neither Westway nor alternate aid."[42] On July 23, Lewis A. Kaplan, a lawyer, was appointed by Judge Griesa to serve as a "special master" monitoring compliance with the court-ordered preparation of new environmental reports.[43] A further instance of scandal marred the project in March 1983 when it was revealed that Colonel Walter M. Smith, an engineer in the Army Corps of Engineers nearing retirement age, sought employment with the firm responsible for the project's overall engineering.[44]

In May 1983, newly elected Governor Mario Cuomo, in a report he had commissioned during his campaign from Thomas P. Puccio, a respected lawyer, was advised that the project, which had ballooned in cost, had become "a luxury the city and state probably cannot afford."[45] Cuomo had supported Westway in his election run, but Puccio's report gave him a way out, suggesting that the number of jobs created by

ABOVE Proposed Westway State Park. Venturi, Rauch & Scott Brown, 1984. Model, view to the south. VSBA

RIGHT Proposed Westway State Park. Venturi, Rauch & Scott Brown, 1984. Rendering of view to the southeast. VSBA

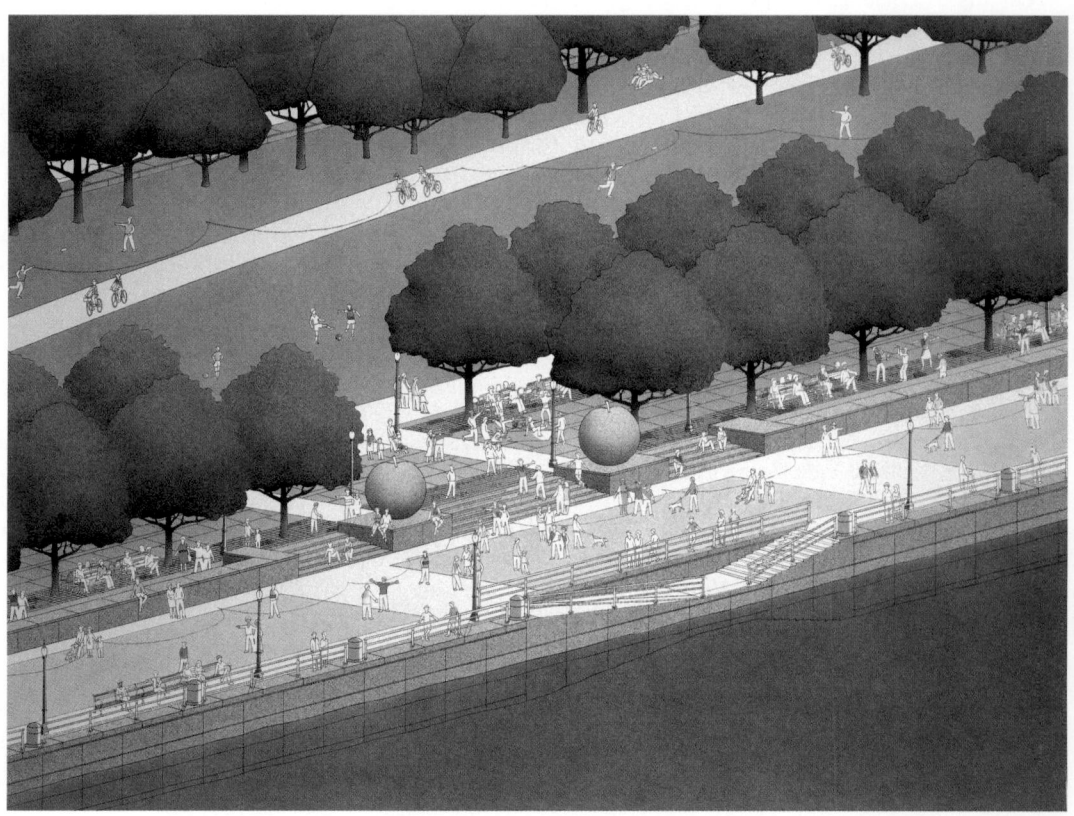

the transit trade-in would probably equal those generated by the highway. Moreover, one of the principal arguments for Westway—that it would spark the renewal of the lower West Side—had come to pass without benefit of the new highway. The *Times*'s editors, now in a virtual war with Schanberg, who extensively quoted from Puccio's report in his columns, dismissed that report as an "unsolicited opinion."[46] In June 1983, state and federal officials went on trial before Judge Griesa on charges of civil contempt, with opponents claiming that the Corps of Engineers, the State Department of Transportation, and the Federal Highway Administration should be held in contempt of court for violating Griesa's orders to follow new procedures for evaluating the environmental impact of the proposed landfill.[47]

In December 1983, but in reality much too late to do any real good, three versions of what was being called Westway State Park designed by Venturi, Rauch & Scott Brown and Clarke & Rapuano were released.[48] Ann Buttenwieser saw this move as "a way to create a constituency for speeding up the construction of the park, and thus the highway. If the public became excited about a park on this extraordinary site, the thinking went, they might fight for it." But, as Buttenwieser put it, "the public would not be fooled, and the number of Westway detractors grew."[49] Daralice Boles noted that, "presented in a vacuum, isolated from the political controversy that has plagued Westway throughout its 10-year history, these otherwise very 'real' designs take on an oddly utopian aura." Boles, writing in *Progressive Architecture*, asked her readers to consider the assumptions behind the park design: "1) that the buried superhighway and landfill park will be built as planned; 2) that the 10-year master plan is still valid in terms of land use designations and park footprints; 3) that the as-yet unplanned blocks separating the park from the city (shown completely blank in the schemes) will extend the existing street grid and adopt the scale of adjacent neighborhoods." Boles continued: "So charged with political implications is anything to do with Westway, however, that conventional design concerns seem somehow petty and these specific alternatives vaguely irrelevant. No park design, however delightful, could convince staunch opponents that the brave new world of Westway is worth the expense."[50]

Paul Goldberger did not get around to discussing the three park plans until late March 1984, when he observed that their most important characteristic was as "a major departure from the concrete and hard-edged school of modern urban park design. If anything," he continued, "they look back in time, most directly to Central Park and Riverside Park . . . and back still more to the work of the great French landscape designer Le Notre." For Goldberger, the larger question was "whether this park, should it ever happen, could achieve the sort of monumental, almost mythic, presence in our lives that Central Park possesses," concluding, Westway had "the elements of a noble riverfront park . . . if only they can be put together in the right fashion."[51]

Months later, in July, after a final design incorporating aspects of the three alternatives as well as ideas from community groups was released, the editors of the *New York Times* embraced it as "a high-water mark in recent urban park design."[52] The 3.5-mile-long, 97-acre design was mostly a narrow ribbon of green along the river's edge but widened to provide three enclaves at Tribeca, Greenwich Village, and Chelsea, where federal highway law required mitigation to

communities losing existing parks to new interstate highways. As the architects wrote: "The design of this long sliver of park acknowledges the park's role as both an edge and a place. The main compositional organizer of the design is rhythm. A series of long and short rhythms form an urbanistic fugue, allowing Westway Park to be continuous and varied in its design. The park reflects the vast scale and linearity of the river it parallels, yet responds to the varied characteristics and needs of the neighborhoods it borders."[53] A model and drawings of the park were put on public display at the World Trade Center on October 1, 1984, and the exhibit was transferred to Grand Central Station four months later.

In March 1984, the U.S. Circuit Court of Appeals in Manhattan rendered a decision allowing New York to proceed with Westway's planning and design in order to meet the 1990 deadline for completing interstate work. The decision allowed the state to spend as much of its own money as it wished, reversing Judge Griesa's 1983 decision to restrict spending until supplemental environmental studies were completed.[54] Eight months after the new ruling, in November 1984, the Army Corps of Engineers released the findings of a new environmental review which stated that the construction of Westway would have a "perceptible" but "minor" impact on wintering bass but would "not threaten" their survival. Taking into consideration the potential risk that Hudson River bass endangerment might have to East Coast fishing, the Corps advised "a conservative evaluation of risks." Moreover, it came down hard against state-initiated proposals to create artificial habitats, which it believed were experimental, posed a threat to navigation safety, and had the effect of "forcing an engineering solution on the fish."[55] Both sides claimed a measure of victory in the report, and the *Times* editorialized that its findings were "reassuring."[56] On January 24, 1985, Colonel Fletcher H. Griffis, district engineer for the Corps, gave a green light to the 272-acre landfill.[57] Griffis's decision was subject to review by superiors in the Corps, as well as officials of the Environmental Protection Agency.

In early 1985 the Westway cliffhanger was played out against a change in policy in Washington when President Reagan proposed massive cutbacks in federal mass transit aid to the city, leading to renewed calls for a mass transit trade-in while there was still money available.[58] On February 19, the Environmental Protection Agency announced that it had withdrawn its opposition to the highway project.[59] The *Times*'s editors, who saw victory at last, had become the project's leading cheerleaders and were overjoyed as they lectured readers on Westway's benefits and hectored opponents for ideologically driven small-mindedness.[60]

The dredge-and-fill permit—the last administrative hurdle—was issued in early March 1985, but Westway's construction could not begin until the court case was resolved.[61] In April the project came under criticism from a new source when Senator Frank Lautenberg of New Jersey, in a rather partisan demonstration of interstate rivalry, labeled Westway an excuse for a real estate development and supported a proposed bill that would bar the federal government from paying for 90 percent of the highway's landfill.[62] But that was only a diversion. The real action began on May 20, when Judge Griesa heard arguments attacking the validity of the Army Corps of Engineers's favorable decision.[63] As the trial progressed, Judge Griesa continued to charge that the Army Corps of Engineers had not maintained adequate records of the meetings,

deliberations, and communications leading to its favorable decision, a failure he regarded as "a most serious violation of a most serious order."[64] Not only were records not kept in an appropriate way, but documents obtained by opponents seemed to indicate that officials in Washington had let it be known that the project was to be approved no matter what, despite opposition from officials within the Environmental Protection Agency.

Final arguments in the case were heard on July 24, 1985.[65] Four days later, Schanberg, about to go on vacation, took up the Westway case yet again, castigating the city's newspapers for failing to cover the story. "As a public works project," Schanberg wrote, "the Westway plan may be this generation's largest suggested misuse of scarce public funds, be we do owe it an educational debt—as a wondrous, unfolding case study of wheeling and stealing on a grand scale."[66] On August 19, 1985, after returning from vacation, Schanberg, who had become somewhat shrill, at least by New York Times standards, was relieved of his twice-weekly "New York" column and, rejecting the offer of a job on the newspaper's magazine, resigned.[67]

While Schanberg was feuding with the Times, Judge Griesa again blocked the project, stating that "two failures to justify the Westway landfill and Federal funding for Westway under the applicable legal standards should bring the matter to an end." Pointing to the differing manners in which Westway appeared to have been defined to suit different federal agencies, Judge Griesa wrote, "This was not fair-dealing with the public or compliance with the public-disclosure law." He also was critical of the Corps of Engineers, stating that his order that the agency keep proper records had been "violated to a gross extent."[68] The judge's decision appeared to have stalled the project, although the case could be taken to the court of appeals.[69] By now Westway had become national news, with Newsweek reporting the situation under the provocative headline, "The Death of a 'Boondoggle'?"[70]

On September 11, 1985, a federal appeals court upheld Judge Griesa's stop-work order, although it held open the possibility that the project could go forward if the Corps of Engineers was able to issue a proper landfill permit.[71] The decision came just as Congress voted by a big margin to bar Westway's funds.[72] Taken together, the appeals court decision and the vote in Congress seemed to doom the project.[73] Just as all seemed lost—and as the story of Westway began to rival an episode in the old film series about the Perils of Pauline— Governor Cuomo, Mayor Koch, and Senators D'Amato and Moynihan agreed to trade in federal funds for Westway should they fail to save the highway as planned. But even that possibility was remote, given that such a trade-in had to be achieved by September 30.[74] On September 18, Senator Moynihan stated that he could see no way to win the extra time needed to refile a proper environmental impact permit and that only a last-ditch effort for the transit trade-in might save the day.[75] Westway's opponents rejoiced. As details of the trade-in plan were ironed out, approximately 60 percent of the nearly $2 billion in federal funds and local grants were allocated to mass transit projects, leaving about $800 million to build the new highway.[76]

Westway died on September 30, 1985, although it was not until 1990 that the federal government formally withdrew its support. The editors of the New York Times greeted its demise rather peevishly as they tried to explain the project's failure:

No matter what Government promised, cartoonists depicted Westway as cutting through the vital organs of the city. No matter how often the law governing the use of trust fund money was explained, Westway's critics insisted that its potential $3 billion cost would be at the expense of the subways and could be restored by trade-in. No matter that the landfill would be used for parkland and restrictively zoned housing, critics called it a boondoggle. Far from being fatal to cities, automotive traffic brings them life. There is no sweeping it away in romantic illusion. Westway may have been an ambitious, complicated and expensive solution. It is survived by the problem.[77]

The finger-wagging negativism of the Times's editors notwithstanding, the death of Westway, though it brought forth many pronouncements concerning New York's inability to conceive and carry out big projects, also invoked more subtly nuanced reactions. Marcy Benstock, director of Citizens for Clean Air, saw the project's defeat as a triumph of the rule of law more than a vindication of the democratic political process. Robert F. Wagner Jr., former deputy mayor, found it "a fascinating case study that only Evelyn Waugh could do justice to. But in terms of the city's future, a footnote," an idea echoed by Governor Cuomo, who called the matter a "walnut in the batter of eternity. When it hits the top of the batter," he went on in explaining what was surely the most obscure metaphor used to describe Westway to date, "it makes an impression. It starts sinking and still makes an impression. And then it's gone forever. Westway won't be news next year."[78] Russell Baker, the humorist who regularly contributed a column to the Times's Op-Ed page, opined that the Westway case "left most people, probably including most New Yorkers, baffled and bored," which he deemed a "pity because at the end it was like those Frank Capra fables about Mr. Deeds going to town and Mr. Smith going to Washington, in which innocent small-town boys with a civics-book faith in democracy challenged the big shots and won."[79]

Carter Wiseman pointed out in his February 1986 review of Westway's history that there were many knowledgeable urbanists who, from the first, thought the plans for Westway were unrealistic. One of these, according to Wiseman, was Robert Moses, who in 1974 asked a reporter: "Can you picture Western and Southern congressmen standing mute while the United States Department of Transportation approves the spending of such monstrous sums to build a four-mile expressway section on the Hudson representing all the federal aid in a Rocky Mountain state for a decade?"[80] But, as Wiseman pointed out, a deeper problem for the project lay in the city's improving fortunes. What had been conceived as the city was skidding toward bankruptcy in the early 1970s began to look less desirable in the booming 1980s: "As the fiscal crisis began to recede . . . and as the unchecked pace of building began to strangle much of Manhattan, development began to look less urgent, and transit suddenly began to emerge as absolutely vital to making the city's economic recovery stick."[81]

Westway Redux
(aka Westway II, Son of Westway, Daughter of Westway, and the Hudson River Boulevard)

Westway's official demise—the transit trade-in plan—brought forth the need for a substitute plan for the highway.[82] Following the recommendations of the West Side Task Force, a nineteen-member state panel, in August 1987 Governor

View of closed portion of elevated West Side Highway, between West Forty-third and West Fifty-seventh Streets, showing cardboard shacks inhabited by homeless, January 1989. Wilson. NYT

Cuomo and Mayor Koch agreed on a strategy for the new Westway: a grade-level six-lane highway from Chambers to Forty-second Street and a waterfront esplanade.[83] No firm decision was made about the stretch below Chambers Street, where both ground-level and below-grade solutions were being considered. Four sections of the highway would either go above or below intersections to ease pedestrian access to the esplanade. The agreement on a plan notwithstanding, the new West Side Highway project continued to drag on.[84]

Early in 1989, the fourteen-block stretch of the elevated West Side Highway extending north of Forty-third Street to Fifty-seventh Street, long closed to traffic and littered with cardboard shacks and other detritus left there by homeless people, was demolished, requiring the closing of Twelfth Avenue below and provoking major traffic delays.[85] Meanwhile, state and city officials continued to squabble about plans for the new highway, officially known as the Route 9A Reconstruction Project or Westway II.[86] At stake was the potential use of the underwater land to the west of the new highway, which many New Yorkers, fearing it would be developed at some future date, wanted for parkland. In April 1989 the *New York Times*, still bitter over Westway's defeat, angrily editorialized that "all those opponents who defeated Westway . . . now seem agreed on an alternative: nothing. One interest group after another says it prefers the present dilapidated piers to the dirt and noise involved in creating new vistas and uses. It's a timid, even irresponsible consensus." But, as the *Times* acknowledged, "the immediate issue" was "not whether to build a road" but what to do with the land between Twelfth Avenue and the river. "Critics want no development,

only parkland. They are also notably unenthusiastic about new development to the east."[87] Development opponents responded to the *Times* by stating that they were opposed to new outboard construction because it would require just the kind of fish-threatening platform construction that had defeated Westway in the first place.[88]

Planning resumed in June 1989, after a complicated legal agreement was worked out between the city and state concerning the value of the Westway right-of-way.[89] The agreement mandated "scenic easements." But city and state officials continued to oppose the idea of a waterfront park, with Mayor Koch going so far as to remove thirty-two three-by-five-foot banners erected between Chambers and Sixteenth Streets proclaiming "Let's Build a Hudson River Waterfront Park" that had originally been put up with permission from the city's Transportation Department.[90]

On October 31, 1989, the West Side Waterfront Panel, a successor group to the West Side Task Force whose members were appointed the previous year by Governor Cuomo, Mayor Koch, and Borough President Dinkins, presented its plan for a new highway, a scheme that, as David Dunlap wrote, "raised the possibility of new buildings on platforms over the Hudson," although four "coves" where no development would be permitted would be located at Tribeca, Greenwich Village, Chelsea, and the Convention Center.[91] According to Gary Hack of Carr, Lynch, Hack & Sandell, planning and design consultants to the panel, the coves or "basins" would be "the front doors of the communities on the water."[92] The potential platform areas, amounting to about 241 acres, euphemistically called "active-use" areas, enraged community

WaterLine, Hudson River waterfront, between Battery Park and West Fifty-ninth Street. Hanrahan + Meyers Architects, 1992. Isometric showing housing for the elderly north of Canal Street. HMA

WaterLine, Hudson River waterfront, between Battery Park and West Fifty-ninth Street. Hanrahan + Meyers Architects, 1992. Plan for housing for the elderly north of Canal Street. HMA

leaders. But city officials dismissed these concerns as obstructionist.

In February 1990 Governor Cuomo and Mayor Dinkins announced their commitment to the development of a four-and-one-half-mile Hudson River park, subject to the approval of the state legislature and the voters, who would have to authorize the necessary bonds.[93] But the costs of the park were widely believed to exceed what the bond issue would authorize, suggesting that federal funds would be required.[94] With the waterfront park seemingly in place, the last remaining hurdle to progress on a new road was the issue of waterfront development.[95] On September 17, 1990, the West Side Waterfront Panel published *A Vision for the Hudson River Waterfront Park*, declaring the planned park "the largest and most important new open space created in New York City in the last half century," stretching "like a band of green along the water's edge between Battery Park City and 59th Street." The park would reach out "onto 13 public recreation piers," encompassing 270 acres including the river areas between the piers.[96] Although the bond act was defeated by the voters in November, cutting $100 million from its $500 million estimated budget, a new spirit of optimism prevailed, with general agreement that the road would be built along with the park.[97] The provision of waterfront development as part of the project continued to meet with community resistance, but not necessarily from architects, such as the young partnership of Thomas Hanrahan and Victoria Meyers, whose 1992 scheme, WaterLine, proposed clusters of public and private development at key points along the shore, especially Canal Street.[98]

In May 1992 the governor and mayor agreed on a plan for the highway and for the forty-acre ribbon of parkland along the river.[99] But community leaders attacked the plan for failing to provide more parkland and for permitting too much in the way of future development, with new private investment anticipated at Chelsea Piers, Pier 40, and near the Jacob K. Javits Convention Center. The announcement called for a new

Proposed Hudson River Park, Battery Park to West Fifty-ninth Street. Quennell Rothschild Associates and Signe Nielsen, 1995. Plan of section between West Houston and West Thirteenth Streets. MN

agency, the Hudson River Park Corporation, which would soon be renamed the Hudson River Park Conservancy, a subsidiary of the State Urban Development Corporation (UDC), to implement the plan. A year later, in May 1993, details of a proposed "boutique" boulevard along the West Side were released by the New York State Transportation Department.[100] But critics complained that the design was in no significant way different from the alternatives previously proposed, while the likelihood of large-scale development along the right-of-way, some of it on the waterside, remained as part of the plan.[101]

The first positive sign of the Hudson River Park's emergent reality was the completion in June 1994 of a nearly two-mile-long, twenty-seven-foot-wide, bicycle/rollerblade/pedestrian path between Little West Twelfth and Harrison Streets.[102] Great though this amenity was, it did not quite live up to the promises of a waterfront park. Certainly, the construction of the recreational development at Chelsea Piers (see Chelsea) confirmed that development-friendly thinking remained part of the plan. In August 1994 State Transportation Department officials settled on a plan, calling for a five-mile-long surface-level, median-divided "urban boulevard" extending from Battery Place to Fifty-ninth Street, accompanied by a riverfront walking and bicycle path. The road would follow the alignment of the old West Side Highway except at Twenty-third Street, where the notoriously tight S-curve would be straightened, leading to the expansion of a small park there.[103]

In 1995 the Hudson River Park Conservancy published its waterfront park plan, developed by a joint team of landscape architects consisting of the firms of Quennell Rothschild Associates and Signe Nielsen.[104] In addition, landscape firms designated as "Community Design Liaisons" were made available to various neighborhoods: Ken Smith for Tribeca; Thomas Balsley Associates for Greenwich Village; and Buckhurst Fish & Jacquemart for Chelsea and Clinton. Progress on the park's implementation was held up in the State Supreme Court, where a judge ruled that the work could

not go forward until the state completed its environmental impact statement for the entire waterfront from Battery Park City to Fifty-ninth Street.[105]

The vision for the new park and its eventual realization emerged on a piecemeal basis. In 1995 Pier 25, opposite North Moore Street, was remodeled to accommodate a volleyball beach, a café, a children's play area with sand and sprinklers, and a historic boat, all replacing the Amazon Club, a disco that had been a community nuisance before closing in 1993.[106] Complex negotiations over the city and state's repayment of the $85 million advanced by the federal government in 1981 to buy Westway's right-of-way continued to stall the progress

Proposed Hudson River Park, Battery Park to West Fifty-ninth Street. Quennell Rothschild Associates and Signe Nielsen, 1995. Model, view to the southeast. QRP

Proposal for Pier 40, opposite West Houston Street. Sebastian Knorr Architects, 1999. Level-one plan. TEC

nity activist Marcy Benstock criticized its provision for offshore commercial development.[110] Most others, however, welcomed the reconstruction of the piers, the provision of food services and the like, even as they remained concerned about potential view- and access-blocking large-scale riverside development. The fate of Pier 40, opposite West Houston Street and containing a two-story structure used as a parking garage and truck terminal, was a particularly contentious point of disagreement between the state, which wanted to develop at least part of it commercially, and Greenwich Village neighbors, who, recalling its controversial use as a docking point for a prison barge in the late 1980s and early 1990s, wanted its superstructure destroyed to make way for a park.[111] Despite the release of a concept plan for the park, funds were not made available for its implementation, leaving the waterfront in limbo.[112] Finally, in April 1997, Governor Pataki committed $100 million in state funds toward the realization of the park.[113] With funds freed for construction, detailed alternate plans were developed. One version proposed a beach at Thirty-first Street and another at Gansevoort Peninsula at Twelfth Street, each testifying to the Hudson's new status as a clean river.[114]

By early 1998 portions of the park were already under construction, although community groups and community leaders continued to bicker over details, especially those concerning future waterside development, which Mayor Giuliani continued to lobby for.[115] In June the city and state reached agreement over the park's governance, with each entity leasing its land to a joint agency staffed by city and state parks department personnel.[116] Meanwhile, progress on Route 9A was moving forward according to schedule.[117] On September 8, 1998, Governor Pataki, in a ceremony held at Pier 25 in Tribeca, signed the law creating the new Hudson River Park Trust, charged with the design, construction, and operation of the new 550-acre recreational facility, the largest open-space development in Manhattan since the completion of Central Park.[118]

As the momentum picked up, key issues were resolved.[119] In April 1999, park advocates won the battle of Gansevoort Peninsula, a spit of land just south of Fourteenth Street that for years had been used by the city's Sanitation Department to store vehicles and salt used in street de-icing.[120] Suddenly,

of the park and highway while die-hard activists on both sides of the Westway debate fought what were now seen by many as ancient and irrelevant battles over turf and vision.[107]

On April 1, Governor George Pataki and Mayor Rudolph Giuliani broke ground for the first phase of the new surface boulevard, running from Clarkson to Horatio Street.[108] But as Joyce Purnick commented in her "Metro Matters" column in the New York Times, Westway II was a pale shadow of its progenitor: "It is the reconstruction of a road, not much more ambitious than the recent renovation of Columbus Avenue. . . . It will have stoplights and intersecting cross streets and is unlikely to relieve other avenues of polluting congestion. . . . The Westway plan was close to phantasmagorical, or, as opponents painted it, nightmarish."[109]

Plans for Hudson River Park were finally released on June 6, 1996, to a generally favorable reception although commu-

Hudson River Park, Greenwich Village section. Abel Bainnson Butz and Sowinsky Sullivan Architects, 1999–2003. View to the north. Ries. SRP

design journals began to publish proposals for various park areas as well as elements such as signage.[121] In July Community Board 2 approved a comprehensive redevelopment plan for Pier 40, built in 1961 as a cruise ship terminal. The scheme, developed by Sebastian Knorr Architects, proposed to replace the small rooftop soccer and baseball field and a center courtyard parking lot with twenty-one acres of recreational space on four levels, including three playing fields, a large lawn, sand beach, jogging track, and dock space as well as a stacking system to accommodate 1,800 parked cars that would relieve local congestion and generate funds for the Park Trust.[122]

By the summer of 1999 many New Yorkers were beginning to enjoy the just-completed first phase of the park designed by Abel Bainnson Butz and Sowinski Sullivan Architects, with 1,000 feet of waterfront paths stretching from Christopher to Bank Street.[123] Amazingly, park opponents staged one last stand in December 1999, when Marcy Benstock successfully enlisted Representative Jerrold Nadler and two out-of-state senators, Ted Kennedy and John Kerry of Massachusetts, to demand that the United States Army Corps of Engineers delay in issuing permits for construction until a Federal Environmental Impact Statement was prepared, potentially setting park construction back for as much as four years.[124] Despite their efforts, federal approval was granted on May 31, 2000, permitting the repair of the Civil War-era seawall and the thirteen rotting piers that formed the centerpiece of the park plan.[125]

After Westway

Westway was both a huge distraction as well as the catalyst for other waterfront initiatives, some of which would be successfully implemented. Upon taking office in 1978 Mayor Koch pledged to help restore the city's decaying waterfront, believing that it represented not only an unrealized amenity for New Yorkers but also a potent stimulant to private development so essential to the city's financial health. In particular, Koch focused on Manhattan's Hudson River waterfront below Sixtieth Street and on the East River shore below Forty-second Street, recognizing in each case that long established patterns of commercial use—shipping, warehousing, and the like—were no longer viable. While largely content to promote waterfront development through individual projects, in September 1982 the Koch administration's City Planning Department released the *New York City Waterfront Revitalization Program*, a 144-page document that was ignored by the press at the time of its publication. The report described the deteriorated state of the waterfront, concluding that for the past twenty-five years "major opportunities were lost" as the shoreline "was taken for granted." Although it claimed to provide "the framework for future policy direction for the City's waterfront," the report included no fresh ideas and merely stated obvious goals—"restore, revitalize, and redevelop deteriorated and underutilized waterfront areas for commercial, industrial, cultural, recreational and other compatible uses" or "protect fish and wildlife resources in the coastal area from the introduction of hazardous wastes and other pollutants"—but offered little direction in how to achieve them.[126] In addition, the revitalization program failed to identify any specific new projects.

In April 1984 over 200 people attended a conference held at Hunter College, "578 Miles of Opportunity: New York City's Waterfront," jointly sponsored by the Regional Plan Association and the Parks Council, designed to solicit ideas for rejuvenating the city's most important untapped physical asset.[127] Although most participants acknowledged that the city had achieved some success in its waterfront projects, most notably the opening the previous year of the South Street Seaport (see South Street Seaport) as well as ongoing work at Battery Park City—including the opening of Gateway Plaza, the beginning of construction on the World Financial Center, and the completion of the first part of the esplanade (see Battery Park City)—there was widespread belief that despite these individual projects the city's waterfront suffered from a lack of coordinated planning.

Nine months after the conference, in January 1985, the Parks Council and the Regional Plan Association published an "agenda for action" based on a consensus of the participants. Complaining that the city's current waterfront policy included "no sense of an overall vision, which is the true hallmark of comprehensive planning," the report concluded that the public interest was being neglected. Although there was a commitment to planning on a citywide basis, for practical reasons the report urged "a borough-by-borough plan" that would "apportion the problem into more manageable entities."[128] Recognizing the confusing maze of overlapping jurisdictions, including agencies such as the Federal Army Corps of Engineers, the State Department of Environmental Conservation, and the City Planning Department, the report placed a high priority on streamlining the approvals process for both small- and large-scale projects, suggesting that the city write a handbook to guide developers and that a computerized inventory of all publicly and privately owned waterfront properties be created and made available to the public.

In July 1986 the Koch administration released *New York City's Waterfront: A Plan for Development*, a fifty-three-page document prepared by the New York City Public Development Corporation, which in December 1985 took over responsibility for the city's waterfront projects from the Department of Ports and Terminals.[129] The report confirmed the worst fears that the Koch administration was not being pro-active in its planning efforts but instead responding to projects and ideas on an individual basis. As with the publication of the City Planning Department's 1982 revitalization program, the 1986 report caused barely a ripple in the press. In addition to self-congratulatory platitudes about current planning efforts, the report highlighted the examples of the South Street Seaport and Battery Park City as proof that substantial progress was being made. The majority of the report simply rehashed projects currently in the planning stages, including two large-scale Manhattan-based proposals, River Walk, along the East River between Sixteenth and Twenty-fourth Streets (see River Walk), and the Hudson River Center, between Thirty-fifth and Fortieth Streets (see The Far West). The most ambitious plan in the waterfront report was South Ferry Plaza, a 1.5-million-square-foot mixed-use development at the southern tip of Manhattan that promised to alter the lower Manhattan skyline as well as provide for a new or renovated Staten Island Ferry Terminal (see South Ferry). Another large-scale project, planning for which began in 1984, called for the redevelopment of ninety-two acres in the Hunters Point section of Long Island City (see Queens). Although it offered little in the way of specific plans, the report also mentioned the possibility of new waterfront development in Brooklyn's Mill

Basin, Ferry Point Park along the East River in the Bronx, and in Staten Island near the ferry terminal. Four months after the report's release, in November 1986, Joseph Giovannini wrote in the *New York Times* that many urban planners remained unimpressed with the city's plans, still complaining that "development is occurring piecemeal." Referring to such projects as Donald Trump's plans for the abandoned West Side freight yards fronting the Hudson River between Sixtieth and Seventieth Streets, at the time known as Television City (see Upper West Side), Giovannini added, "There are no design guidelines to insure that builders approach the waterfront with the sensitivity demanded by such a natural boundary."[130] After the October 1987 stock market crash, the ensuing collapse of the real estate market halted progress on most of the waterfront projects described in the city's 1986 plan, with many abandoned forever but a few eventually developed in the 1990s, albeit on a reduced scale, like the Queens West project at the Hunters Point site.

In 1987 waterfront activists as well as local residents were outraged when the city announced plans to dock two prison barges at Pier 36, between Clinton and Montgomery Streets on the Lower East Side, and Pier 40, opposite West Houston Street in the West Village.[131] Pointing to an exploding prison population that in 1987 numbered 15,444 inmates as opposed to 8,904 only four years earlier, Richard J. Koehler, the City Correction Commissioner, argued that the city had little choice, pointing to the fact that the "floating facilities can be made ready in record time to serve a real need for inmate beds."[132] The city leased two British troop barges that had served duty in the 1982 Falklands War, the *Bibby Venture* and the *Bibby Resolution*, capable of housing 379 and 450 prisoners, respectively, after a refitting. Despite protests and lawsuits from neighborhood groups, low-risk inmates were transferred to the two ships in 1988 and 1989. As Raymond Gastil put it, "The floating prisons hulked over the waterfront as a symbol of a city whose economy and culture had gone terribly wrong. If the shipping industry had been replaced by the corrections industry, New York's future was in doubt."[133] In 1992, at which time the city exercised its lease option to purchase the vessels for twenty dollars, the two prison ships were shuttered, testament to a quicker transfer rate from city to state jails as well as the delivery of a new purpose-built 800-bed prison barge to be docked in the South Bronx near the Hunts Point Terminal Market. After sitting vacant at their Manhattan docks for the next two years, the *Bibby Venture* and the *Bibby Resolution* were sold to a European company in July 1994.

In 1990, when the new mayor, David Dinkins, took office, development activity on the waterfront was stalled, still suffering the effects of the real estate collapse following the 1987 stock market crash. Not only were the recently proposed megaprojects at a standstill but recent success stories were also now in trouble, including the South Street Seaport, where many retail establishments were going bust and tourist activity was significantly in decline, and Battery Park City, where apartments were being sold at auction at prices up to 50 percent below asking and the northern half of the site remained empty, with development prospects dim. Also in 1990, the Port of Los Angeles supplanted the Port of New York as the nation's leading port, with the value of cargo handled on the West Coast estimated at $55 billion as compared to $49 billion in New York.[134] Despite the seeming hopelessness of the

situation, the Dinkins administration committed itself to an active waterfront planning agenda. As Ann Buttenwieser explained, "The Dinkins administration began its work on the waterfront knowing what advocates had declared for years: that without controls, the development that had been viewed as beneficial for the opening and regeneration of the waterfront in the 1980s now threatened to block off and privatize the shoreline. The newfound popularity of the waterfront in the 1980s had also created a tension between competing needs: for mixed-use development, for open space, for the remaining maritime and industrial uses, and for preserving a fragile ecosystem."[135]

In August 1992, with the release of the *New York City Comprehensive Waterfront Plan: Reclaiming the City's Edge*, the city finally produced the kind of all-embracing citywide plan that watchdog groups had long clamored for.[136] The City Planning Department under the guidance of its director, Richard L. Schaffer, and Wilbur T. Woods, director of the department's division of waterfront and open space, devised a plan in consultation with a thirty-five-member panel composed of civic leaders, elected officials, and representatives of various city and state agencies. The scope of *Reclaiming the City's Edge* was enormous, covering such topics as piers, docks, esplanades, residential projects, factories and other commercial development, marinas, bays, beaches, and wetlands. The plan, whose main goals were to reduce the scale of residential development, increase public access, and encourage commercial development in keeping with the city's maritime history, was organized around four principal functions: the natural waterfront (beaches, wetlands, wildlife habitats), the public waterfront (parks, esplanades, piers), the working waterfront (maritime and industrial uses), and the redeveloping waterfront (vacant or underutilized areas ripe for change, either for housing, commercial, or recreational uses). At the heart of the plan were new zoning regulations, the first ever proposed to apply specifically to the waterfront. Roughly 30 percent of the city's waterfront, encompassing Jamaica Bay, the Harbor Herons Complex in the northwest corner of Staten Island, and the Long Island Sound/Upper East River area, would be designated as special natural waterfront areas, free from any development pressures. Other efforts to preserve the "natural" waterfront included tighter controls to reduce illegal dumping, the designation of additional wetlands, and a call to upgrade the city's water pollution control plants.

In order to ensure a more publicly accessible waterfront, with the goal of increasing access from a current 35 percent of the shoreline to at least 60 percent, new zoning would establish mandatory access requirements in all medium- and high-density residential and commercial developments and in large, low-density developments. Throughout the five boroughs the plan identified more than 100 areas where access could be improved. The plan's public access provisions also emphasized the importance of view corridors ensuring visual access to the shoreline and recommended continuous access parallel to the waterfront with perpendicular upland connectors.

Owing to its density as well as existing esplanades and parks, Manhattan's shoreline would be the most highly developed, and the plan recommended a public esplanade, at least twenty-five feet wide, encircling virtually the entire borough. Acknowledging the impracticality of continuous access along parts of the Harlem River, it proposed bridge connections to

Connect Ft. Washington
Park with Inwood Hill Park
through new Dyckman St. Marina

Improve bicycle
connection over
Henry Hudson Bridge

Close gap in
Ft. Washington Park
(181 - 187 Sts.)

Connect to proposed Harlem
River Esplanade on Bronx
shore over Broadway Bridge

Develop
new parkland
155th - 158th Sts.

Sherman Creek
Rowing Center

Connect Riverside Park
North and South through
Harlem on the Hudson and
alongside Riverbank State Park

Connect to proposed Harlem
River Esplanade on Bronx shore
over the Madison Ave., 145th St.,
or Macombs Dam bridges

Close gap in
Riverside Park esplanade
(86th - 90th Sts.)

Develop Harlem
Beach and connect
to East River Esplanade

New park
at proposed
Riverside South

Reuse Washburn Wire Bldg.

Improve access across FDR
(103rd - 125th Sts.)

New West Side
waterfront park
& esplanade

Rehab 91st to
94th Sts.

Adapt E.60th St. MTS
for open space use

Increase access
across West St.

United Nations

Interim esplanade
34th - 36th Sts.

Esplanade at
Stuyvesant Cove

Connect
Battery Park with
Battery Park City
at Pier A

Incorporate access
in reuse of Pier 36

Upper
New York
Bay

Catherine Street

Upgrade existing portion of esplanade

1 MILE

Esplanade connection at ferry terminal and
interim access at East River Docks

Public Waterfront Recommendations for Manhattan, New York City
Comprehensive Waterfront Plan. Department of City Planning, 1992. DCP

an esplanade on the Bronx side of the river. In the Bronx, new esplanades were proposed along the Hudson River, the Harlem River, Soundview Park, and Ferry Point Park. The plan also included a new upland bicycle path in Riverdale with a connection over the Henry Hudson Bridge. In the industrial sections of the South Bronx, improved street end access was proposed at several locations. In addition to a new waterfront park at the site of the Hunts Point Marine Transfer Station, the plan recommended an additional connection to Randalls Island to increase access to this underutilized recreational amenity. The plans for Queens included linear public access corridors along the East River at Long Island City as well as projects for the borough's north shore, including a rehabilitation of the esplanade at the Flushing Bay Marina, new street end access points at the College Point industrial area, and the possibility of a new park at the historic Fort Totten Battery. Along the southern shore of Queens, the plan envisioned improved esplanades in the Rockaways as well as limited access to the environmentally sensitive Jamaica Bay area. The public waterfront recommendations for Brooklyn included

new parks and mixed-use developments that would increase public access along the East River and Upper Bay coastlines. Access could also be improved by the redevelopment of Piers 1-5 in Brooklyn Heights and a waterfront greenway along Shore Parkway, Coney Island, and Jamaica Bay. The plan proposed no public access at important industrial areas along Newtown Creek and the Gowanus Canal but suggested that they could be provided in connection with new industrial development at Sunset Park. For Staten Island, the plan recommended the completion of the North Shore Esplanade, a new beach at Cedar Grove Avenue along the South Shore, as well as new boat launches in the Outerbridge area providing access to the Arthur Kill. The plan also projected the eventual closing of the Fresh Kills landfill and its redevelopment as a waterfront park.

For the "working waterfront," the plan, recognizing that most of the port's oceangoing shipping was now concentrated in New Jersey, focused instead on infrastructure improvements that would promote current industrial and maritime uses. The plan designated six specific areas—the South Bronx, the Kill Van Kull, Newtown Creek, Sunset Park, Red Hook, and the Brooklyn Navy Yard—where industrial zoning would be retained, representing 15 percent of the city's shoreline, or about 4,000 acres. The plan also recommended that waterborne transportation to La Guardia and Kennedy Airports be improved.

The most controversial elements of the plan were zoning changes and new requirements proposed for the "redeveloping waterfront" that drew the attention of the real estate industry, which was concerned that new regulations might seriously inhibit future development. One important change was aimed at preventing the kind of megaprojects proposed in the 1980s. As Richard Schaffer explained: "We did not believe it was appropriate to be building new piers or platforms over open water for the purpose of building new apartments or office buildings."[137] But new piers and platforms were allowed to be built for parks, playgrounds, and what were labeled "water-dependent" uses, including docks, boatyards, and heliports. There was a loophole, however, allowing developers to apply for a special permit for new piers and platforms to accommodate "water-enhancing" uses, potentially including things like hotels, restaurants, theaters, skating rinks, and tennis courts. On existing piers, the plan limited the size of commercial buildings to 20,000 square feet, with structures smaller than 200 feet allowed to rise forty feet while longer shedlike buildings could only be thirty feet high. To further reduce the scale of new development, the plan eliminated the ability to transfer development rights from underwater property between the bulkhead and pierhead lines to upland development sites. In medium- to high-density residential districts, building heights could range between 150 to 390 feet, or roughly fifteen to forty stories. Floor sizes would be limited to 8,100 square feet, while upper floors parallel to the shoreline were not allowed to be wider than 100 feet. Overall, the plan identified more than twenty sites throughout the five boroughs that could accommodate a total of 50,000 new residential units, requiring that between 15 and 20 percent of each site be built and maintained as public open space. Another component of the comprehensive waterfront plan was a set of land-use studies that divided the shoreline into twenty-two separate sections, or "reaches," a nautical term meaning a continuous stretch of water. Detailed versions of these studies, compiled on a bor-

ough-by-borough basis, were published in 1993 and 1994.[138] Each reach study included an analysis of existing conditions, an explanation of relevant issues, as well as recommendations for action based on the principles articulated in the plan and grouped according to its four main categories—natural, public, working, and redevelopment.

Designated a "public discussion" document by the City Planning Department, meaning that opinions and suggestions were requested before the draft was deemed complete and sent to the City Council for approval, the highly anticipated plan sparked considerable interest. Even before its official release, in June 1992, Michael Specter reported in the *New York Times* that despite a number of skeptics who were convinced that the proposal was destined to be delivered "stillborn," there were plenty of others who felt that the timing was fortuitous: "They say that New York finally seems on the verge of creating the type of recreational and commercial amenities on its waterways that have become successful hallmarks of other major cities—from Baltimore, Boston and Toronto to Seattle and San Francisco."[139]

Two months later, after the plan was issued, Manhattan Borough President Ruth Messinger praised City Hall for moving "the waterfront to the forefront. It really portrays a vision for the use of the waterfront in Manhattan and the rest of the city that is right on target."[140] Ron Hine, director of the Coalition for a Better Waterfront, endorsed the blueprint, stating that it did "a lot to preserve environmentally sensitive areas."[141] Writing in *Metropolis*, Marta Mestrovic was relieved that the city had finally recognized "the shoreline as a unique asset of the city in need of its own zoning regulations," and predicted that "as the waterfront emerges as the city's next development frontier, the plan should create common objectives to avoid site-by-site confrontation and litigation." She also hoped that the new guidelines would "prevent blunders like the Javits Center . . . which turns its back on the Hudson."[142]

The Real Estate Board of New York vigorously opposed the plan. As Michael Slattery, the group's senior vice president, stated: "The city must recognize that mandating public open space on private property, severely restricting the design of buildings and removing lands that generate floor area all have major implications on the feasibility of any development on the waterfront. This radical approach is so extremely costly that without an up-front commitment of public funds to secure the public benefits, any development would prove unlikely."[143] There were others who also saw the plan as unrealistic, a pie-in-the-sky scheme that would be far too expensive to implement, a view bolstered by the recent defeat by voters of a bond act that would have authorized the state to borrow up to $800 million for public works, including many projects along the city's waterfront.

One interesting criticism of the plan came from a veteran observer of the waterfront scene and one of the original designers of Westway, Craig Whitaker: "Where possible, the Department has suggested a 25-foot-wide public walkway. However, it has 'forgotten' to include vehicular streets. It may seem apostatic, but great waterfronts have both." Whitaker pointed to recent problems with development along New Jersey's Hudson River shoreline with its thirty-foot-wide required public walkway at the water's edge because no vehicular streets were included, causing developers to "orient the backyards of their buildings to face the esplanade and the waterfront. After all, why not? They could easily market the

idea of backyard barbecues on the waterfront, with the Manhattan skyline beyond. The only problem was the walkway. Residents didn't want the public watching them in their backyards." Despite New Jersey's good intentions, Whitaker noted that "every ounce of the developers' energy was now focused on keeping the public out of the backyards," pointing out that "several walkways are now in litigation, others are closed off completely from the public, and none seem open or inviting." Whitaker went on to make the case for including streets, writing that "it is a remarkably simple notion, yet one missed time and again by designers and planners. Front doors are where we meet the mailman, wait for a taxi, and where we put most of our architecture. Back doors are where we put the trash, have family get-togethers, and read the Sunday paper. Front doors are public and back doors are private. Front doors create life, activity, and security because they face a street. Therefore, if one wants to increase activity and security at the waterfront by having more front doors, it means creating more streets. Specifically, it means putting a street between the front doors and a waterfront walkway. On reflection, an intervening street is the common denominator for most of the world's great waterfronts. The typical section for each has front doors on one side of the street and the waterfront on the other. This is true on Chicago's lakefront, at the Copacabana in Rio de Janeiro, and on Riverside Drive in New York. The street can be quite narrow, as it is on Miami's South Beach or at the Vieux Port of Marseilles, but it is always vehicular." Whitaker urged New York to "map narrow vehicular streets behind the waterfront walkways now to save us all the headache of trying to solve the mess later."[144]

In August 1993 the City Planning Commission adopted the comprehensive waterfront plan, and in October the City Council approved the measure after reaching a compromise with the real estate community. Although the city still required developers to build public space along the waterfront, they could then give the property back to the city, which would assume responsibility for maintenance. Alternatively, if developers decided to continue ownership of the public space, they would be responsible for maintenance but the city would indemnify them against liability for personal injuries, acts of nature, or civil insurrection. In addition, the compromise exempted from the public space requirement some medium-density residential developments composed primarily of garden apartments or two- and three-family rowhouses. The editors of the New York Times welcomed the "wise modifications" as well as the overall plan, writing that it represented "an ambitious step toward reclaiming the waterfront . . . [that] could make an invaluable contribution to a city that has for too long squandered its potentially magnificent shoreline."[145] The paper's architecture critic, however, was not so sure. Writing two weeks after Mayor Dinkins's failed bid for reelection, Herbert Muschamp felt that the new zoning rules, in their attempt to both promote development as well as increase public access, too closely "resembled a formula that has already produced dubious public amenities like the atriums in Trump Tower, Olympic Tower and the Sony Building." Muschamp saw the waterfront effort as another lost opportunity to imaginatively plan for the city's future. "Rather than merely balancing the competing interests of the public and private sectors, the plan could have united the two in the pursuit of higher goals. The waterfront marks a border between the urban and natural realms. The plan was an ideal opportunity to introduce ideas for reconciling these traditionally divided spheres. New design codes for 'sustainable'—environmentally responsible—development. Waste-treatment plants transformed from unwanted projects to desirable public spaces. Incentives for biotechnology and environmental industries to locate on the waterfront, as apparel is concentrated on Seventh Avenue or finance on Wall Street. Recreation areas landscaped by brilliant environmental artists." Muschamp complained that "instead of fostering a new relationship between culture and nature, the waterfront plan envisioned nature in 19th-century terms, as a scenic backdrop or as a wilderness to be segregated into parklike preserves."[146]

Interest in the fate of the city's waterfront continued to grow after the adoption of the city's comprehensive plan, including an exhibition and related panel discussions sponsored by Cooper Union in early 1994.[147] Curated by Kevin Bone and Mary Beth Betts, The Essential City: The New York Waterfront Survey traced the history of the city's waterfront from its critical role in the city's economy beginning in Dutch times all the way to its recent troubles and diminishing commercial character. The goal of the exhibition, as Sarah Amelar put it, was to use "the harbor's history as a point of departure for envisioning its future."[148] The exhibition also included a review of recent large-scale projects like Westway, the North River Pollution Control Plant, Battery Park City, and Riverside South, raising the point of whether "increasing complexity in the decision-making process" had doomed substantial progress on the waterfront, limiting the city "to implementing low impact planning solutions."[149]

The Van Alen Institute was also active in soliciting ideas to improve the waterfront, including a December 1996 symposium, co-sponsored by the Parsons School of Design, on the future of New York Harbor, a 1997 exhibition of contemporary photographs by Maggie Hopp of the Hudson River shoreline between Battery Park City and Fifty-ninth Street, a competition to redevelop Pier 40, a series of waterfront tours in conjunction with the Municipal Art Society beginning in 1998, and a panel discussion held on September 6, 2001, "New York City on the Verge," concerning the design of new public space, ferry terminals, and other infrastructure projects.[150] In 1998, with progress well under way along the Hudson River shoreline, including renewed building activity at Battery Park City, the completion of the recreational complex at Chelsea Piers, approval of a plan for the Hudson River Park, and the beginning of construction at Riverside South, the Van Alen Institute sponsored a competition and accompanying exhibition for what it referred to as "New York's other river": "Owned and controlled by a myriad of City and State agencies, the East River and its waterfront communities have been denied the sort of master vision currently in place for the Hudson. As a result, the East River waterfront has remained under-utilized and cut-off from upland areas for decades." The institute received 214 entries for the competition intended to "generate new design visions for sites along the river, from new buildings to new open spaces, from the scale of a small lot to the scale of the city."[151]

Third prize was awarded to Dirk Bertulant of Berlin whose untitled proposal for Greenpoint called for the re-creation of the area's destroyed marshlands and wetlands as well as new stone piers to replace the existing dilapidated wooden piers. "Tidal Landscape," the second-place winner, was designed by

Till, winning entry,
East River Project,
Van Alen Institute.
Victoria Marshall and
Steven Tupu, 1998.
Presentation board.
TERR

East River Corridor:
Manhattan Segment.
Reiser + Umemoto,
1998. Photomontage,
view to the north-
east. RU

Aaron Neubert and Michael Jacobs of Brooklyn and was aimed at eliminating "the present disconnectedness of the edge" by inserting a huge jettylike extension that would link "the scattered public and abandoned spaces that currently dot the riverbank." Supplementing this "new occupiable path" would be "floating program vessels" that could house a variety of functions, like a library, produce market, or meeting hall.[152] The winning entry, "Till," submitted by Manhattan-based landscape architects Victoria Marshall and Steven Tupu, called for creating landfill from waste for the Brooklyn and Queens shorefront. As the designers put it: "If waste is considered a natural process, its pattern of accumulation can be used . . . to build livable and evocative landscapes."[153]

Also included at the exhibition of fifty entries was a study by Reiser + Umemoto specially commissioned by the Van Alen Institute in connection with the competition. "East River Corridor: Manhattan Segment" proposed to radically rework the "destructive" FDR Drive and create a dynamic path incorporating a variety of new public spaces as well as buildings and pier complexes along the water's edge. As Raymond Gastil, executive director of the Van Alen Institute, put it, the plan was "not a Jane Jacobs-inspired celebration of urban life of the street. Instead, it looks to the interaction among pedestrian, vehicular, and waterborne transportation systems, together with the programming of recreation and commercial space, to create an authentic contemporary public realm." But Reiser + Umemoto's plan was hardly seen as a realistic alternative, as Gastil admitted: "It is probably not a vision that New York needs to see built—Manhattan really does not need to thicken its edges with such a complex infrastructure—but the project has compelled New York to see its waterfront anew, recognizing that a bold design can keep major infrastructure at the waterfront and still provide a compelling future for public life."[154]

The rejuvenation of the waterfront in the 1990s was also aided by New Yorkers' increasing desire to be closer to the water's edge, a direct consequence of significantly cleaner water, especially in New York Harbor, achieved after more than two decades of federally mandated clean-up efforts following the passage of the Clean Water Act in 1972.[155] Although commercial fishing was still banned in the Hudson River, recreational fishing in all five boroughs had a strong resurgence, with numerous environmental and outdoor groups sponsoring fishing lessons and contests for children.[156] Despite warnings about eating too much fish caught in the city's waters, a fish-cleaning station was included in the construction of one of the city's most substantial new piers, the 750-foot-long Pier 1 (2001) on the Hudson River near Seventieth Street (see Upper West Side).

The clean water vastly increased the amount of recreational boating, with kayaking, hitherto virtually unknown to New York, enjoying wide popularity beginning in the mid-1990s.[157] One of the city's oldest waterborne sports, rowing, began to grow in popularity as well, and in 2004 the first new rowing boathouse in nearly 100 years, Robert A. M. Stern's Peter Jay Sharp Boathouse, opened along the Harlem River in Upper Manhattan (see Harlem and Upper Manhattan). The clean water gave rise to plans for floating swimming pools, once a familiar sight on the city's waterfront—there had been more than twenty floating pools along the city's shore each summer at the end of the nineteenth century. In 1999 Meta Brunzema, an architect specializing in pool design, proposed a

pool with a transparent floor that would either attach to a pier or a floating structure.[158] That same year architect Jonathan Kirschenfeld designed a barge-based pool that found inspiration from both land-based and floating public swimming pools built in the 1930s by the Works Progress Administration. Though both schemes remained unrealized, the interest they generated reflected, as Raymond Gastil put it, the public's increasing "confidence in the cleanliness of the river."[159] One unintended and expensive consequence of the cleaner water was the revival in the 1990s of marine borers, tiny wood-gnawing pests that attacked wood pilings throughout the city's waterways.[160] In 1997 borer damage caused a twenty-foot section of the India Street Pier in Greenpoint to collapse, and the following year Pier 84 at West Forty-fourth Street had to be closed for repairs because of borer activity. The most common method of defeating the borers was to treat wood pilings with a chemical or wrap them in plastic, but at Battery Park City the damage was so extensive that a new 740-foot-long concrete wall had to be built to reinforce the timber wall under attack. To prevent future damage, it was estimated that construction costs at the Queens West development would rise between one and two dollars per square foot in order to chemically treat all the project's pilings.

Another sign of a rebounding waterfront was the revival and proliferation of ferry service.[161] In the nineteenth century, before the construction of bridge and tunnel crossings, there were more than 100 lines plying the city's waterways, but by 1968 ferry service had reached a low point, with only the city-controlled Staten Island Ferry in regular operation. Arthur E.

Proposed floating swimming pool. Meta Brunzema, 1999. Model. MB

Proposed floating swimming pool. Jonathan Kirschenfeld, 1999. Model. JKA

Imperatore, the New Jersey-based developer and trucking company magnate, sparked the resurgence of private ferry service in December 1986 with a line that connected Weehawken, New Jersey, with Pier 78 at West Thirty-eighth Street. Additional companies entered the scene and new routes were added so that private ferry service ridership levels rose every year, in part testament to the dramatic redevelopment of New Jersey's Hudson River shoreline. Ferry service also connected Manhattan to Queens at Hunters Point and the Rockaways, to Brooklyn at Fulton Ferry and Bay Ridge, and to Long Island at Glen Cove. To make their operations more practical, several companies added bus service to bring passengers to inland locations from relatively inconvenient, far-flung piers not served by existing mass transit. The importance of ferry service to the area's transportation needs was officially validated when the Metropolitan Transportation Authority included more than a dozen ferry connections in its new comprehensive map issued in 1998. By 2001, five private ferry operators carried between 30,000 and 35,000 passengers each weekday on fifteen different routes, with the majority traveling between Manhattan and New Jersey. In addition to the new ferry routes, the city proposed substantial new ferry terminals for the Staten Island Ferry in Staten Island (see Staten Island) and lower Manhattan (see South Ferry) as well as more modest facilities such as Smith-Miller + Hawkinson's Wall Street Ferry Terminal Building (see South Ferry).

IN THE HARBOR

Statue of Liberty

On May 11, 1980, two men, Stephen Rutherford and Edwin Drummond, climbed a third of the way up the Statue of Liberty (Frédéric-Auguste Bartholdi, sculptor; Gustave Eiffel, engineer; Richard Morris Hunt, architect of base, 1886) to protest the conviction in 1972 of a former Black Panther, Elmer Platt, for the 1968 killing of a schoolteacher, Caroline Olsen.[1] The stunt provoked widespread concern about the statue's security system but also about its physical condition: careful inspection of the damage to the statue's thin copper skin made by the protesters revealed that the monument, which had not been carefully inspected since repairs were last made in 1938, was showing signs of corrosion, much of it attributed to the effect of acid rain.[2] But Liberty's real structural problem lay not with its skin but with the original iron strapping, a kind of interior metal girdle for the statue's steel skeleton.[3] The statue was not only in danger of falling apart; by virtue of its universally acknowledged success as a symbol of liberty, and poor security, it was also in danger of being blown to bits by political activists intent on their causes. Less than a month after the climbing stunt, on June 3, a bomb planted by political protesters exploded in the statue's base, injuring no one but damaging an exhibition room.[4]

On May 18, 1982, President Reagan appointed Lee A. Iacocca, the outspoken and highly visible chairman of the Chrysler Corporation, to chair a commission charged with raising the money needed to restore the Statue of Liberty as well as Ellis Island (see below). Plans were announced in November 1982 for the statue's reconstruction, which required its closing to the general public for at least one year, with the expectation that all the work would be completed in time for a gala reopening on July 4, 1986, timed to its 100th

Statue of Liberty (Frédéric-Auguste Bartholdi, sculptor; Gustave Eiffel, engineer; Richard Morris Hunt, architect of base, 1886), Liberty Island. Restoration by Swanke Hayden Connell in collaboration with the Office of Thierry W. Despont, 1986. Model. Hoyt. ESTO

birthday.[5] But after work began, it was discovered that the corrosion was so great that the torch would need to be removed and rebuilt by craftsmen in Rheims, France. Liberty had been so modified over the years that even computer-aided analysis was not able to determine exactly how Eiffel's three-part structure actually functioned. Moreover, the statue's very nature—it was built and assembled in France before being disassembled and shipped to America for reassembly—had added to its problems, including the misalignment of Miss Liberty's head and her right arm by American workers, which forced a point of her crown to chafe against the arm's skin. In addition, the statue's right arm, damaged in the Black Tom munitions explosion of 1916, was very shakily connected to the torso.

The Torch

Problem: The lantern leaks, the iron structure is severely corroded, and the copper envelope has deteriorated.
Solution: Remove and rebuild Torch.

The Shoulder

Problem: Weak connection of right arm to central pylon.
Solution: Rework connection.

The Skin Support System

Problem: Advanced corrosion of iron armature ribs, failure of copper saddles.
Solution: Replace all ribs and saddles.

The Secondary Frame

Problem: Warped and buckled bars.
Solution: Reinforce bars.

The Guy Rods

Problem: Sag from lack of tension.
Solution: Restore tension.

The Tie Rods

Problem: Possible lack of tension.
Solution: Restore tension.

The Crown Platform

Problem: Advanced corrosion of iron framework.
Solution: Replace iron framework.

The Head Arches

Problem: Weak connection to central pylon.
Solution: Rework connection.

Emergency Elevator

Problem: Difficulty to respond rapidly to emergencies.
Solution: Provide emergency elevator level 1P to level 8.

The Helical Staircase

Problem: Unsafe condition of handrail and rest seats.
Solution: Replace handrail, remove seats.

The Copper Envelope—Exterior

Problem: Color variations in copper sheets.
Solution: To be determined by additional testing.

The Lattice Girders

Problem: Advanced corrosion of girder components.
Solution: Replace corroded components.

Visitor Circulation

Problem: Circulation patterns confused, limited elevator capacity.
Solution: Provide separate up and down stairs, new double deck elevator, handicapped access to level 5P.

Statue of Liberty (Frédéric-Auguste Bartholdi, sculptor; Gustave Eiffel, engineer; Richard Morris Hunt, architect of base, 1886), Liberty Island. Restoration by Swanke Hayden Connell in collaboration with the Office of Thierry W. Despont, 1986. Section identifying restoration problems and solutions. SHCA

A team of French and American architects and engineers led by Swanke Hayden Connell, working in collaboration with the Office of Thierry W. Despont, undertook the restoration effort that began after two years of research and design. The restoration included significant interior upgrades, including the installation of a double-level hydraulic glass-enclosed passenger elevator to take visitors to the foot of the statue, above which point only those with enough stamina and mobility could climb to the crown via the restored spiral staircase. The decaying statue received its last visitors on May 29, 1984, but the island remained open to those interested in observing the work. In February 1986 the scaffolding that encased the statue began to come down just as Lee Iacocca got himself enmeshed in controversy over the future of Ellis Island and over the lavish plans for the July 4, 1986, all-weekend birthday bash which was intended to reprise the glories of the city's bicentennial celebrations in 1976, when the harbor, filled with Tall Ships, was lit by spectacular fireworks.[6]

Controversy aside, the July 1986 party, dubbed Liberty Weekend, blessed by splendid weather, was a brilliant success. The eyes of the world focused on New York and the statue as President Reagan, joined by President Francois Mitterand of France, "unveiled" Miss Liberty on the evening of July 3 by triggering a 1.4-million-watt series of laser beams that shot across the harbor to bathe her in patterns of colored light. The laser show was followed by music, speeches, a mass swearing-in ceremony of new American citizens presided over by the Chief Justice of the United States Supreme Court, the singing

Statue of Liberty (Frédéric-Auguste Bartholdi, sculptor; Gustave Eiffel, engineer; Richard Morris Hunt, architect of base, 1886), Liberty Island. Restoration by Swanke Hayden Connell in collaboration with the Office of Thierry W. Despont, 1986. View of centennial celebration, July 4, 1986. Tannenbaum. AT

of "God Bless America," and finally by the relighting of the torch itself at 11:08 P.M. On the evening of July 4, all of lower Manhattan was turned into a car-free zone allowing some two million celebrants to enjoy the biggest display of fireworks in American history, lasting twenty-eight minutes.

Ellis Island

Like the restoration of the Statue of Liberty to which it was linked, that of Ellis Island was a product of the booming, laissez-faire capitalism of the Reagan era, in which the federal government seemed more than willing to abdicate authority to the private sector. Closed in 1954 and since 1965 part of the Statue of Liberty National Monument, Ellis Island had been the arrival point for 12 million immigrants. Though it was widely revered as sacred ground, its physical condition was a national embarrassment. As the editors of the New York Times put it in May 1976: "No piece of historic land has been harder to deal with. The abandoned structures . . . have continued to decay, resistant to anything except massive infusions of funds. . . . Macabre and surreal, these empty halls suggest the grim realities as well as the dream of refuge."[7]

Efforts to preserve the island during the 1970s were led by the Restore Ellis Island Committee, an organization founded in 1974 by Dr. Peter Sammartino, chancellor and founder of Fairleigh Dickinson University in Rutherford, New Jersey. As a result of pressure from the committee, on May 28, 1976, for the first time in twenty-two years, Ellis Island was opened to visitors, a decision that was politically risky.[8] As Milton Leebaw and Harriet Hyman wrote in the New York Times, the "tours may . . . arouse anger. Ellis Island . . . has deteriorated to the point where many of the buildings are unsafe and will not be included on the tour. The grounds are unkempt, and the seawall and one ferry slip have collapsed into the harbor."[9] The first day of tours, requiring reservations for a special ferry leaving from the Battery, was a sellout, bringing former immigrants as well as ordinary citizens, many of whom had parents or grandparents who had entered the United States via the island.

Stimulated by renewed interest in the island, the Argentine-born architect Susana Torre developed a scheme for its rehabilitation as a public park and museum.[10] The project was one of a number commissioned by the Architectural League of New York to celebrate its 100th birthday and was displayed with the others at the New-York Historical Society in 1981. In a series of beautiful drawings, Torre documented the island's evolution from 1812, when it became Fort Gibson, and proposed that one half of its land, including the Immigration Station, be retained as a museum, while the rest of the space, lying on the southwest side of the hospital building, be developed as open space for special events and as a formal garden that would include a labyrinth, presumably intended to reflect on the immigrant's experience.

The National Park Service announced its own plans in 1981: it would enlist private support for its efforts to restore the island and its buildings. In return for their contributions, private developers were to be permitted to use the buildings as offices, shops, or other facilities that the service deemed appropriate. The favored scheme for Ellis Island, developed by

LEFT Proposal for Ellis Island. Susana Torre, 1980. Rendering of view to the northeast. ST

BELOW Proposal for Ellis Island. Susana Torre, 1980. Plan. ST

the Center for Housing Partnership, a New York City organization headed by William Hubbard, was prepared by architects Conklin Rossant. It called for an Aspen Institute-like hotel and conference center, an idea that extended back at least to 1959, when Frank Lloyd Wright developed a proposal to turn the entire island into such a facility (Philip Johnson's equally grandiose proposal of 1966 called for a monument enumerating the names of the immigrants).[11] Hubbard proposed to use more than thirty of the abandoned buildings as well as some new construction, incorporating tennis courts, swimming pools, a health center, and a marina into the plan.

On May 18, 1982, James Watt, Secretary of the Interior, considering a plan to restore the Statue of Liberty under a public-private partnership, appointed Lee Iacocca as chairman of a nineteen-member commission to raise private funds for the restoration of the monument.[12] Iacocca, whose parents had come to America through Ellis Island, suggested the inclusion of Ellis Island in the project, and the Statue of Liberty-Ellis Island Centennial Commission was formed to serve as the primary advisory board for the Department of the Interior and the National Park Service on the two projects. Almost immediately after his appointment to the commission, Iacocca got things rolling, suggesting that the restoration projects might cost up to $230 million (they eventually cost $248 million). Because the commission's charter did not allow it to solicit money, a separate nonprofit organization was formed, the Statue of Liberty-Ellis Island Foundation, with responsibility for raising funds. Iacocca worked closely with the foundation and became its chairman in September 1984.

Skeptical of the tennis courts, swimming pools, and other aspects of Hubbard's hotel and conference center proposal, Iacocca asked that the plan be tabled while the architect John Burgee, who had been one of the commission's incorporating officers, reviewed the situation. In September 1982, the Park Service announced its "General Management Plan," outlining the overall objectives of the Ellis Island restoration and, significantly, dividing the island into two zones: the northern part, which was designated for "preservation/interpretation," and the southern part, which was slated for "adaptive reuse." In early 1983 Burgee, working with Herb Rosenthal & Associates, an exhibition and economic consulting firm, submitted his plan for the island that, in compliance with the Park Service's guidelines, called for saving and restoring the Great Hall, building a Museum of Immigration, and creating an exhibition on "the special skills, ideas and customs of individual ethnic groups."[13] However, Burgee, who was not known for an interest in historic preservation, startlingly proposed to demolish the buildings on the southern part of the island—approximately two-thirds of the total—replacing them with a large glass structure of his own design. According to Burgee, these buildings were not only unsuited to museum purposes but had also been experienced by so few of the immigrants that they weren't "historically or architecturally important."[14] This attitude was contrary to Park Service restoration guidelines. Consequently, and also for reason of its great cost, Burgee's plan was faulted by the Park Service's preservation and restoration committee, headed by Russell Dickenson, director of the National Park Service, who described it as "the antithesis of what we are trying to do."[15]

Meanwhile, as funds were being raised and plans made for the restoration of buildings on the northern half of the island, the Park Service began actively collecting artifacts illuminating immigrants' experiences of the island. In 1983 two firms specializing in preservation architecture, Beyer Blinder Belle, of New York, and Anderson Notter Finegold (which became Notter, Finegold & Alexander), of Boston and Washington, D.C., were hired to supervise the restoration. Questions addressing how much of the buildings should be retained, how much restored, and what to put in them, were not easy ones. As Roberta Brandes Gratz and Eric Fettman wrote in an essay documenting the preservation efforts: "The restoration of Ellis Island is infinitely more complex than the work on the Statue: Miss Liberty is a technical nightmare; Ellis Island, an interpretive challenge."[16] As work began, despite the positive support of many people for the project, the prominent and the ordinary alike, there were articulate naysayers such as Arnold H. Vollmer, principal of Vollmer Associates and long-time associate of Robert Moses, who argued in a letter to the editors of the New York Times that "the symbolism of the immigration station is best forgotten. It offered neither welcome nor haven. At best it served as a chute or maze through which immigrants passed as rapidly as possible. . . . Like the Bastille, it has not been missed."[17]

A key issue confronting the architects was the Park Service's typical prejudice against reconstructing its holdings to re-create a particular era. But given the extreme state of decrepitude on the island, the architects argued not only for a complete exterior restoration of Boring & Tilton's Main Building (1898), but also for the reconstruction of certain key features, such as the enormous entrance canopy and the Main Building's grand stairway, often called the "forty second physical," which all immigrants were forced to climb so that government staff could scrutinize them for limping and shortness of breath. Final renovation plans, announced on May 23, 1984, also called for the establishment of a computerized genealogy center where visitors would be able to review immigration information on their ancestors. Later phases were expected to bring an oral history center, an art gallery, museums, a library, a research center, and a restaurant. Despite the massive repairs and reconstruction required and the interpretative apparatus proposed, John Belle, speaking for the architects, expressed hope that the "eerie vibrancy" of the place would be maintained, although many observers felt that the restoration architects proposed to walk a fine and shaky line between authenticity and sincerity.[18] Moreover, Belle was himself not convinced about a strict restoration, so that a hybrid approach evolved that would prove problematic. Putting the best possible spin on the situation, Belle argued that the architects were "not going to try to make (the new components) look old-timey, like they were put there years ago," though they would "use materials that would have been used during the (early 20th Century)—the same colors and textures—but the detailing will be modern."[19]

In 1985, a proposal by the National Park Service to build a temporary construction bridge to connect with the mainland at Liberty State Park, which won the approval of New Jersey and the United States Coast Guard, became the first step in an ongoing battle between the State of New York and that of New Jersey over ownership of Ellis Island. Completed a year later, in May 1986, the temporary 1,458-foot-long, twenty-seven-foot-wide bridge was a so-called Bailey bridge, like those constructed during World War II according to the designs of its inventor, the British engineer, Sir Donald Coleman Bailey. Meanwhile, the question of the disposition of the south half of the island remained unresolved—Iacocca advocated Burgee's revenue-generating proposal over Hubbard's, saying it was too commercial—although Iacocca's fund-raising efforts were proving so successful that many hoped any such development would prove unnecessary. Iacocca's own ideas were vague: he was said to have wanted "an ethnic Williamsburg."[20] As a result, Burgee's design called for a large glass exhibition center that was demeaned by some critics as an "ethnic Disneyland."[21]

On February 12, 1986, in a surprise move, Donald P. Hodel, Reagan's third Secretary of the Interior after James Watt and William Clark, ordered Iacocca to choose between running the committee or the foundation, setting off a public furor that pitted the Reagan administration against a corporate leader with enormous grassroots popularity. Iacocca chose to retain his role as chairman of the Statue of Liberty–Ellis Island Foundation, a strategic position given that in less than five months the restoration of the Statue of Liberty would be celebrated. Hodel argued that the move was made to avoid any conflict of interest, but his request no doubt also reflected Iacocca's objection to Hubbard's proposal and his promotion of his own plan, designed by Burgee, who, to protest the snub to the car maker, resigned from his position on the committee. The editors of the New York Times felt that neither plan was satisfactory: "Both sound thoroughly commercial. The golden door contemplated in both sounds more like Elizabeth Arden than Emma Lazarus, more like a luxury spa than a place to ruminate on the tired, poor and tempest-tossed."[22]

Soon both Herb Rosenthal, the exhibit consultant hired by

Proposal for Ellis Island. Conklin Rossant, 1986. Rendering of view
to the northeast. WJC

Iacocca, and James S. Rossant, the architect who had worked
with Hubbard, were sending strongly worded letters to the
Times's editors. According to Rossant, while his conference
center scheme would restore the twenty-seven hospital build-
ings on the southern section of the island to their original
appearance, Burgee's plan not only proposed their demolition
but also included "an ersatz ethnic street in a huge mall-like
structure," ironically located "in the harbor of a city with a
genuine Chinatown and Little Italy!"[23] Manuela Hoelterhoff,
the *Wall Street Journal*'s acerbic occasional architectural
critic, was even more dismissive: "The booklet Mr. Burgee
hands his visitor is the ground plan for Iacoccaland: a food-
stuffed place with miles of exhibits. Rehabbing the entire dis-
ease complex didn't fit into this happy picture. But Mr. Burgee
did offer to design a new glass building for special exhibits.
Apparently, the 200,000-square-foot Great Hall (about one-
fourth the size of the Metropolitan Museum of Art) wasn't big
enough. Just pondering the plan is so exhausting, you want to
immigrate back to Manhattan, whose ethnic diversity looks
relaxing in contrast."[24]

Mildred Schmertz, in a strongly worded editorial in
Architectural Record emphasizing that the totality of Ellis
Island's design was the result of Boring & Tilton's master plan,
lent her support to Conklin Rossant's proposal. Faced with
opposition on virtually every side, Iacocca abandoned Burgee's
plan and, in a statement made on May 14, 1986, called atten-

tion to certain merits in that of Conklin Rossant. In
September, with Iacocca gone from the commission, the archi-
tectural advisory subcommittee approved a version of
Hubbard's scheme that omitted its marina, tennis courts,
swimming pools, health center, and commercial hotel. The
plan had evolved into an international conference center to be
managed by area universities. But in March 1987 the finance
committee of the commission, a three-member advisory
panel, rejected both the Burgee and Rossant schemes in favor
of a third option: the preservation of just three buildings and
the demolition of the rest. Economics was the driving force
behind the decision, but in September, Secretary Hodel gave
the developers of the conference center an opportunity to real-
ize their project if private funds could be found.

Throughout the controversy, work proceeded on the north
half of the island, constituting one of the largest restoration
projects in the history of the United States. Left unheated and
exposed for decades, Boring & Tilton's masterwork had to be
dried out—this process alone took about eighteen months,
whereupon demolition of extraneous elements went forward.
Then came the actual construction, including new mechani-
cal systems, repair of tilework, and extensive replastering,
especially on the upper walls which needed to simulate Caen
stone stucco. Amazingly, the Guastavino tile vault of the
Registry Room was in excellent shape: all tiles were tested for
soundness with only 17 of the 28,282 tiles needing replacement.

ABOVE Main Building (Boring & Tilton,1898), Ellis Island. Renovation by Beyer Blinder Belle, 1990. View showing new entrance canopy. Aaron. ESTO

RIGHT Main Building (Boring & Tilton,1898), Ellis Island. Renovation by Beyer Blinder Belle, 1990. Registry Room. RAMSA

Surprisingly, it was discovered that the spectacular vaulted ceiling of Guastavino tiles which soared over the 160-foot-long, two-story Registry Room was not original to Boring & Tilton's building of 1898 but was added in 1918 after an explosion led to the collapse of the original ceiling. Two of the original chandeliers designed by Boring & Tilton were restored and rehung; a third one had to be reproduced. The building's exterior, also ravaged by time and neglect, was restored and rebuilt, with the original roof tiles removed to permit the construction of a new roof structure and then replaced. New copperwork was also installed, with spires lowered in place from a helicopter. In addition, the architects designed a new canopy of glass and steel extending from the ferry slip to the entrance, suggesting, but not reproducing, the look of the original. The restored hall opened after eight years of planning and construction as the Ellis Island Museum of Immigration on September 10, 1990, almost a year and a half ahead of schedule. Inside the 100,000-square-foot Main Building, the new museum, one of the nation's largest strictly historical museums, was filled with more than 2,000 artifacts, 1,500 photographs, a library, and two theaters. Though the museum told the story of Ellis Island, it sought to paint the much broader picture of American immigration, including the arrival of Africans, Asians, and Hispanics, who had no direct experience of Ellis Island.

Although critics were generally enthusiastic about the project, they each picked on some different aspect of the work, so that the public was left in some doubt about the accomplishment as a whole. For example, Paul Goldberger quarreled with the clumsy attempts to be both modern and historically correct that resulted in the glass-and-steel canopy, "which seemed intrusive, as if trying almost too hard to avoid being mistaken for something old."[25] Jane Holtz Kay was one of the few to get to the heart of the problem at Ellis Island—the seeming emptiness of the experience. "Ellis-as-museum offers a pleasant sojourn, but something seems missing," she wrote. "Beyond the charming collection of vintage baggage in the echoing entry hall, the exhibits and building fail to cohere. The massive Registry Room seems more void than haunted chamber." It is a place "where the sense of history has been stripped too bare. . . . Something . . . poignant has been lost. The human epic, within flaking paint and crumbling walls, might have been preserved with a neglected room or two along with the restored monument. Whatever the reason, few shadows fill these spaces: for all the celebration and scrubbing—or perhaps because of them—the ghosts are gone."[26]

In November 1991 the Park Service, after fighting for years to save all thirty-two historic buildings on the island, agreed to a plan that would demolish twelve small structures to provide room for a conference center with 325 hotel rooms. Because both New York and New Jersey were entitled to comment on proposals for the site under a provision of the Natural Historic Preservation Act, they did so, with New Jersey endorsing the plan and New York State's Parks Commissioner Orin Lehman opposing it as an act of "commercialization . . . not consistent with the national significance of this resource, and, indeed, its very reason for recognition as a national monument."[27] The proposed plan also included the provision of the replacement of the Bailey bridge with a pedestrian bridge from New Jersey which, given the distance—three miles round-trip—stretched credulity.[28] Ironically, Beyer Blinder Belle designed the new plan (though it was not responsible for the call to build the replacement bridge, which was suggested by the New Jersey legislature in response to a public outcry).

The debate heated up again, with a public hearing conducted by the Park Service on December 17, at which more than twenty-five organizations and agencies voiced opposition. Suzanne Stephens, editor of *Oculus*, editorialized against it, pointing out that just as Frank Lloyd Wright's and Philip Johnson's schemes for the island had once seemed acceptable, they were now no longer viewed so benignly: "Historic attitudes do change. One reason the present opposition has formed to stop Beyer Blinder Belle's privately owned center is to keep the buildings intact—not because they are architecturally stunning but because their history and meaning are so integrally embedded in their walls."[29]

In summer 1992, the National Park Service withdrew its plan to demolish the twelve buildings to make way for a hotel and conference center. As for the bridge, Congress authorized $15 million to widen and upgrade the Bailey bridge or, alternately, build a new one. In November 1993 New York Governor Mario Cuomo voiced his opposition to the bridge. On February 8, 1994, the city voted to make Ellis Island an official New York City landmark, thereby hoping to introduce a note of "moral suasion" into the debate, which seemed to pit state against state and New York City against the rest of America—or at least the U.S. Congress.[30]

Though Ellis Island was the province of the National Park Service, under an 1864 compact, New York State had civil jurisdiction. New Jersey, however, challenged New York's claim of control over the island. To resolve the dispute, the United States Supreme Court appointed Paul R. Verkuil, dean of the Benjamin N. Cardozo School of Law, as a special master in charge of conducting a hearing on the subject as well as making a recommendation in the case. On, of all days, April Fool's Day, 1997, Verkuil suggested that the island be split in two, essentially drawing the line largely where New Jersey wanted it, with the museum and major monuments, but only six acres, in New York's hands, and with the twenty-two acres of landfill added after 1890 in New Jersey's, that land containing the hospital wing where a hotel-conference center remained a possibility, as well as the bridge that would lead from one part of New Jersey to another.

Meanwhile, in 1996, the World Monuments Fund included the south side of the island in its "List of 100 Most Endangered Sites," and in June 1997, the National Trust for Historic Preservation put the buildings on its list of "Eleven Most Endangered Historic Places."[31] Impatient with the federal government's unwillingness to support preservation efforts, in 1997 the New York Landmarks Conservancy cobbled together $50,000 in cash and services to shore up a two-story pharmaceutical building in the former hospital group.

On May 26, 1998, in a 6-to-3 vote, the United States Supreme Court concluded that special master Verkuil's recommendations were in fact too generous to New York, ruling that only 3.3 acres of Ellis Island were in New York. The decision was based on an 1834 compact between New York and New Jersey declaring that New York would "retain its present jurisdiction" over the island, only 3.3 acres in size at that time, while New Jersey would take ownership over the surrounding waters and submerged land.[32] The 24.2 acres of landfill added to the island after 1834 were thus determined to be part of New Jersey. On July 4, 1998, Governor Christine Todd Whitman joined New Jersey's two United States senators in raising the state flag on Ellis Island's sole flag pole, where it would fly under the Stars and Stripes. The unthinkable was true. Except

for about three acres, Ellis Island was now in New Jersey. But amid the political tomfoolery there was at least some good news when, in spring 1998, Congress appropriated limited funds to begin to stabilize the buildings on the south side. In May 1999, additional funds for the New Ferry Building (Delano & Aldrich, 1936) between the north and south sides of the island were made available from the federal government as part of President Clinton's "Saving America's Heritage" millennium program, and New Jersey announced it would match the funding. Governor Whitman also announced an ambitious, $300-million three-part plan featuring a Center for Immigrant Contributions and Ethnic Learning, which would mount exhibitions, a Public Health Learning Center, planned to complement a proposed public health museum in Washington, D.C., and an International Conference Center, which could be used for peace talks and global economic meetings.

Governors Island

When, in February 1995, the *New York Times* reported that the United States Coast Guard was considering closing its Governors Island base, the largest in the country, it put in play the tantalizing prospect that for the first time since coming under American military control 212 years earlier, this 173-acre asset, just minutes by ferry from Manhattan and within a stone's throw of Brooklyn, might be opened up to the public.[33] Governors Island, known by the Dutch as Nooten Eylandt, meaning "nut island" in reference to its groves of oak, hickory, and chestnut trees, was purchased from the Manahata Indians by Wouter Van Twiller, a Dutch official, in 1637 for two ax heads, a string of beads, and some iron nails.[34] In 1674 the island was taken over by the British, who referred to it as Nutten Island, and was named Governors Island in 1698 when it became home to England's colonial governors. Though held by the patriots at the beginning of the American Revolution, during which time it housed the Bunker Hill Regiment, the island was retaken by the British on September 15, 1776. In 1783 the United States military took control and the island served as an army base from 1821 until the Coast Guard took it over in 1966. Governors Island's illustrious past included both the imprisonment of 1,000 Confederate soldiers during the Civil War and that of Walt Disney during World War I, incarcerated for going AWOL. Wilbur Wright took off on the first flight over American waters from Governors Island in 1909 and flew around Grant's Tomb and the Statue of Liberty.

Before the Coast Guard's departure, the island had a permanent population of 4,000. It had its own public school, six tennis courts, four baseball diamonds, a nine-hole golf course, a motel, beauty salon, movie theater, hospital, a bowling alley, and the nation's only Burger King restaurant serving beer. The island's northern and southern halves were distinct, separated from one another by McKim, Mead & White's Building 400 (1929–30), which at 400,000 square feet was the largest military building in the world at the time of its construction, built to house an entire regiment of 1,375 men. The northern half of the island, designated a National Historic Landmark by Interior Secretary Donald P. Hodel on May 6, 1985, featured a range of historic buildings including five individual New York City landmarks designated in 1967: the Governor's House, dating from the early eighteenth century, the star-shaped Fort Jay (1794–98, rebuilt 1806), Castle Williams (Lieutenant Colonel Jonathan Williams, 1807–11), the Admiral's House (1840), and the Block House (Martin E. Thompson, 1843).[35]

The southern half of the island, built in 1912 using fill from the excavation of the Lexington Avenue subway, later supplemented with fill from the Brooklyn–Battery Tunnel, was home to nondescript barracks circling the athletic fields.

On October 17, 1995, the rumors reported earlier in the year were verified when the Coast Guard formally announced that, in the face of cost-cutting measures, it would close its base on Governors Island—the oldest continuously operated military post in the United States—by the end of 1998. The island was to be turned over to the General Services Administration (GSA) of the federal government, which would then decide on how to dispose of it. The news instantly generated a buzz in the development and planning communities, with ideas pouring forth about how the spectacularly located property could be redeveloped. Some saw it as a suitable conference center, its isolation, charm, and views perfect for creating what Raquel Ramati, an urban designer and planner, called a "think-tank environment."[36] Donald Trump felt it "could be appropriate for absolutely top-end housing because its views are so incredible" but stated "public access is obviously a problem, because you have to rely on ferries."[37] Lewis Rudin, the real estate developer and president of the Association for a Better New York, voiced what many others felt, that if New York State were to allow it, "it would be an exciting place for casino gambling."[38] The writer Phillip Lopate, asked to comment for the New York Times's Op-Ed page, also saw casino gambling as a possibility but added that in the midst of the debates over sex-related businesses in the five boroughs, the answer was to "move them all there. . . . I see a fleet of pleasure craft docked in Manhattan, ready to ferry those in the mood for an evening's adventure."[39] Marcia Reiss, the Parks Council's deputy director for public policy, more earnestly expressed the feelings of a large number of concerned citizens when she stated: "It really bothers me when I see people talking about Governors Island as a prime piece of real estate. It is a prime piece of open space, and creating public access and parkland should be the priority."[40]

Surprisingly, the development community was not really interested in Governors Island, with the general consensus among them that the island's relative inaccessibility rendered any sort of commercial development infeasible. Moreover, for the purposes of balancing the federal budget, the Congressional Budget Office estimated the market value of the island to be $500 million, a figure so high as to discourage even the best financed big-name private developers. In fact, though it wouldn't be made public for another year and a half (and it would never be made in writing), in October 1995, during a helicopter trip over the harbor from Kennedy Airport to Manhattan, Senator Daniel Patrick Moynihan elicited an offer from President Clinton to use the power of the White House to transfer ownership of Governors Island to the city and state for one dollar if the city and state could prepare a plan for the island's future use as a public place. The one-dollar figure was symbolically, if unintentionally, poignant, given that the state and city had sold the island to the federal government in 1800 for the same amount.

Moynihan immediately relayed Clinton's offer to Governor Pataki and Mayor Giuliani, expecting the two to begin working on a proposal. The stakes seemed high: were New York unable to deliver an appropriate plan, the island would be auctioned to the highest bidder. But Pataki and Giuliani were reportedly unable to agree on a direction, although Mayor

Guiliani set up a task force to study the issue. With the Coast Guard preparing for its departure, the Municipal Art Society began to seek historic district designation for the northern portion of the island in an effort to protect the buildings during the transfer of ownership and to safeguard their future condition and use.[41] MAS's efforts were successful and on June 18, 1996, the Landmarks Preservation Commission designated the northern ninety acres of the island as the city's sixty-seventh historic district, encompassing over 100 buildings dating from the early eighteenth century to the 1980s, including the five that were already individual landmarks.[42]

As Giuliani's task force considered the island's future, the GSA undertook its own study, hiring Beyer Blinder Belle to establish guidelines for the development of the southern, non-designated, portion and to prepare an overall analysis of possible public and private uses ranging from the construction of a marina and hotels to a conference center and elderly housing.[43] Proposals, both serious and not so serious, began to roll in. In January 1996, John McGinnis, assistant features editor of the Wall Street Journal's editorial page, only half-jokingly suggested that the island be renamed Garcia's Island in memory of Jerry Garcia, lead guitarist and singer of the cult rock group the Grateful Dead, who had died on August 9, 1995: "With such a wealth of tradition and infrastructure," McGinnis wrote, "Governors Island is the perfect place to establish a colony of Deadhead entrepreneurs and artists to preserve and build upon the rich, much-needed Dead legacy. . . . It'll all make for the East Coast's own magic kingdom, a needed counterpoint to Wall Street's nearby temples to reality."[44] The architect and critic Michael Sorkin threw his hat in the ring in 1995–96, proposing a "'University of the Earth' devoted to environmental science and policy . . . the island in the harbor standing in for the planet's own situation in the universe." Sorkin's scheme was dotted with round buildings, inspired by the shape of Castle Clinton in Battery Park, containing brick-walled lofts, mixed with his characteristically jagged and blob-shaped forms that were not assigned "exact activities save that they be dense and public."[45]

In March 1996, Raymond Gastil and Andrea Kahn, working with the Van Alen Institute, sponsored "Public Property," an international ideas competition questioning the belief that Governors Island's future was as "the perfect site for exclusive enclave development" and encouraging "strategies that challenge the inevitability of that approach."[46] According to Gastil, a wide range of solutions were proffered: "Entrants carved through the landfill to treble the island's shoreline, added extra islands to the south. They razed the historic district, added towers a thousand feet high, installed megastructures, and laid over grids whose imperious scale and discipline would give Le Corbusier pause."[47] First place was awarded to Peter Hau, who proposed a series of ecologically friendly gardens and environments, including a salt marsh and a field of wind turbines that would at once serve as a cleansing mechanism for the harbor and island and also provide an exciting form of open space.

A separate, more detailed study of Governors Island was commissioned from the Urban Land Institute (ULI) in 1996 by the city acting in partnership with the Alliance for Downtown New York, the Battery Park City Authority, and Community Board 1.[48] The ULI concluded in a report that a public/private development authority, which they named the Governors Island Development Corporation (GIDC), should be set up, in

essence, to own the island and oversee its redevelopment. "Over the long term," the report read, "the panel envisions that Governors Island should be a historically based, active, and pedestrian-oriented public space developed on a human scale and open for all citizens to enjoy." Over the short term, "maximum use should be made of the existing residential housing on Governors Island to provide revenue to protect this historical resource and to begin work on the long-term vision." The northern half of the island would become a "lively historic village" with restaurants, galleries, "interactive cultural displays," an "Education Green" for use by colleges, and a conference center and retreat.[49]

Five months after the ULI released its report, on March 27, 1997, the Regional Plan Association (RPA) released its proposal for Governors Island.[50] Designed in collaboration with the architects Jane Thompson and J. Max Bond, Parks Council director Paul Willen, and Anthony Walmsly, a landscape architect, the scheme included a 320-room hotel, the Governor's Island Inn, to occupy McKim, Mead & White's Building 400, whose basketball court would become a ballroom. Nolan Park, a charming neighborhood of two-story clapboard houses lining brick-paved streets on the island's eastern shore, would become a conference center and retreat, while other historic north-side buildings would be adapted for use as a performing arts school, museum, and banquet hall. Envisioning the island as a public space second only to Central Park, the RPA plan called for two miles of waterfront walkways ringing the island and a 4,000-seat amphitheater, aquarium, and environmental education center on the south side, replacing a majority of the existing buildings.

By March 1997, the state and the city had made little progress in preparing a plan, and Moynihan accused officials of "dithering."[51] Though the offer of an island for a dollar seemed a no-brainer, the cost of maintaining its protected buildings and operating a ferry—estimated at more than $30 million per year—was deemed too much to place on the shoulders of taxpayers. Officials, concerned that the island not become a white elephant, began to seek a guarantee of future federal support for the cost of maintaining the island, making it clear that if the federal government didn't agree to help, any development would surely have to incorporate income-generating uses despite President Clinton's spoken mandate that the island be used for public purposes in order to be transferred for a dollar.

In April 1997, one of the first plausible scenarios for the island's future began to take shape when New York University expressed interest in using its open spaces as athletic fields and potentially building student and faculty housing and classroom spaces. Columbia University was not far behind in eyeing the island for similar purposes. Though the city was receptive, it was not ready to consider the idea in detail. Three months later, at a congressional hearing intended to encourage New York officials, business people, and civic groups to speculate about the future of the island, what was expected to be an optimistic discussion was darkened repeatedly by the overarching sentiment that, as the developer Douglas Durst put it, "It is just not logical to consider this as an attractive development site."[52] By November, the Coast Guard, which had originally planned to vacate the island near the end of 1998, was gone, leaving Governors Island's buildings empty and vulnerable to the elements. When Congress passed its Balanced-Budget Act of 1997—which still valued the island at $500 million—a new deadline was declared. If New York

Proposed University of the Earth, Governors Island. Michael Sorkin, 1995–96. Plan. MSS

Proposed University of the Earth, Governors Island. Michael Sorkin, 1995–96. Rendering of view to the north during winter. MSS

failed to seal a deal by 2002, the island would first be offered to government or public service organizations, then sold to the highest bidder. In December 1997, Beyer Blinder Belle completed its land-use study for the GSA, calling for various mixes of parks, a marina, a college campus, residential development, retail, cultural, and other uses. After having waited so long for the results, the city deemed none of the alternatives to be economically viable.

A year later, in December 1998, one day after Governor Pataki remarked that he would pressure the state legislature to legalize gambling in parts of New York, an unnamed official in the Giuliani administration announced the mayor's interest in developing part of Governors Island with "a major casino and five-star hotel," claiming that gambling constituted the only viable way of creating revenue for the island's maintenance.[53] Because of the political and legislative hurdles required in legalizing gambling in New York, 1999 would be the earliest that legalization could occur. At once critics brought attention to the improbability that the federal government would consider gambling to be compliant with the "public purpose" clause in Clinton's one-dollar offer, though the general idea was that if gambling were to come, so would enough money to buy the island. The editors of the *New York*

HISTORIC FORT JAY, CASTLE WILLIAMS,
AND INTERPRETIVE DISPLAYS

PEDESTRIAN FERRY DOCK

CASTLE WILLIAMS

COMMERCIAL AND ENTERTAINMENT ACTIVITIES

UPPER NEW YORK BAY

EDUCATIONAL FACILITIES
AND WELLNESS CENTER

BUILDING 400

FORT JAY

RESTORED LAWN

GOVERNORS GUEST HOUSES
AND CONFERENCE CENTER

PEDESTRIAN ESPLANADE CIRCLING THE ISLAND

LANDSCAPED BERMS

FUTURE EXPANSION
OF EDUCATIONAL
FACILITIES OR
CITY RETREAT

TENNIS
COURTS

RECREATIONAL FACILITIES
AND OPEN SPACE

POOL

GOLF COURSE

HOUSING FOR PEOPLE ASSOCIATED
WITH THE ISLAND'S ACTIVITIES AND
TIME SHARES

TENNIS COURTS

MARINA

AUTO FERRY DOCK

PLAYING FIELDS

INDOOR RECREATIONAL
FACILITIES

BUTTERMILK CHANNEL

BROOKLYN

N

Proposal for Governors
Island. Urban Land
Institute, 1996. Plan. ULI

Proposal for Governors
Island. Regional Plan
Association in association
with Jane Thompson, J. Max
Bond, Paul Willen, and
Anthony Walmsly, 1997.
Plan. RPA

Proposed broadcast tower, Governors Island. Kohn Pedersen Fox, 2002.
Photomontage, view to the north. KPF

Times were quick to offer their dissent: "This historic section
of New York Harbor cannot be treated like a hotel site on the
Las Vegas strip."[54] The gambling industry itself considered
expansion onto Governors Island to be a long shot. Donald
Trump, owner of the biggest casinos on the East Coast, stated,
"The talk of having a gambling casino on Governors Island is
ridiculous and everybody knows it. It can't work."[55] Still, in
June, two studies—one independent and one commissioned
by the city—were released, confirming the obvious: of all pos-
sible uses, casino gambling would create the greatest source of
revenue on Governors Island. Fearing the worst, at the urging
of the Municipal Art Society, the National Trust for Historic
Preservation included the island on its annual list of the
nation's eleven most endangered historic places.[56] The follow-
ing month the mayor's office appeared to be acknowledging its
critics when it solicited development ideas from private com-
panies, though it did not issue a formal "request for propos-
als."[57] Only about a third of the twenty submissions came
from groups able to provide some measure of financial back-
ing and none was considered compelling enough on its own
accord to move forward. In January 1999, conceding that the
prospects for casino gambling on the island were slim,
Giuliani established a new task force to study the island's
redevelopment.[58]

Just as progress finally seemed imminent, Governor Pataki
unofficially boycotted the mayor's task force and, in fact, set
up his own task force to study the island including Battery
Park City Authority officials, the planning firm of Hamilton,
Rabinovitz & Alschuler, and Skidmore, Owings & Merrill. At
the same time, the federal government, anxious about the fate
of the $500 million in its budget, began to warn that the $1
deal would not go forward unless all of the island was used for
public purposes. By April 1999, two of the proposals that had
grown out of the previous year's solicitation of ideas were
being taken more seriously. Tivoli Gardens, a Danish com-
pany, wanted to build a historically themed amusement park,
similar to their signature park in Copenhagen, in the northern
sector of the island. Tivoli's plan called for an old-fashioned
wooden roller coaster, cobblestone paving, and, more dramat-
ically, a man-made mountain, a replica of a nineteenth-cen-
tury castle, and a series of new canals leading to a man-made
lake surrounded by gazebos, gardens, and small rides. The idea
enraged preservationists, who called it disrespectful.

The second and more attractive plan was pieced together
from several of the previous year's proposals by the Boston-
based developer Corcoran Jennison. The plan called for a con-
ference center and hotel in the 400,000-square-foot Building
400, with the remainder of the historic northern end dedicated
to housing, artists' studios, restaurants, and retail businesses.
Both NYU and Columbia University would be given space for
housing and classrooms, and two sites were designated as
being suitable for museums. The Smithsonian and the

Guggenheim Museum were reportedly interested, the latter in establishing an outdoor sculpture garden and developing a Frank Gehry–designed building that would later be proposed at a larger scale for the lower Manhattan waterfront (see Wall Street Guggenheim). The proposal also called for a fifty-acre park to be built in the island's southwest quadrant, a two-mile esplanade wrapping the island, and an educational center with an aquarium. The development would be managed by a not-for-profit state agency overseen by appointees of the mayor and the governor.

In January 1999, Giuliani and Pataki's task forces agreed to move forward with the Corcoran Jennison proposal.[59] Joseph Giovannini was disappointed with the plan, describing it as "underwhelming and anticlimactic, long on political correctness but short on an artistic and civic vision equal to the charge. . . . The potentially saccharine family townscape avoids any architectural invention that would capture the spirit of New York now and might seem more in place in a Florida retirement community." Even worse, however, was the lack of coherence among the manifold projects currently going up around New York Harbor: "Without the big picture, the plan for Governors Island cannot resonate within a larger whole: No one knows what the harbor will become, or even wants to become, so this design is flying blind and bland in a vacuum."[60]

Shortcomings aside, the important fact was that a plan, any plan, was agreed upon and that the state and city could now begin negotiations with the federal government for the transfer of the island. By the end of 2000, however, as the *Times* reported, New York's politicians had spent the better part of a year arguing "over details of the transfer" and dealing with "territorial squabbles."[61] Nonetheless, Senators Daniel Patrick Moynihan and Charles E. Schumer, backed by Pataki and Giuliani, were able to introduce the Governors Island Preservation Act of 2000, calling for the transfer of Castle Williams and Fort Jay to the stewardship of the National Park Service and for the conveyance of the remainder of the island to the city and state at little or no cost. On January 19, 2001, a day before he left office, President Clinton, responding to an urgent letter from his wife, Hillary Rodham Clinton, who had just begun her term as New York's junior senator, approved the transfer of Castle Williams and Fort Jay to the National Park Service, protecting them as national monuments and paving the way for the opening of the island to the public, expected to occur two years later, following the construction of a dock that could accommodate large ferries.[62] Legislation for the transfer of the rest of the island languished in the House, but Clinton's national monument designation, which implicitly ruled out certain kinds of development, was seen as pivotal in discouraging Congress from putting the island on the market, even though months later the Justice Department under the new Bush administration announced it would likely attempt to do so, a move that could override Clinton's transfer.[63] In June 2001, New York's public-use plan was rejected by the GSA, which seemed dead set on following Congress's mandate to achieve fair market value. The events of September 11, 2001, sidetracked matters but the outlook finally brightened in late March 2002 when Governor Pataki and Mayor Bloomberg, encouraged that President Bush was prepared to transfer the island if an acceptable plan was proposed, set off in a new direction, touring the island and determining that it would make an ideal flagship campus for the City University of New York (CUNY), including CUNY's

teacher training program. Such a use would, without an overwhelming amount of construction or adaptation, take full advantage of the island's existing facilities while opening up some of CUNY's properties in the city for use as public schools. Bush accepted the plan and on April 2, 2002, announced the transfer of Governors Island to New York for a nominal fee.[64]

Despite what seemed like a promising new beginning for the island, President Bush's announcement set off a new wave of proposals, most of them similar to those tossed around over the previous six years except for one unsuccessful but notable plan to replace the broadcast antenna lost in the attack on the World Trade Center with a 2,000-foot-tall broadcast tower designed by Kohn Pedersen Fox.[65] Governors Island was officially transferred to New York on January 31, 2003, but by 2006 the future of the island remained undetermined.

REEL NEW YORK: THE CITY AND CINEMA

While New York had figured prominently in the film industry since the early days of motion pictures, during the last decades of the twentieth century the city gained new importance both on camera—as a setting, subject, and quite often as a character in movies—and behind the scenes as a hotbed of on-location photography. Until the breakup of the Hollywood studio system in the 1950s and 1960s, much of the New York that audiences saw on the silver screen was represented by backdrops and sets built on Hollywood soundstages. But as film producers attained more independence and technological advances made it easier and more affordable to shoot on location, more and more movies were shot in the city. Stanley Donen and Gene Kelly's 1949 musical, *On the Town*, the rollicking story of three sailors on a twenty-four-hour leave in New York, exemplified the move from soundstage to on-location live-action photography.[1]

The film industry in New York grew exponentially and established itself as an important economic engine under Mayor John V. Lindsay, a show-business enthusiast who in 1966 created the Mayor's Office of Film, Television and Broadcasting, an agency that both marketed New York as a location and served as a concierge of sorts to filmmakers, easing the complicated processes of obtaining permits, negotiating with city offices, and the like by instituting a "one-stop system." The efforts paid off as the number of films made in New York rose from thirteen in 1965 to twenty-one in 1966 and continued to grow, even though, as the Lindsay era drew to a close, many films, such as William Friedkin's *The French Connection* (1971) and Joseph Sargent's *The Taking of Pelham One Two Three* (1974), tended to portray New York as a city gone out of control.

Throughout the 1970s New York was a preferred setting for major feature films, a fact that contributed significantly to the city's economy in a time of severe recession. *New York* magazine kicked off 1976 with an issue devoted to "Manhattan Movie Madness," and by early 1978 John Corry, writing in the *New York Times*, could claim that "Hollywood's Biggest New Star Is Little Old New York," citing a host of movies recently shot in the city, including *The Eyes of Laura Mars* starring Faye Dunaway, *Superman: The Movie* with Christopher Reeve, *Paradise Alley* with Sylvester Stallone, and Paul

The Wiz, 1978. Scene still. Art director, Philip Rosenberg; director, Sidney Lumet. Universal/The Kobal Collection

Mazursky's *An Unmarried Woman* with Jill Clayburgh and Alan Bates.[2] According to Corry, Hollywood spent an unprecedented $100 million in New York in 1977. In 1975 there were thirty-one movies made in the city in 190 weeks of shooting, a figure that rose in 1977 to forty-two over 280 weeks' time. Suddenly it seemed that the city was one big movie set: "In the waning months of 1977, 'The Wiz' laid down the Yellow Brick Road at the 14th Street Subway Station, . . . people from 'Hair' were scrubbing off the graffiti on the arch over Washington Square, . . . Faye Dunaway was in Columbus Circle, Farrah Fawcett-Majors was in Greenwich Village, and Woody Allen was all over the place. Pulses fluttered, gaiety arose, and New Yorkers said they were living on the biggest back lot in the world. New York would no longer be Hollywood on the Hudson," Corry proclaimed, "Los Angeles would be New York on the Pacific."[3]

Filming in New York did have its drawbacks, not the least of which was cost—between 6 and 15 percent more to make a movie in New York than in Los Angeles, in part because local union work rules were frequently archaic, created to unnecessarily increase the manpower needed to perform a task. Mayor Koch, trying to overcome the problem of excessive costs without tackling the unions, put a different spin on it: "The city is like an extra star in the cast."[4] Certain directors, especially dedicated New York storytellers like Paul Mazursky, Sidney Lumet, Martin Scorsese, Woody Allen, Martin Bregman, and, later, Spike Lee, knew how to play that star for its full value. Lumet, who worked almost exclusively in New York, was its best booster: "I don't believe the incredible paintings I see here, the newspapers, the information, the ballet, the music, all of it. I work here because it makes me a better director."[5]

During the 1980s the number of New York-made films grew steadily, from 85 in 1985 to 110 in 1989, a year in which location shooting was estimated to have brought more than $2 billion into the city.[6] While 1990 saw a record 143 films shot in New York, it also marked the year in which Hollywood producers became so frustrated with the high costs of union labor that they boycotted the city, steering feature films to places like Chicago, Pittsburgh, and Toronto that could offer a passable New York "feel."[7] During the seven-month boycott that lasted from November 1990 until May 16, 1991, when the unions agreed to a new contract giving concessions on overtime wages (making nighttime and weekend shooting cheaper) in exchange for better health and pension benefits,

filmmaking in New York fell off by 70 percent. Lower-budget independent films, however, enjoyed a surge in activity because of the unions' creation, during the boycott, of the East Coast Council, which negotiated bargain rates for such projects, effectively helping New York take a leading role in independent filmmaking during the 1990s.

The slump in commercial filmmaking in New York in the early 1990s, exacerbated by the recession and a lack of leadership in the Mayor's Office of Film, Television and Broadcasting, was followed by five consecutive years of record-breaking activity, beginning in 1994, when 157 films were shot in New York, and rising to 221 films in 1998.[8] The high level of activity was both a considerable boost to the New York economy and, for many photogenic neighborhoods, an enormous headache as the seemingly constant street closures and detours due to filming quickly turned the novelty of catching a glimpse of a movie star into the aggravation of being inconvenienced by film and television crews. In one of countless examples of civil (and not so civil) disobedience aimed at the film industry, residents of Grand Street in SoHo yelled out of their windows and threw eggs during the making of *The Devil's Advocate* in 1996.[9] The city designated areas in which residents became too agitated as "hot spots," banning filming until things cooled off, often a period of only weeks.

The strength of the movie business in the city also brought to light an old reason why New York could not seriously rival Hollywood—the lack of soundstages and production facilities in the city that led most filmmakers to shoot exterior scenes in New York and then head back to California, and increasingly Canada, to film interiors and do post-production work, representing a huge loss of potential business. The incremental expansion of Kaufman Astoria Studios (see Queens) provided much-needed space, as did the establishment of smaller outfits such as Silvercup Studios in Long Island City, Queens, which opened in a former bakery in 1983 and was used mostly for television. Numerous other efforts to build film studios were thwarted, however, often because of the difficulty of obtaining financing for projects that by nature had no permanent tenant. Notable among the failed attempts were Forest City Ratner's 1997 plan to transform Piers 92 and 94 in the Hudson River between Fifty-second and Fifty-fifth Streets into a 500,000-square-foot complex of production facilities and a proposal to build five soundstages for television and film on top of the four-story St. John's Park Terminal on West Street between Houston and Charlton Streets, to be known as Hudson River Studios.[10] One project did go forward, an ambitious plan to build Steiner Studios, the largest modern production facility east of Los Angeles containing five soundstages comprising 100,000 square feet in an 800-by-180-foot building as well as 170,000 square feet of offices and dressing rooms, a 100-seat screening room, parking for 1,000 cars, and other facilities on fifteen acres in the Brooklyn Navy Yard. The complex was completed in fall 2004.[11]

The near-constant portrayal of New York on film from the 1970s to the 1990s served not only as a visual record of the city's transformation during those years but also as a dramatized rendering of its culture, mores, dangers, and delights. New York at the end of the twentieth century had many faces, depicted as a city of violence and fear, as a center of business and power, as a perfect setting for romance, as a melting pot, as an imaginary landscape manipulated by fantasy, and as an invitation to disaster and chaos.

Making It

New York's reputation as *the* place to make it big in almost every field was mythologized in movies. The path to the top often bypassed the relatively mundane strategy of hard work in favor of more dramatic and film-worthy means such as deception, murder, and sexual misadventure. If New York's corporate culture was symbolized on film during the postwar era by the advertising industry, in the 1980s it was replaced by the slick, ruthless, deal-making world of big business and high finance. Oliver Stone's *Wall Street* (1987) took a sober look at the Wall Street power players of the 1980s who had become nationally known celebrities and in some cases crooks, high-lighting the suspicion that, once achieved, power seemed to go hand in hand with corruption.[12] The film reveled in its New York setting, with sweeping shots of the Manhattan skyline, scenes filmed at the "21" Club and in Central Park, and a meticulously accurate, but artificial, trading floor.

Brian De Palma's *Bonfire of the Vanities* (1990), based on Tom Wolfe's bestselling 1987 novel about a powerful Wall Street lawyer who is brought down by the web of lies, infi-delity, and racial prejudice that he has created, was filmed on location around the city.[13] A dramatic time-lapse view from the top of the Chrysler Building opened the film. Residents of 800 Park Avenue (Electus D. Litchfield and Pliny Rogers, 1925), which served as the fictional 816 Park Avenue, home of the protagonist, used the location fee paid by the studio to ren-ovate the building's lobby. Residents of the Bronx, however, did not benefit so directly and were less than pleased by the story's negative portrayal of their borough, leading Borough President Fernando Ferrer to successfully lobby Warner Bros. to add a short disclaimer to the beginning of the film remind-ing viewers that it was a work of fiction. Edward I. Koch, reviewing *Bonfire* for the *Wall Street Journal*, called the movie "an insult to blacks and Hispanics, as well as to one of the city's greatest boroughs." But he also enjoyed the movie and recognized it to be fictional to the point of fantasy, stating that "it is worth seeing if you liked 'Dick Tracy' and 'Batman' [see below]. The opening scene displays Manhattan in all of its grandeur, bathed in sunrise/sunset colors. The shot . . . con-veys power, majesty, and fear. It is magnificent."[14]

While audiences thrilled to the shenanigans of the rich and powerful, they could better relate to Cinderella stories that featured lower-level workers who, through guise and guile, proved themselves capable of doing an executive-level job. Mike Nichols's *Working Girl* (1988) starred Melanie Griffith as Tess McGill, a secretary from Staten Island who sneakily usurps her boss's job—and wardrobe—while putting together a big business deal.[15] According to Vincent Canby, the movie "might easily have been set in Chicago or San Francisco instead of Manhattan. Yet that would have lowered the stakes for which" the characters "are fighting, Manhattan being the financial center of this country."[16]

Herbert Ross's *The Secret of My Success* (1987), telling a similar story as the musical and film *How to Succeed in Business Without Really Trying* (1961, musical; 1967, film), starred Michael J. Fox as a young man transplanted from his family's Kansas farm into Manhattan, where he works in the mailroom of a huge corporation and takes over an empty office to lead a double life as an executive.[17] Canby appreci-ated the film's "glittery, glass-and-steel look," stating that "the Manhattan that Mr. Ross shows us is a Kansan's fantasy city."[18] Janet Maslin noted that the cinematography by Carlo DiPalma took a "sardonic yet admiring view of big, bold, depersonalized corporate architecture," pointing out that a sequence in which Fox's character works late "concentrates less on the work he is doing than on the stunning spires of the Chrysler and other buildings at night, which appear as beacons to this up-and-coming young man steering his course."[19]

Jan Egleson's *A Shock to the System* (1990), based on the novel by Simon Brett, starred Michael Caine as an advertising executive who is passed over for a promotion but discovers that murdering his competitors is an effective way to move up the corporate ladder.[20] The film added a measure of dark com-edy to the struggle for career advancement. But for the enter-tainment reporter Jeannie Park, the film incorporated "the

Steiner Studios, 15 Washington Avenue, Brooklyn Navy Yard, Brooklyn. Gensler, PS&S Architecture, and Richard Dattner & Partners Architects, 2004. View to the northeast. SS

Wall Street, 1987. Scene still. Art directors, John Jay Moore and Hilda Stark; director, Oliver Stone. 20th Century Fox/The Kobal Collection

grim reality of city life below, where the homeless haunt the street corners and the subway tunnels. In fact, it is a persistent panhandler who sets the frustrated Graham on his murderous course."[21] The old concept of selling one's soul to the devil in exchange for success was taken nearly literally in Taylor Hackford's *The Devil's Advocate* (1997), in which Keanu Reeves is a young attorney who quickly rises in stature after taking a job at a major New York firm but learns that his ruthless, persuasive boss, played by Al Pacino, is in fact the devil himself and New York a sort of Babylonian hell. The movie was filmed on location in areas including SoHo, Central Park, the Municipal Building, and Trump Tower.

Ever since the movies began to talk, and even before, they reveled in one of the most popular career struggles in New York—to make it in show business. Alan Parker's 1980 musical, *Fame*, followed a group of would-be stars at New York's High School of the Performing Arts, 120 West Forty-sixth Street (C. B. J. Snyder, 1893), from auditions through graduation. Exterior shots of the high school were used in the film but another C. B. J. Snyder school, DeWitt Clinton High School (1906), 899 Tenth Avenue, between Fifty-eighth and Fifty-ninth Streets, provided the school interiors.[22] For Parker, a British director, New York, a "startlingly beautiful" city, "has been poorly served by American cinematography. We might

Working Girl, 1988. Scene still. Art director, Doug Kraner; director, Mike Nichols. 20th Century Fox/The Kobal Collection

Fame, 1980. Scene still. Art director, Ed Wittstein; director, Alan Parker. MGM/Photofest

Saturday Night Fever, 1977. Scene still. Production designer, Charles Bailey; director, John Badham. Paramount/The Kobal Collection

Annie Hall, 1977. Scene still. Art director, Mel Bourne; director, Woody Allen. United Artists/The Kobal Collection

get criticized for making New York look too beautiful, but we used no trickery. It just depends on where you put the camera." Scenes were filmed on location around the city, with students dancing on top of taxi cabs, along sidewalks, and at night in Times Square, which Parker found to be "possibly the sleaziest place on earth; but for some weird reason, at that point in the evening, it looks eerily beautiful. It's that line between beauty and vulgarity that I think New York *is* all the time."[23]

In Sydney Pollock's *Tootsie* (1982), Dustin Hoffman starred as an out-of-work actor who achieves show-business success by disguising himself as a woman in order to get a role on a television soap opera.[24] Scenes were filmed in the Russian Tea Room, in Central Park, outside of Bloomingdale's, and at the National Recording Studios, 460 West Forty-second Street, where the movie's fictional soap opera was made. The idea of cross-dressing one's way to the top reemerged—this time in the business world—in Donald Petrie's *The Associate* (1996), in which the black actress Whoopi Goldberg impersonated a white man in order to succeed in the white-male-dominated culture of Wall Street.[25]

Ron Howard's *The Paper* (1994) took a detailed look at the newsroom culture of New York's tabloid newspapers, depicting twenty-four hours at the *New York Sun*, the historic newspaper that had closed down in 1950 but was resurrected for the purposes of the film.[26] In 2002 a new version of the *Sun* began to be published, supporting the old adage that life imitates art. Howard and the screenwriters, David and Stephen Koepp, sought a high degree of verisimilitude, but while the film's version of the *Sun* closely resembled a tabloid newsroom, its depiction of the *New York Times* (called the *Sentinel* in the movie) couldn't have been further off, according to Paul Goldberger, who stated that the oak-paneled soft-lit rooms "bore absolutely, totally and completely no relation to reality."[27] The *Sentinel* scenes were filmed in Brooklyn, at the back offices of the investment bankers Morgan Stanley.

Harold Becker's *City Hall* (1996), based on a screenplay originally written by former deputy mayor Ken Lipper (it was later rewritten with three other screenwriters), was intended to provide a realistic portrait of the mayor's office. The "many-tentacled tale of urban corruption," as Janet Maslin described it, starred John Cusack as a deputy mayor who, investigating the killing of a young boy during a shootout, discovers a line of corruption that leads to the desk of the mayor, played by Al Pacino. *City Hall*'s greatest distinction may have been that it

was the first film ever to be shot in City Hall, though the mayor's office seen in the film was actually that of the city council speaker, dressed up to resemble the real thing.[28]

In some cases, the desire to "make it" in New York was not so much about professional ambition as it was about simply escaping from one's old life and "arriving" in Manhattan. Few movies made the point better than John Badham's *Saturday Night Fever* (1977), in which the hero, played by John Travolta, escapes from his workaday life in Brooklyn by dancing at a local club on the weekends, reigning supreme to songs performed by the Bee Gees that became disco classics.[29] Though discounted by some as simply a vehicle for arresting dance performances, especially by Travolta, the story became an anthem for New York's rejuvenation, anchored in reality with location shooting in Bay Ridge and Bensonhurst, Brooklyn, and pivotal scenes on the Verrazano-Narrows Bridge.

City as Romancer

Long a popular backdrop for romance, post-1970s New York emerged as an active, often meddling, participant in love stories, frequently portrayed as a matchmaker, able by its very breadth and diversity to bring together people who might never meet anywhere else. This was true not only for bubbly young singles, but also for those who were older, jaded, disenchanted, lonely, or, in what was an increasing phenomenon, divorced. More than any other author, director, or actor—and he is all three, a "triple threat"—Woody Allen reaffirmed New York's image as the world's premier setting for romance. In his films *Annie Hall* (1977) and *Manhattan* (1979), Allen established a new level of reverence for the city itself. As opposed to the classic New York-based Hollywood love stories, Allen's introspective films were not so much about falling in love as about wanting to be in love in a city where complex relationships are the essence of everyday life. *Annie Hall* presented the relationship between two neurotics: Allen's alter ego, Alvy Singer, a comedian who was raised as a poor Jew in a house under a Coney Island roller coaster, and Annie Hall (Diane Keaton), a singer and actress with a WASPy Midwestern background.[30] Instead of being set, as James Sanders noted in *Celluloid Skyline; New York and the Movies* (2001), in the familiar places of "postwar romantic comedies, the sleek Madison Avenue of Doris Day and Rock Hudson's 'pillow talk' films or the sparkling Park Avenue offices surrounding Audrey Hepburn and George Peppard in *Breakfast at*

Manhattan, 1979. Scene still. Production designer, Mel Bourne; director, Woody Allen. United Artists/The Kobal Collection

When Harry Met Sally, 1989. Scene still. Production designer, Jane Musky; director, Rob Reiner. Columbia Pictures/Photofest

Tiffany's," the film "very deliberately" took place in offbeat places such as an East River pier at dusk, offering a sense of the city as both romantic and earthy.[31] Just as the city was emerging from the fiscal crisis, it was depicted with a glamour that was far deeper and more profound than that of familiar set pieces such as the Plaza or Madison Avenue.

In *Manhattan*, Allen played Isaac Davis, a forty-two-year-old comedy writer dating a seventeen-year-old student at the Dalton School played by Mariel Hemingway, but who soon takes interest in Mary Wilke (Diane Keaton), a journalist and the wife of a close friend (Michael Murphy).[32] *Manhattan* was a carefully calculated, utterly endearing celebration of the city. Allen hoped it would capture his own "subjective, romantic view—of contemporary life in Manhattan" and, in a hundred years' time, would be an accurate reflection for the audience of "what life in the city was like in the 1970s. They'll get some sense of what it looked like and an accurate feeling about how some people lived, what they cared about."[33] Filmed in black and white, the movie opened with a nine-minute montage in which, as Vincent Canby wrote, Allen "sends up (and forever out) Manhattan as evoked by old-time studio movies, which would give us the opening bars of 'Rhapsody in Blue' accompanied by a couple of aerial shots of the city. Mr. Allen does just this, but he adds his own voice-over, that of a would-be novelist searching for the perfect first line: 'He adored New York City, although to him it was a metaphor for the decay of contemporary culture. How hard it was to exist in a society desensitized by drugs, loud music, television, crime, garbage.'"[34]

Manhattan, according to Vincent Canby, writing a decade after its release, was perhaps "the last believable romantic Manhattan comedy."[35] Its successors included *Arthur* (1981), a screwball comedy written and directed by Steve Gordon that featured Dudley Moore as the wealthy, lonely drunk who will inherent a fortune only if he marries a woman who meets his parents' social criteria but instead falls in love with a waitress played by Liza Minelli.[36] The movie's most lasting impression of New York was not its extensive use of city locations but the song "Arthur's Theme," written by Burt Bacharach and performed by Christopher Cross, which proclaimed: "If you get caught between the moon and New York City, the best that you can do is fall in love." Ulu Grosbard's *Falling in Love* (1984) brought together two suburbanites, Robert De Niro and Meryl Streep, who live separate married lives in Westchester but both commute into Manhattan, where the hubbub of the city allows them to continually, unbeknownst to one another, cross paths "on the train to Manhattan, at Grand Central Station telephone booths, on Fifth Avenue, at restaurants and other pretty locations,"[37] as Vincent Canby put it, before meeting on Christmas Eve at the Rizzoli bookstore and eventually falling for one another. In Norman Jewison's *Moonstruck* (1987), the singer-turned-actress Cher stars as a widow in a large Italian family living in Brooklyn who falls in love with her fiancé's brother. New York played a prominent role, with scenes filmed at the Metropolitan Opera House, in the Grand Ticino restaurant on Thompson Street in Greenwich Village (it served as the setting for a Brooklyn restaurant in the movie), and at the Cammareri Brothers Bakery in Carroll Gardens, Brooklyn, which was briefly made famous by the film but folded in 1998 after its star faded.[38]

Spike Lee's intensely focused *Jungle Fever* (1991), the story of an interracial relationship between Flipper Purify (Wesley Snipes), a happily married, successful black architect who lives on Striver's Row in Harlem, and Angela Tucci (Annebella Sciorra), his Italian-American secretary from Bensonhurst, Brooklyn, was what Vincent Canby called a "vividly realized panorama of New York City urban life."[39] Though Lee portrayed parts of Harlem in a very positive light, showing the world its less-well-known prosperous aspect, his was hardly a pollyannaish vision, with one of the most poignant sequences involving what Canby described as "a descent into hell, that is, into a Harlem crack house known as the Taj Mahal, referred to by one of its habitues as the 'eighth wonder of the world' . . . a vision of physical and spiritual desolation of near-Fellini proportions."[40]

Lee's decision to make the protagonist an architect aimed to address yet another social issue: the scarcity of blacks in the architectural profession. Snipes played the only black architect at a large firm who, when denied partnership, quits to go on his own. Jack Travis, a black architect in Manhattan, consulted on the film, taking Snipes on tours of his own office and those of Kohn Pedersen Fox, while the movie's architectural scenes were filmed at the offices of the Walker Group in Manhattan. According to Nicolai Ouroussoff, *Jungle Fever* "made black architects real for a moment, but things quickly settled back to normal" and "normal means a general ambivalence about integration within the profession."[41]

Rob Reiner's *When Harry Met Sally* (1989), from a screenplay written by Nora Ephron in collaboration with Reiner and Andrew Scheinman, reprising, as it were, Woody Allen's take,

You've Got Mail, 1998. Digitally rendered computer model by Milton Glaser, Walter Bernard, Mirko Ilic, and Lauren De Napoli. Art directors, Ray Kluga and Beth Kuhn; director, Nora Ephron. MGI

The Warriors, 1979. Scene still. Art directors, Don Swanagan and Robert Wightman; director, Walter Hill. Paramount/The Kobal Collection

starred Billy Crystal and Meg Ryan as friends who struggle with the question of whether platonic friendships between men and women are possible.[42] As Caryn James described it, they "saunter through the romanticized lives of intelligent, successful, neurotic New Yorkers" in a "blatant bow" to Allen, complete with Gershwin soundtrack and a "camera infatuated with Manhattan": "At the Temple of Dendur in the Metropolitan Museum of Art, they discuss dating. In autumn, they stroll by gloriously bright trees in Central Park (Sally wears an Annie Hall hat) and describe their recurring sex dreams. They walk by the glittering Christmas display at Rockefeller Center and the decorated windows at Saks Fifth Avenue." A high point of the movie, Meg Ryan's classic fake orgasm scene, was filmed at Katz's delicatessen.[43]

From *When Harry Met Sally*, it was but a short step to a more retro approach revisiting Hollywood's New York but with the real city as opposed to back-lot sets and Technicolor. In 1993 Nora Ephron directed Meg Ryan and Tom Hanks in *Sleepless in Seattle*, in which Hanks, a divorced architect living in Seattle, falls for Ryan, a newspaper feature writer on the East Coast. New York—specifically the top of the Empire State Building—serves as the setting for their long-awaited meeting, an allusion to Leo McCarey's *An Affair to Remember* (1957).[44] Michael Hoffman's *One Fine Day* (1996) starred Michelle Pfeiffer and George Clooney in a typical love story of two single parents (Pfeiffer plays an architect—the sudden popularity of architects as appealing characters parallels the growing prominence of architecture as a cultural phenomenon and real-life architects as celebrities—and Clooney a *Daily News* columnist) whose coincidental meeting turns into a romance that, as Janet Maslin wrote, "revels in New York City at its touristy best, dashing madly among appealing landmarks . . . from the '21' Club to the Circle Line to Central Park to City Hall and . . . the environs of Radio City Music Hall."[45]

Less sunny in very many ways was *The Mirror Has Two Faces* (1996), directed by Barbra Streisand and co-starring Streisand and Jeff Bridges as two Columbia professors who intellectualize love and marriage before giving in to their more animal desires.[46] The film was shot on the Columbia campus and at 505 West End Avenue, Streisand's fictional home. While residents of West Eighty-fourth Street were peeved at the filming, the movie's location manager, Gary van der Meer, explained, "It is, unfortunately, a very beautiful

New York neighborhood. You couldn't build it on the back lot for a million dollars."[47]

Nora Ephron's *You've Got Mail* (1998) made even more use of the Upper West Side in its story about Kathleen Kelly (Meg Ryan), a children's bookshop owner who is about to be put out of business by a large chain owned by Joe Fox (Tom Hanks).[48] The two wage a bitter personal battle, all the while unaware that they are becoming deeply involved with each other in an online friendship and romance. The movie's opening sequence zooms in from spinning planets in the universe to a digitally rendered computer model of the Upper West Side designed by Milton Glaser, Walter Bernard, Lauren De Napoli, and Mirko Ilic. The model, which Patricia Leigh Brown called a "three-dimensional ode to Manhattan," was given more and more detail as the camera closed in on the Upper West Side, although it eliminated, according to Glaser, "the people, the noise, the litter. It's probably a more benign and harmonious West Side than there will ever be."[49] According to Janet Maslin, the neighborhood was "so picturesquely idealized that it feels like Paris. Even if you already live on the Upper West Side, you might feel the urge to move there before the film is over."[50]

Mean Streets

The 1973 release of Martin Scorsese's influential *Mean Streets*, which told the violent story of Mafia activity in Little Italy, set into motion a new and raw style of filming the gritty action of city streets in a true-to-life manner.[51] Many of the subsequent films that portrayed New York as an unpredictable and often dangerous world of loners, loose cannons, and lunatics attempted to harness the energy of the streets in a similar fashion. *The Warriors* (1979), directed and cowritten by Walter Hill, depicts New York as a lawless city in which gangs rule. When one leader is killed at a gang rally in the Bronx, the Warriors are falsely held responsible and hunted as they journey back to their Coney Island turf, transforming the city's streets, subways, parks, and even beaches into an urban battlefield, an updating, as Vincent Canby noted, of the World War II–era "lost patrol" movie in which a "small band of infantrymen . . . find themselves trapped behind enemy lines and spend the next 90 minutes trying to get back to their base."[52] According to Janet Maslin, the film provided "gorgeous nocturnal city images that splash blaring neon colors against filthy rain-slicked gray."[53]

John Carpenter's futurist *Escape from New York* (1981), starring Kurt Russell, was based on the premise that the city's crime rate would quadruple by the late 1980s and that by 1997, when the story took place, the entire island of Manhattan would become a federal prison run by its own inmates. As Canby described it, "The place is a zoo without bars, but there's no way out. The bridges have been mined and walled off. The tunnels are sealed. The once great buildings are mostly shells." The production designer Joe Alves complemented location photography in St. Louis, Los Angeles, and New York with what Canby described as "some stunning miniature sets, to create a marvelously credible, lost city."[54]

Other films focused on the attempts of the police to bring order to the chaos of the streets, even as cops faced corruption within their own ranks. In the controversial *Fort Apache, The Bronx* (1981), starring Paul Newman, director Daniel Petrie portrayed the South Bronx as a hopeless physical and psychological wasteland in which the only bastion of safety, the precinct house known as Fort Apache, is home to officers who commit the same kinds of mindless murders as the criminals out on the street.[55] Sidney Lumet's *Prince of the City* (1981) was based on Robert Daley's book of the same title recounting the true story of a cop in the Special Investigating Unit in the Narcotics Division who turns against his corrupted fellow officers but ultimately confesses to the same crimes they committed.[56] The film's elaborate sets took over five floors of Cass Gilbert's U.S. Custom House on Bowling Green, which was vacant at the time.

During the late 1970s and early 1980s a bumper crop of films played on the idea of New York as a dangerous and deadly city, especially for women, a place where psychopaths preyed and not even the police, let alone strangers, could be trusted. In *Looking for Mr. Goodbar* (1977), an adaptation of the Judith Rossner novel directed by Richard Brooks, Diane Keaton, as Theresa Dunn, spends her days teaching deaf children and her nights frequenting bars, consuming drugs, and picking up men for sexual encounters, with deadly consequences. While Rossner's novel, "very much a New York novel," according to Vincent Canby, moved "around the city—from the Bronx to Brooklyn to Greenwich Village . . . during the day and late at night—in such a way that the city becomes an always visible if silent conspirator in Theresa's tragic fate," the city portrayed in the film "is never identified. At times it looks a bit like Chicago, then Los Angeles, sometimes New York, thus to become Nowhere, U.S.A."[57] In *Dressed to Kill* (1980), directed by Brian De Palma, Michael Caine stars as a psychiatrist who is also a transsexual murderer thirsty for the blood of one of his patients, played by Angie Dickinson, while Brian G. Hutton's *The First Deadly Sin* (1980), starring Faye Dunaway and Frank Sinatra, played up the idea that a serial killer could come in many forms, in this case as a well-to-do executive who lives in a fictitious forty-one-story building on West Eighty-third Street.[58] In Irvin Kershner's *Eyes of Laura Mars* (1978), Faye Dunaway plays a fashion photographer whose life is in danger and who makes the mistake of becoming romantically involved with the police officer (Tommy Lee Jones) assigned to protect her, not knowing that he is also out to kill her. Edward Bianchi's *The Fan* (1981), starring Lauren Bacall as a Broadway actress who is terrorized by a psychotic admirer, was filmed on location around the theater district and in Eighth Avenue bars. In *A Stranger Is Watching* (1981), Sean S. Cunningham brought the

Fort Apache, The Bronx, 1981. Scene still. Art director, Christopher Nowak; director, Daniel Petrie. 20th Century Fox/The Kobal Collection

fears of the street to the tunnels beneath Grand Central Terminal, where a reporter and her stepdaughter are imprisoned by a kidnapper.[59]

As violent as the streets seemed, films portrayed the subway system as being even more so. The subway had a rich tradition of hosting big-screen chases, shootouts, and murders; recent examples included *The Warriors* and *Dressed to Kill*, in which Angie Dickinson's character is chased by would-be rapists onto a subway car where the would-be murderer awaits. More recently Kathryn Bigelow's *Blue Steel* (1990) featured a shootout on a subway platform and Brian De Palma's *Carlito's Way* (1993) included an underground chase sequence. Beginning in 1993, however, the Transit Authority restricted filmmakers from portraying violence in the subway, claiming that in light of a reduction in crime over recent years, negative portrayals were unwarranted and could result in decreased ridership.[60] Representatives of the film industry objected to this censorship, and Mayor Giuliani, cognizant that any sort of deterrent to filming in the city could threaten the industry, which was just recovering from a boycott (see above), urged the Authority to reconsider its prohibition. The Transit Authority conceded to a certain extent, just in time for the production of two big-budget blockbusters that depended upon the subway. In John McTiernan's *Die Hard: With a Vengeance* (1995), the tunnels are used to rob the Federal Reserve Bank, and in Joseph Ruben's *Money Train* (1995), a transit cop (Woody Harrelson) hijacks a subway car that carries millions of dollars each day in collected fares to the Federal Reserve Bank.[61] Transit Authority officials, concerned that the latter script gave away too many details about how money was in fact collected and transported, succeeded in having the script modified and prevented any scenes of violence from being shot in the tunnels, leading them to be filmed on a Hollywood set. But in an unfortunate and ironic twist, scenes in *Money Train* depicting a character who terrorizes token booth clerks by shooting a flammable liquid through a tube into the booths and then igniting it were mimicked at the Kingsbridge-Throop Avenue stop in Bedford-Stuyvesant, Brooklyn, on November 26, 1995, four days after the film opened, killing the clerk, and then seven more times around the city in the following weeks.[62]

Beginning in the late 1980s a wave of films depicted the struggle of urban youths to rise above the drug-infested and often murderous environments that seemed to lure so many of

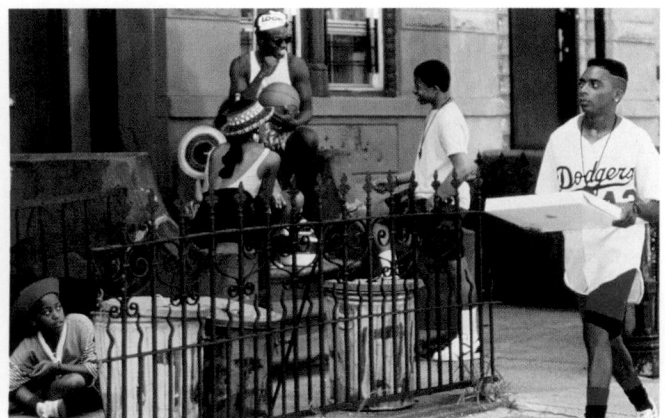

Do the Right Thing, 1989. Scene still. Production designer, Wynn Thomas; director, Spike Lee. Universal/The Kobal Collection

their numbers into criminal behavior or, worse, death. Many of these stories were told by young black filmmakers who had themselves made it off the streets and out of the projects to turn an artful and critical eye toward the physical and sociological conditions of their old stomping grounds. In *Do the Right Thing* (1989), director Spike Lee, who was black but also middle class, depicted a single day on a single block in Bedford-Stuyvesant; the movie was filmed on location on Stuyvesant Avenue between Quincy and Lexington Avenues. Lee wrote and starred in the film, which takes place on the hottest day of summer, showing the neighborhood in the morning when it came to life as what Paul Goldberger described as "funky, friendly, full of people who know one another and take care of one another, a black version of Jane Jacobs's ideal urban village. . . . The buildings are as friendly as the people: they are pleasant brownstones with stoops used for sitting and windows used for looking out."[63] Through the course of the day, humor and goodwill turn into heat-fueled animosity toward the white owner of a pizza shop (Danny Aiello) who had been beloved the day before. That night, following a police shooting, violence takes over as the block erupts in riots.[64] As James Sanders noted, "Lee makes clear that far from being the source" of "deep-seated social and economic problems . . . the traditional street can serve as a kind of harbor against them."[65]

Abel Ferrara's *King of New York* (1990), shot in various locations throughout the city, delivered its version of an uplifting message in the tale of a white ex-drug dealer played by Christopher Walken, who, released from prison, sets up shop in the Plaza Hotel and seeks to eliminate his competition in order to reap greater profits to funnel into a hospital he hopes to build for the poor in the South Bronx.[66] Nineteen-year-old Matty Rich's *Straight out of Brooklyn* (1991) was, according to James Sanders, the cinema's "first truly sustained look at a New York housing project."[67] The story took place and was shot entirely on location in the Red Hook Houses (Electus D. Litchfield, 1935–37) where Rich had grown up.[68] The largely autobiographical story portrays the teenage son of an alcoholic, rage-driven father and a battered mother, whose objective, as the name of the film implied, was to get out of the projects and into Manhattan.

The film *Juice* (1992), a loss-of-innocence story about four teenage friends caught up in a spree of violence, was directed by Ernest R. Dickerson, the cinematographer who had worked on all of Spike Lee's films and who shot his own debut in such

a way as to give "the Harlem streets a rare crispness and clarity," as Janet Maslin wrote.[69] The story grew out of Dickerson's own memories of growing up in the housing projects of Newark, New Jersey, and starred the rapper Tupac Shakur, who was gunned down four years after the film's release.

New Jack City (1991), directed by Mario Van Peebles from a screenplay by Michael Cooper and Thomas Lee Wright, conveyed a strong antidrug message through its portrayal of a crack-dealing kingpin battling it out with cops on the streets of Harlem, where, according to Maslin, the film's use of "once-imposing, now-crumbling New York architecture is particularly effective in underscoring the story with an air of widespread urban decay."[70] Graham Court (Clinton & Russell, 1901) was featured in the film as a crack factory that appeared to be crumbling on the outside but was ultra high-tech within. In Leon Ichaso's *Sugar Hill* (1994), also from a screenplay by Michael Cooper, the deteriorating buildings of Harlem were similarly employed to illustrate lost grandeur both in the physical neighborhood and in the psyches of its residents.[71] This time around Graham Court (interiors were filmed on soundstages) served as a romantic setting between a dealer who wanted out of the drug trade and his girlfriend. Another scene was filmed beneath the arches of the Riverside Drive viaduct at 125th Street, which Ichaso called "the spinal cord of this city. It looks like inside a monster, almost like bones. And for what they're talking about, two brothers trying to stay alive in Harlem, it was appropriate."[72] Based on the novel by Richard Price, Spike Lee's 1995 *Clockers* depicts the lowest level of drug dealers, called "clockers" because they'll work at any hour. The movie was set in the "Nelson Mandela Houses," which were represented on film by the Gowanus Houses in Brooklyn (Rosario Candela, Kahn & Jacobs, and William T. McCarthy, 1949).[73]

The streets could also be rough outside of poorest neighborhoods, where youth faced equally pernicious, if less violent, temptations, according to Larry Clark's 1995 film, *Kids*, which told the grim story of a young man unknowingly spreading the AIDS virus among his group of friends. Along the way, the kids growing up on the unsupervised streets of lower Manhattan, where the on-location cinematography, as James Sanders wrote, conveyed a "heightened sense of the physical danger posed by the street," elated in drug use, stealing, trespassing, even beating a man to near death with their skateboards in Washington Square Park.[74] Morgan J. Freeman's *Hurricane Streets*, released in 1998, painted a less abjectly corrupt picture of "aimless street youth roaming through Manhattan's Lower East Side," according to Stephen Holden, focusing especially on a "troubled 14-year-old boy drifting toward a life of crime on the streets."[75]

In 1999 Martin Scorsese returned to the themes of his *Mean Streets* (1973) and *Taxi Driver* (1976) with *Bringing Out the Dead*, an adaption of the Joe Connelly novel about a Hell's Kitchen ambulance driver, played by Nicholas Cage, who is losing his grip on reality in the midst of a dark, deeply troubled city that seems to be as wired and strung out as its low-life inhabitants.[76] For David Kamp, writing in *Vanity Fair*, the city was represented as the "crawly, maggot-infested, filth-encrusted New York we'd forgotten still existed–the Abe Beame New York, the *Kojak* New York, the godforsaken *Pelham One Two Three* New York," a city of "unromanticized blight–an anti-*noir* nightscape of shadowy crack dens, public housing, and cruddy Chinese take-out joints."[77]

Homelessness gave new meaning to New York street life as filmmakers turned their attention to those actually living their lives on the streets and in shelters, often seeking to humanize a population that many preferred to ignore while exposing the harsh realities of their living conditions. Charles Lane's *Sidewalk Stories* (1989), a black-and-white silent film about a Greenwich Village street artist who sleeps in an abandoned tenement and becomes the temporary guardian of a young child, was filmed on location in the Village and the Lincoln Center area during a bitterly cold February that offset the story's heartwarming moments with New York at its most frigid and impersonal.[78] *Rooftops* (1989), directed by Robert Wise, who initially planned to use the title *Lower East Side Story* in reference to his 1961 *West Side Story*, depicted a homeless teenager who resides in a water tank on the roof of an abandoned tenement that has been taken over by a crack dealer. According to Richard Bernstein, the Lower East Side is depicted as a world of "graffiti-stained urban wreckage, single-parent households, [and] homeless teenagers who grow up fast."[79] For Joel Rose, writing in the *New York Times*, however, Wise did not go far enough in exposing the real physical and social decay in the area, failing "to fathom that living the homeless life takes its toll on the youngest and fittest as well as the oldest and most infirm, and when summer is over and winter is upon us, living in a water tower on the roof of an abandoned building . . . is going to be none too comfortable."[80]

The Saint of Fort Washington (1993), in which director Tim Hunter presented a more realistic view of life in New York's overcrowded shelter system, starred Matt Dillon and Danny Glover as homeless men—one mentally ill and the other a Vietnam veteran—who meet in the Fort Washington Armory shelter (Walker & Morris, 1909–11) in upper Manhattan and come to rely on one another.[81] On-location filming took place at the armory, where residents were employed as extras. For Janet Maslin, cinematographer Frederick Elmes succeeded in creating "vivid urban landscapes" ranging from "hellish, impersonal" city shelters to drab government offices to Potter's Field, on Hart Island, "a seldom-seen location that lends real sorrow to the film's closing moments, especially when" the director "quietly depicts the procedures by which the homeless are buried there."[82] In Jonathan Nossiter's *Sunday* (1997), a homeless man residing in a Queens shelter finds a friend and lover in a nonhomeless woman.[83]

Terry Gilliam's *The Fisher King* (1991) was the era's most memorable rendering of homelessness, in part because of its imaginative but only slightly exaggerated delineation of Manhattan's extremes of poverty and wealth.[84] The movie stars Jeff Bridges as a radio celebrity who, after being stripped of his lifestyle of limousine travel and a glitzy apartment in the Metropolitan Tower (see Fifty-seventh Street), gets a job in a video store and comes into contact with Parry, a half-crazy homeless man played by Robin Williams, who lives in a basement boiler room but seems to be Jack's only chance at redemption. Several disturbing scenes take place in a homeless encampment beneath the "massive, classical arches and buttresses" of the Manhattan Bridge. "It's the closest I could come to Piranesi in New York," explained Gilliam. "It's like moving back in history to an earlier time which is now where the homeless live. They are literally living in a Piranesi world, as opposed to the modern world."[85] Additional location photography took place in Central Park; on the Upper East Side, where the former Squadron A Armory (John Rochester Thomas, 1895), later incorporated into Intermediate School 29 (Morris Ketchum Jr. & Associates, 1969), is imagined as a fortified mansion; at the mega office building 101 Park Avenue (see Terminal City); and in Grand Central Terminal, where 400 extras transformed the concourse, as Julie Salamon described it, into a "a lyrically romantic set piece. The crush of commuters, tourists and homeless people suddenly breaks into a dizzying waltz, under the glow of the elegant chandeliers. Instead of pressing ahead to the individual concerns propelling them forward, these people are all swept up in the fantasy that is implied in the grandeur of the architecture."[86]

Ethnic New York

New York's diverse ethnic population, a popular subject of postwar films, continued to be depicted from the 1970s through the 1990s by filmmakers who examined the immigrant experience itself, exploring matters of assimilation, prejudice, and the clash of old- and new-world mores. Joan Micklin Silver, who had portrayed Jewish life on the Lower East Side at the turn of the century in her 1975 film, *Hester Street*, revisited the neighborhood and its residents in *Crossing Delancey* (1988). This time she depicted the erosion of the community's identity and ideals in the story of thirty-three-year-old Isabelle "Izzy" Grossman (Amy Irving), the manager of a literary bookstore living on the Upper West Side. She is romanced by a pretentious poet while her grandmother, who remains in the old neighborhood, which has been altered both physically—with the construction of housing projects in place of tenements—and socially—with an influx of Asians and Hispanics—seeks a more traditional path for Izzy, hiring a matchmaker to set her up with a local pickle merchant who represents the world that she has tried to leave behind.[87] James Gray's *Little Odessa* (1994), set in the immigrant Russian Jewish community of Brighton Beach, Brooklyn, follows Joshua Shapira (Tim Roth), a young hit man who had been ostracized from the tight-knit community.[88] The movie was "beautifully shot," according to Caryn James, on location during the winter, conveying "an extraordinary sense of place and of drama," with "a slight blue tinge as if the entire world were overcast."[89]

Janusz Zaorski's *Happy New York* (1997), the first Polish movie to be filmed in New York, required two weeks of shooting in the Polish community of Greenpoint, Brooklyn. The comedy describes a common experience among newcomers who find the American dream more elusive than expected and must devise ways of making their families back home think that they are living prosperously.[90] Co-written by Zaorski and Edward Redlinski, the film was inspired by Redlinski's own experiences living in Greenpoint during the 1980s.

A number of films depicted the struggles of New York's burgeoning, multifaceted Hispanic population, often portraying the city as an unaccommodating and unforgiving place that laid waste to those who could not—or would not—fit in. According to James Trager, Orlando Jimenez-Leal and Leon Ichaso's *El Super* (1979) was possibly the first Spanish-language film to be made in New York, following a middle-class Cuban family living on the Upper West Side, where the father is employed as a building superintendent who, as Vincent Canby noted, "refuses to learn English as a matter of principle and . . . sees the members of his family and friends drifting away as they become assimilated."[91] *The Two Worlds of Angelita* (1982), directed by Jane Morisson, who had previously made only documentaries, tells the story of a family

The Brother from Another Planet, 1984. Scene still. Art director, Stephen J. Lineweaver; director, John Sayles. Columbia Pictures Corporation/Photofest

from Puerto Rico that comes to start a new life on the Lower East Side but finds the language barrier and economic pressures overwhelming.[92] *Nueba Yol* (Angel Muñiz, 1995), the title being Dominican slang for "New York," featured a popular Dominican television character, Balbuena (Luisito Marti), who in this comedy comes to New York but does not speak English, can't get a job, and returns home after "everything from the mechanics of unlocking an apartment door to finding his way around on the subway becomes a potential crisis," according to Stephen Holden.[93] David Riker's *La Ciudad* (1998) took a somber look at the experiences of Latin American immigrants in four vignettes about a day laborer, a sweatshop worker, a puppeteer who lives with his daughter in their car, and a newly arrived teenager from Mexico.[94] For Holden, the "indelible, deeply disquieting" movie "plunges you onto the streets of some of New York's poorer neighborhoods where immigrants, many of whom barely speak English, live at the mercy of exploitative employers and inflexible institutions."[95]

New York: Another Country
Experiencing New York through the eyes of an outsider was a popular subject for films that portrayed often comedic contrasts between the culture and habits of the natives and those of nearly anyone else. This sense of alienation was taken literally in the 1984 comedy *The Brother from Another Planet*, written and directed by John Sayles, in which a mute black extraterrestrial (Joe Morton) arrives on Ellis Island, then makes his way up to Harlem, where on-location photography depicts him in a struggle to rid the area of drugs.[96] Frank Oz's *The Muppets Take Manhattan* (1984) imagined the popular television puppet characters created by Jim Henson as college graduates who have come to New York to try to make their senior-class musical, "Manhattan Melodies," a hit on the Great White Way.[97]

In *Moscow on the Hudson* (1984), Paul Mazursky directed Robin Williams as Vladimir Ivanoff, a Soviet circus musician who defects while in Bloomingdale's (scenes were filmed in the store).[98] Peter Faiman's *Crocodile Dundee* (1986) stars Paul Hogan as an Australian crocodile hunter who leaves the Outback for the first time to come to New York, finding more similarities than one would expect between the two wilds. And John Landis's comedy *Coming to America* (1988) featured Eddie Murphy as the prince of a fictional African nation who, to avoid an arranged marriage and find a wife suitable for a

future king comes—where else?—to Queens, hiding his pedigree by living in a derelict apartment and working at a fast-food restaurant so that he will be loved for who he is and not for his kingdom.[99] Locations included Queens Boulevard in Elmhurst and the Waldorf-Astoria Hotel.

Penny Marshall's *Big* (1988) captured the city from the eyes of a twelve-year-old boy who, overnight, is magically made into an adult (played by Tom Hanks), leaving his parents' home on a quiet suburban street for Manhattan, where he gets a high-paying job at a toy company and rents a loft in SoHo; memorable scenes were shot in F.A.O. Schwarz. Chris Columbus's *Home Alone 2: Lost in New York* (1992) followed a precocious ten-year-old out-of-towner (Macaulay Culkin) through New York after a mix-up at an airport brings him to the city armed with a credit card. His holiday romp is based at the Plaza Hotel, which is fictionally altered to have a pool.[100] Perhaps the silliest of the lot was Gregg Champion's *The Cowboy Way* (1994), which depicted two rodeo champions (Woody Harrelson and Kiefer Sutherland) who traverse the city in a pickup truck and on horseback, with location shooting on the Manhattan Bridge, in the subway system, Central Park, the Waldorf-Astoria, and Times Square.[101]

Fantastical City
New York continued to be an ideal setting for film fantasies. Sidney Lumet's *The Wiz* (1978), based on the Broadway musical and featuring an all-black cast, was reported to be the largest and most complicated film ever shot in New York, single-handedly resuscitating the newly reopened Astoria Motion Picture and Television Production Center (see Queens) and boosting the film industry's confidence in the city at a crucial time.[102] The film took the familiar story of *The Wizard of Oz* and situated it in New York, which became a wondrous, unfolding land of opportunity as well as, according to producer Rob Cohen, "a star of the movie. But it is not the New York we would shoot in reality . . . Oz is a fantasy made up of the essence of New York."[103] About half the filming took place in Astoria, while the other half was shot on about twenty locations around the city, including Coney Island; the New York Pavilion from the 1964 World's Fair in Flushing Meadows, Queens; the Brooklyn Bridge; the Hoyt–Schermerhorn subway station in Brooklyn, which was completely paved in vinyl "yellow brick"; a block in Bedford-Stuyvesant, which was covered in 52,000 pounds of artificial snow; and the World Trade Center's plaza, which served as the Emerald City, the heart of Oz, decked out with 38,000 light bulbs.

Ivan Reitman's imaginative comedy *Ghostbusters* (1984) starred Bill Murray, Dan Aykroyd, and Harold Ramis as a group of bumbling scientists who, fired from various positions at Columbia University, band together to fight the ghosts that seem to have taken over New York, establishing a headquarters in the real-life firehouse of Hook & Ladder No. 8 at Varick and North Moore Streets in Tribeca.[104] The locus of the city's supernatural activity is 55 Central Park West (Schwartz & Gross, 1930), called 550 Central Park West in the film. "A virtual character" in the movie, according to Paul Goldberger, the building was embellished by the art director, John DeCuir Jr., with several additional stories and an elaborate water tank enclosure that turns out to be a temple.[105] The film made extensive use of location photography, with scenes shot at Tavern on the Green, the main branch of the New York Public Library, the Municipal Building, and in Columbus Circle,

The Wiz, 1978. Scene still. Art director, Philip Rosenberg; director, Sidney Lumet. Universal/Photofest

where an oversized "marshmallow man" begins a destructive trek up Central Park West.

Ghostbusters II (1989), also directed by Reitman, focused even more on New York as a participant in the story, premised on the idea that the massive amount of negative energy produced by anxious and depressed New Yorkers had begun to manifest itself in a pernicious pink ooze that flowed beneath the city through what Goldberger described as "a surprisingly elegant system of tiled tunnels, the relics of an abandoned subway system."[106] This time around, the center of the film's evil spirits was an art museum represented by Cass Gilbert's U.S. Custom House. Goldberger noted that the Ghostbusters could triumph over the negativity only by "invoking the help of the one physical thing in New York that people still love, the one landmark that still inspires positive emotions: the Statue of Liberty."[107]

In Joe Dante's *Gremlins 2: The New Batch* (1990), the city is plagued not by ghosts but by an imaginary breed of furry creatures that turn evil under certain conditions. The film-makers did not pass up the opportunity to offer a critique of New York power players, offering a thinly veiled caricature of Donald Trump in their villain, Daniel Clamp, a real estate developer, businessman, and author whose headquarters, Clamp Center, is a mixed-use building modeled on Trump Tower but represented in the film by 101 Park Avenue, which is imagined as an overly computerized building with automated doors, elevators, lights, fountains, and digital voices welcoming, for instance, tenants to the men's room and wish-

ing people a "powerful day."[108] Paul Goldberger found the building itself to be more of a villain than Clamp. "A horrifyingly sleek and impersonal glass skyscraper built by a horrifyingly sleek and impersonal developer . . . Clamp Center embodies all that is awful about contemporary skyscrapers: it is huge, cold, and automated to a fault."[109]

In Barry Sonnenfeld's *Men in Black* (1997), the presence of extraterrestrials on Earth and especially in New York is understood to be part of everyday life. Two government agents played by Will Smith and Tommy Lee Jones are employed to keep tabs on them, leading to one sequence, according to Janet

Ghostbusters, 1984. Scene still. Art director, John DeCuir Jr.; director, Ivan Reitman. Columbia/The Kobal Collection

Men in Black, 1997. Scene still. Art director, Thomas Duffield; director, Barry Sonnenfeld. Columbia Pictures/Photofest

Maslin, in which a "chase leads spectacularly through the Guggenheim Museum, filmed not only for its dramatic look but also for its suggestion of spacecraft." Later in the story, "the World's Fair grounds in Flushing, Queens, are used to similarly ingenious effect."[110] James Sanders noted that these postwar landmarks suggested "an otherworldly dimension woven right into the city's fabric." A ventilator tower for the Brooklyn-Battery Tunnel in lower Manhattan, for example, "serves in the film as the secret entrance to the headquarters of a shadowy agency located deep below the surface" that turns out to be "an interplanetary Ellis Island, where refugees from across the galaxy are processed and admitted to Earth."[111]

Annabel Jankel and Rocky Morton's *Super Mario Brothers* (1992), based on the popular video game, imagined New York as it might exist in a sort of futuristic parallel universe where, as Michael Specter described it in the *New York Times*, "a giant fungus crawls across the city, feeding on brick and mortar. The Hudson River has become a dusty plain, and what's left of Manhattan—five seedy blocks surrounding the plundered towers of the World Trade Center—has turned into an eerie universe of reptiles and con men" known as Dinohattan.[112] The elaborate Dinohattan set was built in an 80,000-square-foot abandoned cement factory in Wilmington, North Carolina. In keeping with the vision of production designer David L. Snyder, who had also served as the art director on Ridley Scott's groundbreaking film, *Blade Runner* (1982), the movie's New York was "to be bright and aggressive and fast. It's a slightly warped Manhattan. . . . It's not supposed to be a bad place, just a crowded, urgent place. Some people may look at it and just say, 'Why would you live there,' just the way people always talk about New York. But I love the city, and I hope New Yorkers who see it will sense that. I don't want anybody to think we are making 'Escape From New York' here."[113]

Luc Besson's *The Fifth Element* (1997), starring Bruce Willis as a New York cab driver in the year 2259 who has to undertake interplanetary travels in order to save the Earth, offered a compelling view of New York in the future, in which a 300-foot drop in the sea level has deprived Manhattan of its status as an island and opened up the river-beds for development.[114]

The Fifth Element, 1997. Scene still. Production designer, Dan Weil; director, Luc Besson. Columbia/Tri-Star/The Kobal Collection

Superman: The Movie, 1978. Scene still. Production designer, John Barry; director, Richard Donner. Warner Bros/DC Comics/The Kobal Collection

Batman, 1989. Scenic painting. Production designer, Anton Furst; director, Tim Burton. Photograph by Stefan Lange. © 1989 Warner Bros. Inc. All Rights Reserved

Skyscrapers have grown to impossible heights while the bedrock of Manhattan has been excavated to a depth of 400 stories. The ground is now lost in a fog, while the city's skyscraper canyons, in a vision reminiscent of the "King's Views" published in the early twentieth century as well as of Fritz Lang's 1926 film, *Metropolis*, are as busy with air traffic as the streets once were with cars. Still, as James Sanders wrote, "however wild and extravagant this vision of the future, it plainly is New York—indeed, seems somehow *more* New York than the city of today, a place in which the energizing madness and near chaos of Manhattan's surface traffic has been extended in literally every direction."[115]

Superhero City

For many Americans, Superman, who first appeared in 1938 as a refugee from the planet Krypton with extraordinary powers to fight crime in the city of Metropolis, was the ultimate New York hero, even though the early television series depicting him used Los Angeles as Metropolis and its iconic City Hall setting as the Daily Planet building where his alter ego, mild-mannered Clark Kent, worked as a journalist.[116] Richard Donner's *Superman: The Movie* (1978) used an undisguised but fictionalized New York to represent Metropolis. Donner headquartered the Daily Planet in Raymond Hood's Daily News Building (1929), 220 East Forty-second Street, while he provided the villain Lex Luthor (Gene Hackman) with an imaginary lair beneath Grand Central Terminal because, according to Donner, "he's too cheap to invest in above-ground property."[117]

Donner's *Superman* was good clean fun, unlike Tim Burton's very dark 1989 film, *Batman*, also based on a comic-book hero.[118] The story of a rich industrialist, Bruce Wayne (Michael Keaton), who avenges his parents' murder by fighting criminals at night, was set in a dark and gloomy Gotham City designed by the production designer Anton Furst (also the designer of Planet Hollywood, see Interiors), whose work earned him the Academy Award. Although the movie was made on a series of soundstages and back lots at the Pinewood Studios outside London, according to Furst, "the idea for Gotham City was to take the worst aspects of New York City, go back 200 years and imagine"[119] what "might have happened if there was no planning commission and had it been run by pure extortion and crime. . . . We completely threw out any

concept of zoning and construction laws that insure skyscrapers are built so that light will still fall on the streets below. Instead, we maximized space, bridged over streets, built the buildings cantilevering toward the streets rather than away from them. . . . It was just a hell that had erupted through the pavement and kept on growing."[120] Paul Goldberger found Gotham City to be "the most extraordinary evocation of New York" since Fritz Lang's *Metropolis*, a New York that "is dark and intense, a place in which growth has run amok. It is full of skyscrapers, but every street feels like the dank spaces under the Brooklyn Bridge, cut off from light, cut off from any sense of urban life at all."[121] In the sequel, *Batman Returns* (1992), also directed by Burton, the art director Bo Welch designed Gotham City with more specific references to New York imagery from the 1930s and 1940s such as Rockefeller Center's heroic statues by Lee Lawrie and Paul Manship. David Ansen, writing in *Newsweek*, called it a "nightmare town: New York reimagined . . . as a half-Gothic, half-Bauhaus three-ring circus of corruption."[122]

Dick Tracy (1990), directed by Warren Beatty, who also starred as the comic-book detective created by Chester Gould in 1931, offered another surreal vision of New York, compressing, as the architectural historian Dietrich Neumann put it, "the imagery from New York City's most celebrated and heroic period, the 1920s to the early '40s, into a grandiose range of backdrops, street vistas, and matte paintings. . . . This is the New York City we know from photographs by Paul Strand or Andreas Feininger, from paintings by Charles Sheeler and Edward Hopper, from films such as King Vidor's *The Crowd* (1928) or Jules Dassin's *Naked City* (1948)." Yet, Neumann continued, "it seems to be much bigger than Manhattan was in the '30s, its skyline extending endlessly. The city has, it seems, continued to grow without adopting the stylistic changes brought about by European modernism in the late 1940s."[123]

While Superman and Batman, both characters created by DC Comics, lived in fictional cities, the superheroes created by DC's rival, Marvel Comics, most often resided in the real city of New York. For instance, the character of Dr. Strange resided at the nonexistent address of 166A Bleecker Street; Captain America lived in Red Hook, Brooklyn; the Avengers occupied a fictitious three-story townhouse built in 1932 at 890 Fifth Avenue; and the Fantastic Four occupied the "Baxter Building" at Forty-second Street and Madison

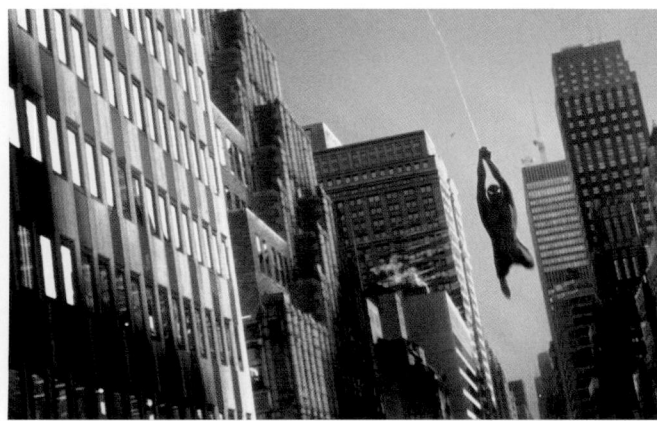

Spider-Man, 2002. Scene still. Art directors, Tony Fanning and Stella Vaccaro; director, Sam Raimi. Columbia/Photofest

Avenue. As Joe Queseda, Marvel Comics' editor in chief, stated, "It's important to us to keep the real world real. . . . The city is magic, total magic. That's why the Marvel Universe is centered here."[124] In the late 1990s, Marvel began putting its characters on film. *X-Men: The Movie* (Bryan Singer, 2000) featured a dramatic finale situated within the crown of the Statue of Liberty while the 2003 film *Daredevil*, directed by Mark Steven Johnson, told the story of Matt Murdock (Ben Affleck) who, blinded as a child growing up in

Hell's Kitchen, stuck around the neighborhood to fight crime as a prosecutor by day and as his alter ego, Daredevil, by night.[125] The film depicted a half-real, half-fantasy New York but lacked the artistic flair or originality of its contemporaries and was shot mostly in studios.

Sam Raimi's *Spider-Man* (2002), however, reveled in its New York location, telling the story of Peter Parker, a high-school student growing up in Forest Hills, Queens, who is bitten by a genetically mutated spider on a field trip to Columbia University (where a laboratory occupies the rotunda of Low Library) and takes on spiderlike powers, allowing him to scale walls and swing from vinelike webs through the skyscraper canyons of Manhattan.[126] Parker lives with his aunt at 20 Ingram Street, an actual address in Forest Hills Gardens that is depicted in the film not as the ivy-covered Tudor house built in 1916 that it is but as a modest, boxy two-story house lined up next to nearly identical neighbors. The movie was shot on location around the city, with the *Daily Bugle*, the hometown tabloid, occupying the Flatiron Building; a battle occurs in Times Square (modified to include a classically inspired skyscraper on the site of One Astor Place) between Spider-Man and his nemesis, the Green Goblin (Willem Dafoe), whose alter ego runs a company, Oscorp, headquartered in Kohn Pedersen Fox's 135 East Fifty-seventh Street (see Fifty-seventh Street); and the final showdown takes place on the Queensboro Bridge in which, according to the film critic A. O. Scott, "part of the

Independence Day, 1996. Scene still. Art director, Jim Teegarden; director, Roland Emmerich. 20th Century Fox/The Kobal Collection

thrill comes from seeing this sturdy structure given a star turn after years of neglect in favor of its more photogenic siblings."[127]

Catastrophe City

New York's status as an important world city, combined with its iconic landmarks and recognizable streetscapes, made it an ideal location for films depicting terrorism and disaster. While Blake Edwards's humorous *The Pink Panther Strikes Again* (1976) features a terrorist who eliminates the United Nations Secretariat with a laser, and Bruce Malmuth's *Nighthawks* (1981), taking a more serious approach, finds Sylvester Stallone dangling from the Roosevelt Island tram as he saves New York from German terrorists, for most of the 1970s and 1980s filmmakers shied away from scenes of devastation in the city. In the late 1990s, however, New York reemerged to play significant roles in a series of fictional events that, taking advantage of the cinematic possibilities of digital photography and special effects, imagined it besieged by one disaster after another. In Roland Emmerich's *Independence Day* (1996), America is attacked by aliens who arrive in spaceships that hover over Washington, D.C., Los Angeles, and New York and begin to beam powerful columns of light onto targets such as the Empire State Building, which is obliterated in a fiery explosion. Emmerich followed *Independence Day* with *Godzilla* (1998), in which the gargantuan lizard that first began its urban rampages in Tokyo in 1954 rose out of the sea to wreak havoc on modern Manhattan as military tanks, helicopters, and soldiers battle to destroy the monster.[128] Hundreds of extras and a dozen stuntmen were used in scenes filmed on Wall Street, at the Fulton Fish Market, on the FDR Drive and the Manhattan Bridge, in Central Park, and in Madison Square, where a huge pile of fish placed in the intersection of Broadway and Fifth Avenue was to lure the computer-animated superlizard who had made Madison Square Garden his nest and had plowed a hole through the Met Life Building.

Two films from 1998 traded on the possibility of destruction from outer space. *Armageddon*, directed by Michael Bay, found the Earth apocalyptically threatened by a Texas-sized asteroid heading toward it. The asteroid is eliminated but not the small meteors that precede it, raining down on various world cities, including New York, where the Chrysler Building, Grand Central Terminal, and the World Trade Center are blown to pieces.[129] Mimi Leder's *Deep Impact* (1998) imagines two comets heading toward the Earth, but only one is destroyed, allowing the other to crash into the Atlantic Ocean causing tidal waves that inundate the city, decapitate the Statue of Liberty, and roll in over the skyscrapers of lower Manhattan.[130]

In Mimi Leder's *The Peacemaker* (1997), destruction is threatened not by natural or even supernatural causes but by terrorists who have stolen nuclear warheads and plan on detonating them in New York. Most of the movie's action takes place in Eastern Europe, save a climactic chase through the streets of midtown Manhattan in which disaster is averted.[131] In Edward Zwick's scarily premonitory 1998 film *The Siege*, Arab terrorists are more successful, setting off a string of bombs destroying an MTA bus in South Williamsburg, Brooklyn, blowing up a Forty-second Street theater filled with a "veritable Who's Who of the city's cultural leaders," and finally ripping away a massive chunk of "One Federal Plaza," the FBI's fictitious counterterrorism headquarters, represented in the film by

Armageddon, 1998. Scene still. Production designer, Michael White; director, Michael Bay. Touchstone/The Kobal Collection

One Liberty Plaza (Skidmore, Owings & Merill, 1972).[132] In response to the attacks, martial law is declared and troops can be seen marching aside lines of armored vehicles all around the city—down Broadway, over the Brooklyn Bridge, and throughout Brooklyn, which, because of its high Arab population, is "sealed off" as Arab men are rounded up in house-by-house searches and brought to detention camps. "Among the film's most ominous shots," wrote Janet Maslin, "is one panning from a New York mosque to the Manhattan skyline, which looks like one big tempting target in the context of this story."[133]

The attacks on the World Trade Center on September 11, 2001, put a temporary halt to films depicting New York's destruction as the profundity of real devastation sank in. Footage of the burning buildings and their collapse, sending smoke billowing through the streets of lower Manhattan as people fled for their lives were eerily similar to Hollywood images. On September 12, MGM shelved production of its action-comedy film *Nosebleed*, which was to star the martial artist/actor Jackie Chan as a window washer at the World Trade Center who battles terrorists plotting to destroy the Statue of Liberty.

Nostalgic New York

Period movies were particularly popular from the 1970s through the 1990s, when filmmakers reveled in revisiting the clothes, cars, music, accents, and mannerisms of old New York, not to mention the long-vanished cityscapes, which were rendered in detail and at great expense through the use of dressed-up locations, scale models, sets, and computers. Martin Scorsese frequently delved into New York's past and made the film that was perhaps more nostalgic for the city itself than any other, the 1977 musical *New York, New York*, starring Robert De Niro and Liza Minelli as a saxophone player and singer who meet on V-J Day in 1945 as the city came alive in optimistic celebration, an apt message delivered as New York began to emerge from its fiscal crisis. Scorsese, one of New York's leading practitioners of location photography, instead used Hollywood back-lot sets for New York's exteriors and extravagant interior sets deliberately made to appear as such.[134] The movie was not well received, but one aspect did prove canonic, the theme song, "New York, New York," with music by John Kander and lyrics by Fred Ebb, whose line, "If I can make it there, I'll make it anywhere," became an anthem for the city as it struggled to recapture its glory.

Gangs of New York, 2002. On/off set. Production designer, Dante Ferretti; director, Martin Scorcese. Miramax/Dimension Films/The Kobal Collection/Tursi, Mario

So many films of the 1980s and 1990s were set in New York's past that nearly every decade since the 1840s can be seen on the silver screen as imagined by one director or another. Martin Scorsese's 2002 film *Gangs of New York* was set in the Five Points sections of lower Manhattan between 1846 and the draft riots in 1863. Inspired by Herbert Asbury's 1928 book and starring Leonardo DiCaprio, Daniel Day-Lewis, and Cameron Diaz, *Gangs of New York* was made on a vast set of lower Manhattan built at the Cinecittà studio complex in Rome, designed with varying levels of historical accuracy by Dante Ferretti, who also worked with Scorsese on *The Age of Innocence* (1993), combining still photography with matte paintings and moving images to re-create the New York of the 1870s described by Edith Wharton in her 1920 novel.[135]

Milos Forman's *Ragtime* (1981), an adaptation of E. L. Doctorow's work of historical fiction set in New York in 1906, starred James Cagney and featured the author Norman Mailer as Stanford White.[136] Filming took over the block of East Eleventh Street between Avenues A and B for a period of months, with entire new storefronts built by a crew of more than sixty. Scenes in the Morgan Library, which is held for ransom by a black piano player who threatens to blow it up, were filmed in studios in England, however, after the library refused to cooperate with the production. The building itself, along with four blocks of Madison Avenue around it, was built on a studio backlot.

Stephen Low's *Across the Sea of Time* (1995) depicted the New York of 1916 in three dimensions, made possible by the use of historical stereopticon slides, which the audience viewed through liquid-crystal lenses.[137] The old views of Hester Street, Union Square, Coney Island, Central Park, the Brooklyn Bridge, the Holland Tunnel under construction, and other sights were contrasted with current views of the same during the story of a young Russian boy who travels to New York. Francis Ford Coppola's *The Cotton Club* (1984), starring Richard Gere, Gregory Hines, and Diane Lane, portrayed the famous Harlem nightclub during its heyday in the 1920s and 1930s.[138] Both Gene Saks's *Brighton Beach Memoirs* (1986), from the Neil Simon play set in Brighton Beach in 1937, and Woody Allen's *Radio Days* (1987), set in Rockaway Beach in 1942, were deeply nostalgic autobiographical stories about coming of age in a Jewish family, both featuring extensive location photography.[139] Paul Kagan's *The Chosen* (1981), an adaptation by Edwin Gordon of Chaim Potok's novel, also focused on Jewish teens in 1940s New York.

Unchanged streetscapes were so hard to come by in the 1980s that the title *The House on Sullivan Street* was changed to *The House on Carroll Street* (1988) after the director Peter Yates deemed it too difficult to find a convincing 1951 location in Greenwich Village. Filming instead took place in Park Slope, Brooklyn, where two houses were used, one on President Street for exterior shots, the other on Garfield Street for interiors.[140] Uli Edel's *Last Exit to Brooklyn* (1990), from the controversial 1964 novel by Hubert Selby Jr., depicted violence, prostitution,

rape, and drug and alcohol abuse against the backdrop story of a union strike on the Brooklyn waterfront in 1952. Filming took place in studios and on location in Red Hook, providing what Roger Ebert deemed "one of the gloomiest and most depressing urban settings I've seen in a movie. . . . Vast blank warehouse walls loom over the barren pavements, and vacant lots are filled with abandoned cars where mockeries of love take place."[141] Richard Benjamin's *My Favorite Year* (1982) provided a more sanguine look at the 1950s, focusing on the early days of television and featuring location photography in favorite New York settings such as Rockefeller Center, Central Park, the Waldorf-Astoria, and on Broadway at Fiftieth Street, where 300 extras and fifty vintage automobiles re-created the hustle and bustle of postwar Times Square.[142] *The Hudsucker Proxy* (1994), directed by Joel Coen, who wrote the screenplay with his brother, Ethan, offered an imaginary view of New York in 1958 through the use of 1:24 scale models, creating what Caryn James, writing in the *New York Times*, described as a "lush, romantic image of a New York City that never was."[143]

Once Upon a Time in America (1984), a story about Jewish kids in Brooklyn who grow up to become mobsters, was directed by Sergio Leone, best known for his westerns. Spanning several decades—from the 1920s through the 1960s—the film was shot in Rome, Montreal, and New York, leading Vincent Canby to note that "nothing in the movie looks quite the way it should. Hilarious anachronisms abound."[144] Martin Scorsese tackled the genre of Italian-American Brooklyn mafiosi masterfully in *Goodfellas* (1990), which extends from the 1950s to the 1970s. Unlike Leone, Scorsese filmed in New York and as a result, as Canby wrote, the film "looks and sounds as if it must be absolutely authentic."[145]

Both Philip Kaufman's *The Wanderers* (1979) and Robert De Niro's *A Bronx Tale* (1993) depicted life in the Bronx during the 1960s. Kaufman's is a feel-good story about relatively harmless teenage gangs focused around the Grand Concourse and Fordham Road in 1963.[146] De Niro, in his directorial debut, "never venturing very far from East 187th Street," according to Janet Maslin, offers "a warm, vibrant and sometimes troubling portrait of the community it describes," aided by location shooting in the Bronx, Queens, and Brooklyn.[147]

Milos Forman brought *Hair*, the Broadway musical about youth counterculture during the 1960s, to the silver screen in 1979. The filming of the 1968-style "Be-in," a climactic moment in the film, involved several thousand extras who, to the annoyance of nearby residents, filled Central Park's Sheep Meadow, where they danced for hours on end to exceptionally loud music.[148]

Spike Lee's *Summer of Sam* (1999) recaptured the frenetic, paranoid, and anarchic mood of the summer of 1977, when the Son of Sam was on his killing spree, the city lost power in the midst of a heat wave and suffered significant looting, the sexual revolution was in full swing, and disco began to give way to punk rock.[149] The movie was centered in the Bronx among Italian-Americans who speculated about who might be the ".44 caliber killer," but also featured location shooting on Bleecker Street, at CBGB's, and in Queens.

The 1998 film, *54*, directed by Mark Christopher, retold the rise and fall of the 1970s' most popular nightclub, Studio 54, from the point of view of a fictional bartender played by Ryan Phillipe. The former *Saturday Night Live* cast member Mike Myers portrayed co-owner Steve Rubell but, as William L. Hamilton wrote in the *New York Times*, the "real star" was

the disco itself, which was reconstructed *in situ* at nine-tenths scale, complete with "the roving, revolving, two-story light columns that descended to the dance floor, the swaying moon with its companion cocaine spoon, the lounge's low banquettes that seemed to slide to the floor with Studio's patrons and the square, bare-chested-bartender showcase bar."[150] Whit Stillman also reflected on New York during the disco era as it faded into the 1980s in his film *The Last Days of Disco* (1998), starring Chloë Sevigny and Kate Beckinsale.[151]

Only six years elapsed between 1983, when Tama Janowitz's best-selling collection of short stories documenting the downtown art scene, *Slaves of New York* (1986), took place and 1989, when the producer-director team of Ismail Merchant and James Ivory released their movie of it. But the filmmakers, masters of the period piece, nonetheless treated it as such.[152] The film concentrates on the character of Eleanor (Bernadette Peters), a hat designer who cannot afford to move out of her artist-boyfriend's apartment (121 Mulberry Street) and is thus a "slave" to him. It was shot entirely on location, tracking Eleanor to art-world parties, galleries (the Pat Hearn Gallery, 735 East Ninth Street between Avenues C and D), artists' lofts (Milo Reice's), nightclubs, a high-style fashion show (filmed at a gay nightclub, the Saint, with 200 extras), and other arty venues. James Ivory, acknowledging that many deemed this a surprising choice of subject for him, explained, "I've been a New Yorker for 30 years. I felt I was neglecting the city, always doing Forster and James and films set in India. One sees so much around New York, and I'm always thinking, 'Gosh, that would be great in a film.'" He continued: "I see Tama's book as a fin de siècle book—its just a different siècle."[153]

Once Upon a Time in America, 1984. Scene still. Art director, Carlo Simi; director, Sergio Leone. Ladd Company/Warner Bros./The Kobal Collection

NEW YORK ON THE SMALL SCREEN

Although once a preferred and common setting for television programs, from the drab Bensonhurst kitchen in Jackie Gleason's *The Honeymooners* in the 1950s to the small but attractive one-bedroom apartment on the Upper East Side in Marlo Thomas's *That Girl* in the 1960s, by the mid-1970s, at the height of the fiscal crisis and a low point in the city's morale and self-esteem, television's most popular shows generally shunned a New York location. As veteran television writer and executive producer Gary David Goldberg noted in 1997 about the situation in the 1970s and early 1980s: "One of the Ten Commandments was, no one wants to see a show set in New York."[1] And the few successful programs set in New York hardly presented an attractive view of the city, whether the lower-middle-class Queens neighborhood inhabited by bigot Archie Bunker, played by Carroll O'Connor in *All in the Family* (1971–79), or the even grittier world found in the Manhattan taxi garage of the hit comedy *Taxi* (1978–83), starring Judd Hirsch and Danny DeVito. Still, there were exceptions, most prominently the irreverent ensemble comedy *Saturday Night Live*, which began broadcasting from Rockefeller Center in 1975 and proudly proclaimed at the beginning of each show, after a brief skit, "Live from New York, it's Saturday night!" What instead dominated the airwaves were shows based in smaller American cities and suburbs such as Milwaukee, *Happy Days* (1974–84) and *Laverne and Shirley* (1976–83); Cincinnati, *WKRP in Cincinnati* (1978–82); Dallas, *Dallas* (1978–91); Boston, *Cheers* (1982–93); and suburban Ohio, *Family Ties* (1982–89). Not only was New York as a location generally avoided but the city was also no longer valued as a production center, a role it had enjoyed at the outset of television's history. By 1965, all but ten of the major networks' ninety-six evening shows were produced in Hollywood, although New York was still home to most network news programs as well as some variety shows and soap operas.

Beginning in the 1980s, as the city's fortunes rose, more shows began to be set in the city, including four short-lived comedies, *Bosom Buddies* (1980–82), *Park Place* (1981), *Checking In* (1981), and *The Two of Us* (1981–82).[2] All were shot in California, with *Bosom Buddies* the best of the bunch, starring Tom Hanks and Peter Scolari as two young poorly paid advertising workers who, forced to leave their apartment after their building was condemned and encountering difficulty in finding an affordable apartment, decide to dress as women in order to gain entrance to a cheap all-women's apartment hotel. The first successful new show in the 1980s to champion city living was also significant as the first major hit to be produced in the city: *The Cosby Show* (1984–92), filmed at the Kaufman Astoria Studios in Long Island City, as well as at the NBC studios at Avenue M and East Fourteenth Street in the Midwood section of Brooklyn. Bill Cosby starred as Dr. Cliff Huxtable, an obstetrician, who occupied a spacious Brooklyn Heights townhouse that he shared with his attorney wife and five children.[3] Although it explored typical situation comedy plots, the series was notable not only as a rare example of presenting to the television audience an upper-middle-class professional African-American family but also because it showed New York City as a desirable place to raise a family. Almost all of the series was shot indoors, and the most prominent exterior scene showing the tree-lined Brooklyn street

where the Huxtables lived was in fact shot in the West Village along St. Luke's Place.

Also showcasing New York as an acceptable and safe environment for families was the comedy *Kate & Allie* (1984–89), starring Susan Saint James and Jane Curtin as two divorced mothers with their three children sharing a Greenwich Village apartment.[4] The popular series was also shot and produced in New York but again mostly limited its exterior views to an opening prologue filmed out-of-doors, often in front of the main characters' apartment building. *The Equalizer* (1985–89), starring British actor Edward Woodward as former spy Robert McCall who set up shop in Manhattan as a private detective specializing in hard-luck cases, was also shot and produced in New York but broke the mold of previous efforts by filming on average in ten different city locations for each weekly episode.[5] In addition to utilizing all five boroughs for street scenes, the show tried to use as many real interiors as possible, with an active crew of location scouts checking out possible apartments throughout the city.

It was not until the 1990s, however, that the city's desirability as a setting for all kinds of television shows really took off with a new generation of programs capitalizing on New York's renewed vitality, led primarily by a series of highly successful sitcoms. The first and perhaps most authentic was *Seinfeld* (1990–98), a self-confessed show "about nothing" that chronicled the daily activities of comedian Jerry Seinfeld and his group of friends who lived on the Upper West Side.[6] Although the show was filmed in Los Angeles, it featured some exterior Manhattan shots, none more prominent than the often-shown neon sign of Tom's Restaurant on the northeast corner of West 112th Street and Broadway in Morningside Heights, which quickly became a popular stop for picture-taking tourists. But the reason the quirky show rang true with city residents was that the characters acted and talked like genuine New Yorkers as they encountered situations that Manhattanites could easily recognize, from the frustrations encountered in apartment hunting, to the annoyance of an extended wait for a table in a restaurant, to the havoc visited on city streets by a major parade. *Seinfeld* was so popular that it set off a mini boom in guided tours visiting its key locations, including one led by Kenny Kramer, the real-life inspiration for the character Cosmo Kramer.

A slew of sitcoms set in New York but filmed in Southern California quickly followed in *Seinfeld*'s wake, including *Mad About You* (1992–99), a series that achieved a certain degree of

Tom's, northeast corner of West 112th Street and Broadway. Site of fictional Monk's coffee shop from *Seinfeld*, 1990–98. RAMSA

authenticity because its star, Paul Reiser, was a veteran New York comedian, and *Friends* (1994–2004), an ensemble piece that achieved enormous national popularity and helped to promote New York as a fun place for twentysomethings to live but never seemed to register with New Yorkers as a genuine reflection of their city. Referring to the spacious apartments enjoyed by characters with decidedly modest incomes, a spokesman for *Friends* stated that they hoped viewers would "suspend disbelief."[7] The growing string of comedy hits from the 1990s also included *The Nanny* (1993–99), *Caroline in the City* (1995–99), *NewsRadio* (1995–99), *Veronica's Closet* (1997–2000), *Just Shoot Me!* (1997–2003), *The King of Queens* (1998–), and *Will & Grace* (1998–2006). One of the new comedies, *Spin City* (1996–2002), was actually filmed in New York at Silver Screen Studios, located on Chelsea Piers. Starring Michael J. Fox as Deputy Mayor Mike Flaherty, the show was set in a re-creation of City Hall that partly rang true with *New York Times* editorial page editor Gail Collins, who wrote, "The offices look very much like the real ones downtown."[8]

It was not only situation comedies but also hard-hitting crime dramas that began to feature New York in the 1990s. *Law & Order* (1990–) and its various spin-offs led the way, with all series notable for being "emphatically New York," according to *New York Times* reporter Eleanor Blau.[9] In addition to filming on the city's streets and hiring New York theater actors, the producers provided local color with frequent cameo appearances by area politicians as well as the use of real police officers, who were sometimes given minor speaking parts. Dick Wolf, the producer of *Law & Order*, also came out with another crime drama set and filmed in the city, *New York Undercover* (1994–98).[10] A grittier, though still largely sympathetic, portrait of the city was provided by the police-drama *NYPD Blue* (1993–2005), which broke network ground for racy content and foul language.[11] Although shot on sound-stages and back lots in Century City, the program traveled to New York several times a season to film exterior scenes. Despite its Southern California base, many New York police officers praised the series as an accurate portrayal of their jobs.

New York also served as the location for an early example of the "reality show" genre when hip cable music station MTV chose the city for its first season of *The Real World* (1992), which followed the unscripted interactions of seven people in their twenties sharing a 4,000-square-foot duplex loft on Prince Street in SoHo.[12] Two short-lived dramas from the 1990s were also both set and filmed in the city: Robert De Niro's *TriBeCa* (1993), which produced only seven episodes, and an evening soap opera titled *Central Park West* (1995–96).[13] New York's television star continued to rise in the 1990s after late-night comedian David Letterman's move from NBC to CBS in 1993 where he occupied the renovated Ed Sullivan Theater on Broadway, often filming bits outside the studio in the immediate neighborhood (see Times Square). The major morning news shows, long headquartered in New York, also raised their city profile in the 1990s by moving to glassy new studios that provided generous exterior views of their environs to a national audience (see Times Square).

In October 1997 *New York Times* television critic Caryn James pointed out, "This season 20 network prime-time shows are set in the city. Seven were added this season, establishing fictional New York as the hot destination for television characters. . . . The reasons behind the new wealth of New York settings are as varied as the images of the city itself, which now veer from loopy to deadly. That variety itself signals a change from the old monolithic view of New York as crime-ridden, dirty, irredeemable. It is common knowledge that crime is down and tourism up in real life New York, making it a less threatening, more appealing locale for characters."[14]

One additional program from the late 1990s helped solidify New York's reputation as the most trendy place to be. *Sex and the City* (1998–2004), a pathbreakingly candid sitcom with soap-opera overtones based on Candace Bushnell's weekly column of the same name published in the *New York Observer*, recorded the social and sexual habits of four single thirtysomething women who were best friends.[15] The enormously popular cable program was shot at the Silvercup Studios in Long Island City but also featured extensive filming on the city's streets, from Jimmy Choo's boutique located in Olympic Tower, where the fashionable Carrie buys her shoes, to the SoHo gallery where Charlotte works, to the Magnolia Bakery on Bleecker Street in the West Village, famous for its sinfully rich cupcakes. Although the widely discussed and dissected program created a virtual cottage industry of columns and musings devoted to an analysis of the characters' motivations and feelings in the larger context of the role of women in contemporary society, the series also managed to stay true to the city. As writer Nancy Hass noted in 1999: "Of all the New York shows on televison, 'Sex and the City,' with its carefully chaotic street scenes, avant-garde fashions and minutely observed social rituals, may be the one that most fully taps into the city's current mood."[16]

NYPD Blue, 1993–2005. Scene still. Photofest

Sex and the City, 1998–2004. Production shot. Photofest

FALLING IN LOVE AGAIN:
NARCISSISTIC NEW YORK

Autobiographies of a Metropolis

Since Washington Irving's *A History of New-York from the Beginning of the World to the End of the Dutch Dynasty* (1809), an account written by the fictional Dietrich Knickerbocker, if not before, New York has been a font of artistic inspiration and a favorite subject of narcissistic self-examination, but never more so than in the years leading up to the millennium.[1] Seeming in direct relationship to its declining status in the hinterland, postwar New York increasingly came to hold itself in high regard as a special place—the urban equivalent of the traditional concept of American exceptionalism. More and more, writers and other artists fell in love with New York, or with an idealized image of the city. By the mid-1970s, the city's interest in itself was such that a bookstore, New York Bound, was opened to satisfy the demand for books, prints, and memorabilia, mostly rare and mostly old, relating to New York. Over the years the shop moved from the South Street Seaport to midtown, eventually settling at 50 Rockefeller Plaza to become a beloved resource for scholars and enthusiasts who previously had to make the rounds to antiquarian booksellers but could now indulge their passion with a visit to a single location. When it closed in 1997 because of lobby renovations to the building that eliminated retail space (the bookstore was profitable at the time of its closing), its devotees were crushed, among them Robert Caro, the historian, who deemed the loss "incalculable."[2] New York Bound was complemented by the Cityana Gallery, which only exhibited art relating to New York, at 16 East Fifty-third Street. Opened in 1977, it attracted wide attention in 1979 when it previewed the new subway map, but was short-lived, closing in 1982.[3]

As New York became increasingly self-involved, it also became more comfortable with itself and its complex history. Long-established institutions with deep ties to the once dominant WASP establishment—among them the New-York Historical Society and the Museum of the City of New York—were joined by new institutions dedicated to alternate histories. The Lower East Side Tenement Museum, opened in 1988, took ownership of an 1863 tenement at 97 Orchard Street and restored apartments within to represent different time periods (see Lower East Side). The Skyscraper Museum, opened on May 1, 1997, though not dedicated solely to New York's tall buildings, geared many exhibitions toward its hometown, also dedicating resources to the publication of books about the city's architecture and planning (see Battery Park City).[4]

Historical and architectural guidebooks to New York had been popular since the 1807 publication of Dr. Samuel L. Mitchill's *Picture of New-York: or, The Traveller's Guide Through the Commercial Metropolis of the United States. By a Gentleman Residing in This City*.[5] I. N. Phelps Stokes's *The Iconography of Manhattan Island* (1915–28) established an unrivaled standard for scholarship and detail while the Federal Writers Project's *New York Panorama*, published in 1938, and *W.P.A. Guide to New York City*, published in 1939, included excellent commentary on New York architecture and urban planning within a general overview of the city that also captured a lost city of incomparable vitality, diversity, and grace.[6] Both E. B. White's essay "Here Is New York," written in 1948 and first published in *Holiday* magazine before its publication

in 1949 as a book, and John Steinbeck's "Autobiography: Making of a New Yorker," published in the *New York Times* in 1953, were succinct but lyrical and nostalgic tributes to the city and all of its frustrations, charms, strengths, and vulnerabilities.[7]

But it wasn't until Norval White and Elliot Willensky prepared an architectural guidebook for visitors to the 1967 AIA Convention that a comprehensive guide to buildings in the five boroughs existed. The popularity of the book was such that a more substantial version was published in the following year.[8] The *AIA Guide to New York City*, short on historical information but vast in scope and full of opinions, was revised and updated in three subsequent editions published in 1978, 1988, and 2000, the last coming after Willensky's death.[9] Though the authorial tone was idiosyncratic to say the least— witty, irreverent, and annoying, with unspoken artistic prejudices and professional friendships frequently clouding the evaluations of individual buildings—the *AIA Guide* proved that there was an audience for architectural guidebooks, a genre that proliferated during the 1980s and 1990s.[10] Paul Goldberger's *The City Observed*, published in 1979, surveyed only Manhattan but provided thoughtful essays on both individual buildings and neighborhoods, tending to emphasize the value of New York's pre-Modernist era.[11]

Barabaralee Diamonstein-Spielvogel's four editions of *The Landmarks of New York*, published in 1988, 1993, 1998, and 2005, not so much a guidebook as a scholarly catalog, described New York's growing inventory of designated landmarks,[12] as did the Landmarks Preservation Commission's own guidebook, published in 1979 and updated in 1992, 1998, and 2000.[13] In 1987 Christopher Gray began his Streetscapes column in the *New York Times*, offering detailed histories of both architectural masterpieces and forgotten workaday buildings in New York that were usually about to undergo some sort of change, be it renovation, restoration, demolition, or sale. In 2003, 190 of the columns were collected in the book *New York Streetscapes: Tales of Manhattan's Significant Buildings and Landmarks*.[14] Other guidebooks focused on specific components of the built environment, among them Margot Gayle and Michele Cohen's *Guide to Manhattan's Outdoor Sculpture*, published in 1988.[15] John Yang's photographic survey, *Over the Door: The Ornamental Stonework of New York*, published in 1995, and Susan Tunick's 1997 study of terra-cotta in New York, *Terra-Cotta Skyline: New York's Architectural Ornament*, featuring photographs by Peter Mauss, complemented earlier examinations of specific building materials, including Margot Gayle's 1974 study, *Cast-Iron Architecture in New York*.[16]

In addition to the steady publication of books on New York's overall history and development,[17] nearly every facet of the city's built environment became the subject of investigation with none more revealing, even shocking, than Jerold S. Kayden's exhaustive study prepared with the Department of City Planning and the Municipal Art Society, *Privately Owned Public Space: The New York City Experience* (2000), in which every one of Manhattan's 503 privately owned public spaces was surveyed, photographed, and analyzed. These spaces had been created in return for additional building bulk, a trade-off that was allowed as part of the new zoning of 1961 which sought to promote the model of isolated towers set in continuous open space as opposed to street-hugging buildings. Kayden's bleak conclusion formed a devastating attack on

Lower East Side Tenement Museum, 97 Orchard Street (1863), between Delancey and Broome Streets. View of restored apartment. SB

prevailing zoning practice as well as lax enforcement of previously negotiated agreements: "Many spaces are nothing more than empty strips or expanses of untended surface," he wrote, "while others have been privatized by locked gates, missing amenities, and usurpation by adjacent commercial activities." While worthwhile privately owned parks could be found, the study concluded that "41 percent of the 503 public spaces are of marginal value."[18]

An important but hitherto neglected aspect of the city's development was its infrastructure. New Yorkers began to see that "the spirit of New York City," as New York Times art critic Michael Kimmelman wrote in 1990, "in other words, its grandness and vitality, has always resided as much in its infrastructure—its snaking tunnels and hulking bridges—as in its superstructure of soaring skyscrapers and glossy storefronts. To miss the unseen city is almost to miss New York."[19] Norval White's New York: A Physical History, published in 1987, was organized into thematic chapters that included not only architectural styles and building types but also discussions of water supply, transportation, and public works, providing what David W. Dunlap called "an appropriate accompaniment to a period in which physical development is a hot topic and a subject of major importance."[20] The history of the subway system was examined in books like Clifton Hood's 722 Miles: The Building of the Subways and How They Transformed New York (1993) and Michael W. Brooks's Subway City (1997), an account of the subway's role in literature, film, art, and popular culture.[21] Sharon Reier explored The Bridges of New York in 1977 while JoAnne Abel Goldman investigated the way New York disposed of its sewage in her 1997 book, Building New York's Sewers: Developing Mechanisms of Urban Management.[22] Harry Granick's 1947 book, Underneath New York, attempting an explanation of nearly every subterranean infrastructural component in the city, was reissued in 1991 with a new introduction by Robert E. Sullivan Jr. that brought the story up to date with topics like cable TV, recent steam pipe explosions and water main breaks, and the removal of asbestos from manholes.[23] Stanley Greenberg took haunting black-and-white photographs of mostly off-limits infrastructural components throughout the five boroughs ranging from the seemingly endless shaft of City Tunnel No. 3 in Queens to the Staten Island anchorage of the Verrazano-Narrows Bridge.[24] Rebecca Read Shanor's 1988 book, The City That Never Was, illustrated and discussed 200

years' worth of mostly unrealized proposals running the gamut in scale and type while making the point that serendipity and chance just as often determined what was built in New York as did planning and principle.[25]

As New York's waterfront emerged from its industrial past to host a range of new uses and become the subject of both comprehensive and piecemeal redevelopment plans, its history was examined in historical works like Ann L. Buttenwieser's Manhattan Water-Bound: Manhattan's Waterfront from the Seventeenth Century to the Present, first published in 1987 and updated in 1999, and contemporary studies like Raymond W. Gastil's Beyond the Edge: New York's New Waterfront, published in 2002 as a timely examination of proposals and recently built projects throughout the five boroughs and New Jersey.[26]

While the outer boroughs and various neighborhoods therein were fodder for their own genre of books focusing mainly on early history and development,[27] seemingly every area of Manhattan was picked apart and examined in volumes devoted to important streets, squares, and neighborhoods, as well as Central Park.[28] David W. Dunlap's On Broadway: A Journey Uptown Over Time described the length of the city's premier thoroughfare from Bowling Green to Marble Hill—address by address—as it existed at the time of the book's publication in 1990 and during earlier eras.[29] Both James Trager's Park Avenue: Street of Dreams (1990) and Jerry E. Patterson's Fifth Avenue: The Best Address (1998) presented a combination of the architectural and social histories of their respective avenues,[30] while Times Square and Forty-second Street inspired numerous publications, ranging from academic works like Inventing Times Square: Commerce and Culture at the Crossroads of the World, a 1991 collection of essays edited and introduced by historian William R. Taylor, to sociocultural accounts such as the one by science-fiction author Samuel R. Delaney, Times Square Red, Times Square Blue (1999), a graphic memoir of the gay movie-house culture of "the Deuce" and Eighth Avenue which had all but disappeared by the mid-1990s, to political and economic considerations of the district's physical redevelopment beginning in the 1980s, the finest being Lynne B. Sagalyn's Times Square Roulette: Remaking the City Icon (2001).[31]

Whole books were also devoted to single buildings—either from the past, like John Tauranac's 1995 Empire State Building: The Making of a Landmark, or from the present, like Jerry Adler's story of the construction of the Bertelsmann Building at 1540 Broadway, High Rise: How 1,000 Men and Women Worked Around the Clock for Five Years and Lost $200 Million Building a Skyscraper, published in 1993.[32] For Adler and others like Tom Shachtman, who wrote Skyscraper Dreams: The Great Real Estate Dynasties of New York (1991), New York's iconic buildings were perhaps only as interesting as the personalities responsible for their construction.[33] Other books were devoted to specific types of buildings, with several works examining, for instance, the city's housing—from low-cost to luxury—of which Richard Plunz's A History of Housing in New York, published in 1990 and delivering what its title promised, served as the most comprehensive.[34]

As the number of studies increased, so too did their scale. Coinciding with similar books about other world cities was the beginning in 1983 of this series on New York's architecture and urbanism with Robert Stern, Gregory Gilmartin, and John Massengale's New York 1900, itself the outgrowth of an

42nd Street. Dan Weaks, 1982. View of the north side of 42nd Street between Seventh and Eighth Avenues. MG

"Williamsburg Bridge" from *Flood! A Novel in Pictures*. Eric Drooker, 1992.
ED

essay in a 1981 book, *The Making of an Architect, 1881–1981: Columbia University in the City of New York*, published on the occasion of the centennial of Columbia's architecture school.[35] Calling *New York 1900* "a monumental achievement of assemblage," Paul Goldberger noted that particular chapters were "thorough and good enough in most cases to stand as books on their own—there is more here on the development of the New York apartment house, for example, than in any other single book, as much on the growth of the Upper West Side or Park Avenue as can be found in any other source."[36] Surprising to the authors, who attempted a distanced perspective, both *New York 1900* and *New York 1930*, published in 1987, were considered by some to be overly romantic views of their respective time periods.[37] *New York 1960*, published in 1995, continued the "encyclopedic" approach that Richard Guy Wilson pointed to in *New York 1930*, where both "grand civic buildings and tiny shops, great complexes like Rockefeller Center and the 1939 fair, 'The World of Tomorrow,'" were discussed.[38] When *New York 1880* was published in 1999, James F. O'Gorman, an art historian, reviewing the volume in the *New York Times*, found the book to be detailed to the point of fatigue but ultimately "architectural history with a capital H. . . . Buildings are tightly locked into the urban technical, social, political, economic, demographic, stylistic, and other conditions of the place and period. They appear to have been extruded out of the historical pressures of the age, and that is what architectural history should achieve."[39]

Detailed though the *New York* series was, it did not attempt the entire city's story, nor was it a political history. It was not until 1999, when Edwin G. Burrows and Mike Wallace published their exhaustively researched *Gotham: A History of New York City to 1898*,[40] that such a history was made available, although for an earlier era, or perhaps even with the monumental publication, *The Encyclopedia of New York City* (1995), featuring more than 4,000 entries written by 680 contributors and requiring, in all, more than a thousand people to bring it to completion over thirteen years.[41] All in all, the most provocative book on New York was Rem Koolhaas's brilliant *Delirious New York*, published in 1978, offering a theory of architecture and urbanism based on the city's growth—a growth that most writers had hitherto dismissed as little more than commercial pragmatism run amok.

The proliferation of scholarly, irreverent, and speculative books about New York had, by the late 1980s, become an undisputed phenomenon of publishing—no longer a self-centered enterprise but a reflection of the world's interest in the city. Though the spate of New York books addressed the city's physical history, these publications also addressed the lost sense of civicism that plagued the century's last decades, as well as the decline in quality of the city's architectural and infrastructural projects. As a consequence of this decline, books about contemporary architecture in New York were scarce. The 1989 volume *New York Architecture: 1970–1990*, edited by Heinrich Klotz with Luminita Sabau, was one of few to present recently built, in-progress, and proposed buildings by prominent designers.[42] When in the late 1990s the city's architecture once again began to capture the world's attention, several works catalogued recent buildings and projects, among them Alan Balfour's *World Cities: New York*,[43] part of a series

on contemporary architecture in cities around the globe, and the critic Susanna Sirefman's pocket-sized but sharp-tongued guidebook, *New York: A Guide to Recent Architecture*, published in 1997 with a second edition issued in 2001.[44]

Accompanying the guidebooks and written descriptions of New York was an outpouring of illustrated books and visual odes to the city.[45] Eric Drooker's *Flood! A Novel in Pictures* (1992) used black-and-white WPA-style illustrations to create what Art Spiegelman called a "complex, dream-charged vision of alienation in the wet, mean streets of New York City."[46] Other such books were written to capture the city's special delights. Folk Artist Kathy Jakobsen's *My New York* showed New York as a wondrous and friendly town, the way a child might see it.[47] In *Manhattan Unfurled* (2001), Matteo Pericoli presented, without narrative, a detailed illustration of the entire perimeter of Manhattan as seen from the water in one continuous drawing that could be folded out, accordion-style, to a length of twenty-two feet while his subsequent *Manhattan Within* (2003) depicted the buildings along all four borders of Central Park, also in one continuous drawing.[48]

For some photographers, documenting the city and its transformation became an obsession. Camilo José Vergara traveled to New York's most blighted areas over a period of decades to record decay and revitalization.[49] Dan Weaks photographed virtually every inch of every street in midtown Manhattan during the 1980s, compiling the images into photomontages. And beginning in 1983, Clayton Patterson filmed life in the East Village and Lower East Side; by 1999 he had an estimated 4,000 hours of 8-millimeter and half-inch footage, including the most complete video footage taken of the August 1988 riots in Tompkins Square Park (see East Village), and over 750,000 color photographs.[50] Other photographers presented the beauty and complexity of the city as seen from above, at night, even underground, as well as the diversity of its environments—from the dense street life of Manhattan to the waterfront to the natural ecologies in the outer boroughs.[51] Jean-Claude Suarès's *Manhattan* (1981) was a compilation of works by some sixty-two photographers who captured "a sense of the city's overwhelming size and vitality, the crushing density of its crowds, the continuous transformation," through color photography arranged in thematic sections like "Winter," "Crowds," "Speed," "Visitors," and "Reflections" to provide a rosy portrait of New York as it emerged with renewed self-esteem from the doldrums of the 1970s.[52] Photographer Richard Berenholtz's *Manhattan Architecture*, published in 1988 after the building boom had given the city many new architectural faces, was a lavish tribute to "the flashiest component of the greater city of New York" and "one of the century's great urban centers" that, "by taking the metropolitan phenomenon to the nth degree . . . has come to symbolize them all."[53] Berenholtz chose only the most photogenic subjects, clearly intending an unadulterated celebration of the city, with sweeping skyline views, detailed depictions of architectural ornament, restaurants, bridges, wall paintings, museums, clocks, and historic buildings as well as gleaming new skyscrapers.

New York: A Documentary Film, written by Ric Burns and James Sanders, and directed by Burns, who also produced the series with Lisa Ades, brought the city's history to a national audience. The project was aired on public television in 1999–2000 as a seven-episode series. An eighth segment was made about the events of September 11, 2001, airing in September 2003.[54] Though the series was packed with historical drawings, photographs, and footage focusing on the physical construction of the city and important historical events, some critics felt that not enough air time was given to the personalities who shaped the city. In 1999 the documentary was condensed into a book, *New York: An Illustrated History*, written by Burns, Sanders, and Ades, which was expanded and reissued in 2003.[55]

STYLES

The replacement of a virtually hegemonic, singular Modernism by the multiplicities of Postmodernism in the late 1970s marked the first significant paradigm shift in American architecture since the Museum of Modern Art successfully proselytized for the International Style almost fifty years before.[1] With traditionalism banished to the margins, Modernist architecture had dominated American practice for over three decades as architectural tastes depended heavily on the example set by the pioneering figures of Le Corbusier, Walter Gropius, and Ludwig Mies van der Rohe, the latter two having immigrated to America from Europe in the late 1930s. These so-called pioneers of Modernism all actively practiced their art well into the 1960s. Their only rival, and the only American-born pioneer of Modernism, Frank Lloyd Wright, continued to produce new designs until his death in 1959. By the late 1950s, the next generation, made up of the students and disciples of Modernism's "form givers," struggled to find new directions for their work. That search, though within the framework of Modernism, took into consideration issues of historical and cultural context, which Modernism had largely dismissed, thus paving the way for a new, or Postmodernist, phase.[2] The neoclassical work of Philip Johnson at Lincoln Center, the Expressionist work of Eero Saarinen at TWA's terminal at Idlewild (John F. Kennedy) airport, and the Venetian Palazzo-inspired Gallery of Modern Art by Edward Durell Stone were notable New York examples of the newly liberated approach of the so-called second, or American, generation of Modernists. Significantly, though Johnson had studied under Gropius at Harvard and had been an important disciple of Mies, both Saarinen and Stone had received their formal training when the Beaux-Arts system still held sway over American architecture schools.

The impulse to link Modernism with the history that the apologists for Modernism had been largely dismissive of was bolstered by historians and theorists such as Colin Rowe, whose essays "The Mathematics of the Ideal Villa" (1947) and "Mannerism and Modern Architecture" (1950) were particularly influential, as were the writings of Vincent Scully, whose book *The Shingle Style and the Stick Style: Architectural Theory and Design from Richardson to the Origins of Wright* (1955) reclaimed nineteenth-century domestic architecture for contemporary practice.[3] But the reaction against the ahistorical, technology-obsessed functionalism of the International Style was also fed by a reactionary anti-Modernism as a whole, as seen in the writings of Henry Hope Reed, whose Pugin-inspired *The Golden City* (1959) offered a devastating critique of contemporary architecture.[4] Reed's book called Modernism to task for its reductivist formalism and even more for its inherent anti-urbanism, an argument that was brought to a wide readership by Jane Jacobs in her best-selling

polemic, *The Death and Life of Great American Cities* (1961).[5]

In the 1960s a new generation began to break decisively with Modernism, formulating an ironic but complex approach to design that embraced two Modernist taboos—architectural history and commercial culture. In a series of provocative projects and with his book of 1966, *Complexity and Contradiction in Architecture*, Robert Venturi established himself as the intellectual leader of this Postmodernist movement (although he later vehemently denied having ever been a Postmodernist).[6] Venturi's contribution was complemented by the writings of the Italian architect Aldo Rossi, whose book *The Architecture of the City* recovered the principles of typological design and traditional urbanism for contemporary practice.[7] Postmodernism tore off Modernism's self-imposed blinkers, repudiating its totalizing utopianism which, in the postwar era, had resulted in buildings belligerently unrelated to place or symbolic purpose and to an urbanism that was largely and, it seemed, deliberately unconcerned with quotidian life, not to mention the vocabulary of streets, boulevards, squares, parks, and the like hitherto shared by virtually every city, town, or village. As Charles Moore, after Venturi, America's most important Postmodernist, put it in 1978: "Sometime in the '60s, many architects and architectural students stopped looking entirely for the light at the end of the tunnel and started adjusting our vision to the light in the tunnel itself."[8]

The late 1970s and early 1980s, especially the year 1978, when Philip Johnson's pedimented design for AT&T was released for public scrutiny (see Madison Avenue), were the heyday of Postmodernism. At its best, Postmodernism was a kind of meta-style, a comment on other styles or phenomena, with a frank use of ornament deliberately "slapped on," as Robert Jensen wrote, not with the intention of decorating "essential parts of the building, as historic ornament was," but to symbolize other things, with the hope that the symbols might be "immediately recognizable to everyone."[9] As Philip Johnson put it in 1979: "What they mean [by Postmodernism] is . . . freedom from the moralities of the do-goodiness and the dullness of flat top boxes. A very important thing to remember, which people accuse me of not remembering, is that modern is one of the things you're post, as well as being post revivalism and so on. . . . I don't think," Johnson added, "the changes are as dramatic as the press has it" or as the "kids making noise" would have it, referring to the younger generation of Robert Stern, Michael Graves, and Peter Eisenman.[10] While efforts by some of the "kids" to promote a Postmodern style, one based on contextualism, allusionism, and ornamentalism, were perhaps overly enthusiastic, a wider and deeper understanding of the Postmodernist condition began to emerge as architects connected with artists and intellectuals in other disciplines to demand a "pluralist and questioning" approach.[11]

Suddenly, in the early 1980s, Modernism's claim to be not only a permanent revolution but also the constituent condition of twentieth-century culture was under attack in a war of words between leaders of the two ideologies. Understandably, the Modernists reacted to the Postmodern challenge with dismissive hostility. James Marston Fitch, an architectural historian, preservation educator, and later consultant to Beyer Blinder Belle, a firm specializing in preservation-related work, was typical of many who dismissed Postmodernism as a

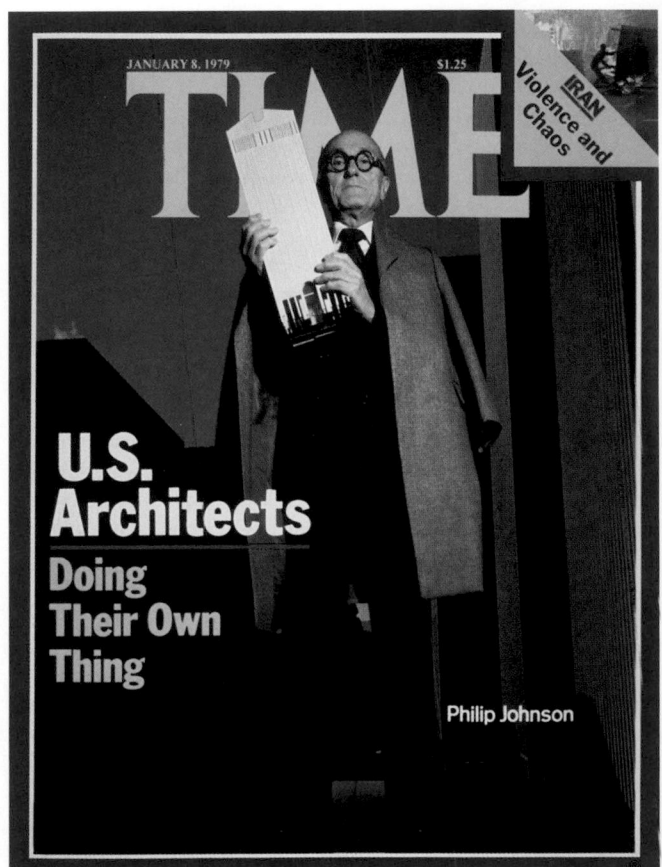

Time magazine, January 8, 1979. Philip Johnson holding a model of the AT&T Building. TIME

return "to that waxwork museum of historicizing anecdote, that prison house of antique gesture which was fin-de-siècle eclecticism."[12] Clearly, there had not been such a battle between ideas or generations since the youth-sponsored International Style swept the traditionalism of the older generation of architects off the center stage of world architecture. Fitch, a young turk in those days, now resentful that a new day was dawning, found the "situation at once perilous and comic. One might liken it to the sacking of Rome by the barbarians. But a more apt analogy might be to those merry, mad and murderous children who, in Richard Hughes's *High Wind in Jamaica*, took control of a ship at sea and forced the adults to walk the plank." Beyond Fitch's anger over Postmodernism, and especially its celebration of historical eclecticism, lay an important point: Modernism had come to the United States as a style sponsored by art historians attached to an art museum (MoMA) that "split the unity of form and function, esthetic and ethic, which the first great revolutionaries aspired to. The profession may have shifted its allegiance from the florid exuberance of the Beaux-Arts to the astringent purity of the Bauhaus. But it continued to celebrate the formal and increasingly to denigrate the functional."[13]

To counterbalance the claim that Postmodernism and especially young Postmodernist architects were "excessively predisposed toward esthetic concerns," and thereby aestheticized and by extension trivialized the critique of Modernism that was at the heart of the student unrest in the late 1960s, Robert Stern attempted to situate the movement in the broad stream of historical and contemporary culture, arguing,

"History, no longer viewed as the dead hand of the past, now seems at the very least a standard of excellence in a continuing struggle to deal effectively with the present. Modernism looked toward the future as an escape from the past. . . . Postmodernism struggles with the legacy of that attitude, a world filled with objects whose principal artistic impetus often came from a belief that in order to be 'Modern' they must look and function as little as possible like anything that had been seen in the world before. The traditional post-modernist struggle then, is not to free itself from the past, but to relax what has been characterized as 'the stubborn grip of the values created by the rebellion against the past.'"[14]

Postmodernism represented a fundamental change in the relationship between architecture and the public, resulting in a shift to an architecture of communication as opposed to one of production or revelation. As Stern put it: "Post-modernism seeks to regain the public role that modernism denied architecture. The post-modern struggle is the struggle for cultural coherence, a coherence that is not falsely monolithic, as was attempted in the International Style in architecture or National Socialism in the politics of the 1920s and 30s, but one whose coherence is based on the heterogeneous substance and nature of modern society; post-modernism takes as its basis things as they are, *and* things as they were. Architecture is no longer an image of the world as architects wish it to be or as it will be, but as it is."[15]

Postmodernism's critique of the Modernist establishment had an impact that was made dramatically clear on December 8, 1980, when the partners of Skidmore, Owings & Merrill, the principal proponents of postwar corporate Modernism, invited a group of Postmodernists to a private meeting in the great hall of the Harvard Club. Participants sat at a U-shaped table, "lined up," as Paul Goldberger reported, "like the opposing sides of an international diplomatic negotiation." The Skidmore firm, though highly prosperous, was no longer the artistic powerhouse it had been in the 1950s and 1960s, when it was the leading corporate interpreter of the ideas of Le Corbusier and especially Mies, and when its principal design partner, Gordon Bunshaft, was considered equal to independent artist-architects such as Eero Saarinen and Philip Johnson. Times had clearly changed. As Goldberger put it: "That the event took place at all was remarkable; it was, in every sense, a confrontation between architecture's establishment and its anti-establishment. But it was also a sign that design directions in architecture have begun to shift dramatically," while SOM "has paid little heed in recent years to new developments."[16]

At the meeting, Skidmore was represented by Michael McCarthy, Raul de Armas, Donald Smith, Thomas Killian, and Jan Pietrzak, while the Postmodernists were represented by Michael Graves, Steven Peterson, Jorge Silvetti, and Robert Stern. Each side presented slides of its current work, with Skidmore showcasing projects that Goldberger felt had "somewhat more eccentricity" than the characteristic "stark boxes of years past." These included the design for Irving Trust's operations center in lower Manhattan (see Financial District), "a bulky structure with elaborate setbacks, a rounded corner, a central atrium and a coating of stripes of white, silver and clear glass." But "that was not enough for the post-modernists, who rejected the new designs as they had rejected the firm's earlier work."[17] As Robert Stern put it: "The kinds of buildings Skidmore builds are boring—tall or short, fat or thin, if you've seen one you've seen them all."[18] Ironically, even Skidmore's partners were reluctant to defend the Modernism with which they were typically associated, with de Armas characterizing it as "exclusive and limiting and often without grace."[19] The most prominent Postmodernist building shown during the evening was Michael Graves's Public Services Building in Portland, Oregon, then under construction, a building Goldberger found reminiscent of "the immense, ornamented storage warehouses that moving companies used to erect in Manhattan decades ago."[20]

In her year-end column for 1980, Ada Louise Huxtable, hardly a Postmodern enthusiast, used the Harvard Club debate as an occasion to discuss the shift in architectural aesthetics. Calling 1980 "the year in which schizophrenia took over officially in architecture," Huxtable described the Harvard Club evening as "the event of the year." "The truly remarkable feature of the meeting," Huxtable continued, "was that S.O.M. asked for it, in a 'What are we doing wrong?' spirit, which might be freely translated as what do you guys know that we don't know. 'Practice' and 'polemic' lined up on opposite sides of the table. S.O.M. was told that the austere glass box is out and decoration, color and historical allusion are in. The ultimate putdown was delivered: Modern is a bore."[21]

Michael Sorkin, another disappointed Modernist, writing in 1980, also had to acknowledge the cultural shift that Postmodernism represented. Convinced that "historicism is unquestionably the dominant mode of the moment," Sorkin wrote, "There is virtually no one involved in the higher aspects of American architecture who fails to describe his or her work in terms of explicit *precedent*. History has reappeared in the schools and magazines and a certain, 'Let a Hundred Flowers Blossom' attitude has cropped up. Even the architectural equivalent of wit has come to be highly valued. As the result of all of this, public consciousness of architecture has never been higher, yielding such things as Philip Johnson on the cover of *Time* magazine which has looked more indulgently on the arts since the death of General Chiang." Sorkin was uncomfortable with Postmodernism's argument: "Since America is a country without a national style, every architect feels obligated to invent it. And to defend it. We never tire of dredging up antecedents for the look of the moment. . . . But one grows bored with this self-conscious polemic and its dubious corollary that anything which can be justified as non-modernist can also be defended as important work."[22]

Sorkin, picking up on Stern, pointed to the emergence of two kinds of Postmodernism, one seeking, as it were, to go behind Modernism and work with traditional styles, the other to revive Modernism by returning to its early iconoclastic tropes, particularly those of Expressionism and Constructivism, and especially the canonical work of Le Corbusier: "Perhaps the most interesting thing about the current wave of eclecticism is that it is the first in which modern architecture has itself been revived, a style coequal with all the rest. The scene abounds with neo-Mieses, neo-Ouds, neo-Corbs, neo-Rationalists, neo-Fascists, neo-Schinkels, neo-Shingles, and neo-neo-classicists. Writers have established reputations simply producing score-cards. Taxonomy fever has swept the country as serious architects busy themselves trying to out-Lutyens one another or to become the first to use

metopes with strip windows or a cyma reversa with glass block. The key figure in all of this just now would seem to be Corb, especially the early cubist Corb, and a kind of cult of the young Corb has sprung up. Like Marx, Corb has left a large and varied body of work which revisionists are able to pick over, hunting up such precedents that resonate with their own sensibilities."[23]

Postmodernism's victory over orthodox Modernism seemed secure when, in 1982, Hilton Kramer, in his last column as the *New York Times*'s art critic, proclaimed, in reference to painting and sculpture: "Modernism is, quite simply, no longer the only game in town. (It never was, of course, but it was often seen to be.) . . . We are none of us now—either artists or critics or the public—quite as susceptible as we once were to the idea that at a given moment in time history ordains that one and only one style, one vision, one way of making art or one way of thinking about it, must triumph and all others consigned to oblivion. If we are not actually wiser now, we are at least a little less foolish than we were."[24] Kramer wisely saw that Postmodernism did not kill Modernism, but instead, altered "our relation to this modernist tradition. . . . The modern movement was always, perhaps, a more complex and pluralistic phenomenon than its more doctrinaire champions—and, for that matter, its more doctrinaire enemies—could ever bring themselves to recognize. It required a certain historical distance to see it whole—to see what it was, and what it was not. In this respect, at least, postmodernist art has certainly performed a service of sorts, albeit at a great cost in spirit. In a purely negative way, it has placed the modernist heritage in dramatic historical relief, and thus helped to redefine its importance to us."[25]

Ada Louise Huxtable, who initially resisted and then came to revile Postmodernism, felt obliged to assess the current situation in two articles each published in the *New York Review of Books* and then republished in *Architectural Record*, ensuring that they would be widely discussed, not only inside the profession but among others interested in the flow of ideas.[26] Huxtable's recognition of Postmodernism's emergence was begrudging, to say the least. For Huxtable, the Postmodern debates went on "*ad ennui*, and in some cases, *ad nauseum*; the different schools are united only by the belief that modernism is a thing of the past. The tendency is to write it all off as a temporary, wrong-headed aberration. Some of this is genuine soul-searching and the painful rites of architectural passage, and some of it is fashion, the cruelest modifier of all. Tough luck for those who believed and built; they are out of fashion now. The rush to renunciation has become a stampede." Huxtable, once the champion of the new, found herself defending the establishment: "Forgive me if I say that I am finding it all very tiresome," she wrote, referring to the proliferation of debates and discussions about Postmodernism. "I mean pretentious, small-minded, lacking in historical knowledge or perspective. First, I do not agree that modern architecture is dead, or even dying. . . . I believe that some of what is called post-modernism is not so much a break with modernism as an esthetic and intellectual enrichment of the modern movement, a more complex and interpretive development that builds clearly on what went before." But in so saying, Huxtable was reflecting the most widely held view of Postmodernism. Like it or not, she was unable to deny the fact that "as a movement . . . modern architecture is growing old." Still, despite her personal displeasure—or was it disappoint-

ment?—with the turn of events, Huxtable proved herself a knowledgeable and discerning critic capable of an admirable balance: "The pendulum is swinging from the desire to remake the world to the desire to remake art. But from the ghetto activism of the architects of the 1960s to the closed and esoteric preoccupations of the 1980s is a traumatic swing."[27]

By the mid-1980s, the debate over Postmodernism had begun to run its course. In his editorial for December 1986, Stanley Abercrombie, editor of *Interior Design*, offered an "Obituary: Postmodernism, 1972–1986," which was, in many ways, on the money.[28] Stylistic Postmodernism, or PoMo as it was widely referred to by the late 1980s, had been born, according to Charles Jencks, its first theoretician, on July 15, 1972, when Minoru Yamasaki's Pruitt-Igoe housing of 1955 was deliberately dynamited because it had become crime-ridden and severely vandalized. But by the mid-1980s, PoMo had begun to seem a stylistic dead end.[29] Many, following the lead of Allan Greenberg, in the United States, abandoned its jokey play of forms for a more scholarly approach rooted in tradition. Others, like Edward Mills, jumped from one stylistic ship to another, adopting a spatially complex, discontinuously composed approach that would soon be christened Deconstructivism or Deconstructionism or just plain Decon.

In the late 1980s, as the historian and theorist K. Michael Hays explained, "Doubts arose about whether an architecture that is nothing more than a practice of signs could ever escape the destiny of becoming one more degraded form of the commodification of information."[30] The principal event marking the shift away from stylistic Postmodernism to what would seem to many a return to Modernism, but was in fact a further development of the Postmodern in the form of a historicized Modernism, was the Museum of Modern Art's "Deconstructivist Architecture" exhibition, staged in 1988 by Philip Johnson and a young New Zealand-born-and-educated architectural academic, Mark Wigley.[31] Efforts to situate the movement as a critique of contemporary culture proposed that its clashing geometries were, as Bernard Tschumi, one of Deconstructivism's leading practitioner-theorists, put it, a reaction to the sense that "our time and age are not about being comfortable, but about disturbance and uneasiness and stress. It is not an integrated, homogenous world, but one of discontinuity."[32] Characteristically, Philip Johnson tended to see it in more strictly aesthetic terms, as a revival and extension of 1920s Expressionism and Constructivism which had been expunged from the mainstream of Modernism in favor of the more classicizing approach of the International Style. Introducing the MoMA show, Johnson was careful to point out that "in art as well as architecture . . . there are many—and contradictory—trends in our quick-change generation" and that "no generally persuasive '-ism' has appeared," adding that "pluralism reigns."[33] For his junior collaborator, Mark Wigley, Deconstructivist architecture was neither an "-ism" nor a new style, but a short-lived episode in which each architect "constructs an unsettling building by exploiting the hidden potential of modernism."[34]

In essence, the form of Postmodernism that Deconstructivism represented emphasized "decentered composition," as Mary McLeod pointed out in 1989 when she lumped both "postmodernism" and "deconstructivism" together as manifestations of Reagan-era architecture and politics. "As a reaction to postmodernism," McLeod opined, "deconstructivism shares certain aspects with modernism. Its

preference for abstract forms, its rejection of continuity and tradition, its fascination with technological imagery, its disdain for academicism, its polemical and apocalyptical rhetoric—are all reminiscent of an earlier modern epoch. But deconstructivism . . . also emerged from many of the same impetuses as postmodernism. Like postmodernism this new tendency rejects the fundamental ideological premises of the modern movement: functionalism, structural rationalism, and a faith in social regeneration. For all its rhetoric against historical quotation, deconstructivism also looks to the past for formal sources, only now the search centers on modernism and machine-age forms. Finally, deconstructivism, too, emphasizes the formal properties of architecture. (In this regard, it is ironic that Russian constructivism, with its political and social programs, is considered the primary source.)"[35]

For two of the architects associated with Deconstructivism, Peter Eisenman and Bernard Tschumi, the Deconstructivist approach was not so much about formal choices as about process, and even more about the search for a content-free architecture, reflecting the post-structuralism then prevalent in literary criticism. While many decried the art-for-art's-sake approach of Deconstructivism, there was a sense that, as McLeod wrote, "it would be a mistake to dismiss its formal explorations as politically neutral or irrelevant. Even artistic abstraction has social implications, and, given the increasingly conservative connotations of postmodern figuration, deconstructivism may well be an instance where abstraction takes on progressive resonances, as modernism did initially. Nor are the forms always as mute as their practitioners sometimes claim them to be. Compared to the tired classical images of postmodernism, these neoconstructivist forms possess for the moment a freshness and energy that embrace the present and the future."[36]

While stylistic Postmodernism was deliberately popular in its imagery, Deconstructivism was almost belligerently elitist. One consequence, as McLeod pointed out, was "a potential narrowing of audience. . . . Most likely only a small cultural elite will appreciate the iconoclasm of forms, the inversions of common sense and everyday expectations." Another result of Deconstructivism's "formal hermeticism," McLeod wrote, "has been a denial of urban context and a renewed focus on the building as object. The fragmentation and formal explosion of these works means that not only do they contrast radically with a traditional urban fabric, but they cannot join readily with other buildings to form defined public space. The single building once again becomes more important than the city, individual creation more important than collective accretion," leading to "an urban vision of negation, rejecting past solutions and denying possibilities of reconstituted community."[37]

Amid all the discussion about Deconstructivist dislocation versus Postmodernist reification, Mrs. John C. Shalvoy, a Fairfield County resident, wrote in a letter to the New York Times:

If Deconstructivism is to be the architectural wave of the future, with its chaotically slanting walls and angling doorways, can a Deconstructivist skyscraper be far behind? Can't you just see it tilting vertiginously out of the rectilinear Manhattan skyline as the population below gulps Dramamine? Picture it rearing coyly back–no doubt in mock horror at Philip Johnson's Chippendale pediment–poking fun at Post-Modernism, all that 'classical form' and 'balanced symmetry.' But hold on a minute! Won't this blithely slanting skyscraper put one in mind of another, much earlier, skyscraper? Won't it, in fact, look like a most imaginative interpretation of the Leaning Tower of Pisa? And then what could you really call it but the ultimate in post-modern statement? Or could it just be that the Leaning Tower of Pisa is actually early Deconstructivist? Has architecture come full circle? Oh dear, it's so confusing![38]

Despite the hoopla over the MoMA show, Deconstructivism sank, as Paul Goldberger wrote, "nearly as fast as it rose," turning out "not to be the architectural event of the year but the architectural media event of the year. . . . Deconstructivism's cool, abstract lines, its disquieting angles intended as a response to post-Modernism's increasing preoccupation with lavish and highly traditional decoration, turned out to be really no more than an esthetic response. Deconstructivist architecture was a different look, to be sure, but underneath its fresh forms it offered no real alternative to the underlying problem of post-Modernism. The reason so much of it had begun to look tired by the end of the 1980's was not its ornament but its indifference to a world beyond fashion."[39]

CRITICS

Ada Louise Huxtable

Ada Louise Huxtable's appointment in 1963 as the New York Times's first architecture critic, and the first one on any daily newspaper in the United States, put an end to the long-prevailing situation wherein, as she put it, "unless a story reaches the proportions of a scandal, architecture is the stepchild of the popular press."[1] Throughout the 1960s and 1970s Huxtable's opinions were respected, even feared, in a city obsessed with real estate. She not only assessed new works of architecture and urbanism but also championed the cause of the preservation of historic buildings and neighborhoods. As the historian Francis Morrone wrote in 2002, reflecting on Huxtable's early career: "Huxtable made a splash at the Times, writing about her subject at a fraught time for American cities. The 'urban crisis' was in full swing. Popular discontent with the unlovely products of modernist architects and planners was at a fever pitch. Preservation, particularly in the wake of the destruction of Pennsylvania Station, was becoming a cause célèbre. Jane Jacobs had taught the public to be very wary of 'urban renewal.' Huxtable entered upon this battlefield equipped with a discriminating modernist judgment, knowledge of architectural history, strong preservationist sympathies, and, above all, a razor-sharp, often brutally sarcastic, prose style. It seemed suited to the embittered times."[2]

In 1970 Huxtable was awarded a Pulitzer Prize, the first given for criticism in any field, making her, as Stephen Grover contended in the Wall Street Journal, "perhaps the most powerful individual on the New York Times's roster of critics—including the newspaper's mighty reviewers of drama."[3] Huxtable's influence seemed to reach its apogee on September 25, 1973, when she was named to the New York Times's editorial board, even though it meant that she would give up her writing in the daily paper, except for editorials, and would confine her signed pieces to the Sunday paper. Buoyed up with a prestigious MacArthur Foundation Prize Fellowship, Huxtable retired from the New York Times on December 30, 1981.[4] The essays of the last period of her eighteen-year tenure

at the *Times* were collected and published in 1986 as *Architecture Anyone? Cautionary Tales of the Building Art*.[5] She also published *The Tall Building Artistically Reconsidered: The Search for a Skyscraper Style* (1984), a book that combined history with a thinly veiled critique of Postmodernism.[6]

On April 9, 1997, Ada Louise Huxtable rejoined the ranks of newspaper critics when she agreed to write at least six columns a year for the *Wall Street Journal*. The announcement raised some eyebrows, including those of real estate reporter and architecture critic Carter B. Horsley, who noted that only three days before, on April 6, the respected critic Witold Rybczynski had, in the *New York Times Book Review*, found Huxtable's new book, *The Unreal America: Architecture and Illusion*, poorly argued and wrongheaded. Rybczynski wrote: "Ms. Huxtable remains an unrepentant modernist. 'I cannot think of anything more ludicrous than the idea that modernism somehow got off the track and was a monstrous mistake that should simply be canceled out,' she writes. 'Revolutions in life and technology can never be reversed.' But if the late 20th century has taught us anything," Rybczynski wryly noted, "it is surely that revolutions can be reversed, as they have been in the Soviet Union and Central Europe. And, sadly, monstrous architectural mistakes were made. In that regard, historic preservation is clearly reactionary. It reflects the public's intense skepticism of the architectural avant-garde, whose misbegotten theories were responsible, in part, for the devastation wrought on American cities in the name of urban renewal."[7]

Rybczynski was not alone in criticizing Huxtable, who had once seemed invincible. In her review of *The Unreal America*, architectural historian Diane Ghirardo found Huxtable to be condescending in her perception of Americans as culturally unenlightened, "addicted to fakes and fantasies" as surrogate experiences for the "real. . . . In fact Huxtable evinces a good deal of contempt not only for the environments inhabited by the 'masses,' but also for the masses themselves. Not only do they prefer the fake, but they are an unpleasant mix as well, sharing some undefined but clearly negative 'common denominator of taste and experience.' . . . Like other elitists, Huxtable is unwilling to locate the true source of the problems she identifies as embedded within capitalism itself."[8]

Paul Goldberger

In contrast to Huxtable's unswerving Modernism, Paul Goldberger, from his debut as a professional writer in 1971, was associated with the Postmodernist point of view, so much so that in 1978, Postmodernism's annus mirabilis, when Philip Johnson and John Burgee's AT&T Building was first published, Goldberger predicted that "the general trends . . . which have come to be summarized by the term 'postmodernism' . . . will continue. The International Style is no longer a valid ideological force today, and I doubt that it ever again will be; it began as a radical idea but by now is conservative, the very establishment that it is fashionable to struggle against." Most significant, Goldberger continued, characterizing the essence of the Postmodernist devolution, "If there is any truth to be stated about our time, it is not so much that the International Style is dead as that *ideology* is dead. There is no longer any belief that dogma will do our work for us; there is no longer any belief that there is one true way to the making of a good architecture. Many styles are valid—each

has a certain place if it can be justified by factors of program, economics, client preferences, contextual relationships and so forth."[9]

Throughout the 1980s, Goldberger was Postmodernism's most sympathetic critical voice; but it was this very openness that would, by the decade's end, become his undoing as a new generation of architects and critics rebelled, seeking to replace what they decried as aesthetic permissiveness with the authority of theory. In effect, they resorted to a neo-Modernism that at first seemed to take on the characteristics of a limiting, specific style, Deconstructivism, but quickly unleashed a period of artistic one-upmanship based on individualistic form-making that can be said to have fulfilled Goldberger's fear, expressed in 1978, that "the end of an ideological basis for architecture, in the worst scenario, leads to chaos."[10]

Paul Goldberger became architecture critic for the *New York Times* in 1973, his appointment coinciding with Ada Louise Huxtable's elevation to the paper's editorial board.[11] Goldberger was not the snappy stylist that Huxtable was. His writing was gentler in tone. And his tastes were far broader. "The critic's job," he stated in 1981, is to serve as "a bridge over that enormous gap that separates the profession from the public. . . . If anything, the critic's job is to be the advocate of the public before the profession." Goldberger didn't eschew strong arguments but he had a clear sense of criticism's limits: "Moral suasion is really the only weapon the critic has in his arsenal, not raw power. Of course, you can drift too close to being a missionary. There is nothing worse than an architectural critic who thinks he's doing God's work." Because he was no ideologue, Goldberger felt obligated to articulate the principals that lay behind his judgments: "There are things I believe in strongly, certainly that set of values that we've come to group under the word urbanism. The idea that in a city the whole is more than the sum of its parts." But Goldberger was frank in his dismissal of orthodox Modernism, which "has not succeeded as a general style."[12]

Paul Goldberger won the Pulitzer Prize in 1984, but his open-minded, evenhanded approach was not appreciated in all quarters. Many architects felt that he had his favorites: Philip Johnson, Robert Venturi, Michael Graves, and a few others whose names seemed to appear very regularly in his columns.[13] Others, including Ada Louise Huxtable, who was too professional to commit her misgivings to print but not especially shy about voicing them in conversation, thought Goldberger's receptivity to Postmodernism represented a collapse of critical standards. Additionally, Huxtable was wary, even dismissive, of developers and other real estate interests, while Goldberger accepted the realities of the marketplace, leading Michael Sorkin, in a much-talked-about, reckless essay of 1985, "Why Goldberger Is So Bad," to ridicule him for allowing his words to be used as part of real estate promotions for buildings whose designs he had praised—a standard practice, for example, in theater criticism. In his attack on Goldberger, Sorkin focused on the controversy over the first scheme of towers proposed for Times Square by Philip Johnson and John Burgee (see Forty-second Street), excoriating the critic for his willingness to assess the project on its own terms. As Sorkin saw it, Goldberger was less interested in the future of Times Square, or the design of the four towers, than power, perceived or real: "By expending his partisanship on behalf of the superficial stylings of the worst kinds of corporate production, Goldberger is complicit in the restriction of

the territory of architecture to its most banal possibilities." Sorkin was railing not only against Goldberger, but also against what he perceived as an establishment cabal that apparently excluded him from its plots or denied him professional opportunities as an architect: "American architecture is too important to be held prisoner by a bunch of boys that meet in secret to anoint members of the club, reactionaries to whom a social practice means an invitation to lunch, bad designers whose notions of form are the worst kind of parroting. It is for being the unquestioning servant of these that I accuse Paul Goldberger."[14]

In 1997, after a three-year stint as cultural news editor at the *Times* and four subsequent years of service as chief cultural correspondent, during which time he continued to write architectural criticism, Paul Goldberger decamped to the *New Yorker*.[15] Taking over the legendary "Sky Line" column, which had recently opened up as the result of Brendan Gill's death (see below), he was published less frequently but given more time and space to think out his arguments. It was an open secret that Goldberger's departure from the *New York Times* was a direct consequence of the demand of his hand-picked successor, Herbert Muschamp, that if he were to remain at the paper rather than go to the *New Yorker*—he had been offered the "Sky Line" slot before Goldberger—he would have total control over its architecture coverage.

Herbert Muschamp

Herbert Muschamp became architecture critic for the *New York Times* on June 3, 1992, nearly two years after Paul Goldberger was elevated to the post of cultural news editor, a move some saw as a response by the newspaper's editors to growing concern in the profession over Goldberger's lack of critical focus.[16] Muschamp, who studied architecture at the Architectural Association in London in 1969–71 after undergraduate studies at the University of Pennsylvania and Parsons School of Design, enjoyed an underground reputation as someone operating in the margins between architectural theory, history, and criticism. His publishing career began with a book, *File Under Architecture* (1974), that was cynical and brilliant, but jejune and without a coherent narrative.[17] A string of aperçus, *File Under Architecture* reflected the author's deep suspicion of architecture as the art of building, revealing little in the way of visual insight. Muschamp's book was largely ignored by the critics, but H. Ward Jandl, an architect at the National Register of Historic Places, did write a short notice of it, calling *File Under Architecture* "a passionate essay on the idea of architecture" characterized by a "rambling style and chaotic organization" that made for "difficult going." His final assessment: "File under inscrutable."[18]

In 1983 Muschamp published his second book, *Man About Town: Frank Lloyd Wright in New York City*, which Paul Goldberger summarized as "a study of Wright's relationship to the city he claimed to have hated."[19] Norris Kelly Smith, one of the shrewdest scholars specializing in Frank Lloyd Wright, was impressed with Muschamp's psychological insights into Wright's ambivalent relationship to the city but could not know how much Muschamp's theory reflected the author's own evolving persona as a critic. Wright, Smith wrote, "came to depend on New York City as a means of perpetually renewing his license to play the Professional Outsider. The debt Wright owed New York was the debt any Romantic artist owes the society he must reject, the society without which his

rejection has no meaning; the world without which he is helpless to define his truth."[20] Muschamp's book was organized in three parts, the last of which, "1960–1980," intended as a separate essay, was the first of the author's meditations on Modernism and Postmodernism, the general subject of a series of brief essays he would publish in *Artforum*, for which he served as architecture critic between 1984 and 1992.[21] In the conclusion to his review of *Man About Town*, Smith stated, "If the book has a major fault, it is Muschamp's own uncommittedness; like the Post-Modernists, he is concerned almost exclusively with theory, history, and aesthetics *per se*: at no point does he address the traditional institutional and political bases of architectural style."[22]

In addition to *Artforum*, Muschamp wrote for the *New Republic* between 1987 and 1992, and in the 1980s and early 1990s he was also an occasional contributor to *Vogue*, *House & Garden*, and the short-lived *Express*.[23] In 1983 he joined the faculty of the Parsons School of Design, where in 1986 he established the school's graduate program in architecture and design criticism, the first such program in the country. By the time he was writing in the *Times*, Muschamp viewed himself as an interpreter, not as a judge, though many architects privately disagreed with his self-assessment. Most of all, he sought to get general readers "hooked into the idea that this subject involves them in countless ways." His most important role, he argued, was "to call into crisis," analyzing the crisis "to see what the stakes are, what the obstacles are to moving forward."[24]

While Goldberger could be chided for his aesthetic approach to problems of development, Muschamp could be accused of a distinct lack of interest in the specifics of buildings as such and for an overly personal tone in writing. In 1995 Muschamp reflected on his work at the *Times*: "My impulse to treat architecture emotionally may come from personal experience, but it corresponds to what has been going on in architecture itself . . . particularly since the decline of the Modern movement. . . . Post-Modernism opened the door to a richer emotional content, especially the retrieval of memory, but then cloaked it beneath the dubious authority of historical style."[25] In 1997, after five years as its critic, Muschamp quit the *New York Times* to join the *New Yorker* but was persuaded to return to the newspaper after it agreed to meet his demand for virtual control over all architecture coverage. At the same time, he was relieved of the Sunday Arts and Leisure column for a year so that he could write in other sections, especially about fashion, which was his passion.[26]

When Muschamp rejoined the *Times* he seemed to enjoy carte blanche as to subjects and to writing style. Returning to a version of the stream of consciousness of his *File Under Architecture*, Muschamp confused many readers; others saw his non sequiturs as a manifestation of the newspaper's dumbing down to meet the needs of a new generation of readers used to the sound bites of televised news and MTV. Hilton Kramer, art critic of the *New York Times* from 1965 to 1982 and now editor of the *New Criterion*, dissected Muschamp's September 7, 1997, *New York Times Magazine* cover story presenting Frank Gehry's Guggenheim Museum in Bilbao, Spain; he dismissed Muschamp's article as a "stunningly unctuous paean" that "shamelessly praised, flattered, extolled and all but deified" the architect. The editorial went on to remind readers of the *Times* that Muschamp, who had previously "compared a Calvin Klein advertisement for men's

underwear in Times Square to Michelangelo's *David*," was now promoting the Bilbao museum as a "masterpiece," a "miracle," a "Lourdes for a crippled culture," and "most exalted" of all, "the reincarnation of Marilyn Monroe." This excessive praise, Kramer continued, "is probably the most egregious bit of writing we have yet encountered in the *Times*. To say that it is overwritten is like saying the Mir space station is a bit cranky. It is smarmy, mendacious, and self-indulgent, with a sugar content that will make diabetics tremble."[27]

Muschamp, more than either of his predecessors at the *Times* and more than any critic in recent memory, was the subject of intense scrutiny by other members of the press. "Since Muschamp pursues a very personal style of criticism," Suzanne Stephens explained, "he is perhaps more controversial than Goldberger. Not that Muschamp's approach is anything like Goldberger's, who, as the joke goes, so desired to appear balanced that the reader got whiplash going from one side of the argument to the other. . . . Supportive readers of Muschamp find refreshing his filtering of building analysis through his personal and emotional state; others consider it narcissistic and self-absorbed."[28]

Muschamp's participation in the architectural selection process for the *New York Times*'s proposed office tower (see Forty-second Street) caused many readers to balk at the seeming conflict of interest. Judith Shulevitz, herself a sometime contributor to the *Times*'s pages, was one critic who took on Muschamp. In her widely circulated article written for the on-line magazine *Slate*, Shulevitz wrote that Muschamp was so heavily involved in the competition that "you needed a graduate degree in *Times* protocol to keep track of all the roles." He was critic; he was employee "who wasn't in the position to judge his bosses' decision too severely"; and he had to be "gracious to the three losing finalists." Muschamp, Shulevitz continued, "juggled the apparently conflicting rhetorical requirements imposed by these roles—the need for tough-mindedness and the need to brown-nose and be generous seemed particularly at odds—by praising Piano [the winner] strongly but praising one set of finalists (Frank O. Gehry and David Childs) even more strongly, then attacking another finalist (Cesar Pelli) harshly. Muschamp thereby sacrificed a modicum of graciousness to gain the aura of independence."[29]

Expanding her critique to encompass not just Muschamp's role in the competition but his towering status, Shulevitz wrote that Muschamp "is the most obsessively dissected cultural critic in American journalism," said to be "the only *Times* critic people talk about who don't have any intellectual interest in culture." For Shulevitz, Muschamp was "an unabashed advocate for the architectural avant-garde, sharing its penchant for expressive irrationalism and intense emotions. . . . A corollary of Muschamp's lust for the new, the bold, the dark, and the seemingly inexcusable is a disdain for postmodernism, with its fixation on the past, and historic preservationism, which Muschamp argues has devolved into a knee-jerk resistance to experimentation that has prevented New York City builders from, as he puts it, 'committing' great architecture." Of course, as Shulevitz pointed out, many found Muschamp and his idea of an avant-garde "about fifty years out of date."[30] As Vincent Scully put it: "All this worship of invention, this worship of having something that nobody's ever seen before, it doesn't seem like it has a great deal to do with architecture."[31]

Muschamp's coverage of the 9/11 disaster and the planning in its aftermath proved a flashpoint for many who objected to the way he aestheticized the destruction and connected it to the work of certain architects whose work he frequently promoted.[32] Robert A. Ivy, editor of *Architectural Record*, castigated the *Times* for permitting Muschamp to be its only architectural voice and raised concern about his role "in cooking up plans" for the rebuilding of lower Manhattan "to stimulate debate (placing the critic in a problematic role for future analysis)" while leaving "other buildings" uncovered. Furthermore, Ivy believed that Muschamp, a "devotee of pop culture," was too personal in his approach: "His subjective critical approach, peppered with the personal pronoun 'I,' reveals much of his own personality and idiosyncrasies along with his ideas." And he has "a shortlist of favorites, architects who fall within his canon of small firms worthy of mention and praise, whom he has described as 'among those at the forefront of intersubjective architecture.'"[33]

Ivy also drew attention to a parody of Muschamp circulating on the Internet. That parody, entitled "Just as I Expected, These Plans Suck," purportedly written by Michael Bierut, a graphic designer in the firm Pentagram, went as follows:

> Striding down the row of design proposals for the World Trade Center site, balefully eyeing each inert mien and artificially enhanced plan, I was reminded of the scene in *Showgirls* where the choreographer grimly surveys his topless charges. Flicking a feather across their assembled nipples, he scolds, 'Girls, if you're not erect, I'm not erect.' Ladies and gentleman, I've seen the master plan proposals from the Lower Manhattan Development Corporation, and, to put it mildly, I'm not erect. My heart sank as I watched John Beyer of the architectural firm Beyer Blinder Belle attempt to describe these hapless proposals. I was painfully reminded of another much more casual presentation one glorious autumn on Capri. The visionary Rem Koolhaas was holding forth on urban planning, shopping, life, and the smell of fresh basil. Wearing beautifully tailored trousers and a tight, cropped black top—need I add it was by Prada?—he gestured energetically as he spoke. With each gesture, his shirt rode up ever so slightly revealing a tantalizing sliver of tan, taut tummy. It is this kind of energetic gesture that those of us who care about contemporary architecture hunger for so desperately. Beyer Blinder Belle's work is occasionally competent: certainly their by-the-numbers renovation of Grand Central Terminal pleases the hordes of moronic commuters who stream through it each day, but it will come as no surprise that this recidivist pile of marble is of little interest to the infinitely more important audience of attractive European architectural students who make pilgrimages to our city each year and can barely choke back their tears of disappointment. John Beyer, whose exposed torso would be unpleasant for even the more adventuresome New Yorker to contemplate, must shoulder the blame for this catastrophic failure. It is now time to list these names: Frank Gehry, Peter Eisenman, Zaha Hadid, Elizabeth Diller and Ric Scofidio, Tod Williams and Billie Tsien, Steven Holl, and, of course, Rem Koolhaas. There.[34]

But no one, it seemed, could parody Muschamp better than the critic himself, even if he did so inadvertently. In an interview with an anonymous source, who Muschamp confirms could only have been Muschamp, the source states that he was a Romantic, referring to the nineteenth century sense of the word, thus making it hard for him to endorse Postmodern buildings, which "are often theatrical, but . . . 'Romantic' only in a Madison Avenue sense of the word. In their disposition to be pleasing, rather than to demand reform, they show none of

the Romantic's need to reject the world and its social conventions. Ideologically, they are far more rational than Modernism, in that they recognize and accommodate the realities of public taste." Anonymous "cling[s] to values" he considers "outmoded" because he "can't help it. I'm just too attracted to big words and cosmic concepts, words like classic and Romantic, concepts like momentous transformation, ideas any truly classical person would consider extremely vulgar. . . . I fell in love with big words and outlandish concepts at a tender age, and I'm too old now to break the habit. I adore the intoxicating Romantic vistas of the grand overview, even if it's just a mirage. As for my theories, it's the best I can do to serve them half-baked; at least it gives them a creamier consistency."[35] Muschamp's tenure as architecture critic came to its end in 2004 when he resigned his position to take up fashion reporting at the *Times*—many said he was asked to resign by his publishers after a fracas with another critic, Suzanne Stephens, had been widely reported.[36] Muschamp was replaced by Nicolai Ouroussoff, previously the critic at the *Los Angeles Times*.

Other Critical Voices

A few "contrary" voices were raised in counterpoint to the established powerhouse succession of Huxtable, Goldberger, and Muschamp. Of these, Michael Sorkin's was the most distinctive. Writing in the once countercultural but increasingly establishment New York weekly newspaper the *Village Voice*, as well as in the *Nation*, *Architectural Digest*, *House & Garden*, and *Architecture + Urbanism*, among others, he also served as a contributing editor at *Architectural Record*, *Metropolis*, and *ID* magazine. Sorkin, a graduate of the University of Chicago, went on to Columbia University, where, according to Martin Pawley, he "was thrown out . . . in 1970 for his student politics" before continuing at MIT, where he was "temporarily expunged . . . together with Radical Environmental DeSign Group (REDS) in the year of the invasion of Cambodia."[37] Sorkin received his master of architecture from MIT in 1973. Like Muschamp, Sorkin was caught up in the rhetoric of the early 1970s, when "it seemed almost impossible to practice architecture. Building was so bound up with structures of power, the only responsible thing, I thought, was to resist. . . . I turned to writing as an extension of architecture by other means, trying to make a space in which I could practice. I never saw myself as an architectural writer but as an architect for whom writing was an additional, necessary medium."[38] This dual role, according to Sorkin, yielded "at least a couple of advantages. The first is a kind of empathy. As an active designer and teacher of design, I'm able to pick up on the kind of drafting-room riffs that yield particular forms, to distinguish between lazy work and work that comes from real investigation. . . . The second advantage of being a practitioner/writer is that it gives a certain edge to one's partisanship. Every critic is a partisan for something. For me the cause is beautiful, serious, and humane buildings. I try to set high standards for both my designing and my criticism and there's a lot of reciprocal reinforcement—sometimes to the point of paralysis!"[39]

Though Sorkin was critical of Muschamp, in many ways they shared the same jaundiced view of the city's architecture and architectural politics. Sorkin found himself "consistently confronted by two striking absences. The first is the almost complete lack of serious building. . . . The second void is that

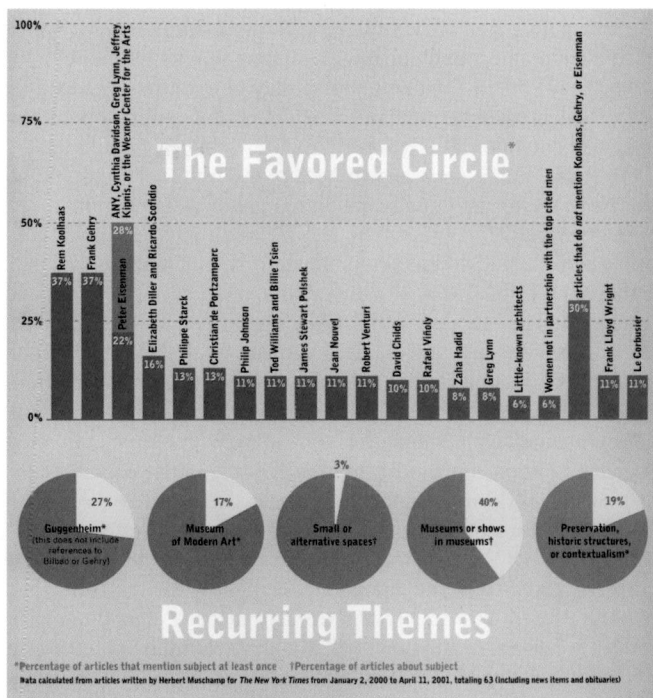

Chart analyzing Herbert Muschamp's preferences among architects and topics that accompanied Michael Sorkin's article, "Herb's Content," in the June 2001 issue of *Architecture*. ARCH

of criticism itself." Though he acknowledged the rise in the "sophistication of academic writing" about architecture, Sorkin felt "the quality of architectural journalism remains dismal." Sorkin admitted to concentrating "on architecture's institutional culture, on critics, cabals, and power trips . . . not simply because these tempests have gathered wind in a city which has forsaken a real building culture but because these debates are agenda setters of global ramification. My Philippics (you know who I mean)," Sorkin continued, "have been frequent because a critic's torpedo must home on power and its symbols. More, as an architect looking for the space of a joyful practice, these were the roadhogs blocking the way for me and many I admire."[40]

According to Peter Kaufman, reviewing the compilation of Sorkin's essays written between 1979 and 1989, *Exquisite Corpse: Writings on Buildings*, Sorkin's "leftist orientation, Jewish 'schtick' style, and New York City locale ensure him a small but devoted readership."[41] Reviewing the same book, Kurt Andersen, then architecture critic for *Time* magazine, wrote: "It is now fashionable to repudiate and decry the 1980s. Yet as pure spectacle, the decade is hard to beat: the rise and fall of Postmodernism, the rise and fall of Deconstructivism, the rise and fall of Donald Trump, the emergence of Disney as the great patron of the age and, as ever, Philip Johnson. Nobody provided a more entertaining and intelligent play-by-play than the critic Michael Sorkin . . . nervy, wisecracking, manic, eloquent." Andersen continued: "What is consistent" in Sorkin's writing "is his reflexive rebelliousness; the idea of a powerful architectural establishment keeps him almost perpetually, giddily angry. And so for Sorkin, Paul Goldberger and Philip Johnson are demons, and denouncing them is something like an ecstatic religious ritual." But Andersen observed that Sorkin was better at troublemaking than praising: "When he writes about architects he admires, he can stumble, sound-

ing like some credulous undergraduate, brimming with naive enthusiasm and mushy prose."[42] Charles Jencks, in his review, wrote that Sorkin "obviously intends his work to be judged as architectural journalism, not criticism; the quick kill rather than the considered judgment."[43]

Brendan Gill's eleven-year tenure as architecture critic at the *New Yorker* was cut short by his death at age eighty-three on December 27, 1997.[44] Gill resurrected the "Sky Line" column, which had been Lewis Mumford's principal platform from 1931 until 1963, during which time he was the most respected critic in the field.[45] Gill, a talented writer who was the author of short stories, light pieces which the *New Yorker* called casuals, and drama criticism, did not have the authority of Mumford, but nonetheless proved to be an important voice, principally because he was so very readable, but also because he took on important causes such as the preservation of historic buildings. Gill had been at the *New Yorker* since his graduation from Yale in 1936 and assumed the "Sky Line" column in 1987 during the final year of William Shawn's long editorial reign over the magazine. But with the appointment of Tina Brown, previously the trendy editor of *Vanity Fair*, as the *New Yorker*'s editor in 1992, Gill had found it increasingly difficult to get space for the column. In an interview he gave a few weeks before his death in 1997, Gill told Suzanne Stephens, "Today the greatest difficulty in writing architectural criticism is the lack of interest in architecture on the part of most editors. And there is the problem of the availability of space. Buildings are treated as events." Gill's job, as he saw it, was "to write criticism, not reviews. I wanted to address the matters that concerned the architect." Taking a jab at some of his rivals, possibly Herbert Muschamp in particular, who was generally anti-preservationist, Gill stated: "While today writers prefer being movie reviewers to being architecture critics, the preservation movement has helped architectural criticism. By preserving buildings, we have become knowledgeable about what we are looking at. As for avant-garde architectural ideas, from what I have seen, there needs to be more rigor, not only in the grammar but in the thinking. You can't invent a grammar that suits your purpose and win the argument. None of us are hard enough intellectually on ourselves."[46]

In addition to Huxtable, Goldberger, Muschamp, Sorkin, and Gill, there was the earnest Ellen Posner and the lively, astonishingly acerbic Manuela Hoelterhoff writing in the *Wall Street Journal*.[47] *New York* magazine pretty consistently provided architectural criticism, from its founding in 1968, with Peter Blake serving as its architecture critic and urban gadfly. From 1980 to 1996, Carter Wiseman was *New York*'s architecture critic, also writing for *Artnews* and other publications. Wiseman could be harshly judgmental, tending to evaluate buildings on their "timeliness—the building's place in its own time. . . . If a building is pretending to be newer or older than it is, you have a problem." Hence he dismissed both the futurism of Piano and Rogers' Centre Pompidou in Paris and the traditionalism of Johnson and Burgee's AT&T Building, which he deemed the worst offender in trying "to evoke the imagery of the past in an illegitimate fashion. . . . Here was a basic American building type, the skyscraper, that we became bored with, so the architect cloaked it in Renaissance masonry. It's unfair and cowardly architecture because it doesn't stand for its time."[48] Though his artistic judgment was a bit shaky, Wiseman, like Karrie Jacobs, his successor at *New York*, was

notably conscientious in explicating the processes of design and development. Jacobs was *New York*'s critic from 1996 to 1999, where her column, "Cityscape," combined architectural criticism with discussions of New York real estate and politics. As Jacobs put it: "The idea was to tackle subjects such as the redevelopment of Penn Station in a provocative, engaging fashion suitable for a broad consumer audience."[49] Joseph Giovannini, who, like Michael Sorkin, was also an architect, wrote variously for the *New York Times* and *New York* as well as other journals.[50] Giovannini was a tireless advocate of Deconstructivism, a term he claimed to have coined.

RESURFACING MODERNISM

Beginning in the early 1980s, in an effort to regain first-class commercial status for their properties, owners began to spruce up and renovate a number of aging office buildings dating mostly from the 1950s and early 1960s. Although structural problems motivated some of the new work, the renovations were principally driven by the need to upgrade mechanical, electrical, and communication systems to meet the demands posed by the dramatic increase of digital technology. But aesthetics played an important role as property owners felt obliged to compete with the new, stylishly distinctive Postmodern office buildings coming on line. Both workaday examples of corporate Modernism as well as some of its most distinguished prototypes were subject to "improvement" attempts, often with the addition of Postmodern touches, raising for the first time in a serious way the thorny issue of the historic preservation of postwar Modernist work.

In November 1980 Chemical Bank announced plans to dramatically reconfigure the entrance to what would in 1981 become its headquarters building, Emery Roth & Sons' 277 Park Avenue (1958–64), between Forty-seventh and Forty-eighth Streets.[1] The building itself was not distinguished, but its worst feature was the underutilized and barren 12,700-square-foot plaza facing Park Avenue that was plagued with seemingly insoluble drainage problems. Haines Lundberg Waehler replaced the plaza with a greenhouse lobby known as Chemcourt (1982). The bank was motivated by a sense that it needed to make a statement in order to compete with its near neighbor and business rival, Citicorp, whose architecturally far more distinguished headquarters building (Hugh Stubbins & Associates, 1977) straddled an elaborate and popular shop- and restaurant-filled atrium.[2] Though much smaller than Citicorp Center and in no way a mall, Chemcourt was nonetheless intended as a crowd-pleaser, a three-story-high greenhouselike structure that included planters, reflecting pools, fountains, and public seating entered both midblock on Park Avenue and at its corners through monumental portals marked by a series of reverse setbacks in the metal frame, designed by Michael Maas and Theodore Hammer, partners in the HLW firm. According to Maas, the aesthetic transformation of the building's Park Avenue entrance was similar to "kissing a frog and turning it into a prince,"[3] a phrase the architect probably came to regret when, in his review, Paul Goldberger observed that the new atrium-like lobby was merely "a better grade of frog."[4]

To Goldberger, regardless of the product, the gesture in itself was "an important event" that marked "the admission by a conservative corporate client that the style of the 1950's

Chemcourt, 277 Park Avenue (Emery Roth & Sons, 1964), between East
Forty-seventh and East Forty-eighth Streets. Haines Lundberg Waehler,
1982. View to the southeast. Cserna. DP

and 60's no longer suits the image it desires."[5] Though
Goldberger felt that Chemical Bank's decision to refashion
Roth's bland design was admirable, he found the outcome less
so: "The new garden court is certainly an oasis of green . . . but
it is strangely uncomfortable as a space," lacking "sweep or
size" and possessed of "few decent places in which to sit. . . .
What it is, in the final analysis, is a very grand lobby." The
critic also felt that the relationship of the addition to the
existing building was unfortunate. The stepped sequence of
metal trusses combined with the glass "might be thought of
as a kind of . . . tent pitched beside the front door of a sky-
scraper," yielding a temporary look that he had not detected
in the early scale models. It seemed to lack dignity, and it
failed to return Park Avenue to its "days of glory."[6] In 1994,
after a merger with the Manufacturers Hanover Bank,
Chemical Bank left the building and two years later
Chemcourt was destroyed and the original entrance restored.[7]

At 270 Park Avenue (1955–60), the changes, designed by
Raul de Armas, a partner at Skidmore, Owings & Merrill, the
same firm that designed the original building, were under-
taken in 1982–83, when the building was taken over by the
Manufacturers Hanover Bank after the original sole tenant,
Union Carbide, for whom the building had been named, relo-
cated to Danbury, Connecticut.[8] While the building's interiors
were entirely reconfigured to meet the bank's needs, the only
significant changes to the exterior were the replacement of the
somewhat flashy pink terrazzo pavement that surrounded the
building with black granite and the construction of two 120-
foot-long fountains on the Forty-seventh Street and Forty-

eighth Street sides of the building. The entrance and lobby
were, however, dramatically reconfigured, with the removal of
3,000 square feet of mezzanine that had been intended for
exhibitions, so that the lobby space could soar three stories
from street level to a stainless-steel ceiling that reflected the
crowds, the street, and the bright red of the elevator core.

Another building reworked on the inside but left intact on
the exterior was the Pan Am Building, 200 Park Avenue
(Emery Roth & Sons, Walter Gropius, and Pietro Belluschi,
1963), the one Manhattan office tower that almost all New
Yorkers seemed to detest but whose lobby was perhaps its
only saving grace.[9] The renovations, executed in 1986 by
Warren Platner, were called for by the Metropolitan Life
Insurance Company, which had purchased the building in
1981. Platner's assignment was to give the lackluster tower a
refreshed, upscale image that would help draw tenants to the
considerable amount of square footage that began to open up
as many of the original long-term leases expired. Platner
respected the original design to a certain degree, retaining the
lobby's gray granite columns and the mezzanine's travertine
walls as well as Richard Lippold's sculpture, *Flight*, and the
Josef Albers mural, *Manhattan*. But his renovations were oth-
erwise a self-conscious departure from the clean lines of
Gropius and Belluschi's design, which Platner deemed "severe
to the point of banal."[10] Setting out to "transform the lobby
into a destination," the architect inserted a broad, curving
staircase with alternating steps of gray granite and travertine
leading from the street-level lobby off Forty-fifth Street to the
mezzanine level, where building tenants accessed the elevator

Pan Am Building (Emery Roth & Sons, Walter Gropius, and Pietro
Belluschi, 1963), 200 Park Avenue, East Forty-fourth to East Forty-fifth
Street. Renovation by Warren Platner, 1986. Lobby. RAMSA

banks.[11] The staircase widened from ten feet at the base to
twenty feet at a midlevel platform, then split in two and rose
to a width of thirty feet at the mezzanine level, where the
landing sadly replaced the aluminum screens designed for the
location by Gyorgy Kepes in 1963. Four triangular planters at
the base of the stair were filled with brightly colored flowers
perhaps meant to reference an orange floral patterned carpet
designed for the mezzanine level. But the most eye-popping
component by far was the collection of bizarre gold-leafed
semicircular discs that were, in some places, suspended from
the ceiling and adorned with dangling pendants resembling
gilded handkerchiefs and, in other places, perched atop octag-
onal travertine pedestals like golden basketball backboards
surrounded by hanging ferns, reminding Suzanne Stephens of
"nothing so much as a high-stepping finale of chorus girls
from Caesars Palace."[12] The renovation also provided an addi-
tional 10,000 square feet of retail space, new elevator cabs, a
new incandescent lighting scheme, and an eighty-four-foot-
wide steel marquee projecting four feet over the Vanderbilt
Avenue entrance and decorated with clusters of clear plastic
lighting globes.

Platner's work, like the building itself when originally
completed, was greeted with nearly unanimous derision from
the architecture community. Paul Goldberger felt the reno-
vated lobby to be "so dreadful that it inspires only a disquiet-
ing nostalgia for the Pan Am Building as it used to be."
Though the lobby was "always a gangling space, stark and

unwelcoming," he wrote, "it is now full of things that are
intended to make it warm and cozy and nice. The problem is
that most of them are ridiculous. And the few elements that
are not inherently silly clash utterly with everything else
about this huge office building. It all adds up to a strange mix
of the inappropriate and the garish." While Metropolitan Life's
desire to make the lobby more inviting and up-to-date was
"laudable," Platner created "a space that is so forced in its joy,
so false and so disingenuous, that [it] makes one yearn for
some good old-fashioned coldness."[13] Carter Wiseman com-
pared Platner's body of work, which included Windows on the
World (1976), to the flamboyant performer Liberace: "over-
done, but few can argue with the technical skill that underlies
the showmanship." With regard to the Pan Am lobby, how-
ever, Wiseman declared, "There is no music here. Even
Liberace would have blushed at the vulgarity." Worst of all for
Wiseman was the Vanderbilt Avenue marquee, "the silliest
gesture of this entire undertaking. . . . Already begrimed by
soot, the clear-plastic globes seem left over from the prop
department of some Hollywood blockbuster."[14]

The Pan Am Building's identity was further obscured
when, in 1992, a year after the airline went bankrupt and gave
up its remaining four floors (it had originally occupied fifteen),
the building was renamed the MetLife Building 200 Park
Avenue, including the address in the official name to distin-
guish it from the insurance company's buildings facing
Madison Square.[15] When rumors spread that Metropolitan Life

Pan Am Building (Emery Roth & Sons, Walter Gropius, and Pietro Belluschi, 1963), 200 Park Avenue, East Forty-fourth to East Forty-fifth Street. Renovation by Warren Platner, 1986. Entrance. RAMSA

might remove the illuminated letters spelling Pan Am from the top of the building and replace them with ones reading MetLife, Robert Stern asked, "Couldn't they just leave the sign up and take the building down?"[16] Metropolitan Life announced it would indeed remove the Pan Am signs and also jettison the two twenty-six-foot-wide globe logos on the east and west sides of the building. Many were disappointed when, on September 24, 1992, dismantling of the Pan Am sign began.[17] The new signs—including two interlocking "M" logos replacing the Pan Am globes—were illuminated on January 13, 1993.

By the end of the decade, with a new surge in office construction and consequently another surge in the modernization of older office buildings, the MetLife Building, its concrete and white quartz facade blackened by nearly forty years of grime and Warren Platner's lobby an embarrassing remnant of the glitzy 1980s, was ready for another overhaul. Happily, the exterior was renewed (2002) not by recladding, as with so many of its contemporaries, but by cleaning. A French-developed process called System Gommage using low-pressure compressed air to shoot streams of mineral powder at the facade was employed by the firm Building Conservation Associates to restore the tower's long-forgotten white sheen. At the same time, Kohn Pedersen Fox brought the lobby back to a semblance of its original form by stripping away Platner's staircase, planters, and ornamentation to achieve what the owners called a "celebration of functionality" with "spare

lines, serene lighting and rich modern materials."[18] The elevator lobbies were appointed with black tile and travertine floors and illuminated glass walls, the mezzanine-level retail spaces were restored to their original condition, and the retail spaces tucked beneath the mezzanine, created during Platner's renovation, were redesigned with crisply detailed metal and glass fronts. But if the renovation rescued the lobby in some sense, it also destroyed an integral piece of it, Josef Albers's twenty-eight-by-fifty-five-foot-high red, white, and black mural, *Manhattan*, which, according to the owners, blocked too much light from entering the space. After the mural was removed, preservationists waged an unsuccessful battle to have it reinstalled. KPF's Eugene Kohn was not swayed, stating, "The mural was peeling and in bad need of repair. It also had asbestos."[19] But the issue was not one of peeling paint and asbestos but aesthetics—Albers had left exact specifications before his death on how to re-create the piece if necessary. In its place, KPF placed a sloping surface covered in gold leaf over the escalators leading to Grand Central Terminal.

Other midtown office buildings were equally compromised by renovations. For example, in 1987 Der Scutt gave Emery Roth & Sons' 505 Park Avenue (1949), northeast corner of Fifty-ninth Street, an excellent example of no-nonsense ribbon-windowed brick-faced Modernism, new bronze-tinted glass and, at the base, a new treatment featuring horizontal bands of polished bronze that was carried into the newly reconfigured, flashily marbled two-story-high lobby.[20] Scutt

MetLife Building, (formerly Pan Am Building, Emery Roth & Sons, Walter Gropius, and Pietro Belluschi, 1963), 200 Park Avenue, East Forty-fourth to East Forty-fifth Street. Renovation by Kohn Pedersen Fox, 2002. Entrance. Woodruff/Brown. WBAP

was also responsible for the new facade at 5 East Fifty-ninth Street (Oppenheimer, Brady & Lehrecke, 1962), formerly home to the Playboy Club, which in 1984 was converted to the U.S. headquarters of the Hong Kong and Shanghai Banking Corporation.[21] Scutt's renovation of 625 Madison Avenue (1987), east blockfront from Fifty-eighth to Fifty-ninth Street, was the second recladding of what had begun life as the ten-story Plaza Building (Sloan & Robertson, 1930). Six floors were added in 1956 by Sylvan and Robert Bien, who replaced the original facade with a formulaic metal-and-glass curtain wall.[22] Scutt's design was a real improvement: a complexly patterned wall of mauve, bronze, and black panels. Inside, a new two-story lobby was sheathed in Breccia Oniciata marble accented by recessed reveals of Emperador Dark marble.

Diagonally across the street from 625 Madison Avenue, Harrison & Abramovitz's elegant, undersized eight-story CIT Building (1958), 650 Madison Avenue, was not so much renovated as absorbed in 1987 by Fox & Fowle; the firm added a nineteen-story tower to the original, cladding the expanded building in a curtain wall of green-tinted glass framed by stainless steel.[23] The new tower was developed by a Japanese real estate company that took over the project from the Prudential Insurance Company of America and the Trump Organization, which had failed to go ahead with a sixty-story residential condominium tower to be called Trump Castle (c.1983), designed by Philip Johnson and John Burgee.[24] Johnson's design consisted of six cylinders of varying heights with gold-leafed, coned and crenelated tops. There was to be a moat and a drawbridge, which Johnson proudly took credit for: "My idea. Very Trumpish."[25]

Other restylings deserving of notice included that of 575 Lexington Avenue (Sylvan and Robert Bien, 1958), northeast corner of Fifty-first Street, a gold anodized aluminum-clad eyesore for which Der Scutt substituted bronze-colored glass set into a large-scale aluminum grid attached to the existing aluminum mullions (1989),[26] and Fox & Fowle's less-well-advised resurfacing in 1990 of Emery Roth & Sons' 380 Madison Avenue (1953), west side between Forty-sixth and Forty-seventh Streets, formerly the site of the Ritz-Carlton Hotel (Warren & Wetmore, 1910), with a blue-tinted mirrored-glass wall occasionally punctuated with horizontal aluminum strips to create an eerily flashy effect quite out of context with the staid surroundings.[27]

The Colgate-Palmolive Building (Emery Roth & Sons, 1954–56), 300 Park Avenue, between Forty-ninth and Fiftieth Streets, was a cut above the typical curtain wall buildings of its era.[28] In 1997 Swanke Hayden Connell renovated the building's lobby, but in 1999–2000, new owners stripped off its warm cream paneled, gridded curtain wall and replaced it with a new skin of alternating bands of transparent Solex green glass and silvery Kynar-finished aluminum, designed by the firm of Moed de Armas & Shannon, which also replaced the buildings's red granite-trimmed base with large panels of clear glass butted together to form a sheer window wall.[29] In redesigning the facade, Raul de Armas, a former partner at Skidmore, Owings & Merrill who had worked on the renovation of the Union Carbide Building, claimed to have been inspired by two landmark SOM designs: Lever House and the Pepsi-Cola Building. Though that influence did not seem evident in the finished product, the design did

RIGHT 505 Park
Avenue (Emery Roth &
Sons, 1949), northeast
corner of East Fifty-
ninth Street. Renovation
by Der Scutt, 1987.
Entrance. DSA

BELOW 505 Park
Avenue (Emery Roth &
Sons, 1949), northeast
corner of East Fifty-
ninth Street. Renovation
by Der Scutt, 1987.
View to the northeast.
DSA

BELOW RIGHT 625
Madison Avenue (Sylvan
and Robert Bien, 1956),
between East Fifty-
eighth and East Fifty-
ninth Streets.
Renovation by Der
Scutt, 1987. View to the
southeast. DSA

LEFT 650 Madison Avenue (Harrison & Abramovitz, 1958), between East Fifty-ninth and East Sixtieth Streets. Renovation and addition by Fox & Fowle, 1987. View to the northeast showing Der Scutt's 1984 renovation of 5 East Fifty-ninth Street (Oppenheimer, Brady & Lehrecke, 1962) on lower left. Goldberg. ESTO

FACING PAGE
CLOCKWISE FROM
UPPER LEFT
575 Lexington Avenue (Sylvan and Robert Bien, 1958), north-east corner of East Fifty-first Street. View to the northeast before renovation showing 599 Lexington Avenue (Edward Larrabee Barnes Associates, 1987) on left. Wright. DSA

575 Lexington Avenue (Sylvan and Robert Bien, 1958), north-east corner of East Fifty-first Street. Renovation by Der Scutt, 1989. View to the northeast showing 599 Lexington Avenue (Edward Larrabee Barnes Associates, 1987) on left. Wright. DSA

300 Park Avenue (Emery Roth & Sons, 1956), between East Forty-ninth and East Fiftieth Streets. Renovation by Moed de Armas & Shannon, 2000. View to the southwest. TS

380 Madison Avenue (Emery Roth & Sons, 1953), between East Forty-sixth and East Forty-seventh Streets. Renovation by Fox & Fowle, 1990. View to the northwest. Gordon. FXF

320 Park Avenue (Emery Roth & Sons, 1962), between East Fiftieth and East Fifty-first Streets. Proposed renovation by Kapell & Kostow Architects, 1990. Rendering of view to the southwest. KGA

320 Park Avenue (Emery Roth & Sons, 1962), between East Fiftieth and East Fifty-first Streets. Proposed renovation by Skidmore, Owings & Merrill, 1992. Rendering of view to the southwest. SOM

reflect de Armas's commitment to refresh and extend corporate Modernism.

The reshaping and recladding of the thirty-two-story 320 Park Avenue (Emery Roth & Sons, 1962), west blockfront between Fiftieth and Fifty-first Streets, was the most dramatic of the Postmodern resurfacings, initially proposed in 1990 at the bottom of the real estate market when it was celebrated by Mayor David Dinkins as "the first new building project on Park Avenue in more than a decade."[30] Inside, because the building, like so many others, was filled with asbestos used to insulate pipes and clad structural metal, its 660,000 square feet of office interiors were to be stripped to their original steel structure. But, in an unusual move, the building's mass was to be reconfigured, eliminating four of its eight setbacks to provide larger tower floors and smaller base floors. The reconfigured mass was then to be restyled by Skidmore, Owings & Merrill, whose scheme suggested a thirty-four-story tower wrapped by eighteen-story granite and glass set-back pavilions. An earlier scheme, prepared in 1990 by Kapell & Kostow Architects, developed the basic massing but was shrill. The SOM proposal, prepared in 1992, owed quite a lot to the design of Rockefeller Center and promised to be a real addition to the street. But four days after New York City enacted a bill, in September 1992, to grant tax

breaks to property owners who modernized office buildings, Mutual of America announced that it had reached an agreement to buy the property, the redevelopment of which had been stalled by the adverse market. The new owner went ahead with its own plans, developed by Swanke Hayden Connell, whose work was completed in 1995.

SOM's proposal reshaped the building, requiring every floor to be altered. The architects' decision to use stone throughout also required that the steel frame be reinforced to take the additional weight. Swanke Hayden Connell's design, with its fifty-two-foot-high gabled peak concealing the rooftop mechanical equipment, differed from SOM's in profound ways. In the Swanke firm's redesign, Sardinian gray granite was confined to the lower eleven floors, above which aluminum panels would form the cladding. While the renewal of 320 Park Avenue had seemed such a good idea at first, at least to city officials, it did not seem so wise five years later when the work was completed. As Paul Goldberger wrote, 320 Park Avenue had gone from one set of clichés to another: "There is a sense of desperation to this whole venture that only makes

FACING PAGE 320 Park Avenue (Emery Roth & Sons, 1962), between East Fiftieth and East Fifty-first Streets. Renovation by Swanke Hayden Connell, 1995. View to the west. D'Addio. SHCA

360 Madison Avenue (Liebman Liebman Associates, 1981), northwest corner of East Forty-fifth Street. Renovation and addition by Richard Cook & Associates, 2003. View to the northwest. Kwon. CFA

the building look worse. In one step 320 Park Avenue has been transformed from a run-of-the-mill piece of commercial modernism to a shrill, overanxious piece of post-modernism. Which is worse, honest 1960's cheapness or disingenuous 1990's attempts at art?"[31]

Five blocks north, in 2002, work was completed on the resurfacing of 430 Park Avenue, west blockfront between Fifty-fifth and Fifty-sixth Streets.[32] Amazingly, this was the building's second major overhaul. First constructed in 1916 as a nineteen-story apartment building, one of Park Avenue's most luxurious, designed by Warren & Wetmore, the building was converted for office use in 1954, at which point it was stripped to its steel skeleton and given a new skin by Emery Roth & Sons. In 2001, when the owners regained control over the building from the Bank of Montreal, which had come to the end of its twenty-five-year lease, Moed de Armas & Shannon was hired to bring the office building up to Class A status. The architects inserted new HVAC, mechanical, and plumbing systems, renovated the lobby and elevator cabs, and replaced the Park Avenue facade's existing hopper windows with a green-tinted glass curtain wall that was carried around to the north and south facades, where the existing white glazed brick surface was covered over with a screened translucent interlayer at the spandrels, corners, and columns. At street level, the architects replaced existing inset storefronts with a full-height glass wall pushed out to align with the facade. A midblock entrance opened into a renovated lobby with illuminated glass walls, an inlaid Cippolino marble floor, and aluminum-sheathed columns. In November 2001, Macklowe Properties announced that Moed de Armas & Shannon, working with Gensler, would reclad in green glass Starrett & Van Vleck's twenty-two-story beige brick 340 Madison Avenue (1921), between Forty-third and Forty-fourth Streets, a job completed in 2004.[33]

Even relatively recent glass curtain walls were not safe from alteration, witness the reskinning of Liebman Liebman Associates' 360 Madison Avenue (1981), northwest corner of Forty-fifth Street, which lasted only twenty-two years before Richard Cook & Associates reworked it. Liebman Liebman's building was, in part, a recladding as well, replacing the twelve-story home of Abercrombie & Fitch (Starrett & Van Vleck, 1917), the venerable sporting goods retailer to the carriage trade, which closed at the end of 1977, a year after declaring bankruptcy.[34] At that time, the Abercrombie & Fitch building was not only reclad in reflective gray glass but also added onto, reemerging as a seventeen-story building. At first, Liebman Liebman proposed to add similarly sized floors conforming to the virtually site-filling footprint of the original building but, in response to opposition from the local community board, the design was changed to provide smaller floors in a tower that began its rise at a thirteenth-floor setback, allowing the project to go forward as of right. When Richard Cook reworked Liebman Liebman's design of 1981, he also undertook both a recladding and a substantial expansion, taking over its neighbor directly to the west, 11–15 East Forty-fifth Street (Gordon, Tracy & Swartwout, 1906), the former Home Club apartment building, which had been renovated in 1921 to accommodate office uses.[35] Cook tore down the nine-story Home Club and added seven stories to 360 Madison Avenue, resulting in a single 345,000-square-foot, twenty-four-story office building, completed in 2003, whose main entrance was on Forty-fifth Street. According to project architect Serge

430 Park Avenue (Emery Roth & Sons, 1954), between East Fifty-fifth and East Fifty-sixth Streets. Renovation by Moed de Armas & Shannon, 2002. View to the northwest. RAMSA

Appel, the white-painted aluminum and clear glass facade was "meant to read like the surface of a pond—sometimes it will be reflective and at other times, completely transparent. Just as in a pond, sometimes you see the bottom, a fish or a reflection off the surface."[36] James Gardner, writing in the *New York Sun*, called 360 Madison "very possibly . . . the best new building in Midtown in over a generation." Gardner found traces of "postmodern contextualism" in the building's horizontal mullions, which evoked cornices, but stated, "The overwhelming impression of the structure is one of mainstream Modernism, distinguished less by any strident idiom than by the consistent skill with which each part has been designed and carried out."[37]

Lever House
While only a handful of purists seemed worried about the loss of typical 1950–70s curtain walls, threats to the integrity of Skidmore, Owings & Merrill's Lever House (1952), west side of Park Avenue between Fifty-third and Fifty-fourth Streets, aroused widespread concern among preservationists. In the early 1980s, the building seemed doomed to make way for a new office building that would not only make full use of the site but would also incorporate the site to the west occupied by the Jofa Building (Robert F. Smallwood, 1930), 49 East Fifty-third Street, which was owned by Lever Brothers and would be

Proposed office building for Lever House (Skidmore, Owings & Merrill, 1952) and Jofa Building (Robert F. Smallwood, 1930) sites, west side of Park Avenue, between East Fifty-third and East Fifty-fourth Streets. Swanke Hayden Connell, 1982. Rendering of view to the northwest. RAMSA

Proposed office building for Jofa Building (Robert F. Smallwood, 1930) site, 49 East Fifty-third Street, west of Park Avenue. Welton Becket Associates, 1982. Rendering of view to the northwest. RAMSA

torn down.[38] The shock that Lever House might be the city's first great Modernist building to succumb to the wrecking ball led to a hearing before the Landmarks Preservation Commission at which Fisher Brothers, a prominent developer said to be interested in the redevelopment of the property, argued with the help of its architects, Swanke Hayden Connell, that Lever House was not as aesthetically significant as its near-neighbor, the Seagram Building (Mies van der Rohe, Philip Johnson, and Kahn & Jacobs, 1958), or the United Nations Secretariat Building (Wallace K. Harrison, Director of Planning, 1947–52). Swanke Hayden Connell not only prepared drawings for a forty-story tower to be built on the Lever House site, with "strong vertical bands of gray-blue glass and granite," but even more outrageously delivered a "white paper" to the commission denouncing Lever House as undistinguished and not worthy of preservation.[39]

On November 10, 1982, the Landmarks Preservation Commission rejected arguments from Fisher Brothers and the Swanke firm and declared Lever House a city landmark. Just thirty years old, it was the youngest building ever to be so honored. In fact, according to a provision of the law, no younger building could be so designated. Undeterred by the designation, Fisher Brothers continued to push its plan along, causing preservationists to fear for Lever House's future, given that the

action of the landmarks commission required ratification by the Board of Estimate, a body notoriously susceptible to pressure from special interest lobbyists. The situation was complicated, in the typical way of New York real estate, because the land on which Lever House stood was in one ownership, that of the old-line Goelet Estate, while the building itself was owned by the Metropolitan Life Insurance Company, which leased it to Lever Brothers. While Fisher Brothers had a contract to buy the land from Goelet, George Klein's Park Tower Group had a contract to buy the building from Metropolitan Life. The two developers refused to work together. In fact, Klein, a developer who prided himself on his commitment to excellent architecture, proposed to preserve Lever House, and in so doing restore its faltering curtain wall, the considerable cost of which would be offset by the returns for an annex he proposed to build on the Jofa site, using the unused air rights of Lever House. To do this, he would need to own the land or to enter into an agreement with the Goelets, but they were in partnership with the Fisher Brothers. To design his building, Klein turned to Kevin Roche John Dinkeloo and Associates, who in a rough zoning study proposed a glass tower for the site inspired by the design of Lever House.

On January 26, 1983, the matter of Lever House's landmark designation was scheduled to come up for a vote before the

Board of Estimate, which had five times before overturned a designation. The vote was postponed to February 10, on which day Paul Goldberger published Swanke Hayden Connell's design for the proposed replacement on the site. To the architects' claims that the design was Art Deco in style, Goldberger countered that it had "no more resemblance to the skyscrapers of the Art Deco period than it does to the Parthenon. It is much more of a glass box, left over from the 1960's and given a few flourishes in the hope of updating it for the 1980's." Goldberger warned that, if built, the new tower, which would rise from the center of the combined Lever-Jofa lot, completely surrounded by a plaza sunk three steps below street level, "could alter the mood of Park Avenue as dramatically as Lever House itself did in 1952. . . . This time, the change would be from a style of fairly formal buildings of glass to one that could be described more in terms of glitter. The thin, ornamental lines of beige masonry that run up and down the facade will do little to offset the general air of shrillness. If there is anything that this building can be called, it is garish."[40]

Even as the vote was about to be taken, many took some comfort in the fact that Lever Brothers, though it had been making noises about relocating to New Jersey, not only still had twenty-eight years on its lease but also had retained Welton Becket Associates to design a tower for the Jofa site. In addition, the company had supported landmarks designation and had also recently petitioned the commission for permission to make some minor changes to the building. According to Goldberger, Welton Becket's design, though no match for that of Lever House, did "suggest a more discreet and mannerly" approach than Swanke Hayden Connell's, "and could sit much more comfortably beside Park Avenue than the alternative."[41]

On February 10, the Board of Estimate once again postponed its decision, allowing Mayor Koch time, in an unusual move, to make public a letter to other members of the board urging confirmation. Koch was supported by City Council President Carol Bellamy and, after a meeting on February 22 with two prominent champions of designation, Philip Johnson and Jacqueline Kennedy Onassis, City Comptroller Harrison J. Goldin said he was "leaning" in favor of upholding designation.[42] On February 24, hundreds, including Johnson and Onassis, rallied in support at Lever House and on March 18, 1983, the Board of Estimate, in a six-to-five vote, upheld the building's landmark status.

With designation behind it, Lever Brothers faced new problems with its building, namely the literal preservation of the curtain wall, where almost 30 percent of the opaque, wire-glass spandrels, cracking as a result of thermal stress, had been replaced with new ones that could not be exactly matched to the color of the originals, so that the once uniformly luminous skin had begun to succumb to a random checkerboarding.[43] By 1995 between 40 and 50 percent of its 120,000 square feet of original glass had been replaced, and engineers were beginning to fear for the building's safety as a result of extensive corrosion in the building's structural steel caused by leaks from bad joints and a "malfunctioning or in some cases, nonexistent" copper drainage system in the building.[44] The corrosion had for a long time gone unnoticed because of the system of stainless-steel cover caps that had concealed the joints in the curtain wall. In 1995, under the direction of Vincent Stramandinoli, a consulting engineer, a plan was devised to reclad the building by wrapping the glass box inside a new glass box, removing the original after the outside work was

Lever House (Skidmore, Owings & Merrill, 1952), west side of Park Avenue, between East Fifty-third and East Fifty-fourth Streets. Detail of curtain wall showing original and replacement spandrels. RAMSA

completed. As a result of the plan, the building's new wall, with its thicker glass to meet contemporary codes, would extend three to four inches beyond the existing wall.

When objections arose, David Childs, head of Skidmore, Owings & Merrill, was brought in to modify the plan. In 1996 the landmarks commission approved a plan to strip off all of the facade and replace it exactly. In so doing, the original arrangement of clear glass spandrels open to painted masonry back-up walls a few inches behind would be returned to, bypassing the backpainted glass panels used as replacements in the intervening years, so that those portions of the curtain wall would regain their original transparent luminosity.

The restoration work did not begin until 1998, after two German-born investors, Aby Rosen and Michael Fuchs, operating as RFR Holding, purchased the building from Unilever, parent company of Lever Brothers. In effect, it wasn't the building's ownership that was transferred, but the remaining twenty-one years on the lease Unilever held for the use of the property from its owner, Sarah Korein, who had acquired both the land and the building in 1985. Under the leadership of Aby Rosen, the building's restoration was to not only include the necessary work on the curtain wall but also to extend to the lobby, which was restored by the architect William T. Georgis. Additionally, Michael Bierut, principal graphic designer at the

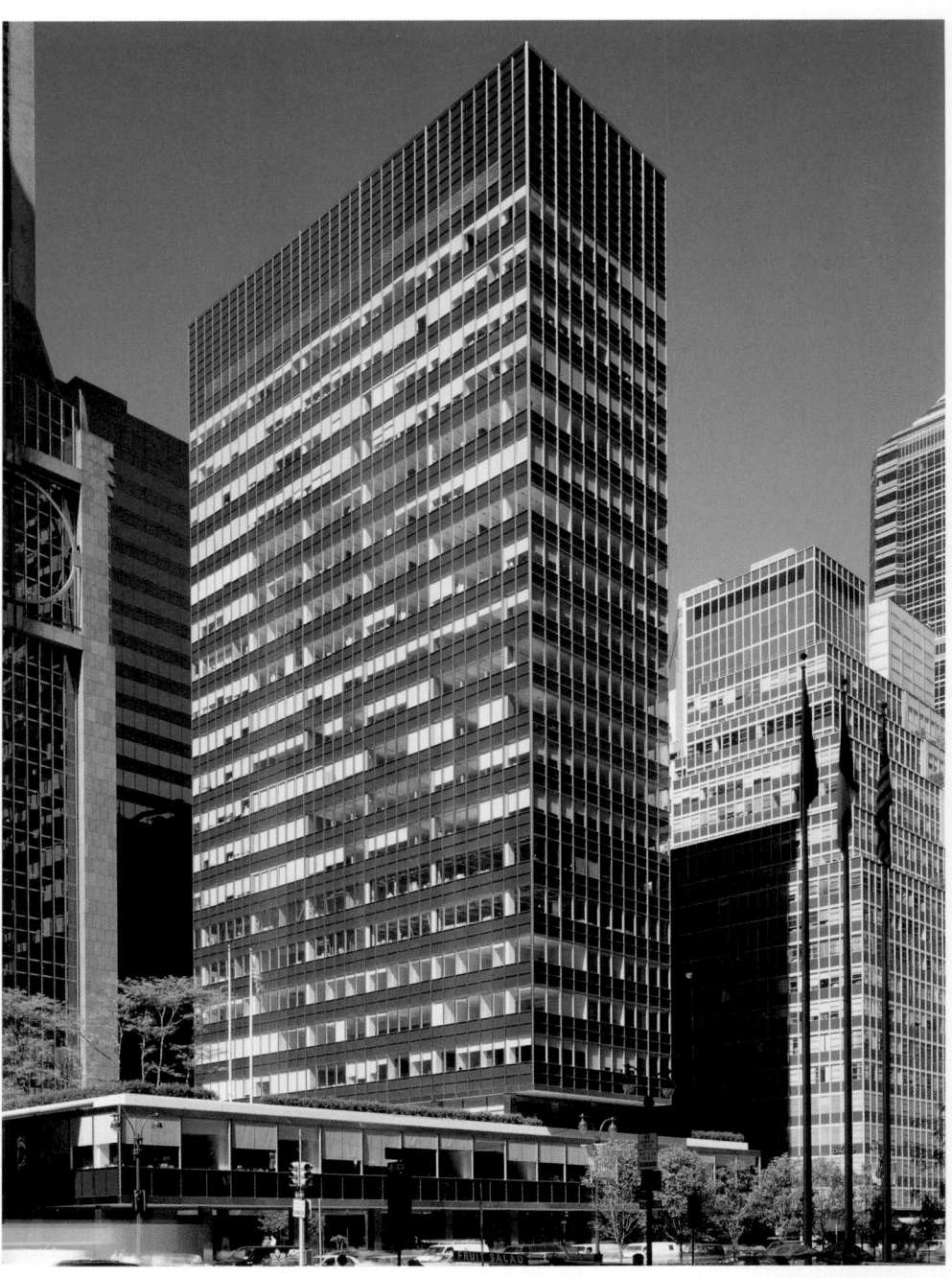

Lever House (Skidmore, Owings & Merrill, 1952), west side of Park Avenue, between East Fifty-third and East Fifty-fourth Streets. Restoration by Skidmore, Owings & Merrill, 2002. View to the northwest. Holzherr. SOM

Pentagram Group, was commissioned to extend the original "Lever House" signage into a full alphabet to be called Lever Sans. Work on the exterior facade began in earnest early in 2000, by which time, according to Gordon H. Smith, the curtain wall specialist brought in to help SOM with the design of the restoration, only a half dozen or so of the original lights remained in place.

As enthusiasm for the restoration continued, attention was focused on the never very successful street-level garden, designed by Skidmore, Owings & Merrill after two earlier versions by the sculptor Isamu Noguchi were both rejected, presumably by the client, who may have been concerned about the impact the artist's politics may have had on the general public.[45] To redesign the garden, Rosen and Fuchs turned to the landscape architect Ken Smith, whose proposal

to realize Noguchi's unbuilt design was rejected by the Noguchi Foundation, justifiably concerned about use of Noguchi's ideas without the benefit of the direct supervision of the now-deceased artist.[46] Instead, Smith designed his own version, using a total of eight Noguchi pieces provided by the foundation on a long-term loan. Both the foundation and the landmarks commission approved a series of stone benches designed by Noguchi for several spots around the plaza because their design had been detailed in SOM's construction drawings. Plans for the conversion of Lever House's cafeteria into a glamorous restaurant fell through when the intended location, the 23,000-square-foot third floor, combining indoor space with a roof garden, was leased by the high-end retailer Prada for use as offices and showrooms. But in 2003 a 6,500-square-foot windowless ground-floor space

Banco Santander, 49 East Fifty-third Street, west of Park Avenue. Rogers, Burgun, Shahine & Deschler in association with Clark, Tribble, Harris & Li, 1994. View to the northwest showing Lever House (Skidmore, Owings & Merrill, 1952) before restoration on right. Mauss. ESTO

behind a black granite wall at the west end of the plaza, formerly used by Lever Brothers as a conference center and company store, was converted into the Lever House Restaurant, designed by the London-based Marc Newson.[47] Entering beneath a new steel-and-glass canopy on Fifty-third Street, visitors traveled through a twenty-foot-long illuminated white Corian tubular passage into a 130-seat dining room, where a hexagonal decorative pattern was incorporated into the floor, walls, and ceiling to suggest a honeycomb. The dining room was devoid of right angles, instead featuring plaster walls with blond oak wainscoting pitched at nine degrees. A bar occupied one end of the long room while the other end was overlooked by a small elevated dining room seating twenty-two. The design was typically trendy and essentially unmemorable.

When Sarah Korein purchased Lever House and the land beneath it, she also gained the right to build on the Jofa Building site, which she in turn sold to Banco Santander Edificio Espana. In 1991–94 the sixty-year-old eleven-story building was demolished, replaced by a twenty-story, 110,000-square-foot tower designed by Rogers, Burgun, Shahine & Deschler in association with Clark, Tribble, Harris & Li.[48] A step-back wall of dark and light gray granite faced Fifty-third Street, but the building turned a glassy face toward Park Avenue, from which it was quite visible over Lever House's third-floor terrace. To help identify the midblock building with the more prestigious Park Avenue, a mansard roof and a large ornamental circle of stainless steel bisected by a mast was an applied flourish. The editors of the *AIA Guide* dismissed the "two elevations as both aggressive and self-promoting."[49]

LOWER MANHATTAN

PREVIOUS PAGES View to the southeast of lower Manhattan across Hudson River from New Jersey, 1988, showing World Financial Center (Cesar Pelli & Associates, 1988) in center. Aaron. ESTO

ABOVE Battery Park City, landfill in the Hudson River, Battery Park to Chambers Street. View to the southeast, 1975. BPCA

BATTERY PARK CITY

By the mid-1970s, Battery Park City was perhaps the most visible symbol of New York's stalled economy. In March 1976, state comptroller Arthur Levitt, having completed a yearlong audit of the Battery Park City Authority's financial condition and prospects, questioned whether the project should be dramatically reshaped or even terminated.[1] When it was first announced in 1966 by Governor Nelson A. Rockefeller and again when an official master plan was released three years later, Battery Park City had been heralded by local and state officials and the architectural and popular press as a bold plan that would resuscitate a moribund lower Manhattan by creating a vast mixed-use complex featuring significant amounts of housing. It was an ambitious attempt to jump-start the rejuvenation of downtown, transforming the almost exclusively daytime area of office buildings into a vital, twenty-four-hour community.[2] But the specific design, proposed by a team of architects led by Wallace K. Harrison, William Conklin, and Philip Johnson, had produced a megascaled project that was not susceptible to piecemeal development. Moreover, with its futuristic imagery, it seemed dated, and many questioned its internalized, city-within-the-city approach. Of course, this might not have stopped it had not the business climate changed so drastically in the 1970s recession. In short, Battery Park City was a very troubled project, with only one sign of development progress: the creation of ninety-two acres of landfill, the by-product of the construction of the World Trade Center (Minoru Yamasaki and Emery Roth & Sons, 1973), that, by its vast emptiness, made the project's plight all too

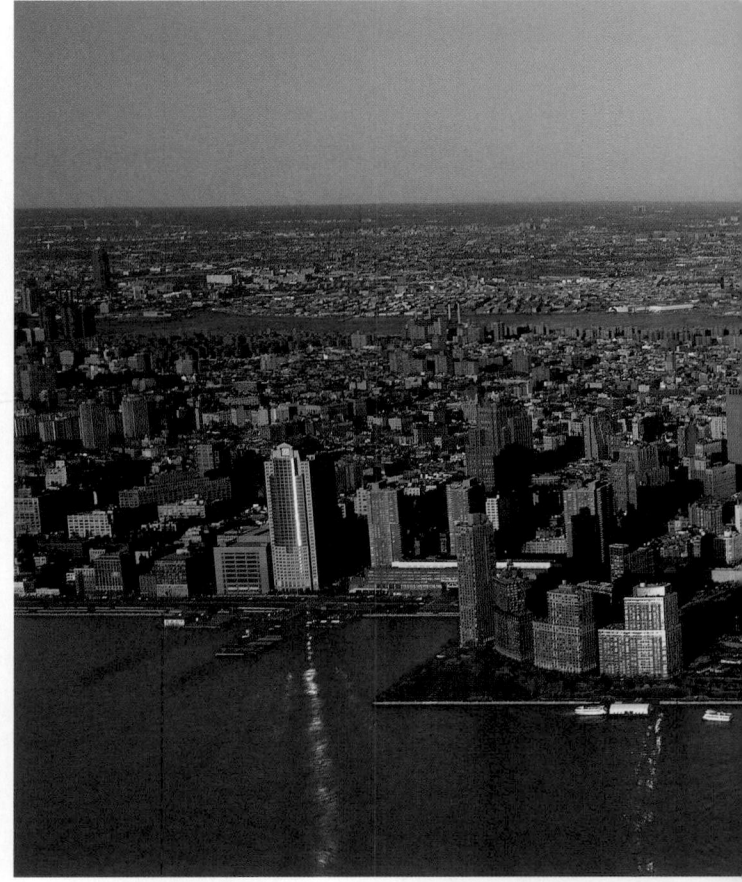

visible.[3] Moreover, the Trade Center itself was part of the problem: its completion at the depth of the economic recession had flooded the market with office space, virtually eliminating the chance of attracting developers to build any new space downtown, which was still suffering in comparison to the situation in midtown. The city's fiscal crisis in 1975 was perhaps the final nail in Battery Park City's coffin. A victim of the tortured bureaucracy that controlled it, an amalgam of city, state, and federal officials whose constant bickering and turf fighting created an environment particularly inhospitable to development, Battery Park City seemed doomed to failure.

Still, there was the landfill, tempting—indeed daring—real estate–minded New Yorkers to devise a development strategy. One developer was willing to take a gamble on Battery Park City's potential: Samuel J. Lefrak, whose Gateway Plaza, a middle-income apartment complex, had been proposed in 1973 by the Battery Park City Authority (BPCA) as a last-ditch effort to build on the site.[4] The Lefrak Organization was one of the city's most successful developers of apartment houses; its extensive portfolio was almost exclusively confined to the outer boroughs of Brooklyn and Queens.[5] To design Gateway Plaza, Samuel Lefrak, no patron of high-art architecture, commissioned his in-house architect, Jack Brown, working with Irving E. Gershon, to prepare plans for 1,712 units at 345, 355, 365, 375, 385, and 395 South End Avenue, constituting a development that bore almost no resemblance to the megastructural images proposed in the 1969 master plan, but instead was a cluster of buildings realized in exposed concrete—three of thirty-four stories, two of seven stories, and one of six stories. The crushing banality of the buildings was somewhat mitigated by the surprisingly pleasant landscape they sat in, designed by Abel, Bainnson & Associates, completed in 1982. At first, there seemed a bit of hope that Lefrak and his team might produce something better, but concern with aesthetic niceties was put aside in favor of the even larger hope that something, anything, would be built at all. In that spirit of hope over judgment, Ada Louise Huxtable rallied around the initial project, concentrating on what was then to be a deck landscaped by Lawrence Halprin, the distinguished San Francisco–based landscape architect and urbanist, whose municipally sponsored study of New York's open space, *New York, New York*, had been published to some acclaim in 1968.[6] Mixing Le Corbusier's description of his unrealized proposal to rebuild Paris as a vertical garden city with the name given to federally sponsored suburban new towns in the 1930s, Halprin put a positive spin on Gateway Plaza by labeling it a "vertical greenbelt town," while Huxtable, virtually blinding herself to the buildings, praised Halprin's plan as yet another step in the improvement of New York's public space.[7]

In order to push the housing toward construction, Peter J. Brennan, president of the Building and Construction Trades Council, agreed to what was just short of a no-strike pledge, promising labor peace during the construction of Gateway Plaza, something not seen in the city since the construction of the 1964 World's Fair. A pattern of optimistic headlines and projections followed by no real progress continued through

Battery Park City, landfill in the Hudson River, Battery Park to Chambers Street. View to the east, 2004. BPCA

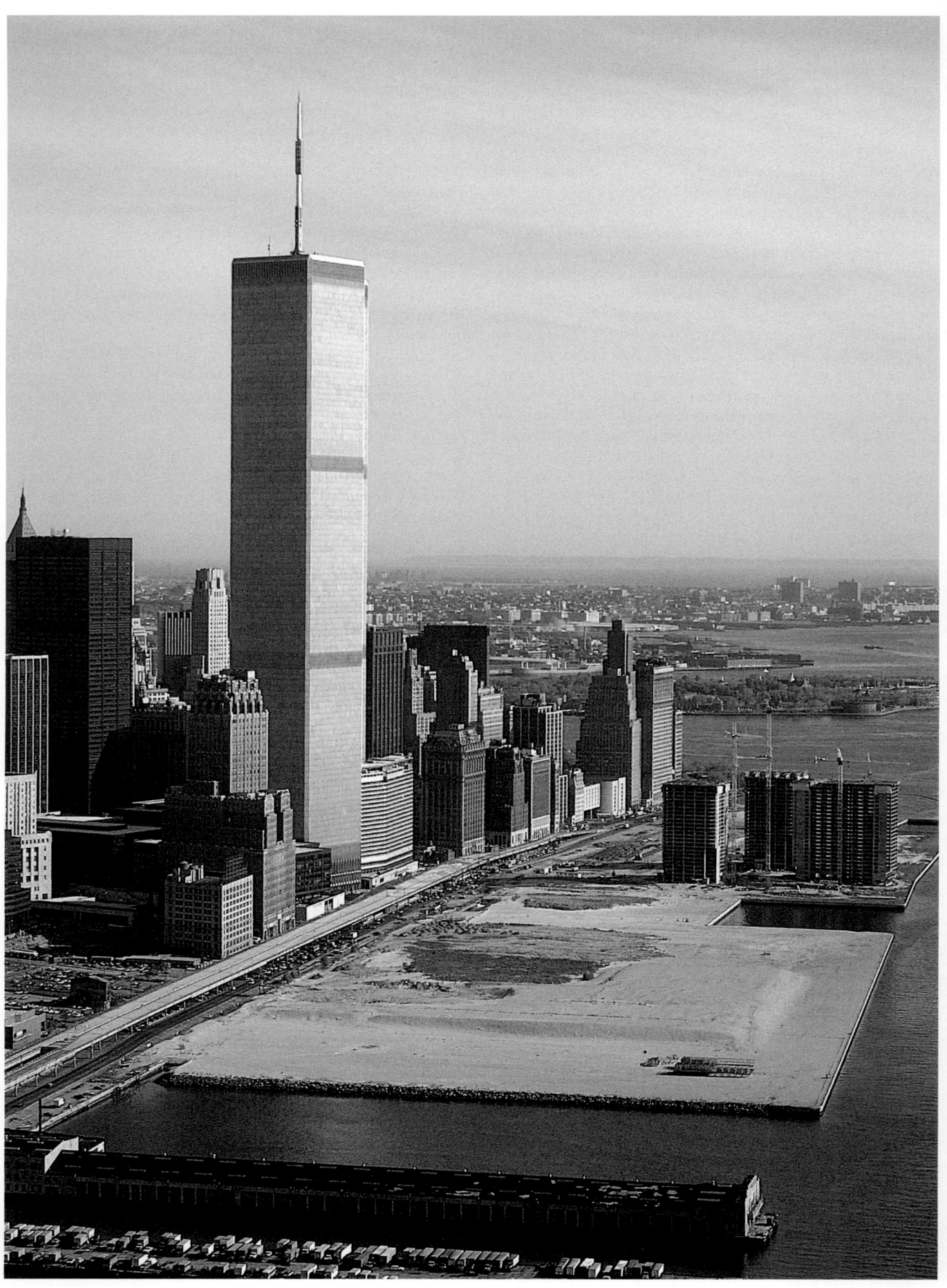

1977: construction on the foundations was under way, though construction of the buildings themselves remained in doubt. Many politicians and the general public were not entirely convinced that this project even deserved the federal government's precious housing dollars being sought in the form of mortgage guarantees. By the time these guarantees were achieved in 1978, Huxtable, who always seemed to be struggling to find something to praise in the proposal, reported that its brightest spot, the innovative work by Halprin, had been abandoned.

Meanwhile, in an attempt to jump-start interest in the remainder of Battery Park City, the influential Downtown-Lower Manhattan Association commissioned the engineering and planning firm Vollmer Associates to look at the site's potential use as a home to a new convention center.[8] Until this study, interest in a new convention complex, to replace the Coliseum, had centered on two sites, Forty-fourth Street and the Hudson River and the Thirtieth Street rail yards. Vollmer concluded that in fact the Battery Park City site, with its proximity to the Trade Center and its subway and PATH connections, was far more suitable than either midtown site. Although the idea for a convention center at Battery Park City never took serious hold, Vollmer's report was important for its emphasis on Battery Park City's strategic links with the Trade Center, bringing up the idea that its commercial complex should be located at the midpoint of the site, rather than at its southern tip, where it had been proposed in the 1969 master plan.

In 1979 the troubles over building Gateway Plaza were eclipsed by fears that the entire Battery Park City project was in real danger of imploding. The Downtown-Lower Manhattan Association again retained the services of Vollmer Associates, who concluded that unless radical changes in its financial structure were made within four years, the Battery Park City Authority would be unable to pay interest on any of the bonds it had issued. Vollmer also reported that the situation, if left alone, was unlikely to improve because future developers were unwilling to involve themselves in a project in which so many conflicting governmental agencies had control. Vollmer's report proved decisive: in order to turn the project around, state and local officials worked together to reconceive it, proposing that a new master plan be undertaken along with tax abatements and other financial incentives to spur private investment.

One of the first steps in Battery Park City's rescue plan took place in January 1979 when Governor Hugh Carey, who had been in office since 1975, was finally given an opportunity to gain control of the Battery Park City Authority board, whose three members had been given fixed terms by Governor Rockefeller. Carey appointed two members to the board: William D. Hassett Jr., the Urban Development Corporation's chairman, and Richard A. Kahan, the UDC's president. Within a month, Kahan was named president and chief executive officer of the Battery Park City Authority. Under a memorandum of understanding with the city, the Urban Development Corporation condemned the site and took possession of it for a dollar. In effect, the Battery Park City Authority became a subsidiary of the Urban Development Corporation and was

Proposed American Stock Exchange, site west of the World Trade Center. Davis, Brody & Associates, 1979. Rendering of view to the northeast. DBB

now exempt from the city's planning regulations and public-review procedures. One of Kahan's first tasks was the renegotiation of the authority's ninety-nine-year lease with the city, which provided for no tax abatements but required the city to pay for the construction of roads and sewers and allowed the city to keep the profit only after the authority paid all its financial and administrative costs, an arrangement that effectively stalled the project because of the city's ongoing fiscal instability. These talks moved slowly as city and state debated the extent of the tax abatements and as critics suggested that a renewed Battery Park City project would drain development away from other areas of the city, a point that was countered by Peter J. Solomon, Deputy Mayor for Economic Development: "Who's going to believe in New York's rebirth so long as we have that hunk of deserted beach down there?"[9]

In announcing his plan of attack, Governor Carey asked the state legislature for $8 million to bail out the authority as well as the bond authorization to build a new headquarters for the American Stock Exchange, which was seen as the cornerstone of the new plan.[10] After I. M. Pei refused the commission, reportedly because he felt it would interfere with his chances of winning the convention center job at Thirty-fourth Street, Davis, Brody & Associates, in association with the planning firm Llewellyn Davies Associates, was hired to plan for the new American Stock Exchange. Their design called for a twelve-story, 300,000-square-foot office tower and a 50,000-square-foot trading floor, twice the size of the exchange's current floor. The $53 million building was to be financed with a $20 million New York state economic development grant and $33 million in bond proceeds from a group of institutional investors. Ground was to be broken in April 1980.

In response to complaints that the deal, which called for the UDC's construction of a building for a private user—the American Stock Exchange—with funds raised by Triborough Bridge and Tunnel Authority bonds, was a form of "blackmail" and "a government subsidy for a bastion of capitalism," Assemblyman Richard W. Gottfried, from Manhattan, stated that the threat by the American Stock Exchange to move to New Jersey was real: "There were those who said that the racetrack and the Giants and the garment and port business wouldn't move to New Jersey. The only problem with that argument is that they've already gone."[11] The American Stock Exchange had been threatening to leave for years, but when its

Proposed plan for Battery Park City, landfill in the Hudson River, Battery Park to Chambers Street. Wallace K. Harrison, William Conklin, Philip Johnson, and Alan M. Voorhees & Associates, 1969. Plan. CRP

Battery Park City, landfill in the Hudson River, Battery Park to Chambers Street. Alexander Cooper Associates, 1979. Design principles diagram from 1979 Master Plan. CRP

1978 plan to merge with the much more powerful New York Stock Exchange failed, there was a belief that this time there was a chance it would go ahead with its threats. Despite it all, the American Stock Exchange did not realize its Battery Park City headquarters (see below).

But Battery Park City needed more than a cash bailout or one major tenant to get back on its feet: it needed a major change in direction, a large-scale plan that would finally garner support in the business community. In an enlightened and politically astute move, Richard Kahan, after consulting with Edward Logue and I. M. Pei, selected Alexander Cooper, a former member of the New York City Planning Commission who had recently reentered private practice as an urban designer, to prepare a new plan for the development.[12] Cooper, working with Stanton Eckstut, who soon became his partner and was coauthor of the master plan, was given only ninety days to prepare the design. Cooper and Eckstut, who were instructed to review the 1969 master plan in order to avoid its mistakes, clearly enunciated the issues:

> Battery Park City is a paradox: it occupies one of the most spectacular and potentially valuable sites in the world, yet it has been unable to generate developer activity. For five years, its landfill has stood substantially complete, but unused. Rarely has such a

development opportunity—92 acres of vacant land immediately adjacent to downtown Manhattan–gone unheeded. But the interplay of changing market forces, national economic trends and the passage of thirteen years since the project was initiated have combined to raise serious questions as to the project's financial stability and its potential contribution to the future of Lower Manhattan.

From the very beginning, Cooper and Eckstut were careful to emphasize that what was needed was a "deliberately flexible" plan that was "capable of refinement."[13] "The premise of the Battery Park City Master Plan is that new urban developments need not be amusement parks," they observed, "but handsome, workable extensions of the city. Manhattan successfully maintains its own vitality; there was no need here to provide a booster shot of new ideas, only more space to encourage natural growth along proven patterns. Now that we have all learned from Las Vegas, it's time to learn also from Fifth Avenue, Gramercy Park and Riverside Drive."[14]

In their master plan, released in November 1979, Cooper and Eckstut criticized the 1969 master plan for being excessively rigid and overly complicated. "Instead of restricting development to huge commercial and residential complexes that only large firms can undertake," they proposed that

provision should be made for small-, medium-, and large-scale building opportunities, concluding, "This should quicken the pace of development and broaden the selection of building types." At the heart of the new master plan were eight "organizing principles": "Battery Park City should not be a self-contained new-town-in-town, but a part of Lower Manhattan"; "the layout and orientation . . . should be an extension of Lower Manhattan's system of streets and blocks"; "Battery Park City should offer an active and varied set of waterfront amenities"; "the design . . . should take a less idiosyncratic, more recognizable, and more understandable form"; "circulation . . . should reemphasize the ground level"; "Battery Park City should reproduce and improve upon what is best about New York's neighborhoods"; "Battery Park City's commercial center should become the central focus of the project"; and "land use and development controls should be sufficiently flexible to allow adjustment to future market requirements." One of the most striking aspects of the new master plan was the dedication to the preservation and articulation of open space: "The Hudson River waterfront is Lower Manhattan's greatest potential recreational amenity. . . . Virtually 70% (65 acres) of the site has been allocated to open space . . . , more than was provided for in the earlier plan."[15]

Cooper and Eckstut were the first to admit that they were the beneficiaries of a much improved economy, which would significantly aid in implementing their master plan. The demand for office space was also rising. In addition, the growth of the economy was particularly suited to the development of lower Manhattan, with financial services companies taking the lead in the boom that was about to be unleashed. Cooper and Eckstut pointed to the phenomenon of loft conversions and the recent explosion of development in the area known as Tribeca as a particularly important factor, popularizing the idea of downtown living. Finally, the planners believed that they benefited from a sea change in thinking in the architectural and planning community itself:

> Radical changes have occurred in the attitudes of urban designers and architects. Battery Park City's original plan conceived of the project as a single continuous building—a megastructure. . . . The concept of the megastructure has been replaced by more traditional and successful concepts of city buildings. The multi-purpose street is seen as the prime organizing element, instead of a complex decked service spine. . . . Even Manhattan's most successful planned development, Rockefeller Center, owes much of its environmental quality to its recognition of the basic street grid. At Battery Park City, the urban design challenge is to recapture this heritage in meeting the development needs of the 1980s.[16]

Cooper and Eckstut's plan was bold, moving the office complex from the south tip to opposite the Trade Center, where it could benefit from proximity to rapid transit and to the business-oriented concentration of activities already in place, and incorporating design controls on future commercial buildings in the relocated business center. The controls encouraged prospective developers and their architects to mass their buildings pyramidally toward the Trade Center in an effort to create a set of mountain-sized foothills that, they believed, would return to downtown's west side skyline the traditional hierarchical massing that Minoru Yamasaki's prismatic Trade Center towers so powerfully repudiated. Additionally, the master plan called for a glass-enclosed mall, or "winter garden," that would tie the office buildings

together with the showpiece of the commercial district, the proposed new headquarters of the American Stock Exchange. To the north and south of the center, the plan of streets took on different specific configurations, with parks and squares to the south to an extent replacing the intimate and idiosyncratic plan of the Dutch city, while to the north was a more regular grid with a central, boulevard-like avenue—perhaps a false note improbably suggesting a very short Paris avenue— and a broad, curving avenue facing the Hudson River that was modeled on Riverside Drive. Working in close collaboration with Amanda Burden, a UDC vice president who led its department of urban design and public spaces, the master planners promulgated extensive development guidelines that governed design as well as land use and bulk. These would prove critical to the success of the defined and distinct neighborhoods that gradually emerged over twenty years, demonstrating that large-scale projects need not result in monolithic uniformity. Stanton Eckstut developed the guidelines for the residential neighborhoods at the south end of the site, while Alexander Cooper formulated the guidelines for the central commercial portion.

Paul Goldberger hailed the plan as "a product of . . . hard-nosed, practical realism," replacing the megastructural heroics of the original and the pretense that what was to be built was "some kind of experimental town" with a "down-to-earth, literally as well as figuratively" arrangement of grade-level streets that "takes as its basic notion the idea that the key to Battery Park City's success is not in making it look different from the rest of New York—as the original scheme did—but in making it look the same," building on "two crucial strengths of Manhattan as it now exists, the gridiron that makes up the island's street pattern and the sense of diversity of its architecture."[17] Ada Louise Huxtable also favored the plan, although her approval seemed somewhat grudging. She did find "one brilliant twist": "Battery Park City's streets [will] follow the diagonal Broadway axis rather than the later right-angled grid that was imposed on it. This [will] create 'bias' streets with long waterfront views, and the chance of interesting intersections."[18] The architect and urbanist J. Michael Kirkland was decisive in his endorsement: "When one finally ignores the glamour and notoriety of a project of so prodigious a nature, one is left feeling that the Battery Park City plan is a landmark in American urbanism. After a period of vapid 'modern' space and institutionalized superblock development, this scheme reasserts a public realm that is figural and inflected, unambiguously public and accessible."[19]

Although Cooper and Eckstut's master plan was well received, not only for its design but also for its perceived potential for tangible progress, there were naysayers as well. Herbert Muschamp, in one of his first bits of critical writing, published in 1981 in the short-lived magazine *Express*, criticized the plan as

> reactionary . . . since its major polemical objective is the restoration of qualities characteristic of New York architecture before the post-War Modern invasion. . . . There is a profound irony to this epic show of sensitivity to traditional urban values, for what was often most objectionable about the Modern invaders . . . was the devastating impact Modern buildings had on "older, more established neighborhoods." Yet, here on Battery Park City's 92-acre landfill site, the developers were given a perfectly clean slate. There were no older buildings to tear down or accommodate; no landmarks to imperil or preserve; no street life to disrupt or

enhance. One could hardly imagine a site more suitable to experiments in Modern town planning: it was the perfect tabula rasa—30 years too late.[20]

Jon Michael Schwarting, an architect-urbanist, also writing in 1981, was more specific in his criticism, observing that the plan

> purports to be an extension of the existing context. One of the strengths of the typical Manhattan block is the hierarchy present in its configuration and proportions: residences on the long sides of the rectangle and commercial on the short avenue sides. Although the street grid laid out in the 1811 Commissioner's Plan is extended, this hierarchy is denied in the plan's inclusion of squarish blocks. Moreover, the pleasant and unexpected open spaces such as Abingdon Square . . . resulting from the collision between the orthogonal grid of the city and the edge grid perpendicular to the waterfront, have been replaced by triangular and oddly shaped blocks. These blocks unsuccessfully attempt to absorb the seam between the two grid systems and have a great potential for disorientation.[21]

But perhaps Michael Sorkin, writing in the *Village Voice*, was the most cutting in his critique:

> The big shtick here (propagated in an atmosphere of endless self-congratulation) is laying out the landfill in "traditional" streets and blocks. . . . The Battery Park City "idea" is an attempt to ape a "natural" process of city extension, to describe and replicate an indigenous way of building. Ironically, this residential gridding

and platting has no real history nearby. The choice to build according to some idealized vision of a New York City residential neighborhood (whatever the conservative appeal of the defense via precedent) is—at this specific place—really just whimsical. In terms of the economics of parcelization, it does have its vulgar logic, facilitating the handing out of pieces to the usual developers. But the real visionary genius of New York lies in the tension between precedent and innovation. There's no better example than the area of lower Manhattan that Battery Park City adjoins, where 20th century skyscrapers rise from the medieval-style street pattern laid out by the Dutch.[22]

Naysayers were in the minority, however, and their criticism was largely ignored as the plan gained support and the rebounding economy made its realization seem increasingly likely. Even when what seemed the development's most important component, the new headquarters for the American Stock Exchange, failed to materialize when the Board of Governors of the exchange voted unanimously in October 1980 to withdraw its plans, the *New York Times* was positively sanguine in its editorial pages, convinced that with the new master plan Battery Park City would have no trouble in finding another developer.[23] Another consequence of the optimism generated by the new master plan and the rebounding economy was the renewal of construction at Gateway Plaza, the last remnant of the old plan.[24] Work started again in the summer of 1980 and the apartment complex was completed

LEFT Proposed World Financial Center, Battery Park City. Mitchell/Giurgola Architects, 1980. Model, view to the southeast. Pottle. MGA

BELOW Proposed World Financial Center, Battery Park City. Kohn Pedersen Fox, 1980. Model, view to the east. KPF

FACING PAGE Proposed World Financial Center, Battery Park City. Zimmer Gunsul Frasca, 1980. Model, view to the east. ZGFP

and ready for occupancy in June 1982. Stanton Eckstut, in a 1986 interview, noted that "because its foundations were already poured before we drafted the 1979 Master Plan, we had to accept it as it was," treating Gateway Plaza as if it were an urban renewal superblock project of the 1950s imposed upon a long-established urban grid, a kind of found object, a theme park of modernity encapsulated in the townscape of post-modernity.[25] When Gateway Plaza was complete, the reaction was largely negative, with Brendan Gill describing the buildings as having "a grim, gray penitentiary look,"[26] although the editors of *Oculus* were pleased to note the "surprising oasis in the middle of the complex."[27]

World Financial Center
In July 1980, with rumors circulating that the American Stock Exchange would not go forward with its plans, the UDC and the Battery Park City Authority, both led by Richard Kahan, sent letters to about two dozen major developers soliciting their interest in the development of the commercial area to the west of the Trade Center, where, according to the new master plan, 6 million square feet of office space could be realized in buildings that were not taller than half the height of the Trade Center, stepped upward in mass from the shore to respect "the traditional pyramidal shape of the Lower Manhattan skyline."[28] The overall density of development was to be limited to a floor-area-ratio of fifteen with no less

than 20 percent of the site devoted to public open space. After months of wrangling, and the American Stock Exchange's official withdrawal, the city and the Battery Park City Authority reached an agreement on a tax abatement plan in the commercial complex, thereby removing the last significant obstacle to its realization.[29]

In November 1980, Olympia & York Properties, a Canadian company that in a few short years, mostly through acquisition of failing properties, had become New York's second-largest commercial landlord, was selected over eleven other candidates and given conditional approval by the state to build the commercial core of the long-delayed project.[30] Theirs was the only bid to develop all the properties offered. The bold move on the developer's part was a tribute to the financial acumen of its principal leader, Paul Reichmann, who understood that the ten-year tax abatement would virtually eliminate the cost of land as a factor in the development, enabling rents to be substantially lower than those of competing buildings in the financial district. Olympia & York chose as its architect the New Haven–based firm Cesar Pelli & Associates, to work in association with different New York and Canadian firms to realize the mammoth office project.[31] Pelli was selected by the developer in an informal competition, which in an intermediate stage reduced the group to his firm and three others: the New York and Philadelphia firm Mitchell/Giurgola Architects, Zimmer Gunsul Frasca of

Portland, Oregon, and Kohn Pedersen Fox of New York. Pelli's proposal stood out, according to one of Reichmann's key assistants, Ron Soskolne, an architect, who stated, "It managed to strike a balance on the one hand being quite simple and easily constructable and on the other hand having a lot of flair, capturing in a sense the essence of what the New York skyscraper had been about traditionally."[32]

Plans for Cesar Pelli & Associates' World Financial Center were released in May 1981. Scheduled for completion in 1987, the fourteen-acre development was initially to add an ice-skating rink, plazas, gardens, a winter garden, and restaurants to the 6 million square feet of office space distributed in four essentially square towers ranging from thirty-four to fifty-one stories, each one rising to a distinct rooftop feature—one a pyramid, another a stepped pyramid, a third a low dome, and the fourth to a shape that Pelli described as a "truncated pyramid." Critical to the project's future were pedestrian bridges across West Street, the fates of which still hung in the balance as the Westway project dragged on (see Digging In, Introduction). Pelli aligned the towers with the characteristic Manhattan street grid, but with a slight rotation to the south of the lower floors of the two northern towers to take into account the specific geometry of West Street and the river's edge. In response to prevailing patterns in nearby buildings, the towers were articulated at the third, ninth, and twenty-fourth floors. Given that the typical floor sizes were the same as those of the Trade Center towers, but that the four new towers were nowhere near as tall, Pelli's subtle modifications of the mass were amazingly effective in overcoming what might otherwise have been perceived as squat, lumpish buildings. However, as Pelli observed, "We all know buildings that have been carefully composed to match basic and subtle alignments but that still remain alien presences." Therefore, he introduced "an additional and different type of relationship . . . a strong vertical thrust" culminating in distinct and individual copper-clad roof "forms, or crowns" that "represent an attitude of optimism and celebration which is what we have always expected of skyscrapers. This attitude is perhaps the key element in making the World Financial Center towers part of downtown Manhattan." Deliberately eschewing the Postmodernist tendency toward overt historical recall, Pelli

World Financial Center, Battery Park City. Cesar Pelli & Associates, 1981. Axonometric. CPA

was careful to make clear that though the buildings were "connected to their place," they were "also connected to their time and to their own reality, which is at least as important." To this end, "at every critical instance" the glass and flame-finished granite cladding was always revealed as a "light-weight envelope," a direct criticism of the distinctly massive handling of the skin at Johnson/Burgee's AT&T building. Moreover, the repetitive window grid was intended to make absolutely clear the uniform nature of the modern office landscape. Most important, Pelli, a keen student of the New York skyline of the 1920s and early 1930s, acknowledged, as most postwar skyscraper architects did not, the public role of commercial skyscraper design: "These are buildings that start at their base as responsible citizens of the ground and sidewalk. As they move upwards, they acquire a vertical visual thrust, becoming idealized buildings of the sky with tops ennobled by copper, a material associated with many of the world's major public buildings," tops that will be "easily recognizable silhouettes and will become as reassuringly familiar as the spires and domes of churches and crowns of the Golden-Age skyscrapers."[33]

Paul Goldberger greeted the project enthusiastically, immediately elevating its status to that of Rockefeller Center. According to the critic, Pelli "has chosen what might be called a middle road" in attempting to humanize the essentially abstract mass of the modern business tower. "The Battery Park City towers are 'modern,' in one sense, and 'traditional' in another. . . . This is the sleek architecture of modernism not molded into a box, but wedded to the classic tower forms of the past. . . . The buildings have tops . . . but underneath those tops . . . there are forms rich in setbacks." Goldberger hedged his bets over Pelli's decision to sheathe the lower floors of his buildings in granite pierced by relatively small windows, changing to sleeker, glassier gridded facades above: "The success of this shift from masonry lower floors to glass upper ones will depend very much on the skillfulness of detailing in these buildings. . . . If Mr. Pelli proceeds with a plan to use different colored granite for each section, as he is considering, that may cause further awkwardness."[34]

The new towers were to have very large floors, ranging from 35,000 to 40,000 square feet. While this represented a response to market demand, it also produced buildings with sufficient heft, given Pelli's sculpting, to provide an appropriate intermediate scale between the scale-breaking Trade Center towers and the traditional skyscrapers of the first thirty years of the century. As Goldberger stated:

> Mr. Pelli's Battery Park City buildings do not look ridiculous next to the World Trade Center, and that is a remarkable accomplishment. Before the most difficult backdrop imaginable, the architect has conceived a . . . set of buildings that will be exciting on the skyline and full of life on the ground. And, happily, the architect did not fall victim to the temptation, so logical at first, to forget about the World Trade Center altogether. Indeed, the plan for Battery Park City works so well, in part, because it takes the presence of the Trade Center into account.[35]

Rising in a set of regular setbacks to a mastaba-like conclusion at the top, One World Financial Center (1985), West Street opposite Cedar Street, was designed by Pelli in association with Adamson Associates. The first of the World Financial Center towers to be completed, housing Dow Jones & Company and Oppenheimer & Co., the forty-story building

was arguably the dullest of the lot. Between it and Two World Financial Center (1987), at Liberty Street, two nine-story octagonal buildings served as symbolic gatehouses, providing easily identifiable entrance lobbies via broad stairs and escalators connecting the street level with the elevated concourse inside. Two World Financial Center, serving as one of two towers housing the headquarters of Merrill Lynch, was designed by Pelli in association with Haines Lundberg Waehler. The tallest building in the group, the fifty-one-story dome-crowned tower, more intricately massed than its predecessor, occupied the key site between Liberty and Vesey Streets, West Street and the North Cove Yacht Harbor. Pyramid-topped Three World Financial Center (1985), housing the headquarters of the American Express Company, on the southwest corner of West and Vesey Streets, a collaboration of Pelli and Adamson Associates, was completed about the same time as One World Financial Center. Together they bookended the center's three-block-long West Street frontage. Compared with Ralph Walker's Barclay-Vesey Building, built on the diagonally opposite corner of West Street for the New York Telephone Company in 1923–26, Pelli's virtually unbroken tower was blocky in mass and dull in profile.[36] In 1986 Pelli's Four World Financial Center, executed in collaboration with Haines Lundberg Waehler, was completed at the southeast corner of North End Avenue and Vesey Street, providing more headquarters space for the exploding business of Merrill Lynch. The thirty-four-story building, the lowest of the group in order to help step the skyline profile down toward the Hudson River, was also blocky, with three major setbacks topped by a stepped pyramid. Pelli prepared designs for a fifth site, facing West Street and North End Avenue, between Vesey and Murray Streets, but the collapse of the financial markets in 1987 and again in 1989, combined with the ensuing real estate crisis that resulted in the collapse of Olympia & York in 1992, left that plan unrealized.

The towers were loosely grouped around a deep yacht harbor sheltered by a breakwater. The harbor formed an outdoor room surrounded by broad plazas, comparable to Rockefeller Plaza in its capacity to create a lively focus, but yielding a total effect that was less central and controlled. Opening onto the harbor was Pelli's 120-foot-tall Winter Garden, a barrel-vaulted 130-by-230-foot glass room recalling Joseph Paxton's Crystal Palace, which provided a year-round complement to the outdoor terraces facing the yacht harbor. Pelli found an architectural scale comparable to that of the concourse at Grand Central Terminal. To compensate for the glassy roof and austere granite walls, the floor was paved in patterned marble punctuated by a grove of sixteen Washingtonian palm trees from California located near the river-facing window wall. The room, which was a product of the collaboration of Pelli, Adamson Associates, and the engineers Lev Zetlin & Associates and Thornton/Tomasetti, was entered from above on steps that served as a viewing platform for the whole space, an idea borrowed from Grand Central. The steps were part of a promenade but also a public stage, like a spillway flowing from the mountain range of Wall Street's skyscrapers toward the Hudson River and the Western landscape beyond, while the palm trees offered an exquisite irony all their own, suggesting that the Sun Belt, the booming region of the 1970s, which posed so crucial a threat to New York's economic vitality, had been encapsulated in a glazed courtyard by the Hudson. Shops and restaurants ringed the great room. Though

World Financial Center, Battery Park City. Cesar Pelli & Associates, 1988. View to the northwest along West Street showing, from left to right, One World Financial Center, Two World Financial Center, and Three World Financial Center, and bridges connecting to Liberty Street, in foreground, and World Trade Center, in middle distance. Hursley. CPA

the specific design of the Winter Garden was dismissed by some as cliché because of its obvious historical recall—Susanna Sirefman, writing a decade later, was to characterize it as a "pleasingly camp space"—it was splendidly effective as a setting for the rituals of daily business life and for special events staged by management to help establish the World Financial Center as a popular workplace and a tourist destination. Critics notwithstanding, the room clicked with the general public. Soon after opening, it became a favorite spot for wedding pictures, with as many as two dozen marital parties coming through each weekend day.[37]

In October 1988, Olympia & York celebrated the opening of the Winter Garden with a five-day-long series of benefits, concerts, and other events. Paul Goldberger reviewed the space two days before the official opening, observing:

It is perhaps the grandest public space built in New York since Grand Central Terminal, and it is surely the most eagerly awaited: it was finished more than a year ago but has been kept under wraps, in part to allow the sixteen 45-foot-tall palm trees that have been planted under its glass roof a chance to acclimatize themselves to New York's uncertain sunlight.

Declaring it the "architectural climax of the World Financial Center," Goldberger noted:

The most impressive thing about the Winter Garden is its ability to be convincing as a monumental space in a time when we have become saturated, not to say jaded, with large-scale public rooms.

Almost every new building these days has an atrium or an arcade or a mall or a plaza, and most of them are dreary devices inserted by their developers primarily for the zoning benefits the city offers their builders. The Winter Garden, however . . . is a triumphal public space that has something to say to an age that is, quite properly, cynical about the meaning of monumentality.[38]

The Winter Garden was the heart of a network of shop-lined passageways that, in emulation of those connecting Grand Central Terminal to hotels and office buildings and those linking the various office buildings of Rockefeller Center, connected the World Financial Center's buildings with each other and, via the two bridges over West Street, with the upland area. Though the decision to lift the shops and tower access points to the second level had disastrous consequences for the evolution of West Street, it was understandable: when the World Financial Center was being planned, the future of Westway was still very uncertain and all planning for the center, as for Battery Park City as a whole, had to take into consideration the possibility of a large highway separating it from the Trade Center. Designed by Pelli in consultation with Haines Lundberg Waehler, Lev Zetlin & Associates, and Thornton/Tomasetti, the thirty-four-foot-high bridges consisted of Vierendeel trusses that allowed for a clear span of approximately 200 feet over West Street. The twenty-seven-foot-wide southern bridge over West Street, at Liberty Street, was not well integrated with the city at its eastern terminus, but the forty-eight-foot-wide northern bridge, if rather anonymously designed, made a somewhat awkward but essential connection between the Winter Garden and the U.S. Custom House, beyond which lay the vast underground concourse of the World Trade Center, leading past shops and restaurants to subways and commuter trains.

With the exception of the Winter Garden, the World Financial Center's interior public spaces were bland. Each tower lobby was essentially the same, each surprisingly, if somewhat cheesily, featuring silk-screened fabrics to clad the upper parts of the elevator cores. Elaborate stenciling enlivened the ceilings of the double-height rotundas that acted as gateway buildings on either side of Liberty Street, hardly much compared to the splendid marbles and mosaics of the important office buildings of the 1920s.

For most observers, the great success of the World Financial Center lay in its relationship to the World Trade Center. As Carter Wiseman put it, "In designing that lamentable pair of 110-story dolmens, Minoru Yamasaki committed the worst of urban sins, which is to destroy the sense of scale. Without discrete windows or recognizable bits of trim, there is no standard by which to measure these buildings relative to their surroundings. But Pelli has turned this facelessness to his advantage. By using the different heights of his own towers to create a series of steps, he has made the World Trade Centers appear to be merely the next steps beyond his own. And since his scale is clearly announced by the details of his buildings, the World Trade towers are 'captured' as part of a new composition."[39] Vincent Scully, writing in 2000, noted that at the time of the buildings' completion, to his "continuing embarrassment," he described the World Financial Center towers as "grossly distended, as if swollen by greed. What I missed," he continued,

Winter Garden, World Financial Center, Battery Park City. Cesar Pelli & Associates, Adamson Associates, Lev Zetlin & Associates, and Thornton/Tomasetti, 1988. View to the west. Hursley. TH

"was the great fact that the towers were beefed up as they were in order to grapple with the impossibly tall but inert towers of Yamasaki's World Trade Center behind them, and were so arranged as to bring those intractable forms—which had destroyed the scale of the older skyscrapers at the tip of Manhattan—back into something approximating the wonderful pyramidal massing of the earlier skyscraper group as a whole. . . . Pelli's Center is a compelling achievement in terms of contextual design and contemporary urbanism. It is deeply respectful of the old city, at once valuing its original intentions, healing its wounds, and expanding its horizons."[40]

But, finally, it was by its architecture rather than its urbanism that Pelli's designs were judged and found wanting. While most observers were impressed by the overall impact of Pelli's grouping, there was much less agreement about the quality of the individual buildings themselves. Robert Campbell was critical of Pelli's "huge gray pile of office towers." Although he liked the Winter Garden and the sequence of internal spaces where "you never lose contact with the outdoors," Campbell felt that the architecture of the towers, while "quiet and elegant," was also "fat, flat and bland. . . . They are smoothly skinned in gray granite and dark glass. As the towers rise, there is more glass and less granite, so that what begins as glass windows inscribed in granite becomes lines of granite traced over glass. The conceit is too delicate for the bulk. . . . Gray understatement, at so huge a scale, becomes monotonous."[41] Campbell concluded that while the World Financial Center was "far above the average of new office development in New York," it was "certainly not . . . in the class of Rockefeller Center."[42]

Rector Place

In March 1981, rental applications began to be taken for Gateway Plaza, the first luxury-priced housing development in lower Manhattan and the first component of Battery Park City to be completed. Developers and Battery Park City officials alike were encouraged by the public's strong show of interest. Despite its dismal design, the project promised to be a marketing success, encouraging the Battery Park City Authority to go forward with requests for proposals to develop, as housing, a group of sites on four blocks surrounding a two-acre park south of the World Financial Center.[43] Known as Rector Place, the neighborhood was one of the largest residential enclaves to be designed in Manhattan in quite some time, comprising nine acres bounded by Albany Street on the north, West Thames Street on the south, the waterfront on the west, and West Street on the east. Moreover, it would be the first opportunity to implement the acclaimed ideals set forth in the 1979 master plan. According to Amanda Burden, the BPCA's vice president of planning and design, the aim was to "create a residential community resembling older New York neighborhoods, reflecting their texture, variety, and continuity," a goal the authority set out to achieve through the establishment of design guidelines, which, it felt, would "purposely allow for architectural creativity within a prescribed context and framework" as well as set a precedent for future development, enhance property values, and protect developers' investments by creating quality controls.[44] Alexander Cooper and Stanton Eckstut, now partners in the firm Cooper Eckstut, were once again called on by the BPCA, this time to create the South Residential Area Design Guidelines. Released with the requests for proposals in April 1981 to help developers in the preparation of their bids, the guidelines were, in essence, an addendum to the 1979 master plan and were intended to ensure a rich mix of individual architectural expressions. To further this goal, and to also help spread the work among a number of firms, the four blocks of Rector Place were divided into twelve separate parcels for development.

According to the guidelines, the buildings themselves were not considered the first priority: "The public spaces of the streets and parks are the emphasis of the design work and the focus of the new development. The buildings are the background." To that end, an elaborate system of landscaping and open spaces was called for, "organized as a sequence of interrelated spaces." Two concerns shaped the design: "The first . . . to recognize and accentuate the special significance of individual places created by the plan in order to develop maximum diversity. . . . The second . . . to provide elements of continuity to create a sense of unity for the overall site."[45] The centerpiece of the neighborhood would be the small but verdant Rector Park. Extending the system of parks, Albany, Rector, and West Thames Streets would each be terminated at its west end by a small, informal park meant as a transitional space between the residential enclave and what would be an important element of the plan—an esplanade along the Hudson River (see below).

The guidelines for the buildings of Rector Place were grounded in a desire to model the new neighborhood on the classic examples of prosperous residential districts in New York, specifically Fifth Avenue, Central Park West, East End Avenue, West End Avenue, Riverside Drive, Park Avenue, Tudor City, and Gramercy Square. A mix of building types was slated for the twelve parcels—brownstones, townhouses, low-, mid-, and high-rise slabs, and towers, all with certain unifying characteristics, the foremost being a street-defining wall. "Street wall buildings built up to the front property line (and without plazas) are the standard. The result is that one building does not necessarily dominate the others and the overall effect of a group of buildings united by their common front wall is a much larger and more striking effect than the special object buildings typically found in 'project' type developments. . . . Yet, there is still ample room in each building for individual identity and differences of architectural style and expression."[46]

The street walls were to be no taller than 60 to 80 feet on the west and south sides of the streets and 110 to 135 feet on the north and east sides. To maximize light and air, Cooper Eckstut mandated that bulk be set back and massed in designated tower locations, chosen to reduce shadows on adjacent buildings and to retain views of the harbor. Bulk and height was also distributed strategically to mark locations and frame vistas, as with the two westernmost parcels, which would be "developed to the approximate same height and . . . setback at the same angle to help dramatize the sense of a gateway to the water." All buildings were to have two-story stone bases to provide continuity and human scale, and also decorate and dignify the streets. The facades were to be "relatively simple with intermediate running bond courses of stone to reduce the scale of the street wall by suggesting heights of lower buildings on the adjacent side streets." Above the two-story base, aside from stone, "the preferred material" was brick, and the "preferred colors . . . neutral and warm earth tones in order to easily blend in with each other." Metal and glass curtain-wall buildings were discouraged, as were all concrete buildings. On the upper floors, roof tops, and bulkheads, designers had "the

Rector Place master plan. Cooper Eckstut, 1981. Site plan. CRP

most opportunity for individual expression—major recesses, balconies and setbacks." In addition, the guidelines called for ground floors "exclusively residential in character," two-story arcades at designated locations which would provide entrances to ground-floor retail and commercial businesses as well as multiple other strictures governing aspects such as pedestrian circulation, parking, and utility provision.[47]

Twenty-seven developers, invited to bid on any or all of the parcels, responded to the request for proposals in the spring of 1981. One of the bids, submitted by Milstein Properties, called for a consortium of twelve prominent architects, each given a different site. Philip Johnson and John Burgee were to design the largest of four rental towers, with another tower assigned to Paul Rudolph, and two others to a joint venture of John Carl Warnecke and Peter Berman. Eight smaller sites containing cooperative apartments were to be assigned to Marcel Breuer Associates, Conklin Rossant, Eisenman/Robertson Architects, Gwathmey Siegel & Associates, Richard Meier & Associates, Mitchell/Giurgola Architects, Elliot Vilkas/Joseph Wills, and Ada Karmi-Melamede & Associates. The housing consortium was an idea advanced by Peter Berman, but the idea also bore the stamp of Peter Eisenman, who likened its potential to that of the Weissenhof Siedlung in Stuttgart in 1927 "in which Mies asked all his friends—Corbusier, Gropius, Behrens, all the hot shots—to participate."[48] But the Battery Park City Authority was not persuaded by the consortium approach. For one thing, it was reluctant to overinvest in any one developer. Instead, in August 1981, it selected six developers: Milstein Properties in conjunction with Goodstein Construction Corporation and Dic-Underhill Construction

Company; Housing Innovations, of Boston; the Center for Housing Partnerships, of Manhattan; LRF Developers, of the Bronx; Jason D. Carter & Associates, of Manhattan; and Rockrose Development Corporation, of Manhattan. Rockrose and Milstein were the only well-known firms, the others being smaller minority-owned enterprises "selected by the authority as a symbol of its dedication to affirmative action."[49] Paul Goldberger called the announcement "a significant event in the history of publicly assisted housing." He also took the opportunity to praise Cooper Eckstut's guidelines as "a major step in the movement away from the modernist principles that guided virtually all large-scale housing design for generations" and as promising new housing that went much further than such recent efforts as Davis, Brody & Associates's East Midtown Plaza (1974) or Johnson/Burgee's master plan for Roosevelt Island (1969) to create the kind of mix of scales and types, all respecting the walls of clearly defined streets, that characterized the historic city as a whole.[50]

On November 14, 1983, the Municipal Art Society, concurrent with an exhibition of drawings and models, held a public meeting to discuss the rationale behind the Rector Place design guidelines. The New York Times's astute real estate reporter, David W. Dunlap, noted, "The conclusion of the discussion was that the effort to summon the best lessons of history was not a bow to architectural vogue but a logical response to what might be the most pervasive architectural influence of all: the marketplace."[51] This was not meant in a cynical way but as a reflection of the sound business decisions that led to the adoption of the plan and its guidelines. Richard Kahan, BPCA president, stated that the authority "had to make a buildable address out of a site that had every disadvantage. We had to defy all the logic of the marketplace and the way to do that was quality—the Rockefeller Center principle." The attention to public spaces grew out of a conviction that "better public spaces translate into higher real estate values and higher real estate values translate into higher rent" and higher rent helped guarantee that the authority's bonds would be a good investment.[52] Of course, higher rent also meant that the original plan to include lower-income housing in Battery Park City would be abandoned, seemingly without regret.

For several years after the winning bids were announced, deals between the BPCA and developers were mired in delays, some of which were bureaucratic in nature, but many more of which had to do with the general timing of the deals. One problem was that the developers were selected just before the 1982 recession and were thus reluctant to commit their own cash at a time when the banks were not lending. Another was that the developers were happy to hold off on deal-making until there was a more proven market and the authority had made further progress on the roads, public spaces, and utility installations it had promised to provide. In late 1983, following the resignation of Richard Kahan, developers once again slowed negotiations while waiting for the appointment by Governor Mario Cuomo of a new BPCA president, thirty-eight-year-old Meyer S. Frucher, whom, one surmises, they hoped would adopt a less rigorous stance on the issue of design guideline compliance. Further delays arose when it was realized that four of the developers were unable to handle the size of their successfully bid projects, leading them to bring in larger development concerns as joint venture partners.

Frucher began his term with a concern about the elimination of lower-income housing from the plan and voiced his

dissatisfaction with the neighborhood's expected social makeup: "Rector Park was not supposed to be a backyard for people fortunate enough to live here," he said. "There are moral questions to be asked when you're building one of the most upscale neighborhoods in New York. Without a social purpose, all the beauty is superficial. We want to give Battery Park a soul."[53] In an attempt to remedy the situation, in August 1984, after calculating higher-than-expected revenue projections, Frucher, Governor Cuomo, and Mayor Ed Koch agreed to commit $400 million in future Battery Park City income to build low- and moderate-income housing elsewhere in the city. Some, it would appear, was to be located off-site. The rationalization, as Eric Uhlfelder would later explain in *Urban Land*, was that "using excess revenue to stabilize and support existing low-income communities was preferable to introducing a token number of poor residents into a residential district that required high rents and apartment prices in order to justify construction. Further, luxury development would generate a continuous flow of cash that, in the long run, could assist more people than could the creation of a limited number of low-income housing units in Battery Park City."[54] The program was an auspicious one, with the BPCA funds contributing to the city's parallel Housing New York program. By 1986 $210 million had been slated for the creation of 1,850 units of housing in the South Bronx and Harlem, and in 1987 the program was expanded by $600 million, making Battery Park City's promised contribution to Housing New York $1 billion.

By October 1984, all lease agreements were finally completed, with 410 more apartments than originally planned included in the mix, mainly studios and one-bedrooms presumably added to maximize profits, bringing the total to 2,210. As the terms and leases were finalized, there were fewer teams and the buildings were fewer in number than originally planned: Rockrose Development Corporation would work with Charles Moore and Rothzeid, Kaiserman, Thomson & Bee to develop two adjacent parcels as one building; the Center for Housing Partnerships, also developing two adjacent sites as one building, brought in the Zeckendorf Co. and Worldwide Realty to work with Davis, Brody &

Rector Park, Battery Park City. Richard Webel with Vollmer Associates, 1985. View to the northeast. Ries. EEKA

Associates; Zeckendorf and Worldwide Realty would also develop two other separate parcels, working with Conklin Rossant on one and Mitchell/Giurgola on the other; LRF Developers with the Related Companies hired Gruzen Samton Steinglass for one site; Housing Innovations teamed up with the Related Companies in the development of two separate sites, both designed by Bond Ryder James; and Milstein, Goodstein Construction Corporation, and Dic-Underhill would develop three sites, two with Ulrich Franzen & Associates and one with James Stewart Polshek & Partners. Indeed, as Alan S. Oser pointed out, after the dust had settled, the "smaller development groups had disappeared or had been absorbed into larger entities, so that four major developers are essentially doing all 10 sites."[55]

As the design process got under way, it became clear that the Battery Park City Authority was serious about adherence to Cooper Eckstut's guidelines. As Carter Wiseman reported, "One developer wanted to leave his roofs flat—in defiance of the requirement for a varied skyline—and was sent back to his drawing board. Another developer's shipment of split cobblestones was returned because the guidelines required whole ones. An architect who picked a deviant shade of mortar was obliged to switch even though he'd already laid two courses of bricks."[56] But despite the seemingly Draconian controls, the individual architects employed at Rector Place, according to their talents and artistic inclinations, were able to introduce considerable individuality into the buildings, and Rector Place emerged as something truly remarkable in postwar urban development: a coherent enclave with its own distinct and identifiable character, comparable to some of the defining neighborhoods of the interwar years. The first piece of the district to be completed was Rector Park, designed by Richard Webel of Innocenti-Webel with Vollmer Associates, opening in spring 1985. It was the last major civic project designed by the genteel, urbane Webel, who had opened his practice with Umberto Innocenti in 1931. The park, two one-acre lots encircled by Rector Street and bisected by South End Avenue, was organized around "the controlled layering of an enclosing landscape—lawn, ground cover, hedge, small tree, canopy tree and street tree, fence, wall, and curb," and featured pink granite posts supporting iron railings and bluestone walkways as well as walkways of red brick in a herringbone pattern.[57] In the opinion of Paul Goldberger, the designers achieved their goal: "Rector Park . . . is the best thing of its kind in New York since Gramercy Park."[58]

The first residential buildings to be completed according to the new Battery Park City master plan were on the north side of Rector Park, beginning with Charles Moore and Rothzeid, Kaiserman, Thomson & Bee's River Rose (1986), which Carter Wiseman called "a fifteen-story essay on the Venetian *palazzo* via Park Avenue."[59] Though it was hardly a major work of its gifted design architect, the subtly modeled facade, with its angled indentations, projecting frames and balconies, richly modeled band courses, and strong corner tower, clearly demonstrated that neither the guidelines nor the demands of a market-driven developer, strict though they were, could totally suppress real talent. But some critics felt the architects tried too hard. Benjamin Forgey, architecture critic for the *Washington Post*, deemed it a "flop," calling it "as close to a cacophony of colors, materials, cornices, belt courses, protuberances, and tops as could possibly have been arranged under the circumstances—an effervescent but not a pleasant sight."[60]

River Rose, 333 Rector Place, northwest corner of South End Avenue. Charles Moore and Rothzeid, Kaiserman, Thomson & Bee, 1986. View to the northwest showing Liberty House (James Stewart Polshek & Partners, 1986) on left. Ries. RKTB

James Stewart Polshek & Partners' Liberty House (1986), at 377 Rector Place, on the northeast corner of its intersection with the esplanade, boasted a skillful use of polychromatic brick to create what Carter Wiseman called "an alluring mosaic" on the building's facade.[61] A sophisticated massing of wall planes framed the northern half of the Rector Place gateway with a broad, flat surface that rose to a curved, ship-shaped penthouse. According to Polshek, the design evolved out of a need "to reduce the bulk of the structure—made almost unavoidable by the shape of our site." The strategy was to "de-laminate" the angled facade, "expressing it as a thin layer of light-colored gray brick, hinged at either end by a continuous vertical string of open balconies that connected to the two darker brick corner towers. . . . The top of the building was intended to evoke the imagery of nautical machinery and the profiles of the uppermost levels of steam ships. The various mechanical contrivances on the roof, such as the water tank, elevator bulkhead, and incinerator stacks are clad in dark green metal and tied together with bands of red and natural aluminum." Polshek chafed at Battery Park City's decision not to approve his choice of light gray brick for the angled layer of the tower, later writing that "despite our warnings about the need for contrast, they imposed a warmer yellow-gray tone and, as we anticipated, the resultant lack of differentiation significantly weakens the overall effect of the building, which, nonetheless, sits comfortably on its spectacular waterfront site."[62]

Mitchell/Giurgola's 110-unit, eighteen-story Hudson View East (1987), at 250 South End Avenue, southeast corner of Albany Street, was an example of designers clearly trying not to play the game according to the rules. Thomas Fisher, writing in *Progressive Architecture*, called it "the most Modern and least demonstrative of the buildings in Rector Place. It uses minimal squares of blue glazed brick to suggest the required horizontal lines, light-colored brick and window frames to emphasize the continuity of the wall surface and syncopated window openings and vertical brick projections to accent the tower's height."[63] Its companion, Conklin Rossant's Hudson View West (1987), at 300 Albany Street, on

the southwest corner of South End Avenue, was originally designed as an interpretation of the Dakota on Central Park West, to be called the South Dakota Towers, an idea Daralice Boles charitably called "playful."[64] But as built, with its flat roof, straightforward brickwork, and two-story limestone and granite-clad plinth, it was not exceptional. Equally disappointing were the townhouse apartments at 320–340 Albany Street (1986), between the esplanade and South End Avenue, six five-story buildings designed by Davis, Brody & Associates that were intended to provide the character and scale of midblock townhouses, which in uptown neighborhoods counterbalanced the big-scale avenue development. Despite stoops and bay windows, these buildings seemed rather heavy-handed, although according to the editors of the *AIA Guide*, "the tiers of connected balconies at the rear lined with black ships' railings reveal a more masterful command of the problem."[65] The same firm's adjacent fifteen-story Hudson Tower, at 350 Albany Street, on the southeast corner of the esplanade, came off somewhat better, combining bay and corner windows that lightened the mass as they opened up apartments to the spectacular views. Thanks to their scale and materials, the combination of the two, according to Grace Anderson, writing in *Architectural Record*, evoked "an ineluctable Manhattan streetscape," which could as much be credited to the Cooper Eckstut master plan as to the work of the architects.[66]

The buildings on the south side of Rector Park were less singular, prompting the editors of the *AIA Guide* to compare them to "West End Avenue: no stars, but very good actors putting on a performance that is greater than the sum of its parts."[67] Gruzen Samton Steinglass's Parc Place (1986), at 225 Rector Place, on the northeast corner of South End Avenue, with its midblock entrance accentuated with light-colored brick and its stone base stepped up on the corner to mark the tower above, was, despite early studies by the Gruzen office that revealed a far more aggressive massing and fenestration pattern, straightforward in an unmemorable sort of way, though generally well liked by the critics. Benjamin Forgey called it "thoroughly conventional and utterly at-home."[68]

Liberty House, 377 Rector Place. James Stewart Polshek & Partners, 1986. View to the northeast showing esplanade (Cooper Eckstut Associates with Hanna/Olin, 1983–92) and Gateway Plaza (Jack Brown and Irving E. Gershon, 1982) in the distance. Warchol. PW

Hudson View West, 300 Albany Street, southwest corner of South End Avenue. Conklin Rossant, 1987. View to the southwest showing River Rose (Charles Moore and Rothzeid, Kaiserman, Thomson & Bee, 1986) on left. Aaron. ESTO

Paul Goldberger was significantly more positive, calling it "the best structure" at Rector Place "from the exterior at least . . . where the color and texture are just right."[69] Liberty Court (1987), 200 Rector Place, between West Street and South End Avenue, occupying an important site forming the northern terminus of Battery Place, the major north–south street in Battery Park City's south end, was one of two buildings designed by Ulrich Franzen & Associates. It was by far the neighborhood's tallest building, rising to forty-four floors and crowned by a stepped tower that recalled Pelli's World Financial Center towers to the north. The architects, in an effort to break down its imposing size, modeled it with setbacks at the ninth, fifteenth, twenty-fifth, and fortieth floors, but regrettably it was still too bulky and underdetailed. More successful was Franzen and the Vilkas Group's Liberty Terrace (1987), at 380 Rector Place, on the key site at the southeast corner of the esplanade, which, with the same massing as Polshek's Liberty House to the north, completed the gateway from the esplanade to Rector Place. A stack of recessed bays in the center of its angled northwest facade and two shades of brick above the stone base meant to distinguish between its part-street, part-skyline scale led the editors of the *AIA Guide* to call the building "fine," and "harmonious—but not compelling."[70] Bond Ryder James's Soundings (1987), at 280 Rector Place, southeast corner of South End Avenue, and, across the street, the same firm's Battery Pointe (1987), at 300 Rector Place, southwest corner of South End Avenue, were each nine stories and had similar bulk and window patterns but, at the Battery Park City Authority's request, different brick color and trim detail. Moreover, the retail arcade on Battery Pointe but not on the Soundings furthered the feeling of individuality, although the editors of *Progressive Architecture* found that this effort to make two similarly massed buildings appear different revealed "a weakness of the guidelines, requiring a superficial diversity when a unified treatment is in order."[71]

The character of individual buildings notwithstanding, Rector Place demanded to be judged as an ensemble. First assessments, which appeared before its 1987 completion, were largely favorable. Carter Wiseman commented in June 1986 that though "this kind of thing could have deteriorated into a Disneyesque pastiche . . . in fact, the buildings work smoothly together without losing their individuality. If there are bits of cutout cuteness (and some messy brickwork) here and there, the ensemble creates a reassuring sense of place."[72] Susan Doubilet remarked that "if you allow your eyes to glaze to a myopic blur, you feel you are in a traditional New York neighborhood—Beekman Place, for example. If you focus, however, the mandated surface variety is generally clumsily achieved."[73] But Paul Goldberger wrote optimistically, "The architecture is a mixed bag, but even the most disappointing of these buildings stands head and shoulders above the normal, private-developer-built housing now rising uptown."[74] When Rector Place was officially finished in 1987, it became clear that the strategy of relatively small building parcels meted out to various teams of architects and developers had yielded an interesting and varied townscape. Although the quality of the individual apartment buildings was uneven, the overall effect was remarkably successful. The very familiarity of the street pattern and the achievement in most cases of a level of architectural detail comparable to that of pre–World War II apartment buildings was widely admired by the public, although critics and some architects regretted the decision to pursue so overtly retrospective a character.

Hudson Tower, 350 Albany Street, southeast corner of esplanade. Davis, Brody & Associates, 1986. View to the southeast showing Liberty House (James Stewart Polshek & Partners, 1986) on right and Liberty Terrace (Ulrich Franzen & Associates and the Vilkas Group, 1987) on far right. Hoyt. ESTO

320–340 Albany Street, between esplanade and South End Avenue. Davis, Brody & Associates, 1986. View to the southeast. Hoyt. ESTO

Liberty Court, 200 Rector Place, between West Street and South End Avenue. Ulrich Franzen & Associates, 1987. View to the northwest showing Liberty Terrace (Ulrich Franzen & Associates and the Vilkas Group, 1987) on left and World Financial Center (Cesar Pelli & Associates, 1988) on right. Aaron. ESTO

Not surprisingly, the criticism coming from within the ranks of those architects who had built in Rector Place was aimed at the design guidelines. Ulrich Franzen brought attention to the fact that no provisions had been made to deal with the strong winds coming off the Hudson River. James Polshek took issue with the mandated entrance locations, claiming,

Affordable Family Housing proposal. Ricardo Bofill, 1988. Building design study for three-block superblock bounded by Chambers, West, and Murray Streets and North End Avenue. View to the south. BPCA

"Entrances were sometimes located in odd places, creating disjunctions in the relationships of lobbies and cores. There was nothing that we could do about it." Polshek also commented on the bigger picture: "The buildings at Rector Place are okay, but just okay. I don't understand the notion that every building had to be a background building."[75] But Stanton Eckstut held the architects accountable for the somewhat anemic ornament, quipping that "the guidelines were aiming at a greater depth of surface variation than some of the architects attempted."[76]

Further criticism began to appear once the buildings were occupied and the public was able to get a sense of Rector Place's success as a residential district. By 1988 it was obvious that, above all, the greatest failure of the neighborhood was also the most predictable one: its demographic homogeneity. Both the cost and the size of the apartments contributed to the emergence of a community made up largely of young, single, well-to-do individuals. In July, Manuela Hoelterhoff, writing in the *Wall Street Journal*, noted that in Battery Park City, "Families are few and toddlers [and children] under 12 are only 5% of Battery Park City's total population. The main reasons are cost and apartment size. The Battery Park Housing Authority left these two crucial matters to the discretion of individual developers, after setting a minimum of 400 square feet for the smallest residential units . . . mostly studios and small one-bedroom apartments designed for the model tenant all builders seem to have in mind these days: sterile investment bankers under 5-foot-2."[77] The small apartment sizes also resulted in greater transience among residents, many of whom, it was found, were moving to other neighborhoods as their families grew. Fearing

that this would hurt its ambitions to foster a healthy community, the Battery Park City Authority, in an effort to provide family housing, hired four firms to explore ways in which space could be increased without increasing cost, with the goal of incorporating the ideas in the construction of three buildings in the North Residential Area (see below), which was at the time in the planning stage.[78] Paris- and Barcelona-based Ricardo Bofill focused on materials to lower costs, calling for the same precast concrete construction he employed in a residential project in Paris and which, if not for higher construction costs in New York, would have lowered costs by about 5 percent. He also took the opportunity to reconsider the existing north area master plan, proposing three alternate schemes—one calling for a monumentally scaled three-block superblock bounded by Murray Street, North End Avenue, Chambers Street, and West Street containing perimeter apartment buildings surrounding a large interior court, the second calling for a similar two-block development, and the third envisioning a single-block project that also featured apartments around a large internal courtyard. In its study entitled *Choice and Flexibility in Housing*, Bond, Ryder & Associates put forward the idea of employing a staggered-truss structure to develop open, highly flexible, raw, loft-like living spaces that individual owners could build out according to their needs, an idea that would, despite lowering building costs and apartment prices, still require from the owner an investment comparable to a traditional apartment. Goody, Clancy & Associates of Boston also honed in on flexibility and family needs, proposing apartments with bright eat-in kitchens, bedrooms that could be easily divided to create two children's rooms with a window each, small studios called "mini-units" that could be joined to neighboring apartments as needed, and twice as much storage space.

But the study by the Ehrenkrantz Group and Eckstut was, for Paul Goldberger, "the most important," and "proposed both a new kind of building layout and a new construction system, which, together, should yield a substantial saving in cost while at the same time considerably improving the quality of apartment units." The proposal called for a "skip-stop" elevator system in which corridors accessing interlocking duplex and triplex apartments were located on every other floor. With the elimination of public halls on alternate levels, about 10 percent more space was allotted to apartments. Similar systems had been conceived before, most notably in Le Corbusier's Unité d'Habitation (1947–52) in Marseilles. In New York, Sert, Jackson & Associates employed a skip-stop elevator system in its Eastwood Apartments (1976) on Roosevelt Island. According to Goldberger, what distinguished Ehrenkrantz's scheme from the others was the split-level system that permitted "80 percent of the units to have some front exposure and thus some Hudson River views. . . . It is a stunning design, with the elegance of a mathematical proof—the interlocking of these apartment units manages to do what has always been thought impossible, which is to bring both enormous construction efficiency and superb layouts for family apartments."[79] But unable to produce significant cost benefits and subject to the ever changing winds of the New York real estate market, the studies would remain academic, a quasi-philanthropic gesture on the part of the BPCA to reconsider the norms of housing in the city. Still, when it came time to build the North Residential Area, the BPCA did make an effort to provide larger, albeit market-rate, units for growing families.

Battery Place

In 1985, as Rector Place was being built, the Battery Park City Authority moved forward with plans for a second neighborhood, the Battery Place Residential Neighborhood, a twelve-acre site made up of nine blocks extending south from Rector Place to Battery Park.[80] Because of the seeming success of their 1979 master plan and 1981 design guidelines, Cooper Eckstut was asked to prepare guidelines for the new neighborhood, which, as completed in May 1985, held to the same tenets established previously, aiming to "reinforce a human scale and produce a New York character." Once again, an emphasis was placed on parks and open space, this time centered on the creation of a one-and-a-half-acre inlet of the Hudson River to be known as South Cove and a three-acre park adjacent to Battery Park (see below). The relationship between street, park, and building was given more attention in the Battery Place guidelines than in those that preceded them: "The streets are designed to appear more park-like than usual in urban settings. The parks, on the other hand, are fully integrated with the streets to assure high visibility and accessibility, preventing them from being isolated and unsafe." Again, street walls were mandated to "provide human scale and a maximum amount of direct sunlight on the streets," but unlike at Rector Place, towers were to be located off the street line and only on the southern and eastern-most lots of the district, "purposely stepped in height toward the south to create a dramatic skyline at the tip of Manhattan." Arcades housing retail and commercial space were, despite earlier criticisms, required in certain locations, primarily along the west sides of the avenues. The guidelines additionally called for stone bases between one and three stories tall, "special and interesting" rooftops with cornices of "stone or rusticated masonry," balconies using decorative metalwork "in order to give additional diversity to the fenestration pattern" of the facades, and rooftops designed "with

Innovative Housing Design Study. Ehrenkrantz Group & Eckstut, 1988. Section. BPCA

consideration to views from above," all contributing to the overall goal of encouraging a mix of developers and architects "to create diversity of design in the neighborhood" while "preventing any one building from dominating others."[81]

The first phase of development at Battery Place included the three sites directly south of Rector Place. The authority received an unexpectedly strong response to its late 1985 request for proposals, with twenty-six developers submitting a total of fifty bids. Following the Rector Place experience, the BPCA required all developers to submit financial credentials with their proposals to avoid overly burdened enterprises selling out to larger developers. In November 1986, one year after it received the bids, the authority chose developers: Milstein Properties, working with Ehrenkrantz, Eckstut & Whitelaw and Costas Kondylis, would build the largest of the buildings, a condominium tower on a 24,100-square-foot site; Goodstein Properties was chosen to construct a nine-story rental building designed by Polshek & Partners on a 29,900-square-foot site; and South Cove I Associates, a collaboration of Property Resources, the Catco Group, and Paine Webber, would build a nine-story condominium designed by Gruzen Samton Steinglass on a 45,200-square-foot site.

Before construction could begin, the October 1987 crash of the stock market slowed residential real estate development in the city and in Battery Park City. Of the three developers, only South Cove I Associates decided to go ahead with the construction of its building as scheduled, while the other two opted to wait until the market recovered. Completed in 1989,

ABOVE Cove Club, 2 South End Avenue, southeast corner of West Thames Street. Polshek & Partners, 1991. View to the northeast showing Liberty Court (Ulrich Franzen & Associates, 1987) in background, left, and Liberty View (Ehrenkrantz, Eckstut & Whitelaw and Costas Kondylis, 1990) in background, right. Goldberg. ESTO

BELOW Battery Park City Parks Conservancy offices, 2 South End Avenue, Battery Park City. Deborah Berke & Partners Architects with Specht Harpman, 1996. Warchol. PW

Gruzen Samton Steinglass's crisply detailed, interestingly fenestrated Regatta, 21 South End Avenue, southwest corner of West Thames Street, was a nine-story structure with a large internal courtyard and 30,000 square feet of retail space with restaurants fronting on the esplanade to the south and shops situated along the streets to the east and north. To take full advantage of its site, the building was trapezoidal in plan, though along South End Avenue the Regatta presented a rectilinear nine-story street wall–defining building with a two-story arcade. The architects created irregular layouts for the condominiums, making few apartments identical and arranging the north-facing units in a sawtoothed plan angled to optimize views to the west for as many apartments as possible. In February 1989, it was reported that the units were selling with ease in defiance of a sluggish market, so much so that the developer raised prices four times in as many months, a strong enough sign to encourage Milstein and Goodstein to begin construction of their respective Liberty View and Cove Club buildings in July 1989. Ehrenkrantz, Eckstut & Whitelaw and Costas Kondylis's Liberty View, 99 Battery Place, between Third Place and West Thames Street, was completed in 1990 and contained 294 condominiums in twenty-eight stories with a limestone-and-granite-clad base. Stanton Eckstut, who with Alexander Cooper had drafted the Battery Park City master plan and design guidelines, but who had since become a partner in the Ehrenkrantz firm, led the design team, cladding the bulky, underdetailed building in a combination of orange and tan brick, the latter accentuating the southwest corner of

Stuyvesant High School, north side of Chambers Street, Battery Park City.
Alexander Cooper & Partners and Gruzen Samton Steinglass, 1992. View
to the west. Mauss. ESTO

the building, where corner windows and hard-edged balconies climbed the tower to meet a two-story loggia near its peak. Courses of banded brick at irregular intervals on the lower levels attempted to break down its scale but only contributed to the building's visual cacophony.

Polshek's Cove Club, 2 South End Avenue, southeast corner of West Thames Street, opened in 1991. It was the smallest of the three so-called South Cove buildings and the most successful, architecturally. To maximize views, the red brick and cast-stone-trimmed bulk of the building was concentrated on the north and east sides, where nine-story components accommodated 163 apartments. The portions of the building along South End Avenue and Third Place were three stories high and housed a total of seven duplex units on the upper two floors, each with a third-story recessed balcony. The intimately scaled west facade was punctuated by double-height, angular metallic bay windows above the ground floor, the points of which were echoed in the south- and west-facing balconies serving the majority of the Cove Club apartments. Programmatically, Cove Club had a bit of a rough start. It provided 10,000 square feet of ground-floor commercial space accessed from the street and, on its east side, from within a two-story-high arcade, but plans for four movie theaters to be accessed by a separate entrance and housed on the building's first two floors and basement were, unfortunately for the entertainment-deprived neighborhood, shelved when the developers were unable to find an operator. For five years, the theater space was used to store landscape equipment, but in 1996 it was built out as offices for the Battery Park City Parks Conservancy, a non-profit organization responsible for the maintenance and pro-

gramming of Battery Park City's open spaces that, since its creation in 1988, had been housed in trailers on vacant development lots.[82] Deborah Berke & Partners Architects, working with Specht Harpman, designed the renovation, inserting a new floor within the twenty-five-foot-high space to provide 18,000 square feet of offices, workshops, and meeting rooms for the Conservancy's various departments. According to Berke, the "principal design challenge was to bring natural light to the diverse areas within the complex," especially those below grade, which she did through the use of glass-block floors and double-height work and lounge spaces that also allowed for visual connections through the complex.[83]

Even with the encouragement gained from the Regatta's reportedly smooth-going sales, Liberty View and Cove Club were considered by the authority to be guinea pigs in an uncertain market. In 1990 BPCA's president, David Emil, who replaced Frucher in 1988, stated: "We are moving ahead as rapidly as possible given the market conditions. But our attitude is that we want to see how these two buildings perform before we release any new sites for development."[84] Lo and behold, when the buildings opened, the market did prove harmful, not only to the two new additions but to the Regatta, which despite its boasts of success, resorted, in April 1991, to auctioning off twenty-three unsold one-bedroom apartments for one-third to one-half the original price. The next month, eighty-three of the Cove Club's 163 condominiums were sold at auction at prices up to 53 percent below asking. With the completion of this first phase of Battery Place, private development in Battery Park City came to an abrupt halt.

Stuyvesant High School

During the economic lull between 1990 and 1994, no plans for privately developed buildings were initiated for the landfill district, but one building, the new Stuyvesant High School (1992), moved forward, paid for by the city.[85] In 1986 the decision was made to build a new home at the northern tip of Battery Park City for the city's academically prestigious Stuyvesant High School, ending a ten-year search for a site for the institution, then located at 345 East Fifteenth Street (C. B. J. Snyder, 1906).[86] This would provide a unique civic presence to what was generally perceived to be a predominantly commercial development area. At first, the high school was to occupy the base of a new apartment building, but when the model of Alexander Cooper & Partners's design, developed in association with Gruzen Samton Steinglass, was unveiled to the press in October 1986, it showed a ten-story, stand-alone building intended to serve 2,700 students with more than seventy classrooms as well as twelve laboratories and three preparation rooms devoted to the sciences. The new facility was to be financed by the city but built by the BPCA, rather than the Board of Education's Division of School Buildings, recently deemed incapable of building schools by the State Senate Investigations Committee. Though not entirely finished, Stuyvesant opened on schedule in September 1992 as the most expensive public high school ever built in America, a fact that immediately roiled some New Yorkers, who felt that the money, entirely drawn from New York City capital funds, could have been used more effectively in financially strapped school districts, of which there was no shortage.

The design of the 402,000-square-foot school was the product of a unique collaboration between the architects and the

Stuyvesant High School, north side of Chambers Street, Battery Park City. Alexander Cooper & Partners and Gruzen Samton Steinglass, 1992. View to the northwest. Goldberg. ESTO

Tribeca Pedestrian Bridge, spanning West Street at Chambers Street. Skidmore, Owings & Merrill, 1994. View to the northwest. Hoyt. ESTO

Stuyvesant Coalition, a volunteer group of students, teachers, parents, and administrators formed in 1985. Consulted throughout the design process, the coalition, and not the Board of Education, was in many respects the client. Their requests for an auditorium with a balcony, a grand stairway, and the use of materials like granite, brick, and wood, all nostalgically referencing beloved elements of the old building, were accommodated in the design of the new school. The coalition also proved pivotal, working with the BPCA, in persuading the city to allow 135 square feet per student in the new school instead of the standard 115 square feet.

Located on a one-and-a-half-acre triangular site, the new Stuyvesant High School was designed with distinctly different facades facing up river on its north side, and into an as-yet unbuilt Battery Park City neighborhood to the south, where a ten-story, buff and brown brick, nearly symmetrical composition rose from a base of white limestone. A sixth-floor loggia identified the south-facing 9,000-square-foot library. The architects sought to break down the scale of the building's north side using a melange of architectural elements, including a boldly scaled pediment, to embellish three discrete volumes: the easternmost housed a stack of two double-height gymnasiums above an Olympic-size swimming pool; the central one contained an 866-seat auditorium in a four-story building; and the five-story westernmost volume housed the school's metal, ceramic, wood, and other shops beneath a 650-seat penthouse cafeteria with dramatic north views. The east facade was also composed of three distinct elements—the two ends of the north and south blocks, and in between, what Peter Slatin, writing in *Oculus*, described as an "off-center tubular hinge" housing a stairwell, dance studios, and lounges. With a pedestrian bridge funneling students over West Street into the building's second floor, the east facade also became the building's primary entrance, rendering the grand staircase on the first floor of the south entrance more ceremonial than functional. Though a blockbuster, the mass of Stuyvesant's new home was sufficiently broken up to suggest, if not a campus, at least an aggregation of buildings clustered together to form what Slatin called a "variegated urban block, a downtown-in-a-school."[87]

Herbert Muschamp interpreted Stuyvesant's jumble of styles and shapes as a "frankly contextual design that seeks to reflect both the industrial vernacular of the Tribeca waterfront and the residential character of Battery Park City." But he wasn't impressed by the north side, calling it the "building's weakest moment—and, alas, one of its most conspicuous." In particular, Muschamp took issue with the auditorium form, which was "screened by a false facade and capped with a classical pediment. The pediment, which was not included in the architects' earlier schemes, is supposed to say 'theater' and to recall a beloved feature from the school's former building. Either way, the form contradicts Stuyvesant's progressive spirit."[88] Peter Slatin shared a dislike for the north facade: "Tentative ornamental pastiches meant to differentiate each component's function, combined with the uniformity of color, instead draw attention to the building's bulk. The assemblages exhibit a staginess that overshadows the attempt to create a genuine urban form."[89] Inside the school, circulation was dominated by an elaborate escalator system at the building's core. Deemed more efficient than elevators, the escalators, despite the students' propensity to press the emergency stop buttons, were able to transport pupils in two-story increments

Proposed North Residential Area design guidelines. Cooper, Robertson & Partners, 1990. Rendered plan. CRP

up and down the school's ten stories within the four-minute intervals between classes.

To provide a safe, grade-separated connection for Stuyvesant's students and faculty, as well as visitors and residents of Battery Park City as they crossed West Street, the BPCA commissioned one of the city's few elegant new works of architectural engineering: Skidmore, Owings & Merrill's Tribeca Pedestrian Bridge (1994).[90] The bridge also had the happy task of acting as a symbolic gateway, marking Battery Park City's northern boundary for motorists on West Street. The 299-foot-long white-painted steel structure consisted of two parallel bowstring trusses offset from each other in response to the diagonal orientation of the street below. Though the arcs of the trusses were dramatic, pedestrians were confined to a more conventionally proportioned glazed enclosure that led from the second-level school entrance on the west to a choice of a glass-enclosed elevator or open-air stairs, each going down to sidewalk level at the other end. The eastern staircase, constructed of cast-in-place concrete, curved around the elevator stack, as the architects put it, "in the tradition of a grand staircase."[91] Extensive use of stainless steel provided sparkle to the ornamental details that gave the bridge a surprisingly intimate scale. But there was a certain aesthetic overkill about the design, which lacked the delicateness of contemporary work by the leading architect-engineer Santiago Calatrava.

Proposed North Residential Area design guidelines. Venturi, Scott Brown & Associates, 1992. Site plan. VSBA

Proposed North Residential Area design guidelines. Venturi, Scott Brown & Associates, 1992. Study of the views from the proposed towers. VSBA

North Residential Area

When it opened, Stuyvesant High School stood starkly alone amid thirty acres of barren landfill north of the World Financial Center. Plans for the north area of Battery Park City had been laid out by Cooper and Eckstut in 1979 but were further developed in 1990 by Cooper, Robertson & Partners.[92] Cooper, Robertson provided more park space, eliminated service alleys, and called for fewer retail arcades for the eight-block neighborhood than had been present in Rector Place and Battery Place. A line of uniform-height apartment buildings reminiscent of Riverside Drive, but topped by set-back towers, was planned along the serpentine length of the neighborhood's westernmost avenue, River Terrace. A taller tower was situated on Vesey Street north of the World Financial Center to mediate between the scale of the commercial and residential districts, and, lined by lower-height apartment buildings on each side, the boulevard-like, Park Avenue–inspired North End Avenue originated at the Stuyvesant High School site and stretched south to offer views of the harbor. Neighborhood facilities and non-residential uses were limited to side streets. Released on the cusp of economic recession, the plan fell victim to its timing.

In 1992, after considering a group of architects that included Skidmore, Owings & Merrill, the Boston firm of Machado & Silvetti Associates, and James Stewart Polshek, the BPCA hired Venturi, Scott Brown & Associates, of Philadelphia, to revise Cooper, Robertson's north residential area guidelines.[93] Robert A. M. Stern Architects was asked to reconsider Cooper Eckstut's guidelines for the six remaining sites in the south residential area (see below). VSBA proposed a number of alternative arrangements, including one that called for four twenty-seven-story apartment towers alternating with townhouse rows along the curving length of River Terrace. The low scale of the townhouses allowed views of the river from a series of apartment towers lining North End Avenue. In addition, the firm sought to ease the transitions between commercial and residential, and residential and park areas.

In 1994, coincident with the resignation of BPCA president David Emil and the appointment of Philip Pitruzzello as his successor, the authority discarded Stern's and Venturi's studies. Cooper Eckstut's existing Battery Place guidelines would remain effective for the south, and for the north area, Princeton University School of Architecture dean Ralph Lerner was hired to develop guidelines in collaboration with Alexander Gorlin and Machado & Silvetti Associates.[94] Intent on creating a district "particularly distinct from, yet harmonious with, those areas of Battery Park City that have already been built," the Design Guidelines for the North Residential Area, released in 1994, shared certain attributes with those that had come before, yet managed to introduce new themes throughout. Street walls of varying heights were again

Massing study for sites 20, 21, and 22, North Residential Area, Battery Park City. Alexander Gorlin, 1994. Model, view to the northeast. Pottle. ESTO

mandated: 150 feet on River Terrace, 135 feet along North End Avenue, and 85 feet on the side streets. Only two towers were planned for the neighborhood, each a different height, and not unlike those at Rector Place, situated to frame an entrance to the community from the waterfront on the west end of Chambers Street. A system of open spaces was again emphasized in the north neighborhood, anchored by the eight-acre Hudson River Park (see below) occupying the northwest corner of Battery Park City and complemented by a series of smaller parks within the neighborhood. As part of the open-space plan, Lerner and his colleagues introduced a requirement that five of the eight buildings have interior courtyards.

Lerner proposed to retain the palette of materials called for in previous plans, such as the use of brick as the "predominant material of the street-walls," and a minimum of 10 percent stone on the nonglass area of building facades. However, bases were no longer required to be only of stone—metal, brick, and wood were also allowed. Such changes resulted from what was the north area guidelines' greatest innovation: the abandonment of historicism in favor of contextualism. While Rector Place and Battery Place were modeled on districts like Riverside Drive, West End Avenue, and Central Park West, revered for their stature as successful residential enclaves, the 1994 guidelines looked to the adjacent district of Tribeca for inspiration. The decision reflected the declining influence of the watery Postmodernism of the late 1980s as well as the growing appreciation for Tribeca itself, which had become transformed in a decade from a still-active district of warehouses into a family-friendly neighborhood. Reflecting the designation between May 1991 and December 1992 of four Tribeca historic districts, architects working in the unbuilt north residential area were urged to go about their designs as though building within a historic district. The guidelines recommended that the architects reference the Tribeca West Historic District Manual, a document published by the Landmarks Preservation Commission to assist in the design of new buildings, and alterations made to existing buildings, in the protected Tribeca neighborhood. Though it was clear that

Lerner, Gorlin, and Machado & Silvetti had loosened the authority's collar in many respects by moving past the Rector and Battery Place models, the strategy of asking a neighborhood of new apartment buildings to mimic the look of a district whose buildings were never intended for housing was questionable if not confounding.

As an extension of the guidelines, Alexander Gorlin devised detailed massing studies for sites 20, 21, and 22 of the north area.[95] According to Gorlin, the aim was "to replicate the city's pattern of gradual growth over time without resorting to the picturesque yet hollow strategies of postmodernism." On Site 22, bounded by North End Avenue, Chambers Street, West Street, and Warren Street, a public school was planned at the base of a series of three apartment towers facing North End Avenue and connected by glass bridges. The presence of the school allowed a greater building area under a bonus in the zoning laws. Site 20, bounded by River Terrace, Warren Street, North End Avenue, and Chambers Street, was composed of a series of slab buildings to help "define the street wall," with the northwest corner of the lot hosting a "tower crowned by exposed water towers in the New York tradition." On Site 21, abutting the west wall of Stuyvesant High School, Gorlin made the neighborhood's northernmost apartment building its tallest. With a curving west facade of glass, the tower was conceived as "a 'lighthouse' on a promontory overlooking the Hudson River and New Jersey."[96]

With the start of a new phase of residential development imminent, Gorlin was commissioned by the BPCA in 1994 to replace a ragtag collection of temporary structures located around Battery Park City to shelter security guards and personnel dispensing information for residents and visitors with four purpose-designed booths.[97] The north and south residential areas each received two booths made to complement the differing characters of the neighborhoods. While each had the same nine-foot-tall welded-aluminum frame and benches attached to the outside, as well as windows on several sides, the exteriors were given individual expressions. For the south residential area, Gorlin created "a *tempietto* and a miniature skyscraper" featuring roofs of lead-coated copper, one capped by a dome, the other a pyramid, in keeping with the traditional look of the neighborhood. For the north end, Gorlin, fresh from his role in helping to reframe its design guidelines, reflected the more contemporary feel that was expected once development was resumed, with booths based on Japanese "transformer" toys of the 1980s. Gorlin gave these "brash and colorful" follies mobility by placing them on wheels, an effort to have them "look avant-garde, as if they are on the edge of what's happening."[98] Though charming, the booths were all a bit silly and, despite the architect's protestations, distinctly Postmodern in a 1980s way.

In August 1994, after a decade of effort, the New York Mercantile Exchange announced that it would relocate from its cramped quarters in Four World Trade Center (Minoru Yamasaki and Emery Roth & Sons, 1973) to a new building it would construct in Battery Park City.[99] As early as 1985, New York's five major exchanges, the Commodities Exchange, the Mercantile Exchange, the Coffee, Sugar, and Cocoa Exchange, the Cotton Exchange, and the Futures Exchange, had planned to build a 1.2-million-square-foot tower designed by Kevin Roche John Dinkeloo and Associates on a platform over the entrance to the Brooklyn-Battery Tunnel, facing Battery Park and Battery Place. The design, one of Roche's most contextual, fitted its lower mass, a 200-foot-high base, to the scale and

Guard Booths, various locations, Battery Park City. Alexander Gorlin, 1994. Frances. ESTO

proportion of neighboring buildings but handled the tower, which was to rise an additional 730 feet above the base, as an independent element appropriately conceived at skyscraper scale. But the restrictions placed on it by tunnel ventilation requirements made the site difficult to develop, and a version of the project was proposed in 1991 for a vacant Tribeca block bounded by Greenwich, Warren, Murray, and West Streets. Although similar in design, the new project's base was reduced in height to better fit in with the lower-scale buildings around it while the tower remained as tall, criticized by many, as Suzanne Stephens reported in *Oculus*, who felt it "would create yet another scale-destroying element in an area known for its five-to-seven-story, nineteenth-century brick warehouses and loft buildings." Offering only forty-seven stories in its 730-foot tower, Roche's scheme was also accused, by those who did not understand the environmental benefits of high ceilings, of using fourteen-foot floor-to-floor heights to boost the building "more for exterior visibility than actual office needs."[100] Roche defended his design, claiming that the base slab, which was 106 feet high on the Greenwich Street side and 130 feet high on the West Street side, was contextual, but many in the architectural community took issue with its appropriateness, including Michael Sorkin, who asked, "Is this gap between use,

density and scale, and design ability too large?"[101] The public succeeded initially in having the height reduced to thirty-seven stories but was dealt an even greater victory when, in January 1992, the Mercantile Exchange unexpectedly withdrew from the project, forcing the other exchanges to scale the plan down further—first to thirty-stories, then to twenty-two, and in August 1992, in the midst of recession, to a seven-story building with only the Coffee, Sugar, and Cocoa, Cotton, and Commodities exchanges on board. When, in April 1994, members of the Commodities Exchange and the Mercantile Exchange voted to approve a merger of the two, making the former a wholly owned subsidiary of the latter, the building project was scrapped altogether.

On August 5, 1994, one day after the merger was complete, the New York Mercantile Exchange (NYMEX) announced its plans to construct a new building in Battery Park City, on a block adjacent to the World Financial Center bounded by Vesey Street, North End Avenue, and the esplanade. The BPCA had been anxious to develop this last unbuilt piece of Battery Park City's commercial sector for some time. In June 1992, the authority had submitted a bid to develop it as the world headquarters of the United Nations International Children's Fund (UNICEF), proposing a twenty-two-story,

Proposal for New York Exchanges building, Brooklyn-Battery Tunnel site, facing Battery Place. Kevin Roche John Dinkeloo and Associates, 1985. Rendering of view to the northwest. KRJDA

Proposal for New York Exchanges building, Tribeca site bounded by Murray, West, Warren, and Greenwich Streets. Kevin Roche John Dinkeloo and Associates, 1991. Rendering of view to the south. KRJDA

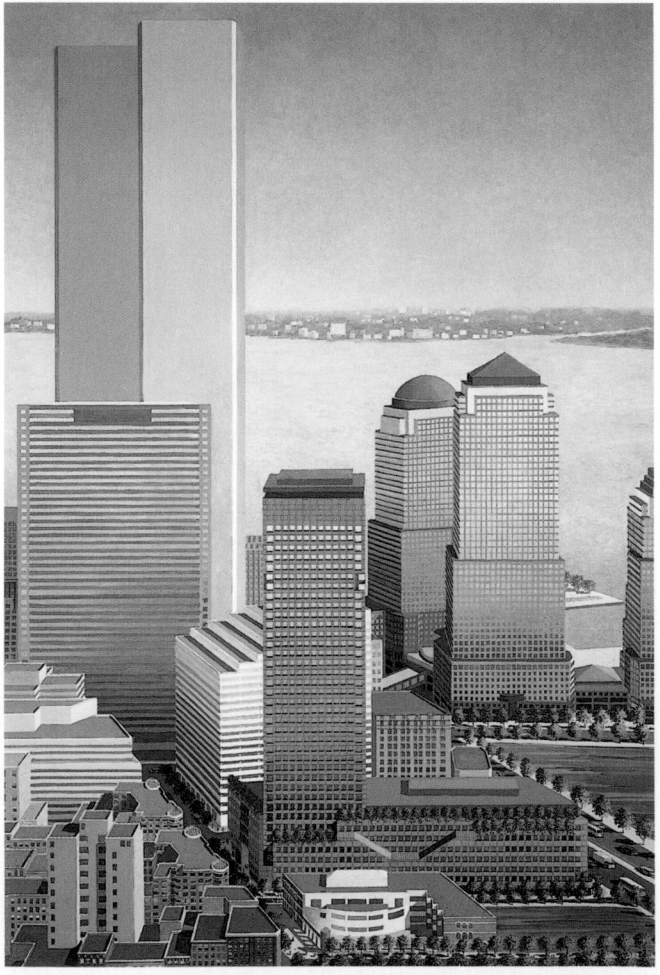

ABOVE New York Mercantile Exchange, site bounded by Vesey Street, North End Avenue, and the esplanade, Battery Park City. Skidmore, Owings & Merrill, 1997. View to the northeast. Hueber. SOM

BELOW Tribeca Bridge Tower, site bounded by Chambers, West, and Warren Streets, and North End Avenue, Battery Park City. Costas Kondylis Architects, Pasanella + Klein Stolzman + Berg, and John R. Menz and Richard Cook & Associates, 1998. View to the northwest. CFA

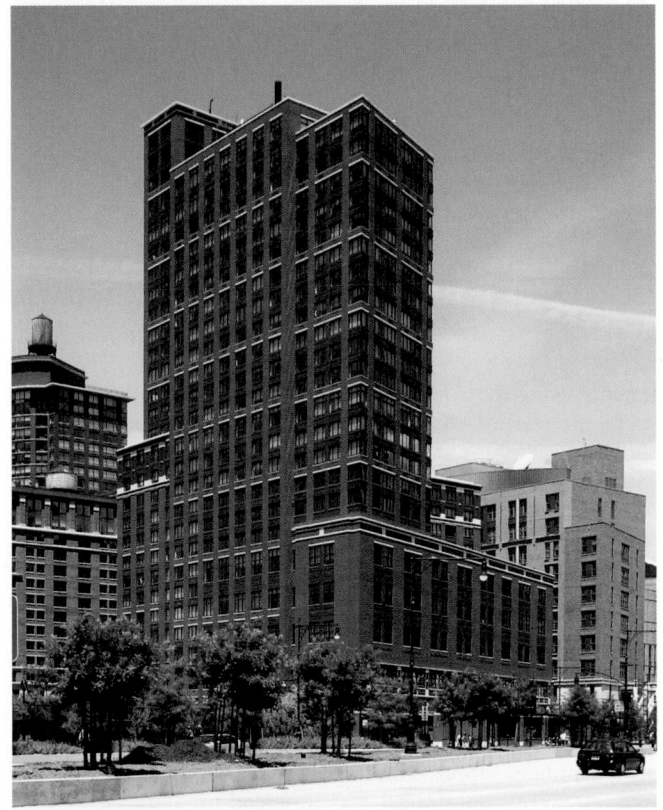

500,000-square-foot tower designed by Skidmore, Owings & Merrill, but the offer was not competitive.[102] When the Mercantile Exchange announced its plans two years later, the BPCA felt that a new look at the existing guidelines would be useful and Robert A. M. Stern Architects and James Stewart Polshek & Partners were each hired to draft alternate proposals leading to a new document under which David Childs of Skidmore, Owings & Merrill designed the new sixteen-story, 500,000-square-foot building.

Ground was broken on September 19, 1995, for the Mercantile Exchange, which opened nearly two years later on July 7, 1997. The low-key building designed by Childs was a refreshing, well-stated addition to Pelli's homogenous World Financial Center. Its handsome west facade, curved to match the sweep of the Hudson River, consisted of polished granite and tinted glass organized within an aluminum grid, suggesting a continuous fabric or skin clipped on to the superstructure. Childs described the design as "a composition of changing grids" with a "straightforward 'gray flannel' exterior" that "belies a complicated cross-section within."[103] A setback at the tenth floor on the north, south, and east sides related to the scale of Battery Park City's residential districts, according to SOM, marking "a transition between the lower mass of the housing and the skyscrapers to the east."[104] Inside, the new exchange contained 385,000 square feet of office space as well as two 25,000-square-foot, three-story-high, column-free trading floors overlooked by two public galleries. The trading floors featured a series of circular pits, separating

traders using the "open-outcry" system of buying and selling from the clerical workers on the rest of the floor, who were able to enjoy a quieter workplace. The tenth floor offered a concentration of mixed-use space including a health club, library, conference rooms, boardroom, and dining room with an outdoor terrace.

As the Mercantile Exchange neared completion, construction began on the first building to join Stuyvesant High School in the north residential area. Developed by the BPCA itself, Tribeca Bridge Tower (1998) ended an almost ten-year lull in residential development in Battery Park City.[105] Originally planned for a site in the heart of the Battery Place neighborhood but relocated to its eastern flank on a full block bounded by Chambers Street, North End Avenue, West Street, and Warren Street, the project was intended to "both expand the

housing stock at Battery Park City by building larger apartments and to include in Battery Park City affordable family housing," while at the same time showing a leery development community that Battery Park City was once again a desirable place to build.[106] It accomplished these ends by developing a mixed-use complex housing a public school on the first five floors of a 245,000-square-foot apartment building. And, frustrated with the lack of economic heterogeneity in their community, the authority decided to subsidize rents in about 20 percent of the building's 151 units using revenue gained from the other 80 percent of the apartments, which would be rented at market rates.

Three teams of architects were hired to work on the complex: Costas Kondylis Architects planned the apartments, Pasanella + Klein Stolzman + Berg designed the public school

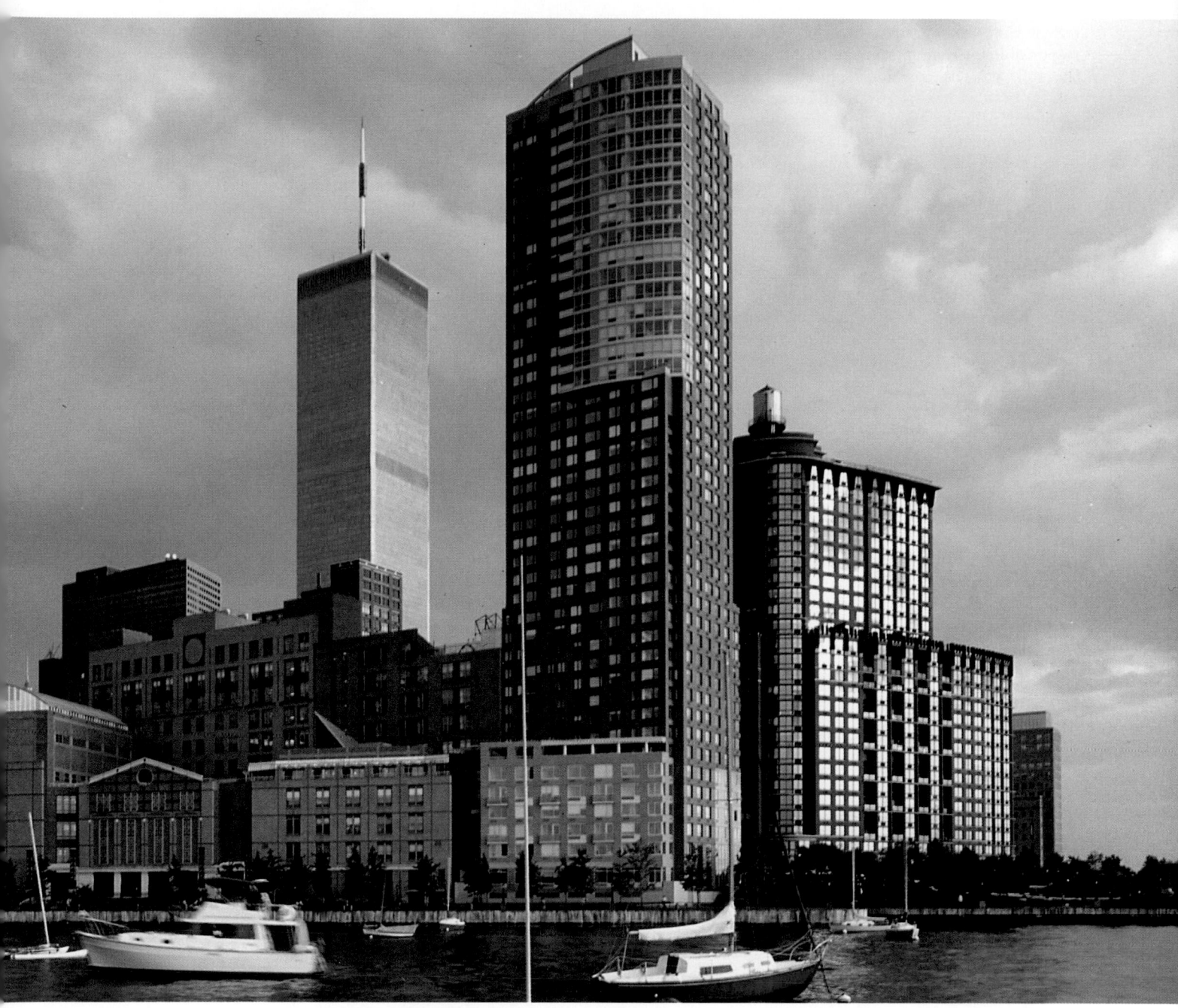

at the base, and John R. Menz and Richard Cook & Associates designed the facades, a combination that would prompt the editors of the *AIA Guide* to later write: "With too many chefs (among the architects), it's not surprising that the whole is less than the sum of its parts."[107] In negotiating what was considered to be a tricky transition of scale between the skyscrapers of lower Manhattan and the future north residential neighborhood, the red-Norman-brick complex was organized as three distinct yet interrelated masses. The school was housed in a five-story, eighty-five-foot-tall block facing West Street, where a two-story base supported a series of three-story-high window groupings with dark-red brick spandrels implying a colossal colonnade. On North End Avenue, where one entered the apartment complex, a thirteen-story, 135-foot-tall street wall met the ground in an irregular rhythm of piers

capped by stone stringcourses defining a one-story base. The third mass was the tallest, occupying the southern portion of the site. With cast stone lintels every three stories helping to break down its scale, the building rose to a height of twenty-one stories before stepping up twice to become a twenty-five-story tower facing the river.

For the design of P.S./I.S.89, Wayne Berg, of Pasanella + Klein Stolzman + Berg, worked closely with neighborhood parents as well as teachers from the nearby, overcrowded P.S. 234 (Richard Dattner, 1988). When it opened in September 1998, the facility, paid for by the New York City Educational Construction Fund, could accommodate up to 900 students from kindergarten to eighth grade. According to the architects, the design was "everywhere influenced by the Lower Manhattan cityscape. . . . Bends in its wide-open corridors

reflect the winding streets of the seventeenth-century city responsible for its trapezoidal site. And in true urban fashion, the tall, well-lit corridors approximate city streets themselves. Besides having twists and turns," the halls featured "storefront-like windows into classrooms, and entrances to more public spaces."[108] The classrooms were situated at the perimeter of the plan to take advantage of natural light, while the center housed an "activity core," consisting of a cafeteria on the first floor, auditorium on the second, a double-height gymnasium on the third and fourth floors, and a library and open courtyard on the fifth floor.

Within two years of its completion, Tribeca Bridge Tower would be joined by two new neighbors: Tribeca Pointe (1999), 401 Chambers Street, developed by Rockrose Development and designed by Gruzen Samton on a site abutting the same firm's Stuyvesant High School; and Tribeca Park (1999), 400 Chambers Street, designed by Robert A. M. Stern Architects with Costas Kondylis Architects and developed by the Related Companies on the west end of the block bounded by River Terrace, Chambers Street, North End Avenue, and Warren Street.[109] Both projects, in response to the BPCA's recent success subsidizing apartments at Tribeca Bridge Tower, received assistance from the New York State Housing Finance Agency under the city's 80/20 program, which mandated that in return for tax-exempt bond financing, 20 percent of a building's units be reserved for tenants with an income less than half the city's median, while the other 80 percent could be rented at market rate.

Construction of the 340-unit, forty-two-story Tribeca Pointe began in September 1997, just as the Manhattan real estate market was once again heating to an overboil. In form and details, Gruzen Samton's design departed from Alexander Gorlin's 1994 study for the site, utilizing less glazing in favor of a vivid palette of limestone, granite, and yellow and orange brick, enlivening

the facade while keeping it compatible with Stuyvesant High School next door. In fact, the building seemed more a downtown version of Gary Edward Handel + Associates' Millennium complex at Lincoln Center than a reflection of Gorlin's concept of the building as a lighthouse for the northern tip of Battery Park City. A curvilinear sixteen-story-high wall of windows, seemingly lodged into the northwest corner of the otherwise rectilinear tower, accomplished the task, as Scott Keller of Gruzen Samton stated, of "tipping its hat to the glass office towers elsewhere in Battery Park City," while also illuminating the tower for onlookers to the north.[110] Another overscaled glass panel was superimposed onto the south side of the tower, more directly referencing, as Jayne Merkel put it, the "shiny skins" of the World Financial Center.[111]

Robert A. M. Stern Architects' and Costas Kondylis's 453,000-square-foot Tribeca Park responded to the scale of adjoining streets as well as its current and future neighbors by utilizing several building heights—one, nine, sixteen, and twenty-seven stories—to break down the apparent mass of the complex. To visually unite the building with Tribeca's warehouses, Stern jettisoned the genteel, Riverside Drive–inspired aesthetic of the south residential area in favor of a tougher vocabulary of hard edges, bold bracketed overhangs, and colossally scaled columnar elements. A palette of red brick with Indiana limestone trim and black window frames, railings, and brackets defined the building above its polished black granite base. A twenty-seven-story tower on the northwest corner of the site marked the intersection of the Chambers Street pedestrian corridor to Tribeca and the culmination of the River Terrace street wall. On Warren Street, a one-story, skylit swimming pool wing framed the south side of the building's courtyard, which was entered through the lobby at the base of the nine-story Chambers Street facade. On River Terrace, four stacks of recessed balconies rose through a

LEFT Public School/Intermediate School 89, 201 Warren Street, between West Street and North End Avenue. Pasanella + Klein Stolzman + Berg, 1998. Warchol. PKSB

FACING PAGE TOP Embassy Suites Hotel, site bounded by Vesey, Murray, and West Streets and North End Avenue. Perkins Eastman, 2000. View to the southeast. Choi. PE

FACING PAGE BOTTOM Embassy Suites Hotel, site bounded by Vesey, Murray, and West Streets and North End Avenue. Perkins Eastman and Alexandra Champalimaud & Associates, 2000. View of atrium showing *Loopy Doopy (Purple and Blue)* by Sol LeWitt. Choi. PE

complex composition of masonry and glass to the top of a six-teen-story street-defining wall, above which the corner tower rose until its termination at 250 feet by a concrete cornice with metal brackets, all capped by a contextually referential exposed wooden water tower on the roof. Francis Morrone, writing in 2002, found Tribeca Park to be "the finest element of Battery Park City's skyline."[112]

In June 2000, a significant step toward establishing the north residential area as a full-service, full-time community was taken with the completion of a 463-room Embassy Suites Hotel (Perkins Eastman and Alexandra Champalimaud & Associates) on the block bounded by Vesey Street, Murray Street, North End Avenue, and West Street.[113] It was the first hotel built in Battery Park City and also contained a sixteen-screen Regal Cinema multiplex theater (Furman and Furman Architects), the first movie theater to be built in lower Manhattan, a 10,000-square-foot conference center, a health club, a twenty-four-hour Kinko's copy center, and two restaurants. Throughout the complex—in both the public spaces and hotel rooms—was a sizable collection of original art. Featuring works by established artists including Julian Schnabel, Roy Lichtenstein, Ross Bleckner, Jennifer Bartlett, and Pat Steir, who painted wall murals at the hotel's entrance and in the two restaurant spaces, the collection had as its centerpiece Sol LeWitt's *Loopy Doopy (Purple and Blue)* (2000), a 129-foot-long, 95-foot-high mural suggesting the movement of the Hudson River and covering one wall of the hotel's soaring 10,000-square-foot atrium. Joseph Giovannini considered the building to be "hardly more than a misplaced suburban import dressed in brick to match other suburban imports straight from the office park. Framed by the stiff architecture, the art inside simply points out the conventionality of the basic design."[114]

In summer 2000, the north area received its next residential building, one that helped round out the diversity of Battery Park

RIGHT Solaire, 20 River Terrace, northeast corner of Murray Street. Cesar Pelli & Associates, 2003. View to the northeast showing 22 River Terrace (Gruzen Samton, 2001) on left and Tribeca Park (Robert A. M. Stern Architects, with Costas Kondylis Architects, 1999) on far left. Goldberg. ESTO

BELOW Teardrop Park, middle of the block bounded by Murray and Warren Streets, River Terrace, and North End Avenue, Battery Park City. Michael Van Valkenburgh Associates, 2004. View to the southeast. Warchol. MVVA

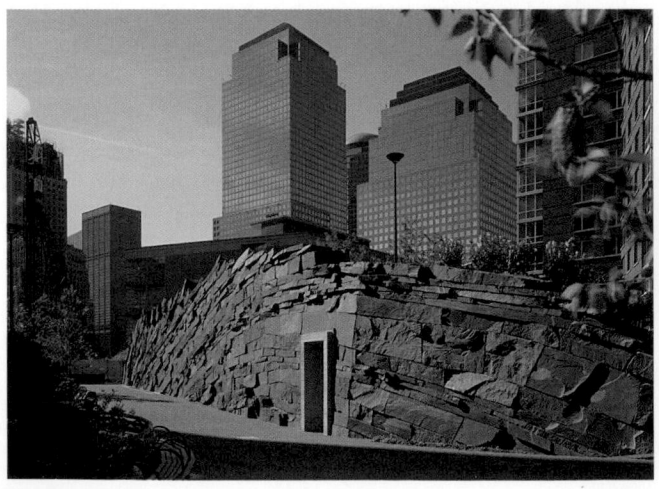

City's population, with the completion of the Hallmark (Lucien Lagrange and Associates and Schuman, Lichtenstein, Claman & Efron, 2000), 455 North End Avenue, between Warren and Chambers Streets.[115] As developed by Brookdale Living Communities, of Chicago, the Hallmark offered luxurious assisted living for tenants sixty-two years of age or older, the first building developed specifically for that purpose in Manhattan. The fourteen-story, 220,000-square-foot, 218-unit building helped define the street wall of North End Avenue with a sheer, red-Norman-brick and cast-stone trim facade rising above a two-story Indiana limestone-clad base to terminate in a painted metal cornice. Attached to the building's west facade, and abutting Stern's Tribeca Park to its west, an eight-story wing provided rooftop balconies for apartments within the main portion.

A significant shift in the future of Battery Park City's development came in January 2000 when the Battery Park

City Authority, under the leadership of Timothy S. Carey, its president and CEO since 1999, released the Residential Environmental Guidelines, also known as the "green guidelines," requiring that the north area's seven remaining residential sites be developed with environmentally responsible apartment buildings. Drafted by Fox & Fowle Architects with the engineering firm of Flack + Kurtz, the guidelines addressed five broad categories: energy efficiency, indoor environmental quality, material and resource conservation, operations and maintenance, and water conservation and site management.[116] Among other requirements, the detailed document called for the use of energy-efficient appliances, building materials made from recycled contents, photovoltaic panels, storm-water collection tanks, bicycle storage areas, and the reuse of gray water (from bathing, laundry, and dishwashing) in toilets and plant irrigation. They also prohibited the use of many com-

mon building materials that were deemed harmful to the environment. The guidelines were expected to add 10 to 15 percent to the cost of new buildings.

The first buildings to follow the strictures were built on a double-sized block formed by the demapping of Park Place West between North End Avenue and River Terrace.[117] The new block, bounded by Warren Street, North End Avenue, Murray Street, and River Terrace, would receive four new apartment buildings on its corners. The roughly cruciform-shaped 1.8-acre space between the buildings was developed as Teardrop Park, designed by Michael Van Valkenburgh Associates.[118] Completed in 2004, Teardrop Park, designed to evoke the natural terrain of the Catskill Mountains, included, according to Van Valkenburgh, "two distinct but complimentary earth forms, shaped and held by stones that create a smaller valley between." The north-facing slope of the valley

featured a twelve- to twenty-five-foot wall of cleft stone "evoking the stone cliffs of upstate New York."[119] A portion of the cliff contained a so-called weeping wall, with water trickling down its bluestone surface. Van Valkenburgh also provided a separate grass lawn for conventional park-sitting.

The first building completed on the new block was Gruzen Samton's 22 River Terrace (2001), southeast corner of Warren Street, a 343,000-square-foot, 324-unit, twenty-seven-story red and tan brick apartment tower with a sixteen-story base beneath a set-back eleven-story tower.[120] Though it was begun before the green guidelines went into effect, the developers, Rockrose Development, voluntarily incorporated some sustainable design elements into the tower, such as low-emissivity windows, high-efficiency refrigerators and pumps, and motion detectors to control the lighting in the building's public areas. Its neighbor to the south, the Solaire (2003), 20 River Terrace, northeast corner of Murray Street, designed by Rafael Pelli, head of the New York office of Cesar Pelli & Associates, was the first building to meet the requirements of the new guidelines and was, as could be read on its cornerstone, "America's First Environmentally Responsible Residential Tower."[121]

The twenty-seven-story apartment house consisted of a set-back eleven-story tower on a sixteen-story base and contained 293 apartments laid out by the firm of Schuman, Lichtenstein, Claman & Efron. The building consumed about 35 percent less energy than similar nongreen buildings, used one-third less potable water due to the gray water system, brought in 30 percent more natural light than required by city codes (100 percent more in the bedrooms), and featured a fresh-air intake system and air filtering system. The roof was covered in lightweight soil and plants to repel heat during the summer rather than absorb it. The seventeenth-floor terrace was landscaped by Diana Balmori and irrigated with storm water collected from rooftop tanks. At first glance, the Solaire was indistinguishable from its neighbors. The building's two-story base of banded brick and Buckingham black slate was a refined touch. But the building's real distinction lay in the twin stripes of blue photovoltaic panels that rose above the entry, which itself was shaded by a glass canopy dotted with photovoltaic cells. In all, the panels generated approximately 5 percent of the building's electricity.

On March 22, 2001, plans were announced for the two remaining sites on the block. Site 19B would become home to a twenty-five-story, 264-unit apartment building, 325 North End Avenue, southwest corner of Warren Street, designed by Robert A. M. Stern Architects with Ismael Leyva as architect of record and developed by the Related Companies.[122] Site 18B, northwest corner of North End Avenue and Murray Street, was to be occupied by a second green apartment building designed by Cesar Pelli & Associates' New York office and developed by the Albanese Development Corporation. Both buildings began construction in 2004.

South Residential Area

As construction north of the World Financial Center proceeded, development in the southern portion of Battery Park City, stalled since the completion of the Regatta, Cove Club, and Liberty View projects in 1990, was slow to regain momentum. In 1992, at the same time Venturi, Scott Brown & Associates was commissioned to develop new guidelines for the north area (see above), Robert A. M. Stern Architects was hired by the BPCA to reexamine Cooper Eckstut's existing plan for the undeveloped sites of the south neighborhood. Stern proposed to soften the profile of the easternmost blocks of Battery Place: where Cooper Eckstut had called for three buildings dramatically stepped up in height from north to south, Stern proposed a complexly massed, but more consistent and subdued skyline to complement that of the financial district. Stern also devised several schemes for the re-parcelization of the six blocks. A proposal to realign First and Second Places so that Second Place would continue the axis of Morris Street was not adopted. As part of his study, Stern was asked to develop guidelines for Site 14, the proposed location of a Holocaust memorial.

Despite having the largest Jewish population of any city in the world, New York was unable to complete a significant memorial to the victims of the Nazi Holocaust for more than fifty years following the Second World War. As early as 1947, a nonprofit organization, the American Memorial to Six Million Jews of Europe, after placing a small plaque in Riverside Park, attempted to build a large memorial in the park at Eighty-third Street, proposing a plan by the sculptor Jo Davidson and the architect Ely Jacques Kahn for a fifteen-foot-high bronze figure on a forty-foot-high base.[123] After the scheme was rejected by the memorial organization's own design committee, the architects Percival Goodman and Erich Mendelsohn each came up with their own schemes in 1949–50 and 1951–52, respectively, but these proposals were unable to move forward because of a lack of funds and the reputed disapproval of the parks commissioner, Robert Moses.[124] In 1965 the sculptor Nathan Rapoport produced two designs for placement in Riverside Park, a monumentally scaled figure surrounded by flames and two twenty-six-foot-high sculpted Torah scrolls, both of which were rejected by the New York City Art Commission.[125] One year later the city offered a site in Battery Park to a new organization, the Committee to Commemorate the Six Million Jewish Martyrs, which commissioned Louis Kahn, who produced an abstract design calling for a sixty-six-foot-square, gray granite podium on which seven glass, ten-foot-square, eleven-foot-high piers would stand, the center one of which would be hollow and open to the sky.[126] The committee requested several changes and cost-cutting features from Kahn, and even though he accommodated their requests, the group lost its drive to build the controversial design. The idea for a memorial was not seriously brought up again until 1981 and even then it took another sixteen years before it could be realized.

In May 1981 Mayor Koch appointed a task force headed by the real estate developer George Klein to produce a report outlining how and where a proper memorial could be built.[127] The following year the New York City Holocaust Memorial Commission was established with Robert Morgenthau, the Manhattan district attorney, joining Klein in heading the group and Koch serving as the founding chairman. At this point the most likely locations for the memorial, which the commission believed should also include a museum, archives, and educational facilities, were the Ethical Culture Center (Robert D. Kohn, 1911), southwest corner of Central Park West and Sixty-fourth Street, the former Gallery of Modern Art (Edward Durell Stone, 1965), Two Columbus Circle, and the United States Custom House (Cass Gilbert, 1900–07), One Bowling Green.[128] The Custom House, controlled by the federal government's General Services Administration, quickly

Proposed Museum of Jewish Heritage—A Living Memorial to the Holocaust, southwest corner of First and Battery Places. James Stewart Polshek & Partners, 1985. West elevation. PPA

Proposed Museum of Jewish Heritage—A Living Memorial to the Holocaust, southwest corner of First and Battery Places. James Stewart Polshek & Partners, 1985. Rendering of memorial building interior. PPA

became the preferred spot and over the next two years the Holocaust Memorial Commission tried to secure the imposing Beaux-Arts building for its own use.

In April 1985 Governor Cuomo proposed a new site for the Holocaust memorial at the southern end of Battery Park City, where the Port Authority of New York and New Jersey had a heliport.[129] What was unusual about this latest development was that the project, intended for completion by 1989 and now named the Museum of Jewish Heritage—A Living Memorial to the Holocaust, was to be tied, both physically and fiscally, to the construction of a thirty-four-story condominium tower which would help subsidize the operations of the museum in a manner similar to that employed by the Museum of Modern Art in its recent addition.

James Stewart Polshek & Partners, who had originally been hired to do a feasibility study for the Custom House site, were the architects chosen for the memorial and apartment building. Their design called for a 165,000-square-foot, five-level exhibition hall, bounded on three sides by the 400-unit condominium complex, that faced New York harbor, offering spectacular views of the Statue of Liberty and Ellis Island. Polshek, who was sensitive to the need for the museum to "appear uniquely separate and distinct from the residential project despite its physical proximity," provided a dramatic entrance sequence.[130]

As described by Joseph Giovannini in the *New York Times*:

> Visitors would enter a two-story hall and face a high, rough stone wall appearing to be 10 feet deep. Passing through a large portal in the wall, they would step down a wide staircase that narrows and leads into a soaring, three-story, skylighted shaft, cylindrical in shape. Inscribed with quotations of people who survived the Holocaust, the chamber would be called the Prologue. Visitors will have stepped out of New York, past the Wailing Wall, into Jewish memory. By taking visitors in the earth and illuminating them from above, the architects intend to condition visitors for a journey of reflection by changing their physical state. This chamber is to be the heart of the building, and should be one of its most successful spaces.[131]

Adjacent to the museum, and connected by an indoor walkway, was the freestanding memorial building, a sixty-foot cube of cut glass and stone panels that was to be illuminated through translucent marble panels set in the roof, a design recalling Louis Kahn's unrealized proposal.

While Polshek was developing his design, and the commission was busy with fund-raising efforts and trying to find a developer for the apartment house, the classical architect Allan Greenberg came forward with an unsolicited proposal for a Holocaust memorial (1984–89) in Battery Park.[132] Greenberg's design called for a four-sided stone arch with prominent key-

Proposed Holocaust memorial, Battery Park. Allan Greenberg, 1989.
Photomontage, view to the northeast. AG

stones representing the Scroll of Law. Inside the memorial, a circular space topped by a dome with an oculus represented the chimneys of the Nazi death camps. The oculus was also able to serve as a symbol of hope because it opened to the sky. The Ten Commandments were carved into as many panels forming a faceted cone at the top of the memorial, and four internal pilasters each supported a six-branch candelabra. Stone tables placed in front of the pilasters would hold a 365-page book—a page turned every day—inscribed with the names of the six million murdered Jews. As Greenberg recalled, "The memorial design began as a reaction to reading Andre Schwartz-Barts's book, *The Last of the Just*. I wondered what a memorial to Europe's dead Jews could possibly look like. And in ca. 1980, around the time of the Lutyens show at MoMA, I produced a design. The memorial arch form was suggested by Lutyens's numerous memorial arches."[133] Michael Sorkin, although he was pleased with the solemnity of Greenberg's design in contrast to the "incompatible" and profane mix of uses in the Polshek scheme, which some wags had come to refer to as the "Holocaust Hotel," still had problems with its approach:

> Greenberg's a dogmatic classicist, wrapped up in quixotic and inexplicable pursuits. . . . A quadrifrons arch in stone, segmented portals, pilasters, mouldings, the whole dreary apparatus of antiquity, surmounted by a hollow 60-foot shaft. It reminded me of those First World War cenotaphs by Lutyens or of the Albert Memorial, that ugliest of such mnemonic piles. . . . There was no gainsaying that Greenberg's act of commemoration and grief was heartfelt, that it was capable of affecting people. . . . Nevertheless, the architecture was so tendentious and specific that its appropriateness as collective expression must immediately be called into question.[134]

The kinds of problems that beset earlier Holocaust memorial projects resurfaced with Polshek's. Fund-raising was not going particularly well, in part because so much energy and money was being directed toward the United States Holocaust Memorial Museum (James Ingo Freed of Pei Cobb Freed, 1993) being planned for Washington, D.C. Things went from bad to worse after the stock market collapse of 1987 and the subsequent downturn in the real estate market. Without substantial individual contributions and the income generated by the condominium tower, the memorial could not go forward. Finances aside, the problem with the project was one that Polshek had identified early on in the process: the potential incompatibility of a Holocaust memorial and a residential property. In September 1988, the tide began to turn a bit when the Koch administration announced that a Swiss company, Noga Hotels International, had agreed to pay $50 million to the Battery Park City Authority and contribute $30 million to the Holocaust museum in exchange for the rights to build a thirty-seven-story hotel. The announcement proved premature, as the city had failed to adequately consult with state authorities, who objected to the plan. A year later, in September 1989, the Battery Park City Authority announced that a new developer, Property Resources Corporation, would be allowed to develop the site with a thirty-eight-story condominium tower. Property Resources would pay the New York Holocaust Memorial Commission $32 million for the right to lease the site and allow the museum to build its facility on a site just to the north of the planned apartment building. Unfortunately, this plan fell victim to the depressed real estate market, and many believed that the New York Holocaust memorial was a

star-crossed project never to be completed, an acute embarrass-ment given that the U.S. Holocaust Memorial Museum was going ahead as planned.

In 1993, ironically the same year that the U.S. Holocaust Memorial Museum opened, the New York version was back on track and the proposed residential component was finally elim-inated, with half the cost of construction to now be carried by the Battery Park City Authority, which commissioned Robert A. M. Stern to develop site and design controls.[135] Also gone was James Stewart Polshek & Partners, which was replaced by Kevin Roche John Dinkeloo and Associates. Kevin Roche's gray granite hexagonal shaped design (1993–97), intended to symbolize the six million lives lost as well as recall the Star of David, was also located at the strategic southern end of Battery Park City but on a much smaller site given that the apartment tower was no longer necessary. The far more modest, three-level, 30,000-square-foot facility, designed with the possibility of future expansion in mind, devoted one floor each to chroni-cling European Jewish life in the century before the Nazi's rise to power, the Holocaust itself, and the renewal of Jewish life after World War II. Roche's building was entered by means of a massive bronze door. A top-floor gallery with views of the Statue of Liberty and Ellis Island was set beneath a stepped, six-tier roof intended to suggest an ascent into the infinite. Patrick Gallagher, principal of Douglas/Gallagher, was placed in charge of the interiors, which consisted primarily of arti-facts, photographs, and videotape testimonials. Fund-raising

picked up considerably after the publication of Roche's design and the return of prosperity to New York, and espe-cially to its real estate community. Ground was broken in October 1994 and the museum opened three years later on September 15, 1997.

Herbert Muschamp, although impressed with the exhibi-tions inside, had serious reservations about Roche's building: "The building is dignified, somber and refined. It is a triumph of prestige design. But it is not a work of art. The architect has not explored his medium's potential either to arouse empathy or to express ideas. . . . Mr. Roche's design conveys none of the brilliant complexity displayed inside. The museum presents the staggering tapestry of life interwoven with death. The building resembles nothing so much as a mausoleum." Muschamp concluded his assessment of the museum with a swipe at Battery Park City and its "well-intended but bleakly suburban concept of modern urban life": "The sad truth is that Battery Park City is itself a memorial: a post-modern shrine to a New York that never was. This is not the ideal con-text for a building that seeks to memorialize the most cata-strophic event in modern history."[136]

In 1999, after just two years of operation, the Museum of Jewish Heritage—A Living Memorial to the Holocaust announ-ced its intention to build a four-story, 82,000-square-foot east wing housing a 375-seat theater, exhibition galleries, class-rooms, a café, and office space. An important component would be the Family History Center, to exhibit the oral histories of

Museum of Jewish Heritage—A Living Memorial to the Holocaust, south-west corner of First and Battery Places. Kevin Roche John Dinkeloo and Associates, 1997. View to the northwest. KRJDA

Holocaust survivors as compiled by Steven Spielberg's Shoah Foundation.[137] The design team of Kevin Roche and Patrick Gallagher was again chosen and the city pledged $22 million for the planned $60 million facility, with the rest of the money to come from private contributions. Ground was broken on October 26, 2000, for Roche's granite and glass addition, named the Robert M. Morgenthau Wing for the Manhattan district attorney and the museum's chairman, and it opened on September 15, 2003. The sleekly detailed addition curved around the original hexagonal building, to which it was linked on three levels. Between the buildings, a one-story education center provided the base for the Memorial Garden, a south-facing terrace featuring the artist Andy Goldsworthy's Garden of Stones, a landscape of dwarf oak trees growing from eighteen hollowed-out boulders each

weighing between three and thirteen-plus tons. The piece was sponsored by the Public Art Fund and the trees, which began as tiny saplings, were to grow over many years through six-inch holes in the glacial boulders, fusing with the stone as they matured to symbolize nature's tenacity and the ability to persevere against the odds. Simon Schama, writing in the *New Yorker* as the garden neared completion, felt the work was "wonderfully well done, a poignant metaphysical conceit strongly realized, the crush and mass of history penetrated by the germination of hope."[138]

Justin Davidson, architecture critic of *Newsday*, called the Morgenthau Wing "a complete and brilliant reinterpretation" of the earlier building, relieving its "stolid symmetry" and endowing it "with a series of subtly complicated views." He was pleased with the way the addition curved to embrace the

Yoes, who had been asked to quickly design the small building, known as the Visitor Center, after museum officials realized that insufficient space had been provided for ticket sales and security screening. The pavilion, a pair of glass and metal-walled, glass-roofed trapezoids designed, approved by the BPCA, and built in eight weeks, was, according to Paul Goldberger, "one of Battery Park City's most admired, if tiniest, gems . . . exhilarating amid the earnest and dutiful brick and stone buildings" surrounding it. In time, he wrote, "it became the part of the museum complex that architects, especially younger ones, talked about. In a city with few strong modern public buildings, it was a kind of minor, underground icon."[140] Though efforts were made by the Department of Cultural Affairs (which owned the building and was still paying off the bonds that financed it) to reuse the building elsewhere in Battery Park City or New York, the dismantled structure remained in storage.

Residential construction in Battery Place was resumed after a nearly decade-long hiatus with the construction of River Watch (1999), 70 Battery Place, between Third Place and Second Place, and South Cove Plaza (2000), 50 Battery Place, between Second Place and First Place, both designed by Hardy Holzman Pfeiffer Associates in association with Schuman, Lichtenstein, Claman & Efron and built under the city's 80/20 program.[141] Each nine-story building was almost identically massed, presenting Battery Place and South Cove Park (see below) with a rhythmic progression of solid and void that, insofar as its massing, conveyed the most fulfilling impression of the long sought-after "traditional New York feel" in Battery Park City to date. River Watch, developed by the Brodsky Organization, employed brown and tan brick above a two-story stone base and featured floor-to-ceiling corner windows. South Cove Plaza, developed by DeMatteis Organization, combined brown and red brick with a grid of punched windows barely enlivened, not by glass corners, but with floor-to-ceiling

LEFT Robert M. Morgenthau Wing, Museum of Jewish Heritage—A Living Memorial to the Holocaust, southwest corner of First and Battery Places. Kevin Roche John Dinkeloo and Associates, 2003. View to the northeast showing Roche's original building (1997) on the left. KRJDA

BELOW Visitor Center, Museum of Jewish Heritage—A Living Memorial to the Holocaust, southwest corner of First and Battery Places. Weisz + Yoes Studio, 1997. View to the west showing Roche's museum (1997) in background. Sundberg. ESTO

original building, "protectively enfolding the hexagon like a runner cradling a football." The curve also allowed the museum to enter into an "architectural conversation" with Handel and Polshek's Ritz-Carlton (see below) to the east, and the two buildings, bending away from one another, allowed Battery Place to "widen as Manhattan tapers to a point. Seen from the waterfront park, the museum almost looks like the base of the hotel's wedge-like tower; the two buildings could be improvising together on a riff of angles, glints and bending walls. With one swoop of a wing, Roche has not only transformed his own museum, but also ennobled a colleague's more pedestrian work."[139]

Unfortunately, the new wing required the demolition of an entry pavilion that had been built in 1997, just before the original portion opened, by the architects Claire Weisz and Mark

Ritz-Carlton New York, 2 West Street, between Battery and First Places. Gary Edward Handel + Associates and the Polshek Partnership, 2001. View to the northeast. Ries. SRP

Skyscraper Museum, 39 Battery Place, southeast corner of First Place. Skidmore, Owings & Merrill, 2004. Polidori. SOM

windows suggesting French balconies. The effect was a bit drab—perhaps a bit too close to classic tenement buildings, but without their ornamental overlay.

In 2001, Battery Park City's second hotel, the Ritz-Carlton New York, Battery Park, 2 West Street, was completed on Site 1, the southernmost development parcel bounded by Battery Place, West Street, and First Place.[142] Plans to build a hotel on the site had been in consideration since the late 1980s but a proposal by a Swiss hotel group and a subsequent RFP issued by the BPCA were all shelved in the face of the collapsing real estate market.[143] In 1998, as Manhattan underwent a gold-rush-like hotel boom, the BPCA issued another RFP that also encouraged entrants to include a public amenity in their proposals. Millennium Properties outbid Donald Trump and Forest City Ratner (which was currently building the Embassy Suites Hotel in Battery Park City's north area) with its proposal to build a thirty-nine-story mixed-use building with a 298-room Ritz-Carlton Hotel on the first twelve floors, 113 condominium apartments on the upper twenty-six floors, and a 5,800-square-foot home for the newly founded Skyscraper Museum on the ground floor. As designed by Gary Edward Handel + Associates with the Polshek Partnership, the 600,000-square-foot building featured a gently curving red-brick base beneath a set-back tower, the latter featuring iron-spot brick on the north and east facades facing the city and glass curtain walls on the south and west facades to optimize views of the harbor and river. The thirteenth floor provided a fitness center, spa, meeting rooms, banquet halls, and a restaurant opening onto a terrace occupying the roof of the base. The southern tip of the site was occupied by a triangular landscaped garden with a 100-seat restaurant and a café. Frank Nicholson designed the Ritz's interiors in a more contemporary style than the one he typically pursued in the hotel chain's other outposts, using a vocabulary suggestive of early-twentieth-century luxury ocean liners, with, for instance, etched glass balustrades and wall sconces that, according to the designer, looked "like they came right off the S.S. *Normandie*."[144]

The Skyscraper Museum, 39 Battery Place, southeast corner of First Place, was provided its space rent-free by Millennium Properties, one of whose founders, Philip E. Aarons, also sat on the museum's board. It was the first permanent home for the institution that, since its establishment in 1996 by the architectural historian Carol Willis, had staged its exhibitions in various temporarily available spaces around lower Manhattan. Skidmore, Owings & Merrill provided architectural services pro bono, with Roger Duffy leading the design effort that transformed the difficult space by covering floors and ceilings in polished stainless steel. The reflections, according to Willis, would "turn the space into a kind of vertical Versailles–a hall of mirrors in the vertical."[145] The display cases, to be lit from within and incorporate ventilation ducts in order to keep the ceiling uninterrupted, were free-standing but designed to extend from floor to ceiling so that their reflections would resemble, as Duffy described, "skyscrapers of improbable proportion and impossible height."[146] A mezzanine-level room was designed to cantilever out over the sidewalk to form a canopy over the museum entrance. The Ritz-Carlton was originally scheduled to open on October 9, 2001, but was delayed by the attacks on the World Trade Center in September 2001, pushing the opening back to January 29, 2002, and making it the first new building to open downtown after September 11. The Skyscraper Museum opened in February 2004.

Freedom of Expression National Monument, near West and Chambers Streets. Erika Rothenberg, Laurie Hawkinson, and John Malpede, 1984. View to the east. SMHA

Open Space and Public Art

The system of public open spaces that formed 30 percent of the district was perhaps the single most successful aspect of Battery Park City—and certainly the one that was far and away the most popular. The wide variety of open spaces ranged from large waterfront recreational parks and promenades to quiet garden squares that were remarkable not only for their diversity and quality but also for the extensive amount of public art incorporated in their design. The presence of public art in Battery Park City had been a fact long before its commissioning was formalized as part of the development process. Beginning in 1978 and after a year's hiatus continuing for six consecutive summers until 1985, after which it moved to Hunter's Point, Queens, a series of summertime exhibitions called Art on the Beach took place on a ten-acre portion of the barren landfill that would become the north residential area.[147] Organized by Creative Time, a not-for-profit arts organization founded in 1973, the program combined sculptural installations with dance, music, and conceptual art performances and featured, in its first years, single artists' works such as Alice Aycock's *Shantytown—City of Doors*, (1980), a group of fifteen small structures made from old doors, and Heide Fasnacht's *Twain (Intermesh)* (1980), which allowed observers to shape the sand with huge rakes. Beginning in 1983, Creative Time began to assemble teams of artists, performance artists, and architects to create collaborative works, eventually adding composers, engineers, poets, and musicians to the mix. James Holl, a sculptor, Kaylynn Sullivan, a performance artist, and the architect Elizabeth Diller conceived *Civic Plots* (1983), featuring two mounds of sand concealing 100 golden slippers that the audience could collect and redeem for prizes and fifteen tripods scattered around the site supporting black, wing-shaped components. Diller's Constructivist-inspired painted black wood "redemption" booth that served as "both a building and a costume," according to the architect, was, for Grace

Glueck, "the most impressive sculptural element . . . a robot-like booth . . . resembling—with its limblike extensions and square facial mask through which the 'redeemer' confronts his clients— something from a Bauhaus play."[148] The team of artist Brower Hatcher, performance artist David Van Tieghem, and architect Billie Tsien designed *The Language of Whales*, a tall, head-shaped three-dimensional frame structure of short bolted aluminum rods incorporating various colored pieces of plastic that was outfitted with acoustical pick-ups to amplify sounds made by the wind and by Hatcher, who played the object like a drum. One of the more memorable artworks of the series was the *Freedom of Expression National Monument* by Erika Rothenberg, a sculptor, Laurie Hawkinson, an architect, and John Malpede, a performance artist. Displayed in 1984, the piece consisted of a fourteen-foot-long elevated orange megaphone aimed at the skyscrapers of the financial district. Visitors could climb a wooden ramp to an orange painted platform and speak their minds into the megaphone that in fact did not amplify sound. The intention, according to the designers, was to make people feel "both powerful and powerless at the same time."[149]

Though not affiliated with Creative Time, in May 1982 Agnes Denes's *Wheatfield—A Confrontation*, commissioned by the Public Art Fund, transformed two acres of landfill near the southern tip of Battery Park City into a field of wheat that, when harvested on August 16, provided more than 1,000 pounds of the grain.[150] According to Denes, "*Wheatfield* was a symbol, a universal concept. It represented food, energy, commerce, world trade, economics. It referred to mismanagement, waste, world hunger, and ecological concerns. It was an intrusion into the Citadel, a confrontation of High Civilization. Then again, it was also Shangri la, a small paradise, one's childhood, a hot summer afternoon in the country, peace, forgotten values, simple pleasures."[151] Grace Glueck asked: "Who can criticize a wheatfield?"[152]

Battery Park City's art program was guided by the Battery Park City Fine Arts Committee, a group established in February 1982. The art committee's first project, and the first component of the open space system to be built, was the three-and-a-half-acre waterside plaza just west of Cesar Pelli's World Financial Center.[153] A competition was held in 1982 to determine the design team. Of the seven artists invited to participate, Scott Burton and Siah Armajani were chosen to work with Pelli and landscape architect M. Paul Friedberg. With the concurrent controversy surrounding Richard Serra's *Tilted Arc* in Federal Plaza undoubtedly on his mind, Pelli was worried that artistic egos might overpower public benefit. But Armajani and Burton, though the latter was often compared to Serra, were artists who had both espoused a design philosophy that embraced functional responsibilities. Known for his "sculpture furniture," Burton approached the project with modesty, stating "I cannot make a bench there that stands for particular political beliefs. I should make a bench because it is comfortable.[154] Likewise, Armajani, whose work was influenced by the Russian Constructivists not only in form but in the belief of architecture as a social catalyst, stated, "Public art's immediate concern is not with the artistic but with the work it is meant to perform. . . . By emphasizing usefulness, public art becomes a tool for activity—sitting, walking, eating, talking."[155]

Drawings and a model of the plaza were unveiled at a press conference held at the Whitney Museum on November 30, 1983. When the design was completed two years later, Pelli explained the heterogenous plan: "We decided people are different—sometimes they want vistas, sometimes shady nooks."[156] Accordingly, the space, completed in fall 1989, was broken up into three distinct areas: a small, oval-shaped park situated to the south of the World Financial Center; a labyrinthine garden adjacent to the oval park; and an expansive, multitiered granite plaza that

descended from the World Financial Center's Winter Garden to meet and embrace the North Cove Yacht Harbor (see below). Art critic Ken Johnson, writing in *Art in America*, noted that the distinction of these spaces was crucial to the success of the plan:

> The main drama of the entire complex . . . is focused in the conjunction of the harborside observation point, the sylvan grove and the maze-passage between them. These spaces are what make the project work as art and as something richer than just design. The effect is subtle, like distant, almost inaudible music, but it creates for the visitor a multileveled experience in which the immediate physical qualities of elegant forms and materials and comfortable functions resonate with mythic, fantastic and theatrical qualities.[157]

The oval park, the most secluded component, situated where the business district gave way to the residential neighborhood, was an understated, green, English-type garden, the simple field of grass at its core ringed by a gravel walkway, a double row of Yoschino cherry trees, and twenty-six teak benches designed by Burton. At the southeast entrance to the park, Armajani created two signature-style metal gateposts made to resemble rustic picket-fence carpentry. The ornamental "maze-passage" garden connected the oval park to the waterfront with a network of pathways traversing an irregular grid of plantings set among low evergreen hedges and tall birch trees. Designed without seating, it was considered to be not so much a physical maze as a psychological place of transition between the divergent modes of city life represented by the bucolic oval park and the urban riverfront plaza.

The plaza was the principal focus of the open space, affording Burton and Armajani their greatest opportunities for expression. Outside the Winter Garden, a "front porch" paved in an intricate pattern of pink, white, and gray granite extended to the west and south to provide two terrace cafés shaded by twin

rows of pleached plane trees, each bordered on its river side by a 150-foot-long, linear reflecting pool smoothly overflowing toward the river to form, as Ken Johnson put it, "a mesmerizing, unbroken liquid sheet."[158] Broad flights of steps descended to a lower-level promenade featuring seating areas designed by Burton, each composed of a shallow cylindrical granite "table" flanked by two "chairs" resembling short flights of stairs. The majority of the plaza's water frontage, which wrapped the north cove and connected to the park system to the north and south, was left unobstructed except for a tall, torchlike beacon designed by Armajani to punctuate the center of the plaza. The monument rose from a Burton-designed granite pedestal and consisted of an oversize version of an old-fashioned street lantern supported by a thick black cylinder.

Armajani's finest contribution to the waterfront plaza was a gently curving balustrade of iron, green enamel, and polished bronze that created a threshold before the plaza descended by steps and ramps to the rim of the yacht harbor. Built into the railing were solid bronze letters spelling out two poems written nearly a century apart. The first was from Walt Whitman's rapturous "City of Ships" (1867): "City of the sea, city of wharves and stores, city of tall facades, of marble and iron, proud and passionate city, mettlesome mad extravagant city." The second was an excerpt from Frank O'Hara's "Meditations in an Emergency" (1957): "One need never leave the confines of New York to get all the greenery one wishes—I can't even enjoy a blade of grass unless I know there's a subway handy, or a record store or some other sign that people do not totally regret life." Paul Goldberger was pleased: "Together, the quotations make a witty and wonderful piece of public wisdom from the one new place in New York in which the idea of the public realm actually amounts to something."[159] Matching the curve of Armajani's railing were four streamlined, polished granite benches by Burton. Ken Johnson felt that "sculpturally, the granite benches are the most gratifying elements [of the plaza]. . . . There is something about the combination of immense weight and precise articulation of minimal form that is reminiscent of ancient Egyptian sculpture."[160] Paola Antonelli, however, was critical, but not so much of the art as its setting: "The minimalist delicacy of the furniture in pink granite by Burton and the spirituality of the reflecting fountain and of the balustrade . . . are dominated by the corporate architecture in the background."[161] But the World Financial Center Plaza was, in general, well received by New Yorkers and non–New Yorkers alike. Kay Kaiser, architecture critic for the *San Diego Union-Tribune*, noted that the plaza "is so exquisitely made that similar places in San Diego look like concrete seawalls fit only for Navy ship berthings."[162]

The north cove itself had been considered by the BPCA for use as a floating swimming pool and a ferry basin before its development as a luxury yacht harbor by Watermark Associates, a company formed by George Nicholson, a yacht broker, and Mexican media executive Emilio Azcarraga.[163] Nicholson had initially proposed that Norman Foster, the British architect, cover the 3.75-acre cove with an eighty-foot-high glass dome, but the idea did not please Cesar Pelli who, perhaps fearing it would overshadow his adjacent Winter Garden, helped squash it. Carl R. Meinhardt Architects of New York ultimately designed the North Cove Yacht Harbor,

World Financial Center Plaza. Cesar Pelli & Associates, M. Paul Friedberg, Scott Burton, and Siah Armajani, 1989. View to the north. Hursley. CPA

Proposed North Cove Yacht Harbor. Foster Associates, 1985. Model, view
to the east. Davies. FAP

which, when completed in 1989, provided twenty-six slips for
vessels no less than eighty feet long, a requirement that
peeved many who resented the plan's inherent exclusiveness.
Meinhardt partially enclosed the harbor with a pair of 350-
foot-long concrete breakwater quays framing its entrance and
extending the esplanade to afford the public a dramatic view
of the yachts with the downtown skyline as a backdrop.

On October 20, 1997, the World Financial Center Plaza
became home to the New York City Police Memorial (Stuart
B. Crawford), a 2,800-square-foot monument set modestly
into the southeast corner of the plaza as a tribute to officers

New York City Police Memorial, southeast corner of World Financial
Center Plaza. Stuart B. Crawford, 1997. View to the south. McGrath. NMcG

killed in the line of duty.[164] Depressed thirty inches below
plaza level, the "sacred precinct" was entered from its north
side and housed a rectangular reflecting pool fed by a fountain
outside the space that symbolized the first day on the job of a
rookie cop. Water from the fountain flowed through a flume
that emerged from the granite eastern wall of the memorial,
and deposited the water into the reflecting pool, symbolizing
the day of death. Atop the east wall of the memorial, three
flagpoles stood as vertical markers. Across the space, the pol-
ished green granite "Wall of Names and Dates" was inscribed
with the names of fallen police officers and the dates on which
they died.

The Belvedere

In 1989, for the first time in twenty-two years, ferry service
resumed between Hoboken, New Jersey, and Manhattan.
Battery Park City was chosen as the Manhattan terminus of
the Trans-Hudson Ferry, and Kohn Pedersen Fox was to be the
architect of a new ferry terminal west of the World Financial
Center.[165] But the KPF plans were not realized, and when serv-
ice began on October 16, 1989, passengers accessed the ferry
from a temporary terminal (FTL Happold, 1989) built on a
reconstructed steel barge located offshore, just north of the
North Cove Yacht Harbor. The terminal was enclosed by bat-
tered glass walls and covered by a tensile roof made of light-
weight PVC-coated polyester fabric providing an appropriately
modest, light-filled shelter for passengers.

With service reinstated, it became a priority to beautify the
1.6-acre tract of land that surrounded the Trans-Hudson Ferry
Terminal. Completed in 1995 to the designs of Mitchell/
Giurgola Architects in collaboration with the landscape firm
Child Associates, of Boston, and sculptor Martin Puryear, the
interstitial area between Rockefeller Park (see below) and the

World Financial Center Plaza was a critical component of Battery Park City's system of open spaces.[166] Known as the Belvedere, the park was to serve a dual purpose: to cohesively connect the completed public spaces at each of its ends and to provide a respectable point of arrival and departure for ferry commuters. The designers employed a mixed palette of materials, combining lush green plantings that linked it to Rockefeller Park with massive and rough stone elements relating it to the hardscape of the World Financial Center Plaza. A battered serpentine wall of rusticated Dakota granite separated a lower waterfront esplanade from an elevated inland platform. Periodic breaks in the wall offered access between levels via stairs and ramps. The southern end of the platform, which, with the completion of the New York Mercantile Exchange two years later, would be relegated to front-porch status, was planted with a gridded bosque of English oak trees and offered a view of the New York harbor from a circular belvedere that extended from its southwest corner. To provide a dramatic marker for the ferry terminal, Martin Puryear flanked its entrance with his sculpture, *Pylons*, a pair of stainless-steel towers that rose from granite bases and recalled Constantin Brancusi's *Endless Column* sculptures of the 1910s and 1920s.[167] The north pylon, 73 feet 5 inches high, was an open lattice of tapered cylindrical segments. The south pylon, 54 feet 6 inches high, was a solid tower of inverted truncated pyramids that became more elongated as they rose into the air. The pylons were dramatically lit at night so that, as Puryear stated, "they are beacons on the waterfront."[168] According to Mildred F. Schmertz, the sculpture was "by far the most successful of the series of installations of public art located within the Battery Park development. Correct in scale and powerful as image, their excellence is fundamentally architectural."[169]

The Esplanade

If the World Financial Center Plaza was the heart of Battery Park City's open space system, then the riverfront esplanade was surely its ventricle artery.[170] Outlined in the 1979 master plan, the esplanade, designed by Cooper Eckstut Associates in collaboration with the landscape architects Hanna/Olin, stretched for 1.2 miles from Battery Park to the northern end of Battery Park City. Initial designs were made public in October 1981, when the Municipal Art Society displayed plans for the first section, a seventy-foot-wide stretch between the south and north coves. The exhibition presented drawings, models, and photographs, as well as a full-scale, thirty-foot-long mock-up displaying in literal terms the esplanade-to-be. Herbert Muschamp, writing in *Express*, conjectured that Cooper Eckstut had chosen "to execute this design themselves precisely because the simplicity of its elements —benches, paving, lighting, landscape—afforded the opportunity for a thorough, practical, easily comprehended demonstration of techniques for carrying out the master plan's overall objectives."[171] The scheme was widely discussed not only because it would result in the first waterfront park built in New York since the Brooklyn Heights Esplanade in 1951, but also because, like the Battery Park City master plan itself, the design was inspired by existing New York models, in this case Riverside Park, Central Park, and Carl Schurz Park. The designers created a familiar New York park-scape, employing hexagonal paving blocks, versions of Central Park's traditional "B-pole" lampposts, cast-iron and wood benches like those

Belvedere, site between Rockefeller Park and the World Financial Center Plaza. Mitchell/Giurgola Architects and Child Associates, 1995. Site plan. MGA

used in the stylishly moderne precincts of the 1939–40 New York World's Fair, and gently curved railings atop a black granite seawall along the water's edge. Writing in October 1981, Paul Goldberger was impressed by the scheme, calling it "an important design . . . [with] virtues that few civic designs in this city have had since the days of Olmsted. . . . There is to be no concrete here, no fancy waterfalls, no lights that look like lollipops. . . . It is a mix of plain and familiar materials with elegant ones, and it will provide a public environment of considerable dignity and comfort."[172]

The park was divided into two levels: a forty-foot-wide upper inland section, with rows of benches set among silver linden trees, a row of Chinese scholar trees, and a dense program of ground cover; and a lower, thirty-foot-wide waterfront promenade meant to maximize sun and provide a sense of the vast openness of the harbor for those sitting on the river-facing benches. The esplanade was built in several phases between 1983 and 1992. At each stage of completion, it was not only lauded by critics, but enthusiastically patronized by the public. In 1983, with only a quarter-mile complete, Paul Goldberger credited the designers with making "a place that is warm, inviting, lyrical and even magical. All of the joy and exhilaration of great public space is here; so are the pleasures of privacy and intimacy in the outdoors. There is a sense on the esplanade that one is in a fresh place, yet a place that connects, in the very deepest way, with the memories of urban life in the past."[173]

At certain points along the esplanade, the master plan called for smaller subparks offering episodic environments within the larger park system. The earliest of these to be developed were the areas where Battery Park City's streets dead-ended against the esplanade, which, as Meyer S. Frucher explained, could have been "bleak spots, but we turned them into focal points for art."[174] As with the World Financial Center Plaza, early in the planning process artists were chosen by the Battery Park City Fine Arts Committee not only to design pieces for each area, but also to give each artist the opportunity to participate in the design of the spaces themselves. In November 1983, the committee announced that it had asked five artists, Richard Artschwager, Nancy Graves, Patsy Norvell, Ned Smyth, and Frank Stella, to come up with preliminary proposals. From these, Artschwager, Smyth, and Graves were selected to design pieces for three sites along the esplanade, though Graves would later be replaced by

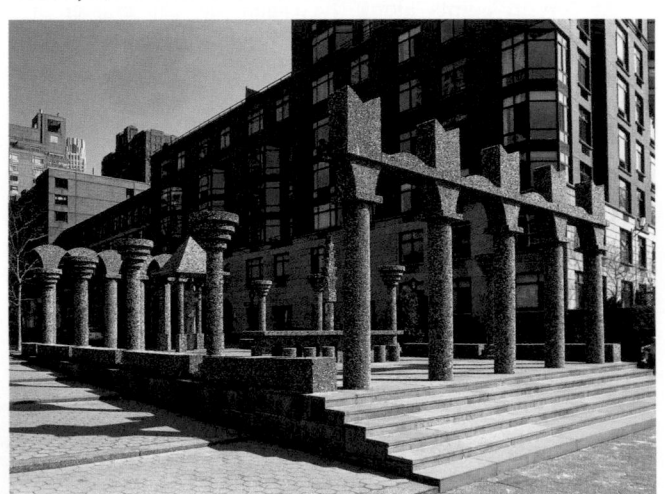

Belvedere, site between Rockefeller Park and the World Financial Center Plaza. Mitchell/Giurgola Architects and Child Associates, 1995. View to the south showing *Pylons* by Martin Puryear. Goldberg. ESTO

Upper Room, western terminus of Albany Street, Battery Park City. Ned Smyth, 1987. View to the southeast. BPCA

R. M. Fischer.[175] At the same time, Mary Miss was commissioned to design a larger waterfront area and a continuation of the esplanade, known as South Cove, in conjunction with architect Stanton Eckstut and Boston-based landscape architect Susan Child.[176]

The northernmost street-end art project, at Albany Street, was the first to be installed. Ned Smyth's *Upper Room* (1987), occupying a sixty-seven-by-thirty-four-foot space, named for the Hindu *chakra* describing the psychic energy that exists above one's head, was rife with religious symbolism. In its center, a thirteen-foot-high pergola with a pyramidal roof housed a mosaic-inlaid, palm-crowned column. Across the court, a long table also inlaid with glass mosaic was set with six chessboards where twelve players could sit. Bordering the court was a colonnade whose inland side featured seven columns, as opposed to only five on the water side, beyond which a series of steps descended to the esplanade—a response to the spatial progression from high-rise density development to the east toward the open river frontier looking west. The

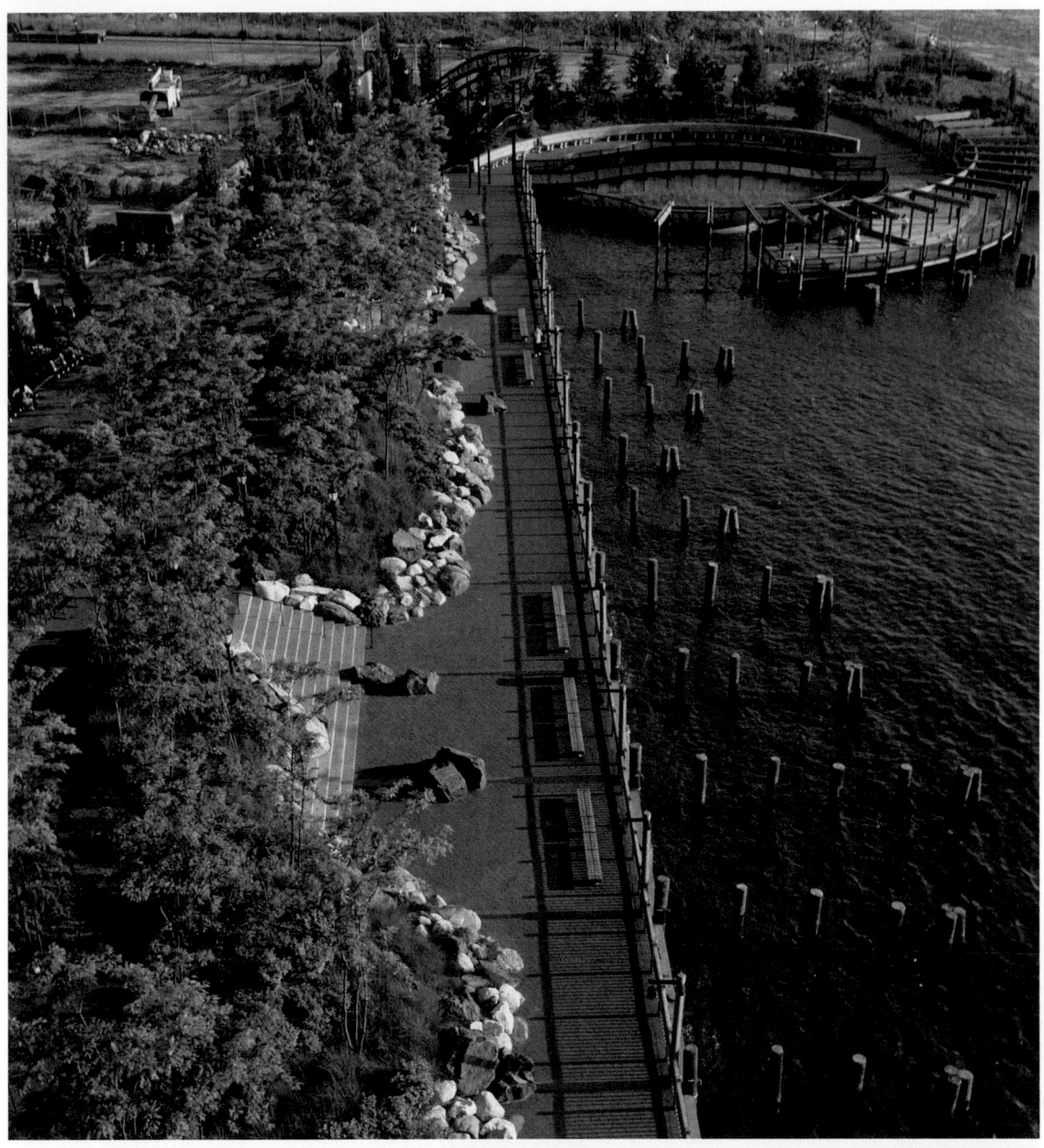

South Cove Park. Mary Miss, Stanton Eckstut, and Susan Child, 1988. View to the south. Penny. BPCA

columns themselves were, as Nancy Princenthal described, "an abstracted version of an Egyptian papyrus column," whose "capital forms a pointed, Gothic arch when joined to its nearest neighbor, and a round Roman arch when its concave line is followed over its neighbor's crown."[177]

To Michael Brenson, writing in the *New York Times*, the "columns seem to be holding hands, like figures in an Israeli dance. . . . Mr. Smyth has clearly tried to incorporate all aspects of life into a work that sings of universality and brotherhood. What makes it successful is his ability to accommodate the disparate aspects of the old and new, tall and squat architecture around it, including the remarkable crowd of buildings that seem huddled together, observing and testing this sculptural upstart from the financial district in the distance."[178]

A few hundred feet south, at the west end of Rector Park, Nancy Graves was to have installed a twenty-foot-high cast-bronze sculpture composed of biological forms that Kay Larson described as "a spectacular, gaudy, many-tentacled sculpture seemingly assembled out of the Museum of Natural History's boneyards."[179] Ultimately, however, sculptor R. M. Fischer, in collaboration with Anderson/Schwartz Architects, designed a fanciful, science fiction-esque, forty-five-foot-tall stainless-steel "gate," almost a futuristic triumphal arch, on a granite base that Nancy Princenthal deemed "equal parts Samurai swordsman and Buck Rogers."[180] Completed in 1988, the asymmetrical *Rector Gate* was elaborately lit by the New York firm Johnson Schwinghammer to help give it a sense of weightlessness.

Further south, at West Thames Street, the conceptual artist Richard Artschwager's superscaled suite of furniture, *Sitting/Stance*, was completed in 1988, and, occupying its triangular site, took a surreal look at domesticity, undercutting the serious upscale apartment neighborhood that rose behind it. Artschwager's initial design was a simple pole that rose from the center of the West Thames rotary before bending at ninety degrees and extending out past the circle to "plug-in" to Ulrich Franzen's Liberty Terrace, forming a literal link

South Cove Park. Mary Miss, Stanton Eckstut, and Susan Child, 1988. View to the east. BPCA

Rector Gate, western terminus of Rector Place, Battery Park City. R. M. Fischer and Anderson/Schwartz Architects, 1988. View to the west. FS

between open space, art, and architecture. But this design was replaced by a rather less startling one in which two ten-foot-high, straight-back granite chairs, what Herbert Muschamp called "ramrod-stiff, Egyptoid thrones," faced each other from opposite ends of the park, along with two oversize reclining redwood lounge chairs that were aimed at one another on the north end of the park, and two tables fashioned from circular metal grills normally used to protect tree roots. The focal point was a lantern from one of the esplanade's historically inspired streetlights enshrined in a framework of metal elevated only a few feet in the air to become the centerpiece of one of the metal-grate tables. Muschamp was not so sure about the realized design, writing that if the Battery Park City design guidelines "sought to create by executive control the kind of environment that once developed without it," Artschwager's piece appropriately "has that look of the artificially natural, the planned spontaneous, the authoritarian casual." Muschamp pointed out that as "symbols of pre-war New York, the lamps are a kind of fetish and are treated as such by Artschwager. . . . The form playfully makes visible the aura of preciousness which Battery Park City's architects exploit but do not acknowledge: if cities are to become museums, then they must have vitrines." He concluded: "The work as a whole projects an oddly suburban mood, a summertime air of odds and ends thrown together for seating at a backyard barbecue," appropriate for Battery Park City, which "despite its urbane yearnings . . . has the sleepy, detached soul of a Westchester bedroom town."[181]

Between First and Third Places, where the shoreline was indented to form a second harbor, lay the very ambitiously conceived, three-acre South Cove Park (1988), designed by the team of Miss, Eckstut, and Child. The designers were charged by the BPCA with the task of extending the esplanade while distinguishing it in character from the corporate-playground feel of the World Financial Center plaza and North Cove. Eckstut described the team's rational, if predictable, strategy: "One, since this is a cove, it was decided that nature should play a prominent role. Two, New York's maritime past is a vital presence on the island and should be addressed in our design. Three, we wanted to respond to the specifics of the place itself. This structure will be built at the terminus of a great street. It should be a fitting conclusion to South End Avenue."[182] Miss saw the project as an opportunity to continue her explorations into the framing, unfolding, and layering of space: "I wanted to make a place where one could really hear the water, smell it, get wet if it was high tide—tying the water and the land together. I wanted there to be a sensuousness to this place—a very rich sense of the land and the water meeting here."[183]

The south cove esplanade was divided into an upper and lower section. In contrast to the formal and manicured upper promenade, the lower level, accessed by several wide stairways, invoked a "wild" environment planted with dense groves of honey locusts. In place of Battery Park City's typical granite and iron seawalls, it provided a wooden bulkhead and railings that contrasted the meticulous linearity of the promenade with an undulating line of seemingly haphazardly placed boulders meant to suggest the character of the city's original shoreline. Just offshore, scattered pilings helped soften the transition between land and water. On the southeast corner of the cove a pair of stairs led to a curving black-steel lookout surmounted by an open armature reminiscent of

Five alternate proposals for Park Pavilion for the Hudson River water-front, Governor Nelson A. Rockefeller Park. Venturi, Rauch & Scott Brown, 1989. Renderings of view to the east. VSBA

the Statue of Liberty's crown, which could be seen from the platform. The perch also overlooked the designers' grandest gesture, a curving pier that reached out into the cove, and, framed by a wooden pergola, spiraled back toward the shore to create an intimate nook within the confines of the cove itself. A bowed bridge bisected the circle, on one side of which the Battery Park City landfill was excavated to reveal its substructure, while on the other side a small island was covered with indigenous plants to recall the wilderness that once permeated Manhattan. The composition ingeniously exposed the man-made landmass upon which the spectator stood and at the same time ironically recalled the natural history of the site through equally man-made means.

Miss's goal, she explained, was to "make a place that people can go to, spend time and relate to it in a different way than they would by going to Shea Stadium or Madison Square Garden."[184] South Cove would prove worthwhile by her own definition: it was very popular with the public. But there were those who saw its inherent accessibility as a sign of artistic pandering. Catherine Howett wrote in *Landscape Architecture*, "The faint trace of a Disney 'marina' hangs over the whole, with its blue harbor lights, roped pilings and carefully orchestrated suggestions of 'wild' nature." But Brendan Gill, acknowledging South Cove as "an irresistibly romantic

stage set of New York Harbor as they wish us to believe it may have looked in the seventeenth century," nonetheless accepted that "if we sniff in the air not only the delicious odor of Atlantic brine but of Disneyland as well, no matter: a fictional seascape of considerable beauty is surely better than no seascape at all."[185]

By 1991 the first phase of public art at Battery Park City was complete and the public seemed to be enjoying it, leading Paola Antonelli to write that "as if following a script, when the weather is right . . . the office workers eat in the *Upper Room*; people stroll and sit in the sun on the Artschwager chaise-lounge; families with children have Sunday picnics on the plaza; couples go to *South Cove* to be alone in the evenings."[186] But the user-friendly environment was symbolic of a deeper transformation, which Kay Larson noted: "The Battery Park City project represents the gentrification of site art—it's been successfully, even brilliantly, tamed, its sting removed."[187]

Rockefeller Park
In August 1992, Battery Park City's network of open spaces was expanded with the completion of its largest component, Governor Nelson A. Rockefeller Park, a densely programmed 8.2-acre site at the northwest corner of the district.[188] When

Proposed pavilion, Governor Nelson A. Rockefeller Park. Tod Williams, 1989. Model. TWBTA

initial plans for Rockefeller Park (first known as North Park, later as Hudson River Park) were displayed in May 1988, Paul Goldberger found the design, by Carr, Lynch, Hack & Sandell Associates and the landscape architecture firm of Oehme, van Sweden & Associates, with its "rolling fields and meadows by the river," to be "loosely inspired by Riverside Park."[189] As it underwent the community review process, however, it was substantially modified to include, alongside its grassy lawns and winding paths, recreational facilities more attuned to the active recreational requirements of residents in Battery Park City and Tribeca, who, as Herbert Muschamp explained, "didn't want the kind of public space the authority had created in the past. Instead of critically acclaimed public art projects prescribed by art experts, the community wanted waterfront pleasures with a somewhat lower brow." A wish list was created that included athletic courts, playgrounds, fountains, playing fields, and community gardens. The BPCA was receptive, and as Muschamp put it, "rendered the community's wishes into a lavish portrait of a city at play . . . , a 'people's park' that's gone to heaven."[190]

The park's triangular site was bisected by a curving north–south path. Between the path and the esplanade, which was expanded to cover the entire north end waterfront, two large open fields of grass offered space for active sports and leisure. East of the path, a series of discrete recreational areas was strung together along the length of the park. At its southern end, a picturesque waterfall overflowed from an upper-level balustrade, the Vesey Terrace, into a lily pool lush with water plants. North of the lily pool, Carr, Lynch, Hack & Sandell designed the Park House, a small, rusticated stone pavilion that was home to park offices and public restrooms. With its organic, rounded form, deep-overhanging slate-roof, eyebrow dormer, and Stick Style wooden brackets, the Park House recalled the small railroad stations designed by H. H. Richardson to serve Boston's western suburbs. North of the Park House, the Brooklyn-based firm of Johansson & Walcavage designed a complex children's playground divided into separate areas for infants, toddlers, and schoolchildren, each with a system of platforms connected by bridges, ladders, and slides, and with handicap-accessible features such as elevated sandboxes for wheelchair-bound patrons.

A competition was held in June 1989 for the design of a pavilion for public gatherings and concerts on a small site

where Warren Street met the park. Three firms were asked to participate: Venturi, Rauch & Scott Brown of Philadelphia; Tod Williams of New York, and Demetri Porphyrios of London, who was awarded the commission. Venturi's firm offered a brilliant series of iconoclastic icons for the site: One, *Big Apple on a Stick*, was a revival of his 1984 proposal for a monument in Times Square, *The Big Apple*, but lacked the advantage of such a potent location.[191] Another Venturi proposal reinterpreted the Chrysler Building as a sort of obelisk, mounting a scaled-down version of the shaft and spire of Van Alen's building on a single pillar. Though the architects considered it "playful" and "whimsical," its "abstracted representational form" only diluted the beloved landmark's meaning.[192] Other proposals by Venturi, Rauch & Scott Brown were for an onion-domed "Baroque Pavilion," an oversize version of Venturi's 1979 Chippendale Chair for Knoll International, and a "House Pavilion."[193] Tod Williams's scheme toyed with the literal representation of Manhattan. The architect proposed a pavilion whose roof was formed by two mirror-image cutouts of Manhattan island situated side by side to resemble a Rorschach test for New Yorkers. Two clusters of thirty-six metallic posts canted inward as they rose to pierce the Central Park area of the translucent "islands" and support an armature from which the roofs hung.

Demetri Porphyrios's design was the most traditional of the three, and was, as the architect put it, "about architecture, about nature, and about the dialogue between the two."[194] On a broad, granite plinth, Porphyrios designed a peristyle of twelve exceptionally slender, round timber columns with aeolic capitals of a copper and bronze alloy supporting timber lintels that carried the rafters of the flat roof and its boarding. Within the peristyle, a five-step-high platform supported four round columns formed with re-used brick, rising to limestone doric capitals to form a central atrium that Porphyrios described as "the primordial reference to the house." But, he stated, "there are no actual rooms surrounding the atrium here since the housing of Battery Park City and the open landscape of its parks are the *rooms* of this symbolic house." He explained, "In the centre of the atrium stands no hearth, nor the statues of the gods but nature itself." Inside the atrium, a tree was to "extend its roots into the mound and beyond while its trunk towers above the flat timber roof of the pavilion until its foliage offers another roof, this time nature's making." The presence of a living tree within the pavilion was essential to its meaning, at once making explicit the architecture-nature dialogue while slowly catalyzing the integration of elements like moss into the pavilion so that it would "become an altar to nature."[195] Unfortunately, as completed in 1992, the pavilion was built without the component of living nature, leaving it aesthetically and functionally pleasing but metaphysically diminished.

As with all of Battery Park City's open spaces, a portion of Rockefeller Park was reserved for public art. Initially, the sculptor Mark di Suvero was commissioned to install a ten-story-high, painted steel structure on a site at the water's edge at the north end of the park.[196] But the community protested the project's size and the idea was abandoned. Instead, artist Tom Otterness, whose cartoonlike figurines addressed sinister themes with deceptively jovial imagery, was chosen to install his work throughout Rockefeller Park but primarily within a seating area at its northeast corner.[197] Entitled *The Real World*, Otterness's installation was a microcosm in bronze of

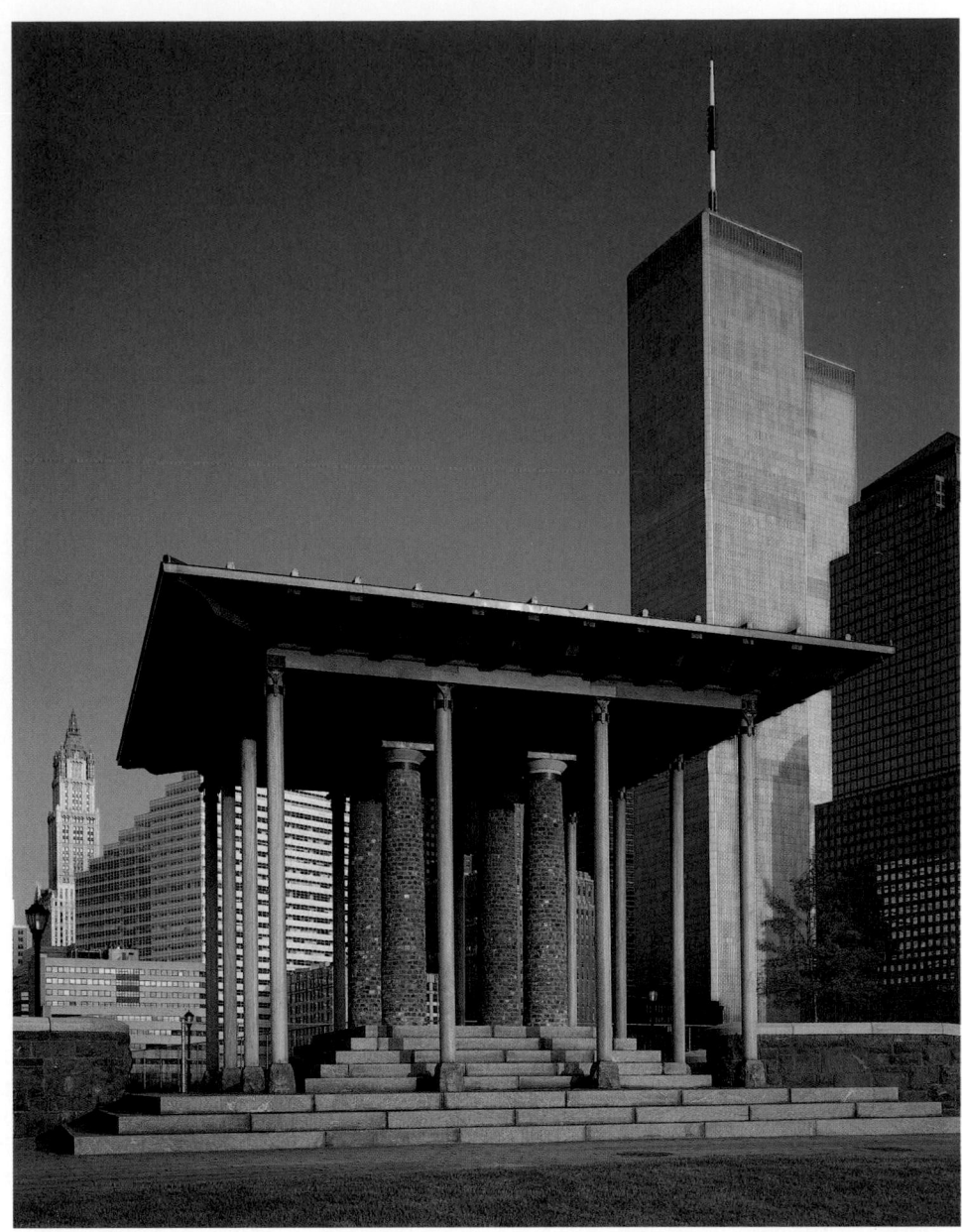

Pavilion, Governor Nelson A. Rockefeller
Park. Demetri Porphyrios, 1991. View to
the southeast. Frances. ESTO

what Karrie Jacobs called "a Smurf kingdom with a social con-
science."[198] In the opinion of Herbert Muschamp, *The Real
World* was "sugar-coated Marxism," but with the sugar coat-
ing and not the Marx coming through: "This may be a bless-
ing. But it is also a tribute to Battery Park City's power to
reduce once radical propositions to sweetness and light."[199]

Notwithstanding some timidity in its final execution, which
in part can be attributed to the fact that the BPCA, for the first
time, took community opinion into consideration as it moved
forward with open space projects, Rockefeller Park was an
undeniable success and a much needed amenity for the matur-
ing neighborhood. But while none could deny the popularity of
the park, many critics took issue with its overall design. One
complaint was that, with the smattering of designers, artists,
and programmatic elements, the park lacked cohesion. Jane
Holtz Kay noted, "With its exhausting tour-de-force of design
types, sculptural kitsch and frenzied, almost theme-park
design," Rockefeller Park "symptomizes some problems. The

realtors, the propertied funders of this first-generation park, are
so well-funded they can actually commission too many stamps
of personal design. Their largess threatens to turn such parks
into incoherent peninsulas for the privileged."[200] And with so
much going on in the park, Mac Griswold felt, it would never
provide the solace of an Olmsted park: "Green it will become,
pastoral never, despite the frequent invocation of Olmsted's
name. Indeed, the curve of the drive recalls Riverside Park and
the flamboyant iron railings and lampposts evoke our urban
past. But eight acres cannot accommodate everything going on
here and solitary communion with nature."[201] To Muschamp,
perhaps the most important casualty of the design process was
topography: "It's as if the designers have flattened Olmsted out
with a rolling pin. In technical terms, the design is Olmsted in
plan but not elevation. . . . Olmsted without elevation is a
miniature golf course."[202]

Near the southern end of Rockefeller Park, a 15,000-
square-foot, half-acre traffic island at the western terminus of

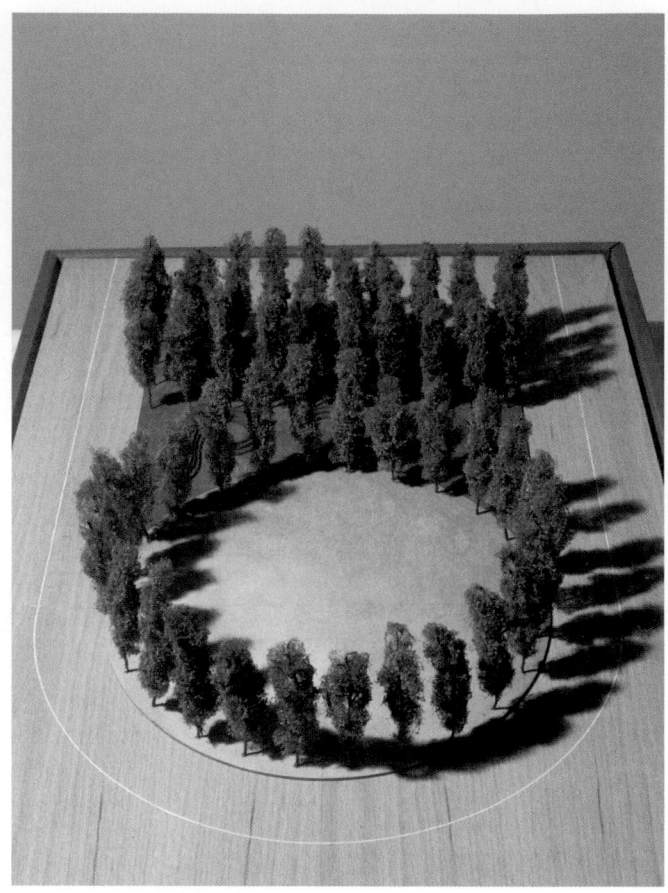

ABOVE Proposal for Vesey Street turnaround, western terminus of Vesey Street. Aldo Rossi, 1995. Model, view to the west. Ransick. BPCA

ABOVE RIGHT Proposal for Vesey Street turnaround, western terminus of Vesey Street. Barbara Stauffacher Solomon, 1995. Model of competition winning entry, view to the east. Ransick. BPCA

BELOW Proposal for Vesey Street turnaround, western terminus of Vesey Street. Eric Owen Moss, 1995. Model, view to northwest. EOMA

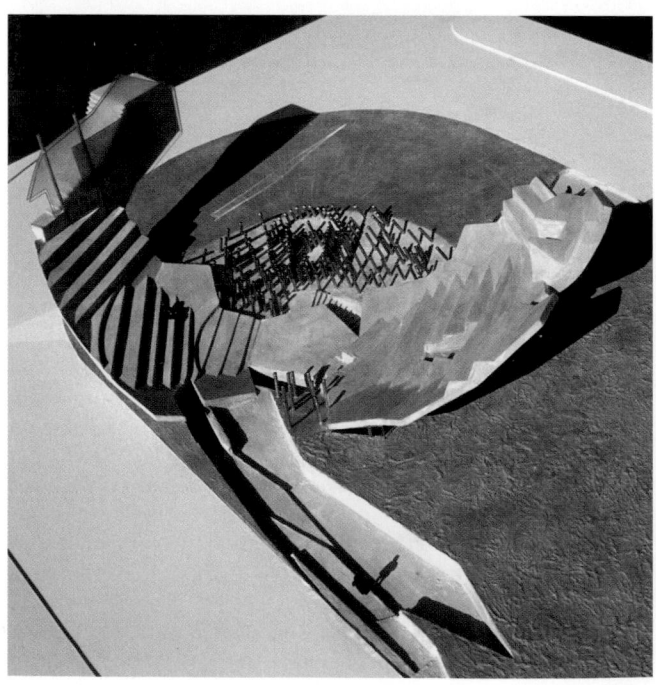

Vesey Street once envisioned by the BPCA as a skating rink but deemed too small for that purpose was the subject of two design competitions, the first held in 1995 after the New York Mercantile Exchange agreed to build its headquarters on the adjacent block to the south.[203] Seven were invited to submit designs: the architects Craig Hodgetts and Ming Fung; Eric Owen Moss; Aldo Rossi; Stanley Saitowitz; Francesco Venezia; and two artists, Per Kirkeby and Barbara Stauffacher Solomon. Surprisingly, Aldo Rossi's scheme was the least compelling, calling for a tall pyramid on the west end of the site entered through a small opening at the top of a long ramp flanked by two rows of trees. As Mary Sherman pointed out, the proposal "would have blocked the view towards the Hudson River—one of the site's main attractions." Inside the pyramid, a depressed seating area was to serve as an amphitheater but was too small to do so practically, the result being, according to Sherman, that "the building would have stood like a darkened interior and mute affront to the site for which it was planned."[204]

Francesco Venezia took advantage of the site's views by proposing a broad sloping plane inclined toward the west—"like a large body stretched out facing the Hudson," as Venezia envisioned it—so that visitors ascending the slope would reach an observation platform where a horizontal rectangular opening in the west-facing wall framed sweeping vistas.[205] Eric Owen Moss's "Vesey Street Theater" was the most detailed proposal, calling for an eccentrically shaped amphitheater that resembled a partial sphere—like a broken eggshell with jagged edges—surrounded by a park. At the base of the theater, a field

of poles jutting out from the ground at varying angles was to provide a space for exhibitions or an exercise obstacle course. Hodgetts and Fung's scheme included a lightweight glass and steel canopy intended to "recall the facades of the slaughter-houses that once occupied the area."[206] Stauffacher Solomon's winning entry was the simplest, calling for a circular lawn ringed by trees at the west end of the site and a grove of poplars to the east. Between the two was a series of curving benches set within a red brick parterre.

Stauffacher Solomon's scheme was not built and plans for the Vesey Street turnaround were postponed until 1999, when Timothy S. Carey, president and CEO of the Battery Park City Authority, and Governor George E. Pataki, traveling together in Ireland, envisioned the site as a memorial to the country's Great Hunger of 1845–52 that took the lives of more than a million Irish and led to the emigration of hundreds of thousands of others to New York.[207] The memorial was also intended to bring attention to the broader issue of current world hunger. Five artists—St. Clair Cemin, Agnes Denes, Richard Fleischner, Kiki Smith, and Brian Tolle—were invited to compete for the commission in 2000. Tolle, a New York–based artist who further developed his design in collaboration with David Piscuskas and Juergen Riehm of 1100 Architect and a landscape architect, Gail Wittwer-Laird, won the competition with a proposal for a 96-by-170-foot, quarter-acre, sloping reinforced scallop-edged concrete platform rising from ground level at the east end of the site to a height of twenty-five feet at the western end, where it cantilevered thirty-five feet over the sidewalk. The platform was landscaped

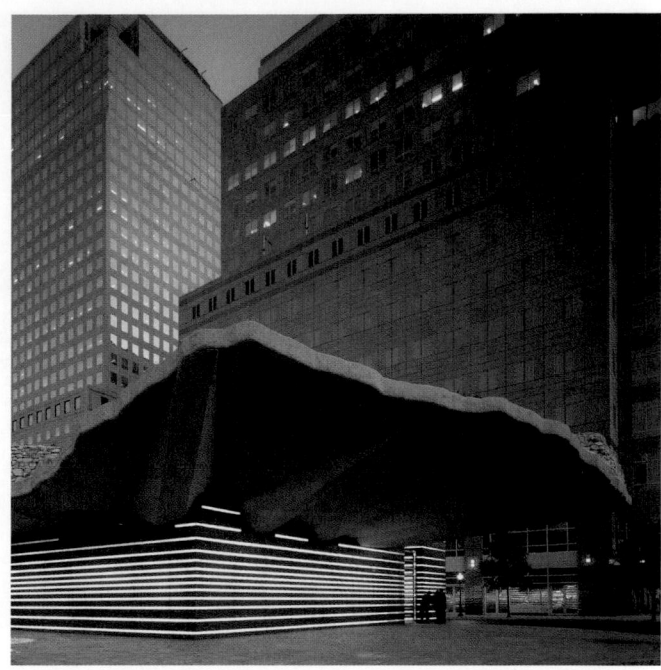

ABOVE Irish Hunger Memorial, western terminus of Vesey Street. Brian Tolle with 1100 Architect and Gail Wittwer-Laird, 2002. View to the southeast. Aaron. ESTO

BELOW Irish Hunger Memorial, western terminus of Vesey Street. Brian Tolle with 1100 Architect and Gail Wittwer-Laird, 2002. View to the southwest. Mauss. ESTO

Proposed South Gardens, southern tip of Battery Park City. Jennifer Bartlett, Alexander Cooper, and Bruce Kelly/David Varnell Landscape Architects, 1988. Model, view to the west. Ries. BPCA

to resemble a deserted village in County Mayo on the west coast of Ireland. It featured sixty-two varieties of plants indigenous to County Mayo, including grasses, wildflowers, dandelions, and thistles, stones from each of Ireland's thirty-two counties, and was crossed by overgrown potato furrows. In the middle of the platform was a two-room, 736-square-foot roofless stone cottage that had stood since its construction in the 1820s on a farm in County Mayo but was disassembled and shipped to Battery Park City for reconstruction. Because of New York's building and seismic codes, the house's rubble stone core was replaced with one of concrete. Its roof, which had been repaired in Ireland, was removed for more symbolic reasons—to reference the practice during the Great Hunger of taking down thatched roofs as proof of destitution and qualification for relief.

The memorial's base provided a sleek and rigid counterpoint to the naturalistic landscape above, clad in alternating bands of glass and fossilized Kilkenny limestone. Set behind 3,700 linear feet of thin glass strips were bands of translucent resin silk-screened with quotations, lyrics, poetry, recipes, statistics, and other texts relevant to both the Great Hunger and current world hunger. The resin was illuminated from behind so that the text appeared as a shadow projected onto the surface of the glass. Visitors to the memorial entered through an opening in the west side of the base, where a ramp led up through the stone cottage and along a winding path to a landing at the western edge of the platform.

The memorial was officially dedicated on July 16, 2002. As such, it was among the first signs of lower Manhattan's post-9/11 rebirth. Roberta Smith, writing in the *New York Times*, found it to be a "startlingly realistic" replication of an Irish hillside that "illuminates Ireland's tragedy in undeniable human, even universal, terms; it can grip the viewer with its combination of informal and spatial experience. . . . Mr. Tolle's memorial," Smith continued, "is a form of populist postmodernism, a combination of reality and simulacra, of high and low, a layering of different historical periods and contrasting points of view. It is also a typically postmodern blend of existing art styles—Realism, Conceptual Art and Earth Art—bound together by historical fact and physical accuracy." In comparison to the earthwork pieces of the late 1960s and early 1970s, however, Smith found the Irish Hunger Memorial to have "a slight theme-park preciousness and detail. It is earthwork as Pop Art, a miniature at full scale."[208] The memorial proved quite popular, so much so that visitors straying from the winding path trampled the field, which required substantive rehabilitation within the first year. Greater problems, leading to major repairs, included a faulty drainage system and the inability of some of the modern materials used—for example, the pathway's paving and the mortar used in the stone walls—to withstand the freeze-thaw cycles of a New York winter, requiring the rebuilding of the perimeter walls and the digging up of the field's edges to provide proper drainage.

South Park

The southernmost park in Battery Park City, the three-and-a-half-acre South Park, for which design was begun in 1986, was intended to be the development's showpiece.[209] But by the time it opened in 1996, it had weathered a prolonged struggle. In 1986 the Battery Park City Fine Arts Committee selected architect Alexander Cooper, landscape consultant Bruce Kelly/David Varnell Landscape Architects, and painter Jennifer Bartlett to collaborate on the design. Bartlett, though inexperienced in landscape architecture and horticulture, became the primary creative force on the team and undertook to design an elaborate, walled-in flower garden. Bartlett's scheme, named South Gardens (1987–92), was controversial to say the least. Probably no landscape project in the city's history evoked such passions among neighbors, artists, scholars, landscape professionals, and the public at large.

Bartlett had been recommended to the fine arts committee by Bruce Kelly, but the painter was not interested in the commission, and in fact attempted to dissuade the panel from selecting her. She later recalled: "I went to a big meeting of the Battery Park City people and told them that the only thing I was interested in doing was a very complicated garden, which would cost an enormous amount of money and be very expensive to maintain."[210] Bartlett kept true to her word,

Proposed South Gardens, southern tip of Battery Park City. Jennifer Bartlett, Alexander Cooper, and Quennell Rothschild Associates, 1990. Rendered plan. QRP

and after two years of planning, a model of South Gardens was displayed in May 1988 at One World Financial Center. Utilizing a fifty-by-fifty-foot grid, the garden was to be organized into twenty-four planting squares separated by gravel paths. The design was complex, with subtle shifts and breaks suggesting Bartlett's 153-foot-long tour-de-force *Rhapsody* (1974), where nearly 1,000 twelve-inch-square painted steel plates were arranged in an open grid. In Bartlett's proposed garden, each hedge-lined "room" within the grid was to have a specific theme or plant type: among them, a color garden, a stone and sand beach garden, water gardens, a flower field, a fragrance garden, an herb garden, a rose garden, an orchard, and a topiary garden with shrubs shaped like living room furniture. The northwest corner of the garden would be occupied by a large, freeform lily pond. The plan was also to contain several small structures, including a granite guard house; a glass-and-anodized-aluminum pavilion opposite the entrance with a pyramidal roof, plaid tile floor, and fireplace that would serve as a visitors' information and events center; and a Cor-Ten steel pavilion set amidst the lily pond, with a cascade of water falling from its crest. The most surprising, and ultimately problematic, aspect of the design was the proposal to enclose the park within massive walls, a decision that was deemed necessary both to shield the vegetation from harmful winds and to moderate traffic into the garden to provide a sense of intimacy. But the walls created a separation that went directly against the nature of Battery Park City's seamless circuit of open spaces. Along the north side, the wall, portions of which were to be ten-and-a-half-foot-high concrete, others made of nine-foot-high iron fencing, contained the single entrance to the park. Along the south and west borders, the designers placed another wall, this one a ten-and-a-half-foot-high concrete barrier along the entirety of the riverfront, blocking the view of the harbor from within the garden except through occasional openings.

From the first, the design proved unpopular. Community Board 1 passed a resolution condemning it shortly after the model was unveiled, and the Parks Council declared that the park was too private, exclusive, and complex, proclaiming an enclosed garden "belongs in almost any location *but* the waterfront."[211] Raymond Gastil, an architect, agreed, writing in *Metropolis* in September 1988, "Despite the plausible pleasures of the gardens, the tip of Manhattan is an odd place for a walled garden, and there are two obvious questions: Why do the gardens prevent the waterfront esplanade—the best-known feature of Battery Park City—from continuing all the way to Battery Park, as was clearly the intent of the 1979 master plan? And why is a spectacular view of New York Harbor largely closed off?"[212] Alexander Cooper's justification for the design—and the break with his and Stanton Eckstut's master plan—was that it was so compelling that it was worth the effort and disruption.

The controversy didn't gain widespread exposure until October 1989, when Patti Hagan, gardening columnist for the *Wall Street Journal*, whose offices in One World Financial Center overlooked the site, brought "one of the more bizarre garden stories since Eden" to public attention. Calling the project a "topiary 'Tilted Arc,'" Hagan wrote, "After four years . . . [it was] 100% uncollaborated Bartlett. She has done little more than recycle her standard motifs—trees, water, landscape fragments, rudimentary square house, circles, triangles, rectangles—and fit them into a grid, as if she were making one of her gridded two-dimensional works for a gallery wall." The grid itself, a "mincemeat of tiny gridlocked squares," was repugnant to Hagan, who exposed its arbitrarily conceived dimensions, quoting Bartlett: "My loft was 50 by 100 feet, so 50 by 50 feet seemed like a good garden room." To make matters worse, according to Hagan, Alexander Cooper "claimed he had never visited, much less built, a garden," and said of the project, "I don't view this as a landscape. I view this as a building."[213]

By late 1989, both ordinary citizens and garden and design professionals were attacking the design. Lynden B. Miller, the garden designer, warned, "The BPCA plan has the potential of making South Gardens a horticultural jail for people *and* plants."[214] The curator of the New York Botanical Garden, Rupert C. Barneby, wrote to the *Wall Street Journal* that asking Bartlett "to design a living garden is like inviting

a pianist without hands to play at Carnegie Hall; it is a bizarre misuse of public funds and encourages a spirit of feckless amateurism entirely inappropriate for so grand and potentially splendid a site." Barneby felt that apart from the design's "lack of originality, its impracticality in the long term is obvious to anyone even tangentially concerned with the health and welfare of public plantations. The design is mean, inverted and horticulturally naive."[215]

At the same time, dissent from within the ranks was damaging the project. Landscape consultants Bruce Kelly and David Varnell had become more and more removed from the design process and disenchanted with Bartlett. Kelly was particularly uncomfortable that no provisions had been made for practical concerns like the replacement of dead trees, which because the gravel paths were too narrow, would have to be lowered in place by helicopter at great expense, as well as the absurd requirement of 100 drain inlets on the 3.5-acre site, which he called "out-of-this-world tortured."[216] In mid-1989, Kelly and Varnell wrote a letter to the BPCA calling the garden design "arbitrary and amateurish," and resigned from the project.[217] With the resignation of Kelly and Varnell, it became clear to BPCA's president, David Emil, that the plan had to be either modified or withdrawn. Emil decided to ask landscape architect Nicholas Quennell, of Quennell Rothschild Associates, to work with Bartlett and Cooper to revise the plan. In February 1990, a new scheme was unveiled. The concrete wall at water's edge had been removed and replaced with a pathway and low handrail. The grid was now less rigid and had fewer rooms, the aisles between the rooms were made wider to allow for maintenance vehicles and to increase space for visitors, and the foreboding wall separating the garden from Battery Park City had been replaced with a Gramercy Park-inspired wrought-iron fence. Paul Goldberger favorably reviewed the new design in March, writing, "the garden this time will be less a place unto itself than a kind of exclamation point to Battery Park City, a lushly landscaped climax at the conclusion of its celebrated long waterfront esplanade." But although Goldberger was optimistic about the viability of the revised scheme, he did find "something oddly disquieting" about it: "It lacks the tough, determined bravado of the first, and possesses that slightly watered-down quality common to so many designs that are the product of compromise. . . . For all its excessively mannered, almost precious, quality, and for all its

Robert F. Wagner Jr. Park. Machado & Silvetti Associates, Hanna/Olin, and Lynden B. Miller, 1996. Site plan. OP

utter impracticality, the first scheme had a kind of to-hell-with-reason aura that gave it a certain strength."[218]

But the debate raged on. The community board, the Parks Council, and other opponents were not satisfied, claiming maintenance costs would be excessive, the public wouldn't use such a park, and more active recreation spaces were needed. The public prevailed. On October 9, 1991, the BPCA announced it would discard Bartlett, Cooper, and Quennell's plan. In February 1992, the BPCA announced a new triad of designers for South Park: the architects Machado & Silvetti Associates, of Boston, the landscape architecture firm Hanna/Olin, of Philadelphia, and the garden designer Lynden B. Miller, who had previously criticized Bartlett's garden.[219] The choices were indeed safe: Laurie Olin had collaborated on the 1979 master plan with Cooper and Eckstut; Rodolfo Machado and Jorge Silvetti, with their widely published but unrealized design for the Piazza Dante (1989), Genoa, were considered to be talented urban designers; and Lynden Miller was at work on the restoration of the Conservatory Garden in Central Park and the redesign of the gardens at Bryant Park.

From the outset, the designers found themselves engrossed in classical-inspired fantasies. For Olin it was "Claude Lorrain's dreamy paintings of classical harbors, of their implied arrivals and departures, of sunset across the water and boats, of pavilions and classical architecture." According to Olin, Machado and Silvetti were inspired by "surreal notions of the Statue of Liberty as a goddess figure who once stood in a ruined temple on the park site and had recently walked out into the harbor."[220] After a year of design, initial plans for the park were released in January 1993. To express their fantastic narrative, Machado and Silvetti designed a two-piece stone structure directly on axis with the Statue of Liberty conceived as "a large, over-scaled, massive masonry wall split in the center . . . [to] appear as a remnant or an exposed foundation of a colossal structure, its 'crumbling' towards the city alluding to a ruinous condition."[221] To Machado, the challenge was "to make it massive. We had to deal with the monumental scale of the Hudson River and the World Trade Center. [The pavilions] had to look bigger than they really are."[222] The roofs of the two structures would offer dramatic views of the Hudson River and could be achieved by a pair of cascading stairwells on the inland side that were turned off axis to suggest deteriorating ruins. Shading the platforms would be a tall arcade of metal-mesh canopies that, with the stone pavilions, were to reference the Statue of Liberty's base and robe. The waterfront plaza was to be mostly stone, and a portion was swollen into a wave to suggest the open book of the monument in the harbor.

On January 19, 1993, David Emil and Rodolfo Machado presented schematic drawings to Community Board 1, which responded favorably despite some concerns about what they saw as an overreliance on pavement and the excessive height of the pavilions. The architects remedied the second objection by eliminating the towering and rather campy metal-mesh canopies, reducing the height from 62 feet 6 inches to 32 feet 11 inches. When final plans were presented to the community on February 15, 1994, the design had undergone heavy revision. To reduce costs, Machado and Silvetti's structures were no longer to be clad in stone but in nearly a dozen patterns of long Roman brick. Shallow but bold relieving arches adorned the waterside facades, suggesting the architecture of Ancient Rome but more fantastically, anthropomorphically suggesting the half-buried head of an imagined colossus, gazing out to the

Robert F. Wagner Jr. Park. Machado & Silvetti Associates, Hanna/Olin, and Lynden B. Miller, 1996. View to the north. Aaron. ESTO

Statue of Liberty. Standing inland from the pavilions, the wooden footbridge that connected one to the other framed a view of the Statue of Liberty at the point where it was closest to the Manhattan shore, contributing a sense of immediacy and intensity to the monument. On the rooftop platforms, long, high-backed wooden benches provided comfortable perches to take in the view, unobstructed from the south pavilion and framed by a low arch on the north pavilion. Programmatically, the buildings provided restrooms, a small café, and a maintenance room. The overall design of the park was organized around a three-piece architectural ensemble that formed a Y-shaped plan, what Machado and Silvetti called "the backbone of the park."[223] Two angled allées of red maple formed the forks of the Y and drew park-goers to the pavilions, the ensemble's second component. On the water side of the pavilions, a vast, elevated rectangular field of grass wrapped by backless teak benches quelled the community's want for green space and completed the tripartite plan.

Surrounding the core of the park was a scattered composition of landscape elements designed by Olin and Miller. Olin turned to the Renaissance Revival plan of Central Park's Conservatory Gardens, where Miller was then working, and proposed "transforming it and pulling it apart, rearranging the pieces, [and] metaphorically spilling them from the land

out toward the water." Each of the rearranged fragments would be a distinct landscape element like a ramp, path, or planted garden. To Olin, the effect was that elements of the park would not "appear stable . . . rising and falling out toward the harbor with its ceremonial and evocative objects, as though responding to the river, the sea and the tide."[224] To provide shelter from the harsh river winds that had prompted Bartlett's walls, Olin and Miller chose the opposite strategy, sinking the gardens eighteen inches beneath ground level. Also within the park was, as promised, public art. But unlike the integration of art and site found elsewhere in Battery Park City, the pieces—*Eyes* by Louise Bourgeois, *Ape & Cat* by Jim Dine, *Raven Puts the Light in the Sky* by Ken Mowatt, and *Resonating Bodies* by Tony Cragg—sat self-contained in their settings, as if in a sculpture garden.

When it opened in 1996, the project, now renamed Robert F. Wagner Jr. Park, to honor the dedicated planner and former mayor's son, was a success, providing a sense of discovery and intimacy not before found in Battery Park City. It was given unanimous approval by the critics, perhaps most eloquently by Paul Goldberger, who described it as a "lush void" that although "utterly empty" and "absolutely flat . . . manages to feel as rich and as sensual—and as tranquil—as a thousand acres in the country, and it is a minor miracle."[225]

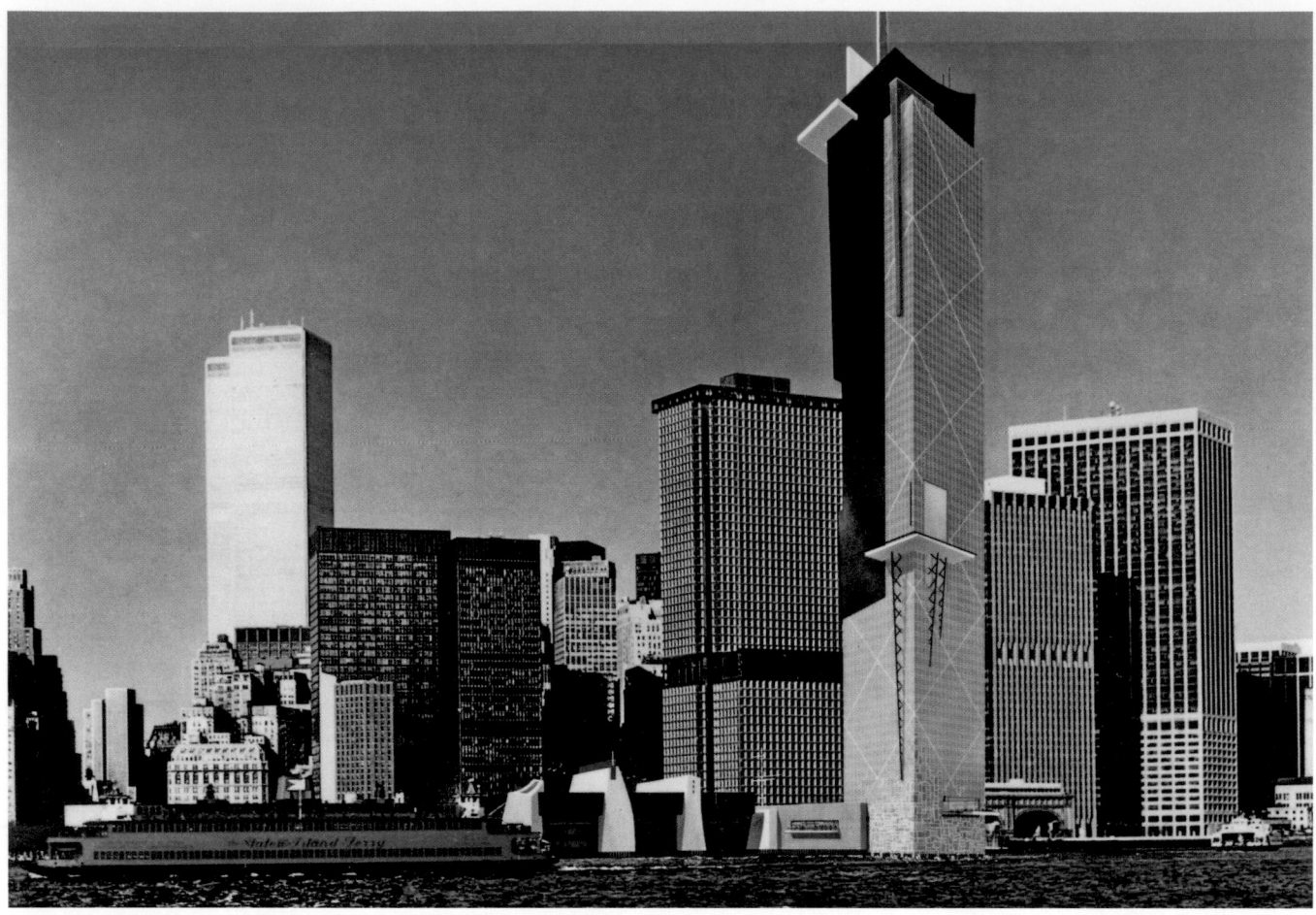

Proposal for South Ferry Plaza, South Ferry. Arquitectonica, 1985.
Photomontage, view to the north. ARQ

SOUTH FERRY

In 1985, inspired by the success that the Metropolitan Transit
Authority enjoyed in auctioning off the Coliseum's redevelop-
ment rights for the largest sum of money ever committed to a
piece of Manhattan real estate (see Columbus Circle), officials
of the city's departments of Transportation and Ports and
Terminals turned their attention to an equally visible, under-
utilized site, that of South Ferry. There, the remaining half of
the elegant Modern French–style Whitehall Ferry Terminal
(Walker & Morris, 1907), designated a historic landmark in
1967, languished for want of funds while the Staten Island
Ferry Terminal, a squat, pale sea green, glass-and-metal-clad
banality designed by the engineering firm Roberts & Schaefer
in 1956, begged for replacement.[1] Perhaps because the disposi-
tion of the Coliseum site was severely criticized for the lack
of public participation and for the absence of design standards,
the decision was made to invite architect-developer teams to
compete for the privilege of restoring the 1907 structure, later
known as the Battery Maritime Building, and designing a sky-
scraper tower on top of a new Staten Island Ferry Terminal or
out in the harbor.[2]

In its request for proposals, the city was more responsive
to public concerns than the MTA had been: in addition to the
restoration of the landmark building and the replacement or
renovation of the Staten Island Ferry Terminal, it also
required provisions for cultural facilities as well as a contin-
uous public esplanade along the property's 800 feet of water-
front linking Battery Park on the west with South Street
Seaport on the east. Eight teams came forward with proposals
for what came to be called South Ferry Plaza. As Peter Lemos,
a writer for *Metropolis*, put it, the plans seemed to suggest
that "when it comes to design," the development community
believed that "anything goes." The submissions ranged from
Kaempter/Clark Enterprises' modest-to-the-point-of-banal
thirty-five-story hotel, designed by Clark Tribble Harris & Li
and intended to sit alongside a new Staten Island Ferry
Terminal that was conceived as a duplicate of the Battery
Maritime Building (half of the steel frame of the 1907 termi-
nal had, ironically, been reused in the new ferry terminal), to
the flashy and flamboyant Deconstructivist sixty-eight-story
"Miami moderne" tower designed by the Miami, Florida,
firm of Arquitectonica for the Jack Parker Corporation.
Murphy/Jahn and James Stewart Polshek collaborated on the
boldest but most iconically confusing design, a sixty-story
Eiffel Tower evocation, with a triangular base intended to
diminish its impact on the upland side. The building's place-
ment right at the water's edge, and its glittery skin combined
with its flashy rooftop terminus, seemed not so much to
overbuild the site, as so many of the others did, but to over-
whelm it. Lemos dismissed the geometric tour de force, to be

ABOVE Proposal for South Ferry Plaza, South Ferry. Murphy/Jahn and James Stewart Polshek, 1985. Photomontage, view to the north. MJ

BELOW Proposal for South Ferry Plaza, South Ferry. Fox & Fowle and Frank Williams, 1985. Rendering of winning scheme's view to the north. FXF

developed by Olympia & York, as a "Buck Rogers office extravaganza with the ferry terminal as launching pad."[3] Emery Roth & Sons/Hardy Holzman Pfeiffer/Hooker Siskind offered a telescoping circular tower dramatically cut through at the base to provide a view of the water from the upland, an enlightened gesture compromised by the decision to fill a part of the arch with a vista-interfering winter garden. Somewhere in between these extremes lay the blandly tasteful, sketchily classical skyscraper proposals of Kohn Pedersen Fox, working with Cooper, Robertson, and of Fox & Fowle, whose submission, planned with Frank Williams, was inspired by Ely Jacques Kahn's unrealized domed tower of 1930.[4] Other fairly conservative submissions included Davis, Brody & Associates square tower crowned by a steep pyramid, rather like the one H. Craig Severance and Yasuo Matsui used to complete their Bank of the Manhattan Company tower in 1930, and a bulky but articulate shaft proposed by Skidmore, Owings & Merrill/Beyer Blinder Belle that set back near the top, where it was to carry a sphere.[5] Another design of note, not prepared in conjunction with a developer, was offered by Peter Pran and Carlos Zapata, who proposed to overlay Russian Constructivist elements on an otherwise straightforward tower.

On July 17, 1986, Mayor Ed Koch announced that a six-member development team headed by the Zeckendorf

Company had been selected over the other contenders. Offering $384 million for the site, the Zeckendorf plan, designed by Fox & Fowle and Frank Williams, promised the renovation of the two terminal buildings, expansion of existing park space and the waterfront esplanade, and the renovation of two subway stations. According to the plan, the Battery Maritime Building would become home to the Children's Museum of New York, then housed on West Fifty-third Street. Paul Goldberger praised the winning team's scheme: "If it is built as designed, it will represent the return of a flamboyant skyline image to Manhattan, a part of town that in the 1930s epitomized the romantic New York skyscraper, but in the postwar years was turned by modern towers into a dreary sea of flat-roofed boxes." While Goldberger deemed Fox & Fowle's "the most romantic" design of those submitted, he did not consider it the "most sophisticated," a distinction he believed belonged to Kohn Pedersen Fox's scheme.[6]

More important than the issue of design, however, was, as Goldberger pointed out, the basic premise of the project: the decision to build "a skyscraper on a site at the very southern tip of Manhattan that has never had anything on it except low civic buildings." According to Goldberger, the new tower would "alter the lower Manhattan skyline forever, and as dramatically, in its way, as did the World Trade Center." Moreover, he pointed out that the need for a new office tower was less than obvious in a "city. . . already groaning from an overabundance of skyscrapers." If the project went ahead, and Goldberger implied that it would not, a view widely shared in the development community, the key question would be whether the amenities provided by the developers would be "a fair exchange for giving up one of the most important pieces of land the city has."[7]

Goldberger's suspicions proved correct: South Ferry Plaza fell victim to the real estate collapse of 1987–89. With the project's failure, it seemed, came an end as well to the effort to reconstruct the ferry terminal—that is, until the morning hours of September 8, 1991, when a spectacular fire of suspicious origin destroyed Roberts & Schaefer's characterless and outmoded structure.[8] Rather than look on the fire as a disaster, it was celebrated as an opportunity to do right by the city's most neglected gateway.

In May 1992, the city's Economic Development Corporation announced its intention to hold an architectural competition for the design of the new terminal and plaza it proposed to build in 1994.[9] Fifty-four firms submitted their credentials, and in August six were chosen to compete for the project: Hardy Holzman Pfeiffer Associates; James Stewart Polshek & Partners; Aldo Rossi Studio di Architettura with Anschuetz, Christidis & Lauster; Skidmore, Owings & Merrill; Rafael Viñoly Architects; and a joint venture of Venturi, Scott Brown & Associates and Anderson/Schwartz Architects. On November 5, 1992, the day the city was to make its selection, the proposals were reviewed by the *New York Times*'s architecture critic, Herbert Muschamp, who found "six lovely visions of the ferry [which,] taken together, demonstrate the range of solutions serious architects can bring to the same problem." Muschamp, who had been appointed to the post five months before, revealed an openness to diverse aesthetic points of view that he was later to close down, exulting in the competition's capacity to illustrate that "architecture can be anything now. It can celebrate history or look afresh at the present. It can be a designer label or a low-profile intervention; an engineering tour de force or an urban shopping mall."[10]

Proposal for South Ferry Plaza, South Ferry. Davis, Brody & Associates, 1985. Model, view to the northwest. DBB

Proposal for South Ferry Plaza, South Ferry. Peter Pran and Carlos Zapata, 1985. Rendering of view to the north. PP

Proposal for Whitehall Ferry Terminal, South Street, foot of Whitehall Street. Aldo Rossi Studio di Architettura with Anschuetz, Christidis & Lauster, 1992. Model, view to the north. MAA

Proposal for Whitehall Ferry Terminal, South Street, foot of Whitehall Street. Skidmore, Owings & Merrill, 1992. Rendering of view to the south. SOM

Proposal for Whitehall Ferry Terminal, South Street, foot of Whitehall Street. James Stewart Polshek & Partners, 1992. Model, view to the north. PPA

Proposal for Whitehall Ferry Terminal, South Street, foot of Whitehall Street. Hardy Holzman Pfeiffer Associates, 1992. Model, view to the southeast. H3

Of all the submissions, Aldo Rossi's was, as Muschamp put it, "the most gravely historical," employing the architect's "familiar vocabulary of spare classicism alleviated by bright colors. Columns, cornices and square Roman windows trim a green temple to water transport" that seemed to lack sufficient iconic power despite conical gatehouses which were to flank an "exquisitely forlorn" arcaded piazza, "a place to listen for the ghostly blasts of long departed liners." Muschamp took note of Skidmore, Owings & Merrill's proposal, which had the support of the Bowling Green Association, declaring it a "bold attempt to break out of [SOM's] recent Art Deco mold" but, "alas, the stretch has pulled the firm's scheme to pieces. An industrial shed, a hat-shaped rotunda, and a floating hairpin ramp, slung from what appears to be the superstructure of a Navy destroyer, cover the ground like urban fragments." He applauded "wonderful spaces within" but regretted that a "project . . . supposed to connect people to the water would instead take us miles away." Muschamp found the proposal of James Stewart Polshek & Partners to be at the opposite extreme of SOM's "on the scale of ambition. Its design is disarmingly modest," with a wavelike canopy floating

above a glass pavilion and "clean, mid-century modern lines [recalling] a time when Kennedy was called Idlewild." Hardy Holzman Pfeiffer's submission sat "somewhere in the middle of these divergent roads," taking "its scale and lines from the Battery Maritime Building next door," but finding "its spiritual cousins" in the "pseudo-industrial sheds of South Street Seaport."[11]

Muschamp lavished his highest praise on Rafael Viñoly's design: "If the purpose of the competition was to transfer the terminal's design to architecture from engineering, then Rafael Viñoly deserves a slap on the wrist. His design shows how expressive engineering can be. With a spectacular roof of cantilevered trusses springing from slender supports, the terminal stretches out toward the harbor like a sinewy hand . . . , partly a place to gather, partly a conduit to move people through space." Although Muschamp found Viñoly's proposed spiral observation tower redundant, he remained impressed with the overall proposal "not because it is physically more striking" than the others "but because its dynamic form projects a stronger connection to an urban vision" of a renewed transportation system. Muschamp was less taken with the proposal from Venturi, Scott Brown and Anderson/Schwartz, a "trademark 'decorated shed'" that he dismissed as "cartoon contextualism" which was little more than "a setting for the design's main feature: a giant clock that faces out to the harbor." Nonetheless, Muschamp had to grudgingly admit, "Of the six designs, this is the most conspicuous landmark, an architectural billboard impossible to ignore," spelling out a message that was hardly romantic: "Time is money."[12]

On November 6, 1992, Mayor David Dinkins announced that the Venturi scheme, estimated at a cost of $112 million and expected to be completed by 1998, was the winner. Robert Venturi and Denise Scott Brown had high ambitions for the project while making a claim about urban infrastructure that seemed generic rather than specific to New York: "In an era when civic space has been supplemented by shopping centers, the Whitehall Terminal becomes an unparalleled opportunity to create a civic setting that celebrates the city and illuminates the everyday lives of twenty-two million yearly commuters."[13] The first reactions to the selection tended to focus on the 120-foot-diameter timepiece, equal to the height of a

Proposal for Whitehall Ferry Terminal, South Street, foot of Whitehall Street. Rafael Viñoly Architects, 1992. Model, view to the north. RVAPC

ten-story building which, if completed, would have been the world's largest clock, a fact that caused Staten Island Borough President Guy Molinari to dismiss it as a feature that would make the terminal "look more suitable for a model village under someone's Christmas tree," something "out of place" which would have as its "only probable benefit" its ability to "remind people that they're late for work—again."[14] Although random ferryboat riders were not taken with the clock, the editors of the *New York Times* were enthusiastic: "New York is a city of grand gestures . . . a place in which an ape *might* scale a skyscraper" or "a clock 120 feet high can make perfect sense. . . . A city with big aspirations can handle—deserves— a big timepiece."[15] Although the clock was controversial, Venturi, Scott Brown's boldly scaled, 125-foot-high waiting room, suggestive of the concourse at Grand Central Terminal, was very well received.

After the Venturi, Scott Brown scheme was selected, Muschamp, indulging the zeitgeist-obsessed Modernist bias that would be a fixture of much of his later commentary, wrote that "the real problem with the design isn't the size of the clock. It's that the whole building has lost track of time. Ferry travelers will have no trouble figuring out the hour. But what about the year? What is a transit hub for the year 2000 doing wearing a Beaux-Arts ball gown? Why must a new civic symbol flirt with the old, even in jest?" Despite the criticism, Muschamp did make an effort to support the Venturi design: "It's about time. That's one way to read the big clock that adorns the winning entry. . . . No, our Swatch-infested city doesn't need another clock," he pronounced, though public clocks were much admired, met a real need, and were dwindling in number. "But a building by Robert Venturi and Denise Scott Brown is long overdue. . . . And the architects . . . have outdone themselves to make this the Venturiest, Scott Browniest building ever." The terminal, Muschamp continued, would be a "hybrid" of the two building types that Robert Venturi, in his landmark book, *Complexity and Contradiction in Architecture* (1966), had said characterized contemporary architecture: "the Decorated Shed (a container enlivened by ornament) and the Duck," an expressive icon. "The terminal is a shed that quacks. And tells time too." Muschamp applauded the "tartan weave of the terminal's windows [which] may be its most impressive feature" as well as "the design's more refined elements: circulation, lighting, the interplay of expansive indoor space and snug exterior arcades."[16]

Suzanne Stephens, writing in *Oculus*, noted that the scheme seemed to frazzle the nerves of architects and lay public alike. "Too bad," she wryly wrote, "they never get so exercised about new, 70-story, banal high-rises." But the attack on the winning scheme was also about the nature of architecture itself, reflecting the seemingly century-old battle between those who believed that it was possible to reform the discipline from within and those who thought that virtually nothing short of an apocalyptic vision of the future, albeit one with a strong basis in traditional engineering, was appropriate. As Stephens put it: "Whether the Grand Central–terminal type," represented by the Venturi scheme, "is more appropriate for a ferry terminal than one of the other edgier designs is. . . open to question." The proposed building is "after all, a terminal for ferries—a form of transportation used as far back as the River Styx. Granted, ferries are now driven by engines, but they are not airplanes or manned spaceships. Why should this terminal express futuristic modes of transportation when it is not meant

Proposal for Whitehall Ferry Terminal, South Street, foot of Whitehall Street. Venturi, Scott Brown & Associates and Anderson/Schwartz, 1992. Model, view to the north. VSBA

Proposal for Whitehall Ferry Terminal, South Street, foot of Whitehall Street. Venturi, Scott Brown & Associates and Anderson/Schwartz, 1995. Photomontage, view to the north. VSBA

to accommodate them (at least now?). More important, really, is the quality of the space and the place for pedestrians."[17]

But the clock-faced terminal was not to be. In late 1995, the Venturi team submitted a redesigned proposal that eliminated the giant clock and the grand waiting room, instead proposing a huge LED signboard.[18] Guy Molinari, who remained unimpressed and thought that the immense zipper sign was no better than the clock, disparaged it, with no apparent irony, as "Las Vegas on the Manhattan waterfront."[19] In October 1996, Venturi and Scott Brown, defeated by the public bickering, bowed out of the project, leaving Anderson/Schwartz Architects in charge.[20] In March 1997, Anderson/Schwartz, working in collaboration with TAMS and Robert Evitts,

unveiled a drastically revised version at a meeting that was wisely held in Staten Island Borough Hall.[21] The relatively modest design stood in stunning contrast to plans released only the month before for a spectacular new combined terminal and museum structure of sweeping inclined planes to be designed by Peter Eisenman for the Staten Island side. While the Anderson/Schwartz (later Frederic Schwartz Architects) scheme incorporated certain functional improvements that had not been part of the original, the key facts were that both the clock and the large LED sign were gone, although LED signs with eight-foot-tall letters were planned for placement over the ferry slips. Gone also were the elliptical arches and the grand space, leading to the conclusion, even among those

ABOVE Whitehall Ferry
Terminal, South Street,
foot of Whitehall Street.
Frederic Schwartz
Architects, 2005. View
to the north. FS

LEFT Whitehall Ferry
Terminal, South Street,
foot of Whitehall Street.
Frederic Schwartz
Architects, 2005.
View to the south. FS

who felt that both Venturi schemes were inappropriate, that the thrill was gone as well.

The new design for the three-slip, four-story, 200,000-square-foot green-tinted glass and corrugated stainless steel terminal, with a 75-foot-high, 19,000-square-foot waiting area, 6,500 square feet larger than the previous facility, featured a V-shaped crown lined with photovoltaic panels that were to help supply part of the building's power needs. Below the crown was a 10,000-square-foot open-air viewing deck, and the terminal also featured direct connections to the South Street subway station and a covered walkway to the Whitehall Street station. The design also included a reconfiguration of Peter Minuit Plaza to allow for a curved bus dropoff and taxi stand. Carter B. Horsley, writing in 1997, was highly critical: "The new design clashes totally with the elegant adjacent Governors Island ferry terminal [Battery Maritime Building] and its square fenestration pattern correlates to nothing in the vicinity and is merely an abrupt intrusion and disruption of the Lower Manhattan approach."[22] But as Guy Molinari, who had done so much to sabotage the previous two schemes, wearily put it, "Almost anything would be an improvement over what was there before the fire."[23] The pattern of delays that had marked previous efforts continued, and ground was not broken for the new terminal until September 25, 2000, with a phased construction schedule that allowed for two of the terminal's three ferry slips to be available for use at all times. The project was delayed by the effects of the Trade Center disaster, but by the spring of 2002, construction was back at full speed and the terminal was completed in 2005.

On a much smaller scale but more satisfying as a work of architecture was Smith-Miller + Hawkinson's Wall Street Ferry Terminal Building (2001), located on Pier 11 in the East River between Wall Street and Gouverneur Lane.[24] Built by the Department of Transportation and the New York City Economic Development Corporation, the 2,815-square-foot pavilion was constructed of galvanized corrugated metal, corrugated fiberglass, exposed structural steel, and large expanses of glass, "all materials," according to the architects, "which are functionally sympathetic to waterfront construction, and are evocative of the working, industrial history of New York's waterfront."[25]

The main waiting area, furnished with simple benches, could be transformed to an open porch by pivoting south-facing glass-and-anodized-aluminum airplane hangar doors. The terminal also included a café as well as additional outdoor waiting space to the east and west of the building sheltered by steel and translucent fiberglass canopies. Paul Goldberger was favorably disposed to the modest structure, noting, "Architects often have more ideas than it is possible to fit into one building, but sometimes they get away with including them all. This is the case . . . at Pier 11 . . . a tiny pavilion that manages to allude to a barge on the Grand Canal in Venice, an aircraft carrier, high-tech industrial structures, New York's old waterfront architecture, and a garage." Golberger described the design as "tough," noting that the "nimble, tensile structure" was able to hold its own against "the skyscrapers of lower Manhattan." He concluded his assessment by declaring the terminal "one of the most refreshing public buildings to have gone up on the waterfront in years."[26]

Wall Street Ferry Terminal Building, Pier 11, between Wall Street and Gouverneur Lane. Smith-Miller + Hawkinson, 2001. View to the northwest. Moran. MM

SOUTH STREET SEAPORT

Plans for the extensive redevelopment of the neighborhood of eighteenth- and nineteenth-century buildings in the blocks bounded by the East River, Front, Fulton, Pearl, and Dover Streets, as well as the rehabilitation of Pier 17, where a fleet of vintage sailing vessels was already docked, were announced on July 28, 1977, just two months after the area, which had come to be called the South Street Seaport as a result of efforts to preserve it begun in the late 1960s, had been designated a historic district by the Landmarks Preservation Commission.[1] A collaboration of the city and the South Street Seaport Museum (a private, nonprofit group founded in 1967), the combined preservation and development project was planned to take advantage of $5.3 million in federal funds as well as substantial private gifts from the Rockefeller Foundation and the Astor Foundation. The plans had been in discussion as early as 1968, when the threatened construction of the Lower Manhattan Expressway had motivated the City Planning Commission to designate the area as a renewal district but with an important twist: in contrast to the typical renewal program of raze and rebuild, the commission wanted the area transformed into an "Old New York" neighborhood of restored buildings.[2] But progress had stalled in the early 1970s and the only modest bit of new work was Charles Evans Hughes III's 1976 installation of the Titanic Memorial Lighthouse in Titanic Memorial Park, on the north side of Fulton Street between Pearl and Water Streets, a narrow slice of land forming a gateway to the Seaport.[3] The commemorative lighthouse, built in 1913 with money raised by public subscription, had originally been installed on top of the Seamen's Church Institute (Warren & Wetmore, 1907), 25 South Street, where, visible from the harbor, it signaled the noon hour to ships by lowering a black ball timed to a clock in Washington, D.C. When the institute building was demolished in 1968, the lighthouse was stored on a pier by the Seaport Museum until funds were donated by the Exxon Corporation in 1975 to reerect it.

In December 1977, the Seaport Museum entered into an agreement with the Rouse Company, developers of Boston's lively but touristy Quincy Market (Benjamin Thompson & Associates, 1976) near Faneuil Hall, to study the feasibility of a similar project at the Seaport.[4] The president of the Seaport Museum, John Hightower, who for a short and stormy period had been director of the Museum of Modern Art, greeted the prospect of commercial development with almost unabashed enthusiasm, proclaiming, to the horror of many, that "Shopping is the chief cultural activity in the United States." While Hightower professed to not wanting to see "the Seaport . . . Williamsburgered," he insisted that the "only way architectural preservation is going to work is if economic arguments are in its favor."[5] Hightower's benign view of commerce was not shared by the Seaport's founder and former president, Peter Stanford, who did not believe commercial concerns should be paramount: "We have to say to a developer, 'Here's what's going on and commercial development that works with this purpose is welcome and other commercial development is not.'"[6] Some observers argued that Stanford's criticism of Rouse's plans reflected cultural elitism, what John Morris Dixon, editor of *Progressive Architecture*, called "the snobbery of the city dwellers who do not want their favorite seedy haunts invaded by people who do not share their appreciation

of cities."[7] Others, not so sure that massive renewal was needed at all, argued that though the Seaport Museum was languishing, the area was still reasonably viable as a waterfront district, still home to fishmongers, chandleries, and other water-oriented businesses that lent considerable authenticity. But Hightower argued that the traditional businesses just didn't pay enough rent, so that what was authentic about the place was not sustainable.

In November 1978, the city requested $18.5 million from the federal government's Urban Development Action Grant program to help finance infrastructure improvements needed by the Rouse Company. But even the city was forced to admit that the ratio of the grant to the amount of private investment it would generate was not very good, with the Rouse Company only committing $25 million of its resources. The Rouse plan envisioned Fulton Street as a shopping "corridor" with the first two floors of Schermerhorn Row (1810–12), on the block bounded by Front, John, South, and Fulton Streets, the most historically important buildings in the area, devoted to commercial uses. Consisting of nineteen buildings gathered together under one hipped roof, Schermerhorn Row had been the pet project of Peter Schermerhorn, a maritime trader. It constituted one of the oldest surviving commercial blocks in the United States. Declared a New York City landmark in 1968, when it was largely vacant, it did not begin to undergo renovation until 1975, when Jan Hird Pokorny was hired to prepare drawings for the preservation of the various modifications of roofline and storefront that reflected the building's nineteenth-century history. The storefronts and second-floor space were to be leased to shopkeepers, but the upper floors were to be renovated as fifteen residential apartments and leased to standing tenants. To complement Schermerhorn Row, Rouse's plan called for the construction on the empty site of the former Fulton Market, north side of Fulton Street between Front and South Streets, of a greenhouse-type 200,000- to 250,000-square-foot structure devoted to shopping and dining, to be designed by Benjamin Thompson & Associates. In the future, a second structure, also devoted to retail and dining, was to be built on a pier extending into the East River.

Ada Louise Huxtable greeted the plan with enthusiasm: "Beyond the money" it would generate for the Seaport—profits of $1 million per year or more were projected—"it will 'save' the Seaport; it will 'recycle' the old buildings to a useful end; and as in Boston, it will add profit and pleasure downtown, where both are needed." Nevertheless, she pointed out that while the strong granite of Quincy Market's block-long Greek Revival buildings could absorb "the overwhelming paraphernalia of a chic and trendy shopping center," it would be "very hard to establish" a balance in the more modest and scattered Seaport buildings. Moreover, she warned about the overall ambiance of the reconfigured Seaport, asking whether it was "possible, or desirable, to avoid an inevitable total metamorphosis of the area? . . . Because what surely will be lost is the spirit and identity of the area as it has existed over centuries . . . the small, shabby streets and buildings redolent of time and fish . . . the cold sunlight of a quiet winter Sunday morning on the waterfront with the Fulton Market cats, when the 19th century still seemed very much alive." Huxtable concluded her assessment with some thoughts on Richard Haas's mural *Arcade, Peck Slip* (1977–78), commissioned by the Consolidated Edison Company, depicting the townscape around Peck Slip that had been lost when a blank-walled

Arcade, Peck Slip, south wall of Consolidated Edison Substation, 235–237 Front Street, between Peck Slip and Dover Street. Richard Haas, 1978. View to the northeast. Mauss. ESTO

Consolidated Edison substation (1975), 235–237 Front Street, between Peck Slip and Dover Street, an embarrassing gaffe of the usually more sensitive Modernist Edward Larrabee Barnes, replaced a row of late-eighteenth- and early-nineteenth-century houses on the north side of the street: "I eye its charm dubiously, because it does nothing whatever to make up for the loss of the landmark buildings that stood there for so long and that should have been preserved."[8]

On September 27, 1979, an agreement in principle was signed with the Rouse Company to build shops and offices at the Seaport. Still, Huxtable remained uncomfortable with the prospect of Rouse's participation: "The new Seaport plan calls for uninterrupted retail space that would push the museum's facilities upstairs and around corners. The main emphasis would be on lively, trendy shops and restaurants, and Fulton Street would become the area's retail spine. The plan is a far cry, in short, from the original idea of a nostalgic street of sailing ships. . . . But," Huxtable continued, "perhaps the plan's most ironic deficiency is that its success would threaten the Seaport itself." With many of the area's properties lying outside the boundaries of the historic district, "they will therefore become instantly vulnerable to market pressures that trade on an area's historic character and charm while at the same time destroying it The message that hasn't arrived from Boston is that Faneuil Hall is part of an official, effective master plan. The New York proposal is welcome, but it needs more thought and work."[9]

Despite Huxtable's reservations and objections from area residents, some of whom were artists, including the sculptor Mark di Suvero, the project received final approval from the Board of Estimate on November 13, 1980, although it could

not go forward without an as-yet unapproved but expected $20 million federal grant to pay for a new pier replacing the two that would be demolished. On December 24, the grant was approved, and ten months later, in October 1981, the Board of Estimate approved the long-term leases involving the city, the Seaport Museum, and the Rouse Company. As the project inched its way toward reality, Huxtable's guarded optimism gave way to a more pessimistic view: "The South Street Seaport has sold its soul (but saved its museum) for a classy mess of pottage in the form of a sleek marketing scheme that will pay the Seaport's way from now on but sacrifice the last of its 19th-century character to the commercial exigencies of a tourist and shopping center. Whether the Seaport was seducer or seducee in this deal is moot."[10]

Restoration of Schermerhorn Row began in earnest in 1981.[11] The project had more than its share of troubles, including a fire of undetermined origin that struck in January 1982 (an earlier fire, in February 1976, said to have been started accidentally by derelicts living on the building's ground floor, had also caused serious damage).[12] But the work went on and the restored building opened in 1983 as part of the first phase of the Seaport as a whole. Jan Pokorny's work was not universally admired because the restoration, which brought the building back to its post–Civil War condition, was "correct" but at the expense of the charming eccentricities and decrepitudes of time. Paul Goldberger, like Huxtable, had an affection for the South Street area that was imbued with nostalgia, not for the past as it was but for the ruin it had become. Writing in the *New York Times*, he found Schermerhorn Row the Seaport's single "architectural disappointment," with a "vibrant pile of buildings that seemed almost to pulsate with

ABOVE Schermerhorn Row (1812), block bounded by Front, John, South, and Fulton Streets. View to the southeast before restoration. Motzkin. JHPA

BELOW Schermerhorn Row (1812), block bounded by Front, John, South, and Fulton Streets. Renovation by Jan Hird Pokorny, 1983. View to the southeast. Motzkin. JHPA

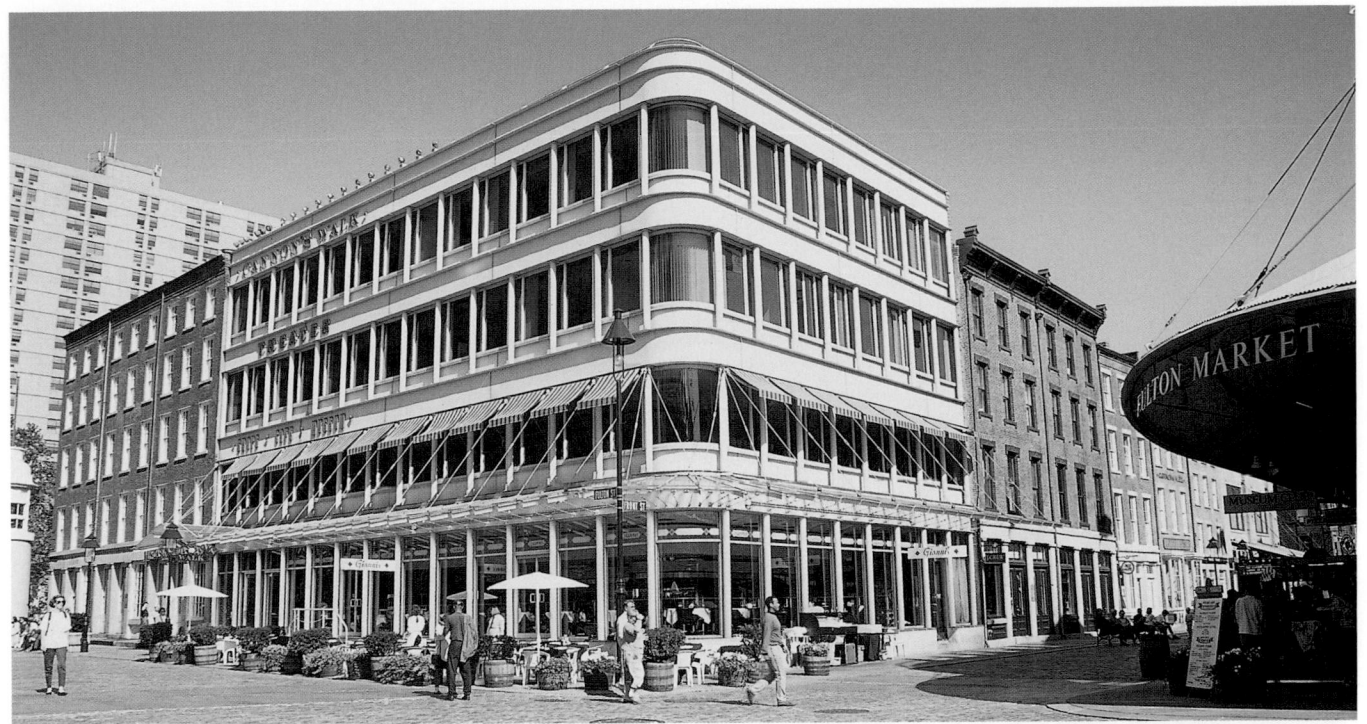

Bogardus Building, 15–19 Fulton Street, northwest corner of Front Street. Beyer Blinder Belle, 1983. View to the northwest. RAMSA

the memories of the generations of riverfront commerce it contained . . . turned . . . into something flat and dull. The brick fronts have been sterilized, made so clean that all sense of time has been wiped out; worse still, the distinctions between the houses that make up the row have disappeared, and so this block looks more like a single, overblown mass of brick than like a real 19th-century street."[13] Though Pokorny was chided for sandblasting the old brick, it had been subjected only to a water bath. The repointing of the mortar did give the walls a decidedly "new" look. According to Douglas Brenner, the critics who took Pokorny "to task for homogenizing a picturesquely varied aggregate of individual structures" ignored the fact that "the architect was engaged to restore the historic character of a group of buildings designed as a single composition."[14] As Pokorny put it, the issue came down to two opposing and largely incompatible points of view: the monumentalists, who preferred an "architectural approach [and] believed this to be a monumental facade that should be restored to its monumental proportions," and the accretionists, who "considered the extension of the . . . building to be part of the history of Manhattan."[15]

John Beyer of Beyer Blinder Belle was in charge of the restoration of the so-called Museum Block, bounded by Fulton, Water, Beekman, and Front Streets, consisting of fourteen buildings of mixed chronology, ranging from the mid-eighteenth to the early twentieth centuries.[16] One part of the block remained empty, a lot above a Metropolitan Transit Authority airshaft, on which Beyer Blinder Belle attempted to locate the dismantled outer walls of the Laing Stores (1848–49), James Bogardus's remarkable panelized cast-iron building. Known alternately as the Bogardus Building, it had stood at the northwest corner of Washington and Murray Streets until 1960, when it was dismantled as part of land clearing for the Washington Market urban renewal project.[17] A key monument

Bogardus Building, 15–19 Fulton Street, northwest corner of Front Street. Beyer Blinder Belle, 1983. View from beneath canopy to southwest. Aaron. ESTO

in the evolution of cast-iron architecture, the Bogardus Building's facade had been assembled out of premanufactured metal panels. Soon enough, being dismantled, enterprising thieves made off with many of the building's panels, which were surely melted for scrap. The Landmarks Preservation Commission moved the remaining fifty-nine panels to a city warehouse, only to learn in late 1976, as plans were being made to re-erect the building at the Seaport, that they had all disappeared, prompting Ada Louise Huxtable to make a mockery of the city's carelessness with its property and its past and to coin the memorable phrase "landmarks lunacy."[18]

The loss of the fragments notwithstanding, Belle and his partners decided to continue with their homage to Bogardus: "We had researched the replication of these fragments using modern materials such as aluminum, [and] we decided that a modern

Fulton Market, northeast corner of Fulton and Front Streets. Benjamin Thompson & Associates, 1983. View to the northeast. Rosenthal. SR

version of this kind of warehouse building should be built with the same rhythm of columns and spandrel beams. In a way, the building almost designed itself."[19] To unite the various buildings and give them an internal focus, an idea that may not have been the best from the point of view of enhancing street life, Beyer Blinder Belle removed some backyard sheds and converted the backyard space into a midblock open-air passage called Cannon's Walk, entered through the lobby of the reinvented Bogardus Building and through an arcade facing Front Street.

The cornerstones of Rouse's plan were the three-story, brick-clad, metal-roofed Fulton Market (Benjamin Thompson & Associates in association with the Eggers Partnership, 1983), 57,000 square feet of leasable space for food vendors, restaurants, and bars, and the 125,000-square-foot Pier 17 Pavilion (1985), also designed by Benjamin Thompson & Associates.[20] Additionally, Rouse was responsible for leasing 68,000 square feet of shops in the various restored buildings—23,000 square feet in the Museum Block and 29,000 square feet in Schermerhorn Row. While the Seaport was expected to attract lunchtime patrons from the downtown business district, its principal appeal was to be to tourists. The Fulton Market, with its deep red granite-trimmed facades wrapped by a broad cable from which hung a corrugated-metal canopy at the ground floor, rose to a high, gabled roof covered in standing seam metal. Goldberger praised the building, which he felt did "not pretend to be left over from the nineteenth century any more than the new Bogardus Building does," but was also free of "modernist hubris." While the critic failed to make clear why

early-twentieth-century revivalism was to be preferred to that based on buildings from the nineteenth century, Goldberger noted with pleasure that the Fulton Market "looks as if it might have been an early twentieth-century industrial building . . . fancied up a bit for the new Rouse marketplace—it could not sit more comfortably . . . and it . . . enriches the structures around it."[21] The editors of *Oculus* felt differently, noting that the "scale of the Market building is too overpowering, . . . a floor too tall, mushrooming over the old Seaport relics."[22]

The Fulton Market stood on a site that between 1883 and 1951, when it was torn down, had been occupied by a one-story building with a two-story pavilionated facade facing South Street. That building had replaced a neoclassical pavilion built in 1822. So, it could be said, the site had a continuous history to which Benjamin and Jane Thompson were sympathetic as they designed their building. As they put it, theirs was to be "a hard-working, shirtsleeves sort of place."[23] The job was complicated by the requirement that the building had to be constructed over and around existing wholesale fish stalls along South Street. One-hundred-foot-long transfer trusses solved that problem. Inside, the interior was shedlike in its directness, but while nineteenth-century sheds were frequently framed with delicately detailed iron columns and trusses, and decorative tile work was also employed, the Fulton Market interiors were bone bare with exposed ducts, electrical conduit, and life-safety systems all too exposed and visually at war with decorative stuffed fish, used signs, and other similar devices employed to help recapture the past. The firm's three-level,

waterside Pier 17 Pavilion was the last significant development of the Rouse plan. The steel-framed structure, built on a new platform in the East River, was sheathed in painted metal siding and roofed in standing seam zinc. It was also largely prefabricated off-site. Two interior atria were complemented in good weather by numerous exterior balconies.

The Seaport opened on July 28, 1983.[24] It quickly became one of the most critically disparaged and certainly the most unsuccessful large-scale project of the 1980s. Begun with high ideals as a place where a slice of nineteenth-century New York could be physically preserved and honestly invoked, it was realized as an urban marketplace in name and a shopping center in reality. Paul Goldberger was virtually the only critic to be impressed, writing that the reconstituted Seaport represented "an intelligently orchestrated mixture of buildings and activities that, if lacking in the spontaneity of the New York neighborhood that is left alone, still manages to have a lot of life to it for a place that is planned down to the last square inch."[25] Kurt Andersen, writing in *Architectural Digest* five years after the opening, reflected:

> A few years ago, it [South Street Seaport] was a decrepit, architecturally remarkable neighborhood . . . that served mainly as a kind of evocative Dickensian backdrop to the city's wholesale water-

front fish market on Fulton Street. For the Rouse Company, which had made pots of money and a reputation as canny urban rehabilitators by turning old waterfront quarters into perky, Disney World versions of themselves, South Street looked like a perfect opportunity to repeat the successes of Baltimore and Boston and elsewhere. And that is the rub: When you are on the cobblestoned midway of the Seaport today, Laura Ashley and Brookstone shops to your left and several indistinguishably singlesy fish restaurants to your right, you are not really in New York—you are in a generic Old-fashioned Urban American Shopping District, circa 1980, and the geographic particulars are practically irrelevant.[26]

The public was not taken in. Shortly after opening, the Seaport experienced a kind of identity crisis as the tourist trade dropped off and the retail establishments suffered.[27] The situation only became worse in the late 1980s and 1990s after the stock market crash, when it was reported that over fifty restaurant and shop owners had felt it necessary to hire a full-time press agent to advertise the area to tourists as well as New Yorkers.[28] In 1997, in order to lure more people to the area in the winter months, the Seaport added a short-lived, elliptical, 60-by-120-foot outdoor skating rink, but the kind of prosperity that was felt in other parts of lower Manhattan continued to elude it and a 1998 article on the area in the *New*

Pier 17 Pavilion. Benjamin Thompson & Associates, 1985. View to the northeast. Rosenthal. SR

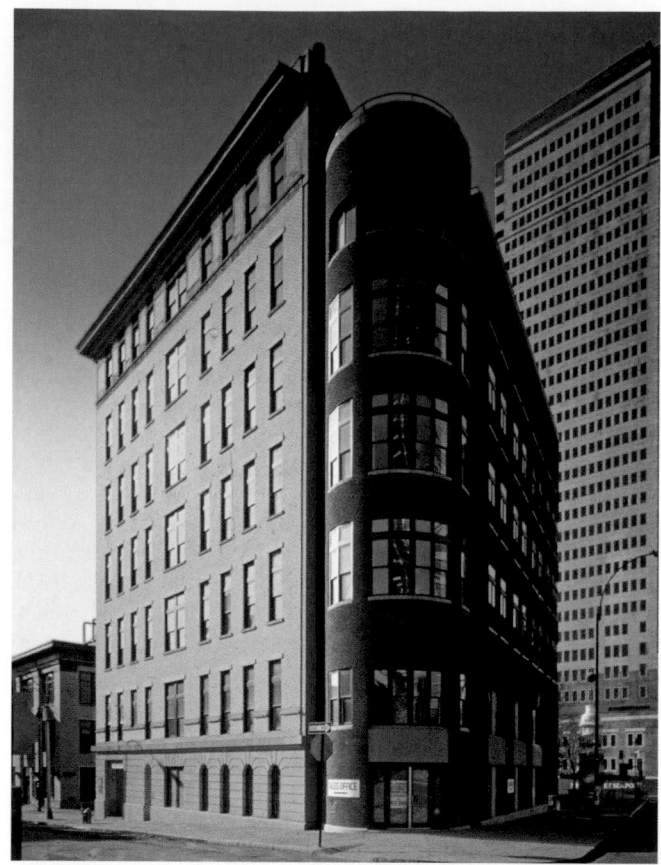

York Times was aptly titled "Rough Sailing for South Street Seaport."[29] Still, the rising tide of lower Manhattan's fortunes eventually washed over the Seaport, and in January 2001, *Crain's New York Business* was able to report that after years of substantial vacancies the Fulton Market was finally fully leased.[30] The collapse of lower Manhattan after September 11, 2001, would take a heavy toll on the Seaport.

In addition to its marketplace, the Seaport area was also home to one notable new apartment building and several new skyscrapers that dramatically altered the character of the neighborhood. Rafael Viñoly designed the Seaport Park Condominiums (1983), 117 Beekman Street, between Water and Pearl Streets, within the boundaries of the South Street Seaport Historic District overlooking Titanic Memorial Park.[31] The thirty-unit apartment building, featuring two penthouse apartments with terraces and ground-floor retail space, was a mixture of 14,000 square feet of new work as well as the renovation of what had been built as the Volunteer Hospital (Adolph Mertin, 1918), a seven-story, 28,000-square-foot yellow brick building rising from a rusticated limestone base. The editors of the *AIA Guide* deemed Viñoly's "combination of old and new . . . among the handsomest buildings in these parts."[32]

Swanke Hayden Connell & Partners' one-million-square-foot, thirty-four-story One Seaport Plaza (1983), located on the full block bounded by Water, Fulton, Front, and John Streets, developed with some of the unused Seaport air rights, was widely touted by its developer, Jack Resnick & Sons, as the

ABOVE Seaport Park Condominiums, 117 Beekman Street, between Water and Pearl Streets. Rafael Viñoly, 1983. View to the southeast. Hoyt. ESTO

BELOW LEFT 180 Maiden Lane, block bounded by Maiden Lane, Front, Pine, and South Streets. Swanke Hayden Connell & Partners, 1983. View to the southeast. McGrath. DSA

BELOW 180 Maiden Lane, block bounded by Maiden Lane, Front, Pine, and South Streets. Swanke Hayden Connell & Partners, 1983. Atrium. McGrath. DSA

"first contextual office building," with each principal facade designed in response to its distinctly different surroundings, notably the Water Street office building corridor on the one hand and that of the historic Seaport on the other.[33] Despite the hype, the building's polished granite facades, with ribbon windows facing the financial center on Water Street and punched windows facing the Seaport, failed to strike a sympathetic note in either context. Swanke Hayden Connell & Partners was responsible for another one-million-square-foot office building completed in the area in 1983, 180 Maiden Lane, built for the Continental Corporation, one of the world's largest diversified insurance and financial organizations, and developed by the Rockefeller Center Development Corporation for a site bounded by Maiden Lane, Front, Pine, and South Streets.[34] Like One Seaport Plaza, 180 Maiden Lane also benefited from the purchase of unused Seaport air rights, in this case more than 300,000 square feet. When Mayor Ed Koch was asked at the press conference announcing the project how much of the building could have been built without the extra air rights, he quickly replied: "Oh, a nice two-or-three-story Colonial."[35] To help reduce the impact of the bulk of the forty-one-story tower, the design team led by Der Scutt sliced off the corners of the large rectangular floors, so that the sides directly facing existing buildings were only fifty feet long at the base. That gesture notwithstanding, the octagonal tower stood out because of its flashy green-glass-sheathed facades. A 30,000-square-foot ground-level atrium crowned by four-story-high, sloping glazed roofs created a glass-enclosed public plaza, containing, in addition to plantings, benches, and exhibit areas, the banks of escalators that took employees and visitors to the main lobby on the second floor.

On a 24,000-square-foot site directly south of One Seaport Plaza, bounded by Water, John, Front, and Fletcher Streets, Fox & Fowle designed 175 Water Street (1983), a thirty-one-story headquarters building for the National Westminster Bank whose enhanced bulk was also permitted due to the purchase of unused Seaport air rights.[36] Developed by the British entrepreneur Howard Ronson, Fox & Fowle's design packed nearly 600,000 square feet of office space in two mirror-glass-clad cylinders that were visually buttressed by slabs of brick and clear glass ribbons. The editors of the *AIA Guide* were not impressed with the effort, finding the jawlike composition a bit schizophrenic, declaring that it was "neither fox nor fowl."[37] A far more successful effort at contextual design was Fox & Fowle's One Seaport Tower (1989), 40 Fulton Street, between Pearl and Cliff Streets, a slender, twenty-eight-story, 226,000-square-foot building that replaced a McDonald's restaurant and featured rather modest 7,000-square-foot tower floors.[38] The facade was composed of tan and red brick and green-tinted ribbon windows with centered bay windows running the full length of the tower portion of the building. Robert Fox claimed a connection to the Seaport, noting that "there is a particular link to Schermerhorn Row. . . . We used them [the historic structures] as our pattern."[39]

In 1983 the announcement by the developers Paul and Seymour Milstein of plans to build 250 Water Street, an office building on a 48,000-square-foot, trapezoidal-shaped site occupied by a parking lot and bounded by Water, Pearl, and Beekman Streets and Peck Slip, located in the northern reaches of the South Street Seaport Historic District, unleashed a storm of protest—and a subsequent series of designs—that would continue for the next twenty years.[40]

175 Water Street, block bounded by Water, John, Front, and Fletcher Streets. Fox & Fowle, 1983. View to the west. Gordon. FXF

One Seaport Tower, 40 Fulton Street, between Pearl and Cliff Streets. Fox & Fowle, 1989. View to the southwest. Gordon. FXF

ABOVE Proposed 250 Water Street, block bounded by Water, Pearl, and Beekman Streets and Peck Slip. Ulrich Franzen, 1983. Model, view to the southwest. MPC

ABOVE RIGHT Proposed 250 Water Street, block bounded by Water, Pearl, and Beekman Streets and Peck Slip. Ulrich Franzen, 1984. Model, view to the northwest. Pottle. ESTO

BELOW Proposed 250 Water Street, block bounded by Water, Pearl, and Beekman Streets and Peck Slip. Jan Hird Pokorny, 1986. Rendering of view to the northwest. JHPA

Ulrich Franzen's first design for the twenty-three-story, 770,000-square-foot 250 Water Street consisted of a concave glass-walled slab framed by granite piers. The proposal was bold but probably out of place. Not surprisingly, considering its stark quality as well as its size, Franzen's proposal was rejected by the Landmarks Preservation Commission. A year later, the Milsteins and Franzen came forward with a new proposal, this time for a forty-three-story, 577,000-square-foot beige brick tower containing approximately 400 apartments set atop a four-story red brick base that filled the site. Franzen described this second scheme as a "kind of two-headed proposal where the base stays part of the neighborhood, respecting the roofscape of the Seaport, and the tower becomes a modern building that separates itself somewhat spiritually from the Seaport."[41] The second Franzen design fared no better than the first and was rejected by the Landmarks Preservation Commission on November 14, 1984, for roughly the same reason: it was simply too big.

In 1986 the Milsteins returned with a different architect, choosing Seaport veteran Jan Hird Pokorny, who produced a 507,000-square-foot structure consisting of a five- and six-story, site-filling base meant to evoke nineteenth-century waterfront countinghouses through the use of varied materials, windows, and roof lines, topped by two apartment towers, one of twelve stories to the south and one of thirty stories to the north. It, too, was quickly rejected by the commission, which noted that the proposal "would dominate and overwhelm the neighboring buildings in this low-scale district."[42] Three years later, in March 1989, the Milsteins launched their fourth design, a fourteen-story, 184-foot-high, 480,000-square-foot office building designed by Robert Sobel of Emery Roth & Sons, which was immediately attacked by neighborhood leaders as well as the executives of the South Street Seaport Museum, who had not publicly stated their opposition to the

ABOVE Proposed 250 Water Street, block bounded by Water, Pearl, and Beekman Streets and Peck Slip. Platt & Byard, 1991. Rendering by Musheer Siddiqi of approved scheme's Water Street elevation. PBDW

BELOW Proposed 250 Water Street, block bounded by Water, Pearl, and Beekman Streets and Peck Slip. Platt Byard Dovell Architects, 1996. Rendering by Musheer Siddiqi of Water Street elevation. PBDW

previous proposals. Sobel believed that his vaguely nautical design of red brick with limestone and granite lintels that rose six stories before setting back was sympathetic to its surroundings. Carter B. Horsley, writing in the *New York Post*, was impressed with the design: "There is more than a touch of whimsy here, as the architects have also sought to lessen the proposed building's visual impact through its unusual, and quite complex, window patterns. Many windows that appear to cover a single floor actually span two, giving the appearance of fewer floors and enhancing the facade texture. The windows also would be recessed to reduce the scale of the facade by breaking the building into smaller segments." Horsley was also a bit weary of the criticism that prevented anything from being built: "While it is tempting to wish that all new buildings be architectural masterpieces, the Landmarks Commission has long recognized the importance of merely

'contextual' buildings that fit, more or less comfortably, into a district's general ambience. The Milsteins' design does."[43]

The Milsteins withdrew Sobel's design before the Landmarks Preservation Commission could vote on it but after it had been criticized as too bulky by the Municipal Art Society's preservation committee, headed by the architect Charles A. Platt, a former landmarks commissioner who had voted to reject Franzen's first design six years earlier. In October 1989, the Milsteins decided to try again and hired Platt, one their most persistent critics. Platt & Byard's design called for a fifteen-story, 185-foot-tall, 480,000-square-foot office building with several setbacks, remarkably similar in overall dimensions to the last failed plan. It divided the four-story brick and granite base into twenty-eight-foot-wide segments. Above the base was a glass-and-painted-metal grid topped first by a mass of cast stone and then by a glass curtain

ABOVE Seamen's Church Institute, 241 Water Street, between Beekman Street and Peck Slip. James Stewart Polshek & Partners, 1991. Chapel. Goldberg. ESTO

RIGHT Seamen's Church Institute, 241 Water Street, between Beekman Street and Peck Slip. James Stewart Polshek & Partners, 1991. View to the northeast showing Richard Haas's mural *Arcade, Peck Slip* (1978) in the middle distance. Goldberg. ESTO

wall in the upper stories. Reaction in the community was still negative, but negotiations with the Landmarks Preservation Commission led to a reworked, compositionally confused, 380,000-square-foot design calling for a ten-story building topped by a mechanical penthouse which was approved in May 1991. By this time, however, the economy had faltered to such a degree that the Milsteins were unable to proceed with 250 Water Street. Plans remained on the shelf until 1996, when the Milsteins changed direction yet again with a new design from Platt Byard Dovell for an apartment complex composed of two towers, one fourteen and the other thirty stories, reminiscent of Pokorny's rejected scheme of 1986. Not surprisingly, reaction in the community was again hostile, with one group, the Seaport Community Coalition, going so far as to produce its own design for the site. Architect and coalition member Barbara Marks designed Water Street Mews, a collection of six- and ten-story buildings bisected by a mews. The Milsteins, who had owned the site since 1979, did not proceed with development, content to hold on to the parking lot and wait for future opportunities.

Another project that also failed to move forward was announced in 1989 by the Metropolis Group, a development concern headed by Douglas E. Palermo, and planned for a city-owned site on both sides of Front Street between Beekman

Street and Peck Slip.[44] As designed by Rafael Viñoly, this scheme, like his nearby Seaport Park Condominiums of six years earlier, called for both renovation and new construction. Viñoly proposed to combine twelve existing four- to five-story buildings dating from 1750 to 1870 with three new six- to eight-story buildings on the site's vacant lots to create two hotel structures on both sides of Front Street for a total of 285 rooms. Although the contextually sensitive plan was quickly approved by the Landmarks Preservation Commission, in the early 1990s the Metropolis Group ran out of money and defaulted on its sublease from the city.

In addition to Viñoly's apartment house, there was one other building of distinction completed in the Seaport, ironically just across the street from the Milsteins' parking lot at 250 Water Street: James Stewart Polshek & Partners' Seamen's Church Institute (1991), 241 Water Street, a facility deftly combining historical buildings with new construction.[45] Associated with the Anglican church, the institute was founded in 1844 for the promotion of seamen's welfare and was originally housed in a floating Gothic-style chapel commonly known as "the doghouse on a raft." From 1907 to 1968 the institute was headquartered in a thirteen-story building designed by Warren & Wetmore that was demolished to make way for Emery Roth & Sons' mammoth 55 Water Street (1972).[46] The Seamen's Church Institute then moved to a new twenty-three-story red brick building (Eggers & Higgins, 1969) at 15 State Street, on the southeast corner of Pearl Street, that was torn down in 1985 to make way for Emery Roth & Sons's forty-two-story 17 State Street.[47] In 1988 the institute purchased 243 Water Street, a late-eighteenth-century midblock building, formerly a ship chandlery belonging to Peter Schermerhorn that was distinguished by a few notable features, in particular a small quoined service entrance to a yard passage, a rare memento of the city's early urban patterns.

To accommodate a complex program that included classrooms to teach computerized navigation, meeting rooms, offices, the Seafarer's Club, as well as street-level retail, Polshek thought of his job as docking a modern ship at a nineteenth-century pier. In effect, the architect wove together, but detailed in a largely abstract way, the historic building and a brick-clad extension to it, surmounting the composition with a ship-shape 1920s Cubist-inspired white porcelain enamel paneled superstructure stretching along the length of the site. While the brickwork rendered the effect of the street front largely traditional, the narrowness of the roadway made the superstructure visible to only those who craned their neck. The rear elevation, which was quite prominent from Front Street, was clad in a distinct, if somewhat retro-Modernist style, with fiberglass and aluminum panels combined with those in white porcelain. The maritime and machine imagery that Polshek borrowed from the aesthetic experiments of the 1920s, especially the work of Le Corbusier, was re-semanticized by the architect, investing them, as Barry Bergdoll pointed out, "at long last with an actual function," housing the boiler, cooling tower, and elevator machine room.[48] Inside, the design was less interesting, although the neatly detailed, asymmetrically vaulted ground-floor chapel was memorable. Less so was the principal stair, which did not connect enough of the floors to relieve the somewhat constricted spaces imposed by the cross-section of the historical structure. The rooftop meeting hall, however, with its vaulted ceiling, offered some sense of relief.

FINANCIAL DISTRICT

The announcement, in the fall of 1979, that several new office buildings would be built in lower Manhattan's financial district was good news to planners and others who had begun to lose hope for the area's revival and future. Ironically, developers turned their attention to the ailing financial district because of the success of midtown, where the cost of land was high and there was a comparative dearth of what were perceived as desirable sites. The most notable of the proposed downtown buildings belonged to a joint venture planned by the insurance giant American International Group and the venerable Bank of New York, which announced their intention to build a massive, sixty-story, 1.7-million-square-foot building at 60 Wall Street on a large site, roughly equal to that of One Chase Manhattan Plaza (Skidmore, Owings & Merrill, 1960).[1] In addition to the existing parking lot at 60 Wall Street, on which had previously stood a twenty-seven-story building by Clinton & Russell (1905), the combined site was also to include the Bank of New York's own thirty-two-story headquarters (Benjamin Wistar Morris, 1927) as well as the building next door, McKim, Mead & White's narrow, 432-foot-high National City Company Building (1928), 52 Wall Street.[2] American International Group (A.I.G.), which shared ownership of the parking lot and 52 Wall Street with the Bank of New York, hired Welton Becket Associates to develop plans for the building. At the same time, the Bank of New York, which owned its headquarters at 48 Wall Street, where it had been located in various buildings since 1797, retained John Carl Warnecke to study the problem. According to Austen Gray of Warnecke's office, two plans were proposed: one, dubbed "Son of Citicorp," called for a sixty-story square tower turned on its axis, with a roof slanting in two directions; the other, dubbed "Son of 30 Rockefeller Plaza," called for two towers on one base, with the higher tower belonging to A.I.G.[3] Welton Becket proposed a slablike tower that would incorporate some of the lower floors of Morris's 48 Wall Street.

Although both companies promised that a formal statement about the direction of the building would come soon, there was no noticeable movement for the next two years. By October 1981, the Bank of New York, having bought out A.I.G.'s interest in the parking lot site at 60 Wall Street and the building at 52 Wall Street, hedged its bets about going ahead with new construction, deciding to demolish the fifty-three-year-old building, a decision that raised no public protests. In fact, there had been no vocal objections to the potential demolition of the more artistically distinguished 48 Wall Street, which the Bank of New York had still not completely ruled out as an option, testimony perhaps to the strong desire for something significant to go forward in the financial district. In September 1982, after the death of its chairman and chief executive officer, Elliott Averett, and the denial by the city's Industrial Commercial Incentive Board of a multimillion-dollar tax abatement package that the bank deemed critical, the Bank of New York, sparing 48 Wall Street, decided to abandon plans for a new building and put the site up for sale, finding a buyer in George Klein of Park Tower Realty in spring 1983.[4] Although the 53,000-square-foot site extending through to Pine Street was not as large as the one originally jointly controlled by A.I.G. and the Bank of New York, it could still accommodate quite a large building if the lucrative air rights of the building across the street, 55 Wall Street

Three schemes for 60 Wall Street, between Pearl and William Streets. Helmut Jahn, 1983. Renderings. MJ

(Isaiah Rogers, 1836–41; addition, McKim, Mead & White, 1907) were secured.[5] Approval for the air-rights transfer would require the consent of the Landmarks Preservation Commission, which had designated 55 Wall Street in 1965. Given the situation, it was not surprising that even before an architect had been selected, the developer stressed the need for a contextual building. As Neil Klarfeld, a vice president of Park Tower Realty, put it: "Sixty Wall Street will be a building of the 21st century, but its design will be compatible with the landmark structures that surround it."[6]

Almost a year after agreeing to buy the land, Park Tower Realty announced the selection of Kevin Roche John Dinkeloo and Associates as the designers of its speculative office building, 60 Wall Street.[7] Roche won the commission over Helmut Jahn, who proposed three different schemes for the site, each of which, according to Nory Miller, represented "the image of traditional, classical forms executed with modern materials and techniques." One design was in the shape of an obelisk, another represented a beacon rising from a stone shaft, and the third suggested a column in what Miller said was an "obvious reference to [Adolf] Loos's [Chicago] Tribune tower" competition entry of 1922.[8] Roche's plans called for a fifty-two-story,

1.7-million-square-foot, glass- and granite-clad tower that was the first new skyscraper in the financial district whose design responded to the then widely debated Postmodern classicism. In deference to the low-scale landmark across the street, the tower sat atop a four-story base that included a boldly scaled arcade carried on paired columns. The design of the building was, according to Roche, "the idea of the column . . . used in a schematic way to articulate the form of the shaft of the building."[9] This theme was repeated in the final eight stories, where four sets of bay windows, arranged to look like columns resting on extremely etiolated pedestals that also visually strengthened the corners of the tower, were placed on each side. The composition was concluded by a steeply raked, forty-foot-high, copper-clad hipped roof.

Roche paid particular attention to the design of the interior public space, which the developers anticipated would grant them a significant bonus that, when combined with the air rights from the landmark across the street, would permit the great mass of the proposed design. Roche rejected the idea of an open plaza because he felt it would destroy the essential character of Wall Street by interrupting the dramatic stone street wall and also because he felt it would be redundant

given the close proximity of the open plaza at the Chase Manhattan Bank. Instead, he called for a thirty-foot-high, 174-foot-long, nearly one-half-acre covered pedestrian space that would go through the block to Pine Street as well as directly connect to the IRT Wall Street subway station at the northwest corner of the site. The elaborate space was dominated by ten eight-sided stone columns with flared capitals that supported a wood and mirror lattice ceiling, a design strategy he had previously used at much smaller scale in his Ambassador Hotel (1975) at One United Nations Plaza.[10] The columns had polished granite bases that could be used for seating. The lattice theme was repeated on the walls, where a decorative arrangement of honed Calacatta White marble and Laguna Green granite was placed against the ashlar-patterned granite walls and the room was enlivened with seasonal plants in granite planters and ficus trees as well as a waterfall. Several retail shops were planned and round metal tables and chairs were provided to further foster the plaza-cum-conservatory ambiance. Roche, who anticipated that "it will be a cheerful space, a welcoming space, a space of convenience and excitement," perhaps overreached when he concluded that he had designed a new kind of enclosed plaza: "It is a space as yet without a name because, in spite of its antecedents, it cannot simply be categorized . . . perhaps because its concept is more ambitious in the desire to create for our time a new and responsive answer to an age-old need."[11]

Paul Goldberger greeted Roche's design with cautious optimism. After noting the revived interest in the towers of the interwar period, "years of particular greatness for skyscraper design in New York . . . [with their] mix of flamboyance and pragmatism," Goldberger deemed the scheme for 60 Wall Street a largely successful attempt "to merge historical form into a new and romantic whole." The critic, exhibiting a surprising suburbanizing preference, was a little concerned about the site: "It is . . . too squeezed, really, to properly accept any very large building. . . . But if it is to be developed at very large scale," he continued, "it is difficult to imagine a much better scheme than Mr. Roche's, which weaves together both classical and modernist elements in such a way as to relate both to the classical and Art Deco buildings nearby."[12] Carter Wiseman, writing in *New York* magazine, was not so sure: "The instant reading of the 52-story tower as a quasi-classical column catches the eye, but only briefly. It's just too obvious to be interesting for long."[13]

The Landmarks Preservation Commission unanimously approved the transfer of air rights from 55 Wall Street, resulting in a bonus of 363,000 square feet. In fact, the whole plan met with little opposition, with the City Planning Commission and the Board of Estimate making only minor adjustments that reduced the below-ground parking space from 197 to 125 cars. All in all, another 166,000 square feet of bonus space was awarded to 60 Wall Street because of the covered pedestrian space. In a City Hall press conference on September 9, 1985, on the eve of the Democratic Party primary, Mayor Ed Koch proudly announced that Park Tower Realty had found a single tenant for the entire building, J. P. Morgan & Company, which had threatened to leave the city for Delaware. In testament to the fickle nature of the real

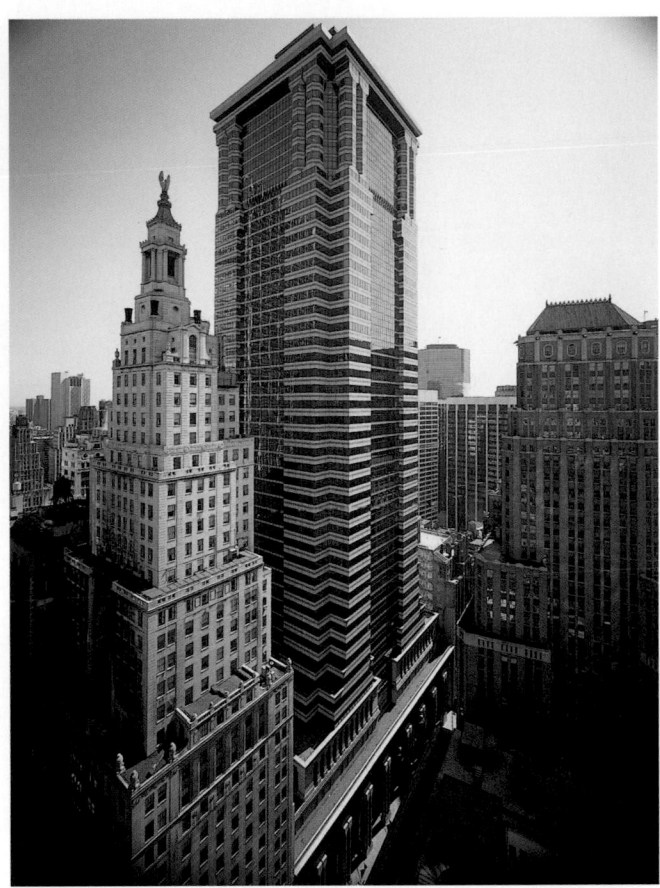

J. P. Morgan Building, 60 Wall Street, between Pearl and William Streets. Kevin Roche John Dinkeloo and Associates, 1988. View to the northeast showing 48 Wall Street (Benjamin Wistar Morris, 1927) on the left. KRJDA

estate market, Morgan Guaranty Trust, the parent company of J. P. Morgan, was given serious tax breaks for its decision to stay—just three years after the Bank of New York had been refused any tax considerations in its quest to develop the site. J. P. Morgan, which would be moving from its nearby headquarters building (Trowbridge & Livingston, 1913) at 23 Wall Street, southeast corner of Broad Street, and the adjoining tower at 15 Broad Street (Trowbridge & Livingston, 1928), essentially decided to accept Roche's design as it was, making no requests for changes to the exterior, as that would have required an expensive and potentially time-consuming trip back to the Landmarks Preservation Commission in order to resecure the air-rights transfer from 55 Wall Street.[14]

Paul Goldberger sustained his enthusiasm for the design when he reviewed the completed building in late 1989, proclaiming the Morgan headquarters one of the few "towers of the overreaching 80s" that had "staying power." According to Goldberger, Roche was able to go beyond the copycat classicism that doomed so many of the era's other designs by "abstracting" it, "making classicism here into something sleek and modern. This tower of gray granite and reflective glass mimics the form of a classical column . . . but it does so in such a way as to reinvigorate historical form with modern meaning." Taking the somewhat unpopular view that Roche successfully slipped his tower in among its distinguished neighbors, especially H. Craig Severance and Yasuo Matsui's Bank of the Manhattan Company Building (1930), 40 Wall

J. P. Morgan Building, 60 Wall Street, between Pearl and William Streets.
Kevin Roche John Dinkeloo and Associates, 1988. Through-block public
plaza. KRJDA

Street, and Clinton & Russell and Holton & George's Cities
Service Building (1932), 70 Pine Street, Goldberger observed
that 60 Wall Street "pays attention to the street: it is not a
piece of sculpture plopped down on open space but a building
designed to strengthen the fabric of the streets of which it is a
part." Goldberger was not so happy with Roche's covered pub-
lic space, however: "The whole thing is a cloying mix of white
marble, lots of trelliswork, mirrors and marble grids, and the
overall effect is oddly frilly, almost feminine, like an ice-
cream parlor blown up to monumental scale."[15]

George Klein and Park Tower Realty, this time working in
partnership with the IBM Corporation, were responsible for
another prominent undertaking in the heart of the financial
district: a speculative office building (1985) designed by Philip
Johnson and John Burgee on a highly visible, vacant site
bounded by Maiden Lane and Nassau and John Streets.[16] The
21,300-square-foot site had been assembled, beginning in the
1960s, by the Federal Reserve Bank of New York, whose York
& Sawyer–designed Florentine-style headquarters (1924) was
across the street.[17] In 1972 Kevin Roche John Dinkeloo and
Associates was commissioned by the bank to design an annex,
proposing a forty-two-story tower (1973) that was dramati-

cally lifted 160 feet off the ground by four colossal columns to
create an open-air plaza whose ceiling height was equal to the
York & Sawyer building.[18] In 1976, after having cleared the
site, the Federal Reserve abandoned plans to build the
new structure. Four years later, Park Tower Realty pur-
chased the eyesore location from the Federal Reserve, and
Johnson/Burgee designed a twenty-seven-story, 570,000-
square-foot building, 33 Maiden Lane, for the site. Fresh from
the triumphant, historically recollective AT&T Building in
midtown, Johnson tried to pay "tribute" to York & Sawyer's
design. "As we don't have the money or pretense of that build-
ing," Johnson noted, "the intent is to be a decent, modest
neighbor." According to Johnson, the plan of rounded bays
breaking the facade into "knuckles" would provide more
visual interest and better office layouts.[19] But the bland tan
brick, which the budget confined him to, and the relentlessly
regular window pattern overcame whatever capacity the
seven crenellated, twenty-foot-diameter turrets had to break
up the boxlike mass of the building that was carried on a forty-
three-foot-high arcade, the height of which matched a balcony
on the Federal Reserve Building. The design also featured a 30-
foot-wide, 150-foot-long covered pedestrian space dominated

by what David W. Dunlap described as "cavernous archways."[20] Paul Goldberger, writing in 1986, a year after the building's completion, described the design as a "mock-castle" that "takes off from the design of the Federal Reserve Bank next door, but seems a bit thin and strained beside its noble inspiration."[21]

Johnson/Burgee's building soon became home to a below-grade, satellite branch (1988) of the Whitney Museum designed by Tod Williams Billie Tsien & Associates.[22] The Whitney had opened its first satellite branch downtown in 1973 in space donated by the Uris Brothers in their 55 Water Street (Emery Roth & Sons, 1972).[23] But in 1980, after that building had been sold to Olympia & York, the new owners rescinded the free use of the space and evicted the museum from its 4,800-square-foot gallery. The downtown branch of the Whitney moved into temporary quarters in the former First Police Precinct Station (Hunt & Hunt, 1909–11), 100 Old Slip, between South and Front Streets, an imposing, heavily rusticated Italian Renaissance Revival palazzo, where for the next two years it shared the space with Creative Time, which was dedicated to finding alternate locations outside of galleries and museums for the display of new art.[24] In 1982 the downtown branch of the Whitney left the First Precinct, which in 1994 became the first permanent home of the Landmarks Preservation Commission, relocating to temporary quarters in the Federal Hall National Memorial, originally the U.S. Custom House (Town & Davis, 1833–42), 28 Wall Street, northeast corner of Nassau Street.[25] During this time the Whitney expanded its program of satellite branches, opening up a facility in 1981 in downtown Stamford, Connecticut, as well as a gallery in 1983 in midtown Manhattan in Ulrich Franzen's new Philip Morris Building. The Whitney continued to add new branches, opening a space in Edward Larrabee Barnes's Equitable Center on Seventh Avenue, and, at the same time, trying to go forward with the expansion of its Marcel Breuer–designed headquarters on Madison Avenue with a design by Michael Graves. Grace Glueck, art critic for the *New York Times*, while acknowledging the benefit of

ABOVE 33 Maiden Lane, northeast corner of Nassau Street. Philip Johnson and John Burgee, 1985. View to the northeast showing a portion of the Federal Reserve Bank (York & Sawyer, 1924) on the right. Lieberman. PTG

LEFT 33 Maiden Lane, northeast corner of Nassau Street. Philip Johnson and John Burgee, 1985. Covered pedestrian space. Lieberman. PTG

Satellite Branch, Whitney Museum of American Art, 33 Maiden Lane. Tod Williams Billie Tsien & Associates, 1988. Moran. TWBTA

increased exposure for the museum, wondered, "Do the museum's branches, housed in expensive lobbies not all that remote from its boutique-y home turf on Madison Avenue, really extend its 'outreach' to different audiences? Or is the Whitney simply enhancing the corporate atmosphere while—as one critic suggests—'bringing more art to the Yuppies?'"[26]

The Whitney closed the Federal Hall branch in 1984 after receiving the assurances of Park Tower Realty that it could have rent-free space in 33 Maiden Lane. The Whitney branch opened in April 1988 in a 3,200-square-foot space located two floors below the sidewalk and one floor below the Fulton Street subway station. The design, by Tod Williams and Annie Chu of his office, was strongly influenced by the subterranean site. "In order to call attention to the location we inserted a tall signpost," the architects wrote, "a mast of aluminum rising from the entry level of the museum to twenty feet above sidewalk level. Rather than enter the museum at the floor level of the gallery space, visitors arrived at midlevel onto a balcony overlooking the room and walked down a flight of stairs inside the space. It was a way to alleviate the sense of constantly descending. At the same time it created a sense of glamorous arrival because one could survey the people . . . before walking downstairs to the crowd."[27] The watchword for the design appeared to be "restraint," and Peter Blake, writing in *Interior Design*, believed that the designers had largely succeeded in creating a space that was "appropriately understated," and in contrast to the "bombastic" nature of the Johnson/Burgee building in which it was housed. Still, Blake referred to the space as a "Wall Street art pit," and noted that the details "all

have a deliberately anonymous, industrial look, vaguely reminiscent of subway technology and of other engineered installations."[28] In 1992 the four-year-old Whitney branch was closed, and development partner IBM took over the space for use as a marketing and education center.

In the same 1979 article that announced what eventually became the J. P. Morgan Building, there was also notice of a new speculative thirty-five-story, 800,000-square-foot, brick-clad office building at Seven Hanover Square (1983), between Water and Pearl Streets, to be developed by Swig, Weiler & Arnow and Seymour and Paul Milstein.[29] In an unusual move, the developers asked Norman Jaffe, an architect best known for his expressionistic houses on the eastern end of Long Island, and who had never designed a skyscraper before, to design the building in association with Emery Roth & Sons. Seven Hanover Square, like the Morgan headquarters, was also to benefit from the transfer of air rights from a landmark building across the street, in this case India House (1851–54), 1 Hanover Square, a three-story, brownstone-clad palazzo whose design was attributed to the builder and land speculator Richard F. Carman.[30] But in contrast to Roche's virtually effortless experience with the Landmarks Preservation Commission and the City Planning Commission, Jaffe met with obstacles, forcing his original design to be radically altered in order to gain 123,000 square feet of bonus space. As a result, the building that emerged was nine stories lower and bulkier, with less open space at street level. The new design for the 247-by-146-foot site would also enclose 800,000 square feet but would only rise twenty-six stories, with office floors of 30,669 square feet instead of 23,900 square feet. The motivation behind the changes was an effort to reduce the shadows the original design would have cast over Hanover Park. As Jaffe put it, "Sunshine in the park was the most important concept of the design."[31]

In an attempt to relate to the design of India House, Jaffe largely eschewed the typical glass curtain wall in favor of a predominantly red brick facade that featured square windows topped by lintels of Lake Placid granite, a palette he believed sympathetic to the materials used by the early Dutch settlers. The building also featured a boldly scaled entrance and a public arcade connecting Pearl and Water Streets with the ground floor devoted mostly to retail uses. Jaffe did not try to echo the design of India House but instead found his inspiration in the Georgian, a perhaps ill-advised move that the editors of the *AIA Guide* belittled: "Twenty-six stories of 'Georgian' red brick and limestone-like lintels over 1,000+ windows, squatting atop an overscaled reinterpretation of Frank Lloyd Wright's Midway Gardens."[32] David W. Dunlap was just as biting, writing in the *New York Times* that he thought the "facade looks something like a waffle iron."[33]

Preceding J. P. Morgan's commitment to occupy 60 Wall Street, a far more massive building, 85 Broad Street (1983), between Pearl and South William Streets and extending to Coenties Alley, one of the era's bulkiest buildings with almost a million square feet of office space distributed on thirty 33,000-square-foot floors, was designed by Skidmore, Owings & Merrill and developed by Galbreath-Ruffin to house the financial powerhouse Goldman Sachs.[34] Like the Morgan headquarters and Seven Hanover Square, the huge size of 85 Broad Street was made possible by the purchase and transfer of air rights from landmarked structures, this time the group of eighteenth- and nineteenth-century buildings across the

ABOVE LEFT Seven Hanover Square, between Water and Pearl Streets. Norman Jaffe, 1983. View to the north showing Cities Service Building (Clinton & Russell and Holton & George, 1932) on the left. Heatley. JHP

ABOVE RIGHT 85 Broad Street, between Pearl and South William Streets. Skidmore, Owings & Merrill, 1983. View to the northwest. McGrath. NMcG

LEFT Seven Hanover Square, between Water and Pearl Streets. Norman Jaffe, 1983. View to the southeast from Hanover Park showing India House (1851–54) on the right. Heatley. JHP

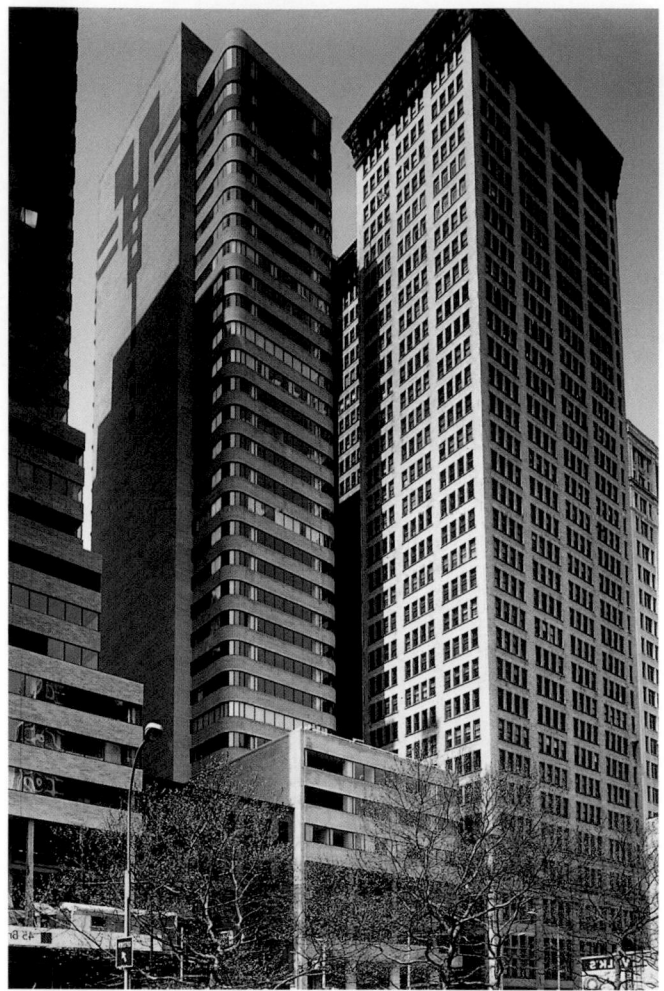

One Exchange Place, 55 Broadway, southwest corner of Exchange Alley. Fox & Fowle, 1983. View to the northwest showing a portion of 45 Broadway Atrium (Fox & Fowle, 1983) on the left and 61 Broadway (Francis H. Kimball, 1913) on the right. Cornish. ESTO

street that included Fraunces Tavern (1719), 54 Pearl Street.[35] The two-block-long, 58,000-square-foot site had been assembled by Lehman Brothers for its own headquarters in 1967. Lehman had hired the newly formed partnership of Philip Johnson and John Burgee, who produced a dramatic black-glass clad design that the investment firm deemed too expensive. Ironically, after Lehman rejected Johnson and Burgee's scheme, it hired Skidmore, Owings & Merill to prepare an alternative that also proved too costly, ultimately abandoning the project in 1974 as a result of high interest rates and a poor market.[36] In addition to its proximity to Fraunces Tavern, 85 Broad Street also stood on a historic site, once home to the city's first City Hall, Stadt Huys, established in 1653 in a three-story building constructed by the Dutch East India Company two decades earlier. An eighteen-member archeological dig led by Nan Rothschild, funded by Galbreath-Ruffin and Goldman Sachs, turned up a number of artifacts dating from Dutch times.

Unlike Johnson and Burgee's glassy, sculpturally inventive design, the scheme by Roy Allen of SOM was overpoweringly massive. Both projects, however, required the closing of Stone Street and Coenties Alley. SOM's trapezoidal tower's tan precast concrete facade was said to have been developed in response to the Landmark Preservation Commission's mandate that the new building harmonize with the historic district's facades. Allowing for the dubious contextualism of the facades, the project's fundamental problem lay in the fact that the building eliminated part of the historic curving alignment of Stone Street, although the introduction of what was charitably described by the editors of the *AIA Guide* as "vestigial" curbs at the intersection of that street with Broad Street and the curved elevator lobby made some amends.[37] Goldman Sachs installed four-by-four-inch tiles through the lobby of its building that retraced Stone Street's crooked path, but the damage to the street was severe, only to be ameliorated some seventeen years later when the Alliance for Downtown New York, as part of the overall effort to help turn the area into a vibrant, twenty-four-hour community, commissioned a master plan from Beyer Blinder Belle for the redevelopment of its remaining length (see Wall Street 24/7). Also, in deference to its neighbors across the street, the height of the first floor of SOM's building was set at thirty feet to align with the height of Fraunces Tavern. All in all, the sheer bulk of the banal design conspired against any sympathetic reading of the attempt to fit in, and the gesture of two glassed-in vitrines set in the sidewalk containing relics from the archeological dig seemed hollow, to say the least.

Even more banal, Gruzen & Partners' twenty-five-story, 260,000-square-foot 40 Broad Street (1983), between Exchange Place and Beaver Street, was representative of the general level of buildings quickly thrown up in the early 1980s to meet the growing space needs of the financial community.[38] In 1984 plans were announced by the British bank Barclays for Welton Becket Associates's thirty-six-story, 660,000-square-foot, red-brown brick clad 75 Wall Street (1987), between Water and Pearl Streets, which emulated the shaped profiles of 1920s skyscrapers–it was claimed as a hybrid of Ralph Walker's Irving Trust Building (1929–31) and his Barclay-Vesey Building (1923–26).[39] One strong feature of the design was the generously proportioned deep entrance cut through the building's flamed granite base.

In 1979 the British entrepreneur Howard Ronson opened operations in New York, at first purchasing two buildings and then focusing on the building scene in lower Manhattan, where he developed a number of office buildings in rapid succession. Ronson originally planned to develop the Broadway blockfront between Morris Street and Exchange Alley with one large building, but when he was unable to secure the purchase of the five-story building at 47 Broadway in which a Chock Full O'Nuts restaurant was operating on a long lease, he decided to go ahead with two relatively modest buildings.[40] Both were designed by the young firm of Fox & Fowle, which would gain a somewhat exaggerated reputation for innovative office building design because of the use of straightforward, horizontally banded facades and wood detailing in the lobbies, which made them seem more friendly than the typical post-Miesian model still generally accepted as the norm. One Exchange Place (1981–83), located on a 15,500-square-foot site at 55 Broadway, southwest corner of Exchange Alley, was distinguished by a slender, thirty-two-story, 300,000-square-foot tower featuring rounded corners that, according to Robert Fox, provided the building with an identity "in contrast with the hard-edged vertical orientation of the adjacent structures."[41] The top twenty floors of the building were column-free, with the service core placed on the south side of the building. To the south, Fox & Fowle's 45 Broadway Atrium (1981–83) was

also thirty-two stories tall but slightly bulkier, accommodating 375,000 square feet. Also recalling International Style skyscrapers of the 1950s, this design consisted of a sawtoothed tower of buff brick and clear glass ribbons atop a six-story base with a deeply recessed entrance. Another downtown collaboration between Ronson and Fox & Fowle resulted in the thirty-story, 370,000-square-foot Broad Financial Center (1984–86), 33 Whitehall Street, between Pearl and Bridge Streets.[42] In this, Fox & Fowle succumbed to the contemporary clichés of curtain wall design, in this case using silver-blue mirrored glass complemented by a three-story gray and blue granite lobby. In order to make the connection to Broad Street that the name of the building implied, a link that Ronson deemed critical in his attempt to market the building, the air rights to the intervening building at the back of the site, Rogers & Butler's two-story New York Clearing House Association (1962), 100 Broad Street, were purchased. Like so many other buildings in the area, the construction of the Broad Financial Center was preceded by an archeological dig that in this case netted the remains of a Dutch warehouse.

Ronson's largest downtown project was One Financial Square (Edward Durell Stone Associates, 1987), located on a site bounded by Front and South Streets, Old Slip, and Gouverneur Lane, a one-million-square-foot, thirty-six-story honed granite and glass clad tower rising from an arcaded granite base and built with 135,000 square feet of development rights transferred from three low-rise neighbors, including Hunt & Hunt's landmarked First Police Precinct Station (1911), 100 Old Slip.[43] The other air-rights contributions came from a demolished fire station (1962), located diagonally across from the building site on Old Slip between Front and Water Streets, which was replaced within the new tower. The now vacant site of the fire station was turned into a modest plaza. The final provider of development rights was the severely detailed, five-story, granite-clad, steel-framed U.S. Assay Building (James A. Wetmore, 1932), 32 Old Slip, which was also demolished.

Gino Valle's eleven-story addition (1982–86) to Francis H. Kimball and Julian C. Levi's eleven-story Seligman Building (1907), at the sharp angled intersection of William and South William Streets, was perhaps the most distinguished office building constructed in lower Manhattan in the 1980s.[44] Valle, a prominent Italian architect based in the city of Udine, had been educated at Harvard in the early 1950s. In this, his first American building, he worked with the American architects Jeremy P. Lang and Fred Liebmann, producing for his client, the Banca Commerciale Italiana, one of the most successful attempts at contextual design in the financial district. One of Italy's largest banks, Banca Commerciale had purchased the Seligman Building and the adjoining site in 1981. Valle's effective effort to complement Kimball and Levi's heavily rusticated limestone-clad mass, designed in an English variation of the Baroque, was not mandated by the City Planning Commission or the Landmarks Preservation Commission, which would not designate the Seligman Building a landmark for another decade, long after the completion of the new work. The relatively small site for the addition allowed for facades on South William and Stone Streets and Mill Lane.

Valle's design not only complemented its companion's height but was also clad in limestone coursed with black granite. Rising from a squared base, the southern, half-round corner of the addition was terminated by a decidedly self-conscious

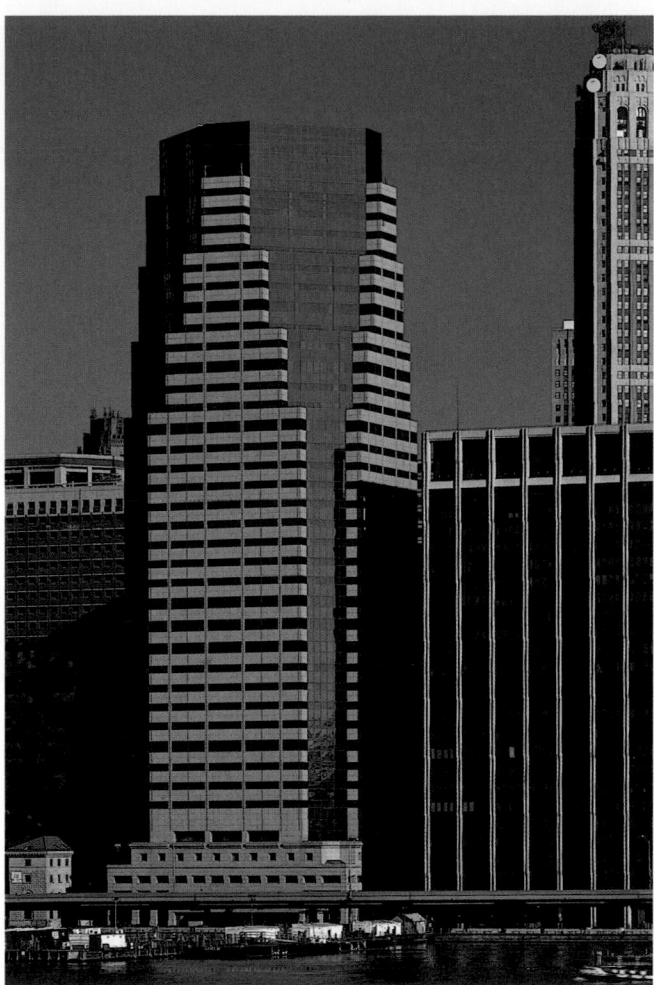

One Financial Square, site bounded by Front and South Streets, Old Slip, and Gouverneur Lane. Edward Durell Stone Associates, 1987. View to the southwest showing First Police Precinct Station (Hunt & Hunt, 1911) on the lower left. Pottle. ESTO

but basically well-meaning, round, ornamental openwork-metal turret that echoed the stone tower form atop the opposite corner on the Seligman Building. On the ninth and tenth floors of the annex on the Mill Lane and South William Street facades, a section of metal spandrel panels alluded to the colonnaded sections of the original building, and curved stainless-steel roof ornaments mimicked the blind bull's-eye windows located on the parapet of Kimball and Levi's design. Double metal entrance doors were placed on South William Street with the service entrance located on Stone Street.

Margot Jacqz, writing in *Skyline* in 1982 when the design was first released, had high hopes: "Valle's detailing creates a minimalist mirror image of the main building in an individualistic yet sympathetic relationship to the styles and proportions of the older neighborhood. His addition appears as the second half of a single building with a dual identity, both traditional and modern."[45] But Valle's building, though it received a Bard Award for excellence in architecture and urban design, failed to capture the significant place it deserved in the history of Postmodernism, perhaps because the designers insisted it was not Postmodern. Kenneth Frampton, writing in the Italian publication *Domus*, avoided the issue of stylistic categorization in his generally positive assessment, ascribing a large measure of Valle's success to his careful treatment of

ABOVE RIGHT Banca Commerciale Italiana, addition to Seligman Building (Francis H. Kimball and Julian C. Levi, 1907), site bounded by William, South William, and Stone Streets and Mill Lane. Gino Valle, 1986. View showing Valle addition on left and Seligman Building on right. GV

ABOVE Banca Commerciale Italiana, addition to Seligman Building (Francis H. Kimball and Julian C. Levi, 1907), site bounded by William, South William, and Stone Streets and Mill Lane. Gino Valle, 1986. View to the northeast. GV

RIGHT Banca Commerciale Italiana, addition to Seligman Building (Francis H. Kimball and Julian C. Levi, 1907), site bounded by William, South William, and Stone Streets and Mill Lane. Gino Valle, 1986. Axonometric. GV

the building's curtain wall: "In many respects this building demands to be understood as a didactic essay in stone revetment; as Gino Valle's 'letter to America' as it were. After the vogue for high-rise, historicist pastiche in New York, carried out in the thinnest of stone veneers backed-up with fibreglass, this work stands out as a contrapuntal essay in what appears to be slightly thicker stone. It is a small difference but one which counts for a lot in this city of glyptic packaging. By stressing the depth of his masonry, Valle is able to create a legible discourse between the existing [Seligman Building] . . . and his own new addition." Frampton did have some reservations about the decorative work at the top of the building, in particular the "Neo-Liberty, tubular stainless steel accoutrements," but in the end he was moved to observe that "this is a remarkable work above all for the abstract rigor of its sculptural stonework, and for its diminutive size and discrete placement; a modest essay by an Italian master hidden way in the dramatic canyons of Wall Street."[46]

The veteran developer Melvyn Kaufman, who made his mark in lower Manhattan in the early 1970s with relatively ordinary glass curtain wall buildings that incorporated some whimsical elements, like the Sopwith Camel perched atop the roof of 77 Water Street (Emery Roth & Sons, 1970), returned to the financial district in the mid-1980s with a new building, 17 State Street (1985-88), that stood out this time for its bold but highly simplistic design.[47] The 29,000-square-foot plot of land, overlooking Battery Park on the southeast corner of Pearl and State Streets, was a highly visible spot,

assuring that whatever was built would become a prominent feature of the lower Manhattan skyline. The site had been home to the twenty-three-story red brick headquarters designed by Eggers & Higgins for the Seamen's Church Institute, which had only been completed in 1969.[48] Kaufman explained that because the Seamen's building had been designed to meet the specific needs of its single tenant that would soon occupy a new purpose-built headquarters designed by James Stewart Polshek in the South Street Seaport area, it was "absolutely unusable for anything but exactly what it was designed for." Therefore, he concluded, it was impractical to renovate and recycle the building as a speculative office venture considering that he "could stand on the floor and touch the concrete slab above."[49]

Kaufman turned to Emery Roth & Sons for the design of the forty-two-story, 525,000-square-foot tower that, in response to the oddly shaped site, adopted a wedge-shaped plan with two sides at right angles to each other and the third side, facing Battery Park, bowed outward to follow the curve of State Street. The nearly 600-foot-high building rose on twenty-five-foot-high aluminum-clad perimeter columns from a granite-paved plaza and featured a curved glass, free-standing, thirty-foot-diameter entrance lobby with the two elevator banks also encased in glass to show the lift mechanism. The curved mirrored glass facade was installed with a new technique called four-sided structural glazing, which required no exterior metal stops to hold the glass in place, permitting a virtually uninflected field of glass to run the full length of the tower. The side walls were sheathed in aluminum and glass. If the prominent site and the reflective glass curtain wall, all the more striking because of the dark bulk of 17 State Street's near neighbors, were not enough to draw attention, the theatrically inclined lighting consultant Howard Brandston added the "Icon," a specially designed beacon that sent a powerful beam of light into the night sky.

Emery Roth & Sons was also responsible for the design of the seventh and last planned component of the World Trade Center complex, Seven World Trade Center (1987), located on a 50,000-square-foot, trapezoidal-shaped site bounded by West Broadway and Vesey, Washington, and Barclay Streets.[50] Plans for the forty-seven-story, 1.8-million-square-foot building were first released in 1981. Although the Port Authority owned the building and the land underneath, the project would be built and operated under a ninety-nine-year-lease with Silverstein Properties, which conceived it as a home for brokers, banks, and other financial service companies. The Roth firm, though it had served as associate architect on the design of the two 110-story Trade Center towers as well as the eight-story and two nine-story buildings on the plaza, eschewed the aesthetic example set by Minoru Yamasaki in 1973, instead sheathing its building in reflective glass and polished and flame-roughened red granite from Finland.[51] Brutally scaled as it rose without setbacks, this most northern element of the Trade Center compound featured exceptionally large, 48,000-square-foot floors as well as an enclosed pedestrian bridge that would directly connect with the plaza level of the center and escalators leading down to the various concourse levels and their retail facilities and links to subway lines and the PATH train. Although there were also street-level entrances, the main entrance to Seven World Trade Center was through this 150-foot-wide walkway located thirty feet over Vesey Street.

17 State Street, southeast corner of Pearl Street. Emery Roth & Sons, 1988. View to the northwest. McGrath. NMcG

17 State Street, southeast corner of Pearl Street. Emery Roth & Sons, 1988. View to the northeast. McGrath. NMcG

Seven World Trade Center, site bounded by West Broadway and Vesey, Washington, and Barclay Streets. Emery Roth & Sons, 1987. View to the northwest. McGrath. NMcG

Silverstein's faith in the market seemed justified when, on May 24, 1986, he was able to announce that Seven World Trade Center would become the new home of the "hot" investment banking firm Drexel Burnham Lambert, a venerable but previously sleepy institution whose business and reputation had recently taken off with the explosion in the junk bond business, which it dominated, ironically, not from its New York headquarters but out of its Los Angeles office headed by Michael Milken, then little known outside of financial circles. In July, when the last piece of structural steel was raised to the top of the tower, Silverstein and Drexel signed their $3 billion lease deal, which also made Drexel an equity partner in the project. But six months later the deal collapsed, in part because of changes in the tax code that Drexel deemed damaging but mostly because of the firm's involvement with a growing insider-trading scandal that would eventually lead to its dissolution. Now, close to two million square feet of prime space was thrust on a market already saturated from the early 1980s boom in construction. As Mark McCain, writing in the real estate pages of the *New York Times*, put it, "Mr. Silverstein has a bleak, 47-story tower . . . that radiates all the charm of a massive shoebox."[52] The building was not substantially filled until November 1989, when Salomon Brothers signed a twenty-year lease for over one million square feet of space.

Salomon Brothers invested an additional $200 million to substantially alter and upgrade the twenty-two floors it rented at Seven World Trade Center. Four new elevators and two new escalators were added inside the tower, with more than 375 tons of steel requiring twelve miles of welding installed to reinforce floors. Salomon also cut out floors to create three new double-height trading rooms. Fortunately, according to Larry Silverstein, "We built in enough redundancy to allow entire portions of floors to be removed without affecting the building's structural integrity, on the assumption that someone might need double-height floors. Sure enough, Salomon had that need."[53] The September 11, 2001, attack on the Trade Center also brought down Seven World Trade Center, which collapsed approximately seven hours after the Twin Towers, at 5:20 P.M., as the result of fire damage.

Directly north of Seven World Trade Center, on a 100,000-square-foot city-owned site bounded by Murray, Greenwich, Barclay, and West Streets, Skidmore, Owings & Merrill's 101 Barclay Street (1983) was built to serve as the clerical and computer operations center of the Irving Trust Company, which still retained its Ralph Walker–designed headquarters at 1 Wall Street (1929–31).[54] The location of the one-million-square-foot, twenty-three-story building was significant, marking an early intrusion of office buildings into the southern edges of the loft district known since the mid-1970s as Tribeca. Designed in the shape of a cube, the massive slope-roofed building consisted of two unequal sections, one rising to twenty-three stories, the other to fifteen stories, separated by a sixty-foot-wide, north–south, full-height atrium that was made possible by the partial closing of Washington Street, resulting in 60,000-square-foot floors linked by bridges and balconies encircling the atrium's perimeter. The upper level of the fifteen-story section, open to the atrium, was turned into a lounge and cafeteria for Irving Trust employees. Despite the enormous floor plates, the atrium placed no employee more than forty-five feet from natural light. The steel-frame structure was enclosed by six-by-four-foot glass panels which created a polychromed, ribboned effect by the use of three

The construction of Seven World Trade Center was complicated by the fact that the building had to be carried by elaborate trusswork over the existing, one-story Consolidated Edison substation, dating from the construction of the original Trade Center, which controlled much of the power needed in the area. But the 618-foot-tall building's reputation lay not with its structure or enormous size, enclosing approximately forty-eight acres of office space, or even with its improbable, anti-contextual cladding, but with its fate as a piece of real estate. Ground was not broken for the building until October 1984, nearly three years after it was first announced and the same year it was originally envisioned to be completed. Larry A. Silverstein, president of Silverstein Properties, began construction with no major tenant in place but believed that he would have no trouble filling the building, a confidence buttressed in part by his deal with the Port Authority that defrayed much of his costs until tenants could be found.

different types of glass, with partially reflective and clear vision glass bands wrapping the building between white opaque glass spandrel panels. A departure for SOM's New York office, the design, credited to Raul de Armas, reflected the influence of John Portman's hotels, not to mention the work of the lead designer in the firm's Chicago office, Bruce Graham, whose contemporaneous 875 Third Avenue featured atria (see Third Avenue).

On the full block site across the street from Irving Trust's operations center and bounded by Murray Street, West Broadway, Park Place, and Greenwich Street, the rush of lower Manhattan office building construction continued with Emery Roth & Sons's 580,000-square-foot, fourteen-story 75 Park Place (1987).[55] Developed by Jack Resnick & Sons on a city-owned, 43,000-square-foot lot that had previously housed a truck garage, the building was one of the first in the city whose basic design incorporated the demands of the new communications technology, with each of the 38,000- to 47,000-square-foot floors containing a room devoted to fiber optics, microwave, and satellite telecommunications. More successful than its SOM-designed neighbor to the west, as well as their own Trade Center building a block to the south, 75 Park Place was able to lighten its boxy mass with a crisply detailed facade that alternated thin blue stripes with silvery reflective glass strip windows.

In January 1984, the joint announcement by Peter A. Cohen, president of Shearson/American Express, and Mayor Koch of an agreement to grant the financial services giant significant tax abatements in exchange for the construction of a

101 Barclay Street, Barclay to Murray Street, Greenwich to West Street. Skidmore, Owings & Merrill, 1983. View to the northwest. Hoyt. ESTO

101 Barclay Street, Barclay to Murray Street, Greenwich to West Street. Skidmore, Owings & Merrill, 1983. Atrium. Aaron. ESTO

Shearson Building, 388
Greenwich Street, northwest
corner of North Moore Street.
Kohn Pedersen Fox, 1989. View
to the northeast along West
Street showing the Borough of
Manhattan Community College
(Caudill Rowlett Scott
Partnership, 1981) on right and
the Faulkner Information
Services Center (Skidmore,
Owings & Merrill, 1986) on left.
KPF

two-building complex on a vacant, city-owned, two-block-long site bounded by Hubert, Greenwich, North Moore, and West Streets set off a firestorm of protest from residents and community groups in Tribeca who feared that this move, the most significant incursion into this prospering mixed-use community of residential lofts, restaurants, art galleries, and high-end retail establishments, could possibly lead to the area's redevelopment as an extension of the financial district.[56] The mayor's office countered that the proposed project prevented the loss of more than 3,000 jobs in light of the threat by Shearson/American Express to leave the city for the new Newport City development across the Hudson River in Jersey City. They also pointed out that the company agreed to pro-

vide funds for the construction of the first new elementary school in Manhattan in thirteen years, Richard Dattner's P.S. 234 (see Tribeca).

The 172,000-square-foot site of the Shearson Building, to the north of the middle-income Independence Plaza housing development (Oppenheimer, Brady & Vogelstein, 1975), was intended to house a computer center, to be completed first, as well as a major office tower located about a half-mile from the building Shearson/American Express was also to occupy in the World Financial Center, then still under construction.[57] On June 28, 1984, the Board of Estimate approved the project, quickly provoking a lawsuit from a local group, the Tribeca Community Association, which was supported by two

prominent politicians, City Councilwoman Ruth W. Messinger and State Senator Franz S. Leichter, who argued that in addition to providing overly generous tax breaks to a wealthy corporation the city had failed to properly assess the impact of the two new buildings on the neighborhood. In November State Supreme Court Justice Martin B. Stecher dismissed the suit.

The first component of the Shearson project to be completed was Skidmore, Owings & Merrill's eight-story, 730,000-square-foot computer operations center (1986), located at the north end of the site at 390 Greenwich Street, southwest corner of Hubert Street and running through to West Street. With its two-acre-sized floors, the building, known as the Faulkner Information Services Center, served as the financial company's nerve center, responsible for the more than 400,000 daily messages between the firm's various offices. The design of the brown concrete framed building was little more than diagrammatic, resulting in a brutal work that was hardly relieved by the three bays of recessed windows on the Greenwich Street facade or the thin red top-to-bottom vertical stripes which were placed at regular intervals all around the building.

Far more successful as a work of architecture was the thirty-nine-story, 1.5-million-square-foot classically inspired Shearson office tower (1989) designed by Kohn Pedersen Fox partner Arthur May, the member of the firm who most favored the reinterpretation of traditional skyscraper models. The firm was well aware of the contextual challenge posed by the site, noting that the building marked "the infiltration" of the skyscraper "into the established medium-scale loft residential neighborhood. To interpolate this contextual juxtaposition, the architects have manipulated the mass of the building . . . to create two separate readings: that of a tower addressing the water and that of a building stepping down to the lower residential scale."[58] Despite the architects' best efforts, there was no denying the validity of the initial fears expressed by local residents that the building would overwhelm the scale of the historic neighborhood. Also contributing to the negative reaction was the fact that KPF's building replaced a short-lived, but nonetheless much admired and heavily used, 200-by-100-foot park (1986) designed by Weintraub & di Domenico that had almost 13,000 square feet devoted to green space. The park that replaced the original, also designed by Weintraub & di Domenico, was only one-quarter the size and basically a glorified entrance plaza dominated by concrete with only two small, sparsely landscaped raised terraces filled with benches, perhaps useful to Shearson employees at lunchtime but hardly hospitable to the families who had enjoyed the earlier Shearson Park.

In May 1997, some eight years after the completion of KPF's office tower, the building came under renewed scrutiny after its new corporate parent, the insurance conglomerate Travelers Group, decided to affix its corporate logo, a red neon umbrella, on the north face of the building as well as place another at the plaza level in the form of an oversized sculpture.[59] While the ground-level addition created no controversy, the four-story neon umbrella located near the top of the tower unleashed a storm of protest far greater than that generated by the construction of the original building complex. Almost immediately, Community Boards 1 and 2 were inundated with complaints, many from Greenwich Village residents who believed that the bright fifty-foot-tall sign not only spoiled their views of lower Manhattan but also cast an eerie red glow inside their apartments. Visible from miles away, the blazing bumbershoot was constructed of enough tubing to ring a football field four times over. The graphic designer Tibor Kalman put his witty spin on the controversy, proposing a series of symbols that instead of a simple umbrella would describe changing weather conditions. But Kalman also noted that while "some areas, like Times Square, are well suited to and even improved by advertising . . . we deserve peaceful exceptions. Our skyline is a treasure. We should preserve it like a redwood forest."[60]

Many thought that the logo had been placed illegally, but in fact Travelers had acted within the law because the Department of Buildings, in a 1991 ruling, deemed that when a sign is an "integral" part of the architecture of a building owned and occupied by a corporation, the sign is really not a sign but a symbol and therefore not subject to the zoning laws. Critics questioned how the sign could be an "integral" part of the building's architecture when it was added on close to a decade after completion. In April 1998, nearly a year after the neon umbrella made its debut, the Travelers Group was again in the news when it announced a decision to merge with Citicorp and at the same time hinted that a new red giant might be affixed to Hugh Stubbins's headquarters building on Fifty-third Street.[61] Perhaps it was this prospect that finally prompted the New York Times to voice its opposition to the enormous intrusion in the night sky in an editorial titled "Fold the Umbrella": "Downtown New York is exactly the wrong place for a sign of this size and candlepower. The steel, stone and glass architecture of lower Manhattan offers one of America's majestic urban profiles, to which the Travelers logo adds nothing. . . . The Travelers logo not only fits imperfectly with lower Manhattan's architecture but trivializes it."[62] On June 24, 1998, a compromise was reached, with Travelers, which abandoned the idea of an umbrella logo placed on Citicorp Center, agreeing to turn off the downtown sign between 7:30 P.M. and 11:30 P.M. from June through October and between 6:00 P.M. and 10:00 P.M. in the winter months; they also agreed to dim the light overnight by 60 percent.

NEW YORK STOCK EXCHANGE

The New York Stock Exchange, the city's and the nation's single most important financial market since its founding in 1792, entered the late 1970s in full control of its dominant position but seriously in need of additional space for trading operations as well as back-office functions. The exchange's almost endless appetite for office space had a long history. Since 1903 it had been headquartered in George B. Post's imposing building at 8 Broad Street, between Wall Street and Exchange Place.[1] In 1922 it expanded into a twenty-three-story building (Trowbridge & Livingston), 11 Wall Street, southwest corner of Broad Street.[2] The booming market of the 1960s encouraged the exchange to consider relocation. Unrealized designs in 1960 and 1961 by Skidmore, Owings & Merrill and Richard W. Adler, part of early proposals for the World Trade Center, were followed in 1963 with proposals drafted by O'Connor & Kilham and I. M. Pei, as well as a 1966 scheme by Gordon Bunshaft of Skidmore, Owings & Merrill.[3] None of these was carried out, and the exchange made do with additional office space in 20 Broad Street (1956), a banal building designed by Kahn & Jacobs and Sidney Goldstone.[4]

In February 1977, rumors began to circulate that in an effort to build a new facility, the New York Stock Exchange would merge with the American Stock Exchange, which was located nearby at 86 Trinity Place in a building designed for the New York Curb Exchange by Starrett & Van Vleck in 1930.[5] Plans for the deal quickly fell through, and the next year the American Stock Exchange was courted by the city and state to build a new headquarters in Battery Park City. The New York Stock Exchange, after briefly considering a merger with the Commodity Exchange, proceeded with fairly modest changes to its home building, including a long-over-due renovation of its visitors' center in 1979, creating a new split-level gallery overlooking the trading floor. Mayor Ed Koch, speaking at the opening ceremonies, gave the beige-carpeted visitors' center a backhanded compliment when he observed, "It looks like a hotel."[6] In 1980 the exchange, still in need of additional office space, rented 25,000 square feet in 100 Broadway (Bruce Price, 1896; renovation, Kajima International, 1975), a fairly inconvenient location.[7] The situation on the crowded trading floor remained a vexing problem that was partially addressed in 1985, the same year that Post's

Proposed New York Stock Exchange Building, site bounded by Broad, Wall, and William Streets and Exchange Place. Skidmore, Owings & Merrill, 2001. Model, view to the southeast. Pottle. ESTO

building was declared an official city landmark, with the announcement of plans, completed in 1988, to go ahead with a renovation that would add 7,000 square feet to the exchange's existing 30,000 square feet.[8]

The stock market crash of 1987 curbed the exchange's appetite for expansion until 1992. The subject was seriously brought up again after the failure of the American Stock Exchange's plan to build a new headquarters in Battery Park City led to discussions, not about merging the two institutions but about sharing a new building.[9] City officials, concerned over the deteriorating economic health of the financial district, which was experiencing a 24 percent vacancy rate in its office buildings, supported the idea. A potential site for a new combined stock exchange facility was located across the street from the New York Stock Exchange on the full block bounded by Broad, Wall, and William Streets and Exchange Place. Olympia & York was to be the developer. J. P. Morgan, which had only recently moved to a new headquarters at 60 Wall Street designed by Kevin Roche, controlled a majority of the site and was more than willing to strike a deal. In addition to Morgan's landmark headquarters at 23 Wall Street (Trowbridge & Livingston, 1913) and the adjoining tower the company occupied at 15 Broad Street (Trowbridge & Livingston, 1928), the site also included 37 Wall Street (Francis H. Kimball, 1907) and 45 Wall Street (Voorhees, Walker, Smith, Smith & Haines, 1959).[10] When Olympia & York encountered financial difficulties, a new development team of Lewis Rudin, Gerald Hines, and Fred Wilpon, along with J. P. Morgan, took over. Although no drawings for the project were ever released, Skidmore, Owings & Merrill's design for the 1.7-million-square-foot super stock exchange was thought to include two 50,000-square-foot trading floors topped by a fifty-story tower. Separate entrances were provided for the two exchanges. Though SOM's proposal retained the facade of 23 Wall Street, all the other buildings on the block were to be demolished. Despite the enthusiastic support of city officials, who continued to believe that lower Manhattan needed the shot of adrenaline that this blockbuster would deliver, the New York Stock Exchange decided in September 1993 not to go ahead with the project.

Three years later, in 1996, the Stock Exchange, impressed by the very generous package that the New York Mercantile Exchange had received in order to build a new headquarters in Battery Park City, and spurred in part by the dramatic increase in trading volume that had more than doubled in the last five years as well as by the addition of more than 1,000 new companies listed on its board in the same period, once again sought to expand. Despite the overall economy's increasing prosperity, vacancy rates for offices in the financial district had escalated in the last three years and Richard A. Grasso, chairman of the Stock Exchange, was confident that he could convince the city and state to put together an even more attractive bundle of incentives. One proposal that captured everyone's attention came from the developer Donald Trump, who, in August 1996, announced his intention to build the world's tallest building for the New York Stock Exchange.[11] This was Trump's second attempt to build the world's tallest building in New York, having failed in his efforts to realize Television City (see Upper West Side). Trump planned to eclipse Cesar Pelli's 1,524-foot-tall Petronas Towers then under construction in Kuala Lumpur, Malaysia, with a 1,792-foot-tall tower whose height was picked to match the date of the New York Stock Exchange's founding.[12] To be designed by

Kohn Pedersen Fox, the 3.5-million-square-foot, 140-story, dramatically tapered, glass-clad obelisk would feature a 50,000-square-foot bottom floor that rose to a 5,000-square-foot floor at the top. The skyscraper would include office space for some 100,000 workers, while the exchange's 120,000-square-foot trading floor would be housed in an intricately roofed 250,000-square-foot freestanding pavilion located next to the tower. Trump proposed his project for the eastern end of Wall Street and the East River, a city-owned site that included two piers.

Eleven weeks after Trump's proposal was first announced, it was all but forgotten when the New York Stock Exchange announced its own plan to expand its trading floor in a radical and controversial way.[13] The plan, produced by HLW International, called for expanding the cramped trading floor on a platform extending one story above Broad Street, connecting the facade of George B. Post's building with that of Trowbridge & Livingston's 23 Wall Street. Atop the new 20,000-square-foot trading floor would be a glass-enclosed gable-roofed atrium rising eight stories to provide exchange employees a dramatic and expanded work space that would allow views of the sky as well as the iconic temple front of Post's building. Reaction in the preservation community was swift and negative. Brendan Sexton, president of the Municipal Art Society, planted his tongue firmly in his cheek in a damning letter to the editor of the *New York Times*: "New York City's planning and civic groups were embarrassed to see that the New York Stock Exchange's plan to expand by building an eight-story structure over Broad Street had scooped us, solving our city's problem of too little space at too high rent. Let's just build in the streets."[14] In December 1996, the exchange, reluctant to abandon the idea, hired Hugh Hardy in an attempt to mollify the preservation community.[15] Hardy's efforts to counter the criticism with a new design featuring a parabolic vaulted atrium still met with broad opposition, and the New York Stock Exchange decided not to proceed with a plan it felt had little chance of being realized.

In February 1998, the New York Stock Exchange, now under increasing pressure from the surging Nasdaq (National Association of Securities Dealers Automated Quotations) market, which had recently eclipsed the NYSE in annual share volume by virtue of the growth of high-technology companies that the upstart exchange specialized in, again made it clear that expansion was necessary.[16] The NYSE first declared its interest in Battery Park City's Site 26, directly north of Three and Four World Financial Center and northeast of the new Mercantile Exchange, but city officials remained intent on keeping the institution in the heart of the financial district. Attention then returned to the site considered in 1992, directly across the street from the Post building and bounded by Broad, Wall, and William Streets and Exchange Place. Christine Todd Whitman, governor of New Jersey, entered the picture in May, offering the exchange a site in Jersey City. Despite Richard A. Grasso's protestation that "the New Jersey Stock Exchange does not have that global ring to it," Whitman's preemptive offer was taken seriously by city and state officials who quickly put together a subsidy package that dwarfed the one previously given to the Mercantile Exchange.[17]

Although an announcement that a deal had been reached was released on December 22, 1998, it was not actually signed until some two years later on December 20, 2000. The deal required that the city purchase the site, still largely

TOP Proposed New York Stock Exchange Building, Wall Street and the East River. Kohn Pedersen Fox, 1996. Rendering of view to the southwest. AWWP

ABOVE Proposed expansion of New York Stock Exchange trading floor, platform extending across Broad Street from New York Stock Exchange Building (George B. Post, 1903) to J. P. Morgan & Co. Building (Trowbridge & Livingston, 1913). Hardy Holzman Pfeiffer, 1996. Model. H3

New York Stock Exchange trading center, 30 Broad Street. Skidmore, Owings & Merrill, 1999. Aaron. ESTO

New York Stock Exchange trading floor operations center, 8 Broad Street. Studio Asymptote, 1999. ASY

controlled by Morgan, and provide substantial tax breaks to the exchange which, in turn, would pay rent. The city would also be given the right to sell the air rights above the trading portion of the building to enable the construction of an office tower that would be the first new skyscraper built in the financial district in a decade. Skidmore, Owings & Merrill was again involved, designing the 800,000-square-foot, ten-story trading podium that included two triple-height 50,000-square-foot trading floors separated by an interstitial floor for telecommunications functions and a data center sized to relate to Post's building across the street as well as to avoid overwhelming Morgan's landmark building at 23 Wall Street. Set back from the trading element was a 1.2-million-square-foot, fifty-story, 900-foot-high, stainless-steel and glass tower with office floors ranging from 25,000 square feet at the bottom to 18,000 square feet at the top. The design would spare 23 Wall Street but would require the demolition of all the other buildings on the site, including 45 Wall Street which, at the city's urging, had been recently converted into an apartment building by the Rockrose Development Corporation (see Wall Street 24/7). In March 2001, when Rockrose informed the tenants of 45 Wall Street that they had to leave, many were outraged by the city's seemingly schizophrenic planning strategy. The effects of the September 11, 2001, disaster took its toll on the Stock Exchange's ambitious plans, and SOM's tower did not proceed. It was officially abandoned in August 2002. In February 2003, the project came full circle with the announcement that Rockrose was again renting apartments at 45 Wall Street. As former tenant Ray Fleischhacker put it, "They disrupted the lives of 400 families. It was all for nothing."[18]

In the late 1990s and early 2000s, some market followers began to believe that with the dramatic increase in electronic trading the exchange might well need less, rather than more, space to complete its transactions. As Junius Peake, a former vice chairman of the rival Nasdaq, put it: "The sooner they turn the floor of the New York Stock Exchange into theme restaurants and bars, the better off they are. Technology is overrunning them."[19] The New York Stock Exchange rejected that notion but certainly didn't ignore advances in technology. In a kind of dry run for its planned new headquarters that had the additional advantage of providing more trading space, the exchange hired SOM to create a high-tech 10,000-square-foot trading facility (1999) at 30 Broad Street (Morris & O'Connor, 1932), southwest corner of Exchange Place, featuring plastic laminate and corrugated metal wall panels.[20] To create a bright and airy feeling in a space dominated by hundreds of flat panel monitors, SOM specified light wood floors and indirect lighting that reflected off a curved white ceiling, while placing as much equipment as possible on an overhead catwalk.

In an even more dramatic example of the New York Stock Exchange's commitment to innovative technology, Hani Rashid and Lise Anne Couture's Studio Asymptote was commissioned to design a computer-generated, three-dimensional, real-time model (1999) of the trading floor in order to help efficiently manage operations as well as alert the exchange to any technical problems or unusual patterns in trading.[21] One of the earliest and largest virtual-reality environments of its kind, the three-dimensional trading floor, or 3DTF as it was known, was located next to the actual trading floor in a 1,200-square-foot operations center designed by Asymptote, which was also to serve as a setting for public events and live television broadcasts. The focus of the operations center was an undulating back-lit blue-glass wall carrying up to sixty high-resolution flat-screen monitors on its surface. The design included fiber-optic illuminated work surfaces, an LED message board, and a stock ticker incorporated as part of the ceiling. Rashid, waxing a bit hyperbolic, compared the space to a cathedral: "In both you have a large number of people passing through and a great deal of information to convey. In a cathedral, frescoes and stained glass carry narratives, making the virtual world real, whereas in the Stock Exchange, we've made the real world virtual."[22]

WALL STREET 24/7

Although the movement to turn the financial district into a seven-day, twenty-four-hour community with a substantial residential component did not come into its own until the mid-1990s, the idea of converting former office space into apartments was pioneered in 1979 at Liberty Tower, 55 Liberty Street (Henry Ives Cobb, 1909), northwest corner of Nassau Street, by the architect Joseph Pell Lombardi working with investors Bertrand L. Taylor and Stephen Globus.[1] The thirty-three-story Gothic-style office tower, clad in white glazed terra-cotta, was two-thirds empty when purchased, and Lombardi, acting under the J-51 tax abatement program, broke it up into sixty-four cooperative apartments, including duplex and triplex units. Adopting the practice followed in loft conversions, the units were sold "as is" in their raw state so that individual purchasers could customize their space according to their own tastes. Lombardi reserved for his own use the 5,100-square-foot full floor that once contained the boardroom of Sinclair Oil, where Harry Sinclair hatched the deals with the Harding administration that were later exposed as the Teapot Dome Scandal. Lombardi rearranged the boardroom space to serve as his triple-exposed living room commanding views of the skyline, river, and harbor. Reusing the old walnut paneling and crown moldings, Lombardi "didn't try to domesticate the space, but kept its men's club board room look." According to the architect, it was the tower's architecture that made the project a success: "Living in a Gothic skyscraper in the center of the financial district is a little like living in the Statue of Liberty."[2] The colorful history of the Lombardi apartment aside, the most interesting apartment in the building was designed by Franklin D. Israel for the fashion photographer and makeup artist Francis R. Gillette (1980–82).[3] At the top of the building in the former boiler room, Israel first gutted the 3,000-square-foot, loftlike, fourteen-and-a-half-foot-high space which, according to the architect, "became a shell for a new, and in some ways foreign, pattern of order."[4] Israel grouped the living and dining rooms and bedroom areas in gabled alcoves around the perimeter of the apartment so that the central space could be left open to accommodate a lath and plaster two-level 'house' containing a darkroom and photo archive, which was reached by a freestanding stair. Another "house" contained a bathroom, closets, and a guest room. Following the request of his client, the design inspiration for the apartment came from the work of the Mexican architect Luis Barragán. Although Suzanne Stephens felt that "the massing of the houses, the configuration of the stair, the use of colored stucco walls (with shades chosen and mixed by Gillette) are . . . reminiscent of Barragán's serene distillation of textures, colors, and planar surfaces," Israel's own voice was able to be heard: "Israel's handling of architectural themes, such as the development of a procession of spaces within the houses, the use of long axes, and the play with symmetry, are important to the architectonic character of the whole." In the end, Stephens concluded, "Sometimes the balance is almost thrown off, but even at its most precarious, the ensemble coheres as an arrestingly idiosyncratic statement."[5]

Despite the success of Liberty Tower, there was hardly a rush to turn the Wall Street area into a residential neighborhood, and only a few more modest conversions were completed, including Wechsler, Grasso & Menziuso's 1979 renovation of the red brick Romanesque-inspired Excelsior Power Company substation (William G. Grinnell, 1887–88), 33–48 Gold Street, between Fulton and John Streets, into 197 apartments and, in the same year, Henry George Greene's reworking of the twenty-four-story New York Cotton Exchange (Donn Barber, 1923), 3 Hanover Square, into 201 apartments.[6] One of the reasons that the conversion market

Joseph Pell Lombardi apartment, 55 Liberty Street, northwest corner of Nassau Street. Joseph Pell Lombardi, 1979. Plan. JPL

Joseph Pell Lombardi apartment, 55 Liberty Street, northwest corner of Nassau Street. Joseph Pell Lombardi, 1979. Living room. JPL

Francis R. Gillette apartment, 55 Liberty Street, northwest corner of Nassau Street. Franklin D. Israel, 1982. Hursley. TH

Francis R. Gillette apartment, 55 Liberty Street, northwest corner of Nassau Street. Franklin D. Israel, 1982. Hursley. TH

did not pick up steam was the rebound in the construction of office buildings in the financial district in the early and mid-1980s. Contributing as well was the fact that the great bulk of downtown residential activity was taking place in Tribeca and in Battery Park City. Only after the 1987 stock market crash and the subsequent severe downturn in the market for office space in lower Manhattan did interest revive for converting outmoded office buildings into residential use.

In October 1992, in anticipation of the City Planning Commission's release of its Plan for Lower Manhattan, the first major planning effort for downtown from the commission since its Lower Manhattan Plan (1966), Ted Cohen, writing in *Metropolis*, noted that residential conversion of office buildings was under "hot consideration" and that the new model for the financial district was Battery Park City:

> But the road to a Battery Park City–like future for the downtown financial district is as narrow and shadowy as Wall Street itself. In terms of its densely packed buildings and the free-market principles to which it has historically linked its fortunes, Wall Street is staunchly resistant to the kind of top-down reorganization that produced Battery Park City. And so, proponents of conversion rapturously recall the redevelopment history of Soho and Tribeca, and cut right to the chase: only through the same kind of partnership that the city and private sector struck in those neighborhoods in the late Seventies will the Wall Street area be able to make a smooth transition to a secure domestic future.[7]

A year later, in October 1993, the City Planning Commission published the Plan for Lower Manhattan, prepared in association with the Downtown-Lower Manhattan Association, which directly supported the idea of residential conversions: "Such a policy would . . . put empty and often handsome older buildings to good use, . . . reinforce the 24-hour activities engendered by local residents; . . . make the area more diverse and less prone to cyclical fluctuations in the commercial real estate market; and . . . create the critical mass of residents needed to support a wide range of stores and services." Despite potential problems—"it is neither simple nor straightforward to introduce scattered apartments into a concentrated office district without jeopardizing the future of the office core itself"—the commission, which had no authority to finance or carry out its recommendations, concluded that the city should grant tax breaks and allow zoning changes that would encourage the conversion market to flourish.[8]

Mayor Rudolph Giuliani took up the cause of residential conversion in the financial district, but it would take another two years, until the New York State Senate's October 12, 1995, passing of a tax abatement bill, before his Downtown Revitalization Plan could be set in motion.[9] In addition to substantial tax incentives, the plan also relaxed zoning laws to allow for residential units as small as 900 square feet, reducing by exactly half the previous standard of 1,800 square feet, which was seen as a serious impediment. Carol Willis, who at the time was trying to establish a skyscraper museum, noted, "Skyscrapers built between the 1890's and the 1940's are beautifully adaptable to residential use. They are natural for conversion. Before the advent of fluorescent lighting and air-conditioning, buildings relied on natural light and air. First-class office space had large, operable windows and a maximum distance of 28 feet from window to corridor wall."[10] Reaction in the development community was swift and

Francis R. Gillette apartment, 55 Liberty Street, northwest corner of Nassau Street. Franklin D. Israel, 1982. Cutaway axonometric. FDI

dramatic. Less than a year after the incentive plan was approved, more than twenty buildings were slated for conversion, and the financial district's population, which numbered just 2,000 in the 1990 census, was projected to reach 15,000 by 2002.

By the late 1990s, there was something of a boom in residential conversions of downtown office buildings, which can be said to have begun with the conversion of the twenty-one-story, 525,000-square-foot 25 Broad Street (Clinton & Russell, 1901), southeast corner of Exchange Place, into 345 apartments with ceilings as high as fifteen feet and none lower than ten feet.[11] Although the upper floors were completely gutted, the marble-clad lobby, with its carved terra-cotta ceilings and palatial staircases, was restored. Costas Kondylis, the architect for the conversion, was able to remove one elevator bank, using its ground-floor area for a lobby and mail room, and the space on the upper floors for laundry rooms and storage bins. In 1996, while 25 Broad Street was undergoing renovation, *New York* magazine, in an article imagining life in the city in ten years' time, chose it as the quintessential address for a hip, successful New Yorker, noting, "Broad Street may be to the *fin de siècle* what West Broadway was to the sixties and seventies."[12]

The next major conversion project was Meltzer/Mandl Architects' reworking of the twenty-eight-story, 490,000-square-foot 45 Wall Street (Voorhees, Walker, Smith, Smith & Haines, 1959) into 435 rental apartments.[13] With Mayor Giuliani wielding a sledgehammer to start the 1996 renovations of the building that had been vacant for several years, 45 Wall Street was one of the most widely talked about conver-

sion projects undertaken in recent years. In 1999, two years after its successful opening, Jennifer Lee profiled the building and its tenants in the *New York Times*:

> The residents of 45 Wall Street are relatively young. They are urban. They are brazenly professional. The converted office building in which they live, one block from the New York Stock Exchange, has become known as an upscale dormitory of sorts for armies of fresh college graduates, who invade Wall Street from the country's premier universities. "The question here is what Wall Street company do you work for, not what do you do," said James Im, a University of Chicago graduate, who was doing stomach crunches in the gym. "Forty-five Wall is famous. It's known to be an analysts' dormitory."[14]

But in December 2000, by which time 45 Wall Street included families as well as single tenants, the New York Stock Exchange, armed with the strong support of city officials, proposed its demolition in order to go forward with its own development plans, persuading the owners of the building, the Rockrose Development Corporation, to sell it. Outraged tenants, and not a few concerned citizens, could only marvel at a planning "strategy" that encouraged conversion one year only to reverse itself a short time later. Although tenants were forced to leave the building beginning in the spring of 2001, they would be back only two years later, in February 2003, after the New York Stock Exchange canceled its plans for a new tower, strong testimony to the impact of the Trade Center disaster.

Other prominent conversions of the late 1990s included Mark Kemeny's reworking of James Brown Lord's eight-story Delmonico's (1891), 56 Beaver Street, into thirty-seven lofts and Schuman, Lichtenstein, Claman & Efron's renovation of Francis Kimball's twenty-two-story Empire Building (1898), 71 Broadway, southwest corner of Rector Street, to accommodate 237 rental apartments.[15] Also announced were plans to convert two neighboring buildings, 21 West Street (1931) and the Downtown Athletic Club (1930), both designed by Starrett & Van Vleck.[16] Although Schuman, Lichtenstein, Claman & Efron renovated the thirty-one-story 21 West Street in 1998, with Starrett & Van Vleck's original lobby restored by Hardy Holzman Pfeiffer, work did not progress on plans to convert the Downtown Athletic Club.

45 Wall Street (Voorhees, Walker, Smith, Smith & Haines, 1959), southwest corner of William Street. Conversion to apartment building, Meltzer/Mandl Architects, 1997. Third- to ninth-floor plan. MMA

Vista International Hotel, 3 World Trade Center, northeast corner of West and Liberty Streets. Skidmore, Owings & Merrill, 1981. View to the east showing Trade Center towers (Minoru Yamasaki and Emery Roth & Sons, 1973). Hoyt. ESTO

Even relatively new office buildings were deemed desirable for conversion. The Rockrose Development Corporation commissioned the architect Avinash K. Malhotra to convert Emery Roth & Sons's thirty-two-story 127 John Street (1971), northwest corner of Water Street, into 576 apartments and 15,000 square feet of retail space.[17] A typical glass-curtain-walled slab, 127 John Street was notable for the whimsical touches added by its developer, Melvyn Kaufman, including a supersized digital clock at the base, a neon-lit tunnel that led to the lobby, and mechanical rooms illuminated at night by the lighting designer Howard Brandston. After Rockrose purchased the building and announced its plans, Brandston sued the developers, fearing that his work, as well as that of other artists, would be destroyed. The parties eventually settled, with Rockrose agreeing to preserve some of the elements, including the clock, but not the neon tunnel. Two years later, in 1999, again working with Rockrose, Malhotra renovated Shreve, Lamb & Harmon's twenty-eight-story 99 John Street (1933) to contain 442 rental units.[18]

In December 1995, Donald Trump assumed control over H. Craig Severance and Yasuo Matsui's seventy-two-story Bank of the Manhattan Company Building (1930), 40 Wall Street, a much-admired skyscraper whose recent history had been less than distinguished following a period of mismanagement

highlighted by the discovery that its owners in the 1980s were the disgraced Philippine leader Ferdinand Marcos and his wife, Imelda.[19] By the time Trump purchased the tower, it had a vacancy rate of 89 percent and was the financial district's most prominent white elephant. But Trump had faith. "Forty Wall Street was a great building," he wrote in his 1997 book, *Trump: The Art of the Comeback*. Even though he was impressed with the Giuliani administration's tax incentives, Trump decided "to go counter to the trend, as I often do. Almost everybody was taking the older buildings and converting them to residential, but I felt that because 40 Wall Street was so good and so well located, . . . I would make it the best office building in downtown Manhattan."[20] Using plans produced by HOK, Trump gutted the interior, installed new mechanical systems, and hired Der Scutt to redesign and enlarge the marble lobby.

Even lower Manhattan's most prominent skyscraper, Cass Gilbert's Gothic "Cathedral of Commerce," the Woolworth Building (1913), 233 Broadway, between Park Place and Barclay Street, proved susceptible to the conversion boom.[21] In April 2000, developer Steven Witkoff, who had purchased the building two years earlier, declared that he intended to turn the top twenty-seven floors of the fifty-four-story building into approximately seventy-five luxury condominiums by 2002. In addition to a 7,500-square-foot five-level penthouse with access, via a cylindrical glass elevator, to the building's long-closed observation deck, the plans by Skidmore, Owings & Merrill also included two 4,100-square-foot duplex apartments to be constructed on the twenty-ninth floor setbacks on either side of the central tower. The lower floors would remain as offices, but the renovation would also feature a seventy-five-seat underground screening room and a new spa created around the original 15-by-55-foot basement swimming pool. In the spirit of the extensive restoration of the Woolworth Building's ornate facade that was undertaken by the Ehrenkrantz Group between 1977 and 1981, Witkoff pledged to completely restore the street-level storefronts to their original condition.[22] Although Witkoff's plans for the conversion stalled after the September 11 attack, he maintained his commitment to the project, applying in 2003 for $80 million in Liberty Bonds, created by the federal government to spur development downtown after the tragedy, to help finance the Woolworth renovation.[23]

In addition to the conversion of office buildings into apartments, the attempt to turn the financial district into a twenty-four-hour, seven-day-a-week community was aided by a small boom in new hotel construction. The first hotel to be completed, and the first major hotel to be constructed in the Wall Street area in 145 years, since the opening of the Astor House (Isaiah Rogers, 1836), west side of Broadway between Vesey and Barclay Streets, which was torn down in 1926, was Skidmore, Owings & Merrill's Vista International Hotel (1981), 3 World Trade Center, southwest corner of the five-acre World Trade Center plaza and northeast corner of West and Liberty Streets.[24] Originally planned in the late 1960s as a 450-room facility, the hotel was virtually doubled in size by the time SOM was called in to design the building in 1978. Operated by Hilton International under a thirty-year contract with the Port Authority, the twenty-three-story, 825-room, 534,000-square-foot Vista was dwarfed by the 110-story World Trade Center buildings (Minoru Yamasaki and Emery Roth & Sons, 1973).[25] Although the architects chose a

light anodized aluminum skin with a silvery sheen in order to be "in the same design vocabulary as the two towers," they felt they were able "to maintain the hotel's own architectural identity" with its contrasting horizontal emphasis.[26]

The Vista's principal entrance was on West Street, where the building took on a surprising specificity as it hugged the roadbed's curving trajectory. The editors of the *AIA Guide* were impressed by the "handsome" hotel with "its elegant . . . curtain wall," declaring it "better than . . . its enormous WTC neighbors" even though it understandably looked "out of place."[27] Well aware of its "isolated" location, the Vista included substantial recreational amenities, including a swimming pool, jogging track, gymnasium, and two racquetball courts. The hotel's operators also offered express bus service to midtown, organized tours of lower Manhattan, arranged for a Lower East Side weekend shopping package, and emphasized in its promotional literature that fifty percent of the rooms offered views of the Statue of Liberty. Writing in the *New York Times* nine months after its opening, Laurie Johnston deemed the Vista, with its "austerely elegant two-level lobby," a success, "bringing new life" to the area, despite the fact that it was "more than three miles south of the midtown hotel heartland and almost in a world, or at least a city, of its own."[28]

A dozen years after its completion, at 12:18 P.M. on February 26, 1993, the Vista was seriously damaged when a powerful bomb, planted by terrorists in an attempt to topple the Twin Towers, exploded in the parking structure beneath the hotel.[29] Although almost one-third of the businesses in the towers were back in operation within a week, the Vista did not reopen for more than twenty months after some initial concern that the structural damage might be so severe as to require demolition. Although there was no damage to the upper floors, the explosion caused the collapse of several floors beneath the hotel that housed vital mechanical systems. The Port Authority, working with W.B.T.L. Architects and interior designer Daiker Howard, decided to use the occasion to completely renovate the hotel. The most dramatic changes were a new, clumsily proportioned three-story glass entrance canopy over West Street and a flashily conceived expansion of the lobby to include a three-story atrium complete with a grand curving staircase and an indoor waterfall. Ultimately, however, the hotel was one of four buildings at the World Trade Center complex to be classified as completely destroyed in the September 11, 2001, attack.

Despite the financial success of the Vista after its 1981 opening, it would take another decade for the next new hotel to open in the area. Located two blocks to its south, at 85 West Street, between Albany and Carlisle Streets, the thirty-seven-story, 504-room Marriott Financial Center (1991) was a fairly tepid effort whose bland aesthetics were geared to the corporate traveler.[30] Designed by Nobutaka Ashihara Associates and Wechsler, Grasso & Menziuso, the building featured a central portion consisting of horizontal bands of windows separated by a strip of greenish gray brick, bracketed on either side by one-window-wide bays of orange brick. The orange brick was repeated at the stepped conclusion to the building and again at the three-story base, which also featured a glassy entrance.

Only a year after the opening of the Marriott Financial Center, the pent-up demand for downtown hotel space was further addressed with the completion of Eli Attia's Millenium (1992), across from the World Trade Center at 55 Church Street, between Fulton and Dey Streets, developed by Peter Kalikow, an active force in the development community but a newcomer to hotel construction.[31] In 1985 Kalikow and Attia released plans for a sixty-story, 608-foot-tall, 700-room hotel featuring a concave reflective glass wall in varying shades of gray and blue. This unrealized scheme was replaced two years later when the developer decided to build a twenty-nine-story office building with 17,000-square-foot floors, also designed by Attia, that required the purchase of 154,000 square feet in air rights from St. Paul's Chapel (Thomas McBean, 1766; spire, James Crommelin Lawrence, 1794), directly across Fulton Street.[32] The new design was meant to harmonize with its neighbor immediately to the east, William Welles Bosworth's AT&T Building (1917), 195 Broadway, which Kalikow also owned.[33] Matching Bosworth's building in height and bulk, Attia proposed a textured and colored glass facade that basically mimicked the three-story grid of the AT&T Building. The Landmarks Preservation Commission, which had a say in the design of the building because it required air rights from the landmarked church, raised objections to Attia's scheme, especially his choice of materials. Rather than fight his way through the complex landmark

Proposal for hotel, 55 Church Street, between Fulton and Dey Streets. Eli Attia, 1985. Rendering of view to the southeast. EAA

Proposal for office building, 55 Church Street, between Fulton and Dey Streets. Eli Attia, 1987. Rendering of view to the southeast. EAA

approval process, Kalikow went back to the idea of a hotel, which required much smaller floors, and built an as-of-right building. Returning to, but greatly simplifying, his earlier hotel design, Attia's 58-story, 380,000-square-foot, 561-room Millenium rose uninterrupted for 588 feet and was sleekly clad in reflective black glass. As Kalikow put it: "We decided to make a statement that had nothing to do with 195. I said to Eli, 'Let's stop trying to blend in.' And he said," referring to Stanley Kubrick's 1968 film, "'You remember the monolith in '2001?' That's what I see there.' . . . Eli and I, through the 1980's, were the leading advocates of glass buildings. I cannot stand new stone buildings. I hate them. One Ninety-five is different. That's a Greek temple. But I can't build a building like that today."[34] Attia's spare facade was relieved to a small degree by two glass-and-steel canopies at the Church and Fulton Street entrances. Inside, the two-story, 19-foot-high, 120-foot-long, and 30-foot-wide lobby was equally austere, featuring dark Minnesota granite and rosewood. Kalikow, who decided to run the hotel on his own instead of leasing the facility to a major chain, busied himself with all details of the project, including the furniture layout of the rooms as well as the decision to misspell the word "millennium," explaining that in the hotel's logotype he thought the word was "ugly" and difficult to read.[35] Shortly after the Millenium's opening, however, Kalikow was forced into bankruptcy protection and lost control of the hotel, which was eventually taken over by the Singapore-based developers CDL Hotels International.

The more budget-minded Holiday Inn chain also opened a hotel in the financial district on an inconspicuous 4,000-square-foot site at 15 Gold Street (1999), between Platt Street and Maiden Lane, that was previously home to a parking lot.[36]

Designed by Alan Lapidus, the seventeen-story red brick Holiday Inn Wall Street adopted a sawtooth shape, with each two-window-wide bay featuring square unadorned punched windows of clear glass. Billed as New York's most high-tech hotel, the building featured high-speed Internet connectivity to appeal to a new niche of business travelers. With its advanced technological features, the Holiday Inn Wall Street qualified for the newly created Industrial and Commercial Incentive Program, allowing Lapidus the luxury of providing half of the hotel's 138 rooms with twelve-foot ceilings instead of the standard eight feet.

In the same spirit that fueled the conversion of office buildings into apartments, there were also new hotels carved out of renovated structures. One such modest effort was the forty-six-room Wall Street Inn (Norman Rutta, 1999), 9 South William Street, located in a six-story and mansard-roofed office building (William Neil Smith, 1929) that was previously occupied by Lehman Brothers.[37] After a complete top-to-bottom overhaul of the structure, it was fitted out with furnishings evocative of Colonial Williamsburg. A more significant renovation involved the conversion of the former Merchants' Exchange (Isaiah Rogers, 1836–41), 55 Wall Street, into the Regent Wall Street in 2000.[38] The building had a long history of conversion: in 1863 it had been altered by William A. Potter to serve as the United States Custom House; it was again remodeled and doubled in size in 1907 by McKim, Mead & White for the National City Bank. In 1979 Citibank, the successor corporation to the National City Bank, after first rejecting several offers from developers interested in constructing a skyscraper on the site of the landmarked building, had decided to renovate and restore for banking use the building's vast 188-by-124-foot, 72-foot-high Banking Room, notable for its elliptical gilded dome, ornate coffered ceiling, and 30-foot-high marble Corinthian columns.[39] The space, unburdened by any interior landmark designation, was to be refurbished by the Walker Group to accommodate the bank's "universal tellers' station," a new unit intended to be installed in all of the bank's branches. Ada Louise Huxtable, though pleased with Citibank's decision to reuse the historic space, had problems with the "imperfect renovation":

> I find the new design disruptive and lacking any real style, in spite of a high level of commercial competence. . . . What the visitor to 55 Wall Street sees now is the grand interior of 1907 . . . with a 20-foot-high, shiny brown, free-standing new counter and wall cutting diagonally across the restored room's traditional classical design. . . . The glossy-brown-lacquer finish and faceted details of the new installation are meant to minimize its bulk and reflect the ornate surroundings; the design is actually supposed to strike a balance between making a modern sculptural statement in the space and de-emphasizing the mass through reflective surfaces. Alas, this does not happen. . . . The installation reflects more of the room's bad lighting than anything else, due in part to a miscalculated facet at the top. This is a heavy, intrusive object without redeeming stylistic grace, while its angle provides conflict, rather than counterpoint, for the room's axial symmetry.[40]

In 1984 the Landmarks Preservation Commission approved the transfer of 55 Wall Street's air rights to a site across the street, making possible the construction of Kevin Roche's sixty-story 60 Wall Street. Three years later Citibank sold the building, and 55 Wall Street experienced a serious downturn in its fortunes, highlighted by high vacancy rates for its office space and the 1992 decision by

Citibank to close its branch in the rotunda. Raymond T. O'Keefe, executive director of the real estate firm Edward S. Gordon Company, succinctly summed up the building's problems in a 1994 interview in the *New York Times*: "Banks no longer need grandiose space, retailers don't like space that's tucked away, and the office floors just don't divide well."[41] Largely vacant, the building did prove popular as a filming location for commercials and movies.

Things began to look up for 55 Wall Street in 1996 when Donald Trump, seeking to complement his recent purchase of 40 Wall Street, announced that he would buy the building and renovate its office space, with a rumor also circulating that he planned to rent out the 34,000-square-foot banking hall for a House of Blues nightclub.[42] Trump backed out of the deal, and the Cipriani family, famous for its hotel in Venice and known in New York for its eponymous restaurant in the Sherry-Netherland hotel, announced in May 1997 that in collaboration with the real estate investors Sidney Kimmel and Richard Butera it would convert the upper five floors of the building into 144 hotel rooms and use the banking hall for banquet space for weddings and corporate parties.[43] MG New York Architects, working with Hablinski Interiors and Wilson & Associates, was hired to do the renovations, which promised to create one of New York's priciest hotels, and certainly the most expensive downtown, and would also feature some of the city's largest guest rooms, with the smallest units measuring 525 square feet. In March 1999, two months after the great hall was declared an interior landmark, the Cipriani family was replaced as the hotel's operator by the Regent International group, which completed the renovations in time for a spring 2000 opening.[44] But the Regent Wall Street did not prosper, especially after the September 11 Trade Center attack, and in December 2003 the hotel announced that it would close its doors.[45]

Over the years the financial district had gradually lost ground as a retail destination, especially after the opening of both the South Street Seaport development as well as the stores at the World Financial Center grouped around the Winter Garden. Still, Nassau and Fulton Streets remained busy shopping locations, but appealing to a bargain-minded crowd. In 1977 the City Planning Commission approved zoning changes to create a four-block pedestrian mall along Nassau Street running from Maiden Lane north to Beekman Street.[46] Opened the following year, the Nassau Street Mall drew on average more than 100,000 shoppers daily who visited the more than eighty-five modest-priced chain stores, discount houses, small specialty shops, and fast-food restaurants that lined its length, which was closed to vehicular traffic during business hours. In 1987 the National Trust for Historic Preservation cited it as the busiest outdoor pedestrian mall in the nation, with many retailers noting that a full 25 percent of their customers were tourists. In 1993 the popular discount department store Century 21, which had been located at 22 Cortlandt Street for more than thirty years, energized the area with a dramatic expansion into its immediate neighbor, Walker & Gillette's four-story, modern classical East River Savings Bank (1935), northeast corner of Cortlandt and Church Streets. In comparing the new space to the bare-bones quality of Century 21's original store, Dulcie Leimbach, writing in the *New York Times*, observed that the 20,000-square-foot addition "ushered in a kitschy

Millenium Hotel, 55 Church Street, between Fulton and Dey Streets. Eli Attia, 1992. View to the southeast. EAA

Banking Room, National City Bank (McKim, Mead & White, 1907), 55 Wall Street, between Hanover and William Streets. Renovation by the Walker Group, 1979. WG

glamour" with the bank building's "vaulted ceilings, mahogany fixtures and chandeliers."[47]

In 1995 the newly formed Alliance for Downtown New York, acting in concert with the Landmarks Preservation Commission, hired Beyer Blinder Belle to create a master plan for turning the two short blocks of Stone Street between Broad Street and Hanover Square into a mixed-use enclave featuring stores, restaurants, and apartments.[48] This stretch of Stone Street, which consisted of fifteen four- and five-story brick buildings dating mostly from the reconstruction of the street following the Great Fire of 1835, had degenerated into a shabby service alley serving restaurants on South William and Pearl Streets. Worse still, it was widely known as a location for low-level drug dealing. In the early 1980s, a chunk of the narrow, winding street running from Broad Street to Coenties Alley was demapped to allow for the construction of Skidmore, Owings & Merrill's massive headquarters for Goldman Sachs at 85 Broad Street. The idea behind hiring the Beyer firm was to consult with property owners before the area was declared a historic district in an attempt to guide as well as promote future development. As John Belle put it: "It was important that we work with owners to show them how they could convert shuttered ground floors into usable retail space."[49] Even the normally landmark-shy Real Estate Board of New York supported the master plan. The Landmarks Preservation Commission designated the two-block stretch of Stone Street a historic district in June 1996.

Beyer Blinder Belle's plan for the restoration of Stone Street included resurfacing the roadbed with Deer Isle granite paving blocks bordered by bluestone sidewalks and granite

Stone Street, between Coenties Alley and Hanover Square. Renovation by the RBA Group and Signe Nielsen, 2000. View to the southwest showing 85 Broad Street (Skidmore, Owings & Merrill, 1983) in distance. MN

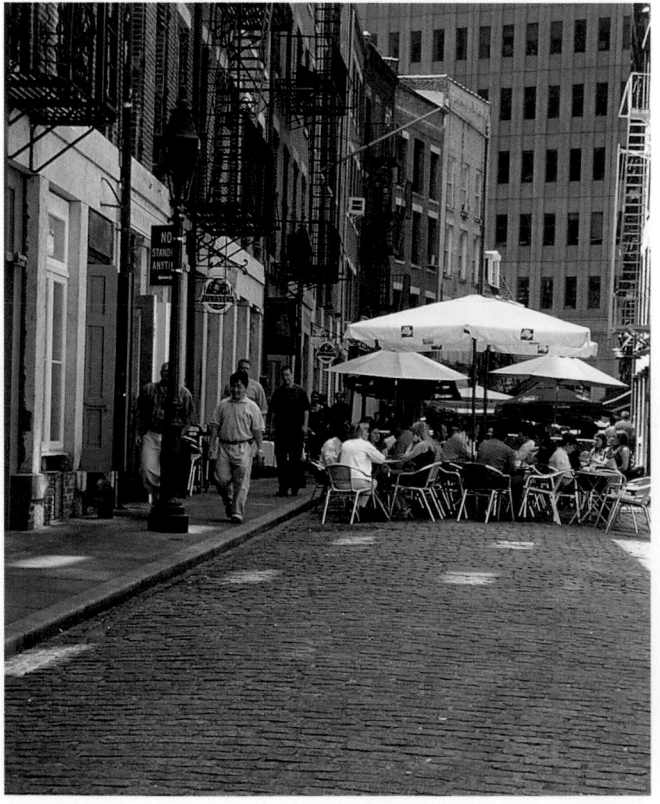

curbs and cast-iron lampposts designed to look like gas lamps. In addition to its support from the Alliance for Downtown New York, the project also received federal transportation grant money, and by the end of 2000, much of the renovation work, completed under the direction of the RBA Group and landscape architect Signe Nielsen, was finished and the restored street was ready for redevelopment. Prominent restaurateur, developer, and Stone Street land owner Tony Goldman envisioned the "new" Stone Street as a sophisticated enclave at the heart of a rejuvenated Wall Street. He also felt that it could avoid some of the problems that had led many to castigate the South Street Seaport development as no better than a suburban mall: "Malls are a suburban approach to attracting people. Street real estate relates directly to the sidewalk. What's most fabulous about Stone Street is its sense of place. And that's the essence that will bring people to it."[50] By the fall of 2003, even with the economic problems associated with the loss of the Trade Center, eight restaurants were prospering along Stone Street.

Historically, the financial district's restaurant scene was primarily devoted to satisfying Wall Street's lunchtime needs. But with the arrival of round-the-clock residents, things began to change. Two new restaurants were located in renovated historic buildings: Tony Goldman's Wall Street Kitchen and Bar (Ingrid Hustvedt, 1997), set in Kirby, Petit & Green's five-story neoclassical American Bank Note Company Building (1908), 70 Broad Street, and Bayard's, a dinner-only restaurant in the three-story, browstone-clad, Italianate palazzo India House (Richard F. Carman, 1851–54), 1 Hanover Square, which was restored under the direction of the Poulakakos family, who owned the venerable Harry's at Hanover Square, located downstairs in the same building.[51] But the restaurant that brought more people to the area at night was a "reclaimed" work of a much more recent vintage. In 1976 the opening of Windows on the World (Warren Platner Associates), occupying an acre of space atop the north tower of the World Trade Center, had been a sign for rejoicing, as much as any other event of that year a sign that the city, still in the grips of fiscal crisis, was regaining its lost momentum.[52] In 1993 the Trade Center bombing gave the Port Authority a convenient excuse to justify closing the restaurant which, once again mirroring the city's fortunes, had drastically lost prestige and patronage. So it was with great anticipation—as much a talisman of good times as of restored culinary accomplishment or architectural splendor—that the almost totally redesigned and reimagined Windows on the World (1996) was awaited.[53] Selected in a competition, Joseph Baum, who had created the first Windows on the World, this time assisted by his business partner of many years, Michael Whiteman, again tackled the problem of making a rooftop restaurant at the top of New York's tallest—and still most reviled, not to mention feared, as a result of the bombing—building work as a destination place for New Yorkers and not just out-of-towners. Baum retained Hugh Hardy of Hardy Holzman Pfeiffer, who had helped Baum reconfigure the Rainbow Room (see Rockefeller Center). Hardy was joined by Milton Glaser, the graphic designer, who had also worked on that project. While Baum, Whiteman, and their partner, real estate heir and former president of the Battery Park City Authority David Emil, were tenants at the Rainbow Room, at Windows, as the restaurant was widely known, they were leaseholders and operators,

Windows on the World, 107th floor of One World Trade Center. Hardy
Holzman Pfeiffer Associates, 1996. Little. H3

raising their personal stake in the project, a situation that,
according to many observers, led to the relatively bland menu
and underchallenging aesthetics.

Corby Kummer, writing in *New York* magazine, put it this
way:

> The idea of the new complex is to remind you insistently that
> you're in the middle of a city; the uniting theme in Hardy's design
> is cities as seen from above. The bar floor is tiled in the gray-and-
> white pattern of the pavement in Venice's Piazza San Marco.
> Carpet squares on both floors show details of grids from a dozen
> city maps; it can take a while to figure out the gimmick. The
> grays, rusts and chartreuses Hardy has chosen have struck some
> early visitors as reminiscent of the seventies, a decade in full-bore
> revival in fashion and music. . . . But the polished-aluminum
> details and the mirrored ceilings, to compensate for the low
> height of the rooms, seem Marriott-like.[54]

Ruth Reichl, the *New York Times*'s food critic in the 1990s,
could not conceal her misgivings about the new decor:

> When the restaurant opened . . . my first sensation was disap-
> pointment. The architect . . . and the designer, did their best to
> inject personality into a sterile space, but they made the room
> look remarkably like an airline lounge. Still, once I was seated,
> the comfortable chairs and pleasantly muted twilight colors com-
> bined with the view to create the illusion of being in an airliner
> hovering magically over Manhattan.[55]

Paul Goldberger had a higher opinion of Hardy's design:

> This is not classical elegance, and it is not Art Moderne or mod-
> ern or much of anything else easily characterized. The new
> Windows on the World is a kind of architectural jazz, full of syn-
> copation, its essence a series of allusions to design themes that
> are played out in a lighthearted yet never too whimsical way:
> swoops and curves and angular, origami-like surfaces; striped
> multicolor fabrics on the walls and carpets. . . . None of it would
> seem to work together, but by and large it does, in part because
> the colors are almost invariably soft and easy, and the juxtaposi-
> tions subtle and painstakingly wrought.[56]

Hardy's redesign would only last five years. It was lost in the
attack on the Trade Center.

In addition to mostly sterile office building plazas, the
cheek-by-jowl character of the financial district's canyon of
streets was relieved by only a few modest interventions,
including the 1977 renovation of New York's oldest existing
park, Bowling Green Park, established in 1733 at the foot of
Broadway.[57] The landscape architect M. Paul Friedberg was
initially hired in 1972 to restore the half-acre oval just north of

the Custom House to its condition in the late eighteenth century, but the project, planned in combination with a subway station renovation, was delayed by the city's fiscal crisis. When funds became available, Friedberg supervised the restoration of the iron fence, which dated from 1770, and installed "antique" lampposts and wooden benches. The most significant change, however, was the restoration of open space, accomplished by the removal of the subway station entrance at the park's west gate that had been added in the 1950s.

Legion Memorial Square, a far less historic or well-defined area than Bowling Green, was little more than a half-block-long triangle of woebegone macadam bounded by Maiden Lane and Liberty and William Streets, that was transformed in 1977–78 into a vest-pocket park planted with pear trees, furnished with dark gray granite benches, and decorated with one massive and six smaller black painted Cor-ten steel sculptures by Louise Nevelson titled *Shadows and Flags*.[58] Paul Goldberger found the largest piece full of energy, with "a sense of great pieces of metal about to fly in all directions, but held together by a mysterious force." However, he regretted the way the smaller sculptures were set in the renamed Louise Nevelson Plaza, designed by the sculptor in association with the Mayor's Office of Development, which rose out of beds of evergreen trees that made them "look like deformed trees" while, "ironically, the *real* trees" in the dark brown brick paved plaza rose out of gray granite beds.[59]

In 1982, the same year that Maya Lin's Vietnam Veterans Memorial in Washington, D.C., was dedicated, Mayor Ed Koch announced plans for New York's own monument to that war, to be located at the slightly more than one-acre brick-paved Jeannette Park (M. Paul Friedberg, 1972), adjacent to Emery Roth & Sons's massive 55 Water Street (1972).[60] Selected after a nationwide competition and heavily influenced by Lin's effort, New York architects Peter Wormser and William Britt Fellows, assisted by Joseph Ferrandino, a writer who had been stationed in Vietnam during the war, proposed a sixty-six-foot-long, three-foot-thick, fourteen-foot-high free-standing wall composed of twelve-inch-square blocks of translucent green glass etched with excerpts from letters written by American soldiers along with responses from friends and families as well as news dispatches from the war. To mitigate its length, two portals were cut into the otherwise unbroken, rather dull slab which also featured a continuous granite shelf at about chest height for visitors' offerings. Completed in 1985, the design for the newly renamed Vietnam Veterans Plaza really only came alive at night with the illumination of the glass blocks, a material choice the architects stated was inspired by Louis Kahn's unrealized Memorial to the Six Million Jewish Martyrs (1968), planned for Battery Park, as well as its "contradictory associations of evanescence and permanence."[61] "Unfortunately," according to Victoria Geibel, writing in *Metropolis*, "the memorial's fragility is much more in evidence than its strength. The glass block, instead of standing forthrightly in the plaza, seems burdened by the weight of its charge."[62] In stark contrast to the monument in our nation's capital, New York's Vietnam Veterans War Memorial was largely ignored by the public. To try and remedy this situation, in May 2000, some fifteen years

Vietnam Veterans Plaza, Coenties Slip, between Water and South Streets. Peter Wormser, William Britt Fellows, and Joseph Ferrandino, 1985. View to the northeast. WAA

after its dedication, fund-raising efforts were begun to renovate the plaza. In an attempt to make it more visible and accessible, E. Timothy Marshall & Associates proposed to build a 125-foot-long, 10-foot-wide "Walk of Honor" lined by a dozen four-and-a-half-foot-high granite pylons faced with stainless-steel panels bearing the names of the 1,741 New Yorkers who died in the conflict.[63] Completed in time for an emotional rededication on November 9, 2001, just two days before Veteran's Day and almost two months after the destruction of the Trade Center, the renovation work also included the addition of ceremonial entrances on Water and South Streets, a pulsating water element of polished granite, six new flagpoles, as well as new paving blocks, plantings, and lighting.[64]

An additional destination spot was created in the financial district with the transformation of one of its most distinguished white elephants, Cass Gilbert's United States Custom House (1900–1907), 1 Bowling Green, into new quarters for the Museum of the American Indian.[65] In 1978 the General Services Administration of the federal government sponsored a design competition for the restoration and adaptive reuse of the building, unoccupied since the Customs Service moved its offices to the World Trade Center in 1973.[66] The competition came one year after the GSA decided to retain the building for its own use, having found I. M. Pei's 1974 study, which proposed a conversion of the building to commercial use incorporating a hotel, theaters, offices, and stores, untenable.[67] The decision to hold a competition for the restoration and reuse plan, was, as Ada Louise Huxtable professed, "a particularly appropriate touch, because the Custom House was itself the result of a competition." Huxtable explained that the program had two parts: "The old offices are to be transformed into updated working floors, and the Custom House's most dramatic architectural features—the huge, oval rotunda with its Beaux Arts details and now-nostalgic Reginald Marsh murals added by the W.P.A. program in the 1930s, and its marble-enriched entrance and stairs of palatial scale and detail—are to be restored to their original splendor."[68] No tenants or exact uses were specified. The only firm commitment was to the building's future as a home to a number of federal agencies to be distributed on its various floors, and as a public institution to be located in the grand rotunda and the spaces below and adjacent to it.

In January 1980, the offices of James Stewart Polshek & Associates, Marcel Breuer Associates, Stewart Daniel Hoban & Associates, and Goldman-Sokolow-Copland were selected from a field of fifty entrants as joint venture architects for the project. Discussing their scheme, Huxtable declared: "The winners have come up with an admirable solution. They have rejected commercial functions for the public space because of the earlier, discouraging [I. M. Pei] studies and the difficulties of servicing them on this site. Their plan is to restore the rotunda and the great hall in a careful, accurate and non-specific way that would be suitable for a number of institutional possibilities, including a branch library or museum."[69] Polshek described the plan: "Using the poché of the four voids surrounding the rotunda, we eliminated their floors at the rotunda level, and created four skylit 45-foot-high atria surrounding the rotunda itself. The subrotunda space opened onto the floor of these four atria and below this floor we inserted a new public auditorium and a series of connections to the subway system."[70]

A victim of red tape, construction on the project had not yet begun by February 1983, at which point the government proposed to declare the Custom House as surplus and sell it to

Proposed renovation of United States Custom House (Cass Gilbert, 1907), 1 Bowling Green. James Stewart Polshek & Associates, Marcel Breuer Associates, Stewart Daniel Hoban & Associates, and Goldman-Sokolow-Copland, 1980. Rendering. PPA

the private sector.[71] Fortunately, as a result of the opposition of Senator Daniel Patrick Moynihan and the American Institute of Architects, the selloff was abandoned and the GSA began looking for tenants in earnest. When efforts by the Museum of the American Indian—which had been in negotiations with the government to occupy space in the building since 1974 and which the Polshek/Breuer team recommended as a tenant in their competition entry—failed, the government considered two proposals for the first two floors of the Custom House.[72] The first, put forth by the New York City Holocaust Memorial Commission, an organization appointed by Mayor Koch in 1981, would create a Holocaust memorial and museum. The second proposal was from the Committee for the Custom House Culture and Education Center, which included the Kitchen, the Dance Theater Workshop, the Theatre Development Fund, and other cultural organizations. The arts center proposal called for offices, a library, performance and rehearsal spaces, a ticket outlet for the various members of the consortium, and an Ocean Liner Museum.

On October 17, 1984, the federal government announced that the New York City Holocaust Memorial Commission had been selected as the Custom House's not-for-profit tenant. The decision was a disappointment to many who felt, as Brendan Gill did, that for "an enormous neo-Renaissance palazzo—dedicated to a manifestation of power, of money, and nothing but money—to be transformed into a museum of the Holocaust is displeasingly, offensively ironic."[73] But on April 4, 1985, Governor Cuomo announced plans to house the Holocaust Museum in a building in Battery Park City, reposing the question of who would occupy the Custom House.

Concurrent with Cuomo's announcement was the ongoing debate in New York of where to house the Museum of the American Indian.[74] The museum's collection of one million artifacts assembled by its founder, George Gustave Heye, had outgrown its little-visited quarters at Audubon Terrace (Charles Pratt Huntington, 1916), Broadway and

George Gustave Heye Center of the National Museum of the American Indian, United States Custom House (Cass Gilbert, 1907), 1 Bowling Green. Ehrenkrantz, Eckstut & Whitelaw, 1994. Gallery. EEKA

155th Street, and two primary options were considered: a merger with the American Museum of Natural History, which offered to build a 225,000-square-foot wing for the American Indian collection; and relocation to Dallas, Texas, a plan championed by the self-made megamillionaire and sometime presidential candidate H. Ross Perot, who offered to build a $70 million, 400,000-square-foot facility for the institution. The potential move of the museum to Dallas had a lightning-rod effect on New York. Not only, it was argued, was New York City the proper home to the museum as stipulated in Heye's will, requiring a ruling by state supreme court to overcome, but others felt that the loss of the museum would be a serious blow to the city's prestige. In light of opposition to the move, Perot retracted his offer in January 1987, officially endorsing the museum's relocation to the Custom House.

In May 1987, the Smithsonian Institution submitted a proposal to relocate the museum to Washington, where it would build an $82.5 million facility on the Mall and a $17.6 million support facility in Maryland.[75] In January 1989, after bitter political battles and more than a decade of uncertainty, the fate of the museum was sealed. All of its holdings would be moved to the Smithsonian Institution, which would build a 400,000-square-foot, $106 million museum on the Mall in Washington and a 150,000-square-foot, $44 million cultural resources center in Suitland, Maryland; in addition, it would renovate 82,500 square feet on the first two floors of the Custom House for use as the George Gustave Heye Center of the National Museum of the American Indian. The agreement satisfied most parties: it retained the museum's presence in New York; it allowed for a flagship museum in Washington, D.C.; and it limited the museum's space in the Custom House to two floors, allowing the Federal Bankruptcy Court to continue occupancy of the fifth and sixth floors and to expand to the seventh floor.

In May 1990, the firm of Ehrenkrantz, Eckstut & Whitelaw was selected by the GSA to repair and restore the Custom House and to design the new quarters of the museum on the first and second floors.[76] The architects transformed halls on the second floor into gallery spaces and added offices, a classroom, a theater, and two gift shops while creating a resource center in the old Cashier's Office. They also added a 350-seat auditorium in the basement space where Polshek had previously proposed subway connections. In 1992 the restoration of the Custom House's public spaces was complete. The museum would ultimately have as its galleries the halls surrounding the grand rotunda, but in November of that year, before the galleries were finished, the museum staged "Pathways," a show held in the rotunda. The fit between the historic building and its new use was less than perfect. Amy Gamerman, writing in the *Wall Street Journal*, found the exhibition incongruous with "the Custom House itself, which with its newly cleaned ceiling murals depicting ferries and ships seems a bizarre venue for looking at Indian art."[77]

The museum's permanent galleries, on the east, west, and south sides of the rotunda, opened on October 30, 1994. Led by Denis Kuhn, a design partner in the Ehrenkrantz firm, the architects developed the idea of a "building within a building,"[78] creating what the *Washington Post*'s Benjamin Forgey described as "neutral containers, a sequence of vaulted rooms ingeniously constructed within the old building frame in order not to damage (or even touch) the original walls."[79] The result was "a theoretically air and moisture-tight, windowless gallery envelope within the main envelope" that allowed for climate control otherwise unattainable in the original Cass Gilbert halls.[80] Many regretted that this strategy concealed the original plaster walls, cornices, and wood doors of the halls. The architects used a subdued palette of waxed ash wall panels, natural wool carpeting, and Winona travertine from Minnesota in an effort "to create an environment sensitive to the cultural objects on display."[81] But the interaction of the gallery spaces with the artifacts was largely overlooked by the press, who focused instead on what they considered to be the larger issue: the combination of the museum and the Custom House, which they assumed to be a culturally and stylistically inconsistent mix despite the fact that the collection had previously been housed in a classical building uptown. According to M. Lindsay Bierman, "The transformation of an inexorable white man's institution into The National Museum of the American Indian has established a difficult truce between Beaux-Arts grandeur and Indian craft, a cultural clash that was all too evident at the museum's opening. . . . The handcrafted intricacy of the tribal moccasins, bowls, masks, and other artifacts is overshadowed, both by the museum's crowded, kitschy installations and by the Custom House's newly restored murals, ornate finishes, and sculptures."[82] Writing in the *Cleveland Plain Dealer*, Randy Kraft noted, "A package never should be so beautifully wrapped that the gift inside becomes disappointing. That's exactly what's wrong with the new National Museum of the American Indian."[83]

WALL STREET GUGGENHEIM

On November 19, 1998, the *New York Times* reported that the Guggenheim Museum was "quietly" exploring the possibility of building a large new branch designed by Frank Gehry on the Hudson River waterfront at Pier 40, opposite West Houston Street. Although the architect and the Guggenheim's director, Thomas Krens, refused to comment on the story, other museum officials confirmed that the idea was "in the early stages of development" and that Gehry had already begun work on its design.[1] The project was one of many planned by the ambitious Krens, then in his eleventh year as director of the museum. Eleventh months earlier, in October 1997, Gehry's Guggenheim Museum in Bilbao, Spain, had opened to wide critical acclaim, and in November 1997, the museum established Deutsche Guggenheim, a 7,000-square-foot exhibition space designed by Richard Gluckman in Berlin.[2] Krens also stated a desire to open additional branches in Venice, where the museum already operated the Peggy Guggenheim Collection, and in Paris and Salzburg, Austria. In New York, in June 1992, work had been completed on two facilities, Gwathmey Siegel's new annex and renovation to Frank Lloyd Wright's building (see Upper East Side) and Arata Isozaki's branch in SoHo (see SoHo). The Guggenheim had also

expressed interest in exhibition space on Governors Island. Krens, deemed by some to be suffering from an "edifice complex," saw his plans for a lower Manhattan museum criticized as unrealistic, especially considering the financial difficulties at the SoHo branch, which was temporarily closed in 1996 for remodeling as a media museum. Still, private funding was rumored to be in place, with a substantial contribution expected from Peter B. Lewis, chief executive officer of the Progressive Corporation, a Cleveland-based insurance company, and the new chairman of the Guggenheim Foundation. Lewis, who earlier in 1998 had pledged $50 million to the Guggenheim, was also close to Gehry, having worked with the architect on an unrealized house project.

The lower Manhattan Guggenheim next resurfaced in the press four months later, in March 1999, not on the Hudson River but on the East River south of the South Street Seaport and encompassing Piers 11, 13, and 14 between Gouverneur and Maiden Lanes.[3] The Economic Development Corporation, the agency in charge of redevelopment plans for the East River piers in question, reportedly asked the Guggenheim to submit a proposal for the site, which included a ferry terminal at Pier 11 and tennis court "bubbles" on Piers 13 and 14. In addition to a new Guggenheim branch, the Economic Development Corporation was rumored to be considering other possibilities for the piers, including a new tennis court complex, a cruise-ship dock, a floating hotel, a youth hostel, and an aquarium.

Gehry's design was not released until April 2000 in conjunction with an exhibition, "Project for a New Guggenheim Museum in New York City," held at the museum's Fifth Avenue building in the hope of generating support for the project. The highlight of the exhibition was a twelve-foot-long, five-foot-wide model of the proposal. More than double the size of the Guggenheim in Bilbao, the building was designed as a 520,000-square-foot free-form, curvilinear structure, possibly clad in titanium, that would be built over connecting platforms jutting into the river and would include a tower rising as high as a forty-five-story building. The building would be lifted eighty feet into the air on six square steel and concrete columns, creating room for substantial public space below, including a park, sculpture garden, waterfront promenade, and an ice-skating rink. The more than 200,000 square feet of gallery space was intended primarily as a home for the Guggenheim's post–World War II collection, including 2,000 works by Robert Rauschenberg to be donated by the artist especially for the new building, as well as a setting for temporary exhibitions. The new branch would allow a greater percentage of the museum's permanent collection from the late nineteenth century to 1945 to be displayed in the Frank Lloyd Wright building. In addition to the gallery space, the program for the Wall Street Guggenheim, as the project was unofficially dubbed, was extensive, including a new architecture and design department meant to rival the one at the Museum of Modern Art, an arts education center and library, a multimedia and film department, a grand skylit entry hall, shops, four restaurants, and a performing arts center with two theaters, one seating 1,200 and a smaller one accommodating 400.

Gehry described the design as "two square doughnuts" with the holes open to the sky atop which would rise a 450-foot tower. The architect, as well as museum officials, took pains to emphasize that, despite obvious similarities, "it's not Bilbao."[4] Gehry added, "As it evolves, I guarantee it will look startlingly different and fit into this skyline and be a good neighbor. I'm

also exploring color more, and that may find its way here."[5] The architect pointed to the inclusion of the tower, whose use remained unspecified, as an example of trying to fit the undulating museum building into its lower Manhattan context, creating an effect that Krens described as "clouds surrounding a skyscraper."[6] As Gehry put it, "Sculpturally, the tower was needed to anchor the thing to the Manhattan skyline and lift it up. Every time we took it out it looked wrong."[7] The titanium cladding was also subject to change, a point that was emphasized early in 2001 when problems surfaced with the stained titanium panels at the Guggenheim in Bilbao. Gehry mentioned stainless steel as a possible alternative, noting that titanium was probably too expensive in a structure so much larger than the Bilbao building.

Reaction to the design was overwhelmingly positive, with many enthusiastic about the possibility of New York finally getting a major building designed by Gehry. Although Paul Goldberger was skeptical that the new Guggenheim would ever get built, he championed the effort in a profile of Gehry published in *Vanity Fair*:

> The building would have all of Gehry's characteristic swoops and curves, but bigger and more sumptuous than at Bilbao, and more full of movement. It would look something like a pile of metal ribbons, jumbled together with sections of glass between the pieces of ribbon, but from a distance the pieces would blur together to make it look like a silver cloud. The centerpiece of the composition would be a tower of metal and glass. . . . By itself the tower section would be an important skyscraper, but here it becomes something altogether brilliant; by pushing out of that metal mass like a tower poking through the clouds, it makes the Guggenheim a comment on the nature of the New York skyline.[8]

Herbert Muschamp began his review of the exhibition introducing the design with the words "How many ways can you say 'Wow'?" The *Times*'s critic made the case that the design, along with that for the Bilbao Guggenheim, proved the point that

> one of the purest ways to honor context is to play against it. Many have seen the Manhattan skyline as a geological formation of cliffs, peaks and canyons. Mr. Gehry treats the site as a natural wonder, a spot where mountains cascade into the sea. He has raised the horizon of the water, in waves that lap against the base of the cliffs, and pulled the sky down to the canyons, with changing light reflected in the museum's wavy metal surface. Expanses of glass, articulated with diagonal mullions, splash upward like jets of water formed by a Manhattan-bound meteor's narrow miss.

Proposed Wall Street Guggenheim, East River, between Gouverneur and Maiden Lanes. Frank Gehry, 2000. Model, view to the west showing lower Manhattan skyline. Heald. SRGM

ABOVE Proposed Wall Street Guggenheim, East River, between Gouverneur and Maiden Lanes. Frank Gehry, 2000. Model, view to the north. GP

BELOW Proposed Wall Street Guggenheim, East River, between Gouverneur and Maiden Lanes. Frank Gehry, 2000. Model, view of ice-skating rink. GP

Like Goldberger, Muschamp was also impressed with the inclusion of a skyscraper element as part of the design:

> With the tower, the vertical dimension of the skyline reverberates into the foreground. The tower's leaning silhouette and flaring top talk back to the World Trade Center's scaleless, impersonal thrust. Some architects, who still regard the Trade Center as an aesthetic abomination, have championed a revival of building crowns, by which they mean paperweights blown up to sky-scraper scale. Here is another way to top a tower. Rip off roof. Cut jaggedly above penthouse. Let curtain walls droop. Instead of hid-ing structural spines behind marble and steel, as Mies van der Rohe did with the Seagram Building, just let them hang out there in the breeze. Ordered complexity, not chaos, is the fundamental principle of this work.[9]

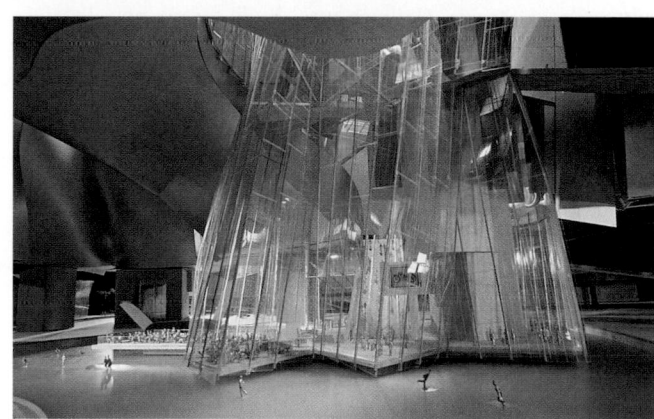

Although the editors of the *New York Times* and *New York Observer* supported the project, with the latter urging the city to treat the plan like the Museum of Modern Art's expansion and contribute at least 10 percent of the cost of construction, the editors of the *Wall Street Journal* believed that lower Manhattan's waterfront was an inappropriate location for the museum: "The last thing Manhattan needs is something else big and tall stuck out over its rivers, further blocking access to the world's greatest urban water edge. . . . If Mr. Krens and his deep-pocketed friends really want to do New York a favor and give the Guggenheim permanent collection an adequate exhi-bition space, let them look for derelict space well inland. But not in our front yard."[10]

The *Journal*'s objection to the proposed site was shared by several members of Community Board 1, including its chair, Madelyn G. Wils, who declared the proposed building too large, and Una L. Perkins, who described the plan as a "disas-ter. We don't need any more tall buildings in Lower Manhattan. We need more open space."[11] Despite these objec-tions, as well as several similar complaints expressed in letters to architectural magazines and the city's papers, criticism was fairly muted, perhaps testimony to the desire for a building by the nation's leading architect. The most vigorous attacks on the proposal had more to do with a disagreement with Thomas Krens and his vision for a global Guggenheim. Eric Gibson, writing in the *Wall Street Journal*, stated that the Guggenheim "isn't a museum, it's a brand. Expanding isn't about securing enough space for your exhibits anymore, but about extending the franchise, brand recognition, positioning."[12] In the same vein, Krens's idea to include private, corporate-sponsored gal-leries, the equivalent of sky boxes found in sporting arenas, was greeted with suspicion if not contempt. Hilton Kramer concluded that the Guggenheim was "no longer a serious art institution. It has no aesthetic standards and no aesthetic

agenda," with the art relegated "to a sideline interest" and the museum transformed "into a branch of the entertainment and tourist industries . . . a kind of up-market Disneyland."[13]

On November 27, 2000, the Economic Development Corporation selected the Guggenheim Museum to redevelop the East River site, and Mayor Rudolph Giuliani announced that the city would contribute $68 million to the cause, or roughly 10 percent of the projected costs. Despite a myriad of city, state, and federal reviews and approvals still required, there was some optimism that the project might be built in six years' time, especially after Peter Lewis pledged to cover 25 percent of the bill. But prospects for the project's realization dimmed after the attack on the World Trade Center on September 11, 2001, and the money promised by the city was put on indefinite hold. The Guggenheim's aggressive expansion plans had also placed the institution in a financial bind, and in December 2001 the SoHo branch was closed. After taking a closer look at the books, Peter Lewis put Krens on a tighter financial leash, stipulating that any future donations from the insurance magnate would depend on the museum's ability to adopt a more realistic budget. On December 30, 2002, plans for the Wall Street Guggenheim were officially scrapped.

TRIBECA

By the mid-1970s, the transformation of the area bounded by Canal Street, Broadway, Barclay, and West Streets into a trendy neighborhood, Tribeca, was under way. Planning—and later real estate marketing—nomenclature for the "Triangle below Canal Street," Tribeca was divided into two districts separated by the north–south trajectory of Greenwich Street. To the east of Greenwich Street was a rich trove of manufacturing and warehousing buildings that, as their original uses were phased out, quickly began to attract loft-hungry New Yorkers. To the west of Greenwich Street, bounded by Barclay, Hubert, and West Streets, was the twenty-five-square-block, 38.5-acre Washington Market Urban Renewal Area that had been cleared for development in the early 1960s, after the Washington Market, the nearest thing in New York to Paris's famed Les Halles but lacking its architectural distinction, was relocated from its home since the early nineteenth century to the Hunt's Point section of the Bronx.[1]

In the years following the Washington Market Urban Renewal Area's clearance, attempts to develop an array of

View to the east along Harrison Street, September 1975. Tannenbaum. AT

Independence Plaza North, west side of Greenwich Street, between Duane and North Moore Streets. Oppenheimer, Brady & Vogelstein, 1975. View to the west. Lieberman. HO

high-density, large-scale office towers, luxury apartment buildings, and hotels each succumbed to the vagaries of the Manhattan real estate market, leaving it to the International Brotherhood of Pulp, Sulphite and Paper Mill Workers, financed by the city's Mitchell-Lama program, to begin construction in 1972 on Independence Plaza North (Oppenheimer, Brady & Vogelstein, 1975), west side of Greenwich Street between Duane and North Moore Streets, the first project built in the renewal area, providing 1,339 middle-income residential units as well as street-level retail space along Greenwich Street in three thirty-nine-story towers and a series of lower two- and three-story "townhouses."[2]

The red brick and striated concrete-block structures of Independence Plaza North erased all memory of the prosperous market it replaced. The elevation of its pedestrian plaza twenty-three feet above street level also isolated it from the still intact street grid and urban fabric to its east. Engulfed within the complex were the Harrison Street Houses, an L-shaped row of nine late-eighteenth- and early-nineteenth-century Federal houses that had been saved and rehabilitated, but whose scale, not to mention charm, was largely compromised by their absurd juxtaposition with the superscaled development, which as Michael Winkleman, writing in *Metropolis* in 1981, put it, offered "a different world. Here there's no sign of industry, no notion of the market that once bustled below. There had evidently been some effort to make the complex visually exciting. . . . There are sharp angles, and balconies are announced by concrete strips. But the effect is muted, if not defeated by the mundane windows and doors which smack of project housing."[3]

As Independence Plaza North neared completion, construction began on the Borough of Manhattan Community College (Caudill Rowlett Scott Partnership, 1981), a relatively

low but exceptionally aggressive virtual megastructure that abutted Independence Plaza North and stretched along West Street from Chambers Street to North Moore Street.[4] The anonymity of the two projects was somewhat relieved by the neighboring 2.2-acre Washington Market Park, completed to landscape architect Leland Weintraub's design in 1983.[5] Located at the northwest corner of Greenwich and Chambers Streets, the park, enclosed within a Victorian-style wrought-iron fence, featured a cast-iron gazebo set amid a romantic, gently rolling lawn encircled by a curving, tree-lined path. For the editors of the *AIA Guide*, it was "one of the city's best small parks, perhaps the best . . . a modern miracle, a spirited amalgam of the natural and the artificial, in the spirit of Olmsted & Vaux."[6]

Inspiration was not to strike the next two projects in the Washington Market Urban Renewal Area, each built in 1983: 101 Barclay Street (Skidmore, Owings & Merrill) (see Financial District), a one-million-square-foot office building for the Irving Trust Company on the block bounded by West, Murray, Greenwich, and Barclay Streets; and the College of Insurance, a small institution housed in scattered locations around the city that consolidated its operations into a new facility on the southwest corner of the block bounded by West, Warren, Greenwich, and Murray Streets, designed by the firm of Haines Lundberg Waehler. Trapezoidal in plan with chamfered corners of varying severity, the college was a self-contained campus providing thirty-eight classrooms, dormitory rooms for 120 students, a library, dining facilities, administrative offices, and a bookstore. Wrapped with horizontal banded, green-tinted windows set in green sash, the building was entered not from either of its south- or west-facing street frontages but from its east facade, facing a parking lot, where a glass-enclosed entry led to a skylit atrium. In form and aesthetic, the college looked neither collegiate nor particularly urban and would have been more at home in a suburban corporate park than in lower Manhattan.

Amazingly, the remainder of the block on which the College of Insurance sat went vacant into the twenty-first century, leaving the building alone in a sea of parked cars, a self-fulfilling suburban prophecy. But the lack of development on the rest of the block was not for lack of trying. In 1981, in the hope of continuing the pace of high-density development set by Independence Plaza North and the Borough of Manhattan Community College, a request for proposals was issued to fill out the remainder of the block as well as the block directly to its north, bounded by West, Warren, Chambers, and Greenwich Streets with high-rise residential and commercial buildings.[7] The favored proposal, submitted by the Goodstein Construction Corporation and Milstein Properties, called for a 696-unit apartment complex designed by Elliot Vilkas on the north site and a one-million-square-foot office tower by Ulrich Franzen on the southern one. The residential portion was to have two brick buildings, one thirty-nine stories tall, the other thirteen stories, while Franzen's plan called for a twenty-eight-story tower consisting of a six-story granite base out of which rose a glass tower with rounded ends. Neither was realized. In 1988 plans were made by the then-hot firm of investment bankers, Drexel Burnham Lambert, to build a 29-story, 1.2-million-square-foot office tower designed by Kohn Pedersen Fox on the southern of the two blocks, but that project was canceled the following year as the Wall Street concern faced financial and legal troubles.[8] Then, in the early 1990s,

the same block was earmarked for a Kevin Roche John Dinkeloo–designed headquarters for New York's Mercantile and other exchanges (see Battery Park City), but that project died in 1994, after the Mercantile and Commodities exchanges decided to relocate to Battery Park City. That year, Alexander Gorlin was asked by the Battery Park City Authority to develop guidelines for the site as well as the block to its north, which had by then been partially developed as P.S. 234 (see below). Gorlin shied away from the tall towers permitted by zoning in favor of lower buildings with less bulk. He explored a number of alternatives, including reestablishing Washington Street; mirroring the bulk of P.S./I.S. 89 across West Street in Battery Park City to create a "gateway"; situating tall buildings on the avenues and six-story townhouses on the streets "in keeping with the tradition of Manhattan urbanism"; and "adding sinuous curving buildings that would allow more sun-light on the site."[9] Despite the new guidelines, no action affecting the site occurred until April 10, 2001, when the Giuliani administration selected Edward J. Minskoff to develop the southern site with a thirty-four-story office building designed by Skidmore, Owings & Merrill.[10] Minskoff planned to begin construction of 270 Greenwich Street, a 600-foot-tall, one-million-square-foot building, with or without a major tenant. Set back from Greenwich Street on a large landscaped plaza and abutting the College of Insurance to the south, 270 Greenwich Street was to feature a black granite base that defined the street wall along Warren and West Streets. Set back upon the base, the tower was designed to resemble two distinct volumes: a tall black granite-clad slab rising along the south edge of the base, and in its shadow, a lower but wider clear-glass volume. The events of September 11, 2001, led to the project's demise.

Proposed Greenwich Street office building, site bounded by Murray, West, Warren, and Greenwich Streets. Ulrich Franzen, 1982. Model, view to the northeast showing mass of College of Insurance (Haines Lundberg Waehler, 1983) in foreground. MPC

Massing study, two-block site bounded by West, Murray, Greenwich, and Chambers Streets. Alexander Gorlin, 1994. View to the southeast. Pottle. ESTO

In contrast to the banalities of most of the new residential and commercial construction in and around the Washington Market Urban Renewal Area, Richard Dattner's P.S. 234 (1988), west side of Greenwich Street between Chambers and Warren Streets, was a genuine success.[11] The first primary school built in Manhattan in thirteen years, it was a convincing work of contextual design—something all the more remarkable given that the client, New York City's Board of Education, had for a long time seemed unable to realize architecturally distinguished work. A permanent home for the school, which had occupied temporary quarters on the ground floor of Independence Plaza North, had first been planned for a site bounded by Greenwich, West, North Moore, and Hubert Streets. In 1984, however, Tribeca's growing residential community was dismayed to learn that the site had instead been offered to Shearson/American Express for development as an office tower and a facility for back-office computer operations (see Financial District). The city's Solomonic solution, offering a portion of the site for the commercial development and a portion for the school, provided inadequate space for both, leading to the designation of the Greenwich Street site, part of the Washington Market Urban Renewal Area, for the school alone.

The three-story school occupied about two-thirds of its site, leaving the remaining third for use as a courtyard and play area.

At first glance, the school's placement on its lot seemed illogical: the building hugged the south and west edges of the site, leaving the playground to face north. But this arrangement made sense because the high-rise construction of the World Financial Center to the south as well as the tall residential buildings to the east and west would keep the southern portion of the site in shadow for much of the year. In addition, locating the school building along Warren Street would keep the classrooms as far as possible from the noise of Chambers Street. The presence of Washington Market Park across Chambers Street to the north also provided the opportunity to create a cohesive composition made up of the two open spaces.

P.S. 234 confronted Warren and Greenwich Streets with fortresslike facades of red brick with tan brick belt courses that joined together rows of arched windows to recall Tribeca's historic building stock. A rounded tower at the intersection of Greenwich and Chambers Streets, reminiscent of a lighthouse, referenced Tribeca's once-waterfront location and contained a bell that was to be rung by a different student at the start of each school day. Continuing the maritime theme, *Dreaming of Far Away Places*, a 224-foot-long steel and brick fence enclosing the playground, designed by local artist Donna Dennis, featured a procession of ships and boats silhouetted against a backdrop of stylized waves. Dennis also depicted scenes from the long-gone Washington Market in a series of thirteen

ceramic medallions set into the masonry piers supporting the fence and into the walls of the school building. Within the gates, three more rounded towers—one that marked the school's main entrance, and two that provided four first-floor kindergarten classrooms with direct access to the playground—gave the building a playful, castlelike feel. The courtyard facades were clad in light tan structural facing tiles; the south wall was enlivened by a shallow curve that formed the rear wall of a 220-seat auditorium; and the west facade featured strips of horizontal banded windows along a sawtooth wall that afforded the rectilinear classrooms inside a degree of individuality. In addition to its twenty-four classrooms, gymnasium, auditorium, cafeteria, and workshop spaces, Dattner convinced the client to allow him to "borrow" space from those programmatic elements to provide an informal gathering space on each floor.

Upon seeing its publication in *Architectural Record*, two readers of the magazine, Robert Bateman and Robert MacLean, wrote a letter to the editor asking if Dattner's design wasn't inspired by Charles Rennie Mackintosh's Scotland Street School (1906) in Glasgow. The writers pointed out numerous similarities between the two buildings, from their rounded turrets and low, arched gateways, to their locations "in industrial neighborhoods close to major rivers," their use of a "similar palette of colors and materials," and their similarly organized plans.[12] Dattner responded that a year of study with a Glaswegian professor, James Gowan, as well as several trips to the Glasgow School of Art "certainly made a strong impression," but that there were other, less direct, reasons for the similarities, namely that "both schools were designed as urban 'cloisters.' . . . Both schools respond to their immediate context . . . [and] both schools attempt to give tangible form to a set of values concerning education. In the case of P.S. 234," Dattner continued, "the entrance gate suggests the dignity and importance of the activity within the building; the small cylindrical transition spaces with conical

roofs respond to the special scale of a child and suggest the 'magic' world awaiting the kids inside the building."[13]

Reviewing Dattner's imaginatively conceived project, Ellen Posner noted, "In another city it might qualify as just one more well-designed school building, but in New York City, P.S. 234 stands out as a small miracle of humanity."[14] Carter Horsley found it "easily the most charming, small new building of any type in the city in several years,"[15] and though Paul Goldberger was oddly troubled by its industrial aesthetic, he felt that all in all the design was "handled with considerable gentleness and ease," resulting in "an inviting and warm presence in the neighborhood."[16]

The relocation of Washington Market in the late 1960s, and the devastating clearance of the Washington Market Urban Renewal Area, compromised the utility of the remaining manufacturing and warehouse buildings east of Greenwich Street. Enough of the old businesses remained so that the aroma of raw food continued to hang over parts of the neighborhood, even as residential loft spaces gradually replaced butter and eggs as the hot commodity. Many of Tribeca's first settlers were artists priced out of SoHo but before long the lofts, generally regarded as less beat-up than SoHo's, became home to design professionals, downtown business people, and most significantly, members of the glitterati including movie stars like Robert De Niro and high-profile social types like John F. Kennedy Jr.

The Pierce Building, 105 Hudson Street, designed by Carrère & Hastings in 1892 and renamed the Powell Building in 1905, when four stories and additional width were added by Henri Fouchaux, was an early building to receive artists and art-related homeowners. The building's manager, Julian Pretto, having seen the departure of its food-importing tenants and sensing that Tribeca was "really where SoHo was in the late 1960's when things were not so chic," convinced the owner that he could make the property profitable by bringing in artists and

Proposal for 270 Greenwich Street, between Murray and Warren Streets. Skidmore, Owings & Merrill, 2001. Model, view to the west. Pottle. ESTO

P.S. 234, west side of Greenwich Street, between Chambers and Warren Streets. Richard Dattner, 1988. View to the southwest showing College of Insurance (Haines Lundberg Waehler, 1983) in the upper left. McGrath. NMcG

renaming it the Fine Arts Building.[17] Nearby, 112 Franklin Street (Samuel A. Warner, 1866–67) was being run as a kind of young artists' colony whose eleven "compatible" members had taken a ten-year lease on the building in 1975, establishing the ground-floor space of the building as Franklin Furnace, a store devoted to books produced by artists. On the second floor, Duff Schweninger, a multimedia electronic artist, and Patrick McEntee, a video technician, were setting up an artists' radio and television performance facility—which was "in all probability," according to the *New York Times*'s veteran reporter covering the art scene, Grace Glueck, "a New York first."[18]

The Board of Estimate's June 1976 approval of a zoning amendment legalizing the conversion of loft spaces for residential use sparked a series of building conversions.[19] Nonetheless, the majority of the conversions were still technically illegal because they did not comply with the state's multiple dwelling law, which mandated that buildings with three or more residential tenants obtain residential certificates of occupancy. Living illegally had its disadvantages. It was not uncommon, for instance, for landlords to raise rents uninhibitedly, evict tenants, or require them to buy their spaces at prices elevated due to improvements they themselves had made. As conflicts between tenants and landlords became increasingly litigious, legal con-

versions became more attractive to both. Davis, Brody & Associates' conversion plan for the Franklin-Hudson Building (Alexander Baylies, 1909–10), 100 Hudson Street, between Franklin and Leonard Streets, was one of the first to take advantage of provision 7B of the multiple dwelling law, allowing for more flexible solutions to problems of introducing natural light and rear-yard setbacks into converted industrial buildings than would be permitted in new construction.[20] All but the first floor of the ten-story building, developed in 1977 by the Recycling for Housing Partnership, was converted to forty-six apartments "by the book," marketed as "legally valid," with a certificate of occupancy obtained before purchasers moved in.[21]

By 1978 the fast pace of redevelopment in SoHo and Tribeca confirmed that manufacturing business was fleeing Manhattan. To counter the trend, new zoning was adopted, the Special Manhattan Mixed-Use Districts, offering hope to Tribeca's new residents that the area would not go the way of SoHo with its trendy shops and restaurants. The new zoning outlawed the conversion of ground- and second-floor spaces into residences, aiming to keep manufacturers alongside residential tenants. But the pace of loft conversions accelerated nonetheless. In 1980 the upper floors of the ten-story Borden's Condensed Milk Company Building (George Howard

Chamberlin, 1902–04), 106–10 Hudson Street, were converted to residential use.[22] The same year, the ten-story Schepp Building (Stephen D. Hatch, 1881), 165 Duane Street, corner of Hudson Street, which bordered the triangular Duane Park, was converted to co-op apartments.[23]

In 1981 the eleven-story American Thread Company building (William B. Tubby, 1893), 260 West Broadway, northwest corner of Beach Street, inaugurated a trend toward luxury conversions that would soon make Tribeca one of the city's priciest residential areas.[24] Developed by Jonathan Rose, the building was renovated into fifty-two high-end condominiums by Stephen B. Jacobs & Associates, which restored original elements such as moldings, paneling, and stained-glass skylights and included such new amenities as a rooftop garden, hot tub, sauna, and exercise room. It was the first building in America to offer computer terminals in each apartment. Even more innovative was the connection of each terminal to an Internet prototype called "the Source" that could provide tenants with news, stock quotes, online shopping, weather, and other services via a central database located in Silver Springs, Maryland. This was remarkable given that personal computers were still in the early stages of development and the Internet wouldn't become available to home users for more than a decade.

In June 1982, acknowledging the reluctance of landlords to make improvements to former industrial and warehouse buildings now legally leased to residential tenants, the city enacted a law requiring that buildings with three or more residential tenants be brought into compliance with housing, building, and fire safety codes, while allowing owners to pass a portion of the cost of the improvements on to the tenants.[25] A "Loft Board," chaired by Carl Weisbrod, was established by the city to set rent levels, monitor the legality of conversions, and resolve disputes, but things were slow to improve. A more serious problem, however, threatened Tribeca's residents: the city, after encouraging the growth of Tribeca as a residential neighborhood in the economically depressed 1970s, shifted its focus to commercial development as the financial markets rebounded.

Mayor Ed Koch offered little solace, bluntly stating at a November 1983 town hall meeting that "whereas before we

P.S. 234, west side of Greenwich Street, between Chambers and Warren Streets. Richard Dattner, 1988. View to the south showing detail of fence, *Dreaming of Far Away Places*, by Donna Dennis. Goldberg. ESTO

were going to build housing, today we're going to build commercial buildings." One resident voiced his concern that the mayor was "forgetting that we are a community" and in need of the city's support in providing housing, schools, and parks; without these and other amenities, he warned the mayor, "You're going to lose the work force . . . they're going to leave." Koch responded callously: "I doubt it. . . . And I hope that you don't. Because there's an enormous line of people that want your apartment."[26] These very real threats led a group of local residents, gathered in the loft of Hal Bromm, a gallery owner and Tribeca resident since 1972, to form the Committee for the Washington Market Historic District in 1984.[27] As committee member, former president of the National Organization for Women's New York chapter, and future president of the Tribeca Community Association, Carol DeSaram, later recalled, "We realized that the city planned to turn our neighborhood into Wall Street North, and unless we wanted to be putting out brush fires for the rest of our lives every time a new project like the American Express building came up, we'd better work for historic landmark status."[28] The committee approached the Landmarks Preservation Commission, which recommended that they research and photograph the ninety-block area intended for preservation, a project the group completed over the next three years.

All the while Tribeca's transformation continued. In 1987 Meile Rockefeller, a granddaughter of Governor and Vice President Nelson A. Rockefeller, transformed the five-story 168 Duane Street (Stephen D. Hatch, 1886–87) between Hudson and Greenwich Streets, long occupied by a butter and eggs wholesaler, into eight condominium lofts.[29] The conversion was undertaken by architect John T. Fifield Associates. More significantly, in the same year, Rockefeller converted the monumentally scaled six-story New York Mercantile Exchange (Thomas R. Jackson, 1884–86), 6 Harrison Street, northwest corner of Hudson Street, home until 1977 to the tenant for which it was named, to commercial condominiums, retaining R. M. Kliment & Frances Halsband Architects, who treated the building to what architectural historian Andrew S. Dolkart called "an exemplary restoration."[30] Apart from restoring existing architectural elements as well as the original entry hall and stairs, the architects replaced the ground-floor loading docks with glazed, painted metal shopfronts and eliminated the original exterior fire escapes by creating a new fire stair and service core. Offices occupied the upper floors, with the street-level space taken over by David and Karen Waltuck's restaurant, Chantarelle, which, since its opening in 1979 at its former location at 89 Grand Street, southeast corner of Greene Street, had become one of the city's most beloved and most respected eateries. To Tribeca's pioneers, the relocation could only mean one thing: fashion had officially taken note of their enclave.

The rapid transformation of Tribeca's dwindling stock of loft buildings sent the value of underdeveloped land skyrocketing. Four largely vacant sites bordering the Washington Market Urban Renewal Area on the east side of Greenwich Street between Murray and Reade Streets had come to be known by planners as the "missing teeth" of Tribeca.[31] Because they were zoned for manufacturing use and manufacturing tenants could not be secured, the buildings were rendered useless to their owners, one of whom demolished the structures on his site on the northeast corner of Greenwich and Chambers Streets to reap income from a parking lot.[32] In

LEFT Greenwich Court I and II, 275 and 295 Greenwich Street, between Murray and Chambers Streets. Gruzen Samton Steinglass, 1987. View to the northeast. GS

FACING PAGE Dalton on Greenwich, 303 Greenwich Street, northeast corner of Chambers Street. Beyer Blinder Belle, 1987. View to the northeast showing Greenwich Court (Gruzen Samton Steinglass, 1987) on the right and Reade House on the Park (Rothzeid, Kaiserman, Thomson & Bee, 1988) on the left. RAMSA

1984 the city addressed the problem by rezoning the parcels for residential or commercial use, mandating that new construction be built to the sidewalk, include ground-floor retail space, and have a 100-foot height limitation. On the two southernmost sites, between Murray and Chambers Streets, "WHERE BUSINESS MEETS TRIBECA" as a promotional sign proclaimed, two nearly identical apartment buildings, Greenwich Court I and II (1987), 275 and 295 Greenwich Street, were designed by Gruzen Samton Steinglass. Each eleven-story, red brick building with limestone and copper trim featured boldly scaled, silolike rounded corners capped by dome-shaped trellises. Two recessed bays in the center of the Greenwich Street facades marked the entryways while round edges and ribbon windows evoked a 1930s Moderne image. Though well-intentioned—Peter Samton's aim was to "reinforce a neighborhood with buildings that are friendly and meant to be there"—the projects looked alien.[33]

Across Chambers Street, Beyer Blinder Belle's 303 Greenwich Street (1987), also known as Dalton on Greenwich, seemed more engaged with the local scene.[34] The project actually comprised four buildings: three existing five-story manufacturing buildings (one on Chambers Street and two on Reade Street) that were rehabilitated as twelve lofts and a new eleven-story corner building containing seventy-two apartments. Developed by three young artists-cum-developers, Anne Dalton, Michael LaBadie, and Philip Mendlow, the design, in part based on the four-story cast-iron Laing Stores (James Bogardus, 1848), which had stood nearby until it was "stolen," and which had in turn influenced the firm's work on the so-called Bogardus Building at the South Street Seaport, had a two-story concrete base finished to resemble limestone,

above which a metal and glass facade with a rounded glass corner was framed by concrete piers and what the architects called a "bold cornice," but what was more of an abrupt and anticlimactic termination to the building.[35]

Although the editors of the *AIA Guide* deemed the building too tall for its idea with a flatness that "compromises the design,"[36] Paul Goldberger found it "actually quite well proportioned, with an unusually handsome set of rhythms to it that recalls the cast-iron architecture of lower Manhattan, and raises this building's exterior considerably above the standard for New York City condominium developments." In an article entitled "Good Buildings That Make Respectful Neighbors," Goldberger lauded the relationship between the Greenwich Court buildings and Dalton on Greenwich, claiming they created "a sense of place. They do not look, like so many recent additions to Manhattan, as if they were placed there to overpower what is beside them, or to stand apart." That Beyer Blinder Belle picked up on the rounded corners at Gruzen Samton Steinglass' Greenwich Court, Goldberger believed, allowed for "a streetscape in which buildings appear to be engaging in genuine dialogue—a theme is initiated by one building and . . . interpreted in different but entirely respectful form by a neighbor." He conceded that "as works of architecture, they are not distinguished, merely decent," but somehow found the group to be "something close to an ideal in urban design."[37]

By comparison, Rothzeid, Kaiserman, Thomson & Bee's ten-story red brick 311 Reade Street (1988), southeast corner of Greenwich Street, also known as Reade House on the Park, occupying the last of the four rezoned Greenwich Street sites to be developed, was disappointing—a watery version of its

neighbors with a chamfered, rather than rounded, corner and facades that were slightly textured with stacks of narrow metal balconies.[38]

The preservation effort in Tribeca was given a renewed sense of immediacy when, in July 1988, one of the district's oldest buildings, 114 Hudson Street, a red brick Federal-era house dating to 1801, was torn down.[39] The same year, as both the World Financial Center in Battery Park City and the Shearson Lehman tower introduced a new scale to the neighborhood, plans to build a twenty-five-story apartment tower at 47 White Street, connected to a nine-story addition atop the Condict Building, a former saddlery two doors down at 55 White Street (John Kellum & Son, 1861), corner of Franklin Place, came dangerously close to realization.[40] A proposal for building over the five-story 55 White Street, one of only nine remaining examples of cast-iron "sperm candle" designs in the city, was first put forth in 1985 to the designs of John Averitt in association with Alex Cooper, of Cooper, Robertson & Partners, whose eleven-story "as-of-right" tower would have rested on twelve columns threaded through the original building. In April 1986, the Buildings Department approved an additional six floors on the tower after the developer purchased the building next door, 51 White Street, and transferred its air rights, but the approval was rescinded when it was found that 51 White Street was a commercial, not residential building, and zoning disallowed the air rights transfer.

By October 1986, a new scheme emerged for a twelve-story addition to 55 White Street, but was opposed by the community, led by Hal Bromm, whose gallery sponsored an auction of works by artists such as Frank Stella and Elizabeth Murray to help fund the cost of engineers, historians, and lawyers needed in the fight. By late December 1987, with rumors abounding that a permit to demolish the building had been sought, the Landmarks Preservation Commission added it to a list of potential landmarks and on March 22, 1988, 55 White Street was given landmark status. Development proposals kept coming, the next from a developer who hired the Liebman Melting Partnership to replace the unconventional, distinctive Shaare Zedek Synagogue (William Breger, 1967) at 47 White Street with a complexly massed, interestingly designed, twenty-five-story street-wall defining apartment tower that would use transfer trusses to bridge over 51 White Street and join a nine-story addition set back atop number 55.[41] As part of the deal, the facade of the landmarked building would be restored and the synagogue would be relocated within it, the third floor removed to accommodate a double-height sanctuary. But the plan proved too costly in the face of a collapsing real estate market, and the developer and architects ultimately completed a more modest undertaking, converting 55 White Street into a sixteen-unit condominium (1989) with two new duplex penthouses and a 2,000-square-foot landscaped roof above the penthouses.

In 1988 plans to build a fifty-two-story, 491-foot-high apartment building on the block bounded by Thomas Street, Broadway, Duane Street, and Trimble Place alarmed the Tribeca community as had no previous proposal.[42] Designed by Schuman, Lichtenstein, Claman & Efron, Tribeca Tower (1991), as it would be called, could be built as-of-right by utilizing air rights from two two-story structures on Thomas Street. Set back from Duane Street amid an 11,500-square-foot public plaza, the red brick building featured octagonal corner towers, seven in all, that provided expansive views from floor-

Proposal for 47 White Street (William Breger, 1967), between Franklin Place and Church Street. Liebman Melting Partnership, 1988. Model, view to the southwest. LMP

to-ceiling windows in the living or dining room of each apartment. Though by no means a work of architectural art, the tower was less intrusive than many had feared, in part because of its proximity to the AT&T Long Lines Building (John Carl Warnecke, 1974) across the street to the north and the United States Federal Building (Alfred Easton Poor, Kahn & Jacobs and Eggers & Higgins, 1967) in Foley Square, two numbingly banal behemoths.[43] But when it was about to open in spring 1991, fewer than sixty-six applications to purchase Tribeca Tower's 440 condominium apartments had been received, leading to a drastic reduction in prices to avoid an auction. Even that didn't help sell the units, however, and the building was eventually marketed as mixed-income rentals.

In May 1988, having completed preliminary documentation and research, Community Board 1 proposed to the Landmarks Preservation Commission the designation of a historic district roughly bounded by Canal, Greenwich, and Murray Streets, and Broadway—almost the entirety of Tribeca.[44] In an effort to isolate any controversies over specific buildings that might arise and slow the process, the commission in turn proposed that the designation consist of four separate, but adjoining, historic districts, as well as twenty-nine individual buildings outside the district lines. The various districts tended to each represent a different period in Tribeca's development. Public hearings were held in June 1989 for the proposed Tribeca West, North, East, and South Historic Districts. Inevitably, the community felt the proposed boundaries were not adequate, while many Tribeca property owners, joined together as the Committee for Fair Landmarking, deemed them too generous, fearing the landmarks laws would, as David Dunlap put it, "lock them into the diminutive scale of the past," and called instead for the designation of individual buildings and blocks rather than districts.[45]

The preservationists were dealt a victory when, on May 7, 1991, the commission designated the Tribeca West Historic District, an irregularly shaped area roughly bounded by Greenwich and Hubert Streets, West Broadway, and Reade Street comprising seventeen blocks and 220 buildings.[46] To help expedite the flood of permit requests for alterations and additions resulting from the designation of a historic district in an area on the front line of development, the Landmarks Preservation Commission, the New York Landmarks Conservancy, and Ehrenkrantz & Eckstut Architects published a thirty-four page guide, the Tribeca West Historic District Manual, that provided information on those features of the district and its buildings considered to be most significant, as well as guidelines for new construction meant to give builders an idea of what the commission would or would not accept.[47] In the eighteen months following its designation, fifty-two buildings within the Tribeca West Historic District received work permits from the commission.[48] On December 8, 1992, the Tribeca North, South, and East Historic Districts were also designated, comprising 333 buildings and nine vacant lots.[49] The north district, roughly bounded by Hubert, Watts, West, and Varick Streets, contained buildings built mostly between 1880 and 1913. The south district, roughly bounded by Chambers and Thomas Streets, West Broadway and Broadway, and the east district, roughly bounded by Worth and Canal Streets, West Broadway to Lafayette Street, were characterized by five-story store and loft buildings with cast-iron and glass storefronts built in the mid-nineteenth century.

The recession of the early 1990s slowed the redevelopment of loft buildings for residential use and afforded an opportunity for businesses and institutions to move to Tribeca. In 1990 Robert De Niro opened the Tribeca Film Center (Prentice & Chan, Ohlhausen) in the former B. Fisher & Co. Building (Joseph Wolf, 1905), later the Martinson Coffee warehouse, 375 Greenwich Street, northeast corner of Franklin Street.[50] Although plans to renovate the 60,000-square-foot building predictably met with community opposition, upon completion neighbors were, as one New York Times reporter described, "grateful that an empty building has what some call a productive use."[51] There was little to complain about. According to architect Lo-Yi Chan, who was responsible for the conversion, De Niro "wanted the existing character of not just this building, but Tribeca, preserved and reflected" in the renovation that provided space for De Niro's own production firm, Tribeca Productions, on the top two floors, as well as production facilities and offices that could be rented or sold to other firms such as Miramax, a film production company, which occupied the third floor.[52] The second floor accommodated a seventy-seat screening room and banquet hall, and the ground floor housed the Tribeca Grill, also designed by Prentice & Chan, Ohlhausen, operated by restaurateur Drew Nieporent, and funded by De Niro and a team of high-profile investors that included actors Sean Penn, Christopher Walken, and Bill Murray as well as dancer Mikhail Baryshnikov.

In 1991 a two-story, 8,000-square-foot building at 172 Duane Street (Jacob Weber, 1872), between Hudson and Greenwich

Streets, previously home to a Kosher cheese and butter whole-sale company, underwent an inventive, artistic renovation into offices for Lovinger/Grasso/Cohn & Associates, a television production company.[53] The architect for the conversion, Vincent Polsinelli, considered the design a melding of New York's cast-iron architecture and Pierre Chareau's and Bernard Bijvoet's Maison de Verre in Paris (1932), which was saluted in the most dramatic element of the project: the redesign of the entry, where the building's original Italianate cast-iron facade was dismantled, restored (several missing elements, such as the pilaster capitals and portions of the arch moldings, were replaced), and put back in place without windows or doors.[54] Set back several feet from the original facade, a wall of glass blocks, square with incised circles, formed a recessed entry that at once recognized the building's history and gave it a distinct new identity. Inside the 130-foot-long, twenty-foot-wide building, two floors and two mezzanines housing offices and conference rooms were connected by stairs that featured glass-block treads on the upper flights to allow light to pass through to the first floor. Two conference rooms were covered by new glass-block skylights that doubled as the ground surface of a terrace, while an original forty-foot-long elliptical skylight was restored, flooding the deep building with light. Though one would have expected the unconventional renovation to set off the ever-sensitive community, many residents, like Cynthia Elitzer, were thrilled: "This happens to be one of the most stunning, most beautiful buildings in the neighborhood."[55]

In the early 1990s, despite the general slowdown elsewhere, the pace of development in Tribeca seemed, if anything, faster than ever, fueled by a healthier economy and guided by new zoning, initially studied after the historic district designations in 1992 and eventually passed in 1995. The zoning was aimed at encouraging the area's growth while making new construction, as Richard Shaffer, director of the City Planning Department and chairman of the City Planning Commission, put it, "more sensitive to the existing fabric of the community."[56] Two basic measures were taken: in eastern Tribeca, the maximum floor-area ratio (FAR) was decreased by varying degrees—from 12 to 6 in some areas and 12 to 10 in others—and plaza bonuses such as that given at Tribeca Tower were eliminated, forcing all new construction to be built to the street wall. The opposite strategy was adopted for western Tribeca, where the FAR of existing buildings was increased from 5 to 7.5, resulting in a flurry of penthouse and rooftop construction, while significantly, new residential construction, previously not allowed at all, was made legal with a maximum FAR of 5.

The new zoning inaugurated what many considered to be the fourth wave of settlement in Tribeca, the first being the artists who fled SoHo in the early 1970s, the second the construction of Independence Plaza North in the late 1970s, and the third the wave of loft conversions of the early to mid-1980s. The residents who came to Tribeca in the 1990s had, by and large, vastly greater wealth than previous settlers, whose relatively low-key, family-oriented lifestyles had given rise to the nickname "Triburbia." With upscale residents came upscale amenities. Not long after the new zoning loosened regulations on ground-floor retail use, the New York Times dubbed Tribeca a "design mecca," citing the many high-end furniture and antique stores that had migrated to the district's comparatively low-rent ground-floor spaces, among them Folly, at 13 White Street, Wyeth, at 151 Franklin Street, and significantly, Urban Archaeology, specialists in recycled

fragments from old buildings, which abandoned its Lafayette Street location in SoHo in 1996 for 143 Franklin Street, between Varick and Hudson Streets.

The most interesting of Tribeca's new retail venues was the result of a collaboration between Frank Gehry and Gordon Kipping on a store (2001) for Japanese fashion designer Issey Miyake at 119 Hudson Street (Thomas R. Jackson, 1889), southwest corner of North Moore Street.[57] Miyake was a long-time admirer of Gehry's work, and the California-based architect in turn brought in Kipping, a young architect and engineer who had recently assisted Gehry in teaching a design studio at the Yale School of Architecture, to work on a project that would include the renovation of 15,000 square feet of space on the first three floors of the six-story building to accommodate a boutique for men's and women's clothes, storage space, and administrative offices. Kipping's firm, G Tects, was also placed in charge of the restoration of the building's exterior, including the repair of the cast-iron framed bays along the base of the Hudson Street facade. The inspiration for the design came from Miyake, who requested that Gehry create a "tornado" that would whip through the space and transform everything in its path. Gehry responded with a sculpture, composed of thin twisting and curling sheets of titanium fastened to a steel armature by Velcro pads, that extended from a shaft at the cellar level to the wood-joist ceiling of the main floor, a dominating presence visible through the glassy entrance. Kipping included a glass-box showroom on the cellar level, glass floors, and stainless-steel-clad display platforms, sales counters, clothing racks, and cash desk. Gehry's son Alejandro contributed two large figurative

172 Duane Street (Jacob Weber, 1872), between Hudson and Greenwich Streets. Renovation by Vincent Polsinelli, 1991. View to the southeast. Warchol. VP

Issey Miyake, 119 Hudson Street, southwest corner of North Moore Street. Gordon Kipping and Frank Gehry, 2001. Entrance. Warchol. GK

murals, one fifteen by fifteen feet, the other eleven by twenty-seven feet. Raul Barreneche, writing in *Interior Design*, noted that "Miyake intended the interior to recall Gehry's raw early work, and there is a definite roughness to the sculpture and the store's overall construction. But the tornado—as it rises from the stairwell, swirls through the front of the shop and around the cashier's desk, and stops just short of the glass facade—also has moments of great lyricism."[58] The gala opening of Issey Miyake Tribeca, planned for September 12, 2001, was canceled because of the attack on the Trade Center, and the store quietly opened its doors five weeks later.

Tribeca also continued its ascent as a hot spot for fine restaurants through the 1980s and 1990s, and in 1996, star chef David Bouley reaffirmed his commitment to the area when he closed his wildly successful Restaurant Bouley, which had opened at 165 Duane Street in 1987, and

announced plans with fellow restaurateur Warner LeRoy to convert two adjacent buildings into Bouley International, incorporating a café, restaurant, cooking school, and residence.[59] Harman Jablin Architects was commissioned to combine the seven-story 36–38 Hudson Street (Babcock & Morgan, 1892), northeast corner of Duane Street, with the four-story 40 Hudson Street (Edward E. Ashley, 1898) next door, a task that, because the floors did not match, called for the lifting of the four-story building's upper three floors by four feet ten inches and the insertion of a compensating masonry band between the first and second floors, all approved by the Landmarks Preservation Commission. The partnership between Bouley and LeRoy came apart, however, and Bouley, who intended to proceed with the plans on his own, though successfully opening in 1999 his restaurant, Danube, at 30 Hudson Street, southeast corner of Duane Street, and the Bouley Bakery at

120 West Broadway, between Reade and Duane Streets, abandoned the project after the events of September 11, 2001, forced the closing of both enterprises for months, dealing the chef a financial blow.[60]

Through the mid- to late 1990s, bigger buildings than ever before were being converted, with individual living lofts averaging 2,400 square feet and luxurious amenities such as twenty-four-hour doormen and concierges becoming common. In 1996 the nine-story former Deitz Lantern factory at 429 Greenwich Street (R. W. Tieffenberg, 1887), between Laight and Vestry Streets, was converted to twenty-eight high-end lofts, all of which were sold before the building opened.[61] Occupying the entire 7,000-square-foot ground floor was the City Wine and Cigar Company, a private club that offered wine storage for members as well as a public restaurant and wine-tasting room. In 1998 the twelve-story Duane Park Building (Rouse & Goldstone, 1911), at 166 Duane Street, southwest corner of Hudson Street, was converted by Hudu Development, working with architects Byrns, Kendall & Schieferdecker, to thirty lofts that ranged in size from 2,700 to 6,000 square feet. Hudu's president, Mark Blau, noted that "the demand is being driven by young Wall Street families," as well as celebrities and families looking for alternatives to the Upper West and East Sides.[62]

One of the largest conversion projects undertaken in Tribeca was of the so-called Ericsson Ice House, a former cold-storage warehouse built for the Merchants Refrigerating Company at 22 Ericsson Place (William H. Birkmire, 1905), between Varick and Hudson Streets. The ten-story, 140,000-square-foot building, which extended the depth of the block to North Moore Street, was part of the Tribeca West Historic District. Plans for the renovation had originally been brought before the Landmarks Preservation Commission in 1992, after Platt & Byard Architects, working with Haines Lundberg Waehler, prepared designs to transform it into a new headquarters for the Blood Services Center of New York.[63] The design, introducing new fenestration to the building's windowless facades, received approval from the commission, exhibiting what commissioner Tracie Rozhon called an "intelligent solution" to introducing light and air to the building. Paul Byard attributed the approval to his having "designed appropriately for the district without being derivative or creating a pastiche."[64] Financial problems prevented the project's realization. Four years later, in 1996, new plans for 22 Ericsson Place were announced, this time calling for its conversion to fifty-seven residential condominium lofts and five commercial spaces by architect Joseph Pell Lombardi, who with Jack Lefkowitz and Abraham Berkowitz, was also the developer.[65] Like Byard, Lombardi inserted new windows into the facades but also carved a courtyard out of the core of the building, enabling him to reallocate the lost floor area to two stories of penthouses. The project also involved a complete restoration of the building's exterior. Known as the Ice House, the renovated building, entered at 27 North Moore Street, was completed in 1999 with its apartments selling briskly to a high-profile clientele including actor Billy Crystal and singer Marc Anthony. In January 2001, however, the developers were sued by New York State Attorney General Eliot Spitzer, who was responding to owners' complaints of major construction defects—and an attempt by the developers to conceal them—including buckling and warping wood floors and leaking roofs. In February 2002, a settlement was reached wherein the spon-

sors turned over 6,000 square feet of the Ice House's commercial space to the condominium, which planned to sell or lease it and use the proceeds to pay for repairs.[66] By the time of the lawsuit, Lombardi and Berkowitz had severed their ties with the project as developers.

Next door, an even larger cold-storage warehouse at 25 North Moore Street (John B. Snook Sons, 1924), northwest corner of Varick Street, was also converted to lofts. The sixteen-story, 130,000-square-foot building was also built for the Merchants Refrigerating Company but was used by the Atalanta Importing Company as a cheese and ham storage warehouse prior to its reopening in 2001 as the Atalanta Apartments.[67] Initial plans for the project, designed by Richard Cook & Associates, included a six-screen, 786-seat movie complex on the first and second floors in addition to forty-two condominium apartments, but the community, led by the Tribeca Community Association and including John F. Kennedy Jr., who lived across the street at 20 North Moore Street, fought the inclusion of a theater component, contending that the potential increase in traffic had not been considered. The City Planning Commission approved the project in the fall of 1997, at which point the Tribeca Community

25 North Moore Street, northwest corner of Varick Street. John B. Snook Sons, 1924. View to the northwest before renovation as Atalanta Apartments. CFA

Atalanta Apartments, 25 North Moore Street, northwest corner of Varick Street. Richard Cook & Associates, 2001. View to the northwest showing the Shearson Building (Kohn Pedersen Fox, 1989) in the background. Kwon. CFA

60 Warren Street, northeast corner of West Broadway. Joseph Vance Architects, 2001. View to the southeast. Sundberg. ESTO

Association sued the city and the developers, claiming an environmental review should have been conducted prior to its approval. But before the case was settled, the developer, in the face of an explosive residential market, decided it would be more lucrative to replace the movie theaters with twelve lofts. In July 1999, the building was purchased by new owners, and by April 2000, its conversion to forty-one lofts and two duplex penthouses was under way. As with the neighboring Ice House, new windows were introduced—in this case over 250—covering nearly 80 percent of the skin and compromising the structure so much that a new structural core of concrete shear walls had to be inserted in the center of the building. The original loading docks on North Moore Street became a deep arcade beneath restored marquees over the building's entrance.

The practice of adding additional floors to buildings in Tribeca had, for financial reasons, come to be generally accepted as a necessary evil in rehabilitating decrepit buildings. When added atop historic buildings, rooftop additions underwent the scrutiny of the landmarks commission and were most often not visible from the street. However, when

not subject to commission approval, additions could be built as high as zoning would allow without design review, as was the case of the five-story building at 60 Warren Street, northeast corner of West Broadway, a red brick 1860s structure that in 2001 was converted for residential use by Joseph Vance Architects, which added a four-story, 10,000-square-foot quadruplex residence to the roof, nearly doubling the building's height yet, the community felt, making no attempt to relate to it architecturally. In fact, the boxy, asymmetrical addition rose in a series of setbacks, that, combined with the varying shades of its green synthetic stucco exterior and the scale of its over-sized steel windows, did relate visually, though perhaps unintentionally, to the bulky twenty-one-story 120 Church Street (Robert L. Bien, 1964) that loomed in the background when one viewed 60 Warren Street from the north.[68]

Within the Tribeca West Historic District, between 1999 and 2001, the four buildings forming the east side of Greenwich Street between North Moore and Beach Streets were combined and converted by architects Byrns, Kendall & Schieferdecker into a thirty-five-unit residential complex known as the Fischer Mills Building (2001), named for the

company that occupied the northern two buildings of the row.[69] Developed by GMA Development, a partnership formed by Glenn D. McDermott, Arthur Fefferman, and Mark Wallach, the project was, as Harry Kendall put it, "more complicated than meets the eye," involving the melding of four very different structures: from south to north, 385 Greenwich Street, built in 1808 as a two-story house and enlarged in 1874 (Peter L. P. Tostevin) into a four-story residential building; 387–391 Greenwich Street, a six-story store and loft building designed in 1890 by William S. Livingston; 393 Greenwich Street, a five-story building designed by Morris A. Gescheidt in 1866; and 395–397 Greenwich Street, a larger five-story store and loft building built in 1861.[70] Because of the buildings' considerable depth, the architects were able to carve a forty-by-forty-foot courtyard out of the complex, allowing light to reach interior spaces. The lost floor area was reallocated to four new highly visible rooftop stories that constituted one of the largest penthouse additions yet to receive approval from the Landmarks Preservation Commission, which, realizing the economic importance of the added space, deemed the reclamation of the crumbling landmarks a benefit that outweighed the visual impact of the new construction. The architects restored the original facades and faced the addition with red brick and decidedly contemporary steel railings and lintels, managing to both address its historic industrial setting while acknowledging, stylistically, its role as a newcomer.

The development community was impressed by the ease with which units sold in the Fischer Mills Building, allowing the enterprising young developer Glenn D. McDermott to capitalize on the success by securing a promising but ultimately ill-fated deal in April 2000 with a small consortium of individual investors and, more important, Goldman, Sachs & Company's Whitehall Street Real Estate Fund, that also agreed to provide 90 percent of the funds for two other projects McDermott was planning in Tribeca: a new nine-story building at 124 Hudson Street, southeast corner of Ericsson Place, and a new fourteen-story building at 3–9 Hubert Street, between Hudson and Collister Streets. The project at 124 Hudson Street followed previous plans by a development group formed by owners of the parking lot that had operated on the site, who had commissioned Peter DeWitt Architects to design, as one of the developers, Craig Harwood, put it, "a building the New York City Landmarks Preservation Commission felt comfortable with and we felt made economic sense."[71] After numerous revisions and reductions in bulk, DeWitt's scheme for a nine-story red brick building with decorative cast-stone and brick detailing, large, recessed windows, and corrugated steel marquees was approved by the commission. But when McDermott's new and well-funded development firm, GDM Projects, offered to purchase the site, Byrns, Kendall & Schieferdecker was hired to readdress the project.[72] According to Harry Kendall, "We redesigned everything, but we kept the original massing and height." Completed in 2001, the 94,000-square-foot building containing twenty-six-units situated around an interior courtyard featured buff iron-spot brick, green fiberglass spandrels with Greek key motifs, cast-stone sills, fiberglass cornices,

Fischer Mills Building, east side of Greenwich Street, between North Moore and Beach Streets. Byrns, Kendall & Schieferdecker, 2001. View to the southeast. Wallen. BKSK

and granite rock-face capitals above a two-story granite, limestone, and brick base with a second-story cast-stone entablature. Kendall stated that the building "walks the tightrope" of Tribeca's grand old structures.[73] Michael Sorkin, whose design firm occupied space in 145 Hudson Street, catercorner from the new building, remarked in March 2001, "It's about the right size for its lot and context, and has been designed in the kind of lite historicism that has become the default for architecture in the neighborhood. A decent, if dull, building, it will in some ways remain unobtrusive, blending with the surrounding lofts. Of course, its inhabitants won't be quite as authentic as the architecture; not too many working stiffs will be moving into those million-and-a-half dollar starter lofts."[74]

Glenn McDermott's plans for 3–9 Hubert Street, like those for 124 Hudson Street, came on the heels of existing plans for the site, in this case by developer Stanley Scott, a former printer who had operated in the neighboring 145 Hudson Street (Renwick, Aspinwall & Guard, 1929), southwest corner of Hubert Street, a fourteen-story Art Deco factory building. Scott had hired architect Joseph Pell Lombardi to renovate and convert 145 Hudson Street into approximately forty 2,000-square-foot lofts with retail spaces on the ground floor and commercial spaces on the first four floors, a project completed in 2000.[75] Lombardi was also asked to design a new twelve-story building for 3–9 Hubert Street that would house sixty-eight condominium apartments and, employing deep-orange brick and large windows with small panes above a two-story

limestone base, relate architecturally to 145 Hudson Street. As Lombardi explained, "We treated this building much like it was an annex to the magnificent . . . building just to the east . . . so that the architecture of the two tied in."[76] A convincing and unusually well-conceived solution to building in a historic district, the design received approval from the Landmarks Preservation Commission in 1997, but was nonetheless opposed by many in the community, including Carole Ashley, who in a letter to the New York Times bemoaned "the philistine concept of a new building having to emulate one from another period," writing, "Mr. Lombardi's dispiriting new-Deco design (if that's what it is) is just another generic postmodern hulk, now all too familiar in downtown Manhattan. . . . We would much prefer a contemporary building by a fine architect, in scale with the district."[77] In 2000 GDM Projects purchased the site and hired Byrns, Kendall & Schieferdecker, working with Alan Wanzenberg, who was responsible for the lobby and other public spaces, to prepare a new design. But only months later, Glenn McDermott's partnership with Whitehall collapsed amid allegations of fraud, leading to the acquisition of the project by Whitehall and subsequently by Ghent Realty Services, which asked the design team to create a new complex incorporating a sixteen-story tower containing twenty-nine loft-style apartments including a two-story penthouse and three maisonettes in the base, and two separate townhouses, enclosing a 3,000-square-foot courtyard to make up a total of 107,400 square feet of new space.[78] The new design of the building, named the Hubert (2004),

124 Hudson Street, southeast corner of Ericsson Place. Byrns, Kendall & Schieferdecker, 2001. View to the southeast. Wallen. BKSK

Proposal for 3–9 Hubert Street, between Hudson and Collister Streets. Joseph Pell Lombardi, 1997. Rendering of view to the southwest showing 145 Hudson Street on left. JPL

Hubert, 7 Hubert Street, between Hudson and Collister Streets. Byrns, Kendall & Schieferdecker, 2004. View to the southeast showing 145 Hudson Street (Renwick, Aspinwall & Guard, 1929) on left. RAMSA

7 Hubert Street, which was approved by the landmarks commission in 2001, was intended, according to Kendall, to have an "independent character, separate from 145 Hudson Street, but that relates more to its lower-scale surroundings."[79] The red brick building, rising with several setbacks above a stone base, featured generous expanses of ten-foot-high industrial sash windows allowing light into apartments with eleven- to twelve-foot ceilings. In all, the complex comprised only thirty-four residences—half the number called for in the previous proposal. The two townhouses featured more contemporary steel and glass facades, roof terraces, rear gardens, and private garages.

Of the various new buildings that attempted to fit into Tribeca's historic fabric during the late 1990s, very many were worse than bland. At 121 Reade Street, southwest corner of Hudson Street, Stephen B. Jacobs Group's Tribeca Abbey (1999), a twelve-story rental apartment building extending through the block to establish a presence at 147 Chambers Street, employed striated red and beige brick "in a contemporary fashion," according to Jacobs, "to recall the historic rustication of the surrounding buildings."[80] The result was garish and incoherent, doing little to enhance or respond to the

district, a particular disappointment given its prominent location. But there were some surprising successes such as the six-story red brick building at 5 Harrison Street, southeast corner of Staple Street, designed by architects Wids DeLaCour and Richard Ferrara and completed in 2001.[81] Built on a site within the Tribeca West Historic District, the design was appropriately restrained, with hefty stone lintels over large windows set between three bays on the north facade and one wider bay on the west facade. The sixth-floor windows were narrower, clustered in groups of two and three beneath a frieze of red tile and stone that ran along the top of the building. A stainless-steel entry and a stainless-steel-clad penthouse, not visible from the street, were the only signs of flash in the modest design.

Guenther Petrarca Architects' Reade Street Townhouses, a row of three identical twenty-five-foot-wide buildings at 148, 150, and 152 Reade Street, between Greenwich and Hudson Streets, were the first single-family townhouses built in the area in nearly 150 years and constituted bold yet appropriate additions to the Tribeca West Historic District.[82] The 7,000-square-foot houses contained common areas, including a ground-floor eat-in kitchen and a second-floor double-height

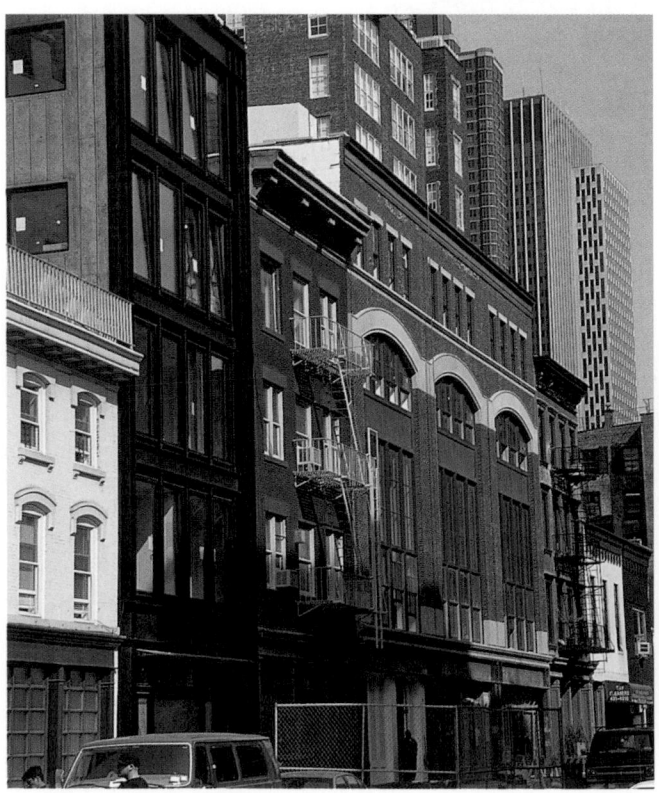

living room with seventeen-foot-tall windows on the lower floors, and five bedrooms on the upper floors, above which were two tiers of set-back rooftop terraces. Each red brick facade was dominated by a triple-height window framed by brick piers supporting a shallow stone arch that united the second, third, and fourth floors. The arches sat atop a massive, exposed I-beam that doubled as a lintel above the ground floor. The combination of glass, brick, and stone, with dark green sash, spandrels, and cornices formed what Abby Bussel, writing in *Metropolis*, deemed a "very contemporary interpretation of industrial architecture."[83] Two doors west, at 156 Reade Street (2001), Petrarca designed a townhouse for his own family. An even more powerful presence than the Reade Street Townhouses, with its sixty-two-foot-tall, nineteen-ton recycled steel facade, lifted into place as one piece after being welded together on-site from twenty-five-foot sections, and its grid of rectangular windows, it was one of the few distinctive new buildings in Tribeca.[84] The first floor of the 6,000-square-foot house accommodated Petrarca's design studio, while the top floor was reserved for the living room; those in between accommodated bedrooms. Heated and cooled by a geothermal system drawing on a 1,250-foot-deep standing column well in the basement, the house was also the tallest building ever—and the first in New York—to employ structural insulated concrete forms (a combination of polystyrene foam insulation and poured concrete).

FACING PAGE Franklin Street Station, intersection of Franklin and Varick Streets and West Broadway. Karahan/Schwarting, 1993. View to the northeast. BKAA

RIGHT Proposal for Tribeca Atelier, site bounded by Sixth Avenue, Walker, Church, and White Streets. Joseph Pell Lombardi, 1998. Rendering of view to the north. JPL

BELOW Tribeca Grand Hotel, site bounded by Sixth Avenue, Walker, Church, and White Streets. John Prince, 2000. View to the north. RAMSA

BELOW RIGHT Tribeca Grand Hotel, site bounded by Sixth Avenue, Walker, Church, and White Streets. Bogdanow Partners, 2000. Atrium. Kleinberg. BPA

The Tribeca Grand Hotel (John Prince, 2000), the neighborhood's first hotel, situated in its relatively untouched northeast corner on a triangular site bounded by Sixth Avenue, Walker, Church, and White Streets, was developed by Hartz Mountain Industries, builders in 1996 of the SoHo Grand Hotel.[85] Previous plans for the site had been announced in 1998 by developers Jack Lefkowitz and Joseph Pell Lombardi, the latter serving as architect as well, to develop a 157-foot-tall, fifteen-story luxury apartment building, the Tribeca Atelier, with a heavily fenestrated curved mansard roof and industrial sash windows, but later that year Hartz Mountain purchased the site and began development of the less ambitious, eight-story, eighty-nine-foot-tall hotel.[86] Even so, area residents were put off by the proposal, stating their preference, as Anita Murray of the Tribeca Community Association stated, for "a quiet residential building for families, not a 24-hour hotel for transients."[87] But the community had little recourse: the site lay outside historic district lines and did not violate zoning. Construction began in 1998 on the 203-room hotel, the design of which, undertaken by Hartz Mountain's in-house architects, led by John Prince, was meant "to fit in with the character of the neighborhood," according to Emanuel Stern, the company's president.[88] The result was a banal, granite-based, red brick building with cloying decorative touches such as wrought-iron rosettes, metal canopies, stone trim, and windows and spandrels in a muted shade of green. The architects seemed so intent on anonymity that one of the most prominent components of its decorative program, the tympanum of the south-facing pediment, was left conspicuously blank. Other aspects of the exterior were also disappointing: the canopies, supported by iron tie-rods, seemed flimsy and cheap, especially in proximity to the substantial awnings of Tribeca's historic warehouses; the building's red brick piers were erratically proportioned, too narrow on the east and west facades and too wide on the south; and the rosettes and brackets meant to "dress the building up" came across as little more than appliqué. The interior of the hotel was more successful, embodying a glamour not at all apparent from, but nearly compensating for, the buildings lackluster street presence. The work was a combination effort of Bogdanow Partners, which designed the atrium and public spaces, and Tsao & McKown Architects, which designed the sleek, high-tech guest rooms. An elaborate lighting program by the New York–based Focus Lighting was vital in defining the hotel's image. With a goal of catering to "creative professionals," the Tribeca Grand boasted Internet-connected guest rooms, a 98-seat basement screening room, a fitness center, a large private dining room entered from Sixth Avenue, and, as the focal point, a 10,000-square-foot atrium serving as a combination restaurant, bar, and lounge. The lobby was entered from White Street, where a curving fabric screen greeted visitors, allowing broken glimpses of the space beyond it. A curving thirty-foot-long ramp descended around the screen, leading to the dramatic, skylight-capped atrium where restaurant, lounge, and bar areas were delineated only by shifts in lighting and decor, or in some cases by architectural elements such as the sloping glass canopy that covered the so-called Church Bar. Inspired by the Bradbury Building (George Wyman, 1893) in Los Angeles, two glass elevators within steel cages helped activate the space, depositing guests on interior balconies that overlooked the atrium and provided access to the guest rooms.

As much as residents were initially attracted to the raw nature of Tribeca, once settled there they inevitably sought to soften its rough edges with parks and greenery as well as beau-

tified infrastructure. In 1993 work was completed on the renovation of the Franklin Street subway station and entrance, intersection of Franklin and Varick Streets and West Broadway.[89] Architects Karahan/Schwarting reused the original railings and green glass globes of the stairwell but covered them with a new sandblasted glass-block and steel canopy inspired by those Otto Wagner designed about 100 years before for Vienna's Metro.[90]

Efforts to renovate the small triangular Duane Park, created in 1797 at the intersection of Duane and Hudson Streets, began in the mid-1980s when Karahan/Schwarting was asked to plan for new street lamps, plantings, grass, and paving, which were not realized.[91] Then, in the late 1990s, a group called Friends of Duane Park, in partnership with the city, succeeded in raising enough money for the park's restoration and hired landscape architect Signe Nielsen to redesign it, taking it back to its condition prior to a 1940 reconstruction.[92] Nielsen planted a framework of evergreens around the perimeter of the park to block views of parked cars. From its borders, plantings cascaded downward in height toward the park's center, a teardrop-shaped open space ringed with benches. Nielsen noted that area residents planted the foliage themselves and Friends of Duane Park maintained it, allowing for more delicate species of plants than would have been possible had the Parks Department been left responsible for maintenance.[93]

The Greening of Greenwich was a somewhat controversial beautification plan, also designed by Signe Nielsen, that narrowed Greenwich Street between Hubert and Barclay Streets from six lanes to four, allowing Washington Market Park to be extended to the east, and provided widened sidewalks, additional lighting, foliage, and seating along the bleak street, which had been excessively widened as part of the Washington Market Urban Renewal project.[94] The project,

first planned in the late 1980s, drew initial criticism from Tracy and Drew Nieporent, owners with Robert De Niro of Tribeca Grill, who feared the narrower roadway would hinder traffic and the delivery of goods to their restaurant and to other local businesses. More detrimental was the discovery in the mid-1990s that roughly 85 percent of the funding for the project, originally provided from the construction of the Shearson Lehman tower and entrusted to the Economic Development Corporation for safekeeping, had been spent on other projects. In addition, because the east side of Greenwich Street had been designated in 1991 as part of the Tribeca West Historic District, all of the widening and planting was limited to the west side of the street, a condition Nielsen deemed "a fatal flaw in planning" because of the dense jumble of utilities that ran beneath that side of the street, delaying work and limiting the type and number of plantings that could be accommodated. Nonetheless, in 1999 construction began on a pared-down version of what was once a grand vision for a lushly planted, pedestrian-friendly corridor. Nielsen was able to add sixty-two trees in two rows, among them honey locusts, Japanese zelcovas, columnar maples, regent scholars, and lindens. A row of street lamps helped illuminate the new fifty-six-foot-wide sidewalk, which was paved with gray- and red-pigmented concrete and featured an undulating red brick pathway, each brick inscribed with the name of a donor to the park. According to Nielsen, the brick path "reflected the waterline of the Hudson at one point in the heyday" of Tribeca and also optically narrowed the width of the walkway.[95] The project was completed in summer 2001.

Greening of Greenwich, Greenwich Street, between Hubert and Barclay Streets. Signe Nielsen, 2001. View to the south. MN

CIVIC CENTER

The Civic Center, roughly bounded by Canal Street to the north, Park Row to the south, and the neighborhoods of Chinatown and Tribeca to the east and west, respectively, had repeatedly resisted planning attempts, beginning in the late nineteenth century, to transform the area into a coherent enclave of buildings devoted to federal, state, and local government institutions.[1] Despite the cacophony, distinguished buildings were built over the years, beginning with Joseph François Mangin and John McComb Jr.'s City Hall (1803–11) and including the Municipal Building (McKim, Mead & White, 1914) and two courthouses overlooking Foley Square, the New York Country Courthouse (Guy Lowell, 1926) and the United States Courthouse (Cass Gilbert, 1936).[2] More recent efforts were less successful, such as Gruzen & Partners' Police Headquarters (1973).[3] Much less satisfactory was the exceedingly banal Jacob K. Javits Federal Office Building and Court of International Trade (Alfred Easton Poor, Kahn & Jacobs, and Eggers & Higgins, 1967).[4] By the late 1970s, many buildings were showing their age and inadequacy, with significant shortages noted for prison, administrative, and courtroom space. In large part, to the surprise of many, these deficiencies were addressed by building campaigns in the 1980s and 1990s. The most dramatic activity in the Civic Center, however, centered around two controversies with national implications, one involving the fate of a Richard Serra–designed sculpture commissioned by the federal government, and the other relating to the startling discovery twenty feet below the city's streets on the construction site of a federal office building of the Negros Burial Ground, an eighteenth-century slave cemetery.

Tilted Arc

In 1979, when the federal government's General Services Administration commissioned the internationally recognized sculptor Richard Serra to create a piece for the barren plaza in front of the Jacob K. Javits Federal Office Building and Court of International Trade, 26 Federal Plaza, overlooking Foley Square between Duane and Worth Streets, little did it know that the executed work, Tilted Arc (1981), would unleash a more than decade-long, passionate, often angry debate between artists, critics, politicians, and local citizens.[5] Igniting local, national, and even international interest, the arguments over this contested work, which was generally admired by the cognoscenti but by and large reviled by the public, centered on important issues of censorship, the government's proper role in dealing with public works of art, and the very nature of what constituted a work of art. Simply put, the fate of Tilted Arc was the nation's most talked about and written about "art" controversy of the 1980s.

The decision to commission a major piece from Richard Serra was hardly undertaken as a provocation. In 1980, the same year that the plans for Tilted Arc were approved and a year before the sculpture was fabricated and installed, Serra had successfully completed two other large-scale works only a short distance away in lower Manhattan, T.W.U. and St. John's Rotary Arc.[6] T.W.U., named in honor of the transit worker's union because the sculpture was finished at the end of a crippling transit strike, was a thirty-six-foot-high, seventy-two-ton Cor-ten steel piece placed at the triangle just outside the IRT subway station at Franklin Street and West Broadway. St. John's Rotary Arc, just outside the entrance to

St. John's Rotary Arc, site bounded by Hudson, Laight, and Varick Streets and Ericsson Place. Richard Serra, 1980. View to the south. Moore. RS

the Holland Tunnel, consisted of five twelve-by-forty-foot, two-and-a-half-inch-thick plates of Cor-ten steel arranged in a curve that, according to Serra, "reinforces the notion of tunneling. The truck traffic emerges from the Holland Tunnel, appears, disappears behind the *Arc*, reappears."[7] Both pieces received predominantly good press. In 1980 Hilton Kramer, then the *New York Times*'s art critic and a brilliant if curmudgeonly opponent of a good deal of contemporary art, observed, "We are in the era of art without tears or conflict. One of the artists who has lately been putting this new tolerance to a severe test is Richard Serra, among whose sculptures may be found some of the most unlovable works produced in our time. Yet hard as Mr. Serra tries to offend established taste with big, simple, ungainly abstract steel construction, it avails not. His projects for public sculpture are promptly accepted, ugly or not."[8] Both installations were temporary, with *T.W.U.* removed in 1982 and *St. John's Rotary Arc* remaining on its site for seven years.

Given the prevailing climate of tolerance for artistic experimentation and Serra's virtually unassailable reputation, it was hardly daring of the GSA to choose him to design a sculpture for the Javits Building plaza as part of its Art-in-Architecture program, in effect since 1972, which mandated that one-half of one percent of federal construction costs would be devoted to public art. Serra was not initially attracted to the commission: "It's a 'pedestal site' in front of a public building. There's a fountain on the plaza, normally you would expect a sculpture next to the fountain, so the ensemble would embellish the building." But, on further reflection, he "found a way to dislocate or alter the decorative function of the plaza and actively bring people into the sculpture's context." This somewhat contrary, not to say subversive, strategy would be achieved by building "a piece that . . . will cross the entire space, blocking the view from the street to the courthouse and vice versa. . . . It will be a very slow arc that will encompass the people who walk on the plaza in its volume. . . . After the piece is created, the space will be understood primarily as a function of the sculpture."[9]

In July 1981, *Tilted Arc* was installed on the plaza. The 77-ton, 120-foot-long, 12-foot-high piece was constructed of three three-inch-thick curved sheets of dark red rusted Cor-ten steel that were tilted one foot off the vertical axis. It was embedded in the steel-and-concrete substructure of the plaza. Douglas Crimp, in one of the few relatively dispassionate and even-handed assessments of the sculpture as a piece of art and not a controversial political issue, described the impact of Serra's work on the "particularly inhospitable" plaza: "*Tilted Arc* . . . does nothing to decorate this product of urban chance, or to make it agreeable or even comfortable. It was clearly no part of Serra's intention to use the sculpture to improve the highly problematical site, even at token level. At the same time the sprawling work presents the pedestrian with a series of contradictory impressions which make crossing the area, in any direction or from any side, a fascinating experience."[10]

Objections were raised almost immediately after its installation, and within two months' time more than 1,300 signatures

Tilted Arc, Jacob K. Javits Federal Office Building Plaza, overlooking Foley Square, between Duane and Worth Streets. Richard Serra, 1981. View to the east. Chauvet. RS

had been gathered from government employees working in the Javits Building requesting its removal on grounds that "whatever its esthetic merits, it is the wrong work of art in the wrong place." The petitioners also argued that the sculpture "brutally destroys the plaza's vistas and amenities" and casts "an ominous and threatening shadow" while rendering access to the building "awkward and confusing."[11] Soon enough the tenants' protests became a matter of wide public debate after Grace Glueck, art critic for the *New York Times*, wrote an article about the controversy in September 1981. Serra's sculpture also picked up a persistent and influential critic in Edward D. Re, chief judge of the United States Court of International Trade, whose chambers adjoined the plaza. Re began a private letter-writing campaign to various local and national officials of the GSA. But the art community overwhelmingly rallied around Serra, and following the first wave of reaction after the petition and protests were publicized, the issue seemed to fade from the public's attention.

Things remained quiet for the next three years until late 1984 when Judge Re, who had continued his protests against the sculpture, gained an important ally in William J. Diamond, the newly appointed regional administrator of the GSA. Diamond announced in December 1984 that the agency would hold a hearing in March to determine the fate of the sculpture. "I want to make it very clear that this is not an attack on the esthetics or the artist," Diamond stated to the disbelief of many. "What we're deeply concerned about is the fact that this

piece . . . has made it impossible for the public and the Federal community to use the plaza."[12] Mention of the upcoming hearing generated a great deal of interest in *Tilted Arc*, which received far more attention than it had when first installed.

Grace Glueck, who believed that "the case bears on the very nature of public sculpture itself and its 'responsibility' to a broad general public," was the first to articulate what became a continuing refrain of many in the art community who didn't like the actual piece but contended that its removal would be a serious mistake:

> To this viewer, who admires Mr. Serra as a sculptor, 'Tilted Arc' is still one of the ugliest pieces of public art in the city, a domineering work that bullies, rather than enhances, the open plaza. . . . [Serra's] hostility to the plaza and its complex seems evident, and perhaps it was a mistake for him to take it on. Admittedly, it makes a great case for the opposition. Yet there 'Tilted Arc' stands, awkward and stubborn, conveying to the viewer the important message that, unlike politics, a work of art is not about compromise. For that very reason, it seems to me that removal of the work would be wrong; that this city, which serves as the stronghold and symbol of contemporary art for the world, can come to terms with, and even learn to enjoy, the pigheaded refusal of 'Tilted Arc' to accommodate.[13]

In February 1985, the architect James Ingo Freed, who would soon collaborate with Serra on the Holocaust Museum in Washington, D.C., tried to strike a compromise with a suggestion that, instead of removing the sculpture from the plaza, the plaza itself could be redesigned by a landscape architect to allow both Serra's work of art as well as the public uses the GSA desired. Serra immediately rejected Freed's proposal, noting that *Tilted Arc* was a site-specific work and any attempt to alter the site or move the sculpture would be the same as destroying it. On the eve of the hearing, Michael Sorkin, the often glibly negative but always verbally brilliant architecture critic for the *Village Voice*, echoed Glueck's assessment of the piece—"a superficial, schematic response, another dull sibling from a generation of too easy art"—but also made the point that what existed around the sculpture was also cause for concern: "Let's face it, the status quo . . . at Federal Plaza was pretty grim: horrible plaza, horrible buildings, horrible bureaucratic interiors, the worst. The hearing about the Serra points up exactly the degree to which citizens have no control over their environment. It's sham democracy offered as a cover-up for the real crimes, a show trial after which the miserable 'Arc' will be taken out and shot and the Federal Building declared once again to be humane. Gimme a break! The Serra's being threatened because that's what can be threatened. And that's why it needs to be defended."[14]

Working against Serra was the public's perception that the sculptor had been selected capriciously and *Tilted Arc* placed in the plaza without any serious analysis of the consequences. In fact, Serra had been selected by a three-member panel consisting of museum directors Suzanne Delehanty and Ira Licht and art critic Robert Pincus-Witten, and the design had been scrutinized by the GSA for its environmental impact, effect on pedestrian traffic, maintenance needs, as well as its appropriateness for the site before it was approved by chief administrator Roland G. Freeman III. But many were still convinced that the piece had been selected on the basis of cronyism. Public interest was so great that the hearings were extended for three days, March 6–8, 1985, with 180 people testifying before the five-member GSA committee headed

Tilted Arc, Jacob K. Javits Federal Office Building Plaza, overlooking Foley Square, between Duane and Worth Streets. Richard Serra, 1981. View to the northwest. Aschkenas. RS

by Diamond. The questionnaire he had placed in the lobby of the Javits Building asking the public to comment on the sculpture's fate, yielded 2,496 respondents wanting the sculpture removed and only 166 thinking it should stay. The hearing attracted a number of luminaries in the art world who supported Serra, including Philip Johnson, art dealer Leo Castelli, composer Philip Glass, and the artists George Segal, Elizabeth Murray, and Claes Oldenburg, whose *Batcolumn* (1977) in Chicago, also sponsored by the GSA, had come in for a fair amount of criticism.

The sculpture's most popular defense was the belief that the government had simply no right to censor an artist's First Amendment rights of free expression and, most important, any attempt to do so would have a chilling effect on artists across America. William Rubin, director of the Department of Painting and Sculpture at the Museum of Modern Art, implored the panel to take a broader view and look beyond what they perceived to be the opinion of the majority: "I must say that I have never heard of the removal of a public monument having been settled by popular vote. If that is what is being contemplated here, it seems to me a most dangerous precedent."[15]

Even though only 58 out of the 180 people testifying at the hearing supported *Tilted Arc*'s removal, it was the opinion of "average" citizens that captured the attention of the local and national press, who seized on this issue as yet another example of the federal government wasting money, a popular topic in the Reagan era, and reiterated the old theme of the arrogant

artist contemptuously imposing his will on an "innocent" public. Other arguments against the piece ranged from the assertion that it would heighten the danger of a terrorist bomb explosion in the area to the belief that it increased the local rat population. But most people, like William Toby, just hated it: "During my 17 years of employment in this building, nothing has offended me and my staff more than the erection of this huge, rusted metal barrier. I am here to recommend its relocation to a better site—a metal salvage yard."[16]

Somewhat lost in the battle over whether the GSA should or had the right to remove the sculpture were the kinds of assessments that judged the piece on its own merits. Paul Goldberger, who ironically enough didn't seem too concerned with its removal in the face of the public's "near-total opposition," had some kind words about how it functioned in the plaza: "The Serra piece is harsh and difficult. But Richard Serra did understand the nature of urban space and Foley Square in a way that the architects Kahn & Jacobs . . . did not. The arc, in its long, gentle sweep, reaches out to embrace the two great classical courthouse buildings across the square, pulling the civic buildings around Foley Square together, where the Federal Plaza building itself tries to stand apart."[17] The most spirited defense of the sculpture came from *New York Times* art critic Michael Brenson: "'Tilted Arc' is an imposing, yet flexible and subtle work. No ambitious sculpture in this setting could be otherwise. For a sculpture to hold its own in a space this confused and disjunctive, it had to be resilient

Tilted Arc, Jacob K. Javits Federal Office Building Plaza, overlooking Foley Square, between Duane and Worth Streets. Richard Serra, 1981. View of demolition, March 15, 1989. Kotter. RS

enough to accommodate the numerous styles and vistas, and compact and insistent enough not to be overpowered."[18]

On April 18, 1985, the GSA panel voted to remove *Tilted Arc* from the Javits Building plaza, pending the approval of Dwight Ink, Acting Administrator of the GSA, which was granted six weeks later. The GSA then requested that the National Endowment for the Arts commission a blue-ribbon panel to find an appropriate spot for the Serra sculpture, the removal of which was estimated to cost $50,000. But before the panel could meet, Serra filed suit against the GSA charging breach of contract and violation of his First Amendment rights, seeking a total of $30 million in punitive damages and compensation for harm to his career and reputation. Judge Milton Pollack of Federal District Court ruled in favor of the GSA on July 16, 1987, declaring the sculpture the property of the government agency and concluding that Serra had been neither harmed nor deprived of his constitutional rights of free expression. Only after Pollack had ruled did the NEA panel, chaired by veteran labor lawyer Theodore W. Kheel, finally meet, and then for just one day, after which they unanimously declared that *Tilted Arc* "could not be removed or relocated without destroying its artistic value," an opinion that had little effect on the GSA.[19] Serra continued the lengthy legal process by appealing the decision, but on June 1, 1988, the United States Court of Appeals for the Second Circuit upheld Judge Pollack's ruling.

From this point forward, the fate of *Tilted Arc* began to resemble that of a criminal defendant on death row as numerous announcements of its impending removal were contradicted by last-minute temporary restraining orders. Finally, on the night of March 15, 1989, with William Diamond on hand to supervise the demolition, *Tilted Arc* was taken apart and removed to a motor-vehicle compound at Third Avenue and Twenty-ninth Street in Brooklyn where, according to Diamond, it took "up eight parking spaces."[20] Serra remained bitter to the end: "This government is savage. It is eating its culture. I don't think this country has ever destroyed a major work of art before."[21] The pieces of Serra's sculpture remained in Brooklyn until 1999, when they were removed to a government storage facility in Middle River, Maryland, where the GSA promised to preserve them but never to erect the sculpture "anywhere else,"[22] ending what Margaret Moorman,

writing in *Art News*, described as a controversy that "may go down in history as the most important—and ugliest—set-to over public art ever."[23]

After *Tilted Arc* was removed, William Diamond announced that a "new art form—open space"—would replace the sculpture. "We are installing 15 benches and planters with trees so that the public can enjoy the plaza again," he declared.[24] Four years later, in 1993, the GSA announced that Martha Schwartz, a landscape architect with a strong bias toward abstract environmental form-making, was hired to come up with a new plan for the plaza.[25] Determined to avoid the kind of controversy associated with the Serra debacle, the GSA submitted Schwartz's plans to the tenants of the Javits Building. Schwartz stated that she thought she had been chosen because her work was "accessible. . . . It was made very clear to me who used the plaza and how it functioned. I gave the office workers a nice place to have lunch."[26] Completed in 1996, Schwartz's design managed to animate the bleak space by threading a double row of back-to-back benches in great arcs through the entire plaza. She also removed the fountain and the planters and replaced them with six-foot-tall, eighteen-foot-diameter turf mounds, each with a mist fountain, that were placed on the interior curves of the benches and were illuminated at night by green light. The editors of the *AIA Guide*, who regretted the loss of the Serra sculpture, nonetheless found Schwartz's design "a happy event."[27]

Expanding the Tombs

In 1982, the year after the *Tilted Arc* brouhaha began, the Department of Correction, responding to a Federal District Court ruling to reduce overcrowding in city jails, announced its intention to build a new prison in the Civic Center area on a 1.25-acre vacant lot on the western edge of Chinatown bounded by Centre, Baxter, White, and Walker Streets.[28] The site was selected because it was next to the venerable Criminal Courts Building and Prison (Harvey Wiley Corbett and Charles B. Meyers, 1939), popularly known as the Tombs. The jail portion had been closed since 1974, but it was undergoing renovation with the expectation that by the next year it could house 426 inmates.[29] Reaction to the proposal from the nearby Chinatown community was swift and angry, with more than eighty business, civic, and community groups joining together to form an organization dedicated to defeating the 500-bed facility. Charles P. Wang, chairman of the newly created Coalition for Lower Manhattan, argued that "it's just going to create a new ghetto," attracting "undesirable elements" that would destroy the ethnic and cultural identity of the neighborhood.[30]

At a September 1982 hearing before the City Planning Commission, the Department of Correction, in an effort to mollify the Chinatown community, suggested that space on the bottom floors of the prison building could be made available for office and retail uses as well as room for various local community groups. The Department of Correction also requested that the site, owned by developer David H. Feinberg, be condemned. Although he had not yet produced any plans or sought any permissions, Feinberg contended that he wanted to build a mixed-use office and retail complex that would also include moderate- and high-priced apartments. Representatives of the Coalition for Lower Manhattan and the Chinese Consolidated Association, another group opposing the project, were not impressed with the Department of Correction's

compromises and vowed to continue the fight. The editors of the *New York Times*, noting that the "need for new jails remains acute," sided with the city: "There is . . . community opposition to the White Street jail, but for once it seems hollow. Chinatown coexisted peaceably with the old Tombs for years."[31]

In October the City Planning Commission unanimously approved plans for a 500-bed detention center as well as a 126-bed juvenile center to be placed at the top of the new jail. It urged but did not require the Department of Correction to offer ground-level space for retail tenants or community groups. The Board of Estimate approved the plans and the condemnation of the site with a 7 to 4 vote on December 2, although it did eliminate the juvenile facility as a compromise measure. Mayor Ed Koch was relieved by the vote but chose the occasion to articulate what he felt was "a disturbing new dimension" each time the city tried to build a controversial project. In a kind of urban version of the growing NIMBY (not in my backyard) movement in the suburbs, Koch declared that a regrettable "outbreak of selfishness" had descended on the city.[32]

A final lawsuit protesting the project was dismissed by state supreme court in August 1983, but the building would not be completed for another six years, during which time 421 renovated jail cells (Gruzen Partnership, 1983) reopened in the Tombs and the project was reduced in size, with the northern half of the block devoted to a mixed-use residential building (see below). The fourteen-story, brown precast concrete White Street Correctional Facility (1989) was designed by Urbahn Associates in consultation with Litchfield-Grosfeld Associates.

The building, in deference to the wishes of the community and the City Planning Commission, included ground-level shops. A concrete-and-glass bridge spanned a spare plaza and connected the building with the Tombs. The new prison included a gymnasium, a rooftop recreation area, and several small libraries. Seventy-square-foot cells, entered through regular doors, were lit with unbreakable windows that were not barred although they were placed at eye-level so that prisoners could not present lewd images to people in buildings across the street. Jeffrey Hoff and Steven Saltzman, writing in *Metropolis*, were impressed with the "grand, new Post-Modern" prison which they felt "creates a dignified but not imposing facade. The building as a whole neither mimics nor clashes with the Art Deco lines of the nearby criminal court complex . . . and the stultifying institutional feel is noticeably lacking."[33] The editors of the *AIA Guide* were not so taken, simply asking, "Tootsie Rolls?" as they dismissively suggested that the dominating piers on the exterior of the building resembled nothing so much as rows upon rows of the chocolate candy placed end on end.[34]

The White Street Correctional Facility was also notable because of its participation in the New York City Department of Cultural Affairs's "Percent for Art" program in which 1 percent of the city's capital construction budget be dedicated to art. The city commissioned the artist Richard Haas, working with Kit Yin Schneider, who created a seven-panel mural chronicling the history of immigration as it affected the area. Haas's mural came under attack from the newly organized Latinos Against the Mural on Baxter Street, which believed that the depiction of a figure lying on the ground next to a

Jacob K. Javits Federal Office Building Plaza, overlooking Foley Square, between Duane and Worth Streets. Martha Schwartz, 1996. View to the north. Ward. MS

White Street Correctional Facility, north side of White Street, between Centre and Baxter Streets. Urbahn Associates, 1989. View to the northeast. Hueber. UA

"Bodega" sign as well as an abandoned, wrecked car, and a woman the group felt was dressed like a prostitute was racist and demeaning to Latinos. Haas, who noted that "it was never my intention to arouse, inflame or offend any ethnic groups in this city," responded to the criticism by changing the panel to a more politically acceptable depiction of salsa musicians, domino players, and a street vendor.[35]

In May 1984, in response to the Chinatown community's hostility to the proposed prison, the city announced plans to construct a new building next door that would consist of a three-story commercial complex topped by an eleven-story tower to house the elderly.[36] Plans for the mixed-use building, to occupy the northern 13,000 square feet of the 50,000-square-foot block bounded by Centre, Baxter, Walker, and White Streets, were announced after more than a year of negotiations between city officials and community groups. Although the neighborhood embraced the project, things did not go smoothly as a turf war erupted between competing community groups. The conflict was settled only after a two-year lawsuit to determine who would serve on the board administering the project. Designed by the Edelman Partnership and completed in 1992, the eighty-eight-unit tower sat atop 26,000 square feet of commercial space that had stores on its ground level, a health clinic on the second floor, and a day care center on the third. Named Chung Pak, or "everlasting pine," the subsidized housing project was open only to those with limited incomes who were over sixty-two years of age. With conventionally articulated banded facades in two colors of brick, the

northeast corner of the building, looking toward Canal Street, featured red metal panels and a chamfered corner at the top floor as well as a rooftop banner with the building's name in Chinese. The project also included a community room, library, and a 1,500-square-foot rooftop terrace.

The Federal Presence

The most significant development in the Civic Center area, resulting in the construction in the mid-1990s of two of the largest buildings built in the neighborhood since the 1970s, was undertaken to address the acute shortage of federal courtroom and office space. On December 22, 1987, the General Services Administration announced plans to build a total of 1.6 million square feet of space on two city-owned lots then occupied by parking lots that were about five blocks apart, one on the east side of Broadway between Reade and Duane Streets, south of the Jacob K. Javits Federal Office Building, and the other across Foley Square on the north side of Pearl Street, just east of the New York County Courthouse (Guy Lowell, 1926) and across the street from the United States Courthouse (Cass Gilbert, 1936).[37] The Broadway building, which the GSA wanted to connect to the Javits Building underground, was planned for office space, while the Pearl Street site was envisioned as a courthouse that would also have an underground connection to Gilbert's building.

From the very beginning of the process, great emphasis was placed on the aesthetics of the two buildings. This was understandable, not only given the fiasco of *Tilted Arc*, but also given the absolute banality of the Javits Building, widely considered a low point for federal architecture. Although Senator Daniel Patrick Moynihan, who along with Representative Guy Molinari of Staten Island co-sponsored the legislation that funded the project, believed that government buildings "should reflect the architecture of American history at the moment they are built," he was fearful that a contemporary design might backfire.[38] The GSA adopted a "lease to own" plan in which private developers would be selected through a competition. The winner or winners of the competition (there was no restriction that one developer-architect team could not develop both buildings) would then finance the project with a government-secured loan backed by the federal government's commitment to rent space for the next thirty years, after which time the titles for the buildings would revert back to the government. The developer, who would profit by bringing the project in on budget, would also receive a long-term building management contract as well as the right to develop and lease retail space in the Broadway building and to control the anticipated underground parking in both buildings.

The GSA planned to select the competition winners in January 1989, anticipating that both buildings would be completed by 1992. Although most major federal buildings took on average six years or longer to be completed, the GSA was optimistic that these two buildings would go much quicker because the "design/build" process frequently used in the private sector would be adopted: in this procedure, teams of architects and developers would agree in advance to a fixed cost for design and construction, saving both time and money. The formal solicitation from the GSA requested that the buildings "establish a public identity and quality of place that integrates the various buildings and functions together into a harmonious and inviting urban setting," specifying materials that would be "sympathetic" to the granite and limestone

TOP Mural depicting history of immigration, White Street Correctional Facility (Urbahn Associates, 1989), Baxter Street facade. Richard Haas, 1989. View to the southwest. RH

ABOVE Controversial mural panel replaced by Richard Haas, White Street Correctional Facility (Urbahn Associates, 1989), Baxter Street facade. Richard Haas, 1989. RH

RIGHT Chung Pak, 125 Walker Street, between Centre and Baxter Streets. Edelman Partnership, 1992. View to the southwest. Cox. ESKW

United States
Courthouse Annex,
500 Pearl Street,
between Worth Street
and Park Row. Kohn
Pedersen Fox, 1994.
View to the east
showing the New York
County Courthouse
(Guy Lowell, 1926) on
left and the United
States Courthouse
(Cass Gilbert, 1936)
on right. Pottle. ESTO

civic buildings in the area.[39] Despite the best efforts of the GSA, bureaucratic inertia set in. Part of the problem was that even after the GSA selected its developers, both buildings would still have to go through the city's Uniform Land Use Review Procedure (ULURP), which could add years, if not potentially stymie, the construction of the two buildings. Complaining that the process was taking longer "than it took Al Smith to build the Empire State Building," Moynihan pushed through legislation signed by President George H. W. Bush in November 1989 allowing the two city-owned sites to be acquired through a process called "friendly condemnation" in which the federal government would condemn the sites through eminent domain and the city would not object and would agree to sidestep its public review procedures.[40]

Finally, in March 1991, the GSA was ready to announce who would design and develop the two buildings. Although the project was conceived to address a real shortage of space, a situation that was still very much true with regard to the courts, by this time the city's economy and especially its real estate market had radically changed. Lower Manhattan, particularly hard hit, had a vacancy rate of 17.5 percent for office space, and private construction work in the city, as Alan S. Oser put it, was "sliding toward its lowest levels since the 70's, dragging construction employment down."[41] In that spirit, the federal project was roundly applauded for ensuring more than 700 construction jobs for the next three years.

The team of Kohn Pedersen Fox and BPT Properties, a partnership of Bechtel Investments Realty and the Park Tower

Group, was selected for the courthouse design, officially known as the United States Courthouse Annex (1994) until December 2000, when it was renamed in honor of Daniel Patrick Moynihan, the retiring senator who had pushed so hard for its construction.[42] Ground was broken for the 921,000-square-foot complex in late 1991. The design for the two-acre site at 500 Pearl Street, between Worth Street and Park Row, consisted of a twenty-seven-story, 410-foot-high tower rising above a broad nine-story base. Clad in Kershaw granite with Vermont marble details, the lower structure, containing offices and support facilities, matched the height of Lowell's New York County Courthouse. The tower, which aligned with Gilbert's United States Courthouse, contained a series of courtrooms and judges' chambers. The arrangement of the courtrooms in the tower was complicated, with two floors of courtrooms alternating with a single floor of chambers, a change in the standard pattern that placed chambers next to courtrooms. Due to this unusual arrangement, judges required their own elevators as well as secure corridors. All in all, three distinct circulation systems were included in the tower: for judges, the public, and prisoners. The complex included a 240-car underground parking garage, forty-three district and magistrate courtrooms, as well as one ceremonial, 5,000-square-foot courtroom with twenty-foot ceilings.

Heidi Landecker, writing in *Architecture* magazine, felt that KPF had fulfilled the GSA's request that the building fit in within its historic context: "The courthouse's plain granite skin and simple, repetitive fenestration distill the more ornate Classical detailing of the nearby Gilbert- and Lowell-designed courthouses."[43] Herbert Muschamp, who didn't disagree with Landecker, was still disappointed:

> This firm [KPF], ordinarily so adept at fusing modern and classical motifs into something vibrantly contemporary, here settles for something ponderous. But you can't accuse the architects of insensitivity to context. Located just behind Foley Square's two

ABOVE United States Courthouse Annex, 500 Pearl Street, between Worth Street and Park Row. Kohn Pedersen Fox, 1994. View to the south. PTG

BELOW *Sounding Stones*, plaza between the United States Courthouse Annex (Kohn Pedersen Fox, 1994) and the New York County Courthouse (Guy Lowell, 1926). Maya Lin, 1996. View to the southwest. McGrath. NMcG

Federal Office Building at Foley Square, 290 Broadway, between Reade and Duane Streets. Hellmuth, Obata & Kassabaum, 1995. View to the southeast. HOK

historic courthouses, the building is in keeping with their spirit of granite-jawed gravity. The massing of volume, the convex and concave indentations of the facade, the care taken with window frames and other details display the firm's high level of formal composition. But a surfeit of stone and symmetry, particularly at the building's top-heavy crown, lays the gravity on a bit thick.[44]

Although the design of the courthouse was favorably, if grudgingly, praised by critics, the building itself—despite the design/build process—generated a fair amount of controversy because of serious cost overruns. In December 1994, after a six-month-long, nationwide investigation of courthouse construction, the Senate Environment and Public Works Committee singled out the United States Courthouse Annex as the most egregious example of "uncontrolled and excessive spending" in the entire country.[45] The report criticized the building as unnecessarily lavish, noting such extras as private kitchens and showers, exotic wood paneling, terrazzo tile floors, and, of all things, operable windows.

In 1996 Maya Lin's water-bathed sculpture, *Sounding Stones*, was permanently installed in the narrow plaza connecting Pearl and Worth Streets between KPF's building and the back of the New York County Courthouse.[46] Commissioned as part of the Art-in-Architecture program, the piece consisted of four approximately six-foot-square blocks of Norwegian granite that were evocative of "scholar's rocks,"

stones that were naturally shaped by water and prized as contemplative objects in Chinese culture, an appropriate reference given the site's location close to Chinatown and the ethnic background of the artist.

The Federal Office Building at Foley Square (1995), the official name of the building located on the 70,000-square-foot site at 290 Broadway, bounded by Duane, Reade, and Elk Streets and Manhattan Alley, was awarded to the developer Linpro New York Realty and the architects Hellmuth, Obata & Kassabaum, working in association with Raquel Ramati Associates.[47] The thirty-four-story, 495-foot-high building not quite convincingly grafted onto traditional New York step-back skyscraper massing aspects of Federal classicism and Postmodern classicism, echoing a bit too obviously Michael Graves's Humana Building (1982–85) in Louisville, Kentucky, which was the formal source for the pilaster-like vertical piers and curved penthouse colonnade that broke up the otherwise generally straightforward fenestration of the building's north facade.[48] The 974,000-square-foot office tower, with space for 4,200 workers, included a 6,000-square-foot, two-story lobby, a 2,500-square-foot restaurant with adjacent 2,000-square-foot dining terrace, and parking for 260 cars in a two-level, below-ground garage. The design of a fifty-foot-high, vaulted storefront arcade along Duane Street had to be simplified, and plans for a 25,000-square-foot pavilion housing a day-care center, auditorium, and health club at the eastern end of the site had to be eliminated after the discovery during construction in October 1991 of an eighteenth-century cemetery, the so-called Negros Burial Ground. After the find, Mayor David Dinkins and various New York congressional members successfully lobbied the GSA to change its plans so that the site could properly be honored (see below).

Susanna Sirefman was not terribly impressed with HOK's design, concluding that the building was "dull but not offensive. Authoritative massing combined with staid grey cladding created a dignified and unobtrusive effect."[49] Herbert Muschamp, in no way sympathetic to an approach that drew on the classical tradition of Federal architecture, thought that both KPF's courthouse and HOK's office building had "more in common than their location," believing that by proposing "an image of dignity for Federal architecture," they "both end up partly trapped within the image they project. . . . Like gray flannel suits, they equate authority with a timeless order—here represented by the two classical revival courthouses that give the square its traditional character. But instead of affirming that authority, the new buildings expose how hollow it has become." Muschamp was grateful that the buildings eschewed the example of the Javits Building and were "deftly knitted into the surrounding streetscape" and used "a rich vocabulary of compositional devices—setbacks, recessed cornices, articulated tops, barrel vaults, bow fronts, pilasters and moldings." Still, he could not help but conclude, "The problem with both new buildings is not that they aspire to transcend the present. It is that they equate the timeless with the old."[50]

African Burial Ground

The accidental discovery of skeletal remains during the excavation of the foundation of HOK's new federal office building set off a firestorm of publicity and speculation about what had been found.[51] Thanks to eighteenth-century maps, it was quickly determined that what had been stumbled upon was the Negros Burial Ground (1712–95), a five- to six-acre predominantly slave cemetery that had been located just outside

the city's northern walls. It was known to historians but long thought disturbed beyond recognition by the intervening two hundred years' worth of building and rebuilding. The story was picked up by the national press and not surprisingly elicited a strong, emotional reaction from the African American community. Construction on the office building was immediately halted. William Diamond, eager to avoid any negative publicity, adopted a conciliatory stance in contrast to the somewhat more blistering way he had handled the removal of Richard Serra's *Tilted Arc* two years earlier.

A team of archeologists headed by Edward Rutsch was called in, and the remarkable condition of the first thirteen exhumed bodies led the scientists to conclude that there was great potential for a major find that could shed abundant light on the lives of Colonial-era blacks, including their diet, child-morbidity rates, customs, and the diseases they were subjected to. The bodies, wrapped in shrouds, had been buried in hexagonal coffins in the Christian tradition with their heads facing west so that, on Judgment Day, they could sit up and face the rising sun. The portion of the cemetery around Broadway and Reade and Duane Streets was relatively undisturbed, it was surmised, because the site had been hilly and, in an attempt to make the land level, some twenty-five feet of fill had been added, ensuring the survival of many graves under the basements of later buildings.

Within just a few weeks of the first discovery, skeletal remains from over 60 bodies had been found, a number that would rise to over 100 by the end of 1991. Despite the assurances of William Diamond and the GSA, members of New York's African American community, led by the city's first black mayor, David N. Dinkins, and State Senator David A. Paterson, representing Harlem and the Upper West Side, became increasingly suspicious that federal officials were more concerned with potential cost overruns at the office building and less sensitive to the proper examination and disposition of the graves. With historians estimating that between 10,000 and 20,000 bodies could have been buried in the cemetery, although no one could be sure of the number on the federal office building site, the GSA feared that the delay in construction could add as much as $6 million to the cost of the building, an especially worrisome proposition for a building planned under the design/build process intended to save both time and money. Diamond tried to appease Dinkins and Paterson, but his call for a lobby exhibition in the new building only served to inflame tensions as both politicians declared that such a remedy was woefully inadequate and an insult to the memory of those interred.

In order to increase both publicity and pressure on federal officials, a new advocacy group, the Coalition for the Preservation of New York's African Burial Ground, was established. Working in conjunction with Dinkins and Paterson, the coalition called for a "fitting memorial," although they offered no specific proposal, as well as the reinterment of the remains on the original site which, as Paterson emphasized, "should have been their final resting place."[52] In July 1992, the GSA, succumbing to public opinion, represented by a petition circulated by the coalition and signed by over 100,000, offered a major concession: the roughly 10,000-square-foot plot on the northeast corner of the office building site, originally planned for a four-story pavilion, would be reserved for a memorial, to be funded with $3 million from the federal government. A twenty-five-member advisory panel, the Federal Steering Committee on the African Burial Ground, a community-based group essentially picked based on recommendations from Dinkins and Paterson, was charged with the responsibility of approving any future plans as well as brainstorming ideas about what form the memorial should take.

Before any plans were released or ideas proffered about a possible memorial, the New York City Landmarks Preservation Commission, in February 1993, declared a new historic district that included the memorial site, the African Burial Ground, and the Commons Historic District.[53] The fairly large site, originally set aside by the Dutch as the Commons, began at the southern tip of City Hall Park and was roughly bounded by Duane and Pearl Streets on the north, Broadway on the west, and Park Row and Centre Street on the east. The federal government followed suit two months later, declaring the African Burial Ground a National Historic Landmark.

Frustrated by the lack of progress from the GSA, a private, multiracial coalition of several different organizations, including the New York Coalition of Black Architects, the Metropolitan Black Bar Association, Professional Archaeologists of New York City, the City Club, and the Municipal Art Society, joined together to form the African Burial Ground Competition Coalition.[54] Announcing an international "call for ideas" in the summer of 1993, the group proposed an intentionally broad competition in order to stimulate interest in the memorial site and to light a fire under the GSA, if not necessarily to come up with a buildable scheme. By January 1994, 170 entries had been received and the jury, which included the architecture critic Robert Campbell as well as the architects

Walking Among African Graves, Speaking Through the Ground, African Burial Ground Competition entry. Karen Bermann and Jeanine Centuori, 1994. Photomontage. KBJC

A Wall of Persistent Acknowledgment, African Burial Ground Competition entry. Lester Y. Yuen and Nana D. Last, 1994. Rendering of view to the southeast. LYY

M. David Lee and Richard Dozier and the sculptor Richard Hunt, selected four "firsts."

One of the winners, Chris Neville, a graduate student at Columbia's Historic Preservation program and a member of the burial ground's excavation team, proposed 53 Elevators, a simple scheme in which a metal plaque with the words "You are now suspended above the African Burial Ground" would be placed inside each of the elevators within the four-block area covered by the original cemetery. R.B.B. Partnership of Portland, Oregon, impressed the judges with a far more monumental if traditional scheme consisting of a seven-story stone wall engraved with Paul Lawrence Dunbar's poem "Sympathy." Karen Bermann, an architect teaching at Iowa State, and Jeanine Centuori, an assistant professor of architecture at Kent State, collaborated on Walking Among African Graves, Speaking Through the Ground, which Kira Gould, writing in Competitions, described as a "lengthy label for a simple, stark, and profound concept. The sidewalks in the area . . . would be transformed into mosaics made up of fragments and texts that would, according to their proposal, 'honor the spirits of the dead and communicate elements of the African American experience in the tradition of the West African gravesite, urban graffiti, and the quilt.'"[55] The last of the winning schemes belonged to Boston architects Lester Y. Yuen and Nana D. Last, who proposed A Wall of Persistent Acknowledgment, consisting of a five-story glass wall along the eastern edge of the pavilion site

that would suspend a grid of 20,000 two-foot-long brass pins symbolizing the shroud pins found at the burial site.

Part of the problem with federal efforts to plan the memorial centered around what became known as the "battle of the bones." After the remains were measured and photographed, they were removed to a laboratory at Herbert H. Lehman College in the Bronx, where a team of forensic anthropologists led by Spencer Turkel was supposed to inspect the specimens. But in more than two years after the first discovery almost no work had been done and the remains, which now numbered more than 400, languished as a turf war broke out among competing scientists, with Dr. Michael Blakey, a prominent African American anthropologist based at Howard University, arguing that the work should be done by African Americans and not the mostly white team at Lehman College. Blakey also argued that Lehman's scientists were cavalierly treating the specimens they possessed. Blakey's criticisms hit a nerve, and the federal government, after prodding by Illinois Congressman Gus Savage, ordered that the remains be transferred to Dr. Blakey's laboratory at Howard.

The only visible progress, if it could be called that, made by the GSA by 1993 was a new sod lawn at the pavilion site, which was enclosed by a clumsy chain-link fence. The GSA had better luck when it commissioned the African American sculptor Clyde Lynds's America Song (1995), located at the Broadway and Duane Street entrance to HOK's office building.[56] Over the words of an anonymous African poet celebrating freedom that were sandblasted into a granite panel, Lynds's piece featured a single fifteen-foot-high concrete wing carved in relief which was animated by a changing, multicolor program of fiber-optic displays integrated into the work's surface.

In spring 1997, the GSA, after consulting with the Federal Steering Committee and the scientists examining the remains at Howard University, finally announced a two-part national design competition for the African Burial Ground.[57] The first part of the competition called for a memorial on the pavilion site that would acknowledge the area "as a sacred place for commemorative and contemplative activities."[58] One important requirement was that any design must accommodate the future reinterment of the burial ground remains. The second part, to be located in the lobby of HOK's building, would feature more traditional, museumlike exhibitions based on the information gleaned from the exhumed graves. The GSA did not announce a winner until March 2000, and even then it was only for the Interpretative Center, as the exhibition space was called. A predominantly African American multidisciplinary team of New York–based designers, curators, and researchers that included the architects Jacqueline Hamilton, Paula Griffith, Atim Annette Oton, and Jasper Whyte was selected. Their design called for a 2,000-square-foot space divided into four separate areas to reflect the traditional African perception of the four stages of life: birth, maturity, death, and rebirth. Featuring multimedia exhibitions, the Interpretative Center would also include a simple "altar" overlooking the memorial to be built on the pavilion site.

The pattern of delays that had plagued the project from its inception only continued, and no progress was made for the next two years on either the Interpretative Center or the exterior memorial.[59] The results of the memorial competition were finally announced in February 2003, with the Federal Steering Committee picking five finalists: Joseph DePace designed an eighteen-foot-tall pyramidal Spirit House at the

ABOVE Proposal for African Burial Ground Memorial, southwest corner of Duane and Elk Streets. McKissack & McKissack, 2003. Rendering of view to the southwest. MCK

LEFT Proposal for African Burial Ground Memorial, southwest corner of Duane and Elk Streets. Rodney Leon, 2005. Rendering of view to the southwest of winning scheme. AARRIS

corner of Duane and Elk Streets; GroundWorks, a group of architects, writers, and an artist, proposed an illuminated vessel serving as a burial vault surrounded by trees; Rodney Leon's submission called for a granite "Ancestral Chamber" rising twenty-four feet above street level and a Spiral Processional Ramp descending six feet below the street; McKissack & McKissack included a large ribbed slave ship surrounded by reflecting pools and waterfalls; and Eustace Pilgrim and Christopher Davis planned to cover the site with dark gravel, grass, boulders, and a reflecting pool to evoke an ancient ruin or temple. Two years later, in May 2005, Rodney Leon's scheme was selected as the winner. More rapid progress was made on the scientific front in the analysis of the skeletal remains taking place in Dr. Blakey's lab at Howard University, with work completed by fall 2003. In a solemn two-day ceremony held on October 3 and 4, the remains of 419 free and enslaved African Americans were finally reinterred at the African Burial Ground site.[60]

The impact of the discovery of the African Burial Ground, despite the delays in constructing a memorial, wound its way into the consciousness of New Yorkers through a proliferation of various art projects inspired by the find, including Leroy Jenkins's performance piece, *The Negro Burial Ground: A Cantata for the Departed* (1996), and Eric V. Tait Jr.'s documentary film, *Then I'll Be Free to Travel Home* (1996).[61] Additionally, as part of an overall face-lift for Foley Square, including new lampposts and benches, the city's Department of Cultural Affairs sponsored a sculpture by Lorenzo Pace, *Triumph of the Human Spirit* (2000), a gigantic 300-ton black granite piece composed of a fifty-foot-high stylized rendition of an ancient West African Chi Wara antelope headdress resting atop a horizontal slab representing Native American canoes and slave vessels, all sitting in a sixty-foot-diameter pool.[62] The piece was officially unveiled on Columbus Day, with Pace boycotting the ceremonies because he believed the holiday "honors a person who started enslavement in this part of the world."[63]

Around City Hall

The Civic Center area received additional sprucing up with the renovation of both City Hall and City Hall Park. Cabrera/Barricklo Architects were placed in charge of the restoration of Joseph François Mangin and John McComb Jr.'s City Hall (1803–11), removing the badly deteriorated Massachusetts marble exterior and replacing it with a new Alabama limestone facade.[64] The work, completed in 1998, also included a new clocktower, fabricated off-site in fiberglass resin and clad in copper, as well as the renovation of the rotunda. In October 1999, work was completed on the restoration of the nine-acre City Hall Park.[65] A fountain designed in 1871 for City Hall Park by Jacob Wrey Mould, which had been located in Crotona Park in the Bronx since the 1920s, was restored and brought back to the site. New benches with hooves on their legs and reproduction gas lamps were also specified. A search of the Art Commission archives revealed that City Hall Park's original fence had been dismantled 120 years earlier and was now guarding a cemetery upstate in Sullivan County. Based on a casting from the original, a new perimeter fence was created with cylindrical steel posts topped by finials. In a departure from nineteenth-century precedent, however, a controversial new security feature closing off the plaza in front of City Hall with chains and guard booths was instituted.

A far more controversial restoration involved the adaptive reuse of the New York County Courthouse (John Kellum and Leopold Eidlitz, 1862–76), 52 Chambers Street, between Broadway and Centre Street, most recently serving as municipal office space. Popularly known as the Tweed Courthouse, it was the city's most prominent symbol of political corruption stemming from the time when William M. "Boss" Tweed, the head of Tammany Hall, siphoned off millions of dollars for his own pocket from its construction budget.[66] There was nothing particularly controversial about the renovation work itself, completed between 1999 and 2001 by John G. Waite Associates. Interest instead focused on the new use for the imposing, four-story, Anglo-Italianate, gray Massachusetts marble building, the exterior and first floor of which had been declared a city landmark in 1984.[67] The Giuliani administration's plan, announced in December 2000, was to move the Museum of the City of New York from its headquarters (Joseph H. Freedlander, 1932), 1220 Fifth Avenue, between 103rd and 104th Streets, to the refurbished courthouse, with the neighboring El Museo del Barrio possibly taking over the museum's vacant uptown space.[68] But in March 2002, the new mayor, Michael R. Bloomberg, declared that he would prefer that the Board of Education leave its Brooklyn headquarters at 110 Livingston Street (McKim, Mead & White, 1926) and move to the restored Tweed Courthouse. As one of his major campaign issues, Bloomberg, like several previous mayors, wanted to take control of the Board of Education, and he believed that the board's physical position so close to City Hall would serve as a strong symbol of his commitment to public education. Bloomberg's plan for the Tweed Courthouse also included the provision of a modest demonstration school on the first floor.

The announcement set off a firestorm of protest, not surprisingly led by the Museum of the City of New York. The editors of the *New York Times* believed that the "mayor's idea of putting the city's education bureaucracy right under his eye makes sense, both managerially and symbolically." But, they contended, it made less sense given that the "city has spent almost $90 million over the last few years to restore the courthouse to the grandeur it must have had when it was first built. . . . If the money and effort had not been spent, and the courthouse were still a warren of shabby offices, using it as a new home for the top school brass might makes sense. But having worked so hard to turn it into a premier public building, the city should think very hard and long before turning back." The editors concluded by noting that especially after September 11, lower Manhattan "needs more cultural attractions to bring people downtown. There should be a way to meet Mr. Bloomberg's goals while saving the courthouse for its planned purpose as a municipal showcase."[69] The writer Pete Hamill dismissed the idea, stating that the Tweed Courthouse "is the most glorious building now in existence in the city. To take 600 Board of Ed people and push them in like straphangers on the D train is crazy. Bureaucrats don't belong in there. The public does."[70] Paul Goldberger, writing in the *New Yorker*, also weighed in, first noting that the courthouse was "one of the finest public buildings the city has ever had, . . . a sumptuous . . . palazzo with more than two dozen magnificent courtrooms arranged around a five-story octagonal rotunda topped by a colored-glass skylight. . . . Running

FACING PAGE New York County Courthouse (John Kellum and Leopold Eidlitz, 1862–76), 52 Chambers Street, between Broadway and Centre Street. Renovation by John G. Waite Associates, 2001. Rotunda. JGWA

Hong Ning Houses, 50 Norfolk Street, northeast corner of Grand Street. Edelman Partnership, 1983. View to the north. ESKW

the schools out of a landmark in City Hall Park," Goldberger continued, "might be a nice piece of political symbolism, but it won't do much for the landmark. . . . Has anyone thought of using it as a courthouse again?"[71]

Despite the heated protests, Bloomberg prevailed, and an additional $13 million dollars was spent to renovate the space for the Board of Education, which began moving in in September 2002. Six months later, the demonstration school opened on the first floor. Known as the City Hall Academy, after Bloomberg's original idea of naming it the Tweed Academy was deemed an ill-advised honor for a corrupt politician, it featured a pilot program in which teachers from all five boroughs would bring their third-grade classes for two-week periods to study a special curriculum focusing on the history of New York. In addition to seven classrooms capable of accommodating 200 students, the renovation included a cafeteria as well as a classroom featuring a large, multicolored map of the city embedded in the floor.

LOWER EAST SIDE

In the century's last years there was no more dramatic story of market-driven urban renewal than that of the transformation of the Lower East Side from one of Manhattan's least prosperous, least beloved neighborhoods into an ethnically diverse mecca of hipness. For most of the 1960s and 1970s, the Lower East Side was bogged down in a seemingly endless succession of failed attempts to rebuild its battered streets, to fill in its many empty sites, and to achieve some new measure of pros-

perity.[1] Emblematic of its malaise was the long-simmering turf war between three competing ethnic groups over the future of the neighborhood's most prominent undeveloped parcel of land, the largely vacant four-block area bounded by Delancey, Clinton, Grand, and Norfolk Streets, cleared in the mid- and late 1960s as part of the Seward Park Extension urban renewal plan.[2] The rivals included the area's then-dwindling but hitherto largest group, Jews, who began flocking to the neighborhood beginning in the 1870s and by the turn of the century had turned the area into one of the largest Jewish communities in the world; a surging Hispanic population, which had been rapidly growing since the first wave of immigrants arrived from Puerto Rico in the late 1940s; and a relatively recent surge of Chinese, many of them elderly, who left China and Hong Kong in greater numbers in the mid-1960s after changes in the immigration laws. The occasion for the controversy was the decision by the Koch administration in early 1980 to try to develop the star-crossed site with an approach that can best be described as something for everyone: increased commercial development for the Jews on a strip of land along the south side of Delancey Street between Essex and Clinton Streets; 100 units of low-income housing for the Hispanics; and a 150-unit senior citizen facility for the Chinese. Many on the Lower East Side, long touted as a first home for immigrants in America, believed that the disposition of these four blocks near the foot of the Williamsburg Bridge would set the tone and direction for the future of the entire neighborhood.

The demand by Hispanic groups, who were led by the Lower East Side Joint Planning Council, for substantial amounts of subsidized housing had galvanized the Jewish community, which was represented by a local organization, the United Jewish Council. In addition to opposing the low-income housing, the group wanted a three-block-long enclosed shopping mall, believing that a larger, more substantial commercial commitment was necessary to create enough jobs and prosperity to halt the continued exodus of the next generation of Jews to other, more affluent parts of the city and the suburbs. The Lower East Side Planning Council contended that the 100 units of low-income housing, although a welcomed first step, represented only a very small percentage of what was needed.

On April 24, 1980, the Board of Estimate, in an unexpected decision, approved plans for the senior citizen housing and the Delancey Street improvement but rejected the low-income housing component, raising strident and bitter charges of racism on the part of the defeated Hispanic groups. Ironically, the only part of the plan to go forward was that advocated by the least-vocal group, the elderly Chinese, represented by the Chinatown Planning Council. In 1983 the fourteen-story, 156-unit Hong Ning Houses opened at 50 Norfolk Street, northeast corner of Grand Street.[3] Designed by the Edelman Partnership, the rather plain red brick apartment house was not nearly as accomplished as the same firm's Chung Pak development in the Civic Center area at the western edge of Chinatown, also for Chinese senior citizens but completed nine years later. The Hong Ning Houses anchored the southwest corner of the urban renewal site that it shared with its immediate next-door neighbor, the Gothic Revival–style Beth Hamedrash Hagodol Synagogue (originally Norfolk Street Baptist Church, 1850), a five-story tenement building around the corner on the northwest corner of Grand and Suffolk Streets, which in 1987 was taken over by the Chinatown

ABOVE Gymnasium addition, Boys' Club of New York, 135 Pitt Street, southwest corner of East Houston Street. George Cooper Rudolph III, 1985. View to the southwest. GCR

BELOW Gymnasium addition, Boys' Club of New York, 135 Pitt Street, southwest corner of East Houston Street. George Cooper Rudolph III, 1985. GCR

Lower East Side Infill Housing 1, Eldridge Street, between Stanton and Rivington Streets. James McCullar, 1987. View to the northwest. Zimmerman. WZ

Planning Council and rehabilitated to provide an additional twenty-six residential units, and a two-story municipal garage used by the police department at 185 Broome Street, between Clinton and Suffolk Streets.[4] The rest of the rubble-strewn site remained empty.

In February 1988, five years after the completion of Hong Ning Houses, the four-block Seward Park Extension site was again in the news with the announcement of an unusual partnership between the city and veteran developer Samuel J. LeFrak to build three apartment buildings totaling 1,200 units for limited profit that, if completed, would be among the largest middle-income projects realized in the city in a decade.[5] Although no drawings were released for LeFrak's Lower East Side project, to be called Bridgepoint Towers, the Koch administration and the developer announced that one building, containing 400 apartments, would be built as a condominium, while the other two, each also containing 400 units, would be rentals, with 640 middle-income and 160-moderate income apartments. What made the project interesting, as well as controversial, was its use of the so-called cross-subsidy strategy, a creative financing arrangement whereby the profits from the condominium would underwrite the cost of constructing the two other buildings as well as help subsidize its moderate- and middle-income rents. LeFrak would purchase the condominium site for one dollar and lease the two other parcels from the city. The city would provide a conventional construction subsidy of up to $25,000 for each of the rental units, which would be subject to rent stabilization laws, and LeFrak agreed to limit his profit to 8.5 percent a year on his equity in the rental buildings, with any excess profits going to repay the city subsidies. Mayor Koch enthusiastically promoted the plan as a generous gift from LeFrak, one that was especially welcome given the Reagan administration's cutbacks on subsidies for inner-city housing. LeFrak, who had just turned seventy, rather melodramatically represented

Bridgepoint Towers as the charitable gesture of a man whose days might be numbered: "I'm really buying my visa to heaven."[6]

Many local community leaders and housing advocacy groups, angered that they had not been consulted, attacked the proposal for its lack of any low-income units. Even the United Jewish Council raised objections to the plan, clearly geared to the middle class, because no major retail component was included. But in keeping with the adage that no (purported) good deed goes unpunished, the very idea that LeFrak's proposal represented some sort of selfless act of generosity was also subject to question and a fair amount of ridicule. Barely a month after the project was first announced, skepticism about LeFrak's altruism only grew when the city was forced to admit that the developer retained the right to convert the 800 rental units to condominiums or cooperatives after twenty years. Still, Bridgepoint Towers picked up the editorial support of *Newsday*, which argued that the objections raised were examples of "carping. In this housing-starved city, nonprofit and low-profit projects should be encouraged, not criticized. Every new nonluxury unit helps."[7]

Despite support in many quarters, LeFrak abandoned his ambitious plans for Bridgepoint Towers in 1989, leaving the same groups to continue their fight over the same issues. A 1993 proposal by Kraus Enterprises for 600 apartments, a park, retail center, and a multiplex movie theater quickly fell by the wayside, and the 1994 promise by the new Giuliani administration to review the situation resulted in no new action for the cleared, city-owned land, which instead largely served as an enormous, open-air parking lot.

The failure to develop the prominent Seward Park Extension site notwithstanding, the neighborhood was not totally bereft of public investment. David Todd & Associates's imposing but not necessarily inspiring Intermediate School 25 (1977), 145 Stanton Street, between Norfolk and Suffolk Streets, reflected the Brutalism of the 1950s and 1960s as it confronted the tenement-dominated landscape with powerfully contrasting ribbons of white concrete alternating with panels of dark red brick punctuated by small windows, anchored by two massive corner stair towers.[8] Another new school, Warner, Burns, Toan & Lunde's Intermediate School 131 (1983), known as the Dr. Sun Yat-Sen School, 100 Hester Street, between Eldridge and Forsyth Streets, also overwhelmed its low-rise neighbors with a similar palette of red brick and white concrete but with an even more aggressive design highlighted by four-story-high curved sections at each corner pierced by narrow bands of windows, invoking less-than-friendly turrets.[9] George Cooper Rudolph III's 1985 gymnasium addition to the Boys' Club of New York's Pitt Street Building, 135 Pitt Street, southwest corner of East Houston Street, was more interesting, an inventive interpretation of the bland white and dark blue glazed brick vocabulary of the original building (Verniar Walter Johnson, 1958), using glass block on a new Houston Street facade.[10]

While the neighborhood's new institutional buildings had some positive claim on architectural aesthetics, the Housing Authority's Lower East Side Infill Housing 1 (1987), designed by James McCullar, did not. Consisting of two long four-story rows on both sides of Eldridge Street between Stanton and

FACING PAGE Garden of Eden, Eldridge Street, between Stanton and Rivington Streets. John Peter Zenger II (also known as Adam Purple), 1975–86. Hultberg. CH

Eldridge Street Synagogue (Herter Brothers, 1887), 12–16 Eldridge Street, between Canal and Division Streets. Restoration overseen by Giorgio Cavaglieri. View of ark, 2001. Milford. ESP

Rivington Streets, the units were finished in "bubble gum pink walls . . . relieved by gray inserts of Post Modern ornamental silhouettes" to yield an effect deemed "grim" by the editors of the *AIA Guide*.[11] The 189-unit project also included another four-story component at 71 Stanton Street, southeast corner of Eldridge Street, which was separated from the eastern row by a small courtyard, and a nine-story building finished in the same manner a half a block away at 175 Eldridge Street, north of Delancey Street. Even more regrettable than the failed attempt at contexualism was the fact that part of the project replaced a local landmark, the Garden of Eden, a community garden created beginning in the mid-1970s by a colorful eccentric, John Peter Zenger II, better known as Adam Purple, who fought the housing project in the courts for more than four years before his garden, which at its height encompassed more than five building lots and included over forty-five fruit and nut trees, one hundred rose bushes, black raspberries, strawberries, corn, cucumbers, and thousands of flowers arranged in concentric rings with a ying-yang pattern at the center, was destroyed.

The increasing focus on preservation in the late 1970s, and the tax benefits that went with it, turned the rich but crumbling architectural heritage of the Lower East Side into a fertile area for renovation. In 1977 Paul Goldberger called attention to the deteriorating condition of one of the neighborhood's best buildings, the Herter Brothers' Congregation K'hal Adath Jeshurun (1886–87), 12–16 Eldridge Street, between Canal and Division Streets.[12] Better known as the Eldridge Street Synagogue, the ornate building, combining elements of Moorish, Gothic, and Romanesque architecture, featured an imposing brick and terracotta facade dominated by a large rose window. Inside, the

dramatic fifty-five-foot-high barrel-vaulted space of the main sanctuary was lit by elaborate brass chandeliers with hand-blown glass shades and included a hand-carved ark of Italian walnut. Although the synagogue, the city's first major purpose-built worship place realized by Eastern European Jews, was still technically functioning, with services for the two dozen or so congregants held in a shabby basement-level room, it had became an "architectural ghost," to use Goldberger's term.[13] The main sanctuary had been closed for over forty years and the entire structure was in disrepair. Official designation as a landmark in 1980 inspired serious efforts at restoration, begun in 1983 when seed money obtained from the Federal Historic Preservation Fund was quickly matched by various local groups. From the very beginning, the restoration project, led by Giorgio Cavaglieri, was viewed as a way not only to save a beloved individual institution but also to improve or at least stabilize a declining neighborhood. Renovation work proceeded slowly but steadily as funds became available, and by 1991 enough progress had been reached to allow tour groups to visit the synagogue on a regular basis. A new slate roof was added in 1999, the same year that the brick facade was repointed, and in October 2000, in a somewhat controversial move raising the thorny issue of church-state separation, the Manhattan Borough President's office and the City Council each awarded the synagogue $500,000 from their respective budgets to help complete the restoration of the sanctuary.

A very different fate, although one that ensured the survival and restoration of a distinguished building, befell Alexander Saeltzer's Gothic-style Congregation Anshe Chesed (1850), 172–176 Norfolk Street, between Stanton and East Houston Streets, the oldest surviving purpose-built synagogue in the city.[14] Abandoned by its last congregation in 1974, Anshe Chesed was in a serious state of disrepair when it was bought in September 1986 by the Spanish sculptor Angel Orensanz, who began a comprehensive renovation of the entire building to accommodate his studio as well as a gallery for a new arts foundation he established in his own name. To help pay for the restoration work, Orensanz rented out the space to such events as Alexander McQueen's first American fashion show, music videos filmed by Lou Reed, Mariah Carey, and Whitney Houston, as well as weddings. In 1997, in a twist of circumstances, a small Orthodox congregation began holding Sabbath services in the building.

In the early 1980s, as plans for the restoration of the Eldridge Street Synagogue were being formulated, some of those involved felt that the renovated building should instead be turned into a museum dedicated to an examination of the lives of Jewish immigrants on the Lower East Side. By 1988 that idea was expanded to incorporate the experiences of all immigrant groups to the area with the establishment of the Lower East Side Tenement Museum at 97 Orchard Street (1863), between Delancey and Broome Streets, a typical brick and brownstone, 25-by-68-foot, five-story Italianate tenement with four three-room apartments per floor.[15] Remarkably, the apartments, which only had windows in one room and often housed more than a dozen people, were intact. They had been vacant since 1935, when the owner shut the building rather than carry out the extensive renovations required by the city's new stricter building codes. At first the museum was confined to first-floor exhibitions, but by 1994 the building had been sufficiently renovated to allow for guided tours of the "restored" apartments, offering a glimpse of early-twentieth-

ABOVE Hamilton Fish Park (Carrère & Hastings, 1900; swimming pool, Aymar Embury II, 1936), east side of Pitt Street, between Stanton and East Houston Streets. Restoration by John Ciardullo Associates, 1992. View to the southwest. Wright. JCA

BELOW Hamilton Fish Park gymnasium (Carrère & Hastings, 1900), 130 Pitt Street, between Stanton and East Houston Streets. Restoration by John Ciardullo Associates, 1992. View of newly created community center. Wright. JCA

century tenement life. The museum proved a popular success, with the added benefit of bringing many to the neighborhood, including tourists who ordinarily might not have ventured to the struggling area, boosting local retailers as well as drawing much-needed positive attention from the press.

In 1986 plans were announced for the rehabilitation of another abandoned structure, the former Gouverneur Hospital (1901), 621 Water Street, between Gouverneur Slips East and West.[16] A U-shaped, six-story, red brick Renaissance Revival facility, the hospital, whose designer is unknown but often said to have been McKim, Mead & White, was unusually graceful with tiers of curved balconies facing the East River. The Geller Development Corporation, working with Wechsler, Grasso & Menziuso, intended to restore the dilapidated shell of the building, empty since 1961, and gut the interior to accommodate seventy-two condominium apartments. After removing part of the roof and a fair amount of the interior, the developers went bust. Help did not arrive until 1991, when the nonprofit group Community Access took title to the building and hired the architects Peter L. Woll and Beth Cooper Lawrence to restore the exterior and renovate the building for use as permanent housing for people with AIDS, those recovering from alcohol or drug abuse, and the homeless mentally ill as well as the working poor.[17] Completed in 1994, Gouverneur Court included 123 single-room-occupancy apartments as well as a communal dining room, classrooms, a medical examination room, and a 2,000-square-foot landscaped courtyard between the two curved bays.

By the 1990s, the fortunes of the Lower East Side were dramatically improving. The restoration in 1992 of Hamilton

Proposed store buildings, 104–106 Delancey Street and 110–114 Delancey Street, between Essex and Ludlow Streets. Eli Attia Architects, 1989. Rendering of view to the northwest. EAA

Fish Park and its two-story, 13,400-square-foot, brick and limestone, Beaux-Arts-style gymnasium (Carrère & Hastings, 1900), 130 Pitt Street, between Stanton and East Houston Streets, proved a real shot in the arm.[18] The gym, inspired by Charles Girault's Petit Palais (1895) in Paris, was the only surviving feature of Carrère & Hastings's original four-acre park, which had undergone various changes over the years, including the 1936 addition of two swimming pools by Aymar Embury II. Although John Ciardullo Associates received the commission for the project in 1978, funding problems forced delays and the architects did not present their plans to the Parks Department until 1984 with actual construction finally beginning at the end of the decade. Not only were the park facilities and the gymnasium run down, but the park itself was infested with drug dealers and virtually abandoned by the very Lower East Side families in need of its services. The highlight of the restoration was the conversion of the gym into a year-round community center. Ciardullo's imaginative redesign relocated changing rooms to the basement, redeploying the two grand spaces previously used for this purpose as meeting rooms. Other work included reducing the entrances from six to a more manageable two, adding a fourteen-foot-high fence, and rebuilding the swimming pools. Herbert Muschamp was impressed with the "remarkable place," believing that its revived state, "although not an elixir for every urban ill," was a "powerful tonic against despair."[19]

The sense of optimism generated by the restoration projects that tapped into the history of the Lower East Side helped catalyze a widespread economic revival of the area, spearheaded not by the kind of large-scale intervention represented by LeFrak's unrealized Seward Park Extension scheme but by relatively modest piecemeal efforts. Despite the collapse in 1990 of plans by Eli Attia for two- and three-story glass and steel clad gridded store buildings at 104–106 Delancey Street and 110–114 Delancey Street, between Essex and Ludlow Streets, neighborhood gentrification picked up speed throughout the decade as small-scale retail establishments on the cutting edge of fashion, fleeing high-rent neighborhoods like SoHo and Greenwich Village, were attracted to the area and its growing population of young consumers who shopped and

then moved into tenement apartments.[20] Suddenly, it seemed, the new Lower East Side was the city's hippest neighborhood. Tenements were renovated to provide studio and one-bedroom rental apartments geared to a young, single crowd, and this also encouraged the development of new restaurants and nightspots, including the Lansky Lounge (1997) at 104 Norfolk Street, located in the back of the venerable Kosher dairy restaurant Ratner's and named after Meyer Lansky, the notorious gangster who allegedly dined there as he hatched many of his nefarious schemes.[21] In 2000 the twelve-story, classical, brick and terra-cotta Forward Building (George A. Boehm, 1912), 175 East Broadway, between Rutgers and Jefferson Streets, a dominant feature on the Lower East Side landscape of five-story tenements, was renovated as a residential condominium.[22] The building had long served as the home of the influential Yiddish language daily newspaper before its sale to a Chinese church in 1974. Embellished with relief busts of Karl Marx and Friedrich Engels above its second story in deference to the *Forward*'s socialist leanings, the Forward Building was granted official landmark status in 1986. The architect Alfred Wen took charge of the redesign, which yielded thirty-nine loft-style apartments.

Still, new housing projects continued to visually compromise large parts of the neighborhood. Flying in the face of the area's incipient hipness, the Suffolk Homes Condominiums (Howard Chin, 2000), 130–148 Suffolk Street, between Stanton and Rivington Streets, and the southeast corner of Stanton and Suffolk Streets, consisted of twelve vaguely Federal-style, four-story, red brick buildings accommodating forty-eight two- and three-bedroom apartments.[23] The partially subsidized units were developed by the architect's own company, Phoenix Builders, with a local group, Asian Americans for Equality, serving as a sponsor, all in consultation with the nonprofit New York City Housing Partnership, which acted as an intermediary between the city, the developer, and several banks providing loans. Despite its pretensions, the Suffolk Homes Condominiums basically repeated the formula established by the Housing Authority's nearby Lower East Side Infill Housing 1.

The Lower East Side's new prosperity was not universally applauded. Many residents, business owners, and institutions were not only concerned about their ability to remain in the rapidly gentrifying neighborhood but also worried about the loss of its essential character. In April 2001, as the result of an effort led by two local groups, the Lower East Side Business Improvement District and the Lower East Side Conservancy, a thirty-one-block area containing more than 500 buildings and extending from Allen to Essex Street and from East Houston to Division Street, with a thin el bounded by East Broadway and Henry Street extending to Columbia Street, was added to the National Register of Historic Places.[24] Andrew S. Dolkart, an architectural historian who wrote the nomination petition, stated that "architecture is not insignificant here, but it's not architecture for the aesthetics. It's the history of housing reform."[25] But Max Page, a historian, faulted the process, criticizing the historic district as a "map-making fiction that says only a little about history and a lot more about cultural politics and the practice of historic preservation today." Page felt that the "narrow lines" of the district resulted in a "Jewish lower East Side historic district—and an incomplete one at that—as a stand-in for the history of the whole neighborhood."[26]

LITTLE ITALY

In the mid-1970s, nearly one hundred years after Italian immigrants settled in the squalid tenements of the Lower East Side, transforming the area roughly bounded by the Bowery, Canal, Lafayette, and Bleecker Streets into Little Italy, the area once made infamous by Jacob Riis was an ethnic enclave in decline. No new housing had been built in the neighborhood in over fifty years. The existing housing stock of primarily Old Law Tenements was deteriorating, shops and businesses were closing, and infrastructure and services were all but ignored by a fiscally overburdened city. Moreover, the community had for decades lived in the shadow of the proposed Lower Manhattan Expressway, which threatened to demolish vast swaths of the area and had itself, in the 1960s, provided SoHo with the near-death experience that inspired its revitalization.[1] The abandonment of plans for the expressway, however, were only partially responsible for the awakening of the dormant Little Italy community, whose members banded together in early 1974 to form the Little Italy Restoration Association, known by its appropriate acronym, LIRA, with an aim to "physically improve and strengthen the existing character and uses of the neighborhood and help to economically stabilize the area."[2] The greater concern was the perceived threat posed by the encroaching Chinatown population to the south. Though the Italian and Chinese communities, as one *New York Times* reporter put it, had for decades "enjoyed a colorful, peaceful, but highly unorthodox coexistence, like wontons in minestrone,"[3] a change in immigration laws in 1965 raised the quota of Chinese immigrants from 102 to 15,000 per year. A significant number settled in Chinatown, resulting in the continued growth and spread of the Chinese in lower Manhattan, so much so that in 1980 a journalist and urban planner, John Wang, reported that the population of Little Italy, "once solidly Italian, is now 70 percent Chinese."[4]

Faced with the influx of so many Chinese, Little Italy's residents, as well as Italian Americans in suburban communities who regarded the area as a landmark of their cultural identity, took action. When in June 1974 trucks arrived to prepare a site on the southern portion of the block bounded by Spring, Mott, Prince, and Elizabeth Streets for the construction of a new 1,200-student public school, the Little Italy Restoration Association, recognizing the opportunity to advocate better housing and aware that the school would enroll mostly Chinese pupils, picketed with signs that declared "Housing, Not Schools" and "A School for Who?"[5] The demonstration was successful, with the State Supreme Court issuing an injunction that halted construction pending a compromise between LIRA and the city, which was reached, much to the dismay of the disenfranchised Chinese population, when both parties agreed to the construction of a complex that contained both housing and a scaled-down school (see below). At the same time, LIRA was working with the Department of City Planning's Urban Design Group on a "risorgimento" study for the area; the word, meaning resurgence, had more than physical implications, referring as it did to Garibaldi's "Risorgimento" unification movement in the mid-nineteenth century that resulted in the defeat of the ruling Austrians and the breakup of independent city-states to make way for the establishment of modern Italy.[6]

Released in September 1974, the risorgimento plan contained a number of suggestions for ways to jump-start Little Italy's revitalization, among them restoring and preserving historic storefronts, rehabilitating existing housing, building new housing, renovating DeSalvio Park, an asphalt rectangle on the southeast corner of Mulberry and Spring Streets, and most ambitiously, transforming the massive, abandoned New York City Police Headquarters building (Hoppin & Koen, 1909) into an Italian American cultural center (see below). The most important suggestion however, and one of the only to reach fruition, was to create a vehicle-free pedestrian zone on Mulberry Street between Grand and Canal Streets that might restore vitality and street life to the historic spine of the district. The mall was intended to be a pilot project of sorts that, if successful, would legitimize a broader, long-term governmental intervention, namely, the designation of a Little Italy special zoning district. The idea, many critics agreed, represented a new and effective method of community-based urban planning. Ada Louise Huxtable felt it was a "prime example of how New York's planners can continue to work on improvement and development schemes at a time when recession has brought private construction to a virtual halt, and the city has no money to spend."[7] The Mulberry Street Mall first opened on weekends during the summer of 1975. Its success was unquestionable. Within two years, the renewed activity had stimulated the rehabilitation of eight buildings and the opening of sixteen new restaurants and cafés, including three restaurants designed by Morsa (see Interiors).

The Mulberry Street Mall gave the community clout at City Hall. In 1977 the City Planning Commission, led by its new chairman, Victor Marrero, who in October 1976 had touted Little Italy as "a magnetic regional asset and one of the city's most vital places," created the Little Italy Special District, encompassing the thirty-one-block area bounded by Bleecker Street on the north, the Bowery on the east, Canal Street on the south, and Mulberry, Baxter, and Centre Streets on the west.[8] With goals to "preserve and strengthen the historical and cultural character of the community of Little Italy . . . protect the scale of the storefronts . . . protect the vitality of street life . . . [and] discourage the demolition of noteworthy buildings," among others, it was, to Carter Horsley, a welcome departure from the "bulldozer approach to urban renewal," and evidence of a "growing phenomenon of community advocacy."[9] Within the district, four areas with varying restrictions were delineated: the Houston Street Corridor, where higher-density construction was encouraged; the Bowery, Canal, and Kenmare Corridors, which could accommodate parking and industrial uses; the Mulberry Street Spine, where the trend of improvements begun by the mall were to be continued; and the remaining blocks of the district, known collectively as the Preservation Area, where new construction would be subject to a height limit of seventy-five feet, street walls were to be maintained, retail uses were mandated, and plantings and sidewalk improvements were to be implemented as part of any new construction or rehabilitation project. To those who had worked so hard to revitalize Little Italy, the special district designation was a terrific achievement. Sadly, and largely because of the city's fiscal crisis, which killed a majority of the initiatives set forth in the 1974 risorgimento plan, it was more an end than a beginning to the city's commitment to a Little Italy revitalization.

The first project realized under the new zoning was Pasanella + Klein's 21 Spring Street (1983), between Mott and Elizabeth Streets, on the site of the school that LIRA had

picketed against in 1974.[10] After a compromise had been reached between the city and LIRA to construct a smaller, 600-to-800-student school as part of the housing complex, economics saw the demise of the school portion of the plan, though initial designs for the building, which featured severe facades of deeply recessed balconies above a ground-floor retail arcade, did include it. After long delays, the housing component, one of the city's last to offer rent-stabilized accommodations under the Section 8 provision of the federal government's United States Housing Act of 1937, was built as a 152-unit U-shaped red brick street wall building enclosing a courtyard; the design, modest to the point of banality, despite carefully proportioned and placed double-hung windows that helped relate it in scale to its neighbors, and a faceted Spring Street facade, lacked the presence of the firm's previous work in the ethnically Italian Twin Parks neighborhood in the Bronx.[11]

Plans to convert the former New York City Police Headquarters, 240 Centre Street, between Grand and Broome Streets, abandoned in 1973 when the police moved its oper-

ations to the Civic Center at One Police Plaza (Gruzen & Partners), had been one of the keystones of LIRA and the Urban Design Group's risorgimento study.[12] With its successful track record, LIRA was able to obtain the lease for the building from the city for the token rent of one dollar per year, but efforts to raise money for the project that had in time broadened in scope from an Italian American cultural center to an all-ethnicity-inclusive "international culture center," were difficult, and in 1977 help was sought from artist and neighborhood resident Louise Nevelson, who agreed to co-chair a Save the Police Headquarters Committee, enlisting the support of Andy Warhol, Robert Indiana, and Jacqueline Onassis. Though a portion of the building was opened briefly in late 1977, it was clear by April 1980 that the community would not be able to raise sufficient funds to operate the center.

The city's Department of General Services reclaimed the former Police Headquarters and turned to the private sector, issuing a request for proposals requiring potential developers to provide space for cultural and community facilities. Of the 200 responses received, only two teams submitted detailed schemes with the requisite deposit. Austin Laber and Jerome Kretchmer's Recycling for Housing Partnership, working with architects Rothzeid, Kaiserman & Thomson, proposed the conversion of the building to fifty-one cooperative apartments. The other team, Toronto-based Trans-Nation, which retained architects Cavaglieri/Edelbaum and the firm SITE Projects, proposed to redesign the building as a "Grand Hotel de Ville," though not a city hall in the traditional sense of the phrase, but in fact a 151-room luxury hotel. Trans-Nation's hotel proposal, which devoted most of the lower floors—20,000 of the building's 131,000 square feet—to theaters, meeting rooms, gallery spaces, and other community facilities while placing guest rooms on the upper floors, was selected. It also called for a restaurant, bar, and ground-floor retail space as well as a 164-foot-high atrium that would rise to the building's central dome and be surrounded by a grand staircase. But the deal fell through when, in 1983, the

Canadian government froze the developer's assets. All the while the massive building, abandoned for ten years, was deteriorating, cannibalized by vandals and neglected so much that the A.S.P.C.A. found four of twelve guard dogs positioned to protect the property starved to death on its grounds.[13] In November 1983, the city issued a new request for proposals, eliciting five responses.

On April 4, 1984, Mayor Ed Koch announced that the Fourth Jeffersonian Corporation had won the commission with its proposal to convert the building to fifty-six luxury residential cooperatives to be known simply as "the Police Building," a project that was successfully completed in 1989.[14] As part of the sale agreement, an 18,000-square-foot space was provided in the basement for nonprofit cultural institutions. The interiors were designed by the firm of dePolo/Dunbar. The Ehrenkrantz Group & Eckstut restored the exterior, where the vandalized copper roof and dome were replaced and a fiberglass cupola took the place of the original.

The untraditional spaces of the Police Building made for dramatic residences: five featured domes and another, occupying the former gymnasium, boasted thirty-two-foot-high ceilings, skylights, and a mezzanine. DePolo's treatment of the interior spaces was, for Paul Goldberger, the best component of the renovation. Particularly successful, he felt, was "the ideological position, or rather the lack of one, that it takes on the matter of old versus new. The Police Building has been designed neither as a faithful historical replica nor as a polemical modernist statement; everything added to the interior is sympathetic to the original building, but little of it replicates the original architecture." The result, claimed Goldberger, was "probably the grandest Manhattan apartment residence south of the Dakota . . . one of the rare renovations that leave a landmark building better off than it was before."[15] Smith-Miller + Hawkinson's model apartment, completed in 1989, converted one of the smaller units into what the architects grandiloquently called an "apartment of the future" though the rhetoric was not quite justified by the jungle gym-like final product.[16] The designers' primary intervention was the insertion of a long cabinet into the middle of the trapezoidal apartment, situating it askew within the space but parallel to the exterior wall, thus delineating different rooms and providing shelving, storage compartments, a pegboard, and a Murphy bed, the latter concealed during the day behind a large translucent panel which pivoted open at night to separate the sleeping and living rooms. The top of the storage unit served as a loft/study area with a third bathroom. The design's "purely willful moment," according to the architects, was a television set suspended from the ceiling, able to move laterally along a track and be raised and lowered to allow for visibility from any part of the apartment.[17] In 2001 one of the Police Building's impressive but forgotten spaces—the former gymnasium, occupying 6,000 square feet on the top floor—

Gymnasium apartment, Police Building, 240 Centre Street, between Grand and Broome Streets. Gwathmey Siegel & Associates, 2001. Warchol. GSAA

RIGHT *Exhibition Structure*, proposed installation for Storefront for Art and Architecture, 97 Kenmare Street, northeast corner of Lafayette Street. Lebbeus Woods, 1987. Rendering of view to the northwest. SITES

BELOW *Toilets (Unprojected Habits)*, installation at Storefront for Art and Architecture, 97 Kenmare Street, northeast corner of Lafayette Street. James Cathcart, Frank Fantauzzi, and Terrence Van Elslander, 1992. View to the northwest. Cathcart SAA

was converted into a residence by Gwathmey Siegel & Associates.[18] The architects transformed the dramatic twenty-five-foot-high barrel-vaulted room into a living area, breaking down its scale by inserting at its east end a two-story "object in the space" containing the master bedroom suite on the first level and, above, a study/library. The second story also housed three guest bedrooms lined up parallel to the vaulted main space. Despite the architects' intention to "physically maintain and visually exploit the volumetric integrity and structural expression of the existing barrel-vaulted space," their decision to cover over the vault's original terra-cotta tile cladding with white perforated fiberglass panels matching the vault's three massive white-painted steel trusses and the room's white walls seemed to serve the opposite purpose, diminishing the grandeur of the space so that it could become a quieter backdrop for the clients' art collection.[19]

The successful conversion of the Police Building triggered interest in its immediate neighborhood, which began to function as an annex to SoHo. Storefront for Art and Architecture, 97 Kenmare Street, only one block north of the Police Building, at the northeast corner of Lafayette Street, was founded in 1982 by Kyong Park and R. L. Seltman as a "guerilla" gallery that sought to offset the "static, and comatose design establishment" by representing the work of

young, talented artists and architects otherwise offered scant opportunity for exposure by New York's existing institutions.[20] After four years at 51 Prince Street, a small gallery with a large show window that inspired its name, Storefront moved to the Kenmare Street location in 1986, occupying an awkwardly narrow, ground-floor space eighty-five feet long, fifteen feet wide at the east end, and only three feet wide at its west end. Herbert Muschamp likened the space to a "nightmare torture chamber with sadistically contracting walls" so cramped that "if the walls contracted one more inch, Storefront would be out on the street, and architecture would move another step closer to homelessness in the imperial city of real estate."[21] In fact, some early artists exhibiting at the new space did bring the Storefront "out on the street": Lebbeus Woods, the architect whose futuristic renderings explored a potential fusion of science and architecture, designed *Exhibition Structure*, a framework of lightweight steel members welded and bolted together on the gallery's facade that Woods intended to have built for the opening of his *Cyclical City* exhibition at the gallery in spring 1988; although *Cyclical City* took place, *Exhibition Structure* was not built. In the early 1990s, Storefront began to formally seek exhibitions that incorporated its facade, or as its director, Kyong Park, put it, "pushed the inside out." This was in part a function of the limited indoor space but equally as much because the windowless membrane of the facade acted, according to Park, "as a barrier between theory and practice," separating the exclusive world of art from the gritty reality of the city.[22] In February 1992, artists James Cathcart, Frank Fantauzzi, and Terrence Van Elslander lodged five portable toilets into the facade. The bathrooms, which were functional, were entered from the sidewalk, with their back sides exposed as the only elements in the gallery space, symbolically reversing the role of the art gallery and the street: the pedestrian became the unknowing gallery-visitor while the art enthusiast was presented with the type of "undesigned" environment usually limited to the public realm. In September 1992, artist Mark West penetrated the facade with *Formworks & Blackouts*, a series of wormlike concrete forms molded in fabric cylinders that emerged from holes in the

ABOVE Storefront for Art and Architecture, 97 Kenmare Street, northeast corner of Lafayette Street. Steven Holl and Vito Acconci, 1993. View to the northeast. Warchol. PW

BELOW Storefront for Art and Architecture, 97 Kenmare Street, northeast corner of Lafayette Street. Steven Holl and Vito Acconci, 1993. Warchol. PW

Proposal for Lieutenant Joseph
Petrosino Park, site bounded
by Lafayette, Kenmare, and
Centre Streets and Cleveland
Place. I-Beam Design, 1996.
View to the southeast. I-BEAM

wall and extended onto the sidewalk, enticing pedestrians to stop and interact with the exhibition.

In November 1993, Storefront invited the artist Vito Acconci and the architect Steven Holl to collaborate on the design of an entirely new front for the gallery that was to be left intact for two years, after which every two years a new team would be chosen to replace it. Holl and Acconci considered their task to be more than aesthetic, conceiving the design, according to Acconci, not "'for' Storefront or 'about' Storefront but [as] a project that could, in fact, change Storefront—that would provide a new use for Storefront. . . . We wanted to make . . . the ultimately adaptable space."[23]

The result was a 100-foot-long facade constructed of gray Supraboard, a composite of concrete and recycled paper, that contained five large, irregularly shaped, rectilinear panels that pivoted on a vertical axis and seven smaller panels pivoted on a horizontal axis; the latter could lock into position to become tables and benches. When open, the metal-framed cut-outs, which rotated on ball-bearing hinges, effectively muddled the boundary between street and gallery, achieving Holl's goal of "breaking down, destroying, or interacting with the kind of a wall between" the art world and the "real" world.[24]

The facade was unique and succeeded in providing the institution with a powerful identity both in its neighborhood and among the greater architectural community, which greeted it enthusiastically. Suzanne Stephens felt that "the effect of the opened wall is as startling as it is stunning, for it makes the viewer fully aware of the blurred distinction between art, architecture, and the gallery space."[25] Susanna Sirefman, in her 1997 architectural guidebook to New York, found it "powerful in concept," and, although "flimsy in detail," considered it "a fantastic project."[26] To Kyong Park, the most poignant aspect of the design was that the collaboration of artist and architect, and the resulting inability to attribute any single idea to one or the other, manifest itself on the identity of the institution. The facade, he stated, "being neither all Acconci nor all Holl, neutralized their authority. Although the result may disappoint those who look for 'who did what,' the ambiguity

of their command undermines the singularity of an artist or an architect. In the end you have a facade that says 'No Wall, No Barrier, No Inside, No Outside, No Space, No Building, No Place, No Institution, No Art, No Architecture, No Acconci, No Holl, No Storefront."[27] The original plan to replace the facade every two years was jettisoned, according to Sarah Herda, Park's successor as director, in part because of its "enormous undertaking financially," but more due to its "wild success," which she deemed a consummate "illustration of our mission."[28]

In 1995 the Storefront for Art and Architecture joined the Lower Manhattan Cultural Council to sponsor an international competition for the design of Lieutenant Joseph Petrosino Park, a tiny .03-acre triangular parcel located adjacent to the gallery at the intersection of Lafayette, Kenmare, and Centre Streets and Cleveland Place.[29] The park, formerly named Kenmare Square, had been renamed in 1987 to memorialize the New York police officer killed in Sicily in 1909 while investigating the progenitor of the mafia, the "Black Hand." More a "traffic island," in the words of Parks Commissioner Henry Stern, than a park, it had for years been paved with asphalt and surrounded by a fence with two crooked gateposts allowing access from the south side.[30] The competition, which called for the expansion of the park into two of Lafayette Street's three traffic lanes, had lofty goals, asking entrants to consider "growing ecological crises and cultural diversity . . . while articulating a shifting relationship between nature and culture."[31]

More than 200 designs were submitted, from which the jury, whose members included Michael Sorkin, Mary Miss, Billie Tsien, Rosalyn Deutsch, and M. Paul Friedberg, among others, chose three winners. The team of Alberto Kalach, Ricardo Regazzoni, and Julio Gonzalez proposed to elevate the northern tip of the park, creating a steep slope, entered from the south, that would be planted with a bosk of trees and supported by a massive retaining wall. Craig Abel's scheme envisioned two long glass tables parallel to Cleveland Place and Lafayette Street flanked by chairs and with racks of donated newspapers, magazines, and books beneath them, the table along Lafayette Street partially shaded by a row of trees and

sharply sloped upwards as it neared the north end of the park. But the most compelling of the winning schemes, and the one generally considered to have earned first place, was submitted by I-Beam Design, a team made up of Suzan Wines and Azin Valey, that called for a number of industrial-strength metal towers scattered within the park supporting a weblike canopy of cables attached to one another and to the surrounding building facades. The cables covered both the park and the perimeter streets and were to be used as a framework for ivy and vines or to support decorations during parades and street festivals. Juror Rosalyn Deutsch was left wishing there would have been "more projects that would be involved in critically questioning, interrogating or redefining the notion of public space from a social and political perspective," but Michael Sorkin, for once the realist, conceded, "we may have overburdened this tiny site with the expectation that it could launch a major reformulation of the relationship of public and private space."[32] None of the proposals was realized.

SOHO

The evolution of SoHo from an architecturally distinguished, gritty industrial area rescued from near-destruction by artists and preservationists in the late 1960s to one of the city's premiere residential and retail shopping neighborhoods in the late 1990s was an internationally recognized symbol of the resurgence in the popularity of inner-city living among the affluent classes.[1] SoHo's evolution can be divided into distinct phases. The first began in the mid-1960s with Mayor Robert Wagner's implementation of the A.I.R. (Artists in Residence) program, allowing artists to occupy the top two floors of manufacturing and commercial buildings. This phase dramatically picked up steam in 1973, when the area was designated a historic district and its architectural stability attracted a monied crowd pushing loft rents higher than artists were able to afford, forcing them to relocate elsewhere as "yuppies" moved in. That first phase ended in the late 1980s, when the art gallery scene was at its peak; the second phase emerged when the area's appeal to retailers willing to pay high rents forced the galleries elsewhere, mostly to Chelsea, transforming SoHo into one of the city's most glamorous fashion districts.

Gentrification and preservation went hand in hand. Not only were 100-year-old buildings restored, so were substantial parts of the area's visible infrastructure, as when, in the early 1990s, in conjunction with routine repairs on parts of Greene and Mercer Streets, asphalt roadbed gave way to Belgian-block cobblestones, the traditional paving material, which had not been installed in a city street since 1938.[2] More controversial was a 1996 plan called "the Greening of SoHo," drawn for the Parks Department by Hank White, a landscape architect with offices in the area, which advocated the planting of hundreds of street trees in the neighborhood and drew the ire of preservationists who pointed out that the area had never had street trees.[3] The gentrification that the repaving and tree-planting program represented only pointed to more basic changes in the neighborhood character, set in motion by the 1982 Loft Law, which established a ten-year time table for building owners to bring residential lofts into compliance with the state's Multiple Dwelling Law. In 1992 the state granted a four-year extension. By then the cost of meeting the requirements had forced many landlords to convert their buildings to cooperative

or condominium status, passing on the obligations to comply to the residential tenants, a move that virtually guaranteed that only the most affluent artists could afford to remain in their lofts and, as Ingrid Wiegand, a real estate broker and one-time loft resident, put it, SoHo would become "a finishing school for the internationally rich."[4]

The explosive growth of retailing initiated concerns about the future of the neighborhood. In 1994 writer Greg Sargent noted that alongside the SoHo of "fashion and focaccia" there remained in the area a second SoHo: "a less visible world of crafts workers, small artisans, and light manufacturers" crowded into the southern end of the neighborhood where rents were cheaper. "Over the years," Sargent observed, "this other SoHo has lent the district its 'mixed-use' feel, a substratum of grit and dirty-hands industry that distinguishes it from the city's other fashionable enclaves." SoHo's artisanal neighborhood was given a reprieve by a 1976 regulation aimed at maintaining a balance between artists and industry by requiring landlords of street-level space to spend a year looking for a wholesaler or industrial tenant before applying for a special permit to bring in a retailer or restaurateur, a restriction that did not apply in SoHo's northern half. The well-intended ruling proved frustrating and costly to landlords who either couldn't find applicable tenants or even ones who could but were forced to accept the lower rents that such tenants could pay—often a third of those paid by retail interests. Noting the dramatic changes in the community, Sargent somewhat melodramatically asked whether the transformation of SoHo might also have been an "attempt, as others contend, by an elite cabal of planners to turn Manhattan into a postindustrial society based on financial services, tourism, and the arts?"[5] According to this version, planners foolishly—or cynically in complicity with developers—actively discouraged manufacturers by awarding tax breaks to developers, thereby hastening the destruction of the city's low-skilled industrial jobs base. There was no arguing that SoHo's development over the past thirty years had been accompanied by a loss of many manufacturing jobs, though it was by no means a certainty that they would have stayed in the area.

Despite the loss of manufacturing jobs, SoHo continued to be a significant contributor to the city's economy, generating tourism that was instrumental in bolstering the city's weakening retail base as people discovered an architecturally interesting, multiuse, pedestrian-friendly neighborhood in which to spend a day or an evening. In thirty years, SoHo had been transformed from a neighborhood devoted to the production and distribution of goods to one almost exclusively devoted to their consumption. By the mid-1990s, Sargent and others worried that SoHo might lose its balance and stumble: "The district's challenge will be to prevent boutiques, and especially national chains, from completely crowding out Soho's other uses. Once you get rid of the artists and workers—and the environment they helped create—what are you left with that you couldn't find in any city anywhere in the world?"[6]

From the early 1970s until the late 1980s, SoHo was the city's principal home to art galleries specializing in contemporary art, its venues outstripping their uptown rivals along Fifty-seventh Street and Madison Avenue in eclat if not necessarily in sales.[7] Few of the SoHo galleries were dramatically styled, with most relying on a simple formula of white-painted partitions played off against the exposed columns of the building's structural system. Gallery renovations were the bread-and-butter staple of a number of young architectural firms but, unlike residential loft renovations, they offered

comparatively little latitude for artistic experimentation. There were some exceptions. For example, Smith-Miller + Hawkinson's Chalk & Vermilion Gallery (1987), 141–145 Wooster Street (Louis Korn, 1897), was one of the comparative few to have a strong street presence and a challenging interior.[8] The shop-front was redesigned as a well-detailed, contextual but not historicist exercise with notable use of translucent panels of sandblasted glass and gray-painted steel folding doors fit into the grid formed by the building's masonry piers, cast-iron posts, and decorative pressed-metal detailing. Inside, a clean axial sequence led visitors down a central stair to the main gallery in the back of the basement. Suspended above the main gallery was the "ark," a cubelike exhibition space that featured a dropped ceiling composed of perforated metal sheets. The architect and theorist Stan Allen completed two modest white-painted-wall galleries in SoHo, the Amy Lipton Gallery (1989), 67 Prince Street, and the Fiction/Nonfiction Gallery (1990), 21 Mercer Street, before completing another, similar facility for the more prominent White Columns Gallery (1991) at 154 Christopher Street in Greenwich Village.[9] The blank austerity of each was barely relieved by a memorable detail or two. Adam Yarinsky and Steven Cassell, practicing as the Architecture Research Office, were able to make a more visible intervention with SoHo's only sculpture garden (1995–97), a reclaimed vacant lot enclosed by an articulated sheet-steel wall adjacent to 54 Thompson Street, on the northeast corner of Broome Street, where they converted the ground floor of a circa 1900 loft building into the home of Art et Industrie.[10]

In October 1996, the Dutch architect Rem Koolhaas realized his first American commission, a 3,500-square-foot storefront space for the Lehmann Maupin Gallery, 39 Greene Street (Richard Berger, 1884), between Grand and Broome Streets.[11] Koolhaas, who first made his mark as a mythologizer of Manhattan, and was climbing to international fame as an architect advocating "bigness," did not seem daunted by the modest commission. Said to be a work in progress, the low-key gallery design had as its principal feature a pair of sixteen-foot-high walls carried on rollers so that the gallery could be subdivided. Also notable were the removable plywood flooring and ceiling panels. These features notwithstanding, the design was, as the *New York Times* reporter Julie Iovine put it, "modest," though the fast-talking epigrammatic architect made the best of it.[12] The new gallery is "an unstable situation," according to Koolhaas; it "reeks of process"; it is "a device allowing modifications and adjustments" that blessedly were "not completely sterile."[13] Susanna Sirefman was not taken in by the design: "One's first reaction to this brand-new space is disappointment—much ado about nothing."[14]

Richard Gluckman was the architect of SoHo's principal galleries, beginning with the Brooke Alexander Gallery in 1985 at 484–490 Broome Street (Alfred Zucker, 1890–91), also known as 59 Wooster Street.[15] While most of Gluckman's galleries were interior spaces, that for the dealer Larry Gagosian, created with the monumentally scaled work of the minimalist sculptor Richard Serra in mind, was an independent structure, a one-story former garage at 136 Wooster Street, between West Houston and Prince Streets, converted in 1991, with the architect replacing the solid doors with ones of glass.[16] Inside, the space was painted white and skylights inserted to flood the room with bright light in keeping with the architect's view that his job was that of "expediter for the artist, not a collaborator."[17] In 1995, ten years after his first work for Brooke Alexander, Gluckman was called in to redesign the space.[18] But the SoHo art world was dealt something of a blow in the following year when Gluckman designed a new gallery for Paula Cooper, who decamped to the burgeoning new scene in Chelsea. Just four years earlier, in 1992, Gluckman had redesigned her SoHo gallery at 155 Wooster Street (George F. Pelham, 1898).[19]

RIGHT Chalk & Vermilion Gallery, 141–145 Wooster Street, between West Houston and Prince Streets. Smith-Miller + Hawkinson, 1987. Warchol. PW

BELOW Chalk & Vermilion Gallery, 141–145 Wooster Street, between Prince and West Houston Streets. Smith-Miller + Hawkinson, 1987. View to the west. Warchol. PW

Lehmann Maupin Gallery, 39 Greene Street, between Grand and Broome Streets. Rem Koolhaas, 1996. Aaron. ESTO

In 1983 SoHo's small group of nonprofit art institutions, which included the Drawing Center, the Kitchen, and the Clocktower, were given a lift when the New Museum of Contemporary Art, the city's only museum exclusively devoted to contemporary art, found a permanent home on the first two-and-a-half floors of the Astor Building (Cleverdon & Putzel, 1895), 583 Broadway, running through the block to Mercer Street between Houston and Prince Streets, a twelve-story loft structure being turned into a commercial condominium.[20] The museum, founded in 1977 by Marcia Tucker, a curator formerly associated with the Whitney Museum of American Art, had been housed in temporary quarters in the New School for Social Research on Fourteenth Street before moving to the Astor Building, where the renovations were handled by Proposition: Architecture. Even as the New Museum was settling into its space, the fate of the Astor Building was falling into question. Plans to turn it into a hotel faltered with the collapse of the 1980s boom, although the owners had already knocked out most of the windows. In 1991 strong winds sheared off its metal cornice. Four years later, Platt Byard Dovell was hired to develop plans for the building's restoration and conversion into artists' studios, offices, and additional museum space, which would require reconfiguring the overall facility; that assignment was handled by Kiss & Cathcart, whose renovated museum on four

levels opened in 1998.[21] The new space featured twice the amount of gallery space, a bookstore, improved offices, and a new elevator; a library and auditorium, planned for the sub-basement, remained unrealized. In its place, Media Z Lounge, a gallery for video and digital projects designed by the firm Lot/ek, opened in December 2000, with flat-screen monitors and other state-of-the-art technology juxtaposed with the rusted and reused hardware from the building.[22] The high point of the Kiss & Cathcart renovation was the new multi-story lobby with an open staircase suspended from the second floor. The lobby vastly enhanced the sense of the place as a public facility.

Maya Lin's Museum for African Art (1993), a 200-foot-deep, 12,500-square-foot storefront renovation at 593 Broadway (1860), designed in collaboration with the museum's director, Susan Vogel, and her staff, and the architect David Hotson, attempted to create an environment that was neither themed to the art nor typical of the "white-cube" galleries of the commercial art world.[23] The unexceptional space was subdivided to include a street-level shop, a dramatically decorated multipurpose events room, staff offices, and galleries on two levels. Eschewing specific references to African culture or symbol systems, and especially seeking to avoid the suggestion of an opposition between the "sophisticated" west and "primitive" Africa, Lin combined the open spaces and abstract shapes of

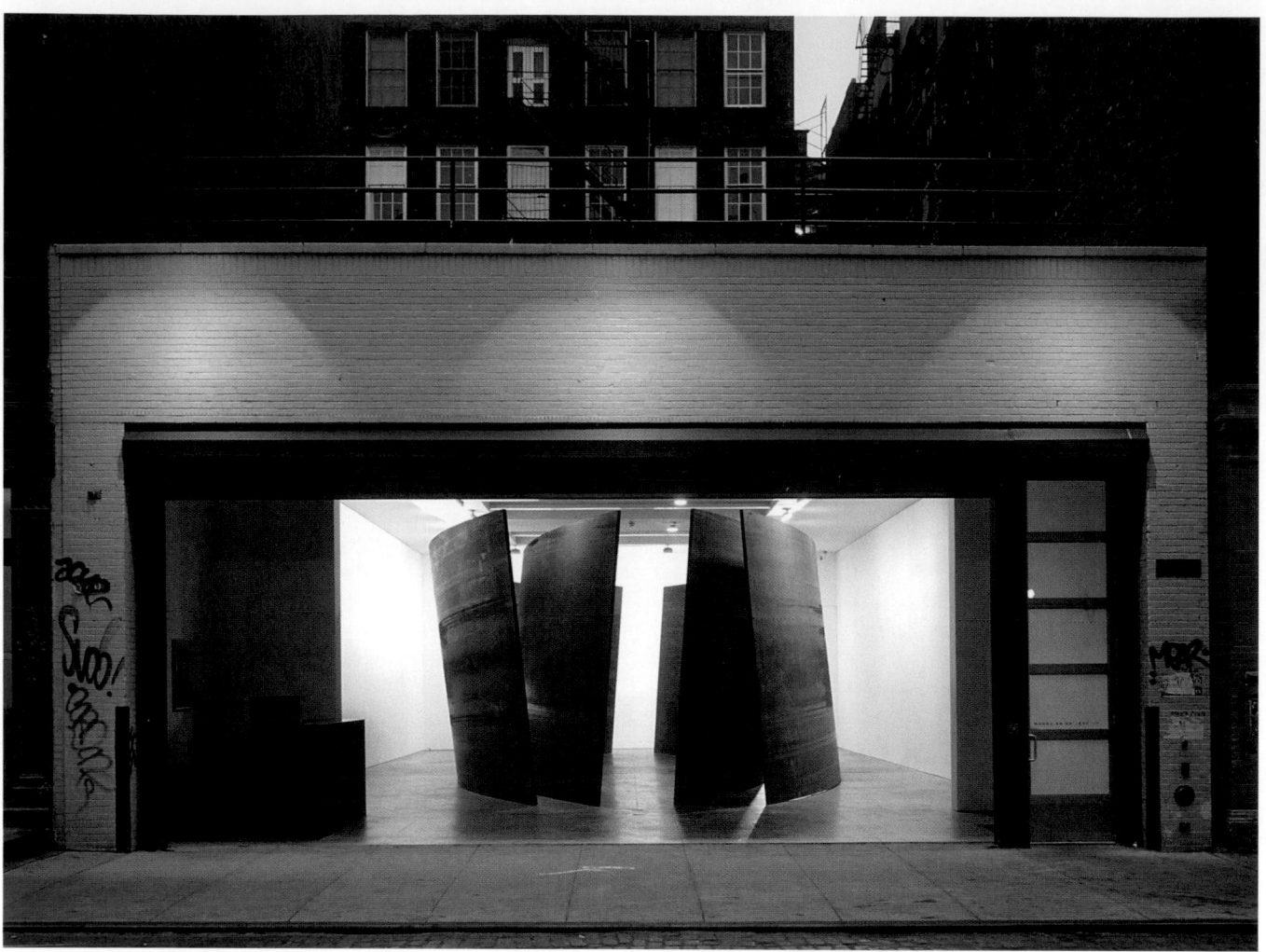

Gagosian Gallery, 136 Wooster Street, between West Houston and Prince Streets. Richard Gluckman, 1991. View to the east. Hueber. GMA

Modernism with distinctly African materials and colors. The controlling plan guided visitors on a journey that in Lin's opening installation took them through a forest of copper tubes suggesting trees but based on an African symbol for humanity and a wall of dramatically lit vitrines along a sensuously curved path which was, as Donald Albrecht wrote, "more experiential than cerebral, more about movement than stasis."[24] In 2000 the museum joined with the Edison Schools, the country's largest school management company, to undertake a combined facility on the blockfront of Fifth Avenue between 109th and 110th Streets facing Duke Ellington Circle (see Central Harlem).

In 1991 the Solomon R. Guggenheim Foundation startled the art world with the announcement that it intended to open a branch in SoHo.[25] Thomas Krens, the foundation's entrepreneurial director, chose the Japanese architect Arata Isozaki, working with Thomas Sansone of New York, to renovate the lower floors of the stone trimmed, cast iron–framed, red brick loft building at 575 Broadway, on the northwest corner of Prince Street, extending back to Mercer Street. The distinguished structure, with exceptionally large, 100-by-200-foot floor plates, was designed in 1881–82 by Thomas Stent to accommodate the Rogers Peet men's tailoring establishment. Internationally respected, Isozaki had completed one museum project in the United States, the Los Angeles Museum of Contemporary Art (1986) and, along with

James Stewart Polshek, had been selected for the renovation and additions to the Brooklyn Museum. The constraints imposed by the SoHo building forced the normally exuberant Isozaki to confine himself to a set of clearly organized bleached white oak floored galleries wrapped around a service core, producing what Joseph Giovannini described as "a subtly detailed space with a character at once distinctive and serene" shaped within "a simple palette of colors into glowing spaces reminiscent of Wright's rotunda. The paleness of Isozaki's space has value, the whiteness hovering like a mist off the walls and floors. Seeing a Kandinsky in the SoHo Guggenheim is experientially different from seeing it in the Wright building or in the Gwathmey-Siegel annex."[26]

The SoHo Guggenheim opened its galleries in June 1992, the same month as the renovated facility on Fifth Avenue was reopened. At the time, the ground floor and basement levels were not quite finished, giving rise to speculation that the museum had run out of money before it could realize Isozaki's plans, which called for an open staircase of raw steel with cable railings, curved frosted-glass-and-steel display cases for the bookstore, and walls of frosted glass at both ends of the second-floor galleries. But the Guggenheim claimed money was less of a concern than waiting to determine who would run the basement café. Although Isozaki had prepared designs for the café, it was ultimately consigned to an outside operator who used

another architect. The bookstore was also finished with simpler casework in wood.

The SoHo branch was not a success, and the building was closed for remodeling in 1996. In July of the same year it reopened as a media museum run by the Guggenheim but sponsored by the telecommunications giant Deutsche Telekom. Not only was the artistic value of the media shows questioned but the redesign of the ground floor to accommodate them was dismissed by Susanna Sirefman as "a mock-industrial look that tries too hard."[27] By this time, director Thomas Krens's ambitious plans for a global Guggenheim were being widely debated and, in many quarters, greeted with suspicion. The below-stairs gossip was more than confirmed when Robert Gebbie, the museum's deputy for finance and administration, revealed that the SoHo branch, which was in leased space, was hemorrhaging money. The SoHo Guggenheim closed its doors again in January 1999 for further renovations intended to revamp the entrance experience and reduce the facility by 7,000 square feet. In effect, the museum leased the southern end of the building to a retailer—the high-fashion clothier Prada, whose eagerly awaited shop was to be designed by Rem Koolhaas (see below). The reduced branch reopened in July 1999 and continued to mount exhibitions and operate its store until December 2001, when financial difficulties suffered by the Guggenheim forced its permanent closure.

SoHo's boom brought with it an almost endless stream of building renovations as ownership was transferred to newly formed residential cooperatives and condominiums. While most of these renovations left the deployment of interior space largely up to the determination of individual residents and shopkeepers, that of 426 West Broadway, between Canal and Howard Streets, a six-story warehouse, was a notable exception.[28] In 1983, under the direction of Peter Nelson, a real estate investor, a team consisting of the architect Ed Mills, of the firm Voorsanger & Mills, and the artists Richard Haas and James Ford, both of whom had previously worked for the developer, transformed the building, which ran through to Thompson Street, into a thirty-five-unit facility combining lofts facing West Broadway and apartments facing Thompson Street. Although the distinction was largely a fiction, reflecting the requirement that West Broadway be redeveloped with artists' lofts, it led to the creation of some unusual duplex and triplex units, providing more spatial variety than was typical of most loft conversions. Moreover, in keeping with Nelson's belief that "the whole idea of the building has to do with . . . a reflection of the phenomenon of Soho," the public spaces were embellished by Haas and Ford, working with Mills, to create a false perspective that would reduce the apparent length of the 100-foot-long lobby.[29]

Given the absence of available sites and the plethora of buildings ripe for conversion, there was little new development in SoHo, especially in the early years of its prosperity. One exception was the reconfiguration of a former commercial bakery and its combination with a totally new structure to form 130 Prince Street (1988), on a 100-by-125-foot lot on the southwest corner of Mercer Street.[30] Designed by Walter B. Melvin, in association with Lee Manners & Associates, the building was first planned to house the Broida Museum, a private museum of contemporary art. When that plan did not go forward, Edward Broida sold the property to a developer, who realized a five-story building with a penthouse on the vacant site, combining a limestone base, cast-stone facade facing Wooster Street, and tan brick on Prince Street. The contextually appropriate design, with its strong pattern of expressed

bays, pleased some observers but was dismissed by Susanna Sirefman, who called it "the epitome of poorly sited retro art deco" and found its facades to be "unwelcomely pretty" and lacking in "the grittiness downtown is renowned for."[31] Had it been realized, Sirefman would probably have felt much better about Frank Lupo and Daniel Rowen's "SoHo Townhouse" (1987), an art gallery and residence proposed for Larry Gagosian on a 25-by-100-foot through-block lot at 65 Thompson Street, between Broome and Spring Streets, which explored a deliberate anti-contextualism, celebrating the project's unique program and scale.[32] The bold, tilted plane appended to the facade of this project compared with Tod Williams and Billie Tsien's use of a similar device on the facade of the Jerry Speyer house on East Seventy-second Street (see Upper East Side). In conjunction with Leo Castelli, Gagosian ultimately built the 65 Thompson Street Gallery (Christian Hubert, 1989) on the site.[33]

At SoHo's fringes was an area that had once been known as Hudson Square, a moniker that was coming back into usage as the area was redeveloped near the end of the twentieth century. On a 31,000-square-foot vacant site along the west side of the Avenue of the Americas, between Grand and Watts Streets, Fox & Fowle's 101 Avenue of the Americas (1992), a twenty-three-story building consisting of a six-story base and a seventeen-story tower that penetrated its mass facing the avenue, was notably in keeping with its neighborhood of 1920s warehouses.[34] Despite its deliberate contextualism, it caught the eye of Herbert Muschamp who rejoiced in it as a "modern monolith . . . slipped downtown to learn a civics lesson from its industrial ancestors." In a review that confused many, Muschamp chose to overlook the generic use of Art

Museum for African Art, 593 Broadway, between Prince and West Houston Streets. Maya Lin and David Hotson, 1993. Warchol. MLS

ABOVE SoHo Guggenheim,
575 Broadway, northwest
corner of Prince Street.
Arata Isozaki, 1992.
Axonometric views of first
and second floors. AI

RIGHT SoHo Guggenheim,
575 Broadway, northwest
corner of Prince Street.
Arata Isozaki, 1992. Second-
floor gallery.
Heald. SRGM

Deco–inspired motifs and instead to concentrate on the play of two brick grids across the facade, one in warm brown brick corresponding to the building's concrete structural frame, the other in light gray brick marking the individual floors. For Muschamp, the intervening grid helped define Fox & Fowle's building as "a gateway to the Hudson Square district," an expression using "visual codes" to fuse the area's industrial past with its clerical present.[35]

Aldo Rossi's Scholastic Building (2001), 557 Broadway, between Prince and Spring Streets, designed in association with Gensler Associates, was a building of genuine distinction, occupying the site of a one-story garage that in 1953 had been erected to replace a five-story cast-iron loft building.[36] To the north lay Ernest Flagg's extraordinarily inventive iron and glass Singer Building (1904), 561–563 Broadway, popularly known as the Little Singer Building, now a residential condominium.[37] To the south of the garage, 549–553 Broadway (1890) was a ten-story cast-iron and stone structure designed by Alfred Zucker for the retailer and auctioneer Charles Baltzell Rouss, who was so enamored of Broadway that he changed his name to Charles Broadway Rouss.[38] The building was expanded in 1900 by the architect William J. Dilthey, at which time it was given the address 555 Broadway.

In 1993–94, Hardy Holzman Pfeiffer Associates substantially altered 555 Broadway for Scholastic, a publishing firm specializing in material for young readers. Previously, in 1983, HHPA had designed Scholastic's offices atop a converted warehouse at 730 Broadway formerly belonging to the John Wanamaker department store, squeezing 500 people into 90,000 square feet on three floors where the architects boldly juxtaposed diagonal and orthogonally arranged cubicles, inserted a diagonal arrangement of skylit open stairs connecting the floors, and refitted the building's abandoned water tank to serve as a conference room.[39] The firm's renovations of fourteen floors of 555 Broadway used a custom-designed movable full-height wall system to create stylish yet flexible work cubicles.[40] But the project's principal feature was an internal staircase rising up a ten-story mirrored atrium constituting "a periscope of natural light."[41] A gabled, skylit penthouse dining room commanded sweeping views of the lower Manhattan skyline.

HHPA's plans provided for Scholastic's anticipated expansion into a new building it proposed to build on the site of the one-story garage. To design the building, which would require approval from the Landmarks Preservation Commission, Scholastic considered Hardy Holzman Pfeiffer as well as Gensler, Fox & Fowle, and Skidmore, Owings & Merrill, but ultimately chose Gensler, who in turn brought in the internationally respected Italian architect Aldo Rossi, with whom the firm had collaborated on the unrealized headquarters offices for Euro Disney outside Paris.

The choice of a European architect to realize a high-profile project in a closely monitored context marked a new trend that would become increasingly important at the century's conclusion. As Patrick O'Malley, architect and vice president of Gensler, recalled, he summoned Rossi because he was "the architect who can walk into Landmarks and make them fall off their chairs."[42] Paul Goldberger, pointing to the disparate scales and characters of Flagg's delicately balconied building and Zucker's much more robustly detailed design, to which the new building was in fact an addition, praised Rossi's scheme as "a textbook example of how to design in an historic

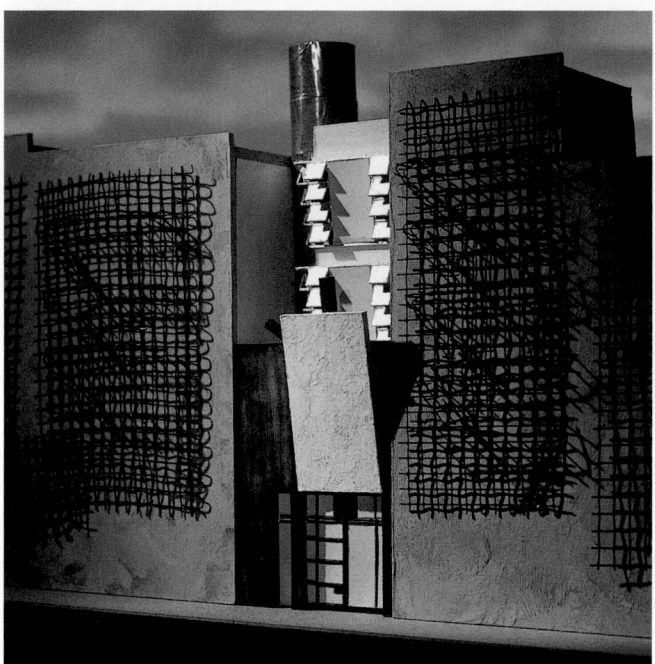

Proposed SoHo Townhouse for Larry Gagosian, 65 Thompson Street, between Broome and Spring Streets. Frank Lupo and Daniel Rowen, 1987. Model, view to the southwest. DRA

101 Avenue of the Americas, between Grand and Watts Streets. Fox & Fowle, 1992. View to the southwest. Sundberg. ESTO

district: subtle, brilliantly inventive, it is the sort of building that, if built, will teach generations of architects the proper way to respond to historic contexts. . . . It is no exaggeration to say this is one of the most distinguished pieces of new architecture to be proposed for any New York City historic district in the last generation."[43]

Scholastic offices, 730 Broadway, between East Fourth Street and Astor Place. Hardy Holzman Pfeiffer Associates, 1983. Water tank conference room. Kaufman. H3

Scholastic Building, 557 Broadway, between Prince and Spring Streets. Aldo Rossi and Gensler, 2001. View to the east of Mercer Street facade. Moran. MM

Rossi's design was approved by the Landmarks Preservation Commission in June 1996 after only an hour of deliberation. As a result of subsequent negotiations undertaken to secure the variances that would permit the building to rise to ten stories—which exceeded the square footage and height limits allowed under current zoning, despite the fact that its two neighbors were even taller and bulkier—two light courts were carved out of the mass, relieving conditions between it and the Little Singer Building as it faced Mercer Street. The modified plan was approved on August 5, 1997. Eighteen days later, Rossi was seriously injured in an automobile accident while driving from his Milan office to his weekend villa on Lago Maggiore. His condition deteriorated, and the sixty-six-year-old architect died on September 4.

The Scholastic Building seemed remarkably right in its setting, although the design was made up of elements Rossi had used in previous work outside the United States. Many observers could not help commenting that its Broadway facade closely recalled Rossi's Hotel Il Palazzo in Fukuoka, Japan, of 1989, and that the steel arches on the Mercer Street side resembled those on the Apita shopping center in Tochi, Japan, of the same year. In fact, the Palazzo was inspired by New York's cast-iron buildings, so the Scholastic Building was just bringing things full circle. As it faced Broadway, the Scholastic Building acknowledged the double-story reading of the Rouss Building with one of its own, while also paying homage to the Singer Building through the scale of its mullioned fenestration and the decorative detailing of its curtain wall, entablatures, and deeply recessed spandrels, for which, in an effort to complement the Singer Building's red terracotta, Rossi had originally specified rusting Cor-ten steel but, in a later decision, substituted bright red paint. Organizing the Broadway facade were boldly scaled, metal half-columns that appeared to support massive steel beams, though both were actually applied decoration concealing the building's concrete structure. Facing Mercer Street, where its context was the relatively undesigned rear facades of the two neighbors, the facade made bold use of five tiers of two-story-high, monumental angled, webbed, bolted steel arches similar to those designed by Peter Behrens in his 1909 AEG Turbine Factory in Berlin, a building Rossi admired.

The peak of the real estate boom in 2000 brought with it two startling proposals for new buildings. The first, 497 Greenwich Street (2004), designed by Winka Dubbeldam of Archi-Tectonics for a site between Spring and Canal Streets, west of the traditional boundaries of SoHo, was an eleven-story, folded-glass-facade building extending four stories over the top of an adjoining six-story brick-faced structure that would be gutted and incorporated into the project.[44] A restaurant and a gallery were the intended ground-floor occupants and a triplex apartment was proposed for the building's owner, who also owned the gallery; the remainder of the building would be given over to residential lofts. The most dramatic feature of the building was the facade, with only the lower three stories set plumb to the street wall, above which it angled forward and back in a series of folds, interrupted by diagonal

FACING PAGE Scholastic Building, 557 Broadway, between Prince and Spring Streets. Aldo Rossi and Gensler, 2001. View to the southwest of Broadway facade showing 555 Broadway (Alfred Zucker, 1890; expanded by William J. Dilthey, 1900) on the left and the Little Singer Building (Ernest Flagg, 1904) on the right. Moran. MM

crimps between the third and sixth stories and above at the seventh, ninth, and tenth floors—devices employed to fulfill zoning setback requirements but used to create solariums within the apartments. As Herbert Muschamp pointed out, Christian de Portzamparc, in his LVMH building (see Fifty-seventh Street), also "used a folded glass wall to overcome the box-on-a-base zoning regulations that have given New York the appearance of a storage depot"—a view not exactly shared by all—"but Dubbeldam's folds are philosophical as well as visually grounded," challenging "the grid as a structure of Western thought. Who wants to think like a box? Why not try turning the lens this way and that? And twinkle when you shake it?" For Muschamp, the grids of the curtain wall provided the "signs of normality that the glass folds then undermine."[45] Dubbeldam situated a stack of cantilevering balconies between the new and the old buildings, "juxtaposing and differentiating between the old and the new, inserting an interactive space into an otherwise neutral streetscape."[46]

Philip Johnson and Alan Ritchie's proposal for the twenty-six-story 348-foot-tall Habitable Sculpture, also called The Seasons, 328 Spring Street, between Washington and Greenwich Streets, on a site occupied by an automobile repair shop housed in a nondescript two-story warehouse, was to have been situated next door to the venerable, century-old Ear Inn tavern, located in the landmarked James Brown House (1817), a wood-framed, brick Federal-style building built by an African American who was reputedly an aide to George Washington.[47] The project was conceived by developer Antonio "Nino" Vendome, who considered his role

497 Greenwich Street, between Spring and Canal Streets. Archi-Tectonics, 2004. View to the southeast. Floto Warner. FWP

to be as much art dealer as developer and the building to be a literal work of art by Johnson. The remarkable scheme was both highly abstract and distinctly vernacular, "turning contextualism on its head," according to Muschamp, by using forms and materials familiar from the immediate surroundings to "fashion a surprise, a symbolic gateway to the downtown state of mind." The fifty-apartment Neo-Expressionist tower, said to be inspired by one of John Chamberlain's semifigurative crushed-automobile constructions, consisted of distinctly shaped, faceted elements cantilevered from a conventional, square-shaped service core and clad in bricks drawn from a color palette based on those found in the neighborhood, punctuated by regularly spaced, traditional double-hung guillotine-type windows and a ziggurat of cascading cornices, which together formed what Muschamp described as the "mirth-making part of the collage. These details are a cackling downtown descendant of the carved masonry facade of 1001 Fifth Avenue," where, to appease the Fifth Avenue neighbors, Johnson provided "a classical limestone mask for a modernoid building already designed." On Spring Street, Muschamp continued, Johnson "deploys the cornices and rows of uniform, period-style windows as a sign of normalcy that is subverted by the fragmented facades. You almost want to see lines of laundry looped along the upper stories."[48]

On June 1, 2001, the Board of Standards and Appeals, acting on strongly worded advice from the City Planning Commission, rejected an appeal by Johnson's clients, the Vendome Group, to realize the project on the site, which was zoned for manufacturing uses accommodated in buildings restricted to twelve stories. Johnson continued to battle for his design, arguing, "It's New York and New York is tall buildings." However, it was not the height of the proposed building that interested him but the interplay of its cubist composition with its down-home fenestration: "I call it 'the victory of double-hung windows.'"[49] In July 2002, Johnson and Ritchie proposed a new fourteen-story, 147-foot-tall design for the site, calling for a banded brick and glass, round-cornered Starrett Lehigh Building–inspired tower. This proposal was also deemed too tall by members of the community. In 2003, approval was given for the construction of a 120-foot-tall building on the site but rather than work with either of the two previous schemes, the developer sent Johnson and Ritchie back to the drawing board. The Vendome Group remained intent on building the original design elsewhere in New York or in another city.

Of SoHo's open sites, some seemed well suited for hotels, particularly given that new residential construction in the area was prohibited by zoning. In 1984 a proposal for a five-story, eighty-room hotel at 35 West Houston Street, between Mercer and Greene Streets, designed by Der Scutt to echo in aluminum the cast-iron frame aesthetic of many of SoHo's historic buildings, met with the strong opposition of the SoHo Alliance, a neighborhood group dedicated to preserving the area's industrial character.[50] Plans stalled for the next decade, but in 1995 Scutt's client, Hank Sopher, acquired an additional block-long sliver of land to the west on Houston Street between Greene and Wooster Streets so that he could build more guest rooms, deemed necessary to an economically viable hotel. To realize the efficiencies of greater size, Sopher proposed to connect the two hotels with a nine-foot-wide underground tunnel below Greene Street. Because Scutt had already received the Landmarks Preservation Commission's approval for the first

Proposal for The Seasons, 328 Spring Street, between Washington and Greenwich Streets. Philip Johnson Alan Ritchie Architects, 2001. Rendering by Sven Johnson Illustration of view to the southeast. VG

building, he proposed to complement it with a clone on the new site.[51] After local residents sued to block the zoning variances that would permit the hotel's construction, a new developer, Ian Bruce Eichner, proposed to build apartment houses on the two sites, which, as the result of a decision of the Court of Appeals, would not be required to house city-certified artists. Beyer Blinder Belle's design for the buildings, 25 and 55 West Houston Street, prepared in association with H. Thomas O'Hara Architect, called for better than run-of-the-mill six- and eight-story buildings but with none of the authority of Scutt's earlier project.[52] Both were completed in 2004.

One 1980s hotel that did go forward was the SoHo Grand, developed by Hartz Associates.[53] The economic recession slowed the project, giving neighbors false hope that the 30,000-

square-foot, weed-choked site on West Broadway between Canal and Grand Streets would remain vacant. But despite the community's efforts to stem the tide of commercialization, the handwriting was on the wall. As Thomas P. McConnell, manager of the hotel-consulting group for the accounting firm of Laventhol & Horwarth, put it, "It's too late to preserve SoHo à la 1973. It's now a big shopping mall and a movie set."[54]

Hartz's plans moved forward in earnest in 1994 under the leadership of Emanuel Stern, a vice president of the family-owned firm, who retained the architect David Helpern and the interior designers Aero Studios to plan the 370-room, fourteen-story SoHo Grand. According to Stern, the hotel would be "a marriage of Victorian New York" as imagined in *The Age of Innocence* "and sleek modern SoHo."[55]

Proposed West Broadway Hotel, 35 West Houston Street, between Mercer and Greene Streets. Der Scutt, 1984. Model, view to the southwest. Checkman. DSA

Intended as a downtown alternative to the affordably stylish redesigned Paramount Hotel uptown, the hotel overcame community opposition, lawsuits, and a protest march to be enthusiastically received by the press and public at its opening in August 1996. While the bulky, cast-stone-trimmed brick building itself was not interesting, the interiors designed by William Sofield of Aero Studios were notable for a suggestive contextualism that included a suspended cable, cast-iron entrance staircase embedded with bottle glass and lighting sconces holding hand-blown bulbs that reproduced those developed by Thomas Edison in 1893. The constraints of the site—it was a flood plain once known as the Lispenard Swamp—forced all hotel functions to be located one floor above street level, making the sequence of arrival from sidewalk to lobby a critical factor in the design. Accessibility for handicapped guests via ramps and elevators had to be taken into consideration in addition to the staircase. As if to drive the point of industrial grittiness home, Joseph Stashkevetch's ten-by-fourteen-foot photographic triptych illustrating urban motifs was virtually overwhelmed by the ironwork of the stairs, balconies, and structural details. The ground-floor entrance was not so much grand as cavernous, dominated by immense brick columns that suggested some lost, nobly proportioned subway station. Upstairs, the lobby was the hotel's high point, with its eclectic mix of details, including Egyptian-inspired columns, Oriental lanterns, and Arts and Crafts–inspired ornament that suggested the waiting room of an early-twentieth-century railroad station.

Complex though the pre-history of the SoHo Grand may have been, it was nothing compared to the seemingly endless process undergone by the sculptor turned hotelier André Balazs and his business partner, Campion Platt, an architect,

to realize their dream of the Mercer Hotel, 93–99 Prince Street, northwest corner of Mercer Street, which began in 1989 and was at last opened for guests in 1998.[56] The plan was kiddingly called "the paralepsis" by its developers, who continually felt obliged to defend their proposal for an 81-room hotel in an existing six-story brick Romanesque-style former commercial and office building (William Schickel, 1888) commissioned by John Jacob Astor III, by stating what it was not—that is, what urban nuisances it would not bring to its most urban nuisance–plagued setting.

Platt was joined by Harman Jablin Architects, stylist Serge Becker, and French designer Christian Liaigre. Additionally, James Sanders, an architect with a reputation for working well with dissident community groups, was added to the team to help sell the project to the preservation community and to build support for the necessary zoning change that would substitute new uses for the light manufacturing that the basement, ground floor, and mezzanine were zoned for. To obtain local support for the zoning change, Marcia B. Nelson, a lawyer brought in to consult, worked out a strategy that had the Landmarks Preservation Commission itself apply for a variance, which they were willing to do once the developers made an extraordinary move: agreeing not only to restore the building's facades but also to donate them to the Landmarks Conservancy along with money to endow an ongoing program of inspection and repair.

With community opposition overcome, work began in earnest in 1992 but quickly became plagued by construction problems that led to a stoppage in 1993, when after millions had been spent and many deadlines missed, the cash-strapped Japanese investors behind the project closed their line of credit. At last, in 1998 the 75-room Mercer Hotel opened, exuding, as a travel reporter for the *New York Times* put it, "a curious blend of serenity and attitude."[57] Inside the building's

LEFT 25 West Houston Street, between Mercer and Greene Streets. Beyer Blinder Belle, 2004. View to the southwest showing 55 West Houston (Beyer Blinder Belle, 2004) on the far right. RAMSA

BELOW SoHo Grand Hotel, 310 West Broadway, between Canal and Grand Streets. Interiors, William Sofield, 1996. View of stairs showing triptych by Joseph Stashkevetch. SYND

meticulously restored shell, Liaigre mixed lots of black, white, and dark-finished African Wenge wood with bursts of purple and pale chartreuse to create a hip version of an old gentleman's club. Jane Withers, writing in the English newspaper *The Observer*, called Liaigre a master of "unchallenging modernity."[58] Another early guest, the journalist Bruce Weber, reported that the effect was "beautifully bland, or maybe blandly beautiful, and I had the distinct sense of walking into the pages of a fashion magazine; before I checked in, I actually sniffed the air, alert for that powdery perfumey odor that I associate with Vogue and Vanity Fair."[59]

Although Stephen B. Jacobs's 60 Thompson Hotel (1999), a twelve-story, 100-room facility at 60 Thompson Street, featured interiors designed by Thomas O'Brien of Aero Studios, it added little to the area's architectural distinction.[60] Far more compelling was the promise of a new hotel developed by André Balazs and designed by the French architect Jean Nouvel for a parking lot site, northwest corner of Broadway and Grand Street.[61] In April 2001, Nouvel's startlingly spare, glassy metal-framed building sailed through a Landmarks Preservation Commission anxious—many would say overanxious—to demonstrate that the suddenly popular fin-de-siècle Neo-Modernism that Nouvel embodied could be handled in a contextually sensitive way. Herbert Muschamp was virtually overcome with enthusiasm: "The design bears little resemblance to the contextual aesthetic promoted by preservation groups and local community boards in recent decades. Mr. Nouvel's design is good news, but the enthusiastic support it received from the Landmarks Commission and its commissioner, Jennifer J. Raab, is an even bigger deal."[62]

While not stylistically contextual, Nouvel's design, with applied steel grids and glass fins used to suggest depth in a glass-curtained building, was sympathetic to the framelike

Proposed Broadway Hotel, northwest corner of Broadway and Grand Street. Jean Nouvel, 2001. Rendering of view to the northwest. AJN

serial repetitions of SoHo's cast-iron buildings. Waxing rapturous and somewhat silly, Muschamp wrote that "it would be obtuse to analyze the design in strictly formal or functional terms. This hotel is made for 'Moody's Mood for Love' as performed by King Pleasure, on a rainy weekday afternoon, downtown, in a room surrounded by low-rise buildings. Think Edward Hopper crossed with Pedro Almodóvar. Not least, this design is about sex. That is its major departure from the glass office towers of mid-20th-century New York." Muschamp attempted to evaluate Nouvel's design in cinematic terms, comparing the design for the proposed building's north wall, a glass wall punctuated by transparent rectangles with blurred images, to "film sprockets or movie stills from an emphatically film noir genre" before classifying Nouvel's design as a "supreme example of what we mean when we talk about an architecture of ideas."[63] The slump in hotel business after September 11, 2001, forced Balazs to shift gears, changing the building's program to that of an apartment house, adding two stories to its height and, in 2003, beginning the lengthy process of seeking a zoning revision that would allow residential development on the site.

While SoHo's ground-level retail space was largely taken up by art galleries in the 1970s and 1980s, with some bars and restaurants interspersed, beginning about 1985 the neighborhood began to attract high-end retailers, mostly sophisticated boutiques featuring pricy clothing and items for the home. Ed Mills's ground-floor shop for Dianne B. (1982), 426 West Broadway, was the first high-fashion women's boutique to locate in SoHo. The design capitalized on the art scene with an elaborately articulated and detailed pastel-tinted space that, as Mildred F. Schmertz put it, seemed to say "Come look at *our* art too."[64] In 1986 Dianne B. expanded with another Mills-

designed boutique, Dianne B. Men and Women, at 102 Wooster Street, a 3,500-square-foot space incorporating black stucco walls and steel-paneled floors into a ninety-foot-long gallery bringing shoppers through three individual boutique areas to the rear of the store where shoes were displayed on sliding aluminum shelves hung from an oxidized copper wall.[65]

Comme des Garçons (1984), 116 Wooster Street, designed by Takao Kawasaki, a Tokyo architect, in association with Howard Reitzes, of New York, set the tone with a design based on the concept of Rei Kawakubo, the Tokyo-based fashion designer whose shop it was.[66] In its stark minimalism, Comme des Garçons was a pitch-perfect reflection of the merchandise it showcased. In 1988 Kawakubo and Yasuo Kondo of Tokyo and Toshiko Mori of New York helped extend the brand with Comme des Garçons Shirt, 454 West Broadway, an 800-square-foot shop where, as Karen D. Stein observed, "architecture takes center stage."[67] The principal features of the design, said to have been inspired by the construction of the shirts sold inside the shop, consisted of two steel display fixtures intended to suggest shirt cuffs and sixty-five-foot-long light troughs forming a collar and button pocket at the ceiling. In 1998 Mori, working independently, designed Issey Miyake Pleats Please, a boutique at 128 Wooster Street. The small, tasteful, if uneventful interior, was notable for its refined detailing and for the innovative use of film-coated windows that suggested a veil, transparent when viewed head on but translucent green when seen at a glancing angle, instilling, as Mori put it, "a sense of curiosity and continuous discovery" in the minds of passersby who "can't resist another pass to observe the simulation."[68]

While the design of the two Comme des Garçons shops largely ignored the architectural context—in the first shop an

ABOVE Dianne B., 426 West Broadway, between Canal and Howard Streets. Ed Mills, 1982. EM

BELOW Dianne B. Men and Women, 102 Wooster Street, between Prince and Spring Streets. Ed Mills, 1986. EM

Comme des Garçons, 116 Wooster Street, between Prince and Spring Streets. Takao Kawasaki, 1984. Warchol. PW

Parachute, 121 Wooster Street, between Prince and Spring Streets. Harry Parnass, 1984. Warchol. PW

existing skylight was blocked up so as not to complicate the visual atmosphere—Parachute (1984), 121 Wooster Street, made the most of its setting, counterpointing the racks of clothing with the building's cast-iron columns, which were painted brilliant white.[69] The SoHo shop was one of four similar installations designed for the clothing chain by the American-educated Montreal architect Harry Parnass, who with his partner, Nicola Pelly, also designed the clothes featured in the shops. In 1988 two other designers opened shops in SoHo: Alaïa, 131 Mercer Street, between Prince and Spring Streets, and Yohji Yamamoto, 103 Grand Street, southwest corner of Mercer Street, each reasonably different in design, both extending the minimalist "where are the clothes?" approach of Comme des Garçons.[70] But neither the Tokyo-based Yohji Yamamoto nor the Paris-based Azzedine Alaïa were involved in the design, and artists rather than architects were asked to take the design lead. Yamamoto's was designed by Alain Munkihrick of Newton Corners, Massachusetts, working with Anthony Donaldson, a London sculptor, and a series of craftsmen who created screen walls and sculpture-like clothing racks. Alaïa's shop was designed by the protean artist Julian Schnabel, then at the zenith of his fame. Schnabel, collaborating with his wife, Jacqueline, punctuated the big, squarish, otherwise bland space with monumental sculptures by the artist, cast-bronze furnishings, and heavy velvet draperies that added drama to the room evoking whispered murmurs such as "strange and tribal" and "sexy" among SoHo locals.[71] The fact that the cases were originally conceived as a symbolic tomb for the artist Joseph Beuys, who had died in 1986, added to the buzz.

SoHo's escalation into a popular shopping destination began in 1992 with the opening of Naomi Leff's A/X, 568 Broadway, northeast corner of Prince Street, a 2,900-square-foot, warehouselike shop replacing two adjacent stores dedicated to the basic line of jeans and casual clothing bearing the label of the fashion guru Giorgio Armani.[72] Conceived as a prototype for other A/X stores as well as boutiques and selling areas in department stores, Leff's design was based on that of P/X or Post Exchange shops located on military bases to provide for the shopping requirements of American soldiers and sailors. Leff, whose skill with retail interiors was honed by years of collaboration with Ralph Lauren, roofed over the squarish space with a falsework of metal trusses and furnished it principally with long tables on which the merchandise was piled. To give the salesroom an Armani spin, the use of industrial materials evoked a high-style yet not particularly contrived Quonset hut. Leff's HR Beauty Gallery (1999), 135 Spring Street, designed for the venerable but no longer hip Helena Rubinstein cosmetics company, evoked the 1930s Moderne that was closely associated with Madame Rubinstein's taste.[73]

The economic recession of the mid-1990s momentarily curtailed the invasion of retail to SoHo, but by the time of the economic rebound in the late 1990s, new shops began to proliferate, driving art galleries to Chelsea. The minimalism of Comme des Garçons was continued with Richard Gluckman's 3,500-square-foot Helmut Lang (1997), 80 Greene Street, a shop so reduced in its elements as to easily be confused with an art gallery.[74] Clearly the intention was at once to rival and comment upon both Comme des Garçons and John Pawson's Calvin Klein shop uptown. But, as Abby Bussel observed, Lang's shop was "less about absence and more about presence, about experiential drama," with greater spatial complexity and even some

color—a bit of blue—as well as art, an installation by Jenny Holzer.[75] The central room was dominated by a totemlike column housing a floor-to-ceiling LED strip that scrolled Holzer's text. Four monolithic cabinets housing the collection were inspired by the work of the architect-turned-sculptor Tony Smith and that of Richard Serra. According to Gluckman, Lang said, "I don't want to see any clothes" and Holzer said, "I don't want to see any art" to which he replied, "I don't want to see any architecture."[76] Gluckman's perfume shop, Helmut Lang Parfums (2000), 81 Greene Street, was even more startling.[77] With very few products to display, it consisted principally of a central work island and a continual LED stream of Jenny Holzer's aphorisms running along the parapet of a spatially provocative bifurcated stair leading to a basement sales area.

Gluckman Mayner's shop for Yves Saint Laurent Rive Gauche Homme, 88 Wooster Street (1998), included an art gallery in the front of the store.[78] David Ling's 1,000-square-foot Philosophy di Alberta Ferretti store (1998), 452 West Broadway, near Prince Street, added a sense of wit and drama to the prevailing minimalism, echoing the designer's layered look with light-filled layers of glass, cotton scrim, water, and wood.[79] The Philosophy boutique was located in an early-nineteenth-century townhouse that the architect gutted to create two double-height levels of loftlike space. The cash wrap, an ebonized truncated cone, was highly visible from the street. SoHo's transformation into a high-end retail district culminated in 2001, when the Guggenheim Museum decamped to make way for the spectacularly ambitious, even overreaching, Prada New York Epicenter, located on the ground floor and basement levels of 575 Broadway, on the northwest corner of Prince Street, extending back to Mercer Street.[80] Prada was designed by Rem Koolhaas, who had never designed a store but had studied the subject as part of a 1997 seminar he ran at

Harvard's Graduate School of Design. The store was part of an ambitious project by the trendy Italian clothing company to create new stores in San Francisco and Los Angeles, designed by Koolhaas, as well as one in Tokyo, designed by Herzog & de Meuron. The centerpiece of the 23,000-square-foot Prada Epicenter, reputed to have cost over $40 million to build, was an undulating, monumentally sized zebrawood stair designed, in the architect's words, to "naturally connect to the large basement area and guide customers to the more invisible parts of the store; the floor steps downwards in its entire width and rises subsequently to re-connect to the ground level, creating a big 'wave.'"[81] At the upswing of the wave, a platform could be automatically folded out to create a small, cantilevered stage, transforming the stair and its space into an auditorium suitable for lectures, performances, and film projections. As Arthur Lubow put it: "Voila! A clothing store has become a theater."[82] In addition to circulation, the stair could also be used as informal display space and seating.

Aside from the boldly sculptured stair, the shop's main floor was relatively simple. Along the Prince Street side, light was admitted through a wall of translucent polycarbonate, while on the north side, the party wall was colorfully wallpapered using a design by the hip graphics firm 2x4 Studios. Inside the Broadway entrance, a circular glass elevator, doubling as display space, brought customers to the lower-level lounge. A discreet entrance for VIPs was located on Mercer Street. What little merchandise there was to be seen on the street level was displayed in large metal cages suspended from a track system. Most of the selling was confined to the basement level, which featured a black-and-white marble floor in homage to Prada's first store in Milan, as well as the most talked-about feature of the design, high-tech dressing rooms replete with adjustable lighting, transparent glass doors that could be rendered opaque at the press of a pedal, and video cameras linked to plasma screens that offered a rear view for customers trying on clothes.

Working with the New York firm Architecture Research Office, Koolhaas finished his eagerly anticipated design in time for a gala opening on December 15, 2001, an event that attracted more than the usual amount of hype given that the city was still in the throes of post-9/11 shock and that Prada's corporate fortunes were said to be in steep decline. Writing in the *New York Times* a day after the opening, Herbert Muschamp was enthusiastic in his praise: "Even if Prada were to tumble into Chapter 11 by New Year's Eve, New Yorkers would still have had a blessed two weeks to walk through a model block of intelligent optimism about urban life." Although he was impressed with the round elevator, declaring that the "sparkling glass shaft epitomizes the game between luxury and rawness that is everywhere played out," Muschamp felt that "space itself is the ultimate luxury at Prada; space, and the dedication of so little room to stuff you can buy. . . . It is not a narrow space, but the extreme length creates the quality of a vortex."[83]

Ada Louise Huxtable, writing in the *Wall Street Journal*, concluded that the Prada design was "all about interaction. The Koolhaas design screams communication. The long . . . through-block space is, in fact, a mall, a people-place raised to the highest power, the platinum standard that shows how it should be done."[84] The combination of fashionable retailer and fashionable architect was a potent cocktail for the press. Ingrid Sischy, a magazine editor and art journalist, glowingly

described the new Prada in the pages of *Vanity Fair* as "a collision of worlds: the place is part 21st-century futurist's daydream, part 19th-century Victorian peep show, part personal beauty stop, and, with screens and media installations integrated into the whole, part cinematic spectacle."[85] But Paul Goldberger did not succumb to the hype, expressing disappointment in a design that "is not a staggering reinvention of the retail environment, no matter what Koolhaas and his followers claim. . . . Designing a store that attempts to combine shopping with entertainment and technology is nothing new, and, other than the juxtaposition of the raw and the refined, there isn't much at all in the way of architectural ideas at Prada SoHo."[86] Michael Sorkin characteristically mixed wit with cynicism in his ambivalent assessment. Referring to the Prada empire's recent corporate acquisitions, Sorkin wrote that the

> architectural haberdashery of the shop . . . similarly compiles brands within the brand—a boutique of received forms—from the Dan Graham light boxes to the Venturiesque supergraphic wallpaper to the Portmanoid glass elevator, the SITE-like objects hung from the ceiling, and the Diller + Scofidio video cams in the dressing rooms, the disco Mylar on the ceiling, the pulsing techno, the personnel dressed in security gray, whispering urgently into their mouthpieces. This conflation of shopping with invention is the *philosophy* embedded in . . . the shop. . . . The store becomes museum and vice versa. Fabulous.[87]

Reflecting on a late December 2001 visit to Ground Zero and to Prada's Epicenter, Maureen Dowd, the widely read *New York Times* columnist, wrote:

> Now we are supposed to be in the era of the real rather than the pretentious, the warm rather than the cool, the fundamental rather than the grandiose. So we must ask: Is the vast new $40 million Prada store that has just opened not far from Ground Zero, trumpeted by the company as the New York Epicenter and designed by the hot architect Rem Koolhaas, a relic of our gluttonous ways or a resumption of them? The place is as elegant and striving as Gatsby's shirt drawer.[88]

EAST VILLAGE

By the mid-1970s, the young artists and hippies who had a decade earlier infused the portion of the Lower East Side between Houston and Fourteenth Streets, Fourth Avenue to Avenue D, with the economic and cultural vitality and Bohemian lifestyle that gave it its identity as the "East Village" were abandoning the neighborhood, leaving behind the Ukrainian population that was its long-established backbone, centered along Second Avenue, as well as a Puerto Rican community between Avenues A and D, an area coming to be known as Loisaida ("Spanglish" for Lower East Side). As the hippies left, so too did businesses and cultural landmarks catering to them and those who liked to be seen among them: the closing of the Electric Circus and Fillmore East left a gaping economic hole in the neighborhood.[1] Blight highlighted the area's poverty and social dysfunction. A retail drug culture stood out in an area characterized by vacant lots and decrepit and abandoned buildings that were the result of a pernicious cycle of disinvestment by owners who found it more lucrative to halt capital improvements, withdraw services, cease paying mortgages and taxes, and in some cases,

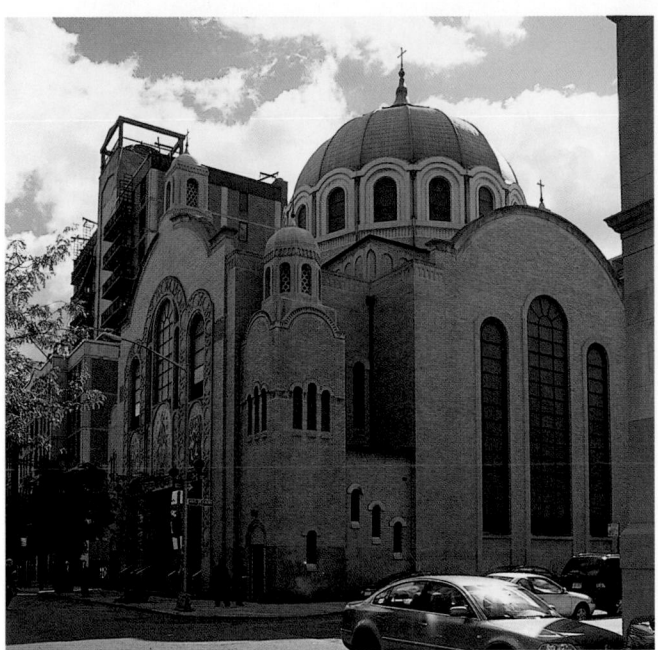

St. George Ukrainian Catholic Church, 30 East Seventh Street, between Second and Third Avenues. Apollinaire Osadca, 1978. View to the southeast showing 28 East Seventh Street (Igor Sedior, 1996) on the left. RAMSA

turn to "arson-for-profit," than to continue ownership.[2] So grim were the prospects for a revitalization during the late 1970s that, according to sociologist Christopher Mele, even "owners of 'healthy' buildings [were prompted] to disinvest and abandon."[3] By 1980 the city had taken ownership of over 200 vacant buildings through tax delinquency procedures.

The scant investments in the neighborhood that were made during the late 1970s were undertaken by institutional entities. In September 1977, the *New York Times* cited two projects that gave hope for some stability: New York University's rehabilitation of the five-story, elegantly proportioned white glazed terra-cotta-clad Saul Birns Building (Ralph H. Segal, 1928), 111 Second Avenue, which it had occupied since 1966 and would continue to use for its School of the Arts, and the construction of the St. George Ukranian Catholic Church, 30 East Seventh Street, between Second and Third Avenues, designed by Apollinaire Osadca and dedicated in April 1978. A version of a traditional Byzantine-style cathedral in miniature with imposing north and west facades, glittering polychromatic mosaic panels above the north-side entry, and a crowning copper-clad central dome, Osadca's new church was dismissed by the editors of the *AIA Guide* as little more than "Atlantic City on 7th Street,"[4] but to its pastor, the Rev. Volodymyr Gavlich, the building was "a sign that this part of the city will not be abandoned."[5] In 1996 the church replaced its former home next door, a Greek Revival church built in 1836, 28 East Seventh Street, with a sixteen-story, 85,000-square-foot, awkwardly massed and detailed concrete-framed red brick tower (Igor Sedior) that combined church facilities on the first four floors and ninety-six cooperative apartments for Ukrainian parishioners above.[6]

While no amount of optimism could brighten the increasingly depressed and lawless reality of the East Village during the late 1970s, by the late 1980s, the neighborhood, this time attracting young professionals, was coming to be known as

Alphabet City, a playful term relating to the names of its north–south avenues.[7] By the 1990s, the neighborhood had been dramatically transformed, rescued from the social and economic margins and turned into a culturally sophisticated, and, ultimately, high-priced residential district while managing to retain a remarkable amount of its physical attributes and heterogenous character. The process of transformation was catalyzed in the early 1980s when the rising cost of space in SoHo forced young artists and start-up art galleries to settle in the East Village. In its physical dilapidation and social marginality, the area perfectly suited the mood of a new generation that, though diverse in the media and styles of expression it explored, was united in rebellion against mainstream pop culture, typified, in the words of performance artist Ann Magnuson, by "disco, Diane Von Furstenberg, and *The Waltons*."[8] To these misfit youths, the East Village offered not only dangerous decrepitude but also the sense of ownership that comes with opening up new and forbidden territory: in its ailing state, the East Village was theirs for the taking.

The new settlers eschewed the term "East Village," preferring "Lower East Side," which according to Gary Indiana, art critic for the *Village Voice* from 1985 to 1988, had a "desperate, bottomed-out ring to it that defined its 'charm.'"[9] The neighborhood, with little to no law enforcement, was well suited to the politically driven art, much of it graffiti, that blossomed there. East Village artists took on the built environment as their canvas. Artists like Jean-Michel Basquiat, Keith Haring, John Fekner, and Richard Hambleton to name only a few, embraced, and painted, the burned-out buildings that others feared. Jean-Michel Basquiat's character, Jean, in the 1981 pseudo-documentary *Downtown 81*, walked past a heavily graffitied building and quipped, "I could read the handwriting on the wall. It was mine."[10]

Toxic Junkie, south side of East Second Street, between Avenues B and C. John Fekner, 1983. Prepared in conjunction with the Black and White show at Kenkeleba Gallery. Fekner. JF

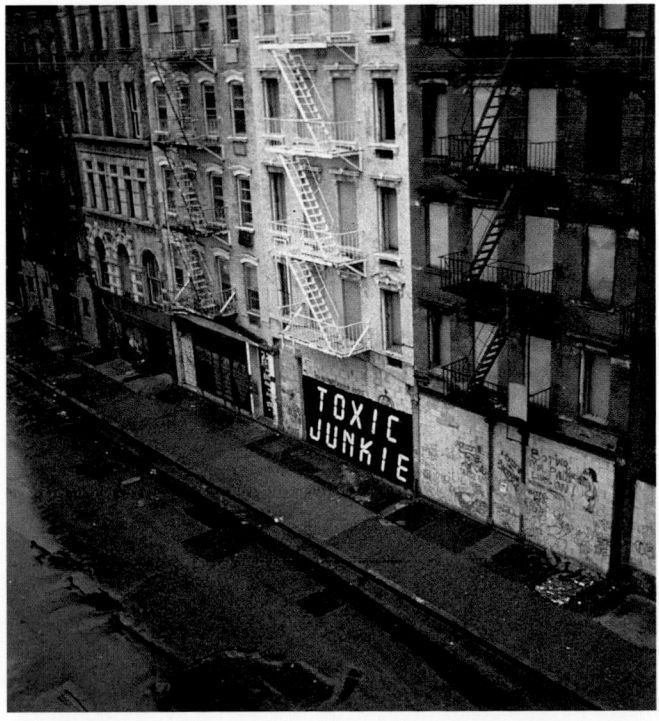

The art scene reached its peak in 1984, when the summer issue of *Art in America* devoted twenty-seven pages to it and forty-seven new galleries opened (a total of 156 would open between 1980 and 1986).[11] Galleries sprung up in every sort of space available. One of the earliest, Loo Division (1982), was established by Gracie Mansion, who, "just for the heck of it," had jettisoned her real name, Joanne Mayhew-Young, to take on the name of the mayor's residence.[12] Loo Division occupied the bathroom of Mansion's apartment at 432 East Ninth Street before moving to 337 East Tenth Street as "Gracie Mansion Gallery" in 1983. Other prominent galleries included the Fun Gallery, which opened in June 1981 at 229 East Eleventh Street, Nature Morte Gallery, opening in 1982 at 204 East Tenth Street, and C.A.S.H. Gallery, opening in 1983 at 34 East Seventh Street.

On January 19, 1984, the city initiated Operation Pressure Point, a widespread crackdown on the drug trade in the neighborhood.[13] The *New York Times* reported that in the first eighteen days, 1,362 arrests were made, a number that would climb to 14,285 by August of the next year.[14] With newfound safety came gentrification, as a real estate market emboldened by the positive media coverage of the area's arts scene swept in.[15] Patrick J. Carroll, coordinator of Operation Pressure Point, brought up the sad possibility that the "great victory was Pyrrhic after all. . . . To many residents, gentrification is more threatening than the drug culture they sought to eradicate."[16] The artists, finding the freedom and absence of authority that had drawn them to the East Village seized and replaced by the intangible but very real control of the real estate developer, were particularly outspoken against gentrification.

Development in the East Village in the 1980s was piecemeal at best. The New York City Housing Authority built a series of three-story brick rowhouses in the area bounded by Fourth and Sixth Streets, Avenues B to D, for low-income residents.[17] Designed by Vitto & Oaklander and completed in 1987, they were, according to the editors of the *AIA Guide*, a group of "pink, bubble gum–colored" buildings that made "the surviving tenements nearby look better and better—at least as far as the quality of their facades" was concerned.[18] Higher-income housing was also produced. In 1985 the American Felt Building (Knight & Collins, 1906), an eleven-story limestone and red brick building on the area's fashionable fringe, at 114 East Thirteenth Street, between Third and Fourth Avenues, was converted into thirty-five residential condominiums.[19] The east wall of the building, which abutted a 20-by-100-foot vacant lot also under the ownership of the developers, was given two new columns of windows by the Architects Design Studio. A one- and two-story glass-enclosed lobby and landscaped garden was built on the adjacent lot to the designs of Kevin Walz. The same year, developer Philip Pilevsky began work on the conversion of two five-story former furniture warehouses at 224 and 228 First Avenue, southeast corner of Fourteenth Street, into a forty-unit condominium to be known as the Crossings.[20]

But one project in particular, the conversion of Christadora House (Henry C. Pelton, 1928), northeast corner of East Ninth Street and Avenue B, became a controversial and conspicuous symbol of gentrification for East Villagers.[21] The sixteen-story building, by far the tallest in the area, had been built as a gift of railroad tycoon Arthur Curtis James to Christadora House, a settlement house founded in 1897 for Russian, Polish, and Ukrainian immigrants. In addition to living quarters, the

Gracie Mansion Gallery, Loo Division, No. 5, 432 East Ninth Street, between First Avenue and Avenue A. View of gallery during Stephen Lack: Evidence show, June 17–July 14, 1982. GMFA

building originally housed a music school, poet's guild, dining hall, and playhouse. It was sold to the city in 1947 and used for various city functions before becoming a community center that offered housing for groups, including the radical Black Panthers. In 1975, it was sold by the city as an abandoned wreck and reopened several owners later in July 1986 as a high-end condominium developed by Harvey Skydell and Sam Glasser. As converted by architects John T. Fifield and Justin Georges, the Christadora was transformed into something vastly different from its origins. With eighty-five apartments, it featured a quadruplex penthouse with private elevator and offered residents a health club, pool, doorman, and concierge—all conveniences that were new to the neighborhood and a far cry from its working-class origins or recent decrepitude. Not surprisingly, the gentrified Christadora's tenants immediately became subject to the collective animosity of the community.

Meanwhile, the demographics of the East Village were evolving. The art scene faded as rapidly as it emerged, according to historian Liza Kirwin, because of "rising rents, bad press, the stock market crash of 1987, the AIDS epidemic, the triumph of thinking art over feeling art, [and] the relentlessly threatening environment of the Lower East Side."[22] In addition, many of the East Village artists and musicians who had struggled incessantly to promote one another and achieve mainstream status had in fact realized that goal, undermining,

in a sense, their own raison d'être. Left in their place was a more sinister subculture of punks and so-called skinheads—self-proclaimed "anarchists," many of whom squatted in the neighborhood's abandoned buildings. Though relatively new to the neighborhood, they shared with longer-term residents a disdain for the yuppies, who were perceived to be fueling the East Village's gentrification. Other social changes occurred as well. The crackdown on drug dealing had made the streets safer. However, the citywide epidemic rise in homelessness was nowhere more visible than in Tompkins Square Park, bounded by Avenue A, Tenth Street, Avenue B, and Seventh Street, the geographic and social center of the East Village, which was quickly becoming both a gathering place for anarchists and other youth protest groups and for the homeless. Patrick J. Pomposello, the Manhattan Borough Parks Commissioner, described the park in mid-summer 1988 as "a 24-hour live-in place. The heat is killing us. The homeless population has doubled. The kids are all coming to the park at night, and it's unbelievably filthy."[23] Although many area residents were sympathetic to the plight of the homeless in the park, the loud music and noise generated throughout the night was not widely appreciated. On July 11, 1988, after years of complaints, the police began to enforce the 1 A.M. curfew to which all city parks were subject, forcing out all but the homeless, who were made to cluster in the park's southeast corner each night and leave each morning. Less than a month later, on August 6, a midnight demonstration organized to protest the curfew turned into six hours of violent confrontations between demonstrators and some 450 police officers, who charged at the crowds in phalanxes using billy clubs.[24] The Tompkins Square Park Riots resulted in the injury of nearly fifty demonstrators, innocent bystanders, and members of the press. It was clear that more was at issue than the curfew. The closing of the park was seen as another bit of freedom taken away to pacify wealthy newcomers. At about 6 A.M., having fended off the police, protestors descended on the Christadora chanting "Die Yuppie Scum!" and rammed through the building's glass and brass doors with parts of a police barricade, triumphantly mounting a banner that read "Gentrification + Class War = Genocide." As details of the riots spread over the next several days and weeks, it became clear that the police had used excessive force and that many officers had put black tape over their badge numbers and in some cases removed their badges entirely. To avoid further incident, Mayor Ed Koch ordered that Tompkins Square Park remain open at night, a signal of triumph for the demonstrators and an affirmation of their radical activism.

With the lifting of the curfew, word of the park's "liberation" spread, and more homeless settled in than ever before.[25] By the summer of 1989, over 200 homeless had transformed Tompkins Square Park into a "tent city." Prostitution and drug use also abounded. In July 1989, police officers "evicted" the homeless from the park, giving them fifteen minutes to collect their belongings.[26] But the diaspora was temporary, and by late fall, they were again settled in. In early December, a social service office was established to help move the homeless to shelters and detoxification programs in preparation for another eviction, and on the morning of December 14, 1989, approximately 270 parks and police officers tore down and disposed of the tents and shelters in Tompkins Square Park, loading more than fifteen trucks with debris as a group of homeless people set ablaze a dozen shelters in protest.[27]

Some improvements were made to the park between 1989 and 1990. The severely vandalized Temperance Fountain (Henry D. Cogswell, 1888) and the Slocum Memorial Fountain (Bruno Louis Zimm, 1906) were both restored.[28] In the northern section of the park, three playgrounds were replaced and new recreation areas were designed by landscape architects Blumberg & Butter. By October 1990, however, there were again reports of fifty to sixty "hard-core heroin and crack addicts"[29] residing in Tompkins Square Park, but no major steps to correct matters were taken by Mayor David Dinkins, who had been elected in 1989, until the aftermath of a May 27, 1991, incident at which fire-setting and looting broke out after the police blocked a group of men who were drinking beer from entering the park.[30] On May 31, 1991, the editors of the *New York Times* demanded that the city "make Tompkins Square a park again," stating, "A park is not a shantytown. It is not a campground, a homeless shelter, a shooting gallery for drug addicts or a political platform."[31] Days later, on June 3, the city exercised its last possible option: it cleared and closed all but the northern section of the park for one year of renovations.[32]

The work, designed by the Parks Department's in-house architects, was intended to modify the park's existing layout as little as possible. Pathways were repaved, lawns replanted, the drainage system replaced, and new wrought-iron and wood benches installed. The removal of the concrete bandshell erected in the 1960s in the southern end of the park—which Parks Department officials saw as a breeding ground for homelessness, drugs, and graffiti—became a point of contention to residents who considered it a vehicle for their freedom of speech. It was replaced by a portable stage. When the park reopened on August 25, 1992, a midnight curfew was put in place.

Meanwhile, throughout the East Village, the pressure to build new housing put into jeopardy the community gardens that, since the 1970s, had been cultivated on vacant city-owned lots. In 1988 a seventy-nine-unit federal low-income housing complex for senior citizens, Casa Victoria, was planned for the site of one garden, La Plaza Cultural, southwest corner of Ninth Street and Avenue C, but a lawsuit filed by the community claiming that associates of United States Senator Alphonse D'Amato exerted pressure on a HUD administrator to approve the project, which was then awarded to Jobco, a general contractor that was also a major contributor to D'Amato's campaign, was successful in stopping the plan.[33] Instead, Casa Victoria was completed in 1997 at 308 East Eighth Street, between Avenues B and C, a bland, vaguely Postmodern tan brick and concrete block building designed by Lee Borrero.

The profit-driven developments of the late 1980s were no less architecturally dispirited, though at times inventively marketed. One of the more interesting approaches to selling a new, typically banal apartment building was that undertaken by developers Michael Rosen and Brian Vail for Red Square, a 130-unit, thirteen-story building (Schuman, Lichtenstein, Claman & Efron, 1989) built on the site of a service station at 250 East Houston Street, between Avenues A and B.[34] For what was essentially a red brick box with balconies and an abutting one-story retail wing that stretched east along Houston Street, the developers hired Tibor Kalman's M&Co., a rising firm of imaginative graphic designers, to give the "very bland apartment building" a punchy

Red Square, 250 East Houston Street, between Avenues A and B. Schuman, Lichtenstein, Claman & Efron, 1980. View to the north. RAMSA

identity, a "hipness treatment" as Kalman put it, by relating it, in a tongue-in-cheek manner, to the famed Communist square.[35] Aside from its name, the designers placed an eighteen-foot-tall statue of Lenin on the roof with his right arm raised triumphantly in the direction of the epicenter of capitalism, the financial district. To make the building even hipper, Kalman placed M&Co.'s famous "Askew" clock face, with its jumbled numbers, on the west and south sides of the rooftop water tank enclosure. New York artists Johnny Swing and Claire Kalimkaris created a thirty-two-foot-long sculptural parapet fence composed of found objects "similar to refuse in the neighborhood," according to Swing, for the roof of the one-story retail portion of the building.[36] But in the final analysis, no amount of buzz or graphic identity could overcome the inherent banality of the design.

After the recession of the early 1990s, apartment construction in the area began to flourish. When in 1994 work began on East Village Gardens (1996), 42 Avenue A, northeast corner of East Third Street, the New York Times reported that it was "the only new construction in the East Village."[37] The twenty-eight-unit, six-story building had 14,000 square feet of retail space at the basement and street levels, above which Simon Fouladian, a Manhasset-based architect, clothed his building with a zig-zag patterned polychromatic brick facade that gave it a refreshing distinction. Fouladian, who was the most prolific architect of East Village buildings in the 1990s—he designed more than twenty—also designed 194 East Second Street, northwest corner of Avenue B, a six-story, sixty-one-unit rental building completed in 1998 that had four penthouse duplexes.[38] Recessed bays helped break down

the scale of the large red brick building, making it appear as a series of smaller tenements, but neither the blue spandrels and yellow window frames that brightened up the recessed stacks of windows and storefronts nor the ornamental marine-themed metal balcony railings were enough to compensate for the building's lackluster aesthetics.

In 1997 Hudson East (Harman Jablin Architects), a seven-story, eighty-six-unit, orange and brown brick apartment building at 225 East Sixth Street, stretching for 200 feet between Third and Second Avenues, was built on the site of the former Loew's Commodore Movie Palace (1928), which operated between 1968 and 1971 as the Fillmore East concert hall, companion to the Fillmore West in San Francisco, both run by the important rock music producer Bill Graham, and between 1980 and 1988 as the Saint, the famed gay dance club. Developer Philip Pilevsky and three partners planned to save the theater building by converting it to a multiplex movie theater in 1989 but the deal fell through three years later.[39] The Anderson Theater (1926), 94 East Fourth Street, between Second and First Avenues, originally the Public Theater, one of the finest Yiddish theaters on Second Avenue, was also lost in 1997, replaced by a nine-story eighty-five-unit apartment building designed by Architects Design Group.[40]

Between 1999 and 2001, the streets of northern Alphabet City became home to a scattering of small-scale, nearly indistinguishable apartment complexes known collectively as Del Este Village, designed by Feder & Stia Architects, a Manhattan-based firm. Ninety-eight condominium apartments were spread among six sites: 383–389 East Tenth Street, between Avenues B and C; 642–648 East Eleventh Street, southwest corner of Avenue C; 503–509 East Thirteenth Street, northeast corner of Avenue A; 613–619 and 625–629 East Eleventh Street, between Avenues B and C; and 511–515 East Eleventh Street, between Avenues A and B, all featuring red brick facades, concrete sills, lintels, and balconies, decorative quoins, and forest green window frames, awnings, and cornices. None was taller than four stories in height and those with avenue frontages offered first-floor retail space. In 1999 the New York Times real estate reporter Alan S. Oser commented that the first completed building of Del Este Village, 503–509 East Thirteenth Street, "blends seamlessly" with the buildings around it.[41] But what might be described as a "contextual" aesthetic solution for one building was stultifying when repeated six times in six locations. Truth to tell, the designs were clichéd, but with one redeeming quality: the untraditional plans eliminated interior hallways in favor of entries from street-facing stoops or elevated courtyards and gardens. Because the apartments of Del Este Village were for buyers with incomes above the citywide median, and because the developer received city and state subsidies, the project angered many in the neighborhood. But even more problematic was the fact that four of the six buildings replaced community gardens.

The long-term future of the community gardens that brightened the neighborhood's abandoned lots came into doubt with the building boom of the late 1990s. Though La Plaza Cultural had been saved in 1988, a widely publicized struggle to save Jardín de la Esperanza, a community garden in existence since 1977 on the southwest corner of East Eighth Street and Avenue C extending through to Seventh Street, was lost.[42] When bulldozers arrived to clear the garden

ABOVE East Village Gardens, 42 Avenue A, northeast corner of East Third Street. Simon Fouladian, 1994. View to the northeast. RAMSA

BELOW Del Este Village, 503–509 East Thirteenth Street, northeast corner of Avenue A. Feder & Stia Architects, 1999–2001. View to the northwest. FSA

RIGHT Eastville Gardens, southwest corner of East Eighth Street and Avenue C. Feder & Stia Architects, 2001. View to the southwest. FSA

BELOW Gateway School, 236 Second Avenue, between East Fourteenth and East Fifteenth Streets. Andrew Bartle Architects/ABA Studio, 2000. View to the southeast showing addition to 1858 building. ABA

for development on February 15, 2000, 150 protestors were on hand, some of them chained to buried concrete blocks and fences, while others occupied a large sculpture shaped like a tree frog, which in Puerto Rican legend is believed to repel attackers. Thirty-one demonstrators were arrested and the demolition, reported on the front page of the *New York Times*, represented an important quality-of-life issue being fought between New York's communities and Mayor Rudolph Giuliani. A week after the garden's demolition, 200 protestors demanded its return. Two weeks after that, a crowd stormed the lot at 2:30 A.M., tore down the eight-foot-tall construction wall, and started planting flowers, prompting a clash with the police.[43] In 2002 the site was reborn as Eastville Gardens, a pair of buildings designed by Feder & Stia Architects in an L-shaped configuration connected at the basement level: on the southwest corner of Eighth Street and Avenue C was a sprawling six- and eight-story Art Deco–inspired polychromatic brick apartment building with 5,000 square feet of ground-floor commercial space; at 223 East Seventh Street, a seven-story building provided a home for the Gethsemane Garden Baptist Church on the basement and first floors and apartments on the upper floors. The development also contained 5,000 square feet of space for community use and 5,000 square feet of outdoor gardens.[44]

At 325 East Eighth Street, between Avenues B and C, a seven-story apartment building designed by Belmont Freeman Architects (2002) was a departure from the brick boxes that had become the East Village standard. To meet the requirements of the New York City Zoning Resolution's Quality Housing Program, which allowed for bonus square footage, all but one of the thirteen apartments was given a terrace, balcony, or garden, and the architects provided for a

windowed laundry room, common roof terrace, and large room sizes.[45] But the granite-clad base and stark facade dominated by bold white stucco balconies were, in the end, banal and inappropriate to the setting.

The most noteworthy architectural additions to the East Village were for purposes other than housing. Andrew Bartle Architects/ABA Studio's modest renovation of a three-story, twenty-five-by-eighty-five-foot townhouse, 236 Second Avenue (1858), between Fourteenth and Fifteenth Streets, to serve as the new home of the Gateway School (2000), an independent elementary school founded in 1965 for children with learning disabilities, provided six classrooms for the school's approximately sixty students, an assembly space, staff offices, and a gymnasium, the latter located in a twenty-foot-high rooftop addition that also incorporated an outdoor play area encased in steel mesh.[46] Inside, new space was created by the insertion of a mezzanine between the second and third floors, and oval openings were cut between several floors to provide visual links and a sense of openness. The second-floor Grandstand Room, once a ballroom, now served as an assembly hall and cafeteria. The gymnasium addition was differentiated from the house's original facade by a more modern composition of eight translucent plastic panels flanked by panels of basket-weave brick.

One of the most imaginative new buildings in the East Village was, surprisingly, built by the public sector. The new home for Police Service Area #4 (2001), 130 Avenue C, northeast corner of Eighth Street, designed by Bodgen Pestka, an architect in the New York City Housing Authority's Design Department who had previously worked in the offices of Moshe Safdie and Philip Johnson, was an appropriately imposing and remarkably tactile 50,000-square-foot, elongated five-story box with an adjacent two-story, 38,000-square-foot parking garage sheathed in aluminum louvers angled at varying degrees to shield views inside from the street. Deeply recessed square punched window openings gave the building's rusticated gray brick facade a relentless geometry. According to Pestka, the aim was to have the cladding appear metallic, an attempt to combat the "brick fatigue" he felt was plaguing East Village architecture.[47] The entrance, on Avenue C, was marked by a three-story glass curtain wall above which a rectangular galvalum-clad volume rose above the roofline and connected to a penthouse level that contained sleeping quarters for police officers and concealed mechanical equipment. A metal armature atop the building played two roles, supporting a series of high-wattage lights for use in case of riots and terminating the building as a cornice. Archaeological artifacts discovered during excavation

Police Service Area #4, 130 Avenue C, northeast corner of East Eighth Street. View to the northeast. Bodgen Pestka, 2001. McGrath. NMcG

ABOVE Ukrainian Museum, 222 East Sixth Street, between Second and Third Avenues. Sawicki Tarella Architecture + Design, 2005. View to the southwest. McGrath. ST

Anthology Film Archives, 32 Second Avenue, southeast corner of East Second Street. Renovation by Raimund Abraham, Kevin Bone, and Joseph Levine, 1988. Main theater. RAA

Proposed library addition to Anthology Film Archives, 32 Second Avenue, southeast corner of East Second Street. Raimund Abraham, 1998. Rendering of view to the southeast showing addition without original building. RAA

Sunshine Cinema, 143 East Houston Street, between Forsythe and
Eldridge Streets. Pleskow + Rael, 2001. View to the southeast. Cox. PR

were exhibited permanently in square display cases built into
the street facades.

The neighborhood's rebirth could also be measured in the
expansion of its cultural institutions. The Ukrainian Museum,
housed since its founding in 1976 in the top two floors of a
brownstone at 203 Second Avenue, announced plans in 1988
for a new building designed by Cesar Pelli at 222 East Sixth
Street, between Second and Third Avenues.[48] Pelli's plan did
not go forward, but in 1997 a new design by an architect of
Ukrainian descent, George Sawicki, of the New York–based
Sawicki Tarella Architecture + Design, was announced for the
same seventy-five-foot-wide site, consisting of a 25,000-square-
foot red brick and stone building containing three floors of
gallery, office, and storage space as well as lecture rooms on a
lower level, a café, museum shop, research library, and audito-
rium.[49] The building was completed in 2005.

In 1979 the Anthology Film Archives, established in 1970
by Jonas Mekas, a poet and filmmaker, as part-museum,
part–movie house, part-foundation dedicated "to the vision of
the art cinema as guided by the avant-garde sensibility,"
acquired the Second Avenue Courthouse (Alfred S. Hopkins,
1918), southeast corner of Second Avenue and Second Street,
an imposing two-story, splendidly arcuated red brick build-
ing, and retained Raimund Abraham, working with Kevin
Bone and Joseph Levine, to redesign the building for its use.[50]

Over the next nine years, the architects converted the court-
house, replacing two courtrooms with two new theaters, and
inserting staff offices into the former jail cells. Fund-raising
proved difficult, but in 1988 the Film Archives began to move
in. Ten years later, in February 1998, plans were announced
to build a library in the 11½-foot-wide-by-100-foot-long alley
that ran along the south side of the building.[51] As designed by
Abraham, the addition would rise seventy feet before can-
tilevering over the existing structure. A café was to occupy
the ground floor, and a third theater was to be built on the
cantilevered upper level, with library stacks on the intermit-
tent floors. Again, fund-raising proved slow going, and the
building was not yet under way in 2006.

In 2001 Sunshine Cinema, an art-house movie theater,
opened in what was once a Dutch Reformed Protestant church
(1898) at 143 East Houston Street, between Forsythe and
Eldridge Streets.[52] The building was used as a Yiddish theater
called the Houston Hippodrome from 1909 until 1917, when it
became a nickelodeon called the Sunshine Cinema, and was
subsequently used as a warehouse by a hardware company
between the early 1940s and 1994. Los Angeles–based archi-
tects Pleskow + Rael, working with the Kansas City firm TK
Architects, who were responsible for the floor plans, gutted
what little was left of the original auditorium, dividing the
space to accommodate five new theaters ranging in size from

Proposal for Theater for the New City, 155 First Avenue, between East Tenth and East Eleventh Streets. SITE, 1986. Model, view to the northwest. SITE

New Theater Building, 240 East Tenth Street, between First and Second Avenues. Schuman, Lichtenstein, Claman & Efron, 2003. View to the southeast. SLCE

130 to 280 seats on three levels. In addition to restoring and rebuilding parts of the original brick facade, which featured a large arched window beneath a curving parapet, the architects added a three-story stair tower to the west of the theater with a canted facade of translucent and clear glass panels, the latter positioned to provide long uptown views. The interiors were treated with more than a bit of dramatic flair, featuring two Japanese rock gardens and metal catwalks.

In 2001 an apartment tower was built above the Theater for the New City, a company founded in 1970 by Crystal Field, an actress. In 1986 escalating rent had forced the group to move from its longtime home at 162 Second Avenue to the former First Avenue Retail Market (1938), 155 First Avenue, between Tenth and Eleventh Streets, a 40,000-square-foot building occupied at the time by the Sanitation Department. Field hired the architecture firm SITE to provide three fifty- to seventy-five-seat theaters, a lobby, café and restaurant, and rehearsal and prop storage spaces.[53] While SITE made an effort to "incorporate as many existing physical elements as possible" in the renovation, the most striking element of the design was the theater's proposed new facade, the upper portion of which was treated as an interior balcony looking onto First Avenue. Six inclined rows of seats were to be set into the facade, which was adorned with Beaux-Arts-inspired festoons—a decorative program continued on the street level. Coats, hats, gloves, and programs were slung over some of the seats to imply that the show was at intermission and, presumably, the passersby were the crowd. To further the effect, theatrical lights attached to the facade flanking the balcony were to illuminate the sidewalk and street in such a manner as to imply a stage in the middle of First Avenue. The first phase of construction, completed in 1991, included the creation of a lobby and 240-seat theater, but the remainder, including the facade, was put on indefinite hold owing to the theater's financial struggles, which by 1999, had become so burdensome as to threaten its survival. To help keep Theater for the New City afloat, the city agreed to renegotiate its mortgage and sell the air rights over the building, of which the city had retained ownership, using some of the proceeds to help pull the company out of debt. Developers Gerald Rosengarten and Michael Walman purchased the air rights and built a scale-bucking seventeen-story apartment tower, the New Theater Building (Schuman, Lichtenstein, Claman & Efron, 2003), 240 East Tenth Street, with thirty-four apartments and two penthouses. According to Crystal Field, the Theater for the New City remained hopeful that sufficient funds could be raised to fully realize SITE's design.[54]

GREENWICH VILLAGE

The establishment of the Greenwich Village Historic District in 1969 and the Landmarks Preservation Commission's strict interpretation of what was "appropriate" in the way of building renovation effectively put the lid on most significant new architectural projects in the heart of what was the city's largest historic district, containing more than 2,000 buildings on nearly 100 blocks roughly bounded by Thirteenth Street, University Place, Washington Square South, St. Luke's Place, and Washington Street.[1] There were, however, occasional exceptions, such as the conversion in 1982 by architect Joseph R. Simmons of the Neo-Renaissance-style twelve-by-fourteen-

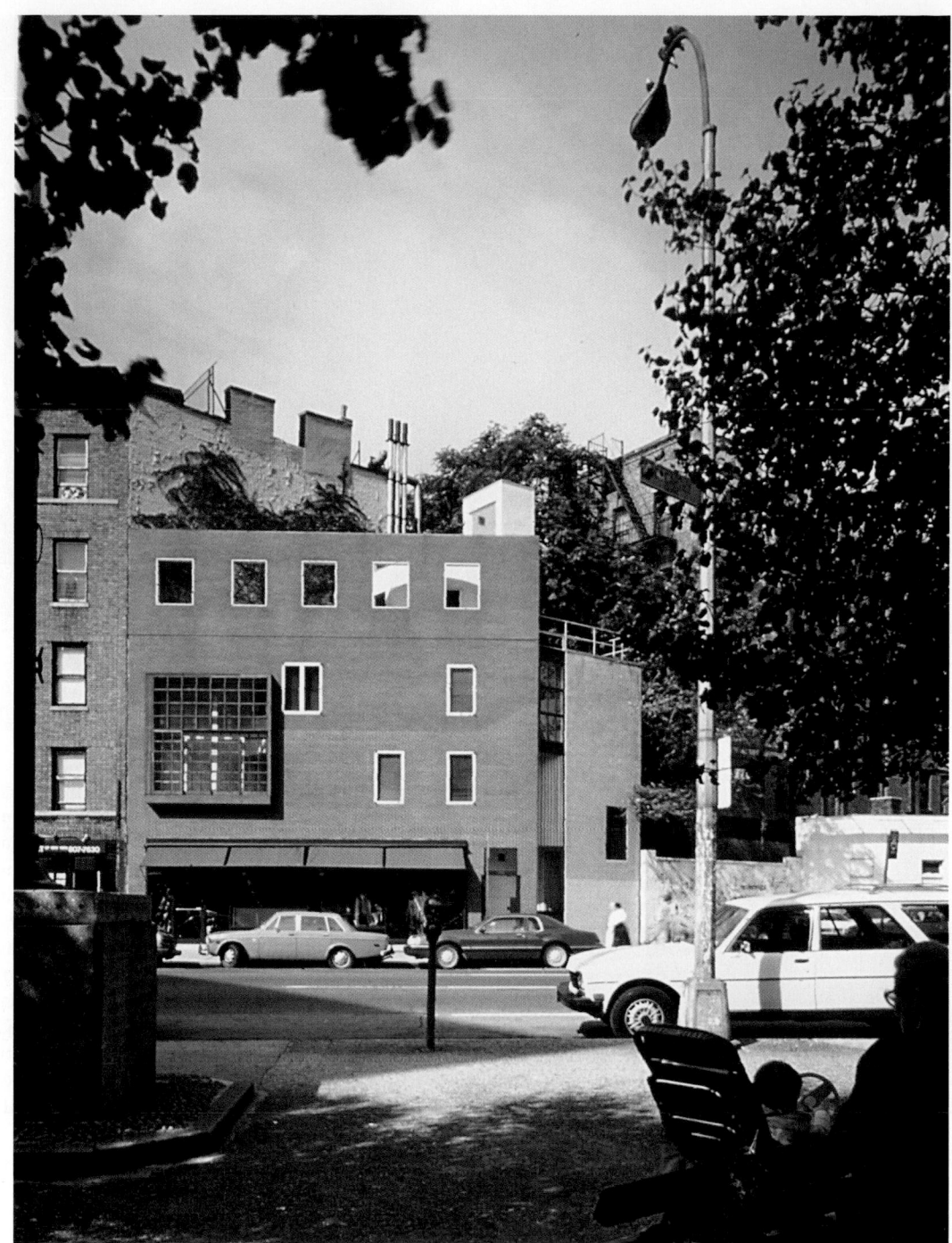

Duane Colglazier house, 156 Seventh Avenue South, between Perry and Charles Streets. Smith & Thompson, 1983. View to the west. Warchol. STA

foot abandoned gas station (1922) at 48 Seventh Avenue South into a guest room/study to be used by the owners of the adjoining townhouse, 66 Bedford Street (1821), to which it was connected by means of an exterior walkway through the garden between the two.[2] Stephen B. Jacobs & Associates' conversion of the twice fire-gutted interior of the Thirteenth Street Presbyterian Church (attributed to Samuel Thompson, 1847), 143 West Thirteenth Street, between Sixth and Seventh Avenues, into fifteen apartments in 1982, another unconventional preservation effort, retained the bold temple-front facade of what was arguably the city's best Greek Revival church, modeled after the Theseum in Athens, while carving up the interior in a wholly disagreeable way.[3]

But the most inventive bit of new construction was the Modernist-inspired design of Smith & Thompson's boldly planned, irregularly fenestrated, three-and-one-half-story home (1983) for Duane Colglazier, 156 Seventh Avenue South, between Perry and Charles Streets, that replaced a triangular vacant lot (formerly the rear yard of a house facing Perry Street) with what the editors of the *AIA Guide* praised as an "unabashedly personal statement which apes no Greenwich Village sentimentality yet fits surprisingly well in the context of the odd-site-filled Seventh Avenue South corridor."[4]

The Colglazier house was small and faced Seventh Avenue South, itself a twentieth-century cut through the historic Village fabric. Much bigger and arousing far more local passion

Washington Court, east side of Sixth Avenue, between Waverly and Washington Places. James Stewart Polshek & Partners, 1986. View to the northeast. Goldberg. ESTO

Washington Court, east side of Sixth Avenue, between Waverly and Washington Places. James Stewart Polshek & Partners, 1986. Warchol. PW

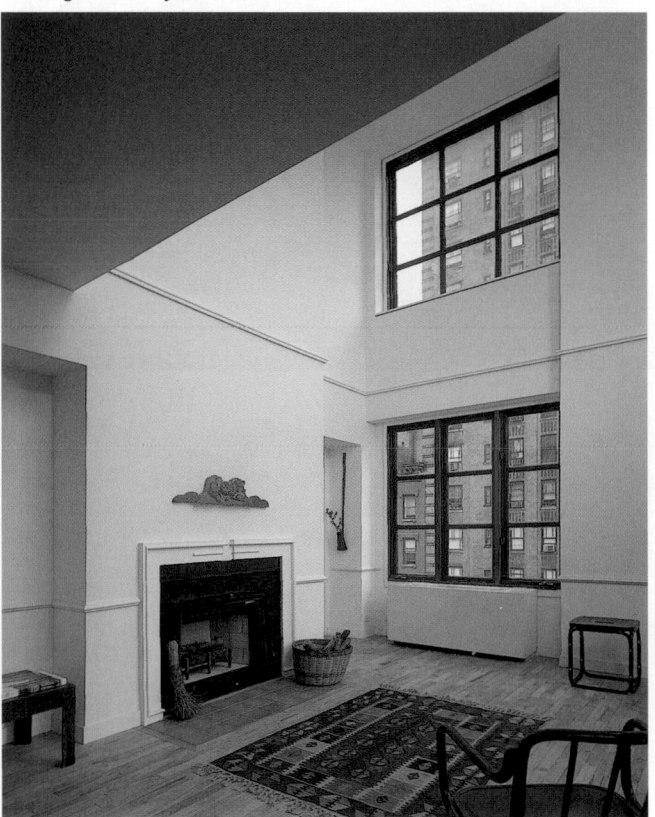

was James Stewart Polshek & Partners's Washington Court (1986), a red brick, limestone-trimmed apartment building that replaced a parking lot which occupied a block-long site on the east side of Sixth Avenue between Waverly and Washington Places, a site that had been made vacant as a result of the construction of the Independent subway system in the 1930s.[5] The site had been the focus of a recent community battle when developers proposed its redevelopment as a home for a multi-screen movie theater. Washington Court, consisting of ground-floor shops and five stories of twenty-eight apartments grouped around a landscaped 60-by-120-foot courtyard, was not only one of the 1980s' more successful examples of contextually sensitive residential design but also one of the few apartment developments to pick up on the tradition of low-rise, high-density urban housing, exemplified in the work of Andrew Jackson Thomas, that had once been a glory of the city's architecture and urbanism.[6] Polshek's design, developed with Jim Garrison, called for a six-story-tall, U-shaped building comprising three "houses" and two corner "towers." The constraints imposed by subsurface conditions where two subway lines converged required the building's weight be kept to a minimum, encouraging the architects to propose an exterior wall of thin face brick trimmed with limestone, cast stone, and terra-cotta. Despite the possible precedents in New York, according to the designers, the inspiration for the building's exterior expression was Karl Ehn's monumental Karl Marx Hof (1930) in Vienna, but the interiors of the apartments, many of them duplexes with double-height living rooms, were inspired by Le Corbusier's houses of the 1920s. In the final analysis, the exteriors seemed closer to a flattened version of some of the housing produced by the Amsterdam School, especially Michel de Klerk's Eigen Haard of 1914–18.[7]

Though the community applauded the site's development for housing instead of a movie theater, and the selection of Polshek to design the apartment house, many were dismayed by the flatness and abstraction of the design—a distinctly Postmodern approach, despite the firm's aversion to the term. Community Board 2 and the Landmarks Preservation Commission initially rejected the scheme, according to Polshek, because it did not echo the architecture of St. Joseph's Church (John Doran, 1834; renovated, Arthur Crook, 1885), a Greek Revival structure across the street.[8] The opposition was so intense that five block association groups in the notoriously fractious Village, which had banded togther as the Village Coalition to oppose the movie theater project, renewed their unity to voice their disapproval of the apartment house scheme.

Many observers regarded the debate over whether or not to have cornices, projecting lintels, or a rusticated base to be something of a tempest in a teapot, as Gregory K. Dreicer, an architectural conservator, implied in a letter to the *New York Times*: "While no masterpiece, James Stewart Polshek's design for a new building in Greenwich Village reaches, in comparison with the work of most architects today, the acme of architectural sensitivity to context."[9] Paul Goldberger echoed this sentiment: "It is not difficult to see that this design started out as a frankly modernist scheme, and then, as neighborhood pressure and negotiations with the Landmarks Commission continued, began to acquire a more historical tone. . . . The design as it now stands is satisfactory, if hardly inspired, and it is vastly better than most new architecture in New York."[10] When completed, the new building did incorporate certain details proposed by the community that echoed traditional building elements such as lintels, windows surrounds, and a strong base, all rendered in cast stone.

In 1987, a year after the completion of Polshek's building, another prominent Village site became home to a far less successful new building, designed by John Klausz of the Architects Design Group at 22 Perry Street, southwest corner of Seventh Avenue South.[11] The site was formerly occupied by a gas station. Commonly known as the "witch's hat," Klausz's five-story, conical-towered red brick building was a clumsy, even laughable, attempt to evoke the turreted corners and mansarded skylines of beloved local landmarks such as the Jefferson Market Courthouse (Calvert Vaux and Frederick Clarke Withers, 1874–77).

With the heart of the Village largely closed to new construction or dramatic conversions, the focus of gentrification and development shifted westward. The removal of the elevated Miller (West Side) Highway in 1976 and the decision, nine years later, to abandon Westway, its proposed replacement, in favor of a surface boulevard, revealed the potential of the area as never before. Even more crucial to the West Village's emergence as a potentially hot new real estate destination was the May 1976 announcement by the federal government of its intention to abandon the 500,000-square-foot warehouse-like Archive Building (1899), filling an entire block bounded by Washington, Christopher, Barrow, and Greenwich Streets.[12] Designed by Willoughby J. Edbrooke for the United States Customs Bureau as an appraisers' warehouse, the building had been used in recent years as a repository for federal records but was now empty, except for a post office occupying part of the ground floor but soon to be phased out. Long a beloved local landmark, the Archive Building was listed in the National Register of Historic Places and declared a New York City landmark in 1966. Because of its size, its prominence, and the sensitivities of neighbors, the city supported the Landmarks Conservancy's proposal for a mixed-use program to fill the building with community facilities in the middle floors, rental apartments on the top floors, and, at street level, a retail arcade set within the high arches of the Romanesque-inspired mass. But as Alan Oser reported in the *New York Times* in July 1977, the rehabilitation plan quickly became one "of only-in-Manhattan complexity."[13] The city not only accepted the Landmarks Conservancy's plan but put the group in charge of implementation. Advertising for interested developers, the Conservancy narrowed a list of developer-architect team respondents to three, each of which rejected as impractical the inclusion of a museum of city archives called for in the Conservancy's plan that had been developed with the assistance of Columbia University's School of Architecture and Planning.

In June 1980, the Department of the Interior, acting in accord with the Historic Monuments Act, a little-known amendment to the Federal Property and Administrative Services Act making it possible for a federal landmark building that has been declared surplus property to be transferred at no charge to a state or local government, authorized the General Services Administration to turn the property over to the New York State Urban Development Corporation, which designated the Teitelbaum Group to go forward with its proposal to renovate the building as apartments and include retail spaces as well as 60,000 square feet of space reserved for rental at reduced rates to nonprofit civic, community, and cultural groups.[14] In lieu of a purchase price, the developers were to contribute to the New York State Properties Fund, a newly established trust fund for the preservation and rehabilitation of other historic properties in New York City.

According to the designs of Warner Burns Toan Lunde, the rooftop skylight over the building's central court was to be removed and replaced with a pyramidal skylight at the first-floor level, where an atrium would lead to the spaces dedicated to nonprofit uses and some of the retail activities. A new glass-enclosed elevator inside the court was to provide access to a health club, penthouse apartments, and rooftop recreational spaces. Not to be overlooked were the 367 rental apartments that would be inserted into the palace-scaled building. Construction was delayed after the Teitelbaum Group's partner, the Starrett Housing Corporation, which was heavily involved with projects in Iran, had its assets frozen when the Ayatollah Khomeini seized power. By the time the project resumed construction in 1986, now under the control of the Rockrose Development Corporation, which would become the dominant force in rebuilding throughout the West Village, even more apartments were proposed—450 to be exact, many of them with mezzanines that took advantage of the building's nineteen-foot-high ceilings. As work progressed, the number of apartments increased again, reaching 479 in 1987.

The Archive opened its doors to tenants in July 1988, although without the glitz of the glass elevator, no longer needed because there was no rooftop health club. The building gleamed with facades cleaned to reveal the rich red brick trimmed with pink granite. New windows and doors designed by interior designer Judith Stockman, who was also responsible for the lobby and residential hallways, seemed appropriate, although some observers were disappointed that wood sash

was used only on the ground floor while above the frames were aluminum. Michele Herman, reviewing the work for *Metropolis*, found the building's new lobby a disappointment, with fussy details such as gold-plated moldings and fake verdigris light fixtures. As to the apartments, each had "the usual nonluxurious look of luxury buildings: the wood-veneer floor tiles, the cheap metal radiators." Still, they were "no worse than most new Manhattan apartments." Due to the work of Daniel Margulies of the firm of Avinash Malhotra, who reconfigured the building's interior spaces, "perhaps they're laid out with a bit more thought than many. It's just unfortunate that the market can't—or won't—bear a rehabilitation in the proud and generous spirit of the original."[15]

The Far West Village

Ironically, the relative success of the Archive project triggered concern among local residents, who worried that the conversion of warehouses and manufacturing buildings to residential uses would compromise the gritty character of the Village's fringe, which developers were coming to call the "Far West Village."[16] A very modest and unusual early example of building recycling in the area was Hurley & Farinella's conversion of the former Charles Street police station (John Du Fais, 1897), 135 Charles Street, between Greenwich and Washington Streets, into the Gendarme apartments (1978), where the former two-story cellblock situated ten feet behind the station house reemerged as eight "townhouse" units.[17]

Memphis Downtown, 140 Charles Street, southeast corner of Washington Street. Rothzeid, Kaiserman, Thomson & Bee, 1986. View to the southwest. Mauss. ESTO

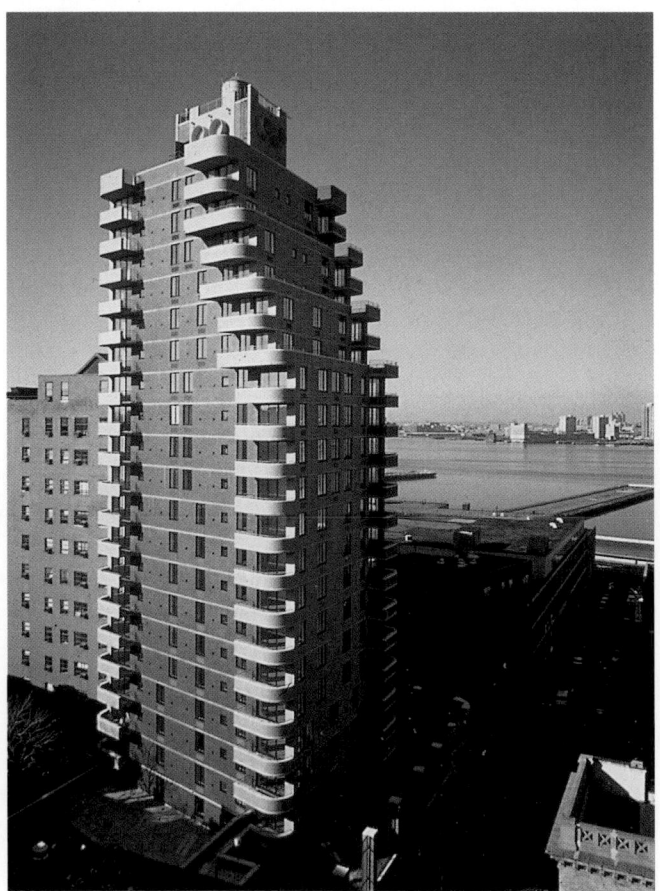

The first bold sign of the transformation from a light-manufacturing and warehouse district to a residential neighborhood was the conversion of the former home of the Manhattan Refrigerating Company, composed of ten adjacent buildings (George P. Chappell, 1898–1900) on the block bounded by West, Washington, Horatio, and Gansevoort Streets, into a luxury apartment building wittily called the West Coast (Rothzeid, Kaiserman & Thomson, 1984).[18] The Manhattan Refrigerating Company had once provided storage space for cattle and poultry. It and a number of other, similar facilities were connected to a system of underground pipes, laid in 1890 by the Gansevoort Freezing and Cold Storage Company, that brought chilled brine to cool the meat and poultry stored in the markets.

Plans to convert the yellow brick Manhattan Refrigerating complex into one 234-unit residential structure were first announced in late 1980 by the Rockrose Development Corporation. Although the plan encountered stiff opposition from local residents and Community Board 2, Rockrose was able to get the City Planning Commission to rezone the area between Gansevoort and Jane Streets, Washington and West Streets, to permit residential development. A year after the completion of the West Coast, Rockrose purchased an eight-story loft building across the street at 114 Horatio Street, southeast corner of West Street, commissioning the architect Avinash Malhotra to renovate the structure for residential use.[19] Clad in orange and purple brick, the apartment building (1985) was also given the name West Coast. In 1991, after long negotiations with Conrail, Rockrose bought and demolished a five-block stretch of the elevated freight viaduct known as the High Line (see Chelsea), running from Bank to Gansevoort Streets, thus freeing up additional space for development. A portion of the High Line had run directly through the second story of the Manhattan Refrigerating Company, the removal of which allowed the addition of thirty-eight new apartments (1994) in the West Coast complex.[20]

The most jarring evidence of the area's changing character was Rothzeid, Kaiserman, Thomson & Bee's Memphis Downtown (1986), 140 Charles Street, southeast corner of Washington Street, confirming local residents' worst fears about the development of unused industrial and railroad sites.[21] The design was purportedly influenced by the Memphis design movement, an Italian form of Postmodernism led by Ettore Sottsass that largely manifested itself in furniture and objects for the home.[22] But the expediently massed, many-balconied, eighty-unit, beige and red brick Memphis Downtown was hardly worthy of its stylistic aspirations, as the editors of the *AIA Guide* pointed out: "Out of scale at 20 stories. Most perturbing is that this quite ordinary box is glitzed-up with all manner of surface decoration undoubtedly meant to enrich the architecture."[23] Somewhat less unsuitable, the Architects Design Studio's River's Edge apartments (1986), 366 West Eleventh Street, between West and Washington Streets, was almost coherently massed, with glassed-in balconies adding a welcome transparency to the river-facing party wall.[24]

Contrary to most of the first wave of new development in the 1980s, Greenwich Village Mews (1987), 693 Greenwich Street, between West Tenth and Christopher Streets, replacing two low-lying storage buildings, formerly part of a trucking terminal, consisted of seven single-family three-and-a-half-story townhouses, located in two rows facing a fenced-in

99 Jane Street, northwest corner of Washington Street. Fox & Fowle, 1999. View to the southwest. Gordon. FXF

mews-type court as well as a single corner townhouse accessed from West Tenth Street.[25] As designed by Anthony (Chip) Caine of Proposition: Architecture, the brick-veneered wood-framed buildings, though in scale with neighboring Greek Revival-style townhouses, clumsily evoked the 1870s and 1880s Queen Anne houses of the West Side.

Rockrose's 100 Jane Street (Avinash Malhotra, 1996), made possible by the removal of the southernmost portion of the High Line, had little to recommend it, but across the street the same developer's 99 Jane Street (1999), northwest corner of Washington Street to Horatio Street, was a far more distinguished design.[26] Fox & Fowle carefully massed an H-shaped plan to form a central eleven-story tower flanked by six-story wings with full and French balconies adding interest to the extensively glazed red-brick-clad facade. The 177,000-square-foot, eighty-three-unit apartment building was set back from Washington Street to create a 7,000-square-foot gated park open to the community. The conversion of 345 West Thirteenth Street (J. M. Farnsworth, 1890), northeast corner of Hudson Street, a 145,000-square-foot loft building extending through to Fourteenth Street, into forty-seven residential lofts

(Byrns, Kendall & Schieferdecker, 1998), one of the more sensitive examples of adaptive reuse in the area, also included the construction of a new floor at the top, forming the second level of seven penthouse duplexes.

In the boom of the late 1990s, when the boulevard-style West Side Highway and Hudson River Park were beginning construction, a number of interesting buildings were realized facing the Hudson River, including the eleven-story, nine-unit condominium loft building at 495 West Street (1999), between Jane and West Twelfth Streets, developed and designed by Cary Tamarkin, an architect who in 1996 had renovated 140 Perry Street (Arthur M. Duncan, 1909), between Greenwich and Washington Streets, a pioneering all-concrete loft building.[27] Tamarkin's West Street design was unusual in many ways: it was a new building providing owners with empty loft space that they could deploy in their own way. Moreover, the boldly banded and corbeled buff and brown brick building looked like the kind of loft most New Yorkers dreamed of, with continuous runs of industrial sash. Above the seventh floor, where the building stepped back, there were two stacked duplex apartments; the upper one was given exclusive roof rights, while the

495 West Street, between Jane and West Twelfth Streets. Tamarkin Architecture, 1999. View to the southeast. TA

lower one had sole use of a ten-by-sixty-eight-foot river-facing terrace. The building, evoking Art Deco industrial architecture, was stylish and individual in its expression, yet seeming to belong to its site and neighborhood.

The success of 495 West Street paved the way for what would be one of the more talked-about new apartment projects of the fin-de-siècle boom, 173 and 176 Perry Street (2003), south and north corners of West Street.[28] Many were surprised that Richard Meier, famed for his vast Getty Center in Los Angeles and for many museum projects worldwide, would take on a small commercial project conceived by a team of entrepreneurs including the master chef and restaurateur Jean-Georges Vongerichten, who proposed to operate a restaurant in one of the buildings. Asked to comment on this, Meier said his interest was a reflection of his desire for a "next phase, a phase that will deal with urban issues," seeming to have forgotten his earlier pioneering work in the neighborhood, the conversion of the Bell Telephone Laboratories into Westbeth (1969), providing living and working space for artists, as well as his 523-unit building in the Twin Parks Northeast redevelopment project (1974) in the Bronx.[29]

As the project evolved, plans to include a hotel in an adjacent garage building to the east were dropped in favor of two differently sized but otherwise virtually identical fifteen-story balconied glass-and-painted-aluminum sheathed buildings rising high above their neighbors, an arrangement that did not sit well with many in the community, who clung to a more contextual approach and sought to extend the boundaries of the historic district to the river. Meier argued that the neighborhood had many styles and sizes of buildings, but developer Richard Born was more to the point: "These two buildings are replacing an asphalt lot and a one-story corrugated Ryder truck-rental place. I don't think the neighborhood is taking an aesthetic hit."[30] Each unit would occupy a single floor—1,800 square feet in the north tower and roughly double that size in the south tower. If asked, Meier was prepared to fit out the interiors. The thermal implications of a glass west-facing facade seemed not to be noticed by those covering the design's progress.

Herbert Muschamp greeted the pair's completion with enthusiasm, declaring them "as handsome to look at as the Hudson River views they overlook from their floor-to-ceiling windows. They catch the light reflected from the water like a pair of frozen mountains."[31] Jayne Merkel was similarly impressed with Meier's buildings, believing them "unique to New York, both in the streetscape and for the apartment market. . . . Meier's transparent towers on Perry Street . . . [are] more like Mies van der Rohe's approach for Chicago's Lake Shore Drive than anything in Manhattan. And with the opening of a new segment of the Hudson River Park . . . the towers are visible from the New York shoreline as well as from New Jersey and the river itself. Reflections from the water make the glass-walled towers, with white metal panels lining their edges and floor plates, seem all the more delicate, flanked as they are by solid brick industrial and apartment buildings." Merkel did, however, caution that "it is not clear to what extent the shimmering towers will be able to maintain their uniform appearance once they are fully occupied, as although all of the units have grey solar blinds, owners may install curtains or blinds of their own inside them."[32]

Architectural merits notwithstanding, as residents moved in it became apparent that the buildings had severe shortcomings that resulted in a swarm of negative publicity culminating in a Vanity Fair exposé titled "Faulty Towers," in which problems ranging from leaking ceilings and poor insulation to flooded balconies requiring the replacement of buckling floors were detailed, as were a host of other concerns regarding building security and services. In June 2005, earlier rumors that the towers' problems had dissuaded Jean-Georges Vongerichten from opening his planned restaurant were disproven when the sixty-seat Perry St. opened in 176 Perry Street.[33] Designed by Thomas Juul-Hansen, formerly of Meier's office, the understated restaurant featured off-white Italian leather banquettes surrounding bare oak tables and clear mesh window shades.

The Perry Street towers inspired another developer to ask Meier to design a third building, the sixteen-story, thirty-one-unit, 165 Charles Street (2005), on an adjacent site to the south, thereby compromising some views from the south

FACING PAGE 173 and 176 Perry Street, south and north corners of West Street. Richard Meier & Partners, 2003. View to the northeast. Schulman. RMPA

165 Charles Street, north corner of West Street. Richard Meier & Partners, 2005. View to the northeast showing 165 Charles Street on the right and 173 and 176 Perry Street (Richard Meier & Partners, 2003) on the left. RAMSA

tower of the earlier development. Though the design of the Charles Street tower complemented but did not repeat that of the previous development, it presented the river with a smoother west facade, devoid of inset balconies, divided in two by a crisply detailed vertical notch—a "central spine," as Meier put it—that demarcated an interior wall separating each floor's two 2,400-square-foot apartments.[34] Ceilings were two feet higher than in the Perry Street towers and the balconies were relegated to the south facade. Meier, who attributed the problems with the Perry Street buildings to value engineering and poorly managed contractors, spent more time on site during the construction of 165 Charles Street and, unlike in the earlier buildings, was retained to design the interiors of all of the units, for which the developer expected to achieve 50 percent more in revenues. The building also featured a thirty-five-seat screening room, a lap pool, a fitness center, and a wine cellar.

Hudson River Park not only provided a first-rate vantage point from which to view Meier's towers, it also supplied much needed open space for West Village residents, a deficiency that was also aided by the opening in 1992 of a more modest effort along the Hudson, Morton Street Park.[35] The 17,000-square-foot park was created to help disguise two new forty-five-foot-high ventilating shafts for the PATH train system as well as provide a new emergency escape stairway replacing the existing narrow spiral stairway at Morton and West Streets. In 1982 a fire forcing the evacua-

tion of 400 commuters convinced the Port Authority of the need to upgrade. Five years passed before the Port Authority came forward with a plan for fifty-six-foot-high ventilating shafts, a scheme that was strongly opposed by local community groups, who convinced the agency to reconsider their plan. In 1989 the Port Authority sponsored a two-way competition calling for a more sensitive design that would also be sympathetic to the not-yet-resolved plans for a post-Westway riverfront boulevard and linear park. One competitor was Robert A. M. Stern, whose design was devised to reflect the immediate vicinity: "The classical vocabulary of the design, which includes brick and stone, relates the new towers to the character of the immediate upland neighborhood, particularly the Greek Revival houses along Morton Street and contiguous blocks. The tower's bold scale and simple details fit in well with the neighboring late-nineteenth- and early-twentieth-century warehouses, which are also classical in design."[36] The winning scheme was designed by Stanton Eckstut of Ehrenkrantz & Eckstut Architects and Lee Weintraub of Weintraub & di Domenico. Eckstut and Weintraub's Morton Street Park featured stiffly shaped and elaborately detailed ventilating shafts clad in granite, glass, and metal, granite colonnades topped by cube-shaped lighting fixtures, and bayberry trees and grasses. Herbert Muschamp described the new park as "a Cinderella story, about a chimney that turned into an oasis. . . . Though the park's forms are derived from traditional garden architecture, no attempt has been made to reproduce these structures literally, or to create a period look. The design manifests a clear sense of the difference between drawing on history for inspiration and retreating to it out of fear."[37]

New York University

In addition to new housing, the most prominent building activity in the Village was generated by the neighborhood's largest property owner, New York University, which continued its expansion of the 1960s with new classroom and residence halls and a gymnasium built in the vicinity of Washington Square. The first move came in February 1978, when NYU revived its decade-old plan for a new gymnasium.[38] Because of the university's tight financial situation, and community opposition, the project had been put on hold in 1974. Zoning restrictions required that no part of the new 114,000-square-foot gym (1981), extending along the west side of Mercer Street from Bleecker to Houston Streets, be taller than twenty-three feet above grade, forcing the architects, Wank Adams Slavin, to design a largely underground facility. The resulting cream-colored box was not, however, exactly gardenesque, confronting the street as it did with a numb blankness. The school's Residence Hall (1981), 240 Mercer Street, southeast corner of West Third Street to Broadway, a 625-unit, twenty-story dormitory replacing Henry Engelbert's Grand Central Hotel (1870), which collapsed in 1973, was designed by Cambridge, Massachusetts–based Benjamin Thompson & Associates in a manner typical of the firm's work. The editors of the AIA Guide commented: "This nicely designed beige brick form totally lacks any display of awareness of the place it's in. It might look fine in Queens, in a nearby suburb or even in Cambridge, Mass. But it doesn't look fine here."[39] Much more sensitive to its context was the same firm's Filomen D'Agostino Residence Hall (1986), 110 West Third Street, between Sullivan and MacDougal Streets, serving the university's law school.[40] The complexly massed twelve-story building

ABOVE Proposal for Morton Street Ventilation Building Competition, Morton and West Streets. Robert A. M. Stern Architects, 1989. Model, view to the southwest. RAMSA

BELOW Morton Street Park, Morton and West Streets. Ehrenkrantz & Eckstut and Weintraub & di Domenico, 1992. View to the northeast. Mauss. ESTO

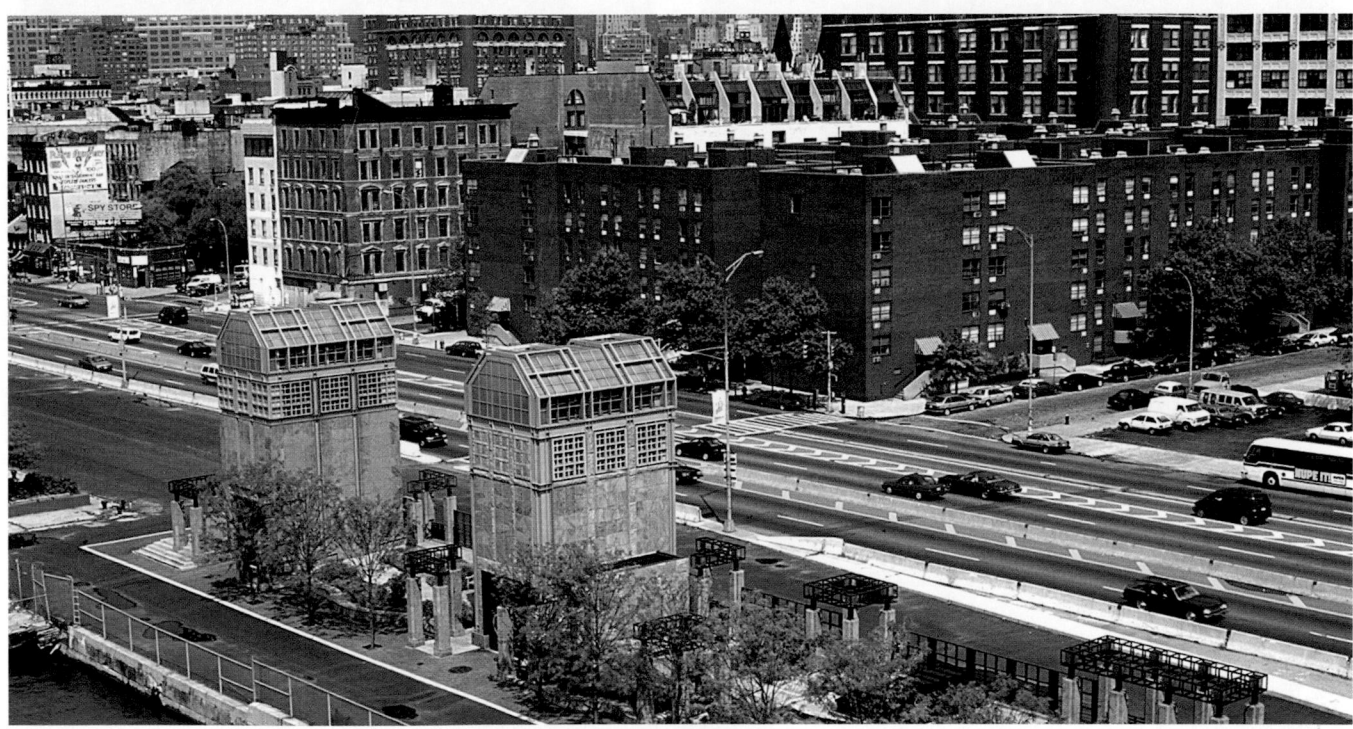

was carefully detailed to sympathize with the older, lower buildings around it. To complement Eggers & Higgins's Georgian-style Vanderbilt Law School (1951), red brick was laid in a Flemish bond, substantially framed windows were set in deep reveals, and decorative ironwork was extensively employed.

NYU's need for additional space forced the campus to spill out from its traditional confines around Washington Square, first to locations along Third Avenue and then, in the 1990s, to Fourteenth Street (see Union Square). A sixteen-story residence hall (1985), 33 Third Avenue, northeast corner of Ninth Street, designed by Voorsanger & Mills, was the first of the university's "outposts," constructed amid consid-

erable community protest.[41] The dormitory building, clad in three colors of brick, rose in three steps from a context-acknowledging six-story base occupying the entire site to a smaller twelve-story middle section and then a smaller-still four-story tower crowned by a vastly overscaled vaulted roof sheltering a mechanical penthouse. A year later Voorsanger & Mills followed with a second NYU dormitory two blocks further up the avenue at 77 Third Avenue, between East Eleventh and East Twelfth Streets, consisting of three connected fourteen-story towers set atop a six-story base that failed in its effort to carry forward the side-street townhouse scale but, with gray brick rather than multicolored walls,

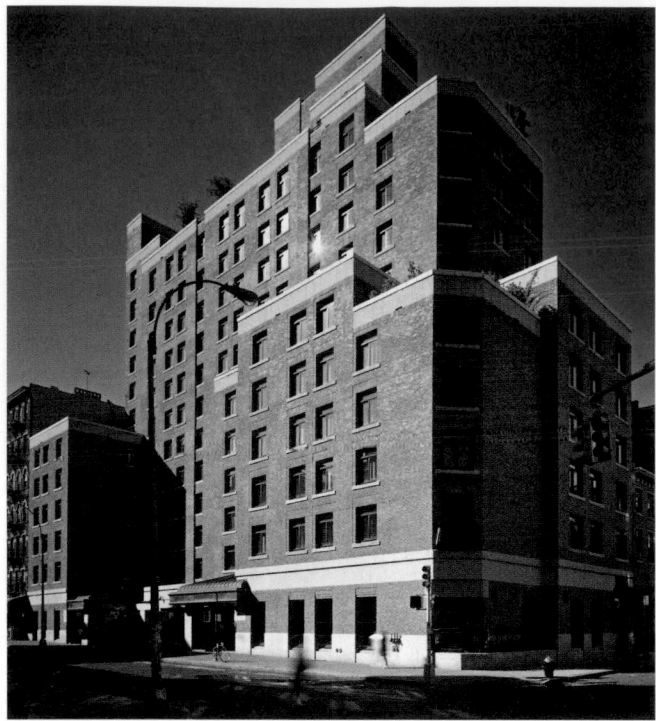

Filomen D'Agostino Residence Hall, 110 West Third Street, between Sullivan and MacDougal Streets. Benjamin Thompson & Associates, 1986. View to the southeast. Rosenthal. SR

New York University Residence Hall, 33 Third Avenue, northeast corner of East Ninth Street. Voorsanger & Mills, 1985. View to the northeast. McGrath. NMcG

was at least less strident than its predecessor.[42] Two below-grade floors, with elaborately and somewhat zanily shaped hallways, provided space for an auditorium as well as computer, study, and game rooms for students. A vaguely classical colonnade carried the building around a second-floor courtyard that was a hidden asset.

NYU also expanded into the neighborhood in less obtrusive ways, frequently housing single academic departments in historic buildings. In 1988 a gift made it possible for the university to convert the Winfield Scott house (1851–52), 24 West Twelfth Street, the interior of which had been gutted in 1979 by a developer intent on turning it into condominium apartments, into the Casa Italiana Zerilli-Marimò (David Paul Helpern, 1990), which mixed careful restoration with a cartoonish classicism.[43] The same year also saw a plan to reuse a pair of houses at 58 West Tenth Street, one from the 1830s facing the street and an 1850s house in the rear. Originally combined for Maitland Armstrong by Stanford White in 1880, the houses were later home to the Tile Club, which met in its first-floor parlor, before being refurbished as the Onassis Center for Hellenic Studies.[44] Helpern served as architect, returning much of the house to its original character despite a

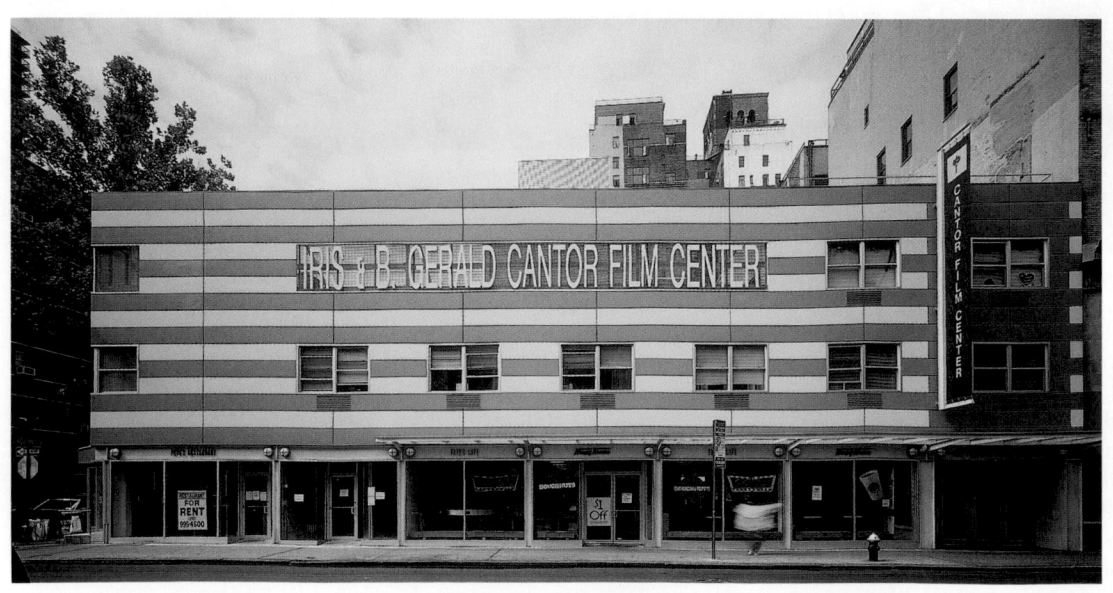

Iris and B. Gerald Cantor Film Center, 36 East Eighth Street, between University Place and Greene Street. View to the south. DBB

fire that swept through its top two floors during restoration. In 1994 NYU acquired the Lockwood de Forest house (Van Campen Taylor, 1887), 7 East Tenth Street, a unique structure best known for its elaborately carved teakwood bay window.[45] Two years later Helpern renovated this structure, which lacked many of its historic interior details, since much had been removed after de Forest had sold the house, to become the Edgar M. Bronfman Center for Jewish Life.

The university also undertook, in 1996, to restore the historic Provincetown Playhouse, 133 MacDougal Street, a former stable and bottling plant renovated as a theater in 1918, famous as the venue for early productions of the plays of Eugene O'Neill.[46] Meltzer/Mandl's renovation for the university's Tisch School of the Arts included a new stage and rehearsal space as well as a new entrance incorporating a gallery named in honor of O'Neill. In 1997 NYU asked Davis Brody Bond to convert Thomas W. Lamb's Eighth Street Cinema (1940), 36 East Eighth Street, into the Iris and B. Gerald Cantor Film Center, also intended to serve the Tisch Center for the Arts, including two 180-seat and one 320-seat screening rooms.[47] The gray and off-white striped metal paneled facade, and the bold canopy above the glazed ground floor that opened to a white brick lobby, presented the Cantor Film Center to the street with appropriate theatricality.

In 1997 NYU created yet another of its international centers, locating the Asian/Pacific/American Studies Institute on the sixth floor of the eight-story 269 Mercer Street (1893), a former warehouse building acquired by the school in 1966. The 2,800-square-foot interior renovation was undertaken by Maya Lin in association with architect David Hotson. Deliberately eschewing references to traditional Asian forms, Lin stated that "I never want to mimic or reduce a culture to a style," although the plan nevertheless featured translucent twin-wall partitions and sliding walls that clearly evoked the shoji found in Japanese houses.[48] In the same year, Polshek & Partners undertook the renovation of four buildings next to the Judson Memorial Church (McKim, Mead & White, 1892), three of which were designed by McKim, Mead & White, to form the King Juan Carlos I of Spain Center, 53 Washington Square South, which contained a library, a two-level gallery, and a rear wall of glass opening on a terraced garden with

waterfalls and pools intended in its abstraction to evoke traditional Spanish gardens.[49]

In 1999, after three years of hand-wringing negotiations, the members of the financially strapped Judson Memorial Church agreed to sell their cherished Judson House, a combination of three brick buildings at 237 Thompson Street devoted to the church's community programs, as well as an adjacent empty lot to NYU, which proposed to build a new building for its law school.[50] The Judson House buildings, originally dating from the 1840s, were combined by Stanford White in 1899 and given a uniform Greek Revival red brick facade. Just around the corner, at 85 West Third Street, NYU already owned a house (1835), once occupied by Edgar Allan Poe, which it also wanted to demolish to make way for the law school building.

Both the Judson House and the Poe house were outside the borders of the Greenwich Village Historic District, but preservationists and other community activists were concerned about

ABOVE Asian/Pacific/American Studies Institute, 269 Mercer Street, northwest corner of West Fourth Street. Maya Lin and David Hotson, 1997. Schiller. MLS

LEFT King Juan Carlos I of Spain Center, 53 Washington Square South, between Thompson and Sullivan Streets. Polshek & Partners, 1997. Rear facade and garden. Goldberg. ESTO

the impact the new law school building would have on the neighborhood as a whole and especially on Washington Square. Residents were still resentful of the size and brooding character of the university's Elmer Holmes Bobst Library (Philip Johnson and Richard Foster, 1973) and angered by the planned destruction of the awkwardly designed but relatively modestly sized Loeb Student Center (Harrison & Abramovitz, 1960) and its replacement by the Kimmel Student Center (see below), both on Washington Square South.[51] At first the battle centered on the fate of the Poe house, slated for demolition, with scholars, preservationists, and university officials debating whether or not the famously dissolute writer lived there at a significant point in his career. As the controversy raged, NYU's law school, led by its dean, John W. Sexton, (who, ironically, had made his reputation in 1987 as the lawyer for the dissident parishioners of St. Bartholomew's Church in their opposition to its proposed office tower addition; see Park Avenue), moved forward with plans for a new building on the site to be designed by Kohn Pedersen Fox.[52] As the debate continued, new facts about Poe's time at the brick cottage at 85 West Third Street came to light, revealing that the author and his ailing wife lived there for several months, during which time he was said to have written some of his best work, including "The Cask of Amontillado," while also publishing his first substantial compilation of poetry.

Poe's occupancy provided the battle a higher profile, but the real issue remained the widespread anger over the construction by NYU of yet another tall building on the south side of Washington Square, thus further altering its historic character and threatening to rob it of precious sunshine. In July 2000, the New York Landmarks Conservancy, joining other groups protesting the loss of the Poe house as well as the

Furman Hall, site bounded by Thompson, West Third, and Sullivan Streets and Washington Square South. Kohn Pedersen Fox, 2004. View to the northeast showing the reconstructed facade of the Poe House (1835) in the center and the Kimmel Center (Kevin Roche John Dinkeloo and Associates, 2003) on the far right. RAMSA

McKim, Mead & White houses, drew attention to the larger issue of the impact NYU's proposed building would have on the Judson Memorial Church and especially on its campanile, which would no longer be silhouetted against the sky when viewed from Washington Square. The Conservancy requested that the mass of the new building be moved to the west, away from the back of the church and that it maintain a low base to reflect the neighborhood's scale in order to "avoid creating another building with the ponderous bulk and institutional character of Bobst and Kimmel."[53]

Most NYU faculty remained publicly silent about the issue, but on July 21, 2000, novelist E. L. Doctorow, a professor of English at the university, protested the demolition in a letter to the editors of the *New York Times*.[54] The filmmaker Woody Allen and the rock-and-roll icon Lou Reed also raised their voices in protest in letters to the *Times*.[55] By August the issue was in the courts. Amid public rallies and continued discussion in the press, State Supreme Court Justice Robert Lippmann ruled in favor of the university on September 29, though his ruling in effect asked the university to reconsider its position and save the Poe house despite its lack of legal protection.

Meanwhile, community pressure led to behind-the-scenes negotiations with Dean Sexton, and on January 22, 2001, NYU announced that it would lop off at least three stories from its proposed thirteen-story building and would also preserve the facades, but not the interiors, of the Judson and Poe houses. According to the new plan, the buildings would be demolished but their facades would be reconstructed. Moreover, the doorway of the Poe house would lead into an area housing artifacts from Poe's New York household. On September 28, 2001, construction began on Kohn Pedersen Fox's revised building, designed by William Pedersen along with Jill Lerner of the firm. Completed in 2004 and christened Furman Hall, it was, arguably, as John Sexton put it, "the first constructive act of building in the city since September 11," a nine-story, 170,000-square-foot, brick-clad facility with a four-story mass along West Third Street, where it incorporated the historic facade and a slab rising to a vaulted roof.[56] James Gardner was impressed with Furman Hall, praising its red brick facade as "an elegantly, if deceptively, plain and planar expanse that fits in gracefully with the other buildings on Sullivan Street."[57]

In March 1999, NYU announced plans to replace its ten-story Loeb Student Center (Harrison & Abramovitz, 1960), southwest corner of Washington Square South and La Guardia Place, often described as its "living room," with a much larger facility, the twelve-level Helen and Martin Kimmel Center for University Life, designed by Kevin Roche John Dinkeloo and Associates.[58] The old building, now vastly overcrowded, had been built to serve 1,000 resident undergraduates, a number that had grown to 9,000. The new center would house offices for various student activities and clubs in a portion that would still carry the Loeb name, as well as lounges, a 700-seat theater, and an 865-seat theater to be known as the Skirball Center for the Performing Arts, in a 210,000-square-foot building, twice the size of the Loeb Student Center, that would rise to a two-story sloping mansard roof, sheathed in fritted glass to reduce the building's impression of bulk and height. Above the site-filling base, the Kimmel Center would in fact appear to be entirely sheathed in glass but overlayed by a boldly gridded pale yellow limestone perforated frame. Even as construction vehicles arrived on the site at the end of

August 1999, community groups continued to protest the new "as-of-right" building which, though only fourteen feet higher than the one it was replacing, was much bulkier.

Critics greeted the design with derision. Writing in *New York* magazine, Karrie Jacobs called it "a flashback to the pomo eighties" that really "didn't belong in Washington Square," but "could be the most architecturally distinguished building in a greater-Atlanta office park."[59] Completed in 2003, the Kimmel Center proved as bulky as feared, with long-time foe Andrew Berman, executive director of the Greenwich Village Society for Historic Preservation, protesting that it overwhelmed the Washington Square Arch. But James Gardner disagreed: "The best thing about the new building is its respect for Washington Square Park, which it overlooks from several terraces and from a two-story atrium window on the seventh floor. But most striking is the 60-foot-wide, glass enclosed entrance on the park, flanked by two masonry pavilions. This leads immediately to one of the most grandiose interior stairways in the city." Gardner also praised the glass-enclosed stairway on the building's western end: "On the outside it looks like a slightly ungainly wall of warped glass. Inside as well, it is rather sparse and utilitarian. But as you descend, your eye travels across the park straight down the center of Fifth Avenue. If I am not mistaken, this is the only spot in the city that affords such an exhilarating view of one of our finest avenues."[60]

Other Village Institutions

Perhaps because NYU was so criticized for its new construction, few other Village-based institutions undertook new build-ings. One exception was the Hebrew Union College, whose five-story red brick Brookdale Center (Abramovitz Harris & Kingsland, 1979), 1 West Fourth Street, northeast corner of Mercer Street to Broadway, was dismissed by the editors of the *AIA Guide* as a "monolithic, crystalline, flat, introverted" building.[61] The addition to the Little Red School House and Elizabeth Irwin High School (1100 Architect, 1997), 260 Sixth Avenue, just south of the Lower School building at 196 Bleecker

Lesbian, Gay, Bisexual & Transgender Community Center, 208 West Thirteenth Street (ca. 1869), between Seventh and Eighth Avenues. Renovation by Françoise Bollack Architects, 2001. Bordes. FBA

Center for Architecture, 536 La Guardia Place, between Bleecker and West Third Streets. Andrew Berman Architect, 2003. Aaron. ESTO

Street, was a far more pleasing example of new construction by a neighborhood institution—a low-key, comparatively small red brick faced insertion, replacing a former courtyard, that packed some interior spatial wallop with a dramatically skylit art studio and clerestory-lit, wavy-ceilinged, below-grade 100-seat cafeteria.[62] A number of institutions, some of them long established, others newly founded, did undertake significant renovations to historic Village properties. In 1985 the Lesbian and Gay Community Services Center, created two years earlier, embarked on an ambitious restoration and reconstruction of Public School 16, 208 West Thirteenth Street, between Seventh and Eighth Avenues, a three-story, brownstone-trimmed Philadelphia brick structure (c. 1869), believed to have been designed by either William H. Willcox or Thomas R. Jackson.[63] The building had been remodeled over the years but was phased out as a school in the 1970s and sold to the center in 1984. In 1985 Françoise Bollack Architects undertook the master plan and two years later the renovation, which was to continue for more than a decade, as funds became available. Work was complete in the fall of 2001, returning the building to full usefulness while also restoring not only the facade but many significant interior details and opening up clear paths of circulation that took advantage of the historic skylit ornamental stair. A new service corridor was inserted in an abandoned light well.

The 1992 renovation by Prentice & Chan, Ohlhausen of Joseph Urban's Modernist masterpiece, the 1930 elliptical auditorium, now named for John L. Tishman, at the New School for Social Research, 66 West Twelfth Street, between Fifth and Sixth Avenues, restored the original color palette of graduated shades of gray sparked by English vermillion as well as the original plan of the stage, introducing the room to a new generation.[64] The firm also restored the New School's

Proposed Cooper Union Dormitory, 29 Third Avenue, southeast corner of Stuyvesant Street. Peter Eisenman, 1989. Model, view to the northeast. Frank. EA

Proposed Cooper Union Dormitory, 29 Third Avenue, southeast corner of Stuyvesant Street. Peter Eisenman, 1989. Model, view to the southeast. Frank. EA

Orozco Room. The skylit Vera List Courtyard, along with two lobbies, was remodeled in 1997, with Mitchell/Giurgola collaborating with the landscape architect Michael Van Valkenburgh and the sculptor Martin Puryear.[65]

In 1999 the New York Chapter of the American Institute of Architects, goaded to action by its then president, Rolf Ohlhausen, in a surprising move, committed to purchasing a 12,000-square-foot storefront and two cellars in a cooperatively owned loft building at 536 LaGuardia Place, marking the first time in anyone's memory that the chapter would not be located in midtown.[66] An open competition to design the new headquarters, intended to better engage the public through the incorporation of an auditorium and a gallery, resulted in the selection, from a first round of fifty schemes, of five finalists who were asked to refine their ideas in a second round: Konyk Architecture, Reiser + Umemoto RUR Architecture, Claire Weisz Architect, Gensler, and Andrew Berman Architect, whose submission was ultimately given the nod. Although Reiser + Umemoto's first-phase proposal had seemed the most provocative, its principal feature of a sweeping stair that opened the design up to three levels had to be rethought in light of new competition restrictions, while Berman, though he did not ignore the sectional possibilities, produced a scheme mindful of budget constraints so that, as Jayne Merkel wrote in *Oculus*, it "would appear complete in the first phase." Merkel added that Berman's design featured a "beautiful minimalist facade that actually makes the otherwise unremarkable, graffiti-strewn building look good."[67] The spacious, light-filled but somewhat sketchily executed Center for Architecture, with its sixty-four-foot-wide glass facade, opened on October 7, 2003, and included galleries, meeting rooms, a lecture hall, a library, an auditorium, and administrative offices.

The AIA's decision to have a more public presence was in part triggered by the traditional success of the Architectural League in bringing new ideas to the profession and by the emergence in the 1990s of the Van Alen Institute, an outgrowth of the National Institute for Architectural Education, which had begun life in 1894 as the Society of Beaux-Arts Architects.[68] As the result of a bequest from William Van Alen, architect of the Chrysler Building, the NIAE was able to purchase a revenue-generating loft building at 30 West Twenty-second Street, where it occupied 3,600 square feet. In 1995 the NIAE was renamed the Van Alen Institute: Projects in Public Architecture, led by a young journalist-architect Raymond Gastil, who commissioned Lewis Tsurumaki Lewis, a stylish firm of design-build architects, to reconfigure the space. Susanna Sirefman praised the design, completed in 1998, as a "cogent, chic think-tank" that cleverly manipulated familiar industrial materials "into a space that exudes the intellectual and tactile glamour appropriate for the institution."[69]

Around Astor Place

New York University was not the only downtown university to feel the need to provide housing for students who, though increasingly attracted to study in the city, seemed to prefer the security of a dormitory. In 1989 Cooper Union, founded in

1859, which traditionally functioned as a commuters' school and provided free college-level education to New Yorkers interested in engineering, fine arts, and architecture, embarked on the construction of its first-ever dormitory, to be located on a triangular site at 29 Third Avenue, southeast corner of Stuyvesant Street.[70] To select an architect, Cooper canvassed twenty alumni and faculty members before asking Peter Eisenman, a longtime member of its faculty, to compete against fellow professor Diane Lewis and an alumnus, Rolf Ohlhausen, whose firm, Prentice & Chan, Ohlhausen, was a solid and well-respected office but not ranked among the city's high-wire performers. The selection of Ohlhausen's clunky, Neo-Brutalist proposal led Herbert Muschamp to stoop to a virtual ad hominem attack when he wrote that the firm's "philosophy . . . is perhaps best summed up by H. H. Richardson's famous remark that the first law of architecture is: Get the job."[71] The choice of Ohlhausen's scheme by the trustees was also derided by Cooper faculty and students, 700 of whom signed a petition that dismissed the design as "a simplistic, developer-style building of mediocre quality and no architectural merit [that] discredits the intentions and work of this institution."[72]

Muschamp came to bat for Eisenman's proposal as one of "the most impressive projects ever to come off [his] drawing board, and certainly the most urbane," resembling "a modern glass slab that has been shattered and put back together to reveal the facets and fault lines of a crystalline structure."[73] Eisenman waxed even more poetic over the possibilities of his proposal: "Our project breaks down those traditional aspects of classical monumentality," he wrote, as if such was ever the issue for what was, after all, a typical background building. Continuing, he stated that he replaced the "symmetries, the singular axes, the regular stacked forms of monumental composition" with "a freer, richer, more playful massing which has no defined frame, no single axis, and no conformity of material to shape or form to function. Rather," he claimed, his design proposed "a symbolic vision of its own time and place: complex, multivalent, tactile."[74] Diane Lewis's proposal, developed with Peter Mickle and a team of recent Cooper graduates, made use of "concrete 'fish bone' structural elements conceived of as a sieve . . . set into the grid of the party

walls of the surrounding buildings." The scheme had more than the effect of 1950s Brutalism, it had the tectonic clarity and a certain playfulness. Less well resolved than the other two, it nonetheless had a spirit of invention they both lacked.

As Ohlhausen's building began to take shape, Muschamp, writing in *Artforum*, attacked it as "terrible architecture: brutal in design, banal in program, insensitive to physical context and community desires."[75] Muschamp, however, seemed not to really be looking at the building which was far more successful than his dire predictions might have led one to expect. As realized in 1992, the building was somewhat toned down and far less aggressive, a fifteen-story, dark purplish brown iron-spot brick–clad reinforced-concrete structure housing 193 students in forty-eight apartments above retail spaces. As Suzanne Stephens pointed out, "The slim, faceted, polygonal tower is low-key—even bland—yet at the same time crisply detailed and tailored."[76] Jacob Alspector, a Cooper trustee who participated in the selection, and a senior associate in the office of Gwathmey Siegel, praised it for what it was, and probably should have always been intended to be: "a good New York vernacular, rationalist building, with a well-built, spartan character in the spirit of Peter Cooper."[77]

Cooper Union seemed to do better with a much more modest project, a café (1997) built in association with the Pasqua chain of coffee bars. As designed by an alumnus, Laurie Hawkinson, of the firm Smith-Miller + Hawkinson, the simple glass pavilion was inserted under the portico of the Engineering Building (Voorhees, Walker, Smith, Smith & Haines, 1961), the ceiling of which it incorporated. A hybrid porch and store, Hawkinson's café led the editors of the *AIA Guide* to praise it as "a new 'hermit crab'" occupying "a previously forlorn cage."[78] In 1999 Cooper embarked on a far more prominently located project that was seen by many as a chance for the school to redeem itself with a work of architectural significance on the vacant site it owned bounded by Fourth Avenue and Astor and Lafayette Places. The school leased the site for ninety-nine years to Ian Schrager, the former co-owner of Studio 54 who had become a successful hotelier, specializing in renovating old buildings into high-style, so-called boutique hotels like Morgan's and the Royalton but had never commissioned a purpose-built hotel.[79] Working

Proposed Cooper Union Dormitory, 29 Third Avenue, southeast corner of Stuyvesant Street. Diane Lewis, 1989. North elevation. DLA

Cooper Union Dormitory, 29 Third Avenue, southeast corner of
Stuyvesant Street. Rolf Ohlhausen, 1992. View to the southeast. ODA

with the Related Companies, experienced residential property
developers, Schrager agreed to Cooper's request that two
prominent architects be asked to submit designs for the hotel,
which was to face a rebuilt Astor Plaza. Initially, the 100-
room, 150,000-square-foot hotel building was to rise twelve
stories, with completion expected by 2002. At Cooper's
request, it was to include an art house cinema in the base-

ment. Schrager was asked to consider the English architect
Norman Foster and Herzog & de Meuron of Switzerland,
among others.

In January 2000, Schrager and Cooper Union announced
that Rem Koolhaas and Herzog & de Meuron would collabo-
rate on the hotel's design.[80] Schrager claimed to have been
drawn to Koolhaas because of his design for an imaginary

RIGHT Pasqua coffee bar, northwest corner of Third Avenue at Astor Place. Smith-Miller + Hawkinson, 1997. View to the northwest. Warchol. PW

BELOW Proposed Astor Place Hotel, site bounded by Fourth Avenue and Astor and Lafayette Places. Rem Koolhaas and Herzog & de Meuron, 2001. Photomontage, view to the south. OMA

Hotel Sphinx, proposed as part of his book *Delirious New York*, published in 1978.[81] Though the two architectural firms were to work together, they were to produce two separate designs, to be reviewed by Schrager and Cooper's planning committee, headed by longtime faculty member Charles Gwathmey. In early 2000, the architects met, and ideas were bandied about between the conceptually daring Koolhaas and the more conservative, if no less extreme, Herzog & de Meuron firm. It took a year before the team could agree on a design, and on May 10, 2001, a day before the design was to be presented to the Cooper Union trustees, Herbert Muschamp hyped it as "the first in what will probably be a long, leggy stretch of New York buildings inspired by the world of fashion." By this time, the proposed hotel had grown to twenty stories, though still "as of right" in terms of the city's zoning. According to Muschamp, its overall shape, that of a truncated obelisk, was in fact that of the northern of what would be two buildings, a scheme adopted to reduce the impression of bulk, with a seven-story annex on the Fourth Avenue side linked to the tower at the basement level. As Muschamp described it, the deep triangular folds of the metal and glass facade gave the proposed hotel "a Cubist twist," surrounded by a 5,400-square-foot landscaped plaza from which the public could glimpse "a craterlike cavity" of the lower level through sloping glass panels. The annex promised to be more interesting than the tower, Muschamp believed, housing "an experimental arrangement of sleeping accommodations that one might call fashion flophouse," with, on the upper stories, an arrangement of sixty to eighty Pullman-size, soundproofed, translucent-doored compartments containing stacks of three beds, similar to those found in Japanese commuter hotels, through which passersby could get hints of the life within. As for the 260-room tower, this was to consist of slightly more commodious but minimally furnished "perches for contemplating the cityscape through their crystalline windows."[82]

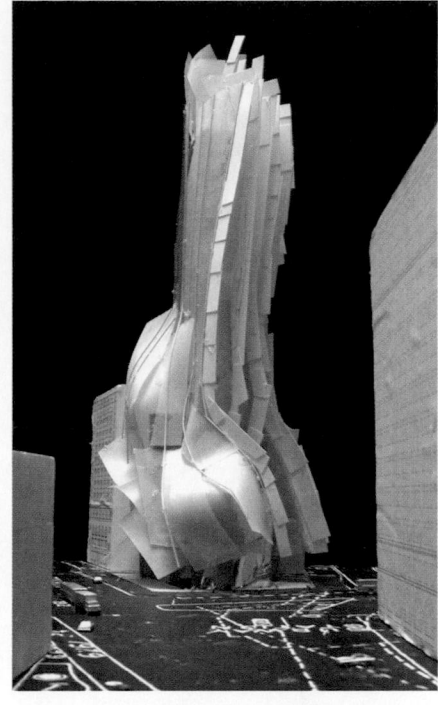

ABOVE Three schemes for Astor Place Hotel, site bounded by Fourth Avenue and Astor and Lafayette Places. Frank Gehry, 2001. Models, view to the south. GP

BELOW Astor Place apartment building, site bounded by Fourth Avenue and Astor and Lafayette Places. Gwathmey Siegel & Associates, 2005. View to the southeast. McGrath. NMcG

Muschamp's gushing approval surprised New Yorkers when a computer-generated image of the planned Astor Place Hotel was printed in the *New York Times*'s Sunday magazine, revealing a tapered but hardly leggy metal-skinned tower punctuated by a random pattern of bloblike window openings and little else. By early July 2001, Schrager, now in partnership with the Related Companies, had reportedly turned to Frank Gehry when the Koolhaas and Herzog & de Meuron scheme proved too costly and the partnership between the two firms less than workable. Gehry, who had apparently worked on the project before, was reluctant to take on the job but, learning that the Schrager/Related team had only six months more to exercise its option for the site, said, "Maybe I should dig out my [old] plans and see what I was thinking."[83] On July 20, Schrager officially announced that Koolhaas and Herzog & de Meuron were no longer involved in the project. Gehry pursued several design ideas, including plans for an open courtyard design, single and multiple tower schemes, as well as a mid-rise design based on a cruciform plan, but Schrager quickly put the project on hold before any of them could be fully developed.[84] In 2003 Cooper Union announced yet another plan for the site, this time calling for a twenty-one-story residential tower designed by Gwathmey Siegel and developed by the Related Companies. The design of the 140,000-square-foot, thirty-nine-unit building combining serpentine and rectilinear forms and rising from a two-story limestone and glass base proved to be controversial. Though the public seemed to like it, architects, especially young architects, saw it as something of a betrayal by Cooper and by the Gwathmey firm. In this they were supported by Paul Goldberger, usually a Gwathmey fan, who weighed in with a negative assessment as the building neared completion in May 2005, describing it as "a slick, undulating tower clad in sparkly green glass . . . that doesn't belong in the neighborhood. . . . Its shape is fussy, and the glass facade is garishly reflective: Mies van der Rohe as filtered through Donald Trump. Instead of adding a lyrical counterpoint to Astor Place, the tower disrupts the neighborhood's rhythm."[85]

MIDTOWN

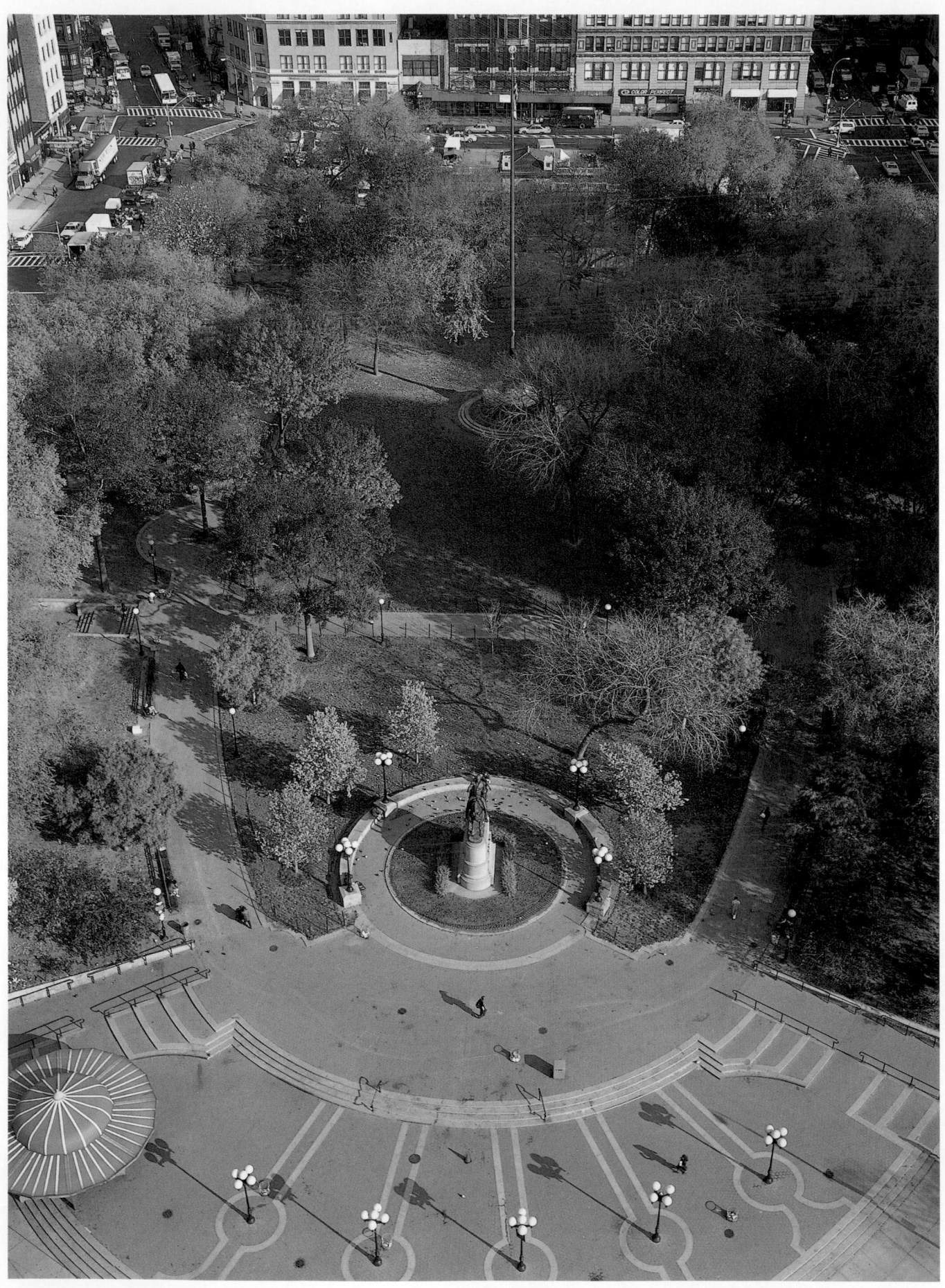

UNION SQUARE

By the mid-1970s, Union Square Park had lost to Central Park its status as a political platform. It had also lost its physical charm, degenerating into a 3.6-acre near wasteland that was a dangerous public place redolent with the scent of marijuana. Union Square Park, laid out by the city's pioneer property developer, Samuel B. Ruggles, in 1833, was midtown's oldest public open space, acquired by the city in 1831 and opened in 1839.[1] Frederick Law Olmsted and Calvert Vaux redesigned it in 1871.[2] When in 1936 the park was elevated about five feet to permit construction of a subway mezzanine below, a change that tended to discourage public access, Union Square became a haven for the idle and, after the 1950s, for drug dealers. Paul Goldberger, in *The City Observed* (1979), described it as "a dreary park, one of the least relaxing green spaces in Manhattan." But he pointed out that there were reminders of a nobler time, when the park was a "grand civic environment" embellished with a fountain, fine statuary, and "an immense flagstaff base . . . with bas-reliefs by Anthony de Francisci symbolizing the forces of good and evil in the Revolutionary War; even if a derelict is relieving himself beside it, it has a rather majestic presence."[3]

Design work leading to the park's renovation began to be considered in earnest in 1976 as a plan, partially financed by the federal government as part of the celebration of the nation's bicentennial, was prepared by the City Planning Commission.[4] Beginning in 1982, under the leadership of the architect Bronson Binger and the landscape architect Hui Mei Grove, both on the city's staff, the Parks Department rebuilt Union Square Park, capturing some acreage formerly given over to parking, incorporating a newsstand on Union Square East opposite Fifteenth Street designed by Kuo Ming Tsu, new

glass-covered subway entrance kiosks designed by Robert Klein of the Parks Department, and suitably ornate multiglobed light standards.[5] The redesign replaced the six paved walkways that converged in the middle of the park with a perimeter walkway, filling up the center with tree-shaded lawns and creating a spacious plaza at the south along Fourteenth Street. At the same time, architects Roy Strickland and Carson & Stillman proposed two covered, open-air markets for the north end of the square, where a highly successful greenmarket had been a regular feature since its founding by Barry Benepe, an architect and planner, and Bob Lewis, a planner, in the 1970s.[6] The Strickland team's structures were not realized. Instead, a pair of twenty-five-foot-high temporary structures that the editors of the *AIA Guide* dismissed as "rather pretentious but sad metallic gateways" were built at the northeast and northwest corners of the park with funds from the Astor Foundation and the local development corporation.[7] Plans for a permanent structure to house the greenmarket resurfaced in the 1990s with a more elaborate scheme by Charles Thanhauser of Thanhauser & Esterson that would allow the market to operate in inclement weather and during the winter months while retaining the open-air feel on warm days by providing a retractable roof and walls.[8] The proposal, which would also eliminate surface parking and a service lane in the northwest and northeast corners of the park, was also rejected by local residents who preferred that the market remain unchanged.

As the park reopened in 1986, artist Krzysztof Wodiczko proposed a public artwork entitled *Homeless Projection: A Proposal for the City of New York*, which adopted Union Square Park's refurbished statuary as a symbol of superficial revitalization. Wodiczko would project onto the statues images of the accoutrements of New York's homeless population,

PRECEDING PAGES View to the east of midtown Manhattan between West Forty-second and West Fifty-second Streets across Hudson River from New Jersey, 2005. Sundberg. ESTO

FACING PAGE Union Square Park, bounded by East Fourteenth and East Seventeenth Streets, Union Square West and Union Square East. New YorkCity Department of Parks and Recreation, 1986. View to the north. Cedar-Miller. SCM

BELOW Proposed Union Square Greenmarket, Union Square Park. Charles Thanhauser, 1996. Rendering of view to the north. TEK

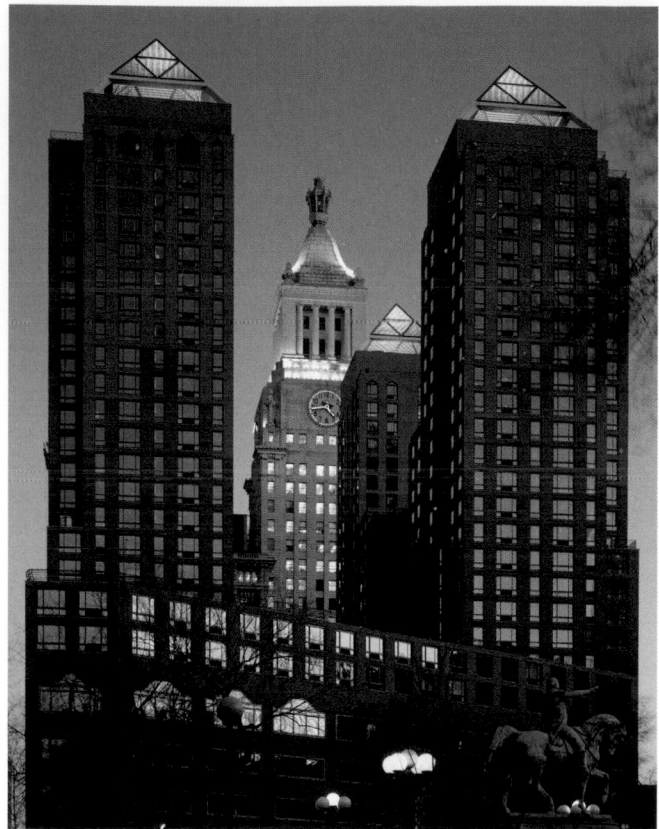

Zeckendorf Towers, east side of Union Square East, between East Fourteenth and East Fifteenth Streets. Davis, Brody & Associates, 1987. View to the east showing Consolidated Gas Company Building (Warren & Wetmore, 1926) in background. Hoyt. ESTO

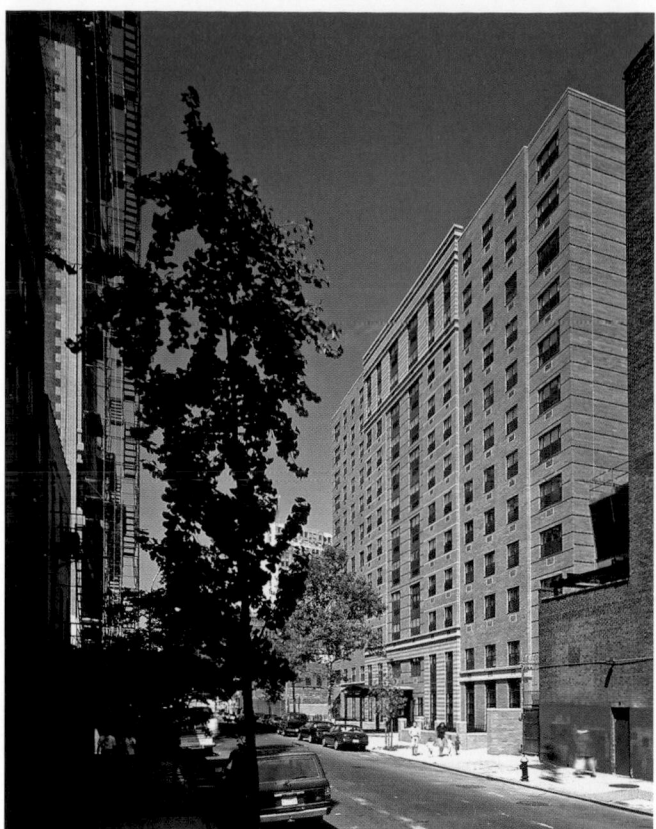

Genesis Apartments, 113 East Thirteenth Street, between Third and Fourth Avenues. Cooper, Robertson & Partners, 1995. View to the northwest. Kaufman. CRP

which Rosalyn Deutsche considered to be "the group most noticeably dispossessed by such preservationism."[9] Thus the statue of Abraham Lincoln would be transformed to show Lincoln with a crutch and a begging cup, while Washington would no longer be riding a horse, but instead sitting in a wheelchair with a bottle of Windex and a cloth. While it was intended for Union Square Park, Wodiczko's unrealized piece was conceived as a series suitable for various locations around the city.

On September 12, 1998, Union Square Park was designated a National Historic Landmark, largely because of its role in the history of the labor movement.[10] Late in December 2000, the park was expanded to the south, eliminating its unusual elliptical shape.[11] The small triangle at the southeast corner was beautified with grass, shrubs, and trees in 2001, at which point a roadway at the southwest corner was also eliminated, all in all enlarging the park by 20,000 square feet.[12]

Though the park had been the blighted center of the Union Square neighborhood in the 1970s, the real estate community had begun, early on, to see its potential as the focus of upscale development strategically located between downtown and midtown. In March 1976, approximately six months after the closing of S. Klein-on-the-Square, the discount department store that had since 1921 occupied a collection of nineteenth-century buildings on Union Square East (Park Avenue South) between Fourteenth and Fifteenth Streets, Julio Tanjeloff, an Argentine lawyer active in retailing, announced plans for the store's reopening as a full department store taking advantage of the untapped trading power of prosperous nearby neighborhoods.[13]

Tanjeloff, who proposed to renovate the 300,000-square-foot store that comprised eleven buildings, commissioned Andrew J. Blackman Associates in association with Stephen Lepp & Associates to reclad the exterior, some of which was built of cast iron, using glass fiber–reinforced concrete, a stuccolike surfacing, punctuated by vertical strips of polished stainless steel.[14] Tanjeloff's plan failed to materialize, dashing the community's hopes of what many saw as an easy fix for Union Square's problems.

Even as plans proceeded to revitalize the park, many observers believed that the key to Union Square's revival remained the future of the S. Klein site. In June 1980, the Klein estate was reportedly in negotiations with five developers seeking to purchase the site and its buildings.[15] But it was not until 1983, when William Zeckendorf Jr., son of the legendary developer of the 1950s and 1960s who had died in 1976, acquired a two-year option on the site, that progress began to be made.[16] Zeckendorf retained Davis, Brody & Associates to develop plans for the block's redevelopment as a cluster of four superscaled apartment towers set atop a seven-story base.[17] The design, vaguely imitating the Italian architect Aldo Rossi's interpretative drawings of some of New York's skyscraper icons, did not capture much support with the public or the architectural press. At the same time, city history buffs and preservationists began to draw the public's attention to the S. Klein site's rich architecture, which included the former Union Square Hotel (1872), designed by James Renwick Jr., architect of St. Patrick's Cathedral.[18] To realize the Zeckendorf plan, the site needed to be rezoned,

a move that was rigorously opposed by the Union Square Community Coalition, a group largely made up of newer residents who had moved into lofts and apartments and feared the impact of real estate speculation on their rented homes. Efforts to rezone Zeckendorf's site coincided with a broader reassessment of the area's zoning, which had been studied in 1979–80 by Hardy Holzman Pfeiffer Associates. Those recommendations formed the basis, in 1984, of the Department of City Planning's proposed special zoning district, intended to encourage mixed-use development on underutilized sites in the park's vicinity, especially Zeckendorf's proposed one-million-square-foot project.[19] Both the district and the Zeckendorf proposal for a twenty-six-story project were approved by the City Planning Commission in November 1984 and by the Board of Estimate in January 1985.[20] Concerns about the fate of historic buildings on other sites around the square led to the designation as landmarks of the Lincoln Building (R. H. Robertson, 1890), 1–3 Union Square West; the Bank of the Metropolis (Bruce Price, 1903), 31 Union Square West; the Century Building (William Schickel, 1881), 33 East Seventeenth Street; the Everett Building (Starrett & Van Vleck, 1908), 45 East Seventeenth Street; and the Germania Life Insurance Company Building (D'Oench & Yost, 1911), later the Guardian Life Building, 50 Union Square East.[21]

As built, the four twenty-story towers of Zeckendorf's project, unimaginatively titled Zeckendorf Towers, contained 670 condominium apartments rising above a seven-story base housing 320,000 square feet of offices, an atrium, a much-appreciated supermarket, theaters, and underground parking. Though banal in their detailed design, the scheme of slender, salmon-colored brick-clad towers, each topped by an open-work pyramidal crown—dismissed by the editors of the *AIA Guide* as "illuminated levitating . . . yarmulkes"—minimized shadows on the square and blockage of views from it to the tower of the Consolidated Gas Company Building (Warren & Wetmore, 1926), which they were intended to complement.[22] The office floors were entered from Fourth Avenue facing Union Square Park, while the apartments were entered off Fifteenth Street. In its bland uniformity and lock-step regularity, Zeckendorf Towers was hardly inspiring, but it did help the reemerging district turn the economic corner.

While most new construction in the area involved demolition of existing buildings, a through-block parcel that had been vacant since the early 1970s permitted the construction of the twelve-story Genesis Apartments (1995) for ninety-four homeless and low-income families at 113 East Thirteenth Street and an attendant 30,000-square-foot, two-story commercial building at 114 East Fourteenth Street.[23] The project was developed by Housing Enterprise for the Less Privileged (H.E.L.P.), a nonprofit organization founded by Andrew Cuomo, son of New York State Governor Mario Cuomo. As designed by Cooper, Robertson & Partners, the quietly contextual apartment building eschewed all outward signs of social engineering in favor of an expression that many would assume was intended for a much more affluent clientele. Additionally, the building's management program included a program-services staff of fifteen to help the homeless tenants, whose stay was limited to twelve months, make an adjustment back into mainstream society. Genesis provided playgrounds, a day-care center, a basketball court, a library, and a laundry room. Although many in the community were initially opposed to the project, it proved an excellent neighbor.

The retail building on Fourteenth Street, however, was not comparable in quality; its low height, a product of zoning restrictions, contributed to its suburban strip-mall character.

Union Square South (1998), designed by Davis, Brody & Associates in association with Schuman, Lichtenstein, Claman & Efron, a twenty-seven-story, 180-unit apartment building atop an eighty-five-foot-high mixed-use retail base that included a fourteen-screen theater, occupied the highly visible 47,500-square-foot full-block site bounded by Fourth Avenue, Thirteenth Street, Broadway, and Fourteenth Street.[24] In 1995 the Related Companies had acquired the site from another developer who had cleared it of its buildings, including the historic Union Square Theater (1871; rebuilt, John Terhune and Leopold Eidlitz, 1889), 58 East Fourteenth Street, which had long been obscured behind a huge McDonald's sign.[25]

Responding to community concerns that this most prominent site might yield yet another business-as-usual apartment house banality, the developers entered into an agreement with the Municipal Art Society to select an architectural firm that would maximize the site's most important attributes, its axial relationship to the vista south along Park Avenue from Grand Central Terminal and its prominent location at the edge of Union Square Park. The society asked two dozen architects to name a firm, besides their own, that they would recommend for the job. From the responses, Related chose three firms to participate in a competition held in 1995: Davis, Brody & Associates, Robert A. M. Stern Architects, and Hardy Holzman Pfeiffer Associates, which later withdrew. Stern proposed an eighteen-story tower on a five-story stone-clad site-filling retail base. The metal-trimmed brick-clad tower was to be set back from the property line to create a strong south terminus for Park Avenue, recalling the campanile-like configuration of Warren & Wetmore's New York Central Building (1929), which, until the construction of the Pan Am Building in 1963, had concluded the axis of Park Avenue on the north side of Grand Central.

Davis, Brody's winning scheme, designed by Steven Davis, son of founding partner Lewis Davis, sought to merge the base with the tower. The initial rendering revealed stylish asymmetrical patterns of windows as well as a deep balcony cut into the north wall. But as built, its blocky mass was pretty banal, the cut reduced to virtual inconsequence, leaving the heavy aesthetic lifting to the work of the artists Kristin Jones and Andrew Ginzel. In a separate competition organized by the Public Art Fund, the two had been chosen to embellish a 100-by-60-foot wall on the building's north facade, between the commercial base and the tower. Jones and Ginzel proposed *Metronome*, confronting the street with a brick wall overlaid with an undulating wavelike pattern of concentric circles and a so-called eye, a four-foot-in-diameter opening that emitted clouds of steam, clearly upstaging the rather tepid facade of the host building. The steam, intended by the artists to recall the geothermal outpouring of Old Faithful, poured forward twice a day, at noon and at midnight, as part of the artists' intention to examine time itself. Each emission was enhanced by the sounding of a long, tapered horn intended to echo the passage of time. A digital clock on the left side of the wall augmented the frequent movements of the city by simultaneously counting and subtracting the hours of the day, with the converging digits in the middle absorbed by a blur of activity, intended to suggest the present.

Proposed Union Square South, site bounded by Fourth Avenue, East Thirteenth and East Fourteenth Streets, and Broadway. Robert A. M. Stern Architects, 1995. Rendering of view to the south. RAMSA

Union Square South, site bounded by Fourth Avenue, East Thirteenth and East Fourteenth Streets, and Broadway. Davis, Brody & Associates, 1995–98. View to the southeast. Sundberg. ESTO

When Union Square South opened late in 1998, its theater complex, designed by associate architects Schuman, Lichtenstein, Claman & Efron, irritated Herbert Muschamp, who found it "an appalling spot with all the charm of a high security prison" in which "the poor moviegoer rises through a bleakly Piranesian escalator core, past sheetrock walls painted a sullen grey" only to find, "on the landings, . . . walls adorned with what look like tubes of spangled gift-wrap."[26] Though the theater was cheap, *Metronome*, at $3 million, was not. It, too, failed to garner much enthusiasm among critics or the public. Muschamp castigated the building as "the worst example yet of a formula that has helped to drain the life out of New York architecture in recent years: the use of public art to cover up for uninspired buildings." Muschamp decried both the building's bulk and *Metronome*'s scale: the "artists' basic miscalculation was to assume that a large surface called for comparably big forms." With the presence of such a massive piece of art, he summed up by asking, "Where's the architecture? . . . The answer is: There's no architecture here. This building has no idea what it is doing here. It has nothing fresh to say, not even an eloquent silence. It's just some space in a box with a leaky hole in it."[27]

In 1995 New York University took over the site to the west of the Genesis Apartments that had, beginning in 1882, been the home to Lüchow's restaurant, at 110 East Fourteenth Street.[28] Lüchow's, a beloved institution that had preserved its 1880s interior, including a skylit courtyard, had decamped in

1982 to a basement location in 1633 Broadway, where it failed to prosper. Its former home, now abandoned after two unsuccessful attempts in 1975 and 1982 to have it landmarked, was taken over by squatters, drug dealers, and prostitutes, before it was torn down. Many had feared that the construction of the low-income Genesis project would doom the through-block site, but its presence had the opposite effect, encouraging New York University to build an undergraduate dormitory on the property, marking the northernmost outpost of the string of residential halls it and the New School for Social Research had constructed north of St. Mark's Place.[29] The university turned to Davis Brody Bond to design 172 two-bedroom apartment suites for 640 students. The firm somewhat redeemed its Union Square South project with a layered composition (1998) that confronted Fourteenth Street with glazed ground-floor storefronts opening to a café, and a limestone-colored precast concrete facade rising fourteen stories before setting back to reveal a well-detailed, glazed, boxlike volume rising five more floors as a large-scale element glowing at night in contrast to the more typical residential pattern of the lower floors. The building was, in fact, U-shaped, extending south to Thirteenth Street. Inside the U, a two-story-high dining hall and cafeteria for 300 students was elegantly roofed by a sloped tensile-structured skylight.

In 1997 New York University announced plans for a second dormitory on East Fourteenth Street, replacing the Palladium, 126 East Fourteenth Street, the former Academy of Music

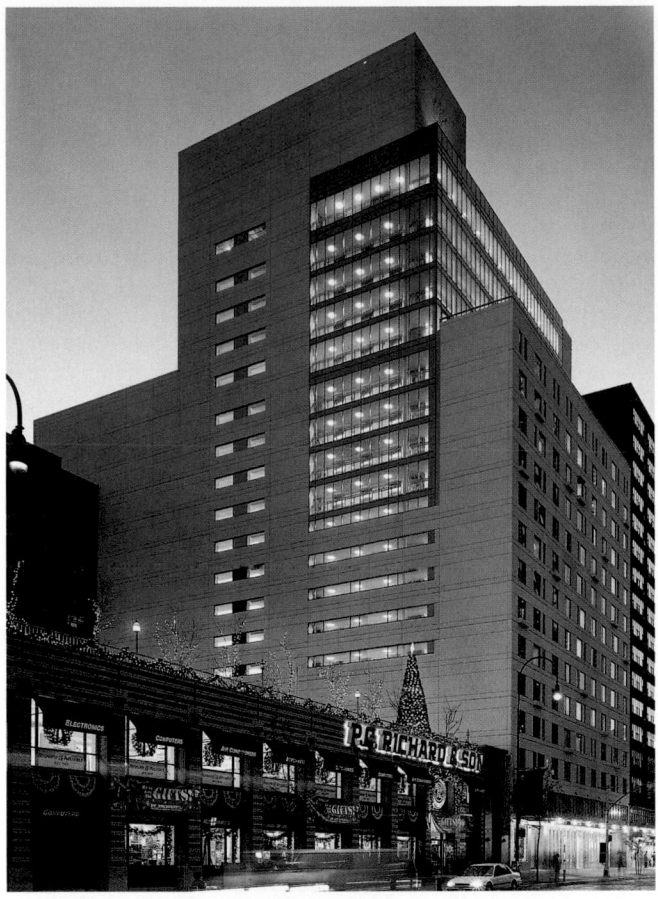

University Hall, 110 East Fourteenth Street, between Third and Fourth Avenues. Davis Brody Bond, 1998. View to the southwest. Warchol. DBB

University Hall, 110 East Fourteenth Street, between Third and Fourth Avenues. Davis Brody Bond, 1998. Dining hall. Warchol. DBB

Theater, which had been reimagined as the high-end, artistically ambitious Palladium night club (1985) (see Interiors) and had a short but incandescent moment on New York's entertainment scene before succumbing to the impact of the AIDS epidemic and the aftermath of the stock market crash of 1987.[30] For the new sixteen-story, 670,000-square-foot, 1,000-bed residence hall and recreation center, NYU turned to Kevin Roche John Dinkeloo and Associates, whose iron-spot brick facade rising over a stone-clad vaguely classical base conveyed a more residential character than Davis Brody Bond had achieved.

Though Zeckendorf Towers and NYU's two blandly faced behemoth dormitories and the strip shopping building between them had robbed the block, and the neighborhood, of a good deal of its historical character and intimacy, by 2000, both Union Square and Fourteenth Street were enjoying something of a renaissance. Fourteenth Street, especially the blocks from Union Square West to Sixth Avenue, was among the city's liveliest shopping streets, catering to bargain hunters. The street had come a long way since the mid-1970s, the nadir of the neighborhood's fortunes, but its retail vitality was dealt a blow in 1989 when the J. W. Mays department store, on Fourteenth Street between Broadway and University Place, a popular regional chain based in Brooklyn, closed its last three stores.[31] In 1994 the renovated Mays space was reopened as a branch of Bradlees, a regional retail discounter. Bradlees folded in 2000. A happier note was the decision made in 1998 by Howard Snyder, a founder of Odd Job Trading, a chain of forty

Palladium Residence Hall, 140 East Fourteenth Street, between Third and Fourth Avenues. Kevin Roche John Dinkeloo and Associates, 2001. View to the southwest. KRJDA

W Union Square Hotel, 50 Union Square East, northeast corner of East Seventeenth Street. Brennan Beer Gorman in association with the Rockwell Group, 2000. Lobby. Warchol. RG

close-out stores, to occupy and partially restore the long-neglected Morris Lapidus–designed, splashily Modernist Paterson Silks building (1949), southwest corner of University Place and Fourteenth Street, a minor work to be sure, but notable for its glazed-in double-height corner tower rising to a projecting monopitch roof. Sadly, however, the "very dramatic, proto-space-age interior, featuring a free-form, cantilevered mezzanine and a suspended staircase" was not so faithfully restored, with the staircase preserved but the mezzanine demolished.[32] On March 8, 2005, the building's fortunes took a turn for the worse when just hours before the Landmarks Preservation Commission agreed to hold a hearing on its potential designation, the glass tower along with the rest of the front facade was demolished as part of the building's renovation as a bank.[33]

Another sign of Union Square's rejuvenation was the conversion of the Guardian Life Building, 50 Union Square East, into the W Union Square Hotel (2000).[34] The Guardian Building began as the Germania Life Building but was renamed when its owners changed their corporate name in response to anti-German sentiment at the time the United States entered World War I in 1917. After the insurance company moved in 1999, the building was renovated as the 270-room W hotel by Brennan Beer Gorman, working in association with the Rockwell Group, who took advantage of the most notable interior details, including the second-floor ballroom, a designated landmark. The hotel's new interiors included a grand limestone staircase that swept up from the lobby to the public rooms on the mezzanine, embellished

with flats of wheat grass embedded on the outer edge of each tread. Less successful was the restaurant, called Olives, which Owen Philips denounced in the New Yorker for its "patchwork-quilt-themed decor from an out-of-date Pottery Barn catalogue [with] overwrought candelabras and droopy blown-glass pod lights [that] make for a strictly suburban fantasy of fanciness."[35] A controversy arose over the replacement of the historic red neon Guardian Life sign on the building's mansard roof with one of a similar scale, font, and color, reading W Union Square. Although the Landmarks Preservation Commission considered the Guardian Life sign an "early and impressive example of modern signage," whose placement on a French mansard roof embodied "the fusion of traditional and modern elements in one design," it approved the new sign.[36]

MADISON SQUARE

By the 1970s, Madison Square and the neighborhood around it were in steep decline.[1] At the district's center was the 6.8-acre Madison Square Park (1847; redesigned, Ignatz Pilat and William Grant, 1870), bounded by Broadway and Fifth Avenue on the west, Twenty-sixth Street, Madison Avenue, and Twenty-third Street.[2] From the 1850s to the 1870s, Madison Square was the city's most fashionable residential district, primarily composed of brick and brownstone townhouses. In the following two decades, as fashion moved farther uptown, the neighborhood became a cultural and entertainment node anchored by P. T. Barnum's Hippodrome (1874), operated beginning in 1879 as Madison Square Garden until its replacement by the second Madison Square Garden (McKim, Mead & White, 1887–90), as well as numerous hotels, restaurants, theaters, and social clubs.[3] The twentieth century saw the emergence of Madison Square as an important business center and a suitable place for tall office buildings with the construction of the Flatiron Building (Daniel H. Burnham & Company) in 1902 at the intersection of Broadway, Fifth Avenue, and Twenty-third Street. The eastern border of the park was transformed by the construction of Metropolitan Life's 1 Madison Avenue (Napoleon LeBrun & Sons, 1909), between Twenty-third and Twenty-fourth Streets, its annex, 11 Madison Avenue (Harvey Wiley Corbett and D. Everett Waid, 1932) across Twenty-fourth Street to the north, and, two blocks north of that, replacing Madison Square Garden, the New York Life Insurance building (Cass Gilbert, 1928), 51 Madison Avenue, between Twenty-sixth and Twenty-seventh Streets.[4] In 1973 Emery Roth & Sons's black glass–clad forty-two-story New York Merchandise Mart was built on the southeast corner of Madison Avenue and Twenty-sixth Street, replacing the Leonard Jerome house (Thomas R. Jackson, 1859), built by Winston Churchill's maternal grandfather and later home to the Manhattan Club.[5] The house had been designated a landmark in 1965, but it was demolished after its owners successfully argued economic hardship.

In 1976 Roger Ferri proposed a visionary skyscraper for the east blockfront of Madison Avenue facing Madison Square Park between Twenty-fifth and Twenty-sixth Streets, ignoring both the New York Merchandise Mart and the Appellate Court (James Brown Lord, 1900) next door to the south, northeast corner of Madison Avenue and Twenty-fifth Street. The courthouse was declared a landmark in 1966 (interior

ABOVE Proposed skyscraper, east blockfront of Madison Avenue, between East Twenty-fifth and East Twenty-sixth Streets. Roger Ferri, 1976. West elevation. CU

BELOW Proposed skyscraper, east blockfront of Madison Avenue, between East Twenty-fifth and East Twenty-sixth Streets. Roger Ferri, 1976. Photomontage, view to the west from skyscraper. CU

Proposed skyscraper, east blockfront of Madison Avenue, between East Twenty-fifth and East Twenty-sixth Streets. Roger Ferri, 1976. Photomontage, view to the south from skyscraper. CU

Proposed skyscraper, east blockfront of Madison Avenue, between East Twenty-fifth and East Twenty-sixth Streets. Roger Ferri, 1976. Rendering of view to the northeast. CU

designated in 1981) and restored, both inside and out, by Platt Byard Dovell beginning with minor repairs to its decorative sculpture in the 1980s and concluding in 2001.[6] Ferri's scheme, proposing to fuse nature and the modern office building, was a cri de coeur inspired by the same sense of outrage against unbridled urban development that had led to the creation of Central Park in the mid-nineteenth century. The first eleven stories of Ferri's forty-four-story fantasy maintained the street wall. Above that base, the building rose in a series of continuous west-facing setbacks upon which bedrock excavated from the site formed the foundation of a proposed wilderness composed of ponds, hillocks, meadows, forested gorges, waterfalls, and trees. To make this "urban landscape," as Ferri called it, even more alive, an array of animals—deer, rabbits, birds, and fish—that thrive in captivity were to inhabit the skyscraper's terrain. Access to the landscape was provided on every office floor. On the first major setback, a restaurant would offer the public an opportunity to experience the forest, while a museum intended to "broaden the visitor's conception of the city through activities and observation" was to occupy the top three floors.[7] Ferri depicted his scheme in a series of remarkable renderings showing the dramatic juxtaposition of sylvan mountainscape with New York's familiar urban scenery as they would be seen from various vantage points in the building.

Paul Goldberger found "splendid irony . . . on several levels" of the design: "It comments at once on the harshness of the glass and steel skyscraper, on the difficulty of introducing a natural landscape to the city, and on the conventional view of early Modernist architects of the skyscraper as an 'urban mountain.'"[8] Ferri's proposal was echoed, though less dramatically, in Norman Foster's 2000 competition entry for the *New York Times* tower, Eighth Avenue between Fortieth and Forty-first Streets, in which the proposed 650-foot-high skyscraper offered set-back tree-filled terraces every seven stories (see Forty-second Street).

In contrast to Ferri's provocative proposal, the reality of Madison Square during the 1970s and 1980s was sobering. Prostitution abounded and drug dealing was commonplace in and around the park. Contributing to the problems was the widespread conversion of once stately hotels into welfare hotels, primary among them the Prince George Hotel (Howard Greenley, 1905), 14 East Twenty-seventh Street, which, with 1,700 tenants, was the city's largest such facility. Nicknamed "the Mayor Koch Hotel,"[9] it was described by the police as "the deadliest address in the city," where five murders were committed in 1988.[10] By 1989 Koch began to shut down welfare hotels, many of which were converted to apartments and some into first-class hotels. In 1996–99, the Prince George Hotel was converted by Beyer Blinder Belle to subsidized

housing for 416 low-income and formerly homeless residents.[11] In return for restoring the ornate ceilings and mosaic tile floors of the lobby, foyer, and former tea room, the developer, the nonprofit Common Ground Community, was granted a Historic Preservation Tax Credit from the U.S. Department of the Interior, possible because the building was listed on the National Register of Historic Places.

Given Madison Square's transitional status, the 1980s building boom passed it by, with a few exceptions, like Madison Green (1983), 5 East Twenty-second Street, a thirty-one-story apartment building of formidable bulk that confronted the park and its public with a meanly detailed light brown brick facade, monotonous stacks of balconies, and boxy massing.[12] Designed by Philip Birnbaum working with David Kenneth Specter, who designed the public spaces, Madison Green afforded its 424 tenants superb park and skyline views as it dominated the park from a 28,000-square-foot site between Twenty-second and Twenty-third Streets on Broadway. The Stanford (Liebman Liebman Associates, 1986), 45 East Twenty-fifth Street, between Madison and Park Avenues, a slender forty-two-story, 120-unit apartment building with rounded corners and semicircular balconies was similarly drab despite a limestone-clad base. A thirty-foot setback from the neighboring Appellate Court provided the developers with a significant height bonus.[13]

The economic recovery of the mid-1990s helped speed the Madison Square neighborhood to recovery, especially after 1994, when the Fox television network's cable arm, FX, took up residence in 70,000 square feet of 212 Fifth Avenue (Schwartz & Gross, 1913), southwest corner of Twenty-sixth Street, and donated funds to help landscape and maintain the park.[14] The network also cosponsored, with the 23rd Street Association, an artwork, *Circle of Hope*, by Melinda Hunt, a circle of Red Seneca corn forty feet in diameter surrounded by a steel fence meant to reference the site's eighteenth-century use as a burial ground and later as a potter's field plowed and planted with corn.[15] In the spring of 1995, two graduates of the architecture school of the Cooper Union, Martin Finio and Kevin Fischer, gave the area a boost when they installed a full-scale version of John Hejduk's drawing *The Conciliator*, constructing an eighteen-and-a-half-foot-tall dark gray-painted wood tower on the traffic island at Fifth Avenue and Twenty-third Street across from the Flatiron Building. Herbert Muschamp characterized the Hejduk piece as "puzzling, enigmatic . . . looking something like an unattended information booth."[16] Fischer and Finio raised the money for the project and built it themselves as a tribute to their former teacher, who preferred to draw and not build. The original (1984) design called for ramps up to the booth from either side; people with a dispute would climb them to confront the conciliator who would, presumably, resolve their differences. In the realized version, the exigencies of the site led to the use of a vestigial wedge instead of ramps and the substitution of the conciliator character with an I-beam section in honor of the Flatiron Building, the city's first steel-framed skyscraper, and Peter Cooper, founder of the Cooper Union and the first manufacturer of rolled steel beams in America.

By 1998 Madison Square Park, though largely relieved of drug dealing and homelessness, was physically rundown—a victim of poor irrigation, cracked asphalt, missing benches, broken fences, and years of general neglect. The future began to look brighter when Danny Meyer, a prominent restaura-

teur, expanded his empire to Madison Square, opening Eleven Madison Park and Tabla, both designed by Bentel & Bentel, in the street-level space of 11 Madison Avenue, which, with a new primary tenant, Credit Suisse First Boston, was being renovated.[17] Before agreeing to the restaurant lease, Meyer required his future landlord, Met Life's chairman and CEO Robert Benmosche, to take a leadership role in the park's restoration, explaining, the "whole reason for [the restaurant] is to rekindle the celebratory spirit and hospitality that the area had 100 years ago."[18] Meyer and Benmosche co-chaired the Campaign for the New Madison Square Park and enlisted the financial support of other area companies as well as the City Parks Foundation, a nonprofit organization that took charge of the restoration effort, helping elicit a commitment from the city to match all private donations. With funding in place, work was under way in January 2000. As renovated by HM White Site Architects, working with garden designer Lynden B. Miller, the park, which reopened on June 12, 2001, benefited from 15,000 new shrubs, plants, and trees, as well as new signage, lampposts, fluted cast-iron perimeter fencing, and 1939 World's Fair–style benches. The fountain at its south end was restored and a new reflecting pool was constructed at the park's north end. In addition, the existing maintenance station was moved underground and a patch of asphalt southeast of the park used for motorcycle parking was reclaimed to become a new formal entrance.

The impact of Madison Square Park's rejuvenation was felt throughout the neighborhood. In 1997 the former Layton Hotel (William H. Birkmire, 1905), 7 East Twenty-seventh Street, reopened as the Gershwin, and two years later, the Hotel Giraffe was completed. In 2000 work was completed on the forty-eight-story Madison Belvedere, 10 East Twenty-ninth Street, a 404-unit apartment building designed by Schuman, Lichtenstein, Claman & Efron.[19] Twenty stories higher than normally permitted by zoning, the Madison Belvedere towered far above its neighbors as a result of transferred air rights and the provision of a quarter-acre public plaza facing Twenty-eighth Street designed by Thomas Balsley. The rather ungraceful, sheer tower, topped by an awkwardly proportioned, three-story-high water tower enclosure with a gilded mansard roof, was at best a clumsy homage to the nearby New York Life building.

The most exciting architectural addition to the neighborhood promised to be SHoP Architects' Museum of Sex, known as MoSex, to replace the five-story building at 233 Fifth Avenue, northeast corner of Twenty-seventh Street, originally a private house that was renovated and expanded in 1890 by R. H. Robertson to serve as the headquarters of the Reform Club.[20] The museum, established in 1998 and touted by its founders as the country's first museum of sexuality, was established as a for-profit corporation after the New York Board of Regents would not allow its incorporation as a cultural nonprofit organization, stating that it "made a mockery of the institution of the museum."[21] SHoP's design, prepared in 1999, called for a 35,000-square-foot, seven-story, L-shaped building organized, in essence, by a series of four parallel undulating planes. The outermost plane, the building's facade, was molded to suggest the contours of the human body and was to be clad in a combination of transparent and translucent glass and plastic panels attached to a grid of flat-rolled steel mullions. The facade's varying degrees of transparency would allow onlookers to see clearly into the building at some angles

but to see only silhouetted figures from others. Inside, the bulges and depressions of the distorted planes were to perform various pragmatic and experiential functions, with, for instance, the innermost plane concealing infrastructural components and the museum's vertical circulation contained between the outermost two planes. The narrow west facade was to feature superscaled letters—one per floor—turned on their side to spell, from top to bottom, *MOSEX*. The ground floor was to be clad in clear glass. Though some doubted the validity of the museum's purpose, SHoP's design was widely applauded. The Museum of Modern Art acquired a model of the building for its permanent collection. Fund-raising efforts did not prove easy, however, and in September 2002, MoSex opened in what was hoped to be a temporary exhibition space occupying 5,000 square feet on the first two floors of 233 Fifth Avenue, with its show "NYC Sex: How New York City Transformed Sex in America."

In July 2001, the Landmarks Preservation Commission designated the Madison Square North Historic District, comprising ninety-six buildings in an irregularly bounded ten-block area between Twenty-fifth and Twenty-ninth Streets, from west of Broadway to Madison Avenue.[22] Many of the protected structures were office buildings from the late nineteenth and early twentieth centuries.

Two blocks east of Madison Square was Baruch College, a senior college of the City University of New York, founded in 1919. By the mid-1980s, Baruch was scattered in so many facilities in the East Twenties around Park and Lexington Avenues that students had come to refer to the school as U.C.L.A.: University on the Corner of Lexington Avenue. In 1986 Davis, Brody & Associates, hired to develop a master plan to guide its growth, identified potential sites for future development and recommended the updating of certain facilities as well as the creation of new ones in an effort to relieve

The Conciliator, Fifth Avenue and Twenty-third Street. John Hejduk, 1984. Realized by Martin Finio and Kevin Fischer, 1995. View to the southwest. Goldberg. ESTO

Madison Belvedere, 10 East Twenty-ninth Street, between Madison and Fifth Avenues. Schuman, Lichtenstein, Claman & Efron, 2000. View to the southwest. SLCE

Proposed Museum of Sex, northeast corner of Fifth Avenue and East Twenty-seventh Street. SHoP Architects, 1999. Rendering of view to the northeast. SHOP

Newman Library and Technology Center, 151 East Twenty-fifth Street, between Third and Lexington Avenues. Davis, Brody & Associates, 1994. Atrium. Aaron. ESTO

overcrowding and eliminate the need to rent space for college use.[23] In 1994 the firm transformed a former cable-car drive station (G. B. Waite, 1894) at 151 East Twenty-fifth Street, between Lexington and Third Avenues, into a state-of-the-art library, the Newman Library and Technology Center.[24] The building's Renaissance Revival exterior of Pompeiian brick, terra-cotta, and limestone was carefully restored, and the original cast-iron structure of the interior was retained. The architects inserted a second floor in what had formerly been an engine room and added a partial ninth floor to the roof to comprise a total of 330,000 square feet. The first six floors of the new building housed the 525,000-volume library, saving the upper levels for much needed conference rooms, offices, and a faculty lounge. A two-story lobby led to the building's former light well, which was reborn as a five-story cherry-paneled atrium capped by a seventy-by-ninety-foot skylight. A semicircular stairwell bounded by a curving glass-block wall adjoined the atrium.

In 2001 the college completed the mammoth Baruch College Academic Complex, 55 Lexington Avenue, between Twenty-fourth and Twenty-fifth Streets, a fourteen-story "vertical campus" designed by Kohn Pedersen Fox.[25] The building contained nearly 50 percent of the school's facilities. The site had originally been marked for development in Davis, Brody's 1986 master plan, which envisioned a boxy twenty-three-story tower situated on Lexington Avenue adjoined by lower midblock portions. When the project went to KPF, concerns over elevator inefficiencies eliminated the tower idea, and the bulk was distributed more evenly across the site. Troubles arose when efforts were made to save some existing buildings on the

site, one of which, a seven-story stable (Horgan & Slattery, 1907) at 155 East Twenty-fourth Street built for the Fiss, Doerr & Carroll company, a horse dealer, had become home to the RCA recording studio where Elvis Presley recorded his first album for the label. The landmark campaign failed.

The 764,237-square-foot facility was designed, according to William Pedersen, to be both "grand and intimate," a real challenge given its dense program, which accommodated a student union, bookstore, and dining facilities on the first floor, lecture halls on the third through fifth floors, the School of Liberal Arts and Sciences on the sixth through eighth floors, the School of Business on the ninth through twelfth floors, and the school's Executive Education Program on the top two floors. Three below-grade levels contained athletic and cultural facilities, including a gymnasium, pool, 300-seat theater, and 250-seat recital hall. To achieve some sense of place, Pedersen centered all these elements around a "vertical quadrangle," a thirteen-story stepped atrium that shifted laterally as it rose through the building.[26] Enormous windows allowed light to enter through the south side of the building, pour through the atrium, and splash onto the facade of the Newman Library across Twenty-fifth Street to the north.

The exterior expression was awkward, to say the least. According to the architects, zoning dictated the building's shape, which combined swooping curves rendered in painted aluminum panels and glass curtain walls with a five-story rectilinear red brick and stone base. The base, presumably meant to reference the scale and aesthetic of the surrounding buildings with its rows of square windows, only barely tempered the colossal bulk of the building's upper reaches, the metal

RIGHT Baruch College Academic Complex, 55 Lexington Avenue, between East Twenty-fourth and East Twenty-fifth Streets. Kohn Pedersen Fox, 2001. Aerial view to the southeast. Moran. MM

BELOW LEFT Baruch College Academic Complex, 55 Lexington Avenue, between East Twenty-fourth and East Twenty-fifth Streets. Kohn Pedersen Fox, 2001. View to the southeast. Moran. MM

BELOW RIGHT Baruch College Academic Complex, 55 Lexington Avenue, between East Twenty-fourth and East Twenty-fifth Streets. Kohn Pedersen Fox, 2001. Atrium. Moran. MM

Baruch College Academic Complex, 55 Lexington Avenue, between East Twenty-fourth and East Twenty-fifth Streets. Kohn Pedersen Fox, 2001. Study for sunlight penetration. KPF

skin and irregular fenestration of which suggested an interplanetary launching site. Joseph Giovannini was taken by the "inflated" form of the upper stories, which seemed "suspended in the city, hovering like a gigantic balloon, wondrously large for the tight streets." Though Giovannini felt that, as a whole, "the design transforms the contextual givens in a polite but strong response that respects the neighborhood without aesthetic servitude," the two style-languages of its facades seemed to leave the Baruch building caught between its own and its neighbors' architecture, failing to fit in but not quite making a convincing statement of its own.[27] The building did, however, function well.

MURRAY HILL

Murray Hill, the mixed-use neighborhood roughly bounded by Fifth and Third Avenues, Thirty-fourth and Forty-second Streets, managed to maintain the faded elegance of its historic residential streets amid major new construction on its avenue blocks. These included three office buildings and two apartment towers on Fifth Avenue (see Fifth Avenue), two office buildings on Park Avenue (see Terminal City), and various apartment houses, including two sliver towers erected just before the type was banned. In 1982, as the citywide furor over sliver buildings was gaining momentum, Sybedon Corporation, a developer, hired David Kenneth Specter to design a twenty-seven-story residential tower on a thirty-one-by-eighty-foot site at 52 Park Avenue, between Thirty-seventh and Thirty-eighth Streets, previously home to a four-story-and-basement brick townhouse (James Brown Lord, 1898).[1] Although the building was legal under zoning—and the developers even gained a 20 percent space bonus under the city's Housing Quality Program—community protest ensued; by 1984, when construction got under way, the plan had been reduced to a twenty-one-story red brick building containing ten 2,600-square-foot duplex apartments. Completed in 1985, 52 Park Avenue, with its white-painted balcony railings and thick white window frames, was, for the editors of the *AIA Guide*, a "glossily detailed narrow Park Avenue facade" counterpointed

with a "huge blaaah side wall."[2] Despite its considerable shortcomings, 52 Park Avenue was, all in all, an acceptable insertion in its staid setting. Such was not the case for another sliver tower completed the same year, Morgan Court, 211 Madison Avenue, between Thirty-fifth and Thirty-sixth Streets, a thirty-two-story, thirty-three-foot wide, forty-unit red Norman brick apartment building designed by Liebman Liebman Associates and featuring horizontal window bands and rounded corners.[3] Although Harold Liebman defended the design as one that tried "as far as possible to blend in with the rest of the block . . . [with] no sharp corners in an effort to soften the structure's slenderness," the building stuck out as a particularly bruised sore thumb given its distinguished low-rise neighbors, the Morgan Library to the north, and Emlen T. Littel's Church of the Incarnation (1865) and parish house (1868) directly to the south.[4] More successful were the ground-level spaces designed by interior designer John Saladino, who created the unusual entry consisting of two limestone gatehouses linked by a patinated cooper roof that led through the cobblestone lobby to a lush rear garden complete with reflecting pool and two-story glazed greenhouse.

Any controversy or worries generated by the construction of two sliver towers in the neighborhood were soon eclipsed by plans to expand Murray Hill's cultural and architectural anchor, the incomparable Pierpont Morgan Library, between Madison and Park Avenues, Thirty-sixth and Thirty-seventh Streets.[5] Though almost every New York museum could rightly complain of a lack of space, conditions at the Morgan Library, a somewhat insular, even clubby, institution, were genuinely distressing. The Morgan, incorporated as a public reference library by the New York state legislature in 1924, was blessed with a remarkable collection of medieval and Renaissance illuminated manuscripts, Old Master drawings, rare musical scores, and literary artifacts, highlighted by three Gutenberg bibles and thirty-nine volumes of Thoreau's journals. Less than 1 percent of the Morgan's treasures could be displayed at any one time. While the amount of space was indeed a problem, the quality of that space was hardly an issue, with the Morgan Library headquartered in Charles McKim's classical masterpiece (1902–7), 33 East Thirty-sixth

Pierpont Morgan Library garden court, east side of Madison Avenue, between East Thirty-sixth and East Thirty-seventh Streets. Voorsanger & Mills, 1991. View to the east showing the Isaac N. Phelps house (1852) on the left and the Annex (Benjamin Wistar Morris, 1928) on the right. VA

Street, between Madison and Park Avenues, with its extraordinarily lavish interiors, commissioned by J. Pierpont Morgan expressly for the purpose of housing his enormous and growing collection of books, and its 1928 wing designed by Benjamin Wistar Morris to complement McKim's building, using the same pink Tennessee marble.[6]

Faced with a space crunch, in the summer of 1987, Charles E. Pierce Jr., who had been appointed director of the Morgan Library in May, was presented with an opportunity to purchase the building directly north of Morris's Annex, 231 Madison Avenue, southeast corner of Thirty-seventh Street. Built for Isaac N. Phelps (1852), the mansion, appropriately enough, had been purchased by Morgan for his son in 1905, but upon J. P. Morgan Jr.'s death in 1943, the forty-five-room Italianate brownstone was sold to the Evangelical Lutheran Church of America. The asking price of $15 million was certainly not a bargain, but Pierce saw it as a unique opportunity. On April 20, 1988, the Morgan Library simultaneously announced the purchase of the Phelps brownstone, along with an adjacent garden and a modest, six-story light brick office building built by the Lutheran Church in 1956 immediately to the east of the mansion on Thirty-seventh Street, the beginning of a $40 million capital campaign, and the

hiring of Voorsanger & Mills to design a master plan for the institution's expansion.

The first important decision concerned the fate of the 45,000-square-foot Phelps mansion, which, because of the susceptibility to fire of its wood framing, was deemed unsuitable for the storage or display of the collection and could be used only for offices and public amenities. Despite annual deficits of more than $200,000, the Morgan rejected the potential windfall of replacing it with an income-producing tower because they felt it would destroy the essential character of the museum, which hosted over 2,000 research historians each year. As Pierce put it when the purchase of the 1852 brownstone was announced in the *New York Times*: "The Morgan Library will grow. But it will not grow at the expense of intimacy and human scale."[7] But the Morgan's decision was also informed by the ill will generated by the Lutheran Church in its unsuccessful attempt in the late 1960s and early 1970s to build an income-producing tower on the Phelps mansion site.[8]

In March 1989, Bartholomew Voorsanger released a two-phase master plan for the Morgan Library's expansion, calling for the renovation of the historic brownstone for offices, an education center, and a bookstore, and the creation of a glass-enclosed garden court to tie together all the museum

buildings. The main building and annex would also be refurbished at this time. The second phase, which was not put on any official schedule, involved the demolition of the small office building on Thirty-seventh Street to make way for a scholars' wing that would include book vaults, a reading room, and support facilities. Pointing to a reworked, handicap-accessible main entrance in the annex, to be clad in the same marble used for the McKim and Morris buildings, as a demonstration of an appropriate approach for the Morgan's future growth, retaining what was fine about the older buildings while creating something new, Voorsanger stated, "One obvious choice was to enter through the garden on Madison Avenue, with a portal at the midpoint on the avenue, and convenient connections to all the surrounding buildings. Easy but problematic. . . . To make the garden the point of entry, with all the activity this implies, would be to destroy that tranquility which is one of the most attractive and, in New York, most irreplaceable attributes of the place."[9]

Although Voorsanger opted to retain the entrance through the Morris building, his proposed glazed garden court, an addition that the architect viewed as the "new central fulcrum for internal circulation," threatened to dramatically compromise the tranquil garden. The garden, a visual delight to passersby, was also an important part of the Morgan "story." After J. P. Morgan Sr. purchased the Phelps mansion for his son, he demolished the intervening building in the middle of the block to create the garden, which, in the 1920s, was redesigned by Beatrix Farrand. By the time of the Morgan Library's repurchase, the garden had become overgrown. Voorsanger believed it was crucial that the spirit of the garden be retained "as much for the morale of the staff as for enhancement of the Institution's public image."[10] Moreover, Voorsanger argued that his glassy garden court was the most powerful and visible sign of the Morgan Library's commitment to growth and public access. The landscape architect Dan Kiley was placed in charge of all interior plantings for the garden court.

Paul Goldberger greeted the plans with cautious optimism: "The most daring aspect of the expansion plan by far is the proposal to fill the 35-foot-wide space between the rear of the present Morgan Library and the south side of the brownstone mansion with a glass conservatory. . . . The long, narrow structure of glass would be asymmetrical and is intended to provide a lighter, more lyrical counterpoint to the formal, classicizing lines of the two buildings flanking it. . . . Programmatically . . . the court is a splendid idea." But Goldberger was concerned about the potential clash of styles:

> Bridging the gap between an Italianate brownstone from 1852 and the Renaissance-style 1928 addition to the Morgan Library . . . is not an easy architectural problem. . . . To use either building's style for the new section in the middle runs the risk of being coy or precious. . . . But adding a third style could bring confusion to this already intense section of the New York streetscape. Given the fairly crisp and modern lines of Mr. Voorsanger's conservatory, the architect obviously has opted to take this chance. He is presumably counting on the asymmetrical curves of his conservatory to soften the transition from one style to another and make this section a visual interlude rather than a main event. Models and photographs suggest that he will pull it off.[11]

Max Alexander, writing in *Art in America*, saw the situation rather more clearly:

Pierpont Morgan Library garden court, east side of Madison Avenue, between East Thirty-sixth and East Thirty-seventh Streets. Voorsanger & Mills, 1991. Warchol. PW

The olive trees and topiary wall of Voorsanger's design look appealing on paper, but will the greening of the Morgan mean an end to the institution's quaint charms? "We will still be small and intimate," promises Michael Kaiser, former associate director of the Morgan and consultant to the expansion. "There are no party rooms." There will, however, be a members' lounge, and the new bookshop just happens to be 40 percent larger than the old. A final feature of the new building will be a permanent display documenting the library's 60-year history. This seems like a timely idea, since the Morgan as we know it is about to become a chapter in its own past.[12]

As built, Voorsanger's too self-important, 4,000-square-foot garden court (1991) challenged the architect's claim that the glassy addition was a "place of meditation" as well as an effective circulation spine.[13] The fear of a serious disruption to the Madison Avenue streetscape, however, proved not so much of a problem given that it was set back twenty feet from the street and partially screened by a freestanding limestone wall carrying the name of the museum. In addition, although the garden court reached a height of forty-three feet at its peak, slightly higher than the annex but lower than the brownstone, its curving glass quickly swept down to a less obtrusive height. In fact, when viewed from across Madison Avenue, the dominating

BELOW Proposed addition, Pierpont Morgan Library, east side of Madison Avenue, between East Thirty-sixth and East Thirty-seventh Streets. Renzo Piano, 2002. Model. Denance. RPBW

ABOVE Proposed addition, Pierpont Morgan Library, east side of Madison Avenue, between East Thirty-sixth and East Thirty-seventh Streets. Renzo Piano, 2002. Model, view to the east. Denance. RPBW

presence on the street continued to be the Morgan's immediate neighbor to the north, C. P. H. Gilbert's exceptionally robust chateau-style Raphael De Lamar house (1902–5).[14]

Raised one level to connect directly to the brownstone, the garden court was reached from the reworked entrance in the annex through a small room with benches and interactive computer displays. The wavelike forms visible from Madison Avenue were repeated throughout in the atrium, which included a small curving balcony serviced by an elevator that also led to a lower level with telephones and restrooms. The floor and some walls of the room were white Vermont crystal stratus marble, but the back wall, inscribed with a list of donors, was made of Indiana limestone. Dan Kiley's planting scheme included four mature black olive trees as well as jasmine, bougainvillaea, bleeding heart, and little leaf ficus growing on the walls. Inaccessible to visitors but glimpsed from inside the atrium, a small "backyard" garden was graced by a single ginkgo tree and a modest water feature of single jets placed about five feet apart. Both the greenery of the garden court and open-air garden were largely lost to passersby on Madison Avenue, where the new limestone wall gave the expanded complex a fortresslike character it had never before had.

The steel-framed garden court seemed rather elaborately structured given its comparatively modest size. Over two-thirds of its load was carried on a fifty-five-foot-long white-painted truss stabilized by pretensioned cables and set on steel-jacketed columns, exerting a powerful presence in the relatively small space. Dominated by the tables and chairs of the modest new restaurant, the enclosure seemed less garden than café, which seriously hampered any chance to refresh oneself

in the light-filled space after spending time in the ornate gallery rooms. The atrium was connected directly to the new bookstore in the renovated brownstone, which was renamed Morgan House. A second entrance on Madison Avenue through the 1852 building led directly to the bookstore and café so one could now browse or eat without paying an entrance fee and skip the collections entirely.

The reaction to the realized design was mixed. After noting that the period rooms in the brownstone had been faithfully restored, Benjamin Forgey, writing in the *Washington Post*, turned his attention to the problem of "stitching together the unlike pieces to make an ensemble. They [Voorsanger & Associates; renamed in 1990] did very well. With a gracefully curved steel-and-glass conservatory roof now mediating between the annex and the brownstone, the Morgan Library is no mere assortment of buildings. Rather, it is a definable low-rise historical place in high-rise New York, an island of civility. . . . The aesthetic philosophy clearly is one of contrast—this is a modern room, with antecedents in Le Corbusier as well as in the engineering feats of the 19th century. But the contrast is muted, polite, first of all because it is a soaring room in a sequence of rooms, and second because it has been skillfully detailed in a combination of contemporary and traditional materials."[15] Clifford Pearson, writing in *Architectural Record*, saw the Garden Court as a "bold stroke in conception and execution" which "created a restrained but elegant room that works as well by day as by night."[16]

Even Paul Goldberger, who had initially greeted the plans with some trepidation, professed himself pleased with the results, although his praise for the project generally had more to do with the Morgan Library's remarkable collection and the brilliance of the McKim building, which he described as a "great temple, at once sinfully opulent and chillingly dry" with its "awesome suite of rooms." When it came time to discuss the garden court, Goldberger was conflicted:

> It's modern in its detailing, yet relatively iconoclastic in its shape, obviously intended to defer to both the powerful Renaissance architecture of the original library buildings and the gentler style of the Morgan house. In principle, this is the right approach. . . . Mr. Voorsanger's semi-soft, abstract form makes a suitable bridge between the various older sections. And the scale of the interior of the garden court . . . is superb. . . . Why then, if the style is right and the scale is right, isn't the conservatory as pleasurable as it ought to be? There is a sleek, almost brittle quality to this space, and it comes off feeling at odds with the tranquility of the Morgan Library as an institution.[17]

Hilton Kramer, an unabashed admirer of the Morgan who acknowledged feelings of "alarm and even dread" when the expansion plans were first announced, was relieved "to be able to report that the worst *hasn't* happened" and that the museum "survived" its redesign. Still, he could not abide Voorsanger's addition: "The Garden Court . . . isn't a real garden but a decorated space that rather resembles the kind of tasteful rest area you might expect to find in an upscale shopping mall or a modern museum structure." Kramer also objected to the architect's newly added limestone wall in front of the atrium, calling it "the ugly parapet that has been constructed along its western flank to separate the court from Madison Avenue traffic. From inside the court it is merely a featureless obstacle, but for pedestrians traversing Madison Avenue between 36th and 37th streets it is a real eyesore."[18] Roger Kimball, writing in the *Wall*

LEFT Scandinavia House, 58 Park Avenue, between East Thirty-seventh and East Thirty-eighth Streets. Polshek Partnership, 2000. View to the southwest showing 52 Park Avenue (David Kenneth Specter, 1985) on the left and the Kitano Hotel (1926; renovation, Bohdan A. de Rosset, 1995) on the right. Barnes. RB

BELOW Scandinavia House, 58 Park Avenue, between East Thirty-seventh and East Thirty-eighth Streets. Polshek Partnership, 2000. Café. Barnes. RB

Street Journal, was even more dismissive of the garden court: "Like so much architecture today . . . it is terribly self-conscious and overdesigned. Its asymmetrical profile—no doubt intended to give the structure a special signature—looks like nothing so much as a gigantic cowlick."[19]

The garden court was, in the last analysis, an artistic and functional failure. In the late 1990s, the Morgan Library again seriously considered additional construction. After a confused search for a new architect, it turned to the Paris- and Genoa-based Renzo Piano, who early in 2002 produced plans for a dramatic expansion (2006), which included extensive below-grade facilities but most significantly not only replaced Voorsanger's garden court with a new glass-roofed courtyard but also broke with his advice and created a monumental entrance from Madison Avenue that cast doubt on the iconic status of McKim's building.[20]

In 1999 the American-Scandinavian Foundation, a non-profit group founded in 1910 to foster cultural and educational interaction between the United States and Iceland, Norway, Sweden, Finland, and Denmark, commissioned the Polshek Partnership to design Scandinavia House (2000), 58 Park Avenue, between Thirty-seventh and Thirty-eighth Streets, its first purpose-built headquarters.[21] The 28,000-square-foot, fifty-foot-wide, six-story building with two basement levels replaced two townhouses, 58 Park Avenue (Horace Trumbauer, 1911), the former Grace Rainey Rogers residence, and 56 Park Avenue (1904), originally the James C. Fargo house, which, combined, had served as the East German Mission to the United Nations until the time of the buildings' purchase by the foundation in 1996.[22] Though the American-Scandinavian Foundation had considered renovating the buildings, Polshek, who in his early career was deemed a preservationist, advocated their replacement. Renovating the existing buildings, Polshek warned, would produce a "schizophrenic result,"[23] whereas a new building would stand "for the unapologetic modernism of Scandinavia, which is as vital today as it was 50 years ago."[24] Sadly, no voices were raised in defense of Trumbauer's design, though the distinguished Philadelphia architect was so little represented in New York.

As a Fulbright scholar, Polshek studied in Denmark in the 1950s, but the overall design made it clear that he had kept in touch with the evolving Modernism of such Danish architects as Henning Larsen, whose Danish Design Center (1994–2000), Copenhagen, could be considered a precedent.[25] But unlike Larsen's supple, layered work, Scandinavia House confronted Park Avenue with a diagrammatic, asymmetrically composed facade with one-third treated as a glass shaft and the other two-thirds a field of pewter-colored zinc framing a five-story rectangular window crossed by louverlike Norwegian spruce slats. Separating the two sections were the words SCANDINAVIA HOUSE stretching vertically from the third to the sixth stories and underlined by a thick line that continued above the building as a flagpole bearing the American flag. The five flags of the Scandinavian countries were incorporated as vertical fins protruding from the facade above the first floor. The glass wall separating the sidewalk from the first-floor café, bookstore, and gift shop was diagonally crossed by a delicately detailed stairwell leading to the second floor, where a 170-seat auditorium featured a silver curtain designed by Jack Lenor Larsen, an American textile designer of Danish ancestry. Exhibition galleries occupied the third floor, and the top three levels contained a library, offices, and a child-care center. An outdoor

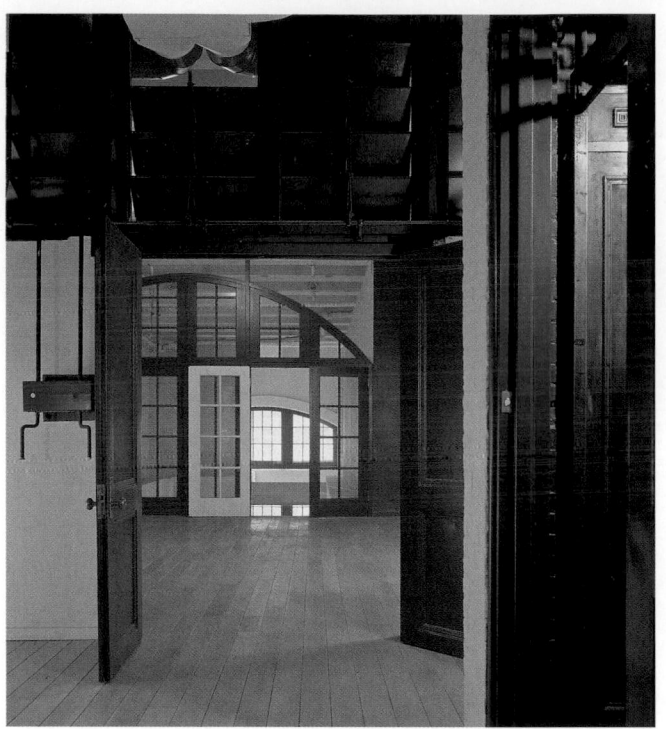

sculpture terrace was located in the building's rear yard. Throughout, the clean-lined interior spaces—softened occasionally by curving elements—were fitted out with products of Scandinavian design.

In the opinion of *New York Times* art critic Roberta Smith, "The building doesn't hit you over the head with newness. Rather, it is infused with a sense of the balanced, domesticated, understated modernism whose familiarity attests to the influence that Scandinavian design has exerted on American taste since [Alvar] Aalto's time."[26] Noting Polshek's recent success with the opening of the Rose Center, "easily the roundest thing in New York City," James Gardner deemed it ironic that Polshek "should have cultivated at Scandinavia House a rectilinearity so severe as to reduce its space to a sequence of cubic modules. On only the rarest occasions—in the lobby's sinuous Aalto-esque coat check and in the big-bellied yellow turret that separates the children's play area from the library on the fourth floor—has Mr. Polshek yielded to the beguilements of a curve. The result of this abstention is an almost Lutheran austerity that, more than once, is saved from tedium only by the vibrant intervention of some item of design."[27]

In addition to new construction, Murray Hill was home to several significant renovation projects. In 1984 the team of Ian Schrager and Steve Rubell launched an important new trend in New York hotel development when they hired the French designer Andrée Putman to convert a run-down hotel into Morgans, 237 Madison Avenue, between Thirty-seventh and Thirty-eighth Streets, creating the city's first so-called boutique hotel. This movement of comparatively small, fashionable hostelries, frequently featuring high-style, cutting-edge interiors inserted into older buildings, would quickly spread to other parts of the city but would also return to Murray Hill in the late 1990s with Rafael Viñoly's Roger Williams (1997), southeast corner of Madison Avenue and

FACING PAGE The Factory, 158 Madison Avenue, between East Thirty-second and East Thirty-third Streets. Proposition: Architecture, 1983. Hursley. TH

RIGHT The Factory, 158 Madison Avenue, between East Thirty-second and East Thirty-third Streets. Proposition: Architecture, 1983. Hursley. TH

Thirty-first Street, Stephen B. Jacobs's Library (1999), northeast corner of Madison Avenue and Forty-first Street, and M. Castedo and Jeffrey Beers's Dylan (2001), 52 East Forty-first Street (see Interiors). In 1991 the Kitano Hotel—which became the first Japanese hotel in New York when it opened in 1973 in a nineteen-story former apartment building, the Murray (1926), 66 Park Avenue, southwest corner of Thirty-eighth Street—underwent a four-year reconstruction resulting in a new spare red brick and cast-stone facade designed by Bohdan A. de Rosset and interiors by Chhada, Siembieda & Partners that included a traditional Japanese tatami guest suite and a double-height lobby finished with mahogany panels, granite floors, and travertine accents and dominated by a dramatic staircase.[28]

A more unusual renovation project, and one that received a fair amount of attention because of its high-profile client, was the 1983 transformation of a former New York Edison Company substation (1929), 158 Madison Avenue, between Thirty-second and Thirty-third Streets, into "the Factory," new headquarters for the varied activities of artist-entrepreneur Andy Warhol, including studio space and offices and production facilities for his magazine, *Interview*.[29] It was the fourth Factory location for Warhol, who had previously occupied smaller space at 231 East Forty-seventh Street, 33 Union Square West, and 860 Broadway, but the first to be given a full architectural treatment. The through-block, T-shaped, twenty-five-foot-wide, five-story building, which Consolidated Edison abandoned as a power facility in 1970, also had entrances on Thirty-second and Thirty-third Streets. As designed by Proposition: Architecture, a firm led by Anthony Caine, much of the work was devoted to restoration, including cleaning the three brick exterior fronts and restoring the putty-colored tiles that covered the walls. Huge basement-level pits formerly housing the electrical transformers were filled in and, in order to increase office space, a 2,000-square-foot mezzanine was added to the Thirty-second Street wing. The offices were furnished with wood and glass partitions salvaged from the Federal Archive Building in the West Village, which would later be converted into residential space. Pilar Viladas, writing about the Factory in *Progressive Architecture*, was impressed with Proposition: Architecture's recreation of the Thirty-third Street facade just inside the northern wing, creating a double layer of windows for the private offices beyond: "Whether seen from inside or out, the effect of the layered facades is dramatically mysterious." Noting that the "interventions in this industrial building are Classically derived," Viladas added that although "it may seem paradoxical that a project rife with historical fragments should exemplify a modern attitude toward design . . . it is that attitude, and not the actual components, that makes all the difference. Existing elements were accepted for what they were, and additions treated as 'found objects' were chosen because they worked with what was already there. The tension between the industrial and the Classical is unpredictably powerful. The spaces are at once grand and intimate, welcoming and spooky, mundane and unforgettable. This is architecture, but it's also art."[30]

RIVER WALK

In November 1979, the Koch administration, through the city's Department of Ports and Terminals, solicited proposals for the redevelopment of a site along the East River between Sixteenth and Twenty-fourth Streets.[1] The thirty-acre waterfront parcel, known since the nineteenth century as Stuyvesant Cove and bounded on the north by the platform containing the United Nations International School (Harrison, Abramovitz & Harris, 1973) and the four apartment towers of Waterside (Davis, Brody & Associates, 1963–74), on

Proposed East Cove, East River between East Sixteenth and East Twenty-fourth Streets. I. M. Pei & Partners, 1980. Model, view to the north. Lieberman. PCFP

the south by Consolidated Edison's East River Plant, and on the west by two huge apartment complexes, Stuyvesant Town (Irwin Clavan, 1947) and Peter Cooper Village (Irwin Clavan, 1947), was largely vacant, except for scattered parking facilities and a cement batching plant.[2] Although the derelict site was physically cut off from the rest of the city by the elevated FDR Drive, Paul Goldberger believed it showed great promise, deeming it "one of the great sites in New York City. . . . The shore here bends inward, making the eight-block stretch more like a cove than a straight riverfront, and the odd shape makes this one of the only places on the Manhattan shore that offers a splendid view back toward the borough's skyline."[3]

Five months later, in April 1980, four development teams responded to the city's request, which called for a mix of uses and the inclusion of a publicly accessible park. A team composed of Rose Associates and the Argentinian developer Francisco Macri, working with I. M. Pei, proposed East Cove, a residential project that seemed to ignore the call for a mix of uses, although it included nine and a half acres of parkland. Daniel Rose argued that commercial development on the site was not feasible, pointing to the failure of the retail spaces at the Waterside development, which his company managed. Pei's design called for four separate seventy-story round towers, two at the northern end of the site and two at the southern end, all in all providing 1,840 luxury apartments in what would have been the city's tallest residential buildings. Developers Alfred Bloomingdale and Melvin Stier, collaborating with Ulrich Franzen, took the opposite tack in their proposal, which they called River Cove, including 380,000 square feet of commercial space, an indoor ice-skating rink, a 400-boat marina, and a shopping center located on a floating barge along with housing confined to two twenty-nine-story towers

at the southern end of the site and 599 units located in townhouses. The plan also included an elaborate waterfront promenade, several restaurants, and a six-story, 600-room hotel.

Cadillac-Fairview, a Canadian firm controlled by Charles and Edgar Bronfman, teamed up with New York developer Related Housing and architects Gruzen & Partners for River Walk, a proposal that seemed to fall somewhere between Pei's and Franzen's schemes and which Goldberger deemed a "handsome, thoughtfully designed mix of medium-height and low buildings scattered through the site."[4] Extending 500 feet out into the East River on platforms, the Gruzen design was divided into four areas connected by pedestrian walkways: Marina North, which included a thirty-two-story, 704-unit apartment tower, the tallest building in the entire complex, as well as restaurants, boutiques, movie theaters, and a small marina; Park Central, a recreational area with terraced landscaping designed by M. Paul Friedberg, as well as an eighteen-story, 245-room hotel; Marina Island, which consisted of ninety townhouse units; and Marina South, which included a public promenade, a shopping center, and a 782-unit apartment building. The fourth proposal, East River Village, was also the least developed and came from restaurateur Michael (Buzzy) O'Keefe and developer Norman Kalikow, working first with the Hillier Group and later with Edward Durell Stone Associates. With six-story apartment buildings, a 300-room hotel, and 100,000 square feet of commercial space grouped around a marina, the proposal, clearly the most speculative of the submissions, promised to be environmentally friendly and technically innovative as well, with O'Keefe claiming that it could be built in a shipyard and floated into place.

Even before a winner was selected, the editors of the *New York Times* bemoaned both the process and the state of the

Revised proposal for River Walk, East River between East Sixteenth and East Twenty-fourth Streets. Davis, Brody & Associates, 1984. Model, view to the southwest. DBB

city's waterfront development: "New York's waterfront renaissance is starting late," especially as compared with cities like Boston and Baltimore. The editors declared the submitted plans "uneven" and complained that "the city has not set standards for comparison. All offer financial benefits. But . . . the suitability of these waterfront projects ought to be at least as important a standard as their profitability. What is needed is a collaborative design effort between the city's planners and private builders, producing a coherent policy for waterfront renewal and, as in other cities, guidelines for development."[5]

Although Pei's proposal was attacked as an isolated preserve for the wealthy and earned the wrath of the other competitors by ignoring the city's request for a mix of uses, it quickly emerged as the frontrunner, winning support from neighborhood residents, many of whom were concerned about the increase in congestion the other proposals would bring. But on July 17, 1980, Mayor Koch, in a surprising move, selected Gruzen & Partners's River Walk, the joint venture of Cadillac-Fairview and Related Housing. Although Paul Goldberger would have preferred Pei's design, he found some merit in the Gruzen scheme:

> The project could appear to be an attempt to recreate Los Angeles's Marina del Rey, a lavish complex of luxury apartment towers, boating facilities and singles bars, on the East River. It is hardly the sort of waterfront development Manhattan is accustomed to . . . but the architects have shown themselves concerned with relating to the urban context, despite the tropical feelings of the design—River Walk's buildings are set to minimize disruption of the views from Stuyvesant Town, and to enhance views from within the project. And there is also a substantial amount of public parkland.[6]

The hope of city officials as well as the developers for an expeditious round of hearings followed by the start of construction was, predictably enough, given the city's checkered history of waterfront development, quickly dashed, as residents from Stuyvesant Town, Peter Cooper Village, and Waterside mounted an aggressive campaign to stop River Walk, fearing overdevelopment of the area as well as the loss of light and views. They were joined by various environmental groups, including the Sierra Club, which argued that River Walk would inflict too much pressure on the city's already overstrained sewage system and kill marine life with its new platforms. As the fight dragged on in the 1980s, River Walk was dubbed "River Crawl," and Cadillac-Fairview dropped out of the project, leaving only Related as the developer. By the mid-1980s, Related had abandoned the Gruzen scheme, replacing it with a mixed-use design by Davis, Brody, architects of Waterside, which called for five luxury apartment towers between thirty-two and forty-seven stories, a ten-story office building, and a twelve-story hotel, as well as park space, restaurants, and stores built on platforms in the river. Again community groups opposed the latest design, but the project's eventual withdrawal in 1990 was perhaps more accurately attributed to the collapsed real estate market triggered by the stock market crash in October 1987.

In 1993 Community Board 6, using funds from the state's Department of Housing and Community Renewal and the Department of Environmental Conservation, as well as the Manhattan Borough President's office, proposed a new plan for the site.[7] As designed by architects Karahan/Schwarting and landscape architects Heintz/Ruddick, the Stuyvesant Cove Open Space Study proposed that the site be converted into a park that would include pedestrian and bicycle esplanades, a 600- to 1,000-seat restaurant sitting atop a

Stuyvesant Cove Park, East River between East Sixteenth and East Twenty-fourth Streets. Johansson & Walcavage, 2002. View to the northwest. DW

Con Edison Service Building, 750 East Sixteenth Street. Richard Dattner, 2002. View to the northwest. RDPA

garage, extensive recreational facilities, including a boathouse for kayaks and an ice-skating rink, as well as an environmental center. Four years later, in 1997, the idea went forward in a reduced way when the Economic Development Corporation announced that Stuyvesant Cove Park would be built on the vacant land between the water's edge and the highway using city, state, and federal funds.[8] As designed by Johansson & Walcavage and opened in 2002, the 1.9-acre park featured a bicycle path and a brick- and flagstone-paved promenade that followed the natural curve of the cove, as well as planting beds with woodchip paths. Like the proposal from 1993, plans for the park included an environmental learning center dedicated to the history and ecosystem of the East River, the first component of which, completed in 2003 under the supervision of Kiss + Cathcart, consisted of an architecturally undistinguished modular classroom-size building featuring rooftop photovoltaic cells providing all the electricity needs of the facility.

Coinciding with the building of Stuyvesant Cove Park was the completion just to its south of a new facility (2002) for Con Edison at 750 East Sixteenth Street, adjoining the East River Plant.[9] Designed by Richard Dattner, the stylish, three-story, 100,000-square-foot building featured a curving green-glass wall facing the FDR Drive.

KIPS BAY

Kips Bay was named for Jacobus Kip, who in the mid-seventeenth century owned the land roughly bounded by Twenty-third and Forty-second Streets, Third Avenue and the East River. In the early-nineteenth century, the area became home to large residential estates as well as Bellevue Hospital, which by the 1890s had grown to occupy the two full blocks between Twenty-sixth and Twenty-eighth Streets, First Avenue and the East River.[1] The construction of the Third Avenue and Second Avenue elevated railways in 1878 and 1880, respectively, ushered in a new era for the district, with tenements replacing estates. An even grittier character began to emerge with the completion in the early 1900s of Consolidated Edison's mammoth Waterside Station, a power plant occupying the blocks bounded by First Avenue, Forty-first Street, the East River, and Thirty-eighth Street.[2] Construction of the East River Drive in the late 1930s and its reconstruction as an elevated highway in the 1960s cut the neighborhood off from the river, just as the opening of the Queens-Midtown Tunnel in 1940 sliced it with entry ramps and new access streets.

North of Thirty-fourth Street, Kips Bay was an industrial district until the 1980s, when incremental zoning changes encouraged the redevelopment of the area's underutilized manufacturing and commercial sites with seven superscaled towers.[3] Almost overnight the area was transformed into a near-textbook exemplar of urban brutishness. The first to go up was Manhattan Place (1984), 630 First Avenue, occupying a 40,000-square-foot site bounded by First Avenue, Thirty-seventh Street, the FDR Drive, and Thirty-sixth Street. Costas Kondylis, then the design partner at Philip Birnbaum & Associates, packaged 487 apartments in a thirty-five-story brown brick and brown-tinted ribbon-windowed elongated hexagonal slab that lay diagonally across its site, allowing for a triangular landscaped public plaza (Thomas Balsley Associates) at the southwest corner that featured a grand, three-tiered circular fountain behind which a sunken buff brick–paved area with a round reflecting pool fronted a café and other commercial spaces located in the building's brass-trimmed base.[4] Two blocks to the south, Rivergate (1985), 401 East Thirty-fourth Street, also designed by Kondylis, with Samuel Braverman, another partner at the Birnbaum firm, rose on a full-block site east of First Avenue between Thirty-fourth and Thirty-fifth Streets previously occupied by a Coca-Cola bottling plant.[5] Although the developer, Donald Zucker, had acquired the lot in 1978, construction did not get under way for five years, a result primarily of negotiations with the community board, which successfully battled for a 20 percent reduction in the building's size as well as a public park along First Avenue. The thirty-five-story build-

ing packed 702 apartments above three floors of retail space in a stepped-back U-shaped plan that formed a deep, narrow courtyard open to the river. The building's banal multibalconied, brown brick–clad mass was dressed up with a 6,000-square-foot, three-story glass-covered atrium lobby embellished by waterfalls and Frank Stella's thirty-two-by-eight-foot *Damascus Gate Variation I* (1969). But Thomas Balsley's public plaza along First Avenue had some real style, providing the rare amenity of an ice-skating rink, a happy contribution to the developing neighborhood that was unfortunately removed in 1996 when the plaza was redesigned by Landgarden Landscape Architects.[6]

The Whitney (Liebman Liebman Associates, 1986), 311 East Thirty-eighth Street, between Second Avenue and the approach to the Queens-Midtown Tunnel, was, at twenty-nine-stories, smaller than its peers but also more comely—a yellow brick tower with rounded corners and thin strips of balconies.[7] The Vanderbilt (Frank Williams & Associates, 1986), 235 East Fortieth Street, between Second and Third Avenues, a fifty-seven-story pink brick apartment tower rising on the site of a *Daily News* truck garage, featured a stepped plan allowing for a profusion of corner balconies creating a serrated southwest-facing facade that was the building's most striking feature.[8]

On February 13, 1985, a joint venture that included Bernard Spitzer, the civil engineer-cum-luxury housing developer, and Peter L. Malkin, the real estate lawyer, purchased the East Side Airlines Terminal (John B. Peterkin, 1951), Thirty-seventh to Thirty-eighth Street, First to

View to the southwest showing, from left to right, Rivergate (Costas Kondylis and Samuel Braverman of Philip Birnbaum & Associates, 1985), Manhattan Place (Costas Kondylis of Philip Birnbaum & Associates, 1984), the Horizon (Costas Kondylis of Philip Birnbaum & Associates, 1988), and the Corinthian (Der Scutt, 1987). RAMSA

Vanderbilt, 235 East Fortieth Street, between Second and Third Avenues. Frank Williams & Associates, 1986. View to the northeast. Goldberg. ESTO

Second Avenue, for what was reported to be the highest price ever paid at auction for a piece of real estate in Manhattan, announcing their intention to replace it with a high-rise luxury apartment building.[9] The brick-clad terminal, once the check-in point for buses connecting to flights departing from Kennedy and La Guardia Airports, was steadily deprived of its function beginning in the early 1970s, when bus departure points were moved to more central locations. In 1977 parts of the terminal were converted for use as tennis courts while other portions were used as offices and parking, but by 1984 the building was no longer profitable to the city. Spitzer and Malkin's Corinthian (1987), 330 East Thirty-eighth Street, an ambitious fifty-four-story, 863-unit apartment tower that incorporated 100,000 square feet of office space on the first two floors, was designed by Der Scutt, working in consultation with Michael Schimenti. Scutt, taking lessons from his former teacher and employer Paul Rudolph and from Harrison & Fouilhoux's Rockefeller Apartments (1936), created the effect of a fluted columnar shape—more slab than column to tell the truth—by using a plan of repeated glazed curving bays to give the building an unusual sculptural power while providing 180-degree views from each apartment.[10] Sixty-five percent of the airlines terminal building was incorporated into the new project, but the portion along First Avenue was demolished to make way for what was, at 27,000 square feet, the largest residential plaza in the city. Thomas Balsley Associates wrapped the plaza's central sloping grass lawn with a border of trees and provided paved areas with benches at the street corners.

Opposite the entrance, a cascading semicircular waterfall fountain arced around Aristides Demetrios's abstract bronze sculpture *Peirene* (1988) and faced a curving, skylit porte cochere that brought tenants into a ninety-foot-long, twenty-eight-foot-high lobby.

Given the dreadful state of most residential design in the city at the time, the hulking Corinthian was seen as something special. Carter B. Horsley said it "bursts with energy,"[11] and the editors of the *AIA Guide* proclaimed in 1988 that it represented the sometimes heavy-handed Scutt at "his best,"[12] although Robert Campbell of the *Boston Globe* regarded the design as "OK if unremarkable." Commenting on the oxymoronic marketing strategy of the building, whose advertisements announced it as "Midtown Manhattan's First Suburban Office Plaza," Campbell wrote, "'Suburban' buildings in the city—buildings surrounded by open space—are usually egotistical disasters. . . . What's wrong with the Corinthian is that it is a leech on the body of New York. Grabbing amenity from everything around it, it offers the city nothing in return . . . only empty greenery, blank walls, tight security and a tower that is hideously, overwhelmingly, out of scale with those 'townhouse lined streets'" bragged about in the sales brochure.[13]

In 1988 work was completed on the Highpoint (Wechsler, Grasso & Menziuso), 250 East Fortieth Street, southwest corner of Second Avenue, an exceptionally slender forty-nine-story red brick and cast-stone tower featuring columns of balconies and a combination of notched and glassy corners inspiring Carter Horsley to remark, "If buildings were people, this might be Tom Wolfe . . . in a pin-stripe suit and white fedora."[14] The same year, the Glick Organization, developer of Manhattan Place, completed the Horizon (Costas Kondylis of Philip Birnbaum & Associates), 415 East Thirty-seventh Street, between First Avenue and the FDR Drive, rising from a red granite base as a forty-four-story L-shaped tower wrapped with bands of dark-gray glass set between bands of pink and gray brick but with continuous dark glass bays at the reentrant corners.[15] Though ordinary in most ways, the Horizon did at least provide 800 feet of a riverfront esplanade outbound of the East River Drive between Thirty-sixth and Thirty-eighth Streets. The waterfront amenity was realized through the efforts of a community coalition, established to reclaim the once-industrial river's edge for recreational use; in 1984, the coalition hired Thomas Balsley Associates to prepare a master plan for the esplanade stretching from Thirty-fourth to Forty-first Street.[16] Because the city had no funds for the project, the plan depended on private developers looking for ways to appease neighborhood residents. Glick, the first to bite, hired Balsley for a two-block stretch, which was transformed into a Battery Park City–inspired esplanade (1992) paved in brick and granite with a curving riverfront railing, 1939 World's Fair–style benches, rows of trees and ornate lampposts, and an ornamental fountain marking the entrance, a necessarily low-ceilinged portal tunneling beneath the FDR Drive at Thirty-seventh Street. East River Esplanade Park, as it was known, was the only component of Balsley's master plan to be realized.

A hiatus in the early to mid-1990s slowed the neighborhood's transformation, though one notable residential tower, the Future, east blockfront of Third Avenue between Thirty-first and Thirty-second Streets, opened in 1993 while the market was bottomed out. The thirty-five-story, 165-unit apartment building featured a glass and silvery aluminum

ABOVE LEFT Corinthian, 330 East Thirty-eighth Street, between First and Second Avenues. Der Scutt, 1987. View to the northwest showing the Highpoint (Wechsler, Grasso & Menziuso, 1988) in the distance on the right. Mauss. ESTO

ABOVE RIGHT Corinthian, 330 East Thirty-eighth Street, between First and Second Avenues. Der Scutt, 1987. Typical floor plan. DSA

LEFT Future, east blockfront of Third Avenue, between East Thirty-first and East Thirty-second Streets. Paul Rudolph with Costas Kondylis, 1993. View to the northeast. McGrath. NMcG

BELOW East River Esplanade Park, East River between East Thirty-sixth and East Thirty-eighth Streets. Thomas Balsley Associates, 1992. View to the north. RAMSA

Montrose, 306–308 East Thirty-eighth Street, between First and Second Avenues. Meltzer/Mandl Architects, 2001. View to the northwest with yellow brick Whitney (Liebman Liebman Associates, 1986) in the background. MMA

exterior designed by Paul Rudolph, who worked as a consultant with architect-of-record Costas Kondylis. The most distinctive feature of the building was its dizzying balconies that extended at a forty-five-degree angle from the facade, creating the illusion that they were pointing sharply toward the sky or toward the ground, depending on one's vantage point.[17] The pace of construction picked up again in the late 1990s, with the completion of three substantial apartment towers, the first being Kondylis's Paramount Tower (1999), 240 East Thirty-ninth Street, between Third and Second Avenues, a fifty-one-story rose-colored brick needle wrapped in bay windows and featuring a prominent limestone-clad porte cochere, followed by the Montrose, 306–308 East Thirty-eighth Street (2001), between First and Second Avenues. Designed by Marvin H. Meltzer of Meltzer/Mandl Architects, it was one of the more modestly scaled additions to the neighborhood, a twenty-story, 97-unit, 104,000-square-foot building with a two-story slate and glass base beneath a tower sheathed in prefabricated panels of red brick tile and silver-blue aluminum that stepped back above the fourteenth floor.[18] On the west side, twelve floors were cantilevered ten feet over an adjacent five-story tenement whose air rights were used in the development, giving the facade, in the words of Meltzer, "a sculptural quality."[19] One block north, the Sonoma (2002), 300 East Thirty-ninth Street, southeast corner of Second Avenue, a luxury rental apartment building designed by Davis Brody Bond, comprised a twenty-one-story red brick and green tinted glass

tower with granite detailing set back on a six-story base. The tower form, combining punched and ribbon windows, was distinguished by a curving south wall that terminated at its west end in a sharp glazed point. Inside, David Rockwell delivered a stylish lobby.

While the majority of development in Kips Bay north of Thirty-fourth Street was residential, the brunt of new construction south of Thirty-fourth Street was institutional, occurring on the superblocks that had, beginning in the late 1800s with the construction of the Bellevue Hospital complex, interrupted the area's street grid. New York University Medical Center's multiblock complex (Skidmore, Owings & Merrill, 1950), Thirtieth to Thirty-fourth Street, First Avenue to the FDR Drive, together with that of Bellevue, constituted a virtually continuous medical campus of nearly eleven acres bounded by East Twenty-sixth and East Thirty-fourth Streets, First Avenue, and the FDR Drive, giving that stretch of First Avenue the nickname Bed-Pan Alley. I. M. Pei & Associates' Kips Bay Plaza (1958–66) was built on another superblock bounded by East Thirtieth and East Thirty-third Streets, First and Second Avenues.[20]

New York University Medical Center expanded modestly during the 1980s with the construction of Greenberg Hall (Pomerance & Breines, 1986), 545 First Avenue, between Thirty-first and Thirty-second Streets, a drab, ten-story, gray brick and limestone slab built to house medical students.[21] But in 1992, what had degenerated into a rather haphazardly situated assemblage of buildings was enlarged considerably and given new coherence with the completion for NYU of James Stewart Polshek & Partners' Skirball Institute for Biomolecular Medicine, 550 First Avenue, a 510,000-square-foot, twenty-three-story building squeezed between Tisch Hospital (Skidmore, Owings & Merrill, 1950), Alumni Hall (Skidmore, Owings & Merrill, 1957), and the Arnold and Marie Schwartz Health Care Center (Skidmore, Owings & Merrill, 1976).[22] Above an aluminum and glass canopy that led to a 16,800-square-foot double-height glass-walled lobby, the tower's first five floors, containing laboratories, were cantilevered over an entrance driveway and clad in flame-finished granite, while the upper stories, comprising offices and staff housing, echoed Tisch Hospital with a sheathing of tan brick and aluminum. Polshek employed a twenty-two-foot structural bay system suitable for offices, labs, and apartments. A round-cornered, five-story "anthropomorphic appendage," as Susanna Sirefman called it, connecting the Skirball Institute and Tisch Hospital, wrapped in alternating bands of aluminum and glass and overlooking a newly defined landscaped courtyard, had a more playful character than the stately main slab.[23] All in all, the size of the building and the repetitiousness of its upper floors swamped the vivacity of some of its details. For the eastern border of the medical center, facing the FDR Drive, Mitchell/Giurgola Architects designed the thirteen-story, 200,000-square-foot Smilow Biomedical Research Center (2006).[24] The pale gray masonry and glass building's trapezoidal plan was arranged to provide open research laboratories conducive to collaboration among scientists.

Bellevue Hospital's long tradition of public health care continued into the twenty-first century as the city, realizing the value of underutilized sites on the campus, undertook a number of noteworthy building projects. In 1994, to bring order to the medical complex, whose clarity had been clouded by ill-planned additions during the 1960s and 1970s,

Skirball Institute for Biomolecular Medicine, 550 First Avenue, between East Thirty-first and East Thirty-second Streets. James Stewart Polshek & Partners, 1992. View to the southeast showing Tisch Hospital (Skidmore, Owings & Merrill, 1950) on the left. Goldberg. ESTO

Skirball Institute for Biomolecular Medicine, 550 First Avenue, between East Thirty-first and East Thirty-second Streets. James Stewart Polshek & Partners, 1992. Courtyard. Goldberg. ESTO

Smilow Biomedical Research Center, between the FDR Drive and First Avenue, East Twenty-ninth and East Thirty-first Streets. Mitchell/Giurgola Architects, 2006. View to the southwest. RAMSA

Lee Harris Pomeroy Associates designed a formal entry to the hospital, replacing a somewhat foreboding spiked iron gate with an entrance arch on the east side of First Avenue at Twenty-seventh Street leading to a walkway covered by a peaked canopy of steel-framed glass panels that brought visitors from the sidewalk to the hospital's main doors. The arch, with a sculpted depiction of the New York City seal flanked by a Native American and a Pilgrim, was a near-replica of one designed by McKim, Mead & White for the west facade of the hospital's Administration Building (1940), lost from sight in 1964 when a parking garage (Pomerance & Breines; Katz, Waisman, Weber, Strauss; Joseph Blumenkranz; Feld & Timoney) was built on the corner of Twenty-eighth Street and First Avenue.[25]

In June 2001, Richard Dattner & Partners Architects completed the transformation of Bellevue's former R&S Building (McKim, Mead & White, 1907–12), southeast corner of First Avenue and Twenty-ninth Street, vacant for two decades, into a facility for the New York City Administration for Children's Services.[26] Dattner, with the intention of creating a "well-lighted room of welcome, and not a cold institution" for children arriving to receive health care and foster home placement, restored McKim's red brick and terra-cotta exterior while gutting the 117,000-square-foot interior (though Guastavino-vaulted ceilings were retained to cover a new dining room), inserting an auditorium and conference center on the ground floor and bedrooms for young children on the second floor and for teenagers on the third floor.[27] The upper three stories housed a caseworker training academy, and a playground was placed on the roof. Outside, a pair of gracefully curving handicap ramps flanked a steel and glass canopy that covered a new entrance on First Avenue, while a second, more discreet entry for children was placed on Twenty-eighth Street.

Across the street, the parking garage that stood on the southeast corner of Twenty-eighth Street and First Avenue was demolished in 2001 to make way for Bellevue's Ambulatory Care Facility (2004). Designed by Pei Cobb Freed & Partners, the five-story-with-penthouse building, serving as the hospital's new main entrance and housing examination rooms, offices, and special facilities, was clad with a combination of gray Roman brick and glass curtain walls. The ground floor, sheathed in floor-to-ceiling glass, was intended to make the upper floors seem to hover while allowing views from the street through the lobby into a soaring atrium between the new and existing buildings. The atrium was covered by a sloping skylight that stretched from the fourth floor of the Ambulatory Care Facility to the eighth floor of McKim, Mead & White's neighboring Administration Building, the facade of which, now indoors, was restored.

In January 2001, the city announced that the sliver of vacant land on the north side of Twenty-sixth Street between First Avenue and the FDR Drive, adjacent to Bellevue's main hospital building, would become the site of the Forensic Biology Laboratory (Perkins Eastman Architects), used by the New York City Medical Examiners Office as the world's largest DNA laboratory.[28] When construction began in October, the city was in the midst of extracting 4,000 DNA samples each day from the wreckage of the World Trade Center, all of which were processed in 6,300 square feet of the hospital's morgue, northeast corner of First Avenue and Thirtieth Street. The new 322,000-square-foot, twelve-story building, scheduled for completion in 2006, would provide

Bellevue Ambulatory Care Facility, east side of First Avenue at East Twenty-eighth Street. Pei Cobb Freed & Partners, 2004. Atrium. Warchol. PCFP

Bellevue Ambulatory Care Facility, east side of First Avenue at East Twenty-eighth Street. Pei Cobb Freed & Partners, 2004. View to the northeast. Warchol. PCFP

four floors of laboratories, as well as specially sealed areas with the capacity to process tens of thousands of cases each year and rooms for reenacting crimes. Unfortunately, it would loom over the eight-story McKim, Mead & White hospital, replacing views of its magnificent facade with a generic metal and glass curtain-walled tower rising from an eight-story cast-stone and glass base.

DIPLOMATIC COMMUNITY?

With the completion of the United Nations headquarters (Board of Design, Wallace K. Harrison, Director of Planning) in 1952, the area in its immediate vicinity was gradually transformed from a run-down neighborhood of tenements and marginal industrial uses into an important district of hotels, office and institutional buildings, and high-end apartment houses.[1] In 1983 work was completed on Kevin Roche John Dinkeloo and Associates' Two United Nations Plaza on East Forty-fourth Street, between First and Second Avenues, a forty-story "sister" building to their neighboring One United Nations Plaza, a combination office building and hotel built in 1975.[2] Both were developed by the United Nations Development Corporation (UNDC), a nonprofit group charged with financing and constructing buildings to accommodate the growth of the U.N. and its related organizations. The first tower was, in Roche's estimate, "a leftover piece" of the ambitious 1969 plan his firm had prepared for the two blocks bounded by Forty-third and Forty-fifth Streets, First and Second Avenues.[3] But its unexpected financial success, its critical acclaim as a work of architecture, and the U.N.'s continued need for more space led the UNDC to commission a second tower poured from the same mold, with chamfers, sloping setbacks, and scale-defying surfaces rendered in blue-green glass wrapping twenty-six stories of office space beneath thirteen slimmer floors containing 115 luxury rental apartments for tenants affiliated with the U.N.

Together, the two buildings powerfully imposed themselves on the skyline, especially when seen from the East River or the Queensboro Bridge. The slablike second tower, separated from its predecessor by thirty feet but connected at ground level and by bridges on the third and eleventh floors, was situated perpendicular to Forty-fourth Street, carving a deep chamfer out of its southeast corner, marking the entrance to a sequence of garish interior lobby spaces—similar but overblown iterations of those in the original building—with kaleidoscopic skylights of glass, mirror, chrome, and miniature marqueelike lights, floors of patterned marble, and octagonal columns with alternating facets of mirror and marble. The only respite from the borderline fun-house environment was the Wisteria Room, a small white trellis-covered café and lounge that in 1995 was painted silver and converted for use as a gift shop. It was the interplay between the two buildings that impressed critics the most. Andrea Dean admired the "constantly changing sculptural relationships" allowing "the shapes of the second to play off the first so as to enliven the forms of both structures."[4] Paul Goldberger was even more taken by the project, which he felt transformed "the vocabulary of Modernism into something more eccentric and picturesque, almost sensual."[5] Considering One and Two United Nations Plaza as nothing less than "exquisite minimalist sculpture," Goldberger called them "arguably the best glass buildings in Manhattan since the Seagram Building."[6]

Across the street, the UNDC again commissioned Roche Dinkeloo to design the third and final building of the United Nations Plaza complex. Three United Nations Plaza (1987), on the south side of Forty-fourth Street, built to provide office and conference space for the United Nations International Children's Emergency Fund (UNICEF), stood in stark contrast to numbers One and Two, fitting neatly into its surroundings with a two-story base lined by "witty, almost cartoonlike"

columns, as Goldberger put it, a thirteen-story-high street-wall-defining facade that continued the cornice line established by its westerly neighbor, the southern of Raymond Hood and Kenneth Murchison's twin Beaux Arts Apartments (1931), and a two-story mansard roof, within which were twenty-nine apartments for U.N. personnel.[7] The facade was striped with alternating bands of light and dark brown granite cut to different thicknesses that referenced the alternating bands of brick and glass on the Beaux Arts Apartments, from which Roche's building was separated by a 100-foot-wide courtyard lined with columns and entered beneath a skylight-capped double colonnade. Roche was also self-referential, framing the windows and cladding the mansard roof with a pale greenish blue metal that picked up the tones of his towers across the street.

Whereas One and Two United Nations Plaza epitomized late Modernism, Three United Nations Plaza was distinctly Postmodern. The change of stylistic gears was, to Goldberger, an acknowledgment on the part of the architect that "what worked for a two-part composition of tall towers playing off against each other was not going to work for a three-part composition in which the third building was by necessity lower, squatter, and across the street."[8] While many saw the use of stone in Three United Nations Plaza as an architectural back-step, Roche considered it innovative, citing recent

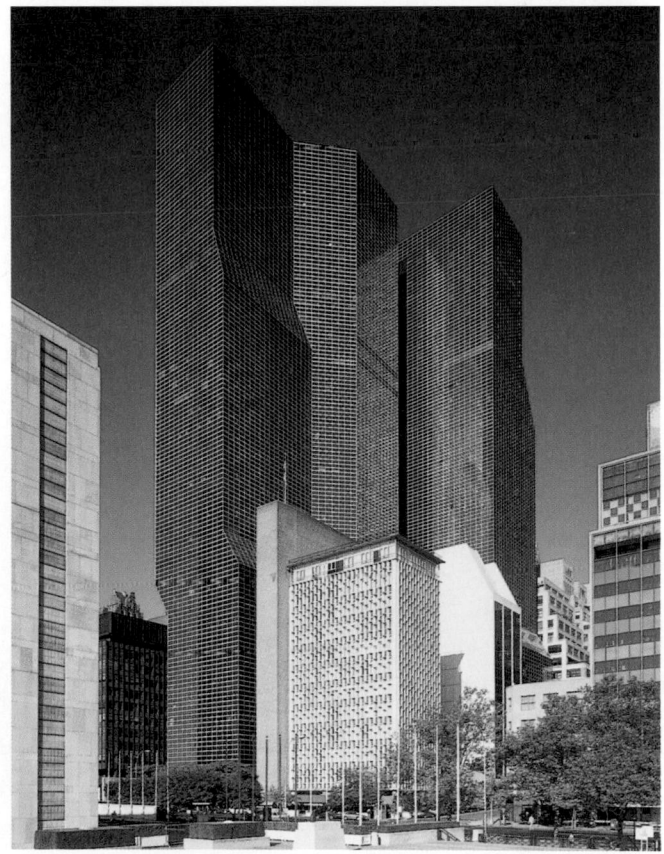

United Nations Plaza, East Forty-fourth Street, between First and Second Avenues. Kevin Roche John Dinkeloo and Associates. View to the southwest showing One United Nations Plaza (1975) on the left, Two United Nations Plaza (1983) on the right, and, in the foreground, the United States Mission to the United Nations (Kelly & Gruzen and Kahn & Jacobs, 1961) in the center and Uganda House (Jae Y. Ko, 1978) on the right. KRJDA

developments in the stone industry that made it "possible to consider granite as an economic alternative to glass."[9] In that way, the building fit neatly into Roche's current interests, bearing a formal resemblance to the mansard-roofed E. F. Hutton Building (1986) (see MoMALand) and the exuberantly classicized 60 Wall Street (1988) (see Financial District).

By the late 1970s, many national missions to the United Nations had outgrown their small quarters—often rented townhouses—leading them to commission buildings that would help them establish a distinct identity in the U.N. community. This strategy proved particularly popular with post-colonial African governments. Among the first of a series that would proliferate in the following decades was Uganda House, 336 East Forty-fifth Street, west of First Avenue, completed in 1978 primarily as a monument to the country's notorious and controversial president, Field Marshall Idi Amin.[10] The fourteen-story, banal boxlike glass building, occupying a fifty-by-eighty-foot lot, was designed by Jae Y. Ko and contained a street-level display area for Ugandan art, a ballroom, offices, and five apartments on the upper floors, including a penthouse, complete with its own terrace, tailored to the needs of Amin, should he choose to visit New York. Intended to serve the country's U.N. mission staff of less than a dozen people, Uganda House seemed to have as its principal distinction the fact that it was three floors higher than its next-door neighbor, the United States Mission to the United Nations (see below).[11] The difference in height was a symbolic one, ordered by Amin as a snub to the United States, which had criticized his tyrannical regime. The United States responded by erecting a taller flagpole on the roof of its building. For Ada Louise Huxtable, Uganda's mission marked yet another entry in New York's unpausing "undistinguished building derby."[12] Amin was toppled from power in 1979, at which point a new team of delegates was sent to New York, where they found the building's living and working quarters elaborately outfitted with surveillance equipment and listening devices. When in July 1980 the garage that adjoined Uganda House to the west was demolished to make way for the construction of Two United Nations Plaza, it was revealed that no exterior wall had been built on the first four floors of Uganda House. Because foreign governments were not required to submit plans to the city for approval, nor undergo building inspections, workers had attached the building's insulation directly to the garage's wall. As demolition work proceeded on the garage, the *New York Times* reported that Uganda's building "trembled" and that the chief delegate had a "view of the sky through a hole in his office ceiling."[13] Repairs were made by the original contractor.

Swelled with cash from soaring oil prices, in 1979 the government of Libya retained the Houston-based firm 3D International to design Libya House, 309–315 East Forty-eighth Street, a twenty-three-story building built on a vacant lot between First and Second Avenues that would combine offices and residences for its U.N. delegation and consulate staff.[14] Excavation got under way in February 1981 for the severe concrete and glass building that, in addition to providing a

United Nations Plaza, East Forty-fourth Street, between First and Second Avenues. Kevin Roche John Dinkeloo and Associates. View to the northeast showing One United Nations Plaza (1975) on the right, Two United Nations Plaza (1983) on the left, Three United Nations Plaza (1987) in the foreground, and 100 United Nations Plaza (Der Scutt, 1986) in the background. KRJDA

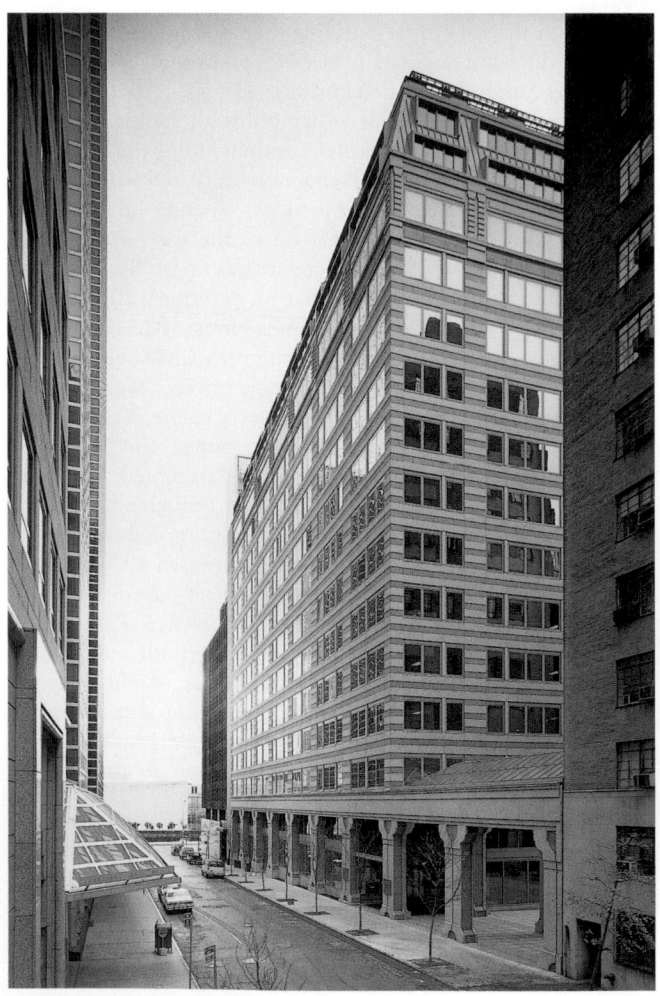

raised public plaza and terraced reception area, contained a
cafeteria, gymnasium, thirty-one residential units and, at the
top, a terraced triplex apartment for Libya's chief diplomat.
The design, essentially two parallel slabs connected by hori-
zontal bands of glass and dark concrete panels, was influenced
by Hugh Stubbins's Federal Reserve Bank (1976) in Boston.[15]
One of the chief features of Libya's building was a long ramp
with illuminated handrails leading from the sidewalk to the
entry—a "tangible reminder" according to one *New York
Times* report, "that the controversial regime of Col.
Muammar el-Qaddafi sponsored the United Nations's designa-
tion of 1981 as 'International Year of Disabled Persons.'"[16]

Swanke Hayden Connell Associates' design for the fourteen-
story Permanent Mission of the State of Kuwait to the United
Nations (1986), 321 East Forty-fourth Street, between First
and Second Avenues, though hardly a design sweepstakes win-
ner, was a cut above its immediate predecessors, incorporating
motifs inspired by traditional Muslim architecture on a dark-
gray polished granite base housing meeting rooms and a ball-
room connected by a crescent-shaped staircase.[17] Above, four
floors of offices could be identified on the outside by a grid of
square windows set in a field of lighter gray granite. The sev-
enth through fourteenth floors were set back, with semicircu-
lar balconies that intimated the residential quarters within.
Though expressive in its details, the composition of the tower
was awkward, placing a small apartment building on an office
building atop a mosque.

The Permanent Mission of India to the United Nations
(1992), 235 East Forty-third Street, between Second and Third
Avenues, designed by one of India's leading architects, Charles
Correa, in association with Bond Ryder & Associates, was a
far more successful work of architecture, both expressive in
form and attentive to its urban context.[18] Correa filled the

narrow, through-block site, which extended to Forty-fourth Street, with an 87,000-square-foot building divided into a four-story podium and a twenty-story red aluminum-paneled tower set back twenty-five feet from Forty-third Street. The base was reserved for an exhibition gallery, meeting rooms, and offices, leaving the tower's 2,200-square-foot floor plates to house five types of apartments ranging from smaller units on the lower floors to two interlocking duplexes near the top of the building (marked on the outside by double-height windows set into the otherwise regular grid of square single-light windows) and a triplex penthouse residence for the consul general that opened onto a series of stepped outdoor terraces shaded by a large cubistic pergola. This was a recurring form in Correa's work that at once referenced the Indian *barsati*, or open-air sleeping area, as well as, according to the architect, "traditional towers in the hill-towns of Yemen."[19] A comparison could also be drawn to the stepped terraces and steel framework atop Paul Rudolph's nearby townhouse (see Upper East Side).

Despite its constricted site, the Indian Mission carried a monumental presence on its two street facades, which were clad in red polished granite quarried in South India. Bold geometric forms were mixed with massive but intricately detailed traditional wood and brass doors made in India by Rajasthani craftsmen. The main Forty-third Street facade, forty-two feet wide, featured an eight-by-nineteen-and-a-half-

foot-high doorway beneath a twenty-six-foot-square opening framed by small circles of rose-colored granite that looked in on a 300-square-foot pergola-covered outdoor terrace. The Forty-fourth Street facade, only twenty-four feet wide, was organized in a similar fashion, with a central doorway situated beneath three square windows at the second level and, above that, an eighteen-foot-diameter circular cut-out opening onto a double-height pergola-covered terrace. Susanna Sirefman, who felt that the building's color "alone reveals that a fresh viewpoint has been inserted into Manhattan's dense cityscape," was most taken by the "monolithic bronze entry-way" that reinforced Correa's reputation as a designer "interested not only in the significance of the ancient, but also in the power of authority."[20]

In 1998 the Federal Republic of Germany completed 871 United Nations Plaza, between Forty-eighth and Forty-ninth Streets, a 112,000-square-foot office building to house its Permanent Mission to the United Nations, Consulate General, and Information Center, three agencies previously scattered in separate locations.[21] The 50-by-100-foot site had been acquired by the Albanese Development Corporation as part of its 100 United Nations Plaza development (see below), but when plans to build a hotel there failed, Albanese hired Schuman, Lichtenstein, Claman & Efron to prepare designs for a speculative office building that it could shop around to

FAR LEFT Permanent Mission of the State of Kuwait to the United Nations, 321 East Forty-fourth Street, between First and Second Avenues. Swanke Hayden Connell Associates, 1986. View to the northwest. Hoyt. ESTO

LEFT Permanent Mission of India to the United Nations, 235 East Forty-third Street, between Second and Third Avenues. Charles Correa, 1992. View to the north. Rahman. CC

Permanent Mission of the Federal Republic of Germany to the United Nations, Consulate General, and Information Center, 871 United Nations Plaza, between East Forty-eighth and East Forty-ninth Streets. Schuman, Lichtenstein, Claman & Efron, 1998. View to the southwest showing 100 United Nations Plaza (Der Scutt, 1986) on the left. SLCE

Permanent Mission of the Republic of Korea to the United Nations, 335 East Forty-fifth Street, between First and Second Avenues. Pei Cobb Freed & Partners, 1999. View to the northeast. Schiller. PCFP

governments in need of space. Recognizing the opportunity to consolidate, the German government purchased the land and hired SLCE to rework the plans, leading to the construction of a twenty-three-story tower sheathed in a smooth but somewhat chaotic amalgam of reddish brown granite, dark glass spandrels, clear glass windows, and stainless-steel ornamentation. Reflecting standard German building practice, a windowed office was provided for every employee. At its base, a long rectangular canopy cantilevered over a small plaza. A year later, in 1999, Pei Cobb Freed & Partners' Permanent Mission of the Republic of Korea to the United Nations, 335 East Forty-fifth Street, between First and Second Avenues, was completed, an eleven-story building whose facade was composed of a seven-bay-wide, five-story grid of square windows topped by an asymmetrical grouping of rectangular and square windows, a recessed terrace, and a glass diamond at the top that served as a skylight for a conference room.[22] Despite the meticulous detailing and the syncopated window pattern, the overall effect was flat and lifeless.

In 1998 Gwathmey Siegel & Associates was chosen to design a new United States Mission to the U.N., a replacement for the twelve-story, 98,000-square-foot cast-stone screen-covered building (Kelly & Gruzen and Kahn & Jacobs, 1961) on the southwest corner of Forty-fifth Street and First

Avenue, a long-outgrown facility whose hallways had been taken over as offices and where overall working conditions were dismal.[23] The proposed 141,000-square-foot, twenty-two-story, 400-foot-high tower was to provide space for offices, a press room for 150 people, a foreign affairs briefing center, a meeting room, a cafeteria, an ambassador's apartment, and a parking garage for ten cars. But the overarching concern was security. Designs for the mission came on the heels of the terrorist bombings of American embassies in Kenya and Tanzania, as well as the bombing of the USS *Cole*, an American destroyer in the Port of Aden, Yemen.

Gwathmey's plans called for thirty-inch-thick walls of smooth-finished sandstone-colored concrete. The north and east facades were to rise without fenestration until the seventh floor, where narrow slotlike windows, "from which one might imagine protruding carbine barrels," as Herbert Muschamp saw it, grew progressively wider toward the top of the building, reflecting the decreasing impact of explosives at the building's higher reaches.[24] At the southeast corner, the concrete wall was stripped back to reveal a zinc-shingle-clad cylindrical core rising the height of the building, extending several floors above the rest of the facade. Within the peak of the cylinder was a reception space with a mezzanine level and high clerestory window. The various roof surfaces of the building were pitched

so that if a taller structure nearby were to collapse, the debris would be deflected from it. As Gwathmey stated: "It is designed to withstand the failure of itself and everything around it."[25] Muschamp concurred, calling it "massively solid, essentially a high-rise bomb shelter." The only "gesture toward friendship and transparency" was the entrance, fronted by a glass wall beneath a free-form curving roof.[26]

High-rise residential construction went hand in hand with institutional growth in the U.N. area. Dag Hammerskjold Tower (Gruzen & Partners, 1984), 240 East Forty-seventh Street, southwest corner of Second Avenue, was a bulky forty-three-story brown brick–clad 133-unit tower laid out in a roughly L-shaped plan. Preassembled brick panels, "the joints of which give a second design rhythm to the facade," as the editors of the *AIA Guide* noted, wrapped the building in horizontal bands that swelled out from the facade near its chamfered northeast corner to embrace elongated balconies that were the most compelling feature.[27] The principal distinction of Schuman, Lichtenstein, Claman & Efron's thirty-three-story Sterling Plaza (1985), 225 East Forty-ninth Street, northwest corner of Second Avenue, was its cartoonlike crown of five triangles, an afterthought of the developer, Sterling Equities, which, seeking to increase marketability, hired the Miami-based firm of Arquitectonica to dress the building up. For Paul Goldberger, Arquitectonica's work was "not only ill-

suited to the building of which it is a part, but unattractive enough to make one yearn for the days of flattops."[28]

Until the construction of Trump World Tower (see below), the biggest of the U.N.–area apartment buildings was Der Scutt's fifty-two-story 100 United Nations Plaza (1986), northwest corner of Forty-eighth Street, designed in association with Schuman, Lichtenstein, Claman & Efron and meant to serve as the signature building in the Albanese Development Corporation's portfolio.[29] Scutt designed a thick slab culminating in a steeply pitched triangular top—containing twenty-three penthouse apartments on eight floors—that became what he referred to as the building's "theme," echoed in the pointed balconies of the south facade and in the street-level windows and entrance canopy.[30] With a brooding exterior of brown brick and dark brown windows, any liveliness in the otherwise massive design rested on the shoulders of the army of balconies (provided for every apartment above the third floor) that climbed the north and south facades and wrapped the corners, giving them a serrated appearance. Only the peak of the roof, hiding mechanical equipment, was left clean-edged. In contrast to the building's aggressive demeanor, Thomas Balsley Associates's verdant 9,100-square-foot plaza offered a pedestrian-friendly setting of pools, waterfalls, and fountains set among shaded seating areas.

Proposed United States Mission to the United Nations, southwest corner of East Forty-fifth Street and First Avenue. Gwathmey Siegel & Associates, 2002. Model, view to the southwest. Pottle. ESTO

Sterling Plaza, 225 East Forty-ninth Street, northwest corner of Second Avenue. Schuman, Lichtenstein, Claman & Efron and Arquitectonica, 1985. View to the northwest. SLCE

FACING PAGE 100 United Nations Plaza, northwest corner of East Forty-eighth Street. Der Scutt, 1986. View to the north-west showing the Engineer Societies Center (Shreve, Lamb, & Harmon, 1961) in foreground, Citicorp Center (Hugh Stubbins & Associates, 1977) in background right, and 885 Third Avenue (Philip Johnson and John Burgee, 1986) in background far right. DSA

RIGHT 100 United Nations Plaza, northwest corner of East Forty-eighth Street. Der Scutt, 1986. DSA

In April 1997, after besting competing bids from a number of the city's leading developers, Donald J. Trump, teamed with the Korean conglomerate Daewoo Corporation, purchased a block-long site on the west side of First Avenue between Forty-seventh and Forty-eighth Streets, announcing his intention to build a large residential condominium, requiring the demolition of a building not likely to be missed, Shreve, Lamb & Harmon's twenty-story stainless-steel and glass Engineering Societies Center (1961), 345 East Forty-seventh Street, northwest corner of First Avenue.[31] In uncharacteristically quiet fashion, Trump, in an effort to build as tall a tower as possible, spent the next year securing air rights from neighboring buildings, including the Japan Society (Junzo Yoshimura, 1971), 333 East Forty-seventh Street, and the Holy Family Church (George J. Sole, 1964), 315 East Forty-seventh Street.[32] The combination of the air rights and a proposed public plaza enabled Trump to persuade the Buildings Department to approve an 861-foot-high "as-of-right" skyscraper that would require no public review. After interviewing Kohn Pedersen Fox, John Portman, Frank Gehry, and Robert A. M. Stern, Trump selected as his architect Costas Kondylis, who had recently collaborated with Philip Johnson on the reworking of the Gulf & Western Building into the Trump International Hotel and Tower. Kondylis's reinforced-concrete frame and bronze-colored glass-skinned 865,000-square-foot, 376-unit apartment building, dubbed Trump World Tower, rose sheer for seventy-two stories, although Trump aggressively marketed it as ninety stories, a common developer strategy justified by the fact that the building featured higher than normal ceiling heights, in this case between twelve and sixteen feet. While the proposed design constituted the tallest residential building in New York, forty-seven feet higher than Helmut Jahn's Cityspire, of even more importance was the fact that it towered 317 feet over the thirty-nine-story United Nations Secretariat, flamboyantly breaking for the first time the unwritten rule that a

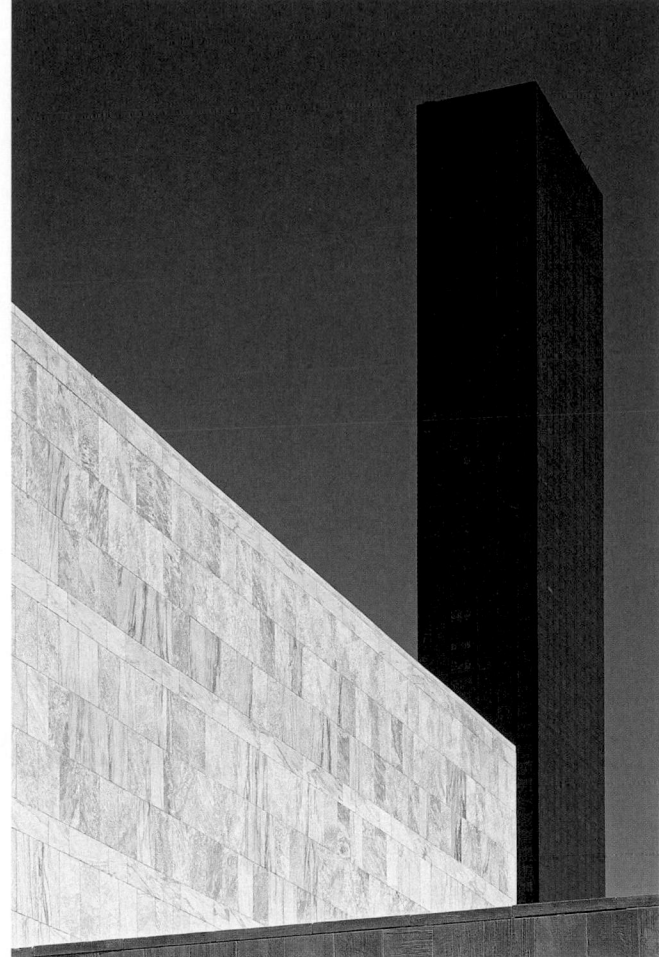

Trump World Tower, 845 United Nations Plaza, between East Forty-seventh and East Forty-eighth Streets. Costas Kondylis, 2001. View to the northwest. Goldberg. ESTO

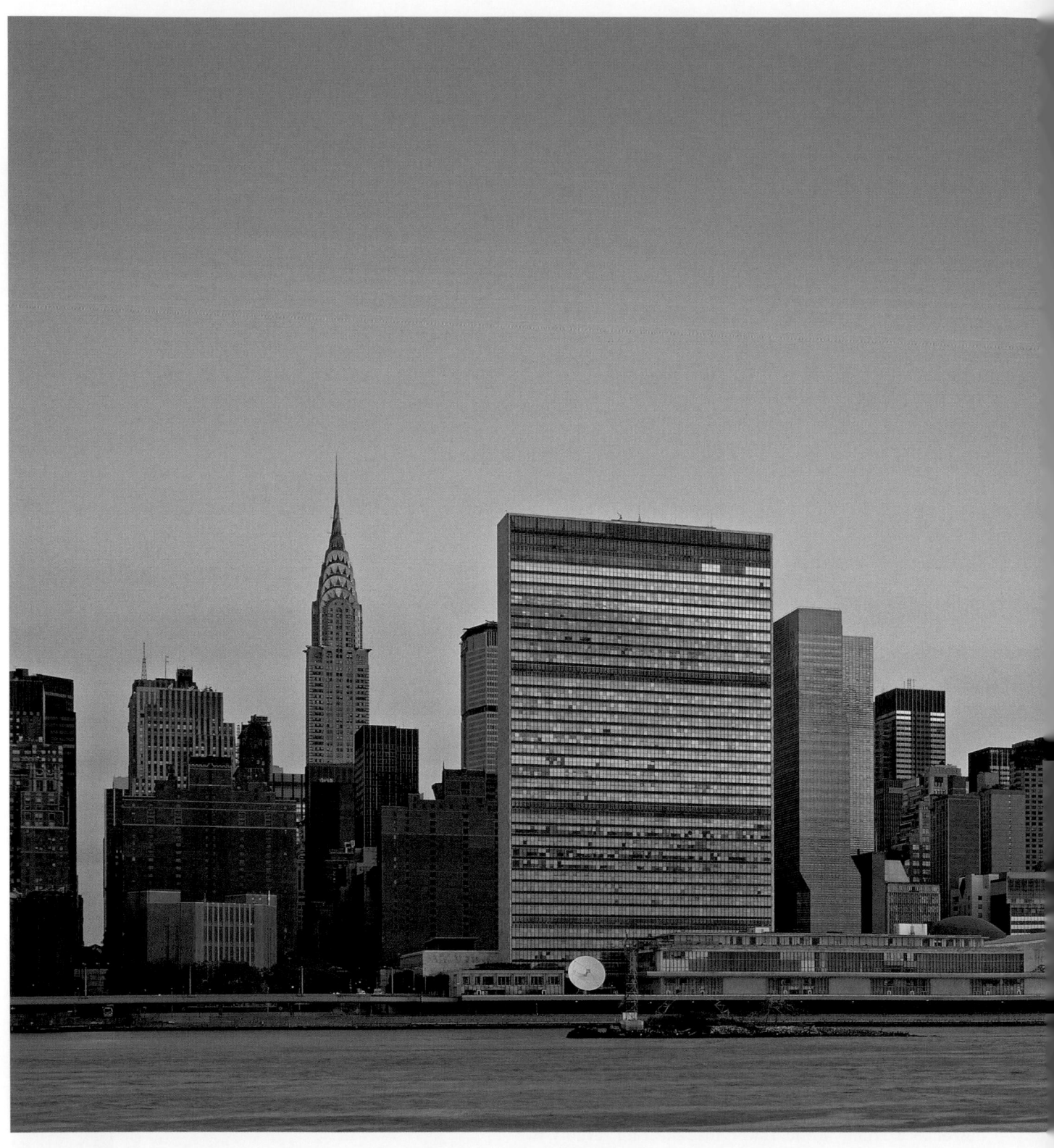

View to the northwest with Trump World Tower
(Costas Kondylis, 2001), center, and United Nations
Headquarters (Board of Design, Wallace K. Harrison,
Director of Planning, 1947–52), left. Goldberg. ESTO

building in the immediate vicinity would not exceed the
height of the U.N.'s skyscraper.[33]

The first response to Trump's tower was mostly one of
shock, as community groups and neighborhood residents could
not quite believe that the proposal was already a fait accompli,
with no further approvals needed. Reaction to Kondylis's design
was not entirely negative. Paul Goldberger wrote that it had

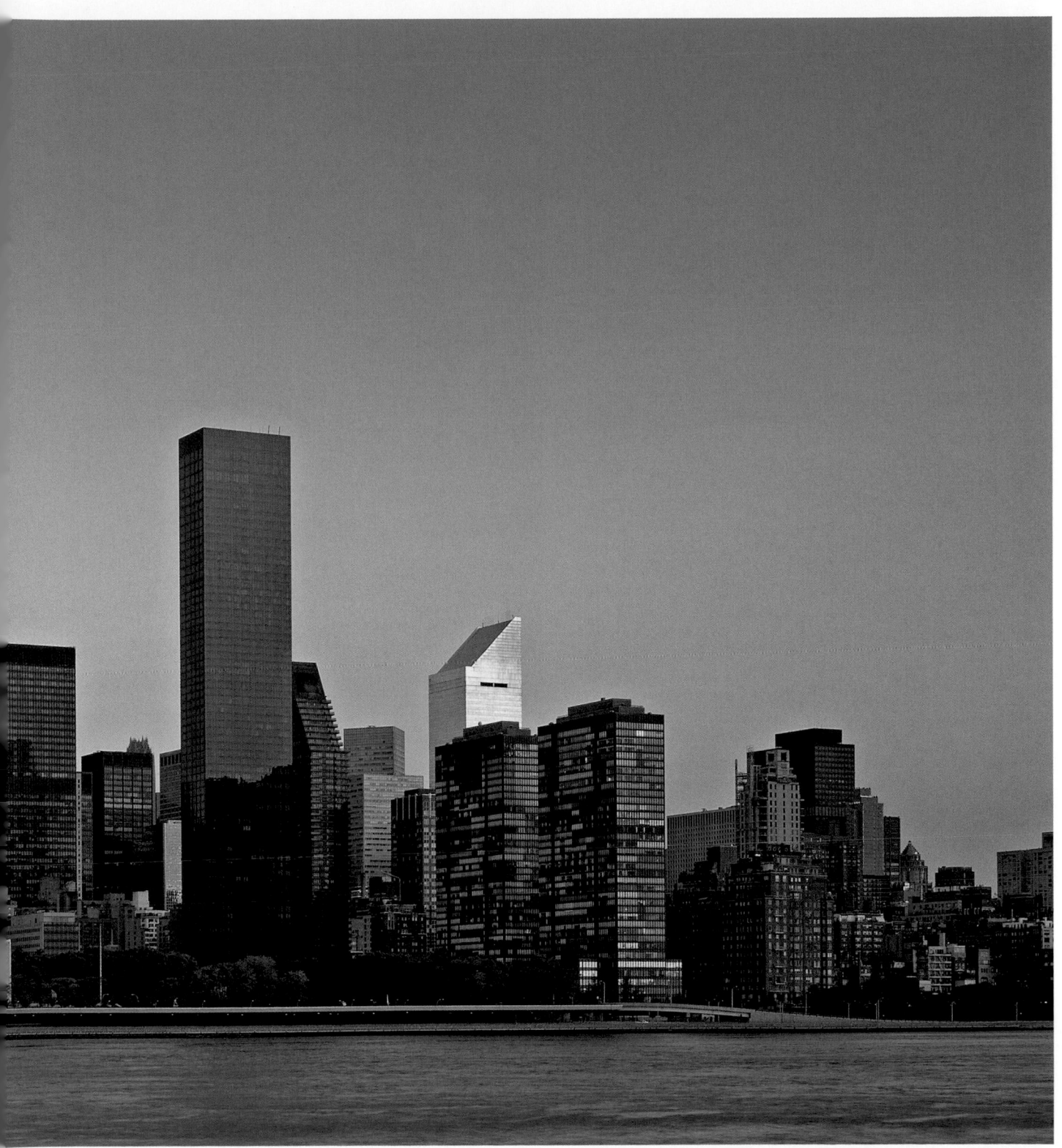

"the un-Trumpian virtue of simplicity; but a lot will depend on the choice of color for the glass, and how it appears in the morning light coming off the East River and the afternoon light reflecting across Manhattan."[34] Karrie Jacobs observed that "while other developers clad residential towers in masonry, striving for the dignity of a classic prewar building, Trump is building New York's first Modernist-revival apartment tower. It

pays homage to Mies and Modernism in a kitschy way that readers of *Wallpaper* magazine will appreciate. Kondylis takes the language of the Seagram Building—all that glass, all those straight lines, the stern, sober mien—and exaggerates it. More glass, more straight lines, and a soupçon of giddiness: Trump's luxe gold trim around the entrance." Although Jacobs regretted that something so banal was going forward, she was less

concerned about the building's effect on the neighborhood: "First Avenue is wide and confusing here: Directly in front of Trump's site, cars surface from a tunnel below First Avenue, adding extra traffic and a maze of metal and concrete barriers. Add the great Modernist slab of the U.N. rising from its concrete plain, and the feel is more Brasília than New York. Donald Trump would be hard-pressed to build anything, no matter the height, that could ruin this particular part of town."[35]

After the initial surprise wore off, neighborhood residents and community groups sprang into action to oppose the project. Of course, many opponents were really concerned about lost views from their apartments. The goal was not necessarily to stop the building altogether but to radically reduce its height. A new group, the Coalition for Responsible Development, formed to lead the fight, was composed most notably of prominent tenants of Harrison & Abramovitz's 860–870 United Nations Plaza (1966), located diagonally across the street from the proposed tower. Despite enormous attention in the press and considerable financial resources to wage its campaign, the coalition had no success with either city agencies or the courts. Demolition of the Engineering Societies Center went ahead as planned.

Trump World Tower was topped out in the summer of 2000, with the first tenants moving in beginning in January 2001, although the building, featuring a forty-foot-high marble-lined lobby by Brennan Beer Gorman/Monk Interiors and a ground-level bar designed by the Brazilian architect Arthur de Mattos Casas, was not quite finished. The bronze-colored facade was darker than the golden version first advertised, looking almost black. But, this being a Trump project, it was not to be without at least some golden glitz: the entrance, a version of that of Trump International Hotel and Tower, featured two-foot-high gold letters spelling out the building's name. The rather mean plaza, located on the Forty-seventh Street side of the building, consisted of nine trees and some granite benches.

In one of his most discussed articles, the mercurial Herbert Muschamp enthusiastically greeted the building by favorably comparing it to Trump's Riverside South development on the West Side (see Upper West Side). He described Trump World Tower as "undeniably the most primal building New York has seen in quite a while." Ignoring the improbable structural shifts at the tower's midpoint and the unrhythmic (and strictly functional) arrangement of the window bays, Muschamp confined his pleasure to a "visual appeal [that] derives, first of all, from the contrast between its amplitude of scale and its simplicity of shape." Muschamp amazingly contrasted it with the Empire State Building (Shreve, Lamb & Harmon, 1931) where he found "an unbalanced ratio of width to depth. Depending on your perspective, the tower shifts from sliveresque to monolithic." Brushing aside the Empire State Building's dramatic massing of base, shaft and concluding, capital-like crowning feature, he shifted his critique to a dismissal of that approach in the city's 1980s skyscrapers: "After all the frou-frou launched into the skyline for the past generation—the fussy attempts at three-dimensional collage; the ersatz Art Deco confections weighed down by stepped silhouettes and ornate crowns—it is pleasing to see a flat roof raised to the top of the skyline by four flush glass walls."[36] Muschamp also quoted Terence Riley, chief curator of architecture and design at the Museum of Modern Art: "It's a Trump building, so you're not supposed to like it. But it works urbanistically."[37] Perhaps the best assessment of the building was also one of the earliest,

Enclave, 224 East Fifty-second Street, between Second and Third Avenues. Marvin H. Meltzer, 1986. View to the south. Darley. MMA

occurring just days after the design was first released. In the Letters to the Editors section of the New York Times, David L. Hunter innocently asked, "Why does it have to be so boring?"[38]

By the mid-1990s, the U.N. complex itself began to show serious signs of wear, neglect, and the strains of overcrowding. When the headquarters opened, there were fifty-seven member nations, with plans to accommodate thirteen more. But the U.N. grew rapidly, and by the mid-1970s, there were over 140 member countries. The international organization, though it had a troubled relationship with its host city, with countless arguments over issues such as diplomatic immunity and parking privileges, was nonetheless important to New York's economic health in its capacity as the third-largest non-governmental employer and a significant tourist draw. In 1978–81 Harrison & Abramovitz oversaw a modest expansion that added an underground, two-story, 60,000-square-foot document-reproduction center beneath the north lawn, a new 750-seat cafeteria, and a forty-foot extension to the Conference Building. But most of the U.N.'s growing needs were met by cramming more people into the limited space as well as by moving some office functions offsite.[39] In October 1999, the situation had gotten so bad that Christopher Wren, writing in the New York Times, could report that the complex "is deteriorating at its core, beset by hundreds of millions of dollars in structural and environmental problems and without the money to fix them. In fact, if the United Nations had to abide by city building regulations—diplomatic

immunity spares it—it might well be shuttered."[40] Although there was some talk of abandoning the facility and moving to Bonn, the U.N. commissioned a report from Ove Arup & Partners which, when it was released at the end of 2000, recommended an extensive six-year-long renovation and rebuilding program and included such controversial options as a ten-story addition to the Secretariat Building. But the U.N., now swelled to 188 members, was unable to proceed meaningfully until a realistic source of funding could be found.

To the north of the U.N., in the predominantly residential, low- and mid-rise streetscapes between Beekman and Sutton Places, four new apartment towers, viewed by many as unwelcome intruders, were completed, beginning in 1981 with Schuman, Lichtenstein, Claman & Efron's thirty-eight-story hexagonal River Tower, 420 East Fifty-fourth Street, between First Avenue and Sutton Place South, designed in association with Rudolph de Harak, a graphic designer.[41] Situated diagonally across its 35,000-square-foot through-block site so that its prowlike ends pointed to the southwest and northeast, River Tower, representing the urban destructiveness inherent in the 1961 zoning, was made possible as a result of bonuses for three distinct public plazas around the base that awarded the building an additional 74,000 square feet. Horizontal ribbon windows alternating with bands of gray brick to wrap the building, swelling with bay windows beginning on the thirtieth floor, were unable to mitigate the brutal scale of the tower.

Directly across Fifty-fourth Street, St. James Tower (Emery Roth & Sons, 1983), 415 East Fifty-fourth Street, between First Avenue and Sutton Place South, also on a through-block site, was, by comparison, modest, a thirty-two-story, 250,000-square-foot luxury apartment house with 106 units meant, according to the developers, to be "a palace for a privileged clientele."[42] Indeed, in 1983 Paul Goldberger discussed St. James Tower together with Trump Tower and Museum Tower, calling the trio "surely the most serious attempts in some years to create truly luxurious urban living space."[43] The apartments, laid out by Bromley/Jacobsen Architecture and Design, which also designed the public spaces, were quite large by postwar standards and featured nine-foot-three-inch ceilings, floor-to-ceiling windows, black marble powder rooms, and white marble bathrooms with bidets. The twenty-seven-foot-high glass-enclosed lobby was flanked by moatlike pools of water and landscaped gardens. The exterior was modeled with rounded corners and a skin of purplish brown iron-specked brick and gray-tinted glass.

The Enclave (1986), 224 East Fifty-second Street, between Second and Third Avenues, designed by Marvin H. Meltzer, who was also vice president of Britton Development Ltd., the developer, was one of the last "sliver" buildings erected before the thin midblock towers were outlawed. To overcome the sense that the sixteen-story, forty-foot-wide, seventy-foot-deep apartment house—deemed by the editors of the *AIA Guide* a "modern eccentric"—would seem like an intruder on the block, it was clad in pink stucco for the first seven stories and the remainder, set back at the eighth and tenth floors, in red brick.[44] Both the north entry facade and the rear south facade featured a stack of prominent semicircular balconies, the north side also punctuated by recessed rectangular balconies whose railings were designed to resemble the fire escapes on neighboring buildings. Above the entrance a glass-block cylinder formed a volumetric canopy. Glass block was also used on the interiors, allowing light to flow deep into the apartments.

Fox & Fowle's Le Grand Palais (1991), 254 East Fifty-fourth Street, southwest corner of Second Avenue—a colorful if somewhat out of character addition to the area—consisted of a forty-story, 179-unit apartment building incorporating 6,000 square feet of ground-level retail space as well as a pool and health club two stories underground.[45] The tower, rising from a three-story site-filling base, was organized as two interlocking masses—one a round-edged glassy volume, the other a rectilinear form overlaid by a grid of aluminum panels that gave it a more solid appearance—closely resembling the same firm's forty-three-story Embassy Suites hotel, southeast corner of Broadway and Forty-seventh Street, completed the year before. Eight evenly spaced bright red bands wrapped the building and seemed to provide the inspiration for a 1993 remodeling (Le Grand Palais was sold after sitting vacant for two years following its completion), at which point new owners renamed the building Le Mondrian and installed a series of colorful geometric panels inspired by the Dutch artist's work at the ground- and second-floor levels.

Le Grand Palais, 254 East Fifty-fourth Street, southwest corner of Second Avenue. Fox & Fowle, 1991. View to the northwest. Gordon. FXF

Joyce Theater, southwest corner of Eighth Avenue and West Nineteenth Street. Hardy Holzman Pfeiffer Associates, 1982. View to the west. Hursley. H3

Joyce Theater, southwest corner of Eighth Avenue and West Nineteenth Street. Hardy Holzman Pfeiffer Associates, 1982. McGrath. H3

CHELSEA

The transformation of Chelsea, roughly bounded by Fourteenth and Thirtieth Streets, Sixth Avenue and the Hudson River, from a sleepy backwater to a vital, fashionable area was fueled by the redevelopment of those parts of the neighborhood then most in decline: its far west industrial fringe, which was reborn as an important new gallery district devoted to contemporary art, and its decaying waterfront, which was revitalized by the rebuilding of the West Side Highway and by the construction of a vast new recreational complex, Chelsea Piers. The mixed-use neighborhood boasted a distinguished architectural pedigree, with rows of fine townhouses from the mid-nineteenth century; venerable institutions like the General Theological Seminary (1836; Charles C. Haight, 1884–1904), Twentieth to Twenty-first Street between Ninth and Tenth Avenues; cast-iron emporiums from the late nineteenth century along its eastern edge; apartment buildings like the Chelsea (Hubert, Pirsson & Co., 1883), 222 West Twenty-third Street, and Farrar & Watmaugh's London Terrace (1930), Twenty-third to Twenty-fourth Street between Ninth and Tenth Avenues; and innovative industrial behemoths like the Starrett-Lehigh Building (see below). But in the three decades following World War II, Chelsea's landscape had

been compromised by huge, primarily bleak, public and private housing complexes.[1]

The renovation of the Elgin Theater (Simon Zelnik, 1942) for use as a 475-seat dance theater set the stage for the emergence of a revived Chelsea.[2] The Elgin, a small, stylish Art Moderne movie house built on the foundations of three brownstones at the southwest corner of Nineteenth Street and Eighth Avenue, was purchased in 1979 by Eliot Feld, the choreographer. Riding the crest of an extraordinary wave of popularity for dance performance, especially modern dance, Feld's theater was to be home to his own company as well as others. Guided by Feld, his administrator, Cora Cahan, and the architects Hardy Holzman Pfeiffer Associates, and supported by foundations and a substantial federal grant, the theater, renamed the Joyce Theater, reopened on June 1, 1982.

Hardy Holzman Pfeiffer was extremely respectful of the theater's polychromed exterior, taking care to expand the black-and-white checkerboard-patterned brickwork and signature stone medallions. But the project's success was as much due to the architects' inventions as it was to their acts of preservation: the marquee, the glass bricks, and neon were new, as was virtually the entire interior, which they essentially gutted to make room for an expanded lobby, a fifty-by-thirty-six-foot stage, and a better rake to the auditorium floor. Reflecting the zip of the theater's exterior, but with largely off-the-shelf materials that the architects preferred and the client could afford, the interior featured lobby columns and balcony fascias sheathed in corrugated steel, pale blue walls achieved with automobile paint, a three-foot-square grid and sheets of expanded metal forming the proscenium and, above, a steel truss—found above the movie house's dropped ceiling –

exposed to support lighting, accessible from new catwalks. A sleekly detailed stair led down to additional lobby space, located beneath the auditorium. As Nicholas Polites wrote of the Joyce, one of Hardy Holzman Pfeiffer's most important works of reinvention, "The design is neither a contrast of new with old nor a confrontation that pointedly comments on the character of what was there before. Instead, everything fits together as one piece, making new and old a seamless whole."[3]

Despite the success and popularity of the Joyce, Chelsea remained in relative anonymity until the 1990s, when the neighborhood was substantially altered, largely through the dramatic influx of art galleries specializing in contemporary art as many dealers fled increasingly expensive SoHo, now a victim of its own success, attracting prominent retail tenants who could pay substantially higher rents. The movement of art galleries to Chelsea was initiated in 1987 by the decision of the influential SoHo-based Dia Center for the Arts, founded in 1974 by Philippa de Menil and Heiner Friedrich to support and promote artists of the minimalist generation, to move to a four-story brick warehouse building (1917) at 548 West Twenty-second Street, between Tenth and Eleventh Avenues.[4] Richard Gluckman, who had worked with Dia on its SoHo space at 393 West Broadway, left the exterior of the 40,000-square-foot loft building alone but gutted the interior to create three 9,000-square-foot exhibition spaces ideally suited for displaying large-scale work. The *New York Times* art critic Roberta Smith was impressed with the "impeccable, stripped-down renovation . . . which brings to New York a rare commodity: optimum viewing conditions for contemporary art on a scale that has not been managed before, not even by an organization with Dia's resources."[5]

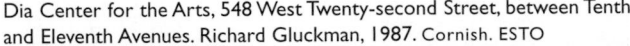

Dia Center for the Arts, 548 West Twenty-second Street, between Tenth and Eleventh Avenues. Richard Gluckman, 1987. Cornish. ESTO

Paula Cooper Gallery, 534 West Twenty-first Street, between Tenth and Eleventh Avenues. Richard Gluckman, 1996. View to the south. Bessler. LGB

Paula Cooper Gallery, 534 West Twenty-first Street, between Tenth and Eleventh Avenues. Richard Gluckman, 1996. Bessler. LGB

In 1992 Dia increased its presence in the neighborhood, purchasing another building on the block, a six-story, 42,000-square-foot loft building at 535 West Twenty-second Street, which Gluckman renovated.[6] Five years later he worked on a third building for Dia, a single-story bow-trussed structure at 545 West Twenty-second Street. In 2000 the Los Angeles–based artist Jorge Pardo renovated the facade of Gluckman's first building for Dia, adding additional windows as well as enlarging existing ones.[7] Pardo also reconfigured the lobby, most notably adding tiles of bright lime, lemon, yellow, and mustard green to the floors and ground-floor columns.

Although the Dia Center for the Arts inaugurated Chelsea's transformation into the city's premiere art center, it was the 1996 decision of one of SoHo's pioneers, Paula Cooper, to leave her Wooster Street gallery for a nineteenth-century warehouse at 534 West Twenty-first Street, between Tenth and Eleventh Avenues, that led to the explosion of new galleries in the area.[8] Richard Gluckman, who had designed Cooper's SoHo gallery, was called in again to completely transform the 6,500-square-foot space, recalling that "it was the barest of skeletons. There was no structure in front, no floors, the roof was in bad condition."[9] Gluckman added an intermediate structure to house the stairs and elevators and used two pairs of steel trusses to create a dramatic, column-free, forty-nine-by-forty-nine-by-thirty-foot main gallery which,

with its restored pitched wood beam ceiling and new sky-lights, resembled a chapel. "This room is so beautiful that it almost doesn't need art," observed Roberta Smith in her review of the opening exhibition of Carl Andre sculptures in the fall of 1996.[10]

In the wake of Cooper's move to Chelsea, an influx of eight new galleries in four buildings transformed the north side of Twenty-fourth Street between Tenth and Eleventh Avenues from a collection of dilapidated industrial structures into an internationally acknowledged art mecca. The first of the new gallery buildings to go forward was the 1997 renovation of a two-story, 150-foot-wide, 30,000-square-foot brick warehouse, formerly home to the knife maker Henckels, 515–523 West Twenty-fourth Street, to serve as new space for three galleries: Metro-Pictures, Barbara Gladstone, and Matthew Marks.[11] Designed by Michael Kostow of Kapell & Kostow Architects, the building was dominated by five glass garage-type doors that allowed natural light to enter the immaculate white-walled galleries as well as roll up to facilitate the installation of large pieces. The feature was a near duplicate of the treat-ment Richard Gluckman had provided in 1991 for the Gagosian Gallery in SoHo. Soon enough, Gluckman himself would be hired to design the rest of the galleries on the block, understandably leading to the widespread belief that Gluckman had reworked all the gallery buildings on Twenty-fourth Street. Andrea Rosen and Luhring Augustine shared a building at 525–531 West Twenty-fourth Street that Gluckman outfitted in 1998 with typically spare galleries and three pivoting green doors that could flip up to serve as canopies over the sidewalk.[12] Next door at 537–541 West Twenty-fourth Street, the prominent dealer Mary Boone shared a Gluckman-designed building (2000) with Charles Cowles. It featured a new brick facade and brushed stainless steel and sandblasted translucent glass doors and windows.[13] Boone's 3,700-square-foot gallery had steel-troweled concrete

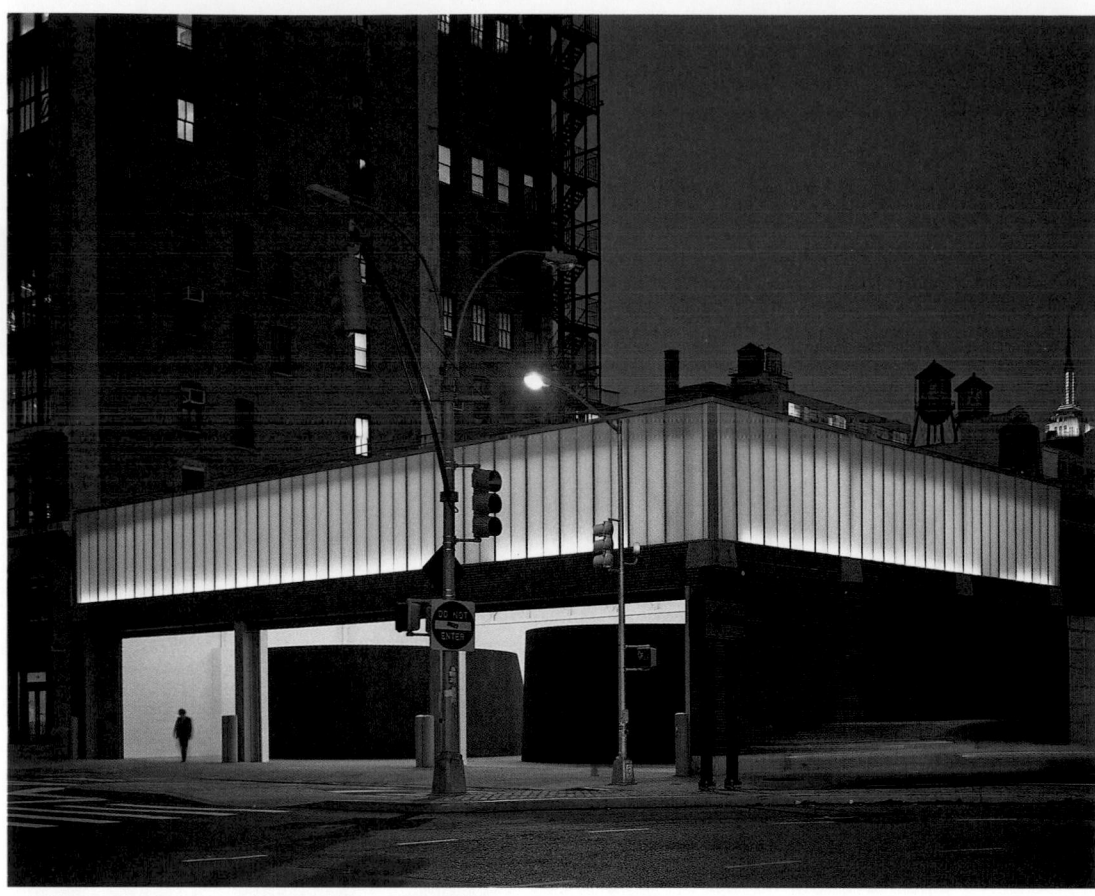

Gagosian Gallery, northeast corner of Eleventh Avenue and West Twenty-fourth Street. Richard Gluckman, 2001. View to the northeast. GMA

floors as well as a dramatic main room dominated by the former warehouse's original wood trusses and wood-plank ceiling. "In contrast to the classic 19th-century cast-iron architecture of SoHo," noted Roberta Smith, "the Chelsea look is 20th-century industrial: concrete instead of hardwood floors, garage-door fronts instead of cast-iron columns and, best yet, largely uninterrupted, column-free interiors. The result is a highly esthetic, object-oriented environment."[14] Gluckman's last gallery on the block was the massive, 25,000-square-foot Gagosian Gallery (2001), northeast corner of Eleventh Avenue and Twenty-fourth Street.[15] This was something of a return for Larry Gagosian who, first arriving in New York from Los Angeles in 1986, a year before Dia pioneered the Chelsea scene, had occupied a small space on West Twenty-third Street. Scaled more like a small museum than a gallery, Gagosian's second Chelsea operation featured a 2,400-square-foot main gallery, two smaller skylit galleries, and a 6,000-square-foot long-term installation gallery created by raising the roof of the one-story former trucking distribution facility. The ten-foot-high translucent plastic clerestory provided abundant natural light and was also lit at night to help advertise the building's presence in what was still a dark and fundamentally deserted part of the city.

In addition to the many renovations, there was at least one new building of note to include significant gallery space. G. Philip Smith and Douglas Thompson designed and developed a multiuse building (1999) on a vacant, fifty-four-by-forty-foot site formerly home to two brownstones on the northwest corner of Twenty-third Street and Tenth Avenue.[16] More than ten years in the making, the unusual 4,800-square-foot, three-

story structure, said to be influenced by contemporary Indian and Japanese architecture, as well as by the Noguchi Museum in Long Island City, provided living and studio space for the two architects as well as space for two galleries. The L-shaped building was organized around an open courtyard and featured paraffin-coated cordovan-colored steel walls and glass walls that allowed glimpses inside but otherwise protected the privacy of the tenants. While some observers dismissed the distinctly houselike design for being too far from the beach, Susanna Sirefman was captivated by the "elegant" building that also included a small opening cut into the steel to accommodate the branch of a tree on Tenth Avenue which stretched into the courtyard: "One would have thought it impossible to create such a tranquil spot on this busy corner. . . . Yet the modular steel armor around the building, made of precut 10-by-20-foot sheets, is an incredible sound barrier. . . . A playful exercise between transparent and opaque materials, solid and void space, this three-story project is a cubist confection."[17]

With over 100 galleries established by the end of the 1990s, Chelsea's status as an art mecca was secure. Still, not everyone viewed the ascendancy of Chelsea in positive terms. Critic Holland Cotter felt that in contrast to the art that "emerged organically" in SoHo in the early 1970s and the East Village in the 1980s, "where artists lived and worked" and where there "was an innocent, ad hoc, optimistic feeling in the air, . . . the Chelsea art development . . . is an artificial life form, dropped into place, fully shaped and heavily financed, from elsewhere. As a result, it seems to have neither roots nor rough edges; its larger galleries tend to look overscaled and impersonal, like car showrooms. The atmosphere is cool, business-like and world-

LEFT 501 West Twenty-third Street, northwest corner of Tenth Avenue. Smith & Thompson, 1999. View to the northwest. Baz. STA

BELOW 501 West Twenty-third Street, northwest corner of Tenth Avenue. Smith & Thompson, 1999. Courtyard. Moran. STA

weary."[18] But the die was cast and Chelsea's art scene would continue to grow. The opening of Steven Learner's Sean Kelly Gallery (2001) at the northern reaches of the district at 528 West Twenty-ninth Street, between Tenth and Eleventh Avenues, and the exodus of yet another major gallery from SoHo, PaceWildenstein, which opened a 10,000-square-foot facility (2001) at 534 West Twenty-fifth Street with a new facade of terra-cotta brick and purple mortar designed by the artist Robert Irwin, made clear that the big art money had staked its claim to the area, at least for the near future.[19]

The successful transformation of a portion of the neighborhood's run-down waterfront was as important to Chelsea's revitalization as its new role as an art center. On June 18, 1992, the Hudson River Park Conservancy, created as a limited-purpose subsidiary of the New York State Urban Development Corporation to oversee the development of the Hudson River waterfront from Battery Park City to Fifty-ninth Street, announced that the team of Roland W. Betts, Tom A. Bernstein, and David Tewksbury had been selected to redevelop a thirty-acre site comprising the four Chelsea Piers (Warren & Wetmore, 1910), stretching from Seventeenth to Twenty-third Street, with an ambitious, 1.7-million-square-foot sports and entertainment complex.[20] Planned for completion in less than three years' time, the massive adaptive reuse of the piers was greeted with widespread skepticism.

Betts and Bernstein, ex-entertainment lawyers who ran Silver Screen Management, were novices as real estate developers, but Tewksbury, an executive with the real estate firm Cushman & Wakefield, was not. Moreover, Betts and Tewksbury were the owners of the Sky Rink, Manhattan's

LEFT Chelsea Piers Sports and Entertainment Complex, Hudson River between West Seventeenth and West Twenty-third Streets. Butler Rogers Baskett, 1995. View to the southeast. George. FG

ABOVE Chelsea Piers Sports and Entertainment Complex, Hudson River between West Seventeenth and West Twenty-third Streets. Butler Rogers Baskett, 1995. View to the southwest. George. FG

only indoor ice-skating rink, located on the top floor of Davis, Brody & Associates's Westyard Distribution Center (1970), east side of Tenth Avenue between Thirty-first and Thirty-third Streets.[21] Disappointed with the Sky Rink's facilities, in 1991 they were attracted to the potential of Pier 61, a long-abandoned, dilapidated 100,000-square-foot structure which, if renovated, could accommodate two full-size ice-skating rinks. The pier was controlled by the New York State Department of Transportation, which had taken possession of it in the 1960s as part of the plans for Westway. But the state was not interested in an isolated development and would only agree to lease the pier if it was part of a coordinated undertaking that would also include the renovation of Piers 59, 60, and 62 and the nearly five-block-long headhouse at the piers' eastern border facing Eleventh Avenue.

As originally realized by Warren & Wetmore, Chelsea Piers and the continuous two-story headhouse containing passenger lobbies, ticket booths, and offices, stretching from Little West Twelfth to Twenty-third Street, were a triumph of Beaux-Arts design servicing the most glamorous transatlantic vessels from the Cunard, White Star, and French lines. The 120-by-880-foot piers served their purpose for twenty years. But larger ships and the creation of more substantial piers to handle them farther uptown, in the West Fifties, led to their refitting for cargo ships. With the growth of containerships requiring vast open piers, as well as the introduction of air cargo, the commercial value of Chelsea Piers declined steeply, reaching a low point in 1963 when, in a failed attempt at reestablishing them as a cargo terminal, the monumental pink granite and cast-concrete eastern facade of Warren & Wetmore's headhouse was replaced with a banal, low-maintenance metal wall. At the same time, the piersheds of Piers 59 and 62 were

removed. By the time Betts surveyed the scene in late 1991 the situation was bleak: Pier 59 was home to garbage trucks from the Sanitation Department; Pier 60 was a graveyard of cars impounded by the police; the piershed of Pier 61 was in complete disrepair with holes in the roof and broken windows; and Pier 62 had been reduced to a concrete slab that was occasionally used for parking. The only bright spot was the studio facilities and soundstages in the headhouse, which served the hit television show *Law and Order*; the other businesses located in the headhouse were a motley collection of offices for limousine and storage companies. Faced with state demands to develop all four piers, Betts turned to his Yale College roommate, architect James Gamble Rogers III of Butler Rogers Baskett, to come up with more elaborate plans for substantial athletic facilities in addition to the two new ice-skating rinks and, taking a cue from the one remaining success as well as their own experience in the entertainment industry, create new movie and television studio space.

Butler Rogers Baskett's plans for the new Chelsea Piers Sports and Entertainment Complex were a publicist's dream, including two full-size ice-skating rinks; two massive outdoor rollerblading rinks; a 150,000-square-foot sports center, complete with the world's largest indoor jogging track, a forty-two-foot-tall fiberglass and pulverized granite rock-climbing wall, and an Olympic-size swimming pool; forty lanes of bowling; a golf driving range; three restaurants; a seventy-slip marina; parking for over 500 cars; a 300,000-square-foot film and television production facility; and a 30,000-square-foot photography studio. Extending the length of the headhouse, Sunset Strip was to be an interior, weather-protected walkway connecting the various facilities; large windows opening to the Hudson River view to the west were balanced by large black-and-white photographs documenting the history of Chelsea Piers on the inboard side. To animate the bleak metal street-facing facade of the headhouse, the architects commissioned murals from the artist John Clem Clarke and employed bright signs and graphics. They also installed a thirty-by-forty-foot electronic billboard. Perhaps the most interesting facility was the Golf Club at Pier 59, which featured a "traditional" Shingle Style 10,000-square-foot clubhouse placed inside the headhouse with a covered portico and bay windows creating a kitschy country-club ambience. The Golf Club also included a four-level driving range with fifty-two hitting stalls equipped with an automatic tee-up system. To prevent the balls from flying into the river, 190,000 square feet of netting, creating the most visible symbol of the entire Chelsea Piers complex, was suspended from twelve, 150-foot-tall freestanding steel towers, support piles for which were driven 250 feet below the riverbed. In terms of purely public amenities, Butler Rogers Baskett, working with the landscape architect Edmund Hollander, created a modest park at the end of Pier 62 and, to better effect, a twenty-foot-wide, 1.2-mile-long esplanade that ran along the perimeter of each of the piers, promoting access to the water's edge.

Despite a myriad of both city and state regulations, in addition to the involvement of the federal government, which controls navigable waterways, not to mention objections from several community leaders—many of the same pressures that had plagued and stymied Westway for two decades—plans for Chelsea Piers proceeded rapidly, with a building permit issued in May 1994 and construction starting a month later. The first facilities were open by the summer of 1995. Paul Goldberger

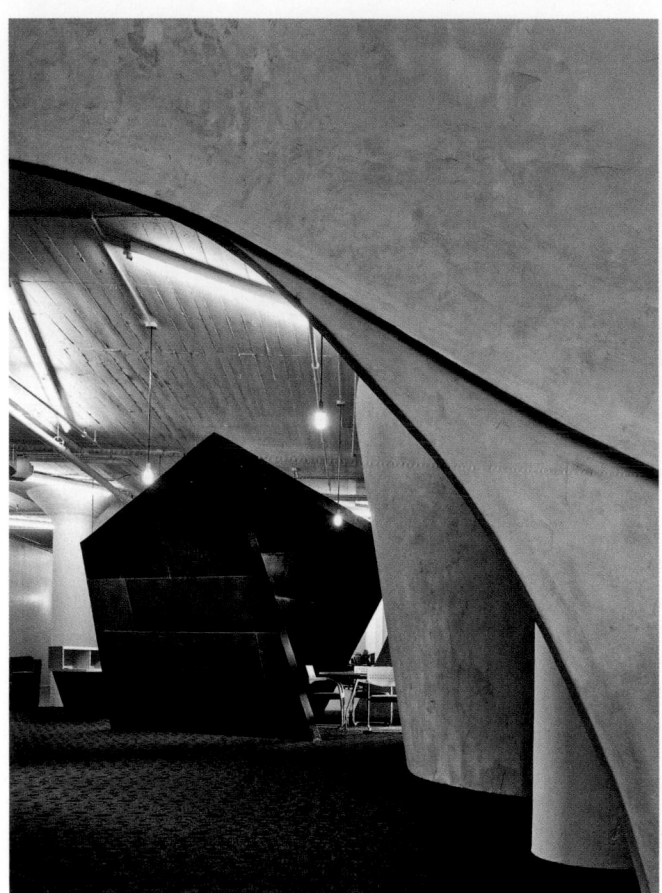

ScreamingMedia, Starrett-Lehigh Building, 601 West Twenty-sixth Street. Hut Sachs Studio, 1999. Goldberg. ESTO

was impressed with the new Chelsea Piers, which was financed totally by private funds: "It is a good work of design, full of a recognition of the potential of this unusual 30-acre site. The place has a presence, a presence that makes it like no other place in New York. Chelsea Piers is at once deeply connected to New York and utterly separated from it." Goldberger felt that the "striking combination of industrial grit and yuppie gleam" worked particularly well in the redesign of the piersheds "in such a way as to make them feel open and full of light while retaining parts of the historic structure, including the original steel truss work. The piers have evolved into huge sheds, with large windows that reflect the original pattern of doors along the sides of the piers. The interiors are spectacular spatially, and the design is lively and, at its best, intensely colorful."[22] While Herbert Muschamp would only note that many "are not thrilled with Chelsea Piers," questioning "whether a public amenity like the waterfront should be exploited by private developers,"[23] it was left to one Stuart Waldman, president of the Federation to Preserve the Greenwich Village Waterfront & Great Port, to blast Chelsea Piers' interiors as a playpen for the rich while describing the complex as "an enormous, squat airplane hangar of a building that stands between us and a great river."[24]

The public flocked to Chelsea Piers, and the new studio space, quickly dubbed "Hollywood on the Hudson," proved popular. Yet the project continued to attract naysayers, ranging from residents across the river in Hoboken who felt "blinded"

by the bright light emanating from the driving range at night to neighborhood activists who felt that the small public park and esplanade were woefully inadequate. Despite the failure of one of the restaurants and a highly visible but poorly received attempt in 1997 to host the "7th on Sixth" fashion show, by 1998 Chelsea Piers had an annual attendance of 3.8 million people, placing it third on the list of most visited Manhattan entertainment destinations behind the Metropolitan Museum of Art and Madison Square Garden. Philip K. Howard, chairman of the Municipal Art Society and a Chelsea Piers regular, listed the complex as one of a handful "of things that have happened in the last two decades that have obviously enhanced the quality of life in New York City."[25]

In addition to the small park at the end of Pier 62 and the twenty-foot-wide esplanade, the far west precincts of Chelsea received additional open space in October 2000 with the opening of Thomas Balsley Associates's Chelsea Waterside Park, located east of the sports complex on a two-and-a-half-acre site bounded by Twenty-second and Twenty-fourth Streets, Eleventh Avenue and the West Side Highway.[26] Built under the auspices of the Hudson River Park Trust, Balsley's design more than quadrupled in size the existing Thomas F. Smith Park (1923), a situation made possible by the release of additional land as a result of straightening the S-curve at Twenty-third Street for the rebuilt highway that followed Westway's collapse. Within the enlarged space, Balsley was able to include an impressive array of amenities, including children's play areas with mosaic tile water sprays, a dog run, basketball courts, picnic areas, gardens, as well as a sports field with spectator bleachers and lighting. The Chelsea Waterside Park required the closing of Twenty-third Street west of Eleventh Avenue, which was replaced with a grand promenade whose entrance was marked by twenty-foot-high stainless-steel pylons resting on granite bases.

Chelsea's emergence as a major center for galleries devoted to contemporary art accounted for the reuse of only a small portion of the area's underutilized commercial real estate, which included one of the world's largest buildings, the nineteen-story, 1.8-million-square-foot Starrett-Lehigh Building (Russell G. and Walter M. Cory and Yasuo Matsui, 1931), occupying the entire block bounded by Eleventh and Twelfth Avenues, Twenty-sixth and Twenty-seventh Streets.[27] In the 1990s, the former factory-warehouse's vast size, for decades seen as a handicap, came to be regarded as an asset, especially by those new-media and high-technology companies uninterested in traditional office arrangements. With floors as large as 124,000 square feet and ceiling heights of up to twenty feet, the Starrett-Lehigh's raw, wide open spaces could be customized in ways that the buttoned-down buildings of midtown and the financial district could not.

In 1998, at the peak of the so-called dot.com boom, the building was put up for sale by Leona Helmsley, whose late husband, Harry, had acquired it in 1974. Despite its relative isolation and inaccessibility, it attracted high-profile bidders from the real estate industry, but the winning bid was submitted by two comparative unknowns, David Werner and Mark Karasick, financed by Credit Suisse First Boston, who pledged over $20 million in renovations, including four new elevators and an upgraded heating and cooling system.[28] The architect Ludwig Michael Goldsmith's conservative reworking of the entrance facade offered little preparation for the lobby designed by Maria Hellerstein and Nikolai Katz, who dramatically expanded it into the space of a former truck bay. The lobby was dominated by John Degnan's sixty-foot-long, seventeen-foot-high glimmering mural created from six sheets of acid-etched tempered glass placed in front of a mirror that Elaine Louie, writing in the *New York Times*, said resembled "Jackson Pollock throwing handfuls of snow on an expanse of glass."[29]

The first major occupant of the rejuvenated building was advertising giant Jay Chiat's new Internet company, ScreamingMedia (1999), located on the thirteenth floor.[30] Chiat, who had commissioned innovative offices from Frank Gehry in Venice, California, turned to Hut Sachs Studio, which populated the company's 25,000-square-foot space, intended for 160 employees, with free-form Formica-topped "pond" tables interrupted by highly sculptural Masonite and plaster enclosures, each a different color, ranging from pale yellow to deep-sea blue.[31] Providing semiprivate space for meetings and phone calls, the enclosures were animated with a graphics program of words and phrases devised by Milton Glaser because, as Jane Sachs put it, a formal art program "would have been too precious."[32] Claiming design inspiration from Richard Serra's sculptures and Frank Gehry's architecture, Hut Sachs sought to create an "energetic," non-hierarchical interior that would "envelope its occupants in dynamically folding spaces: no doors, no corner offices, no traditional cubicles."[33] This arrangement extended to chairman Chiat as well, who occupied a standard-issue five-foot-four-inch-wide by three-foot-deep sanded acrylic–topped desk in the middle of the room.

Soon enough, innovative companies flocked to the building, frequently commissioning stylish interiors. The architects Scott

Inside.com, Starrett-Lehigh Building, 601 West Twenty-sixth Street. Specht Harpman, 2000. Moran. SH

Comme des Garçons, 520 West Twenty-second Street, between Tenth and Eleventh Avenues. Takao Kawasaki, Rei Kawakubo, Future Systems, and Studio Morsa, 1999. View to the southwest. Davies. RD

Comme des Garçons, 520 West Twenty-second Street, between Tenth and Eleventh Avenues. Takao Kawasaki, Rei Kawakubo, Future Systems, and Studio Morsa, 1999. Eberle. CDG

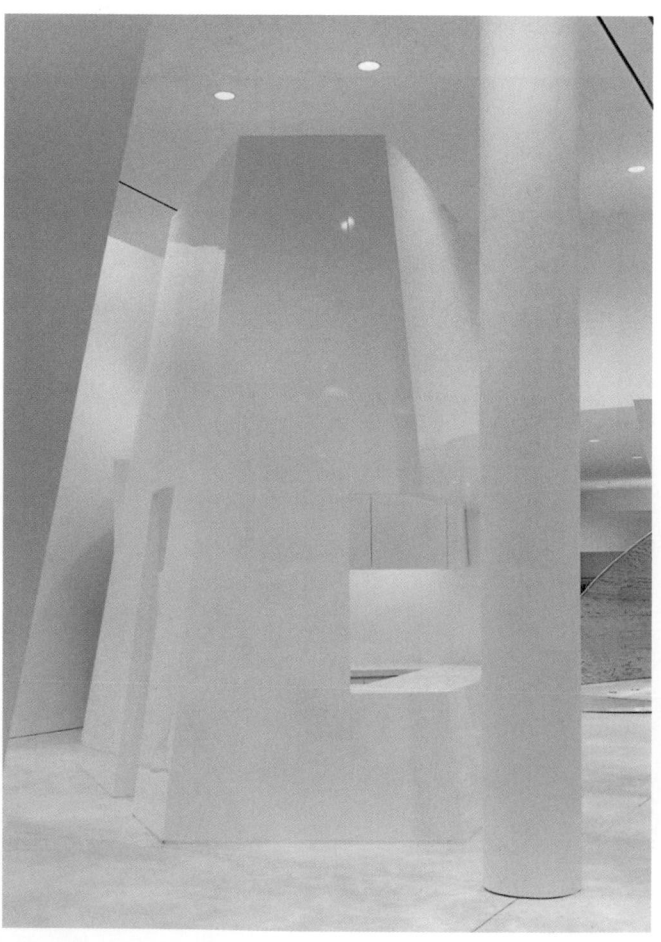

Specht and Louise Harpman completed four installations in quick succession, including 12,000 square feet for Doublespace (2000) and 6,000 square feet for Powerful Media (2000).[34] Kurt Andersen, Michael Hirschorn, and Deanna Brown gave Specht Harpman only ninety days and not much money to design and build new offices for their start-up Internet company, Inside.com, dedicated to covering the media and entertainment industry.[35] The architects made few structural changes to the 6,000-square-foot space (2000) on the thirteenth floor and selected their materials from industrial supply catalogs. The most interesting part of the design was the cylindrical meeting room just beyond the reception desk, which impressed Henry Urbach, writing in *Interior Design*: "Framed with exposed wood members sheathed in blue industrial plastic, the chamber provides an intensified sense of interior space while also evoking the crown of five water towers atop the Starrett-Lehigh roof."[36] Specht Harpman's more substantial, 40,000-square-foot offices for Web-site developer Concrete Media (2000), located on the eighth floor, included meeting rooms that repeated the water tank motif, but this time the semicircular "think tanks," to use Scott Specht's phrase, were fabricated by a Long Island boatbuilder out of translucent resin fiberglass tinted "surfboard clear."[37] Specht Harpman also tracked down the manufacturer of Starrett-Lehigh's original windows, Bliss Cashier Steel Products, and used its product for the interior windows of the main conference room.

The Starrett-Lehigh Building's status as the "new headquarters of the new economy" was firmly cemented in August 1999 when Martha Stewart, the super-successful guru of home style, leased the entire ninth floor to house several divisions of her newly founded Martha Stewart Living Omnimedia empire.[38] "I love the double-height ceilings, with the skylights and that wonderful light," Stewart remarked. She was also intrigued by the still-rough-around-the-edges neighborhood, but what most appealed to her was that she could "drive a truck into the elevator up to my floor and unload things. It's very weird and wonderful."[39] As designed by the minimalist architect Daniel Rowen, Omnimedia's white- and dove- and putty-colored space (2000) took advantage of a double-height clerestory flanked by column-filled aisles. In addition to photographic studios and stainless-steel test kitchens, the space was dominated by hundreds of similar workstations custom-designed by the architect. Unlike Jay Chiat's decision to occupy an ordinary desk, Martha Stewart situated herself in an inner sanctum composed of floor-to-ceiling butt-jointed clear glass. Rowen, ever the minimalist, was not worried about maintaining the purity of his design: "It'll be okay, Martha has good taste."[40]

The high-style chic put some observers off. According to Mayer Rus, writing in *Interior Design* in November 2000, "All sorts of groovy, mysteriously funded dot.com outfits have set up shop there. . . . The trouble is, Starrett-Lehigh is a drag. Not just because building systems are struggling to keep pace with rising occupancy. . . . Not just because 11th Avenue is still too remote and desolate to support a decent street/dining/entertainment culture. Starrett-Lehigh is a drag because it all too often represents the failure of imagination of designers seeking to create an appropriately progressive environment for their newfangled, high-tech 21st-century clients." Citing the many "shimmering, hard-edged, steel-and-glass fantasies" as well as the "kooky" land-

scapes "of torqued, twisted, tortured drywall pavilions," Rus worried that today's designers were shedding "a bunch of old clichés only to embrace equally tired new ones."[41]

The fear that Chelsea might become another SoHo, with prominent retail tenants attracted to the area because of its new prosperity and cachet as a gallery district, gained credibility in 1998 with the announcement that the high-fashion clothier Comme des Garçons would soon open a boutique on the same block as the Dia Center for the Arts at 520 West Twenty-second Street, between Tenth and Eleventh Avenues.[42] In 1984 Comme des Garçons had been one of the pioneers of the SoHo retail scene, and many believed that this move to Chelsea would set off an avalanche of new stores in the neighborhood. If Comme des Garçons's SoHo store, designed by the architect Takao Kawasaki in collaboration with Rei Kawakubo, the owner of the chain and its chief designer, was a masterpiece of minimalism, the 5,000-square-foot Chelsea version (1999), also designed by Kawasaki and Kawakubo with the help of Future Systems and Studio Morsa, took the opposite tack. The shop was located in an unassuming three-story nineteenth-century brick warehouse, the run-down facade of which was left largely alone, complete with its fire escape and signage from its last tenant, the Heavenly Body Works auto repair shop. The only intervention—and the most striking feature of the store—was the insertion of a dramatic entrance tunnel, "like the glowing gangway to a Hollywood-style UFO," according to Marcus Field, writing in the British publication *Blueprint*.[43] Designed by Future Systems and the engineers Ove Arup & Partners, the hand-polished silver structure was formed from computer-cut, invisibly welded six-millimeter aluminum panels. The cavelike opening was constructed using the latest boat-building technology at the Pendennis Shipyard in Cornwall, England, and was then taken apart and shipped to New York, where it was reassembled. A pivoting glass door was placed in the middle of the asymmetric shimmering tunnel, which also featured recessed light fixtures in the floor. The entryway, deemed the "coolest . . . in all of New York" by Susanna Sirefman, was most visible at night when the store was closed, with red and white light from the glowing floor filtered through the bars of the stainless-steel security screen.[44] The inside of the concrete-floored eighteen-foot-high store, designed by Studio Morsa, was dominated by six freestanding uniquely shaped "pods" used to display the clothes. The pods, clad with bright white bent metal panels scooped out to accommodate shelving and display bars, were a stunning departure from the stark open plan of the SoHo store. "Like a futurist version of Manhattan's skyline," wrote Abby Bussel in *Interior Design*, "the monumentally scaled pods define a series of internal, interconnected streets that lead visitors through the shop, offering an experience of discovery, of unexpected vistas at every twist and turn in the road."[45] In addition to the large white pavilions, two curvilinear walls of black-lacquered Sheetrock in emulation of a Richard Serra sculpture were used to define a fitting room as well as additional stockroom space.

Another feature of Chelsea's industrial past, an abandoned elevated freight track running parallel to Tenth Avenue between Gansevoort and Thirty-fourth Streets and commonly known as the High Line, became a point of contention and debate in the neighborhood beginning in September 1992 when the Federal Interstate Commerce Commission issued a "Conditional Demolition Order" for the 1.45 miles of track.[46]

High Line (1934), elevated freight track running between Tenth and Eleventh Avenues from Gansevoort to West Thirty-fourth Street. View to the south, 2003. Sternfeld. FHL

Finished in 1934 as part of the vast West Side Improvement plan, the High Line was a thirty- to fifty-foot-wide stretch of viaduct raised fifteen feet above the ground that had been literally cut through existing factory and warehouse buildings, allowing freight to be conveniently loaded and unloaded within a building and helping to avoid the many grade-level accidents that had led Tenth Avenue to be referred to as "Death Avenue."[47] The Commerce Commission's order was prompted by a lawsuit filed by the Chelsea Property Owners, a group of more than twenty individuals and businesses owning land beneath the elevated railroad, who wanted Conrail, the owner of the High Line, to tear it down. The city supported the owners' group, while Conrail, having ended freight service in 1980 with the delivery of three carloads of frozen turkeys, was mostly concerned about the cost of demolition, which the federal agency had declared should be split between the property owners and the railroad. The order was no idle threat. Only a year earlier, in 1991, a five-block-long stretch in Greenwich Village from Bank to Gansevoort Streets had been torn down to make way for apartments developed by the Rockrose Development Corporation.

A series of lawsuits stymied the High Line's demolition for the next several years as the Chelsea Property Owners, led by Edison Properties, the development arm of a parking conglomerate, and Conrail argued over how much each should pay. The city still supported the High Line's removal, and the public remained relatively apathetic to its fate, although one architect, Steven Holl, had very early on, in

Bridge of Houses, High Line site between West Nineteenth and West Twenty-ninth Streets. Steven Holl, 1981. Site axonometric. SHA

Bridge of Houses, High Line site between West Nineteenth and West Twenty-ninth Streets. Steven Holl, 1981. Perspective. SHA

1981, seen its potential.[48] Holl's Bridge of Houses, a self-generated proposal, called for the reuse of the elevated viaduct as the structural foundation for eighteen romantically individualistic houses to be located on the ten-block straight leg of the line running from Nineteenth to Twenty-ninth Street. The idealistic plan, providing for a wide range of apartment types from single-room-occupancy units for the homeless to luxury apartments, left half of the site open, placing the houses in an alternating pattern with a series of seventeen 2,000-square-foot courtyards. Holl was the first to see the High Line's recreational potential, calling for the conversion of a portion of the structure into an elevated public promenade connected to the Javits Convention Center, then in its planning stages.

The public's apparent indifference to the High Line's survival seemed to change almost overnight in the late 1990s when the enormous growth of the entire Chelsea area suddenly made the High Line very visible as a potential recreational asset and, equally appealingly, as a superb bit of industrial archaeology. Not surprisingly, with the West Chelsea area now "hot," the property owners renewed their efforts to demolish the High Line, stimulated by the interest of its new owner, the Richmond, Virginia–based CSX Corporation, which took over control of the freight line from Conrail in June 1999. As Thomas J. Lueck, writing in the *New York Times* a month later, put it, "The platform now sits at the center of a wave of new development pressures, making it either a cornerstone or a barrier in what real estate experts say could be a sweeping renaissance of the far West Side of Manhattan."[49]

Chelsea Carwash, east side of Tenth Avenue, between West Fourteenth and West Fifteenth Streets. Cybul & Cybul and Christopher K. Grabé, 2000. View to the northeast. Koch. RK

The renewed pressure for destruction gave life to an effort to protect the High Line, led by the Friends of the High Line, a local, nonprofit group that quickly garnered the support of influential writers, artists, and art dealers such as Chelsea pioneer Paula Cooper. The organization believed that the former freight tracks could be transformed into an incomparable recreational amenity through an existing, federally sanctioned rail-banking program whereby out-of-service lines could be converted into park space while still retaining the railroad's original right-of-way. To heighten awareness among prominent New Yorkers and members of the press, the Friends of the High Line organized walking tours of the elevated steel structure. What at ground level appeared forbidding seemed sheer delight to those who got to walk along its length. As David W. Dunlap put it in December 2000:

> If you stand under the High Line . . . it looks like a hazard, threatening to rain concrete chunks, steel plates and pigeon droppings down on the street. If you stand next to it, it looks like an obstruction, blocking Hudson River vistas, depressing property values and inhibiting development. But if you stand on it, the High Line looks like a floating carpet of meadowland that has been unrolled improbably through a raw industrial precinct. With no boxcars to screech over the rusting tracks and frozen switches, the . . . elevated structure has been colonized by chest-high grasses, dotted with asters, bittersweet, chrysanthemums, goldenrod, grape hyacinth, irises, lamb's ear, wild roses and zinnias.[50]

Apparently unmoved by Dunlap, Joseph Rose, head of the City Planning Commission, in a particularly Grinch-like response, categorically proclaimed: "That platform has no right to be

there except for transportation, and that use is long gone. . . . The bottom line is that the High Line will have to come down."[51] Rose was probably responding to pressure from the Chelsea Property Owners, who continued to proclaim the High Line's unsuitability for use as a park, arguing that it was structurally unsound, despite an engineering report to the contrary commissioned by CSX.

Meanwhile, an artistically compelling case for the High Line's potential reintegration into the city's daily life was provided by Cybul & Cybul and Christopher K. Grabé's Chelsea Carwash (2000), a new gas station sheltered underneath the viaduct on the east blockfront of Tenth Avenue between Fourteenth and Fifteenth Streets, replacing a nondescript parking lot with a dramatic, transparent, billboardlike 202-foot-long steel-and-glass facade affixed to the elevated structure. Anne Guiney, writing in *Architecture*, praised the stylish facility: "The program is straightforward, and no different from its anonymous highway brethren: There is a mini-mart, lube station, car wash, and several gas pumps. But unlike them, the Chelsea Carwash manages to transform a mundane lube job or fill-up into an aesthetic experience." Noting the absence of signage on the glass panels, Guiney observed that "regular billboards don't even seem necessary to attract attention to what is going on inside. The glassy skin over the dark steel is a more arresting sight than any blinking neon wonder."[52]

In the fall of 2001, the Friends of the High Line joined forces with the Design Trust for Public Space in order to generate additional ideas for the elevated structure. At the same time, a project involving a small stretch of the rail bed pointed to the kind of incremental approach that would most

likely go forward, barring the development of an acceptable proposal for the entire structure's preservation and reuse. The project, designed by Jean Nouvel, the brilliant but sometimes less-than-site-sensitive French architect, called for a three-building, mixed-use development on a site bisected by the High Line and bounded by West Thirteenth Street, Little West Twelfth Street, Washington Street, and the West Side Highway, in the Gansevoort Market area, which was coming into its own as a trendy neighborhood.[53] Consisting of a thirty-two-story residential tower, an adjacent five-story wedge-shaped commercial building, and an eight-story mixed-use structure linked to the residential tower by glass-covered bridges, Nouvel's design also called for the transformation of a 300-foot section of the High Line into a pedestrian park.

While plans for Nouvel's complex were soon stalled by community protests over height and land use, calls for the High Line's preservation and reuse as a recreational amenity continued to gather support. One important ally was the new mayor, Michael Bloomberg, who in December 2002 formerly embraced the structure's conversion into a park.[54] Working in partnership with the Friends of the High Line, the city, in August 2004, announced that Field Operations and Diller Scofidio + Renfro had won a design competition for a master plan for the High Line. Released in April 2005, the preliminary design for the first section to be converted into public space, running between Gansevoort and Fifteenth Streets, included a wetland water feature, woodland thicket, vegetal balcony, and a sundeck overlooking the Hudson River. According to Ricardo Scofidio, the grand stair located at Gansevoort Street was intended to "decelerate the visitors' urban pace and allow them to appreciate this

ABOVE Proposed mixed-use development, site bounded by West Thirteenth, Little West Twelfth and Washington Streets and the West Side Highway. Jean Nouvel, 2001. Rendering of view to the northeast. AJN

RIGHT Proposal for the High Line, elevated freight track running between Tenth and Eleventh Avenues from Gansevoort to Thirty-fourth Street. Field Operations and Diller Scofidio + Renfro, 2005. Rendering of view to the northwest of Gansevoort Street entry. FHL

incredible structure and landscape. . . . We want the new architecture to be synthetic with the High Line, to grow on it, like the wild plants that have grown there spontaneously."[55]

In addition to the renovation and reinvention of buildings from Chelsea's industrial past, there was new construction as well, confined primarily to residential development, beginning in 1980 with an unusual example, Schuman, Lichtenstein & Claman's Selis Manor, 149 West Twenty-third Street, between Sixth and Seventh Avenues, the city's first apartment house built exclusively for blind tenants.[56] The twelve-story, 205-unit tan brick building, replacing a vacant site once home to a row of four-story brick and stone houses (H. T. Borreaux, 1898), was sponsored by the Associated Blind, a self-help organization. Behind its bland institutional exterior, the building's specially designed interior appointments included oversize mailboxes to accommodate tape recordings and packages of items in Braille, textured doorknobs, and elevator buttons that popped out when the correct floor was reached. Although it more closely resembled a market-driven apartment house than did Selis Manor, Perkins Geddis Eastman's fourteen-story red brick building with green window frames and trim at 590 Sixth Avenue, southeast corner of Seventeenth Street, was in fact the new home (1988) for the New York Foundling Hospital—a specialized healthcare facility that provided treatment and therapy rooms for babies as well as teenagers, along with room for full-time residents—which sold its previous facility at Third Avenue between Sixty-eighth and Sixty-ninth Streets to Donald Trump, whose Trump Palace would replace it.[57]

Speculative residential development in Chelsea advanced in the late 1980s with the completion of four apartment buildings. Located on the site of a former parking lot, the Architects Design Studio's 181 Seventh Avenue (1987), between Twentieth and Twenty-first Streets, was a narrow fifteen-story red brick tower set back and rising from a two-story gray stone commercial base with a central arched glass entrance.[58] The forty-five-unit condominium featured two sets of stacked balconies rising along its three-bay-wide Seventh Avenue facade. More successful was the better-detailed and well-massed Sequoia (1987), located at the southern end of Chelsea at 222 West Fourteenth Street, between Seventh and Eighth Avenues.[59] As designed by Ted Reeds Associates, the 132-unit red and dark-purple brick Postmodern design rose seven stories before setting back to climb eight additional floors, with the upper portion of the building featuring three sets of gently curving brick-faced balconies rising for five floors in the center and on the east and west ends of the building. One year later, in 1988, Der Scutt completed the similarly massed fifteen-story Milan, 120 West Twenty-third Street, between Sixth and Seventh Avenues, one of the more explicit examples of stylistic Postmodernism in the city, representing an early manifestation of the commercial acceptance of the new style at its most clichéd.[60] An essay in false gables pierced by oculi, Scutt's building nonetheless exuded a certain architectonic power, largely as a result of the deeply recessed balconies of the seven-story base whose bright red railings, along with the gilded entrance gable, provided the only notes of color in an otherwise gray brick design. James Stewart Polshek's 168,000-square-foot, 157-unit, red and gray brick Grand Chelsea (1988), east blockfront of Eighth Avenue between Sixteenth and Seventeenth Streets, replacing a gas station and eight three- and four-story mid-nineteenth-century

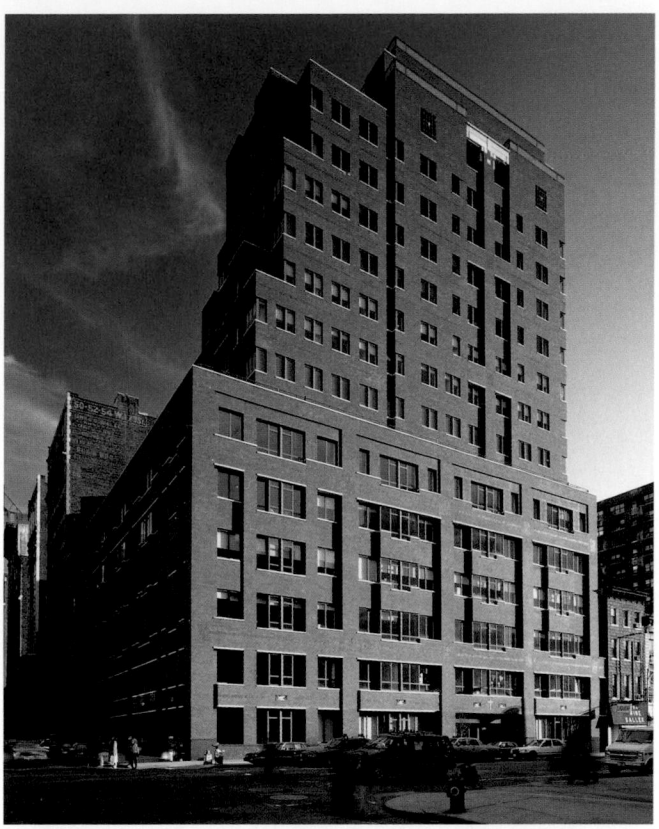

New York Foundling Hospital, 590 Sixth Avenue, southeast corner of West Seventeenth Street. Perkins Geddis Eastman, 1988. View to the southeast. George. PE

Milan, 120 West Twenty-third Street, between Sixth and Seventh Avenues. Der Scutt, 1988. View to the southeast. Mauss. ESTO

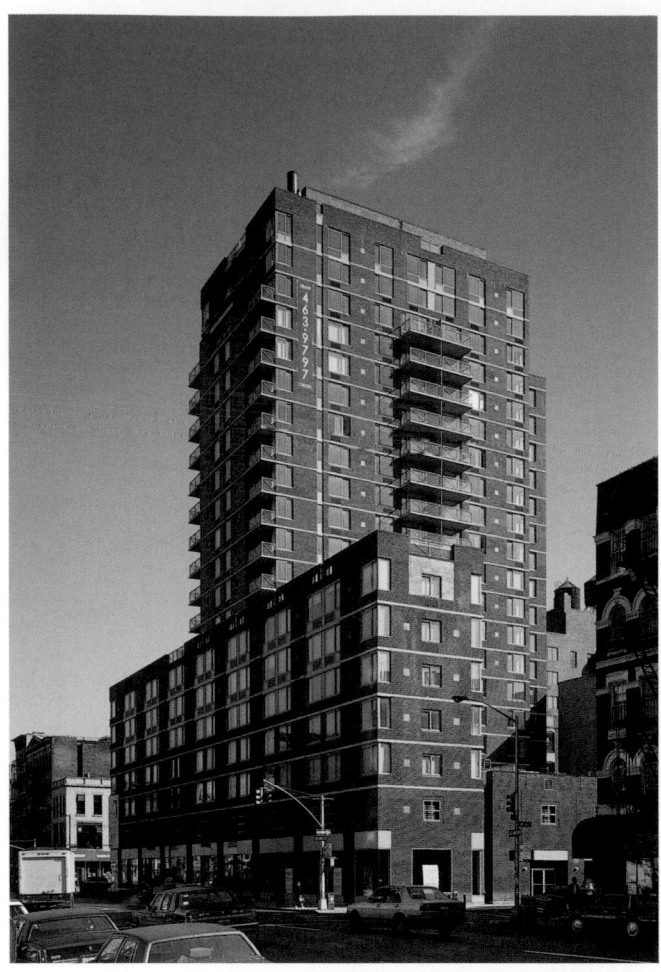

tenements, was a less-refined version of the architect's well-received Washington Court apartments in Greenwich Village, completed two years earlier.[61] Polshek's design for the 22,000-square-foot site called for a seven-story, block-long base, with two floors of commercial space topped by apartments, and a twenty-one-story slablike tower, turned on its axis to rise perpendicular to the avenue, set back and placed at the northern end of the site.

In 1995 the rezoning of a large portion of Chelsea to encourage residential development, first along Sixth Avenue between Twenty-fourth and Thirty-first Streets and four years later in a larger area bounded by Fourteenth and Twenty-third Streets, Sixth and Tenth Avenues, set off a frenzy of building activity. To replace a parking lot on the west side of Seventh Avenue between Twenty-fifth and Twenty-sixth Streets, the Rockrose Development Corporation hired Costas Kondylis in 1999 to design the 340,000-square-foot Chelsea Centro (2001), the first rental building developed under a city-sponsored subsidy plan where 80 percent of the units were rented at market rate while the remaining apartments were set aside for moderate-income tenants, a scaled-down version of an earlier program, the so-called 80/20 plan, which applied to lower-income tenants.[62] Located on an L-shaped plot, the block-long 365-unit building rose for ten stories along the avenue before setting back to rise an additional seven stories. According to Kondylis, Chelsea Centro's grayish-beige brick and cast-stone facade was chosen to blend in with the coloring of the Fashion Institute of Technology's Seventh Avenue buildings (De Young, Moscowitz & Rosenberg and Lockwood & Green, 1977) just to the north.[63]

Robert A. M. Stern's fifteen-story, 270,000-square-foot, 254-unit Westminster (2002), east side of Seventh Avenue

ABOVE Grand Chelsea, east side of Eighth Avenue, between West Sixteenth and West Seventeenth Streets. James Stewart Polshek & Partners, 1988. View to the northeast. Goldberg. ESTO

RIGHT Westminster, east side of Seventh Avenue, between West Nineteenth and West Twentieth Streets. Robert A. M. Stern Architects, 2002. View to the east. Aaron. ESTO

Caroline, east side of Sixth Avenue, between West Twenty-second and West Twenty-third Streets. Richard Cook & Associates and Costas Kondylis, 2001. View to the southeast. Kwon. CFA

between Nineteenth and Twentieth Streets, replacing a gas station, maintained the street wall on the avenue but set back from the property line on the north and south sides to respond to the quieter character of the side streets.[64] To break down the scale of the building as a whole, the avenue-facing facade featured alternating recesses and was set back above the tenth floor. At the ground floor, which contained retail spaces along Seventh Avenue, the facades, reflecting the Art Deco character of many buildings in the immediate neighborhood, were clad in limestone with detailing in satin stainless steel at the residential entrance on Twentieth Street, while the upper floors were clad in gold-colored bricks with brown and black accents. The stylish lobby employed a rich palette of materials, including Cipollino marble floors and pearwood and stucco Veneziano walls.

It was on Sixth Avenue, however, that the building boom most dramatically manifested itself, with five large apartment buildings constructed in quick succession between Twenty-second and Twenty-seventh Streets. The best was the Caroline (2001), east side of Sixth Avenue between Twenty-second and Twenty-third Streets, designed by Richard Cook & Associates in collaboration with Costas Kondylis, replacing a parking lot.[65] The block-long, long-vacant eyesore of a site, once home to the Booth Theater (Renwick & Sands, 1869) and then to a department store for James T. McCreery (Hale and Rogers, 1894) until its demolition in 1975, was located in the Ladies' Mile Historic District, designated in 1989 and roughly bounded by Fifteenth and Twenty-fourth Streets, Sixth Avenue and Park Avenue South.[66] Cook's design, approved by the Landmarks Preservation Commission in late 1997, was intended to complement the area's cast-iron dry-goods emporiums. The 450,000-square-foot 440-unit Caroline, rising ten stories on the avenue and Twenty-second Street with a twenty-story tower along Twenty-third Street, featured a solid two-story limestone and granite base and prominent red brick piers, with windows detailed to resemble its cast-iron predecessors. An exceptionally strong cornice rose above the tenth story, a motif that was repeated above the tower.

Four blocks to the north, just outside the historic district, Costas Kondylis's thirty-seven-story, 400-unit orange and red brick Capitol (2001), 776 Sixth Avenue, between Twenty-sixth and Twenty-seventh Streets, unfortunately replaced an important part of the city's architectural heritage, Alfred H. Thorp's innovative six-story Racquet Court Club (1876), 55 West Twenty-sixth Street.[67] With its arcaded red brick facades and remarkable friezelike attic carrying a cornice on metal brackets, the Coogan Building, as the Racquet Court Club eventually came to be known, provided one of the most sophisticated expressions of the volumetric character of a cast-iron structural cage encased in a masonry bearing wall. Thorp's building had been designated an individual landmark in October 1989 but in only the third case since the Landmarks Preservation Commission had been created in 1965 the decision was overturned by the Board of Estimate two months later.[68] Although there were protests when Kondylis's plans were released, the building went forward as planned, with an immense round-cornered tower, topped by a round water tank enclosure, rising from a four-story base. In an attempt to relate to the area's historic cast-iron buildings, Kondylis included double-height windows at the base, which were prominently detailed with silver-colored spandrel panels and columns.

Schuman, Lichtenstein, Claman & Efron was responsible for the remaining three Sixth Avenue apartment buildings: the red brick Vanguard (2001), 77 West Twenty-fourth Street, composed of a thirty-story tower rising behind a five-story base; the thirty-one-story, tan brick 777 Sixth Avenue (2002), between Twenty-sixth and Twenty-seventh Streets; and, next door to 777 Sixth Avenue, the far glassier, thirty-four-story Chelsea Tower (2003), 100 West Twenty-sixth Street, northwest corner of Sixth Avenue.[69]

THE FAR WEST

North of Chelsea, the Far West Side, extending roughly from Thirtieth to Forty-second Street, was a hotchpotch of early-twentieth-century industrial buildings and infrastructure devoted to transportation interspersed with vestigial tenements. After 1976 this area—hardly a neighborhood—became the scene of intense planning and building activity, including the construction of a long-anticipated convention center, plans to replace Madison Square Garden, and the renovation and expansion of Pennsylvania Station.

Javits Center

On January 2, 1976, David L. Yunich, chairman of the Metropolitan Transportation Authority, announced that he favored a site for a new convention center on the rail yards between Thirty-third and Thirty-seventh Streets, Eleventh to Twelfth Avenues, over one at Battery Park City.[1] The new convention center would replace the much-derided Coliseum (Leon and Lionel Levy, in consultation with John B. Peterkin, Aymar Embury II, and Eggers & Higgins, 1954), at Columbus Circle, a facility that had been deemed inadequate for more than a decade.[2] Previous efforts in the early 1970s to build a new convention center on West Forty-fourth Street and the Hudson River had faltered.[3] On January 5, the *New York Times* published a letter from Donald J. Trump, written a week earlier, in which he attacked the Battery Park City site and advocated the Penn Central's Thirty-fourth Street rail yards, which he had recently proposed to develop.[4] Trump's arguments, involving convenience to subways, airports, and hotels, were compelling. And the design he commissioned from Gruzen & Partners and Der Scutt of Poor, Swanke, Hayden & Connell, with its elaborately landscaped roof deck and dramatically glazed concourse, was promising. On January 19, 1976, the New York Times editorial board announced that the Thirty-fourth Street site "wins hands down. . . . A preliminary design suggests a kind of park-fronted crystal palace rather than a concrete blockbuster. It has everything going for it—except the money to build it."[5] City officials remained attached to the Battery Park City site, where it was expected that the Port Authority, anxious to shore up its investment in the World Trade Center, would lend financial support to the convention center project. But on January 23, 1976, the *New York Times* reported that the Port Authority would meet with the Trump Organization to consider the uptown site.

In April 1976, a new complication emerged when the Regional Plan Association endorsed midtown as the best location for the convention center but offered a radically different location. According to the RPA's president, John P. Keith, "Times Square needs the convention center" to help transform it "from one of the tawdriest" areas in the city.[6] But the association, misreading the inherently anti-urbanistic character of such big-box facilities and working on the advice of the architectural firm Pomerance & Breines, recommended that the center be built on a superblock between Seventh and Eighth Avenues, Fortieth and Forty-third Streets, where it would eliminate about a dozen theaters, or at a midblock site between Sixth and Seventh Avenues, Forty-second and Forty-seventh Streets. The editors of the *New York Times* were appalled: "The idea is to upgrade Times Square, not destroy it." The editors understood what the Regional Plan Association did not: "At best, a convention center is an inert blockbluster."[7]

In June 1976, the Port Authority issued its long-awaited study evaluating the Thirty-fourth Street and Battery Park City sites, concluding that either would be effective, but noting that though the facility would cost about the same amount—$170 million—wherever it was built, land acquisition costs would be double at the Battery.[8] Meanwhile, Pomerance & Breines, authors of the Regional Plan Association's proposal, argued for their plan, which would reconstruct four theaters—the Belasco, Hudson, Lyceum, and Henry Miller—as theaters and meeting halls, and would reduce Forty-fourth Street to the status of a tunnel. In April 1977, the Times Square sites were ruled out and, for a while, Thirty-fourth Street seemed the likely choice.[9] But a special committee appointed by Mayor Abraham Beame and Governor Hugh Carey was said to be "leaning" toward the original Forty-fourth Street and Hudson River site.[10]

Although Skidmore, Owings & Merrill had prepared a design for the Forty-fourth Street site in 1973, it was not suited to the less contorted geometries of the two other sites under consideration. Moreover, SOM's design had not been well received. But in January 1977 an unrealized scheme for Chicago's convention center, prepared in 1953–54 by Mies van der Rohe, was published in the *New York Times* by Ada Louise Huxtable in an article discussing Alison Sky and Michele Stone's book, *Unbuilt America*.[11] Mies's scheme caught the eyes of three power brokers close to Mayor Beame: Victor Marrero, chair of the City Planning Commission; John Zuccotti, First Deputy Mayor; and Lloyd Kaplan, a city planner who was an assistant to Zuccotti. By May 1977, the three had had extensive conversations with Dirk Lohan, Mies's grandson and partner in the successor firm Fujikawa Conterato Lohan, and had ascertained the feasibility of using the elegant design with its column-free, eighty-foot-high, 350,000-square-foot exhibition floor, and a smaller 200,000-square-foot hall, and estimated its cost in the range of $175 million. While Mies's proposal was not realized in New York, its introduction clearly raised the level of architectural expectation for the new center.

On May 25, the Board of Estimate rejected Beame's request for $6.5 million to cover convention center design fees, dealing the project, and the increasingly unpopular mayor, a substantial blow. The editors of the *New York Times* were unusually outspoken in their dismay over the Board of Estimate's action, opening their arguments with a salty observation: "New York City needs no adversaries out there; it grows its own. . . . After undoing a year's work on a plausible plan to limit pornographic blight, the board now threatens to wreck the equally well-laid plans for a new convention center. It is a familiar routine: sabotage the voter's interest in the voter's name; waste money in the name of saving it." The *Times* emblazoned its editorial with a reproduction of Mies's convention center design, objecting not only to the Board of Estimate's refusal to authorize design fees but also to its proposal to instead consider the enlargement of the Coliseum, at roughly half the center's cost, using bonds floated by the Triborough Bridge and Tunnel Authority, labeling this idea a "charade." According to the *Times*'s editors, the Coliseum expansion had been studied and found an inadequate response to the needs. Not only was the Coliseum too small, they pointed out, its distribution of exhibition space on six floors was not efficient and a distinct marketing disadvantage. "Spending $90 million of the Triborough's money may seem

Proposed Convention Center, site bounded by Forty-second and Forty-seventh Streets, Sixth and Seventh Avenues. Pomerance & Breines, 1976. RAMSA

more attractive than spending $180 million of the city's in these hard times, but the arithmetic is deceptive," they wrote. "New York needs a new convention and exposition facility as the cornerstone of its future economy and it needs it quickly. Economic development will henceforth depend not on manufacturing but on the exploitation of New York's cosmopolitan and cultural strengths. The city can profit from people, from services and tourism, entertainment and the arts, retailing and communications—all areas to which a flourishing convention center will contribute. To settle for less is to vote for becoming second-rate."[12]

A second and longer part of the editorial was devoted to the issue of site selection. While the *Times*'s editors had previously supported the Thirty-fourth Street site, they were now, like the Beame administration, leaning to Forty-fourth Street, despite higher development costs, because "all the time-consuming preparatory work has been done—the necessary public hearings have been held, community endorsement is in hand." Nonetheless, they cautioned that, at Forty-fourth Street, "any building there is going to be a wall on the water, cutting off river access and views for four blocks." Nevertheless, with the proposed reuse of the Mies design, that wall would be "stunning . . . an engineering and architectural spectacular."[13] Apparently the Board of Estimate listened to the *Times* because it restored the allocation for preliminary planning.

Meanwhile, as backers of the various sites jockeyed for attention, a special committee appointed by Mayor Beame was struggling to make a final selection.[14] With the mayoral election coming up in 1977, both the site and the convention center itself had become issues in the campaign; many politi-cians accused Beame of holding back on his decision so as not to offend potential voters. On November 22, 1977, two weeks after the election of Edward I. Koch as mayor, Beame's seven-member site selection committee, consisting of the developer Richard Ravitch as chairman, and a number of businessmen as well as architect Kevin Roche, ruled out the Forty-fourth Street site and recommended the Thirty-fourth Street site, which it believed could be built faster, with greater floor area than on any of the alternative sites.

Mayor Koch deemed the convention center a top priority, directing Robert Wagner Jr., chairman of the City Planning Commission, to determine its proper size and to provide engineering analysis of the Thirty-fourth and Forty-fourth Street sites.[15] By late March 1978, it was rumored that Koch had made up his mind: the convention center would be built on the Thirty-fourth Street site using funds raised through the sale of Triborough Bridge and Tunnel Authority bonds. On April 30, Koch's decision was made public with the announcement that the new center, expected to be completed in 1983, would be built on the twenty-five-acre rail yard site that stretched between Thirty-fourth and Thirty-ninth Streets, Eleventh and Twelfth Avenues. Immediately, land values in the area began to climb and McDonald's announced plans to build its only outlet in Manhattan to have parking and a drive-thru on the southwest corner of Tenth Avenue and Thirty-fourth Street.

Ada Louise Huxtable greeted the news with a call for an imaginative, urbanistically responsible design:

> It must be made clear that a convention center is not in itself a vitalizing thing, whatever economic vitality it may generate. It is, essentially, an enormous box, often of heavy concrete, stretching for hundreds of feet and many blocks, offering blank vistas of endless solid walls. It breeds empty streets, except at show or meeting time when it brings streams of traffic. Even skillful and elegant structural systems do not ameliorate this undesirable result. . . . Obviously, since the impact of the convention center will be inescapable, that impact must be controlled. It can kill or cure, blight or beautify a large section of the city. It is all a matter of design. That is the challenge now.[16]

On March 13, 1979, Koch reached an agreement with Governor Carey and legislative leaders in Albany on a plan for the convention center, with the expectation that construction would begin in eighteen months. The new building, to be financed through the sale of Triborough Bridge and Tunnel Authority bonds and developed by the state's Urban Development Corporation and administered by an independent corporation, the Convention Center Development Corporation, to be headed by Richard Kahan of the UDC, would open in 1984.[17] Praising the design and urbanism of Dallas's Municipal Administration Center (1966–77) designed by I. M. Pei, the editors of the *New York Times* greeted the rumor that the same architect would be selected for the convention center with enthusiasm: "New York could have a world-class building that would be an international tourist attraction like Paris's Beaubourg, even when trade shows are not there. At last the city is moving on the right track, if it can stay on the fast track."[18] On March 29, 1979, the state legislature approved the deal.

On April 21, 1979, Pei's selection was confirmed.[19] In addition, James Stewart Polshek, previously retained to carry out detailed preliminary planning and cost studies, which included a schematic design, was hired to oversee Pei's work and that of his associate minority firm, the Lewis-Turner Partnership. Pei

was selected after a lengthy interview process that began with twenty-four firms submitting credentials before a selection committee led by Polshek, who for a short time had worked for Pei in William Zeckendorf's office, attorney Thomas H. Baer, and Robert A. M. Stern representing the mayor. The list was later narrowed to eight, with Philip Johnson and John Burgee, Richard Meier, Hugh Stubbins, and Helmut Jahn emerging as the front-runners. The choice of Pei was not a sure thing; in its deliberations late in 1978, the committee was also very impressed with Johnson and Burgee, recommending both the Pei and Johnson teams to the mayor and the governor. When the committee was reconvened after the UDC was brought in, it also interviewed Gruzen & Partners and Davis, Brody, who proposed themselves as a team of local firms who could get the job done. According to Paul Goldberger, Pei was reported to be so interested in the convention center that he turned down the opportunity to design the new headquarters of the American Stock Exchange in Battery Park City, another UDC project but one that did not go forward. Pei did make a big point of the fact that although he had spent his entire professional life in New York, he had never gotten a major civic commission—implying that if selected he would personally take charge of the project, which he did not, turning it over to an associate partner in the firm, James Ingo Freed, who stated that his first challenge would be "to humanize it—to make it something other than a big blank box."[20]

Initial drawings and a model of Freed's design for the convention center, which was to be named in honor of the ailing former senator Jacob K. Javits, were released to the public in December 1979 and displayed at the Museum of Modern Art between February 21 and March 30, 1980. The design for the

Jacob K. Javits Convention Center, site bounded by West Thirty-fourth and West Thirty-ninth Streets, Eleventh and Twelfth Avenues. I. M. Pei & Partners, 1986. Site plan. PCFP

1.8-million-square-foot building contained approximately 750,000 square feet of exhibition space on two levels in a five-block-long, semireflective-glass-sheathed superstructure that was notched every ninety feet to identify the scheme's structural module and punctuated by entrance doorways at regular intervals to help create a more approachable scale. The main entrance was to face Eleventh Avenue between Thirty-fifth and Thirty-sixth Streets. Inside, the exhibition space was arranged on two levels visually connected by a skylit galleria running west from the principal door and Great Hall, a 160-foot-high, 270-foot-square, glass-sheathed cube that resembled the 112-foot-high glass-enclosed atrium of the Pei firm's recently completed John F. Kennedy Library in Boston, which had received mixed reviews.[21] At the western terminus of the galleria, a restaurant was to overlook the river across Twelfth Avenue. A ninety-foot-wide concourse, located just inside the building, would run north–south along Eleventh Avenue, providing additional access to the exhibition halls as well as space for ticketing, information, and the like. The structural system promised to be a major part of the building's aesthetic: the ninety-by-ninety-foot structural bay, derived from dimensions dictated by exhibition display modules, consisted of an open-work metal space frame carried on four metal tubes forming an openwork column. A ten-foot-square tubular "capital" was proposed to make the transition between the space frame and the columns. The glass skin was detailed to provide, according to Michael Flynn, an associate partner for technology in the Pei firm, a "graphic description" of the skeleton it sheathed.[22] Although Freed likened the design to that of a soap bubble, perhaps more tellingly, given its size, he also called it "an elephant dancing on its toes."[23]

Paul Goldberger described the design as "a pile of glass cubes, mounting one atop the other to create the monumental interior hall" that was "intended both to bring some visual relief to the outside, making it less of a box, and to add some symbolic presence to the inside, a monumental space that will enhance the notion of this building as a public place and not just as private buildings for meetings and trade shows." Freed's design, Goldberger continued, promised "to be lively, genuinely innovative and respectful of the architectural traditions of the city of which it will be a part." Still, there was no getting around the sheer size of the project. "Five blocks of reflective glass may be better than five blocks of concrete," Goldberger noted, "but it is still five blocks, and there is no way to bring to this kind of thing any really modest scale. But if we grant the essential impossibility of bringing any truly small scale to this project, short of giving the center a front of five blocks' worth of fake brownstone facades, the architects have produced a sensitive solution."[24] Philip Winslow, chairman of the Park Council's design committee, expressed concern over the design of the barren concrete plaza across Eleventh Avenue between Thirty-fifth and Thirty-sixth Streets, calling it "no more than a glorified traffic island, lacking any life of its own and uninviting except perhaps to the local prostitutes, to whom it is ideally suited."[25]

Ground was broken on June 17, 1980, and by early 1982, with barely more than a hole in the ground and a field of concrete footings, the Convention Center Operating Corporation was successfully booking exhibits for the facility, which was expected to open in 1984. But early in 1983, problems began to emerge. Construction cost overruns of $16.8 million were anticipated, though the project was expected to remain within

Jacob K. Javits Convention Center, site bounded by West Thirty-fourth and West Thirty-ninth Streets, Eleventh and Twelfth Avenues. I. M. Pei & Partners, 1986. Preliminary sketches by James Ingo Freed. PCFP

Jacob K. Javits Convention Center, site bounded by West Thirty-fourth and West Thirty-ninth Streets, Eleventh and Twelfth Avenues. I. M. Pei & Partners, 1986. Space frame model. PCFP

its $375 million budget. More significantly, the building was rumored to be behind schedule, with the opening projected to be delayed by at least six months or more likely a year or more principally because of problems encountered with the fabrication and installation of the steel space frame. As the story unfolded, it turned out that the problem was not with the assembly of the steel space frame but with the spherical nodes used to lock together the various pieces of steel. The nodes had developed hairline cracks. While they met conventional

tests with loads three to five times greater than they were intended to carry, Lev Zetlin, an engineer retained by the development corporation, did not regard these tests as sufficient, requiring the nodes to undergo "analytical" tests that took into account long-term stress and "methodological" tests to establish the long-term viability of the metallurgical and chemical properties of the steel used. Zetlin found that the original nodes, manufactured by Goltra Foundries, a Chicago company sub-contracted to the Karl Koch Erecting

ABOVE Jacob K. Javits Convention Center, site bounded by West Thirty-fourth and West Thirty-ninth Streets, Eleventh and Twelfth Avenues. I. M. Pei & Partners, 1986. Exhibition Hall. Lieberman. PCFP

LEFT Jacob K. Javits Convention Center, site bounded by West Thirty-fourth and West Thirty-ninth Streets, Eleventh and Twelfth Avenues. I. M. Pei & Partners, 1986. Great Hall. Lieberman. PCFP

BELOW Jacob K. Javits Convention Center, site bounded by West Thirty-fourth and West Thirty-ninth Streets, Eleventh and Twelfth Avenues. I. M. Pei & Partners, 1986. Curtain wall detail, typical vision unit. PCFP

ABOVE Jacob K. Javits Convention Center, site bounded by West Thirty-fourth and West Thirty-ninth Streets, Eleventh and Twelfth Avenues. I. M. Pei & Partners, 1986. View to the southwest. Lieberman. PCFP

RIGHT Jacob K. Javits Convention Center, site bounded by West Thirty-fourth and West Thirty-ninth Streets, Eleventh and Twelfth Avenues. I. M. Pei & Partners, 1986. View to the northwest. Lieberman. PCFP

Company of Carteret, New Jersey, failed these tests. The economic consequences were serious, not only involving additional construction costs but, because of delays, lost revenues and potential lawsuits from sponsors of shows already booked. Revised estimates for the building's construction projected overruns of between $50 and $75 million.

As finger-pointing began, the editors of the *New York Times* wisely urged caution, stating that though there appeared to be nothing scandalous about the delay there was something scandalous about "the misconceptions conveyed by [certain] public officials . . . who persistently gave the public the wrong idea that the center was as easy to build on time as an office building." Coming down decisively on behalf of the project and its design, which they described as "a modern crystal palace of impressive dimensions supported on a novel, though not untried, framework of pipes held together with cast steel balls," the editors declared: "To become a major convention and trade show city, New York entered a branch of show business. The design of its center was deliberately unconventional, an attraction enticing visitors who could see the same new products cheaper in Podunk."[26] As Carter Wiseman pointed out in his biography of I. M. Pei, there was concern that the "node" problem might have serious repercussions for the firm, which was still recovering from the bad publicity associated with the "cracked windows" at its John Hancock Tower (1966–76) in Boston, designed by Henry Cobb, another partner in the firm.[27]

By July 1983, the convention center's opening was pushed back to summer 1986, two years behind schedule, although a partial opening was still thought possible for 1985. In addition, a $125 million cost increase was acknowledged, including the expense of 18,000 new nodes. The construction problems that plagued the project were no longer in evidence over the next two years, and by fall 1985 the Javits Center was far enough along for James Freed to lead C. Ray Smith, editor of *Oculus*, on a tour. Smith was impressed with the "self-effacing" quali-

ties of the low, silhouetted "blocky black box" and with the quality of the interior space, which he felt was at a virtually unprecedented level for a municipal project.[28] According to Smith, Javits Center officials insisted on calling the building the Crystal Palace. Freed had taken to calling the windowless, 250,000-square-foot concourse exhibition space the "Egyptian Hall" in part because of its relentless structural grid and in part because of the round reinforced-concrete columns rising to square, blocky concrete capitals and precast concrete beams that suggested the scale, if not the character, of the hypostyle halls of ancient Egypt.[29] The color of the five-foot-square glass panels represented a key change from the original design. At first, the solar coating was intended to be relatively light in color, but when that product proved unavailable, a darker brownish gray tone was selected so that the completed building was substantially less transparent—and far less crystalline—than the early renderings had suggested it would be. The ten-foot-square glass panels over the entry doors were, however, clear. The convention center also failed to realize any connection to the river, an amenity the scheme largely ignored, in part because the future of Westway was still uncertain during the critical early stages of design.

The Javits Center, which opened on April 3, 1986, immediately enjoyed strong business. Out of all the seeming chaos and political posturing that accompanied its long and troubled gestation, Deborah K. Dietsch, writing in *Architectural Record*, found the results "a vast improvement over the ugly, congested New York Coliseum, not only in its size—the third largest in the country after Chicago and Las Vegas—but in its celebration of public-spirited monumentality, a quality not associated with the building type." According to Dietsch, Freed and his team created "a series of ambitious public spaces" comparable in grandeur to those of nineteenth-century public architecture, a result that was deliberate, with Freed visiting the Palm House (Decimus Burton and Richard Turner, 1848) at Kew Gardens in London in search of "a tool that capitalized on the exposition side of a convention center, and that promoted light and transparency." She was particularly taken by the 150-foot-high lobby, "framed by the intricate tracery of the space frame" and warmed by the rose-colored patterned terrazzo floor and, in daylight, flooded by natural light. But, as Dietsch pointed out, the benefits of the glass mostly accrued to those inside: "Apart from the chamfered, jewel-like boxes stacked over the crystal palace and a few notches carved into the 4-block-long exterior, the massive building's slightly reflective, dark gray curtain wall remains oppressively lifeless for most of the day, appearing more like a sprawling, suburban, speculative office building than an important civic structure. The monumentality of the interior is only revealed at night, when the entire bulk of the building is lit from within by a luminous pattern of suspended, twinkling lights that transforms the crystal palace into a giant, glowing lantern."[30]

Paul Goldberger was generally pleased by the completed effort, although he too found it "disappointingly dark on the outside." Goldberger felt that "when the political squabbles that have surrounded the center since its inception fade away, it will become clear that this is a work of architecture that is grand in scale and sweeping in ambition. It is not the typical New York public building of our age at all."[31] In a rare instance, Michael Sorkin, writing in the *Village Voice*, seemed to agree with Goldberger, finding the Great Hall "one of New York's great rooms, an exhilarating place, an achievement to be celebrated." But, Sorkin continued, "the relationship of this lofty enclosure to the larger character of the center is problematic. Circulation from space to space lacks the energy and proportion of the spaces themselves and the sequence of spatial events is unconvincingly arranged. Entering the great hall, one is set up for axial movement towards the river. But the actual activities of the center are a 90 degree turn to the right and downstairs, off the long entrance gallery. The sequence from this gallery to the exhibition halls is also graceless, requiring passage though a concrete barrier meant to read as pavilion but actually more evocative of bunker." Sorkin was most troubled by the Javits Center's relationship to the river, noting that "the architects have devoted this edge to loading docks, storage, and mechanical rooms, erecting a vast and brutal concrete wall along the West Side Highway, unequivocally declaring this the building's backside. . . . This is a real affront."[32] The Javits Center was widely discussed in the European press, where the structural bravura of the space frame construction, the largest ever built in the United States, proved particularly interesting. But as similar experiments with large-scale, glass-enclosed structures became more commonplace, the Javits Center's particular deficiencies became increasingly obvious. Eleven years after its completion, Susanna Sirefman wrote, "Piped music and pink marble floor notwithstanding, the concrete benches and columns leave one with the impression that this is just a giant shed constructed with fancy materials." She also confirmed early fears about the plaza, "a frightening 1.1-acre outdoor plaza occupied by pigeons and the homeless [which] sits derelict across the street. There was to have been a waterfall and underground access to the center, but neither facility is functioning. Arriving here as a pedestrian or even by cab is daunting."[33]

Only four years after its completion, after the failure of the Hudson River Center proposal (see below), a planned development directly west of the convention center that would have included additional exhibition space as well as apartments, hotels, and marina facilities, calls for the center's expansion began to be heard.[34] By the mid-1990s the need to expand the Javits Center was becoming something of a drumbeat, with officials from the Convention Center Operating Corporation claiming that an enlarged facility was urgent if the center was to maintain its competitive edge with recently expanded facilities in Atlanta, Chicago, and Las Vegas. In 1998, to provide some relief, the center's management accepted a private company's proposal to build a 400-foot-long, 136-foot-wide, metal-sided, vaulted-roof structure on the site of a former parking lot just north of the Javits Center. Serving as "a Band-Aid approach to try to keep the major shows in New York," according to Robert E. Boyle, chairman of the convention center, the banal temporary structure accommodated 300 booths.[35] Significant expansion to the north, however, seemed unlikely given the substantial investment made in a 300-space bus depot between Fortieth and Forty-first Streets, Eleventh and Twelfth Avenues, as well as Larry A. Silverstein's stated intention to build 1,800 rental apartments on a site stretching from Forty-first to Forty-second Street between Eleventh and Twelfth Avenues. Growth to the south seemed just as unlikely, given the barrier of West Thirty-fourth Street and the increasing interest in a possible but ultimately unrealized new baseball or football stadium to be built as part of the city's bid for the 2012 Olympics.

Proposed Hudson River Center, Hudson River between West Thirty-fifth and West Fortieth Streets. Gruzen Samton Steinglass, 1987. Model, view to the east. GS

Hudson River Center

In December 1983, with Pei's convention center two years behind schedule and well over budget, the city's Department of Ports and Terminals solicited proposals for the development of a 900,000-square-foot site directly behind it along the west side of Twelfth Avenue between Thirty-fifth and Fortieth Streets.[36] Though much of the site was underwater and would require the construction of extensive platforms, it also consisted of several dilapidated piers, including Pier 76, currently in use as a pound for illegally parked cars towed from city streets. The ventilating towers for the Lincoln Tunnel lent their presence to the otherwise featureless site. Although the city did not specify the size of the proposed development or an exact mix of uses, there were several requirements, including the provision of new hotel space, a marina and ferry terminal, stores and restaurants, a public esplanade, a rebuilt version of the municipal car pound, and additional exhibition space that could connect directly to the convention center via an overpass. The city had originally intended to accept proposals from anyone who paid an application fee, but in 1985 Mayor Koch switched responsibility for the project, now known as Hudson River Center, from the Department of Ports and Terminals to the Public Development Corporation, which organized a limited competition between three architect/developer teams to be judged by an advisory panel consisting of architects Theo. David, George Lewis, Alan Melting, and Paul Segal, landscape architect Signe Nielsen, and planner John Shapiro.

One team consisted of Cesar Pelli working for Arthur E. Imperatore, Jerrold Wexler, and Edward R. Ross. Imperatore, a trucking executive and would-be developer who had recently gone into the ferry business, owned a two-mile-long site directly across the river as well as a one-acre parcel near the site at Thirty-eighth Street. Pelli's design called for the cre-

ation of an 18.4-acre platform, a 20-berth marina, and a group of three twelve-story apartment buildings. The centerpiece of the proposal was a thirty-three-story hotel that echoed the architect's domed tower at Two World Financial Center. A second team, composed of Welton Becket Associates and developers Larry A. Silverstein and MAT Associates, proposed a much larger complex on a 16.7-acre platform with a 120-berth marina, 192,000 square feet of retail space, and a 4,400-foot esplanade. As designed by Roger Ferri of Becket's office, the plan placed four thirty- to thirty-two-story apartment buildings at the north end of the site and a forty-story luxury hotel closer to the Javits Center.

The winning proposal, announced in February 1987, came from Gruzen Samton Steinglass working with Julien J. Studley, Manhattan Equities, Arthur G. Cohen, and Brooker & Webb. The Gruzen scheme, calling for a 13.1-acre platform, was organized around a gently curving marina with twenty-four- and thirty-story apartment buildings at the north end of the twenty-five-acre site and a cluster of three hotels—a forty-two-story luxury facility flanked by two twenty-one-story buildings—on a separate platform connected by a causeway to the southern platform. The judges deemed this entry "clearly superior," creating an "exciting waterfront environment" with its "promenade reaching out to embrace the river [and] its buildings poised over the water."[37] Hudson River Center did not move forward, falling victim to the collapse of the real estate market.

Madison Square Garden and Pennsylvania Station

Charles Luckman Associates' Madison Square Garden (1968), on the western portion of the site of the former Pennsylvania Station, immortalized by the playwright John Guare as "the dump that replaced the masterpiece," proved to be not only

Proposed Madison Square Garden, site bounded by West Thirty-first and West Thirty-third Streets, Tenth and Twelfth Avenues. Cesar Pelli, 1987. Tenth Avenue elevation. CPA

Proposed Madison Square Garden redevelopment, east side of Eighth Avenue, between West Thirty-first and West Thirty-third Streets. Murphy/Jahn, 1987. Axonometric. MJ

Proposed Madison Square Garden redevelopment, east side of Eighth Avenue, between West Thirty-first and West Thirty-third Streets. Murphy/Jahn, 1987. Rendering of view to the southeast. MJ

ugly but financially unprofitable, leading the city in 1981 to consider taking it over or providing substantial subsidies in order to keep two important sports teams, the Knicks and the Rangers, from leaving the city for New Jersey or Long Island.[38] But the claims of unprofitability made by the Garden's management, the Madison Square Garden Corporation, a part of the entertainment-based conglomerate Gulf & Western Industries, were challenged in court by the Penn Central Corporation, owners of the land under the sports palace and the air rights above it.[39] In March, negotiators brought in to help settle the dispute offered a substantial cut in city taxes, reduced utility costs through the State Power Authority, and revised union rules reducing featherbedding.[40] A version of this deal was accepted in April, ensuring the Garden's future and the presence of the two teams in New York for ten more years. But the deal did not guarantee that the present Garden building would be retained.

On September 17, 1984, the Penn Central Corporation agreed to sell the land under the Garden to Gulf & Western Industries, giving the owners an incentive for undertaking substantial improvements to the property or, as one financial analyst noted, making it easier for them to get rid of the Garden operation as a whole.[41] Gulf & Western did not sell, but late in 1985 it was rumored to be considering the construction of a new Garden complex on the air-rights site above the Long Island Rail Road storage yard two blocks south of the Javits Center, as well as the redevelopment of the more strategically located Garden site that lay between Seventh and Eighth Avenues, Thirty-first and Thirty-third Streets.[42]

By April 1986, the Garden's owners were ready to reveal their plan: to raze the arena, replacing it with twin office towers, and to build a new Madison Square Garden, the city's fifth, on the air rights over the tracks. Given the necessary delays for permitting, the developers expected to begin construction of the new Garden in 1988 with completion to follow two years later, at which time the old structures would give way to new development. Because Charles Luckman placed the Garden's main arena five levels above the street (the building was actually the equivalent of thirteen stories in height), it required the costly use of elevators to move equipment in and out. The new facility, which would occupy the four-block site bounded by Thirty-first and Thirty-third Streets, Tenth and Twelfth Avenues, could sprawl horizontally. It would house just over 20,000 spectators, making it slightly larger than the one it

Proposed Madison Square Garden redevelopment, east side of Eighth Avenue, between West Thirty-first and West Thirty-third Streets. Richard Meier & Partners, 1987. Model, view to the northeast. Stoller. ESTO

Proposed Madison Square Garden redevelopment, east side of Eighth Avenue, between West Thirty-first and West Thirty-third Streets. Richard Meier & Partners, 1987. Model, view to the southwest. Stoller. ESTO

Proposed Madison Square Garden redevelopment, east side of Eighth Avenue, between West Thirty-first and West Thirty-third Streets. Skidmore, Owings & Merrill and Frank Gehry, 1987. Rendering of view to the northeast. SOM

would replace. Additionally, there was to be parking for 2,000 cars and the possibility of a new station for a shuttle service to Pennsylvania Station as well as an extension of the subway system to the site.

By April 1987, plans for the new Garden had grown in ambition as Gulf & Western, working together with Olympia & York, developers of the World Financial Center at Battery Park City, was said to be on the verge of an agreement to convert the twelve-block strip leading west from Pennsylvania

Station to the Hudson River into an enormous office and entertainment center that, if realized, would be larger than either the original Rockefeller Center or the World Financial Center.[43] Although key parcels in the plan, including one belonging to the United States Postal Service, were not under the developer's control, the thinking was that over the ten years needed to realize the plan, these could be acquired and integrated into the grand scheme. The expectation was that a large-scale plan would permit the transfer of the unused air rights from the General Post Office to the office building site across Eighth Avenue. Most critical of all was the need for the development team to reach an agreement with the Metropolitan Transportation Authority over the use of the air rights above the Long Island Rail Road train storage yard, which represented about half the development area.

Gulf & Western and Olympia & York announced their partnership on May 27, 1987, with the expectation that construction work on the new 22,000-seat arena, to be designed for the 712,000-square-foot rail yards site by Cesar Pelli in association with Howard, Needles, Tammen & Bergendorff, a firm specializing in stadium design, would go forward late in 1988. A preliminary design prepared by Pelli called for a patterned brick box wrapping the amphitheater and its surrounding concourses but splitting apart facing Tenth Avenue to reveal a glass-enclosed bay-fronted lobby surmounted by a pediment-like exposed steel truss.[44] The proposed arena was to be outfitted with technologically advanced facilities for television and cable programming produced or distributed by the Madison Square Garden Network, a division of Gulf & Western's Paramount Pictures unit and its one-third-owned USA Network.

Plans for the redevelopment of the Madison Square Garden site, leaving in place Luckman's twenty-nine-story office building, Two Penn Plaza, facing Seventh Avenue, progressed throughout most of 1987, with a design competition between Helmut Jahn of Murphy/Jahn, Richard Meier & Partners, and the seemingly improbable team of Skidmore, Owings & Merrill and Frank O. Gehry.[45] In Helmut Jahn's view, the new buildings had to reinforce the site as a gateway. Jahn was presumably asked to compete as the result of his work on the smaller but similarly complex 1.6-million-square-foot Northwestern Atrium Center (1987) in Chicago, a thirty-four-story office tower above 85,000 square feet of street-level and below-grade commuter terminal facilities that replaced the existing Chicago and Northwestern Train Station on an important downtown site.[46] For the Madison Square Garden site, Jahn proposed three rigorously gridded towers surrounding a raised plaza and linked by skybridges. To avoid the extensive use of transfer beams as the towers' columns threaded between the station's platforms and the tracks below, Jahn, working with the engineer Charles H. Thornton, proposed a "superframe" that would support each of the towers on four columns, leading to an expression he believed was "in tune with the simplicity of the massing and monumentality of the spaces."[47]

Richard Meier and his partner Thomas Phifer proposed three related but distinctly different towers accommodating 4.4 million square feet of office space, including trading floors set inside a podium. The towers, surrounding a central open space, were to be of varying heights ranging from thirty-eight stories at the east end of the site, where Meier felt it would best respond to the random low-scale nature of its surroundings, to

seventy-two stories on the north and south. Whereas Jahn created a scheme of monumental axiality, Meier arranged his towers, each aligned with one of the site's outer boundaries, in an asymmetrical manner that resulted in a more dynamic composition on the skyline but ill-defined pedestrian spaces at the base. The extraordinary and extraordinarily complex massing and detailed expression of Meier's towers was unprecedented. Thomas Phifer, overlooking the obvious connections to the historical tradition of 1920s Modernism, argued that the design was an antidote to Postmodernism: "These are the urban towers of the future, what you see is what you get. No historical references, no illusion, no tricks, no attempt to look like the past, no symbolism, no rhetorical jokes, no Classical, neo-Classical, Georgian, Edwardian, Victorian, Art Deco, Art Nouveau, or Surrealistic implications." According to Phifer, the complex cladding proposed "is not simply a wrapping . . . but . . . a definition of materials which express the complex attitude about the development of the site. Metal panels with punched windows are used on the rectilinear edges of the building expressing the core and structure, while glass and a glass material panel banding is used to articulate the more freely expressive sides of the building. These are not three buildings in repetitive form but three buildings which are individual yet responding to and respecting one another."[48]

Phifer's windy rhetoric notwithstanding, the SOM/Gehry team was selected to go forward with its 4.5-million-square-foot plan, which called for three buildings that would be set on a single ninety-foot-high plinth and joined by a glass-roofed "Great Hall" linking Eighth Avenue with a private midblock cross street, which they introduced at approximately the same point where McKim, Mead & White's Ticketing Room had previously been located. The Great Hall was far and away the most powerfully conceived public space of the three schemes, while the three SOM/Gehry towers offered the most believable balance between businesslike efficiency and the playfulness of shape and silhouette that was typical of New York's interwar-era skyscrapers. Borrowing motifs from New York such as the crown of Cross & Cross's RCA Victor Building (later General Electric) (1931), 570 Lexington Avenue, and Gehry's beloved fish, the designers proposed a strong, asymmetrical gateway-like composition facing Eighth Avenue, which they convincingly compared to the west facade of Chartres cathedral. SOM designed the seventy-story RCA-inspired north tower while Gehry's 1.7-million-square-foot southern tower was composed of a sixty-one-story rectilinear armature flanked by a fifty-seven-story knife-edged wedge and a fifty-five-story fish form to be sheathed in sandblasted stainless-steel panels. The third tower, a twenty-four-story building on the eastern portion of the site, was collaboratively designed by the two firms. The sophistication of the towers and their siting, combined with the sense of the remembered monumentality of the old station, especially at the ingeniously recollective entrance pavilion that they proposed to punctuate the Great Hall, marked this as one of the era's most sophisticated attempts to wrest meaningful

Proposed Madison Square Garden redevelopment, east side of Eighth Avenue, between West Thirty-first and West Thirty-third Streets. Skidmore, Owings & Merrill and Frank Gehry, 1987. Section. SOM

Entrance pavilion, Long Island Rail Road, south side of West Thirty-fourth Street, west of Seventh Avenue. R. M. Kliment & Frances Halsband Architects, 1994. View to the southwest. Robinson. KHA

Entrance pavilion, Long Island Rail Road, south side of West Thirty-fourth Street, west of Seventh Avenue. R. M. Kliment & Frances Halsband Architects, 1994. Section. KHA

public space out of the era's virtually unbridled commercialism.

The collapse of the real estate market resulted in the abandonment of the project early in 1988.[49] By January 1989, the plan to relocate the Garden was also abandoned and a $100 million renovation of the existing facility was undertaken (Ellerbe Becket, 1991).[50] In September 1991, the Felt Forum, a smaller venue within the Garden complex, reopened as the 5,600-seat Paramount Theater, designed by Ellerbe Becket, a surprisingly intimate space geared to concerts by popular entertainers.[51] With the failure of plans to redevelop the Madison Square Garden site, attention turned to Charles Luckman Associates' near universally despised Pennsylvania Station (1968), the dismal replacement for McKim, Mead & White's masterpiece of 1904–10, which was demolished in 1963–66. In December 1990, designs were released for a new Thirty-fourth Street entrance to the Long Island Rail Road concourse designed by R. M. Kliment & Frances Halsband Architects working with Tippetts-Abbett-McCarthy-Stratton (TAMS), an architecture-engineering firm.[52] Realized as part of the ongoing overhaul of the Long Island Rail Road's portion of Penn Station, the project, completed in 1994, consisted of a ninety-two-foot-high entrance pavilion that formed the vestibule to a hall of escalators, stairs, and an elevator leading to the concourse two levels below the street, providing easy access not only to suburban trains, but also to city subways. The pavilion and escalator hall, replacing a 6,000-square-foot fast-food restaurant, featured a patterned brick outer wall wrapping a transparent, painted steel-formed glass box evocative of McKim's glass-roofed train room. A spectacularly intricate system of cables, hung from a 107-foot-high eccentrically located stainless-steel mast, held in place the 600-square-foot glass and steel canopy that extended twenty-one feet over the normally thronged sidewalk. The brick walls not only wrapped the glass vestibule, they also served as the base for artfully placed cooling towers that formed a notable rooftop feature. A four-sided clock salvaged from the original Penn Station hung above the granite floor inside the vestibule. Over the escalators and stairs, a folded ceiling, consisting of metal panels that concealed indirect lighting in a manner recalling the work of Alvar Aalto, eased the transition from the street and spatially generous vestibule to the lower, broader, and far more chaotic concourse below, where the artist Andrew Leicester recorded his sense of loss for the old station in compelling terra-cotta bas-reliefs of colossally scaled ruined Corinthian columns. Overhead, another work of art, *Eclipsed Time*, by the sculptor-architect Maya Lin, far less effectively and much more abstractly marked time with a clock based on the concept of a solar eclipse. An aluminum disc rotated over a twenty-four-hour period to obscure a light source above a fixed glass disc. Susanna Sirefman found Lin's work "conceptually powerful" but had to admit that the installation was "unfortunately misplaced and rarely noticed."[53]

By far the most provocative proposal to cope with Penn Station's inadequacies and at the same time to try to redress the sense of loss many New Yorkers still felt over the destruction of the McKim, Mead & White building was that calling for the adaptive reuse for railroad purposes of the underutilized United States General Post Office Building (also known as the Farley Building) one block to the west.[54] In 1992 Amtrak, expecting significant growth in ridership over the next decade as the result of the introduction of high-speed service along the Northeast Corridor line, announced its intention to renovate the post office building and turn it into

a new station that would create a grand civic gateway. The post office building, also designed by McKim, Mead & White, but not finished until 1913, was stylistically compatible with the old station—it indeed was designed to complement it and create a grand impression—but it was in no other way a natural fit for its proposed transformation into a gateway: for the most part it, and the almost identical addition behind it to the west, built in 1935 (McKim, Mead & White), were without significant interior spaces. The post office was expected to need much less space after 1993, when its 850,000-square-foot, three-story beige brick with tinted bronze glass General Mail Facility (Lockwood Greene Engineers), occupying the entire block bounded by Ninth and Tenth Avenues, Twenty-eighth and Twenty-ninth Streets, an addition to the 1933 Morgan Station facility across Twenty-ninth Street, would open.[55] Although the tracks and some platforms were already located under the post office, the provision of the public spaces and other needed improvements was estimated to cost at least $100 million, for which no government funding or private financial backing was in place.

In May 1993, plans for a possible new station were revealed. As designed by Hellmuth, Obata & Kassabaum, the station would have at its heart a vast concourse topped by 120-foot-high parabolic-shaped steel trusses covered in glass to form a room as high as the concourse at Grand Central Terminal. This concourse was set in the building's 150-by-230-foot central light court, a space currently roofed over by a vast skylight. HOK's plans called for the establishment of new entrances at the Eighth Avenue corners and the retention of the monumental 270-foot-long, thirty-step flight of stairs along Eighth Avenue accessing the grand entry corridor that

ABOVE Proposed Penn Station, west side of Eighth Avenue, between West Thirty-first and West Thirty-third Streets. Hellmuth, Obata & Kassabaum, 1993. Model of concourse. HOK

LEFT Proposed Penn Station, west side of Eighth Avenue, between West Thirty-first and West Thirty-third Streets. Hellmuth, Obata & Kassabaum, 1993. Cutaway rendering. HOK

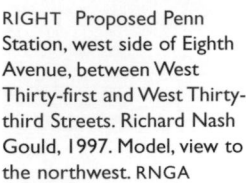

RIGHT Proposed Penn Station, west side of Eighth Avenue, between West Thirty-first and West Thirty-third Streets. Richard Nash Gould, 1997. Model, view to the northwest. RNGA

BELOW Proposed Penn Station, west side of Eighth Avenue, between West Thirty-first and West Thirty-third Streets. Richard Nash Gould, 1997. Great Hall. RNGA

Fair of 1889. Muschamp was more on target when he lamented the design's inherent commercialism—it was prepared as the result of Amtrak's request for revenue-generating development proposals—compared with the original station, which was built so as to thwart commerce: not only did Charles McKim talk the railroad out of its plan to build an enormous hotel in the air space over the station but there were also no advertising signs permitted inside, so that Penn Station's "glory . . . wasn't just what was there, it was what wasn't there."[56] Suzanne Stephens was more interested in the aesthetic problems the HOK design posed, especially the strong axiality of the concourse, with a procession of arches that "forces the eye to the west wall," where the drawings "show only a desultory-looking, bulging Amtrak ticketing counter and a glassed-in Portmanesque café occupying the visual focal point." She also deplored the array of commercial signs depicted in the rendering which she believed (as, to an extent, did Muschamp) suggested the tawdriness of run-down West Forty-second Street rather than the "thrilling New York character, like the old Times Square" that Dan Dolan, HOK's design director, had hoped to invoke.[57]

Despite some critical reservations about the design, the idea of a new Penn Station caught the imagination of the public and of politicians, especially Senator Moynihan, who became a tireless and eloquent advocate. Thanks in part to his influence, President Bill Clinton also endorsed the project, providing in his 1994 budget $90 million for the renovation, though New York State, New York City, the Long Island Rail Road, and New Jersey Transit would still have to allocate additional funds. As these funds began to fall into place over the next three years, the project's estimated cost kept rising, reaching $455 million by July 1997, leading to design modifications, including the scaling down of the 120-foot-high skylight over the central court. With these modifications, confidence in the project and especially in HOK's design began to erode, especially as the post office began to place increasing restrictions on the building's use, and indeed, the availability of space, leading the Municipal Art Society to prepare its own proposal, designed by a little-known architect, Richard Nash Gould, who called for a Great Hall for ticketing comparably sized to

would continue to serve the post office's retail operations and be used as a gallery overlooking the new concourse. With strong support from Senator Daniel Patrick Moynihan of New York, the plan began to make some headway in Congress. But at $315 million, the project was already three times as expensive as when it was first proposed. Herbert Muschamp welcomed the proposal, especially the use of a parabolic arch, which he deemed a symbol of modernity, even though its design was based on a 100-year-old precedent, Contamin & Dutert's Galerie des Machines, a pavilion at the Paris World's

the concourse at Grand Central Terminal roofed with shallow cross vaults in the manner of Sir John Soane; a glass-roofed concourse at the building's east end, also equivalent in size to the Grand Central concourse and in function to the glazed concourse of McKim's station; a Metropolitan Hall at the building's west end, intended as a flexible venue for fashion shows, live performances, and conventions, with seating for 7,000; and 100,000 square feet of retail space on the ground and concourse floors. Midblock pickup and dropoff areas for taxis and other vehicles would give direct access to the central Great Hall much as McKim's pioneering versions of the same led to his 147-foot-high General Waiting Room.

In March 1998, the Postal Service agreed to abandon about half of the Farley Building's ground floor, although the total amount of space it would eventually give up still remained open to question. The agreement to vacate was accompanied by increased funding from Washington and, near the same time, the decision by the Penn Station Redevelopment Corporation, the group created in 1995 to oversee the project, to abandon the HOK plan and the development team behind it, replacing project manager Amy Linden with Alexandros Washburn, an architect who had worked in Moynihan's office and whose permanent marching orders from the senator, who would choose not to stand for reelection in 2000, were "You get Pennsylvania Station built."[58] The redevelopment agency advertised for new architectural teams to develop ideas for the project, narrowing the choice to Skidmore, Owings & Merrill with Hardy Holzman Pfeiffer Associates; Richard Meier & Partners; and Beyer Blinder Belle Architects and Planners with Santiago Calatrava, the Spanish architect and engineer. In June 1998, the team led by Skidmore, Owings & Merrill was selected to design the new Penn Station, now to include the Manhattan terminal of the proposed rail links to Kennedy and Newark airports in addition to hubs for Amtrak, the Long Island Rail Road, and New Jersey Transit.

Like earlier schemes, SOM's plan retained the broad steps facing Eighth Avenue, and the entry hall that they served, for the Postal Service, whose most successful retail operation it would continue to house. Virtually all other postal activities would take place in the 1935 annex facing Ninth Avenue. In order to

accommodate a proposed grand ticketing hall at the midblock, postal truck docks were to be relocated at the Ninth Avenue end of the building in space below grade. With the plan to finance a part of the project through revenues generated by 200,000 square feet of retail set aside, at least temporarily, in an accord reached on December 21, 1998, the civic character of the ticketing hall and the proposed 160-by-205-foot atrium, incorporating a series of terraces that cascaded down to the train platforms and housing preboard waiting areas for long-distance travelers, was established. The scheme, designed by SOM's lead partner, David

Childs, was very much in the spirit of McKim's original, daringly combining the classicism of the post office building with advanced engineering in the form of a dramatically, if eccentrically and even self-importantly, configured glass and metal truss structure sheltering the ticket hall and identifying its midblock location and that of the station's vehicular entrance. The arcing trussed enclosure, quickly dubbed the potato chip, occupied the ninety-foot-wide roadway that separated the original building from the annex (the gap had previously been screened from the street by the original facade), soaring seventy-five feet above the Farley Building to enclose a 150-foot-high space comparable in height to McKim's General Waiting Room. Herbert Muschamp waxed enthusiastic, accepting its scale, which he believed made an "ethereal impression."[59] But, according to Muschamp, the most spectacular space promised to be the train concourse, housed within the building's enclosed courtyard—once the mail sorting room—where the double steel trusses of the original design were to be retained, a decision that no doubt had more to do with cost and issues of historic preservation than aesthetics. Paul Goldberger's assessment was somewhat hyperbolic and in its tone echoed Muschamp's: "It is nearly as brilliant as [Frank Gehry's Guggenheim Museum in] Bilbao, and it will be right in the center of New York, which for most of the last twenty years has been the city that architecture forgot." Goldberger was optimistic about both the design and the symbolic gesture of Childs's glass and steel ticketing hall, which "in a sense . . . [joined] the scale and placement of the original Pennsylvania Station waiting room with the industrial tradition that brought forth [McKim's] train concourse. And he has done it in a way that uses the complex geometries of the end of the twentieth century. Sometimes playing around with buildings that are merely good—like the Farley Building—can make them better."[60]

On May 19, 1999, President Clinton joined Senator Moynihan and other officials to unveil the new design, now estimated at $484 million. Clinton was perhaps its most prominent supporter, labeling it "the first great building of the 21st century."[61] But high praise for the design was tempered with a disturbing financial reality: not only did $134 million of its $484 million remain to be raised, but Mayor Rudolph Giuliani—who boycotted the ceremony, criticizing both the scope of the widely supported project and its cost—could block the use of federal funds should he choose. While Giuliani did not dismiss the project's design, he did criticize the midblock location of the new station's entrance, a point supported by quite a few others who took the time to express their concerns in letters to the editors of the New York Times. And the issue of aesthetics was not to be ignored. For example, one observer, Allen Salkin, compared Childs's glass ticketing hall, inspired by I. M. Pei's pyramid at the Louvre, Nicholas Grimshaw's addition to Waterloo Station in London, and Norman Foster's dome for the Reichstag, Berlin, to "a flash-frozen fragment of a perfect tidal wave coming in off the Hudson."[62]

In late June 1999, a model of Childs's design was placed on view in the Museum of Modern Art, where it remained until August 1. On September 27, federal officials announced that the project had been selected to receive $160 million in loans through a new program for transportation improvements. This good news came at a time when, as a result of the boom in construction, the project's estimated cost had been revised upward to $550 million. On November 18, 1999, the United States House of Representatives approved $60 million in federal aid for the project, with Senate support certain to follow. Though a comparatively small appropriation, it was deemed crucial to the project's realization, leading Senator Moynihan to proclaim: "It's done. Excelsior!"[63] Despite Moynihan's optimism, progress on the new station, with an expected groundbreaking in November 2000 and completion forty-two months later, soon stalled. Although there were persistent rumors that the project would be dropped, even after the tragedy of September 11, 2001, city, state, and federal officials insisted that it would be built. With no visible progress, in March 2003, after Moynihan's death, Governor George Pataki and Mayor Michael Bloomberg announced that the station would be named in his memory, an honor the senator consistently refused during his lifetime. In July 2005, the Related Companies and Vornado Realty Trust were picked to develop the Farley Building site. Accompanying the announcement was a new design from James Carpenter, in association with HOK, architects of the 1993 proposal for the station, a scaled-down scheme, expected to be completed in 2010, that called for a single-level concourse topped by a 100-foot-high skylight carried on steel columns which recalled the Labrouste-inspired design of the concourse in McKim, Mead & White's Pennsylvania Station.

Westyards

Extending west from the General Post Office to the Hudson River, the twelve-block stretch between Thirtieth and Thirty-fourth Streets containing the open-air, below-street-level West

Proposed Penn Station, west side of Eighth Avenue, between West Thirty-first and West Thirty-third Streets. James Carpenter Design Associates, 2005. Concourse. JCDD

Side Railyards, for a generation the subject of study by planners, architects, and real estate analysts, was midtown's largest undeveloped piece of real estate. Only one building had been built above the tracks, Davis, Brody & Associates' overpowering Westyard Distribution Center (1970), which ran along the east side of Tenth Avenue for two blocks between Thirty-first and Thirty-third Streets.[64] In November 1998, the Canadian Centre for Architecture, founded and led by Phyllis B. Lambert, announced that the West Side Railyards would be the subject of the first of a triennial series of invited competitions the CCA proposed to encourage innovative planning for pivotal sites in major cities.[65] From a list of over 100 considered, five teams were invited to compete for the CCA's $100,000 prize—Ben van Berkel and Caroline Bos of UN Studio, Amsterdam; Peter Eisenman, New York; Thom Mayne of Morphosis, Santa Monica; Cedric Price, London; and Jessie Reiser and Nanako Umemoto of RUR Architecture, New York. Rem Koolhaas's name was conspicuously absent: he opted not to compete. Chosen in February 1999, the architects toured the site in March and submitted their proposals for review by the jury in June. No program was issued to the competitors, who were asked to create their own, as well as to develop their own sets of density controls. Many hoped the competition would help lift the debate about the site's future to a higher ground than some observers felt it had hitherto occupied. Herbert Muschamp saw the competition as a way to return to the spirit of the 1950s and 1960s when, as he remembered those years, the city was more open to first-class architecture than it had been in the decades since, which he deemed an era of preservation.

Most of the schemes submitted reflected previous work of the architects: they did not cut new aesthetic ground, nor were they strongly grounded in New York. Cedric Price surprised the jury with an ecologically oriented scheme that would take advantage of river breezes to power "wind-blinkers," seventy-foot-high windmills that he called "the lungs of Manhattan." Preserving most of the site in its present state and somewhat cryptically stating that "there are many situations in which to be systematically late is to be systematically wrong," Price offered perhaps the most adventurous proposal.[66] Van Berkel and Bos proposed a superscaled version of the Javits Center, a new Hudson River pier, and riverfront gardens; Thom Mayne of Morphosis created a spinelike struc-

ture extending the site's length with a public landscaped roof garden, and called for a new Madison Square Garden west of the General Post Office. The winner, Peter Eisenman, who developed his scheme with the collaboration of David Childs and Marilyn Taylor, partners at Skidmore, Owings & Merrill, which was said to have invested extra funds in the presentation, proposed integrating three "buildings"—a stadium, an expanded convention center, and a new Madison Square Garden—into a continuous fabric of urban and park space. Though the projects were all conceptual in nature, Eisenman's was certainly understandable as a megastructure that robbed the individual buildings of their identities in order to overcome the presumed defects of Modernist urbanism with its emphasis on isolated, objectlike buildings and at the same time rejecting the coherent order that goes hand in hand with the gridded streets and figural plazas of traditional town planning. Eisenman saw his proposal as post Postmodernist. His goal was clear: "The city and the building as a unity, as a single thought generating new urban space, blur the edges of the project and modify the city's form."[67]

The projects were exhibited in Grand Central Terminal in October 2000 but failed to make much of an impact with critics. Karrie Jacobs, in *New York* magazine, argued that Eisenman's scheme was "the perfect merger of outlandish and practical. Between a stadium, conventional but for the fact that it's partially submerged in the Hudson River, and a more-or-less-rectilinear office tower on the present site of Madison Square Garden stretches a bizarre man-made terrain, a building four avenue blocks long and five street blocks wide. The idea is that a verdant rooftop park, resembling a geologic model of restless tectonic plates, sits atop a variety of moneymaking concerns. . . . This project," she concluded, "has a monolithic, master-builder quality reminiscent of the bad old days of urban renewal. The design may be breathtakingly au courant, full of complex and irregular forms inspired and facilitated by the computer, but the plan itself is retrograde, promising to impose a unified vision of 100 acres of New York City."[68]

In 1999 the entire swath of land bounded by Thirty-fourth and Forty-second Streets, Eighth Avenue and the Hudson River, became the subject of a planning study sponsored by a local community group, the Hell's Kitchen Neighborhood Association (HKNA), working with the not-for-profit Design Trust for Public Space and the firm Design + Urbanism, which invited fourteen firms to submit schemes for the area's redevelopment.[69] The site was labeled Hell's Kitchen South, with the sponsors deliberately choosing the neighborhood's more colloquial name, which they felt reflected its gritty character better than Clinton. In their mission statement, they encouraged the designers to maintain the area's historic commercial character while not displacing the low- and moderate-income residents. The organizers made it clear that "this heterogeneous landscape does not need to be cleaned-up, filled-in, covered-over or replaced. Judging from opinions voiced by the people who live and work in Hell's Kitchen South . . . they not only like its quality, but want more of it."[70] Given market pressures, however, many felt that change was inevitable and that the area's industrial character was a thing of the past.

The solicited schemes, coming from a group of mostly young design teams including the Brooklyn Architects Collective, Studio a/b, Briggs/Knowles, Marpillero Pollak

Proposed redevelopment of site bounded by West Thirty-fourth and West Forty-second Streets, Eighth Avenue and the Hudson River. Brooklyn Architects Collective, 1999. Site plan and section. BAC

Proposed redevelopment of site bounded by West Thirty-fourth and West Forty-second Streets, Eighth Avenue and the Hudson River. Brian McGrath with the Columbia University Urban Design Studio, 1999. Rendering of view to the northwest. BM

Architects, Todd MacDonald, Benites & Florez, Life in Hell, Brian McGrath with the Columbia University Urban Design Studio, and the Dutch firm UN Studio, were exhibited at the Storefront for Art and Architecture, 97 Kenmare Street, from November 19 to December 23, 1999. Michael Sorkin found the show "well organized and winningly installed" by Michael Conard and David Smiley of Design + Urbanism. Compared with the more polished submissions in the "big money" competition sponsored by the Canadian Centre for Architecture, Sorkin deemed the entries "refreshingly inductive.... Many of the teams paid special attention to the panoply of small and undeveloped sites in the neighborhood, as well as to the possibilities of insinuating green spaces into this concrete jungle, the finessing of mixed use and scale, and the elaboration and securing of neighborhood boundaries and textures."[71]

Of particular note were three schemes that focused on the Javits Center, which formed the site's west edge. UN Studio, the only team to also have participated in the Canadian Centre for Architecture competition, proposed to replace the Javits Center with an undulating, low-rise, mixed-use complex combining housing, retail, and cultural facilities, as well as a new convention facility. Brooklyn Architects Collective created a new public galleria running through the Thirty-fifth Street axis of the Javits Center that would connect directly to the waterfront and a renovated Pier 76; their plan also added new retail to the front of the center and much-needed expansion space in smaller buildings scattered throughout the entire site. Todd MacDonald's scheme would expand the Javits Center to the east across Eleventh Avenue in three single-block buildings connected back to the original center by bridges, a fairly practical solution that Todd Bressi, writing in Oculus, felt "made a persuasive case that the eventual Javits Center expansion might be scaled to the existing block pattern."[72] The McGrath/Columbia plan focused on what Michael Sorkin described as Hell's Kitchen South's "identifying feature both visually and functionally . . . , the tangle of ramps that form Manhattan's automotive umbilicus," by reducing the number of access routes to the Lincoln Tunnel, thereby creating additional building space in the form of a "sinewy band of public housing" which Sorkin deemed "a convincing move both formally and socially." Briggs/Knowles's

"absolutely beautiful scheme" reworked the Dyer Avenue viaduct to create a new three-block park as well as a new building housing an auditorium, classrooms, and recreational spaces. But Sorkin reserved his highest praise for the "elegant submission" of Glynis Berry and Hideaki Ariizumi of Studio a/b, who proposed "perhaps the most readily and immediately realizable of all the projects," a series of pedestrian "urban trails" running throughout the entire site, supplemented by "a set of lapidary interventions—cuts in visual barriers, a 'vehicle riverbank,' pavilions—to deepen and focus neighborhood texture and identity."[73]

Although no specific projects resulted from the competitions sponsored by the CCA and the HKNA, and preliminary designs by Gwathmey Siegel for a thirty-two-story, one-million-square-foot building at the southwest corner of Ninth Avenue and Thirty-third Street, introduced in 1987 and briefly revived in 2000, did not progress, one large-scale speculative building, the Pennmark (SBLM Architects, 2002), was completed at 315 West Thirty-fourth Street, between Eighth and Ninth Avenues. The through-block, thirty-five-story, 333-unit, 650,000-square-foot, green glass–clad apartment building rose 500 feet from a five-story metal-clad base that included a fourteen-screen movie theater complex designed by the Rockwell Group which was entered from Thirty-fourth Street.[74] The building made a powerful impression on the skyline, not only by virtue of its bulk but also as a result of an unusual rooftop feature. Thin, evenly spaced rods of unequal height partially camouflaged the water tank during the day but at night could be illuminated, creating an effect "that from a distance resembles birthday cake candles," according to New York Times reporter Edwin McDowell.[75]

Pennmark, 315 West Thirty-fourth Street, between Eighth and Ninth Avenues. SBLM, 2002. View to the northwest. Ali. SBLM

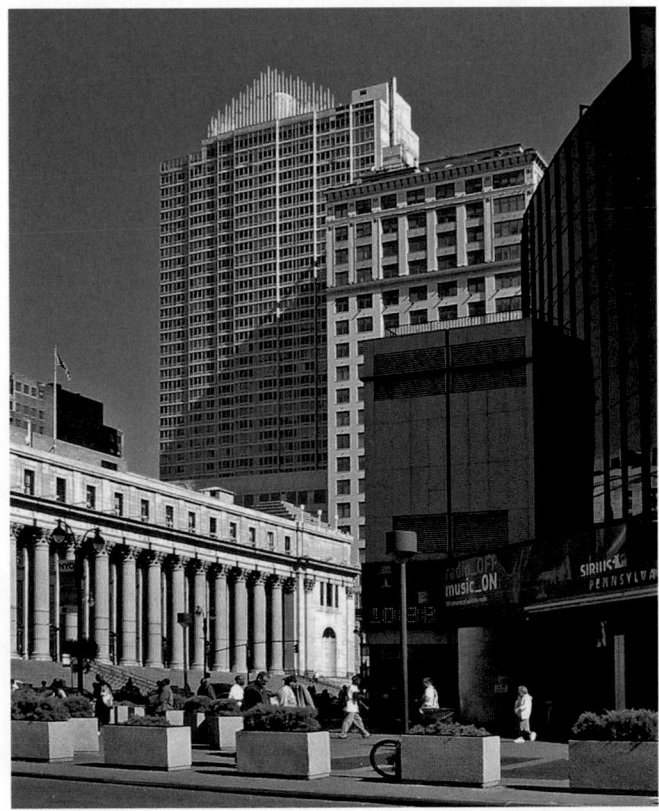

CLINTON

Clinton was the recently minted name used to describe the neighborhood historically known as Hell's Kitchen.[1] Nineteenth-century rowhouses and tenements shared Clinton's streets with large industrial buildings, automotive dealerships, garages, parking lots, and a few significant public facilities, including Kelly & Gruzen's High School of Printing (1959), 439 West Forty-ninth Street, and Park West High School (Max O. Urbahn Associates, 1977), 525 West Fiftieth Street. The adoption in 1969 of the Clinton Park Housing Plan (also known as the Clinton Urban Renewal Area), covering a six-block area bounded by Fiftieth and Fifty-sixth Streets, Tenth and Eleventh Avenues, gave rise to the thirty-nine-story Clinton Towers (Hoberman & Wasserman, 1975), 790 Eleventh Avenue, which provided much needed and welcomed affordable housing but still roused fears throughout the neighborhood of overdevelopment, especially in light of the threatened westward expansion of the midtown office district. In 1974 Clinton exercised its political muscle, resulting in the enactment of a Special Clinton Zoning District, a large precinct bounded by Eighth Avenue (150 feet west of the sidewalk) and the Hudson River, Forty-first and Fifty-ninth Street, wherein the height of any new construction would be governed by the context.[2] The creation of the district banished high-rise buildings to the neighborhood's fringes, leaving much of Clinton relatively untouched during the booming construction cycles of the 1980s and 1990s.

The most prominent fringe development was Emery Roth & Sons' Sheffield (1979), 322 West Fifty-seventh Street, between Eighth and Ninth Avenues, a forty-eight-story brown brick apartment house that began life in 1972 as an addition to one of the city's immense courtyard apartment buildings, the Parc Vendôme (Farrar & Watmaugh, 1931), which lay immediately to its west.[3] The project was initiated by the developer Hyman Shapiro, who had purchased the Parc Vendôme—a pair of slablike buildings along Fifty-sixth and Fifty-seventh Streets separated by a landscaped courtyard—a few years before, planning to transfer its air rights to the through-block site next door and build a nearly 1,000-unit apartment building to be known as the Parc Vendôme Addition.

The development would include a 450-car garage built beneath the tower and beneath a portion of the Parc Vendôme's courtyard, a through-block driveway, a small plaza adjacent to the tower, and a larger, 13,000-square-foot bonus plaza on Ninth Avenue between Fifty-sixth and Fifty-seventh Streets, provided in exchange for extra square footage. The disconnection of the bonus plaza from the proposed new building was unorthodox but justified by Shapiro's intention to connect the two by way of the Parc Vendôme's courtyard. The new cruciform apartment tower was to rise sheer, set back only slightly from the sidewalk. It required waivers of height and setback requirements from the City Planning Commission, which approved the project.

Construction quickly got under way, but in December 1974 Shapiro, faced with financial difficulties, abruptly halted six of his building projects, including the Parc Vendôme Addition. The brutally scaled and detailed tower, nearly topped out but with only about half its brick cladding in place, sat in an unfinished state, a crane standing atop its roof, for three years until the project was taken over by Rose Associates, which renamed it the Sheffield and saw to its completion. The Sheffield was built as originally designed by Emery Roth & Sons with only a few changes: six apartments on the upper floors were eliminated to provide space for a swimming pool with a retractable roof, a tennis court, health club, and several communal rooms, one of which had a barbecue pit and was capable of seating 200. The project also included 90,000 square feet of office space in its first five floors and an attached five-story through-block building entered at 320 West Fifty-seventh Street.

The fate of the Sheffield's bonus plaza on Ninth Avenue was not nearly as happy. Because different owners had taken over the Parc Vendôme as a result of Shapiro's financial reverses, plans to use its courtyard as a connector between the Sheffield and the Sheffield's bonus plaza went unrealized. Consequently, the plaza, separated by more than 200 feet from the Sheffield, remained out of sight and out of mind for Rose Associates. But the city had not forgotten about it, and Rose Associates was denied a Certificate of Occupancy for the Sheffield pending the plaza's completion, which eventually came to pass in 1980. As designed by the landscape architects Abel & Bainnson, the plaza was severe and hard-edged, though a waterfall, planters,

Sheffield Plaza, east side of Ninth Avenue, between West Fifty-sixth and West Fifty-seventh Streets. Abel & Bainnson, 1980. View to the northeast. Tupu. TBA

and a small sunken stage with amphitheater-style seating provided some relief.[4] From the first, it was a failure. Students at nearby John Jay College of Criminal Justice had offered to provide security patrols, and staff of WNET/Channel 13 across the street had agreed to organize programs in the plaza, but the promises were soon forgotten; a planned café never materialized; the waterfall was turned off; and before long the homeless moved in, at one point co-opting electrical outlets to plug in television sets.

No physical improvements were made to the scandalously public eyesore until 1998, when Rose Associates hired the prolific landscape architect Thomas Balsley to replace the lackluster plot with a dynamic landscape of sloping surfaces, elliptical curves, and bright colors.[5] When it reopened in July 2000, Balsley Park (renamed by Rose Associates in honor of the designer, whom they deemed an "unsung hero" of public spaces) was a success.[6] Where the plaza had previously run bluntly into the blank western wall of the Parc Vendôme, Balsley created a softer border of trees behind an undulating green corrugated metal fence. A curving grass-covered mound covered the area of the former sunken amphitheater, a children's play area was installed at the south end, and an oval-shaped coffee kiosk was placed at the northwest corner next to café tables and chairs situated in a raised terrace accessible from the sidewalk. A conspicuous path through the park cut the corner of Ninth Avenue and Fifty-seventh Street, encouraging pedestrian traffic.

Despite strict controls and community resistance to large-scale development, in September 1985 Glick Development Affiliates and Segal-Brodsky released plans for the coordinated redevelopment of two city-owned blocks on the west side of Tenth Avenue between Fifty-first and Fifty-third Streets.[7] The plan, sponsored by the city's Department of Housing Preservation and Development, called for two new apartment towers, a twenty-seven-story building at the southern end of the site designed by the Gruzen Partnership for Glick and a thirty-two-story building between Fifty-second and Fifty-third Streets designed by Liebman Liebman Associates for Segal-Brodsky.

Of the development's 780 units of new housing, 80 percent were to be market rate, with 20 percent reserved for low- and moderate-income tenants. The motley site included a row of run-down turn-of-the-century tenements, a few modest storefronts, a gas station and automobile repair shop, several abandoned buildings, and a ten-story city-owned building at 549 West Fifty-second Street. Though the site was just west of the Preservation Area of the Special Clinton Zoning District, in which building heights were restricted to seven stories or sixty-six feet, it was within the smaller urban renewal area that had originally been the site of the Clinton Park Housing Plan.[8]

The reaction to the proposed two towers was swift and overwhelmingly negative as fears of gentrification spread, fueled by the sense that other recent developments in the neighborhood, including the Javits Center, which was nearing completion, the proposed Worldwide Plaza (see below), the proposed redevelopment of Times Square, and the announcement of several new market-rate apartment towers planned for far west Forty-second Street, were already fueling real estate speculation. Opposition was first led by three arts groups, the Women's Interart Center, the Ensemble Studio Theater, and Soundscape, which would be forced out of the ten-story city-owned building. Writing on January 16, 1986, Paul Goldberger felt that the

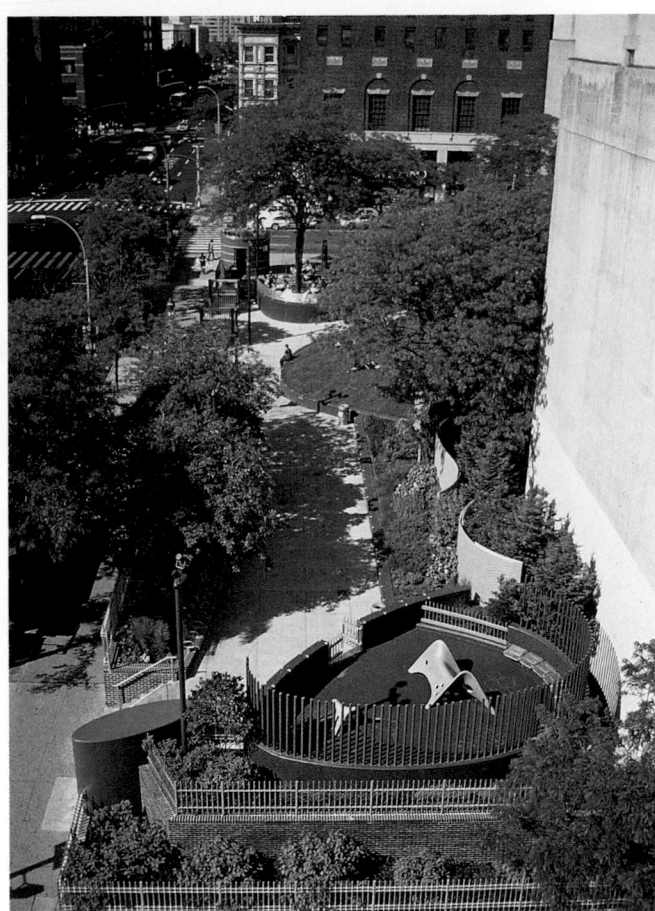

Balsley Park, east side of Ninth Avenue, between West Fifty-sixth and West Fifty-seventh Streets. Thomas Balsley Associates, 2000. View to the north. Koontz. TBA

debate over the proposal transcended the particularities of the two blocks under discussion. At stake, he believed, "was the very future of Clinton itself, and the question of to what extent this complex and ramshackle neighborhood on the west side of midtown Manhattan ought to be rebuilt at all. It is a debate that rather eerily recalls the arguments over urban renewal that were common a generation ago, when tearing down old buildings and replacing them with tall towers was standard operating procedure."[9]

What distinguished this conflict from the typical confrontation of concerned residents opposing what they considered ill-advised and inappropriate development that would destroy the character of their neighborhood was the action of a newly formed group, the Clinton Preservation Local Development Corporation, which commissioned its own highly sophisticated plan for the site. Composed of a "novel coalition," in the words of New York Times reporter Martin Gottlieb, of residents, local entrepreneurs, and performing arts organizations, and supported by Community Board 4, the new group pledged to provide space for the businesses currently located on the site as well as to replace the planned Tenth Avenue towers with lower buildings more in keeping with the tenement scale that largely defined Clinton.[10] The alternative plan, drawn up by Peterson, Littenberg Architects, working in consultation with Michael Kwartler, was committed to preserving all of the site's existing tenement stock through renovation as well as maintaining the area's historic commercial and light-industrial character. The

LEFT Proposed Clinton redevelopment plan, site bounded by West Fiftieth and West Fifty-sixth Streets, Tenth and Eleventh Avenues. Peterson, Littenberg Architects, 1985. Axonometric. PL

BELOW Proposed Clinton redevelopment plan, site bounded by West Fiftieth and West Fifty-sixth Streets, Tenth and Eleventh Avenues. Peterson, Littenberg Architects, 1985. Model, view to the southeast. Pottle. ESTO

plan would also provide a significant amount of new housing in two new apartment buildings but, reversing the developers' formula, would provide only 20 percent of the units at market rate while the remainder would serve low- and moderate-income tenants. In addition to specific plans for the site under question, the architects expanded their scope to include a master plan for the entire six-block urban renewal area.

Peterson, Littenberg's plan was a landmark for New York— a large-scale plan that was decisive in its rejection of the super scaled, isolated, Le Corbusier–inspired urbanism which had governed large-scale proposals for a generation or more in favor of an urbanism of streets and squares owing a lot to the arrangements typical in traditional European cities. Reversing the usual pattern of placing tall towers on the avenue, Peterson, Littenberg set its twin sixteen-story apartment buildings behind the renovated Tenth Avenue tenements between Fifty-first and Fifty-third Streets, where they would rise over an existing railroad cut. The two courtyard buildings were to include 652 apartments which, when combined with the renovated units, provided as much new housing as the HPD scheme proposed by Glick and Segal-Brodsky. Behind the apartment buildings, Peterson, Littenberg proposed a two-block-long public space, Triangle Square, whose shape was defined by the railroad right-of-way and which was linked to a midblock pedestrian passageway and led to garden entrances to the new housing. The rest of the master plan was centered around a new piazza-like public space, Clinton Market Square, to be located between Fifty-second and Fifty-fourth Streets and just east of DeWitt Clinton Park (1905), which would retain its recreational function. During business hours Clinton Market Square was planned to accommodate truck loading for the mixed-use buildings surrounding the space, but at night and on weekends the square was intended for public fairs and performances. The architects adopted the "SoHo model" for the buildings surrounding the square, which served commercial interests on their ground floors and were topped by loft apartments, an arrangement Steven Peterson felt worked "architecturally and socially."[11]

Paul Goldberger was impressed by Peterson, Littenberg's "appealing alternative," which received wide publicity. Although Goldberger conceded that the plans were too preliminary to appropriately judge them from a practical economic point of view, he did feel that "from the standpoint of architecture and urban planning, the Peterson, Littenberg plan is far superior to the two towers that are now proposed for 10th Avenue . . . an unusually sophisticated interworking of preservation and urban design." The critic concluded that the Peterson, Littenberg plan was the "right direction for Clinton. For this old area . . . may well be the closest thing left in Manhattan to a true mixed-use neighborhood. . . . At a time when virtually all of Manhattan appears to be succumbing to the pressures of gigantism and to the forces of gentrification, it is not a bad idea to keep one part of town small in scale and heterogenous in its mix of uses. Clinton may not win any beauty contests, but the wisdom of the Peterson, Littenberg plan is in its ability to see beyond this, and know that despite its roughness this neighborhood is worth treating gently."[12] The widely admired scheme received a coveted urban design award from *Progressive Architecture* magazine.

Notwithstanding Peterson, Littenberg's innovative design, the twin apartment building proposal from Glick and the Segal-Brodsky team was approved by the City Planning Commission in March 1986 but soon came under fire from a new source as the project got caught up in the burgeoning corruption scandals plaguing members of the Koch administration.[13] Literally hours before the plan was to go before the Board of Estimate, Koch withdrew it from consideration. Koch himself eventually admitted that his decision was affected by concerns over the appearance of influence peddling as the result of recent publicity surrounding substantial campaign contributions made by one of the developers, Reuben Glick, to the mayor as well as to other members of the Board of Estimate. The decision pleased no party, as the developers were obviously miffed over the lost opportunity, and Clinton residents were also disappointed because they had strongly rallied around the alternative proposal from the Clinton Preservation Local Development Corporation, believing that even if it was naïve to imagine that the entire master plan had a chance of being implemented, there was some hope that Peterson, Littenberg's innovative ideas might at least help shape the development of the two-block stretch of Tenth Avenue between Fifty-first and Fifty-third Streets. Although the Department of Housing Preservation and Development pledged to find another development team quickly, the site remained in its dilapidated state. In 2003, four tenements on the northern block, 773, 775, and 777 Tenth Avenue and 501 West Fifty-second Street, were rehabilitated (Feder & Stia Architects) to provide twenty-seven apartments for existing and low-income tenants.

Significant construction within the urban renewal area stalled until 1998, when HPD offered an L-shaped parcel on the west blockfront of Tenth Avenue between Fifty-fourth and Fifty-fifth Streets, formerly occupied by a parking lot and taxi garage, for development as an apartment house with 80 percent market-rate units and 20 percent low- and moderate-income units, an offer that troubled many in the community who felt the city's dedication to affordable housing was waning. Nonetheless, in 2001 construction was completed on the Foundry (Schuman, Lichtenstein, Claman & Efron), an apartment complex comprising two buildings that shared a courtyard garden but were separated by a group of tenements on the southwest corner of Fifty-fifth Street.[14] It was the first significant housing development in the far west Fifties in over a decade. The primary building, entered at 505 West Fifty-fourth Street, fit 164 units and 13,500 square feet of commercial space into its twelve-story round-cornered form while the second building, entered at 510 West Fifty-fifth Street, was an unassuming six-story midblock building containing fifty-eight apartments. Both were cut from the same cloth, clad in dark red brick and meeting the sidewalk with oversized storefront windows topped by segmented arches. No doubt the industrial look of the building was intended to reflect Clinton's building stock, but the architecture of the Foundry was more closely tied to lower Manhattan's older manufacturing buildings, a fitting match to the developers assertion that "the neighborhood has the potential to be the next TriBeCa."[15] The architect Joel Sanders, retained to design the lobbies, called for a suspended concrete floor in the Fifty-fourth Street lobby with backlit openings cut around the mottled dark gray fiberglass-clad columns to allow glimpses of a rock garden below. Concrete furniture and a terrazzo concierge desk rose smoothly from the floor. The lobby was far more interesting than the building.

Across Fifty-fifth Street, the west blockfront between Fifty-fifth and Fifty-sixth Streets was one of two sites within

Foundry, northwest corner of Tenth Avenue and West Fifty-fifth Street. Schuman, Lichtenstein, Claman & Efron, 2001. View to the northwest showing the Westport (Costas Kondylis, 2003) on the far right. SLCE

Foundry, northwest corner of Tenth Avenue and West Fifty-fifth Street. Schuman, Lichtenstein, Claman & Efron, 2001. View of lobby by Joel Sanders. Aaron. ESTO

830 Eighth Avenue, northeast corner of West Fiftieth Street. William S. Fryer Associates and Mario Ingrami, 1984. View to the northeast. RAMSA

the urban renewal area not owned by the city. In 1999, the warehouse discount store Costco planned to build its first Manhattan outpost on the lot, a two-level, 75,000-square-foot so-called big-box store. Rising construction costs combined with community opposition, which grew in 2000 when Costco confirmed it had applied for a zoning variance allowing the construction of an apartment tower above the store, led to the project's demise.[16] The Related Companies purchased the site and hired Costas Kondylis to design the Westport (2003), 500 West Fifty-sixth Street, a twenty-four-story T-shaped stack of red brick and glass boxes that added up, according to Kondylis, to a "contextual building with a six-story base that contains a four-story transition area" followed by a tower. The architect's effort to "create a distinctive geometry" through the building's varying grids of brick and glass was a success.[17] The Rockwell Group was hired to fit out the interiors.

The lion's share of residential development in Clinton during the 1980s and 1990s occurred on the western reaches of Forty-second Street and along Eighth Avenue. On Forty-second Street, a small residential boom in the late 1980s was followed by a surge in construction beginning in the late 1990s (see Forty-second Street). The stretch of Eighth Avenue in the Forties and Fifties was, through the 1970s and much of the 1980s, one of the seediest strips in the city, all but lost to adult movie houses, drug sellers and users, prostitution, and a dense concentration of single-room-occupancy (SRO) hotels protected by a citywide moratorium on demolition imposed in January 1985 and deemed unconstitutional in 1989, at which time 4,300 units of SRO housing still existed between Forty-second and Fifty-seventh Streets.[18] Developers avoided the area, and when the relatively tiny, 17,500-square-foot,

ten-story office building at 830 Eighth Avenue (William S. Fryer Associates and Mario Ingrami) was completed in 1984 on the northeast corner of Fiftieth Street, it was the first such building to rise on Eighth Avenue in recent memory. With what Christopher Gray later described as a "peculiar Vasarely-style" yellow and gray geometric paneled facade, the building's "mechanical modernism" was a lighthearted distraction from its bleak environs.[19]

Worldwide Plaza

A critical turning point was reached in November 1985 with the announcement of the most consequential building in Clinton and one of the city's largest private projects of the 1980s: the full-block development of Worldwide Plaza (Skidmore, Owings & Merrill), 825 Eighth Avenue, between Forty-ninth and Fiftieth Streets, an office building, and its attendant apartment house (Frank Williams), completed in 1989.[20] The site, bounded by Forty-ninth and Fiftieth Streets, Eighth and Ninth Avenues, had once been home to the third Madison Square Garden (Thomas W. Lamb, 1927), which was demolished in 1967 when the new garden was built on the former site of Pennsylvania Station.[21] The neighborhood was marginal at best, squalid even, but in 1984 William Zeckendorf Jr. acquired the site and, in January 1985, chose Skidmore, Owings & Merrill, with design principal David Childs leading the team, to plan for the development of what would be the first office building of any importance to be built west of Eighth Avenue since the completion of Raymond Hood's McGraw-Hill Building in 1931.[22] The building would also be the first significant project for Childs since his move to New York after thirteen years of practice in SOM's Washington office. Though the four-acre site, one of the largest undeveloped properties in single ownership in midtown, had been used as a parking lot since 1967, it had for some time been slated for redevelopment as the future headquarters of the Gulf & Western Corporation, which owned the land. Gulf & Western had, from time to time, indicated its intention to combine an office building with residential and retail uses, and the Skidmore firm had prepared studies. In November 1985, Zeckendorf's plans were announced at a press conference in City Hall, calling for a forty-five-story, 1.5-million-square-foot office tower on Eighth Avenue, a thirty-eight-story apartment tower containing 268 condominiums to the west and several six- and seven-story residential buildings housing 386 units filling the western end of the block on Fiftieth and Fifty-first Streets and Ninth Avenue. In addition to a landscaped midblock park, the complex would include, underground, a six-screen movie theater, a 35,000-square-foot health club, and a 450-car garage. While the site was considerably smaller than that of Rockefeller Center, it was nonetheless big enough to sustain some of that landmark's urbanism.

By 1988, with construction well under way, most of the space in the office building was leased to two prestigious tenants: the advertising firm Ogilvy & Mather Worldwide and the law firm Cravath, Swaine & Moore. Ten years before, the firms would never have considered a building on the West Side, much less one on the west side of Eighth Avenue. But the flexibility of internal layout made possible by the building's very big 30,000-square-foot floors, which gave it an incredible heft on the skyline, were a great attraction. The construction of Worldwide Plaza received international attention as the result of a five-part weekly television series that traced the project's four-year-long evolution and of Karl Sabbagh's book accompanying the series, *Skyscraper*.

Paul Goldberger praised the colossal project's overall urbanism: "So this place does prove that it is possible to insert a vast project into the fabric of New York without cataclysmic effect."[23] Though the residential portions evoked the Moderne or Art Deco work of the early 1930s, the office tower, rising to a steep copper-clad pyramidal roof crowned by an illuminated lantern, suggested in its massing such previous skyscrapers as Cass Gilbert's New York Life Insurance Company (1926) on Madison Avenue and Whitney Warren's New York Central Building (1929) on Park Avenue.[24] But in contrast to those stylistically consistent designs, the one Gothic, the other baroque classical, David Childs's design tried to combine the two, with the brick piers of the tower evoking the Gothic and the granite-clad base, which Goldberger singled out for praise, executed in the classical manner with bold arcades. Though he had reservations about the site plan, Goldberger was pleased with the finished tower: "a 770-foot pile of maize-colored brick, its verticals accented by rust-colored brick and its setbacks marked by white brick intended to suggest stone, all set on a granite base full of cornices and columns and pilasters and arches. . . . On the skyline, the mass of the tower, though a bit bloated, has a romantic presence that evokes the best towers of the 1920s."

Goldberger deemed the building's "monumental" base, with its colonnade, "perhaps the . . . finest feature of all. This is public architecture at its best: an elliptical passage beside granite pilasters under a vaulted roof, the details handsome,

Worldwide Plaza, site bounded by West Forty-ninth and West Fiftieth Streets, Eighth and Ninth Avenues. Skidmore, Owings & Merrill, 1989. View to the west. Goldberg. ESTO

the scale grand yet comfortable." The critic did, however, regret that there was a blank quality to the facade, which he attributed to the use of single-pane windows whose "plainness [and] utter lack of texture, undercuts all the attempts to use the classical language to give life to the facades of this building."[25]

A hidden asset of the project was the elevated garden reserved for residents that lay to the west of the condominium tower; on the other hand, all New Yorkers could enjoy the residential streetscape of multiple entrances leading to maisonettes and, along Ninth Avenue, the well-proportioned storefronts.

Still, the project's sheer size offended many, most notably Brendan Gill, who was not impressed with Childs's attempt to reduce the bulk of the 165-by-165-foot tower "by chamfering its corners, by limiting the number of its window openings, by varying the textures and colors of its brick cladding, and by employing at intervals triangular bricks that, projecting from the surface of the building, provide a number of supposedly 'slimming' vertical shadow lines." Gill, seeming to contradict Goldberger almost line for line, word for word, attacked the project for the "cool reasonableness with which the plan has been thought through," reasonableness being "a defect that its designers and builders must have assumed would be seen as a virtue." Forgetting or overlooking the initial impression the new Rockefeller Center made as it rose amid scruffy brownstones filled with speakeasies and the like, Gill found the "very tidiness" of Childs and Williams's complex "unfriendly, and perhaps adversarial." Gill objected to the location of the bulkiest building in the complex facing Eighth Avenue, rather than on the midblock as was the RCA building at Rockefeller Center, and he took objection to the "posture and dress of the 825 Eighth Avenue tower [which struck] a note of Roman grandeur which even that voluptuary of the classic, Whitney Warren, might have found too much."[26] In all the hubbub about the office tower, the apartments by Frank Williams, with their warm pink and buff brick facades, stylish, elegantly thin-mullioned corner windows, and well-composed setbacks, were largely ignored, through they added a graceful note of humanity to the development as a whole.

Along Eighth Avenue

Following the completion of Worldwide Plaza, Zeckendorf, who had been amassing land in the area, was reported to be considering plans for three other nearby projects, though none went forward during a seven-year lull in construction along Eighth Avenue that only ended in the mid-1990s, when a strengthened economy, the revitalization of Forty-second Street, and the proposed redevelopment of the Coliseum site on Columbus Circle sparked renewed interest in the avenue that linked those increasingly pivotal areas. Several nearby buildings did reach completion during the construction of Worldwide Plaza. In 1987 Der Scutt converted the eight-story 355 West Fifty-second Street, between Eighth and Ninth Avenues, a former industrial building, into offices and ground-floor retail space, resurfacing the facade with a combination of beige stucco and burgundy trim.[27] The same year, Eighth Avenue's first significant residential building of the

FACING PAGE Worldwide Plaza, site bounded by West Forty-ninth and West Fiftieth Streets, Eighth and Ninth Avenues. Skidmore, Owings & Merrill, 1989. View to the southeast. Goldberg. ESTO

Worldwide Plaza, site bounded by West Forty-ninth and West Fiftieth Streets, Eighth and Ninth Avenues. Skidmore, Owings & Merrill, 1989. Arcade. Goldberg. ESTO

Proposed office building, east side of Eighth Avenue, between West Forty-ninth and West Fiftieth Streets. Pei Cobb Freed & Partners, 1990. Model. PCFP

Gershwin, east side of Eighth Avenue, between West Forty-ninth and West Fiftieth Streets. Schuman, Lichtenstein, Claman & Efron, 1998. View to the southeast. SLCE

Longacre House, west side of Eighth Avenue, between West Fiftieth and West Fifty-first Streets. Schuman, Lichtenstein, Claman & Efron, 1998. View to the northwest. SLCE

era was completed: Emery Roth & Sons' Ellington (1987), 260 West Fifty-second Street, southeast corner of Eighth Avenue, a twenty-nine-story striated brown brick tower with cast-stone trim that rose fourteen stories along the street wall before setting back to rise as a fifteen-story balconied box.[28] Four blocks to the north, Emery Roth & Sons' Symphony House (1987), occupying the north blockfront of Fifty-sixth Street, between Eighth Avenue and Broadway, was a banal but imposing forty-three-story combination office building, entered at 1755 Broadway, and residential tower, entered at 235 West Fifty-sixth Street.[29] Rising on the site of the Lozier Motor Company Showroom (Francis H. Kimball, 1905), Symphony House consisted of a reddish brown granite-clad seven-story base with 30,000-square-foot office floors aligned to meet the diagonal course of Broadway beneath a thirty-two-story pink-brick set-back tower slab with a broad south facade, littered with over 270 balconies, that David Dunlap called "staggering."[30]

In 1988 work was completed on another profusely balconied slab, that of the Ritz Plaza apartments, 235 West Forty-eighth Street, between Broadway and Eighth Avenue (Schuman, Lichtenstein, Claman & Efron, 1989), a forty-four-story, 479-unit, 500,000-square-foot apartment house on a 24,000-square-foot site previously home to four brownstones

that had been combined to create a once extremely popular restaurant, Mama Leone's.[31] Ritz Plaza was clad in beige brick to match the color of the neighboring Ritz Theater (Herbert J. Krapp, 1920), 225 West Forty-eighth Street, after which it was named. Billed as an apartment hotel where one could rent furnished quarters, have daily maid service, and enjoy meal service in a ground-floor restaurant, Ritz Plaza also contained 25,000 square feet of office space. The building's substantial bulk was made possible by the acquisition of 160,000 square feet from the air rights of the Eugene O'Neill Theater (Herbert J. Krapp, 1925), 230 West Forty-ninth Street, and the Ritz Theater, the latter restored by the developers in association with the Martin Beck Theater Company, which took a 50 percent interest in the renovated venue. Another 40,000 square feet was gained by the provision of a 7,200-square-foot plaza to the west of the building that proved too inviting for the homeless, leading to its redesign, completed in May 2002, by Thomas Balsley, who was asked after construction was under way to create a memorial for the fifteen firefighters from Engine 54, Ladder 4, Battalion 9, who perished in the terrorist attacks of September 11, 2001.[32] The memorial, a granite fountain inscribed with the names of the victims, was embraced by two semicircular benches and placed in the southern portion

of the plaza, now renamed Firefighters' Memorial Park.

The full blockfront directly across Eighth Avenue from Worldwide Plaza, between Forty-ninth and Fiftieth Streets, occupied by a parking lot, was owned by a Washington, D.C.–based developer planning to ride Zeckendorf's success by constructing an office building designed by Pei Cobb Freed & Partners.[33] The firm's design, prepared in 1990, was a fairly complex assemblage of simple geometries: the two-story base of the 700,000- to one-million-square-foot building featured recesses in the middle of each facade, allowing it to read as four distinct cubelike volumes meeting each corner of the site. Above, a tower of approximately thirty stories was planned as an eight-pointed star with four slender, square towers nestled into the star's reentrant corners. Each corner tower was capped by a cylindrical lantern complementing a larger cylindrical mechanical enclosure atop the tower's main volume. Those plans did not go forward, but in 1996 the 35,000-square-foot site fell into the hands of Jack Resnick & Sons, who, encouraged by strong leasing activity at Symphony House, another of the firm's projects, built the Gershwin (Schuman, Lichtenstein, Claman & Efron, 1998), 250 West Fiftieth Street, a forty-one-story, 550-unit apartment building with 39,000 square feet of retail space and a 122-car garage.[34]

Diagonally across Eighth Avenue, the blockfront site between Fiftieth and Fifty-first Streets became home in 1998 to Longacre House, 305 West Fiftieth Street, a twenty-six-story, 292-unit apartment building with 13,000 square feet of retail space also designed by Schuman, Lichtenstein, Claman & Efron.[35] The site had formerly housed tenement buildings and, more notably, the Adonis (formerly Tivoli) Theater (Eisendrath & Horwitz, 1921), operated as a gay pornographic movie house from 1975 to 1989, when William Zeckendorf Jr., as part of his deal with tenants at Worldwide Plaza, saw to its closing. Zeckendorf's plans to build a hotel or apartment building on the site were halted by the recession, and in 1997 Harry Macklowe bought the property and built the glassy, exposed-slab apartment tower striped with vertical bands of rose- and beige-colored brick rising out of a one-story base where regularly spaced piers, extending above the roofline, were capped by ersatz lanterns. For Christopher Gray, Longacre House was "more in context with the less pretentious atmosphere of Eighth Avenue" than the Gershwin, which had more in common with "the sleek, Upper East Side style that was especially popular earlier in the 1990's."[36]

The tallest of the new crop of Eighth Avenue apartment towers was the Biltmore (Schuman, Lichtenstein, Claman & Efron, 2003), east blockfront between Forty-seventh and Forty-eighth Streets, a fifty-one-story, 464-unit building that borrowed its name from the adjacent Biltmore Theater (Herbert J. Krapp, 1925), 261 West Forty-seventh Street, whose air rights lent it extra square footage.[37] The theater itself had a troubled recent history. After closing with the musical *Stardust* in May 1987, its interior was given landmark status on November 10, 1987.[38] One month later, on December 10, a fire, believed to be arson, was set on the stage and in the orchestra pit. Declared unsafe by the Buildings Commissioner in August 1988, the theater was subsequently shuttered by the city. After several changes in ownership, in March 1997 the Moinian Group, a developer, signed a contract to purchase the Biltmore, its air rights, the air rights to the Brooks Atkinson Theater (Herbert J. Krapp, 1926), 256 West Forty-seventh Street, and five tenements on the Eighth Avenue blockfront,

where it announced it would construct a forty-three-story, 750-room hotel. But the developer's plan to "restore" the Biltmore Theater and reuse the auditorium as the hotel's lobby was immediately ruled out by the Landmarks Preservation Commission.

After delays stemming from a lawsuit over the ownership of the site, Moinian—paired with a new developer, the Jack Parker Corporation—shifted gears to erect the Biltmore apartments, a gray brick and glass-clad needlelike building with an angular southwest-facing glass volume jutting out from the facade above the twentieth floor. With 30,000 square feet of commercial space on four floors, 6,000 square feet of retail space, and a 60-car underground garage, the Biltmore was eighteen stories taller than the thirty-three stories allowed under zoning. Extra square footage was gained by the restoration of the Biltmore Theater, which became home in 2003 to the Manhattan Theatre Club, whose current operations at the City Center, 131 West Fifty-fifth Street, would also continue.

As renovated by the Polshek Partnership, the Biltmore's rear wall was moved twenty-two feet forward to create a smaller performance hall seating 623 (as opposed to the original design's 948-seat capacity) and provide space for an upper lobby and patrons' lounge. A second lounge was created by excavating the basement. The auditorium itself was nearly a pure restoration, though the

Biltmore, east side of Eighth Avenue, between West Forty-seventh and West Forty-eighth Streets. Schuman, Lichtenstein, Claman & Efron, 2003. View to the northeast. SLCE

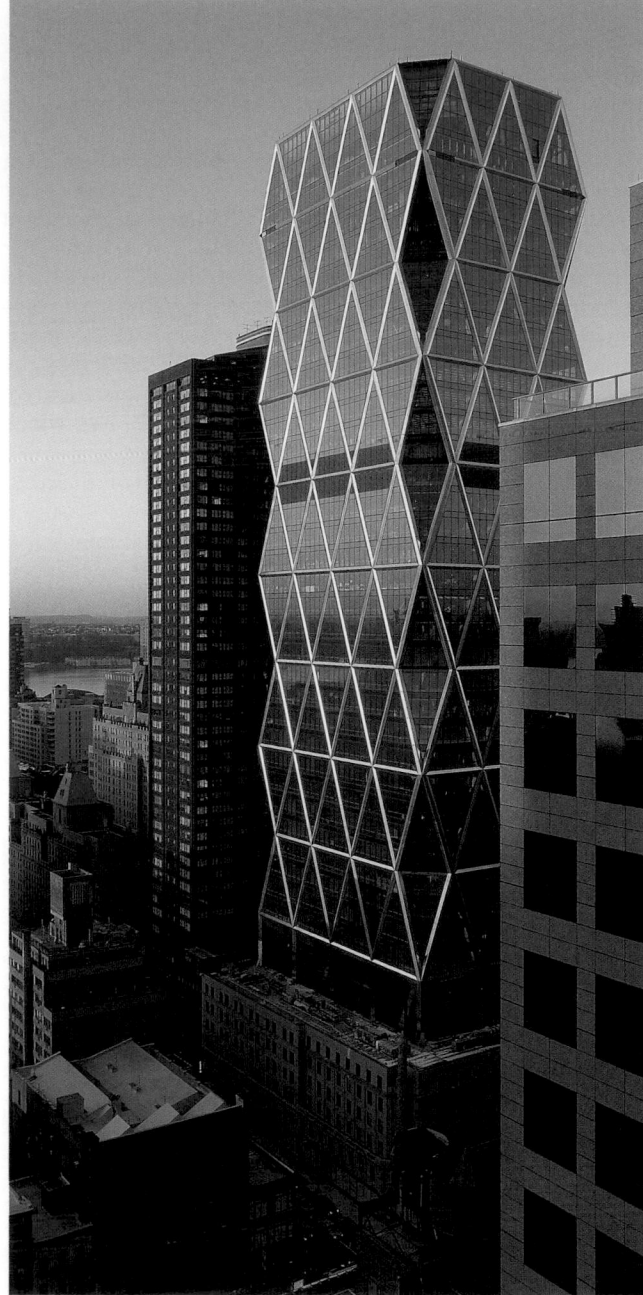

Hearst Tower, west side of Eighth Avenue, between West Fifty-sixth and West Fifty-seventh Streets. Foster and Partners, 2006. View to the northwest. Charles. FCP

Hearst Tower, west side of Eighth Avenue, between West Fifty-sixth and West Fifty-seventh Streets. Foster and Partners, 2006. View to the northeast. Charles. FCP

rake of the orchestra floor was increased and the balcony seats received more legroom. The Landmarks Preservation Commission unanimously approved the work. The exterior, which was not protected as a landmark, was given a new glass canopy and glass doors.

The most significant building proposed for Eighth Avenue was the work of the important and influential English architect Norman Foster, who in 2001 designed a tower "addition" to sit atop Joseph Urban and George B. Post & Sons' International Magazine Building of 1926–28, 959 Eighth Avenue, between Fifty-sixth and Fifty-seventh Streets.[39] Urban's squat, elegant, and some might say whimsical, six-story limestone building was designed to support an additional

seven-story tower, plans for which fell victim to the Depression and Second World War. What the additional stories might have looked like is unknown. William Randolph Hearst, who owned a considerable amount of real estate in the area, undertook the project expecting the area to soon boom, fueled in part by the planned construction of a home for the Metropolitan Opera on the block, though that idea was abandoned and the Parc Vendôme apartments were built on the intended site. Plans to build above the Hearst Magazine Building, as it had become known, were again considered in 1946 with a design prepared by George B. Post & Sons and then later in the 1980s according to plans by Beyer Blinder Belle for a thirty-four-story tower sheathed in semi-reflective gray-green

glass, but neither went forward. Then, in 2000, the Hearst Corporation, publisher of seventeen magazines, the offices of which were scattered in half a dozen New York locations, announced its intention to build a "world-class headquarters building in combination" with the Urban building, which, having gained landmark status in 1988, would be preserved.[40] Hearst's proposed headquarters joined a growing spine of media giants along Broadway and Eighth Avenue stretching from the Condé Nast and Reuters buildings in Times Square and the planned *New York Times* headquarters on Eighth Avenue and Forty-first Street, up through the Random House building on Broadway and Fifty-fifth Street to the headquarters of Time Warner at Columbus Circle.

Hearst executives reportedly met with the Polshek Partnership early on, but in January 2001 the company announced it had hired Norman Foster to "explore development of the building," a process that led to a spectacularly conceived, geometrically daring, hyperaggressive, and contextually challenging thirty-six-story glass and steel icon.[41] Foster was no stranger to tackling historic buildings, having received critical acclaim for his 1999 addition to the Reichstag in Berlin and his more recent Great Court at the British Museum.[42] And his selection, coming on the heels of his failure to secure the commission for the *New York Times*'s tower, prompted one architect to wonder if "Hearst wanted to outdo" the newspaper.[43]

Foster's scheme, addressing what Kent Barwick, president of the Municipal Art Society, called "one of the toughest architectural problems to come along in a long time," devised in collaboration with the engineer Ysrael A. Seinuk, called for a 597-foot-tall transparent glass tower with a visible triangulated diagrid structure that formed a structural tube allowing for column-free office floors within.[44] Foster had employed a similar structural system in the Swiss Re building then under construction in London, whose tapering cylindrical mass had earned it the nickname of the "gherkin." The skeleton's nine tiers of interlocking triangular trusses were clad in stainless steel on the outside, giving a sleek look to the tower, which rose with faceted corners to a flat top. As part of the plan, Urban and Post's Hearst Building was gutted, with retail space kept on the first two floors but the third floor, accessed by a bank of escalators rising from the entrance on Eighth Avenue, forming the expanded building's main lobby, or as Foster described it, a "piazza" located at the intersection of the old and the new buildings that were fitted together, as Herbert Muschamp put it, like a "glass square peg" inserted in a "solid square hole."[45] The soaring lobby was topped by the underside of the first floor of the tower, which was elevated above the roof of the Hearst Building enough to allow for a ring of clerestory windows between the new and old structures.

The plan went before the Landmarks Preservation Commission in late October 2001 and was approved after a formal review on November 27, at which members of the Municipal Art Society, the New York Landmarks Conservancy, and Community Board 4, all of whom had received previous briefings on the project by Foster, testified in favor of the design. The only naysayer of significance was the Historic Districts Council, whose executive director, Simeon Bankoff, objected, "It does not respond to, respect or even speak to its landmark base."[46] But, given the pro-development mood of the post-9/11 city, and the generally permissive, pro-Modernist bias of the Giuliani-era Landmarks Preservation Commission, the sentiment went virtually unaddressed. David Dunlap, perhaps the wisest observer of the shifting landscape of the city's development scene, called the project, completed in 2006, "the most striking evidence yet of a change in New York's aesthetic landscape, in which contextualism has long been the watchword when it comes to historic buildings and districts."[47]

In Clinton's Heart

Because the supersized towers that went up on either side of Eighth Avenue and along Forty-second Street were prohibited within the Preservation Area of the Special Clinton Zoning District, new market-rate apartment buildings in Clinton's heart were rare. An exception, located a few doors west of Longacre House (see above), was Schuman, Lichtenstein, Claman & Efron's modestly ingratiating 311 West Fiftieth Street (2001), between Eighth and Ninth Avenues, built on a site used for parking since the 1970s.[48] The seven-story, 100,000-square-foot building, of gold and burgundy brick with a polished granite base, contained 102 apartments and 5,200 square feet of medical offices.

Typically, Clinton's height restrictions discouraged profit-driven developers yet attracted nonprofit organizations, many of which, offering to build subsidized housing of one sort or another, were encouraged by the local community board to establish centers in the neighborhood. Commendably, Clinton residents, unlike those in many other neighborhoods, did not resist the construction of affordable housing. And with the pickup of construction in the 1990s, Clinton did become home to a number of midblock, affordable apartment houses. Richard Dattner Architects' Clinton Gardens Apartments (1993), 404–410 West Fifty-fourth, between Ninth and Tenth Avenues, a simple, red brick building with light gray brick accents, double-hung windows, and cast-stone trim, was developed by the New York Foundation for Senior Citizens as a residence for the low-income elderly.[49] The 80,000-square-foot building comprised 100 apartments, a 3,000-square-foot community space, and a 4,375-square-foot garden. The building, which gained a zoning variance allowing it to reach ninety instead of sixty-six feet, rose seven stories, then set back for another three. Dattner's effort to design "interventions that lift the curse of banality from what tends to be a shoebox" included arcing parapets and lintels with

Hearst Tower, west side of Eighth Avenue, between West Fifty-sixth and West Fifty-seventh Streets. Foster and Partners, 2006. Section through main lobby. FAP

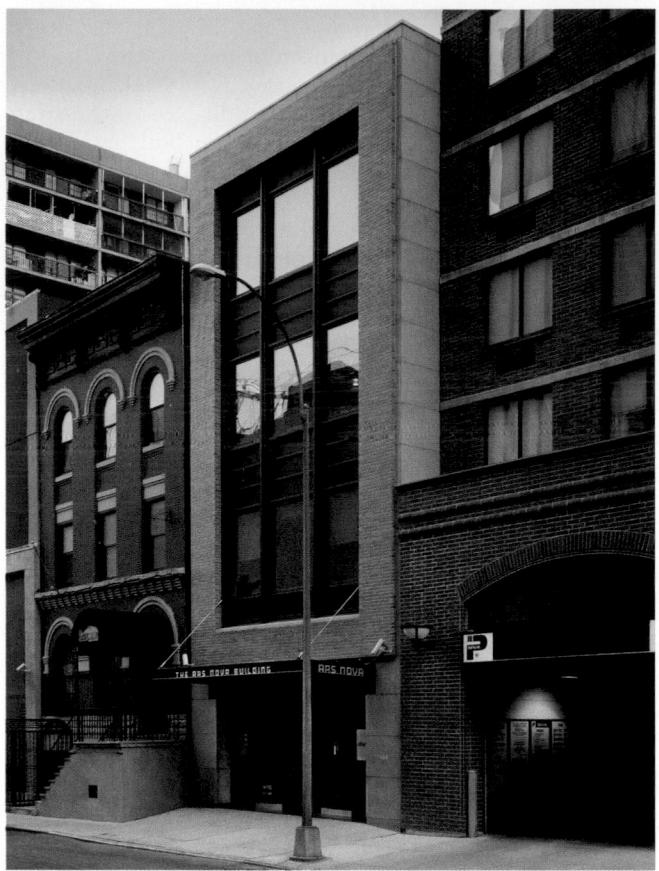

Salvation Army Times Square Ministries, 315 West Forty-seventh Street, between Eighth and Ninth Avenues. Hillier Group, 2003. View to the northwest. RAMSA

Ars Nova PGM, 511 West Fifty-fourth Street, between Tenth and Eleventh Avenues. Franke, Gottsegen, Cox Architects, 2002. View to the northwest. Wallen. FGCA

keystones.[50] Cleverly, Dattner placed the south-facing common garden, designed by Abel Bainnson Butz, one level below the street so that the community room, kitchen, laundry, and arts and crafts spaces, located in the basement, would open to the outdoors. Ivan Shapiro House (Gran Sultan Architects, 1996), 459 West Forty-sixth Street, between Ninth and Tenth Avenues, a residence for formerly homeless, mentally ill men and women, was an inoffensive addition to its block, its six-story orange brick facade with green metal trim blending in well with its neighbors yet distinguishing it as newer construction.[51] Ryan Chelsea-Clinton Community Health Center and the Village at 46th and Tenth (Horowitz & Immerman, 2002), southwest corner of Tenth Avenue, combined a 20,000-square-foot community health center entered from a one-story appendage on Tenth Avenue with an eighty-four-unit apartment building, entered at 510 West Forty-sixth Street, providing housing for low- and moderate-income senior citizens.[52] The otherwise bare-bones design was enlivened by a combination of pink, beige, and gray brick and the placement of oversized geometric windows at the first and second levels.

In 2003 the Salvation Army, after twelve years without a chapel in the Times Square area, moved into new quarters at 315 West Forty-seventh Street, between Eighth and Ninth Avenues.[53] As designed by the Hillier Group, the five-story red brick and cast-stone building with a two-bay-wide two-story stone-framed window dominating the center of the facade featured a first floor clad in a combination of metal

and glass to allow views through the lobby directly into the 156-seat "worship theater," a maple-paneled sanctuary that could also serve as a venue for outside productions. As a backdrop for the stage, Hillier designed a sleek, twenty-two-foot-high curving metal mesh screen onto which a cross could be projected from behind. The building also provided a dance studio and rehearsal spaces and, on the fifth floor, an apartment for officers of the Salvation Army.

Perhaps the most architecturally distinguished addition to the neighborhood was also one of the most modest: Franke, Gottsegen, Cox Architects' four-story home (2002) for Ars Nova PGM, 511 West Fifty-fourth Street, between Tenth and Eleventh Avenues, a film, television, and theater production company. Above the gray French limestone and steel-clad ground floor, the facade consisted of a triple-height orange Roman brick proscenium-like frame set on a field of limestone and surrounding a grid of steel and glass. Inside, a ninety-nine-seat theater occupied the first floor, with offices and entertainment and lounge spaces above. At a completely different scale but almost as stylish was the New York City Transit Authority's Subway Command Center (Ellerbe Becket, 2003), 354 West Fifty-fourth Street, between Eighth and Ninth Avenues. Occupying roughly half a city block, the low-lying but massive structure, rising the equivalent of seven stories and facing Fifty-fourth Street with a sleek metal facade above a two-story orange and brown banded brick base, replaced a former trolley barn (Anthony Vincent Porter, 1909) later used as an MTA bus

garage. The barn had extended to Ninth Avenue, but the new facility used only a portion of the site, leaving the rest vacant for future development. The entrance was marked by a cantilevered metal-clad canopy above which a collection of glass, stone, and metal planes intersected, the latter enclosing a light court above the lobby.

Farther uptown, at the traditional northern boundary of Hell's Kitchen, C. B. J. Snyder's Dutch Colonial–style DeWitt Clinton High School (1906), 899 Tenth Avenue, between Fifty-eighth and Fifty-ninth Streets, home since 1929 to Haaren High School, which occupied the building after its namesake school moved to the Bronx, was vacated in 1978 when Haaren was itself relocated and renamed Park West High School.[54] In 1979 the DeWitt Clinton building was slated for conversion into the Clinton Plaza Production Center, a video, audio, television, and film production complex to include an 800-seat theater, recording studios, and shooting stages.[55] This plan was halted when the developers ran out of money, but in 1985 another scheme was put forth by a reorganized partnership which added offices and a retail complex to the original program and proposed to rename the high school the Metropolis Building.[56] As designed by John M. Storyk Associates, an architect specializing in studio design, the project was to be centered around a three-story, 8,000-square-foot skylit atrium with restaurants, stores, two thirty-foot-high waterfalls, and escalators linking it to the building's upper floors. Construction began in 1985, but near the end of the year, John Jay College of Criminal Justice, then housed in two facilities, one of which was located diagonally across the street from the

school building, entered into negotiations with the Metropolis's developers, reaching an unusual agreement wherein the developers would abandon their plan and instead take on the conversion of the building for John Jay, which would then rent the facility, building equity along the way, and ultimately come to own it and the vacant remainder of the block extending behind it to Eleventh Avenue.[57] Rafael Viñoly was hired to design the fast-track project, completed in twenty-four months and opened in 1988. Viñoly added a two-story glassed-in atrium in the former courtyard and a gridded-glass-walled library occupying the perimeter of the original school. A new sixth floor, meant to "reinterpret the original mansard roof," according to Viñoly, housed administrative offices, while a red brick addition to the west accommodated a new gymnasium, a 650-seat theater, a swimming pool, and a rooftop track and tennis court.[58]

Across Tenth Avenue from the DeWitt Clinton building lay another Clinton institution, Roosevelt Hospital. Founded in 1864, occupying a Gothic-inspired complex designed by Carl Pfeiffer in 1871 on the block bounded by Ninth and Tenth Avenues, Fifty-eighth and Fifty-ninth Streets, Roosevelt was the most prominent health-care facility on the west side of midtown.[59] Nonetheless, like many hospitals, by the mid-1970s, Roosevelt was operating at a significant financial loss and in 1979, in a do-or-die measure, it merged with St. Luke's Hospital, another venerable institution located in a number of relatively nondescript buildings constructed between 1954 and 1968 as additions to what remained of Ernest Flagg's original and remarkable hospital of 1892–96, 113th Street between Amsterdam Avenue and Morningside Drive.[60]

Subway Command Center, 354 West Fifty-fourth Street, between Eighth and Ninth Avenues. Ellerbe Becket, 2003. View to the southeast of entrance. RAMSA

John Jay College of Criminal Justice, west side of Tenth Avenue, between West Fifty-eighth and West Fifty-ninth Streets. Renovation and expansion of DeWitt Clinton High School (C. B. J. Snyder, 1906) by Rafael Viñoly, 1988. Goldberg. ESTO

St. Luke's-Roosevelt Hospital Center, east side of Tenth Avenue, between West Fifty-eighth and West Fifty-ninth Streets. Skidmore, Owings & Merrill, 1990. View to the southeast. Hoyt. ESTO

Roosevelt East, 925 Ninth Avenue, between West Fifty-eighth and West Fifty-ninth Streets. Buck/Cane Architects, 1997. View to the southwest showing Syms Operating Theater (W. Wheeler Smith, 1892) at base. Allison. RCA

In 1986 the new institution, St. Luke's-Roosevelt Hospital Center, hired Skidmore, Owings & Merrill to prepare a master plan for its growth and consolidation. SOM's proposal to situate critical-care, high-technology, and teaching facilities in the midtown location and community-based services in the uptown facility, building two new buildings along the way, was adopted, and in 1990 work was completed on the new 550,000-square-foot, fourteen-story St. Luke's-Roosevelt Hospital Center, Tenth Avenue between Fifty-eighth and Fifty-ninth Streets, providing 563 hospital beds, surgery facilities, ambulatory care services, and a cancer center on the site of Roosevelt Hospital's former boiler house, nursing school, and two residence halls. The building, set back from Tenth Avenue behind a pair of landscaped gardens, was entered beneath three superscaled arches flanked by the ends of two rose-colored brick slabs situated parallel to Fifty-eighth and Fifty-ninth Streets housing patients' rooms. The bases of the slabs featured three-story-high brick piers infilled with curtain walls of clear glass and aqua-colored glass spandrels. Given the generally deplorable level of postwar hospital architecture, the new building was a notable success. At the Morningside Heights location, SOM undertook extensive interior renovations of the existing buildings and integrated a new ten-story rose-colored brick and glass structure east of Amsterdam Avenue between 114th and 115th Streets that was connected to the hospital complex to the south by a two-story glass-enclosed bridge spanning 114th Street.

The expansion was funded in part by the hospital's sale of two midtown properties to the Brodsky Organization, which redeveloped them both with apartment towers.[61] The first site, comprising 32,000 square feet on the west side of Tenth Avenue between Fifty-ninth and Sixtieth Streets, gave rise to the Concerto (1991), 200 West Sixtieth Street, designed by Buck/Cane Architects and Schuman, Lichtenstein, Claman & Efron as a thirty-five-story, 248-unit red brick and gray glass balconied building with 132 additional apartments reserved for hospital housing situated in a twelve-story base along Tenth Avenue.

The second site was a 60,000-square-foot parcel on the west blockfront of Ninth Avenue between Fifty-eighth and Fifty-ninth Streets, the northeast corner of which was home to Roosevelt Hospital's Syms Operating Theater (W. Wheeler Smith, 1892), an architecturally distinguished building and a notable landmark in health care that when completed was considered to be one of the best surgical facilities in the world but was converted to office space in 1941.[62] Its red brick and granite exterior had been left largely intact but inside, except for the foyer, which retained its mosaic floor and ironwork, the space was compromised, with the height of the skylit operating theater halved by a hung ceiling. Beginning in the 1950s, the hospital announced plans to demolish the Syms building, but in 1979 it was still standing and caught the eye of the landmarks commission, which designated it in 1989.

Brodsky's plans for the site called for a pair of apartment towers, one located in the midblock adjacent to the St. Luke's-Roosevelt Hospital Center, to the west, and the other situated along Ninth Avenue abutting the south side of the operating theater. Designed by Buck/Cane Architects (with Schuman, Lichtenstein, Claman & Efron), Roosevelt East (1997), also known as One Columbus Place, contained 729 rental apartments, 65,000 square feet of second- and third-floor office space, 24,000 square feet of ground-floor retail space, 294 parking spaces, and a 7,500-square-foot health club in two forty-six-story towers rising from a three-story site-filling base. Clad in dark red brick on the lower stories and a combination of dark and light red brick above, the buildings, which featured corner windows on the upper floors, were adroitly massed, with horizontal and vertical setbacks giving them a deceptively slender appearance. The base employed brick and cast-stone detailing to complement the Syms Operating Theater, which now provided 8,000 square feet of office space and retained its conical skylight, though little else remained of its original interior.

Though the western reaches of Clinton remained gritty into the twenty-first century, some of the area's industrial buildings succumbed to the pressures of midtown's office district. Der Scutt's 1995 headquarters for International Flavors and Fragrances (IFF) was a renovation of two adjacent ten-story former automobile buildings between Tenth and Eleventh Avenues: 521 West Fifty-seventh Street (1916), a 420,000-square-foot, concrete frame and red brick sales and service center designed for the automobile manufacturer Willys-Overland, and 533 West Fifty-seventh Street (1927), a

International Flavors and Fragrances, north side of West Fifty-seventh Street, between Tenth and Eleventh Avenues. Der Scutt, 1995. View to the northeast. Wright. DSA

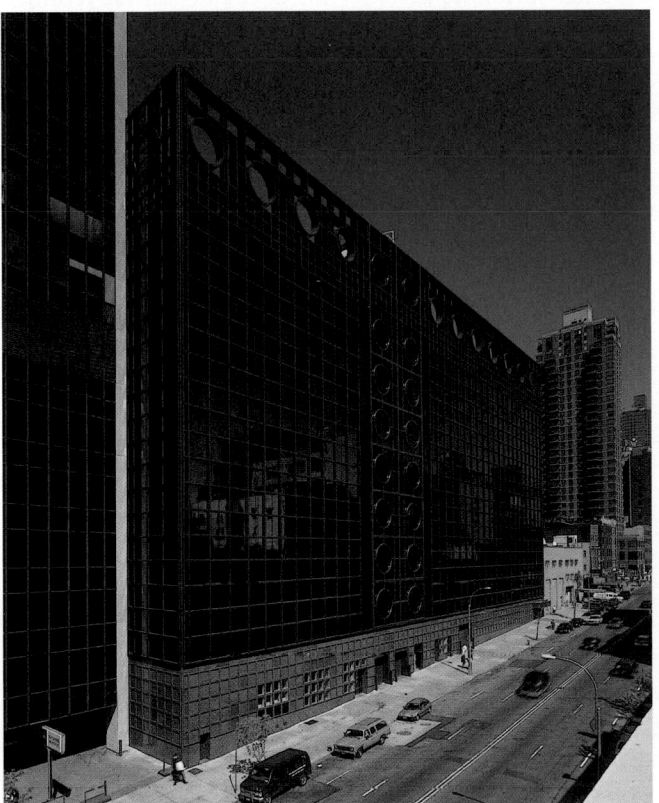

130,000-square-foot concrete and buff brick building designed by Frank S. Parker, an associate of Albert Kahn.[63] Scutt, charged with creating a cohesive look for the two structures, which between them had twenty different variations of window openings and floor heights that did not align, designed a new, relentlessly gridded curtain wall of bronze glass and bronze-colored aluminum above a granite base. Designed around a "theme of circles and squares," as Scutt described it, the curtain wall extended above the top floor to form a parapet-like trellis that shielded views of rooftop machine rooms, bulkheads, and mechanical equipment.[64] Inside, only the lobby and top three floors, comprising 100,000 square feet, were renovated for IFF. The lower floors were leased to outside tenants, the first three occupied by CBS, whose broadcast studios were across the street. IFF's offices, finished in marble, wood paneling, and fabric wall coverings in a palette of beige, brown, and gray, were brightened by multistory atriums lit by skylights cut into the roof. The company's thirteen perfumers—considered to be the most valuable employees—were situated in perimeter offices on the eighth floor surrounding a 5,200-square-foot laboratory, where a special air-handling system provided clean air at a velocity three times faster than was customary in normal office buildings.

TERMINAL CITY

By the mid-1970s, Terminal City, the blocks around Grand Central Terminal, as well as Reed & Stem and Warren & Wetmore's Beaux-Arts masterwork of 1903–13, were in a state of quasi decrepitude. The area's rejuvenation began in 1976 with Donald Trump's redevelopment of the 2,000-room Commodore Hotel (Warren & Wetmore, 1919), just east of the railroad terminal at 125 East Forty-second Street, as the Grand Hyatt.[1] The old hotel, part of the holdings of the bankrupt Penn Central Company, then in the course of liquidating some of its assets, was unlikely to remain open unless drastic action was taken. Trump's project would not only result in an increase of jobs—the new hotel promised to employ 1,500 people—but a visible shot in the arm for the city's tourist industry. The editors of the *New York Times* praised the Commodore deal, the first venture under a tax-abatement plan that the city crafted to stimulate much-needed real estate investment. The *Times*'s editors were especially impressed with the provision that Trump would contribute "substantially" to cleaning and restoring Grand Central Terminal: "This fusion of landmark upgrading and property revitalization can be a potent tool for urban improvement in a broad and lasting sense."[2]

Although other real estate developers and hotel operators questioned the generosity of the deal, Trump prevailed, and on May 20, 1976, the Board of Estimate approved the complex plan, awarding the developer an annual $4 million tax abatement, in return for which he would buy the hotel from the railroad for $10 million and then sell the property to the New York State Urban Development Corporation for $1 to take advantage of the state's powers of condemnation. The state would then lease the hotel to Trump for ninety-nine years. A formula for payments to the city in lieu of taxes was also part of the arrangement. In addition, the city would share in the profits on a sliding scale that would increase to 50 percent of any profits over $5.5 million a year.

Grand Hyatt Hotel, northwest corner of East Forty-second Street and Lexington Avenue. Gruzen & Partners and Der Scutt, 1980. View to the northwest. Ross. DSA

The agreement brought Donald Trump, son of veteran outer-borough developer Fred Trump, to the forefront of the Manhattan real estate scene.[3] One real estate expert, choosing to remain anonymous, likened Trump to William Zeckendorf, the previous generation's most visible, imaginative, but often overextended developer: "You might call him 'the William Zeckendorf of Bad Times.'"[4] Financing for the deal was in place in late December 1977, at which time Trump announced that the new 1,407-room hotel, to be run by the Pritzker family's Hyatt chain, would be ready by spring 1980.

Trump retained Gruzen & Partners with Der Scutt as consulting architect, and the interior designers Dale Keller & Associates and GKR Design Consultants-Barbara Greene, to reconstruct the entire hotel. Rather than replacing the stone-trimmed brick walls of the exterior, the architects sheathed the walls with a skin of bronze-colored glass set in a regular grid of dark anodized aluminum. They stripped the lobby of its classical details, expanding it vertically to the equivalent of four stories and organizing its dramatically reconfigured marble-lined space around a cascade of water. A new glass-enclosed restaurant was cantilevered over the Forty-second Street sidewalk, doing double duty as a marquee. Additionally, the 16,000-square-foot ballroom was expanded to 22,000 square feet, although many of its elaborate original details were kept. Conceived in an era of "commercial travelers," the

tiny, cubiclelike spaces of what had been a standard business hotel were combined to create large rooms with luxurious bathrooms. In his book *The Art of the Deal*, published in 1987, seven years after the Grand Hyatt's opening, Trump made his redevelopment strategy clear: "The key thing. . . was to create something that looked absolutely brand-new. I was convinced that half the reason the Commodore was dying was because it looked so gloomy and dark and dingy. . . . I wanted a sleek contemporary look, something with sparkle and excitement that would make people stop and take notice."[5]

Initially, Paul Goldberger was not taken with the design. While he did not advocate the preservation of Warren & Wetmore's 1919 facade, he objected to dropping a glass box into the middle of one of the city's most memorable groupings of masonry buildings, including Grand Central Terminal, the Chrysler (William Van Alen, 1930) and Chanin (Sloan & Robertson, 1929) skyscrapers, as well as the Bowery Savings Bank (York & Sawyer, 1923). Still, "on balance," Goldberger observed, "something . . . good is about to happen on East 42nd Street, which has been in desperate need of a new boy on the block for a long time now," a claim made without taking into consideration the strikingly different stainless-steel-clad Socony-Mobil Building (Harrison & Abramovitz in association with John B. Peterkin), diagonally opposite the hotel, which was, admittedly, twenty-two years old.[6]

As the hotel neared completion in late 1980, Goldberger greeted the Grand Hyatt with enthusiasm tempered by sarcasm: "The mirrored glass is as sleek a facade as any building in New York has; it brings to 42nd Street something of the air of those shiny, jazzy glass boxes that line the freeways of Houston and Dallas." Nonetheless, he admired the skin's detailing and the decision to replace the bronze-colored glass originally proposed with a more silvery-toned surface. But he deplored the fun-house reflection of Grand Central Terminal in the building's west facade, which, he believed, reduced it to "something of a huge sculpture rather than a real building." Inside, the hotel's grand lobby exhibited, according to Goldberger, "flashiness directed toward a more understandable end. This is the most spectacular large convention hotel New York has seen in more than a generation—a building that thrusts aside the banality and triviality of the design of structures like the New York Hilton [William B. Tabler, 1963] and the Sheraton Centre [originally the Americana Hotel, Morris Lapidus, Kornblath, Harle & Liebman, 1962] in favor of a kind of glittery cosmopolitan elegance New York has not seen in a big new hotel building since the Waldorf-Astoria [Schultze & Weaver, 1931]." While the developer and his architects were anxious to describe the lobby as an "atrium . . . on its side," reflecting the cachet ascribed to atria since the success of John Portman's Regency Hyatt in Atlanta, completed in 1967, in fact the expansive 275-foot-long, two-level room, with its extensive Paradiso Italian marble paving and fountain, bronze-sheathed columns, brass hardware, and Peter Lobello's 77-foot-long brass-rod sculpture suspended over the fountain, was a refreshing departure from that cliché, as was the 160-foot-long Sun Garden café, the greenhouse-like restaurant cantilevered over the sidewalk.[7]

Ada Louise Huxtable somewhat surprisingly concluded that the hotel's "showy" mix of materials "works," from Der Scutt's "much better than anticipated" gray mirror glass

ABOVE Grand Hyatt Hotel, northwest corner of East Forty-second Street and Lexington Avenue. Gruzen & Partners and Der Scutt, 1980. Section perspective. DSA

LEFT Grand Hyatt Hotel, northwest corner of East Forty-second Street and Lexington Avenue. Gruzen & Partners and Der Scutt, 1980. Sun Garden café. Ross. DSA

BELOW Grand Hyatt Hotel, northwest corner of East Forty-second Street and Lexington Avenue. Gruzen & Partners and Der Scutt, 1980. Lobby. Ross. DSA

Bank of America Plaza, 335 Madison Avenue, between East Forty-third and East Forty-fourth Streets. Environetics, 1984. View to the northeast. McGrath. NMcG

facade to the "highly polished bronze, stainless steel and mirror" of the interior. But she was most impressed with the handling of the Grand Hyatt's public spaces, especially considering the difficult job of "adapting [Hyatt's] trademark lobby atrium to the restriction of [the Commodore's] existing steel frame. This has been done with ingenuity and elegance, and the result is . . . a vast improvement over the spiritless interior court that has become an overreaching cliché." Huxtable made special mention of the ballroom, which, despite earlier commitments to sensitive restoration, was substantially reconfigured. She declared it "the best 'modern' ballroom in the city, thanks to the high ceilings of the existing structure that have been kept, and 'chandeliers' of crystals architecturally massed in large brilliant rectangles. . . . None of this is standard Hyatt, or any other standard hotel design. It is urbane and elegant New York."[8]

Another, even more distinguished Terminal City hotel, the Biltmore (Warren & Wetmore, 1913), directly across from Grand Central Terminal and occupying the entire block bounded by Madison and Vanderbilt Avenues, Forty-third and Forty-fourth Streets, was treated even more brutally when it was stripped to its structural frame and rebuilt as the Bank of America Plaza (Environetics, 1984).[9] The Biltmore was most famous for the clock located in its grand public lounge, the Palm Court. The clock was Manhattan's most popular meeting place, so ingrained in the public imagination that the phrase "meet me under the clock" needed no further explanation. Another well-known Biltmore fixture, the Men's Bar, was all but doomed after a successful suit undertaken by feminists in 1970 forced the establish-

ment to open itself to the opposite sex and, two years later, to change its name to the Biltmore Bar. When the Biltmore Bar closed at the end of June 1977, its heyday that stretched from F. Scott Fitzgerald's 1920s to the 1950s of Sloan Wilson's *Man in the Grey Flannel Suit* was history.[10] The bar was replaced by a restaurant, Café Fanny (Daroff Design, 1978), operated by George Lang, that attempted to recreate an old Viennese coffeehouse and restaurant but ultimately proved unsuccessful, closing in April 1979.[11]

In July 1981, the San Francisco–based Bank of America announced its intention to lease the Biltmore Hotel, strip it to its steel skeleton, and rebuild it as a granite-clad office building of one million square feet where it would consolidate its scattered midtown offices. The hotel's owners, Seymour and Paul Milstein, had already planned to reskin the building with a reflective glass facade reportedly similar to that of the Grand Hyatt, but with the entrance of Bank of America, the design was reconsidered. Though the Landmarks Preservation Commission was said to have been considering for designation several of the Biltmore's interior spaces, on Friday night, August 14, 1981, unannounced and highly unexpected by guests, employees, and the commission, the owners of the Biltmore closed its doors and began demolition within. Permanent residents were given thirty days to vacate.

By the end of the following day, preservationists led by the New York Landmarks Conservancy and the Municipal Art Society had won a temporary restraining order banning the hotel from continuing demolition, but not before the entrances to the Palm Court were boarded up and mirrored French doors, decorated balustrades, and elaborate sconces and fixtures sat piled up on Vanderbilt Avenue, ready to be hauled off for eventual auction.

According to Milstein representatives, work commenced as abruptly as it did because financial arrangements were completed the previous day and stipulations in the lease with Bank of America called for tight deadlines, leaving no time to waste. Despite the restraining order, work—perceived by preservationists to be demolition but described as safety measures by the owner's lawyers—continued through Sunday, August 16, when a second stay was issued halting demolition until Monday morning, at which point a hearing was to be held. When landmarks commissioners toured the building on Tuesday, August 18, hope was lost for its preservation. The three main salons—the Palm Court, the Bowman Room, and the Madison Room—were destroyed. The only intact public space was a nineteenth-floor ballroom. A landmarks hearing was scheduled for September 9, 1981, to consider the designation of the ballroom, the lobby stairway, and the building's exterior. In the meantime, Acting State Supreme Court Justice Stanley S. Ostrau declined to issue further injunctions against demolition.

As demolition proceeded, the fate of the ballroom remained uncertain, though the Milsteins promised to notify preservationists before demolition reached that level. When the September 9 landmarks hearing arrived, an unusual private agreement between the Milsteins and the Landmarks Conservancy was disclosed wherein the Palm Court would be restored to a "reasonable approximation" of its original condition and the East Forty-third Street entrance and marble-clad lobby would be retained as long as the Landmarks Preservation Commission promised not to designate the building's exterior, the nineteenth-floor ballroom, or the lobby as landmarks, a

move that would have derailed redevelopment plans.[12] The plan was endorsed by the Municipal Art Society. On September 16, the Landmarks Preservation Commission paradoxically showed its support for preserving the building by voting not to designate the Biltmore Hotel.

As part of the agreement, Hardy Holzman Pfeiffer was brought on as a consultant, chosen by the Landmarks Conservancy to work with Environetics on the restoration. In August 1982, however, the arrangement collapsed when HHP pulled out of the project after learning how little of the Palm Court remained. According to Norman Pfeiffer, though the initial demolition a year earlier had left enough original material to allow for an interpretive restoration, by July 1982 "we discovered that further demolition had taken place. That is when we drew the line. There was nothing left to give [us] even the beginning of a restoration."[13]

Demolition and construction moved forward, and in September 1983 the building was nearly complete, revealing a bland lobby where the Palm Court was to have been rebuilt. The developers announced that instead of pursuing plans to reconstruct the court, they would donate $500,000 to the Landmarks Conservancy, an unsettling offer that amounted to little more than blood money. As built, the Bank of America Plaza was a listless replacement for the elegant old hostelry. A new elevator core and lobby were built, essentially closing the Biltmore's U-shaped plan and creating at the same time a full-height skylight-capped interior atrium. A special truss system was devised by Murray Shapiro of the Office of James Ruderman to support the new core while leaving untouched a landmarked portion of Grand Central Terminal directly beneath it. The removal of the masonry facade also stripped the building of its wind bracing, requiring perimeter columns and spandrel beams to be encased in reinforced concrete, a clever move that also provided fireproofing and a suitable surface for attaching the new curtain wall, a combination of vertical piers of Cornelian granite and gray vision glass. Paul Goldberger called the result "a bloated, heavy form of glass and polished granite, unrelieved by any of the gracious ornament that made the old Biltmore so beloved a presence."[14] On May 15, 1984, the building officially opened at a ceremony held in its lobby. Awkwardly and anomalistically perched above the proceedings was the original Biltmore clock, described by Goldberger as "stranded on a stark metal beam over the concierge's desk, and looking altogether lost."[15]

Terminal City began to rebound as the economy recovered. The most optimistic sign of its renewal was the announcement on August 1, 1978, that Philip Morris, the tobacco company that had grown into a large, diversified, international corporation, would demolish the Airlines Terminal Building (John B. Peterkin, 1940), 120 Park Avenue, between Forty-first and Forty-second Streets, and build a twenty-six-story headquarters office building designed by Ulrich Franzen & Associates on the site.[16] Philip Morris's plan to purchase three stories of airspace from above Grand Central Terminal, combined with the six additional floors granted in exchange for an enclosed, forty-two-foot-high pedestrian plaza, as well as a $3 million tax abatement payable over ten years granted by the city, made the project feasible.

As designed by Ulrich Franzen, Philip Morris's granite-clad building, housing 1,100 employees, was a rather stiff slab, with banded windows on the north and south facades, but on the east, facing Park Avenue, the bands were overlaid by vertical piers to create a richly textured, plaited effect. At the base of the twenty-six-story building, the pedestrian plaza stretched along Park Avenue, at once constituting the lobby and a public sculpture garden maintained by the Whitney Museum of American Art, which also ran a small branch of the museum located at the building's northwest corner. Above the main entrance at the middle of the Park Avenue side, a medallion designed by the painter Pierce Rice and modeled by sculptor George Kelly was a discreet bit of corporate identification that reinforced the architect's intention to connect his design with Terminal City's classicism.

The medallion was but one example of Franzen's desire to create a building with strong classical recall, relating in height and character to Grand Central Terminal. The detailing of the granite on the lower stories gave the building a heft, weight, and dignity quite unlike that of most new office towers. But Paul Goldberger felt that Philip Morris, which opened in April 1983, was "a disappointing box of granite, with neither the visual liveliness of many of the sleeker towers around town nor the solidity and self-assurance of the kind of classical buildings that this structure seems, at bottom, to want to emulate." Furthermore, Goldberger felt that Franzen's intention to have the building's facades reflect the distinct differences between the character and scale of Park Avenue and of Forty-second Street was "stretching the point beyond reason, for it denies that this building is viewed most often from such vantage points as the corner of Forty-second and Park, opposite Grand Central Terminal, where we see

Bank of America Plaza, 335 Madison Avenue, between East Forty-third and East Forty-fourth Streets. Environetics, 1984. View of lobby showing Biltmore clock above reception desk. McGrath. NMcG

both facades at once. In such a case, the sense we get of the building as a whole can be more important than the expression of the different parts of the city its sections face."[17] Revisiting the design in a later article, Goldberger went even further: the facades not only clashed with each other, but those on Forty-first and Forty-second Streets, were "especially dreary, like industrial buildings given a fast overlay of granite."[18] Design aside, Philip Morris had one notable distinction: it was energy-responsive, with operable windows, ceiling fans, and other features that reduced energy consumption by 75 percent over the average comparable building. As such, it was virtually unique in its time.

One year after Philip Morris announced its intention to build a new headquarters, Peter Kalikow came forward with plans for a speculative office building a block to the southeast at 101 Park Avenue (Attia & Perkins, 1982), east blockfront between Fortieth and Forty-first Streets, replacing several noteworthy buildings including the Architects Building (Ewing & Chappell and LaFarge & Morris, 1912) and the townhouses at 109–111 East Fortieth Street (1906–8), designed and built by Ernest Flagg as his residence and office.[19] Eli Attia's design for 101 Park Avenue called for a 1,030,000-square-foot, fifty-one-story, 620-foot-tall, double-glazed dark gray nonreflective glass-clad essay in diagonal geometry. Attia situated the building at a forty-five-degree angle to the corner of Park Avenue and Fortieth Street,

which he considered to be the 52,831-square-foot site's only significant entry point since the rest of the Park Avenue frontage faced the barrier wall formed by the ramp to Grand Central Terminal and the northern edge of the site was diminished by the downward-sloping topography. The architect began by placing a 20,000-square-foot rectangular plan at an angle on the site, then chamfered the north and south corners to meet the lot lines and, in essence, relocated the excised triangles to the eastern and western corners, creating a dynamic, pinwheeling form that provided each office floor with eight corner offices, two of which would enjoy 315-degree panoramic views. A six-story base filled all of the site except for the granite-paved entrance plaza at the southwest corner and was pulled back from the Fortieth Street sidewalk, where a landscaped multitiered plaza with an undulating granite seating ledge was book-ended by a circular fountain and a circular alcove elevated nine steps above the sidewalk. The monumental set-back entryway was marked by four concrete columns and an eighty-five-foot-high skylight that sloped inward at forty-five degrees. Within, a ninety-foot-high lobby was connected by way of a shopping arcade to a seventy-foot-high lobby accessed from a secondary entrance on Forty-first Street.

Attia had worked for Johnson/Burgee when, as Ada Louise Huxtable put it, that firm was producing "such designs as the stunning, trapezoidal Pennzoil Building in Houston" but

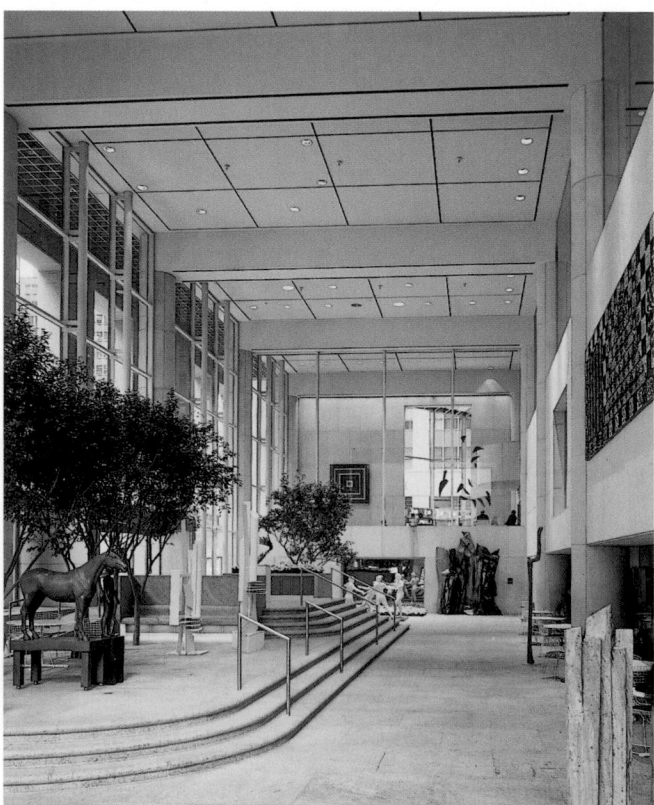

LEFT Philip Morris Building, 120 Park Avenue, between East Forty-first and East Forty-second Streets. Ulrich Franzen & Associates, 1983. View to the southwest. FLL

BELOW Philip Morris Building, 120 Park Avenue, between East Forty-first and East Forty-second Streets. Ulrich Franzen & Associates, 1983. Lobby. McGrath. NMcG

before its principal designer, Philip Johnson, went on "to fancy-dress historicism." Not surprisingly, given Huxtable's increasing sense of betrayal as Modernists like Johnson turned to Postmodernism, the usually uncompromising critic was a bit soft on Attia's design: "Mr. Attia, who has no patience with the allusive and decorative pretensions of 'post-modernism,' has produced architecture at its most elegant, controlled, abstract and precise. Like the rest of the 'new wave,' it breaks the scale, with many of the problems that result, but it also raises the standard of New York building."[20]

Paul Goldberger, who was more sympathetic to Postmodernism than the *New York Times*'s senior critic, writing before 101 Park Avenue's completion, deemed it "an odd mix of angles yielding a final shape that appears almost to have fins. But the architecture, while striking and surely lively, seems not to relate at all to the eclectic, predominantly masonry context of the buildings around it, among them Grand Central Terminal." Though "stylish" and "flashy," the design was, in Goldberger's opinion, "essentially a collection of axioms and eager contortions."[21] After it was completed, the critic remained unswayed, stating that the building "put to rest any naive belief that all architects who have departed from the dullness of the glass box have done so in search of forms that will relate more carefully to their surroundings."[22]

Park Avenue Atrium (1984), 466 Lexington Avenue, between Forty-fifth and Forty-sixth Streets, was in fact not a new building but Edward Durell Stone Associates's reconstruction of Terminal City's sixteen-story Railroad Mail Service Building, which began life as a four-story building designed by Warren & Wetmore in 1914 and was given an additional twelve stories by the same architects in 1922.[23] As redesigned by Peter Capone of the Stone firm, the existing brick and stone facade was stripped off the frame and replaced with sheets of granite cladding alternating with continuous bands of glass. More significantly, the building was given two more floors, for a total of eighteen, and its open-air central court was glazed to create a 290-foot-high, twenty-three-story, stainless-steel-and-glass-wrapped atrium originally intended to be traversed by sky bridges and overlooked by landscaped terraces, but more conventionally realized as an elaborately mirrored and polished metal-clad vertical slot filled with plants and flowers in polished stainless-steel pots. The artist Dan Graham, writing with Robin Hurst, described the atrium as "the most futuristic of the indoor parks in New York."[24] Forty-five thousand square feet of retail space was partially located in a shopping lane parallel to Depew Place, but was mostly grouped around the soaring, central space in which Richard Lippold's 245-foot-high *Winged Gamma* was suspended. Featuring the city's first glass-enclosed elevators, the atrium quickly became a popular noon-hour shopping and dining destination.

In 1984 the United States Postal Service invited nine developers to compete for the lease to the eight-story Grand Central Post Office (Warren & Wetmore, 1910), the oldest surviving building in the Terminal City complex, located on the west side of Lexington Avenue between Forty-fourth and Forty-fifth Streets.[25] According to the terms of the offering, about 120,000 of the one million square feet of space in the redeveloped site would have to remain for post office use. One proposal, prepared for Harry Macklowe by Hugh Hardy of Hardy Holzman Pfeiffer, called for "an extension of the original Whitney Warren design" in the form of a forty-story tower.[26] The contract eventually went to a three-

101 Park Avenue, between East Fortieth and East Forty-first Streets. Attia & Perkins, 1982. View to the northeast. McGrath. NMcG

101 Park Avenue, between East Fortieth and East Forty-first Streets. Attia & Perkins, 1982. Site plan. EAA

450 Lexington Avenue, between East Forty-fourth and East Forty-fifth Streets. Skidmore, Owings & Merrill, 1992. View to the southeast. Zankovic. SOM

member development team consisting of Sterling Equities, the Gerald D. Hines Interests, and the Prudential Insurance Company of America, with David Childs of Skidmore, Owings & Merrill retained to lead the project's design team.[27] Construction was slow to get going, as negotiations to realize an early scheme based on the acquisition of unused air rights from Grand Central Terminal failed to produce the desired results, leading the developers to build an as-of-right tower, 450 Lexington Avenue (1992), rather than the 1.3-million-square-foot one they initially preferred. Childs's design preserved the original post office building, but his tower interpreted Whitney Warren's design in an abstract way, with strongly expressed corners outlining glassier walls that culminated in a quirky crown of rotated squares illuminated at night—a motif borrowed from the window frames in the original building. Entering on Forty-fifth Street through the original granite portals, the visitor traversed a barrel-vaulted hall to reach express elevators that connected with a main lobby on the eighth floor, a "garden room" opening onto a terrace. Construction was very tricky, with the core of the post office building reamed

out but its walls and perimeter structure left in place. Four "megacolumns," two of which were about twenty feet square, were then created inside, their foundations dug by hand to a depth of more than forty feet below the rail yard. The columns acted like table legs to support a platform needed to help brace the tower against horizontal stress. Above, the tower was conventionally framed with column-free spans up to forty-five feet in length.

The area's best-known office building, the Chrysler Building (William Van Alen, 1930), 405 Lexington Avenue, between Forty-second and Forty-third Streets, arguably the city's most beloved and identifiable skyscraper, was in a bad state by the mid-1970s, having been neglected by its owners and deemed a difficult-to-market dinosaur because of its comparatively minute tower floors and aging infrastructure. Although the land on which the building stood had belonged to the Cooper Union for the Advancement of Science and Art since 1902, the building itself belonged to the Chrysler family until they sold it to William Zeckendorf in 1953. Zeckendorf in turn sold it in 1960 to Sol Goldman and Alex DiLorenzo, who, in the words of one observer in the real estate industry, ran the building "like a tenement in the South Bronx," letting leaks, cracked walls, and malfunctioning mechanical systems go unrepaired as well as allowing a reported 1,200 cubic yards of garbage to accumulate in the basement.[28] When in 1975 Goldman and DiLorenzo defaulted on their mortgage, the lender, Massachusetts Mutual Life Insurance Company, foreclosed, deciding not to sell the building but to keep it as an investment. In March 1978, a renovation was planned to upgrade the HVAC systems, restore the lobby's floor, and make improvements to the slow-moving elevators, leading an optimistic Mayor Ed Koch to declare at a news conference, "the steel eagles and the gargoyles of the Chrysler Building are all shouting the renaissance of New York."[29] Word of the renovations piqued the interest of the Landmarks Preservation Commission, which held a public hearing in July 1978. While proclaiming "sensitivity and respect"[30] for the original design, Massachusetts Mutual opposed designation, making the far-fetched arguments that the Chrysler Building was "only one of several buildings of similar design," that there was "no substantial history connecting the Building and the City," that it was "no longer a substantial tourist attraction," and that "the interest in Art Deco design" was "a result of change in fashion rather than because of its permanent distinguished quality."[31] Closer to the truth was the owners' concern that the planned renovations, deemed necessary to reestablish Chrysler as a viable office building, would be slowed by burdens imposed by the commission, delaying the ability to sign new tenants. Ignoring the owners' protests, the exterior and public interior spaces were given landmark status on September 12, 1978.[32]

Contrary to the owners' fears, a major effort undertaken by the Edward S. Gordon Company, a prominent leasing and managing agency, raised the building's tenancy to a healthy level even though the Landmarks Preservation Commission rejected the proposal by Josephine Sokolski, of JCS Design Associates, working with the architect Joseph Pell Lombardi, to revamp the lobby. Sokolski advocated a liberal reworking of Van Alen's design, placing new panels above the elevators bearing a fan motif similar to those on the elevator doors, inserting stepped-back ceilings in the elevator halls, and dotting the lobby with planters. Paul Goldberger stated that the proposed embellishments made it seem as if "Mrs. Sokolski

and the new owners did not have enough faith in the quality of the original design."[33] By August 1979, though only partial improvements had been made, the building was 96 percent full and Massachusetts Mutual sold it to Jack Kent Cooke, a California businessman, who hired the interior designer Kenneth Kleiman, of Descon Interiors, to carry out a more accurate renovation of the lobby and the restoration of the wood-inlaid elevator cabs.

Cooke's greatest moment as owner came at 8:59 P.M. on September 16, 1981, when a lighting scheme designed by William Van Alen but only partially installed at the time of the building's construction was completed.[34] The tower had been floodlit until the late 1970s, but the new lighting program added 580 hand-blown flourescent tubes framing the 120 triangular windows of the chrome-nickel steel spire, creating a "more eccentric" effect, as Goldberger put it, than its solely floodlit peers, exaggerating "the particular architectural features of this building by outlining them. It thus makes Chrysler's exuberant, joyful crown not merely visible at night, but a new object altogether at night from what it is during the day . . . [giving] us the sense that a jolt of electricity is passing through the skyline."[35] Cooke also financed another wave of renovations (Hoffman Architects) in 1995–96, cleaning the exterior and its spire and further improving the building's infrastructure.[36]

After Cooke's death in April 1996, his estate defaulted on the mortgage, leading the lender, the Fuji Bank Ltd., to foreclose and announce the building's sale, prompting eager responses from a wave of prospective buyers.[37] The property comprised not only the Chrysler Building but also the entire block bounded by Forty-second and Forty-third Streets, Lexington and Third Avenues, home to the Kent Building (originally Chrysler Building East) (Reinhard, Hofmeister & Walquist, 1952), 666 Third Avenue, as well as five smaller midblock structures.[38] In November 1997, Fuji sold the property to a joint venture of Tishman Speyer and the Travelers Group, which the following year announced an ambitious plan to transform the entire block into the Chrysler Center, an office and retail complex.[39]

Beyer Blinder Belle was hired to restore the Chrysler Building once and for all, while Philip Johnson Alan Ritchie Architects, working with Adamson Associates, was charged with expanding and recladding the Kent Building and replacing the midblock structures with a new, eye-catching retail building. By far the happiest part of the Chrysler Building's renovation was the rediscovery and restoration, performed by EverGreene Painting Studios, of William Trumbull's *Energy, Result, Workmanship, Transportation*, a 100-by-76-foot mural on the lobby ceiling that had been covered with a dark polyurethane coating and cut into for the installation of recessed spotlights during Josephine Sokolski's 1978–79 renovation.

Philip Johnson's redesign of the bland white-brick-clad Kent Building (renamed the East Building), which Lewis Mumford felt had "the sophistication of a six-year-old's drawing of a skyscraper," took advantage of the unused air rights from the midblock properties to add 150,000 square feet to the west, turning what had been a side-core to a central-core building.[40] To make the new and old appear as one, Johnson covered the austere, if not dull, buff brick facade, featuring small punched windows, with a glittering, dark blue-gray glass curtain wall installed four inches out from the existing facade. The new cladding eschewed any reference to the

Chrysler Building (William Van Alen, 1930), 405 Lexington Avenue, between East Forty-second and East Forty-third Streets. View to the northwest showing lighting originally designed by Van Alen but not installed until 1981. TS

Trylons, north side of East Forty-second Street, between Third and Lexington Avenues. Philip Johnson Alan Ritchie Architects, 2001. View to the north. Payne. RP

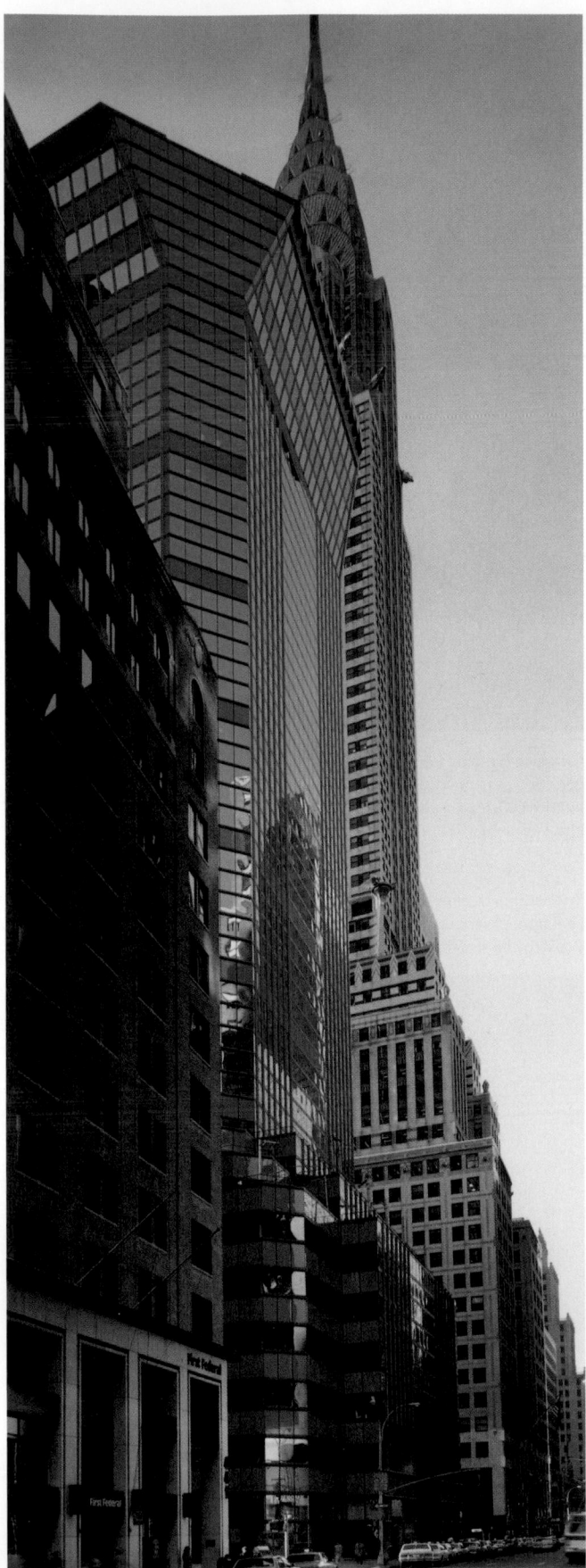

425 Lexington Avenue, between East Forty-third and East Forty-fourth Streets. Helmut Jahn, 1988. View to the southeast. MJ

Chrysler Building, about which the mercurial Johnson explained, "I don't even *like* the architecture of it, but it's become sacred now. It's the most loved building in New York."[41] But tribute to the Chrysler Building's crown was paid in the design of a cluster of three clumsily detailed, awkwardly massed, glassy trylons, fifty-seven-, sixty-eight-, and seventy-three-feet-tall, located at ground level between the two buildings. The trylons, each angled at a different direction and covered in panes of semi-reflective gray glass with stripes of finlike mullions that led David Dunlap to describe the structures as "pinstriped crystal shards," were flanked by two three-story boxlike gray-granite-clad retail structures. The trylons gave the project an identifiable street presence, but they failed to achieve the monumentality to which they aspired. And the sculptural forms, engineered by Severud Associates and requiring the support of massive ten-inch steel tubing, seemed heavy-handed, lacking the grace or delicacy in detail of other, similar buildings, such as I. M. Pei's pyramidal additions to the Louvre (1989).[42]

Helmut Jahn's 425 Lexington Avenue (1988), a thirty-story building occupying the east blockfront between Forty-third and Forty-fourth Streets, was also an attempt to address the strong forms of the Chrysler Building, its immediate neighbor.[43] Jahn's design was an abstracted version of what the architect called "architectural history's most ideal tower-and-base configuration"—that is, Adolf Loos's entry into the Chicago Tribune competition of 1922.[44] A delay in the project caused by a city-imposed moratorium on the demolition of single-room-occupancy facilities left the site nearly vacant for a year and a half in 1985–86. It also revealed the mass of the Chrysler Building more fully than ever before, creating a diagonal vista of the soaring skyscraper when seen from the north that would indelibly imprint itself in the public's mind as it watched with increasing resentment the ultimate construction of Jahn's stubby, truncated, awkwardly proportioned, decisively chamfered tower of glass, dark green granite, marble and buff granite, with its flaring cornicelike top. Ellen Posner dismissed the 565,000-square-foot 425 Lexington Avenue as "anti-urban and even scary."[45] The editors of the *AIA Guide* decried the building as "an ugly dwarf next to the venerable reality of the adjacent Chrysler Building," with an entranceway that "suggests a stage set from a terrifying 1930s movie, perhaps the portal to the lair of the Emperor Ming (Flash Gordon's nemesis)."[46]

The largest and most controversial of the new office buildings to go forward in the area had a long and convoluted prehistory, beginning in November 1983 when plans were announced by a Boston-based developer for the transfer of most of the unused air rights from Grand Central Terminal to the site of the Knapp Building (Cross & Cross, 1923), 383 Madison Avenue, which would be demolished and replaced by a 140-story tower that would occupy the full block bounded by Madison and Vanderbilt Avenues and Forty-sixth and Forty-seventh Streets.[47] The building was initially to be designed by Skidmore, Owings, & Merrill, but the firm of Kohn Pedersen Fox was ultimately chosen to develop plans for the structure, the height of which, as the design developed over the next six years before it was abandoned, was cut in half to seventy-two stories, yielding 1,556,000 gross square feet organized in a cruciform mass that responded to the hitherto untested Tier One provisions of the city's new midtown zoning law and to the wind-generated lateral loads that would

Proposed 383 Madison Avenue, between East Forty-sixth and East Forty-seventh Streets. Kohn Pedersen Fox, 1984. Model, view to the southeast. KPF

Proposed 383 Madison Avenue, between East Forty-sixth and East Forty-seventh Streets. Kohn Pedersen Fox, 1987. Model, view to the east. KPF

383 Madison Avenue, between East Forty-sixth and East Forty-seventh Streets. Skidmore, Owings & Merrill, 2002. View to the southeast. Goldberg. ESTO

play against its slender shape. Kohn Pedersen Fox worked with the structural engineer William LeMessurier, who had to contend with a number of unusual constraints, including the setback requirements imposed by zoning, the requirement for clear-span trading floors at the base, and the need to straddle submerged railroad tracks at the foundation level. LeMessurier's design proposed the use of reinforced concrete to accommodate the trading floors and midlevel office floors, which would be tied together at the top by a "shoulder" truss that, in turn, would carry twenty additional floors. In an effort to fit in with the remaining masonry-clad buildings of the Terminal City area, the lower floors were to be curtained in gray granite, but above, a more cagelike composition of metal and glass was to rise to an open crown.

The proposal involved complicated landmarks issues that centered around a concept called "the chain of ownership," which permits unused air rights to be transferred to nearby but not adjacent properties provided that they can move along a series of properties all controlled by the seller. Opponents to the transfer argued that there was no such chain of ownership because the Penn Central Railroad, owner of Grand Central Terminal, had sold the Biltmore and Roosevelt hotels, breaking the chain. But proponents of the transfer argued that since the railroad continued to own all

the underground property in the area (which it used for operations), the chain was not broken because, in effect, it was the land and not the buildings on it that mattered. This in turn led to concerns that the transfer could take place anywhere along the railroad's right of way—a remote likelihood.

In 1987 a new scheme, labeled Scheme III—no Scheme II was published—was proposed, calling for a forty-eight-story tower, but with much larger floor plates, though the mass still tapered toward a skyline feature, in this case consisting of corner spires to be lighted at night so as to suggest the tops of earlier Manhattan skyscrapers. Despite the development of this alternative scheme, the developers continued to press for a ruling on their seventy-two-story proposal, opposed by the City Planning Commission, which argued that three successive commission counsels had concluded that there was no basis for the transfer of development rights by way of underground tax lots.

On August 23, 1989, the City Planning Commission unanimously rejected the air-rights transfer request, insisting that development rights could only be transferred between adjacent buildings or between buildings across from one another. The developers countered with a suit against the city as the City Planning Commission came forward, in November 1989, with a new plan that would extend the allowable transfer area to cover all sites linked to the terminal by existing or potential underground pedestrian passageways. The transfer plan, though not adopted in that form, eventually led to the creation of the Grand Central zoning subdistrict in 1992, which took a new look at the bulk and density of the district surrounding the terminal, establishing mechanisms that would allow its air rights to be transferred within a greater geographic area.

In August 1991, a state judge upheld the City Planning Commissioners' rejection of the air-rights transfer. Meanwhile, a deal was made in 1994 to sell the property to the British developer Howard Ronson, who announced plans for a twenty-four-story, 800,000-square-foot building on the site, with huge, virtually column-free floors ideally proportioned to accommodate the trading rooms and computer bullpens demanded by the financial services industry. But in 1996, the influential brokerage firm Bear Stearns bought the site from Ronson in a deal enhanced by significant tax incentives requiring the company to stay in the city for fifty more years.[48]

David Childs of Skidmore, Owings & Merrill was put in charge of the building, which used 275,000 square feet of air rights from Grand Central made possible by the creation of the Grand Central subdistrict, of which Bear Stearns was the first to take advantage. The plan included an underground pedestrian connection to Grand Central Terminal as well as a public passageway through the lobby. It was not the building's floor area but its bulk that proved controversial when early designs revealed that, to satisfy the extensive requirements for mechanical systems, the building would be 756 feet tall, but only forty-five stories. Taking advantage of a provision of the zoning code that exempts mechanical space from floor area, the building would "bulk up" significantly, with the mechanical systems representing 26 percent of the building's 1.2 million square feet of "gross" floor area. The deal was closed in August 1997 and demolition of the Knapp Building began in May 1998.

The SOM design was not as complex structurally as Kohn Pedersen Fox's previous proposals. Nonetheless, 60 percent of

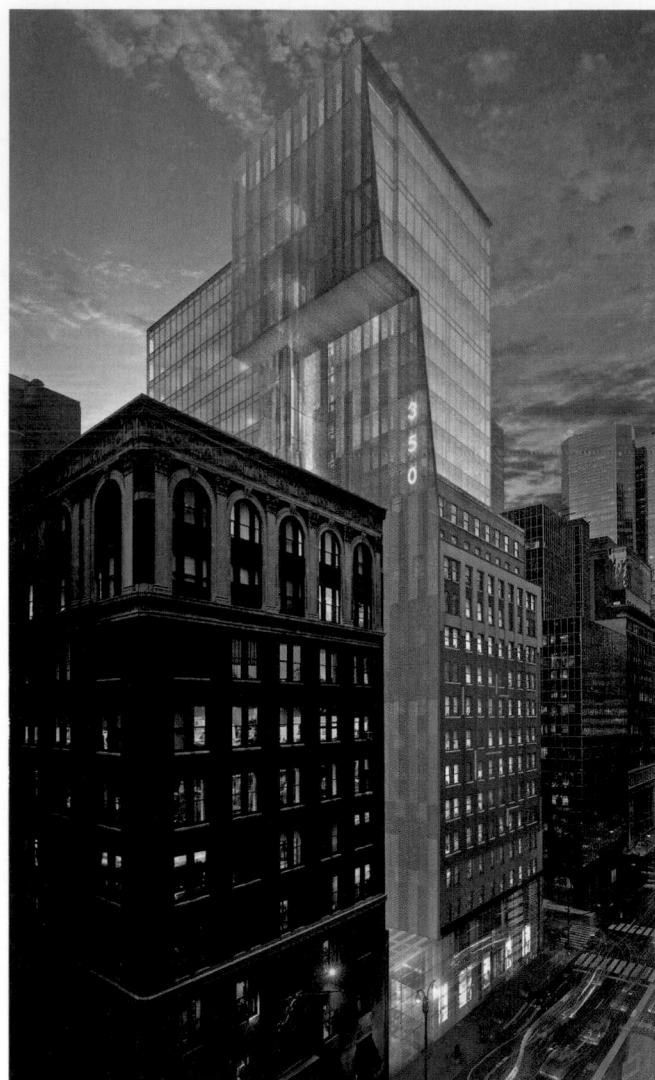

Proposed 350 Madison Avenue, between East Forty-fourth and East Forty-fifth Streets. Skidmore, Owings & Merrill, 1999. Rendering of view to the northwest. dbox. SOM

the site lay over railroad tracks, leading the structural engineers, Cantor Seinuk, to combine the footings that had been put in place to support the Cross & Cross building with new supports. Above grade, the lower half of the new building would have an offset core, dictated by foundation constraints and by the need to locate elevator pits in an area of the site that was free of subsurface railroad tracks. This feature had as its principal benefit a sixty-foot-deep open area on the east side and a thirty-foot open area on the west side, which would prove ideal for trading rooms. In addition to seven trading floors with 2,000 trading positions, the nine-story base of the building, with its 42,000-square-foot floor plates, housed a cafeteria and auditorium, as well as lobby spaces and the pedestrian passageway, which was embellished by James Carpenter with glass columns displaying stock quotes and news. A block-long tunnel under Vanderbilt Avenue led to the newly created north entrance to Grand Central Terminal. Above the base, the tower took the form of an octagon, with two setbacks between the tenth and seventeenth floors, using the rotation of two squares in a plan that maximized the amount of perimeter wall and provided eight corners available for private offices. Mechanical equip-

ment occupied the fourteenth to seventeenth floors, while the eighteenth and nineteenth floors housed the users' technology. The building rose to a seven-story octagonal crown sheathed in patterned "crinkle" glass, which was brightly lit at night.

When Bear Stearns was completed in 2002, Joseph Giovannini, writing in *New York* magazine, found it "lugubrious" and "predictable." Recalling Louis Sullivan's dictum that a tall building should soar, Giovannini acknowledged that "Bear Stearns does indeed telescope upwards: The 1.2 million-square-foot tower steps back and pushes up several times to satisfy setback requirements. Beveling the corners to allow more sun and views, the architects also pry back the granite for an all-glass moment there. But they have still devised a fussily gridded facade that stops the eye. Whatever dynamism inheres in the telescoping volumes and mitered corners is lost to the pattern." Giovannini concluded that the "facade never quite resolves its identity crisis, and the rigid design straitjackets other intimations of a hidden life. Major bracing x-ing through the facade is papered over by the egg-crate pattern. Symmetry here emerges as a dictator that doesn't acknowledge the flows of urban forces and gravitational pulls on the site."[49]

By the late 1990s, with plans under way for 383 Madison Avenue, few large development sites remained in the Terminal City area. Several sleek retrofits were undertaken, including those of 340 Madison Avenue and 360 Madison Avenue (see Resurfacing Modernism, Introduction), and an ambitious expansion was proposed for 350 Madison Avenue, between Forty-fourth and Forty-fifth Streets, where Skidmore, Owings & Merrill was hired in 1999 to design a twenty-six-story glass-clad addition atop Ely Jacques Kahn's twenty-four-story 1924 edifice.[50] Designed by Roger Duffy, the expansion was to form an inverted "L" rising from the old building and cantilevering to the south over a gap between 350 Madison and its southern neighbor. The alley was to be transformed into a 22-foot-wide, 100-foot-long glass-enclosed lobby where light emitted from below a translucent floor would shine through the two-story-high glass ceiling to illuminate a patterned frit glass, corrugated metal, and metal mesh skin unifying the south facade of the new and old sections and the underside of the cantilevered portion, creating, according to Duffy, a "chunk of light."[51] This effect would be particularly vivid at night, when steam was to be piped into the 250-foot-high intervening space. While the lobby was renovated (2000), the remainder of the project fell victim to a deflated economy.

One exceptionally large Terminal City site that remained ripe for development was the 40,000-square-foot parcel on the west blockfront of Madison Avenue between Forty-first and Forty-second Streets stretching west to comprise nearly three-quarters of the block. Nine buildings stood on the site, among them the three-story stainless-steel ornamented Brill Building (Shreve, Lamb & Harmon, 1935), located at 304–308 Madison Avenue; the twenty-two-story 310 Madison Avenue (Buchman & Fox, 1913), southwest corner of Forty-second Street extending to Forty-first Street; the sixteen-story 300 Madison Avenue (Fred F. French Company, 1921), northwest corner of Forty-first Street; townhouses at 15 and 19 East Forty-first Street; and tenements at 18, 24, and 26 East Forty-second Street.[52] Much of the site was assembled in the 1980s by a real estate investor, Edward Strasser, who held onto the properties until the trouble-prone developer Harry Macklowe purchased 310 Madison Avenue in 1997 and subsequently cobbled together several other parcels on the block.[53] In March 1998, Macklowe announced plans to replace the existing buildings with a one-million-square-foot skyscraper designed by Skidmore, Owings & Merrill with a garden in the lobby, floor plates capable of accommodating trading floors, and elevators placed behind glass walls to be visible from the street. By February 1999, the project's size was reduced to 600,000 square feet, but Macklowe still could not secure a major tenant. When he defaulted on his mortgage, the site was sold in June 2000 to a partnership of the Canadian Imperial Bank of Commerce (CIBC) and the Toronto-based Brookfield Properties Corporation, the development company that took over the remnants of Olympia & York.[54]

Brookfield and CIBC reassembled and expanded the site and asked Skidmore, Owings & Merrill to begin anew on plans for a thirty-five-story, 1.1-million-square-foot banded granite and glass-clad office tower, 300 Madison Avenue (2004), that would profit in size from the air rights of three adjacent townhouses, 485 Fifth Avenue (the Rogers Peet building, Townsend, Steinle & Haskell, 1910), and Grand Central Terminal. Two basement levels containing subway connections, a cafeteria, a fitness center, a mailroom, and training centers were illuminated with natural light from a 150-foot-high glazed atrium situated at the building's northeast corner, where a pair of entrances provided access from both Madison Avenue and Forty-second Street. The lobby, elevated eighteen feet above street level, was accessible by escalator, stair, or elevator and sat beneath two 41,000-square-foot trading floors that filled out the 150-foot-high base. Above, a flat-topped monolithic tower clad in granite and glass contained twenty-five 24,000-square-foot office floors. The design was by Roger Duffy, who was succeeding David Childs as SOM's lead design partner.

Extensive demolition work on the site was completed in May 2001 and ground was broken in June. In the aftermath of the World Trade Center collapse, numerous changes were made to the base of the building to increase safety, including the use of shatterproof glass and the replacement of plasterboard walls separating the building's offices and public spaces with steel-reinforced concrete and masonry walls. In addition, fireproof insulation was applied in far thicker coats, an extra set of pipes was installed to provide a backup water supply for firefighting, and heavy steel plates were welded to the original columns to withstand the lateral force of a blast.

Grand Central Terminal

Ironically, the engine behind Terminal City's growth and prosperity, Grand Central Terminal (Reed & Stem and Warren & Wetmore, 1903–13), proved to be the laggard in its recovery.[55] On June 26, 1978, the United States Supreme Court, in a vote of six to three, ruled in favor of the Landmarks Preservation Commission's decision not to permit the construction of a building atop the terminal.[56] Led by Jacqueline Onassis and other individuals and groups, including the Municipal Art Society, the battle to uphold the commission's 1967 decision to landmark the terminal was not only critical for the building's future but also for that of the preservation movement itself.[57] On April 16, 1978, the day before the case went to the Supreme Court, a "Landmark Express" of celebrity passengers led by Mrs. Onassis and Brendan Gill made a whistle-stop rail tour from New York to Washington, where they were met by Senator Daniel Patrick Moynihan and Joan Mondale, wife of

Grand Central Terminal (Reed & Stem and Warren & Wetmore, 1903–13), north side of East Forty-second Street at Park Avenue. View showing lighting scheme by Sylvan Shemitz and Benjamin Thompson & Associates, 1991, with mounted lights on Bank of America Plaza visible in upper left. McGrath. NMcG

the vice president. The trip, though seemingly powerless to influence the decision, was nonetheless a highly effective way to focus media attention on Grand Central and on the preservation movement as a whole.

With the station's exterior secure, Hardy Holzman Pfeiffer Associates was put in charge of its cleaning and restoration, using $2 million in funds reserved for that purpose as part of the agreement for the redevelopment of the Commodore Hotel (see above).[58] Cleaning was completed in 1981, at which time Hardy Holzman Pfeiffer also studied the interior pedestrian network that emanated from the terminal.[59] The interior of the terminal, with its stupendously scaled concourse and waiting room, as well as its ingenious network of ramps and passageways, was not protected by the Landmarks Preservation Commission and continued to be victimized by unchecked commercialism until September 23, 1980, when it, too, was designated.[60] Two years later, in September 1982, the Municipal Art Society sponsored an exhibition at the New-York Historical Society documenting the evolution of the terminal's design and construction as well as its influence on the growth of midtown.[61]

The landmarking of the terminal's interior encouraged the Metropolitan Transportation Authority (MTA), which leased the building from the Penn Central Corporation, to improve the facility, beginning with the establishment in March 1981 of a café on the west terrace overlooking the main waiting room.[62] So successful was this that Hardy Holzman Pfeiffer was hired to prepare a retail development plan, which they submitted in 1985.[63] Other improvements were also undertaken in anticipation of the building's seventy-fifth anniversary in 1988. In 1987 the Incoming Train Room, with its broad stairs leading to Forty-third Street, west of Vanderbilt Avenue, was renovated by Giorgio Cavaglieri, who saw to the cleaning and repair of marble and ornamental plasterwork and the cleaning as well as rewiring of original sconces and chandeliers.[64] In the same year, the terminal's copper roof was also restored, including its six-foot-high cornice. Lee Harris Pomeroy Associates was put in charge of this long overdue critical piece of work, which also included the restoration of skylights that had been blackened during World War II.[65] When the seventy-fifth anniversary arrived, an exhibition of the terminal's history was presented at the Municipal Art Society, and a number of public events and art exhibits focused public attention on Grand Central's tarnished glory. Public response to the fanfare convinced the MTA to hire a firm to prepare a master plan for the terminal that would outline a long-term strategy for its revitalization. In fall 1988, a selection process produced eight finalists; Beyer Blinder Belle won the commission with a team of thirteen other firms, including Harry Weese Associates, architects for the wildly successful renovation of Union Station in Washington D.C.; the lighting designers Fisher, Marantz, Renfro, Stone; the graphic designers Vignelli Associates; and the engineering firm STV/Seeyle Stevenson Value and Knecht.

On April 27, 1990, the MTA's Metro-North division, charged with operating Grand Central, announced a $400 million renewal plan that promised to turn the station, as Metro-North's president put it, into "a destination in its own right."[66] The first glimpse of what lay ahead came with the dismantling of the eighteen-foot-high, sixty-foot-wide Kodak sign that had since 1950 blocked light from entering the windows above the east balcony. In June, with the Kodak sign

gone, Paul Goldberger shared the public's pleasure in seeing "the avalanche of morning light that now cascades in from that direction."[67]

Slowly, as plans developed for the restoration of the terminal's interior and for its redevelopment as a retail center as well as a transportation hub, the Grand Central Partnership, a BID organization, working with the MTA and the city, undertook a restoration of the viaduct that carried Park Avenue from Fortieth to Forty-second Street.[68] Though originally planned, the viaduct was not completed until six years after the terminal opened in 1913. Running the length of the structure were 136-foot-long steel girders made to look like arches but actually cantilevered from the intervening piers. In 1939, to help promote the World's Fair, the space under the viaduct on the south side of Forty-second Street was filled in with a tourist information center, which was now slated to be removed and replaced with a restaurant that opened in 1998. Removed, as well, were the "temporary lights" installed by New York City's Department of Transportation in 1986. They were replaced in 1992 with seven of the original lamp standards, now refurbished, rewired, and equipped with a better, glare-free light. In addition to restoring the viaduct, in 1990 the Grand Central Partnership lit the terminal's exterior with 185 powerful halogen lights mounted on adjoining buildings, an arrangement said to be brighter than any in the city, designed by Sylvan Shemitz, working with Benjamin Thompson & Associates, architects based in Cambridge, Massachusetts.[69] On April 4, 1991, Mayor Dinkins threw the switch turning on the 124,000 watts of light that lit 72 percent of the building's exterior, bathing it with warm light tempered by a shower of cool light to soften the shadows.

Though most New Yorkers welcomed the prospect of a renewed station, some advocacy groups concerned with the plight of the homeless who lived in Grand Central protested the proposed work.[70] The presence through the 1970s and 1980s of the homeless in the waiting room, public spaces, and labyrinthine tunnels was so pervasive that it had come to seem normal. The situation was difficult to mend, with the most desperate measure coming when the city attempted to pass an antiloitering law that would allow those sleeping in the terminal to be arrested. The law was deemed unconstitutional in 1988. By 1990, little had improved, and the issue of the station's hordes of homeless proved a national embarrassment when in February and again in June 1990, the widely watched television news magazine *60 Minutes* broadcast a segment that was, as Carter Wiseman put it, "brutal. There again were the legions of homeless trudging through the main waiting room, and the overworked cops rousting them out of the steam tunnels."[71] A joint state and city program, New York/New York, initiated in 1990 to relocate the homeless while also providing them with mental health, drug treatment, and other services, met with some success. Other citywide programs to help the homeless, together with an improving economy, eventually brightened the situation.

The restoration plan involved extraordinarily complex rehabilitation work, including significant replacement of the

ABOVE Grand Central Terminal (Reed & Stem and Warren & Wetmore, 1903–13), north side of East Forty-second Street at Park Avenue. Renovation by Beyer Blinder Belle, 1998. East–west section. MNRR

LEFT Grand Central Terminal (Reed & Stem and Warren & Wetmore, 1903–13), north side of East Forty-second Street at Park Avenue. Renovation by Beyer Blinder Belle, 1998. North–south section. MNRR

building's fabric and especially its vastly antiquated electrical and mechanical systems. A number of improvements made a dramatic impact on the public, including the removal of intrusive kiosks and run-down shops and their replacement by new commercial venues lining the passageways, as Warren & Wetmore had originally intended. Even more dramatic was the removal of the ticketing offices, built in 1927 above the so-called Oyster Bar ramps, which were thus transformed into bleak single-story passages leading from the main to the lower level between Vanderbilt Hall and the Main Concourse. With the offices gone, sunlight once again illuminated the ramps and revealed the daring spatial engineering of the original plan. Also appreciated was the reproduction of bronze grills that once covered the twenty-eight ticket windows but had been melted down for armaments during World War II. Most thrilling of all was the restoration of the grimy celestial sky ceiling and the construction of a flight of steps at the east end of the Main Concourse to give access to the encircling balcony at that end, creating the sense of balance in the room originally intended but never realized. The new east stair, though very similar to the existing west stair, and built from the same Tennessee pink marble as the original, requiring millions of gallons of water to be pumped from a quarry that had not been used since World War II, was a compromise between those who felt its design should look contemporary—and therefore clearly a later addition to the terminal—and those who wanted an exact replica. In the end, as John Belle put it, what was built was "Warren's original design with a few small changes to the balustrades that in their simple modern details would signal to future visitors that the stair was built eighty-six years after first being designed and using late-twentieth century technology."[72]

A feature of the plan that would vastly improve the terminal's utility but have comparatively little effect on its aesthetics was the decision to construct new entrances to the platforms at the north end, enabling passengers to enter from Park Avenue and Forty-eighth Street, Madison Avenue and Forty-seventh Street, and through two entrances in the Helmsley (New York Central) Building and avoid the Main Concourse. As part of this plan, two platforms were converted to north–south walkways connected by cross passages. This work was completed in 1999.

The 15,000-square-foot waiting room was the first major space to undergo restoration, constituting, according to Belle, "a wonderful laboratory" that held nearly all the different types of material found in the building: Bottocino marble, Tennessee marble, Caen stone, plasterwork and metalwork, and wire glass.[73] It was also a potential showpiece that could serve as a fund-raising tool once restored. By May 1992, the room began to take shape, just as Jules-Alexis Coutan's colossal statuary group atop the Forty-second Street facade was emerging from a good bath and "a little arthroscopic surgery," as Ed Valeri, architect in charge of this part of the restoration, described it.[74] Initial plans to find an operator for a restaurant in the waiting room were dashed when potential restaurateurs expressed concerns about the impact of the cross traffic at the room's midpoint. One aspect of the restoration that did not reflect original conditions was the removal of the grandly proportioned oak benches that had become "attractive nuisances," encouraging idlers and homeless people to congregate. The waiting room was reopened in late 1992 with a series of events, including a reception for the Democratic National Convention and a display of the artist

Red Grooms's raucous versions of Manhattan, which included a walk-in Subway, a fifty-foot-long Wall Street, and fifty-foot-high World Trade towers.

As work proceeded, it became clear that the most astonishing element of the renovation would be the cleaning of the Main Concourse ceiling. The original ceiling mural was conceived by Whitney Warren and Paul Helleu and painted by Charles Basing and J. Monroe Hewlett in 1913. (Ironically, it was intended as a temporary feature, to be replaced within a short time by a skylight.) Half as big as a football field with fifty-nine stars illuminated by tiny electric lights that could be reached from catwalks above, it illustrated constellations such as Pegasus and Aquarius. By the 1940s the mural had become irreparably deteriorated because of leaks in the roof. In 1944 the New York Central Railroad, then the terminal's owners, replaced the ceiling by bolting and gluing an entire new ceiling to it made up of four-by-eight-foot panels onto which a similar but simplified version of the original constellation was painted. When the time came to restore the ceiling, some art historians called for the removal of the panels and the restoration of the original ceiling, but the MTA and Beyer Blinder Belle decided to stick with the 1944 panels, arguing that the original was far too deteriorated to undergo restoration. More to the point, however, the decision not to go back to the 1913 ceiling seemed to revolve around the problems that accrued from the use of asbestos in the 1940s panels, which would create a potential health hazard to the public during the removal process. When restoration of half the ceiling was complete in March 1997, New Yorkers thrilled to its clear color, more green than blue, seen in vivid contrast to the tobacco-juice tone (the residue was 70 percent nicotine) of the yet uncleaned other half. Of the 2,000 stars in the ceiling, only 59 actually glowed, with fiber optic lights replacing the original ten-watt light bulbs. Varying lengths of fiber optic cable affected the brightness, which was calculated to a fairly accurate representation of the actual star as seen from earth.

Progress on the restoration hit a significant snag when on June 29, 1997, the Oyster Bar and Restaurant burst into flames, loosening hundreds of the Guastavino tiles that held its impressive vaulted ceiling in place. Fortunately, the vast, venerable dining hall was returned to glory well in time for the completion of the terminal's restoration. Even before the Main Concourse began to reemerge from the colossal scaffolding that had been erected to enable the ceiling's repair, significant new shops and, especially, restaurants began to occupy surrounding spaces. In May 1998, the Campbell Apartment, a bar, opened in a suite of rooms whose splendors had been virtually forgotten in the decades when they had been encased in the wallboard and fluorescent lighting of the MTA's offices.[75] The 1,300-square-foot suite, at the southwest corner of the terminal, had been empty until 1923, when John W. Campbell, the Brooklyn-born president of the Credit Clearing House, a

FACING PAGE Oyster Bar ramps, Grand Central Terminal (Reed & Stem and Warren & Wetmore, 1903–13), north side of East Forty-second Street at Park Avenue. Renovation by Beyer Blinder Belle, 1998. Aaron. ESTO

FOLLOWING PAGES Main Concourse, Grand Central Terminal (Reed & Stem and Warren & Wetmore, 1903–13), north side of East Forty-second Street at Park Avenue. Renovation by Beyer Blinder Belle, 1998. View to the east. Aaron. ESTO

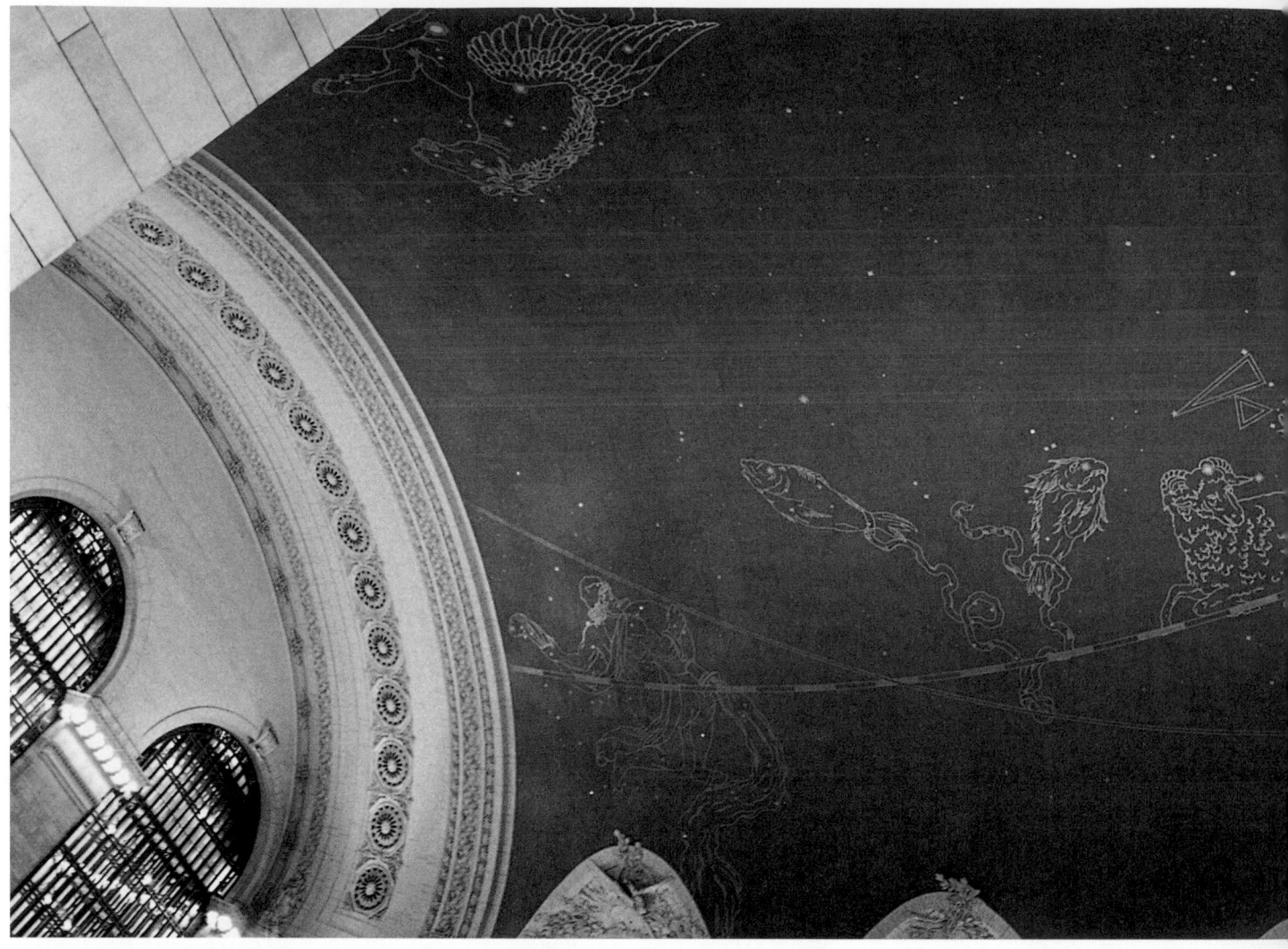

Grand Central Terminal (Reed & Stem and Warren & Wetmore, 1903–13), north side of East Forty-second Street at Park Avenue. Renovation by Beyer Blinder Belle, 1998. Ceiling. Aaron. ESTO

credit-reference firm specializing in garment-related businesses, commissioned Augustus N. Allen, an architect specializing in townhouse design who had also designed the private office of Charles W. Barron at the *Wall Street Journal*, to create a stylistically eclectic fifty-eight-foot-long, twenty-five-foot-wide, twenty-foot-high baronial hall to be used as a private office, with adjacent support spaces that included a kitchen. Campbell kept the office until the 1950s, years after his company became part of Dun & Bradstreet in 1942. When the Metro-North Commuter Railroad police took over the space, they stored their guns in Campbell's curio cabinet.

July 20, 1998, marked the opening of the terminal's first new restaurant, Michael Jordan's, specializing in steaks.[76] Named for the famous basketball player, who was an investor, the restaurant played against type. Instead of the typical celebrity restaurant that traded on the career of a notable sports or entertainment figure, and sacrificed everything else, Michael Jordan's featured excellent food in a spectacular setting, the northwest balcony, which was complemented by David Rockwell's installation, leading Ruth Reichl, the food critic of the *New York Times*, to herald it as "New York's best-looking steakhouse."[77] Eschewing anything to do with Jordan's career in basketball, Rockwell enhanced the splendid setting with what

New York's restaurant critic Hal Rubinstein described as "a quietly harmonious enclave of burgundy, gold, and wood, with a few swooping curves, concentrically etched glass discs, and unobtrusively framed photos that offer the faintest whistle of a train motif."[78] On the south side of the west balcony, Cipriano Dolci, a restaurant operated by Arrigo "Harry" Cipriani and designed by Arturo di Modica, opened in March 2002.[79]

In January 2000, the newly accessible east balcony of the Main Concourse became home to Métrazur, a restaurant named for a train that ran along the French Riviera.[80] Designed by Tsao & McKown Architects, the 8,000-square-foot establishment greeted diners with an illuminated onyx slab facing the top of the stairs, behind which bathrooms were tucked into one of three niches in the balcony's east wall. In the northern half of the balcony an informal bar, lounge, and café seated 100 while the southern half contained a more traditional eighty-eight-seat restaurant with an open kitchen occupying that side's niche. Just off the south end a passageway led to a private thirty-person dining room with a wall of windows overlooking the so-called Oyster Bar ramps. Unlike Michael Jordan's, which provided a secluded environment distinct from the terminal, Tsao & McKown, asked by the MTA to keep partitions low enough

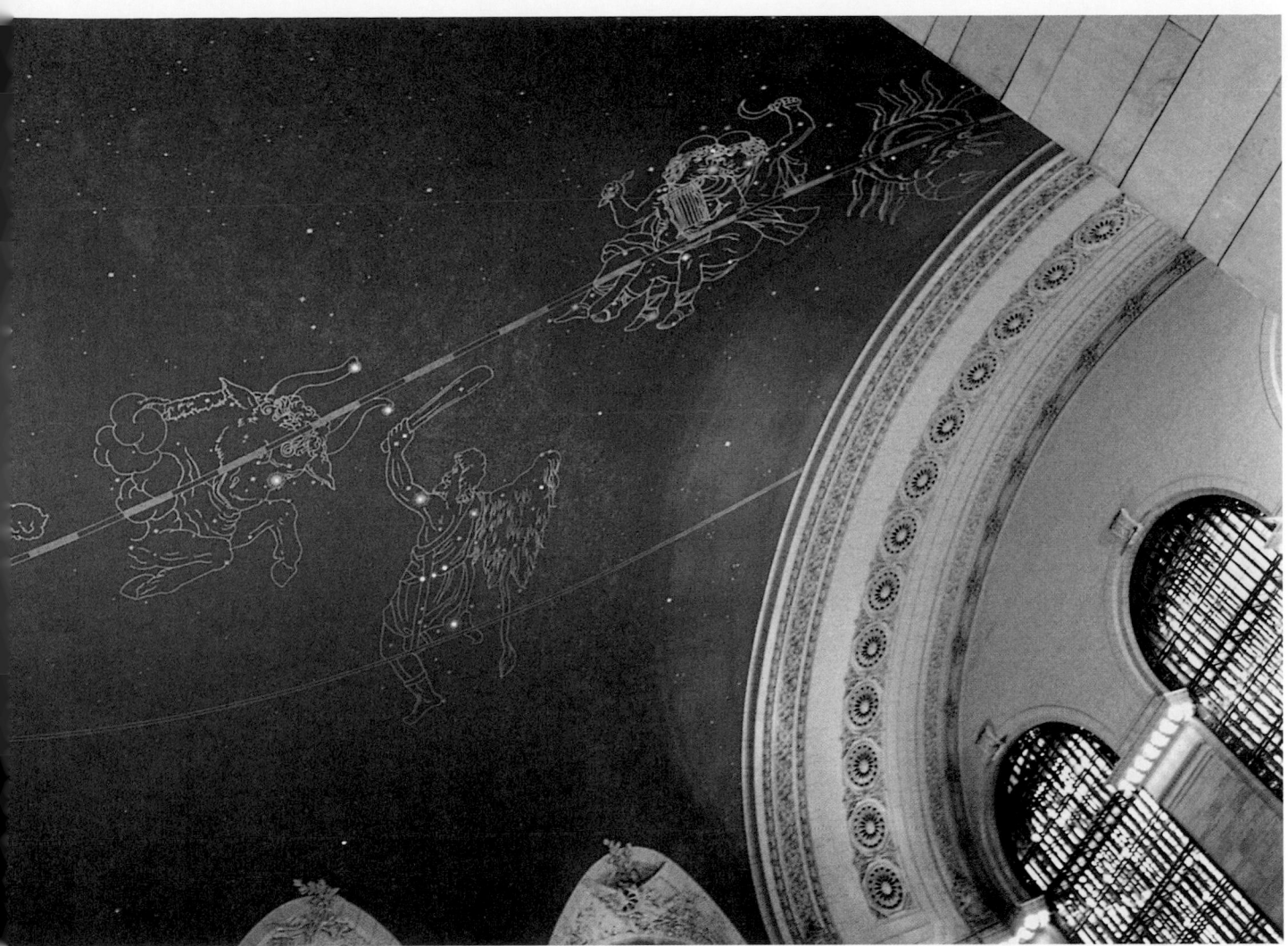

so that they would not be seen from the middle of the concourse, designed subtle mahogany chairs and banquettes and bronze-edged tables, ensuring that Métrazur would be open to the action below, leading William Grimes to describe it as a "café with the bustle and hum of a public square."[81]

On October 1, 1998, ten years after the project was first announced, a rejuvenated Grand Central Terminal was formally rededicated. What the public did not see but could appreciate about the $196 million project was its first centralized air-cooling system, its complete electrical upgrade, and many other operational features. What the public did see was an old beauty, gloriously restored and rejuvenated with high-style shops and restaurants to serve the 500,000 people a day who passed through its Main Concourse. The rededication ceremony, honoring ten years' work and the twentieth anniversary of the Supreme Court's decision ensuring the building's preservation, included speeches by Governor George Pataki and John F. Kennedy Jr., who unveiled a plaque honoring the work of his mother in helping to save the building. Also included was a laser-light show, a trapeze performance featuring an artist from the Big Apple Circus who was hauled up 120 feet to the vaulted ceiling where, clothed in a taxicab-yellow body suit, he dangled and flipped

to the amazement of the packed audience below, and the premiere of a new work for wind orchestra and train whistle by the composer Bruce Saylor. The enthusiastic spirit of the dedication proved infectious—a public outpouring of good will filled newspapers and the buzz of optimism was virtually palpable in the terminal, where usually harried travelers joined countless others to pause and look around them at the city's glorious town square. Just off the Main Concourse, in Vanderbilt Hall, an interactive multimedia display was projected onto three spherical kiosks designed by Michael Sorkin.[82] Called "The Triumph of Grand Central," the exhibit allowed commuters to add personal recollections of the station to a time capsule filled with documentary footage. It also presented a survey of the building's construction and the struggle to preserve it.

The terminal's revitalization continued well after the formal rededication. In October 1999, the areas devoted to shops were significantly increased by the opening of the Grand Central Market, where twenty-four vendors of fresh produce and gourmet foods occupied a former service alley east of the station that lay between the Graybar Building and Grand Hyatt passages to Lexington Avenue.[83] A cast-iron eagle with a thirteen-foot wingspan, a feature of the original

ABOVE Dining court, Suburban Concourse, Grand Central Terminal. Rockwell Group, 1999. Warchol. RG

LEFT Grand Central Market, Grand Central Terminal. Beyer Blinder Belle, 1999. View showing *Sirshasana* by Donald Lipski. Aaron. ESTO

BELOW LEFT Michael Jordan's, Grand Central Terminal (Reed & Stem and Warren & Wetmore, 1903–13), north side of East Forty-second Street at Park Avenue. Rockwell Group, 1998. Warchol. RG

Grand Central Terminal (John B. Snook, 1871) that had somehow come to roost in a Bronxville garden, was donated by its owners to enhance the glassy Lexington Avenue entrance to the market, which was the work of Beyer Blinder Belle. Just inside, *Sirshasana*, a sculpture by the artist Donald Lipski, featured more than 5,000 crystals dangled from the branches of a twenty-five-foot diameter tree hung upside-down from the ceiling. After innumerable delays and false starts, more food venues opened in a new dining court located below the Main Concourse in the original Suburban Concourse. Designed by David Rockwell, the dining area consisted of a ring of vendors surrounding two circular seating areas flanked by a pair of semi-enclosed dining rooms shaped to resemble Pullman cars with large photographs taking the place of the cars' windows.[84]

Jeffrey Hart, writing in the *National Review* in November 1998, felt "the renovated Grand Central symbolizes the strong sense of civic rebirth that has been growing during the past few years. . . . Set against the memory of Pennsylvania Station, the renovation . . . reminds us that a dynamic economy can not only destroy in order to make way for the new, but also preserve what is valuable in the past."[85] Although Herbert Muschamp hailed the restoration, he also took the opportunity to indulge his oft-voiced complaint that not a single "landmark quality" building had been constructed in the city since the Supreme Court's decision on Grand Central twenty years earlier, making an interesting observation that the restoration of Grand Central constituted the best piece of "new" architecture to emerge during that period because "landmarks preservation—architectural history—has been asked to do the work of architecture."[86]

MADISON AVENUE

In the two decades following World War II, the midtown stretch of Madison Avenue, while still retaining a measure of its traditional character as an upscale retail address, became a preeminent location for high-rise office buildings. The avenue was home to a fair number of pedestrian examples of office buildings from firms such as Sylvan and Robert Bien and Emery Roth & Sons, though the latter was responsible for at least one high-quality effort, the insistently horizontal, International Style Look Building (1950), 488 Madison Avenue, northwest corner of Fifty-first Street.[1] By the late 1960s, Madison Avenue seemed pretty well built-out as a location for new office buildings, with the real action taking place farther east along Third Avenue. But in the late 1970s, a series of surprising developments took place that for a short time returned the street to the center stage of New York real estate development and architecture. That return can be accurately dated: on June 17, 1977, without official confirmation from the client, the *New York Times* reported that the firm of Philip Johnson and John Burgee had been selected to design a new headquarters for the American Telephone and Telegraph Company on the west side of Madison Avenue between Fifty-

fifth and Fifty-sixth Streets.[2] The announcement coincided with plans for another major building by the nation's other technology giant, the IBM Corporation, to be designed by Edward Larrabee Barnes on a site just north of the planned AT&T Building. The editors of the *New York Times* enthusiastically greeted the pair in January 1978 as a sign that the city might soon be able to shake off its economic doldrums. While conceding that "two buildings do not make an office construction revival," they felt that the proposed work represented a "declaration of corporate commitment to New York City."[3] Three months after the editorial, on March 30, the AT&T design was officially released at a City Hall press conference, with a rendering of the proposal prominently featured on the front page of the next day's *New York Times*.

Johnson and Burgee's controversial design for AT&T, developed in association with Harry Simmons, called for a thirty-seven-story, 684-foot-high, 800,000-square-foot steel-framed tower clad in rough-finished pink Stony Creek granite, a stone that, in the era of Beaux-Arts classicism, was the material of choice, but since then had been absent from large-scale architectural construction. The scheme adopted the classical tripartite division of base, shaft, and capital, with the top in this case generating the most controversy.

AT&T Building, 550 Madison Avenue, between East Fifty-fifth and East Fifty-sixth Streets. Philip Johnson and John Burgee, 1984. Rendering of main entrance arch and details of columns and cladding, 1978. IAUS

Elevation at Base

View B

Plan of Column

Section A-A

Rising thirty feet above the last floor was an immense broken pediment, which caused the building to be immediately and popularly likened to either a Chippendale highboy or an eighteenth-century grandfather clock, a characterization that the architects would later describe as an "unending irritation."[4] Although one former building on the 37,000-square-foot site, William Van Alen's Delman Building (1927), featured an abstract rendition of a broken pediment for its top, Johnson denied that it was an influence.[5]

The base of the AT&T Building was dominated by a 110-foot-high central arch flanked by columns framing an almost 60-foot-high covered loggia, its size and scale only comparable in New York to that of the south loggia of McKim, Mead & White's Municipal Building (1914).[6] The 14,000-square-foot loggia was framed by sixteen-foot-high columns, topped by walls pierced by oeils-de-boeuf openings. Office workers and their guests would take shuttle elevators to the white marble sky lobby raised sixty feet in the air and lit in part by a thirty-foot-diameter oculus in the building's central arch. Parallel to Madison Avenue and set behind the tower was a 100-foot-high, 5,800-square-foot through-block skylit galleria modeled after the one in Milan, but with only a half barrel vault glass roof supported by filigreed metal arches. A three-story, sixty-foot-high annex placed behind the galleria contained shops at ground level with space for a museum on the upper floors. Although AT&T planned to leave its longtime home in 195 Broadway (William Welles Bosworth, 1914–17), the company decided to take uptown its most cherished symbol, Evelyn Beatrice Longman's twenty-two-foot-tall, 20,000-pound statue, the *Spirit of Communications* (1916), popularly known as *Golden Boy*.[7] One of the city's largest heroic sculptures, the gilded bronze winged figure, with one arm stretched skyward grasping bolts of electricity and with coils of cable winding around its torso, would be regilded and placed inside the new building's lobby.

Paul Goldberger, who would write repeatedly about AT&T, initially perceived the building as an intentional "rebuke to the towers of steel and glass that have turned midtown Manhattan into a city of boxes," labeling the design "clearly post-modernism's major monument" and "the most provocative and daring—if disconcerting—skyscraper to be proposed for New York since the Chrysler Building shook up the traditionalists of the 1930's." Although Goldberger felt that "the instinct" behind the design, especially its bold top, deserved to be "respected," and that the confluence of "an architect and . . . a supportive corporate client . . . eager to bring some romance back to the skyline" was to be applauded, he was troubled by the particular device chosen because "its very resemblance to a piece of furniture suggests that a joke is being played with scale that may not be quite so funny when the building . . . is complete." According to Goldberger, the source of Johnson's entrance arch was Leon Battista Alberti's fifteenth-century church of St. Andrea in Mantua, and he went on to suggest that what was happening was "a historical game, but . . . surely more than that. . . . We are . . . now at a

FACING PAGE AT&T Building, 550 Madison Avenue, between East Fifty-fifth and East Fifty-sixth Streets. Philip Johnson and John Burgee, 1984. View to the northeast showing, from left to right, Trump Tower (Der Scutt, 1983), IBM Building (Edward Larrabee Barnes Associates, 1983), AT&T Building, and 535 Madison Avenue (Edward Larrabee Barnes Associates, 1982). Payne. RP

AT&T Building, 550 Madison Avenue, between East Fifty-fifth and East Fifty-sixth Streets. Philip Johnson and John Burgee, 1984. Alternate facade studies, 1978. IAUS

time in which the use of history . . . is the most avant-garde thing to do—as the erection of a 'modern' building of steel and glass would be the most conservative."[8]

Ada Louise Huxtable soon weighed in with her not-very-favorable assessment of Johnson's design, calling it "a monumental demonstration of quixotic esthetic intelligence rather than of art." She dismissed the proposed building's urbanism as "clearly an architectural and corporate statement in search of a Park Avenue site." Still, she acknowledged that "once . . . constructed," the AT&T Building would be "far more impressive than it is on paper because of its immense size. What

seems trivial in concept will become monumental in actuality. . . . The pedestrian will experience only the grandeur of that massive masonry base and arcade, and the large rhythms of the colonnaded ground floor. The pediment will be an identifying symbol for the company and the architect. But the building's impact will not come from the creative power or stylistic integration of its design."[9]

The release of the design elicited many letters from the general public and architects alike, with most of the missives negative and often sarcastic in tone. One layman, Eugene J. Johnson, writing to the *Times*, placed the design "in the con-

text of recent telephone design. . . . The pediment is a telephone cradle; the round hole 'baroquen' in its middle, a place to insert a coin. In short, Philip Johnson has given us a Renaissance revival pay phone, an extraordinary example of the neo-classical notion of *architettura*[*sic*] *parlante*."[10] Typical among architects was Daniel Beekman's letter to *Progressive Architecture* in which he declared the design "verbal architecture. As long as you listen to Johnson's explanation of the design, you imagine you are about to behold a subtle, witty commentary on modern architecture in the form of a building. It is only when you look at the rendering that you are confronted by the reality. There is nothing polemically wrong with the AT&T project. It's just ugly as hell."[11]

Michael Sorkin delivered perhaps the most blistering attack on the design and the kid-glove treatment he believed it received in the *New York Times*: "The deluge of well-orchestrated publicity surrounding AT&T, the nattering insistence that the building represents a bold departure from previous thinking, and the intimation that it embodies a new style understood only by a few prescient apostles of progress has had the effect of deflecting serious attention from the design itself. Not to put too fine a point on it, the building sucks." Sorkin went on to declare the "so-called 'post-modern' styling in which AT&T has been tarted up . . . simply a graceless attempt to disguise what is really just the same old building by cloaking it in this week's drag and by trying to hide behind the reputations of the blameless dead. Cribbing the odd detail from Alberti, Boullée, McKim, Mead and White, or Raymond Hood is all well and good, but ultimately such historicism means little unless it abets some larger aim. Johnson's borrowings are entirely decorative," Sorkin continued, "a thin veneer meant to hide rotten goods . . . yielding . . . no more than a decorated slab, little different than the despised modern buildings it purports to confound. AT&T is the Seagram Building with ears." Not only did Sorkin object to Johnson's design, he also believed the building was ill-suited to its site: "Madison is one of the city's narrower avenues. It is not the kind of street where a building can stand back behind a plaza like Seagram's, nor does it have the width to allow very tall buildings to rest comfortably hard by it. . . . Into this situation," Sorkin concluded, "Johnson has introduced a prodigious building that rises sheer from the street with nary a set-back, placing its entire bulk right on the street, casting the entire block into darkness."[12]

Johnson strongly defended his design, which marked a distinct development of ideas he had first explored at 1001 Fifth Avenue. In a *New York Times* op-ed piece published in December 1978, he wrote about the new stylistic changes in architecture and about the design of the AT&T Building:

> We architects stand at a watershed . . . between what we have all been brought up with as 'modern,' and something new, unchartered, uncertain and absolutely delightful. . . . It seems to me our sensibilities have changed in three basic respects. 'Modern' hated history, we love it. 'Modern' hated symbols, we love them. 'Modern' built the same look in any location; we search out the spirit of the place—the *genius loci*—for inspiration and variation. . . . So in New York when John Burgee and I were faced with designing the American Telephone and Telegraph building, we had to think of the spirit of historic New York. The architecture of New York has two great periods—the 1890's with McKim, Mead and White, and in the 1920's with Raymond Hood. So with those fine examples in front of us, we decided that here in Manhattan, the glass box maybe had had it.[13]

Ada Louise Huxtable remained skeptical. In her year-end review of the architecture of 1978, published just three days after Johnson's op-ed piece, she deemed AT&T "the non-building of the year. . . . It is fascinating to see just how far it is possible to stretch a weak idea; a tiny concept has been turned into a monument by sheer size and scale. Mr. Johnson has put together some currently fashionable features that appeal to his educated eye and mind—a Lutyens oculus here, a pop art pediment there—in what is supposed to be the spirit of the new eclecticism. As noted before, the design fails to achieve that creative life and synthesis that marks a successful eclectic work, or even a successful work of architecture; it has neither genuine quirkiness nor real style. In spite of some passing shock value, this is a dull building—a pedestrian pastiche pulled together by painstaking, polished details."[14]

A week later, on January 8, 1979, just as construction began, the project received even more publicity, and a far wider audience, when Philip Johnson appeared on the cover of *Time* magazine clutching a model of the AT&T Building. In his article about the current state of American architecture, art critic Robert Hughes believed the design would have a significant influence even beyond issues of style: "In the end, the importance of AT&T may not be its status as a single act of building, but rather the permission it will grant other architects to build their own monuments of the hybrid. Johnson did not create the way of thinking that his building reflects. But he helped bring it about, and now he has given it a degree of public validity that cannot help affecting other corporate clients."[15]

AT&T Building, 550 Madison Avenue, between East Fifty-fifth and East Fifty-sixth Streets. Philip Johnson and John Burgee, 1984. View to the northwest showing Central Synagogue (Henry Fernbach, 1872) on left. Payne. RP

AT&T Building, 550 Madison Avenue, between East Fifty-fifth and East Fifty-sixth Streets. Philip Johnson and John Burgee, 1984. Detail of entrance. Payne. RP

AT&T Building, 550 Madison Avenue, between East Fifty-fifth and East Fifty-sixth Streets. Philip Johnson and John Burgee, 1984. View to the southwest. Payne. RP

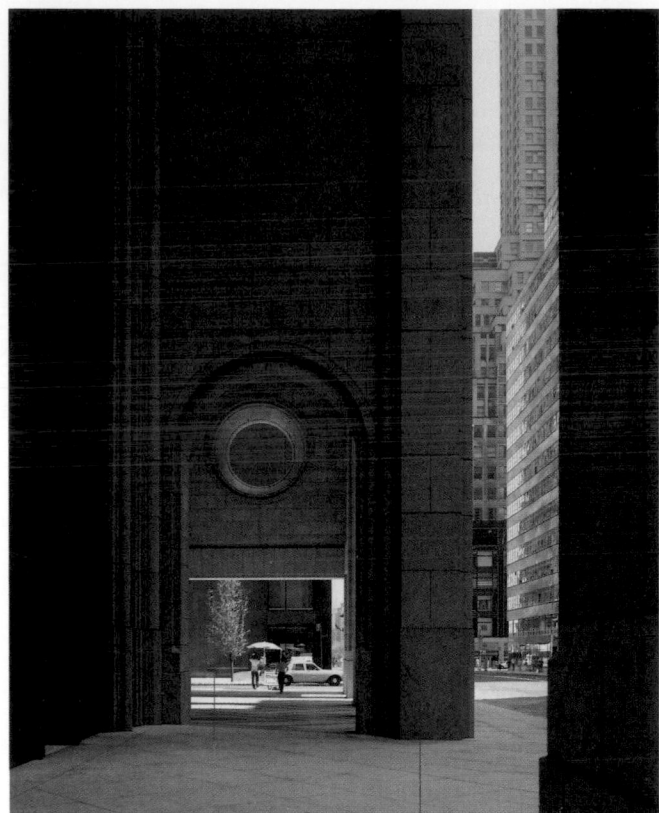

AT&T Building, 550 Madison Avenue, between East Fifty-fifth and East Fifty-sixth Streets. Philip Johnson and John Burgee, 1984. Detail of base. Payne. RP

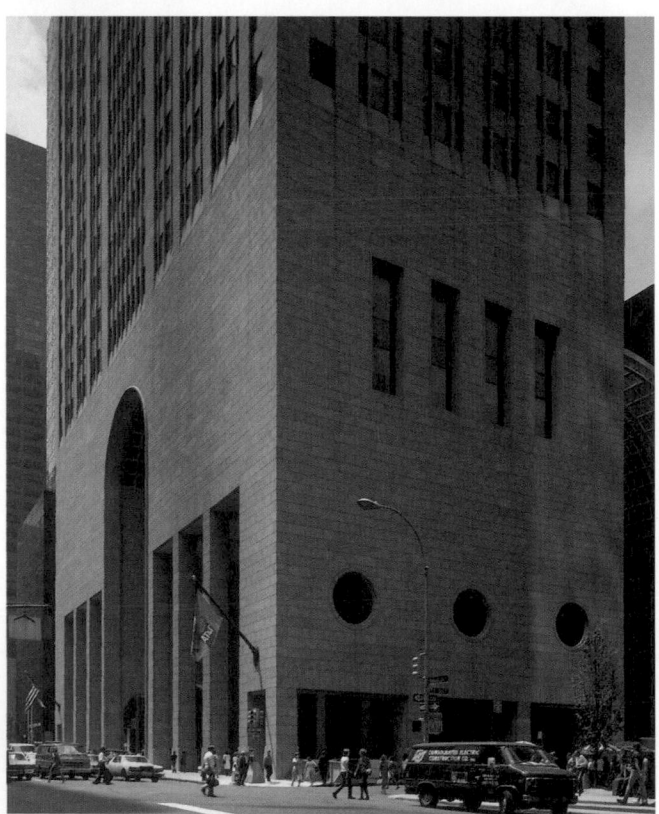

In September 1983, with the building almost completely finished, Paul Goldberger described it as a "strange combination of the noble and the institutional. The A.T.&T. Building is as grandly conceived and lavishly executed a skyscraper as New York has seen since the 1930's, and the effect of some of its parts is exhilarating, even overpowering. This building has a remarkable architectural presence—it is impossible to stand in front of it and not think about the nature of space, the nature of light and the nature of stone." Still, Goldberger found some parts of the building "strangely flat" although "not grotesque, as so many feared when its design was announced in 1978, just a bit heavy." In particular, he called attention to the "awkwardly high and narrow" entry lobby and the proliferation of white marble in the public spaces, "giving them a bit of the air of a government building from the 1930's." But the most serious objection the critic raised was the architects' "commitment to classical architecture, which seemed so daring in 1978 [but] now seems, oddly, not to go far enough. The expanses of flat surface on this building, particularly just over the colonnades at the base, are made pleasing only by that beautiful pink granite. They would be bleak, even dull, otherwise. There is simply not enough texture to the facade." In the end, Goldberger chose to emphasize the building's "importance to this moment in architectural history. It reminds us, more firmly than anything in New York yet has, that the stark glass and steel boxes of the International Style are something of an era already gone."[16]

The project's official completion in January 1984 occasioned another wave of assessments, but this time, in contrast to the harsh tone that accompanied the original release of the design six years earlier, there was a far more favorable reaction. Although Susan Doubilet, writing in *Progressive Architecture*, still had problems with aspects of the design, she believed the building "delivers—and this is the best news—more pleasure to passers-by than anyone would have predicted. Who could have known—distracted by those flinty drawings of a pedimented granite tombstone—that the deep-cut, curved, and faceted stone piers and archways of the loggia would be so palpably fine, deep, and grand; that the loftiness of the space would be so awe-inspiring; that the play of high square openings and low arches, and the bending effect of the centrally placed oculi, glimpsed through off-center archways, would be so exquisite."[17] Vincent Scully praised Johnson and Burgee's "giant" for taking "charge of the street. It both acknowledges its flow and rounds it out into an event. It shapes an urban place of enormous authority, instantly making the International Style skyscrapers on either side of it look captious, insubstantial and obsolete—in fact, not like buildings at all. The lift of Johnson's broken pediment has the effect of making us wonder why we ever allowed people to build skyscrapers with flat tops."[18] Reyner Banham was also impressed by the effect of the completed AT&T Building, predicting its wide influence on the city's future: "Unexpected, enigmatic, slightly disturbing, and thus much like its designer, it will sit around in Manhattan defying the conventions of its neighbors ancient and modern, annoying the mature and established, and—doubtless—fulfilling their worst fears by corrupting the young. That was what they killed Socrates for doing, of course!"[19]

In a curious twist, the completion of AT&T's new headquarters coincided with the court-ordered deregulation of the company's monopoly over telephone service, breaking it into regional components and leaving AT&T itself a dramatically smaller company than the one that had originally commissioned the building.[20] In July 1991, AT&T announced it would lease the entire building to the Japanese electronics and entertainment giant Sony Corporation but would still keep its headquarters in

the city, moving executives to its Long Lines Building (Cyrus L. W. Eidlitz, 1914; Voorhees, Gmelin & Walker, 1932) at 32 Sixth Avenue, between Walker and Lispenard Streets.[21] Soon after signing a twenty-year lease, Sony announced the hiring of Gwathmey Siegel to renovate the tower's office space and, on a far more controversial note, to dramatically reconfigure the public spaces at the building's base. As a consequence of the change in tenancy, *Golden Boy* was removed from its black-marble pedestal in the lobby and relocated to AT&T's suburban office park in Basking Ridge, New Jersey.

Gwathmey Siegel's plan, developed in consultation with Philip Johnson, called for enclosing the open arcades in glass and turning the space into two retail shops facing Madison Avenue, compensating for the loss of the public amenity of the loggia by adding ground-level space behind the building's elevator core to that of the midblock glass-covered galleria, which would be enclosed at each end to provide a climate-controlled environment. The annex behind the galleria would become home to the Sony Wonder Technology Lab, a new multimedia exhibition space highlighting the latest Sony products. The retail shops and technology museum were designed in association with exhibition specialist Edwin Schlossberg. In arguments before the City Planning Commission, whose approval was required because the building had received a six-floor bonus for its public spaces, Sony and its architects claimed that the public would gain by their plan, noting that "retail continuity" would be restored to Madison Avenue and that the new space would "promote and encourage pedestrian use and circulation," unlike the current street-level spaces.[22]

Suddenly, it seemed, the only recently completed and widely admired loggia, had come to be seen as a failure, in part because in the evening hours, it attracted the city's rising tide of homeless people. "From a purely esthetic point of view," Paul Goldberger felt Gwathmey Siegel's design was "unquestionably an improvement. The tall openings in the Madison Avenue facade would not be changed but would be filled in with windows of a design consistent with those used elsewhere in the building. Functionally, the plan makes sense, too: a solid facade with storefronts is better on Madison Avenue

AT&T Building (Philip Johnson and John Burgee, 1984), 550 Madison Avenue, between East Fifty-fifth and East Fifty-sixth Streets. Renovation by Gwathmey Siegel & Associates, 1994. View to the west. McGrath. NMcG

than the present open facade broken up by columns. And public space belongs off the avenue, in the glass-roofed arcade, which even now is a far more successful space than the one in front." Although Goldberger acknowledged that "the public is forfeiting open space to private retail uses," he asked, "Are we really losing overall? Somewhere there are people who like the A.T.&T. space as it is, but I doubt there are many."[23]

Patricia McCobb, spokesperson for the League of Urban Landscape Architects, was not so sure, either about the supposed "improvement" of the new design or the assessment about the current plaza's failure as a public amenity. "One needs only to walk by the Sony-A.T.&T. Plaza any day of the workweek to observe its popularity with the public," McCobb wrote in a letter to the editor of the *New York Times*. "There is barely an empty seat to be found. . . . It is a great people-watching space, and Madison Avenue puts on a lively show."[24] But this view was ignored in the face of Sony's formidable campaign and, with the support of the Municipal Art Society, the City Planning Commission quickly approved the changes.

Gwathmey Siegel's Sony Plaza, as the new public space was called, opened on May 24, 1994, with a glamorous charity benefit. It received generally high marks and was regarded as a distinct improvement over the Johnson and Burgee–designed space, with elegant new details such as the sheets of black

Sony Plaza, 550 Madison Avenue, between East Fifty-fifth and East Fifty-sixth Streets. Gwathmey Siegel & Associates, 1994. Saylor. GSAA

glass fitted into the arched recesses of the lobby's colonnade drawing particular attention. Schlossberg's highly theatrical approach for the retail shops and four-story technology lab, including innumerable video screens placed at every conceivable angle, dramatic colored lighting coming from all directions, and a wide palette of materials ranging from galvanized steel to glass block, bordered on hyperactivity, and perhaps for that reason the spaces were enthusiastically welcomed by the public, especially the young. Gwathmey Siegel was also responsible for the renovation of the office floors in order to accommodate a Sony workforce that numbered 800 more employees than AT&T had placed in the building. Keeping the original perforated metal pan ceiling of Johnson and Burgee's design, the new office floors, replacing, according to Beverly Russell, the "formal Colonial ambience" of AT&T's installation, were fitted out in a Modernist vocabulary typical of Gwathmey Siegel's office work and designed to accommodate a more casual and flexible arrangement of spaces appropriate for a company in the record and movie business.[25] In addition to the new offices, Gwathmey Siegel created new executive dining rooms on the top floor, complete with elaborate catering facilities that included a five-seat sushi bar, all run by chef Barry Wine, owner of the Casual Quilted Giraffe, a restaurant located in the building's midblock galleria until its closing in 1992. Of particular note was the reworking of the sky lobby, where Gwathmey Siegel attempted to warm up and animate the vast white-marble space with the addition of wood paneling and black glass, as well as two huge abstract frescoes by Dorothea Rockburne depicting curling black lines against a yellow and orange field.

Three and a half months after AT&T startled the city—and the world—with the design for its new headquarters, on July 11, 1978, the IBM Corporation released plans designed by Edward Larrabee Barnes for a new headquarters a block to the north at the southwest corner of Fifty-seventh Street and Madison Avenue.[26] The computer giant had pondered for years whether or not to build a skyscraper on the site of several buildings it had owned since 1973. The site consisted of the eastern half of the block bounded by Madison and Fifth Avenues, Fifty-sixth and Fifty-seventh Streets, and included two buildings designed by Carrère & Hastings, a 1924 home for the art dealer M. Knoedler & Company at 14 East Fifty-seventh Street, and an eight-story gallery-apartment house at 12 East Fifty-seventh Street (1914) for the Durand-Ruel family, as well as the twenty-two-story Ley Building (Donn Barber, 1926) at the corner.[27] The buildings occupied by the department store Bonwit Teller (Warren & Wetmore, 1929; remodeled, Ely Jacques Kahn, 1930) and Tiffany & Company (Cross & Cross, 1940), the jewelers, filled the remainder of the block.[28] Barnes began work in 1973 on preliminary studies for a thirty-eight-story, 830,000-square-foot building for IBM, but plans did not move forward. Although talks were revived in 1976, it was not until 1978 that IBM came forward with Barnes's plans for a prismatic, five-sided, forty-three-story building which, when complete, would, according to the architect, "look like a slab from one angle, like a shaft from another and like a block from another."[29] The one-million-square-foot tower, occupying 40 percent of its site, was clad in polished gray-green granite and horizontal bands of tinted gray-green glass.

In its way, Barnes's design was a challenge to the prevailing Modernist taste for glass, but it lacked the iconoclastic panache of Johnson's AT&T design. Taking a cue from Hugh

Sony Building, 550 Madison Avenue, between East Fifty-fifth and East Fifty-sixth Streets. Executive dining room by Gwathmey Siegel & Associates, 1994. Saylor. GSAA

Stubbins's Citicorp Center (1977), the IBM Building performed a feat of structural bravura: while Citicorp was carried by four enormous columns located at the midpoint of each of the tower's sides, IBM rose directly from the ground except at the corner of Fifty-seventh Street and Madison Avenue, where the first three floors were sliced away to mark the entrance, resulting in a disquieting sense of structural insubstantiality which Barnes believed produced "an unexpected sense of openness at what would otherwise be a crowded corner."[30] Also like Citicorp, IBM included an important public space, a sixty-eight-foot-high triangular climate-controlled glazed atrium topped by a sawtooth-shaped glazed roof. Barnes claimed that the tower's unusual shape reinforced the city's street grid while allowing the maximum amount of light into the atrium, located along Fifty-sixth Street. Designed in association with landscape architects Zion & Breen, the 10,000-square-foot atrium, featuring some 300 North Carolina bamboo trees located in eleven groves, would, as public space, bring a substantial development bonus. The scheme also included a thirty-five-foot-tall through-block pedestrian arcade located behind Garden Place, as the atrium was called, as well as a below-grade, 13,000 square-foot exhibition space, the Gallery of Science and Art.

Paul Goldberger greeted the design with caution: "By today's standards, [it's] a conservative design, bringing sensitivity and intelligence to the corner of 57th and Madison, but not daring innovation. It is a building that inches away from recent skyscraper traditions; it does not break away dramatically." To defend his claim, Goldberger pointed out that "the building is still an abstract shape—a more interesting one than a box, but an abstract shape nonetheless. And

one might further question the design's flat top, the symbol of all of the banal buildings Mr. Barnes is attempting to supersede." Although the critic described the IBM Building as "conservative indeed," he maintained that it would be "a dignified addition to midtown Manhattan."[31]

As the IBM Building rose, it was eclipsed by the construction of its prominent near neighbors, AT&T and Trump Tower. Goldberger continued to be of two minds about the design, still finding the five-sided shape of the tower and cantilevered corner "dramatic gestures," but also observing that the "granite is so slickly polished it seems to be trying to look like metal rather than stone."[32] The completion of the building in 1983 banished any ambiguity from the critic's mind. Goldberger simply hated the results: "The I.B.M. Building . . . must be considered the greatest disappointment of the current wave of high-rise construction in Manhattan." Goldberger found the atrium, which also provided access to the retail spaces of Trump Tower, as "uninviting an interior public space as any that has been created in New York in years. It is awkward in shape, cold in feeling and subject to a constant roar from the building's air-circulation system, so that it gives time spent within it the feeling of being on the subway." Preferring by far Barnes's tower three blocks south at 535 Madison Avenue (see below), Goldberger reiterated his objection to the "sleek" and "untextured" granite skin but saved his most stinging criticism for the cantilevered corner, which he dismissed as "structural exhibitionism. . . . It is a case of a big box of a building trying to balance on tiptoe like a ballet dancer, and it just doesn't come off."[33]

Brendan Gill was far more succinct, but equally devastating: IBM's "idea of social awareness was to include a museum and an atrium lobby. They forgot that the building destroys the scale of the area."[34] While Martin Filler was equally disappointed in the tower and only barely tolerated the atrium, he did praise as "superb" the stainless-steel and granite fountain, *Levitated Mass* (1982), designed by Michael Heizer, best known for his monumental environmental pieces in the Mojave Desert. The low, horizontal piece, located on the open

Sony Building, 550 Madison Avenue, between East Fifty-fifth and East Fifty-sixth Streets. Renovated sky lobby by Gwathmey Siegel & Associates, 1994. Saylor. GSAA

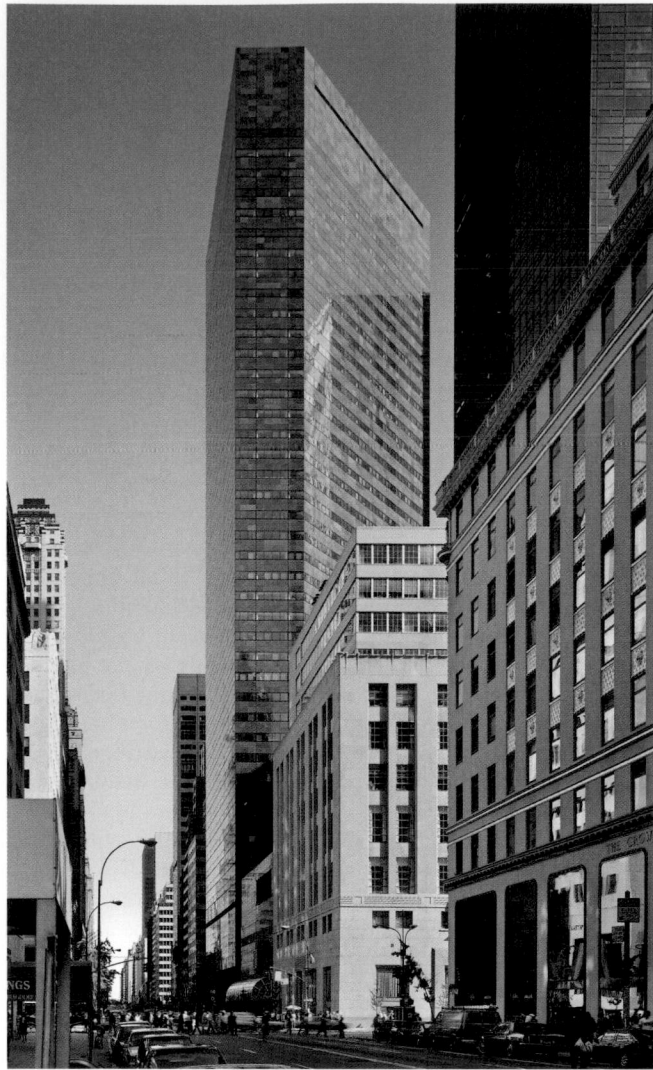

IBM Building, 590 Madison Avenue, between East Fifty-sixth and East Fifty-seventh Streets. Edward Larrabee Barnes Associates, 1983. View to the southeast. Robinson. CR

IBM Building, 590 Madison Avenue, between East Fifty-sixth and East Fifty-seventh Streets. Edward Larrabee Barnes Associates, 1983. View to the northwest. Robinson. CR

space at the corner of Madison Avenue and Fifty-sixth Street, featured rushing water and an eleven-ton boulder sitting in a 25-by-16-foot frame, which provided pedestrian seating. For Filler, it was "one of the few deviations from the cascading wall fountain that has become such a cliché fixture in the New York skyscraper lobby, and it proves that imaginative solutions can indeed be forthcoming if the right people are engaged."[35]

Ada Louise Huxtable, who was increasingly disturbed by the rising Postmodernist movement, rallied behind the IBM Building as if to find some antidote to Johnson's AT&T Building, which she abhorred. "IBM's taut, refined skin of granite and glass upstages AT&T like a suave fashion model next to a fussy dowager in a home-made dress," she wrote. "The difference in the two buildings—IBM is by far the better one—is the demonstrable way in which the design process gives meaning to idea and purpose. AT&T's ideas are as thin as its borrowed symbols are large. . . . Although IBM is plainer, it is richer in its concern with urban relationships and its immediate world; it sets up tensions and responses of far greater architectural inferences and rewards."[36] Mildred

Schmertz was also moved to defend the IBM Building. She was particularly impressed with the urbanistic implications of Barnes's design, observing that "he deliberately shaped the IBM tower to put the mass on the wide streets, indeed to help define them, and at the same time to preserve the lower scale of at least the middle of the north side of 56th Street. . . . At the four corners of the IBM lot," she continued, "there is a release of space—an easing of the compression of normal side-walk width. There are little recessed plazas on 56th and 57th. There is a corner plaza on Madison with a small fountain and places to sit. And there is the enthralling space under the great cantilevered corner—a sudden release easing pedestrian flow and celebrating the entrance to IBM."[37]

Like AT&T, IBM soon relinquished its headquarters, selling the building to developer Edward J. Minskoff in May 1994, having announced the previous year the closing of its Gallery of Science and Art, which had become an important venue for traveling exhibitions.[38] Time had not been kind to the atrium. There had been trouble at the beginning with the bamboo trees, planted under the supervision of the New York

Botanical Garden, with a large percentage dying after only six months. Over the years, horticulturalists had learned how to manage the situation better by adopting a policy of regular rotation, which IBM scrupulously supported until the company's fortunes tumbled, taking with it the attention lavished on the upkeep. By the time Minskoff took over, the space was in poor physical condition with a sizable homeless presence. When the new owner announced plans to convert the atrium into a sculpture garden to be managed in partnership with the Pace Wildenstein Gallery, many civic groups, including the Municipal Art Society, voiced opposition.[39] Although Gwathmey Siegel, architects for the renovation of the public spaces at AT&T, had made some preliminary drawings at the request of Pace Wildenstein, for whom they had just designed a gallery in Beverly Hills, California, Charles Gwathmey, who along with Robert Siegel had worked for Barnes early in their careers, denied that his firm had any intention of further involvement, stating that he had told Pace Wildenstein's Arne Glimcher that they would not redesign the space for a sculpture court. After rumors that Kohn Pedersen Fox would do the work, it was announced that the job belonged to Robert A. M. Stern, whose redesign was approved by the City Planning Commission in October 1995. Besides a much-needed cleanup, Stern's modest renovation involved the removal of three groups of trees, the inclusion of more seating than existed before, and the relocation of the food kiosk nearer to the Madison Avenue entrance, where it

IBM Building, 590 Madison Avenue, between East Fifty-sixth and East Fifty-seventh Streets. Edward Larrabee Barnes Associates, 1983. Site plan also showing Trump Tower. FLL

IBM Building, 590 Madison Avenue, between East Fifty-sixth and East Fifty-seventh Streets. Edward Larrabee Barnes Associates, 1983. View to the northeast showing Garden Place. Robinson. CR

IBM Building, 590 Madison Avenue, between East Fifty-sixth and East Fifty-seventh Streets. Edward Larrabee Barnes Associates, 1983. Garden Place. McGrath. NMcG

535 Madison Avenue, northeast corner of East Fifty-fourth Street. Edward Larrabee Barnes Associates, 1982. View to the northeast. Lieberman. PTG

would be more visible to passersby. Stern also designed new security desks for the office building's lobby, and Minskoff and Pace placed a bright orange stabile by Alexander Calder under the entrance's cantilevered corner, largely filling the space that Barnes had created to relieve congestion. Paul Goldberger, seeming to forget that he had initially likened time spent in the atrium to a trip on the subway, now protested the change, claiming that the space had been one of "unusual serenity" and adding, "When the I.B.M. atrium was at its best, it provided something unique in Manhattan, a sense of quiet, rhythmic calm. . . . It was midtown, made magically, momentarily, Zen."[40]

In 1982, as construction was under way on the IBM Building, Edward Larrabee Barnes Associates' thirty-six-story, 450,000-square-foot 535 Madison Avenue was completed a few blocks to the south, on the northeast corner of Madison Avenue and Fifty-fourth Street, one of three skyscrapers that would, by 1986, dramatically transform the intersection and add to the increasingly cramped row of office towers along the

avenue.[41] Barnes's design for 535 Madison Avenue called for horizontal bands of silvery gray aluminum and blue-green windows sheathing a virtually sheer 120-by-95-foot tower undercut by a seven-story-high diagonal passage at the southeast corner of the base in the manner of the IBM Building—but with an eighty-four-foot-tall corner column—and another seven-story southwest-facing chamfer at the top of the building. A forty-four-foot-wide, 5,000-square-foot public plaza to the building's east dotted with fifteen trees, movable tables and chairs, and a waterfall along the eastern edge emptying into a semicircular pool was, in the opinion of plaza specialist Jerold S. Kayden, "one of the best designed outdoor spaces in midtown Manhattan."[42]

Though a quieter version of Barnes's own 599 Lexington Avenue (see Lexington Avenue), 535 Madison Avenue would, given its proximity to the IBM Building just three blocks to the north, inevitably be contrasted with that more prominent structure. In 1983 Paul Goldberger, calling IBM "heavy-handed and overblown," deemed 535 Madison Avenue "lean and trim. The skin here is metal, as it should be for an aesthetic that aspires to such sleekness, and it is of a gray aluminum that has a particularly pleasing tone." Moreover, he continued, at 535 Madison Avenue, "the prismatic effect the architect was seeking with the shape of I.B.M. comes off, and it is made to work through gestures simpler and less pretentious than those used at the big brother up the street." He felt the corner column at the building's cut-away base was a "happy presence . . . that was so woefully missing in I.B.M., so that there is no disquieting feeling as one approaches the front door."[43]

Diagonally across the avenue, Swanke Hayden Connell's forty-three-story, 849,000-square-foot Continental Illinois Center (1982), 520 Madison Avenue, west blockfront between Fifty-third and Fifty-fourth Streets, was designed by Der Scutt, a partner in the firm, and developed by Robert Tishman and Jerry Speyer.[44] The site consisted of a variety of low buildings, including a five-story brownstone at 22 East Fifty-fourth Street, built in 1875, that had been converted to commercial use just before World War I and given a new, Secessionist-inspired facade (Ford, Butler & Oliver, c. 1914). The former brownstone had been occupied since 1932 by Reidy's, a restaurant, which, refusing to move, entered into an agreement with the developers wherein the top three floors of the building would be demolished while the first two floors, which were architecturally united by a pair of two-story primitive Doric columns supporting an entablature, were preserved. When 520 Madison Avenue was completed, Reidy's, having remained proudly open for business during construction, protruded ten feet from the office tower, providing a welcome humanizing note. Changes in drinking and dining habits resulted in its closing in 1995.

As designed by Scutt, the Continental Illinois Center, so-named in November 1980 when the Chicago-based Continental Illinois Bank leased 260,000 square feet for thirty years in what was ballyhooed as the biggest lease in dollar amount in the city's history, was a polished brown granite and brass-trimmed tower emerging from a thirteen-story base of steeply sloping walls that at first glance recalled Hugh Ferriss's 1922 studies of the maximum mass allowed under the 1916 zoning resolution.[45] Martin Filler was critical of the base, which had come to be known by some as the "Elephant's Foot," associating it with the outward-flaring bases of Gordon Bunshaft's W. R. Grace Building (1972) and 9 West Fifty-seventh Street (1974), both of which Filler deemed "poor architectural neighbors indeed, and particularly

Continental Illinois Center, 520 Madison Avenue, between East Fifty-third and East Fifty-fourth Streets. Swanke Hayden Connell, 1982. View to the southwest. SHCA

appalling examples of the tricks that SOM turned to when it began to run out of legitimate architectural ideas." At 520 Madison Avenue, not only did the "gimmick" evoke an "impending avalanche" of stone, "the unusual angle also emphasizes the building's bulk. What we have here is a kind of entasis-in-reverse. . . . Buildings that flare outward with exaggeration at the base seem much bulkier than they actually are, and the upper stories seem much farther away." Worse yet for Filler was the "extremely cramped" outdoor plaza to the west of the building, from which "one is constantly and uncomfortably aware of the awkwardly scaled, showily sheathed structure overhead. . . . There is something repellent about this building, and not only in an esthetic sense. The way in which its base sweeps out seems to push the pedestrian back." As one approaches the building, Filler concluded, one feels compelled to "cross the street and walk a little faster."[46]

Fox & Fowle's 527 Madison Avenue (1986), southeast corner of Fifty-fourth Street, echoed 535 Madison Avenue's diagonal geometry with a pleated glass and two-toned granite facade and,

along the Fifty-fourth Street side, a huge glass skylight over the entrance whose dramatic tilt also referenced the sloping base of 520 Madison across the avenue.[47] Designed in association with the Canadian firm Webb, Zerafa, Menkes, Housdon Partnership, the twenty-six-story, 200,000-square-foot tower housed small office floors ranging from 5,600 to 11,900 square feet and 5,600 square feet of ground-floor retail space within a complexly massed envelope of rectilinear and sloping surfaces peeled away by horizontal and vertical setbacks so that it came across as a typical office tower of banded glass and granite overlaid on the north side by a twenty-story staggered sloping curtain wall. Paul Goldberger deemed 527 Madison Avenue "a very perplexing building. . . . It is almost two buildings slammed together into one, and while the architects try to justify this as a way of relating the building to the different elements around it, it is really a tower at war with itself. It comes off as disquieting at best, grotesque at worst." Still, he deemed the "more conventional" Madison Avenue facade to be "not bad . . . even good," crediting the materials and massing with accomplishing "the neat trick of merging elements of the two very different buildings on either side of it—the horizontal windows of the sleek 535 Madison Avenue. . . and the stepped-back shape of 515 Madison Avenue . . . a genial eclectic relic from the 1920's. It is a graceful urbanistic gesture to mediate so well between two different buildings." Any benefit gained from this, however, was "thrown to the winds," when the building was viewed from the north, where, Goldberger stated, "the architects' next trick, the decision to turn the north facade into a ski slope" constituted a "wild shift of gears, made worse still by the fact that the building not only changes shape abruptly but also the design of its skin, moving from a rather decently scaled and acceptably detailed system of panels of granite and glass to a flatter design for the ski-slope section that looks like the worst first-year architect's knockoff of Mies van der Rohe."[48]

Scale-bucking towers were also built on side streets just off Madison Avenue, one of the more imposing being Skidmore, Owings & Merrill's Tower 49 (1984), 12 East Forty-ninth Street, between Madison and Fifth Avenues, a forty-five-story green glass megalith that extended through the block to Forty-eighth Street.[49] Developed by Solomon Equities, the design called for a sixteen-sided tower with 15,000-square-foot floors. Two shallow landscaped plazas with serpentine polished-granite benches were situated along Forty-eighth and Forty-ninth Streets, where the building's two entrances, leading to a lobby that doubled as a through-block passageway, were set beneath arcades.

Marking the northern edge of Madison Avenue's office district was David Paul Helpern Associates' 667 Madison Avenue (1987), southeast corner of Sixty-first Street, a twenty-five-story, 243,000-square-foot, buff and gray granite tower with limestone trim.[50] The tower replaced a ten-story apartment house (Horgan & Slattery, 1901) that was later converted to stores, doctors' offices, and, on the top four floors, a sanitarium called the Harbor (Christian F. Rosberg, 1924), but was not included in the Upper East Side Historic District, whose boundary lay on the north side of Sixty-first Street. Helpern's building rose from its 14,000-square-foot site for six stories before a series of setbacks brought the tower back from the corner while providing seven usable terraces accessible from the office floors via French doors. Double-height ground-floor shops featured two-story storefront windows capped by a row of third-story oversized lunette windows. Above, the

527 Madison Avenue, southeast corner of East Fifty-fourth Street. Fox & Fowle, 1986. View to the southwest showing Continental Illinois Center (Swanke Hayden Connell, 1982) on the right and 535 Madison Avenue (Edward Larrabee Barnes Associates, 1982) on the far right. Goldberg. ESTO

667 Madison Avenue, southeast corner of East Sixty-first Street. David Paul Helpern Associates, 1987. View to the southeast. Aaron. ESTO

restrained facade was given some visual interest by the asymmetrical placement of a black columnlike mullion in each of the window openings. Paul Goldberger greeted 667 Madison Avenue with enthusiasm, calling it a "reasonable, intelligent and civilized" building "in an age in which pretension has become the architectural norm."[51]

New construction along Madison Avenue during the 1980s was complemented by the renovation—both interior and exterior—of office buildings from the recent past. The new exteriors were often glitzy reflective glass curtain walls decidedly out of character with their surroundings. An exception was Fox & Fowle's 1987 renovation and expansion of Harrison & Abramovitz's CIT Building (1958), 650 Madison Avenue, between Fifty-ninth and Sixtieth Streets (see Resurfacing Modernism, Introduction). Other examples were Der Scutt's 1987 retrofit of 625 Madison Avenue (Sloan & Robertson, 1930; addition by Sylvan and Robert Bien, 1956) and Fox & Fowle's ill-advised renovation in 1990 of 380 Madison Avenue (Emery Roth & Sons, 1953) (see Resurfacing Modernism, Introduction). After a hiatus during the early and mid-1990s, construction along Madison Avenue picked up again in the late 1990s, centered around Terminal City, where in addition to Moed de Armas & Shannon's renovation of 340 Madison Avenue (Starrett and Van Vleck, 1921) and Richard Cook & Associates' recladding of 360 Madison Avenue (Starrett & Van Vleck, 1917) (see Resurfacing Modernism, Introduction), two major new sky-scrapers were completed, both by Skidmore Owings & Merrill: the Bear Stearns Building (2002), 383 Madison Avenue, between Forty-sixth and Forty-seventh Streets, and 300 Madison Avenue (2004), southwest corner of Forty-second Street (for these buildings, see Terminal City).

PARK AVENUE

In the twenty-five years following World War II, the midtown stretch of Park Avenue was transformed from a residential boulevard to the urban equivalent of a corporate office park. In the 1980s and 1990s, the most significant activity on the avenue was not new construction but the renovation and in many cases recladding of those very office buildings that twenty or so years before had given Park Avenue its eclat as New York's most modern street.[1] Perhaps of even more consequence, for the street as well as the city, was the long-running saga of a Park Avenue tower that was ultimately not built, one proposed for a portion of the highly sensitive site occupied by St. Bartholomew's Protestant Episcopal Church and its community house on the east side of Park Avenue between Fiftieth and Fifty-first Streets.[2] Even more than the fight to save Grand Central Terminal, the battle to preserve St. Bartholomew's Church engaged the public in crucial issues of aesthetics, real estate development, and constitutionality.

St. Bartholomew's Church (1919), designed by Bertram Grosvenor Goodhue and declared a landmark in 1967, incorporated into its west facade the portal commissioned by Mrs. Cornelius Vanderbilt and designed by Stanford White for the church's previous home (Renwick & Sands, 1872–76), southwest corner of Madison Avenue and Forty-fourth Street.[3] Goodhue's building was expanded in 1927 when his successor firm, Mayers, Murray & Philip, designed a community house attached to the church on the southeast corner of the lot containing dining rooms, an auditorium, a gymnasium, and a swimming pool. In 1971, a long overlooked former service ramp on the north side of the church was rebuilt as a garden, designed by Hamby, Kennerly, Slomanson & Smith and landscape architect Paschall Campbell.[4] The story of the struggle to preserve St. Bart's, a cautionary tale of the manic real estate market of the 1980s, began in September 1980 when Carter B. Horsley, real estate writer for the New York Times, reported that the church was seriously considering the offer of a prestigious, unidentified American corporation of $100 million for its 50,000-square-foot site, believed to be the highest value ever put on a Manhattan parcel of land. It was not clear whether the offer was for the entire site or just for the community house and the unused air rights over the church. Though St. Bart's congregation had declined to 2,000 parishioners from its peak of about 3,300 in the 1950s, and although its considerable program of community outreach had been somewhat compromised by rising inflation, the well-endowed church was still very active. News of the impending sale immediately split the parishioners, but it was clear that the church's rector, the Reverend Thomas D. Bowers, who had only come to the congregation in 1978 from a parish in Atlanta, was determined to use the offer as an occasion either to sell or to stimulate increased individual support for the church and its programs.

The editors of the New York Times were quick to rally in support of the preservation of the entire complex: "The church and its later community house. . . are a unit in scale and style, set in a terraced garden of great intimacy and charm. The gift of space, sun, flowers and art, and the relief from the super-scaled buildings all around, serve both the spirit and the city. . . . Even at $100 million, we hope the parishioners can resist temptation."[5] As the debate over the church's future heated up, it not only became clear that the offer was for the entire site but also that the Reverend Bowers, who pointed out that the congregation had moved twice before settling on Park Avenue, was not committed to Goodhue's building: "The physical beauty of the building is not enough to breathe life into the church. . . . It would be wrong to be primarily in the business of preserving buildings rather than people."[6] J. Sinclair Armstrong, an attorney and former chairman of the Securities and Exchange Commission who had been a parishioner since his baptism in 1915, began to rally the opposition in proposing, and ultimately passing, an amendment to the church's laws requiring the approval of the entire congregation, and not just the vestry, for any sale or lease of church property. According to Brent Brolin, who in 1988 published a not exactly balanced account of the St. Bart's controversy, The Battle of St. Bart's: A Tale of the Material and the Spiritual, "By mid-October 1980 negative publicity had made the church leaders regroup," deciding at an October 14 meeting to offer for sale only the community house and the garden—about a third of the church's property.[7] The editors of the New

York Times were not impressed with the church's decision: "That is sad news for the city. The community house . . . would be amputated. And the church, suddenly a jewel without a setting, would be overwhelmed by the kind of tower—enormous—that the area's zoning allows. This truncation of building and site would be a subtler form of destruction than outright demolition, but it should never be represented as an act of salvation."[8]

While Ada Louise Huxtable was surely the persuasive force behind the New York Times's editorials, she also weighed in on her own, pointing out that though the church saw "no loss of spiritual values in its decision," it was defending that decision with "convenient, if confused, rationalizations. Bricks and mortar are called secondary to human needs; it is said that cash will serve society better than beauty. And solvency has a beauty of its own. That the beauty of the St. Bartholomew block contributes to the spiritual welfare of the city and all of its people is not part of the reckoning. . . . Only in a culture where commercial values have vanquished spiritual values would such a church and its setting not be considered a legacy beyond price from the past to the present."[9] Many congregants, sharing Huxtable's point of view that the ensemble was a unique public benefit and an appropriate community contribution for the congregation to make, banded together to form the Committee to Preserve St. Bartholomew's Church and proposed its own slate of candidates for the next vestry election. The church retaliated with a court order forbidding the committee from soliciting funds while using the church's name, a move derided by J. Sinclair Armstrong as an act of "repression of the boldest, crassest sort."[10]

Amid growing dissension within the congregation, the church proceeded with its plans to solicit proposals from potential developers, including the Cohen Brothers, who proposed a twenty-six-story, domed, set-back tower designed by Richard Dattner & Associates with stone facades facing Park Avenue and Fiftieth Street to harmonize with those of the Waldorf-Astoria (Schultze & Weaver, 1931) but with a curving wall of glass on the north side wrapping around the church. The tower was to cantilever about sixty feet over the garden. Dattner claimed that his 225,000-square-foot tower "would minimize its presence by the setbacks and cantilever."[11] Donald Trump and Peter Kalikow also submitted a scheme, designed by Eli Attia, that overwhelmed the church and obliterated the garden with a dark-glass-clad tower that seemed a hybrid of Attia's 101 Park Avenue, developed by Kalikow, and Der Scutt's Trump Tower.

On June 3, 1981, the rector and the vestry announced their plans to lease a portion of their property. Justifying their decision on theological grounds, they claimed that the proposed development would enable the church to expand its ministry: "To do less would be blasphemy because it would be idolatrous."[12] In a surprise move that did little to enhance his reputation, Robert Geddes, dean of the Princeton School of Architecture, agreed to advise the vestry and its real-estate committee, chaired by Anthony P. Marshall, on the suitability of the various developers' proposals. As the developers pressed on, the controversy would not die down, in part because of Bowers's aggressive promotional style, exemplified by the placement of a full-page advertisement in the Sunday New York Times on June 28, 1981, signed by the church's vestry and endorsed by prominent ministers and rabbis, arguing that the issues were theological and not architectural. At the same

RIGHT Proposed office tower addition to St. Bartholomew's Church, northeast corner of Park Avenue and East Fiftieth Street. Richard Dattner, 1981. Rendering of view to the north. RDPA

BELOW Proposed office tower addition to St. Bartholomew's Church, northeast corner of Park Avenue and East Fiftieth Street. Richard Dattner, 1981. Rendering of view to the southeast. RDPA

time, encouraged by the Committee to Oppose the Sale of St. Bartholomew's Church (formerly the Committee to Preserve St. Bartholomew's Church), architects and preservationists along with the Municipal Art Society and the New York Landmarks Conservancy formed Save St. Bartholomew's, an organization rallying against the sale.

In late October 1981 the vestry accepted the proposal of the developer Howard Ronson who, after being turned down by many leading architects, including Philip Johnson and Cesar Pelli—who deemed the idea of the tower "a disaster . . . it's a matter of conscience"—had selected Edward Durell Stone Associates to design the fifty-nine-story, 745-foot-high, 760,000-square-foot mirror-glass-clad tower that he intended to build on the site.[13] As designed by Peter Capone, lead designer of the Stone firm, whose founder had died in 1978, the tower would preserve the garden facing Park Avenue but would replace the community house, the Fiftieth Street facade of which would be reconstructed at the tower's base. It would also block views from the Eggers Group's recently completed office building, 560 Lexington Avenue. Paul Goldberger was quick and decisive in his assessment of the massive scheme: "This is the wrong building in the wrong place. And there is considerable question as to whether there is such a thing as a right building for this place." Goldberger dismissed the design as a version of Trump Tower. He also went after Robert Geddes for what he deemed a misleading word-picture of the proposed design which the Princeton dean had described as a slender "crystalline object" that would rise behind the church "like a traditional campanile," a description, Goldberger

Proposed office tower addition to St. Bartholomew's Church, northeast corner of Park Avenue and East Fiftieth Street. Eli Attia, 1981. Model, view to the southeast. EAA.

Proposed office tower addition to St. Bartholomew's Church, northeast corner of Park Avenue and East Fiftieth Street. Edward Durell Stone Associates, 1981. Model, view to the southeast. SBC

Proposed office tower addition to St. Bartholomew's Church, northeast corner of Park Avenue and East Fiftieth Street. Edward Durell Stone Associates, 1981. Rendering of view to the northeast. SBC

argued, that did not fit Capone's design but that did describe that of Cross & Cross's General Electric tower (1931), southwest corner of Lexington Avenue and Fifty-first Street.[14]

According to Marie Brenner, a journalist meeting with Philip Johnson when he was presented with renderings of the proposed tower, "a kind of terrible quiet filled the room. When he finally spoke, his voice was grave: 'It would be preferable to tear the church down. They have been very clever to do the proper kinds of renderings so it will not look overpowering, but clearly the building will hang over the dome. To overhang a church is to kill it.' He paused. 'Can you imagine erecting a glass tower over St. Peter's?'"[15] In response to Capone's scheme, Percival Goodman offered a tongue-in-cheek alternative of his own, calling for a tower lifted over the church complex on four colossally scaled arches. Goodman mockingly noted: "Albeit clever, the cantilevered squeezed-in shoehornitecture[sic] proposed to replace your community building is perhaps the result of too narrow a vision."[16]

Public opposition continued not only to the tower's design but to an issue, which though not really grounded in law, had some standing. That issue was well expressed by Julian H. Salomon, a landscape architect, in a letter to the editors of the *New York Times*: "The church has been compensated handsomely for its contribution of light and air by having been granted tax exemption over the years. By the same token, the city and its people have acquired a right and interest in the property."[17]

Mayor Ed Koch, sympathetic to the church, took no official stand over the proposal. But seven Manhattan members of the

City Council opposed it, as well as the members of Community Board 5. As the battle continued, in and out of the courts, Bowers became even more visible and even more vocal. As a result, he became the focus of many people's objections—so much so that Capone's design came to be called "Bowers' Towers." Moreover, Bowers shifted the argument from one claiming that the church's responsibilities to its ministry obliged it to sell and or develop its assets to one based on what he called "justice" and the "separation of church and state."[18] As Marie Brenner put it in her devastating portrait of Bowers in *New York* magazine: "He knows that tearing down a landmark is against the law. He says, 'We're going to change the laws.'" According to Brenner, Bowers didn't understand New York's power structure: "The other day, Father Bowers was moved to remark about two of his adversaries, Jackie Onassis and Brooke Astor [who was Anthony Marshall's mother], 'You think that those two care about poor people? They despise poor people. Do you think Mrs. Astor thinks about Harlem? Do you think Mrs. Onassis knows what it is to starve?'"[19]

When the State Supreme Court postponed a mid-November 1981 vote by the vestry on whether or not to sell their site, agreeing with claims that such a vote would disenfranchise much of the congregation, Bowers objected, arguing that the state was interfering in "spiritual" church matters. Justice Edward J. Greenfield replied: "Nothing could be more temporal and of this world than a proposed multimillion-dollar sale of a valuable parcel of New York realty."[20] On December 18, 1981, the vote was held, closely supervised by the state courts. With 729 votes cast, the parish approved, but by only twenty-one votes, plans for the new tower, opening the way for the church to seek approval from the diocese and to go ahead with their hardship appeal before the Landmarks Preservation Commission.

By this time, the "Battle of St. Bart's," as it was being called, was being waged not only in the church and the local press but also in the media like *Newsweek* magazine and London's *Economist*. On February 14, 1982, Bishop Paul C. Moore, head of the Episcopal Diocese of New York, announced his approval of the project. J. Sinclair Armstrong vowed to keep up the fight, and for months the battle dragged through the courts while rumors circulated that Ronson was losing interest in the project. The rumors were confirmed by Bowers, who acknowledged that only $200,000 had been received from the developer instead of the $1 million that was to have been paid when a lease was signed. Bowers was forced to admit that the deal was "on hold."[21] Nonetheless, the church proceeded in its attempt to gain approval of its scheme from the Landmarks Preservation Commission, with Bowers and the church vestry pinning their hopes on a clause in the designation report of 1967, stating that "designation is not intended to freeze the structures in their present state" or to "prevent erection of other structures."[22]

Preservationists were given a boost in 1983 with the publication, by the Victorian Society of America, of David G. Lowe's history of St. Bartholomew's three churches, which included an afterword, "St. Bartholomew's in the 1980s," written by Margot Gayle, a widely respected preservationist who had been instrumental in the movement to recognize the value of the city's cast-iron buildings. Gayle pulled no punches, characterizing Capone's design as a "gargantuan ice cube tray" about to "crush" the Goodhue church. Moreover,

she clearly enunciated the threat to the preservation movement that the church's battle plan for the tower presented: "Anticipating difficulty in securing" permission to demolish all or part of the historic property, "efforts are afoot to exempt St. Bart's along with other religious institutions from protection of the landmarks law."[23]

On December 12, 1983, the church moved forward again with the project, requesting "a certificate of appropriateness" for its plan to build the tower and alter the community house, arguing that the city's Landmarks Preservation Commission was infringing on the church's First Amendment right to freedom of religion by prohibiting it from disposing of its property. The battle was now being waged in earnest, with the clergy, on the one hand, rallying around Bowers's argument that the issue was that of freedom of religion, and preservationists, on the other, defending the public value of great architecture and landscape. While the preservationists could no doubt get heated in their arguments, none chose to match the frequently abusive tone of the Reverend Bowers who, from the pulpit, accused Brendan Gill of being an "architectural idolater."[24] Gill, in an op-ed piece in the *New York Times*, eloquently defended his point of view and effectively reminded readers of the church's cynicism in this matter: "None of the champions of this monstrosity dares to pretend that it will be thought to be an improvement to the landmark; by an irony that Mr. Bowers as a learned churchman must be uncomfortably aware of, the new tower is urged on the grounds that the end justifies the means. Mr. Bowers and his vestry ask that the landmarks law be bent to their purpose to make possible an extension of the church's ministry. But good ends achieved by means that are not themselves good are a perennial temptation to the land-speculators and real-estate developers of this city: which among them would not be happy to set aside for philanthropic purposes a fraction of vast profits not normally attainable by him?"[25]

On June 12, 1984, the Landmarks Preservation Commission unanimously rejected the church's plan. But the struggle continued when, on December 20, 1984, the church submitted a scaled-down version of the tower. Also intended to replace the community house, the design, again by Peter Capone of Edward Durell Stone Associates, called for a forty-seven-story, 343,874-square-foot, limestone- and brick-clad structure that, like the earlier version, would include space for a new community house. Paul Goldberger was blunt about Capone's artistic turn-about: "Like a politician who runs against his own record, Mr. Capone's new design renounces every principle of his first one." Goldberger then went on to wryly observe, "Well, almost every principle. It is still a skyscraper, still to be shoehorned into a tight site on already overcrowded Park Avenue." Goldberger, however, did applaud the new design's intricate silhouette and its contextually considered palette of materials, but nonetheless deemed it lacking in subtlety, with a "nervous and overactive" shape, "as if the architect, once he had learned to make 1930s-style setbacks, did not know how to stop."[26]

The reduced scheme failed to persuade preservationists and the New York Chapter of the American Institute of Architects, which joined together in voicing their opposition at a hearing of the Landmarks Preservation Commission on January 29, 1985. Ten days later, Paul Goldberger weighed in with a thoughtful essay speculating on the relationship between architecture and the kinds of quality-of-life issues

Proposed office tower addition to St. Bartholomew's Church, northeast corner of Park Avenue and East Fiftieth Street. Edward Durell Stone Associates, 1984. Photomontage, view to the northeast. SBC

presented by the St. Bart's case: "But does the decision to devote resources to architecture, as in the case of St. Bartholomew's, mean that the social good is not being served? Hardly. In the strictest sense, it may mean that less will be available to aid the poor. But it is worth thinking, again, of the balancing act that all decisions involving social priorities must entail. After all, as individuals, there are few of us who choose to live like Mother Theresa, giving up all personal property to help the poor. And we do not sell off the pictures at the Metropolitan Museum and devote the profits to feeding the poor, for example, though that would certainly provide one kind of social benefit. We do not do that, of course, because the pictures are a public trust—private property in the strict legal sense, but part of our shared culture in the larger sense. But is that not what can be said of great architecture . . . that it is part of a larger whole, and in that sense part of a public trust? . . . It is disingenuous to suggest that the decision to build a skyscraper at St. Bartholomew's, no matter how much profit it would throw off to aid the poor, would necessarily be of only positive social effect."[27]

The strength of Goldberger's convictions was not reflected in the *New York Times*'s editorial, which waffled over the merits of the revised design. The Landmarks Preservation Commission showed no such ambivalence, rejecting the church's second scheme on July 9, 1985. Meanwhile, seven parishioners filed suit in State Supreme Court to get an account of funds spent on the proposals and to prevent the church from spending additional funds they claimed had not been approved by the congregation.

On September 3, 1985, the church stepped up to the plate one more time, announcing that it would once again file for the approval of the Landmarks Preservation Commission, this time with a plea of hardship, which it would demonstrate by submitting an account of its finances. While the church claimed that $11 million was needed to repair its buildings, and that it was operating at a loss despite its considerable endowment and annual gifts, opponents argued that it had spent $1.6 million in legal and other fees in connection with the proposed tower and that the church owned and maintained a sixteen-room apartment at 860 Park Avenue for the use of the rector, estimating that property's worth at between $1 and $3 million.

On February 24, 1986, the Landmarks Preservation Commission overwhelmingly rejected the plea of financial hardship with one commissioner, the architect David Todd, dismissing the cost of the estimate for repairs as "sheer nonsense."[28] In April 1986, St. Bart's filed a suit in Federal District Court contending, as it had threatened earlier, that its First Amendment rights had been violated. But the church was delivered a setback in a unanimous ruling in July when the Appellate Division of State Supreme Court, First Department, reversing a lower court, ruled that the church's leaders had violated church bylaws by not submitting the plans for the project to a full vote of the parish. At the same time, the Reverend Bowers sent a letter to Protestant churches in New York City asking members to contribute money and public support for the $110 million lawsuit St. Bart's had filed against the city and the Landmarks Preservation Commission. In September, forging ahead, the church again put the plan for the forty-seven-story tower to a full vote, with 403 parishioners in favor and only 240 opposed. Almost immediately opponents were back in court, arguing that the vote was conducted unfairly—the suit was dismissed in April 1987—while Bowers took his fight nationwide, organizing a National Advisory Board "to do God's work in the City of New York and the Nation."[29]

Things brightened a bit for the tower's opponents on December 13, 1989, when the United States District Court for the Southern District of New York dismissed the claims of St. Bartholomew's suit against the City of New York, saying that the landmarks law was constitutional on its face with respect to the First and Fifth Amendment claims and did not interfere with the church's mission; that the church had not demonstrated that it could no longer carry out its mission in its existing building; that the recommendations by design and engineering firms backing up the church's desire for new facilities were incorrect; and that the church would not necessarily suffer financial hardship without the tower. The decision dealt a decisive blow against efforts of religious institutions to plead the First Amendment in opposing landmark designation.

But with the support of the Roman Catholic Church Diocese of New York and that of Brooklyn, the New York Board of Rabbis, the Council of Churches of the City of New York, and the New York State Council of Churches, among others, St. Bart's carried on, appealing the decision. On September 12, 1990, the Federal Court of Appeals unanimously upheld the decision of the lower court. The church fought on until the United States Supreme Court declined, on March 4, 1991, to hear an appeal. It was a great victory for preservationists but a price none would have chosen to pay: a historic site undefiled but a congregation torn apart by

499 Park Avenue, southeast corner of East Fifty-ninth Street. I. M. Pei & Partners, 1981. View to the southeast. Lieberman. PCFP

dissent, a clergy whose integrity was besmirched, and a church with severely depleted assets.

St. Bart's was one of the few, but not the only, Park Avenue site potentially available for redevelopment. Another was the former Arion Society clubhouse (DeLemos & Cordes, 1886), which in 1981 was replaced by 499 Park Avenue, southeast corner of Fifty-ninth Street, a twenty-seven-story black glass–clad office building designed by James Ingo Freed of I. M. Pei & Partners.[30] The loss of the Arion building was mildly mourned by Paul Goldberger, who noted that while it was "not of true landmark status," it was still "worthy of note," with "the richness" of its palazzo-like form providing "a pleasant break in scale from the towers that line the midtown portion of the avenue now," and "an especially effective counterpoint to the excellent and delicate Olivetti Building [originally the Pepsi-Cola Building, 1956–60] across the street by Skidmore, Owings & Merrill, a sort of Miesian version of an urban palace."[31]

At 499 Park Avenue James Freed departed as far as possible from the palazzo mode of DeLemos & Cordes, designing what he called "a black diamond."[32] The 264,350-square-foot tower, rising sheer from the street, was interrupted only by subtle chamfers—one beginning at the third floor on the southwest corner to signal the main entrance and another on the northwest corner beginning near the top of the building. In view of high energy costs, the dark glass facade was in fact only half

transparent, significantly less than what might be found on some previous glass-sheathed towers. In an unusual move, Irwin Cantor, the building's structural engineer, recommended that the building be framed in concrete, a decision he arrived at because the small, 90-by-120-foot site, combined with the architects' decision to locate the elevator core at its inside corner in order to maximize uninterrupted floor space (steel would have required intermediate columns), robbed it of the core's additional contribution as a stiffening element.

For Paul Goldberger, "the new structure is hardly the Seagram Building, but it is significantly above the level of most of New York speculative office construction." Acknowledging that "most New York office buildings are constructed to an embarrassingly low standard," Goldberger rather glibly blamed zoning as the culprit responsible for the poor quality of typical commercial design, failing to hold the developers or their architects at least in part culpable. Likening Freed's building to the glass-slip-covered One United Nations Plaza (Kevin Roche John Dinkeloo and Associates, 1975), Goldberger praised its slightly sculpted silhouette for "an urban suavity that most other dark glass buildings in New York, like the banal Olympic Tower [Skidmore, Owings & Merrill, 1976], surely lack. This building does not appear to have been dropped on the street with a thud; it seems to have slid into its position on Park Avenue with relaxed ease." Even so, Goldberger found Freed's box less "alive" than the "light, tensile gem" that was Skidmore, Owings & Merrill's Pepsi-Cola Building just across the street at 500 Park Avenue: "No. 500 has the grace of a natural athlete; No. 499 seems more like an overachiever."[33]

Inside, Goldberger wrote, the gray granite–clad lobby with its green marble–clad elevator core and polished stainless-steel columns enjoyed "an elegance, though not a majesty of scale, that no New York lobby has had since the Seagram Building." A four-story-high atrium, separating the building from its neighbor on Fifty-ninth Street, was tiny but refined in its detailing, affording dizzying vertical glimpses of the towering building and its neighbor through a glass roof. All in all, Goldberger concluded, 499 Park Avenue was "not great architecture, but . . . an attempt to find a point at which architectural concerns can coexist with the demands of the marketplace: That is what has been absent for too long in New York."[34] Ada Louise Huxtable was far more dismissive: for her, 499 Park Avenue was an "oppressive black tower" that was "permitted to plunge down for almost total lot coverage with no redeeming urban feature worthy of the name— or of I. M. Pei's office, which designed it."[35]

Although sporting a Park Avenue moniker, Skidmore, Owings & Merrill's Park Avenue Plaza (1981), between Fifty-second and Fifty-third Streets, was in fact a through-block prismatic green glass tower situated west of the avenue where it rose ominously and overwhelmingly behind McKim, Mead & White's Racquet and Tennis Club (1918).[36] Despite its location, it was awarded its Park Avenue Plaza address by the Borough President's office after attempts by the developers, Fisher Brothers, to negotiate a Park Avenue entrance through the Racquet and Tennis Club failed. Evaluating early designs by the architects, Ada Louise Huxtable forecasted a "very big and very dark" building she feared might be a "lifeless bore" like the same firm's Olympic Tower, though she at least felt that the proportions of the proposed six-story-high through-block arcade were "keyed to the Renaissance measure of the Racquet and Tennis Club." Huxtable was also "uneasy" about

the building because its location away from the avenue represented the loss of one of "the elegant and intimate mid-blocks that mark this part of town . . . [and] provide much of the style and character of the city."[37]

While Huxtable was still fretting over the loss of midblock charm caused by the proposed supersized building, in August 1978, the Racquet Club submitted plans prepared by Jonathan Morse, of Morse & Harvey, to the City Planning Commission calling for a 486-room, 475-foot-tall, thirty-five-story luxury hotel with a restaurant above the clubhouse that would block out most of the views from the Fisher Brothers' building behind.[38] Meanwhile, the Landmarks Preservation Commission scheduled a hearing in September to discuss designation of the clubhouse (it was designated on May 8, 1979).[39] The hotel scheme, which Philip Johnson deemed "amazing, in the fun-and-games department," was intended to pressure the Fisher Brothers into offering more money for the club's air rights. These negotiations were abandoned, however, when the City Planning Commission, in a split vote, introduced the so-called public galleria legislation, by which the Fisher Brothers would be granted a bonus of 200,000 square feet of leasable floor space in exchange for the provision of a sixty-foot-high, two-level, 20,000-square-foot public space.[40]

In November 1978, the Fisher Brothers, seemingly bullied by the club's plans, initiated a most unusual action, "returning" to the city the floor area bonus they received in exchange for the galleria and reopening negotiations with the Racquet and Tennis Club.[41] By December 1978 an agreement was reached whereby the Fisher Brothers would indeed purchase the club's air rights. Describing the incident in 1997, Christopher Gray called the exchange the "biggest game of real estate 'chicken' ever played in New York," noting that Morse "still won't say if the club was ready to build, or even could have built, the hotel." According to Morse, "That's a

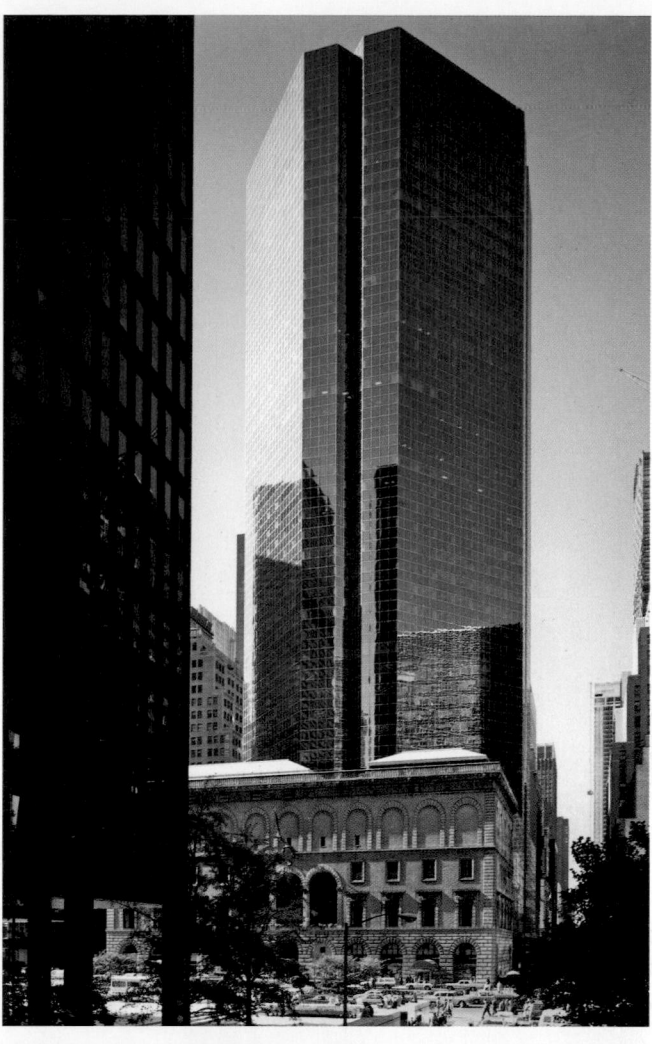

ABOVE Park Avenue Plaza, 55 East Fifty-second Street, between Park and Madison Avenues. Skidmore, Owings & Merrill, 1981. View to the southwest. Hoyt. ESTO

LEFT Park Avenue Plaza, 55 East Fifty-second Street, between Park and Madison Avenues. Skidmore, Owings & Merrill, 1981. Galleria. Hoyt. ESTO

secret I'm taking to my grave."[42] As Martin Filler later described it: "To prevent what would have been New York's most spectacular spite building," the Fisher Brothers "had no choice but to accede to urban planning blackmail."[43] With the award in December 1978 of a generous tax abatement payable over ten years, the project was ready to go forward, and ground was broken on March 13, 1979.[44]

In its final form, the 575-foot-tall, forty-four-story green glass building not only used the Racquet Club's unused air rights, it also took advantage of the zoning bonus previously awarded for the galleria, though, with the approval of the City Planning Commission, the galleria's height was lowered to accommodate two more office floors the developers claimed were deserved to offset the cost of the air rights. Still, the public space was high enough so that, with the mechanical floors located just above, the first floor of offices would be higher than the club's roof and would thereby enjoy views toward Park Avenue.

The chamfered-triangle-shaped plan, notched to provide more corner offices, resulted in a fifteen-sided structure. A year after the building began accepting tenants, but still a few months short of the complete fitting out of the elegantly detailed bow-fronted retail shops tucked away in a too-hidden arcade off the interior concourse, Paul Goldberger called attention to the massive office tower as a harbinger of midtown's new and not so welcome super scale. While he was overwhelmed by the building's size, Goldberger was not so taken with its design: "The results are mixed. . . . Architecturally, Park Avenue Plaza is an earnest, if tame, example of the genre of the abstract tower that we are seeing more and more of around the country; it is the skyscraper as a piece of minimal sculpture." Although there was no way that one million square feet of constructed space could be fit into the middle of a Manhattan block without being noticed, Goldberger credited Raul de Armas, the project's lead designer, with making the building "at least reasonably discreet, and in its symmetry . . . certainly respectful of both the Racquet Club and the new tower's great neighbor across Park Avenue, the Seagram Building."[45] But Goldberger found fault with the building's green skin, which he dismissed as contextually inappropriate given that only one building in the immediate area was so-colored—the firm's thirty-year-old Lever House.

The critic was more taken with the three-story-high concourse, an interior place where elegantly detailed polished green marble walls and polished stainless-steel columns were combined with plants—perhaps too many plants—and a waterfall to create "a cool sleek aura" that, if not "the public square it aspires to be," was at least "a lot more grandiose than the average lobby. . . . While there is reason to question whether the city would not have been better off without this huge interior space—and with a smaller building instead—it is clear that an interior space like that of Park Avenue Plaza is far better than the 'amenity' offered by an earlier generation of office buildings, the outdoor plaza."[46]

Martin Filler saw the building's "sleek curtain wall" as being "virtually identical to those SOM has been producing for over 30 years. That is to say, it is a much better example of its type, but formulaic in the extreme." Any success the architects achieved

500 Park Tower, East Fifty-ninth Street, between Park and Madison Avenues. James Stewart Polshek & Partners, 1984. View showing 500 Park Avenue (Skidmore, Owings & Merrill, 1960) on the left. Hursley. TH

in their unconventional plan, Filler proclaimed, was "seriously sabotaged" by their "selection of cladding material. . . . This well-intentioned attempt to be 'contextual' has backfired disastrously, for the eye is inevitably drawn toward the much smaller and much better Lever House, which in turn seems pathetically shrunken by the adjacent color-matched monolith."[47]

The unused air rights of a third landmark, Skidmore, Owings & Merrill's 500 Park Avenue, built as the headquarters of the Pepsi-Cola Company in 1960, provided another development opportunity resulting in an admirable, contextually responsible design by James Stewart Polshek & Partners for 500 Park Tower (1984).[48] Indeed, Polshek's building could be seen as one of the city's architectural success stories of the 1980s, involving historic preservation—of a Modernist building ten years too young for designation by the Landmarks Preservation Commission—and new construction of a mixed-use skyscraper of exceptional suavity. Described rather improbably by Ada Louise Huxtable as "a kind of Pazzi Chapel of corporate design," Pepsi-Cola was designed by Gordon Bunshaft.[49] When it was completed, Pepsi joined Lever House lower down on Park Avenue, Manufacturers Trust Company on Fifth Avenue and Forty-third Street, the Chase Bank in the financial district—all designed by Bunshaft for Skidmore, Owings & Merrill—and Mies van der Rohe's Seagram Building to form the greatest concentration in one city of artistically exceptional commercial Modernism.

Since its completion, the eleven-story gem had a somewhat bumpy history, beginning in 1970 when Pepsi-Cola left the city for a campuslike setting in Purchase, New York. Olivetti,

Securities Groups offices, 500 Park Avenue, southwest corner of East
Fifty-ninth Street. James Stewart Polshek & Partners, 1980. Warchol. PW

the sophisticated Italian manufacturer of business equipment,
took over, only to sell the building in 1978, when hard times
hit the company.[50] At that point, the then-fledgling firm of
Kohn Pedersen Fox, founded to provide not only design but
economic feasibility studies for developers, evolved a number
of strategies—said to be fourteen—for the reuse of the prop-
erty, putting it into play as a prime location for a large office
building. Soon, 500 Park Avenue and the neighboring Nassau
Hotel (originally the Hotel Roland, F. W. Fisher, 1897), 56–60
East Fifty-ninth Street, an eight-story building of no particular
distinction, were acquired by the Kalikow interests only to be
resold to the Securities Groups, a New York investment firm
headed by Charles and Randall Atkins.

The Atkinses were intent on retaining 500 Park Avenue in
their redevelopment plans and in 1980 hired James Stewart
Polshek to design new offices for their company on the tenth
and eleventh floors.[51] Polshek's interiors were elegant in an
overdetermined sort of way, with insistent, meticulously
detailed metal-gridded glass walls bounding a stairwell and
double-height reception room and corridor. The walls, com-
bining clear, translucent, opaque, and reflective panes of glass,
created what Carter Wiseman called a "slightly disorienting,
but nevertheless entertaining, play of solid and void with
echoes of Vienna and, even more, Japan."[52] At the same time,
the Securities Groups also undertook a broader upgrading of
the building's office space. The floor plates, originally unparti-
tioned, were divided during the renovations into cubicles that
lined up with the window bays. A sophisticated new reflective
lighting design by Carroll Cline placed indirect light fixtures
above each cubicle, indicating the interior partitioning system

to observers on the street. The ground-floor space was also
divided to accommodate new commercial uses but, in Cervin
Robinson's opinion, the "new cell-like spaces above and . . .
the tactfully handled divisions below are likely to be seen (and
ignored) as the minor and mildly regrettable price we pay for
the building's continued existence."[53]

In June 1982, the Amsterdam Rotterdam Bank (AMRO)
opened a New York branch in the basement, ground, second,
and third floors of 500 Park Avenue.[54] Polshek was retained for
the design, which contrasted a wall of horizontal bands of
white marble and thin red metal strips with another wall that
substituted black fabric for the white marble. The centerpiece
was a cantilevered black glass and black chrome staircase
leading from the street-level public banking area to offices and
conference rooms on the second floor.

The Atkinses then asked Polshek, working in association
with Schuman, Lichtenstein, Claman & Efron, to prepare
designs for a 250,000-square-foot mixed-use tower on the site
of the Nassau Hotel containing eleven floors of office space
comprising 60,000 square feet that would connect with the
floor plates of the SOM building—making its offices more
marketable—and, above that, fifty-six condominium apart-
ments housed within a twenty-eight-story tower that would
cantilever twenty-five feet over the west end of 500 Park
Avenue. Polshek noted that the building would have to per-
form the challenging "urban design function of clearly indicat-
ing the east-west boundary between commercial Park Avenue
to the south and residential Park Avenue to the north."[55]

Polshek devised a complexly massed tower of aluminum,
glass, and stone that foregrounded Bunshaft's masterwork
while establishing its own clearly identifiable presence. If a
specific source for the design were to be identified, it would be
that of the PSFS Building (1932) in Philadelphia, designed by
George Howe and William Lescaze, the former having been
chairman of Yale's architecture department when Polshek was
a student there in the early 1950s.[56] Both the north and east
tower facades were to be clad in a thermal-finish gray-green
granite with small punched windows. The south and west
facades would be curtain walls of alternating bands of pale
green glass and aluminum, a similar, but more thinly striated
expression of those on Bunshaft's original building. Emerging
from the granite east facade was the cantilevered section, a
seemingly weightless volume of aluminum and glass. Most
impressive was Polshek's contrapuntal treatment of windows
as, on the one hand, smooth ribbons with glass corners subtly
detailed with black metal joints and, on the other, square
punched openings set one foot deep into the granite walls.

Approval of the plan was held up by the City Planning
Commission's study of midtown zoning, and by 1981, when
the Atkinses found themselves in deep financial trouble, the
Securities Groups sold the property to the Equitable Life
Assurance Society, which entered into a joint partnership with
Tishman Speyer Properties to develop the project according to
Polshek's plans. When Ada Louise Huxtable reviewed models
and drawings for the scheme in May 1981, she called it "one of
the most skillful 'shoehorning' jobs, involving an unusual, and
uncommon, sensibility to considerations of style and scale."
Huxtable was particularly taken with Polshek's handling of the
"materials and details, and the treatment of the large building
surfaces. . . . The tower walls are handled as projecting and reced-
ing elements to visually decrease the bulk of the new construc-
tion; changes in material also break it down and relate to the

Park Avenue Tower, 65 East Fifty-fifth Street, between Park and Madison Avenues. Helmut Jahn, 1986. Detail of entry. MJ

smaller, older structure." Most risky, she felt, was the tower's cantilever—"a device that combines shoehorning and piggy-backing with rather staggering ingenuity" in order to provide the required amount of space to make the project viable while creating "an illusion of vertical slenderness."[57]

Polshek's plan faced difficulties at the City Planning Commission. The design, calling for a FAR of 16.78, was more than the FAR of 15 that the commission hoped to establish in the area, but was still less than the 18 possible under current law. But the building went forward as planned and, upon its completion, 500 Park Tower was hailed as a success. Though initially skeptical, Goldberger revisited the subject in 1984 and acknowledged that Polshek, challenged "to create a new tower that stands on its own, yet respects the landmark-quality" of 500 Park Avenue, "has largely succeeded." The "only failing," according to the critic, was the "brooding" gran-ite skin, which he deemed "handsome in a cold and official sort of way, but . . . strongly undomestic."[58] Otherwise, the domestic portion of the building was one of its most praisewor-thy attributes, with the apartments, numbering three per floor on the lower levels and two per floor above the eighteenth story, enjoying nine-foot-two-inch ceilings and dimensions so lavish as to draw repeated comparisons to the sprawling lay-outs of the 1920s and 1930s. The residential entrance, located at the point where the rough granite facade met the ground on Fifty-ninth Street, consisted of an inconspicuous portal leading to a small but finely finished lobby covered with alternating bands of salmon-colored marble and gray granite.

Carter Wiseman reacted favorably to 500 Park Tower. "Elegant as the design is in itself, it is even more impressive

for what it does for the immediate area. What might have been an oppressively bulky shaft is broken up visually by the alter-nation of forms and materials. . . . [500 Park Avenue] is not just preserved; it is given the sympathetic environment with-out which its pristine geometry always seemed slightly alien."[59] Best of all, as Wiseman saw it, 500 Park Tower per-formed "the neat trick of being authentically new while look-ing as if it has been there all along—or should have been."[60]

Following Park Avenue Plaza and 500 Park Tower were two additional midblock towers of note, both completed in 1986 on either side of Fifty-fifth Street between Park and Madison Avenues, making the number of new buildings built just off Park Avenue greater than those built on the avenue itself. Helmut Jahn's thirty-six-story, obelisk-like Park Avenue

Park Avenue Tower, 65 East Fifty-fifth Street, between Park and Madison Avenues. Helmut Jahn, 1986. View to the northwest. Lieberman. PTG

Tower, located on the north side of the street at number 65, was the Chicago-based architect's first New York tower and arguably his best.[61] Set back fifty feet from Fifty-fifth Street to create a south-facing, 7,000-square-foot plaza, Park Avenue Tower reflected the loose, colorful play on the classical skyscraper type that Robert Stern's intentionally provocative, Adolf Loos–inspired project for the second Chicago Tribune competition of 1980 can be said to have initiated.[62] Jahn's 550,000-square-foot tower, replacing eight small mixed-use buildings, clearly was not content with what traditionally would have been a midblock backwater. It was designed as an iconic tower and, even at its base, every effort was made to wrest it from its immediate context—the Renaissance-style Friars Club (Harry Allan Jacobs, 1916) on the west, which sold its air rights to the building's developer, Park Tower Realty, for $1.2 million to help finance its own renovation, and Emery Roth & Sons' slablike 430 Park Avenue to the east, a 1954 recladding of Warren & Wetmore's 1916 apartment house.[63] Though many admired the brio of Jahn's initial midtown

Heron Tower, 70 East Fifty-fifth Street, between Park and Madison Avenues. Kohn Pedersen Fox, 1986. View to the southeast showing Park Avenue Plaza (Skidmore, Owings & Merrill, 1981) in background right. KPF

Banca Di Roma, 34 East Fifty-first Street, between Park and Madison Avenues. Piero Sartogo and Nathalie Grenon, 1996. View to the southeast. SA

effort for its recall of the towers of the great skyscraper era of the 1920s, as the editors of the *AIA Guide* put it, there was a "catch": his "new vast office structures have the waistline of a Dutch burgher rather than a Chanel model."[64]

Directly across the street at 70 East Fifty-fifth Street was the Heron Tower, a twenty-five-story mini-skyscraper designed by Kohn Pedersen Fox in a restrained version of their classical manner.[65] The building, a throwback in both size and style to the midblock towers of the 1920s such as Raymond Hood's American Radiator Building (1924), took advantage of its unique situation so that what was in fact an infill building appeared to be an isolated tower by virtue of the low brownstone row on its west and the setback massing of 410 Park Avenue (Skidmore, Owings & Merrill and Emery Roth & Sons, 1957–59), southwest corner of Fifty-fifth Street, which gradually gave prominence to its east-facing facade so that above the twenty-first floor the mass could be reduced to form a cruciform shape transformed at the top into two towers.[66] As in other of the firm's classically inspired buildings, the Heron Tower made use of a tripartite window in which the two side panels were set to the back of the mullion while the larger center panel of glass was kept flush with the stone, suggesting a greater depth of the wall and allowing for a rhythmic interplay between large areas of

glass and of stone that complemented the facades of traditional buildings in the area.

A relatively modest midblock building of interest was Piero Sartogo and Nathalie Grenon's Banca Di Roma (1996), 34 East Fifty-first Street, between Park and Madison Avenues, a particularly inventive reworking of a ten-story, 42,000-square-foot building (Fred F. French Company, 1922) that the architects renovated to provide a two-story lobby, offices, conference rooms, a cafeteria, and a trading floor.[67] The new facade, which Massimo di Forti deemed "nothing less than a compositional tour de force," said to have been inspired by Borromini's Oratory of St. Philip Neri in Rome, featured a wide, slightly recessed central bay flanked by two outer bays.[68] A combination of lime plaster and white Venetian stucco was used as surfacing, and at each level, a concave horizontal copper rib stretched across the central bay.

LEXINGTON AVENUE

Just as controversy was beginning to brew over Edward Durell Stone Associates' proposed tower addition to St. Bartholomew's Church, a smaller but more sensitive, though not particularly distinguished, office building was being built directly behind St. Bart's, the Eggers Group's 560 Lexington Avenue (1981), northwest corner of Fiftieth Street, a twenty-two-story, 330,000-square-foot building that was, at the behest of the Landmarks Preservation Commission, designed to sympathize with the facades of St. Bart's as well as those of the General Electric Building (built as the RCA Victor Building, Cross & Cross, 1931), its immediate neighbor to the north.[1] The building, replacing Robert J. Reiley's seven-story Cathedral High School (1926), consisted of a light brown brick–clad box rising with only one setback on its west side to a height of twenty-two stories, corresponding roughly with the first major setback on the GE Building.[2] The design's most successful element was the thirty-foot-high covered street-level arcade cut into its southeast corner that led to the building's entrance as well as to that of the Cathedral Branch of the New York Public Library and also incorporated stairs leading to the downtown subway platform of the Fifty-first Street station as well as 3,000 square feet of retail space. The walls of the arcade were covered in part by a 125-foot-long-by-14-foot-high brick relief sculpture by the artist Aleksandra Kasuba.

The then-young firm of Fox & Fowle completed two office buildings on the side streets off Lexington Avenue, beginning in 1982 with Tower 56, 126 East Fifty-sixth Street, between Park and Lexington Avenues, a slender midblock tower containing only 150,000 square feet in its thirty-three stories.[3] The building gained 50,000 square feet from the purchase of the air rights of two adjacent townhouses owned by the nearby Central Synagogue (see below). Though the tower was a straightforward rectangular shaft clad in alternating bands of clear glass and reddish brown granite, it was livened up near street level, where an angled setback occurred at each of the first five floors, and at the top, where the uppermost office floor was recessed so that the mechanical enclosure above was offset to give the building a distinct crown marred by a gratuitous vaulted scoop. As Paul Goldberger saw it, Tower 56 "rises far too high for its tiny site—this building is to office towers what 'slivers' are to apartment buildings. That the details are more sophisticated here than on the typical sliver is not enough."[4] Fox & Fowle's 150 East Fifty-

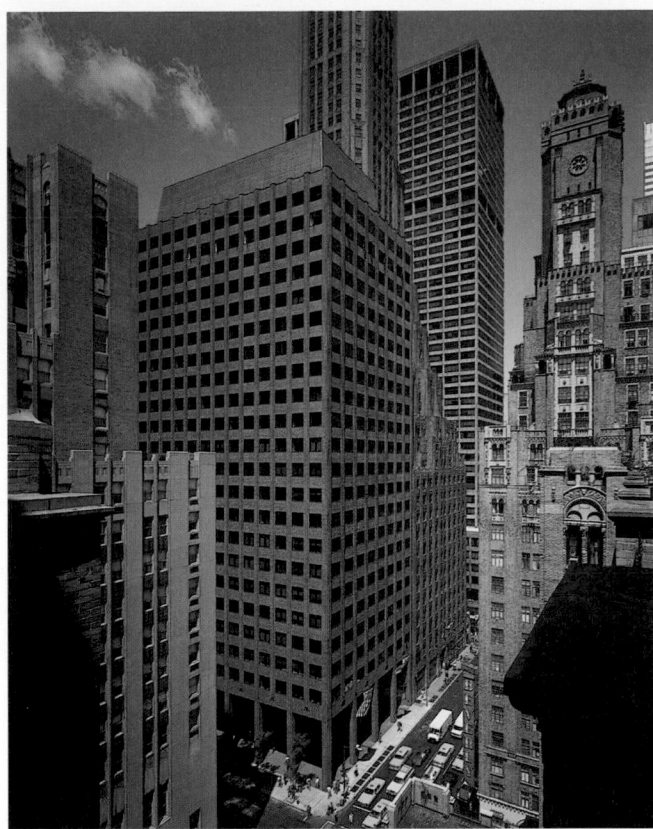

560 Lexington Avenue, northwest corner of East Fiftieth Street. Eggers Group, 1981. View to the northwest. Aaron. ESTO

560 Lexington Avenue, northwest corner of East Fiftieth Street. Eggers Group, 1981. View of covered arcade showing relief sculpture by Aleksandra Kasuba. Hartman. AK

Tower 56, 126 East Fifty-sixth Street, between Lexington and Park Avenues. Fox & Fowle, 1982. View to the southwest. Gordon. FXF

150 East Fifty-second Street, between Third and Lexington Avenues. Fox & Fowle, 1983. View to the southeast. Hoyt. ESTO

second Street (1983), between Lexington and Third Avenues, was more substantial, a thirty-five-story, 270,000-square-foot midblock office building consisting of a six-story base beneath a set-back twenty-eight-story tower.[5] The tower floors were relatively small but, with a sawtooth plan that allowed for ten corner offices per floor, were well geared toward companies that wanted, according to the developer, the "psychological advantage of a full-floor presence."[6] Clad in black glass overlaid by a grid of red mullions, the building was, for Goldberger, "quite jazzy."[7]

One of the period's surprising successes was Edward Larrabee Barnes Associates' 599 Lexington Avenue (1987), southeast corner of Fifty-third Street, replacing an assemblage of low- and mid-rise buildings that had been acquired by Citicorp to protect the context of the Citicorp Center (Hugh Stubbins & Associates, 1977) across the street after Walter B. Wriston, Citicorp's chairman at the time, had looked out of his window in the bank's Park Avenue headquarters and said, "Get rid of those massage parlors."[8] In July 1983, the site was sold by Citicorp to Mortimer B. Zuckerman, a Boston developer entering the New York market for the first time. Early in 1984, Zuckerman offered to build a long-wished-for pedestrian tunnel connecting the two subway lines that crossed near the site in return for a 20 percent greater floor area than normally permitted. The proposal was accepted, and the building increased

to forty-seven stories, containing 917,000 square feet of space in a frosted, silver-colored metal and lightly tinted blue-green glass-sheathed triangulated tower designed to blend in with Citicorp Center. According to Barnes, "the cutaway terraces and the angular facades" were to act as "a foil to the rectangular bulk of Citicorp."[9] Amid the period's material overkill, the silvery facades, with their glassed-in shadow boxes to suggest depth, were a welcome relief, as was the fifty-foot-high, green and white marble lobby, one wall of which, visible from the street through a wall of clear glass, was devoted to a thirty-by-thirty-five-foot relief painting, *Salto nel Mio Sacco*, which translates as "Jump into My Sack," by Frank Stella.

Further north lay one of Lexington Avenue's boldest new office buildings, the thirty-one-story 750 Lexington Avenue (1989), occupying the west blockfront between Fifty-ninth and Sixtieth Streets, across from Bloomingdale's department store (Starrett & Van Vleck, 1930), where architect Helmut Jahn wrapped a series of dramatically arranged setback masses around a cylinder that emerged pure at the top to culminate in a telescoping truncated cone supporting a decorative sphere.[10] Double-height bay-windowed shopfronts added sparkle to the

FACING PAGE 599 Lexington Avenue, southeast corner of East Fifty-third Street. Edward Larrabee Barnes Associates, 1987. View to the northeast (left). View to the southeast (right). Rosenthal. SR

retail frontage along Lexington Avenue, where the building was set back from the lot line to create a much-valued widened sidewalk at one of the city's busiest locations. Though the compositional strategy of the tower was inventive, the effect, especially at the top, was outrageous, looking as if the building contained a rocket ready for blast-off. Carter Horsley deemed the ringed crown "spectacular and very effective,"[11] and Paul Goldberger praised the building as "a wonderful, even witty piece of inadvertent dialogue in the cityscape . . . a kind of science-fiction Postmodernism" that was "particularly good when seen from a short distance away as part of the skyline."[12]

An amusing aspect of 750 Lexington Avenue's design was the inclusion within its mass of a brownstone house (1865), 134 East Sixtieth Street, where one resident, Jean Herman, refused the financial settlement offered to her to vacate her apartment.[13] In order to get on with construction, Cohen Brothers Realty Corporation, the developers, decided to tear down the back half of the brownstone, where other apartments had been vacated, and build around the remainder, also shaving off the fifth floor. The Cohen Brothers restored what remained of the facade, con-

necting the ground-floor space to that of the Dry Dock Savings Bank, a principal retail tenant in the office building. When the dust settled, Herman was happy despite the inconveniences of having lived virtually within a construction site. At the time of her death in 1992, by which time she was well known in real estate circles as "the Geranium Lady" and "the Last of the Red-Hot Tenants," the developer and historian of New York Seymour Durst, who had cowritten the book *Holdouts!*, paid her the highest tribute, calling her "the ultimate holdout."[14]

Sharing the block with 750 Lexington Avenue was the headquarters of the Lighthouse, an eighty-six-year-old organization formerly called the New York Association for the Blind, which occupied Kahn & Jacobs's 90,000-square-foot gray-tinted glass and precast-concrete-panel building (1964), 111 East Fifty-ninth Street. In 1990 the Lighthouse announced plans to replace its flagship building with a larger facility to be designed by Mitchell/Giurgola Architects.[15] As realized, a new sixteen-story building at 110 East Sixtieth Street replaced a six-story brick and limestone building (Clay, Potter & Coulter, 1950) owned by the Lighthouse and serving as its

administrative headquarters, and was connected to a gut renovation of Kahn & Jacobs's Fifty-ninth Street building that kept only its steel frame. The combined new structure contained 170,000 square feet of space. Two stories had to be added to Kahn & Jacobs's fourteen-story building to allow for a floor-by-floor alignment with the new Sixtieth Street building. The charitable organization noted that because most legally blind people retain some ability to perceive light and contrasts, the design of its new headquarters would emphasize getting as much natural daylight as possible into the building's offices, staircases, and halls.

Mitchell/Giurgola's handsome buff brick, stone, and glass design featuring white-trimmed, metal-framed windows and three terraced setbacks kept the main entrance on Fifty-ninth Street, housed in a glassy two-story base extending out to the property line, while the facade facing Sixtieth Street rose from a brick and glass base. The building, completed in 1994, included a street-level store, a conference center with a 237-seat auditorium, a cafeteria, a library, classrooms, a child developmental center and preschool, as well as administrative offices and research facilities. To help people with partial or low vision, the architects not only made the space brighter than the old headquarters, but also provided strong contrasts in colors and materials. For example, the staircase landings and treads were made of black precast terrazzo while the risers were constructed of white terrazzo. The main stair

also featured a colorful mural by Sol LeWitt, *Styrofoam Installation*, which stood in sharp contrast to the walls, which were painted in a low-reflective, warm eggshell color. The architects also made changes in the texture of the terrazzo floors to delineate pathways and warn of turns and cross corridors. According to Peter Slatin, an architectural journalist suffering from retinitis pigmentosa, the new space successfully imposed "order as well as comfort" with an entrance hall "divided by a railing in the center that separates those entering from those leaving the building and keeps people on course. . . . A waiting area set out of the main traffic flow is indicated by a textured strip along the terrazzo floor; benches provide seating and space below for guide dogs to rest." Slatin was impressed with the signage by graphic designer Roger Whitehouse and the glare-free lighting designed by Howard Brandston, concluding that the new Lighthouse proved that "accessibility and attractiveness are not mutually exclusive."[16] Mildred Schmertz was pleased with the results as well, noting that the building also worked for the sighted: "On the exterior, it is bright and spirited. Within, the public spaces have the kind of clean elegance that one is happy to find in any place the community gathers for educational and cultural pursuits."[17]

By far the largest potential development site on Lexington Avenue was the entire block bounded by Fifty-eighth and Fifty-ninth Streets, Lexington and Third Avenues, a block that accommodated a discount department store, Alexander's, in

The Lighthouse, 111 East Fifty-ninth Street and 110 East Sixtieth Street, between Lexington and Park Avenues. Mitchell/Giurgola Architects, 1994. View to the northwest showing East Fifty-ninth Street facade. Goldberg. ESTO

The Lighthouse, 111 East Fifty-ninth Street and 110 East Sixtieth Street, between Lexington and Park Avenues. Mitchell/Giurgola Architects, 1994. View of main stair showing *Styrofoam Installation* by Sol LeWitt. Goldberg. ESTO

731 Lexington Avenue, between East Fifty-eighth and East Fifty-ninth Streets. Cesar Pelli & Associates, 2005. View to the southeast showing 750 Lexington Avenue (Helmut Jahn, 1989) in foreground. Goldberg. ESTO

731 Lexington Avenue, between East Fifty-eighth and East Fifty-ninth Streets. Cesar Pelli & Associates, 2005. View to the north. Goldberg. ESTO

an Emery Roth & Sons-designed 486,000-square-foot, five-story virtually windowless marble-clad building (1965).[18] On May 15, 1992, Alexander's, long considered more valuable for its real estate holdings than for its retail operations, filed for protection under Chapter 11 of the Federal Bankruptcy Code, announcing the closing of its eleven remaining stores, including its flagship operation on Lexington Avenue.[19] The publicly traded retailer was reorganized in 1993 under the control of Steven Roth's Vornado Realty Trust and it was thought by many that the redevelopment of the 80,000-square-foot site would quickly proceed. But successive negotiations to develop the site to meet the requirements of the two major auction houses, Sotheby's and Christie's, failed.

In 1999, worried about proposed changes to the zoning laws that would have limited the size of future development, Vornado demolished the Alexander's building without revealing a definitive plan for the site, although it was strongly rumored that it would become home to a tower containing the new headquarters of financial news company Bloomberg.[20] But negotiations between Roth, dubbed the Hamlet of Lexington Avenue for his inability to decide on a development direction, and Michael Bloomberg, head of the financial information giant, lasted for the next two years and it was not until April 2001, by which time Bloomberg had

decided to seek the Republican nomination for mayor, that an agreement was officially confirmed. As designed by Cesar Pelli, the fifty-five-story, 1.4-million-square-foot 731 Lexington Avenue, included, in addition to about 700,000 square feet of office space for Bloomberg, high-end retail stores on the first three floors and 200 condominium apartments on the upper floors. Completed in 2005, the 870-foot-tall tower, clad in glass of varying textures and reflectivity and accented with protuding horizontal painted aluminum bands wrapping the building at each of its floors, rose from a ten-story base occupied by Bloomberg's offices to culminate in a brightly lit but visually disengaged crown. Facing Fifty-eighth Street, the building's base was cleaved at midblock by a dramatically sculpted curved courtyard passage, dubbed Beacon Court, that allowed both pedestrians and automobiles through-block access while providing distinct entrances for the office tenants and apartment owners. For Justin Davidson, writing in *Newsday*, Beacon Court, while a "startling" space with a "kinetic, baroque sensibility" that "offsets the tower's austere form," seemed in essence to be a "private driveway disguised as a public piazza. . . . If it were truly open—if security guards did not track your steps through the premises or prohibit snapshots—it would be a marvelous civic gift."[21]

Central Synagogue

At 5:00 P.M., on August 28, 1998, during the evening rush hour, the roof of the Central Synagogue (Henry Fernbach, 1872), southwest corner of Lexington Avenue and Fifty-fifth Street, became engulfed in flames.[22] The accidental five-alarm blaze, sparked by a welder's blowtorch ignited during renovation work, raged out of control for more than three hours, not only destroying the roof but extensively damaging the interior of the 126-year-old building, the oldest in continuous use as a synagogue in New York. Fernbach's Moorish-style masterpiece, modeled after Ludwig von Forster's Dohany Street Synagogue (1854–59) in Budapest, was designated a city landmark in 1966 and a national historic landmark in 1975. Noted for its twin 122-foot-high minaret towers topped by gilded onion domes, the synagogue was especially treasured for its stunning and elaborate interior, including twelve double-height stained-glass windows, intricately carved black walnut woodwork trimmed with white oak, encaustic and quarry tile floors, and remarkable geometric-patterned wall stenciling finished in a rich profusion of colors, including several shades of blue, earthy reds, ochre, coral, and brown.

Amazingly, despite the devastation, no one was injured, and bits and pieces of the interior, including the thirty-eight-foot-tall ark, survived, as did the exterior walls of New Jersey brownstone and Ohio sandstone and the interior cast-iron columns. In another stroke of good fortune, many of the synagogue's most prized possessions, including historic Torah scrolls as well as Fernbach's original architectural drawings and plans, which would prove invaluable in the restoration effort, had been moved off-site to facilitate Schuman, Lichtenstein, Claman & Efron's five-year renovation plan, begun in 1995, to improve seating and acoustics, and add air-conditioning. Hardy Holzman Pfeiffer Associates, which had recently completed very well received renovation projects for the New Amsterdam Theater (see Forty-second Street) and Radio City Music Hall (see Rockefeller Center), was awarded the commission to restore the fire-damaged temple. Hugh Hardy noted at the outset that "it's not possible to do a perfect restoration," preferring instead a method that Ken Shulman, writing in *Metropolis*, described as "interpretive restoration— a subjective approach to architectural restoration that seeks to reconcile the soul of an historic building with the realities of contemporary design, function, and building codes."[23] Complicating matters was the history of the synagogue itself. Over the years the stenciling had faded, and in 1937 it was repainted. Ely Jacques Kahn undertook extensive renovations in 1946, removing the chandeliers, which had been converted from gas-fired to electric in 1903, substituting some of the stained-glass windows with windows of abstract design, and replacing the slate roof with one of metal. After careful research, the architects were able to document the many changes that had occurred over the years, so the question soon centered on whether the goal was to return the building to its look prior to the fire or whether to get as close as possible to Fernbach's original vision, which had initially been compromised by a fire in 1886. The synagogue's building committee took the high road, authorizing the architects to return the building to the splendors of 1872, with exceptions made to accommodate contemporary demands as well as some acknowledgment of the building's history.

Hardy's plans, approved by the Landmarks Preservation Commission without public opposition, began with a new black and red slate roof from the same quarry that produced the original, laid in the same geometric arrangement as Fernbach's, a pattern confirmed by checking World War II–era military surveillance photos of Manhattan. The onion domes were regilded and the stone repointed. One significant change was the reconfiguration of the entrance to better accommodate the congregants, who had long complained that the front steps were too steep. Shallower steps were installed, requiring the lobby to be lowered thirteen and a half inches. This apparent improvement, which also involved enlarging the entrance, produced a rare note of criticism when architectural historian and synagogue member Joy Kestenbaum complained that "each alteration initiates a sequence of related changes that in total will seriously compromise the design of this . . . landmark."[24]

The highlight of the restoration was undeniably the reworked interior, especially the return of the vividly polychromed decorative walls. A few members of the building committee balked at the reintroduction of such bright colors, fearing that the result would be too garish, but Jonathan Schloss, the architect in charge of the project and a veteran of the Radio City job, explained the subtlety of the Hardy firm's approach: "We could easily duplicate the exact original colors from existing samples. But the effect would be very different

Central Synagogue (Henry Fernbach, 1872), southwest corner of Lexington Avenue and East Fifty-fifth Street. Renovation by Hardy Holzman Pfeiffer Associates, 2001. Aaron. ESTO

from what we believe it was. On average, lighting is 30 percent brighter today than it was a century ago. The identical colors with today's illumination would be far more vivid than they were when the synagogue was opened. This wasn't the statement that we wanted to make."[25] Two of the twelve stained-glass windows were restored to their appearance in 1872, but the rest were redone to duplicate their look before the fire. In order to create a more flexible sanctuary space, the new wooden pews, based on the original design but more generously proportioned, were now movable, and the bimah was redesigned to allow it to be lowered and extended closer to the congregation for more intimate services. The chandeliers, with powerful up-lights hidden inside, were returned, and new floor tiles were commissioned from the same British company that had supplied the originals. The architects created a modest glass-roofed atrium space out of a former alleyway as well as a new basement-level social hall, which was intentionally kept free of most ornament. The restored Central Synagogue was rededicated on September 9, 2001, and Hardy Holzman Pfeiffer's work was greeted with the same approval that accompanied the renovated New Amsterdam Theater and Radio City Music Hall, with most observers concluding that the architects were masters of preserving the character of historic buildings while updating them to meet contemporary needs.

THIRD AVENUE

In 1983 the *New York Times* reported that since the demolition of the Third Avenue El in 1955, thirty-four office towers had been built on the twenty-block stretch of Third Avenue between Thirty-ninth and Fifty-ninth Streets.[1] The first was William Lescaze's 711 Third Avenue (1956), between Forty-fourth and Forty-fifth Streets, but the majority were realized in the 1960s.[2] After a hiatus during the 1970s, the early 1980s saw a virtual explosion of office construction along the avenue, leading Carter Horsley to write in 1981 that this second generation of office building "will nearly complete the transformation of the avenue from rows of ramshackle railroad flats to a broad boulevard with a distinctive character."[3] By 1983, enough had changed for Suzanne Stephens to call Third Avenue "a 1980's strip. Eye-catching, but still with limited architectural means. . . . For all the differences that [the builders are] pushing, they're not getting high-quality design—they're getting slick packaging." But, she recognized, "you can't tell how the whole set of teeth will look until it's done."[4]

Most of the new buildings were located between Forty-seventh and Fifty-fifth Streets, the first of six buildings erected in that strip between 1980 and 1986 being 767 Third Avenue (1981), southeast corner Forty-eighth Street, designed by the new firm that would specialize in office buildings, Fox & Fowle.[5] Built by the Kaufman Organization in association with the English developer Howard Ronson, the tower required the demolition of the western half of a nine-story, ninety-unit apartment house, 212 East Forty-eighth Street (John H. Duncan), which had been built in two equal parts in 1923. Fox & Fowle's design called for a 275,000-square-foot, thirty-nine-story building on the 14,000-square-foot site rising with a six-story base surmounted by a set-back, round-cornered roughly L-shaped tower with floor plates of only 6,500 square feet wrapped in alternating horizontal bands of windows and brick, with the corner windows dipped to just four-

teen inches above the floor. The use of brick was unusual for the Kaufmans, but Melvyn Kaufman justified the choice as appropriate for the building's curved corners.

Pamela Waters, a favorite designer of Kaufman's, was commissioned to design the street-level environment, which would have no retail space at all but instead an assortment of whimsical public amenities and distractions like those that had come to typify Kaufman's New York office buildings, among them the nearby 777 Third Avenue (William Lescaze, 1963) and 747 Third Avenue (Emery Roth & Sons, 1972).[6] Working with the architects, Waters enclosed the building's nineteen-foot-high lobby with a curvilinear wall of white-oak-framed square windows that the editors of the *AIA Guide* likened to "'Japanese' Post Modern wood grillage."[7] Three wood-clad revolving doors penetrated the west side of the wall, which snaked around the corner to a terraced side-street plaza where an antique Ford Model-T and a stagecoach were stationed. The focal point, however, was a three-story-high chessboard affixed to the wall of 212 East Forty-eighth Street with circular pieces that were repositioned by a workman to play out famous chess matches at a staggeringly slow pace—often one move per week. As 767 Third Avenue neared completion in late summer 1981, Paul Goldberger weighed in with an assessment, finding it "much better" than most of the midtown buildings then being built, but he acknowledged that it didn't "fit in terribly well with what is around it." Still, Goldberger continued, "what is around it isn't very coherent anyway, and what Fox & Fowle have made is a pleasant tower with rounded corners and a well-detailed, warm and gracious lobby of—if you can imagine such a thing in a modern midtown skyscraper—wood."[8]

Developed by Cohen Brothers Realty & Construction Corporation, Emery Roth & Sons' thirty-one-story Crystal Pavilion (1982), 805 Third Avenue, east blockfront between Forty-ninth and Fiftieth Streets, utilized air rights from the two-story taxpayer on the northeast corner of Forty-ninth Street and from Amster Yard, 211–215 East Forty-ninth Street, which it abutted (see below).[9] The project had a rough start, with the determination by the City Planning Commission that the planned public amenity—an enclosed retail atrium that allowed four additional floors to be built—was not ultimately worth the size of the bonus. The commission cut back the design from thirty-five to thirty-three stories, forcing the developer to renegotiate already signed tenant leases. Worse news awaited when the Board of Estimate, sensitive to the area's growing density, went even further than the City Planning Commission, denying the project any bonus at all for the retail atrium and lowering the height to thirty-one stories.

The board's unprecedented move was the result of a desire not to seem a rubber stamp of the City Planning Commission, but was also influenced by the considerable protest of watchdog groups—including the Parks Council, the Municipal Art Society, and the Landmarks Conservancy—that saw no public benefit from the transfer of Amster Yard's air rights and no real use for the atrium. Also affecting the board's decision was the fact that the tower would rob Greenacre Park (Sasaki, Dawson, DeMay Associates, 1971) of a half an hour's worth of early afternoon sunshine, a factor not usually taken into consideration in New York where, unlike many other cities such as Tokyo, no law protected neighboring properties from loss of light due to new development.[10]

767 Third Avenue, southeast corner of East Forty-eighth Street. Fox & Fowle, 1981. View to the southeast. Cornish. ESTO

767 Third Avenue, southeast corner of East Forty-eighth Street. Fox & Fowle, 1981. View of chessboard designed by Pamela Waters. RAMSA

As built, the Crystal Pavilion, a double-glazed reflective gray glass box with a single west-facing setback near the top, met the street with a recessed three-story base lined with polished stainless-steel columns. Polished stainless steel also wrapped the tower's rounded corners but did little to ameliorate the ominous banality of the twenty-four-floor 555,000 square-foot-building. The atrium ended up as devoid of public benefit as the city's planners had predicted, a 32,000-square-foot space occupying the basement, street, and mezzanine levels, designed by Bromley & Jacobsen with retail shops, two waterfalls, escalators, and a glass elevator, all executed in a monochromatic vocabulary of stainless steel and gray granite, with the only significant source of natural illumination coming from a skylight in the forty-five-foot-high ceiling. Paul Goldberger deemed 805 Third Avenue "less a building than a hulking square mirror with a big hole in the middle."[11]

Just east of the Crystal Pavilion was Amster Yard, developed in 1944 by James Amster, a young decorator, who, working with architect and painter Harold Sterner, transformed two brownstones, 211 and 215 East Forty-ninth Street, and a collection of back buildings in their L-shaped rear yard, into a community of residences, workshops, and offices devoted to the decorating trade.[12] Designed to evoke the scale and character of the flats below Boston's Beacon Hill, the small buildings and the charming courtyard they surrounded earned landmark sta-

tus in 1966. In 2002, however, preservationists were alarmed to discover that Amster Yard had been demolished by its owners, Instituto Cervantes, a nonprofit cultural group created by the Spanish government, which had purchased the complex three years earlier.[13] As it turned out, the demolition was to be followed by a complete reconstruction of the yard and its attendant buildings and had been undertaken in consultation with the Landmarks Preservation Commission, which endorsed the insertion of a 132-seat auditorium nineteen feet beneath the yard. The replicated buildings were designed to house a 65,000-volume library, classrooms, and a 1,600-square-foot exhibition space. Though the preservation community was appalled at the seeming secrecy with which the work was carried out, the owners contended that after modest demolition had begun the buildings were discovered to be too unsafe to renovate, with structural cracks running the entire height of some walls and wooden joists burned from the heat of nearby chimneys. The one significant new component was a multilevel bridge clad in clear and textured glass that spanned the original entryway, a modern touch designed by Ad Hoc MSL, based in Murcia, Spain, working with the Manhattan architect Victor Schwartz. The new complex opened on September 10, 2003.

The Crystal Pavilion was followed by 875 Third Avenue (1982), east blockfront between Fifty-second and Fifty-third Streets, designed by Bruce Graham of Skidmore, Owings &

Crystal Pavilion, 805 Third Avenue, between East Forty-ninth and East Fiftieth Streets. Emery Roth & Sons, 1982. View to the northeast. Ries. SRP

Amster Yard, 211 and 215 East Forty-ninth Street, between Second and Third Avenues. Renovation by Ad Hoc MSL and Victor Schwartz, 2003. View to the southwest of interior court. IC

Merrill's Chicago office.[14] The decision to bypass Skidmore's New York office raised a number of eyebrows, with Graham brashly touting his design as a departure from what he deemed the banalities of New York practice. Graham's self-proclaimed lesson to New York took the form of a 675,000-square-foot prismatic, fourteen-sided, twenty-eight-story black-painted steel-framed tower with black aluminum spandrel panels and a combination of silver reflective and clear glass that he argued was designed in the "way" of Louis Sullivan, the more "honest way" than that of "most New York buildings [which] are playful with the wall."[15] Its plan, as described by Robert Gladstone, a principal in the development firm Madison Equities, was like that of a "butterfly with one bad wing."[16] In part, the polygonal geometry was developed because Madison Equities, which at one time owned 85 percent of the block, was not able to buy out the tenant leases in four small tenements at the Fifty-third Street corner. Consequently, the building was realized in two stages, with 875 Third Avenue built to wrap around the holdout buildings until their demolition in 1990, at which point a more monumental entrance was created on the building's reentrant northwest facade, set far back on a broad new plaza.

The primary, presumably Chicago-born innovation was Graham's incorporation of four atria into the tower, similar to the ones he had designed for the Skidmore firm's 33 West Monroe Street in Chicago (1980).[17] Three of the atria, each forty-eight feet high with clear northwest-facing glass walls, served the building's upper floors—stretching from the tenth through the fourteenth, the eighteenth through the twenty-first, and the twenty-fifth through the twenty-eighth stories. Within each grouping, floors were stepped back ten feet farther than the one below so that their sizes ranged from 26,000 to 29,000 square feet, forming office "precincts," a term of Graham's, that would be ideally suited to multifloored tenants who could create their own distinctive environments and identities within the building.[18] At ground level, a soaring eighty-five-foot-high public atrium that connected with the Fifty-third Street subway station was ringed by 35,000 square feet of retail space and three floors of offices. In 2000, the atrium was renovated by Beyer Blinder Belle, which replaced its red and black color scheme with shades of white and gray.[19]

Graham's boastful approach to the design was greeted with derision by his New York colleagues, as best summed up by the editors of the *AIA Guide*: "The ghost of the Mies van der Rohe grid appears in this Windy City octopod invention that is about as much New York as pan pizza or cherry phosphate. Poor Mies."[20] Paul Goldberger also objected to the architect's self-portrait as the inheritor of the principles of the so-called

Chicago School and his suggestion that Chicago enjoyed a special proprietorship over structural rationalism, stating that "Graham's claim . . . that the walls express the structure and therefore the building will be a lesson in Chicago design for those unstructurally expressive New Yorkers" didn't hold up.[21]

In 1984, as if to make amends for the Chicago office's bluster, Raul de Armas, of SOM's New York office, designed the 570-foot-tall, forty-nine-story super-minimalist, scale-bucking Wang Building, 780 Third Avenue, west blockfront between Forty-eighth and Forty-ninth Streets, a highly polished red Balmoral granite and gray-tinted glass monolith whose window arrangement suggested the pattern of the diagonal structural bracing within.[22] The rectangular slab occupied only 40 percent of its 22,092-square-foot site, creating a broad, essentially featureless plaza facing Third Avenue and wrapping around to the side streets. De Armas used a braced concrete tube system, the first of its kind, developed several years before by another Chicago-based SOM partner, the engineer Fazlur Khan (who also designed the braced steel tube structure of Chicago's John Hancock Tower). This option made it possible to eliminate interior columns, thereby gaining significant square footage on each floor, with the structural loads distributed evenly over perimeter columns located within the 69-by-125-foot exterior wall. The concrete tube system, further stabilized by diagonal bracing, was the most sensible means of accommodating the 470,000-square-foot tower's exceptional height-to-slenderness ratio of 8:1. A shear wall also rose through the center of each 8,836-square-foot floor plate, forming the eastern wall of the building's off-center core. The slenderness was impressive to be sure and indeed made 780 Third Avenue one of the last remarkable buildings realized in midtown under the laws of the 1961 zoning—as de Armas put it, it was the zoning's "final exclamation point."[23]

Despite the participation of two talented design architects, Cesar Pelli and Rafael Viñoly, working in association with the firm of Emery Roth & Sons, and the best intentions of a prominent Argentine developer, Jacobo Finkielstain, seeking to make a good impression in New York, 900 Third Avenue (1983), northwest corner of Fifty-fourth Street, was a sleek, well-detailed, but largely unmemorable box.[24] The first design for the 26,500-square-foot site, calling for a round-cornered tower shaped by four shallow setbacks, soon gave way to a hard-edged, 450,000-square-foot, thirty-six-story pile with only one awkwardly scaled north-facing setback near the top of the building that provided a springboard for an arcing four-story-high greenhouse stretching from the thirtieth to the thirty-fourth floor, serving as a reception area for the thirtieth-floor offices of Finkielstain's company, Progress Partners. The building was uniformly wrapped in ribbon windows and gray granite except for the first six stories at the building's southeast corner, where granite was replaced with the same satin finish silver aluminum skin that wrapped the neighbor to the south, Citicorp Center, thereby forming a well-intended but ineffectual gateway on Fifty-fourth Street. Plans to demolish the five-story tenement adjacent to the tower to the north and replace it with a six-story extension of the office building were abandoned, reportedly because of difficulties in breaking the tenant leases.

In contrast with 900 Third Avenue, Philip Johnson's design for 885 Third Avenue (1986), east blockfront between Fifty-third and Fifty-fourth Streets, undertaken for the

875 Third Avenue, between East Fifty-second and East Fifty-third Streets. Skidmore, Owings & Merrill, 1982. Aerial view to the southeast showing 885 Third Avenue (Philip Johnson and John Burgee, 1986) in middle left and 900 Third Avenue (Cesar Pelli, Rafael Viñoly, and Emery Roth & Sons, 1983) in lower left. Amiaga. AP

875 Third Avenue, between East Fifty-second and East Fifty-third Streets. Skidmore, Owings & Merrill, 1982. Detail of base. RAMSA

Wang Building, 780 Third Avenue, between East Forty-eighth and East Forty-ninth Streets. Skidmore, Owings & Merrill, 1984. View to the southwest. D'Addio. SOM

900 Third Avenue, northwest corner of East Fifty-fourth Street. Cesar Pelli, Rafael Viñoly, and Emery Roth & Sons, 1983. View to the southwest showing Citicorp Center (Hugh Stubbins & Associates, 1977) on the right. Hoyt. ESTO

Houston-based developer Gerald Hines, was an engaging knockout.[25] Hines, in partnership with Sterling Equities, hired Philip Johnson and John Burgee to design a 580,000-square-foot office building that benefited in size from improvements the developers would make to the Fifty-third Street subway station. In August 1981, Kenneth Hubbard, head of Hines's New York office, reported that the design for 885 Third Avenue was still in "styrofoam" but that the present thinking called for an elliptical plan.[26] Indeed, the ellipse would become the building's trademark feature, with Johnson stating early on that the tower would "have an enormous skyline identity because of its shape . . . an oval building in a square environment." Proclaimed the architect, "It will be one of the special monuments in New York."[27] Designed when Johnson was being phased out of his partnership with Burgee, so that the official credit for the building reads John Burgee Architects with Philip Johnson, the thirty-four-story tower was sheathed in faceted bands of red-polished and pink-flame-finished Swedish Imperial granite alternating with bands of brushed stainless steel in varying widths and gray-tinted ribbon windows.[28] According to Paul Goldberger, Fifty-

third at Third, the awkward but official name of the building, took its elliptical stepped-back form in anticipation of the passage of new midtown zoning rules being widely discussed at the time of its design in 1981.[29] The building bore a striking resemblance to an early rejected design of Raymond Hood's for a building—the so-called oil can—intended for Rockefeller Center, but Johnson's interpretation, much taller than Hood's eleven-story original, required that the upper floors be telescoped back to stay within the zoning envelope, creating an effect of dynamic movement that the public instantly likened to that of the emergence of a lipstick from its canister.[30] Hence the building was immediately dubbed the Lipstick Building. The setbacks, occurring at the nineteenth and twenty-seventh floors, brought the building back from Third Avenue and from the streets, leaving the easternmost edge sheer. Atop the building, a two-story elliptical granite-clad mechanical enclosure was set back further. Though seemingly curved, the ellipses were actually composed of two-foot-seven-and-a-half-inch-wide facets, numbering 180 on the lower section, 164 above the first setback, and 156 above the second setback.

The Lipstick Building's two-story-high glass-enclosed lobby was finished with a checkerboard-patterned granite floor and a glass mosaic ceiling. Outside, twenty-eight granite and stainless-steel columns, each twenty-eight feet tall, wrapped the building. As in the case of the Seagram Building, with which it shared an overt desire to be perceived as a free-standing object, Fifty-third at Third was anchored to its block by a "bustle," in this case a nine-story rectangular building intersecting with the building's northeast edge, inside of which space was set aside for a restaurant, Toscana (Piero Sartogo and Nathalie Grenon and Vignelli Associates), which opened in 1987. In 1992 Toscana was replaced by Haverson/Rockwell Architecture's Vong, at which point the firm also remodeled a portion of the lobby as the Lipstick Café.

Reactions to Fifty-third at Third were generally positive, as critics found themselves taking the building for what it was: an arresting design that, though highly individualistic, seemed just what was needed in its bland Third Avenue setting. In the opinion of Michael Sorkin, the building could, "with the addition of palm trees . . . easily pass for the Sunbelt." Surprisingly, Sorkin took on the unusual role of apologist for Johnson, writing in 1986, "This is a part of town dominated by recent construction, a place in which the idea of a continuous urban convention—never mind an indigenous one—has almost completely disappeared. As in Houston or Dallas, the plot is privileged over the aggregate, the suburban model, a perfect parable of capitalist initiative. Johnson apparently does not choose to question this pattern of isolation but to reinforce it, to go it one better—a logical choice in Houston and, alas, a logical one in this quarter of Manhattan." The usually acerbic critic seemed taken by the building's "good" and "distinct" shape: "I was braced by the oval: curvilinearity at last in a town whose relentless rectilinearity seems needless." But, Sorkin continued, "The project loses it in the details. The streamline of the strip windows is suffocated by a surfeit of materials and poor proportions. Moreover, the building doesn't know how to land, resting on awkwardly capped, woefully striped, and badly spaced columns. As with so many Johnson projects, the idea—a banded oval building—is insufficient to solve the problem of making the architecture, the slick slather of stone too inarticulate to substitute for real detail."[31]

885 Third Avenue, between East Fifty-third and East Fifty-fourth Streets. Philip Johnson and John Burgee, 1986. View to the northeast showing 875 Third Avenue (Skidmore, Owings & Merrill, 1982) on far right before demolition of holdout buildings, center. Payne. RP

885 Third Avenue, between East Fifty-third and East Fifty-fourth Streets. Philip Johnson and John Burgee, 1986. Lobby. Payne. RP

FIFTH AVENUE

Murray Hill

Anchored by the Empire State Building (Shreve, Lamb & Harmon, 1931) to the south and the New York Public Library (Carrère & Hastings, 1897–1911) to the north, the once-elegant Murray Hill stretch of Fifth Avenue between Thirty-fourth and Forty-second Streets reached a low point in 1976 with the opening of a Burger King fast-food restaurant on the ground floor of the former home of Tiffany & Company (McKim, Mead & White, 1906), an event that Ada Louise Huxtable cited as a particularly egregious example of the street's "mutilation."[1] In the first two decades of the twentieth century, the eight-block expanse had been home to grand department stores, such as B. Altman & Company (Trowbridge & Livingston, 1905 13) and Lord & Taylor (Starrett & Van Vleck, 1914) as well as the high-end jewelers Tiffany's and Gorham's (McKim, Mead & White, 1905).[2] During the Depression, the avenue's carriage trade retail began to give way to more popularly priced venues with the introduction of two new large five-and-dime emporiums for S. H. Kress (Edward Sibbert, 1935) and Woolworth's (1938) as well as smaller stores like the Lerner shop (Starrett & Van Vleck, 1938) and the A. S. Beck shoe store (Louis Allen Abramson, 1938).[3] Despite the growing "democratization," this stretch maintained its dignity until after World War II, when it entered a long period of decline, a reversal of fortune that achieved full speed in the 1960s and 1970s.

The area began to make a recovery of sorts in 1978 with the decision of the Republic National Bank, headquartered since 1965 in the ten-story limestone Beaux-Arts-style Knox Building (John H. Duncan, 1902; renovated for bank use, Kahn & Jacobs, 1964), southwest corner of Fifth Avenue and Fortieth Street, to build a new headquarters building on a portion of the west blockfront from Thirty-ninth to Fortieth Street.[4] As designed by Attia & Perkins, a newly formed partnership of Eli Attia and Bradford Perkins, the twenty-seven-story tower would wrap around the Knox Building, which would be included in the project, and cantilever over Sibbert's eight-story S. H. Kress Building, which had closed for business in December 1977. The modern classical stone facade of the Kress Building would be stripped and reclad in rose, beige, and gray granite. Attia, concerned primarily with not overwhelming Duncan's Knox Building, set his tower back ten feet from the common lot line, a strategy he believed would sympathetically frame the landmark building while making its own mark. Conceived as a pleated glass curtain drawn behind the Knox Building, the tower was clad in clear tempered floor-to-ceiling butt-glazing, resulting in a slightly greenish tint, while the Fifth Avenue-facing facade featured bronze-tinted glass. Atop the former Kress Building, Attia created a two-story skylit trading floor. Construction began in 1981, but delays associated with a holdout tenant in the top floor of the Kress Building slowed the project's completion until 1985. Paul Goldberger, while acknowledging the constraints of the "shoehorn" site, was nonetheless unimpressed: "The north face of the new tower, which forms the backdrop for the old building, has a zig-zag pattern, and it is obviously intended to look like a shimmering curtain of glass. But these good intentions are not enough; the tower bears down over the old building, turning this strong classical structure into a quaint little toy." Even worse, the critic noted, "is the fact that the splendid

Republic National Bank, southwest corner of Fifth Avenue and West Fortieth Street. Attia & Perkins, 1985. View to the southwest showing the Knox Building (John H. Duncan, 1902) in the foreground. McGrath. EAA

Art Deco facade of the Kress store was ripped off, then replaced not with the glass of the tower rising above but with another masonry skin that is vastly inferior to the one destroyed." Goldberger concluded that the building "is a jumble of the new, the old, the old trying to look new and the new trying to look old, and the result bespeaks nothing so much as a shrieking confusion."[5]

The Republic National Bank intended to build a thirty-two-story companion building, also designed by Attia, directly across the avenue on the site of the Woolworth store, northeast corner of Fifth Avenue and Thirty-ninth Street, which had closed in 1979. The bank acquired the site and demolished the building but was unable to proceed. The site was instead developed by Arthur G. Cohen and Martin Goodstein, who hired Emery Roth & Sons to design the undistinguished thirty-three-story Fifth Avenue Tower (1986).[6] Looking more like an office building than a residential tower, the bronze-colored glass building consisted of 175 studio and one-bedroom apartments on the top twenty-three floors with 64,000 square feet of office space and 26,000 square feet of street-level retail space behind broad arches of light-colored precast concrete. Soon, other high-rise structures followed, beginning with Skidmore, Owings & Merrill's twenty-five-story, 198,000-

461 Fifth Avenue, northeast corner of East Fortieth Street. Skidmore, Owings & Merrill, 1988. View to the east. Hoyt. MDA

420 Fifth Avenue, between West Thirty-seventh and West Thirty-eighth Streets. Brennan Beer Gorman, 1990. View to the southwest. Mauss. ESTO

square-foot 461 Fifth Avenue (1988), northeast corner of Fortieth Street, diagonally across the street from the Knox Building.[7] Carter B. Horsley enthusiastically praised Paul de Armas's design, which revealed a new Postmodern direction in the firm's hitherto straight-line Modernist work. Declaring it Manhattan's best new office building of 1988, Horsley wrote in the *New York Post* that it was a "stunning example of how a new structure can harmoniously relate to the avenue's rich traditions while asserting itself in a modern context." Horsley was impressed by the light-colored precast-concrete curtain wall and especially by the "exposed steel trusses in the center of the tower, with their circular design in front of gently curved window facades. It is high-tech structuralism reminiscent of some early cast-iron designs."[8] Paul Goldberger, however, was not so sure about the "four bizarre metal trusses. . . . They look like abstractions of classical pediments, and there is nothing stranger than a tower with classical pediments piled atop each other at four-floor intervals."[9]

Brennan Beer Gorman's 420 Fifth Avenue (1990), a thirty-story, 600,000-square-foot office condominium, occupying the full blockfront between Thirty-seventh and Thirty-eighth Streets, was clad in Stony Creek granite and reflective glass accented with vertical bands of polished red granite.[10] The site

was previously home to the A. S. Beck and Lerner stores as well as the Franklin Simon Building (Necarsulmer & Lehlbach, 1922). Perhaps the most notable feature of David Beer's design was the provision for 50,000 square feet of retail space on the bottom three floors, planned in an attempt to "help restore the high-toned look to an area that had become burdened with fast-food restaurants, cheap electronic stores, cut-rate rug bazaars and souvenir stands."[11] The completion of the building coincided with the downturn in the real estate market, and the retail space remained empty until 1994, when a large computer store took over 80 percent of the space.

In 1998 came the announcement of the tallest new building on this part of the avenue, Robert A. M. Stern Architects' fifty-four-story stone and precast-concrete residential tower, 425 Fifth Avenue, northeast corner of Thirty-eighth Street, to be developed by RFR/Davis.[12] Designed in consultation with H. Thomas O'Hara Architects, the scheme called for a six-story base containing 26,000 square feet of retail space and 37,000 square feet of commercial space as well as a tower cantilevered over a five-story structure to its north. After stepping back three times, the tower was to reach a height of 560 feet on the narrow 150-by-77-foot site. In May 2001, after Stern's firm withdrew from the project, Michael Graves & Associates

RIGHT Proposed 425 Fifth Avenue, northeast corner of East Thirty-eighth Street. Robert A. M. Stern Architects and H. Thomas O'Hara Architects, 1998. West elevation. RAMSA

FAR RIGHT 425 Fifth Avenue, northeast corner of East Thirty-eighth Street. Michael Graves & Associates and H. Thomas O'Hara Architects, 2004. View to the northeast. GRV

was asked to take over.[13] Graves, also working with O'Hara, reconfigured the building's mass and details, emphasizing the vertical with piers of glazed white brick. Thomas Balsley Associates was placed in charge of the small public plaza on Thirty-eighth Street. Topped out in April 2002, the 617-foot-high tower (2004) accommodated eighty-one condominium apartments on the top twenty-eight floors as well as ninety-fourlong-stay furnished rental apartments. Writing in the *New York Sun* in June 2002, James Gardner labeled the design, along with Arquitectonica's Westin Hotel on Forty-second Street, "among the ugliest our city has ever seen." He castigated the effort as representing "a kind of mongrelized modernism—an arch allusion to that movement, with none of its tough integrity," a building that "rises in a series of three clumsily centralized setbacks set over a six-story base that is rather maladroitly joined to the first setback." For Gardner, the Westin Hotel and 425 Fifth Avenue "will constitute an eyesore for generations yet unborn and, like all modern engineering, will grow only uglier as they grow older, without the possibility of that patinated enhancement that age traditionally conferred upon older buildings."[14]

While Lord & Taylor, northwest corner of Fifth Avenue and Thirty-eighth Street, was able to survive and prosper, such was not the case with B. Altman & Company, Thirty-fourth to Thirty-fifth Street, Fifth to Madison Avenue. In November 1984, as a consequence of changes in the law governing foundations, the Altman Foundation, which had owned the building since its founder's death in 1913, was forced to sell the business and its palazzo to a consortium of real estate investors.[15]

In March 1985 the exterior of the building was declared a landmark.[16] Two months later, a proposed conversion was reported that would confine the selling areas to the Fifth Avenue side of the building, resulting in a reduction of the store by half, with the rest of the space to be converted for use as offices.[17] This plan was not carried out, and in 1987 the L. J. Hooker Corporation, the American arm of the Hooker Corporation of Australia, headed by George Herscu, purchased the retail operations of B. Altman & Company from KMO-361 Realty Associates, who retained ownership of the chain's real estate holdings.

In November the two companies announced plans to add six floors of office space on the Madison Avenue side of the building, bringing its height to nineteen stories while confining retail operations to the first five floors of the entire building.[18] To be called the Altman Midtown Center, the expanded project would combine 405,000 square feet of retail space with 550,000 square feet of offices.

Hardy Holzman Pfeiffer Associates was retained to oversee the expansion, which Hugh Hardy saw as part of an ongoing process: the store itself had been built incrementally over eight years' time; moreover, the exterior of the building had been considerably modified in 1936 when severe deterioration of the French limestone led to the removal of sections of the cornice, the simplification of capitals, the coarsening of decorative details, and the removal of molded window surrounds and lintels once supported by console brackets. In addition to the six new office floors, Hardy's scheme called for the construction of a pavilion on the main roof and a four-story

atrium located pretty much at the place where the original domed rotunda had cut through the building's section until 1938 when it was filled in to make way for the installation of escalators and an increase in selling space.[19] Hardy proposed to use the same glazed brick and limestone of the original building and to "echo" its window details, fenestration patterns, and proportions "to permit the existing building and the addition to appear as one."[20]

Neighbors, not so concerned about the fine points of preservation aesthetics, pleaded that the taller building along Madison Avenue would rob them of sunlight. The project languished as L. J. Hooker suffered financial losses at Altman's as well as at Bonwit Teller, its other American retail chain. In August 1989, the retailer filed for bankruptcy following the collapse of its parent corporation in Australia. After 124 years in business, Altman's was forced to close in November 1989.[21] Thousands of New Yorkers packed the store on its final day, many in search of bargains, others for a glimpse into the last monument of a world they sensed was gone forever.

The economic downturn forced a reconsideration of the project, and in 1991 plans were announced for the conversion of 650,000 square feet of the retail portion of the Altman building to serve as home to the New York Resource Center, showrooms for the contract and residential design industry intended to supplement or perhaps even replace the International Design Center in Long Island City, which was proving unpopular with buyers.[22] As plans drawn by Hardy's firm in conjunction with Emery Roth & Sons to create the resource center proceeded, the New York Public Library came forward with a proposal to lease the remaining space in the six stories and the basement of the building facing Madison Avenue to serve as home to its new Science, Industry and Business Library.[23] In 1991 the firm of Gwathmey Siegel & Associates was hired to prepare plans for the library, which

quickly came to be known by the acronym SIBL, the classically allusive pronunciation of which was particularly appropriate given the mysteries that the facility's "super-high tech" approach to research promised to unlock.[24] By early 1993, the New York Public Library had completed the purchase of 213,000 square feet of space from the developers. SIBL opened in May 1996, providing space at one central location for a 1.2-million-volume research collection, the library's archive of 18 million United States patents, a 50,000-book circulating collection, and an open-shelf reference collection of 60,000 volumes as well as 110,000 periodicals, all of which had previously been housed at various locations. Gwathmey Siegel's plan compressed five floors of closed stacks into what had been three stories of retail space. By redistributing the floor levels, a total of 235,000 square feet was produced out of the original 213,000 square feet. When opened, the library occupied 160,000 square feet, with the remaining space slated for future expansion. The spacious, 44,000-square-foot basement was transformed into a research library and reading rooms, the architects overcoming the darkness of the location with a double-height atrium-like lobby in which a dramatic curved staircase led readers down from the Madison Avenue entrance.

Despite all the emphasis on the advanced technological retrieval and delivery of information, the goal was to demonstrate that the new electronic world was not only liberating for scholars but for all who wanted to learn, so that computer classrooms to train young and old were provided to offer the equivalent of the adult literacy programs of an earlier era. Nonetheless, as Paul Goldberger wrote, technology ruled at SIBL although "the goal" was "to prove that it can be a benign dictator. Lest all this interactivity make SIBL seem like yet another attempt to turn the city into a theme park, the architecture gives the new library a firm and solid grounding. The

RIGHT Healey Hall, Science, Industry and Business Library, New York Public Library, west side of Madison Avenue, between East Thirty-fourth and East Thirty-fifth Streets. Renovation of B. Altman & Company (Trowbridge & Livingston, 1905–13) by Gwathmey Siegel & Associates, 1996. Aaron. ESTO

BELOW Proposed Altman Midtown Center, Thirty-fourth to Thirty-fifth Street, Fifth to Madison Avenue. Renovation and expansion of B. Altman & Company (Trowbridge & Livingston, 1905–13) by Hardy Holzman Pfeiffer Associates, 1987. Model, view to the north. H3

collection's 1.2 million books and publications are housed in an architectural environment that manages to walk a delicate line between respect for the traditional library ambience and an expression of the sleek, light forms associated with the computer age." Goldberger noted the absence of "glitz" in the classic Modernist oak-paneled spaces of the lobby and reading rooms, although there was plenty of stainless steel, glass, and gray terrazzo.[25] Francis Morrone, writing in the *New Criterion*, was not so enthusiastic about SIBL's design. He found the dominant note of the architecture "tinny . . . followed by mean." For Morrone, the thirty-three-foot-high Healy Hall, named after Timothy Healy, the president of the New York Public Library when the project was initiated, was a "feeble 1990's slap at a grand foyer," while "the lower level, where the action is, has depressingly low ceilings, contributing to one's overall sense of being cramped—the polar opposite of Carrère & Hastings's masterpiece" on Forty-second Street.[26]

Two other enterprises rounded out the roster of tenants filling the remaining space in the Altman building. In 1995 Oxford University Press occupied 110,000 square feet of space facing Thirty-fifth Street and Madison Avenue. Designed by Hellmuth, Obata & Kassabaum, the publisher's offices

Proposal for Mid-Manhattan Branch, New York Public Library, 455 Fifth Avenue, southeast corner of East Fortieth Street. Hardy Holzman Pfeiffer Associates, 2000. Rendering of view to the southeast. H3

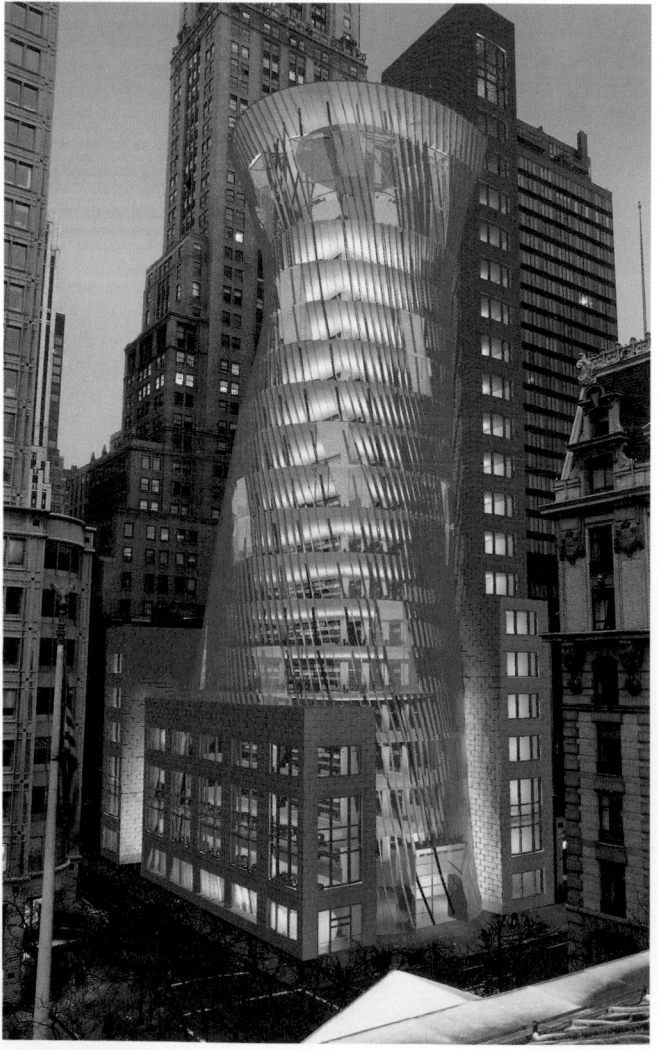

included a lobby, waiting room, mezzanine library, and "great room" to be used for seminars on the ground level and offices in the tower floors above.[27] When plans for the New York Resource Center failed to materialize, the City University Graduate Center entered into an agreement to purchase 582,000 square feet facing Fifth Avenue to which, in August 1999, it relocated from its building at 33 West Forty-second Street and from other nearby properties.[28] Gwathmey Siegel was hired to fit out the City University's space with offices and classrooms, a 70-seat multipurpose theater, a 185-seat recital hall, and a 389-seat auditorium. A new dining commons replaced the former Charleston Gardens Restaurant, where generations of shoppers had taken refreshment in a simulated southern garden.

Altman's was the second Fifth Avenue department store to become overflow space for the New York Public Library. Since 1964, the Mid Manhattan branch had occupied the top three floors of the former Arnold Constable store (T. Joseph Bartley, 1915), 455 Fifth Avenue, southeast corner of Fortieth Street.[29] After the closing of the store in 1975, the library gradually took over the rest of the six-story granite and limestone building, which it had owned since 1961, substantially renovating the space in 1982 under the direction of Giorgio Cavaglieri.[30]

In March 2000, the New York Public Library announced the results of an invited competition to greatly expand its Mid-Manhattan branch.[31] Following on the success at SIBL, Gwathmey Siegel & Associates was again picked by the library to do the work, besting competition entries from Hardy Holzman Pfeiffer and Smith-Miller + Hawkinson. Instead of an expansion and renovation, Hardy Holzman Pfeiffer had proposed replacing the existing building with a light-filled sculptural glass and metal volume featuring naturally lit open stairways. According to Craig Kellogg, Smith-Miller + Hawkinson's "ambitious" scheme, prepared in association with library experts Shepley Bulfinch Richardson & Abbott, "would have added no new weight to existing structural columns," with the glass addition, extending over half of the existing roof, suspended from a large truss.[32] The highlight of their plan was a column-free reading atrium with a diagonal glass wall affording views over Fifth Avenue. Gwathmey Siegel's winning entry used the existing building as a base for an eight-story, 117,000-square-foot tower with vertically ribbed wavy glass walls. The plan also proposed gutting the Arnold Constable building, with the ground floor converted into a revenue-producing retail space. Herbert Muschamp enthusiastically greeted the winning proposal, calling the "surreal" design "a transformation in Gwathmey's architecture. . . . To be as blunt as the design is curved: Gwathmey proposes to put a gigantic bustier atop the old department store."[33] Gwathmey's design did not move forward, however, victim to budget cuts imposed after September 11, 2001.

Any effort to revitalize the Murray Hill stretch of Fifth Avenue would have to come to terms with two other landmarks of the carriage trade area, each designed by McKim, Mead & White. Not only had Stanford White's Tiffany's, southeast corner of Fifth Avenue and Thirty-seventh Street, modeled on the Palazzo Grimani in Venice, suffered the indignity of a fast-food restaurant on its ground floor in 1976, it was sold in the following year to the Rev. Sun Myung Moon's Unification Church. After pledging a full restoration, the church did virtually no work and in 1987 came forward

Proposal for Mid-Manhattan Branch, New York Public Library, 455 Fifth Avenue, southeast corner of East Fortieth Street. Smith-Miller + Hawkinson, 2000. Photomontage, view to the southeast. SMHA

Proposal for Mid-Manhattan Branch, New York Public Library, 455 Fifth Avenue, southeast corner of East Fortieth Street. Gwathmey Siegel & Associates, 2000. Model, view to the southeast. Pottle. ESTO

Proposal for Mid-Manhattan Branch, New York Public Library, 455 Fifth Avenue, southeast corner of East Fortieth Street. Gwathmey Siegel & Associates, 2000. Rendering by Jim Akers. GSAA

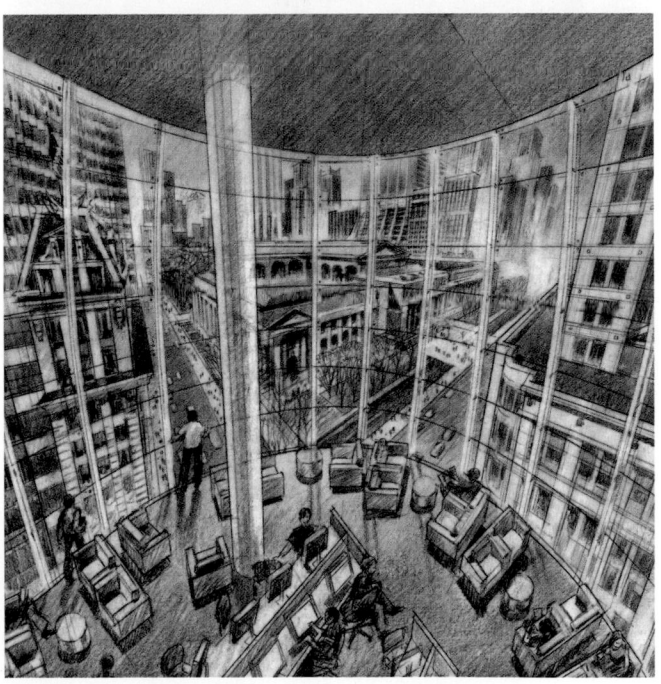

with a short-lived proposal to build a tower atop the building, which had just received official landmark status.[34] Hardy Holzman Pfeiffer's plan for the forty-story precast-concrete-clad Tiffany tower, which would also involve a faithful restoration of most of the building's facade—two bays of the top two floors were to be removed to form light courts—was abandoned after a similar effort to top the Metropolitan Club with a tower by James Stewart Polshek was rejected by the Landmarks Preservation Commission (see Upper East Side). In 1990 Christopher Gray described the state of the Tiffany building as a "notorious object lesson in how not to treat a landmark," with the structure "now as grimy as week-old snow on a New York street. Age and the atmosphere have corroded the soft marble and the windows are so dirty it is hard to tell if the lights inside are on or off."[35] A change in ownership a decade later promised some good news for the beleaguered landmark, with David Dunlap reporting in February 2002 that Beyer Blinder Belle was at work on a restoration plan that would return the building "to something resembling its original integrity, if not quite its belle epoque grandeur."[36] Such was sadly not the case for the Gorham Building across the street, which had been radically altered by Herbert Tannenbaum in 1960 to serve as an office building, destroying its eight-foot-deep cornice and three-bay avenue-facing arcade.[37] In 1998 the Gorham Building was landmarked.[38] In

2000 its owners, in an attempt to spiff up the property, retained the architect Eric Cohler and the decorative painter Andrew Tedesco to re-create the original bottom floors of the building, not in permanent stone, but with a trompe l'oeil painting on sheets of four-by-eight-foot outdoor signboard. The Landmarks Preservation Commission, however, was not impressed with the plan, and the owners withdrew it before a vote could be taken.

The northern linchpin of the Murray Hill stretch of Fifth Avenue, the main branch of the New York Public Library, was the subject of a masterful restoration in conjunction with the reworking of Bryant Park (see below). The prominent southern anchor, the Empire State Building, was also the subject of dramatic improvements in 1976 when, as part of the Bicentennial celebrations, outdoor lighting veteran Douglas Leigh installed more than 200 floodlights above the Seventy-second floor, allowing for brilliant nighttime multicolor lighting displays.[39] The popular lighting effects were changed seasonally and in relation to important holidays and events. In 1979 the observatory on the eighty-sixth floor was renovated by Alan Sitzer Associates, and in 1981 the exterior of the building and its ground floor were granted official landmark status.[40] Beginning in the late 1980s and lasting through the mid-1990s, an extensive renovation program was undertaken that included the installation of 6,300 new windows with red frames to re-create the original effect, computerized elevators, new central air-conditioning, and a cleaning of the limestone facade.[41] The collapse of the World Trade Center towers on September 11, 2001, returned to the Empire State Building its status as the tallest—and most prominent—building in New York.

Proposed addition to Tiffany & Company (McKim, Mead & White, 1906), southeast corner of Fifth Avenue and East Thirty-seventh Street. Hardy Holzman Pfeiffer Associates, 1987. Model, view to the southeast. H3

New York Public Library

The New York Public Library (Carrère & Hastings, 1897–1911), west side of Fifth Avenue between Fortieth and Forty-second Streets, one of the world's great research institutions, was home to more than 29 million items stored in eighty-eight miles of stacks made available to 1.5 million people each year.[42] By the late 1970s, the building was in an appalling state of disrepair and the library was also financially stressed, prompting the trustees to begin a major fund-raising campaign that did not get going in earnest until April 1981, when Vartan Gregorian replaced Richard W. Couper as president.[43] Gregorian brought remarkable energy and enthusiasm to the library—much-needed attributes for the daunting task of bringing Carrère & Hastings's building back to something even approaching its glory days. As Paul Goldberger wrote shortly after the library's trustees, in April 1982, announced the first phase of what would be a twenty-year-long project of reconstruction and restoration, the library over the years had been "altered and chopped up so that almost none of its great interior spaces can be seen in their original condition."[44]

The plan for the library's restoration was drafted by Davis, Brody & Associates in conjunction with Giorgio Cavaglieri working with Arthur Rosenblatt, vice president for architecture at the Metropolitan Museum of Art, who took on the job of part-time consultant to the library.[45] Even before the master plan was produced, the library announced in December 1981 that the main exhibition room, which had been divided into offices in 1942, would be restored to its original purpose by Davis, Brody and Cavaglieri. As the exhibition hall was stripped of its encumbrances, Goldberger marveled at "one of the building's finest, if most eccentric rooms," with marble walls and an ornately carved wooden ceiling as well as a "series of unusual partitions that look like triumphal arches flanked by Ionic columns and pilasters."[46] Renamed the Gottesman Exhibition Hall, the room was reopened in 1984. Also under Cavaglieri's guidance, work began in early 1982 on the restoration of the periodical room at the south end of the main floor, where Richard Haas was commissioned to paint a series of thirteen murals illustrating the headquarters of great New York periodical publishers. When it reopened in 1983, the periodicals room was named in honor of DeWitt Wallace. In the early 1920s Wallace had used the room as his office, condensing magazines and journals into what would become *Reader's Digest*.

Every aspect of the project was undertaken with great care and deliberation, including the bright blue nineteen-foot-high, 200-foot-long construction fence that closed off the Fifth Avenue terraces in 1982–83 so that work could proceed on their restoration as well as that of the building facade. The elaborate fence, an idea of Arthur Rosenblatt's, also had another purpose: it was part of a campaign to fight the drug culture that spilled over from Bryant Park to plague the library's terraces, which when the renovation was finished were to be filled with kiosks in daytime hours and brightly lit as part of an overall scheme of nighttime floodlighting. Laurie Olin, who was in charge of the landscaping plans for Bryant Park (see below), worked with Davis, Brody on the redesign of the Fifth Avenue terraces. Hugh Hardy, who was also involved with the plans for Bryant Park, designed the kiosks.

While Gregorian and the trustees who brought him to the library and supported his vision can be credited with making the library project one of local pride, it was the May 1983

DeWitt Wallace Periodicals Room, New York Public Library, west side of Fifth Avenue, between West Fortieth and West Forty-second Streets. Restoration by Davis, Brody & Associates, 1983. View showing murals by Richard Haas. Mauss. ESTO

decision of the philanthropist Brooke Astor to concentrate all her considerable energies on the project that guaranteed the social cachet required to raise the enormous funds needed to see the restoration through to completion. By May 1984, with the Gottesman Exhibition Hall and the Wallace Periodicals Room already reopened, work on the restoration of Astor Hall, the main entrance facing Fifth Avenue, as well as the cleaning of the Fifth Avenue facade, had also been completed. Goldberger applauded the results, although he did point out what he felt was the exhibition hall's "frustrating and awkward" plan: "It is difficult to know quite what [Carrère & Hastings] were thinking when they set aside this room in their original plans as an exhibition area, for it is so powerful an architectural presence that it struggles with anything put on display inside it."

By June 1985, the library's collection, which was gaining 150,000 volumes each year, had long since outgrown the main branch's storage capacity, prompting a plan to construct book stacks under Bryant Park. The project was to include the restoration of the park itself, which would be closed and surrounded by a chain-link fence until the work was completed. The new stacks (1987–89), connected back to the library building through a sixty-two-foot-long tunnel, were designed by Davis, Brody in consultation with Laurie Olin to make sure they made as minimal an intrusion on the park as possible. The 121,500 square feet of space in two levels beneath the park provided eighty-four additional miles of shelving able to house 3.2 million books and 500,000 microform reels. Despite

the increased capacity, less than ten years later the library was again running out of space, leading to a collaboration with Columbia and Princeton to build an off-site, no-frills storage warehouse in Princeton, New Jersey, that would offer cheap, climate-controlled book storage.

By the time of the library's seventy-fifth anniversary in May 1986, much of the building's restoration had taken place or was well under way, refuting forever any argument that the sumptuously detailed, grandly proportioned building could not accommodate modern requirements for climate control and lighting, not to mention information and book retrieval, and at the same time be as it was on May 23, 1911, when President William Howard Taft presided over its opening. When the almost half-acre terrace facing Fifth Avenue reopened in 1988, New Yorkers were surprised to find that the space had been subtly transformed by Davis and Olin, who made the library's facade more visible and the space safer by removing the planting that was massed against the building and replacing it with a double row of lacy Japanese locust trees located near the east edge of the platform. Olin devised a new paving scheme of granite, bluestone, and cobbles and placed movable chairs and tables beneath the locusts. Hardy's 1983 kiosks, estimated to last only five years, were still in good shape and remained.

In 1986 work began on the restoration of Room 80, a prosaically titled skylit crystal palace that originally served as the circulating library. Its reemergence was far and away the most surprising of all the library's revelations. The 80-by-80-by-30-foot-high room had been inserted into the library's plan by Carrère & Hastings, who originally intended the space as an open courtyard. Much later, probably in the 1940s, the glass-and-cast-iron ceiling was tarred over and a false ceiling hung, concealing this feature entirely, as bookshelves and wallboard obscured the yellow and gray Siena-marble-clad walls. As restored, the room, renamed the Celeste Bartos Forum, became a 500-seat lecture hall as well as a meeting room for

Kiosk, New York Public Library, west side of Fifth Avenue, between West Fortieth and West Forty-second Streets. Hardy Holzman Pfeiffer Associates, 1983. View to the northwest. H3

the Friends of the Library. With the glass-covered train room of McKim, Mead & White's Pennsylvania Station (1904–10) only a dim memory to older New Yorkers, the Bartos Forum revealed anew the daring engineering that accompanied Beaux-Arts architecture of the fin de siècle. The elliptical glass skylight, carried on elliptical cast-iron arches was, for Goldberger, "proto-high-tech joined to voluptuous ornamentalism."[48] But the renovation of Room 80 came with some compromises to the original, most notably the acoustic-driven decision to carpet over the beautiful tile floor and the decision to leave the perimeter skylights covered so as to more easily dim the room for slide projection, thereby sacrificing the impression of a glass-enclosed courtyard that Carrère & Hastings originally intended.

In 1997–98, with funds donated by the Rose family, the library was able to restore its greatest glory: the 297-by-78-by-51-foot-high, 23,000-square-foot wood-paneled Main Reading Room—one of the nation's largest column-free rooms—where Davis Brody Bond uncovered windows tarred over during World War II blackouts, increased seating capacity, accommodated electronic workstations and readers' laptop computers, and rehabilitated the mechanized book-retrieval system. Wiring for new computers was slid up through the Carrère & Hastings-designed readers' tables, which were meticulously restored to their original splendor. Because the original ceiling murals by James Wall Finn were badly damaged from leaks,

ABOVE Celeste Bartos Forum, New York Public Library, west side of Fifth Avenue, between West Fortieth and West Forty-second Streets. Restoration by Davis, Brody & Associates, 1987. DBB

FACING PAGE Rose Main Reading Room, New York Public Library, west side of Fifth Avenue, between West Fortieth and West Forty-second Streets. Restoration by Davis Brody Bond, 1998. DBB

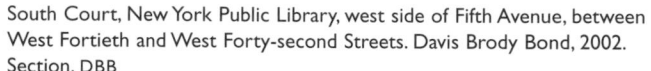

South Court, New York Public Library, west side of Fifth Avenue, between West Fortieth and West Forty-second Streets. Davis Brody Bond, 2002. Section. DBB

South Court, New York Public Library, west side of Fifth Avenue, between West Fortieth and West Forty-second Streets. Davis Brody Bond, 2002. DBB

new murals were commissioned from Yohannes Aynalem, who executed a series of thirty-six-by-eighteen-foot panels that were then affixed to the ceiling. Renamed the Deborah, Jonathan F. P., Samuel Priest, and Adam Raphael Rose Main Reading Room, the restored space opened to the public on November 16, 1998. Novelist Thomas Mallon described his maiden trip back to the renovated space: "My first sensation was of an unfamiliar brightness. New lights shone on the ceiling and bookcases; old blackout paint had been scraped from some of the windows; and all 1,620 bulbs in the 18 chandeliers appeared—as never before—to be working. The bronze table lamps, all shined up after 87 years, seemed lit from without as well as within. But all this new illumination," Mallon was forced to admit, "soon revealed a space that looked remarkably the same," perhaps the highest compliment the architects could have hoped for.[49]

While renovation of the reading room was still in progress, plans were announced in 1998 for a further expansion of the library's facilities through the construction of the so-called South Court addition that was, with the exception of the underground book-storage facility, the first major permanent structure to be added to the building since its completion in 1911. Designed by Davis Brody Bond, it consisted of 40,000 square feet of space for offices, operations, and training rooms on six levels, ingeniously inserted into a former light well yet visually held free from the historic building's walls by a continuous perimeter skylight. The South Court, largely unknown to the public, was originally used by the staff for recreational and social events. It held a marble fountain and a marble horse trough and, after 1919, a trellis-covered bungalow that served as a rest and luncheon room for employees. The fountain was demolished in 1950 and the bungalow was razed to make way for the new construction. Visitors would enter the seventy-three-by-seventy-three-foot addition through the Astor Court and would use a glass staircase to reach the below-grade 178-seat auditorium for lectures and conferences; the glass-walled top floor would house an employee lounge. An angled glass skylight connected the addition to the main building at the third-floor level, permitting natural light to reach the lower floors and light the courtyard's facades. Raul Barreneche found the South Court, completed in September 2002, "a graceful, seemingly effortless addition that stakes out a strong modern presence within the library's marble halls, frescoed walls, and carved plaster ceilings. It uses both light and a lightness of touch to convey a sense of transparency that more accurately reflects the essence of the contemporary library than grand, gilded interiors. It has just enough character not to fade into the background, but lets the surrounding historic architecture become an active part of its composition."[50]

Bryant Park

While Forty-second Street's most troubled block lay between Seventh and Eighth Avenues, the impact of its decrepitude spread east toward the seemingly prosperous midtown business district. Between Sixth and Seventh Avenues, though there were no theaters, the pattern of cheap restaurants and cheap shops interspersed by those specializing in pornography was almost identical to that of "the Deuce." As if to anchor the urban blight, Bryant Park (Lusby Simpson, Aymar Embury II, and Gilmore D. Clarke, 1934), though still physically elegant, had became an increasingly dangerous nine-acre oasis lying between Fortieth and Forty-second Streets, Sixth and Fifth Avenues, where petty crime, gambling, and drug trafficking were daily occurrences. A fatal stabbing in June 1976 so aroused the public that some civic leaders suggested closing the park, whose origins as a public open space dated back to 1842 when the land, directly west of the newly built Croton Reservoir, was set aside as Reservoir Square.[51] In May 1977, the park's fortunes began to look up when a small Bryant Park Fix-Up Fair, organized by local and community groups, drew attention as part of a study financed by eleven corporations and prepared by the City University's Graduate Center, which suggested that repairs of park facilities, plantings, increased police coverage, and the staging of public events were all needed to rescue the park from the drug dealers and others who compromised its enjoyment by the public at large.[52] Police were put on duty in the park in 1978 so that the Parks Commissioner could state in early July that he thought people were not afraid to go there anymore.[53]

In 1979, with the trustees of the New York Public Library beginning their efforts for a major restoration and renovation of the main branch, the problems of neighboring Bryant Park were seen as a possible impediment to that institution's successful rehabilitation. The park and the library were connected by more than just their obvious physical proximity: when the library replaced the Croton Reservoir, Thomas Hastings, the library's co-designer, had reworked the park with a design that lasted until its redevelopment in the 1930s. In a move that many have pinpointed as the real turning point in Bryant Park's future, the Rockefeller Brothers Fund, active in the efforts to refurbish the library, hired William H. Whyte to study the park and make recommendations for its improvement.[54] Whyte, a journalist and former editor of *Fortune* best known for his landmark book on the sociology of corporate culture, *The Organization Man* (1956), had turned his attention to the problem of cities and in particular to the issues surrounding the use and abuse of urban open spaces. After a detailed survey of how the park functioned on a day-to-day basis, Whyte concluded that its

Proposed restaurant pavilions for Bryant Park, site bounded by West Fortieth and West Forty-second Streets, Fifth and Sixth Avenues. Hugh Hardy, Jack Beal, and Sondra Freckelton, 1981. Rendering of view to the east. H3

most significant problem was underutilization. "Psychologically, as well as physically, Bryant Park is a hidden place," Whyte wrote. "The best way to meet the problem is to promote the widest possible use and enjoyment by people."[55] Specifically, Whyte suggested that more entrances be created in addition to the existing six. He also called for the restoration of the Lowell Fountain (Charles Adams Platt, 1912), the rehabilitation of the Carrère & Hastings–designed restroom structures, the provision of ramps for the handicapped, and the removal of the iron fence and shrubbery. Most important of all, he envisioned the transformation of a passive oasis into an extensively programmed public place.

In 1980, responding to Whyte's report, the Rockefeller Brothers Fund provided seed money to establish the Bryant Park Restoration Corporation, dedicated to improving conditions in the park.[56] Under the leadership of the Restoration Corporation's chairman, Andrew Heiskell, former head of Time, Inc., and chairman of the board of the public library, and its executive director, Daniel A. Biederman, the not-for-profit group, working in concert with the Parks Council, installed canopied book stalls, an open-air café, and new flowerbeds. Mime and musical performances were scheduled, but Biederman recognized that special programs and events were not enough because "when the concert is over, the audience leaves and the drug pushers drift back."[57] Consequently, security patrols were substantially increased and a massive program of graffiti removal was instituted.

In 1981, as part of the centennial celebration of the Architectural League of New York, which commissioned eleven architect-artist collaborations, Hugh Hardy, working with artists Jack Beal and Sondra Freckelton, in a harbinger of things to come, proposed two restaurant pavilions for Bryant Park.[58] Hardy's glass-and-steel pavilions, embellished by Freckelton's murals and Beal's colored glass ceiling, would flank the existing Lowell Fountain, which would itself be framed by a semicircular pergola supported by whimsical columns designed by Beal. Reviewing the exhibition in the *Village Voice*, Michael Sorkin deemed the collaboration "pure cotton candy, charming and insubstantial. The best bit is the . . . pergola around Lowell Fountain, which is made with ceramic columns whose imagery is largely vegetable in origin."[59]

The ameliorative efforts of the Bryant Park Restoration Corporation continued, bringing increased concerts, a reseeded lawn, and in 1982–83 a reduced-price ticket booth,

an idea modeled after the very successful TKTS booth in Times Square but offering no direct competition, selling only tickets to musical concerts and dance performances.[60] Located in the northwest corner of the park, the modest booth was run by the Theatre Development Fund, administrators of the Times Square facility, with William Whyte serving as a consultant on traffic patterns for the ticket lines. By August 1982, the improvements to the park seemed to be paying off, with the announcement that crime had dramatically decreased. But as Deirdre Carmody noted in the *New York Times*, the park still displayed a "Jekyll and Hyde character": "The public did indeed flock to the park . . . but as soon as evening came or the weather turned cool, the crowds disappeared and . . . drug dealers and other shadowy characters lurked along the long allées of plane trees and around the rear of the library."[61]

In December 1983, a public-private collaboration between the Parks Department, the New York Public Library, and the Bryant Park Restoration Corporation produced a plan for the dramatic physical reconfiguration of the park as well as a radical reorganization of its administration.[62] Under the terms of the controversial and unprecedented plan, the Bryant Park Restoration Corporation would lease the entire park from the city and be responsible for its operation, although the Parks Department would retain veto power over the corporation's decisions. Laurie D. Olin, of Hanna/Olin, was placed in charge of the landscaping, proposing a pair of long, narrow reflecting pools flanking the central lawn. Olin also proposed moving the

Approved plan for Bryant Park, site bounded by West Fortieth and West Forty-second Streets, Fifth and Sixth Avenues. Hanna/Olin, 1987. OP

Lowell Fountain back to its original location on the east terrace and placing the statue of William Cullen Bryant (Herbert Adams; canopy and pedestal, Thomas Hastings, 1911), the park's namesake since 1884, on the west side. Olin's scheme would offer new lighting, create gravel paths to encourage people to walk through the park and, as William Whyte had advised, remove the large hedge and renovate the existing comfort stations. Hugh Hardy was placed in charge of a huge new restaurant to be built at the park's eastern edge, along the back wall of the library. Likened by some to George Carstenson and Charles Geldemeister's Crystal Palace (1853), built for America's first world's fair and located on the grounds of the park until its destruction by fire in 1858, the two-story glass-and-steel 1,000-seat restaurant was to be run by Warner LeRoy, the flamboyant owner of the Tavern on the Green, located in Central Park, and Maxwell's Plum, on First Avenue, who would contribute $2 million for the cost of the renovation work as well as set aside a percentage of the proceeds from the restaurant toward the maintenance of the park.[63] The redevelopment would add four food kiosks and tables and chairs for 4,000 people and called for a permanent private security force.

For Paul Goldberger, the new plan was "sweeping not only in a physical way, but in an ideological one as well, for it envisions the park taken out of the direct control of the city government and placed in private hands." Goldberger praised Olin and Hardy for largely succeeding in the difficult task of changing the park "drastically" while also preserving "what is best about it in its present state." But he noted that in direct contrast to Whyte's advice, the number of entrances was actually reduced instead of expanded, going from six to four. The critic was not completely enamored of Hardy's large pavilion, which he deemed "a bit too sleek, a bit too smooth and shiny, and a bit less deferential to the library than it should be." Rising as high as eighty feet, the restaurant would obscure almost entirely the unique rear facade of the library, composed of twenty-six alternating bands of light marble and dark window strips marking the location of the book stacks. "Is it worth covering up a part of the library?" Goldberger asked. "The answer, in this case, should be a very cautious yes. The library . . . has always had a terrible relationship to Bryant Park. There is no way to get in or out of the library from the park . . . and there is no logical way in which to add an entrance or exit through the library stacks. The result has been that the wide terrace behind the library, the least used

part of the park, is a grandiose cul-de-sac. But by filling up this terrace with a large and spectacular pavilion-like restaurant what has been the emptiest part of this sad park could become its most active. It could be the magnet that would attract people to the entire park and, indeed, on off-hours to this whole section of midtown, letting Bryant Park at last be the piazza for midtown Manhattan that it should be."[64]

Notwithstanding Goldberger's lukewarm approval, the public reception was largely negative, with the Parks Council taking the lead in protesting the plans, in particular the idea of ceding public control of parkland to a private entity, even if it was a not-for-profit. The council also objected to the size of the restaurant, with the group's executive director, Jeanette Bamford, caustically noting that if built according to present plans, it would "turn the park into a lovely setting for the restaurant."[65] Five months after the plan was announced, the Bryant Park Restoration Corporation scaled back its privatization demands to include only the land on which the restaurant would sit, with the rest of the park to remain under the control of the Parks Department. As the plan wound its way through the complicated approvals process, Olin's landscaping scheme also came under attack, with the idea of reflecting pools falling into disfavor. In 1985 the plan was knocked somewhat off stride when the New York Public Library realized that it was running out of space and proposed to build underground stacks beneath Bryant Park. Prospects for the plan's realization were further dampened when Warner LeRoy dropped out of the project in May 1986, fearing that the delays would only continue. The Bryant Park Restoration Corporation decided to press on, with Olin working on a new design and Hardy scaling back his restaurant scheme.

In September 1987, in an effort to restart the project, a revised design was released, one that more directly addressed the recommendations articulated by William Whyte.[66] Laurie Olin's new landscape plan kept the basic layout of the park the same, including the locations of the Lowell Fountain and the Bryant statue, but instituted a number of changes to "open up" the space, increasing the number of entrances from six to eleven. The ceremonial entrance at Forty-first Street and Sixth Avenue would be reconfigured to improve sightlines and visibility by flattening out the main stairway with broad landings. The entrance plaza at Forty-second Street and Sixth Avenue would be enlarged and two new fifty-foot-wide midblock entrances created. A new north–south path at the east end of the park would be added to allow pedestrians to use the park as a direct link from Fortieth to Forty-second Street. The considerably expanded central lawn remained the focus of the park, but four new openings would be punched through the limestone balustrade on its north and south sides, encouraging cross-circulation and inviting more people onto the lawn. To supplement the bench seating, more than 1,200 lightweight metal and wood chairs, modeled after the ones in the Tuileries garden in Paris, were to be placed throughout the park. Whyte considered this addition crucial to the park's success, noting that the new chairs "make the user of the park sort of a planner because the user has to decide where to sit."[67] Although Whyte's request that the hedge be removed was accepted, his proposal to take down the spear-tipped perimeter fence was

FACING PAGE Bryant Park, site bounded by West Fortieth and West Forty-second Streets, Fifth and Sixth Avenues. Renovation by Hanna/Olin and Lynden B. Miller, 1992. View to the southeast. Charles. FCP

rejected after several groups, including the Friends of Cast-Iron Architecture, objected. Instead, the historic fence was dismantled, repaired, repainted, and put back in place.

A key feature of the landscape plan was the introduction of two 300-foot-long, 12-foot-deep garden beds flanking the north and south borders of the central lawn, constituting one of America's largest public perennial flower and plant displays. According to garden designer Lynden B. Miller, her design was "in the tradition of the great English mixed-herbaceous borders," with the goal of providing continual color throughout the year.[68] In an effort to entice more people into the park, the gardens, divided into six beds backed by dark green yew trees and featuring over 360 shrubs and 2,500 perennials, were also designed to appeal to office workers observing the display from buildings overlooking the park. The revised plans also included an extensive program of lighting devised by Howard Brandston, who restored many of the original fixtures and created fourteen faithful cast-bronze reproductions of lampposts originally designed by Carrère & Hastings for the New York Public Library to line the park's entrances. To cast a soft, moonlightlike glow on the central lawn, Brandston placed eleven 1,000-watt floodlights atop the New York Telephone Building (Kahn & Jacobs, 1974), across from the park on the west side of Sixth Avenue between Forty-first and Forty-second Streets.[69] In addition to restoring the Lowell Fountain and refurbishing the various statuary, the plans included the renovation of the two twelve-by-twenty-foot granite-faced restroom buildings by Carrère & Hastings; under the direction of Kupiec & Koutsomitis, the structure at Forty-second Street would become "New York's flagship restroom," according to Joan K. Davidson of the J. M. Kaplan Fund, who donated funds to the cause, while the one at Fortieth Street would serve as a potting shed.[70]

Bryant Park, site bounded by West Fortieth and West Forty-second Streets, Fifth and Sixth Avenues. Renovation by Hanna/Olin and Lynden B. Miller, 1992. RAMSA

Bryant Park, site bounded by West Fortieth and West Forty-second Streets, Fifth and Sixth Avenues. Renovation by Hanna/Olin and Lynden B. Miller, 1992. View to the northeast showing Bryant Park Grill (Hardy Holzman Pfeiffer Associates, 1995). H3

The most dramatic change, however, in the revised plans was the scaling back of Hugh Hardy's restaurant pavilion. Replacing the enormous single 40,000-square-foot structure were two symmetrical, 122-by-50-foot pavilions flanking the Bryant statue on the park's east terrace but rising only eighteen feet against the 110-foot rear facade of the library, as opposed to the 80-foot height of the original proposal. The one-story, 5,250-square-foot glass-and-steel buildings featured weathered-wood trellises supporting wisteria. Hardy was also responsible for the design of four freestanding kiosks, smaller versions of the restaurant pavilions, three of which would dispense food while the fourth would serve as a discount ticket booth.

Although the Bryant Park Restoration Corporation was willing to compromise on design issues, in terms of the administration of the park, the revised proposal reverted to the earlier arrangement in which the Restoration Corporation would lease the entire park from the city and be responsible for its management. The reaction to the revised scheme was very positive, with the Municipal Art Society quickly approving the new plans and the Parks Council, which had done so much to scuttle the previous proposal, also coming on board

with not a peep of protest concerning the privatization of the park. Paul Goldberger, seemingly forgetting that he had "cautiously" supported the first plan, including Hardy's large pavilion, blasted the four-year-old scheme and praised the new one, writing that the "architecture and design aspects this time are vastly improved."[71]

Work on the new plan began in earnest in the summer of 1988, after approval by the Art Commission, with the excavation necessary to create the New York Public Library's underground stacks. Olin, working with the library's architects, Davis, Brody, made every effort to conceal the existence of the stacks, carefully hiding vents and camouflaging beneath a commemorative plaque the trapdoor that served as the stack's emergency exit into the park. Surrounded by a chain-link fence for almost four years, Bryant Park reopened in April 1992 to rave reviews and not a little astonishment on the part of many New Yorkers. Mitchell Owens, writing in the *New York Times*, gushed: "Once derelict, now divine," the restored park "is eloquent proof that in the city that never sleeps, pockets of Seurat-style serenity can survive, even flourish. An estimated 10,000 visitors a day can't be wrong."[72] The restaurant pavilions, however, were far behind schedule because the first selected operator, Jerome Kretchmer, was unable to raise enough money to proceed. Michael Weinstein, of Ark Restaurants, took over the project, and the Hardy-designed pavilions, with interiors by Cary Tamarkin and Nancy Mah, opened in 1995. One functioned as a casual café while the other, the Bryant Park Grill, was a more formal restaurant. *New York Times* critic Ruth Reichl deemed the "gorgeous" grill "more Paris than New York City,"[73] while Matthew Barhydt, writing in *Oculus*, believed that Hardy had "created a background building in the best sense of the term."[74]

After the successful reopening of the park, the Bryant Park Restoration Corporation continued its program of events and concerts, augmenting the fare in 1993 with a summertime program of Monday night movies projected from the back of a trailer onto a twenty-by-forty-foot screen set up in front of the Lowell Fountain, drawing large crowds. In October 1993 the park became the annual host to a week-long fashion show sponsored by the Council of Fashion Designers of America.[75] Dubbed "Seventh on Sixth" and intended to rival the large shows in Paris and Milan, the popular and highly publicized shows took place under two thirty-foot-high white polyester white tents designed by architect Todd Dalland. A little more than a year after the park's reopening, the *New York Times* reported that office leasing rates in the direct vicinity of Bryant Park had increased significantly, with many in the real estate community attributing the rise to the renewed park, whose success would also have a major impact on future public-private partnerships in the city.

Fifth Avenue Face-lift

The character of Fifth Avenue between Forty-second and Fifty-ninth Streets began to shift with the completion of Olympic Tower (Skidmore, Owings & Merrill, 1976), northeast corner of Fifty-first Street, a fifty-one-story black glass monolith that defied the elegant limestone-clad, small-scaled townhouses and mansions that had come to house luxury boutiques and shops. Writing in 1976, Ada Louise Huxtable called attention to the imposing effect of Olympic Tower as well as to the street's changing retail scene, which witnessed stores once occupied by sophisticated retailers increasingly taken over by "those multiplying rug-linen-souvenir shops" that always, according to their garish signs, seemed to be going out of business, losing their lease, or clearing out inventory. "The problem," Huxtable noted, "is that Fifth Avenue has survived these assaults with a false air of security because it has some spectacular anchors. Rockefeller Center gets better—partly through contrast and partly through the prescience of its planning—as the years go on. The Avenue's churches . . . are the best of their kind. Even black with soot, McKim, Mead and White's University Club is an event." But for Huxtable, the direction was clear: "The street is being lost to junk, greed, tastelessness, exploitive design and those parasitic enterprises that use the address while destroying it."[76]

The construction of John Carl Warnecke & Associates' thirty-six-story 650 Fifth Avenue, southwest corner of Fifty-second Street, a building whose origins dated back to the planning of Olympic Tower but which was not completed until 1978 and thus constituted the first building to be entirely conceived under the rules of the Fifth Avenue Special Zoning District (1971), while an unoffensive work of architecture, further obscured the avenue's historical character.[77] In 1979 Paul Goldberger described the continued transformation, if not degradation, of Fifth Avenue, where he found "old storefronts of masonry . . . giving way increasingly to storefronts of shiny, glaring metal, and the aura of the street . . . becoming shrill in a way that it never was at all. It is as if the design motifs of the cheap discount stores, which for some time have been the thorn in the avenue's side, had suddenly become the preferred style of the avenue's better stores." Goldberger went on to write that the stretch of Fifth Avenue between the mid-Forties and Central Park South was "becoming a festival of architectural overachieving" with "mirrors, mirrors, everywhere." Not only was he critical of Santini and Bachond's Ted Lapidus clothing store in the Tishman Building, 666 Fifth Avenue, "framed in shiny chrome" that did not sparkle but just glared, he found the new two-story zig-zag glass and chrome of the Fortunoff store, designed by Weisberg Castro Associates, "an immense sign" with a "few heavy handed Art Deco details" that failed to "erase the general feeling of being in a suburban department store." Goldberger also took aim at the misplaced sleekness of Daniel Krief's Francesco Smalto boutique in the Sherry Netherland Hotel, and the recently renovated Doubleday Bookstore (Weisberg Castro Associates, 1978), 724 Fifth Avenue, which he believed felt "more like an airport than a piece of the nation's premier retail avenue, thanks to its harsh red trim and bright lighting." He also deplored King Fook (1979), 675 Fifth Avenue, between Fifty-third and Fifty-fourth Streets, "an Oriental stage set pasted onto the front of a fairly straightforward masonry building, a piece of Disneyland dropped onto Fifth Avenue."[78]

The most significant threat to the avenue's traditional character, however, emerged on February 28, 1979, when the thirty-two-year-old developer Donald J. Trump released plans for a sixty-story, bronze-colored, glass-clad, concrete-framed tower featuring apartments, office space, and a six-level retail atrium for the northeast corner of Fifth Avenue and Fifty-sixth Street, a site occupied by the eleven-story home of the department store Bonwit Teller (Warren & Wetmore, 1929; remodeled, Ely Jacques Kahn, 1930).[79] A month earlier, Trump had purchased the store's lease from Genesco, the financially troubled, Nashville-based parent of the Bonwit chain, and had entered into a fifty-fifty partnership with the owner of the underlying land, the Equitable Life Assurance Society. Trump

was also able to buy air rights from its immediate neighbor to the north, Tiffany & Company (Cross & Cross, 1940), the jewelers, after convincing the company's president, Walter Hoving, that the sale would secure the store's future at its desirable location because, as Trump put it, "no one will ever be able to build over it, and therefore no one will ever try to rip it down." To further convince Hoving, Trump showed him a model of a "hideous alternative" built without air rights that featured fifty stories of "lot-line windows—tiny little windows with wire mesh" rising directly over the store building.[80] The L-shaped site also included a small parcel just east of Tiffany facing Fifty-seventh Street.

Many welcomed the new development as a sign that the city's economy was finally turning around. But there was also concern that Trump's tower, coming on the heels of the recent announcements of a thirty-seven-story building for AT&T and a forty-three-story headquarters for IBM, both located just to the east of Trump's site where they would occupy two full blockfronts of Madison Avenue from Fifty-fifth to Fifty-seventh Street, would kill the area with overdevelopment. There was also some disappointment voiced over the loss of the Bonwit Teller building, a refined example of the modern classicism of the late 1920s that began life as Stewart & Company, a women's specialty store that quickly fell victim to the Depression but was reborn as Bonwit Teller. In the mid-1970s Walker/Grad had renovated Bonwit Teller in an attempt to liven up the interiors, which had come to be seen by the retailer, if not by the public, as staid, although the merchant's problem lay not with its building but with its merchandise: the once top-line Bonwit's was losing ground to its traditional rival, Bergdorf-Goodman, across the street, as well as other high-fashion-oriented department stores like Bloomingdale's.[81]

Designed by Der Scutt of Poor, Swanke, Hayden & Connell, Trump Tower, as the mixed-use building was quickly dubbed, featured a twenty-eight-sided tower, said to complement IBM's five-sided tower, set atop a street-defining base. At the rear, a retail atrium was connected to the avenue by a wide, shop-lined public corridor, a zoning-inspired provision that yielded extra square footage for the developer, despite the fact that it did not meet the objectives of the Fifth Avenue Special Zoning District, intended to reward midblock north–south arcades. Trump and Scutt argued that the east–west design was deserving of a bonus because it would connect with IBM's interior garden, granting passage from Fifth Avenue to Madison Avenue, and that, given IBM's provision of a midblock north–south connection, another north–south passage would be redundant. In addition to minimizing the bulk of the tower, Trump pointed out a further advantage of the design's sawtooth arrangement: "The multiple sides would ensure at least two views from every room, and in the end, that would make it possible to charge more for the apartments."[82] Before coming up with his final design, Scutt experimented with numerous alternatives, including a version with a rectangular limestone base as well as a tower featuring three exterior glass elevators that was rejected because it required the sacrifice of too much saleable interior space. Like the model shown to Hoving to convince him to sell his air rights, Scutt also produced a seventy-seven-story as-of-right design. Although Trump was probably not serious about building this version, the developer hoped it would dramatize to the City Planning Commission the advantages of his preferred design, which required considerable zoning concessions.

Paul Goldberger greeted Trump's proposal with skepticism, labeling the building featuring forty floors of apartments and twelve floors of offices "an architectural Trojan horse" which "at first glance . . . looks like what planners have been calling for for years—a mix of stores, apartments and offices." Goldberger was concerned about the addition of one more super skyscraper to the area, writing that "density is now reaching untenable proportions." Nonetheless, he praised Scutt's "slim tower of bronze glass, rising not as a rectangle but in a sculptural shape that is best described as a series of setbacks. . . . At the bottom will be an 85-foot base, with setbacks in profile this time, looking like a pile of children's blocks and providing more than a dozen small, landscaped terraces." Despite the elegance of its silhouette, Goldberger felt that the building was likely to be an "inappropriate" neighbor to Cross & Cross's limestone-clad Tiffany & Company. Moreover, he wrote, taken as a group, Bonwit Teller and Tiffany's "form a remarkable pair of limestone fronts, as crucial to the making of the classic image of chic New York retailing as anything on Fifth Avenue. Breaking up this set will be a loss to the entire city—and replacing it with a building of bronze-colored glass will mean a clash not only with Tiffany's to the north, but also with the elegant green glass Corning Glass tower [Harrison, Abramovitz & Abbe, 1959] to the south." Goldberger also wondered whether the interior shopping mall might not "pull a lot of retail activity off the street, which is no help to the city at all."[83]

Michael Sorkin, writing in the *Village Voice*, had nothing positive to say about the design, declaring it "wrong on absolutely every urbanistic count. . . . The demon insensitivity of the architects is amazing: Could they have confused the site with one in Houston?"[84] But the senior critic of the *New York Times*, Ada Louise Huxtable, who found Scutt's building "undeniably, a dramatically handsome structure," concentrated the thrust of her assessment on the issues of real estate and zoning that allowed so dense a use of the land: "The changes on Fifth Avenue have a lot more to do with high land values than with high style." If Trump's new building "is in the wrong place," she concluded, "it is the city's zoning that has put it there, and not much can be done about it. Right or wrong, and unlike some others going ahead in midtown, this one happens to be of potentially superior quality. Look not for villains in this case; look to the city's laws."[85]

A citizens group calling themselves the New York Committee for a Balanced Building Boom opposed the Trump proposal in testimony before the City Planning Commission. But on October 19, 1979, the commission unanimously approved a fifty-six-story mixed-use skyscraper for the Bonwit Teller site, four stories lower than originally proposed by Trump but one that achieved a FAR of 21 on a site that, without the bonuses and the air rights, would have yielded a FAR of just 8.5. In part, Donald Trump credited Ada Louise Huxtable with getting the project through the City Planning Commission. Even though her review had hardly been a rave, Trump noted that simply the title of the article, "A New York Blockbuster of Superior Design," was enough to influence the commissioners: "That headline probably did more for my zoning than any single thing I ever said or did."[86]

Demolition of the Bonwit Teller building began in spring 1980 and was soon enveloped in controversy. On the morning of June 6, readers of the front page of the *New York Times*

Proposal for Trump Tower, northeast corner of Fifth Avenue and East Fifty-sixth Street. Der Scutt, 1979. Rendering of design with three exterior glass elevators, view to the northwest. DSA

Proposal for Trump Tower, northeast corner of Fifth Avenue and East Fifty-sixth Street. Der Scutt, 1979. Model, as-of-right design, view to the southeast. DSA

woke to learn that on the previous day, workers, acting on instructions from Trump, had jackhammered two fifteen-foot-high bas-relief stone sculptures depicting stylized, partly draped female nudes, located on the facade between the eighth and ninth floors, which had been promised to the Metropolitan Museum of Art. Trump had apparently changed his mind about donating the pieces after learning it would cost $32,000 to remove them. The following day the *Times* reported that the Trump Organization had also lost track of the twenty-by-thirty-foot bronze grille that had sat above the store's Fifth Avenue entrance, which had also been promised to the Metropolitan. By now public opinion was turning against Trump, with even the designer of the new building, Der Scutt, speaking out against the loss of the bas-relief panels and the decorative ironwork: "They were beautiful panels, just magnificent things."[87] Ironically, the furor over the lost sculptures and grillework eclipsed the outrage over the demolition of the building itself, with the editors of the *New York Times* blasting the developer: "Whether Mr. Trump acted out of fiscal miscalculation or civic lapse is now beside the point. The city has lost an important work of art and many New Yorkers are simply outraged. Obviously, big buildings do not make big human beings."[88] Though

viewed by many as a philistine, Trump was able to turn the debacle to his advantage, claiming that "the publicity caused us to sell tremendous numbers of apartments."[89]

While Trump Tower was under construction, the new management of Bonwit Teller, Allied Stores, attempted to find a new home for the specialty store, ultimately returning to the Trump Tower site in a much smaller facility (1981) at 4 East Fifty-seventh Street, cobbled together from buildings Bonwit Teller had used before and new construction.[90] Paul Goldberger was not impressed with the new exterior, designed by Kennerly, Slomanson & Smith, which he described as "a stark wall of polished, reddish granite, with a rounded glass marquee at the bottom and an odd, rectangular cutout, like a big, glassless window, at the top. It is a facade that tries very hard to be dignified, and ends up looking dull instead." Goldberger did, however, praise the architects for choosing a masonry facade to complement its neighbors, Tiffany & Company and the IBM Building, adding, "In a further gesture of urbanistic good manners, they inserted a band of light granite across the facade to continue an ornamental band above Tiffany's third floor." Goldberger much preferred Norwood Oliver's interiors, which he found "quite sleek, fairly well organized and elegant."[91]

Trump Tower, northeast corner of Fifth Avenue and East Fifty-sixth Street. Der Scutt, 1983. View to the northeast. DSA

Trump Tower, northeast corner of Fifth Avenue and East Fifty-sixth Street. Der Scutt, 1983. Atrium. DSA

Trump Tower, northeast corner of Fifth Avenue and East Fifty-sixth Street. Der Scutt, 1983. View to the northeast. DSA

Trump Tower, northeast corner of Fifth Avenue and East Fifty-sixth Street. Der Scutt, 1983. Section perspective. DSA

Ludwig Beck, Trump Tower, northeast corner of Fifth Avenue and East Fifty-sixth Street. Hans Hollein, 1983. AH

Ludwig Beck, Trump Tower, northeast corner of Fifth Avenue and East Fifty-sixth Street. Hans Hollein, 1983. AH

As completed in 1983, the 756,000-square-foot, 664-foot-high Trump Tower, the tallest concrete-framed building in the city, included thirteen office floors and 263 condominium apartments, all sitting atop the 100-foot-high, six-level atrium. The tower's glass facade was darker than the original drawings suggested. Ada Louise Huxtable, who had initially praised the design, dismissed the building's "unexceptionally detailed, dark glass skin" as "dull and ordinary," and the editors of the *AIA Guide* described it as little more than "a simplistic folded glass tower."[92] Martin Filler could hardly generate much more enthusiasm, writing that "the best that can be said for it is that Der Scutt's serrated setbacks . . . help reduce the impression of its enormous size."[93]

The most talked-about feature of Trump Tower was the skylit atrium, with its forty-four stores, five sets of switchback escalators, eighty-foot-high waterfall, and monumental thirty-foot-wide Fifth Avenue entrance, all dominated if not overwhelmed by the predominant materials of choice, polished brass and 240 tons of Breccia Perniche marble in shades of rose, peach, pink, and orange. Jerold Kayden, in his comprehensive study of New York's privately owned public spaces, captured the mood perfectly: "Hyperbole is the order of the day. The interior at Trump Tower is eye candy, a confection of colors, layers, reflections, movements, and glitz."[94] But Paul Goldberger represented popular taste when he deemed the space a "pleasant surprise": "It is warm, luxurious and even exhilarating—in every way more welcoming than the public

arcades and atriums that have preceded it in buildings like Olympic Tower, the Galleria, and Citicorp Center."[95] Popular taste notwithstanding, critics tended to emphasize the gaudiness of it all, with Ada Louise Huxtable deriding the "pink marble maelstrom and pricey superglitz of the shopping atrium . . . unredeemed by the posh ladies' room decor."[96] Considering both the tower and the atrium, Martin Filler concluded, "What was once one of the most graceful and humane shopping streets in America has vanished under the shadow of this gaudy looming interloper."[97]

The most distinguished of the atrium stores was Hans Hollein's 3,500-square-foot fifth-floor shop (1983) for Ludwig Beck, the first American branch of the Munich-based department store specializing in hand-crafted clothes.[98] The internationally recognized Viennese architect, in his most playful, Postmodernist mood, provided a rotunda with faux marble columns and a Carrara marble floor inset with a blue-and-white ceramic-tile star, the traditional symbol of the city of Munich. The rotunda, just inside the store's entrance, which was marked by six gold-leaf columns, also featured an antler's horn, a motif repeated in other parts of the store, as well as a plaster dome painted to resemble a winter sky. Radiating out from the rotunda were three major selling areas, the largest of which was a three-quarter-circle space created by a series of curved metal screens that were shaped at the top to suggest a dragon's tail. The highly flexible screens, from which coats and dresses could be hung or shelves mounted for the display of glassware, were

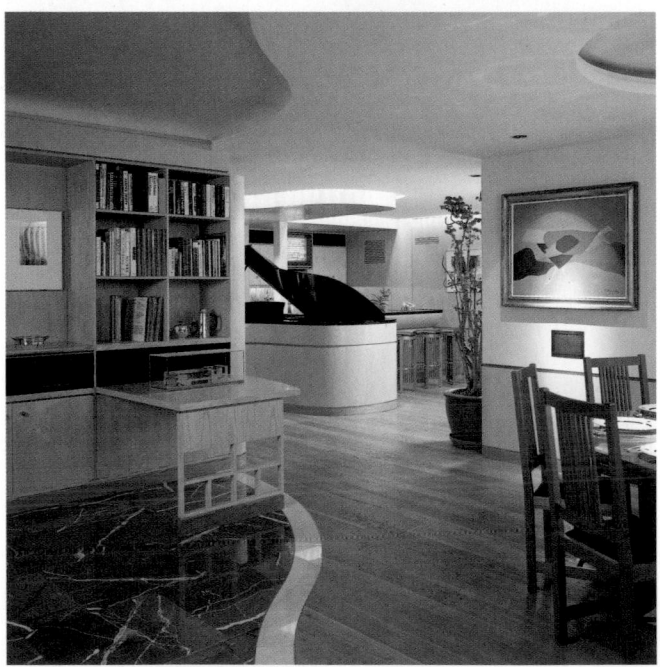

coated with a sprayed-on finish suggesting suede. Opposite the rotunda was an elegant space of gold-trimmed vitrines, set in a faceted curve of light wood cabinetwork, for the display of hand-blown glass and Nymphenburg china. Also of note were deep maroon columns, trompe-l'oeil paintings, including a reproduction of the Plaza Hotel decorating the arched entrance to the dressing room, and the blue-and-white ceiling made up of angular panels. Amazingly, the highly detailed, stylized design was largely ignored by the press, with only Walter Wagner Jr., editor of *Architectural Record* but an infrequent writer, taking on the project. Wagner was impressed with the space, noting that "the images here are as rich and varied as the shop's offer-

ings—romantic, fanciful, baroque; a suitable setting for a store that was prospering during the reign (starting in 1864) of Ludwig II—the last of the Bavarian royalty."[99]

Within the sea of glitz that was Trump Tower, perhaps the most over-the-top spot was Trump's own triplex penthouse apartment. Designed by Angelo Donghia in a style that Trump described as "warm modern," it featured a rich display of opulent materials and gleaming surfaces, including onyx flooring inset with brass, a stairwell lined with beveled bronze-mirror panels, and a curving staircase with a brass banister. Steven M. L. Aronson, writing in *Architectural Digest*, noted that "everything in the Trumps' two-story living room savors of the luxurious: from the understated chairs and sofas to a banquette covered with a fabric painted in 24K gold; to the antique Venetian-style mirror and the brown marble fireplace; up, up, up to the gold-leaf ceiling."[100] But after visiting Saudi financier and arms dealer Adnan Khashoggi's apartment at Olympic Tower, Trump began to feel that his own apartment was perhaps a bit too modest, and he decided to take over the adjacent triplex, which he had fortuitously kept off the market. As redone by the developer and his wife, Ivana, in 1987, the nearly doubled space was an unrestrained homage to the image, if not to the reality, of the taste of Louis XIV.

The perfect aesthetic foil to Trump's triplex was provided by Gwathmey Siegel in a 2,500-square-foot apartment (1985) for film director Steven Spielberg, located on the building's fifty-second floor.[101] The design represented a continuation of the firm's move away from the hard-surface Modernism that had characterized their work in the 1960s and 1970s. The apartment was divided into public and private sections, with the former composed of an interconnected volume consisting of an entry foyer, bar-study, kitchen, and living and dining areas finished in oak, ash, and marble. The L-shaped private wing consisted of two bedroom-and-bath suites. The Spielberg apartment was furnished with custom-designed

Secessionist-inspired pieces as well as a piano sleekly encased in wood, with Monica Geran noting: "timber, it transpires, does not impair timbre."[102] Although Charles Gwathmey tried to emphasize that his firm had moved beyond its hard-edged past by boasting that "the only white in this apartment is the sheets on the beds," Deborah Dietsch countered that "a strip of glass block between bathroom and hall, and mirror, albeit wood-framed and banished to the bedroom, serve as subtle reminders that he hasn't quite surrendered to history, yet."[103]

In 1990 Bonwit Teller, now owned by the Hooker Corporation, went bust and its Fifty-seventh Street site became home to the first American branch of Galeries Lafayette, the French department store chain.[104] Galeries Lafayette opened in the fall of 1991 after an ill-advised renovation, at least according to Donald Trump: "They stripped the store virtually down to its steel frame to build an almost identical new store, but with lower ceilings, fluorescent lighting, and cheap flooring to replace the marble that had existed before."[105] The store proceeded to rack up heavy losses and in 1994 it was closed, replaced two years later by Niketown (see Fifty-seventh Street).

The next tall building to go up along Fifth Avenue was Emery Roth & Sons' 575 Fifth Avenue (1984), which, following Trump Tower's lead, similarly featured a multistory retail mall in its base.[106] It occupied the northern half of the east blockfront of Fifth Avenue between Forty-sixth and Forty-seventh Streets, a site that had achieved its apogee in 1901 with the construction of Charles Berg's Windsor Arcade, one of the most lavishly ornate so-called taxpayer structures ever built in the city. The Windsor Arcade was demolished in 1912 and replaced by the W. & J. Sloane Building (John B. Snook, 1912), which occupied the northern half of the site, and the S. W. Straus & Company Building (Warren & Wetmore, 1921), on the southern half.[107] In 1980 a group of developers led by Fred Wilpon purchased the Sloane building, at the time home to an E. J. Korvette's discount store, hiring Emery Roth & Sons to design a tower to house offices and stores for the Forty-seventh Street diamond exchange. A downturn in the gem market forced the exchange to pull out, but the developers continued with the project and in 1984 completed 575 Fifth Avenue, a forty-story office tower whose retail component the developers hoped would extend the Fifth Avenue luxury shopping district south past Saks Fifth Avenue, its unofficial border at Forty-ninth Street. The eight-story Sloane building was stripped to its steel frame and reclad in flame-finished rose and pink granite. Set back atop the base was a lackluster twenty-seven-story tower awkwardly combining windows set flush to the wall with recessed windows arranged to describe the profile of a typical set-back skyscraper on the building's north elevation. At the base of the 475,000 square feet of office space, a so-called vertical mall comprising 55,000 square feet of stores was organized around a four-story-high atrium entered from the avenue. Aping Trump Tower atrium's glossy pink, rose, and peach surfaces, crisscrossing escalators, and glass elevator, the designers of 575 Fifth Avenue added their own touch, a rather insipid 1,600-square-foot Frank Lloyd Wright–inspired stained-glass ceiling.

The avenue's retail fortunes began to look up with the opening in 1983 of the Bijan boutique in the St. Regis Hotel, said to be the most exclusive clothier in the city, open by appointment only, and a new shop just off the avenue at 11 West Fifty-sixth Street showcasing the work of the provoca-

tive fashion designer Norma Kamali, who dubbed the boutique OMO (On My Own). As designed by Peter Michael Marino, working with Rothzeid, Kaiserman, Thomson & Bee, the "somewhat fortified appearance" of Kamali's stuccoed facade troubled the editors of the AIA Guide.[108] But the facade, brought to life with four gold lamé banners, was well within a tradition of townhouselike fashion boutiques going back to Shreve, Lamb & Harmon's 1937 design for a fashion doyenne of an earlier era, Lily Daché, at 78 East Fifty-sixth Street.[109] Stylish though it was, with slit windows and receding planes suggesting streamlines running up the facade, Marino's design had a quality of seriousness reflecting Kamali's ambivalence about undertaking the project: "Fashion has a nervous quality. It appeals to moods and senses that change rapidly. The architecture I like least is the kind that looks like fashion: you know you're not going to want it next season. It's scary to think of disposable buildings."[110] Inside the three-level store, Douglas Brenner wrote, "hand-troweled cement plaster takes on a nacreous patina under mottled light; shadowed facets suggest the ziggurats and fluting of some archaic shrine—with more than a glimmer of art deco theatrics."[111]

Also encouraging was the opening of Michael Graves's Diane von Furstenberg boutique (1984) at Fifty-ninth Street (see below) and the continuing prosperity of Bergdorf Goodman, the city's, if not the world's, most stylish department-store-scaled purveyor of high fashion, located at the key intersection of

575 Fifth Avenue, southeast corner of East Forty-seventh Street. Emery Roth & Sons, 1984. View to the east. Mauss. ESTO

OMA Norma Kamali, 11 West Fifty-sixth Street. Peter Michael Marino and Rothzeid, Kaiserman, Thomson & Bee, 1983. View to the north. Warchol. RKTB

OMA Norma Kamali, 11 West Fifty-sixth Street. Peter Michael Marino and Rothzeid, Kaiserman, Thomson & Bee, 1983. Warchol. RKTB

Fifth Avenue and Fifty-seventh Street. In 1983–84, Bergdorf's completed a renovation and updating of its facade by the classicist architect Allan Greenberg. In the 1950s attempts at catering to a younger crowd had somewhat compromised the store's elegance, and an effort to branch out into the suburbs had proved a financial and public relations disaster.[112] In the late 1970s, Bergdorf's set out to regain its lost prestige and, as part of a comprehensive renovation of the store, retained Greenberg to replace the Delman Shoe Salon, which was being phased out, facing Fifth Avenue, with a new, grandly scaled entrance that would lead directly into the main floor selling area.[113] Originally occupying only one of a coordinated block-long group of seven buildings constructed in 1928 to the designs of Ely Jacques Kahn on what had been the site of George B. Post's Cornelius Vanderbilt II house (1879–82), the store gradually expanded to occupy space in all the buildings.[114] Greenberg's mandate was to create a more unified presence on Fifth Avenue, so well related to the architecture of the original complex "that it would look as if it had been there all the time."[115] The new entrance was intended to become the store's main entrance, leading to escalators being introduced inside for the first time. Greenberg's boldly scaled arch, with a pedimented bronze revolving door set within it, framed by rusticated voussoirs, was crafted in a hard Wisconsin limestone expected to match the color of the no-longer-quarried

marble used on the original building. After the building was cleaned in 1998, Christopher Gray noted that "when fresh, [the limestone] gleamed in comparison to the dirty marble; now that the original stone has been renewed, the later material looks pasty and wan."[116] For Paul Goldberger, Greenberg's renovation was "elaborately overblown."[117]

Bergdorf continued to renovate its main store. Shiro Kuramata's 1,000-square-foot Issey Miyake boutique (1984) on the main floor was daring, with a tiled floor and walls made of a terrazzo that substituted shattered Coca Cola bottles for the usual marble chips.[118] In 1993 Eva Jiricna, a Czech-born minimalist practicing in London, was hired to transform the maze-like fifth floor into a sleek selling area that opened the 5,000-square-foot space, last renovated eleven years earlier, to city views, a notion borrowed from street-level boutiques but hitherto eschewed by department store owners, who tended to regard reality as a deterrent to shopping.[119] At the virtual center of the plan, a space-frame stainless-steel and etched glass staircase—a Jiricna signature—was installed, its forced perspective leading nowhere, but useful for display (the stair was originally to have connected to the sixth floor but by the time the decision was made to drop that plan it had already been fabricated and was put in place at the client's request).

Despite Fifth Avenue's prosperity at Fifty-seventh Street, much of its once-fabled stretch of shops extending north from

Saks was in danger of descending into mediocrity. As Shawn Kennedy noted in the *New York Times*, after the Ted Lapidus boutique closed in summer 1984, the west side of Fifth Avenue between Fifty-third and Fifty-fifth Streets "and half a block to the north was left without a single retail tenant except for a few small discount electronics and camera shops."[120] Paul Goldberger was also concerned about the future of Fifth Avenue, noting that the stretch between Forty-second and Fifty-ninth Streets had just received its first fast-food restaurant, a Roy Rogers, on the southwest corner of Forty-sixth Street, "complete with a brick sidewalk altogether out of character for Fifth Avenue." But Goldberger's fear at this point was not so much with "the glaring lights of the cheap storefronts," but that "those medium-sized masonry buildings that remain" were threatened with the prospect of skyscrapers that could make "this crucial avenue . . . come to look too much like the rest of midtown Manhattan."[121]

Especially poignant for Goldberger was the fate of the west blockfront between Fifty-fifth and Fifty-sixth Streets, where in August 1984, after a five-year-effort to get control of an L-shaped site that stretched westward to include 2–6 West Fifty-sixth Street finally succeeded, a development team composed of Solomon Equities, First Boston, and G. Ware Travelstead announced plans to build 712 Fifth Avenue, a forty-four-story residential tower to be designed by Kohn Pedersen Fox.[122] Although the scheme was still in its early stages, the developers pledged that the 450,000-square-foot building, whose size depended on air rights purchased from the neighboring Fifth Avenue Presbyterian Church (Carl Pfeiffer, 1875), northwest corner of Fifth Avenue and Fifty-fifth Street, would respect its historic environs by being clad primarily in limestone as well as by stepping back from the avenue from a five-story base that would mimic the scale and character of the three avenue-facing buildings which would be destroyed to make way for the skyscraper: the Rizzoli Building (originally built for Cartier's, A. S. Gottlieb, 1908; renovated for Rizzoli, Ferdinand Gottlieb, 1964), 712 Fifth Avenue; the Coty Building (built as a group of rowhouses, Charles Duggin, 1871; renovated for commercial use, Woodruff Leeming, 1908), 714 Fifth Avenue; and 716 Fifth Avenue (originally the Andrew C. Zabriskie house, c. 1900; renovated for commercial use, Van F. Pruitt, 1939).[123] Although there was an immediate call from preservationists to save the elegantly detailed and massed Rizzoli Building, a five-story limestone building resembling an eighteenth-century Parisian townhouse, hopes were not high, given that the Landmarks Preservation Commission had twice before considered the case and failed to designate the structure only a year earlier. The fate of the two other Fifth Avenue buildings, the three-story 716 Fifth Avenue and the five-story Coty Building, whose ground floor had been horribly reconfigured to suit the needs of a cheap electronics store, failed to elicit any serious reaction until the dramatic discovery in December 1984 by architectural historian Andrew S. Dolkart of the fact that, hidden beneath layers of dirt and grime, the Coty Building contained a remarkable treasure, 204 lead crystal panels depicting intertwining vines and poppy blossoms spanning the width of the building and rising from the second through fourth floors, all the work of René Lalique, the French master craftsman of glass.

The impact of the discovery of the sensuously molded Art Nouveau Lalique windows, which François Coty, the perfumer, had commissioned in 1912 but whose identity was for-

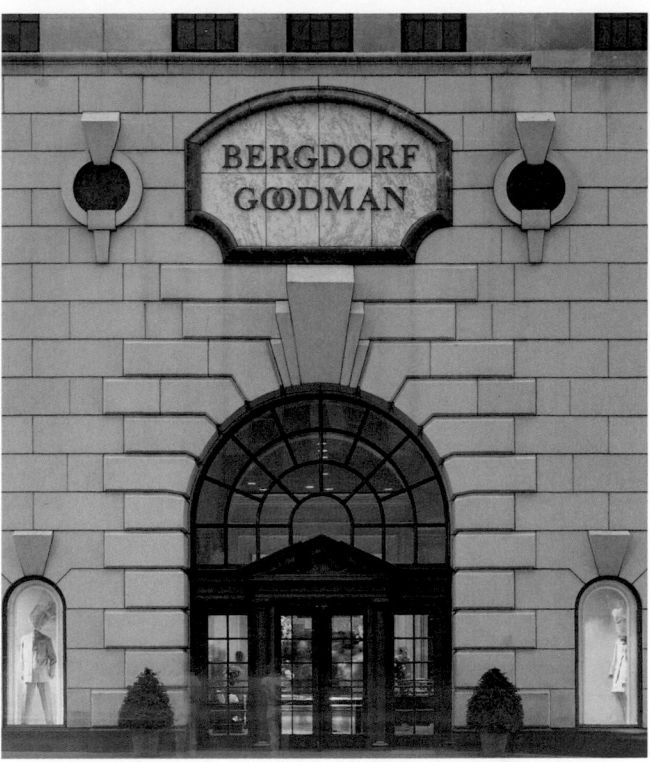

Bergdorf Goodman, west side of Fifth Avenue, between West Fifty-seventh and West Fifty-eighth Streets. Renovation by Allan Greenberg, 1984. Detail of entrance. AG

Bergdorf Goodman, west side of Fifth Avenue, between West Fifty-seventh and West Fifty-eighth Streets. Eva Jiricna, 1993. Paige. PPP

Proposed 712 Fifth Avenue, between West Fifty-fifth and West Fifty-sixth Streets. Kohn Pedersen Fox, 1984. Model, view to the southwest. KPF

gotten after Coty left the building in 1941, was galvanic, spurring the movement to oppose the tower. In addition to saving the individual buildings, resistance to the project stemmed from the belief that the character of the midtown stretch of Fifth Avenue was in danger of being lost, especially with the recent completion across the street of the glassy Trump Tower in 1983 replacing the Bonwit Teller store. Paul Goldberger felt that "the project would cut out the heart of the finest intact ensemble of old Fifth Avenue buildings" which in addition to the three threatened buildings also included, at the southern end, Pfeiffer's English Gothic Fifth Avenue Presbyterian Church and, at the northern corner, the five-story, travertine-clad home of the jeweler Harry Winston. "All of the bouncy, uneven scale of Fifth Avenue is here," Goldberger continued in defense of the block, "but so is the discreet, understated masonry architecture that gives the avenue its continuity and its character."[124] Some of the block's classical hauteur was of quite recent vintage: Harry Winston's building, designed by the French architect Jacques Regnault in 1959, was in fact a drastic remodeling of one of the avenue's early Modernist landmarks, Platt & Platt's Corning Building (1937), notable for its dramatic glass-block facade, an irony apparently lost on the critic.[125]

The developers protested that the Rizzoli Building was hardly a distinguished work and tried to cast doubt on the provenance of the Coty Building's etched windows. The fight to save the Rizzoli and Coty buildings (no attention was devoted to the cause of 716 Fifth Avenue) did result in some strange bedfellows, most notably when Donald Trump, who four years before had acted callously in destroying Bonwit

Teller to build Trump Tower, joined the Municipal Art Society's Committee for the Future of Fifth Avenue, formed in the summer of 1984, and blasted the proposal to tear down the two buildings. Trump was hardly revealing a Saul-Paul conversion to the cause of historic preservation; rather, he was protecting the value of his Trump Tower property across the street, as G. Ware Travelstead made clear when he let it be known that Trump had approached him about buying the property to build his own skyscraper.

Less than two months after Dolkart's find, on January 29, 1985, the Landmarks Preservation Commission declared both the Rizzoli and Coty buildings landmarks, a decision that enraged the editors of the *New York Times*, who agreed with the developers that in their zeal to protect the character of the Fifth Avenue streetscape the commissioners had exhibited a "tendency to confuse landmarking with zoning."[126] While the developers, who already had acquired a permit to alter the Rizzoli Building, threatened litigation, a compromise was soon worked out whereby the facades of the Rizzoli and Coty buildings would be saved and the tower moved back fifty feet from the avenue, requiring the demolition of the back half of the two landmark buildings, while permission was granted to completely replace 716 Fifth Avenue.

Architectural historian Charles Lockwood was not impressed with the compromise: "If the proposed development plan were carried out, the truncated Rizzoli and Coty buildings would look like stage sets, not historical structures, and this violation of their landmark character would be obvious to anyone walking down the avenue."[127] Paul Goldberger had similar reservations, calling into question the practice of "'facadism,' as the business of saving the fronts but scooping out the backs of landmark buildings has come to be called. . . . While facadism pretends to a certain earnestness, it is at bottom rather pernicious. For the compromise it represents is not really preservation at all. To save only the facade of a building is not to save its essence."[128]

While Kohn Pedersen Fox reworked its design to accommodate the compromise solution, the development team partially changed hands, with G. Ware Travelstead and First Boston dropping out, replaced by shopping-center magnate A. Alfred Taubman, who joined forces with Solomon Equities. The project also changed from a residential tower to an office building. In October 1986, the fashionable retailer Henri Bendel, which had just been acquired the year before by Leslie H. Wexner's Limited Inc., agreed to move from its building at 10 West Fifty-seventh Street, where it had been located since 1912, to the base of the new building. Bendel hired its own architect, Beyer Blinder Belle, to renovate the two landmark buildings and design a replacement for 716 Fifth Avenue as well as to oversee the restoration of the Lalique windows.

Kohn Pedersen Fox's design, prepared in collaboration with Schuman, Lichtenstein, Claman & Efron, was approved by the Landmarks Preservation Commission in March 1987. After abandoning an early, fussy version calling for a tower with gently battered sides and a shaft dominated by a series of white Vermont marble piers within a field of punched windows, the architects settled on a straight, fifty-three-story, 650-foot-high, 500,000-square-foot tower (1990) with a regular grid of windows where the piers had been. Clad in gray Indiana limestone with a central recessed midsection of honed white Vermont marble, the building's shaft also featured thermal-finished green granite quoins and was articulated at the

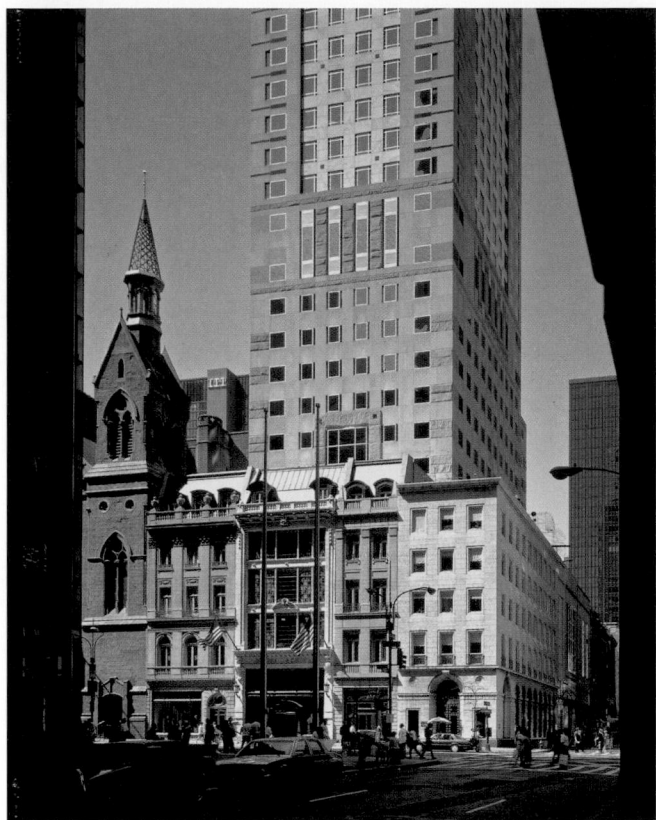

712 Fifth Avenue, between West Fifty-fifth and West Fifty-sixth Streets. Kohn Pedersen Fox, 1990. View to the southwest. Robinson, KPF

712 Fifth Avenue, between West Fifty-fifth and West Fifty-sixth Streets. Kohn Pedersen Fox, 1990. View to the northeast showing Trump Tower (Der Scutt, 1983) on the right. Pottle. ESTO

fourteenth, fifteenth, forty-third, and forty-fourth floors with bands of rusticated limestone. The slender tower, comprising boutiquelike 7,500-square-foot office floors, was placed fifty feet back from the avenue and twenty-seven feet from Fifty-sixth Street. The office building's five-story entrance, in emulation of the Lalique windows, was topped by a two-story window of etched glass depicting the signs of the zodiac by Thierry Bruet and Amy Rassinforf.

The centerpiece of Beyer Blinder Belle's renovation work was the French limestone and marble four-story atrium carved out of the Coty Building, providing an appropriately spectacular setting for the Lalique windows, restored by Greenland Studios. The firm was able to save 75 percent of the fourteen-by-fourteen-inch panes, requiring only forty-six new panels. Topped by a circular wrought-iron and glass dome, the public atrium, providing circulation to the Bendel boutiques, featured walkways at each level offering visitors close-up views of the windows. The facade of the Rizzoli Building was restored, and Beyer Blinder Belle designed a new five-story limestone and granite building at 716 Fifth Avenue that featured wood casement windows. The 80,000-square-foot Bendel's store, designed in collaboration with French decorators Marie-Paule Pellé and François Catroux, opened on February 27, 1991, appropriately enough with a gala party to benefit the Municipal Art Society.

Despite his original skepticism, Goldberger was very pleased with the results of both the renovated landmarks and the new tower: "This mix of new architecture and old, skillfully integrated, holds more promise for the revival of Fifth Avenue than anything that has happened to that troubled boulevard in the last decade." He was particularly impressed with Kohn Pedersen Fox's tower: "Its slender form makes for small floors (and is thus less efficient from a rental standpoint) but it's great on the skyline. . . . What is most striking is the top, where the four sides look like four free-standing planes of stone, free at the corners—a subtle but strong gesture perfectly balanced between tradition and abstraction."[129] Although most everyone applauded the new Bendel's, and especially the rediscovered Lalique windows, Christopher Gray pointed out something of importance that was in fact lost, "the most evanescent of unofficial landmarks . . . , the view south toward the Empire State Building." Noting that 712 Fifth Avenue "already has come to overpower" the midtown stretch of Fifth Avenue, Gray wistfully observed that from Seventy-ninth Street "its giant rectangular mass blocks everything but the disembodied TV tower of the Empire State Building."[130]

Another office tower to be built behind a prestigious Fifth Avenue retailer was Lee Harris Pomeroy's Swiss Bank Tower (1989), built on a midblock site between Forty-ninth and Fiftieth Streets to the east of Saks Fifth Avenue (Starrett & Van Vleck, 1924), 611 Fifth Avenue.[131] The idea for the tower dated back a decade, to when Saks announced plans in February 1979 for the first ever remodeling of its Fifth Avenue store.[132] Saks, though a department store in scale, was in essence a huge specialty shop. It had been a pioneer in the use of indirect lighting and in the deployment of boutiquelike selling areas showcasing the work of individual designers. News of the renovation, which would include the installation of the store's first escalators in a new nine-story addition to be built behind the building in the "backyard of a former brownstone,"

Henri Bendel, 712 Fifth Avenue, between West Fifty-fifth and West Fifty-sixth Streets. Beyer Blinder Belle, 1990. Atrium. Aaron. ESTO

sent shivers through old-line New Yorkers who feared that the store would be dumbed down to the status of Bloomingdale's or Macy's.[133] Saks's plans were formulated not only for its short-range growth but also for its long-range preservation in an increasingly expensive and desirable piece of real estate. In July, Saks filed preliminary plans for a 900,000-square-foot tower to be built on a 19,000-square-foot site behind the store, replacing seven small buildings.

The construction of the addition housing Saks's new escalators preceded work on the tower. Designed by store specialist James Terrell of Hambrecht Terrell International, as the first stage of a storewide makeover, the gently curving wall of elevators at the rear of the store's selling floors was broken at the center to make way for a new passage leading to a vertical room of escalators. When they were opened for use in November 1979, Paul Goldberger was pleased: "Although the escalators are tightly interlocked and thus not given as much space as they might deserve, the whole arrangement nonetheless suggests that the escalator has been given its due as a true architectural element."[134] Hambrecht Terrell followed with reconfigured second and third floors, replacing what had devolved over the years into a jumble of departments with a wood-vaulted, brick-floored street of shops on the second floor devoted to prominent fashion designers who were allowed to put their distinct touch on the design of individual boutiques. On the third floor, now home to the store's most expensive

women's merchandise, a grand mall lined by boutiques, each devoted to a particular designer, led to the place of honor at the terminal point, a rotunda housing the reigning star of the fashion firmament, Yves Saint Laurent. The sixth floor was also completely renovated as an open selling environment featuring more moderately priced clothing for the "working woman" who was increasingly the target of merchants.

The designation of Saks Fifth Avenue as a landmark in December 1984 was actively supported by the store's management, who saw an opportunity to transfer the store's undeveloped air rights to the adjacent site and at the same time be able to expand their store's selling area into the base of the planned tower. Though they remained connected with the project, Pomeroy took over the design of the tower from Abramovitz, Kingsland, Schiff, whose brown and white horizontally banded design was criticized for its less-than-contextual Brutalist approach. Pomeroy's tower was a thirty-six-story limestone-clad north–south slab, the ten-story base of which, facing both side streets, literally extended the Saks facade with details reproduced by hand in what was probably the largest such project in the city in years. Above, the tower, like the base, was clad in limestone, with squarish windows recessed into the facade. In an effort to reduce the tower's impact as an intrusive terminus along the axis of Rockefeller Center's Channel Gardens, Pomeroy recessed the slab at the center, creating two baylike towers at the ends, and chamfered its corners to relate to those on Saks itself. Because Herbert Sturz, chairman of the City Planning Commission, had requested that the height be kept similar to that of 444 Madison Avenue (Kohn, Vitola & Knight, 1931) behind it, the ceiling heights in the finished building were a bit on the low side—8 feet 8 inches. As well, the 13,000-square-foot floor plates were small, but that was not deemed a problem by the bank, which used the tower to house its American headquarters staff. The bank did, however, balk at Saks's demands for maximum ground-floor space, especially along Fiftieth Street, facing St. Patrick's Cathedral, where the bank wanted a grand lobby. The final design, somewhat Solomonic in its disposition, provided a large, three-story-high entrance, leading to a small lobby with a reception desk and elevators that took bank visitors and staff to an eleventh-floor skylobby embellished with a waterfall and a sculpture by Richard Serra. Paul Goldberger characterized the design as an "architecture of good intentions" but little more: "This tower looks as if it was designed out of hesitation more than conviction—out of fear that it might disturb its powerful neighbors." In this building, he continued, "the idea of deference has turned into a colorless, blank stare."[135]

In addition to 575 Fifth Avenue (see above), Emery Roth & Sons contributed two other office buildings to the avenue, beginning with 590 Fifth Avenue (1987), west side between Forty-seventh and Forty-eighth Streets, a narrow, nineteen-story, 85,000-square-foot building with column-free floors developed by Manhattan Equities.[136] The first nine stories, clad in brown granite and glass, hugged the street wall while the upper stories were set back and sheathed in a tightly gridded glass curtain wall. The firm's 546 Fifth Avenue (1990), northwest corner of Forty-fifth Street, a thin, twenty-two-story silver mirror glass-covered tower, was built by a British development company that had hoped to erect what the company's president called a "trophy building,"[137] but instead produced what Paul Goldberger called "a loud box of reflective

glass. . . . The only ambiance a building like this respects is that of a Houston freeway; it is a shame that it cannot be taken to a remote turning of the Gulf Freeway and left there."[138]

Although Fifth Avenue's future as a fashionable retail destination remained problematic, a few stylish shops joined Bijan's, OMO Norma Kamali, and the relocated Bendel's, including the first American store for the Italian fashion house of Fendi (1989), 720 Fifth Avenue, northwest corner of Fifty-sixth Street.[139] As designed by Rafael Viñoly, the Fendi boutique featured a travertine facade inset with black granite, maple-veneered cabinetry, and, most dramatically, a central spiral staircase that enclosed a glass-walled elevator. A year later, just to the north, Piero Sartogo and Nathalie Grenon's Bulgari, 730 Fifth Avenue, southwest corner of Fifty-seventh Street, replacing Victor Lundy's idiosyncratically spectacular I. Miller shoe store (1961), was one of the era's most ambitious shop design efforts, and a serious bid by its architects to inherit the mantle of the Italian architect and designer Carlo Scarpa.[140] Paul Goldberger's somewhat breathy assessment of the shop compared the design to the jeweler's art of transforming "raw stone into refined object." The overscaled layered arch of the entrance, intended as an homage to a similar device in Tiffany's shop across the way, was also, by default, similar to the brassy Tiffany knock-off that formed the principal entrance to Trump Tower's atrium. Nonetheless, as Goldberger wrote, Bulgari's "exaggerated frame, a vast doorway, as much as it is a facade" presented a "powerful front to Fifth Avenue," appearing "to weave in and out" of its host building "like a vastly overscaled piece of furniture . . . poised

Swiss Bank Tower, east of Fifth Avenue, between East Forty-ninth and East Fiftieth Streets. Lee Harris Pomeroy, 1989. View to the southeast showing Tower 49 (Skidmore, Owings & Merrill, 1984) on the far right. Warchol. PW

Fendi, 720 Fifth Avenue, northwest corner of West Fifty-sixth Street.
Rafael Viñoly, 1989. View to the northwest. Goldberg. ESTO

Bulgari, 730 Fifth Avenue, southwest corner of West Fifty-seventh Street.
Piero Sartogo and Nathalie Grenon, 1990. View to the west. SA

Bulgari, 730 Fifth Avenue, southwest corner of West Fifty-seventh Street.
Piero Sartogo and Nathalie Grenon, 1990. SA

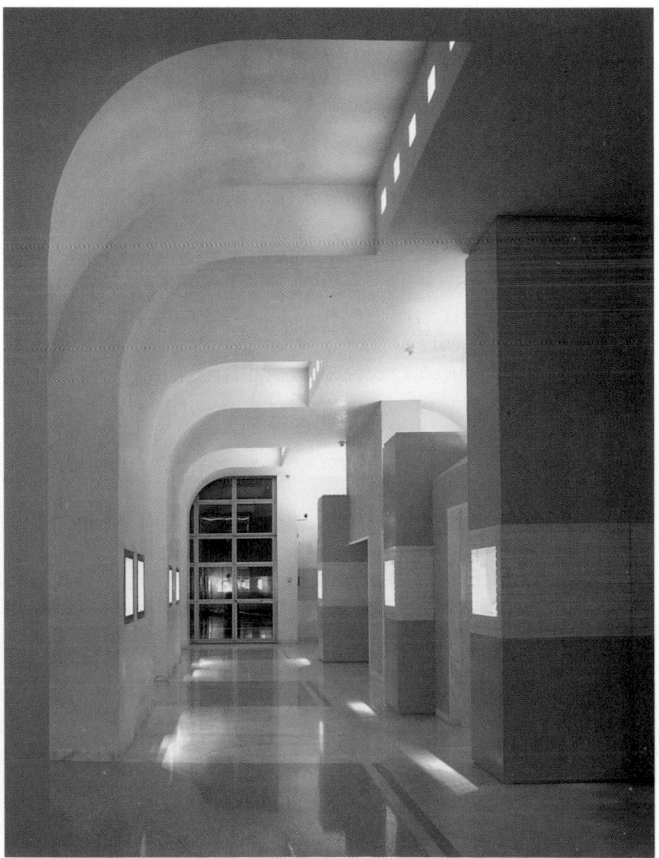

on the cusp of inside and outside." Aside from the glimpses
afforded by the gridded bronze and glass entrance door, the
shop was concealed from the street. Inside, an arcadelike hall-
way capped by a half-vaulted ceiling leading past a series of
small, officelike consultation rooms took a turn before reach-
ing its conclusion at a window facing Fifty-seventh Street. For
Goldberger, the officelike spaces, in effect softly lit sales
salons, taken together with the arcade, constituted a "verita-
ble Aladdin's Cave . . . a series of shops within a shop, the ide-
alized urban fabric of some ancient street mirrored in
miniature by the scent of numerous architectures deftly inter-
locked." These numerous architectures, according to
Goldberger, were not only "the restrained Classicism of the
existing building" and the "aura of a galleried hall flanked by
botteghe" but also "the suggestive fragments of giant coursed
marble" combined with meticulously crafted metal work that
suggested "the substantive and eternal remnants of Classical
Antiquity. Here all is sublime as the ruins, rendered as mono-
lithic marble entablatures and portals. . . . This is no paper-
thin boutique à la mode."[141]

Despite the marked presence of high-profile retailers, by
1988 fourteen tourist-oriented shops dotted the avenue from
Forty-second to Fifty-ninth Street, down from twenty-three in
1985 but still enough to raise concern among the upscale
neighbors. Another deterrent for top-quality merchants was
the proliferation of sidewalk street merchants, many of them
disabled veterans exempt from municipal regulations on ped-
dling, but many others illegal.[142] While the problem was occur-

ring throughout the city, it was particularly rough along Fifth Avenue, where a survey found 166 street vendors between Forty-ninth and Fifty-ninth Streets on one Sunday in 1990.

The recession of the early 1990s kept Fifth Avenue in a semi-depressed state, with vacant retail spaces and office buildings like 546 Fifth Avenue that stood tenantless for two years, as well as continued street peddling and an all-around lack of sufficient municipal services. Samuel G. Freedman, writing in the *New York Times* in 1991, described a typical avenue scene: "Break dancers throbbed across the street from Tiffany. A steel drummer played around the corner from the Museum of Modern Art. Sidewalk merchants offered Gucci knock-offs next door to Gucci. A portable stand styling itself the House O' Weenies peddled dollar hot dogs down the block from La Côte Basque."[143]

Also contributing to the new, "democratized" character of the avenue was the proliferation of theme retail establishments, beginning in 1991 with the opening of a 3,000-square-foot store for Coca-Cola selling toys, clothes, and memorabilia on the ground floor of the company's New York headquarters, 711 Fifth Avenue (Bethlehem Engineering Corp., 1927), northeast corner of Fifty-fifth Street.[144] In 1993 Michael L. Leclere Associates, James Mansour, and Jon Greenberg & Associates completed the 30,000-square-foot Warner Bros. Studio Store, occupying three floors in Cross & Cross's white-marble-clad New York Trust Company Building (1930), northeast corner of Fifth Avenue and Fifty-seventh Street.[145] Carter B. Horsley was surprisingly impressed with the effort, noting that the bas-reliefs of cartoon characters cast in crushed and poured limestone located on the facade between the first and second floors were "executed with considerable artistry and gracefulness."[146] Three years later, at which time Disney joined Coca-Cola at 711 Fifth Avenue with a new 40,000-square-foot store, Warner Bros. more than doubled its facility to occupy nine floors and 75,000 square feet.[147] While Jon Greenberg & Associates's media-saturated interiors were not without interest, it was the modifications to the exterior of Cross & Cross's comparatively small, elegant building that caused the most concern, especially the decision to remove the marble at the corner and replace it with plate glass.

In an effort to improve the avenue's fortunes, the Fifth Avenue Association proposed the creation of a Business Improvement District that would stretch from Forty-sixth Street (the boundary of the Grand Central BID) north to Sixty-first Street, also branching out to cover Fifty-seventh Street between Sixth and Madison Avenues.[148] The creation of the BID made significant strides in eliminating unwanted peddlers—or at least pushing them west to Sixth Avenue, where they soon began to congregate. When BID staffers would see unlicensed street merchants, they would alert the police and, if the peddlers attempted to conceal their wares or close up shop, swear a deposition that allowed the police to arrest them.

In 1993 two new buildings, Norman Jaffe's 565 Fifth Avenue, northeast corner of Forty-sixth Street, and John Burgee's Takashimaya, 693 Fifth Avenue, between Fifty-fourth and Fifty-fifth Streets, provided reassurance that things were looking up for the avenue. Abutting Emery Roth & Sons's 575 Fifth Avenue, 565 Fifth went up on the southern half of the east blockfront between Forty-sixth and Forty-seventh Streets, twelve years after the S. W. Straus & Company Building (Warren & Wetmore, 1921) was purchased by Axel Stawski, a Ph.D. in international law who was lured into the development

565 Fifth Avenue, northeast corner of East Forty-sixth Street. Norman Jaffe, 1993. View to the northeast showing 575 Fifth Avenue (Emery Roth & Sons, 1984) on the left. Heatley. JHP

565 Fifth Avenue, northeast corner of East Forty-sixth Street. Norman Jaffe, 1993. Lobby. Heatley. JHP

game when his father's troubled real estate holdings required his involvement.[149] In 1988 Stawski announced plans to demolish the Warren & Wetmore building, which had once boasted a grand second-floor banking room long since cut up to accommodate offices and the broadcast studio of a local radio station. Three years later, plans were announced for a twenty-eight-story, 300,000-square-foot pink granite–clad office building to be designed by Emery Roth & Sons' Richard Roth Jr., surely an effort to complement the firm's 575 Fifth Avenue. But the developers soon shifted gears, hiring Norman Jaffe to take over the design but keeping Emery Roth & Sons on as associate architects. Jaffe, based in Bridgehampton, Long Island, and best known for his idiosyncratic, individualistic houses, had designed one other office building in Manhattan, Seven Hanover Square (see Financial District). His design for 565 Fifth Avenue (1993) called for a 323,000-square-foot, twenty-nine-story reinforced-concrete-framed tower sheathed in clear glass, aluminum, and stainless-steel, an essay in what he considered to be a "new international" style, one that took advantage of advances made in curtain wall and material technology since the 1950s. With an aim to "weave the base components out of the curtain wall," Jaffe designed an intricately detailed bracketed stainless-steel cornice separating a two-story retail base from a glass and aluminum tower that set back above the ninth floor.[150] Breaks in the second-story cornice marked the endpoints of narrow vertical reveals that ran the height of the building, organizing the facade into a series of bays, a subtle detail that differentiated 565 Fifth Avenue from its midcentury predecessors. On Forty-sixth Street, a geometric stainless-steel canopy led to a lobby featuring a ceiling of interlocking steel grids, walls of flame-finished gray marble, illuminated niches, and steel sconces all designed, in the opinion of Suzanne Stephens, with an "enthusiasm that borders on obsessive."[151] The remarkable level of detail and the clarity and crispness of the 565 Fifth Avenue curtain wall led to comparisons with Skidmore, Owings & Merrill's Manufacturers Trust Company building, 510 Fifth Avenue, of 1954.[152] Stephens called the new building "shockingly refreshing" and lauded the "lavishly articulated stainless steel detailing"[153] that Paul Goldberger agreed was not only "elegant" but very much "Mr. Jaffe's own," even though the squares, grids, and stepped-back forms "loosely echo Frank Lloyd Wright." For Goldberger, the building was "a stunning modernist object, one part homage to the best 1950's and 60's modernism, one part new."[154]

The return in 1993 of the Japanese department store Takashimaya to New York, and especially to Fifth Avenue, was an important vote of confidence in the city's future.[155] Takashimaya had in 1958 become the first Japanese retailer to open a shop (Junzo Yoshimura in association with Steinhardt & Thompson) in post–World War II New York. The design of that shop was widely admired and, together with the goods it showcased, did much to stimulate American appreciation for Japanese domestic arts and to rekindle American affection for the Japanese nation.[156] But by 1966, the shop and especially the merchandise had come to seem clichéd, a victim of changing consumer tastes. Takashimaya relocated to a small second-floor space at 509 Fifth Avenue, at Forty-third Street, before temporarily going out of business in the late 1970s, when the rising yen made its Japanese merchandise too expensive for the New York market. In 1988, when the strong yen made New York real

estate seem ridiculously cheap to Japanese investors, Takashimaya, planning to build a new store, purchased the two-story building at 695 Fifth Avenue, located between the St. Regis Hotel (see below) and the Aeolian Building (Warren & Wetmore, 1926), which had for thirty years been home to Chandler's, a women's shoe store.[157]

The new store occupied nine floors in a 101,000-square-foot, twenty-one-story, 300-foot-high, classically inspired, limestone-clad midblock tower designed by John Burgee Architects which, by the time of the building's completion, had gone bankrupt.[158] The facade was certainly one of the most declamatory in a long time, having about it some of the swagger of the Edwardian era in English architecture. Above a three-story base with a pair of arched entrances (one for the store and one for the offices above) flanking a large storefront window, the limestone-clad facade was organized as a series of stacked two-story sections, each unified by a major order of engaged polished African black granite columns and, above a ninth-floor setback, paired Scandinavian red granite columns flanking a central bay of windows that bowed out from the facade. Two additional bays of double-height windows flanked the central bay, but the facade's glassiness was mitigated by dense grids of bronze and black mullions that gave it an appearance of solidity. The eighth and nineteenth floors each read as a single story, the latter treated as a loggia forming the base of a pediment-capped duplex penthouse below which the building's upper ten floors housed offices for Takashimaya and outside interests, while the lower floors served as Takashimaya's 20,500-square-foot store.

Writing in *Oculus*, Suzanne Stephens reported that the building's exuberant, "columniated, bowed window and tempiettoed facade" made her "nostalgic" for the 1980s, "when such gestures were redolent of money."[159] Paul Goldberger greeted the building as "an earnest if slightly self-conscious attempt to replicate the traditional look of the avenue," but was sour on the end result, opining that it "never overcomes the sense that it has emerged from a classical kit of parts," especially "at the bottom, where an obsession with symmetry has ruled out a central entrance to the department store in favor of a tiny side door, and at the top, where the pedimented crown seems like a too-small cottage plunked down on the roof."[160] Carter Horsley disagreed, calling Takashimaya "the best Post Modern building in the city."[161]

Like Beyer Blinder Belle's Bendel store across the street, the lower two floors of the Takashimaya store surrounded a forty-two-foot-high atrium that, continuing the classicism of the exterior, with marble, onyx, and bronze fittings, complemented an arcade of cast-metal Doric columns carried on Roman parapets to create a remarkably rich effect. Boldly breaking with standard department-store practice, which crammed high-yield impulse items like cosmetics on the ground and second floors, Takashimaya featured a 4,500-square-foot street-level art gallery showcasing young Japanese and American artists, and at the center of the atrium, a gardening center whose display of plants and flowers provided a breathtaking change of pace for harried shoppers. The actual selling floors were designed by Larry Lazlo who, according to Stephens, "injected now-familiar vocabulary from other new

FACING PAGE Takashimaya, 693 Fifth Avenue, between East Fifty-fourth and East Fifty-fifth Streets. John Burgee Architects, 1993. View to the northeast. Mauss. ESTO

emporia—skylit barrel vaults with no sky above, more columns, domed and curved cut-out soffits, cove lighting, and gilt." Clearly, the acerbic and mildly petulant critic was not pleased, but she did at least salute the effort: "Any attempt at urbanity and elegance, even if gratuitously pumped up, is almost welcome on Fifth right now."[162] Shortly after opening, the art gallery, which had proven a financial failure—it was also deemed a dull space—was replaced by the inevitable: a cosmetics department, installed with great elegance by David Mann and Russell Groves operating as MGR Architects.

In addition to new construction, the avenue also benefited from the careful treatment of some of its most distinguished buildings, including the University Club (McKim, Mead & White, 1899), which was meticulously cleaned in 1984–85, restoring the beautiful pinkish gray hue of its granite exterior.[163] Even more notable was the restoration and renovation of the St. Regis Hotel (Trowbridge & Livingston, 1904; addition, Charles A. Platt, 1927), 2 East Fifty-fifth Street, southeast corner of Fifth Avenue, and the Gotham Hotel (Hiss & Weekes, 1905), 2 West Fifty-fifth Street, southwest corner of Fifth Avenue, which, upon their completion in 1904 and 1905, respectively, formed a symbolic gateway to the Central Park hotel district to the north.[164] The St. Regis, founded by John Jacob Astor, was once the city's, perhaps the world's, finest hotel—the tallest building on Fifth Avenue when completed and the first hotel in America to have central air conditioning and heating. By the time it closed for renovations in 1988, it had fallen in stature, to say the least.[165] Brennan Beer Gorman was hired to work on the landmark-designated exterior, which was cleaned and given 1,200 new windows, and the firm's interior arm, Brennan Beer Gorman Monk/Interiors, and Graham Design, redesigned the interiors, "'re-creating' in the existing style," as the architects put it, 95 percent of the interiors, meaning that nearly all the public spaces and many of the guest rooms were newly designed to "match the original grandeur of the 1904 lobby and meeting rooms."[166] The designers significantly reworked the ground floor, creating a new double-height Astor Court tea lounge, with a ceiling of trompe-l'oeil clouds in the 1927 wing that gave the lobby a much-needed center. The King Cole Bar, with its famous Maxfield Parrish mural, *Old King Cole*, originally commissioned for the Knickerbocker Hotel on Forty-second Street, was relocated to sit on axis with the lobby so that guests could enjoy views of the mural as they checked in. Its former space was reinvented as the restaurant Lespinasse. Four kinds of Italian marble were used, and enough twenty-two-karat gold leaf covered the new moldings and trim to make the project, according to Edie Lee Cohen, the second-largest U.S. installation of the material, the first being Salt Lake City's Mormon Tabernacle. When it reopened in the midst of the recession in 1991, the St. Regis was the most expensive hotel in the city.

The Gotham's path to rejuvenation was much bumpier.[167] Built as an apartment hotel across the avenue from the St. Regis, the Gotham was never a great success. It was foreclosed upon only three years after its completion and went through over a dozen subsequent owners until 1979, when René Hatt, a flamboyant Swiss hotelier, purchased it. He announced plans to reopen it in 1983 as the Hotel Nova-Park Gotham. Stephen B. Jacobs was hired to design the renovations according to the eccentric aspirations of Hatt, who believed that, in modern society, the "lack of interpersonal contact may lead to serious sociological problems. An up-to-date hotel must create a vil-

lage square of its own, providing the local population with a focus of activity with attractive and psychologically stimulating features, and offering ample variety."[168]

In realizing this vision, Jacobs gutted the twenty-one-story building and rebuilt it as an ultra-luxurious hotel. While the exterior was treated delicately, its copper cornice restored along with the profusion of ornament on the lower floors, Jacobs added a glassy rooftop pavilion with a health club, pool, and outdoor restaurant—all available for public use—occupying three floors and surrounding a four-story-high atrium. The rooftop restaurant was to complement the hotel's five other upscale eateries, ten bars, a nightclub, and conference and banquet facilities. The opening was postponed from February to October 1983, but by November 1984, the project was still unfinished and the hotel had fallen into the hands of the European banks that had financed it after Hatt went into a financial tailspin, overburdened in part by his lavish spending on the Gotham.

In August 1986, a consortium of investors joined together to complete the renovation and reopen what would be called Hotel Maxim's de Paris, the name licensed from Pierre Cardin, who owned the brand.[169] Hatt had completed nearly three-quarters of his work, including a presidential suite with bulletproof glass and rooms with purple bathtubs next to the beds. Hirsch/Bedner & Associates, a Los Angeles-based design firm, and AiGroup/Architects, of Atlanta, designed the new renovations, featuring Louis XV antiques, marble floors, and Oriental rugs.

In December 1987, Maxim's de Paris opened, but in August 1988, a Hong Kong–based hotel chain announced it would purchase the hotel's lease for the highest price-per-room ever paid for a Manhattan hostelry and rename it the Peninsula.[170] In November 1988, the hotel building was given landmark status and was operating profitably a decade later when Brennan Beer Gorman began a renovation of the guest rooms and suites that would bring it up to five-star status.[171] The hotel was gutted once again and rooms were reconfigured to create larger units, reopening in November 1998.

In addition to the renovation of some of the avenue's more prominent landmarks, some of its smaller gems were also well cared for. In 1996 Italian fashion designer Gianni Versace faithfully restored 647 Fifth Avenue (Hunt & Hunt, 1905), east blockfront between Fifty-first and Fifty-second Streets, built as part of a pair of rowhouses known as the Marble Twins and recently home to an Olympic Airways ticket office, to serve as his flagship New York store.[172] The Milan-based firm of Laboratorio Associates was responsible for the work, restoring the facade with its vermiculated base and fluted Corinthian columns and re-creating the serpentine stairway inside that had once separated the townhouse from its twin to the south, long since demolished. Clearly, the stretch of Fifth Avenue between Tiffany's and Saks was regaining its prestige as a location for high-end retail, so that in 1998, the year it was found to command the highest retail rents in the world, Cartier hired the architects Butler Rogers Baskett, working with the French architect Jean-Michel Wilmotte, to renovate 653 Fifth Avenue (Robert W. Gibson, 1905; renovated for Cartier by William Welles Bosworth, 1917) and the adjoining townhouse at 4 East Fifty-second Street (1903).[173] The Butler firm, led by Timothy P. Greer, reestablished the original entrance at 2 East Fifty-second Street, which had been closed since Cartier moved in, placing a new glass canopy above it. The architects cut a new entrance into the Fifth Avenue facade, two bays south of the existing

one, and removed a mezzanine from the Fifth Avenue sales room, restoring the original height of the space. Display windows were also enlarged, bronze window grilles were brought around from the Fifth Avenue facade to the Fifty-second Street side, and new retractable awnings were installed above the first-, second-, and third-floor windows. According to Alain Viot, president and chief executive of Cartier, the project, completed in 2001, was "like a Cartier product that you redesign as it was before and make it contemporary at the same time."[174]

Another renovation of significance involved one of the avenue's more prominent postwar buildings, Carson & Lundin's Tishman Building, 666 Fifth Avenue, west block-front between Fifty-second and Fifty-third Streets, completed in 1957, which was subjected to a damaging modernization in 1997 when its owners, the Tokyo-based Sumitomo Realty and Development Company, announced plans to upgrade the building and give its ground-level retail and lobby spaces a more inviting feel.[175] As originally designed, these spaces were organized as a T-shaped open-air pedestrian arcade consisting of a wide, shop-lined passage extending back from Fifth Avenue—in the middle of which was Gio Ponti's Alitalia ticket office—connecting to a north–south through-block passage, the west side punctuated by Isamu Noguchi's waterfall sculpture of vertical stainless-steel fins set on a field of corrugated glass.[176] Twin, parallel elevator lobbies were accessed from this north–south passage. The lobby's ceilings boasted Noguchi's other contribution to the building, what the artist called a "landscape of the clouds," featuring row after row of sinuously curving fins illuminated by flourescent lights set beneath translucent panels in the interstitial spaces.[177]

Sumitomo's original plans called for the removal of the ceiling sculpture, but the decision was soon changed, even before pressure to save it was exerted by a belatedly outspoken Municipal Art Society. The building had already lost one of its great public spaces when in 1996 the rooftop restaurant, Top of the Sixes, was replaced by a private cigar club. Though Brennan Beer Gorman had kicked off the redesign process, the job was soon handed over to another New York firm, Nobutaka Ashihara Associates, whose boldest move was to enclose the ground-floor public spaces with revolving doors at each entrance to create a more conventional lobby for the office tenants. The Alitalia ticket office was demolished, opening up, for the first time, long views of Noguchi's waterfall from Fifth Avenue. As well, the subway entrance within the lobby was redirected to provide direct access from Fifty-third Street. While the Noguchi pieces were retained, the rest of the 15,000-square-foot lobby was transformed, with a vaulted ceiling and columns, striped pink and red granite walls, and conventional granite replacing the bold white, black, and red marble of the original floor.

Integral to the renovation was the wrapping of the first two stories of the east, north, and south facades in a twenty-five-foot-high sleek glass wall that provided a fresh image for new retail spaces, most notable among them two prime multilevel stores flanking the Fifth Avenue entrance. The glass storefronts did away with visible mullions in favor of structural glass fins hung from the second story—an attempt, according to Dan Hsu, an architect working on the renovation, to allow "people across the street to be able to see what is in the store."[178] The southern retail space, at the corner of Fifty-second Street, was taken over by the National Basketball Association, which in 1998 opened the first retail store to be owned by a U.S. sports league.[179] The NBA

Superstore, designed by the Phillips Group, working with Richard Altuna, a Los Angeles–based designer responsible for the store's layout and graphics, occupied 35,000 square feet on the ground, basement, and second levels. A thirty-six-by-fifty-four-foot opening was cut into the ground and second floors to create a forty-foot-high space at the bottom of which, accessible by a spiraling maple wood ramp, was a half-sized basketball court surrounded by bleachers for special events. Outside, aside from the sleek glass wall, the facade was, as Karrie Jacobs put it, "what we've come to expect of a brand palace."[180] A light fixture shaped to resemble a basketball hoop—with a ball permanently in the net—was hung like mistletoe above the entrance, revolving doors featured handles fashioned to look like arms holding basketballs, and an oversized gold-leaf NBA logo was carved into a limestone portion at the second-story level.

In May 1999, the Madison Avenue clothier Brooks Brothers opened a two-level outpost in the northern storefront of 666 Fifth Avenue in an attempt to attract Fifth Avenue's plentiful tourist population.[181] Designed by Paul Haigh, working with Pucci International, which chose the store's fixtures, the 23,000-square-foot store was entered beneath an angled aluminum and etched-glass canopy flanked by superscaled photographs dominating the storefront windows. The store's thirty-five-foot-high central selling area featured two open limestone stairs with glass balusters and wood handrails leading to the second floor.

The refurbished 666 Fifth Avenue was rededicated on July 14, 1999, but in 2000, Tishman Speyer purchased the building and hired Moed de Armas & Shannon to perform further renovations: the newly created Fifth Avenue entrance was transformed into a third avenue-fronting shop and the building's primary entry was relocated to Fifty-second Street.[182] The new lobby, measuring seventy-by-seventy feet, connected unceremoniously to Fifty-third Street. It featured a glass and steel reception desk that was unfortunately placed directly in front of

666 Fifth Avenue (Carson & Lundin, 1957), between West Fifty-second and West Fifty-third Streets. Renovation by Nobutaka Ashihara Associates, 1999. View to the west. NAA

ABOVE 666 Fifth Avenue (Carson & Lundin, 1957), between West Fifty-second and West Fifty-third Streets. Renovation by Nobutaka Ashihara Associates, 1999. View of lobby showing Isamu Noguchi sculpture. NAA

BELOW 666 Fifth Avenue (Carson & Lundin, 1957), between West Fifty-second and West Fifty-third Streets. Renovation by Moed de Armas & Shannon, 1999. View of lobby showing Isamu Noguchi sculpture. de Armas.MDA

Hickey-Freeman, 666 Fifth Avenue, between West Fifty-second and West Fifty-third Streets. Robert A. M. Stern Architects, 2001. Aaron. ESTO

Noguchi's waterfall, which was given a new pumping mechanism and a second overhaul, eliminating plastic parts that had been used in the previous renovation, causing a buildup of algae. The retail space on Fifth Avenue was occupied by the clothier Hickey-Freeman, which hired Robert A. M. Stern Architects to design its 4,000-square-foot flagship store (2001), the first shop built exclusively to showcase the company's line of clothing.[183] Stern wrapped the space's existing structural supports with oversized Doric columns and applied abstracted coffering and beams to the ceiling to suggest a grand hall dedicated to men's tailoring.

In January 2002, at the request of Citigroup, which occupied six floors within the building, the three "666" signs that had long marked the north, west, and south sides of the building's crest were removed and replaced by three versions of Citigroup's new Pentagram-designed logo featuring the pseudo-word "Citi" beneath a thirteen-foot-long red arc alluding to the umbrella logo of the recently acquired Travelers Group.[184] The nine "6"'s of the old sign were stored in case they were needed in the future, for instance, when Citigroup's lease expired in 2009.

While the resurgence of luxury retailing was a welcome sign that Fifth Avenue had regained its high-end character, a trend reinforced by the closing in 2000 of the Coca-Cola and Warner Bros. stores, the loss of the avenue's bookstores was regretted in equal measure. Although there had been a boom in midtown Fifth Avenue bookstores in the late 1970s, by 1997 the only remaining Fifth Avenue bookstore was Barnes and Noble's store at 600 Fifth Avenue.[185] The closing that was most regretted—although the historic interior itself was fortunately not lost—occurred a year earlier when Brentano's, which occupied the city's most distinguished book-selling space in Ernest Flagg's Scribner Building (1913), 597 Fifth Avenue, between Forty-eighth and Forty-ninth Streets, shuttered its doors on January 19, 1996.[186]

Brentano's was only the third tenant of the two-story, plaster-paneled, vaulted space, distinguished by its elegant cast-iron and glass storefront, having taken over the shop in 1989. The previous tenant, Rizzoli, had in turn taken over the space from Charles Scribner's Sons in 1984 after its seventy-one-year run.[187] Rizzoli, which moved its corporate headquarters to the eleven-story Scribner Building, kept the Scribner logo on the bookstore and purchased the right to open additional bookstores under the Scribner name. In 1988 the Scribner Building, which Charles Scribner III had sold to the real estate arm of the Duane Reade Corporation at the same time he had relinquished control of the bookstore, was sold to the Italian clothing company Benetton, which tripled the rent, forcing Rizzoli to close the store in January 1989.[188] The closing prompted widespread concern that the remarkable space would either be demolished or ruined by an insensitive renovation. The Landmarks Preservation Commission, which had landmarked the exterior of the building in 1982, quickly stepped in and on July 11, 1989, granted landmark protection for the interior. With the help of the Municipal Art Society, a new bookstore tenant, Brentano's, was found and it occupied the space for the next seven years until Benetton decided it wanted to take the space over for a retail store.

Benetton, 597 Fifth Avenue, between East Forty-eighth and East Forty-ninth Streets. Renovation by Phillips Janson Group, 1997. Mauss. ESTO

Benetton hired the Phillips Janson Group to oversee the renovation, which was completed in 1997.[189] The Italian clothier then entered into an agreement with Rizzoli to stock about 300 titles devoted to fashion or geared toward visitors to be sold in the store's lower-level 1,200-square-foot café. Indeed, the whole renovation was aimed at maintaining the original spirit of the store. Dennis Janson, the partner in charge of the project, spent more than two months researching the history of the building in order to determine original conditions. Terra Firma, a decorative art company, was called in to analyze paint samples in an effort to ascertain the original color scheme. The first order of business was a cleaning of the facade as well as a regilding of the cast-iron and glass storefront. Although Phillips Janson installed some new lighting fixtures to go with twelve original pendants, the bulk of its work in the 13,000-square-foot space was devoted to careful restoration, including reconstructing some of the original cabinetwork as well as replacing one of a pair of spiral staircases that had long ago

been removed. The "crowning glory" of the work, according to Monica Geran, writing in *Interior Design*, was the reopening of a newly discovered skylight at the rear of the mezzanine level which had been blacked out during World War II.[190]

Unfortunately, not all of the avenue's historic buildings fared so well. In July 1990, Tokyo-based developer Touko Hous announced plans to demolish one of the oldest buildings on Fifth Avenue, the six-story Levi P. Morton house (1860), 503 Fifth Avenue, northeast corner of Forty-second Street, in order to make way for an office building.[191] Morton, a governor of New York and vice president of the United States, had purchased the four-story house, originally built by an unknown architect for Montagnie Ward, in 1871, and eight years later, working with the architect J. E. Terhune, added an additional two stories. Terhune's expansion also replaced a stable (1871) at the rear of the site designed by Richard Morris Hunt. The building began serving as a hotel at the turn of the century; in 1920, about the time its facade also became home to bill-

boards, it was renovated for office space, with its ground floor leased to retail. The building remained in Morton family hands until 1980, when it was sold to Vector Studley Associates. In 1987 the building was sold to Touko Hous, which over the next three years acquired adjacent parcels at 1 East Forty-second Street and 4 East Forty-third Street in order to build its planned 190,000-square-foot building.

Although the editors of the *New York Times* mourned the passing of a potent literary relic—the house was immortalized by Edith Wharton in her 1934 autobiography, *A Backward Glance*, as the setting for her society debut in 1879 at the age of seventeen—they didn't appear overly concerned about the loss of the brick building: "It hasn't been declared a landmark because, architecturally, it doesn't deserve to be."[192] Although the editors of *Oculus* castigated their colleagues at the *Times* for their "less than reassuring estimation of architecture (and preservation)," no movement to save the Morton house materialized and the 130-year-old building was demolished at the end of 1990.[193]

The subsequent collapse of the real estate market forced Touko Hous to abandon its plans, and in 1992 the Morton house site was the subject of a short-lived plan for an eighty-five-foot-high, six-level, glass-clad exposition center.[194] Dubbed America's Exposition Pavilion by its sponsor, George Stonbely, the proposed building was designed by John Burgee Architects. Instead of Burgee's ambitious plan, however, the site became home to a hideous one-story taxpayer, International Plaza, a ramshackle flea market selling discount goods. In 2001 plans were announced for its replacement when the new owners, developers LCOR, released a scheme designed by Kohn Pedersen Fox for a twenty-three-story, 275,000-square-foot office building.[195] To be clad in floor-to-ceiling sheets of glass, the aggressively shaped design, plans for which were canceled, would have also replaced the two buildings directly to the north, the eighteen-story 505 Fifth Avenue (Maynicke & Franke, 1909) and the twelve-story 507 Fifth Avenue (Buchman & Fox, 1908), both of which had been recently emptied of tenants. A new development team, the Kipp/Stawski Group, then took control of the site, again hiring Kohn Pedersen Fox to produce plans for a more conventional, twenty-seven-story, 300,000-square-foot glass-clad version, construction of which began in March 2004, with completion expected in 2006.[196]

Grand Army Plaza

Grand Army Plaza, west side of Fifth Avenue between Fifty-eighth and Sixtieth Streets, New York's most elegant and refined outdoor public space, was initially planned by Frederick Law Olmsted and Calvert Vaux in 1858 as a gateway to Central Park. In 1912 Joseph Pulitzer bequeathed money for a fountain to be named in his honor and built at or near the intersection of Fifth Avenue and Fifty-ninth Street.[197] A limited design competition held in 1913 was won by Thomas Hastings, who situated the Pulitzer Fountain (1916), composed of five stone basins rising concentrically to Karl Bitter's statue *Abundance*, symmetrically across Fifty-ninth Street from Augustus Saint-Gaudens's Sherman Monument, which had rested on a Charles McKim–designed base north of Fifty-ninth Street since 1903. The square was named Grand Army Plaza in 1923 and received landmark status in 1974. By the early 1980s, however, it had become somewhat seedy. Not only was its pavement cracked, but the space had been

Diane von Furstenberg boutique, Sherry-Netherland Hotel, east side of Fifth Avenue, between East Fifty-ninth and East Sixtieth Streets. Michael Graves & Associates, 1984. View to the east. GRV

Diane von Furstenberg boutique, Sherry-Netherland Hotel, east side of Fifth Avenue, between East Fifty-ninth and East Sixtieth Streets. Michael Graves & Associates, 1984. Paschall. GRV

stripped of numerous elements, including a stone balustrade that had surrounded and united the Pulitzer Fountain and the Sherman Memorial as well as a pair of columns that once flanked the fountain, which itself had been turned off in 1982. The Sherman Monument was also in a downtrodden state, its original layers of gold leaf long since removed after excessive peeling and its base blackened with grime. With numerous improvements under way within Central Park, the Central Park Conservancy hired the firm of Buttrick White & Burtis to prepare a plan for the plaza's renovation.[198] The restoration would rehabilitate the plaza's existing features as well as return to the traffic-ridden square a sense of unity by replanting a double row of trees around its perimeter and reconstructing Hastings's stone balustrade. With no funds made available by the city, the work was financed privately by the Conservancy and through the efforts of the Grand Army Plaza/Pulitzer Fountain Partnership, a group led by Leonard and Ronald Lauder, whose company, Estée Lauder, overlooked the plaza from offices in the General Motors Building, and Ira Neimark, the chairman and CEO of Bergdorf Goodman.

The restored space, completed in 1990, featured a single ring of Bradford Callery pear trees, repaired paving, and new lamps and cast-stone benches. Unfortunately, not enough money was raised to replace the stone balustrades or the two stone columns flanking the Pulitzer Fountain. The Pulitzer Fountain was brought back to life with new plumbing and electrical work and a new granite central basin (the original was of limestone but was replaced by granite in a 1970 renovation). The statue of Pomona, removed for restoration in 1988, was back in place when, on June 7, 1990, the fountain once again flowed with water. The Sherman Monument was also dutifully restored, though its renewed gilding was seen by some as a sign of unnecessary opulence in a time of austerity and by others as a tacky focal point for the otherwise subdued elegance of the plaza. By 2002, the gilding was once again peeling and the statue itself had become a pedestal for pigeons.

Across Fifth Avenue from the Sherman statue, in the northern storefront of the Sherry-Netherland Hotel (Schultze & Weaver and Buchman & Kahn, 1927), fashion designer Diane von Furstenberg opened a boutique designed by Michael Graves in 1984.[199] The once well-married fashion designer had made millions in the early 1970s with a wrap-around dress that it seemed almost every woman in America wanted in ten different colors and patterns, but by 1977 didn't ever want to wear again. Seeking to reignite her career with a more up-market line, she hired Graves, then at the peak of his fame as the result of his Portland Building and his selection as architect of the Whitney Museum's expansion, to design a 1,200-square-foot shop, one of the loveliest of the decade.[200] The store was notable not only for its beautifully conceived and detailed suite of salesrooms but for its refined restoration and enhancement of the exterior shopfront, the only portion to remain mostly intact after another fashion designer, Geoffrey Beene, took over the premises in 1989 and tore out the interior.[201] Except for the fabric-draped tent room, Graves's interior was not so much a shop as a walk-in cabinet, suggesting an elegant and luxurious yet refined dressing room in a lavish private home.

Anchoring the southeast corner of Grand Army Plaza, Ely Jacques Kahn's Squibb Building (1930), 745 Fifth Avenue, southeast corner of Fifty-eighth Street, the architect's self-proclaimed masterpiece, underwent an unfortunate renovation completed in 1990 by Hammond, Beeby & Babka.[202] In

1986, fourteen years after Squibb relocated to 40 West Fifty-seventh Street and one year after F.A.O. Schwarz, which had been the building's most prominent retail tenant, moved across Fifty-eighth Street to the General Motors Building, a Dutch investment consortium purchased the building, announcing the following year that in addition to an exterior cleaning, mechanical systems upgrades, and window replacements, the structure would be further "improved" by a renovation of the first six stories. The plan called for the replacement of the base's pristine white marble cladding with large panels of green, pink, and black marble trimmed with bronze and stainless steel, the rationale being that the renovation would bring the building closer to Kahn's original plans, which, in the healthy imagination of the owner, called for the sort of polychromatic vigor that characterized Kahn's Two Park Avenue (1926–27) but had been compromised due to cost cutting after the stock market crash of 1929. Christopher Gray reported in the New York Times that the building had indeed been built according to Kahn's original drawings, which were on file at Columbia University's Avery Library. In fact, Kahn was so pleased with his work that he outlawed any future alterations without his approval. But after Abe Adelson, the original owner, lost control in 1933, a number of changes were made: the marble base was painted, the nickel-steel screen above the Fifth Avenue entrance was removed, and the lobby's ceiling mural, by Arthur Covey, was pierced through with ventilation ducts.

Hammond Beeby & Babka's renovation was initially designed to reconfigure the 50,000-square-foot retail space formerly occupied by F.A.O. Schwarz into fifteen three-story units that would be articulated on the exterior as a row of townhouses. But the prime location soon captured the interest of major retailers, and on August 30, 1988, Bergdorf Goodman announced it would lease the space as a new home for its men's store. Seeking to match the classical elegance of Bergdorf Goodman's primary quarters across Fifth Avenue, which had been remodeled by Allan Greenberg in 1983–84 (see above), the Hammond firm stripped the first two stories to their steel frames and resheathed them in black granite trimmed with stainless steel and bronze grillwork and detailing. Above the second floor, a new layer of limestone was attached to the existing facade to form fluted piers extending from the third to the fifth floors. But it was the row of fifteen large square medallion windows framing geometric patterns of diamonds, circles, and squares at the sixth-floor level that compromised the building's modern classical restraint. On the upside, the office building's Fifth Avenue entrance and lobby was sensitively restored, including Covey's ceiling mural, and a metal grille similar to Kahn's long-lost original was installed over the entry.

Bergdorf's men's store, occupying 40,000 square feet in three stories, was conceived, according to Ruth La Ferla, a style-oriented reporter for the New York Times, as a "monument to opulence," but had the misfortune of opening in 1990, when economics and consumer psychology combined to curtail lavish spending.[203] The shop was designed by James and Christine Nakaoka, a California-based team specializing in retail environments who had previously helped redesign interiors in Bergdorf's main store. The Nakaokas dispensed with mahogany paneling—deemed a cliché in men's retailing—to create a series of classically organized and detailed rooms, the walls of which were lined with gray limousine cloth with woodwork finished

Squibb Building, 745 Fifth Avenue, southeast corner of East Fifty-eighth Street. Renovation by Hammond, Beeby & Babka, 1990. View to the east. Amiaga. AP

in a variety of hues from ash to eggplant, resulting in a "simultaneously soothing and intimidating" atmosphere echoing that of the main store across the street.[204] According to James Nakaoka, the aim was "to create a mood of height and hush," which was certainly achieved in the shop's centerpiece, a two-story, shallow-domed rotunda.[205] Ironically, the new store lacked a Fifth Avenue entrance—a low-end jewelry store with six years to run on its lease refused to be relocated. But in 1997, after the jeweler's lease had run out, Bergdorf expanded the men's store, adding not only 2,000 square feet of street-level selling space but also a Fifth Avenue entrance, both designed by Stephen Miller Siegel in a manner that blended the Art Moderne aesthetics of the Squibb Building with the Edwardian classicism of the store interior.

The Plaza Hotel (Henry J. Hardenbergh, 1907), southwest corner of Fifth Avenue and Fifty-ninth Street, was the crown jewel of Grand Army Plaza and remained one of New York's most beloved and symbolic buildings.[206] Designated a landmark in 1969, the hotel had nonetheless undergone countless alterations, especially on the inside, since taking its current form after the construction of Warren & Wetmore's 300-room addition along Fifty-eighth Street in 1921. Most notable was the loss in 1943 of the Tiffany stained-glass ceiling in the Palm Court, sacrificed to provide space above for air-conditioning units. More recently, public protest over the 1971 transformation of the Edwardian Room into the gimmicky Tulip Room resulted in its restoration in 1974.[207] The following year, Western International (later Westin) purchased the hotel and undertook an extensive program of improvements that began to reclaim some of its lost splendor. The restoration of the Oak Room was completed in 1976, and in the years to come, windows were restored to their original brass finish, rooms were renovated, the facade was cleaned, and mechanical systems were upgraded.

In January 1977, a 204-seat theater, Cinema III, opened in the basement of the Plaza.[208] To gain approval from the Landmarks Preservation Commission and the City Planning Commission, a waiting area capable of accommodating the entire capacity of the theater was required inside the hotel, thereby avoiding ungainly queues along Central Park South that might detract from the dignity of the building. In addition, small signs marking the entrance were called for instead of marquees. Designed by John McNamara and James McNair, the theater was reached by a flight of stairs leading from Central Park South down to two box offices, beyond which a narrow lobby lined with mirrors and ultrasuede-covered banquettes was decorated with a gold-brass relief by Norman Ives and tapestries by Stuart Davis, Jean Arp, and Sonia Delaunay. The art gave the space a refined feel, making it seem more akin, as Paul Goldberger described it, to "an expanded screening room than a commercial movie house." The theater space's ultrasuede walls, green velvet seats, and golden curtain contributed to a "total look," in the opinion of Goldberger that, "while hardly advancing the frontiers of design, is one of comfort and dignity."[209]

Despite Westin's investment in the hotel's renovation and maintenance, the Plaza suffered from the inevitably homogenized management of a hotel chain and, by the mid-1980s, seemed to be living off its reputation.[210] The architect Lee Harris Pomeroy, who established his offices in former maids' quarters on the seventeenth floor in 1970, explained: "It's become more commercial and lost a little bit of its old glamour and grandness."[211] In 1987 a change in leadership at Allegis, the parent company of United Airlines and the owner of Westin, led the company to auction off its nonairline assets. More than 100 investors showed interest in the Westin chain, which comprised sixty hotels other than the Plaza, but in October 1987, days after the stock market crashed and sent the auction process into a tailspin, a partnership of the Tokyo-based Aoki Corporation and the Texas millionaire Robert Bass successfully negotiated the purchase. Bass's agreement with Aoki gave him majority ownership of the Plaza as well as the right to sell it. After dabbling with the idea of inserting a four-story retail atrium in the Palm Court modeled after the atrium in Trump Tower, Bass decided to unload the hotel.

In late February 1988, the New York Times reported that the team of Philip Pilevsky and Arthur G. Cohen was close to buying the Plaza, with plans to convert a portion of it into cooperative apartments.[212] But on March 26, Donald Trump proudly announced he had purchased the Plaza with plans to make it "the most luxurious hotel in the world."[213] Under the terms of the sale, Westin would continue to manage the hotel for two years, but Trump's wife, Ivana, would be named its president and receive a $1 a year salary "plus," Trump proclaimed, "all the dresses she can buy."[214] The media had a field day with that rather chauvinistic comment.

Trump was well aware that his reputation for glitz—not to mention his vow to "upgrade everything"—had many observers clenching their teeth at the news of the sale.[215] He solicited renovation proposals from James Stewart Polshek & Partners, Hardy Holzman Pfeiffer Associates, and Beyer Blinder Belle. Hardy Holzman Pfeiffer, whose recent renovation of the Rainbow Room was a well-publicized hit, was awarded the job, working with Lee Harris Pomeroy, who was hired as architect of record and who would handle much of the interior work. The architects focused their efforts on restoring the building's original elements. The exterior would be cleaned, finials and stonework would be replaced along the roofline, and the cast-iron entrance canopies restored with

Plaza Hotel (Henry J. Hardenbergh, 1907), southwest corner of Fifth Avenue and West Fifty-ninth Street. Proposed rooftop addition by Hardy Holzman Pfeiffer Associates, 1988. East elevation. NYT

new glass roofs. The Fifth Avenue lobby would regain its old splendor, as would the Rose Room (later the Persian Room and then a clothing store), where dropped ceilings had for years hidden ornamental plaster ceilings. Ballroom windows, lost after the Baroque Room (a former ballroom situated off the Grand Ballroom on the second floor) was converted for office use, would be re-created along Central Park South. New touches were also planned for overlooked spaces such as the light well, which, seen from many guest-room windows, was to be gussied up with vine-adorned metal trelliswork, window boxes, a decorative lighting scheme, and, at the ground level, a formal garden. The only controversial aspect of the renovation stemmed from Trump's plan to add fourteen new suites in the hotel's uppermost floors—six within the mansard roof on the seventeenth floor, where existing windows would be enlarged, and eight new duplex suites built above it which would require cutting new dormers into the hotel's boldly scaled mansard. The duplexes were to occupy the existing eighteenth floor and a new nineteenth floor, replacing an accretion of shabby mechanical enclosures and paint sheds. The penthouse level would be set back seven feet from the edge of the mansard, which would be lowered by three feet and have five dormer windows introduced into each of its three corner pavilions.

Paul Goldberger greeted the restoration plans warmly, writing that, for the most part, Hardy's ideas "make much sense, and should enrich this splendid building." Though many were displeased at the reconfiguration of the upper floors and the addition of the penthouse level, which would be visible from the north side of Fifty-ninth Street and from Central Park, Goldberger stated, "This part of the plan, too, deserves to go ahead. . . . The Plaza is not a museum piece but a living, functioning hotel. To agree that it must be treated with care is hardly to say that it must be frozen in time." For Goldberger, it was piddling to argue over the new roofline: "In

truth, this penthouse will have much less effect on the Plaza than the huge, looming skyscrapers that have gone up around the hotel in the last generation—buildings like the glass tower to its south, which gives the hotel a perpetual dark backdrop. These harsh neighbors are the Plaza's real nemesis."[216]

The plans were presented to the Landmarks Preservation Commission on December 20, 1988, and approved in a 7 to 4 vote in May 1989. While allowing the new nineteenth floor, the commission did not permit the addition of the five dormer windows to the corner pavilions. In October 1989, HHPA presented a pared-down plan to add three smaller dormers to each pavilion, but that, too, was denied. Trump's financial difficulties in the early 1990s halted most of the major work, including the construction of the penthouse. What did move forward were extensive renovations to the guest rooms, guided by Ivana, who conceived several suites named for famous past hotel guests, including the Vanderbilts and Astors. Trump also "re-created" the Frank Lloyd Wright suite with furniture reproduced by the Wright Foundation, though the new set of rooms was as much a tribute to Wright—with framed plans of the Guggenheim Museum hanging on the walls—as a reconstruction of the quarters Wright designed for himself in 1953.[217]

In 1991 Trump, trying to raise cash, intended to convert 800 of the Plaza's 813 units into condominiums, but the plan did not proceed, and in March 1992, Trump agreed to relinquish all but 51 percent of his ownership of the hotel to creditors. In 1995, he became a minority partner when he sold more of his interest to a Saudi Arabian prince and a Singapore-based hotel company.[218] The new owners completed a 9,000-square-foot health club and spa designed by the firm of Stonehill & Taylor, and, more notably, commissioned Adam Tihany to tinker with the admired but continually underpatronized Edwardian Room, which was reborn as One C.P.S., a 190-seat restaurant that opened on September 13, 2000.[219] Even after Tihany sheathed

the existing chandeliers in red lampshades, uncovered bright mosaic tile floors, replaced dark drapery with wooden blinds, and placed a bar near the entrance, William Grimes felt the designer had failed to make the room—"one of the deadest spots in the city"—into "a fresh-feeling brasserie."[220]

Donald Trump's part love affair, part obsession with all things bordering Central Park continued in 1998 when, in partnership with the insurance company Conseco, he won a fierce bout of bidding to purchase the General Motors Building (Edward Durell Stone, 1968), occupying the entire block bounded by Fifth and Madison Avenues, Fifty-eight and Fifty-ninth Streets.[221] From the moment it was completed, the General Motors Building, which replaced McKim, Mead & White's Savoy-Plaza Hotel of 1927, took a hailstorm of criticism for its general disregard for the existing character of the urban ensemble it joined around Grand Army Plaza. In particular, it was the provision of a vast, mostly sunken plaza on Fifth Avenue adjacent to Grand Army Plaza—what was widely considered the ultimate urban redundancy—that served to destroy the coherence of what had been a near-perfect outdoor room. The plaza, sunken eleven feet below grade, failed to attract pedestrians. Without a *Prometheus* and an ice-skating rink to draw the eye, it was a failed stepchild of the quintessential sunken plaza at Rockefeller Center.

Trump was no fan of the plaza and announced shortly after taking ownership that he would radically revamp it. Whatever restraint the developer showed in his tenure as owner of the Plaza Hotel was absent in his management of the General Motors Building, which was renamed the General Motors

Building at Trump International Plaza. To further announce his arrival, Trump quickly installed two sets of four-foot-high titanium letters spelling out T-R-U-M-P along the marble piers at the base of the building facing Fifth and Madison Avenues. Four more smaller sets of TRUMPs were hung at each of the corners. Each of the larger letters was wider than the pier to which it was attached and actually wrapped around their beveled edges so that, as Paul Goldberger put it, "Trump's name appears almost to float in front of the building, like a vast, shiny hologram."[222] The letters were widely criticized as garish and, prodded by numerous discontented tenants, Trump replaced the titanium letters with more muted antique-finished bronze ones and removed the corner nameplates altogether.

Trump returned to his trusted architect, Der Scutt, who was hired to renovate the lobby, leaving its distinctive hexagonal patterned ceiling intact but recladding the walls in Vermont Verde Antique and Greek White Pentelikon marble and installing a new geometric Vermont Verde Antique marble floor with one-half-inch-wide inset brass strips. Green marble also covered new reception desks and stair and elevator door surrounds, while the brass trim carried over to furniture, lighting, and hardware. Thomas Balsley Associates, working with Leclere Associates Architects, renovated the plaza, whose sunken courtyard was, after so much discontent, roofed over to form an elevated platform covering 21,500 square feet of retail space accessed by a thirty-seven-foot-wide glass entry set at the base of a short flight of stairs centered between Fifty-eighth and Fifty-ninth Streets. Despite Trump's track record for

General Motors Building Plaza, east side of Fifth Avenue, between East Fifty-eighth and East Fifty-ninth Streets. Renovation by Thomas Balsley Associates and Leclere Associates Architects, 1999. View to the northeast. Loo. TBA

successful deal making, the retail space proved difficult to lease, remaining vacant for years after its completion. Two sixty-five-foot-long fountains flanked the elevated platform and were set into troughs clad in the same green marble employed inside the lobby. Trees were clustered throughout the salt-and-pepper granite-paved plaza, located so as not to obstruct certain camera angles used by CBS television's morning show, which occupied the northern half of the building's lobby (see Times Square).

Central Park South

Donald Trump's first foray into developing the precious real estate bordering Central Park came in 1981, when he purchased both the thirty-eight-story Barbizon Plaza Hotel (Murgatroyd & Ogden, 1930), northwest corner of Sixth Avenue and Fifty-eighth Street, an L-shaped tower that also fronted Central Park South, and 100 Central Park South (Schwartz & Gross, 1918), southwest corner of Sixth Avenue, a fifteen-story apartment building in the shadow of the much taller hotel.[223] Trump planned to demolish both buildings and replace them with a seventy-story hotel designed by Der Scutt, whose scheme for a reflective glass-skinned tower with Art Moderne–inspired curving setbacks would have been grossly out of scale with its neighbors. Trump's plans hit a snag, however, when he attempted to evict tenants from 100 Central Park South who enjoyed rent-controlled and rent-stabilized apartments. It was a near impossible task and in 1982, a year after Trump bought the building, only ten of the 100 or so apartments were vacated. In a thinly veiled effort to speed the departure of the residents, Trump began to cut services to the building, use dimmer light bulbs in the corridors, strip door-

men of their uniforms, and, in the most extreme measure, he offered to house the city's homeless in the building's vacant apartments, a proposal greeted with skepticism by administrators at the Human Resources Administration. Meanwhile, the tenants, united against Trump, complained of general harassment and, in 1984, filed charges leading to city and state action against their landlord for mistreating the tenants.

In the midst of the legal turmoil, Trump later explained, he sensed that "architectural tastes and trends began to shift." He moved away from the Modernist design and commissioned a new one from Scutt "that incorporated older, classical elements compatible with 100 Central Park South."[224] More important than the issue of style, however, were the zoning changes that went into effect while Trump's plans were tied up in tenant conflicts—changes that substantially decreased the potential size of a new building on the site. Scutt's second scheme called for the renovation of the Barbizon-Plaza Hotel and the replacement of 100 Central Park South with a thirty-story limestone-clad apartment house whose two-story living rooms allowed additional square footage to be allocated to the penthouse floors. In December 1985, facing the realization that he would not be able to win the suit against the tenants of 100 Central Park South and aware that he could not build more square feet than what already existed, Trump abandoned his plans to demolish either of the existing buildings and instead hired Frank Williams & Associates to transform the pair into Trump Parc (1988), a single apartment house containing 340 units ranging from 300 to 3,500 square feet, though the buildings would not be connected from within. The residents of 100 Central Park South were allowed to keep their rent-controlled and rent-stabilized apartments, which

Proposed hotel, southwest corner of Sixth Avenue and Central Park South. Der Scutt, 1981. Photomontage, view to the southwest. DSA

Proposed apartment house, southwest corner of Sixth Avenue and Central Park South. Der Scutt, 1982. Photomontage, view to the southwest. DSA

would be remodeled as they became available. Frank Williams relocated the Barbizon's primary entrance from Fifty-eighth Street to 106 Central Park South and created new terraces on the building's setbacks. The most alarming element of the design was also the most typical of Trump: nearly all of the buildings' exterior ornament was gilded, including the Barbizon's original glass and stone crown, the ribs of which were extended upward to conceal new mechanical equipment.

In 1985, amid his unsuccessful battle to remove tenants from 100 Central Park South, Donald Trump purchased the thirty-three-story, 775-room St. Moritz Hotel (Emery Roth, 1930), southeast corner of Central Park South and Sixth Avenue.[225] Trump took control of the St. Moritz in September 1985 and continued to operate it as a hotel until January 1988, when he sold the building to the Australian billionaire Alan Bond.[226] Trump made a hefty profit on the sale, though not quite the 600 percent the newspapers originally reported. About a year after Bond took ownership, however, sources reported that he had "overextended himself" and was looking for a buyer.[227] When none could be found, Bond defaulted on payments and in 1989 the Australian lender F.A.I. Insurances took control of the property. The hotel was the only of F.A.I.'s holdings outside the Pacific Rim and quickly became a financial drain on the company as it allowed the St. Moritz to become what the *New York Times* described in 1997 as "a somewhat dowdy refuge of bargain-conscious international tour groups."[228]

Donald Trump came back on the scene in 1997 when he entered into an agreement with F.A.I. to reinvent the hotel as luxury condominiums.[229] Trump would provide the insurance company with development and marketing expertise in return for a share in future profits. Early plans called for the hotel to be gutted, reskinned in bronze-tinted glass with a pleated glass top, and rechristened Trump Pinnacle. Hearing news of the plan, preservation groups including Landmark West and the Municipal Art Society quickly advocated the designation of all of Central Park South as a historic district, but the Landmarks Preservation Commission was lukewarm. Chair Jennifer Raab tried to strike a deal, telling Trump, "If you will commit to me to build a 1920's building, I'll agree not to rush to designate.'"[230] Herbert Muschamp was disappointed by Raab's offer, commenting in his end-of-the-year architecture review: "The low point of this year and many other years was reached when" Raab instructed Trump to construct a 1920's "skyscraper on the site of the St. Moritz Hotel. . . . A person who could say such a thing has no business being in landmarks preservation, because she has no sense of history. She is unable to distinguish between a landmark and an ersatz version of one, and she evidently conceives of architecture as a practice tantamount to arranging throw pillows on a sofa."[231]

Trump retained Robert A. M. Stern Architects to handle the conversion, which called for a total recladding of the structure necessitated by what was perceived to be the instability of the existing brick walls and the need to create fewer and much larger windows to coincide with the transformation of the interior plan from one of small, virtually identical hotel rooms to one of large apartments. Stern's proposed facade gestured to the stylish modern classicism of the 1930s with abstract details in cast stone and metal trim, intended as a contextual response to its neighbors, primarily the Barbizon, Hampshire House, and Essex House hotels to the west. The Landmarks Preservation Commission, however,

Proposed Trump St. Moritz Condominiums, southeast corner of Sixth Avenue and Central Park South. Robert A. M. Stern Architects, 1997. Rendering of view to the southeast. RAMSA

did not see merit in the design, with Raab stating that though Trump had "committed to preserve" the hotel's "traditional look . . . the plans we were shown did quite the opposite: They were about destruction not preservation."[232]

Though not legally obligated to follow the commission's advice, Trump did so, hiring Beyer Blinder Belle to prepare designs that would also strip the building to its steel frame but rebuild it with a limestone and brick skin similar to the original but with larger window openings.[233] The new windows were to be six to seven feet high, and the hotel's 775 rooms would become 130 apartments in what would be called the Trump Regent. But on April 30, 1998, only ten days after Trump's plan was announced on the front page of the *New York Times*'s Metro Section and just a month before work was to begin, the hotelier Ian Schrager announced he had purchased the St. Moritz from F.A.I.[234] Schrager continued to operate the St. Moritz, planning to hire Philippe Starck to turn it into his most luxurious hotel yet, but after eighteen months the hotel was in new hands again, this time those of Millennium

Partners, which would succeed in converting it to a 300-room flagship for the Ritz-Carlton hotel chain.[235] Schrager remained in the mix as a partner in the conversion of the building's top twelve floors to eleven super-luxurious condominiums. Gary Edward Handel + Associates was architect for the renovation (2002), which gutted and rebuilt the interiors, rehabilitated the exterior skin and details, and increased the size of the floor plates by adding incrementally onto the south facade.

ROCKEFELLER CENTER

Begun in 1929 and virtually complete in 1939, Rockefeller Center was, by 1976, as Paul Goldberger wrote, "one of the 20th Century's great prototypes, and one of the city's great gifts to the nation."[1] But it was also showing its age, and efforts at keeping it up as a real estate investment had somewhat blurred its features. While management's decision to wash the crisply detailed facades revealed anew the splendid limestone and aluminum long buried under layers of urban soot, other efforts to freshen things up were sometimes ill-advised, such as the 1976 decision to remove original canopies and signage, elements just then enjoying newfound appreciation by a younger generation of enthusiasts discovering for the first time the pleasure of the newly labeled Art Deco style of the late 1920s and early 1930s.

Worse still, the center's great public places seemed to be succumbing to a devastatingly destructive combination of public apathy and business ineptitude. The Rainbow Room, its once glamorous sky-high dinner and dancing club, was badly managed and a victim to changing tastes in entertainment. Radio City Music Hall was losing business for similar reasons. Even worse, the center seemed in danger of losing its competitive edge as an office address: though its natural-light-filled, shallow-depth office floors were the most enlightened and humane ever devised, they were planned before air-conditioning made deep floors possible and new office procedures demanded a horizontal flow of work, favoring much larger floor sizes than the center provided. The prognosis for the center's future seemed, at best, mixed.

Nevertheless, as Rockefeller Center celebrated the fiftieth anniversary of its 1932 opening, it had recovered from its economic low point in the early 1970s, when 15 percent of its space was empty.[2] The birthday celebrations included significant improvements, including the restoration of the Prometheus statue in the sunken plaza—and the return to the statue's flanks of two other Paul Manship sculptures, *Youth* and *Maiden*, which had been removed in 1935, a year after the group was installed—and the restoration of the famous rooftop gardens in 1986.[3] The need to meet the financial expectations of the growing number of Rockefeller family members led management, encouraged by the property's strong market value, to consider selling the center to outside investors.[4] At the same time, preservationists began to campaign for the legal designation of the complex as a landmark. On September 20, 1983, the Landmarks Preservation Commission heard testimony that did not revolve around designation per se—the Rockefeller family recognized the center's unofficial landmark status—but around the extent of the complex that was to be legally protected.[5] The Rockefellers' spokesman, John E. Zucotti, was willing to concede only that the two-block heart of the complex—that is, the RCA Building, RCA Building

West, the plaza and skating rink, the Channel Gardens, and the British Empire building and Maison Française, as well as certain works of art outside the area—merited protection. Most of the twenty or so others testifying, although not the New York Chapter of the American Institute of Architects, called for landmark designation for all of the thirteen limestone-clad structures as well as their plazas and gardens. The situation was complicated by the fact that the land under the center was leased from Columbia University, which was particularly concerned about the potential economic implications of the proposed designation. In 1984, however, Columbia sold the land to the Rockefeller Group, the Rockefeller family's investment company, and on April 23, 1985, the entire complex was declared an official New York City landmark.[6] Three years later, in 1988, Rockefeller Center was designated a National Historic Landmark by the National Park Service.[7]

The prosperity of the mid-1980s and the impending designation brought some significant changes. In 1984 Abe Feder, who had first designed lighting for Rockefeller Center in 1948, embarked on an extensive new program of night lighting for the complex, flooding the RCA Building in icy white light, as well as relighting the Promenade, Channel Gardens, and Lower Plaza. In 1988 Feder, recognizing that the lighting of the RCA Building upstaged the Prometheus fountain, created an elaborate system of colored lights and water jets operating on a twenty-six-minute repeating program, which brought well-deserved attention to the fountain.[8] In addition, in 1984, four restaurants designed by Philip George were added to the sunken plaza that was surrounded by a new, somewhat antiseptic, white marble hallway designed by John Portman, who was also responsible for two elevators leading down to the plaza accessed through glassy, futuristic but fundamentally innocuous street-level capsules reminiscent of his work at the Marriott Marquis Hotel.[9]

Most dramatically of all, the Rainbow Room was restored and its adjoining bars and meeting rooms completely reimagined to adapt the glory of the skyscraper glamour of the 1930s to the realities of contemporary nightlife and corporate entertaining.[10] Hardy Holzman Pfeiffer was put in charge of the Rainbow Room restoration. Working under the direction of Joseph Baum and Michael Whiteman, restaurateurs and food service consultants, Hugh Hardy and the graphic designer Milton Glaser tackled the entire sixty-fourth and sixty-fifth floors of the RCA Building, a total of 46,000 square feet, with only the deliriously mirrored Rainbow Room left more or less as it had been originally designed, though even this incomparable room was tweaked, but in ways that did not alter its essential character. At the point of arrival on the sixty-fifth floor, Hardy created a dramatic cross hall, lined and lit by chunkily proportioned super-pilasters consisting of alternating bands of mahogany and translucent glass. Diners were led south to a new bar (rather than north as in the original), so that they might take in a sweeping view of the Manhattan skyline, which was brightly lit at night, in contrast to the relatively dark vista of Central Park that the old bar had provided. The interiors for the new dining rooms and the Rainbow Grill were inventive but well within the spirit of the original. As Hardy put it, the goal "was not to make a

FACING PAGE RCA Building (Associated Architects, 1933), 30 Rockefeller Plaza. View to the west showing night lighting by Abe Feder, 1984. Hoyt. ESTO

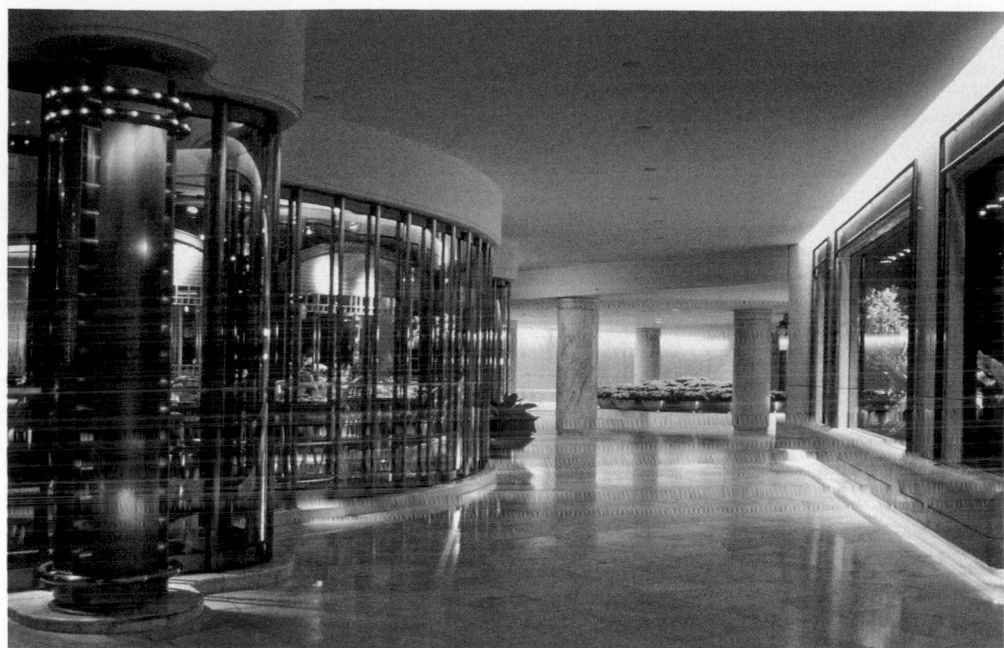

Concourse, Rockefeller Center.
Renovation by John Portman, 1984.
Ardiles-Arce. JP

confrontation between the old and new but to see them inte-
grated into a seamless whole."[11] Paul Goldberger admired the
results, writing that the project "has the ability to make us
think we are looking at the 1930's for the first time, to wipe
away all of the trite knockoffs of Art Deco and bring us back
to that moment—in the early 70's for many people, in the late
70's for others—when we first realized that there was some-
thing utterly glorious to the world of great 30's design."[12]

The transfer of control over Rockefeller Center from the
family to a real estate investment trust in the late 1980s and
then its purchase for a staggering price by the Mitsubishi
Estate, of Japan, in 1989 was headline news.[13] But it was the
1988 decision of Robert C. Wright, president of the National
Broadcasting Corporation, which had recently been purchased
by the General Electric Company, to rename the RCA
Building after the parent company that really made news, at
least among longtime New Yorkers, especially those who
knew that 570 Lexington Avenue (Cross & Cross, 1931) was

Elevator enclosure, Rockefeller Center, West Fiftieth Street, between
Rockefeller Plaza and Fifth Avenue. John Portman, 1984. View to the south.
Parker. JP

called the General Electric Building, although truth to tell
that building had been originally conceived as the RCA Victor
Building.[14] Among those opposed to the new name were sixty
employees of NBC, who petitioned the Landmarks Preser-
vation Commission to forbid the change, to no avail.

The infusion of Japanese capital brought modest improve-
ments to the center, such as the restoration in 1990 of the lobby
of 1270 Sixth Avenue by Hellmuth, Obata & Kassabaum.[15] The
architects replaced the hung ceiling and travertine floors and
walls installed in the 1950s with black granite walls and ter-
razzo floors more in keeping with the original design.[16] In 1992
Heery International developed a comprehensive renovation
plan for sidewalks and building enhancements that resulted in
the planting of 130 new trees set in diamond-shaped sur-
rounds as well as building address plaques designed to reflect
motifs used in the original design. But the economic down-
turn of the early 1990s brought Rockefeller Center to its
knees. Mitsubishi, having paid too much, abandoned the prop-
erty, which was purchased in 1996 by a consortium made up
of Tishman Speyer Properties, Goldman Sachs & Company,
and David Rockefeller.[17] With the rebirth of New York's office
market, the new owners brought a fresh wave of changes,
touted as improvements, though they were not so regarded by
many preservationists. Led by Jerry Speyer, the new manage-
ment's plan to return the center to profitability was based to a
considerable extent on revitalizing its retail spaces as well as
finding new ones. The first big change came in 1997 with the
announcement that Christie's would take over the 300,000-
square-foot-space at 20 Rockefeller Plaza that had been built
as a five-story parking garage.[18] The auction house had out-
grown its architecturally drab headquarters (Goldstone &
Dearborn, 1977) at 502 Park Avenue but failed in an attempt
to relocate in a building long slated for the site of the former
Alexander's department store. The renovation of Christie's
Rockefeller Center space by Beyer Blinder Belle (1999), which
was responsible for the exterior and new entrances on Forty-
ninth Street, and Gensler, in charge of the interiors, was work-
manlike, but the glory of the project was very much in the

Rockefeller Center tradition: a boldly colored abstract mural painted by the noted artist Sol LeWitt that nearly over-whelmed the 29-foot-high-by-17-foot-wide entrance hall.

Other changes initiated by the new management generated increasing concern about what might become a wide-reaching attack on the center's artistic integrity. The fears of many preservationists seemed all too justified when, in May 1998, plans were announced for the rearrangement of the entrances to the concourse that flanked the Prometheus statue and the enlargement of the understated shop windows along the center's Fifth Avenue frontage.[19] According to Speyer, the changes were a response to the changing nature of retailing, with bigger stores and flashier merchandising techniques. In anticipation of the objections of preservationists, John Belle of Beyer Blinder Belle was hired to undertake the redesign. Ronald J. Kopnicki, Matt McGhee, and Christabel Gough, editors of the feisty and influential pro-preservationist magazine *Village Views*, immediately rallied to the cause. "Every decade must have its great historic controversy," they observed. Citing the efforts to save Pennsylvania Station in the 1960s, the battle for Grand Central in the 1970s, and the debate over the St. Bartholomew's tower in the 1980s, the last two acts of preservation being upheld by the United States Supreme Court, they went on to nominate the renovation of Rockefeller Center as the great preservation battle of the 1990s. According to the editors, "amazing feats of logical hopscotch were performed" in order to make the case for the proposed alterations. For example, "in justifying their alterations to the setting of *Prometheus*, the applicants turned to a 1932 design study which was never carried out, invoking a sort of pre-existent Platonic Rockefeller Center made up of ideas discarded by Associated Architects. But when there was a need to justify changes with no arguable antecedent, Rockefeller Center was found to be an 'evolving landmark,' also known as an 'ever-changing product,' 'not a static icon' but, we are left to suppose, an example of Heraclitean flux."[20]

Among the principal points of opposition was the proposal by Gabellini Associates to convert the one-story show

windows into two-story elements, a strategy that Charles Platt, a former Landmarks Preservation Commission member and chairman of the preservation committee of the Municipal Art Society, believed would have a "particularly disturbing effect on the beautifully executed existing entrances."[21] David Garrard Lowe, president of the Beaux-Arts Alliance, argued that the window redesign would absolutely destroy the facade. Lowe also objected strongly to the reduction of the red granite wall behind Paul Manship's *Prometheus* by five and a half feet on either side of the statue and the creation of a new semicircular basin in front of it, which he likened to a soap dish. Most strikingly, Gene A. Norman, who had been chairman of the Landmarks Preservation Commission in 1985 when the center had been designated, in an unusual and bold move—former chairmen rarely testified in public on applications before the commission—spoke out against the alterations to *Prometheus's* setting. Sadly, in what many regarded as a misguided decision to placate influential supporters,

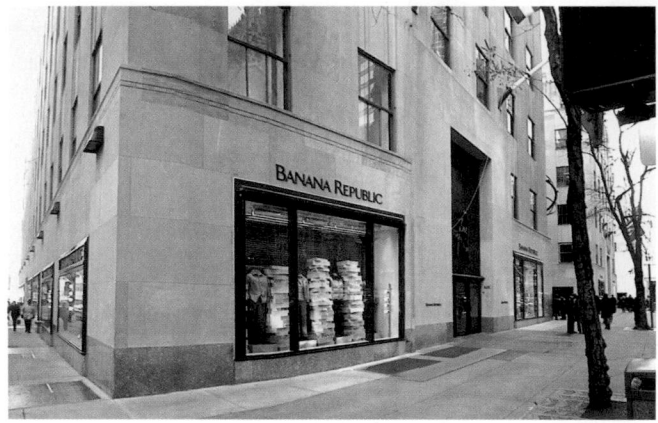

Roger Lang, representing the Landmarks Conservancy, supported the changes "enthusiastically," arguing, "The best way to preserve landmark buildings is to ensure that they're economically viable."[22] But even Lang would not go so far as to support the widely lampooned proposal to embed a large granite NBC peacock in the pavement of Rockefeller Plaza. Most others were also upset by plans for a 20,000-square-foot store at the base of the GE Building, opposite the new NBC studios. This shop was to be home to a new venture whose working name was "The NBC Experience."

On May 31, 1998, the Landmarks Preservation Commission recommended that the owners scale back their plans, with Chair Jennifer Raab suggesting that they were "out of character" with "Rockefeller Center's architecture."[23] Four months later, on September 15, scaled-down plans were approved, with the center agreeing to heighten Fifth Avenue windows by only three feet three inches but also permitting the widening of the entrances on either side of *Prometheus* and the relocation of the flanking Manship sculptures, *Youth* and *Maiden*, to other locations in the complex—their second trip in fifteen years.

The proposed renovations of 1998 were, however, only part of a larger plan for the revitalization of Rockefeller Center's retail spaces. In February 1999, readers of the *New York Times* were made aware of the demolition of the darkly sleek, glass-lined, 400-foot-long north corridor under the GE Building and the impending removal of its companion on the south to make way for a shopping mall that, in the words of Jerry Speyer, would help make the complex "the center of the universe of Manhattan."[24] The corridors, a hallmark of the center's original plan whose renovation had first been studied in 1978 by the Walker Group, were not landmarked, but their destruction was bemoaned by many preservationists.[25] The new concourse

ABOVE Renovated Fifth Avenue storefronts, Rockefeller Center. Gabellini Associates, 1999. View to the northwest. GA

RIGHT Proposed Fifth Avenue storefront renovations, Rockefeller Center. Gabellini Associates, 1999. Existing (bottom) and proposed (top) elevations. GA

mall, completed according to plans drawn up by Beyer Blinder Belle, opened the space up to views of the sunken plaza and its wintertime ice-skating rink, placed numerous seating areas at the eastern end of the concourse, and specified a lighter overall palette of materials, with bush hammered limestone walls and black and light gray terrazzo floors. In September 1998, management closed the doors of the Guild Theater, descendant of the 450-seat Newsreel Theater that had been a center fixture since 1938.[26] The theater was replaced by retail space.

Rockefeller Center had expanded in the late 1950s with the construction of the Time & Life Building (Harrison, Abramovitz & Harris, 1959) and in the early 1970s with the three powerfully monolithic so-called XYZ towers (Harrison, Abramovitz & Harris, 1971–73) that lined the west side of Sixth Avenue between Forty-seventh and Fiftieth Streets.[27] Late in 1986, amid the booming real estate economy, the center again embarked on westward expansion with a planned fifty-seven-story tower designed by Kohn Pedersen Fox for a site stretching along the east side of Seventh Avenue between Forty-ninth and Fiftieth Streets. After sixteen years, the tower was completed in 2002 (see Times Square).

Radio City Music Hall
By the early 1970s, Radio City Music Hall (Associated Architects, 1932), the nation's most famous entertainment venue and the life-enhancing heart of Rockefeller Center, was not only losing ground as an attraction but was also, in physical terms, worn out and technically outmoded.[28] On January 5, 1978, New Yorkers were shocked to learn that on the previous day Alton G. Marshall, the president of Rockefeller Center Inc., had broken the news to Mayor Ed Koch, to the head of the world-famous Rockettes, and to leaders of other affected unions that the music hall would close at the end of its annual Easter show.[29] The announcement dealt a stunning blow to a city still reeling from the effects of the fiscal crisis. The music hall's financial losses in recent years were considerable and well known, the result in part from the reduction in the number of feature films produced by Hollywood each year and a lack of family-fare movies to fill the vast 6,000-seat auditorium, but also attributable to changing patterns of theatergoing that rendered its fifty-two-week-a-year film-cum-stage formula anachronistic. Efforts had been made to remedy the situation: the music hall had been closed for fourteen weeks during each of the previous four years, and it had opened its stage to rock concerts and pop festivals as well as to closed-circuit telecasts of important boxing matches, but to no avail.

Almost immediately after the decision to close was announced, public and private efforts got under way to save the much beloved hall, widely regarded as a symbol of the city and of the state. Of the many proposals that poured in, one rose to the top of the list: that the theater should be landmarked so that it could take advantage of tax benefits. But the management of Rockefeller Center was highly resistant to this idea, largely because it clearly wanted to replace the property with something more lucrative, a fact that was confirmed when Alton G. Marshall entertained the suggestion of Vincent D. McDonnell, the New York State labor mediator, that the theater be converted into a "multipurpose shopping and artistic arcade" that would include a health club, movie theaters, and a new music hall where the Rockettes as well as other groups could perform."[30] Such a strategy was deemed a sacrilege by many New

Yorkers, including the editors of the New York Times, who, in their passionate plea for the theater, began their lead editorial on January 10, 1978, by writing, "If Radio City Music Hall really closes after the Easter show, it will be a little like closing New York." Recognizing that it "won't do to play 'Memories' on the mighty organ," the Times editors opined, "Radio City needs two things: a new kind of expert, contemporary entrepreneurial guidance and a new financial setup. Piecemeal attempts to tap the profitable mass entertainment market have been no answer; an aggressive managerial policy is required. . . . To suggest tennis courts or shopping centers for the auditorium is to miss the point of that superb interior; it exists as a great theater or it does not exist at all." The Times advocated immediate landmark designation and the creation of a nonprofit entity to manage the hall, which would then be eligible for foundation and government support. "What is at stake," the editors concluded, "is a great 20th-century architectural and cultural landmark that means New York City to much of the world. We must not let that last curtain fall."[31]

Gradually, it became clear that Rockefeller Center's management did not really want to save the music hall on any basis. On March 14, 1978, the New York City Landmarks Preservation Commission, under the leadership of its newly appointed chairman, Kent L. Barwick, took up the case of the music hall, with more than 100 people offering emotional testimony, mostly in favor of designation, and Alton G. Marshall stating that landmark designation might "well be the last nail in the Music Hall's coffin."[32] On March 19, in her regular Sunday column, Ada Louise Huxtable spelled out in considerable detail how the Rockefellers had recently changed their attitude toward the center in an effort to increase profitability. "What is little known" outside real estate circles, she wrote, "is that Rockefeller Center itself has become an intensive real estate operation," a "role developed gradually over 40 years of growth and office modernization" but, in 1976, taken to a new level when Rockefeller Center Inc. "took the plunge to become what its own releases call 'a full service real estate company and one of the largest integrated real estate service organizations in the country.'"[33] Now two entities, one that of a developer and the second that of a contractor, were each committed to generate business, so that the music hall was seen not as an ornament to an existing development but as a possible development site which had already led to Harrison & Abramovitz's design of a tower (1972), a project reluctantly abandoned in the dwindling market for office space in the early 1970s.[34] "With this clear bias toward real estate," Huxtable argued, "Rockefeller Center cannot be seen as totally disinterested or paternalistic in the matter of Radio City's survival. . . . And an examination of some of the studies Rockefeller Center has made for the Music Hall's reuse, which will undoubtedly be employed as ammunition against preservation, reveals a development-oriented approach of a peculiarly unfit nature, singularly lacking in any creative or cultural sensitivities."[35]

Huxtable's attack must have made unpleasant reading at the Rockefeller family's breakfast tables. For two generations, through philanthropy and public relations, the family had fought and largely succeeded in overcoming its early reputation for untrammeled greed. Rockefeller Center was one of its great successes, an enlightened development that made money but contributed to the public realm. Now all that good reputation was being challenged by a courageous critic who had done some serious research to back up her passions. "There is an

Proposed office tower above Radio City Music Hall, east side of Sixth Avenue, between West Fiftieth and West Fifty-first Streets. Davis, Brody & Associates, 1978. Section looking east. DBB

Proposed office tower above Radio City Music Hall, east side of Sixth Avenue, between West Fiftieth and West Fifty-first Streets. Davis, Brody & Associates, 1978. Section looking north. DBB

inch-thick consultants' report," Huxtable informed readers of the *Times*, "of an economic thoroughness matched only by its architectural flat-footedness that seriously considers salvation as an indoor theme park with a flume and other rides and food services in a completely gutted theater." Huxtable also revealed that, as late as 1973, with diminishing attendance at 3.5 million people annually, Radio City still attracted more visitors than anything else in New York, including the Metropolitan Museum of Art, the Museum of Natural History, and the Bronx Zoo. While she reported management claims that since then annual visits had plunged by a million, apart from the dearth of films and suburban flight there was at least one cogent reason for the public's declining interest: "Radio City is the Madame Tussaud of the entertainment world. Rockefeller Center's theatrical management has been as bad as its business management has been good. . . . The Music Hall is a fossilized anachronism devoted to a myth of family entertainment, a temple of corn or high camp. It is hard to know whether this is pious miscalculation or a conscious death wish. Theatrically, Radio City has been geared to extinction."[36]

Huxtable also reported that Lieutenant Governor Mary Anne Krupsak, herself a former Rockette, had asked Hardy Holzman Pfeiffer to study the problem. On March 28, 1978, the interior of Radio City Music Hall, largely the work of the thirty-year-old Edward Durell Stone and the thirty-eight-year-old Donald Deskey, was declared a New York City landmark. Over 100,000 people had petitioned the commission on behalf of designation. Less than a month later, the state and Rockefeller Center agreed in principle to a plan permitting a tower to be built over the theater, with some of its revenues earmarked for the hall's continued operation. According to the plan, the tower and the theater would be operated by a nonprofit corporation formed as a subsidiary of the New York State Urban Development Corporation. No sooner had the story been released than did Rockefeller

Center deny its willingness to participate. A last-minute accord between Rockefeller Center and the UDC was entered into on April 12, guaranteeing the theater's continued use, with the nonprofit entity agreeing to assume management responsibilities and all losses for one year. Despite dire predictions, the UDC did so well that Rockefeller Center took back the music hall, surprising everyone with the announcement of the formation of a corporation to package for national consumption popular entertainment showcased at Radio City.

Throughout 1978 and into 1979, plans were explored for a permanent solution. One idea, the construction of the office building atop the theater, was costly and unpopular with architects and preservationists; another scheme involved the transfer of air rights to another property. Davis, Brody & Associates was hired to design the tower over the theater. Developed with the assistance of the engineer Ysrael A. Seinuk, Davis, Brody's proposal called for a 900,000-square-foot, thirty-five-story, steel-framed tower straddling but not intruding on the hall itself with tower loads gathered on thirty-five-foot-deep perimeter beams that distributed the weight onto two pairs of massive, ten-by-ten-foot concrete columns located at either side of the stage and at opposite sides of the promenade areas between the lobby and the auditorium. While the new tower would only minimally interfere with the sixteen-story Associated Press Building (Associated Architects, 1938) on its east flank, it would require the demolition of the Guild Theater (originally the Newsreel Theater), 33 West Fiftieth Street. Its relationship to the building to its west, the thirty-one-story Amax Building (built as the RKO Building, Associated Architects, 1932) was more complicated, leading Davis, Brody to propose a slender, dizzyingly vertical twenty-two-story atrium between the two that would appear as little more than a glass seam when viewed from the street but because of setbacks in the new tower would achieve some hor-

izontal expanse inside.[37] At the base of the atrium, a "garden lobby" connection to all three buildings and an outside terrace would in some ways realize Raymond Hood's original idea for linking Rockefeller Center's buildings by bridges. The new tower, plans for which did not go forward, was to include nineteen floors of offices and, above, twelve floors for a hotel that would have its own entrance carved out of the music hall's lobby at the corner of Sixth Avenue and Fiftieth Street; the hall itself would be entered only from Fiftieth Street.

Radio City's future was secured in February 1979 when its programming was turned over to an independent production company led by Robert F. Jani, a former vice president and creative director of Walt Disney Productions. A month later, a "master plan" to restore the theater was announced. As part of the turnabout, Rockefeller Center Inc. made a substantial investment in physical improvements to the hall itself. New carpets and curtains were installed, and wood paneling was refinished—all said to be in keeping with the original designs, although research in connection with a later overhaul would prove otherwise. A glittering black-tie gala marked the refurbished hall's reopening on May 31, 1979, with guests previewing the music hall's new entertainment format of seasonally themed musical extravaganzas, this one called "A New York Summer." The music hall also became a leading venue for special-event presentations, from rock shows featuring the likes of Twisted Sister to megastar specials with entertainers such as Bill Cosby, Liberace, and Bette Midler.

In 1997, only one year after Tishman Speyer Properties had taken over as Rockefeller Center's new owners, Radio City Music Hall was leased to new operators, Cablevision Systems Corporation, which undertook a massive, scholarly renovation (1999) of the facility under the direction of Hardy Holzman Pfeiffer collaborating during the initial stages with the Rockwell Group.[38] The meticulous renovation was not quite what Cablevision originally had in mind when it asked the flamboyant, theme-oriented architect David Rockwell to work along with Hugh Hardy. But early Rockwell-generated ideas such as a nightclub behind the marquee sign and interactive kiosks in the lobby were abandoned in favor of pure restoration. Hardy, who made something of a specialty of theater restorations, beginning with the Joyce (see Chelsea), usually preferred to retain some sense of the effect of time on the building's history. But in this case, in part because of pressure from the Landmarks Preservation Commission, in part because of the extraordinary nature of the music hall itself, he set out to erase the incursions of history and return the theater as much as possible to its original grandeur.

The project, one of the most technically complex preservation efforts ever undertaken, was completed in an astonishingly short amount of time, squeezed between the closing of the music hall's perennially popular Christmas show in February and the opening of a new season in October. As the work proceeded, costs rocketed—from early estimates of $20 million to over $70 million, making the music hall one of the most expensive theater renovations in the city's history. Some 5,900 seats were replaced; 720,000 sheets of gold and aluminum leaf were used; and all 4,178 pipes of the "Mighty Wurlitzer"—the largest organ ever built for a theater—were refurbished. Ezra Winter's sixty-foot-wide, thirty-foot-high mural, *Fountain of Youth*, was restored; Stuart Davis's *Men Without Women*, rescued by the Museum of Modern Art in 1974 when the smoking lounge was turned into a storage room for popcorn, was returned to its proper setting of Deskey-designed chairs and new cork walls.

But Yasuo Kuniyoshi's pastel peach and pink blossomed mural of flowers, hanging in the women's powder room on the mezzanine, had been so hideously overpainted that it was decided in the interests of economy to seal, remove, and store the original and replace it with a reproduction painted by Yohannes Aynalem. Historic wall coverings and fabrics were faithfully reproduced, and the massive, 3,100-pound gold-threaded satin and silk fire-retardant stage curtain was reproduced, replacing the original, which had faded to a dirty-brown.

Led by Raymond Pepi, president of Building Conservation Associates, scholars and chemists scoured hundreds of paint chips to determine original colors. Lighting, including six miles of new red, blue, and gold neon for the marquees, was completely overhauled and enhanced to balance historical hues with contemporary expectations for high levels of visibility. Research showed that the letters spelling "Radio City" on the marquee were originally rather purplish in hue and not the red long familiar to New Yorkers. But after shining a purple glow from the marquee for a few nights before the opening, the red lights were brought back. "People thought it looked too much like a bordello," Hugh Hardy observed.[39] Additionally, the entire infrastructure was rebuilt. As Hardy stated, "We had to destroy it to rebuild it. . . . It's been fixed before, but it's never been made like new again."[40] More than 175 electricians were employed to service the theater and add thirty-two new camera positions for live-wire feeds to enable events to be broadcast "live from Radio City." All the expense and effort produced high dividends, and the music hall, which when new was derided by the political pundit Walter Lippmann as "a pedestal built to sustain a peanut," reopened to rave critical reviews on October 4, 1999.[41]

Radio City Music Hall, 1260 Sixth Avenue. Renovation by Hardy Holzman Pfeiffer Associates, 1999. View to the northeast. Cox. WC

Radio City Music Hall, 1260 Sixth Avenue. Renovation by Hardy Holzman Pfeiffer Associates, 1999. View of lobby showing *The Fountain of Youth* by Ezra Winter. Cox. WC

Radio City Music Hall, 1260 Sixth Avenue. Renovation by Hardy Holzman Pfeiffer Associates, 1999. View of men's smoking room showing *Men Without Women* by Stuart Davis. Cox. WC

RIGHT Radio City Music Hall, 1260 Sixth Avenue. Renovation by Hardy Holzman Pfeiffer Associates, 1999. Auditorium. Cox. WC

MoMALAND: CROSSROADS OF CULTURE AND COMMERCE

More Modern

The completion in 1939 of Philip L. Goodwin and Edward Durell Stone's Museum of Modern Art, 11 West Fifty-third Street, between Fifth and Sixth Avenues, set into motion the aggregation of numerous cultural institutions in the immediate environs, among them the Whitney Museum of American Art, the Donnell branch of the New York Public Library, the Museum of Contemporary Crafts, and the Museum of American Folk Art, redrawing the cultural map of Manhattan.[1] In the last two decades of the twentieth century, the concentration of museums intensified with the continued expansion of the Museum of Modern Art and the construction of new buildings for the Folk Art and Crafts museums, the Museum of Television and Radio, and the Austrian Cultural Forum. Midtown was hardly a typical cultural district. Given the realities of New York real estate, its institutions took on the characteristics of the high-rise commercialism that typified the area to an amazing extent. When the Museum of Modern Art first opened, the block west of Fifth Avenue on Fifty-third Street was a low-scale, townhouse-lined residential street. By 2000, it was a canyon of office buildings, with a towering apartment house developed by the museum to help finance its expansion. But what many regretted as a loss in intimacy of scale was celebrated by others as an architectural showcase of work by some of the period's most talented architects.

In the early 1960s, following a disastrous fire in 1958, the Museum of Modern Art renovated its existing facilities and added to them.[2] Only a few years later, shortly after the retirement in 1967 of the founding director, Alfred H. Barr Jr., the museum embarked on an intensive examination of its identity: should it remain devoted to a strict view of Modernism in the face of attacks on its values by Postmodernists? And if so, would its collections need to grow? Should it become the Museum of (the history) of Modern(ist) Art? Or should it subtly recalibrate its conception of Modernism, broadening its definition to accommodate countervailing trends? No definitive direction was established, however, and that was reflected in the various and somewhat contradictory plans for expansion undertaken by the museum in the century's waning years.

In the late 1970s, uncertain about its future and burdened with enormous expenses, MoMA sought to secure its economic future and, secondarily, to provide increased gallery space by entering the perilous business of real estate development. According to Arthur Drexler, the director of the Department of Architecture, the museum was operating at a deficit, making up shortfalls with funds from its endowment, which, at that rate of expenditure, would be depleted by 1984. To help solve the problem, the museum's management proposed expansion rather than retrenchment: it was thought that more space would enable a richer mix of programs and, thereby, increase membership, box-office receipts, and donor support. It was also believed that it would provide gallery space for the crowd-pleasing blockbuster exhibitions that typically jolted attendance. To finance this expansion, the museum's trustees turned to their one potentially marketable asset, the air rights above the comparatively low-rise, low-density buildings that housed the collections and staff, and especially those over the 107-by-200-foot garden.

In February 1976, encouraged by the financial success of the nearby Olympic Tower (Skidmore Owings & Merrill, 1976), 645 Fifth Avenue, northeast corner of Fifty-first Street, the museum informally announced a plan to build a forty-story condominium tower above a new through-block gallery wing located immediately west of the existing facility on Fifty-third Street.[3] The master plan for the expansion was prepared by a team headed by Richard Weinstein, who had cofounded the Urban Design Group during the administration of Mayor John Lindsay before becoming director of the Mayor's Office of Lower Manhattan Development in the same regime. To realize the project as a benefit to the nonprofit museum, enabling legislation would have to be approved in Albany to exempt the tower from real estate taxes. The legislation called for the creation of a new institution, the Trust for Cultural Resources, that would not only be able to collect the equivalent of tax payments on behalf of the museum, but would also be able to transfer the unused air rights to the tower's developer.

The plan specified that the lower floors of the tower would provide additional space for galleries and other museum facilities; it also called for the replacement of the original building's rear wall with a glass wall extending several feet into the garden.[4] Behind the new wall, an area served by escalators would be built to handle the crowds that the museum expected to attract. As realized, the glass wall and the escalators were deemed inappropriately commercial by many and would prove very controversial, with responsibility for the strategy unfairly ascribed to Cesar Pelli, the architect ultimately selected to carry out the expansion plan, when, in fact, they were part of Weinstein's initial proposal, as developed by Brian Smith, a member of the Weinstein team, leaving Pelli little choice but to base his work on this scheme.

On July 29, 1976, enabling legislation was signed into law by Governor Hugh Carey with the stipulation that the museum submit the project to the city's Board of Estimate, which approved the creation of the Trust for Cultural Resources on September 16. Though the trust was criticized by some who felt it was granted too much responsibility for planning and development and others who questioned the tax exemption, it was generally agreed that it was needed to realize the projected expansion.

No sooner had the Modern's plans been broadcast than waggish New Yorkers began to have fun with the idea of such an intimate relationship between culture and commerce. "Are they going to offer up a few of their Picassos as a bonus with the bigger apartments?" one wit was heard to ask at an Upper East Side dinner party.[5] Quips aside, the plan was generally considered realistic and appropriate. Even the frequently negative art critic Hilton Kramer, writing in the New York Times, pointed out that while most recent museum construction in the United States had been undertaken in anticipation of acquiring collections, in the case of the nearly fifty-year-old Modern, the new space would permit long-buried treasures to be displayed.[6]

One of the strongest arguments against the proposed plan was offered by Suzanne Stephens, who worried that the museum was entering into a Faustian pact with the developer of the condominium, Arlen Realty, which had been responsible for Olympic Tower: "Like an aging belle convinced that she must soon cash in on what nature or circumstance has bestowed upon her, the Modern has taken to flirting with rich,

dangerous men—private developers." Stephens also called attention to the potential bulk of the proposal, noting that Fifty-third Street was once "an integrated low-scale environment of brownstones and a few Beaux-Arts mansions . . . housing restaurants, galleries, art supply stores. Its human scale, variety and tradition so special to New York is slowly being eroded." But her biggest concern was whether the financial salvation offered by the tower would result in the loss of the museum's soul. "Beyond the role cultural institutions now play as defenders of civilization's ethics," Stephens wrote, "is what MoMA itself has stood for—a dedication to the life-affirming qualities of modern art, excellence and high standards, never to be dominated by the marketplace. The galleries and the garden of the Modern, where art, nature and architecture converge, subtly impart these ideals. . . . In the heart of midtown it offers an uncompromising example of noncommercial, esthetic commitment. And in a strange way, so does its single-purpose nature. . . . Standing apart from the city, it still exudes an essence that is New York. An integral work of everyday life in the city, it transcends everyday life. Thus when a tower rises from its torso, it will communicate more than MoMA's physical violation to those who gaze upon it. It will signify a deep cultural malaise, a conflict between what the museum wants to be and what it has been."[7]

In October 1976, the museum's expansion project was given a boost when Roy V. Titus, son of the late Helena Rubinstein, the founder of the eponymous cosmetics business, made a substantial contribution to cover the cost of renovating its 460-seat auditorium.[8] By this time, an architect-selection committee had been formed by MoMA's trustees, with Donald Marron, the president of the brokerage Paine Webber and an art collector, as its chairman. Conspicuously absent from the list of architects being considered were Philip Johnson, Edward Larrabee Barnes, Gordon Bunshaft, and Wallace K. Harrison, all members of the Board of Trustees who were asked to serve as consultants. Philip Johnson was said to have been particularly miffed, not only because of his long and intimate affiliation with the museum, but because he had proposed an office tower using the museum's air rights in 1969. Franz Schulze, in his 1994 biography of the architect, characterized the snub as Johnson's "most painful professional defeat of the 1970s," leaving him "crushed, humiliated, and embarrassed." According to Schulze, many trustees, including David Rockefeller, who was said to have promised a considerable contribution if Johnson was passed over, believed that Johnson

> had been insufficiently mindful of budgetary constraints and overly proprietary in his previous building efforts for the museum and that he would thus have found it difficult to mediate among the varied commercial, institutional, and political factors that comprised a highly complicated project. Since the expansion program was driven by the hardest financial facts, there could be no place in it for anyone, least of all the architect, who might be indifferent to economies or other practicalities. The decision to withhold the commission from any of the trustee architects, so as to avoid any possible conflict of interest, was a defensible reason for eliminating Philip, but a secondary one.[9]

In November, Paul Goldberger reported that Kevin Roche, a leading contender for the job, had let it be known that he was not interested—a rare occurrence of an architect turning down what many viewed as a plum commission. (Roche, who already had the job of expanding the Metropolitan Museum, may have been a mite busy and have seen the MoMA job as a potential conflict of interest.) Goldberger also reported that Cesar Pelli, formerly chief designer for the commercial firm of Gruen Associates in Los Angeles and recently appointed dean

Proposed Museum of Modern Art tower addition, West Fifty-third Street, between Fifth and Sixth Avenues. Cesar Pelli & Associates, 1977. Model, view to the north. CPA

of the Yale School of Architecture, was being considered, along with Mitchell/Giurgola Associates and I. M. Pei & Partners, whose acclaimed work on the expansion (1968–78) of the National Gallery in Washington had virtually erased in the public's mind the embarrassing technical failures of the John Hancock Tower (1966–76) in Boston.[10]

Late in January 1977, Cesar Pelli was selected as the architect for the tower and the addition to the galleries.[11] In defending the choice, Donald Marron emphasized the unusual nature of the commission: "Being a businessman, I had to be impressed with someone who could combine economics with artistic content. We found we could communicate well with him on both an artistic and an economic level."[12] Models and drawings of the design were publicized in late June, making the rounds of community groups for approval. In the arrangement of its parts, Pelli's scheme closely followed Richard Weinstein's plan, although an early proposal for a Fifty-fourth Street entrance for the tower was replaced with one on Fifty-third Street. Pelli had many masters, in the public realm as well as within the museum family. None was more contentious than the committee of architect-trustees who had been asked to advise whomever was selected. According to Pelli, it was Gordon Bunshaft who urged him to strip away the facades of the earlier buildings and create a uniform facade. And it was Edward Larrabee Barnes who advocated tearing down the north–south wing that had been home to the Whitney Museum (Miller & Noel, 1954) and replacing it with a tower that would form a symmetrical relationship with the garden, an arrangement Pelli felt would overwhelm the garden and destroy the scale of West Fifty-fourth Street, casting it in deep shadow.[13] Pelli believed, rightly, that West Fifty-third Street, which had long since lost its townhouse scale, was the best place for the tower. Paul Goldberger noted that many feared the design would be "like a broth tended by too many cooks," given the involvement of not only Pelli and Weinstein, but Jaquelin T. Robertson, a partner in the firm of Llewellyn-Davies, and the architect-trustees. Robertson, whose assistant on the project was Thierry Despont, represented Arlen Realty, which had hired him to lay out the apartments.

Goldberger was particularly taken with the design of the proposed glass-clad forty-eight-story tower, which, he wrote, would "appear to have the sort of solidity we associate with a masonry building." Inside the tower, plans called for a complex cross-section not unlike that at Warren & Wetmore's 1020 Fifth Avenue (1924–25), so that the living rooms could be one and one half floors tall, an idea that did not survive the project's early stages. Goldberger also admired the early design's top two setbacks, which he believed would "give the building a crown of sorts—an important gesture that, when viewed in conjunction with the varied and tight-fitting glass skin, should make it clear that this is not another commercial glass box." But, he cautioned, "nothing can allay the feeling" that the 561-foot-high tower "is too big. . . . But size, of course, is an economic decision, not an architectural one, and Mr. Pelli appears to have done his best to reduce both the sense of height and bulk of the tower." For Goldberger, the most interesting part of Pelli's work was the handling of the facades, which he deemed "excellent: a continuation of the window pattern of the museum's original 1939 facade across the entire expanded front, and an inventive new canopy" based on the one Goodwin and Stone used to shelter the dining terrace. Such a plan required the refacing—and alteration—of Goodwin and Stone's facade,

which, according to Pelli, was in drastic need of repair. Pelli also argued that creating a continuous facade, covering Philip Johnson's 1951 and 1964 additions, and eliminating Hunt & Hunt's George Blumenthal house (1904), 23 West Fifty-third Street, a robust French-inspired design, would make for a base big and bold enough to counterbalance the massive apartment tower. One key aspect of the design had yet to be revealed: the choice of materials for the new base. Goldberger suggested that the marble used in the Goodwin and Stone building would create a desirable blur between the old and new, pointing out that "if another material is used, the old facade for all intents and purposes will disappear."[14]

Pelli's design had a harder time gaining community approval. It failed to clear its first hurdle in early August 1977, when the Community Board 5 subcommittee on new construction voted to oppose it, just as special committees of the Municipal Art Society and the New York Chapter of the American Institute of Architects were preparing reports on the tower and the Landmarks Preservation Commission was scheduling a discussion for its next meeting. According to Richard E. Oldenburg, the director of the museum, the Community Board's vote was motivated by a belief held by "some members . . . that there are other alternatives open to the museum, including disposing of parts of the collection, or moving the museum to another location."[15] Despite the Rockefeller Brothers Fund's pledge of $10 million toward the construction of the new galleries, there were doubts that the expansion made economic sense, given the museum's large annual operating deficit (said to be in excess of $1 million), a point of view that Ada Louise Huxtable endorsed as part of her assessment of the Pelli proposal, which she characterized as "an essentially dubious undertaking." She deplored the tower as "a mid-block behemoth that will destroy exactly the kind of small-scale amenity and variety between the avenues that has made this particular street . . . a model of civilized pleasure."[16]

Huxtable also pointed out that "all kinds of diagrams and measurements" notwithstanding, "the famous museum garden is being encroached upon—primarily for a restaurant to cover its upper level—a feature with income possibilities." Moreover, "the design of the new building, which involves the restyled, incorporated facade of the original building, smudges to the point of obliteration the already compromised 1939 Museum of Modern Art . . . one of the city's major architectural and cultural landmarks. To justify this kind of destruction, survival has got to be the name of the game." She also reported that Philip Johnson, who had designed the garden—"one of the city's great amenities"—had approved the sacrifice of the entrance terrace and steps to make room for an enlarged lobby and escalators, and of the upper garden level to accommodate the multistoried restaurant addition, although she was not reassured by the endorsement: "The loss of the terrace, while regrettable, can be justified in terms of circulation and space for the larger building, but covering the raised part of the present garden, no matter how under-utilized it may seem, is an unacceptable sacrifice of open space."[17]

In what would prove a decisive step leading to Pelli's redesign of the facades, Huxtable also came down hard in favor of preserving the original Goodwin and Stone street facade, "a rare, superb and almost unique example of the International Style. The museum built it in its enthusiasm for that style, with which the museum was identified and which it helped put on the map. There is a confluence of singular, cultural,

TOP Museum of Modern Art, 11 West Fifty-third Street, between Fifth and Sixth Avenues. Renovated and expanded by Cesar Pelli & Associates, 1984. Section, view to west. CPA

ABOVE Museum of Modern Art, 11 West Fifty-third Street, between Fifth and Sixth Avenues. Renovated and expanded by Cesar Pelli & Associates, 1984. Section, view to north. CPA

artistic and historical factors here that is compelling. It is unthinkable that those who owe so much to this image would simply wipe it out." In what was surely a difficult opinion to render, given her early and fond association with the institution, she concluded:

> in order to condone this overbearing project, so destructive of urban, esthetic and cultural values, it is essential to accept the assumption that this plan is the museum's only financial hope. One must also believe, with its trustees, that the original Museum of Modern Art as well as the high moment in art and cultural history that it represents are expendable. This massive new cultural-commercial hybrid cannot recreate those important concepts and ideals that the museum lives on today. That currency is running out. The Modern's problem is ideological as much as financial. Is this salvation or the end of an innovative institutional force that did much to change the image and vision of its age?[18]

Huxtable's article provided powerful fuel for the opposition. Charles K. Hoyt, an architect and a staff editor at

Architectural Record, echoed Huxtable's concerns about the financial viability of the project in a letter to the editor of the *New York Times*: "Why can't the Modern just stick to excellence and survive? Why does it even need the tower, if the final design is so bad? . . . The tower provides no definite ongoing income to the Museum. The basic financial plan is to draw income from more gallery space that will in turn encourage more memberships, donations and income for a new sort of art supermarket."[19] Nevertheless, on August 11, 1977, Community Board 5 endorsed the museum's plan, rejecting the recommendations of its subcommittee. The plan also received the unanimous endorsement of the City Planning Commission on September 26, despite considerable ambivalence about the propriety of a midblock tower. A week later, on October 6, the Board of Estimate approved the plan. Significantly, by the time the project had its final review, Pelli had revised the Fifty-third Street facade to retain the identity of Goodwin and Stone's building and Philip Johnson's 1964 addition.

In January 1978, Paul Goldberger looked back on the controversy that surrounded Pelli's first design, remarking that "the early plan . . . was overpraised by some critics and excessively damned by others."[20] The project was still facing opposition, however. Five months after ground was supposed to have been broken, it was delayed when the Appellate Division of State Supreme Court declared unconstitutional the two-year-old law creating the Trust for Cultural Resources. The court ruled that the provision limiting benefits to museums that owned at least 50,000 square feet of contiguous property effectively excluded most museums in New York City. The court raised other objections, not the least of which was that the legislature had violated the state's constitution by passing a special law affecting New York City without first obtaining home-rule permission from the City Council. Further complicating the situation, Arlen Realty was facing severe financial problems, which led, in the spring of 1978, to the dissolution of their agreement with MoMA. The museum, however, was more determined than ever to go forward with its plan. According to Richard H. Koch, a deputy director and the museum's general counsel, the museum's 1964 expansion had doubled its attendance. The present expansion was not necessarily intended to attract new visitors but to "bring more people back because you won't be able to see the whole museum in two hours, as you do now. Repeated visits make membership more attractive. Our declining cycle of shows has lost us membership."[21]

In November 1978, the museum took its case to the Court of Appeals, the state's highest court. Its arguments were aided by an *amicus curiae* filing by the Whitney Museum, which claimed not to be contemplating an addition, but, according to a spokesman, believed that "it's always nice to have the law available if we wish to do something similar."[22] On December 27, 1978, the Court of Appeals reversed the lower court's decision, and by the following May, the museum was close to signing a contract with a new developer for the apartment tower. The aesthetic problems with the design, especially the relationship of the tower's facades to those of the expanded museum, had been resolved, leaving only the size of the garden wing housing the restaurant to be determined. By early June the deal seemed at last in hand. A new developer, Charles H. Shaw, of Chicago, would build the fifty-two-story, 263-unit apartment building known as Museum Tower, paying $17 million, said to be the highest price ever paid for air rights in midtown. According to the agreement, the museum would retain control over the tower's exterior design as well as the public areas, the ceiling heights, and the number of apartments, which were to be laid out by Edward Durell Stone Associates, replacing Robertson's firm, Llewellyn-Davies, in consultation with Pelli. The Trust for Cultural Resources held a hearing in July 1979 at the Donnell Library, where museum officials, neighborhood residents, members of the community board, and representatives of the developer viewed a model of the tower, presented for the first time in public. The community board reiterated its support but made clear its frustration with the City Planning Commission, which had labeled the design changes as "minor" instead of "major," to avoid seeking community board approval.

In an interview published in *Perspecta*, Pelli tried to emphasize how the design was influenced and shaped by its context, stating that "the primary reading of the new west wing will be a shiny dark wall, in the same relation to and contrast with the Goodwin-Stone facade as Johnson's east wing. The Goodwin-Stone building will continue being the symbol and entrance of the Museum of Modern Art and will maintain its now-historical relationship with the rest of the block as a white medallion on a dark background." He pledged that the garden would "remain as unchanged as possible" and that the "crystalline" forms of the new glass hall would "coincide with and extend the floors of the Goodwin-Stone building. It will be pulling things together while adding a new element." Pelli also stressed that he was "dealing with a building that already has several layers—like geological layers—of design. And those layers are important and of the relatively recent past. So we cannot consider a major transformation, as when remodeling an older, pre-modern building," concluding, "This is not a composition but an aggregation, a new entity, respectful of its own past, with all the intermediate stages remaining apparent."[23]

Finances for the expansion fell into place in early 1980, when the city's comptroller approved the $40 million bond issued by the Trust for Cultural Resources. In June, Ada Louise Huxtable reported on a model of Pelli's final version of the design, which had been put on display for the benefit of staff and trustees in the Founders Room and would be put on public display in the museum in October. The three-quarter-inch-to-one-foot scale model was so big that less than half the height of the tower could be represented. In an assessment that seemed something of an about-face, Huxtable remarked that the museum's expansion and renovation, which would double its gallery space, was long overdue, calling the existing building "an esthetic slum." She described the decision to intrude eighteen feet into the garden with a glass-walled, sky-lighted escalator hall as a "functional solution [that] will be a spectacular esthetic addition. There will be views of the garden and galleries on every level. And while it is not exactly Beaubourg, there is an interesting kinship in making the glassed-in ride as much of an experience as the art itself." She also praised the museum's decision "not to cannibalize its architectural past. The old facade will be cleaned and restored, rather than resurfaced." The module used for the panels of gray glass that would cover the expanded museum and the apartment tower was, in fact, based on the dimensions of the original glass panels. "The abstract patterns that result," Huxtable observed, "are like a glistening tapestry. Although the old facade is flush and continuous with the new one, its white marble framing will set it apart from the rest as a discrete architectural and historic event. It will serve as illusion and allusion, as artifact and metaphor. And it will also preserve, or suggest, a more intimate scale for the street."[24]

In March 1982, when the tower was barely clad and the project was still two years away from completion, some of the new galleries were opened to the public through a temporary entrance on Fifty-fourth Street. Although Paul Goldberger admitted that it was "too early . . . to evaluate the renovated museum as a whole," he did note that the main circulation space, which museum officials had taken to calling the "Garden Hall," and which was not yet complete, would be the key element in the internal reorganization. "If that space . . . does not work," he wrote, "this intrusion of escalators into the museum's heart would make the place look like Bloomingdale's." Goldberger also reported that though the new galleries looked like their predecessors—"cool and white, and without natural light"—they were in

Museum of Modern Art, 11 West Fifty-third Street, between Fifth and Sixth Avenues. Renovated and expanded by Cesar Pelli & Associates, 1984. Garden Hall. Robinson. CPA

many cases symmetrical and formally arranged, and conveyed an "overall sense . . . that there are more large spaces than small ones," suggesting that "there will be considerably less intimacy" in the rebuilt museum than there was before, a result he deemed "unfortunate."[25]

The expanded museum, officially dedicated on May 7, 1984, with a gala party attended by 800 invited guests, was opened to the general public ten days later. It was twice as big as before, with 87,000 square feet of gallery space and 370,000 square feet of facilities in all, including a new theater, the Roy and Niuta Titus Theater II, a 217-seat house supplementing the original auditorium, which the Tituses had paid to refurbish, and a gallery named after Philip Johnson, which was said to be the first space in a major American museum specifically dedicated to the display of a permanent collection of architectural drawings and models. Not surprisingly, critical responses focused on two key features of the design: the reconfigured and expanded galleries and the Garden Hall. The issue of Fifty-third Street's new institutional scale was largely ignored, and Pelli's original plan to unify the entire complex behind one facade was almost forgotten. In fact, by the time the new museum opened, Pelli seemed to have forgotten it too: asked about it in 1984, he claimed that "to reface" Goodwin and Stone's building "would be like painting over a Cézanne."[26]

Although the new galleries were accepted as revised versions of their predecessors, the reality was that they were far different from the existing galleries; the loss of intimacy in the expanded museum was not only a function of the vastly increased size but also the abandonment of the original model. In fact, Pelli's design reflected the museum's dramatic institutional change from a kind of club for connoisseurs to a large-scale, public institution. In the new galleries, Suzanne Stephens commented, the "ceilings are reasonably high . . . and the installations have been carefully composed in generousspaces. But the effect is hardly gripping. In the now expanded museum the visitor threads his way through neutral, anonymous galleries. Anything 'architectural,' such as a window, is concentrated at circulation points, outside the galleries." Most dismaying in this regard was the decision to circumscribe the original museum's open stair, which had been modeled on the one at the Bauhaus and had long been presided over by Oscar Schlemmer's *Bauhaus Stairs* (1932), a depiction of Walter Gropius's famed staircase. It had been retained only between the second and third floors, so that it now looked, as Stephens put it, "like some remnant of a building washed ashore during a flood."[27] Losing the stair, the original museum's only memorable public space, represented an unwelcome break with the past. While the new galleries had their defenders, it was largely because so much more of the permanent collection could be displayed. According to the artist Jasper Johns, who was well represented in that collection: "The thing that is the most impressive is the extent of it. You keep walking through and think you're going to get to the end of it—and there's more, of both space and pictures."[28]

The introduction of escalators was in and of itself not so shocking, though even more than the revamped galleries, it epitomized the loss of long-cherished intimacy. But their prominence, and the vertiginous space of the room they virtually filled, did shock, bringing to mind Paul Goldberger's earlier warning that the Garden Hall might introduce, if only by association, an unwelcome suggestion of department store commercialism. Arthur Drexler had become so invested in the expansion that he began to overstep the usual boundary between client and critic, extolling the new space as if he had had nothing to do with it. "The Garden Hall is extraordinary," he stated, noting that although it seemed rather small from the outside, "standing in it on any level, it looks enormous," and pointing out that it offered dramatic views of the sculpture garden, which was restored by the landscape architects Zion & Breen.[29] But Stanley Abercrombie, writing in *Architecture*, was troubled by the structure's detailing, especially its "crude framework of 12-inch diameter steel pipes, quite roughly finished."[30] Others were critical of the glassy exterior wall. True, the faceted triangulations broke down its scale and eased the transition between the garden and the apartment tower that dominated it, but as Daralice D. Boles wrote, "one struggles to catch a glimpse of the old Goodwin/Stone facade behind Pelli's heavy-metal greenhouse."[31] On a lighter note, Amanda Burden, who attended the opening-night party, found at least one advantage in the new arrangement: "Escalators are wonderful social mechanisms. You can see people or miss them if you choose."[32]

Years later, however, critics were still complaining about the design. In 1997, the landscape architect Laurie D. Olin attacked the Pelli addition for its impact on Johnson's garden: "Put simply, the additions of 1984 not only truncated the

LEFT Museum of Modern Art, 11 West Fifty-third Street, between Fifth and Sixth Avenues. Renovated and expanded by Cesar Pelli & Associates, 1984. Garden Hall. Robinson. CPA

FACING PAGE Museum of Modern Art, 11 West Fifty-third Street, between Fifth and Sixth Avenues. Renovated and expanded by Cesar Pelli & Associates, 1984. View to the southwest from sculpture garden. Robinson. CPA

garden but also encroached on it in several ways that have changed its character, meaning, function and quality. The result has been the nearly complete destruction of what Johnson had achieved. To be sure, several of the terraces, trees and sculptures remain physically. To the ignorant and uninformed it presents an attractive picture, but a masterpiece has been ruined forever." In particular, Olin called attention to the loss of the upper terrace and its replacement by a two-story café and members' restaurant, which he believed reduced the garden and its collection of sculpture "to the role of decoration or of muzak for the eyes. The selling of food . . . is now considered to be far more important than the quality, extent and scope of the sculpture collection."[33]

The Museum Tower condominium, 15 West Fifty-third Street, was generally better received than the museum itself.

Although Stanley Abercrombie was not convinced by Pelli's claim that "the effect of the tower in its present position is rather slight," he did deem as "skillful" the architect's "treatment of the tower's bulk." But he was most impressed with the tower's skin, which he found "remarkable in its subtle coloration, the product of a carefully considered pattern of almost a dozen tints of opaque glass, chosen to blend happily with each other and with the colors of neighboring buildings. The tower mass is also lightened by a series of recessed—not projected—terraces. Even from the garden, the tower is an elegant and benign neighbor, whereas the tops of Der Scutt's Trump Tower and Philip Johnson's AT&T building, while both farther away, are more aggressive presences."[34] Edward Durell Stone Associates' apartment plans were a cut above the norm, in part due to Pelli's insistence that the living rooms

have floor-to-ceiling glass and be located at the tower corners, where, lit at night, they contributed a residential character to the otherwise sleek corporate design. Philip Johnson, who had apparently recovered from the slight of not getting the commission, took an apartment on the eleventh floor. For his apartment, Johnson concentrated his design on the squarish living room, which he lined with bookcases detailed and painted in the manner of Sir John Soane, with a shallow vaulted ceiling based on that in Soane's breakfast parlor at Number 12 Lincoln's Inn Fields, London, although the idea for the suspended vault is better seen in Soane's adjoining house at Number 13. An over-the-top crystal chandelier from Vienna illuminated a small round table in the windowed corner of the room where Johnson and his guests could command a view of his garden and, in the distance, his AT&T Building. Suzanne Stephens noted that the view was "almost obstructed by another Johnson creation inside the apartment. Here he has built a 'room-within-a-room' of wood paneling with classical motifs. In one corner of the room-within-a-room is a classical style pier carefully dropped in front of the apartment's large

corner window, although arches placed on either side of the pier do allow interested persons to see out and around to the garden below and AT&T beyond."[35]

And More Modern

Nearly ten years after the 1976–84 expansion, the Modern began to contemplate further growth, in reaction partly to infusions of capital and art bequests from new trustees, and partly to the need to create more and bigger galleries to accommodate the super-scaled art that had become the norm in the 1980s. The rush to take on another expansion so soon was not unprecedented; MoMA had contemplated a new wing in 1946, only seven years after moving to Fifty-third Street, and in 1965–67, just a year after completing a massive expansion, a number of studies had been undertaken by in-house staff under the direction of Arthur Drexler, but they were overshadowed by the era's widespread political protests and ultimately doomed by economic considerations. One of these proposals, according to Stanley Abercrombie, was notable: a ground-level and

underground wing on the site of the garden, with an entrance on Fifty-fourth Street and a new garden on the expanded building's roof.[36]

By 1991, the pressure to expand had become so intense that Cooper, Robertson & Partners, hired to study options for growth, recommended drastic measures such as moving the museum to Columbus Circle or the south side of Union Square, creating a secondary off-site location to show more recent work, or constructing an addition over the Donnell Library across the street.[37] Relocation was not considered feasible, and separating the contemporary galleries from the rest of the museum was seen as contradicting the institution's long-standing belief in Modernism as a continuous narrative. Another idea—building a gallery for contemporary art thirty feet below the sculpture garden—was favored by the museum's chairman, David Rockefeller, but vigorously opposed by several board members including Philip Johnson, who explained to the board that it was not "a good idea to go down 30 feet to an important gallery."[38] Johnson later reconsidered, saying, "the trees, the water, the paving are sacred. It would all go back. It is not as bad as it sounds."[39] But many outside the boardroom shunned it as well, among them Suzanne Stephens, who proclaimed that the loss of the garden would mean the loss of the "only real architecture the museum now has."[40]

The very idea of another expansion, especially to house contemporary art, once again raised fundamental questions about the curatorial direction of a museum so reluctant to engage with contemporary trends that Hilton Kramer, in 1989, predicted "a new period at the Museum of Modern Art, and there is every reason to believe that it is not going to be a very good period. We may in fact be seeing the beginning of the end of MoMA as we have known it . . . and what is now looming as the shape of the future at MoMA looks extremely grim for anyone who still believes in the great achievements of modernist art." According to Kramer, the museum's long-time refusal to recognize new art had left a "museological void" that was willingly filled by "rival institutions—museums unhampered, for the most part, by stuffy scruples about aesthetic standards." MoMA was no longer a trendsetter in the art world but was at the mercy of an art scene driven not by curators and critics but by dealers and collectors. In a quick, and in Kramer's view ill-considered, attempt to catch up, MoMA, "rather than face the risk of being left on the sidelines in what has become a fierce competition for money, attention and acclaim . . . [has] moved to disburden itself of all inhibition and hesitation in regard to the new art, and is now rushing to match and, if possible, overtake its rivals in advancing the interests of the post-modern bandwagon." A two-part series of exhibitions, lectures, and events called "Contemporary Art in Context" was for Kramer indicative of this effort and "designed to make it seem as if MoMA is the hottest place in town as far as contemporary art is concerned."[41]

In 1993 Kramer's fears were further fueled when the museum reorganized its administration according to a model used by the Metropolitan Museum of Art and recruited its first paid president, Glenn Lowry, who took office in 1994.[42] The changes coincided with announcements that MoMA was seeking to expand, though officials would only say the site being considered was not far from the museum. While Lowry's duties were intended to focus on raising money for the expansion, once in office he quickly restructured the staff, hiring six deputy directors (with higher salaries than the curators) to act as vice presidents would at a large corporation. By then, it had become clear that the museum's burgeoning, no-holds-barred growth would require more space, leading some critics to wonder how big a museum devoted—in name at least—to modern art could become. At issue was whether MoMA should officially change its mission to focus not only on Modernist art, a decidedly twentieth-century movement, but also on contemporary art, which would bring the museum into the twenty-first century. While similar philosophical issues had been pondered before the previous expansion, they were now considered with a greater sense of urgency.

In February 1996, after years of quiet negotiations, MoMA announced its acquisition of the twenty-one-story, 393-room Hotel Dorset (Emery Roth, 1927), 30 West Fifty-fourth Street, an adjacent brownstone at 42 West Fifty-fourth Street, and

Philip Johnson apartment, Museum Tower, 15 West Fifty-third Street, between Fifth and Sixth Avenues. Philip Johnson, 1985. Vecerka. ESTO

another brownstone at 41 West Fifty-third Street that adjoined two more, 37 and 39 West Fifty-third Street, which the museum already owned.[43] Glenn Lowry stated, "We're not rushing into anything. This is space to be used over the next century, not tomorrow morning. We have made our first critical step."[44] But later that year, the next critical step took place when the museum announced its plan to conduct an unusual, two-stage architect-selection process, including an invited competition, leading to its most comprehensive expansion and reconfiguration yet.[45] Holding a competition, even a closed one, was unorthodox for a museum that traditionally chose its architects under a veil of secrecy according to the very subjective opinions of its trustees. As part of the new approach, the heady questions regarding the philosophical implications of expansion that had gone unanswered for decades would be self-consciously and exhaustively addressed in a series of private and public seminars held that year, the proceedings of which the museum published in 1998 as *Imagining the Future of The Museum of Modern Art*.[46] The first sessions, held in early October 1996 at a weekend retreat at the Rockefeller estate in Pocantino Hills, were closed to the public. Among those invited to take part in four conversations—covering topics such as how architecture affected a viewer's experience of art, how the story of modern art was best told, the role of technology in museums, and the difference between a museum of art and a museum of modern art—were curators and directors from MoMA and other museums, the architects Peter Eisenman, Arata Isozaki, Rem Koolhaas, and Bernard Tschumi, the artists Bill Viola, Richard Serra, and Robert Irwin, and Adam Gopnik, a *New Yorker* writer.

The retreat gave the museum trustees enough confidence in their vision to release an executive statement later that month: "On the cusp of a new century," it read, "the Museum of Modern Art is now engaged in an important dialogue about its future direction. The trustees of the Museum have concluded that it should not be a shrine to the twentieth century but rather a vital, forward-looking institution committed to the art of the present as well as to the great achievements of the modern tradition." The choice had finally been made. For the new expansion, "MoMA requires a fundamentally new architecture to express the changes that have occurred in its thinking about itself. . . . The project must create a building, or complex of buildings, that demonstrates a sensitivity to the history and culture of the institution" and that would be "recognized as a great achievement in architectural design that is subtle yet polemical, substantial, and enduring." Not since its founding, the statement concluded, "has the Museum had such a unique opportunity to undertake such an extensive redefinition of itself. That the Museum is doing so at the birth of a new millennium could not be more appropriate, for the Museum's mission demands that we traverse the twenty-first century with the same confidence and boldness that we did the twentieth."[47]

Between October 22 and December 12, 1996, the discourse was opened to the public with a pair of lectures and panel discussions on topics ranging from the architectural context of the new addition to the role of modern art museums. Participants included Terence Riley, who had become chief curator of the museum's Department of Architecture and Design in 1992, the art historian Helen Searing, the critic Janet Abrams, and Robert A. M. Stern. Meanwhile, members of the museum's Architecture Selection Committee—which was chaired by Sid R. Bass and included Lowry and various trustees, as well as Philip Johnson and Edward Larrabee Barnes (Barnes was retired from practice and Johnson, for the second half of 1996 and the first half of 1997, was seriously ill)—were guided by Terence Riley on a tour of works by leading architects in thirty cities in the United States, Europe, and Japan in order to prepare for the selection of ten architects who would participate in a five-week charrette aimed not at eliciting specific design proposals but, according to Lowry, at gleaning "a variety of urbanistic and schematic proposals" that considered the possibilities open to the museum "within the constraints of its site, existing zoning regulations, and the Museum's conceptual and programmatic needs."[48] Cooper, Robertson & Partners was hired in September 1996 to undertake a detailed needs analysis and, eventually, to organize a design competition between three of the ten architects. To discourage elaborate presentations, entrants were required to limit submissions to paper, preferably in sketchbook form, so that all materials could fit into the eleven-by-seventeen-by-three-inch box provided by the museum.

The architects were selected in January 1997: Wiel Arets and Rem Koolhaas, both of the Netherlands; the Swiss team of Jacques Herzog and Pierre de Meuron; the French architect Dominique Perrault; Yoshio Taniguchi and Toyo Ito, both of Japan; and the four New York firms of Bernard Tschumi, Rafael Viñoly, Steven Holl, and Tod Williams and Billie Tsien. The list immediately elicited gossip and debate in architecture circles, primarily because the usual roster of candidates—the likes of Peter Eisenman, Frank Gehry, Richard Meier, I. M. Pei, and Renzo Piano—had been overlooked. Herbert Muschamp called the list "notable for the relative youth of the architects, most of whom are in their early 50's, and for its relative lack of star power," which reflected "the museum's belief that the process of selecting an architect should be as creative, and as modern, a venture as the process of designing the expansion itself."[49] More than anything, Muschamp saw the selection as evidence that the museum hoped that "the process of redesigning one of the world's most vital cultural institutions will itself be the lead performer."[50]

Architects had difficulty not talking about the implications of the list. Ralph Lerner, the dean of Princeton's School of Architecture, commented, "once you operate by eliminating groups—'too old,' 'too established,' 'too expressive'—you throw out the baby with the bathwater," while Michael Rotondi observed that "MoMA had the chance to focus the debate in architecture for the next century. Instead, this list makes MoMA into a client, not an agent of change. It's just a missed opportunity." At least one architect, Stanley Tigerman, seemed to keep things in perspective: "Why so much fuss about this list? Because architects my age seem to need to suck every last drop of oxygen out of the air—their insatiability drives me crazy. Pass the baton."[51]

Speculation about who might make the next cut began well before the schemes were available for scrutiny. *New York* magazine's Alexandra Lange, a brash, young, gossipy voice on the critical scene, identified a few no-brainer eliminations, one being Tschumi: "The only thing harder to understand than his writing is his architecture." Herzog and de Meuron would also surely be eliminated, she argued, because they already had the commission to design an addition to the Tate Gallery in London and would not be asked to do both, and Taniguchi was "the darkest of dark horses" and "an

almost inexplicable choice" to begin with: "Basically, no one in the U.S. has heard of him—not even the MoMA bookstore has a monograph of his work—despite the fact that he's built a dozen buildings in Japan, four of them museums." The bottom line, she wrote: "Out. Simple as that."[52]

On April 10, 1997, Sid Bass announced that Bernard Tschumi, Herzog and de Meuron, and Yoshio Taniguchi would compete in the second round, proclaiming, "The new expansion and renovation will set a trajectory for the Museum far into the next century."[53] Four weeks later, on May 5, the museum displayed to the public and critics for the first time the results of the ten-architect charrette in an exhibition, "Toward the New Museum of Modern Art: Sketchbooks by Ten Architects," so titled to reference the 1959 exhibition "Toward the 'New' Museum of Modern Art: A Bid for Space," held in preparation for the 1964 expansion. The exhibition, designed by Terence Riley and Mathilda McQuaid, an associate curator, quickly drew as much criticism as the entries themselves. Anxious observers found it difficult to glean much of anything from paltry displays of the schemes—conceptual to begin with—most of which were represented by a single, two-page sketchbook spread and cryptic excerpts from the architects' written statements. Herbert Muschamp acknowledged that without knowing the complex restraints put upon the architects, it was "nearly impossible to assess the forms these architects came up with."[54] More egregious still was the accidental but telling absence, pointed out by Julie Iovine in the New York Times, of any reference to Pelli in the chronology of MoMA's expansion displayed at the entrance to the exhibition. When notified of the omission, Pelli remarked, "That's amazing! What could have prompted that?" Confronted with the gaffe, Terence Riley commented, "Uh, oh."[55]

Although a broad spectrum of ideas had been proposed, certain consistencies emerged. All the architects retained the sculpture garden in one way or another—leaving it in its place, expanding it, duplicating it, moving it, elevating it, or depressing it—and all felt comfortable erasing Pelli's additions to the rear of the museum, though several "excavated" the shaft of his tower so that it could extend down to the ground. Several architects, including Holl and Herzog and de Meuron, offered alternative schemes, one adding distinct new structures to the hodgepodge complex of buildings and the other reworking the existing buildings to create a coherent new design. The latter strategy arose out of the belief that, as Martin Filler observed, "MoMA is the inverse of Frank Lloyd Wright's Guggenheim, which is often described as that museum's greatest artwork. It could equally be said that MoMA's wings are unworthy of being in its own collection."[56] Witold Rybczynski did not agree. "There is something wrongheaded about the very idea of 'making over' the Modern," he wrote. "The most that can be said about the varied bits and pieces is that they reflect their different times: the white box of the idealistic thirties, the perfect Miesian garden of the fifties, the curtain walls of the self-assured sixties, and the atrium of the pragmatic eighties. For better or worse, this clumsy patchwork embodies the ebb and flow of modernism itself. If we must have austere minimalism in the nineties, then let it take its place alongside the other styles. It, too, will pass."[57]

Despite the jabs of the critics, the proposals were rich with ideas. Wiel Arets called for a double-height, through-block entry sequence with a monumental flight of stairs from a Fifty-third Street lobby to a second-story deck overlooking the sculpture garden. He filled the site of the Dorset Hotel with a six-story gallery wing topped by a garden for museum employees, who would be housed in four rectangular towers of varying heights emerging from the structure.

Steven Holl organized his submission around the concepts of "cutting" and "bracketing." His cutting scheme involved adding identifiable new construction in the tradition of MoMA's previous growth and exploiting verticality, with a new tower on the Dorset site shaped by the angular form of the zoning envelope and pierced by irregular openings into idiosyncratic gallery spaces. The bracketing scheme reworked the

Proposed expansion of the Museum of Modern Art, 11 West Fifty-third Street, between Fifth and Sixth Avenues. Steven Holl, 1997. Charrette submission. Concept A: Cutting. West Fifty-third Street elevation (left) and section (right). SHA

existing buildings into a unified whole, with two new wings bracketing the campus on either side of the sculpture garden, which would be shifted to the west and raised eleven feet to allow space below for a 21,000-square-foot contemporary art gallery. Unlike the vertical galleries of the cutting scheme, those in the bracketing scheme were horizontally organized, and the varying floor levels of the existing museum were bridged with ramps. Holl used one watercolor rendering of a big fish swallowing successively smaller fish to illustrate the concept of MoMA's continued expansion and another in which he projected a 2029 "Centennial Wing" of the museum facing Sixth Avenue. Ada Louise Huxtable credited him with being "today what the museum so bravely championed at its start—an original talent with a personal style and a vision so clear and complete that it probably frightened everyone half to death. . . . He created a new kind of museum, a place of extraordinary space and light."[58]

Toyo Ito, who described MoMA as a "Manhattan within Manhattan" because of its many distinct "places," developed the theme of museum as urban microcosm by proposing what he called a "lying skyscraper" (equal in length to the height of the condominium tower) along Fifty-fourth Street. Composed of new buildings and the existing sculpture garden, it was to be separated by a central space from the Fifty-third Street buildings, just as traditional Manhattan townhouses were separated on a block by rear yards. Ito equated the plan of this traditional arrangement of thin, parallel structures with a bar code (he coyly used the phrase "Bar[r] Code" as a reference to the legendary founding director, Alfred Barr), a system that "juxtaposes all the components in parallel without any center, and creates a kind of abstract space which enables free expansion." The central space, providing access to ten elevators and eleven escalators, was, according to the architect, "a devicelike space, which we propose to call 'Manhattan.'"[59]

Dominique Perrault's proposal, like Ito's and several others, began with the establishment of a central, east–west spine of circulation and public spaces dividing the block in half, with a built portion on Fifty-third Street and an open portion on Fifty-fourth Street. Using a tortured metaphor of the museum as a tree, Perrault, the architect of the controversial and functionally challenged National Library in Paris, stated "it digs down into the earth as if searching its 'life force' there. In an opposed movement, it thrusts a long built mass emphatically upwards to form its 'trunk,'" or the existing buildings, where the offices and administrative functions would be located. The exhibition spaces would "blossom out" as the tree's branches, occupying new galleries in one of three proposed locations, each named according to its relation to the sculpture garden: "Aside," "Along," and "Above." "Aside" called for a new building on the site of the Dorset Hotel; "Along" suggested a five-story stack of galleries extending halfway over the garden at the fourth-floor level, with the garden elongated to encompass the entire length of the Fifty-fourth Street frontage; and "Above," which also gave the north half of the site over to the garden and called for a dramatic "hanging extension"—a single through-block level of galleries—jutting out over the garden at the seventh-floor level and casting it in perpetual shadow.[60]

Rafael Viñoly's proposal was the least focused, offering ten different "sketchbooks" that explored the gamut of architectural and urban issues faced by the museum, including the establishment of several terraced gardens, the relocation of the entrance or the creation of multiple entrances, the formation of a 600-foot-long diagonal circulation spine extending from below

Proposed expansion of the Museum of Modern Art, 11 West Fifty-third Street, between Fifth and Sixth Avenues. Rafael Viñoly, 1997. Charrette submission. Sketchbook #8: Path of glass and light. Section. RVAPC

Proposed expansion of the Museum of Modern Art, 11 West Fifty-third Street, between Fifth and Sixth Avenues. Rem Koolhaas, 1997. Charrette submission. Rendering of view to the southwest. OMA

Proposed expansion of the Museum of Modern Art, 11 West Fifty-third Street, between Fifth and Sixth Avenues. Rem Koolhaas, 1997. Charrette submission. Model. OMA

Proposed expansion of the Museum of Modern Art, 11 West Fifty-third Street, between Fifth and Sixth Avenues. Rem Koolhaas, 1997.

Charrette submission. Rendering of Odyssey: A new transportation system. OMA

grade on the east side of the site to the seventh-floor level on the west side, and other schemes that consolidated the galleries on three vast floors, dispersed them on different wings, and created a "horizontal tower" along the lines of Ito's lying sky-scraper. One of the proposals placed a framework atop Pelli's tower, doubling its height and supporting a movie screen, to give the "Museum a place in the skyline of the city."[61]

Tod Williams and Billie Tsien were intent on limiting the height of the additions to the fifty-foot setback of the museum tower, noting that the visitor was thereby encouraged to explore the sprawling museum by foot at an "appropriate pace," with less of a need for elevators or escalators. They proposed to span the north edge of the site with a two-story bridge at the fourth- and fifth-floor levels (although they also submitted a proposal without the bridge), connecting new galleries on the site of the Dorset Hotel with others that occupied an expanded restaurant wing to the east, making Fifty-fourth Street "the unifying facade of the Museum." They also created a great light court by carving out the lower floors of the Museum Tower, leaving only the core, to produce "dramatic

vertical shafts of space between the old museum and the addition."[62] The top floor of the addition would house a temporary exhibition room with forty-foot ceilings and a thirty-by-thirty-foot room open to the sky at the westernmost edge.

Rem Koolhaas was the only one to offer a single strategy, calling for a vast open space at street level created by eliminating the existing ground-level walls. In a bold move that Terence Riley characterized as a fusion between Rockefeller Center and Lever House, Koolhaas proposed sinking the garden one story below grade so that pedestrians could walk beneath the museum-on-stilts from either Fifty-third or Fifty-fourth Street and look down into the garden. Edward I. Mills called it an "unpardonable sin . . . that [Koolhaas], with his urban design background, must realize goes against the fabric of New York City."[63] Koolhaas was in direct opposition to most of the other architects, who made it a point to provide naturally lighted galleries. "Whereas painting and sculpture are best revealed in conditions of (simulated) daylight," he remarked, "new arts need a darker, more artificial accommodation, an American night, illuminated by electric haze, glowing and flickering."

With a sure sense of a future of his own imagining, Koolhaas called for an automated system of retrieving works of art from storage at the request of visitors, allowing for a "more customized, individual museum experience" and providing for curators a "new way of conceptualizing the collection." His next technological feat, bolstered by his assertion "that circulation is what makes or breaks public architecture," was a melding of the escalator and the elevator called "Odyssey: A New Transportation System." Developed by the Otis elevator company, it could travel diagonally like a funicular, as well as move horizontally and vertically. Koolhaas envisioned it transporting people diagonally from the west edge of the sculpture garden up through six stories of new gallery spaces and then vertically up through a sixteen-story, triangular, zoning envelope–inspired multipurpose tower on the site of the Dorset Hotel, extending through to Fifty-third Street. He called for the reuse of the Goodwin and Stone building as a home for the museum's six curatorial departments—one per floor—and for the construction of seven floors on top of Johnson's 1964 addition. The new building, an administrative headquarters where "plans are made and funds raised," was to be called MoMA, Inc.[64] The result would be a conceptual flow of energy from building to building, from the development offices to the curatorial offices to the art galleries.

Despite its status as an also-ran, it was Koolhaas's submission that received the most attention, in part because it was the closest to an actual proposal and in part because of the architect's irreverence and biting commentary about the museum. Herbert Muschamp devoted a full page of the *New York Times* to it. He saw it as a welcome alternative to the three chosen schemes, which he considered "as tasteful as table water biscuits." Koolhaas, characteristically "youthful, even bratty, with bright new ways to frighten the horses," had made his entry into "as much a philosophical critique of the museum as a plan for its physical enlargement." Accordingly, Muschamp noted, the "plan is not easy to love. It doesn't begin to be elegant. It lacks the grace of formal simplicity. . . . His cutaway ground space brings to mind the gloomy space beneath the floating garden slab of Lever House. His sunken garden will elicit shudders of recognition from those who've suffered the damp sculpture moat at the Whitney. The whiffs of technology, like the automated painting retrieval system, summon forth memories of French rinky-dink modernism from the 1960's." Koolhaas's headstrong assertions and visionary suggestions were, according to Muschamp, too much for MoMA to handle: "To make something successful from this proposal would take a client with more strength of will than the Modern is presently able to muster. It would take a client with the capacity to think yes and no simultaneously: Yes, your mind is working. No, you may not sink our garden into the basement. No, you can't cut away the ground floor. You may not use robots. Cut the cute stuff about MoMA Inc. Nix the chandeliers. Can the Odyssey. Got any more ideas?"[65]

Paul Goldberger felt Koolhaas offered "the best chance of instantly reasserting the museum's status on the international buzz circuit," calling him the "obvious, sexy choice; he presented himself as the least corporate candidate, and all but dared the museum to hire him." MoMA's decision not to, according to Goldberger, was a sign of maturity gained in its self-evaluating selection process.

Though critics like Muschamp called the Modern's choices timid, Goldberger wrote:

Koolhaas would have represented not courage but denial. The museum was emerging from its analysis to accept itself as it is: a place that has ridden the wave of modernism all the way from the avant-garde to the establishment. It knows that it is big and grown-up, and that big institutions shouldn't behave the way littler, younger ones do. While it fears being written off as conservative, the museum has come, in maturity, to realize that it cannot reject its now venerable roots. . . . All three architects on the museum's short list have tried to build on the early traditions of modernist architecture and send them in a new direction—Herzog & de Meuron through a kind of understated yet powerful sensual beauty, rich in texture; Tschumi through complex forms emerging from the Deconstructivist movement; and Taniguchi through a kind of serene elegance. There are no bad boys among them.[66]

Herzog and de Meuron, whose submission the selection committee found "provocative and thoughtful, reflecting a keen awareness of the evolving role of museum architecture in shaping the appreciation of art,"[67] focused on rediscovering the roots of the art museum, observing that "an art museum is a place for art and people: it is not Disneyworld; it is not a shopping mall; it is not a media center." They offered two options: an "agglomerate" and a "conglomerate" scheme. In the agglomerate plan, expansion would occur as it always had, with discrete additions to what already existed, creating what the architects referred to as a "still life" in which elements could be added or removed. On the site of the Dorset Hotel, a broad, angular tower with skylighted galleries would rise to become "a new landmark in Manhattan." In the conglomerate scheme, all the museum functions would be contained within a continuous building envelope with an eighty-five-foot roofline that could be shaped by gardens and roof galleries. The Goodwin and Stone building and Miller & Noel's four-story Whitney Museum of 1954 would both be "transformed" into courtyards that "could work as entrance areas where a first encounter with art would be possible," while the existing sculpture garden would be built upon. The architects seemed most levelheaded in their assertion, counter to Koolhaas's, that one need not "try to invent 'futuristic' spaces for some art to come in the next millennium. Gallery spaces need a solid floor, solid walls, and a ceiling that provides daylight and artificial light. This sounds very simple but it is very difficult to achieve in a straightforward and bold way."[68] Ada Louise Huxtable was not impressed, dismissing the scheme as "absolutely alien" to its context and the courtyard as "too European, the decorated facade materials too fussy and costly; this may be another Museum of Modern Art, but not the right one."[69]

Bernard Tschumi, the only architect who did not submit exterior renderings, explored the concept of gallery spaces organized like a "sponge," an idea that had been discussed at great length at the Pocantino Hills conference, of which he was a part. Instead of creating a linear spine of galleries, he designed a looser collection of spaces that would allow the visitor to move freely through the museum. Conceiving the exhibition spaces in the obscure terms of "hot magma" and "gases," Tschumi called for "a reversal of the traditional concept of the Museum, in which certainty is at the core and peripheral values are located at the edges." In his plan, permanent collection galleries would be located at the perimeter and flexible, temporary exhibition rooms in the center, like a volcano, where the shell is solid and the inside molten. Important interior spaces were located at the intersection of "the old and the new, between the permanent and the temporary, between the

painting and sculpture collections and the other departments, between the public area and the curatorial offices of the education areas," Tschumi stated, to create "a sequence of interlinked courts: tower court, upper court, garden court, entry court."[70] He also proposed a "Modern Multiplex" of four theaters beneath the sculpture garden and "MoMall," a theme mall that contained the design store, the bookstore, and a café.

Ada Louise Huxtable wrote that Tschumi, in spite of his "arcane, highly theoretical style and bad-boy personality, has produced a thoughtful, program-driven analysis and appealing plan, and would appear to have a genuine edge. . . . For an architect who has been the apostle of the incomprehensible, this is a surprisingly gentle and user-friendly scheme."[71] Herbert Muschamp agreed that Tschumi had "cleaned up his woolly act" for the competition. While he complained that Tschumi's presentation came "adorned with some pretentious pedigrees," such as its dedication to Italo Calvino's *Invisible Cities* and "arcane talk about a sponge," he admitted that "Mr. Tschumi's plan is so simple and clear you might almost mistake it for the work of Richard Gluckman, the minimalist designer of the Whitney's expansion." Noting the absence of exterior renderings, Muschamp called Tschumi's approach "as much curatorial as architectural . . . [and] the only one that tries to spatialize the museum's present historical situations. It is both the custodian of a modern tradition and a living institution that must periodically rethink that tradition as time moves on."[72] Michael Sorkin praised Tschumi for having "created the most impressively massed and expressed scheme . . . although his scheme had circulation problems and an uncompelling ground-floor plan."[73]

Yoshio Taniguchi's scheme, which the selection committee felt "combined an elegance and clarity of conception with a sensitivity to light and space,"[74] was "the most classically modern" of the lot, according to Herbert Muschamp, skillfully

ABOVE Proposed expansion of the Museum of Modern Art, 11 West Fifty-third Street, between Fifth and Sixth Avenues. Bernard Tschumi, 1997. Charrette submission. Flows and voids study. BTA

BELOW Proposed expansion of the Museum of Modern Art, 11 West Fifty-third Street, between Fifth and Sixth Avenues. Bernard Tschumi, 1997. Charrette submission. Conceptual sketches, core and satellite galleries. BTA

incorporating "the museum's existing buildings into a harmonious whole" so that it seemed to be "the same Modern, only bigger and better. . . . Conservative but impeccably proportioned," he continued, "it comes along at a time when changing taste is bringing the International Style back into public favor. In this sense . . . [it] would be as faithful to this moment as the original building was to its time."[75] Taniguchi proposed leaving the Fifty-third Street buildings intact and adding a simple, rectangular volume west of the Museum Tower to create a "collage of historical buildings." On Fifty-fourth Street, he called for a "seamless architectural expression of simple geometric volumes"—two low buildings on either side of the garden—that would "create a powerful horizontal presence . . . in stark contrast to the random verticality of Manhattan."[76] Ada Louise Huxtable called the proposal "no gamble . . . he has cut right to the chase—a workable, rational, extremely handsome and eminently buildable proposal . . . , the only one who really brings it all together with an understated skill and art." Taniguchi's "relationship of stacked galleries over open space would create spectacular interlocking exhibition areas," she argued, and the circulation was "practical and visually low key." His design, she concluded, was "International Style grown up; a sophisticated perfectionism exactly right for the Modern—its heritage updated, its character maintained and projected, no fumbling for reincarnation."[77]

The three finalists submitted their designs to the selection committee on September 26, 1997, and on December 8, the museum announced its choice: Yoshio Taniguchi, whose proposal exhibited the greatest degree of sensitivity to the institution's historic fabric, to its awkward midblock site, and to the complex curatorial requirements.[78] At sixty, he was the oldest of the three and by far the least known in America. The three submissions went on display at the museum the following March. Herzog and de Meuron's scheme was a departure from their first-round proposal in part because the competition guidelines mandated that the sculpture garden not be relocated. The "most modern and least sentimental" proposal, according to Cynthia Davidson, it featured an eye-catching, twenty-three-story, asymmetrical prismatic tower housing curators' offices that rose at an angle from Fifty-third Street and, in an awkward collection of planes, bulged east toward the garden. Two entrances, one from each street, had large lobbies that connected midblock. Galleries were situated on the second, third, and fourth floors. Though the so-called Bauhaus stair was restored, most circulation would be by escalator, because, as the architects put it, "nobody uses stairs anymore." The team, known for their elegant use of innovative materials, proposed to wrap the complex in a consistent "glass shell," the surfaces of which could be "transparent, translucent, or opaque" and treated with "printing or etching . . . so sometimes it doesn't look like glass at all but more like stone."[79]

Though Suzannah Lessard considered Herzog and de Meuron's proposal "the closest to what the [selection] committee had in mind when it embarked on its journey," she reported that the committee had begun to doubt certain aspects of the proposal. For instance, the placement of a roof garden with skylights and reflecting pools over a gallery did not take into consideration the possibility of leakage. And the curatorial tower's small, irregular, and inefficient floors hinted that it would need to be significantly redesigned were the proposal to go forward. If the tower were built as proposed, according to Lessard, the committee feared its idiosyncratic design "might become

Proposed expansion of the Museum of Modern Art, 11 West Fifty-third Street, between Fifth and Sixth Avenues. Herzog and de Meuron, 1997. Competition entry. Photomontage, view to the northeast of West Fifty-third Street. HDM

known as the Edsel of the design world."[80]

Bernard Tschumi expanded on the ideas in his charrette submission, laying out a "sequence of interior courts" and galleries that would "work as a long promenade looping through the building," a conceptual image inspired by "Kafka's burrowing through the earth and resurfacing at various points from the ground."[81] He described the challenge of placing spatial objects on the constrained site as "playing chess with a very difficult opponent" but was still able to pull off a bold architectural gesture in the form of an exhibition space that cantilevered east from the Dorset site toward the garden at the seventh-floor level, hovering above a sculpture garden on top of the former Whitney Museum, which would remain. At the west edge of the Dorset site, a flat-topped mechanical tower with canted north and south facades would rise from each street according to the angled profile of the zoning envelope and double as a screen for projections, banners, and video art. Tschumi separated temporary exhibition galleries, placing them in a new building east of the sculpture garden facing Fifty-fourth Street, with a three-story glass curtain wall that would have offered unfortunate views of the museum's escalators. Michael Sorkin wasted no words, stating that Tschumi was "certainly my pick, and seemed like a shoo-in for professional, political, and architectural reasons," but conjectured that the "real causes of his failure to get the commission are doubtless political. . . . Which is to say, Tschumi probably lost because someone (and there's plenty of speculation as to whom) didn't like him."[82] Sorkin was alluding to the widely assumed wisdom that Herbert Muschamp did not like

Tschumi or his work, as evident in his extremely negative assessment of the architect's MoMA show in 1994.[83]

Taniguchi proposed by far the quietest scheme. He called for the removal of Pelli's escalators, the restoration of the garden to its original size—including the south terrace that had been swallowed up by the Garden Hall—and, in a brilliant move, the extension of the Museum Tower down to the ground at the corner of the garden, giving it the dignified setting that its mass and inherent qualities surely deserved. Remarking on this aspect of the design, Philip Johnson stated, "Here's this building you can't do anything about, and he just went with the flow. It was a brilliant idea that never crossed my mind. I'm thunderstruck!"[84] Two new buildings would be placed on West Fifty-fourth Street, flanking the sculpture garden "like two halves of a stage curtain," in the words of Herbert Muschamp.[85] Each would face the street with a sleek, black slate facade and the garden with a glass-and-aluminum curtain wall. The north facade of Johnson's East Wing facing the garden would also be reclad in glass. The building to the east of the garden would be an eight-story, 80,000-square-foot education-and-research center, while on the Dorset site a sixteen-story gallery wing would rise sheer for eight stories on Fifty-third and Fifty-fourth Streets, before giving way to north- and south-facing setbacks with skylights. The museum's main entrance would be relocated to the base of the gallery wing on Fifty-fourth Street, which Taniguchi called "a quiet street appropriate for a cultural experience," and open into a through-block lobby—soon nicknamed "Fifth-and-a-half Avenue"—with a 110-foot-high atrium rising midblock, capped by a glass roof that provided dramatic views of the Museum Tower above.[86] Circulation spaces overlooked the atrium, and the galleries were organized so that, as Glenn Lowry put it, the museum remained "grounded in the present," with contemporary art on the second and third floors, galleries for the permanent collection on the fourth and fifth floors, and temporary exhibition spaces above.[87]

Both the Goodwin and Stone building and Johnson's East Building would be restored to accommodate staff offices. The long-departed yet much missed asymmetrical entrance and curving canopy of the Goodwin and Stone building would be rebuilt as a separate entrance for two theaters on Fifty-third Street, and the rebuilt Bauhaus stairway would lead to the Department of Architecture and Design's third-floor galleries. Though Kenneth Frampton was pleased that the architect went "out of his way to maintain the original stair shaft,"[88] Victoria Newhouse dismissed Taniguchi's acts of preservation and recollection as a "look to the past, not the future. . . . As with MoMA's previous expansions, this translates into more of the same: a sacred sanctuary for MoMA's gospel of art."[89] Joseph Giovannini was perhaps Taniguchi's most outspoken detractor, calling the scheme a case of the "emperor wearing no clothes . . . an embarrassment for the museum and the city and . . . a provincializing setback for the profession." He objected to the scheme's vertical organization: "Curators may have visions of Kyoto serenity in their heads, but what the sections show is basically an American department store with a shifted donut plan. Think J.C. Penney's on a bad escalator day." But Giovannini was really concerned with the design's lack of cutting-edge modernity. "This is comfort Modernism—practiced in a safe realm," he noted. "With this design, MoMA abdicated its leadership position and failed its own stated mission. . . . Taniguchi's design sets the clock back. MoMA's deci-sion-makers opted for the traditional, not for a museum of the 21st century understood in freshly defined contemporary terms. . . . MoMA has chosen not to face the Millennium."[90]

The sense of disappointment among the critics and younger architects was probably fueled by the extensive publicity received by two recently completed museums: Frank Gehry's Guggenheim Museum in Bilbao, Spain, and Richard Meier's Getty Center in Los Angeles, both striking designs that captured the attention of the public. Taniguchi's plan, in contrast, was so understated that some museumgoers studying the exhibition of his winning proposal were said to have wondered out loud whether the work had already been completed. But while outsiders seemed hungry for a bold stroke of design for one of the world's most important museums, Taniguchi's gesture-free solution was a perfect match for the site, and his willingness to let his architecture take a backseat to the art seemed exactly what the trustees wanted: a building that stood behind MoMA's belief that its collections had always been more challenging to the status quo than its architecture. Terence Riley later recalled that after winning the competition, Taniguchi told him, "Terry, if you raise a lot of money I'll give you really great architecture. And if you raise a whole lot of money I'll make the architecture go away."[91]

The approach pleased Kirk Varnedoe, the chief curator of painting and sculpture, who explained, "There was a joke that the restraints on the site left no room for architecture. Taniguchi answered all the restraints and yet produced the most poetic building. It's the old dream of modernism, that if you really bear down on function with clarity there isn't a

Proposed expansion of the Museum of Modern Art, 11 West Fifty-third Street, between Fifth and Sixth Avenues. Bernard Tschumi, 1997. Competition entry. Model, view to the southwest. BTA

wall between function and poetry. For the first time, now we will have real physical spaces that will have a force consistent with our museum. The gap between what we are and what we look like will be closed."[92]

In February 2000, Kohn Pedersen Fox was hired to work with Taniguchi as executive architects, a relatively new title that intimated more of a role in the design process than "associate architect" or "architect-of-record," reflecting William Pedersen's insistence that "we are design architects, not production architects."[93] By June, economic considerations had forced a reduction in Taniguchi's budget and the introduction of some lower-quality materials—as MoMA President Agnes Gund put it, "We're resorting to 'B+' instead of 'A' to save money."[94] In addition to budgetary frustrations, Taniguchi was reportedly strained by working in New York, which necessitated ceding some control: "In Japan I can control everything," he explained, "but here it is a team effort. It has been hard."[95] In late 2003, according to Julie Iovine, Taniguchi admitted "that he would have preferred being the sole architect," lending some credibility to rumors that Kohn Pedersen Fox's vast experience building in New York City on a budget had resulted in a greater influence on the design of the museum—and especially its interiors—than originally expected. The demolition of the Whitney Museum building was completed in August 2001, and the Hotel Dorset followed in December. Foundations were completed in March 2002, and in May the last portion of the museum was shut down and a temporary home called MoMA QNS was opened in Long Island City, Queens (see Queens).

Museum of Modern Art, 11 West Fifty-third Street, between Fifth and Sixth Avenues. Renovated and expanded by Yoshio Taniguchi, 2004. View to the northeast. Hursley. TH

The opening on November 20, 2004, of the expanded museum, increasing its overall size from 378,000 to 630,000 square feet and its gallery space from 85,000 to 125,000 square feet, elicited a massive and decidedly mixed critical reaction. Although Taniguchi still regretted several decisions dictated by the limited budget, including a reduction in the number of skylights, he pronounced the results to be "nearly perfect. I'm not supposed to say that because I'm Japanese. I'm supposed to sound humble."[96] Nicolai Ouroussoff, Herbert Muschamp's successor at the New York Times, described the reworked museum as "one of the most exquisite works of architecture to rise in this city in at least a generation . . . a serene composition that weaves art, architecture and the city into a transcendent aesthetic experience. Its crisp surfaces and well-proportioned forms clean up the mess that the building had become over the course of three expansions." The critic embraced Taniguchi's dreamy promise of making the "architecture go away," writing that as one ascended the gallery wing, "views cut diagonally across the atrium and between the gallery bridges, where a distant, fractured view of the garden magically reappears. At these moments, the building virtually dissolves into thin air." The "most startling transformation" from the museum's previous incarnation, according to Ouroussoff, was that of the Museum Tower, now "exposed . . . down to its base in a corner of the garden, so that it becomes the anchor around which the entire composition turns, locking the museum buildings into the Midtown skyline."[97]

Paul Goldberger found the design to be the "most splendid, and subtle, in its urbanism," noting that while the Modern's presence had historically challenged its brownstone neighbors, it had now grown to take over nearly the entire block, a change that Taniguchi saw "as a chance to weave the building into the fabric of the city." The creation of a Fifty-fourth Street entrance and through-block lobby signaled that "it has finally become part of the connective tissue of Manhattan. The old Modern occupied the street in sullen isolation; this one dances with its neighbors."[98] In contrast with Goldberger, Boston Globe critic Robert Campbell, admitting to be "one of only a few critics around who isn't crazy about the new" MoMA, called the building "rude to the city. No building has the right to be contemptuous of other buildings around it." Especially on Fifty-fourth Street, he wrote, "MoMA makes no gesture in response to the fact that it's on a busy residential street in Manhattan. Here the museum is an endless, nearly block-long blank wall that varies only in material. It's black or white glass, but always forbidding, articulated only by the museum entrance and a truck dock. Even where you know the Philip Johnson garden is right behind the wall, you're not privileged to see it. You might as well be walking past a convention center."[99]

Campbell also felt that Taniguchi's efforts to make the architecture disappear had resulted in "an endless rabbit warren of more or less identical white-walled galleries with track-lit ceilings. Every attempt is made to remove any sense of the presence of architecture. . . . Architecture has failed to create a place that either the paintings or you yourself can inhabit with a sense of presence." Even more regrettable for Campbell were the supersized galleries, where "artworks intended to confront or absorb you with their bold size and scale—Pollocks, Miros,

FACING PAGE Museum of Modern Art, 11 West Fifty-third Street, between Fifth and Sixth Avenues. Renovated and expanded by Yoshio Taniguchi, 2004. View to the southwest. Hursley. TH

Museum of Modern Art, 11 West Fifty-third Street, between Fifth and Sixth Avenues. Renovated and expanded by Yoshio Taniguchi, 2004. Hursley. TH

Kellys, Monets, and others—now find themselves in spaces that are tailored to fit them. In proportion to the space they occupy, these big paintings are now the same size as smaller works in smaller galleries. They've been tamed."[100]

Hilton Kramer was even more dismissive of the "ill-conceived architecture. Yoshio Taniguchi's redesign has at every turn in its cold and elephantine structure the look and feel of a Japanese parody of the kind of American modernism that has itself long outlived its expiration date. Thus the galleries are essentially an architectural assemblage of—what else?—bleak, oversized white boxes in which the scale of the interior space and the unrelieved whiteness of the walls conspire to discomfort the viewer while diminishing the aesthetic integrity of the works of art marooned in an environment remarkably hostile to the pleasures of the eye."[101] Martin Filler was also disquieted over the museum's new scale, terming it the "new maxi-MoMA," and mourning that the "sociable character" of the old museum "is now all but lost. The colossal new spaces make the museum feel entirely different from the place we once knew," so alien that at a recent press preview he overheard a "disoriented observer" quip, "Where's the Egyptian wing?"[102]

Ada Louise Huxtable and Suzanne Stephens similarly voiced concern with the gallery spaces and especially the atrium, the huge size of which they both believed overwhelmed the art. Otherwise, Huxtable was impressed with Taniguchi's "suavely sophisticated, exquisitely executed, ele-

gantly understated building. . . . Mr. Taniguchi's style—where less is so much more than trendy minimalism, with every carefully reasoned detail honed as close to perfection as possible—is the right architecture for the Modern. It is also the right building for New York . . . unifying old and new elements into a harmonious, smoothly functioning whole. The reconfigured complex employs an uncompromisingly contemporary vocabulary, a lesson to those who confuse nostalgia with compatibility. This is genuine contextualism."[103] Stephens also believed that the "architectural expression," though "in some places too stark," was "the right one" for the museum. "As a reflection of its institutional, cultural, and architectural history," Stephens concluded, "Tanighuchi's renovation and expansion . . . seems to have evolved naturally out of the institution's own architectural unconscious. It's what the Modern always wanted to be."[104]

Also in the Neighborhood

Taking its cue from the Museum of Modern Art, in August 1980 the Museum of American Folk Art (renamed the American Folk Art Museum in 2001) announced plans to build a four-story museum surmounted by a revenue-generating thirty-story tower.[105] Founded in 1961, the museum had been headquartered in 1,500 square feet of space in a brownstone at 49 West Fifty-third Street since 1963. A modest-sized institution compared with MoMA, it nonetheless needed additional space to display a collection of nearly 5,000

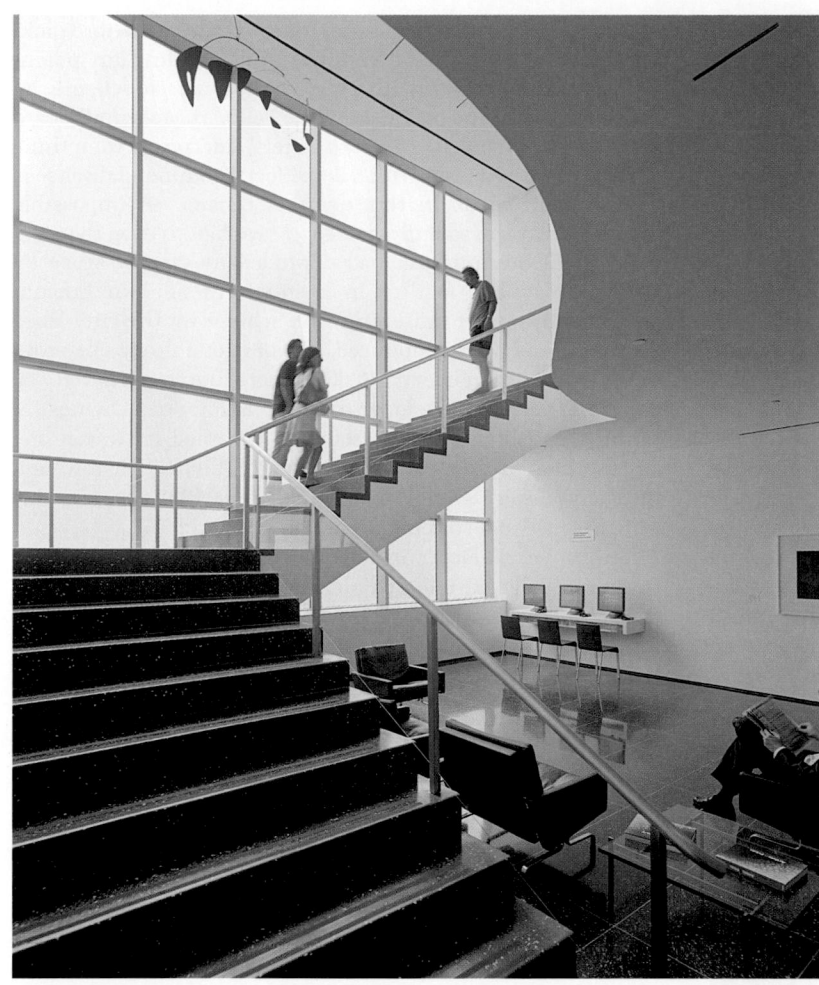

LEFT Museum of Modern Art, 11 West Fifty-third Street, between Fifth and Sixth Avenues. Renovated and expanded by Yoshio Taniguchi, 2004. Bauhaus stair. Hursley. TH

BELOW Museum of Modern Art, 11 West Fifty-third Street, between Fifth and Sixth Avenues. Renovated and expanded by Yoshio Taniguchi, 2004. Fifth-floor galleries. Hursley. TH

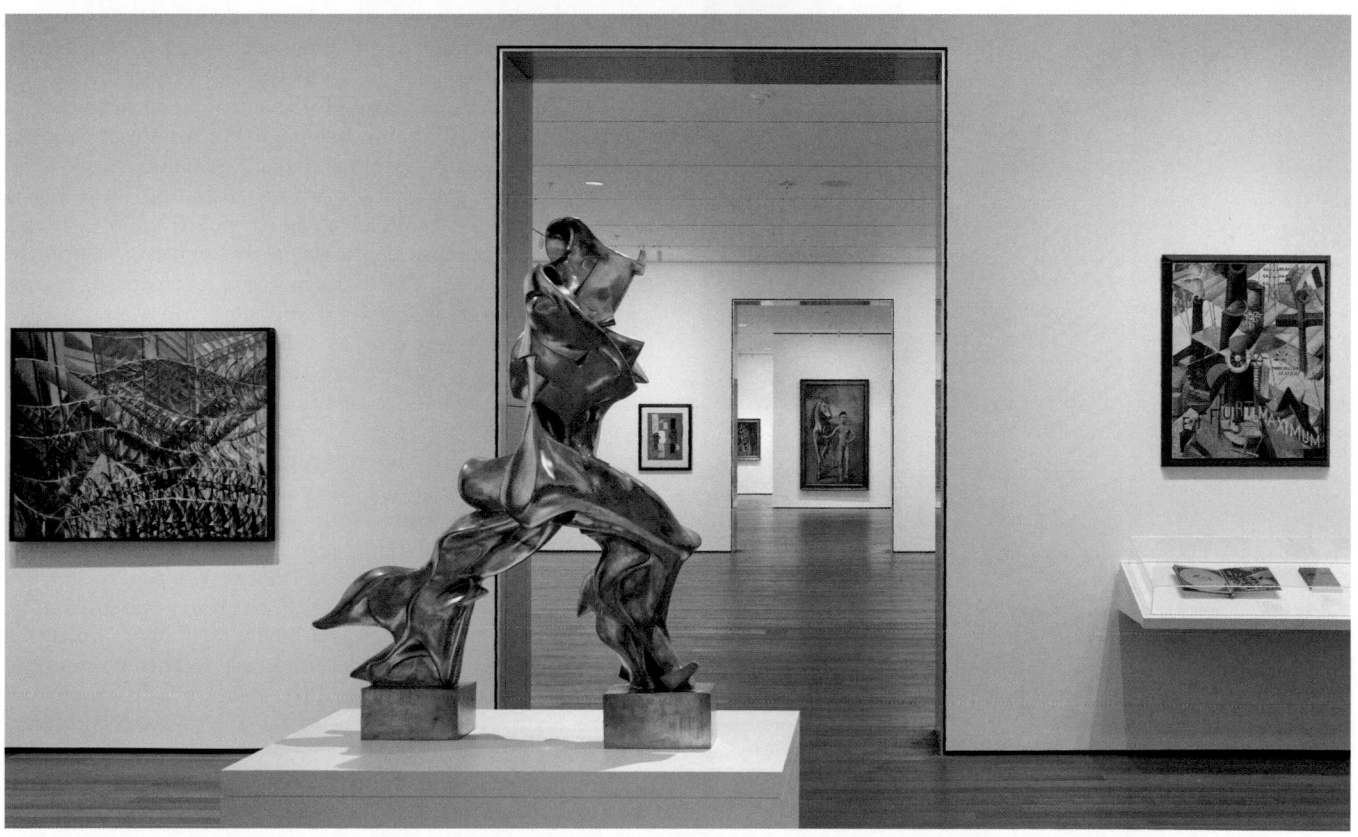

decorative and utilitarian items produced by artisans who lacked formal training—from weather vanes and quilts to furniture from the eighteenth and nineteenth centuries and contemporary works by self-taught artists.

The proposed tower and museum were designed by the Surrealist-influenced, New York– and Bologna-based architect Emilio Ambasz. His plan for the 100-by-128-foot site at 45–55 West Fifty-third Street, between Fifth and Sixth Avenues, replaced six brownstones and echoed the strategy of the neighboring Museum of Modern Art, with which the architect was quite familiar, having served as its curator of design from 1970 to 1976. Contained within a crisp geometric frame intended to relate to its immediate "prismatic" neighbors—Emery Roth & Sons' ABC headquarters at 1330 Avenue of the Americas (1966) to the west and Cesar Pelli's still-under-construction tower for the Museum of Modern Art to the east—were three separate office blocks (intended to read as base, shaft, and capital) that stepped forward as they ascended. This arrangement was advocated as a way of reducing the tower's perceived mass, allowing greater penetration of light, and drawing attention to the dramatic, freestanding eighty-foot-high entrance portal at the base, where two symmetrical stairways were to lead to the museum's grand foyer, a skylit, three-story space (the office tower would be entered at street level). The

Proposed Museum of American Folk Art, West Fifty-third Street, between Fifth and Sixth Avenues. Emilio Ambasz, 1980. Rendering of view to the northeast. AMB

museum, however, had commissioned the design before picking a developer for the office tower, thus saddling any potential real estate investor with a highly idiosyncratic scheme. As Ralph Esmerian, the president of the Folk Art Museum's board of trustees, observed, "Unfortunately, marrying something that is strong in design with a developer's commercial sense is very difficult to do in this town. It became an impossible design for anyone to build and so . . . we had to drop that."[106]

By 1990 the museum had expanded its display space by adding a satellite facility in a storefront at Two Lincoln Square, and another museum/tower scheme for the Fifty-third Street site had been announced, this one for a thirty-one-story tower and a three-story, 40,000-square-foot museum to be designed by the developer-friendly Skidmore, Owings & Merrill.[107] Although the museum had learned its lesson and already had the development team of Lionel Kustow and Investcorp International in place, the project failed again, this time because of a softening real estate market.

Seven years later, in October 1997, the Museum of American Folk Art released plans for yet another project, this time forgoing a revenue-producing tower in favor of a stand-alone museum building, the first entire new structure of its kind to be completed in the city since Marcel Breuer's Whitney Museum in 1966.[108] Once again, the museum was bold in its architectural ambitions, choosing the innovative team of Tod Williams and Billie Tsien to design the six-story, 30,000-square-foot building that would open in 2001 on a 40-by-100-foot site at 45–47 West Fifty-third Street, close to the expanded Museum of Modern Art. MoMA had tried to get the Folk Art to agree to leave the block or at least move to the western edge of the site, to allow for the possibility of continuing its expansion in the future, but the smaller institution balked at any move, preferring to stay not only on the street but on the site, which had great visibility because it terminated a vista afforded by the midblock plaza between Eero Saarinen's CBS Building and Kevin Roche's E. F. Hutton Building (see below), a location the architects believed would help prevent the museum from being swamped by its much larger neighbor.

As designed by Williams and Tsien, the American Folk Art Museum was housed behind a virtually scaleless, eighty-five-foot-high, nearly solid facade whose sculptural form was a highly abstracted version of an outstretched hand, a fitting emblem for a museum dedicated to the works of self-taught craftsmen and artists. The folded facade was composed of sixty-three half-inch-thick panels of Tombasil, a white bronze alloy usually specified for fire nozzles and ship propellers, mixed with nickel to increase resistance to weathering. In its first architectural use, the architects poured the molten material into concrete or metal forms directly on the foundry floor to achieve rough-hewn yet subtly varied panels. To make it look as if they were floating on the facade, the panels were hung from stainless-steel pins and mounted with open joints, exposing the dark supporting wall behind. Ranging from a silvery pewter to a burnished near-bronze, the color of the angled panels changed throughout the day, giving "the building greater presence on the narrow street," according to the architects. "This inflection will expose the western side of the facade to Fifth Avenue and the cool of the eastern morning light and, similarly, the eastern face to Sixth Avenue and the reddened western afternoon light."[109]

Though the sheer ornamentalism of the facade attracted the attention of passersby, first-time visitors were put off by

American Folk Art Museum, 45 West
Fifty-third Street, between Fifth and
Sixth Avenues. Tod Williams Billie
Tsien & Associates, 2001. View to
the north. Moran. MM

the somewhat obscured entrance doors. Once discovered,
however, they led through a twenty-three-foot-high lobby to
an eight-level, skylighted space that belied the building's nar-
row dimensions. As at Frank Lloyd Wright's Guggenheim
Museum (1943–59), visitors were encouraged to start at the
top level and circulate down. But the various sets of stair-
cases—including one in the center of the space at the western
end of the building connecting only the fourth and fifth

floors—did not have the clarity of Wright's single ramp. The
clarity was also compromised by a somewhat self-conscious
use of materials, including thin, sea-green molded fiberglass
panels and bush-hammered concrete polished to look like ter-
razzo. Williams and Tsien claimed influences not only from
the Guggenheim and Whitney but also from Sir John Soane's
house-museum (1812–24) in London and their own design for
an East Seventy-second Street townhouse for the realtor Jerry

FACING PAGE American Folk Art Museum, 45 West Fifty-third Street, between Fifth and Sixth Avenues. Tod Williams Billie Tsien & Associates, 2001. Moran. MM

ABOVE American Folk Art Museum, 45 West Fifty-third Street, between Fifth and Sixth Avenues. Tod Williams Billie Tsien & Associates, 2001. Moran. MM

Speyer (see Upper East Side).[110] Soane's influence could be seen in the complexity and verticality of the central space and in the cluttered display, an understandable response to what was essentially a very small space, especially considering the area dedicated to circulation. Two below-grade levels contained offices, a library, and an auditorium, and the museum featured a ground-level store, accessible both from within the museum and from a separate door on Fifty-third Street, and a small café on a mezzanine level overlooking the lobby.

Herbert Muschamp greeted the proposal enthusiastically, calling it "good news . . . for those who remain optimistic about the future of architecture in New York," and describing Williams and Tsien as "the first top-rank New York architects of their generation to design a public building in their home town." Praising the effort as a "modern building that embodies the strong continuities between modern architecture and the crafts tradition," he described it as "restrained but not impoverished. Like Shaker furniture, its forms are nearly abstract but invite a range of meanings."[111] The finished building did not disappoint, and its positive reception was heightened by the timing of its opening on December 11, 2001, exactly three months after the World Trade Center tragedy. Martin Filler, with characteristic exaggeration and combativeness, claimed

that the building was "not only New York's greatest museum since Frank Lloyd Wright's Guggenheim was completed in 1959, but nothing less than the city's best work of architecture since then, period. With its seductive faceted façade . . . and its soaring, light-struck interior spaces, which take your breath away, this instant landmark single-handedly breaks the city's long architectural drought. . . . It took courage for the museum to commission a bold work of contemporary architecture, rather than giving in to the more obvious temptation of displaying its holdings in a self-consciously quaint setting. But by doing it this way, the institution honors its works of art much more than some sham Shaker meeting house would have."[112]

In June 1981, with the construction of Cesar Pelli's apartment building and the expansion of the Museum of Modern Art well under way, Madison Equities announced plans for a fifty-eight-story tower across the street, just east of the CBS Building (Eero Saarinen & Associates, 1961–65), on a through-block site extending from Fifty-second to Fifty-third Street between Fifth and Sixth Avenues.[113] As designed by Raul de Armas of Skidmore, Owings & Merrill, the 650-foot-high, 300,000-square-foot building, to be known as 33 West Fifty-second Street, was to be a needle-thin shaft of rough and polished granite alternating with glass, employing a bundled tube

E. F. Hutton Building, east of Sixth Avenue, between West Fifty-second and West Fifty-third Streets. Kevin Roche John Dinkeloo and Associates, 1986. View to the southeast showing Museum Tower (Cesar Pelli & Associates, 1984) on far left and CBS Building (Eero Saarinen & Associates, 1965) on far right. KRJDA

E. F. Hutton Building, east of Sixth Avenue, between West Fifty-second and West Fifty-third Streets. Kevin Roche John Dinkeloo and Associates, 1986. Lobby. KRJDA

structural system similar to one the architect was using at 780 Third Avenue. Occupying 40 percent of a landscaped plaza surrounding it on all four sides, the sculpturally massed skyscraper, which was to replace a garage and the building housing the New York New York restaurant and discotheque, included twenty-four floors of offices topped by sixty-five apartments, many with projecting balconies.

Plans fell through when the CBS Corporation partnered with Gerald Hines Interests to take over the site and add additional properties along Fifty-third Street, including that of the American Craft Council's museum, America House, 40 West Fifty-third Street, located in a brownstone renovated in 1961 by David R. Campbell. After successful negotiations with the museum and the completed assemblage of a 46,000-square-foot site, in March 1984 the developers announced their intention to construct a thirty-story, 660,000-square-foot office tower with a new home for the American Craft Museum in a four-story wing on Fifty-third Street, matching in height its neighbor to the east, the Donnell Free Circulating Library and Reading Room (Edgar I. Williams in association with Aymar Embury II, 1955), 20 West Fifty-third Street.[114] Kevin Roche John Dinkeloo and Associates was picked to design the office component, but the American Craft Council, which retained control over its space, hired Fox & Fowle.

While the selection of Roche was hardly a surprise given his collaboration with Eero Saarinen on the CBS Building, the design that the Irish-born, Connecticut-based architect produced turned more than a few heads. Instead of the glassiness

of his One United Nations Plaza (1975) and his additions to the Metropolitan Museum of Art, Roche followed Saarinen's lead at CBS and produced a masonry-clad tower. While the design of CBS had been structurally determined, Roche's new building reflected a decidedly historicist approach.[115] The 421-foot-high, steel-framed tower (1986), named for its lead tenant, the brokerage house E. F. Hutton, was clad in pinkish granite, aluminum, and glass, and featured a sixty-eight-foot-high colonnade composed of granite-clad, six-sided, "Karnak-like columns," according to Ada Louse Huxtable, similar to those Roche had proposed for the Central Park Zoo.[116] Topped by a tiered, mansardlike crown, which the editors of the *AIA Guide* characterized as a "serrated Halloween crazy hat . . . breaching the skyline," the building was cut away on all four sides to create visual interest and twelve glassy corner offices per floor.[117] It was entered at the northwest and southwest corners of the base in order to be visible from Sixth Avenue across a forty-five-foot-wide, landscaped, open-air passageway that connected Fifty-second and Fifty-third Streets. The passage, which separated the new building from that of CBS, included benches, large trees in planters, and Jesús Bautista Moroles's *Lapstrake*, a twenty-two-foot-high Aztec-inspired sculpture composed of stacked slabs of polished granite alternating with rough-hewn circular granite blocks, altogether a fitting complement to Roche's work, especially the dramatic and ornate hypostyle-hall-like lobby principally populated by sixty-five-foot-high columns and decorated with reddish gold glass mosaic tiles.

Paul Goldberger was harsh in his assessment: "The building's overall shape is awkward and squat, and its relationship to CBS virtually irrelevant; it is hard, looking at these two buildings side by side, to sense any real communication of design ideas at all. And the skin of thin slabs of granite set in horizontal stripes at some points and in vertical stripes at others seems like the sort of showy gesture one expects to find in an overachieving suburban office building, not in a headquarters building by one of the nation's most gifted architects working for one of its most eminent real-estate developers."[118] Carter Wiseman, writing in *New York* magazine, was more sympathetic: It "picks up design motifs from both its sober neighbors [CBS Building and Pelli's MoMA tower]. . . . Roche chose to acknowledge the vertical thrust of CBS with powerful verticals of his own on the main facades, but cut into them at the corners with a strongly articulated floor treatment that nods to Pelli's horizontals. For the top, Roche chose a setback profile that terminates the tower with a minium of fuss. . . . Although the result is chunkier than it might have been, it succeeds in its neighborly intentions and still manages to create a presence on Sixth Avenue by extending its street-level portico slightly to the north and south of the CBS tower."[119]

Fox & Fowle's four-level, 18,000-square-foot American Craft Museum, 40 West Fifty-third Street, on the northeast end of the development site, was more understated and, consequently, better appreciated. Although the exterior closely adhered to the base of Roche's tower design, the museum managed, in the words of Bruce Fowle, to establish "a distinct identity and presence." Behind the glassy, seventy-two-foot-long facade, set twenty-two feet back from the street, the architects carved out a forty-foot-high atrium space dominated by a sensuous, parapeted curving staircase linking the exhibition areas. Visible from the street, the "atrium-stair," as Fowle called it, provided the only architectural drama in an otherwise intentionally neutral space of white walls, terra-cotta tiles, and pale maple floors.[120] Thomas Hine, covering the museum's October 1986 opening for the *Philadelphia Inquirer*, felt that Fox & Fowle had done their job: "The result is no tour de force, but neither does it look or feel like an afterthought. It is at the bottom of a massive tower, but it does feel like a place of its own."[121]

In 1997 Deutsche Bank, which had been leasing about half the tower's space since 1988, when E. F. Hutton was taken over by Shearson Lehman, bought a controlling interest in the property and radically reconfigured the lobby, drastically reducing its height in order to create additional office space. Carter Horsley, who had little good to say about the building's exterior, was outraged by the "dismasting [of] the awesome columns" and the destruction of the "most glamorous lobby in midtown . . . a splendiferous space that would make Croesus smile." Although Horsley was clearly overstating his case by comparing the lobby's disfigurement to the loss of Pennsylvania Station and the Singer Tower, the character of the space was inarguably compromised. The following year the lobby was remodeled again, but the "attempt to disguise [the] radical surgery" did little to assuage Horsley's anger: "A new ceiling was installed in the lowered lobby and it had a mosaic and sculptural treatment similar to the original, but the delicate proportions are now gargantuan and completely out of scale. What once was glorious is now merely curious, sadly."[122]

While most of the neighborhood's cultural action was on Fifty-third Street, two modestly sized midblock towers

on Fifty-second Street emerged as important exemplars of architectural taste. One, Philip Johnson's Wisconsin limestone–clad William S. Paley Building (1991), 23 West Fifty-second Street, housed the Museum of Television and Radio, an institution founded in 1976 as the Museum of Broadcasting by Paley, the founder of CBS Inc. and the man widely credited with having given shape to the radio and television industries. Paley established the museum as a "cultural and educational institution" that would "collect, preserve, and present the programs and historical materials of radio and television;" it was his effort to give credibility to forms of media that had hitherto been considered not only outside the traditional world of art, but low even on the entertainment totem pole.[123] Beyer Blinder Belle had designed the museum's original modest home, which opened on November 9, 1976, in 8,000 square feet on three floors of 1 East Fifty-third Street, northeast corner of Fifth Avenue, consisting principally of individual viewing and listening consoles, group viewing rooms, a library, a small theater, and offices.[124]

By the early 1980s, Paley was promoting the construction of a new facility, an entire building that could provide a spacious, permanent home to the rapidly growing museum. By 1986 he had received funding from the three major networks—CBS, ABC, and NBC—and had convinced the museum's board to approve the purchase of a nearby site at Fifty-second Street between Fifth and Sixth Avenues. The site, adjoining the home of the "21" Club, had been occupied by a five-story nineteenth-century townhouse at 23 West Fifty-second Street and a two-story commercial structure at number 25

American Craft Museum, 40 West Fifty-third Street, between Fifth and Sixth Avenues. Fox & Fowle, 1986. Goldberg. ESTO

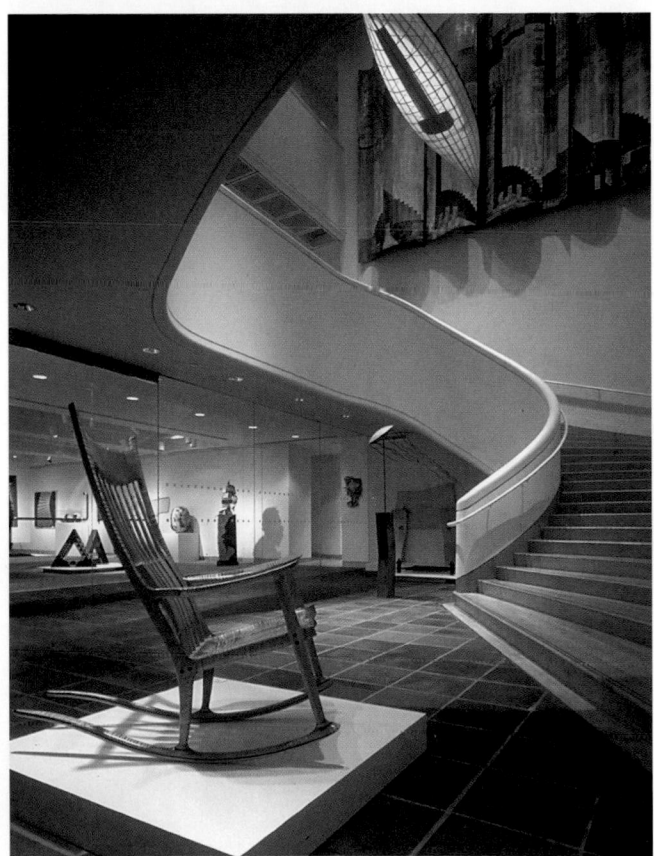

that together had served as the former speakeasy's wholesale liquor operation until the mid-1970s, at which point a string of owners successively envisioned for the site an expansion of "21" into a twenty-eight-story apartment building and a luxury hotel, the last devised by a partnership that went so far as to raze the two existing buildings in 1985 before abandoning the plan. The following year, Paley bought the property and donated it to the museum, announcing on December 2, 1986, that Philip Johnson, a longtime friend, working as design consultant to John Burgee Architects, would design the new home for the renamed Museum of Television and Radio.[125]

On July 7, 1988, after nearly two years of design, during which Paley reportedly found Johnson's highly ornamented proposals "too gimmicky, too frilly," a model was unveiled at the Plaza Hotel.[126] The architect's intention to "keep to the height and scale of the houses on the east" while identifying the building "as a public institute among its house-like neighbors" resulted in a six-story, street-wall-defining base beneath a ten-story, set-back tower.[127] Acknowledging that the final product was a significantly pared down version of earlier schemes, Johnson remarked somewhat disappointedly, "There used to be turrets and arches, [but] now it's extremely simple, it's just there."[128]

But the Paley Building, which was dedicated on September 12, 1991, was rather more than Johnson intimated it would be. Inspired by Bertram Grosvenor Goodhue's Nebraska State Capitol of 1920–32, it had "strong corners," to make it "stand

Museum of Television and Radio, 25 West Fifty-second Street, between Fifth and Sixth Avenues. Philip Johnson with John Burgee Architects, 1991. View to the north. McGrath. NMcG

out from the neighbors," and octagonal corner turrets.[129] The base, capped by a shallow pediment, was dominated by a three-story, stone-mullioned window. A recessed entrance was, in the words of the architect, "flanked by conically tapered columns supporting a baroque arch not unlike the [Hanover] bank designed by Cross and Cross on East 72nd Street," while the tower was "a functional necessity, not an architectural feature," an elongated, flat-roofed version of the base with fenestration on all four facades.[130] Inside, the museum occupied 55,000 square feet. The remaining 17,000 square feet on the top four floors was leased to nonaffiliated tenants. The museum's high-tech facilities, located on the first six floors and a basement level, included a 200-seat theater, a 90-seat theater, two 45-seat screening rooms, 95 television consoles, 25 radio consoles, and three exhibition galleries.

Paul Goldberger called the Paley Building a "sober and traditional" building, "a limestone-clad tower that aspires to dignity (and largely achieves it)." But he called the design "big and toylike" and was dissatisfied with its classical details; the arched entrance, he observed, "couldn't be more bland."[131] Johnson later responded, "Paul Goldberger criticized the . . . entrance as a throwaway. It was. It's a piece of the familiar form, and I see nothing wrong with that even now. . . . This site was no place to try modern post-deconstructivist shapes. . . . I was trying to be a good citizen, and I think we've succeeded."[132]

While Johnson played the "good citizen," Raimund Abraham clearly played the outlaw in designing his Austrian Cultural Forum, 11 East Fifty-second Street, perhaps the most self-consciously arty building realized in New York in a generation.[133] Replacing the French Renaissance–style, limestone-faced Harley T. Proctor townhouse (Trowbridge & Livingston, 1905), which the Austrian Cultural Forum had occupied since 1965 but long outgrown, the new building opened on May 16, 2002, almost ten years after Abraham's design was selected from among those of 226 other Austrian architects, including Coop Himmelblau and Wilhelm Holzbauer, very many of whom proposed glassy curtains that played against the zoning's diagonal sky-exposure plane. Though an Austrian, Abraham had lived for at least twenty years in New York, building little but enjoying an influential career teaching at Cooper Union.

Abraham's 33,000-square-foot, twenty-four-story, sloped, scaffoldlike tower, which rose 220 feet tall on a twenty-five-foot-wide, eighty-one-foot-deep lot, confronted the street with an assertive form second to none in the city—its implacable symmetry, relentless sloping glass wall, and zinc-clad projections rendering frivolous the seemingly arbitrary faceted planes of the LVMH Tower (see Fifty-seventh Street), the only other high-style sliver tower in the city with which it might be compared. Abraham exulted in the building's confrontational stance. As it was being designed, he joked with his assistants that it would be a cross "between *Blade Runner* and Easter Island sculptures."[134] At other times, he likened it to a guillotine. Behind the masklike facade, he squeezed art galleries, a theater, a library, and other public spaces into the lower six floors and basement level, a director's office with a large bay window into the seventh floor, and an apartment for the director in the sixteenth to nineteenth floors. Small offices on the top floors completed the arrangements. To keep the tiny floors as uncluttered as possible, scissor fire stairs crisscrossed the rear facade, recalling Brancusi's rising spirals.

A month before the building was to open in April 2002, Abraham, disturbed by the extreme conservative turn of the

LEFT Austrian Cultural Forum, 11 East Fifty-second Street, between Madison and Fifth Avenues. Raimund Abraham, 2002. View to the northwest. Moran. MM

RIGHT Austrian Cultural Forum, 11 East Fifty-second Street, between Madison and Fifth Avenues. Raimund Abraham, 2002. Section. RAA

Austrian government, became an American citizen, calling it "an act not against Austria, but for Austria."[135] When the Austrian Cultural Forum opened, it could not shake its image as a glassy guillotine, leading the *Chicago Tribune*'s critic, Blair Kamin, to quip that the design was "on the cutting edge." As Kamin put it, the "tower etches its own distinct mark on the sky, with a . . . facade that slopes and steps, creating the illusion that its sheets of glass are suspended in the air—and might, at any moment, come crashing down. Nothing could be more different from Manhattan's optimistic skyscrapers stretching upward to the heavens. . . . Once, man was the measure of all things. Now he's the target. Where has our gentle humanism gone?"[136] Even supporters like Herbert Muschamp seemed unable to ignore the building's threatening demeanor, which, he said, communicated "the idea that serious disturbances may lie beneath a

Austrian Cultural Forum, 11 East Fifty-second Street, between Madison and Fifth Avenues. Raimund Abraham, 2002. Reception area. Moran. MM

Austrian Cultural Forum, 11 East Fifty-second Street, between Madison and Fifth Avenues. Raimund Abraham, 2002. Director's office. Moran. MM

relatively smooth appearance. Call this a psycho-building; every skyline goes a little crazy sometimes." He claimed that he thought of the building as the "'wedge' because it invites New York to reacquaint itself with the distinction between people-pleasing fluff and the kind of architecture that gets inside your head."[137]

HERALD SQUARE

By the mid-1970s, the area that took its name from its principal open space had lost the stature it enjoyed early in the century as the city's premier shopping district. The department store triumvirate of Macy's (De Lemos & Cordes, 1901; expansion, Robert D. Kohn, 1924, 1928, 1931), Saks & Company (Buchman & Fox, 1902), and Gimbel's (D. H. Burnham & Company, 1910), located north to south along the west side of Broadway and Sixth Avenue between Thirty-fifth and Thirty-second Streets, formed the northern end of the great shoppers' paradise that stretched south along Sixth Avenue to Fourteenth Street, east to Broadway and south again to Wanamaker's at Astor Place. In the 1920s, the new luxury department stores that were being built along Fifth Avenue eclipsed Herald Square, reducing it, as Christopher Gray later put it, to a "middle-class shopping ghetto."[1] The decades following World War II found Herald Square in steep decline, with waning middle-class patronage leading to the 1966 replacement of Saks with an E. J. Korvette's discount store, the operators of which covered the elegant neoclassical limestone facade with a windowless skin of vertical marble strips

designed by Maurice B. Levien.[2] Though by 1979 Herald Square had acquired, according to Carter Horsley, a "rather drab and disheveled look," it remained the city's most heavily traversed intersection, where the junction of trains, subways, automobiles, and pedestrians made navigation difficult.[3]

Amid this odd combination of vitality and faded glory, the area's stronghold, Macy's, staged a comeback. In 1976, under the new leadership of Edward Finkelstein, the department store undertook an extensive campaign to regain its standing in the retail world, ridding the main floor of bargain bins, modernizing its many selling floors, and once again gearing its merchandise toward middle- and upper-income shoppers.[4] Renovations were made throughout the store, including a successful, stylish conversion of the basement level into "the Cellar," where housewares, food, and gifts were sold. The most dramatic improvement was made in 1983, when the Macy's visual merchandising staff under the leadership of Joe Cicio, vice president for store design, working with Norman Rosenfeld Architects, renovated the main selling floor of the original 1901 building along Sixth Avenue, which Robert D. Kohn had given a modern classical makeover during the store's late 1920s expansion. The ceiling and 105 marble-clad columns were restored, and new marble floors and glass and mahogany merchandise cases were added. Five three-tiered period-inspired chandeliers of etched frosted glass were hung above a wide central aisle, and the balconies that ran along the Thirty-fourth and Thirty-fifth Street sides of the main floor, long treated as incidental selling spaces, were reclaimed for use as smaller boutiques and shops. Paul Goldberger was taken by the work:"The newly redone main floor . . . suddenly ranks with the best retail spaces in New York. It is expansive and gracious, with precisely the right combination of elegance and bustle that should characterize a great New York selling floor."[5] The renewed main floor continued to please, leading Herbert Muschamp, in 1996, to call it "always glorious. Architecturally, it is a temple space, a hypostyle hall. . . .The main aisle is one of New York's great promenades."[6]

Across Thirty-fourth Street, an even greater effort was made to pull Herald Square out of its slump. In 1982, two years after particularly hard times forced the closure of the E. J. Korvette's chain, plans were announced by the New York Land Company, a real estate investment trust, to reinvent the former Saks & Company building as a vertical shopping mall; it was a concept explored previously in New York, but at a smaller scale, at the Citicorp Center's Market.[7] The new project, originally dubbed Herald Square—the Center of New York, but eventually known simply as the Herald Center, contained space for 140 stores in 260,000 square feet on nine floors and a basement level. Macy's and Gimbel's were to act, in effect, as the center's anchor stores, leaving more space in the mall for the kind of high-end boutiques that had for so long been absent from the district.

As designed by Peter Claman, of Schuman, Lichtenstein, Claman & Efron, working with Copeland, Novak and Israel, who were responsible for the interior layouts, the Saks/E. J. Korvette's building was shorn of its masonry and wrapped in a new skin of dark-blue reflective glass. Two arbitrarily conceived sets of decorative stripes rose up the north and east facades on either side of the angled corner entry before turning to run horizontally across the building. Shops were grouped around four double-height atria, at the center of which rose a bank of escalators. On the exterior of the Thirty-fourth Street corner, the city's first glass elevators delivered shoppers from one level to another. Each floor was decorated to resemble a New York neighborhood: the basement was given a Greenwich Village theme, the main floor Herald Square, the mezzanine was decorated to look like Wall Street, the third floor Madison Avenue, and so on. Daralice Boles was not impressed: "Focused inward

Herald Center, southwest corner of West Thirty-fourth Street and Sixth Avenue. Schuman, Lichtenstein, Claman & Efron, 1985. View to the southwest. Mauss. ESTO

on its escalator bank, the Center turns a blind eye to the street. Worse still, it dares to duplicate within what it ignores without."[8] When it opened on March 29, 1985, only forty tenants had signed on. Over the years, the project was plagued by poor business and bad press and remained troubled even after attempts to reinvent itself with moderately priced shops.

In June 1986, as Herald Center struggled, Batus, the parent company of Gimbel's, announced that it would close the chain's two Manhattan stores—the flagship at Herald Square and a branch at Eighty-sixth Street and Lexington Avenue. A consortium of Silverstein Properties, the Zeckendorf Company, and Melvin Simon Associates, an Indianapolis-based developer of suburban shopping malls, purchased the properties, converting the Herald Square building to a vertical mall not unlike Herald Center but with a few key differences: the new shopping complex would have an anchor tenant within, its stores would cater to middle-income shoppers, and it would have a more inviting street presence.[9]

RTKL Associates, a Baltimore architecture firm specializing in retail buildings, was hired to design the project, which would be called A&S Plaza after the Brooklyn-based department store Abraham & Straus signed on as the anchor tenant, occupying approximately 300,000 square feet in the western portion of eight of the mall's floors. Though a dignified cubic mass, the original Gimbel's building was in no way as elaborately fitted out inside as Macy's had been, so that the drastic renovations undertaken by the new developer did not sacrifice much that was missed. A core was carved out of the building to create a thirteen-story-high skylit atrium, around which nine shopping levels—two subterranean and seven above grade—were grouped. Above the retail levels, four stories comprising 330,000 square feet were reserved for showrooms and offices that would house facilities for the children's clothing industry, entered through a separate lobby at 100 West Thirty-third Street. With its soaring height, navigated by a

combination of escalators and four zooming glass elevators, the atrium was a dazzling space. But the garish decor consisting largely of mirrors, stainless steel, and glass added frenzied vulgarity to the already vertiginous atmosphere.

The glitz was not confined to the interior; seven floors of Burnham's quiet masonry facade facing Sixth Avenue were replaced with a glass curtain wall, although above the seventh floor and on the western portions of the street facades, the architects retained the original window openings, resulting in a confused composition that left just enough of the original to make one yearn for the old Gimbel's. The exterior was further muddled by a new, dark glass mansard roof set back atop the building. At street level, a metal marquee decorated with neon lights adorned the shopping center's main entrances at the corners of Thirty-second and Thirty-third Streets, adding, in the opinion of Clifford Pearson, "a flourish of theatricality to the once-somber exterior."[10] A stone cornice was added at the eighth floor where large letters once spelled out "Gimbel Brothers." A&S Plaza opened on November 9, 1989, to a lukewarm reception. In 1995, it was renamed Manhattan Mall after A&S, forced to abandon the location as the result of the merger of its parent corporation, Federated Department Stores, with R. H. Macy & Company, was replaced with a Stern's department store. Stern's, which experienced mediocre sales, closed in March 2001.[11]

Though the experiments in "vertical retailing" found little success in Herald Square, the 1990s saw a resurgence of street-level shopping in the area, primarily along Thirty-fourth Street. The many retailers that emerged were diverse, catering both to bargain hunters and style seekers, and the Herald Square intersection became a dividing line of sorts. To the west, large-scale discounters like Daffy's, a clothing store that opened in several floors of the Herald Center in 1994, and Kmart, which opened a 145,000-square-foot branch in One Penn Plaza, 250 West Thirty-fourth Street, between Seventh and Eighth Avenues, in 1996, profited from their proximity to Penn Station and Macy's.[12] To the east, trendy chain clothing stores flourished. By far the most invested retailer in the revitalized district was Gap Inc., which established major outposts of its three clothing brands all within a block of Herald Square: a Gap clothing store—the chain's largest—was opened in the base of the McAlpin Hotel (F. M. Andrews & Company, 1912); a two-story Banana Republic store opened at 17–19 West Thirty-fourth Street, between Fifth and Sixth Avenues; and, most significantly, an 80,000-square-foot through-block Old Navy store opened west of Herald Square at 150 West Thirty-fourth Street, between Broadway and Seventh Avenue, in 1999.[13] James McCullar & Associates' design of the four-story building, which replaced Gallery 34, a through-block shopping arcade built in 1919 as the Pennsylvania Arcade, took its cues from train shed architecture—a nod to its neighbor, Penn Station.[14] The two facades facing Thirty-third and Thirty-fourth Streets were each dominated by a large frosted-glass window and featured marquees that reminded shoppers of old-fashioned arrivals and departures boards.

Herald Square was, of course, not a square, but a triangle of open space bounded by Broadway, Sixth Avenue, Thirty-fourth and Thirty-fifth Streets; to its south lay another such triangle, Greeley Square, bounded by Broadway, Sixth Avenue, Thirty-second and Thirty-third Streets. Both derelict spaces were minimally renovated in 1992 as part of the municipal housecleaning that accompanied the Democratic

convention,[15] but in 1996 significant improvements were undertaken when the 34th Street Partnership, a Business Improvement District, replaced the Parks Department as the responsible party for the 9,830-square-foot Herald Square park and the 13,715-square-foot Greeley Square park. The BID then retained Vollmer Associates to transform them with decorative paving, new trees and plantings, movable tables and wooden chairs, concession stands, and perhaps most notably, a welcome rarity in New York—two public pay restrooms that opened in 2001.[16]

SIXTH AVENUE

The surge of office building construction along Sixth Avenue above Fortieth Street during the late 1950s and 1960s left few blockfront sites available for development when the building boom of the 1980s hit and the Special Midtown Zoning District pushed office development westward.[1] However, four new office buildings were realized—two on blockfront parcels and two in the midblock near the avenue—in the three-block stretch between Forty-fourth and Forty-seventh Streets, beginning with Emery Roth & Sons' 1155 Sixth Avenue (1984), a 694,000-square-foot, forty-one-story tower, one of the first to be completed after the passage of the 1982 Special Midtown Zoning.[2] The tower was built by the Durst Organization, whose patriarch, Seymour Durst, having predicted the shift in development from the east side to the west, had for years been piecing together large parcels of land in the area, so that during the 1970s the real estate family owned ten acres of land between Forty-second and Forty-seventh Streets, Broadway and Sixth Avenue.[3] The brooding, polished black granite–clad 1155 Sixth Avenue occupied the entire blockfront between Forty-fourth and Forty-fifth Streets,

Old Navy, 150 West Thirty-fourth Street, between Broadway and Seventh Avenue. James McCullar & Associates, 1999. View to the south. Zimmerman. WZ

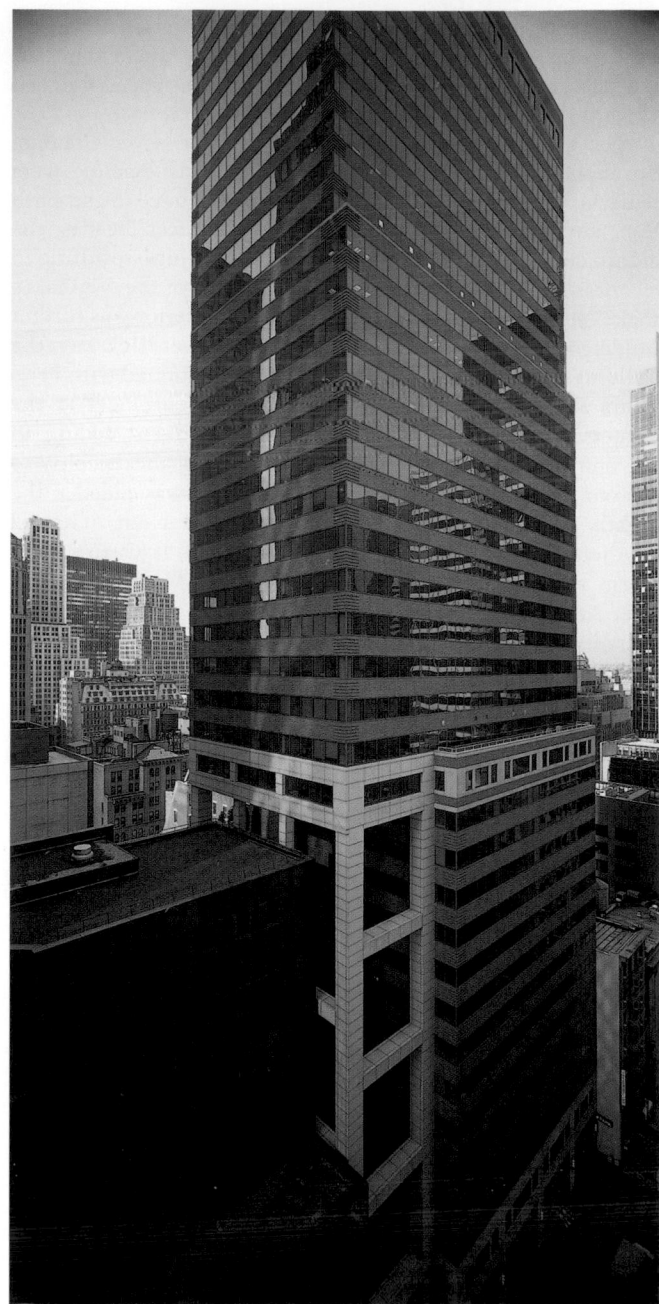

1155 Sixth Avenue, between West Forty-fourth and West Forty-fifth Streets. Emery Roth & Sons, 1984. View to the northwest showing Tower 45 (Swanke Hayden Connell, 1989) on the left and Americas Tower (Swanke Hayden Connell, 1994) on the right. Miller. SMM

Tower 45, 120 West Forty-fifth Street, between Sixth Avenue and Broadway. Swanke Hayden Connell, 1989. View to the southwest showing 1155 Sixth Avenue (Emery Roth & Sons, 1984) on the lower left. Mauss. ESTO

built as-of-right with a chamfer-cornered tower rising from an offset base with a "bustle" adjoining the tower to the west, making its sheer facade and 4,000-square-foot entrance plaza, as Alan S. Oser explained, "the quintessential building fashioned by the 1961 zoning law" that encouraged such towers to rise from generously scaled public plazas.[4] Paul Goldberger, appalled by the "crushing dullness of the black facade," opined that it "makes one yearn for the comparatively brighter sterility of the Avenue of the Americas a few blocks northward—could it be that we have reached a time when the Exxon and McGraw-Hill buildings would seem, by comparison, appealing?"[5]

Abutting 1155 Sixth Avenue on the west was Tower 45 (1989), 120 West Forty-fifth Street, a forty-story office building developed by Feldman Equities and designed by Swanke Hayden Connell; the architects took advantage of the 135,000 square feet of air rights from the neighboring Belasco (originally Stuyvesant) Theater (George Keister, 1907), giving the building an additional twelve stories.[6] Though described as a "typical 1980's box" by the New York Times's Mark McCain, the rectilinear building, which rose from a limestone-clad base as a series of alternating horizontal bands of gray glass windows and red brick with striated corners evoking quoins, did have one unusual feature: a fifteen-story-high, thirty-five-

Americas Tower, 1177 Sixth Avenue, between West Forty-fifth and West Forty-sixth Streets. Swanke Hayden Connell, 1994. View to the northwest. Gordon. SHCA

United States Trust Company Headquarters, 114 West Forty-seventh Street, between Sixth and Seventh Avenues. Fox & Fowle, 1990. View to the southwest. Gordon. FXF

foot-wide coffer-ceilinged covered open-air plaza realized as part of a deal between Feldman Equities and the Durst Organization so that offices on the lower floors of Durst's neighboring 1155 Sixth Avenue would not have blocked windows.[7] The plaza was framed by eight massive cable-braced aluminum-sheathed steel columns supporting twenty-five floors of the office building above.

Across the street to the north, Swanke Hayden Connell's 1177 Sixth Avenue, known as the Americas Tower, filled the west blockfront between Forty-fifth and Forty-sixth Streets with a forty-eight-story office building whose considerable bulk could be attributed to the transfer of 204,000 square

feet of air rights from the neighboring High School of the Performing Arts (C. B. J. Snyder, 1893), 120 West Forty-sixth Street, a vacant Romanesque Revival landmark that had been gutted by fire in 1988.[8] As part of the air-rights deal, the developers paid for the restoration of its facade and for architectural plans for its renovation as a new arts high school (Jack L. Gordon Architects, 1992).[9] Insufficient funds halted construction of Americas Tower in December 1989, when it was nearly 75 percent completed. The building sat unfinished for over a year, during which time David Dunlap called it "a three dimensional symbol of the end of the 1980's building boom."[10] When completed in 1994, the 900,000-

1301 Sixth Avenue, between West Fifty-second and West Fifty-third Streets. Renovation by Skidmore, Owings & Merrill, 1990. View to the northwest showing *Looking Toward the Avenue* (1990) by Jim Dine. Hoyt. ESTO

square-foot rose colored granite and gray glass building, with a crown of polished granite and a stainless-steel spire, seemed a less glassy version of the architects' 1990 recladding of 320 Park Avenue (see Resurfacing Modernism, Introduction). According to John Peter Barie, of Swanke Hayden Connell, the design signaled a "dramatic departure from neighboring international-style buildings" and gave a nod to the neighboring high school in the scale of its windows and the continuation of the school's cornice lines.[11] Continuous granite piers, pronounced vertical mullions, and setbacks also related Americas Tower loosely to the nearby buildings of Rockefeller Center. The lobby, finished with a rare, exquisite Brazilian granite, was entered beneath an east-facing colonnade with a central five-story-high opening flanked by lower one- and three-story sections.

Fox & Fowle's United States Trust Company Headquarters (1990), 114 West Forty-seventh Street, just west of Sixth Avenue, a twenty-four-story tower for the banking firm long located in the Atlantic Building (Clinton & Russell, 1901), 45 Wall Street, was a complexly massed through-block structure developed by the Durst Organization on the 22,000-square-foot parcel that had been home to the Luxor Baths.[12] Though Robert Fox stated, "We've always felt that this building would be an extension of Rockefeller Center," its massing, materials, and midblock location effectively disconnected it from the center's architectural character.[13] The building's form was principally defined by a pair of octagonal towers—each capped by a zinc-clad octagonal stepped pyramid—that emerged out of boxy setbacks above a gray granite–clad base. Two shades of iron-spot brick were used inventively, both in pattern and relief, to give the office building an uncommon, and welcome, tactility.

New construction along Sixth Avenue was accompanied by the renovation of a number of existing buildings, several fairly young, built in the 1960s, but in need of updating. In 1981 Kohn Pedersen Fox Associates drastically renovated the so-called Bryant Park Building (Maynicke & Franke, 1907; addition, York & Sawyer with Joseph Kleinberger, 1926), 1100 Sixth Avenue, northeast corner of Forty-second Street, as a

new home for the cable television network Home Box Office, recladding the fifteen-story masonry structure with a gridded green glass curtain wall and a one-story granite base.[14] The original core was moved to the center of the plan, unneeded air shafts were filled in, and the main entrance was relocated from Forty-second Street to Sixth Avenue. Kohn Pedersen Fox Conway Associates, KPF's interior design subsidiary, fitted out HBO's offices with a Postmodern palette of pastel hues and bold geometric forms. The editors of the 1988 edition of the *AIA Guide* were taken by the "scintillating mirrored curtain wall sitting atop a thermal granite base . . . [that] tames the excesses of 42nd Street's other tawdry retail shops into a coherent whole."[15] But in the 2000 edition, the word *scintillating* was replaced by *tedious*.[16]

In 1985 Emery Roth & Sons reclad its 1963 mini-masterpiece, the Phoenix Building, 1180 Sixth Avenue, northeast corner of Forty-sixth Street, which the editors of the 1967 *AIA Guide* had praised as "perhaps the finest handling of an office tower within the maximum envelope of the [1916] Zoning Law . . . [with] syncopated setbacks . . . , carefully studied detailing of the strip windows and tiers of continuous brick spandrels."[17] In 1983 a pair of British companies bought the building and asked the Roth firm to raise the lobby from a single- to a double-height space and replace the building's aluminum and banded glazed brick exterior with a combination of horizontal bands of stainless steel and vertical anodized aluminum finlike mullions.

Just north of Rockefeller Center, 1301 Sixth Avenue (Shreve, Lamb & Harmon, 1963), west blockfront between Fifty-second and Fifty-third Streets, known as the J. C. Penney Building for the company that was headquartered there until its departure left the building entirely vacant in 1988, was renovated in 1990 by a Skidmore, Owings & Merrill team led by David Childs and Raul de Armas, who gave the forty-six-story tower a new look by recoating its blue porcelain spandrels in two shades of silvery gray and repainting the mullions with a

1290 Sixth Avenue, between West Fifty-first and West Fifty-second Streets. Lobby renovation by David Kenneth Specter Associates, 1997. View to the southeast showing *America Today* (1930–31) by Thomas Hart Benton. McGrath. NMcG

1970s-era blue automobile paint favored by the new lead tenant, Credit Lyonnais, for whom the building was renamed.[18] SOM also redesigned the building's public spaces, redirected the building's entrance from the street sides toward Sixth Avenue, and most notably, filled in the original plaza, sunk twenty-one steps below the sidewalk, to create a street-level plaza punctuated by three bronze sculptures that the artist Jim Dine modeled after the Venus de Milo. The colossal statues, collectively named *Looking Toward the Avenue*, installed in late 1990, stood fourteen, eighteen, and twenty-three feet tall. They were an unqualified success for Diana Ketchum, who, writing in *Metropolis*, felt that their figurative nature challenged "the assumption that public sculpture should take its cues from its architectural setting. In this forest of glass-and-steel office buildings, what individual I beam, even twisted into sculpture, could compete with the allure of Venus?"[19]

In 1997 the Equitable Life Assurance Company relocated its offices from Edward Larrabee Barnes's Equitable Center (1986), 787 Seventh Avenue, to 1290 Sixth Avenue (Emery Roth & Sons, 1961), where the Switzer Group fitted out twelve floors for the company and David Kenneth Specter Associates redesigned the lobby to showcase Thomas Hart Benton's ten-piece mural, *America Today*, which Equitable brought with it from its former home.[20] Specter's design called for a warm-toned illuminated white, blue, and gold glass ceiling that both complemented the Benton masterpiece and gave the lobby a decidedly contemporary look, which was carried outside to a pair of metallic canopies flanking the glassy entrance to the building, renamed the AXA Financial Center for the French insurance giant that acquired Equitable.

In 2000 another of Sixth Avenue's Modernist lobbies was made over when the International Center of Photography (ICP), a private group founded in 1974 by Cornell Capa to preserve photographic works, prepare exhibitions, and provide educational programs, completed the renovation of its existing facilities at 1133 Sixth Avenue (Emery Roth & Sons, 1969), northwest corner of Forty-third Street.[21] The center had, since 1989, occupied 16,000 square feet of ground-floor and below-grade space in the building, using it as a midtown satellite to its main quarters, located in the former Willard Straight house (Delano & Aldrich, 1914), 1130 Fifth Avenue, northeast corner of Ninety-fourth Street.[22] By 1999 the ICP had outgrown the Georgian mansion, which it sold before setting out on a dual initiative to renovate and expand its midtown facilities and build a new, separate home for its school.

Gwathmey Siegel & Associates was put in charge of renovating the midtown branch, which gained 14,500 square feet by relocating office and storage spaces to the contiguous twelfth and fourteenth floors of 1133 Sixth Avenue, made available by the Durst Organization at a highly discounted rent. The Gwathmey firm relocated the gallery's entrance from a midblock side-street plaza to the avenue and inserted a museum store and coatroom flanking a terrazzo-floored lobby that led to a street-level gallery, with blond maple floors, illuminated in part by a large, translucent south-facing window. Adjacent to the window, an amoeba-shaped recessed lighting cove in the ceiling seemingly hovered, cloudlike, above a stairwell leading to a lower-level café and a series of meandering episodic gallery spaces shaped alternately by walls suspended from the ceiling and partitions. James Gardner, writing in the *New York Observer*, described the "Gwathmian"

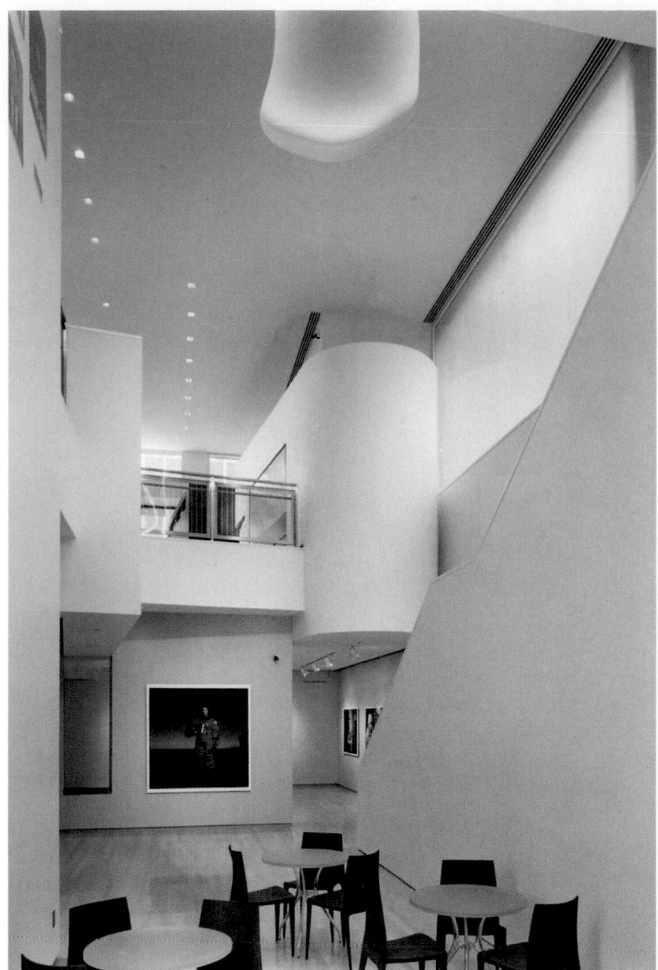

International Center of Photography, 1133 Sixth Avenue, between West Forty-third and West Forty-fourth Streets. Gwathmey Siegel & Associates, 2000. Warchol. GSAA

spaces as being like an "ethereous gas" flowing "into and around one another in a seamless legato," though, he also noted, "there is something flaccid in the relentless movement at I.C.P., something unresolved and almost irresolute that makes one wish at times for a more emphatically defined vertebral column along a central axis."[23]

In February 2001, construction began on the ICP's new school, built beneath Grace Plaza, southeast corner of Sixth Avenue and Forty-third Street, an 18,873-square-foot wasteland constituting the unceremonious rear entrance of the Grace Building (Skidmore, Owings & Merrill, 1974).[24] Separated from Bryant Park and deprived of direct sunlight as well as benches or landscaping, the north-facing plaza was, through the 1970s and 1980s, used primarily by drug peddlers and their clientele, leading one Grace Building tenant to dub it "dis-Grace Plaza."[25] Cordoned off by a spiked iron fence temporarily in August 1981 (reportedly to shield it from the hazards of a nearby construction site, but in actuality to be a deterrent against vice), the plaza was the subject of a 1983 unrealized reinvention by Roger Ferri that called for a three-story market building infused with natural imagery such as stemlike columns rising to flower petal capitals supporting a complex skylight roof. The following year a scaled-down set of improvements was

Proposed market building, Grace Plaza, southeast corner of West Forty-third Street and Sixth Avenue. Roger Ferri, 1983. Column studies. CU

Proposed market building, Grace Plaza, southeast corner of West Forty-third Street and Sixth Avenue. Roger Ferri, 1983. Site axonometric. CU

Proposed market building, Grace Plaza, southeast corner of West Forty-third Street and Sixth Avenue. Roger Ferri, 1983. Rendering. CU

School of the International Center of Photography, 1114 Sixth Avenue, southeast corner of West Forty-third Street. Gensler, 2001. View to the southeast showing 1100 Sixth Avenue (Kohn Pedersen Fox, 1991) in background right and Grace Building (Skidmore, Owings & Merrill, 1974) in background center. Warchol. PW

suggested by the plaza's owners that would have activated the space with cafés, a book stall, flower stand, fountain, and sculptures, but the plan did not move forward and Grace Plaza remained one of midtown's most uncongenial locations, despite the revitalization of Times Square and Bryant Park.[26] The ICP retained Gensler, led by vice president Madeline Burke-Vigeland, to transform 27,000 subterranean square feet formerly used as the library of the City University of New York's Graduate Center into darkrooms, digital labs, a 1,350-square-foot library, photographic studios, a lounge, administrative offices, and classrooms. The only publicly visible portion of the school was a succinct one-story glass-and-steel entrance pavilion near the plaza's northwest corner, a much-needed, well-scaled amenity appropriately embellished by seasonal plantings and furniture.

6½ AVENUE

In May 1982, the Special Midtown Zoning District was enacted with the principal intention of shifting new construction from the overcongested East Side to the underdeveloped West Side. Before 1982, zoning had protected the low scale of west midtown's side streets, permitting the retention of many rowhouses and townhouses, with lower floors devoted to retail, especially restaurants, and, to a surprising extent, residential occupancy above. In addition to the rowhouses, midtown's midblocks were also home to small apartment houses and residential hotels, mostly built in the 1910s and 1920s. In its zeal to encourage development on the West Side, the City Planning Commission promulgated new zoning rules that encouraged an even higher level of density than that prevailing on the East Side, allowing a FAR of 15, as opposed to 12 for east midtown's midblocks. In so doing, the commission virtually guaranteed that west midtown's long blocks would be stripped of their vitality and redeveloped as canyonlike corridors.

To compensate for the environmental bleakness the planners surely knew would be the consequence of their development largesse, they endeavored to mitigate the extreme length of the east–west blocks by advocating public north–south pedestrian passageways for the new midblock developments. As a result, between 1986 and 1990, on the blocks between Fifty-first and Fifty-seventh Streets, Sixth and Seventh Avenues, eight supersized buildings were realized, each including through-block covered pedestrian passages resulting in a six-block-long north–south midblock corridor—the longest of any such series in the city.[1] The desire for midblock streets was hardly a new one; in 1831, when Samuel B. Ruggles laid out Gramercy Park, he created a new north–south street between Third and Fourth Avenues, known as Irving Place between Fourteenth Street and the southern boundary of Gramercy Park at Twentieth Street, and continuing as Lexington Avenue north of the park.[2] Jane Jacobs, in her book *The Death and Life of Great American Cities*, devoted a chapter to the "need for small blocks," attributing the greater real estate value of the East Side to its shorter blocks. Indeed, Jacobs concluded that the success of Rockefeller Center was due in large measure to its three-block-long north–south "extra" street, Rockefeller Plaza.[3] A series of midblock passages was incorporated in Rockefeller Center's expansion on the west side of Sixth Avenue in the late 1960s and early 1970s.[4] These promenades west of the so-called XYZ buildings between Forty-seventh and Fiftieth Streets, Sixth and Seventh Avenues, though a welcome amenity, were pale reflections of the Urban Design Group's original proposal for a midblock pedestrian promenade that would have provided access to the below-ground subway concourse. Most important, the XYZ passageways were not aligned one with the other.

The problems posed by the new six-block-long development area north of Fifty-first Street were significant. Although the pedestrian arcades from Fifty-first to Fifty-fourth Street could be aligned, allowing one, in a sense, to "see through" three city blocks, north of that point existing property conditions forced a staggered alignment that blocked the continuity. In addition, though four of the passages were open to the air, as were those behind the XYZ buildings, an equal number were enclosed behind doors, isolated from the public and easily mistaken for building lobbies. Although required by the new zoning, the passages were realized with hostility and

indifference by developers, who stalled for absurdly long periods after the completion of the income-generating new buildings to which they were attached. Such lengthy delays further compromised the goal of creating a public amenity.

The most elaborate of the new midblock passages, constituting the southern anchor of the group, was realized as part of the first important office building to take advantage of the new zoning and "go west": Edward Larrabee Barnes's fifty-four-story, 750-foot-high, 1,740,000-square-foot Equitable Center (1986), 787 Seventh Avenue, between Fifty-first and Fifty-second Streets, which revealed the hitherto minimalist architect struggling with his client's taste for classically recollective form.[5] The Equitable had a long and largely commendable history of architectural patronage in New York, beginning with the construction in 1867–70 of its first headquarters building at 120 Broadway, designed by Arthur Gilman and Edward H. Kendall.[6] In 1875–76 Kendall and Theodore Weston expanded the building and in 1886–89 George B. Post, who had assisted on the original, expanded the structure yet again.[7] Between 1912 and 1915 the old buildings were demolished and a new headquarters was built on the same site.[8] Known as 120 Broadway (Graham, Anderson, Probst & White), the forty-story clifflike building was so bulky that it was the catalyst for the city's landmark zoning

Map showing midblock passageways from West Fifty-first to West Fifty-seventh Street, Sixth to Seventh Avenue. Richards. RAMSA

ABOVE Proposed Equitable Center, 787 Seventh Avenue, between West Fifty-first and West Fifty-second Streets. Edward Larrabee Barnes Associates, 1981. Model, view to the northeast. FLL

BELOW Equitable executive offices, 787 Seventh Avenue, between West Fifty-first and West Fifty-second Streets. Kohn Pedersen Fox Conway, 1986. Boardroom. Warchol. PW

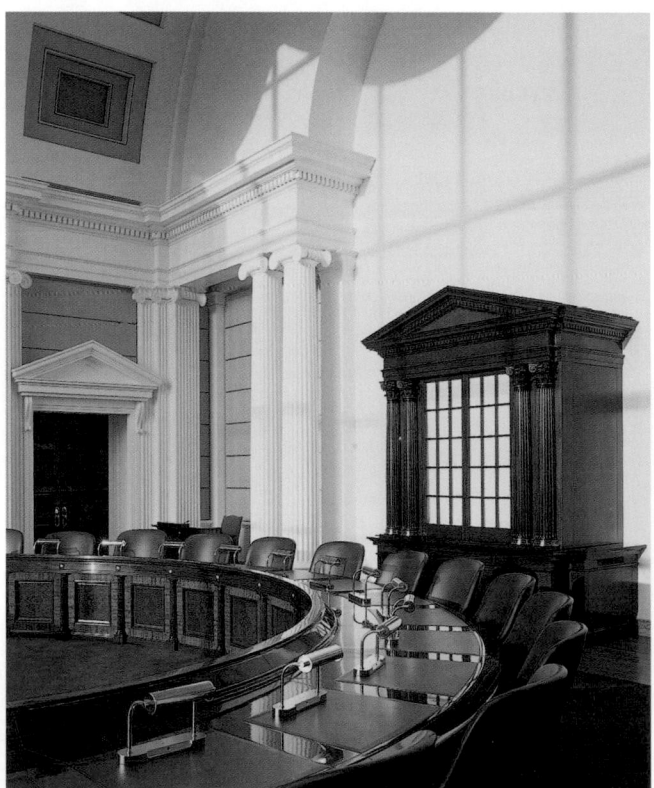

resolution of 1916. The Equitable moved to midtown in 1924 with a new building designed by Starrett & Van Vleck at 393 Seventh Avenue, between Thirty-first and Thirty-second Streets, and in 1959–61 the company built a forty-two-story headquarters (Skidmore, Owings & Merrill) at 1285 Sixth Avenue, between Fifty-first and Fifty-second Streets.[9]

The Equitable Center, replacing the dreary Abbey Victoria Hotel, built as the Hotel Victoria (Schwartz & Gross, 1928), was directly west of the Equitable's current Sixth Avenue headquarters, which occupied the east half of the block.[10] Technically it was not a midblock building but one with a prominent avenue frontage. But given its connection to the previous Equitable Building to the east, it had a major impact on the midblock, which was to be substantially ameliorated by the creation of a north–south skylit open-air pedestrian passageway. The simple, if not plain, facade of the colossal building consisted of alternating bands of buff limestone and glass, trimmed in polished red granite. The tower sat atop a five-story base containing offices, 26,000 square feet of street-level retail space, and a grandly proportioned atrium lobby onto which two corporate-sponsored art galleries opened. Set back ten feet from the building line on three sides, the symmetrically massed tower stepped back three times along the north–south to conclude in a penthouse that incorporated, as part of an executive commons, two soaring vaulted rooms lit by forty-two-foot-diameter windows on the east and west facades which in their exterior expression suggested

FACING PAGE Equitable Center, 787 Seventh Avenue, between West Fifty-first and West Fifty-second Streets. Edward Larrabee Barnes Associates, 1986. View to the northeast. AXA

BELOW Equitable executive offices, 787 Seventh Avenue, between West Fifty-first and West Fifty-second Streets. Kohn Pedersen Fox Conway, 1986. Dining room. Warchol. PW

Equitable Center, 787 Seventh
Avenue, between West Fifty-first
and West Fifty-second Streets.
Edward Larrabee Barnes
Associates, 1986. View of lobby
showing *Mural with Blue Brushstroke*
by Roy Lichtenstein and *Lobby
Furnishment* by Scott Burton.
McGrath. NMcG

Serliana or so-called Palladian windows. An early scheme, which Barnes clearly preferred, choosing to illustrate it in his monograph where he banished the project to the addendum, had bolder setbacks on the east but sheer sides north and south as well as a deeply recessed entrance facing Seventh Avenue. An intermediate plan called for deep, scale-giving porches at the setbacks and a keyhole-motif entrance, the latter replaced in the final version by a seventy-two-foot-high arched portal.

When the new Equitable Building opened, Paul Goldberger greeted it as "among the most curious buildings in New York . . . at once adventurous and timid . . . modern and 'postmodern,' . . . grandiose and restrained. As a work of architecture, it represents 54 stories of ambivalence." Despite its fine materials and extravagantly scaled interior spaces and public art, for Goldberger it was "one of the duller buildings to come along in many a year," adding "almost no grace to the skyline." Goldberger assigned the blame for the building's failure to a conflict between the client, who wanted something "fairly traditional . . . a building that would be considerably grander in scope than its previous headquarters," and the architect, whose "best skyscrapers have all been buildings of metal, towers that celebrate sleekness, not ones that evoke the solidity and grandeur of classical architecture."[11]

Suzanne Stephens also put the responsibility for Barnes's artistic misstep on his inherently Modernist preferences,

describing the architect as one "more adept at chipping, chamfering and chiseling buildings with rotated geometries."[12] Roger Kimball, writing in the *New Criterion*, was also disappointed in the building, in which "Mr. Barnes seems to have abandoned any attempt at a cogent architectural design," concocting, instead, "to produce one of the most pretentious and ungainly new buildings in New York," characterized by "stodgy and enervated" proportioning and a "large, clunky base [that] waddles out toward Seventh Avenue, while the tower rises in weary shrugs to its cookie-cutter top." Kimball also found fault with the Equitable's offices and meeting and dining facilities, designed by Kohn Pedersen Fox Conway, whose "postmodernist interiors . . . have all the schmaltzy, theatrical feel of opulent stage sets." But the Equitable's executive suite was convincingly, if improbably, classical, with finely and elaborately detailed woodwork, a gracious interconnecting stair, and a nobly scaled boardroom that Kimball dismissed as "a study in bureaucratic bombast."[13]

While the architecture of the Equitable Building disappointed many critics, the extensive art program undertaken by the company was more successful.[14] The eighty-foot cube of the main lobby was presided over by Roy Lichtenstein's joyous sixty-eight-by-thirty-two-foot *Mural with Blue Brushstroke*.[15] The room also incorporated Scott Burton's *Lobby Furnishment*, a forty-foot semicircular green marble bench and "water table." The sculptor also designed black granite seating for the broad sidewalk along Fifty-third Street. Burton's cerebral and rather austere work proved remarkably popular with the public, perhaps because, as he put it, "I don't feel the need to establish it as art, as much as I feel the need to establish it as furniture."[16] The passage connecting the lobby with the office elevators was made home to Thomas Hart Benton's *America Today* murals, painted in 1930–31 for the New School for Social Research.[17]

The partially skylit forty-five-foot-wide, ninety-one-foot-high midblock galleria-like passageway proved to be a surprising enhancement to the public realm, considerably enlivened by Sol LeWitt's superscaled drawings lining the side walls and, at either end, Barry Flanagan's large bronze sculptures, *Young Elephant* and *Hare on a Bell*. Suzanne Stephens, who seemed to prefer a museum-like approach, called this public space "the only really disastrous meeting of art and architecture in the building. The Sol LeWitt drawings are too close in size and pattern to the flat, contrasting bands of Barnes's granite and limestone cladding; in the context, they tend to disappear. And here the bronze masses of the Flanagan sculptures look small, dark and lumpish against a background of similarly toned materials and high, shadowy spaces."[18] Off the passageway was Skidmore, Owings & Merrill's Palio (see Interiors), an upscale restaurant whose dining room was on the building's second floor but whose ground-floor bar featured Sandro Chia's lushly colored mural depicting the eponymous horse race that has for centuries taken place in Siena, an artwork that remained in the space even after the restaurant closed in January 2002. The work of many other artists was acquired for the company's own offices, and the Whitney Museum of American Art was retained to operate as a branch museum the two 3,000-square-foot galleries that opened off the lobby.

Though the art went a long way toward brightening up the building's public areas, many regarded it as an afterthought, although it was said that the idea for the art program itself was an early selling point of Barnes's proposal. Roger Kimball was dismissive about a program he felt was less about art than about

Equitable Center, 787 Seventh Avenue, between West Fifty-first and West Fifty-second Streets. Edward Larrabee Barnes Associates, 1986. View showing *America Today* (1930–31) by Thomas Hart Benton. McGrath. NMcG

money: "Art at the Equitable is at bottom a kind of decoration, a fringe benefit, an 'extra' fitted to the structure in the hope of commanding higher prices."[19] The recession of the early 1990s led to the closing of the building's Whitney branch in 1992, but the Equitable continued to operate the gallery spaces on its own as a kind of *kunsthalle* hosting traveling exhibitions. In 1997, after eleven years in its Seventh Avenue headquarters, Equitable moved yet again, this time to 1290 Sixth Avenue, taking its Thomas Hart Benton murals, which were reinstalled in the Sixth Avenue building's newly renovated lobby (see Sixth Avenue).

Across Fifty-second Street, the relentless, scaleless character of Rafael Viñoly & Associates' forty-eight-story, 287,000-square-foot Manhattan (1986), 135 West Fifty-second Street, and the saga of its long-blockaded midblock passageway, raised serious concerns about the City Planning Commission's west midtown strategy.[20] One of the more troubled projects of the 1980s, the Manhattan was designed as an abstract, geometric facade of glass and precast concrete applied to a subtly shaped and profiled stepped-back tower. A sculptural prowlike crown of concrete aspired to make itself noticed among the city's distinctive pinnacles. With a heavy-handed base of precast concrete from which sprung the deliriously gridded reflective glass skin meant to complement the Sheraton Center (originally Americana Hotel, Morris Lapidus, Kornblath, Harle & Liebman, 1962) next door, Viñoly's design eluded easy categorization. Clutching at straws, the editors of the *AIA Guide* saw it as a "handsome cubistic, neo-1930s" design "in the popular PoMo" vocabulary with a profile "both subtle and elegant."[21] But marketplace perception was less positive. The Argentinian developer Jacobo Finkielstain had hoped to fill the building's 172 apartments, located on forty-one residential floors above seven commercial floors comprising 46,000 square feet, with "sometime New Yorkers," primarily out-of-town businesspeople and corporations.[22] But despite the city's booming economy, one year after completion the Manhattan was still unoccupied. Additionally, the through-block passage remained unfinished and closed to the public even as construction wrapped up on the rest of the building. One consultant called the Manhattan "totally the wrong product in the wrong place. It should have been an office building . . . The placement of the units made no sense at all. Huge studios were on the high floors with prices nobody would pay and two-bedrooms were on lower floors looking into walls."[23] By April 1987, the Manhattan's financial backers were fighting Finkielstain for ownership, and the developer was facing his own downfall as he began serving a seven-year prison sentence for bank fraud. In 1990 Euro-American Lodging purchased the building and reopened it in 1992 as Flatotel, a 460-room hotel.

The through-block pedestrian passage was finally finished in 1992 but didn't prove to be the amenity many had hoped for. It seemed bleak, despite a canted glass ceiling. It lacked the required amount of seating and was often closed off behind steel gates. In 1997 the *New York Times* published a quasi-exposé concerning the lack of access to the arcade and showing that, when open, it was filled with cars belonging to the

Through-block passageway, Equitable Center, 787 Seventh Avenue, between West Fifty-first and West Fifty-second Streets. Edward Larrabee Barnes Associates, 1986. View showing murals by Sol LeWitt on wall and *Hare on a Bell* by Barry Flanagan in foreground. RAMSA

Manhattan, 135 West Fifty-second Street, between Sixth and Seventh Avenues. Rafael Viñoly & Associates, 1986. View to the north. Hoyt. ESTO

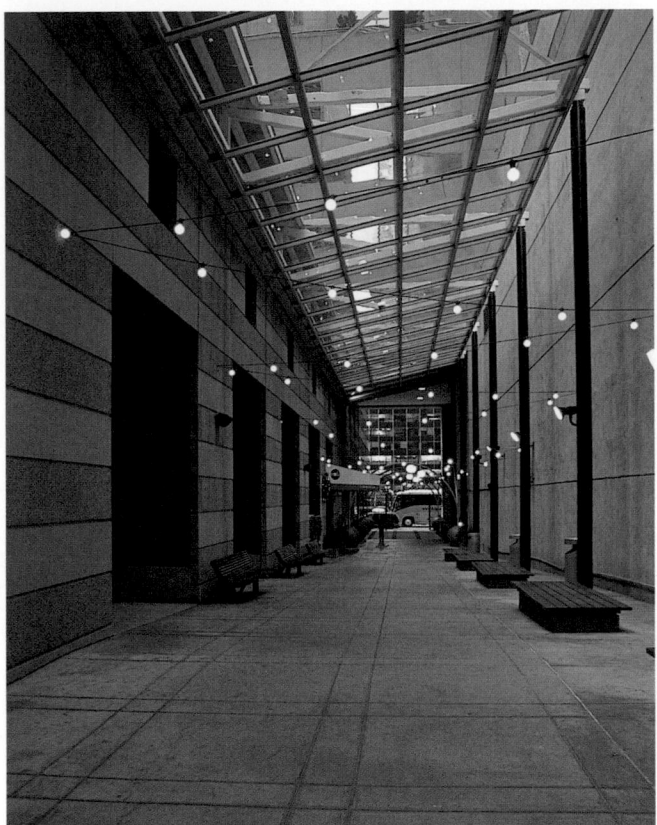

Through-block passageway, Manhattan, 135 West Fifty-second Street, between Sixth and Seventh Avenues. Rafael Viñoly & Associates, 1986. RAMSA

hotel's owners. Though the cars were subsequently removed, access to the two-story, thirty-three-foot-wide passage continued to be unpredictable, even after 2002, when Flatotel undertook an extensive renovation by Glen Coben, of Glen & Company, who placed within it one of two entrances to Moda, an eighty-seat restaurant separated from the hotel lobby by a wood and glass partition.

A far more successful pedestrian arcade, representing the third link in the consecutive row of midblock passages, was provided by Kohn Pedersen Fox in its 1325 Sixth Avenue (1987–90), between Fifty-third and Fifty-fourth Streets.[24] The site, beginning in the 1960s, had been earmarked for an expansion of the neighboring New York Hilton Hotel (William B. Tabler, 1963), 1335 Sixth Avenue. In July 1979, the City Planning Commission awarded a permit for the construction of an 834-room, forty-three-story addition that would make it the nation's largest hostelry.[25] But in June 1981, citing inflation and rising construction costs, the hotel abandoned the plans.

In order to prevent its thirty-four-story, 750,000-square-foot office tower from overpowering the midblock site, Kohn Pedersen Fox shaped the mass to suggest a conjoined pair of granite-clad slabs running north–south, each end punctuated by a stack of triangular bay windows. Two semicircular lobbies—one for each of its street frontages—offered access to the building's central elevator core as well as to the four-story-high, thirty-five-foot-wide, barrel-vaulted, skylit, through-block passageway featuring wooden benches. Passing through the galleria's length, pedestrians could look into three restaurants, including Adam Tihany's Remi (see Interiors), set behind glass walls. Above, bridges connected the tower's 70,000

square feet of second- and third-floor exhibition spaces to those of the Hilton Hotel, at once satisfying Hilton's need for added space and providing a link that somehow allowed the new building, though 450 feet west of Sixth Avenue and in fact closer in proximity to Seventh Avenue, to nonetheless enjoy the corporate cachet of a Sixth Avenue address.

The series of aligned midblock passageways was broken by Frank Williams & Associates' fifty-four-story, 584-foot-tall Rihga Royal Hotel, 151 West Fifty-fourth Street, between Sixth and Seventh Avenues, whose unremarkable, narrow, barrel-vaulted passage was located far enough west of that of its southern companion to break the north–south visual axis.[26] When it opened in 1990, the Rihga Royal (Rihga being an acronym for Royal International Hotel Group and Associates) was the tallest hotel in Manhattan and, with an 11:1 aspect ratio, the most slender building built to such a height in the city. The developers, William Zeckendorf Jr. and Sol Goldman, who initiated plans for the site in 1981, were delayed in part by hold-out tenants of the Holbein Studio (E. Bassett Jones, 1888), 154 West Fifty-fifth Street, a three-story Romanesque-style structure that originally housed a stable on the first floor and artist studios above.[27] In 1987, the remaining tenants of the Holbein Studio made a last-ditch effort to have the building designated a landmark but were unsuccessful. When the hotel was completed, the Holbein Studio remained, but its first floor was replaced by the hotel's loading dock.

Rising from a granite base, the rose-colored brick Rihga Royal was shaped with bay windows and chamfered corners that accentuated its verticality and mitigated the potentially overwhelming broadness of the south facade. Numerous

1325 Sixth Avenue, between West Fifty-third and West Fifty-fourth Streets. Kohn Pedersen Fox, 1990. View to the northwest. Nolan. KPF

Through-block passageway, 1325 Sixth Avenue, between West Fifty-third and West Fifty-fourth Streets. Kohn Pedersen Fox, 1990. RAMSA

setbacks occurred in the faceted shaft of the building, which culminated in a crenellated crown. Robert Rosenwasser Associates served as engineer, employing concrete for the structure instead of steel, with six major interior shear walls, two exterior shear walls, and a fifty-two-foot-square core at the center of the plan. Interior designer Birch Coffey was responsible for the design and layout of the 514 suites, which were finished in light, monochromatic colors. Though the editors of the *AIA Guide* quite dismissively called the base "gaudy and heavy-handed" and the tower "innocuous,"[28] Michael J. Crosbie was much nearer to the mark when he wrote, "It does not pay homage to any one skyscraper in particular, [but] suggests a tradition of building in New York—through its materials and form—that most New Yorkers and visitors love about the architecture of the city."[29]

Completed three years after his Equitable Center, Edward Larrabee Barnes's more modestly scaled 125 West Fifty-fifth Street (1989), between Sixth and Seventh Avenues, a twenty-three-story, 550,000-square-foot office building clad in blue-green glass and featuring canted street facades that created small plazas off the sidewalk, extended through to Fifty-sixth Street with an enclosed pedestrian passage, one of two on the block along with Cityspire's (see below), that seemed more like an extension of the building's lobby.[30] This was probably just as well since its location prevented it from connecting with the chain of midblock passageways south of Fifty-fifth Street. The design vaguely referenced Metropolitan Tower to the north (see Fifty-seventh Street), also developed by Harry Macklowe.

If not a welcoming gesture to pedestrians, Barnes's through-block indoor passageway nonetheless was a dramatic space, with four Roman statues placed atop white and gray marble pedestals that matched the floors and walls. In the center of the ceiling was a large, indirectly lit recessed dome covered in silver leaf. Barnes's building replaced the four-story Choir School (1919) of the St. Thomas Church, which relocated in 1987 to a new fifteen-story, 55,000-square-foot somewhat diagrammatic Georgian-inspired red brick building with limestone and gray brick trim designed by Buttrick White & Burtis at 202 West Fifty-eighth Street.[31] The symmetrical six-story street facade of the new school was dominated by a three-story-high, four-bay-wide rectangular window. Above the sixth floor, the building stepped back twenty feet and rose with several more setbacks to a central, gabled roof above a large oculus that allowed light to reach the school's chapel within. The program was complex, providing housing for the boarding students, classrooms, a library, a laboratory, a dining hall, faculty apartments, and a gymnasium designed to mimic the acoustics at St. Thomas Episcopal Church, where the student choristers regularly performed.

Given the reputation of the designers, Murphy/Jahn's Cityspire (1987–90), 150 West Fifty-sixth Street, between Sixth and Seventh Avenues, held out the promise of being the best of the new midblock towers.[32] Sadly, the building was unsatisfying, as was the enclosed pedestrian arcade, the second on the block, which provided ample evidence, if any were needed, of the dubious value of the presumed zoning bonus

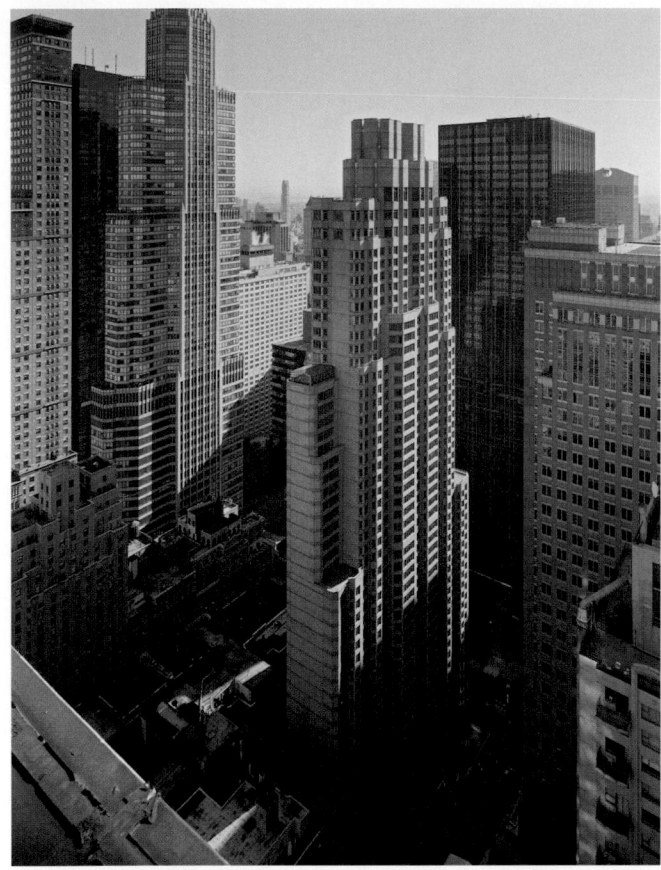

Rihga Royal Hotel, 151 West Fifty-fourth Street, between Sixth and Seventh Avenues. Frank Williams & Associates, 1990. View to the northeast showing Cityspire (Helmut Jahn, 1990) on the left. Goldberg. ESTO

Through-block passageway, Rihga Royal Hotel, 151 West Fifty-fourth Street, between Sixth and Seventh Avenues. Frank Williams & Associates, 1990. RAMSA

amenity. One of the era's most complex, troubled, and ultimately artistically disappointing skyscrapers, Cityspire, like Carnegie Hall Tower (see Fifty-seventh Street), was part of a plan of institutional revitalization: in this case the renovation of the City Center, 135 West Fifty-fifth Street, built in 1924 as the Mecca Temple (Harry P. Knowles) and since 1943 a city-owned home to numerous performing arts groups.[33]

Sale of the City Center's air rights to Cityspire's developer came after the City Center had already completed a modest renovation in 1982, undertaken by Fred Nebenzahl, a Toronto architect, and Bernard Rothzeid of New York.[34] Two years later, as the city's appetite for office space and new apartments was beginning to grow, developer Ian Bruce Eichner came forward with a plan to build a through-block 847,000-square-foot, seventy-two-story commercial and residential tower—twenty-two stories of office space and forty-nine stories of condominium apartments—on a site west of the theater building. Under the city's "theater bonus" program, in return for the use of the City Center's unused air rights, Eichner proposed to augment the theater's backstage space. In a surprise move, Eichner turned to the Chicago architecture firm whose principal designer and owner since 1983, Helmut Jahn, then at the peak of his influence, had targeted New York, garnering three new skyscraper commissions within a very short time: Park Avenue Tower (see Park Avenue), 425 Lexington Avenue (see Terminal City), and the tallest of all, Cityspire. Jahn's appeal to New York was professional and personal: his buildings in Chicago were flamboyant, as was his way of dressing—a "dude," his photo

was on the cover of *Gentleman's Quarterly* in May 1985. But he was not particularly popular with the New York architectural establishment. According to Joseph Giovannini, "Many New York architects find more showmanship than substance in his work."[35]

But Paul M. Sachner, writing in *Architectural Record*, felt that of all architects specializing in high-rise commercial buildings, Jahn could best adapt the traditional look of classic New York examples to contemporary programs realized with contemporary technologies. For Sachner, Jahn's "high-tech historicist" work seemed just right. Sachner did note, however, that "many question the appropriateness of a 70-story building—no matter how well-designed—on an 80-foot-wide midblock Manhattan site."[36] Paul Goldberger was also concerned about the height, but he felt that "at least" Jahn "had shown some understanding of what designing in the middle of a city is all about." Goldberger pointed out that the design related not only to the City Center's Moorish-inspired architecture but also to "the traditions of eclectic skyscrapers that is one of the greatest parts of New York's architectural legacy." He noted that Jahn had picked up on Halsey, McCormick & Helmer's Williamsburgh Savings Bank Building (1927–29), 1 Hanson Place, at Ashland Place and Flatbush Avenue, Brooklyn, "one of the city's finest and least appreciated skyscrapers." But he did not find the specific details of Jahn's proposal quite so satisfying: "Most of the tower's exterior is horizontal in emphasis, but a central shaft with strong vertical lines rises to meet the dome. The idea is

125 West Fifty-fifth Street, between Sixth and Seventh Avenues. Edward Larrabee Barnes Associates, 1989. View to the northeast. MP

Through-block passageway, 125 West Fifty-fifth Street, between Sixth and Seventh Avenues. Edward Larrabee Barnes Associates, 1989. MP

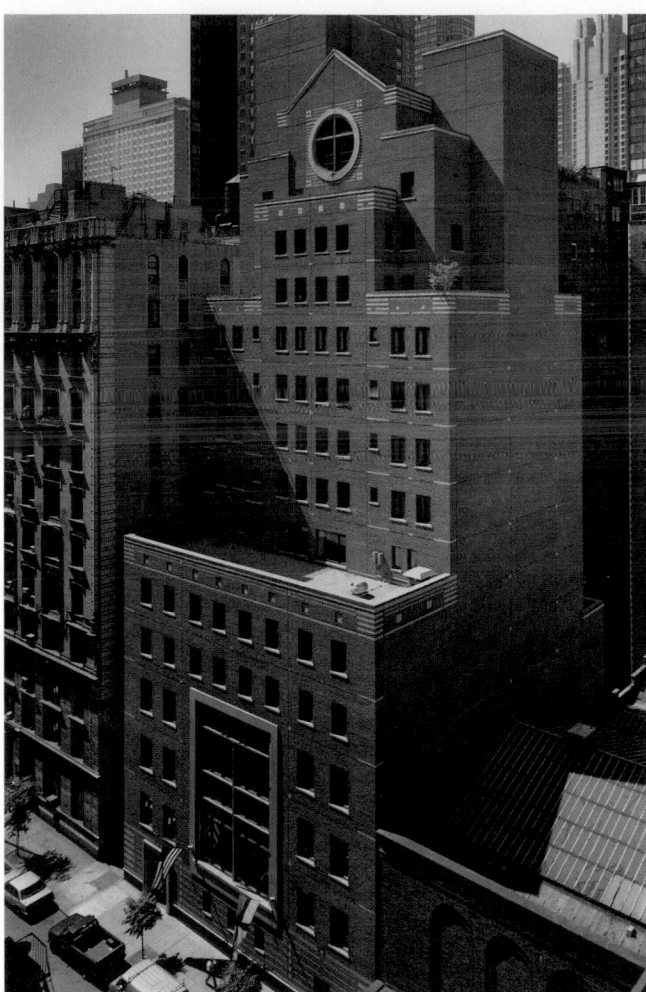

St. Thomas Choir School, 202 West Fifty-eighth Street, between Seventh Avenue and Broadway. Buttrick White & Burtis, 1987. View to the southeast. Warchol. MBBA

to let the vertical section appear to the observer as a separate, thin building, with the horizontal section becoming a kind of background. Alas, it does not seem to work—there is simply too much going on in this facade, and the horizontal and vertical sections clash instead of supporting each other."[37] Surprisingly, one of the design's most colorful criticisms came from Ian Bruce Eichner himself, as related by Jerry Adler in his book *High Rise*: "'Go up to the forty-sixth floor of this building where it sets back and look out the window,' Bruce [Eichner] said bitterly. 'You'll see a wall. A parapet. The wall is there for the *design intent*. It's there to *carry a line*. Helmut Jahn ought to be buried in that wall, and there should be a plaque there, so that everyone who buys an apartment on that floor can look out at it and know that they're looking at a wall instead of Central Park so that Helmut Jahn can rest easy knowing that his *artistic integrity* is intact.'"[38]

The issue of height came to the fore again in 1987 when the building was almost topped out and was found to be eleven feet higher than the original plans approved by the Landmarks Preservation Commission, the local Community Board, the

FACING PAGE Cityspire, 150 West Fifty-sixth Street, between Sixth and Seventh Avenues. Helmut Jahn, 1990. View to the northwest. MJ

Through-block passageway, Cityspire, 150 West Fifty-sixth Street, between Sixth and Seventh Avenues. Helmut Jahn, 1990. RAMSA

City Planning Commission, and the Board of Estimate. According to a lawyer working for Eichner, the extra height was the result of a decision to help stabilize the tower by thickening each floor slab two inches. Surprisingly, no stop-work order was issued, although the project was taken through the review process a second time. The Community Board and City Planning Commission refused to allow the extra height. In order to avoid having to remove a floor or more from the building, Eichner proposed to provide 7,200 square feet of rehearsal space for nonprofit dance groups in the base, a plan that was approved in April 1988, irritating many civic groups, who regarded the arrangement as a dangerous precedent. They were also incensed by Eichner's plan to reduce the height of the midblock pedestrian passageway connecting Fifty-fifth and Fifty-sixth Streets in order to make way for the rehearsal hall. When negotiations between the city and the developer stymied in July, a stop-work order was issued against the building. The dispute was finally resolved in February 1989, allowing the added height in exchange for rehearsal space that did not compromise the arcade.

When Cityspire was at last complete, in 1990, Goldberger compared it to both Carnegie Hall Tower and Metropolitan Tower: "In plans and models, City Spire looked the best, the building that tried to effect a reasonable stylistic bridge. But now that all three buildings are done . . . , City Spire is by far

the weakest of the three . . . architecturally, less a strong synthesis than a lackluster compromise."[39] By this time, no other architectural critics seemed to care, and Cityspire would have become just another largely unleased player in the early 1990s real estate drama of glut and glory, were it not for the fact that the tower, or more particularly the dome, had developed a whistling sound, leading Allan R. Gold, a writer for the *New York Times*, to observe that the "skyscraper best known for being too tall . . . has [now] been deemed too loud."[40] By December 1990, residents as far away as Third Avenue had filed hundreds of complaints with the Department of Environmental Protection. The high pitched sound, as it turned out, was apparently created by wind blowing over the dome's louvers, inspiring Monroe Price, dean of Yeshiva University's Benjamin N. Cardozo School of Law, to write in the *New York Times* that "the first, predictable reaction of bureaucrats . . . , to 'arrest' the building for speaking out of turn" by issuing an $880 summons against Eichner before requiring him to alter the dome, was "far too unimaginative." According to Price, "The community should attempt to understand what the building is trying to say. Is Cityspire's whistle a lonely call for companionship to Citibank's far-off tower in Long Island City, a siren-like wooing of the World Trade Center, a fraternal nod to the Empire State Building? . . . As we come to appreciate Cityspire's whistle, perhaps we will not condemn it so readily. . . . One day, the Municipal Art Society might even oppose construction modifications that would alter a building's sounds—a step in the direction of landmarking the music of the architectural spheres."[41]

Price's witty send-up notwithstanding, the sound, likened by the *New York Times* to "blowing across the neck of a soda bottle," was silenced by removing every other louver in the cooling tower, thereby widening the channels through which the wind whistled. By that time, in June 1993, 80 percent of its apartments were sold, but the building was in bankruptcy. Eichner lost Cityspire to the Bank of Nova Scotia, but the building's problems were not yet over: as late as December 1995, the pedestrian arcade was not finished and construction of the three floors of dance rehearsal studios not begun, their future canceled by the Federal Bankruptcy Court in 1992 which, instead, required the new owners to pay $2.1 million to New York City, some of which was used to renovate rehearsal spaces under the existing City Center theater. At last, in September 1997, the midblock arcade was finished, having existed for years, according to David Dunlap, as "a gaping hole framed by cinder blocks and barred by a chain-link fence and razor wire." It was the final link in the six-block network of passageways, with the northernmost links to Fifty-seventh Street provided by the enclosed pedestrian passageways at Metropolitan Tower and Carnegie Hall Tower, completed in 1987 and 1990, respectively, although there was a third enclosed passageway linking Fifty-sixth and Fifty-seventh Streets supplied by the Parker Meridien Hotel that had been completed one year before the passage of the 1982 zoning law. Dunlap compared the struggle to complete the pedestrian corridor "with the driving of the golden spike that joined the railroads of the East and West. . . . And it took even longer to achieve. By the time railroad crews met at Promontory Point, Utah, on May 10, 1869, seven years had passed since Congress authorized an overland route from the Missouri River to California. By the time the Cityspire link is completed . . . 12 years will have passed since it was authorized by New York City officials."[42]

TIMES SQUARE

The Worm in the Apple

Plagued by crime and unlawful sex, Times Square was by the mid-1970s New York's most visible public embarrassment, the "worm in the apple," to use Dick Netzer's phrase.[1] The term Times Square was used not only to describe the bow tie of open space between Forty-third and Forty-seventh Streets created by the intersection of Broadway and Seventh Avenue but also the stretch of Forty-second Street between Sixth and Eighth Avenues and especially its intersection with Broadway and Seventh Avenue, where the *New York Times* built a headquarters in 1904, an area also known as the Crossroads of the World. The approval by the Board of Estimate, on January 8, 1976, of legislation—said to be the first of its kind in the country—banning "massage parlors," many of which were little-disguised houses of prostitution, zoning them out of the Times Square theater district and the adjoining Clinton residential neighborhood, marked a significant first step toward cleaning up the area.[2] The estimated forty-nine existing parlors were to be allowed a one-year grace period before closing. To prevent their relocation elsewhere in the city, a five-borough twelve-month moratorium on any new establishments of the sort was included in the legislation. But no single law was enough to stem what appeared to be the area's uncontrollable lawlessness: in March 1976, Seymour Durst, owner of the nine-story building that housed the once-luxurious and totally respectable Luxor Baths, 121 West Forty-eighth Street,

Times Square Love for Sale, 1976. Tannenbaum. AT

a famous gathering place for men in show business, the sporting world, and the garment industry, reported that he was powerless to close down secret renovation work being carried out by his tenant, who was in the process of converting the building into a massage parlor.[3] The city urged Durst to take trespass action, but the developer said the civil courts were his only recourse. Within the month, however, Durst withdrew his eviction notice against the occupants, announcing that he had sold the building to the interests he had sought to evict, leading Mayor Abraham Beame to ask Durst to resign from his post on the Midtown Citizens Committee, which had been established in 1975 to clear pornography and prostitution from the midtown area.[4]

Though massage parlors, it was hoped, might soon be a thing of the past, prostitution was still rampant, especially along Eighth Avenue, where "intimate" theaters that showed erotic films and frequently functioned as rendezvous places for casual sex were a growing problem, tolerated under the Supreme Court's recent interpretations of the First Amendment, most notably in its 1975 decision *Erznoznik v. City of Jacksonville*.[5] In May 1976, Mayor Beame tried to stop the carving up into three small theaters of the 2,300-seat De Mille Theater, originally the Mayfair (Thomas W. Lamb, 1930), 701 Seventh Avenue, between Forty-seventh and Forty-eighth Streets.[6] While the owners' intention to show pornographic films in the new theaters was public knowledge, Cornelius Dennis, the Buildings Department's Manhattan superintendent, felt unable to comply with the mayor's request that a building permit be denied. Shortly after it was granted, the permit to convert the De Mille was revoked by Dennis, who cited nine relatively minor technical flaws in the plan but also admitted feeling pressure from the mayor's office.

In March 1976, Alex Parker, the new owner of the former Allied Chemical Building, which had once been the Times Tower (Cyrus L. W. Eidlitz, 1904; renovated, Smith, Smith, Haines, Lundberg & Waehler, 1965), on the block bounded by Broadway, Seventh Avenue, Forty-second and Forty-third Streets, perhaps prematurely staged a party to celebrate his property's rebirth as One Times Square, intended as home to tourist-related enterprises, including a Songwriters' Hall of Fame, to be located on the eighth floor, and a ground-floor shop to be run by the Walt Disney Company.[7] Pint-size Mickey Mouse was on hand to greet bantam-size Mayor Beame, who proved the taller of the two. The Disney shop never opened. Before the end of the year, a new advertising spectacular was added on the north facade of the tower. Called Spectacolor, the computer-operated forty-by-twenty-foot multicolored sign, with 8,192 bulbs bright enough to be seen during daylight hours, flashed both editorial and advertising matter, making it, in the words of its thirty-year-old developer, George N. Stonbely, "a true communications medium."[8] By 1980 the sign had become more than a local institution as a result of its prominent placement in the cast introductions of *Saturday Night Live*, a popular late-night television program. In 1982 Spectacolor became the venue for high-profile artworks under the sponsorship of the Public Art Fund, which commissioned among other artists Keith Haring and Jenny Holzer, whose five-year-old series of Truisms was for the first time displayed on an electronic sign.

In June 1976, the Supreme Court ruled that it was constitutional for cities to use zoning ordinances, backed by criminal penalties, to restrict movie theaters that showed sex films.[9] Even

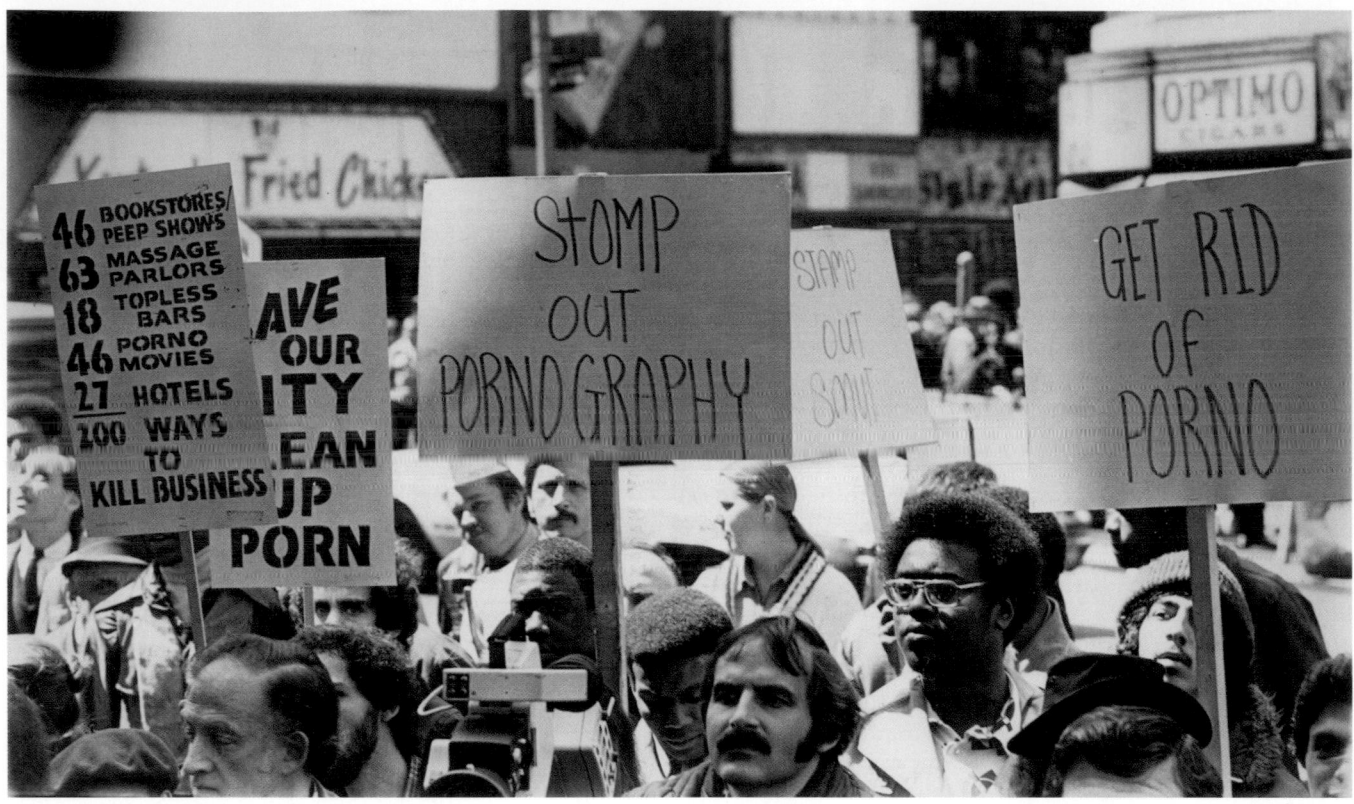

Rally against pornography, Seventh Avenue and West Forty-second Street, April 11, 1977. Boenzi. NYT

as the nation's highest court was deliberating, New York was preparing special zoning for the Times Square area intended to protect and reinforce the existing theater district by requiring special permits for certain uses that, in the eyes of some, might involve pornography.[10] But as prostitution and drugs were driven from theaters and massage parlors, they found new homes in parking lots that were becoming "outdoor bordellos," in the words of local residents, as a new sidewalk blight appeared in the form of three-card monte, a fast card game almost guaranteed to favor the card shark and not the player.[11] In a thoughtful discussion of the civil liberties issues that affected the mayor's ability to control the seamier side of Times Square's nightlife, Maurice Carroll, a *New York Times* reporter, reminding his readers that Times Square had "always had a rhinestone glitter," quoted Junius Henri Browne, one of the city's leading post–Civil War chroniclers, who in 1869 noted that on Broadway, "Vice wears a fair mask at every corner." Browne continued: "Art smiles in a thousand bewitching forms. Hotels and playhouses and bazaars and music halls and bagnios and gambling hells are radiantly mingled together; and any of them will give you what you seek, and more sometimes."[12]

Encouraged by the Supreme Court's decision to uphold anti-pornography zoning in Detroit, the Beame administration pushed forward with special zoning that went even further in its reach, forbidding so-called adult establishments from being set up within 500 feet of areas zoned exclusively for residential use, thereby virtually wiping out this activity on Eighth Avenue between Fourteenth and Fifty-eighth Streets, while also imposing certain restrictions in commercial districts, so that in Manhattan no more than three such establishments

would be permitted within a 1,000-foot radius, and in the outer boroughs, only two such establishments would be allowed within the same area.[13] Additionally, unlike Detroit's plan, New York's called for phasing out, over a year's time, all pornographic establishments found in residential areas, as well as those within commercial and shopping districts that exceeded the maximums proposed, with the most recently opened businesses to close first.

Protest against pornography intensified shortly after the zoning was proposed, with a public demonstration held on Eighth Avenue on November 14, 1976, when a delegation from Actors' Equity and several politicians, including City Council member Henry J. Stern and Assemblyman Richard Gottfried, joined more than 1,000 demonstrators. Days later, the editors of the *New York Times* opined in support of the proposed zoning, stating that it would "neither condemn nor prohibit sex activities nor anyone's right to participate in them. It would simply determine the placement and number of such establishments . . . much as other obnoxious or disturbing uses, such as junkyards and signs, are at present controlled by zoning. . . . This is no blue law: it is a giant step forward in sophisticated—and necessary—environmental legislation."[14] On January 26, 1977, the City Planning Commission unanimously approved the new zoning banning all so-called massage parlors and completely eliminating topless bars, peep shows, and adult bookstores, in and near residential areas, while curtailing them in commercial districts.[15]

A visible sign of remedial action also seemed an appropriate way to convey the government's commitment to improving Times Square's public environment. A quick fix in keeping

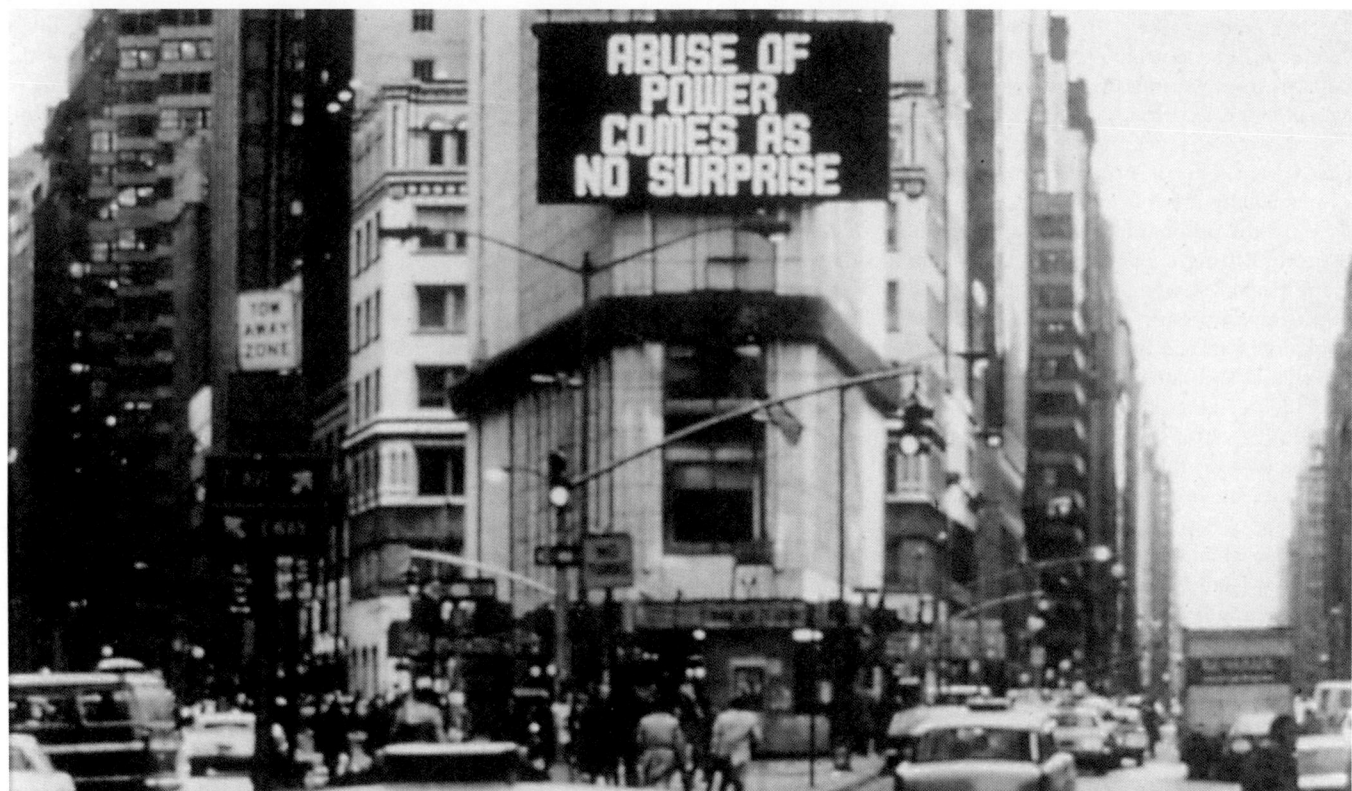

One Times Square, block bounded by Broadway, Seventh Avenue, West Forty-second and West Forty-third Streets. View to the south of

Spectacolor showing *Abuse of Power Comes as No Surprise* (1982) by Jenny Holzer. LS

with the lingering popularity of urban pedestrian malls called for the conversion, at least on a test basis during the fall of 1977, of the portion of Broadway between Forty-fifth and Forty-eighth Streets into what would be called Broadway Plaza, an improvement to be paid for with a $500,000 federal grant.[16] The plan, based on one initially proposed in 1974, was to be executed in a series of experiments to be conducted between September 1977 and January 1978, when all vehicles, including buses and taxis, would be detoured onto Seventh Avenue, leaving Broadway a traffic-free zone for the three-block stretch, though east- and west-bound traffic would continue to be served by Forty-sixth and Forty-seventh Streets, respectively. Were the plan to prove successful, and should the city be able to obtain an additional $4.8 million from the Federal Urban Mass Transit Administration, the Broadway roadbed would be lifted to sidewalk level and decoratively paved, while sidewalks would be lined with trees and an information kiosk would be built between Forty-sixth and Forty-seventh Streets.

As the plan for Broadway Plaza was being promoted by a booster-ish group of city officials, Times Square lost a bit more of its glitter when the fifty-by-sixty-two-foot Canadian Club whiskey sign that for twenty-four years had bathed its northern end with the rippling glow of 1,400 bulbs and five miles of neon tubing shining white and red was taken down from its rooftop perch. But no matter how ardently the Beame administration pumped for the Broadway Plaza plan, the *New York Times*, in a strong editorial probably written by Ada Louise Huxtable, would have none of it, calling the idea a "kind of dated window dressing. . . . We are promised trees, benches, cafes and fancy paving. The better, no doubt, to enjoy

Proposed Broadway Plaza pedestrian mall, Broadway between West Forty-fifth and West Forty-eighth Streets. Rendering of view to the northwest from West Forty-fifth Street. LS

the surrounding views. Or to browse pleasantly in bookstores. There will be potted plants in season. (Seasons in Times Square? Its tawdriness is timeless.) . . . And it will certainly aggravate an existing bottleneck . . . by choking off an alternate route that saves the crossroads of the world from certain chaos. . . . This is not planning; it is fancy fiddling while Times Square rots."[17]

With the pornography cleanup plan about to go before the Board of Estimate, on March 7, 1977, a divided City Planning Commission approved two amendments to twenty-six anti-pornography zoning regulations that would ban all "adult" bookstores, movie theaters, and the like from within 200 feet of schools and houses of worship, as well as from C-4 zones that included regional shopping districts, in effect eliminating all adult uses for Brooklyn, but leaving room for such activities in two neighborhoods each in Staten Island, the Bronx, and Queens.[18] On March 24, following Mayor Beame's lead, the Board of Estimate, concerned over the constitutionality of the proposal and feeling pressure from the borough presidents of Staten Island, Queens, and the Bronx, who feared that the new law might drive prostitution and porn into their jurisdictions, abruptly reversed itself and rejected the proposed zoning regulations, putting off for future action a less restrictive version.[19] While the theater industry did not give up the fight, the public seemed to become apathetic, or resigned, to the situation.[20] To further the protest, Alex Parker, owner of One Times Square, turned off the electric "zipper" signboard circling the building which had continuously flashed the news since 1928, announcing that it would not be turned back on nor would the New Year's Eve ball be dropped unless he got 100,000 signatures on a petition demanding that the area be cleaned up.[21] The sign would remain unlit until 1986, when *New York Newsday* signed a five-year lease to operate it.[22]

Amid all the grandstanding about cleaning up Times Square, Joseph M. Conforti, an associate professor of sociology at the State University College at Old Westbury, offered a thoughtful and incisive analysis of the recent, seemingly exponential growth of vice-related activities in the area. In an April 1977 letter to the editors of the *New York Times*, Conforti wrote that the generally held view that pornographic and sexually oriented enterprises were "an intruding evil, an alien invasion that drove out much that was desirable," was "simplistic" because it ignored factors in the area's changing character, including the shift uptown to the area around Lincoln Center and Bloomingdale's of a lot of the city's nightlife. Moreover, "the introduction of commercial office buildings," which came to the area because of its transit facilities and proximity to Rockefeller Center, represented a type of development that was "usually designed to stand apart from and independent of the activities in the streets where they were located. This was epitomized in the sheathing of the landmark Times Tower, which turned a blank cold wall to 42nd Street." Conforti also took note of the suburbanization of population, restaurants, and theaters, the role of home entertainment, the high cost of Manhattan nightlife, and "a media image of New York as dangerously crime-ridden," all of which taken together suggest "that sexually-oriented activities did not push out the area's previous activities and their clientele, but rather that they filled the void as Times Square was otherwise abandoned as an entertainment district." Conforti's conclusion was not likely to give much comfort to the theater industry and others heavily invested in the area. In

effect, he argued that the removal of massage parlors, dirty bookstores, and pornographic theaters would not necessarily reduce prostitution. In fact, the loss of these activities might have a worse effect, contributing "to the area's further decline as a center of activity."[23]

In February 1978, early on in his first term, Mayor Ed Koch tackled Times Square smut with a far less ambitious plan than the one Beame had unsuccessfully proposed. Koch's plan would restrict the opening of nine sex establishments through zoning and, far more significantly, offer tax abatements and other financial incentives to attract legitimate development.[24] Koch also supported the Broadway Plaza idea. In June 1978, the mayor authorized a vast increase in police patrolling the Times Square area. At the same time, he announced that twelve leading private corporations, initiated by the two-year-old 42nd Street Redevelopment Corporation, had contributed a total of $110,000 to finance a preliminary study and economic analysis of the area and identify appropriate private projects. An action plan relying on zoning changes and anti-prostitution laws was prepared by Koch's aides, who proposed to turn what was now the city's unofficial red-light district into a more wholesome entertainment district by 1980.[25] On November 16, 1978, intent on replacing the eighteen-month-old temporary citywide moratorium on the establishment of new, adult massage parlors, the Board of Estimate, acting a week after the City Planning Commission, approved an amendment forcing all existing massage parlors to close within a year.[26]

Around 1980, Times Square's fortunes began to brighten as architects, public officials, and real estate developers grew to appreciate its strategic importance in the westward expansion of midtown's office building district. In 1979, a proposal by Jack L. Gordon, an architect, called for a ten-story-high space-frame media wall to wrap Times Square from Forty-second to Forty-eighth Street, a provocative design for a curbside wall lifted on columns to keep precious ground space as clear as possible and to bridge streets as well as some existing facades.[27] The 250,000 square feet of space on the wall would be leased like conventional billboard space, but it would feature rear-screen projections, light shows, laser displays, holographic and supergraphic advertisements, and public announcements, as well as an illuminated news headline strip that would form a kind of kaleidoscopic cornice. A monorail or people-mover could also be included, while the structural supports could incorporate newsstands and information booths. When asked about the plan, Douglas Leigh, Times Square's leading sign designer, replied, "It is nice to dream like that."[28]

Another idea for the area's improvement came as the result of the collaborative contribution of architect James Freed and the sculptor Alice Aycock to the 1981 exhibition commemorating the 100th birthday of the Architectural League of New York. The pair proposed a four-block-long waterwork for Times Square, using Archimedean screws to keep the water flowing. Jonathan Barnett, the urban designer and League president, saw a parallel between the rushing water and the "bustle and low-life activities of Times Square," with an emphasis on "the futility of much of the activity and the cruelty and sadism of many Times Square denizens."[29] In his review of the show, Michael Sorkin wrote, "The drawings, which sacrifice Aycock's typical spindly complexity for a more practical, architectural approach to structure, are dull."[30]

Proposed media wall, Times Square, West Forty-second to West Forty-eighth Street, Broadway to Seventh Avenue. Jack L. Gordon, 1979. Model, view to the west. JLGA

Proposed media wall, Times Square, West Forty-second to West Forty-eighth Street, Broadway to Seventh Avenue. Jack L. Gordon, 1979. Model, view to the west. JLGA

In May 1979, the City Planning Commission ordered a nine-month-long study intended to explore ways of deflecting development from the increasingly congested east side of mid-town to Times Square, a measure that ultimately helped lead to the creation in 1982 of the Special Midtown Zoning District.[31] Even without special stimuli, according to Glenn Fowler, a respected *New York Times* real estate reporter, so much was happening in west midtown that "1979 could be the turn-around year for the Great White Way."[32] The optimistic signs included the likelihood that financing was about to be arranged for the Portman Hotel (see below) and the impending conversion of the vacant Manhattan Hotel (Schwartz & Gross, 1928) on Eighth Avenue into an apartment building (this did not happen, but the hotel was reborn as the Milford Plaza hotel in 1980).[33]

By mid-1981 the expectation of renewed real estate activity in the Times Square area made the prospects of the long-considered Broadway Plaza pedestrian mall, to be designed by Tippetts-Abbett-McCarthy-Stratton working with M. Paul Friedberg, more likely than ever before.[34] Two sizable grants from the federal government were secured in September, increasing optimism for the mall's realization. But Richard Bassini, head of the Broadway Association, expressed the fear of many that the mall might "fall prey to street people, drug

traffickers and peddlers."[35] In response to those worries as well as concern over traffic congestion, plans for the plaza were revised to shorten its length so that it would extend only between Forty-fifth and Forty-seventh Streets. Even this shorter version required the elimination of Duffy Square, as the northern end of the Times Square bow tie was officially designated, and the relocation of the statue of the World War I chaplain of the "Fighting 69th" Regiment as well as that of the composer and playwright George M. Cohan, author of the perennially popular song "Give My Regards to Broadway." It also called for the demolition of the TKTS discount theater ticket booth at Forty-seventh Street, which would be replaced with a new facility to be designed by Mayers & Schiff, architects of the original facility (1973).[36] Realization of the plan, still lacking approval of the local community board and the Board of Estimate, was far from certain. Still, some observers believed that the project's long association with the Portman Hotel—though no official link existed between the two, only the contemporaneousness and adjacency of the plans—virtually guaranteed the plaza's realization, especially since the hotel, at the high point of enthusiasm for the plaza, had been redesigned to project out into Broadway, a design decision urged and supported by the plaza-advocating Koch administration. But by May 1982, even official support for Broadway

Plaza had substantially eroded, and the idea would soon be discarded, as many city officials and community groups endorsed the request of the League of New York Theaters and Producers and the Theatre Development Fund that "Broadway, the most famous street in the world, not be truncated as it passes through Times Square."[37]

The Portman Hotel

In 1976 nothing seemed less likely than the construction of architect-developer John Portman's proposed hotel for the west blockfront of Broadway between Forty-fifth and Forty-sixth Streets. First announced in 1972 and at the time viewed as crucial to the renaissance of Times Square, the fifty-six-story, 2,000-room building was put on hold in 1975, a victim of bureaucratic infighting and the city's fiscal crisis.[38] So shabby had this Broadway blockfront become that the owners proposed modest interim improvements to the facades of the existing buildings in an effort to upgrade tenancy.[39] However, in the wake of the city's successful summertime celebrations in 1976 and with its economy improving, largely because the general profile of the city was higher in the minds of most Americans than it had been for a decade, the city's hotels were running at near capacity, encouraging Portman to revive his plans.[40]

Slowly the project heaved to renewed life. Early in 1978, Portman announced that he could raise $150 million privately if $15 million in federal government funds were made available as a second mortgage. Though Times Square was still considered an "adverse" location by the banking community, its appeal as a hotel site nonetheless remained strong. In

Alternate proposal for Portman Hotel, west blockfront of Broadway, between West Forty-fifth and West Forty-sixth Streets. Lee Harris Pomeroy, 1981. Rendering of view to the south. LHP

October 1979, the *New York Times* reported that Truste House Forte, the London-based hotel management firm, was seriously considering signing on as operators of the proposed hotel. But seemingly innumerable and typically New York–style obstructions lay ahead. For example, on November 12, 1979, the owners of the twenty-six-story Piccadilly Hotel (George and Edward Blum, 1928), 227 West Forty-fifth Street, announced they would not sell their property, which was deemed essential to the hotel site's assemblage.[41] Portman had once had an option on the Piccadilly Hotel but did not secure it when his project stopped in 1975. One day later, on November 13, the *New York Times* reported that mortgage financing for the project was again proving hard to secure, and Portman seemed back at square one.

Portman's problems were not only financial, but also cultural. His projected hotel was not popular, especially in the entertainment industry and among preservationists who focused on the proposed demolition of three theaters on the site. Though Portman pledged to include a new theater in his building, many theater people recognized that it would probably be supersized and impersonal, like the relatively recent Uris (Ralph Alswang, 1968) and Minskoff (Kahn & Jacobs, 1971) theaters.[42] Together with the preservationists, they pointed out that one of the existing theaters on the site, the Helen Hayes Theater, originally the Folies Bergère (Herts & Tallant, 1911), was uncommonly distinguished as a work of architecture—an internal document from the Landmarks Preservation Commission deemed it "one of the finest theaters" in the city—while the other two, the Morosco Theater (Herbert J. Krapp, 1917) and the Bijou Theater (Herbert J. Krapp, 1917), were also quite fine.[43]

Resistance to Portman's hotel increased after a rally on February 27, 1980, when top Broadway actors, including Anthony Perkins, José Ferrer, and Tony Randall, protested the project. David Mamet, the only playwright participating in the rally, stating that he was from Chicago and that he knew Chicagoans who frequently visited the city, felt that "no one" was going "to come from Chicago and go to the Statue of Liberty in the afternoon and in the evening say, 'Let's go over and see what's happening at the Portman Hotel.'"[44]

In March 1980, Paul Goldberger weighed in with an appraisal that supported the project, although he was troubled by the destruction of the three theaters:

> There can be no argument offered against these buildings, and actors are correct when they point out that these older theaters are far more pleasing to both performers and theatergoers than such oversized and awkwardly designed extravaganzas as the Uris and Minskoff theaters. The record of architects designing New York legitimate theaters over the last decade is not a distinguished one; it seems no accident that these theaters are named for real-estate developers and not actors, for they seem designed with the values of real estate in mind more than the values of the theater.

Nonetheless, recognizing that "the life of an ongoing city is always one of tradeoffs," he felt the sacrifice an acceptable one, and he believed Portman's argument that the new theater would be less barnlike than the Minskoff and Uris. Moreover, the overall picture was more palatable given the growing interest in recovering for legitimate use Forty-second Street's old theaters, thereby increasing the number of historic playhouses in active use. Goldberger found the "slightly

View to the northwest showing Marriott Marquis (John Portman, 1985) under construction. Ries. SRP

Marriott Marquis, 1535 Broadway, between West Forty-fifth and West Forty-sixth Streets. John Portman, 1985. View to the southwest. Parker. JPA

redesigned" hotel now being proposed "an improvement over the original version," and he claimed that the "arguments in favor of putting a sizable luxury hotel on Times Square have not lost their merit. This is a neighborhood in need of the kind of major help that this large-scale work can provide, and Times Square is one of the few parts of Manhattan in which more high-rise construction is not going to cause an intolerable increase in density." Goldberger felt that the revolving restaurant, the thirty-seven-story atrium, and the twelve glass-enclosed elevators serving them were appropriate to Times Square, but he did object to the inward-looking nature of the hotel's design, "a problem shared by many Portman buildings around the nation [and] . . . their major weakness" which "clearly reduced the sense of appropriateness of this design for a place so based on surfaces vibrant with color and texture as is Times Square." Goldberger welcomed the decision in the redesigned hotel to move the theater up from the basement and express it on the Times Square facade with a curving drum atop which there was to be a revolving restaurant, "a cliché in those skyscraper hotels in Detroit and Kansas City where there is not much for the revolving diner to view, but a splendid idea when the vision is the lights and signs of Times Square."[45] He also called for more signs on the hotel's exterior and a reduction in its bulk.

On July 17, 1980, the editors of the *New York Times* reported that "thanks to the drop in interest rates and the high demand for hotel rooms," the project would likely go forward,

with construction to begin early in 1981. Recognizing the recent spate of protests about the demolition of the three theaters on the site, the *Times*'s editors, whose employer was a key player in the area and a key investor in its real estate, stated their support for the hotel, noting that "nothing would do more to strengthen the district than a luxury hotel. . . . Treasuring a living theater, we wish the new hotel success, without reservations."[46] That same day, after five hours of debate, Community Board 5 voted to "reaffirm its approval" of the project. Speaking against the project at the meeting were the producer Joseph Papp and the prominent philanthropist Joan K. Davidson, representing the week-old Save Our Broadway Committee, who felt that Portman's scheme was "grotesquely out of harmony" with the area and that it was not too late to redesign it.[47]

In late November 1980, the city green-lighted a request to seek $21.5 million in federal funding, $6.5 million more than it had originally planned to ask. But in January 1981, in a surprising change of fortune, the project was put in serious financial jeopardy when the Department of Housing and Urban Development denied the federal funding. Behind the rejection was newly elected President Ronald Reagan's objection to the urban grant program, which he was seeking to eliminate. The city remained undaunted and, in a seesaw adventure worthy of the early *Perils of Pauline* movie series, in late March, federal officials reversed their decision and approved the funding for the hotel that Portman was now to develop in concert with

Marriott Marquis, 1535 Broadway, between West Forty-fifth and West Forty-sixth Streets. John Portman, 1985. Atrium. Parker. JPA

statements in lawsuits by preservation groups in state and federal courts, Nofziger had told officials of the Advisory Council on Historic Preservation, which under federal law is an independent arbiter of the government's preservation actions, to approve the theaters' demolition "by the close of business" on November 20 or face a White House order putting the advisory council "out of business."[48] While Nofziger claimed he was just trying to cut through the bureaucracy and speed up the decision-making process, both theaters were given a stay of execution by a federal appeals court on January 6, 1982, but three days later a State Supreme Court judge approved the demolition.

Meanwhile, demolition of other properties, including the Bijou Theater, began while the *Times*'s editors joined officials to insist that the hotel was needed and that the theaters were expendable. In a less than enlightened moment, the newspaper editorialized that the two unused theaters were "probably unusable." So irritated was the *Times* with the various opponents and the extended legal debate that the editors cited the court battle as "an illustration of the redundancy in America's legal process," likening the case to "a satire on Dickens's Jarndyce v. Jarndyce in 'Bleak House.'"[49]

As the project bounced around the courts, members of the theatrical community continued to protest Portman's hotel. At a large rally on March 3, 1982, the playwright Arthur Miller read excerpts from eight Pulitzer Prize–winning plays, seven of which had been presented at the Morosco, while the eighth, Eugene O'Neill's *Long Day's Journey into Night*, played at the Helen Hayes. Virtually at the same time, the theaters received a reprieve from the courts when Associate Justice of the United States Supreme Court Thurgood Marshall issued an order preventing demolition at least through the weekend until representatives of the Portman interests could file a response on March 8.

The New York State Court of Appeals, in a March 16, 1982, ruling, refused to block the demolition of the theaters. After a last-minute petition was dismissed in State Supreme Court, only the temporary stay issued by Judge Marshall of the United States Supreme Court remained. When this was lifted on March 22 at 10:00 A.M., 170 protestors, including Joseph Papp and the actress Colleen Dewhurst, were arrested and demolition began. By May, the theaters were gone and construction was finally ready to begin. The only solace the protestors could take from the loss of the historic theaters was the fact that their protests, along with the important work Hugh Hardy had done in highlighting the potential reuse of Forty-second Street's theaters for the City at 42nd Street project, motivated the city to create the Theater Advisory Council, ultimately leading to the Landmark Preservation Commission's designation of twenty-eight midtown theaters (see Forty-second Street).

The Portman hotel itself was something of a construction marvel. By mid-summer 1983 its 550-foot-high minaret-like slip-formed concrete core rose from a cat's cradle of steel framing that would carry the structure over the 1,500-seat theater at its base. When the fifty-story, 1,877-room hotel, now named by its operators the Marriott Marquis, opened in October 1985, it was greeted mostly with a sigh of relief—a thirteen-year-long psychodrama at last concluded. The hotel's brutal, slab-sided facades; its aggressive confrontation of Times Square; its introspective plan; its confusing circulation, with elevators and escalators connecting the street level and the ninth-floor atrium lobby, where there were restaurants and

the Marriott Corporation, which would manage the property.

Those opposed to the project continued to fight, and in September 1981, after the city issued an Environmental Impact Study supporting Portman's plan, the Actors' Equity Association's Committee to Save the Theaters commissioned the architect Lee Harris Pomeroy to study the possibility of building the hotel above the Hayes and Morosco theaters. Concluding that such a plan was feasible, eliminating the need for a new 1,500-seat theater, Pomeroy also claimed that the city's Environmental Impact Study did not study feasible alternatives to the hotel project. John Portman's team of architects did not challenge the feasibility of Pomeroy's proposal, choosing instead to take issue with the time it would take for redesign—between six and nine months—and the fact that aspects of the hotel would have to change, leading to a reduction in its amenities. Moreover, and possibly more to the point, a spokesman for Portman stated that a redesigned building would require a new financial package and a renewed approvals process, probably causing the architect-developer to abandon the project out of frustration.

At the end of 1981, the project became tinged with scandal when the *New York Times* reported that two associates of President Reagan, Lyn Nofziger, his top political aide, and James G. Watt, Secretary of the Interior, had stepped up to help counter the effects of opposition from groups objecting to the demolition of the Morosco and Helen Hayes theaters, which were listed on the National Register of Historic Places. According to the *Times*'s report, which drew on several sworn

bars as well as guest registration; its narrow, somewhat lugubrious thirty-seven-floor-high atrium, with mild connotations of a jail; and its revolving rooftop restaurant, which reminded one of similar eateries in smaller cities—all added up to a building that wasn't very good as a piece of urbanism or as a work of architectural art.

With the completion of the project, Paul Goldberger replaced his previous ambivalence with relentless criticism, dismissing the design for shortcomings that were obvious to most knowledgeable observers from the outset. Goldberger condemned the hotel as "an upended concrete bunker, its harsh, ribbed walls turning a cold face to Broadway. There is no relationship to Times Square, or to any part of New York, here; the building is a fortress, a sealed environment in which visitors do not really interact with the city—they play city, riding up and down in glass elevators and looking at each other across a badly proportioned atrium, all the while cut off from the real streets outside. . . . The Marriott is a hulking, joyless presence, looming over the one part of New York that, whatever its problems, always used to walk with a spring to its step."[50]

A year before the Marriott Marquis opened, in October 1984, another hotel was completed in Times Square by the Paris-based hotel chain Novotel on the west blockfront of Broadway between Fifty-first and Fifty-second Streets.[51] As designed by the Gruzen Partnership, the twenty-six-story, 480-room hotel was set back atop the Broadway Block Building (Schultze & Weaver, 1928), 1651–1657 Broadway, also known as the Wilfred Building, a four-story-with-penthouse office building originally intended to support a taller structure that was never built. The Broadway Block Building was stripped of its Art Deco cladding and resurfaced with a rather dull reddish brown brick to complement the brighter red and green brick highlights of the hotel above, which, entered at 226 West Fifty-second Street, featured a sixth-floor lobby.

Legislating Whoopee

The adoption in 1982 of the Special Midtown Zoning District, permitting in west midtown the construction of buildings 20 percent larger than normally allowed under zoning but including a so-called sunset provision that dissolved the extra bulk allowances on May 13, 1988, more than any other single factor, triggered the redevelopment of Times Square. By 1986 it was reported that as many as six large-scale office buildings were being contemplated for the Times Square area, with about twenty more in various stages of study. The consequent blitz of high-density development seemed inimical to Times Square's character, not only because it would shift its focus from entertainment to office uses but also because it would compromise its physical attributes, darkening this surprisingly sunsplashed bow tie of space by day and, by night, darkening its sky as well, as brightly lit signs gave way to tasteful corporate logos, given the preferences of corporate tenants for buttoned-down near-anonymity. In 1985, as part of its efforts to bring public attention to the shortcomings of the 42nd Street Development Project, the Municipal Art Society commissioned a fourteen-foot-long scale model of Times Square, illustrating the threat posed by the high-rises being planned to beat the 1988 "sunset," as well as those proposed by Johnson and Burgee for the Forty-second Street Development Corporation (see Forty-second Street).[52] Additionally, the Municipal Art Society commissioned a San Francisco–based company, Simulation Laboratory, to produce three videos of the model depicting the view of a pedestrian traversing the district, showing the area as it currently appeared, as it would look when developed according to the 1982 zoning, and as it would appear if developed under a set of "ideal" guidelines developed by Hugh Hardy, co-chairman of the MAS Committee on Times Square. Hardy's plan called for more restrictive setback requirements and encouraged the incorporation of signage in new construction.

The MAS efforts proved effective. Commenting on the depiction of Times Square if developed under current zoning, Paul Goldberger wrote: "What is left is not Times Square, or even the moderate order of Park Avenue; it is a rampantly overbuilt canyon, with only the diagonal of Broadway left as a remnant of the neighborhood's character."[53] But it was Brendan Gill who most awakened the public to what might happen unless drastic action was taken:

Given its location at the center of overcrowded, over-built-upon Manhattan, Times Square at present is a remarkably open and airy space, from which much sky is visible; sunlight readily penetrates the skeletal frames of the great illuminated signs for which it is celebrated—signs that perch on buildings modest in height and agreeably ramshackle in appearance. G. K. Chesterton once said that it would be a paradise for anyone lucky enough to be unable to read; that quality of bedazzlement, of honky-tonk high spirits, is about to be extinguished forever by an unbroken fortress wall of monstrous commercial structures, of which the Minskoff building and the hulking and inimical Marriot Marquis Hotel on the western edge of the square are only the first installments.

Gill felt that if development proceeded according to the 1982 zoning, the district would become the "bottom of a well, sunless in winter and without cooling breezes in the summer." Moreover, with so much of the new construction devoted to office work, Gill feared the buildings "will be empty and dark after six."[54]

In order to meet the potential threat posed to the entertainment district, the City Planning Commission and the Public Development Corporation, the municipal equivalent to the state's Urban Development Corporation (UDC), pooled forces to study the area with the intention of "enhancing [its] chaotic liveliness."[55] The services of three firms were enlisted to help prepare a report: the architects Mayers & Schiff to consider issues of "streetscape"; the lighting designers Jules Fisher & Paul Marantz to study lighting in other cities such as Rome, Paris, and especially Tokyo, and to draft plans to increase the square's fading glitter; and the Halcyon Corporation to develop strategies to enhance retail business. In July 1986, having used the study as a springboard, the City Planning Commission proposed new zoning for the "theater subdistrict," constituting seventeen blockfronts along Broadway and Seventh Avenue from Forty-third to Fiftieth Street. The zoning amendments legislated not only the size and number of new signs but their manner of illumination, level of movement or animation, and type, differentiating between store signs at the retail level, traditional advertising signs at heights of up to fifty or sixty feet—at which point setbacks of at least fifty feet were called for—and so-called supersigns that would, in the Times Square tradition, sit atop the setbacks and rise to heights of 120 feet. The zoning would also trim the heights of new buildings along the avenues by one-sixth.

The implications of the proposal were complex, calling for the difficult combination of two divergent ends of the cultural spectrum—business and pleasure—in an attempt to create a

Times Square existing conditions, 1985. Model, view to the northwest from West Forty-fifth Street. MAS

Times Square if developed according to Municipal Art Society's proposed zoning, 1985. Model, view to the northwest from West Forty-fifth Street. Bosselmann/Webb. MAS

brand-new yet "authentic" Times Square. Lynne Sagalyn would later observe that "the truly vexing problems were how to mandate diversity and how to encourage by legislation an environment that had evolved through the spontaneous actions of competitors trying to outshine one another."[56] Alan Lapidus, architect of the Holiday Inn Crowne Plaza Hotel (see below), summed up the dilemma: "It is very hard to codify whoopee."[57]

The majority of observers greeted the proposed zoning with optimism, viewing it as a method of preserving Times Square's tradition of signage and ensuring a continuity between the past and future of the Great White Way. Community board members, sign manufacturers, and Broadway celebrities, among others, spoke in its favor at public hearings in late 1986, though the district's three major theater operators lobbied for a toned-down set of guidelines that would allow imaginative lighting schemes in lieu of flashy advertising. The editors of the *New York Times* were quick with their endorsement, warning that if the zoning was not passed, and the buildings rose "as they now legally can, from the edge of the sidewalks, New York's most vital plaza would disappear in their shadows and Broadway's excitement would be dimmed to the point of extinction."[58]

The strongest opposition predictably came from developers who, having been encouraged to undertake complex, large-scale projects in the area were, after years of planning and design, now faced with having to go back to the drawing boards at their own expense. Yet the zoning seemed sensible and wise; so much so, that even before it was adopted in February 1987, William Zeckendorf Jr., the developer of the Holiday Inn Crowne Plaza, had Lapidus redesign the project in conformity with its provisions. But there was real fear among office devel-

opers that straitlaced tenants already lined up to lease space in the new projects would not take well to the flashy changes, that tenants in business suits would not come to work in a building dressed, as some felt, like a clown. David Solomon, a Chicago native, whose firm, Solomon Equities, was developing two office buildings, 750 Seventh Avenue (see below) and 1585 Broadway (see below), threw down the gauntlet in opposition. According to Solomon, his main tenant for 1585 Broadway, the investment banking firm Morgan Stanley, was threatening to leave New York if forced to hang signs from the building. Solomon argued that "investment bankers don't want to work in an environment surrounded by flashing lights. They want museums and sidewalk cafes."[59] To appease Morgan Stanley, Gwathmey Siegel & Associates, architects of the building, proposed to encase the required signs behind dark-tinted glass within the facade, so that during the day they would not be noticeable, but at night, when illuminated, they would stand out, an idea that Paul Goldberger felt "brings into focus the very contradiction that the whole evolution of Times Square represents. It is not really possible to have a place that is at once both a formal, dignified office environment and a lively entertainment district; some side of this equation has to give." To Goldberger, the priority was clear. There are "numerous other parts of town in which office buildings can be erected. . . . The honky-tonk vitality of Times Square and its incomparable visual energy have no equal in New York, and if they are to be lost in the current wave of office construction, they will be lost forever."[60]

As the proposed zoning made its way through the approval process, plans progressed, unfettered, for at least

Times Square if developed according to current zoning, 1985. Model, view to the northwest from West Forty-fifth Street. Crawford. MAS

six large-scale Times Square projects, alarming the Municipal Art Society so much that it urged the City Planning Commission to impose a moratorium on new construction until the zoning was officially put to a vote, a move Gregory Gilmartin later credited with convincing several developers to abandon their objections and comply with the amendments.[61] After the zoning was approved by the City Planning Commission, the Board of Estimate met on February 5, 1987, and gave its endorsement as well. Later that year, the future of Times Square as an entertainment district was secured when the City Planning Commission adopted an amendment to the zoning mandating that 5 percent of new floor space be set aside for entertainment-related enterprises.

In 1991, after several projects were completed in accordance with the 1987 amendments, Ada Louise Huxtable delivered her assessment: "In fairness, one must say that this is an unusually skilled and thoughtful set of urban design rules." But she tempered her praise with a kind of exhausted defeatism: "Never was a barn more splendidly locked after the horse was out." Huxtable took note of New York's "absolute mastery of Catch-22: The zoning defines the characteristics of the area brilliantly and supplies the criteria meant to protect and preserve those charactcristics; but because they are being destroyed by the new construction, and because the new construction is also destroying the place that supplied the characteristics, recreating them is an exercise in artifice and futility. They become a kind of splendid wallpaper, or light show for a performance that isn't there." Huxtable concluded, "Times Square cannot be saved in any form resembling what so many want to save; the process of physical and economic conversion is overwhelmingly and irre-

versibly at work. What we are talking about is saving an image or a legend. This is not the first change in the area or the last. What is different is that this one is unique in terms of scale and destruction, and the sense that something is being lost rather than gained. Even if the performing arts and the theaters can hold fast, it will be in a context of an overpoweringly standardized commercial culture, and no matter how distinguished the artifacts, this will be another kind of place. Times Square is dead; long live Times Square."[62]

Post-Portman Boom: The New Hotels

Though many had predicted that the seedy reputation of the area would doom the Marriott Marquis, in 1988 the hotel achieved the highest occupancy rate—just over 80 percent—of any Manhattan hotel with over 800 rooms, igniting a hotel building boom that Mark McCain, writing in the *New York Times* in 1989, characterized as one "surpassing any that Times Square has seen in more than half a century."[63] Within three blocks of Portman's Marriott, four hotels were built in rapid succession, bringing over 2,100 new rooms to the area. In addition to the influence of the Marriott Marquis, the rush to build was stimulated by the impending expiration in May 1988 of the 1982 west midtown zoning bonus.

The design of the new hotels, at least the three located directly on Broadway, was significantly influenced by the 1987 changes to the zoning law mandating a dramatic increase in signage. The first to go forward was the 770-room Holiday Inn Crowne Plaza (1987–89), located on the west side of Broadway between Forty-eighth and Forty-ninth Streets.[64] The site had once been home to Churchill's Restaurant (Herbert M. Baer, 1910; rebuilt as a theater, Eugene De Rosa, 1937),

Holiday Inn Crowne Plaza, 1605 Broadway, between West Forty-eighth and West Forty-ninth Streets. Alan Lapidus, 1989. View to the west. Mauss. ESTO

which by the 1980s had become the area's most elaborate and well-maintained pornographic movie house, the Pussycat Cinema; it was demolished in 1986. As developed by William Zeckendorf Jr. and designed by hotel specialist Alan Lapidus, the forty-six-story, 800,000-square-foot building responded to the proposed zoning changes regarding signage and setback requirements even before the law was passed, with Lapidus envisioning the possibility of even more spectacular effects on the Broadway facade, including three-dimensional holograms and laser light shows, but having to content himself with abstract patterns of flashing bulbs on the first twelve stories of the building—advertising signs would come later, as Times Square's renaissance spilled over to the hotel's slightly invisible location. Holiday Inn Crowne Plaza rose from its two-step base to an eye-catching tower sheathed in pinkish brown reflective glass except at its southeast and northeast corners, where pink brick and granite formed a turretlike element housing the elevators. According to Lapidus, the inspiration for the 100-foot-tall proscenium-like entrance came from an icon of popular culture: "The Wurlitzer Company designed a jukebox that imitated the design of the buildings that went up around Times Square in the 1930's and 1940's, and now I'm imitating Wurlitzer."[65]

The critics were in almost equal measure elated and appalled by Lapidus's bravura approach. Ada Louise Huxtable seemed to take the project as a serious work of architecture. While most observers were content to downplay the aesthetics and consider the design as a successful test of the practical-

ity of the new zoning, Huxtable found it "earnestly flamboyant" but "singularly joyless. It is not easy for a 46-story structure faced in burgundy glass and pink granite, shaped like a juke box, with a 100-foot-high arched entrance . . . and 12 stories of light and signs to be dull, but this one succeeds. . . . If this is fantasy, how impoverished are our dreams!"[66] But Jerry Adler, writing in *Newsweek* magazine, planted his tongue gently in his cheek, parodying the criticism Lapidus's much more famous father, Morris, received for his concept of an "Architecture of Joy." Adler described the almost-complete Holiday Inn Crowne Plaza as perhaps "the most gorgeous building in all Manhattan, a great pink tongue of lasciviously rounded brick and glass sticking up at the sky. It will be even more gorgeous at night, washed in the lurid megawattage of its billboards, raining gorgeousness down on the radiance-starved multitudes."[67]

Nine months after the opening of the Holiday Inn Crowne Plaza, in September 1990, the Holiday Corporation, the parent company of Holiday Inn, completed another Times Square hotel, the Embassy Suites, this time working in partnership with the developer Larry Silverstein and the architects Fox & Fowle.[68] Located on the southeast corner of Broadway and Forty-seventh Street, the forty-three-story, 430,000-square-foot, 500-foot-high hotel filled a narrow 21,730-square-foot lot, 13,500 square feet of which was occupied by the Palace Theater (Kirchhoff & Rose, 1913), the interior of which had been landmarked in 1987, although the eleven-story office building portion facing Seventh Avenue was torn down except for its ground floor, which formed the theater's lobby.[69] In order to preserve the Palace's auditorium, the hotel structure was cantilevered over the five-story theater. To pull off this considerable feat of structural acrobatics, the engineers, DeSimone, Chaplin & Dobrin, called for two 130-foot-long, 57-foot-deep concrete-encased steel trusses carried on four 145-foot-tall, concrete-and-steel supercolumns, two of which straddled the theater entrance on Broadway while the other two rose out of an existing alleyway on the east side of the site. Above the eighth floor, the building was supported by a conventional arrangement of flat-slab reinforced concrete.

Fox & Fowle's design for the 460-unit all-suite hotel featured a gray brick and blue-tinted glass facade enlivened by red and blue glazed brick accents. An ornamental "fin" marking the intersection of the two interlocking masses of the tower ran the full height on the west facade. To comply with the new zoning requirements, a curved wall containing more than 10,000 square feet of illuminated signs wrapped the bottom 120 feet of the building. Due to the constrained site, the public spaces, including the third-floor "sky" lobby and the five-story atrium illuminated by a skylight at the eighth-floor setback, were stacked in front of the theater. A new lobby and marquee, as well as additional dressing rooms and backstage space, were required for the 1,701-seat Palace Theater, whose landmarked auditorium was restored.

In its massing and some of its details, Fox & Fowle's design recalled Howe & Lescaze's pioneering International Style skyscraper, the PSFS (Philadelphia Saving Fund Society) Building (1932), a connection Paul Goldberger suggested when he characterized it as "a kind of jazzed-up International Style building in gray masonry, with red stripes and blue accents. . . . If all this seems to be old-style modernism made sleek and trendy, it feels energetic and zestful, and is just right for Times

Square."[70] Ada Louise Huxtable was just as pleased with the results: "The building's exterior of dark metal and glass, with vertical and horizontal sections divided by a striking red fin, is a complex composition that emits a number of stylistic signals, from basic Bauhaus to Detroit modern with Constructivist overtones. It is saved from cleverness by the expert and rigorous organization of its parts."[71]

The most controversial of the post-Portman hotels to go forward, though not from an architectural standpoint, was Harry Macklowe's eponymous hotel at 145 West Forty-fourth Street, running through to Forty-fifth Street, just off Times Square and east of Broadway, a site not covered by the new zoning mandate for increased signage.[72] The Macklowe project had a curious, even sinister, history. On the night of January 7, 1985, with not a single permit in place and having failed to turn off the gas, electricity, and water service, Brooklyn contractor Mitran Associates began the demolition of four low-rise buildings on the site, leading to what Joe Klein, writing in *New York* magazine in December of the same year, would revile as "*the* symbol of real-estate development gone amok."[73] Having blocked off the street with a parked car whose license plate was covered and working with a 100-foot-high boom and a front-loader outfitted with a twenty-foot-long rake, the demolition contractors were stopped after a few

hours' work by the police, alerted to the scene by onlookers astonished not only by the unusual time of the work but by the fact that the area of destruction was not even cordoned off to protect pedestrians, with bricks and debris littering the street, forcing its closure for a week. The partially damaged structures included two single-room-occupancy (SRO) hotels that had only recently become vacant, an eighteen-unit, five-story building at 143 West Forty-fourth Street, and the seven-story, fifty-nine-room Lenox Hotel at 149 West Forty-fourth Street, as well as two long-vacant five-story walk-up residential buildings at numbers 145 and 147.

The story quickly became front-page news in the *New York Times* as the mystery of who ordered the demolition heated up. The owner of the four buildings was quickly identified as prominent real estate operator Sol Goldman, who denied responsibility, pointing the finger at another major player in the New York real estate market, Harry Macklowe. Macklowe, who also asserted his innocence, was a property owner on the block, having purchased in May 1984 the Hudson Theater (J. B. McElfatrick & Son and Israels & Harder, 1903), 141 West Forty-fourth Street, shuttered since 1983.[74] The Hudson was located just to the east of the affected buildings. While city officials tried to identify the guilty party, the motivation and timing of the action became very clear: the

Embassy Suites, 1568 Broadway, southeast corner of West Forty-seventh Street. Fox & Fowle, 1990. View to the east showing United States Trust Company Headquarters (Fox & Fowle, 1990) in background. Gordon. FXF

Embassy Suites, 1568 Broadway, southeast corner of West Forty-seventh Street. Fox & Fowle, 1990. View to the west showing Marriott Marquis (John Portman, 1985) on the left and 1585 Broadway (Gwathmey Siegel & Associates, 1990) on the right. Gordon. FXF

Hotel Macklowe, 145 West Forty-fourth Street, between Sixth Avenue and Broadway. Bill Derman and Perkins & Will, 1990. Lobby. MP

City Council was on the verge of signing legislation that would place an eighteen-month moratorium on either the demolition or conversion of SRO hotels, a law that would take effect on January 9, just two days after the illegal demolition of the four buildings, two of which were legally classified as SROs, began. More than 35,000 rooms in SRO hotels had been lost in the late 1970s and early 1980s, when they were either torn down or renovated to make way for market-rate housing and commercial space, and the city wanted to at least temporarily stop a process that many regarded to be a major reason for the dramatic rise in the city's homeless population.

The Koch administration, noting with regret that the most severe penalty anyone could be charged with for the illegal demolition, despite the potentially disastrous consequences of having failed to turn off the utilities, was only a misdemeanor, threatened a $10 million civil suit against the individuals found responsible for the action. In May 1985, after a four-month grand jury inquiry, Harry Macklowe pleaded guilty to reckless endangerment, while the demolition contractors were indicted for the same offense and Sol Goldman was charged with lying before the grand jury about Macklowe's culpability (after an eleven-week trial in 1986, Goldman was found not guilty of perjury, with the jury returning a verdict after only fifteen minutes of deliberation). Macklowe received no jail sentence, but he agreed to pay $2 million to settle the city's $10 million civil suit, with the money earmarked to finance programs for the homeless, including the renovation of SRO hotels. The New York Times did not celebrate the settlement, believing that Macklowe got off far too easily, buying "public justice at a private sale, and a clear path to profits that make the price a bargain."[75] The Koch administration defended the

settlement and noted that in addition to the substantial financial penalty, a new law had been passed by the City Council that would prevent Macklowe, who had exercised an option with Goldman and now owned the four buildings that remained partially destroyed and boarded up, from building on the site for a full four years, a severe prohibition they felt would discourage other developers from repeating his strategy.

Only two years later, however, in September 1987, after Macklowe paid an additional $2.7 million as a "buyout" payment required to finally demolish the seven-story Lenox Hotel, foundation work began on his new hotel. City Council members and citizen groups were outraged to learn that when the moratorium on SRO demolition and conversion came up for renewal, the Koch administration had removed Macklowe's four-year prohibition, "almost as furtively as Mr. Macklowe's crew had cleared the site," according to the New York Times, alternately arguing that they feared the measure was unconstitutional because it was enacted retroactively, only after Macklowe's demolition attempt, and that there was no public benefit in leaving the site in so shabby a condition.[76]

Macklowe's plans for the fifty-two-story, 638-room hotel, aimed at the high-end business traveler, included 45,000 square feet of commercial space as well as a 100,000-square-foot conference center that would make use of the restored 1,100-seat Hudson Theater whose interior and exterior had been landmarked in 1987. In addition to close to 180,000 square feet of air rights gained from the theater, the great size of the hotel was secured because Macklowe did not have to wait the full four years until 1989 to start construction as the original penalty required, allowing him to take advantage of the 1982 West Midtown Zoning Resolution, which was set to expire in May 1988. Gruzen Samton Steinglass was hired as the architect but, as was the case in many of Macklowe's projects, the real design work was done in-house, with Bill Derman, who had worked with Macklowe on the black glass Metropolitan Tower, overseeing the design; the Gruzen firm was eventually let go, and Perkins & Will, consultants on the project, served as the architects of record. The design consisted of a seven-story limestone base topped by a tower. According to Philip M. Jones, of Macklowe's in-house design team, the stone base was meant to harmonize with the adjacent Hudson Theater, "creating the sense that they're one structure, giving the buildings one identity."[77] While the base may have related well to the Hudson Theater, Paul Goldberger felt that it came at the expense of the hotel building as a whole, which he described as a "mediocre new tower of dark green glass on a stone base that appears to have been designed for another building altogether. If ever there was a building in Manhattan where it is better to be inside looking out than outside looking in, it is the Hotel Macklowe." Goldberger focused his attention on what he deemed one of the city's "most impressive and sophisticated" new interiors, especially the through-block lobby with its black-absolute and leopard marbles, African-mahogany and lacewood-veneer paneling, and polished and brushed stainless-steel detailing. "The lobby," Goldberger gushed, "comes closer than any space since the renovated Rainbow Room to evoking the spirit of New

FACING PAGE Ramada Renaissance, Two Times Square, site bounded by Broadway, Seventh Avenue, West Forty-seventh and West Forty-eighth Streets. Mayers & Schiff, 1992. View to the northeast. Warchol. PW

Proposed Hotel Sofitel, 45 West Forty-fourth Street, between Fifth and Sixth Avenues. Michael Graves, 1997. Model, view to the southeast. GRV

Hotel Sofitel, 45 West Forty-fourth Street, between Fifth and Sixth Avenues. Brennan Beer Gorman, 2000. View to the northeast showing the New York Yacht Club (Warren & Wetmore, 1899; restoration including replica of original pergola, Paino/Soffes, 1993) on the right. Mauss. Esto.

York City in the 1930's—not literally as it was in the 30's, but how it would have been had the image of the city from the movies existed in real life."[78]

To help decorate the guest rooms, Macklowe's wife, Linda, a former museum curator, commissioned a series of limited-edition prints from contemporary architects, including Michael Graves, Zaha Hadid, Arata Isozaki, Rem Koolhaas, Daniel Libeskind, Morphosis, and Bernard Tschumi. The five-story conference center, geared primarily for New York firms needing additional meeting space but not wanting to leave the city, was entered on Forty-fifth Street and included thirty-three meeting rooms but was most notable for its inclusion of the restored landmark Hudson Theater, a two-balconied house with a lavish interior, including lobby walls of verde antique marble, a coffered stucco ceiling inspired by the Baths of Titus in Rome, and triple-domed ceiling lights designed by Louis Comfort Tiffany. After its use as a legitimate theater, the Hudson served in the 1950s as television studios for the first production of NBC's *Tonight Show*, with live drama returning in the 1960s; from 1981 to 1983, the theater was home to a nightclub called the Savoy. Stonehill & Taylor was placed in charge of the restoration, scheduled to be completed after the opening of the hotel, and the theater space was used during the hotel's construction to promote

the project, with replicas of two guest rooms and conference facilities built on the stage.

Macklowe received some good news in the form of a check drawn from city coffers to the tune of more than $3.3 million, paid to the developer because the United States Supreme Court let stand a ruling by the New York State Court of Appeals that declared unconstitutional the city's moratorium on the demolition or conversion of SRO hotels. Macklowe's restitution, including more than $645,000 in accrued interest, covered his costs for the "buyout" of the Lenox Hotel, although his payment of $2 million to settle the city's $10 million civil suit was unaffected. But the developer was not to have the last laugh. In 1994, under the threat of imminent default on a $100 million mortgage held by Chemical Bank, Macklowe was forced to surrender the hotel as well as several other properties to the bank, which quickly sold the hotel to the Singapore-based developers CDL Hotel International, who changed the name to the Millennium Broadway.[79] In 1997 the new owners purchased the three-story building (1911; renovated, John J. McNamara, 1947) just to the east of the Hudson Theater at 133 West Forty-fourth Street, home to the Newspaper Guild since 1946, and built a twenty-two-story annex (Stonehill & Taylor, 1999) adding 122 oversized rooms and duplicating the architecture of the original building.

The last of the quartet of post-Portman hotels to be finished, Mayers & Schiff's Ramada Renaissance (1992), Two Times Square, was also the one that most enthusiastically embraced the call for increased, exuberant signage.[80] The smallest but the most prominently sited of the new hotels, the twenty-five-story, 230,000-square-foot, 300-room Renaissance was located at the north end of Times Square on the 14,000-square-foot trapezoidal islandlike block bounded by Broadway, Seventh Avenue, Forty-seventh and Forty-eighth Streets. The site was previously home to two taxpayers—the three-story Theater Arts Building (1925), 1576 Broadway, and the two-story Palais Royal (Shire & Kaufman, 1912), 1578 Broadway—but was most notable for the immense, much-loved, forty-by-forty-four-foot red neon Coca-Cola sign that was affixed to the Theater Arts Building in 1965. Jeffrey Katz, president of Sherwood Equities, the owner of the site and developer of the project, pledged a suitable replacement.

As Mayers & Schiff designed it, the Renaissance was as much a framework for billboards as a hotel. All in all, 23,000 square feet of signage was specified, or about 4,700 square feet more than required. The enthusiastic adoption of the signage mandate was hardly surprising: the architects had been instrumental in the original studies leading to the zoning changes (see above) and were also responsible for the pipe-and-canvas TKTS pavilion (1973) directly in front of the hotel in Duffy Square, a highly successful modern icon of Times Square that was in effect one large sign.[81] Budgetary considerations, however, eliminated the architects' initial proposal to crown the reflective black glass and gray brick building with a flamboyant top, designs for which ranged from a rotating circular sign equipped with a beacon to a large elliptical sign decorated with illuminated concentric rings. Still, the Times Square razzle-dazzle of the design was impressive, especially after the arrival of a spectacular, fifty-five-ton, sixty-five-foot-

Hotel Sofitel, 45 West Forty-fourth Street, between Fifth and Sixth Avenues. Brennan Beer Gorman, 2000. View to the northwest. Mauss. ESTO

ABOVE Proposed Harvard Club addition, north side of West Forty-fourth Street, between Fifth and Sixth Avenues. Edward Larrabee Barnes, 1986. Model, view to the north. HC

BELOW Proposed Harvard Club addition, north side of West Forty-fourth Street, between Fifth and Sixth Avenues. Richard Cameron, 2001. Photomontage, view to the northeast. ARIEL

high, forty-one-foot-wide sign illuminated by more than sixty miles of fiber-optic tubing and 13,000 light bulbs depicting a forty-two-foot-high bottle of Coca-Cola topped by a cap that flipped on and off. In fact, it was the revenue from the signage, even more than from the rooms, that was vital to the project's financial success.

Critical reaction to the Ramada Renaissance was generally positive. Herbert Muschamp singled out the Renaissance as the "only one of the new [Times Square] buildings [that] walks a perfect line between the sober and the gaudy." Instead of pasting signs onto the facade, Muschamp noted, Mayers & Schiff "turned the signs into the facade. They're attached directly to the building's structure, its concrete columns exposed through notches cut through the skin of dark gray brick and glass. This taut fusion of architectural rigor and Madison Avenue seduction is the most advanced piece of design to go up in Times Square since the TKTS booth was created (also by Mayers & Schiff) 19 years ago."[82] In 1996 Gretchen Dykstra, then president of the Times Square Business Improvement District, offered compelling testimony as to the impact and importance of the new hotel: "Those signs at Two Times Square changed the classic orientation of the area. In the past the most common view was to the south. Now it is more to the north."[83]

Designed with all the flamboyance of a Times Square hotel, but located to the east on the button-down Club Row block of Forty-fourth Street between Fifth and Sixth Avenues, Brennan Beer Gorman's Hotel Sofitel (2000), 45 West Forty-fourth Street, was built by the Paris-based hotelier Accor in conjunction with Alan B. Friedberg, who rejected an equally flashy but better-resolved scheme by Michael Graves.[84] Project architect Yann Leroy's task was to make the 280,000-square-foot, thirty-story hotel emit a "Frenchness" at once related to the architecturally rich context of its block and at the same time belonging, aesthetically, to the twenty-first century. The midblock site, just west of the New York Yacht Club (Warren & Wetmore, 1899), was a T-shaped, 15,800-square-foot vacant lot once home to the twelve-story Beaux-Arts-style Seymour Hotel (Ludlow & Valentine, 1903), demolished by real estate investor Marvin S. Winter in the early 1980s to make way for an office tower that was never built.[85] Leroy fit the hotel's 402 rooms into a limestone, glass, and precast concrete building confronting Forty-fourth Street with an overscaled sixty-foot-high limestone-framed glass and bronze entrance that managed to upstage the Yacht Club, hitherto regarded by most observers as New York's most over-the-top Beaux-Arts monument. Above the base, the hotel rose in a series of telescoping blue-tinted glass cylinders that defied the context. Two lower twenty-story limestone and precast concrete wings flanked the glass tower but did little to mitigate its alien presence. To Herbert Muschamp, the building was "a coltish performance" by an architect with great potential, a design "more promising than accomplished." In particular, Muschamp was offended by the tower's cladding: "The appeal of tinted blue glass escapes me. A gem in old small-town drugstores, this material has become debased by overuse in the lesser suburban office parks. . . . It is particularly regrettable compared with all the supertransparent, so-called white glass in recent French architecture."[86]

The classicism of the Club Row block was further challenged in 2001 when the Harvard Club released plans to build a glassy addition between the Yacht Club and its land-

Harvard Club addition, 35 West Forty-fourth Street, between Fifth and Sixth Avenues. Davis Brody Bond, 2003. View to the north. Warchol. DBB

marked, McKim, Mead & White–designed red brick and limestone clubhouse.[87] The Harvard Club had expanded several times since the first three-story portion was completed in 1894. In 1903 and 1915 McKim, Mead & White designed substantial additions, and in 1946 Henry Ives Cobb added a two-story western wing, but all of the new work was in sympathy with the character of the original Georgian building. A proposal in 1986 that called for an eight-story addition surprisingly designed in the Georgian manner by the arch-Modernist Edward Larrabee Barnes, who held two Harvard degrees, did not move beyond the planning stages.[88] In 1991

another plan for an eight-story red brick and limestone addition designed by Buttrick White & Burtis to fit in with the club's existing buildings failed to move forward.[89] As designed by Harvard alumnus Max Bond and Christopher Grabé of Davis Brody Bond, the proposed glass, steel, and limestone 40,000-square-foot annex rose three stories to match the cornice line of McKim's 1894 building before setting back for an additional five floors. The fifty-foot-wide addition contained eighteen guest rooms, two squash courts, a fitness center, meeting and dining rooms, as well as administrative offices. It would replace two buildings, 33 West

Forty-fourth Street, a three-story building housing a hardware store that was originally a stable (1860), and 35 West Forty-fourth Street, another stable (1859) that had been reworked in Cobb's 1946 addition. The Modernist wing had its own entrance shielded by a steel canopy, but the clubhouse's original entry was retained.

When proposed, the addition was quickly enveloped in controversy, with preservationists claiming that the design would make an unsuitable neighbor for both the Yacht and the Harvard clubs. Surprisingly to many, the Landmarks Preservation Commission, in a phase that seemed overly anti-contextual in its leanings, deemed the new design appropriate to its setting. Hackles were also raised within the Harvard Club itself as some members, while acknowledging the need for growth, strongly protested the plan. Financier and classical architecture enthusiast Richard Jenrette spoke for many when he labeled the addition "a totally discordant note" that "looks cold and uninviting—like one of the 1960's Bauhaus office buildings."[90] Several dissident club members joined together as the Committee for HCNY Choice, filing a lawsuit to stop the project as well as commissioning a counterproposal for the site. Over a weekend, Richard Cameron, a co-founder of the Institute for Classical Architecture, designed a limestone-trimmed red brick Georgian-style addition that was remarkably stylish and distinct yet completely sympathetic to the historic clubhouse.

While defending his scheme as contemporary but "respectful" of its landmark neighbors, Max Bond attacked Cameron's proposal by stating, "It demeans the existing buildings to mimic them."[91] Bond's scheme won the support of architect Roger K. Lewis, who wrote in the *Washington Post* that the

> stepped-back massing and rectilinear composition of the addition's transparent facade, a glass and metal curtain wall, are derived from both the massing and vertical and horizontal compositional patterns of the older clubhouse and the 1899 New York Yacht Club abutting the site from the west. . . . This is no trend-setting or avant-garde scheme, but rather another competent, respectfully composed addition to the New York City streetscape, a non-threatening 'background' building, even with its politely audacious transparent skin. Ultimately it will be neither an architectural embarrassment nor provocation.[92]

Construction began after the lawsuit brought by the Committee for HCNY Choice was dismissed in State Supreme Court, and the completed building was officially dedicated on November 5, 2003. Although the enlarged space and new interior amenities were welcomed by many, criticism still dogged the project, with club member Lloyd Zuckerberg regretting that "it's worse in reality than it was on paper."[93]

Corporate Times Square

Fox & Fowle's 1675 Broadway (1986–89), west blockfront between Fifty-second and Fifty-third Streets, was among the first in the wave of new office buildings completed after the establishment of the 1982 Special Midtown Zoning District encouraging high-density development in west midtown.[94] The thirty-five-story, 750,000-square-foot green granite–clad tower adjoined and cantilevered forty-five feet over the Broadway Theater (Eugene De Rosa, 1924), originally B. S. Moss's Colony Theater, southwest corner of Fifty-third Street, whose air rights were transferred to the tower, the design of which, inspired by 30 Rockefeller Plaza (Associated Architects, 1933), consisted of a broad rectangular slab shaped

by slender horizontal and vertical setbacks.[95] Terminated by a rectangular volume of polished granite, the tower rose out of a stepped base, creating a wealth of corners that, as Susanna Sirefman conjectured, were a response to the many corner offices required by the "intended tenants, corporate law firms."[96] The windows, recessed on the base only, were, on the tower, given an illusion of depth by a pattern of nondirectional flame-finished granite overlayed with a grid of polished granite and metal panels.

The most impressive aspect of Fox & Fowle's design was the bold cantilever over the theater, a feat James Ruderman, the structural engineer, made possible by employing six north-south trusses, the largest weighing 200 tons, to transfer the load of the north side of the building to the south, and consequently allow for two 28,000-square-foot floors above the theater and, above them, ten 24,000-square-foot column free floors. Before construction on the tower began, the Broadway Theater underwent an interior renovation under the direction of set designer Oliver Smith, reopening in 1986. During construction of the office tower, the theater's facade was resurfaced in granite to make it and the tower "seem like one solid building," according to Bruce Fowle, and a new Art Deco–style marquee was designed to project over the sidewalk in contrast to the office building's recessed entry.[97] Paul Goldberger deemed the building "exceptionally handsome, even dignified."[98] But Sirefman was not so sure: "An elaborate combination of thermal and polished granite does not alleviate the sombre massing. Multiple setbacks and recessed windows add an element of verticality, but sadly the overall effect is unpleasantly monolithic."[99]

In 1990 three major office buildings were completed on Broadway between Forty-fifth and Fiftieth Streets. The largest was Gwathmey Siegel & Associates' 1585 Broadway, occupying the west blockfront between Forty-seventh and Forty-eighth Streets, a bulky 1.3-million-square-foot, fifty-two-story tower replacing the four-story neoclassical Strand Theater (Thomas W. Lamb, with George Keister and Otto Bauer, 1913–14), the first Broadway theater built for motion pictures, as well as Leighton's Haberdashers and Clothiers, a sixty-seven-year-old stalwart among Broadway retailers.[100] The first skyscraper designed by the Gwathmey firm (which worked in association with Emery Roth & Sons), the project represented a huge jump in scale from its previous work consisting primarily of houses, office interiors, and small office buildings. Attempts to mitigate the building's massive bulk were made in part with notches and setbacks and in part with what the architects called the "layered graphic" of its sheathing of blue-green, white patterned, and mirrored glass, silver-gray aluminum panels, and polished stainless steel, intended to encourage "multiple facade readings" and produce "images of both opacity and reflectivity, creating a simultaneous sense of fluidity and permanence."[101] The base, trapezoidal in plan to meet the diagonal of Broadway, rose in a series of setbacks—the first two rectilinear and the third a bold segmented curve at the level of a double-height mechanical floor—that facilitated an axial shift to the orthogonal orientation of the tower, which was crowned with four sloping backlit panels constituting a variation on a mansard roof. All in all, the building enjoyed a distinctive skyline presence.

The considerable amount of signage required under the 1987 zoning amendment was handled uniquely at 1585 Broadway—hidden behind dark-glass panels within the building's

1675 Broadway, between West Fifty-second and West Fifty-third Streets. Fox & Fowle, 1989. View to the southeast. Gordon. FXF

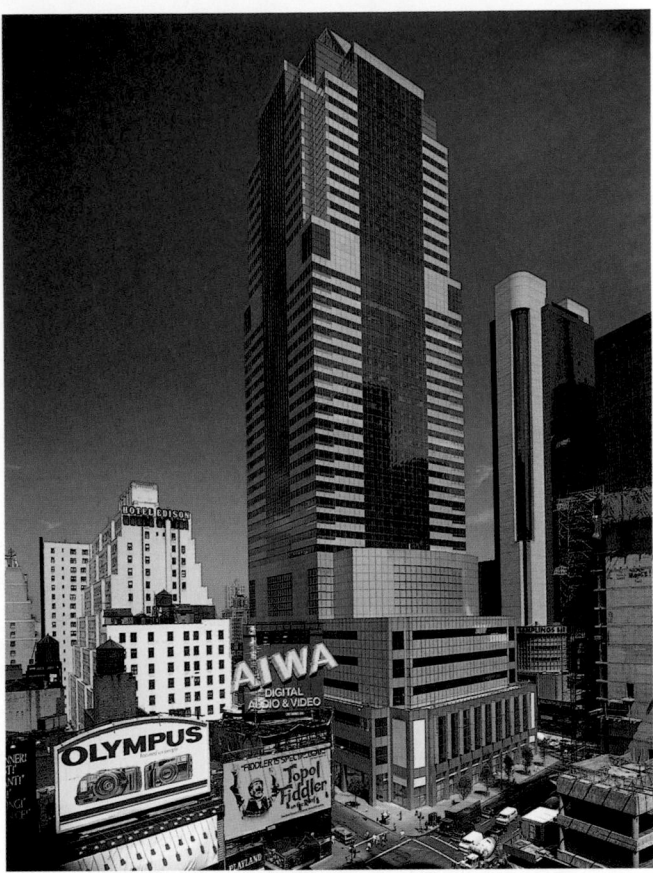

1585 Broadway, between West Forty-seventh and West Forty-eighth Streets. Gwathmey Siegel & Associates, 1990. View to the northwest. Goldberg. ESTO

base instead of hung on the exterior—so that it could appear staid and businesslike during the day yet showy when lit at night. When the building was completed in 1990, the slumped economy found many of Times Square's signs conspicuously blank, leading Paul Goldberger to comment, "The one thing that can absolutely be said in favor of the Gwathmey Siegel solution [to the signage requirements] is that it leaves 1585 Broadway better prepared for the recession, at least esthetically. For this building has a real facade, designed to stand on its own, that looks reasonable even when not a square inch of the sign space is rented."[102]

The building was widely praised for the formal precision of the detailing of its glass curtain wall, which was seen as a welcome departure from the stone-clad Postmodern towers of the 1980s. Goldberger called its skin "a kind of laundry list of modern elements, but here put together into a geometric pattern that manages to be neither flat nor dull. The real achievement is that the architects have found a way within the modernist vocabulary to give their building the thing most modern buildings most urgently lack: texture." Although he objected to certain features of the building—"the top . . . couldn't be more wrong," for instance—Goldberger was pleased overall, declaring the building "exactly right at street level." He was even more enthusiastic about its lobby, a vast, handsome space shaped by gray granite and dark green marble walls, a patterned white, black, and dark green marble floor, and a wood coffered ceiling that the critic considered "striking, almost daring."[103] Ada Louise Huxtable was a bit more

measured but nonetheless positive, calling 1585 Broadway "a stunning event" that "carries the sheer, sleek precision of the modernist curtain wall to new intricacy and richness."[104]

Like many of its peers at the time, 1585 Broadway opened to an office market whose bottom had fallen out. The law firm of Proskauer Rose Goetz & Mendelsohn, which, in 1988, had signed on to lease 365,000 square feet in eleven floors and a sub-basement of the building, was the sole tenant from 1990 until 1995. In 1992 the owners filed for Chapter 11 bankruptcy protection. By 1993, though other hard-strapped neighbors had pulled out of their economic nosedives, the *New York Times* reported that 1585 Broadway was still the "one big loser" of the area, a victim primarily of disagreements among the three banks that controlled the building about who to accept as tenants.[105] In August 1993, Morgan Stanley, the investment banking firm that ten months earlier had threatened to move to Stamford, Connecticut, but was given generous tax incentives to stay in Manhattan, purchased 1585 Broadway, and by 1995 consolidated its Manhattan offices into 935,000 square feet of the building, putting a stamp of approval on Times Square as a viable location for serious business. Gwathmey Siegel was hired to design the office interiors, retrofit the lobby, which would now offer access to a below-grade 500-seat employee cafeteria built in a former storage area, and reconfigure two upper floors for executive offices.

Morgan Stanley also asked Gwathmey Siegel to design new signage for the building that would finally embrace, not subvert, the 1987 zoning. According to Bob Jackowitz, the project

1585 Broadway, between West Forty-seventh and West Forty-eighth Streets. Gwathmey Siegel & Associates, 1990. View to the southwest. Goldberg. ESTO

1585 Broadway, between West Forty-seventh and West Forty-eighth Streets. Gwathmey Siegel & Associates, 1990. View to the southwest showing new signage, 1996. Aaron. ESTO

1585 Broadway, between West Forty-seventh and West Forty-eighth Streets. Gwathmey Siegel & Associates, 1990. Lobby. Aaron. ESTO

manager at Artkraft Strauss, the sign company working on the project, the information displayed "had to emerge smoothly as if from the heart of the building, travel, and reenter the building smoothly, as if for reprocessing."[106] The results included three 160-foot-long, ten- to twelve-foot-high zipper signs along Broadway that displayed real-time stock quotes and financial news; two forty-four-foot-high faceted cylindrical signs on the building's two Broadway corners, each showing an image of the world's continents and time zones; two thirty-by-sixty-foot video screens hung from the base facing north and south; and, above street level, ten vertical black glass fins, each with a letter or number spelling out "1585 B'way."

Across the street from Gwathmey Siegel's tower, Kevin Roche John Dinkeloo and Associates' 750 Seventh Avenue occupied the block bounded by Seventh Avenue, Broadway, Forty-ninth, and Fiftieth Streets.[107] Completed in 1990, 750 Seventh Avenue awkwardly piled 640,000 square feet into a thirty-five-story glass-clad continuously stepped back tower rising to form a prismatic, ziggurat-inspired ascending spiral and culminating in a beaconlike spire that evoked, for many, a skyward-pointing

FACING PAGE 1585 Broadway, between West Forty-seventh and West Forty-eighth Streets. Gwathmey Siegel & Associates, 1990. View to the east. Goldberg. ESTO

finger, suggesting "a rude hand gesture" to Carter Wiseman. The base was covered in 17,664 square feet of signage, above which two types of glass—ceramic-coated panels that expressed the vertical and horizontal structure and dark gray reflective glass for office windows—sheathed its form. Reflecting upon the inherent challenge of mixing office building seriousness with Times Square hootenanny, Wiseman felt that Roche was simply not up to the task, perhaps because he was too "classy" an architect to succeed at what the critic termed "legislated costumery."[108] But if not a masterful work of architecture, the "agreeably quirky" building, as Paul Goldberger called it, did have a quality that begged interpretation. Goldberger was reminded of "a high-tech version of an old factory smokestack,"[109] while Susanna Sirefman likened it and the "short stubby aerial" to a "gigantic gadget—perhaps an enormous mobile phone." But Sirefman was not impressed by the design's chief characteristic: "The helical form was intended by Roche to be more dynamic than a series of stacked rectilinear boxes. It does not succeed."[110] Still, Ada Louise Huxtable gave credit to

both 750 Seventh Avenue and 1585 Broadway for utilizing "dramatic developments in glass technology in which the material reacts visibly to changing conditions for a subtler, more elaborate and dynamic aesthetic than previously possible."[111]

Fifteen-forty Broadway, occupying the east blockfront between Forty-fifth and Forty-sixth Streets, was first known as One Broadway Place and later as the Bertelsmann Building, after the German media company that purchased it in 1992.[112] Designed by Skidmore, Owings & Merrill, the forty-six-story, 1,075,000-square-foot tower was built for the Broadway State Partnership, a group headed by Ian Bruce Eichner and VMS Realty Partners, to replace the Loew's State Theater and the sixteen-story Loew Building (1920) above it, both designed by Thomas W. Lamb.[113] Initially, Eichner retained the Chicago-based firm Murphy/Jahn to design a fifty-eight-story mixed-use skyscraper containing 900,000 square feet of theater, retail, hotel, and residential space.[114] As plans progressed, Eichner gradually abandoned the mixed-use program in favor of that of an office tower, which, he was advised, would cost far less to

750 Seventh Avenue, block bounded by Seventh Avenue, Broadway, West Forty-ninth and West Fiftieth Streets. Kevin Roche John Dinkeloo and Associates, 1990. View to the northwest. KRJDA

Proposal for east blockfront of Broadway, between West Forty-fifth and West Forty-sixth Streets. Murphy/Jahn, 1985. Rendering of view to the northeast. MJ

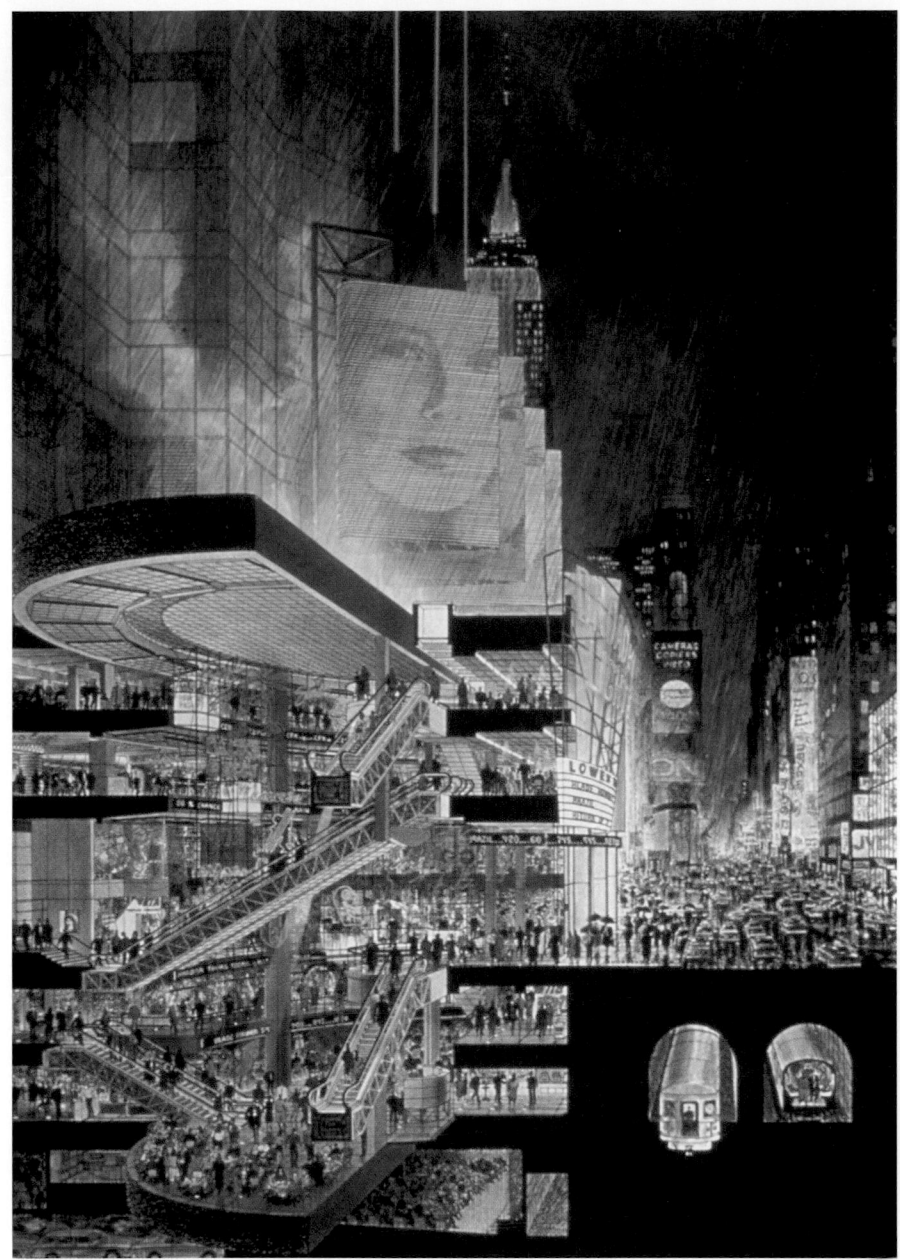

build and bring in an equal amount of revenue. Eichner retained SOM, with David Childs in charge, to design 850,000 square feet of office space including in the base four movie theaters, a garage, and, in an attempt to tie it in with the commercial extravagance of Times Square, a planned 150,000-square-foot retail complex on six levels designed by the Los Angeles–based Jerde Partnership. The vertical mall, dubbed "Metropolis Times Square," was to feature a 90-by-120-foot semicircular wall of neon signs, lighting, and sound effects—known slangily as the "Whiz Bang"—conceived as a "distillate of Times Square," according to Jon Jerde, all separated from the street by a clear glass wall.[115] Financial considerations rendered the mall unrealizable, and the impressively scaled space lay vacant until April 1996, when part of it became the Virgin Megastore (BNK Architects), the largest music store in the world, with appropriately scaled video screens, crisscrossing escalators, and a fifty-foot-high DJ booth.[116]

1540 Broadway, between West Forty-fifth and West Forty-sixth Streets. Skidmore, Owings & Merrill, 1990. View to the southeast. Mauss. ESTO

Proposed Rockefeller Plaza West, 745 Seventh Avenue, between West Forty-ninth and West Fiftieth Streets. Kohn Pedersen Fox, 1987. Model, view to the southeast. Pottle. ESTO

The Bertelsmann Building, clad in black, blue, and light green glass with aluminum mullions, was topped by a Deconstructivist-inspired skeletal steel spire that prompted David Childs to exclaim, "We've pinned the bow tie!"[117] The building was designed to reflect the contradictions of its program and site, facing Broadway with what Childs called a "bright and brassy" facade consisting of a sixty-two-foot-high base covered in 16,000 square feet of signs, out of which emerged a tower with more polychromatic vigor and complex massing, including a prominent prowlike triangular bay—originally conceived as a protruding sign but later extended to the entire height of the building, then evolved into a skeletal truss and eventually leasable office space—effectively raising the building's pulse to keep up with the frenzy of the

square.[118] The north facade was comparatively toned down, with stainless-steel panels and green glass that conveyed the look of classic SOM corporate Modernism. But the south side of the building, visible from Times Square, was livened up with square and rectangular patches of green glass slightly recessed in an otherwise dark glass curtain wall. In June 1989, while 1540 Broadway was still under construction, Karrie Jacobs commented, "It's a building so divided between the subdued aesthetics of premium office space and an attempt to cash in on the mythology of Times Square that it's positively schizophrenic." But this schizophrenia, she continued, "is in tune with the craziness of Times Square itself."[119]

The story of the Bertelsmann Building, a perfect metaphor for the excesses of real estate in the 1980s, was recounted in

melodramatic detail in Jerry Adler's 1993 book, the title of which said it all: *High Rise: How 1,000 Men and Women Worked Around the Clock for 5 Years and Lost $200 Million Building a Skyscraper.* Like 1585 Broadway and 750 Seventh Avenue, 1540 Broadway was in bankruptcy within three years of completion, by which time the west midtown market had been flooded by nearly 9 million square feet of new office space.[120] Six new towers—three hotels and three office buildings—had been erected along Broadway and Seventh Avenue between Forty-fifth and Fiftieth Streets, leading Eve M. Kahn, writing in the *Wall Street Journal*, to note: "They rise like vapors, the new towers of Times Square, with so few tenants you feel you could run your hands right through their filmy walls."[121] But as the recession ended, the office market got back on its feet, and in late 1992 Bertelsmann acquired 1540 Broadway at a bargain-basement price and Times Square began its spectacular rebirth.

Although it was part of the westward expansion of Rockefeller Center, Kohn Pedersen Fox's 745 Seventh Avenue (2002), on the east side of the avenue between Forty-ninth and Fiftieth Streets, also fell within the boundaries affected by the "theater subdistrict" zoning.[122] Rockefeller Center had expanded in the late 1950s with the construction of the Time & Life Building (Harrison, Abramovitz & Harris, 1959) and in the early 1970s with the so-called XYZ towers (Harrison, Abramovitz & Harris, 1971–73) that lined the west side of Sixth Avenue between Forty-seventh and Fiftieth Streets.[123] Late in 1986, before the new Times Square zoning was officially passed and amid the booming real estate economy, the center again embarked on new construction with a planned fifty-seven-story tower to be called Rockefeller Plaza West. To the east of Kohn Pedersen Fox's proposed new building lay the Exxon Building, the so-called building X of the Harrison plan. While the design of the XYZ group pretty much broke with that of the original center, that of Rockefeller Plaza West responded positively to the center's original architecture as if its extreme location on the fringes of the theater district demanded a formal invocation of its namesake, much as remote colonial cities reflected the names and the architectural character of those in their mother country. The architects attributed their stainless-steel-ornamented limestone and clear glass–clad design to "the contrasting models of corporate and public modernism—Rockefeller Center and Times Square—[which] set the stage for the project and inform its design."[124]

When the scheme was released to the public in early 1989, two years after the passage of the legislation that mandated a minimum of 15,000 square feet of illuminated signage, it was very well received, not only by Paul Goldberger, writing in the *New York Times*, but also by four leading architects who cited it in the annual awards program sponsored by *Progressive Architecture*. But while Goldberger admired William Pedersen's deft invocation of the center's formal language, he found the complexly massed tower a bit overwrought, almost to the point of cacophony. He was also troubled by the sheer size of the project, which would contain 1.36 million square feet of space, more than twenty-two times the area of the site, and well above the zoning's mandated FAR of 13. What made it possible to increase the building's bulk by 60 percent was the transfer of unused air rights from the older, landmarked Rockefeller Center buildings. Unnoted at the time was the fact that the new tower would replace what remained of the former Earl Carroll Theater (George Keister, Thomas W. Lamb, and

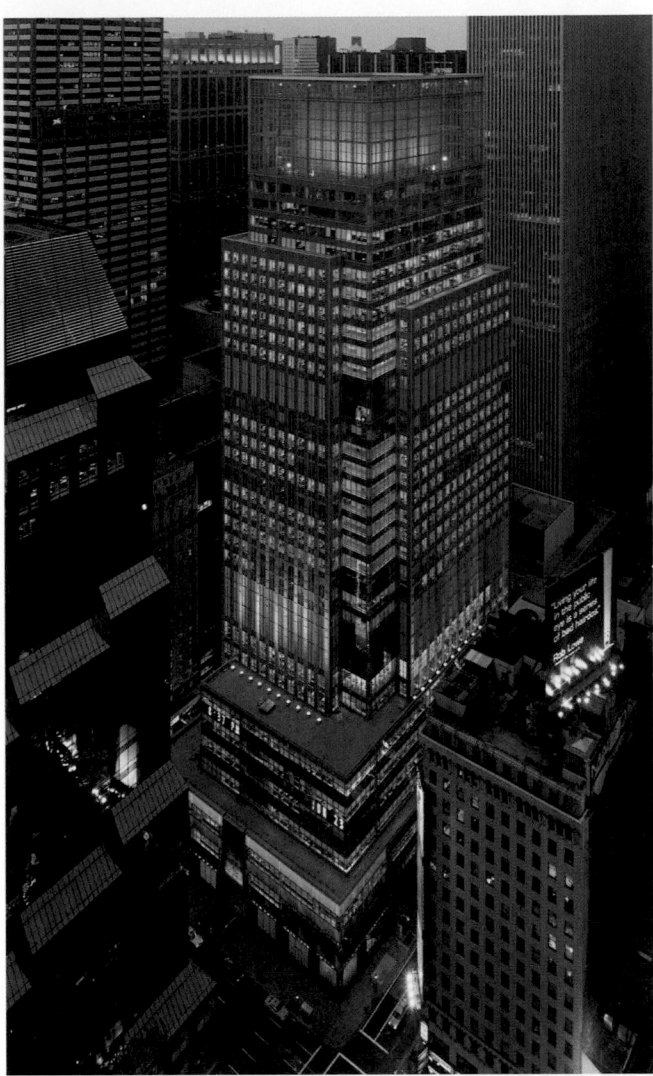

745 Seventh Avenue, between West Forty-ninth and West Fiftieth Streets. Kohn Pedersen Fox, 2002. View to the northeast. KPF

745 Seventh Avenue, between West Forty-ninth and West Fiftieth Streets. Kohn Pedersen Fox, 2002. View to the southeast of base. KPF

Joseph J. Babolnay, 1931), which in 1976 had been substantially renovated to accommodate a Woolworth's store.[125]

By the time Rockefeller Plaza West had been approved by the Landmarks Preservation Commission and the Board of Estimate in May 1990, the market for new office space was close to nonexistent. Nonetheless, the site was cleared in 1990 and construction was slated to begin in the first half of 1991. But the project did not move forward, and in 1994 the owners requested and received city permission to turn the site into a parking lot.[126] At last, in 1998, after numerous potential tenants proved elusive, Morgan Stanley Dean Witter, occupants of two neighboring buildings, Gwathmey Siegel's 1585 Broadway and Kevin Roche's 750 Seventh Avenue, just across the street, agreed to develop the site along with the Rockefeller Group. But the building would be drastically different from the one originally proposed. Reduced in height to 575 feet encompassing thirty-two stories of office space, 745 Seventh Avenue, which would connect through to Rockefeller Center's system of below-grade concourses, was seen less as part of Rockefeller Center than, as Tommy Craig, a member of the development team put it, an attempt by Morgan Stanley "to create a Midtown urban campus."[127] More accepting of its Times Square neighborhood than was its predecessor, the new design incorporated a 200-foot-long, 40-foot-high display made up of high-resolution, computer-programmed LED's that ran along Seventh Avenue and also wrapped around the Forty-ninth Street and Fiftieth Street corners. Collaborating with KPF on the sign was Imaginary Forces, a company primarily known for its innovative work in creating short promotional films and title sequences for movies. Paul Goldberger deemed the two-and-a-half-story sign "a generation ahead of such high-voltage Times Square showpieces as the cylindrical Nasdaq sign on the Condé Nast Building. . . . The sign is visually stunning, like an IMAX screen in the middle of a Manhattan street, and it all but dematerializes the facade, turning it from an object of glass and metal into a cavalcade of constantly changing colors and shapes."[128] By the time the building opened at the beginning of 2002, Morgan Stanley had sold it to another securities company, Lehman Brothers, a move attributed in part to the attack on the World Trade Center, which called into question the idea of consolidating critical operations and employees in one area; in addition, Lehman Brothers, forced out of its headquarters at Three World Financial Center by the tragedy, urgently needed the space.

In 2003 another tower serving the needs of a major media company was realized in the area with the completion of Skidmore, Owings & Merrill's fifty-story, 840,000-square-foot Random House Building and Park Imperial, west blockfront of Broadway between Fifty-fifth and Fifty-sixth Streets, a complex mixed-use project combining the corporate offices of the publishing company with a 111-unit luxury condominium apartment building.[129] A portion of the site comprising a four-story garage, a three-story building on the corner of Fifty-sixth Street, a one-story building at 1739 Broadway, and a parking lot was sold by the Durst Organization after a failed attempt to purchase two holdout properties, 1733 and 1741 Broadway, that would have allowed for a full blockfront assemblage. The roughly F-shaped parcel was bought by the Zeckendorf Company, which was unable to proceed with plans to build a hotel. In 1996 the Related Companies acquired the property at auction with the intention to build a forty-five-story, 500-unit rental apartment building with a five-story retail base that

Random House Building and Park Imperial, west blockfront of Broadway, between West Fifty-fifth and West Fifty-sixth Streets. Skidmore, Owings & Merrill, 2003. View to the northwest. Holzherr. SOM

was to include a movie theater and theme restaurant.

Plans changed once again when, in 1999, the site was chosen by Random House from among six other proposals for its new headquarters. Random House's parent company, Bertelsmann A.G., had been searching for years for a suitable location for its subsidiary company and had most recently failed in negotiations to build a tower across the street from its own Times Square headquarters at 1540 Broadway, with the two buildings to be linked by a bridge (see below). With plans moving ahead, owners of the four-story building at 1741 Broadway finally reached an agreement with Related in late 1999, at which point it stood alone in a construction site, the developer having clearly stated its intention to build around the small structure if need be.

As designed by SOM, the 630-foot-tall tower was in many ways two buildings in one. The lower twenty-six floors provided 650,000 square feet of offices for Random House and, entered from Broadway, were collectively known as the Random House Building. The top twenty-three residential floors were known as the Park Imperial and were entered from 230 West Fifty-sixth Street. Apartments ranged from one to

three bedrooms, included ten-foot ceilings, and, with the lowest apartments 360 feet above the street, featured sweeping views. Two separate structural systems were utilized—a steel frame for the office portion and concrete slabs and columns for the residential portion. As Moshin Ahmed, a principal of Thornton-Tomasetti Engineers, described it, there stood "a 27-story foundation for a 25-story building up in the sky."[130] The twenty-sixth and twenty-seventh stories served as transfer floors, where the concrete structure's loads were transferred to the steel portion by massive steel trusses. To help stabilize the slender hybrid structure against lateral movement, a fluid mass tuned damper was employed—the first use of such a device in the United States. The damper, consisting of two U-shaped water-filled concrete tanks on the fiftieth floor, was so heavy it required another structural shift back to steel above the forty-eighth story.

Above a granite-clad base housing retail tenants, the building rose as a glass curtain-walled tower resembling, according to SOM, "three sliding crystals" sandwiched between two twenty-five-story rectangular granite-clad volumes to the north and south that perhaps intentionally resembled bookends—suitable expressions for the publishing house within.[131] The residential tower continued to rise with a reflective glass skin and a sawtooth plan that provided many of the apartments, laid out by Ismael Leyva, with two glass corners. Adam D. Tihany designed the lobby, shaping it with curving wooden walls, mirrors, and an onyx-inlaid terrazzo floor, as well as the Imperial Club, a multiuse facility for residents of the condominium.

Delirious Times Square

By 1996 the renaissance of Times Square was charging forward, although many observers believed that its long-range health depended on the revitalization of Forty-second Street, which was having trouble getting started. The enactment of the 1982 Special Midtown Zoning District ensured that new economic development would come to Times Square in the form of office buildings; the zoning of 1987 would preserve the square's character as a billboard park; but what was not clear was whether appropriate retail uses would choose to locate in the bow tie. Suddenly, around 1995, Times Square became the city's "hot" retail spot. Businesses of all types considered locating in the square, from swank New York eateries like Nobu and Gramercy Tavern, to out-of-town restaurant chains as well as big-box retailers like Bed, Bath & Beyond.[132] Most of them chose to stay away, but restaurants, and especially themed restaurants, flocked to the area that seemed tailor-made for a synthesis of food, entertainment, and theater. While theme restaurants owed their origin to Murray's Roman Gardens, which opened on Forty-second Street in 1907, in recent years it was the Hard Rock Café, offering diners the chance to eat in the midst of rock 'n roll memorabilia, that set the pace for a near-mania that, in the mid-1990s, included all sorts of contrived dining environments.[133] Although Fifty-seventh Street had, since the opening of the Hard Rock Café, been the favored home to such establishments, with its rebirth, Times Square became the preferred location, though it proved too late, given that by the late 1990s the public had become bored with themed dining, especially because of the international proliferation of the various chains. Comedy Nation, an 18,000-square-foot comedy-themed restaurant located in the ground floor of 750 Seventh Avenue above Caroline's Comedy Club opened on April Fool's Day, 1997.[134] The Official All Star Café, a sports-themed restaurant owned by Planet Hollywood International and designed by David Rockwell, opened in 1540 Broadway in 1996 but closed four years later in part because it failed to deliver enough sports celebrities (see Interiors). Others planned but never realized included NBA City, a joint venture of the National Basketball Association and Hard Rock Café; a Las Vegas–themed restaurant to be called Vegas; Marvel Mania, a comic book–themed restaurant; Copperfield Magic Underground, a magic-themed restaurant owned in part by celebrity magician David Copperfield; and Rainforest Café, a Minneapolis-based chain serving food in a jungle atmosphere with mechanized gorillas, talking trees, jungle mists, and the like.[135]

Some large-scale retail stores thrived in Times Square, including the Virgin Megastore and the Disney store on Forty-second Street, but the Warner Bros. store in the former Times Tower had a short life (see Forty-second Street). New forms of razzle-dazzle interactive entertainment experimented with Times Square locations: XS New York, a 20,000-square-foot high-tech video arcade in 1457 Broadway, between Forty-first and Forty-second Streets, opened on December 31, 1996, but lasted only until 2000, when the site was cleared to make way for Skidmore Owings & Merrill's Times Square Tower (see Forty-second Street). Lazer Park (1997), 1560 Broadway, a 13,000-square-foot game arena in which players would shoot one another with light-emitting guns, lasted into the new millennium.[136] In 1997 Times Square was rated the sixth most expensive retail real estate location in the world, an incredible jump from four years earlier, when, as Mayor Rudolph Giuliani stated, "it was met with a tremendous amount of cynicism that anybody would go to Times Square."[137]

The presence of so many safe, relatively fun-loving, family-oriented forms of entertainment made for a dramatically different Times Square than anyone had ever experienced. For Herbert Muschamp, the "transformation of Times Square from a notorious vice zone into a year-round 'Babes in Toyland'" was "shocking."[138] The New York Times magazine devoted its May 18, 1997, issue to the transformation of Times Square, asking nineteen prominent photographers to document the square and its many personalities.[139] Philip-Lorca diCorcia captured day-to-day street scenes of office workers and crowds; Mitch Epstein photographed a customer with a video game rifle at the XS New York arcade; Michael O'Neill documented the block of Forty-second Street between Seventh and Eighth Avenues at a point when its eastern half was once again active but its western half boarded up, ready for demolition; Annie Leibovitz photographed several women, long-term residents of an SRO; Richard Burbridge shot portraits of "The Rebuilders," people who played a leading role in the area's redevelopment; Chuck Close made portraits of Broadway stars; and Nan Goldin photographed what remained of the area's transvestite, transsexual, and gay hustler bars. The portfolio showed readers the multiple faces of Times Square—its grit, glamour, wealth, poverty, crime, safety—all together evidence that, contrary to the beliefs of many contemporary critics, Times Square retained a good deal of its historic edginess.

The late 1990s saw an unprecedented surge of attention given to Times Square, as well as all of New York City, by television programmers who recognized that though their medium had traditionally reflected the suburban milieu it had grown up with during the post–World War II era, national

Ed Sullivan Theater, 1697 Broadway, between West Fifty-third and West Fifty-fourth Streets. Renovated for the *Late Show with David Letterman*, James Stewart Polshek & Partners, 1993. Wyner. PPA

audiences were increasingly shifting to issues and aspects of urban life, even though they themselves remained complacent in their suburbanism. The first program to show the nation a revitalized Times Square was the *Late Show with David Letterman*, a wildly popular eleven-year-old talk show that shifted from NBC and its Rockefeller Center studios to CBS in 1993.[140] After the changeover was announced, Letterman considered relocating the production to Los Angeles, but New York triumphed when the network convinced him that the Ed Sullivan Theater (originally Hammerstein's Theater, Herbert J. Krapp, 1927) would be a perfect venue, purchasing it, as well as the adjacent twelve-story Hammerstein's Theater Building (Herbert J. Krapp, 1927), 1697 Broadway, between Fifty-third and Fifty-fourth Streets, for Letterman's use.[141] Built by Arthur Hammerstein to honor his father, the impresario opera producer, Oscar Hammerstein I, the Gothic-style theater had been bought once before by CBS—in 1936—and converted for use as a radio playhouse by the Swiss-born architect William Lescaze, who gave it a Modernist reworking that covered much of the original's stained-glass windows and Gothic tracery with smooth white surfaces and draperies.[142] In 1949 the space was remade as a television studio, from which the leg-

endary *Ed Sullivan Show* was broadcast until 1971. In 1988, seven years after CBS relinquished control of the building, the theater's interior received landmark status. James Stewart Polshek & Partners, hired by CBS to redesign the theater for the *Late Show*, was able to expedite the landmarks commission's approval process by agreeing to restore the interior and make any alterations reversible so that the space could be left in its original state when the show ended its run. Beyond that, the main task, according to Richard Olcott, the principal designer on the project at Polshek's office, "was to make this huge space feel intimate," a particular challenge given the need to transform it from a 1,275-seat to a 400-seat venue, a feat that was accomplished by inserting, in effect, a smaller theater inside the shell of the original.[143] An elliptical ring was hung beneath the five-story-high ribbed dome to provide a framework from which lights, monitors, and other equipment could be suspended. A curving wall of fabric-covered-plywood acoustical "sails" sprung from midway up the balcony and connected to the hanging ellipse, eliminating the rear rows of balcony seating and shielding from view the elaborate ventilation system that kept the theater at Letterman's preferred sixty-two degrees Fahrenheit. When the premier taping

ABC Studios, 1500 Broadway, southeast corner of West Forty-fourth Street. Walt Disney Imagineering with HLW International, 1999. View to the east. RAMSA

occurred on August 30, 1993, it was a media event not to be missed, with more than thirty television stations from across the nation covering the boisterous scene on the Broadway sidewalk. Within months, Letterman had, in classic form, co-opted the neighborhood, dubbed "Daveland" by the *New York Times*'s William Grimes, turning the everyday people and shops of Times Square's northern reaches into nationally recognized television stars.[144]

On June 20, 1994, NBC's popular morning show, *Today*, in an effort to regain its position at the top of the ratings, moved from a closed studio to a glass-walled street-level location in Rockefeller Center, providing viewers nationwide with a backdrop of one of New York's most dignified yet lively public spaces.[145] The move was a success, helping to propel *Today* to the number one position and breathing new life into Rockefeller Center. The new *Today* studios, designed by the Manhattan-based firm Phillips Janson Group in conjunction with Thornton-Tomasetti, occupied 18,000 square feet in three stories of 10 Rockefeller Plaza (originally Eastern Airlines Building, Associated Architects, 1939), southwest corner of Forty-ninth Street, separated from the sidewalk by bulletproof Plexiglas panels that could be covered by movable

interior walls. In 1997, so that its own morning show would "feel as if it is coming from the heart of New York City and feel as big, bold, and busy as New York City is," as one CBS News spokeswoman put it, CBS followed suit, hiring Manhattan-based Meridian Design Associates and the California-based firm Broadcast Design International to outfit 24,000 square feet in the ground floor of the General Motors Building (Edward Durell Stone in association with Emery Roth & Sons, 1968) at Fifty-ninth Street and Fifth Avenue.[146] The studio occupied the former General Motors car exhibition rooms designed by LeRoy Kiefer. The CBS program, renamed *The Early Show* to complement Letterman's *Late Show*, began broadcasting from the facility on November 1, 1999, but the classy yet somewhat out-of-the-way location behind the General Motors Building's lifeless plaza denied the CBS show the urban engagement that NBC's *Today* enjoyed.

Not to be left behind, ABC set its sights on Times Square, announcing plans to build new studios there for its morning show, *Good Morning America*, and news magazine, *20/20*, along with other programs, in November 1997, two months after Viacom's MTV network began broadcasting from a second-floor studio in 1515 Broadway, southwest corner of Forty-

Nasdaq MarketSite,
Four Times Square, south-
east corner of Broadway and
West Forty-third Street.
Einhorn Yaffee Prescott,
1999. View to the southeast.
Warchol. PW

fifth Street. With floor-to-ceiling windows, MTV's studios provided easy visibility up and down the avenue, making viewers feel a "part of that incredible playground down there," as Judy McGrath, the network's president, described it.[147] ABC chose to occupy 75,000 square feet of space on the first three floors of 1500 Broadway, southeast corner of Forty-fourth Street, retaining Walt Disney Imagineering with HLW International, architect of record, to create its Times Square Studios.[148] The primary studio was located on the second floor, a so-called marquee studio that cantilevered over the sidewalk to achieve a clear view up Broadway, though in September 1999 network executives were shocked to discover that the view focused on advertisements for the MTV network. The marquee was covered with nine ribbons of free-form curvilinear zipper signs that together formed 4,000 square feet of signage undulating out from the Broadway facade to wrap around to Forty-fourth Street. The effect was spectacular. A second studio, on the ground floor, was designed to resemble a classic New York

subway station with three removable six-ton windows that dissolved the boundary between studio and sidewalk, stirring commotion among passersby and occasionally clogging the sidewalks with spectators.

On December 31, 1999, Nasdaq entered the fray with the opening of its Nasdaq MarketSite, a 28,500-square-foot, three-level facility in Four Times Square (see Forty-second Street).[149] As designed by Einhorn Yaffee Prescott Architecture and Engineering, Nasdaq MarketSite comprised a public exhibition space, seventy-two-seat auditorium, conference center, broadcast booths, and two broadcast studios anchoring the southeast corner of Forty-third Street and Broadway beneath a mammoth cylindrical Nasdaq sign. The street-level studio was designed to address both the broadcast audience and the people on the street. To that end, it was effective, opening to view a high-tech broadcast studio separated from the sidewalk by a faceted, circular clear glass curtain wall through which one observed a twenty-foot-tall semicircular wall of ninety-six

video screens displaying market and stock information that acted as a backdrop for live broadcasts made by financial reporters from numerous networks. A mezzanine allowed visitors access to the "MarketSite Experience," a museum of sorts tracing the history of the exchange. One observer, David Barbour, astutely commented, "Like everything else in Times Square, it's all about the transformation of information into entertainment—who knew that the stock market, once considered the most arcane area of knowledge, could become another family fun center?"[150]

Times Square's broadcast studios, new as they were, seemed a fitting complement to the district's historic character of spectacle and street life. Michael Sorkin, writing in late 1999, noted, "Times Square has become the epicenter, a universal photo-op, pure celebrity. . . . Throughout the area, all the networks (and MTV) have fishbowl-style broadcast environments—stationary Popemobiles—for their morning shows, the lead disassemblers of the news-entertainment distinction. . . . Still, there's a whiff of the old Times Square: those studios are a lot like traditional peep shows. The object is still to be safely part of something unattainable, whether it's a naked woman's attentions or a chat with Diane Sawyer and Bill Bradley."[151]

Shortly after New Year's Day in 2000, Herbert Muschamp offered his take on the new Times Square: "The creation of storefront broadcasting studios, record outlets, movie theaters and live performance spaces has, in turn, generated street life of unparalleled vitality. For the last year every day has been like New Year's Eve."[152] In his 2004 book on the history of Times Square, *The Devil's Playground*, James Traub, a *New York Times* reporter, wrote that "this new Times Square of office

Nasdaq MarketSite, Four Times Square, southeast corner of Broadway and West Forty-third Street. Einhorn Yaffee Prescott, 1999. Street-level broadcast studio. Warchol. PW

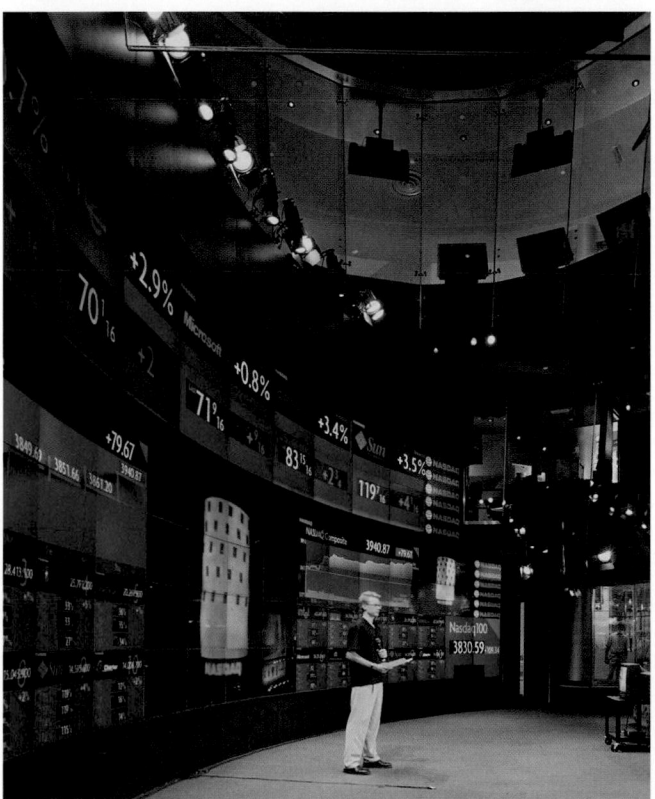

towers and theme restaurants and global retailers and crowds and light and family fun is so utterly different both from the pathological Times Square of twenty years ago and the naughty, gaudy Times Square of seventy years ago that we almost need a different name for it. Certainly we need a new way of thinking about it. What are we to make of this place? For the city's financial and governmental elite—for the leading forces in real estate and tourism and entertainment and retail, for civic boosters and public officials—Times Square is overwhelming proof of New York's capacity for self-regeneration."[153]

The mix of workers, tourists, gawkers, performers, and shoppers gathering in the new Times Square caused a new problem—pedestrian gridlock.[154] Studies commissioned by the Times Square BID in 1997 found two people per second passing a Times Square corner at peak periods during the day. Many were tourists, who moved more slowly than New Yorkers (according to one social psychologist studying the issue, New Yorkers walk 30 percent faster than pedestrians in many smaller U.S. cities). As the millennium approached, congestion began to prove very serious, with pedestrian traffic overflowing sidewalks and impeding automobile traffic. Ideas were considered that ranged from embedding signs in the sidewalk which would direct pedestrians to midblock passageways to simply widening sidewalks. But little was done to improve the pedestrian experience, though the streets of Times Square did get a bit prettier with the 1999 installation of Karim Rashid–designed manhole covers featuring a warped grid pattern.[155]

Times Square's private boosters were trying in other ways to cope with the throngs of out-of-towners flocking to the area. In February 1997, the Times Square BID announced plans for the city's first large-scale full-service visitors center to be located in the renovated space of the Embassy I Theater (Thomas W. Lamb, 1925), 1560 Broadway, between Forty-sixth and Forty-seventh Streets.[156] Plans to realize the new visitors center, intended to replace the modest facility designed by Robert A. M. Stern Architects for the lobby of the Selwyn Theater, were accelerated when the existing center was forced to close after the partial collapse on December 31, 1997, of the building, the facade of which was to have been incorporated into Platt Byard Dovell's New 42nd Street Studios. Ronnette Riley, placed in charge of the new tourist center's design inside Lamb's ornate movie theater, removed the auditorium's 582 seats and installed information booths designed to recall theater boxes. Riley tried to preserve the room's previous identity as a theater by defining the floor with zinc terrazzo strips outlining the original seat and aisle locations, by keeping the historic chandeliers, and by restoring Arthur Crisp's hand-painted murals. Opened on September 1, 1998, the 6,000-square-foot visitors center provided a variety of services, including much-needed attended restrooms open to the general public.

Just across the street from the new Times Square Visitors Center, in Duffy Square, the triangular island bounded by Broadway, Seventh Avenue, Forty-sixth and Forty-seventh Streets, stood Mayers & Schiff's pipe-and-canvas TKTS pavilion (1973), an unofficial New York landmark as well as a remarkable success, dispensing more than 1.7 million same-day discount theater tickets annually.[157] Despite a refurbishment in 1988, some felt that the pavilion had outlived its usefulness. On June 15, 1999, Mayor Giuliani announced a design competition for its replacement, to be known as

RIGHT Proposed TKTS2K pavilion, Duffy Square, West Forty-seventh Street, between Seventh Avenue and Broadway. John Choi and Tai Ropiha, 1999. Photomontage, view to the north. VAI

BELOW Proposed TKTS2K pavilion, Duffy Square, West Forty-seventh Street, between Seventh Avenue and Broadway. Thomas Phifer, 1999. Rendering of view to the northwest. TPP

TKTS2K in honor of the millennium year.[158] Sponsored by NYC 2000, the official New York City Millennium Committee, the Theatre Development Fund, the nonprofit organization in charge of the pavilion's operation, and the Van Alen Institute, which was to oversee the proceedings, the competition was open to anyone willing to pay the $50 registration fee and submit a design by the October 14, 1999, deadline. Despite the pavilion's popularity, the call for a competition was widely applauded, with *New York Times* reporter David Dunlap offering a rare negative voice: "The

competition seems to doom one more facet of Broadway's architectural past, which has been chipped away piece by piece in recent years until very little remains of what was once a splendidly pungent esthetic amalgam, made of dozens of incongruous icons layered one on top of another."[159]

The competition specified a freestanding pavilion of no more than 800 square feet and with a height limit of sixteen feet. Designers were also required to consider the two artworks on the site, Charles Keck's statue of Father Duffy (1937) at the north end of the island and George Lober's George M. Cohan statue (1959) at the southern point. The competition brief made it clear that the goal was to create not only a more efficient structure but also one that would have a visual profile in scale with the blaring cacophony of the renewed Times Square. Although no budget estimates were asked for, there was an emphasis on submitting a design that could be realized. The four-month-long competition, estimated to yield some 200 entries chasing a $5,000 prize, instead brought forth 683 submissions from thirty-one different countries.

On February 17, 2000, the results of the competition were announced. Third place was shared by Piero Lissoni Associates, furniture designers from Milan, who topped a ticket booth with a horizontal glass canopy emblazoned with the TKTS logo and whose design featured LED panels inlaid in the pavement to announce ticket availability, and Leo Mieles of Toronto, whose steel-clad cubic booth featuring information panels on the east and west sides was capped by a collapsible metal-mesh stage to be used for live performances and announcements. Thomas Phifer, in collaboration with the engineers Ove Arup & Partners, garnered second prize with a translucent triangular glass-and-steel canopy spanning the length of Duffy Square and providing year-round climate control through concealed air-conditioning and heating units, with tickets dispensed from a circular pavilion located at the north end of the site. The winning

scheme came from two Australian architects, twenty-eight-year-old John Choi and thirty-six-year-old Tai Ropiha. Their design consisted of a wedge-shaped bleacherlike structure incorporating a sixteen-foot-high south-facing staircase rising from the base of the Father Duffy statue. The staircase was to be formed out of translucent red resin planks lit from below at night.

Dubbed by Ned Cramer an "urban version" of the Casa Malaparte (Adalberto Libera, 1938–42) in Capri, the winning entry was praised by most observers, even veterans groups who for a long time had felt that the Mayers & Schiff pavilion slighted the statue of Francis Duffy, the World War I hero, and were worried that the new structure would be similarly insensitive.[160] In fact, the only negative reaction seemed to come from people who felt that the design's reliance on stairs was an affront to the physically challenged. Despite the enthusiasm for the design and the promise to go forward with construction by the end of 2000, there was no funding for the project: the Theatre Development Fund had put the cart before the horse, hoping that the positive reaction to the scheme would stimulate the fund-raising. But the post-millennial malaise, combined with the negative impact of the Trade Center attack, left this a dream on hold.

At the southern end of the bow tie, in the triangular spit of land in the shadow of One Times Square bounded by Broadway, Seventh Avenue, Forty-third and Forty-fourth Streets, stood the utilitarian steel and tinted-glass U.S. Armed Forces Recruiting Station (1950).[161] Although an aesthetic disaster, it was welcomed as a sturdy replacement for the ram-shackle wood structure erected in 1946. An obstacle to pedestrian traffic, the one-story booth, however, was a remarkably successful recruiting tool, routinely signing up more army, navy, marine, and air force candidates each year than any other facility in the country. In a December 31, 1995, editorial celebrating the ongoing renewal of Times Square from "run-down seedy to modern glitz," the editors of the New York Times took the occasion for a New Year's Eve wish regarding its future: "Alas, there are some obstacles to ideal development, among them the . . . armed forces recruiting office—an eyesore that squats on an island in the middle of the square. The Pentagon plans a new, livelier design. Better it should yield the site entirely and unclog the square."[162] The federal government chose to ignore the Times's advice, resulting in a pleasant surprise, a powerfully elegant stainless-steel and glass pavilion (1999) of roughly the same size as its predecessor designed by a pair of innovative young architects, Stephen Cassell and Adam Yarinsky, who had founded their own firm, the Architecture Research Office (ARO), in 1993.[163]

Cassell and Yarinsky's design for the 520-square-foot pavilion was dominated by thirty-three-by-fourteen-foot American flags on the building's long east and west elevations made from thirteen bands of fluorescent lights rendered red, white, and blue by newly developed gels from the 3M Corporation that colored the lights at night and reflected sunlight during the day. At the narrow, eleven-foot-wide north end of the booth, a nine-panel video screen was used to show commercials of the military at work, while the eighteen-foot-wide south facade sported a surface, which Nina Rappaport likened to a "vertical subway ventilation

LEFT U.S. Armed Forces Recruiting Station, site bounded by Broadway, Seventh Avenue, West Forty-third and West Forty-fourth Streets. Architecture Research Office, 1999. View to the southwest. Joseph. ARO

BELOW U.S. Armed Forces Recruiting Station, site bounded by Broadway, Seventh Avenue, West Forty-third and West Forty-fourth Streets. Architecture Research Office, 1999. Aerial view. ARO

ESPN Zone, Four Times Square, northeast corner of Broadway and West Forty-second Street. SOSH Architects, 1999. McGrath. NMcG

broadcasts could be made, transforming the casual diner into a member of a studio audience.

ESPN Zone, designed by SOSH Architects, opened on September 15, 1999, in 42,000 square feet on four levels of Four Times Square.[167] It was the flagship location for the chain, which had existing branches in Baltimore and Chicago, and offered sports fans a 10,000-square-foot video arcade and 220 television monitors located throughout numerous bars, restrooms, and eating and viewing areas, one of which allowed diners to recline in leather easy chairs with speakers set into the headrests while watching oversized projection screens. A ground-floor retail store was accessed by a separate entrance. The following year, the World Wrestling Federation (WWF), the popular purveyors of choreographed wrestling matches featuring superhero-like personalities, opened WWF New York, a 45,000-square-foot themed venue designed by CMS Architects with a 610-seat, basement-level restaurant and bar that could double as a nightclub, as well as a video arcade and street-level retail store.[168] The site was the basement and ground floor of the thirty-three-story Paramount Building (Rapp & Rapp, 1927), west blockfront of Broadway between Forty-third and Forty-fourth Streets, originally home to the Paramount Theater but lost in 1967 to offices.[169] Designated a landmark in 1988, the Paramount Building had recently undergone a ten-year-long renovation designed by the New York–based firm Tobin + Parnes Design Enterprises working with Ann Kale Lighting Design that included new lighting for the building's setbacks, four-sided clock tower, and iconic copper and glass globe. Particularly significant was the reconstruction of the theater's marquee, which had been removed in 1964 to meet an unknown fate. The new thirty-nine-foot-long, eighteen-foot-deep marquee, recreated according to historical photographs, was carefully considered by the Landmarks Preservation Commission, primarily because the WWF proposed to fill in the curvilinear frame with LED displays, an idea the commission nixed in 1996 but later approved as other LED signs proliferated in the area.

Just as the idea of themed restaurants seemed dead, on March 19, 2000, the National Rifle Association (NRA) stirred up more than a bit of controversy when it announced its intention to open one based on firearms.[170] The establishment, NRASports Blast, was to offer diners wild game and mineral waters from around the world as well as a video arcade full of shooting games in what the organization described as "an exciting total shooting sports and sporting goods experience."[171] While no guns or ammunition would be sold in the restaurant's retail store, the very idea of promoting the use of guns, recreational or otherwise, in a city that had worked hard in recent years to reduce crime, and particularly in a part of that city that had pulled itself out of dereliction and vice to become a desirable family destination, was to nearly every observer outside NRA membership not only inappropriate but obscene. To the editors of the *New York Times*, the proposal was "unsettling," not because the "newspaper, which has long opposed the N.R.A.'s policies, happens to be in the same neighborhood" as the proposed restaurant but because "the cleanup of Times Square over the last few years has made it a favorite destination for parents and children. The last thing these kids need is somebody trying to disguise the fact that guns represent a tremendous public health threat, especially for children and especially in urban areas like New York."[172] In June 2000, the City Council passed, forty-six to one, a symbolic

grate," decorated with circular emblems of the four major military branches.[164] As a safety measure for nighttime drivers, the perimeter of the site was framed by reflective bollards. In a witty move, the roof was painted with a camouflage pattern. The crisply detailed interior was divided into distinct areas for each of the four military branches. The spare room featured a parabolic ceiling but received the most attention for its inclusion of a bathroom, an amenity lacking in its predecessor. At night, the Armed Forces Recruiting Station more than managed to hold its own with the bright lights of commercialism, exerting a strong, dignified, but definitely dazzling presence.

By 1999 Times Square was, according to Charles V. Bagli, a "kaleidoscope of tourists, neon signs, entertainment centers and corporate headquarters."[165] But that was also the first year that the feverish pace of development momentarily slowed.[166] The theme restaurant craze had died down, taking among its casualties Comedy Nation, the Official All Star Café (replaced in 2000 by Planet Hollywood's flagship restaurant, relocated from Fifty-seventh Street), and the proposed Planet Hollywood Hotel (see below), but Disney's ESPN Zone, a sports restaurant, bar, and retail center, and WWF New York, an endeavor of the World Wrestling Federation, did succeed, in part because they expanded the idea of the theme restaurant to include more engaging forms of entertainment such as video arcades, but in greater measure because they capitalized on their connections with television, providing not only dazzling numbers of video monitors alive with programming, but sets from which live

Toys 'R' Us, 1530 Broadway, northeast corner of West Forty-fourth Street. Gensler and Joanne Newbold Associates, 2001. View to the northeast. GEN

ABOVE Toys 'R' Us, 1530 Broadway, northeast corner of West Forty-fourth Street. Gensler and Joanne Newbold Associates, 2001. View to the northeast. GEN

LEFT Toys 'R' Us, 1530 Broadway, northeast corner of West Forty-fourth Street. Gensler and Joanne Newbold Associates, 2001. GEN

resolution against the restaurant, admonishing the NRA for taking the "unconscionable step of promoting guns and gun use" in New York.[173] By 2002 the idea was abandoned.

More in tune with the new Times Square was the flagship store of Toys 'R' Us, opening in 2001 at 1530 Broadway, east blockfront between Forty-fourth and Forty-fifth Streets.[174] The site was, through the 1990s, the largest underdeveloped parcel in Times Square. It had been home to Hammerstein's Olympia

Theater (J. B. McElfatrick & Son, 1895) until 1935, when the colossal four-story entertainment palace, the first major theater to be built on Times Square, was demolished and replaced by the International Casino, a nightclub, and the Criterion movie theater (Thomas W. Lamb and Eugene De Rosa, 1936). In 1988 the space, which had for years housed Bond's clothing store, was converted to two theaters called the Criterion Center and leased to the Roundabout Theater Company from 1991 until 1997,

W New York-Times Square Hotel, 1567 Broadway, southwest corner of West Forty-seventh Street. Frank Williams & Associates, 1999. View to the southwest. Goldberg. ESTO

Moss ultimately found a tenant in the international toy store chain Toys 'R' Us, which opened the world's biggest toy store and the largest retail establishment in Times Square on the site, a brilliant 110,000-square-foot fusion of signage, entertainment, retailing, and architecture designed by Gensler in collaboration with Joanne Newbold Associates, the latter responsible for the concept, theming, and retail design. The store was conceived as a vehicle to propel Toys 'R' Us back to its position as the number one toy retailer in the nation as well as provide the company with an image that would put it in direct competition with F.A.O. Schwarz, the de facto mecca of upscale toy shopping across town on Fifth Avenue. When it opened on November 17, 2001, the public caught a first glimpse of what the future of toy sales might be. The "expansive and column-free spatial opportunities" were "leveraged" by introducing, as the store's centerpiece, a sixty-foot-tall Ferris wheel from which four selling floors could be glimpsed, each featuring episodic themed environments including a 4,000-square-foot Barbie mansion, a five-ton, twenty-foot dinosaur, and a twenty-five-foot-tall model of the Empire State Building.[177] Like many of the new businesses dotting the periphery of Times Square, the store featured numerous television monitors throughout and was broadcast-ready, so that it could become the on-location launchpad for new toy lines. The store was enclosed in a chamfer-cornered nonreflective glass curtain wall made up of 165 thirty-square-foot panels (six feet high by five feet wide), each backed by a motorized forty-eight-foot-long scroll with seven different graphics that could be choreographically lowered. Each scroll also contained one clear panel that, when in place, rendered the facade transparent. Seen from the street, the facade was a dynamically changing billboard. A cornice supported 1,000-watt metal halide lamps to illuminate the building and an LED-filled marquee extended over the Broadway sidewalk.

In December 2001, the W New York-Times Square Hotel opened, occupying a fifty-seven-story tower (Frank Williams & Associates, 1999) at 1567 Broadway, southwest corner of Forty-seventh Street, that the now financially troubled Planet Hollywood had initially undertaken as its first foray into the hospitality market.[178] The exceptionally banal, tan-colored brick tower rising above a four-story-base and topped by four eighty-foot-tall sign panels utilized air rights from the Lunt-Fontanne (formerly Globe) Theater (Carrère & Hastings, 1909), 205 West Forty-sixth Street.[179] As much a signpost as a hostelry, the needlelike W Times Square was anchored to bedrock fifty feet beneath the street so it could tolerate greater wind loads. An internally braced steel truss was employed to support the heaviest signage spectaculars available. In all, the 340,000-square-foot building could carry 75,000 square feet of signs. Starwood Hotels' "W" division became the hotel operator, hiring Toronto-based architects Yabu Pushelberg, working with Brennan Beer Gorman, to outfit the interiors. The most public feature of their work was a fifty-by-eighty-foot panel above the entry proclaiming the "W" brand in a composition of red fins. Blue Fin, the 400-seat two-level seafood restaurant, themed with Japanese artist Hirotoshi Sawada's school of black polycarbonate fish suspended from the ceiling of the main dining room on fishing line and a dramatic terrazzo staircase set against a textured concrete "Wave Wall," proved a surprising hit with food and architectural critics.

when skyrocketing real estate prices forced the theater company to relocate.[175] The German media company Bertelsmann, with headquarters at 1540 Broadway across Forty-fifth Street to the north, hoped to purchase the site from Charles B. Moss Jr. and erect a thirty-five-story tower for its recently acquired subsidiary, Random House, proposing to build a bridge connecting the two buildings, emblazoned with the word "Bertelsmann."[176] Moss's desire to keep the existing building and its framework of signs forced Bertelsmann's architects, Fox & Fowle, to place the so-called Random House Building on a platform above the extant structure, but the deal fell apart after six months of negotiations when Moss reportedly objected to the intrusion of the platform's supporting columns on the retail space below, leading Bertelsmann to instead move Random House to a new skyscraper at 1739 Broadway (see above).

THE BRIGHT LIGHT ZONE: THE FALL AND RISE OF FORTY-SECOND STREET

Decline and Fall

Forty-second Street, twentieth-century Manhattan's most representative street, was lined with some of its most important institutions, from the New York Public Library (Carrère & Hastings, 1897–1911) and Grand Central Terminal (Warren & Wetmore; Reed & Stem, 1903–13), to the United Nations (Board of Design, Wallace K. Harrison, Director of Planning, 1947–52) and the Ford Foundation (Kevin Roche and John Dinkeloo, 1967).[1] Its theater block, between Seventh and Eighth Avenues, was initially developed in the late nineteenth century as a street of brownstone residences and churches that distinguished it from the raffish activities of what was called Longacre Square. In 1904 the name of that bow tie of land and streets defined by Broadway, Seventh Avenue, Forty-second Street, and Forty-seventh Street was changed to Times Square to honor the relocation, from Printer's Row downtown, of the headquarters of one of the city's important newspapers.[2] This block was dramatically rebuilt in the first ten years of the twentieth century to become the city's most sophisticated entertainment zone, home to eleven theaters, the densest such concentration in the world: Hammerstein's Victoria Theater (J. B. McElfatrick & Son, 1898), 201–205 West Forty-second Street; the Theatre Republic (after 1902, the Belasco) (Albert E. Westover, 1900), 207–211 West Forty-second Street; the New Amsterdam Theater (Herts & Tallant, 1903) with its rooftop theater, the Aerial Gardens; the Lyric Theater (V. Hugo Koehler, 1903), 213 West Forty-second Street; the Liberty Theater (Herts & Tallant, 1904), 234 West Forty-second Street; the Lew M. Fields Theater (Albert E. Westover, 1904), 254 West Forty-second Street; the Eltinge (Thomas W. Lamb, 1912), 236–242 West Forty-second Street; the Selwyn Theater (George Keister, 1918), 229 West Forty-second Street; the Apollo (Eugene De Rosa, 1920), 215–223 West Forty-second Street; the Times Square Theater (Eugene De Rosa, 1920), 219 West Forty-second Street; and the Candler (later Harris) Theater (Thomas W. Lamb, 1914), 226 West Forty-second Street, adjoining the Candler Building (Willauer, Shape & Bready, 1914), 220 West Forty-second Street.[3] Other entertainment-related activities quickly followed, especially those providing services to actors, theatrical agents, and to the pleasure-seeking public, as well as restaurants, most notably Murray's Roman Gardens (Henry Erkins, 1907), arguably the first-ever themed eatery.[4] Though initially developed to stage live performances, Forty-second Street's theaters kept pace with evolving tastes, first offering movies on a regular basis in 1915, when D. W. Griffith's *Birth of a Nation* was presented at the Liberty Theater, accompanied by a live orchestra. By the 1930s, almost all of Forty-second Street's theaters were presenting first-run movies, and after 1942, when the puritanical Mayor Fiorello La Guardia banned burlesque, the Theatre Republic, home to that bawdy but largely good-natured popular entertainment, and the last on the block to feature live performances, was forced to succumb to celluloid. The closing of burlesque did not do away with adventurous popular entertainment on Forty-second Street, but paved the way for sophisticated foreign films, often more risqué than their censored American counterparts. The tradition that these films established, plus the association with burlesque, helped enforce in postwar minds Forty-second Street's long-standing reputation as "naughty" and "bawdy," immortalized in the classic film musical *Forty-second Street* (Lloyd Bacon, 1933).[5]

The dramatic increase of suburban living in the post–World War II era, combined with the impact of television, transformed America's entertainment patterns: Hollywood began to produce fewer films, forcing the operators of Forty-second Street's movie houses to become home to lower-priced reruns and, in the 1960s, "action" films that appealed to teenagers. Given its tradition of action and adult adventure, it was almost inevitable, after the United States Supreme Court's decision liberalizing the definition of pornography in 1973, that Forty-second Street would become the city's principal venue for hard-core erotic films, bringing with them drug trafficking and prostitution: "naughty" and "bawdy" quickly turned tawdry and outright dangerous.[6] The middle-class audiences that had patronized the theaters showing post-premier runs of popular films stayed away in droves. The street's reputation as the quintessential setting for urban lawlessness was solidified with the appearance of two films, *Midnight Cowboy* (John Schlesinger, 1969) and *Taxi Driver* (Martin Scorsese, 1976).[7] By the mid-1970s, Forty-second Street had become the poster child for the horrors of modern urban life.

Theater Row

But just as the street seemed beyond redemption, signs of renewal began to appear, especially after the Manhattan Plaza apartment house complex (David Todd & Associates, 1974–77), occupying the full block between Forty-second and Forty-third Streets, Ninth and Tenth Avenues, brought 1,690 apartments to the immediate area, most of them occupied by people connected to the theater and its allied arts.[8] Across Forty-second Street, a plan to insert six small theaters specializing in plays by little-known talent into existing tenements between Ninth and Tenth Avenues emerged as part of a project called Theater Row, sponsored by the 42nd Street Redevelopment Corporation, a not-for-profit organization founded in 1976—with seed money from the Ford Foundation—by a public relations and advertising executive and former president of the Municipal Art Society, Frederic S. Papert.[9]

Theater Row, celebrated at its completion in 1978 as "one of the greatest little victories of recent New York urban renewal," was begun in January 1975, when Playwrights Horizons, a group headed by Robert Moss, reclaimed a derelict building on the south side of Forty-second Street between Ninth and Dyer Avenues for use as a theater.[10] In three years' time, six abandoned buildings on the south side of the block housing, among other uses, three massage parlors and a burlesque house, were renovated as theaters by David Todd & Associates, contributing to the city's greatest concentration of Off Off Broadway playhouses. Among the nine new occupants were the Lion Theater Company, 422 West Forty-second Street, and the Nat Horne Theater, 440 West Forty-second Street. Playwrights Horizons, 416 West Forty-second Street, occupied a derelict facility that realtor Irving Maidman, in an effort to revive the street, had fitted out in 1961 by removing the second floor and raising the roof.[11]

Many saw the success of Theater Row as a critical step on the way to tackling the real challenge—the return to glory of the theater block between Seventh and Eighth Avenues. At the groundbreaking ceremony, the mood was one of high optimism,

West Forty-second Street, south side between Ninth and Dyer Avenues. View to the southeast before renovation as Theater Row. MAS

with the new theaters seen not as an isolated development but as part of a community anchored by the theater-connected residents of Manhattan Plaza. As Albert Reyes, head of the Lion Theater Company, put it: "When I need an ingenue, I'll just lean out the window and yell."[12]

In April 1979, a year after Theater Row's completion, the federal government agreed to put up $1.9 million to help implement the second phase of the project, consisting of two 225-seat theaters, two restaurants, a retail store, rehearsal and office space, and an audio-video taping center to be housed in the largely abandoned West Side Airlines Terminal (Port of New York Authority staff architects, 1955), east side of Tenth Avenue between Forty-first and Forty-second Streets.[13] In 1982 Hardy Holzman Pfeiffer Associates completed the renovation of the first three floors of the building, converting it to studio and postproduction facilities for the National Recording Studios, an audio and television producer. Additionally, a 700-seat theater intended to showcase three regional theaters—the Long Wharf of New Haven, the Tyrone Guthrie of Minneapolis, and the Mark Taper Forum of Los Angeles—as well as local companies was to be built on the top floor and roof of the terminal, but after completion of the National Recording Studio facilities, plans for the theater were abandoned. Instead, 33,000 square feet on the upper floors of the airlines terminal and in a two-story, thirty-five-foot-high rooftop addition—a curving volume that, on the inside, formed a south-facing skylit atrium with two levels of clerestory windows, a mezzanine, and overlooking balconies—were

converted by Hardy Holzman Pfeiffer Associates for use as executive offices for the Spanish International Network, a television network.[14]

The Deuce

Despite the success of redevelopment between Ninth and Tenth Avenues, closer to Times Square, especially near Eighth Avenue, where the waiting rooms and concourses of the bus terminal provided all-weather shelter for seedy characters as well as the growing ranks of the homeless, Forty-second Street was a locus of social dysfunction. The block between Seventh and Eighth Avenues, once a glamorous center of New York nightlife, was commonly known since the 1970s as "the Deuce," short for "Forty-Deuce," a term that was also the title of a 1979 musical about Times Square and a 1981 play by Alan Bowne, later made into a movie, about young male prostitutes working in the area.[15] On May 26, 1977, a police substation opened in what had been the space occupied by the Crossroads Bookstore, perhaps New York's most prominently located shop specializing in salacious materials.[16] The store was located on the street level of the never-completed Crossroads Building (Henry Ives Cobb, 1910), once home to a popular café. But within a few months, the owners of the bookstore were reported ready to reopen half a block away, at 228 West Forty-second Street, between Seventh and Eighth Avenues, in the premises then housing Playland, an amusement arcade with twenty-five-cent mechanical games and a shooting gallery, but longtime home until the late 1950s to

ABOVE Theater Row, south side of West Forty-second Street between Ninth and Dyer Avenues. David Todd & Associates, 1978. View to the southeast. MAS

BELOW View of west blockfront of Seventh Avenue, between West Forty-second and West Forty-third Streets, ca. 1984. Robinson. MAS

Hubert's Flea Circus, a once internationally famous sideshow that included, along with the fleas, a fat lady, a bearded lady, and strong-man acts.[17] In recent years, the Playland store had become a reputed hangout for so-called "chicken hawkers," older men in search of young male prostitutes. By 1980 blight had infected the entire theater block and was spreading across all of Times Square as well, leading one concerned group to observe that "the 'Crossroads of the World,'" which had once "embodied and projected the optimism, vitality and dreams of American culture," now provided a "central location for social degradation of every sort which depends on the linkage between crime, physical decay, pornography, drugs and the prostitution of children."[18]

The success of Theater Row marked the beginning of Forty-second Street's return to grace as a key part of the city's great entertainment district, showing by example that legitimate theater could still hold its own in such improbable conditions. Robert Moss hoped the accomplishments at Theater Row would lead to a renewed appreciation of the historic theaters to the east: "Some of those theaters, such as the New Amsterdam, are gorgeous," continuing farsightedly if not a bit naively: "All those theaters need is scrubbing and cleaning."[19] The ten remaining theaters lining Forty-second Street between Seventh and Eighth Avenue—Hammerstein's Victoria Theater had been transformed in 1916 into the Rialto, which in turn was replaced in 1935 by a new building, the Rialto Theater Building—represented a hidden resource. Of the ten, the original Lew M. Fields Theater, by 1940 renamed the Anco, was by the 1970s thought to be beyond repair, as its facade had been removed and its stage sealed, leaving nine salvageable theaters on the block.

In 1978, with funds provided by the Ford Foundation, which was, at the time, "focusing a lot of energy to see if we cannot rescue at least four of the nine great theaters," a team of twenty social scientists from the Graduate Center of the City University of New York prepared a 230-page report entitled *West 42nd Street: The Bright Light Zone.*[20] In the broad-based study, they stressed that economic development must accompany police efforts to force pornography from the area; they also argued that the removal of pornography from the area would not cause it to proliferate elsewhere in the city, a fear that had led the outer borough presidents to stymie Mayor Abraham Beame's initiative. The report concentrated on the two blocks of Forty-second Street between Sixth and Eighth Avenues, especially the Deuce, which was typically traveled by 5,000 pedestrians an hour, making it the busiest in the city. This block, according to the report, was visited by a wide variety of people who "still [see] West 42nd Street as a major entertainment area," even though "they are afraid of what they see there now." Moreover, a survey undertaken by the team revealed that, despite fear of the area, there was widespread support for returning legitimate theater to West Forty-second Street and "an immense public desire" to see it "brought back to its former greatness."[21]

Apparently, the owners of the Brandt Theater chain, which operated seven theaters in Times Square, agreed. In November 1978, they undertook to clean the elaborately detailed terracotta Forty-third Street facade of the Lyric Theater, proposing to remold the faces of the gargoyles as part of a plan to convert it and the Apollo Theater, both currently in use as movie houses, into legitimate theaters.[22] While the Lyric's facade was cleaned, only the Apollo was converted back to use for live

performances. The Apollo Theater, built in 1920 as a vaudeville and movie house, had been converted into a playhouse in 1924, when a new passageway was constructed so that its entrance could be relocated from the backwater location of its auditorium on Forty-third Street to Forty-second Street. In 1934 the Apollo became home to Minsky's Burlesque but returned to its origins as a movie house in 1938. When it reopened as the New Apollo Theater in February 1979, Paul Goldberger praised John McNamara's renovation of the largely intact playhouse interior for its modest deference to the original, with warm beige painted walls, rich burgundy upholstery on the chairs, and a "slew of fine crystal chandeliers" that made it "a far cry from the shabby, decaying auditoriums of so many of Broadway's legitimate theaters," and a "far cry from the Minskoff and the Uris . . . huge barns, with Miami Beach hotel ballroom design and not a hint of intimacy anywhere." Goldberger did not seem particularly troubled that the passageway from Forty-second Street was used as an intermission lobby. Like most New Yorkers, he seemed to take for granted that no respectable theatergoer would want to be on Forty-second Street itself, and, as a denizen of the *New York Times*'s headquarters, the so-called *New York Times* Annex (Ludlow & Peabody, 1913, 1924), 229 West Forty-third Street, he was pleased that the renovation brought "life and vibrancy to a street that for a while has gained most of its excitement from goings-on at a massage parlor at one end and a welfare hotel at the other." Goldberger also reported that, unlike the rather banal facade of the Apollo, the Forty-third Street facade of the lushly ornamented Lyric Theater revealed "what a truly landmark facade" it is, "designed to remind us how very much theater-going was an event, a public celebration," while also celebrating "the notion of the building as a great civic presence." Regrettably, the Lyric's interior had long "before been largely stripped of its interior fittings and finishes" and would remain in such a state until the mid-1990s, when it was combined with the Apollo Theater and reinvented as the Ford Center for the Performing Arts (see below).[23]

The 42nd Street Redevelopment Corporation, led by Frederic Papert, was intent on nothing less than the street's complete redevelopment. Preparing a first plan called Cityscape, the group called for the retention of most of the valued theaters along the street but the demolition of the rest of the two blocks between Forty-first and Forty-third Streets, which would become a city urban-renewal project permitting the condemnation of buildings and the construction of a tourist-oriented theme-park-like development spanning Forty-second Street.[24] The preliminary plans incorporated in Cityscape were developed by Richard Weinstein, an urban designer who had run the city's Office of Lower Manhattan Planning under Mayor John Lindsay. Weinstein worked with the architect Jaquelin T. Robertson, the firm of Davis, Brody & Associates, the exhibit designers Chermayeff & Geismar, and Donald H. Elliot, a lawyer and former chairman of the City Planning Commission under Lindsay. The specific suggestions put forth by the designers, especially the one proposing a platform covering and darkening the street for most of the block in order to create a privatized public realm above the sidewalks, reflected the worst kind of anti-urbanism. The plan also called for two bridges crisscrossing Forty-second Street above the platform, two glass-enclosed atria, and an array of exhibition spaces, stores, and amusement rides, one of which Papert described as simulating "movement through layers of

Proposed Forty-second Street trolley. Rendering of view to the west between Fifth and Sixth Avenues, 1993. 42SF

New York, from the subway to the tip of a skyscraper."[25] In January 1979, Mayor Ed Koch let it be known that he was not prepared to go along with the Ford Foundation–sponsored Cityscape, explaining, "People do not come to midtown Manhattan to take a ride on some machine. This is a nice plan and we want to be supportive—but we have to be sure that it is fleshed out in a way appropriate to New York. We've got to make sure they have seltzer instead of orange juice."[26]

Koch was more receptive to another of the proposals—that of a proposed light-rail line along Forty-second Street, to be paid for with a combination of federal, state, and local funds.[27] There had not been a trolley on the street since November 17, 1946, nor one in Manhattan since April 7, 1957, when service was terminated on the shuttle across the Queensboro Bridge.[28] Plans for the trolley fizzled (though Papert continued to advocate it through the 1990s) after it became clear that the cars would not be the charmers of Judy Garland's "Trolley Song" but rather "little more than subway cars brought into daylight," as the editors of the New York Times put it.[29] Worse yet, they were to run along the south curbside to make possible the construction of safety platforms required to meet current standards of accessibility, thereby necessitating that Forty-second Street become a one-way westbound street, with eastbound traffic diverted to Fortieth Street.

In December 1979, Cityscape was redesigned by the same team and again released, this time under the auspices of a not-for-profit offshoot of the 42nd Street Redevelopment Corporation, the City at 42nd Street, Inc., for which Richard Weinstein served as vice president of design.[30] The new plan, called the City at 42nd Street, significantly greater in scope than its predecessor, included in the redevelopment site the blockfront along Eighth Avenue between Fortieth and Forty-first Streets as well as several sites on the east side of Broadway, defining boundaries that would be accepted in all subsequent plans. While five of the block's theaters—the New Amsterdam, the Harris, the Victory (formerly the Theatre Republic), the Apollo, and the Selwyn—would be retained and restored "to their original uses as legitimate stagehouses," and the facades of three others—the Lyric, Times Square, and

Empire (formerly the Eltinge)—would be restored, the rest of the block, except for the Candler Building, would, as in the previous proposal, be demolished to make way for elaborate mixed-use structures on either side of the street containing additional theaters as well as studios, a 500,000-square-foot exhibition and entertainment center, a fifteen-story indoor Ferris wheel, retail shops, restaurants, and multimedia displays that would introduce citizens and visitors to the city and its cultural life. A significant addition to the plan was to be the construction of 4 million square feet of office space in three new office buildings: one was to be on the east blockfront of Broadway between Forty-second and Forty-third Streets, replacing Clinton & Russell's Longacre Building (1912); another on the west blockfront of Seventh Avenue between Forty-second and Forty-third Streets, replacing some small buildings as well as the four-story Rialto Theater Building (Thomas W. Lamb and Rosario Candela, 1935), 1481–1483 Broadway.[31] A third building, replacing the Brokaw Brothers Building (Rouse & Goldstone, 1915) and the Crossroads Building, would occupy the triangular block bounded by Broadway, Seventh Avenue, Forty-first and Forty-second Streets. In addition, the plan called for a 2.1-million-square-foot merchandise and apparel mart, a facility that had been on planners' agendas since the end of World War II. The mart would be built along Eighth Avenue between Fortieth and Forty-second Streets.[32] The two blocks of the development would be connected across Forty-second Street by two elevated platforms, and a sky bridge would also connect the south block to the Port Authority Bus Terminal across Eighth Avenue.

The plan was as bold as anything ever proposed for the area, marking the first time the city had called for urban renewal and land condemnation in the central business district. Eleni Constantine, reporting for Progressive Architecture, feared that features such as pedestrian bridges could result in "an introverted mall with barren street frontage [that] might kill the activity that the 42nd Street Corporation has done so much to promote."[33] And, in what would become a critical leitmotif from artists, writers, and other intellectuals, Philip Lopate asked the readers of the

ABOVE City at 42nd Street, site bounded by Seventh and Eighth Avenues, West Forty-first and West Forty-third Streets. Richard Weinstein with Jaquelin T. Robertson, Davis, Brody & Associates, and Chermayeff & Geismar, 1979. Cutaway rendering of view to the northwest. CGS

RIGHT City at 42nd Street, site bounded by Seventh and Eighth Avenues, West Forty-first and West Forty-third Streets. Richard Weinstein with Jaquelin T. Robertson, Davis, Brody & Associates, and Chermayeff & Geismar, 1979. Model, view to the southeast. 42DP

Op- Ed page of the *New York Times* to consider the positive virtues of the block as it had evolved: "Do planners know how hard it is to achieve a visual clutter so extreme that it makes the simple traversal of one city block as adventurous as passing through a gauntlet? Sure, there are hustlers, thieves, prostitutes, cripples, derelicts, winos, molesters, monsters, droolers, accosters. I'm not denying it. Would you prefer to cement over the whole beehive with a dipsy-doodle exhibition hall and kick out those people so they'll congregate on another block and make a new heaven and hell somewhere else, maybe not as bright and never as satisfyingly central?"[34]

The City at 42nd Street plan was ambitious not only in its provisions for theater preservation and new entertainment venues but also in its call for 6 million square feet of rentable space—more space than offered in the original Rockefeller Center. With the increasing prosperity of the early 1980s, these goals seemed achievable. The dissent of Lopate and others notwithstanding, the public seemed to support the project, except for one of its provisions—the call for the destruction of the former Times Tower, a demand of the Canadian development firm Olympia & York, which was seriously considering the construction of the three office buildings needed to generate the funds to pay for the public benefits. Though bereft of its original terra-cotta Italian Renaissance-style skin, the 362-foot-high Times Tower (Eidlitz & McKenzie, 1905), from the roof of which an illuminated ball was dropped to celebrate each new year, was still a much beloved icon (the tower had not housed its eponymous newspaper since 1913; its skin had been stripped and replaced by Eidlitz & McKenzie's successor firm, Smith, Smith, Haines, Lundberg & Waehler, in 1965 with a banal one of white marble, when the Allied Chemical Corporation became its owner and prime tenant).[35] The Times Tower was owned by Alex Parker, who in 1975 had commissioned a second recladding in mirror glass from the firm of Gwathmey Siegel, which was not executed.[36] Parker was against the tower's demolition. Ada Louise Huxtable also opposed the demolition of the "much remodeled" building, calling it "unnecessary nonsense." Moreover, Huxtable labeled the proposed construction "an overly brutal scheme tacked onto a questionable land use for Midtown, as well as more theater destruction on the 42nd Street block than some of the city's planners think necessary. The project is far more intriguing as a legal and financial exercise than it is admirable as design. With all of its expertise, the scheme has an unhappy resemblance to a discredited tradition of urban renewal."[37]

Mayor Ed Koch, lukewarm at best about the plan for the City at 42nd Street, echoed comments he had made with regard to the earlier Cityscape scheme, labeling it "Disneyland on 42nd Street."[38] Taking a hint from Koch's remark, the planners had already begun to move away from tourist-oriented theme rides toward showcasing the performing arts, as well as providing studios for films and television. But Koch had more serious reservations than "Disneyfication," a term that would come into use later on when the company did indeed play a critical part in Forty-second Street's revival: he was, as Paul Goldberger wrote, "a bit edgy about committing the city to the $25 million in capital funds" needed to purchase the land, which the city would own.[39] As the debate over the City at 42nd Street plan swirled, in an effort to encourage public confidence in the possibility of saving the street, Richard Haas, a muralist, was commissioned by the 42nd Street Redevelopment Corporation, the city's Midtown

The Times Tower, Crossroads Building, 1465 Broadway, between West Forty-first and West Forty-second Streets. Mural, Richard Haas, 1979. View to the southwest. Mauss. ESTO

Office of Planning and Development, and the Office of Economic Development to paint the incomplete tower facades of Henry Ives Cobb's Crossroads Building, 1465 Broadway, between Forty-first and Forty-second Streets.[40] Previously, the same clients had commissioned the artist to paint monumental gateways reflecting the design of the Lincoln Tunnel's portals on the blank end walls of the buildings that flanked Dyer Avenue, the street that was cut through the block between Ninth and Tenth Avenues to lead traffic from the Lincoln Tunnel to Forty-second Street.[41] The Crossroads commission posed a tricky problem: the building was six stories tall, but its elevator and staircase had been built ten stories taller in anticipation of a vertical expansion that was never realized. In a brilliantly subversive move, Haas proposed to turn the towerlike exposed core into a version of the original Times Tower, explaining that, even though now compromised, the original image of that building had "never left. . . . It declared the identity of Times Square. Some buildings don't go away."[42] Ironically, Haas later happened on Cobb's design for the incomplete Crossroads Building and, in a reversal of history, found that it echoed the painter's design.

Though Mayor Koch did not favor the City at 42nd Street plan, many inside his administration, as well as important voices in the theater and hotel communities and businesspeople

Dyer Avenue Mural, southeast corner of West Forty-second Street and Dyer Avenue. Richard Haas, 1979. View to the east. Mauss. ESTO

Dyer Avenue Mural, southwest corner of West Forty-second Street and Dyer Avenue. Richard Haas, 1979. View to the west. Mauss. ESTO

concerned for the city's overall economic health, felt that it, or some other big idea, was in order. In June 1980, six months after the plan was released to the public, the editors of the *New York Times*, in a piece most likely written by Roger Starr, whose conservative, pro-development point of view clashed with that of Huxtable, chastised the city, noting that New York's "failure to develop strong and accepted planning procedures exposed it to harmful, even if exaggerated complaints of bad faith. If the city wasn't going to say yes to the Times Square ideas, then it should have said no, and sooner."[43] In large part, the famously egocentric Koch didn't like the initiative because it wasn't his own. So it came as no surprise when, less than a month after the *New York Times*'s knuckle-rapping, the mayor announced that the city was developing its own plan involving federal seed money, state condemnation powers, and private financing, to turn Forty-second Street west of Times Square into "the world's greatest entertainment district."[44] But, as the *New York Times*'s reporter Robert McG. Thomas put it, the new proposal, which contained no specific projects, was "in effect, a plan for a plan, in that it merely calls for private developers to submit specific proposals based on a generalized development program to be devised during the next six to nine months by the state's Urban Development Corporation."[45] Real estate insiders had, in fact, pushed the mayor into action: the rising tide of the city's overall economy had created a market for the superscale office buildings that would either replace the theaters or take advantage of their air rights. So much so, in fact, that one more office building was to be permitted on the west side of Seventh Avenue, between Forty-first and Forty-second Streets, replacing four- and five-story buildings facing Forty-second Street, a parking lot on the Forty-first Street corner, and the underappreciated, largely derelict Hermitage Hotel (Robert D. Kohn, 1907), a first-rate example of Secessionist-inspired work.[46]

In May 1981, design guidelines for Forty-second Street's redevelopment were released, formulated by Cooper Eckstut Associates, which had recently developed guidelines for Battery Park City's growth, working in cooperation with the Department of City Planning, the city's Public Development Corporation, and the state's Urban Development Corporation

(UDC).[47] The essential feature of the new plan, echoing the City at 42nd Street, was the construction of high-rise office buildings at the Times Square end of the block in order to generate funds to preserve and rehabilitate the rich trove of theaters that extended along much of both sides of the midblock between Seventh and Eighth Avenues. Retail development would also be encouraged and the previously announced merchandise or apparel mart would anchor the west end of the block. Significantly, the guidelines called for the renovation of the former Times Tower into what was described as a "potential civic sculpture."[48] The editors of the *New York Times* couldn't have been happier: "Finally here is a 42nd Street Development Project that promises to be more than idle chatter."[49] But Paul Goldberger could only muster guarded optimism for the proposal, praising its "realism: it recognizes that since the legitimate theater left West 42nd Street 50 years ago for the blocks just to the north, the street has been a void between three major districts—the garment center to the south, the midtown office center to the east and the present theater district. West 42nd Street is a kind of 'no man's land' between these areas, part of none of them and a barrier to expansion for all of them." Goldberger, accurately mirroring public sentiment, concluded: "No one is predicting too much for 42nd Street this early in the game. It is a street of too many failed hopes—of planners' failures as much as people's failures, and at this point almost everyone, government official and citizen alike, is somewhat jaded. But if there was any scheme that appeared to have a chance, it is this one—not because it is big, or splashy, or spectacular, but because it is realistic. It calls for a 42nd Street that is part of the rest of New York, not a thing apart."[50]

On June 4, 1981, state and city officials formally requested proposals for the redevelopment of key sites that were to be developed according to Cooper Eckstut's design guidelines.[51] Requirements called for special effects of lighting and signage, rooftops outlined in neon or clear lamps, floodlighting, and other traditional forms of Times Square razzle dazzle. Alexander Cooper presented his proposed redesign for the former Times Tower, which would be reclad with a sign-friendly scaffolding that would modify the building's profile so that it

would slope up from south to north, where its height would be almost doubled. The change in the building's geometry reflected the then generally held belief that Times Square could be reclaimed as a popular entertainment center with enough crowds to justify the expense of the signs and that, with the construction of new office towers, Forty-second Street would not be a real player in the Bright Lights district but would become a comparatively conventional midtown street, serving large numbers of office workers and commuters by day and by night a comparatively small number of theatergoers. Rigid guidelines for massing were established, with the desired shapes modeled after those found at Rockefeller Center, but incorporating a lesson from Cesar Pelli's newly developed plans for the World Financial Center, where stone-clad bases gave way to glassy tops. Unlike the Battery Park City work, the bases on Forty-second Street were to be metal. Guidelines for storefront design were based on those of the Empire State Building (Shreve, Lamb & Harmon, 1931).[52] As if to reassure all involved that the plan was serious and viable, and as a harbinger of the legal maneuvering that would thwart the project for years, a state judge, acting on a petition made by several businessmen on the street, ruled on September 1, 1981, that the UDC had not followed proper procedures in holding public hearings and ordered a new hearing.[53] Undeterred, twenty-six teams of developers offered plans for the property.[54]

42nd Street Development Project

In April 1982, the Koch administration announced that four, or possibly five, major developers had been conditionally chosen for what Karen Gerard, Deputy Mayor for Economic Planning and Development, termed "the largest redevelopment plan in the city's history."[55] On April 6, 1982, the developers were announced, with George Klein's Park Tower Realty receiving the largest contract calling for four one-million-square-foot skyscrapers to be erected at the corners of Seventh Avenue, Broadway, and Forty-second Street. Additionally, Housing Innovations/Planning Innovations, a minority-controlled developer specializing in housing, would construct a 500-room luxury hotel and retail complex on the east side of Eighth Avenue between Forty-second and Forty-third Streets; David Morse and Richard Reinis, California-based developers currently operating a Los Angeles wholesale mart, would develop a similar facility on the two blocks running along the east side of Eighth Avenue between Fortieth and Forty-second Streets, though the team would be dropped in November 1982 after it experienced difficulties acquiring funds.[56] The fate of the midblock theaters was not yet clear, but it was believed that they would be renovated, if not by the owners, the Brandt family, then by others. If the Brandt family joined the project, the Times Square and Victory theaters would be acquired with funds contributed by Park Tower. The New Amsterdam and Harris theaters were controlled by the Nederlander family, prominent owner-operators who were expected to renovate their properties. The Apollo Theater, recently renovated, would be unaffected, although its Forty-second Street entrance would be reopened. With at least a six-month-long period of public review ahead of it, the project also faced the likelihood of delay as the result of prolonged civil suits brought by owners of the pornographic establishments in the area as well as various property owners seeking to maximize settlements in the condemnation proceedings. Once approved, the project was to be completed by the state's Urban Development Corporation, possessed of extraordinary development powers including the ability to override local zoning restrictions, which created a subsidiary, the Times Square Redevelopment Corporation, composed of two city-appointed members, two state-appointed members, and a chairman chosen by the four members.

Forty-second Street Design Guidelines, West Forty-second Street, Broadway to Eighth Avenue. Cooper Eckstut Associates, 1981. Model, view to the south. CRP

Amazingly, there was little public discussion of the plan, perhaps because the editors of the *New York Times*, acknowledging their newspaper's interest in the street as nearby neighbors, did not question its provisions and did little to encourage the sponsors to clarify their concept for the street's future as an entertainment district. Mayor Koch was also enthusiastic about the plan, which would increase by 70 percent the theater district's capacity: "Forty-second Street was once famous for its theaters and nightlife. When this project is completed, night life and theaters will make it famous again."[57]

But it wasn't long before the city-state partnership began to derail. On August 9, 1983, Mayor Koch pulled out of the agreement with the UDC, saying that the city would complete the $1 billion project itself. The rift came about when the board of the Times Square Redevelopment Corporation rejected Koch's choice of a replacement developer for the mart project. By October Governor Mario Cuomo and Mayor Koch had reached a compromise, announcing that the Dallas developer Trammel Crow would operate the mart, Tishman Speyer Properties would build it, and the Equitable Life Assurance Society would provide most of the financing, with completion slated for 1987. Kohn Pedersen Fox, hired to design the behemoth, called for a twenty-story, 2.4-million-square-foot, granite- and limestone-clad, terra-cotta-trimmed block meant "to relate both to the original architectural nature of the theatre district, with its exuberant interpretations of Classicism, as well as to the technological aspects of the program," that reflected changing priorities by calling for showrooms for both the computer and apparel industries, the former occupying about 80 percent of its leaseable floor area.[58] KPF called for wide arched entrances facing Eighth Avenue with a superscale clock to be mounted atop the central arch that carried the huge bulk of the proposed building over Forty-first Street. To help reduce the impact of the mass, the building was composed as a series of towerlike pavilions, culminating in ten pyramidal roofs and a central, taller stepped pyramid, presumably lighting an atrium. The mart, deferred until market conditions improved, would not be realized. The two-block site remained undeveloped until 2005, at which point construction began on a new headquarters for the *New York Times*

Proposed Merchandise Mart, east side of Eighth Avenue, between West Fortieth and West Forty-second Streets. Kohn Pedersen Fox, 1984. Model, view to the northeast. KPF

designed by Renzo Piano (see below) on the southern block, while the northern block was slated for a 1.1-million-square-foot, thirty-four-story office building designed by Fox & Fowle (see below).

On August 10, 1982, Philip Johnson was named master planner and John Burgee Architects coordinating architect of the four-tower office group to be built by Park Tower Realty. Initially George Klein, head of Park Tower, suggested the possibility of having a different architect for each building, with Helmut Jahn's name being mentioned as one who might be tapped, but the idea was dropped. On April 1, 1983, the redevelopment plan passed its first court test when, in response to a property owner's suit, the state's highest court, the Court of Appeals, unanimously determined that there were "no legal deficiencies" in the way the Urban Development Corporation conducted a public hearing on the project in August 1981.

Meanwhile, the fate of the former Times Tower remained unresolved. Alex Parker, who had bought the building in 1974, sold it to a Swiss company in February 1981, which in turn sold it to the TSNY Realty Corporation five months later.[59] In December 1983, TSNY filed suit against Park Tower, which a week before had offered to buy the tower in order to tear it down. In fact, the first presentation of Johnson and Burgee's plans for Park Tower's four new towers showed the Times Tower removed, an act that, in a strongly worded letter to the UDC, Theodore Liebman, president of the New York Chapter of the American Institute of Architects, not only deplored but also pointed out to be a significant departure from the May 1981 42nd Street Development Project Design Guidelines, which explicitly called for it to be preserved and, if a developer so chose, modified to "dramatize" the tower's "function as a night-time civic sculpture and focal point."[60]

The removal of the Times Tower was advocated by Philip Johnson, who believed that what was important was the relationship of his four towers "to one another" and to the streets, a relationship that the Times Tower "destroys . . . because of its prominent central position." What Johnson had in mind, and in this he had the enthusiastic support of his client, was Rockefeller Center. Johnson was willing to entertain the idea of replacing the Times Tower with a low pavilion dedicated to public services or retail uses, but its height should "maintain the feeling of openness." Mindful of the role the Times Tower had traditionally played in New Year's Eve celebrations, Johnson proposed relocating the "New Year's Ball" to the building he was designing for the Crossroads site. The crux of the strategy was the idea that the intersection of Forty-second Street and Times Square would reemerge not as an entertainment and outdoor communications center but as a dignified office group: "Without the removal of the tower, the new office buildings are merely individual structures with very little relationship to each other." By "grouping the new buildings around an open public plaza," Johnson stated, the development could take on "a sense of place. . . . It is this sense of urban center, which Times Square now lacks, that we feel is so important."[61]

Presented to the public on December 20, 1983, Johnson and Burgee's scheme packaged 4.1 million square feet in four limestone-trimmed-in-red-granite mansarded and crocketed French-Renaissance-via-Second-Empire-Paris towers of heights varying from twenty-nine to fifty-six stories. Goldberger wrote that the towers were likely to be "the most striking additions to a skyline that has recently had its share

of striking things." Many disagreed with his choice of superlatives, believing that the towers promised to be not the most striking but rather the bulkiest buildings in the city. The tallest among them was situated on the northeast corner of Forty-second Street and Broadway, enjoying a floor area ratio of 45 compared with the FAR of 18 that was then common in midtown. Goldberger found the historically recollective design, which would give the "effect . . . of glass towers sitting on stone bases and partly covered by stone walls," to be quite original in its "mix [of] elements that are historical with others that are more purely modern. While a set of mansard roofs hundreds of feet above Times Square cannot but seem bizarre, the fact is that it is the historical elements that are the most successful part of this design by far," promising to "cut a sharp and lively profile on the skyline." Goldberger pointed out that Times Square had traditionally been home to "fairly serious works of architecture," such as Clinton & Russell's exuberantly mansarded Astor Hotel (1904–9). Acknowledging that the square's buildings were frequently overlaid with signs and that high art and the signs could work well together, Goldberger endorsed Johnson and Burgee's proposal: "They may be sheathed in stone, but they do not look as though their integrity would be shattered by a neon sign going up across the street." Across the street, yes; but, many would ask, would the architects and their developer client permit signs on the buildings themselves as the guidelines called for?—for as Goldberger pointed out, there was "one school of thought that holds that Times Square is all signs and lights and visual energy . . . and nothing is more out of place [there] than 'real' architecture." Goldberger also supported Klein's desire to demolish the Times Tower. Citing the 1965 renovation of the building by the Allied Chemical Corporation, Goldberger explained, "All of the architectural quality of this landmark was lost at that time, and right now, there could be no better use for this site than as an open space to pull together the new towers that are to surround it."[62]

While many would debate the merits of Johnson's design, there was general agreement that the buildings were too bulky. Michael Sorkin slammed them as "a group of four extravagantly ugly and mercenarily large office towers designed . . . in flagrant disregard for the design guidelines," which called for stricter setback provisions but which were waived by the UDC after Klein argued that the smaller upper floors would be difficult to lease to corporations.[63] Ada Louise Huxtable, no longer connected with the *New York Times* after her retirement from its editorial board in 1982, described the towers as "enormous pop-up buildings with fancy hats."[64] She later stated that it was "as if the hard lessons of recent decades about the interaction of buildings, people, and cities had never been learned. Times Square's image and role in the city's history were completely ignored as a source and function of the new design. But the most disturbing lesson, which occurs over and over in the annals of city planning, is the fact that enough time had elapsed, and enough speculation and development had started on the midtown West Side, to raise serious questions about the need for the financial and urban giveaway and the impact of this inhumane scheme on the area's density and character."[65]

The criticism of the towers was taken up by public interest groups, especially the Municipal Art Society. MAS board member Thomas Bender, in an essay published on the *New York Times*'s Op-Ed page, denounced the project for "ruining Times Square": "The Klein-Johnson plan rejects any notion of

Proposed Times Square Center. Philip Johnson and John Burgee, 1983. Model, view to the south. Lieberman. PTG

a five-story street wall and of the street as a significant public place. . . . The kind of street Mr. Klein and Mr. Johnson offer us is the kind found in downtown Washington—and everyone knows what kind of frightening urban space that becomes after 5 o'clock. They may have devised the only conceivable plan that could make the Times Square and 42nd Street area more threatening than it is at present."[66]

The architects were also criticized for their apparent lack of interest in the large signs and bright lights that had defined both Forty-second Street and Times Square for eighty years. Yet prominent critics such as Paul Goldberger, whose once-influential role was beginning to be compromised by what some saw as a too eager acceptance of developer-driven aesthetics, continued to defend Johnson and Burgee's design. In the face of many other observers who saw the buildings as totally out of keeping with Times Square's historic character, Goldberger went so far as to claim that "if the buildings were smaller, less overwhelming in bulk, they would not be bad at all. They contain a mix of formality and playfulness that could be just right for Times Square—if only there were less of it." Still, Goldberger, who seemed increasingly inclined to step beyond the role of critic to, at least with words, that of architect, went on to propose that the "themes" of the buildings be varied according to their locations with respect to the square, an idea Johnson and Burgee would embrace with a vengeance in 1989.[67]

Not surprisingly, the editors of the *New York Times* offered

unqualified support for the project, going so far as to claim that "the office buildings that are to encircle the southern end of the square will provide a backdrop."[68] But Brendan Gill mounted a campaign against the office towers, "which . . . are exceptionally repellent not only in bulk but also in the silliness of their French Empire detailing (fake-mansard roofs, surmounted by pretentious iron crestings)," and ultimately against the Forty-second Street project as a whole.[69] In a letter to the editors of the *New York Times*, taking on both the Johnson and Burgee towers and the Robert Venturi apple (see below), Gill wrote: "What on earth causes these distinguished architects to make design suggestions that a talentless, comic-strip-besotted schoolchild could devise in the course of a few moments of idle doodling? Is it possible that they unconsciously share the revulsion that so many ordinary laymen feel at this disembowelment of Times Square and for that reason proffer us examples not of their best thinking but of their worst?"[70] Gill expanded his critique to focus not just on the specific design of the buildings but also on the impact they would have on the future of the entire entertainment district. He found no evidence that the 4 million square feet of "conventionally dreary office space" were needed to achieve the area's revitalization, warning that unless the plans were changed "to preserve the life and flavor of Times Square . . . disaster awaits. . . . The operation will be a success and the patient will die."[71]

Theodore Liebman, representing the membership of the New York Chapter of the American Institute of Architects, criticized the plan for its distinct lack of Times Square verve, in particular for its lack of bright lights. The chapter, he stated, supported the guidelines' stipulation that "large areas at the base of the towers and portions of the facades rising to the very top . . . contain signs and lighting as response to the [tower's] location in Times Square."[72] To make the point more vivid, at the invitation of Van Wagner Advertising and Artkraft Strauss, which together owned and operated 99 percent of the Times Square signs, the Architectural League of New York, the Landmarks Conservancy, the Regional Planning Association, and the New York Chapter of the AIA jointly sponsored a half-hour Times Square blackout, from 7:30 to 8:00 P.M. on Saturday night, March 24, 1984.

John Burgee defended the design and its departure from the guidelines. Given the need to maintain a minimum thirty-six-foot-nine-inch depth between the window wall and the core, he argued, the Cooper Eckstut setbacks could simply not be made to work. Moreover, he pointed out, the design did provide setbacks at the fifty-five-foot level, albeit just at the corners, and did use sloping roofs to help reduce the apparent mass. Moreover, he claimed that the signage requirement was being met with thirty-foot-high, eight-foot-wide finlike fixtures to be set ten feet on center on each of the towers, a strategy he believed would yield, when viewed from the street, the equivalent of the forty-by-sixty-foot sign suggested in the guidelines.

The debate over the buildings and their impact on the future of Times Square was taken up by the national press. In June 1984, John Morris Dixon, editor of *Progressive Architecture*, weighed in, arguing that Johnson and Burgee and Park Tower were "making modest concessions to public organizations—and the local AIA—who want them to honor planning guidelines that call for lively signs on the buildings to maintain the famous image of the square. . . . Now, ironically,

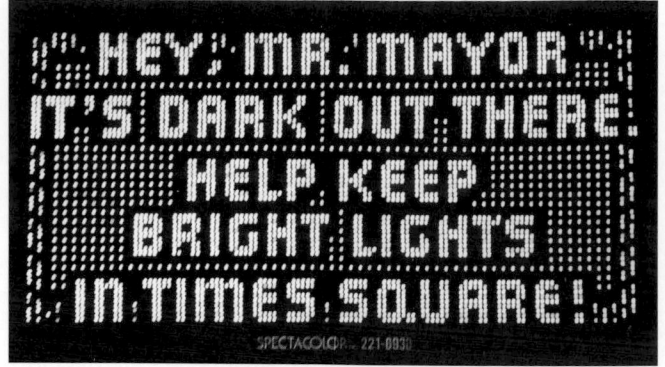

Spectacolor, One Times Square, 1984. MAS

public spokesmen are challenging a building client's lapse into what would otherwise be called good taste."[73] Carter Wiseman, architecture critic at *New York* magazine, took issue with Dixon's argument: "The sanitizing Burgee/Johnson designs for the proposed towers are a long way from the architectural 'good taste' ascribed to them in [Dixon's] editorial. The short-sighted enthusiasm for a real estate coup is even further off the mark. This is the most striking example of architecture being abused to sell bad urban planning."[74]

James S. Russell, an architect and journalist, was the first to raise yet another issue, that of "theme": the entire project, he claimed in October 1984, "would result in the utter transformation of Times Square and the end of the area as the 'Rialto' of honky-tonk amusements. These would remain in the proposed development as no more than a theme, suggesting the museumization of what is perhaps most quintessentially 'New York' about New York." Though Russell was critical of Johnson-Burgee's architecture, it was the Cooper Eckstut guidelines that he really took to task:

> There seems never to have been a recognition that forms of entertainment other than theater are also 'legitimate.' The guidelines do not encourage movie theaters or nightclubs, rehearsal space, or stages for dance and music (except Broadway musicals). These uses frequently cannot generate the revenues per square foot that office or retail space can. They are, however, indispensable elements of what makes New York a center for the arts. . . . The environmental impact statement prepared by the UDC recognizes that commercial occupancies and rehearsal space related to the theater may be pushed out by the new development, but it offers no mitigating measures. The giantism of the plan, then, is at odds with the idea of a coherent theater or entertainment district. Without Times Square as the linchpin, there will be no recognizable district, just a bunch of theaters scattered along various side streets.[75]

The concerns of many public-spirited New Yorkers about the scale and character of the proposed buildings, and about Times Square's potential loss of glitter, were matched by those of residents of Hell's Kitchen (a neighborhood that had recently come to be known as Clinton), who feared that crime in Times Square and on Forty-second Street would simply move west into their area, and that the affordable rents characteristic of the area would spiral out of reach as west midtown revived.[76] Last-minute negotiations with the city and state allocated funds for housing rehabilitation, small businesses, and programs to combat juvenile prostitution as well as a fund to help stabilize rents.

As the project moved through the approval process, George Klein asked Venturi, Rauch & Scott Brown to develop a design for the site of what he expected to be a demolished Times Tower. Klein's decision to hire the Venturi office, which was probably encouraged by Johnson, was astute, part of a shrewd calculation to win the critical support among high-style architects for the destruction of the Times Tower. Venturi had been almost alone to appreciate Times Square in the 1960s when he wrote about its "jarring inconsistencies of billboards and buildings . . . contained within the consistent order of the space itself" and the "seemingly chaotic juxtapositions of honky-tonk elements [that] express an intriguing kind of vitality and validity, and . . . produce an unexpected approach to unity as well."[77] Venturi's Philadelphia-based firm proposed a giant, ninety-foot-high red apple to be set atop a five-story building—the top floor of which would be ringed by an electronic news zipper.[78] This pun on the city's then almost universally acknowledged nickname, the Big Apple, was not only rejected by Klein, who still wanted a full-blown plaza, but also failed to garner widespread support among architects or the public. Tim Prentice, who would later contribute a design for a sculpture to the Municipal Art Society's competition for the site, wrote to the *New York Times*'s editors that Venturi had "it backward. It is more important to have a core in the Big Apple than a big apple in the core."[79]

While the Venturi team's scheme was constrained by the client's wish to see the Times Tower demolished to make way for a plaza, those asked to submit their ideas to the virtually simultaneous competition sponsored by the Municipal Art Society and the National Endowment for the Arts were asked to do just the opposite: to redesign the tower itself.[80] A large and diverse jury was selected to cull through the 565 submissions, each confined to a single thirty-by-forty-inch board. Of the eight prizewinners, Raimund Abraham's was the most arty. Combining a movie theater at the base with a slender tower that was little more than a scaffolding of stairs, Abraham proposed a:

Fragment of
past memories
sediment as
Time
moving toward the
Sky
passing through
layers of Horizons
compressed
projected
Totem
Sign
of another
Time
towering endlessly
like the
Column
of
Brancusi.[81]

Frank Lupo and Daniel Rowen's call for a tower supporting a huge pair of winglike electronic video screens that would open at night was poetic in its ambitions but decidedly grandiose in form, as was Machado & Silvetti's quite similar but less site-specific design. The proposals of Taeg Nishimoto, who called for a version of a Metabolist scheme from the 1960s, and of Carol Rusche and Paul Bentel, who called for a super-scaffolding, were even more overblown. Despite their self-importance, the selected submissions, and the competition itself, was effectively subversive, if not quite as clever as Richard Haas's mural on the Crossroads Building had been. A few entrants, however, picked up on Haas's idea. For example, David Stein's building was shaped like the old Times Tower but sheathed in glass so as to

Proposal for *The Big Apple*, site bounded by Broadway and Seventh Avenue, West Forty-second and West Forty-third Streets. Venturi, Rauch & Scott Brown, 1984. Rendering of view to the south. VSBA

Proposed Times Tower, site bounded by Broadway and Seventh Avenue, West Forty-second and West Forty-third Streets. Raimund Abraham, 1984. RAA

Proposed Times Tower, site bounded by Broadway and Seventh Avenue, West Forty-second and West Forty-third Streets. Frank Lupo/Daniel Rowen Architects, 1984. DRA

reveal behind it a system of bulbs arranged to reproduce the original tower at full scale; Craig Whitaker and Demetri Sarantitis suggested that the old Times Tower be restored and that a smaller version be put in Duffy Square, a design based on Venturi, Rauch & Scott Brown's earlier proposals for Copley Square, Boston, and Pennsylvania Avenue, Washington, but nonetheless powerful in a New York setting.

The Spanish architect Ricardo Bofill, one of the period's most accomplished architect-urbanists, offered a proposal that for sheer temerity was unparalleled. Bofill proposed to eliminate all the buildings on both sides of Forty-second Street between Seventh and Eighth Avenues to create a pedestrian plaza. A large building would form a triumphant arch over Forty-second Street and a classical tower sheathed in reflective glass would occupy the Crossroads site. Finally, an obelisk with a laser would mark the crossing of Broadway and Seventh Avenue: "These ideas," wrote Patrick Dillon, a member of Bofill's design team, "should be seen as suggestions and are meant to keep alive the debate about the quality of space and style of buildings in the most beautiful historic city of the late twentieth century."[82] Some of the proposals were sheer fun: Tim Prentice, the architect turned sculptor, proposed a colossal statue of Diamond Jim Brady, while Michael Monsky and David Suter proposed colossi.

The fate of the Times Tower, officially an excluded parcel in the plan, remained unresolved through the 1980s, during

which time it enjoyed partial tenancy at best, leading its owners, who valued its worth as a conventional office building, for which it was largely useless, to file for bankruptcy protection in 1992.[83] In 1993 Madame Tussaud's, the London-based chain of wax museums, began to develop plans to purchase the building and transform it into an elaborate wax museum incorporating robotics and electronic machinery to depict the history and culture of New York City.[84] But in late January 1995, when the tower was auctioned by the Banque Nationale de Paris, which held the mortgage on the property, Tussaud's was unexpectedly outbid by the investment banking firm and financial powerhouse Lehman Brothers. Lehman's higher-than-expected purchase price reflected its vision of the tower not as usable office space but as a cash cow of rentable advertising space. Capitalizing on some of the ideas in the 1984 Municipal Art Society competition and taking cognizance of the rapidly escalating interest of advertisers in displaying their products on spectacular electronic signs in Times Square, a trend that would predictably continue at least until the millennium celebrations, when the media would focus their cameras on the square and its signs, Lehman Brothers envisioned the building as little more than a scaffolding for signs, although the company was mindful of the value of the retail space at the base. In November 1996, less than a month after Disney opened its retail store across the avenue on the southwest corner of Forty-second Street

and Seventh Avenue, Warner Bros., another film company, then expanding its own chain of retail stores, announced its intention to enter into a long-term lease for the Times Tower, hiring Frank Gehry to uninhibitedly explore a new design for the building.[85] Gehry proposed to strip the tower of its white marble facade and cover its steel skeleton with a translucent metallic fabriclike mesh that could billow and move with the wind as well as be manipulated by large clockwork machinery occupying eight stories on the lower half of the building, where the floor plates were to be removed. The machinery was used to mobilize a cast of mechanized Warner Bros. cartoon characters—among them Superman, Bugs Bunny, and Elmer Fudd—that would, at each hour, wind through the building's labyrinthine skeleton on tracks, emerging from the superstructure to transform the Times Tower into an enormous cuckoo clock—complete with lasers and smoke machines. The elaborate works would be visible from the square as well as from a street-level public plaza beneath the tower created by the removal of the building's first four floors. Gehry proposed to locate the Warner Bros. retail space below grade, accessed by escalators, and a restaurant and bar on the top floors. After presenting the design to his clients, Gehry never heard from them again.

Herbert Muschamp was taken by the design, placing it in the context of Gehry's evolving career: "The mesh skin of the tower design descends from the chain link fence" used in Gehry's 1976 remodeling of his Santa Monica home, and Gehry's inclination toward the "artistic elevation of humble materials and forms" is evidenced in his reference to "the structural frame, construction scaffolding and netting used to shroud buildings during renovation. Probably many New Yorkers have been impressed by the visual power of this hardware, an effect few completed buildings can match. The architect heightens the effect with esthetic intent." Muschamp went on to place the design in its historical and cultural context, noting that the Statue of Liberty also wore a "metal dress" and suggesting that one could consider the tower to be "a Statue of Liberty for an era when Times Square has become the city's Ellis Island, a symbolic port of entry for many of the city's newest arrivals. At least it's a terrific symbol of the creative freedom for which the city stands." In essence, wrote Muschamp, "Mr. Gehry grasps the spirit of infantilism at large in this area today: the happy-face regressiveness, the laid-on-thick veneer of innocence and play, an ethos conceived in reaction to the area's lingering reputation for vice and crime. . . . Mr Gehry's design is adult fantasy; it even strips," wrote Muschamp, referring to the way the mesh skin could be drawn back, "That's what distinguishes it from, say, the Disney Store across the street. It's the difference between children's theater and theater."[86]

Despite, or perhaps because of, Warner Bros.' insistence that Gehry pay no attention to cost, the proposal proved too expensive, and the Michigan-based JGA Inc., put in charge of planning the Warner Bros. retail store that would occupy 15,000 square feet in three levels of the tower, filled its awkwardly shaped interior with a confusing jungle-gym-like arrangement of display areas (1998) that were not well suited to retailing.[87] When the fad for themed merchandise declined precipitously in 2001, the store closed along with all the others in the chain. Not much note was taken of the store's departure because what New Yorkers cared most about was preserved: the silhouette of the beloved Times Tower and the

Proposal for Times Square. Ricardo Bofill, 1984. Site plan. RBTA

Proposal for Times Square. Ricardo Bofill, 1984. Broadway perspective looking south. RBTA

Proposal for Times Square. Ricardo Bofill, 1984. Forty-second Street perspective looking west. RBTA

drama of its presence cleaving the two avenues at the south end of the city's most vital and democratic public place, which entered the new century, as it had the last, as the Crossroads of the World.

The 42nd Street Development Project (the successor organization of the Times Square Redevelopment Corporation) negotiated its last legislative hurdle when the Board of Estimate unanimously approved the plan on November 9, 1984, after fifteen hours of public hearings and days of behind-the-scenes negotiations. The project was considered so important that Mayor Koch decided to chair the proceedings—the first time he had done so in five years—and Governor Cuomo chose to attend, becoming the first governor in at least a generation to enter the board's chambers. As approved, the plan called for extensive demolition on thirteen acres along Forty-second Street between Seventh and Eighth Avenues, the rehabilitation of the subway stations at each end of the block, the construction of four office buildings, a hotel, and a merchandise mart, with one of the office buildings containing more than twice the bulk normally allowed under city zoning regulations.

The project's approval brought on yet more lawsuits—mostly from property owners threatened with condemnation proceedings—that joined previously filed lawsuits from developers who had not been selected.[88] Within seven weeks of the plan's approval by the Board of Estimate, nineteen legal actions were filed to block the project's progress, challenge the predicted environmental impact, or change builders. The attendant publicity rendered the project even more unpopular than it had already become. The situation was aggravated by the departure of Robert T. Hall, president of the 42nd Street Development Project, in 1986; a new leader for the project was not appointed until May 1987, when Carl Weisbrod, executive director of the city's Department of City Planning, took over as president.

As the lawsuits proliferated, Klein, faced with the Times Tower conundrum, began to give ground on the plaza, shopping around a seven-story Italianate-style bell tower designed by Johnson and Burgee, a structure that, according to Paul Goldberger, would have had "the appearance of a brand-new ruin [with] an open staircase running up its middle and a waterfall running over rough stones at its base." Goldberger was not amused. He found the proposal "a stage set, to be built at overwhelming scale in the middle of the most famous public space in New York."[89]

By fall 1986 the project, once bogged down by twenty-seven direct legal challenges and embarrassed by the indictment of one sponsor, former taxi czar Michael Lazar, who was convicted of racketeering, was now free of all but two of the lawsuits and seemed poised to move forward. But as Carter Wiseman put it, "The time they have consumed [has] taken its toll," allowing local groups to exert considerable pressure on officialdom and eroding the self-confidence of a mayor who declared "it will be done" and an Urban Development Corporation that dismissed the concerns of citizens as "trivial." More significantly, the prestigious law firm Dewey Ballantine, which had been Park Tower's only prospective tenant, had backed out, instead taking space in 1301 Sixth Avenue. Additionally, guidelines drafted by the City Planning Commission for the Times Square and Duffy Square "bow tie" seemed a further form of repudiation; as Wiseman put it, they "are strikingly like the ones overridden by Philip Johnson and John Burgee."[90] And though the real estate market as a whole

Proposed renovation of Times Tower, site bounded by Broadway and Seventh Avenue, West Forty-second and West Forty-third Streets. Frank Gehry, 1996. Model, view to the southwest. GP

was softening, the rezoning of midtown made it inevitable that new office construction would move westward without subsidy, so that the concern among many was not the need to subsidize construction on Forty-second Street and in Times Square, but the need to channel it in an effort to prevent the complete loss of the neighborhood's character. Public groups and some elected leaders, many of whom did not grasp the project's implications for the redevelopment of Forty-second Street's theaters, questioned the value of the project as a whole. Local political leaders, including Councilwomen Carol Greitzer and Ruth Messinger and State Senator Franz S. Leichter, increasingly disenchanted not only with the lack of progress but also with the project itself, cited changes in the project and the cost of tax subsidies offered to the developer when they filed suit on December 9, 1987. Leichter, an opponent since the project's inception, called it "the longest-running farce that Broadway has ever seen." Leichter had a point when he claimed that after almost ten years, "the only thing the plan" had so far succeeded in doing was to freeze "the sleazy quality of 42nd Street because, as a result of the plan being state policy, no other developer, no private-sector business is going to go in and do anything on that street."[91]

In October 1986, Park Tower brought the Prudential Insurance Company in as a partner, ostensibly because the

increased financial clout of the team would make it possible for construction to go forward on the first two buildings by mid-1987. Closer to the truth, Park Tower needed Prudential's financial resources to make up for the fact that its $1.1 billion mortgage plan with Manufacturers Hanover Trust Company, presumably entered into in 1984, had not worked out.

The appointment of Carl Weisbrod as president of the 42nd Street Development Project brought new optimism and energy to the project. In June 1988, the state at last entered into a lease agreement with Times Square Center Associates, the joint venture between Park Tower and Prudential. Presumably this would lead to some real changes on the street, but still-pending lawsuits, combined with a precipitous decline in the real estate market as a result of the stock market crash in 1987 and deeper issues in the economy that led to a recession in 1990–91, prevented any progress.

The Theaters Take Center Stage

Ostensibly the raison d'être for the 42nd Street Development Project was not the construction of new office buildings, a hotel, and a mart, but the preservation, architectural restoration, and programmatic reinvention of at least seven of the theaters that occupied the bulk of the street's midblock real estate. The effort to preserve the theater district in the wake of the westward expansion of the midtown office building district had once before been addressed, in the late 1960s, leading to the creation of a special theater zoning district that awarded developers bonuses for extra office space in exchange for the promise of new theaters.[92] This plan led to the construction of two of the city's least loved theaters, the Uris and the Minskoff, which were decried almost as much for their huge size as for their ice-cold featureless interiors. In fact, as Paul Goldberger pointed out, "the failure of the newer theaters as works of design is a perception that fires the entire debate over the future of the theater district."[93] Construction under the 42nd Street Development Project was expected not to include such new venues but to generate money to revive the Deuce's dilapidated historic theaters. While some argued that the theaters were not only physically neglected by their owners but were also programmed to appeal to the lowest common denominator of public taste, X-rated pornography, the theater owners and operators, with considerable justification, claimed otherwise: what was mostly being shown by the late 1980s were action films made by Hollywood studios.[94]

In 1987–89 the money advanced by Park Tower/Prudential enabled the 42nd Street Development Project to hire Robert A. M. Stern Architects to prepare a plan for the reuse of five Forty-second Street theaters and to collaborate with Hardy Holzman Pfeiffer Associates on a conjectural model of what Forty-second Street might be like once the five theaters, as well as four others that Hardy had previously analyzed for the 42nd Street Development Project, were restored. This marked the first time that architects were asked to take a serious look at the future of the theater block since Hugh Hardy had prepared a proposal for the restoration of the street for the City at 42nd Street in 1980, calling for the reuse of five of the theaters: the Lyric, Apollo, Selwyn, Times Square, and Victory. Absent the ability to study the theaters in detail—they were virtually in continuous use—or to consult architectural drawings, which their owners and operators had, over the years, done their best to remove from view so as to minimize liability in the event of fire and to camouflage failures to meet ever tighter building codes, Hardy's 1980 study concentrated on the impact they made on the street, drawing attention to the fact that competition between theater owners over time had led to many renovations. As a result, few of the original facades were completely intact and the introduction of large fluorescent-lit marquees in the 1970s, set at approximately the same height, brought more visual uniformity than had been present when the theaters were first constructed.

Hardy's report, combined with the bitterly opposed demolition of the Folies Bergère (Helen Hayes) and Morosco Theaters to make way for the Portman hotel, led officials of the Landmarks Preservation Commission to undertake a survey of every midtown theater in 1982, about fifty in all.[95] In May 1982, a provision of the new midtown zoning regulations established a year-long moratorium—later extended—on theater demolition and created a Theater Advisory Council to make recommendations on theater preservation, which was bound to become an issue as a result of the new zoning that favored development on the west side.[96] While theater owners were in general committed to the preservation of most of the theater district's important theaters, they did feel that some special consideration was their due to make theater preservation more financially attractive, especially since the Landmarks Preservation Commission placed virtually all of the theaters on its calendar for a public hearing, the first step toward official designation.[97] The critical issue, given the willingness of owners to agree to theater preservation, was that of the lucrative transfer of air rights to development sites—about 4 million square feet in all.

In September 1983, after thirty often contentious meetings, the Theater Advisory Council proposed a plan that would permit theater owners to sell an estimated 3.9 million square feet of development rights through a broad swath of midtown, in return for guarantees that the theaters would be maintained and operated as such. The three leading theater owners, who between them owned virtually all the theaters, were willing to participate in the plan but were opposed to having their buildings designated as New York City landmarks, feeling that such designation would interfere with creativity, especially inside the auditoriums, where directors and set designers often wished to make changes. Landmarking was supported by Actors' Equity and the Save the Theaters group. But no matter the preservation strategy, both groups were united in the conviction that the older Broadway houses, with their intimate size—ninety feet from the back of the auditorium to the back of the stage was typical—and their elaborately detailed facades and interiors, constituted an invaluable and irreplaceable asset.

On October 13, 1983, the Theater Advisory Council voted eight to six to advocate the use of conventional landmark procedures employed on a theater-by-theater basis. It would take another two years, however, until August 1985, before the Landmarks Preservation Commission designated any theaters, conferring landmark status on the Neil Simon, formerly the Alvin (Herbert J. Krapp, 1927), 254 West Fifty-second Street; the Ambassador (Herbert J. Krapp, 1921), 223 West Forty-ninth Street; and the Virginia, formerly the Guild (Crane & Franzheim, 1924).[98] The commission indicated that it expected to designate as many as two dozen more theaters in the very near future. Reaction from the three major theater owners was predictably swift and negative and the *New York Times*, in an editorial published only a few days after the three

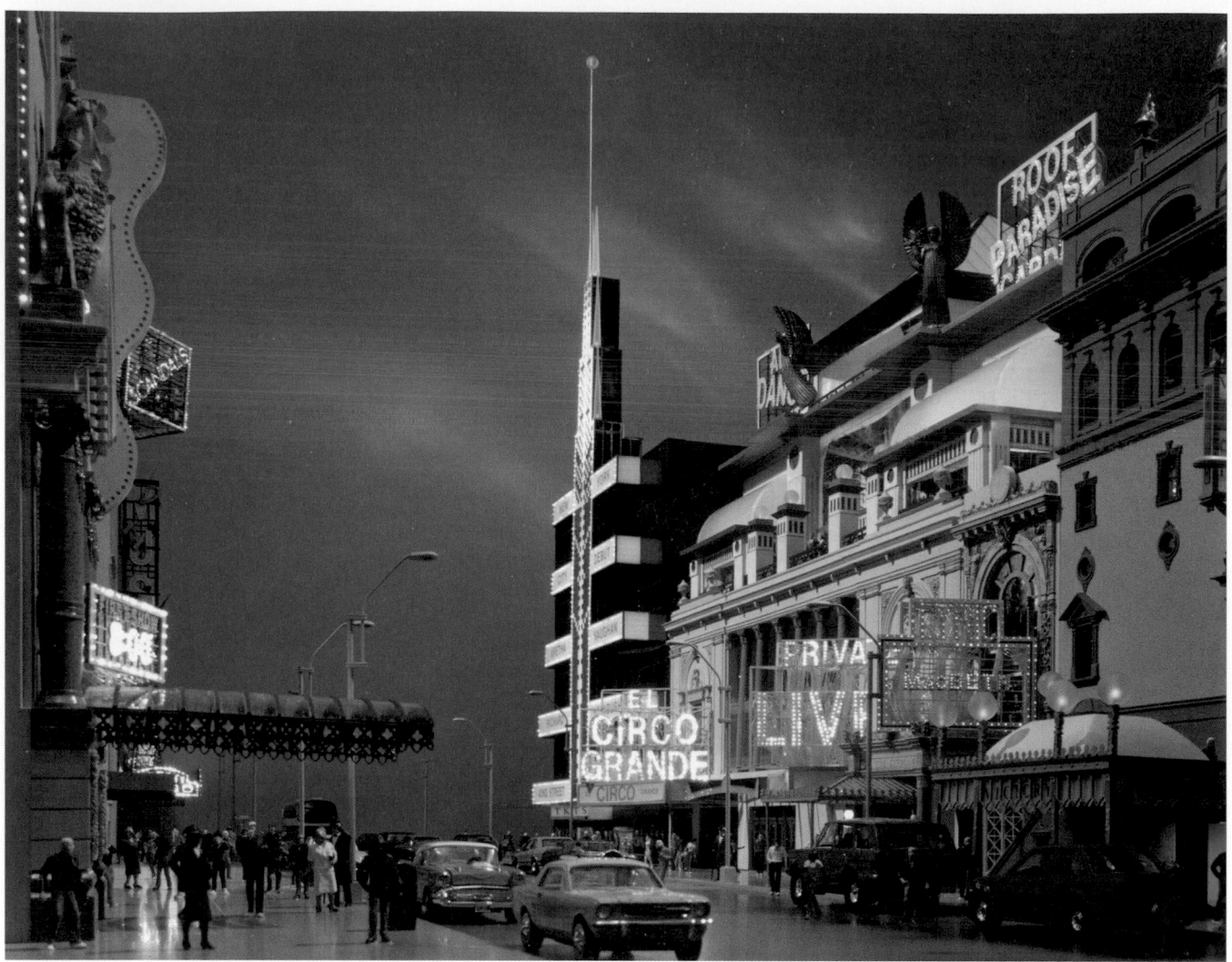

Study for revitalizing West Forty-second Street between Seventh and Eighth Avenues. Robert A. M. Stern Architects and Hardy Holzman Pfeiffer Associates, 1988. Model, view to the northwest. Hoyt. ESTO

theaters were designated, was harsh in its criticism of the agency.[99] Perhaps influenced by the vociferous objections, or simply a failure of nerve, the Landmarks Preservation Commission decided to slow the process, foregoing the quick designation hearings it had only recently promised. This delay lasted another two years, but in the last months of 1987, twenty-eight theaters were landmarked. After a contentious hearing ending at 3:00 A.M. on the morning of March 11, 1988, the Board of Estimate unanimously approved the measure. But the theater owners were not quite done yet, beginning an extensive legal battle that only ended four years later, in May 1992, when the United States Supreme Court refused to hear the case, upholding the previous ruling by the New York State Court of Appeals.

In October 1988, Stern and Hardy exhibited a model and drawings at the Municipal Art Society illustrating the independent and collaborative work of the two firms on Forty-second Street's theaters that together not only demonstrated a variety of ways the theaters could be restored and in some cases combined to meet contemporary performance standards but also offered the first positive vision of a renewed Forty-second Street that met the public's expectations.[100] When the

exhibition "42nd Street: Glorious Past–Fabulous Future" opened, the marquee of the Apollo Theater bore a message of protest, "Must We Spend a Billion Dollars to Destroy Times Square," sponsored by theater owners and Brendan Gill's Committee to Reclaim Times Square. But the success of the Hardy/Stern collaborative undertaking helped to deflate Gill's negative campaign. Stern, responsible for the five theaters on the north side of the street—the Apollo, Times Square, Selwyn, Lyric, and Victory—argued that they could be imaginatively and flexibly reused for a wide variety of entertainment while maintaining the integrity of their architectural elements. The contiguous theaters were not by any means alike: they differed in architectural character, staging potential, and seating capacity. While the general goal of Stern's study was to encourage the return of all the theaters to live or media-oriented performance, the study also included a proposal for the incorporation of retail and theater-oriented commercial space in and around the theater buildings. This would allow the performance aspect of the entertainment district to be reinforced by appropriately related uses. To address limitations from the past, Stern's proposal called for the reconfiguration of the Selwyn Theater, which had been built for

Study for revitalizing West Forty-second Street between Seventh and Eighth Avenues. Robert A. M. Stern Architects and Hardy Holzman Pfeiffer Associates, 1988. Model, view to the southeast. Hoyt. ESTO

musicals and plays, to permit intimate drama and the replacement of the office building to its west with a new rehearsal building. Stern proposed retaining the Apollo Theater as a showcase for drama while converting the Times Square Theater, the only one of the theaters with an auditorium directly on Forty-second Street and consequently acoustically unsuited to live performance, for use as a media center. Stern also recommended that the Lyric Theater, the interior of which was largely stripped of its original decor, be reconfigured as a 2,500-seat auditorium to accommodate spectacles such as the Big Apple Circus; a rooftop glassed-in Tavern on the Green–like restaurant would be built over the Times Square and Victory Theaters, thereby recalling the roof gardens that had once been a summertime feature of New York nightlife, one of the most famous of which had extended from the roof of the Victory to that of the now demolished Hammerstein Theater to its east.

While the study had initially been intended as an internal document, Stern, supported by Hugh Hardy, pushed for a public exhibition, which proved decisive in giving the public some sense of the redevelopment's higher purpose. For the first time, preservationists and the theater community could

see a future for the theaters, and the public could see a restored street that could appeal to a wide cross section of the populace, from formally attired first-nighters to jeans-clad kids and tourists. The model and the studies that led to it were generally well received, with Paul Goldberger writing, "To look at it is to rejoice in the long-lost glory of the street that was once New York's entertainment mecca, and to be tempted to believe that its architectural splendors can be renewed in our time. . . . The plan involves a mix of restoration and new construction that is consistent with the atmosphere of raffish vitality that is 42nd Street's legacy."[101]

In spring 1989, the UDC received four proposals from non-profit theater companies to take over the operation of the legendary but dilapidated theaters. The selection process was delayed by lawsuits. Once the theater sites were acquired in April 1990, a more focused strategy began to emerge, especially after Rebecca Robertson took over as president of the 42nd Street Development Project on the same day that the state took title to the theater sites and Cora Cahan, who had developed the Joyce Theater as a center for nonprofit dance companies, was named executive director of the 42nd Street Entertainment Corporation, better known as the "New 42," which was

established in September 1990 to handle the physical restoration of the theaters and to find both nonprofit and commercial uses for them. The establishment of the New 42 coincided with the release of $9.2 million from Times Square Center Associates for the explicit purpose of theater restoration.

Meanwhile, plans to realize Johnson and Burgee's towers continued to make their way through litigation, criticism, and a poor economy. In his February 1989 reassessment, Paul Goldberger, in something of a turnabout, distanced himself from the design which, he wrote, "has come to seem a truly depressing prospect as the years have gone on, making this surely one of the only major works of architecture to look utterly out of date before it was even started. Everything about the design suggests that the priorities of real-estate developers, and not of the public, were put first."[102]

In April 1989, the project was dealt a severe blow when Chemical Bank, which had been expected to be a prime tenant in the tower to be located at the southwest corner of Forty-second Street and Seventh Avenue, decided to withdraw. Undeterred by the Stern-Hardy proposal, Brendan Gill's Committee to Reclaim Times Square stepped up opposition with a large advertisement in the *New York Times* and a poll of the membership of the New York Chapter of the American Institute of Architects that solicited opinions about the buildings, leading John Burgee to write a letter to the chapter's members attacking the survey as "most objectionable and a dangerous precedent."[103]

In late 1989, the ongoing saga took a surprising new twist when the developers called a press conference to unveil four completely restyled towers credited to John Burgee Architects with Philip Johnson Design Consultant (an arrangement the two former partners had entered into in 1986 and which would prove to be disastrous for Burgee).[104] In a bid to be more responsive, not only to the historical image of Forty-second Street and Times Square but to the fact that the flamboyant commercialism of Times Square was reviving on its own, the ever-mercurial Johnson, whose interest in work based on nineteenth-century precedents was in any case waning as he became enamored of 1920s Constructivism, restyled the buildings. The move was not exactly undertaken voluntarily, but came in response to a directive from the 42nd Street Development Project, which required that illuminated signs be incorporated into the building design. At the same time, the 42nd Street Development Project categorically resolved the fate of the Times Tower: it would definitely be excluded from the project and therefore would remain in place.

Freed from any chance to create a united group of buildings facing a plaza, Johnson and Burgee proposed to treat each building differently. The tower proposed for the Crossroads site would remain very similar to its appearance in the 1984 proposal. Closer to Times Square, north of Forty-second Street, the architects proposed complex assemblages of stone and intricately gridded glass, with huge electric signs, invisible by day but coming alive after normal business hours (and presumably not turned on during the dark days or late afternoons of winter when it was essentially night but workers were still at their desks). The signs were to consist of thousands of computer-controlled nine-inch disks set between the windows that could generate very large, moving images, an early version of the LED signs that Kohn Pedersen Fox was to use on its Lehman Brothers building (see Times Square). Though it was not made clear whether the signs would carry commercial messages or just abstract patterns, what was established was their size, with the largest anticipating what would in fact occur when the site was at last developed in 2000 (see below).

According to James S. Russell, Johnson's redesign "might be called neo-decon, reminiscent of the work shown in the 'Deconstructivist Architecture'" show, curated by Johnson and Mark Wigley in 1988 at the Museum of Modern Art. "Certainly the design turns the fragmenting, program-distorting strain of thought innate to Deconstructivism on its head. Instead Modernist and Constructivist devices are *applied*, an exercise in packaging and precooked diversity that is wholly within the Postmodern canon (at least as it has evolved in American office-building design)."[105]

Paul Goldberger greeted the redesign as "a stunning public reversal, less an architectural event than a marketing one, a sort of architectural equivalent of the Coca-Cola Company's abrupt replacement of New Coke. The Times Square towers, too, bombed in the marketplace," Goldberger continued, but "at Times Square the architects, unlike Coca-Cola's executives, have not gone back to a tried and true formula; they have tried instead to blaze new ground. The four office towers now planned by John Burgee Architects (Mr. Johnson is now largely retired from the practice, but did serve as a consultant) are brash, colorful buildings full of signs and lights and mirrors and jarring angles. They are as different from the . . . cookie cutter classicism of the previous project as Disneyland is from the Albany Mall." Goldberger nonetheless pointed out that the innovations were, in effect, "all cosmetics." The towers' colossal size, which had always been the problem, had not changed. As a result, the "token changes" did not alter "the prognosis for Times Square: to be an office district with some theaters appended to it, not a neighborhood whose primary purpose is to provide entertainment and public space."[106]

The upstaging of Johnson by Burgee at the press conference was part of a deliberate reorganization of the firm that was to backfire dramatically, putting the junior partner not only in the spotlight, which he craved, but also in the aesthetic hot seat. Although Burgee claimed the design had moved beyond Postmodernism to New Modern, Goldberger disagreed: the "only thing really new about these buildings" was the integration of "high-tech signs as actual architectural elements, spectacular presences on the outside but invisible to the office workers within." To Goldberger, Burgee's New Modern was something of a mish-mash. The northwest tower, on the west block of Broadway between Forty-second and Forty-third Streets, would have seven different facades, realized in glass and granite and culminating in a "top that looks like a glass office tower trying to poke its way out of the steel truss of the nearby Port Authority Bus Terminal." He continued, "There is some of last year's trendy style, Deconstructivism, here, and plenty of Modernism and Postmodernism, too. Mr. Burgee has surely succeeded in impersonating three different architects in this project, if he has not quite made it all the way to four."[107]

Ada Louise Huxtable also weighed in with one of the few articles she published in the *New York Times* after leaving the newspaper in 1982. She, too, was unimpressed with the stylistic games and continued to insist that the problem was a failure in public policy even more than one of architecture. Were they to be built, the Johnson/Burgee towers "could be an effective memorial to Times Square."[108] Readers of the *New York Times* were treated to yet another assessment of the office towers when Herbert Muschamp, the recently appointed

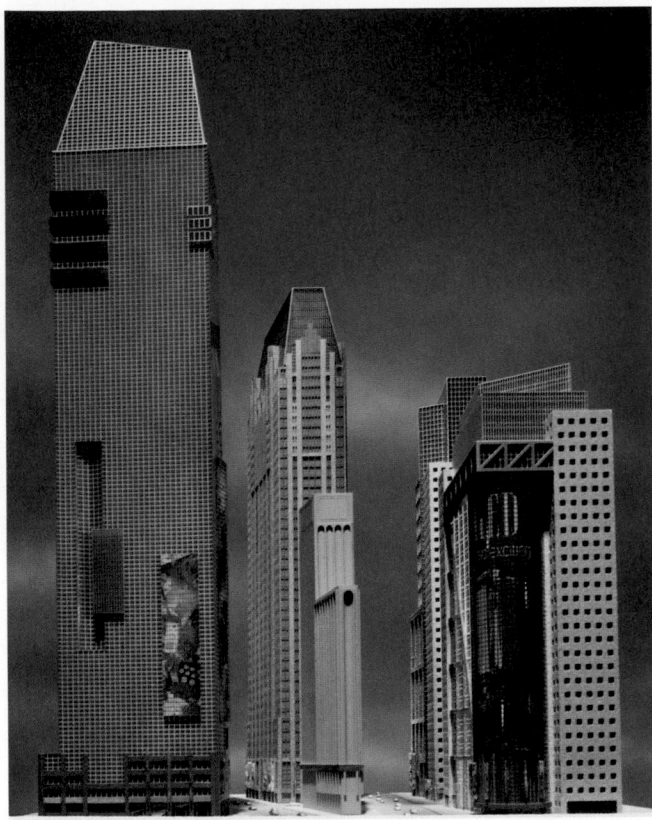

Proposed Times Square Center. John Burgee Architects with Philip Johnson Design Consultant, 1989. Model, view to the south. Lieberman. PTG

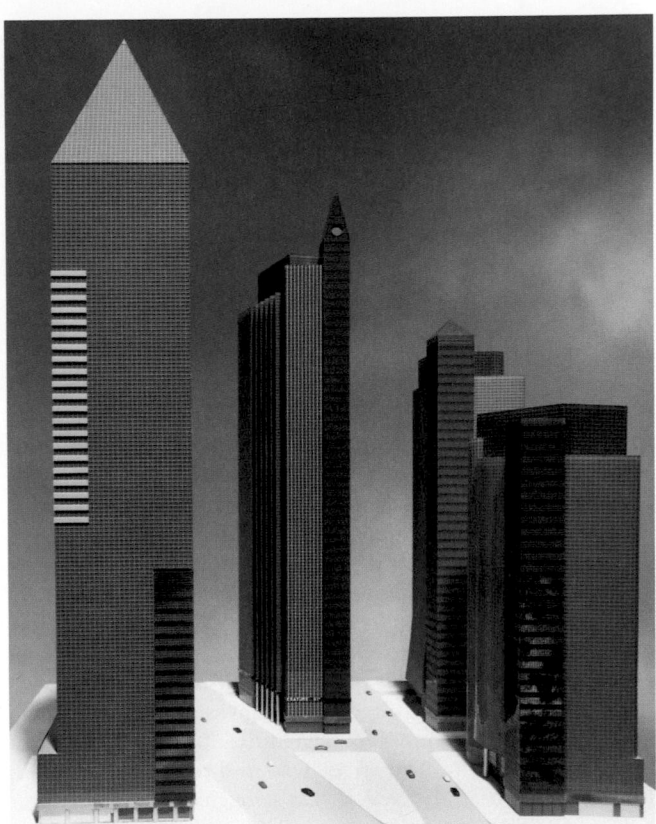

Proposed Times Square Center. John Burgee Architects with Philip Johnson Design Consultant, 1991. Model, view to the south. Lieberman. PTG

architecture critic, revisited the project in August 1992. Characterizing the design as "the apotheosis of architecture as entertainment for the star-struck," Muschamp attacked the towers as "the grotesque, paradoxical climax of what had once seemed a highly desirable end: not just fixing up Times Square, but also using one of its favorite preoccupations of the 1980s—architecture—to do it." Muschamp was dismissive of both the first and second versions of the towers, characterizing the latter as "a stodgy imitation of the jazzy style pioneered by the Miami firm Arquitectonica"—a confirmation of "what an impoverished conception of architecture had been operating here all along. The 'new' design," he stated, represented the application of "a new veneer to the same set of jumbo parcels."[109] Like most other observers, Muschamp lay the blame for the project's shortcomings on the failure of administering officials to hold to the Cooper Eckstut guidelines and, neglecting to account for the considerable sums of money that the new development was to spin off to enable the derelict theaters to be renovated, for insisting that private development could only take place on Forty-second Street with public subsidies.

Unquestionably, the new designs were offered up as a bid to gain public support, a cynical but realistic response to the fact that the public had come to hate the 1984 designs, finding them ugly and inappropriate. As in a similar situation at Columbus Circle, the developers used redesign to get the project back on track. But, as Lynne B. Sagalyn wrote in her thoughtful and probing history of the Forty-second Street project, *Times Square Roulette: Remaking the City Icon*, "In varied ways and to different degrees, both opposition

tacks—litigation and aesthetic criticism—pushed the redevelopment plan off course like a nor'easter. . . . Though moving on widely spaced parallel tracks, these strategies of opposition eventually coalesced to effectuate a radical—and politically sustaining—shift in focus of the redevelopment plan. It was a stunning turnabout."[110]

On April 19, 1990, soon after Rebecca Robertson became president of the New York City Public Development Corporation, the state acquired through condemnation most of the development land, leaving only the hotel and mart sites in private hands.[111] In June tenants began to move out of the buildings on the east blockfront of Broadway between Forty-second and Forty-third Streets. Among the first to go was Nathan's Famous, the hot dog purveyors, which occupied a once notable Modernist building, 1482–1490 Broadway, on the southeast corner of Forty-third Street and Broadway, designed by Skidmore, Owings & Merrill in association with Walker & Gillette in 1940 for Toffenetti's restaurant.[112] Nonetheless, the depressed economy of the early 1990s made the promise of new construction seem increasingly unlikely and, as rumors abounded that the Klein/Prudential team was looking for ways to get out of the project, in November 1991 they asked for a delay in the construction timetable, while at the same time authorizing Johnson and Burgee to take what would be their last stab at the design of the four office towers, though the product, a quartet of simplified dark glass towers of varying heights—some incorporating obelisk-like forms with pyramidal tops and others stripped-down, flat-roofed Modernist-inspired volumes seemingly lacking any of the signage incorporated into their previous design—was given little attention by the press.[113]

With the buildings along the street now in public hands but largely boarded up, Forty-second Street never looked worse. Commuters walking to and from the Port Authority Bus Terminal avoided it. With no theaters and no commuters, the street was eerily empty. With no one to rob, the criminal element vanished. As David Dunlap put it, Forty-second Street had become a "ghostly strip."[114] Failed redevelopment had killed Forty-second Street. Robertson, who brought to the project the genuine passion for battle that had previously been lacking but would prove itself essential, recognized that in order to rebuild public confidence in the overall plan, Forty-second Street had to be brought back to life.

42nd Street Now!

In August 1992, Robert A. M. Stern Architects was once again asked to work on Forty-second Street, this time as leader of a team that included the graphic designer Tibor Kalman, head of M & Co., as well as other consultants, among them the Rockwell Group. The Stern team was charged with preparing an interim plan to guide the development of properties along Forty-second Street for five to fifteen years, by which time permanent construction was sure to be in place.[115] The properties were now mostly in the state's control and, as a consequence, largely vacant. Given the depressed economy, there was little immediate prospect of significant private, long-term investment in sight. The street was in dire need of help. As Robert Stern put it, the eleven-year struggle by the state to get hold of the site and evict tenants had created "a street that even the vitality of vice has disappeared from."[116]

Stern's appointment had a bittersweet side—he had long been a protégé of Philip Johnson who, asked to comment on the appointment, was gracious: "I think Stern's a very good man. It sounds like the right direction."[117] From the start, Stern and his collaborators recognized that because "everyone has a different idea of what 42nd Street once was," they would "try not to plan, but to design and orchestrate."[118] "We want it to be a dazzling

place to shop, to go to the theaters," Stern added. "We don't want to make it so gentrified that there is no sleaze or sensationalism. We want big signs . . . but not in a way that looks as if we've re-created the past. . . . You have to have a little sense of threat, excitement, derring-do—a sense of adventure." Instead of giant, category-killing retailers—the only ones who'd expressed any interest in leasing space along Forty-second Street—Stern advocated "different, small, exciting things. Lights. Banners. Colors. We have to make it an urban pageant."[119]

From the first, Stern and his team insisted that no matter the current state of acquisition negotiations, the entire block had to be examined as a unit and that it be seen in relation to midtown as a whole. Before tackling the street's specific possibilities, Stern addressed two issues that were critical given the public's general lack of enthusiasm for the project. Crucial to the process was the preplanning needed to reaffirm the street's importance. The Stern team's analysis determined that the Crossroads of the World was still the epicenter of New York's tourism, with almost all major midtown cultural and entertainment destinations within a fifteen-minute walk, and that Forty-second Street in its entirety was one of the city's most varied and significant arteries, with important anchors at each river—the United Nations on the East River and the various water-oriented tourist attractions on the Hudson River. Analyses confirmed what was obvious to most observers: Forty-second Street's long-neglected blocks between Sixth and Ninth Avenues were the weak links in the chain, and the reclamation

of the theater block, the center of the three, would undoubtedly lead to the further development of the other two.

Stern's plan, which had come to be known as *42nd Street Now!*, was released in summer 1993. Concentrating on the theater block, it called for a mix of refurbished buildings and new structures, with tourist-oriented retail stores at the Crossroads of the World, the restoration of six of the nine historic theaters in the midblock, and large, popular entertainment or tourist venues to be located at the intersection of Eighth Avenue, with a hotel on the site long held open for that use and an as yet undetermined indoor sports club or sports arcade for the site originally intended for the mart. Both the hotel and mart sites remained in private hands. Stern and Kalman, though in many ways quite opposite in their views, agreed on a few key things. The office towers, now fortuitously on hold, "were overplanned and overdesigned and sterile," as Kalman put it. The street had to return to its naughty, bawdy image with, as Kalman stated, the "cacophony, excitement and democracy of the sidewalk. . . . It should be a zoo, like the rest of New York, but a well-maintained zoo."[120]

The plan, intended to set in place conditions that would ensure that the street would evolve in accordance with its own character and not succumb to ideas imposed on it from outside, was notable in that it dealt in minimums rather than maximums—that is to say, it described the minimum brightness of lights, the minimum size and number of signs for a shop, and so on—but it left open to the individual designer and entrepreneur the opportunity to do more, recognizing that the forces of the marketplace would take over and naturally foster the competition for attention that had historically worked to give the theater block its character and vitality. The open-endedness of the plan, flying in the face of typical "design controls," was intentionally adopted to make sure the new Forty-second Street would be as far as possible from the developers' Rockefeller Center–inspired vision for the office towers.

The plan was based on six principles that "have governed the street's development over the last 100 years and define its essential character": *Layering*, to "reveal generations of boisterous commercialism and entrepreneurial efforts, in which new has been grafted onto old"; *Unplanning*, to "create visual diversity by prohibiting any uniform or coordinated system among adjacent storefronts and signage"; *Contradiction and Surprise*, to give "the city its characteristic exuberance," which could be fostered by a "situation . . . where national retail establishments co-exist with small local entrepreneurs, each developing their storefront in their own way"; *Pedestrian Experience*, to avoid "long, uninterrupted facades by specifying frequent entrances and the presence, where possible, of small, individual stores"; *Visual Anchors*, to "draw people regardless of their economic or social background"; *Aesthetics as Attractions*, to "encourage a design virtuosity similar to that seen at a World's Fair."[121]

A major impetus for swift implementation of the guidelines was the upcoming millennium celebration, when the world's media would focus on Times Square and Forty-second Street. If left in its abandoned state, the square would prove a colossal embarrassment to New York. At the same time, the publicity generated by such an event would motivate advertisers to seek locations for signs that would be seen by millions on television. To help focus marketplace attention on the street, concept drawings were prepared not only to illustrate ways the street might be developed but also to entice the newly emerging media companies who might be willing to invest in it in anticipation of the forthcoming millennium celebration. Perhaps the most important image was that of the media globe proposed for the Crossroads of the World site, which was to have had moving electronic signage and direct television from all the competing media companies. While the globe was not built, the half-size model of the Concorde airplane that was built atop an interim two-story beer restaurant, Hansen's, was almost bold enough to hold down the spectacular site on which Skidmore, Owing & Merrill's Times Square Tower was eventually constructed (see below).

In order to generate interest in the street's potential, Robertson and her team also sponsored the "42nd Street Art Project," curated by Creative Time, a New York–based nonprofit arts organization.[122] The temporary exhibition, which opened on the theater block in the summer of 1993, imaginatively used the spaces left empty by condemnation, employing more than fifty artists working in a wide variety of media, from sculpture to video to large-scale air fresheners. The artworks were installed in an equally wide variety of places, including windows, walls, marquees, gates, and the sidewalk. Of particular note were Ned Smyth's nine sculptural figures, each modeled after a famous historical work of art, which were placed in procession along the sidewalk; Donna Dennis's multimedia installation *Strike Up the Band*, which used artfully peeled-away theater posters and music to create a visual and aural journey through time and space on the roll-down security gates

Concorde model and interim retail building, south side of West Forty-second Street, between Broadway and Seventh Avenue. Fox & Fowle, 1996. View to the southeast. Aaron. ESTO

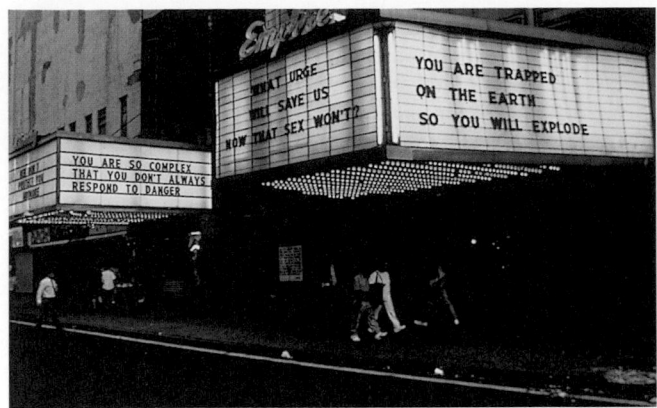

Truism series, south side of West Forty-second Street, between Seventh and Eighth Avenues. Jenny Holzer, 1993. CT

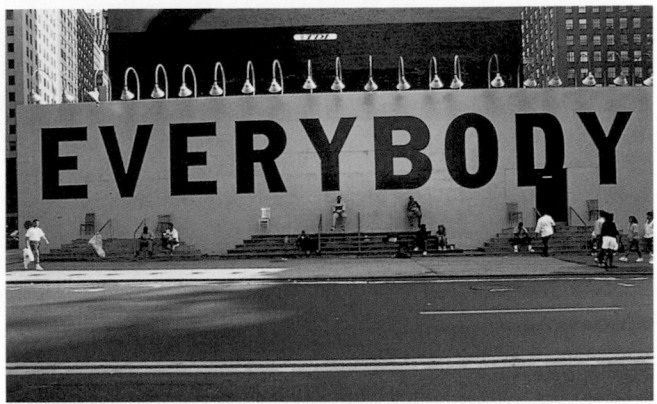

EVERYBODY, south side of West Forty-second Street, between Broadway and Seventh Avenue. Tibor Kalman and Scott Stowell, 1993. CT

and facade of the Times Square Theater; Jenny Holzer's use of the empty marquees for her Truism series of pithy statements, such as "Sloppy Thinking Gets Worse Over Time"; and a painting from Theodor Geisel, better known as Dr. Seuss, of the Cat in the Hat, appropriately placed on the former site of Murray's Roman Gardens and Hubert's Museum and Flea Circus. Herbert Muschamp was not ambivalent in his reaction to "Soft Sell," the contribution from Elizabeth Diller and Ricardo Scofidio, the only architects in the exhibition, consisting of a gigantic pair of red lips projected onto a screen in the entry of the Rialto Theater which spoke "in the juicy tones of a 900-number voice. . . . With a soundtrack blaring from a speaker in the abandoned ticket taker's booth, the mouth has been the biggest hit on 42nd Street since they stopped screening kung fu movies. But you can't get inside this theater, or, rather, the theater has moved outside—evicted, so to speak, like most of the tenants that once did business here. The simple setup resembles the sidewalk video monitors that preview coming attractions, but here the preview is the show. And its message is that the show is a preview. People come here to be teased. They expect to enter a state of desire unspoiled by mere gratification. Though the scarlet lips flirt with porn-shop imagery . . . , the mouth speaks for the entire city: for Madison Avenue, for Wall Street, for the garment district, for an infernal machine that manufactures desires for people who have no patience with satisfactions."[123] But perhaps the most widely disseminated image from the two-year exhibition belonged to one of the interim plan's creators, Tibor Kalman, working with fellow graphic designer Scott Stowell, who covered a large billboard on the former Police Information Center at 158 West Forty-second Street with the word "EVERYBODY" in black letters against a yellow background. At the base of the billboard were broad groups of stairs leading to seven colored chairs attached to the billboard.

In September 1993, Herbert Muschamp greeted *42nd Street Now!* as "a smoothly choreographed step in exactly the right direction."[124] For the first time in the history of the Forty-second Street project, a proposal for the street's future was almost universally well received. True, there were those who claimed they would miss its seediness. Rem Koolhaas, the Dutch architect who invented the term "Manhattanism," writing in April 1996, three years after the plan's release, felt that the "imminent transformation of 42nd Street, or more precisely the replacement of an Empire of Tawdriness with a State of Fun," inspired "a malaise, . . . a bizarre sense of foreboding. . . . 42nd Street was utterly *authentic*, a throbbing Zone of flickering,

stroboscopic liveliness and energy, of invention and exploitation. Perhaps what is most shocking about the loss of Forty-second Street is its un-Americanness." Objecting to the cleanup operation, which he saw as a betrayal of the American city as "the *par-excellence* plain of laissez-faire, fertilized by economic determinism," Koolhaas argued that a cleaned-up Forty-second Street "hardly seems a good omen for Manhattan's continuing relevance in the twenty-first century."[125] In August 1996, several months after Koolhaas published his remarks, Herbert Muschamp attempted a similar argument in the *New York Times*, sharing with his readers his "nostalgie de la boue—the sentimental attachment to decrepitude and sleaze": "Where have they gone, the chicken hawks and stiletto knife displays, the peep show shills, pickpockets, coke heads, winos, pimps and tramps? We had a world class gutter here. Must we trade it in for a shopping strip of chain retail outlets?"[126] Other critics, like Douglas N. Cogen, the Municipal Art Society's Menapace Fellow in Urban Land Use Law, attacked the plan as "bait and switch," pointing out that given its interim status, most of the shops and many of the preserved buildings would soon enough give way to supersized office towers.[127] But by the end of 1993, with the Walt Disney Company a likely tenant on the street, even the Klein/Prudential team was beginning to realize that the street's destiny had been determined and it was to be not a new corporate corridor but a renewed entertainment district.

Sensing that at last it had a winner in its interim plan, the state began to exercise its muscle with Times Square Center Associates. Once Disney signed on to take over and restore the New Amsterdam Theater (see below) in February 1994, the state got tough. As Vincent Tese, chairman of the UDC, put it: "The developer has always attempted to reduce the entertainment and signage aspects on his sites and on adjacent sites. We'd have no Disney right now if it were up to the developer." According to Tese, in a meeting with Disney officials, the developers "said they thought Disney didn't bring anything to the project."[128] But George Klein, who as a New Yorker understood the changing dynamics of the situation better than his partners did, tried to mollify the situation: "We agree in principle that [the project] needs to be bright, lively and reflect what Times Square should be. It's just a question of interpretation" of Stern's plan.[129]

Nonetheless, Klein/Prudential stonewalled an attempt to locate Madame Tussaud's in the base of one of the proposed office towers—it was subsequently located on a midblock site,

234 West Forty-second Street (see below)—claiming that there really was no viable deal but also not encouraging such a deal for fear of scaring off potential corporate tenants to the office space above. Stern argued that the two could co-exist: "I think the world is different now than it was in 1950. This is no longer the time of 'The Man in the Gray Flannel Suit.'" The developers, he continued, "are behaving like the heavies in a melodrama. And soon they're going to have the crowds hissing."[130] The state and city held their ground. "Enough is enough," said Rebecca Robertson. "These negotiations have been going on way too long and it's time for them to end."[131] Meanwhile, Klein/Prudential hired their own consultants, Thompson & Wood, of Cambridge, Massachusetts, who proposed canvas billboards—specifically forbidden in the Stern controls, which called for illuminated signs. Thompson & Wood claimed that "the city and state's design is more nostalgic. It's composed of art works of coffee cups or cigarettes that you tend to associate with Times Square in its heyday. But it completely contradicts the techniques of today's advertisers."[132] Again Robertson stood firm: "Not doing the Stern plan means something that's uniform, dull and doesn't move. It would look more like a shopping mall."[133] As the deadline for accepting the interim development agreement drew close, Robertson remained intransigent: "Lighting and signage should not be a big issue, but for them it is. No way around it, we are going to have glitz on 42nd Street."[134] On August 2, 1994, the developers and the UDC came to terms on a new agreement carrying forward the 1981 plan and adopting an interim plan pending the rebound of the office building market.

The Stars Are Reborn

The complete restoration of the New Victory Theater marked the first tangible step in the revitalization of Forty-second Street.[135] The theater had undergone many vicissitudes in the ninety-three years before Hardy Holzman Pfeiffer undertook a comprehensive renovation, transforming the Victory into a theater aimed at young audiences. Built by Oscar Hammerstein in 1900 as the Republic, Albert E. Westover's Italian Renaissance-style design, with its arcaded rooftop garden, was rechristened the Belasco in 1902. Once home to serious drama—the pavement outside was covered with sand to muffle the sound of the horse-cars when Mrs. Patrick Campbell played there in 1908—the theater was forced to downgrade with the arrival of talking pictures and the impact of the Depression. The Republic was home to Billy Minsky's Burlesque from 1931 to 1942, when Mayor La Guardia forbade that venerable form of entertainment. After 1942 it was renamed the Victory and showed movies.

When the New Victory reopened on December 11, 1995, audiences marveled at its beauty, with much of the original work—but not its rooftop arcade or street-level iron-and-glass marquee—restored on the basis of careful scholarship. Although Herbert Muschamp dismissed it as a nostalgic gesture, the construction of a version of the original grand double staircase on the outside—it had been removed in the 1920s to widen the sidewalk—proved welcome, forming a kind of viewing platform from which the public could watch the street literally transform itself. A new rooftop sign stood in for the long demolished skyline arcade. Inside, there was more

ABOVE Victory Theater (Albert E. Westover, 1900), 207 West Forty-second Street, between Seventh and Eighth Avenues. View to the north, 1988. RAMSA

RIGHT New Victory Theater, 207 West Forty-second Street, between Seventh and Eighth Avenues. Renovation by Hardy Holzman Pfeiffer Associates, 1995. Auditorium. Kaufman. H3

FACING PAGE New Victory Theater, 207 West Forty-second Street, between Seventh and Eighth Avenues. Renovation by Hardy Holzman Pfeiffer Associates, 1995. View to the north. Kaufman. EK

New Amsterdam Theater (Herts & Tallant, 1903), 214 West Forty-second Street, between Seventh and Eighth Avenues. View to the south, 1992. Cox. WC

New Amsterdam Theater (Herts & Tallant, 1903), 214 West Forty-second Street, between Seventh and Eighth Avenues. View of auditorium before renovation. Cox. WC

lobby space than in the past, made possible by removing seats from the auditorium and by digging under the orchestra floor. But the great glory was the domed two-balconied auditorium itself, beautifully painted and gilded, seating 500 people. Splendid though the interior was, the restoration of the facade had the greatest impact on the street as a whole: to see Forty-second Street with the New Victory's exquisite facade restored—and the gross marquee of the Lyric Theater next door removed to allow some breathing space—was, as Paul Goldberger put it, "to rediscover not only a single building but an entire block."[136]

Even more dramatic than the renovation of the New Victory, the transformation of the New Amsterdam Theater (Herts & Tallant, 1903), 214 West Forty-second Street, was far and away the single most significant event to happen in the 42nd Street Development Project since its inception: an incomparable theater brought back from shocking dereliction by the Walt Disney Company, then at the peak of its reputation as a publicly recognized and respected entertainment enterprise.[137] At issue was not so much Disney's decision to undertake the restoration, but its willingness to identify its wholesome family brand with the street at all. Ever since the New York–born Michael D. Eisner had become chairman of the company in 1984, his mother's friend, Marian Sulzberger Heiskell—a member of the family that owned the New York Times and, after September 1990, the chairman of the 42nd Street Entertainment Corporation, the organization created to oversee the redevelopment of the theaters—had tried to interest him in bringing Disney entertainment to Forty-second Street.[138] Some studies were made by the company, but the idea was not adopted for a variety of reasons, not the least of which was that the Disney Company's theme parks, hitherto the setting for its principal live entertainment venues, were gated, and the company recognized that by entering the public arena, it would risk compromising its reputation for cleanliness and its ability to maintain a high standard of civility among employees and guests. Robert Stern, who worked on a number of Disney projects beginning in the late 1980s, also tried to interest Eisner in the possibilities of the street, but Eisner remained cool to the idea, telling Stern to "call me back in ten years."[139] It was not until March 1993, when Stern's office had virtually completed work on the 42nd Street Now! project, that Eisner asked to see a very large model of the entire block, which had been prepared to study signage placement and the massing of the hotel. Eisner's interest was based on the company's decision to transfer some of its animated films to live-action Broadway productions. He and his producers had come to the realization that owning a theater for their New York productions would have important financial benefits. While it was too late to restore a theater for Disney's first Broadway production, Beauty and the Beast, which was to open in spring 1994, a second production, based on the remarkably successful animated film The Lion King, was scheduled to follow soon after.

Following Eisner's review of the model, Stern arranged for the Disney chairman to tour the acoustically superb Art Nouveau New Amsterdam Theater. The exterior and interior of the New Amsterdam had been declared a New York City

FACING PAGE New Amsterdam Theater (Herts & Tallant, 1903), 214 West Forty-second Street, between Seventh and Eighth Avenues. Renovation by Hardy Holzman Pfeiffer Associates, 1997. Auditorium. Cox. WC

New Amsterdam Theater (Herts & Tallant, 1903), 214 West Forty-second Street, between Seventh and Eighth Avenues. Renovation by Hardy Holzman Pfeiffer Associates, 1997. Auditorium. Cox. WC

landmark in 1979, and the theater had been taken over by the state in September 1992.[140] By this time, preservationists had begun to despair for its survival. Once home to the top musical shows, many produced by Florenz Ziegfeld, whose *Midnight Frolics* featured his stars in risqué after-theater cabarets on the roof of the eleven-story office building that was part of the complex, the New Amsterdam had become a movie theater, and its conservatory-like rooftop cabaret theater, the former Aerial Gardens, a preferred rehearsal hall. In 1983 the English director Peter Brook proposed to stage a dramatic version of Prosper Mérimée's *Carmen* in the rooftop theater, but when he embarked on a significant restoration, certain structural problems, including corroded steel beams, became apparent. Brook's production was moved to Lincoln Center and the theater was abandoned. A number of the openings that had been cut into the roof were left unprotected, with catastrophic results: water seeped to the auditorium below, eroding a good deal of the main theater's remarkable plasterwork, and birds were allowed easy entry, leaving enormous mounds of droppings on stairs and floors. Even in its decrepitude, the theater had a certain magic, which was recognized by the filmmaker Louis Malle, who used it as a Surrealist backdrop for his film *Vanya on 42nd Street* (1994).[142]

When Eisner toured the theater, the brilliance of Herts & Tallant's architecture came through, despite the general filth. Especially remarkable was the intimacy of the three-balcony auditorium that once held 1,537 seats, as well as the extraordinary generosity of its public spaces, second in size among Manhattan's theaters only to those in Radio City Music Hall, and the striking details, many executed in terra-cotta and therefore still in perfect condition, others in plaster in an advanced state of decay. Almost exactly one year after the state took the New Amsterdam over, Disney's interest in taking on the project of restoring the theater was reported in the *New York Times*. Despite some grumbling about incipient Disneyfication, the decision was generally welcomed by New Yorkers, with even the often curmudgeonly Frank Rich, once the feared drama critic for the *Times* and now a regular contributor to its Op-Ed page, writing, "The sleepy 42nd Street block . . . requires Disney-style commerce if Times Square is ever again to be the crossroads of the world." Rich also felt that Forty-second Street had "something to give back to Disney: increased contact in the real world beyond its parks and studios."[143]

On February 2, 1994, the deal between Disney and the state was announced at a City Hall press conference attended by the new mayor, Rudolph Giuliani, and the longtime governor,

Mario Cuomo, who was as blunt about the street's past as he was optimistic about the future: "This was a sewer and everybody knew it, right in the heart of New York City. Now 42nd Street's going to be back."[144] Hardy Holzman Pfeiffer—which had first studied the theater in 1984 for the 42nd Street Redevelopment Corporation and had been hired by the UDC to prepare plans immediately after the 1992 acquisition, when the architects stabilized the structure, sealed the roof, and installed a heater to dry out the auditorium—carried out the comprehensive restoration of the New Amsterdam for Disney.[145] The task was daunting. As Hardy put it: "*All* the painted artwork needed restoration; half the oak paneling had to be completely re-created and the other half refurbished; *all* the decorative plaster surfaces required repainting; and three-quarters of the original plaster decoration had to be reconstructed, not to mention the work needed on new mechanical systems, structural steel, light fixtures, production and rigging systems, and electrical wiring. Worst of all, the twelve cantilevered boxes originally flanking the proscenium had been blitzed to accommodate a wide CinemaScope movie screen in the early 1950s."[146] Restoration revealed unknown treasures: in the foyer, a glorious glass ceiling dome, a particular treasure of the Art Nouveau style, was discovered under layers of accumulated grime. Beyond the foyer lay the promenade and behind it the reception room, providing oceans of splendidly detailed public space. Below, the former men's smoking room, renamed the New Amsterdam Room, which had been severely water-damaged in the 1980s, was restored, with a drinks bar set inside the elliptical arcade that was perhaps the theater's most unusual architectural feature, a virtual blending of the Gothic and the Art Nouveau. Despite the care given to architectural preservation, the renewed New Amsterdam was not only loaded with the latest in theatrical technology but was also as convenient, if not more so, than any Broadway house. Even though capacity was increased to 1,814—some 277 more seats than in the original house—it also offered greater legroom than most other New York theaters as the result of some ingenious rearranging of the rows.

It was not simply the ornamental richness that rendered the theater remarkable, but also the total integration of virtually all aspects of architecture, decoration, and stage-craft: the New Amsterdam was the embodiment of the nineteenth-century idea of a total work of art, with daring structure—it had New York's first and largest cantilevered balcony—and remarkable spatial inventiveness so that it avoided the boxlike character of most theaters. As Paul Goldberger wrote, it "swoops; it is less a box than a space brought forth out of the confluence of great, curving lines, with a huge proscenium embracing the entire front and an open gallery, defined by vaults and arched openings, filling the rear. The whole thing is somewhat overscale, which has the effect of making the room feel more intimate; the terra-cotta balustrades and plaster-clad columns and huge decorative mural panels—even the eighty-foot-high domed ceiling—all seem so close you ought to be able to reach out and touch them from any seat."[147]

While the restoration of the theater's interior was a difficult task, in which Hardy was assisted in particular by the conservator Ray Pepi, the questions raised by the multilayered evolution of the narrow facade of the office building, incorporating the patrons' entrance, were more intellectually challenging. At one point, New York State's preservation officer wanted the facade returned to its 1903 condition, but Hardy and many others involved balked at that idea, because the marquee, added in 1937 when movies replaced live performances, was in itself a quite interesting example of its kind.

Before the New Amsterdam reopened, Disney established a retail shop next door at the southwest corner of Seventh Avenue, fulfilling the unrealized intention of Alex Parker, who in 1976 had brought Mickey Mouse to Times Square in a bid to renew the Times Tower's viability. Although the shop was a great hit with the public, Frank Rich thought it compromised the value of the theater renovation. The Disney store, "for all its Broadway-ish signs, brings a mall sensibility to what was once a quintessentially urban block." Rich continued with a disquisition on "the essence of Disney-fication," but he and many others seemed to miss the point that before there was a Hollywood entertainment factory, there was one in New York, centered on Forty-second Street, where theatrical dreams were manufactured and sent out to the entire nation not only in the form of songs but whole productions—road shows—that reproduced New York's stage plays, especially its vaudeville and musicals. Along with that earlier, pre-Hollywood entertainment factory went costumers, makeup shops, souvenir shops, and restaurants, including Murray's Roman Gardens, which was celebrated hand in hand

New Amsterdam Theater (Herts & Tallant, 1903), 214 West Forty-second Street, between Seventh and Eighth Avenues. Renovation by Hardy Holzman Pfeiffer Associates, 1997. View to the south showing Disney store on the left. Aaron. ESTO

Ford Center for the Performing Arts, 213 West Forty-second Street, between Seventh and Eighth Avenues. Beyer Blinder Belle, 1997. View to the southwest along West Forty-third Street. Charles. FCP

Ford Center for the Performing Arts, 213 West Forty-second Street, between Seventh and Eighth Avenues. Beyer Blinder Belle, 1997. Section before renovation. BBB

Ford Center for the Performing Arts, 213 West Forty-second Street, between Seventh and Eighth Avenues. Beyer Blinder Belle, 1997. Section after renovation. BBB

with the New Amsterdam Theater in a 1908 publication, *New York Plaisance*.[148]

When it opened in 1997, the restored New Amsterdam was a hit. Even the famously anti-Disney Ada Louise Huxtable gushed. "If this is Disney Magic we need more of it," she wrote, calling particular attention to the restoration of the amazing colors of the theater—what she described as "a delicate pastel world of sage and celadon green, rose-pink, lavender and orchid"—a stunning contrast to the heavy reds and golds typical of theaters of the day.[149] Herbert Muschamp joined the chorus, praising the restoration and the changed fortunes of Forty-second Street. To Muschamp, however, the splendid theater seemed out of sync with the razzmatazz of Broadway: "It is hard to imagine that hard-bitten, gold-digging Ziegfeld girls and oily Adolphe Menjou types ever felt at home at the New Amsterdam Theater, for the place is an architectural version of an American Eden, the unsullied natural paradise in which European explorers cast the New World."[150]

Not wishing to confuse the opening of the restored theater with the critical reception of its eagerly anticipated theatrical production of *The Lion King*, Disney chose to reopen the house with a limited run of a pop oratorio, *King David*, with music written by Alan Menken and lyrics by Tim Rice. With no stage set and limited special effects, the oratorio allowed the opening-night audience to take in the splendor of the renewed theater. Muschamp took the opening as an opportunity to assess the progress of Forty-second Street's renewal and to situate the New Amsterdam in the context of the city as it entered the

new millennium: "In 1903, the New Amsterdam was shamelessly escapist: in the industrial city, a theater might well want to resemble a park; it performed a similar function. The context of the New Amsterdam has changed. New York is no longer an industrial city. It is an informational city, driven largely by images. It is folly to think that the meaning of the restoration is the same as the meaning of the original design. The New Amsterdam was, essentially, an escape from business. The restored New Amsterdam is business itself, a building integral to the economy of tourism and mass media on which New York's economy now largely depends."[151]

The restorations of the Victory and New Amsterdam Theaters, while challenging, did not come close to the complexity of what came to be called the Ford Center for the Performing Arts.[152] Following ideas suggested in Robert A. M. Stern's study of 1988 (see above), the space was created by combining the Lyric and Apollo Theaters to form one 1,839-seat, two-balconied house suited to musicals. Beyer Blinder Belle, in collaboration with Peter H. Kofman, an architect and engineer based in Toronto, completely rebuilt the auditorium of the Apollo (Eugene De Rosa, 1920), 223 West Forty-second Street. Piece by piece the theater's interior was disassembled and shipped off-site for repair and cleaning, then reinstalled in the totally reconfigured space. The orchestral-level floor was resloped, two shallow balconies replaced the one deep one, and a new, expanded stage opened through a fifty-foot-wide proscenium. The ceiling dome, retained but expanded, was relocated above the new hall. Richard Blinder, partner in

ABOVE Ford Center for
the Performing Arts, 213
West Forty-second Street,
between Seventh and Eighth
Avenues. Beyer Blinder
Belle, 1997. Auditorium.
Charles. FCP

LEFT Ford Center for the
Performing Arts, 213 West
Forty-second Street,
between Seventh and Eighth
Avenues. Beyer Blinder
Belle, 1997. Lobby. Charles.
FCP

charge of the project, commented, "We are essentially reconstructing a new theater out of the components of two old ones."[153] The interior of the Lyric Theater (V. Hugo Koehler, 1903), 213 West Forty-second Street, which had long ago lost its architectural features, was gutted to house a grand elliptical staircase and office spaces.

In January 1997, the Ford Motor Company agreed to sponsor the theater, causing some consternation. Disney's sponsorship was more easily understood—the company was in show business after all. But for a carmaker to put its name on the marquee, a spot traditionally reserved for the names of actors, producers, and theater owners, was another matter. Nonetheless, on December 12, 1997, the Ford Center opened to acclaim, barely making the deadline of year's end to take advantage of soon-to-expire investment-tax credits of between $4 and $5 million. Visitors touring the theater did not see what had initially been hinted at—some kind of alchemical merging of the auditoriums of two theaters—but saw, instead, what was in effect a completely new interior using bits and pieces from the two, especially De Rosa's Apollo.

Behind the Lyric's carefully restored Forty-third Street facade lay a new four-story structure containing the main lobby, a box office, and two rehearsal halls. Behind its narrow Forty-second Street facade, also carefully preserved, a renovated three-story structure housed another box office and a passageway linking back to the main lobby. Just west of the Lyric, facing Forty-third Street, was the new red brick facade, somewhat ham-fistedly echoing that of the old Apollo, screening the ninety-four-foot-long, seventy-foot-high auditorium and the 100-foot-high stage house topped by a forty-foot-high rooftop sign culminating in the Ford Motor Company's logo. Herbert Muschamp likened the collage to that of a sparkling medley in an overture: "Though the lights never go up on architecture here, the rousing prelude deserves a round of applause. The theater is a beautifully orchestrated pastiche." Muschamp, comparing Beyer Blinder Belle's methodology to the way Renaissance architects plundered old buildings to build anew, found the pleasures of "space, comfort and procession" paramount in the work. But, all in all, he deemed the Ford Center a "house of paradox. Though owned by Mr. Drabinsky's company, Livent Realty, the theater is, in part, an advertising vehicle for the Ford Motor Company. The interiors are sprinkled with plaques inscribed with quotations from the company's founder. Like 'Ragtime,' which inaugurated the house [in 1998], the maxims define Henry Ford as a man of progress. The theater, however, offers an architectural glimpse through the rearview mirror." But, Muschamp continued, "there is none of the ironic invention that enabled" *Ragtime*'s author, E. L. Doctorow, "to push the literary envelope while questioning the mythology of progress."[154] Faced with the reality of the theater, with its superb craftsmanship, Muschamp could not dismiss it, though he clearly didn't like it.

In January 1997, rumors began to circulate that the prestigious Roundabout Theater Company would take over the last of the historic theaters, the Selwyn Theater (George Keister, 1918), 229 West Forty-second Street, whose lobby was currently serving as the home of the Times Square Visitors Center designed by Robert A. M. Stern Architects and open since April 1996.[155] A new ten-story, 84,000-square-foot building, to house rehearsal studios and a 199-seat "black box" theater, was to be designed by Platt Byard Dovell, whose essay in glass was wrapped, on the Forty-second Street side, with deli-

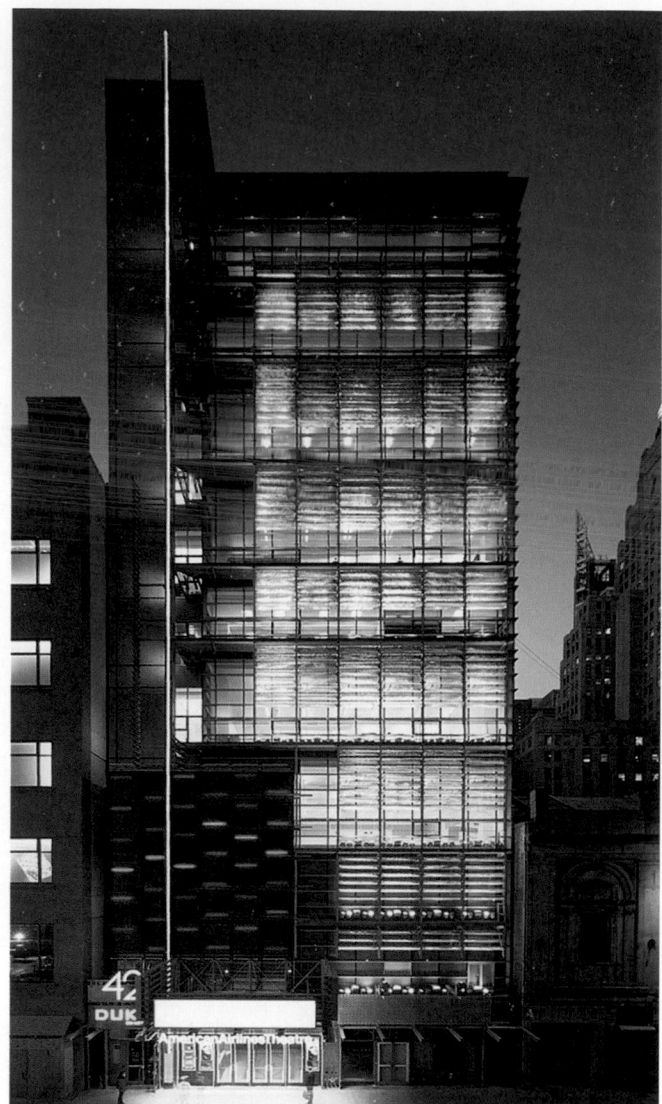

New 42nd Street Studios, 229 West Forty-second Street, between Seventh and Eighth Avenues. Platt Byard Dovell, 2000. View to the north. Kaufman. PBDW

cately scaled metal *brises-soleil*, or sunscreens which, during the day, would make visible to passersby the rehearsal activities in the studios within and at night become the screen for a computer-generated constantly changing show of colored lights. In effect, the design, attributed to Charles Platt and Ray Dovell and the lighting designer Anne Militello, was intended to transform the "whole building into a sign," according to Platt, as well as a "symbol . . . for all of 42nd Street," an ambitious aim given its comparatively modest size.[156]

In keeping with the goal of maintaining as many of the street's historical layers as possible, Platt Byard Dovell's design was to have incorporated the terra-cotta facade of the six-story Selwyn Building, as well as the passage, renovated in the 1940s, that served as the entrance to the theater, the auditorium of which was located on Forty-third Street. But on December 30, 1997, a day after engineers for the Tishman company working on the E-Walk project next door (see below) began to notice cracks developing on the old building's ground floor, but failed to notify the Building Department of potential danger or make any special efforts to shore up the structure,

the Selwyn Building collapsed, forcing the street's closing and the cancellation of a preview performance of *Ragtime* at the new Ford Center.[157] The building's demise was probably hastened by a pounding rainstorm. Lost in the collapse was a collection of Times Square memorabilia that had been stored in the visitors center, including old pinball machines, marquees, and neon signs, one of which promised "Sex Sex Sex." Destroyed as well was the Grand Luncheonette coffee shop, which until it closed for business six weeks before the accident, had been a fixture on the street.[158]

With the loss of the Selwyn Building, the rehearsal building was modestly redesigned so that the screen on its second through fourth floors covered only half of the building's width, leaving room for a ghosted memory of the old building in the form of a sign scaffolding backed by a translucent glass screen. In March 2000, American Airlines, following the example of the Ford Motor Company, added its name to a Forty-second Street marquee, but in this case it provided sponsorship of the not-for-profit Roundabout Theater Company in exchange for naming rights. The New 42nd Street Studios building, incorporating the American Airlines Theater, opened on June 21, 2000. To Elaine Louie, writing in the *New York Times*, it proved "that a glass building can have a 21st-century reason for its transparency and not just be a nod to old-fashioned Modernism."[159] The computerized uplights were projected against the perforated stainless-steel *brises-soleil* that were, in turn, silhouetted against a blue background. A 175-foot-tall wand of light, designed in collaboration with the glass artist James Carpenter, was located at the facade's western edge, as if to provide the energy source for the light symphony that played across the building every evening. Joseph Giovannini's assessment was uncharacteristically balanced: "For New York, this building is a fresh face. The architects may have designed only what is, in the end, a familiar glass box, but with their totally original use of light they infused it with new life."[160] For Paul Goldberger, the New 42nd Street Studios was "the best new building in Times Square," turning at night into a "performance. It glows, it flashes, it changes from red to blue and then to yellow, orange, and green. . . . The lights do not cover up the architecture, like the commercial billboards up and down the rest of the street; they are completely in tune with the structure of which they are a part. They make it dance."[161]

Encore on Forty-second Street

Michael Eisner's decision to come to Forty-second Street proved crucial for the revival of the area. The original development controls called for one new hotel to be built on the northeast corner of Forty-second Street and Eighth Avenue, the construction of which was deemed critical to the success of the plan because it would anchor the west end of the block, which had historically been weak: Eighth Avenue had been home to the roughest burlesque venues, which contented themselves with outmoded theaters mostly built in the last decades of the nineteenth century. The presence of the expanded bus terminal on one corner, a one-story bunkerlike bank facility on a second, and a parking lot directly across Forty-second Street, combined with the subway entrances incorporated in the one-story taxpayer occupying the corner of the hotel site, made for a busy but decidedly degraded atmosphere. The original guidelines had permitted an on-site traffic dropoff for the hotel on Eighth Avenue that would have further compromised the area's

pedestrian life, but the interim plan rejected this, insisting on shops lining both Forty-second Street and Eighth Avenue with the hotel's main entrance, sans dropoff, located on Forty-third Street. In early 1994, in anticipation of a request for proposals from teams of developers and architects, Robert A. M. Stern Architects, working with the hotel specialist Alan Lapidus, developed a conceptual model for the site's development.

In September 1994, four teams were selected by the state and city to compete for the hotel and entertainment complex for the 57,500-square-foot site.[162] Frank O. Gehry, with Alan Lapidus, was to work with Disney, Tishman Realty and Construction Company, and Westin Hotel and Resorts; Eisenman Architects, with Brennan Beer Gorman, was to work with the Hilton Hotels Corporation, the LCOR development company, and the Hahn Company; Venturi, Scott Brown & Associates, with Nobutaka Ashihara Associates, was to collaborate with Marriott International and the Triarc Equities Corporation; and William B. Tabler was to work with Milstein Properties Company and the Weiler Arnow Management Company. By the time the proposals were evaluated and the winner selected in February 1995, Gehry had been replaced by Arquitectonica, the Eisenman team had dropped out, Venturi had been replaced by Michael Graves, and Zaha Hadid as well as Platt Byard Dovell had joined with Tabler to work on Milstein's team which, because the developer also controlled the parking lot across the street, included an additional hotel and retail space to be built there.

Assessing the various design proposals, Jayne Merkel, editor of *Oculus*, called it "the most fun-filled competition for the most forlorn corner in America."[163] While the Venturi, Scott Brown scheme was ultimately not part of the competition, it was published: a quite conservative, strip-windowed tower with outdoor elevators in the reentrant southwest corner rising past the top floor to engage with a superscaled, starburstlike billboard crown.[164] Michael Graves's classically inspired scheme, replacing Venturi's, called for a 470-foot-high, pink ochre and green brick–clad 945-room campanile-like hotel to be run as part of Marriott's low-cost Courtyard Chain. Though its sign-encased site-filling base, incorporating a 2,000-seat theater, had some zip, with a Venturi-inspired big red apple at the corner housing a café above a street-level subway entry, the design was, as Herbert Muschamp put it, "dignified but unassertive."[165]

By far the most unusual of the three proposals belonged to Zaha Hadid, the highly regarded, Iraqi-born, London-based architect.[166] Her scheme included television production studios in the low Forty-second Street base, but the real contribution was the forty-eight-story, glass-sheathed mass she threaded through with what, according to Muschamp, "would become in effect, a vertical street" of public rooms interspersed with blocks of hotel rooms, with the various uses "expressed architecturally by the shaping of the exterior into a powerful composition of crystalline walls" overlaid with a scattering of electronic signs, many projected onto the building's facades. This concept, Muschamp continued, "raises a major problem"—the dependence on a still-experimental technology that might be difficult to sell to potential advertisers. More significantly, as Muschamp noted, "even if these problems were solved the result is likely to have an esthetic uniformity that the design guidelines were expressly devised to overcome." In short, the level of this project's architectural sophistication may have been "too high . . . for gaudy, bawdy 42nd

ABOVE LEFT Proposed hotel, northeast corner of Eighth Avenue and West Forty-second Street. Venturi, Scott Brown & Associates, 1994. Model, view to the northeast. VSBA

ABOVE RIGHT Proposed hotel, northeast corner of Eighth Avenue and West Forty-second Street. Michael Graves, 1994. Rendering of view to the northwest. GRV

RIGHT Proposed hotel, northeast corner of Eighth Avenue and West Forty-second Street. Zaha Hadid, 1994. Rendering of view to the southeast. ZH

BELOW Proposed hotel, northeast corner of Eighth Avenue and West Forty-second Street. Zaha Hadid, 1994. Model, view to the northeast. ZH

Westin Hotel, 270 West Forty-third Street, southeast corner of Eighth Avenue. Arquitectonica, 2002. View to the northeast. McGrath. ARQ

Westin Hotel, 270 West Forty-third Street, southeast corner of Eighth Avenue. Arquitectonica, 2002. Atrium. McGrath. ARQ

Street."[167] On closer examination, especially of the building's cross section, the design recalled the stacked atria of John Portman's hotel in Times Square.

Muschamp applauded Arquitectonica's proposal, which was selected on May 11, 1995, declaring it a plan so good that "one wants to send out for mouse ears." (Ironically, the Disney Company would soon withdraw from the project when it abandoned a plan to expand its time-share hotels beyond its California and Florida facilities.) In fact, many felt that the selection of Arquitectonica, which had never built in New York, had more to do with the solid reputation of the Tishman company and the magic of Disney than with the scheme itself. Calling the design "a jazz age version of the apocalypse" because of the "stylized architectural image of a comet" crashing down one side of the zanily polychromed, bulky, glass-sheathed, forty-five-story tower, Muschamp was also taken with the overall interlock of the component parts, "the changes in scale, function and esthetic approach; the transition from the abstract forms of the tower to the figurative images of the signs: these elements adhere strictly to the design guidelines, but kiss them with inspiration. Forty-second Street in its present form already looks like a meteor has struck, but this design is an explosion of life."[168] Less convincing was D'Agostino, Izzo, Quirk's handling of the base, devoted to retail and entertainment uses. Diller + Scofidio's big permanent mosaic billboards wrapping what was called "the bustle"—that is, the transitional element intended to house the 100-room Disney Vacation Club located between the retail base and the hotel—promised to enliven the

aggressively sculpted intermediate mass, as did the firm's proposed tower of televisions. While the meteor-like slice helped reduce the visual bulk of the tower, conceived as two interlocking prisms, the decision to clad parts of its west side with vertical strips of blue-toned glass and the east side with horizontal bands of copper and orange may have had the opposite effect, though it certainly fit in with Forty-second Street's reviving stridency. The project was realized in two stages, with E-Walk, as the four-story, 200,000-square-foot entertainment base was called, completed in November 1999, and the 667,000-square-foot, 858-room hotel, for which financing proved more difficult, not completed until late 2002. E-Walk included a thirteen-screen movie theater complex containing a total of 3,500 seats designed by the Rockwell Group and operated by the Loews chain. Combined with the twenty-five-screen AMC Theater across the street (see below), with 4,916 seats, the west end of the block now totaled 8,416 seats, probably the highest concentration of movie seats in the world.

When the Westin Hotel opened in October 2002, one adjective appeared in nearly every review: "ugly." James Gardner, writing in the *New York Sun*, deemed the building "among the ugliest our city has ever seen," referring to Arquitectonica as the "perpetrator" of an "unconscionable" design that featured "muck-colored reflecting glass, punctuated with little rash-like dots of turquoise and flesh tone." The building's signature swooping line was, for Gardner, lacking in "oomph," with "no energy or movement," more like "a collection of glass panes clumsily and laboriously set in place."[169] Paul Goldberger called the Westin "the most garish tall building

that has gone up in New York in as long as I can remember. It is fascinating, if only because it makes Times Square vulgar in a whole new way, extending up into the sky." Goldberger was at peace with the building's shape, but was wholly dissatisfied by the skin, calling it "the ugliest curtain wall in New York. Make that the two ugliest curtain walls in New York, since the pink section and the blue section are ugly in different ways. They are both unpleasant to look at—tawdry colors, gaudy finishes. . . . It's as if [the architects] had no faith in the shape they made, and could not stop themselves from tarting it up." The entrance was a welcome relief for Goldberger, set into a "blessedly ordinary modern base of clear glass on Forty-third Street," as were the interiors. The lobby details, he continued, "like the elevator cabs with curving, backlit metal panels, are splendid," as was the incorporation of the building's exterior swooping line into the atrium inside: "As much as I dislike that white line on the exterior, I like seeing it close up. In the atrium, it operates in a very different way than it does on the facade. It reveals how the building is made, and is completely engaging."[170]

Herbert Muschamp put a positive spin on the building's ugliness, writing: "We live in one great ugly town. Not being too hung up on beauty is what makes life here possible, even thrilling. In exchange for surrendering refinement, we get a kind of urban poetry that is the envy of the world." Muschamp hailed the Westin as a sign that "Latin American architecture is here! . . . We have work by Latin American architects" in New York "but not, thus far, an easily discernible Latin American architecture. This is changing." The design, he continued, represented the "exhaustion of the northern European version of the Western tradition." For this reason, he argued, "the Westin Hotel is a pivotal building. Like it or not, the building signifies an important shift in the history of taste." Whereas Goldberger found the Westin's cladding to be garish, Muschamp celebrated the "carnival skin" as a "Postmodernized" version of Mondrian's Broadway Boogie Woogie: "Broadway Samba . . . accented with stripes of contrasting colors that evoke the movement of traffic on uptown and crosstown streets. Beep-beep. Toot-toot."[171]

While the original development controls called for only one hotel on the block, a second midblock hotel was added to the plan as part of the development that included a twenty-five-screen theater complex operated by AMC Entertainment, a Kansas City–based chain of movie theaters not yet represented in New York; a branch of Madame Tussaud's, the London-based wax museum founded in 1835; and 135,000 square feet of other retail space, including a 20,000-square-foot HMV music store, several inexpensive restaurants, and an Internet café, all designed under the direction of Beyer Blinder Belle.[172] The midblock site on the south side of Forty-second Street proved to be critical to the project's success. Egged on by the Disney Company, which would not enter an agreement to renovate and operate the New Amsterdam unless at least two other family-friendly entertainment companies also agreed to locate on the block, officials scrambled in the spring of 1995 until, just two weeks before Disney's do-or-die date, the state and city, working with Forest City Ratner, obtained a commitment from Madame Tussaud's and AMC Entertainment. The site and its redevelopment was unique. It included the Harris, Liberty, and Empire Theaters. To make way for the retail complex and the hotel, the Empire Theater (Thomas W. Lamb, 1912), 236 West Forty-second Street, was

moved 168 feet to the west. Opened as the Eltinge in 1912, the theater was home to burlesque in the 1930s but after 1942 featured movies. The name was changed to the Empire in 1954, perhaps as an homage to the recently destroyed Empire Theater (J. B. McElfatrick, 1893), 1430 Broadway, on the northeast corner of Thirty-ninth Street.[173] Although the Empire had been abandoned since the early 1980s, the ornamental plasterwork of the 750-seat theater's vaulted interior, including Roman and Greek motifs as well as Egyptian figures playing pipes, had miraculously survived, in part because state officials had kept the building heated. In February 1993, as part of the filming of Arnold Schwarzenegger's *The Last Action Hero*, directed by John McTiernan, the theater had been "restored" by art director John Wright Stevens and production designer Eugenio Zanetti. Christopher Gray was impressed with the effort, noting that the "changes are enough to reward a visit by the architectural pilgrim. . . . It looks like solid stone and bronze but—thonk! thonk!—it is Hollywood hollow."[174]

The dramatic potential of the Empire Theater's relocation was appropriately exploited. A test move of thirty feet was successfully undertaken on February 22, 1998, demonstrating that the building could travel without damage to the delicate plasterwork. A week later, on March 1, according to plans drawn by the engineer Robert Silman, the 3,700-ton Empire inched its way down Forty-second Street toward its new foundation, guided atop eight steel rails at the rate of about a foot per minute. Scores of people watched as giant balloons representing the comedy team Abbott and Costello, who had met at the theater, appeared to tug the building along. After the move, the Empire's grandly classical arched facade and spacious auditorium served as the entrance and ticketing lobby of the new twenty-five-theater movie complex that was built immediately to its east.

The disposition of the two other theaters on the Forest City Ratner site proved much less challenging. All that was left of the Liberty Theater (Herts & Tallant, 1904), 234 West Forty-second Street, were portions of the facade and the interior, which were incorporated into the new complex. Similarly, there was little left of the Harris, which began as the Candler, 226 West Forty-second Street, a companion to the office building next door.[175] Both the theater and the building had been investments of Asa Candler, founder of the Coca-Cola Company. In March 1998, Forest City Ratner was reported to be in negotiations for the right to construct a 444-

View to the southwest showing the moving of the Empire Theater, March 1, 1998. Hogan Charles. NYT

Hilton Hotel, south side of West Forty-second Street, between Seventh and Eighth Avenues. Beyer Blinder Belle, 2001. View to the southeast. Brandt. PB

room, twenty-five-story hotel as part of its midblock project. Seen as a sign of the remarkable resurgence of Times Square and Forty-second Street, the proposed hotel raised issues of density, scale, and, in particular, the potential loss of sunshine on Forty-second Street's midblock stretch. The Municipal Art Society, which had five years earlier protested the Forty-second Street project on the grounds that it would never generate any development to cover the restoration of the theaters, now became concerned that the street would be overbuilt if the revised plan, calling for 850,000 square feet of new construction, was realized. But state officials were fundamentally in favor of the hotel, which they believed would help enliven not only Forty-second Street but also Forty-first Street—hitherto largely ignored but undergoing a mini-revival of its own as a result of the successful musical *Rent*, enjoying a long run at the Nederlander Theater, 208 West Forty-first Street, and attracting a young crowd drawn by its story of countercultural life in the East Village.[176] The hotel project, to be run by Hilton, was approved in 1998. Beyer Blinder Belle's design managed to be jazzy yet banal, with an oddly shaped spiraling rooftop structure that seemed ill integrated with the plaid pattern of the not-too-refined curtain wall. However, the overall structural system required to create the necessarily column-free theater space below was no mean piece of engineering, the high

cost of which was largely justified by the potential advantages of a hotel in what had become a hot location. The hotel's principal entrance was on Forty-first Street, but there was a second entrance on Forty-second Street. Both entrances were embellished with witty sculptures by Tom Otterness, based on the theme of time and money, depicting his signature cartoonish small bronze figures holding up and hanging onto large off-kilter clocks. Elevators from the Forty-second or Forty-first Street entries led to the ninth-floor sky lobby that afforded superb views over Forty-second Street toward Times Square. Below the hotel, the 85,000-square-foot Madame Tussaud's Wax Museum, incorporating historic elements of the Harris and Liberty Theaters, was designed by Ian McGonigal of Architecture IMG and Deborah Fantera of Ohlhausen DuBois. Opened in October 2000, the ten-level space, planned to accommodate 1,200 visitors per hour, included over 200 wax figures.

Just to the east of the hotel, a 17,500-square-foot McDonald's restaurant—the company's largest metropolitan eatery—opened in September 2002 in the first three floors of the Candler Building, making its presence well-known on Forty-second Street with a bold marquee studded with 7,500 light bulbs.[177] Charles Morris Mount, who designed the restaurant as well as six other McDonald's in the city for the same owner, Irwin Kruger, jokingly boasted that "you could get a sunburn

LEFT Four Times Square, east blockfront of Broadway, between West Forty-second and West Forty-third Streets. Fox & Fowle, 1999. View to the southeast. Goldberg. ESTO

FACING PAGE Four Times Square, east blockfront of Broadway, between West Forty-second and West Forty-third Streets. Fox & Fowle, 1999. View to the northwest. Goldberg. ESTO

standing underneath" the marquee.[178] James Gardner was taken with the gesture, writing that the brightly lit canopy blazed, "even at noon, with an intensity that recalls the Great White Way in its glory."[179] Inside, the 300-seat restaurant, designed to have a "backstage" vibe, featured exposed brick walls, a plethora of plasma screen monitors, and theatrical light fixtures outfitted with colored gels. Working with Beyer Blinder Belle, Mount carved away a portion of the building's second floor to allow a pair of staircases with railings fashioned from structural rebars to rise to a mezzanine-level dining area and, on the third floor, a dining room with two forty-seat communal tables overlooking Forty-second Street.

The Towers Return

In what proved to be one of the great ironies of the 42nd Street Development Project, the office buildings that were to have

been the engine leading the project proved to be its caboose: construction of the towers moved forward only after plans for the redevelopment of five theaters were secured—only the Times Square (Eugene De Rosa, 1920), 219 West Forty-second Street, slated for reuse as an entertainment-related nontheatrical facility, had no committed tenant as of December 2001—and construction of two new hotels and substantial retail entertainment spaces was under way. In September 1996, about six months after having secured the site from the Klein/Prudential team, the Durst Corporation broke ground for Fox & Fowle's Four Times Square, soon named the Condé Nast Building after its principal tenant, the publishers of fashion and lifestyle magazines, occupying the west end of the block bounded by Broadway, Sixth Avenue, Forty-second and Forty-third Streets.[180] It was the first groundbreaking for a speculatively undertaken midtown office building in fifteen

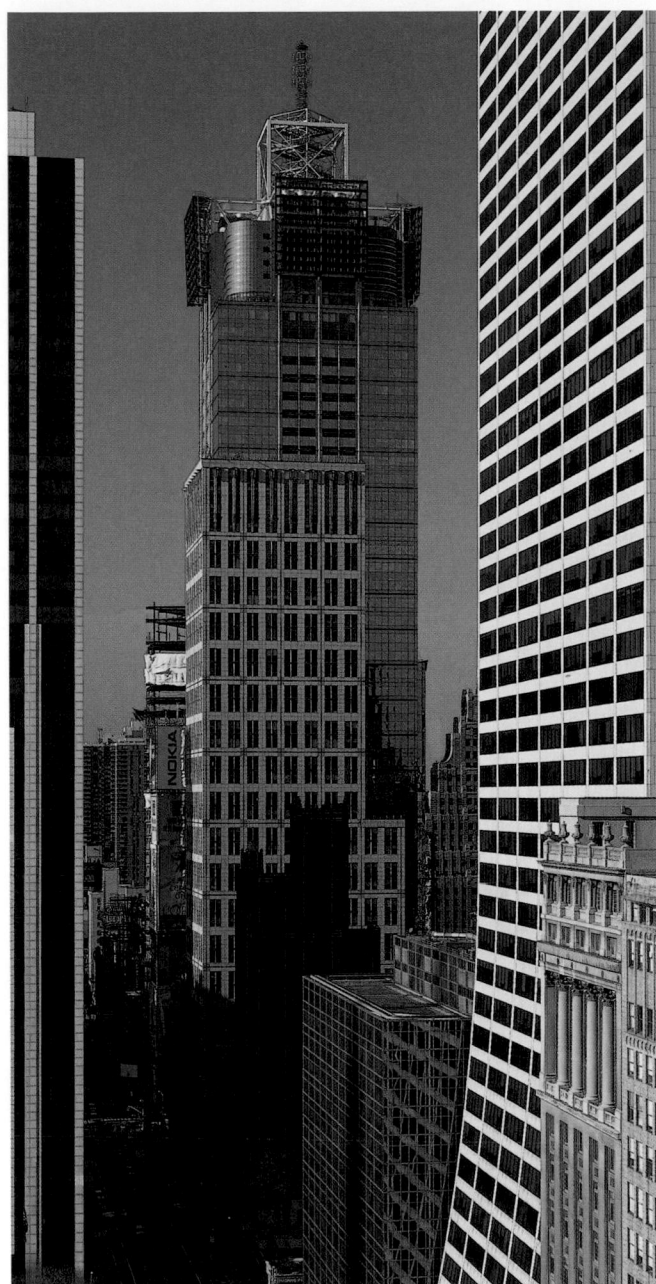

that blue chip tenants should be in elegantly aloof midtown towers or on manicured suburban campuses. Durst's message is that right outside the door are customers doing things that companies need to be aware of to improve their products."[181]

Fox & Fowle, a firm that had hitherto enjoyed a reputation for safe, even bland, office building designs, surprised knowledgeable observers with a multifaceted, complexly massed and complexly articulated composition. The firm's design varied the massing not only to take advantage of the irregularities of the site caused by the diagonal of Broadway, but also to be contextually sensitive, confronting Bryant Park and the midtown office district with a regular grid of masonry and glass but letting loose with a reflective glass curtain wall and some bold shapes on the sides facing Times Square. Significantly, the building was not a unified tower, as many previous proposals for the site had been, but was broken up and set back in ways not determined by zoning but instead by the architects' sense of what was needed to create something as lively as its setting, to make an icon appropriate for what Suzanne Stephens aptly characterized as a "neon park."[182] At the building's top, four sixty-foot-square illuminated signs and a communications tower pierced the skyline, evoking Russian Constructivist precedent from the 1920s, not frivolously but as the result of a decision to expose the so-called hat-truss used to stiffen the building by tying external columns to the core, an aesthetic conceit, as Bruce Fowle conceded, to suggest that "the building decomposes as it reaches the sky, so the guts show."[183] Because of the destruction of the World Trade Center, the communications tower atop Four Times Square was increased in height to 385 feet so that it rose 1,142 feet above the ground, dramatically raising the building's profile and increasing broadcast quality for stations that had had difficulty transmitting since 9/11, but not measuring up to the 1,750-foot-tall antenna on the World Trade Center or the Empire State Building's 1,454-foot-tall mast, which provided the city's highest antenna after 9/11.[184]

At the behest of Durst, Fox & Fowle was encouraged to give serious consideration to environmental and energy conservation issues, although in the end, the results proved more valuable as a marketing tool than as a contribution to environmentalism. The incorporation of 208 photovoltaic panels, replacing 2,955 square feet, or half of a percent, of the building's spandrel areas, proved to be a token gesture—the electricity they created would supply a half dozen or so houses but meant little in view of the building's overall needs. Two, 200-kilowatt alternative-energy fuel cells, converting natural gas into electricity without the noxious emissions of conventional combustion, were installed instead of the eight originally proposed but nonetheless still generated 8 percent of the building's electricity. Passive environmental strategies proved more practical: larger-than-usual windows—five by seven feet—helped bring daylight deeper into the building, thereby reducing energy consumption, though some waggishly pointed out that many employees situated on the enormous 35,000-square-foot floors were barely within walking distance of the windows. The mechanical ventilation system introduced 50 percent more fresh air than required by national standards; an extensive program of recycling extending from the disposition of construction materials to the selection of new ones was also instituted. All in all, Four Times Square used 41 percent less nonrenewable energy than the typical building built ten years before, but as Suzanne Stephens put it,

years and a key vindication of the Forty-second Street project. Condé Nast signed on for more than one-third of the 1.6-million-square-foot, forty-eight-story tower and, soon afterward, the law firm Skadden, Arps, Meagher & Flom signed on for 660,000 square feet, making the building a virtual sellout. The significance of so prominent a tenancy was also not to be gainsaid: the presence of the giant law firm affirmed George Klein's expectation that Times Square would become a corporate center. And the decision of Condé Nast to vacate its Madison Avenue headquarters and consolidate activities in a building located at the city's most raucous intersection reinforced Times Square's emerging role as the corporate capital of popular media. Initially, many snickered at the thought of fashionistas picking their way through Times Square touristas. As James Russell explained to the readers of *Urban Land*, the project broke a market taboo, reversing "the convention

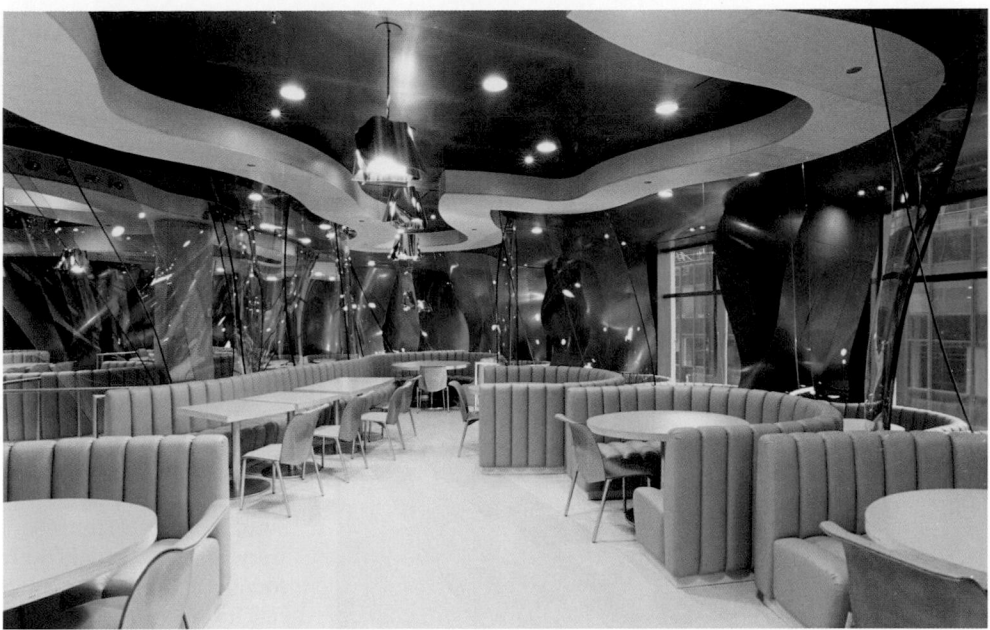

FACING PAGE AND RIGHT
Condé Nast cafeteria, Four Times
Square, east blockfront of Broadway,
between West Forty-second and
West Forty-third Streets. Frank
Gehry, 1999. Dong. CN

efforts "to save electricity at Times Square may be a little like opening up a smoke-enders clinic on a tobacco farm."[185]

Four Times Square, the ultimate contextualized Postmodern skyscraper, seemed to some too much so. After deciding that the building's "most endearing quality is that it *isn't* the tower designed for the same site in 1984 by architects John Burgee and Philip Johnson," Karrie Jacobs realized that the difference was merely composition, because Fox & Fowle's building was even bigger, 1.6 million square feet rather than the 1.54 million initially planned, although only forty-eight stories tall instead of the original fifty-six.[186] Carefully reading Fox & Fowle's August 1996 press release, which stated that the building was to be built over a one-year-long period, Jacobs objected to the architects' attempt to suggest "a characteristic Times Square layering of building and happenstance that might have evolved over time." Instead, she wrote, what the building's design "may represent is the architectural style of the moment, with its lack of focus and specificity. It's a building that has something for everyone; it metes out its architecture in sight bites. It's the perfect building for a culture that consists of nothing but fragmented references to what has come before."[187]

Although Herbert Muschamp clearly did not like the building, he couldn't quite dismiss it out of hand. Calling it "a skillful piece of urban collage," he nevertheless found "something disingenuous about the overall effect. You know the building wants very much to be noticed, but it tries so hard to be 'appropriate' that it brings to mind Phoebe, the character who turns up at the end of 'All About Eve,' bowing this way and that, gazing the whole time at her reflection in the mirror."[188] Suzanne Stephens took the long view, noting that the city's most memorable skyscrapers were not formal or technological innovators but romantic towers that celebrated themselves and their clients.[189] Paul Goldberger, weighing in after the building opened, put Fox & Fowle's design in a wider context than that of Times Square: "The varying facades and fidgety, edgy forms of the new buildings are not simply a response to the visual cacophony of Times Square, since it isn't only at Times Square that you see this new kind of tower. In almost every major city in the world, restless, agitated, disconnected buildings are going up. The skyscraper has become a collection of parts."[190]

While Four Times Square was greeted with a kind of dismissive praise, the eagerly anticipated cafeteria that its principal tenant, Condé Nast, commissioned from Frank Gehry, who at century's end was unquestionably the world's most famous and most admired architect, did not in any way disappoint.[191] Occupying 10,800 square feet on the building's fourth floor, with a 253-seat main dining room plus private dining areas for meetings and presentations, the thirteen-foot-two-inch-high room exuded glamor. Sensuously undulating titanium-surfaced alcoves wrapped the space, and veils of clear, contoured, laminated glass shaped the midroom alcoves that snaked through it. Gehry and his colleagues used CATIA software, developed for the aerospace industry, to help translate into built form the complex curvilinear shapes and to realize the overlaps and interlocks between the glass panels that enriched the subaqueous feel of the room (in the private dining rooms, the glass was sandblasted to give the effect of billowing curtains). Stretching glass technology to new limits, Gehry succeeded in giving real meaning to the clichéd term "interior landscape." As the architect put it: "The lines of the glass edges look like reeds swaying in the breeze."[192]

If nothing else, the decision of the Nasdaq market to locate its media information center on the building's ground floor (see Times Square) and to place a sign at the building's Forty-third Street corner made Times Square's renewal official.[193] Because projects in the 42nd Street Development Project were not subject to city zoning regulations, the sign could be boldly shaped and project out over the sidewalk. When news of the eight-story-high, 14,000-square-foot LED sign, said to be as big as three basketball courts and capable of allowing single or multiple images to move across its surface, became public, Condé Nast and the building's developer found themselves locked in a very public dispute about lost views in the publisher's offices. Though the cylindrical sign did not technically obstruct the thirty square windows behind it, and was itself only about eighteen inches thick,

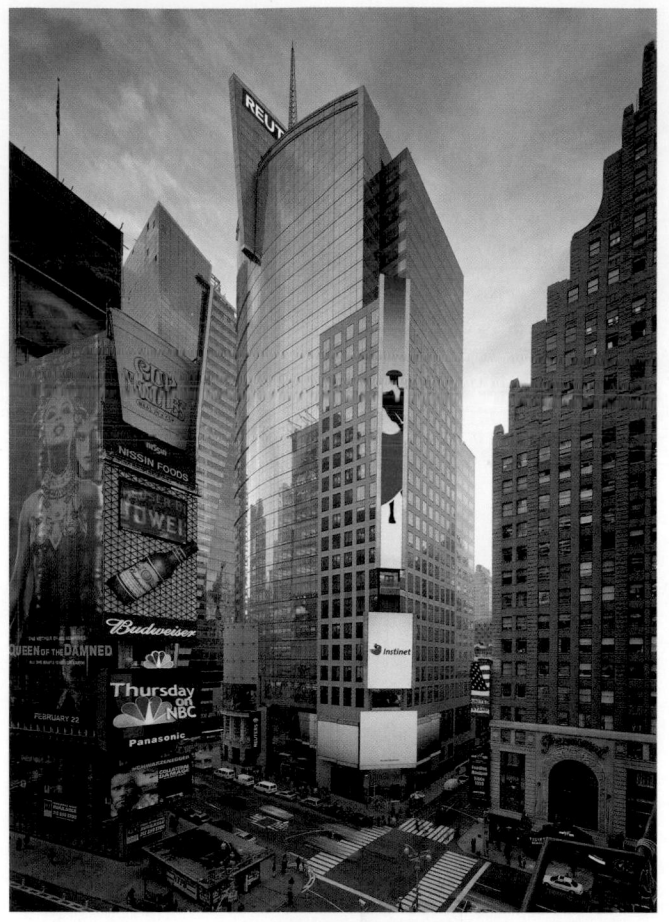

the space between it and the building wall needed for ventilation and a three-foot-wide catwalk needed for maintenance were said to produce a tunnel-like effect around the windows. The dispute was resolved by an arbitrator in August 1999, who ruled in favor of Nasdaq. The sign, made up of 8,900 approximately foot-square panels capable of displaying more than 16.7 million distinct colors, was turned on on December 28, 1999, but its amazing luminosity and intense colors did not swamp the scene so much as ratchet it up to a new level.

The successful development of the Condé Nast site by the Durst organization encouraged Klein/Prudential to put the remaining sites it controlled up for sale. News soon came that the so-called Rialto site, west side of Seventh Avenue between Forty-second and Forty-third Streets, would be developed by the Rudin organization for Reuters, the British-based international media company.[194] Fox & Fowle was hired to design the building, Three Times Square, an 855,000-square-foot, thirty-story building widely welcomed as another step toward the completion of the seemingly endless Forty-second Street project. Its construction, however, meant the loss of Thomas W. Lamb and Rosario Candela's Rialto Theater Building, whose construction in turn had required the demolition of J. B. McElfatrick's Victoria Theater. The likely destruction of Lamb and Candela's building was the subject of some concern, especially after it received light restoration (1995) as part of the interim plan for Forty-second Street. At the earliest signal of the interim plan's success, the Rialto Theater Building, cleaned and relit, became home to stylish retail tenants willing to accept short-term leases.

ABOVE Reuters Building, Three Times Square, west blockfront of Seventh Avenue, between West Forty-second and West Forty-third Streets. Fox & Fowle, 2001. View to the southwest. Sundberg. ESTO

RIGHT Reuters Building, Three Times Square, west blockfront of Seventh Avenue, between West Forty-second and West Forty-third Streets. Fox & Fowle, 2001. View to the northwest. Sundberg. ESTO

In addition to office space, Reuters, which would occupy 506,000 square feet in the building, required a securities trading floor and television studios. Three Times Square was also to be "green" in a modest way, with two 400-kilowatt fuel cells to provide large amounts of low-pollution power and to serve as a backup in the event of an outage. According to Robert Fox, one of the building's architects, the exterior wall of the new building would be so efficient and the amount of heat generated by people and machines so great that it would not have to be mechanically warmed, even on cold days in winter. The Reuters Building also was to include 80,000 square feet of retail space as well as 34,000 square feet of signage, including an illuminated blue wedge slicing through the curtain wall at the top of the building, announcing the corporation's presence to all New York, an advertisement that would not have been permitted by zoning regulations elsewhere in Manhattan's choice business neighborhoods. In addition, a sign-capped curved glass wall swept around the corner of Forty-second Street and Seventh Avenue, one of the city's busiest, where projecting bays of stone, terra-cotta, and metal framed glass were shaped to recall the now much missed Rialto Theater Building. The curve also helped open up the view of Kohn Pedersen Fox's Five Times Square (see below) to Times Square.[195]

Herbert Muschamp greeted the drawings and model of the proposed Reuters Building as the "30-story equivalent of Mayor Giuliani's civility campaign. It is decent, well mannered, and if you were a gentleman, you'd tip your hat." Damning it with faint praise, Muschamp wrote that the best news about the building was that "it is going up in Times Square. While New Yorkers like to ridicule this overhauled district as the creation of Mickey Mouse, in fact it is becoming the media center of the world."[196]

Despite Muschamp's reservations, Three Times Square played its part in the urban drama with considerable élan. Bruce Fowle's "struggle . . . [to] create corporate dignity and [at the same time] fit into the razzle-dazzle" of Times Square led to what Paul Goldberger described as "a building that sometimes seems like a bunch of unintegrated pieces."[197] Perhaps for this reason, Joseph Giovannini, a critic partial to stylistic Deconstructivism, glowed with appreciation:

> Fox & Fowle has opened the normally closed skyscraper form to a part of the city that's already layered in short and tall, new and old buildings. The Reuters Building does not strive to be a perfect whole but is a fuzzy, indeterminate figure that blends into a context from which it takes its cues. The concept is best understood from the Port Authority Building at Eighth Avenue and 42nd Street, where in a kind of spatial collapse, the Reuters and Condé Nast buildings merge into a single composite of some twenty apparent buildings, as in a Renaissance *veduta*—those scenes once imagined by architects clustering disparate buildings into the same view.[198]

But Ned Cramer, writing in *Architecture*, crankily protested the design: "Reuters' piecemeal surface treatment is an outgrowth, in more conventional architectural terms, of the cancerous, pedestrian-oriented advertising mandated by the design regulations of the 'improved' Times Square." For Cramer, Reuters exhibited "so many different types of cladding" that the building, as well as the firm's Condé Nast, could not "be recognized as icons of the companies whose names they bear. This may be a savvy developer's deliberately ambiguous branding

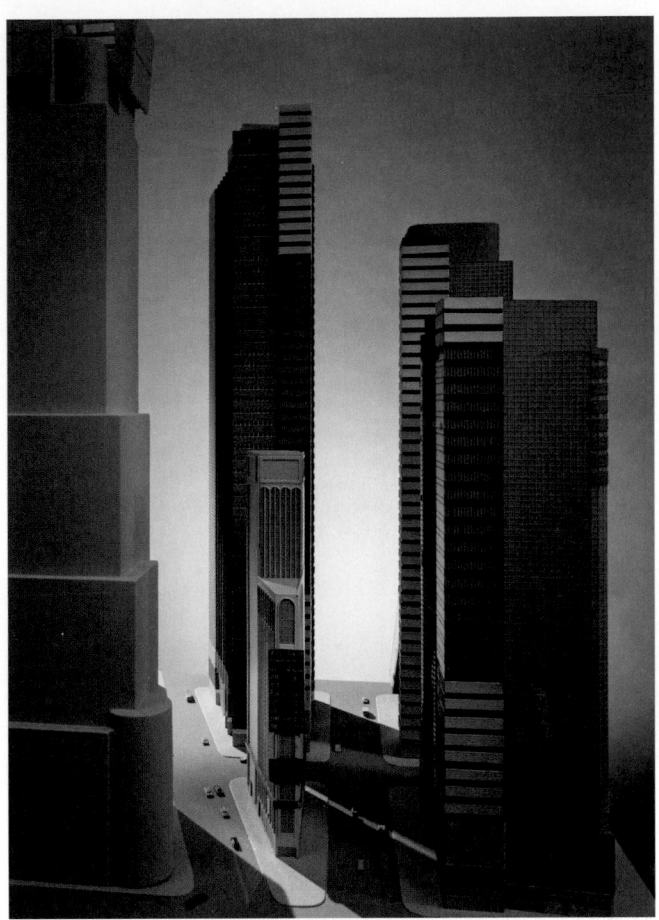

Proposed Times Square office buildings. Philip Johnson Alan Ritchie Architects, 1997. View to the south. Walker. RW

strategy . . . but it makes for confusing architecture. Fox & Fowle probably had complexity in mind instead. What they built is more of an identity crisis—a mish-mash of forms and materials utterly lacking in finesse or wit or high meaning."[199]

In 1997 the two remaining office building sites were put on the market by the Prudential Insurance Company, which had parted ways with Park Tower Realty in 1996.[200] In dramatic contrast to the project's early, lean years, the combination of a booming economy and the obvious success of the renewal efforts on Forty-second Street elicited wide interest among developers. Both sites went to Boston Properties, a firm headed by Mortimer Zuckerman, who paid an enormous price for them, in part justified by the willingness of the Empire State Development Corporation (successor to the UDC in 1996) to add an additional 71,442 square feet of floor area to the combined sites. Seeking to take advantage of the likely prospect of construction of the Forty-second Street project's last two office buildings, Philip Johnson, then ninety-two years of age and just recovering from two years of complications following the replacement of a heart valve, with his current partner, Alan Ritchie, made a bid to reclaim a spot in the limelight with a proposal using a facade system designed by Fernando Vasquez, an architect, and Sussman/Prejza, graphic designers, that would enable the buildings to be wallpapered with advertising.[201] According to Muschamp, Johnson's speculatively developed design, "nearly identical to the version" he had prepared in 1992, had "earned a place in the history of ideas" for its "geometric composition with a rectangular core of glass with faceted

Five Times Square, west blockfront of Seventh Avenue, between West Forty-first and West Forty-second Streets. Kohn Pedersen Fox, 2002. View to the southwest. KPF

View to the north of Times Square showing, from left to right, Five Times Square (Kohn Pedersen Fox, 2002), Three Times Square (Fox & Fowle, 2001), and Four Times Square (Fox & Fowle, 1999). Sundberg. ESTO

corners" and its "new wrapper" consisting of rectangular panels clipped to the building skin's spandrels that could either be embossed with graphics or equipped with electronic gadgetry to permit illuminated, moving signs that could be made large by spreading the image across the facade (the windows of which would be narrow enough so as not to break the continuity). Seizing on the design as an opportunity to reflect on Johnson's long career, Muschamp mused, "The Times Square design represents our historical moment as fully as the Seagram Building represented mid-century New York. The Seagram Building arose at a pivotal time, when the industrial city was dying and the mass media city was being born. Times Square is the heart of this new city. Its economic base rests not on production, but on promotion. No architect alive is as thrillingly attuned as Philip Johnson to promotion's sordid glories."[202]

By May 1998, Kohn Pedersen Fox had been selected to design the thirty-eight-story, one-million-square-foot Five Times Square to occupy the west block of Seventh Avenue between Forty-first and Forty-second Street Streets,[203] and Skidmore, Owings & Merrill had been tapped for the forty-seven-story, 1.2-million-square-foot Times Square Tower to occupy the Crossroads of the World block, bounded by Broadway, Seventh Avenue, Forty-first and Forty-second Streets.[204] Kohn Pedersen Fox's building, which, when completed in 2002, became home to Ernst & Young, the accounting firm, featured a slashing diagonal fracture focusing on the corner of Forty-second Street and Seventh Avenue. The fracture was articulated by contrasting planes of plain and striped glass curtain walling. Viewed from the northeast, the building revealed major fissures on the Broadway and Forty-second Streets facades, where the mass was broken apart and angled toward the center. Efforts to integrate signage with the architecture in keeping with the still-pervading belief among developers that the corporate world was troubled by commercial display were not enthusiastically received by the 42nd Street Development Project, leading to a hybrid solution that concentrated signage at the base and along a twenty-two-story-high blade that would be visible at great length along Seventh Avenue.

Skidmore, Owings & Merrill's design for Times Square Tower, prepared under the leadership of David Childs, was the least noisy of the lot and most directly dependent on the geometry of its site. According to T. J. Gottesdiener, managing partner of SOM's New York office, Times Square Tower, completed in 2004, "picks up on the very strong geometry of the bow tie to generate the form . . . emphasizing the shift with two different facades, articulated with different skins."[205] Most of the interest and pizzazz was concentrated on the Broadway elevation, the building's most prominent. Finding a tenant proved difficult, but in December 2000, Arthur Andersen, competitor to Ernst & Young, signed up as lead tenant to occupy 55 percent of the building. Ground was broken on September 5, 2001, but in June 2002, as a result of its involvement in the scandalous collapse of Enron, the Andersen accounting firm terminated its deal to occupy 650,000 square feet in the tower. Replacement tenants were even harder to come by, and as the building neared completion, more than half of its office space was still available.

FACING PAGE Times Square Tower, block bounded by Seventh Avenue, Broadway, West Forty-first and West Forty-second Streets. Skidmore, Owings & Merrill, 2004. View to the south showing Four Times Square (Fox & Fowle, 1999) in background left and Three Times Square (Fox & Fowle, 2001) in background right. Holzherr. SOM

Times Square Tower, block bounded by Seventh Avenue, Broadway, West Forty-first and West Forty-second Streets. Skidmore, Owings & Merrill, 2004. View to southwest of base. Holzherr. SOM

Taking stock of the ensemble as it was evolving in 2000, Paul Goldberger wrote:

The new towers in Times Square show us, unambiguously, that the idea of the skyscraper as a pure object is dead. The new buildings have a fluid identity and it is tempting to think of their dematerialization as neatly paralleling the shift toward cyberspace—from mechanization to electronics, from atoms to pixels. This notion is especially appealing as an explanation of why so many of the new skyscrapers have gone up in a place where media headquarters converge and the latest technologies enliven the signs. What better architectural expression of the new world could there be?

Goldberger concluded:

The post-iconic skyscraper—the skyscraper that isn't so much a thing as a collection of things—isn't easy to love, but it does evoke a curiously traditional idea, one worth holding on to, which is that the concept of the city is more important than an individual building. Every one of the new buildings has been designed as a piece of a big, messy whole. The new towers both assert themselves within this environment and step back from it. Their shapes can't be separated from their surroundings. The signs, in the end, pull the new Times Square together, as the softer, whiter lights of another generation pulled the old Times Square together. . . . Towers want to be alone. The new, post-iconic skyscraper loves crowds.[206]

New York Times Tower

In 1999 the *New York Times* surprised many observers when it announced a bold decision to move its headquarters from a backwater location at 229 West Forty-third Street to the east blockfront of Eighth Avenue, between Forthieth and Forty-first Streets.[207] The site, the southernmost in the Forty-second Street project area, had originally been acquired in an effort to make possible the supersized merchandise mart (see above) slated for it and the blockfront across the street to the north. Though the site enjoyed great visibility, largely because it

faced the low-lying bus terminal across Eighth Avenue, it was definitely on the fringe—both of the Forty-second Street project area and the Garment Center, immediately to its south. The economics of the fringe location no doubt attracted the *Times*, as did the promise of large floors to accommodate its newsroom, which had sprawled in 1967 into floors created in what had been the auditorium of the Paramount Theater (Rapp & Rapp, 1926).[208] Working with Forest City Ratner, co-investors in the project, to develop the proposed 1.37-million-square-foot tower, only about half of which it would occupy, the *Times*, at the behest of the 42nd Street Development Project, and with the internal encouragement and advice of its architecture critic, Herbert Muschamp, conducted a competition to select an architect, choosing between the English architect Norman Foster, the Italian Renzo Piano, and three Americans: Cesar Pelli, and the team of Frank Gehry and David Childs of Skidmore, Owings & Merrill.

Prior to the competition Robert Stern and his design partner Paul Whalen, working with Naresh Kapadia, assistant vice president of planning and design for the 42nd Street Development Project, had prepared a prototypical model of the new building that incorporated the ideas of Joseph Rose, chairman of the City Planning Commission, who wanted the new building to be massed along the lines of Shreve, Lamb & Harmon's Empire State Building (1931). This was shown to the competitors, who were also given a forty-eight-page program that, as Paul Goldberger put it, "included a statement by Muschamp, which, like many of his columns, was an ode to the idea of the avant-garde."[209] For the *Times*'s business representative, vice chairman Michael Golden, the goal was simpler: "We are the foremost consumer publication that comments on architecture. We need to contribute to the skyline of New York. We don't want to have people say, 'Gee, *The New York Times* built a four-story brick warehouse in Manhattan.'"[210]

The four architectural teams submitted their designs in September 2000, each a response to the *Times*'s request for an

Proposed *New York Times* Tower, east blockfront of Eighth Avenue, between West Fortieth and West Forty-first Streets. Cesar Pelli, 2000. Rendering of view to the southeast. CPA

Proposed *New York Times* Tower, east blockfront of Eighth Avenue, between West Fortieth and West Forty-first Streets. Frank Gehry

Proposed *New York Times* Tower, east blockfront of Eighth Avenue, between West Fortieth and West Forty-first Streets. Norman Foster, 2000. Rendering of view to the northwest. FAP

and Skidmore, Owings & Merrill, 2000. Model, view to the northeast. GP

affordable "icon that speaks to our heritage and also speaks to our future."[211] Pelli proposed a dramatically chiseled and chamfered but otherwise conventional glass tower set on a site-filling base; Foster offered a veritable right triangle that would rise sheer but would fail as a piece of pragmatic real estate, providing only small floors at the top, where Forest City Ratner hoped to reap large rentals from outside tenants; and Renzo Piano proposed a conventional glass tower on a base, but with the tower wrapped in sun- and heat-modulating louvered screens like those he had employed in his 1996–99 buildings at Potsdamer Platz, Berlin.[212] Piano had been reluctant to enter the competition, but he plunged ahead when his early sketches convinced him that he could design "a building that will disappear in the air, that will bring the same magic to the sky line that the neo Gothic brings," an idea that might well have been Minoru Yamasaki's in designing the World Trade Center towers a generation before.[213]

Gehry and Childs offered the most thrilling and beautiful of the schemes, a forty-five-story tower rising from the base at midsite but wrapped in what appeared to be billowing curtains of glass, "twisting sinewy planes that blossom at the top and bustle at the bottom; not unlike pappardelle pasta on a colossal scale," as David Dunlap put it.[214] Though the skin of Gehry

Proposed *New York Times* Tower, east blockfront of Eighth Avenue, between West Fortieth and West Forty-first Streets. Renzo Piano, 2000. Model, view to the northwest. Pottle. ESTO

and Childs's proposal appeared to be complex, closer examination revealed a relatively straightforward arrangement that separated the panes of glass, placing winter gardens between for much of the tower's height, so that only 15 percent of the surface required curved glass. The scheme was undoubtedly the most admired of the four proposals, but at the last minute Gehry and Childs backed out of the competition. In October 2000, Renzo Piano, in association with Fox & Fowle, was selected to carry the project forward with the understanding that the rather unpublic character of the building's base would have to be reconsidered.

Herbert Muschamp withheld comment until after the decision was made public, at which time he reported on his six-month-long involvement in the process leading to Piano's selection. After praising Piano as the "greatest living practitioner of what I call 'normative' architecture," but others call "the classical humanist tradition," Muschamp shared the concerns of many observers about the eleven-level interior mall-like space Piano had initially proposed. Muschamp, describing the design of the base as baroque, felt it lacked "contrast with the city outside." But he had nothing but praise for the proposed "triple-skin wall that lifts the material city's grid into a metaphysical realm. A thermal wall of double-pane panels is shielded on the exterior by a sunscreen of white ceramic rods."[215]

Despite the praise for Piano's scheme from the *Times*'s own critic, there was wide speculation that the commission was first awarded to Frank Gehry and David Childs, who balked at terms laid down by Michael Golden and Forest City Ratner. Certainly, as compared with Piano's rather stiff geometry and his rehashing of motives already in place in his Berlin work, the Gehry/Childs design was far more sensuous, inventive, and, in its technology, more innovative. But Gehry, as Paul Goldberger reported, had already "begun to fear that the Times was more like a conventional big corporation than he had realized" and though he was eager to follow the triumph of his Guggenheim Museum in Bilbao with a prestigious office building in New York, "he felt . . . [that] Golden and the Times people were starting to sound less like patrons of architecture and more like real-estate developers, the sort of businessmen who treat their architects as enemies, to be fought with and controlled at all costs." Moreover, Forest City Ratner "was not the sort of client Gehry found easy to please." Gehry was also concerned about the design review that his proposal would undergo because the site was part of the 42nd Street Development Project—though he and Childs were both aware that it had the enthusiastic support of Robert Stern and Paul Whalen, as well as others who would have to pass on it. At Gehry's behest, the two-firm team withdrew its submission, to the utter surprise of the *Times*. As Goldberger wryly commented about his former employers: "They hadn't expected to be fired by an architect before they had even hired him."[216]

Before securing the commission, Piano was asked to make certain revisions to the design, especially to the proposal for grouping the elevator and service stairs along the south wall, where his clients felt windowed offices might be more appropriate, and to rethink the organization of the building's base to present a more open impression to pedestrians. As planning progressed on Piano's building, attention turned to the design of the newspaper's offices, a commission awarded to Gensler. As finally planned, Piano's building was to rise forty-seven

stories above a five-story base, accommodating 1.37 million square feet of space in a 776-foot-tall structure. The building would be clad in a skin of insulated transparent glass wrapped in turn by another skin of approximately 250,000 white ceramic rods, one and five-eighths of an inch in diameter, that would form a screen set one and a half feet outside the glass wall but organized in such a manner as to permit some unobstructed views for workers inside the building. The ceramic screens would rise to 840 feet, a point above a small rooftop conference room and maple-planted terrace, while a central decorative mast would reach 1,142 feet. According to Piano, the building would "speak to the street. When people circulated between its floors, they will take stairs that are located on the facades and their flow will be visible from the exterior. This is, after all, only appropriate, as it is from the street itself that the newspaper metaphorically gathers its inspiration."[217] Half of the space was to be leased, with the other half to be used by the *Times*, including a gallery and a 350-seat auditorium. Construction began in 2005, with completion expected in 2007.

As the heady boom reached its crescendo in 2000, the Milstein family, which controlled the last prime site, also originally assembled as part of plans for the merchandise mart, on the southeast corner of Forty-second Street and Eighth Avenue, joined with two other developer families and hired Fox & Fowle to design a thirty-four-story, 1.1-million-square-foot office building.[218] But as the courts struggled to resolve a very public quarrel between the two Milstein patriarchs, Paul and Seymour, the deal unraveled. Additionally, Fox & Fowle's design was predicated on the use of over 600,000 square feet of unused 42nd Street Development Project air rights, and as the Milstein family quarrel dragged on through the courts, the state allocated 120,000 square feet of those air rights to the *New York Times*. In 2002 Paul Milstein's side of the family gained control of the site, and in October his sons Howard and Edward revealed their intention to build a thirty-five-story, 850,000-square-foot glass-and-aluminum-clad tower, 11 Times Square, also known as Times Square Plaza, designed by Fox & Fowle. Construction, scheduled to begin in 2003, was delayed.

West of the Deuce

By the late 1990s, the revitalization of Forty-second Street and Times Square, not to mention general improvements along the once-seedy strip of Eighth Avenue in the Forties, had come far enough that renewal spread west of the specific boundaries of the 42nd Street Development Project. In 1999 Rem Koolhaas, of the Rotterdam-based Office for Metropolitan Architecture, in collaboration with Richard Gluckman, of New York's Gluckman Mayner Architects, and Fisher/Dachs Associates, theater consultants, converted the former State Bank and Trust Company Building (Dennison & Hirons, 1927–28), 681 Eighth Avenue, northwest corner of Forty-third Street, into a 296-seat Off Broadway playhouse for the Second Stage Theater.[219] It was Koolhaas's second project in New York, the first a relatively small commission to design the Lehmann Maupin Gallery, 39 Greene Street, in 1996 (see SoHo).

Koolhaas's approach was characteristically cerebral. A small first-floor lobby within the building's Forty-third Street entrance gave access to a ticketing booth that occupied the original bank vault, its massive steel door locked in the open

Second Stage Theatre, 681 Eighth Avenue, northwest corner of West Forty-third Street. Renovation by Rem Koolhaas and Richard Gluckman, 1999. Hallway. Powell. SST

position.[220] An original marble staircase took theatergoers to the second floor, where a "wedge" that would "perform all the tasks necessary to turn the space into a theater" was inserted within the twenty-four-foot-high, 6,000-square-foot former banking hall. The twelve-foot-high wedge, finished in concrete coated with green-gray epoxy resin, formed one wall of the main lobby while supporting the theater's fourteen rows of east-facing seats, effectively defining the two spaces by its form. The walls, floor, and ceiling of a hallway and two restrooms, housed within the wedge and accessed from the lobby, were painted brilliant orange and lit by naked fluorescent lightbulbs, the bathroom mirrors offering what Herbert Muschamp called a "reflection [that] is perversely consoling: this is the worst you are going to look all day."[221] In an unusual move, Koolhaas kept three twelve-foot-high windows on the south wall of the theater overlooking Forty-third Street, replacing the original glass with soundproof glazing, making Second Stage, in the architect's words, "the only theater that can claim Manhattan itself as its decor."[222] Five additional windows, including three behind the stage, were to be uncovered when additional financing was secured. The Dutch designer Petra Blaisse, a longtime collaborator of Koolhaas's, designed gold velour curtains punched with grommet holes to cover the windows of the south wall, inverting the theater norm so that a show began not when the curtain rose but when it was drawn.[223] The third floor housed dressing rooms and production spaces, as well as a "balcony" consisting of a row of seats situated behind a long rectangular opening in the theater's north wall.

In comparison with the neighboring theaters of Forty-second Street, Second Stage was, to Muschamp, an "oasis. . . . There is no theming, no nostalgia, plaster nymphs or gilt rosettes."[224] The architects' use of unorthodox materials, ranging from translucent polycarbonate glazing screens for the north wall of the auditorium to seat cushions made from a flesh-colored gel pad usually used to make bicycle seats, was certainly progressive, giving the space an "austerely chic" aesthetic, as the *Wall Street Journal*'s Linda Sandler put it, though Sandler felt they gave the theater "a hollow, chilly feel."[225] But most observers appreciated the architect's fresh take on theater design and were, if nothing else, pleased to

Proposed 20 Times Square, southwest corner of Eighth Avenue and West Forty-second Street. Skidmore, Owings & Merrill, 2001. Rendering of view to the southwest. SOM

have another example of Koolhaas's work, however modest, in the city. Suzanne Stephens called the project "a smart renovation performed knowingly with clarity and bravura."[226]

In October 1999, the Port Authority announced that it had entered into an agreement with the developers Lawrence Ruben and the Vornado Realty Trust to build a Skidmore, Owings & Merrill–designed one-million-square-foot tower atop the northern portion of its almost universally disliked but exceptionally busy bus terminal.[227] The original terminal building (Walter McQuade, 1950), which occupied the block between Fortieth and Forty-first Streets, had been expanded several times, most recently with a 1975–81 addition that stretched the facility to the southwest corner of Forty-second Street.[228] Although McQuade's comparatively modest red brick building was hardly considered an aesthetic success, the

addition, which brought a new common facade dominated by an oppressive forty-foot-high steel truss that spanned the two buildings as well as the intervening street, had an aggressively negative impact on the street. Besides dramatically increasing capacity, the addition anticipated future growth and was designed to accommodate a tower as large as forty stories and 1.25 million square feet.

In the late 1980s and early 1990s, the Port Authority improved the quality of the bus terminal's interiors spaces, adding more upscale retailers.[229] In February 1997, in an attempt to "bring the Port Authority Bus Terminal into the neighborhood," in the words of Cherrie Nanninga, the authority's director of real estate, as well as generate some much needed revenue, the Port Authority hired outdoor advertising company TDI, which was already working across the street on E-Walk (see above), to design massive signs to hang from the terminal's X-shaped trusses, which New York Times reporter Anthony Ramirez likened to a "distracted child's not-quite-finished erector set."[230] Under advice from Robert A. M. Stern Architects, the trusses were repainted a soft green to complement the color of Raymond Hood's McGraw-Hill Building (1931), immediately to the west.[231] Although plans for high-tech three-dimensional interactive signs, "with no holds barred on size, animation, and illumination," according to TDI's Jodi Yegelwel, were superseded by the tower scheme, the company did design some temporary billboardlike signs for the trusses as well as a more "traditional" video-screen-like sign for the southwest corner of Forty-second Street and Eighth Avenue.[232] Karrie Jacobs, writing in New York magazine, was not impressed: "Logic dictates there is no way to ruin a building as unfortunate in every respect as the Port Authority Bus Terminal. But the vinyl billboard that wraps, Christo-style, around the building has done the illogical, the impossible, the inconceivable: It has made the bus terminal uglier still."[233]

Skidmore, Owings & Merrill's glass-and-steel thirty-five-story design, to be built over the north wing of the terminal, was, in an attempt to capitalize on the area's revitalization, originally marketed by its developers as Seven Times Square but by the end of 2001 readdressed as 20 Times Square. In keeping with other recent development in the area, the base of the tower was to be awash in signs, this time designed by the graphic design firm Pentagram. Plans for the building appeared to falter somewhat as the search for an anchor tenant, deemed critical by the developers before any work could proceed, proved difficult. Delays set in just as progress on the far more prominent building located across the street, the New York Times Tower, seemed to be moving forward. The threat of terrorism after the destruction of the World Trade Center drastically reduced the likelihood that an office building would be realized above the bus terminal.

Living on Forty-second Street

Beginning in 1987, the stretch of Forty-second Street between Ninth and Twelfth Avenues was the subject of two separate waves of privately financed residential development, creating over 2,500 units by century's end with the new construction in part replacing a bleak landscape dominated by industrial and warehouse buildings, run-down tenements, and parking lots. The area had been opened up to high-density residential development with the construction of the twin-towered Manhattan Plaza (David Todd & Associates, 1974–77), occupying

the full block between Forty-second and Forty-third Streets, Ninth and Tenth Avenues, but its 1,690 apartments were heavily subsidized, tenanted predominantly by people involved in the performing arts.[234] The residential boom began in earnest with Hardy Holzman Pfeiffer's forty-four-story, 418-apartment Riverbank West (1987) on the east side of Eleventh Avenue between Forty-second and Forty-third Streets, a rental building developed by Harry Macklowe, who purchased the 375,000-square-foot parcel in 1981 from the 42nd Street Redevelopment Corporation, which retained a 25 percent interest in the project.[235] Hugh Hardy conceded that Riverbank West's beige and terra-cotta brick cladding and off-the-shelf aluminum windows made for "a very conventional building."[236] But the architect nonetheless succeeded in enlivening the building with a handsome patterned facade, staggered cantilevered concrete balconies with glass handrails, and a distinctive syncopated top that Carter B. Horsley believed "finely mimicked the Art Deco roof" of the McGraw-Hill Building a few blocks east along Forty-second Street.[237] Originally, Hardy proposed a more dramatic statement, calling for a black-and-white facade, a palette rejected by the developer but one the firm was later able to bring to the area in a second apartment building (see below). Although it sported a Forty-second Street address because Macklowe thought it "sounded good," the building was entered on Forty-third Street via a gated 10,000-square-foot landscaped courtyard with a circular driveway that provided a sense of security for the isolated site.[238] Riverbank West also provided more than 19,000 square feet of retail space and substantial health club facilities, a strategy widely imitated by subsequent developers, who recognized the relative lack of amenities in the immediate vicinity. Ten years after opening, in 1997, a portion of the retail space along Forty-second Street at the eastern end of the site was renovated to make way for a 280-seat theater run by Eric Krebs's Signature Theater Company, dedicated to focusing on the work of a single playwright for an entire year.

Before the completion of Riverbank West, construction was well under way on Forty-second Street's next major apartment building, Philip Birnbaum & Associates's forty-two-story, 311-unit Strand (1988) on the west side of Tenth Avenue between Forty-second and Forty-third Streets, which replaced six run-down two- and four-story buildings serving as warehouse space.[239] As designed by Costas Kondylis of Birnbaum's office, the tower sat on a one-story base topped by a landscaped area complete with a vine-covered pergola that seemed fussy and suburban. Kondylis's lively facade was composed of alternating bands of red, peach, and beige brick. But the tower was most memorable for its diagonal placement on the half-acre site. As Kondylis explained it: "Across the street we had Manhattan Plaza, which is a large-scale building, and we wanted to avoid the canyon effect on 10th Avenue."[240] Carter Horsley thought the Strand was one of the "prolific firm's best," finding the tower's proportions "very fine," taking special note of the "pyramid-like top that is . . . very handsomely and gracefully designed."[241] Horsley also felt that, "when viewed from the north," the combination of the Strand, Riverbank West, and Manhattan Plaza "make a striking argument for the 'towers-in-a-park' approach, as they appear to march proudly from midtown to New Jersey."[242]

With the completion of the Strand, some voices of concern were raised about possible overbuilding in the area, with one of the objections coming from a group of investors who had purchased nineteen apartments in the Strand and were now worried about the threat of a new thirty- to forty-story building, tentatively named Renaissance 42 and developed by Lewis J. Futterman, who had renovated many neighborhood buildings, which would be built directly west of the condominium and block both light and views. With at least three more market-rate projects on the boards and rumors of many more to follow, far louder protests about the possible destruction of the neighborhood through gentrification came from Community Board 4 and a very active group of local citizens who had previously banded together in 1974 to lobby successfully for the creation of the Special Clinton Zoning District, which prohibited midblock construction over seven stories from Forty-first to Fifty-sixth Street, between Eighth and Tenth Avenues, but excluded the stretch from the north side of Forty-first Street to the south side of Forty-third Street.[243] Even though the heart of Clinton was therefore protected from massive high-rise construction, many feared that the dramatic rebuilding of the far west Forty-second Street corridor would negatively affect the rest of the neighborhood. The collapse of the real estate market in the late 1980s and the subsequent recession temporarily relieved concerns about overbuilding.

The second wave of speculative residential construction did not begin until the late 1990s, composed primarily of projects put on hold in the previous decade. This time, however, many believed that the results would be different, attracting a decidedly upmarket clientele. Indeed, with all the new office

Riverbank West, east side of Eleventh Avenue, between West Forty-second and West-Forty-third Streets. Hardy Holzman Pfeiffer Associates, 1987. View to the northeast. Kaufman. H3

River Place I, east side of Twelfth Avenue, between West Forty-first and West Forty-second Streets. Costas Kondylis, 2001. View to the southwest. Orlewicz. FOT

420 West Forty-second Street, between Ninth and Dyer Avenues. Hardy Holzman Pfeiffer Associates, 2001. View to the northeast. Kaufman. EK

construction, the far west end of Forty-second Street was being marketed as a walk-to-work neighborhood. The first post-recession project to go forward was the thirty-three-story New Gotham (1998), 530 West Forty-third Street, between Tenth and Eleventh Avenues, on the site directly west of the Strand that failed to go forward as the Renaissance 42.[244] As designed by Schuman, Lichtenstein, Claman & Efron, the building's bland facade was clad in two shades of red brick with a two-story granite and limestone base. The L-shaped site, previously home to a piano factory, had 75 feet of frontage on Forty-second Street and a far more generous 160 feet on Forty-third Street, where the bulky tower was entered. The rental building included 375 apartments, 20 percent of which were leased to low-income tenants in return for tax concessions from the city, a strategy widely adopted in the period.

The largest new project in the area was Larry A. Silverstein's River Place development, a two-stage, 1,800-unit apartment complex planned for a 160,000-square-foot site bounded by Forty-first and Forty-second Streets, Eleventh and Twelfth Avenues, currently serving as a parking lot.[245] Silverstein, who had owned the site since 1984, was stymied in his development plans not only by the early 1990s recession but also by the inability of the city and state to decide if they wanted to expand the Javits Center to the north and thus take over the property, a route ultimately not taken. Construction on River Place I, a forty-story, 921-unit building located at the western end of the site, finally began in the spring of 1999, and the apartments were ready for occupancy in early 2001. As

designed by Costas Kondylis, the 900,000-square-foot building was a massive undulating wave of tan brick and aluminum-framed ribbon windows, constituting a less distinguished, residential version of the Starrett-Lehigh Building (Russell G. and Walter M. Cory with Yasuo Matsui, 1931), which sat fifteen blocks to the south and was directly visible from the new building.[246] The original plan was to build a near-twin on the eastern half of the site following the first building's completion, but Silverstein had Kondylis rework the design of River Place II, requesting that it be "higher to achieve greater views."[247] Kondylis's new design called for a slender, fifty-three-story, glass-clad tower that would accommodate 882 apartments. Thomas Balsley proposed an elaborate landscaping plan for the space between the two buildings but provided only a few benches near the completed apartment house in the interim. Construction for the new building did not begin after River Place I's completion, and the site remained a parking lot.

On the northwest corner of Forty-first Street and Tenth Avenue, long the site of four tenements and a parking lot, rose the tan brick and glass Victory (2002), a forty-five-story, 462-foot tower containing 417 rental apartments.[248] Schuman, Lichtenstein, Claman & Efron's design grew glassier as it rose, forming a V-shape at the top of the building's southeast corner to celebrate the building's name. To further the effect, the building's water tank was also clad in glass. As part of the project, SLCE renovated Ernest Flagg's six-story brick building (1900) located just north of the tower at 500 West Forty-second street, southwest corner of Tenth Avenue, a pioneering

Playwrights Horizons, 416 West Forty-second Street, between Ninth and Dyer Avenues. Mitchell Kurtz, 2003. View to the southwest. Davis, DCA

Ivy Tower, 343 West Forty-second Street, between Eighth and Ninth Avenues. Schuman, Lichtenstein, Claman & Efron, 2003. View to the northeast showing 360 West Forty-third Street (Buck/Cane Architects, 2003) on the far left. SLCE

model tenement sponsored by the New York Fireproof Tenement Association.[249] To be run by the nonprofit Clinton Housing Development Company, the renewed tenement would provide apartments for low- and moderate-income tenants although the developer retained the use of the ground floor for retail space.

By the mid-1990s, Theater Row (see above) was showing signs of age, and the 42nd Street Redevelopment Corporation planned for the extensive alteration of the stretch to accommodate not only new and renovated theaters but an apartment building developed by Daniel Brodsky for the southeast corner of Forty-second Street and Dyer Avenue.[250] Hardy Holzman Pfeiffer was hired for both the theater and apartment house work, where they were finally able to realize their desire for a black-and-white-striped building, a hope dating back to the design of Riverbank West but which probably had its origins in the Chrysler Building, as Hardy noted, and, more amusingly, in Adolf Loos's proposed house (1925) for the American Negro music hall star Josephine Baker, which he did not cite. Loos's programmatic meditation on black and white seemed particularly appropriate on Forty-second Street, given that one of Baker's twelve adopted children, Jean-Claude Baker, operated a successful nearby restaurant, Chez Josephine, 414 West Forty-second Street. Although the color palette was actually purplish black and cream, Hugh Hardy's forty-story, 260-unit brick tower (2001), with contrasting horizontal bands that got thinner as the tower rose, was quickly nicknamed the zebra building, an appellation

that did not bother the architect. Hardy, who noted that "it's a traditional, conventional apartment building . . . if you strip off the stripes," tried to enliven the design, explaining that the tower "is intended to be a building of special character— I don't want to say legendary character. But the Chrysler Building is at the other end of the street, and the patterning and decoration here is meant to have its own pizzazz and reflect the energy of 42nd Street."[251] At the base of the tower, on the former site of three 99-seat theaters, Hardy created a new 499-seat theater, the Little Shubert (2002), decorating the exterior with a random pattern of terra-cotta tiles and a stylish glass and steel canopy. The Little Shubert was the city's first commercial stage built specifically as a transfer house devoted to developing work for the larger Broadway theaters. At the eastern end of Theater Row, Hardy designed five new small theaters: the 199-seat Acorn, the 88-seat Lion, and three 99-seat theaters, the Kirk, Becket, and Clurman. All of the theaters, completed in 2002, were located in a five-story building with extensive rehearsal and studio space as well as a café. They were served by a common lobby and single box office, with a color-coded system directing patrons to the proper theater and a distinctive graphics program designed by Ivan Chermayeff. Playwrights Horizons, the original pioneers of Theater Row, sold their air-rights to build the apartment tower and also renovated their space (2003), hiring the architect Mitchell Kurtz to create office and rehearsal space and two theaters, one seating 198, the other 128, as well as a new glass and stone facade.

The residential boom crossed Ninth Avenue where, on the northeast corner of Forty-second Street, Daniel Brodsky commissioned Buck/Cane Architects to design 360 West Forty-third Street, a 256-unit red and tan brick building (2003) with a twenty-three-story section on Forty-second Street wrapping around a row of four-story tenements and connecting to a ten-story wing on Forty-third Street.[252] East of Brodsky's building was Schuman, Lichtenstein, Claman & Efron's Ivy Tower (2003), 343 West Forty-second Street, between Eighth and Ninth Avenues, located on a 22,000-square-foot through-block site formerly occupied by a parking lot.[253] The forty-three-story, 270-unit tower consisted of a three-bay red brick western section connected to a wider, glassier portion topped by a stepped back rooftop feature at the eastern edge of the site that was colorfully lit at night. Behind the tower was a 4,000-square-foot landscaped courtyard separating the main building from a more modest seven-story, fifty-unit component (2002) facing Forty-third Street.

FIFTY-SEVENTH STREET

Fifty-seventh Street's status as a fashionable residential street with a slightly bohemian edge began to emerge in the 1880s. Initially, its significant development was largely west of Fifth Avenue, around Seventh Avenue, with a surprising concentration of interesting buildings catering to persons with artistic tastes, beginning with the Rembrandt Apartments (Hubert, Pirsson & Co., 1881), 152 West Fifty-seventh Street, just east of Seventh Avenue, the city's first cooperative apartment house, and James E. Ware's opulent and massive eleven-story Osborne Apartments (1883), northwest corner of Seventh Avenue.[1] The area furthered its special cultural cachet with the completion of such buildings as William B. Tuthill's Carnegie Hall (1891), southeast corner of Seventh Avenue, Henry J. Hardenbergh's American Fine Arts Society (1892), 215 West Fifty-seventh Street, Cyrus L. W. Eidlitz's clubhouse (1898) for the American Society of Civil Engineers, 220 West Fifty-seventh Street, and Louis H. Chalif's School of Dancing (G. A. and H. Boehm, 1917), 163 West Fifty-seventh street, as well as various studio apartment houses like the Rodin Studios (Cass Gilbert, 1917), southwest corner of Seventh Avenue.[2] East of Sixth Avenue, Fifty-seventh Street was largely lined with fashionable townhouses, the grandest clustered at the corners of Fifth Avenue.[3] Beginning around the time of World War I, Fifty-seventh Street, especially the blocks between Fifth and Park Avenues, was transformed into one of the city's most pricey shopping districts, combining prestigious antique and art dealers with specialty retailing. The street's success was based on its location as the northernmost wide commercial street below Central Park, rendering it the gateway to the exclusive residential precinct of the Upper East Side. The intersection of Fifth Avenue and Fifty-seventh Street became the epicenter of the city's carriage trade with the construction of Bergdorf Goodman's block of shops (Buchman & Kahn, 1928), west side of Fifth Avenue between Fifty-seventh and Fifty-eighth Streets, and the palatial Tiffany's (Cross & Cross, 1940), southeast corner of Fifth Avenue.[4] To the east, elegant skyscrapers such as the residential Ritz Tower (Emery Roth and Carrère & Hastings, 1925), northeast corner of Park Avenue, and the Fuller Building (Walker & Gillette, 1929), northeast corner of Madison Avenue, a forty-story office building with specially configured space reserved for art galleries, changed the street's scale but not its essential character.[5] East of Park Avenue, the street was a middle-class brownstone and tenement neighborhood that was transformed between the two world wars into a desirable residential address, beginning with the construction of the block of luxurious townhouses on the east side of Sutton Place, between Fifty-seventh and Fifty-eighth Streets, in the 1920s, followed by a number of apartment buildings, including One Sutton Place South (Cross & Cross with Rosario Candela, 1927), southeast corner of Fifty-seventh Street, developed by the Phipps family as one of the city's grandest.[6]

In the 1950s and 1960s, Fifty-seventh Street between Sixth and Madison Avenues was the premier showcase for the sale of contemporary art. But in the 1970s, Fifty-seventh Street's primacy was compromised as the scene shifted to SoHo, where many artists lived and where galleries could occupy large loftlike spaces that mirrored the artists' studios. Still, Fifty-seventh Street retained its traditional character until the construction of two blockbuster office buildings between Fifth and Sixth Avenues, the massively banal but urbanistically tolerable Squibb Building (Jack Brown, 1972), 40 West Fifty-seventh Street, and the urbanistically egregious but artistically provocative 9 West Fifty-seventh Street (Gordon Bunshaft of Skidmore, Owings & Merrill, 1974).[7] Even more threatening to the street's character was the invasion of themed dining and retail, which first began with the opening

Le Parker Meridien Hotel, 118 West Fifty-seventh Street, between Sixth and Seventh Avenues. Philip Birnbaum, 1981. View of atrium designed by Todd Lee. TLA

Carnegie Hall (William B. Tuthill, 1891), southeast corner of Seventh Avenue and West Fifty-seventh Street. Renovation by James Stewart Polshek & Partners, 1983. View to the southeast showing new marquee. Mauss. ESTO

Carnegie Hall (William B. Tuthill, 1891), southeast corner of Seventh Avenue and West Fifty-seventh Street. Renovation by James Stewart Polshek & Partners, 1983. Lobby. Robinson. CR

of the Hard Rock Café (1983), 221 West Fifty-seventh Street, a location chosen because Times Square was in a downward spiral. By the early 1990s, so many themed restaurants, including Planet Hollywood, Motown Café, and the Brooklyn Diner (see Interiors), had settled on Fifty-seventh Street that the street came close to becoming, if not a replacement for Times Square, its somewhat more respectable suburb. The rebirth of Times Square and Forty-second Street in the late 1990s, combined with the waning popularity of themed dining and retailing, saved Fifty-seventh Street from virtual extinction as a sophisticated address.

Around Carnegie Hall
In the 1980s the block of Fifty-seventh Street between Sixth and Seventh Avenues was the scene of intense building activity, with four substantial new buildings completed in ten years' time. The boom began in 1981 with Philip Birnbaum's Le Parker Meridien Hotel, 118 West Fifty-seventh Street, running through to Fifty-sixth Street, which replaced the twelve-story, 400-room Great Northern Hotel (Schwartz & Gross, 1910).[8] Plans for the forty-story building that combined a 600-room hotel with 100 rental apartments located on the top nine floors were approved in May 1979 by the City Planning Commission. Birnbaum situated his drab white brick slab parallel to Fifty-sixth Street, linking it to Fifty-seventh Street by means of a twenty-foot-wide, sixty-five-foot-high through-block passage, which would later be paralleled by two others on the block at Metropolitan Tower and Carnegie Hall Tower (see below). The design of the midblock galleria was entrusted

to the architect Todd Lee, who marked the entrance on Fifty-seventh Street with a classical pediment that led to a vaulted faux-painted Tuscan colonnaded passage opening to a three-story-high rectangular midblock atrium, then connecting through to Fifty-sixth Street. Completely different from the anonymity of Birnbaum's slab, the passageway and lobby provided a visually engaging respite from the bustle of midtown, with polished marble floors and mirror-infilled arches. Two restaurants were located off of the atrium, which was overlooked by a loggia.

Carnegie Hall, southeast corner of Seventh Avenue and Fifty-seventh Street, generally regarded as one of the city's architectural and cultural treasures and the defining element of its West Fifty-seventh Street neighborhood, got a much-needed restoration beginning in the early 1980s. Built as the Music Hall in 1891 by Andrew Carnegie, it was threatened with destruction in 1956 by the Glickman Corporation's proposed speculative skyscraper (Pomerance & Breines) but was saved when Louis Glickman failed to secure financing and the building was purchased by the city and leased to the tax-exempt Carnegie Hall Corporation with the aid of fund-raising efforts headed by the violinist Isaac Stern and the J. M. Kaplan Fund.[9] Though its status as a preeminent showcase was initially threatened by the construction of Lincoln Center, Carnegie Hall became increasingly revered as musicians and audiences realized that its warm sound was not duplicated in the dry acoustics of Philharmonic Hall (Max Abramovitz, 1962; redesigned auditorium, Philip Johnson and John Burgee with Cyril M. Harris, 1975–76). Valued though it was, Carnegie

Hall was nonetheless a rather dilapidated mess with hopeless air-conditioning that rendered it unusable in summer, aged equipment, and a café that Harold C. Schonberg, the *New York Times*'s respected music critic, described as "one of the more hideous affairs in hangout history."[10]

In 1980 New York City and the Carnegie Hall Corporation began negotiations that would enable the corporation to develop its unused air rights by building a large tower on an adjacent lot being used for parking in order to pay for a thorough renovation of the eighty-nine-year-old structure.[11] The next year, as talks proceeded between the city and James D. Wolfenson, the cello-playing investment banker who headed the nonprofit group, a federal grant of $1.8 million to help with renovation costs was added to $2.2 million in other federal funds and modest contributions from the city and the Astor Foundation.[12] In February 1982, plans were announced for the hall's renovation and for the construction of a high-rise building designed by Cesar Pelli on the adjoining lot.

The plans for the restoration, commissioned some four years earlier, were prepared by James Stewart Polshek & Partners. The architects called for improvements to the building's mechanical and ventilation systems as well as for the addition of two arches on the east side of the Fifty-seventh Street facade and for the lowering of the lobby to grade level, bringing with it more space and access for the disabled.[13] Polshek's restoration, developed in collaboration with one of his partners, Paul Byard, was thwarted by the lack of original drawings for the building, which appear to have been lost, forcing the architects to rely on period photographs. Abraham Melzer, who had just helped with the restoration of Salle Pleyel in Paris, was retained to oversee the preservation of Carnegie Hall's highly prized acoustics.

Phase one of the work was completed in 1983: restoration of the facade, creation of a new lobby and stairs for the recital hall, a new box office, new elevators, and a new coat of paint for the main hall itself. Working with Tyler Donaldson of his office, Polshek tried to be true to the spirit of the past but not slavish to its details. The new lobby, in part replacing a storefront, was the most inventive part of the work, with a vaulted ceiling carried on Corinthian columns and some metalwork recalling the gridded patterning of Charles Rennie Mackintosh. Though critics accepted the Mackintosh motifs, the designers were rightfully called to task for their decision to split open the classical capitals and make them do double duty as lighting fixtures, which was, as Paul Goldberger observed, a "silly and unnecessary" moralizing protest against literal preservation.[14]

Major restoration work in the hall began in 1985 after the Landmarks Preservation Commission approved the plan on July 24.[15] As work progressed, special care was taken with the brickwork, with three old bricks used for every new one in an effort to preserve the vivid salmon color that was revealed after cleaning. In order not to interrupt the concert calendar for too long, the renovation project, a marvel of organization, was completed in just seven months, with construction carried out seven days a week. According to Lawrence Goldman, a vice president of the Carnegie Hall Corporation, the idea was "to bring the lobbies and the backstage of the hall *forward* into the twenty-first century and to bring the main auditorium *back* to the way it looked and sounded in 1891."[16] Once restoration of the hall began, previous mischief revealed itself, especially the nearly complete demolition of the original curved ceiling above the stage, which had been chopped into

to provide a hole to light a Hollywood feature film, *Carnegie Hall* (1947). A new mahogany wood floor was installed to approximate the original wood floor that had been replaced by vinyl. To protect the acoustics, an old seat was measured for sound absorption by an acoustical laboratory and new seats were wood-backed like the originals and upholstered in the familiar red mohair.

Polshek's boldest addition to the original building was a marquee with clear glass panels. Here he looked back to Mackintosh but even more so to fin-de-siècle Viennese Modernism, then very much in the public eye as a result of the books by the historian Carl E. Schorske and the exhibition, "Vienna 1900: Art, Architecture, and Design," at the Museum of Modern Art.[17] Goldberger was not completely convinced by Polshek's decision to employ a grid as the design motif for the marquee and for stair balustrades inside, a theme the critic felt was "a bit too hard-edged for this easy-going building."[18]

The hall opened to generally favorable reviews for both the aesthetics of the renovation and the acoustics with a gala concert featuring Vladimir Horowitz, Leonard Bernstein, and Yo-Yo Ma on December 15, 1986. The renewed Carnegie Hall enjoyed a month-long period of glory until January 29, 1987, when Bernard Holland, one of the *New York Times*'s music critics, weighed in with an unfavorable judgment, claiming that "the acoustics of this magnificent space [were] not the same" as before the renovation. Holland reported that "the new sound, by general agreement, is brighter, sharper, aggressive—and also more dangerous for the performer. The 'new' Carnegie Hall, in other words, offers fewer places to hide."[19] Complaints about the hall's new sound continued to mount, leading Judith Arron, the hall's general manager, to announce on September 21, 1988, that "minor acoustical adjustments, in the form of absorptive panels . . . set into free-standing screens" would be undertaken.[20]

In spite of these adjustments, dissatisfaction over the new acoustics did not abate, with many critics and musicians blaming the loss of the hall's famously lush, warm tone on the placement of a layer of concrete under the stage, a charge vehemently and consistently denied by Carnegie Hall management and its team of architects and acousticians. But when hall officials, noticing that the stage floor had begun to warp, had it ripped up during routine annual maintenance in August 1995, they discovered to their chagrin that the critics had been right, although no one could explain how the one- to four-inch-thick layer had gotten there in the first place. As architects, engineers, and contractors combed their records to explain the mystery, John L. Tishman, whose company had overseen the hall's renovation and who was himself a member of Carnegie Hall's board of trustees, claimed that the below-stage layer of concrete was already in place when the hall was rebuilt in 1985–86. With this revelation, the skeletons began to come out of the closet with former Carnegie Hall employees declaring that management knew about the concrete from the beginning but chose to ignore it and later, as a result of criticism of the hall's acoustics, they took an "official line . . . that there was no concrete."[21] With the concrete removed, critics reassessed the hall, with most reporting favorably.

In addition to his work in the main hall, Polshek also transformed the upstairs recital hall, renamed in honor of Joan and Sanford I. Weill. The 268-seat hall's plywood proscenium as well as paneling behind the stage, both later additions, were removed, the floor was re-raked to improve sight lines, and a

Kaplan Space, Carnegie Hall, southeast corner of Seventh Avenue and West Fifty-seventh Street. James Stewart Polshek & Partners, 1985. Warchol. PW

motif of Palladian arches, said to reflect the room's original design, was introduced. The Weill Recital Hall opened on January 5, 1987, to mixed reviews. Although Bernard Holland was quite impressed with the look of the recital hall, he could not endorse the new sound: "Once a seedy upstairs hall-for-hire . . . it has become a feast for the eyes, enriched by its creamy paint job and elegant new lines. It is all very encouraging—that is, until the musicians start to play. The changes in Weill have made a bad acoustical situation worse. In the past, we put up with its blaring, almost vulgar sound, perhaps because it seemed an apt metaphor for the level of most concerts there. Now the look of Weill Recital Hall and the high artistic ambitions held for it have raised our musical expectations."[22] In August 1987, in order to improve the acoustics, eight sets of drapes were hung along the side walls and fabric was placed on part of the back wall and over the curved wall above the balcony.

Polshek was also responsible for the renovation of the old Chapter Room into the multipurpose Kaplan Space. Designed at the same time as the Weill Recital Hall, it was the least historicist of his Carnegie renovations, with "sound control paraphernalia, cooling ducts, control room, emergency lighting and structure forming the decoration and conveying a sense of informality," according to Polshek.[23] In 1992 Carnegie Hall also opened a small museum endowed by Elihu and Susan Rose. Tucked into a space to the east of the main hall, it connected with what was called the East Room, a reception space carved out of a lower floor of Cesar Pelli's tower. The museum and the East Room were both fitted out by Polshek in a manner that extended the Viennese Secessionist direction of his previous work.

Despite the various acoustic crises, Carnegie Hall's management forged on with what would be its most ambitious project, the creation of a third performance hall, also designed by Polshek.[24] Announced in January 1998, the new house was, in fact, a reinvention of a previous recital hall located in the building's basement that had opened to the public on April 1, 1891, even before the main hall had been completed. The original beam-ceilinged, columned hall, with two slightly raised side galleries, seated 1,200 persons in seats that must have been very closely spaced. Removable chairs allowed the hall to be used as a ballroom and banquet hall. From 1896 to 1954

the space was home to the American Academy of Dramatic Arts. Other theater groups continued to use it until 1960, when it was converted to a cinema, the Carnegie Playhouse, at which time a screen was dropped in front of the stage, the side galleries were walled up, and the balcony was made to serve as a projection room.

In rebuilding the hall, modern standards of life safety and comfort resulted in a drastic reduction of the original capacity, so that only 640 seats were provided. As plans advanced, it became clear that this was not a project of restoration or even renovation but one that involved the construction beneath the main auditorium of an entirely new room because acoustic demands requiring greater volume could only be achieved by excavating below the level of the basement floor. Moreover, to create a modern hall, the twelve original cast-iron structural columns were replaced by twelve-inch-diameter, forty-five-foot-high steel pipe columns carrying twenty-four-inch steel I-beam girders topped by thick pads of Neoprene, a rubberlike synthetic that would cushion the hall from vibrations, including those of the subway under Seventh Avenue.

Zankel Hall, named for its donors and completed in September 2003, was a ninety-six-foot-long, thirty-foot-high space encircled by an elliptical concrete wall carrying the load of the floor above. In contrast to the fixed orientation of Carnegie Hall's main auditorium, which in 1997 was named after Isaac Stern, Zankel Hall was flexible, with a floor made up of nine forty-five-foot-wide sections that could be raised or lowered on independent lifts to create a stage at the end with raked seating or a completely flat floor. Herbert Muschamp was impressed with the new space: "A luxury version of a black-box theater, the hall has the feel of a broadcasting studio. . . . Forest colors set the ambience. Walls, floors and seat frames are fashioned from maple and American sycamore. The seats are upholstered in sage. We are in an outdoor clearing, in other words, a space set aside for civilized ritual."[25] Although New York Times music critic Anthony Tommasini was pleased overall with the new hall's acoustics, he did note "that telltale distant rumble" of passing subway cars. But, he added, "It didn't bother me a bit. There is something affirmingly urban about this 21st-century space and New York's ancient, clanking subway system having to get along."[26] Although warmly welcomed as a new concert venue, in November 2005, Daniel J. Wakin reported in the New York Times that the much-touted seating flexibility had been used on only one occasion in the first two and a half seasons.[27]

In March 1982, as part of its renovation plans, the Carnegie Hall Corporation invited proposals for a new commercial building to rise along the Music Hall's eastern edge on a vacant site owned by the city and used as a parking lot.[28] Until demolished in 1963, the Rembrandt Apartments had occupied the 12,500-square-foot lot. Despite the small site, Carnegie Hall's unused air rights would allow for an approximately 570,000-square-foot building. The request for proposals required that the building's lower floors function as "a cultural, entertainment, retail and restaurant center," and mandated a masonry-clad building that would be compatible with the hall and its two studio towers.[29] A seven-story structure facing Fifty-sixth Street would be required to expand Carnegie Hall's back-of-house space and provide it with a loading dock and backstage entrance.

With just fifty feet of frontage on Fifty-seventh Street, the modest site, coupled with stiff artistic and functional requirements, discouraged many prospective developers, and

Zankel Hall, Carnegie Hall, southeast corner of Seventh Avenue and West Fifty-seventh Street. Polshek Partnership Architects, 2003. Goldberg. ESTO

only three developer-architect teams emerged: George Kaufman and Cesar Pelli; Rockrose Associates and Charles Moore; and Harry Macklowe and Skidmore, Owings & Merrill. Although Macklowe paid SOM $250,000 to produce a design featuring a masonry-clad base rising to a green glass tower, he was not really interested in the Rembrandt site and instead was intent on acquiring the land to its east occupied by the Russian Tea Room, next door to a property he had recently acquired on which he proposed to build what became known as Metropolitan Tower (see below).[30] With Macklowe out of the picture, negotiations were begun with Kaufman, who soon also dropped out, leaving only Rockrose, which decided to replace Moore with Pelli. The Rockrose-Pelli team was officially selected in June 1985 for what would be known, when completed five years later, as Carnegie Hall Tower, 152 West Fifty-seventh Street.[31]

Pelli's plan, unveiled in April 1986, called for a 756-foot-tall, fifty-nine-story, 535,000-square-foot office tower, which Paul Goldberger greeted enthusiastically, calling it a "masterwork of respectful, responsible urbanism. It rises mainly as a narrow slab, and with its rich, decorative pattern of brickwork and cast-concrete ornamentation it has the air of some of the best slab-shaped buildings of the 1920's," like the Fred F. French Building (H. Douglas Ives and John Sloan, 1927), northeast corner of Fifth Avenue and Forty-fifth Street."[32] Pelli's contextual design, though related to the Postmodernism of the 1980s, was in important ways quite different. As Douglas Davis, *Newsweek*'s art and architecture critic, put it: "Unlike the postmoderns, Pelli pushed the new technology of glass, plastic and wafer-thin stone to its limit—part of what he called 'extreme modernism.' . . .

While gracefully echoing the sturdy, weight-bearing bricks next door, Pelli's bricks are so much ornamental frosting."[33]

Pelli's scheme was approved by the Landmarks Preservation Commission in October 1986, and ground was broken on November 20, 1987. Foundations were completed, not entirely by coincidence, on May 13, 1988, ninety-eight years to the day after the cornerstone was laid for Carnegie Hall. In most ways the building was unusual, not the least of which was its exceptional slenderness, supported by a system of concrete structural tubes. Two distinct slabs interlocked to reiterate at a large scale the composition of Carnegie Hall and its subsequent studio campanile (Henry J. Hardenbergh, 1894–96). Crowning the building, four metal aluminum grids were rakishly affixed to the tower to create a bold, ten-foot-wide, projecting, picketlike cornice that perfectly exemplified Pelli's approach: "We picked up threads of the past with a contemporary technology and contemporary sensibility."[34] The building also included an elaborately marbled vaulted through-block public pedestrian passage, a zoning requirement, the design of which seemed flashy in contrast to the tower. Along with those at Metropolitan Tower and Le Parker Meridien Hotel, the passage provided the northern link with the system of midblock passageways that stretched south to Fifty-first Street (see 6½ Avenue).

FACING PAGE Carnegie Hall Tower, 152 West Fifty-seventh Street, between Sixth and Seventh Avenues. Cesar Pelli & Associates, 1990. View to the southeast showing Metropolitan Tower (Schuman, Lichtenstein, Claman & Efron, 1987) on the left and Cityspire (Helmut Jahn, 1990) on the right. Goldberg. ESTO

Carnegie Hall Tower, opened in September 1990, was widely admired. Kurt Andersen, *Time* magazine's architecture critic, perhaps overenthusiastically welcomed it as "the finest high-rise to go up in New York City in a generation."[35] The eleven colors of brick, ranging from dark greens to vibrant reds, provided the key: "If you fly over New York, the visual impression is that it's a study in grays," Pelli observed. "We chose a variety of brick, not only to relate the tower to Carnegie Hall, but to pop this building out on the skyline."[36] Only Carter Wiseman, *New York* magazine's critic, took exception to Pelli's tower, claiming that it tried to do too much, was "much too tall," and, when seen from the north or south, appeared "perilously insubstantial." The entire composition, he concluded, was "badly out of balance."[37]

Separated from Carnegie Hall Tower by the diminutive, twenty-five foot-wide Russian Tea Room (see below), Metropolitan Tower (Schuman, Lichtenstein, Claman & Efron, 1987), 146 West Fifty-seventh Street, a black glass, 716-foot-tall, wedgelike shaft, was perhaps the boldest skyscraper of the 1980s boom, and also the most controversial.[38] The discord over Metropolitan Tower related not only to its dark, intrusive massing and its exceptionally confrontational knife-edge corner facing Fifty-seventh Street, but also to the diagonal orientation of its east facade, which disrupted the typical geometry of Fifty-seventh Street and of the midtown skyline when viewed from Central Park. Plans for Metropolitan Tower were announced in 1982 when the Little Carnegie Theater, which for over fifty years had shown films on the site, and various other tenants,

Carnegie Hall Tower, 152 West Fifty-seventh Street, between Sixth and Seventh Avenues. Cesar Pelli & Associates, 1990. View to the southwest. Goldberg. ESTO

Metropolitan Tower, 146 West Fifty-seventh Street, between Sixth and Seventh Avenues. Schuman, Lichtenstein, Claman & Efron, 1987. View to the southeast showing in background, from left to right, IBM Building (Edward Larrabee Barnes Associates, 1983), Trump Tower (Der Scutt, 1983), AT&T Building (Philip Johnson and John Burgee, 1984), and Citicorp Center (Hugh Stubbins & Associates, 1977). MP

were closed down by the Feinberg Realty & Construction Company, which had assembled a 1,850-square-foot, midblock site extending to Fifty-sixth Street with the intention of building a 350,000-square-foot mixed-use building of apartments, offices, and stores. Within a year, Feinberg was bought out by the controversial developer Harry Macklowe, of Wolf and Macklowe, who had also purchased 140 West Fifty-seventh Street (Pollard & Steinam, 1908), a 90,000-square-foot, fourteen-story building that gave him air rights transferrable to the site. By February 1983, Macklowe had increased the size of the parcel by acquiring 148 West Fifty-seventh Street and 137 West Fifty-Sixth Street and by June 1984 he had purchased the air rights over 130 West Fifty-seventh Street (Pollard & Steinam, 1908) and 131–135 West Fifty-sixth Street. In hopes of expanding the size of the site further, Macklowe mounted an unsuccessful campaign to buy the adjoining Russian Tea Room.

In 1984 ground was broken for Metropolitan Tower, the design of which had by then evolved into a seventy-eight-story, 653,000-square-foot structure with an enclosed pedestrian passageway running through to Fifty-sixth Street, 5,000 square feet of retail space, 225,000 square feet of commercial space and, beginning on the twenty-first floor, a tower housing, in 423,000 square feet, 246 one- to three-bedroom luxury apartments as well as even larger duplexes on the upper floors.

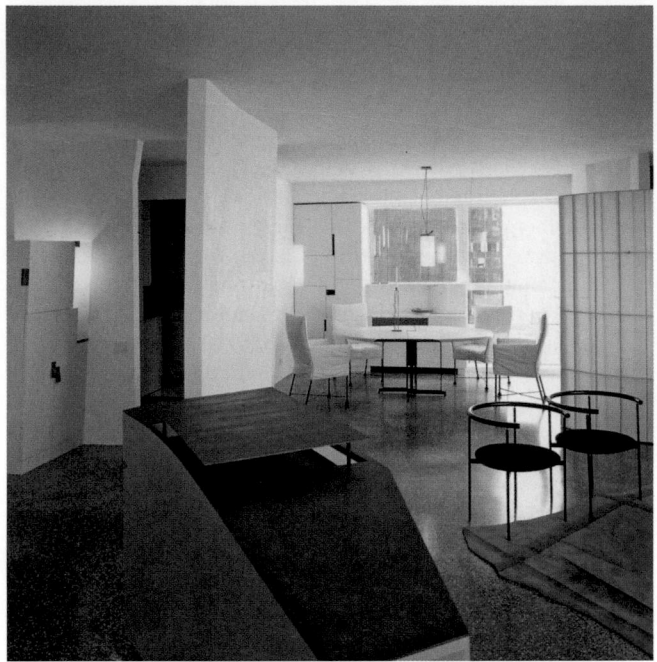

Apartment, Metropolitan Tower, 146 West Fifty-seventh Street, between Sixth and Seventh Avenues. Steven Holl, 1988. SHA

Apartment, Metropolitan Tower, 146 West Fifty-seventh Street, between Sixth and Seventh Avenues. Steven Holl, 1988. Plan. SHA

Model apartment, Metropolitan Tower, 146 West Fifty-seventh Street, between Sixth and Seventh Avenues. Tod Williams Billie Tsien & Associates, 1987. Moran. TWBTA

Model apartment, Metropolitan Tower, 146 West Fifty-seventh Street, between Sixth and Seventh Avenues. Tod Williams Billie Tsien & Associates, 1987. Plan. TWBTA

The building was only sixty-five stories tall. But employing a uniquely New York form of math, Macklowe, in addition to the local practice of skipping the traditionally unlucky thirteenth floor from his count, failed to include floors eighteen to twenty-nine from his number sequence because the lower floors of the building had floor-to-floor heights of thirteen-and-one-half feet—customary for offices but four-and-one-half-feet higher than the standard height of a residential floor in Manhattan—resulting in an eighteenth floor that was more than 250 feet above street level, a height that would be typical of the thirtieth floor in a conventional residential building with nine-foot ceilings.

The tower's design was the work of a number of people, including Bill Derman, a former staff member of James Stewart Polshek's firm, Sheldon Werdiger, who had been on the staff of Skidmore, Owings & Merrill, and Peter Claman and his partners. Both Derman and Werdiger were on Macklowe's payroll, which led the developer to self-aggrandize his role in the design process, implying that the design

was also his: "I am god-damned sick of the design community criticizing my buildings just because I'm a developer and we do the architecture ourselves. . . . We get more involved in design than any other developer in the city." To Macklowe, Metropolitan Tower was "a seminal building. It will reshape architectural thinking. It will arrest the postmodernist movement. It will, I think, eventually be recognized as a classic."[39] Paul Goldberger, who was later to soften his views, initially condemned the design as "dreadful architecture." Shortly after construction began, Goldberger attacked the scheme as "an arrogant intrusion": it "could not be more out of place on the eclectic, masonry streetscape of West 57th Street."[40] Joe Klein, a reporter who would go on to fame as a political writer, deemed it a "glass-and-steel Godzilla looming ravenously over the elegant shoulders of the Essex House and St. Moritz."[41]

To publicize Metropolitan Tower, which included a waiting room off its parking garage for chauffeurs, a separate floor of bedrooms for bodyguards or domestic help, a private dining club, and a catering service, Macklowe hired a top publicist, Bobby Zarem, and the graphic designer Massimo Vignelli, whose eighty-four-page promotional book was a landmark of its kind. He also commissioned a fourteen-minute film featuring himself in a cameo role as well as actors portraying an international array of likely buyers, and spectacular views of New York taken from a helicopter in emulation of Federico Fellini's film 8½. To further promote sales of the condominiums, Macklowe hired four prominent design firms to decorate model apartments on the thirty-fifth floor of the tower: Andrée Putman's was "Sleek Continental," Juan Pablo Molyneux's "Plush Romantic," Tod Williams and Billie Tsien's "Hip Contemporary," and Gensler and Associates's "Faux Cowboy."[42] Putman was asked to design a 1,400-square-foot apartment that, because of its acute north-facing apex, she considered akin to a ship's prow, reserving the sharp angle for the master bedroom and formalizing her analogy by creating an observation post at the would-be hull, complete with telescope. Putman used blond sycamore for the walls, ceilings, and cabinetry and had bookshelves of black epoxy-finished steel and sandblasted glass custom-made for the project. Tod Williams and Billie Tsien created an even more polished environment, employing free-standing metal screens and a full-height aluminum mesh curtain to help divide the space as well as ebonized oak furniture, silk upholstery, and stainless-steel-inlaid gray terrazzo floors. They, too, adopted a maritime theme, thinking of the apartment as "a floating island." The sharp corner was used as a dining area, and the designers reconfigured the plan of the apartment to lead "the visitor's eye directly to the point of the triangle."[43] Gensler's design, featuring Ralph Lauren furnishings, was intended to push the sale of the small, less-well-located apartments to corporations.

The building's triangular plan provoked an even more complex geometric strategy from Steven Holl, who designed a pied-à-terre for one of the condominium purchasers.[44] Holl embraced the building's geometry, allowing its forty-degree apex to become the crucial character of the interior. Eschewing any "apparent traditional domesticity," his design fostered "free floating spatial tilting" with free-form creased walls that themselves titled four degrees to "accompany the acute angle of the existing plan." Rather than risk a collision course of triangles, Holl's indeterminate plan deliberately shattered spatial boundaries to convey a light, airborne qual-

ity that was enhanced by a basswood screen covered in airplane fabric, an "Icaran wing" separating the nearby bedroom from the living room.[45]

In 1990, when Carnegie Hall Tower and Metropolitan Tower had become established fixtures on the Fifty-seventh Street scene, and when the economic downturn had made it clear that the exuberance of the 1980s was a thing of the past, Paul Goldberger toned down his earlier criticism of the black glass building. Though he still "in many ways" considered the building "an alien object," Goldberger had to admit that "it is a lot less destructive to the cityscape than it looked as if it was going to be. The slender wedge of black glass has a certain elegance, like minimalist sculpture. . . . What is most remarkable about Metropolitan Tower is the way in which it does not ruin 57th Street, for all that the building defies the street's architectural context." This Goldberger attributed to its slender mass and shape that "is just quirky enough to be interesting, not so different as to look bizarre on the skyline."[46]

Eight years after the completion of Metropolitan Tower, on December 31, 1995, Faith Stewart-Gordon, the owner of the tower's neighbor to the west, the diminutive holdout Russian Tea Room, officially announced the closing of the venerable, seventy-two-year-old restaurant.[47] Stewart-Gordon sold the property, a four-story Italianate brownstone originally designed by John G. Prague in 1876, to another experienced restaurateur, Warner LeRoy, who had made his reputation first with Maxwell's Plum (1968) and then with the over-the-top renovation of the Tavern-on-the-Green (1976) in Central Park.[48] Pledging to keep the year-round Christmas decorations in the first-floor dining room, LeRoy, working with the architectural firm of Harman Jablin, proposed a new nine-story building with a dramatic exterior and interiors that pushed political and art history to the limits. Blending "the Russian Futuristic and Constructivist periods" of the 1920s and 1930s with "the Czarist period," LeRoy opted for a burst of geometry on the exterior, using "the colors of the czars—royal blue stippled by its white undercoat, red, gold and white trim."[49] The interior would also work out Russian themes, with a sixteen-foot-high clear acrylic Russian bear on the second floor and a bejeweled palace resembling the Kremlin on the third. LeRoy also wanted to reuse some of the stained-glass ceilings that he had salvaged from Maxwell's Plum. Plans were slow to develop, however, and LeRoy quarreled with his partner, David Bouley, the talented chef-owner of the highly regarded eponymous Tribeca restaurant, who ultimately withdrew from his association with LeRoy. Eventually, in 1998, LeRoy tore down the old building and announced his intention to replace it with a seven-story building.[50] The Russian Tea Room reopened in October 1999, with interiors as flamboyant as advertised, complete with remnants from Maxwell's Plum, but with a far more restrained exterior by Harman Jablin consisting of a spare white stucco–clad facade embellished with bas-relief sculptures and a central bay of windows. But the reinvented Russian Tea Room was a financial failure, closing in July 2002, seventeen months after LeRoy's death.

Across the street, the Nippon Club Tower (1991), 145 West Fifty-seventh Street—a 77,000-square-foot, twenty-one-story granite and glass tower developed, designed, and constructed by the Takenaka Corporation, one of Japan's largest contracting and design firms—housed a social club founded for Japanese executives in 1905 and originally headquartered at

161 West Ninety-third Street (John Vredenburgh Van Pelt, 1912).[51] The first through seventh floors of the new building contained galleries, a health club, auditorium, banquet halls, dining rooms, a restaurant, a tea room, and classrooms for the club, with the rest of the building leased as offices to outside tenants. According to Takenaka's in-house architect, Noboru Uenishi, the design expressed "liberation from perpendicularity," a concept that translated to an angular glass volume jutting out of the building's first setback and a tall parapet-like plane rising at an angle near the building's crest to hide mechanical equipment.[52] The effect was concentrated on the south facade, facing Fifty-seventh Street, while the north facade was quite straightforward, with double-hung strip windows. But the blank walls of the east and west facades were livened up with diagonal lines and patches of shading.

East of Fifth Avenue

New construction on East Fifty-seventh Street was concentrated between Fifth and Lexington Avenues, with the first new building completed, Edward Larrabee Barnes's monolithic forty-three-story IBM Building (1983) (see Madison Avenue), southwest corner of Madison Avenue, raising serious concerns about overcongestion in the area as well as the loss of the small-scale buildings typically necessary to maintain an upmarket retail trade, a threat dramatized by the contemporaneous completion of IBM's neighbor to the south, Philip Johnson's thirty-seven-story AT&T Building, and its neighbor to the west, Der Scutt's fifty-six-story Trump Tower. As these buildings reached completion, work began on another super-scaled skyscraper, but one that took a more sensitive approach to its prominent site and to the area's retail character, Kohn Pedersen Fox's 135 East Fifty-seventh Street (1983–88), northwest corner of Lexington Avenue, replacing Thompson & Churchill's technically ingenious, stylistically innovative, seven-story 137 East Fifty-seventh Street (1930) and a number of surviving rowhouses to the west.[53] Though clearly a landmark of American Modernism, Thompson & Churchill's building vanished without a protest. To the west of KPF's building stood David Kenneth Specter's mixed-use Galleria (1975), a predominantly residential tower notable for its ninety-foot-high atrium, quirky four-story penthouse apartment, but poorly conceived street frontage.[54]

The 27,000-square-foot assembled corner site became something of a zoning anomaly when, in 1982, the newly enacted midtown zoning affected about half of it, requiring a low, bulky, street-respecting approach to the west, while the zoning for the rest of the site nearer Lexington Avenue remained unchanged, permitting—indeed encouraging—a tower set behind a plaza. In response, William Pedersen, KPF's lead designer, working with Gary Handel, an associate in the office, came up with what was surely one of the period's most unusual arrangements for an office building, consisting of a twenty-eight-story midblock tower known as 125 East Fifty-seventh Street and a thirty-four-story corner tower called 700 Lexington Avenue, the latter a concave mass wrapping a plaza that featured a tempietto-inspired thirty-three-foot-high roofless gazebo marking the intersection of the two streets. The buildings were in effect one, packaging approximately 460,000 square feet of space in an intricately detailed silver reflective glass and light and dark gray granite modern classical mass that at its base made an attempt to suggest the scale, if not necessarily the character, of the

135 East Fifty-seventh Street, northwest corner of Lexington Avenue. Kohn Pedersen Fox, 1988. View to the northwest showing 750 Lexington Avenue (Helmut Jahn, 1989) on the far right. KPF

brownstones that had for fifty years or more been home to small retail shops, some of which it was hoped would return to the site in the new building, either at street level or in the below-grade mall known as the Place des Antiquaires.

Paul Goldberger greeted the completed building, now known as 135 East Fifty-seventh Street, as a "startling success as a work of architecture and even more as a piece of urban design," with a corner plaza that was positively shaped and in no way random or diffuse, and a mass that "does not appear to sit on its plaza like an object dropped from outer space" but as one that "looks as if it were built for its site, and no other." Clearly one of the best of the crop of Art Moderne–inspired buildings, the design had about it, according to Golberger, "something of the air of the W.P.A. classical buildings of the 1930's . . . but jazzed up, given a shot of adrenaline," yet not completely free of "the pomposity of a lot of 1930's classicism. . . . There's a lot of overachieving to the lobby, for example, where white marble, black marble, green marble, gray granite, bronze, stainless steel, and white plaster all come together in a relentless mix of abstracted classical details." All in all, Goldberger was pleased, calling 135 East Fifty-seventh Street "a brilliant building, one of the best office towers of the last generation in New York, and one of the only ones that bring inventive thinking to a difficult urban problem."[55] Susanna Sirefman, writing in 1997, disagreed, finding the composition "disconcerting," with the

Four Seasons Hotel, 57 East Fifty-seventh Street, between Park and Madison Avenues. Pei Cobb Freed & Partners in association with Frank Williams, 1993. View to the northwest. Williams. FWPA

Four Seasons Hotel, 57 East Fifty-seventh Street, between Park and Madison Avenues. Pei Cobb Freed & Partners in association with Frank Williams, 1993. Hambourg. PCFP

Four Seasons Hotel, 57 East Fifty-seventh Street, between Park and Madison Avenues. Pei Cobb Freed & Partners in association with Frank Williams, 1993. View to the north. Orlewicz. PCFP

tempietto in a "vast expanse of empty space,"[56] while the editors of the *AIA Guide* in 2000 dismissed the plaza as "silly."[57] The subterranean, two-level, 50,000-square-foot Place des Antiquaires, at one time home to nearly 100 antique and art dealers as well as an eighty-seat café, was not a financial success, and in 1994 the space was taken over by Daffy's, a discount clothing store.

One block to the west, between Park and Madison Avenues, Pei Cobb Freed & Partners' 367-room, fifty-two-story, 682-foot-high Four Seasons Hotel (1988–93), 57 East Fifty-seventh Street, designed in association with Frank Williams and extending through the block to Fifty-eighth Street, was the city's tallest hotel and its first new super-luxury hotel since the completion of Schultze & Weaver's Waldorf-Astoria in 1931.[58] Developed by William Zeckendorf Jr., son of the man who first employed a then recently graduated Pei as an in-house architect, the Four Seasons was the architect's first New York skyscraper. Clad in honey-colored Magny limestone, the same material used by Pei in his expansion (1983–89) of the Louvre in Paris, it replaced a number of former rowhouses as well as the Blackstone Hotel (Robert T. Lyons, 1914), 50 East Fifty-eighth Street.[59]

The design of the hotel was more deliberately historical in its character than virtually any other of Pei's American buildings. It was also somewhat fussy, with almost innumerable set-

backs embellished by twelve-foot-high lanterns that, when lit against the night sky, made the building appear flashy. The principal entrance was surprising, through a narrow but dramatically designed portal distinctly reminiscent of details used by Sir Edwin Lutyens in his 85 Fleet Street (1935), London, and in the gardens of his Viceroy's Palace (1930) in New Delhi, India.[60] Through the portal, a flight of stairs led to a vertiginous thirty-three-foot-high backlit onyx-ceilinged lobby that was both austere in its minimalism and luxurious in its effect. While Marilyn Bethany, design editor of *New York* magazine, saw the interiors as a "love song to New York,"[61] Suzanne Slesin, writing in the *New York Times*, was a little more to the point, describing the hotel's "gestalt" as that of "New York in the 30's—you expect Fred and Ginger to take a spin around the lobby—with a hint of the Temple of Dendur."[62]

According to Paul Goldberger, "The slender limestone tower . . . is a bit too reliant on simple geometries, and there are details that seem to try too hard—the huge empty circle over the front door on East 57th Street," which the critic likened to a Chinese moon gate, "or the angular lights that mark the balcony setbacks. There are moments when this feels less like a romantic New York tower than a Pei modernist museum trying to pass itself off as one." As to the arrival experience from Fifty-seventh Street, Goldberger observed that the "stairs mounting toward a reception desk that looks like a Judgement Day platform is not exactly homey," although it "has a staggering grandeur."[63] Morris Lapidus, who bypassed staying at one of the hotels he designed in the city to stay at the Four Seasons, stated: "When I first went in, I went up the stairs and I said, 'Where is the body?' The place looks like a mausoleum."[64] But Goldberger acknowledged that, overall, the grand foyer was a "beautiful room," going on to praise all the public spaces as "a truly serious attempt to explore the sensual side of modernism, and it is an attempt that, if somewhat startling from so buttoned-down an architect as Mr. Pei, is entirely successful. . . . I'm not sure that the building as a whole isn't best thought of as an effort to find a meeting point between the serious, rather corporate, modernism of most of Mr. Pei's work and the kind of fantasy modern architecture we know from the movies. What happens when I. M. Pei meets Cedric Gibbons? Come to the Four Seasons and find out."[65]

Fifty-seventh Street between Fifth and Madison Avenues managed to retain its cachet for top-class retailing despite the incursion of three theme retail establishments, including a store for Warner Bros. that opened in 1993 at the northeast corner of Fifty-seventh Street and Fifth Avenue (see Fifth Avenue). In 1996 Swatch, the makers of high-style, affordable watches, opened a shop, 5 East Fifty-seventh Street, bringing a pop retailer, similar in character to the theme restaurants, to what had until recently been among the city's swankiest streets.[66] Designed by Daniel Weill of the London office of Pentagram and his New York counterpart, James Biber, the sleekly designed and detailed, metal-lined shop included a gallery and a café as well as a video room. The interactive environment featured a sinuously arranged system of transparent pneumatic tubes running through the 5,000-square-foot, three-story store, which permitted shoppers to see their orders traveling from the stock room to the sales counter. In the same year a much larger, more prominent store opened: Niketown, 6 East Fifty-seventh Street. It replaced the ill-fated, short-lived Galeries Lafayette department store (see Fifth Avenue) and was designed by an in-house team led by Gordon Thompson working with Boora Architects

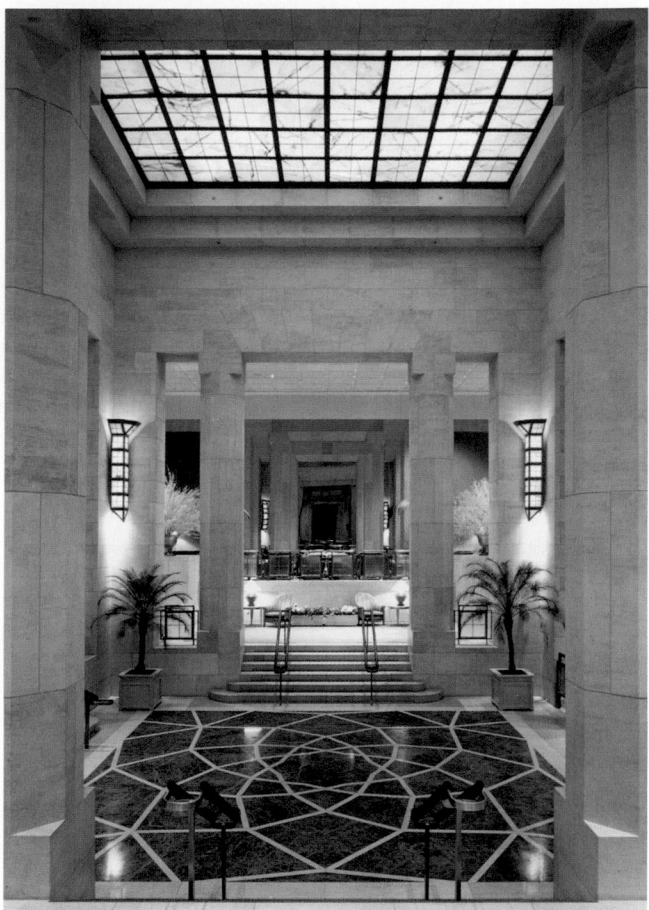

Four Seasons Hotel, 57 East Fifty-seventh Street, between Park and Madison Avenues. Pei Cobb Freed & Partners in association with Frank Williams, 1993. Lobby. Orlewicz. PCFP

of Portland, Oregon.[67] Intended to look like a prototypical New York public high school gymnasium of the 1910s or 1920s, the 66,520-square-foot Niketown store was conceived as a tourist attraction that happened to sell shoes—well, actually, sneakers. Penetrating the exterior, with its bold glazed arch, visitors, after passing through sports-arena-like turnstiles, were confronted with a dark, balcony-ringed, four-story-high atrium, punctuated by wire-mesh-filled arched windows, gym-mat-covered structural columns, exposed-brick walls, and aged wood floors that all combined to suggest that the old gym had been taken over by NASA for use as a rocket launching site. Accompanied by a continuous, pounding sound track, every thirty minutes a three-story-high screen was lowered to display Nike-related sports films and sophisticated video promotions of the company's products. Surrounded by displays of sports memorabilia, sales areas of the company's famed sneakers were confined to alcoves and upper-level balconies, leading Paul Goldberger to observe, "The merchandise is secondary to the experience of being in this store, an experience that bears more than a passing resemblance to a visit to a theme park."[68]

In 1996 Chanel, Inc., the American arm of the French high-fashion company, built a seventeen-story, 65,000-square-foot office building, 15 East Fifty-seventh Street, between Fifth and Madison Avenues, designed by Platt Byard Dovell in a version of the modern classicism that had been employed more than

sixty-five years before by such top-level retailers as Stewart & Company (Warren & Wetmore, 1929) and L. P. Hollander & Company (Shreve, Lamb & Harmon, 1930).[69] The lower three floors were given over to a Chanel shop designed by Christian Gallion with Brand & Allen. On the third floor, there was a private room for fashion shows, parties, and couture fittings that evoked the legendary designer's salon on Rue Cambon, Paris. Herbert Muschamp greeted the building with guarded enthusiasm as a "blow against kitsch.... Tall, slim, clad in a symmetrical facade of gray granite, steel and glass, it is a classical piece of architecture, understated and easily underrated." He went on to say, however, that "the big news on 57th Street" was Christian de Portzamparc's LVMH Tower (see below).[70] In 1999, as his enthusiasm for LVMH increased, Muschamp would further qualify his praise for the design. "With its impeccably tailored facade . . . , the Chanel Building is perhaps the best of the

Chanel Building, 15 East Fifty-seventh Street, between Madison and Fifth Avenues. Platt Byard Dovell Architects, 1996. View to the northeast. McGrath. NMcG

Dead Deco breed, a place where the ghosts of departed Rockettes go browsing after dark."[71] Echoing the New York Times's critic, Paul Goldberger, now writing for the New Yorker, also made the tailoring analogy, calling Platt's mid-block infill "a proper tailored suit of a building which is deliberately evocative of older towers; its message to the streetscape is that to get along you have to go along."[72]

Christian de Portzamparc's LVMH (Louis Vuitton Moët Hennessy) Tower (1994–99), 17–21 East Fifty-seventh Street, between Fifth and Madison Avenues, was the most aesthetically overreaching effort of the 1990s, a sixty-foot-wide, twenty-four-story-tall, 100,000 square-foot infill building, desperately anxious to be perceived as an iconic tower and as a hypermodern antidote to what some perceived as the too commercial, too contextual conformity of typical New York architecture.[73] In its exaggerated ambitions, the building was supported by the impressive publicity machine of its owners, a French company specializing in retailing high fashion, and by Herbert Muschamp, who saw it as a decisive blow against the contextual Postmodernism he abhorred and as a welcome return to the heroic, typically contextually dismissive Modernism that had characterized the work of many important architects in the 1950s and 1960s.

De Portzamparc, a Paris-based, Casablanca-born architect, had not previously designed a building for New York. He had lived in the city for nine months in 1966 when he took time out from his studies at the Ecole des Beaux Arts in Paris to work as a waiter by day and be a cultural explorer by night, before returning to France. At first, the site for the LVMH Tower was even narrower than the sixty-foot width de Portzamparc ended up with, so that preliminary studies, which were broken up in their massing, were gladly abandoned when the owner of a holdout property housing the Findlay Gallery agreed to sell, allowing the architect to rethink the design. Initially, the rethought building was little more than a wider version of the first design. Then a bolder idea of faceted planes emerged, but it proved too costly, leading to another scheme using curved surfaces that was also too expensive. Eventually, a final design materialized that juxtaposed the curved and angular planes of a curtain wall of water white, super clear, and translucent glass. The glass wall was manufactured by Saint Gobain, which had supplied the glass for I. M. Pei's pyramids at the Louvre, in Paris. To achieve the glassy effect, the typical thirty-six-inch vertical fire separation between floors usually expressed on the exterior by an opaque spandrel panel was eliminated in favor of a costly system of sprinklers set on five-foot centers along the perimeter of each floor. In the event of fire, the sprinklers would produce a continuous water curtain.

De Portzamparc, who designed the building with the assistance of the New York office of the Hillier Group, a firm headquartered in Princeton, New Jersey, was straightforward in explaining his approach:

This tower must aim to be a striking presence with undeniable visibility in a city where the architecture is so forceful, so innovative and the blocks so tightly knit together. This . . . flagship building . . . also had to fit into an extremely narrow site . . . caught between a corner building—the Chemical Bank [Charles E. Birge, 1920]—and the gray stone Chanel Building. Opposite, the brick [actually, dark green polished granite] mass of the IBM building ran the major risk of a facade mirror effect, likely to reflect the heaviness of that facing block, rather than the LVMH tower maintaining its own presence.

De Portzamparc took pride in the logic of his unorthodox facade, which he arrived at by "making smart use of New York's operating regulations." But most importantly, he emphasized, the building was "a whole body, not a facade."[74]

The tightly buttressed tower was climaxed by a two-story, thirty-foot-high penthouse dubbed the "Magic Room," to be used for fashion shows and parties. At the tenth story, atop one of the building's setbacks, a blue glass crystal was, in the architect's words, the "heart of the flower" that was the petal-like layered and folded facade.[75] The metaphor was silly, and de Portzamparc would come to regret it. At night, the building could be subtly washed with a slowly changing palette of soft gold, blue, red, and green light controlled by a computer and emanating from neon tubes hidden in a 300-foot-long trough that rose diagonally across the facade, a feature, sadly, that was only occasionally employed after the building opened. At street level, two storefronts on either side of the discreet entrance, occupied by LVMH subsidiary Christian Dior, were designed by Peter Marino, who had previously been chosen by LVMH chairman Bernard Arnault to redesign the Dior boutique (1997) at 30 Avenue Montaigne in Paris. On Fifty-seventh Street, the larger Dior store to the east was devoted to clothes and accessories, while the western unit was reserved for the sale of jewelry.

When construction was about to begin, the project was presented at a press conference but was also exhibited at the Architectural League of New York, a rare instance when that venerable institution elected to endorse a single commercial project. Reacting to the design, Michael Sorkin provided perhaps the clearest description of the building's composition: "It answers the legal requirement to move mass away from the street both by stepping back in the traditional way and by folding its facade inward. The organizing compositional move is a slightly curving diagonal running from lower left to upper right; the right side of the building is pushed forward and the left is folded back. This angling seam is reinforced by a difference in materiality: greenish glass to the left and wonderfully white sandblasted panes to the right." According to Sorkin, the building's design evolved from a "Cubist composition—a still life with highly autonomous, pretty Euclidean parts—and moved by stages to its . . . final version, grasping at the conceit of kinesis" but ultimately failing to completely transcend its "origins as a pile of shapes. The elegant new skin feels like it's drawn over the old body, a form caught somewhere in the middle of its own evolution."[76]

As the building neared its completion—it opened on December 8, 1999, with a big party to benefit the Municipal Art Society—Muschamp weighed in, writing that de Portzamparc had "reimagined the idea of Art Deco. In doing so, he has released the city from the grip of the Dead Deco imitations that in the 1980's began to turn New York into a theme park version of itself." Muschamp, repeating de Portzamparc's by now overworked metaphor for the building's facade as flower, wryly commented that it was "safe to assume that a shrinking violet" was not what the architect had in mind. "Though the facade remains strictly within the boundaries set by the city zoning code, it appears to burst forward from the perpendicular plane of the typical curtain wall in a flourish of tapering, origami-like folds. The heart of this exotic bloom is a pillbox of blue glass, lodged on the [western] edge of the facade at the 10th-floor level. The petals, of irregular size and contour, radiate upward in crystalline shapes

LVMH Tower, 17–21 East Fifty-seventh Street, between Madison and Fifth Avenues. Christian de Portzamparc with the Hillier Group, 1999. Early study models, 1994–95. Borel. CDP

that recall a bird of paradise." According to Muschamp, the alternating pattern of clear and sandblasted glass produced "a pattern of clear wedges—windows within windows (or petals within petals). The wedges, in turn, are incised with a pattern of delicate horizontal bands that increase in thickness toward the top. From within, the sandblasted lines create the effect of skinny Venetian blinds."[77]

LVMH, as Muschamp pointed out, was startling and, as such, provocative, though its urbanistic implications were largely ignored: what would the effect of a full block of crystalline forms be on the street as a whole? While the *Times*'s critic pointed to the use of crystalline geometry in Czech Cubist architecture of the 1920s, he neglected to call attention to the sequence Hugh Ferriss and Harvey Wiley Corbett devised in the early 1920s to illustrate how architects might respond to the zoning laws of 1916, more than likely known by de Portzamparc, which showed the evolution of crystal shapes to the more reasonable geometries of conventional building.[78] Muschamp concluded his appraisal on a note calculated to disarm even the naysayers: "The LVMH Tower was worth the wait. Watching the building rise, seeing people on the street look up as its faceted, crystalline contours took shape, even overhearing people say

how much they hate it: this has been like watching a flat-liner's pulse revive."[79]

De Portzamparc appeared to be somewhat chagrined by the building's reception, especially by Muschamp's assessment: "I read in the *New York Times* that this building was a lively and interesting renewal of the Art Deco style. The article recalled that as a whole [the] school of postmodern architecture was engrossed in the study of the Chrysler Building [and] after the rigors of functionalism, New York architecture had replunged itself into the 1930s by producing a dead and embalmed city architecture. This building would reactivate a certain dynamism was how they analyzed it. By going from the cylinder to the prism, I became more of a New Yorker, according to one of my American friends."[80] De Portzamparc seemed to resent the misinterpretation of the flower metaphor that he pointed out was meant only to apply to the box on the tenth floor, which was tinted blue at the request of Bernard Arnault, who "wanted the whole building to be blue" but compromised on "a little piece of blue like the center of a flower."[81]

While most critics treated LVMH as a bit of fin de siècle aesthetic titillation, Diane Lewis, an architect and educator,

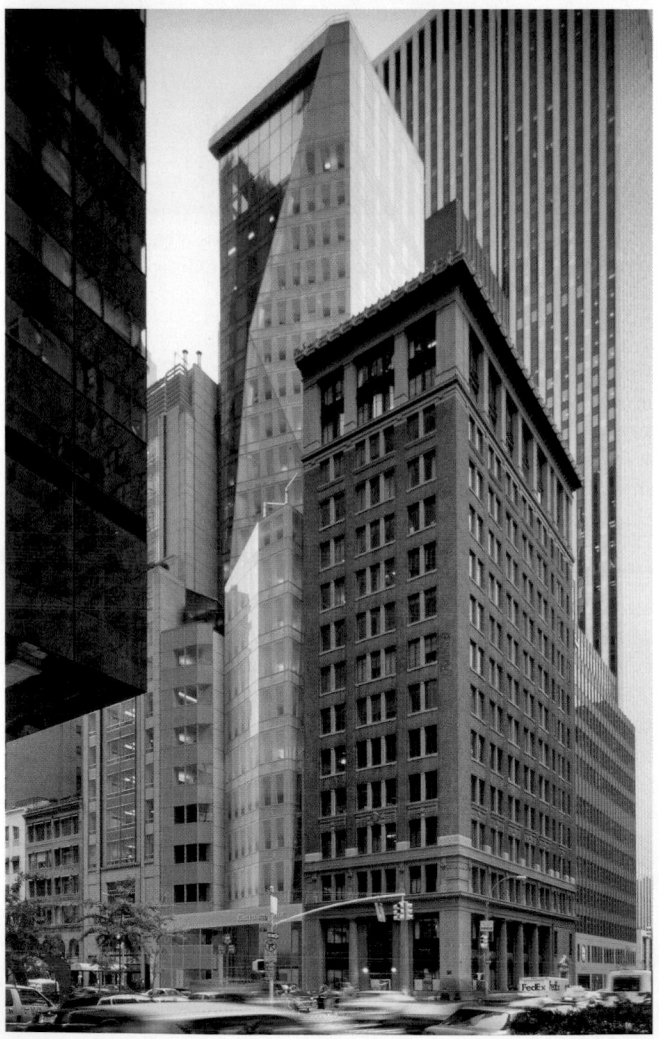

LVMH Tower, 17–21 East Fifty-seventh Street, between Madison and Fifth Avenues. Christian de Portzamparc with the Hillier Group, 1999. View to the northwest. Borel. CDP

tackled its urbanism head on. Writing in *Oculus*, Lewis posed a number of important questions: "Does the . . . project establish a dialogue with the existing civic fabric, whether his strategy is to leave that fabric intact, interrupt it, or create a new condition? And, is it possible to accept the idea that 'spectacle' (raised when the architect presented the building at a Museum of Modern Art symposium on 'Urban Spectacle') was germane to either the program or the mid-block site? The building vacillates on both questions," Lewis argued, "which gives it a fashionable ambivalence and moral contemporaneity." According to Lewis, de Portzamparc avoided discussions of the fit between the building's form and its content—something that, she argued, should be essential to a facility devoted to French fashion—but concentrated, at least in his MoMA presentation, on his efforts to beat the zoning envelope so as "to arrive at a radical formalist spectacle. But," she continued, "New York has always been a to-the-lot line setback, commercially conservative, grey-flannel-chorus line city which nonetheless managed to produce radical social programs and dramatic urban spatiality. A taut chess game." LVMH, she concluded, is "the distorted last gasp of a Corbusian ideal projected on Manhattan fabric."[82]

For Ada Louise Huxtable, who had helped select de Portzamparc as the youngest winner of the Pritzker Prize in 1994, when the architect was only forty-nine, the LVMH Tower was "not just another pretty face" but a "brilliantly creative interpretation of New York's notoriously restrictive zoning and building codes [de Portzamparc had in fact said that those in Paris were even more so] to a post-post-modernist aesthetic that makes everything else look definitely old chapeau." The *Times*'s respected former critic, now writing in the *Wall Street Journal*, joined Muschamp to extol the building as "the best new building in New York—not by small degrees but by the equivalent of a jump-shot to the moon." Huxtable, more the historian than Muschamp, pointed out that the "fractured forms" evoked "1920s renderings by that poet of skyscraper drawings, Hugh Ferriss." But she agreed with the younger critic that "while there are references to Art Deco, and suggestions of '50s details, there is no nostalgia here; grounded firmly in 20th-century modernism," she wrote in the first month of 2000, "and filtered through a uniquely French taste," LVMH was "part of a radical departure in style marking much new work that is having an international impact. As usual, New York is the last to know." Huxtable found only the lobby less than perfect, writing that the decorative patterns added to the white glass panels, not designed by the architect, busied up the already small space and closed it in. On the other hand, "the elevator cabs, which repeat the sandblasted lines of the exterior glass on a mirrored back wall and the sycamore of the lobby, are the most elegant in town."[83]

Paul Goldberger was impressed with the Magic Room, a "spectacular . . . magnificent space, a kind of glass box hovering twenty-four floors over midtown Manhattan. The proportions are superb—it is twice as wide as it is high, but not so grand that it doesn't feel intimate. The main space, which fills the twenty-fourth floor, is overlooked by an arrival balcony on a mezzanine, so that guests can alight from the elevator, show their faces on the balcony, then descend via a curving staircase to the crowd below. This is what is known

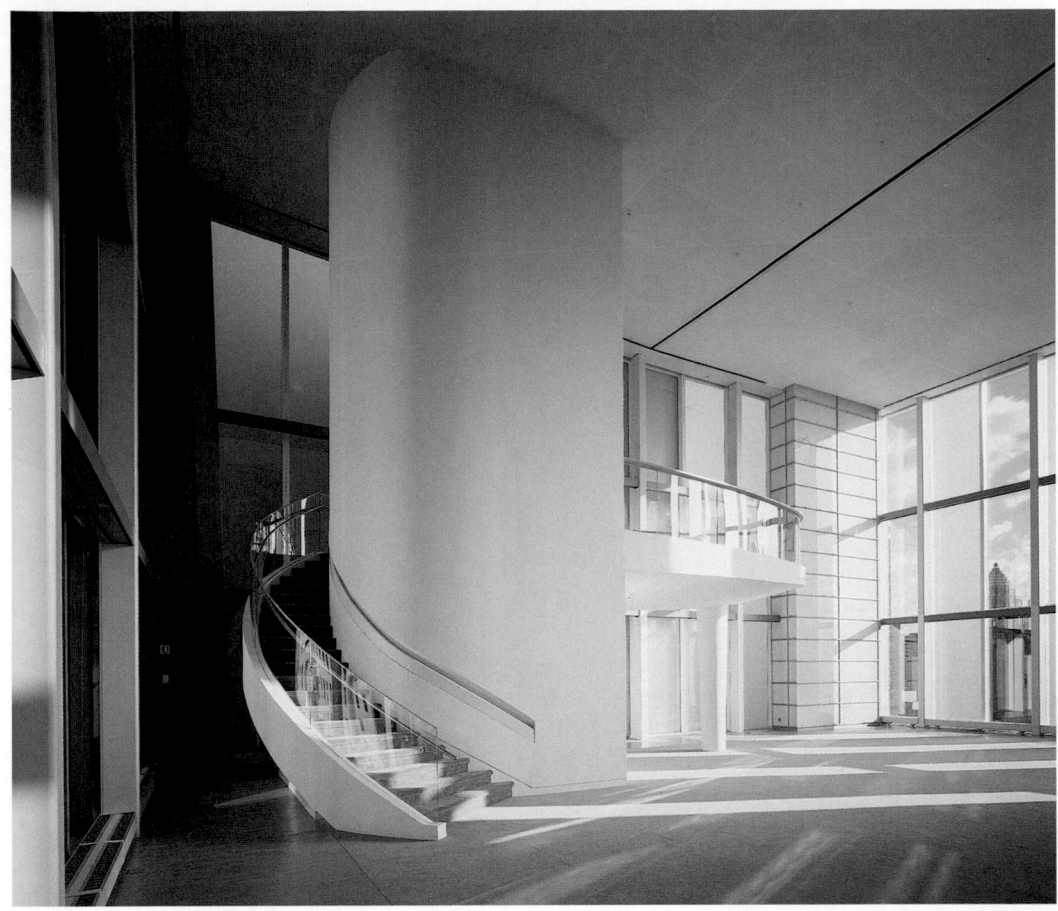

as making an entrance, and there are few architects—at least few modern architects—who would bother with it." Notwithstanding Goldberger's enthusiasm, the claims for the Magic Room were rather exaggerated. The room paled beside the great skyscraping lounge at the top of Ralph Walker's Irving Trust Company Building (1931), not to mention the dramatic Rainbow Room (see Rockefeller Center), both of which also had the advantage of luxurious detailing and really commanding views. With the exception of the Magic Room, Goldberger did, however, find the interiors "disappointing." De Portzamparc "produced dull, flat spaces for the office floors, which do not carry through any of the promise of the facade."[84]

Of all the critics, only Suzanne Stephens had the courage to state that the "tower is basically a room and a facade," and to ask, "What is all the fuss about?" Although she acknowledged that the building stood out amid so many mediocre lookalikes of the New York scene, she pointed out that its architect enjoyed a bigger than usual budget and a corporate client as opposed to a developer. But she wondered whether "all LVMH's exotic design ingredients make it 'architecture,' or is it just an office building with a chic facade?" Stephens concluded that the LVMH Tower owed "its success to its location, size, scale, and price tag. Its custom design, a welcome addition to New York's streetscape is one-of-a-kind. As a new response to . . . zoning, it makes a strong contribution. As a prototype for the skyscraper form, it doesn't. It is runway couture that would lose its essence in translation to ready-to-wear."[85]

COLUMBUS
CIRCLE

Proposal for Coliseum site, west side of Columbus Circle, between West Fifty-eighth and West Sixtieth Streets. Victor Body-Lawson and Ray Tong, 1982. Rendering of view to the southwest. VBL

Proposed massing for Coliseum site development, west side of Columbus Circle, between West Fifty-eighth and West Sixtieth Streets. Cooper Eckstut Associates, 1984. Model, view to the west. NYT

Time Warner Center

The construction of the Javits Center in 1980–86 (see Far West) sealed the fate of the Coliseum (Leon and Lionel Levy, in consultation with John B. Peterkin, Aymar Embury II, and Eggers & Higgins, 1954), one of Robert Moses's most banal and least-loved projects.[1] Plans to close the Coliseum and redevelop the strategically located site led architects to dream of its possibilities. For example, in 1982, Victor Body-Lawson and Ray Tong, students at Columbia University, published a proposal developed in a studio led by Michael Mostoller and Michel Kagan, which was to prove highly prescient, calling for two towers set atop a continuous base that defined the circle (as the Coliseum did not).[2]

With the city still recovering from the fiscal crisis of the late 1970s, some argued against tearing down so large a structure, which included an income-generating office building, but in March 1984, an agreement entered into by the city, the state, and the Municipal Assistance Corporation permitted the city to offer the 150,000-square-foot site for sale or lease. At the press conference announcing the pact, Kenneth Lipper, Deputy Mayor of Finance and Economic Development, set the tone for what would follow by stating that the site, one of the

largest in Manhattan, could become home to "the tallest building in the world."[3] As details of the agreement were hammered out over the following month, development of the site remained the responsibility of the Metropolitan Transportation Authority (MTA), with proceeds from the sale earmarked for critically underfunded mass transit.

Developers immediately went into high gear, stimulated by a series of urban design strategies developed for the MTA by Cooper Eckstut Associates, including several proposals honoring the site's unusual geometry and one calling for a 130-story tower rising from a low base, with the tower closing the axis of Fifty-ninth Street.[4] Although many were surprised by the density of development possible on the site, the way had been paved for the site's intensive redevelopment in 1982, when the City Planning Commission included it in its Midtown Zoning Resolution, permitting it to support over 2.5 million square feet.[5] In February 1985, the MTA officially placed the parcel on the market, the largest to be offered for sale in midtown Manhattan in fifty years.[6] Prospective bidders were asked to demonstrate design excellence, but development requirements were largely nonexistent, although retail space was required for the Columbus Circle frontage and developers were asked to make the new building relate to Edward Durell Stone's Gallery of Modern Art (1965) at Two Columbus Circle (see below). Otherwise, the deal was to be strictly commercial, with the purchase price the main consideration and the mandate that the developer selected utilize a

PREVIOUS PAGES Proposal for Coliseum site, west side of Columbus Circle, between West Fifty-eighth and West Sixtieth Streets. Moshe Safdie, 1985. Photomontage, aerial view to the southwest. Rosenthal. SR

Proposal for Coliseum site, west side of Columbus Circle, between West Fifty-eighth and West Sixtieth Streets. Eli Attia, 1985. Model. EAA

Proposal for Coliseum site, west side of Columbus Circle, between West Fifty-eighth and West Fifty-ninth Streets. Skidmore, Owings & Merrill, 1985. East elevation. SOM

Proposal for Coliseum site, west side of Columbus Circle, between West Fifty-eighth and West Sixtieth Streets. Michael Graves, 1985. Rendering of view to the southwest. Paschall. GRV

20 percent zoning bonus, in return for which the developer was required to renovate the labyrinthine Columbus Circle subway station, a major hub connecting several different lines.

Thirteen developers, working with architects, submitted proposals in time for the May 2, 1985, deadline. The Lefrak Organization and Galbreath-Ruffin, working with the Chicago office of Skidmore, Owings & Merrill, proposed a 135-story glass-and-latticed-exoskeleton steel tower that bore a similarity to I. M. Pei's tower for the Bank of China (1982–90) in Hong Kong but was bizarrely contradicted by a classical street wall complete with statuary. Columbus Towers Management Corporation and Metropolitan Property proposed a seventy-six-story Postmodern tower, containing a hotel and 580 condominium apartments designed by Wong & Tung, who also proposed to renovate the Coliseum office building in order to bring it into visual conformity. Donald Trump and Peter Kalikow, working with Eli Attia, proposed a 137-story decagonal tower—the world's tallest—that would contain office, residential, and hotel spaces, an atrium, and, at the top, an observation deck. Given the limit on allowable square footage, Attia's proposal achieved its extraordinary height by means of a thirty-story hollow core intended as an atrium. Additionally, to achieve large open floors, the design had no interior columns, relying on an exterior steel frame. The telescoping tower was quite elegant and reflected Cooper Eckstut's earlier proposal as well as Harvey Wiley Corbett and

Proposal for Coliseum site, west side of Columbus Circle, between West Fifty-eighth and West Sixtieth Streets. Kevin Roche John Dinkeloo and Associates, 1985. Rendering of view to the west. KRJDA

Proposal for Coliseum site, west side of Columbus Circle, between West Fifty-eighth and West Sixtieth Streets. Cesar Pelli & Associates, 1985. Model, view to the west. Markese. CPA

D. Everett Waid's unrealized proposal of 1929 for an 80- to 100-story tower for the Metropolitan Life Insurance Company.[7] The New York Land Company, working with Swanke Hayden Connell, proposed an eighty-story mixed-use tower. William Zeckendorf, in partnership with A. Alfred Taubman, and working with Michael Graves and Gruzen & Partners, proposed a tripartite design consisting of a base containing retail space, an atrium, a supermarket, and movie theaters, with office and hotel space above the base, topped by two thirty-three-story residential towers. Larry Silverstein, in partnership with Robert Bass and Mel Simon, working with the New York office of Skidmore, Owings & Merrill, proposed two forty-two-story foreground towers and a sixty-three-story tower slab behind, as well as a galleria serving the shopping mall that filled the base, all skillfully modeled to reflect the streamlined Moderne aesthetic of the Century (Irwin S. Chanin with Jacques Delamarre, 1931) and Majestic (Irwin S. Chanin with Jacques Delamarre, 1930–31) apartment houses nearby on Central Park West. George Klein and Bechtel Investments, working with Kevin Roche, proposed to retain the Coliseum office building and build an RCA Building–inspired eighty-three-story tower slab on the northern part of the site. Rich-Eichner, working with Cesar Pelli, proposed two 520-foot-high cylindrical foreground towers and, on axis with Fifty-ninth Street, a 950-foot-high telescoping tower, a design Pelli was later to recycle as the basis of his eighty-eight-story, 1,483-foot-high twin-towered Petronas Towers in Kuala Lumpur, Malaysia.[8] Hirschfeld Realty, Rapid America Corp., and Drexel Burnham Lambert joined forces, commissioning James Stewart Polshek, who proposed a Dutch Modernist–inspired eighty-story tower intended to house medical offices and a science center topped by telecommunications equipment and a "moon" that would change colors. Prudential Insurance Co. and Sterling Equities, working with Hellmuth, Obata & Kassabaum, proposed to re-create the street-level axis of Fifty-ninth Street, positioned between the existing office building, which they would refurbish, and a seventy-one-story tower. Charles Ackerman, working with Welton Becket, proposed a fifty-four-story granite-clad tower resting on four columns as well as a 450-room hotel tower

ABOVE LEFT Proposal for Coliseum site, west side of Columbus Circle, between West Fifty-eighth and West Sixtieth Streets. James Stewart Polshek, 1985. Rendering of view to the southwest. PPA

ABOVE RIGHT Proposal for Coliseum site, west side of Columbus Circle, between West Fifty-eighth and West Sixtieth Streets. Murphy/Jahn, 1985. Rendering of view to the southwest. MJ

LEFT Proposal for Coliseum site, west side of Columbus Circle, between West Fifty-eighth and West Sixtieth Streets. Moshe Safdie, 1985. Photomontage, view to the west. Rosenthal. SR

appended to it, visually balancing an extremely modified version of the existing office building. Boston Properties and Salomon Brothers, working with Moshe Safdie, proposed two crystalline towers, the taller one of which reached seventy stories. Donald Trump and Peter Kalikow submitted a second proposal, this one designed by Murphy/Jahn, calling for a strikingly aggressive, glass-skinned 135-story terraced building that would spiral upward as an octagonal tower.

As soon as the schemes were published, the public began to take sides. In a poll conducted by the *New York Post*, Attia's design was the popular favorite, followed by the New York office of SOM's Central Park West–influenced design, with Cesar Pelli's earning third place. While many New Yorkers were entranced by the idea that New York might recapture the "world's tallest building," some, especially such outspoken critics as Michael Sorkin, were not. "Don't get me wrong," Sorkin wrote in the *Village Voice*, "I'm in favor of the world's tallest building. It just doesn't belong in Columbus Circle." Citing a number of reasons, including the shadow it would cast across Central Park and much of the Upper West Side, he also believed that such a colossus would "be completely misplaced in the skyline, an artistic resource that demands conservation. Despite intrusions, the basic figure of the Manhattan skyline depends on the legibility of the double crescendoes of Midtown and Downtown. To locate its tallest structure outside of this rhythm of peaking would be to assault its most central qualities, a terrible vandalism." Sorkin found only three schemes to be "remote possibilities," with something of the scale appropriate to the site: Michael Graves's, which was "so ineptly expressed as to suggest a student knockoff"; that of the New York office of SOM for Larry Silverstein, which "would work much better massed as four buildings rather than three"; and Cesar Pelli's proposal, which, though "too tall by perhaps a third, has the best, most Gothamesque spirit of any."[9]

Paul Goldberger followed Sorkin with an even more dismissive assessment, timed to an exhibition of the schemes sponsored by the Municipal Art Society at the Urban Center: "Some are better than others, but on balance they constitute no more than a pretentious parade of overblown skyscrapers, a packaged set of every design cliché of the last decade." For Goldberger, Attia's proposal looked "like storybook pictures of the Tower of Babel, and it could not be less appropriate for Columbus Circle." Murphy/Jahn's spiraling tower was "not much better in terms of its relationship to the surrounding city, but at least its central void promised to preserve an open vista westward from Central Park South." Goldberger, like Sorkin, saw promise in the proposal of SOM's New York office, but he rated Michael Graves's "overdetailed" scheme second to the Skidmore scheme: "It suggests a real understanding of the complex problems of the site." He found Kevin Roche's proposal equally knowing and "a case in which a gifted architect properly realized that reinventing the wheel made no sense, and the best solution need not be the most spectacular." Moshe Safdie, however, did seek to reinvent the wheel: he "unfortunately" designed a "cacophony of anxious diagonals—a pair of towers whose shape seems to have been created by slicing and dicing, not by a true understanding of the difficult urban site." While Goldberger seemed to hold Pelli's scheme in higher regard as "a pleasing fantasy of towers," it too seemed generic, at home "at the end of any long vista anywhere," while Polshek's building was "nicely composed, but far too massive for this site," and HOK's "shrill 76-stories of glass and stone" was "a stretched out building from a Dallas freeway."[10]

Meanwhile, public concern over the process, and the proposals, was growing, led by West Side citizens. On June 18, 1985, the Architectural League sponsored a discussion of the proposed schemes. A week later another session, attended by over 150 neighborhood residents, was called by the various leaders of the affected community boards. Also in June, the *New York Times* reported that plans to build the world's tallest skyscraper on the site had apparently been shelved, leaving the focus on the deal itself, which was said to consist of a $477 million bid for the 3.43-acre site made by the Coliseum Land Company, a joint venture between the New York Land Company and Kumagai Gumi, a construction company based in Japan, employing Swanke Hayden Connell, whose scheme had hitherto been largely ignored. This partnership seemed to have the edge over Boston Properties and Salomon Brothers, working with Moshe Safdie. But not even a month later, on July 12, 1985, the *Times* reported that Boston Properties and Salomon Brothers's bid of $455 million had been accepted. Although the offer was less than that proposed by its Japanese rivals, theirs promised $300 million more in tax revenue over a fifteen-year period. In addition, Salomon Brothers, at that time the most prominent and powerful investment bank in the city, pledged to lease 1.5 million square feet of the building as its corporate headquarters and to increase its New York workforce by 3,500 jobs.

In an unusual move, Frances Halsband, president of the normally apolitical Architectural League, published a fiery op-ed piece in the *New York Times* a week after the announcement of Safdie's winning scheme, objecting "to the selection process that deliberately disregarded design" and calling for the mayor and the MTA to reject the proposed design and "insist that . . . a new proposal that does not overwhelm its surroundings" be submitted. Halsband's letter asked for a more contextual approach, and included a request that Fifty-ninth Street be reopened, stating that while its closing "to make a larger site for the Coliseum may have seemed appropriate in 1956 . . . selling our street to private developers is no longer looked on so benignly."[11]

Paul Goldberger revisited the Coliseum project in August 1985, stressing the prominence of the site and its strategic position as the hinge between West Midtown and the Upper West Side, both areas undergoing rapid redevelopment: "It is a major challenge. And so far, the architect who has been given it, Moshe Safdie, has failed utterly" with a proposal that bears "almost no relationship to this important site, or to the traditions of skyscraper design in New York. At a time when the best towers are designed to connect to the surrounding context and to relate in some manner to the romantic and quasi-historical heritage of the New York skyscraper, Mr. Safdie has come up with a scheme that looks more like Buck Rogers," a scheme that fails to satisfy not only because it seems "futuristic" but also "simplistic."[12] Soon enough other critics began to weigh in against Safdie's design, including Walter McQuade, writing in *Connoisseur*, who proclaimed that it would "cast a long shadow over Central Park [and] a metaphorical shadow on the architecture of New York City."[13]

Besieged by criticism, Safdie continued to refine his project, unveiling a model of the developed design in July 1986, thereby launching the formal process of public review.

Goldberger was not swayed, though he was softer in his assessment: "It does have a kind of futuristic zest to it, to be sure, but it seems almost as comfortable in Columbus Circle as a rocket ship. . . . It stands alone, aloof, admittedly full of energy, but a kind of energy that seems to be more an explosion on the skyline than a unifying force."[14] Suzanne Stephens was more probing in her assessment: "Placing the same square footage in a series of lower buildings would be one alternative [to the building's height]—not that a low-rise version of [its] obsessive geometries . . . would suffice to make a good design. The situation has a certain degree of pathos. Safdie decries the neoclassical symmetry New York architects seem obsessed with; he doesn't want to rifle through history's 'bag of tricks' like the postmodernists. But he has proved to be as morbidly nostalgic about modernism."[15]

Things did not go well for the Safdie project. By mid-September 1986, the members of Community Board 4, in which one corner of the site lay, and those of Community Boards 5 and 7, which were immediately adjacent, had all disapproved the plan, criticizing its height and bulk. But on December 10, the City Planning Commission approved the project, acting unanimously. The Municipal Art Society and various Upper West Side groups tried to head the project off at the Board of Estimate, claiming increased air pollution from more traffic, overcrowded streets, and an overburdened subway line among reasons for their opposition. But most of all they pointed out that Safdie's towers would blanket acres of Central Park in shade, especially in winter and early spring, when the low sun would create shadows extending almost to Fifth Avenue. At 1:27 A.M., Friday, January 23, 1987, after a marathon session, the Board of Estimate voted ten to one in favor of what was now known as Columbus Center, with only David N. Dinkins, Manhattan Borough President, dissenting.

One of the most ardent opponents of Safdie's scheme was Joan Davidson, a prominent community activist with considerable clout derived from her role as head of the J. M. Kaplan Fund, founded by her father. Davidson, who described the MAS board as "very hemmy and hawy at first," enlisted the support of Paul S. Byard, a lawyer who had helped create the Urban Development Corporation before becoming an architect.[16] At the urging of Byard and Davidson, the Municipal Art Society agreed to instigate a suit. While Byard and others felt that the real issue was the zoning code and its propensity for overbuilding, the matter that they felt could be used to effectively combat the project was its negative environmental effects. The required Environmental Impact Statement had claimed that traffic moved through perpetually clogged Columbus Circle at a steady twenty-five miles per hour, yet such was patently not the case. More development, it was feared, would further congest the area and increase air pollution. But the real breakthrough came when Philip Howard, a lawyer and MAS board member, hit upon the project's Achilles' heel. As Gregory Gilmartin wrote in his history of the Municipal Art Society, *Shaping the City: New York and the Municipal Art Society*, "The city wasn't granting a zoning bonus" when it required developers to utilize all of the extra 20 percent of the zoning envelope in order to offset the cost of the subway station improvements; "it was selling [the bonus] to the highest bidder. . . . The city had created an impossible conflict of interest for its own planning commission."[17] As Howard explained, although zoning bonuses were in fact granted almost automatically, there was supposed to be

Proposal for Coliseum site, west side of Columbus Circle, between West Fifty-eighth and West Sixtieth Streets. Moshe Safdie, 1985. Photomontage, view to the west. Rosenthal. SR

discussion of the public purposes served by such grants, and that by bypassing the review process, the city was "prejudicing the outcome of a purportedly democratic decision-making process."[18] Howard was keen for action, and the Municipal Art Society filed its lawsuit in June 1987, charging that a "fundamentally and fatally flawed" process led to the project's approval.[19] Soon after, a coalition led by Jacqueline Kennedy Onassis was formed in support of MAS's suit. The Municipal Art Society suit took on an almost Robin Hood–like character. As a spokesman for the coalition put it, "The only flag now flying above this city is a price tag; our municipal officials must declare that some things, such as sun and space, are not for sale."[20]

By September, Jacqueline Onassis was joined by the influential journalist Bill Moyers, who was most concerned about the impact of the development on Central Park. But behind the pleas for sun in Central Park lay an even more basic problem. Many New Yorkers really didn't like Safdie's proposed design, which as John Taylor reported in *New York*, had been called "a mess," "a disaster," "the hulk," "ice mountain," and just plain "ugly."[21] *New York*'s own architecture critic, Carter Wiseman, described it as "an apparently random stacking of forms" and

"an open shirt where collars and ties are called for."[22] Brendan Gill dismissed Safdie's design as a "grotesquely convoluted twin-towered carved-iceberg of a skyscraper" that would dominate its site "with something like the air of arrogant self-importance displayed by the Victor Emmanuel II monument in Rome," wisely pointing out, however, that though once deemed "a laughing stock," that monument had become "to some postmodernists, an icon."[23] Even I. M. Pei, a close friend of Jacqueline Onassis, who as Taylor wryly noted for his readers, had "inflicted the Hancock Tower on Boston's Back Bay," allowed his name to be added to the list of the project's opponents. "I was astonished," Safdie stated. "I wrote him a note saying people in glass houses shouldn't throw stones."[24]

Even before the court delivered its response to the Municipal Art Society's suit, the project began to come unglued as a result of Salomon's own fiscal crisis, leading it to announce on October 12, 1987, the dismissal of 12 percent of its workforce, the closing of its municipal bond department, and the reexamination of its space requirements in New York City and other locations. The following day, Mortimer B. Zuckerman, faced with what seemed a dramatically different market, said he would reduce the building's bulk in order to resolve the lawsuit against it. On Sunday, October 18, 800 people formed a line through Central Park, opening black umbrellas on cue, in a symbolic protest of the shadows that would be cast by Safdie's Columbus Center at certain times in the winter. Trade unionists, anticipating the end of the building boom, countered four days later with a rally in favor of the project as well as the equally beleaguered Television City (see Upper West Side). Held in front of the Coliseum, it brought out 7,000 union members. Along with Television City, Columbus Center had become a flash point, a symbol of rampant overdevelopment. And the public antipathy to the projects marked what Robert Caro described as "a turning point for New York." Caro explained that "over the last few years, New York has been transformed into a different city, and no one has paid attention. Well, all of a sudden people have awakened to what's happening."[25] To this, William H. Whyte, the urban sociologist, added: "This is a real revolt, not just by a bunch of troublemakers."[26]

In early December, Salomon backed off from taking space in Columbus Center or even acting as an investor. But the battle continued, with an exhibition in December at the Municipal Art Society's galleries in the Urban Center featuring a five-by-seven-foot model of the area between Fifth Avenue and the Hudson River, Fifty-seventh to Eighty-first Street, showing existing and proposed buildings and their patterns of sun and shadow as well as patterns of wind. On December 7, Justice Edward H. Lehner of State Supreme Court in Manhattan declared "null and void" the sale of the Coliseum site to Boston Properties, arguing that "zoning benefits are not cash items."[27]

Things went from bad to worse for the city administration when it was revealed that after Salomon's pullout, Boston Properties had agreed to continue with its plan only after being given a $5 million reduction on the site's purchase price as well as what was the equivalent of a $5 million short-term loan. Faced with the project's collapse, Mayor Ed Koch stepped

Photomontage showing the shadow that Moshe Safdie's proposal for the Coliseum site would cast on Central Park. MAS

"Stand against the shadow" protest in Central Park, October 18, 1987.
MAS

up his lobbying on its behalf. With the fate of the project in the balance, Boston Properties made a bold move, replacing Moshe Safdie with David Childs of the firm of Skidmore, Owings & Merrill, whose Central Park West–inspired scheme had been widely admired in the early stages of the selection process.[28] To complicate matters, David Childs was a member of the Municipal Art Society's board and one of the few who had argued against filing the lawsuit. Once hired by Zuckerman, he announced his intention to resign from the Municipal Art Society but was successfully convinced to stay, provided that he recuse himself from discussion of the Coliseum project.

The selection of Childs was widely regarded as a positive sign, but the future of the project remained shaky as the city and the developer, negotiating new terms for the sale of the site, missed by ten days the deadline for an agreement before finally striking an accord on December 31, 1987. Though criticized as a "deal . . . gone bad" by the city's comptroller, Harrison J. Goldin, and by the Municipal Art Society, the promised reduction of the building's height to 850 feet, seventy-five feet less than originally proposed, and the reduction by $18 million of the price to be paid to the city, represented the changed political and economic climate.[29]

On June 2, 1988, Mayor Koch and Mortimer Zuckerman unveiled David Childs's plan, which featured a cluster of brick and glass towers.[30] Overall, the revised proposal was reduced by 500,000 square feet. While Paul Goldberger was quick to

point out that Childs's design effectively contextualized what had been generally regarded as an alien imposition on the site and the city, he also noted that despite the reduction in square footage, the project was still very bulky. In his initial assessment, Goldberger reported that "close observers of the situation believe that Boston Properties is interested not so much in winning an appeal on the legal issues, which could take years, as in trying to shift popular opinion toward the project."[31] Thomas Hoving, editor of *Connoisseur* and an outspoken architectural gadfly, was not so taken with Childs's scheme, calling it a "huge and unintentional parody of Manhattan deco [that] is in many ways less agreeable than Moshe Safdie's scheme . . . it is bland to the point of pusillanimity, and, even worse, it is a mediocre rip off of what was already hackneyed back in the thirties; a pulp edition of Rockefeller Center."[32]

Aside from its stylistic contextualism, Childs's scheme was ingenious in its massing, with most of the offending shadow concealed behind that cast by the Gulf & Western Building (Thomas E. Stanley, 1967), thereby weakening the basis of the Municipal Art Society's opposition. Furthermore, the decision to reduce the fee for the site eliminated the need for a zoning bonus. Nonetheless, despite enormous pressure for approval from the city, which desperately wanted the developers' money to plug gaping holes in the municipal budget, the Municipal Art Society decided to go on with the legal battle. Moreover, the new design did not work quite the magic that had been hoped for it, with the site's three abutting community boards remaining opposed to the scheme and to the renegotiated deal. Even more significantly, on February 1, 1989, Harrison Goldin took the occasion of a City Hall hearing on the project to contend that the Koch administration had violated the City Charter in striking a new deal and that he might sue the mayor to undo the settlement. The Planning Commission effectively approved the plan on March 22, 1989, when it approved the disposal of the city's interest in the Coliseum property, the removal from the official map of a small section of roadway on Eighth Avenue, and an amendment to the thirty-six-year-old urban renewal plan for the site. The project was not itself reviewed because it was technically to be built "as-of-right," an irony if ever there was one.

In an effort to bring the divisive situation to a close and go forward with the project, the city and the developer agreed to once again revisit the design, and on April 19, 1989, a third version was released that had the approval of civic groups.[33] The new scheme, also by David Childs of SOM, and a variation on his previous effort, was not only 620,000 square feet smaller than his previous scheme but also further reduced in height, below Safdie's 925-foot scheme of 1985 and SOM's previous 805-foot version to a more manageable 752 feet. Additionally, the roughly twenty-six-story section of building connecting the two towers that blocked the visual axis of Fifty-ninth Street was eliminated in favor of a four-story-high bridge above an arch at the nineteenth floor. Besides the reduction in bulk, the developer also agreed to provide 120 single-room-occupancy units for homeless persons to be located near the project. Zuckerman's company also agreed to pay one-third of the $12 million cost of improvements to the Columbus Circle subway station and to provide 4,000 square feet of public space in the complex to be used for community meetings and performances. But the deal was not yet done. On May 2, Community Board 7 voted to reaffirm its opposition to

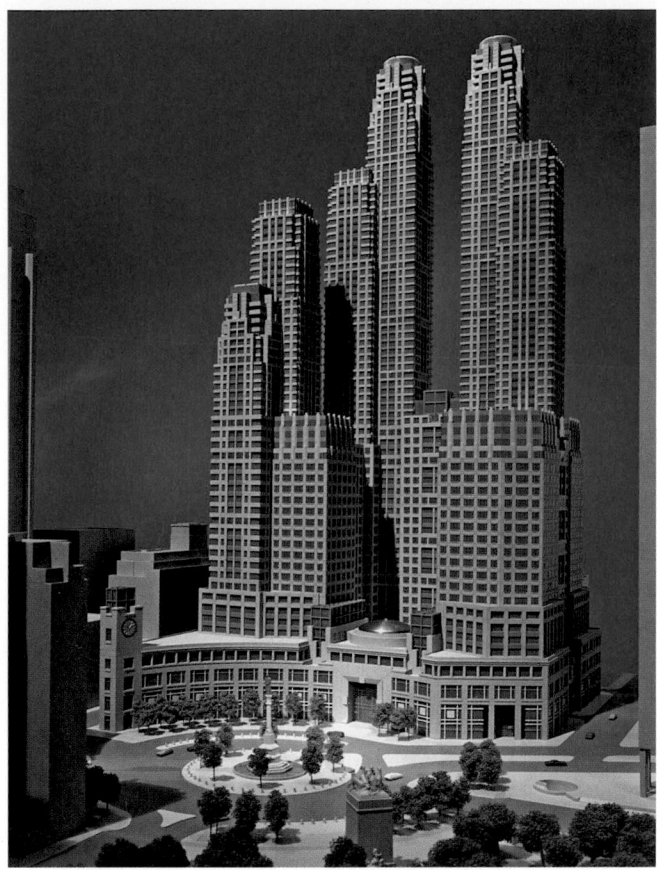

Proposal for Coliseum site, west side of Columbus Circle, between West Fifty-eighth and West Sixtieth Streets. Skidmore, Owings & Merrill, 1988. Model, view to the southwest. Hoyt. SOM

Proposal for Coliseum site, west side of Columbus Circle, between West Fifty-eighth and West Sixtieth Streets. Skidmore, Owings & Merrill, 1989. East elevation. SOM

the project and Community Board 4 followed suit the next day. Nonetheless, on May 4, 1989, four years after it was first proposed, the Board of Estimate, with Harrison Goldin dissenting, approved the project, which would realize $337 million for the city. Six days later, the MTA agreed to sell the property, and the deal at last seemed done.

But the critical returns on the new design's aesthetics were just beginning to come in, with Carter Wiseman damning it with feint praise: "The latest design has its virtues. The massing is better. Along with the defection of Salomon, Inc., as the original tenant went the need for vast office floors. . . . The relationship of the . . . towers to the lower portion of the building has been improved by reducing their height. And with its old-timey clock tower and decorative detailing, the building no longer looks like an extraterrestrial, as Safdie's spiky assemblage sprinkled with greenhouses did." Nonetheless, he continued, "SOM's deferential overlay of cornices, parapets, and assorted other friendly protrusions makes Columbus Center . . . look like any number of New York buildings from the thirties, only woefully out of scale, as if an air hose had been attached to the Century or the Eldorado apartment blocks."[34]

The project continued to be plagued by opposition, with three Democratic political leaders from Manhattan—two state senators and a United States representative—pressing forward with a suit to block construction as the mayor, facing massive layoffs in the financial industry and a declining municipal economy, pleaded for it as a source of jobs, supported by the editors of the New York Times. The suit was dismissed in Federal Court on February 7, 1990, but by this time the real estate market was in terrible shape and the developers were unwilling to meet their commitments unless they were able to secure a major tenant. By September, Charles Bagli, the real estate columnist, reported the wide-ranging speculation that the project might never go ahead.

Although the New York State Court of Appeals removed yet another legal barrier to the project in November 1990 by refusing to overturn a lower court decision that upheld an agreement by the Triborough Bridge and Tunnel Authority, the state agency owning the site, to sell development rights to Boston Properties without competitive bidding, hope for the new project's realization was dimming. The abandoned Coliseum, and especially the broad sidewalks that ringed it, gave birth to a new problem as the homeless took up residence, only to be forced out by the city in June 1991, just as a federal judge, Shirley Kram, ruled that the project could only go forward if the city came up by late 1992 with a plan to meet federal air-quality standards in all five boroughs. The city immediately appealed, and the decision was overturned in June 1992. With the question of the Coliseum's near-future unresolved, the facility was reopened for small-scale exhibitions, which proved a healthy market.

As pressure mounted for the developer to close the deal, Mortimer Zuckerman put forward yet another proposal in

Proposal for Coliseum site, west side of Columbus Circle, between West Fifty-eighth and West Sixtieth Streets. Robert A. M. Stern Architects, 1996. Rendering by Ernest Burden III of view to the west. RAMSA

With a failed deal, the MTA began putting pressure on the city to either support a plan for the Coliseum's interim use or create a new proposal to sell it.[38] In November 1995, after a decade of effort, the city, state, and the MTA announced that they would go back to square one and issue a new request for development proposals.[39] But by April 1996, the city and state were at a standoff, with the city insisting that the site would be more beneficial as—of all things—a convention center, a use that it had reclaimed on an interim basis for commercial trade shows in September 1995. The city claimed that the Coliseum could generate substantial tax revenues and more new jobs than the office and apartment complex the state continued to advocate. At last, on May 29, 1996, the city and the MTA reached an agreement, with the city dropping its demand that the new development include convention and exhibition space and the MTA agreeing to go ahead with the sale rather than wait for a more favorable real estate market. With the announcement of the agreement to go forward, public-spirited individuals and groups began to lobby for a strategy for selling the property that would take issues of architecture and urban design more seriously into consideration than in the prior sale that led to the selection of Boston Properties. The new plan for the site limited the height of the buildings to fifty-nine stories and stayed within normal zoning limits for floor area and density. Like its predecessors, it called for a "base" curved to conform to the geometry of Columbus Circle. William Donohoe, working for the MTA, formulated development guidelines, and the city's leading developers began to line up major tenants. By the November 1 deadline, nine teams had submitted bids.

Proposal for Coliseum site, west side of Columbus Circle, between West Fifty-eighth and West Sixtieth Streets. HLW International, 1996. Rendering by Lawrence Shum of view to the west. HLW

December 1993, this time calling for the preservation of the office tower at 10 Columbus Circle and the replacement of the Coliseum with a 600-foot-high office building, both tied together with a base comparable in volume to the existing exhibition hall.[35] Whether the plan was a "straw man" or not, in early December 1993, the outgoing mayor, David N. Dinkins, set a ninety-day deadline for the developer to either close the deal or forfeit his $33.8 million down payment, a move supported by the editors of the New York Times. With three weeks left before the clock was to run out on Zuckerman's deal, Herbert Muschamp, the recently appointed architecture critic at the New York Times, endorsed the Dinkins-brokered compromise leading to Zuckerman's latest 1.1-million-square-foot, 600-foot-tall office tower proposal, which the critic believed could lead to a more "thoughtful architectural resolution."[36]

After a postponement of Zuckerman's deadline in March 1994 and intense negotiations with the newly elected Giuliani administration that the New York Times regarded as political favoritism in support of the developer whose newspaper, the Daily News, had supported his campaign, the value of the site was reappraised downward, and in June 1994, the developer agreed to buy only the northern half of the site for less than a quarter of the original price. But even this deal unraveled in July when Zuckerman failed to meet a deadline to sign a contract with the MTA, at which time the Times editors celebrated: "Goodbye to a Bad Deal."[37]

In January 1997, Jayne Merkel, editor of *Oculus*, reviewed the nine proposals, remarking that "though concern for context was evident in the urban design of the schemes—and mandated in the guidelines developed by Ehrenkrantz & Eckstut Architects for the MTA"—most architects "expressed . . . [a] new-found optimism with a modern idiom more reminiscent of Zaha Hadid than McKim, Mead & White."[40] The Trump Organization in partnership with Colony Capital of New York retained Robert A. M. Stern Architects and Costas Kondylis & Associates, and the team proposed a single 750-foot-tall tower slab containing apartments and a hotel set diagonally on the southern half of the site, where "competition for vistas with One Trump Plaza [Trump International Hotel & Tower] would be minimized."[41] The diagonal orientation was also in keeping with the already established diagonals at the northwest and northeast corners of Central Park, where similar, if less complex, traffic circles existed. The slab was articulated with bay windows that gave it a folded appearance. According to Stern, the decision to pile the bulk on the south side of the site, left the "great raw bulk" of the Coliseum facility undisturbed, pending the emergence of a tenant who could take advantage of its flexible interior spaces.[42] The proposal of Discovery Circle Partners, which consisted of Hines GS Properties, the Simon Property Group, and David Plattner of Original Ventures, was also massed on the south side of the property and called for a taller, thinner tower than Stern's, articulated by an abstract composition of a few thick horizontal notches played off against numerous thin vertical mullions. A cylinder on a triangular slab on the roof

furthered the impression of "futuristic amazement" in the old Coliseum, which would house a science museum, entertainment complex, shopping mall, and a domed rooftop swimming pool complete with bodysurfing waves.[43] Far and away the most bizarre proposal, the scheme, described as a "World's Fair for the new millennium," designed by Andrew Cohen of the Los Angeles office of Gensler & Associates, consisted of 600,000 square feet of retail and entertainment space as well as a 400,000-square-foot exhibition area to be housed in the existing Coliseum building, which would be given four additional floors and a new facade with a huge window overlooking Sixtieth Street that would provide passersby with a look into a giant aquarium.[44] A single residential tower would complete the development.

HLW International's boldly triangulated tower was another one confined to the south side of the site. As designed for Peter Kalikow, it was intended to house offices for a global communications company as well as twenty floors of apartments. Like Stern's proposal, this one, designed by Paul Boardman of HLW, proposed that the Coliseum roof be developed as gardens and a restaurant overlooking Central Park. Another south side tower was proposed by Murphy/Jahn for the partnership of Tishman Speyer, Mirage Corporation, and Morgan Stanley. This called for a high degree of transparency, with two angular glass towers housing apartments at each end of the site's Fifty-eighth Street frontage, together forming parallelograms where they were joined on the lower floors. Gary Edward Handel + Associates, working with James Stewart Polshek & Partners, produced a more dramatic and elegant essay in lightness and transparency.

Proposal for Coliseum site, west side of Columbus Circle, between West Fifty-eighth and West Sixtieth Streets. Murphy/Jahn, 1996. Rendering of view to the southwest. MJ

Proposal for Coliseum site, west side of Columbus Circle, between West Fifty-eighth and West Sixtieth Streets. Gary Edward Handel + Associates, with James Stewart Polshek & Partners, 1996. Rendering by Tom Schaller of view to the west. PPA

Proposal for Coliseum site, west side of Columbus Circle, between West Fifty-eighth and West Sixtieth Streets. Kevin Roche John Dinkeloo and Associates, 1996. Rendering of view to the northwest. KRJDA

Their proposal, developed for Millennium Partners, called for two towers of radically different size: a sixty-four-story glass tower to be built on the south side of the site, more or less where the 10 Columbus Circle office building stood, and a much smaller, largely masonry-clad tower on the north. According to Handel, the idea behind this split was contextual, with the taller building scaled to midtown's skyscrapers and the lower tower relating to those towers along Central Park West. The proposal combined 500 apartments with a 1,000-room hotel, an electronics exhibition hall occupying the space of the Coliseum, and what was billed as "New York's first urban spa," complete with outdoor tennis courts, a pool, and landscaped roof terrace, all visible through a gridded glass wall wrapping the circle.[45]

Kohn Pedersen Fox and Gruzen Samton proposed an unmatched pair of flat-topped towers that were each partly sheathed in glass and partly horizontally banded in masonry. Their client was Coliseum Partners, a joint venture of the LeFrak Organization, Edward Minskoff Equities, and DLJ Real Estate Capital Partners. The architects emphasized that the geometry of their towers would mirror that of the city grid, with a portion of each tower rotated to parallel the axis of Broadway. The principal designers were KPF's James von Klemperer and Joshua Chaiken, working with William Louie. Kevin Roche John Dinkeloo and Associates, working for Silverstein Properties and Cousins Market Centers of New York, proposed to reclad Levy & Levy's office tower, adding four more floors in a gabled glass crown, and to build two new fifty-eight-story glass-sheathed residential towers containing 840 apartments in all facing Sixtieth Street, each set on the diagonal and perpendicular to each other.

The two remaining schemes proposed to distribute the bulk throughout the site. Cesar Pelli & Associates, working for Columbus Circle Associates, a group made up of Forest City Ratner, Daniel Brodsky, and Peter Lehrer, rejected the glassy fronts of many others, preferring to frame Columbus Circle at the base and to sheathe the towers in abstractly patterned, chunkily detailed masonry. But, as Jayne Merkel observed, the scheme developed by David Childs with his firm, Skidmore, Owings & Merrill, working in association with Elkus/Manfredi Architects of Boston, was "the most dramatically contextual" of all the proposals.[46] Developed for Columbus Centre Partners, a collaboration of the Related Companies and Himmel and Company, the distinctly historicizing project had about it both a whiff of Rockefeller Center and a heavier scent of the twin-towered apartment houses of the 1920s and 1930s that gave Central Park West its memorable and distinct character. Childs proposed three complexly massed, many cornered, step-back towers, the tallest two of which framed the mandated Fifty-ninth Street view corridor that was punctuated by a large globe of the world suggestive of Lee Lawrie's Atlas statue (1936) in the courtyard of 630 Fifth Avenue in Rockefeller Center.

Ada Louise Huxtable, writing for the *Wall Street Journal*, greeted the nine schemes with characteristic sarcasm in a review called "Feeding the Coliseum to the Lions," which portrayed the MTA's selection process as worthy of a circus. Returning to a phrase she had used a number of times before, Huxtable wrote, "Columbus Circle is an object lesson in how not to build a city." Given the financial stakes, the architectural proposals were irrelevant: "You could put the Taj Mahal (from Agra, not Atlantic City) here and it would be lost in the messy maze of hazardous mediocrity that creates no place and answers to no plan." Huxtable was particularly critical of the failure of the MTA to demand "a coordinated overview and effort by those who have the talent, training and understanding to guide development in the ways that make a city great, or at the very least, define a public place. You do not get this by selling off publicly held chunks of land for a free-for-all of real estate opportunities. Instead, long-term leases can assure continuing cash flow and control." Huxtable argued that the site should "not be 'privatized'. . . . The Coliseum land was expensively purchased in the first place—at six times the cost of any other public redevelopment site. . . . What is being lost forever by the aggressive and conspicuously unrelated disposition of these public parcels at Columbus Circle is the opportunity, finally, to create a unified, distinguished urban solution for a prime public space in New York." Huxtable singled out Murphy/Jahn's "cool, composed, well-organized architectural response to the site . . . in an appropriate style for the time and place, with towers that do not sprout like asparagus or wear neoclassic aedicule ears, but relate to each other in form and plan and to a skillfully integrated base."[47]

In a move that surprised many observers, Herbert Muschamp seconded Huxtable's assessment, casting his vote in a splashily illustrated presentation that pronounced Helmut Jahn's plan "more than worthy of this site. It is on a par with the best architecture in the world today. . . . Jahn pushes glass beyond the building envelope, so that one sees the glass as pure transparency, as well as the semi-opaque curtain wall." Polshek & Partners' scheme was the "only other proposal" Muschamp "could reasonably call architecture. . . . But Polshek's is cautious compared with Jahn's design."[48]

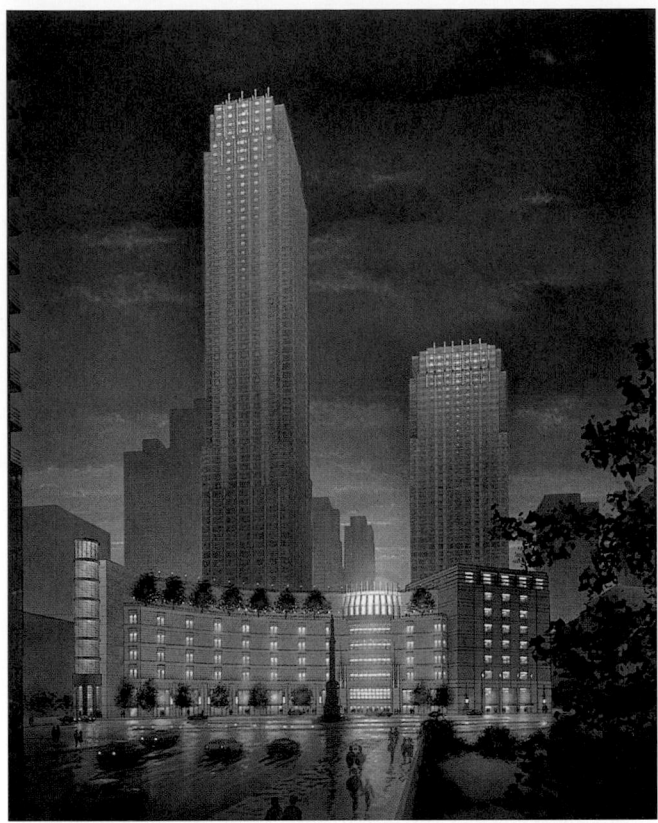

Proposal for Coliseum site, west side of Columbus Circle, between West Fifty-eighth and West Sixtieth Streets. Cesar Pelli & Associates, 1996. Rendering by Lee Dunnette of view to the west. CPA

Proposal for Coliseum site, west side of Columbus Circle, between West Fifty-eighth and West Sixtieth Streets. Skidmore, Owings & Merrill, 1996. Rendering by Michael McCann of view to the west. SOM

Given his reputation for flamboyance and the fact that his team was rumored to offer $300 million for the site in part to protect his investment in the Trump International Hotel and Tower (see below), Donald Trump's proposal, for a while seen as a likely victor in the MTA auction, was parodied by the writer Larry Doyle and the illustrator Joe Davis, who together created a witty spread for the *New York Observer*. When the editors of *Oculus* asked five architects to make their own observations, Diana Agrest, preoccupied by the site's intersecting geometries, chose Cesar Pelli's and KPF's proposals, each with two towers, each preserving an open visual corridor along Fifty-ninth Street, and each completing the context "to become part of the fabric of the city."[49] Frederic Schwartz, taking a more cynical view, wrote that all nine proposals were "essentially the same, clothed in different styles." Schwartz felt that no matter which scheme was chosen, the rich in their condos would benefit at the expense of the public realm: "Poor Columbus," he wrote, "once again overwhelmed and overshadowed in the center of his circle." But Schwartz did have a winner: "the Dynamic Duo: Stern and Trump. A perfect match. Most likely to succeed. Most New York knowledgeable. Most likely to work with Upper West Siders. Architects won't like it; people will."[50]

As the city and state crunched numbers, the Municipal Art Society began to question the selection process, asking for an opportunity to review and evaluate the designs. In February 1997, the Municipal Art Society exhibited the nine designs in an exhibition, "Full Circle," which drew over 4,500 people to the Urban Center during its run through April 1. The exhibit was accompanied by a two-day symposium held on February

19–20, 1997, at 10 Columbus Circle. Intended to focus attention on the traffic circle's design potential, the symposium would lead to a Municipal Art Society–sponsored competition early in 1998 (see below). While the proposals were being evaluated, the Municipal Art Society lobbied the MTA, the governor, and the mayor to give more consideration to neighborhood issues, to the public character of the street wall, and to the shadows the proposed buildings would cast. In the face of governmental intransigence, the Municipal Art Society let it be known that it would once again take legal action to assure a more responsive project.

Early in May, the number of competitors was reduced to five: Millennium Partners; Ratner, Brodsky, and Lehrer; Related and Himmel; Tishman Speyer; and Trump and Colony Capital.[51] But in July 1997, in a surprise move, Mayor Rudolph Giuliani threatened to block the sale because there was not enough emphasis being put on long-term benefits or on the architectural merits of the various proposals. In what was perhaps the most startling moment in the almost endless saga of the project's gestation, Giuliani, an avowed opera lover who had nonetheless hitherto shown no significant interest in the city's cultural life, insisted that the project include a theater for jazz, opera, or Broadway performances, soon deciding to go with the jazz programs sponsored by Lincoln Center, which had for years been seeking to create a new venue in a building in the immediate area of its campus on Broadway and Sixty-fourth Street. In February 1998, the city and state agreed to require the inclusion of a 2,000-seat hall, and developers were asked to resubmit their bids. In April 1998, the media powerhouse Time Warner joined forces

Proposal for Coliseum site, west side of Columbus Circle, between West Fifty-eighth and West Sixtieth Streets. Skidmore, Owings & Merrill, 1998. Rendering of view to the southwest. SOM

with Stephen Ross's Related Companies, overshadowing what had been a seeming lead by Millennium Partners, and bringing with it the possibility of creating the city's largest digital television production studio, to be shared by the Cable News Network (CNN) and New York 1 cable channel. Moreover, with Time Warner, the Related Companies had a blue-chip tenant. Still, the selection process dragged on, with fears widely expressed that by the time a decision was made and the plans realized, the project might fall victim to a collapsed real estate market.

By this point, Donald Trump, whose interest in the project had begun to waver early in the year, was once again enthusiastic, offering what was the highest bid, but the single slab approach designed by Stern was not looked on favorably, and Trump's oversized ego was hardly an asset. On July 27, 1998, a deal was struck, with the Related Companies paying about $345 million for the right to develop the site according to a design by David Childs that had been revised since its last iteration in 1996, but still called for two intricately massed towers framing the Fifty-ninth Street axis, where a skylit atrium replaced the globe of previous versions.[52] More to the point, as Herbert Muschamp noted, "instead of sheathing the project's two towers with masonry, the architect now proposes to dress them in glass." Though the critic found this change in material to be "a major improvement, one that will open up the potentially hulking project to reflections of sky, light and space," he did not concern himself with the complex

issues of privacy and exposed visual clutter such transparency would bring with it. Muschamp was not, however, convinced that Childs's design was an appropriate expression of the times, writing that it was "skillful, earnest, and devoid of meaning."[53] By year's end, Muschamp was even more negatively disposed, stating that Childs's project "epitomizes the architecture of denial," representing "an utter lack of awareness that New York today differs dramatically from the city in the 1930s, and that this difference demands architectural interpretation. In particular, the design denies the extent to which the city is now governed by congestion, density and bulk"–as if the city of the 1920s and 1930s, when the cult of congestion was at its peak, was not. "Should this building rise in its present form, we will all hate ourselves for tolerating structures so flagrantly out of touch with the imagination we all came here to exercise."[54]

Demolition of the Coliseum began in September 1999 when Paul Manship's four decorative plaques were removed from the principal facade and taken to Warren, Connecticut, for restoration, with their ultimate fate undetermined.[55] A month later, the flea market that for five years had occupied the southeast corner of the building closed, and in November the MTA, which had occupied a good deal of space in 10 Columbus Circle, relocated downtown to Two Broadway.[56] By February 2000, the interiors of the complex had been largely stripped, and the actual demolition of the superstructure got under way.[57] With the building's removal by June, New Yorkers marveled at the amplitude of the site and enjoyed the long-blocked vista down Fifty-ninth Street.[58]

As demolition proceeded, so, too, did the detailed development of the selected design, which was revised to meet the specific needs of the numerous tenants and the growing sense among city planners and others that David Childs's Art Deco–inspired scheme was somehow old hat. Late in June 2000, Childs unveiled what would be the final scheme, in which the basic parts remained the same but their detailed arrangement and exterior cladding were dramatically changed.[59] The redesign process had not been a particularly smooth one. The difficulty in arriving at the final solution had lay in the inability of the panel of experts convened by Joseph B. Rose, chairman of the City Planning Commission, to decide on a direction. The tension between the review committee, which included Jaquelin T. Robertson, John S. Dyson, a former deputy mayor, Jack L. Goldstein, executive director of the Theatre Development Fund, Andrew Heiskell, chairman emeritus of the New York Public Library, and the architects was almost unbearable. As Rose put it: "When the architects came back treating the feedback as if it were 'tweak this and tweak that,' the response was fairly brutal."[60] The normally unflappable Childs neared the end of his patience: "I'm pretty good at compromise," he said, "but at a certain point, I said: 'I've let this go too far. We'll get the building done but frankly, I don't want to have my name on it.'"[61] With the steel already ordered, everyone was resigned to a design that no one really liked when Childs and his partners T. J. Gottesdiener and Mustafa K. Abadan made one more try, proposing broad planes of lightly tinted glass arranged to transform the boxy towers into parallelograms reinforcing Broadway's diagonal geometry, a design that at last broke the logjam of disagreement and allowed the team of architects, which had by now grown to include Rafael Viñoly for the concert hall, Elkus/Manfredi Architects for the

Proposal for Coliseum site, west side of Columbus Circle, between West Fifty-eighth and West Fifty-ninth Streets. Skidmore, Owings & Merrill, 2000. Rendering by Tom Schaller of view to the west. SOM

contemporary place in the skyline. Aesthetic backsliding," he continued, "also infects the main base facade," which he felt was a failed lingering effort to treat Columbus Circle as a classical rond-point." But all in all, Muschamp seemed to think the project was on track:

> Even in its compromised state, the new design is a compelling recapitulation of S.O.M.'s history. It fuses the International style crispness of the firm's vintage years with the revivalist imagery of more recent work. And it reaches back further, attempting to reconcile the differences that divided modernist architects from their Art Deco counterparts in the 30s. Like a jazz figure, the design picks up a tune that has been bouncing around town for the better part of a century. At dusk, when the lights come up on the skyline, indigo will reverberate between the towers. Only in New York could a colossus become a mood piece.[62]

Martin Filler, who only recently had found a regular home for his outspoken criticism in the pages of the *New Republic*, would have none of it: "What is all the cheering about?" he asked. "There is no cause for celebration." Filler was particularly troubled by Childs's use of glass:

> In his present and presumably final version, Childs has sleeked down the exterior in superficial accord with the current fashion for 'light construction' (the term that Terence Riley popularized in 1995 with his Museum of Modern Art exhibition of the same name, documenting a widespread tendency toward a neo-modernist high-tech aesthetic). The cast-stone paneling of Childs's 1988 scheme has given way to an opalescent glass skin, and the finicky detailing has been replaced by smooth surfaces. Yet light construction also implies the dual phenomena of weightlessness and transparency; and there is none of the former and little of the latter in evidence here.[63]

As construction of the Time Warner Center, so named after the prefix "AOL" was dropped both from the name of the company and the building in 2003, proceeded, opponents made last-ditch efforts to slow things down. Notable was the fact that the building's gross floor area of 2,787,000 square feet was actually greater than the 2.1 million square feet the site was zoned for—a circumstance attributable to the presence of so much mechanical and basement space, which didn't contribute to the official amount allowed under zoning. The Committee for Environmentally Sound Development challenged the project in 2001, saying it was 33 percent larger than when it had undergone an environmental review in 1997, before developers were selected, but they lost the case in December 2001.

In February 2002, the steel portion of the building was topped out, forming the structure of the lower floors that housed Time Warner's 864,000 square feet of offices and studios, and the retail portion of the building, which provided more than 500,000 square feet of stores and restaurants. The towers, not requiring such large clear spans, were built of concrete. The scale of the project was immense, in all requiring twenty acres of glass, 26,000 tons of steel, and 215,000 tons of concrete. In addition, according to Robert D. Feller, the president of North American operations for the GMAC Commercial Mortgage Corporation, the $1.1-billion construction loan and $200 million of other financing provided to the developers constituted "the largest single commercial construction loan ever made in the history of this country."[64] Another of the building's superlatives was the water-clear

retail space, Brennan Beer Gorman Architects working with Hirsch Bedner Associates for the hotel, Ismael Leyva and Thad Hayes for the residential units, and HLW International for the offices (Perkins & Will took over in May 2001 for the interior fit-out), to move forward.

Herbert Muschamp greeted the final scheme with considerable enthusiasm: "The new design . . . is an asymmetrical composition of crystalline contour. Sleek, abstract geometry has replaced excessively detailed Art Deco motifs. . . . Instead of mimicking" Irwin Chanin's Central Park West towers, "at three times the scale, the design taps into what was essential in his work." But Muschamp demurred over the handling of the building's base and the crowning features of its towers, where he believed "the design withdraws into nervous period mannerisms." Given the participation of Jazz at Lincoln Center, Muschamp could not resist making analogies to music: "Even the two towers now have swing," promising to "rise like upended prisms." He admired the pearlescent shade of the glass proposed for the skin, like "a friendly ghost," and seemed to accept the small fins of glass that would project from the top of the towers to suggest a crown: "Depending on the sun, and on one's angle of vision, these will scatter light across the surface, as if a jeweler's hammer had split the building's crystalline formation into a thousand glinting shards." But he did not like the three-story lanterns that crowned the towers, feeling that they introduced a "note of pastiche at precisely the climactic moment when the towers should claim a

Time Warner Center, 10 Columbus Circle, west side between West Fifty-eighth and West Sixtieth Streets. Skidmore, Owings & Merrill, 2004. View to the northwest. Sundberg. ESTO

Associates. Opened on November 15, 2003, the 277,000-square-foot, 251-room hotel, occupying the thirty-fifth through fifty-fourth floors of the north tower, was entered through a Sixtieth Street lobby featuring a smoke-colored glass chandelier by the artist Dale Chihuly. Elevators brought guests up to the thirty-fifth floor, which accommodated the hotel's lobby, a ninety-seat restaurant, Asiate, designed by Tony Chi, and MObar, a bar and lounge that quickly became well known for its stunning views of the city. The hotel also provided a 5,000-square-foot ballroom, meeting rooms, and a fitness center with swimming pool. Despite the luxury, Paul Goldberger found the interiors to be "conventional—lots of marble and swirling decorations that are intended to distract the eye from the spaces, which are often cramped and awkward."[66]

Time Warner Center's retail component, combining the so-called Shops at Columbus Circle with five restaurants known collectively and not a little pretentiously as the "Restaurant Collection," opened on February 5, 2004, with an overblown celebration for 8,000 invited guests, not all of whom were so impressed, among them David Hershkovits, the editor of *Paper* magazine, who commented: "I ask my wife out for a night on the town and we wind up in a food court," and Alex von Bidder, an owner of the Four Seasons restaurant, who when asked why he wasn't wearing a tuxedo, responded, "Black tie? Why? It's a shopping mall."[67] The retail space was about 90 percent occupied at the time of the building's opening, with stores situated around a four-story, eighty-five-foot-wide atrium aligned with Fifty-ninth Street and crossed by a crescent-shaped north–south passage connecting Fifty-eighth and Sixtieth Streets. For many, the most welcome retailer was the grocery store Whole Foods, whose 59,000 square feet incorporating a 248-seat café and forty-two cash registers, and requiring 390 employees, qualified it as the largest supermarket in Manhattan. Upscale as the stores were, in the final analysis the retail component was very much a typical, albeit expensive, shopping mall, a term the developers struggled to banish from the discussions, instead promoting the Shops as an "urban retail center."[68] For Goldberger, the potentially dynamic shape of the retail atrium was not well handled: Elkus/Manfredi "turned what might have been a stunning, curving arcade into something unpleasantly close to a suburban mall, full of fussy decorative columns."[69] Joseph Giovannini found the environment to be "lavish with rich marbles and exotic metals, yet oversized, frigid, and charmless."[70]

The third and fourth floors housed the Restaurant Collection, with the fourth floor accommodating the more haute cuisine eateries, including Thomas Keller's 13,000-square-foot, sixty-four-seat Per Se, designed by Adam Tihany; Jean-Georges Vongerichten's 225-seat, 9,000-square-foot steak-house, Rare, designed by Jacques Garcia; and Masa Takayama's Masa, where dinners cost $500 per person and seating was limited to a ten-seat counter and two eight-seat private rooms. Rande Gerber's Stone Rose was also opened on the fourth floor, a bar and lounge designed by the Toronto-based firm of Yabu Pushelberg serving food by Jean-Georges Vongerichten. The third floor housed chef Gray Kunz's Café Gray, designed by the Rockwell Group, but another venue planned for the third floor, a seafood restaurant to be run by Chicago chef Charlie Trotter and designed by Michael Graves, did not open. Addressing concerns that well-to-do patrons prepared to spend a good amount of money on a meal might not enjoy a four-story escalator ride

glass and stainless-steel cable net wall, the largest of its type in the world, suspended from a truss at the top of the base to face Fifty-ninth Street above the building's main entrance. Designed by James Carpenter Design Associates and measuring 149 feet tall by 86 feet wide, it was intended "to be as delicate, transparent and diaphanous as possible, both to afford views in and simultaneously views out," according to Carpenter.[65]

The first component of the building to be completed was the Mandarin Oriental Hotel, with interiors designed by Brennan Beer Gorman Architects working with Hirsch Bedner

Time Warner Center, 10 Columbus Circle, west side between West Fifty-eighth and West Sixtieth Streets. Skidmore, Owings & Merrill, 2004. View to the west. McGrath. NMcG

through a shopping mall, a separate bank of three elevators afforded more direct access to the restaurants from the Sixtieth Street entrance.

The Time Warner Center's 191 residential units, located on the upper floors of the south and north towers, where they were known respectively as One Central Park and the Residences at the Mandarin, sold with mixed success. While there were still plenty of units available at the time of the building's opening, a 12,000-square-foot duplex penthouse in the south tower was sold to a London-based financier for $42.5 million, making it—at $3,541 per square foot—the most

expensive condo ever sold in the city. The apartment was fitted out by Peter Marino.

The last component of the building to open was the new home for Jazz at Lincoln Center, designed by Rafael Viñoly and named after Frederick P. Rose, whose posthumous gift ensured its construction, although it represented only 10 percent of the project's $103 million price tag.[71] Plans had been unveiled in May 2000 for what was believed to be the world's first performing arts facility designed specifically for jazz, a medium more traditionally associated with street corners, nightclubs, and recording studios. Viñoly's design called for

the Rose Theater, a 1,100- to 1,300-seat reconfigurable concert hall with a ninety-foot fly and rigging suitable for full operatic and theatrical productions; the Allen Room, a 600-seat performance atrium overlooking Central Park through a fifty-foot-high glass wall; a 140-seat café called Dizzy's Club Coca-Cola, also overlooking the park; an education center; rehearsal, recording, and broadcast studios; and an interactive hall of fame named for the jazz record producer Nesuhi Ertegun. While the Rose Theater proved to be a fine if somewhat bland room, the Allen Room, with its giant window and tiered seating platforms ascending from the stage level to a dance floor with movable tables and chairs, was far and away more spectacular.

Despite the fact that the light gray, nearly colorless glass originally specified to clad the Time Warner Center was replaced by a much darker shade of gray, fostering a sense of brooding bulkiness, the complex was greeted with general approval by many critics, including Ada Louise Huxtable, who found it to be "exactly what a New York skyscraper should be—a soaring, shining, glamorous affirmation of the city's reach and power, and its best real architecture in a long time. . . . The wonder is the delicacy, the elegance, of these perfectly calibrated, glittering glass facades, the suave, sharp-edged precision that is amazingly subtle and refined for a structure of this enormous size."[72] Herbert Muschamp, who, it is said,

played a behind-the-scenes role as design consultant as the scheme was in its last stages of evolution, enthused that the building was a "giant cluster of glass crystals, which appears to have been quarried from the sky." The two towers, he felt, were "worthy descendants of Radio City." Referring to the 1987 protest in Central Park against the shadows that would have been cast by Moshe Safdie's proposal, Muschamp wrote: "Mr. Childs's response to this demonstration is somewhat perverse. As realized the two towers of 10 Columbus Circle have taken the form of shadows themselves: they resemble the oblique, cinematic oblong forms cast over the cityscape in black-and-white movies of the 1940's and 50's. Now we've got four shadows for the price of two."[73]

Paul Goldberger, perhaps closer to the mark, wrote that the Time Warner Center wasn't "a bad piece of urban design," especially in light of the curve of the base, which gave "the circle a monumentality that it never had before." But that was about as much enthusiasm as he could muster: "If you don't look up, you could like this building. . . . The architecture above the rounded base is dull and conventional. The towers are nicely shaped but banal, and the glass is far too dark. . . . Childs did add some small glass fins that project from the tower facades and provide a bit of texture, but they are not enough to give any real panache or dignity to the place." Goldberger wasn't thrilled by the mix of uses either, calling the building a "theme-park version of a sophisticated urban building . . . the sort of thing you would expect to find on North Michigan Avenue in Chicago but not in a city that is as fully defined by its street life as New York is."[74]

Joseph Giovannini agreed with Goldberger that a lighter-colored glass would have been better, taking issue with the "dull pewter-colored glass with little life and none of the light promised" by the most recent renderings and models. Giovannini was further frustrated that "the knife edges that now define the outside corners of the building bracket facades whose mullions pucker the surfaces like a seersucker jacket. The oil-canning, as it is called by architects, undermines the prismatic purity of the forms. Energy standards for glass and tight budgets often compromise the quality of high-rise cladding, but normally SOM architects, experts in skin, pull off elegant facades: Here they did not solve that problem." Echoing Goldberger, Giovannini concluded, "What starts as a geometrically liberated building with great urban promise finally emerges as a sanitized urban environment with a skin problem. The building that thrives off New York and looks like New York behaves like Houston."[75]

The Circle

In 1981 the Institute for Architecture and Urban Studies sponsored an ideas competition for the redesign of Columbus Circle, long the most famously bedraggled of New York's open spaces. In the 1950s, the classical architect John Barrington Bayley had proposed a grand scheme for the circle, as had Edward Durell Stone.[76] The IAUS competition's schemes, according to Aaron Betsky, "unfortunately showed more conceptual than applicable originality."[77] One of the proposals, Billie Tsien's "Dig a Hole to China," called for a vast hole in the middle of the traffic circle. Herbert Muschamp exulted in

Allen Room, Jazz at Lincoln Center, Time Warner Center, 33 West Sixtieth Street. Rafael Viñoly Architects, 2004. Feinknopf. RVAPC

Dig a Hole to China, proposal for Columbus Circle. Billie Tsien, 1981.
Rendering of view to the northwest. TWBTA

Proposal for Columbus Circle. Frederic Schwartz, 1981. Rendering of view
to the south. FS

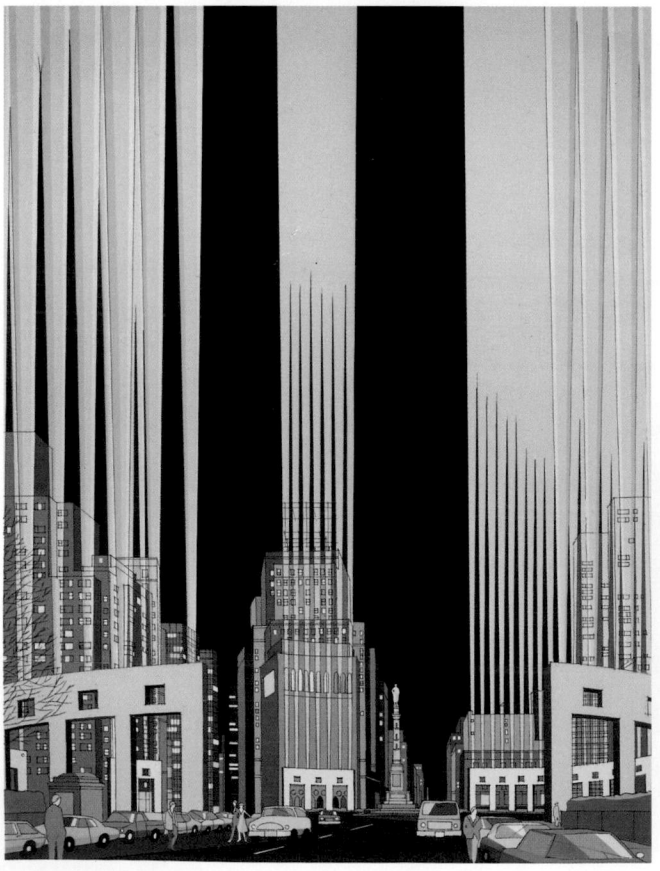

the design years later, calling it "the best and the darkest of the many proposals ever put forward" for Columbus Circle.[78] According to Betsky, only Frederic Schwartz's proposal "had any degree of relevance to the actual complexity of the problem."[79] Schwartz, recalling Stone's proposal to situate the demolished Penn Station's columns around the circle's perimeter, proposed his own broken colonnade around the circle supporting high-intensity lights that would beam upward into the night sky. Diller + Scofidio's proposal, *Traffic*, calling for 2,500 regularly spaced orange traffic cones to be placed in the "island" portions of the circle, was installed for less than twenty-four hours in 1981.

In 1997 the Municipal Art Society turned its attention to the circle.[80] Working with the Tri-Board Task Force on Columbus Circle, which consisted of Community Boards 4, 5, and 7, MAS invited proposals based on Skidmore, Owings & Merrill's 1986 circulation plan, which demonstrated that a circular flow of traffic could replace the utterly chaotic and pedestrian-unfriendly pattern that held sway since the last major reworking of the circle just before the Coliseum opened in 1956.[81] Out of sixty-five architects responding to the call, five firms were selected, each preparing a scheme for the exhibition, "Full Circle: Invited Designs for Columbus Circle," which opened at the Urban Center on February 18, 1998. The five firms were Rafael Viñoly Architects; Michael Sorkin Studio; Machado & Silvetti Associates in association with Olin Partnership; Weiss/Manfredi Architects; and Kennedy & Violich Architects. In addition, the landscape architect Dan Kiley prepared his own entry.

The deliberately provocative schemes were mostly spectactularly unaffordable and not a little mad. Rafael Viñoly proposed a large hemispherical trellis forming a transparent dome over the circle into which was slung a system of pedestrian ramps and elevated walkways around Gaetano Russo's statue of Christopher Columbus (1892), which would be raised on a new pedestal emerging from a reflecting pool. Michael Sorkin's scheme called for a large, walkable dome with a ramp, in this case connecting the two halves of the circle's subway system. Machado and Silvetti proposed an almost extraterrestrial 340-foot diameter halolike canopy of lighted cables and ramps carried on 140-foot-tall columns. Weiss/Manfredi's plan would remove the ground plane and reveal the subway below. They also proposed a system of ramps, and a new support for the Columbus statue, a strategy similar to Kennedy & Violich's but rather more spectacularly designed and represented. Dan Kiley's, not surprisingly, and rather refreshingly, relied on traditional landscape elements: clipped tree bosks reinforcing the circle's geometry. In spring 1999, Henry Hope Reed weighed in with a plea for a classical treatment of the circle, illustrating his article with a modest scheme of balustrades and lamp standards designed by Ben T. Pentreath of Fairfax & Sammons, architects specializing in traditional design.[82]

As the Coliseum gave way to the wrecker's ball, beginning in August 1998 the city initiated a six-month evaluation period during which time, *mirabile dictu*, the traffic

FACING PAGE TOP *Traffic*, Columbus Circle. Diller + Scofidio, 1981.
View to the north. DSR

FACING PAGE BOTTOM Proposal for Columbus Circle. Rafael Viñoly
Architects, 1997. Rendering of view to the south. RVAPC

FACING PAGE TOP Columbus Circle, 1998. View to the south. Higgins. NYT

FACING PAGE BOTTOM Columbus Circle. Olin Partnership, 2005. View to the east. OP

RIGHT Proposal for Columbus Circle. Weiss/Manfredi Architects, 1997. Model, view to the southwest. Pottle. ESTO

BELOW Proposal for Columbus Circle. Dan Kiley, 1997. Site plan. FLL

rotated in counterclockwise fashion, around a temporary circular central island that was formed with concrete "Jersey barriers" typically used to divide opposing streams of highway traffic. The barriers formed the edge of the island and, after the new pattern proved its efficacy, were used as retaining walls for soil piled behind them which soon enough sprouted shrubs and seasonal flowers.[83] After over a century of chaos, Columbus Circle at last achieved navigational dignity.

Despite the enthusiasm, the scheme was temporary, pending completion of the Time Warner Center, whose developers funded the reconstruction that was completed in summer 2005, when New Yorkers immediately took to its landscaped centerpiece.[84] The Olin Partnership was hired to redesign the circle, calling for a new fountain with arcing jets around a

FACING PAGE Central Park Place, 301 West Fifty-seventh Street, northwest corner of Eighth Avenue. Davis, Brody & Associates, 1988. View to the northwest. DBB

RIGHT Four Columbus Circle, southwest corner of West Fifty-eighth Street. Swanke Hayden Connell, 1989. View to the southwest. Warchol. SHCA

plaza at the base of the Columbus monument, an inner ring of yellow buckeye trees, a concentric landscaped berm, and an outer ring of honey locusts. The inner plaza, lined with benches, was reached by three walkways with decorative paving.

Around the Circle

At the southern edge of the circle, just south of the Coliseum site, the west blockfront of Eighth Avenue between Fifty-seventh and Fifty-eighth Streets was entirely rebuilt in the late 1980s by a group of developers led by the Zeckendorf Companies, whose initial plans called for a mixed-use building with offices, a hotel, and apartments.[85] The northern half of the blockfront, however, occupied by the eight-story former Alpine Hotel, now an SRO, was, according to a citywide moratorium on demolishing such buildings, untouchable. Zeckendorf consequently transferred air rights to the southern portion of the block and hired Davis, Brody & Associates to design Central Park Place, a fifty-five-story, 274-unit apartment tower on a seven-story commercial base completed in 1988. The slender, sculpted tower, shaped by bay windows, chamfers, and small groupings of balconies, was rather disappointingly clad in various shades of gray aluminum and green-tinted glass and topped by an awkwardly massed octagonal water tower enclosure. Though the editors of the *AIA Guide* were "sad that Manhattan's tower mania" had forced the architects of "the city's most distinguished publicly assisted housing . . . to play the 1980s urban finial game," they grudgingly praised Central Park Place as "nicely done, but it's not San Gimignano."[86]

Zeckendorf eventually gained approval to demolish the Alpine Hotel by agreeing to pay for the replacement of its fifty-one units of housing. In its place rose a seven-story, 104,000-square-foot office building, Four Columbus Circle (1989), southwest corner of Fifty-eighth Street, designed by Swanke Hayden Connell, which became the building's main tenants, occupying 68,000 square feet on the top four floors and a penthouse.[87] When the firm suffered severe business setbacks in the early 1990s and relocated to cheaper real estate downtown, its space was taken over by furniture manufacturer Steelcase, which hired Kohn Pedersen Fox to restyle the interior.[88]

At the north end of the circle stood Thomas E. Stanley's Gulf & Western Building (1967), One Central Park West, the city's most inescapably ugly skyscraper, a building fraught with technical problems ranging from the presence of asbestos (typical for buildings of its period) to structural instability—it was said to twist slowly in the wind, causing the potential for its misaligned facade panels to blow off in a windstorm.[89] Early in 1993, General Electric, which held the mortgage to the building that was about to be abandoned by its principal tenant, Paramount Communications (successors to Gulf & Western), foreclosed on the property, leading to an announcement in March 1994 that the building would be converted into an apartment tower developed by Donald J. Trump.[90] After soliciting designs from Robert A. M. Stern Architects and Philip Johnson, Trump turned to the latter, who promised a fin-de-siècle version of the Seagram Building, presumably a favorite of the developer, whose shaky architectural taste was frequently derided by the press. To remove the forty-four-story

building's structural sway, Ysrael A. Seinuk, the engineer, decided to stiffen the structure with two concrete and steel sheer walls in the form of a cross at the building's core. Seinuk pointed out that the sway, which amounted to disconcerting but not dangerous two-and-a-half-foot lateral movements, occurred in part because unlike many towers in Manhattan, "this building is totally exposed," at which point Trump jumped in to say that its isolation was its virtue: "It's a great asset for views."[91] But from Trump's point of view, the building had many other assets besides its location. Its floor slabs were twelve feet apart, allowing for ten-foot-high ceilings, typical for office buildings but virtually unheard of in postwar apartment house construction; it had tremendous height and bulk—579 feet tall and 610,000 square feet—that was actually too much for an apartment building which, according to zoning, could not occupy more than twelve times the lot area. Gulf & Western enjoyed a FAR of 18. To get around this, Trump ingeniously split off the fourth through seventeenth floors to create a condominium hotel containing 167 units with its own separate lobby and elevators, leaving the upper 28 floors for 166 luxury condominium apartments.

Many people were surprised by Johnson's decision to sheathe the building in glass—certainly a request of Trump's. Ever flexible, the architect, just recently famous for his stone-clad skyscrapers—especially his granite-sheathed AT&T Building—proclaimed himself a "glass man."[92] While Costas Kondylis, Johnson's collaborating architect, concentrated on the apartment plans, Johnson worked on the facade, which, in the end, as David Dunlap, the New York Times's savvy real estate writer, noted, looked a lot more like the architect's Pittsburgh Plate Glass office building in Pittsburgh than Mies van der Rohe's Seagram Building in New York. To give the facade sparkle, Johnson treated the exterior columns like glass-sheathed prows.

As construction began in June 1995, Herbert Muschamp likened the redesign to "a 1950s International Style glass skyscraper in a 1980s gold lamé party dress," a transformation he viewed as an "undeniable improvement." Muschamp acknowledged that Johnson had "introduced considerable refinement to an essentially crass idea." The critic welcomed the decision to eliminate the arcade at the base and the crown at the top, yielding "a more dynamic vertical thrust," and admired the projecting V-shaped columns and overall detailing of the curtain wall. But these features could not overcome what Muschamp saw as the "symbolic stridency" of the golden skin proclaiming "the triumph of private enterprise in such a publicly conspicuous place," Columbus Circle. "Now a new Trump flagship sails into these troubled civic waters, carrying with it more than the faint air of a floating casino, or perhaps the winnings from one."[93] Muschamp would be put at least partially at ease when, during the design process, several elements of the project were modified to conform to feng shui principles. Under the advice of Pun Yin, of the Tin Sun Metaphysics Corporation, which was hired, according to Trump, "in respect to our Asian customers," many of whom "have asked us to do feng shui on the building," Trump was dissuaded from using the garish gold skin he originally preferred in favor of a more subdued bronze-tinted glass.[94]

Speaking of the effect of the skin, Johnson proclaimed that the glass would be crinkled "so the reflections on the skyscraper will be constantly changing. When it's finished," he stated in 1996, "it should be visually stunning because, depending upon the play of light, some parts will be black and some pure white."[95] But in fact the surface effects proved to be much less varied. The feng shui consultant also called for the construction of a globe at the south end of the tower, where the site came to a point, because "it neutralizes the forces" with its rings representing "the unity and harmony of the world."[96] Many observers deemed the globe a risible version of the Unisphere, one of the few remaining features of the 1964 World's Fair.

Two Columbus Circle

In December 1976, Gulf & Western Industries purchased as a gift to the city Edward Durell Stone's critically controversial ten-story gray-veined white Vermont marble-clad Gallery of Modern Art (1964), Two Columbus Circle, located on a small, wedge-shaped block bounded by the circle, Broadway, Fifty-eighth Street and Eighth Avenue.[97] Never able to secure a niche in New York's art world, the museum's founder, A & P supermarket heir Huntington Hartford, had transferred the building in 1969 to Fairleigh Dickinson University, which used the space for the New York Cultural Center, a gallery dedicated to innovative rotating exhibitions, from 1970 until its closing in September 1975. According to Charles G. Bluhdorn, chairman of Gulf & Western, headquartered on the north side of the circle, the decision to buy the building and give it to the city, which intended to use it as a home for its Department of Cultural Affairs and the New York Convention and Visitors Bureau, was motivated by "enlightened self-interest" on the part of his company and by a desire to demonstrate "confidence and credibility in our country and our city."[98] Although the editors of the New York Times applauded Gulf & Western's generosity, writing that "there is good news for the little seraglio on Columbus Circle" that has "always been a better traffic island than museum," they were concerned about potentially escalating maintenance costs: "Its third incarnation . . . raises doubts. There are discrepancies between past operating costs and projections for the future that could perform the zoological feat of turning a well-meant gift horse into a white elephant." The editors concluded on a pessimistic note: "There is little question about the civic spirit of Gulf & Western's fine gesture. But this seems like one more maverick solution for the albatross of Columbus Circle, rather than a constructive planning effort."[99]

The decision of Gulf & Western to pay for four years' worth of maintenance costs as well as the renovations themselves convinced Mayor Koch to support the plan. In November 1980, the work was complete, with the Department of Cultural Affairs occupying four floors as well as controlling the 154-seat auditorium and the upper-floor restaurant, both of which could be rented to nonprofit groups at modest rates. The Convention and Visitors Bureau took over three floors and opened an information center in the lobby. In April 1981, the City Gallery opened on the second floor, home to modest temporary exhibitions.

In October 1995, fifteen years after the renovations, the new Giuliani administration announced its intention to sell the building.[100] In addition to raising revenue, there was also the widespread belief that the space had not worked well for

its municipal tenants, which, as Paul Goldberger put it in 1991, fit "no better into its awkward, cramped galleries than Mr. Hartford's pictures did."[101] Nine months passed, however, before the subject was raised again by city officials. In July 1996, as part of plans to reinvigorate the development of the Coliseum site (see above), and with construction having begun on the conversion of the Gulf & Western Building into a hotel and condominium tower (see above), the Giuliani administration repeated its desire to sell the building to private interests and officially requested proposals for its redevelopment.[102]

Although Herbert Muschamp had some kind words about Stone's building, writing that the "gallery was a remarkable example of the cultural and material abundance that New York enjoyed in the mid-1960s," he concluded that there was "little likelihood" that Two Columbus Circle would survive.[103] But a vocal movement to save Stone's building emerged, one that completely caught government officials off guard. As Charles Millard, president of the New York City Economic Development Corporation, quipped: "I wasn't aware that people thought it was important to the urban milieu to preserve ugly architecture."[104] An early and enthusiastic supporter of the building was novelist Tom Wolfe: "It's a very elegant, beautifully decorated civic ornament. It is the only distinguished piece of architecture at Columbus Circle, and it really is a jewel. It's this lovely white . . . piece of drama!"[105] Another leader in the effort to preserve Stone's building was Robert Stern, who noted to a reporter from the New York Observer in October 1996, "Some people think it's a silly building and some people don't. If you used that standard, we would have torn down every building from the Victorian era, which, in fact, we were hellbent on doing for a while. It's an idiosyncratic building, but New York City is a city full of idiosyncratic buildings, and we don't want everything to be plain vanilla, do we? By any and every standard of what a landmark is, this is a landmark."[106] Although several attempts were made to bring the matter before the Landmarks Preservation Commission, to the dismay of the building's supporters, the commission steadfastly refused to hold public hearings on the proposed designation of Stone's building.

In February 1997, the Economic Development Corporation announced that it had received seven proposals for the site, which ranged from the Calder Foundation's plan to reuse the galleries but reclad the facade to a proposal from the New Thought Institute to turn the building into a spiritual retreat and conference center. Two candidates quickly emerged as the most likely to go forward. The Dahesh Museum, founded in 1995 and located in 1,800 square feet of space in 601 Fifth Avenue, proposed to keep Stone's building and return it to museum use. The bid from the Dahesh Museum, an institution dedicated primarily to the display of European academic art from the nineteenth and early twentieth centuries, attracted many supporters, not only because museum officials pledged to save Stone's building but because the Dahesh collection seemed an appropriate successor to the representational art in Huntington Hartford's museum. The other leading competitor was Donald Trump, who had just completed the renovation of the former Gulf & Western Building and was still actively pursuing the development rights to the Coliseum site. Trump proposed to tear down the Stone building and replace it with a thirty-story hotel. The developer was hardly apologetic about his intentions, deeming Stone's museum "a terrible building. It's really an atrocity to Columbus Circle."[107]

While preservationists mounted a campaign in defense of Stone's building, the Economic Development Corporation refrained from selecting a developer. In April 1998, the Department of Cultural Affairs moved its offices, leaving the building vacant. Four months later, interest in the project gained momentum when the city announced that a developer had finally been chosen for the Coliseum site. Those in favor of retaining Stone's building picked up an ally in David Childs, the architect for the new Columbus Circle building, who stated that Stone's design represented "a moment in this century extremely well. If someone could figure out a use for it, it would really be a good thing to save."[108]

For the next two years, no progress was made, and in March 2000, the city announced that it would issue a second request for proposals and abandon its current effort.[109] The delays continued, and a tight-lipped City Hall did not reveal its selection until June 20, 2002, when it was announced that the American Craft Museum would get Stone's building, besting a slightly higher bid from Donald Trump, who still wanted to demolish the building and replace it with a hotel.[110] The American Craft Museum, currently located in a purpose-built facility designed in 1986 by Fox & Fowle at 40 West Fifty-third Street (see MoMALand), stated its intention to replace the facade of Stone's building as well as extensively renovate its interior. Supporters of Stone's building, upset that the Dahesh Museum's bid had been rejected, pledged to continue their efforts to retain the original design.

In November 2002, five months after being picked by the city and a month after changing its name to the Museum of Arts & Design, the museum announced that it had chosen Brad Cloepfil of Allied Works Architecture, based in Portland, Oregon, to design its new home, picking from a short list that also included Zaha Hadid, Smith-Miller + Hawkinson, and Toshiko Mori.[111] Cloepfil's revision of Stone's building was not released until April 2003, and though it called for keeping the size and shape of the original, it otherwise radically transformed the 1964 building with a new facade composed of terra-cotta panels. Daylight would filter in between slits and openings between the four-inch panels, allowing museumgoers glimpses of Central Park. Except for a pledge to largely keep the auditorium intact, the plans called for a complete overhaul of the interior.

Reaction to Cloepfil's design within the preservation community was swift and, not surprisingly, highly critical. "Whatever its merits," wrote Kate Wood, executive director of Landmark West, "Brad Cloepfil's design is hardly an homage to Stone, one of America's most significant architects, a leader who challenged orthodox Modernism and argued that the inspiration for a building should be in the accumulation of history. The proposed new design utterly erases Stone's vision for 2 Columbus Circle by eliminating its most evocative features: its noble white-marble cladding, 'porthole' windows and whimsical 'lollipop' arcade."[112] In a lengthy two-part op-ed article in the New York Times that was published on consecutive days in October 2003, Tom Wolfe defended the merits of Stone's building while attacking Cloepfil's redesign. "Does the municipal log duly show that Brad Cloepfil . . . means to render [Stone's building] 'more ephemeral'?" Wolfe asked. "'Ephemeral' is Architect Cloepfil's own word, I hasten to add, as in here today and gone tomorrow. . . . The average

savant might assume Architect Cloepfil (rhymes with 'hopeful') was trying to say 'ethereal' or perhaps 'inimitable' when his tongue slipped to 'ephemeral'; but the average savant avoids the coherently challenged theoryspeak of contemporary architecture like a brain-invading computer virus—and is therefore unlikely to know that Ephemeralism was once (1994) This Year's Architectural Style of the Century." Wolfe explained that to realize Cloepfil's design, the

> marble will be removed and carted off somewhere, very likely New Jersey, to be fed as landfill to the mucky maw of the Jersey marshes, at a cost of millions. The marble walls will be replaced by, one scarcely need add, glass walls. In place in front of the glass walls . . . will be curtain walls, top to bottom and all around. The curtain walls, known as 'scrims,' 'veils' or 'layers' in theoryspeak, will be made of panels of perforated glazed terra cotta, probably 18-or-so inches from the glass walls. The perforations in the terra cotta will offer peekaboo voyeurism. At intervals will be wide glass 'columns,' so called, but rectangular, flush with the plane of the curtain walls. They will offer the voyeurs outside the full Monty, a direct look at what's going on inside. In 2006, when it is completed, we will see the Platonic ideal of plain transparency, confusing transparency, peekaboo voyeurism, I-see-you voyeurism and hide-and-seek deception of the dominant regime.[113]

In November three preservation groups, Landmark West, the Historic Districts Council, and the New York chapter of Docomomo filed a lawsuit in State Supreme Court seeking to block the sale of the building to the Museum of Arts & Design, alleging that the environmental review that allowed the building to be transferred to the Economic Development Corporation was flawed and that the city was attempting to relinquish a landmark quality building "without adequately considering the consequences of its loss." The lawsuit further claimed that the "city's economic objectives infected the process of considering the potential landmark status of the building."[114] At the same time, the Preservation League of New York State placed Stone's building on its annual "Seven to Save" list of the most endangered historic sites in the state. Although Herbert Muschamp dismissed Cloepfil's design as "an unwelcome exercise in caution," he saved his most biting criticism for the Landmarks Preservation Commission and its failure to hold hearings on the possible designation of Stone's building, which he deemed "a shocking dereliction of public duty."[115]

In January 2004, the same month that a revised design by Cloepfil was released that added a thirty-inch-wide glass winding channel to the facade, Ada Louise Huxtable finally weighed in. Huxtable, whose 1964 characterization of the building as a "die-cut Venetian palazzo on lollypops" had damned Stone's design, wrote, "I have been watching, with wonder and disbelief, the beatification of 2 Columbus Circle. . . . This small oddity of dubious architectural distinction . . . has been elevated to masterpiece status and cosmic significance by a campaign to save its marginally important, mildly eccentric, and badly deteriorated facade—a campaign that has escalated into a win-at-any-cost-and-by-any-means vendetta in the name of 'preservation.'" Huxtable also noted that with the completion of David Childs's Time Warner Center (see above), a design she described as an "astonishing and unexpected beauty, the shabby little punchboard facade of 2 Columbus Circle sticks out like a small, sore thumb. It didn't seem so bad before, but the sophisticated finesse of Mr. Childs's first-rate building makes it look like the second-rate building that

Museum of Arts & Design, Two Columbus Circle, bounded by the circle, Broadway, West Fifty-eighth Street, and Eighth Avenue. Allied Works Architecture, 2004. Model, view to the southwest. Pottle. ESTO

it really is. Its retro mannerisms are suddenly crude caricatures." Huxtable was also pleased by Cloepfil's preliminary designs. Describing Cloepfil as an architect "who designs with a precise delicacy, the new look for 2 Columbus Circle works in this setting. . . . What is bad about [Stone's] building–the dark, cramped and virtually useless interior and those faux harem walls that close off spectacular views–will be changed. Yes, we will lose the facade, and the new one will not offer the instant appeal of exotic kitsch; it is a restrained, expressive reflection of an unusual way of using the concrete frame to open the building visually, inside and out. It is hard not to see this as a trade-off worth making."[116]

Despite the best efforts of civic groups and their supporters to halt the plans and secure a public hearing for the building before the Landmarks Preservation Commission, on June 29, 2005, a week after the building was added to the World Monuments Fund's list of the world's 100 most endangered sites, the Buildings Department issued work permits for the demolition of Two Columbus Circle's marble exterior as well as its interiors. The new museum is scheduled to open in 2007.

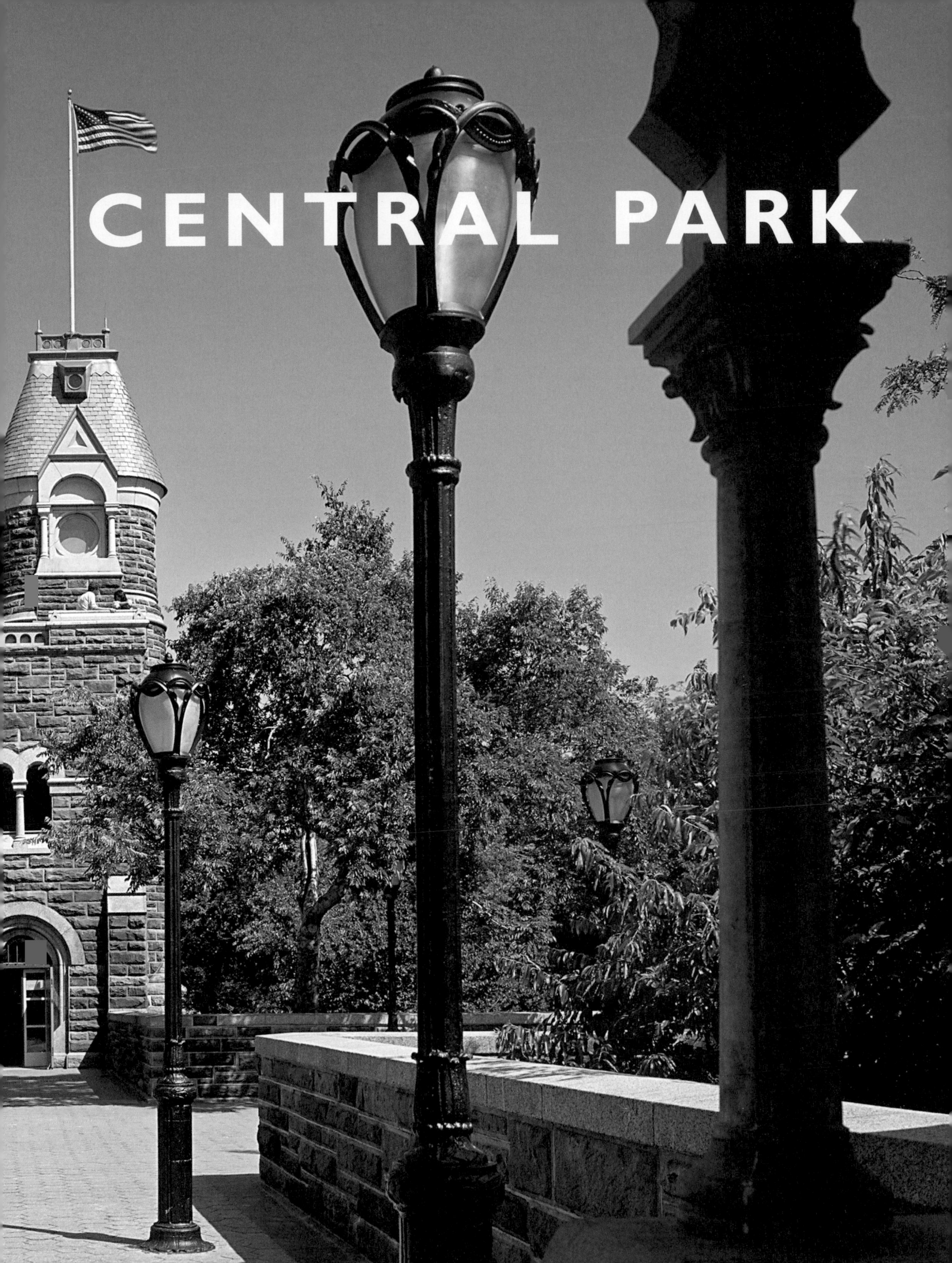

CENTRAL PARK

Central Park (Frederick Law Olmsted and Calvert Vaux, 1858–73), an 834-acre expanse bounded by Fifty-ninth and 110th Streets, Central Park West and Fifth Avenue, Manhattan's essential green lung and New York's greatest public place, was the victim of both its own popularity and the city's precarious financial situation, which had led to an even more drastic reduction in spending for parks than for a host of other public amenities.[1] Amid growing concern that municipal finances would barely be able to support the parks, and in recognition of Central Park's unique role in the city's daily life, in 1975 the Astor Foundation funded the Central Park Task Force as a private agency within the Parks Department. Elizabeth Barlow, a city planner specializing in the heritage of Frederick Law Olmsted, was the spearhead behind the task force, which was intended to organize volunteer programs and encourage philanthropy.

Nevertheless, by 1977, vandalism in the park had reached such serious proportions that the National Weather Service, which had operated from Central Park since 1869, temporarily moved its equipment to La Guardia Airport (the machinery—but not the technicians—returned two years later).[2] That same year, the release of *The Central Park Book*, published by the task force and written by Barlow with Vernon Gray, Roger Pasquier, and Lewis Sharp, proved to be a key event in the turnaround of the park's fortunes.[3] As Paul Goldberger noted in his review, the book, which combined history, architectural and landscape history, and discussions of the park's horticulture, was not a "what-to-do-now" response to the park's problems "but a book aimed at creating a more educated public and, hence, a public more respectful of the treasure that the park represents."[4]

Information kiosk, Central Park, Sixtieth Street and Fifth Avenue. Hardy Holzman Pfeiffer Associates, 1979. McGrath. H3

PREVIOUS PAGES Belvedere Castle, Central Park. Reconstructed by James Lamantia, 1982. View to the east showing lighting standards by Gerald Allen and Kent Bloomer (1981) in foreground. Aaron. ESTO

With the election of Ed Koch as mayor the following year, the movement to restore Central Park gained additional momentum. In April 1978, the Parks Department reversed a policy that went back to the first administration of Mayor John Lindsay permitting virtually any kind of public event to take place in the park. The first to be denied access to the park was the Taste of the Big Apple celebration, which had attracted 300,000 people the previous year but had seriously damaged the park's physical condition.[5] In February 1979, when Barlow was appointed the first Central Park administrator, the park's situation truly began to improve.[6] The creation of such a position was prompted in part by a study funded by the Russell Sage Foundation and released in late 1978 that pointed to the park's dangerously deteriorating state and called for the designation of a park administrator and the establishment of a citizens' "board of guardians" to combat the disrepair and vandalism.[7] During the Lindsay administration, Henry Hope Reed had served as the Central Park curator, an unsalaried post he occupied from 1966 to 1977. Reed was the conscience of the park, but his authority was limited. Barlow, who was paid for her work, was, quite simply, in charge. Her appointment at a time when the city's coffers were being replenished was also fortuitous. A few months later, she implemented plans to hire some 100 uniformed park rangers to serve in the city's five largest parks.[8]

Within a year, with the encouragement of Mayor Koch and Gordon J. Davis, the new head of the Parks Department, Central Park had been reimagined, as the *New York Times* art critic Grace Glueck put it, as "a cultural institution on the order of museums, orchestras and ballet companies."[9] With its new status came a sense that, like other cultural institutions, it had to be preserved and maintained with private funds. In August 1980, the Central Park Conservancy was founded, with Barlow at its head.[10] By this time, Davis and Barlow, the latter appointed by the former, had become a great team. Barlow attracted substantial support from charitable foundations and some money from New York State, which led to the realization of a number of important projects, undertaken primarily by a team of architects and landscape architects she had assembled by 1981. Her close architectural adviser was Gerald Allen, a sometime collaborator of Charles Moore, with whom he had studied at Yale. Allen, a member of the office of Peter Gluck & Associates, recruited other Moore disciples, including Richard Oliver and Kent Bloomer, an architectural sculptor who was a colleague of Moore's at Yale.

The park's transformation in the early 1980s was astonishing. Not since the early 1930s had so much been accomplished so quickly. Much of the Moses-era work had removed Olmsted- and Vaux-era features, as well as late-nineteenth-century contributions from the Ignatz Pilat era. Moses had provided adequate but bland new facilities, most notably children's playgrounds. The new campaign was distinctly different, based as it was on a commitment to restoration and reconstruction. The work was guided by an extensive master plan written by Barlow in 1981, which formed the basis for an even more detailed management and restoration plan Barlow prepared in 1987 with the assistance of the landscape architects Bruce Kelly, Philip Winslow, Marianne Cramer, and Judith Heintz. The ten-year goal, according to Barlow, was to "put the entire park into first class condition."[11]

Among Barlow's many early successes was the resodding of the Sheep Meadow. The location of innumerable rallies and

concerts in the 1960s and 1970s, it had been reduced to a dust bowl. On July 31, 1979, it endured one last concert, a fundraising effort for the park given by James Taylor, the rock and folk singer, before a crowd of 250,000 people.[12] Beginning in the fall, the meadow was closed to the public for almost a year while a sprinkler system was installed and new grass was planted. By the following June, the result had enchanted Paul Goldberger, who noted that the chain-link barrier fence still in place to keep the public out ought to be permanently kept in place, "on the theory that the people of New York will derive more pleasure from being able to stare at the miracle of a real lawn in the midst of the park than they would from walking on it and, ultimately, destroying it."[13] Like so many others in the park, the project was fraught with false starts. A few weeks after Goldberger's review, Edith Evans Asbury reported in the *New York Times* that despite massive expenditures on an upgraded irrigation system, the new sod was not emerald green but brown, and signs had been posted saying that its opening was delayed until August or September.[14] In an effort to assign blame, fingers were pointed in many directions, with Gordon Davis—as if confirming how bad things had become in the park—claiming that the grounds staff was unaccustomed to dealing with healthy, mechanically irrigated turf. Just before the meadow's reopening, Davis hinted that "limitations" and "controls" would be imposed on public use, an announcement that promised yet another departure from the free-spirited libertarianism of the Lindsay-Hoving era.[15] Indeed, the chain-link fence was kept to restrict access.

Not every Barlow project was well thought out. Hardy Holzman Pfeiffer Associates' Victorian-inspired information kiosk (1979), located at the Sixtieth Street and Fifth Avenue entrance to the park, was a first, false architectural step. According to Malcolm Holzman, the idea was "to create a super-terrific stage set, in the style that the designers of the park might have done."[16] Goldberger, however, found the kiosk "much too cute . . . a friendly, welcoming little place, playful and happy—but . . . rather like the sort of person who giggles at you constantly when what you wanted was . . . a quiet conversation."[17]

The reconstruction of Olmsted and Vaux's 1870 Dairy in 1981 was more successful.[18] Initially intended, according to Olmsted, as "a refreshment room for adult visitors, and for the furnishing of supplies to parties of children who will congregate in the rustic shelter in the play-grounds," the Dairy had been turned into a warehouse by Robert Moses in the 1930s, its ornate loggia destroyed in 1955.[19] Restored by the Central Park Community Fund and Revlon, Inc., the Dairy found new life as an information center. The restoration was originally planned by James Lamantia, whose open-air restaurant at Bethesda Terrace (1966) was for a few years a sparkling addition to the park, but the final work was carried out by Weissberg, Castro Associates, in consultation with William Alex, who had organized a comprehensive traveling exhibition, "Frederick Law Olmsted/U.S.A (1822–1903)," in 1972.[20] Inside the Dairy, Richard Oliver designed a heroically scaled, vividly polychromed, Victorian information-and-sales desk in the main hall in 1983. It was slyly dedicated to Robert Moses, the man who savaged Olmsted and Vaux's architectural and landscape work while publicly celebrating their achievement in speeches.

Barlow's next project, and one of the most dramatic she was to undertake, was the reconstruction of Belvedere Castle

Dairy, Central Park. Interior renovation by Richard Oliver, 1983. Aaron. ESTO

(Calvert Vaux, 1871) by James Lamantia in 1982.[21] Although it occupied the highest site in the park, Belvedere Castle, with no public function, was vulnerable to vandals who destroyed its ornament as they covered its surfaces with graffiti. To prevent further vandalism, the renovation incorporated a park use—headquarters for the department's corps of urban rangers. The building's original profile was restored—the peaked roof of its crenellated Norman tower had been flattened to make way for meteorological instruments in the 1930s—and a long-ago-demolished wooden pavilion northwest of the castle was rebuilt by Russo & Sonder in 1982. In 1996 the castle was rehabilitated once more by Campagna & Russo and approximately thirty new windows and doors were added to accommodate the new Luce Learning Center, featuring exhibits and programs on the park's natural environment.[22]

If the Belvedere Castle's restoration was the most dramatic sign of renewal, then the new path lighting designed in 1981 by Gerald Allen and Kent Bloomer, working with lighting designer Howard Brandston, was the most pervasive.[23] The lights—cool, white metal halide lamps that replaced glaring mercury vapor lamps—were set inside luminaires affixed to the lampposts designed in 1910 by Henry Bacon. While 1,000 lamps were replaced, 500 more were phased out, not only to offset the cost, but also to concentrate lighting at critical areas and give up on others plagued by vandals. Olmsted and Vaux had not believed in lighting because they did not want to promote after-hours use, which they felt would encourage crime. Nonetheless, the appeal of the park at night proved so great that in 1872 Vaux designed a gracefully curving standard with a pendant globe. Allen and Bloomer paid homage to it in their design, encircling the globe with ornamental, high strength

aluminum leaves crowned by an acorn, yielding an effect that actually bore a stronger resemblance to Henry Bacon's work.

Gerald Allen was also responsible for the restoration and renovation of the Cherry Hill Concourse in 1982.[24] A circular turnaround for carriages off the Seventy-second Street drive, just west of the Mall, the concourse was sited to provide views across the lake and originally had an elaborate fountain that filled a pool where horses could drink. The area had been turned into a parking lot. The fountain was accurately reconstructed and restored with gilded metalwork, variegated granite, and polychromed tile work. The water flowed for a brief time but was turned off because of a malfunctioning water pump and problems with the electrical system. In 1998, after sixteen dry years, the fountain was resurrected a second time, when the metalwork and the bluestone basin had to be reconditioned again.

Although each restoration project had its own special headaches, none came with more problems than that of Bethesda Fountain and Terrace in 1988. It required, among other things, the removal of part of a grove of twenty-four pin oak trees planted as a war memorial in 1947, because the trees' roots were wreaking havoc with drainage, causing erosion and destructive below-ground heaving. The project was undertaken by the Ehrenkrantz Group, led by Theo Prudon, assisted by Jean Parker Murphy and Kate Ottavino, who documented much of the early work.[25] While the badly eroded and vandalized sandstone on the fountain, the balustrades, and the retaining walls was stabilized or sympathetically patched, the forty-nine glorious nine-foot-square panels of Islamic-patterned Minton encaustic tiles that lined the ceiling under the Seventy-second Street roadway—some 16,000 tiles in all—were removed because of a lack of funding for repairs, depriving the public of one of the city's great outdoor experiences of art. A plan to line the walls of the arcade with painted panels by a trompe l'oeil specialist, Lucretia Moroni, illustrating *The Flowing of Time*, was not executed.

Fortunately, the plaza itself was beautifully restored, presided over by two dramatic gonfalons (long banners typical of medieval Italian processions) suspended from new bronze poles and crosspieces. In 1997 the Central Park Conservancy, with grants from the National Endowment for the Arts and the J. Paul Getty Trust, conducted a feasibility study for the rebuilding of the Minton ceiling. Two panels were restored to see if the installation system devised on paper would work, as well as to determine how much it would cost to put the entire ceiling back in place. In 2003 the Conservancy announced that it had secured funding. The reconstruction was scheduled for completion in 2007.

In addition to these highly visible showpieces, appealing to the monied crowd that supported the Conservancy's work, numerous small structures were restored or re-created, including several pavilions and shelters. The most elegant was the Ladies' Pavilion (Jacob Wrey Mould, 1871), a nine-by-fifteen-foot, open cast-iron structure on the western shore of the lake near Seventy-fifth Street that was restored in 1979.[26] Others included two of an estimated fifteen rustic shelters designed by a Hungarian named Anton Gerster, one of which was rebuilt in the Ramble in 1982. Another, just north of the Sixty-seventh Street Playground near Fifth Avenue in an area called the Dene, was re-created in 1983 in unmilled red cedar by a student team working from old photographs and etchings.[27] In 1983 Buttrick White & Burtis renovated the rather

dull Moses-era Loeb Boathouse (Stuart Constable, 1954) to accommodate a year-round restaurant.[28] Many of the park's fifty beautiful but sadly neglected bridges and stone arches were restored as well, with the assistance of Beyer Blinder Belle, including the gloriously elegant Bow Bridge, Pine Bank Arch, and Gothic Bridge.[29] Barlow also undertook innumerable detailed studies of the park's infrastructure and its horticulture. One study surveyed every one of the 24,000 trees with trunks of six inches or more in diameter.[30] Taking a cue from university fund-raising, permanent "chairs" for gardeners were endowed, one each for the Conservatory Garden, which was turned into a model of formal planting by Lynden B. Miller in 1983,[31] Bethesda Terrace, and Strawberry Fields, a garden created in 1985 near the park's West Seventy-second Street entrance by Yoko Ono in honor of her husband, the singer-composer John Lennon, who was shot by a crazed man while entering his apartment building, the Dakota, just across the street, on December 8, 1980.[32] Named after a Lennon song, "Strawberry Fields Forever," the three-acre site was designed by Bruce Kelly in a naturalistic manner. A pavement mosaic spelling out the word "Imagine" was the central focus of the plan. In February 1984, at a ribbon-cutting ceremony at the Girls' Gate, 102nd Street and Fifth Avenue, Barlow announced that 50,000 square feet of graffiti had been removed from the park, perhaps the greatest gift of all.[33]

Wrap It Up

In October 1980, just as the implementation of the Conservancy's master plan was getting under way and the benefits of Gordon Davis's strategy to reduce the park's use for special events were beginning to be appreciated, the environmental artist Christo (Christo Javacheff), who worked in close collaboration with his wife, Jeanne-Claude, announced plans to transform Central Park into an art project (1979) for two weeks.[34] Christo, whose large-scale art projects included the 365-foot-high *Valley Curtain* (1972) in Colorado and the twenty-four-mile-long *Running Fence* (1976) in Sonoma and Marin counties, in California, which required 110,000 pounds of steel cables and two million square feet of woven nylon, proposed to build a series of 11,000 steel gates, one each at nine-foot intervals along twenty-seven miles of Central Park's walkways. Each fifteen-foot-high gate was to carry a free-flowing panel of saffron- or apricot-colored nylon; the panels would be so sensitive to air movement that even in a gentle breeze they would stretch out horizontally above the walkway. The project would be realized at no cost to the city— Christo proposed to pay for it himself, profiting only from the sale of drawings—and after fourteen days it would be dismantled. Initial responses were quite favorable, but soon enough reservations began to be expressed, none more decisively than by the editors of the *New York Times*: "Central Park is already a work of art—arranged by Olmsted and Vaux. Their design has been endlessly, often needlessly violated. But does that justify another violation merely to impose one new artist's vision on another's? Central Park needs loving hands of restoration, not of exploitation."[35]

The *Times*'s editorial got the debate going, and it raged on for months. Parks Commissioner Davis rejected the proposal on February 25, 1981, saying, "The project is, after all, in the wrong place, at the wrong time, and in the wrong scale. In all these respects the defects of the physical project mirror the defects in the artist's grasp and understanding of Central

Park." Davis went on to say that "because of what the Gates offers as public art, our decision is made more in sorrow than in anger."[36] Davis had arrived at his conclusion after a serious study resulting in a 107-page report, which identified as a principal problem the length of time the park would be affected by the construction and dismantling of the gates: nearly six months. Moreover, the estimated cost of $5 million—$1 million more than the park's annual maintenance budget and the equivalent of five years' worth of capital budget restoration funds—would have set a bad precedent. The *Times* editorialized that, because the project would be financed out of the highly profitable sale of related drawings, there was "also an inescapable question about exploiting public land for private gain."[37] Learning of the decision, the endlessly genial and optimistic Christo announced, "I am in good health, the park is still there, and I will do that project."[38]

Christo persisted, and in March 2002, some twenty-three years after he first conceived the project, he and Jeanne-Claude managed to get the ear of the newly elected mayor, Michael Bloomberg, whose support brought *The Gates* to realization.[39] For sixteen days between February 12 and 28, 2005, the artwork, officially called *The Gates, Central Park, New York, 1979–2005*, was installed, consisting of 7,503 sixteen-foot-high, five-foot-six-inch- to eighteen-foot-wide gates lining twenty-three miles of footpaths. The gates, significantly fewer in number than originally proposed, consisted of orange vinyl-tube frames anchored to steel footings which were heavy enough so that unlike in the earlier plans, no holes needed to be drilled into the ground. As completed, the project, employing 5,290 tons of steel, six miles of vinyl tubing, and 1,067,330 square feet of pleated saffron-colored nylon panels, left no permanent mark on the park.

Viewed as the temporary work of public art that it was, *The Gates* left little to complain about, and, except from the most curmudgeonly of critics, responses to it were overwhelmingly positive. As the artists predicted, the juxtaposition of the brilliant curtains with the park's leafless trees and drab winter colors made for dramatic, if not surreal, vistas. The piece attracted tourists from around the world, boosting the city's economy by some $254 million, and energizing the park so that it was as active during the coldest of winter days as it was on a summer afternoon.

New York Times art critic Michael Kimmelman offered an unabashedly enthusiastic appraisal, calling it "a work of pure joy, a vast populist spectacle of good will and simple eloquence, the first great public art event of the 21st century." Reminding those who were perhaps looking for a profundity in the project that Christo's philosophy "has always been rooted in the utopianism of Socialist Realism, with its belief in art for the Everyman," Kimmelman brought attention to *The Gates*'s "social value, in gathering people together for their shared pleasure." He continued, "Some purists will complain that the art spoils a sanctuary, that the park is perfect as it is, which it is. But the work, I think, pays gracious homage to Olmsted's and Vaux's abiding pastoral vision: like Magic Marker lines, the gates highlight the ingenious and whimsical

FACING PAGE *The Gates, Central Park, New York, 1979–2005,* Central Park. Christo and Jeanne-Claude, 2005. Aerial view. Volz. REDUX

ABOVE *The Gates, Central Park, New York, 1979–2005,* Central Park. Christo and Jeanne-Claude, 2005. McGrath. NMcG

curves, dips and loops that Olmsted and Vaux devised as antidotes to the rigid grid plan of the surrounding city streets and, by extension, to the general hardships of urban life."[40]

Hilton Kramer was among its few detractors, deeming *The Gates* a "massive assault on . . . a defenseless Central Park . . . nothing less than an unforgivable defacement of a public treasure." Kramer, choosing to overlook the fact that the fleeting installation would leave no physical scars, called it a "wanton desecration of a precious work of art. After all, Central Park is the creation of two of the greatest landscape artists in our history . . . and it's entitled to the kind of care and protection that civilized societies normally accord to works of art that belong to the community." But Kramer was most vexed about the implications that "an event as shallow and transitory as the erection of these gates" might have on New York's reputation as a serious art center: "For what they signify is New York's surrender to a kind of tourist trade devoid of artistic consequence. Except as some sort of ultimate parody of Minimalist art, all those orange curtains fluttering on their orange steel frames contribute exactly nothing to the realm of artistic achievement. On the contrary, they make our city look more and more like a pushover for provincial charlatans—which is decidedly not how a great art capital ought to conduct its public affairs."[41] Perhaps Mike Donovan, writing to the editors of the *New York Observer* in response to Kramer's rant, put it best: "My advice to Mr. Kramer is that he

lightens up before he drops over from apoplexy. The Gates will be gone before he knows it, and New York, Central Park and the world of art (as Mr. Kramer knows it) will be none the worse off."[42]

Polishing the Park

By the 1990s, Central Park was well along the path to revitalization, with many of the major elements restored or rebuilt. Several small new structures had been added, including Buttrick White & Burtis's 1990 Ballplayers' Refreshment Stand, located at the Heckscher Ballfield north of the site of the Ballplayers' House (Calvert Vaux, 1865), which had been demolished in 1969. A 448-square-foot, slate-roofed, red brick structure with a glazed ornamental tile frieze and aluminum cresting, it was in many ways the happiest of the firm's several contributions to the park's revitalization, its design owing as much to Vaux as to Robert Venturi's 1970s work, filtered through that of the Boston-based architect Graham Gund.[43] Buttrick White & Burtis was also retained to restore the stables, mid-park at Ninety-seventh Street, to form the North Meadow Recreation Center (1995),[44] and to design the Tennis House, north side of the Central Park Tennis Courts near the Ninety-seventh Street Transverse, a project begun amid controversy in 1987, when observers mistakenly confused a surveyor's markings for a plan to remove eleven oak, maple, and poplar trees to clear the way for construction.[45] The proposed

polychrome-slated, hipped-roofed, porch-girdled pavilion, which was to replace the existing Tennis House (Gustavo Steinacher, 1931), a classical, stucco-clad building south of the tennis courts, was clearly mandated by the mission to return the park to its Olmsted and Vaux character, which the existing structure did not honor in either its design or siting. Though the new design was winning, the project remained unpopular. Tennis players called for an upgrade of the courts instead and others argued that the location of the present pavilion afforded better views of the play than the proposed site to the north, but it was the threatened loss of a group of cherry trees lining the courts near the new site that ultimately derailed the project, which quietly died in 1988.

Buttrick White & Burtis's most ambitious contribution was the somewhat overblown Dana Discovery Center (1993) facing Harlem Meer in the park's northeast corner.[46] The project began as an attempt to replace the burned-out boathouse at 110th Street (1941) with a 500-seat restaurant operated by Warner LeRoy, whose Tavern on the Green was a park showpiece.[47]

In the early 1970s, an attempt to establish a restaurant in the boathouse, called Across 110th Street, failed, in part because its capacity was too small for private banquets. Many community leaders rallied around the idea of a new restaurant, although die-hard preservationists, including Robert M. Makla, remained unconvinced. Makla, a founder of Friends of Central Park, was flying in the face of local political interests. Percy Sutton, a prominent Harlem politician and businessman, was behind the project. Makla reminded the public that "when they proposed the Huntington Hartford Café [in the early 1960s], every do-good group came up and shouted against it. But now that it's up where the blacks live, no one gives a damn."[48]

The proposed facility was part of a larger project to reclaim the Harlem Meer, a fourteen-acre lake created in the 1860s when the park was extended from 106th to 110th Street by blocking up Montayne's Rivulet and flooding a salt marsh leading to the East River. Over the years, especially in the racially troubled 1960s and 1970s, the Meer's landscape had been diminished, its naturalistic character compromised by too many walkways, fences, and general neglect of planting. It had also silted up and required extensive dredging. Buttrick White & Burtis's plans called for two buildings: a 400-seat restaurant and café and a visitor center and boathouse. By the late 1980s, however, Warner LeRoy had lost interest in the project, and when the city called for proposals from other operators, only one, Calvin Copeland, who ran an eponymous restaurant on 145th Street, responded. The Victorian-inspired buildings, approved by the Landmarks Preservation Commission in 1989, had, according to the architects, "slate roofs, painted wood windows and detailed brick shapes [to] enliven the facades and connect the buildings to the park's 19th Century past."[49]

The principal designer of the buildings was Samuel G. White. As approved, the restaurant was big: at 14,000 square feet, less like a restaurant and more like the sort of big country house Stanford White, Samuel White's great grandfather, and his partners designed early in their careers. Samuel White was acutely aware of the problem posed by the size. "It will be heavily planted," he said. "The design of the landscaping is as important as the building itself."[50]

Restoration work began on the Harlem Meer in 1990. Forty thousand cubic yards of soil and debris were dredged up and the boathouse was demolished, but public opposition to the proposed structure itself was mounting, centered around its size. The restaurant portion of the project remained in abeyance as the developers sought funds, but in 1993 work was completed on the 5,000-square-foot Dana Center, financed by the Charles A. Dana Foundation and the Central Park Women's Committee. The facility provided rods and bait to those who wanted to take advantage of the restored Meer, now stocked with 50,000 fish. Also included was a Discovery Chamber devoted to an exhibition about urban woodlands. According to Michael M. Dwyer, who worked with White, it was "a straightforward building, two masonry rectangles with pitched roofs and a lantern at the intersection" with roof overhangs "supported by a variety of verge-boards, arches, pendants, and brackets, which give the building its picturesque character and reinforce the romantic landscape design."[51]

Ballplayers' Refreshment Stand, Heckscher Ballfield, Central Park. Buttrick White & Burtis, 1990. View to the north. Cedar-Miller. SCM

Proposed Tennis Pavilion, Central Park. Buttrick White & Burtis, 1987. Rendering. PBDW

ABOVE Proposed restaurant, visitor center, and boathouse, Harlem Meer, Central Park. Buttrick White & Burtis, 1989. Rendering by Herb Kashian of view to the northwest. PBDW

RIGHT Dana Center, Harlem Meer, Central Park. Buttrick White & Burtis, 1993. View to the northwest. Cedar-Miller. SCM

The Reservoir and the Great Lawn

In 1993 city officials decided to stop the 131-year-long practice of pumping drinking water from the Central Park Reservoir, now deemed by federal environmental officials a ripe prospect for contamination.[52] The billion gallons of water in the reservoir would remain available as a reserve supply until 1999, but ideas for how to reuse its 106 acres were bandied about immediately—ranging from opening the reservoir up for public swimming and boating to draining it and converting the site to green space or ball fields, as had been done with the old Yorkville Reservoir (1842), which became the Great Lawn in 1936. In October 1993, however, the Dinkins administration announced that a Memorandum of Understanding had been signed, insuring the preservation of the reservoir as "a permanent water feature of Central Park."[53]

Central Park's primary gathering place and its geographical center, the Great Lawn had become more a dirt field than the verdant expanse its name implied.[54] A plan prepared in 1987 would have shrunk the lawn by three acres and reshaped the fifty-four-year-old Belvedere Lake to the south had it not raised concern among naturalists about the fate of nineteen species of dragonflies and damselflies that were said to use the north shore as a "rendezvous."[55] Behind the plan lay the largely unspoken desire to provide a pier to accommodate an enormous, movable stage used by the Philharmonic Orchestra and the Metropolitan Opera for their popular summertime concerts. The plan did not go forward, but even as the city slipped into economic decline in the late 1980s and the Great Lawn became little more than hardpan, concerts and gatherings continued to be held there, providing much needed income to the Parks Department through donations from the performers and sponsoring corporations. On August 16, 1991, the popular singer and composer Paul Simon performed on the Great Lawn to an audience estimated at 750,000, and on June 26, 1993, the opera star Luciano Pavarotti sang for a crowd of some 500,000.[56]

Plans to irrigate and reseed the Great Lawn and the North Meadow in the upper portion of the park were given a real boost in 1993 when Richard Gilder, an investment banker and a trustee of the Central Park Conservancy, made a sizable gift, but funds were still insufficient and the Great Lawn continued to host major events.[57] In June 1995, the Walt Disney Company held what it touted as the "family Woodstock of the 90's," closing the lawn for two weeks to prepare for a premiere screening of its animated film *Pocahontas*.[58] In return for the use of the Great Lawn, the film company gave the city $1 million toward its restoration. It was the first event on the Great Lawn requiring attendees to have tickets, and although they were distributed free of charge, scalpers could be found hawking them for fifty dollars apiece. Though the event was well received by most, it managed to draw the ire of fiery columnist Jimmy Breslin, who declared it "probably the worst day the city has had. . . . In all the history of Central Park, the place never has been closed for two weeks for anybody. In all the history of Central Park, tickets have never been required for anybody to get in. . . . The park is open to the public because it is owned by the public. And then last week these cheap, grasping, indecent Hollywood bindlestiffs got together with Giuliani the mayor, who is essentially a tasteless fool, and they stole the park from the people."[59]

At the time of the Disney screening, work on the lawn was set to begin. But it was delayed until after a visit from Pope John Paul II, who celebrated Mass there with 125,000 ad hoc congregants on October 7, 1995.[60] Within a week of the Pope's visit, the lawn was closed for two years. In the most costly improvement undertaken in the park's history, its fifty-five acres were dug up to make way for new drainage and an irrigation system, and new soil was introduced.[61] The Great Lawn reopened on October 10, 1997, amid various complaints about rules that restricted its general use but permitted scheduled softball games. Many resented that the Great Lawn, like the Sheep Meadow, was permanently fenced in.

The continued improvement of the park's physical plant, which was widely attributed to the efforts of the Conservancy, focused attention on the administration of the park. Although some elected officials voiced concerns about the Conservancy's apparent lack of public accountability, these criticisms seemed mostly politically motivated, and when Elizabeth Barlow Rogers stepped down as its president in 1995, there was a general sense that she and the organization had rescued the park. Despite concerns about privatizing Central Park, a movement to further distance the park's management from the vagaries of municipal finance and bureaucracy began to grow in strength, especially after 1997, when Richard Gilder argued in an article in the *City Journal* that the Conservancy should contract with the city for the entirety of the park's management, except for police and electricity, drawing revenues from the park's concessions.[62] The idea appealed to Mayor Giuliani, who endorsed the plan in early September, and a contract was executed on February 1, 1998.[63]

The Zoo

On October 22, 1981, the Board of Estimate agreed to relinquish the operation of the Central Park Zoo and the two other municipal zoos (one in Brooklyn's Prospect Park, the other in Queen's Flushing Meadows–Corona Park) to the New York Zoological Society, which was already managing the Bronx Zoo.[64] The history of the Central Park Zoo—arguably the oldest zoo in the United States—extended back to 1858, but the current facility was built in 1934, when Robert Moses, then parks commissioner, gave a team of fifteen architects led by Aymar Embury II six days to design a new home for the animals.[65] The resulting small-scale, red brick menageries grouped around a sea lion pond were delightful, but the conditions for the animals were primitive, consisting of interconnected open-air and indoor concrete-floored cages, and little more. By the late 1970s, Gordon Davis declared that the zoo had become "a Rikers Island for animals," referring to the city's notorious house of detention.[66]

The redesign of the Central Park Zoo, a small but strategically located facility—its five and a half acres were smaller than some individual exhibits at the Bronx Zoo—was put in the hands of Kevin Roche John Dinkeloo and Associates. The firm was selected on the basis of its work for the Metropolitan Museum of Art (see below), which was much admired by Lila Acheson Wallace, the principal benefactor of the new project. Roche was reluctant to take on the job, but Mrs. Wallace is said to have made it a condition of the gift, even though Gordon Davis was not as pleased with the selection. Dr. William G. Conway, the general director of the Zoological Society, noted that "we never would have dreamed of Kevin if Mrs. Wallace hadn't suggested him. We'd have picked someone who had done zoos. But when we were handed an architect of his quality on a platter, we were delighted."[67] Roche

Central Park Zoo. Kevin Roche John Dinkeloo and Associates, 1988. View to the west. KRJDA

recalled that "the initial pass at the thing was a rather unambitious look at keeping all the existing buildings. Then it got to be more and more ambitious. We would demolish *all* the buildings and have an indoor zoo and enclose all the exhibits in a glass dome," an idea that failed to meet with Parks Department approval.[68] Roche and Dinkeloo's ultimate plan, unveiled in April 1982, called for a dramatic redesign of the facility, replacing the buildings around the sea lion pool with five new structures linked by a glass-covered colonnade supporting a vine-covered wood trellis, designed in collaboration with landscape architect Philip Winslow.

The animals were moved out in November 1982 to make way for the new construction, and demolition began in December. When the first bids for the project came in too high, much of the scheme was redesigned and two buildings were eliminated. Richard L. Lattis, the zoologist in charge, struggled to develop appropriate displays amid public concern that animal rights activists notwithstanding, the zoo would be a dull place. Gradually, a balance emerged between those who wanted exotic environments and those who wanted something more traditional. Roche chose to preserve the much beloved Delacorte Clock (Edward Coe Embury, 1965) and F. G.

Roth's limestone friezes, which had decorated the 1934 buildings, as well as the Arsenal (Martin Thompson, 1851) and the Monkey House and Bird House flanking it.[69] The central pool was also retained and rebuilt at a larger size with a glass wall that allowed visitors to watch the animals underwater.

Construction began in April 1985, almost two years later than originally planned. As the project progressed, the British landscape architect Sir Peter Shepherd was brought in to work with Philip Winslow. Shepherd's proposal to remove nine crab apple trees raised a fuss, however, and he left the project. Winslow then received horticultural assistance from the painter-turned-plantswoman Lynden B. Miller, who helped rearrange the paths and planted a perennial garden. The zoo finally reopened on August 8, 1988, six years after the design was first publicized.

The three new buildings were designed to replicate a rain forest, a temperate zone, and a polar region. Roche said that he "wanted a sense of no buildings."[70] The old buildings were converted to house educational exhibits, a bookstore, and service functions. Throughout the design's evolution the idea of an arcade remained, with its "zoo order," to use Roche's phrase, of brick columns with chamfered limestone bases and

capitals. Sometimes a bombastic designer, Roche revealed a new sensitivity, leading Carter Wiseman to observe that "for once, the cross-cultural and historical allusions postmodernists have talked about so much seem absolutely unforced."[71] Roche's best move was to eliminate the cafeteria that paralleled the Arsenal to the west, leaving open a view of Central Park seen through the arcade and across the outdoor area temperate zone. Inside the exhibition halls, the displays of fake rockery and trees worthy of a Disney theme park proved far more interesting than most had expected, creating a totally immersing experience. Though the zoo environment as a whole was generally admired, some observers, including Elizabeth Barlow, were disappointed that security and the need to charge admission meant sacrificing the serendipitous zoo going that been a beloved tradition.

Paul Goldberger greeted the new zoo as "one of the few pieces of civic architecture built in New York in the last generation about which it is possible to be almost completely enthusiastic. It is beautiful, it is fun to be in, it respects the park and it respects the animals. What more could we want?"[72] Susanna Sirefman, writing in 1997, was not happy with the design that by then had been adopted by New Yorkers as a beloved landmark: "It is excruciatingly conservative . . . [and] another example of how frustrating Manhattan architecture has become. . . . Nothing about this project dares to be anything but recognizable and familiar."[73]

By the early 1990s, the much-loved "fairy-tale buildings and miniature barnyard pens and sties" of the Children's Zoo (Edward Coe Embury, 1961) were showing such serious signs of wear, with unsafe conditions for animals and visitors alike, that absent a significant infusion of private funds there seemed no choice but to close down the facility, which in fact was done in February 1992.[74] In 1995 an anonymous donor said to live in a Fifth Avenue apartment overlooking the Children's Zoo—who apparently had no affection for the cutesy architecture of the ark, the whale, or the once quite daringly modern, thin-shelled reinforced concrete vaulted entrance pavilion—came forward with a gift to replace the entire complex with a new, naturalistic version set under a nearly invisible tent of netting designed by landscape architects Quennell Rothschild & Partners with Cabrera/Barricklo Architects. But many New Yorkers objected, and the Landmarks Preservation Commission was faced with opposition from preservationists and nostalgic baby boomers alike. For some, such as Robert Stern, the issue was crucial, involving not just the preservation of the academically validated Modernist architecture of the recent past but of more offbeat, counterintuitive, and even experimental work. Stern saw this as a battle against apostles of good taste dismissing the "vulgar" work of the recent past just as the previous generation

had dismissed the Victorian heritage. Margot Gayle, presumably a preservationist, proved a vocal advocate for the Children's Zoo's destruction: "The truth is it's very vulgar and ugly and Disneyland-like. It is intrusive and inappropriate."[75] Stern, in an op-ed piece in the *Daily News*, stated: "The real issue may be that quite a few New Yorkers—including many preservationists and zoological experts—seem to have lost their senses of humor. But 'real' people, especially children and their parents, have not lost the capacity to smile at the inherent silliness of a whale and a castle and a version of Noah's Ark right in the middle of the city. These are precisely the zoo's charms. The zoo is a whimsical little antidote to much of life's seriousness. . . . Let's stop arguing, fix up the zoo and start having a little more fun."[76]

As Karrie Jacobs, *New York* magazine's critic, wisely put it: "In the battle over Central Park's cute, kitschy Children's Zoo, the choice is between *faux* 1961 and *faux* nature," noting that the new design called for plastic trees.[77] On April 17, 1996, *faux* nature won when the Arts Commission, following ratification by the Landmarks Preservation Commission, unanimously approved the plans despite the objection of Penny Lehman, the granddaughter of Governor Herbert H. Lehman and his wife, Edith, the donors of the original facility. Demolition began in August 1996, but in May 1997, the previously anonymous donors of the new zoo, Henry and Edith

ABOVE Central Park Zoo. Kevin Roche John Dinkeloo and Associates, 1988. Site plan. KRJDA

BELOW Central Park Zoo. Kevin Roche John Dinkeloo and Associates, 1988. East–west section. KRJDA

Central Park Zoo. Kevin Roche John
Dinkeloo and Associates, 1988.
View to the west. KRJDA

Everett, withdrew their gift in a dispute over, among other things, the way it would be acknowledged, only to be replaced by Laurence Tisch, whose son James had become embroiled in a very public but unrelated dispute with the Everetts. In October 1997, the Tisch Children's Zoo opened. Gone, as Jacobs wrote, was "the Candyland aesthetic of the original 1961 zoo . . . , replaced with a childproof version of nature, cushioned with beautiful bark and stocked with the world's most even-tempered animals. . . . It is possible, in theory, to regard this zoo as a bland . . . showcase of environmental sanctimony." But the critic did admit that once inside the "arch cut into a fiberglass tree," one entered an enchanted forest where toddlers, liberated from their parents, could roam the nearly acre domain with relative freedom.[78] Meanwhile, the still-beloved whale of the old zoo—bereft of its tail, which had been removed to fit it in a delivery truck—lay in ignominy and disrepair at the base of the Cross Bay Veterans Memorial Bridge in the Rockaways, awaiting funds for its refurbishment. Finally, Carl Migliaccio, a Parks Department employee, undertook the job free of charge and restored it in four months' time for all to enjoy by December 1997.

Koch Trumped

One project in the grand restoration plan proved so vexing that it rendered the entire municipal government ridiculous: the rebuilding of Wollman Rink (Aymar Embury II, 1950).[79] In 1975 there was no money available for capital projects in Central Park, with the exception of one, and that project, as the *New York Times* observed, was "in danger of going desperately wrong." Wollman Rink urgently needed repair as a result of its summertime use as an outdoor concert venue, which had resulted in severe cracking of the concrete slab and destruction of the surrounding landscape to such an extent that the stabil-ity of the facility as a whole was threatened. The Parks Department had proposed to rebuild the rink in a naturalistic fashion, replacing the ice with a pond in the summer, a scheme the *Times*'s editors praised as "an exemplary exercise in park design—for a change." Concert enthusiasts attacked the scheme as elitist and exclusionary, but the *Times* insisted that "the real concern" was "use versus abuse, or destructive overkill."[80] As the debate dragged on, things got muddier in their New York way, so that by 1977 the plan was vigorously opposed by the Friends of Central Park, who believed that it was environmentally inappropriate because the deep drilling required to relieve the stress on the structure would forever alter the character of the land. Parks Commissioner Martin Lang dismissed the objections as those of an "elitist" group that "thinks of the park as a passive, pastoral retreat."[81]

Demolition of the old rink began in 1980, with the expectation that skaters would be back on the ice by 1982. But in 1982, skaters were told the rink would be ready in winter 1983 and the restaurant would not open until mid- to late 1983. Early in 1984 skaters were told that there had been "a series of setbacks" involving an unseen drainage line encountered during excavation and that fall had been set as the new completion date.[82] But come November 1984, the opening was delayed again as a result of pinhole leaks found in the steel tubing that carried the Freon gas needed to make ice. Mid-December was the date now being proposed. But by December 31, the rink was still not open, and for a fifth season in a row ice-skating New Yorkers were without their big frozen pond. The Freon tubes were still leaking as the result of a stray current in the ground that caused the metal in the piping to corrode and dissolve where it crossed the reinforcing bars in the concrete. It was suggested that the entire slab would have to be ripped up and another year passed with no visible progress.

On May 28, 1986, Donald Trump, the developer, stepped in with an offer to take over the project, promising to have skaters on the ice by winter—at no profit to himself. After his offer was rebuffed twice by Parks Commissioner Henry Stern, Trump wrote to Mayor Koch, "For many years I have watched with amazement as New York City repeatedly failed on its promises to complete and open the Wollman Skating Rink," pointing out that during those years of municipal ineptitude, he had built innumerable major projects including (in twenty-six months) Trump Tower (see Fifth Avenue). "Building the Wollman Skating Rink," he went on, "which essentially involves the pouring of a concrete slab, should take no more than four months' time." Trump deemed as "unacceptable" the city's estimate of two more years of construction, offering to lease and run the facility at "a fair market rental."[83] Mayor Koch refused Trump's offer, asking instead for $3 million as a gift.

Trump had kept his letter private, but Koch released his reply. Once the press got wind of Koch's high-handed rejection of what appeared to many a sincere offer, they had a field day. By June 6, Trump and Henry Stern were negotiating the terms of the deal. Trump was to build the rink and would be reimbursed for his costs out of whatever profits were generated, but the city balked at the terms, fearing that Trump would make a profit. The developer then promised to give any profits he did realize to charity. In the end, Trump agreed to lend the city $3 million, closing the deal with a promise to finish the job by December 15. In his autobiography, *Trump: The Art of the Deal*, the developer recounted in detail the city's missteps, concluding that the fundamental problem, aside from the decision to use a temperamental and unproved floor system instead of the traditional brine system, was that "there was absolutely no one in charge."[84]

Working with his consultants, Trump rebuilt the rink, pouring a new slab atop the older one. On October 15, some four months later, the new system was tested. It worked to

perfection, and the rink officially reopened on November 13, 1986. City officials were less than gracious about Trump's efforts. But he had the last laugh when the rink made a considerable profit in its first season; all the money went to the Parks Department and to charity.

And the Band Played On
The first stumbling block in the Conservancy's effort to remove notable—and, in the eyes of some, objectionable—post-Olmsted-era monuments came in 1989, when the Conservancy and the Parks Department proposed to tear down the Naumburg Bandshell, built in 1923 and designed by William Gabriel Tachau, a graduate of Columbia University and the Ecole des Beaux-Arts.[85] Sometimes called the Goldman Bandshell because of its longtime use by the Goldman Band, conducted by Edwin Goldman, the Naumburg Bandshell, east side of the Mall near Seventieth Street, was a richly detailed Roman classical hemisphere of reinforced concrete sheathed in Indiana limestone. The gift of Elkan Naumburg, a retired merchant and banker, who secured the commission for his architect nephew in 1921, it had replaced the much smaller, less monumental, though quite ornate, bandstand by Jacob Wrey Mould that had stood on the west side of the Mall. The coffered inner surface of Tachau's dome was intended to be gilded, and the structure carried an inscription, "Presented to the City of New York and its Music Lovers." Naumburg's son, Walter, established a series of free concerts by the Naumburg Orchestra, which continued into the early 1980s, by which time the ambient noise of the park, the crime, and the desolation of the paved area in front of the shell had conspired to drive away audiences.

A proposal from Mitchell Leigh, a theatrical composer and director, to build a new seasonal stage on the site prompted the proposal to raze the historic structure. When the Landmarks Preservation Commission approved demolition in

Aerial view to the northeast, c. 1984, of the Metropolitan Museum of Art, Fifth Avenue at East Eighty-second Street. Ries. SRP

1985, it elicited no comment from any preservation or parks organization. The Naumburg family, however, was not pleased, and Christopher London, a great-grandson of Elkan Naumburg, led a campaign to preserve the band shell. Quickly, officials began to take sides, with many running for cover, as the family argued that under Article 78, an 1865 statute of the city's Administrative Code, gifts to the City of New York "shall be forever properly protected, preserved and arranged for public use and enjoyment."[86] Aside from concerns over legality, the proposed demolition raised a critical issue: should Central Park be restored to reflect Olmsted's vision exclusively, or should the accretions of time be given a place as well? Henry Hope Reed argued that the only reasonable justification for demolishing the band shell was the restoration of Olmsted and Vaux's design for that part of the Mall, with the original polychrome bandstand. Others argued that it should be removed because it had become a home to drug dealers and a resting place for the homeless. Betsy Gotbaum, who had replaced Henry Stern as parks commissioner in 1990, announced on December 19, 1991, that she would listen to the objections of the Naumburg family, but that her mind was all but made up. "From an aesthetic point of view," pronounced Gotbaum, whose credentials for judgment in this area were unknown, "and very, very much from a practical point of view, it's very bad," to which Christopher London compellingly replied, "The whole city is vandalized and is an area for drug dealing and homelessness. The bandshell should not be torn down on such a fatuous argument. Should we tear down every building we can't secure?"[87]

On January 18, 1992, over the protests of many, the New York City Arts Commission authorized the band shell's demolition. But the newly founded Coalition to Save the Naumburg Bandshell filed suit in State Supreme Court to prevent dismantling or demolition, citing Article 78 of the Administrative Code and arguing that New York officials had acted arbitrarily and capriciously. On July 15, 1992, State Supreme Court Justice Eugene Nardelli concurred, contending that the city's claim that Article 78 did not apply because the structure was in bad repair could, "in taking it to its logical extreme," be grounds for demolishing Grand Central. He continued, "The bandshell is not being used because the city has chosen not to use it, not because it is unusable," adding that the city "cannot profit from its own wrong. . . . The conditions at the bandshell are a result of the city's failure to police it."[88] The city pressed on, seeking to overturn the ruling in Appellate Court where, to its chagrin, on February 10, 1993, a four-judge panel ruled unanimously against demolition. On July 8, the New York State Court of Appeals blocked the demolition, ending the four-year-long battle.

Two months earlier, just as the band shell was nearing its reprieve, the Parks Department had removed construction barriers to reveal its restoration of the Mall in front of it, with an Olmsted-inspired scheme of fixed wood benches encircling islands of greenery, evocative of the original elm islands removed at the time of the band shell's construction to make way for theaterlike arrangements of benches for concertgoers. But, of course, the band shell itself had not been restored; the city and the Parks Department placed that burden on the Naumburg family.

Metropolitan Museum of Art

When Thomas Hoving, the controversial, innovative director of the Metropolitan Museum of Art, resigned in 1977 after ten stormy years, the museum was in the midst of the most ambitious program of expansion in its history.[89] In 1970, timed to coincide with the museum's centennial, Hoving had released a master plan by Kevin Roche John Dinkeloo and Associates calling for the addition of 325,000 square feet of new space to create a museum a third larger than the present facility.[90] After leaving his position at the Metropolitan, Hoving intended to

Metropolitan Museum of Art, Fifth Avenue at East Eighty-second Street. Kevin Roche John Dinkeloo and Associates, 1978. Ground-floor plan. KRJDA

Sackler Wing, Metropolitan Museum of Art, Fifth Avenue at East Eighty-second Street. Kevin Roche John Dinkeloo and Associates, 1978. Interior showing Temple of Dendur. KRJDA

head a communications and education center housed in a new wing at the southwest corner of the museum, a spot originally earmarked for the western European arts departments.[91] Publisher Walter H. Annenberg had pledged $40 million for the facility, which quickly became immersed in controversy, as city officials and the public questioned whether it was a proper use of the museum's space. In March 1977, Annenberg withdrew his offer and subsequently established the center at the University of Pennsylvania, and the proposed southwest wing was again reserved for more traditional museum uses.

While the bulk of the master planning had been done under Hoving, most of the plan's execution—with the exception of the reworking of the Fifth Avenue facade (1970), the reconstruction of the Great Hall (1970), and the construction of the glazed octagonal Robert Lehman Wing (1975)—was realized after Philippe de Montebello took over as director in May 1978.[92] Under de Montebello, the long-awaited Sackler Wing housing the Temple of Dendur, opened in September 1978 at the north end of the museum.[93] Based on Arthur Rosenblatt's

hastily formulated proposal of 1967, the Sackler Wing housed the Aeolian sandstone temple fragment given to the United States by Egypt in 1965 in recognition of a substantial contribution to UNESCO's campaign to save Egyptian monuments from the flooding caused by the construction of the Aswan High Dam and the 300-mile-long Lake Nasser. Unfortunately, the 50-foot-high, 200-by-165-foot exhibition hall—which had a continuous, north-facing glass wall, a 102-by-32-foot reflecting pool in the front, and two 45-by-7-foot side pool extensions—overwhelmed the 41-by-21-foot temple and its 11-by-12-foot gateway. As Ada Louise Huxtable put it, "The Egyptian temple is tiny and delicate and the Sackler Wing is big and barren. It is like putting a desert flower in a gymnasium. *Poverina.*"[94]

The Sackler Wing was followed in 1980 by Roche Dinkeloo's column-free, 200-by-120-foot André Meyer Galleries devoted to nineteenth-century European art, located on the second floor on the museum's south side.[95] With its freestanding silk-covered, wall-like partitions arrayed under an orthogonally gridded luminous ceiling, the Meyer Galleries

were, according to Huxtable, "among the most successful of the museum's changes to date." The critic acknowledged that the "thirteen galleries surrounding a large center space" were not as "obviously 'architectural' as some recent new museum construction," but she nonetheless deemed them a "near-perfect synthesis of the arts of scholarship, building and display."[96] Manuela Hoelterhoff did not agree. She had few kind words for the Meyer Galleries in the pages of the *Wall Street Journal*, concluding that the design was not appropriate for the museum but instead represented "an ennobled version of the open-office plan."[97]

Reservations about the design of the Meyer Galleries would increase over the years. In 1993, after three years of work, the entire area was gutted and reconfigured as a suite of classically proportioned and detailed galleries.[98] Although the original plan had been designed to be as open and flexible as possible, with seven tall, movable partitions, as Philippe de Montebello recalled, "The flexibility wasn't really flexible, since we never moved any of the partitions. They chopped up the space and people wandered around lost, trying to make sense of it all."[99] The new space was designed by Gary Tinterow, a curator, David Harvey, an exhibition designer, and Alvin Holm, a classical architect based in Philadelphia, in collaboration with Roche Dinkeloo. The resulting galleries were "similar in scale and design to those for which the artists created their pictures," according to Tinterow.[100] Michael Kimmelman greeted the new galleries as a "big improvement." The Meyer Galleries, he wrote, had "never meshed with the other paintings galleries at the Metropolitan and soon came to seem dated, not to say shabby. The new galleries are, in a sense, already dated: they emulate the 19th-century Beaux-Arts style of the galleries originally conceived for the museum by its earliest architects."[101] Some critics correctly observed that the new rooms were slightly cramped and underscaled, in part because of the inherent height limitations of the space and in part because of the need to create twenty-one galleries to show off the immense wealth of the Metropolitan's collection in the field.

Two months after the completion of the original André Meyer Galleries, in May 1980, Roche Dinkeloo's new 130,000-square-foot home for the American Wing, located in the northwest corner of the museum, opened.[102] Paul Goldberger,

Sackler Wing, Metropolitan Museum of Art, Fifth Avenue at East Eighty-second Street. Kevin Roche John Dinkeloo and Associates, 1978. View to the southeast. KRJDA

writing three weeks before the opening, reflected the high hopes of the museum's administration:

> With the opening of the American Wing . . . a major part of the master plan will be finished. With it, museum officials hope, will come a major change in the museum's physical relationship to the park. The immense new American Wing is built around a glass-enclosed, glass-roofed garden, intended as an interior public park. It has glass walls facing the park, and is intended . . . to be a benign, Crystal Palace–like presence in Central Park. . . . It seems the least intrusive, the least awkward physically and, because it is set entirely on the west, or park, side of the huge building, there is no disquieting clash between it and the older, classical wings, as there is with, say, the Temple of Dendur enclosure on the north side.[103]

In another review published after the official opening, Goldberger took the opportunity to assess what Roche Dinkeloo had accomplished to date at the museum:

> The additions to the Metropolitan Museum of Art that have been completed bit by bit over the last seven years, additions so extensive that they constitute virtually a new museum, have not been an unqualified success. The problems have been enumerated many times in the past: the new glass and limestone buildings . . . do not join gracefully with the old, classically inspired wings of the Metropolitan; certain sections, such as the Lehman Wing and the Temple of Dendur installation, seem to make the art secondary to the architecture, and the complex as a whole has had a somewhat cool, austere quality to it.

But, he observed, the American wing was very different. It was "surely the best piece of the Metropolitan's new architecture yet completed," which he deemed "ironic" given that it derived from the same "basic intentions" as the other additions. Goldberger admired the seventy-foot-high, glass-covered Charles Engelhard Court, with its glass wall overlooking Central Park, that created "a feeling of sumptuous space, and a sense that the park and the museum, which have struggled architecturally with each other for so long, have finally come to some sort of understanding." He only regretted the "fussy" and "precious" landscaping of Innocenti & Webel, which did not honor Kevin Roche's original plan for four large trees at each end of the court and changed "the mood of the space entirely—what could have been robust and in character with the strong American works of art and architecture on display has turned out to be prissy. It is a planting scheme more appropriate for a lady's garden than for a noble space such as this one."[104]

Ada Louise Huxtable also used the occasion to reflect on what Roche Dinkeloo had achieved: "This is the third and best of the skylit courts that are a repeated theme of the museum's remodeling and reconstruction. . . . The American Wing court is the first of the glassed-in spaces that relates satisfactorily to the park and the existing building, creating a transitional structure that is also an extraordinarily handsome indoor-outdoor room." Nonetheless, she felt that "taken as a whole. . . the architecture of the new wing, like that of the other additions, is disruptively strong, with a tendency to overshadow the old Beaux Arts building and the exhibits alike. The new construction is aggressively stylish and coldly monumental; it has produced impressive amounts of space and a creeping corporate veneer. It is also proving distressingly insensitive to the job at hand, the integration of new and old in the appropriate service of the arts." Huxtable agreed with Goldberger that Roche's reinstallation of the white marble

facade of Martin E. Thompson's Branch Bank of the United States (1824), or Assay Building as it was frequently called, which was more or less pasted to the back wall of the Metropolitan's old American Wing after the building's destruction in 1924, was ill-advised and "would have been better if it had projected beyond the containing walls for a sense of its original three-dimensional quality." She found the garden rather more agreeable than Goldberger had: "A pool and fountain and 19th-century American garden furniture complete the setting. The esthetic and environmental quality of this area does a lot to make up for the fact that the park land used for the court is no longer open public space, but has become a part of the museum."[105]

Roche Dinkeloo also oversaw the construction of the Astor Court (1981), although it was not part of the master plan.[106] A recreation of a Ming dynasty–era scholar's courtyard from Suzhou, a city near Shanghai known for its garden architecture, the skylighted court was located in a two-story space in the Far East Galleries, at the north end of the museum, which had been a disheveled utility area. Made possible by a gift from Brooke Astor, the handcrafted space was realized with materials and twenty-seven workmen from China. William Marlin,

André Meyer Galleries, Metropolitan Museum of Art, Fifth Avenue at East Eighty-second Street. Kevin Roche John Dinkeloo and Associates, 1980. KRJDA

André Meyer Galleries, Metropolitan Museum of Art, Fifth Avenue at East Eighty-second Street. Gary Tinterow, David Harvey, Alvin Holm, and Kevin Roche John Dinkeloo and Associates, 1993. Holm. AHA

American Wing, Metropolitan Museum of Art, Fifth Avenue at East Eighty-second Street. Kevin Roche John Dinkeloo and Associates, 1980. Charles Engelhard Court. View showing facade of Branch Bank of the United States (Martin E. Thompson, 1824). KRJDA

American Wing, Metropolitan Museum of Art, Fifth Avenue at East Eighty-second Street. Kevin Roche John Dinkeloo and Associates, 1980. View to the east. KRJDA

writing in the *Journal of the American Institute of Architects*, was impressed with the new space: "The court is a place of intense tranquility and of the most cunningly crafted quietude, a place discovered deep within the museum."[107]

In 1982 the next phase of the master plan was completed with the opening of Roche Dinkeloo's Michael C. Rockefeller Wing for the arts of Africa, Oceania, and the Americas, located on the south side of the museum.[108] The 2,000-piece collection of primitive art was largely donated by former Governor Nelson A. Rockefeller and named for his son, who disappeared in 1961 while collecting artifacts in New Guinea. Like the Sackler Wing on the north side of the museum, the Rockefeller Wing featured a sloping glass-and-metal wall overlooking the park. The 42,000-square-foot exhibition hall was divided into three separate areas with varying ceiling heights of eleven, twenty-six, and fifty feet. In addition to nearly an acre of exhibition space, the wing contained 14,000 square feet of offices, conservation studios, and a library. Paul Goldberger felt that the abstract design of the Rockefeller Wing and the art on display "could not be less similar," but he conceded that the contrast produced excellent results: "If we are willing to make the great leap, and accept the modernist esthetic that

ABOVE Michael C. Rockefeller Wing, Metropolitan Museum of Art, Fifth Avenue at East Eighty-second Street. Kevin Roche John Dinkeloo and Associates, 1982. KRJDA

BELOW Lila Acheson Wallace Wing, Metropolitan Museum of Art, Fifth Avenue at East Eighty-second Street. Kevin Roche John Dinkeloo and Associates, 1987. KRJDA

Carol and Milton Petrie Sculpture Court, Henry R. Kravis Wing,
Metropolitan Museum of Art, Fifth Avenue at East Eighty-second Street.
Kevin Roche John Dinkeloo and Associates, 1990. KRJDA

has come to control all at the Rockefeller Wing, this is an installation of both beauty and power. To see the tall, carved pieces against Mr. Roche's glass wall, with the skyline of Manhattan behind, is to feel tremendous drama."[109]

It was another five years before the next piece in the master plan puzzle was filled in, when Roche Dinkeloo's Lila Acheson Wallace Wing, devoted to contemporary art, opened in February 1987.[110] Located in the southwest corner of the museum, over the parking garage, in the space once set aside for the Annenberg Center, the four-level structure resembled the American Wing and contained 70,000 square feet of exhibition space in twenty-two galleries, including a 135-foot-long, 22-foot-high, mezzanine-level sculpture court with a sloping glass roof. The wing also featured a 10,000-square-foot, rooftop sculpture garden, paved in granite and enclosed by a limestone wall, an idea suggested by Kevin Roche after Philippe de Montebello complained that there wasn't room to display large sculpture. Joseph Giovannini, writing in *Artforum*, severely criticized the Wallace Wing, noting that "the addition that contains the spirited art of this century is itself opaque in its organization, muddy in its details, and leaden in spirit." Giovannini was particularly disappointed in the "undeveloped" main entry, which should have prepared visitors for viewing the collection but was instead "nothing more than a long, low, narrow corridor, with a pair of glass doors at either end and a bank of elevators and bathrooms. . . . This introductory space has little dignity, no mystique, and not even much clarity, and it squeezes visitors into the first room as though shooting them out of a tube of toothpaste— there is no time or space to take stock and reflect on the coming experience; there is no architectural caesura." Overall, he found the gallery spaces "confusing," with "too many doors, no visual peace, and no clarity about paths through the wing." Giovannini's criticism extended to the bland limestone and glass exterior as well: "A wing that seems to offer views into the park does not reciprocate with facades worthy of being viewed. . . . Instead of giving people in the park the architectural company of engaging details, shapes, and surfaces, the wing presents a high, sheer, blank face."[111]

The expansion called for in the 1970 master plan was finished in late 1990 with the completion of Roche Dinkeloo's Henry R. Kravis Wing, dedicated to European sculpture and decorative arts, including the Tisch Galleries and the Carol and Milton Petrie Sculpture Court.[112] Located north of the Wallace and Rockefeller wings, the highlight of the new construction was the 240-foot-long, 32-foot-wide, 63-foot-high

Petrie sculpture court topped by a pyramidal skylight, which overlooked Central Park with a 44-foot-high glass wall and was flanked on the south by a French limestone facade that evoked the Orangerie at Versailles, a design decision reflecting Roche's new openness to historical influence. The north wall consisted of a portion of the restored granite and red brick south facade of Theodore Weston's 1888 addition to the museum, recalling Roche's widely praised decision twelve years earlier to reveal a portion of Calvert Vaux and Jacob Wrey Mould's original 1880 building as part of his Lehman Wing.[113]

Paul Goldberger took the completion of the master plan as an opportunity to assess Roche's work at the Metropolitan over the past twenty-three years. Recalling that at the beginning of the collaboration "it didn't seem excessive to hope for an architectural masterpiece," Goldberger observed that at the conclusion of "one of the longest-running and most ambitious construction programs of any museum," the results were hardly impressive. "Somehow, Mr. Roche and the museum have never quite brought out the best in each other; their relationship has been like one of those marriages that don't end but don't soar, either. Except for the new front stairs on Fifth Avenue, which serve as a glorious drumroll of limestone up to the museum's main door, it has always seemed as if Mr. Roche has wanted none of the old museum, that he wished its classically styled buildings would simply go away. His sleek walls of slanted glass butt up against McKim, Mead & White's sumptuous classical palazzo with the presumption of an *arriviste*."[114]

After the completion of the master plan, Roche continued his association with the museum and, as if in response to Goldberger's criticism, took on with great sympathy the restoration and expansion of the Greek and Roman galleries beginning in 1994.[115] The renovated space on the southeast side of the museum reopened as the Mary and Michael Jaharis Gallery on April 20, 1999, to wide critical acclaim. Michael Kimmelman described the 140-foot-long central gallery as "the most spectacular space to be opened in New York City since the renovation of Grand Central Terminal."[116] Roche reinvigorated the sixty-two-foot-high, twenty-seven-foot-wide, barrel-vaulted corridor that connected the Great Hall to the restaurant by restoring the three twenty-foot-long skylights, which had been blackened since World War II, and adding French limestone walls to replace the originals, which had only been painted to resemble stone because of shortages caused by the First World War. The design represented another example of Roche's new-found sensitivity to historical precedent. To guide him in his work, Roche was able to take advantage of a recent discovery in a tunnel under the museum of meeting minutes, photographs, and some of McKim, Mead & White's original drawings for the space. Following the traditional character of the Kravis Wing and Petrie Sculpture Court and the renovation of the Meyer Galleries into a suite of classical rooms, the new Greek and Roman Galleries could be seen as one more significant step away from the Modernism of the 1970 master plan, if not a repudiation of it. As the editors of the *New York Times* noted, "what makes this restoration exceptional is that it represents a rediscovery of the Metropolitan Museum's original purpose, in architecture and in content."[117]

Mary and Michael Jaharis Gallery, Metropolitan Museum of Art, Fifth Avenue at East Eighty-second Street. Kevin Roche John Dinkeloo and Associates, 1999. KRJDA

UPPER
WEST SIDE

HISTORIC DISTRICTS

Bookended by the Lincoln Center complex to the south and the campus of Columbia University to the north, the Upper West Side was a battleground for the struggle between those forces committed to preserving the scale and character of the neighborhood, which had been in decline between the 1950s and 1970s but was now rapidly gentrifying, and those intent on building new large-scale projects. As with the Upper East Side, where in 1981 the Landmarks Preservation Commission created a historic district composed of more than sixty blocks and 1,000 buildings, large-scale historic districting seemed more effective than traditional zoning as a way to curb excessive redevelopment. With the potential threat of huge building projects, such as the redevelopment of the Coliseum site at Columbus Circle as well as the development of the West Side rail yards between Fifty-ninth and Seventy-second Streets, West End Avenue and the Hudson River, many West Siders and preservationists, led in part by community-based groups like Landmark West, felt that action needed to be taken quickly in order to save what remained of the area's historic core. Two Upper West Side districts were formed within four months of each other: the Riverside Drive West End Historic District, designated on December 19, 1989, and the Upper West Side Central Park West Historic District, designated on April 24, 1990.[1]

Although the Landmarks Preservation Commission had already created six historic districts on the Upper West Side, these were for the most part relatively uncontroversial one- or two-block enclaves.[2] But with the simultaneous attempt to create both the Central Park West and Riverside-West End districts, the stakes were far greater, as Anthony DePalma made clear in the *New York Times* in 1987 by noting that the combined districts "would, if designated, constitute the largest historic demesne in the city. This attempt to preserve the past comes at a time when the Upper West Side is struggling with the greatest changes it has faced since it shot up in the lowlands west of an inchoate Central Park a century ago. In both size and scale, this preservation effort may be the strongest test of the city's authority to protect the look of an area targeted for, but not yet designated as, a historic district."[3] The proposed Central Park West Historic District, roughly bounded by Sixty-second and Ninety-fifth Streets, Central Park West, and Columbus Avenue but extending as far west as the east side of Amsterdam Avenue between Seventy-second and Eighty-eighth Streets, was the larger of the two, including over 2,000 buildings, or about twice as many as in the Upper East Side Historic District. That would make it the second-largest of the fifty-one historic districts in the city, topped only by the Greenwich Village Historic District.

The proposed mixed-use Central Park West district, composed of Italianate and Neo-Grec rowhouses on the side streets, tenements along Columbus and Amsterdam Avenues, and grand apartment houses on Central Park West, as well as architecturally distinguished churches, synagogues, schools, and museums, was largely built in a fifty-year spurt of construction begun after the completion in 1879 of the Ninth Avenue elevated and halted by the Great Depression, a "rather cohesive period of development," according to architectural

historian Andrew Dolkart, that gave the area "its very special architectural character."[4] The proposed Riverside Drive West End district was much smaller, roughly bounded by Eighty-fifth and Ninety-fifth Streets, Riverside Drive and West End Avenue, a primarily residential enclave of 265 buildings built largely between the 1880s and 1920s and including rowhouses and single-family houses from the earliest part of the period as well as more recently constructed apartment houses along West End Avenue and Riverside Drive.

The most vocal proponents of the new historic districts were, not surprisingly, various civic and preservation groups, including Landmark West, the Landmarks Conservancy, the Historic Districts Council, and the Municipal Art Society. These groups were able to rally support in the community for designation as well as raise the general profile for the city's historic preservation movement as a whole, in part by recruiting many well-known Upper West Siders to the cause, including the actors Lauren Bacall, Christopher Reeve, and Tony Randall, Yoko Ono, the novelist E. L. Doctorow, and Jacqueline Kennedy Onassis, who lived across the park. Community Board 7 also strongly supported the designation of both proposed districts, and in January 1988, former mayor John Lindsay, in his first public testimony on an urban issue since leaving office in 1973, spoke in favor of the Central Park West Historic District before the Landmarks Preservation Commission. Lindsay, a neighborhood resident for the past fifteen years, felt a need to protect the area from "unrestrained, unplanned, unthinking, rampant development."[5]

Opposition to the creation of the new historic districts included individual and small property owners who were worried about the increased costs that designation would impose on routine building maintenance and renovation. Large property owners, such as the American Broadcasting Corporation, which controlled several properties in the West Sixties between Central Park West and Columbus Avenue and was interested in further expansion in the neighborhood, also protested. The strongest opposition, however, came from a coalition of twenty churches and synagogues in the neighborhood whose leaders not only believed that designation would severely limit their ability to raise much-needed revenue by selling or developing their historic properties but would also impose an undue financial burden on them by increasing maintenance costs, thereby affecting their primary responsibility to serve the community and the poor. Representing this group was the Rev. Jay Gordon, rector of the Church of St. Matthew and St. Timothy, 26 West Eighty-fourth Street, which ironically was housed in a cast-concrete Brutalist design (1967) by Victor Christ-Janer that broke with the scale of the residential block and would likely have been considered a noncontributing building to the proposed district. Despite the protests, the Board of Estimate unanimously approved the designation of both the Riverside Drive West End and Upper West Side Central Park West historic districts, safeguarding a huge stretch of the Upper West Side as well as influencing the character of the development that would go forward within the historic districts and the neighborhood at large.

In addition to the debate over the designation of the two new historic districts, there were also battles involving individual landmarks, especially ones belonging to financially strapped institutions, such as the New-York Historical Society, which attempted to build a revenue-producing apartment tower above its building (see Institutions, Upper West Side). More often than not, these fights involved religious institutions

PREVIOUS PAGES Aerial view to the northwest of West Side, 1985. SKY

seeking to raise revenue by either selling their air rights or trying to reverse their landmark status in order to sell their buildings, which would presumably be demolished to make way for larger, for-profit buildings. The most contentious example involved the Church of St. Paul and St. Andrew, originally St. Paul's Methodist Episcopal Church (R. H. Robertson, 1897), northeast corner of West End Avenue and Eighty-sixth Street, an eclectic mixture of early Italian Renaissance and German Romanesque precedents that had a low square tower at its northwest corner and a tall octagonal tower at its southwest corner.[6] The church, which had been landmarked in 1981 over the strenuous objections of the congregation, claimed that the cost of maintaining its building would bankrupt the congregation. It sought to reverse the landmark designation in order to sell its building to a developer who would demolish it and replace it with a twenty- to twenty-five-story apartment tower that would incorporate modest ground-floor facilities for the 220-member congregation, which no longer needed a sanctuary designed to seat 1,400 worshipers.

The Church of St. Paul and St. Andrew filed suit against the Landmarks Preservation Commission, arguing that designation violated the First Amendment right to the free exercise of religion by prohibiting the church from freely disposing of its property. But in 1986 the New York State Court of Appeals ruled that the church was obliged to exhaust all of the administrative procedures provided by law. After the United States Supreme Court refused to hear the case, the church attempted to argue its case before the Landmarks Preservation Commission on the basis of financial hardship. The Rev. Floyd George, pastor of the church, along with a trustee, the Rev. G. Morris Gurley, emphasized that "this is not real estate speculation, as some claim. This is survival. . . . The landmark designation would bankrupt this church and cause the dissolution of its congregation."[7] Rev. George also took the opportunity to deliver an aesthetic potshot. Although the commission had characterized the church as an important example of Scientific Eclecticism, he saw it quite differently, describing its facade as "architectural mishmash."[8] In unanimously denying the hardship request in 1989, the Landmarks Preservation Commission again asserted its belief in the architectural distinction of Robertson's building but also noted that the church had failed to produce a "concrete proposal" for the site, content to verbally describe its plans for a "new building, with safe, modern and functional facilities for the church."[9]

In 1983 the Landmarks Preservation Commission denied another religious institution's request to sell its air rights when Congregation Shearith Israel, 2 West Seventieth Street, southwest corner of Central Park West, proposed to build an apartment tower adjacent to its synagogue.[10] Declared a landmark in 1974, Brunner & Tryon's 1897 classical synagogue represented a significant move away from the Moorish- and Byzantine-inspired designs more typical of synagogue architecture at that time. It served the needs of the oldest Jewish congregation in the United States, dating back to 1654. David Kenneth Specter's unrealized, limestone and buff-colored brick tower would have replaced a four-story community house (1954) located just to the west at 6 West Seventieth Street.

The Landmarks Preservation Commission did, however, permit the demolition of the 1,000-seat Mt. Neboh Synagogue (Walter S. Schneider, 1928), originally built as the Unity Synagogue, 130 West Seventy-ninth Street, between Amsterdam and Columbus Avenues, a notably restrained design combining

Proposed apartment tower, south side of West Seventieth Street, between Central Park West and Columbus Avenue. David Kenneth Specter, 1983. Rendering of view to the southwest showing Congregation Shearith Israel (Brunner & Tryon, 1897) in the foreground. SDA

Moorish and Byzantine motifs.[11] In February 1982, eight months after being sold to developers by the Seventh-Day Adventist Church, which had owned and occupied the building since 1978, the synagogue received landmark status, with the commission acting on the request of community residents, who were justifiably concerned for its future. But exactly one year to the day after designation, on February 9, 1983, the commission approved the hardship application of the developers, paving the way for its destruction. The developers did not carry out their expressed desire to incorporate at least a portion of Schneider's sandstone facade in the nineteen-story, ninety-four-unit completely banal red brick apartment tower they commissioned from Vito J. Tricarico in 1986.

LINCOLN CENTER

Lincoln Center, housing the greatest concentration of performing arts venues in the world, and the model for countless imitations, including the John F. Kennedy Center in Washington, D.C., was essentially complete in 1969 when the Juilliard School of Music moved into its new home.[1] The center was the catalyst for the Upper West Side's dramatic rebirth as a highly desirable residential district, bringing with it the extensive rehabilitation of existing townhouses and apartments, as well as considerable new construction. Lincoln Center also generated a lively new retail district principally consisting of restaurants but also, by the 1980s, of record and book shops and, by the 1990s, of a wide variety of other, typically high-end, retail stores. Lincoln Center's success belied Jane Jacobs's argument that the distribution of its venues throughout the city would have been a more effective way to stimulate neighborhood growth.[2] Others argued that its aloof, even elitist, character contradicted the efforts of the various enterprises to attract more economically and culturally diverse audiences.

Early on, the limitations of the center's buildings became glaringly obvious. In 1975–76, the acoustically challenged auditorium of Philharmonic Hall (Max Abramovitz, 1962) was stripped to its shell and redesigned by Johnson/Burgee working with the acoustician Cyril M. Harris.[3] Renamed after the renovation's donor, the acoustical engineer Avery Fisher, the new hall, modeled on McKim, Mead & White's smaller Symphony Hall (1900) in Boston, offered improved but not truly reverberant acoustics.

In 1977, 12,000 square feet of basement space under the plaza facing the Vivian Beaumont Theater was transformed by Gwathmey Siegel & Associates into new offices for the center's overall administration arm, the Lincoln Center for the Performing Arts.[4] Two years later, the same firm renovated the dingy passageway leading from the garage to the Metropolitan Opera House into a shop-lined promenade.[5] In each case, Gwathmey Siegel pursued its characteristic vocabulary of shiny metal planked ceilings combined with plate glass, glass block, and ceramic-tile-clad walls.

Weather and air pollutants proved hard on the travertine-clad buildings. Worse hit were the heavily traveled plaza spaces, which received their first major refurbishment in the early 1980s.[6] Upkeep for the plaza remained a constant problem, with a second major repair effort undertaken in 1990.[7] One unintended victim of the center's plaza restoration efforts was the underappreciated landscaping designed by Dan Kiley, whose work had been first damaged by the decision in 1981 to erect at the Christmas season a 1,600-seat tent housing the Big Apple Circus.[8] Beginning in 1993, Kiley's formal, bosk-like arrangement of London plane trees was seriously compromised when it was decided to replace the four trees that occupied each twenty-foot-square planter with a single Bradford pear tree, a change first publicized by Armand Le Gardeur, an architect at Robert A. M. Stern Architects, whose offices were located in the neighborhood. Stern protested the move, likening the new grove to "a bunch of lollipops on sticks. It's ruined."[9]

While Philharmonic Hall's functional deficiencies were widely known from its first weeks of performances—and the artistic deficiencies of the building itself even before its doors were first opened to the public—the plight of Eero Saarinen's 1,143-seat Vivian Beaumont Theater was more complex.[10] Admired for its relatively uncompromised stylistic

Modernism, the Beaumont Theater was perceived as a chilly, inhospitable theatrical venue, with an overscaled lobby. Its highly flexible stage, designed by Jo Mielziner, combining a traditional proscenium format with a small apron thrust, was from the first deemed too deep, so that those seated at the sides of the auditorium could not see the action taking place at the rear of the stage. Additionally, the Beaumont's acoustics were poor, forcing the management to provide electronic amplification, then unheard of in a live-performance spoken-word playhouse. Under two separate management groups, the theater had proved unworkable, but a substantial gift from the Fan Fox and Leslie R. Samuels Foundation in 1981 made it possible to undertake renovations of the Beaumont as well as of the New York State Theater, which needed extensive acoustic enhancements to allow for the fact that it was now home to the New York City Opera as well as the New York City Ballet, for which it had initially been designed.[11] While the State Theater's renovation only somewhat affected the shape of the hall, most notably modifying the size and proportion of the proscenium aperture, proposed changes at the Beaumont were drastic. At first, I. M. Pei was hired to carry out the theater's redesign, but after a year's work he resigned the commission over differences with acoustician Cyril M. Harris. Escalating costs were also said to be part of the problem. Although Philip Johnson was said to have been named as Pei's replacement, no action was taken while Richard Crinkley, executive director of the Lincoln Center Theater Company, and the Beaumont Theater board openly quarreled with Lincoln Center management. Consequently, the Fox-Samuels gift of $4 million, contingent on matching funds being raised, was withdrawn. More than a decade later, in 1995, renovation plans were announced again, but this time on a more modest scale and not involving a radical redesign of the stage or a major reworking of the sightlines but instead concentrating on much-needed acoustical improvements, replacement of heating, ventilation, and air-conditioning systems, and a renovation of the lobby spaces.[12] The latest plans also involved renovating Saarinen and Mielziner's smaller theater in the building, the 299-seat Mitzi Newhouse Playhouse. The renovation, which was delayed until 1998, was undertaken by Hugh Hardy, who had, appropriately enough, begun his professional career by working for Saarinen and Mielziner on the design of the Vivian Beaumont Theater.

Lincoln Center was significantly expanded in 1990 with the completion of Davis, Brody & Associates' seventeen-story, nearly white, Wisconsin Valders stone–clad Samuel B. and David Rose Building (the Valders stone was chosen for its close match to Lincoln Center's problematic travertine) and Three Lincoln Center, also by Davis, Brody, with apartment layouts by Harman Jablin Architects, a forty-four-story apartment tower atop a ten-story base largely occupied by Lincoln Center.[13] Located along West Sixty-fifth Street, the Rose Building immediately adjoined the Juilliard School, for which it provided expanded performance space, dormitory rooms for 350 students from Juilliard and from the School of American Ballet, and a home for the newly established Lincoln Center Film Society. To the Rose Building's west, the glass-clad 347-unit apartment tower incorporated an existing firehouse, southeast corner of Sixty-sixth Street and Columbus Avenue, and provided, at the northeast corner of Sixty-fifth Street and Columbus Avenue, space for a new Riverside branch of the New York Public Library, also designed by Davis, Brody. The sale to the condominium apartment developer of Lincoln Center's unused development rights helped offset the cost of the Rose Building.

The construction of the apartment house and the Rose Building, first announced in 1984, was opposed by local residents whose principal objection was the height of the apartment building, which, at 575 feet, would be the tallest residential tower on the Upper West Side. Nevertheless, construction got under way in January 1988. The apartment tower's street-level lobby was connected by escalators to the third-floor level of the Juilliard School's plaza, giving residents easy access to Lincoln Center's venues. Named after the composer Meredith Willson, the residence hall, occupying the bulk of the Rose Building's space, was imaginatively planned to accommodate, on each floor, individual bedrooms, floor lounges occupying each of the four bay windows, and two music practice rooms. Near the top of the building, the 2,500-square-foot Rose Suite was a luxurious three-bedroom apartment worthy of 1920s Park Avenue or Riverside Drive. Above it, the Stanley H. Kaplan Penthouse, with sweeping views of the city, incorporated a chamber music studio and a 2,500-square-foot reception room, its sixteen-foot-high ceiling carried on polished stainless-steel columns that reflected the light pouring in from two walls of floor-to-ceiling glass.

The Rose Building also was home to the 268-seat Walter Reade Theater, designed by Davis, Brody, to be the principal venue of Lincoln Center's film program. Vincent Canby, the *New York Times*'s respected film critic, praised the theater as "handsome, comparatively small but spacious" with a "nervy character, seemingly unencumbered by its high-art context." Canby deemed "the décor . . . as eclectic as the theater's programming policy," discreetly suggesting "the more florid look of the Ziegfeld Theater [Emery Roth & Sons, Irving Gershon, and John McNamara, 1969], the 1,151-seat house built by Walter Reade Jr., the exhibitor for whom the Lincoln Center house is named."[14] The decision to locate the entrance to the

Reade theater, as well as the Juilliard box office and bookstore, on the elevated plaza brought new life to an underutilized asset. New elevators and escalators, sheltered by elegantly minimalist glass-enclosed kiosks, also designed by Davis, Brody, were intended to encourage greater public use of the open space.

In 1996 Movado, the watchmaker, commissioned Philip Johnson to design a clock intended for placement on Lincoln Center's main plaza. The clock—or to be accurate, the four clocks—bearing the sponsor's name on each face, would be housed in an eighteen-foot-high torqued and inverted four-sided irregular obelisk, an eccentric shape the ninety-year-old architect, then under the influence of Frank Gehry, was exploring in a number of sculpturelike projects intended for public plazas.[15] The project was opposed by Joseph Volpe, general manager of the Metropolitan Opera, the center's most powerful tenant, who deemed it a further erosion of the complex's public space. "Nobody is protecting the integrity and dignity of Lincoln Center," Volpe stated, lumping the clock tower in with the restaurant, summer dances, banners, and flea markets that he felt detracted from the center's larger purposes.[16] Dissension at Lincoln Center delayed the project, and in 1998 Johnson, asked by Movado to propose a different site, selected the north end of Dante Square, across the street from the center, where the bronze clock tower was installed in 1999. To Francis Morrone, the traditionalist architectural critic, Johnson's design was "kitschy . . . looking like a refugee from Disney's Beauty and the Beast."[17]

Though some saw the intensely programmed summertime use of the plaza as a conflict with the center's principal purposes, others, especially those interested in the city's street life, deemed the heavy use as proof that Lincoln Center was not the elitist enclave many had feared it might become. "Like the Campidoglio in Rome," wrote Herbert Muschamp in 1996, "Lincoln Center is a great urban stage. The main plaza and the three buildings facing onto it add up to one great theater, a monumental showcase of urban spectacle." Though Muschamp was less than comfortable with the center's modern classical architecture, he found it "ahead of its time, at least in one disturbing respect: It previewed the stylistic confusion that would overtake architecture in the decade to come. Classical buildings for a time that didn't believe in classicism, ornamented buildings for a time that didn't believe in ornament, public space for a city that has always had great difficulty grasping the concept of public amenity: architecturally, Lincoln Center is the sum of its contradictions."[18] A year later, New York Times music critic Bernard Holland addressed the center's principal functional shortcoming: acoustics. "If architects have visions and musicians have needs," Holland asked, "why did so much go wrong in the building of Lincoln Center?"[19]

These reassessments of Lincoln Center may have been motivated by rumors that management was contemplating momentous physical changes for the complex which, though eligible for designation as a historic site, had not been considered by the New York City Landmarks Preservation Commission. In February 1997, plans were announced for a new midsize, 1,000- to 1,200-seat hall with a spacious stage area suitable for a variety of performance modes to be built as part of a high-rise apartment building being planned by Millennium Partners for the Broadway blockfront between Sixty-fourth and Sixty-fifth Streets, directly east of the center.[20] The proposed site was occupied by the Goelet Garage

TOP Stanley H. Kaplan Penthouse, Rose Building, 165 West Sixty-fifth Street. Davis, Brody & Associates, 1990. Warchol. DBB

ABOVE Walter Reade Theater, Rose Building, 165 West Sixty-fifth Street. Davis, Brody & Associates, 1990. Auditorium. Aaron. ESTO

BELOW *Time Sculpture*, Dante Square, site bounded by West Sixty-third Street, Broadway, and Columbus Avenue. Philip Johnson Alan Ritchie Architects, 1999. View to the west. Payne. RP

Grand Tier, 1930 Broadway, between West Sixty-fourth and West Sixty-fifth Streets. Costas Kondylis, 2004. View to the southeast. Choi. CCAP

(Frank M. Andrews and Maynicke & Franke, 1907), 1926 Broadway, a six-story white brick loft building distinguished by broad window bays and white terra-cotta detailing. The building was the only significant structure of its type in the area left over from the earlier part of the century when this stretch of Broadway was called Automobile Row. Beginning in the early 1990s, Millennium Partners had become the dominant developer in the Lincoln Center area (see below) but this time failed to gain control of the site, thwarting Lincoln Center's plans. After failed efforts by preservationists, led by Landmark West, to have the building designated a landmark, the Goelet Garage was demolished in 2002 to make way for the Grand Tier (2004), a twenty-nine-story, 232-unit apartment building designed by Costas Kondylis. Kondylis also designed the thirty-two-unit residential building next door (2003), adding four stories to the eight-story Liberty Storage Warehouse (1891), 43 West Sixty-fourth Street, notable for the thirty-seven-foot-high replica of the Statue of Liberty on its roof, installed in 1902, which was relocated to a garden at the Brooklyn Museum.[21] Lincoln Center did get a new theater, though not on this site, but as part of the Related Companies' development at Columbus Circle.

In June 1999, the New York Times reported that the administration of the now forty-year-old Lincoln Center was considering a "vast fund-raising campaign to address the wear and tear of decades and other gnawing problems, from crippling shortages of backstage space to troubled acoustics to underground leaks."[22] While many imagined a program of high-level restoration and renovation, at least one outspoken member of the Philharmonic's board, Rita E. Hauser, an international lawyer, called for the replacement of almost every performance venue—a move that she estimated would cost $500

million. Already, Skidmore, Owings & Merrill, commissioned to study Avery Fisher Hall, had reported that three strategies for its renovation were possible, the most expensive of which could cost $200 million. The Met's consultants estimated that $350 million would be needed to address its problems properly. Additionally, Beyer Blinder Belle was hired by Lincoln Center's management to study its capital needs. Over the next few years, Hauser's bold vision, fueled by a booming economy, would hold Lincoln Center's management in thrall, unheeding of John D. Rockefeller 3rd's forty-year-old hope that the center would "last for generations."[23]

In December 1999, the Lincoln Center Committee for the 21st Century proposed a wide-ranging renovation that, at $1.5 billion, vastly exceeded even Rita Hauser's estimates.[24] The plan, prepared by Beyer Blinder Belle, presented a wide range of options, including new buildings, rooftop extensions, an opera museum, a visitors' center, and extensive reconstruction and repair projects needed to keep the center going. Though some preservationists began to argue for a plan that would value the center's architecture, voices from surprising quarters called for its complete replacement. None was more surprising than that of Myron Magnet, editor of the conservative and influential City Journal who, in conclusion to his encomium to the Rose Center for Earth and Space, noted that Lincoln Center was "prematurely aging, as modernist buildings do." He called for something following "the planetarium's example: tear down the whole complex and build something grand and enduring."[25] Acting on his own instincts, Magnet commissioned sets of plans from Quinlan Terry and Robert Adam, both English classicists, and from the Washington, D.C., firm of classicists Franck Lohsen McCrery. Presenting the schemes to readers of City Journal, Magnet made the point that, at the time of Lincoln Center's construction, "most critics . . . charged that they failed because they weren't modernist enough. In fact," he argued, "the reverse was the case: they were insufficiently traditional. As it was, the architects of the three principal buildings fell between two stools," creating "a kind of proto-postmodernism: modernist buildings with some traditionalist doodads tacked on. . . . These buildings really are nothing but kitsch—sentimental and insincere evocations of something meaningful, without any understanding of, or passion for, the underlying ideal."[26]

Of the three schemes, Robert Adam's was the most freewheeling, calling for an informal arrangement of theaters around a central plaza reached from Columbus Avenue by a covered loggia or across a new plaza replacing Avery Fisher Hall. In representing his buildings, which included an apartment tower to be built above the stage house of a new opera house, Adam was almost playful, indeed almost Postmodern, offering a Leon Krier–inspired scheme that mixed prototypes from the classical and vernacular. But his scheme made important urbanistic points, turning its back on the ill-fated axial plan that was to link the cultural complex to Central Park and on the so-called Lincoln Square—in reality a triangular site—which he felt was hardly a park, but a patch of green "lost in the urban shuffle."[27] Quinlan Terry, in "defiance against the construction of flimsy and ephemeral modern buildings," proposed a group of Indiana limestone buildings situated around plazas much like those already built.[28] Though Terry's basilica-like state theater and concert hall, modeled in part on bathing structures from Imperial Rome, seemed too big for their sites yet too small for their programs,

LEFT Proposal for Lincoln Center, between Columbus and Amsterdam Avenues, West Sixty-second and West Sixty-sixth Streets. Robert Adam, 2000. Rendering of view to the southwest. RA

LEFT Proposal for Lincoln Center, between Columbus and Amsterdam Avenues, West Sixty-second and West Sixty-sixth Streets. Franck Lohsen McCrery, 2000. Rendering of view to the west. FLM

BELOW Proposal for Lincoln Center, between Columbus and Amsterdam Avenues, West Sixty-second and West Sixty-sixth Streets. Erith & Terry, Architects, 2000. Rendering of view to the west. QFT

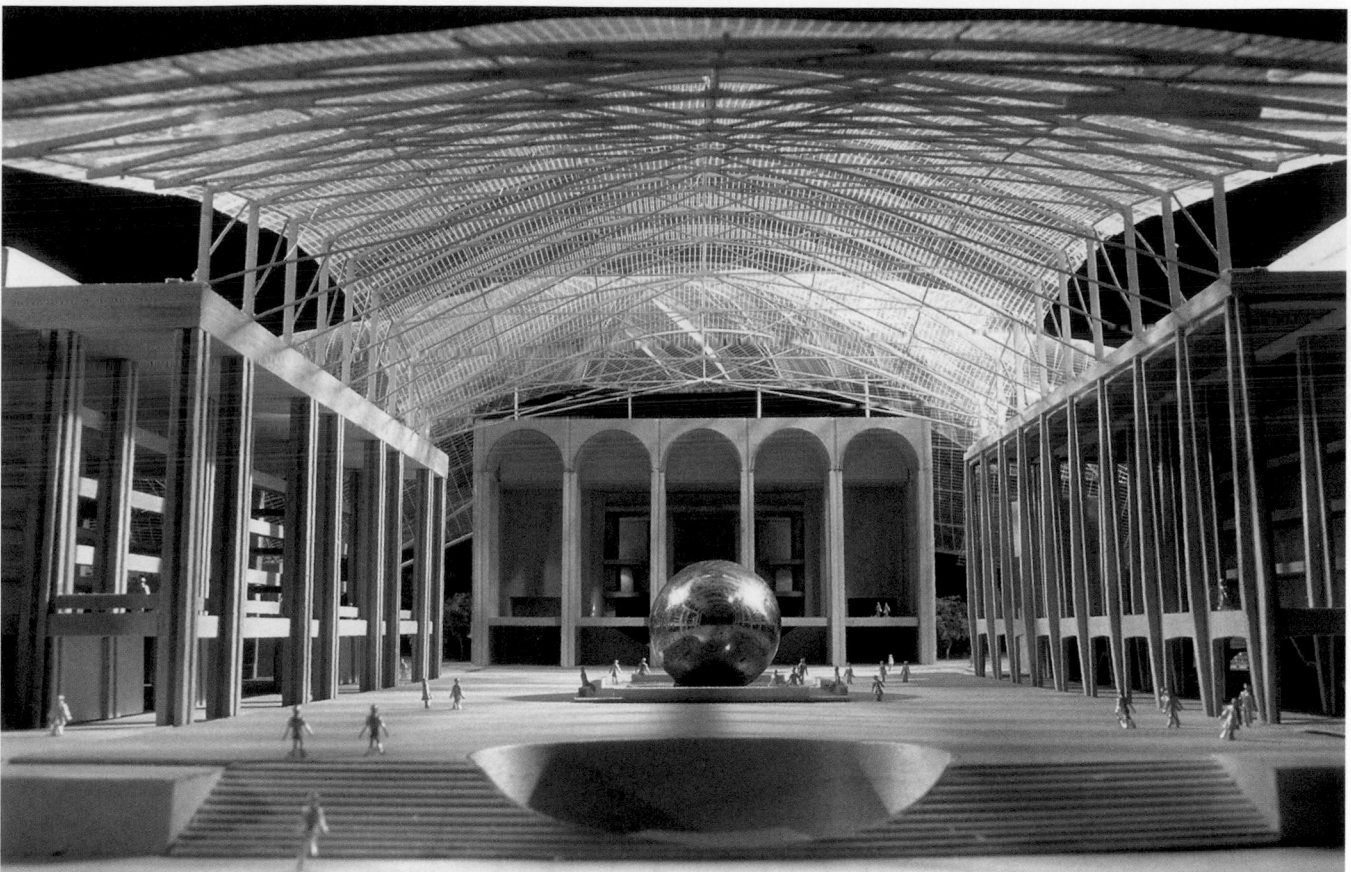

Proposal for Lincoln Center, between Columbus and Amsterdam Avenues, West Sixty-second and West Sixty-sixth Streets. Frank Gehry, 2001. Model, view to the west. Preston. GP

his opera house, with its grandly proportioned temple front porch, surely rose to the Metropolitan's sense of entitlement. Franck Lohsen McCrery's proposal consciously built upon the intentions of the original Lincoln Center, carrying the Campidoglio metaphor further, specifically in the dramatically raised approach to the central plaza and in the robust classicism of the three buildings that flanked it.

The revolutionary messages embodied in the classicist schemes did not fall on deaf ears. For Bernard Holland, the *City Journal*'s proposals and especially the idea of replacing all of Lincoln Center, represented "a window of opportunity that may never come again." Holland offered "the assembled British and American architects, all of them committed to the enduring values of Classical style," this "essentially sneaky" suggestion: "Let our champions of the past build their updated Greek temples and Roman basilicas and baths. A lot of us will happily walk along any corridor of Corinthian capitals or through any number of Caesarian triumphal arches if a new ground zero for the eyes can be accompanied by a new ground zero for the ears. . . . Opera houses and concert halls that let listeners listen, allow music and theater their proper scale and restore singers to environments that neither dwarf nor deaden their voices are what Lincoln Center needs. We'll gladly put on togas if that's what it takes."[29]

The proposal to renovate Lincoln Center moved into high gear with the appointment, in late July 2000, of Rebecca Robertson, former president of the 42nd Street Development Project, as executive director of the reconstruction commit-

tee.[30] Robertson reported to Marshall Rose, a real estate developer who, as vice president of Lincoln Center, was to lead a renovation committee. Rose's committee was in turn responsible to a Project Leadership Committee composed of former opera star Beverly Sills, the chairwoman of Lincoln Center, and artistic directors of Lincoln Center's twelve resident arts organizations, a route of command that was, to put it mildly, fraught with peril. Sills then announced her intention to step down as chair, and Nathan Leventhal, president of Lincoln Center for the past seventeen years, also resigned, to be replaced by Gordon J. Davis, a lawyer, former Parks Commissioner, and the chairman of Jazz at Lincoln Center.[31]

In January 2001, New York City, which owned the land under the center, committed $240 million toward its overhaul, and an anonymous donor promised a significant gift to help build a new opera house for the exclusive use of the New York City Opera Company.[32] At this time, the firm of Cooper, Robertson & Partners was brought in to work with Beyer Blinder Belle on the master plan and things seemed to be falling into place—that is, until a week later, when the Metropolitan Opera announced its withdrawal from the project and its intention to proceed with its own restoration plans.[33] The decision was largely political, based on the balance of power between the center's various entities as specified in the composition of the new corporation being organized to oversee the center's reconstruction. After two months of behind-the-scenes maneuvering, the Metropolitan rejoined Lincoln Center's redevelopment project under much

more favorable rules that increased the participation of the constituent companies in the planning process, thereby reducing the authority of Marshall Rose and Gordon Davis. Additionally, the authority of the various groups would be weighted, with the Metropolitan's vote representing 29.1 percent, exceeding even the 20.4 percent of Lincoln Center itself.

In mid-May 2001, news was leaked of the redevelopment corporation's most provocative proposal: a glass enclosure for the plaza designed by Frank Gehry.[34] The dramatic impact of this news was somewhat dulled by the resignation under pressure from staff of Gordon Davis on September 29, 2001, the first indication, in the aftermath of September 11, that the ambitious reconstruction project was in serious jeopardy.[35] A month later, on October 22, Marshall Rose announced that he would resign as well. Rose's efforts to forge a working relationship between the cash-rich Metropolitan and the other, much poorer constituents, had clearly failed.

A glimpse of plans for the renewed center was offered in December 2001, but in the wake of 9/11 the public seemed focused on other things.[36] Notably absent from the material presented was any depiction of Frank Gehry's "dome" over the plaza or the two "gallerias" that he proposed for the west facades of the New York State Theater and Avery Fisher Hall. Shown instead was a soft, sketchy rendering of a reconfigured Sixty-fifth Street, with a narrowed roadway, steps bathed by an amazing northern sun, and in place of the windswept expanse of the elevated plaza, a paper-thin, arched, glass-sided bridge. The redevel-

opment plan's troubled fate was sealed in January 2002 when newly elected Mayor Michael Bloomberg, until recently a vice chairman of Lincoln Center, raised questions about the city's ability to provide the center with the $240 million over ten years that the Giuliani administration had committed to it.

Around Lincoln Center

One block north of the Lincoln Center complex, another cultural institution was completed in 1978, the Hebrew Arts School's Abraham Goodman Center, 129 West Sixty-seventh Street, between Broadway and Amsterdam Avenue, which included a 457-seat concert hall as well as a 150-seat recital hall; meeting rooms; classrooms; music, dance, and fine arts studios; and a 5,000-volume Judaica library.[37] As designed by Ashok Bhavnani of Johansen & Bhavnani, the seven-story building was a Russian Constructivist–inspired late Brutalist design whose framelike concrete facade was clad in part with aluminum panels and, at the third and fourth floors, was left open to reveal a red brick wall pierced by portholes. Paul Goldberger believed that the "strong facade" created "a dignified presence on the street."[38]

In contrast to the experience at Lincoln Center, the acoustics of the concert hall were well received by both critics and musicians, with the *New York Times*'s Peter G. Davis deeming it "just about an ideal place to hear music of chamber proportions." He did find the space, with its white walls, concrete floors, and pressed-wood acoustical panels hung

Abraham Goodman Center, 129 West Sixty-seventh Street, between Broadway and Amsterdam Avenue. Johansen & Bhavnani, 1978. View to the north. McGrath. NMcG

from a black ceiling, "a trifle Spartan . . . but not unpleasantly or distractingly so."[39]

Besides the Lincoln Center complex itself, the most dominating presence in the neighborhood was the group of buildings occupied by the American Broadcasting Company. Begun as a government-ordered spin-off from the National Broadcasting Corporation in 1943, ABC consistently ranked at the bottom of the three networks in terms of prestige, power, and ratings until 1952, when it was purchased by Leonard Goldenson, head of United Paramount Theaters.[40] Goldenson leased the ballroom of the Hotel des Artistes (George Mort Pollard, 1917), 1 West Sixty-seventh Street, for use as a studio.[41] The next year, he located the network's electronics in the former St. Nicholas Skating Rink (Ernest Flagg with Walter B. Chambers, 1895–98), 57 West Sixty-sixth Street, between Central Park West and Columbus Avenue.[42] In 1966, as the network prospered, ABC established headquarters at 1330 Avenue of the Americas, between Fifty-third and Fifty-fourth Streets, just a block from Eero Saarinen's imposing building for the Columbia Broadcasting Corporation, popularly known as Black Rock, which opened the year before.[43] Designed in typical fashion by Emery Roth & Sons, ABC's new forty-one-story, 500,000-square-foot building was disparagingly belittled as the crate that the CBS Building came packed in. Even with the move of its offices to midtown, operations remained in the West Sixties. But by 1973 the increasingly prosperous company had sprawled, owning nineteen properties in New York and New Jersey and leasing nineteen more in New York. Faced with the choice of building a major new facility, as proposed by John Carl Warnecke in 1976, the architect whose firm then employed Eugene Kohn, William Pedersen, and Sheldon Fox, the management put off action, preferring to reinvest its cash in programming. However, when the network for the first time earned the coveted number one prime-time status from the Nielsen ratings in 1976–77, management decided to consolidate operations on the West Side.

In 1976 the company bought at auction what had been the First Battery Armory (Horgan & Slattery, 1901), 56 West Sixty-sixth Street, then home to an indoor tennis court and a neighborhood cultural center known as the Double Image Theatre.[44] The purchase of the armory was the first in a series of real estate acquisitions that would trigger extensive neighborhood concern and result in the construction between 1976 and 1992 of seven major production and office facilities. Reading about the acquisition of the armory in the New York Times, Eugene Kohn, who, with Bill Pedersen and Sheldon Fox had left Warnecke's office to found the firm of Kohn Pedersen Fox (KPF), wrote to inquire about an interview for the commission for the building he felt the company would be constructing on the site.[45] According to Robert T. Goldman, ABC's vice president of administration, ABC was attracted to the new firm of KPF because it was "hungry. They really wanted the work."[46] KPF was awarded the commission, beginning with the development of a master plan for all the ABC properties on Sixty-sixth and Sixty-seventh Streets as well as for other sites the company owned or leased, including several along the Hudson River.

By 1977 KPF was actively at work on plans for two buildings along West Sixty-seventh Street: one an operations center on the south side of the street next to an apartment building at 40 West Sixty-seventh Street (Rosario Candela, 1929); the other building, to house studios for ABC's local television

station, Channel 7, was to replace the Columbia Fireproof Storage Warehouse (G. A. Schellenger, 1893), southeast corner of Sixty-seventh Street and Columbus Avenue.[47] Residents of the block, which was long admired for the architecture of its apartment houses, many of them built as artists' studios, were, as Paul Goldberger reported, "up in arms over the plan." Goldberger regarded designs for the 195-foot-high, 120,000-square-foot midblock operations center, 30 West Sixty-seventh Street, as too tall and too bulky. He also felt that the proposed horizontal window bands, though "visually attractive, are the one openly modern gesture that clashes with the ambiance of the street." The studio building, he observed, "should provoke less dispute," largely because the multipaned glass wall proposed to sheathe the upper three stories was "a welcome attempt to allude in modern terms to the large studio windows of such 67th Street buildings as the des Artistes."[48] Moreover, KPF also proposed to reerect as an ornament on the studio building the Romanesque triple entrance arch of Schellenger's warehouse. The plan began to move forward in earnest when, in April 1977, ABC received a real estate tax abatement from the city's Industrial and Commercial Incentives Board. Incorporating the new studios on the site of the armory, the midblock operations center, and the building for Channel 7, the plan was expected to consolidate ABC's operations, bringing 850 workers together from various scattered sites and creating 160 new jobs, a welcome addition to the city's sluggish economy.[49] The first stage of the ABC project consisted of the renovation of the armory in 1976-77. This was followed in 1976–79 by Seven Lincoln Square, WABC-TV's 85,000-square-foot studio office building, designed by William Pedersen, whose refined detailing in brick, metal, and glass managed to transform what could have been a totally introspective six-story windowless box into a relatively transparent structure that revealed on the top floors a three-story-tall

lobby uniting the upper-floor offices.[50] Instead of incorporating the triple-arched entrance of Schellenger's warehouse, a glass-fronted reception and waiting area opened the building up to passersby.

The facade of the operations center at 30 West Sixty-seventh Street was redesigned, foregoing the originally proposed horizontal banded windows in favor of a version of the densely gridded curtain wall of Seven Lincoln Square, with light buff-painted aluminum mullions holding vertically proportioned two-foot-eight-inch-wide panels of floor-to-ceiling glass in place, intended to complement the studio glazing in buildings across the street. Although the building stepped back five times, the decision to slope the parapets at forty-five degrees helped give the impression that there was a continuous cascade of glass down to the street. In 1979 Goldberger assessed KPF's early work for ABC: "Neither of the two new ABC structures is a masterpiece. . . . They are both intelligently designed, discreet buildings . . . background structures more than foreground."[51]

A second phase of work, principally consisting of a 250,000-square-foot midblock building at 47 West Sixty-sixth Street, which adjoined ABC's operations center at the rear, was designed by a new partner in the firm, Arthur May, working with Judy Di Maio, and was completed in 1986.[52] The new building, with its facade of hard buff brick trimmed with Stony Creek and Milford pink granite, housed offices, technical facilities, and a television newscasting studio. The building's setbacks and elaborate-to-the-point-of-fussy detailing reflected the Postmodern classicism of the late 1980s. Joseph Giovannini deemed its "textural and material weaves," which helped minimize the impact on the street of its bulky fourteen-story mass, and the "intimations of spatial depth in shallow curtain walls" to be "highly literate, even witty . . . with . . . surprising scale jumps and dropped panels."[53]

While the building at 47 West Sixty-sixth Street was being realized, ABC undertook the reconstruction of a 320,000-square-foot former printing plant, 320 West Sixty-sixth Street, west of West End Avenue, in which it located a production facility that included two sound stages and support and technical facilities. The Brick Institute of America praised the "symmetrically balanced composition" and the "exhilarating brick patterning of the exterior" that rendered notable "what would have been a rather ordinary industrial building."[54]

By 1986 ABC's collection of buildings on West Sixty-sixth and West Sixty-seventh Streets was being referred to as a "campus." That year Capital Cities bought ABC. So pleased were the new owners with the West Side location that the company decided to sell its midtown headquarters building and construct an additional building to replace the St. Nicholas Skating Rink, which had been abandoned since 1985, thereby permitting most of its operations to be consolidated on the West Side.[55] News of ABC's latest plan, which would bring 1,000 workers from Sixth Avenue to Sixty-sixth Street and house them in a 400,000-square-foot, twenty-two-story tower, was not exactly greeted with open arms by area residents.[56] So rancorous had relations between ABC and its neighbors become that when the communications company could not reach what would normally be a routine agreement with the cooperative next door at 50 West Sixty-seventh Street permitting construction workers onto the roof of the older building, it instructed KPF to cut a four-foot notch into the new building to accommodate the equipment needed to build the east wall of the building's tower without overhanging the neighbor's property.

At issue was not the aesthetics of the building but its sheer size, which would cast deep shadows on Sixty-seventh Street, and the fact that it replaced a familiar, if not necessarily revered, neighborhood landmark. Despite the battle between

Capital Cities/ABC
Headquarters Building, 77
West Sixty-sixth Street,
between Central Park
West and Columbus
Avenue. Kohn Pedersen
Fox, 1989. View to the
northwest showing 47
West Sixty-sixth Street
(Kohn Pedersen Fox,
1986) on the right.
Robinson. KPF

ABC and its neighbors, KPF responded to many of the local residents' requests, reducing the amount of glass in the building—especially as compared with its previous ABC buildings—and increasing the use of limestone. Additionally, KPF's brick palette was more subtle and complex than before, and the building's shape, with its setbacks above Sixty-sixth Street and its curved, baylike south facade, was good, though, as Paul Goldberger pointed out, the building's crowning feature, an "inverted mansard at the top," made "this dignified tower meet the sky with an uncharacteristic touch of shrillness."[57] The Capital Cities/ABC Headquarters Building (1986–89), 77 West Sixty-sixth Street, as it was officially designated, occupied an L-shaped site and was clad in rose brick with contrasting lime-

stone sills. Designed by Robert Evans with Yolanda Cole and Christian Carlson, the building featured decorative brick coursing that further enlivened the composition and reduced the sense of mass, as did the two-story-high window panels.

The last building to be built on the ABC campus, 147 Columbus Avenue (1990–92), northeast corner of Sixty-sixth Street, designed by William Pedersen with the assistance of senior designer James Papoutsis, represented a return to the Modernist aesthetic that the series began with.[58] The design of the ten-story building reinterpreted that of the six-story WABC building at Seven Lincoln Square but at a larger scale and in a deliberately picturesque way. The building was divided into a five-story brick-clad base and a five-story dark glass top that gave

way to more brick along Sixty-sixth Street. Deeply recessed punched windows with cast-stone lintels punctuated the lower floors, above a somewhat contrived ground-floor enclosure that set translucent glass into a de Stijl–inspired pattern. To prevent the compositional duality from coming apart visually, a vertical mast rose from the base to above the roof. This somewhat rhetorical gesture constituted the most theatrical representation of ABC's presence in the neighborhood. The ground floor was remodeled when, after Capital Cities/ABC's acquisition by the Walt Disney Company in 1996, the space became a Disney retail store.

The completion of 147 Columbus Avenue, and with it the ABC campus, gave rise to assessments of the overall approach. Susanna Sirefman deemed the 1989 Capital Cities/ABC Headquarters building an "office tower angling to appear residential . . . unobtrusive yet irritating." She was even less satisfied with 147 Columbus Avenue, declaring it "perhaps the least attractive of all," with "heavy brick massing and a top layer of six stories of black glass [that] seem oppressive. Essentially two rectangular volumes that intersect with a faceted curtain wall, the proportions seem out of whack" while the mast "only adds further confusion to the facade."[59] In contrast to Sirefman's peevishness, Paul Goldberger's view was more statesmanlike. While he was not particularly enthusiastic about the architecture of the individual buildings, he admired the ensemble: the buildings "stand as proof that it is possible to fill an entire Manhattan block with large-scale architecture that enlivens the street and yet fits neatly into a complicated and often contradictory urban context. . . . [The idea is] that a street is a thing in itself, a thing more important than any individual building."[60]

Fordham University's Lincoln Square campus, bounded by Columbus and Amsterdam Avenues, Sixtieth and Sixty-second Streets, was not nearly so distinguished as ABC's. It expanded modestly with the completion of a 275,000-square-foot, twenty-story, 850-bed, tan brick dormitory (Schuman, Lichtenstein, Claman & Efron, 1993), 155 West Sixtieth Street, just west of the Leon Lowenstein Building (Voorhees, Walker, Smith, Smith & Haines, 1962).[61] A more memorable addition to the campus was M. Paul Friedberg's 1994 relandscaping of the vast elevated Robert Moses Plaza, located behind the Lowenstein Building and reached by a broad flight of stairs from Sixty-second Street.[62] Friedberg transformed the barren, inhospitable, 2.2-acre paved space, previously home to a green marble slab decorated with a bas-relief of Moses, into an urban park, with a new lawn and trees, flower beds, a small amphitheater, space for many more sculptures, and an extension of the cafeteria with three gabled glass-and-steel wisteria arbors. In addition to the Sixty-second Street stairs, the plaza could be reached by a new twenty-foot-tall glass-block-enclosed stair and elevator tower (John Gillis Architects) located near the Sixtieth Street and Columbus Avenue entrance to the campus that was dramatically backlit at night.

Another institutional presence in the neighborhood, the American Bible Society, 1865 Broadway, northwest corner of Sixty-first Street, added a two-story glass entrance pavilion (1998) on the plaza in front of its formidable, superscaled, twelve-story headquarters (Skidmore, Owings & Merrill, 1966).[63] As designed by Fox & Fowle, the pavilion seemed flimsy, with the green-glass panels of the curving, twenty-eight-by-sixty-foot facade held in place by X-shaped stainless-steel bars. The terrazzo-floored lobby included a 2,200-square-foot bookshop and a second-level, 3,460-square-foot gallery that was

American Bible Society pavilion, 1865 Broadway, northwest corner of West Sixty-first Street. Fox & Fowle, 1998. View to the west. Goldberg. ESTO

reached by a steel staircase. In order to reverse the anonymity of the exposed precast concrete headquarters, which suffered from being set far back from the street, the high-tech pavilion also featured a Broadway-facing, ten-by-twelve-foot video wall composed of thirty-six monitors and two speakers which, according to Karrie Jacobs, displayed a "holy version of MTV: music videos of biblical parables. . . . The New Testament never looked so much like an ad for aftershave."[64]

In the mid-1980s, there was a small boom in apartment-house construction in the Lincoln Square special zoning district, an area of restricted development created in 1969 that was roughly bounded by Sixtieth and Sixty-eighth Streets, Amsterdam Avenue, and Columbus Avenue and Central Park West. Over the years, the legislation defining the district had undergone some revisions, most notably the elimination of the bonus for the inclusion of covered pedestrian plazas.[65] One of the district's best new buildings was Buck/Cane's 225,000-square-foot, thirty-two-story, 172-unit 45 West Sixty-seventh Street (1983), northeast corner of Columbus Avenue, located on a 16,000-square-foot site that had been used as a parking lot for more than fifteen years.[66] Developed by Daniel Brodsky and designed in association with Schuman, Lichtenstein, Claman & Efron, the skillfully massed red brick condominium tower, which admirably fitted in to both the residential character of Sixty-seventh Street and the commercial bustle of Columbus Avenue, rose from a five-story base, the bottom two floors of which were clad in limestone and granite and featured mahogany-framed windows, a treatment that Paul Goldberger found "exceptionally elegant [recalling] the best Manhattan apartment-house traditions."[67]

Less successful was Buck/Cane's mixed-use South Park Tower (1986), located just outside the zoning district at 124 West Sixtieth Street, between Columbus and Amsterdam Avenues.[68] Also developed by Brodsky and designed in association with

45 West Sixty-seventh Street, northeast corner of Columbus Avenue. Buck/Cane Architects, 1983. View to the northeast. Allison. RCA

Copley, 2000 Broadway, northeast corner of West Sixty-eighth Street. Davis, Brody & Associates, 1987. View to the northwest. DBB

Schuman, Lichtenstein, Claman & Efron, the fifty-two-story 498-unit rental tower, which lacked the refinement of the firms' Sixty-seventh Street collaboration, included 100,000 square feet of office space in its nine-story base. The building was clad in a gray brick meant to harmonize with its neighbor to the east, the Church of St. Paul the Apostle (Jeremiah O'Rourke, 1876–85), the previous owners of South Park Tower's midblock 22,000-square-foot site.[69] Just south of the church, Buck/Cane designed another apartment building, Two Columbus Avenue (1999), northwest corner of Fifty-ninth Street, which employed banded brick and granite to relate to O'Rourke's building, whose air rights allowed the apartment building to reach a height of forty-one stories. A setback at the fourteenth floor kept the building in alignment with the parapets of the church towers. The Boston firm Jung/Brannen Associates' thirty-eight-story Alfred (1987), 161 West Sixty-first Street, northeast corner of Amsterdam Avenue, occupied a vacant site west of Fordham's campus previously home to the Power Memorial Academy, a Roman Catholic high school headquartered in an 1893 building originally built for the New York Infant Asylum.[70] The 224-unit condominium featured an extensively balconied, sienna-colored brick tower with bronze-tinted windows rising from a limestone base. The building

proved exceptionally prominent, especially when viewed from the Lincoln Center plaza, where it loomed over the cultural complex like an unwelcome intruder wearing a large black mansard hat. The former Kent Automatic Parking Garage (Jardine, Hill & Murdock, 1930), 43 West Sixty-first Street, northeast corner of Columbus Avenue, was renovated in 1984 by the team of Alan Lapidus and Rothzeid, Kaiserman, Thomson & Bee.[71] The architects inserted ninety-three apartments in the twenty-seven-story building, now known as the Sofia. The building had been declared a landmark the previous year in recognition of its distinguished design of orange and black brick with extensive polychromed terra-cotta detail belying its status as a parking garage and, after, 1943, as warehouse space.

On the Broadway stretch of the Lincoln Square zoning district, three new towers were completed in quick succession in the late 1980s, the least banal of which was Davis, Brody & Associates' twenty-eight-story, 162-unit Copley (1987), 2000 Broadway, northeast corner of Sixty-eighth Street, replacing the Colonial Bank (Hoppin & Koen, 1907).[72] Eschewing a contextual approach in favor of piling up horizontal bands of windows alternating with tan brick spandrels, the design, with its round corners, impressed the editors of the *AIA Guide*, who

West End Towers, 55-75 West End Avenue, between West Sixty-first and West Sixty-third Streets. Buck/Cane, 1995. View to the southwest. Allison. RCA

101 West End Avenue, between West Sixty-fourth and West Sixty-fifth Streets. Moed de Armas & Shannon and Schuman, Lichtenstein, Claman & Efron, 2000. View to the northwest. MDA

deemed it "a sleek, smooth, modest, understated, rounded tower among the mess of Broadway."[73] Paul Goldberger was also favorably disposed to the Copley, calling it the "best new building on Broadway . . . from an architectural standpoint."[74] Such praise for so mediocre a building suggested the low standards of the late 1980s, represented by John Harding & Associates's red brick Bel Canto (1987), 1991 Broadway, between Sixty-seventh and Sixty-eighth Streets, a twenty-seven-story, seventy-five-unit, narrow midblock building with chamfer-cut balconies for each apartment, and by Eli Attia's 120-unit, charcoal-gray-brick Chequers (1989), 62 West Sixty-second Street, southwest corner of Broadway, which was only a bit better, a twenty-five-story tower rising in a sawtooth pattern behind a seven-story base angled to hold the line of Broadway.[75]

The greatest potential for new initiatives remained on the western fringe of the Lincoln Center area, where Donald Trump proposed the redevelopment of the Penn-Central freight yards between Sixtieth and Seventieth Streets, West End Avenue and the Hudson River (see below). Just east of this extraordinary site, on a four-acre parcel on the west side of West End Avenue between Sixty-first and Sixty-third Streets, the Brodsky Organization developed the 850,000-square-foot, 1,000-unit West End Towers (1995), 55–75 West End Avenue.[76]

Originally called Manhattan West, the tan and red brick design, by Brodsky favorite Buck/Cane, again working in association with Schuman, Lichtenstein, Claman & Efron, included twin thirty-eight-story towers and an eighteen-story building at the southern end of the site. Although the Brodsky development was scaled back from plans that originally called for 1,200 units and over one million square feet of space in taller towers, it still was big enough to generate funds for the development and maintenance of a 45,000-square-foot public playground and park between Sixty-third and Sixty-fourth Streets. Five years later, just north of the park between Sixty-fourth and Sixty-fifth Streets, Moed de Armas & Shannon, in association with Schuman, Lichtenstein, Claman & Efron, and working for Tishman Speyer Properties, designed a glassier, tan brick, thirty-five-story twin-towered version of West End Towers, 101 West End Avenue, which provided 504 rental apartments.[77]

Closer to the heart of the neighborhood, on a site bounded by Sixty-sixth and Sixty-eighth Streets, Columbus Avenue and Broadway, one developer, Millennium Partners, significantly transformed the character of the Lincoln Center neighborhood with the completion of three large apartment towers in the mid-1990s, each containing a substantial retail component at its

Millennium Tower, site bounded by West Sixty-seventh and West Sixty-eighth Streets, Columbus Avenue and Broadway. Kohn Pedersen Fox, Gary Edward Handel + Associates, and Schuman, Lichtenstein, Claman & Efron, 1994. View to the northeast. Gordon. HA

Sony Theatres, Millennium Tower, east side of Broadway, between West Sixty-seventh and West Sixty-eighth Streets. Gensler & Associates, 1994. Lobby. GEN

base. The first building to go forward, and the most prominent, was the forty-seven-story, 800,000-square-foot, 368-unit Millennium Tower (1994), located on a trapezoidal site bounded by Sixty-seventh and Sixty-eighth Streets, Columbus Avenue and Broadway, and replacing H. I. Feldman's four-story white brick Ansonia Postal Station (1955).[78] Designed by Kohn Pedersen Fox, in association with Gary Edward Handel + Associates and Schuman, Lichtenstein, Claman & Efron, the 545-foot-high tower, clad in a combination of orange, dark red, and charcoal brick and aluminum and glass, incorporated a twelve-screen movie theater complex, a 117,000-square-foot health club, retail space, and a new home for the post office in its six-story base. For its bulk, the design drew a considerable amount of protest. Brendan Gill, writing in the New Yorker, found it "hard to imagine any structure less suitable for a comparatively small block in that severely congested area." He described the "immense structure" as "grossly overscaled" and objected to the "exceptionally busy" mix of uses.[79] Despite objections from community groups and residents, the as-of-right building went forward as planned. The most unusual aspect of the design, according to Herbert Muschamp, who liked the building, was at the top, where "a cantilevered steel and glass cube juts from the southeast corner; it's a bit as if the old Pepsi-Cola Building (500 Park Avenue) [Skidmore, Owings & Merrill, 1960] had blown across town and got stuck on the West Side skyline."[80]

Filling much of the Millennium Tower's Broadway base, the 125,000-square-foot, eight-level movie theater complex,

including an Imax theater with an 80-by-100-foot 3-D movie screen, the world's largest, was a lame attempt by Gensler & Associates to re-create the glamour of the movie houses of the 1920s, with each theater getting its own design treatment. Muschamp applauded the effort, describing the complex as "a movie palace for the multiplex age," with each theater

named for some vanished dream palace of Hollywood's golden age. Avalon. Valencia. Capitol. Majestic. And they have the ornamental motifs to go with all the memories those names summon up. The entrance to each auditorium is framed with a miniature version of a movie-palace facade. There are sphinxes. Palm trees with golden trunks and feathery black fronds. Mayan temple arches. Neoclassical festoons. Pagodas. Spanish baroque wrought iron grilles. Miles of Art Deco carpeting. Modernism is also represented in this stylistic parade: in the spare look of the auditoriums, in the escalator that rises four heart-stopping stories through the atrium lobby and in the glass-curtain wall that gives moviegoers great views of the city while turning the interior into lively street theater.[81]

In actuality, a few decorative details aside, the theaters were bland boxes with none of the transporting drama of their picture palace namesakes, which led Susanna Sirefman to write that "the context of post-urban Manhattan as the site for this suburban freak is inexplicable. The kitsch, overscaled architecture and tacky theme-park interior of this vulgar vertical film mall is disturbing." Despite "the embarrassingly gauche architecture," Sirefman was forced to admit, "New Yorkers seem to love the space for its comfort."[82] On the

Columbus Avenue side of Millennium Tower, the otherwise blank, featureless brick base behind which lay the movie theaters was decorated with James Carpenter's 46-by-100-foot mural, *Dichroic Light Field* (1995). Composed of laminated glass and anodized aluminum, the abstract mural featured thin symmetrically placed blades of dichroic glass protruding two feet from the wall, creating an ever changing pattern of color depending on the time of day and light conditions.

A second tower, One Lincoln Square, also developed by Millennium Partners, was completed one year later, in 1995, on the prominent site overlooking Lincoln Square bounded by Sixty-sixth and Sixty-seventh Streets, Columbus Avenue and Broadway, replacing several small buildings including the four-story Lincoln Square Building (Louis C. Maurer, 1906) and the two-story Bank Leumi (built as the Colonial Bank by Alfred H. Taylor, 1898; rebuilt for Bankers Trust by Oppenheimer, Brady & Lehrecke, 1963).[83] Designed by Gary Handel, working with Schuman, Lichtenstein, Claman & Efron (KPF had voluntarily withdrawn from Millennium's

Lincoln Square projects), the thirty-story, 320,000-square-foot, 143-unit buff brick tower rose from a four-story retail base containing a 65,000-square-foot Barnes and Noble bookshop. In 1996 Handel added a third tower to the group, the thirty-two-story, 500,000-square-foot, buff brick Grand Millennium, west blockfront of Broadway between Sixty-sixth and Sixty-seventh Streets, replacing H. I. Feldman's five-story Empire Building (1966), most recently home to Tower Records.[84] Also designed by the team of Handel and Schuman, Lichtenstein, Claman & Efron, the 297-unit tower, which featured a slightly curving glassy south-facing facade, rose from a seven-story base containing a 45,000-square-foot new home for Tower Records and the four-story, 100-unit Phillips House, intended for extended-stay hotel space. In 1999 the Phillips House portion of the Grand Millennium was expanded by taking over and renovating its neighbor to the west, the ten-story, 140,000-square-foot former Chinese Mission to the United Nations (Henry Liu, 1974), originally built as the Lincoln Square Motor Inn (Leo Stillman, 1963).[85]

Dichroic Light Field, Millennium Tower, west side of Columbus Avenue, between West Sixty-seventh and West Sixty-eighth Streets. James Carpenter, 1995. View to the southwest showing One Lincoln Square (Gary Edward Handel + Associates and Schuman, Lichtenstein, Claman & Efron, 1995) on the left. McGrath. NMcG

One Lincoln Square, site bounded by West Sixty-sixth and West Sixty-seventh Streets, Columbus Avenue and Broadway. Gary Edward Handel + Associates and Schuman, Lichtenstein, Claman & Efron, 1995. View to the east. Gordon. HA

In 2001 Beyer Blinder Belle, working with Costas Kondylis, completed work on the forty-one-story, fifty-three-unit Park Laurel, 15 West Sixty-third Street, between Central Park West and Broadway.[86] Built above the western end of Dwight James Baum's West Side Branch of the Y.M.C.A. (1930), the project had been in the works for fifteen years. In 1986, when plans for the project were first announced, it was fiercely opposed by neighborhood residents and preservationists, who argued that Baum's artfully massed Lombardy-inspired building, with Romanesque and Gothic details, not recognized as an official city landmark, would be overwhelmed by the proposed apartment tower. The real estate collapse temporarily shelved the project, and though it was similarly opposed when it sprung to life again a decade later, in 1997, the opposition was less intense. Despite the warnings about its size, as realized, Beyer Blinder Belle's 438-foot-high tower, clad in a light red brick meant to harmonize with the South Carolina pastel brick of Baum's building, did not overwhelm the area. But from an aesthetic point of view, the narrow, four-bay-wide, stepped-back tower, with cast-stone trim and cornices, rising to a prominent, pyramidal top concealing the building's mechanical equipment, was a dud, giving off an unwelcome blankness of effect.

Park Laurel, 15 West Sixty-third Street, between Central Park West and Broadway. Beyer Blinder Belle and Costas Kondylis, 2001. View to the northwest showing West Side Branch of the Y.M.C.A. (Dwight James Baum, 1930) in center. Charles. FCP

RIVERSIDE SOUTH

Riverside South, consisting of the abandoned West Side rail yards of the Penn Central Railroad, facing the Hudson River between Fifty-ninth and Seventy-second Streets, was one of the city's most coveted and contested parcels of open land. The site first came into play in 1961–62 when Litho City—a 5,000-unit housing scheme that would have also parked 5,000 cars, provided 1,000 dormitory rooms for foreign students, and included a 500,000-square-foot international conference center—was proposed by Local 1 of the American Lithographers Union.[1] In 1969 the New York City Educational Construction Fund proposed that the site be developed with athletic fields for West Side high schools, as well as 6,000 to 12,000 apartments, the profits from which would pay for the parkland. In 1974–75 Donald Trump, then a fledgling developer, released his plans for the site, calling for 12,450 apartments, and in 1976, echoing a proposal of Robert Moses, Trump called for the rerouting of the elevated section of the West Side (Miller) Highway that bisected the length of the site to permit the southward extension of Riverside Park.[2]

Trump's plan faltered in the sluggish economy of the late 1970s. But in January 1981, a new developer came onto the scene, Lincoln West Associates, a joint venture between an Argentine firm, Macri Associates, and a local operation, Hirschfeld Realty.[3] Their plan, called Lincoln West, proposed a mixed-use project to be realized over a ten-year period. It was to include 4,850 apartments in towers and midrise buildings, 500,000 square feet of retail space, one million square feet of office space, a 500-room hotel, parking for 3,700 cars, and twenty-eight acres of open space, twenty-two of which would be in the form of a waterfront park and promenade. All in all, 7.3 million square feet of floor area was proposed, making Lincoln West one of the most ambitious new proposals since Battery Park City. The plan, developed by Gruzen & Partners (which had worked on the Litho City and Trump schemes) and Rafael Viñoly, a Uruguayan-born, Argentine-educated architect new to New York, would not only have rehabilitated the West Side Highway as it traversed the site, but also introduced a new north–south boulevard bisecting the site. The developers also committed to the reconstruction of the Seventy-second Street IRT subway station and to improvements to the Sixty-sixth Street IRT station. Lincoln West was approved by the City Planning Commission and the Board of Estimate in 1982, although the number of apartments was reduced to 4,300, with 5 percent of these set aside for low- and moderate-income households. Additionally, the developers pledged to set aside funds to assist the New York State Department of Transportation in financing new rail freight facilities in the Harlem River Yard in the Bronx. By this time rail operations at the West Side site, which had been declining in volume, ceased and its ownership, which had gone through many hands as the New York Central Railroad merged with the Pennsylvania Railroad to become Penn Central, was taken over by Conrail. As the plans for Lincoln West were developed, no new construction was proposed for the area west of the Lincoln Towers apartments (S. J. Kessler & Sons, 1962–64), eliminating the objections of the residents in that complex whose river views would otherwise be blocked.[4] Though Gruzen and Viñoly had overall control of the project, the eight thirty-three- to thirty-nine-story towers were to be designed by different architects, including Gruzen and Viñoly, as well as Cesar Pelli, Edward

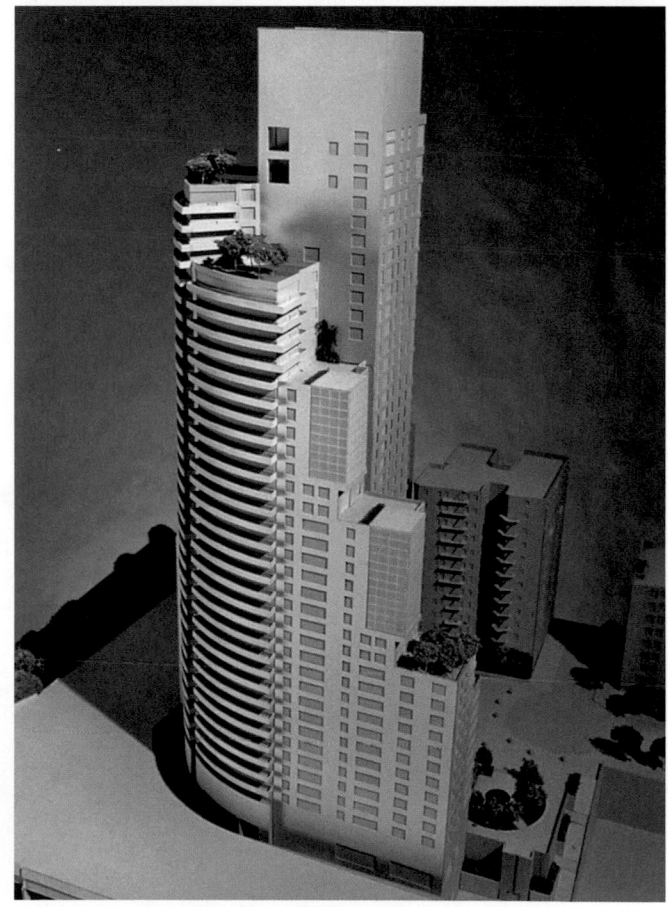

ABOVE Lincoln West, site bounded by West Fifty-ninth and West Seventy-second Streets, West End Avenue and the Hudson River. Gruzen & Partners and Rafael Viñoly, 1981. Model, view to the northeast. Hoyt. ESTO

RIGHT Lincoln West, site bounded by West Fifty-ninth and West Seventy-second Streets, West End Avenue and the Hudson River. Proposed apartment tower by Rafael Viñoly, 1981. Model. Hoyt. ESTO

Larrabee Barnes, Kohn Pedersen Fox, I. M. Pei & Partners, Mitchell/Giurgola, and Richard Meier. Initial reaction to the proposal was not favorable, especially from neighborhood residents, one of whom, Jane Levy, a member of the local community board, dismissed the scheme of eight towers rising from their own bases as "the Miami Beach Maginot Line."[5]

Just before the political fate of the project was to be decided by the Board of Estimate in 1982, Paul Goldberger weighed in with an assessment of the proposal for the seventy-seven-acre parcel, fourteen acres of which were under water. Goldberger's article addressed social as well as architectural issues, pointing to the challenges that Lincoln West posed to the "old-time mix" of "ethnic and economic diversity" that was a West Side hallmark. He also pointed out that the opening of so large a site to residential development would relieve pressures to tear down rows of low-rise buildings and replace them with block-buster-scaled new apartment houses, a practice that was fracturing established neighborhoods, including those of the West Side. But he was not sold on the master plan itself. Not only did he balk at the high density of accommodation, he also faulted the overall arrangement of isolated towers on the west side of the new boulevard, which though it protected river views for upland residents also might "make Lincoln West

look a lot more like the superblock developments of the 1960s than like the denser urban fabric we prefer in the 80's." Most significantly, Goldberger reflected on the public's generally unconsidered yet wholesale antipathy to large-scale projects and its growing obsession with "process" over "product."[6]

Although some demolition on the site took place, Lincoln West did not go forward, doomed to failure because it was economically impractical, promising far more in up-front improvements than any single private developer could afford. Macri was spared finding this out the hard way in 1984, after his company went into a tailspin as a result of faltering economic conditions in Argentina. Lincoln West was foreclosed on by its bankers, who succeeded in selling the site to Donald Trump at three times the price Macri had paid for it, reflecting the rising tide of New York's real estate market and the fact that the land came with a set of development approvals establishing an acceptable density.[7] Trump named Helmut Jahn, design partner of Murphy/Jahn, a leading Chicago firm, as his architect. Kurt Andersen, *Time* magazine's architectural critic, deemed "the match of developer and designer an apt" one: "Jahn's work tends to be glossy, imposing and a little martial, the architectural equivalent of Wagner played on a synthesizer at full blast. He is the Donald Trump of his field, a showman enthralled by sheer size."[8] Jahn was already at work in New York on four buildings, including what would become Cityspire, the city's tallest residential structure (see 6½ Avenue). According to Trump, who for once didn't exaggerate, the rail yards project "was one of the most sought-after architectural contracts in a long time because it is an opportunity for an architect, working with the community and myself, to literally design a city."[9]

In December 1985, Trump revealed his and Jahn's plan for what he was calling Television City. The plan called for the construction of the world's tallest building, a 150-story, 1,670-foot-high, three-armed, telescoping tower to be located on the axis of Sixty-sixth Street. The new tower would surpass Skidmore, Owings & Merrill's Sears Tower in Chicago by 216 feet. Three seventy-six-story apartment towers were to be built close to the water at Sixty-ninth and Seventy-second Streets and three more, nearer to West End Avenue, would rise in an echelon between Sixty-first and Sixty-fourth Streets. Additionally, a sixty-five-story office tower would be located between Fifty-ninth and Sixtieth Streets facing West End Avenue, to the west of which they also proposed to build a fifteen-story television production center that would define the south end of the site. The entire development was to be raised on a landscaped podium set at the height of the West Side Highway. All in all, 18.5 million square feet of space was to be constructed, yielding 8,000 residential units, 3.6 million square feet of television and motion picture studios, 8,500 parking spaces, 1.7 million square feet of retail space, and forty acres of park and open space. It was estimated that 20,000 people would live in Television City and 40,000 would work there.

While some viewed the plan, and especially the elegantly shaped supertower, as a red herring concocted to achieve concessions from the city and especially the upland community, Trump presented the design with dead seriousness, trumpeting it in a press release as "the master planner's grandest plan yet."[10] Paul Goldberger dismissed the proposed tower as "hardly a real building meant for real people in a real city,"[11] and Michael Sorkin, who would later offer his own unsolicited design for the site, blasted the plan: "Looking at the boneheaded proposal, one wonders whether the architect even visited the site. Indeed, there's evidence that he did not. The rank of glyphs bespeaks lakeside Chicago, and the centerpiece of the scheme, the 150-story erection, Trump's third go at the 'world's tallest building,' looks to be the same world's tallest building proposed earlier this season for the Columbus Circle site. Was ever a man more preoccupied with getting it up in public?"[12]

Television City, site bounded by West Fifty-ninth and West Seventy-second Streets, West End Avenue and the Hudson River. Murphy/Jahn, 1985. Site plan. MJ

Though one might argue about the utility or aesthetics of Jahn's triangular supertower, there was no question that it was ingenious. The tower was to be carried by two gigantic composite steel-and-concrete columns, ten by twenty feet in cross section, that would run down the interior of the building to collect loads transferred from the edges. Jahn believed that his building was contextual—if not to the immediate West Side neighborhood, then to the scale of waterfront developments such as Battery Park City and the World Trade Center, and that his design, with its soaring antenna acting as a spire, would be literally and figuratively in communication with those great city spires as well as that of the Empire State Building. In fact, the plan was a parodistic version of Le Corbusier's urbanistic ideas for the Paris of the 1920s but with imagery that seemed nostalgic for the twenty-fifth-century world of Buck Rogers. In one significant way, Trump's plan was, as Carter Wiseman pointed out, an accurate mirror of the city's prevailing mood: fear. As Trump proclaimed, "This will be its own location, its own area, its own context, its own city."[13]

By mid-summer 1986, West Side neighbors had banded together to form Westpride, an organization dedicated to opposing the project but also concerned with other issues in the community. Faced with this well-financed group, Trump added Alexander Cooper to his team, replacing Jahn as master planner. Cooper, enmeshed in the somewhat acrimonious process of splitting apart his successful partnership with Stanton Eckstut, which was best known for its plan for Battery Park City, had his work cut out for him. Trump was willing to try a new scheme, but his heart was really in the mega-bravura of his first idea. Nonetheless, he did see the handwriting on the wall and gamely opined: "Cooper is good at working with the community. I don't want to take the best piece of urban land in America and do something urban America doesn't like."[14]

Trump did back off from Jahn's grand plan. He also backed off, gradually, from Jahn's architecture, soon agreeing to parcel out the various projected buildings to different architects, as was the case at Battery Park City. But Cooper felt that the overall strategy for Battery Park City—a strategy heavily based on situations found in the west end of the Upper West Side, where the short blocks lead up to a waterfront park and a strong north–south boulevard forms the principal spine—would not work at Trump's site: "The piece of property is so separate and special that it shouldn't just take a city grid. It is not doable."[15]

The fundamental conflict between Trump's vision and any approach Cooper might evolve was clear from the beginning. As Karen Cook, a journalist, observed: "What Trump was hiring, presumably, was the good will that has followed Cooper since Battery Park City, a wave that crests ever higher as the project completes each successive" phase.[16] When Cooper first saw the Television City plan, he found plenty of open space but objected to its diffuse character and to the proposed project's disassociation with the river. Finally, "the buildings were too damn big."[17] Trump was surprised by Cooper's condemnation, and after Trump asked him to adjust the concept, Cooper decided to bow out, only to be called back eight months later. In the end, Cooper couldn't resist tackling Trump's project and Trump: "My God, it's three-quarters of a mile of Hudson frontage, so you don't lightly just walk away."[18] Trump, sensing Cooper's conflicted frame of mind, characteristically challenged and cajoled: "Goddamn it, Cooper, you have to change your image. It's about time you got associated with something huge! And something not so bloody civic!"[19]

Television City, site bounded by West Fifty-ninth and West Seventy-second Streets, West End Avenue and the Hudson River. Murphy/Jahn, 1985. Model, view to the southeast. MJ

When Cooper finally accepted Trump's commission, he did so with the understanding that he would work with the same program of 19 million square feet of leasable space that Jahn had worked with but that he would not in any way be bound by Jahn's design. But Trump remained committed to his dream of building the world's tallest building on the site, which he deemed a powerful marketing tool; Cooper saw it as a serious handicap in the public approvals process. By mid-August 1986, a new plan began to take shape that called for the relocation of the world's tallest building to a site at Fifty-ninth Street, which would better suit NBC, a likely tenant. It also provided for a 1.3-million-square-foot, three-level shopping mall to include a 200,000-square-foot branch of Bloomingdale's department store, half the size of the main store on Third Avenue, that, together with parking, formed the base for a landscaped roof on which river-facing townhouses would be perched above the level of the West Side Highway. The negotiations with NBC, which was alternately considering a move to New Jersey and a decision to remain at Rockefeller Center, took on considerable complexity when, in May 1987, Trump offered to sell his land to the New York State Urban Development Corporation for $1, allowing the project to go forward as a tax-free, zoning-immune project, but with Trump still enjoying the development rights, an arrangement similar to the one under which he rebuilt the former Commodore Hotel, transforming it into the Grand Hyatt (see Terminal City). Such a move would unquestionably be favorable to keeping NBC in New York—the broadcast company was not entitled to tax abatements (said to be worth some $10 million a year) for needed renovations to its current studios but could get them for new construction. While the economics of Trump's offer made sense, the developer's hope that the state would override the city's zoning review, which it had the power to do, was unlikely. Trump's plan to bring in the UDC irked the normally developer-friendly Mayor Ed Koch, who informed NBC that in fact it could transfer tax credits to any site in the city, including its own present headquarters where, after some further sweetening of the deal, it chose to remain.

Cooper's plan, released in October 1986, was not the breakthrough many had hoped for. Marginally less dense than Jahn's, it included a sixty-five-story office building, six seventy-six-story apartment towers, and a 150-story, 1,670-foot-high, needlelike tower to incorporate 2,500 apartments in its top 100 floors. Despite the creation of 13.6 acres of parkland and the promise of $800 million in annual property taxes, sales taxes, and commercial occupancy taxes, all benefiting the city, the revised project not surprisingly raised objections. Studies revealed that morning shadows from the superscaled tower would reach across the Hudson to Park Avenue in West New York, New Jersey, and that those generated in the late afternoon would extend across the intersection of Eighty-sixth Street and Columbus Avenue. The daily arrival of over 17,000 workers to the site, as well as the 45,000 visitors per day expected to come to the site to shop at the mall or ascend to the 150-story observation tower atop the world's tallest building, concerned West Side observers, as did the addition of about 13,000 residents.

Paul Goldberger tactfully characterized the Cooper plan as one that was "both completely different from last year's plan and very much the same. It is different in that it drops Mr. Jahn's simplistic idea of putting 7 immense towers . . . in a straight row" and plunking them down in open parkland, and replaces them with "more buildings, slightly shorter in height, which would be lined up along a boulevard that would have many of the qualities of a traditional city avenue. But the project is the same as the Jahn plan in that it is also far, far too big."[20] Meanwhile, Westpride grew in strength as a civic action group, funded by the proceeds of star-studded celebrity parties and performances. Over and over, the community meetings it organized to protest the project drew heavier-than-expected crowds. While Mayor Koch's liberal interpretation of the city's tax incentive plan was decisive in influencing NBC's decision to remain at Rockefeller Center, the West Side community's hostile reaction to the plan also had a definite effect, leading Henry Kanegsberg, an NBC executive, to cite community fervor as a significant reason for the decision not to move to the development.

In February 1988, bowing to the inevitability of NBC's decision, Trump renamed the project Trump City, a term by which Cooper had long referred to the project. He also released a new version of the plan with buildings as tall as before but with two thirty-story office buildings replacing the television studios. More parking spaces for cars, six and a half acres more parkland, and 760 low-cost apartments for the elderly were added to help garner public support for the project. But aside from the antipathy to Trump and the sheer density of the proposed development, the problem lay in the dismaying obviousness of Cooper's plan, which in fact did acknowledge the Manhattan street grid but also created a "Chinese wall" of superscaled buildings facing the river. A "simulation" model of the West Side including the proposed buildings, funded by a variety of local foundations including those of Vincent Astor, J. M. Kaplan, and Charles Revson, was placed on public view at the Apple Savings Bank (York & Sawyer, 1928), Broadway to Amsterdam Avenue, between Seventy-third and Seventy-fourth Streets, in October 1988.[21] The effect was chilling, further rallying community opposition.

As of 1990, Cooper's plan called for eleven residential towers between forty-five and fifty-seven stories tall providing 7,600 apartment units. Also included was 1.5 million square feet of retail space, 3.7 million square feet of office space, a 750-room luxury hotel, and parking for 7,346 cars. Unlike the Jahn plan, which elevated the public space sixty or seventy feet above grade, Cooper's put it at the grade level of the upland streets as well as at the level of the river. Formal review of the project was delayed in May 1990, when city officials asked Trump to revise statements about traffic and air

quality included in the plan's draft Environmental Impact Statement.

The forces of opposition began to garner allies from outside the West Side when, in June 1990, the Penn Yards Task Force of the New York City Chapter of the American Institute of Architects came out against the project, criticizing its density, which it claimed was twice that approved for the site in 1982. The task force, chaired by Paul Willen, objected to the wall-like character of the shopping mall and garage, which would rise 120 feet above the waterfront park, and the series of virtually "identical semi-continuous slabs with a narrow range of apartment types, far removed from the streets and parks."[22] The AIA group also found fault with the "world's tallest building," which it felt would dominate the open spaces and, moreover, was destined to be "a lonely spire tottering at the edge of the island."[23] The task force concluded that the plan failed to meet the three goals established by the City Planning Commission for the area: continuity of the street grid, access to the riverfront, and view corridors leading from the upland to the river. As a matter of professional courtesy, Alexander Cooper's name was not cited in the report, leading Suzanne Stephens, the editor of *Oculus*, the New York chapter's newsletter, to ask slyly, "Shouldn't credit be given where credit is due?"[24]

A few weeks after the publication of the AIA task force's report, a counterproposal was offered by three leading civic organizations: the Parks Council, the Municipal Art Society, and the Regional Plan Association.[25] The plan was developed by the chair of the task force, Paul Willen, an architect with considerable experience in housing design, some of it while in the office of Gruzen & Partners, who, working with Daniel Gutman, an urban planner, as well as with the firm of Andrews & Clark, proposed the relocation of the West Side Highway to a new location farther east, thereby permitting the creation of a wide, twenty-five-acre extension of Riverside Park and the creation of a southerly extension of Riverside Drive along which medium to tall apartment houses would be constructed. Paul Goldberger expressed the opinion of many when he greeted Willen's plan as one that "celebrates the urbanism of New York and pushes it forward."[26]

One issue that the Willen plan threw into sharp focus was that of the decrepit stretch of the West Side Highway running along the site's length. The federal government had allocated $85 million for the highway's reconstruction; the plan argued that, with about the same amount of money, the highway could be built in a better place—ironically the one Robert Moses had proposed in 1974. As Goldberger put it, "the only advantage to leaving the highway in its present position" was that it made it "easier for Trump City," which was "an exercise in gigantism, not sound planning." According to Goldberger, Cooper had lost the way that had been so clear in Battery Park City: "The Trump City design rejects not only the esthetics of Battery Park City but the conceptual thinking behind it. It denies the fabric of New York, ignores the scale of the Upper West Side and does violence to the city's spirit. Trump City as now proposed is not a part of New York." Goldberger argued that it was not just the gigantism of Trump and Cooper's plan that was wrong, it was also the mix of program ingredients. He was especially critical of the "world's tallest building," finding it "all wrong, a triumph of image over substance," and of the shopping mall, which he believed would cannibalize existing retail and create unnecessary traffic. Most significantly, he felt that the city was negligent in its responsibilities, failing to actively plan for the site: "It has let the developers set the agenda, as if it were afraid to set one itself."[27]

Another proposal for the site was drafted by Joseph Wasserman, also a member of the AIA task force, and Christoph Riedner. This plan accepted the idea of superscaled towers but aligned them on an east–west axis separated by generously sized, naturalistically landscaped parks. While this plan could work with the West Side Highway in a number of

RIVERSIDE SOUTH PARK

LANDSCAPE ARCHITECTS
THOMAS BALSLEY ASSOCIATES
ARTISTS
MEL CHIN JOYCE KOZLOFF MARY MISS FRED WILSON

different locations, the designers preferred an idea suggested to them by Craig Whitaker, an architect specializing in urban design, which would relocate the road to grade level at the river's edge and cover it with a landscaped deck in the manner of the East River Drive as it slips under Carl Schurz Park.[28] Whitaker, who had honed his skills as lead designer of the Wateredge Development Study and Westway, assessed the two proposals and offered a modest one of his own based on ideas in each but adjusted to the realities of the city's politics and real estate markets. Whitaker called for the reconstruction of the West Side Highway at grade just outside its present location, decking it over to create a park and promenades. He then suggested that Riverside Drive be extended and built "at a proper place," allowing the debate "over the ratio of density to parkland to reach its own separate conclusion."[29]

The discussion over the fate of Trump City intensified in late 1990 as the conditions in the real estate market worsened, with Trump, like many other developers, faced with mountains of debt accumulated in the roaring 1980s. The debate was made even more urgent as the result of a November 1990 decision of the New York State Supreme Court that struck

down a provision of the zoning permitting developers to demonstrate environmental impact on the basis of citywide conditions.[30] The lawsuit leading to the decision had been brought by a number of local groups, including Westpride, and by the Natural Resources Defense Council.

By early 1991, rumors of a compromise between Trump and the six major civic organizations opposing the project—including Westpride, the Municipal Art Society, and the Parks Council—began to surface.[31] The civic groups, led by Richard A. Kahan, former president of the Battery Park City Authority, advocated a version of Paul Willen's plan, which David Childs and Marilyn Jordan Taylor of Skidmore, Owings & Merrill were preparing in association with Willen, Daniel Gutman, and Steven Robinson, an architect living in the area. At stake was not only the character and size of the development—the new plan would virtually halve the square footage of the Cooper plan—but also the fate of the West Side Highway, which was scheduled to be rebuilt but which Trump, influenced by Kahan, was in favor of relocating.

In March 1991, just before formal public review of Trump's project, the developer concluded intensive negotiations with

the opposition groups and, with characteristic boldness, agreed to jettison his plans for Trump City and develop a version of the plan first proposed by Willen and Gutman that called for moving the elevated West Side Highway to the east, where it would be reconstructed at grade level, building a twenty-three-acre park between the relocated roadway and the Hudson River, and reducing the scope of the project from 14 million to 8.3 million square feet, most of which would be used for residential, rather than commercial, purposes. The scheme made sense. Ironically, it was more like Battery Park City—especially its north end—than Cooper's had been. As D. Graham Shane reported, "The flexibility of the system of small parcels, allowing the developer to follow the cautious model of the public corporation in Battery Park City" even permitted the reintroduction of a variety of commercial components, such as a version of Television City at the southern end of the site, where it could be located under the platform of built-up side streets and avenues. Moreover, as Shane wrote, "in a move unimaginable without the cooperation of the powerful Lincoln West Community Group, the tallest residential apartment buildings [were] . . . clustered in the north in front of Lincoln West [Lincoln Towers], blocking their cherished views," an arrangement justified by the argument that the shadows of the new buildings would fall to the north on

the surrounding streets and not on the new waterfront park which would have been the case in the Willen scheme.[32] By April the six opposing groups had joined with Trump to form the Riverside South Planning Corporation to "design and expedite" the reduced project.[33] Childs and Taylor, who replaced Alexander Cooper, were selected largely on the basis of their success in redesigning Mortimer Zuckerman's proposed office complex at Columbus Circle. The coalition also chose four artists—Mel Chin, Joyce Kozloff, Mary Miss, and Fred Wilson—to collaborate with the Willen-SOM team and with the landscape architect Michael Van Valkenburgh, who was succeeded by Thomas Balsley. The collaboration resulted in a proposal for an arc-shaped lawn sloping gradually to the river, where tidal grasses and the remains of abandoned piers would create a shoreline rife with memory. The design bumped up against Parks Department concerns, leading to the withdrawal of the artist members of the design team. The objections led to a revised plan in which the soft "toe in the water" edge of grasses at the waterfront would be replaced by nontidal wetlands poised atop stone riprap.

The Willen-SOM design, which abandoned all lingering aspects of enclavelike development in favor of a plan that simply extended the upland toward the river, was released to the public in August 1991.[34] The AIA-sponsored Penn Yards

Riverside South, site bounded by West Fifty-ninth and West Seventy-second Streets, West End Avenue and the Hudson River. Skidmore, Owings & Merrill and Paul Willen, Daniel Gutman, and Steven Robinson, 1991. Rendering of view to the south. SOM

Riverside South, site bounded by West Fifty-ninth and West Seventy-second Streets, West End Avenue and the Hudson River. Skidmore, Owings & Merrill and Paul Willen, Daniel Gutman, and Steven Robinson, 1991. Conceptual diagram showing how massing responds to width of park and curve of highway. SOM

Urban Design Review Workshop Report, which received scant attention in the press, revealed that Willen's original plan had shown apartment houses insufficiently large to generate the square footage required to make the project a reality—Willen's buildings could only accommodate 5 million square feet, not the 8.3 million square feet Trump agreed to reduce his project to or even the 7.2 million square feet agreed upon in 1982. Childs and Taylor's revisions to Willen's plan raised the height of the buildings along the southward extension of Riverside Drive—Willen proposed buildings typically 85 to 150 feet high north of Seventy-second Street, but Childs and Taylor proposed heights between 180 and 190 feet in the new extension. In fact, as Childs and his team freely admitted, the conceptual model for their plan was not the development of Riverside Drive but that of Central Park West with its much bulkier buildings. Paul Goldberger noticed the change and greeted the plan as the "most complete and successful version yet." For Goldberger, the "most striking thing about the . . . plan" was the "new skyline" it projected: "a curving, up-and-down sequence of buildings, ranging in height from 15 to more than 50 stories, with lively tops based heavily on the profiles of the skyscrapers of the 1920s and 30s. The tall buildings are slender and carefully placed, so that their height becomes not an oppressive mass but an energizing force on the skyline."[35]

While the architectural imagery projected by Childs and his team seemed promising, Suzanne Stephens cogently

Tracked Housing, site bounded by West Fifty-ninth and West Seventy-second Streets, West End Avenue and the Hudson River. Michael Sorkin, 1990. Model. MSS

argued that "without extremely detailed controls and zoning," Childs's Riverside South "can only be viewed as a scenic assemblage of buildings that can only be achieved in the best of all possible worlds, with saintly, spendthrift developers."[36] Echoing Stephens, Goldberger called attention to the handling of Freedom Place, "a truly wretched street tucked behind the huge Lincoln Tower project," where a mix of retail and commercial space was proposed to "enliven" its "banality." The proposed design didn't promise to "make Lincoln Towers go away, of course, but it helps."[37] A point Goldberger overlooked, which would soon become a sticking point, was the fate of the West Side Highway, proposed for reconstruction on its present right-of-way and then, as part of the development of Riverside South, for its eventual relocation and reconstruction on a new right-of-way, all because of a redundant process deemed necessary because of the near-to-collapse condition of the existing elevated roadway.

While the plan seemed to gain a wide measure of local support, some remained firmly entrenched in their opposition. Led by Congressman Jerrold Nadler, a member of the House Transportation and Infrastructure Committee, opponents, mistakenly thinking that the failure to relocate the highway would thwart Trump's plans, succeeded in killing the relocation plan. Kent Barwick, president of the Municipal Art Society, was particularly disappointed in the failure of some critics to acknowledge the vast reduction of scope and increase in urbanistic sensitivity that the new plan represented. He also felt that Trump was being treated unfairly in that his efforts to do the right thing were being ridiculed on the basis of his earlier performances.

In July 1992, Community Board 7 rejected the Riverside South Planning Corporation's plan by a vote of 35 to 1, but by late summer the likelihood of its being accepted began to increase after Trump agreed to contribute $5 million to the renovation of the Seventy-second Street IRT subway station, to set aside 10 percent of the apartments for subsidized housing, and to ensure that there would be no net increase of sewage to the North River treatment plant in Harlem. In order to achieve this last goal, the developer promised either to build an independent sewage treatment plant or to hook into the North River plant while keeping the flow of volume into that facility low by using state-of-the-art plumbing fixtures needing comparatively little water in the new buildings and by retrofitting fixtures in thousands of existing apartments in the upland neighborhood. Trump also agreed to bear half the annual maintenance costs of the new riverfront park. Still, many balked at the prospect of having the elevated highway, then under reconstruction, torn down as soon as its rebuilding was completed. Brendan Gill was the most articulate of the opponents, pointing out "two commonly accepted false assumptions . . . : one is the assumption that making our city bigger is indispensable to making it better, and the other is that arranging for a handful of real estate operators, banks, and insurance companies to become richer makes the rest of us richer as well." Gill believed that "the pretty little park" would principally benefit those who lived in the development and that the project would bring nothing of value to New York as a whole.[38]

The protracted debate over Riverside South's future stimulated a number of provocative counterproposals. In 1990 Michael Sorkin, an architect much better known as a critic, offered his Tracked Housing project, which proposed the

Parallax Towers, Hudson River between West Sixty-sixth and West Seventieth Streets. Steven Holl, 1990. Photomontage, view to the southeast. SHA

recycling of outmoded passenger railway cars as housing.[39] The cars, enhanced with small towers, skylights, and balconies, would presumably be shunted around the abandoned Penn Yards. Sorkin's proposal was not only intended as a rebuke to Trump's ambitions but also as a response to the deplorable conditions that existed just north of the site along the tracks as they tunneled under Riverside Park, where a sizable homeless colony flourished in the late 1980s. Also in 1990 Steven Holl, another architect-provocateur, offered a West Side proposal. But Holl's Parallax Towers, improbably thin skyscraper apartments, were set offshore in the river between Sixty-sixth and Seventieth Streets, leaving the entire freight yard site free for development as an Olmsted-inspired park that would cover a rebuilt West Side Highway.[40] Additionally, a floating public space was proposed for use as a concert stadium, large-screen movie theater complex, or grand festival hall. The Parallax Towers were to bracket, but not block, the view of the upland Lincoln Towers. Horizontal underwater transit systems would link the buildings to each other and to park-side lobbies.

On December 17, 1992, the City Council, exercising its land-use power newly acquired from the defunct Board of Estimate, approved Riverside South. Nearly a year later, in November 1993, Trump announced that Philip Johnson in collaboration with Costas Kondylis would design Riverside South's first four buildings.[41] The buildings, ranging from eighteen to forty stories, were to provide some 1,700 apartments. Johnson expressed concern about taking on the job given the stringent zoning controls—"The buildings are practically designed"—but he did admit to taking pleasure in working out the details.[42] One of the ironies in Johnson's participation, as David Dunlap pointed out to readers of the *New York Times*, was that the master plan's controls seemed "to call for Art Deco detailing—exactly what Mr. Johnson repudiated in the 1930's as an early champion of the spare, serene International style."[43] But the eighty-seven-year-old Johnson looked at his challenge more pragmatically: "I was the big enemy of this type of architecture with rare exceptions," he averred. "To take over this wedding-cake approach is an extraordinary step for me." But, he continued, "I've learned to see that it has its own disciplines."[44] Johnson was to be the first of the architects working on the project. At the time Johnson's selection was announced, Robert A. M. Stern, Frank Gehry, and David Childs were said to be in line for later buildings.

Although government approval and the choice of architect were resolved, one essential hurdle remained: the raising of the necessary capital, which was proving as elusive as government approval had been in the 1980s. Fortunately for Trump, the national economy began to improve in the mid-1990s just as Hong Kong investors, concerned about their future in the face of that British colony's imminent handover to the Chinese in 1997, began to seek American investment opportunities, and by July 1994, Trump had made a deal with a group of them that would make it possible to get the project going.

While waiting for the development to begin, in 1994, Stan Herd, an environmental artist, undertook "New York Countryside," a project of land-shaping that transformed one acre of the site opposite Sixty-eighth to Seventieth Street into a living painting of trees and clouds using a variety of planted crops including squash, as well as flowers, grasses, clover, groundcover, and paving stones. Herd, the son of a Kansas farmer, had for over ten years been using large plots of land to create artworks, but this was the smallest he had ever undertaken and "also the first one that will be visible to passers-by on an overlook, and to the people in Lincoln Towers who face New Jersey." Herd's modesty was as refreshing as his art: "It may seem presumptuous to lay down a piece of art so large that it's hard to ignore. But I presume most people will enjoy it, and if they don't, well it won't last forever."[45]

Local groups continued to protest the project, supporting Congressman Nadler's successful effort to block funds for the relocation of the West Side Highway. But Trump proclaimed himself delighted with Nadler's victory, for he believed his project would now cost less to build and would proceed more swiftly without having to incorporate a relocated highway: "I have to say we get a bigger benefit from leaving the highway where it is, because when cars go by they will look at our masterpiece."[46] Neither the West Side protestors nor Nadler regretted their opposition. For the Congressman, the park was a $10 million-an-acre "private backyard" for the people who would live in Trump's buildings.[47]

The issue of sewage disposal continued to cloud the project's future, with government officials claiming that the North River plant could handle the increased load while local opponents continued to press their opposition. In December 1996, the Department of Environmental Protection issued a permit for the first of the development's projected sixteen apartment towers to be hooked up to the North River Sewage Plant, a forty-six-story, 377-unit condominium to be built between Sixty-ninth and Seventieth Streets. A second permit soon followed, and construction of the first two buildings began in May 1997. Meanwhile, some local residents continued to protest the proposed park, claiming that it would not be truly public, especially for the elderly and disabled. Ironically, this seemingly endless chain of protests, yet another in a series of delaying tactics on the part of the neighbors, was almost welcomed by Trump, who had benefited enormously from the dissidents' two and a half years of litigation: the delays "brought us into the best real estate market in the history of New York."[48] As the buildings rose, the full magnitude of the project began to become apparent. The focus of the campaign against the project shifted after construction began, when neighbors realized that Trump planned to build the new Riverside Drive–like street that would front his development on fill, rather than pilings, thereby seeming to permanently close the door on relocating the West Side Highway beneath the road.

The forty-six-story, 377-unit 200 Riverside Boulevard, between Sixty-ninth and Seventieth Streets, and the forty-story, 516-unit 180 Riverside Boulevard, between Sixty-eighth and Sixty-ninth Streets, were completed in 1999, setting the tone for a dispiriting series of buildings that continued to be realized into the new century. After all the drama of their planning and construction, they were accepted, if not necessarily welcomed, by a community largely resigned to its fate. As Robin Pogrebin wrote in the *New York Times*: "Can peace be at hand? Have those very people who resisted the property as just another attempt by Mr. Trump to take over the world actually come around? Have those reputedly rigid Upper West Siders—many of them residents of Lincoln Towers, just behind the Trump development—who initially cried foul in the face of potential overcrowding and blocked views changed their minds? Well, let's not go that far. The people moving into these buildings are not the same ones who pummeled or lamented it initially; some of those original protesters are still pummeling and lamenting, furious at their lost views and worried about crowds and congestion, air pollution and the more-than ever jammed subway station at 72d Street. Nevertheless, it seems at least symbolically ironic that some natives of the Upper West Side are embracing a building that was once such a pariah to their brethren."[49]

Construction of another Johnson/Kondylis building, the twin-towered, thirty-four-story, 455-unit 160 Riverside Boulevard, between Sixty-seventh and Sixty-eighth Streets, began in June 1998 and was completed by 2001. Kondylis, without Johnson, was responsible for two more buildings begun late in 2001, the forty-nine-story, cylindrical-topped 220 Riverside Boulevard, between Seventieth and Seventy-first Streets, and the thirty-story 140 Riverside Boulevard, between Sixty-sixth and Sixty-seventh Streets, both completed in 2003. Kondylis's thirty-one-story 240 Riverside Boulevard, between Seventy-first and Seventy-second Streets, spurred its own set of lawsuits as tenants of the neighboring twelve-story Chatsworth (John E. Scharsmith, 1902), 344 West Seventy-second Street, complained that a portion of the new building would come within three to forty-eight inches of its 102 river-facing windows. Still, construction began on 240 Riverside Boulevard in 2002. The court case was decided in Trump's favor in March 2003, and the building was completed in 2005. Writing in June 2002 in the *New York Sun*, James Gardner described the completed buildings of the Riverside South development, also known as Trump Place, "as more classical than Trump's black monoliths [Trump Tower; Trump World Tower]. Architecturally they too are undistinguished. And yet, even that is a blessing compared with some of the ghastly, hyper-modern plans for the site that had been floated over the past 40 years. In judging these new buildings, it pays to remember that the first rule in assessing New York architecture is to lower our expectations to such a degree that even mediocrity comes as a slightly pleasant surprise."[50]

Although there were few kind words for the architecture of the individual buildings at Trump Place, there was some relief that progress was made on the reconstruction of the Seventy-second Street subway station, which the developer helped fund (see Digging In, Introduction). Despite the disruptive presence of the elevated highway, there was also praise for the seven completed acres of Thomas Balsley's planned twenty-one-acre waterfront park, the highlight of which was the 750-foot-long Pier I (2001), near Seventieth Street, along with a new promenade and baseball and soccer fields and basketball courts.[51] Contrary to Nadler's arguments, the park attracted a broad audience from across the city. David Dunlap was impressed with the fifty-foot-wide pier, which jutted into the river at a 55-degree angle, providing "an entirely new way to see the towering palisade skylines

of New York and New Jersey and the broad waterway between them, liberated from the shoreline and unconfined by gunwales." Despite cost-saving measures such as a deck composed of precast concrete paving blocks instead of wood planks, Dunlap took note of several design touches, including the scalloped southern edge of the pier that created "a sense of harmony with the river," as well as the "L-shaped jog at the end, which contributes considerably to the feeling of being afloat and cut off from the land." Moved by the effect of the pier, Dunlap went so far as to note that the elevated highway "undulates like a ribbon, fused almost seamlessly to the roller-coasterlike outline of Pier D to the south, which was twisted by fire into a polymorphous contortion worthy of Frank Gehry. Even the towers of Trump Place momentarily take on Venetian magic, glimpsed as sensuous, rippled reflections in the wake of a passing ship."[52]

APARTMENT HOUSES

The renewal of the Upper West Side as a fashionable residential district sped ahead with the completion of Lincoln Center. Despite the economic slowdown of the 1970s and early 1980s, building renovations continued as rental apartment buildings were converted to cooperatives and brownstones were renovated. While many avenue locations were initially targeted for replacement with large apartment houses, some efforts were made to retain the historic neighborhood scale, as in Marvin Meltzer's prominently located 100 West Eighty-first Street (1981), southwest corner of Columbus Avenue, facing Theodore Roosevelt Park, a conversion and expansion by two and a half floors of four contiguous four-story brick-faced rowhouses that Meltzer painted gray but against which he played curving gray stucco fire balconies facing the avenue and contrasting angular balconies facing the street.[1] Sixteen loftlike apartments, eight of them duplexes, were created within the new complex using the interior walls of the component buildings and retaining differences in floor heights by inserting stairs within the apartments or in hallways. The existing street-level commercial spaces were combined to form a 130-seat restaurant, Danon's on the Park, also designed by Meltzer, who served as the entire project's developer, architect, and contractor. While Meltzer's design was complex inside and out, David Gura's Pythian (1982), 135 West Seventieth Street, between Columbus Avenue and Broadway, a recycling of a formerly windowless building to serve as an apartment house, presented a unity to the street but incorporated eighty-three interior unit types. The reconfiguration of the terra-cotta-ornamented building—formerly the Pythian Temple (Thomas W. Lamb, 1927), a clubhouse for the Knights of Pythias, a group founded during the Civil War—was a complex project for Gura, who described the conversion as "dealing with an enormous Rubik cube."[2]

The city's decision to eliminate by November 29, 1985, the 421a benefits program that since 1971 had provided tax abatements to developers of luxury apartments between Fourteenth and Ninety-sixth Streets triggered a boom, leading Paul Goldberger to warn that the Upper West Side was "on the verge of explosive growth" that threatened to "change the face of this part of the city altogether." Construction, Goldberger noted, "has begun to leapfrog" from the Lincoln Center area "through various sites as far uptown as 96th Street."[3] To help guide the impending boom, the City Planning Commission began studying the Upper West Side's zoning in November 1982 and, two years later, proposed new "contextual zoning" for the area bounded by Central Park West and the Hudson River, Fifty-ninth and Eighty-sixth Streets.[4] The new zoning was not intended to restrict development but to discourage the tower-on-plaza type of apartment houses that were being constructed along the avenues of the Upper East Side. Instead, the Upper West Side's new buildings were to be lower, bulkier, site-filling buildings that rose along the lot line for no more than 150 feet, above which floors would have to be set back. As well, the zoning governed the type of materials that would be used, requiring brick cladding and stone bases, which would fit in with the Upper West Side's existing architecture while still allowing the generous use of glass typical of newer apartment buildings.

On April 9, 1984, the City Planning Commission approved the zoning revisions, and on May 24, the Board of Estimate gave its approval. As enacted, the new zoning subjected the Lincoln Square area to a distinct set of controls deemed appropriate to its special character, while the contextual zoning was applied to the area west of Central Park from Sixty-eighth to Eighty-sixth Street. From Eighty-sixth to Ninety-sixth Street, only the avenues and both sides of Ninety-sixth Street were subject to the new rules. An unintended consequence of the new zoning was an increase in the number of studio and one-bedroom apartments in the new crop of buildings, a result of the replacement of tower floors with broad lower floors where apartments were deprived of sweeping views and instead faced rear yards and light courts. At a public forum held prior to the passage of the zoning, William Zeckendorf Jr., a leading developer active in the Upper West Side at the time, warned, "You have to be very careful in reducing the height of the buildings . . . that you do not create something that makes it less desirable to live in the apartments."[5]

Zeckendorf completed two significant apartment buildings prior to the enactment of the zoning. The first, Liebman Williams Ellis's Columbia (1983), 275 West Ninety-sixth Street, filling the west blockfront of Broadway to Ninety-seventh Street, rose after years of false starts on a site that was long deemed marginal.[6] The site, once home to the Riviera-Riverside theater complex, built in 1913 by the trailblazing movie producer William Fox, had been slated in the late 1960s as the site of an Alexander's department store, but community protests blocked the project. In 1974 a thirty-four-story slab-like apartment building was proposed by the politically well-connected developer Christopher Boomis, but the plans were halted when his development empire collapsed.[7] But that turn

100 West Eighty-first Street, southwest corner of Columbus Avenue. Marvin Meltzer, 1981. View to the southwest. MMA

Columbia, 275 West Ninety-sixth Street, northwest corner of Broadway. Liebman Williams Ellis, 1983. View to the northwest. McGrath. NMcG

Park Belvedere, 101 West Seventy-ninth Street, northwest corner of Columbus Avenue. Frank Williams, 1985. View to the northwest. Hoyt. ESTO

of events had little effect on the fate of the Riverside-Riviera theaters, which were razed in December 1976 after Chemical Bank foreclosed on the properties. The community was pleased to see the abandoned theaters go, and late in 1977 the Starrett Housing Corporation took over the property, announcing plans for a twenty-eight-story residential tower designed by Liebman Williams Ellis's design partner, Frank Williams.

In November 1979, Starrett surprised elected officials and community groups by announcing that 20 percent of the Columbia's apartments would be subsidized for low-income residents, a plan that infuriated many in the community who felt the area already had more than its fair share of the poor, mostly living in single-room-occupancy hotels. By May 1981, community concerns had prevailed and the plans were revised by the architects to provide larger family-sized apartments that would attract affluent tenants. As well, the building would benefit in square footage by incorporating features of the city's Housing Quality Program such as rooftop recreational space and windows in public corridors.

As the community and developers wrangled over the details, several neighborhood residents turned the cleared site into an award-winning community garden. The Columbia's groundbreaking ceremony on October 15, 1981, attended by dignitaries including Mayor Ed Koch, was greeted by hoots and catcalls from protesting community residents who wanted to keep the open garden as it was. In May 1982,

William Zeckendorf Jr. took the project over from Starrett and with a partner, Justin Colin, proceeded with the construction of what in its final state would be a thirty-two-story, 320-unit apartment building with 35,000 square feet of commercial space, a two-floor, 16,000-square-foot health club, a 200-car garage, and, as a gesture to the community, a 7,000-square-foot community garden on the roof of the building's garage along Ninety-seventh Street. Clad in bands of tan brick and glass, a fifteen-story base faced Broadway topped by a thick band of glass allowing light into the building's health club and pool. Set back from Broadway and rising along Ninety-sixth Street, an apartment tower rose with a bold interweaving of cantilevered balconies jutting out from the corners and staggering up the center of the south facade. The editors of the *AIA Guide* deemed the Columbia "a bit brash," evoking "the cubistic dreams of Walter Gropius in his wonderful but losing scheme for the Chicago Tribune Tower" in 1922.[8]

Zeckendorf followed the construction of the Columbia with the Park Belvedere (1985), 101 West Seventy-ninth Street, northwest corner of Columbus Avenue, a thirty-three-story apartment house of salmon-colored brick with matching mortar rising on a prominent 13,000-square-foot site overlooking the Museum of Natural History.[9] Also designed by Frank Williams, now in independent practice, the building utilized 80,000 square feet of air rights from four adjacent buildings on Seventy-ninth Street, packing 154 apartments into a 125-foot-tall base that set back at the thirteenth floor, then, beginning

Montana, east blockfront of Broadway, between West Eighty-seventh and West Eighty-eighth Streets. Gruzen Partnership, 1986. View to the northeast. McGrath. NMcG

Bromley, east blockfront of Broadway, between West Eighty-third and West Eighty-fourth Streets. Costas Kondylis of Philip Birnbaum & Associates, 1987. View to the southeast. McGrath. NMcG

above the twenty-fifth floor, featured a series of complex setbacks providing terraces for six 2,000-square-foot penthouse apartments with ten-foot-high ceilings. For Paul Goldberger, the Park Belvedere was "far from the worst way to lose [the] open vista across Central Park from East 79th Street." Appreciative of the decision to "cover over the exposed concrete floor slabs that, when visible, connote cheapness," Goldberger felt "the only problem, aside from the building's size, is its clear orientation toward the east. The Park Belvedere turns an all-too-stark back to the rest of the west side."[10]

The following year the last major Upper West Side apartment building reached completion under the old zoning: the Gruzen Partnership's Montana (1986), 247 West Eighty-seventh Street, east blockfront of Broadway to Eighty-eighth Street, a 180-unit rose-gray brick-clad building.[11] If it alluded in name to Henry J. Hardenbergh's Dakota (1882–84), 1 West Seventy-second Street, northwest corner of Central Park West, its form was clearly an homage to the Dakota's twin-towered 1920s neighbors on Central Park West, rising with a thirteen-story base before setting back to a pair of chamfer-cornered thirteen-story towers where apartments, numbering two per floor, were conceived, according to the developer, Norman Segal, as 1,500-square-foot "ranch houses in the sky," with three bedrooms, two-and-a-half baths, and sweeping views in three directions.[12] Paul Goldberger was not impressed, writing that "the mundane detailing of the

Montana exterior and of its apartment interiors could not be further from its distinguished architectural ancestors."[13]

Between 1986 and 1988, a spate of new buildings reached completion along Broadway, rising on blockfront sites previously occupied by low-rise theater buildings and taxpayers. The new apartment houses, built according to the strictures of the 1984 zoning revisions, were characterized by wedding-cake-style set-back penthouses atop squat, streetwall-defining bases dressed up with a variety of recesses, bay windows, chamfered corners, and balconies that caused them to resemble, as Goldberger pointed out, "the buildings of the late 50's more than the towers of the 60's and 70's." Goldberger observed that although these buildings were often "marked by classical details at their bases" which were "cautious and even a bit crude," they were "nonetheless a welcome improvement over the Manhattan standard."[14]

The firm of Schuman, Lichtenstein, Claman & Efron was responsible for two new additions to the neighborhood, both completed in 1987. The Savannah, 2409 Broadway, southwest corner of Eighty-ninth Street, an eighteen-story red brick building replacing the Adelphi (also known as New Yorker) Theater (Rouse & Goldstone, 1914, renovated by Boak & Paris, 1933), was notable for its highly glazed and balconied north facade indicating double-height rooms within.[15] The firm's Princeton House, 215 West Ninety-fifth Street, northeast corner of Broadway, was a similarly modeled but less

interesting seventeen-story bay-windowed, chamfer-cornered block containing 213 units in its beige brick and tinted-glass skin rising from a cast-stone trimmed base.[16]

Philip Birnbaum & Associates' New West (1986), 250 West Ninetieth Street, southwest corner of Broadway, replaced the Standard Theater (Thomas W. Lamb, 1914–15), used as a supermarket since the 1950s, with a twenty-two-story, 158-unit beige brick block distinguished by an asymmetrical placement of balconies and brick piers on the east facade counterbalanced by a glassy, balconied north facade.[17] Another Birnbaum effort, by design partner Costas Kondylis, was the Bromley (1987), 225 West Eighty-third Street, filling the east Broadway blockfront to Eighty-fourth Street and swallowing up within its mass the former Loew's Eighty-third Street Theater (1921) which was expanded and converted (Held & Rubin, 1985) into one of the city's first multiplex movie play-houses, with ten auditoriums.[18] Kondylis's trendily inventive design included interestingly profiled flat limestone piers at the base and a subtly articulated mass that rose sixteen stories to regular setbacks culminating in an awkward octagonal watertank enclosure. Bands of green-tinted glazing alternating with red brick added life to the twenty-three-story building but didn't win over Paul Goldberger. "Its limestone base and its brick mass do not relate comfortably to each other at all," the critic observed, "and the oculi . . . that have been stuck here and there look like random polka dots, not well-conceived classical details."[19]

The Broadway (theater renovation, Beyer Blinder Belle; apartment tower, William A. Hall and Charles B. Ferris Associates, 1987) was a break from the norm, involving the preservation of the three-story exterior of Keith's Eighty-first Street Theater (Thomas W. Lamb, 1914), 2250 Broadway, southeast corner of West Eighty-first Street, and the construction of a new twenty-story building behind and cantilevered over it. As the editors of the *AIA Guide* perceived it, Lamb's theater was turned into "a venerable frontispiece" of a "blank brown brick tower. Somehow what should have been architectural consonance and context here misfired."[20] The Boulevard (1988), 2373 Broadway, occupying the entire west blockfront between Eighty-sixth and Eighty-seventh Streets, was yet another Broadway blockbuster.[21] The upper six floors of the twenty-one-story building, designed by Alexander Cooper & Partners working with Schuman, Lichtenstein, Claman & Efron, were set back in two-story increments, offering a delicate glassy alternative to the light red and beige brick mass below. Looking to the Belnord (H. Hobart Weekes, 1908–09), across the street, for inspiration, Cooper called the older building "formidable, marvelous, chunky."[22] The Boulevard was formidable and chunky, if not especially marvelous, filling its 30,447-square-foot site with 24,740 square feet of retail space and medical offices on four floors (including two basements), parking for 124 cars, and 354 apartments.

The most flamboyant of Broadway's new generation of apartment houses was the Alexandria (1991), 201 West Seventy-second Street, northwest corner of Broadway, a collaborative design between Skidmore, Owings, and Merrill's David Childs, who served as design consultant, and Frank Williams, the two having recently worked in concert on Worldwide Plaza (see Clinton).[23] William Zeckendorf Jr., developer of both projects, purchased the 17,000-square-foot Alexandria site in 1986, at which point City Councilwoman Ruth W. Messinger warned: "In many people's minds, that

Broadway, 2250 Broadway, southeast corner of West Eighty-first Street. Apartment tower, William A. Hall and Charles B. Ferris Associates; theater renovation, Beyer Blinder Belle, 1987. View to the southeast. McGrath. NMcG

Boulevard, west blockfront of Broadway, between West Eighty-sixth and West Eighty-seventh Streets. Alexander Cooper & Partners and Schuman, Lichtenstein, Claman & Efron, 1988. View to the northwest. McGrath. NMcG

Alexandria, 201 West Seventy-second Street, northwest corner of Broadway. Frank Williams and Skidmore, Owings & Merrill, 1991. View to the northwest. Goldberg. ESTO

corner is the beginning of the Upper West Side. Massive development there will sound a death knell to every lower density, reasonable height building on Broadway."[24] Once home to the Hotel St. Andrew (Andrew Craig, 1893), the site housed the two-story Embassy Theater Building (Peter Copeland and Schwartz & Gross, 1938), which had a long history as a modest-sized movie house showing offbeat films.[25] Zeckendorf planned to expand the theater to become a 1,250-seat, five-screen complex, but the plan proved uneconomical when his attempt to assemble the full Broadway blockfront failed.

By purchasing the air rights of five adjacent tenements to the west, Zeckendorf was able to gain an additional three floors for a total of 297,000 square feet in twenty-four stories containing 202 apartments and 25,000 square feet of retail space in the basement and first two levels. The building rose 150 feet as a combination of bay windows and recessed balconies with a balconied turretlike corner tower, then set back at the sixteenth floor in eight steep increments culminating in an overblown glazed octagonal watertank enclosure that was illuminated at night. The design featured orange brick, white painted iron balcony railings, green metal spandrels, cast-stone trim, and two-story columns with lotus leaf capitals along the base. Carter Horsley praised the Alexandria as a "wonderful Postmodern concoction of Egyptian motifs."[26]

While Broadway bore the brunt of the Upper West Side's 1980s residential boom, several other prominent apartment buildings were erected along other avenues during the same time period. Ted Reeds Associates' Packard (1987), 176 West Eighty-sixth Street, southeast corner of Amsterdam Avenue, built on a hotly contested site cleared to make way for a McDonald's, which was canceled in the face of community protest, recalled the inventive studio apartment type that characterized one of the Upper West Side's most impressive streets, the park block of West Sixty-seventh Street.[27] The eleven-story red brick building with narrow frontage on Eighty-sixth Street featured a three-story limestone segmented-arch-topped portion above the entry that stepped down to two stories then to a single story along the avenue, where a double stringcourse framed the second-story windows.

In 1989 Riverside Drive received its first new apartment house in thirty-five years: Fox & Fowle's 222 Riverside Drive, northeast corner of Ninety-fourth Street, a twenty-one-story, 104-unit red-orange Norman brick–clad building rising above a limestone base with a curving column of windows centered on the west facade above the entry.[28] The site lay within two zoning districts as well as the proposed Riverside Drive West End Historic District (designated in 1989), leading Fox & Fowle to expand the limestone base to cover three stories, a typical condition in the area. The tower, shaped with chamfered corners, punched windows, and ornamental iron railings, rose to three setbacks above the fifteenth floor, each marked by a thick horizontal band. The family-sized apartments (more than sixty were two- and three-bedroom units) featured traditional layouts with high ceilings, foyers, and formal dining rooms.

The upper reaches of Central Park West contained a number of institutional, townhouse, and tenement buildings that had the potential for redevelopment as prestige apartment houses. In 1989 Costas Kondylis's 279 Central Park West, northwest corner of Eighty-eighth Street, a twenty-three-story luxury apartment house, replaced the five-story Progress Club (Louis Korn, 1904), a German-Jewish men's club that, since 1932, was part of the neighboring Walden School, which would occupy 22,000 square feet in the base of the new apartment tower.[29] Efforts by neighborhood activists to have the Progress Club landmarked were unsuccessful. Early plans for a black glass tower with stainless-steel banding on the site were dashed by the 1984 zoning amendments that called for more traditional materials, resulting in a beige brick, round-cornered tower rising from a limestone base for fifteen stories above which the building, in a dizzying series of setbacks, rose to an elevator bulkhead and watertank enclosure that was faced with decorative windows recalling those of the Beresford (Emery Roth, 1929) several blocks to the south.[30] The building aimed for an affluent clientele, with eleven of its forty-four apartments planned as duplexes and all units featuring nine-foot ceilings, separate service entrances, and formal dining and living rooms. The success of the building's attempt at contextual responsiveness was a subject of some debate. One observer, Alex Cohen, writing in *Oculus*, felt that its facade was "interrupted by awkwardly framed bay windows and partial rustication. Thin stone pediments give the building the look of a new kid on the block who is trying too hard to fit in."[31]

More successful was the nineteen-story 353 Central Park West (1992), northwest corner of Ninety-fifth Street, designed by Yorgancioglu Architects in association with the Vilkas Group.[32] The site was a fifty-by-sixty-foot lot formerly occupied by three Renaissance Revival buff and gray brick rowhouses (G. A. Schellenger), 351–353 Central Park West, built in 1892–93 as part of a cohesive group of five private residences. In 1987 the rowhouses were designated landmarks, but Kiska Developers claimed economic hardship and they were demolished two years later.[33] Still, the site's location within the new Upper West Side

Packard, 176 West Eighty-sixth Street, southeast corner of Amsterdam Avenue. Ted Reeds Associates, 1987. View to the southeast. McGrath. NMcG

222 Riverside Drive, northeast corner of West Ninety-fourth Street. Fox & Fowle, 1989. View to the northeast. George. FXF

Central Park West Historic District meant that the design had to be vetted by the Landmarks Preservation Commission. As completed, the beige brick tower rose fifteen stories along the street wall from a limestone-clad base before a series of setbacks provided terraces for those apartments on the upper floors. The sculpted crown was dominated by two chimneys that formed an interplay with the rooftop mechanical and watertank enclosures and was illuminated at night in the tradition of its Central Park West peers. Inside, the sixteen apartments were luxurious, featuring fireplaces, libraries, formal dining rooms, and maids' quarters. Medical offices were housed in 2,400 square feet of the first two floors along with a 1,500-square-foot recreation area for the building's occupants. Suzanne Stephens was pleased with 353 Central Park West, comparing the "intricacy" of the crown, with its "play of horizontal and vertical elements," to the early modern works of Joseph Maria Olbrich, Frank Lloyd Wright, and Henri Sauvage. The two "massive" chimneys that rose above the penthouse level to form the belvedere, Stephens wrote, continued "the vertical thrust established by the shaft's composition. The only cavil one might have is that a few of the crenellations above the top penthouse apartment seem to have been left out between the drawing stage and the building's execution. Small details matter."[34]

With so much real estate incorporated in historic districts and Broadway virtually redeveloped, the 1990s saw only modest residential construction on the Upper West Side, an exception being the Lyric (Costas Kondylis, 2000), a twenty-two-story apartment house that rose from one of Broadway's few remaining developable blockfronts.[35] The site, on the west side of Broadway between Ninety-fourth and Ninety-fifth Streets, had been occupied since 1915 by a two-

story building developed by Vincent Astor as the 95th Street Market (Tracy & Swartwout). In 1917 Thomas Healy, the restaurateur, converted the building into the Crystal Palace ice-skating rink and transformed a fish market in the basement into the Sunken Gardens restaurant. He also built Pomander Walk (King & Campbell, 1922) just to the west, two rows of cottages bordering a midblock garden-lined walkway that received landmark status in 1982.[36] After Healy's death, the Sunken Gardens restaurant was transformed into the Thalia Theater (Schlanger & Irrera, 1932), a 200-seat Art Moderne revival movie house entered from Ninety-fifth Street that was infamous for its unconventional floor, which sloped upward toward the movie screen.[37] The Crystal Palace skating rink became the 20,000-square-foot Symphony Theater, a movie house, in the early 1920s, and in 1978 was reinvented as Symphony Space, a popular performing arts venue.

The fact that the site survived the development boom of the 1980s was attributable primarily to a protracted battle over its ownership that began in 1985 and ended in 1996 in a victory for Symphony Space but left the organization with a considerable tax burden. To cover its debt, Symphony Space had little recourse but to sell its more than 200,000 square feet of air rights for development. But it would only sell to a developer who would agree to leave its performance hall intact and include low- and moderate-income housing in any new apartment building. In 1998 the Related Companies purchased the Symphony Space air rights and announced plans for a 285-unit apartment building that would sit atop the existing auditorium and provide seventy-one units of low-income housing. Because no new columns could be introduced into the auditorium, the seventeen stories of

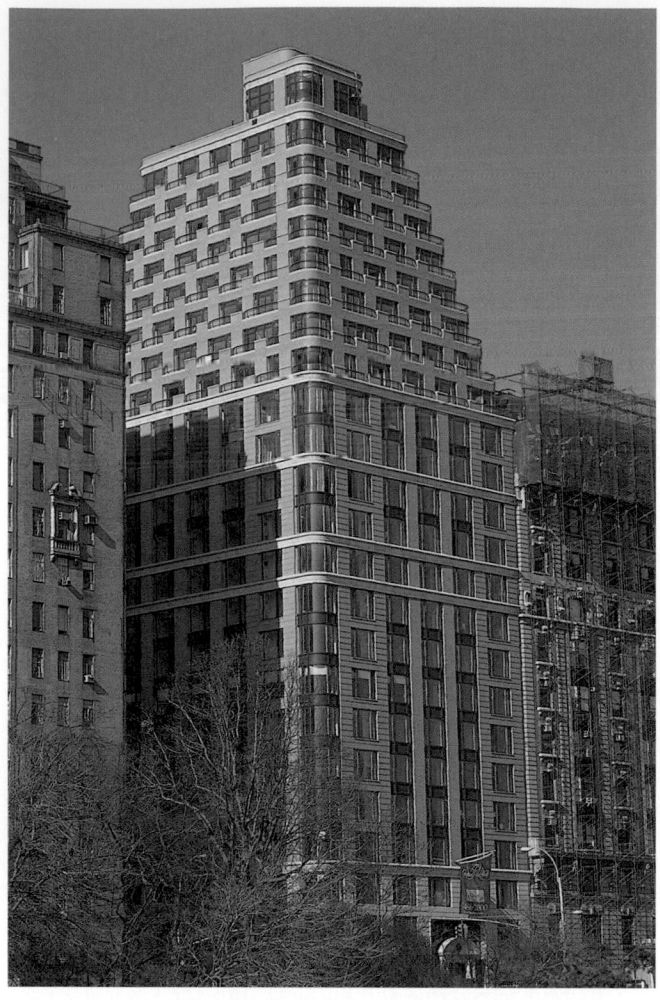

279 Central Park West, northwest corner of West Eighty-eighth Street. Costas Kondylis, 1989. View to the northwest. Goldberg. ESTO

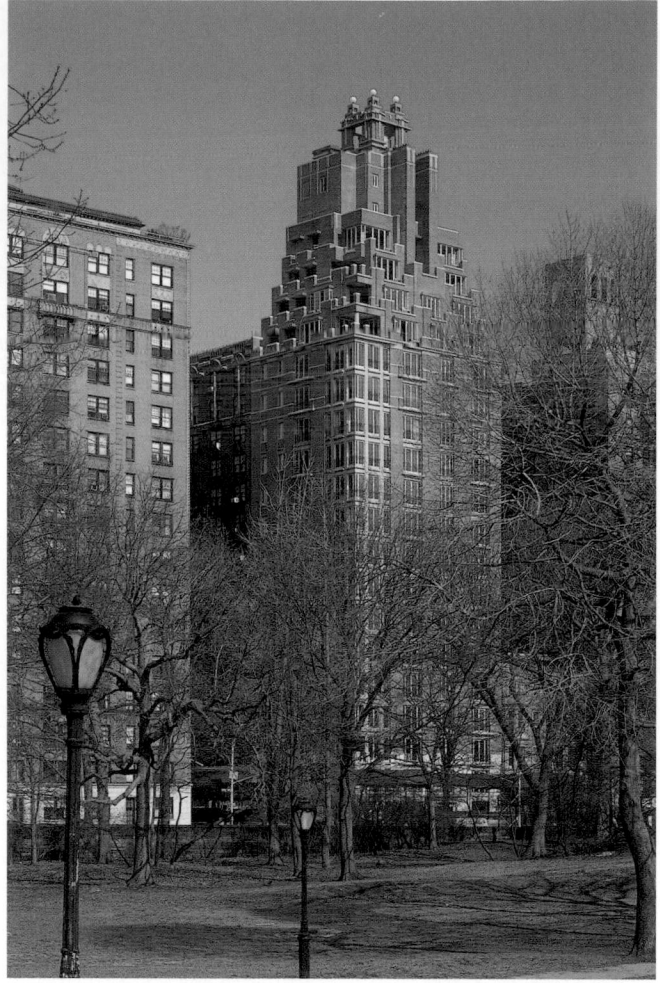

353 Central Park West, northwest corner of West Ninety-fifth Street. Yorgancioglu Architects and the Vilkas Group, 1992. View to the northwest. Mauss. ESTO

apartments were supported by what was in essence an above-ground foundation. As devised by Rosenwasser/Grossman Consulting Engineers, five steel girders—each 108 feet 11 inches long, 5 feet 5 inches high, and weighing 23 tons—acted as cores for two separate concrete beams spanning the entire length of the auditorium hall. Costas Kondylis's architectural design was less innovative, an Art Moderne–inspired pink and red brick box with cast-stone finials and glassy corners that afforded residents choice views up and down Broadway.

More interesting was the renovation of Symphony Space by the Polshek Partnership. The performance hall, renamed the Peter Norton Symphony Space when it reopened on April 8, 2002, enjoyed excellent acoustics. Polshek was given a free hand in improving circulation; creating new lobby and café spaces, bathrooms, and a new box office; and providing additional backstage areas. He left the beloved auditorium pretty much untouched but gutted and redesigned the Thalia Theater. As renovated, the newly renamed Leonard Nimoy Thalia, operated by Symphony Space as an adjunct film and performance space accessible both from Ninety-fifth Street and through a shared lobby with Symphony Space, was a state-of-the-art 176-seat theater reconfigurable for live shows.

Working with Paula Scher of the graphic design firm Pentagram, Polshek designed Symphony Space's two-story street facade at the corner of Ninety-fifth Street and Broadway "to create a powerful and individual look" for the organization and "to put it on the map visually as they already are artistically."[38] Inspired by the "guerrilla aspect" of Symphony Space's programming, Polshek stated, "There's nothing conventional, nothing predictable about it at all. What that indicated, first of all, was that the facade should not be politely absorbed into the residential building that's been constructed over and around Symphony Space. It was very important that the exterior should . . . celebrate its 'differentness' and express its energy." Polshek and Scher introduced "elements of geometry and color"—interlocking planes of glass, aluminum, and cement plaster rendered in red, yellow, and blue—that, the architect noted, "were clearly influenced by some of the theaters built in the 1920s in the Netherlands, particularly by the people associated with De Stijl. Those buildings, by their very being, made an avant-garde statement about the institutions they represented. Those were the formal influences that I kept going back to for Symphony Space—Rietveld on Upper Broadway!"[39]

Lyric, west blockfront of Broadway, between West Ninety-fourth and West Ninety-fifth Streets. Costas Kondylis, 2000. View to the southwest showing Symphony Space (Polshek Partnership, 2002) at base. Mauss. ESTO

Symphony Space, 2537 Broadway, southwest corner of West Ninety-fifth Street. Polshek Partnership with Pentagram, 2002. View to the southwest of entrance. Mauss. ESTO

Leonard Nimoy Thalia, 2537 Broadway, southwest corner of West Ninety-fifth Street. Polshek Partnership, 2002. PPA

Hall of Minerals and Gems, American Museum of Natural History, Central Park West, between West Seventy-seventh and West Eighty-first Streets. William F. Pedersen & Associates, 1976. AMNH

INSTITUTIONS

American Museum of Natural History

Although the American Museum of Natural History, Seventy-seventh to Eighty-first Street, Central Park West to Columbus Avenue, was unquestionably headquartered in distinguished individual works of architecture (original building, Calvert Vaux and Jacob Wrey Mould, 1874–77; Seventy-seventh Street facade, Cady, Berg, & See, 1892; Central Park West facade, Trowbridge & Livingston, 1924; New York State Theodore Roosevelt Memorial, John Russell Pope, 1936), by the 1970s it had acquired a reputation for being a sleepy institution with tired exhibitions that were no longer able to engage the general public.[1] As Paul Goldberger put it in 1977: "Mention of the Museum of Natural History calls to mind labyrinthine corridors, dimly lit halls with stuffed-animal dioramas, and the general architectural ambiance of an old high school." In an effort to shed this image, the museum began a modest renovation program in 1976, hiring William F. Pedersen & Associates to restore the museum's auditorium (Cady, Berg & See, 1900) as well as update its Hall of Minerals and Gems, a reworking that Goldberger deemed "one of the finest museum installations that New York or any city has seen in some years." Pedersen transformed the nearly one-third of an acre of galleries into "a lively dynamic space, alive with level changes, curves, ramps, and steps."[2] With earth-tone carpeting covering floors and walls, the emphasis was placed on the

gems, minerals, and meteorites, which were arranged in brilliantly lit glass cases. For some large specimens, no cases were required.

It would take another fourteen years, however, before more dramatic change would come to the museum. In November 1990, the museum embarked on the largest remodeling project in its history, a seven-year, $44 million, multiphased renovation of its six fourth-floor fossil halls.[3] The renovation was initiated by George D. Langdon Jr., who came to the museum as its first salaried president in 1988, succeeding its volunteer president Robert G. Goelet. Langdon's appointment was part of a larger initiative on the part of the museum's trustees to increase its financial base and modernize its public exhibits. After a five-year term and midway through the renovations, Langdon stepped down, having, in the opinion of William T. Golden, changed the institution "from a medieval to a modern organization."[4] In June 1993, he was succeeded by former Barnard College president Ellen Futter.

Perhaps the most important aspect of Langdon's legacy was to make the museum's fossil halls "the most important and comprehensive display of vertebrate fossils in the world."[5] While the collection was the world's most extensive, the fossils were poorly exhibited. Design, however, wasn't the principal shortcoming: scholarship was a bit shaky as well, given the 1970s discovery that the 150-foot-high Brontosaur fossil dominating the Hall of Early Dinosaurs since its opening in 1953 had the skull of an entirely different animal—the

Library, American Museum of Natural History, Central Park West, between West Seventy-seventh and West Eighty-first Streets. Kevin Roche John Dinkeloo and Associates, 1992. View to the southeast. KRJDA

Camarasaurus. The museum not only failed to remove the skull after the discovery but did not post an acknowledgment and explanation of the error until 1989.

One fundamental change in the theory underpinning the revised displays became a point of considerable contention: the proposed redesign of the dinosaur halls would organize the fossils according to "cladistics," a system that, instead of the traditional chronological display of organisms, grouped them according to shared physical characteristics and evolutionary kinship, regardless of whether the animals lived in the same time or place. The traditionalists at the American Museum of Natural History, led by Dr. Edwin H. Colbert, who, with Henry Fairfield Osborn, was one of the original curators of the museum's dinosaur displays, made an unsuccessful attempt to retain the museum's chronological arrangement of fossils, with Colbert pointing out that "cladistics has resulted in serious errors of classification. A kitten may have been born in an oven, but you can't assume, as the cladists might, that the kitten is therefore a biscuit."[6]

The American Museum of Natural History first considered the idea of building an entirely new dinosaur wing but decided it would take too long to complete. Instead, to open up more space for its fossils, the 450,000-volume library, which occupied space on the fourth floor, was relocated to a new 55,000-square-foot, eight-story library building (Kevin Roche John Dinkeloo and Associates, 1992) constructed in what was the southwest courtyard of the museum's original master plan.

According to director of exhibitions Samuel Taylor, the idea was then to reuse the former library space as fossil halls "within a black box, so we could control the lighting and the exhibit environment. When we began punching holes in the walls to see what was there, we discovered, to our delight, that the original architectural detail was intact."[7] This discovery led to the bold decision to retain the original architecture in the redesigned galleries.

The museum hired Kevin Roche John Dinkeloo and Associates, a firm that had also designed the master plan and several wings for the Metropolitan Museum of Art, and designers Ralph Appelbaum Associates to renovate the fourth-floor galleries. Appelbaum, who was the leading force in the design of the spaces, described the sole admonition given to him by his client: "Make sure we never hear again the criticism that this is a dusty, musty museum." The designer would achieve this in part by returning the ceilings to their original height and clearing the windows to once again introduce natural light and views of Central Park. His desire to "integrate the exhibits with the architecture," coupled with the cladistic grouping of the specimens, produced a cohesive design, with the new fossil halls forming a continuous loop organized as a metaphorical evolutionary tree. Guided along a black pathway embedded in the terrazzo floors, viewers would begin in an orientation room and, progressing through the six halls, reach circular nodes representing evolutionary breakthroughs such as the backbone, hoof, or rear-pointing extension of the pubis.

At those points museumgoers could veer "off the path" into ancillary exhibition alcoves which, alongside the fossils on display, offered detailed information via interactive multimedia kiosks with touch-screen computers, audiovisual effects, film clips, and digital animations. In designing the new galleries, Appelbaum opted for the use of "real" materials such as steel, terrazzo, and glass instead of plastics, polycarbonates, and vinyls.[8] He also detailed the metal posts and railings that protected the exhibits to play off the skeletal nature of the fossils themselves.

The galleries were reopened in three phases between 1994 and 1996, beginning with the Lila Acheson Wallace Wing of Mammals and Their Extinct Relatives, inaugurated on May 14, 1994, in time for the museum's yearlong 125th anniversary celebration. The 16,500-square-foot space consisted of two halls—Advanced Mammals and Primitive Mammals—displaying 250 specimens. Clifford Pearson, writing in *Architectural Record*, called the new halls "a radical departure from, and a return to, a former incarnation. With its interactive displays, video screens, and revised scientific principles, the exhibit is right on the cutting edge. But by renovating two grand halls, removing hung ceilings, replicating historic lighting fixtures, and opening the rooms to views of Central Park, the project brings back the glory of the museum Calvert Vaux designed in the 1870s."[9] Christopher Gray, writing in the *New York Times* in 1994, was less enthusiastic: "The museum has removed the drop ceilings, exposing the Vaux ironwork, and calls this a 'sympathetic restoration.' Sadly, that is just lip-service preservation. There is no sense of the original character of the museum as a series of distinct buildings; they have been homogenized for the sake of convenience."[10]

The second phase of the renovations, completed in June 1995 and encompassing 18,000 square feet of space, introduced the Hall of Saurischian Dinosaurs and the Hall of Ornithischian Dinosaurs. The design of the exhibitions, also by Appelbaum, was similar to that of the Mammals wing, with the fossils taking center stage. In the Hall of Saurischian Dinosaurs, a raised glass platform allowed museumgoers the opportunity to closely inspect the skeleton of an Apatosaurus while providing a view of a fifty-foot-long Barosaurus spine underfoot. When reopened, though, it was the radical remodeling of the fossils—the Tyrannosaurus rex was no longer displayed upright like Godzilla, but in a birdlike pose with its tail in the air and its backbone parallel to the ground—and not the architecture that captured the public's interest.

One year later, in June 1996, the final phase of the fourth-floor fossil halls renovation—the Hall of Vertebrate Origins and the Miriam and Ira D. Wallach Orientation Center—was finished. The orientation center featured an open auditorium that was intended to be the origination point for the six-hall progression. The Hall of Vertebrate Origins was housed in Calvert Vaux's 1877 gallery. In an odd homage to Vaux's building, Appelbaum decided to "restore" a piece of its original exterior, now indoors, creating a gallery adjacent to the Vertebrate Hall in which one could view what had become the excavated fossil of Vaux's east facade. A similar strategy had been used before by Kevin Roche at the Metropolitan Museum in the Lehman Wing and Petrie Sculpture Court.

Unquestionably, James Stewart Polshek & Partners' Rose Center for Earth and Space at the museum was conceived as—and in many ways succeeded at being—the defining millennium building project in New York and perhaps in the United States.[11] Even globally this distinction might apply given that only London's Millennium Dome (Richard Rogers, 1999) attempted anything like the Rose Center's reach but was hampered by delays in construction and, especially, by an overreaching program of exhibits that were not open to the public in time for the celebrations on December 31, 1999.[12] Planning for the Rose Center began in 1994, shortly after Ellen Futter took over as president. The original idea was to renovate the Hayden Planetarium (Trowbridge & Livingston, 1935), a severe but not unstylish red brick building that housed a 742-seat theater where pre-space-age generations had thrilled to the stellar projections of the once innovative Zeiss Optical star projector.[13] But this light show looked pretty tame to new generations raised on photographs of outer space and on Hollywood technology such as that in Stanley Kubrick's film *2001: A Space Odyssey* (1968). Moreover, the projector itself was unable to keep up with new discoveries in astronomy.

The decision to tear down the Hayden Planetarium, though surely not undertaken casually, was first proposed by Polshek. Although the Hayden Planetarium was not beloved as great architecture, it shared the landmark status of the American Museum of Natural History as a whole, although the designation report did not say anything specific about it.[14] Polshek worked quickly, happening onto the sphere idea early in the design process as a result of his study of a drawing of the cross section of the Hayden Planetarium's seventy-five-foot dome. Placing the point of a compass on the center of the drawing, Polshek formed a full circle, and thus the concept for the Rose Center emerged: an eighty-foot-diameter sphere entered by a 320-foot-long spiral ramp that wrapped around it one and one-half times while constantly changing in height and radius, a feature that proved an extremely tricky bit of construction given its lack of constant dimension. The scheme was presented to the trustees in fall 1994. But because of its landmark status and because of the potential opposition to the project from local residents, particularly those living in the pricey apartment houses across from the planetarium on West Eighty-first Street, the museum did not make the design public until January 1995, after it had been vetted with a number of influential citizen groups.

Polshek's plan called for the new planetarium to be housed in a softly lit sphere within a 95-by-95-foot, 95-foot-tall, seven-story cube that would be sheathed with glass only on its north and west sides, with the other two sides being formed by the "courtyard" elevations of Trowbridge & Livington's 1924 north wing.[15] The glass wall, like Bernard Tschumi's at the Lerner student center at Columbia, had as its immediate precedent the scheme by Peter Rice and Hugh Dutton for the La Villette science museum in Paris.[16] Polshek's wall was engineered by Matthys Levy of Weidlinger Associates. To allow maximum visibility in and out during various daylight and nighttime conditions, high quality so-called water white glass, with very little of the iron that usually gives glass its green tinge, was specified. While the Hayden Planetarium had been intended to ultimately be invisible—it was situated in an area designated as courtyard space in the museum's then master plan—the Polshek scheme was seen as providing the northern limit of a museum that was not expected to physically expand. In that sense, it was very much like the strategy adopted by Arthur Rosenblatt and Kevin Roche to conclude the northern expansion of the Metropolitan Museum with a

Hall of Primitive Mammals, American Museum of Natural History, Central Park West, between West Seventy-seventh and West Eighty-first Streets.

Kevin Roche John Dinkeloo and Associates and Ralph Appelbaum Associates, 1994. Frances. ESTO

glass-walled superscaled room, in that case housing a small Egyptian temple. In addition, Polshek's plan called for an adjoining Hall of Planet Earth as well as a 350-car underground parking garage to be built beneath the site of an existing surface parking lot. The roof of the garage was to serve as a public plaza, the design of which was entrusted to Kathryn Gustafson, whose "eclipse garden" included fountains depicting meteor showers and the well-known constellation Orion picked out in sparkling lights. Additionally, there was to be some other new gallery space, a restaurant, and a small public entrance portico on Columbus Avenue. Except for the portico, the new construction represented no encroachment on the parkland surrounding the museum.

The project enjoyed the political support of both Mayor Rudolph Giuliani and City Council Speaker Peter F. Vallone, who set the tone for the plan by proclaiming that it would "catapult the American Museum of Natural History, and the City of New York, far into the next millennium."[17] But some preservationists and neighbors were not quite so enthusiastic. Polshek addressed their objections head-on: with regard to his new design he implied that the sphere had a "universal"

meaning that was "right" for this project. As to its glowing surface and the well-lit cube in which it was to sit, he stated that "the light levels coming from the sphere will actually be lower than the floodlit dome of the present planetarium."[18] An early idea to transform the outside of the sphere into a massive projection screen had been dropped, and the dome was clad in perforated metal panels that effectively dampened ambient noise in the hard-surfaced cube.

Yale professor David Gelernter raised some other issues that continued to plague the project—issues that were generally characterized by the rubric "theme-park architecture." According to Gelernter, the museum's need for a new planetarium was suspect, as was its general approach to revamping its galleries. He argued that the museum was too intent on thrilling audiences: "I'll miss the old building, not because it is an architectural masterpiece. . . . Those bulldozers will be plowing calm dignity under and replacing it with glitz, hype and somersaults, and we will all be worse off for it."[19]

Picking up on Gelernter's argument, others claimed the planetarium's dwindling attendance was not due to out-of-date facilities but to neglect by indifferent museum directors.

ABOVE Geology Hall, American Museum of Natural History, Central Park West, between West Seventy-seventh and West Eighty-first Streets. View before renovation as library in the 1950s and as fossil hall in 1996. AMNH

RIGHT Hall of Vertebrate Origins, American Museum of Natural History, Central Park West, between West Seventy-seventh and West Eighty-first Streets. Kevin Roche John Dinkeloo and Associates and Ralph Appelbaum Associates, 1996. Frances. ESTO

Claudio Veliz, a New York architect and amateur astronomer, argued that in the name of maintaining profits, rock-and-roll laser shows became one of the planetarium's staples on weekends instead of stimulating astronomy programs, creating a situation that was "so infamous" that a 1994 essay about the planetarium, "Science Fiction at the Planetarium," in the *New York Times* by Ken Kalfus, became the catalyst for a book of essays titled *Dumbing Down: Essays on the Strip Mining of American Culture*, which included pieces by Cynthia Ozick, George F. Kennan, and Carole Rifkind in addition to the one written by Kalfus. Despite his reservations, however, Veliz expressed confidence in the Polshek design and in the ability of the planetarium's "animated, politically savvy" new director, Neil deGrasse Tyson, to make a real contribution.[20]

As the museum moved forward in its campaign to minimize neighborhood opposition to the project, Polshek and design partner Tod Schliemann struggled to resolve the dilemma posed by their design strategy, which could be likened to that of suspending an egg in a cage. Their proposal of a sphere ringed by ramps was hardly without precedent. It echoed Wallace K. Harrison's Perisphere at the 1939–40 New York World's Fair, a beloved lost landmark that offered a powerful vision of the future such as the new planetarium was intended to do, but which also, like the planetarium, struggled with the same formal problems—those of supporting the sphere and of entering what was an inherently closed volume. Polshek's scheme also resembled two unrealized icons of neoclassicism: Étienne-Louis Boullée's project (1784) for a cenotaph for Isaac Newton, which was intended as a planetarium

ABOVE Rose Center for Earth and Space, American Museum of Natural History, Central Park West, between West Seventy-seventh and West Eighty-first Streets. James Stewart Polshek & Partners, 2000. Sectional perspective. dbox

FACING PAGE Rose Center for Earth and Space, American Museum of Natural History, Central Park West, between West Seventy-seventh and West Eighty-first Streets. James Stewart Polshek & Partners, 2000. View to the southeast. Goldberg. ESTO

with stars shining through holes cut into the dome; and Claude-Nicolas Ledoux's design for the Maison des Gardes Agricoles (1785).[21] It also related to the geodesic-style sphere used as the gateway to the Epcot development at Walt Disney World in Florida, but no one among the project's supporters seemed to notice that. The idea of a time line along the ramp was attributed to Ralph Appelbaum, who proposed that it display the history of the universe; given the ramp's comparatively short length, 13 billion years were spread out at 3.6 million years per inch, at which scale the last ten feet represented the age of the dinosaurs, and that of human history was the size of a hair.

On November 21, 1995, the Landmarks Preservation Commission approved the plan to demolish the Hayden Planetarium. Community Board 7 approved the museum's preliminary environmental impact statement on July 2, 1996, pushing the project closer to reality. Four months later, on November 6, a previously anonymous gift of $20 million was publicly attributed to Frederick P. Rose and his wife, Sandra, and the project took on the name Rose Center for Earth and Space.

Lawsuits by neighborhood groups attempting to block construction were dismissed in State Supreme Court on February 26, 1997, clearing the way for construction and for the presentation, on March 1, by Herbert Muschamp in the New York Times, of drawings and model photographs of the fully developed scheme, which now called for an eighty-seven-foot sphere covered in perforated metal panels "floating inside a crystal cube," but in reality resting on three diagonal struts, or "prongs," as the critic called them. The internal organization of the 4-million-pound sphere proved more complex and interesting than its rather simplistic shape: a 440-seat sky theater that would retain the Hayden name was set atop a Hall of the Universe in which visitors would be treated to a 3-D simulation of the Big Bang. Muschamp was impressed with the design, claiming that it "should reactivate memories of a time when New York's architecture was on the cutting edge." He accurately characterized the "deep rooted . . . historical awareness" of this "classical piece of architecture." Like the Seagram Building, he argued, it dramatized the "continuity between the classical and the modern," but in an even more

emphatic way. In addition to its precedents in French neoclassicism, Muschamp also drew attention to Karl Friedrich Schinkel's Hall of the Stars set for an 1816 production of The Magic Flute. But despite his seeming enthusiasm for the project, the critic saw clearly that Polshek's scheme was fundamentally traditional, and this disappointed him: "It does not articulate the relativistic universe of warped space, black holes or other phenomena that engage physicists today." But all in all he remained convinced by the design: "The planetarium is a homage to the Enlightenment ethos that nurtured modern science and the institution of the museum itself."[22]

While the awkward resolution of the problem of supporting the sphere did not seem to bother Muschamp, he was concerned that, though the red brick and rose-colored stone covering the two-story base "makes a respectable attempt to mediate between the metal and glass structure and the masonry buildings that surround it," the building required a bolder, perhaps metal-clad base, because "incremental buildings best declare their awareness of context through composition, not by matching up materials."[23]

Later, when the building was complete, Paul Goldberger would also criticize the design of the base and especially the low sprung arch that served as the entrance. Overall, however, Goldberger liked Polshek's design. Forgetting, for example, John Russell Pope's Jefferson Memorial, as well as Eero Saarinen's memorial arch, also dedicated to Jefferson, in St. Louis, he hailed the Rose Center as "perhaps the purest piece of monumental architecture built in the United States since the Washington Monument went up on the Mall more than a century ago" and went on to find "its only true comrade" in I. M. Pei's pyramid at the Louvre. "Like Pei, Polshek has rendered a classic, simple geometric form with the lightest, most advanced technology possible, so that an immense shape appears to be almost weightless: a vast ball held in the lightest of tethers."[24]

Muschamp was equally enthusiastic about the finished product: "This is a mature modern building, a structure unafraid of revealing the deep roots from which modern architecture arose. The design's historical awareness far exceeds that of buildings that merely ape period styles. . . . The Museum of Natural History has essentially brought Boullée's

Rose Center for Earth and Space, American Museum of Natural History, Central Park West, between West Seventy-seventh and West Eighty-first Streets. James Stewart Polshek & Partners, 2000. Barnes. ESTO

design to realization more than 200 years after it was conceived. . . . The design transports us to an era when physicists called themselves natural philosophers and the United States was new. And it propels us into the architecture that emerged in the 20th century as the built version of Enlightenment."[25]

Ken Kalfus, who had bemoaned the show-biz techniques used in the waning years of the Hayden Planetarium to make that facility attractive to young people, found much to admire in the Rose Center, but he deplored the use of "virtual" journeys that were being undertaken inside the new dome, which, he wrote, "disconnects us from the universe we can experience. The night sky, eclipses, tides, phases of the moon, or the changing seasons—phenomena happening right in our faces— are barely mentioned. . . . In an effort to entertain, the Rose sells short the excitement of the scientific enterprise."[26] Sadly, for many, this was all too readily confirmed when, at a $5,000 per plate dinner that accompanied the celebration of the new $210 million facility, Ellen Futter proclaimed, "Tonight we reveal that it's not just bones and dinosaurs, not just birds, fish, and mammals, dead and stuffed. No, my friends, the new American Museum of Natural History species is unveiled. We are the party animals, *Celebrataurus perpetualus*, live and raring to go, ready for the third millennium."[27]

Once the reverberations of the initial hype began to die down, and the sense of the Rose Center's alternative destiny as a party palace began to become more apparent, the spirit behind the enterprise was questioned and criticized. As Lee Rosenbaum, a contributing editor of *Art in America* magazine, put it in the *Wall Street Journal*: "Never has the hyperbolic rhetoric of a project's promoters been so uncritically adopted by the press, which has pronounced this I. M. Pei imitation . . . to be an architectural triumph."[28]

Soon enough the presentation of scientific materials began to be scrutinized. Not only did the sky show in the new Hayden Hall take only twenty minutes—twenty-five less than in the old planetarium—it was narrated by a movie star, Tom Hanks. Even more vexing, at least for Rosenbaum, were the exhibits designed by Ralph Appelbaum, whose main goal was, as Appelbaum put it, to "create an environment that reflects the culture of scientific inquiry."[29] "How much of this information can you remember?" Rosenbaum wondered. "We used to remember quite a lot of 'stuff' as we left the old Hayden Planetarium—perhaps because we weren't distracted by glitz and glamour. No wonder some of us, seeing the universe through Rose-colored glasses, are feeling slightly lost in space."[30]

Rosenbaum's concerns were shared by many visitors who left the Rose Center in confusion. As Tina Kelly, a *New York Times* reporter, put it: "Turns out, it really *is* rocket science."[31] To help people better understand the exhibits, computer-equipped mobile carts called "explainers" were commissioned from the Eli Whitney Museum in Hamden, Connecticut. Still, there was no discounting Polshek's achievement. As Clifford Pearson stated in *Architectural Record*: "The result is a building immediately recognizable as an icon, but one that seems ready to float away or, at times, almost disappear. By combining the grand with the ethereal, the Rose Center achieves a sense of timelessness that hints at the mysteries of the cosmos."[32]

New-York Historical Society

In 1976, amid considerable neighborhood protest, the New-York Historical Society announced that it intended to build a revenue-generating apartment house on a 100-by-125-foot-site it owned to the west of its ascetically magnificent classical building (York & Sawyer, 1908; expanded and renovated by Walker & Gillette, 1938), which occupied a full blockfront along Central Park West between Seventy-sixth and Seventy-seventh Streets.[33] The site of the proposed apartment tower, largely vacant except for a derelict brownstone, had been purchased by the society in 1937. Because the site was small, the plan called for a new twenty-story building that would extend over the original building, combining additional museum space with new apartments. The building had been designated a landmark in July 1966; additionally, the houses on the park block of West Seventy-sixth Street had been landmarked in April 1973.[34]

Plans evolved slowly until 1983, when Hardy Holzman Pfeiffer Associates came forward with a proposal for a monumentally scaled, bulkily proportioned twenty-three-story, 340-foot-tall set-back tower rising to a pyramidal roof. The proposed building was to provide space for archival storage and offices in its lower floors and incorporate seventy to eighty-five apartments above. The architects' proposed elevations ingeniously adapted the stiff classicism of York & Sawyer's museum to the requirements of a high-rise apartment house. Though it would have presented a symmetrical composition when viewed from the park, like other towers facing Central Park West, it responded to side-street zoning constraints with a more picturesque massing. Still, the "centrally tapered tower," as Paul S. Byard wrote, was not a welcome addition to the Society's building: it "firmly fixed

the old building like the ground under a rocket" with an "energetic form and strongly animated surfaces" that made it seem "the most magnetic part of the composition" while its "friendly, scenographic takeoff of the old building's decoration undercut its seriousness, a deflation hard for the old building to survive."[35]

The project was opposed by many, including the New York Chapter of the American Institute of Architects, which praised the "admirable design" but argued that its approval would "open the doors for developers to begin imagining the possibilities in major alterations of landmarks all over town."[36] Robert A. M. Stern's letter to the Landmarks Preservation Commission was widely quoted: "To reduce the Society building to the role of pedestal for a tower is . . . insensitive and destructive. . . . The proposed addition would destroy the original building's sensitive scale and deny its integrity."[37] The proposed tower, though its design was admired by some of the members, was rejected by the majority of the commission early in 1984.

With the promise of a development windfall behind it, the society began to face its fiscal problems, cutting staff and programs in an effort to reduce its considerable annual deficit.[38] A saga of fiscal and curatorial mismanagement unfolded during the summer of 1988, highlighted, among other things, by the shocking disarray of the society's incomparable library, where, for instance, centuries-old books were repaired with masking tape and the collection of Cass Gilbert's drawings, letters, and other personal and professional papers lay uncataloged and molding in a storeroom. Addressing these discoveries, in 1989 the society completed two new book and paper conservation laboratories. Skidmore, Owings & Merrill was

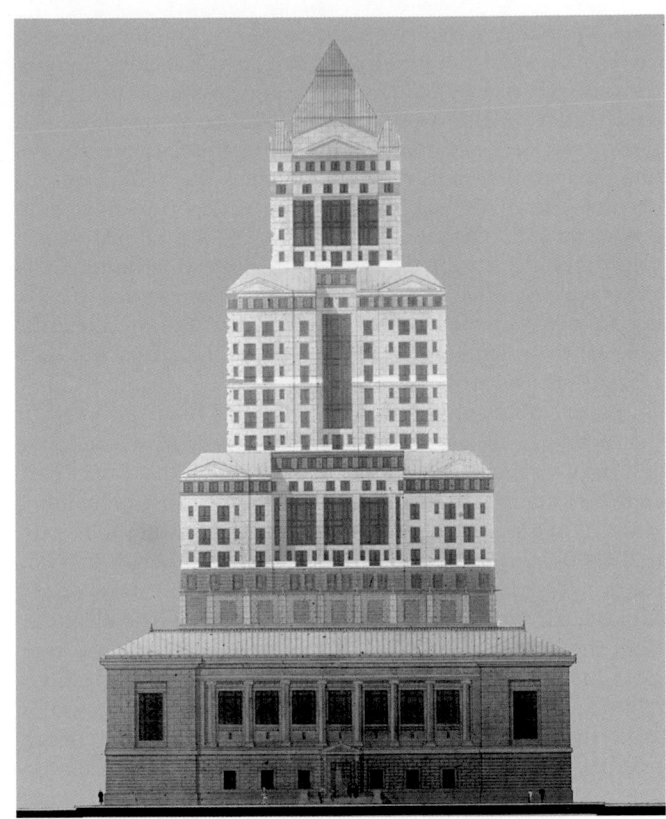

Proposed apartment house west of the New-York Historical Society, Central Park West, between West Seventy-sixth and West Seventy-seventh Streets. Hardy Holzman Pfeiffer Associates, 1983. Rendering of east elevation. H3

Henry Luce III Center, New-York Historical Society, 170 Central Park West, between West Seventy-sixth and West Seventy-seventh Streets. Beyer Blinder Belle, 2000. Aaron. ESTO

hired to prepare a five-year master plan calling for new storage facilities and an upgraded library. As the society began to rebuild its finances, Allan Greenberg designed the Luman Reed Gallery (1990), a suite of rooms on the second floor that showcased the collection of Luman Reed, a nineteenth-century businessman and art patron who had originally displayed his artworks, including Thomas Cole's allegorical five-painting series, *The Course of Empire* (1833–36), which he had commissioned, on the top floor of his three-story house at 13 Greenwich Street (1832).[39] Greenberg's galleries were, according to the architect, meant to "recreate the architectural spirit of the original two-room gallery of the 1830s, but with a twentieth-century lighting system."[40]

As part of its uphill battle to reestablish financial stability, the society pressed forward with its proposed tower, misguidedly arguing financial hardship though it had made only half-hearted attempts to conduct either fund-raising or building renovation campaigns. But the tower was not to be, and by the mid-1990s, the society, after an enforced shutdown in 1993, began to restructure its management and return to its principal task, the management and interpretation of its collections. With the appointment as director in August 1994 of the energetic and well-connected Betsy Gotbaum, the society began to rebuild, again looking into the idea of building a tower in 1995, this time hiring Beyer Blinder Belle to prepare conceptual plans for a fifteen-story addition that would accommodate a combination of housing and space for the society. Again

the plans were scrapped. In 1997 the New-York Historical Society affiliated its library with the Bobst Library of New York University, which agreed to undertake the mammoth task of cataloging and preserving its treasures of manuscripts, photographs, prints, architectural records, and books. Three years later, in November 2000, the Henry Luce III Center, a 21,000-square-foot exhibition, research, and storage facility designed by Beyer Blinder Belle, was completed, occupying the building's entire fourth floor.[41] The space, which had been closed off ten years earlier after the building's roof began to leak, was rebuilt with a 4,500-square-foot mezzanine to provide open storage for 40,000 of the museum's objects that would be visible for public viewing on maple, steel, and aluminum shelves and in glass display cases.

Other Museums and Public Institutions

The Children's Museum of Manhattan, which began life in 1973 in a rented storefront at 260 West Eighty-sixth Street, returned to the Upper West Side in 1989 after leaving 10,000 square feet of space in the Clinton Youth and Family Center (James Stewart Polshek with Walfredo Toscanini and David Bliss, 1970). The museum's new home was in a renovated four-story former parochial school (Thomas Dunn, 1929) at 212 West Eighty-third Street, between Broadway and Amsterdam Avenue.[42] Except for a new entrance and a handicapped-accessible ramp, Paul Segal's work was confined to 36,000 square feet of new interior space with more than sixty

Children's Museum of Manhattan, 212 West Eighty-third Street, between Amsterdam Avenue and Broadway. Paul Segal with Lee Skolnick, 1989. McGrath. NMcG

Jewish Community Center, 334 Amsterdam Avenue, southwest corner of West Seventy-sixth Street. A. J. Diamond, 2002. View to the southwest. Evans. DS

Columbia Grammar and Preparatory School, 4 West Ninety-third Street, between Central Park West and Columbus Avenue. Pasanella + Klein, 1986. View to the southeast. Pickman. PKSB

separate exhibition areas, designed in consultation with Lee Skolnick. The highlight of the technologically sophisticated museum was a nineteen-foot-diameter white gunite sphere, the "Brainatarium," a permanent interactive exhibition explaining how the five senses functioned. On the second floor, Segal created a 2,000-square-foot media center, complete with a fully functioning television studio that allowed youngsters to create their own videos.

Like the Children's Museum, the Jewish Community Center also left 10,000 square feet of rented space to occupy its own purpose-built headquarters (2002), an eleven-story building at 334 Amsterdam Avenue, southwest corner of Seventy-sixth Street, a site formerly home to a gas station.[43] Designed by Toronto-based architect A. J. Diamond, working in association with Schuman, Lichtenstein, Claman & Efron, the 137,000-square-foot glass and slate-gray brick building accommodated a myriad of uses, including a ground-level café, extensive health-club facilities, a black-box theater, photography darkrooms, classrooms, meeting rooms, an egg-shaped meditation room, a gift shop, and a nursery school. Diamond noted the difficulty of designing "a building that has to be a landmark but doesn't want to be one because of the nature of the client, which doesn't want to be ostentatious." The architect responded with a discreet, well-detailed design that was, according to Diamond, in "a very classical mode, with glass at the base, a shaft of masonry, and glass at the capital, or top, as a restatement of the initial theme."[44]

In 2000 the Polshek Partnership renovated and expanded a townhouse (Buchman & Fox, 1907) at 18 West Eighty-sixth Street, between Columbus Avenue and Central Park West, for use by the Bard Graduate Center for Studies in the Decorative Arts, restoring the five-story brick and limestone Beaux-Arts facade but stripping down the remainder of the building to its steel frame to make room for a new lobby, a seventy-seat lecture hall, classrooms, and offices.[45] Polshek also expanded the 17,000-square-foot building into the rear yard, added a rooftop terrace, and designed a new brick, copper, and glass facade for the block's inner court.

Several of the neighborhood's private schools expanded modestly, beginning in 1986 with Pasanella + Klein's new six-story, three-bay-wide, dark red brick building for the Columbia Grammar and Preparatory School, 4 West Ninety-third Street, between Central Park West and Columbus Avenue, replacing a vacant lot.[46] The editors of the *AIA Guide* were impressed with the effort, calling it "a handsome modern building, happily scaled for the block with crossed blue mullions, both lively and elegant. A welcome Modern outpost in these northern blocks."[47] One year later, Pasanella + Klein renovated Columbia Grammar's building across the street at 5 West Ninety-third Street (Beatty & Stone, 1907). In 1996 Wurmfeld Associates completed a 38,000-square-foot, five-story, through-block middle school for Columbia Grammar, 36 West Ninety-third Street, also replacing a vacant lot. Wurmfeld's design featured the same dark red brick used by Pasanella + Klein, but this time animated by horizontal accents of glazed blue brick.[48]

Trinity School, 115 West Ninety-first Street, between Columbus and Amsterdam Avenues. Buttrick White & Burtis, 1998. View to the northeast. Joseph. PBDW

In 1997 the Trinity School commissioned Buttrick White & Burtis to replace a one-story gymnasium at 115 West Ninety-first Street, between Columbus and Amsterdam Avenues, with a four-story, lead-coated copper pitched roof, red brick, cast-stone, and glass middle school.[49] Located just east of the former St. Agnes Parish House (William Appleton Potter, 1892), now used by Trinity for classrooms, the 42,000-square-foot addition, completed in 1998, included fourteen classrooms as well as two 100-foot-long gymnasiums. A bell and clock tower at the west end housed cooling equipment.

WEST SIDE URBAN RENEWAL AREA

Presented by Mayor Robert Wagner in 1958 and adopted by the Board of Estimate in 1962, the West Side Urban Renewal Area, lying between Eighty-seventh and Ninety-seventh Streets, Central Park West and Amsterdam Avenue, was the first to depart from the established Robert Moses model of wholesale slum clearance and near total reconstruction in favor of the retention of neighborhood characteristics through a mix of new construction and the rehabilitation of existing buildings.[1] Development in the urban renewal area did not get under way in earnest until the late 1960s, when a string of new buildings and brownstone renovations noticeably improved the neighborhood and increased property values. Progress stalled, however, in 1975, when the city's fiscal crisis, combined with the drying up of most federally sponsored housing-subsidy programs, made the hope of any further construction in the area unlikely, leading the Housing and Development Administration to "dedesignate" all the sponsorships of the remaining development sites, some of them fourteen or fifteen years old. In

1977 HDA administrator Thomas Appleby asked Community Board 7 to reconsider both the sponsorship and the nature of the nine remaining development sites.[2]

In December 1977, the community board gave final approval to its recommendations for the remaining sites, constituting the fifth proposed amendment to the urban renewal plan. Significantly, the plan called for reduced density, permitting only 916 additional units of new and rehabilitated housing, less than half the number previously proposed. Of these units, 275, or 30 percent, were to be reserved for the less advantaged, a decision the New York Times's editors applauded as an important step forward in creating inner-city neighborhoods that, though they provided for the poor, could attract and hold the middle class, which would be able to move into market-rate housing that was now, for the first time, included in the plan.[3] New construction, according to the proposed amendment, would also diverge from the high-rise type that characterized the Columbus and Amsterdam Avenue sites already developed and instead be built as low- and mid-rise buildings which were more in tune with the existing scale of the neighborhood. The proposal also provided for the expansion of the Claremont Riding Academy on Eighty-ninth Street (see below) and new quarters for the Ballet Hispanica created from a pair of former carriage houses (Frank A. Rooke, 1892), 167–169 West Eighty-ninth Street, gutted and renovated in 1989 by Buck/Cane Architects.[4]

In early October 1979, the City Planning Commission voted to approve the fifth amendment. It was adopted just as the area was at last beginning to come into its own as a renewed neighborhood. One sign of the new maturity was the success of West Side Storey, a restaurant-bakery-delicatessen that opened for business on Labor Day weekend of 1979.[5]

Located in 700 Columbus Avenue, southwest corner of Ninety-fifth Street, the new shop was designed by the architect Ricardo Scofidio, whose use of glass brick and white ceramic tile on the storefront gave the dreary streetscape more than a little dash.

In October 1981, the Board of Estimate approved a version of the plan that reduced the number of subsidized apartments from 30 to 20 percent of the total of new housing to be built. Having gained approval from Community Board 7, the mayor, the City Planning Commission, the Board of Estimate, and the local office of the Federal Department of Housing and Urban Development, and with nine developers approved and two of them ready to begin construction, all that was needed for progress to begin was Washington's consent. In December 1981, the fifth amendment was given the final go-ahead when Mayor Ed Koch received a letter from the secretary of the Department of Housing and Urban Development stating that the federal government had ended its twenty-two-year supervision of the West Side Urban Renewal Plan. After a six-year hiatus in construction, work began at once on the two buildings that had been awaiting approval.

The first, Phelps House (1983), 595 Columbus Avenue, east blockfront between Eighty-eighth and Eighty-ninth Streets, was a nondescript 168-unit, eleven-story red and orange brick apartment house that provided affordable housing for the elderly and mobility impaired but was quite banal, its blank corners and the lack of shops along the street showing little respect for its urban context.[6] Directly across the avenue, the Centra Apartments (David W. Roth, 1985), 100 West Eighty-ninth Street, west side of Columbus Avenue extending to Eighty-eighth Street, was the first entirely market-rate apartment house to reach completion in the renewal area. Though hardly architecturally significant, the 108-unit, nine-story box, clad in three tones of reddish brown brick rising from the property line on each of its three street frontages, contributed a welcome row of shops to the avenue.[7]

The most hotly contested site in the urban renewal area was known as Site 30, a 30,123-square-foot parcel on the west side of Columbus Avenue between Ninetieth and Ninety-first Streets. In the original renewal plan, the site had been slated for moderate-income family housing. But when the city changed its course in 1971 and announced plans for a seventeen-story, 160-unit low-income public housing project, a lawsuit to block the project's federal funding was filed by the Trinity School, which lay across the street, and the Committee of Neighbors to Insure a Normal Urban Environment (CONTINUE), a group of largely white property owners.[8] Trinity dropped out of the lawsuit in 1978, but CONTINUE kept up its fight, and in December 1978, a federal appeals court blocked funding for the project, stating that its construction would thwart plans for racial and economic integration in the area. In January 1980, however, the United States Supreme Court overturned the appeals court's ruling, clearing the way for the project but also approving a development that went against the grain of the fifth amendment. In an editorial, the *New York Times* pointed out that while the Supreme Court had ruled that another 160 units of low-income housing could be built on the site next to the 400-unit Stephen Wise Towers (Knappe & Johnson, 1964), "it did not say that such *had* to be built, only that lower courts exceeded their authority in barring the project, allegedly to protect the environment."[9] In the *Times*'s opinion the possible concentra-

tion of 560 low-income units on a single block "threatened the social environment that an imaginative renewal plan has struggled for two decades to create."[10]

The site's future remained uncertain until September 1983, when the Koch administration proposed the construction of two buildings, a nineteen-story, 185-unit market-rate apartment building rising on Columbus Avenue and a ten-story, eighty-unit building for the elderly on West Ninety-first Street.[11] Low-income housing advocacy groups viewed the plan as a betrayal, charging that low-income tenants who had once lived on the site had been promised new housing there. Koch ceded, and in May 1985, the Board of Estimate approved plans for the site's redevelopment as James Tower (1987), 101 West Ninetieth Street, a lackluster twenty-one-story beige-brick and concrete tower with 20 percent of its 201 units subsidized by rents from the other 80 percent of the market-rate apartments. An adjacent three-story building along Ninetieth Street was billed as townhouses but lacked any trace of the charm usually associated with the building type. The senior citizens' residence, the Sondra Thomas Apartments (James McCullar & Associates, 1993), 102 West Ninety-first Street, was an eleven-story, eighty-seven-unit, 73,000-square-foot pink brick building with exposed concrete floor slabs. Funded by the New York City Housing Authority, it was bare-bones

Sondra Thomas Apartments, 102 West Ninety-first Street, between Columbus and Amsterdam Avenues. James McCullar & Associates, 1993. View to the southwest. Zimmerman. WZ

both inside and out but nonetheless a refreshing presence in its setting. Residents were provided a 3,575-square-foot community center with an outdoor terrace.

By 1987 four more sites governed by the fifth amendment were built out. Columbus Green (Edelman Partnership, 1987), 101 West Eighty-seventh Street, northwest corner of Columbus Avenue, was, after the Centra, the second and only other fully market-rate new building built according to the amendment. It had a bit more pulse than its predecessor but was still dull, squeezing ninety diminutive market-rate apartments in a nine-story light red brick, bay-windowed building entered from a four-story component on Eighty-seventh Street. Also completed in 1987, Hoberman & Wasserman's 600 Columbus Avenue, west blockfront between Eighty-ninth and Ninetieth Streets, a fourteen-story, 166-unit red brick and concrete-block tower with two rows of boldly protruding balconies on the upper stories beneath a superscaled crenellated parapet wall, packed a wallop in its massing but was poorly detailed.[12] To the west of the tower, the 80,567-square-foot site, occupying roughly half the block, also accommodated sixty cooperative apartments in two rows of handsome five-story townhouse-scaled buildings (1990) along Eighty-ninth and Ninetieth Streets separated from one another by a shared garden designed by the Schnadelbach Partnership. As part of the project, collectively known as Columbus Commons, a new 17,500-square-foot community garden was situated to the west of the townhouses.

Near the northern border of the renewal area, the Westmont (Eggers Partnership, 1986), 730 Columbus Avenue,

west side between Ninety-fifth and Ninety-sixth Streets, contained 163 studio to three-bedroom apartments, a forty-six-car garage, an exercise room, meeting room, and 10,000 square feet of retail space in sixteen stories rising on the avenue and a four-story extension along Ninety-fifth Street.[13] Alan Oser generously saw in it "the comfortably familiar look of a 1920's West Side apartment" building, contrasting "sharply with the tall, setback towers from an earlier era of urban-renewal construction on the east side of the Avenue."[14] Across the street, the Key West (Schuman, Lichtenstein, Claman & Efron, 1987), 750 Columbus Avenue, west side between Ninety-sixth and Ninety-seventh Streets, rising on a 40,323-square-foot site, was a relentlessly bay-windowed U-shaped red brick apartment house enclosing a garden courtyard.[15] The Key West rose eleven stories on Columbus Avenue and Ninety-seventh Street and stepped down to four stories on Ninety-sixth Street. In addition to 207 units—20 percent of them subsidized—it contained a 30,000-square-foot neighborhood health center and 10,000 square feet of commercial space.

The last of the renewal area's undeveloped sites was the east blockfront of Amsterdam Avenue between Eighty-eighth and Eighty-ninth Streets, where, according to the fifth amendment, a new arena for the Claremont Riding Academy was to be erected to the south of a twelve-story, 160-unit apartment building. In 1988, however, the Related Companies proposed to build a twenty-story, 300-unit building with 80 percent market-rate units and 20 percent subsidized housing on the entire

blockfront, requiring a sixth amendment to the urban renewal plan.[16] Both the city and the community board were won over by the proposal because proceeds from the sale of the 13,600-square-foot site were to be funneled back into the rehabilitation of nearby housing. The community board did, however, feel that the project was too dense as proposed and Related responded by eliminating two floors and thirty apartments. As completed in 1998, the Sagamore (Schuman, Lichtenstein, Claman & Efron), 189 West Eighty-ninth Street, covered in orange and red brick with a limestone base, rose eighteen stories on Amsterdam Avenue but stepped down in height along Eighty-ninth Street. The Claremont Riding Academy remained in its building at 175 West Eighty-ninth Street (Frank A. Rooke, 1892), which received landmark status in 1988, and was treated to a much-needed renovation in the early 1990s.[17]

Manhattan Valley

To the north of the West Side Urban Renewal Area was Manhattan Valley, bounded by 100th and 110th Streets, Central Park West and Broadway, its name referring to the slope of Manhattan Avenue, which extended north from 100th Street. Manhattan Valley was a predominantly working-class neighborhood. Puerto Ricans, Dominicans, and South Americans began settling in the area in the late 1940s and by the 1980s had come to number roughly 15,000, constituting about half the area's population.[18] Dominated by the Frederick Douglass Houses, a twenty-nine-building housing project

Manhattan Valley Townhouses, east side of Manhattan Avenue, between West 104th and West 105th Streets. Elliot Rosenblum and James Harb, 1989. View to the northeast. Lubarsky. JHA

455 Central Park West, between West 105th and West 106th Streets. Rothzeid, Kaiserman, Thomson & Bee and Perkins Eastman Architects,

2004. View to the northwest showing former New York Cancer Hospital (C. C. Haight, 1890) in foreground. Bartelstone. RKTB

(Kahn & Jacobs, 1957–70) between Manhattan and Amsterdam Avenues, 100th to 104th Street, the area still retained a building stock of townhouses and tenements that were suitable for rehabilitation.[19] Renovations outstripped new construction during the 1980s, and new housing consisted primarily of small-scale single infill buildings.

An exception was the Manhattan Valley Townhouses (Elliot Rosenblum and James Harb), an ambitious and well-publicized effort to build quality low-income housing that ultimately fell short of its goal.[20] The complex, conceived in 1982, was to comprise seventy-six units of government-assisted housing in twenty-two three- and four-story attached townhouses on the east blockfront of Manhattan Avenue between 104th and 105th Streets and extending east along the side streets toward Central Park West. The project ran into trouble when labor issues led to the bankruptcy of the contractor. Rather than foreclose on the project, Citibank decided to complete construction itself and to hire a real estate brokerage to sell the remaining units—approximately half the total—at market-rate prices that were up to six times those

originally set. Completed in two phases in 1987 and 1989, the townhouses were clad in a combination of dark red, terra-cotta, and rust colored brick and embellished with turretlike elements marking the corners, bay windows, terraces, stoops, and varied rooflines. The editors of the *AIA Guide* weren't convinced by the results, calling the project a "reductionist row that pales in comparison to the richly detailed 1888 houses across Manhattan Avenue."[21]

The most successful developments in Manhattan Valley involved the adaptive reuse of existing buildings, two of which were of exceptional architectural quality and survived periods of decline and decay. The first, Richard Morris Hunt's Association Residence for Respectable Aged Indigent Females (1883; expanded by Charles A. Rich, 1903), 891 Amsterdam Avenue, between 103rd and 104th Streets, had been in continuous use as a home for the elderly since its construction.[22] In June 1974, however, although it still provided quarters for over eighty women, plans were announced to demolish the building and replace it with an eleven-story, 248-bed state-financed nursing home for men and women, to be designed by

Bernard M. Deschler Associates and called the Association Residence Nursing Home.[23] The decision to raze Hunt's building came in the wake of several nursing home fires elsewhere in the state that led to the declaration of the Hunt building and many other such facilities as unsafe. Paul Goldberger commented that the building's loss would be "a painful one for the city in general, [and] will leave an especially major void in its neighborhood." He called the replacement "a banal building that looks like it was designed to blend invisibly into the landscape of public housing towers that surround it."[24]

Goldberger was not alone in his criticism. As residents of the home were moved out in 1974, neighborhood activists, led by two students in Columbia University's historic preservation program, formed the Committee to Save the Nursing Home.[25] The group submitted the building for inclusion on the National Register of Historic Places, which would make it eligible for financial assistance from the federal government. When the Landmarks Preservation Commission decided not to consider the building for designation, Robert A. M. Stern, writing to the editors of the New York Times on behalf of the Architectural League of New York, asked the commission to reconsider, calling the building "an outstanding example of institutional and functional architecture as well as one of the few remaining examples of 19th-century medical architecture in the United States. . . . A building replete with the dignity of age," Stern continued, Hunt's nursing home "remained a superb model of what one of America's finest architects did when faced with a program of sociological urgency—a program that continues to concern all of us as architects and citizens alike."[26]

In 1975 the bid to have the building entered on the National Register proved successful, but the structure lay dormant as its future was pondered. During the blackout of 1977 a fire broke out, damaging the upper floors and destroying much of its roof. The following year the city took over ownership for nonpayment of back taxes and the building slipped into decay, becoming, as one New York Times reporter described it, "a burned-out cavern used by drug dealers and derelicts."[27]

Then, in 1980, the city awarded a grant to the Valley Restoration Local Development Corporation, a local community organization, which hired a consulting firm to examine the possibility of reusing the building as a youth hostel. In 1983 Hunt's building was designated a city landmark, and in November of the following year, American Youth Hostels, a nonprofit group, proposed to convert the building to a 480-room lodging house for young travelers on a budget, the first of its kind in New York.[28]

The architectural firm of Larsen Associates was hired to design the renovation, which Paul Goldberger described as "functional and decent," with "considerable respect for the original building."[29] Completed in April 1990, the American Youth Hostel provided 477 beds in ninety bedrooms, a ninety-nine-seat community theater located in the former chapel, a 3,500-square-foot restaurant, conference center, lounges, offices, and an outdoor garden designed by Quennell Rothschild Associates. Where possible, the architects retained tile floors and uncovered long-hidden features such as brick arches. On the outside, Hunt's finials and gargoyles were restored and the facades were cleaned and fitted out with 400 new double-hung windows.

Manhattan Valley's other rescued treasure was the former New York Cancer Hospital (C. C. Haight, 1884–90), 455 Central Park West, between 105th and 106th Streets, the nation's first dedicated cancer hospital and the predecessor to the Memorial Sloan-Kettering Cancer Center.[30] The building, a French Renaissance–inspired red brick and sandstone structure defined by its forty-foot-diameter circular, conical-roofed towers, served, beginning in 1956, as the Towers Nursing Home, a 347-bed facility that closed in 1974 amid allegations of patient neglect. In 1976 the building was granted landmark status but, in its abandoned state, fell into disrepair.[31] In 1986 plans were presented to the Landmarks Preservation Commission for a thirty-nine-story, 400-foot-high apartment building to rise in the rear court of Haight's structure, also replacing some minor post-1900 additions.

In October 1987, despite community opposition, the commission approved a scaled-down version of the plan, designed by Victor Caliandro and John Harding for the developer Lewis Futterman. The new scheme called for a twenty-six-story, 265-foot-tall tower to rise from the 112-by-60-foot courtyard to the west of the hospital. The deep red brick building would not be capped by the copper-clad octagonal peak originally called for but by a mansard roof with a corner tower and dormer windows.

Futterman failed to move forward with the project, and in 1988 the developers Arthur Cohen, Philip Pilevsky, and Ian Schrager purchased the hospital building and announced in 1989 that they would develop a very similar project to Futterman's using Caliandro's approved designs, with Caliandro hired to continue working on the project with Costas Kondylis, who would lay out the interiors.

This project also failed to materialize, and in 1997 a new team bought the building from the bank that had foreclosed on the property and announced their intention to build the Towers at Central Park West, a half-luxury and half-senior-assisted-living facility, each component with its own entrance, that would occupy the hospital building and the same apartment building that had been approved by the landmarks commission years earlier. Only the interior layouts would differ significantly, with the old cancer hospital housing common areas for the assisted-living units, which would range in size from 400 to 700 square feet. Joining Victor Caliandro on this redesign were Rothzeid, Kaiserman, Thomson & Bee and Perkins Eastman Architects. But in 2000 the site once again changed hands, this time falling into the ownership of a Chicago-based developer who beat out the second-place bidder, Columbia University. Last-minute efforts by a recently formed group led by a physician at Memorial Sloan-Kettering to transform the hospital building into a museum of American medicine were unsuccessful. Construction commenced in 2001 but was halted after the developers lost their construction loan in the wake of the events of September 11.

Progress resumed when Columbia University made a deal to purchase the second through fifteenth floors—comprising fifty-three apartments—which it would use to house senior faculty and visiting dignitaries. The building, ultimately designed by the Rothzeid firm and Perkins Eastman, was completed in 2004, with the hospital building transformed to house nineteen apartments on five floors. The tower addition, twenty-five stories in its final form, was separated from the original by a bluestone-paved courtyard designed, along with the lobby, by David Rockwell. It accommodated eighty-one units in 207,000 square feet.

ABOVE East Campus dormitory, Columbia University, west of Morningside Drive, between West 117th and West 118th Streets. Gwathmey Siegel & Associates, 1981. View to the north of courtyard. Payne. GSAA

BELOW East Campus dormitory, Columbia University, west of Morningside Drive, between West 117th and West 118th Streets. Gwathmey Siegel & Associates, 1981. Axonometric. GSAA

COLUMBIA UNIVERSITY

In the late 1970s, Columbia University concluded an ambitious program of capital improvements including such notable work as Alexander Kouzmanoff's addition to Avery Hall (1977) and Mitchell/Giurgola's Sherman Fairchild Center for the Life Sciences (1977).[1] With the new decade, Columbia moved forward with the large and ultimately problematic 750-student East Campus dormitory (1977–81), located on what was one of the topographically highest points in Manhattan.[2] The new dormitory, including the Heyman Center for the Humanities, an interdisciplinary teaching and research center that could house up to sixteen postdoctoral fellows, was built to ameliorate the overcrowding in existing dilapidated residence halls. As designed by Gwathmey Siegel & Associates, in association with Emery Roth & Sons, the East Campus dormitory consisted of a twenty-three-story slab facing Morningside Drive between 117th and 118th Streets and a four-story building that formed a stark courtyard-cloister to the tower's west. The four-story building and the lower floors of the slab were clad in reddish brown tile; above, gray tiles were used as cladding. Extensive programming lay behind the plan, which sought to address the shortcomings of older campus housing, typically consisting of double-loaded corridors lined with single- and double-occupancy rooms served by gang toilets and showering facilities. In their place, the new dorm provided low-rise walk-

up suites of rooms in the cloister combined with duplex suites in the tower served by a skip-stop elevator. A typical residential unit in the tower consisted of four single rooms on one level and a living-dining room and kitchen above. Bathrooms were located within the suite. Double-height lounges cantilevered from the south end of the tower provided spectacular views. In plan and section, the complex did indeed have about it something of the character of a "typical English college," but in three dimensions the effect was distinctly different and rather less ingratiating.[3]

Although Ada Louise Huxtable admired Gwathmey Siegel's design, the firm's first major New York building, she was quick to point out the flawed, rather cynical, premise that lay behind it: "Consider a building that has to be vandal-proof, constructed of maintenance-free materials, with every surface resistant to neglect and abuse, where violation of design and function must be an anticipated fact, along with defacement and petty thievery—a place where surveillance is a necessity and population is transient. A description of a maximum security prison? Not at all. This is a dormitory at Columbia University." According to Huxtable, despite this brutal and brutalizing mandate, Gwathmey Siegel "produced a first-rate work that makes impressive contributions to the design of housing and the treatment of urban space. If there are parts of the buildings that are too bleakly institutional, it is easy to see how an austerely simple esthetic can be brought down to this level very quickly when the practical requirements for building survival require a quasi-penal solution."[4]

Although the architects had worked closely with the students in planning the building, once the students moved in, new and disturbing patterns of use and behavior began to emerge. As Huxtable pointed out, after only a few months in operation, most of the furniture had been removed from the lounges to student rooms while chairs, tables, and bulletin boards had been "liberated. . . . One can only look at the fresh-faced, clean-cut young graduate students [they were, in fact, mostly undergraduates] who occupy the new buildings and try to guess who threw the paint in the courtyard, and why they try to pry the floor-stop number plates off the elevators. One wonders what kind of humanists they can be."[5] In her article, Huxtable neglected to point out that the university had unwisely allowed students to move in midyear, when final construction work on the building was still going on. As Susan Doubilet, a new critical voice writing for the iconoclastic magazine *Skyline*, put it, the students came to associate the residence hall "with (and treat it as) a construction site."[6] As they became more accustomed to the building, vandalism declined.

Although Huxtable regarded the tile-clad exterior as a response to issues of initial cost and maintenance, she admired its surfaces as a reflection of a "'modern' style drawn from history and memory and [the architects'] post-graduate pilgrimages to the European works of Le Corbusier and the early 20th-century masters. . . . These neo-modernist buildings often bear a remarkable resemblance to some of the pictorial images of the classic black-and-white photographs of the revolutionary structures of the 1920's and 30's. Today, art imitates art." Huxtable was particularly taken with the cloister-surrounded, sixty-foot-wide courtyard, "flanked . . . by sentinel rows of curved stair towers . . . , the 'look' [of which] . . . is of a formal, rather handsomely eerie city landscape, rigidly neo-rational in style, with shades of Le Corbusier's Salvation Army period in Paris, Russian Constructivism,

East Campus dormitory, Columbia University, west of Morningside Drive, between West 117th and West 118th Streets. Gwathmey Siegel & Associates, 1981. View to the east. Payne. RP

Italian rationalism and a suggestion of the symmetries of Aldo Rossi." She was also impressed with the dramatic composition and scale of the entrance to the complex at its southwest corner, where "an essentially awkward and unceremonious approach . . . dictated by the tightness of the site and the surrounding construction" was overcome by opening up the building for a full three stories and playing off "a massive corner column . . . against a recessed, undulating wall" to form a "device . . . strong enough to be read as a formal entrance and [to succeed] in visually reducing the tower behind it to a backdrop. That," she wrote, "is architectural legerdemain of a very high order."[7]

Other observers were not as convinced. Susan Doubilet could not support the building's aesthetics: "The brilliant Cloister nestles between two slabs, one low and the other tall. Both—especially the latter—are 'downright ugly' . . . because of ill-proportioned windows in a poorly defined skin." In contrast to Huxtable's enthusiastic appraisal of the building's entrance, Doubilet slammed the lower structure's tile and aluminum-windowed wall as a "slab of mitigated bleakness." Writing in 1982, a year after the building's opening, Doubilet had the advantage of certain knowledge that Huxtable had not: the tiles in Mitchell/Giurgola's Sherman Fairchild Center for the Life Sciences, the university's most recently completed significant work of architecture and, from a technical point of view, in many ways East Campus's progenitor, had begun to

Proposed Chandler Laboratories extension, Columbia University, between Amsterdam Avenue and Broadway, West 118th and West 120th Streets. James Stirling, Michael Wilford & Associates, 1980. Rendering of view to the west. CCA

Proposed Chandler Laboratories extension, Columbia University, between Amsterdam Avenue and Broadway, West 118th and West 120th Streets. James Stirling, Michael Wilford & Associates, 1980. Rendering of view to the southeast. CCA

fall out of their reinforced-concrete panels, casting doubt on Gwathmey Siegel's design. But Doubilet's concern was not with the technical issues that would soon plague the building, but with the aesthetic choice of materials: "The red tile . . . is intended to represent the brick color of the older Columbia buildings. The gray tiles are meant to simulate the campus' limestone. The intention, however, is based on faulty assumptions. The old limestone, richly carved, is enlivened by its varying surface shadows. . . . In the East Campus Complex the gray 'limestone' rises flat and bleak into the sky. . . . The use of tile to blend into its environment remains a vain hope."[8]

Michael Sorkin was not impressed with the building or with Gwathmey Siegel's work as a whole, which he felt contained "an element of pastiche . . . a sense that all the parts don't quite add up to anything beyond their aggregation." Sorkin felt that "this disembodying" was "carried to an extreme" in the Columbia building, "a paste-up of the entire glossary of familiar moves . . . appliqued to a mass of such clumsiness that their presence is entirely arbitrary—just so many period pieces." Sorkin objected to the building's looming presence over Morningside Park and the Harlem plain from which it seemed to him "an alien and offensive presence, conceding nothing to the lovely scale and character of the street (not even an entrance) save the feeble gesture of changing the bathroom tiles with which it is covered from off-white to red in its lower stories." Sorkin also found the platform-facing west side of the building wanting with its "blank and intimidating wall, a gesture of unvarnished hostility which fairly pleads for graffiti." As for the projecting, glass-tile-sheathed "bull-nosed" stair towers that projected into the court, they seemed "only concerned with their iconic shape and substance, and not at all with what is actually to take place in the invented environment. Rather than creating a

congenial quadrangle on the Oxbridge model—surely the architects' rhetorical paradigm—they have carried the fashion for tile and grid to the point of fascism."[9]

Though built to be maintenance free, the dormitory proved virtually the opposite. In 1983 administrators reported that the building placed a huge strain on resources. Charles Gwathmey, defending the integrity of his firm's work, laid the blame on Morse Diesel, the general contractors, claiming that they changed specifications during construction, cheapening the building's cost but also compromising quality in the process. Tiles began to fall off the facade in 1986, and in February 1988, a big chunk of the west facade tumbled into the interior courtyard. As more and more tiles fell off, the university had the building wrapped in scaffolding. After determining that water leakage and loose tiles in the building's exterior wall were the result of poor construction, Columbia undertook an ultimately unsuccessful suit against Gwathmey Siegel and Morse Diesel. The university, in an artistically shocking move, retained Gruzen Samton Steinglass to prepare designs for the total recladding of the East Campus complex, which was undertaken in 1990–91.[10] While the new scheme, executed with brick cavity walls, attempted to be contextually responsible to the traditional buildings of Columbia's campus, it was fundamentally uninteresting. Moreover, the university failed to deliver on its promise to the community to create storefronts along Morningside Drive as part of this renovation, instead beefing up security with fencing.

In 1980 the university embarked on what promised to be an even more ambitious project, the construction of an extension to Chandler Laboratories (McKim, Mead & White, 1925), southeast corner of Broadway and 120th Street, the central campus's last remaining open space facing Broadway.[11] Encouraged by James Stewart Polshek to hire top

talent for this sensitive project—as dean of the School of Architecture, Polshek was also architectural adviser to the president and trustees—the university chose the English architect James Stirling, whose firm, James Stirling, Michael Wilford & Associates, joined with the New York firm Wank Adams Slavin Associates to execute the project. The site was not only highly visible to the community but also included the podium-like Marcellus Hartley Dodge Physical Fitness Center (Eggers Partnership, 1974), the roof of which formed a campus-level plaza.[12] Stirling's brilliantly eclectic proposal called for an eight-floor slab atop the podium running most of the length of the available Broadway frontage but separated from Chandler to its south by a glassy connector in keeping with the rhythm of gaps between buildings characteristic of the McKim master plan as a whole. The handling of this wing was sympathetic, but in a somewhat diagrammatic way, to the typical architecture of the campus, with window openings set in masonry walls rising to an unadorned but boldly profiled cavetto cornice. A two-story-high glassy lounge broke the mass at the fourth floor, introducing an element that related to the bold figuration of McKim's detailing. Within the campus precinct, Stirling created a diagonal mass carried over the gymnasium on bold exterior trusses. The decision to create this mass, the exposed face of which looked to the northeast, was the result of Stirling's belief that a building confined to the Broadway frontage and big enough to accommodate the program, which was technically possible, would swamp the scale of both the Columbia campus and the street itself. Though he could have taken advantage of four heavily engineered columns that had been incorporated in the gym in anticipation of an "air rights" building, Stirling chose instead to "drop a structural pylon (and freight lift) into the service yard" behind Chandler, leading to the "bridge-type structure, positioned to skew half the floor plan diagonally back into the campus" and thereby maintain the critical gap between the end of the new extension and Pupin Hall (McKim, Mead & White, 1925) while reducing the overscaled and underutilized outdoor terrace above the gym to a more manageable size.[13] In 1982 the project was killed by the university, done in "by its own ambitions," as Barry Bergdoll, professor of art history at the university, noted. "Their truss raised not only the building to the level of McKim's campus but also elevated the cost far beyond the university's budget and its fund-raising capacities."[14]

Four years later, in 1986, with the assistance of a sizable grant from the United States Department of Energy, a scaled-down facility for the chemistry department designed by Davis, Brody & Associates was built on the north side of Havemeyer Hall (McKim, Mead & White, 1897), a site slightly to the southeast of Stirling's proposed addition that, most importantly, lacked a Broadway frontage.[15] The eight-story, 29,000-square-foot annex, known as Havemeyer Extension, had a brown brick exterior and large window openings that attempted to relate in scale to existing campus buildings. Though bland in its unornamented directness, the building represented a return to Columbia's architectural language though, by the standards of Stirling and Wilford's project, a much cruder and more reluctant one, with profile-free windowpanes set in cream tile surrounds recessed behind the plane of the brick.

While the university's big construction projects faltered and stumbled, it achieved reasonable success at a smaller scale, most notably with R. M. Kliment & Frances Halsband Architects' Computer Science Department Building (1983), a two-story facility adroitly slipped onto the terrace between Schermerhorn Hall Extension (McKim, Mead & White, 1928),

Havemeyer Extension, Columbia University, between Amsterdam Avenue and Broadway, West 118th and West 119th Streets. Davis, Brody & Associates, 1986. View to the southwest. DBB

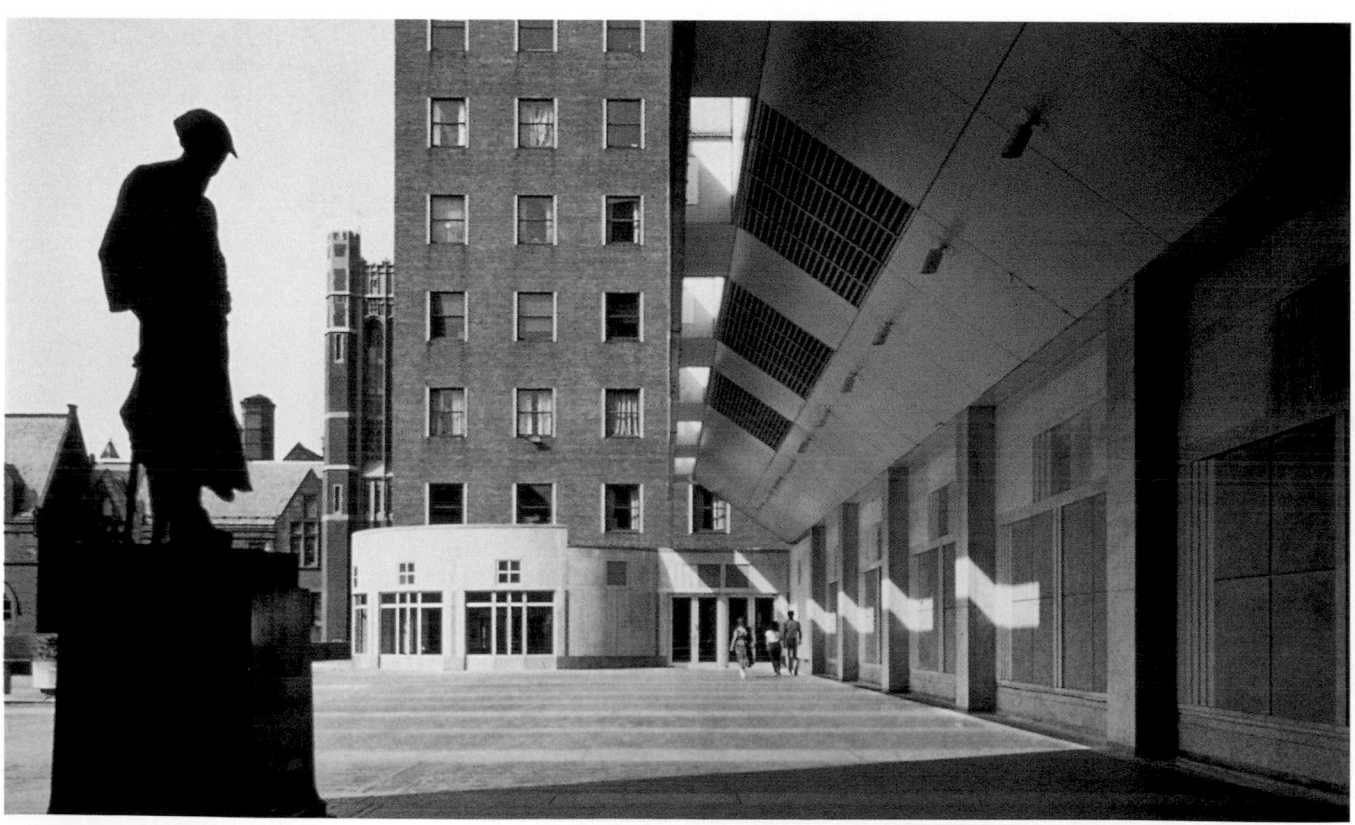

ABOVE Computer Science Department Building, Columbia University, between Amsterdam Avenue and Broadway, West 118th and West 119th Streets. R. M. Kliment & Frances Halsband Architects, 1983. View to the west. Robinson. KHA

BELOW Computer Science Department Building, Columbia University, between Amsterdam Avenue and Broadway, West 118th and West 119th Streets. R. M. Kliment & Frances Halsband Architects, 1983. View to the north. Robinson. KHA

Uris Hall addition, Columbia University, between Amsterdam Avenue and Broadway, West 118th and West 119th Streets. Peter Gluck, 1984. View to the north. Warchol. PW

the recently completed Sherman Fairchild Center for the Life Sciences, and the crushingly banal Mudd Hall (Voorhees, Walker, Smith, Smith & Haines, 1961), housing the School of Engineering.[16] To accommodate a newly established department of computer sciences within the School of Engineering, the building contained classrooms and offices in suave, if underbudgeted, Postmodernist interiors. Its success lay in the deftly proportioned facades, especially the one facing east over Amsterdam Avenue, where a subtle rhythm of bluestone panels and polished granite implied pilasters set into a limestone wall managed to live up to the expectations for a modern, astylar classicism, at once relating to McKim's buildings of the early 1900s and the paneled screen wall of Mitchell/Giurgola's Fairchild building. The curving volume of the Computer Science Department Building squeezed below Fairchild contained a lounge facing the campus, a strategy that worked miracles minimizing the visibility of Mudd but was perhaps overly ambitious given its size.

With its strategic location on the campus's principal axis immediately behind McKim's masterly Low Memorial Library (1897), where the campus's unrealized student center, University Hall, was originally to have been located, Uris Hall (Moore & Hutchins, 1964) was an embarrassingly prominent work of extraordinary banality.[17] While many believed Uris Hall required complete replacement or drastic reconfiguration, only enough funds were raised for the construction of additional classrooms and new public stairs in an addition

(1983–84) that ameliorated the impact of Uris's tower mass.[18] The new extension was designed by Peter Gluck, assisted by his partner, Kent Larson. Gluck, who normally worked on smaller projects, mostly houses, designed a three-story somewhat inertly proportioned, limestone-clad volume with heavily framed two-over-two windows deeply recessed into the facade. In the handling of the facades, the design lacked the kind of articulation that enlivened Kliment and Halsband's Computer Science Department Building. Most significantly, the extension crowded the plaza separating Uris Hall from Low Library. While entrances to Columbia's buildings typically projected from their facades, Gluck, who was an adjunct professor of architecture at the university, chose to recess his, lowering the roofline over the door itself: the specific stylistic reference was the highly mannered entrance to Edwin Lutyens's country house, Nashdom (1905–9).[19] Inside, a wide, double-height skylit hall, flanked by stairs leading to the second floor, did much to overcome the provincial-airport-like qualities of Moore & Hutchins's original interiors.

Roger Kimball was impressed with Gluck's 30,000-square-foot addition and with its relationship to the McKim buildings: "Not only does the new facade do a great deal to bring Uris Hall into scale with the rest of the McKim, Mead & White plan, but the limestone also blends naturally with Low Library and helps to mute the depressingly institutional effect of the original glass and aluminum tower." He praised Gluck's decision to finish the metalwork in a warm green and

Rare Book and Manuscript Library, Butler Library, Columbia University, between Amsterdam Avenue and Broadway, West 114th and West 115th Streets. Cain Farrell & Bell, 1983. Naar. JNP

especially admired the gridded grillwork over the entrance that "neatly recalls the curtain wall of the old tower without seeming dated or out of place."[20] Barry Bergdoll also had kind words for the reworked business school: "Not the least of [Gluck's] accomplishments is to have turned the slab of Uris Hall into something of the background building administrators had disingenuously claimed it to be in the 1960s."[21] But Susanna Sirefman, in her guidebook of 1997, found the addition, "though well-received by critics," to be "something of a misfit. Brutally po-mo, pompous and oppressive, it envelops the front of the original edifice by fitting between the existing three-story wings and granite stairs. Although it doesn't hide the old structure completely, it is so overpowering one forgets what is behind it."[22]

All in all, Columbia's larger projects of the 1980s failed to project either confident contextualism or bold artistic experimentation. In the same way, interior renovations were also disappointing, as a strong, consistent policy with regard to historic preservation failed to develop. One small effort did achieve a considerable level of accomplishment: the renovation and expansion in 1983 of a new Rare Book and Manuscript Library into the top two floors of Butler Library (James Gamble Rogers, 1934) by the firm of Cain Farrell & Bell.[23] The rare book library included a skylit, 240-foot-long, twenty-five-foot-wide reading and exhibition room, as well as a mezzanine housing offices. Using a terraced setback on the south side, the gallery-like library was almost invisible from the street. Though prized for its dramatically lit space, the detailing was, however, trite and diagrammatic.

Schermerhorn Hall renovations, Columbia University, between Amsterdam Avenue and Broadway, West 118th and West 119th Streets. Susana Torre, 1985. Corridor, 800 level. McGrath. ST

Schermerhorn Hall renovations, Columbia University, between Amsterdam Avenue and Broadway, West 118th and West 119th Streets. Susana Torre, 1985. Stair hall, entry level. McGrath. ST

Sulzberger Hall, Barnard College, west side of Broadway, between West 116th and West 118th Streets. James Stewart Polshek & Partners, 1988. Axonometric showing existing conditions. PPA

Sulzberger Hall, Barnard College, west side of Broadway, between West 116th and West 118th Streets. James Stewart Polshek & Partners, 1988. Axonometric showing new building. PPA

Sulzberger Hall, Barnard College, west side of Broadway, between West 116th and West 118th Streets. James Stewart Polshek & Partners, 1988. View to the west. Goldberg. ESTO

In 1985 another Columbia renovation, by Susana Torre in association with Wank Adams Slavin Associates, attempted to be more sympathetic to its host building, two floors of Schermerhorn Hall (McKim, Mead & White, 1897) housing the departments of art history and archaeology as well as the building's campus-level entrance, which had been badly mangled in 1939, when the university destroyed a monumental stairway to make way for new elevators.[24] Although Torre could not rebuild the lost stair, she was able to introduce a new pair of somewhat ponderous stairs leading to the building's amphitheater-like lecture hall, which she renovated in a bid to return it to its roots in classicism. The project included a new art gallery on the eighth floor, named for the donors, Miriam and Ira D. Wallach. Perhaps the most controversial aspect of the scheme was the decision to break up McKim's broad corridors into a series of alcoves using plinthlike cross walls that carried torcheres.

While Columbia stumbled, its quasi-independent undergraduate college for women, Barnard, succeeded with an admirably contextual new dormitory, Sulzberger Hall (1988), designed by James Stewart Polshek & Partners, the construction of which was intended to help mark the college's centennial and to emblematize its institutional survival in the face of Columbia's decision in 1982 to admit women into its hitherto all-male undergraduate college.[25] The new building, housing 400 students, consisted of an eighteen-story tower attached to an eight-story base which together completed a quadrangle begun in 1906–7 with Brooks Hall (Charles A. Rich), continued in 1925 with Hewitt Hall (McKim, Mead &

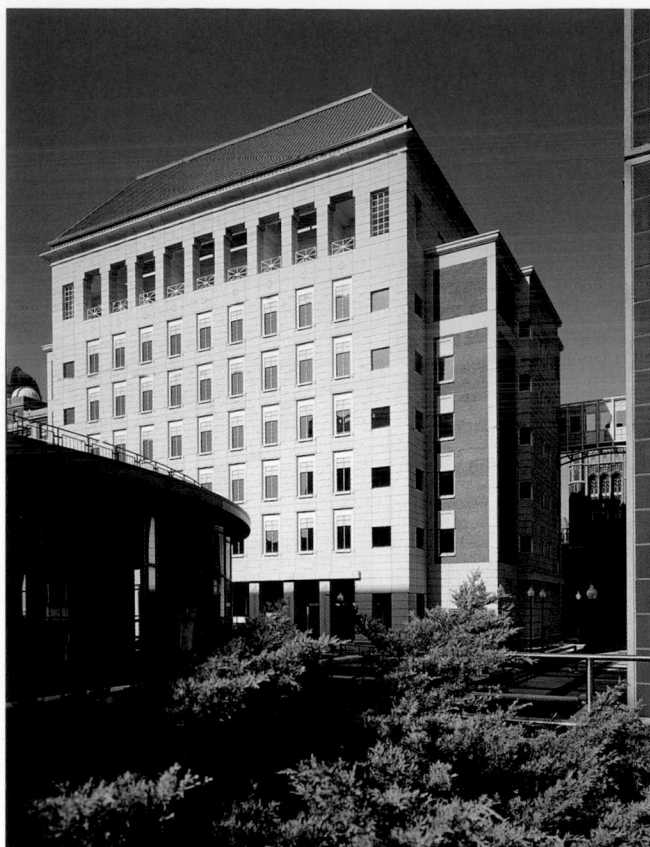

Schapiro Hall, Columbia University, 615 West 115th Street, between Broadway and Riverside Drive. Gruzen Samton Steinglass, 1988. View to the northwest. Goldberg. ESTO

Morris A. Schapiro Center for Engineering and Physical Science Research, Columbia University, 500 West 120th Street, between Amsterdam Avenue and Broadway. Hellmuth, Obata & Kassabaum, 1992. View to the northwest. HOK

White), and expanded in 1957–59 with the construction of Helen Reid Hall (O'Connor & Kilham).[26] The choice of the site was controversial, with many students preferring one near the little-used McIntosh Center at the north end of the four-acre campus. Polshek and his project architect, Joanne Sliker, a Barnard graduate, saw the building as a campanile for the college as a whole, best located near its central building, Barnard Hall (Arnold W. Brunner, 1917). Polshek's composition was particularly adroit, with the tower engaged in a dynamic interlock with the base, and a meaningful breakdown of the tower's apparent mass achieved by the use of metal and large panels of glass to denote the public places inside—lounges, seminar room—and a simple, regular, and familiar pattern of double-hung single-pane windows and Flemish bond red brick walls to enclose the dormitory rooms.

The admission of women had a tonic effect on Columbia College, leading to a decision to increase the size of incoming classes and, consequently, to construct another new residence hall, named for Morris A. Schapiro, whose gift toward the project was the largest alumni gift to the college.[27] Completed in 1988, Schapiro Hall, 615 West 115th Street, between Broadway and Riverside Drive, was a 420-bed red brick and imitation limestone–clad facility designed by Gruzen Samton Steinglass, with Scott Keller, a Columbia graduate, serving as project designer. Banished were the apartment-like suites as well as the complex arrangement of skip-stop elevators that were deemed alienating in the East Campus dormitory. In their place was a more conventional arrangement of single and double rooms arranged along double-loaded corridors with lounges and shared kitchens located at each floor opposite the elevators, thereby fostering sociability and a sense of community for the first- and second-year undergraduate residents. A combined study-room and lounge at the roof level provided sweeping Hudson River views. The building's complex massing formed a shallow south-facing courtyard, and the use of bay windows, in a deliberate contrast with the abstract monumentality of Gwathmey Siegel's dormitory, provided a more contextual approach that gestured to its neighborhood setting of townhouses and fin de siècle apartment houses.

Morris Schapiro's generosity to the university extended to its School of Engineering, which in 1992 completed the Morris A. Schapiro Center for Engineering and Physical Science Research, 500 West 120th Street, on the extreme north end of the campus, directly behind Uris Hall.[28] Hellmuth, Obata & Kassabaum (HOK) designed the 120,000-square-foot, eleven-story Schapiro Hall, built on an extension of the campus podium containing a new boiler plant. Though HOK made an effort to fit in to the McKim campus, employing a regular rhythm of vertically proportioned windows along the sheer, limestonelike, cast-concrete south and north walls, the detailing was crude; the vast bulk of the building, combined with its cheap-looking standing-seam metal mansard roof, unbroken by the dormers that prevailed on many other campus buildings, proved less than satisfying. As the editors of the *AIA Guide* put it: "Postmodernism in a heavy hand. Neither historicist nor Modernist, it fails to resolve its program

Proposed Columbia University dormitory, Woodbridge Hall site, northeast corner of West 115th Street and Riverside Drive. Robert A. M. Stern Architects, 1994. Rendering of view to the northeast across Riverside Drive. RAMSA

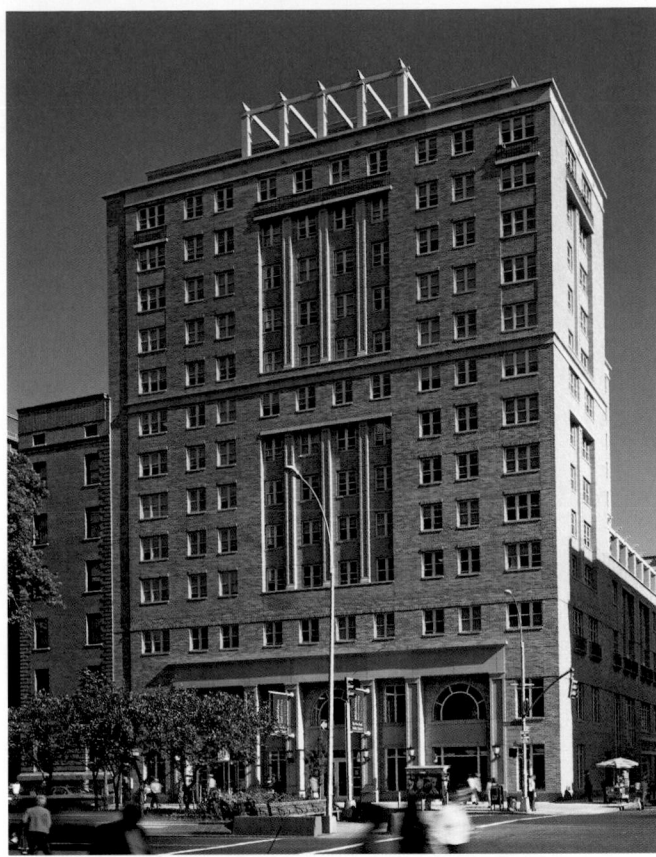

Broadway Residence Hall, Columbia University, northeast corner of Broadway and West 113th Street. Robert A. M. Stern Architects, 2000. View to the northeast. Aaron. ESTO

gracefully."[29] Glass-enclosed bridges connected the building to Pupin Hall to the west and to Mudd Hall to the east.

As the college increased in its academic standing among its peers during the 1990s, greater class size was increasingly regarded as an advantage, leading to the decision to raise, by 2002, the number of students to approximately 1,000 per class. As a result, studies were made for new dormitories on two separate sites, one of which would require the demolition of 431 Riverside Drive (George Keister, 1901), northeast corner of 115th Street, a seven-story apartment house that in 1957 had been converted to use as Woodbridge Hall dormitory for married graduate students.[30] Robert A. M. Stern Architects was retained to study this site in 1994. At the same time, R. M. Kliment & Frances Halsband Architects was asked to study the site at the northeast corner of Broadway and 113th Street, occupied by a two-story branch bank building of no distinction (which had replaced a seven-story tenement house in the early 1950s), a four-story abandoned parking garage, and, at 565 West 113th Street, a five-story red brick Georgian townhouse, long home to a fraternity.[31] Also designed by Keister, the house had been built in 1903 by hotelier Charles Dederer and his wife, Martha, to serve as their home.

At first the Woodbridge Hall site seemed the most promising, in part because it could support a 427-bed residence hall that would rise to a twenty-first-floor study center providing sweeping river views. But the site had its complications: it required the acquisition of two rowhouses that had for almost fifty years been home to the Korean Methodist Church and

Institute, which, under the plan, would be rehoused on the dormitory's lower floors. Preservationists protested the loss of Woodbridge Hall, the oldest apartment house on Morningside Heights. The Riverside Drive site was abandoned and, in 1996, Stern was asked to prepare a second proposal, this time for the 113th Street site, where in 2000, a fourteen-story, 374-bed residence hall surmounted by a rooftop study center opened, a year in advance of the scheduled completion of a 17,000-square-foot Morningside branch of the New York Public Library, also designed by Stern, that occupied most of the building's ground and second floors as well as a portion of its basement. For zoning purposes, the site was combined with the university's Hogan Hall, southeast corner of 114th Street and Broadway, built as the St. Luke's Home for Indigent Christian Females (Trowbridge & Livingston, 1898) and converted by the university for use as offices and graduate student residences in 1974–77 by R. M. Kliment & Frances Halsband Architects.[32] The combined site permitted the new dormitory as well as the residential portion of Hogan Hall to be entered on 114th Street, opposite the main campus, where a new doorway in keeping with the language of McKim, Mead & White's campus led to a shallow-vaulted, wood-paneled lounge that looked out on backyard gardens and connected to a new atrium-like café constructed at the bottom of Hogan Hall's rear court. The facade of George Keister's townhouse was preserved and restored, but its abused interiors were replaced with new seminar and music practice rooms directly linked to the dormitory. Significantly, unlike Schapiro Hall, at the request of the neighbors, the new

Faculty Residence and School, Columbia University, southeast corner of Broadway and West 110th Street. Beyer Blinder Belle, 2003. View to the southeast. Aaron. ESTO

residence did not reflect the coloration of the Columbia campus, but instead, using a light tan brick and limestonelike cast-stone trim, took on the coloration and mass of the high-rise apartment houses typical along Broadway.

The community also played a significant role in the design of Beyer Blinder Belle's Faculty Residence and School (2003), southeast corner of Broadway and 110th Street.[33] As a result of local opposition, the building was reduced in height from its originally planned eighteen stories to twelve stories. Inside, twenty-seven two-, three-, and four-bedroom apartments for university faculty were situated in 74,000 square feet on the seven upper floors, a newly established K–8 school, known simply as the School, occupied 77,000 square feet on the second through sixth floors, and retail space was provided at ground level. The community seemed more focused on issues relating to the school than on the building's design, with some neighbors arguing that the planned "lab school," where new curricula were to be developed and passed on to local public schools, should be public and not private. After considerable wrangling, Columbia agreed to a plan whereby approximately half of the expected 650 students would be faculty children and the other half would come from the larger community. The school, which included a cafeteria, gymnasium, and playroom, went ahead as planned. According to John Beyer, "in height, bulk, setback and materials," the somewhat restlessly composed and detailed building was intended to "refer to those around it."[34] Both the base and the top two floors, however, were rather incongruously covered in alternating bands of white and

peach-colored brick while the midsection was clad in peach brick and broken up by two bands of cast stone and white brick referencing the height of neighboring buildings.

Columbia's willingness to address community concerns also affected plans for a new building for its School of Social Work, which was originally intended to rise ten stories on a 113th Street site between Broadway and Riverside Drive, across the street from the school's existing facilities.[35] Just after ground was broken in November 2000, however, Columbia, responding to community opposition, agreed to relocate the building to a larger site, in use as a parking lot, on Amsterdam Avenue between 121st Street and Morningside Drive. As designed by Cooper, Robertson & Partners, the unremarkable building was completed in 2004. Clad in red brick with a double-height base, it contained 137,000 square feet in eleven stories with classrooms situated on the lower floors and faculty, research, and administrative offices above. Around the corner, Gruzen Samton's Lenfest Hall, 425 West 121st Street, an apartment building for graduate law students accommodating 211 residences, lounges, seminar rooms, recreation areas, and a rear bamboo garden, was completed in 2003.[36] The 118,600-square-foot building, also replacing a parking lot, was clad in brick, granite, and glass, and, aside from a portion of the lower seven stories that rose along the street wall, was set back from the lot line to rise sheer for sixteen stories.

Columbia's law school, one of the nation's most prestigious, and also one of the university's best-endowed graduate schools, had been housed on the East Campus since 1961, occupying Harrison & Abramovitz's brutally scaled, vertically finned glass tower set atop a virtually windowless podium on the northeast corner of 116th Street and Amsterdam Avenue.[37] In 1977 the law school modestly expanded by taking over the former Women's Faculty Club, in effect a three-story wing of Johnson Hall (McKim, Mead & White, 1925), which was refitted by Robert A. M. Stern to become Jerome L. Greene Hall.[38] In 1984, during his brief term as dean before becoming president of Yale University, Benno Schmidt embarked on a major addition to the law school, commissioning Kallmann McKinnell & Wood Architects, of Boston, to prepare a design that would add 67,000 square feet of space by building a twelve-story addition at the south side of the existing tower in a deliberate attempt to mask its appearance and present a facade to 116th Street and Amsterdam Avenue more like that of Kent Hall (McKim, Mead & White, 1910), the law school's beloved previous home, which it would face across the avenue.[39] With Schmidt's departure for Yale, the law school was unable to raise funds to carry out the bold scheme, and in 1988 the architects prepared a more modest three-story version that would wrap Harrison's tower on three sides. This scheme also proved overly ambitious, and in 1992 Steven Holl Architects was selected to undertake a partial renovation of the building, which would be reconfigured to recognize the fact that the original main entrance at the top of the podium where it connected to the main campus, via a plaza built over Amsterdam Avenue, was seldom used, and that side doors entered from 116th Street were in effect the building's front door.[40] But Holl did not prove to be the right architect for the project, and in 1994 James Stewart Polshek, who had also been considered for the job in 1992, was asked to take it on.[41]

As completed in 1996, Polshek's three-story scheme, following the proposal from Kallmann McKinnell & Wood, provided the law school with a new entrance, and indeed a new

ABOVE Jerome L. Greene Hall, Columbia University, 435 West 116th Street, northeast corner of Amsterdam Avenue. James Stewart Polshek & Partners, 1996. Axonometrics before and after addition. PPA

BELOW Jerome L. Greene Hall, Columbia University, 435 West 116th Street, northeast corner of Amsterdam Avenue. James Stewart Polshek & Partners, 1996. View to the northeast showing Law School (Harrison & Abramovitz, 1961) in background. Goldberg. ESTO

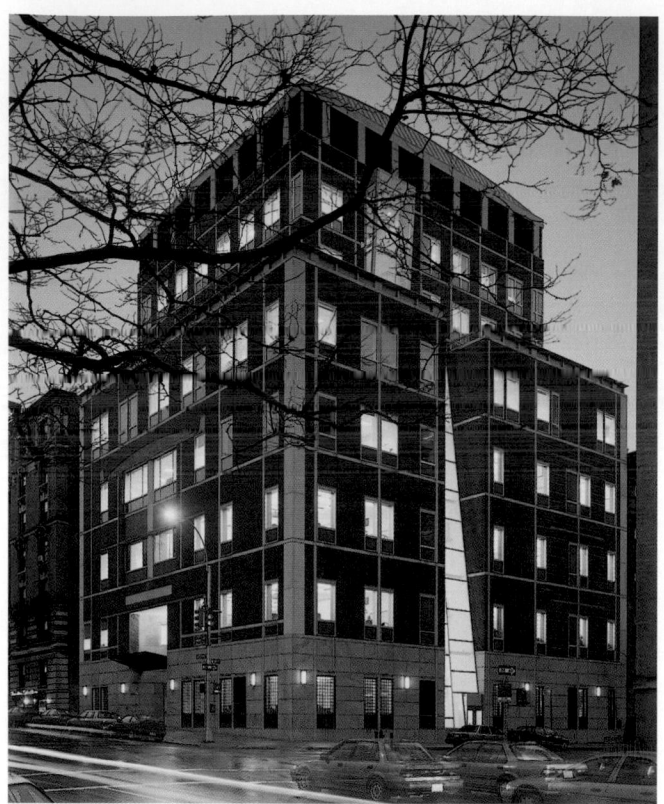

identity, on West 116th Street. But where KMW had proposed to visually connect the school with the main campus to the west, Polshek and his partners were contextual to the Modernism of Harrison & Abramovitz, designing a 70,000-square-foot building, named Jerome L. Greene Hall, that incorporated a thirty-seven-foot-high lobby, a cafeteria, student and faculty lounges, and a computer lab, all giving the law school a dramatic new identity but one that was, in its way, equally alien. Nonetheless the design, developed by Polshek and his associate Richard Olcott, was very elegant and very clever, as it reinterpreted Harrison & Abramovitz's heavy limestone vertical fins with sleek strips of steel-framed granite, horizontal ribbon windows, and aluminum brises-soleil. As Polshek's former partner Paul S. Byard put it in his book *The Architecture of Additions*: "The Columbia Law School was a stumpy block-and-base combination that oppressed the university and its neighborhood with its coarse modernity. The bridge and raised podium that separated it from the city streets became Columbia's trophy example of a very bad urban planning idea." Polshek's addition tied together the building's split circulation system, and, as Byard noted, allowed it "as a whole to lighten up." The effect on 116th Street was a bit corporate, but the handling of the plaza level, where the lantern over the second-floor lounge recalling Harrison's "dome" at the United Nations General Assembly Building (1947–52) enlivened the scene, transformed, as Byard

ABOVE William and June Warren Hall, Columbia University, 1125 Amsterdam Avenue, northeast corner of West 115th Street. Hillier Group, 1999. View to the northeast. Goldberg. ESTO

RIGHT East Campus master plan, Columbia University. Skidmore, Owings & Merrill, 1990. Axonometric looking northwest. CU

FACULTY CLUB
5 STORIES ABOVE PODIUM
50,000 GSF

HOTEL/DORM
20 STORIES ABOVE PODIUM
10 STORY HOTEL - 51,000 GSF
10 STORY DORM - 51,000 GSF

INTERNATIONAL AFFAIRS
12 STORIES ABOVE GRADE
12 AT BASE OF CASA ITALIANA
ADDITION AT BASE OF CASA ITALIANA
414,179 GSF

CASA ITALIANA
RELOCATION
OPTIONAL

EXISTING EAST CAMPUS HOUSING
23 STORIES ABOVE GRADE
REFACED TO MATCH NEW DORMS
267,200 GSF

CHASE HIGHRISE DORMS
23 STORIES ABOVE GRADE
DINING & AMENITIES IN PODIUM
154,950 GSF

CHASE HIGHRISE DORM
23 STORIES ABOVE GRADE
DINING & AMENITIES IN PODIUM
63,795 GSF

LOWRISE RESID MEWS
5 STORIES ABOVE PODIUM
REPLACES EAST CAMPUS LOWRISE
3 BARS AT 10,000 GSF EACH

NEW LAW SCHOOL QUAD
10 STORIES ABOVE GRADE
LIBR./LECT. RMS IN PODIUM
319,150 GSF

BUSINESS SCHOOL TOWER
14 STORIES ABOVE GRADE
LIBRARY & LECTURE HALLS IN PODIUM
287,725 GSF

East Campus master plan, Columbia University. Kohn Pedersen Fox, 1990.
Axonometric looking northeast. CU

observed, the composition "into the work of art it wished to be."[42] Interestingly, where Polshek had a freer hand he stumbled with the twenty-five-foot-wide, ten-story infill building, William C. Warren Hall (1995), 410 West 116th Street, housing the *Columbia Law Review*, the Morningside Heights Legal Services Clinic, and several seminar rooms for the law school.[43] The building's asymmetrically composed facade, with its red brick planes set against glass, seemed a bit generic and was opposed by local residents, who argued for a more contextual design.

As designed by Alan Chimacoff of the Hillier Group, William and June Warren Hall (1999), located on the northeast corner of 115th Street and Amsterdam Avenue, more perfectly fulfilled community expectations, though the refusal of the university to provide ground-floor retail space facing Amsterdam Avenue was not well received.[44] In an unusual act of interdepartmental collegiality, the building provided classroom and office facilities for both the business and law schools. The 85,000-square-foot, eight-floor facility replaced a two-story post office building. Inside, five two-story vaulted

Proposed renovation of Casa Italiana, Columbia University, east side of Amsterdam Avenue at West 117th Street. Buttrick White & Burtis and Italo Rota, 1993. Model, view to the southwest. PBDW

Casa Italiana, Columbia University, east side of Amsterdam Avenue at West 117th Street. Renovation by Buttrick White & Burtis and Italo Rota, 1996. View to the west of remodeled east facade. Hueber. PBDW

atria inspired by the work of Sir John Soane effectively relieved the building's dense programmatic packaging. Chimacoff's palazzo-like mass rose four floors above a granite base before a mandatory setback. Above the base, brick walls and limestone-trimmed, vertically proportioned windows suggested the background classroom and dormitory buildings of McKim's campus, which it faced across Amsterdam Avenue, although without the ornamental flourishes of the original and with a slightly self-conscious handling of the main entrance facing the avenue and a vertical glass slot lighting a principal stairwell, breaking up the scale of the 115th Street facade by suggesting two volumes.

By the mid-1980s, it was clear that, on the main campus, the amount of space available for expansion was virtually used up. Although there were some building sites called for in McKim's plan that had never been built on, the community generally preferred the greenery and the slightly random condition of the campus to the strict scheme of tight courtyards that would prevail were the plan fully built out. Moreover, despite the interest in historical form shared by many architects who might be called upon to help fill out the plan, there was a fear that bulky programs and limited budgets would result in parodistic versions of the buildings McKim and his partners had designed for the campus, a point proved by HOK's Schapiro Hall.

In a 1985 report, *Physical Resources of the University*, which James Stewart Polshek helped draft, McKim's plan was described as "an impossible act to follow," particularly because it was so good, and his buildings so good, that all other efforts since have proven generally inferior, demonstrating "that McKim's contribution was a mixed blessing."[45] No matter that McKim's plan had guided the university for almost 100 years or that his buildings had accommodated an astonishing array of programmatic changes and physical modifications, in a bit of twisted reasoning McKim was somehow held responsible for the university's space shortage, while the trustees, who had failed to acquire more land when it was readily available, and who had been profligate in the use of what extra they had (as in the case of the East Campus, which

contained unused development capacity), were made to appear blameless.

In 1990 two firms, Skidmore, Owings & Merrill and Kohn Pedersen Fox, were asked to study the East Campus, where, as Barry Bergdoll wrote, "comprehensive planning had been abandoned since the mid-1960s superblock project."[46] In assessing the problem, Skidmore, Owings & Merrill was on the mark when its report pointed to the development of the East Campus on a "parcel by parcel basis over an extended period of time without a coherent master plan for the block or for its relationship to the Main Campus."[47] In an effort to meet the needs of the space-starved university, each team of architects turned to the development model they knew best, the high-rise office tower, but SOM, led by David Childs, offered the more compelling design, calling for twin twenty-eight-story towers on either side of 116th Street near the corner of Morningside Drive that, if realized, would create a major visual gateway to the campus and strongly identify the university on the city's skyline. Childs's plan also called for the destruction of Wien Hall, built as Johnson Hall, and Harrison & Abramovitz's law school and their replacement with four lower buildings emulating McKim's pavilions and, like them, forming small courtyards. In another scheme, Childs and his team proposed a single skyscraper set within the East Campus superblock. While SOM proposed that the elevated pedestrian plazas of the East Campus be abandoned, KPF held on to them in the best of its three options, grouping the mid- and high-rise buildings around a new focus, a centrally planned octagonal faculty club that Bergdoll described as "practically a Postmodern academic baptistery."[48] Shockingly, KPF argued that it was the buildings entered at street level that gummed up the East Campus plan and proposed to relocate the landmarked Casa Italiana (McKim, Mead & White, 1927) and the President's House (McKim, Mead & White, 1912).[49] According to the architects' proposal, Casa Italiana would either be dismantled or rolled to the vacant site that balanced Avery Hall on the main campus, while the President's House would become a pendant to Buell Hall, presumably completing the original McKim, Mead & White plan.

According to Bergdoll, the schemes were not seriously considered by the trustees.

Casa Italiana did not go anywhere. But it was renovated and modestly expanded in 1996 by the firm of Buttrick White & Burtis working in association with Italo Rota, an Italian architect who had worked for Gae Aulenti on the renovation of the Museé d'Orsay in Paris.[50] The renovation was undertaken with extensive contributions from the Italian government that, as a result, was given title to the building, leasing it back to the university. Originally an urban palazzo with only two finished sides facing Amsterdam Avenue and 117th Street, Casa Italiana became somewhat marooned with the demolition of the townhouses along 117th Street to make way for the East Campus; its unfinished east wall was fully exposed to the elevated plaza that awkwardly formed a kind of misaligned backyard. Rota and BWB initially proposed to restore the two principal interior rooms—the library and the auditorium—and create an interior atrium that would visually unite the offices on the building's top three floors. But the plan met with heavy opposition when it was put forward at two hearings of the Landmarks Preservation Commission in fall 1993, largely because it also included a proposal to construct a stainless-steel-clad exterior stair tower designed by Rota for the building's east side. The protests were heeded, and after the architects' third submission in March 1994, a plan was approved that eliminated the stair tower and instead called for the construction of a facade on the east wall recalling but not directly imitating that facing Amsterdam Avenue. The rejection of the proposed exterior stair led to one of the renovated building's most delightful surprises: a new, marble-lined stair tower located inside the building.

The university also undertook a number of other interesting renovations to its aging building plant. In 1989 the university began to plan for the renovation of Nicholas Murray Butler Library (James Gamble Rogers, 1934), a vast undertaking that continued into the new century.[51] The project was carried out by Shepley Bulfinch Richardson & Abbott, a Boston firm specializing in libraries, which simultaneously was performing similar work at Yale's Sterling Library (1930), also designed by Rogers. While much of the work, which only began in earnest in 1995, involved the repair and updating of the building's infrastructure, it also included the restoration of reading rooms, a process that removed hung ceilings and inappropriate lighting fixtures to reveal a far more distinguished set of interior spaces than any remembered or thought to exist. Additionally, Eugene Savage's mural, *Athena* (1934), dull with over sixty years of dirt, once again was made to glow with color as it presided over the shallow-domed, polychromatic entrance hall, which was also restored and brilliantly relit.

Because the university's new president, George Rupp, appointed in 1993, was genuinely interested in architecture, during the 1990s even small renovations were undertaken with care in various departments. Weiss/Manfredi's renovations of Lewisohn Hall, the auditorium in Uris Hall, the Schermerhorn Auditorium, the King's Table Dining Hall, and John Jay Lounge each revealed a quiet Modernism that respected the architectural setting, yet were fresh and inventive.[52] Pasanella + Klein Stolzman + Berg's 1995 renovation of the journalism school (McKim, Mead & White, 1913) was less successful, with over-scaled and too-numerous roof dormers added to help create usable attic space and an elevator bulkhead that provoked widespread criticism among preservationists.[53]

Of all Columbia's new building projects, the one that posed the greatest artistic challenge was that of Lerner Hall, the 213,000-square-foot student center facing the South Field at the southwest corner of the historic campus.[54] Replacing the artistically weak and programmatically outmoded Ferris Booth Hall (Shreve, Lamb & Harmon, 1960), Lerner Hall was designed by the New York– and Paris-based Swiss-French architect Bernard Tschumi, dean of Columbia's Graduate School of Architecture, Planning, and Preservation, working in association with Gruzen Samton. It was Tschumi's first American building. The construction of Lerner Hall, containing cafés, a bookstore, offices for student clubs, a remarkably flexible set of meeting rooms and theaters, and 6,000 student mailboxes, was announced in late 1995 when Alfred Lerner, a businessman and graduate of Columbia College, made a significant pledge to fund the project. The project had begun more modestly as an expansion and renovation of Ferris Booth Hall by Gruzen Samton, but when George Rupp succeeded Michael Sovern as Columbia's president, he called for a new structure and asked that Tschumi be brought in to collaborate on the design.

The building opened in fall 1999. Though almost doubling the size of its predecessor, Lerner Hall managed not to swamp the southwest corner of McKim, Mead & White's south campus any more than had Ferris Booth Hall because of Tschumi's decision to break the composition into three distinct volumes, bracketing a glass-walled, ramp-filled, atrium-like space with

Casa Italiana, Columbia University, east side of Amsterdam Avenue at West 117th Street. Renovation by Buttrick White & Burtis and Italo Rota, 1996. Stair hall. Hueber. PBDW

brick and cast-stone pavilion-like elements. The flanking pavilions were said to be like the two dormitory buildings McKim and his partners had proposed for the site in 1903, while the glass atrium was claimed to represent an interior version of the open-air courtyard that would have been formed between the dormitories. The clarity of the composition was compromised by a cluttered, cheesily finished roofscape, and Tschumi's "courtyard" analogy for the atrium was never convincing, but the building as a whole attracted wide praise from critics hungry for adventurous modernity. Behind the atrium, or "hub," as it was sometimes referred to, lay a 1,500-seat auditorium with a balcony that could be closed off to form a cinema. The Broadway-facing pavilion or wing was eight stories high in keeping with its neighbor to the north, Furnald Hall (McKim, Mead & White, 1913), while the campus wing, running parallel to Butler Library, was held to four stories, where it was lower than the height of that massive building's first setback.

Although Tschumi did not have a long record of built projects, he had published a number of provocative books expounding theories of modernity that established him as a major critic of both Late-Modernist uniformity and Postmodernist eclecticism. Despite this, his major project in Europe, the master plan and twenty-five pavilions for the Parc de la Villette (1983), was, in its way, decidedly Postmodernist, depending heavily on revived forms and planning strategies of the Russian Constructivists of the 1920s, especially Vladimir Tatlin and Alexander Rodchenko.[55] In *Manhattan Transcripts*, his book of 1981, Tschumi advocated a "post-humanist architecture," hardly a position calculated to reassure those concerned for the preservation of Columbia's traditional campus.[56]

Given his predilections, Lerner Hall proved a challenge to Tschumi. From the first, he maintained that the building would be a Modernist building that would fit in with the McKim, Mead & White campus. But the two flanking wings

ABOVE Lerner Hall, Columbia University, between Amsterdam Avenue and Broadway, West 114th and West 115th Streets. Bernard Tschumi and Gruzen Samton, 1999. View to the southeast. Mauss. ESTO

BELOW Lerner Hall, Columbia University, between Amsterdam Avenue and Broadway, West 114th and West 115th Streets. Bernard Tschumi and Gruzen Samton, 1999. View to the southwest. Mauss. ESTO

Lerner Hall, Columbia University, between Amsterdam Avenue and Broadway, West 114th and West 115th Streets. Bernard Tschumi and Gruzen Samton, 1999. Mauss. ESTO

were distinctly related to the character of McKim, Mead & White's work, so that the exterior expression of modernity was confined to the glass-faced hub with its crisscrossing of ramps, adopted to take advantage of the half-level change between the campus and Broadway. According to Tschumi, the ramps were to act "as a continuous link connecting what would normally have been discontinuous and even contradictory activities." The ramp-filled atrium "is simultaneously a void (the void of McKim) and a route."[57] The hub, the steel structured ramps in it, and especially the inclined glass wall facing the campus were the principal features of the design. Because glazing bars would have overcomplicated the reading of the composition, the structural glass wall was composed of laminated units of clear toughened glass, each unit supporting its own dead weight and wind loads, achieving what engineer Hugh Dutton called "a clear distinction . . . between the steel structure and the pure transparent glass weatherproof surface."[58] The system of holding the glass in place was relatively innovative: it had been developed in the 1980s for La Villette in Paris by Dutton and Peter Rice, the lead engineer for the Ove Arup group, and had only been used one other time. The engineers used bolts incorporating spherical bearings to allow a moment-free connection of the glass at the holes drilled to accept the brackets needed to attach the wall to the structural frame. The walking surfaces on the ramps were also glass, in this case laminated tiles with the upper sheet toughened and covered with an anti-slip treatment. The glass wall and ramp system, engineered by the New York office of Ove Arup and fabricated in Paris by Eiffel Construction Métallique, which

built the Statue of Liberty 110 years before, was no easy job: "The [builders] called it a psychotic Swiss watch," a phrase Tschumi hated.[59] To foster activity, Tschumi lined the ramp landings with 6,000 student aluminum mailboxes. The very idea that the mailboxes would be frequently visited by students seemed almost nostalgic in a time when electronic mail was already well established at Columbia.

Eeva Liisa Pelkonen, a Finnish-born architect and historian teaching at Yale, assessed the building "in relation to Tschumi's many writings on the notion of 'event,'" stating that "the student center crystallizes the difficult moment when a theoretical model finds its architectural translation. . . . [Tschumi's] notion of 'event space' is informed by the French intellectual and artistic culture of the 1960s dominated by radical left wing politics and social critique based on the belief that each individual is able to transgress the existing sociopolitical order and experience moments of self-realization." But, for Pelkonen, Tschumi's building fell short of Gilles Deleuze's notion of "event space as a constantly fluid condition marked only by shifting intensities," remaining, instead, "curiously trapped in a dialectic between static and dynamic, between the campus and the city. . . . Viewed from the main lawn, the circulation zone, with its large glass wall, appears as an isolated element trapped between the two slab buildings, as people moving along the ramps disappear at each landing into the blind end-pieces."[60]

Herbert Muschamp, who had written devastatingly about Tschumi's work when it was the subject of an exhibition at the Museum of Modern Art in 1994, offered a standoffish assessment

of Lerner Hall which, he said, "will plunge some baby boomer alumni into a cool nostalgic bath" for the "events of '68" that Tschumi "has long made a touchstone" of his own work. "Quite apart from its own merits as a piece of architecture," Muschamp continued, Lerner Hall "is an opportunity to weigh the impact of those years on the profession. It is not the most convincing building put forth by a 60's survivor. But no building more graphically represents this generation's complex relationship to architectural theory, practice and education." For Muschamp, the new building was "physically and metaphorically . . . a bridge—a link between exterior and interior, opacity and transparency, Beaux Arts classicism and modernist structural expression." Muschamp acknowledged that the Glass Court (as the ramp atrium was alternately called) was "the heart of the building; a performance space where architecture and the student body compete for the lead role." While he was impressed with the "panorama that changes as you move through the interior," he was not convinced that the "visual connections" between the building's various functional components "actually create events," as Tschumi's polemic would suggest, although he did acknowledge that "they do heighten the sensation that things are happening."[61]

Muschamp was, however, taken with the "sky lounge," a small informal seating area on the third floor suspended above the atrium's well which he deemed "a dream place . . . where visitors of a certain age and temperament might feel an irresistible urge to give in to the building's vestigial 60's spirit. Why resist? Let's have a little riot. We'll start by protesting the willfulness of that great metal and glass wall" which, despite its "elegance . . . raises expectations that the design does not fulfill. The structure looks like a machine. It should be operable. You should be able to crank a handle and make a row or two of the glass panels swivel into open position." To Muschamp, the glass wall failed to breathe, not only in the sense that advocates for sustainable building design called for, but also in the sense of "the progressive social goals implied by Tschumi's 60's pedigree."[62] Despite its glassiness, the building seemed to him a secure fortress, no more open than the classical buildings of the pre-Modernist past held in such contempt by Tschumi.

Robert Campbell, the architecture critic of the *Boston Globe*, also was disappointed. Writing in *Architectural Record*, he labeled Lerner Hall "a series of clashes of material and style. You can say [it is] the perfect and inevitable expression of the pluralism of our culture. Or you can say it lacks confidence in its own character. Maybe it doesn't matter." Campbell, like most other observers, focused on the Glass Hall, questioning Tschumi's claims that the room was the last word in transparency: "So intricate is the steelwork of the ramps and trusses that what you get, instead, is a sense of enormous complexity. The feeling, as you walk the ramps, is that you're threading your way through a kind of architectural sculpture not unlike the great bridges of the industrial era, an erector-set world of struts and bolts and clamps and joints and turnbuckles. . . . This is a rich, exhilarating experience, not at all the minimalist transparency Tschumi describes."[63]

Campbell couldn't buy Tschumi's argument that the tripartite composition of Lerner Hall was a return to McKim's original campus plan: "Neither in daylight nor at night do the ramps read as a void. Nor do the wings, of different heights, shapes, and materials, read as a pair." Campbell also had reservations about the building's lack of openness to Broadway,

though he recognized that this was a traditional Columbia pattern. He was also troubled by the way in which Lerner dealt with the traditional details of the McKim buildings, picking them up "in a Postmodern way that sometimes is arbitrary . . . [as] along Broadway [where] the old granite bullnose string course is imitated by a pretty illogical (and, as it turned out, tough to build) bullnose course of glass block. The old parapets reappear in an uninteresting, radically stripped-down form," while on the campus side, "a truly weird cylindrical brick column is supposed to carry the theme of Butler Library around a corner. . . . A final problem is the depth of the floor plate. Few of the student clubrooms or staff offices enjoy any natural light or views; once you penetrate beyond the ramps, you feel you're in the back of the house."[64]

The year after Lerner Hall's debut, Gruzen Samton completed the Robert K. Kraft Family Center for Jewish Student Life (2000), 606 West 115th Street, a six-story, 28,000-square-foot, midblock building incorporating a grand hall and sanctuary seating 375, a 175-seat chapel, libraries, conference rooms, lounges, and offices, as well as two residential suites for visiting scholars.[65] The design had been carefully scrutinized by neighbors, who pressed for the quiet facade of gridded panels of Ramon gray Jerusalem stone, the densest variety available, selected to meet the rigors of New York weather.

In late 2000, recognizing the need to consolidate its School of the Arts, then housed in ten different facilities, Columbia hired the architectural firm of SHoP/Sharples Holden Pasquarelli to study options for expanding Prentis Hall (Frank A. Rooke, 1917), 628 West 125th Street, a 50,000-square-foot white terra-cotta-faced building that once served as a milk depot for the Sheffield Farms Slawson Decker Company and was later used by Columbia as art studios, a library, and book storage.[66] Following its study, SHoP was hired to design a 50,000-square-foot addition next to and above the original structure to accommodate the school, but the project that proposed a series of internal ten-story "voids" was shelved in 2003 after Columbia's new president, Lee Bollinger, hired the Renzo Piano Building Workshop and Skidmore, Owings & Merrill to study the university's long-term expansion.[67]

Cathedral of St. John the Divine

With the outbreak of World War II, construction of the Cathedral of St. John the Divine was effectively terminated.[68] In 1955–56, a number of Modernist proposals were advanced to complete the cathedral.[69] But in 1967, after adopting a new design (Adams & Woodbridge, 1966), Bishop Horace A. Donegan, concerned about the city's fiscal plight, declared a moratorium on further construction.[70] Six years later, in 1973, encouraged by the cathedral's new dean, the Reverend James Parks Morton, the policy was changed, leading to the announcement in December 1978, by Bishop Paul Moore Jr., who described the cathedral as a "symbol and rallying place in our sorely beset city," that after a thirty-seven-year hiatus, construction would be resumed.[71]

During the previous few years, the church trustees entertained dramatic proposals to redesign the structure—most recently one prepared by R. Buckminster Fuller and Shoji Sadao calling for a breathtakingly overscaled icosahedron truss carrying an observation platform over the crossing. But the adopted plan was far less radical, calling for the completion of the 150-foot-tall west towers with the effort led by James R. Bambridge, a master mason from England who committed himself to three

years of work on the tower and on the construction of a parapet at the base of the crossing dome. Bambridge initially proceeded under the direction of John Doran, of the Boston firm of Hoyle, Doran and Berry, successors to Ralph Adams Cram, author of the cathedral's Gothic design.

The decision to continue with the construction, which had been halted as a response to the declining urban situation, was made in response to the very same condition: Bambridge would not only supervise the work but establish a program to train inner-city youth in the art and craft of stone carving. Work began in June 1979, with five apprentices chipping away to form the 12,000 pieces of Indiana limestone needed for the first tower. Dean Morton, its tireless supervisor and advocate, believed that the training program for would-be masons could prove widely beneficial in creating craftsmen able to work not only on the cathedral but on the very many building conservation and restoration projects that were coming on stream as a result of the recently enacted Tax Reform Act of 1976. In 1989 the successful training program was expanded to become Cathedral Stoneworks, a partnership that contributed profits from outside work back to the cathedral.

On September 29, 1982, with enough stone blocks on hand, construction was resumed with the setting of the cornerstone for the southwest tower. A commemorative ceremony featured Philippe Petite, the aerialist, who walked a wire stretched 150 feet above Amsterdam Avenue. Under Dean Morton's leadership, the cathedral's crypt and the grounds bustled with workers and artisans, not only carving stone for the tower but also helping Greg Wyatt, a sculptor, to complete his colossal "Peace Fountain," which was unveiled on the grounds in October 1984. Others were engaged in creating fabrics and artifacts for sale in the gift shop. But clearly this source of income was not enough to support the enterprise, so that in January 1985, Morton invited potential donors of many faiths to help aid the construction and its social benefits to inner-city youth. Donald Trump pledged $1 million to the Building and Construction Fund; many others followed, impressed as much by the training program as by the work itself. In so reaching out, and in the many and various new ways Morton found to bring the cathedral's activities to a wide circle of New Yorkers, the goal of an ecumenical house of

ABOVE Proposed Bioshelter, Cathedral of St. John the Divine, between Morningside Drive and Amsterdam Avenue, West 110th and West 113th Streets. Section. David Sellers, 1979. SCA

BELOW Proposed Bioshelter, Cathedral of St. John the Divine, between Morningside Drive and Amsterdam Avenue, West 110th and West 113th Streets. South elevation. David Sellers, 1979. SCA

Proposed Bioshelter, Cathedral of St. John the Divine, between Morningside Drive and Amsterdam Avenue, West 110th and West 113th Streets. Santiago Calatrava, 1991. Sketch. SC

Proposed Bioshelter, Cathedral of St. John the Divine, between Morningside Drive and Amsterdam Avenue, West 110th and West 113th Streets. Santiago Calatrava, 1991. Model, view to the southwest. SC

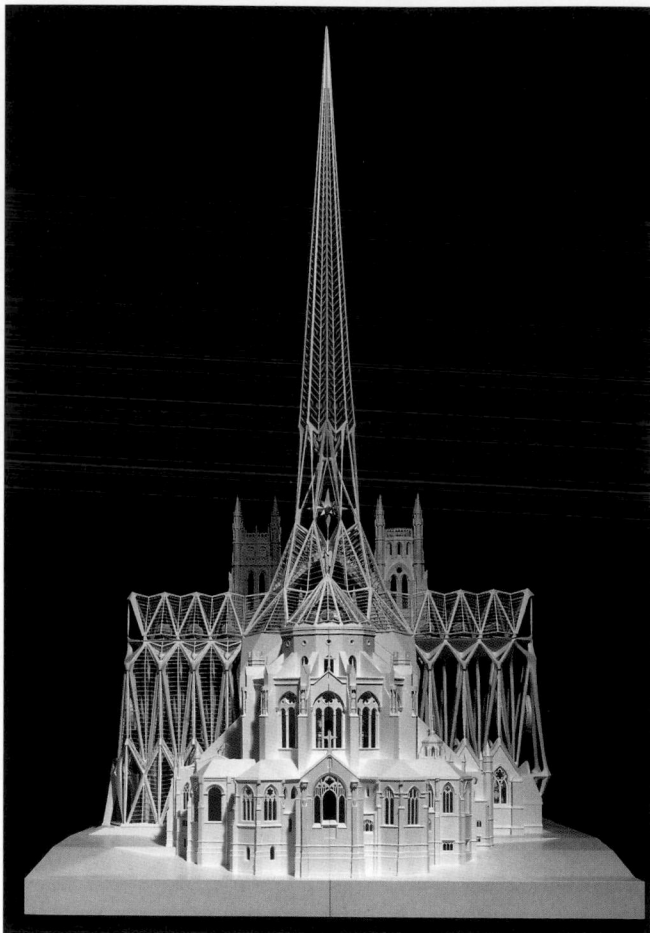

Proposed Bioshelter, Cathedral of St. John the Divine, between Morningside Drive and Amsterdam Avenue, West 110th and West 113th Streets. Santiago Calatrava, 1991. Model, view to the west. SC

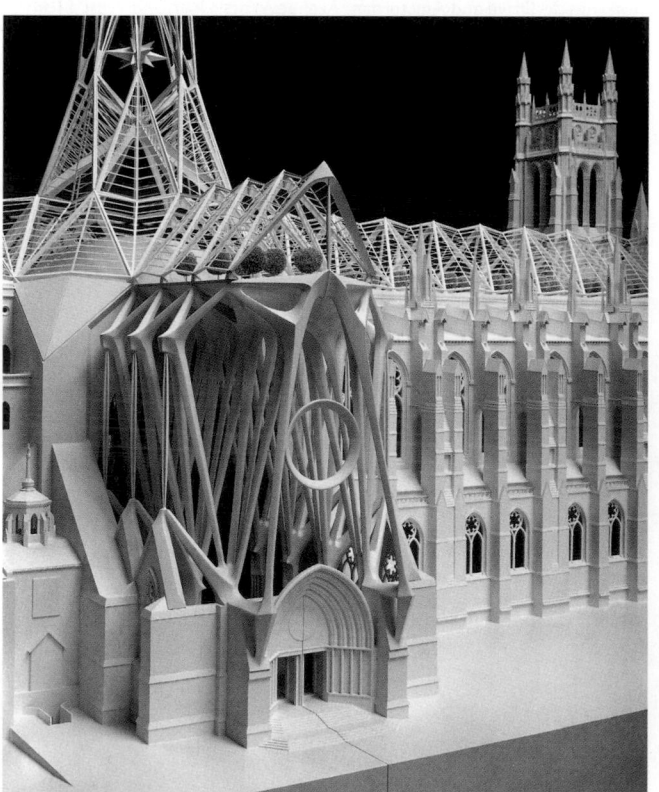

worship its founders embarked on 100 years before began at last to seem realized.

As the work on the tower progressed, Morton struggled with the future of the south transept. In 1979, the same year that construction resumed, Dean Morton, who had studied architecture as an undergraduate at Harvard, devised a new concept for the completion of the cathedral based upon his own understanding of the teachings of St. Paul, which discarded the canonical hierarchy of man over nature in favor of equality among all living entities. To Morton, St. John the Divine's accommodation of humans only, and not plants and animals, perpetuated that hierarchy. Borrowing nomenclature from the ecologist and founder of the New Alchemy Institute, John Todd, and still consulting with Buckminster Fuller, Morton decided to hold a competition for a bioshelter that would incorporate plant life into the cathedral. Four firms were invited to compete: Van der Ryn, Calthorpe & Partners; Shepley Bulfinch Richardson & Abbott; Malcolm Wells; and Keith Critchlow. David Sellers, an architect practicing in Warren, Vermont, alerted to the competition through word of mouth, submitted an unofficial and last-minute entry, which he produced in a two-day charrette and hung outside the exhibition room, where the jury members could see it as they proceeded with their deliberations. Amazingly, Sellers's scheme was chosen, principally because his plan called for constructing the bioshelter exclusively of glass and stone in the

Proposed Bioshelter, Cathedral of St. John the Divine, between Morningside Drive and Amsterdam Avenue, West 110th and West 113th Streets. David Sellers, 1991. Section. SCA

Proposed Bioshelter, Cathedral of St. John the Divine, between Morningside Drive and Amsterdam Avenue, West 110th and West 113th Streets. Keenan/Riley, 1991. Model, view to the northeast. Pottle . ESTO

Proposed Bioshelter, Cathedral of St. John the Divine, between Morningside Drive and Amsterdam Avenue, West 110th and West 113th Streets. Antoine Predock, 1991. Model, view to the northwest. Reck. RR

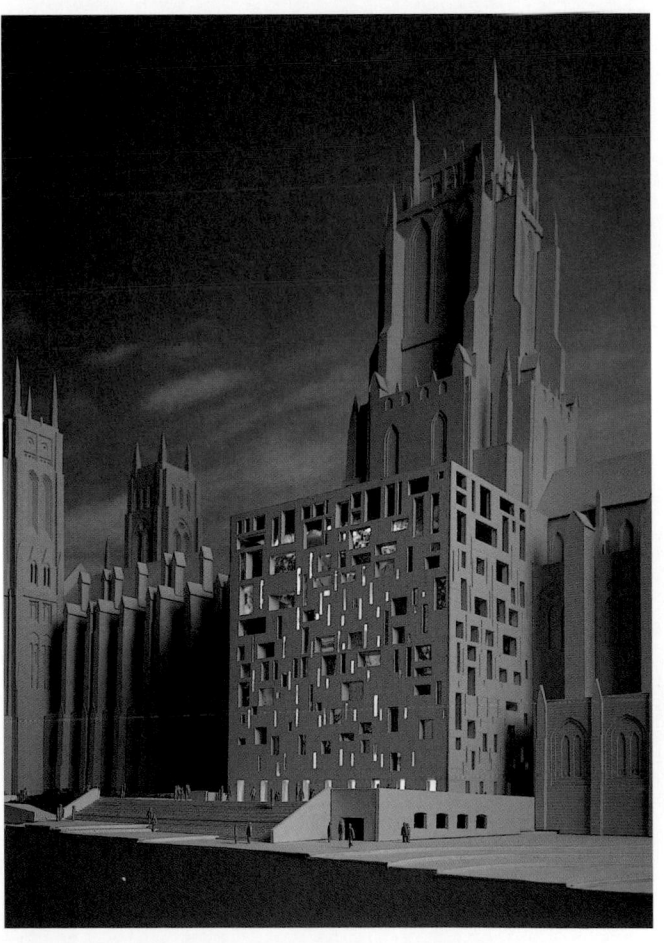

tradition of Gothic cathedral building, and situating the structure on the site of the unfinished south transept, integrating it more with the cathedral than was proposed in the competing schemes. Though plans for the bioshelter were developed with significant, even pioneering efforts to employ recycled materials in its construction, including metal cans and glass bottles, the decision by the board of trustees to continue stone carving for the towers of the western facade consumed the available resources, and Sellers's scheme fell by the wayside.

According to Sellers, "As a last gasp effort to get public energy for the cathedral," Morton held a two-stage "Bioshelter Competition" in 1991, incorporating the ideas put forth in Sellers's scheme into the program.[72] The possibility of realizing the project was cloudy at best, but a gift from the family of Rene Dubos, the discoverer of the first antibiotic and a dedicated ecologist, encouraged Morton to take it on. Five firms were selected for a new competition: Antoine Predock; Tadao Ando; Holt Hinshaw Pfau Jones; Keenen/Riley; David Sellers; and the Spanish architect-engineer Santiago Calatrava, then little-known in America, whose Gaudi-inspired, tendril-like glazed design was selected. Calatrava's new south transept was to provide 100,000 square feet of space that would integrate the working laboratories and ongoing permanent exhibits of the Rene Dubos Biosphere with liturgical space, a sacristy, classrooms, and offices. His glassy structure would rise to an attic

Proposed Union Theological Seminary apartment tower, southeast corner of Claremont Avenue and West 122nd Street. James Stewart Polshek & Partners, 1986. North–south site section looking west. PPA

Proposed Union Theological Seminary apartment tower, southwest corner of Broadway and West 122nd Street. Robert A. M. Stern Architects, 1986. Model, view to the northwest. RAMSA

rain forest of trees, vines, and lichens intended to provide the cathedral's cooling. David Sellers's proposal was extremely historicist, a cross between Viollet-le-Duc and midcentury English Gothicists such as Burgess or Street. At the opposite extreme, Tadao Ando proposed a giant hemicircle adorned with grapevines that, according to the somewhat acerbic John Brodie, "called to mind a Dionysian festival or a campfire sing-along," while the firm of Keenen/Riley "lobbied for futuristic gardens whose intricate mechanization spooked the jury."[73] Antoine Predock decided that the south transept would be, as he later put it, "another stone mountain and proposed that it be generated from an ordering system based on sacred Christian numbers. . . . Lodged in the stone mountain are thin sheets of marble arranged to create an occupiable stained-glass window, one that can be encountered in three dimensions."[74]

Calatrava's proposal was not realized, a victim of the collapse of the 1980s boom. The failing economy also forced the closing of the stoneyard in 1992, when construction on the south tower was stopped after fifty feet of height had been achieved, and all construction on the cathedral was halted in June 1997, with the completion of the double procession of biblical figures carved on the flanks of the great bronze doors of the Portal of Paradise. The abandonment of construction at the cathedral was not so much a result of financial or ideological reasons as of practical ones. After Morton's retirement in 1996, the new dean, the Reverend Harry H. Pritchett, shifted the emphasis to conservation and preservation, including repairs to the leaking roof, restoration of the Great Organ, and the conservation of twelve seventeenth-century Barberini tapestries, projects directed by the Polshek Partnership and Building Conservation Associates. On December 18, 2001, an electrical fire broke out in the cathedral's gift shop, injuring no one but shattering several stained glass windows and severely damaging two of the Barberini tapestries, whose remains—roughly 40 percent of each tapestry was destroyed—were painstakingly cleaned and conserved during the following years.[75]

Union Theological Seminary

In 1980 Union Theological Seminary, occupying a two-block-long campus bounded by 120th and 122nd Streets, Broadway and Claremont Avenue, embarked on a plan of renovation for its Gothic quadrangular campus (Allen and Collens, 1906–10).[76] The firm of Mitchell/Giurgola was retained to do the work, at first consisting of a new bookstore and commons (1980), but then expanded to include an enlarged and reconfigured Burke library.[77] While much of the work was confined to the interiors, a new stair, illuminated through a gridded glass oriel and an equally glassy reading room, projected new shapes into the courtyard. Although the firm's principal designer, Romaldo Giurgola, professed a strong interest in "working with an old building [that] can teach you to appreciate careful detailing, to value the quality of materials, and to look for (and give employment to) traditional craftsmen," the absolute abstraction of the design language he adopted was distinct and opposite to that of the multilayered Gothic of the original.[78]

In 1986 the seminary announced plans to replace portions of Hastings Hall, a dormitory at the northeast corner of its campus, and all of the adjacent Knox Hall, which lay along West 122nd Street, with an apartment tower that would provide new residential space for the seminary at its base and revenues from the sale of condominium units on the upper floors.[79] Four plans were submitted by developers in 1986,

including a proposal prepared by James Stewart Polshek & Partners and one prepared by Robert A. M. Stern Architects. While the proposed removal of Knox Hall raised issues among preservationists, not so much as a result of its own qualities but because of its proximity to James Memorial Chapel, James Memorial Tower, and Brown Memorial Tower, which were in fact the only portions of the complex to be legally designated landmarks, many felt the complex as a whole would be negatively affected by the imposition of a superscaled tower.

Polshek's proposal called for a thirty-nine-story tower buttressed by two lower towers, replacing Knox Hall, but with the bulk of the new construction set at the northwest corner of the campus, on the corner of Claremont Avenue and West 122nd Street. The skillfully massed tower, abstractly detailed with horizontal bands to help reduce its apparent height by grouping together three floors to suggest one, was almost as tall as its close neighbor, Riverside Church (Allen & Collens, 1930). It was also close to Sakura Park, across which it would have cast a considerable shadow. Stern's proposal also called for a thirty-nine-story, 400-foot-tall building with 345 units but was located at the northeast corner of the site, where it would have less impact on Riverside Church and Sakura Park. While Polshek proposed to remove virtually all of the base buildings, Stern's tower rose from a base made up of Knox and Hastings Halls, much as the Harkness Tower rises from Branford College at Yale. As a result, the somewhat casually organized courtyard would have been reconfigured into two intimately scaled, integrated but separate spaces, with proportions closely resembling those proposed by the three finalist schemes of the 1907 competition for the selection of an architect for the seminary.

In late September 1987, the seminary opted not to go forward with the tower plan, deciding instead to renovate Hastings Hall and to sell one of its dormitories, Van Dusen Hall (Rogers & Butler, 1962), 527 Riverside Drive, to the highest bidder among the area's major institutions, citing a greater demand for institutional housing than luxury residences. International House purchased the dormitory in 1989. James Stewart Polshek & Partners was commissioned to renovate the seven-story, 65,000-square-foot Hastings Hall, which was stripped to its granite shell and rebuilt with a new arrangement of apartments.[80] While much of the work was not artistically significant, Polshek's decision to close a formerly open archway leading to the courtyard from Broadway provided an opportunity for some aluminum-framed glass enclosing walls, the detailing of which, along with that of the new pendant light fixtures, was intended to recall the Gothic original.

When the seminary decided against building its condominium project in 1987, an alternate strategy was proposed, wherein the Manhattan School of Music (Donn Barber, 1910; Shreve, Lamb & Harmon, 1931; MacFadyen & Knowles, 1970), north side of 122nd Street, between Broadway and Claremont Avenue, would build a thirty-four-story tower on a vacant lot it owned to its north. The first four floors were to accommodate expansion space for the school, while the apartment tower would contain 265 apartments, a health club, and underground parking for 120 cars.[81] Robert A. M. Stern, asked to develop the scheme, which he had initially proposed as a joint venture between the seminary and the school, proposed a classically inspired tower rising from a rusticated limestone base continuing that of Donn Barber's building, and concluding past a series of setbacks, in a square, columned lantern. The collapsing economy halted the project, and the school

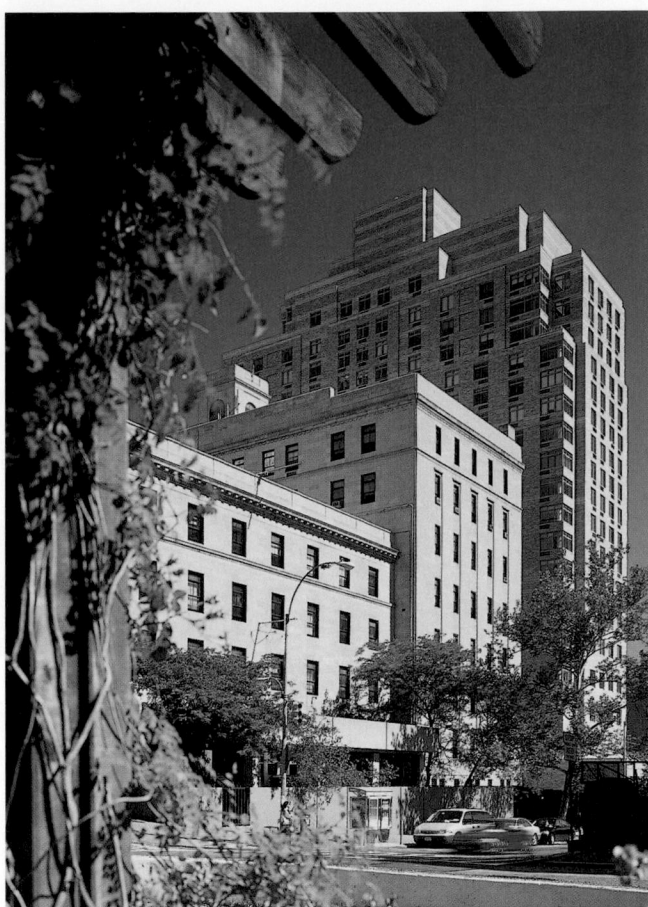

Andersen Hall, Manhattan School of Music, 134 Claremont Avenue, between West 122nd and LaSalle Streets. Beyer Blinder Belle, 2001. View to the northwest. Charles. FCP

Student Pub, International House, 508 Riverside Drive, between West 122nd Street and Tiemann Place. Robert A. M. Stern Architects, 1984. RAMSA

turned to improving its existing facilities, hiring Philip Johnson Alan Ritchie Architects in 1993 to restore its principal concert hall, John C. Borden Auditorium, to its original 1932 condition.[82] Plans for a tower resurfaced in April 2000, when the neighborhood was surprised by news that the Manhattan School of Music had begun site preparations for a bulky, twenty-one-story dormitory-classroom building on the site, designed by Beyer Blinder Belle.[83] Despite the community's outrage, the building, though later reduced in height to twenty stories, went forward. In addition to 382 beds on ten

Library, Jewish Theological Seminary, between Amsterdam Avenue and Broadway, West 122nd and West 123rd Streets. Gruzen & Partners, 1983. View to the east. GS

Jewish Theological Seminary, 3080 Broadway, northeast corner of West 122nd Street. Renovation by Jack L. Gordon Architects, 2001. View to the northeast. JLGA

floors, the new 180,000-square-foot Andersen Hall, completed in late 2001, included two performance spaces, a 250-seat recital hall, a black-box theater, offices, classrooms, a cafeteria and student lounge, sixty practice rooms, and a penthouse apartment for the school's president. The base was clad in Indiana limestone to match the existing school buildings, but the rose-colored brick of the tower above seemed out of place.

Across from the Manhattan School of Music lay International House (Louis Jallade, 1921–24), 508 Riverside Drive, where Robert A. M. Stern undertook a number of renovations in the 1980s in an attempt to restore portions of the neglected but still elegant dormitory and spaces for activities not originally anticipated.[84] These included a Television Room (1981), a self-consciously theatrical Student Pub (1984) intended to bring some downtown glamour to a captured, windowless basement space, and the Kathryn & Shelby Cullom Davis Hall (1987–89), a dramatic restoration and enhancement of the original 800-seat auditorium.

Jewish Theological Seminary

In 1980 the Jewish Theological Seminary (William Gehron, 1930), east side of Broadway between 122nd and 123rd Streets, announced plans to renovate its campus and build a library to replace the one formerly housed in the tower that succumbed to fire on April 19, 1966, destroying 70,000 of the 150,000 books in its collection.[85] The renovations to the 1930 facility were needed because the buildings, originally built to serve thirty rabbinical students and twenty undergraduates, now housed more than 500 students. Plans developed by Gruzen & Partners called for a four-level skylit library and a 400-seat auditorium to be housed in a new midblock red brick and limestone building that would extend from 122nd to 123rd Street, forming the fourth wall to the seminary's courtyard, hitherto bounded by the original U-shaped building. Work on the expansion and library, which the editors of the *AIA Guide* deemed "both understated and appropriate," was completed in 1985.[86]

In 1999 the seminary announced plans to revitalize the fire-damaged ten-story tower that was the institution's most prominent feature.[87] The renovation completed in 2001 by Jack L. Gordon Architects called for the replacement of the old low-ceilinged library stack floors with six new floors aligned with those in the flanking seminary wings and four additional floors above. The new tower contained a language lab, classrooms, an eighty-seat lecture hall, a conference center, and offices. An elevator core and stair tower were added to the courtyard side of the structure; the opposite facade, facing Broadway, was altered to accommodate a rather heavy-handed five-story-tall central window replacing the eight narrow windows that originally dotted the tower.

While the alterations of this facade were the cause of some alarm, it was the relocation of two iron entrance gates designed in 1934 by Samuel Yellin to another spot on the seminary's campus that led the architectural historian Andrew S. Dolkart to write in a letter to the editors of the *New York Times* that their "displacement from public display on a well-traveled corner will be a major loss to New York City."[88] The gates were replaced by a glass walled entry that was a bit out of character with the tower, enclosing the former open-air breezeway.

Amsterdam House

One comparatively minor institutional project brought with it more than its share of controversy rising from issues of historic preservation and aesthetics: the expansion of Amsterdam House (Kennerly, Slomanson & Smith, 1976), 1060 Amsterdam Avenue, northwest corner of West 112th Street, with a new wing (Geddis Partnership, 1997) paralleling Amsterdam Avenue, on the site of the garden that lay to the south of the 113th Street New Croton Aqueduct Gatehouse (1876), a hipped-roof, rock-faced granite pavilion.[89] In 1990 the operators of Amsterdam House, which had replaced a previous building, the Home for Old Men and Aged Couples (Cady, Berg & See, 1897), encouraged the City's Department of Real Estate to put the lot, including the gatehouse, up for auction, with the condition that future development be limited to "'nursing home' use and uses ancillary thereto," with demolition of the gatehouse to be prohibited.[90] Neighbors and landscape architects protested the loss of the garden, said to be as old as the Croton building. The garden was valued as open space and for its role as a visual, if not particularly accessible, forecourt to the Cathedral of St. John the

Divine. To help mollify the neighbors, the thirteen-story, 106-bed extension was clad in red brick and cast stone, detailed to resemble the buildings of Columbia University two blocks to the north. Nevertheless, a suit by neighbors led to a declaration by the New York State Office of Parks, Recreation, and Historic Preservation that the addition would have an "adverse effect" on the gatehouse, which was not a protected landmark, a nearby firehouse, and the Cathedral of St. John the Divine. This led to a review at the federal level, with all parties agreeing that the project could go forward as long as the gatehouse, which was to become the nursing home's Adult Care Center, was treated delicately: the wrought-iron fence around it was to be restored, its windows left at their original size, and its monumental south-facing doors retained and locked in the open position to serve as a link between the new building and the gatehouse. Concerned by the gatehouse's near-demolition, the Morningside Heights Residents' Association, which had led the protest against the extension to Amsterdam House, petitioned the Landmarks Preservation Commission to have a similar gatehouse, on the southeast corner of 119th Street and Amsterdam Avenue, designated a landmark, which it was in 2000.[91]

Amsterdam House addition, 1060 Amsterdam Avenue, between West 112th and West 113th Streets. Geddis Partnership, 1997. View to the southwest showing New Croton Aqueduct Gatehouse (1876) on the right. Benson. RBP

UPPER
EAST SIDE

PRESERVATION AS PLANNING

The adoption of the Upper East Side Historic District on May 19, 1981, was the single most important event in the neighborhood's postwar evolution.[1] Not the city's largest historic district but its most complicated, with the highest real estate values at stake, it exemplified the crucial role historic districting had come to play in the face of the city's increasingly discredited planning process, governed as that process was by zoning laws that were generic rather than site specific. Between World War II and the establishment of the Landmarks Preservation Commission in April 1965, the Upper East Side's "Gold Coast"—the area between Sixtieth and Ninety-sixth Streets and Fifth and Third Avenues—lost more architecturally significant buildings than any other quarter in the city, including the widely protested demolition of the Isaac Vail Brokaw family houses—1 East Seventy-ninth Street (Rose & Stone, 1887–90), 984 Fifth Avenue (Charles Frederic Rose, 1905), and 7 East Seventy-ninth Street (H. Van Buren Magonigle, 1911)—to make way for two undistinguished apartment buildings, 980 Fifth Avenue (Paul Resnick and Harry F. Green, 1966) and 985 Fifth Avenue (Wechsler & Schimenti, 1970).[2] Even after the formation of the commission, important buildings continued to be demolished, including Carrère & Hastings's English Regency-style Elihu Root house (1903–5), southeast corner of Park Avenue and Seventy-first Street, replaced in 1969 by an apartment house by Kahn & Jacobs.[3] While the Landmarks Preservation Commission designated twenty-seven historic districts between 1965 and 1975, only three affected the Upper East Side: the Treadwell Farm Historic District (1967), Sixty-first to Sixty-second Street between Second and Third Avenues; the Henderson Place Historic District (1969), Eighty-sixth to Eighty-seventh Street between Henderson Place and East End Avenue; and the Carnegie Hill Historic District (1974), which stretched from Ninety-second to Ninety-fifth Street between Fifth and Madison Avenues and Ninetieth to Ninety-second Street between Madison and Park Avenues.[4] In 1977, after failing to save three townhouses between Eighty-first and Eighty-second Streets—1006 Fifth Avenue (Richard W. Buckley, 1899), 1007 Fifth Avenue (Welch, Smith & Provot, 1901), and 1008 Fifth Avenue (Welch, Smith & Provot, 1901)—which were sacrificed to Philip Johnson and John Burgee's 1001 Fifth Avenue (1979) (see below)—the commission created a second protected area in the neighborhood, the eight-block Metropolitan Museum Historic District, running from Seventy-eighth to Eighty-sixth Street between Fifth and Madison Avenues.[5]

Calls for a more comprehensive approach to preserving the historic character of the Upper East Side were triggered by George Klein's November 1978 proposal for a twenty-five-story apartment building on East Sixty-second Street, immediately east of Delano & Aldrich's four-story, Federal-style Knickerbocker Club (1914), southeast corner of Fifth Avenue and Sixty-second Street.[6] Emery Roth & Sons' design

for a seventy-nine-foot-wide tower, replacing two five-story limestone-clad buildings, 4 East Sixty-second Street (Clinton & Russell, 1898) and 6 East Sixty-second Street (Welch, Smith & Provot, 1901), the interiors of which had been combined in 1931 by John Hamlin for the York Club, required the purchase of air rights from the Knickerbocker Club as well as significant zoning variances from the city. While the Knickerbocker Club was in the high-density Special Park Improvement District, numbers 4 and 6 East Sixty-second Street were not, and Klein needed a variance to build a twenty-five-story tower where zoning only allowed a fourteen-story building. Coming on the heels of Ulrich Franzen's hotly contested and artistically disappointing apartment house at 800 Fifth Avenue (1978), just south of the Knickerbocker Club, opposition to new development on the block was strong.[7] Although Ada Louise Huxtable dismissed the Roths' design—"The rendering suggests that a better building could be pulled out of a hat"—she was more concerned about the effect any large new building would have on the block. Huxtable's argument was not limited to the case of a single proposed building but was instead a call to arms for the preservation of the Upper East Side's Gold Coast blocks, which she feared were in great peril. Huxtable contended that zoning alone could not save the especially vulnerable midblock buildings and that the Landmarks Preservation Commission needed to step in and assert itself. "Beginning with the construction of 800 Fifth Avenue at 61st Street," she concluded, "the line is being erased, or smudged, between the densities allowed in the central business district and in residentially zoned areas. If the line moves from 61st to 62d Street, can 63d, 64th, or any others, be far behind?"[8]

In January 1979, the City Planning Commission informed Klein that it would oppose the project "as a dangerous precedent for midblock development." Chairman Robert F. Wagner Jr., picking up on Huxtable's point, suggested that the neighborhood's "elegant and historic character" would best be served by the creation of a new historic district safeguarding a large portion of the Upper East Side.[9] Four months later, in May 1979, the Landmarks Preservation Commission released a proposal for just such a protected area. The proposed Upper East Side Historic District was bounded on the west by Fifth Avenue from Fifty-ninth Street north to Seventy-eighth Street. It covered most of the area east of that avenue to a point between Park and Lexington Avenues. A tentacle extended east toward Third Avenue between Sixty-ninth and Seventy-first Streets and one stretched north to Seventy-ninth Street along Park Avenue. Between Fifty-ninth and Sixty-first Streets, it extended only a short distance east of Fifth Avenue. With 1,044 buildings, it would be the city's fourth-largest historic district, ranked behind those in Brooklyn Heights (1965), Greenwich Village (1969), and Park Slope (1973). The designation was more controversial than those previous efforts, in large part because the area constituted some of the city's most valuable real estate, incorporating the city's premier high-end shopping street, Madison Avenue, with 281 storefronts.

Predictably, opposition ran high among property owners, with even such seemingly high-minded and public-spirited members of the real estate community as Peter Sharp and Daniel Rose taking strong public positions against it. Sharp, proprietor of the Carlyle Hotel (Bien & Prince, 1930), east side of Madison Avenue between Seventy-sixth and Seventy-seventh Streets, spoke for many real estate owners when he labeled the proposal "ill-conceived and very dangerous and

deleterious. The minute you go to discretionary zoning, you turn to the Napoleonic Code and not our traditions of common law."[10] Or, as developer Daniel Rose put it: "To protect specific buildings is historic preservation; to petrify 60 busy square blocks is urban planning run amok."[11] While acknowledging the "architectural richness" of the area, the editors of the *New York Times* would have preferred a revision of "the zoning to reduce the permitted size and bulk of new buildings and to limit the way large sites can be used. But," they admitted, "zoning changes alone won't do enough. To keep the area's architectural character, new designs would have to be reviewed in advance, as a substitute for the kind of controls that strictly historic zoning achieves. The best solution, we suspect, would be a special Upper East Side zoning district with such design controls."[12] Counteracting the naysayers, the proposal had passionate advocates, none more so than writer Brendan Gill, actress Tammy Grimes, and Councilwoman Jane Trichter, who together solicited support for the new district, calling it "a visually intact record of New York City's turn-of-the-century splendor. Designation is essential if the fine row-height architecture along the side streets and the concentrated mix of small shops, galleries and residential buildings along the avenues are to be preserved."[13]

The contentious debate over the establishment of the Upper East Side Historic District lasted for the next two years. In an article published on May 21, 1981, two days after the Landmarks Preservation Commission designated the district, Paul Goldberger observed that a key issue regarding the controversy was "the extent to which the Upper East Side fits together as a complete urban unit—as a *tout ensemble*, to use the French phrase that people use in New Orleans to describe their French Quarter, the nation's first major historic preservation district." Acknowledging the neighborhood's diversity, the commission's report pointed to the presence of a considerable number of banal buildings within the area, buildings of minimal architectural value, many of which they labeled "non-contributing," that could be demolished or renovated without a public hearing but still required the approval of the commission. As well, it was assumed that most storefronts could be changed on the same basis. But Goldberger wisely sensed that the realities of the situation might prove quite different:

> Guiding a neighborhood in slow evolution is difficult, particularly at a time when the economics of real estate do not permit the re-creation of works of architecture of the modest scale—not to mention the gentle style—of what is now here. But that very fact is what underlies a great deal of support for the historic district—the belief that the Upper East Side must be preserved because whatever would replace it would be inferior. In its decision to designate the Upper East Side, the commission was clearly walking a fine line between its traditional role as protector of landmarks and another underlying role, that of city planner. All landmark designation is planning of a sort. As a governmental decision to preserve a particular place, it precludes some other use for that place.[14]

Kent L. Barwick, the commission's chairman, put a somewhat brighter spin on the situation, stating that the commission's job was "to note what should be protected, and the City Planning Commission's job is to control that which will be built. Designating the Upper East Side does not change that at all."[15]

While one result of the designation was to push major new development outside the historic district, east of the Upper

East Side's Gold Coast, there were still possibilities for new construction in the newly created historic district, especially as developers recognized the potential value of needlelike towers replacing buildings deemed by the Landmarks Preservation Commission to be noncontributing to the district. These so-called sliver apartment buildings quickly became a flash point of controversy. Usually between fifteen and twenty-five stories tall and between twenty-two and forty feet wide, sliver buildings caused a great deal of concern, especially when they were placed on sensitive midblock sites. While it is not quite accurate to speak of a sliver tradition, sliverlike apartment buildings had appeared on the scene before, when developer Edward W. (Daddy) Browning, who began his building career with the twenty-seven-foot-wide twelve-story loft building (Otto Strack, 1908) at 11 West Seventeenth Street, put up three identical apartment buildings (Buchman & Fox, 1915) at 42 West Seventy-second Street, 118 West Seventy-second Street, and 126 West Seventy-third Street that were each thirteen stories tall but only twenty-five feet wide.[16] After World War II, however, the cost of building such narrow, tall buildings, often with only one apartment per floor, rendered them economically infeasible. But with the difficulty in assembling large construction sites and the dramatic increase in property values, developers enthusiastically embraced this now potentially profitable building type. Moreover, the assurance of distant views from midblock sites,

Viscaya, 110 East Seventy-first Street, between Lexington and Park Avenues. Architects Design Group, 1982. View to the southeast. Ries. SRP

328 East Eighty-sixth Street, between First and Second Avenues. Architects Design Group, 1981. View to the southeast. Ries. SRP

266 East Seventy-eighth Street, between Second and Third Avenues. Noah Greenberg, 1981. View to the southwest. Ries. SRP

which the legal preservation of the existing townhouse fabric guaranteed, made midblock sliver apartments especially appealing. But it was obvious that these buildings, with their prominent blank side walls, were creating a blight on the area's streets and clearly contravening the spirit, if not the letter, of the districting plan. The effect of sliver buildings was regrettable even on the less architecturally distinguished streets east of the historic district where they were proliferating.

One of the most egregious sliver apartment houses was the Viscaya (Architects Design Group, 1982) where sixteen stories of streamlined modernity were cantilevered over 110 East Seventy-first Street (Hill & Stout, 1917), between Park and Lexington Avenues, a five-story, thirty-foot-wide red-brick Georgian townhouse that since 1948 had served as the headquarters of the New York Society for the Prevention of Cruelty to Children.[17] The project was the work of first-time developer Harold Lynn, a former garment district executive, who had purchased the townhouse in the late 1970s and claimed credit for the design of the apartment building, the construction of which was well underway by the time the site was included in the Upper East Side Historic District. The reinforced-concrete tower, with rounded corners, large windows, and one apartment per floor, rose from the back half of the formerly dignified townhouse, whose facade was left intact and whose reinforced roof served as the site for a landscaped garden, "giving the impression from below," according to Alan S. Oser, "that the two elements are barely connected. The tower seems almost to be floating on air."[18] The Architects Design Group was also responsible for the much less distinguished

two-bay-wide, sixteen-story 328 East Eighty-sixth Street (1981), between First and Second Avenues, which featured stacked curved balconies.[19]

The architect Noah Greenberg designed three sliver towers, including the eighteen-story, twenty-two-foot-wide dark brown brick 177 East Seventy-ninth Street (1980), between Lexington and Third Avenues, and the thirty-two-foot-wide red brick 266 East Seventy-eighth Street (1981), between Second and Third Avenues, a design that "visually bullies the corner," according to Stan Pinkwas, writing in *Metropolis*, by rising eight stories before stepping back for an additional eleven stories.[20] Greenberg's most controversial design was for Lexington House (1983), northwest corner of Lexington Avenue and Eighty-first Street, a site that had only thirty-four feet of frontage on the avenue and fifty-five feet on the side street, permitting a nine story base and a needle tower set back fifteen feet on the Lexington Avenue side and twenty feet on the side street before rising another eleven stories, clearly an impractical arrangement.[21] The developer successfully appealed to the Board of Standards and Appeals for a variance allowing less stringent setback requirements, arguing that the site's size created an economic hardship. Of course, the zoning had been written to discourage the overbuilding of small properties and to encourage the protection of the traditionally low-scale side streets in the midblock.

With more than a dozen sliver buildings either built or on the drawings boards, the City Planning Commission, goaded into action by the public outcry from vocal community groups, responded remarkably quickly. On February 2, 1983, the commission passed a measure prohibiting the worst midblock

examples on a large swath of the residential blocks of the Upper East Side between Fifty-ninth and Ninety-ninth Streets, including the particularly sensitive blocks between Park and Lexington Avenues.[22] The ruling applied to lots up to forty-five feet wide and limited a building's height to the width of the street, typically equivalent to a five- or six-story building, or the building next door, whichever was greater. Four weeks later the Board of Estimate unanimously confirmed the zoning change, which would take effect immediately. Unfortunately, one sliver building slipped through the cracks because foundation work had been completed before the new law was passed. Levien Deliso White Songer's twenty-two-foot-wide, twenty-one-story 14 East Ninety-sixth Street (1985), between Fifth and Madison Avenues, replacing a brick townhouse demolished in 1981, did, however, manage to fit in among the tall apartment houses on Ninety-sixth Street.[23]

The issues of sliver buildings and of the preservation of neighborhood character coalesced in 1981 when the Canadian developer Fieldhouse Realty announced plans for a fifteen-story, 245-foot-high apartment tower designed by Diana Agrest and Mario Gandelsonas to rise over the forty-five-foot-wide, five-story, limestone-clad Italian Renaissance-style townhouse (C. P. H. Gilbert, 1923) at 22 East Seventy-first Street, between Fifth and Madison Avenues.[24] According to the proposal, the 20,000-square-foot townhouse was to serve as a base for the slim 36,000-square-foot tower containing twenty-four apartments. Reminiscent of a Florentine campanile, the limestone-clad tower was topped by a copper-faced pyramid and featured a perhaps overly prominent clock on its east elevation. Unfortunately for the developer, the design's release coincided with the establishment of the Upper East Side Historic District. Brendan Gill, chairman of the New York Landmarks Conservancy, led the opposition. He was especially outraged because of the tower's location on the "so-called Frick block—one of the two blocks in the entire Upper East Side district that have an almost uniform skyline, welcomely low. In many ways, this block represents the very ideal of what preservationists have been fighting for; it would be a bitter irony indeed if that block were the first to be mutilated since the designation and if its mutilation were, at least indirectly, at the hands of the Landmarks Preservation Commission." Gill was also opposed to the kind of building type that he felt Agrest & Gandelsonas's design represented, the reviled sliver building that he deemed "utterly unsympathetic to the neighborhoods into which they are wedged; their sole purpose is to make wealth for the few at the expense of the many."[25] The architects countered that their design established "a dialogue between the district and the city at two different levels: the untouched base at the level of the street preserves the sense, nature, and scale of the street and the avenue, and the new top interacts with the skyline that has become a symbol of New York City itself."[26]

The Landmarks Conservancy lobbied heavily against the proposal, taking out a full-page advertisement in the Sunday *New York Times* on October 25 that more or less repeated Gill's letter but added to the critic's signature those of many important citizens, including Senator Daniel Patrick Moynihan and former mayor Robert F. Wagner.[27] The proposal had its supporters as well, including Community Board 8 and the New York Chapter of the American Institute of Architects, who pointed out that many townhouse blocks in the historic district were punctuated by high-rise apartment buildings.

On October 27, 1981, the Landmarks Preservation Commission, by a vote of five to three, denied a certificate of appropriateness for the apartment building. But that ruling was not final until ratified by six commissioners, necessitating another vote two weeks later. Between the commission meetings, Paul Goldberger weighed in with his assessment of the situation, noting that after the creation of the new historic district, many had thought that "the commission's role would be fairly clear-cut—it was assumed that it would keep big white-brick apartment towers out of the neighborhood." But the Agrest & Gandelsonas design hardly fit into that category, "making a lot of people squirm" because "the tower is precisely the sort of sensitive design the landmarks commission has always wanted to encourage." Indeed, Goldberger had high praise for the proposal: "On purely architectural grounds . . . it is among the most promising residential projects to be proposed in some years." Disagreeing with Gill, Goldberger declared the design "an object lesson in architectural tact" and "no 'sliver' building, no representative of that wretched new genre of the cheap but tall apartment box squeezed into an expensive site. It is a tower that has the potential of rising freely and of making a relatively minor intrusion into the cityscape."[28] The Landmarks Preservation

Proposed 22 East Seventy-first Street, between Madison and Fifth Avenues. Agrest & Gandelsonas, 1981. East elevation. AAGA

Proposed Metropolitan Club Tower, 1 East Sixtieth Street, northeast corner of Fifth Avenue. James Stewart Polshek & Partners, 1986. Model, view to the north. Lieberman. PPA

Commission, on November 10, formally rejected the tower by a six-to-five vote, although some of those opposing the project noted that they did so with sadness. Significantly, the design was supported by the members of the commission who were architects, including Vice-Chairman William J. Conklin, Charles Platt, Elliot Willensky, and Anthony M. Tung.

At the southern end of the Upper East Side Historic District, the 1985–86 attempt by James Stewart Polshek to add a narrow tower atop an existing building, in this case McKim, Mead & White's Metropolitan Club (1894), 1 East Sixtieth Street, northeast corner of Fifth Avenue, a five-story white marble palazzo that was designated an individual landmark in 1979, also met with defeat.[29] Polshek's scheme, developed for Park Tower Realty, which planned to purchase 150,000 square feet of air rights from the financially strapped club, called for a thirty-seven-story apartment building rising above the club's ceremonial entry court on Sixtieth Street and atop the two-story library wing and six-story eastern annex, designed in 1912 by Ogden Codman Jr. The classical character of the 400-foot-tall limestone-clad tower, accented with copper details and featuring bay windows facing west toward Central Park and south over the annex, was surprising for Polshek, who typically hewed to a more conventionally Modernist line. The design was topped by a ten-foot overhanging

cornice complementing the prominent cornice of Stanford White's building. Although the proposed tower was set back from Fifth Avenue, one of its columns would still run through the clubhouse, and its construction would require the removal of forty-four feet of original cornice. The proposal was vehemently opposed by preservation groups and the owners of the neighboring Pierre Hotel (Schultze & Weaver, 1930), virtually against which Polshek's planned tower would rise, resulting in the loss not only of light and views on both its southern and eastern sides, but also of the hotel's iconic singularity on the skyline when viewed from Central Park. But Paul Goldberger defended the scheme: "The proposal is better than most of what gets built in this city, and better than almost any tower that has been put up beside or astride a landmark building." However, Goldberger did object to the scheme on grounds of overbuilding: "There is real architecture here—and, alas, questionable urban planning. The city, as it struggles to determine whether to let this tower go ahead, must choose between advocating good architecture at the price of more density, or quashing good architecture for the worthwhile sake of less density."[30] Although the landmarks panel praised Polshek's design as "thoughtful, careful and in many ways sensitive," they rejected the proposal on November 17, 1987, by a vote of 7 to 0, with two abstentions, concluding that it would fundamentally alter the character of the McKim, Mead & White building, leading to a "loss of [its] integrity."[31]

Recognizing that the diversity of the entire Upper East Side was threatened by the construction of new supersized apartment houses and by the fact that the closing of the Gold Coast to most new high-rises effectively intensified the pressure on the rest of the neighborhood, the Board of Estimate, on September 19, 1985, unanimously approved the most sweeping zoning changes since the passage of the 1961 law, effectively barring high-rise buildings from most of the area's side streets.[32] The new "contextual" zoning, similar to the measure passed the previous year on the West Side, reduced by a third the maximum permissible size of a building on the roughly 175 midblocks bounded by Fifth Avenue and the East River, Fifty-ninth Street and Ninety-sixth Street, with midblock being defined as that part of a side street more than 125 feet from an avenue. The rules required new buildings to line up with the facades of adjacent structures and restricted height to six stories (or eight if the top two were sufficiently set back from the street wall). The new regulations, developed out of fear of overbuilding, were designed to locate development along the avenues and the major crosstown streets. As Assemblyman Alexander B. Grannis stated in a public hearing before the Board of Estimate: "Everybody and their brother wants to build on the Upper East Side, and unless you stop them, they will."[33]

Barely two years after the passage of the new zoning regulations, a movement began to extend the downzoning to the major crosstown streets and the avenues from Third Avenue eastward.[34] Despite the initial reluctance of the City Planning Commission to extend the zoning reform, attention soon focused on a proposal to do away with the 20 percent plaza bonus in order to eliminate tall, thin towers that often sat isolated behind open spaces of no particular public value. According to the plan, the lower floors of buildings would rise between 60 and 100 feet, lining up with neighboring structures, and the upper floors would be set back, with 60 percent of the building's floor space concentrated on the first fifteen floors.

This would result in thirty- to thirty-six-story tower-on-a-base designs built to the street line, a formula that seemed more in keeping with the evolution of New York's urbanism. While the commission considered the proposal, a special committee was convened by *Oculus*, the newsletter of the New York Chapter of the American Institute of Architects. The committee worked with Michael Kwartler's Environmental Simulation Center of the New School for Social Research, a pioneer in the use of computer modeling for urban planning. Although no single proposal emerged from the collaboration, the committee was in regular contact with the City Planning Commission, serving as a sounding board for ideas as well as making suggestions for changes. According to Suzanne Stephens, *Oculus*'s editor, the committee emphasized "the need for a highly articulated tower—one in which the base and the tower, plus a transition zone between them, are carved with recesses to vary the massing of these potential behemoths."[35]

Opposition to the zoning changes predictably came from the real estate industry. Michael Slattery, representing the Real Estate Board of New York, argued that these changes would add to the cost of housing and reduce affordable housing. Architect Sherida Paulsen, in testimony before the City Planning Commission, protested that "the proposed rezoning would negatively affect the ability of developers to provide efficient apartment layouts and designers to create alternative spaces."[36] On February 9, 1994, after more than seven years of debate, the city finally approved the zoning changes, a decision that the editors of the *New York Times* endorsed as "sound new rules that [will] prevent developers from building any

more of those tall, skinny towers that New Yorkers have every reason to hate."[37] Although *Oculus* committee member Bruce Fowle was pleased that the "remarkable" measure was passed, he noted, "It will still be possible for a developer to construct an as-of-right building that is out of character with its neighborhood. . . . What is needed now are refinements of the new resolution to protect neighborhoods from bland, box-like towers, arbitrarily plopped on top of bland, box-like bases."[38]

Apartment Building Boom

In 1985, according to the Real Estate Board of New York, of the seventy-seven apartment buildings under construction in Manhattan below Ninety-sixth Street, fifty-four were being built on the East Side.[39] Apartment house construction had picked up progressively beginning in 1982, but the surge in multifamily residential development that came in 1985 was primarily a result of the city's decision to eliminate, for projects built between Fourteenth and Ninety-sixth Streets, the 421a benefits that since 1971 had given tax abatements to developers of luxury residences. In altering the 421a program, the city allowed projects with all necessary building permits and whose foundations were laid before the November 29, 1985, deadline, to remain eligible for the abatements—thereafter, only projects that set aside 20 percent of the units (either in the building or built elsewhere) for low- or moderate-income residents would receive the abatements. Anticipating the new law's enactment, developers rushed into action, triggering a mini-boom in apartment house construction throughout the Upper East Side but especially along Third Avenue

Trump Plaza, 167 East Sixty-first Street, northwest corner of Third Avenue. Philip Birnbaum, 1984. View to the northwest. McGrath. NMcG

Savoy, 200 East Sixty-first Street, southeast corner of Third Avenue. Philip Birnbaum, 1986. View to the southwest. McGrath. NMcG

where, the *New York Times* reported in March 1985, more than a third of the 9,000 apartments under construction south of Ninety-sixth Street were being built.

Along Third Avenue

Despite the fact that the elevated railroad had been demolished thirty years before and that many popular restaurants and boutiques were located along it, Third Avenue, the long-recognized boundary of the Upper East Side's Gold Coast, remained an unfashionable address. Though developers touted it as "the crossroads of New York's energy and elegance," they were still hesitant to attach Third Avenue addresses to their buildings, opting more often to take on side street addresses.[40] But after the early 1980s, when the enactment of historic districts in much of the Upper East Side drastically curtailed apartment house construction there, Third Avenue's fortunes began to change.

Third Avenue had experienced a building boom in the late 1950s, when many white brick–clad apartment buildings were rushed to completion to take advantage of prevailing entitlements under the 1916 zoning ordinance, soon to be replaced by the more restrictive 1961 ordinance.[41] But aside from Manhattan House (Skidmore, Owings & Merrill and Mayer & Whittlesey, 1950) at Sixty-fifth Street, Tower East (Emery Roth & Sons, 1962) at Seventy-second Street, and the brooding Ruppert Towers (Davis, Brody & Associates, 1975) between Ninetieth and Ninety-first Streets, Third Avenue was lacking in identifiable landmarks until, in a misguided attempt to create an unofficial gateway to the emerging Third Avenue residential corridor, Philip Birnbaum, the city's most prolific apartment house architect, designed two virtually identical buildings, one each for two of the city's most prominent developers, on sites diagonally opposite each other.[42] Whether Birnbaum's decision to twin his buildings was a result of urbanistic beau geste or artistic laziness would soon become the subject of public debate. Birnbaum's Trump Plaza (1984), 167 East Sixty-first Street, occupied the west blockfront of Third Avenue between Sixty-first and Sixty-second Streets. His Savoy (1986) 200 East Sixty-first Street, built for Morton L. Olshan, occupied the east blockfront of Third Avenue between Sixtieth and Sixty-first Streets. Completed first, Trump's building was planned, as Paul Goldberger described it, like a corner-balconied "stubby three-pointed star" of

Royale, west side of Third Avenue, between East Sixty-third and East Sixty-fourth Streets. Alfredo De Vido Architects, Schuman, Lichtenstein, Claman & Efron, and Voorsanger & Mills Associates, 1986. View to the northwest of plaza on East Sixty-third Street. McGrath. NMcG

limestone and glass horizontal bands rising thirty-nine stories from a two-story retail base topped by a bronze-tinted glass skylight. Goldberger, after accurately describing Birnbaum as the architect of "many of the city's most banal apartment buildings," noted that, working with Trump, he seemed to have created what "looks as if it might be the finest building in Caracas—all of this sleekness is chic in a particularly Latin way, quite uncharacteristic of New York, despite the lavish use of limestone. . . . No one looking at Trump Plaza's strong horizontals and rounded balconies could possibly mistake it for yet another Third Avenue high-rise."[43]

But when in 1984 construction commenced on the planned forty-two-story Savoy, the *New York Times* saw signs of impending trouble: "Looking at the rendering of the Savoy on the construction fence one gets the impression of a mirror image of Trump Plaza."[44] Olshan did not counter the claim, instead commenting, "They both have the same architect . . . and they complement each other making a sort of gateway to the northern residential area."[45] The differences, he noted, could be found in the squared, not rounded, balconies of the Savoy, and the provision of two public plazas at street level, as opposed to Trump's one. But the other details—the nearly identical plans of the towers, both of which rose over street-hugging retail bases, and the use of the same materials—were too much for Trump, who filed suit against Olshan and Birnbaum. It was hard to argue that Trump's claim to have wanted a distinctive building was false—an unusual clause in his contract with Birnbaum stated that the drawings were "not to be used for any other building."[46] In October 1984, an out-of-court settlement was reached whereby Olshan agreed to change the Savoy's design, eliminating the bronze glass, limestone cladding, and brass banding that likened it the most to Trump Plaza. But while the cladding was changed to stainless steel and glass, the Savoy's shape remained the same, so that the two buildings functioned as unidentical twin gateposts to the Third Avenue residential corridor—or to a boulevard in Caracas?

Ulrich Franzen & Associates' forty-nine-story uniformly colored, rather bland brown brick Bristol Plaza, 200 East Sixty-fifth Street (1987), occupying the east blockfront of Third Avenue between Sixty-fourth and Sixty-fifth Streets, was the anticlimactic result of a hard-fought community battle.[47] When initially planned, the 46,190-square-foot site was zoned for a thirty-two-story building on the avenue and a twenty-story building in the midblock. The developers, Paul Milstein and Robert Olnick, wanted to build an even taller building on the avenue to be able to offer the sweeping views that commanded the highest prices; their architects at the time, Davis, Brody & Associates, prepared a scheme intended to please community opponents, stepping the tower back from the avenue as it rose and giving it faceted glass northwest and southwest corners. The developers also offered to turn the midblock portion of the site into a 21,087-square-foot public park, proposing what amounted to a transfer of air rights from the midblock portion of the site to the avenue. In September 1983, Community Board 8 voted to support a forty-eight-story tower on the avenue as part of a memorandum of agreement with the developer, who had his sights set on a fifty-one-story tower with a total of 534,000 square feet. In either case, the building would be significantly higher in floor area than zoning allowed, requiring a variance that the Board of Standards and Appeals denied in August 1984.

Bristol Plaza, east blockfront of Third Avenue, between East Sixty-fourth and East Sixty-fifth Streets. Ulrich Franzen & Associates, 1987. View to the northeast. McGrath. NMcG

Kingsley, 400 East Seventieth Street, southeast corner of First Avenue. Stephen B. Jacobs & Associates, 1984. View to the northeast. SBJG

The developers, in turn, got to work on a new scheme designed by Ulrich Franzen that placed a one-story commercial building on Third Avenue with a forty-nine-story tower behind it and a twenty-one-story building, operated as a hotel, on the midblock portion of the site, eliminating the park completely. This plan went forward, but the built tower, despite glassy corners devised to evoke a residential character and dramatize views for tenants, struck the editors of the *AIA Guide* as "a stark intruder that gives little opportunity for the talents of its designer."[48] As a crown, the open-work faux mansard, soon crammed with electronic equipment, was unconvincing, to say the least.

Developer Ian Bruce Eichner's Royale (1986), 188 East Sixty-fourth Street, west side of Third Avenue between Sixty-third and Sixty-fourth Streets, came two years after his Kingsley apartment building (Stephen B. Jacobs & Associates, 1984), 400 East Seventieth Street, southeast corner of First Avenue. In both instances, before hiring an architect, Eichner enlisted marketing consultant Gilbert Charles Beylen to determine exactly what kind of building affluent New Yorkers would prefer.[49] For the Kingsley, a survey of 1,500 people determined everything from the building's amenities to floor sizes, brick color, and apartment layouts. The result was a 210-unit, forty-story beige brick tower set back on a 1,000-square-foot plaza wrapping the corner. Balconies, instead of being stacked one on top of another, were staggered from floor to floor to allow more light penetration. Stephen B. Jacobs described the design as being "reminiscent of Art Deco," a reference to the multitudinous setbacks at the building's top ten stories that were meant to give it a ziggurat-like silhouette.[50] Though Paul Goldberger called it "a step above the East Side boxes that surround it," he quipped: "Rounded balconies and a few setbacks at the top do not make for architectural distinction. The facade has exposed floor slabs, that hallmark of inexpensive construction, and details do not seem finished at a high level within."[51] For the Royale, Eichner assembled a team of architects and designers that included Alfredo De Vido Architects for the building's exterior, Schuman, Lichtenstein, Claman & Efron for the apartments, Voorsanger & Mills Associates for the lobby spaces, and Quennell Rothschild Associates for the landscape design of a slightly underscaled plaza on the Sixty-third Street corner.[52] Yet for all the talent brought to bear on it, the Royale was hardly an artistic success, despite the chamfered balconies and generous expanses of glass.

The needlelike Trump Palace (Frank Williams & Associates, 1991), 200 East Sixty-ninth Street, east blockfront of Third Avenue between Sixty-eighth and Sixty-ninth Streets, was, at

623 feet high, the tallest building on the Upper East Side when built, seventy-two feet taller than its nearest competitor in midtown, the Galleria (David Kenneth Specter, 1975).[53] Trump Palace was situated on a 42,175-square-foot site that extended 210 feet east of Third Avenue, replacing the ten-story home of the New York Foundling Hospital (1959), a Roman Catholic child welfare agency, which Trump bought in 1985 (the Foundling Hospital relocated to 590 Sixth Avenue, see Chelsea). The Coalition of East Side Neighbors, a community group, lobbied against redeveloping the Foundling site with a high-rise, but Trump was able to build his project as of right, though he eliminated a 1,900-seat, five-screen movie theater from the plan when he was unable to gain the requisite zoning variance. Trump Palace consisted of a 196-unit, fifty-six-story tower situated at the north end of the avenue blockfront, a one-story wing occupying the southern portion of the blockfront containing 10,300 square feet of retail space, and, to comply with the city's midblock zoning restrictions, eighty-six units in two rows of so-called townhouses—one eight stories tall extending along Sixty-ninth Street and one nine stories on Sixty-eighth Street, the latter separated from the tower by a public plaza. The needle-thin brick-clad tower was a welcome departure from the usual glassy glitz demanded of Trump's architects. Though Williams claimed his design was a tribute to Rockefeller Center's RCA Building (Associated Architects, 1933), it seemed more closely connected to such Moderne skyscraper apartments as the Century (Irwin Chanin, Jacques Delamarre, and Sloan & Robertson, 1931), the Majestic (Irwin Chanin, Jacques Delamarre, and Sloan & Robertson, 1930), and, in the handling of the crenellated three-tiered crown of white and rose brick, to Sloan & Robertson's Chanin Building (1928). A lively pattern of windows and balconies added interest to the telescopic tower, which proved to be just the kind of landmark Third Avenue needed, though Herbert Muschamp did not see its bravura in positive terms, agreeing in essence with Kenneth Koyen, a neighbor of the tower, who called it "as appropriate as an asparagus spear on a golf green."[54] Muschamp took issue with several aspects of the design, beginning with the detailing at the base, which he castigated as "tacky Art Deco trim." He also felt that the brick walls, "glamorous from a distance, look cheap up close." To Muschamp, Trump Palace was "a building that possesses star power but lacks a significant urban role," making "little effort to fit into its surroundings."[55]

Trump Palace, whatever its faults, was a work of architectural consequence—certainly by comparison to the string of banalities and near-banalities that were thrown up along Third Avenue in the 1980s. These included the thirty-one-story Turnberry Tower (1984), 1430 Third Avenue, west side between Eighty-first and Eighty-second Streets, a tan brick building designed by the firm of Wechsler, Grasso & Menziuso with balconies on the east and west facades and cantilevered shafts of windows on the north and south sides.[56] Directly across the avenue was Le Trianon (Liebman Liebman Associates, 1985), 1441 Third Avenue, a twenty-four-story orange brick building developed by Robert Batz that sat back from the sidewalk on its midblock site, rising with a central

FACING PAGE Trump Palace, 200 East Sixty-ninth Street, east side of Third Avenue, between East Sixty-eighth and East Sixty-ninth Streets. Frank Williams & Associates, 1991. View to the northeast. Pottle. ESTO

200 East Eighty-seventh Street, southeast corner of Third Avenue. John Ciardullo Associates, 1992. View to the southeast showing the Colorado (Emery Roth & Sons, 1986) in background right. Wright. JCA

column of rectangular balconies to a misconceived gable roof.[57] The absolute lack of distinction of so many of the apartment towers of the time was made all too clear when the perpetrator of a great deal of them, Philip Birnbaum, described his yawningly conventional project at 171 East Eighty-fourth Street (1985), northwest corner of Third Avenue, a thirty-five-story tower set back on a two-story limestone base, as a "typical" East Side high-rise.[58]

In the late 1980s, block after block of Third Avenue seemed to give way to new construction. For example, both sides of the avenue between Eighty-sixth and Eighty-seventh Streets were almost entirely rebuilt, leaving only a pair of five-story tenements and a single-story taxpayer. Emery Roth & Sons' Colorado (1986), northeast corner of Eighty-sixth Street, a drab, thirty-seven-story, two-tone gray brick apartment building rising as two chamfer-cornered towers connected by a recessed two-bay-wide section allowing, in all, the provision of twelve corners, replaced a long-standing Woolworth's store but provided ample room for a new one in its 24,000-square-foot, five-story retail base.[59] During construction of the Colorado, Norman Segal, the developer, announced plans to build a similar tower on the northern portion of the blockfront rising twenty-eight stories from a two-story base. But when the project was granted an additional 30,000 square feet in exchange for providing a gymnasium for the nearby Dalton School, it was redesigned. As built, the 131-unit apartment building, 200 East Eighty-seventh Street (1992), designed by John Ciardullo, happily deviated in form

Gotham, 170 East Eighty-seventh Street, southwest corner of Third Avenue. Frank Williams & Associates, 1992. View to the southwest. Goldberg. ESTO

from the urbanistically disengaged tower of the Colorado, meeting the sidewalk with a two-story retail base above which its sheer mass rose to fourteen stories before a series of wedding cake setbacks brought the building to a total of twenty-two stories.[60] The beige-colored brick building was saved from monotony by irregular fenestration where the 32,000-square-foot Dalton Physical Education Center (Fox & Fowle Architects), comprising two gymnasiums, a wrestling room, and a training and sports therapy room, occupied the third through seventh floors, with apartments on the eighth through twenty-second floors. Directly across Third Avenue, on the west blockfront, Frank Williams & Associates' Gotham (1992), 170 East Eighty-seventh Street, a twenty-seven-story, 241-unit apartment building, was of greater interest than most of Third Avenue's typically run-of-the-mill work.[61] Occupying an L-shaped site that formerly housed a movie theater, the Gotham was geared toward affluent young professionals and families, offering fireplaces in many apartments, numerous duplexes, and a floor plan arranged to facilitate the combination of smaller units to form large suites. A swimming pool and health spa for residents was located below grade, as was a new seven-screen cinema entered from Third Avenue. The building's almost overwhelming bulk was mitigated by a central, three-bay-wide stack of recessed balconies on the Third Avenue facade and a series of two-bay-wide recesses along Eighty-seventh Street faced in red brick to contrast with the otherwise beige brick and stone exterior. The fifteenth and sixteenth floors, set back from the street wall, were lined with red brick piers, suggesting a loggia. Above that, eleven more stories rose in two-story incremental setbacks culminating in an octagonal lantern enclosing the water tank, an element Williams had previously used, in a more prominent but less refined way, in his Alexandria apartment building on the Upper West Side.

Upper Yorkville

Upper Yorkville, the area bounded by Eighty-sixth and Ninety-sixth Streets, from Third Avenue to the East River, was perhaps the most dramatically transformed district on the Upper East Side. In May 1984, the New York Times reported that seven new apartment buildings were in the works for the blocks between Ninety-third and Ninety-sixth Streets, Second to Third Avenue.[62] Many others around the area were in various stages of planning. To August Heckscher, chairman of CIVITAS, a neighborhood watchdog group, and a former parks commissioner, "the fear is that we will get a wall of 34-story buildings on East 96th Street when we need low-rise development and relief from the sense of tension you get from these towers."[63]

Perhaps the most threatening and the most egregiously out-of-scale project erected in Upper Yorkville was Normandie Court (Abraham D. Levitt Associates/The Vilkas Group, 1985–86), a row of four nearly identical thirty-four-story buildings—three joined to form an immense slab and one standing alone perpendicular to the others—occupying the entire block bounded by Third Avenue, Ninety-sixth Street, Second Avenue, and Ninety-fifth Street.[64] Though the complex could be built as-of-right, CIVITAS and other local groups opposed the development, going so far as to hire the urban planners Buckhurst Fish Hutton Katz to prepare an alternative design that called for high-rise towers on the avenues, fifteen- to twenty-story buildings along Ninety-sixth Street, and lower-rise structures on Ninety-fifth Street, all separated by public plazas. That plan, however, would not be considered by the developers, Milstein Properties, because according to current zoning, it would have required a variance, thereby delaying the project. Ironically, the size of the project had a precedent in the London Terrace apartments (Farrar & Watmaugh, 1930)—which also occupied a full block.[65] But London Terrace closely respected the street, had an internal landscaped courtyard, and was so subtly massed and lavishly detailed that its enormity—1,670 apartments—was not a problem. Normandie Court, on the other hand, consisted of coarsely conceived, indifferently sited, red and tan brick monoliths in which were packed 1,480 apartments that were advertised in 100 college newspapers around the country to attract recent graduates, who flocked to it as a port of entry to the New York scene and commonly referred to it as "Dormandie Court." Diagonally across the street, Costas Kondylis's hulking Monterey (1994), occupying a 35,000-square-foot site at 175 East Ninety-sixth Street, northwest corner of Third Avenue, was also bulky, cramming 522 apartments into a twenty-nine-story, 500,000-square-foot pile with alternating bands of pink brick and brown tinted glass.[66] But the sweeping curve of its massing, even bolder than Wechsler & Schimenti's at 200 Central Park South (1964), established a gateway to East Harlem, especially for motorists proceeding north on Third Avenue. For neighborhood residents, a 7,680-square-foot French-style public garden designed by Weintraub & di Domenico amounted to what the editors of the AIA Guide called a "substantial" payback, provided in exchange for extra footage.[67]

In August 1981, the Koch administration announced that the Enterprise Development Group, with Davis, Brody & Associates as architects, had been selected to build on the east blockfront of Third Avenue between Ninety-third and Ninety-fourth Streets, a 1.5-acre plot that constituted the second and

final piece of the Ruppert Urban Renewal Area, bounded by Ninetieth and Ninety-fourth Streets, Third and Second Avenues.[68] Occupied by the Jacob Ruppert Brewery until its closure in 1965, the Ruppert Urban Renewal Area was redeveloped so that by 1975 three large-scale housing projects—Yorkville Towers, Knickerbocker Plaza, and Ruppert Towers—were completed on the southern three blocks of the four-block swath, all designed by Davis, Brody & Associates.[69] Of the nine proposals submitted for the final parcel in 1981, the team working with the architect Ulrich Franzen had gained the unanimous support of Community Board 8 and was expected to win the job. Franzen's proposal for a thirty-story slab situated along Ninety-third Street with a lower, nine-story section wrapping the corner of Third Avenue and Ninety-fourth Street was thought to create a better transition to the lower-scaled community north of Ninety-fourth Street (Normandie Court had not yet been conceived), but it was Davis, Brody's proposal for a thirty-story L-shaped tower on the corner of Third Avenue and Ninety-fourth Street, and a long, lower wing running east along Ninety-fourth Street that won the competition, largely because of the provision for a landscaped interior courtyard and larger apartments to accommodate families. Completed in 1986, the final Ruppert build-

ing consisted of three components—market-rate rental apartments, subsidized housing units, and housing for the elderly—built by two separate developers both using Davis, Brody to achieve a cohesive design, although the selection of three different architects might have helped modify the institutional character of the development. The largest building was the market-rate Carnegie Park, 200 East Ninety-fourth Street, southeast corner of Third Avenue, a thirty-story, 460-unit L-shaped red brick tower with rounded corners and horizontal banded windows flanked by nine-story wings running along Third Avenue and Ninety-fourth Street. A separate nine-story red brick building containing housing subsidized by the market-rate rentals sat on the northeast corner of the site. Completing the trio and enclosing an interior landscaped courtyard was the Arthur B. Brown and Thomas Brown Gardens building, a twelve-story apartment house developed by the New York Foundation for the Elderly, located in the midblock along Ninety-third Street with punched windows and alternating bands of red and light red brick. Abutting the Carnegie Park project on the eastern portion of the block, fronting Second Avenue, was Schuman, Lichtenstein, Claman & Efron's thirty-two-story Astor Terrace (1985), 245 East Ninety-third Street, a brooding, dark red brick tower with

Normandie Court, block bounded by Second and Third Avenues, East Ninety-fifth and East Ninety-sixth Streets. Abraham D. Levitt Associates/The Vilkas Group, 1986. View to the northwest. McGrath. NMcG

Monterey, 175 East Ninety-sixth Street, northwest corner of Third Avenue. Costas Kondylis, 1994. View to the northwest. McGrath. NMcG

Carnegie Park, 200 East Ninety-fourth Street, southeast corner of Third Avenue. Davis, Brody & Associates, 1986. View to the southeast. George. FGP

Waterford, 300 East Ninety-third Street, southeast corner of Second Avenue. Beyer Blinder Belle and Vinjay Kale, 1987. View to the southeast. McGrath. NMcG

exposed concrete floor slabs slightly set back from Second Avenue above a 15,000-square-foot retail base.[70]

Occupying a smaller footprint and quite out of scale with its neighbors, the Monarch (Schuman, Lichtenstein, Claman & Efron, 1986), 200 East Eighty-ninth Street, southeast corner of Third Avenue, an unmemorable, beige brick, balconied, forty-four-story slab, was at its completion the tallest residential building north of Seventy-second Street.[71] Rather more interesting, the Waterford (Beyer Blinder Belle with Vinjay Kale, 1987), 300 East Ninety-third Street, southeast corner of Second Avenue, was a slender forty-eight-story dark gray and blue glass slab with west-facing balconies and stacked bay windows on the upper floors. An awkwardly perched concrete prowlike protrusion near the building's peak supported a red mechanical equipment enclosure. Although a building of no particular aesthetic distinction, 108 East Ninety-sixth Street (Schuman, Lichtenstein, Claman & Efron, 1986–94), between Park and Lexington Avenues, was not without interest as the

result of a complex legal case revolving around an issue of zoning.[72] As the building was under way, Genie Rice, the president of CIVITAS, observed that it was rising above the nineteen stories she believed were allowable under zoning. It was soon determined that Rice was correct in her suspicion that the building was twelve stories taller than zoning permitted. The problem, argued the developers, Parkview Associates, was a misunderstanding on the part of the architects, who had used a zoning map that did not clearly depict whether or not the site lay within a special zoning district that extended 150 feet east of Park Avenue. In fact, the site straddled two zoning districts. In July 1986, the Buildings Department issued a stop-work order, but construction was allowed to continue while the developer appealed the ruling. On October 14, with the building's shell complete but the interior still raw, the Board of Standards and Appeals ruled that in fact the building did not comply with zoning and that its top twelve stories would have to be removed. The developers appealed once again and

the building sat vacant through February 1988, when the New York State Court of Appeals upheld the lower court's ruling.

The situation soon took on political dimensions. In May 1988, the editors of the *New York Times* offered their advice on how to properly and "constructively" punish the developers. Instead of requiring the removal of the floors, the editors argued, Parkview should be "required to rebuild 100 city-owned apartments with the [money] it would spend on demolition. . . . Instead of insisting on destruction, the city would gain badly needed housing for the poor."[73] The editors of the *New York Observer* took a different tack: "The issue here is not one of violation, but the integrity of our zoning law. To require the demolition of those 12 illegal floors would be a civic victory."[74] The seldom modulated Mayor Koch, who had been so outraged when he first heard of the violation that he said he would remove the extra floors himself brick by brick, reversed his opinion in August 1988: "There are people who don't want any resolution other than whack off the top 12 stories. When you have such a housing shortage, that doesn't make any sense."[75] Parkview, facing the collective opposition of numerous civic groups and seven community boards, including one from Queens, took the path advocated by the *Times*, entering into talks with St. Francis de Sales Church, located across the street from the building, that raised the possibility of rehabilitating two five-story buildings on East 102nd Street as housing for low- and moderate-income elderly citizens.

But on October 3, 1988, the United States Supreme Court declined to hear the appeal, effectively upholding the decision of the lower court and forcing the developer to make a last-gasp attempt to gain a variance based on economic hardship from the Board of Standards and Appeals. The board did not grant the variance, and in 1991 the developers finally accepted their fate, agreeing to dismantle the building's top twelve stories, a difficult task requiring the removal of approximately 3,000 tons of debris. As part of the settlement, Parkview was allowed to build a nineteen-story, two-bay-wide addition on the vacant lot abutting the building to the east and would receive a thirteen-year property tax exemption on the original structure. Demolition began in March 1993, seven years after the excess floors were erected. With one floor coming down each week, the process marked all too literally the collapse of the real estate market.

Carnegie Hill

Carnegie Hill, bounded roughly by Fifth and Third Avenues, Eighty-sixth and Ninety-sixth Streets, was one of the first neighborhoods in the city, and the first on the Upper East Side, to be designated a historic district, on July 23, 1974 (the boundaries were extended on December 21, 1993).[76] Though Carnegie Hill had very few sites available for new large-scale construction, a notable exception was the group of tenements (1331 and 1335 Madison Avenue and 60 East Ninety-fourth Street) on the southeast corner of Madison Avenue and Ninety-fourth Street that gave way to the thirty-two-story Carnegie Hill Tower (Edward V. Giannasca, in association with Philip Birnbaum, 1983), 40 East Ninety-fourth Street.[77] The seven-sided chamfer-cornered pale brick and brown-tinted-glass apartment house containing 223 units and 5,000 square feet of ground-floor retail space dwarfed its neighbors, although it attempted to make up for its immensity with a landscaped mews tucked away in the back and featuring a semicircular waterfall, brick paving, and clusters of trees and benches.

Developers had long eyed a second Carnegie Hill site, northeast corner of Ninety-first Street and Madison Avenue, occupied by a vaguely Georgian one-story bank building (Lusby Simpson, 1950), which had replaced two five-story apartment buildings. The sixty-eight-by-sixty-eight-foot site had been generally regarded as too small for a profitable project until February 1999, when the city's seemingly insatiable appetite for high-end residential real estate emboldened Tamarkin Architecture and Development to announce plans to build a sixteen-story apartment house above the building, originally constructed for the First National City Bank and now occupied by its successor, Citibank.[78] The proposal drew far more than the usual amount of publicity and controversy, mainly because of the star power of one of its opponents, the filmmaker and quintessential New Yorker Woody Allen, who in 1998 had moved into a double-width Georgian townhouse at 48 East Ninety-second Street (James C. MacKenzie Jr., 1931–32), the garden of which abutted the site.[79]

The proposed design, by Platt Byard Dovell Architects, would use the red brick bank building, reclad in limestone, as the base of a 190-foot-tall tan brick tower set back above the tenth floor. To overcome the disadvantages of the site's small footprint, the building would contain only nine units—all duplexes. The west and south facades would incorporate recesses and steel casement windows that, according to the architect, Charles A. Platt, would add

108 East Ninety-sixth Street, between Lexington and Park Avenues. Schuman, Lichtenstein, Claman & Efron, 1986–94. View to the southwest, 1993. CIV

Proposed 47 East Ninety-first Street, northeast corner of Madison Avenue. Platt Byard Dovell Architects, 1999. West elevation. PBDW

Proposed 47 East Ninety-first Street, northeast corner of Madison Avenue. Platt Byard Dovell Architects, 2000. West elevation. PBDW

Proposed 47 East Ninety-first Street, northeast corner of Madison Avenue. Platt Byard Dovell Architects, 2001. West elevation. PBDW

"texture and expression" to the facade.[80] The tower, which gained five floors by using the air rights of an adjacent townhouse, would be capped by a two-story glazed penthouse and an exposed water tower. Because the site lay within the Expanded Carnegie Hill Historic District, the plans had to be approved by the Landmarks Preservation Commission, a prospect local residents were intent on preventing. Numerous civic groups spoke out against the design, including the newly formed Citineighbors Coalition of Historic Carnegie Hill, the Municipal Art Society, CIVITAS, and Friends of the Upper East Side Historic Districts, which specifically criticized the lack of window openings on the second level, the bleakness of the rear facades, which were visible from many neighborhood vantage points, and the glassiness of the penthouse.

The battle gained more publicity when, in preparation for a February 8 hearing at the Landmarks Preservation Commission, Woody Allen made a short video showcasing the merit and charm of Carnegie Hill. When the commission ruled that the video could not be shown at the hearing, Allen added music and narration and distributed it to the twelve commissioners himself. The night before the hearing, a group of local residents, including the actors Kevin Kline and Paul Newman, placed a wreath in front of the Citibank building to symbolize the death of the neighborhood. The next day, Allen testified to a standing-room-only crowd, much to the dismay of the developers, whose lawyer commented, "When Woody

47 East Ninety-first Street, northeast corner of Madison Avenue. Platt Byard Dovell Architects, 2004. View to the northeast. PBDW

Allen walked into the hearing room, all eyes turned to the door he walked in through and away from the historic preservation consultant who was speaking on our behalf."[81] On June 13, 2000, the commission rejected the plan.

In December 2000, a new design optimistically given the address of 47 East Ninety-first Street was put forth calling for a ten-story tower to rise above the single-story base for a total of eleven stories—seventy-two feet shorter than the previous scheme. Also clad in tan brick with limestone trim, the building still housed nine apartments but only the penthouse would be a duplex. The design gained the support of nearly every civic group that had opposed the first scheme with the exception of the celebrity-filled Citineighbors group and the community board, which voted in March 2000 not to support it. Lisa Kersavage, executive director of Friends of the Upper East Side Historic Districts, testifying at the April 3 landmarks hearing, called the design "contextual to the Carnegie Hill Historic District yet contemporary in spirit. While the . . . previous proposal was trying to be tall and glamorous, this building is its plain cousin; humble but with surprising depth."[82] The commission approved the design contingent on the removal of one story, leading to the final design, released in November 2001, calling for a nine-story tower—one apartment per floor—with a single-story penthouse. Commissioner Sherida Paulsen called what was at this point a simple Indiana limestone and tan sand-cast brick building with corner windows, a "very elegant . . . contextual building that is inspired by the French flat apartments throughout Carnegie Hill."[83] In 2002 Citineighbors filed suit to stop construction of the building, but New York State's Court of Appeals dismissed the lawsuit. James Gardner found a happy ending to the story, calling the apartment building, completed in 2004, "an adornment to its neighborhood" that "occupies its corner extremely well."[84]

The Far East Side

East of Third Avenue lay block after block of old and new law tenements interspersed with comparatively modest six- to twelve-story apartment houses as well as schools, firehouses, and religious buildings. The neighborhood was home to families, the elderly, and a constantly changing population of young people, many new to the city, who gave the area its special vitality, supporting storefront self-service laundromats, tailor shops, hairdressers, and, most of all, along Second and First Avenues, casual eateries that stayed open late into the evening, spilling out into sidewalk cafés in summer. To developers, the tenements that housed the residents and the shops were "soft sites" that made this formerly fringe area the likely target of expansion for so-called luxury apartment buildings that had been blocked from the traditional Upper East Side by the creation of historic districts.

Amid the predominant tenements were enclaves of luxury, most notably along East End Avenue, which was developed in the 1920s and expanded in the 1950s and 1960s.[85] This established neighborhood, combined with the presence of Rockefeller University and New York Hospital as well as other medical institutions between York Avenue and the East River in the Sixties, meant that very little waterfront was available for prime development. One exceptionally located, sizable soft site remained, occupied by the City and Suburban Homes, Seventy-eighth to Seventy-ninth Street, York Avenue to the

FDR Drive, which Peter Kalikow sought to redevelop in April 1985, proposing to demolish the fourteen six-story courtyard apartment buildings built to house families of modest means between 1901 and 1913 by the City and Suburban Homes Company and designed by three architectural firms—Harde & Short, Percy Griffin, and Philip Ohm—and replacing them with 1,676 rental units in four forty-six-story apartment buildings designed by Eli Attia.[86]

The project would require the displacement of more than 1,200 rent-regulated tenants. Instead of the typical practice of paying the current residents to move, Kalikow wanted to evict them, a long-shot strategy that was technically possible if the developer was able to meet several stringent requirements, including the relocation of the existing tenants as well as a demonstration of financial hardship. Reaction from residents, the neighborhood, and almost the entirety of the city's political establishment was swift and so overwhelmingly negative that within six months Kalikow drastically scaled back his plans, calling for the demolition of only four of the walk-up buildings near the river, where he proposed to build a single sixty-five-story-tall, 1,425-unit apartment tower, also designed by Attia. Kalikow's reduced plans, displacing approximately 400 people, were still vigorously opposed. A coordinated effort to save the experimental working-class development quickly developed, focused on the goal of getting the entire complex officially landmarked, a hope buoyed by the recent decision of the Landmarks Preservation Commission to grant protection to the East River Houses, a group of model tenements located just to the south.[87] But that development of four courtyard apartment houses, which the City and Suburban Homes Company purchased in 1924, was clearly of a much greater architectural distinction than the comparatively bland stone and terra-cotta-accented buff Milwaukee brick complex to the north. Nonetheless, the coherence of the Seventy-eighth to Seventy-ninth Street group, combined with the fact that they provided affordable housing to so many families, made for a powerful argument in favor of their preservation.

On April 24, 1990, the Landmarks Preservation Commission unanimously designated the apartment complex a landmark. Kalikow, who actively campaigned to have the decision reversed by the Board of Estimate, was rewarded for his efforts when the board, in literally its last meeting before being disbanded, revoked the designation of the four easternmost buildings in a six-to-five vote, marking only the twelfth time that a decision by the landmarks commission had been overturned. Kalikow's plans for a single tower replacing the four buildings remained in place, but the size of the building was increased to eighty-one stories, which would have made it the tallest building on the Upper East Side. Although the State Supreme Court upheld the Board of Estimate's ruling, on May 19, 1992, the Appellate Division unanimously overruled the decision, arguing that the Landmarks Preservation Commission "had designated the complex as a 'landmark site' and not 14 individual buildings. The position that a part of the complex should be considered worthy of designation as a landmark for its historical, architectural, cultural and esthetic value, and part should not, is inherently inconsistent."[88] By this time it didn't much matter to Kalikow, who had been forced to declare bankruptcy the previous year. Subsequent owners rehabilitated the complex's heating, plumbing, and electrical systems.

The Promenade (1987), 530 East Seventy-sixth Street, west side of the FDR Drive extending to East Seventy-fifth Street,

ABOVE Proposed City and Suburban Homes redevelopment, East Seventy-eighth to East Seventy-ninth Street, FDR Drive to York Avenue. Eli Attia, 1985. Rendering of view to the southwest. EAA

RIGHT Proposed City and Suburban Homes redevelopment, East Seventy-eighth to East Seventy-ninth Street, FDR Drive to York Avenue. Eli Attia, 1985. Site plan. EAA

EAST END AVE.

EAST 79 STREET

YORK AVE.

F.D.R. DRIVE

EAST 78 STREET

CHEROKEE PLACE

JOHN JAY PARK

0 40
 20 80

EXHIBIT C

PROPOSED SITE DIAGRAM

Promenade, 530 East Seventy-sixth Street, west side of the FDR Drive, extending to East Seventy-fifth Street. Philip Birnbaum & Associates, 1987. View to the southwest. Mauss. ESTO

was designed by Costas Kondylis of Philip Birnbaum & Associates to maximize river views.[89] The thirty-eight-story charcoal gray concrete and gray glass building with bands of gray brick and stainless steel was divided into thirds so that it appeared as a trio of round-edged joined towers that grew narrower and glassier from west to east. The base of the Promenade provided a new auditorium, kitchen, and classrooms for the adjacent Town School, a private elementary school, one of whose buildings, on Seventy-sixth Street, was replaced with the Promenade's sixty-foot-high granite street facade featuring an overscaled archway that reflected Philip Johnson's at the AT&T Building.

Despite the attractions of the few river-facing sites, the most viable location for high-end apartments proved to be Seventy-second Street east of Third Avenue, where the Wellesley, 200 East Seventy-second Street (Philip Birnbaum &

Associates, 1979), southeast corner of Third Avenue, a completely bland, thirty-six-story, 432-unit dark red brick box was followed by the Knickerbocker (1996), 308 East Seventy-second Street, southeast corner of Second Avenue, a twenty-one-story red brick apartment building, and Le Chambord, 350 East Seventy-second Street, between First and Second Avenues, designed by Costas Kondylis of Philip Birnbaum & Associates (1987), which featured a two-story rusticated limestone base with a jokily scaled oculus-flanked entrance above which a row of double-height arched windows related to a four-story-high arch at the building's summit containing recessed balconies for the four penthouse duplexes.[90] The Oxford (Emery Roth & Sons, 1990), 422 East Seventy-second Street, between First and York Avenues, was, at forty-four stories, one of the few midblock high-rises erected after a zoning ordinance outlawed so-called sliver towers on most Upper

East Side streets, with the exception, among a few other areas, of the six blocks south of Seventy-second Street between First and York Avenues.[91] Rising on a T-shaped through-block site, the Oxford was set back sixty-five feet from Seventy-second street on a plaza designed by Thomas Balsley Associates, while on Seventy-first Street the tower rose from a 225-foot-wide, one-story base set back fifteen feet from the street that housed a 9,500-square-foot terrace on its roof. The glassy, balconied building was enlivened at the top by setbacks at every floor on the north facade and a steeper series of multistory setbacks on the south side.

The block on the Far East Side that was most dramatically transformed during the 1980s and 1990s was Seventy-second Street between York Avenue and the FDR Drive, beginning with the completion in 1985 of River Terrace, 515 East Seventy-second Street, a forty-one-story, 485,000-square-foot residential high-rise developed by Harry Macklowe.[92] Designed by Schuman, Lichtenstein, Claman & Efron, River Terrace received a 20 percent floor area bonus under the city's housing quality ordinance because it provided amenities such as a pool, squash courts, windowed laundry rooms and corridors, and walk-in closets. At ground level, a red brick–fronted arcade paralleled the sidewalk. Above, the profusely balconied box rose with shallow setbacks on the east facade at the thirteenth, twenty-second, and thirty-first floors. A clockface on both the north and south facades sat beneath a mansard roof concealing mechanical equipment. To satisfy community members concerned about the loss of still-active manufacturing businesses on the site, Macklowe integrated into the project a 37,000-square-foot manufacturing building along Seventy-third Street, the roof of which was landscaped as a terrace reserved for tenants of the apartment building.

The Belaire (Frank Williams & Associates, 1988), 524 East Seventy-second Street, was erected on a site owned by the Hospital for Special Surgery.[93] In exchange for the property, William Zeckendorf Jr., who developed the Belaire in partnership with the Japanese company Kumagai Gumi, agreed to build new facilities for the hospital in the base of the building. Ulrich Franzen & Associates designed the hospital facilities, which filled the tower's lower fourteen floors with 103 below-market-rate rental apartments, offices, and a computer center entered on Seventy-first Street across a sunken landscaped plaza organized around a polished granite fountain. The tower's not unattractive red brick exterior and the 189 condominiums that occupied its fifteenth through fortieth floors were glassier than the lower floors.

At the choice riverfront end of the block, One East River Place (Davis, Brody & Associates, 1988), 525 East Seventy-second Street, southwest corner of the FDR Drive and East Seventy-third Street, was a 521,000-square-foot, forty-nine-story apartment building.[94] Its 28,000-square-foot L-shaped site—formerly home to a gas station, a parking lot, and a six-story apartment building—ran through the block, providing a Seventy-second Street address that gave the building considerably more cachet than if it were associated with the perceived shabbiness of Seventy-third Street's eastern extremities. Developed by Sheldon Solow, the slablike, charcoal gray glass tower, situated east–west on its site, tapered in plan to better orient apartments to southeast views over the river. Deep notches in the west facade and in the narrower east facade contained windows that allowed light to penetrate through to the interior corridors. According to architect Lewis Davis, the uniformity of the glass skin was partially in deference to the seven tenements at 527–541 East Seventy-second Street (1894), dubbed the "black and whites" because of the decorative scheme of painting that had been adopted when they were renovated by Sacchetti & Siegel in 1938.[95] The landscape architecture firm Zion & Breen was retained to design One East River Place's 4,900-square-foot courtyard, a rectangular space on Seventy-second Street. High-branching trees, rough-stone block pavers, Bertoia tables and chairs, and a stepped waterfall at the park's north end recalled the same firm's highly regarded Paley Park (1966) on East Fifty-third Street.[96]

While most of the development on the Far East Side took place around Seventy-second Street, activity was also concentrated in the East Sixties. Gruzen & Partners' darkly elegant forty-six-story, round-cornered, black glass–covered 265 East Sixty-sixth Street (1978), northwest corner of Second Avenue, was developed by Sheldon Solow, who in 1984, as part of the project, built a row of eleven townhouses, 222–242 East Sixty-seventh Street (see below), on the rear of the L-shaped site.[97] The tower benefited in size from the unused air rights above the townhouses as well as from the provision of two small plazas on Sixty-sixth and Sixty-seventh Streets and a plaza along Second Avenue, each one offering access to, respectively, the apartment tower, medical offices housed in the base of the building, and twin 500-seat basement-level movie theaters. The 301-unit building offered what was said to be the

River Terrace, 515 East Seventy-second Street, between the FDR Drive and York Avenue. Schuman, Lichtenstein, Claman & Efron, 1985. View to the northeast. MP

city's most glamorous laundry room, a spacious forty-fifth-floor aerie facing northeast toward the East River, strategically located next to the health club and one floor below an indoor swimming pool. Charles K. Gandee, writing in *Architectural Record*, had mixed feelings about the building, calling it "decidedly out of scale with the neighborhood" and pointing out that "the three plazas at the building's base provide questionable amenity for the public. If you consider this building as an independent entity, as an architectural object, it is an elegant, refined, and admirable example of Modern architecture executed with notable finesse. But within its urban context, this tower points to the pressing need for comprehensive urban planning and more stringent zoning regulations."[98]

The Memphis Uptown (later renamed the Evansview), 305 East Sixtieth Street, between First and Second Avenues, running through to Sixty-first Street (1987), designed by Abraham Rothenberg and the Gruzen Partnership, was developed by Aaron Green, who also was responsible for the Memphis Downtown (see Greenwich Village).[99] The name Memphis referred not only to the Egyptian city founded around 3100 B.C. but to the design movement founded in 1981 by the Italian architect Ettore Sottsass, known for its combination of explosive color and elementary geometry manifest primarily in furniture and product design. Accordingly, the Memphis Uptown, a thin forty-story apartment tower, was clad in white and black brick with yellow and green balcony

Memphis Uptown, 305 East Sixtieth Street, between First and Second Avenues. Abraham Rothenberg and the Gruzen Partnership, 1987. View to the northeast. McGrath. NMcG

Rio, 304 East Sixty-fifth Street, southeast corner of Second Avenue. Gruzen Partnership, 1988. View to the southeast. GS

railings and blue ventilation grills all meant to elicit "architectural emotion," in the words of Green.[100] A red pitched roof inspired Carter Horsley to dub the Memphis Uptown "the city's cutest high rise apartment tower."[101]

In 1988 the Gruzen Partnership completed the Rio, 304 East Sixty-fifth Street, southeast corner of Second Avenue, a forty-story, 150-unit building.[102] The plum-colored brick tower rose with notched corners and bold circular balconies on the lower half and arced balconies and angled dark-glass bay windows filling in the notched corners above. Though clunky, the building was dynamic in comparison with many of its contemporaries. Schuman, Lichtenstein, Claman & Efron's twenty-story, 127-unit Pearl (2000), 400 East Sixty-sixth Street, southeast corner of First Avenue, as a consequence of its exterior design, with thin chevron-profiled piers of limestone and cast stone rising from a one-story retail base, resembled an office building.[103] Buck/Cane Architects designed the building's lobby and corridors.

While the size of most sites in the East Sixties was limited, in 1986 Jeffrey Glick announced his intention to develop a 2.3-acre plot he had assembled on the east side of First Avenue between Sixtieth and Sixty-first Streets with a 1.6-million-square-foot mixed-use project consisting of two forty-nine-story towers housing 520 apartments, a luxury hotel, a health club, commercial and office space, and six movie theaters.[104] Glick had put the site together piece by piece in 1985 and then spent two years meeting with community groups to build support for the project, which he hoped would transform the block's melange of gas stations, garages, and small-scale manufacturing and commercial buildings into, as Glick put it, "a new community."[105] Glick's plan, designed by Costas Kondylis of Philip Birnbaum & Associates, with Clark, Tribble, Harris & Li designing the commercial spaces and Thomas Balsley Associates in charge of the landscaping, called for two round-cornered L-shaped towers clad in bands of limestone and light-gray-tinted glass and capped by aluminum domes that would be illuminated at night. Separated by 100 feet at their peaks, the towers would be joined by a limestone and granite base with Palladio-inspired arches and oculi containing a health spa entered from Sixty-first Street. The twenty-seven floors of apartments would begin at the thirteenth story, with the base of the western tower occupied by twelve floors of offices and those in the eastern tower by the hotel. Outdoor plazas were to be situated along the First Avenue blockfront and midblock on Sixtieth Street.

Glick's initial hurdle was to gain several zoning variances for the site, which could contain only 500,000 square feet under current rules—less than a third of what he was proposing. To help win the city's favor, Glick volunteered to fund

Pearl, 400 East Sixty-sixth Street, southeast corner of First Avenue.
Schuman, Lichtenstein, Claman & Efron, 2000. View to the southeast. SLCE

Bridge Tower Place, 401 East Sixtieth Street, northeast corner of First
Avenue. Costas Kondylis, 2000. View to the southeast. Orlewicz. FOT

the improvement of several nearby parks and open spaces, though his offer to rebuild the Little League baseball diamond under the Queensboro Bridge ramps as a grassy park with passive recreational areas drew severe criticism from residents. Responding to pressure from Community Board 6, Glick revised the scheme in September 1988, agreeing to improve the Little League ballfield with an Astroturf playing surface, add a large waterfall, gazebo, and seating areas to the park, reduce the proposed curb cuts on Sixtieth Street from seven to three, and reduce the number of movie theaters from six to five, with 1,100 fewer seats. But because of the inflated price at which Glick purchased the land and his need for a significant return on his investment, he was adamant that the height—and consequently the residential density of the project—not be reduced.

On November 16, 1988, the City Planning Commission approved the plan but pared it down further, reducing the towers to 509 feet—or forty-two stories—the hotel to 195 rooms, and the garage to 419 cars, as well as making the spa and commercial spaces smaller. The new total square footage would be 1.28 million. The Board of Estimate approved the application in January 1989. Soon after the decision, three civic groups—CIVITAS, Sutton Area Community, and the Parks Council—along with the Abigail Adams Smith Museum (located across Sixty-first Street from the site), rep-

resented by the National Resources Defense Council, filed suit against the city, not Glick, contending not only that the environmental impact statement prepared did not thoroughly consider matters of air quality, traffic, and sewage disposal, but also that it did not take into account the potential impact of future developments on nearby sites. But Glick's real opposition came from the recession of the late 1980s and early 1990s, when the developer found himself unable to secure a financial partner for the project. Though he had hoped to break ground in July 1989 and complete the project in 1992, the schedule was continually pushed back. By 1991, unable to make payments on the twin tower site as well as other properties, the developer was forced to give up.

Eventually, an L-shaped portion of the site that ran along First Avenue and extended east on Sixty-first Street was sold to Milstein Properties, which razed a gas station and several small buildings there and completed 60 percent of a foundation before deciding not to go forward with its plans, instead selling the parcel to the Brodsky Organization in October 1999, which, in partnership with Peter M. Lehrer, reworked the foundation and built the thirty-eight-story Bridge Tower Place (2000), 401 East Sixtieth Street, a 218-unit apartment building on First Avenue abutted by a lower ten-story wing facing Sixty-first Street.[106] Costas Kondylis's design for the tower seemingly hung square sections of light brick above a

field of bronze-colored aluminum combined with bronze-tinted glass on the north and south sides, while the east and west facades were treated with the reverse color scheme. The pattern making was visually distinctive but structurally disturbing, as it carried heavy masonry above lightweight metal. The Rockwell Group designed the lobby, entered from Sixtieth Street, employing anigre wood paneling, stonework, and backlit wall tiles alluding to the Guastavino vaults of the adjacent Bridgemarket. Sheldon Solow purchased the remainder of Glick's site, which sat behind the York Avenue–fronting parcel he already owned, and in 2000 began construction of the first of two forty-story dark gray glass-clad residential towers that would be known as One Sutton Place North, 420 East Sixty-first Street. Designed by Davis Brody Bond in a manner that built upon that firm's One East River Place, the first tower was completed in 2002.[107]

In Search of a Usable Past:
Historicizing High-Rises

Typically, New York's postwar apartment houses were designed by a handful of firms that specialized in the building type, mastering the intricacies of zoning and a kind of space planning that took the greatest possible advantage of the area available but often produced awkward room arrangements. For the most part, the exterior appearance of these buildings was not uppermost in the minds of the developers who patronized these firms, so that the work was, in a way, "pure" or "essentialist." Those terms, typically used in praise of high-concept minimalist functionalism, in this case refer to the fact that facade designs were directly determined by internal planning arrangements. Occasionally, either to mollify outraged neighbors or more typically to help create a more marketable product, developers gave so-called design architects responsibility for the massing, exterior expression, and public spaces, forging collaborations between these architects and the apartment house specialist firms. As a working arrangement, this was not without precedent, in that design architects frequently collaborated with firms specializing in other building types, especially office buildings. And it had frequently been the practice in the 1920s and 1930s to form similar associations for apartment houses, as in the case of the collaboration on the Ritz Tower of Thomas Hastings, the established designer, and Emery Roth, the experienced apartment house specialist, or that of the experienced apartment house specialist Rosario Candela with Walker & Gillette on 2 East Seventieth Street (1927–28), with Cross & Cross on 720 Park Avenue (1928–29), and with Mott B. Schmidt on 19 East Seventy-second Street (1937).[108] The most significant aspect of this trend in the 1980s and 1990s was not, however, that high-profile design architects were being asked to take on a building type long denied them in New York but that they were encouraged to recapture the traditional language of New York apartment houses, that is, to once again adapt traditional styles to the problem of tall buildings.

Ulrich Franzen's 800 Fifth Avenue (1978) can be said to have inaugurated a new phase of "designer dwellings," with Franzen brought in to rework plans originally drawn by Wechsler & Schimenti in the belief that his contribution would facilitate the approval of a size bonus for the building.[109] Franzen's initial design for a fourteen-story street-wall-defining base beneath a set-back nineteen-story bay-windowed slab was rejected by the community board. A second version was built, presenting the avenue with a five-story classically inspired limestone screen

wall as the only arresting feature, and a banal tower set twenty feet behind it. Philip Johnson and John Burgee's 1001 Fifth Avenue (1979), between Eighty-first and Eighty-second Streets, was the first of the "designer dwellings" to make a real impact.[110] The twenty-three-story building with eighty-eight apartments occupying a seventy-five-foot-wide midblock site had a controversial history. In the early 1970s, community groups vehemently opposed the plans of the property's previous owner, Sol Goldman, who had intended to build a twenty-five-story luxury apartment building in place of three townhouses: 1006 Fifth Avenue (Richard W. Buckley, 1899), 1007 Fifth Avenue (Welch, Smith & Provot, 1901), and 1008 Fifth Avenue (Welch, Smith & Provot, 1901). Community Board 8, arguing that the Eighty-second Street block, including the stretch of Fifth Avenue between Eighty-first and Eighty-second Streets, should be preserved as the stylistically compatible architectural gateway to the Metropolitan Museum, asked that it be designated a historic district. The landmarks commission, however, reporting that a larger Metropolitan Museum historic district that would include the buildings was currently under study, refused to take up the case.

In the meantime, Goldman demolished the two six-story houses at 1006 and 1007 Fifth Avenue and in 1977 sold the project site, which was still home to the extensively and unsympathetically renovated 1008 Fifth Avenue.[111] The buyer was H. J. Kalikow & Co., whose president, Peter Kalikow, announced his company's intention to go forward with an as-of-right building under the terms of the Fifth Avenue Special Zoning District that, in return for a financial contribution to the city to assist in park maintenance in the district, would allow for a sixteen-unit density bonus.

From the tenants' point of view, Kalikow's proposed 1001 Fifth Avenue was by most definitions an ordinary building in an extraordinary setting. Although the building was to sit tight against the line of the Fifth Avenue street wall, the relatively low ceilings of the proposed building permitted twenty-three floors, nine more than the fourteen typical of the prewar luxury apartment houses that lined the avenue's park-facing blocks. Nonetheless, according to Elliott Vilkas, an architect associated with the building's designated architect, Philip Birnbaum, the firm was "trying to make [the new building] agreeable to the design of Fifth Avenue," letting it be known that 1001 Fifth Avenue was to be clad in light brick and glass, with two terraces per floor.[112]

The community and the editors of the *New York Times* urged that activity on the Kalikow site be delayed until the public hearing of the landmarks commission scheduled for March 8, 1977, at which the museum district would be considered. The Metropolitan Museum Historic District, including Fifth Avenue and side streets between Seventy-eighth and Eighty-sixth Streets, was approved on September 20, 1977, and ratified by the Board of Estimate on November 3, 1977.[113] But on March 1, 1977, after weeks of argumentative opposition, and seven days before the public hearing, wreckers began to tear down 1008 Fifth Avenue, a move that allowed the Neighborhood Association to Preserve Fifth Avenue Houses to obtain an injunction against the construction of Kalikow's apartment building. Though this failed to save the townhouse, it resulted in an unusual compromise: a court order "specifying that the builder, a neighborhood group, and the Landmarks Preservation Commission review together the plans for the twenty-three-story luxury building so that it will harmonize

1001 Fifth Avenue, between East Eighty-first and East Eighty-second Streets. Philip Johnson and John Burgee, 1979. View to the southeast. Payne. RP

with its surroundings."[114] The agreement required that the local group and Kalikow each retain architects to help them review the plans and that in case of a stalemate they return to court for a decision by an impartial third-party architect.

James Stewart Polshek, who was selected to represent the community group, prepared studies that, according to Ada Louise Huxtable, "explored ways to make the project more compatible with its setting," raising "the standards of design and sensitivity that were essential to the site." The studies were made available to Kalikow, who in turn commissioned Philip Johnson and John Burgee to undertake the exterior design while keeping Philip Birnbaum's existing apartment plans. Elaine Hochman, a local resident and architectural historian known to Kalikow and Johnson, oversaw the collaboration. In July 1977, as plans for 1001 Fifth Avenue moved along, Huxtable reported, "The Fifth Avenue house is turning out not only to be a far better building than anyone expected but also

promises to be an architecturally interesting building (on the outside, at least)—a statement that can be made about very few speculative New York apartment houses, even of the 'luxury' variety." Huxtable greeted Johnson and Burgee's classically inspired design as "an intriguing and unexpected solution," offering "a departure from modernist orthodoxy. . . . Its eclecticism borrows, mixes and suggests references to its Beaux-Arts neighbors and to the architectural past in an apparently arbitrary and highly unconventional way."[115]

Johnson, faced with a building code that restricted projections to ten inches beyond the building line, a developer unwilling to lose any space, and neighbors insistent that the Fifth Avenue street wall be preserved, proposed a limestone-clad facade with columns of vertical gray-tinted windows and pewter gray metal spandrels that seemed more akin to the facades of 1930s classical office buildings than those of traditional apartment houses. Nonetheless, the slight suggestion of bay windows did convey some impression of domesticity, even if the overall effect was one of explosive verticality. The facade of the 250-foot-high building was articulated with horizontal moldings, said to have been copied from ones on the Villard Houses, sliced through by the vertical bay windows in a bold but decidedly untraditional way. The moldings connected with strong horizontal lines on McKim Mead & White's 998 Fifth Avenue (1910), the apartment building immediately to the south. To Huxtable, the "deliberately flat composition . . . without the solemnities of 'proper' copying of the past" was a "high-wire act of 'recall.'"[116]

But it was the proposed building's base and top that were really startling. The twenty-foot-high limestone wall forming the base was to be pierced by an arched entrance inspired by the work of Louis Sullivan—a deliberately eccentric feature ultimately replaced by a more conventional rectangular opening in the executed building. At the top, a cartoonish, false-fronted, and absolutely vertical mansard roof propped into place from behind by concrete struts clearly visible from many neighborhood vantage points echoed Welch, Smith & Provot's mansarded townhouse (1901) to the north.

Huxtable's support of Johnson and Burgee's design was certainly key to its realization. And her assessment of the anomalous planning and preservation issues that brought it into being offered important insights into the dilemma posed by the conflict between the futuristic bias of the 1961 zoning ordinance and an increasingly preservation-minded city:

> The villain . . . is the Fifth Avenue zoning. The city's planners, who have so successfully helped to preserve neighborhoods with special district zoning in recent years, destroyed this one in their zeal to protect it. Trying to outlaw unnecessary street plazas, since the park was just across the way, they decreed an unbroken street line. To achieve this, they gave height bonuses equal to those of the unwanted plazas, which disrupt the avenue's present uniform scale, [leading to the] real trouble . . . , the greatly increased height of the new buildings, which is insoluble.[117]

The design of 1001 Fifth Avenue marked a dramatic change in Johnson's work, escalating the mercurial architect's shift from a Modernist take on traditionalism as seen in his New York State Theater (1964) into a full-fledged embrace of historicism.[118] According to Paul Goldberger, Johnson spent weeks walking Fifth and Madison Avenues, "his head up, his eye riveted to the ornament on the buildings lining the street." Admirable though Johnson's field research may have

Belgravia, 124 East Seventy-ninth Street, between Lexington and Park Avenues. Gruzen Samton Steinglass Architects, 1985. View to the southwest. McGrath. NMcG

been, it was not enough for Goldberger, who believed that the building suffered "from a conflict between the strong verticality of the strips of windows and the horizontality of . . . [the] ornamental moldings—a factor which will probably render 1001 Fifth Avenue, in the final analysis, no more than a well-meaning attempt."[119]

Huxtable, who had lavished praise on the preliminary design, took a hard look at the nearly completed building and was not as pleased with what she saw, likening the moldings to "sliced-off Tootsie Rolls." But she found the "elegant Johnson touch" in the revised entrance that she regarded as the "best part of the building" for its "simple rectangles of intersecting stone and void" suggesting solidity and openness at once, a currently "popular kind of ambiguity that is richly resolved in a much more 'modern' treatment than anything else in the building, whatever the source."[120] Herbert Muschamp, looking back on 1001 Fifth Avenue in 2001, called it "a contextual essay . . . one of my favorite Johnson designs."[121]

Though awkward, unresolved, and even jokey, 1001 Fifth Avenue touched a chord with the public. The building not only looked, albeit in some strange way, like the apartment palazzi of its neighborhood, it also showed that the use of traditional form would help ease the way with neighbors for

large-scale new construction proposed for historical settings. Most important, it demonstrated that a building with a distinctive appearance designed by a noted architect could, in a way, make its own market by generating a lot of publicity. The public clearly admired 1001 Fifth Avenue for its embrace of traditional architectural language, an embrace that suggested, by association, "class." The marketing success of 1001 Fifth Avenue made clear that a distinctive building, especially one that seemed consistent with the traditional fabric of the Upper East Side, would attract potential tenants who otherwise would not consider living in a new building. As a result, other developers elected to commission "designer buildings," typically from those architects who, like Johnson, were willing to step outside the box of abstract Modernism and explore more traditional architectural languages. Uneven in quality though these buildings were, and meager, even inadequate, in comparison with their benchmarks from the 1920s, these "traditional"-style buildings did succeed in breaking the hammerlock hold of bland uniformity that had characterized postwar apartment house construction in the city.

One of the first to take on at least a semblance of traditional character was the Belgravia (Gruzen Samton Steinglass Architects, 1985), 124 East Seventy-Ninth Street, between Park and Lexington Avenues, a twenty-one-story red iron-spot brick apartment house with a granite watertable and a minimal amount of ornament limited to semicircular stone lintels above the doors of the entryway and at points where setbacks occurred.[122] The building was developed by Haseko, a Japanese company that sought to bring a touch of Japanese style to the Upper East Side, though it was limited to the decorative program of the public interior spaces. Mass, not ornament, fit the building to its context. While zoning called for a taller, narrower tower set back from the street on a plaza, the developers fought to maintain the street wall, which the architects did for the full width of the building on the first five stories. The facade then continued to rise sheer on a slender, six-bay-wide central portion with chamfered corners that narrowed even further—to four bays—above the thirteenth floor, while the flanking portions of the facade continued to set back.

Conklin Rossant's 76 East Seventy-ninth Street (1988) was more inventive in its historical recollections—and also more problematic. In 1985 the Landmarks Preservation Commission approved plans for a nineteen-story apartment building to rise behind the facades of three Queen Anne–style townhouses between Park and Madison Avenues: 72 and 74 East Seventy-ninth Street (Anson Squires, 1882–84) and 76 East Seventy-ninth Street (James E. Ware, 1883–84).[123] The plan followed two earlier proposals for a portion of the site, the first by Richard Chapman, who was issued a permit in 1980, the year before the townhouses would be included in the Upper East Side Historic District, to build an eighteen-story tower that would replace 72 and 74 East Seventy-ninth Streets, leaving only their facades. Chapman sold the site in 1982 to a development team led by George Langer and Emil Talel, whose similar plans for a tower, calling for certain structural changes, were approved by the Department of Buildings in December 1982. But because the site now lay within a landmark district, the Landmarks Preservation Commission was supposed to have approved the plans before the buildings department did, a procedural error that allowed neighbors and preservationists to oppose the project successfully. Though demolition of numbers 72 and 74 was under way, the landmarks

commission ordered that work be halted in January 1983. Further complicating matters for the developers was the passage in 1983 of zoning prohibiting so-called sliver towers on sites narrower than forty-five feet, of which this was one. Because the foundation had not been completed by the time the zoning was passed, it was ruled that the project could not proceed. The developers appealed the decision, but their financing soon dried up, and the two freestanding townhouse facades were left to decay.

Though prospects for the site were bleak, progress was eventually made when Florence Gelfand, owner of 76 East Seventy-ninth Street, purchased the site and combined the lots, exceeding the forty-five-foot width requirement. Gelfand hired Conklin Rossant, whose scheme called for the demolition of number 76 except for its facade, a prospect that upset local residents and advocacy groups more than it did the landmarks commission, of which William Conklin was a former vice chairman. As a result, all three facades were preserved. As completed, 76 East Seventy-ninth Street consisted of a nineteen-story tower set fifteen feet behind the townhouse fronts (the middle one, number 74, serving as the new building's entry). Rising with a red brick facade for seven stories to a triplet of false stone balconies that doubled as a cornicelike element and formed the base of a double-height

gridded glass wall, the building culminated in a two-story-high copper and glass mansard roof. Behind the townhouse facades, Conklin re-created the spatial characteristics of the former townhouse rooms in size, height, and layout. The "townhouse" apartments, entered from the main elevator lobby, extended back from the street to occupy portions of the tower, requiring internal stairs to mediate between the differing levels.

Beyer Blinder Belle's 60 East Eighty-eighth Street (1986), between Park and Madison Avenues, a fifteen-story apartment tower with three floors of medical offices at the base, attempted, as Frederick Bland, a partner in the firm put it, "to create a contemporary version of a prewar Park Avenue building."[124] With only eighteen units, six occupying an entire 3,500-square-foot floor each and two terraced duplex penthouses, perhaps the most authentic aspect of its historical aspirations was the extravagant size of the apartments, an amenity included, according to some observers, because the building could not rise high enough to offer the desirable sweeping views available in so many rival Upper East Side apartment towers. Its ninety feet of Eighty-eighth Street frontage allowed for a driveway leading to the front entrance, where a copper canopy modeled after that on the Carnegie mansion (Babb, Cook & Willard, 1899–1902) sat beneath a

76 East Seventy-ninth Street, between Park and Madison Avenues. Conklin Rossant, 1988. View to the southwest. Zimmerman. WZ

60 East Eighty-eighth Street, between Park and Madison Avenues. Beyer Blinder Belle, 1986. View to the south. McGrath. NMcG

Claremont House, 52-54 East Seventy-second Street, between Park and Madison Avenues. Norval White, 1987. View to the southeast. McGrath. NMcG

Park Avenue Court, 180 East Eighty-seventh Street, southwest corner of Lexington Avenue. Skidmore, Owings & Merrill, 1989. View to the northwest. Hoyt. ESTO

large oculus set into a two-story rusticated limestone base.[125] Wrought-iron railings formed French balconies, which were highly unusual in a new building. The banded red brick building culminated in an awkwardly proportioned mansard roof. Nonetheless, the ingredients of an elegant building, if not necessarily the refinement of execution, were there in enough supply to convince potential buyers that, as advertisements for the building proclaimed in 1986, "The last of the great prewar buildings was built this year."[126]

Claremont House (1987), 52–54 East Seventy-second Street, between Park and Madison Avenues, was designed by Norval White, an editor of the *AIA Guide*, in association with Goldhammer, Wittenstein, & Good.[127] The most traditional of the designer apartment houses, Claremont House replaced two townhouses within the Upper East Side Historic District—52 East Seventy-second Street (McCafferty & Buckley, 1887–89; remodeled by Schuman & Lichtenstein, 1950) and 54 East Seventy-second Street (McCafferty & Buckley, 1887–89; remodeled by Morris Lapidus, 1949); the latter had some claim to Modernist distinction and was contextual to the apartment house to its east, 750 Park Avenue (Horace Ginsbern, 1951).[128] White's design took no notice of Ginsbern's watery Modernism and little sustenance from the watery Georgian of Lafayette A. Goldstone's red brick 50 East Seventy-second Street (1927–28)

to the west.[129] The kinship was with Mott Schmidt's 53 East Sixty-sixth Street (1923), though White lacked Schmidt's subtlety of proportion and detail.[130] Above a two-story rusticated limestone base, the eighteen-story building's twenty one-, three-, and four-bedroom apartments sat behind a red brick facade comprising a seven-by-fourteen grid of six-over-six punched windows broken up only by band courses above the third and thirteenth floors. The absolute regularity of the window pattern gave the building a notable presence and made it believably Georgian. Norval White and his coeditor of the *AIA Guide* humbly, but accurately, categorized Claremont House as an "infill" building "intended as background in the district, blending in with its neighbors."[131]

One designer apartment house proved surprisingly successful at capturing what had come to be known in real estate circles as the "prewar style": Skidmore, Owings & Merrill's 180 East Eighty-seventh Street, a building with no Park Avenue frontage misleadingly named Park Avenue Court (1989), was a conversion of the former Gimbels East department store (Abbott, Merkt & Co., 1972) that occupied the west blockfront of Lexington Avenue between Eighty-sixth and Eighty-seventh Streets.[132] The year after the Gimbels chain closed its doors in December 1986, SZS Associates, a partnership of Silverstein Properties, the Zeckendorf Company, and Melvin

Simon Associates, announced its intention to strip the twelve-story windowless box down to its steel frame and concrete floors and reinvent it as a luxury apartment building. Neighborhood residents, who had long resented the store's looming presence, welcomed the conversion of the rapidly deteriorating, inherently ugly building.

SOM's design partner David Childs headed up the design effort, which called for the demolition of the top floor of the Gimbels building, the removal of a portion of the building to provide a courtyard, and the addition of six new set-back stories that split into two towers rising to 291 feet. Because of the sixteen-foot floor-to-floor heights of the original department store and the provision of fourteen-foot floor-to-floor heights in the new construction, 200 apartments on seventeen stories were awash in vertical space, but the developers eschewed a loftlike aesthetic in favor of one rooted in the traditional Park Avenue apartments of the 1920s and 1930s: an entire new Georgianesque red brick, limestone-trimmed skin was set atop a limestone and glass-clad two-story base housing 75,000 square feet of retail space. Large-paned mullioned windows for the apartments were appropriately scaled to the interior room heights, helping to break down the sense of the building's mass, while a twenty-eight-foot-high, two-story rotunda lobby with mahogany walls and marble floors conveyed a sense of hotel-like grand luxury to residents and their guests. As executed, the building was simpler and better than the too-literal, fussy design initially proposed.

Trafalgar House (1986), 180 East Seventieth Street, southwest corner of Third Avenue, went even further in its embrace of traditional apartment house imagery.[133] As designed by Arthur May, a partner at Kohn Pedersen Fox, the thirty-three-story, red brick–clad, Edwardian Georgian–inspired design reflected the developer's expressed desire to convince prospective residents that a Third Avenue building could have the same aura of history, permanence, and luxury as older buildings on Park and Fifth Avenues. The 101-unit tower replaced the terra-cotta-clad Pinehurst Garage (George F. Pelham, 1916).[134] Above a two-story rusticated limestone-clad base with tapering quoins, the building filled the site to nine stories, then set back on the north side to form a stepped tower that rose to a triple-pedimented crown inspired, according to the architects, by William Kent's Holkham Hall.[135] Unlike Park Avenue Court, which had high ceilings, Trafalgar House did not extend the prewar feel very deep into the conventionally planned, low-ceilinged apartments. Athough Paul Goldberger rated the building "among the finest postwar apartment buildings on the Upper East Side," he appeared uncomfortable with the design's traditionalism, noting that it was "not as provocative" as the firm's "better towers, but in a city in which a garish box of white brick passes for luxury housing, its exterior, at least, deserves to rank with the Dakota."[136]

Hardy Holzman Pfeiffer Associates and Schuman, Lichtenstein, Claman & Efron collaborated on the Siena (1996), 188 East Seventy-sixth Street, southwest corner of Third Avenue, a 152,000-square-foot, 125-unit apartment house with medical offices on the first two floors.[137] The vacant 8,670-square-foot site was separated from the Italian Renaissance–style St. Jean Baptiste Church (Nicholas Serracino,1910), a protected New York City landmark, by the church's five-story rectory. The sale of its air rights to the developers of the Siena enabled the church to undertake an extensive interior and exterior restoration.[138] At its base, the Siena was unapologetically

designed to relate to the neighboring church, with strongly modeled cast stone and granite matching the height of its cornice. Above, a brick-clad, chamfer-cornered shaft was shaped and fenestrated to complement the church, not by mimicking its style but by echoing the geometry of its corner bell towers with corner towers of its own surrounding a thirty-five-foot-high octagonal mechanical equipment enclosure at the top. Karrie Jacobs, writing in 1996, worried that the current preoccupation with contextual design was, for architects, an "excuse to retreat from new ideas," often giving rise to "peculiar, historically inspired confections."[139] But few could dispute the contribution that the Siena's rich sculptural form and lively surface patterning made to a neighborhood burdened by so many uninspired, blocklike apartment buildings.

Capitalizing on the Siena's success, Harry Macklowe retained Hardy Holzman Pfeiffer Associates and Schuman, Lichtenstein, Claman & Efron to design another building at the opposite end of the block, 145 East Seventy-sixth Street (1999), northeast corner of Lexington Avenue, a pared-down, palazzo-aspiring, beige brick luxury apartment building offering only twenty units in its fifteen floors.[140] Above an

Trafalgar House, 180 East Seventieth Street, southwest corner of Third Avenue. Kohn Pedersen Fox, 1986. View to the southwest. Aaron. ESTO

elegantly detailed rusticated limestone base featuring a cavernous arched entryway with glass and antique-nickel front doors on Seventy-sixth Street, the apartment house rose nine floors to a setback marked by a parapet punctuated by limestone orbs. The setback doubled as a terrace for the single tenth-floor apartment and supported three independent structures that held two levels of balconies serving apartments on the eleventh and twelfth floors. To Paul Goldberger, the building's overall shape, which had much in common with its prewar models, made "covering the thing in traditional garb seem less contrived" than with many of its towering peers. The critic credited Hugh Hardy with having "inventively blended" classic apartment architecture into a new building, and the result was a soft-spoken success: "This isn't a masterpiece. It's just decent background architecture, which is exactly what we seem to have so much trouble producing these days."[141]

In 1989 William Zeckendorf Jr. and George Klein, two of the city's most prominent developers, purchased 515 Park Avenue (Denby & Nute, 1912), southeast corner of Sixtieth Street, a twelve-story apartment building converted to offices in 1958; its location just outside the jagged southern boundary of the Upper East Side Historic District made it ripe for redevelopment.[142] But their plans to build a hotel on the site soon fell victim to the collapsed real estate market of the early 1990s and it wasn't until the mid-1990s, after a series of financial transactions left the property in the hands of Zeckendorf's sons, William Lie and Arthur, and their financial partner, Goldman Sachs's Whitehall Street Real Estate Fund, that

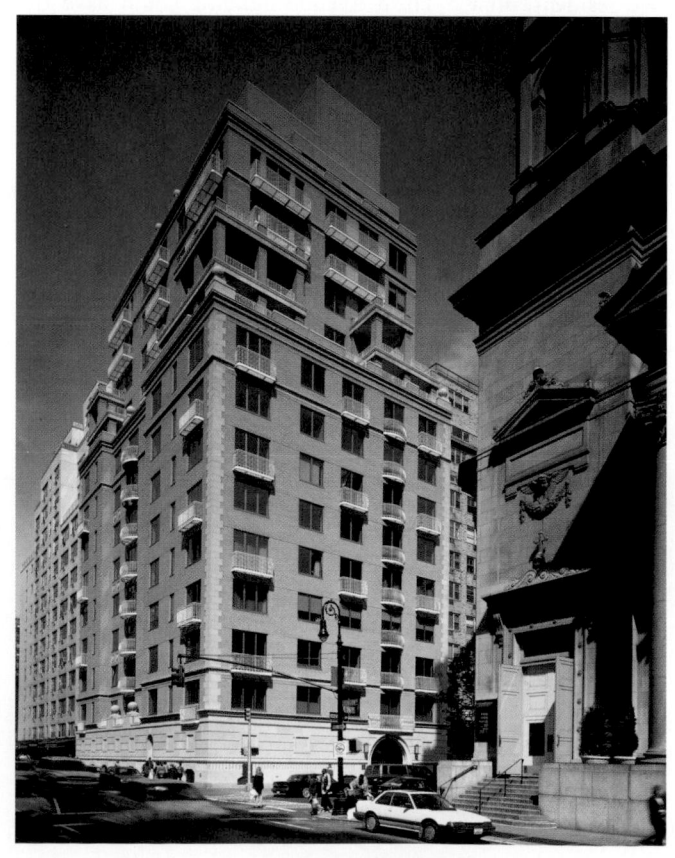

plans for the site were revived, this time calling for a superluxurious residential tower.

Frank Williams & Associates was hired to design the new 165,000-square-foot apartment house (2000), a forty-three-story campanile of beige brick with French limestone and cast-stone trim. Its height rivaled that of the Ritz Tower (Emery Roth and Carrère & Hastings, 1925), two blocks to the south, but where the Ritz Tower gracefully set back on all four sides as it rose, 515 Park Avenue set back only on the north and west sides at three abrupt intervals at the fifteenth, thirty-third, and forty-third floors, resulting in an awkward silhouette. The detailing was heavy-handed, with cast-stone corners, double-height pilasters below each setback, and two cast-stone-clad mechanical equipment enclosures set atop the building. In terms of sheer space, however, the interior left little to be desired. Only forty apartments occupied the building, with two per floor on the lower nine levels, a mix of full-floor apartments and duplexes on the tenth through thirty-first stories, and six duplexes on the building's top twelve floors. As the apartments were sold, the number of units was reduced even further when buyers combined them. Ceilings were typically ten feet high and layouts were sprawling. The second floor provided ten suites for use as servants'

quarters and the basement held fifteen private climate-controlled wine cellars and thirty-eight storage rooms. Other amenities included a gymnasium, caterer's kitchen, and professional laundry rooms.

But for all the luxury (and sales success), the building was deemed a poor addition to Park Avenue. Paul Goldberger found 515 Park Avenue to be "particularly ungainly," its bulk "stretched and pulled to the point where all sense of proportion is lost." Remarking on Williams's professed examination of Park Avenue precedents, Goldberger felt the architect "seems not to have picked up the most important characteristic of the city's older apartment buildings—their quiet dignity. The corners at 515 Park Avenue are lined with cast stone . . . [and] come off as heavy and awkward." And, he stated, though the cast stone replaced limestone only above the fourteenth floor, "we are supposed to assume that the real stone has been used all the way up . . . [but] it's obvious that the material is different, and not as good. Add the murky-colored brick, which doesn't mix well with the color of the cast stone, and some awkward fake pilasters, and you have a facade that is a pretentious muddle."[143]

Rivaling 515 Park Avenue in luxury was Beyer Blinder Belle's conversion in 2001 of the eleven-story 838 Fifth

515 Park Avenue, southeast corner of East Sixtieth Street. Frank Williams & Associates, 2000. View to the southeast. FWPA

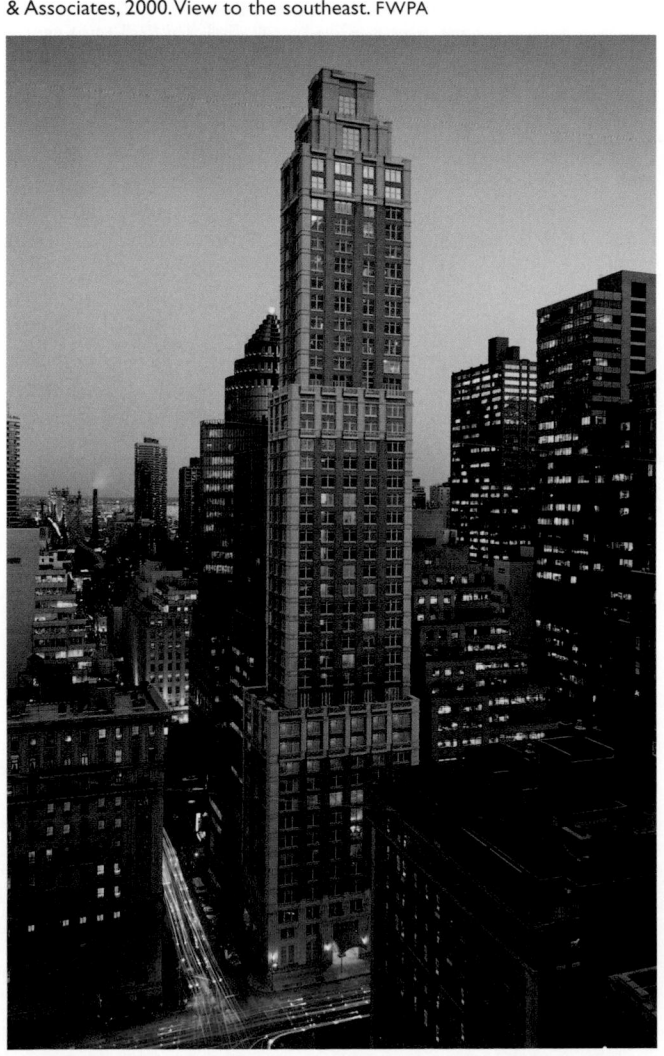

838 Fifth Avenue, southeast corner of East Sixty-fifth Street. Renovation by Beyer Blinder Belle, 2001. View to the southeast. Charles. FCP

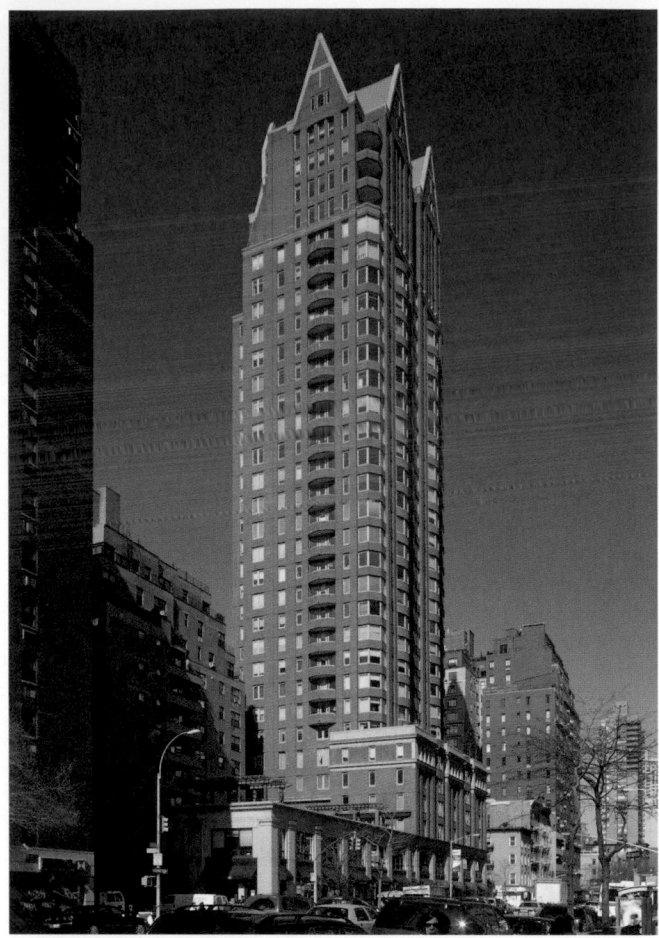

Empire, 188 East Seventy-eighth Street, southwest corner of Third Avenue. Hartman-Cox, 2000. View to the northwest. McGrath. NMcG

Avenue (Harry M. Prince, 1950), southeast corner of Sixty-fifth Street, from offices for the Union of American Hebrew Congregations to apartments.[144] The Union announced it would sell the 50,000-square-foot building, also known as the House of Living Judaism, in June 1996. A year later, Edmond Safra, founder of the Republic National Bank, submitted the highest bid, planning to transform the structure into a synagogue for the Sephardic congregation Beit Yaakov, named for his father. But that sale was canceled, although construction of a new synagogue for Beit Yaakov would go forward on a nearby site (see Houses of Worship, Upper East Side). In October 1998, a partnership of A. Alfred Taubman, the chairman of Sotheby's and a resident of the neighboring 834 Fifth Avenue (Rosario Candela, 1930), Louis Dubin (Taubman's son-in-law), and Metin Negrin purchased the building with plans to convert it into a luxury apartment house. Beyer Blinder Belle's design, approved by the Landmarks Preservation Commission in August 1999, called for the addition of a one-story, 5,400-square-foot penthouse and a forty-five-foot deep addition to the rear of the building replacing the five-story apartment building at 2 East Sixty-fifth Street (Thom & Spaulding, 1880–81; new facade by B. H. Whinston, 1950), which was demolished in late 1999. The new eight-story building, combined with 838 Fifth Avenue, allowed for larger floor plates for some of the apartments.[145] The Sixty-fifth Street addition was clad in Indiana limestone to match the main building but was otherwise articulated as a distinct

building with Juliet balconies and its own entrance that was, in fact, the service entrance for the combined buildings. The original Union building was gutted and its columns were reinforced to allow the floor slabs to be thinned, increasing floor-to-floor heights to nine feet. The apartments, laid out by Schuman, Lichtenstein, Claman & Efron, were offered to buyers as raw, loftlike spaces that could either be fitted out by the buyers' architects or by the Schuman firm.

In May 1997, Aby Rosen, Michael Fuchs, and Trevor Davis, all comparative newcomers to the small world of New York developers, announced plans for a thirty-two-story apartment building for the west side of Third Avenue between Seventy-seventh and Seventy-eighth Streets.[146] The site was currently occupied by the "Cottages," a two-story dark red brick taxpayer that, despite efforts by residents, neighbors, and preservationists over the previous twelve years, had been refused consideration by the Landmarks Preservation Commission. Designed by E. H. Faile in 1937, the Cottages consisted of first-floor retail space along Third Avenue topped by eight modestly scaled one-bedroom apartments shielded from the noise of Third Avenue (until 1955 generated by the elevated railroad) by glass-block walls. A gatehouse on Seventy-eighth Street marked the building's entrance and opened onto an 11,000-square-foot garden that originally contained two tennis courts and two badminton courts, which were eliminated with the construction of the apartment house at 177 East Seventy-seventh Street in 1941. In contrast to the Modernism of the glass and brick Third Avenue–facing facade, the garden front, with its flights of stairs leading to the raised terrace, had overtones of the late Georgian and Regency styles. Despite the commission's repeated refusal to grant landmark status, the five remaining elderly tenants of the Cottages were joined by an active group of local residents and preservationists, organized as the Coalition to Save the Cottages and Garden, in trying to fight the new apartment house with lawsuits and various bureaucratic challenges. In 1998, after the lawsuits were exhausted and with the Landmarks Preservation Commission's continued refusal to hold public hearings, the developers reached an agreement with the remaining cottagers, and plans for the new building proceeded. As designed by Hartman-Cox, a Washington, D.C., firm specializing in traditional work, in association with Schuman, Lichtenstein, Claman & Efron, the Empire (2000), 188 East Seventy-eighth Street, consisted of a twenty-six-story tower facing Seventy-eighth Street. A six-story base was reduced to two stories on the southern half of the block, where it incorporated four of the former Cottage apartments. The entire project was sheathed in limestone on its two lower floors, and rose-colored brick trimmed in cast stone above. Topped by prominent, steeply raked gables with finials, the tower was enlivened by corner bay windows and curved balconies. The building's marble lobby included a grand staircase leading to the Empire Club, designed by Birch Coffey Design Associates, which featured a fitness center, a children's playhouse, a screening room, and a private dining room.

Designed by Robert A. M. Stern Architects with Ismael Leyva Architect, the Chatham (2000), 181 East Sixty-fifth Street, northwest corner of Third Avenue, was a ninety-four-unit, 231,000-square-foot, thirty-four-story red brick and limestone-clad condominium tower set atop a site-filling eighty-five-foot-high base that incorporated 22,000 square feet of retail space.[147] The slender tower, articulated with French balconies, bay windows, and subtle changes in plane,

LEFT Chatham, 181 East Sixty-fifth Street, northwest corner of Third Avenue. Robert A. M. Stern Architects with Ismael Leyva, 2000. View to the northwest. Aaron. ESTO

BELOW Chatham, 181 East Sixty-fifth Street, northwest corner of Third Avenue. Robert A. M. Stern Architects with Ismael Leyva, 2000. View to the north of base. Aaron. ESTO

BOTTOM Chatham, 181 East Sixty-fifth Street, northwest corner of Third Avenue. Robert A. M. Stern Architects, 2000. Lobby. Aaron. ESTO

America, 300 East Eighty-fifth Street, southeast corner of Second Avenue. Murphy/Jahn, 1987. View to the southeast. MJ

the street of the Phoenix House apartment building (Emery Roth & Sons, 1969), the campanile-like Chatham enjoyed exceptional views in most directions and exceptional prominence in the neighborhood. Though the building was planned to provide a level of accommodation comparable to those of prewar buildings, the apartments were not nearly so lavishly sized as those at 515 Park Avenue. At the top, below the sculpted enclosure of the water tower, inspired by rooftop features at Rosario Candela's 770 Park Avenue (1929–30) and 778 Park Avenue (1929–31) and River House (Bottomley, Wagner & White, 1931), the two penthouse apartments each featured grand sweeping stairs and terraces.[149] The lobby and elevator cabs as well as the typical hallways were designed by Stern, incorporating Perlino Bianco and Breccia Onicatto marbles and specially designed fixtures. Stern also worked closely with Leyva on the apartment plans. Inside, Stern fitted out one apartment for a client on the eleventh floor and, on the sixth floor, he designed his own apartment with French windows and a projecting balcony overlooking the Jones Wood Gardens.[150]

Not every high-profile architect tapped to design apartment houses employed "traditional" motifs. In 1987 the America, designed by the Chicago-based architect Helmut Jahn, opened at 300 East Eighty-fifth Street, southeast corner of Second Avenue.[151] The slender charcoal and beige brick tower was notable for its checkerboard surface patterning, the power of which was compromised by two columns of arc-shaped balconies rising at the edges of the west facade. The America's name came into its own in the lobby, where sculptures of an oversized wedge of cherry pie, a baseball, and a bouquet of roses greeted tenants but would be removed in a later renovation. Though normally a gifted designer, Jahn did not seem comfortable with the project, and his participation was not promoted by the developer.

James Stewart Polshek & Partners' Leighton House (1990), 360 East Eighty-eighth Street, southwest corner of First Avenue, a forty-six-story, 163-unit apartment building clad in purple brown Norman brick, metal, and glass, breathed new life into the typical modern box through a sure sense of proportion and an adroit use of materials.[152] Leighton House's sleekly detailed three-story metal and glass base contained space for the Rhinelander Children's Center, which, as part of the development deal, was renovated by the developers, General Atlantic Realty Corporation (later Millennium Partners). But it was the thoughtfully massed and carefully fenestrated rose brick–clad tower that gave the building its real distinction, contributing to what Suzanne Stephens called a "well-syncopated orchestration of advancing and receding planes, cantilevered elements, reveals, and articulated detailing." For Stephens, who admired its "quiet, crisply tailored air," Leighton House was a success: "In architectural deportment it is miles ahead of its clunky neighbors . . . a good example of how a 'typical' luxury building, designed according to modernist principles, can be elegant and can impart a sense of domestic grandeur and warmth."[153]

Robert A. M. Stern Architects' Seville (2002), designed in association with Schuman, Lichtenstein, Claman & Efron, 300 East Seventy-seventh Street, southeast corner of Second Avenue, a thirty-one-story, 170-unit apartment tower comprising 238,000 square feet on a 12,000-square-foot site, was, with its light-colored brick facade and black columnar brick accents, an interpretation of New York's towerlike hotel and

culminated in a series of setbacks topped by a lantern. The Chatham replaced a row of four-story apartment houses, 1110–1118 Third Avenue (John Snook, 1868), and 166 East Sixty-sixth Street, also designed by Snook as part of two series of rowhouses, 154–166 East Sixty-sixth Street and 157–167 East Sixty-fifth Street, which were renovated in 1919 by Edward Shepard Hewitt, who created a common garden between them that came to be known as the Jones Wood Gardens, named after Jones's Wood, an early-nineteenth-century summertime pleasure ground that had been located near the East River and was considered for a great public park before the site of Central Park was settled on.[148] Because of the low scale of the Jones Wood townhouses on Sixty-fifth and Sixty-sixth Streets and the St. Vincent Ferrer Church complex on Lexington Avenue, as well as the setback from

Leighton House, 360 East Eighty-eighth Street, southwest corner of First Avenue. James Stewart Polshek & Partners, 1990. View to the southwest. Goldberg. ESTO

Seville, 300 East Seventy-seventh Street, southeast corner of Second Avenue. Robert A. M. Stern Architects and Schuman, Lichtenstein, Claman & Efron, 2002. View to the southeast. Pottle. ESTO

apartment buildings of the late 1920s and 1930s.[154] James Gardner, the architecture critic of the newly revived *New York Sun*, wrote that there was "nothing Sevillan" about the building. "While [Stern's] highly vernacular Chatham . . . reeked of Britishness, the romanticism of this newer name is immediately belied by the four-square modernism of the design. Like most architects of his generation, Stern was born into the International Style, against which, in the 1980s, he famously rebelled in favor of contextualism. In the Seville he has returned to his roots. But his responsiveness to questions of light and texture shows how well he has learned the lessons of the postmodern movement."[155]

The Impala (2000), 404 East Seventy-sixth Street, southeast corner of First Avenue, consisting of three buildings comprising 268,000 square feet surrounding a landscaped courtyard, was the first large-scale project in New York to be realized by Michael Graves.[156] The centerpiece of the composition, a thirty-one-story, 194-unit apartment tower on the southeast corner of Seventy-sixth Street and First Avenue, was complemented by an adjacent seven-story building facing Seventy-sixth Street and a separate seven-story building on Seventy-fifth Street. Though the lower buildings, with bluestone bases and predominantly red brick facades, were fundamentally sympathetic to the scale and character of the side streets, less certain was the six-story base of the tower, which featured a recessed central portion and a chaotic window pattern, or the rectangular tower itself, with its busy facades largely composed of square, double-height white-colored cast-stone framelike panels interleaved by single floors of red brick, a strange motif devised to bring down the scale

Impala, 404 East Seventy-sixth Street, southeast corner of First Avenue.
Michael Graves and H. Thomas O'Hara, 2000. View to the southeast.
McGrath. NMcG

Impala, 404 East Seventy-sixth Street, southeast corner of First Avenue.
Michael Graves and H. Thomas O'Hara, 2000. View to the northwest.
McGrath. NMcG

Proposed Sotheby's tower, 1334 York Avenue, between East Seventy-first
and East Seventy-second Streets. Michael Graves, 1986. Model, view to the
southeast. GRV

of the building so that, according to Graves, the Impala would look "like a big town house rather than a tower."[157] H. Thomas O'Hara planned the apartments, but Graves took responsibility for the lobby, which featured maple-paneled walls and limestone floors, as well as the 15,000-square-foot courtyard, where the South African sculptor Danie de Jager installed a series of fourteen life-size bronze statues of impalas, the African antelope. A fifteenth impala was attached to the facade above the apartment building's primary entrance on Seventy-sixth Street.

Michael Graves had also drawn plans for a residential tower to be placed atop the headquarters of Sotheby's, the auction house, at 1334 York Avenue, east blockfront between Seventy-first and Seventy-second Streets. Constructed in 1922 as a cigar factory for the Lorillard Tobacco Company and later occupied by Eastman Kodak, 1334 York Avenue was renovated as a branch operation for the auctioneers by Lundquist & Stonehill in 1980.[158] But on June 10, 1982, in the midst of financial worries, Sotheby's announced that it would consolidate its New York headquarters in the four-story, 160,000-square-foot York Avenue building, leaving once and for all its established home in the Parke-Bernet Building (Walker & Poor, 1949) at 980 Madison Avenue, between Seventy-sixth and Seventy-seventh Streets.[159] The announcement to fully relocate to the Far East Side took the

art world by surprise, particularly gallery owners who had settled on Madison Avenue in the Seventies because of the auction house.[160] Despite dire predictions, the fringe location did not affect business, and on February 5, 1986, after nearly four years on York Avenue, Sotheby's announced plans to build a twenty-seven-story apartment tower designed by Graves on top of its existing building that would also provide an extra floor for the auction house. Graves proposed to reclad the building in a gray-green stone, forming a base atop which he placed a sixteen-story pink terra-cotta midsection with widely projecting balconies that formed a diagonal pattern. An eleven-story upper section, also clad in pink terra-cotta with more generously sized windows, was capped by a line of rectangular projections that formed a stylized cornice. Centered above the base was an appliquéd eight-story gray green stone section with a bold semicircular arch that Graves hoped would create "a visual link between the auction house and the residential tower."[161]

The fact that Sotheby's plan required the site to be rezoned from light manufacturing to residential and commercial and that the auction house was seeking a 20 percent bonus in exchange for building low- and moderate-income housing elsewhere on the Upper East Side opened the door for opposition from Community Board 8, which felt that the area was already too dense to accommodate another apartment building. Although on June 27, 1990, the City Planning Commission approved the project, Sotheby's ultimately decided to abandon it.

By 1992 both Sotheby's and its rival, Christie's, were experiencing significant growth, prompting each to consider relocating to larger facilities with greater space for exhibition

ABOVE Sotheby's, 1334 York Avenue, between East Seventy-first and East Seventy-second Streets. Kohn Pedersen Fox, 2001. View to the northeast. Sundberg. ESTO

LEFT Sotheby's, 1334 York Avenue, between East Seventy-first and East Seventy-second Streets. Interiors by Swanke Hayden Connell, 1999. View of salesroom. Aaron. ESTO

and storage. Sotheby's entered into negotiations to occupy space in the Vornado Realty Trust's planned project for the site of the former Alexander's department store at Fifty-ninth Street and Lexington Avenue, but the talks ended in frustration in 1995. Sotheby's then considered a move to the Millennium Partners' proposed building on the site of the Coliseum at Columbus Circle, but the developers had not yet secured the site (and wouldn't), leading Sotheby's to revive the more secure idea of expanding at its current site. The decision was greeted dourly not only by the auction house's employees, who had been hoping for a more central location, but by many other observers who felt Christie's recent announcement of plans to move to Rockefeller Center would give them a crucial competitive edge. Nonetheless, Sotheby's went forward with an expansion on York Avenue that added six floors and an additional 240,000 square feet.[162] A power trio of designers was retained, with Kohn Pedersen Fox designing the exterior, Swanke Hayden Connell the interior, and Gluckman Mayner Architects responsible for the top floor—a set-back skylit penthouse with twenty-two-foot-high ceilings to showcase contemporary art. The new building was sheathed in an aluminum curtain wall fenestrated with a mixture of translucent and clear glass. Just enough granite was used at street level to provide a "regal" presence, as KPF design partner Kevin Kennon put it.[163] Above the street, granite suggested a frame

or host for the glass, which on the midblock of the York Avenue elevation revealed the building's most distinct feature, a soaring 150-foot-high, nine-story atrium whose location facing the street was supposed to make the auction house seem more inviting. Unlike the former facility, which had only one showroom, the new building would have seven floors of galleries accessed by the atrium's escalators. The location of the 9,500-square-foot, 1,200-seat salesroom on the seventh floor meant that customers would glimpse the various galleries' merchandise on their way to an auction. On the first floor, a bookstore and 125-seat destination restaurant, Bid, designed by Dineen Nealy Architects, further engaged passersby who could potentially be future clients.

Townhouse Revival

The returning popularity of townhouse living first manifested itself in the late 1960s, especially with the "brownstoning" movement on the Upper West Side and in Brooklyn's Park Slope.[164] On the Upper East Side, the trend accelerated in the 1980s after large sections of the area were designated as historic districts, a moment that coincided with both a rising prosperity, particularly among the rich, and a general reappreciation of city life. Mostly, the increase in townhouse living came as a result of the reconversion of previously subdivided dwellings into single or two-family usage. But a number of new undivided townhouses were built, as well as one significant row undertaken by the developer Sheldon Solow, who in 1980 announced his intention to build eleven eighteen-foot-wide, five-story townhouses on a 100-foot-deep site on the south side of East Sixty-seventh Street between Second and Third Avenues, representing the first significant development of a coordinated group of townhouses in seventy-five years.[165] Plans for the row had been long in the making and were part of a larger project, a black glass–clad apartment tower, 265 East Sixty-sixth Street (see above), also developed by Solow, which had been completed two years earlier southeast of the planned houses. The land for the townhouses had been purchased as part of the assemblage of the apartment house site, with the townhouses built on top of the tower's subterranean garage. Solow held a competition among three architects: the English architect James Stirling, Richard Meier, and the surprising winner, the comparatively unknown Israeli-born, New York–based Eli Attia, who had worked as a designer in Philip Johnson's office before setting up his own firm with Bradford Perkins. Although Attia was picked to do the work, Stirling's and Meier's designs were publicly displayed first, forming the

ABOVE Proposed townhouses, East Sixty-seventh Street, between Second and Third Avenues. James Stirling and Partner, 1980. Cutaway axonometric, view to the southwest. CCA

RIGHT Proposed townhouses, East Sixty-seventh Street, between Second and Third Avenues. Richard Meier, 1980. North elevation. RMPA

inaugural show in new ground-level exhibition space established by developer Harry Macklowe in the lobby of an office building at 369 Lexington Avenue (Joseph W. Northrop, 1927), between Fortieth and Forty-first Streets, which recently had been renovated by Stephen B. Jacobs.[166]

The exhibition was organized by Barbara Jakobson, a curator and collector as well as a trustee of the Museum of Modern Art. Jakobson was prevented by Solow from showing Attia's design alongside the two others, prompting Paul Goldberger to describe the "modest display" as having "something of a salon des refusés air to it." According to Goldberger, Stirling's proposal for "a set of rather bulky forms" to be executed in brick and set behind small front gardens bore "a distant resemblance to the work . . . of Michael Graves" with "a mix of small, square windows, large, oddly shaped windows . . . and bay windows" accommodating floor plans that were "especially varied and intricate." Stirling's plan was ingenious, with alternating thin man (eighteen feet wide) and fat man (thirty-six feet wide) houses, the latter providing a three-story unit topped by a duplex apartment. Meier's "sleeker and flatter" proposal set each house on a single base above which a two-story interior space was lit by a large, gridded window. Inside, besides the double-height studio-like north-facing rooms, small garden courts brought natural light into the plan. Goldberger clearly preferred Meier's "more conventionally 'modern'" scheme, writing that "the grid patterns of the large windows provide an especially lively visual treat and the whole row seems especially compatible with the sleek Solow tower next door."[167]

Attia's eleven eighteen-foot-wide, 5,300-square-foot houses, 222–242 East Sixty-seventh Street, were completed in 1984. The rose-colored Canadian granite–clad buildings presented a uniform row to Sixty-seventh Street, varied only by alternating flat-fronted and bow-fronted houses, with the former featuring arched entrances and the latter with rectilinear ones; both types sported identical single-pane windows in bronze frames. Goldberger labeled the completion of the houses a "significant architectural event . . . , marking the return of an ambitious and deeply civilized idea: the belief that the individual house enriches the city more by being part of a group and that the street becomes a richer place by being planned as a totality." Although Goldberger was quick to "celebrate Mr. Solow's intentions," he nonetheless had problems with Attia's design: "The effect is one of unexpected and considerable mass. The houses have a solid, self-assured presence. The problem is that they are almost too massive and solid. They join together so completely that they read almost as one huge building, a granite castle." Goldberger was more favorably disposed to the "spatially exciting, yet practical" interiors that featured a skylit, forty-foot-high central stairwell atrium with the stairs turned in a cross-house layout allowing stacked bedroom units in the front and a seventeen-foot-high living room in the rear with glass walls overlooking the thirty-foot-deep garden.[168] Only one of the houses was finished to serve as a sales aid, with the rest left essentially as shells to be completed by their new owners. The model unit, with interiors designed in collaboration with Skidmore, Owings & Merrill and a garden landscaped by Zion & Breen, was decorated with furniture and contemporary paintings from Solow's widely respected personal collection. The Solow Townhouses, as they were known, were a financial failure, with many convinced that their asking prices were too steep for a location far to the east of the Upper

Solow Townhouses, 222–242 East Sixty-seventh Street, between Second and Third Avenues. Eli Attia, 1984. View to the southeast showing 265 East Sixty-sixth Street (Gruzen & Partners, 1978) in background. Warchol. EAA

View to the northwest showing, from right to left, 209 East Seventy-first Street (Richard Gordon, 1983), 207 East Seventy-first Street (Ernest Castro, 1983), and 203-205 East Seventy-first Street (Ernest Castro, 1983). RAMSA

Proposed 110 East Sixty-fourth Street, between Lexington and Park Avenues. Diana Agrest and Mario Gandelsonas, 1980. Model, view to the southeast. AAGA

110 East Sixty-fourth Street, between Lexington and Park Avenues. Diana Agrest and Mario Gandelsonas, 1984. View to the southeast showing Asia House (Philip Johnson, 1959) on the left. RAMSA

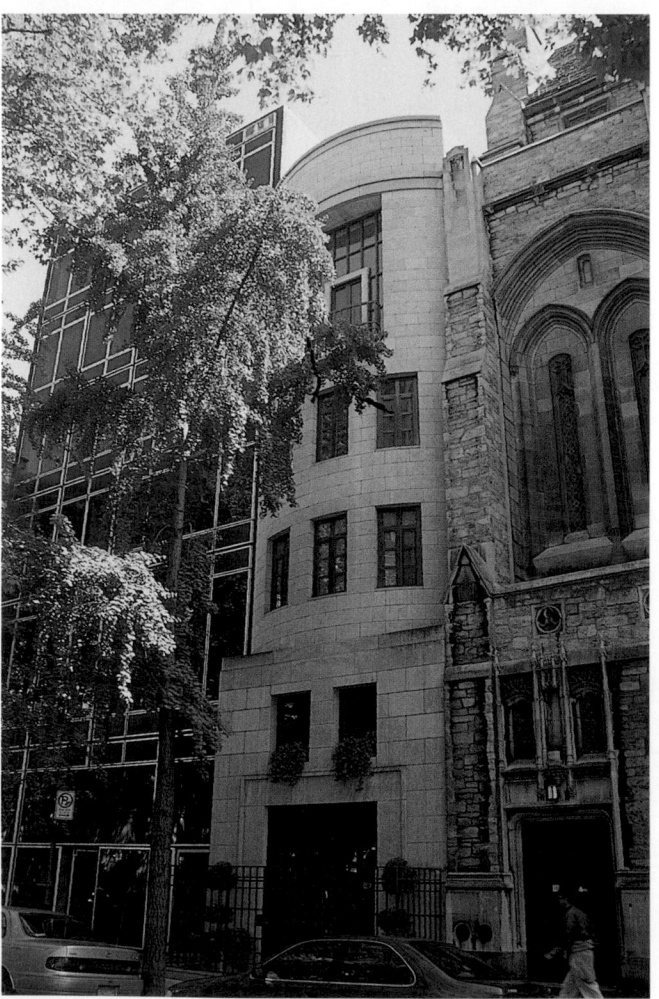

East Side's Gold Coast. In 1989, with none of the houses sold, Solow had them converted into rental units, carving out one triplex and one duplex apartment in each of the unfinished houses but keeping the model unit as a single-family dwelling.

Dreary though the Solow row was, it seemed preferable to the group of three individually but ineptly designed townhouses replacing a building from the 1880s that had served as a dormitory for the Dominican Sisters.[169] The row, 203–209 East Seventy-first Street, between Second and Third Avenues, was completed in 1983 for three different owners. Architect Ernest Castro was responsible for two of the designs, the four-story 203–205 East Seventy-first Street, whose curved front facade featured wide horizontal bands of limestone and thin vertical piers of red brick and its far more traditional neighbor at number 207, a four-story, Georgian design in the same brick with limestone trim. Richard Gordon designed 209 East Seventy-first Street with a Modernist limestone facade dominated by a grid of windows and an interior featuring a three-story atrium. Although developed together, the three houses, in stark contrast to Solow's effort, represented "wildly conflicting architectural statements cheek by jowl," according to the editors of the *AIA Guide*, who deemed the trio "a lesson in how not to design neighboring house facades."[170]

Several individual townhouses built in the 1980s and 1990s were architecturally distinguished. In 1984 the husband-and-wife team of Diana Agrest and Mario Gandelsonas designed a six-story townhouse (1988) for Matt Sabatine on an 18-by-100-foot site at 110 East Sixty-fourth Street, between Park and Lexington Avenues, replacing a five-story brownstone (F. S. Barus, 1876; renovated, Crow, Lewis & Wick, 1934).[171] The architects were faced with a particularly challenging site, flanked by two very different but distinguished buildings, the Gothic-style nine-story granite Central Presbyterian Church (originally the Park Avenue Baptist Church, Henry C. Pelton and Allen & Collens, 1922) to the west and Philip Johnson's seven-story Asia House (1959) to the east with its crisply detailed Miesian facade of dark-tinted glass panels set into white-painted steel frames.[172] Agrest and Gandelsonas had originally planned a sixteen-story, 18,000-square-foot apartment house for the same narrow site in 1980, a twin-towered masonry design heavily influenced by the same firm's simultaneous plan for a more ambitious apartment house nearby at 22 East Seventy-first Street which in 1981 became the first test of the Landmarks Preservation Commission's newly created Upper East Side Historic District (see above).[173] After the East Seventy-first Street building was rejected by the Landmarks Preservation Commission, plans for the East Sixty-fourth Street apartment house were dropped as well, replaced by the townhouse scheme. Agrest and Gandelsonas's classicized design in Indiana limestone and brown-tinted glass was intended, in the architects' words, "to act as a hinge between the two larger structures," with the square two-story base aligning with the church.[174] The upper floors consisted of a three-bay, two-story bowed section topped by the fifth floor, where a double-height central window and projecting balcony formed the building's most memorable feature. The interior was organized around a central oval staircase. Although plans for the townhouse were approved by the Landmarks Preservation Commission in 1985, the project still faced opposition from some neighborhood residents, Community Board 8, and the Parks Department, which objected to the planned garage that would necessitate the removal of a venerable,

much-beloved seven-story-high ginkgo tree. Ultimately, the tree was spared and the ground-level space redesigned.

Gwathmey Siegel's two adjacent townhouses at 16 and 18 East Eighty-fifth Street (1990), between Fifth and Madison Avenues, sat just outside the boundaries of the Metropolitan Museum Historic District.[175] Replacing a late-nineteenth-century carriage house, the six-story limestone-clad houses, developed as a pair by Phyllis Rosen, a first-time developer who retained 18 East Eighty-fifth Street for her own use, were each a generous twenty-five feet wide but only fifty feet deep. The 7,000-square-foot townhouses, featuring spiral staircases, sixth-floor balconies, and basement-level lap pools, exerted a strong presence on the street, essentially constituting an essay in the disposition of small and large gridded windows. Charles Gwathmey, noting that the challenge was "to design something that was respectful of the context, yet individual," provided two similar schemes which varied on the bottom three floors, with the building to the west featuring a garage topped by a double-height atrium lit by an enormous gridded window with an onyx medallion.[176]

Charles Gwathmey almost had an opportunity to design an even wider new townhouse in 1994 after entertainment mogul David Geffen purchased a thirty-four-foot-wide site occupied by two undistinguished three-story brick residences of relatively recent vintage, Louis Kurtz's 7 East Sixty-fourth Street (1939) and Strass & Barnes's 9 East Sixty-fourth Street (1929).[177] Geffen parted ways with Gwathmey, replacing him with Richard Meier, but soon thereafter abandoned the project, a decision many attributed to fears that the Landmarks Preservation Commission would either block plans for a Modernist design entirely or put up endless time-consuming roadblocks. Even though the buildings to be replaced were hardly noteworthy, the Sixty-fourth Street block between Fifth and Madison Avenues had come under heightened scrutiny from the commission as a result of a highly publicized case in which Ivana Trump, former wife and business partner of the developer Donald Trump, undertook illegal alterations to her townhouse across the street at 10 East Sixty-fourth Street (Donn Barber, 1923), gilding the wrought-iron front door and installing a burgundy and gold canopy without permission. In 1996 Geffen sold the sixty-nine-foot-deep site to noted labor lawyer Theodore W. Kheel, who planned to build Foundation House, a mixed-use building with five floors of apartments atop two stories intended to provide office space for a variety of foundations, including those specializing in the arts, environmental issues, and conflict resolution.[178] More than a quarter century earlier, Kheel had planned a similar facility, Automation House (Trowbridge & Livingston, 1914; renovation, Lehrecke & Tonetti, 1970), 49 East Sixty-ninth Street, which contained no revenue-producing apartments but included a comparable mix of art and labor groups, in that case concerned with the effect of new technologies on workers.[179] For his new project, Kheel hired Henry George Greene, whose classical limestone-clad scheme was in keeping with the spirit of the block. Demolition began on the site in January 1997, but by the end of the year the eighty-three-year-old Kheel, disenchanted with cost overruns and delays, decided to abandon the project, which had promised to include such environmentally progressive features as Manhattan's first geothermal heat pump, the 1,500-foot-deep holes for which were dug into bedrock at great cost. The 3,500-square-foot plot was finally developed in 2000, with the completion of a five-story classical,

16 and 18 East Eighty-fifth Street, between Madison and Fifth Avenues. Gwathmey Siegel & Associates, 1990. View to the southeast. Zimmerman. GSAA

16 and 18 East Eighty-fifth Street, between Madison and Fifth Avenues. Gwathmey Siegel & Associates, 1990. Second-floor plan. GSAA

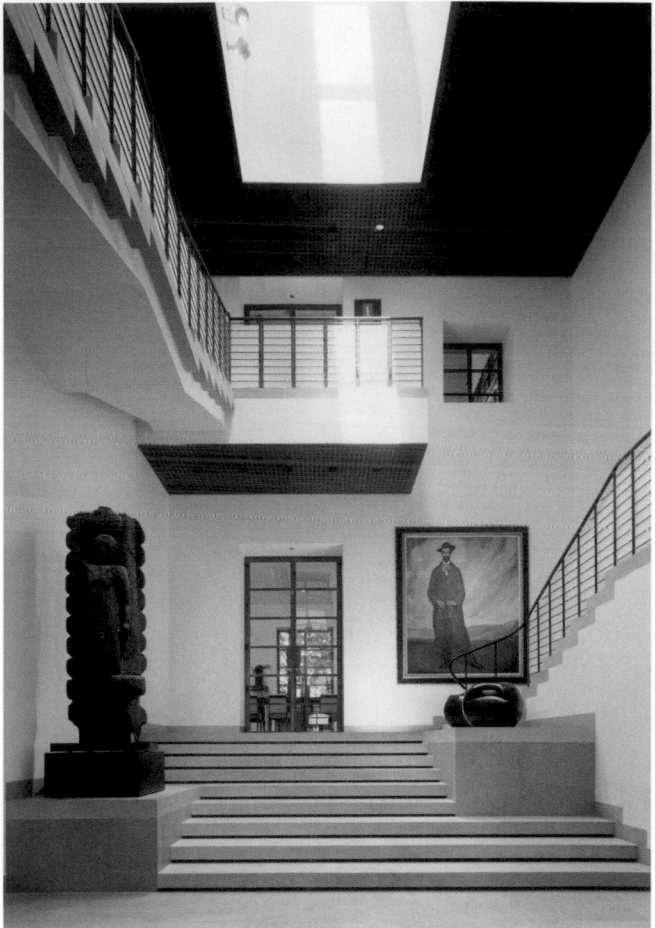

15 East Sixty-fourth Street, between Madison and Fifth Avenues. Renovation by Peter Rose, 1999. Moran. RGS

15 East Sixty-fourth Street, between Madison and Fifth Avenues. Renovation by Peter Rose, 1999. Sectional perspective. RGS

Indiana limestone building designed by ERG Architect, which took its stylistic cues from Greene's unrealized design but seemed unable to capture the verve of more distinguished neighbors on the block.[180] Topped by an underwhelming copper mansard roof and nearly swamped by a central double-height arched entrance, the building contained three large apartments and no offices.

In 1996 there was additional activity on the block when the Italian fashion designer Gianni Versace, just a year before his sensational murder in Miami Beach, renovated 5 East Sixty-fourth Street (Irving Margon, 1950), a limestone-clad neoclassical townhouse.[181] Versace reworked the entry in his flamboyant manner, decorating the front door and two flanking bull's-eye windows in bold tones of black and gold, but also added two nondescript stories to the top. Three years later architect Peter Rose, based in Cambridge, Massachusetts, completed a drastic interior renovation of the thirty-one-foot-wide, five-story 15 East Sixty-fourth Street (John C. Greenleaf, 1918; converted into apartments, 1941, Louis Weeks) for Edgar Bronfman Jr. and his Venezuelan-born wife, Clarissa, whose uncle was a prominent architect in Caracas.[182] Rose got the job on the recommendation of Bronfman's aunt, Phyllis Lambert, for whom he had designed the Canadian Centre for Architecture (1989).[183] Rose responded to Bronfman's request for a "noble, not grand," design that was "anti-artifice, no faux anything," by rejecting the typical townhouse layout, explaining that "the model of the townhouse, for all its aspirations, is uncomfortable. I never loved the stacked sixplex with its grand stair going up to something not very important. I wanted to create options and a momentum so that all the power isn't turned over to a living room that isn't used much."[184] Rose's Modernist solution was to remove the core of the house and organize the rooms around a two-and-a-half-story skylit atrium, which Julie Iovine felt looked "something like a minimalist opera set for 'Cavalleria Rusticana,'" reached through steel-and-glass doors from an entrance hall paneled in waxed sheets of bronze-colored steel.[185]

Perhaps in response to concerns about potential objections from the Landmarks Preservation Commission or simply as a reflection of the conservative tastes of their patrons, many of the new townhouses located within the confines of the neighborhood's historic districts employed a traditional vocabulary, though with varying degrees of conviction. Hobart Betts's six-story, 10,000-square-foot 7 East Sixty-ninth Street (1986), between Fifth and Madison Avenues, located on one of the few empty plots of land in the area, a 21-by-100-foot parcel that had functioned as a garden for the apartment house (Sylvan Bien, 1939) next door, was a not particularly witty Postmodernist take on the Georgian, leading the editors of the *AIA Guide* to ask if the limestone and rose-colored brick facade was "Neo-Georgian-Palladian-PoMo?"[186] Stylistic categorizations aside, the editors noted that the townhouse's most distinctive feature, the prominent second-story arch supported by Tuscan columns, was out of scale with the rest of the design. Buttrick White & Burtis's heavily rusticated limestone French neoclassical five-story townhouse at 14 East Eighty-first Street (1991), between Fifth and Madison Avenues, replacing an 1884 brownstone by Thom & Wilson that had been extensively renovated in 1930 by Frederick Rhinelander King, was far more scholarly, with a completely new facade reflecting the elegant manner of Jacques-Ange Gabriel.[187] The facade of the four-story, 18,000-square-foot 209 East Seventy-

7 East Sixty-ninth Street, between Madison and Fifth Avenues. Hobart Betts, 1986. View to the northwest. McGrath. NMcG

14 East Eighty-first Street, between Madison and Fifth Avenues. Buttrick White & Burtis, 1991. View to the southeast. Wargo. PBDW

209 East Seventy-second Street, between Second and Third Avenues. Peter Pennoyer Architects, 1996. View to the north. Frances. PEN

second Street (1996), between Second and Third Avenues, a site outside the Upper East Side Historic District previously occupied by a late-nineteenth-century rowhouse which over the years had been stripped of all its ornament, was transformed for Anthony Blumka by Peter Pennoyer Architects into a classical composition dominated by a prominent central second-story pediment.[188]

The most striking new townhouse design came from the husband-and-wife team of Tod Williams and Billie Tsien, who were hired by the real estate developer Jerry I. Speyer and his second wife, Katherine Farley, who was trained as an architect, to design a five-story-and-basement house at 176 East Seventy-second Street (1996), between Lexington and Third Avenues.[189] Speyer initially asked Philip Johnson to work on the project, and the architect produced several preliminary schemes, including a design that took its inspiration from Antonio Gaudi's Casa Mila (1910) in Barcelona, Spain.[190] The 33-by-100-foot site, outside the Upper East Side Historic District, was previously home to two five-story late-nineteenth-century brownstones. Speyer, who had owned a far less distinguished Modernist townhouse at 209 East Seventy-first Street (see above), was interested in showcasing his extensive collection of contemporary art but was also committed to a design that would both guard his privacy and hold its own amid the tall apartment buildings lining a major crosstown street. Williams and Tsien's solution, in many ways a forerunner of their work for the American Folk Art Museum (see MoMALand), called for a facade dominated by a four-inch-thick plane of hammered

Proposal for 176 East Seventy-second Street, between Third and Lexington Avenues. Philip Johnson, 1994. Rendering of view to the southwest. PJAR

176 East Seventy-second Street, between Third and Lexington Avenues. Tod Williams Billie Tsien & Associates, 1996. View to the southwest. Moran. MM

Indiana limestone floating atop a frame of aluminum and transparent and translucent glass, allowing light to filter through while providing protection from the busy street. The dramatic, open, loftlike 13,700-square-foot interior was washed by abundant natural light coming from an eighty-five-foot-high skylight, expressed on the facade as a canted glass mansard. The light poured all the way down to the basement-level twelve-by-forty-six-foot lap pool. The rear facade, composed almost entirely of glass, overlooked two gardens, a small pool-level space and a thirty-by-thirty-foot garden reached by a bridge over the lower garden. Inside, a central stair, with glass balustrades and cherry handrails, was framed by an imposing white wall that echoed the front facade's limestone screen while providing a dramatic staging area for art. The architects, who worked in collaboration with Schuman, Lichtenstein, Claman & Efron, a firm typically hired to design apartment houses, were responsible for the interior appointments as well, designing new carpets and furniture for much of the house. Though some regarded the character of the perhaps too diagrammatic street facade as confrontational, the Speyer house was praised by the architectural journalist Karen Stein for being "comfortably and not aggressively at home in the most old-world of the city's neighborhoods."[191] English journalist Peter Davey, writing in the British-based *Architectural Review*, reveled in its combination of "almost staggering luxury" and its "modesty and restraint, speaking to us in terms of space, light, and beautifully honed and fondly understood materials rather than the language of advertising and window-dressing which we have come to expect from such houses on the East Coast."[192]

Although it did not serve as a residence, Bell-Larson Architects' new building (1999) for the Council on Foreign Relations intentionally resembled a townhouse both in its scale and details.[193] In 1997 the council, headquartered since 1945 in Delano & Aldrich's grand Georgian-style Harold I. Pratt house (1919), 58 East Sixty-eighth Street, southwest corner of Park Avenue, commissioned a building at 50 East Sixty-eighth Street for additional office space as well as a study center and a conference hall. The five-story, L-shaped Peter G. Peterson Hall, named after the investment banker who was a principal donor, replaced a five-story stucco and brick town-house (Harry Allan Jacobs, 1928) and wrapped around the rear yards of the four-story brownstone at 52 East Sixty-eighth Street (John Duncan, 1900) and the five-story limestone-clad 54 East Sixty-eighth Street (Donn Barber, 1910), both owned by the council. Bell-Larson's severely detailed building, whose entry was recessed behind two flanking ten-foot-tall columns, took some of its stylistic cues from the Pratt house, with a limestone-clad facade, scallop-shell ornamentation, and rooftop balustrade.

In addition to new townhouse designs, there were several important renovations. One remodeling that promised a significant addition to what the critic Russell Sturgis once called "the Art Gallery of New York Streets," failed to materialize, though the project, which came at the expense of an underappreciated landmark, did go forward with notably second-rate results.[194] In 1978 Michael Graves was asked to design a new facade for William Hamby and George Nelson's Sherman M. Fairchild house (1941), 17 East Sixty-fifth Street, between Fifth and

ABOVE 176 East Seventy-second Street, between Third and Lexington Avenues. Tod Williams Billie Tsien & Associates, 1996. Garden. Moran. MM

BELOW LEFT 176 East Seventy-second Street, between Third and Lexington Avenues. Tod Williams Billie Tsien & Associates, 1996. Moran. MM

BELOW 176 East Seventy-second Street, between Third and Lexington Avenues. Tod Williams Billie Tsien & Associates, 1996. Rear facade. Moran. MM

Proposed 17 East Sixty-fifth Street, between Madison and Fifth Avenues. Michael Graves, 1978. Five elevation studies and a model. GRV

Madison Avenues, perhaps the most distinguished and certainly the most abstract International Style townhouse of its era.[195] The house had recently been acquired by the owner of French & Company, specialists in seventeenth- and eighteenth-century antique furniture, to serve as a first-floor showroom, with the rest of the building to be used as a residence. Graves, who had briefly worked in George Nelson's office following his graduation from Harvard in 1959 but seemed unconcerned by the prospect of replacing so important if contrary a facade, produced several different facade studies, all of which, according to Vincent Scully, represented the architect's "titanic struggle with the keystone," adding that "since these were preparatory sketches they were all compression and flourish, solid weighing upon void."[196] The redesign would have added a fourth floor for a rooftop terrace and greenhouse.

For reasons best known to the owner, the influential architect was dropped in favor of little-known Milton Klein, who in 1980–81, just before the adoption of the Upper East Side Historic District, produced a conventionally Modernist four-story design clad in flamed red granite featuring a second-floor balcony with a stainless-steel railing and three large bands of horizontal windows offset by three slit windows. Klein's bland design was immortalized on film by Woody Allen in his 1986 comedy, *Hannah and Her Sisters*, when actor Sam Waterston, playing architect David Tolchin, begins a tour of his favorite city buildings with one of his own, 17 East Sixty-fifth Street. In what was clearly intended as a send-up of the design, the fictitious architect opines that the facade "is deliberately non-contextual, but I wanted to keep the atmosphere of the street in the proportions and in the materials."[197]

Though not within the strict boundaries of the Upper East Side, Paul Rudolph's five-story townhouse at 23 Beekman Place, between Fiftieth and Fifty-first Streets, where he had been living since the mid-1960s, reflected the era's most extreme exploration of the townhouse type. First occupying only a portion of a 1900 structure, the architect took over more and more of the space in the house and an adjoining structure until the interior emerged in 1975 as a remarkable composition of floating platforms and mirrored surfaces.[198] In addition to his own apartment, the building contained duplex rental apartments. Rudolph tinkered with the space for close to twenty years as a laboratory for testing out new ideas, making it an ever bolder essay in spatial dematerialization.

Rudolph's apartment was much more than an interior. It was a four-story Constructivist-inspired composition of steel-framed balconies and vine-covered open lattices "clamped like a modernist vice[sic] to the top of a Georgian-style town-house," in the words of Tim Rohan, an architectural historian.[199] Most dramatic was the explosive addition at the top, where metal frames defined an expansive rooftop pergola that was begun in 1978. The rooftop expansion was not warmly greeted by neighbors on the sedate and tony two-block-long street, especially those living across the street who lost their East River views. Commenting on the design in a review of an exhibition of Rudolph's drawings held at the Spaced Gallery, Paul Goldberger felt that it "demonstrates both Mr. Rudolph's strengths and weaknesses. The addition is a handsome composition, a neat arrangement of geometric forms that is visually pleasing in itself, and a welcome addition to Beekman Place's already long list of architectural styles. But it makes few gestures to its context; it projects out into the street in a way that seems unnecessarily aggressive, putting the building into con-

17 East Sixty-fifth Street, between Madison and Fifth Avenues. Milton Klein, 1981. View to the northeast. McGrath. NMcG

siderable tension with its neighbors."[200] But Joseph Giovannini celebrated Rudolph's assertiveness, writing that the "exuberant and joyous gesture was the best thing that could have happened to the rather pickled enclave." Inside, the townhouse was reorganized as a vertiginous series of interpenetrating spaces, the definitions of which were rendered scarily obscure through the extensive use of mirrored walls and glass floors. Giovannini recalled a visit to the dizzying multilevel space in the mid-1980s when he "put down a plastic cup of wine on what I thought was a shelf, only to see the cup drop three stories straight through projecting transparent acrylic planes to the white marble floor below."[201] Michael Sorkin deemed the "incredibly rich environment . . . easily one of the most amazing pieces of modern urban domestic architecture produced in this country, a structure packing more finesse and design wallop in its compact volume than many architects manage to produce over entire careers."[202]

After Rudolph's death in 1997, it was feared that given the vagaries of local taste and the pressures of New York's overheated real estate market, his remarkable New York home might be dismantled. A number of critics rallied the public to the apartment's greatness, and just as the nine-story townhouse was about to be sold to a developer intent on gutting it for conventional apartments, Gabrielle and Michael Boyd, Modernist furniture collectors from northern

23 Beekman Place, between East Fiftieth and East Fifty-first Streets. Renovated by Paul Rudolph, 1978–87. View to the northeast. Aaron. ESTO

23 Beekman Place, between East Fiftieth and East Fifty-first Streets. Renovated by Paul Rudolph, 1978-87. Section perspective looking south. PRF

California, came forward to buy it in early 2000, pledging to keep most of Rudolph's challenging spaces. Working with Thomas Stephens, the Boyds made only minimal changes to the townhouse, returning one wall in Rudolph's former bedroom that was taken down when the architect was infirm and removing the tiny elevator in the penthouse. In addition, the see-through Plexiglas halls, stairs, and landings were made opaque by sandblasting, but the stairs remained rail-free. Originally, the Boyds contemplated purchasing all of Rudolph's furniture and art and properly restoring the apartment, but the executors of Rudolph's estate withdrew their offer to sell the pieces and the Boyds were left to decorate on their own. Mildred Schmertz, writing in *Architectural Digest*, was impressed with their efforts: "The penthouse now has more chairs, tables, lamps and other objects than Rudolph would ever have put there, yet his spaces have proved to be splendidly adaptable and hospitable to the Boyds' rich trove of modernist design."[203]

In addition to his Beekman Place townhouse, Rudolph, in a little-known project begun in 1989, renovated a twenty-foot-wide nondescript commercial structure at 246 East Fifty-eighth Street, between Second and Third Avenues. Working with Ernst Wagner and Donald Luckenbill, he transformed the building into a two-level commercial space topped by a duplex apartment. The new facade consisted, according to Joseph Giovannini, of an "intricate series of steel frames pinwheeling around squares, subdividing the glass wall into large and small windows that advance and recede within a depth of several feet. Like Italian architects carving Renaissance and Baroque facades to be revealed in Mediterranean light, Rudolph succeeded in suggesting depth within shallow dimensions."[204] The commercial space was not completed until 1996, a year before Rudolph's death, and was occupied by Modulightor, a lighting store selling products designed by Rudolph and Wagner. Wagner did not complete the 3,000-square-foot duplex, another exercise in spatial complexity inspired by the

FACING PAGE 23 Beekman Place, between East Fiftieth and East Fifty-first Streets. Renovated by Paul Rudolph, 1978–87. Aaron. ESTO

246 East Fifty-eighth Street, between Second and Third Avenues. Paul Rudolph with Ernst Wagner and Donald Luckenbill, 1989–96. View to the southwest. Luckenbill. DL

Proposed renovation of 147 East Sixty-ninth Street, between Third and Lexington Avenues. Frank Gehry, 1978. Model, view to the south. GP

Proposed renovation of 147 East Sixty-ninth Street, between Third and Lexington Avenues. Frank Gehry, 1978. Model, view to the northeast. GP

Beekman Place apartment, until 2003, when it became home to the Paul Rudolph Foundation, dedicated to providing information about the work of the late architect.

Although they did not involve any changes to the facades, there were three extensive interior renovations of interest, all taking place within a few blocks of each other in converted carriage houses from the 1880s. In 1978 Frank Gehry proposed a drastic remodeling of the three-story carriage house at 147 East Sixty-ninth Street (John Correja, 1880), between Lexington and Third Avenues, which Barney & Colt converted in 1913 to a two-story garage topped by an apartment.[205] Working for Christophe de Menil, who requested two different living spaces, one for her and the other for her daughter, Gehry produced plans for two separate "houses" within the gutted carriage house interior. Separated by a glass-roofed space crossed by bridges, the houses would be placed above a shared garden. The bottom two floors would be built within the existing walls and would keep the original windows, but the top floor of the "houses" would break free, placed somewhat off the orthogonal to create, in Gehry's words, "eccentricities with the vertical and horizontal spatial organization."[206] Unfortunately, de Menil scaled back her plans, and what

would have been, from the point of view of spatial complexity, a landmark in the evolution of the architect's approach, was not executed. However, in 1980 Gehry oversaw a lesser remodeling mostly devoted to opening up the space and bringing in more light, including the use of glass-brick skylights and glass-brick floors as well as a glass elevator shaft that divided the living and dining areas without closing off the space. The architect also added a forty-foot-long, eight-foot-wide lap pool on the first floor. In 1983, upon Gehry's recommendation, de Menil hired Los Angeles–based light artist Douglas Wheeler to take down even more walls and design new furniture for the house.

In 1984 Michael Graves designed a suavely detailed new interior for a two-story Romanesque Revival carriage house at 110 East Sixty-sixth Street (George E. Harney, 1880), between Park and Lexington Avenues, owned by Flora Miller Biddle, a trustee of the Whitney Museum of American Art actively involved in promoting Graves's proposed controversial addition to the Marcel Breuer–designed museum (see below).[207] The main goal of the renovation was to bring more light into the deep and awkward space that Graves likened to a loft "because the main light sources are on two sides of the building—front and back—and the structure is impacted by buildings on both sides."[208] His solution was the creation of a new entrance foyer with a skylit rotunda, located at the top of an existing stair and separated from the side walls to appear like a freestanding object, "a clever device," according to Carol Vogel, which acted as a "unifying element" linking all the rooms.[209] Biddle was very pleased with the results, particularly the shallow gridded vault in the living room, and preferred to view the whole exercise, undertaken amid the fight over the Whitney's expansion, as "a wonderful affirmation of our belief in Michael's talent."[210]

A most unusual carriage house renovation involved the conversion of the extraordinarily deep fifty-foot-wide, two-and-one-half-story Romanesque Revival 153 East Sixty-ninth Street (William Schickel, 1884), between Lexington and Third Avenues, built by the financier James Stillman with a riding ring for his children's lessons and for many years the studio of the abstract painter Mark Rothko, into a mixed-use facility (1981) consisting of a second-story-and-attic residence renovated for Peggy and Richard Danziger by Jeremy P. Lang and, on the ground floor, headquarters for the New York Center of the Urasenke Tea Ceremony Society.[211] Danziger, a lawyer, was president of the Urasenke Society and helped the group buy the building which, after eight Japanese workmen constructed a traditional Japanese teahouse in what had been the space of the riding ring, was, as an unidentified society spokesman put it, "the largest and most authentic tea complex outside of Japan."[212] The teahouse was designed by T. Neghishi, an architect working in the Urasenke Design Studio in Kyoto, who used only materials brought over from Japan.

Paul Goldberger was impressed with Lang's Western-style entry area, "a subtle blend of wood, plaster and slate" that hinted "at the Japanese esthetic without directly imitating it," while preparing visitors for the teahouse itself, "a complex of small one-room structures built around a central garden courtyard [that] has the air of a small, very private village." Under a thirty-eight-foot-high ceiling carried on open-work metal trusses, the teahouse, washed in natural light from a central roof monitor, gave the impression of "a great Western tent set over the little complex of Japanese buildings."[213]

110 East Sixty-sixth Street (George E. Harney, 1880), between Lexington and Park Avenues. Renovation by Michael Graves, 1984. Himmel. GRV

Urasenke Tea Ceremony Society, 153 East Sixty-ninth Street, between Third and Lexington Avenues. T. Neghishi, 1981. Teahouse. Stoller. ESTO

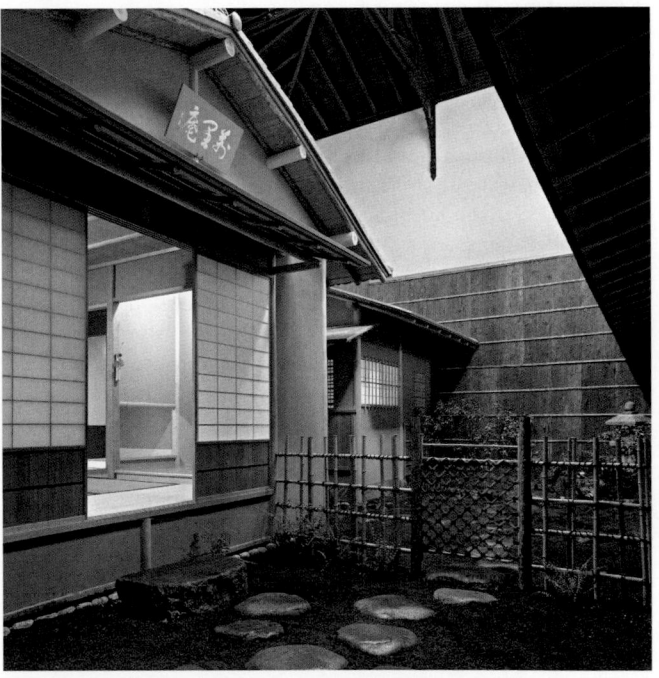

A TALE OF TWO MUSEUMS:
THE GUGGENHEIM AND THE WHITNEY

Two of the Upper East Side's most prominent cultural institutions, the Guggenheim Museum and the Whitney Museum of American Art, planned significant, controversial additions to their headquarters but met with very different results. Since its opening in 1959, Frank Lloyd Wright's brilliantly conceived, monumentally scaled, but highly idiosyncratic Solomon R. Guggenheim Museum, 1071 Fifth Avenue, east blockfront between Eighty-eighth and Eighty-ninth Streets, had been subjected to a number of unsympathetic renovations, including the remodeling (1963–65) by Wright's son-in-law, William Wesley Peters, of the small rotunda, originally intended as apartments for Guggenheim and his art adviser, Hilla Rebay, but instead used as offices, storage space, and galleries for the Justin K. Thannhauser collection, which featured works by Cézanne, Gauguin, Manet, van Gogh, and Picasso.[1] The construction in 1966–68 of a modest addition along the museum's eastern flank, also designed by Peters, and a brutal renovation in 1973–74 by Donald E. Freed that closed in the driveway, seriously compromised the clarity of Wright's design.[2]

But in 1978 the Guggenheim's leadership seemed to renew its pact with architecture when a little-used, awkwardly shaped space off the main spiral, said to have been originally intended as an architectural archive, was dramatically fitted out by Richard Meier to serve as the Aye Simon Reading Room.[3] While Meier typically explored the 1920s work of Le Corbusier, in tackling the Simon project he revealed a strong affinity for some of Wright's own Modernist work, such as Fallingwater (1934–37) and, even more so, the headquarters building (1936–39) for the S. C. Johnson Company in Racine, Wisconsin, and the house, Wingspread, built for S. C. Johnson's grandson, Herbert F. Johnson, in 1937.[4] Meier's scheme of curving oak bookcases, reading tables, and specially designed chairs played nicely against the room's quasi-elliptical shape, leading Paul Goldberger to write that the Simon Reading Room was "not imitation Wright, though . . . Wrightian in spirit," nor like the rest of Meier's work, "though it is similar to that in spirit, too."[5]

Just as the reading room was about to open to the public, the Guggenheim embarked on a five-year fund-raising drive intended to support several initiatives, including an expansion of its facilities.[6] Although originally intended to house a specific collection, the Guggenheim was now actively engaged in acquiring new works of art, necessitating an increase in display space. To the surprise of many, the commission for the museum's expansion went not to Meier, whose museum experience included the Guggenheim-inspired High Museum (1980–83) in Atlanta, but to Gwathmey Siegel, who in 1982 began to design a building that would replace Peters's addition but use its structural frame, which had the capacity to take a building twice its height.[7] The construction of what was in effect a tower was intended to free up the entire Frank Lloyd Wright building for exhibitions. Gwathmey Siegel's building would add six floors to Peters's four, with the ground floor principally accommodating an enlarged bookstore; the second-, third-, and fourth-floor galleries tying into Wright's building; the fifth and sixth floors given over to storage and conservation; the seventh serving as a library; the eighth and ninth used for offices; and the double-height tenth floor to be a restaurant and special function room with sweeping views

over Wright's rotunda to Central Park. The plan, proposing 13,000 square feet of new space, was presented to the public in February 1985, at which time its hulking mass was justified as a reinterpretation of an early design of Wright's for a considerably smaller tower. The proposed extension, intended to honor Justin K. Thannhauser, a major donor, was to rise 135 feet without setbacks, requiring a zoning variance. The strategy was arrived at after alternatives, including an underground expansion, were deemed infeasible. Ironically, a tower rising above the building's small rotunda at Eighty-ninth Street and Fifth Avenue could have been realized without any special permits, but it would have savaged Wright's design.

Gwathmey Siegel's proposal was bound to be controversial. On the simplest level, it blocked park views from apartments at 4 East Eighty-ninth Street (Eggers & Higgins and H. I. Feldman, 1954), a building the museum had owned until the mid-1970s. But the real problem lay in the fact that while Wright had proposed a backdrop slab, intended as artists' studios, for the 4 East Eighty ninth Street site, thereby rising free of the rotunda, the construction of that apartment building required Gwathmey Siegel's tower, though only forty-two feet deep, to intersect with the rotunda, causing it, as Paul Goldberger pointed out, to "appear from Fifth Avenue less as the almost completely freestanding form that it is now."[8] It was this issue that was to be the undoing of the scheme: in an era that placed a high premium on the inviolate nature of existing artifacts, architects, preservationists, and others objected to any strategy that threatened to compromise Wright's design. To put it another way: Gwathmey Siegel's proposal to lock the Guggenheim into the city fabric was faulted for contextualizing Wright's deliberately anti-contextual building.

Despite the protests of neighbors and preservationists, the plan was received with enthusiasm by members of the museum world such as Arthur Rosenblatt, vice president in charge of architecture and planning at the Metropolitan Museum of Art, who remarked that while Wright's Guggenheim was "a great building . . . Gwathmey will make it a better museum."[9] But when more developed drawings and a model were made public in the fall of 1985, criticism focused on the greater mass and more aggressive composition of the new design, referred to as Scheme I. Gwathmey's building would consist of two components, a background slab clad in beige tile and a second, boxlike loft structure clad in gray green tile that would be cantilevered out from that slab, carried on white-painted steel girders, seemingly hovering above the lower rotunda.

Paul Goldberger objected to Scheme I's "forward section," which "would project out so far that it would reach the midpoint of the main rotunda [thus filling] at least in part, the void over the north half of the Guggenheim that is absolutely critical to the integrity of this great building."[10] Martin Filler was more outspoken in his criticism of "this potentially disastrous scheme," which "ought never to have been given, let alone accepted." For Filler, the idea of a tower hovering over Wright's building was an image "so symbolic and disturbing" that one feels "that the urban apocalypse cannot be too far off and, much more vividly than the frantic overbuilding of midtown Manhattan, brings into sharp focus just how much we are losing and how very little we are gaining."[11] One particularly significant, influential voice representing the interests of the public at large was that of the architectural historian and publisher Victoria Newhouse, who wrote, "To gain 13,000 square feet—the amount of space provided by a typical luxury home

Aye Simon Reading Room, Solomon R. Guggenheim Museum, 1071 Fifth Avenue, between East Eighty-eighth and East Eighty-ninth Streets. Richard Meier, 1978. Hoyt. ESTO

today—the directors of the Guggenheim Museum are contemplating the sacrifice of New York's most important building."[12]

In counterpoint to these voices, some leading architects and critics rallied around the project. Henry N. Cobb wrote that the scheme was "distinguished by its sensitivity to the many difficult contextual problems impinging on this site," and the not notably contextually minded architect Kevin Roche supported it as an addition that would "solve the museum's functional needs . . . without impairing the character of one of Wright's great masterpieces."[13] Lewis Davis and William Pedersen also came out in support of the addition, and the architectural writer Wolf Von Eckardt wrote to Gwathmey, "You actually improve Frank Lloyd Wright's building."[14] Carter Wiseman, the architecture critic at *New York* magazine, praised it as "an outstanding example of how to accommodate this city's inexorable pressure for change while honoring and amplifying the best of the past."[15]

The Guggenheim building was not old enough to qualify for designation as a landmark, although most New Yorkers regarded it as such. When the proposed addition was taken before the Board of Standards and Appeals, whose approval was required to override certain conditions of zoning, the Fine Arts Federation, an umbrella organization that included among its members the New York Chapter of the American Institute of Architects, the Architectural League, and the Municipal Art Society, gingerly stated that the proposed addition, though "distinguished in its own terms," adversely impacted on the integrity of Wright's building.[16] More outspoken were the Friends of the Upper East Side Historic Districts and a group of neighbors who banded together as the Guggenheim Neighbors and hired the architect Michael Kwartler to help oppose the design. While the debate over Michael Graves's addition to the Whitney Museum was very vocal and public (see below), that over the Guggenheim proposal was much less so, in part because of the high regard New York architects held for the quiet rationalism of the Gwathmey Siegel firm, as opposed to their rather brutish contempt for the brasher individualism of Michael Graves.

On February 25, 1986, the New York Chapter of the American Institute of Architects, repeating a similar meeting held months before to discuss the Whitney Museum's expansion plans, held a public meeting in the auditorium of the Donnell Library at which Charles Gwathmey and Robert Siegel presented their plans. Thomas Messer, the museum's director, did not attend the meeting. Also conspicuously absent was Michael Graves. Gwathmey Siegel's proposal was supported, if somewhat tepidly, by Richard Meier, who felt that "an extremely difficult problem" had been "handled masterfully," but Meier concluded his remarks with the "wish that the program might be slightly smaller, that the museum's needs were not as great as they are."[17] Peter Eisenman also spoke on behalf of the scheme while railing against "the loss of nerve exhibited by the American architectural community today." The point of his mild tirade was that "Charles Gwathmey's and Robert Siegel's building is not arrogant enough." Ignoring the evidence of Wright's own proposal for an addition to the museum, not to mention his notably contextual project for the Masieri memorial in Venice, Italy, of 1951–55, Eisenman insisted that Gwathmey Siegel's design was "not in fact taking a stance that Wright would have taken if he had been asked to come back and fulfill this commission. I believe that what they have done, in fact, is brave, but not arrogant, and almost in the spirit of Frank Lloyd Wright, but not quite there yet."[18]

Reporting on the February 25 meeting at the Donnell Library, the *Wall Street Journal*'s critic, Manuela Hoelterhoff, pulled few punches, noting that though the proposed Guggenheim addition "was lost in the dust-up over the Whitney," New Yorkers were beginning to figure out "that while the Whitney is trying to gussie up a minor example of modernism, the Guggenheim is trying to murder a major modern monument." Hoelterhoff marveled at "back-slapping architects [who] told us this plan was so sensitive they couldn't believe they hadn't done it themselves (in contrast, the Whitney's plans by Mr. Graves have been mauled by local artists and architects). Why? Could it be that Wright remains despised locally as a Midwestern eccentric and loner, while Breuer, whose acolytes still aggregate, knew New York was the center of the universe?" Hoelterhoff went on to lambast the scheme for its passages that would "connect the new space and Wright's snail on several floors" so that "the entire viewing experience as imagined by Wright is ruined. . . . The addition punches too many holes" in the "tense, pulsating fabric" of the rotunda.[19]

Daralice D. Boles, writing in *Progressive Architecture*, was also amazed by the shuffling performances of Gwathmey Siegel's co-professionals whose "condemnation" of the design as "'too timid' diverted the focus of the session's attention, defusing criticism of the scheme by claiming it *tame*." Moreover, as Boles put it, Gwathmey's refusal to discuss the very necessity of the addition, which many privately questioned given its small size, or to consider the option of establishing satellite facilities or a merger with other museums to permit exhibition exchanges, effectively "cut off all criticism save that related directly to his design." "The fundamental issue," Boles declared, "isn't whether this addition is right or wrong, compatible or crushing, but whether there should be any addition at all, let alone one of this size, on this location."[20]

On June 25, 1986, a standing-room-only crowd attended a day-long hearing before the New York City Board of Standards

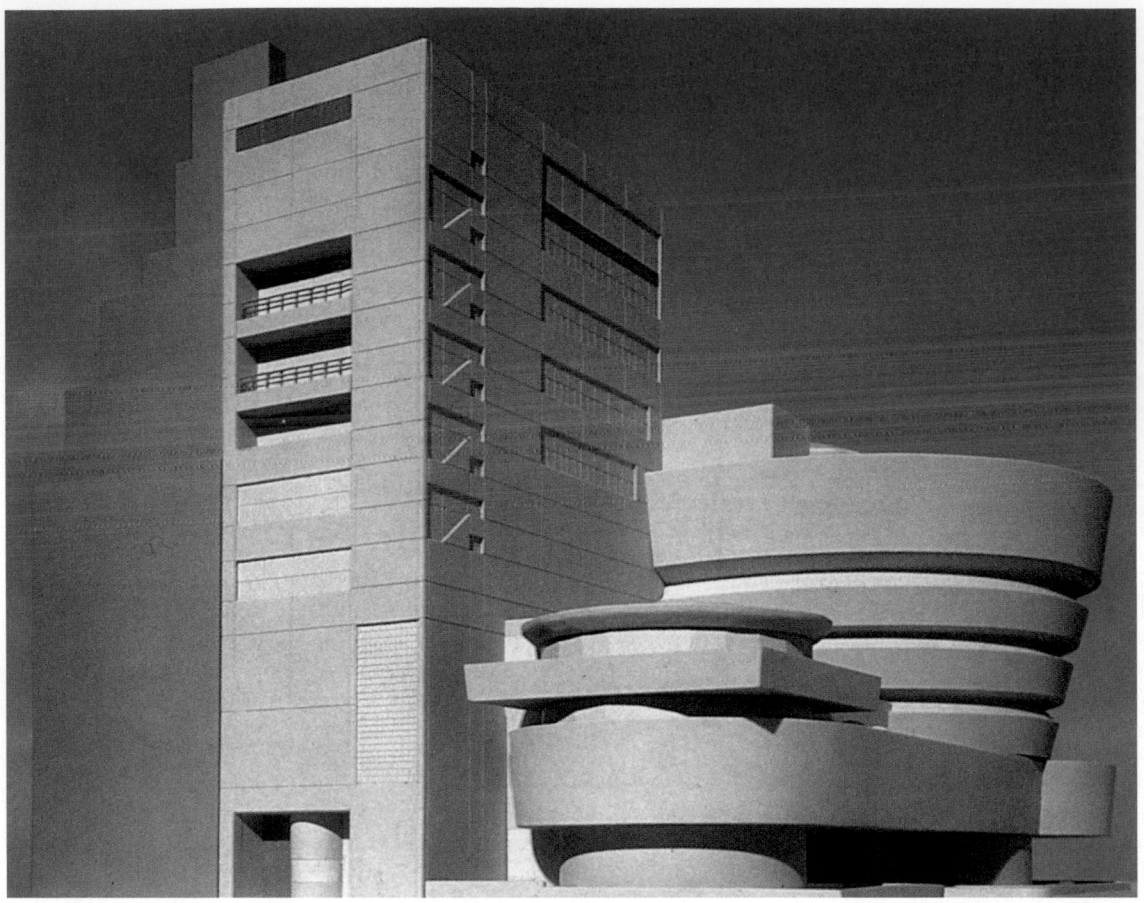

Proposed addition, Solomon R. Guggenheim Museum, 1071 Fifth Avenue, between East Eighty-eighth and East Eighty-ninth Streets. Gwathmey Siegel & Associates, 1982–84. Model of a preliminary design released in February 1985, view to the southeast. GSAA

and Appeals to testify for and against the museum's appeal for the zoning variances and special permit needed to go forward with the project. A key argument revolved around where Wright had sited the fifteen-story studio building that he had proposed for behind the museum—that is, whether it would have been on the museum's property, which was unlikely given the narrowness of the available area behind the original building, or on the site of 4 East Eighty-ninth Street. But for many, the issue was the integrity of Wright's building. The architect-critic Michael Sorkin posed a question to the board: "If the Guggenheim isn't a landmark, what is?"[21] Other critics testified against the project, as did neighbors and a number of celebrities, including the filmmaker Woody Allen. Alistair Cooke, the respected and notably elegant journalist, said in a letter that the design would make the museum look like "the biggest outdoor toilet in the world."[22] On September 17, the Board of Standards and Appeals held a second public hearing, at which time Michael Kwartler, representing the Guggenheim Neighbors, presented a plan to build an underground extension to the museum that Thomas Messer dismissed as extravagantly costly and possibly unsafe as a storage place for works of art.[23] By October, with clear indication that its request for a zoning change would not be approved, the museum surprised everyone by asking that the hearings be reopened so that it could present a modified design.

The board set the date for the hearing on the new proposal, designated Scheme II, for March 3, 1987, but the design was ready for public scrutiny by mid-February, at which time Gwathmey and the museum had already begun to solicit sup-

port for it in the profession.[24] The new proposal was far more restrained than its predecessor; it called for a background slab, echoing Wright's studio proposal in its simplicity and in its handling of the wall, where a grid pattern in the stone suggested the structural grid of the master's unrealized proposal. The new scheme was conceived in direct reference to both Wright's original proposal for an annex (1949–52) and to William Wesley Peters's existing annex, which was intended as a ten-story structure. As Gwathmey put it: "History and precedence were regarded as primary."[25] Pointing out that the facade of Wright's proposed annex was derived from the museum's four-by-eight-foot grid and that, contrary to the claims of some, it was intended for the site on which Peters's annex was partially realized and that, had it been built, it would have intersected the large rotunda and its triangular fire stair, Gwathmey began to build a case for his new design, making it a point to note that Peters's realized annex was deeper by ten feet in its east–west dimensions than Wright's was to have been but equal in length (100 feet) and proposed height (133 feet) and that it was constructed with enough added capacity to accommodate six more floors on top.

Scheme II proposed to devote the entirety of Wright's original structure to permanent exhibition space with the exception of the location on the upper level of the small rotunda of a restaurant that could be opened to an existing terrace with superb park views. Above this level, the new background slab represented a reduction in total mass—both in area and height—over the previous proposal, conforming to the dimensions Peters had initially proposed. The smaller size of the

new design—29 feet lower, 15 feet narrower, and 5,750 square feet smaller—was achieved by locating the art storage in an off-site facility. Facing Fifth Avenue, a limestone-clad facade was to be rendered as an eight-foot tartan grid forming two-by-six-foot square modules broken by four recessed, horizontal slit windows to light offices. Gwathmey pointed out that the new addition would make it possible for visitors to experience all of Wright's museum for the first time, especially the seventh coil of the ramp, which had served as a storage area since the building's opening in 1959.

On March 13, 1987, Community Board 8 voted in favor of the new design. But Ada Louise Huxtable was not won over. After characterizing the original design as a "porcelain enamel fixture to be attached to Frank Lloyd Wright's spiral," she greeted the new design as a "more modest version, which looks more like a kitchen cabinet than a bathroom fixture."[26] Moreover, supported by William Wesley Peters, she challenged the claim that Wright's proposed annex was to have been built where Peters's was built, instead locating it on the site now occupied by the apartment house at 4 East Eighty-ninth Street. Peter Lawson-Johnston, the museum's president and a descendant of the original donor, took exception to Huxtable's and Peters's claim, stating that a body of evidence in the form of drawings and a building permit existed to support the fact that Wright intended the building to be put on the site of the Peters annex. In a letter sent to the *New York Times*, Lawson-Johnston went on to ask why Peters went forward with the plan on the contested site, to which Huxtable replied that the facts and evidence are

inconclusive. What the drawings, plans and correspondence reveal is that there was no cast-in-concrete precedent of incontestable validity for the current proposal; the addition was never fully defined or designed. The present site was not established by divine Wright decree, as the museum's arguments imply. Mr. Peters's foundations suggest structural discretion and future expansion rather than architectural predestination. . . . The problem here is not the proper definition of precedent or what precedent justifies; it is that the real issues are not being addressed. These issues are design suitability and irreversible impact—the Wright building will be permanently altered—and the nature and effect of the special permits being requested.[27]

Manuela Hoelterhoff weighed in on Huxtable's side, stating that if the Guggenheim Museum "tinkered with art the way it does with Frank Lloyd Wright's building, nobody would give it any." To Hoelterhoff, the second scheme not only failed to recognize the "uniqueness of the building" but was also "a mediocre and unnecessary addition." Calling Scheme II "an outsized filing cabinet," the *Wall Street Journal*'s critic concluded, "This addition isn't really architecture; it's strategy. While seeming humble, and cutting a few feet here and a few inches there, the museum is still doing exactly what it shouldn't and needn't be doing: planning to mess with a 20th-century monument."[28]

Despite the criticism, Scheme II was approved by the Board of Standards and Appeals on October 20, 1987. The Board of Estimate, the ultimate arbiter, upheld the decision in a vote on January 14, 1988, just eight months before Wright's building would turn thirty years of age and become eligible for designation as a New York City landmark. With

Proposed addition, Solomon R. Guggenheim Museum, 1071 Fifth Avenue, between East Eighty-eighth and East Eighty-ninth Streets. Gwathmey Siegel & Associates, 1987. Rendering of view to the southeast showing outline of proposed Scheme II as compared to Frank Lloyd Wright's unrealized annex (1951). GSAA

Proposed addition, Solomon R. Guggenheim Museum, 1071 Fifth Avenue, between East Eighty-eighth and East Eighty-ninth Streets. Gwathmey Siegel & Associates, 1987. North elevation showing Scheme I (1985) and Scheme II (1987) designs. GSAA

the decision behind it, the museum appointed a new director, Thomas Krens, who would see the project through to completion. Ironically, Krens adopted the strategy that several critics had advocated—that of establishing satellite museums to handle the seemingly endless expansion of the collection.[29] Meanwhile, opponents battled the project in the courts. While the addition was not blocked, a year later, when construction was well under way, the Landmarks Preservation Commission held a public hearing on the matter of designation and on August 14, 1990, Frank Lloyd Wright's Guggenheim Museum became an official landmark.[30]

On April 29, 1990, the Guggenheim closed its doors to make way for the renovation and expansion.[31] Gwathmey Siegel's design evolved under the glare of public scrutiny. In October, an alternative facade design was released, brought about, it was argued, by the decision to raise the heights of the galleries. Neighbors argued that the replacement of the four slot windows of the accepted proposal with a combination of three large windows, a slit window, and an open loggia seemed to compromise the near anonymity of the earlier design that had so effectively quashed opposition. Faced with the possibility of more protests and lawsuits, the museum withdrew this proposal in November, promising another version soon but ultimately staying with the approved plan. The restored museum and its annex were officially opened on June 24, 1992, with a gala black-tie bash that rivaled and perhaps outstripped the glamour of the inauguration of Wright's design in 1959.

Under Thomas Krens's leadership, the museum took on a new institutional energy and also embraced the Wright building as never before, restoring or adapting design features that had been neglected or ignored. For example, the space that Wright had intended as a restaurant on the Eighty-eighth Street side of the building but which had been used as a conservation laboratory was not only returned to its intended use, but also designed to reflect the architect's original plans. The

ABOVE Addition, Solomon R. Guggenheim Museum, 1071 Fifth Avenue, between East Eighty-eighth and East Eighty-ninth Streets. Gwathmey Siegel & Associates, 1992. Axonometric. GSAA

LEFT Addition, Solomon R. Guggenheim Museum, 1071 Fifth Avenue, between East Eighty-eighth and East Eighty-ninth Streets. Gwathmey Siegel & Associates, 1992. Section. GSAA

top coil of the main ramp was converted from art storage to display space, reflecting Wright's intention, and the smaller rotunda, called the Monitor Building, was liberated from partitions that compromised its integrity. Additionally, all the original glass was replaced with thermal panes that could filter out ultraviolet and infrared rays harmful to works of art. The clerestory windows were reopened, as was the scalloped flat clerestory at the perimeter of the ground-floor exhibition space—all in all bringing to full realization Wright's brilliant plan for natural illumination. The hitherto uninsulated gunited exterior walls were insulated, a necessity of modern climate control; the auditorium's stage was reconfigured to

make it more useful for performances; and, despite the previous administration's protests that underground expansion was infeasible, 10,000 square feet of new basement space was created to accommodate some conservation space and storage (mostly these functions were relocated off-site on the West Side and in SoHo).

Of course, the key issues for critics and the public were not the restoration of the rotunda and the return of abandoned aspects of Wright's design, but the new wing, its galleries, and the transformed sequence of the galleries as a result of the integration between the rotunda and the wing on each cycle of the once almost purely self-referential spiral. No one faulted the

new terrace created at the fifth-floor level of the annex, from which visitors could enjoy sculpture in the out-of-doors, the roof of Wright's dome, and a sweeping view over the trees of Central Park. For Paul Goldberger as for many other observers, the pleasures of the restoration were negatively offset by the transformation that Gwathmey Siegel's oh-so-genteel backdrop building wrought on Wright's aggressively anti-contextual monument, which now seemed "reined in and tamer, anchored where it once floated free." But all in all Goldberger felt the price paid in contextual freedom was worth it. He welcomed the new galleries and the liberated plan. As if in riposte to Arthur Rosenblatt, Goldberger stated: "The building is now a better museum *and* a better work of architecture."[32]

Martin Filler, a vigorous opponent of the original plan, was not pleased with the realized expansion, decrying the fact that the "high-rise actually penetrates the great circular form" of Wright's rotunda and that the "exterior detailing of the extension is poorer than had been anticipated, with a lifeless plaid-like pattern cut into its limestone cladding." But for Filler "the most tragic result of the Gwathmey Siegel scheme" was "its destruction of Wright's powerful internal dynamic, which made the rotunda one of the world's most compelling architectural volumes." He found that the renovation of the circular monitor to serve as an exhibition space was "a kitschy conception . . . belittling" both the monitor and the rotunda in the process. But more troubling was the connection of the rotunda to the new Gwathmey Siegel tower galleries by which means "the architects have broken into Wright's carefully controlled vortex . . . to disastrous effect. One can almost feel the building's energy escaping, its power dissipating. . . . By allowing, in fact encouraging, visitors to saunter from the heroic Wright rotunda into the constricted, mediocre galleries of the Gwathmey Siegel addition and back again, the architects have reduced the work of their genius predecessor to an episode in a larger but lesser experience."[33]

Mildred Schmertz was more reserved in her criticism of the annex which, "though decent and quiet, could never be decent and quiet enough. Rammed into the narrow remainder

FACING PAGE Addition, Solomon R. Guggenheim Museum, 1071 Fifth Avenue, between East Eighty-eighth and East Eighty-ninth Streets. Gwathmey Siegel & Associates, 1992. View to the southeast. Goldberg. ESTO

BELOW Addition, Solomon R. Guggenheim Museum, 1071 Fifth Avenue, between East Eighty-eighth and East Eighty-ninth Streets. Gwathmey Siegel & Associates, 1992. Fourth-level gallery. Goldberg. ESTO

Addition, Solomon R. Guggenheim Museum, 1071 Fifth Avenue, between East Eighty-eighth and East Eighty-ninth Streets. Gwathmey Siegel & Associates, 1992. View to the south. Goldberg. ESTO

of the Guggenheim site, it crowds Wright's structure. As viewed from the north, the slab itself is well differentiated from the museum's small rotunda wing by means of an intersecting glass curtain wall. The westward facing limestone wall, however, collides with the uppermost spin of the large rotunda at an angle that subverts its radial geometry. This unavoidable juncture, defiling Wright's building, looks worst when one looks south from the opposite side of Fifth Avenue." Schmertz, like many others, applauded the restoration of the interior, but she correctly pointed out that in painting it "stark white, instead of the beige putty Wright specified, the effect was now more austere than originally intended."[34]

In October 1992, long after the hoopla of the museum's reopening had died down, Carter Wiseman, somewhat surprisingly given his early, quite positive reception to the first proposal in 1985, weighed in with a very negative view of the tower's design published in *Architectural Record*. Wiseman labeled the addition "insipid," with its principal galleries "totally without character, too narrow for its height, and coldly lit."[35] So outspoken was the criticism that Charles Gwathmey was moved to respond at some length. In his response, published in that same issue of *Architectural Record*, Gwathmey emphasized that he had never hesitated in taking on the commission nor had had a moment's apprehension about his ability to add on to the building: "to have declined the commission, as some architects advocated, would have been culturally and historically antithetical. Architecture is not static, nor is perception," he continued, expressing his

belief in the "idea of the addition. . . . The idea of resurrecting and transforming a seminal work for posterity was our continued motivation."[36]

In December 1993, Samuel J. and Ethel LeFrak made a substantial donation to the museum, on the condition that the building be named after them.[37] The move was extremely unpopular, especially with the architectural press, who held the donor in low esteem as developer of what Suzanne Stephens called "one of the dreariest travesties of non-architecture in New York, Lefrak City [Jack Brown, 1960–67] in Queens."[38] While the issue of the gift and the renaming may have at first seemed extra-architectural, it proved otherwise when the Landmarks Preservation Commission undertook to review for appropriateness the new exterior lettering required to celebrate the gift. In 1994 the commission ruled against the proposed signage. The LeFraks were said to be wavering in their commitment to the museum, but in 1995 the issue was settled when the fifth-floor gallery and sculpture terrace were named after the developer and his wife, with discreet white plaques, using Frank Lloyd Wright's original typeface design, placed over the gallery's entrance and the door to the terrace.

Six years after the completion of Gwathmey Siegel's annex, Paul Byard, an architect specializing in preservation, delivered a negative assessment: "The addition has a double impact: while the new box tames the rotunda outside, its galleries undermine the effect of its interior ramp. The result is a pretentious failure of curatorship, of understanding and respect, on the part of an owner who should have known better."[39] Perhaps the last word was that of Victoria Newhouse, a longtime opponent of the expansion whose book of 1998, *Towards a New Museum*, became the definitive text on the explosive building and rebuilding of museums at the century's end. As Newhouse put it: "The Guggenheim is a building that should never have been altered. The problem is not so much with the design of the alteration as with the decision to alter it at all. The only positive outcome of the enterprise was the simultaneous restoration of Wright's building, accomplished with sensitivity by Gwathmey Siegel."[40]

Like Frank Lloyd Wright's Guggenheim Museum, Marcel Breuer and Hamilton Smith's Whitney Museum of American Art (1966), southeast corner of Madison Avenue and Seventy-fifth Street, was more successful as an icon than as a working museum. But its strategic location in the heart of New York's most fashionable residential and shopping neighborhood had a remarkably beneficial effect on the somewhat pokey institution, turning it into a far more popular museum than it had ever been when its previous location at 22 West Fifty-fourth Street (Miller & Noel, 1954) made it a virtual stepchild of the Museum of Modern Art.[41] Typically, when Breuer's building was discussed in the press, its bold shape and dark color were an occasion for aesthetic debate. Little attention was paid to its value as a functioning museum and, as Bernard Spring, dean of the School of Architecture at City College, observed in 1978, "the activity program and the form of the building" were treated "virtually as one and the same. . . . The initial published presentations of the Whitney show, more than anything else, how completely the concept of the marriage of form and function was accepted as the essence of quality in architecture. It was the peak and perhaps the beginning of the end of an era."[42] In many ways, as Spring pointed out, the programming of the Whitney's building reflected the building's past, while its strong form, as well as the escalating public interest in

contemporary art, propelled the institution to a new role for which the building, in its planning, was not well suited.

The Whitney Museum began in 1931 when the immensely rich artist Gertrude Vanderbilt Whitney founded what was as much a club as a public museum. Since that time, there remained, as John Morris Dixon observed in his comments on the building in 1966, a sense of its patrician origins which, despite the bold Breuer building, lingered in some ways, conveying "a rich character more like that of a private mansion than of an anonymous public treasury."[43] By the mid-1970s, renovations to the Breuer building were already under way: gone were the carpeted, wood-paneled galleries furnished with comfortable sofas, lounge chairs, desks, and tables suggesting that the museum was "a home, albeit open to the public, for the Whitney family and for the artists and friends with whom they shared an interest in the development of American art."[44] Blockbuster shows, an increasingly popular feature of museum programming in the 1970s and 1980s, attracting between 3,000 and 5,000 visitors to the Whitney on busy days, swamped not only the galleries but also the elevators, stairs, toilets, coatroom, and café. The crush of humanity not only led to the abandonment of the clublike galleries, with the wood paneling replaced by plaster to accommodate more artwork, but also forced more dramatic interventions. Breuer's oddly compelling if eccentric windows were frequently covered to provide more hanging space. Similarly, the modular partitions on the fourth floor, once seen as remarkably innovative, had proven a failure: the frequent joints and the "float-ing" relationship to the stone floor were deemed visually distracting. By the late 1970s, conventional partitions were being used in their place.

Changing architectural tastes also played a part in the reassessment of the Breuer building's value in the late 1970s. For example, Robert Venturi challenged the building's self-referential status as an icon by mounting a giant billboardlike cutout reproduction of Hiram Powers's sculpture *Greek Slave* on top of its hooded entry as promotion for a bicentennial exhibition, "Two Hundred Years of American Sculpture," which the pop-realist architect designed in 1976.[45] Inside, Venturi abandoned Breuer and Smith's two-by-two-foot ceiling grid in order to create a dramatic sequence of galleries that included a forced perspective. He also abandoned any trace of Breuer's partitions in favor of a system of walls that created roomlike galleries.

The logical solution to the Whitney's space problems was expansion to the south, where a row of five brownstone buildings filled the other half of its Madison Avenue blockfront. Such expansion had been anticipated by Breuer and Smith, who located "knock-out" panels in the finlike concrete wall that formed the museum's south party wall. In the late 1960s, at the behest of David M. Solinger, the museum's president, the Whitney acquired two of the brownstones in the middle of the block, thereby effectively blocking commercial interests from assembling the site for redevelopment.[46] In 1978 a group of Italian developers, Sviluppo Tecnica and SGI/Sogene, commissioned two English architects, Norman Foster and Derek

Addition, Solomon R. Guggenheim Museum, 1071 Fifth Avenue, between East Eighty-eighth and East Eighty-ninth Streets. Gwathmey Siegel & Associates, 1992. Sculpture terrace. Goldberg. ESTO

Walker, working in collaboration, to prepare proposals for a mixed-use tower on the southern half of the block, the base of which would provide 5,000 square feet of expansion space for the Whitney, while the tower would contain apartments.[47] For two years the museum and the developers studied the project, encouraged by the Museum of Modern Art's success with its expansion plans. Ada Louise Huxtable likened Foster and Walker's proposal, designed with the eminent English structural engineer Frank Newby, to "a startling, vertical Beaubourg," referring to the museum (1971–77) in Paris designed by Foster's friend and former partner turned rival, Richard Rogers, in partnership with Renzo Piano.[48] That the proposal for a thirty-five-story building did not go forward can be attributed to a certain reluctance on the part of the trustees to participate in a speculative project and, in part, to a growing belief that the bold, highly tectonic design, with its dramatic slope-sided glass base and overall exploration of expressed superscale metal framing, might experience rough sledding under the Upper East Side Historic District plan, which was expected to be implemented by 1981. While the tower design seems to have been only lightly sketched, the base was developed in some detail, indicating five floors of museum space exposed to view behind a glass-enclosed atrium-like sculpture court. The tower would have been Foster's first—he soon went on to realize one of the era's landmark skyscrapers for the Hong Kong and Shanghai Banking Corporation (1979–86) in Hong Kong.[49] The design was intended to contrast the solidity of Breuer's Whitney (which Foster deemed a "fortress-like tomb for art") with its glassy opposite while also restating the classic New York skyscraper-on-base parti of the Carlyle Hotel, two blocks to the north.[50]

Early in 1981, rumors of a new strategy for the museum's expansion began to circulate, fueled by public knowledge that the trustees had completed their acquisition of the remainder of the Madison Avenue blockfront.[51] In October of the same year, the Whitney named Michael Graves as the architect for a new building, which it would build for its own use and which would not include a residential tower.[52] Graves was asked to consider a single-use building with the possibility of ground-floor commercial space, much like the arrangement that Louis I. Kahn developed for the Yale Center for British Art (1969–74) in New Haven, believed to be the only museum in the country to have such a layout.[53] Graves's appointment was greeted with great interest as well as not a little wariness. Susan Doubilet, an architecture journalist, went right to what would be the heart of the controversy that would surround and ultimately defeat Graves's proposal: the mixed regard but grudging respect architects had for Breuer's building which, she wrote, is "nothing if not idiosyncratic, with surprising refinement" despite "its abstractness and its deliberate violation of the neighborhood's scale. . . . Still, the Breuer building," Doubilet continued, "in all its contrariness and deliberateness, is endearing" and its very qualities of eccentricity, such as the "askew windows," "quirky and personalized as any of Graves's inventions," promised to make this a "marriage of two distinctive personalities . . . brilliant, if tempestuous."[54]

Even before Graves's scheme was complete, students in various architecture schools tackled the problem. At Columbia, during the Spring 1982 term, the project was studied in the "advanced architecture studio" for post-professional students led by Steven Peterson and Charles Gwathmey and in Robert Stern's second year studio in the Master of Architecture program.[55] For Peterson and Gwathmey's studio, Terence Riley proposed a self-contained cubic mass, whereas William MacDonald attempted to engage the Whitney in a "dialectic relationship" that eliminated the sheer wall of Breuer's design and introduced a glassy hingelike tower between the original building and the addition.[56] In Stern's studio, Graham Wyatt and Harry Toung, who had each studied under Graves while undergraduates at Princeton, proposed

FACING PAGE View to the northeast showing Robert Venturi's 1976 reproduction of Hiram Powers's *Greek Slave* (1844) atop entry to Whitney Museum of American Art (Marcel Breuer with Hamilton Smith, 1966), 945 Madison Avenue, southeast corner of East Seventy-fifth Street. VSBA

RIGHT Proposed mixed-use tower, east side of Madison Avenue, between East Seventy-fourth and East Seventy-fifth Streets. Norman Foster and Derek Walker, 1978. Rendering of view to the northeast. FAP

Proposed addition, Whitney Museum of American Art, east side of Madison Avenue, between East Seventy-fourth and East Seventy-fifth Streets. Terence Riley, 1982. Rendering of view to the northeast. TR

Proposed addition, Whitney Museum of American Art, east side of Madison Avenue, between East Seventy-fourth and East Seventy-fifth Streets. William MacDonald, 1982. Rendering of view to the northeast. KMS

a tripartite cubic mass that convincingly used their former teacher's classically inspired vocabulary. More radically, Richard Levitz proposed a boldly classical scheme with colossal columns carried on brackets above a patterned wall punctuated at street level by shop windows, entering, as Levitz put it in his description, into "a dialogue between the old and new Whitney, between modernity and tradition—a continuing dilemma in the arts."[57] When Arthur Drexler, director of the Museum of Modern Art's Department of Architecture, sat in on the final review of the Stern studio's work, he was so impressed with Levitz's project that he asked for the drawings on behalf of the museum. Drexler said it represented

> everything that twentieth century museums were supposed to get rid of, overcome, and improve upon. Mainly, the original intention (of the Whitney) was to replace the museum as a palace with the museum as warehouse or department store. . . . For one reason I find this project very pleasing, apart from quibbles I might have about scale of detail, is that, I think (unless I'm deceiving myself), I know what your intention is: you do not seem to be making fun of the Breuer building. You are proposing a different model, a different image.[58]

Graves's first design—there would be three—calling for a building clad in red and pink granite was not made public until May 1985. It would more than double the museum's space—from 83,500 square feet to 217,000 square feet—by adding a ten-story building south of the museum, the top five floors of which would extend over the existing building. The new facility would include a 250-seat auditorium and a public restaurant. According to Graves, the decision not to build a tower atop an expanded museum, as Foster and Walker had proposed, was based on the need to create the large museum floors desired by the curators and achievable only by building on top of the Breuer building. This proved to be the single most controversial aspect of the design. Although Graves's work was not any more known for its anonymity than Breuer's, his was, however, a more contextually responsive approach. Graves claimed that his proposal was sensitive not only to the neighborhood but to Breuer's building: "It attempts to be an

American building by making an amalgam of the modernity one finds in the Breuer building, as against the more elaborate and figurative tradition in the rest of the street. That's the kind of amalgam that this country is known for."[59]

Paul Goldberger, who immediately weighed in with an assessment, was particularly sensitive to the difficulties of the problem: "There can be few urban design problems in New York more difficult than adding on to the Whitney Museum of American Art, a building whose essential architectural idea is its own aloofness." Not prepared to "lie down and play dead beside such a powerful and difficult building," Goldberger continued, which is "what many architects would do," Graves incorporated it into a larger, more complex design, a "richly ornamented assemblage of pure geometries and variations on classical elements such as colonnades and pergolas" that "feels right for the eclectic mix of Madison Avenue." One feature of Graves's design that proved to be particularly controversial was his decision to tear down Breuer's concrete party wall and replace it with a hingelike stair tower intended to mediate between the thirty-foot street-level setback of the original building and the street-hugging wall of the proposed addition. Goldberger deemed this feature, which in effect would create a kind of architectural diptych out of the old and new buildings, a "masterly" stroke.[60]

More controversial than the "hinge" was the five-story penthouse that strode most of the length of the block, "a vast colonnaded temple, slung across the top of both buildings," as Goldberger put it, with a low, arched eyebrow window that was intended to help visually unite the two buildings and, more important, to give the impression that the penthouse was a relatively light, bridgelike structure spanning the two (the blocky colonnade at the top somewhat mitigated any impression of lightness). Despite his enthusiasm for Graves's design, Goldberger did see its perhaps unavoidable failure: "For all the quality of Mr. Graves's design, the Breuer building remains a nagging presence, a problem that defies complete solution. It does not go gently into that good composition Mr. Graves has built around it; it has been

Proposed addition, Whitney Museum of American Art, east side of Madison Avenue, between East Seventy-fourth and East Seventy-fifth Streets. Graham Wyatt and Harry Toung, 1982. Rendering of view to the northeast. PRE

Proposed addition, Whitney Museum of American Art, east side of Madison Avenue, between East Seventy-fourth and East Seventy-fifth Streets. Richard Levitz, 1982. West elevation. RL

tamed, and made a more civil part of the streetscape than it is now, standing alone. But to tame it is to lose its original essence."[61]

Release of Graves's design to the media unleashed a firestorm of controversy. The depth of hostility to the scheme seemed to extend to the architect himself, who was resented by many of the older generation as the leading challenger to the prevailing late Modernist orthodoxy. Wright's design for the Guggenheim Museum probably aroused a similar reaction among the waning Beaux-Arts establishment, but the architects of that "gentlemanly" era kept their opinions to themselves or to the privacy of intimate conversations. In the far more unbuttoned 1980s, virtually no one and virtually nothing was held back. There was not a little irony to the Whitney backlash, as Peter Lemos, writing in *Metropolis*, observed: the debate over the addition had "turned the architectural politics of New York around. In defending the Breuer building, which exemplifies the modernist urge-to-purge as much as anything does, several of the city's die-hard modern architects have suddenly been cast in the novel role of preservationists, arousing instincts in them that they surely never felt back in 1966 when the original block-buster went up."[62]

Opposition to Graves's scheme was spearheaded by Breuer's widow, Connie, but it was Abraham W. Geller, a respected architect of the second tier, who made the matter public when he took the opportunity of his acceptance speech for the 1985 Medal of Honor of the New York Chapter of the American Institute of Architects to condemn the proposed addition and to criticize the decision to hire Graves, whose "philosophy is the antithesis of the philosophy of the museum's originator, Marcel Breuer." Geller felt that Graves's use of "applied classical forms" represented the museum's "backing away from its original concept." Most damningly, Geller claimed that the Breuer building was being "literally crushed. It is being subjugated to an assemblage of many diverse and unrelated blocks." He ended his speech with a "plea," begging that the Breuer building be given "air to breathe and exist, both on the side and on the top. Don't smother it."[63]

Geller's attack was picked up by a number of writers, including the curmudgeonly Hilton Kramer, who saw Graves's proposal as "nothing if not entirely faithful to the spirit of his client's wishes—a spirit governed by an invincible preference for glitz and specious glamour at the expense of art itself." Kramer believed the building program to be vastly inflated, more like that of "a new corporate headquarters" than a museum.[64] Michael Sorkin acknowledged the difficulties faced by any architect in "adding to a masterpiece" but was nonetheless outraged by Graves's design, which he deemed not just "simply disrespectful" but "hostile, an assault on everything that makes the Breuer original particular. It's a petulant, Oedipal piece of work, an attack on a modernist father by an upstart, intolerant child, blind or callow perhaps, but murderous." Sorkin went after many aspects of Graves's solution, attacking none more articulately than the "pivotal" concept of the "hinge," which "eras[ed] both Breuer's own asymmetry and its asymmetrical relationship to the rest of the block" and further rationalized the "spurious balance between the original and its hulking doppelgänger."[65]

The normally languid summer months were kept lively by the debate. Hamilton Smith—who had designed the original building with Breuer and whose current firm, the successor to Breuer's (Breuer had died in 1981, the year of Graves's appointment), had been considered for the addition—weighed in against the Graves design. In late July, Smith wrote an Op-Ed piece for the *New York Times*, offering the opinion that "rather than see his museum invaded and disfigured as is proposed, Mr. Breuer, I believe, would have strongly preferred to have it completely torn down."[66] Five days after Smith's essay was published, at a meeting called by the New York Chapter of the American Institute of Architects, held in the auditorium of the Donnell Library, Graves and other architects, including Philip Johnson and Ulrich Franzen as well as the Yale art historian and critic Vincent Scully, spoke in defense of the design before a standing-room-only audience. Although Scully now found himself liking Breuer's building more than ever, he still applauded Graves's intervention, especially its "New Yorker penthouse

Proposed addition, Whitney Museum of American Art, east side of Madison Avenue, between East Seventy-fourth and East Seventy-fifth Streets. Michael Graves & Associates, 1985. Model, view to the east. GRV

fantasy, up above." By "putting a weight on the Breuer building, it now gives that building what it never had before, that is, that lifting facade now has something to lift."[67]

Graves, in his explanation at the AIA meeting, likened his design to Fra Angelico's *Annunciation*, a diptych painting much beloved by the architect. Like the *Annunciation*, the proposed combined Whitney would also be a diptych "mediated" by a column, leading the not very sympathetic critic Roger Kimball to observe, "It wasn't difficult to guess who was to play the savior in the scenario." According to Kimball, Graves's claim for unity was only an "abstract, 'paper' unity. . . . The meaning, the feel of Breuer's building would be transformed utterly. The truth is, in Graves's design Breuer's building would lose its architectural autonomy, becoming little more than a facade, little more than a picture, a representation of its former self. (Perhaps this is the real significance of his invocation of Fra Angelico's painting: not that the proposed design reconstitutes Breuer's building as one-half of a diptych but that it *pictorializes* the building, turning architecture into a decorated surface.)" In short, Kimball claimed, Graves's design offered "not so much a plan for the expansion as for the usurpation of the Whitney Museum."[68]

A public hearing before the Landmarks Preservation Commission was delayed after the Whitney withdrew its original proposal, leading to speculation that the scheme was being revised. In mid-August 1985, Goldberger revisited the scheme and the ensuing controversy, pointing out that Graves's design "brings into focus all the emotions that have surrounded modern architecture in the last generation." Breuer's building, for all its faults, has "what one might call a kind of nasty integrity, and that obviously has a certain appeal in an age when much of the architecture produced gives the impression of being concerned more with superficial effects than with underlying truths." Goldberger's real purpose in writing, however, was not to rehash the argument but to propose that the addition be reduced in size, a process

already under way but not yet known to the public. "Must the Whitney," he asked, "like so many other museums, also be a research center, an archive, a library and a public meeting and eating place? There is a real question as to whether the museum must be all things to all people, or even all things to all people interested in American art."[69] A reduced building program, Goldberger argued, would undoubtedly improve the building, ridding it of the heavy-handed top, not only assuaging the Breuer partisans but also the influential group never publicly discussed, the abutting apartment house neighbors whose views would be blocked and who were actively pressing for the preservation of the brownstones to maintain the area's light and air.

While some critics and neighborhood groups rallied around the preservation of the brownstones, Cynthia Nadelman, a contributing editor of *Art News*, raised the issue of the preservation of "modernist architecture": "With all that we've learned about the sudden alteration and destruction of works of art attendant upon style shifts, we should be doing something right now to preserve examples of" this kind of architecture "held in ever decreasing" esteem. "Landmarks Commissions and similar entities would be well advised to set up protective measures for certain buildings—often especially vulnerable—built *within* the past 30 years. Many are saddened and angered to think that soon we won't even recognize in the Whitney a time, only 20 years ago, when integrity and originality, though often overwrought and sometimes overrated, were beliefs on which to build."[70]

On October 5, the *New York Times* reported that 600 people, including such architects as Edward Larrabee Barnes and I. M. Pei, as well as sculptor Isamu Noguchi and playwright Arthur Miller, had signed a petition circulated by the Ad Hoc Committee to Save the Whitney asking the museum's trustees to abandon their plan to build Michael Graves's design. Suzanne Stephens greeted Pei's decision to sign the

Proposed addition, Whitney Museum of American Art, east side of Madison Avenue, between East Seventy-fourth and East Seventy-fifth Streets. Michael Graves & Associates, 1987. Model, view to the southeast. GRV

petition with wry amusement, pointing out that though the six-story glass pyramid Pei proposed for the Louvre courtyard "spurred resounding public and professional outcry in Paris, there the protest was to no avail. Obviously Pei must believe such actions carry more weight in the U.S. . . . For his part, Graves had been asked to sign an anti-Louvre expansion petition but declined, saying 'Architects don't do that.'"[71] Barnes's objection to the Graves scheme had, as Martin Filler observed, "more than a touch of irony" given the fact that his IBM Building "is far more destructive" to Madison Avenue "than the Whitney scheme could have been by any stretch of the imagination." Moreover, Filler pointed out, another signatory was Hugh Stubbins, "he of the inhumanly scaled and stupefyingly banal Citicorp Center."[72] Later it was revealed that the architects Romaldo Giurgola and John Johansen also signed the petition, as did the artists Robert Motherwell, Julian Schnabel, and Saul Steinberg.

Things got a bit "ugly" at a three-part symposium on the architecture of art museums sponsored by the New York Architectural League in December 1985. The event's moderator, Suzanne Stephens, referred to Hamilton Smith's observation in a letter to the editor of the *New York Times* that the Breuer building was a complete work of art and not a scrap to be used in a collage, and then confronted Graves with some architects' claims that because of the program he should have refused the job. To this Graves, never one to pass a chance for a witticism by, asked: "Do you think *they* would have?" and went on to say that "given that Breuer wanted to build a tower on top of Grand Central, we know that if he were alive he would accept the Whitney Commission." Graves then went on to state, rather testily, but justifiably given the hostility of much of the criticism that his design and, indeed, his work, had engendered: "I'm really tired of the assumption that he [Breuer] or others in this room wouldn't have designed a building spanning the present Whitney. I've done it. It is worth discussing. But the size of the build-

ing is quite okay. It is not inappropriate for that street. It's not inappropriate for that site. The problem, I think, with the original building is that it was conceived by Marcel Breuer and his partner Hamilton Smith to stand alone."[73]

Perhaps Stephens, better than any of the other critics, put Graves's design in the larger context of Postmodernist aesthetics:

> The Whitney addition is not a drop-dead sublime harmonious whole. Rather it is something that requires another look. Graves had come up with the very kind of architecture Robert Venturi seemed to be propounding in his seminal tract *Complexity and Contradiction in Architecture*—which was published the year the Breuer Whitney opened. He has given us what Venturi termed the 'difficult whole,' which searches for a 'unity through inclusion' of strangely familiar building parts that keep wanting to separate. His scheme even has the 'duality' and 'degrees of multiplicity' that Venturi deemed implicit in architecture that attempts to learn from the past. Indeed, Graves has here pushed duality and multiplicity to the hilt, holding it all together through a certain febrility of compositional grouping.[74]

Stephens went on to place the controversy surrounding Graves's design within the politics of architecture as well, not only calling attention to the fact that the opposition was led by older architects of the late Modernist generation who had been unwilling or unable to enter into the Postmodernist discourse because, by talent and especially by training, they were unable to "turn out luscious drawings" or "talk theoretically about 'meaning' in architecture, and above all, could not allude to past historical styles with understanding." But Stephens, publishing her ideas in January 1986, went on, with considerable prescience, to observe that the "tide" was "turning on postmodernism," with

> younger as well as older architects . . . criticizing the style for its trivialization of architecture. Pretty drawings, it is now evident, don't guarantee great buildings. Too many of postmodernism's perpetrators were overly optimistic about being able to weld

historical elements to today's building materials, methods, and programs. Too many cavalierly changed the scale and proportion of borrowed arches, columns, and windows. And the postmodern belief that architects should not be so serious often resulted in concoctions that traded the grimness of modern architecture for lighthearted silliness.

Still, she continued, Graves's proposed Whitney expansion was "not . . . silly." And, she went on to observe that the very idea of the addition, like that of the Guggenheim Museum, which was almost always discussed in tandem with that of the Whitney, "brings up once again the issue of how close another building can come to the 'perceptual field' of the artifact without destroying its visual identity." Finally, Stephens weighed in with her own judgment: "This observer initially found the scheme just too overburdened. But then, after looking at the model and the drawings over and over again, perceptions began to change. The surface discontinuity of the separate buildings began to cohere. The older Whitney—sculptural, asymmetrical, and jagged—started to come forward and the other buildings receded into a dimensional mosaic. It has begun to look good."[75]

Proposed addition, Whitney Museum of American Art, east side of Madison Avenue, between East Seventy-fourth and East Seventy-fifth Streets. Michael Graves & Associates, 1987. Photomontage, view to the southeast. GRV

But Stephens's sympathetic appraisal, written for *Manhattan, inc.*, a short-lived journal of little influence, came too late. By the next month, February 1986, Calvin Tomkins could report in the *New Yorker* that, as "one experienced urban administrator" had said to him, the project had "lost momentum" and seemed doomed by "a determined and well- organized opposition, a bad press, and a highly complex series of public hearings and official reviews."[76]

In March 1987, the Whitney unveiled a revised plan that, in response to protests, offered an addition almost 25 percent smaller than the one originally proposed. But the basic composition remained the same, although the top structure spanning the "old" and "new" Whitney was forty-seven feet lower in the new scheme. It was also simpler in appearance—plainer, many said—and it lacked the low-slung, eyebrowlike window. It was set back twenty feet on the corners of the rear facade, addressing the concerns of neighbors who had objected to what they regarded as an unnecessarily tall, sheer facade. While the so-called hinge was redesigned, it remained as a prominent feature.

Despite the overall reduction of the proposed addition, it contained about 3,000 square feet more exhibition space than the previous design, achieved by cutting back on other aspects of the expansion, such as office space, a museum store, restaurant, theater, and library, all elements that had seemed irrelevant or unnecessary to many critics. In the new scheme, the top-floor restaurant, which was to have commanded views of Central Park, was relegated to the basement. Paul Goldberger, who felt that the new design was "not so much a different solution . . . as a smaller version of the last one," believed it would not change opinions about the project's overall merits. The reduced rooftop connector was low enough to ease the objections of Park Avenue apartment dwellers whose views to Central Park would have been blocked by the earlier scheme. In fact, it was so low that it would have been virtually invisible from Madison Avenue, emphasizing more than before the diptychlike aspect of the composition. But Goldberger was quick to point out that the new design was not "the profoundly stimulating structure one assumes Mr. Graves is capable of producing."[77] It was rather blank, mute almost, in its appearance, with little articulation and virtually no windows except for some street-level shopfronts and an alabaster panel that cleverly played on the trapezoidal windows of Breuer's building.

Victoria Geibel's assessment in *Metropolis* was more devastating than Goldberger's: "Even with the modified changes, Graves's new scheme . . . recalls an image" not of the diptych of Renaissance composition but one of a "Cubist fragmentation. By placing a ziggurat-shaped alabaster window on his building's red granite face . . . Graves has created an overall composition that registers as much discord as Picasso's fragmented female in the 1939 painting *Woman with a Blue Hat*. With one eye horizontal, the other vertical, Picasso's woman is an image of schism, of the personality divided. . . . The Graves building . . . does not submit readily to any notion of the Breuer building's supremacy. This is conflict held in check, antagonism sustained and not suppressed."[78]

Not all of the reaction was negative, however. Although Martin Filler found Graves's revised scheme to be a much-diminished version of the first proposal, he nonetheless thoughtfully championed it as "still far and away the most interesting to be advanced for a museum in this city" since the completion of the Guggenheim.[79]

Proposed addition, Whitney Museum of American Art, east side of Madison Avenue, between East Seventy-fourth and East Seventy-fifth Streets. Michael Graves & Associates, 1987. Photomontage, view to the northeast. GRV

On May 19, 1987, the Landmarks Preservation Commission heard eight hours of testimony concerning the fate of the row of five brownstones (Silas M. Styles, 1876) occupying the site of the Whitney's expansion, four of which were in something approximating their original condition while one, 943 Madison Avenue, had been stripped of its detailing and was not considered a contributing building in the Upper East Side Historic District.[80] While many preservationists came to the defense of the row as a matter of principle, Brendan Gill, a trustee of the museum and a key member of the building committee but also a well-known preservationist, stated that he "shed no crocodile tears on behalf of these woebegone orphans." The Whitney, he continued, "is an exceptional problem and required an exceptional answer. We are not private developers; we are a cultural institution serving all Americans everywhere."[81] On June 18, the project passed a major hurdle when Community Board 8 voted to approve two

key historical landmark issues, agreeing to the propriety of the museum's expansion and the proposed demolition of the brownstone row.

Before the Landmarks Preservation Commission could rule, the Whitney withdrew the second scheme from consideration. In December 1988, Graves unveiled a third version of the scheme that eliminated the hinge, thereby liberating Breuer's building, and introduced a bold red and gray granite colonnade facing Madison Avenue to replace the reinterpreted "cyclops" window that had been the dominant feature of the second scheme. The rooftop bridge was also reworked, but its reduced size made it less convincing as the composition's culmination. The scheme, which owed much to the work of the Italian architect Aldo Rossi, was more abstract than its predecessors and therefore more like Breuer's building. A column made for a dramatic corner at Seventy-fourth Street.

Proposed addition, Whitney Museum of American Art, east side of Madison Avenue, between East Seventy-fourth and East Seventy-fifth Streets. Michael Graves & Associates, 1988. Model, view to the east. GRV

Library, Whitney Museum of American Art, east side of Madison Avenue, between East Seventy-fourth and East Seventy-fifth Streets. Richard Gluckman, 1995. GMA

Paul Goldberger was impressed by Graves's third scheme: "This new design calls for a building that would be every bit as imposing as Breuer's, and every bit as distinctive a statement. Mr. Graves is still speaking his own words;—the most important difference between the new design and its predecessors is that this time, Mr. Graves appears to be saying those words in Marcel Breuer's language." Goldberger went on to muse about the colossal amount of attention the Whitney's expansion plan had been given by the public: "This has become one of the most compelling esthetic battles in architecture, in part because it truly is an esthetic one. While there are social, planning, financial and historic preservation issues here, they pale beside the esthetic ones: What value does the Breuer building have, both as a work of architecture unto itself and as a part of the streetscape? And how gingerly, therefore, should it be treated?"[82]

By the end of 1989, the collapse of the stock market, combined with internal dissension on the Whitney board over whether Tom Armstrong's sixteen-year-long term as director had run its course, placed the project in serious jeopardy. By late fall of 1991, Armstrong had been replaced by a new director, David A. Ross, and Graves's third scheme was placed on hold. In March 1992, the Whitney officially abandoned its effort to expand Breuer's building. In 1995 the museum hired Richard Gluckman, an architect specializing in commercial art galleries but who had recently completed the conversion of a former warehouse into the Andy Warhol Museum (1994) in Pittsburgh, to undertake an almost invisible expansion, linking the building to two townhouses at 31 East Seventy-fourth Street (Alexander M. Welch, 1897) and 33 East Seventy-fourth Street (Grosvenor Atterbury, 1901) where staff offices, lecture and conference rooms, and a research library were located.[83] Gluckman also restored the Breuer building while reconfiguring its former fifth-floor offices as well as the fourth-floor mezzanine, which served as the library, into new galleries. The changes added about 13,000 square feet that resulted in an increase by 25 percent of the museum's exhibition space, although the height of the new galleries was rather low.

Gluckman's work was deft and the building's exterior reemerged from extensive structural repairs and cleaning to reveal a lighter aspect than most people remembered, with delicate white veining in the gray granite cladding. But the fundamental dilemma posed by the original design—its inherent anti-contextualism and deliberate standoffishness—continued to rankle, leading Edward R. Roehm, an e-mail correspondent to *Metropolis* magazine, to lambast it as a "clumsy attempt to defy gravity" looming over the street "like a malevolent fortress. The fact that Michael Graves struggled, unsuccessfully, for years to come up with a solution to expand this museum testifies to its problematic concept."[84] In 2004, after briefly considering Rem Koolhaas, the Whitney announced that Renzo Piano, who two years earlier had won the commission to expand the Morgan Library (see Murray Hill), had been selected to design an addition to the museum. In May 2005, Piano's scheme for a nine-story, 176-foot-high tower rising behind the row of brownstones, only one of which would be demolished, and connecting to Breuer's building with a series of glass bridges, was unanimously approved by the Landmarks Preservation Commission.[85]

Other Museums and Their Struggles

In addition to the highly charged and exhaustively documented sagas involving the Guggenheim and Whitney, there were several significant expansions planned by other Upper East Side museums, including new work at the Metropolitan Museum of Art (see Central Park). In January 1975, the Asia Society, headquartered since 1959 in a crisply detailed seven-story glass-and-steel building designed by Philip Johnson at 112 East Sixty-fourth Street, between Park and Lexington Avenues, publicly disclosed its desire to purchase and demolish its near neighbor, the nine-story Gothic-style Central Presbyterian Church (originally the Park Avenue Baptist Church, Henry C. Pelton and Allen & Collens, 1922), 593 Park Avenue, southeast corner of Sixty-fourth Street, with the goal of building a new, larger home.[86] The desire for additional space was prompted by the recent donation of more than 300 art objects from the collection of John D. Rockefeller III, who founded the society in 1956. I. M. Pei was announced as the architect for the project, which would also replace the building just south of the church, the undistinguished five-story 591 Park Avenue (A. Murphy, 1878; reconstructed, Robert W. Meagan, 1959).[87] Despite the objections of some members of the congregation, the sale of the church, which, ironically enough, had been built by the Rockefeller family, was approved by a 65-to-54 vote and accepted five months later by the Presbytery of the City of New York, the governing body of the denomination. But after a series of lawsuits, the congregation reversed course, rejecting the sale of its church in May 1976, forcing the Asia Society to look for a new site.

Nineteen months later, in December 1977, the Asia Society purchased a 5,000-square-foot site on the northeast corner of Park Avenue and Seventieth Street.[88] The change in location brought a change in architect as well, with Edward Larrabee Barnes replacing Pei. Asia Society's new site was occupied by what had originally been five brownstones, 721–729 Park Avenue (John G. Prague, 1882); the three southern ones had been combined to create a house for Gerrish Milliken, with numbers 721 and 723 joined by Walker & Gillette in 1917 and, eleven years later, 725 Park Avenue added by the same firm, forming a fifty-room Georgianesque

mansion.[89] On June 5, 1979, ground was broken for the 79,000-square-foot building combining gallery space, office and meeting rooms, and a 258-seat auditorium and the work was completed in time for a gala opening celebrating Asia Society's twenty-fifth anniversary on April 14, 1981. Barnes's eight-story building was sheathed in two colors of Oklahoma granite: a polished dark red at the two-story base and again at the top, and thermal-finished light red granite for the five middle floors. The design responded to the difficult contextual problems posed by the site, with a strong mass on Park Avenue maintaining the street line and a less aggressive stance along Seventieth Street, where the building stepped back to create a second-level garden terrace complementing the street's low-rise domestic scale. As the building rose on its site, Paul Goldberger found it a "welcome addition to Park Avenue" that largely succeeded in creating "a transition from the huge and chilly bulk of the avenue to the gracious variety of the side street—a transition from the ridiculous to the sublime, one might almost call it," with the ridiculous represented by Kahn & Jacobs's thirty-story apartment tower, 733 Park Avenue (1971), to the north, and the sublime exemplified by Walker & Gillette's Tudorbethan Thomas W. Lamont house (1921), 107 East Seventieth Street, directly to the east.[90] But Goldberger was less pleased with the detailed development of the building's facades: "Mr. Barnes has come up with a front that seems to be trying hard not to look too institutional but has not fully succeeded. . . . The building will be dignified and reasonably handsome, and the use of granite will bring

Asia Society, northeast corner of Park Avenue and East Seventieth Street. Edward Larrabee Barnes Associates, 1981. View to the northeast. RAMSA

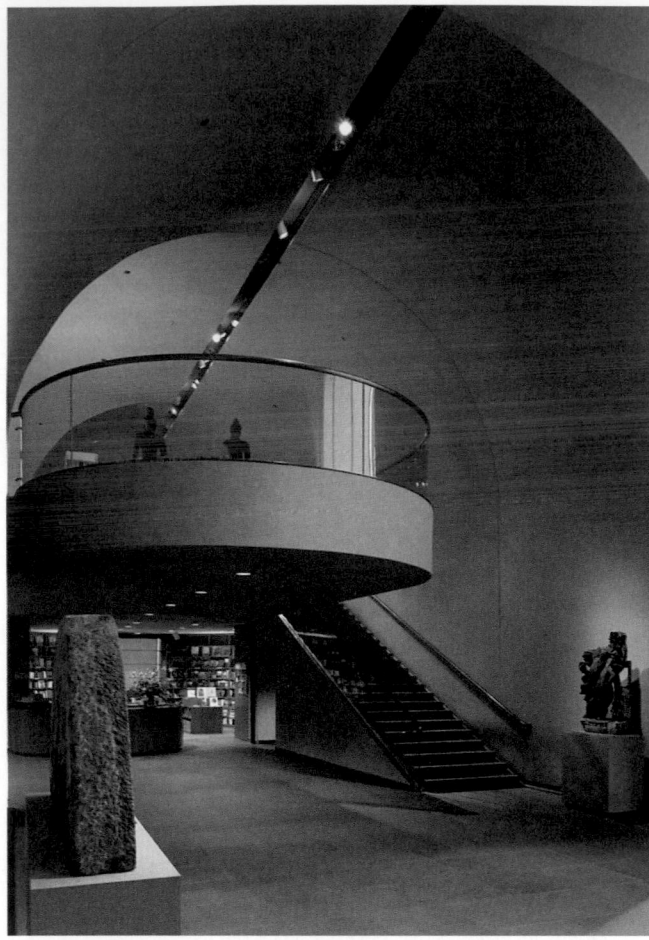

Asia Society, northeast corner of Park Avenue and East Seventieth Street. Edward Larrabee Barnes Associates, 1981. Entry hall. Wheeler. AS

Atrium addition, Asia Society, northeast corner of Park Avenue and East Seventieth Street. Voorsanger & Associates, 2001. View to the northeast along East Seventieth Street. VA

warmth and solidity. But it may be a little bland," despite the two semicircular windows, one large one at the top of the Park Avenue facade serving "as a sort of punctuation mark" and the other at the base of the Seventieth Street side. The critic believed that the rest of the large-paned rectilinear windows "look all too much like the vast sheets of glass that bring such dullness to office tower facades, even though Mr. Barnes has inserted small operable sashes below each large pane and recessed the windows several inches behind the masonry facade to create a bit of depth and shadow, enhancing the sense of texture."[91]

Goldberger's lukewarm feelings were not altered by the completed building. Taking exception to the "attempt to give the building a vaguely Asian air through the use of reddish granite finished in two tones," he continued to have problems with the two semicircular windows, "which do not seem to fit naturally—they come off as slightly jarring, as if drawn on in a hasty gesture to enliven the facade."[92] Goldberger took more pleasure in the interior spaces, especially the "at once gracious and monumental" two-story barrel-vaulted entry hall, with floors of Indian red sandstone, running the full length of the Park Avenue frontage which he found "pleasing as pure space and absolutely suited" to its multiple functions as entrance and gallery filled with monumental stone sculptures.[93] Also of note was the specially commissioned furniture for the upper-floor offices designed by Tod Williams and Billie Tsien, including lacquered wood chairs featuring high sides with small square openings that Suzanne Slesin thought looked "slightly like a confessional."[94]

In August 1998, seventeen years after the completion of Barnes's building, Asia Society announced plans for an extensive renovation and expansion to add much-needed exhibition space as well as upgraded mechanical equipment.[95] The most controversial part of the scheme, to be designed by Voorsanger & Associates, called for a four-story glass atrium to enclose the garden terrace facing Seventieth Street. Ironically, this terrace had been the one feature of the original building that was universally well received. Designed by landscape architects Zion & Breen, it included sycamore trees, a wisteria-laden trellis, and a fountain. Bartholomew Voorsanger was chosen for the commission based in part on the glassy addition he had designed for the Morgan Library in 1991 (see Murray Hill), even as the Morgan's trustees were considering its replacement. Reaction in the neighborhood, particularly on the block of Seventieth Street between Park and Lexington Avenues, was swift and overwhelmingly negative. Objections to the initial design centered on the atrium, which would contain a café and have its own Seventieth Street entrance complete with a canopy and banners.

Voorsanger traveled to Cambridge, Massachusetts, to get the support of the recently retired Barnes, who not only refused to endorse the proposal but also wrote a letter of protest to the Landmarks Preservation Commission, which had jurisdiction over the project because of its location in the Upper East Side Historic District, a restriction that Barnes did not have to contend with when he designed the original facility. The commission sent Voorsanger back to the drawing boards and he successfully returned with a much-reduced addition, lowering the height of the atrium from forty-two to

FACING PAGE Asia Society, northeast corner of Park Avenue and East Seventieth Street. Voorsanger & Associates, 2001. Renovated entry hall. VA

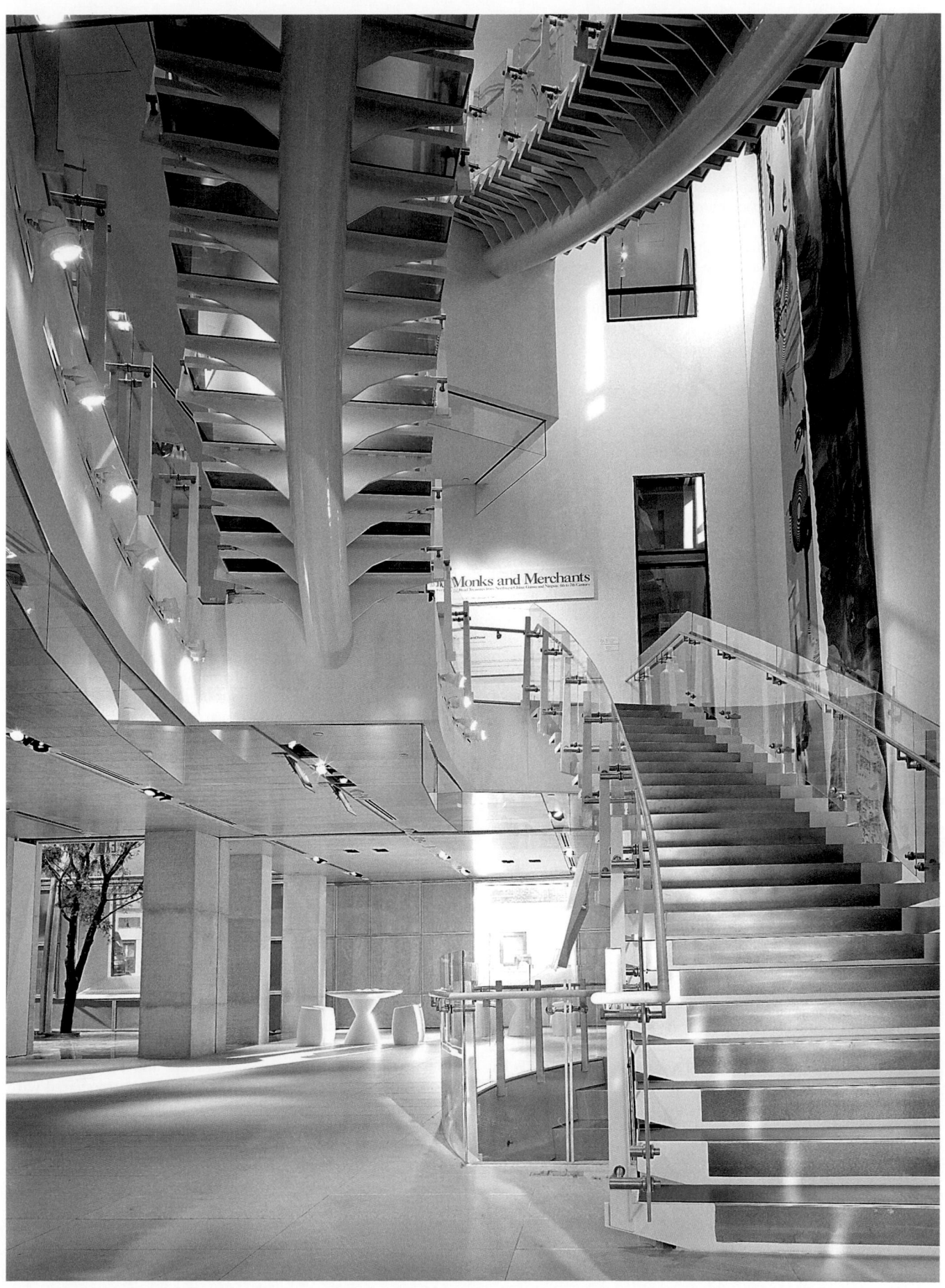

twenty-three feet as well as eliminating the side-street entrance. As completed in 2001, the L-shaped enclosed garden court, with blue-green marble floors and limestone walls, was topped by an undulating glass roof supported by an "architectonic parasol," in the words of Voorsanger, composed of bronze-colored steel beams and steel beams clad in teak.[96] According to Paul Goldberger, the "design appears almost to sway, a soft counterpoint to the solid masonry of Barnes's building."[97] Voorsanger was also responsible for the extensive reworking of the interior, doubling the exhibition space by reconfiguring former administrative and support areas. The most dramatic change was the new double-height entry hall highlighted by a rather exuberant curving blue glass and sandblasted steel staircase with birch handrails linking the new gallery spaces.

Also in need of more space because of increased attendance, the Frick Collection, 1 East Seventieth Street, located in the Modern Renaissance mansion (1914) designed by Carrère & Hastings for Henry Clay Frick and sensitively altered and expanded by John Russell Pope in 1935 to serve as a museum, added a one-story, thirty-four-by-ninety-one-foot pavilion (1977) east of the main building on Seventieth Street.[98] Inspired by Jules-Hardouin Mansart's seventeenth-century Grand Trianon at Versailles, the new building, designed by Harry Van Dyke working in association with John Barrington Bayley and G. Frederick Poehler, was constructed of limestone from the same Indiana quarry as the original building. The 16,500-square-foot addition was dominated by a large waiting/reception room, with expanded information, sales, and coatroom facilities, but also included three other levels: a mezzanine housing office and storage space and two basement levels for additional storage as well as seminar and study rooms for the education department. The pavilion opened onto a fifty-four-by-seventy-six-foot garden designed by English landscape designer Russell Page, who "decided to make it mainly lawn with low plantings concentrated in narrow beds at the foot of the north and east walls" to give a sense of spaciousness.[99] The garden was enclosed by a restored iron fence original to the Carrère & Hastings building that had been in storage for over fifty years. It included a large rectangular pool that took up nearly a third of the space, equipped with a fountain jet and filled with waterlillies and American lotus. In order to provide shade, Page planted four different types of trees asymmetrically on the lawn, including a crabapple, a sargent cherry, a koelreuteria, and a Japanese pagoda. Somewhat petulantly, David Morton felt that the "handsome" pavilion's details were "overwrought and heavy-handed," and claimed that "for many people, the rectangular pond in the rectangular space with walks and hedges at right angles is static and does not make the most dynamic or pleasing solution."[100]

Four years later, in 1981, the Jewish Museum, founded in 1904 by the Jewish Theological Seminary of America and located since 1947 in C. P. H. Gilbert's French Gothic Felix Warburg mansion (1908), 1109 Fifth Avenue, northeast corner of Ninety-second Street, was locked in a battle with its neighbors and preservationists over plans to enhance its revenue stream by developing a twenty-five-story apartment building to be connected to and cantilevered over its existing headquarters.[101] Although the plans drawn up by Gruzen & Partners were never officially released and the museum's trustees continued to emphasize their commitment to the preservation of the Warburg mansion, opposition ran high to the proposal, which would stack nineteen floors of cooperative apartments

atop six new floors for the museum. The Jewish Museum, perhaps taking its cue from the expansion plans then under way at the Museum of Modern Art, argued that it needed expanded exhibition space as well as additional revenue, in part because of the more than $500,000 in estimated repairs required by the Gilbert building. In 1963 the museum had constructed the banal Modernist Albert and Vera List Wing, designed by Samuel Glazer, which Elliot Willensky and Norval White described as "a Miami Beach annex" to a "Gothic chateau."[102] The List Wing had become for a while an important showcase for avant-garde modern art, but the museum had recently rededicated itself to traditional Jewish themes and wanted to display more of its impressive permanent collection.

Neighborhood residents, over 1,000 of whom signed a petition requesting landmark status for the Warburg mansion, worried that the new apartment building would destroy the scale of the area as well as overwhelm Gilbert's building. The museum didn't debate the merits of its building but instead expressed concern that it would be unable to expand if the building was landmarked and that repairs to the seventy-three-year-old structure would then be significantly more expensive. On November 24, 1981, the Landmarks Preservation Commission, without the support of Community Board 8, designated the Warburg mansion a landmark.[103] In April 1982, the Board of Estimate unanimously upheld the building's landmark status but left open the door to possible expansion, negotiating with the museum for a narrower nineteen-story-high addition that would not cantilever over the former Warburg mansion.[104] But later that year the Jewish Museum dropped its plans for the apartment tower.

Still saddled with significant annual deficits and a lack of exhibition space, the museum announced in 1985 that it would go ahead with a permanent multimedia exhibition tracing 4,000 years of Jewish history.[105] The problem was still one of a suitable location, and the museum's director, Joan Rosenbaum, when announcing the exhibit plans, declared that the museum was now interested in establishing a satellite facility, preferably in midtown Manhattan. The next year brought rumors of a proposed site in the Lincoln Center area on land to be donated by Fordham University.[106] None of these projects went forward, but in 1987 the museum did go ahead with a much-needed refurbishment of its galleries in the Warburg mansion.

In May 1988, with the idea of a second branch abandoned, the museum announced new expansion plans for the Warburg site that would more than double existing exhibition space and provide room for a substantial new educational program, improved staff offices, as well as a host of important public amenities, including a café and auditorium.[107] The seven-story, 32,000-square-foot addition, which would make the Jewish Museum the largest such facility in the world outside of Israel, also provided two floors for the permanent exhibition first announced in 1985, "Culture and Continuity: The Jewish Journey." Well aware of the problems associated with its last major effort at expansion, the museum took pains to convince preservationists and residents of the neighborhood that this time things would be different, releasing a drawing of the proposed scheme that showed the three-story List Wing, unpopular with almost everyone, replaced by an almost literal extension of the Warburg facade, designed by a most unlikely architect, Kevin Roche, who as master planner for the Metropolitan Museum had surrounded the original classical buildings with radically Modernist wings.

Addition, Jewish Museum, east side of Fifth Avenue, between East Ninety-second and East Ninety-Third Streets. Kevin Roche John Dinkeloo and Associates, 1993. View to the southeast showing Roche's addition on the left and the Warburg mansion (C.P.H. Gilbert, 1908) on the right. KRJDA

Roche explained his thinking in an interview in the *New York Times* at the time of the announcement: "You could design a modern facade, but what would it say? The Warburg mansion is the Jewish museum. Anything else you'd do would make it an annex. I asked myself, 'What would Charles Gilbert . . . do if faced with this situation?' And I did what I think he would have."[108] Within the context of two far more prominent museum expansions being proposed at the time on the Upper East Side, that of the Guggenheim and Whitney, immediate public reaction was quite favorable for this "safe" design. Three weeks after its release, Paul Goldberger assessed Roche's design, using the occasion for a commentary on the current state of architectural thinking: "No skyscraper, no football stadium, no shopping mall could possibly say as much about how our culture's attitudes toward architecture have evolved as the diminutive addition that has been proposed for the Jewish Museum on Fifth Avenue. The extraordinary thing about this addition is that when it is finished, no one is supposed to know that anything happened at all. . . . It is the ultimate act in disappearing architecture. No one who follows architecture can fail to be astonished by it, in part because Mr. Roche has always been an architect of considerable assertiveness." Goldberger felt that there was "something almost too pleasing" about the design, "something too soft and sceno-

graphic. This architecture makes about as many intellectual demands on us as elevator music." But Goldberger also saw Roche's reticence as a proper reading of the site:

What this tight site needs is not that [previously proposed apartment] tower or the little modern building [List Wing] that is there now. The site is an esthetic gap in the streetscape of Fifth Avenue, and it needs to be filled in sympathetically. . . . So here, in this place, what would appear to be the timid solution—giving up all aspirations toward originality in favor of imitating the older building—is in fact the most reasoned one. A generation ago it would have been unthinkable for anyone to suggest adding to a French Gothic mansion by copying it. Even now it is more than a little shocking to see it proposed by one of our age's most eminent architects, a man for whom formal inventiveness has been a calling card. But Mr. Roche's recognition that discretion can sometimes be the better part of architectural valor shows that he is both as inventive and as responsive to particular circumstances as ever. This design, scenographic work that it is, represents a welcome degree of urban sensitivity.[109]

Suzanne Stephens, writing in *Architectural Digest*, noted the skepticism with which Roche's design was greeted: "Many architects are certain that Roche caved in to pressures from New York's ever-growing landmark-happy citizenry. . . . Roche's faithfully historicist scheme lacks even a whiff of the irony of

the work of Venturi, Rauch and Scott Brown or any of the other architects known for manipulating traditional architectural elements for postmodernist effects." But Stephens took Roche at his word that his design was not a compromise but the proper solution to a specific problem: "The decision of the Jewish Museum and its architect to expand in this self-effacing manner, without making a bold new architectural statement, is significant. Also significant is the decision not to try to take advantage of zoning allowances and air rights to build an apartment tower that would theoretically pay for the cost of expansion. For the Jewish Museum ultimately to opt for a seven-story structure just for galleries and offices strongly suggests that both client and architect have come to terms with certain beliefs about the role of the museum in the urban landscape."[110]

The Landmarks Preservation Commission approved Roche's design in August 1988, and ground was broken for the addition in November 1990. Construction proceeded according to schedule, with some of the limestone coming from the same quarry in Indiana that had supplied Gilbert's original building. Much of the exterior ornamental stonework was undertaken by Cathedral Stoneworks. After two and a half years of construction the Jewish Museum reopened with a gala reception on June 13, 1993.[111] Public reaction to Roche's completed work was largely favorable, with most observers agreeing that he had achieved his goal of complementing the Warburg facade by extending but not simply duplicating it. Peter Slatin, writing in *Architecture*, summed up the view of many by observing, "Instead of a nudge-and-wink interpretation, Roche's faithful simulation is a welcome solution to the museum's dignified landmark."[112] There was also no doubt that the museum's interiors, fitted out by the exhibition specialists Ralph Appelbaum Associates, were a dramatic improvement over the cramped spaces in the Warburg mansion. The museum now had modern gallery spaces with interactive computer displays, room for its curatorial and education departments, as well as a café lit by stained-glass windows. Not surprisingly, there were naysayers as well, with most objections centering on the belief that Roche's design represented a failure of nerve. Susanna Sirefman believed that Roche "missed an opportunity to effect a bold, meritorious architecture" with his "almost imperceptible" addition.[113] John Morris Dixon, writing in *Progressive Architecture*, was even harsher in his criticism:

It is all too characteristic of our times to do the improbable with great skill. And what could be more improbable than the much honored Modernist Kevin Roche expanding a French-chateau-style mansion by replicating and reshuffling its bookish details to cover all the new needs? . . . One is tempted to accept Roche's rationale that this is the way C. P. H. Gilbert himself would have expanded the mansion. But Gilbert, although less honored in his time than Roche is in ours, might have been able to introduce at least some distinctive motifs in the extension. He would have recognized the repetition of the same devices over another 50 feet of frontage to be, at best, an uninspired expedient.[114]

Herbert Muschamp disagreed with Dixon, arguing that Roche had "successfully managed to crawl inside Gilbert's skin" as well as provide at least some visual interest: "To compose the facade, he has faithfully adapted the two vertical bays that are joined at the Warburg mansion's 92d Street corner. He has unfolded the corner, reversed its sides, and recessed the right side slightly from the street wall, a subtle

shift that helps to animate the entire surface." But for Muschamp the question remained,

Was it worth doing? . . . The question might not come up if the architect were of lesser stature than Kevin Roche. But as the work of one of America's most celebrated architects, the museum's expansion, like the museum itself, transcends purely local interest. And as the work of an architect who defines himself as a modernist, the design's significance is rooted in a wider sphere of cultural history. . . . To be modern today does not mean to adhere to old functionalist or minimalist dogmas. It means to grasp modern history: to be aware of the layers of forms and ideas that have gone into the making of modernity. Building additions are ideal projects for expressing that awareness. Like exposed, above-ground archeological digs, they can represent the past as a foundation of the present. That opportunity has been missed here. Though the expansion means to honor history, it ends up sacrificing history to taste. Mr. Roche has enlarged a chateau but not our view of its place in time.[115]

One block south of the Jewish Museum, the Cooper-Hewitt Museum, since 1967 a part of the Smithsonian Institution and housed in the former mansion of Frick's one-time business partner and later archrival, Andrew Carnegie (Babb, Cook & Willard, 1902; renovation, Hardy Holzman Pfeiffer Associates, 1977), southeast corner of Fifth Avenue and Ninety-first Street, was again renovated and modestly expanded by Polshek & Partners in 1996.[116] Polshek's first order of business was to rework the entrance to make it comply with the requirements of the Americans with Disabilities Act (ADA). The architect extended the front steps and inserted a ramp behind an existing balustrade that was moved four feet forward. Polshek's work also included the installation of a new temperature and humidity control system as well as the renovation of the garden terrace, some galleries, and the glass ceiling of the conservatory. Herbert Muschamp was mildly disappointed: "The renovation is not the radical overhaul one might hope for. Nonetheless, the mustiness is gone" and even if the "improvements do not fully dispel the museum's Addams Family atmosphere, at least they convey the impression that the family's mood has lightened up."[117] Polshek's plans also called for renovating and combining two neighboring five-story townhouses owned by the museum at 9 and 11 East Ninetieth Street (George Keister, 1903) to create the Design Resource Center, which was sensitively connected back to the main building by a brick, granite, and cedar bridge. Benjamin Forgey, writing in the *Washington Post*, was not impressed: "With its copycat details—pergola-like roof, granite columns and enormous glass windows—the new piece is bland testimony to the power of New York's landmarks regulators. One might have expected a national design museum and its architects to push for a more adventurous and inventive design."[118]

The Upper East Side also became home to a distinguished new museum. In 1994 cosmetics magnate and art collector Ronald Lauder joined forces with longtime friend Serge Sabarsky, an internationally known art dealer and leading authority on German and Austrian Expressionist art, to purchase Carrère & Hastings's five-story red brick and limestone Modern French–style William Starr Miller house (1914), 1048 Fifth Avenue, southeast corner of Eighty-sixth Street, with the intention of turning it into a museum dedicated to Sabarsky's specialty.[119] The mansion, reminiscent of the seventeenth-century buildings on Paris's Place des Vosges, was bought from the YIVO Institute for Jewish Research, which had been located there since 1953 after the death of the

Neue Galerie, 1048 Fifth Avenue, southeast corner of East Eighty-sixth Street. Annabelle Selldorf, 2001. Second-floor gallery. Hueber. API

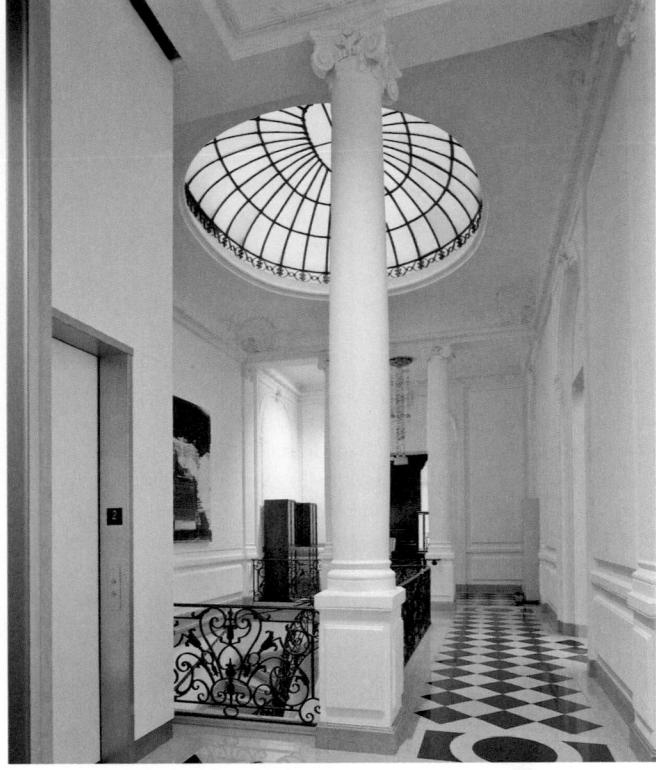

Neue Galerie, 1048 Fifth Avenue, southeast corner of East Eighty-sixth Street. Annabelle Selldorf, 2001. View of main stair showing restored skylight and new elevator. Hueber. API

house's owner of nine years, Mrs. Cornelius Vanderbilt III. In 2000 the YIVO Institute, joining forces with four other Jewish organizations to form the Center for Jewish History, relocated to four buildings on Sixteenth and Seventeenth Streets, between Fifth and Sixth Avenues, that Beyer Blinder Belle combined and added on to with a six-story addition on Seventeenth Street.[120] Although Sabarsky died in 1996, Lauder, a former ambassador to Austria and current chairman of the Museum of Modern Art, continued with the project, hiring the German-born architect Annabelle Selldorf to restore the 23,000-square-foot house to as much of its original glory as possible while also creating a workable museum.

As completed in November 2001, Selldorf's Neue Galerie, named after the Viennese gallery of the same name founded in 1923 to showcase the Secessionist artists Gustav Klimt, Oskar Kokoschka, and Egon Schiele, among others, was a stunning success, creating 4,300 square feet of new display space as well as a café, bookstore, design shop, and administrative offices. Selldorf dubbed the job "a painstakingly discreet renovation" while noting that "it's important not to over-restore."[121] Her boldest move was the reintroduction of natural light into the stair hall, the skylighted dome of which had been covered over by the YIVO Institute, which had ignored or covered up many of the house's magnificent details. Selldorf was able to restore much of the space, particularly on the second floor, where three new galleries were devoted to the permanent collection. After restoring the oak wainscoting and marble trim in what had been the music room, Selldorf added a gridded, backlit, glass-paneled ceiling. The third-floor galleries were completely new, featuring a neutral backdrop of white and gray painted walls and four-

inch-wide dark oak planked floors. Suzanne Stephens was impressed with the work on the third floor: "The luxurious sheen of [the floor's] horizontal planks bring Adolf Loos to mind, just as the linear stretches of gridded steel grills for return air are reminiscent of Josef Hoffmann."[122] Selldorf also added a new elevator, with a cab modeled on those at the Seagram Building, set in a white-glass shaft. As the architect put it: "I didn't want to make a big statement and put in a transparent elevator or something. . . . Instead of a spectacle, we made the elevator a white, silent, shiny Miesian box, to look as if it had always been there, unless you thought about it."[123] The Neue Galerie proved popular with the public, especially because of its ground-floor seventy-seat Café Sabarsky, a rendition of a Viennese coffeehouse, the design of which combined original wood paneling from the house, a Hoffmann chandelier, and tables and bentwood chairs originally designed by Loos for his Café Museum (1899) in Vienna.

The museum's interesting collection and its intimate scale, which many likened to a modern-day Frick or Morgan, not to mention the Café Sabarsky, all worked to its advantage. But Hilton Kramer felt that the museum "would be worth a visit even if there were nothing else in the building to look at," writing that Selldorf's renovation "instantly establishes the Neue Galerie New York as one of Manhattan's most beautiful architectural interiors."[124] Suzanne Stephens agreed, concluding her assessment of the design by declaring "the result . . . a highly disciplined work of art that recaptures the spirit of the old New York town house, but allows the German and Austrian artifacts to emerge brilliantly and clearly from their elegant backdrop."[125]

SCHOOLS

By the 1970s, Hunter College had outgrown its two-building campus comprising 695 Park Avenue (Shreve, Lamb & Harmon in association with Harrison & Fouilhoux, 1940), between Sixty-eighth and Sixty-ninth Streets, and 930 Lexington Avenue (C. B. J. Snyder, 1913), between Sixty-eighth and Sixty-ninth Streets, originally built for the Normal College (renamed Hunter College in 1914 after its first president, Thomas Hunter), and later home, between 1940 and 1977, to the Hunter College High School, which relocated to what had been built as Intermediate School 29 (Morris Ketchum Jr. & Associates, 1969) on Park Avenue between Ninety-fourth and Ninety-fifth Streets.[1] Hunter College began considering an expansion in the early 1960s, and by 1971 its architect, Ulrich Franzen, had prepared a plan calling for the construction of two towers on either side of Lexington Avenue at Sixty-eighth Street and the construction of a new facility on the site of two nearby historic buildings: the 19th Police Precinct Station House (Nathaniel D. Bush, 1887), 153 East Sixty-seventh Street, and the New York City Fire Department Headquarters (Napoleon LeBrun & Sons, 1886), 157 East Sixty-seventh Street, both between Lexington and Third Avenues.[2] New quarters for the fire and police departments

were to be provided in Hunter's facilities. In 1974 ground was broken for the two seventeen-story towers: the so-called West Building was to occupy the west blockfront of Lexington Avenue between Sixty-seventh and Sixty-eighth Streets and the East Building was to be situated on the southeast corner of Lexington Avenue and Sixty-eighth Street. Construction was halted after only four months—after the foundations were completed—as a result of the city's fiscal crisis. For five years the concrete foundations were a vivid reminder that the city was too poor to carry out its own projects and that even the State Dormitory Authority could not sell bonds to make the project possible.

During the hiatus, the community board approved a proposal made by the Landmarks Preservation Commission to protect the police and fire buildings as well as two others on the block—the Park East Synagogue (Schneider & Herter, 1889–90) and the former Mt. Sinai Dispensary (Buchman & Deisler and Brunner & Tryon, 1889–90), 151 East Sixty-seventh Street. All were designated landmarks on January 29, 1980, but the Board of Estimate overturned the landmarks commission's rulings on the fire and police buildings after Mayor Ed Koch promised that their facades would be preserved as part of a project to renovate and expand the facilities into a new joint police station and firehouse designed by the

Combined Police and Fire Facility, East Sixty-seventh Street, between Third and Lexington Avenues. Stein Partnership, 1991. View to the north showing addition flanked by 19th Police Precinct Station House

(Nathaniel D. Bush, 1887) on the left and New York City Fire Department Headquarters (Napoleon LeBrun & Sons, 1886) on the right. SWN

Stein Partnership and completed in 1991. The two facades were meticulously restored and the buildings were renovated and joined by a recessed five-story gray granite–clad infill structure that was appropriately deferential to the historic buildings, both of which were given landmark status—for the second time—in 1998–99.[3]

Franzen's project came back to life in November 1979 with the sale of bonds to finance its realization. Construction began again in summer 1980, and the new buildings officially opened on January 19, 1984. As completed, the gray precast-concrete and glass towers were joined by skywalks at the third and seventh floors. An additional third-story skywalk connected the West Building to the college's main building across Sixty-eighth Street. Though the community board had approved plans for the skywalks in 1972, the construction nonetheless shocked some in the neighborhood who were sorry to see the long Lexington Avenue vista blocked for the first time, among them the Municipal Art Society's executive director, Margot Wellington, who commented, "It's the one at the third-story level that's the most oppressive, I think, because it's low. And the two together, one above the other, take out more sky than you would think."[4] Franzen intended the ten-foot-wide walkways to relieve and prevent further pedestrian traffic on the congested sidewalks below, a problem

West Building, Hunter College, southwest corner of Lexington Avenue and East Sixty-eighth Street. Ulrich Franzen, 1984. Sectional perspective looking west. FLL

ABOVE East Building, Hunter College, southeast corner of Lexington Avenue and East Sixty-eighth Street. Ulrich Franzen, 1984. View to the southeast. Hoyt. FLL

he also sought to alleviate by carving a plaza out of the southwest corner of Lexington Avenue and Sixty-eighth Street, thus providing a more spacious entrance to the subway station, which the architect redesigned to connect internally with the new buildings. Franzen envisioned the third level of the complex as a "main street"—an urban alternative to a traditional college commons—from which one could access the school's library, cafeteria, snack bar, lounges, and circulation system, all situated to facilitate "socializing and a sense of community and place."[5]

The East and West Buildings contained 800,000 square feet and included, among the more than 2,000 rooms, gymnasiums, classrooms, auditoriums, a 500,000-volume library, faculty offices, and numerous irregularly shaped lounges and informal gathering spaces. An eight-story-high escalator system worked in combination with several banks of elevators to quickly transport the college's more than 10,000 students. Carter Wiseman, noting that the design had developed in the early 1970s, said the complex was "of its time—an example of basic modernism, relying on geometric forms free of embellishment. . . . The sober towers project to the street a sense of earnest academic purpose." The corner plaza, seemingly enclosed by the skywalks, "made the intersection something

of an open-air room. . . . The overall effect," he felt, "is of rather grim dignity—appropriate for a school eager to stiffen its image. But the architectural statement is not one that grows on you."[6]

By the last quarter of the twentieth century, the Upper East Side's dense concentration of private schools, many of which had built stately quarters in the 1920s and 1930s aimed at serving the children of the area's well-to-do, were feeling pressure both to increase enrollment and to bring their facilities up to date with modern auditoriums, gymnasiums, science labs, and the like. One of the more extensive building projects was undertaken by the Ramaz School, 60 East Seventy-eighth Street, between Madison and Park Avenues, an Orthodox Jewish day school established in 1937, which hired Conklin Rossant to replace five brownstone rowhouses with the Morris and Ida Newman Educational Center (1980), a preeminently Postmodernist design consisting of a seven-story box clad in pewter-colored aluminum panels.[7] To evoke the rowhouses it replaced, the facade was divided into five distinct sections. Narrow, vertically proportioned windows meant to relate in scale to residential fenestration were organized in groups and shaped to resemble three-dimensional architectural elements such as domes, bay windows, and skylights. Above the

East and West Buildings, Hunter College, southeast and southwest corners of Lexington Avenue and East Sixty-eighth Street. Ulrich Franzen, 1984. Cutaway axonometric at third floor. FLL

Morris and Ida Newman Educational Center, Ramaz School, 60 East Seventy-eighth Street, between Park and Madison Avenues. Conklin Rossant, 1980. View to the southwest. Hoyt. RAM

Morris and Ida Newman Educational Center, Ramaz School, 60 East Seventy-eighth Street, between Park and Madison Avenues. Conklin Rossant, 1980. Hoyt. RAM

entrance, a glass shaft vaguely resembling the shape of a traditional bell tower allowed light into a vertical axis of stairs and double-height lounges. The tower of windows split in two toward the top, culminating in arches that continued upward in aluminum, with two semicircular panels interrupting a stylized parapet to evoke on the one hand, according to William Conklin, "lyrical aluminum waves . . . [suggesting] the ringing bell of the mirage school," and more symbolically, the domes of Jerusalem or the tablets of the Ten Commandments.[8] The two most religious spaces—the Beit Midrash, where religion was studied, and the chapel—were located on the second floor, the latter set behind a two-dimensional "bay window" placed above a composition of glass blocks on the facade that suggested a silhouetted city skyline. Two bays of slanted windows on the top floor, recalling the skylit mansard-roofed artist studios of the 1900s (that Conklin Rossant would more literally reference in the design of the apartment building at 76 East Seventy-ninth Street in 1988), did in fact illuminate the school's art rooms with north light. Other facilities included a below-grade gymnasium and a street-level cafeteria and auditorium, the latter employing panels of the same pewter-colored aluminum used on the facade cut to resemble drawn curtains framing actual curtains of aluminum beads. Though in 1988 the editors of the *AIA Guide* found the Newman Educational Center to be a "witty visual play of fact and fiction,"[9] in the fourth edition of the guide, published in 2000, they called it "dated. . . . Let's pursue style, not the ephemeral stylish."[10]

In 1999 Ramaz completed construction of a new middle

Benjamin and Esther Gottesman Education Center, Ramaz School, 114 East Eighty-fifth Street, between Lexington and Park Avenues. Horowitz/Immerman, 1999. View to the south of entrance. RAM

school building, the Benjamin and Esther Gottesman Education Center, at 114 East Eighty-fifth Street, between Park and Lexington Avenues.[11] The 60,000-square-foot facility replaced four brownstones, three of which were previously occupied by York Prep, another private school, which had relocated to 40 West Sixty-eighth Street. This time there was no witty Postmodernist play. Horowitz/Immerman designed the seven-story school in a heavy-handed way with square windows set into a facade of precast-concrete panels that hugged the street wall for five stories, then set back and rose to a rooftop athletic yard. Long strips of ventilation grilles divided the facade at each floor, working in combination with cornices at the fifth and top floors and a dentiled cornice above the first story, where the school was entered through a pair of arches reminiscent of those on the affiliated synagogue,

Congregation Kehilath Jeshurun (George F. Pelham, 1905), 125 East Eighty-fifth Street, across the street.

In summer 2000, the Lycée Français, a private school founded in 1936, announced it would sell the six townhouses that formed its scattered Upper East Side campus and build a new school designed by the Polshek Partnership on a through-block site between Seventy-fifth and Seventy-sixth Streets east of York Avenue.[12] The school's collection of townhouses was distinguished, consisting of the Henry Sloane house (Carrère & Hastings, 1896), 9 East Seventy-second Street, a five-story limestone mansion between Fifth and Madison Avenues, and the adjacent Jennings house (Flagg & Chambers, 1898–99), 7 East Seventy-second Street, both of which it had purchased in 1964; 3 East Ninety-fifth Street (Horace Trumbauer, 1913–16) and 5 East Ninety-fifth Street (Henri

Durieux, 1957–58), the latter having been built for the school; the Virginia Graham Fair Vanderbilt house (John Russell Pope, 1930–31), 60 East Ninety-third Street; and 12 East Seventy-third Street (Harry Allan Jacobs, 1920).[13] The townhouses were sold off between December 2001 and August 2002.

The site of the new Lycée Français, previously occupied by a four-story garage and an auto dealership, had been slated for redevelopment in 1999 by the Albanese Development Corporation, which proposed a thirty-one-story apartment building designed by Costas Kondylis & Associates.[14] Community opposition led to a scaled-down scheme calling for two fourteen-story buildings. Although that plan was approved by the planning commission, further opposition resulted in a City Council ruling limiting new construction on the site to seven stories, leading Albanese

to sell the site to the Lycée. As completed in 2003, the 163,000-square-foot school, designed by Polshek partner Susan T. Rodriguez, was organized as two five-story, six-bay-wide buildings—one facing Seventy-fifth Street and the other facing Seventy-sixth Street—joined by a two-story dining hall topped by a grassy courtyard. The building's three below-grade floors contained an auditorium and two gymnasiums. A granite base incised with the names of French and American cultural and historical figures was common to both street facades, but above the base, the north facade was sheathed in translucent channel glass while the south facade was clad in precast concrete with clear glass windows, the combination of materials intended "to connect the past and the future by invoking memories of the masonry traditions of the original school buildings

Brearley School, southwest corner of East Eighty-third Street and the FDR Drive. Addition by Platt Byard Dovell Architects, 1996. View to the southeast. Cornish. ESTO

Spence School addition, 22 East Ninety-first Street, between Madison and Fifth Avenues. Fox & Fowle, 1997. View to the southeast showing John Russell Pope building (1929) on left. Gordon. FXF

and the promise of the future conveyed by the glass."[15] James Gardner lauded the design's "majestic intelligence," commenting that "in one of the city's least distinguished architectural zones, only the new Sotheby's headquarters . . . comes anywhere close to the Lycée."[16]

More common than the construction of entire new buildings were additions and renovations to existing schools. The Brearley School (Benjamin Wistar Morris, 1929), southwest corner of Eighty-third Street and the FDR Drive, chose to expand vertically. In 1996 work was completed on a two-story penthouse addition atop the existing twelve-story building housing classrooms, meeting rooms, and offices.[17] As designed by Platt Byard Dovell Architects, the first story of the addition matched the red brick cladding of the tower below while the upper portion was sheathed in an aluminum and glass curtain wall providing sweeping views to the east. Nearby, the Chapin School, 100 East End Avenue, northwest corner of East Eighty-fourth Street, occupying a Delano & Aldrich–designed building (1928), built a three-story rooftop addition designed by Butler Rogers Baskett in 1998.[18] The expansion added 22,000 square feet of new space, including the 10,000-square-foot Annenberg Center for Learning and Research (a two-story library), a gymnasium, a seventy-two-seat black-box theater, and a rooftop playground. As part of the project, the architects also renovated 26,000 square feet of the original school.

In 1997 Fox & Fowle Architects completed a decade of renovations and additions to John Russell Pope's Spence School (1929), 22 East Ninety-first Street, between Madison and Fifth Avenues.[19] The modernization included a new library, science labs, and classrooms, but the most significant change was a 25,000-square-foot wing added to the west on the site of a former playground. The new addition, providing space for a gymnasium, offices, classrooms, and conference rooms, was clad in red brick with limestone trim in deference to Pope's design. A wrought-iron fence enclosed a new rooftop playground, replacing the lost street-level facility. Two double-height bay windows—an appropriate touch—sat between the original building and a towerlike element whose extra story, rising above the three-story addition, was punctuated by an

Proposed addition to the Nightingale-Bamford School, 20 East Ninety-second Street, between Madison and Fifth Avenues. Jack L. Gordon Architects, 1986. North elevation. JLGA

Nightingale-Bamford School, 20 East Ninety-second Street, between Madison and Fifth Avenues. Addition and renovation by Jack L. Gordon Architects, 1991. View to the southwest. JLGA

oculus matching ones designed by Pope for the original building.

Jack L. Gordon Architects' 1986 proposal to add four stories to Delano & Aldrich's Nightingale-Bamford School (1930), 20 East Ninety-second Street, between Madison and Fifth Avenues, gave rise to a good bit of controversy, primarily because the additional height flew in the face of the restrictive R8b zoning that the community had fought hard to have passed in September 1985, decreasing midblock development on most of the Upper East Side from FAR 6.02 to 4 (or for community facilities, 5.1).[20] At eighty-eight feet tall, the existing school was already taller than zoning permitted. Gordon's proposal to increase the height by sixty feet would require three zoning variances and a special permit. Community groups were split on the issue, but Community Board 8 approved the plans. In all the hubbub regarding the building's height, little attention was paid to the design itself, which offered little to fight for. In addition to the extra floors, two brownstones to the west were to be replaced by a twenty-two-foot-wide wing.

Above it all (including a five-story addition designed by Adams & Woodbridge and built on the east side of the school in 1968) would sit a massive block decorated with an ornamental program that sought to unify the old and the new but in actuality was a poorly rendered mockery of Delano & Aldrich's design, with two-story-high two- and three-bay-wide vaguely Serlian archways flanking a single-story arched colonnade suggestive of a loggia.[21] A total of 41,700 square feet would be added, allowing for, among other amenities, a gymnasium with twenty-three-foot-high ceilings.

Community residents continued to fight the project as it went through the complex process needed to override the zoning. Just as the Board of Standards and Appeals was to vote on it, the proposal was withdrawn. Another plan was prepared in 1988 that lowered the height by one story, but it, too, was withdrawn. A third proposal by Gordon presented in mid-1988 called for a 125-foot-high building—twenty-two feet less than that originally proposed but still considerably over both the height and FAR limits allowed by zoning and still vociferously opposed by several community groups. By October 1988, the proposal was scaled down again to call for a two-story, twenty-two-foot-high vertical expansion as well as the twenty-two-foot expansion to the west. This scheme was accepted and the project, which also included a total renovation of the existing structure, was completed in 1991. As built, Gordon's design was far less intrusive than the one originally proposed, soberly combining red brick and horizontal bands of limestone that helped differentiate the addition from the original. The new western wing, like that of Adams & Woodbridge on the east, protruded slightly toward the street, framing Delano & Aldrich's original portion. Above, a row of square windows relating in scale to the existing fenestration sat beneath a single-course brick segmented arch. Gordon's work doubled the number of classrooms and allowed for a full-size gymnasium, a two-story library, computer and art rooms, and a 300-seat auditorium dug into the rock beneath the existing basement level.

HOSPITAL ROW

In 1994 the Upper East Side was home to fourteen hospitals and nursing homes, two medical schools, and Rockefeller University, the medical research institution, offering, in all, over 5,000 hospital beds.[1] In addition, at least 2,387 doctors were based between Fifty-ninth and Ninety-sixth Streets, making the ratio of doctors to population more than seven times the city's average. Nowhere was the concentration of medical facilities greater than along York Avenue between Sixty-third and Seventy-second Streets, an area known as Hospital Row, where Rockefeller University, Memorial Sloan-Kettering Cancer Center, New York Hospital-Cornell Medical Center, and the Hospital for Special Surgery sat side by side.

While proximity to each other had its advantages for the various institutions, it also brought with it intense competition for available space. At the same time, area residents viewed institutional plans for expansion with suspicion, if not out-and-out hostility. To stem the encroachment of medical institutions into the largely residential district to the west, an agreement was made in 1973 whereby Rockefeller University, New York Hospital, and the Hospital for Special Surgery were given the right to build over the FDR Drive for a ten-block

ABOVE Chiller Plant Enclosure, Rockefeller University, west side of FDR Drive at East Sixty-fourth Street. Hillier Group, 2002. View to the north-west showing Rockefeller Research Building (Abramovitz, Kingsland & Schiff, 1992) on platform. Hahm. HIL

LEFT John D. Rockefeller and David Rockefeller Research Building, Rockefeller University, over the FDR Drive between East Sixty-fourth and East Sixty-fifth Streets. Abramovitz, Kingsland & Schiff, 1992. View to the southwest showing Scholars Residence (Abramovitz, Harris & Kingsland, 1987) on the left. AKS

stretch from the north side of Sixty-second Street to the south side of Seventy-second Street. As part of the agreement, Rockefeller University was also allowed to build on platforms above Sixty-third Street between York Avenue and the FDR Drive, and New York Hospital-Cornell Medical Center was able to do the same at Seventieth Street east of York Avenue.

Rockefeller University was the first to take advantage of the arrangement, announcing in 1984 that in conjunction with Memorial Sloan-Kettering Cancer Center, it would build the Scholars Residence (Abramovitz, Harris & Kingsland, 1987), 500 East Sixty-third Street, a thirty-six-story faculty and staff residence hall built over the FDR Drive between Sixty-second and Sixty-third Streets.[2] The building, carried over the drive on four trusses anchored between the north-bound and southbound traffic lanes, was dramatically can-tilevered toward the river. But the drama of the engineering was not matched by the building's architectural expression. The concrete-frame tower's rough-textured ribbed concrete exterior and bay windows related it overtly to Horace Ginsbern & Associates' neighboring Faculty House of 1975.[3] Together they constituted a formidable, brutalizing mass.

Rockefeller University followed the Scholars Residence with the John D. Rockefeller and David Rockefeller Research Building (1992), a 200,000-square-foot, fourteen-story biomed-ical research laboratory standing on a platform twenty-four feet above the FDR Drive between Sixty-fourth and Sixty-fifth Streets, spanning all six of its lanes.[4] The Research Building was also designed by Abramovitz, Kingsland & Schiff, but with a rather lighter touch, combining granite and Alabama limestone to frame sleek tinted-glass and aluminum curtain walls. Inside, a two-story-high, 1,800-square-foot stone-floored atrium lobby was covered by a skylit barrel vault. Ysrael A. Seinuk, president of the Office of Irwin G. Cantor, was responsible for the project's impressive structural engi-neering, which elegantly carried the broad platform on two

V-shaped trusses rooted in the FDR Drive Esplanade and incorporated into the building's mass four two-story-high steel funicular segmented arches that allowed for seventy-five-foot clear spans to provide flexibility for the design of the laboratories. Fabricated in Quebec, the arches were floated on barges from Canada's St. Lawrence River to Lake Erie, then to the Hudson River and on to the East River, where they were lifted in place by a barge-mounted crane. Tucked beneath the platform of the Rockefeller Research Building and sweeping south 136 feet along the FDR Drive was the Hillier Group's Chiller Plant Enclosure (2002), featuring a sleek twenty-two-foot-high curving green glass and aluminum facade topped by a Kalwall skylight that stood in contrast to the university's historic, craggy stone retaining wall to the north.

In November 1999 a pedestrian bridge was completed linking Rockefeller University's residence halls—the Scholars Residence and Faculty House—to the main campus across the busy thoroughfare of Sixty-third Street, which also served as an access road to and from the FDR Drive.[5] The challenge of spanning the roadway without the use of a support on the cramped south side of Sixty-third Street was met by the architect, Wendy Evans Joseph, and the structural engineer, Matthys Levy, of Weidlinger Associates. Joseph and Levy called for a 180-foot-long cantilevered cable-stayed bridge, the first of its type in New York, supported by an eighty-seven-foot-high V-shaped concrete tower on the north side of the street. From the tower, ten one-and-a-half-inch galvanized steel cables were attached to two sixteen-inch-diameter steel outriggers along either side of the walkway, allowing for a 118-foot-long main span. Suspended thirty-four feet above the street, the ten-foot-wide overpass also carried pipes for the university's steam system encased in a perforated stainless-steel cage on the bridge's underside. A split at the north end of the bridge sent the pipes off in one direction to connect to the steam system while pedestrians forked to the other, continuing into the cafeteria of the Benjamin and Irma G. Weiss Research Building (Campbell, Aldrich & Nulty, 1974). The bridge was hailed by the editors of the *AIA Guide* as "both an architectural and engineering tour de force."[6]

Rockefeller University Pedestrian Bridge, spanning East Sixty-third Street, between the FDR Drive and York Avenue. Wendy Evans Joseph and Weidlinger Associates, 1999. View to the northwest. Gallery. WEJA

When in 1932 the New York Hospital-Cornell Medical Center (the two entities had joined in 1912) completed its new home, designed by the Boston firm of Coolidge, Shepley, Bulfinch & Abbott on a swath of land east of York Avenue between Sixty-eighth and Seventy-first Streets, it became one of the nation's most distinctive and most appealing large-scale building groups, rivaling Rockefeller Center in artistic sophistication.[7] By the 1970s, however, the institution had for decades been staving off obsolescence by redesigning interior spaces to accommodate new standards of health care. Plans for a major expansion in the early 1970s faltered, but beginning in 1981, the medical center embarked on a building campaign that would, by 1997, see the construction of four major facilities all inspired architecturally by the vaguely Gothic design of the original hospital, but compromised by a lack of detail and by a general artistic impatience. Somehow, though, with so many variations on the same theme in such proximity to one another, the mediocre results were not nearly as noticeable as they could have been. The first of the new buildings was Perkins & Will's C. V. Starr Pavilion (1986), built on a platform forty feet above East Seventieth Street between York Avenue and the FDR Drive. The 200,000-square-foot facility, which housed the hospital's radiology and neurology departments, outpatient services, laboratories, and offices, connected the main hospital building to a power plant annex on the north side of Seventieth Street.[8] Rising nine stories above the platform, the building, clad in the same white glazed brick used in the original medical center, was intended, according to James J. Sficos, a partner at Perkins & Will, to emulate the Gothic motif of the original hospital "in spirit, if not in detail."[9] Indeed, the three eight-story-high lancet windows on the east and west facades were not capped by pointed Gothic arches but by triangular peaks that were bisected by vertical metal mullions running the height of the building. The building's northwest and northeast corners were chamfered and rendered in glass. Paul Goldberger declared that the design was "in the finest spirit of contextualism—real contextualism, that is, not something else masquerading as it."[10]

The very glassy thirty-six-story Helmsley Medical Tower (Schuman, Lichtenstein, Claman & Efron, 1987), 1320 York Avenue, between Seventieth and Seventy-first Streets, provided 520 units of nurses' housing and 160 apartments for families of patients along with commercial and retail spaces at street level.[11] Rising parallel to the avenue with north- and south-facing setbacks near the top, the slab parodied, rather than recalled, the main hospital building. Above a six-story limestone base, thin piers of gray brick outlined vertical shafts of gray glass windows and gray glass spandrels, with the central shaft on each facade topped by a pointed arch.

One block south, the William and Mildred Lasdon Biomedical Research Center (1988), northeast corner of York Avenue and Sixty-eighth Street, designed by the Boston-based firm Payette Associates, with Rogers, Burgun, Shahine & Deschler, associate architects, energetically reinterpreted the hospital's architecture.[12] The ten-story, 140,000-square-foot laboratory building with a limestone base and gray brick facade was entered from York Avenue, where two symmetrical six-story rectangular volumes hugged the street wall, flanking a central facade recessed behind a row of pointed arches marking the entrance. Three prowlike bays of windows on the recessed facade culminated in triangular points above a sixth-floor setback before appearing again above the tenth

Helmsley Medical Tower, New York Hospital-Cornell Medical Center, 1320 York Avenue, between East Seventieth and East Seventy-first Streets. Schuman, Lichtenstein, Claman & Efron, 1987. View to the northeast showing C. V. Starr Pavilion (Perkins & Will, 1986) in background right. SLCE

William and Mildred Lasdon Biomedical Research Center, New York Hospital-Cornell Medical Center, northeast corner of York Avenue and East Sixty-eighth Street. Payette Associates and Rogers, Burgun, Shahine & Deschler, 1988. View to the southeast. Ferrino. PAY

floor to decorate a brick-clad mechanical enclosure. In contrast to the relatively austere massing of the base, the tower was more subtle and complex, its multitudinous setbacks reminiscent of 1930s skyscrapers.

With all the expansion at New York Hospital-Cornell Medical Center, the one project still to be completed was also the most important: a modern replacement for its inpatient facilities. Housed in the original 1932 building, the hospital's 970 beds offered accommodations well below the standards set by other institutions, with only some of the tiny rooms served by window-mounted air conditioners, only two bathrooms for every thirty beds, and operating rooms that lacked sufficient wiring to handle up-to-date electronic equipment. In 1987 the hospital hired the architect Eli Attia and the health-care design specialists Taylor Clark Architects to explore options for a new inpatient facility. Among other ideas, the Attia-led team proposed options for building a platform over the FDR Drive between Sixty-eighth and Seventieth Streets to support a thirty-story building.[13] A strained relationship between the architects led to the dismissal of Attia in 1988 and his replacement in 1989 with Hellmuth, Obata & Kassabaum. The project was scaled down to sixteen stories in 1990 and by 1993, when the City Planning Commission approved it, the building had been reduced to twelve stories. Ground was broken for the Greenberg Pavilion (1997), named for the donors, Maurice R. and Corinne P. Greenberg, on May 10, 1993. Though smaller than originally planned, the facility was still a vast, 185-foot-

tall, 900,000-square-foot building comprising 776 beds, an emergency pavilion, an intensive-care unit, a pediatric floor, a burn center, examination rooms, nineteen operating rooms, and labor and delivery suites.[14] It sat atop a ninety-foot-wide, 490-foot-long platform over the FDR Drive stretching from Sixty-eighth to Seventieth Street formed by nine-foot-wide trusses placed on columns spaced twenty-five feet on center. The double-level platform, built in compliance with forthcoming federal seismic codes for hospital buildings, provided a parking deck on the lower level and, on the upper level, a loop road connecting Seventieth and Sixty-eighth Streets. Above, the white glazed brick building rising from a precast concrete base featured a varied roof line, subtly protruding bays, and pointed arches that complemented the 1932 building to which it was appended.

In May 1995, Eli Attia filed suit against New York Hospital, HOK, and Taylor Clark Architects, claiming that one of the designs he devised and copyrighted for the hospital in 1987 and 1988 called Option 1A had been illegally used in the design of the Greenberg Pavilion.[15] Attia claimed that before he was taken off the project, Option 1A had been used to gain the approval of the New York State Department of Health. "No owner should be forced to marry an architect," he remarked, "but owners cannot take architectural plans and give them to others to complete. It happens all the time. I decided not to keep quiet."[16] The United States Court of Appeals for the Second Circuit ruled against Attia in 1999,

Greenberg Pavilion, New York Hospital-Cornell Medical Center, platform over the FDR Drive, between East Sixty-eighth and East Seventieth Streets. Hellmuth, Obata & Kassabaum, 1997. View to the northwest showing Coolidge, Shepley, Bulfinch & Abbott's building (1932) on the left and the Hospital for Special Surgery (Architecture for Health, Science and Commerce, 1996) on the right. HOK

stating that ideas could not be copyrighted, but the architect, enlisting support from numerous other practitioners, petitioned the United States Supreme Court, which would not hear the case.

North of the Greenberg Pavilion, the Hospital for Special Surgery built a 160-bed, 123,000-square-foot, seven-story facility (Architecture for Health, Science and Commerce, 1996) on a platform spanning the FDR Drive between Seventieth and Seventy-first Streets. Clad in alternating bands of white and gray granite and black glass, the building's glassy pediment rising above the east facade was not enough to save it from banality.[17]

As part of the deal allowing Rockefeller University, New York Hospital-Cornell Medical Center, and the Hospital for Special Surgery to expand over the FDR Drive, the three institutions agreed to contribute money to a so-called amenity fund. Part of the fund went toward the creation of a public park built atop a former Sanitation Department transfer station at East Sixtieth Street and the East River.[18] Sanitation station or not, the location seemed an improbable one for a park considering its position at the cacophonous fulcrum of the Queensboro Bridge, the Roosevelt Island Tramway, the FDR Drive, and the East Sixtieth Street heliport, which transported corporate executives, wealthy Upper East Siders, and celebrities to and from the island between thirty and sixty times a day. Nonetheless, the park was realized as the East

River Waterfront Pavilion, a 12,000-square-foot facility opened in May 1994. Quennell Rothschild Associates was responsible for the design, stripping the top floor of the sanitation building to its steel skeleton, which was left in place and painted slate gray, and installing decorative paving, benches, and railings. But the most eye-catching element was Alice Aycock's sculpture, *East River Roundabout*, integrated into the exposed roof structure. Inspired, according to press releases, "by the elegant choreography of Fred Astaire's dance," the looping aluminum form reminded many observers of a roller coaster, or at the very least of the incessant movement that took place all around the park.[19] Though shortly after its opening a *New York Times* article described the pavilion as "amazingly pristine," by the turn of the century it was a drab, nearly derelict place offering little in the way of respite.[20]

In 1989 Paul Goldberger called Memorial Sloan-Kettering Cancer Center, anchored by James Gamble Rogers's Main Building (1938), 1275 York Avenue, between Sixty-seventh and Sixty-eighth Streets, but occupying bits and pieces of the three blocks bounded by First and York Avenues, Sixty-sixth and Sixty-ninth Streets, "one of the least appealing sets of buildings in New York . . . a confused mess of buildings whose only common denominator has been their nearly total lack of architectural quality."[21] Noting the opulent architecture of the New York Cancer Hospital's (progenitor of Memorial

East River Waterfront Pavilion, East Sixtieth Street and the East River. Quennell Rothschild Associates, 1994. View to the north showing *East River Roundabout* by Alice Aycock. QRP

Sloan-Kettering Cancer Center) original home at 106th Street and Central Park West (Charles Coolidge Haight, 1884–90), Goldberger stated that several of the current wings "look like factories. . . . Given that most visitors to Memorial Sloan-Kettering are under tremendous stress—they are either cancer patients themselves or their relatives and friends—an environment like this can only make the tension worse."[22]

Goldberger's concerns were already being addressed by the institution, which beginning in the late 1980s undertook numerous projects aimed at modernization and providing a more pleasant environment for patients. The first such project was the Rockefeller Research Laboratories (Davis, Brody & Associates, 1988), 430 East Sixty-seventh Street, between York and First Avenues, an eleven-story, 375,000-square-foot lab building with classrooms, a conference center, a library, and a 343-seat auditorium.[23] To alleviate the double and triple parking that clogged the street outside the Main Building, the new building included an automobile entrance leading to an underground parking garage connected to the hospital. Davis, Brody's decision to clad the structure in a combination of gray and white speckled brick relating in color to the main hospital building was an attempt, as Goldberger put it, to "bring some unity to the chaotic" medical complex. But the critic also saw it to be potentially problematic: if the architects "followed the existing architecture

too closely," he remarked, "they would merely be extending the mediocrity." Though the brick patterning was lively, the square punched windows were lifeless and protruding corners of banded dark glass and brick made the squat building seem even bulkier. Goldberger considered the building to be "a responsible presence on the street," though he wished "some of the handsome limestone that lines its lobby had been used on the outside."[24]

Beginning in 1998, Perkins Eastman Architects completed a series of small projects intended to make the cancer center more hospitable to a wider range of patients, among them: a forty-two-bed facility for women undergoing cancer treatment on the tenth floor of the Main Building; a library, a lounge, and a new nurses' station; an 18,000-square-foot inpatient center with fourteen suites for patients requiring (and able to afford) heightened security and privacy; and most significantly, the transformation of a 12,000-square-foot bank building at 1429 First Avenue into the International Center, a facility for international patients and their families offering video conferencing capabilities, reception spaces, and offices in addition to medical examination rooms.[25]

In 2002 work was completed on the Sidney Kimmel Center for Prostate and Urologic Cancers (DaSilva Black Calcagni Chesser Architects), 353 East Sixty-eighth Street, between First and Second Avenues, a 62,000-square-foot,

Rockefeller Research Laboratories, Memorial Sloan-Kettering Cancer Center, 430 East Sixty-seventh Street, between York and First Avenues. Davis, Brody & Associates, 1988. View to the southeast. Goldberg. ESTO

Sidney Kimmel Center for Prostate and Urologic Cancers, Memorial Sloan-Kettering Cancer Center, 353 East Sixty-eighth Street, between First and Second Avenues. DaSilva Black Calcagni Chesser Architects, 2002. View to the northeast. Sundberg. ESTO

six-story outpatient center packed with consultation and examination rooms, a pharmacy, a laboratory, and diagnostic and treatment areas as well as offices, a conference room, and a research library on the top three floors.[26] The building's stylish neo-Modernist facade was crowned by a sixth-floor set-back penthouse and a roof terrace sheltered by a cornicelike plane punctured by three openings in a manner recalling the penthouse of Goodwin and Stone's Museum of Modern Art (1939).[27]

In 2001 Memorial Sloan-Kettering began construction on a four-story, 47,430-square-foot addition to an existing four-story hospital building on the north side of Sixty-seventh Street between First and York Avenues.[28] Rafael Viñoly Architects designed a new facade for the combined buildings, which would house a pathology laboratory, operating suites, and a pediatric center. Granary Associates was architect of record. The inability of the original building to support the addition led to the construction of a superstructure of four columns rising through the existing floor slabs to support 129-foot-long trusses from which the new floors were hung. Viñoly's curtain wall of shadow boxes and solar control louvers rose above a two-story base to a height of six stories, then set back to provide a planted terrace.

In May 2001, Memorial Sloan-Kettering announced plans for its most ambitious undertaking since the completion of the Rockefeller Research Laboratories, a two-phase project to be built on a midblock site extending from Sixty-eighth to Sixty-ninth Street between First and York Avenues. Designed by Skidmore, Owings & Merrill in collaboration with the Oregon-based firm Zimmer Gunsul Frasca Partnership, the first phase would consist of a 684,000-square-foot, 440-foot-tall, twenty-three-story laboratory building cantilevering over the adjacent Kettering Research Laboratory, 430 East Sixty-eighth Street.[29] During the second phase, the Kettering building would be razed and replaced by a seven-story facility, also designed by SOM and Zimmer Gunsul Frasca. After the completion of the second phase, the hospital reported, it planned to replace the Main Building entirely. The laboratory building would require a zoning change that designated it as a large-scale community facility, thereby enabling it to accept air rights from other properties. But to allow for future projects, the institution sought a broad rezoning of all midblock sites between Sixty-sixth and Sixty-ninth Streets, First and York Avenues, increasing their FAR from 6.5 to 10, a prospect that triggered twenty-six civic groups from around the city to coalesce in opposition. The rezoning, opponents argued, would set a bad precedent, increase traffic and pollution, overload local services, destroy views, and create shadows.

On December 19, 2001, the City Council approved the rezoning and a revised design for the tower, which was lowered by twenty feet and modestly reduced in size. Construction began in 2002 and was completed in 2006. SOM's Mustafa Abadan led the design effort, cladding the building in masonry at the base and glass on the tower above, where a rectangular slab comprising twelve floors of laboratories was sheathed in a fritted glass skin that, by modulating the amount of light entering and escaping the building, added to the structure's energy efficiency. A second glass-sheathed volume accommodating offices cantilevered from the tenth story of the east facade over the existing Kettering building.

Islamic Cultural Center, 201 East Ninety-sixth Street, northeast corner of Third Avenue. Skidmore, Owings & Merrill, 1991. View to the northeast showing minaret (Swanke Hayden Connell, 1991) on the right. Hoyt. ESTO

HOUSES OF WORSHIP

In 1991 Skidmore, Owings & Merrill's Islamic Cultural Center, 201 East Ninety-sixth Street, northeast corner of Third Avenue, representing not only the city's first purpose-built mosque but the largest such facility in the United States, joined the Upper East Side's rich mix of imposing worship places.[1] Plans for the center dated back to 1966, when a consortium of forty-two delegations representing Islamic countries at the United Nations joined together to purchase the 80,000-square-foot tenement-filled site with the intention of building a mosque for their own use as well as for the estimated 400,000 Muslims living in the five boroughs who wor-

shiped in approximately fifty mosques often located in modest converted storefront facilities. Progress on the project was stymied by fund-raising problems, but the site running though to Ninety-seventh Street was cleared by the mid-1970s and in 1980 the group hired Iranian-born architect Aly S. Dadras, who had worked in the office of Harrison & Abramovitz in the 1960s, to design the center, which was planned to include an eight-story octagonal mosque, a 100-foot-high minaret, and a school, bazaar, library, museum, convention hall, restaurant, and apartment house. Tensions between the countries involved, brought about by the Iran-Iraq war, frustrated fund-raising efforts, however, and rumors of an October 1984 start of construction proved false.

On May 28, 1987, the project, in reduced form and now including only the mosque and minaret, finally moved forward with groundbreaking for the mosque by Skidmore, Owings & Merrill, replacing Dadras. The minaret would be designed by Swanke Hayden Connell. Michael McCarthy, the SOM partner in charge of the design, was relatively free of constraints in coming up with his scheme, with Islamic law mandating only two major requirements: no figurative representations could be displayed and the prayer hall must face the closest route to Mecca, Saudia Arabia, the spiritual heart of Islam, which in this case required that the building be rotated twenty-nine degrees off the street grid. McCarthy produced a design contained within an imaginary ninety-foot cube, divided in turn into smaller cubes arranged on a five-by-five-by-five-foot grid. The eight-story steel-frame mosque was clad in panels of grayish rose Stony Creek granite bordered by thin strips of glass. Above the granite panels were twelve large clerestory windows patterned with fired-ceramic surface decorations that in turn were topped by a forty-four-foot-diameter precast copper-clad ribbed dome crowned by a thin gold crescent pointing toward Mecca. The dome rested on sixteen articulated metal connections enclosed by a one-foot-high strip of clear glass, allowing a halo of natural light to illuminate the prayer hall below. Entered through a fifteen-foot-high bronze door, the perfectly square column-free interior served 800 male worshipers and an additional 200 women in the balcony. In addition to natural light, the interior was illuminated by a ring of suspended lights evoking the oil lamps often found in traditional mosques. Because representational images were prohibited, the spare space, finished in shades of light green, a color symbolizing paradise in Islam, was decorated at the entrance with an abstract arch motif created by layers of cut glass. Stone calligraphy above the front door, rendered in a computer-generated adaption of Kufic, an ancient Arabic script, provided further decorative relief. The mosque also included a basement-level meeting hall with separate ablution facilities for men and women as well as space for an additional 1,000 worshipers expected to attend services on major holidays.

Directly to the east of the mosque was Swanke Hayden Connell's 130-foot-high cast-concrete minaret, clad in the same granite as SOM's building and also topped with a copper dome and gilded crescent. The minaret, traditionally used to call the faithful to prayer five times a day, was largely symbolic, with no muezzin climbing to the top but instead a loudspeaker system installed but scheduled to broadcast only on special celebrations and once on Fridays and even then at a volume that would only be heard by worshipers already on the site.

Various work stoppages associated with the invasion of Kuwait by Iraq and the subsequent Gulf War (1990–91) delayed completion of the Islamic Cultural Center. But it finally opened to wide critical acclaim on April 15, 1991, when David Dunlap found the "serene and deliberately modernist work" unlike any other mosque: "There are no arches shaped like keyholes and horseshoes here, no walls that glisten with riotously colored tiles or bristle with sinuously organic calligraphy."[2] Taking note of the many

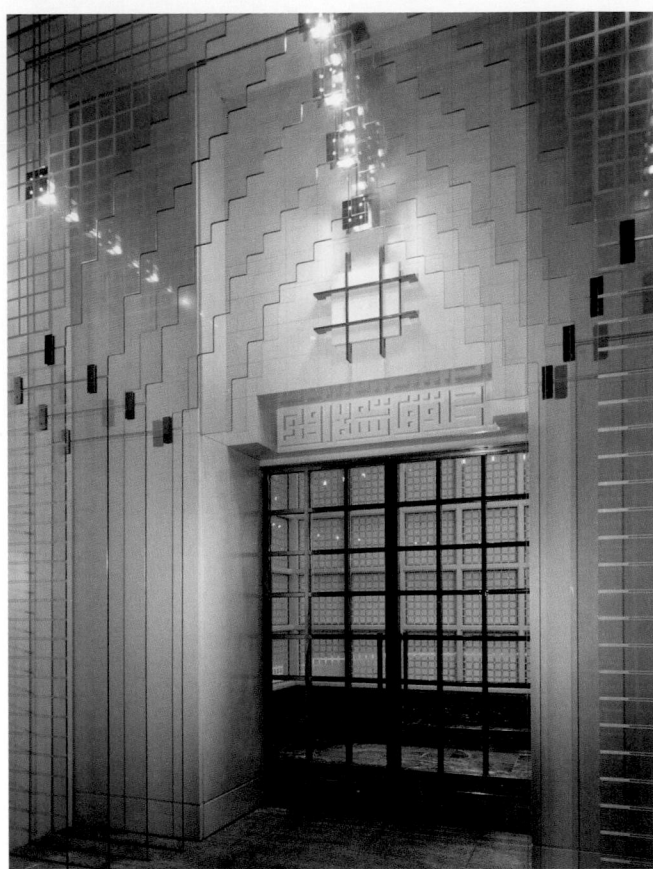

Islamic Cultural Center, 201 East Ninety-sixth Street, northeast corner of Third Avenue. Skidmore, Owings & Merrill, 1991. Entrance. Hoyt. ESTO

internecine battles that had delayed the project for so many years, Dunlap called attention to the advantages of a design that had no strong national identity. Although Eve Kahn, writing in the *Wall Street Journal*, was also impressed by the design, she objected to the way the dome "rests on a stack of three horizontal slabs held apart by slim vertical supports; they bring to mind a mall parking garage. But the minaret, with its simple flared base and simpler dome, is a masterpiece: sleek, well-proportioned, neither cute nor intimidating."[3] The domed prayer hall, which Dunlap described as having a "crisp, machine-tooled precision to it," was similarly well received.[4] But Dunlap felt that the Islamic Cultural Center, in addition to sitting outside the architectural traditions of previous mosques, was also somewhat apart from the city, especially because of its prominent placement off the city's grid: "The mosque is very much like an island, self-possessed, hewing to a rhythm different from Manhattan's. Even its gently sloping, grassy site stands apart from the neighborhood."[5]

On a more modest note, James Jarrett's five-story palazzo-esque annex (1980) to the Park Avenue Synagogue (Walter S. Schneider, 1927), 50 East Eighty-seventh Street, southeast corner of Madison Avenue, was emblematic of the growing rejection of the orthodox Modernism that had dominated much of the city's postwar architecture, especially that of synagogues built in the city, such as William Breger's Civic Center Synagogue (1967) on White Street, not to mention the very many in the suburbs. Paul Goldberger placed the golden-

Park Avenue Synagogue, 50 East Eighty-seventh Street, southeast corner of Madison Avenue. James Jarrett, 1980. View to the southeast. McGrath. NMcG

Congregation Orach Chaim, 1459 Lexington Avenue, between East Ninety-fourth and East Ninety-fifth Streets. Renovation and addition by Alexander Gorlin, 2000. View to the northeast. Mauss. ESTO

Congregation Or Zarua, 127 East Eighty-second Street, between Lexington and Park Avenues. R. G. Roesch Architecture, 2002. View to the northwest. Roesch. RGRA

colored rusticated Mankato-stone-clad arcaded building, which Jarrett executed in association with Schuman, Lichtenstein, Claman & Efron, "among the significant buildings of the past years in Manhattan, if only because it underscores with particular eloquence the extent to which talented architects have abandoned the modernist mode."[6] The annex, housing classrooms, a chapel, and an auditorium, seemed to pick up on its classicism where Henry Hobson Richardson's Marshall Field Warehouse (1887) left off, lacking its force but not its clarifying civility.[7] That lack of force, most clearly seen in the thinness of the stone walls, could be understood in terms of the project's odd history. It was begun with a design by another architect, and Jarrett was called in by a dissatisfied congregation only after the steel had been erected, leaving him little latitude for invention.

Also of interest was Alexander Gorlin's renovation of Congregation Orach Chaim (2000), 1459 Lexington Avenue, between Ninety-fourth and Ninety-fifth Streets, which restored the interior of the 1907 synagogue to its former glory as well as

Congregation Or Zarua, 127 East Eighty-second Street, between Lexington and Park Avenues. R. G. Roesch Architecture, 2002. Shapiro. RGRA

Congregation Beit Yaakov, 11 East Sixty-third Street, between Madison and Fifth Avenues. Thierry W. Despont, 2003. View to the northwest. McGrath. NMcG

creating a new entrance in the adjacent townhouse to the south, which was also adapted to provide a chapel, meeting space, day care facilities, and catering services.[8] Additionally, two new synagogues were built in the neighborhood. R. G. Roesch Architecture's Congregation Or Zarua (2002), 127 East Eighty-second Street, between Park and Lexington Avenues, replaced the New York headquarters of the First Waldensian Church, a three-story building (1883) that had begun life, appropriately enough, as the Kehilath Jeshurun synagogue.[9] The new twenty-five-foot-wide, sliverlike, 107-foot-tall, eight-story building, including a 200-seat sanctuary, social hall, library, and five classrooms, was clad in granite and limestone and featured strip windows and a large gridded panel of translucent glass framed in stainless steel which helped light the synagogue's two-story sanctuary. James Gardner was impressed with the sanctuary, deeming it "one of the most surprisingly happy interior spaces in the city. As you sit in its steep-set pews [in the balcony], made of beech wood from Israel and covered in blue velvet cushions, you

feel you are floating above the service. Such restrained sumptuosity contributes to the religious mood but never overwhelms it."[10] At the opposite end of the stylistic spectrum was Thierry W. Despont's Beaux-Arts-style Congregation Beit Yaakov (2003), 11 East Sixty-third Street, between Fifth and Madison Avenues, also known as the Edmond J. Safra Synagogue, in memory of the financier who died in an arson-related fire in Monaco in 1999 and whose widow paid for the new building.[11] Replacing two noncontributing buildings to the Upper East Side Historic District, a pair of four-story townhouses at numbers 11 (D. & J. Jardine, 1879) and 13 (McElfatrick & Sons, 1885) that had been joined together and given a new facade in 1937 by Johnson & Porter, Despont's four-story synagogue was clad in Jerusalem limestone quarried from the Judean Hills. David Dunlap described the restrained design, which featured a Star of David above the single central window and eighteen-foot-high double bronze doors depicting the Tree of Life, as a "sumptuous work of Beaux-Arts revival."[12]

Renovated Marine Division 5 fireboat house, East River at East Ninetieth Street. Total Environmental Action, 1979. View to the northwest. Molitor. CU

RECYCLING THE PAST:
ASPHALT GREEN AND BRIDGEMARKET

Two unusual adaptive reuse projects, Asphalt Green and Bridgemarket, helped to transform two underutilized pieces of the Upper East Side's infrastructure into exceptionally lively and useful gathering places. The reopening in 1984 of Kahn & Jacobs's parabolic Municipal Asphalt Plant (1941–44), 555 East Ninetieth Street, as the George and Annette Murphy Center, a neighborhood sports and arts facility, was a triumph for community activists.[1] Derided by Robert Moses as "the most hideous waterfront structure ever inflicted on a city by a combination of architectural conceit and official bad taste," yet hailed by the Museum of Modern Art as one of the ten best-designed structures built in America between 1932 and 1944, the steel-framed, reinforced-concrete structure, until its abandonment by the city in 1968, was used to mix asphalt from materials stored in several other buildings on its five-acre Yorkville site.[2] When demolition of the complex began in 1968, the parabolic structure resisted the wrecking ball and after three weeks of effort was left standing alone. In 1969–70 the New York Educational Construction Fund planned to redevelop the site as two forty-eight-story luxury residential towers, a twenty-eight-story low- to moderate-income residential tower, and a public school. Davis, Brody & Associates was hired to design the project and planned to incorporate the asphalt building into the new school, placing an auditorium on its ground floor and a gymnasium in the dramatic vault above. But shortly after the plan was announced, Dr. George E. Murphy, a longtime Yorkville resident and a professor of pathology at New York Hospital-Cornell Medical Center, began to question the appropriateness of the proposal and to envision alternate uses for the site. Believing that new housing was unnecessary in the area, that Yorkville's existing schools were underutilized, and that there was a substantial need for local recreational space, Murphy banded together with nineteen sympathizers to form the Neighborhood

Committee on the Asphalt Project and began lobbying for the designation of the asphalt plant as a landmark and the retention of the open space around it. The group also conceived what it considered to be a better use for the site: a sports and arts center within the shell of Kahn & Jacobs's building, and outdoor playing fields and courts on what was then a patchwork of concrete and asphalt. For three and a half years, the NCAP waged a grassroots war, amassing 26,000 signatures for its petition. The effort led to the abandonment in May 1975 of the Educational Construction Fund's project.

Meanwhile, the NCAP had attained permission from the city to create a temporary football field and basketball court on the grounds, realized with the help of a grant from the Vincent Astor Foundation. The new 100-yard-long field, which Murphy claimed as "the only grass playing field on the East Side between Sixth and 112th Streets," and its adjoining basketball court were surrounded by trees, shrubs, and grassy copses.[3] Dubbed "Asphalt Green," a name that remained with the project as it continued to evolve, the fields were a success, quickly becoming home to 150 sports teams and community groups.

On January 27, 1976, the NCAP had a second taste of victory when the Municipal Asphalt Plant was declared a landmark. That day the *New York Times* publicly announced the committee's plan to recycle the building. The group had hired architects Pasanella + Klein working with Kahn & Jacobs's successor firm, Hellmuth, Obata & Kassabaum, to integrate offices and small rooms in the wide base of the structure and a gymnasium in the upper portion, a plan not unlike Davis, Brody's earlier proposal. In May 1976, the city agreed to lease the plant and its site to the group, which had by then become an incorporated not-for-profit organization renamed the Neighborhood Committee for the Asphalt Green.

After raising money from the private sector through door-to-door solicitations and donations from sources such as the Samuel H. Kress Foundation, the committee decided in 1977 to seek public funding. With the support of Community Board 8, the NCAG jockeyed for assistance from the Federal Community Development Fund which, in April 1979, announced support for the project with the stipulation that the committee operate and maintain the facility thereafter at its own expense, a mandate the group was eager to accept. At the same time, the group won another battle it had been fighting—this one for the right to reuse the Fire Department's abandoned Marine Division 5 fireboat house across the FDR Drive on the East River at Ninetieth Street.[4] Total Environmental Action was hired to redesign the building for use as a "'hands-on' marine studies" center for schoolchildren which opened in 1979 with exhibitions about the biological ecosystem of the Great South Bay. By 1981 the building was further developed by Asphalt Green for the study of energy conservation, with an added second story containing offices topped by a curved roof, vents, and smokestacks "designed to enhance the building's nautical image."[5] The south side of the building was turned into what the architect Daniel Scully, TEA's project manager, called "a solar smorgasbord" complete with solar panels, thermosiphoning air panels, skylights, and domestic hot water collectors.[6] The former fireboat house was destroyed by fire on July 8, 1999.

Well established and with funding in place, the NCAG moved ahead with the redesign of the asphalt plant. Pasanella + Klein created a four-floor facility within the plant's original concrete shell: the first level housed offices, locker rooms, and

RIGHT George and Annette Murphy Center, 555 East Ninetieth Street, between the FDR Drive and York Avenue. Pasanella + Klein, 1984. Sectional perspective. PKSB

BELOW LEFT George and Annette Murphy Center, 555 East Ninetieth Street, between the FDR Drive and York Avenue. Pasanella + Klein, 1984. View to the northeast. Darley. PKSB

BELOW RIGHT George and Annette Murphy Center, 555 East Ninetieth Street, between the FDR Drive and York Avenue. Pasanella + Klein, 1984. Pickman. PKSB

a theater; the second level contained a weight room and a small double-height gym; and the third floor housed painting and photography studios and three classrooms. All were compressed in height as much as possible to liberate the fourth floor, whose parabolic vault accommodated a basketball court with roll-out bleachers capable of seating 140 spectators and a mezzanine-level running track suspended twenty-two-feet above the gymnasium floor. Natural light was introduced to the gym via a skylight installed where an exhaust fan had previously pierced the roof.

In keeping with the efforts initiated at the fireboat house, the new center also incorporated an extensive energy-conservation program, expected to lower energy costs to about a third of those in conventional systems. A windmill built on Millrock Island, in the East River, aided by gas-driven generators, provided electrical power for the building. Heat from the generators, lights, and building occupants was recovered and conserved by the heavy insulation of the concrete shell, which, owing to the decision to locate many of the building's mechanical systems in a separate structure beside the parabola, was able to retain its pure geometric form. During construction, which commenced in July 1981, several enhancements were made to the project: in 1982 money was raised to upgrade the barebones flat assembly room on the first floor to a ninety-three-seat theater with curving tiers and a twenty-seven-by-eighteen-foot stage designed by Harry Darrow with Wollens & Sachs; and in the spring of 1984, a private donation funded the construction of a sunken, salmon-colored brick plaza on the south side of the building with a circular fountain surrounding a twenty-foot-high bronze sundial sculpture by Robert Adzema.

ABOVE Asphalt Green AquaCenter, 1750 York Avenue, between East Ninetieth and East Ninety-second Streets. Richard Dattner, 1993. Swimming pool. Goldberg. ESTO

LEFT Asphalt Green AquaCenter, 1750 York Avenue, between East Ninetieth and East Ninety-second Streets. Richard Dattner, 1993. View to the northeast. Goldberg. ESTO

recreational facilities with an ambitiously programmed building containing an Olympic-size swimming pool and a sports medicine facility.[8] Foster de Jesus Architect of New York was initially hired for its design, but the firm was replaced by the architect Richard Dattner, who was currently working on the design of Riverbank State Park, the only other park in Manhattan to boast an Olympic-size pool. The city government, barely able to fund the ongoing operations and maintenance of its existing pools, nevertheless recognized the opportunity to continue the rare and fruitful collaboration that had begun with the Murphy Center and agreed to lease to Asphalt Green a small triangular site wedged between the FDR Drive on the east, the Asphalt Green playing field to the southwest, and the small De Kovats Park on the northwest, pledging funds from its capital budget for the project's development. Additional funds raised from private schools, individuals, and corporations allowed for the transformation of what had been conceived as a relatively modest swimming facility for area residents into a world-class sports and medical center featuring a high-tech, fifty-meter-long pool with a four-by-twelve-foot underwater observation window for coaches, an underwater speaker system, four diving platforms, scoreboards, bleachers for 700 spectators, and a hydraulic floor that could raise one end of the pool to the elevation of the floor deck, providing easier access to people with disabilities, the elderly, and children while also accommodating swimming events requiring shorter lengths. Unlike the pool at Riverbank State Park, which was limited to four feet in depth, Asphalt Green's sixteen-foot-deep pool would meet all international competition standards, allowing the city not only to host major swimming competitions for the first time ever, but to spawn athletes who could compete in them. While the pool complex, soon known as the Asphalt Green AquaCenter, would be staffed, operated, and maintained by Asphalt Green, because of its public and private funding, it would be open to patrons from both sectors, with fees from the 70 percent of users with paid memberships supporting the public uses that would be provided at no cost. Construction of the AquaCenter

On October 24, 1984, when the George and Annette Murphy Center opened to the public, Paul Goldberger commented on the challenge of fitting a new program into such an idiosyncratic space, writing that Pasanella + Klein's work accomplished this "so naturally one could almost imagine it having been there originally." The architects' stylish handling of common materials such as cement plaster, glazed masonry units, and exposed metal, selected to retain the raw character of the plant and take the punishing wear that was anticipated, persuaded Goldberger that this was "a building at once practical and grand, with all of the architectural integrity of the original preserved."[7]

The success of the Murphy Center encouraged the NCAG to continue its efforts. In July 1986, Asphalt Green replaced its perpetually worn-out grass playing field with Astroturf. At the same time, the organization announced plans to expand its

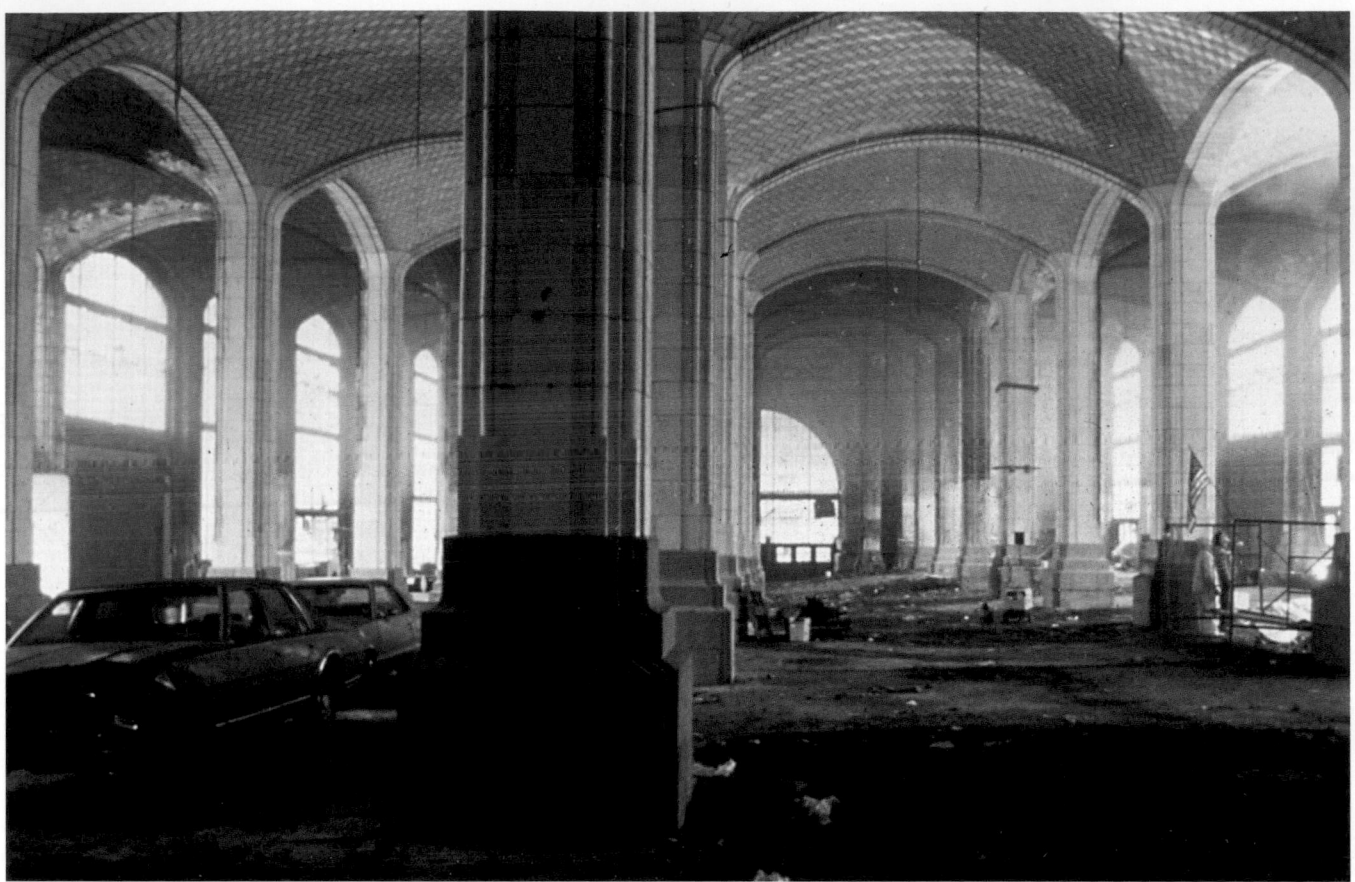

Vaults, Manhattan approach to Queensboro Bridge, East Fifty-ninth to East Sixtieth Street, Sutton Place to First Avenue. Existing conditions, c. 1980. H3

began in 1991. To take advantage of as much of the site as possible, Dattner called for a triangular plan, with the pool dominating the eastern hypotenuse of the site, running parallel to the FDR Drive and covered by a soaring, curved-steel-trussed translucent roof intended to reference the parabolic form of the Murphy Center. An abutting five-story steel-framed triangular stack accommodated locker rooms, administrative offices for the NCAG, a fitness center, and a well-equipped sports medicine facility with rehabilitation areas operated by the Mount Sinai Medical Center.

The Asphalt Green AquaCenter opened in June 1993, satisfying critics with its stylishly undulating orange-brick and glass-block envelope and wavy canopies and sunshades that, particularly on the west-facing entrance facade, helped soften the building's impact on the adjacent De Kovats Park. Effie MacDonald, writing in *Architectural Review*, compared the look to "the leisured streamlining of the 1930s,"[9] while Susanna Sirefman felt that the building was appropriate to its site and program: "an exterior suggestive of the parabola, the riverside and the indoor Natatorium it houses."[10] The editors of the *AIA Guide* were also pleased: "A sensuous Post Modern construction," it is "an honor for the neighborhood."[11]

The opportunity to make use of the vaulted halls formed by the structural supports for the Manhattan approach to the Queensboro Bridge (Henry Hornbostel, architect; Gustav Lindenthal, engineer, 1909) had for some time attracted the attention of architects and various teams of developers.[12] The actual bridge supports were steel, as was the bridge structure

as a whole, but to take advantage of the soaring, strategically located space under the Manhattan approach, Hornbostel devised a lining of granite and terra-cotta, climaxed by a canopy of thirty-four vaults tiled by the Guastavino company according to its patented system developed in Catalonia, Spain.[13] For the first thirty years of the Queensboro Bridge's life, the vaulted halls served as a green market, which was closed as part of a campaign against public markets by the La Guardia administration. Later the vaulted halls became staging and storage areas for various city departments. In 1973 I. M. Pei developed a proposal for an American version of the Paris-based Cinémathèque using the 120-foot-wide, 270-foot-long, 60-foot-high space under the bridge as well as the open land immediately to the south running along Fifty-ninth Street.[14] But it was not until 1977 that a project for the use of the space along the lines originally intended—that of a market—first began to seriously take shape when the city's Public Development Corporation proposed to sublease the 50,000-square-foot site to a little-known but visionary developer, Harley Baldwin Associates, working out of an apartment in the Dakota on the West Side.[15] Baldwin's proposal was to transform the sixty-foot-high vaulted space under the bridge, then being used by maintenance crews of the Police and Traffic departments, into a market filled with independent food vendors and to build a greenhouse on part of the plaza space south of the bridge, leaving room for a grove of trees and a seasonal farmers' market. The idea was approved by the City Council on July 7, 1977, just as vast numbers of New

Proposed Bridgemarket, East Fifty-ninth to East Sixtieth Street, Sutton Place to First Avenue. Hardy Holzman Pfeiffer Associates, 1977. Rendering. H3

Yorkers were becoming very food conscious and enterprising immigrants from Korea were opening appetizingly merchandized fruit and vegetable stands all over Manhattan in what the *New York Times* called a "greengrocer explosion."[16]

The space under the bridge was remarkable, not only for its size but for the fact that as the bridge rose above it the land itself sloped down toward the river, creating a dynamic perspective. To help shape what he called "Bridgemarket," Baldwin hired the architects Hardy Holzman Pfeiffer Associates and the landscape architects Zion & Breen. In order to increase the usable enclosed floor area, Hugh Hardy proposed a mezzanine around three sides of the vaulted space. The scheme received the City Planning Commission's approval on August 8, 1977, just as area residents began to voice concern for the effect that a popular market might have on their once working-class but now very tony neighborhood. On October 6, 1977, the project was approved by the Board of Estimate, only to be blocked in July 1978 by the State Assembly's Committee on Cities, which felt the deal shortchanged the city. The action of the assembly effectively killed the project until Mayor Ed Koch revived it in 1981. After another round of negotiations Baldwin, now working in association with Sheldon Gordon, a California-based mall developer, entered into a second lease with the city in August 1983, promising the start of construction on November 1. Delays blocked progress and final permits were only issued in the spring of 1985, with construction expected to begin in August. On July 9, a revised scheme was approved by the Landmarks Preservation Commission.

Construction plans were announced for May 31, 1987, after new bank financing was obtained and commitments for 70 percent of the retail space was secured. With construction under way in April 1988, a neighborhood group sued the city and the developer, claiming that necessary approvals were never granted for the enlarged project. Indeed, an amended lease that did not go before the Board of Estimate had dramatically expanded the permissible square footage, reflecting, it was claimed by the city, proposed use of basement space.

The renewed controversy resulted in the halt of construction in summer 1988, with demolition and excavation completed and the foundation in place. In July 1989, after the State Supreme Court ruled in favor of the neighbors, resident opposition was assuaged when Baldwin agreed to build a much smaller project, with fewer shops and restaurants and increased public space. According to the new plan, the interior mezzanine was eliminated, retail space halved, and the glass-enclosed greengrocers' stand eliminated from the plaza. But these changes forced Baldwin to restructure the project's financing. The downward spiral of the economy stalled the project, seemingly permanently, leaving the site raw with incomplete construction. By July 1990 the city, fed up with the developer's failure to pay rent, threatened to take back the lease. Meanwhile, neighborhood opponents were arguing before the New York State Court of Appeals to stop the project entirely. On March 24, 1994, the Court of Appeals ruled that additional approval was not required to amend the lease. With this decision the project began to come back to life.

ABOVE Bridgemarket, East Fifty-ninth to East Sixtieth Street, Sutton Place to First Avenue. Hardy Holzman Pfeiffer Associates, 2000. View to the east showing Terence Conran Shop (C. D. Partnership). Aaron. ESTO

FACING PAGE Guastavino's, Bridgemarket, East Fifty-ninth to East Sixtieth Street, Sutton Place to First Avenue. Hardy Holzman Pfeiffer Associates, 2000. Smith. H3

But it was not until 1996, when British design and restaurant guru Sir Terence Conran—also in partnership with developer Sheldon Gordon—decided to take on the project that Bridgemarket at last began to move to its ultimate realization.[17] Also in 1996, as part of a much larger renovation of the bridge, the city's Department of Transportation began restoration of the Guastavino tile work. Extensive testing preceded replacement of about half of the more than 1,600 tiles in each vault—the new tiles were made by Boston Valley Terra Cotta, a company located near Buffalo, New York. Although the structure as a whole was remarkably sound, the easternmost bay was completely rebuilt to isolate it from steel girders that reverberated with the heavy pounding of bridge traffic.

In a dramatic departure from the uses, if not necessarily the spatial arrangements, of previous proposals, Conran, working with Hugh Hardy, devoted the entire space under the bridge to a high-end food purveyor and a restaurant. Additionally, a Conran's home furnishings shop occupied the length of Bridgemarket's lower level and a glass-enclosed building on the south side was built to contain elevators and escalators leading down to it. The revised plan was approved in October 1996. Still, the project lagged, held up in part by a dispute, in 1998, between Conran and his development partner that arose when a supermarket—one of the city's largest—on 38,000 square feet of ground-floor space was substituted for the food hall that had been previously assigned to a Boston-based com-

pany, which withdrew from the project in January 1998. Nonetheless, construction began to go ahead in earnest in early 1999, after the Great Atlantic & Pacific Tea Company, parent company of the objectionable supermarket, the Food Emporium, agreed to give Conran an advisory role in the store's design.

On March 22, 2000, the 35,000-square-foot Food Emporium, occupying twenty-four bays at the western end of the hall, opened. Designed by Sam Burman and Roland Gebhardt, it was, despite its spectacular setting and large size, more or less a typical supermarket. Entered through the trendily red Modernist 3,800-square-foot pavilion designed by Hardy Holzman Pfeiffer, the antiseptically white, basement-level, 22,400-square-foot Terance Conran Shop, designed by C. D. Partnership, could have been virtually anywhere. Only the restaurant saved the project from banality. The 26,000-square-foot restaurant, Guastavino's, named to honor the designer of the tile vaulting system that was its principal feature, opened in January 2000, with a preview hosted by the New York Post to celebrate its widely read, gossipy "Page Six" feature. The restaurant proved a culinary and architectural success, with two levels of dining—a café on the ground level and a quieter, more upscale restaurant on the mezzanine reached by a curved oh-so-sort-of-stylish marble staircase—all sheltered by the soaring vaults lit by floor lamps and candles casting a warm glow on lavender uphol-

Bridgemarket, East Fifty-ninth to East Sixtieth Street, Sutton Place to First Avenue. Hardy Holzman Pfeiffer Associates, 2000. Air movement diagram, longitudinal section. H3

stered couches, white tablecloths, and slipcovered chairs. Down below, under the mezzanine, a slightly curving, hull-like rosewood ceiling concealing the ventilation system added warmth and a modicum of intimacy, as did the super-scaled wall construction at the entrance, formed of twisting strips of birch plywood sculpted by the British artist Thomas Heatherwick. Paul Goldberger thought the piece looked "like the result of an explosion in Frank Gehry's model shop," deeming it "superfluous."[18] Otherwise, he gave Guastavino's high marks, noting that "putting a balcony into the middle of this kind of room is usually a disaster, but this one works perfectly well, partly because no one tried to make it look as if it had always been there. The balcony is a discreet intervention, with perforated wood paneling on the underside and simple glass balustrades above." Goldberger rather sunnily concluded that the enterprise was "about as perfect a combination of entrepreneurial ambition and found space as the New York restaurant business is ever going to see."[19] Suzanne Stephens was not so sure: she found the overall character of the furnishings "bland" but noted that at Guastavino's "there is Space," with the vaults flooded by halogen light from fixtures attached to the tops of the piers.[20]

Technically, the project was quite complex. Not only did the landmark guidelines prevent new penetrations in the existing building fabric, but the structural limitations of the bridge required that additional loads be carried independently, yielding the unanticipated advantage of obviating vibration problems. Mechanical systems were fed from the basement and carefully threaded through the thickened floor slabs of the restaurant's mezzanine, in the casework of the supermarket, and in a former elevator shaft within one of the bridge's stone piers, all in all yielding remarkably uncluttered interiors. Outside, Lynden B. Miller's plaza was modest in scale, with a formal garden incorporating the seventeen-and-one-half-foot-tall granite and mosaic Evangeline Wilbour Blashfield Fountain (Charles W. Stoughton, 1919) that had been commissioned to provide additional tap water for the original green market.[21]

ROOSEVELT ISLAND

In the early 1970s, Roosevelt Island, a 147-acre, two-mile-long, 800-foot-wide sliver of land lying 300 yards off Manhattan's shore in the East River between Fiftieth and Eighty-sixth Streets, began its remarkable transformation from its former role as a repository for the insane, indigent, criminal, and ill into a "new town in town."[1] Working with a master plan devised by Philip Johnson and John Burgee, the New York State Urban Development Corporation (UDC) oversaw the development of the island, known by a variety of names throughout its history and called Welfare Island from 1921 until 1973. The idealistic plan called for an economically and racially diverse community of 20,000 people that would be relatively automobile free, with residents and visitors to the island traveling along Main Street, its central north–south spine, in shuttle buses. The comparatively isolated island was connected to Queens by a bridge built in 1955. In addition to the first commuter aerial tram, Roosevelt Island would be directly connected to Manhattan by an extension of the subway. Although the tram was opened in 1976, plans for the subway, also expected to be completed in 1976, were far behind schedule, with no realistic completion date in sight. Still, by 1976, despite the city's fiscal crisis and the ensuing financial collapse of the UDC, four apartment buildings in the area designated as Northtown designed by Sert, Jackson & Associates and Johansen & Bhavnani were completed, housing 5,500 people in 2,138 apartments.

In 1977 the UDC announced plans to lease eight and a half acres on the western side of the island, north of the existing apartment complexes and just west of the Motorgate parking garage (Kallmann & McKinnell, 1974), to the Starrett Housing Corporation, which proposed to complete the second phase of Roosevelt Island's development plan with 1,000 units of moderate- and middle-income and luxury housing.[2] The site, known as Northtown II, had been the subject of a prominent competition sponsored by the UDC in 1974, but the troubled finances of the city and the state agency caused the development

to be curtailed.[3] The Starrett Housing Corporation, working with the assistance of James Stewart Polshek, who had been hired by the UDC to act as its design consultant, chose Gwathmey Siegel to prepare preliminary designs for the apartment complex, which would also include an intermediate public school, day care and community centers, and a 1,500-car, six-story concrete parking structure with commercial space at its base to complement the existing 1,000-car Motorgate, which was already filled to capacity and also included shops, a fire station, and a post office in a recessed sidewalk arcade. Located on the west side of an extended Main Street, Gwathmey Siegel's plan called for 700 market-rate units in three twenty-one-story buildings and 300 subsidized units in two L-shaped eleven-story buildings. All of the buildings featured covered arcades at their bases and would be constructed of reinforced poured concrete with polychromed brick infill walls, with charcoal gray for the bases and circulation elements, rose for the spandrels, and red for the remaining walls. The plan also included a continuation of the

riverfront pedestrian promenade and included a large landscaped central square named Northtown Plaza.

Plans for Northtown II quickly stalled, but Starrett remained committed to the project even as the development company's financial outlook was clouded when its assets in Iran were frozen following the seizure of the American embassy in November 1979.[4] Stalled as well was the completion of the long-delayed subway station, prompting architect and architectural historian G. E. Kidder Smith to suggest in a letter to the editors of the *New York Times* in November 1982 that a new, low automotive bridge directly connecting Roosevelt and Manhattan Islands was needed, as the "aerial tram is filled to capacity during rush hours and there must be few inhabitants who relish driving a car to Manhattan via the labyrinth of the industrial section of Queens. The subway—when finished—will obviously improve the situation, but development of the island, both physical and psychological, will still be compromised by its lack of convenient, spontaneous, automotive connection with midtown Manhattan."[5] Former UDC head Edward J. Logue

ABOVE Proposal for Northtown II, Roosevelt Island. Gwathmey Siegel & Associates, 1977. Site plan. GSAA

BELOW Proposal for Northtown II, Roosevelt Island. Gwathmey Siegel & Associates, 1977. West elevation. GSAA

responded to Kidder Smith's letter by noting that the idea of a bridge to Manhattan was considered and discarded in 1969 at the beginning of planning after the Army Corps of Engineers deemed the proposal "utterly unfeasible." Logue also dismissed the desire to make Roosevelt Island "an extension of Manhattan–Ile St. Louis transplanted," writing that the master plan represented "the antithesis of an extension of Manhattan. Today, Roosevelt Island has fewer moving cars than any other part of the city. The people who live there like it that way."[6]

In 1983 Robin Lynn, a Roosevelt Island resident, assessed the state of the island in *Metropolis*: "Today, the island represents everything New York City is not supposed to be. It's a planned community in a city that prizes the unexpected, a matching ensemble in a city that grew piecemeal. The color of the pavement matches the skins of the buildings. The street signs are uniform in type, size, and color. The kiosks, street lights and garbage containers on Main Street are stationed at regular intervals. The entire community is represented by one logo." Lynn also noted the ambivalence of many residents who realized that in order to thrive, Roosevelt Island would have to grow but who worried that the completion of the master plan with the Northtown II and Southtown developments might alter the essential character of the place. "The Catch-22 . . . is that although the island cannot prosper without development, it cannot stay the same with it. With full development, which can only come with the subway link, residents fear the island will lose its insular, close-knit quality and safe reputation."[7]

In 1984 the state created a new agency, the Roosevelt Island Operation Corporation (RIOC), to take over administrative control of the island from the UDC, but financial problems

Manhattan Park, Roosevelt Island. Gruzen Partnership, 1989. View to the west showing the Promenade (Philip Birnbaum & Associates, 1987) across the East River. GS

continued, especially in the operation of the aerial tram.[8] Plans for Northtown II were finally back on track in May 1986 when the RIOC approved plans for 1,108 new apartments, still to be developed by the Starrett Housing Corporation, now working in association with the Cohen Brothers Realty Corporation.[9] By this time Gwathmey Siegel had been replaced by the Gruzen Partnership, whose design for Manhattan Park, as the project was now called, consisted of four twenty-one-story market-rate buildings accommodating 884 apartments and one fourteen-story building with 224 federally subsidized units, including 94 for the elderly and 12 specially designed for the handicapped. Although the need for a new public school was acknowledged, this latest version of the project did not include one. The development did provide more parking spaces, community and day care centers, and extensive landscaping, including a continuation of the riverfront pedestrian promenade. Although some objected to the segregation of the subsidized units, believing that such a strategy compromised the original intention of the master plan for a racially and economically diverse population, plans for Manhattan Park went forward without further delay. In October 1988, the first model apartments were opened, with new tenants to move in around the beginning of the new year. Charles Bagli, writing in the *New York Observer*, noted that the orange-red and gray brick with stone trim buildings of Manhattan Park had a decidedly "more upscale caste" than previous development on the island, pointing out the green- and rust-colored marble lobbies, mahogany-paneled elevators, and oak parquet flooring of the market-rate buildings, which also featured terraces.[10] The project, which would have seemed pretty run-of-the-mill if built in Manhattan, impressed the critics, perhaps because it featured extensive amenities on its more than five acres of landscaped space, including a seventy-foot-long outdoor pool, two tennis courts, a baseball field, five outdoor playgrounds, and community gardens. Paul Goldberger was impressed with Manhattan Park: "It is a handsome and workmanlike improvement on the older buildings of Roosevelt Island, with significantly better apartment layouts and much more appealing brick and trim colors as well. And Manhattan Park's overall layout, with a park much like a village square in the center of a group of towers, has a refreshing openness after the excessive tightness of Main Street."[11]

Coinciding with the 1989 completion of Manhattan Park was the opening on October 28 of that year of the island's subway station.[12] The 3.2-mile extension of the Sixth Avenue line also included stops at Sixty-third Street and Lexington Avenue in Manhattan and in Long Island City at Twenty-first Street and Forty-first Avenue. But until its connection with trunk service in Queens in December 2001 it was dubbed the "subway to nowhere." In addition to concerns among residents that convenient subway access would forever change their enclave, there were also worries that the more efficient subway would lead to the closing of the expensive tram, a fear that did not materialize. New hope for Southtown, a major component of the original master plan located on a nineteen-acre site south of the existing housing and north of the tramway terminal, was also raised in 1989.[13] The RIOC, working with the State Division of Housing and Community Renewal and the New York City Housing Partnership, issued a request for development proposals that specified 1,956 mixed-income apartments divided equally between market-rate and subsidized units. Raquel Ramati Associates drew up the master plan for

Southtown master plan, Roosevelt Island. Raquel Ramati Associates, 1989. Rendering of view to the southeast. RRA

Southtown, calling for seven towers ranging in height from sixteen to twenty-eight stories. Instead of Northtown's single, narrow spine, Ramati's scheme for Southtown included two parallel roads and a central square lined with stores. Paul Goldberger deemed the effort "a good but somewhat timid plan. It improves on many of the failings of Northtown, which has a main street that at some points feels more like a dark canyon than a village street. In the new plan, open space and buildings are mixed in a more subtle and complex way. . . . There will be river views from the streets, and a real village square, something Northtown does not have." But Goldberger felt that the plan was "marred by an excessive symmetry and by too much closeness in size from tower to tower. . . . From a distance Southtown could look too much like a collection of identical towers floating in open space, even if different architects do design each building."[14]

The request for development proposals attracted scant interest in a troubled real estate market, and plans for Southtown languished. In 1993 J. P. Olsen took the pulse of Roosevelt Island and found that the opening of the subway had not, as feared, radically changed life for the approximately 8,000 people who called it home: "All indications are that the island has retained its small town way of life, a community dominated by families and free-roaming children. Indeed, Roosevelt Island has emerged as an unlikely model of urban planning—unlikely in the sense that it has all the hallmarks of urban renewal failures: a centrally planned and controlled single-use large scale high-rise development. . . . And yet the island works, in no small measure, because it is an island; its natural water borders give it the definition every neighborhood needs, providing an unceasing buffer against the uncertainties of urban life."[15]

ABOVE Southtown master plan, Roosevelt Island. Gruzen Samton, 2000.
Aerial view to the southwest. GS

BELOW Phase 1, Southtown, Roosevelt Island. Gruzen Samton and
Schuman, Lichtenstein, Claman & Efron. View to the east showing resi-
dences for Memorial Sloan-Kettering Cancer Center (2003) and the Weill
Cornell Medical Center (2003) and preliminary design for last building of
Phase 1 on the right. GS

P.S./I.S. 217, 645 Main Street, Roosevelt Island. Michael Fieldman, 1992. View to the east. Choi. MFA

In the late 1990s, as the economy improved, interest in Southtown again picked up, and at the end of the decade the Hudson Companies and Related were picked as developers of a projected nine-building complex to be built on an extension of Main Street that abandoned Ramati's master plan in favor of a scheme by Gruzen Samton that placed six sixteen-story buildings on the west side of the street and three taller buildings of twenty-one, twenty-five, and twenty-eight stories on the east side of the street.[16] The first phase of the project consisted of three sixteen-story buildings designed by Gruzen Samton in association with Schuman, Lichtenstein, Claman & Efron. Two buildings from this phase were completed in 2003, serving as housing for two medical centers located across the East River in Manhattan, the Memorial Sloan-Kettering Cancer Center and the Weill Cornell Medical Center.

In addition to new housing, Roosevelt Island got a much-needed public school with the completion of Michael Fieldman's 108,000-square-foot P.S./I.S. 217 (1992), 645 Main Street, located near the Motorgate garage complex.[17] Accommodating 850 students from kindergarten through the eighth grade, Fieldman's school took the form of a mini campus surrounding a playground, including a four-story classroom wing that followed the slight curve of Main Street, a two-story cube

for music and art, and a two-story block housing the library, gym, dining rooms, and a 350-seat auditorium. The highlight of the design was the two-story, glass-enclosed main corridor that stretched from the school's Main Street entrance to the western end of the building, framing a view of the East River and the Manhattan skyline. The editors of the *AIA Guide* welcomed the new school: "A new architect on the island gives some vigor to what was beginning to seem like a senior architectural thesis at Pratt or City College."[18] Susanna Sirefman was even more enthusiastic: "Shining jubilantly amid this sour urban experiment is PS 217, a decidedly deconstructivist public school. . . . Grids within grids organize . . . primary elements around a courtyard. . . . The modular grid is repeated in various scales and materials throughout: as a concrete sunshade, glass fenestration and a cantilevered metal frame. Formal geometry and tough urban materials are enlivened by sunny primary colors. The edifice dextrously addresses its waterfront site while simultaneously creating a private enclave" for students and teachers.[19]

At the northern portion of the island, Weintraub & di Domenico created the fifteen-acre Octagon Park (1992) that included tennis courts, a soccer field, garden plots, and an open area near the waterfront planted with butterfly bushes,

zebra grass, roses, bayberry, and viburnum.[20] At the center of the park was the landmarked Octagon Tower, a stabilized ruin that was the only remaining portion of the New York Lunatic Asylum (Alexander Jackson Davis, 1839; additions, Joseph M. Dunn, 1879). Although plans for its restoration were repeatedly called for after a 1982 fire, including an attempt in the mid-1990s by Margaret Helfand Architects working with Tanner Leddy Maytum Stacy Architects, no renovation efforts were undertaken.[21] At the southern end of Roosevelt Island, a happier fate befell another landmarked building from the island's past, Withers & Dickson's Strecker Laboratory (1892; addition, William Flanagan Jr., 1905). In 2001 Page Ayres Cowley completed work on converting the building, originally used as a pathology lab for postmortems done on prisoners who died on the island, into a substation providing power to the subway tunnel running under the island.[22]

In 1992 hope was briefly raised that the long-dormant plans for Louis I. Kahn's memorial to Franklin Delano Roosevelt, the design of which was completed shortly before the architect's death in 1974, would be revived.[23] Kahn's classically inspired scheme, to be located on a 780-foot-long triangular site at the southern tip of the island, called for a seventy-two-foot-square roofless "room" framed on three sides by granite walls but open to the south. Despite the strong support of the editors of the *New York Times*, who called Kahn's design "one of the noblest unbuilt projects in New York," plans for the memorial remained on the drawing boards due to a lack of funds.[24] With the failure of the Roosevelt memorial to be realized, plans were also dropped for a nearby stone and glass pavilion (1995) designed by Santiago Calatrava to serve as a visitors' center with a 250-seat restaurant equipped with an operable brise-soleil roof of thin aluminum fins.[25]

UPPER EAST SIDE **1003**

HARLEM
AND UPPER
MANHATTAN

PREVIOUS PAGES View of the southeast corner of West 125th Street and St. Nicholas Avenue, 2001, showing Harlem USA (Skidmore, Owings & Merrill, 2000) on the left and right. Vergara. CV

ABOVE View to the northeast along West 125th Street from St. Nicholas Avenue showing the Harlem State Office Building (Ifill Johnson Hanchard, 1973) on the far right, 1988. Vergara. CV

125TH STREET

In 1978 the Rev. Robert Chapman, the African American archdeacon of the Episcopal Diocese of New York, stated, "No matter how Harlem is measured—by its infant mortality rate, its housing abandonment, its welfare dependency, its population loss or its low level of school achievement—this section of Manhattan seems to be poorer and less equal than it was a decade ago."[1] The roughly two square miles of Harlem had been devastated by the social upheaval of the 1960s and early 1970s, leading to the neglect and abandonment of a significant amount of its building stock and the loss of more than 100,000 residents, leaving behind the least advantaged. The evidence

of this decline could be seen, Michael Sterne reported in the *New York Times*, in the "boarded-up stores along the . . . 125th Street shopping corridor; burned-out abandoned buildings demeaning almost every block of Harlem's broad avenues, from 110th Street north to 155th; hundreds of idle men clustered at corners, drowning empty days in wine and whisky; youths barely into their teens selling drugs as openly as other boys hawk newspapers."[2] But by the end of the century, a significantly different picture of Harlem could be painted: the venerable neighborhood was experiencing a genuine revival, if not the second renaissance some pundits claimed.

Harlem's bumpy twenty-five-year renewal process was most publicly and tellingly played out on its most important

street, concentrating first on the blocks between Fifth and St. Nicholas Avenues but making provisions for the future rehabilitation of the eastern part as well. Prepared a year earlier, the far-reaching plans calling for new cultural, commercial, and governmental buildings, as well as extensive refurbishment of the street itself, with plans for new water mains, sidewalks, and redesigned uniform facades for the existing small-scale buildings, were met with suspicion by local residents, whose cynical attitude had been formed after the successive failure of several previous planning schemes prepared for the street in the 1960s.[5] Despite the general skepticism, most observers agreed that Harlem's fortunes would rise with the renewal of 125th Street.

At the heart of the HUDC's plan was the Harlem International Trade Center, intended to complement the World Trade Center downtown but concentrating on developing countries.[6] An idea of Representative Charles B. Rangel, the powerful Harlem Democrat who was charged with convincing the Carter administration of the worthiness of the scheme, which would require a substantial federal investment, the 775,000 square-foot complex was planned for a through-block site between 125th and 126th Streets, Lenox Avenue and Adam Clayton Powell Jr. Boulevard, just east of the last significant building completed on 125th Street, Ifill Johnson Hanchard's mammoth, nineteen-story, poorly received Harlem State Office Building (1973).[7] Preliminary plans drawn up by James Stewart Polshek & Partners included a forty-four-story building, with office space for foreign legations and missions on the first twenty stories topped by a 500-room hotel, a 3,000-seat convention center, a trade mart for the display and sale of items from the Third World, and a 450-space parking garage. Expected to provide more than 2,000 construction jobs as well as 3,000 permanent new jobs, the Harlem International Trade Center was planned for completion by 1983.

Polshek's firm, in collaboration with Bond Ryder Associates, was also responsible for preliminary plans for the other major component of the HUDC's revitalization proposal, a four-level, 225,000-square-foot shopping mall to be located on a vacant lot on the south side of 125th Street between St. Nicholas Avenue and Frederick Douglass Boulevard.[8] The block-long building was planned as the western anchor of the redevelopment scheme. The essentially suburban plan was largely internalized, with glass block rather than clear glass at ground level. Inside, a serpentine vaulted galleria was to rise through four levels of shopping to the roof. Benefiting from a direct connection to a major subway line, the shopping center seemed a sure thing when the department store Korvettes was rumored to have signed on as an anchor store, occupying 100,000 square feet, while the rest of the space was planned for boutiquelike shops. Korvettes went out of business in 1980, dashing hopes for the project, and the Harlem International Trade Center fell victim to a change in administration in Washington when Jimmy Carter's successor, Ronald Reagan, chose not to support the kind of federal subsidies that the plan required. Only the municipal parking garage, atop which the convention center was planned to sit, was completed, along with modest storefronts on the 125th Street side of the trade center site.

Despite the failure of the HUDC's plans, 125th Street slowly began to come to life. In 1978, after being shuttered for two years, Harlem's most famous cultural landmark

thoroughfare, 125th Street. By the late 1970s, the two-mile-long stretch of 125th Street, Harlem's commercial and cultural center, was hardly the lively shopping street it had been from the 1880s to the 1950s.[3] Well-stocked shops and a department store, Blumstein's, had given way to marginal retail catering to the poorest class of customers. Still, the street teemed with life even as community leaders complained that the "bustling, even prosperous spirit" betrayed a much darker reality, which discouraged the kind of investment needed to restore 125th Street to something approaching its heyday.[4] In April 1979, the Harlem Urban Development Corporation, a subsidiary of the New York State Urban Development Corporation, released plans that promised to revitalize the

ABOVE Proposed Harlem International Trade Center, site bounded by West 125th and West 126th Streets, Lenox Avenue and Adam Clayton Powell Jr. Boulevard. James Stewart Polshek & Partners, 1978. Model, view to the northeast. Amiaga. AP

RIGHT Proposed shopping mall, south side of West 125th Street, between Frederick Douglass Boulevard and St. Nicholas Avenue. James Stewart Polshek & Partners and Bond Ryder Associates, 1978. Model, view to the southwest. Amiaga. AP

and the symbolic capital of the African American entertainment world, the Apollo Theater (George Keister, 1914), 253 West 125th Street, between Adam Clayton Powell Jr. and Frederick Douglass Boulevards, reopened.[9] Originally built as Hurtig & Seamon's New Burlesque Theater, beginning in 1934 after its white-only admission policy was dropped, the Apollo became home to some of black America's most talented musical artists, including jazz greats Billie Holiday, Duke Ellington, Count Basie, and Dizzy Gillespie. The Apollo was noted for its amateur contests, where many future stars first performed. The editors of the *New York Times* were cautiously optimistic that this "casualty of its deteriorated neighborhood . . . may become part of the resurgence of the entire 125th Street corridor, the commercial hub of Harlem. . . . A thriving Apollo would be good for New York City, great for Harlem, and sensational for 125th Street."[10] The *Times*'s enthusiasm was, however, a bit premature and the reopened 1,700-seat theater was only sporadically used. In 1982 the Inner City Broadcasting Corporation, owners of radio stations and cable television franchises, announced plans to convert the Apollo into a video center where live performances, including a revival of amateur night, could be taped, edited, and transmitted.[11] Although the financing for the project, largely provided by the HUDC, took two years to secure, the refurbished Apollo, with plush purple carpeting, restored chandeliers, and red-and-gold-trimmed box seats, as well as new editing rooms and recording facilities, all the work of LeGendre, Johnson & McNeil, was finished in time for a gala reopening hosted by comedian Bill Cosby on May 4, 1985.

In 1986 the 2,300-seat Victoria Theater (Thomas W. Lamb, 1918), 233 West 125th Street, a former vaudeville house closed since 1977, was transformed into a five-screen movie theater complex, bringing first-run films to Harlem for the first time in sixteen years.[12] The Victoria was located a few storefronts east of the Apollo on 125th Street, but on 126th Street both auditoriums sat next to each other. In the HUDC's original plans, the Victoria, an architecturally distinguished design with extensive ornament including Ionic columns, carved animal heads, rosettes, and anthemion leaves on its facade, was to be the site of a new cultural complex with four new theaters for both film and stage productions. With the failure of those plans to move forward, the HUDC settled for the more modest but very welcome multiplex.

Although the only progress achieved by the HUDC on Polshek and Bond Ryder's four-level shopping mall was a COMING SOON! billboard on the site, a more modest facility, also sponsored by the HUDC, Mart 125, built to accommodate street peddlers, was completed in 1986 at 260 West 125th Street, between Adam Clayton Powell Jr. and Frederick Douglass Boulevards, a site cleared seven years earlier.[13] As designed by Hardy Holzman Pfeiffer, the two-story bare-bones building accommodated seventy-five eighty-foot-square stalls in an open skylit space. Mart 125 was built to answer local merchants' complaints that street peddlers were interfering with their business by clogging sidewalks and blocking access to their stores, as well as providing unfair competition because the itinerant merchants didn't pay taxes. It proved a success and by 1988 almost all of the spaces were rented and congestion on the street was significantly reduced.

Beginning in 1987 and continuing over the next three years, some of the street improvements originally contemplated by the HUDC in 1978 were finally completed, includ-

Mart 125, 260 West 125th Street, between Adam Clayton Powell Jr. and Frederick Douglass Boulevards. Hardy Holzman Pfeiffer Associates, 1986. View to the south. McGrath. NMcG

ing the removal of the old trolley tracks, the construction of new water mains and sewers, rebuilt sidewalks and curbs, up-to-date street lights and traffic signals, and the planting of more than 100 trees.[14] By 1989 the situation along 125th Street had so improved that the HUDC was encouraged to revive its plans for the Harlem International Trade Center.[15] Planned for the same site, but this time designed by Emery Roth & Sons, the project, though much less promising as architectural art, was similar in its planning to Polshek's, calling for a 400,000-square-foot, forty-four-story office-hotel tower and an international merchandise mart above a parking garage, along with a significant retail presence on the ground floor. Despite the partial revival of 125th Street and a commitment from the Port Authority to rent space in the new building, the project faltered when proper financing could not be arranged and a private developer could not be found.

In 1992, with the help of government subsidies as well as private philanthropies, two commercial enterprises known for their social conscience opened retail stores on 125th Street. On the southeast corner of Fifth Avenue, an 890-square-foot Ben & Jerry's ice-cream shop was designed by Michael Avramides to "evoke an ice cream parlor typical of one in the area's heyday in the 1940s," complete with a pressed-tin ceiling, a ceramic-tile floor, mahogany booths, and a soda fountain–style counter.[16] Avramides donated his services and Ben & Jerry's waived its customary franchise fee and sold the ice-cream making equipment at cost. Many of the employees in the shop were formerly homeless, and 75 percent of profits were directed to a nearby shelter. Across the street at 1 East 125th Street, the English purveyor of environmentally friendly soaps and cosmetics, the Body Shop, opened a small store and pledged 5 percent of its sales to local charities as well as to providing four full-time jobs for neighborhood residents.[17] The Body Shop store, along with three other retail spaces, was located on the ground floor of a new building housing the National Black Theater, also completed in 1992.[18] As designed by Gerard Paul of Geppaul Architects, the three-story, 32,000-square-foot masonry building with aluminum-clad structural columns and a hexagonal dome replaced the theater's previous home on the same site, which had been

National Black Theater, northeast corner of Fifth Avenue and East 125th Street. Geppaul Architects, 1992. View to the northeast. Vergara. CV

largely destroyed by fire in 1983. The building housed a 288-seat theater, rehearsal space, and offices, in addition to the ground-level retail space meant to provide income for the non-profit theater company.

By 1993 the revitalization of 125th Street was such that Walter Stafford, a professor of urban policy at New York University, could proclaim "not . . . a renaissance, as happened back in the 1920s and early 1930s . . . [but] certainly . . . a major rebuilding. There's a new faith about what can be done."[19] Far more dramatic change was soon to come as a result of the enactment into law in December 1994 of a bill creating six new empowerment zones throughout the United States.[20] Sponsored and introduced by Charles Rangel, who was then the second-highest-ranking Democrat on the influential House Ways and Means Committee, the legislation affected New York, Atlanta, Baltimore, Chicago, Detroit, and the Philadelphia-Camden area. In addition to Harlem, New York's Upper Manhattan Empowerment Zone also included

Metro-North Station (Morgan O'Brien, 1897), East 125th Street and Park Avenue. Renovation by di Domenico + Partners, 1999. DDP

Harlem USA, south side of West 125th Street, between Frederick Douglass Boulevard and St. Nicholas Avenue. Skidmore, Owings & Merrill, 2000. View to the southwest. Zucker. SOM

Washington Heights, Inwood, and parts of the South Bronx. For New York, the federal initiative would provide a $300 million development fund as well as $250 million in tax incentives to be spent over ten years.

Immediate progress was stymied first by infighting between Mayor Rudolph Giuliani and Governor George Pataki over control of the administration of the federal dollars. In 1995 Pataki disbanded the twenty-four-year-old HUDC, folding its functions into a new agency under the control of the Empire State Development Corporation headed by Charles Gargano. Then, a bizarre crime threatened to halt all progress when, on December 8, 1995, eight people died in a fire at Freddie's Fashion Mart, 272 West 125th Street, set by an arsonist who shot himself.[21] The tragedy proved to be a racially motived attack prompted by the decision of the white Jewish owner of Freddie's, which opened three years earlier, to evict a popular subtenant, the Record Shop, a fixture on the block for seventeen years catering to and operated by blacks, in order to expand his discount apparel store. Inflammatory rhetoric quickly heated up, led in part by the politically ambitious Rev. Al Sharpton, who condemned "white interlopers" whom he believed were intent on taking over 125th Street and Harlem. Despite serious concerns that major businesses might be reluctant to relocate to an area involved in a racial crisis, by the summer of 1996 the twenty-three-member board of the Upper Manhattan Empowerment Zone Development Corporation was up and running, actively soliciting proposals for ways to distribute the federal largesse.

The first project to go forward, and the one that proved essential for the success of later development, seemed an unlikely catalyst: a new 50,000-square-foot Pathmark supermarket completed in 1999 on a 67,000-square-foot site on the south side of 125th Street between Lexington and Third Avenues, previously home to a parking lot, representing the first major chain supermarket to open in Harlem in three decades.[22] First proposed in 1991, the supermarket project, located well east of earlier planning activity on 125th Street, was unable to get off the ground until the creation of the empowerment zone. The new Pathmark caused considerable controversy. It was not only protested by local bodega owners understandably concerned about the competition, but also by many neighborhood residents who, echoing the issues raised by the Freddie's Fashion Mart disaster, worried that outsiders would turn out to be the prime beneficiaries of the federal aid, despite the fact that the development team for the project included Harlem's Abyssinian Baptist Church, led by the city's most prominent black cleric, the Rev. Calvin O. Butts. After numerous delays, groundbreaking commenced on August 25, 1997, and the twenty-five-aisle, suburban-sized supermarket opened on April 15, 1999. In addition to the twenty-four-hour market providing 200 full-time jobs, the block-long development also included a Chase Manhattan Bank branch, a pharmacy, and rooftop parking for 130 cars. Writing in the New York Times seven months after its opening, Terry Pristin noted that not only had Pathmark "altered the fortunes of the unsightly intersection where it is located, it is also helping to spur development across 125th Street."[23]

In 1999, in an improvement unrelated to the establishment of the empowerment zone, di Domenico + Partners completed the much-needed renovation of Metro-North's 125th Street Station (Morgan O'Brien, 1897), located along Park Avenue beneath the steel viaduct, which was also undergoing extensive repairs.[24] In addition to restoring the waiting room's tongue-and-groove wainscoting and raised oak paneling, the

LEFT Proposed Harlem International Trade Center, site bounded by West 125th and West 126th Streets, Lenox Avenue and Adam Clayton Powell Jr. Boulevard. Roberta Washington and Mitchell/Giurgola Architects, 1994. Model, view to the northwest. Pottle. ESTO

BELOW Harlem Center, north side of West 125th Street, between Lenox Avenue and Adam Clayton Powell Jr. Boulevard. Hardy Holzman Pfeiffer Associates, 2002. View to the northeast. RAMSA

architects added two elevator towers to make the elevated platforms accessible to the handicapped and replaced the almost 100-year-old viaduct with a steel and concrete structure that was four feet wider, allowing for more ample platforms for passengers. The renovation realized its intended purpose: to encourage more local usage and also attract suburbanites as well as Upper East and Upper West Siders who had typically avoided the station even if it was more convenient than traveling to Grand Central Terminal.

The surest sign of 125th Street's rebirth was the construction of Harlem USA (2000), a six-level, 275,000-square-foot retail-entertainment complex, located on the 62,000-square-foot site previously earmarked for the HUDC's multilevel shopping mall.[25] As designed by Skidmore, Owings & Merrill, the building avoided some of the suburban introspection of the early Polshek, Bond Ryder proposal through the use of a low-iron glass curtain wall that allowed for almost total transparency. The key to the project's success was the ability of the developers, Grid Properties and the Gotham Organization in association with the Harlem Commonwealth Council, to exploit the advantages of the empowerment zone and attract an impressive number of high-profile retailers. The most important tenant was the nine-screen Magic Johnson Theatres, a partnership of the basketball superstar and Sony Entertainment. A year before the multiplex opened, in 1999,

Magic Johnson was responsible for another visible symbol of 125th Street's growing gentrification when his development company teamed up with the Starbucks Coffee Company to open an outlet at 77 West 125th Street, just east of Lenox Avenue.[26] Charles David, writing in April 2001 in *Urban Land*, declared Harlem USA a "success" that "has sparked a renaissance in the local real estate market."[27]

Although the Harlem International Trade Center never went beyond the planning stages, including another failed effort in the mid-1990s to revive the project with a reduced scheme calling for a twenty-two-story office-hotel tower rising from a five-story base designed by Roberta Washington, working in collaboration with Mitchell/Giurgola Architects, the 80,000-square-foot site on the north side of 125th Street between Lenox Avenue and Adam Clayton Powell Jr. Boulevard was finally developed as the Harlem Center, a 110,000-square-foot retail and office complex with plans for a second phase consisting of a 200,000-square-foot building with office space and 150 hotel rooms.[28] A joint effort of Forest City Ratner and the development arm of the Abyssinian Baptist Church, the first phase consisted of an almost interesting orange and brown brick building designed by Hardy Holzman Pfeiffer and was completed in September 2002, anchored by a 57,000-square-foot Marshalls discount clothing store.

In 2001 work was completed on Rogers Marvel Architects' expansion and renovation of the Studio Museum of Harlem,

Studio Museum of Harlem, 144 West 125th Street, between Lenox Avenue and Adam Clayton Powell Jr. Boulevard. Rogers Marvel Architects, 2001. View to the southwest. Vecerka. ESTO

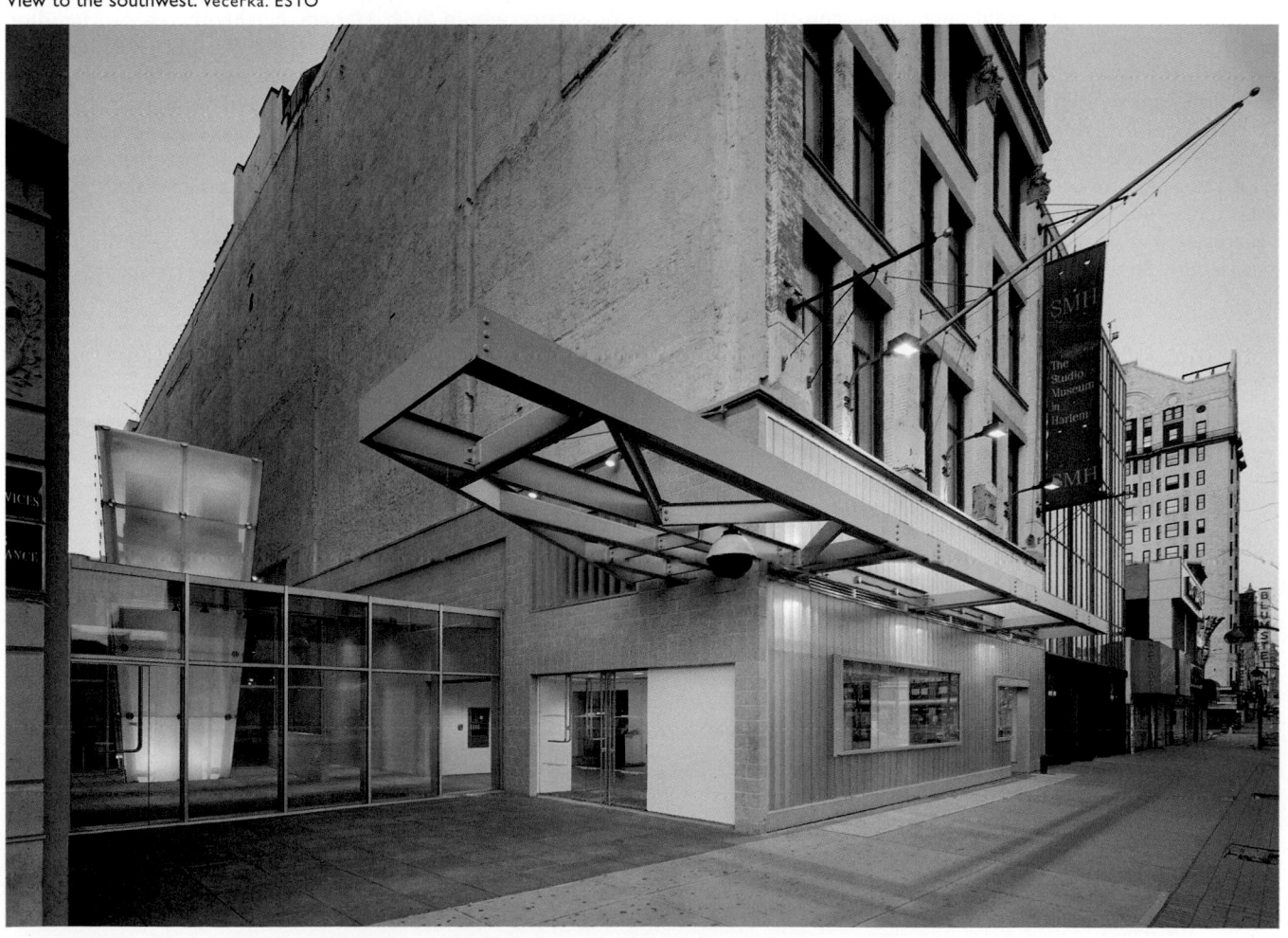

144 West 125th Street, between Lenox Avenue and Adam Clayton Powell Jr. Boulevard, across the street from the Harlem State Office Building.[29] Founded in 1968 and first located in very modest facilities above a liquor store at 2033 Fifth Avenue, between 125th and 126th Streets, the museum moved in 1981 to a six-story building (c. 1900) that was renovated by Bond Ryder Associates.[30] When the Studio Museum obtained a long-term lease from the city on a neighboring 25-by-200-foot vacant lot, Rogers Marvel transformed the space into an entrance courtyard and sculpture garden. Set behind a glass wall, the sculpture garden sat atop new galleries that received natural light from an eye-catching glass tower shaped like an inverted, truncated pyramid. At the rear of the garden, a second tower, realized in concrete, contained stairs leading to the below-grade spaces, which included a new auditorium and café. Rogers Marvel's design also featured a new green glass and steel facade on the bottom two floors of the museum building and a dramatic openwork metal marquee.

Despite the improved economic climate on 125th Street, some of the early success stories proved short-lived. The Victoria, which had reopened as a first-run multiplex in 1986, struggled throughout the 1990s and was often closed.[31] The Apollo's triumphant rebirth in 1985 was also followed by some hard times, mainly self-inflicted, as the administration of its finances by the nonprofit Apollo Theater Foundation in the late 1990s brought the theater unwanted attention that severely compromised its prosperity.[32] In 2001 an ambitious scheme was announced for a new cultural complex that would encompass both the Victoria and Apollo.[33] To be designed by Davis Brody Bond, in association with Beyer Blinder Belle, the new center, plans for which stalled over the next four years, included a completely renovated Apollo and a new 2,800-seat performance venue to replace the Victoria.

A strong sign of confidence in 125th Street's future was the decision in 2001 by former President Bill Clinton to lease 7,000 square feet of office space on the top floor of the fourteen-story 55 West 125th Street (Kahn & Jacobs, 1973), between Fifth and Lenox Avenues.[34] Clinton, who had taken up residence in suburban Chappaqua, New York, following the end of his second term and his wife's election as United States Senator representing New York, had first tried to rent space on the fifty-sixth floor of Cesar Pelli's Carnegie Hall Tower, 152 West Fifty-seventh Street, but that deal collapsed over controversy surrounding the high rent that would have to be paid by the federal government's General Services Administration. The move to 125th Street seemed a natural to many. Not only was the former president enormously popular in the black community, but he had also signed the empowerment zone legislation that many credited for the street's revitalization. A crowd of more than 2,000 greeted Clinton on his first day at his new office, an occasion described in the *New York Times* as a "day to celebrate the arrival of a new neighbor whose move has seemed to affirm Harlem's resurrection."[35]

BROWNSTONE REVIVAL

While 125th Street was Harlem's commercial and cultural capital, the neighborhood's greatest resource was its rich heritage of architecturally distinguished townhouses and rowhouses, a majority of which dated from the last two decades of the nineteenth century and the first decade of the twentieth century.[1] Beginning in the 1980s, Harlem experienced a "brownstone revival" that echoed in spirit, if not in sheer number and success, the similar movement that had helped transform the Upper West Side and the Park Slope section of Brooklyn beginning in the mid-1960s. Although there were stable pockets of prosperity within such Harlem neighborhoods as Hamilton Heights, the social upheaval of the 1960s and 1970s had initiated a downward spiral of disinvestment not only in Harlem's real estate but also in municipal services, especially schools that were essential to attract the middle-class professionals needed to purchase and renovate the often abandoned and dilapidated properties. Additionally, parochial politics motivated by fear that Harlem would "go white" and thereby erode the power base of its black politicians discouraged investment. But the hot real estate market of the 1990s, driven by the desire

Proposed redevelopment of Apollo and Victoria Theaters, north side of West 125th Street, between Adam Clayton Powell Jr. and Frederick Douglass Boulevards. Davis Brody Bond and Beyer Blinder Belle, 2001. South elevation. DBB

View along the west side of Malcolm X Boulevard between West 122nd and West 123rd Streets showing renovated and dilapidated brownstones, 2002. Vecerka. ESTO

of more and more middle-class people to live in Manhattan, made Harlem's rebirth almost inevitable. Harlem also enjoyed some distinct advantages. Well served by mass transit, it was much more convenient to midtown than comparable neighborhoods in Brooklyn or Queens. The price of the housing was a relative bargain compared with the rest of Manhattan, and for African Americans, even those who had never lived there before, it possessed one important intangible—an emotional attachment: moving to Harlem was "coming home."

The most important player in the brownstone revival was the city government itself. As a result of abandonment or the failure of the previous owners to pay property taxes for at least three years, by 1980 the city owned some 60 percent of Harlem's residential property, including more than 300 rowhouses, most located in West and Central Harlem. The Koch administration was convinced that selling its vacant townhouses to private individuals would have benefits beyond the rehabilitation of the houses in question, spurring additional private development with new restaurants and stores built to serve the middle-class homeowners as well as encouraging the restoration by private developers of the area's many abandoned tenements and apartment houses. In addition, as city officials readily admitted, there simply was a lack of public funds to do the work.[2]

Despite the high hopes, as well as the fact that the number of black New Yorkers with middle-class incomes had more than tripled in the past decade, progress was slow and by 1983 the city had sold only twelve townhouses in Harlem for renova-tion. The problem centered on the Department of Housing Preservation and Development's inability to come forward with a specific plan to sell a large number of houses, a failure attributable to a contentious debate over who should be allowed to buy them. In 1985, however, the issue was settled and the city announced that it would conduct a sealed-bid auction for 149 vacant, mostly dilapidated rowhouses.[3] In a compromise, ninety-eight of the houses were reserved for residents of Community Boards 9 and 10, encompassing most of West and Central Harlem. Prospective bidders were required to live in and rehabilitate their homes but could sell them with no restrictions after three years of ownership. To help with the purchase price, the city offered subsidized mortgages and arranged with a Harlem bank, the Freedom National Bank, to provide subsidized loans to help pay for the renovations. Reaction in Harlem was generally positive, although one group, the National Reclamation Project, protested the plan, arguing that poor families be allowed to take over the abandoned houses at no cost, substituting "sweat equity" for purchase prices. More than 1,200 bids were received, and on August 16, 1985, at a City Hall reception attended by Mayor Ed Koch, the winners were announced. On average, prices ran about 25 percent higher than predicted, with those ninety-eight within Harlem bidding about 20 percent less than the fifty-one from outside the neighborhood. Although skeptics predicted that more than 75 percent of the winning bidders would simply walk away, four years after the auction the city could point to tangible, positive results. Of the 149 houses put up for bid, 131 had been conveyed to new

Astor Row (1883), 34–36 West 130th Street, between Fifth Avenue and Malcolm X Boulevard. View to the north before restoration. RWA

Astor Row (1883), 34–36 West 130th Street, between Fifth Avenue and Malcolm X Boulevard. Renovation by Roberta Washington, 1992. View to the northeast. RWA

owners: ten had been completely refurbished; twenty-three were under construction; fifty-six were in various stages of planning; and only forty-two were completely untouched.

Thanks to the city-sponsored plan, as well as the continued rehabilitation of rowhouses purchased from private sources, in May 1988 Howard W. French could report in the *New York Times* on the "growing number of well-educated, middle-class blacks who have been arriving in Harlem in the last decade."[4] One month later, the Hamilton Heights Homeowners Association sponsored its first Heritage House Tour of twelve townhouses either in the process of renovation or fully rehabilitated in the West Harlem neighborhood bounded by West 140th and West 155th Streets, St. Nicholas Avenue and Riverside Drive.[5] Organized by Michael Henry Adams, then a graduate student in Columbia's historic preservation program who would soon found a new advocacy group, the Upper Manhattan Society for Progress Through Preservation, the tour proved a success and became an annual event, helping to further raise the profile of Harlem's brownstone revival.

In 1991 the Harlem Urban Development Corporation, best known for its large-scale plans to revitalize 125th Street, became an unlikely ally in a trend geared to middle-class professionals.[6] In terms of housing, the nonprofit agency had previously confined itself to low-income units, aiding in the rehabilitation of over 5,000 rental apartments since its founding in 1971. As in the previous city-sponsored plan, precedence was given to Harlem residents, with no restrictions placed on future sales after three years of ownership. The HUDC took charge of the renovations, hiring architects Robert Arthur King and Joseph E. Sutton to create twenty-one condominium units consisting of duplex and floor-through units in eight houses, including a row of five from the mid-1880s on West 122nd Street between Lenox Avenue and Adam Clayton Powell Jr. Boulevard. The group of renovated houses also included two in the Hamilton Heights Historic District, the brick and limestone 475 West 143rd Street (Clarence True, 1896), between Convent and Amsterdam Avenues, and the Romanesque Revival 472 West 144th Street (Harvey L. Page, 1889), between Convent and Amsterdam Avenues, originally built as a group of four brick houses.[7] The remaining house renovated by King

and Sutton was 254 West 139th Street (Bruce Price and Clarence Luce, 1891), between Powell and Douglass Boulevards, located within Harlem's, if not the city's, most distinguished enclave of rowhouses, David H. King Jr.'s Model Houses, popularly known as Strivers' Row.[8]

The largest coordinated renovation of rowhouses for private owners was Roberta Washington's restoration of the so-called Astor Row in the early and mid-1990s.[9] Located at 8–62 West 130th Street, between Fifth and Lenox Avenues, the unusual row of twenty-eight three-story houses with wide wooden front porches sheltering brick facades was built between 1880 and 1883, with the first group, numbers 8–22, designed by Charles Buek and the remainder built after his example. Although the group of paired houses had been declared a landmark in 1981, many had fallen into disrepair. The project was spearheaded by the New York Landmarks Conservancy and, appropriately enough, largely subsidized by a grant from the Vincent Astor Foundation—Vincent Astor was a grandson of the original developer, William B. Astor II. Washington's work included facade and interior renovation as well as the restoration of the fragile, ornately spindled porches, many of which had collapsed or long ago been removed.

In the 1990s, the Department of Housing Preservation and Development, in an attempt to build upon the success of its earlier plan that auctioned off 149 rowhouses, embarked on a more modest program, CityHomes, to rehabilitate seventy houses for first-time buyers, uncovering and restoring at least one long-neglected gem. In 1998 the architect Hamlett Wallace renovated Calvert Vaux and Frederick Clarke Withers's 28 West 126th Street (1871), between Fifth and Lenox Avenues, a three-story dark red Philadelphia brick rowhouse, trimmed with light-colored Ohio stone, that had been vacant since the 1970s.[10] Although Wallace did not restore the original mansard roof punctuated by a dormer that had earlier been removed, the architect rebuilt the collapsed first-story bay window, gutted the interior, and attempted to clean the badly stained facade, ultimately being forced to paint the stone trim.

In 1998, in a front-page article in the *New York Times*, Lisa W. Foderaro assessed the impact of the brownstone revival,

now nearly twenty years old: "What started . . . as a trickle of young African American lawyers, doctors, professors and bankers moving back to Harlem . . . seems now to have reached the flood stage. Black professionals are snatching up 5,000-square-foot brownstones off avenues named for black leaders. And their financial commitments extend beyond new boilers and restoring woodwork; they are also looking to bring the amenities they had found in SoHo and the Upper West Side to neighborhoods that, while on the upswing, are still marked by abandonment and a dearth of shops and restaurants."[11] Two years later, additional evidence of this growing prosperity was provided by the announcement by the Corcoran Group, which billed itself as the city's "premier luxury residential real estate" company, of plans to open an office in Harlem specializing in townhouses, representing the first of the top real estate brokers to do so.[12] But as was often the case in Harlem, this enthusiasm proved premature. The Corcoran Group did not open its Harlem branch until 2005.

With the brownstone revival highlighting the value of restoring Harlem's historic buildings came a fear that prosperity might be accompanied by unthinking reconstruction of the neighborhood's housing stock. Consequently, beginning in the early 1990s, claims were increasingly made that the Landmarks Preservation Commission was neglecting Harlem's architecture.[13] These were not unfounded: the commission had designated only three modestly sized historic districts in the late 1960s and early 1970s and twenty-one individual landmarks by 1991 in Harlem, a dramatic contrast with the five historic districts, two of which were substantial, and eighty-five individual landmarks on the Upper East Side.[14] Michael Henry Adams was a leading preservation activist, bringing a dramatic flair to the debate that included chaining himself to the front door of the Landmarks Preservation Commission's Old Slip headquarters to draw attention to the cause. In 1999 Adams, who was working on an architectural and social history of Harlem published three years later as *Harlem: Lost and Found*, stated: "It is an utter scandal that the incredible architectural and cultural heritage here can be destroyed when we have a law in place to protect it. But it is being used in an inequitable way."[15]

Not all were in agreement. Karen A. Phillips, chief executive officer of the development arm of the Abyssinian Baptist Church, worried that large-scale landmarking could inhibit desirable redevelopment by making it too expensive or too difficult: "If you landmark all of Harlem, you're preserving a ruin rather than preserving a community."[16] In response to the criticism, between 2000 and 2002 the Landmarks Preservation Commission expanded the existing Hamilton Heights Historic District, thereby creating Harlem's largest protected area, the 282-building Hamilton Heights/Sugar Hill Historic District, roughly bounded by 145th and 155th Streets, Edgecombe and Convent Avenues.[17]

CENTRAL HARLEM

Central Harlem—bounded by Park Avenue and its viaduct on the east, Morningside, St. Nicholas, and Colonial Parks on the west, and the Harlem River and Central Park to the north and south, and including a stretch of 125th Street—was where most renewal efforts were concentrated. Once Harlem's heart of fashion, the area had been physically ravaged in the 1960s and 1970s. In 1979 a plan to rescue the blocks north of Central

Towers on the Park, southwest and northwest corners of 110th Street and Frederick Douglass Boulevard. Bond, Ryder & James Associates, 1987. View to the northwest. RAMSA

Park, between 110th and 112th Streets, Manhattan and Park Avenues, an area designated the Harlem Gateway Neighborhood Strategy Area, was announced by the Harlem Urban Development Corporation.[1] The plan for the twelve-block area consisted of new and rehabilitated housing. The fact that most of the buildings were vacant made it possible to attract residents of various incomes without a major relocation problem.

While not completely successful, the Gateway plan did provide a boost for several renovation efforts, among them the West 111th Street Block Association's struggle, which began in 1971, to keep the city from demolishing a row of seven abandoned five-story tan brick and concrete apartment buildings between Madison and Lenox Avenues dating from the early 1920s.[2] With the assistance of city, federal, and private sector funds, the buildings, renovated by the Lewis-Turner Partnership to accommodate 174 apartments, reopened in two phases in 1979 and 1982. A more difficult path lay ahead for the Semiramis (Henry Anderson, 1901), 137 West 110th Street, between Adam Clayton Powell Jr. Boulevard and Lenox Avenue, and Lido Hall, 1800 Adam Clayton Powell Jr. Boulevard, northwest corner of 110th Street, two abandoned apartment buildings that the HUDC unsuccessfully attempted to rehabilitate in 1979 as low-income housing.[3] In 1983, however, the development corporation found success with a plan to renovate the pair as market-rate condominiums, signifying the first time that properties seized through tax foreclosure were sold by the city for market-rate housing.[4] Though disputes with former mortgage holders held up the project, the buildings eventually reopened in 1987.

By far the most dramatic change to the Harlem Gateway area was the construction of Towers on the Park (Bond, Ryder & James Associates, 1987), a brutally scaled and brutally detailed pair of apartment towers anchoring the northwest corner of Central Park on a two-acre urban renewal site occupying the northwest and southwest corners of Frederick Douglass Circle, the intersection of 110th Street and Eighth Avenue.[5] The parcel had previously been slated for low-income housing, but that project was canceled in light of the anticipated high cost of site work. Plans were revived in 1982 with the help of the HUDC and the New York City Housing Partnership, a private civic group founded the year before and chaired by David Rockefeller to help the city build 5,000 new units of housing on city-owned land for moderate- to middle-income residents. As with the Semiramis and the Lido, the move to build such housing was greeted warmly by many in the Harlem community who were concerned that local families above the low-income level had too few housing alternatives to keep them in the neighborhood. Towers on the Park would provide 599 units of housing for three tiers of income levels in two twenty-story buildings, each flanked by midrise nine-story wings. Both buildings provided retail spaces at ground level, and the north tower was abutted by a 100-car parking garage, while the southern tower snaked across its site to enclose a south-facing courtyard along 109th Street. The pair provided a typological, if not formal, symmetry with the twin towers of Arthur A. Schomburg Plaza (Gruzen & Partners in association with Castro-Blanco, Piscioneri & Feder, 1975), on the northeast corner of the park.[6] The editors of the *AIA Guide* were surprisingly respectful when they described the buildings as "crisp but bland. They bow, however, to the circle and consciously make a corner for the park."[7]

On the northeast corner of the park, an eighteen-year endeavor to have Frawley Circle (named in 1926 for James Frawley, a Tammany Hall politician), created by the intersection of Fifth Avenue and 110th Street, reinvented as a memorial to the composer Duke Ellington came to fruition in 1997.[8] The effort had begun in 1979, five years after Ellington's death, when Bobby Short, the nightclub singer and pianist, commissioned the figurative artist Robert Graham to create a bust of Ellington that would be placed in an undetermined location. Short and several park officials scoured Harlem before deciding on a small spot at the edge of Central Park near 106th Street (Duke Ellington Boulevard). Graham convinced Short that the sculpture should be more monumental than a bust and Short, agreeing, created the Duke Ellington Memorial Fund to raise money for it. A design was presented to the public in 1990 as a larger-than-life-size black-coated-bronze likeness of Ellington standing next to a grand piano twenty-five feet in the air atop three columns, each one supporting three caryatids representing the muses.

In the early 1990s, the Central Park Conservancy approached Short with the idea of locating the monument in Frawley Circle as the centerpiece of a renovated public plaza, and in 1995 the intersection was renamed Duke Ellington Circle. Mark K. Morrison Associates designed the new circle (1997), actually two semicircular plazas bisected by Fifth Avenue, with cobblestone paving, concentric rows of trees, and granite-stepped seating areas that formed an amphitheater. The monument to Ellington was placed on the western plaza.

The realization of Duke Ellington Circle stimulated nearby improvements with the announcement in July 2000 by Edison Schools, the country's largest private operator of public schools, and the Museum for African Art, to build a combination museum, elementary school, and Edison Schools headquarters on the southeast corner of Fifth Avenue and 110th Street.[9] The museum's presence would extend Fifth Avenue's museum district farther north. The elementary school would be Edison's first in New York City, and the relocation of Edison's offices would represent the first publicly traded company to be headquartered in Harlem. The site comprised four city-owned parcels and one Edison-owned property fronting Fifth Avenue. The land would have to be rezoned to allow for office use in addition to residential and community use.

Several architects competed for the job, including Rafael Viñoly, whose proposal envisioned three buildings expressed as discrete volumes situated around a public plaza, with the museum fronting Fifth Avenue and the school facilities to the east.[10] Viñoly's proposed museum building featured a glass facade covered by movable louvers that were painted black on one side and various colors on the other so that the building could have a pan-colored, mutable skin. Viñoly was passed over, however, for an unusual collaboration between Bernard Tschumi, who prepared plans for the Museum for African Art, and Venturi, Scott Brown & Associates, the firm responsible for the Edison school and headquarters. Gruzen Samton collaborated on both projects. The proposed buildings would enclose a public plaza on the southeast corner of Fifth Avenue and 110th Street with the Museum for African Art in its own building to the south of the plaza and the Edison facilities to the east. Tschumi's design called for a 125-foot-tall glass box enclosing a

FACING PAGE Duke Ellington Circle, 110th Street and Fifth Avenue. Mark K. Morrison Associates, 1997. View to the southwest. Morrison. MKM

Proposed Museum of African Art and Edison Schools Headquarters, southeast corner of Fifth Avenue and East 110th Street. Museum, Bernard Tschumi; headquarters, Venturi, Scott Brown & Associates, 2000. Rendering of view to the southeast showing museum on right and Edison Schools building on left. VSBA

wood-sheathed core whose undulating envelope bore some formal resemblance to Alvar Aalto and Aino-Morse Aalto's Finnish Exhibit at the 1939 World's Fair.[11] Circulation spaces were situated at the periphery between the wooden volume and the glass, thus giving museum visitors views of Central Park. Locating circulation towards the exterior also allowed for three column-free floors. The 60,000-square-foot museum would contain temporary and permanent exhibition spaces, an auditorium, lobby, store, café, and a 500-person-capacity "event space," all topped by a landscaped roof deck and sculpture garden.

Venturi, Scott Brown & Associates' design for the Edison school and headquarters called for a fifteen-story building accommodating a 650-student elementary school on the first seven red brick–clad floors below a set-back white brick ribbon-windowed office tower for 450 employees. At ground level, a glazed west-facing lobby featured an electronic banner sign that would display news, community events, and other messages. Students would enter on 109th Street, while the entrance to the offices faced 110th Street. The architects intended to reflect the school's curriculum—which separated the kindergarten through second grades and the third through fifth grades into two "academies," each of which featured "houses" of six classes—by situating one "house" per floor, each containing a mix of classrooms and art, music, or special education and tutoring rooms.

In September 2002, Edison, faced with declining fortunes, announced its withdrawal from the project. Plans for the

Museum for African Art, which had in the meantime relocated from its Maya Lin–designed facilities in SoHo to temporary quarters in Long Island City, were set back until mid-2003, when a deal was reportedly made between the museum and private developers who would build a nineteen-story, 250,000-square-foot residential apartment tower that provided 60,000 square feet for the museum. Although Tschumi prepared a revised design, no tangible progress was made. In 2005 it was announced that Robert A. M. Stern Architects had been hired to come up with a new scheme for the museum.

In 1995 Elizabeth Barlow Rogers, outgoing president of the Central Parks Conservancy, formed the Cityscape Institute, a nonprofit organization whose first goal was to revitalize the entire stretch of Central Park North.[12] Cityscape organized a team of consultants led by Hardy Holzman Pfeiffer Associates and including Cline Bettridge Bernstein Lighting Design, landscape designers Ken Smith and J-P Design Group, and environmental graphic designers Roger Whitehouse/Anthony Williams to work with community residents in beautifying the street with new lighting, signage, public art, street furniture, sidewalk improvements, and public spaces. The project achieved early success with the creation of the 100-by-200-foot Malcolm X Plaza (2000), formed by the intersection of 110th Street, St. Nicholas Avenue, and Malcolm X Boulevard, where Ken Smith and J-P Design Group transformed a barren asphalt intersection into a lively public place.[13] Located above

a subway station, the site was divided into two triangular sections, with one to the east featuring a large triangular planter pointing south to seemingly complete the angle formed by St. Nicholas Avenue and Malcolm X Boulevard. To the west was a triangular grove of catalpa trees, each set in a triangular planter. Much of the plaza was enlivened by an Islamic-inspired geometric pattern of black, tan, terra-cotta, and green parallelogram-shaped pavers. Space was left on the north end of the plaza for a future piece of artwork, and flowers that bloomed only after May 19, Malcolm X's birthday, were planted. As well, the Cityscape Institute successfully advocated the planting of trees in a continuous ten-foot-wide by three-feet-deep pit extending north on Malcolm X Boulevard to 117th Street.

Cityscape also proposed to bring the north side of 110th Street closer to the character of Central Park by rebuilding it with the same distinctive paving and planting pattern as the south side, including trees evenly spaced in continuous cobblestone planters and distinctive sidewalk paving in front of each building entrance. In addition, a "Heritage Corridor Light Fixture" designed by Hugh Hardy in consultation with CBBLD was to replace the street's existing standards with ones that featured eight display panels above the base containing images and text relating to celebrated Harlem citizens. The plan to install the roughly fifty new light standards, however, was compromised in July 2000 when the city's Art Commission approved the lights but not the display panels. A redesigned light standard with a scaled-down base and rethought bracketing mechanism and finials was approved,

but when Mayor Bloomberg came to office, typical street lamps were erected on a temporary basis, casting doubt on the likelihood of Cityscape's design being implemented.

Frederick Douglass Boulevard

Between 1970 and 1980, the stretch of Frederick Douglass Boulevard between 110th and 125th Streets lost 42 percent of its population and 23 percent of its housing stock, with roughly a quarter of the remaining housing units left vacant to decay.[14] The construction of Towers on the Park (see above) brought optimism that revitalization might be on the horizon, but it was followed by only two meager additions to the boulevard: the Antlers Apartments, 2079 Frederick Douglas Boulevard, a red brick box of no distinction built on the southwest corner of 113th Street in 1986 to provide subsidized housing for senior citizens, and the Wyatt Tee Walker Senior Housing (1990), 2181 Frederick Douglass Boulevard, southwest corner of 118th Street, an equally banal 63,000-square-foot, seven-story building with eighty apartments for senior citizens.[15]

In 1989 the HUDC commissioned the firm of Hermanuz, Ltd., led by Ghislaine Hermanuz, working with Strickland & Carson Associates, Jose Chieng and Rita Webb-Smith Associates, to undertake an in-depth study of Frederick Douglass Boulevard between 110th and 125th Streets as well as of the avenues to its east and west. In their report, *Frederick Douglass Boulevard: A Strategy for Revitalizing Morningside Valley*, the team presented a broad array of proposals ranging from designs for affordable housing and street furniture to the

Malcolm X Plaza, site bounded by West 110th and West 111th Streets, St. Nicholas Avenue, and Malcolm X Boulevard. Ken Smith and J-P Design Group, 2000. View to the northwest. RAMSA

Boulevard/Manhattan study, 110th to 125th Street, Manhattan and Morningside Avenues to Adam Clayton Powell Boulevard. Hudson Studio, 1991. Rendering of view to the northwest. BLVD

provision of social services and the programming of public spaces. Two years later, in 1991, a second study of the same area was commissioned by the HUDC, this time from Roy Strickland, who had participated in the initial project but now coheaded the firm Hudson Studio with Linda Gatter.[16] The results, displayed at Columbia University from November 1991 to January 1992 as "Boulevard/Manhattan: An Exhibition of the Frederick Douglass Boulevard Project by the Hudson Studio," proposed 2,500 units of new housing, 100,000 square feet of commercial and retail space around the intersection of 116th Street and Frederick Douglass Boulevard, 31,000 square feet of "cooperative work space," and 100,000 square feet of institutional and social service spaces as well as new parks and subway improvements. Half of the new housing was to be for low- and moderate-income families, and two new single-room-occupancy hotels were proposed. The

area's existing building stock was to be retained wherever possible, and new residential construction was to be low-rise and high-density. A Frederick Douglass–Frederick Law Olmsted museum adjoining a new 600-unit apartment house was envisioned on the northeast corner of Frederick Douglass Circle, and a theater at 115th Street and a YMCA at 120th Street would help increase pedestrian activity up and down the stretch.

In spring 1999, Manhattan Borough President C. Virginia Fields called on the Columbia University Graduate School of Architecture, Planning, and Preservation's Urban Technical Assistance Project, led by Lionel C. McIntyre, to work in consultation with Ghislaine Hermanuz on a third study of the Douglass Boulevard corridor, this time going into a greater level of detail and examining a broader study area that reached north to 135th Street and west to Morningside and St. Nicholas Parks. The UTAP study identified thirty sites that

Harriet Tubman Gardens, 2235 Frederick Douglass Boulevard, between West 120th and West 121st Streets. John Ellis & Associates, 2003. View to the northwest. RAMSA

were available for development; sixteen of these, mostly city-owned sites occupying a total of thirteen acres of land, were deemed "critical to the transformation of the boulevard."[17] Each site was assigned a specific retail or residential use. The UTAP plan was completed in December 1999, and many of the recommendations were achieved, in part because of two city-sponsored housing initiatives: the New York City Housing Development Corporation's New Housing Opportunities Program, established in 1998 to meet the needs of middle-income New Yorkers long neglected by programs that had established either market-rate or low-income housing but nothing in between, and the Department of Housing Preservation and Development's Cornerstone Program, created in 1999 to encourage middle-income residential construction on city-owned vacant parcels, which would in many cases be offered to private developers for one dollar. The two programs were often employed in concert to offer a full package of incentives to private developers who would build middle-income housing for qualified tenants selected through a lottery system.

The UTAP study recommended the issuance of a "First Action Plan" to get development off the ground and act as a pilot project that might inform future development in the area. In summer 2000, the Office of the Manhattan Borough President released the "Frederick Douglass Boulevard First Action Plan–Harriet Tubman Square," governing the portions of Frederick Douglass Boulevard and St. Nicholas Avenue between 119th and 123rd Streets.[18] In keeping with the series of public spaces in Harlem named for prominent African American figures, the plan called for the prominent intersection of Frederick Douglass Boulevard and St. Nicholas Avenue to be named Harriet Tubman Square, with a memorial statue to be placed on an expanded traffic island on the northern portion of the site.[19] In addition, the portion of St. Nicholas Avenue between 111th and 141st Streets was to be renamed Harriet Tubman Avenue. Both names were adopted by the city in 2001.

The plan also proposed that a 1,914-square-foot vacant lot on the northeast corner of St. Nicholas Avenue and 121st Street become Abolitionists' Corner, enclosed by a low sitting wall, lined with trees, and featuring decorative paving and a water wall adjoining the party wall of the building to the north. Blank party walls throughout the First Action Plan area were to be decorated with banners displaying the artwork of local community groups. To reinforce the residential character of the boulevard, missing cornices would be replaced, street trees planted, and distinct sidewalk paving laid near residential building entrances.

As the First Action Plan was being prepared, the city solicited proposals to develop the large vacant lot on the west blockfront of Frederick Douglass Boulevard between 120th and 121st Streets as part of its Cornerstone Program, the first phase of which got under way in December 2000 when Mayor Rudolph Giuliani announced the selection of twenty-one developers to take over fifty vacant lots and boarded-up buildings. The 120th Street site was awarded to the Bluestone Organization, which in 2003 completed Harriet Tubman Gardens, 2235 Frederick Douglass Boulevard, a seventy-three-unit middle-income and market-rate apartment building with 9,500 square feet of ground-floor retail space, a twenty-six-car underground parking garage, a community room and garden, and, extending along the side streets to the west, nine four-story, three-family townhouses.[20] Designed by John Ellis & Associates, the decidedly Postmodern eight-story avenue-fronting building, clad in light red and gray brick, was made to seem less imposing by a recessed, gabled central bay while the entire facade was dressed up with gold-hued cast stone covering the base and forming quoins, lintels, window surrounds, and decorative trim. The top floor was set back to provide terraces for seven penthouse apartments. The townhouses—303, 305, 307, and 309 West 120th Street and 302A, 302B, 304, 306, and 308 West 121st Street—each featured a stoop, a central

Douglass, 279 West 117th Street, northeast corner of Frederick Douglass Boulevard. Scarano and Associates, 2003. View to the northeast. RAMSA

Shabazz Gardens, 117th Street, between Lenox Avenue and Adam Clayton Powell Boulevard. Danois Architects, 2000. View to the southwest. RAMSA

second-story bay window, separate entrances for the owners and tenants, and individual rear gardens. All of the townhouse and apartment building units were purchased by lottery before construction was completed.

By 2001 construction outside the boundaries of the First Action Plan was also under way, with developments ranging from new buildings to small-scale rehabilitations. Gaetano DiPlacidi and Associates, a developer, undertook a series of blockfront renewal projects with financing from the New HOP program. The first, Gateway I (Steven C. Gaetano, 2002), revitalized the west blockfront between 111th and 112th Streets, where four dilapidated five-story tenements, 2053, 2055, 2061, and 2063 Frederick Douglass Boulevard, were gut renovated and a new curved-fronted stucco-faced five-story infill building, 2057 Frederick Douglass Boulevard, was built to provide a total of fifty units of middle-income housing with commercial space at ground level.[21] As Gateway I opened, construction commenced two blocks to the north on Gateway II (Steven C. Gaetano, 2004), a similar combination of rehabilitation and new construction on the east blockfront of Douglass Boulevard between 113th and 114th Streets, where a new pair of red brick infill buildings with stone trim was erected between five derelict tenements, all refurbished and joined on the interior.[22]

The intersection of Frederick Douglass Boulevard and 117th Street was particularly bleak, described by Nina Siegel, writing in 1999 in the New York Times, as "abandoned by landlords, razed by arsonists, forsaken by the body politic."[23] In August 1999, the city announced plans to build an Emergency Medical Service ambulance station on the vacant lot on the southwest corner, but the proposal dismayed the community, which wanted residential development instead. Manhattan Borough President Fields endorsed residential development and also suggested a charter school for the site.

The idea succeeded, and in May 2000, plans were announced for Cornerstone Plaza (Larsen Shein Ginsberg + Magnusson), an eight-story, 100-unit orange brick with cast-stone trim rental apartment building with 8,000 square feet of ground-level retail space.[24] At the west end of the site was a 30,000-square-foot, three-story annex to the John A. Reisenbach Charter School. On the northeast corner of the intersection, a ninety-eight-unit apartment building, the Douglass, 279 West 117th Street (Scarano and Associates, 2003), rose on an L-shaped site extending east on 117th Street and occupying the entire blockfront except for a five-story tenement that remained on the north corner. The complexly massed building featured projecting red brick sections that recalled the scale and ornamental programs of its neighbors while recessed beige brick portions were more modern, with asymmetrical fenestration and stripped-down ornament.

By the late 1990s, residential construction was strong throughout Central Harlem. Although various plans for the city-owned site on the east side of Lenox Avenue between 116th and 117th Streets had been introduced since the 1980s, it was not until the late 1990s, under the auspices of a new city program, that the 1.8-acre site, vacant except for a temporary vendor's market but highly desirable because of its proximity to a subway express stop, would be developed as Renaissance Plaza (Greenberg Farrow Architects, 2001), a 360,000-square-foot building combining housing and 60,000 square feet of retail space.[25] The new program, sponsored by the Department of Housing Preservation and Development and the New York City Housing Partnership, was given the acronym Anchor (Alliance for Neighborhood Commerce, Home Ownership and Revitalization) and was geared specifically to encourage mixed-use projects with a substantial retail component. Seventy-five percent of the 240 co-operative one- to three-bedroom units were reserved for moderate-income families, with the remainder available to those with middle-class incomes. Developed by Suna Levine Inc., the project allotted half the units to current Harlem residents, with owners required to evenly split with the city any profits they realized in selling their apartments. Renaissance Plaza was also sponsored by a local religious institution, the Masjid Malcolm Shabazz Mosque, located diagonally across the street from the development.[26] Led by Imam Izak-el M. Pasha, the mosque, where Malcolm X once ministered, was responsible for two projects designed by Danois Architects: the Malcolm Shabazz Harlem Market (1999), a vendor's market for 116 booths located on a vacant 22,700-square-foot site on the south side of 116th Street between Fifth and Lenox Avenues; and Shabazz Gardens (2000), forty-one exceptionally inventive three-story red brick and cast-stone rowhouses imaginatively detailed with Islamic-inspired decoration, built under the city's New Homes Program, with thirty-four on both sides of 117th Street west of Lenox Avenue and seven more on 118th Street just east of Lenox Avenue.[27] As designed by Navid Maqami, head of the New York office of Atlanta-based Greenberg Farrow, the red brick Renaissance Plaza, with a cast-stone retail base, rose eleven stories along Lenox Avenue but stepped back to eight floors along 116th Street and six facing 117th Street. Although the architect's attempt to create a "dignified building" came off as perhaps more stolid than "solid," the Renaissance Plaza included such amenities as a 10,000-square-foot landscaped interior courtyard and below-grade parking for 200 cars, in addition to the much-needed retail space.[28]

ABOVE Renaissance Plaza, 130 Malcolm X Boulevard, between West 116th and West 117th Streets. Greenberg Farrow Architects, 2001. View to the northeast. Bartelstone. GFA

BELOW 1400 Fifth Avenue, between West 115th and West 116th Streets. Roberta Washington, 2004. View to the southwest. Choi. RWA

Maple Court, 1901 Madison Avenue, between East 122nd and East 123rd Streets. Ehrenkrantz & Eckstut, 1995. View to the southeast from Marcus Garvey Park. Ries. EEKA

The second building realized under the provisions of the Anchor program in Harlem was 1400 Fifth Avenue (2004), located one block east of Renaissance Plaza on the long-abandoned west blockfront between 115th and 116th Streets.[29] As designed by Roberta Washington, in association with William Brothers Architects, the 286,000-square-foot, eight-story brick and cast-stone building, which included 28,000 square feet of ground-floor retail space and 129 condominium apartments and featured forty-three market-rate units located in three-story townhouses facing 115th Street, was exceptionally lively in its massing, patterning, and coloration. As such, it was one of the more interesting apartment house designs of the 1990s. Washington, an African American architect educated at Columbia, was not only active in other projects in Harlem but lived in the neighborhood and located the twelve-person firm she headed on 125th Street. The mixed-use 1400 Fifth Avenue was publicized as an early "green" building, the city's first affordable multiple dwelling to qualify for state tax credits for its innovative environmental features, including a sophisticated air-filtration system to remove allergens from the air. Over 60 percent of the building was constructed from either recycled or renewable resources and 1400 Fifth Avenue included a geothermal heating and cooling system, consuming 35 percent less energy than permitted by state codes.

The Central Harlem stretch of Madison Avenue between 116th and 124th Streets was remarkably improved beginning in 1988, when North General Hospital (originally the Hospital for Joint Diseases; Buchman & Kahn, 1923), 1919 Madison Avenue, northeast corner of 123rd Street, the only minority-owned hospital in the state and, since its founding in 1979, a financially strapped institution, received state financing to build a new 240-bed hospital, 1879 Madison Avenue, east side between 121st and 122nd Streets, just two blocks south of its existing facility.[30] Designed by Architecture for Health, Science and Commerce, the new 240,000-square-foot red brick North General Hospital (1991), with an extruded semi-circular volume over the entrance and a cylindrical stack of bay windows rising up the center of the facade, gave new life to the institution that in 1992 was Harlem's largest private employer. Though the editors of the *AIA Guide* dismissed the design as "bland modernism," the new hospital was nonetheless a bright institutional presence along the otherwise derelict stretch of Madison Avenue.[31]

North General Hospital itself played an active role in the neighborhood's reconstruction. It was the nonprofit sponsor for the construction of Ehrenkrantz & Eckstut's Maple Court (1995), 1901 Madison Avenue, between 122nd and 123rd Streets, a 135-unit limited equity co-operative apartment building for moderate- to middle-income buyers consisting of a beige and red brick six-story mass facing the avenue, its entrance marked by a protruding bell-tower-like element, and two four-story wings extending along the side streets enclosing a landscaped courtyard.[32] Medical offices were housed in 7,000 square feet of ground-level space and surface parking was provided for eighty-three cars in a lot facing Park Avenue. As residents began moving into Maple Court, construction began on Maple Plaza (Architecture for Health, Science and Commerce, 1998), 1919 Madison Avenue, across the street to the north on the site of North General's former home, which was razed soon after the hospital moved.[33] Also sponsored by the hospital, Maple Plaza, a white, red, and gray brick H-shaped building of six and eight stories, with courtyards in the

Fifth Avenue Partnership Homes, block bounded by Madison and Fifth Avenues, East 117th and East 118th Streets. Danois Architects, 2001. View to the northeast. Didomenico. DA

front and back, provided 155 units of mixed-income housing as well as 12,000 square feet of ground-floor space for North General. The apartments in both Maple Court and Maple Plaza were offered by lottery, with 40 percent of the units reserved for neighborhood residents.

Improvement along Madison Avenue continued with the construction of the Tony Mendez Apartments (DePasquale & Geremia Architects and Planners, 2001), comprising 130 low-income rental apartments and 6,000 square feet of retail space in two buildings, one on the northeast corner of 116th Street and Madison Avenue and the other midblock on 117th Street between Madison and Park Avenues.[34] The red brick buildings with orange brick stripes were clad on the upper floors in cement panels that arced above the roofline to form distinct parapets. Another important improvement came with the construction of the Fifth Avenue Partnership Homes (Danois Architects, 2001), occupying the entire previously vacant city-owned block bounded by Fifth and Madison Avenues, 117th and 118th Streets. The collection of forty four-story, three-family, 3,600-square-foot townhouses was built by a private Queens-based developer, Briarwood Organization, in partnership with Hope Community, the community sponsor, as part of the New Homes Program.[35] Each townhouse comprised a three-bedroom owner's unit and two two-bedroom rental apartments. The project broke with the traditional Manhattan urbanism of midrise buildings fronting the avenues and low-rise structures on the side streets. The red brick houses with stoops, cast-stone trim, and cornices, though attempting to capture the character of traditional townhouse design, were diagrammatic in detail. Nonetheless, unlike the new, neighboring, expediently Modernist apartment houses, they made a

significant contribution to the revival of the neighborhood's sense of itself as a distinct urban place.

Across Madison Avenue, the construction of three more full-block housing complexes occupying the previously vacant contiguous blocks between 117th and 120th Streets, Madison and Park Avenues, would solidify the area's new stature as a recovered residential district. In July 2001, ground was broken for Madison Park Apartments (Feder & Stia Architects, 2002), 1831 Madison Avenue, between 119th and 120th Streets.[36] The building—and the related buildings that would follow—was a distinct aesthetic cut above most of the street's redevelopment, a beige and brown brick apartment house with a two-story stone base and rounded balconies that rose nine stories along Madison Avenue and was set back at the seventh floor to provide large terraces for some of the 129 middle-income co-op apartments. Behind it, extending to the east, two groups of rowhouses, the Madison Park Partnership Homes, fronted 119th and 120th Streets, separated by individually parceled rear yards. A parking lot was situated along Park Avenue in the shadow of the elevated railroad tracks. Next to be completed was Madison Court Apartments (GF55 Architects, 2003), 1787 Madison Avenue, two blocks to the south. Similar to Madison Park, it provided 103 apartments in an eight-story orange and beige brick building with a two-story stone base along the avenue and rows of three- and four-story bay-windowed rowhouses containing forty-eight units behind it. The interior of the block was used as parking. Madison Plaza Apartments (Feder & Stia Architects, 2003), 1825 Madison Avenue, completed the trio, providing ninety-three apartments ranging in size from 602 to 1,308 square feet and parallel strips of four-story red brick rowhouses, the Mt. Morris Homes (Butt

LEFT Madison Court Apartments, 1787 Madison Avenue, between East 117th and East 118th Streets. GF55 Architects, 2003. View to the northeast. Kornfeld. GF55

BELOW Madison Plaza Apartments, 1825 Madison Avenue, between East 118th and East 119th Streets. Feder & Stia Architects, 2003. View to the northeast showing Madison Park Apartments (Feder & Stia Architects, 2002) on far left. FSA

St. Charles Condominiums, Frederick Douglass Boulevard, between West 136th and West 138th Streets. Stephen B. Jacobs Group, 1994. View to the east. SBJG

Otruba-O'Connor Architects, 2003), extending on the north side of 118th Street and the south side of 119th Street toward Park Avenue. The unfortunate side effect of Madison Avenue's improvement was that the west side of Park Avenue between 118th and 124th Streets was lined with a series of fenced-in parking lots that did little to ensure a prosperous future for that thoroughfare, already blighted by the elevated railroad leading to Grand Central Terminal. Amazingly, this, like so much of Harlem's redevelopment at the turn of the last century, went unreported in the media and thereby virtually unappreciated by the public at large.

North of 125th Street, the most significant new housing development in Central Harlem was the St. Charles Condominiums (1994), geared toward moderate-income New Yorkers and located on four vacant blocks on both sides of Frederick Douglass Boulevard between 136th and 138th Streets.[37] As designed by the Stephen B. Jacobs Group, the 116-unit four-story, red brick townhouse development, with its prominent lintels and strong cornice, clearly took its stylistic cue from nearby Strivers' Row, "reinterpreting in a contemporary manner," according to the architects, "the scale, materials, massing and style" of the 1880s development.[38] Sadly, tight budgets and diminished proportions took their toll and the results bordered on the parodistic. Each 1,100-square-foot duplex unit could be entered directly from the street, with wrought-iron staircases leading to the upper apartment while the lower unit, with a private fourteen-by-thirty-foot garden, was reached down two steps.

Within Central Harlem, the most troubled area was the Bradhurst section, roughly bounded by 139th and 155th Streets, Adam Clayton Powell Jr. Boulevard and Edgecombe Avenue, a forty-block zone with Harlem's highest unemployment and housing abandonment rates. As E. R. Shipp put it in the *New York Times* in 1991: "Since 1970, an exodus of residents has left behind the poor, the uneducated, the unemployed. Nearly two-thirds of the households have incomes below $10,000 a year. In a community with one of the highest crime rates in the city, garbage-strewn vacant lots and tumble-down tenements, many of them abandoned and sealed, contribute to the sense of danger and desolation that pervades much of the area."[39] Although proposals for the area's renewal dated back to the early 1970s, it was not until the early 1990s that redevelopment plans for Bradhurst were put on the front burner, with an ambitious proposal that would create more than 2,000 units of new housing and 300,000 square feet of commercial space over ten years, including as well job-training programs, recreational and cultural activities, and a dramatic increase in social services.[40] But the large-scale plans were too grandiose for a one-term mayor and David Dinkins's successor, Rudolph Giuliani, severely scaled back the scope and partially reversed the direction of the redevelopment plans, placing new emphasis on private development. Recalling the situation on 125th Street (see above), the catalyst for development in Bradhurst was to be a 45,000-square-foot Pathmark supermarket, which was to anchor a residential-retail complex on a site bounded by 145th and 146th Streets, Bradhurst Avenue and Frederick Douglass Boulevard.[41] This Pathmark was also subject to local opposition, but in this case, in June 2000, after more than three years of contentious debate, the supermarket chain withdrew from the project, leaving the city-owned site

Hamilton, 330 West 145th Street, between Bradhurst and Edgecombe Avenues. Greenberg Farrow Architects, 2004. View to the southeast. GFA

Bradhurst Court, block bounded by West 144th and West 145th Streets, Frederick Douglass Boulevard and Bradhurst Avenue. Meltzer/Mandl Architects, 2005. View to the southwest. Lovi. MMA

Bradhurst Court, block bounded by West 144th and West 145th Streets, Frederick Douglass Boulevard and Bradhurst Avenue. Meltzer/Mandl Architects, 2005. View to the northeast. Lovi. MMA

vacant except for three abandoned tenements.

Although plans for the large mixed-use development were stalled by Pathmark's decision, the Bradhurst area was revitalized to some extent through the renovation of its existing housing stock, including Rod Knox's 1997 rehabilitation for the Department of Housing Preservation and Development of a five-story late-nineteenth-century tenement on the west side of Douglass Boulevard between 139th and 140th Streets creating fifty-four duplex apartments.[42] The following year, for the CityHomes program, Roberta Washington renovated eighteen abandoned rowhouses scattered throughout Bradhurst.[43] In 2001 Larsen Shein Ginsberg Snyder completed work on the gut

rehabilitation of six dilapidated late-nineteenth-century brick tenements on West 152nd Street between Douglass Boulevard and Bradhurst Avenue, creating 132 apartments for the city's Neighborhood Redevelopment Program.[44]

Buoyed by the general prosperity throughout Harlem attributable in part to the effect of the empowerment zone legislation, Bradhurst's fortunes really began to look up in 2002 with the announcement of plans for a new apartment building geared to the middle-class, Greenberg Farrow's eight-story red brick and cast-stone Hamilton (2004), 330 West 145th Street, between Bradhurst and Edgecombe Avenues, a seventy-seven-unit co-operative with ground-floor

retail space, a fitness center, a landscaped courtyard, and penthouse apartments with wrap terraces.[45] Another sign of optimism was the Bloomberg administration's decision to revive the Pathmark project on the same block-long site located diagonally across the street from the Hamilton, this time as part of the seven-story Bradhurst Court (Meltzer/Mandl Architects, 2005), where it would occupy 45,000 square feet below 126 units of affordable housing.[46]

Schomburg Center

Since its acquisition by the New York Public Library in 1926 with a grant from the Carnegie Foundation of $10,000, the collection of materials devoted to black history and culture originally put together by Arthur A. Schomburg, a black Puerto Rican who came to New York in 1891, had grown to enormous proportions. The Schomburg Center for Research in Black Culture was housed first in the 135th Street Branch of the New York Public Library, 103 West 135th Street, between Lenox Avenue and Adam Clayton Powell Jr. Boulevard, a three-story, Italian Renaissance design (McKim, Mead & White, 1905) representing one of the more inventive of the ten Carnegie branch libraries the firm designed between 1902 and 1908.[47] In 1941 Louis Allen Abramson added a wing to the McKim building facing 136th Street, a vigorous four-story design in tan brick with large metal-framed windows that principally served as a new branch library, the Countee Cullen Branch, named for the African American poet, but also included some space for the Schomburg collection.[48]

By the early 1970s the ever-expanding Schomburg collection required suitably designed archival space that would include proper air conditioning and humidity control.[49] In 1972 the Schomburg Center, previously deemed a branch library, was designated a research library, providing it with access to more funds. Bond Ryder Associates was selected to design a new facility, but municipal bureaucracy slowed the process of developing plans for a new building. When fiscal disaster struck the city in 1975, Bond Ryder's master plan and library design were almost complete. But in October of the same year, the city canceled the architects' contract for lack of funds. In April 1976, Ada Louise Huxtable took the problem to her readers, praising Bond Ryder's reworked plan that transformed "a large demolition and rebuilding project to something far more sensitive and sensible by calculating the future maintenance and staffing cost for what would have been an overambitious museum and library combination." Bond Ryder called for the preservation of the McKim, Mead & White building and asked that it be used for displays, while locating the new building on Lenox Avenue with an open, arcaded front. New and old buildings were to be linked by an interior garden court in a scheme Huxtable praised as a "simple, rational design, rich in neighborhood amenity, at once economical and potentially elegant."[50]

Late in 1976, the project was revived when a federal pump-priming program made available over $200 million to the city to complete stalled or abandoned capital projects.[51] Ground was broken for Bond Ryder's five-story red brick design in 1978, and the new Schomburg Center for

Schomburg Center for Research in Black Culture, 515 Malcolm X Boulevard, between West 135th and West 136th Streets. Bond Ryder Associates, 1980. View to the north showing 135th Street Branch, New York Public Library (McKim, Mead & White, 1905) on the left. DBB

Thurgood Marshall Academy, northeast corner of West 135th Street and Adam Clayton Powell Jr. Boulevard. Renovation by Gruzen Samton, 2004. View to the northeast. Vecerka. ESTO

Research in Black Culture was opened on September 28, 1980. At the southern end of the site, the building was raised three stories on pilotis, sheltering the main entrance. A rather forbidding design, the block-long narrow Lenox Avenue facade featured a row of horizontal windows topped by eight thin vertical window slits. Boldly chamfered corner stair towers, which were sometimes animated by banners advertising current exhibitions, anchored both the north and south ends of the building. On the 136th Street side, an outdoor amphitheater largely intended for nonlibrary use was created between the new building and Abramson's Countee Cullen Branch. After its opening, the new library flourished as never before, with more than 250 visitors each weekday and a veritable avalanche of readers on Saturdays. Featuring state-of-the-art laboratories for the restoration and preservation of historic materials, the building included a special-collections reading room lined in sapele wood paneling from Nigeria as well as a two-story-high main reading room.

In 1985, five years after the completion of the Schomburg Center, plans were announced for Bond Ryder Associates' renovation of both Abramson's Countee Cullen Branch and McKim, Mead & White's still-idle library, which was being used as storage space and had been declared a landmark in 1981.[52] By this time, the collection had grown to more than 5 million items, including rare books, letters, original manuscripts, photographs, and sheet music. Work was not completed until 1991, by which time Bond's firm had merged with Davis, Brody. Davis Brody Bond's restoration included not only the refurbishment of both buildings but the creation of a 1,700-square-foot exhibition gallery on the first floor of the 1905 library. Replacing the outdoor amphitheater was a new 350-seat theater, the Langston Hughes Auditorium, intended for theatrical and dance works, literary readings, and community events.

Two of Harlem's best-known historical venues for jazz were renovated to serve other uses. In 1988 Roberta Washington completed work on the gut rehabilitation of the former Hotel Cecil (1895), 206–210 West 118th Street, between Adam Clayton Powell Jr. Boulevard and St. Nicholas Avenue, creating 112 single-room-occupancy rooms for low-income and previously homeless residents.[53] On the ground floor of the apartment-hotel was Minton's Playhouse, considered the birthplace of the jazz style known as bebop; the playhouse enjoyed its heyday in the fifteen years following World War II. Although the hotel and club had been shuttered in 1974, eleven years later Minton's was placed on the National Register of Historic Places. Originally, Washington wanted to create a new version of Minton's, but the project's sponsor, Housing & Services Inc., was able to raise only enough money to pay for the renovation of the rooms.

A plan was announced in 2001 by the development arm of the Abyssinian Baptist Church to renovate and add on to the three-story building (1924) formerly home to one of Harlem's most famous jazz clubs, Small's Paradise, northeast corner of West 135th Street and Adam Clayton Powell Jr. Boulevard, to create a new 750-student, 87,000-square-foot middle and high school, the Thurgood Marshall Academy, as well as accommodate income-producing ground-floor retail space.[54] Vacant since the mid-1980s, Small's boasted an illustrious history dating back to the 1920s. Formerly the haunt of such jazz greats as Duke Ellington, the club thrived until the 1960s under the ownership of basketball star Wilt Chamberlain. As designed by Gruzen Samton, the three-story addition (2004) was set back and designed to complement the brick and terracotta exterior of the existing building. Despite some community protests, construction on the six-story structure began in 2002 after the International House of Pancakes signed on to lease the 5,000-square-foot ground-level space.

EAST HARLEM

Bounded by the Harlem and East Rivers on the north and east and by Ninety-sixth Street and Park Avenue to the south and west, East Harlem encompassed the area known since the 1950s as Spanish Harlem or El Barrio as a result of its resettlement by Hispanics, who replaced a predominantly Italian American population. The neighborhood was physically transformed by large-scale housing projects in the decades following World War II, institutionalizing near-poverty-level demographics and drastically reducing the area available for new construction.[1]

East Harlem's most consistent source of new construction was also its most significant institutional presence, the Mount Sinai Medical Center, encompassing the Mount Sinai Hospital and the new Mount Sinai Medical School, established in 1968. Mount Sinai expanded from the 1950s to the 1970s with a series of rather banal Modernist buildings that contributed to what had become, by 1976, a twenty-one-building campus on and around a superblock bounded by Fifth and Madison Avenues, Ninety-eighth and 101st Streets.[2] As the medical center continued to build new facilities in the last quarter of the twentieth century, the quality of its architecture improved, beginning with Davis, Brody & Associates' Jane B. Aron Residence Hall (1984), 50 East Ninety-eighth Street, southwest corner of Park Avenue, a fifteen-story residence for doctors, nurses, students, and hospital workers built to provide the kind of quality housing that was considered critical to the institution's future.[3] Rising on a vacant 30,780-square-foot site, the building, clad in oversized four-by-eight-inch tan bricks, was set back fifteen feet from the property line on Ninety-eighth Street to allow for a double row of trees on the sidewalk and ten feet back from the Park Avenue property line. Despite "stringent" budget constraints, the architects aimed to "respect the essentially residential quality of the neighborhood" and simultaneously "clearly characterize the housing as associated with the medical center."[4] On the first ten stories, the living rooms were projected out toward the street to form a rhythm of bays intended to suggest the nearby apartment houses of the Upper East Side but, in effect, looking like certain photos of midtown office buildings in Erich Mendelsohn's book, *Amerika* (1926). The quasi-commercial character was even more discernible at ground level, where rusticated brick was complemented by a slate and glass-block entry covered by a large semicircular canopy, and on the top five floors, where faceted cylindrical glass bays enclosed the interior stairs and landings of the duplex apartments. The issue of character and the lack of detail did not seem to concern John Morris Dixon, who wrote that "possibly no American apartment building of recent years has represented this urbane type more eloquently."[5]

In late 1981, Mount Sinai Hospital announced plans for a new 800-bed medical complex that was to span three blocks between Fifth and Madison Avenues, Ninety-eighth and 101st Streets.[6] Though he had never designed a medical facility, I. M. Pei was selected for the job. Working with Ellerbe Associates and Mason, DaSilva Associates, both specialists in medical buildings, Pei intended to unify the hospital complex with a new entrance on Fifth Avenue. Construction was scheduled to begin in 1983 but was delayed by Governor Mario Cuomo's imposition of a freeze on major hospital expansions, a response to the overwhelming $4 billion in

Jane B. Aron Residence Hall, Mount Sinai Medical Center, 50 East Ninety-eighth Street, southwest corner of Park Avenue. Davis, Brody & Associates, 1984. View to the southwest. Hoyt. ESTO

construction proposed by New York City medical centers. Mount Sinai was asked to scale back its plans by 40 percent and also take over various specialty clinics of the struggling North General Hospital. North General would henceforth concentrate on providing primary and preventative care to the underserved Harlem community.

In March 1985, Mount Sinai's revised plans were approved by the New York State Hospital Review and Planning Council. Completed in 1992, the 990,000-square-foot Guggenheim Pavilion replaced ten structures on its block-long site spanning the south side of 101st Street between Fifth

and Madison Avenues. In form, the building could be thought of as an eleven-story block with two triangular wedges cut out of its north side above the fourth story to create the appearance of three separate towers touching point-to-point atop a site-filling podium. Hand-laid iron-spot beige and gray brick covered the structure, which also featured granite trim at the base and limestone trim above, the latter used to soften the effect, typical of low-budget housing, of exposed floor slabs, by connecting them to the lintels above the facade's square windows. Inside, the three towers housed 625 hospital beds on the seventh through eleventh floors, while the base was filled

with twenty-two new operating rooms, seventy-four intensive-care beds, a new and expanded emergency room, a chapel, a synagogue, a conference center and auditorium, offices, a cafeteria, and rehabilitation and nuclear medicine facilities.

The building's signature feature was a pair of triangular skylit atriums clad in the same brick used on the exterior. The first was connected to a double-height lobby on Fifth Avenue and rose eleven stories from the ground level while the second, to the east, began on the seventh floor and rose five stories to serve as a less public dayroom for patients. The atriums were appealing, but in an austere way. Pei's most important challenge was to redesign the medical center's circulation, which had been cobbled together over the years so that a single basement passageway required, for instance, a patient traveling from the operating room to the intensive-care unit to be wheeled for three blocks down a hallway shared with food delivery carts and visitors. Pei situated the new circulation spaces within a slim, eleven-story rectangular block that ran the full width of the south side of the site and formed the southern wall of the two atriums. A network of bridges, stairs, and corridors provided for doctors and patients was completely separate from the circulation for visitors and recovering

East Building, Mount Sinai Medical Center, 1425 Madison Avenue, between East Ninety-eighth and East Ninety-ninth Streets. Davis Brody Bond, 1997. View to the northeast. Sundberg. ESTO

patients, who used a more dramatic series of open balconies overlooking the atria.

A third, low atrium was located to the south of the building, where a pavilion covered by a canted glass skylight connected the Guggenheim Pavilion with the Annenberg Building (Skidmore, Owings & Merrill, 1976) and the Klingenstein Clinical Center (Kahn & Jacobs, 1952). The firm of Wank, Adams, Slavin Associates designed an adjacent L-shaped exterior court that fronted Fifth Avenue, and, along with what Herbert Muschamp described as "an awkward collage of Central Park lampposts, flower beds, [and] a filigreed metal gate," showcased a brass sculpture by Arnaldo Pomodoro that had previously stood on the site. Calling Pei's Guggenheim Pavilion "as contextual as a large modern building can be in a neighborhood of prewar residential buildings," Muschamp deemed it "a modern building that looks nothing like a hospital, even though it is one. It resembles, rather, a health spa, a tranquil oasis where trees grow and space soars amid urban bustle and big-city hospital commotion."[7]

The editors of Oculus viewed Pei's Mount Sinai as part of a "new breed of hospital-as-hotel," pointing to its "zoomy interior courts" that had been "de rigueur features of hotels since John Portman's days." They took issue, however, with the use of the exterior brick to clad the interior of the atria: "Because of the tone of the brick, and because the skylight framing is

black, the interior has a decidedly gray cast to it, especially on cloudy days." From the courtyard-facing rooms, which made up approximately a third of the patients' quarters (the others looked out on city and park views), "it is hard to tell what time of day it is or what the weather is like outside."[8]

In 1997 Mount Sinai School of Medicine expanded its biomedical research facilities with the completion of Davis Brody Bond's East Building, 1425 Madison Avenue, between Ninety-eighth and Ninety-ninth Streets. The eighteen-story, 740,000-square-foot facility, set back on its nearly full-block site, was clad in beige brick with square windows, notches, and angled cutaways that related its mass to that of the Guggenheim Pavilion but found its own voice with a loggia-like element at the fifth floor and two multistory dark glass rectangular volumes protruding from the corners to form what the editors of the AIA Guide called "an austere, but richly modeled, composition."[9]

Two venerable East Harlem public buildings were rehabilitated in the late 1990s. In 1996, after a three-year renovation under the direction of Gruzen Samton, Herts & Tallant's Aguilar Free Library, 174 East 110th Street, between Third and Lexington Avenues, was restored to something approaching its earlier glory and modernized to accommodate the handicapped.[10] An independent library built to serve Jewish immigrants, the East Harlem library became part of the public library system set up by Andrew Carnegie. In 1905 the building was doubled in size by the original architects, who replaced a somewhat eccentric rock-faced design with a neoclassical scheme dominated by two fluted limestone Ionic piers carrying a limestone entablature, an impressive building on an otherwise tenement-filled block. Also in 1996, Lee Borrero and Raymond Plumey completed the transformation of one of the city's most imposing public schools, David I. Stagg's neo-Grec 60,000-square-foot, 1,800-student Public School 72 (1879–82; addition, C. B. J. Snyder, 1911–13), west side of Lexington Avenue between East 105th and East 106th Streets, into the Julia De Burgos Latino Cultural Center.[11] In addition to restoring the exterior of the building and installing new mechanical equipment, the architects carved out a two-story lobby for art displays and added a 265-seat performing arts center on the second floor.

A measure of artistic interest was provided by Police Service Area 5 (Herbert Beckhard Frank Richlan & Associates, 2000), 221–235 East 123rd Street, between Second and Third Avenues, housing facilities for police officers, detectives, and administrators in a 37,000-square-foot through-block red brick, limestone, and granite-trimmed building intended to fit in with its neighbors, though perhaps to the detriment of its own design, which was eccentrically massed and fenestrated.[12] The editors of the AIA Guide called it a "nice neighbor" for the Chambers Memorial Baptist Church (1891) next door to the west, whose steeply raked gable was repeated on the police building but cut off at the apex, where it dropped vertically to continue eastward as a flat roof. On the east side of the building, a driveway leading to a parking area was separated from the street by a two-story screenlike brick and limestone wall with a separate floating wall at the third story that continued the roof line of the neighboring house. A second, similar facility served the needs of Central Harlem. Police Service Area 6 (New York City Housing Authority with Gruzen Samton, architect of record, 1998), 2770 Frederick Douglass Boulevard, between West

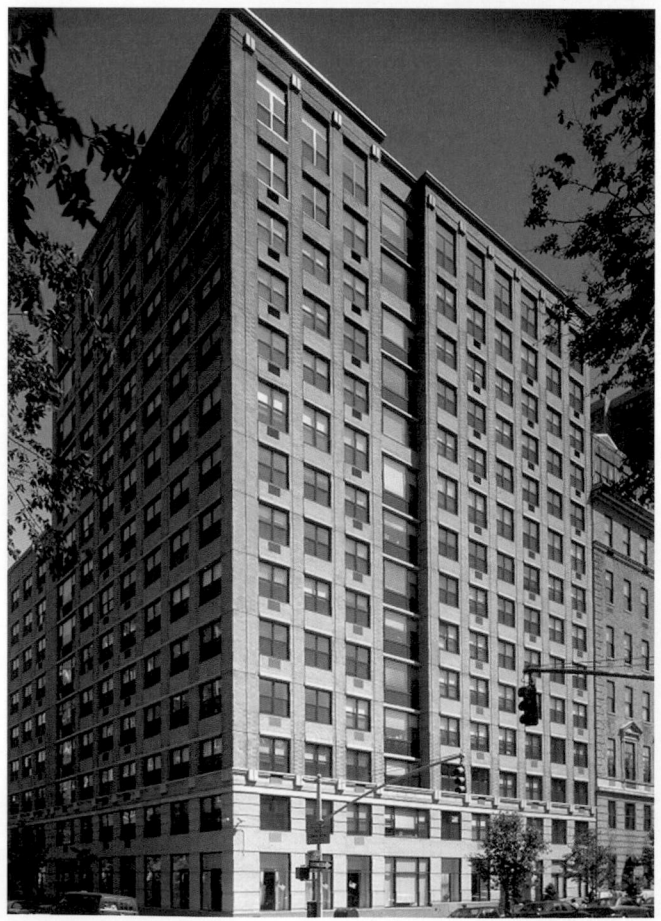

147th and West 148th Streets, was a six-story, 111,000-square-foot red brick building with a combination of square punched windows and ribbon windows wrapping the corners.[13] A reception area, holding areas, and a community briefing room were situated on the first floor; offices, locker rooms, a fitness center, a lunch room, and dormitories occupied the second through fourth floors; and an auditorium and additional offices for chief officers opened onto 5,000 square feet of terraces on the set-back fifth floor. Parking was accommodated at street level and underground. The editors of the *AIA Guide* liked the "smart corbels" above the second story and felt the free-form aluminum-clad mass of the fifth-floor auditorium made it look as if the "United Nations General Assembly sits on the roof."[14]

Although most new housing in East Harlem was confined to the renovation of rowhouses and tenements for low-income tenants, a new apartment building rose on one of the last available Fifth Avenue parcels facing Central Park. In October 1998, construction began on Schuman, Lichtenstein, Claman & Efron's 127-unit, tan and light orange brick de Sales Residence (2000), southeast corner of Fifth Avenue and 108th Street, replacing a parking lot.[15] Sponsored by St. Vincent's Hospital and the SFDS Development Corporation, a consortium of nine Roman Catholic parishes in East Harlem, the fourteen-story rental building, carefully proportioned to fit in with Fifth Avenue's prewar apartment-house blocks, provided assisted-living services for low- and moderate-income senior citizens and included such amenities as a landscaped interior courtyard and 10,000 square feet of common space with a library, lounges, music and exercise rooms, and a top-floor dining room.

North River Water Pollution Control Plant, Hudson River, between West 137th and West 145th Streets. Tippetts-Abbett-McCarthy-Stratton, Gibbs & Hill, and Feld, Kaminsky & Cohen, 1986. View to the southeast from New Jersey. McGrath. NMcG

WEST HARLEM

Bordered by 125th and 155th Streets, St. Nicholas Avenue and the Hudson River, West Harlem was the least devastated of Harlem's neighborhoods. But its dramatic waterfront remained underexploited and largely inaccessible until 1986, when after two decades of opposition and delay, the mammoth North River Water Pollution Control Plant, with its as-yet-incomplete rooftop park, was opened. The plant processed 170 million gallons of effluent produced by Manhattan's West Side each day.[1] The decision in 1963 to locate the facility on the Hudson River waterfront between 137th and 145th Streets was condemned by many as an act of environmental racism, with local politicians and neighborhood residents fighting for its relocation during the late 1960s and 1970s out of fear that it would contaminate the area with foul odors, cause health problems for neighborhood residents, and potentially explode as a result of the methane gas it generated. In an effort to appease the community, the city promised an improvement

for the roof of the plant, hiring Philip Johnson for its design (1968) as a water garden, but neighborhood residents were dissatisfied and ultimately convinced Governor Nelson A. Rockefeller to pledge the construction of a state park on top of the plant.[2] After the schemes of Gruzen & Partners (1969) and Bond Ryder Associates with Lawrence Halprin (1979) were rejected, Richard Dattner was selected in 1980 as architect for what would be known as Riverbank State Park.

The design of the North River plant was undertaken by Associated Engineers, a joint venture of Tippetts-Abbett-McCarthy-Stratton, Gibbs & Hill, and Feld, Kaminsky & Cohen. The facility was required to provide "secondary treatment," or the removal of 85 percent of biological pollutants, from the sewage produced in Manhattan west of Fifth Avenue, from Bank Street to the northern tip of the island. Hitherto, the sewage had been discharged directly into the Hudson River. At $1.2 billion, with 75 percent of its financing from the federal government, 15 percent from the state, and 10 percent from the city, the plant was conceived to be the most

LEFT North River Water Pollution Control Plant, Hudson River, between West 137th and West 145th Streets. Tippetts-Abbett-McCarthy-Stratton, Gibbs & Hill, and Feld, Kaminsky & Cohen, 1986. View to the northwest. McGrath. NMcG

ABOVE North River Water Pollution Control Plant, Hudson River, between West 137th and West 145th Streets. Tippetts-Abbett-McCarthy-Stratton, Gibbs & Hill, and Feld, Kaminsky & Cohen, 1986. McGrath. NMcG

expensive building project in New York City history. The mechanical guts, located on and below a thirty-acre platform supported by 2,400 concrete-filled steel caissons and divided into fourteen discrete sections to allow for expansion and contraction during temperature changes, were encased in a 2,000-foot-long-by-700-foot-wide shell, larger than the Pentagon, reaching from fifty feet below the waterline to seventy-five feet above.

Although construction had begun in 1972, delays brought about by the city's fiscal crisis obstructed progress; by 1977 only the first component of the plant, its $232 million platform, the largest nonmilitary contract bid in the Western Hemisphere to that date, was realized. Further progress was stifled by a federal study in 1979 that reassessed the plant's capacity requirements, ultimately calling for the treatment of 50 million gallons per day less than originally specified and leading to a redesign of its treatment facilities. Also in 1979, with construction at a standstill, a consent decree mandated that the facility provide partial (35 percent) treatment by 1986 and full treatment by 1991. However, President Jimmy Carter's $4.2 billion federal clean-water budget was cut by the Reagan administration to $2.4 billion, effectively slowing construction of the plant and prompting the city, in 1982, to apply for a waiver of the mandated treatment requirements in an effort to save money. The city's application for a waiver, seen by the editors of the *New York Times* as an effort "to turn back the course of water quality progress," was rejected by the Federal Environmental Protection Agency in June 1983.[3] With a new influx of funding, largely redirected from other planned sewage-treatment projects in the state, construction on the North River plant picked up at a frenzied pace in an effort to

meet the 1986 deadline. The fast-tracking of the construction would prove to be expensive, in part because the design of Riverbank State Park had begun in 1980 and its requirements had to be accommodated in the plant's construction as they were defined. After sundry last-minute fixes and redesigns, in 1986 the plant commenced operations, although it was not quite finished.

Writing in *Metropolis* that year, Peter Salwen marveled that "the largest construction project now underway in New York is probably also the least noticed."[4] As with most civic projects of its nature, the client's primary concern was with functionality and cost control rather than aesthetics. The plant had originally been designed to be fully enclosed, but with the city in the throes of fiscal uncertainty, Comptroller Harrison J. Goldin, claiming that New York would lose $1.5 million a year in heating and ventilation costs, deemed a closed building unnecessary. Theodore Long, TAMS's lead designer on the project, began "looking at ways to open up the solid walls for natural ventilation." After considering decorative programs such as backlit portholes evoking an ocean theme and a wire grid overgrown with ivy, both of which were rejected as "too romantic and difficult to maintain," Long opted instead for Louis I. Kahn–inspired rows of arches that would run the lengths of the four facades, which he said resembled those of Roman aqueducts and the projects of the McKim Mead & White and Robert Moses eras.[5]

The building was originally to be clad in granite, but in another effort to trim costs, this time saving $30 million, square panels of textured, cream-colored concrete were used to create an effect Peter Salwen called "agreeable; the building's textured surface shows an interesting play of direct and reflected light."[6] Julie Iovine, writing in *Connoisseur* in 1988, was taken with the brutally scaled and detailed concrete facade: "Anyone crossing the George Washington Bridge cannot fail to take notice of the new plant's arches leaping for ten blocks along the Hudson River, echoing the romantic filigree arches of the bridge beneath Riverside Drive."[7] Despite its massive size and civic importance, however, the plant received little attention in the architectural press. In 1989 it did garner some acclaim when it was chosen for an Albert S. Bard Award for excellence in architecture and civic design from the City Club of New York, which called it "strong, simple and serene . . . a success story in a city where successful megaprojects are rare."[8]

Construction of the rooftop Riverbank State Park began at about the same time the North River plant began processing sewage.[9] After his selection as architect for the park in 1980, Richard Dattner, working with landscape architects Abel Bainnson Butz, embarked on the thirteen-year-long process of designing the $129 million, twenty-eight-acre park. It would be the largest rooftop park in existence and the first recreational facility built on a waste-treatment plant in the United States (ten others had been built in Japan). Working on a controversial project with a sensitive community, Dattner appropriately described the design process as an "architectural triage," a process of balancing "choices, priorities and the determination of what will yield the greatest good for the greatest number."[10] The committee's wish list would evolve into one of the most expansive recreational complexes in the city, including a football field surrounded by a 400-meter track, a baseball field, a cultural center with an 834-seat auditorium, a gymnasium, basketball and handball courts, tennis

courts, an Olympic-size indoor swimming pool, an outdoor pool, an ice- and roller-skating rink, picnic areas, a 300-seat amphitheater at river level, a greenhouse, a restaurant, and a carousel. Although the community was heavily involved in the park's design, the process wasn't entirely smooth. According to Dattner, "Resentments over the treatment plant lingered. The Park project was seen by some as a trick to divert the community's attention from the problems anticipated when the plant began operation."[11] Still, the community had input in every planning decision, from the placement of the two access bridges spanning the Henry Hudson Parkway from Riverside Drive, one at 138th Street the other at 145th Street, to the decision to allow only pedestrians, public buses, and emergency vehicles over those bridges.

Dattner's firm prepared six conceptual schemes for the park, from which the steering committee, composed of community residents, local elected officials, and representatives from the major federal, state, and city agencies that would pay for and operate the park, selected two that were developed further and presented at a public hearing with scale models, renderings, and plans. After evaluating comments from the hearing, the steering committee chose the scheme that best met the perceived needs of the public, organizing the largest buildings–the skating rink, the cultural center, and the gymnasium—around a south-facing, wind-shielded courtyard in the middle of the platform that would form the north boundary of the football field while leaving the edges of the park available for a waterfront promenade. The other major building, housing the swimming pool, would be located to the west of the field and would connect to the gymnasium via an enclosed walkway. Tucked away at water level on the west edge of the park, an amphitheater would be accessible by a stair tower and elevator and, welcoming visitors coming over the 145th Street bridge, the restaurant and carousel would be sited at the north end of the park.

With an approved plan, Dattner began dealing with the unique set of limitations posed by the challenge of designing a park on the roof of a sewage plant. Of primary concern was the plant's structural system, whose fourteen discrete sections each had varying load-bearing capacities. None of the park's buildings could span two roof plates, and all new columns had to be located directly on top of the existing plant's irregularly spaced supports. Dattner explained that the entire park was held to "a strict diet because of the plant's limited load-bearing capacity Buildings could only be lightweight steel structures with metal- or tile-faced panels."[12] To further reduce loads while allowing for some topography on the vast roofscape, Abel Bainnson Butz incorporated 8 million board feet of Styrofoam, ranging from one to three feet in thickness, underneath 75 percent of the park. While only twelve to eighteen inches of soil could be laid under the playing fields and general park areas, nearly 1,000 trees were placed in eight-foot-square planters that could hold up to four feet of soil. To compensate for a lack of groundwater, a large-capacity sprinkler system was designed with a built-in filtration system that could desalinate water from the Hudson River in case of drought.

At several points during the design process, value engineering took a heavy toll. First to go were the impressive high-tech roof systems, including angled skylights with light-actuated shades that would exclude the hot summer sun but allow sunlight to enter on winter days. The roofs were redesigned with simple trusses and skylights. Another victim was the

Riverbank State Park, Hudson River, between West 137th and West 145th Streets. Richard Dattner, 1993. View to the northwest showing park on top of North River Water Pollution Control Plant (Tippets-Abbett- McCarty-Stratton, Gibbs & Hill, and Feld, Kaminsky & Cohen, 1986). McGrath. NMcG

elevated, enclosed walkway between the gymnasium and the pool; it would be reduced to a covered pathway. Late in the design process, with parts of the park already under construction, $20 million was cut from the $150 million budget, resulting in further downgrades, including the replacement of most remaining skylights with metal decks, the substitution of many translucent walls with metal panels, and the replacement of the entire skating rink building with a roof-covered outdoor skating rink.

Construction of Riverbank State Park began in 1987, at which time the sewage treatment plant itself was awash in controversy. When the plant had opened a year earlier, the community's worst fears were vindicated: a stench of sewage filled the air along a two-mile stretch of West Harlem.[13] While plant officials claimed that the smells were caused by spillage or improper operations, most Harlem residents suspected that the problems were the result of the plant's design. Robert Hennelly explained in the *Village Voice* that while the open arcades "looked handsome from the water, they created pockets where odor lingered. The archways also served as a seven-block-long wind tunnel through which the prevailing river

breeze blew sewer gas into West Harlem."[14] Others suspected that the sewage aeration tanks—twice the standard depth so as to decrease the amount of space the plant would occupy on the waterfront—were a cause. But officials in the Koch administration would not admit the existence of an odor, infuriating area residents and inspiring them to form West Harlem Environmental Action (WE ACT), an organization created as a "strong voice opposing the faulty operation of the sewage treatment plant."[15]

The problem would draw the attention of residents all over the city, becoming a rallying cry against social injustice. Joyce Purnick, writing in the *New York Times* in 1989, fumed that the city's "indifference is baffling To let the smell persist only strengthens one of the city's most insidious enemies— Nimby, the attitude of 'not in my backyard' that complicates the construction of urgently needed public works. Until the North River mystery is solved, all the elegant architecture and parkland won't count for much, next to the perceived betrayal of public trust."[16]

In 1991, five years after the smell was first detected, under the mayoralty of one-time plant opponent David Dinkins, the

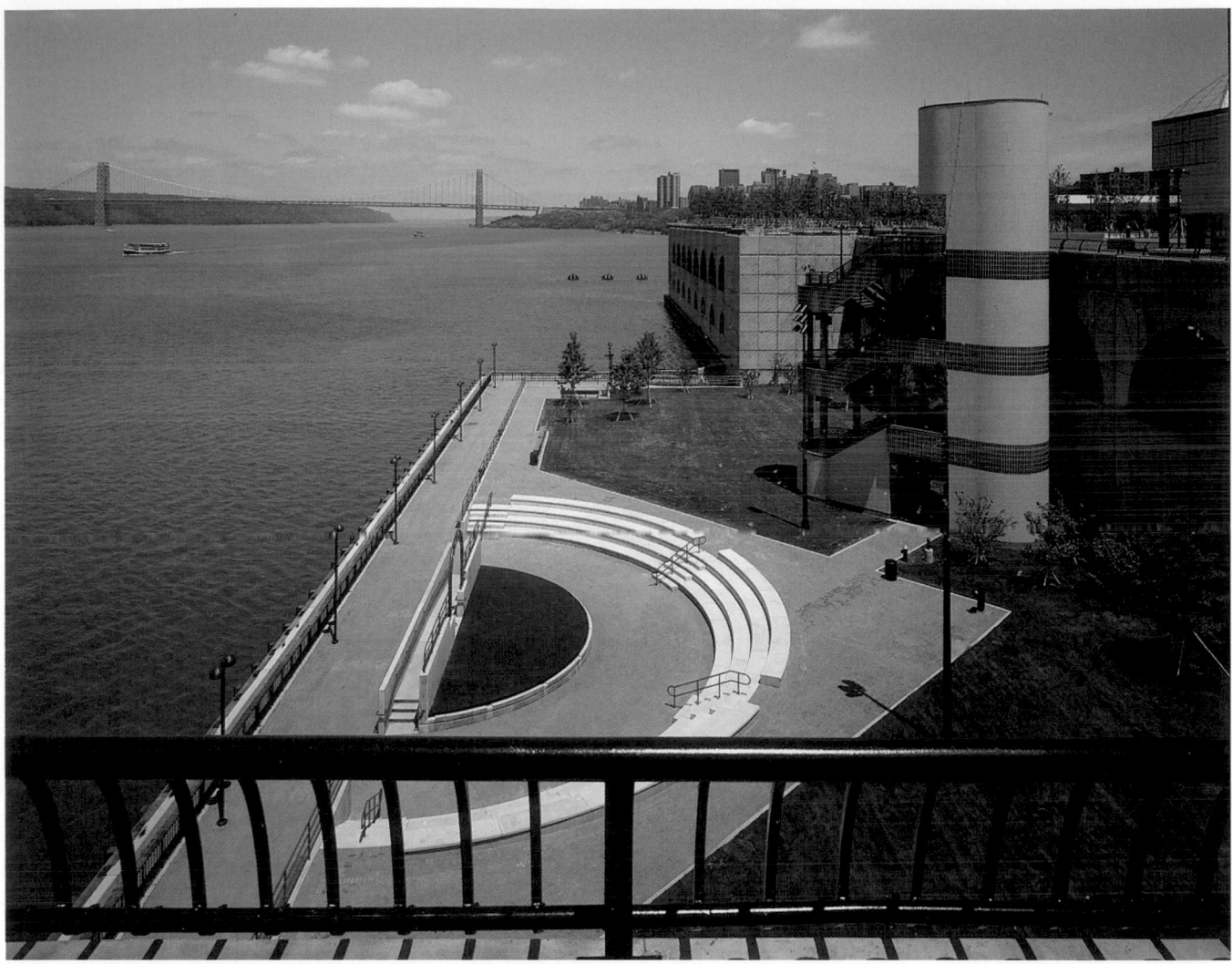

Riverbank State Park, Hudson River, between West 137th and West 145th
Streets. Richard Dattner, 1993. View to the north showing amphitheater.
McGrath. RDPA

city finally acknowledged the existence of the odor. In April
1992, the cause was identified as a combination of uncovered
sewage tanks and the openness of the building. Some officials,
such as Albert F. Appleton, commissioner of the city's
Department of Environmental Protection, went so far as to
imply that the odor was directly attributable to compromises
made to appease the community throughout the design
process: "This is absolutely a case study on how not to build
any big plant . . . [showing] the cost for decades of making
political decisions when good scientific decisions were really
required. Every compromise that was made to build this plant
has come back to haunt the city and its residents."[17]

Despite the controversy, work on Riverbank State Park
continued, and, with the odor in attendance, it opened to a
crowd of thousands on May 27, 1993, after six years of con-
struction. Odor or no, the park was a hit, maintaining an aver-
age daily attendance of 10,000 in its first month and receiving
positive reviews in the press, which almost never failed to
highlight the irony that the easiest place to evade the smell of
the plant was on its roof. As completed, the major structures
in the park—the 40,000-square-foot gymnasium, the 30,000-
square-foot cultural center, and the 57,000-square-foot swim-

ming pool building—all shared a cohesive, if less than light-
hearted, aesthetic, clad with a combination of green- and rust-
colored brick tiles and featuring pyramidal fiberglass skylights
at their corners. The critics welcomed the industrial look of
the buildings. Charles D. Linn felt that, stylistically, Dattner's
work had weathered the lengthy design process well, even
with its bouts of value engineering: "Despite the fact that the
buildings at Riverbank State Park were designed over a decade
before they were built, and even then endured several rounds
of redesign, their age is not betrayed by layers of Postmodern
frosting, a tribute to Dattner's philosophy that buildings
should be timeless."[18] Herbert Muschamp called the park "as
colorful and trim as the latest gym attire,"[19] and Peter Slatin
described it as having "a spacey, toy-playground feel."[20] Jane
Holtz Kay wrote that "no one stinted on the buildings. No
second-rate cinderblock gyms here. The structures . . . are
handsome and colorful."[21]

Abel Bainnson Butz planted nearly 1,000 gingko, Norway
maple, thornless honey locust, Japanese black pine, sycamore,
birch, and Radiant crab apple trees. The firm also designed
ornate entry gates for the access bridges at Riverside Drive
reminiscent of the ironwork in adjacent Riverside Park.

Muschamp lauded the landscape architects' overall design, writing that it "didn't fight the flatness of the rooftop site with undue displays of pastoral imagery. Instead, the tree-lined terraces and promenades create a lofty platform for enjoying what New York's early-19th-century planners envisioned as the city's major open space: the Hudson River."[22]

Despite the exceptional difference in program between the two entities, the separation between park and plant was remarkably successful. Indeed, aside from the odor, the only evidence of the plant below was a cluster of seventeen 100-foot-high exhaust-emitting smokestacks that, set into a landscaped oval, formed the center of a traffic-turnabout in the park at the 145th Street entrance. Muschamp was critical of the independent feel of the park, complaining of "the pernicious disconnection between the city and the natural resources that sustain it. . . . A plant like this is as vital to the city's operation as the subway system. . . . It is a cultural artifact, a monumental instrument designed to mediate between the city and the water supply on which it depends. . . . What's missing is a window onto the extraordinary aquatic mechanical ballet taking place just beneath."[23]

But the community obviously would have been happier not to be reminded of the plant—the smell was enough and it appeared as if it was there to stay. In 1993 a $55 million odor fix was offered calling for an intricate air-filtration system and the covering over of the problematic open sewage tanks. In 1994, on the last day of Mayor Dinkins's term, the city awarded a $1.1 million settlement to WE ACT, the National Resource Defense Council, the Hamilton Grange Day Care Center, and eight West Harlem residents in a lawsuit they had filed to ensure that the incoming Giuliani administration would fulfill Dinkins's promise of eradicating the odor. Despite the promised remediation by 1996, the intermittent smell of sewage persisted in the West Harlem community into the twenty-first century.

To the south of Riverbank State Park and the North River Water Pollution Control Plant, the shore stretching from 125th to 133rd Street, where the Henry Hudson Parkway and Riverside Drive were elevated above the streets, was the only place that upland Harlem could connect directly with its Hudson River waterfront. This tantalizing stretch, the gateway to what was known as the Harlem Valley—in effect the lowland on either side of West 125th Street that lay between Morningside Heights on the south and Hamilton Heights on the north—extended east under the two roadways to Twelfth Avenue.[24] The waterfront site had historically been home to stables, ice houses, warehouses, and storage and distribution facilities, many of which were later converted to meat market buildings and automobile garages. Between the 1920s and 1940s, ferry service was offered from piers at 125th Street to Fort Lee, New Jersey, and other destinations along the Hudson River, but after the piers were demolished in the 1950s, the waterfront fell into disrepair and was frequented primarily by fishermen. The transformation of the shorefront into a community asset came under consideration beginning in the 1960s, most notably as part of the Museum of Modern Art's 1967 exhibition, "The New City: Architecture and Urban Renewal," for which the team of Peter Eisenman and Michael Graves, working with G. Daniel Perry, Stephen Levine, Jay Turnbull, Thomas C. Pritchard, and Russell Swanson, prepared a broad plan for the waterfront from 125th to 155th Street that envisioned an activity center at the intersection of 125th Street and the river and, to the north, an off-shore megastructure containing shops, housing, and light industry.[25] But politics and economics rendered that plan and other serious proposals untenable until the 1980s, when Harlem's fortunes began to look up.

In September 1986, the Harlem Urban Development Corporation began sponsoring events that would help attract the public to the river's edge, offering music, dancing, and exhibits for adults and children as part of a short-lived series of so-called Harlem on the Hudson festivals.[26] In the following year, as 125th Street was revivified by the recently reopened Apollo Theater, the renovated Victoria Theater, and the opening of Mart 125, a buzz of optimism was in the air and the HUDC proposed Harlem-on-the-Hudson, a forty-acre riverfront development that was to include a center for high-technology companies, a convention center, and a 1,000-unit residential complex, all meant to complement but not replace the existing meat market and auto repair businesses concentrated on Twelfth Avenue.[27] The Ehrenkrantz Group & Eckstut was hired to design the project, which was expanded to include the area east of the Hudson extending to Broadway. The expanded plan called for the displacement of the very businesses with which the earlier plan was to coexist, proposing 1,800 units of housing in four towers lining the east side of Twelfth Avenue between 130th and 134th Streets, a 350-room hotel, a pedestrian mall lined with stores and nightclubs, an arts and cultural center with a 5,000-seat theater and 2,000-seat movie theater complex, recording studios, a 75-slip marina, and a floating restaurant.

A developer was found for one of the residential towers and in March 1988 the *Village Voice* reported that a consortium of

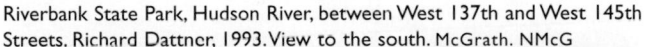

Riverbank State Park, Hudson River, between West 137th and West 145th Streets. Richard Dattner, 1993. View to the south. McGrath. NMcG

Proposed Harlem-on-the-Hudson, Hudson River to Twelfth Avenue, 125th to 134th Street. Ehrenkrantz Group & Eckstut, 1986. Rendering of view to the southeast. EEKA

forty Japanese companies was interested in investing in the project. At the same time, opposition was mounting within the West Harlem community, which had come to dismiss the proposal as "Harlem into the Hudson," claiming that the majority of apartments would be unaffordable to Harlem residents and that the project as a whole would bring on full-scale gentrification. Particularly egregious for many was the idea of undertaking such a development when Harlem was faced with so many other problems. As Community Board 9 withheld its endorsement until more detailed information was available on the plan, members of the Koch administration also grew skeptical of a proposal that they felt was incomplete and not at all guaranteed to gain the zoning variances it would require. Another stumbling block was that the Metropolitan Transportation Authority had begun to build a three-story bus depot between 132nd and 133rd Streets, east blockfront of Twelfth Avenue, a site upon which the HUDC hoped to build 400 apartments. In April 1988, however, a resolution was reached wherein the MTA agreed to decrease the size of the depot, providing space for a future residential building.

The downtrodden economy of the late 1980s and early 1990s halted progress on the project, with only one visible sign of improvement, a folly that the HUDC had commissioned in 1987 to buoy support for the waterfront plans.[28] Designed by Rod Knox, an architect and professor at Cooper Union, the installation, constructed in six weeks, was a cathedral-shaped scaffolding of off-the-shelf galvanized steel pipes and girders with a seventy-five-foot-tall openwork tower anchored by concrete footings and adorned with Mylar streamers, pink and fuchsia banners, and strings of lights. Originally known as the Harlem-on-the-Hudson Esplanade and meant to be temporary, the structure, stretching north for three blocks from 125th Street, provided the setting for occasional concerts before being stripped of its lights and streamers and becoming a popular jungle gym for local children. In early September 1998, less than two weeks after an otherwise innocuous photo appeared on the front page of the *New York Times* depicting a group of youngsters playing rather precariously on the rusted scaffolding, the structure was demolished by the New York City Economic Development Corporation, which owned the site.

Hopes of realizing Harlem-on-the-Hudson seemed all but dashed when a jolt of vitality came to the waterfront area in the form of a group of entrepreneurs who announced the opening of By Choice (1993), a discount fresh food store to occupy a 43,000-square-foot former meat-packing plant beneath the Henry Hudson Parkway between 132nd and 133rd Streets.[29] Although By Choice closed in February 1994, the owners of Fairway, a highly successful food market on Broadway between Seventy-fourth and Seventy-fifth Streets, were so taken with the idea and the location that they opened a branch of the store there in December 1995. Harlem's Fairway proved a boon to the neighborhood, from which it drew 80 percent of its 370 employees, each of whom was given an ownership stake in the company. In 1998, as Fairway's success brought new life to the area and 125th Street continued its renewal, the Economic Development Corporation again took interest in the future of the waterfront, issuing a request for proposals for a 40,000-square-foot site along the river between 125th and 131st Streets, just south of a 120-car parking lot serving Fairway.[30] One developer proposed a glass-wrapped twenty-four-story, 500-foot-long, 450-room hotel designed by Wurmfeld Associates with a rooftop restaurant; a dinner theater to be run by Sylvia's Restaurant, a leading Harlem venue; an arts and crafts market; a bandshell; and, capitalizing on the river, water sports. Another developer, resuscitating the name Harlem-on-the-Hudson, proposed to dock three floating piers offshore to form a marina and provide spaces within for community use, meetings, and parties. A third developer, paired with Vilkas, Peles Architects, proposed the Harlem River Center, two barges containing the bizarre combination of a golf driving range, an entertainment complex, a restaurant, a parking lot, a ferry terminal, and a bald eagle sanctuary and museum.

Dissatisfied with all three proposals and the RFP process in general, Community Board 9 and West Harlem Environmental Action, along with numerous other community groups, organized the Harlem on the River Steering Committee in 1999 to prepare a proposal of its own. Working with the planning consultants Abeles Phillips Preiss & Shapiro and the landscape architect Thomas Balsley, this group created a Harlem-on-the-River plan calling for three piers to be used for recreation and park space only—without any commercial component. The chief concern for the community, which had unsuccessfully battled against the construction of the North River Water Pollution Control Plant, was that any redevelopment be geared toward them and not built to please tourists or visiting shoppers.

The Economic Development Corporation listened to the community's concerns and in 2001 hired Ten W Architects to use the steering committee's plan as a starting point in the development of a master plan for the waterfront between 125th and 133rd Streets, an area now being called the Harlem Piers.[31] Ten W Architects, a collaboration between the Mexico City–based Enrique Norten and the Maryland-based Barbara

Harlem-on-the-Hudson Esplanade, Harlem River esplanade, between West 125th and West 133rd Streets. Rod Knox, 1987. View to the northeast. RKA

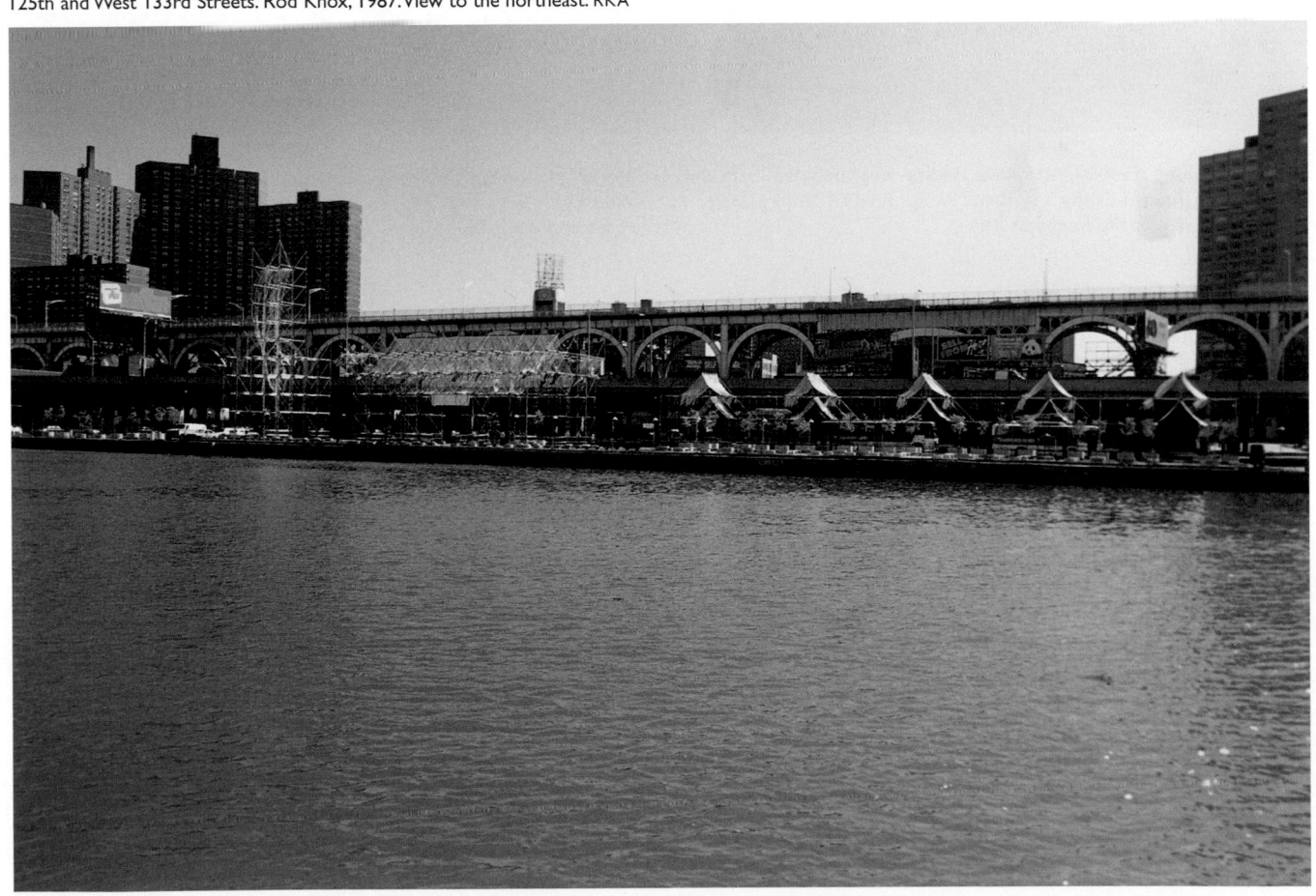

Wilks, had recently designed improvements to Baltimore's Inner Harbor but, after initial designs were developed, Norten left the partnership and Wilks, now operating as W Architecture, proposed a boat pier at 125th Street and another general recreational pier to the north that led to two smaller piers for fishing and kayaking farther out in the water. An esplanade would run the length of the waterfront, while inland, set back from a thin grass lawn, an elongated glass pavilion would house a restaurant, the income from which would help maintain the park. Despite efforts by Representative Charles B. Rangel to create a tourist-driven entertainment center with a permanently docked 2,000-person-capacity Mississippi river boat, the city decided to pursue W Architecture's scheme, though scaled down to be realizable in phases. Delays continued to haunt the project, but in October 2005 construction began on what was now called West

Harlem Piers, with plans for a new bicycle and pedestrian path, landscaped open space, and a recreational pier.

In addition to activity along the waterfront, West Harlem's most important institution, the City College of the City University of New York, made significant additions during the 1980s to its large campus bounded by Amsterdam Avenue and St. Nicholas Terrace, West 130th and West 140th Streets.[32] Following the completion of John Carl Warnecke & Associates' master plan, drawn up in 1969 and revised in 1971, the college commenced construction of two buildings in 1974: the North Academic Center (1983), designed by Warnecke, and Aaron W. Davis Hall (1979), a performing arts center designed by Abraham W. Geller & Associates and Ezra D. Ehrenkrantz & Associates.[33] Progress on both projects was halted in November 1975 amid the city's fiscal collapse, but work on the performance hall, which sat 30 percent complete,

ABOVE Proposed Harlem-on-the-River, Hudson River, between 125th and 134th Streets. Thomas Balsley and Abeles Phillips Preiss & Shapiro, 1999. Rendering of view to the southeast. TBA

BELOW Harlem Piers master plan, Hudson River between West 125th and West 133rd Streets. W Architecture, 2001. Rendering of view to the southeast. WA

resumed in October 1976 when the president of City College arranged for the use of the City College Fund as collateral against bonds the Bowery Savings Bank would buy from the State Dormitory Authority, surely one of the most elaborate financing mechanisms devised by a public institution to help itself weather the city's economic crisis.[34]

Considered by some to be a successor to the much-beloved open-air Lewisohn Stadium (demolished to make way for the North Academic Center) that drew thousands of New Yorkers to the summer "Concerts Under the Stars," Davis Hall, located within the South Campus on the east side of Convent Avenue near 135th Street, incorporated a traditional 750-seat proscenium theater, a 300-seat experimental theater, a 75-seat workshop theater, and a small recording studio opening off a tent-inspired multistoried lobby that was the principal feature of the seventy-foot-high glass, metal, and brown brick stepped-back structure.[35] A plaza facing Convent Avenue also doubled as an outdoor amphitheater. Paul Goldberger greeted Davis Hall with enthusiasm, claiming that as "a piece of architecture for the performing arts," it put Lincoln Center "to shame." But, he continued in that give-with-one-hand-take-away-with-the-other manner that became his critical hallmark throughout much of the 1980s, the design of Davis Hall was "not . . . innovative" and the building's appearance was, in some ways, "not great . . . like a building one might expect to find on a college campus in the Middle West."[36]

The North Academic Center was completed four years later, a significantly greater undertaking whose construction was delayed not only by the fiscal crisis but also, in 1980, by a pair of damaging fires thought to be arson.[37] The gargantuan, angular three-block-long building, zigzagging from 135th to 138th Street between Convent and Amsterdam Avenues, was

North Academic Center, City College of New York, between Amsterdam and Convent Avenues, West 135th and West 138th Streets. John Carl Warnecke & Associates, 1983. View to the southwest. Carvalho. CCNY

designed by William Pedersen, then working at John Carl Warnecke & Associates and later a co-founder of Kohn Pedersen Fox. Clad in brick, glass, and steel, the nine-story gray and black monolith, hulking on its hilltop site, seemed to dwarf not only its on-campus neighbors but much of Hamilton Heights. The design had in fact been revised from the original form proposed in Warnecke's 1969 master plan, which called for a rectilinear building running north–south along Amsterdam Avenue and enclosing a quad to the east, to become a slightly smaller building reshaped to meet Amsterdam Avenue at a forty-five-degree angle, thereby avoiding the kind of blank wall formerly presented to the avenue by Lewisohn Stadium. As realized, the North Academic Center, containing, in addition to a student center, over 2,000 offices, classrooms, laboratories, and dining rooms, was, as the editors of the *AIA Guide* accurately observed, "perhaps an acropolis for Harlem . . . [but] more likely a stranded aircraft carrier amid these small-scaled tenement and town house blocks."[38]

In addition to new construction, City College embarked on numerous renovations during the 1980s and 1990s. In 1992, only thirty years after its construction, plans were announced to replace the white glazed brick and glass-block skin of Lorimer & Rose's Steinman Hall (1962), housing the School of Engineering, with an anodized aluminum–paneled cladding designed by the firm of Pomerance & Breines.[39] The six-story, 300,000-square-foot laboratory building was also gut renovated and expanded with a 14,000-square-foot, nine-story addition to the east.

The renovation of Steinman Hall was a minor task for City College when compared with the renovation and restoration of its six buildings designed by George B. Post: Baskerville Hall, Wingate Hall, Townsend Harris Hall, Shepard Hall, Compton Hall, and Goethals Hall, the last of which was designed by the successor firm, George B. Post & Sons, in

1929. Post was a well-established architect when he entered and won the competition to design City College's campus in 1897, but his use of glazed terra-cotta—a relatively new and unproven building material—in massive amounts would prove disastrous, primarily because the architect treated it as a load-bearing material, piling blocks one on top of the other without additional stiffeners or backing. In fact, the terra-cotta was so poorly maintained and reacted so differently to freeze/thaw cycles from the load-bearing Manhattan schist walls that severe deterioration occurred within twenty-five years of completion. In 1979 Post's buildings were given landmark status even as they continued to slip into various degrees of decay.[40] Repair efforts, which were incredibly expensive—far more costly than most new construction—began in the mid-1980s and lasted into the twenty-first century. Baskerville Hall and Wingate Hall were the first to be restored; the firm of Fuller & D'Angelo Architects and Planners carried out the work and also completed the exterior restoration of Townsend Harris Hall in 2000, replacing much of its terra-cotta with a combination of precast concrete and terra-cotta blocks individually attached to a system of new structural supports. Inside, Townsend Harris Hall was renovated in 1990 by Richard Dattner to house the School of Nursing and facilities for the English and mathematics departments.[41] Dattner's work included the insertion of a new floor in the shell of a former auditorium, where the architect set the floor plate several feet back from the exterior wall so as not to obscure an existing two-story-high Gothic window. Compton and Goethals Halls were combined into a single facility for the art and dance programs in 1988 by Lee Harris Pomeroy & Associates and were restored on the exterior by Fuller & D'Angelo beginning in 2003.[42]

But it was Shepard Hall, the campus's centerpiece and a landmark of Collegiate Gothic architecture, that proved the

Harlem School of the Arts, 645 St. Nicholas Avenue, north of West 141st Street. Ulrich Franzen & Associates, 1978. View to the northwest. McGrath. FLL

Harlem School of the Arts, 645 St. Nicholas Avenue, north of West 141st Street. Ulrich Franzen & Associates, 1978. Cutaway axonometric of first floor. FLL

most complicated to rehabilitate.[43] Having received makeshift repairs over the years, Shepard Hall stood with windows boarded up, tension rods stabilizing parts of the building, and a thirty-foot-tall section of wall completely collapsed. The main tower had begun to lean away from the rest of the building and only two of thirty-two original gargoyles remained. By 1992, according to Christopher Gray, Shepard Hall had become "the largest example of terra-cotta failure in New York City and perhaps the country."[44] The Stein Partnership was responsible for exterior renovations to Shepard Hall, devised and carried out in phases between 1986 and 1999. The building had to be redesigned in significant ways, with new concrete walls and floors required for structural stability and the eventual replacement of roughly 75,000 pieces of terra-cotta with a fiberglass-reinforced cement material called Design-Cast. As with Harris Hall, each block of the new material was independently bolted onto the new structural frame. The first phase of the work, completed in 1992, included reconstruction of the tower and renovations to offices and classrooms, the latter, along with the rest of the interior work, designed by the William A. Hall Partnership between 1982 and 1994. In the South Wing, which housed the music, communications, and film and video programs, a new recital hall was fashioned out of a former dark-wood-paneled and stained-glass-windowed dining room, and a larger two-story, 100-seat auditorium was placed in former ground-floor mechanical spaces that were excavated to extend below grade. This new hall featured three glass-bowl chandeliers six to nine feet in diameter and a "quarter-turn" fixture spanning the back wall of the auditorium, all designed by Fisher Marantz Renfro Stone to provide light and also improve the acoustics.

Just north of City College was another important cultural institution, the Harlem School of the Arts, 645 St. Nicholas Avenue, north of 141st Street, formed in 1964 as a nonprofit

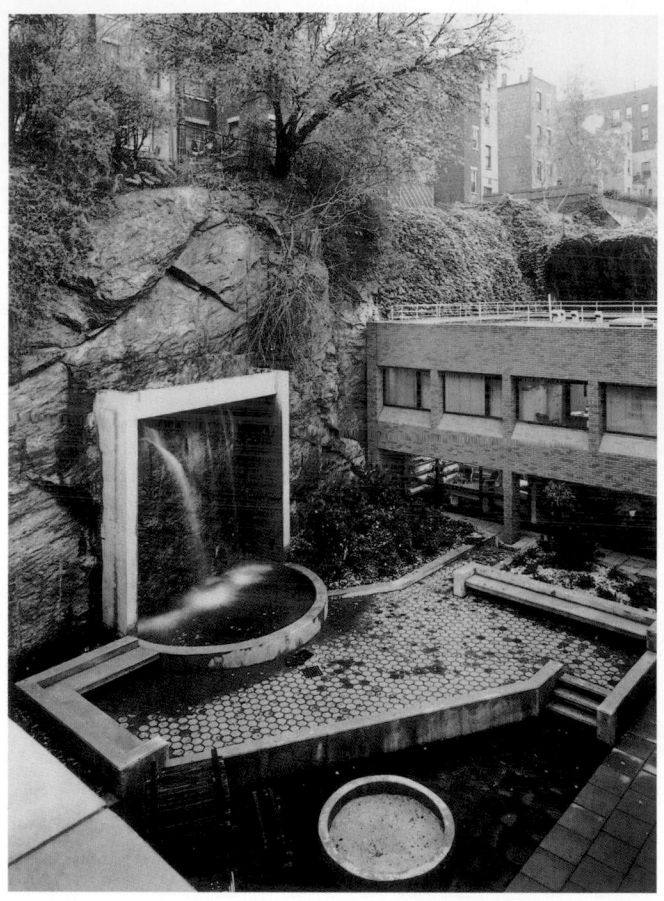

organization for underprivileged children and their parents to be what its founder, soprano Dorothy Maynor, called "an oasis of hope in a sea of despair."[45] First housed in the basement of the St. James Presbyterian Church's community house, where Maynor's husband was pastor, the school proved so popular that in 1978 an entire new building, designed by Ulrich Franzen & Associates, was constructed next door to the community house.[46] Keeping the mass low in deference to the surroundings, Franzen covered 90 percent of the 37,288-square-foot site so that HSA's new facility rose only two stories above a basement. For security and privacy, the architect shielded the school from the street with a rather severe gray brick wall softened by a curved recess leading to the service entrance and a double-height angled recess, open to the sky, leading to the main entrance, which was marked by the letters HSA rendered in metal and standing one story high beneath a horizontal strip of windows that allowed light to enter the lobby. Franzen's U-shaped plan enclosed a cloisterlike landscaped courtyard, the fourth boundary of which was a nearly vertical forty-five-foot-high rock outcropping that the architect adorned with a waterfall. Inside, the lobby, a central two-story space, doubled as a concert hall and auditorium and a waiting area for parents. The first floor also accommodated one double- and two single-height dance studios, a library, a photography studio, and two painting and sculpture studios, while the second floor was primarily occupied by small soundproof music practice rooms with windows facing the courtyard and a faculty lounge opening onto a south-facing terrace. A small third floor was fitted out as a caretaker's apartment. Evaluating the design in 1978, Paul Goldberger called it "a bold structure . . . a strong

ABOVE Harlem School of the Arts, 645 St. Nicholas Avenue, north of West 141st Street. Ulrich Franzen & Associates, 1978. View to the northwest of courtyard. McGrath. FLL

RIGHT Harlem School of the Arts, 645 St. Nicholas Avenue, north of West 141st Street. Ulrich Franzen & Associates, 1978. Lobby. McGrath. FLL

but rather fortresslike presence on the street" that was "best inside, where Mr. Franzen has fashioned out of limited space and still more limited budget not only a grand and welcoming central hall, but also an attractive exterior courtyard and a myriad of lively class and practice rooms."[47]

In 1969 Arthur Mitchell, a featured dancer with the New York City Ballet and an instructor at the Harlem School of the Arts, formed his own company, the Dance Theater of Harlem, a dance school and professional ballet company that operated for two years in a church basement before moving into a two-story garage, 466 West 152nd Street, between Amsterdam and Convent Avenues, which Hardy Holzman Pfeiffer Associates renovated (1971) to house administrative offices and studios, with the main studio located on the second floor and lit by a newly created skylight.[48] By the early 1990s, the Dance Theater of Harlem's success warranted a significant expansion, and the Hardy firm was again called on to design the Everett Center for the Performing Arts (1994), a 13,000-square-foot, three-story addition to the west of the existing facility that nearly doubled its size.[49] The expansion would

Heritage Health and Housing, 416 West 127th Street, between Morningside and Amsterdam Avenues. Caples Jefferson, 2001. View to the south. Vecerka. ESTO

allow both the school and the dance company, previously located in different areas of the city, to exist side by side. The Everett Center, containing four dance studios, offices, locker rooms, a library, sewing shop, lounges, and classrooms, was linked to the first building by a narrow anodized-aluminum and frit-glass curtain wall rising above a new entrance that left Hardy's older clear-glass and brick entry to be replaced with a masonry and glass-block wall. The steel-framed addition, clad in a combination of glazed black and white ceramic block, red brick, and diamond-patterned surfaces of multicolored synthetic shingles, led Susanna Sirefman to see a "spirit of exuberance . . . reflected throughout the design."[50] The top-floor dance studio, illuminated in part by broad expanses of translucent glass, was covered by an arcing, painted galvanized-steel roof that was topped on the outside by a playful homage to Arthur Mitchell—a weather vane shaped like the dancer performing an Italian changement.

One of the more interesting renovation projects in West Harlem was Caples Jefferson's transformation of two abandoned back-to-back buildings, a two-story building on 126th Street and a garage on 127th Street, into an 8,000-square-foot headquarters (2001), 416 West 127th Street, between Morningside and Amsterdam Avenues, for Heritage Health and Housing, a nonprofit social agency working with recently released prisoners.[51] The architects created soothing, virtually all-white, light-filled spaces for the interior, saving their dramatic touches for the remarkably colorful exterior where, working with artist Nathan Slate Joseph, they clad the building in a patchwork of painted galvanized-steel panels. One year later, Perkins Eastman Architects completed work on a more conventional renovation project also earmarked for former prisoners, with a facade restoration and gut rehabilitation for the Fortune Society, an inmate advocacy group, creating counseling space and housing for forty-one ex-offenders in a former Roman Catholic boarding school vacant since 1980, St. Walburga's Academy of the Holy Child (John W. Kearney, 1913), northeast corner of 140th Street and Riverside Drive, popularly known as "the Castle" for its Collegiate Gothic design reminiscent of Post's nearby City College buildings.[52]

UPPER MANHATTAN

Upper Manhattan, extending north of Harlem, from 155th Street to the tip of the island, encompassing the Washington Heights and Inwood neighborhoods, was the least physically transformed section of Manhattan during the last quarter of the twentieth century. The most significant new construction occurred at Columbia-Presbyterian Medical Center (1928–47), West 165th to West 168th Street, Broadway to Riverside Drive, the area's dominant institutional entity housed in a vertical campus designed by James Gamble Rogers with some additions by his successor firms.[1] In 1983 Columbia University bought the historic Audubon Ballroom, a two-story building on the east side of Broadway between 165th and 166th Streets, held by New York City for tax arrears.[2] Isolated from the medical center by the busy, barrier-like width of Broadway, the Audubon building was nonetheless exceptionally convenient to public transportation. Moreover, it offered one of the only potential development sites in the area. Columbia intended to raze the ballroom, as well as a few surrounding buildings already occupied by the university, and replace it with a biomedical research facility. The Audubon Ballroom (Thomas W. Lamb, 1912) began life as the first of William J. Fox's vaudeville-cum-movie playhouses, seating over 2,500 people. Between the 1930s and the 1950s, it was a popular venue for jazz and big-band music, but it achieved international recognition in February 1965 when the Black Muslim leader Malcolm X was shot there.[3]

From the outset the project was complex, involving loans from the Urban Development Corporation of New York State to cover the construction costs, and agreements with the New York Transit Authority, which was considering the renovation of the West 168th Street subway station as part of the city's investment in the project. Columbia's proposal called for a ten-story, 220,000-square-foot commercial laboratory building to be rented out by the university to companies interested in employing its faculty as researchers. In an effort to defuse the neighborhood's growing resentments against Columbia's presence, the ground floor was to be devoted to retail space. But the decision not to retain any part of the ballroom's structure, which, some claimed, had been a commitment of Columbia's in the early stages, stymied the project as preservationists argued for the retention of the building's terra-cotta glazed, shallow-arched polychromatic facade, touting its aesthetic merits and its significance as a historical site. By the time the proposed research building began to make its way through the city's review process, it had been redesigned by Perkins & Will in association with Bond Ryder Associates as a 115-foot-high, 100,000-square-foot facility with facades calibrated to recall the vaguely Art Deco composition of Rogers's medical center. As for the foxes, griffins, and the enormous sea-borne female figures standing before an ancient sailing ship that were the highlights of the Audubon's facade, they were to be preserved, though most preservationists felt this was an unsatisfactory form of tokenism.

A rally on February 21, 1990, the twenty-fifth anniversary of Malcolm X's assassination, marked the beginning of a serious campaign to save the Audubon Ballroom and put it into community service. In May, the proposal went before the City Planning Commission, where community leaders, many citing Columbia's ill-considered 1960s gymnasium plan for Morningside Park, argued alongside preservationists for the

building's future, while others from the community defended the project in terms of jobs creation and an enhanced local economy.[4] In June 1990, Mayor David Dinkins, who had backed the plan as Manhattan borough president, but now, as the city's first black mayor, felt forced to take a slightly different tack, crafted a compromise that called for the preservation of a part of the building as a museum dedicated to Malcolm X, while making no commitment for municipal support for it. Dinkins's compromise plan moved toward the decisive vote of the Board of Estimate, which would review it in its last session, to be held on August 21, before going out of existence in accordance with the ruling of the federal courts.

The alliance of preservationists and civil rights activists was unusual, to say the least. Together, they supported a plan crafted by the Municipal Art Society that would preserve the entire ballroom and the building's terra-cotta facade on Broadway, dismissing at the same time the city's "ludicrous" proposal to save a portion of the ballroom building and build the laboratory around it to the north.[5] On August 3, Manhattan Borough President Ruth W. Messinger, using her powers under an obscure state law, weighed in by placing such tight restrictions on money to be issued for the laboratory building so as to effectively doom the project. The *New York Times* editorialized against her decision, describing it as "an irresponsible message to a frustrated business community just when New York most needs sound economic development."[6] At 1 A.M. on August 22, the Board of Estimate voted unanimously in favor of the Audubon research building. For her vote, Messinger got the city and the university to commit to a more extensive preservation of the facade, as well as the building's lobby and the ballroom itself, the creation of a community health facility within the building, and the establishment of community-based job-placement and training programs.

Efforts to stop the project in the courts were defeated and construction began in May 1993, more than ten years after Columbia announced its intentions to redevelop the property. By this time, the original design firm, Bond Ryder Associates, had disbanded, and Max Bond had become a partner in what had become Davis Brody Bond, which reshaped the building in a manner that, according to Herbert Muschamp, gave "new meaning to the term civil engineering." Muschamp singled out for particular praise the work of John Torborg, Davis Brody Bond's project architect, who, with preservation consultant Jan Hird Pokorny Architects, researched the original building and developed the techniques to see parts of it restored to glory. Perhaps under pressure from his editors, but certainly surprisingly, Muschamp, who usually had little use for historic preservation projects, or for that matter, for so-called everyday masterpieces, admired Lamb's design, although he regretted the pristine state it would enjoy: "It cannot match the emotional intensity of a hastily painted graffito proclaiming that 'Malcolm X lives.'" Muschamp also admired Davis Brody Bond's master plan for the Audubon Biomedical Science and Technology Campus, which was expected to fill the entire five-acre site assembled by the university but, "unlike the hospital complex . . . [would] be aerated by streets passing through it. With their low roof lines and ground-floor shops, the buildings won't be blockbusters. Instead, they'll filter out into the neighborhood like ambassadors of architectural good will."[7]

Even after the state's highest court upheld the university's right to proceed, neighborhood activists as well as Columbia students vigorously protested the project. While Davis Brody Bond's six-story, gray-painted aluminum and green-glass-clad building was unexceptional, the Audubon building became home to a street-level branch bank, a restaurant, a coffee bar, and a bookshop, giving the formerly drab location renewed luster. Sadly, about half of the Audubon building's second floor remained only as a disembodied facade. The medical facility opened in fall 1995, named the Mary Woodard Lasker Biomedical Research Building in honor of its principal donor. The Malcolm X memorial in the partially preserved ballroom remained unrealized at the time of the building's opening. After Malcolm X's widow, Betty Shabazz, died in a fire in 1997, the New York City Economic Development Corporation announced its intention to establish the Malcolm X and Dr. Betty Shabazz Education and Research Center in the former ballroom space. The center was dedicated on May 19, 2005. A second building of the Audubon complex, at Broadway and 168th Street, was begun in June 1995 to house the newly established Center for Disease Prevention, also designed by Davis Brody Bond.[8] Named the Russ Berrie Medical Science Pavilion, the facility opened in May 1997, providing one-stop service for diabetics. A "clone" of the Lasker Building in many ways, the precast concrete, glass, and metal clad Berrie building was, as the editors of the 2000 *AIA Guide* put it, "sleek, stylish and antiseptic."[9] Davis Brody Bond's third building in the complex, the thirteen-story Irving Cancer Research Center (2005), located between the two earlier structures on the east side of Broadway between 166th and 167th Streets, was the strongest of the group, nearly twice the size of its predecessors and featuring more elegant curtain

Audubon Biomedical Science and Technology Campus master plan, site bounded by Audubon Avenue and Broadway, West 165th and West 168th Streets. Davis Brody Bond, 1992. DBB

walls and a greater amount of precast concrete paneling that gave the building a decided air of substantiality.[10]

Presbyterian Hospital's ten-story Milstein Pavilion (1989), designed by Michael McCarthy of Skidmore, Owings & Merrill to complement the massing and stylistic expression of James Gamble Rogers's best early work at the medical center, without slavishly imitating it, was a 745-bed adult-care hospital replacing obsolete inpatient facilities in the Presbyterian Hospital.[11] The building was a single slab lying across two existing parallel twenty-two-story slabs of the hospital, forming an open-air courtyard crisscrossed by glassy skybridges. The boldly scaled fenestration included various-sized glass panels that helped give a human scale to the supersized mass

that confronted the Hudson River at a particularly visible point. Unfortunately, the building's blank lower floors were not so thoughtfully conceived in terms of Riverside Drive and the original Psychiatric Institute building, immediately to the north. SOM's Allen Pavilion (1988), Columbia-Presbyterian's community hospital facing the Harlem River at Broadway and 220th Street in Inwood, was much less intricately composed and, therefore, bland and rather anonymous.[12]

The most architecturally ambitious addition to the medical center, Ellerbe Becket's 330,000-square-foot New York State Psychiatric Institute (1998), providing facilities for research as well as patient treatment, occupied a tricky, steeply sloped site wedged between Riverside Drive and the

Henry Hudson Parkway, just south of the interchange leading to the George Washington Bridge.[13] As designed by Ellerbe Becket's design principal, Peter Pran, with dramatic glass-enclosed pedestrian bridges linking it back to the medical center, a curved, sweeping glazed curtain wall facing the Hudson River, and a six-story atrium, the building promised great excitement. As realized, it was far less dazzling, in part because the budget was slashed. Nonetheless, a lot of the original design survived, but it was crudely executed: especially disappointing was the too brightly colored green-glass curtain wall. A rather more refined concrete facade confronted the city. Other key features remained, including the sky bridges and a south-facing patient's garden that was not only medically beneficial but also a deliberate departure from the fortresslike situation at the base of SOM's Milstein Building.

Other new institutional construction in Upper Manhattan included several projects designed by Richard Dattner, including the five-story Salomé de Henriquez Intermediate School (I.S. 218), 4600 Broadway, between 196th and Ellwood Streets, which, at the time of its dedication in 1993, was hailed by Schools Chancellor Joseph Fernandez as "the school of the future," a distinction referring to its program accommodating 1,800 sixth, seventh, and eighth graders in the upper four floors and, on the first floor, a health and community center offering before- and after-school programs operated by the Children's Aid Society and a satellite branch of Mercy College offering adult-education classes to parents and neighborhood residents.[14] The beige and red brick banded Broadway facade

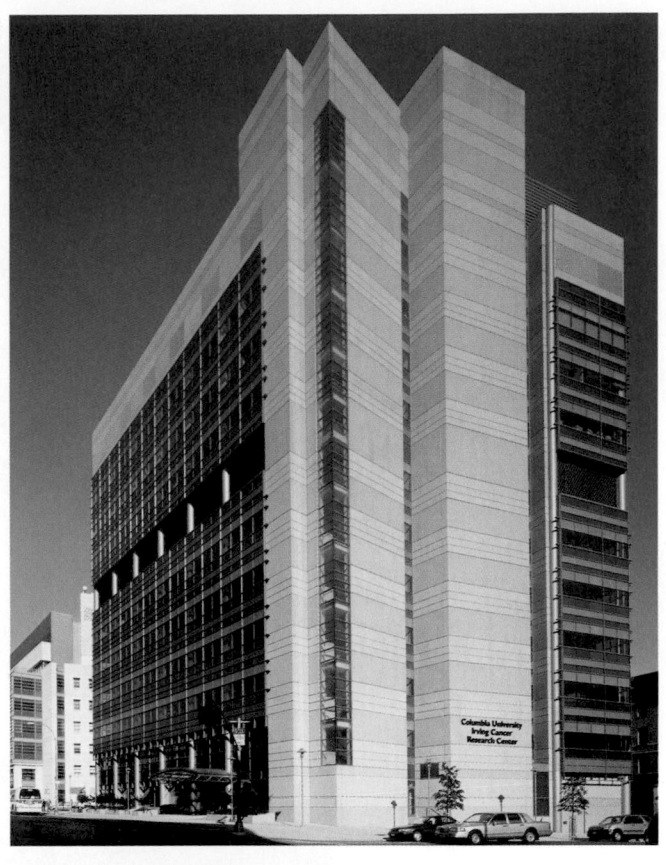

ABOVE Irving Cancer Research Center, east side of Broadway, between West 166th and West 167th Streets. Davis Brody Bond, 2005. View to the northeast showing Russ Berrie Medical Science Pavilion (Davis Brody Bond, 1997) on the left. Zimmerman. DBB

LEFT Milstein Pavilion, site bounded by Fort Washington Avenue and Riverside Drive, West 165th and West 168th Streets. Skidmore, Owings & Merrill, 1989. View to the northeast. Hoyt. ESTO

formed a broad crescent punctuated at its midpoint by a cylindrical brick and glass-block stair tower. The curved plan provided all classrooms with views of Fort Tryon Park. As Dattner explained, "At MIT I lived at [Alvar Aalto's] Baker House and I remember being impressed by the way Aalto used a curving edge to give all rooms a view of the river."[15] The rear facade, facing West 196th Street, was fortresslike, with large rectilinear volumes expressing the twenty-six-foot-high gymnasium and 600-seat auditorium within. This portion of the school also accommodated special-purpose rooms, laboratories, and the primary student entrance, highlighted by Joyce Kozloff's brightly colored mural depicting Caribbean imagery. Jayne Merkel compared the school's "clear symmetry, flat roofs, square windows, and cylindrical, central staircase" to "both Venturi & Rauch's Guild House retirement home in Philadelphia and Susana Torre's Fire Station No. 5 in Columbus, Indiana." But, she continued, "the artful matter-of-factness of I.S. 218 is crowned with a meaningful flagpole, instead of the ironic antenna that Venturi used at the Philadelphia retirement home."[16]

Richard Dattner's 33rd Precinct Station House, 2207 Amsterdam Avenue, southeast corner of 170th Street, was

completed in 2002 for a police precinct created in 1994 to address the high level of crime and violence in the area.[17] After eight years in temporary quarters five blocks to the south, during which time overall crime in the 33rd Precinct decreased by more than 60 percent, officers moved into the new two-story building, which faced Edgecombe Avenue with a convex, curving brown brick facade cleaved by a clear glass-walled entry that led to a central atrium. An asymmetrical metal-clad vaulted roof rose to a clerestory, a device chosen when a skylight was ruled out as a vandalism risk.

To the north, in Inwood, Columbia completed in 1984 the much-needed replacement of its football stadium at Baker Field, the twenty-seven-acre athletic complex bounded by 218th Street, Broadway, and the Harlem River.[18] Built as a temporary facility in 1928, with wood bleachers, and renovated and expanded by Eggers & Higgins in 1955, the 32,000-seat stadium was, by the late 1970s, in serious disrepair, highlighted by its rotting stands with only half of the original seating available for use. As designed by Richard Dattner, the 15,000-seat replacement, Lawrence A. Wien Stadium, named for its donor, was partially built into a hillside to minimize its visual impact. The design, utilizing a combination of cast-in-place concrete seating and reinforced concrete for the upper sections, included a three-level press box as well as an observation deck and VIP lounge for university events. In addition to the football

facility, Dattner was also responsible for a new 400-meter running track, made available to the community when not in use by the university, and a 2,500-seat soccer stadium.

In an effort to stimulate interest in the reclamation of the decayed Harlem River waterfront, plans were announced in 1998 by the New York Restoration Project (a nonprofit privately funded group founded three years earlier by singer and actress Bette Midler to help restore, develop, and maintain the city's neglected parks, community gardens, and open spaces) for the new five-acre Swindler Cove Park, facing Sherman Creek at the Harlem River Drive and Dyckman Street.[19] The park would include the city's first new rowing boathouse in nearly a century. Designed by Robert A. M. Stern Architects, the Peter Jay Sharp Boathouse (2004), named for the late philanthropist whose foundation supported the project, featured a painted wood board-and-batten exterior, a bracketed metal roof, and decorative details that recalled time-honored maritime building traditions. In the late nineteenth and early twentieth centuries, the area was home to a number of boathouses, including those of Columbia and Fordham Universities, that served a flourishing network of competitive rowing clubs. Although rowing activity on the Harlem River had significantly diminished over the years, the end of the bulkhead just south of the boathouse site still served as the finishing line for Columbia's intercollegiate races. To avoid harming the fragile

LEFT 33rd Precinct Station House, 2207 Amsterdam Avenue, southeast corner of West 170th Street. Richard Dattner, 2002. View to the south. RDPA

BELOW Lawrence A. Wien Stadium, Baker Field, site bounded by West 218th Street, Broadway, and the Harlem River. Richard Dattner, 1984. View to the west. Rosen. RDPA

FACING PAGE Salomé de Henriquez Intermediate School (I.S. 218), 4600 Broadway, between West 196th and Ellwood Streets. Richard Dattner, 1993. View to the northeast. McGrath. NMcG

intertidal environment, the boathouse was designed as a floating structure, as were earlier facilities located on the site. Access to the boathouse from the promenade atop the nearby embankment was through an entrance gate composed of aluminum oars and down a series of ramped fixed piers leading to floating docks. The first floor contained storage space and a launching area for sixteen boats while administrative, exercise, and meeting rooms were located on the second floor, where spectators would be able to view crew practice and races from a generously sized deck.

Upper Manhattan also became home to two schools built as part of the prototype school initiative that grew out of the Board of Education's inability during the late 1970s and 1980s to maintain its facilities or build much-needed new ones.[20] In 1987 a twelve-member task force was formed to assess the situation. Its inventory of the physical and operational status of the 1,050 public schools was the first ever undertaken in the history of the Board of Education and the results were even worse than expected: half of the schools were over forty-five years old; overcrowding was found in 400 schools; and major repair work was required for more than 600 schools, more than a third of which were still operating with coal-burning furnaces.

In December 1988, after the task force concluded that the Board of Education was not up to the job, the School Construction Authority (SCA) was created by the New York

State Legislature to oversee the construction and maintenance of public schools. The SCA's ambitious five-year plan called for the construction of fifty new schools. To expedite the process—which at that time typically took eight to twelve years, from site acquisition to completion—the SCA was spared the oversight of any city or state agency, was exempted for at least five years from the Wicks Law, which required separate contractors for each important trade utilized to realize a project, and was not subject to the Uniform Land Use Review Procedure (ULURP).

Integral to building fifty schools in five years would be the preparation of a prototypical school design that could be repeated on numerous sites, an idea that followed the example set roughly 100 years earlier by the Board of Education's Superintendent of Public School Buildings, C. B. J. Snyder, whose prototypical schools, each built with certain variations, proliferated throughout the city and were studied and widely emulated by other cities.[21] Although the SCA initially sought one architect to create a single design for the new schools, the inability to find large, uniform sites resulted in the decision to hire four firms to each develop a school design composed of a modular "kit of parts" that could be assembled in different ways to meet the demands of irregular sites. The four firms chosen were Gruzen Samton Steinglass, Perkins & Will, Richard Dattner, and the Ehrenkrantz Group & Eckstut.

Peter Jay Sharp Boathouse, Swindler Cove Park, Harlem River. Robert A. M. Stern Architects, 2004. View to the northwest. Aaron. ESTO

During the first phase of the program, each firm designed three schools, with all twelve buildings completed during the early 1990s in what were determined to be four of the city's most overcrowded school districts.

Construction began in 1992 on Richard Dattner's 184,700-square-foot I.S. 90 (1994), located on a 116,600-square-foot site bounded by Jumel Place, 167th Street, and Edgecombe Avenue, in Washington Heights. Dattner viewed each of his prototype schools as a "community, with a 'downtown' area of shared facilities and 'uptown' neighborhoods of classrooms."[22] Each downtown component consisted of a four-story rectangular building containing administrative spaces, a kitchen, and a cafeteria on the first floor, a library and technical shops on the second floor, and two-story gymnasium and auditorium spaces on the third and fourth floors. The placement of the gymnasium and auditorium on the top floor allowed for reduced construction costs because the ceiling did not have to be reinforced to support floors above. The classroom modules were four stories each and featured a curved courtyard-enclosing facade and a separate student entrance. In these "'uptown,' sub-school neighborhoods," according to Dattner, "the mood is less formal, smaller scaled, and more supportive of the students' needs for individualized learning."[23] Each of Dattner's prototype schools was clad in a combination of red, tan, and brown brick with decorative patterning, combinations of oculi, square, and ribbon windows, and convincing, boldly profiled precast concrete cornices. Dattner's two other prototype schools were I.S. 2 (1994), 655 Parkside Avenue, in Brooklyn, and I.S. 5 (1996), 50–40 Jacobus Street, in Queens.

Gruzen Samton Steinglass's P.S. 5 (1992), 3704 Tenth Avenue, on the northeast corner of Harlem River Drive, in Inwood, was a 93,200-square-foot facility serving 998 pre-kindergarten to fifth-grade students.[24] The four-story building, sitting on a two-and-a-half-acre site surrounded by a 1,200-foot-long, blue-painted steel and brick pier fence, was clad in a lively combination of pink and brown brick, blue-tinted glass curtain walls, and red aluminum window frames. The Gruzen firm's prototype consisted of separate modules for classrooms, administrative functions, and common areas, connected by "links" providing vertical circulation as well as entrances at ground level either from the street or a playground. The repetition of bays created by the side-by-side classroom units gave the schools a quasi-residential character with, as project architect George Luaces explained, each module treated to read as a house: "The child can identify from the outside of the building whether he or she goes to the house on the right or the house on the left. There's a real personal relationship between the building and the child."[25] Public facilities, such as the medical offices and dental clinic that were accommodated within P.S. 5, were separated by gates from classroom areas to allow for after-hours use by the community. Gruzen Samton Steinglass's other prototype schools were P.S. 6 (1992), on the northwest corner of Bedford Avenue and Snyder Street, in Brooklyn, and P.S. 92 (1992), 99–01 34th Avenue, in Queens.

BELOW Intermediate School 90, site bounded by Jumel Place, 167th Street, and Edgecombe Avenue. Richard Dattner, 1994. View to the southeast. Goldberg. ESTO

ABOVE Public School 5, 3704 Tenth Avenue, northeast corner of Harlem River Drive. Gruzen Samton Steinglass, 1992. View to the northwest. Ries. SRP

BELOW Prototype School design. Richard Dattner, 1988. Axonometric of "kit-of-parts." RDPA

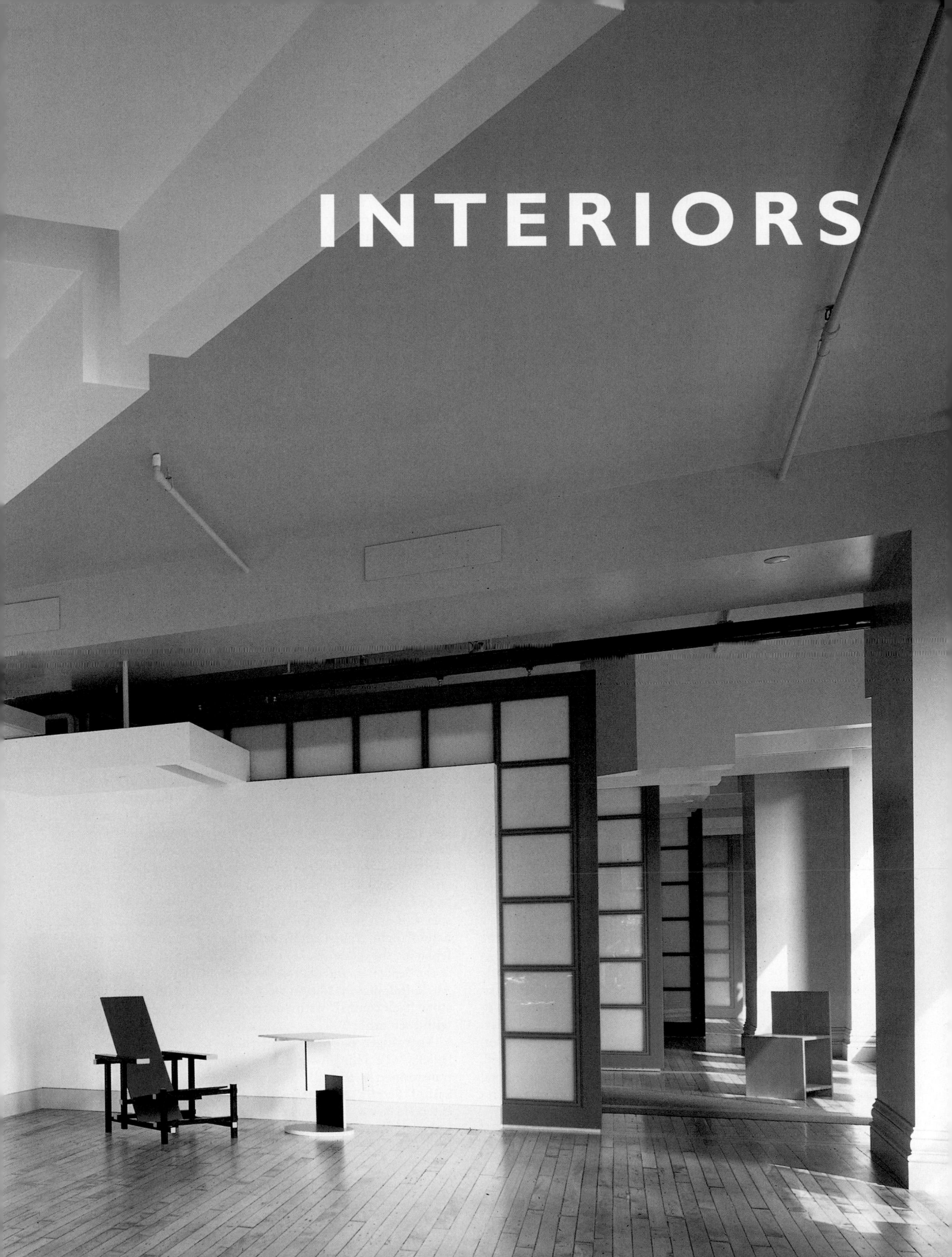

INTERIORS

RESTAURANTS

Late in 1976, Suzanne Slesin, a veteran discerner of design trends, asked the readers of *New York* magazine: "Have you noticed? Restaurants are looking better and better . . . no matter what their style. And it all seems to have happened in the last year. . . . At a number of new dining places, going out is a feast for the eyes; these restaurants actually look good enough to eat in. It has nothing to do with period. Architects and designers are doing beautiful modern, but they have revived the old as well, re-creating the atmosphere of imaginative eating places of the past. Whatever the style . . . designers aren't falling back on the old clichés."[1]

By 1985 the emphasis on designed dining environments had grown to such proportions that Regina S. Baraban, a writer who chronicled the trend, observed that "even the most confirmed epicurean would have to admit that large numbers of New York restaurant-goers are out less for a meal than for an experience; one that defines a personal measure of style and status. . . . We are what we eat may still reflect our karmic selves, but 'we are where we eat' reflects what we want to be."[2] The spectacular increase in the number of restaurants could be attributed in part to the newly rich yuppie culture. With so many single people in their twenties and thirties needing places to socialize, many new restaurants were designed not only to purvey food and drink but to function as social halls or "'meet' racks," in the witty if obvious parlance of the day. But the obsession with keeping up with the evolving restaurant culture affected virtually every New Yorker who could afford a moderately expensive evening on the town, including Mayor Ed Koch, who so exemplified this trend of endlessly tracking down new venues that seemed to open almost weekly, that in endorsing his bid for a third term in office the *New York Times* dubbed him the "Restaurant Mayor."[3]

The evolving pattern of restaurant openings was a visible metaphor for the resurgence of the city's economy and for the rebirth of marginal neighborhoods as hot new enclaves of activity. As the editors of *Interiors* magazine put it in 1985: "Almost weekly, it seems, dead or broken-down neighborhoods are transformed into gentrified enclaves, real estate speculators' battlegrounds—and restaurant frontiers. These days, one way to discover when a neighborhood is hot or about to get there is to check out the restaurants."[4] The frequency of restaurant openings, with almost as many closings, could be compared to a heady season on Broadway in the late 1920s, especially given the theatricality of most of the new dining establishments. Indeed, it was argued that restaurant-going had replaced play- and even to some extent movie-going as the main social event of the 1980s. The Broadway play analogy extended to the business side as well, where new restaurants coming on line as "backers" or "angels," to use the show-business term, could be found for up-and-coming chefs seeking to combine their skills in the kitchen with their flair for entertaining the public. As one well-known restaurant investor, Edward Meyer, head of a leading advertising agency, noted: "It's really a lot like investing in a play. When I see a good crowd there [in a restaurant], I feel I've had a small part in creating a hit."[5]

PREVIOUS PAGES Toms loft, 644 Broadway. Peter Eisenman and Faruk Yorgancioglu, 1984–87. McGrath. NMcG

Luxury Restaurants

Even the traditional, high-end restaurants specializing in superb cuisine and luxurious service felt the pressure to renew their decor. The venerable restaurant Lutèce, occupying a rowhouse at 249 East Fiftieth Street, was world renowned for its cuisine. Its decor was rather less distinguished. In 1976, amidst the wave of innovative restaurant design, André Soltner, the owner, asked Roger Ferri to propose designs for the restaurant's garden room, which had been created in the backyard years before. Ferri proposed three schemes. One would have wrapped the room with a freestanding sandblasted glass screen, with panels depicting landscapes of the "remains of the Manhattan skyline reclaimed by an idealized jungle vegetation," separated by fruitwood volutes, evoking "the voluptuous body-forms of classical style." The second scheme offered a more impressionistic interpretation of the garden, with "elements . . . magnified as in a dream."[6] In this version, which like the first was not realized, a freestanding colonnade of glazed terra-cotta budding rose stems were to grow from a plinth, the rose buds serving as up lights to reflect off a canopy, bathing diners in a clear, pink light free of shadows. The third scheme was to provide a cheaper solution: it consisted of canvas stretched over a wood frame and painted with scenes of a "fantasy landscape of Manhattan." Evoking the spirit of the suggestive drawings of Hugh Ferriss in *The Metropolis of Tomorrow*, it was to depict a "mythic landscape; the myriad temples, palaces and other fictive places of past cultures that top the skyscrapers of Midtown are a memory garden of civilization. Here they are submerged in a paradisiac garden."[7] This design was also not executed.

While Lutèce, Le Grenouille, La Côte Basque, and La Caravelle continued to command fashion's pickiest eaters in traditional rooms, some dating back to the 1950s, a few new high-end French restaurants attempted to challenge the competition by combining fine cuisine with stylish settings. Voorsanger & Mills's Le Cygne (1982), 53 East Fifty-fifth Street, occupied a brownstone at the eastern edge of the plaza that separated Edward Larrabee Barnes's 535 Madison Avenue (see Madison Avenue) from its side-street neighborhood.[8] Previously located in a building that had been demolished to make way for Barnes's tower, Le Cygne occupied two floors in its new home, the facade of which was also transformed by the young firm of architects whose attempted synthesis of Modernist and Postmodernist stylistic approaches produced lively, even overheated effects. While generally impressed with the spatially inventive, windowless, pale blue-gray rose and white interiors bathed by Jules Fisher and Paul Marantz in soft artificial lighting to suggest hidden sources of shuttered natural light, Paul Goldberger found Le Cygne's new facade replacing the old brownstone to be "the least successful aspect of the design, a kind of cross between Michael Graves and the Anglo-Italianate tradition from which the New York brownstone itself comes," with "the two aspects" seemingly "at war with each other."[9]

Voorsanger & Mills followed Le Cygne with Nightfalls (1983), 7612 Third Avenue, Bay Ridge, Brooklyn, where they transformed a partially completed skylit facility begun by Saltini Ferrara Associates, Brooklyn-based architects, that extended across two adjacent brownstones into a series of linked dining rooms, most of which were oriented to the back garden where there was another dining room featuring a twelve-foot-high waterfall spilling across a copper surface.[10]

Proposal for Lutèce, 249 East Fiftieth Street. Roger Ferri, 1976. Scheme 2.
CU

Led by Edward Mills, the design team executed columns, colonnades, and vaults in a rich palette of materials including marble and opaque glass. Fifty paint colors were used, ranging from mellow grays to lavenders, pale blues, and deep pinks.

Often the decor triumphed over the food as in the case of Mr. Chow (1979), 324 East Fifty-seventh Street, which was softly flattering luxe itself. Occupying a two-level space in Harry M. Clawson and Caughey & Evans's apartment building of 1930, the very pricey restaurant typically served indifferent fare but was much beloved by the glitterati. According to the Shanghai-born Michael Chow, its owner-designer who was a former painter and actor, the restaurant was "half-London, half L.A.," but "richer looking . . . enriching the style of the Bauhaus without junking it up."[11] A far cry from most restaurants, the room's walls were finished with six coats of glossy white paint, laid on as smoothly as possible. In keeping with Chow's dislike of restaurants "quiet like a church . . . [with] chairs like waterbeds, or tables far apart," the center of Mr. Chow's dining room had a white marble floor: "The noise will be terrific. Everyone will complain about it, but they'll still come." If not for the food, then for the scene and the furniture and art objects, including reproduction Josef Hoffmann chairs, new to the market. "In the beginning, the chair feels weird and uncomfortable," Chow conceded, "but after a while, by the time the bill comes, it feels better. I guess it should be the other way around." There was also an Alberto Giacometti bronze standing-lamp, double glass doors designed by René Lalique, and a soaring, seven-panel, kitelike piece by the English painter Richard Smith. In place of traditional lamps, the room was lit by wall sconces designed in the 1920s by the French decorator-architect Emile-Jacques Ruhlmann, and the tables were lit from below to provide "a sense of security, or focus." Glancing over the room, Chow said it reminded him of "a swimming pool—watery and glamorous."[12]

Threatened by Mr. Chow's glamor, in 1983 one of the city's venerable and distinguished Chinese restaurants, Shun Lee Palace, 155 East Fifty-fifth Street, was redesigned by Joseph Villano, designer of the over-the-top Grand Café (1976),[13] who reconfigured the restaurant, introducing streamlined, horse-shoe-shaped banquettes and sophisticated lighting that flattered diners and highlighted a collection of antique robes and objects.[14] In 1985 the owners of Shun Lee updated their five-year-old branch at 43 West Sixty-fifth Street, just east of Broadway, which catered to the Lincoln Center crowd.[15] Seeking to break with the literal chinoiserie of both the old West Side room and the renewed East Side restaurant, the owners retained the designer Stanley Felderman whose minimalist, almost all-black interior, with sensuous curved corners and a dramatically lit seven-headed translucent dragon sculpture by Mary Constantini wrapping the room, conveyed an appropriate sense of the exotic. The expansive dining room ringed with banquettes had a dropped center for tables, forming a dramatic amphitheater. Next door, Felderman designed the Shun Lee Café, which carried the Wiener Werkstätte into the Postmodern age.

High design did not guarantee success. One of the most dramatic designs for a high-end restaurant was not a successful venture: Diane Lewis, Peter Mickel, and Christopher Compton's Les Tuileries (1983), 40 Central Park South, between Fifth and Sixth Avenues.[16] Diane Lewis, the principal designer, sought to dematerialize the irregular boundaries of the black, white, and gray colored space with large windows facing the street. But despite wall-hung panels of lacquer, marble, and taffeta as well as mirrored panels at the cornice, the effect was harsh, contributing to the restaurant's early demise.

Aurora (1985), 60 East Forty-ninth Street, was a still more famous flop.[17] To transform an unremarkable ground-floor space into what was intended as a dream restaurant, famed restaurateur Joseph Baum retained the graphic designer Milton Glaser, himself a serious student of dining but an initiate in restaurant design, and veteran restaurant designer Philip George. Until Aurora, Baum, who had created La Fonda

Le Cygne, 53 East Fifty-fifth Street. Voorsanger & Mills, 1982. Aaron. ESTO

Toscana, 200 East Fifty-fourth Street. Piero Sartogo and Nathalie Grenon, 1987. McGrath. SA

Casual Quilted Giraffe, 15 East Fifty-fifth Street. McDonough Nouri Rainey & Associates, 1986. Lieberman. NL

del Sol (1961) and Windows on the World (1976) among other famous eateries, had never owned his own restaurant.[18] Consequently, expectations ran high, amid speculation about the high costs of the renovation and about Baum's intention to create a definitive dining experience offering classic cuisine in a dignified setting. Alas, the decor was ambitious but bland: cherry wood wainscoting, voluptuous leather upholstery, and soft pink lighting from specially designed but rather diagrammatic pendants resulted in an overall effect that lacked sparkle or drama. Rather, as Regina S. Baraban put it, the restaurant enfolded diners "like a warm cocoon."[19] What was intended to be suavely elegant seemed just plain pretentious to many, including Bryan Miller, the New York Times's respected food critic, who felt that it forced one "to take an

esthetic stand immediately upon passing the uniformed doormen and entering the winsomely plush dining room . . . [which] combines a very establishment, corporate ambiance . . . with a playful bubble theme more appropriate to a trendy yuppie bar."[20]

Toscana (1987), at 200 East Fifty-fourth Street, also stumbled.[21] An established restaurant moving to a new location, Philip Johnson and John Burgee's 885 Third Avenue (aka the Lipstick Building, see Third Avenue), the fact that Johnson and Burgee were moving their offices to the building from the Seagram Building (Ludwig Mies van der Rohe, Philip Johnson and Kahn & Jacobs, 1958), where they had been located for thirty years, led Toscana's owners to hope their restaurant would give the Four Seasons restaurant a run for its money. But the Lipstick Building was no Seagram; nor was the space devoted to the restaurant nearly as grand. Toscana occupied a slightly contorted area of ground-floor space in the building's nine-story "bustle." As designed by the architects Piero Sartogo and Nathalie Grenon, assisted by the graphic designers Vignelli Associates, the restaurant responded to its awkwardly shaped real estate with a loosely organized suite of spaces leading from a forty-seat bar to a ninety-seat main dining room and a forty-seat private dining room. To make the most effective use of the awkward space, Sartogo and Grenon designed a sensuously curved wall clad in pear wood trimmed in ebony that at once enhanced the sleekness of the shape and suggested the warm colors of Tuscany, an idea also advanced by the use of encausto on the straight walls. Custom hardware and an imaginative use of copper as well as specially designed light fixtures added sparkle to the space. The "Toscana" chairs designed by the architects became a staple of interior design. The high point of the interior was the fifteen-foot-tall main dining room where "walls and ceiling undulate like a banner in the wind," as Regina S. Baraban put it, and where a grand-piano-shaped false skylight suggesting a velarium was surrounded by a cornice painted pale lavender.[22] Toscana did not catch on, and its business slackened considerably in the recession of the early 1990s. In 1991 the restaurant closed, and the space was taken over by Jean-Georges Vongerichten, who hired David Rockwell to transform it into Vong (see below).

An even bigger bust, the 2,200-square-foot, 90-seat Casual Quilted Giraffe (1986), located in the midblock public arcade beneath Philip Johnson and John Burgee's AT&T Building (see Madison Avenue), was developed by superstar restaurateurs Susan and Barry Wine, whose Quilted Giraffe restaurant, said to be the city's most expensive, had been a gourmet shrine of the late 1970s and early 1980s.[23] The new restaurant was designed by McDonough Nouri Rainey & Associates, who in response to the owners' request for an "environment that would offer our usual customers a change of pace, a certain ease," created a meticulously detailed—many would say obsessively over-detailed—room, principally finished in glass, granite, stainless steel, and aluminum.[24] The design hinted at early twentieth-century Viennese design and Art Moderne work from France or America in the late 1920s and early 1930s but was, in the final analysis, its own distinct thing.

The principal designer and spokesman for the team, J. Woodson (Woody) Rainey, saw the assignment in a rather different way from the owners: "Searching for the right palette, we turned to the AT&T building and cracked it open like a geode," allowing the cool palette of materials, "without color," to "let people and flowers and food provide color of their own."

Palio, 151 West Fifty-first Street. Skidmore, Owings & Merrill, 1986. View of bar showing mural by Sandro Chia. McGrath. NMcG

As Rainey observed: "Susan Wine reminded me there's something celebratory about going out to dinner. So just for the hell of it, we took 50 different titanium 'jewels' by Tamiko Ferguson and set them at random into the tabletops. Titanium has moving, *electric* color. It adds joy."[25] The sheer perfection of the design and its high sheen proved the Casual Quilted Giraffe's undoing. Though the owners publicly extolled the design, they quickly put pink gels over the wall lights and gift-wrap bows over the torcheres to mollify, as Barry Wine put it, "a certain segment of the restaurant-going public that feels it's too cold a design."[26] Pilar Viladas, an editor at *Progressive Architecture*, tried to defend the designers' approach: "Unlike much of today's restaurant design, which is either mock-period-piece or safely Minimalist, McDonough Nouri Rainey's design is a piece of real architecture, and a good one. If it seems cold, it may be because the palette, which is intended to be neutral, is just too monochromatic. The elephant-gray upholstery looks too corporate against the beautifully crafted stainless steel, the light-reflecting potential of which would be increased even further by the substitution of white table cloths for black tabletops This is a design that needs, if anything, dressing up—not dressing down."[27]

Palio (1986) was one of two restaurants in Edward Larrabee Barnes's Equitable Center (see 6½ Avenue).[28] The other, a superb seafood restaurant called Le Bernardin (1986), designed by Philip George, though attractive, was not remarkable as a work of design.[29] Palio, featuring Italian food, designed by the interiors division of Skidmore, Owings & Merrill, was much more interesting, not only because of its twenty-four-foot-tall, thirty-by-thirty-foot ground-floor bar, the attic frieze of which was a bold, colorful, and bawdy mural painted by the artist Sandro Chia, but also for the subtly detailed second-floor dining room with its hand-painted banners hung on the walls and its custom furniture designed by Davis Allen of SOM and table settings by Lella and Massimo Vignelli.

Combining space in two adjoining buildings, Eldorado Petit (1991), 49 West Fifty-fifth Street, between Fifth and Sixth Avenues, a branch of a prestigious Spanish restaurant, introduced a new look to New York restaurants.[30] Designed by two Catalan architects, Jaime Tressera and Robert Pallí, the two-story restaurant exemplified a dense minimalism of severe planes and surfaces largely made of concrete and stucco, rendered in various tones of terra-cotta, embellished with alabaster, walnut, and iron fittings.

Grand Cafés

Although the quite meticulously reproduced version of Paris's Art Deco café of cafés, La Coupole (Adam Tihany, 1982; see below), failed in its New York venture, the idea of a stylish, French-inspired café did catch on brilliantly in Lynn Wagenknecht and Brian and Keith McNally's Odeon (1981), 145 West Broadway, southeast corner of Thomas Street, on the ground floor of two neighboring buildings, 145 West Broadway (William Kuhles, 1888) and 147 Broadway (John J. O'Neil, 1870).[31] Previous to Odeon, the space had been a 1930s café and a 1950s cafeteria, neither the glamorous dining destination that Odeon quickly became, where Wall Street business people successfully mixed with artists and their smart crowd of camp followers. Odeon's improbable mix of exposed acoustic tile ceilings, chrome tube furniture, and terrazzo floors worked particularly well because a good deal of it carried with it some measure of authenticity—so that although some things were in the manner of, and many were from the less than fabulous venue of the 1950s, such as metal doors and window cornices, other parts revealed good things from the 1930s café, including the dark-wood paneling. The quality of the room was highly studied but seemed effortlessly thrown together, an approach to interior decoration very much in vogue with many of the trend-setting diners.

Gotham (1984), 12 East Twelfth Street, was designed by James Biber of Paul Segal Associates to seat 165 people in a

Odeon, 145 West Broadway. Lynn Wagenknecht and Brian and Keith McNally, 1981. View to east. McGrath. NMcG

Odeon, 145 West Broadway. Lynn Wagenknecht and Brian and Keith McNally, 1981. McGrath. NMcG

spacious ground-floor room that was slightly elevated above the street.[32] The idea for the restaurant was that of one of the owners, Jerome Kretchmer, who imagined a white, hard-edged room. But Biber softened the concept, principally through the use of large, billowing, parachute-like chandeliers designed by the lighting designer Jerry Kugler, which according to Paul Segal were "the single most important feature in the design, because they attract attention and evoke a sense of romance and fantasy."[33]

America (1985), 9 East Eighteenth Street, was perhaps the most extreme of the grand, i.e. very loud, café restaurants.[34] Only a sandblasted star set atop a brass pole announced what was for a time in the mid-1980s a premiere setting for the mingling and mating rituals of the "swinging singles" set. According to Regina S. Baraban, America was not so much "a dining experience as a social event."[35] As designed by McClintock Grammenopoulos Soloway Architects, America was a big room focused on a raised, skylit bar that served as a stage for the nightly show of meeting and eating. Streaks of neon across the ceiling were the principal decoration. The big room, seating 350 people, was punctuated by cast-iron structural columns and a skylight. Otherwise, it was pretty bare. But, when packed with patrons, it was its own best advertisement, revealed to passersby on the street through a wall of glass set behind the cast-iron frame of the host building's facade. McClintock and Grammenopoulos, this time without Soloway, went on to repeat America's success with Ernie's, a not-quite-so-large eatery on the east side of Broadway between Seventy-fifth and Seventy-sixth Streets.[36] Even more than America, Ernie's put dining on public display, with four pivot-

B. Smith's Restaurant, 771 Eighth Avenue. Anderson/Schwartz, 1986. View to the northwest. Kaufman. EK

ing doors that formed its facade but could be opened in summer to turn the entire restaurant into something like an outdoor café. Here too the emphasis was on the "singles" crowd. In a time before cell phones, a highly visible row of public telephones formed the principal feature of the cavernous and relatively austere room, an at once functional and symbolic feature highlighting the need many of the young patrons had to connect with each other.

Randolph Croxton's Positano (1985), 250 Park Avenue South, on the southwest corner of Twentieth Street, another of the cavernous restaurants of the mid-1980s, departed from the usual policy of single-level dining space. Croxton tiered the 2,500-square-foot room so that, as the editors of the *AIA Guide* put it, "spry thighs deliver goodies on multiple elevations, a kinetic event that gives three dimensions to this restaurant world."[37] Somewhat smaller than the typical grand café, Ross Anderson's B. Smith's Restaurant, (1986), at 771 Eighth Avenue, on the northwest corner of Forty-seventh Street, designed in partnership with Fred Schwartz, was, as the editors of the *AIA Guide* wrote, a "supersleek Italo-new wave restaurant, topped with a penthouse of corrugated steel in the fashion of California architect Frank Gehry."[38] To heighten the "tech" effect, the surrounding sidewalk was inlaid with little nuts, bolts, and gold chains, which were also worked into the terrazzo floors inside. A pair of pyramidal skylights focused the drama on the bar, which was placed directly behind the large windows overlooking Eighth Avenue. Other features that bespoke the new taste for industrial materials and ad-hoc composition were the buffed stainless-steel bar and the aluminum staircase, with its cast aluminum treads and backlit translucent glass risers, leading to the corrugated-metal-clad, shedlike penthouse where diners sat under a web of lights woven by Ingo Maurer.

China Grill, opened in 1987 in Black Rock, CBS's headquarters building (1961–65) by Eero Saarinen, added very good food to the bumptious chaos of the grand café type. The space had originally been home to Warren Platner's The Ground Floor (1965), which William S. Paley, chairman of CBS, worked very hard to make a gastronomic and architectural landmark.[39] The Ground Floor was never a success, partially because its dark interior seemed forbidding, and in the early 1970s, Harper & George tried to warm the room up with bright orange and turquoise metal piping. This transformation was also not successful. In 1979 Judith Stockman, who had

Gotham, 12 East Twelfth Street. James Biber of Paul Segal Associates, 1984. McGrath. NMcG

recently "freshened up" the long-neglected Café des Artistes, at 1 West Sixty-seventh Street, attempted to bring the room to life as the restaurant was metamorphosed into the American Charcuterie. Keeping Platner's bronze table vases but reupholstering the chairs, Stockman added dark-green-glass shaded lights over the bar, a marble and brass central counter, and touches of color to build, as Paul Goldberger put it, "on what was best in the original architecture and the two previous designs, but [make] the room softer and more sensual."[40] The American Charcuterie also failed, giving way in 1983 to the Rose, a restaurant that had opened in 1918 and had for years been operated at 41 West Fifty-second Street before it was forced by CBS to relocate to make way for an expansion which was materialized for another tenant, E. F. Hutton, in a building designed by Kevin Roche (see MoMALand).[41] By the time Jeffrey G. Beers was called in to create the China Grill in 1987, the space had been empty for a year.[42] Beers, working with a team of collaborators, including Jerry Kugler, completely reimagined the space, going so far as to move its entrance from Fifty-second to Fifty-third Street, which he reasoned was busier because of the Hilton hotel, MoMA, and the American Craft Museum. Beers also moved the bar to the center of the through-block space where the kitchen had been and used it as a way to reconfigure what had until then plagued designers: a large room constricted at the center resulting in the impression of two rooms separated by a narrow passageway. Enormous kitelike fixtures, reminiscent of those Kugler had first used at the Gotham Bar and Grill, lowered the space and banished its stygian gloom. Beers also created raised seating platforms to break the space up and provide opportunities for customers to see and be seen.

James Biber's Mesa Grill (1991), occupying the high ground floor of John Woolley's Schuyler Building (1910–12), 102 Fifth Avenue, between Fifteenth and Sixteenth Streets, was one of the era's most successful grand cafés, featuring southwestern food produced by a hot new chef, Bobby Flay.[43] It was the third restaurant to occupy the space, which was notable for its nineteen-foot-high ceiling carried on four columns crowned by foliated Ionic capitals. Biber painted the columns earth red to contrast with the white ceiling and black stained oak floors. The walls were hung with large-scaled black-and-white photographs lit by rakishly angled wall sconces with punched metal shades. The restaurant opened in January 1991, the darkest moment of New York's post-crash gloom, yet made a brilliant success.

Theme Restaurants
Themed restaurants have been a part of New York's dining culture since 1907 when Murray's Roman Gardens opened in the city's newly developing entertainment center on Forty-second Street.[44] Murray's grandly classical rooms catered to the Diamond Jim Brady set, but in the 1920s, Mrs. MacDougall's highly themed coffeehouses, located in various midtown locations, provided light meals to middle-class office workers in settings that ranged from quaint imitations of Italy in the Cortile and Piazzetta to the Spanish-themed Sevillia with its Alhambra Room.[45] Themed environments made a strong comeback in the late 1950s and early 1960s with two notable restaurants: William Pahlmann Associates' Forum of the Twelve Caesars (1957) and Alexander Girard's La Fonda del Sol (1961).[46] While the Forum was a movie version of ancient Rome inspired by twelve portraits Pahlmann had

Mesa Grill, 102 Fifth Avenue. James Biber, 1991. Mauss. ESTO

found in an antique shop, La Fonda's theming was more subtle—an abstractly Modernist version of Mexico imbued with lessons from the work of Luis Barragán. Although high-style design types were frequently dismissive, the popular appeal of theme restaurants was enduring. As one knowledgeable observer, John Hench of the Walt Disney Company, put it, they played an important role: "As long as every detail is consistent" the imagination is liberated. "The adult can become the child, free to dream."[47]

While the themed restaurants of the 1950s and 1960s offered sophisticated, high-end dining, those of the 1980s and 1990s were distinctly populist. Sports (1986), seating 500 patrons, was one of the earliest of the new generation of sports-themed restaurants.[48] Located at 2182 Broadway, between Seventy-seventh and Seventy-eighth Streets, the restaurant, as Suzanne Slesin noted in the *New York Times*, went "beyond the television-at-the-end-of-the-bar concept" and was quite different from its nearest prototype, the "clubby restaurant in which the walls are festooned with football jerseys and silver cups."[49] Sports was designed by Patricia Sapinsley, a young architect who was surprised to get the job: "I know nothing about sports, and I'm a woman to boot." To prepare herself, Sapinsley, intent on creating a stadium-like effect, visited sports venues at Harvard, Brown, and Cornell and studied old photographs of Yankee Stadium and the Coliseum in Rome. The research paid off, leading her, among other things, to locate the kitchen through the break in the bleacher stair so that waiters and waitresses would "come running out of that opening like football players out of a locker room." Seeking to cater to jocks as well as their dates,

Sports, 2182 Broadway. Patricia Sapinsley, 1986. Saylor. PS

Hard Rock Café, 221 West Fifty-seventh Street. Isaac Tigrett, 1983. View to the northwest. Oristaglio. ESTO

Trattoria dell'Arte, 900 Seventh Avenue. Milton Glaser, 1988. Mauss. ESTO

Sapinsley stripped the 6,000-square-foot, 30-foot-tall, former supermarket to its bare essentials, exposing the steel trusses as well as the brick party walls, building bleacherlike elevated seating areas and generally capitalizing on the largeness of the room: "For Manhattan, and especially if you live on the Upper West Side, this is a huge space. People who come here often live in small apartments. To them it's like being in a luxuriously open environment."[50]

Jackson-Knudsen Associates' short-lived Ristorante 75 (1983), on the southwest corner of Seventy-fifth Street and Columbus Avenue, in a way could be regarded as an updated version of a MacDougall coffeehouse. Ristorante 75 was a stage set of a room, suggesting a piazza in a small Italian city seen through the eyes of the painter Giorgio di Chirico and influenced by the etiolated classicism of school-boy Postmodernism.[51] Milton Glaser's Trattoria dell'Arte (1988), 900 Seventh Avenue, between Fifty-sixth and Fifty-seventh Streets, was even more explicitly themed. Conceived of as an art academy exhibition of works-in-progress, the restaurant's anatomically obsessed decor was, as Bryan Miller put it, "about as subtle as Pee-wee Herman" with a "loud (aurally and visually) peach-toned main dining room adorned with giant renderings of everything from noses to derrières." At first visit, Miller found this to be "fun, even though the lighting was harsh. But on subsequent visits the art, like a bad comedian, just didn't let up. The oversize drawings do not adorn, they attack. And the colors—a smaller side dining room is sort of an eerie chlorophyll shade—seemed more suited to interrogation than dining."[52] Glaser worked with Tim Higgins, an architect, to render the three-floor Italian restaurant lively and intimate. Despite Miller's damnation of the design, the restaurant thrived, partially because of the food (which even Miller liked) and partially because, despite the sensory overload, there was somehow an overall sense of space and even comfort. Success was also due, probably, to the fact that by the late 1980s New Yorkers once again needed something to laugh at and what better than views of faces very much like their own?

Trattoria dell'Arte was just around the corner from Fifty-seventh Street, which became home to so many theme restaurants that by 1995, M. Lindsay Bierman, writing in *Interior Design*, could characterize it as "America's Street of Themes."[53] A year before, Herbert Muschamp had observed that the "quintessentially Manhattan thoroughfare looks to be on the verge of seceding from New York and linking up with Anaheim, California, and Orlando, Florida, in a confederacy of kitsch."[54] The Hard Rock Café (1983), 221 West Fifty-seventh Street, between Seventh Avenue and Broadway, was the first of the theme establishments to open on Fifty-seventh Street.[55] Featuring a menu of hamburgers and fries and stocked with rock-and-roll memorabilia, the restaurant was most notable for its entrance marquee consisting of the rear end of 1960 Cadillac, an idea of Isaac Tigrett, one of the owners. Although the city initially issued a summons, declaring the canopy an illegal sign that lends "a honky-tonk atmosphere to a pleasant business district," it ultimately relented and allowed the Cadillac fragment to remain.[56]

Movie set designer Anton Furst, known for his work on *Full Metal Jacket* (1987), *Batman* (1989), and *Awakenings* (1990), was the designer of Planet Hollywood (1991), 140 West Fifty-seventh Street, between Sixth and Seventh Avenues, which would become an overnight sensation and go on to

develop as a chain designed by David Rockwell after Furst's suicide shortly after the New York venue opened.[57] Although in its early days the restaurant was visited by movie stars, some of whom, like Arnold Schwarzenegger, Sylvester Stallone, and Bruce Willis, were investors, the "real stars" were, as Lucie Young, writing in an English journal, put it, "the fixtures. Every one of the three dining room drips with movie memorabilia."[58] The center room was perhaps the most predictable, but nonetheless glamorous: a forty-foot-long backdrop sinuously wound around the fiber-optics-laden space to suggest that diners were perched at a midnight supper in Bel Air overlooking Los Angeles in the 1940s. The back room was no less interesting, suggesting the interior of a blimp; it featured assorted memorabilia that seemed to float in space just outside.

David Rockwell saw the boom in theme restaurants not as something unprecedented but as an intensified manifestation of a long-standing phenomenon: "I think they've always been pervasive. Even if you go back to the way restaurants are perceived in movies or represented in theater. Look at Harmonia Gardens in *Hello Dolly*. . . . Restaurants are about entertaining experiences. Theming is just another word for evocative design that is narrative and transports you to another time and place. . . . When you have a limited amount of time and only so much disposable income, you want to go to places that are meaningful, places that touch a nerve and create an emotional response."[59]

The Jekyll & Hyde Club (1994), 1409 Sixth Avenue, between Fifty-seventh and Fifty-eighth Streets, was developed by D. R. Finley who already owned three Greenwich Village restaurants: Jack the Ripper, the Slaughtered Lamb, and another Jekyll & Hyde, but none designed to the level of the midtown eatery.[60] As designed by Rosenberg Kolb Architects and Eerie Entertainment, its over-the-top, Victorian-inspired interiors, stacked up on four balcony-like floors, included a second-floor library, a doctor's laboratory on the third floor, a fourth-floor mausoleum, replete with a collection of crypts and coffins, and an observatory, in effect a tower through which stagelike platforms could be raised and lowered so that patrons on the various floors could be entertained. All this macabre splendor was represented on the street by a collage-like composition consisting of a stunted column, a supersized death mask, a skeleton, and other elements, all fabricated in glass fiber reinforced concrete.

The Motown Café occupied the former Horn & Hardart Automat restaurant (Ralph B. Bencker, 1938), at 104 West Fifty-seventh Street, between Sixth and Seventh Avenues, a superb example of its genre.[61] Since the chain's demise, the building had housed the New York Delicatessen (remodeled, Hochheiser-Elias Design Group, 1983) and, after 1995, Jay Haverson's renovation as Motown, which successfully built upon the building's surviving features while adding many more in character. While Planet Hollywood occupied a nondescript space, Motown Café had the luxury of a memorable Art Moderne building with a grand, two-story-high central volume ringed by a balcony which Haverson took advantage of as he scattered memorabilia about and created eddies of space working to create "five or six places in one, a series of vignettes of Motown's history."[62] Other theme restaurants on Fifty-seventh Street included Jay Haverson and David Rockwell's Le Bar Bat (see below) and Aumiller & Youngquist's Brooklyn Diner (1995), 212 West Fifty-seventh

Motown Café, 104 West Fifty-seventh Street. Jay Haverson, 1995. Warchol. PW

Sullivan's Restaurant and Broadcast Lounge, 1697 Broadway. James Biber, 1996. Mauss. ESTO

Street, between Seventh Avenue and Broadway, which featured a fifteen-foot mural depicting the Dodgers World Series victory.[63] Nearby, on the southeast corner of Fifty-sixth Street and Sixth Avenue, Tony Chi designed the Harley-Davidson Café (1993), complete with full-size motorcycles with vibrating handlebars.[64]

James Biber's Sullivan's Restaurant and Broadcast Lounge (1996), 1697 Broadway, near Fifty-fourth Street, at some remove from the Fifty-seventh Street scene, was created to take advantage of the popularity of the David Letterman television show, Late Night, which was taped at the Ed Sullivan Theater next door before a live audience in the early evening (see Times Square).[65] The restaurant was a slightly cynical send-up of the 1950s when deadpan television host Ed Sullivan hosted "The Toast of the Town," essentially an hour of vaudeville-type entertainment broadcast on Sunday nights. Ruth Reichl, the *New York Times*'s food critic, was on to the gag. "You have only to look at the hostess's stand to see what . . . [Biber] is up to," she wrote. "Reservations are checked atop an old television that has been turned into a fishbowl." Sullivan's was pure invention, and the food was good enough and the showbiz mood convincing enough for Reichl to "leave, humming and bouncing down that long, wide stair-case . . . wondering what the Great One [Jackie Gleason, the comedian] and the Great Stone Face [Ed Sullivan] would have made of the restaurant. I think they would have been happy to have some glamour back on

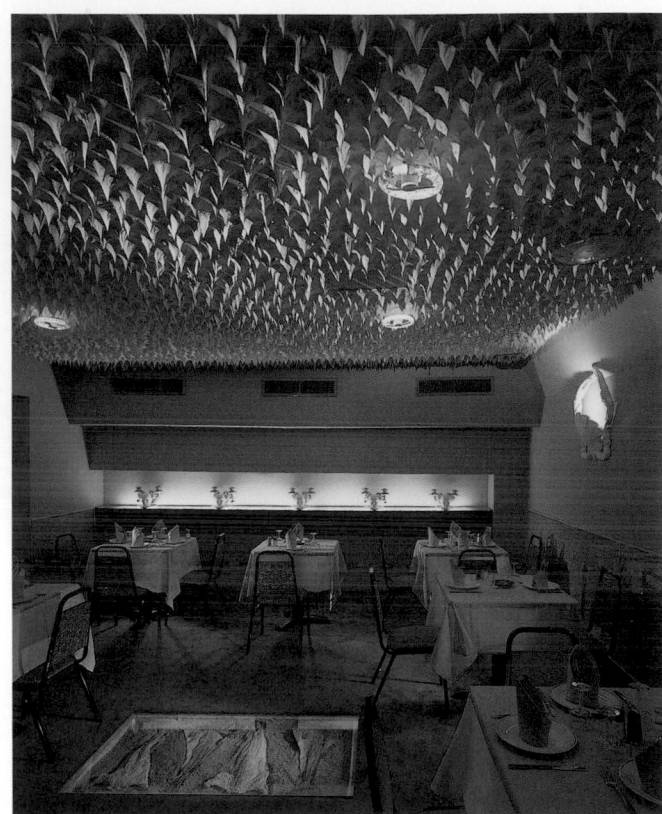

El Internacional, 219 West Broadway. Antoni Miralda, 1984. View to the east. Aaron. ESTO

El Internacional, 219 West Broadway. Antoni Miralda, 1984. Aaron. ESTO

Broadway."[66] Despite its seemingly excellent location and very good reviews, amid the runaway prosperity of the late 1990s, Sullivan's closed on January 31, 1998, after only twenty-two months in business.

Sullivan's failure was symptomatic of a trend: by early 1999, most theme restaurants seemed to be failing with the public. In addition to Sullivan's, two others failed to catch on, Fashion Café and Television City, both in Rockefeller Center. As one analyst specializing in restaurants put it: "The life cycle of theme restaurants has been a lot shorter than anyone expected. Even in New York, where there's a huge tourist population, the novelty's gone. It turns out that the consumer had a lot more entertainment alternatives."[67] But in Times Square, where the theme restaurants should have been located in the first place had the area not undergone such a decline in the early 1980s when the concept first got going, several establishments were built, including Disney's ESPN Zone (see Times Square), a venue sponsored by the World Wrestling Federation (see Times Square), and David Rockwell's Official All Star Café (see below).

One theme restaurant was in a class by itself. El Internacional (1984), 219 West Broadway, opposite Franklin Street, began life in the 1920s as a cafeteria called Teddy's, and then in the 1940s it became an Italian-American steakhouse.[68] In the mid-1950s it was vastly expanded and glamorized, becoming known as "fabulous" Teddy's, a destination for movie stars in the early 1960s. By 1984 the glamor was gone, and it was transformed into El Internacional, an art installation by a Catalan, Antoni Miralda, masquerading as a tapas bar. Notable not only for its extraordinary interior decor, it proclaimed itself to the public with a sidewalk embedded with smashed Coca-Cola cans and a spectacularly decorated black-and-white giraffe-skin-like facade climaxed by a full-size replica of the Statue of Liberty's crown. El Internacional was short-lived, closing in 1987, but reopening two years later as El Teddy's.

The high point of the restaurant's history was the renovation of 1984 undertaken by Miralda, an artist who had lived across the street from it during the 1970s. Miralda thought the building looked like a ghost town in a Spaghetti Western. His redesign took on aspects of archaeology. Removing a heavy brown carpet revealed a tile mosaic surely dating from before World War II, which was preserved as though from ancient Pompeii. Stripping away layer after layer of renovations, Miralda hit pay dirt when he uncovered fragments of a wall of glass and ceramic tiles in gold and turquoise, which were pieced together to form the back of the bar. When all was said and done the effect was overwhelming and not for everyone. "As the briefest glimpse will attest," Charles Gandee wrote, "the conventional rules do not apply. El Internacional exists beyond the limits of good and bad taste—out where the parrot, official bird of kitsch, spreads his colorful wings and flies free."[69]

Jordan Mozer and Associates, the Chicago firm specializing in restaurants, was intent on outdoing any of the locals in its first New York venture, Iridium (1993), a 9,000-square-foot restaurant and music spot in the Empire Hotel, on the southeast corner of Columbus Avenue and Sixty-third Street.[70] Mozer knew what he was doing as he warped the planes of his facade and sculpted the shapes of banquettes and chairs to create effects he described as "animated," "liquid," and "alive."[71] But the effect, instead of being hip, was a bit like that of Toon

Town at Disneyland, or, as Ruth Reichl rather bluntly put it, "a place the Seven Dwarfs might have imagined during a particularly hallucinogenic acid trip."[72] Mozer obsessively pursued a single idea: "What would music look like if you could see it?"

To this end, he was inspired by leaping dancers and justified the undulating waves of the copper roof that enclosed the sidewalk café as a "Baryshnikov roof."[73] Three structural columns were modeled on important musical figures: one representing the composer-conductor Leonard Bernstein had a television for a face; a second, dressed in tails, represented the tenor Placido Domingo; and the third, with a fat stomach, was for another famous tenor, Luciano Pavarotti.

The Diner Revival

The "diner revival" was related to theme restaurants but much less intrusively so, perhaps because on the whole the designs were much more architectural and, at least in some cases, the food was better. Carl Laanes's Empire Diner, at 210 Tenth Avenue, on the northeast corner of Twenty-second Street, a 1976 renovation of a 1943 diner, began the trend. The editors of the *AIA Guide* were impressed: "The reincarnation of, and ultimate homage to, the American diner. Stainless steel never looked better, set off by black and chrome furnishings."[74]

While the architect Alan Buchsbaum's stylish and witty take on Modernism, combining high and low tastes, would seem to have been a natural match with the problem of restaurant design, he only designed one eatery, the very modest Moondance Diner (1983), 80 Sixth Avenue, at Grand Street.[75] Assisted by Davis Sprinkle, Buchsbaum renovated the seventy-year-old Tunnel Diner for Larry Panish, a hot young Manhattan chef. Taking his cues from the automobile world that the building and its setting were bound up in, the architect designed a screaming yellow half-moon back-lit sign which rotated above the entrance; he also splashed the restaurant's name across the building's length using reflective sequins like those used by car-wash owners. Inside, all was vinyl and laminate.

Boogies Diner (1991), 711 Lexington Avenue, between Fifty-seventh and Fifty-eighth Streets, combining a boutique and eatery, was the flagship of a developing chain based in Aspen.[76] As designed by Himmel/Bonner Architects of Chicago, with the collaboration of Mark Kruger, the lighting

Boogies Diner, 711 Lexington Avenue. Himmel/Bonner Architects, 1991. View to the east. Frances. ESTO

designer, Boogies was a desperately hyperkinetic version of a 1950s diner organized on three levels, at once conjuring up images of the Jetson cartoons and "space-age" Modernism. The glass garage-door-like facade using chromafusion glass supported by tapered and raked metal fins could be rear-lit by powerful projector lights to entertain pedestrians with an explosive show of asymmetrical shapes and bold colors. Inside, an elevator tower connected the basement and main floors with the skylit restaurant at the top. An open stair also connected the levels making diners into shoppers as they filed past the clothing on their way to and from the seventy-five-seat diner modeled after the Baltimore, Maryland, eatery featured in Barry Levinson's film *Diner* (1982).

Closest to the spirit if not the aesthetics of the typical diners of the past, which specialized in good, simply prepared food in stylish but unpretentious surroundings, The Good Diner (1992), northeast corner of Eleventh Avenue and Forty-second Street, was a team project of the New York office of Pentagram, the Anglo-American group of graphic designers and architects, principally James Biber, architect, Michael Bierut, graphic designer, and Woody Pirtle, illustrator.[77] The project was the brainchild of Sheldon Werdiger and Evan Carzis, two architects-turned-real-estate developers, who wanted to serve unaffected food in a simple but high-style setting. Michael Bierut came up with the restaurant's name and Woody Pirtle drew the logo, a cup of coffee elevated to sainthood. James Biber designed the interior as an homage to the vernacular of typical diners, sparing no amounts of Naugahyde upholstery in bright, primary colors and covering the tabletops with three types of linoleum.

Moondance Diner, 80 Sixth Avenue. Alan Buchsbaum, 1983. View to the east. Gili. FS

Short Orders

Sometimes ambiance and cuisine were more or less balanced, especially in more modest, "neighborhood" venues. An early effort in this trend was Susana Torre's Laughing Mountain Bar and Grill (1982), 148 Chambers Street, between Hudson and Greenwich Streets, intended to serve the inexpensive lunch-time needs of the Wall Street crowd and for downtown sophisticates at night.[78] The establishment was split between a prominent and visible street-fronting bar intended to bring the city inside and an abstract topiary to suggest a garden setting for the restaurant at the back. Peterson, Littenberg Architects' hole-in-the-wall Indian Oven II (1986), 913 Broadway, between Twentieth and Twenty-first Streets, a one-hundred-foot-long, twelve-foot-wide venue, was re-imagined as a metaphoric garden with linked arcades but without any literal representation of traditional architectural detail, depending instead on a rigorous panelization of ceiling and walls to form shaped volumes.[79]

Gwathmey Siegel's Due (1988), 1396 Third Avenue, between Seventy-ninth and Eightieth Streets, occupied a fourteen-foot-wide, eighty-foot-deep shoe box of a storefront. It was transformed into an elegant eatery by Charles Gwathmey, who was intrigued with the challenge of transforming "an empty shell into a terrifically interesting graphic environment—a *designed* space—yet still keep it calm and ordered."[80] This was accomplished by organizing the bounding walls in square grids, some covered in fabric, others with black glass and wood painted terra-cotta or gray. The complexity of Gwathmey's grid distracted diners from the limitations of the room's dimensions including a low ceiling, the plane of which was manipulated to form what he described as a "skylight ceiling" created in etched glass, a strategy that yielded "a sense of roof top separateness and special placeness."[81]

The "Art" of Dining

150 Wooster Street (1989) was designed by Agrest & Gandelsonas.[82] The Brazilian restaurant's principal design feature was a blue-and-yellow tile floor recalling the sidewalks of Rio de Janiero. The frequently over-theoretical design team made a lot out of a little project, treating the restaurant as an "opportunity to inspect the possibility of generating formal arrangements and configurations that allow an exotic theme to be read without resorting to direction representation." The

150 Wooster Street. Agrest & Gandelsonas, 1989. Warchol. AAGA

facade of the building was left in its found state, including the rolling garage door and the graffiti. Inside, "a strategy of metonymic montage was used" with "materials, primary colors, and abstract, minimal shapes . . . selected so that they play in at least two symbolic 'registers' [proposing] a syntactic reading of the surfaces and at the same time recall Brazilian outdoor urban spaces. The syntax distorts the reading of the box by means of folded and overlapping walls, suggesting an urban space rather than the potential metaphoric reading of an outdoor room or courtyard."[83] Despite this, food and drink were also served.

Rafael and Diana Viñoly, assisted by artists including Damien Hirst, Sean Landers, and David Salle, renovated a former truck garage into Lot 61 (1998), named for the project's number on official city maps.[84] Holding onto the raw quality of the 5,500-square-foot space at 550 West Twenty-first Street, in a block mostly occupied by taxi garages but near to the emerging Chelsea art gallery district, the Viñolys introduced sliding frosted panels to create smaller rooms when needed for private parties. Also located in Chelsea was Bottino (1998), 246 Tenth Avenue, between Twenty-fourth and Twenty-fifth Streets, started by the owners of art galleries because there was no up-scale dining in the area. As designed by Thomas Leeser, Bottino, housed in a former hardware store, was an elegant if comparatively modest effort, inspired by 1950s Modernist suburban houses, which were a specialty of Leeser's architect-father in Germany: "I wanted to create an unpretentious atmosphere, a place like the suburban houses that many New Yorker's have escaped from, with a play of contemporary style and issues of domesticity, here in the

Due, 1396 Third Avenue. Gwathmey Siegel & Associates, 1988. McGrath. NMcG

city."[85] The narrow, dark bar at the entrance opened to a spacious dining room, two walls of which had glass walls that folded back to reveal a decidedly urban backyard garden surrounded by tenements and townhouses.

As the century drew to a close, Pop (1999) sought to meld dining with architectural discourse in ways hitherto unimaginable. The 2,500-square-foot restaurant, at 127 Fourth Avenue, near Twelfth Street, was well designed with blond-wood banquettes and Alvar Aalto–designed chairs arranged under an intermittently gridded ceiling of cherry-red steel described by designer Ali Tayar as "a riff on standard acoustical tile systems" and about which *New York Times* reporter Rick Marin observed, "it puts the din in dinner." But, as Marin pointed out, it was Tayar's 200-word manifesto "which could have been written for an installation at the Whitney Biennal" that "left some diners scratching their heads."[86] Even the owner, Roy Liebenthal, confessed to not quite understanding what Tayar had written, but he decided to include it as part of the menu because "it played into the whole futuristic karma of the restaurant."[87] Tayar, citing influences as disparate as Eero Saarinen's TWA Terminal at Kennedy Airport and "the trailers of 'Dr. No' and 'Contempt,'" saw his work as a tribute to the "homaged era" of the 1960s, whatever that meant.[88] Despite all the high-minded architecturally referential palaver, Tayar's design, according to Marin, fell into the category already occupied by Lot 61, "the industrial gallery/meet market," as well as Tayar's previous restaurant design, the garagelike Waterloo (1997), 145 Charles Street. At the same time, Pop was as self-consciously designed as any restaurant in town, reinforcing what had for the most part been true of the entire decade. As Marin observed: "High design is now as important as cuisine."[89]

In 2000 Diller + Scofidio completely reworked the Brasserie, 100 East Fifty-third Street, bringing the hip of downtown to a ground-level space in the northeast quadrant of Ludwig Mies van der Rohe's Seagram Building, replacing Philip Johnson and William Pahlmann's design of 1959, which had closed in 1995 after a kitchen fire.[90] A key element in the design of the windowless restaurant was the use of video cameras and monitors in an installation, *Brasserie Video Beam*, conceived and executed in collaboration with Ben Rubin/Ear Studio. As patrons passed through the revolving doors at the entrance their pictures were taken. After descending the glass staircase, they could see their images displayed on flat screen

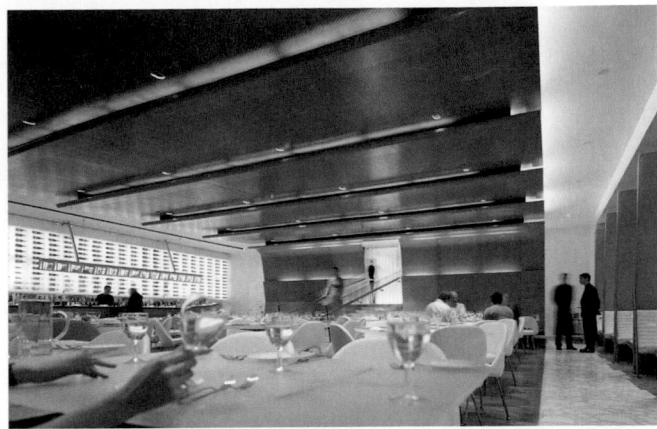

Brasserie, 100 East Fifty-third Street. Diller + Scofidio, 2000. Moran. DSR

monitors placed over the bar. The main dining area was framed by a curved ceiling composed of pear wood and a madrone wood floor. Comparing the design to Johnson's Four Seasons, the Seagram Building's other, more formal restaurant, Herbert Muschamp declared the new Brasserie "spatially richer. This is mainly because of the visibility of the entrance stair from most of the tables. The architects also enlarge the sense of open space by playing with enclosure. This is most evident in the treatment of the semi-enclosed booths, with tilted dividers that extend from floor to ceiling, and in the counterpoint between the large and small dining rooms." Muschamp also believed the design played well against the "conceptual framework of the Miesian aesthetic. In contrast to rationality, Diller and Scofidio gives Mies a surreal twist. Transparency, for instance, has given way to translucency. Table tops of molded pale green resin allow glimpses of the legs and the cantilevered braces that support them. They are structural ghosts, dimly visible through hazy planes."[91]

Four Master Chefs
Morsa, Sam Lopata, Adam Tihany, and David Rockwell dominated restaurant design, raising what had been at best a hit-or-miss business into a recognized professional specialty combing technical know-how with artistic distinction. So important did these design specialists become that their very association with a project was considered as much an asset as that of the chef in the capitalization and public relations campaigns deemed necessary to ensure success.

Morsa
Donato Savoie and Antonio Morello, practicing as Morsa, specialized in designing stylish restaurants, frequently featuring Italian food. Morsa fought against the stereotypical decor that Little Italy's restaurant owners believed best expressed their ethnicity. As Savoie put it, the typical restaurateurs "had the idea that Italy is spaghetti and mandolins" in part because World War II and the neighborhood's inherent insularity had cut the residents off from evolving Italian culture.[92] Savoie was trained as an architect, but Morello came to interior design with a background in art and theater. Morsa introduced Little Italy's restaurateurs to recent trends in Italian design. They began tentatively with Il Cortile (1975), 125 Mulberry Street. With its exposed brick walls and dark stained wood storefront, it was not particularly adventurous except in the context of Little Italy, where it was one of the first to open up

Lot 61, 550 West Twenty-first Street. Rafael and Diana Viñoly, 1998. Kleinberg. RVAPC

to the backyard space with large windows at the rear of the dining room. Morsa also provided the menu, substituting northern Italian dishes for the then almost ubiquitous ones from the south, helped hire the staff, and handled promotion, which involved the media but eschewed an outside sign on the restaurant's street front. Il Cortile was followed by a series of increasingly sleek and sophisticated designs that were familiar enough in their elements so as not to overly challenge either their clients or the patrons but were, nonetheless, fresh. According to Paul Goldberger, Cafe Biondo (1977), 141 Mulberry Street, was "perhaps the best summary" of Morsa's early style, with a glass front and lacquered black cast-iron columns.[93] Morsa's La Griglia (1977), 117 Mulberry Street, was only nine feet wide but the daringly detailed plate-glass square bay window put the diners as well as the grill in full view of passersby.[94]

Arqua (1987), a one-room, thirty-five-seat restaurant occupying the corner retail space of 281 Church Street (1866–67), between Franklin and White Streets, was named after the town where both the owner and the poet Petrarch were born.[95] Using a nineteenth-century Tuscan technique called *grassello*, which mixes pigmented oils into wet plaster to yield a mottled effect, Morsa finished the walls in ochre, which, together with the warm lighting from specially designed fixtures and the bleached oak bar, created an atmosphere that was at once cozy yet suitable to the tough ambience of its still-ungentrified Tribeca setting. Felidia (1985), uptown at 243 East Fifty-eighth Street, between Second and Third Avenues, was another jewel, with a small, mostly skylit dining room filling its backyard space between a brownstone and a small building constructed to house the kitchen and more dining.[96] Barolo (1990), 398 West Broadway, between Broome and Spring Streets, was much larger than the typical Morsa restaurant, seating 280 people in a room that extended through three separate buildings overlooking a garden that was created out of a former truck parking area.[97] So big was Barolo that Regina S. Baraban, writing in 1990, said it felt "more like a culmination of the ambitious Eighties than a leap into the more modest Nineties."[98] Amid the increasingly over-commercialized and over-designed SoHo scene, Barolo was distinctly understated, with a single glass wall facing the street. Inside, Pietra Serena gray stone, white Carrara marble, and terra-cotta tile floors contrasted with pale yellow *grasello* walls and rich, dark green upholstery.

Barolo, 398 West Broadway. Morsa, 1990. SM

Morsa also tried other approaches. Paul Goldberger found their Art Deco–inspired Lombardi's (1976), 53 Spring Street, "less original and less relaxed" than their typical work but he was charmed by their evocation of a Provencal farmhouse for La Colombe d'Or (1976), 134 East Twenty-sixth Street, between Lexington and Third Avenues, one of the partnership's occasional forays uptown and outside the Italian milieu.[99] As if in reply to Goldberger's criticism, Morello stated, "We have a lot of styles. It depends on the client. You have to make a suit that the customer feels comfortable in."[100]

Sam Lopata

In 1987, when he was at the peak of his influence, Sam Lopata was described by Mimi Sheraton, a leading food writer and former restaurant critic for the *New York Times*, as America's "most prolific and imaginative restaurant designer."[101] The idea that a restaurant's design was as important as its cuisine did not become a serious topic for general discussion until 1979, when Lopata's gastronomically indifferent but stylish Joanna, 18 East Eighteenth Street, became a huge hit.[102] Lopata did not have a signature style: "I design for the owners. I design according to what they serve, who they want to serve. No restaurant should look like any other."[103] And Lopata realized that restaurant design was not a thing for the ages: "In Europe things last. In New York, you come back after six months and even your neighborhood isn't there."[104] The French-born, Polish-descended Lopata studied architecture at the Ecole des Beaux-Arts before coming to New York in 1971, where he made his way as an artist, as a loft designer, and as a waiter, which led to his first restaurant commission, Chez Pascal (1975), 151 East Eighty-second Street. There Lopata introduced a level of detail and elegance usually seen in only the most important restaurants. But Joanna was his first major success, a "vast reverberating" place, as Patricia Leigh Brown, a *New York Times* reporter specializing in design, put it, "in which the pulsating noise level was more memorable than the food."[105] It was also the first of the superscale brasseries that were to become ubiquitous downtown and later to spread to the West Side. Joanna, developed by a British entrepreneur, Sheldon Haseltine, and his wife, Joanna, was perfectly timed to the revitalized city, which was being energized by scores of European business travelers and high-end tourists. It also took advantage of a neglected neighborhood, the Flatiron district,

Arqua, 281 Church Street. Morsa, 1987. SM

where big street-level spaces went largely unrented and loft buildings were being transformed from low-end light manufacturing functions to residential lofts and the offices of advertising agencies and publishers fleeing midtown's high rents. Inspired by La Coupole but especially by Chez Julien, both in Paris, Lopata hung lacy curtains in Joanna's windows, hung vaguely erotic flower photographs on the wall as well as plenty of mirrors, and eschewed acoustical treatments in favor of noise which, he argued, kept the adrenaline going. After Joanna, the hushed tone of New York restaurants was a thing of the past.

Lopata followed up on Joanna's success with Café Seiyoken (1982), 18 West Eighteenth Street, between Fifth and Sixth Avenues, where the decor outstripped not only the food but also the management's ability to serve it up. Described as a "culinary discotheque," Café Seiyoken was a place that catered exclusively to "the seen-and-heard crowd" of young trendsetters. The innovative but not quite convincing menu melded Continental and Japanese cuisine, which Lopata captured in a decorating scheme that Daralice D. Boles, writing in *Progressive Architecture*, described as a blend of "Orientalizing Art Deco and Elsie de Wolfe."[106] Shoji-style mirrors, burled madrone wainscotting, frosted glass, and classical mouldings all played off against each other and against zebra-striped chairs and black, steel-clad columns. Everywhere, gridded glass lanterns and light columns washed the cavernous room in a brightness that seemed to suggest Japan, or at least Tokyo's Ginza.

Lopata's next assignment was very different: Prunelle (1984), 18 East Fifty-fourth Street, was a high-end serious French restaurant located in a shop-front space in 520 Madison Avenue, a new office building by Swanke Hayden Connell (see Madison Avenue).[107] Here, Lopata explored Art Deco luxe, but the low ceilings and constricted space seemed unsympathetic to the dark wood and elaborately worked glass and metal surfaces. Private Eyes (1984), 12 West Twenty-first Street, between Fifth and Sixth Avenues, was almost Prunelle's opposite, a video bar principally consisting of a single space dominated by two flanking bars and thirty-two built-in televisions stacked in various combinations as well as two huge screens that displayed images selected by an operator in a control booth.[108]

By the mid-1980s, commissions were rolling in to Lopata's studio. For Café Marimba (1985), replacing the rear section of the last surviving Longchamps restaurant in the base of the Manhattan House apartment building (Skidmore, Owings & Merrill and Mayer & Whittlesey, 1950) at Third Avenue and Sixty-fifth Street, Lopata created a jazzed-up version of Mexican vernacular with a nod to the work of Barragán.[109] But it was Lox Around the Clock (1986), 676 Sixth Avenue, on the northeast corner of Twenty-first Street, that broke new ground. A seventy-seat restaurant designed to look as if it were still under construction, it was a send-up of the "de-construction" movement beginning to sweep through advanced architectural circles.[110] Lox Around the Clock was bold and irreverent, brutal in its way but undercut with wit. In a boarded-up storefront once home to a nightclub, Lopata and his design partner Barbara Pensoy more or less took the hoardings down and left things as they were, revealing different layers of its architectural history. To further the historical theme, Lopata installed an "antique" corner featuring seventeenth-century paneling and an elaborate, white-painted chandelier.

Café Seiyoken, 18 West Eighteenth Street. Sam Lopata, 1982. McGrath. NMcG

No style or mood seemed beyond Lopata's range: Extra! Extra! (1986), in the Daily News Building extension (Harrison & Abramovitz, 1958), southwest corner of Second Avenue and Forty-second Street, was a casual eatery with walls painted to suggest pages from recent newspapers and life-size cutout characters from the funnies.[111] Lopata's Chop Suey Looey's Litchi Lounge (1992), 1345 Sixth Avenue, at West Fifty-fifth Street, was a stage-set send-up of traditional Chinese restaurant decor.[112] Occupying a long narrow space on three levels, the restaurant was treated as a Chinese garden with synthetic trimmed hedges, red walls, and garden lanterns lifted on turquoise-colored bollards. Green Astroturf formed the wall-to-wall "lawn."

Batons (1985), 62 West Eleventh Street, managed to make high comedy out of Japanese austerity, with concrete floors, black-and-white zig-zag lightning-bolt-like lighting on the ceiling as well as black-and-white illuminated batons, designed with the help of James Hong, casually and rakishly sprinkled throughout the room.[113] But the room's tough chic, intended to showcase "California cuisine" served up by a disciple of the Los Angeles–based master chef Wolfgang Puck, proved too "cool" and too noisy for New York tastes; the exposed concrete floors were quickly carpeted. Batons reflected the restless frenzy of New York's boom-time trendiness. It was, as Regina S. Baraban wrote, "important as a restaurant of the moment, informed by clever design rather than architectural exploration. Like it or not," she continued, "it reflects a measure of thematic and spatial inventiveness rarely evident in the derivative world of restaurant design."[114] But as Anthony Brandt put it: "Like a Broadway show, Batons opened like a flash and flopped like a turkey."[115]

Home on the Range (1987), 135 Third Avenue, between Fourteenth and Fifteenth Streets, specializing in Texas

Extra! Extra!, southwest corner of Second Avenue and East Forty-second Street. Sam Lopata, 1986. Milroy & McAleer. MMC

Chop Suey Looey's Litchi Lounge, 1345 Sixth Avenue. Sam Lopata, 1992. Kaufman. EK

barbecued ribs, was Lopata's take on Southwest architecture. Anxious to avoid the clichéd stucco of typical restaurants specializing in Texan and Mexican cuisine, he confronted the street with a deliberately stage-set-like version of a porch at a down-at-the-heels ranchhouse, complete with a clothesline strung with long-johns. After hours, a chain link fence was drawn across the front. Inside, Lopata mixed exposed ducts for the air-conditioning with a host of found objects to suggest an "architectural dig where an Indian village has been uncovered."[116] The effect was a "calculated mess," as Regina S. Baraban put it, yet somehow reassuring. But, as with Lopata's other restaurants, there was method behind the madness. As Baraban wrote: "What makes the high-camp antics . . . significant as restaurant design are the ways in which the operational components fit in with the design solutions."[117]

Lopata stumbled badly with Pipeline (1989), a restaurant on the ground floor of Two World Financial Center in Battery Park City, a 3,500-square-foot, low maintenance, no-frills eatery designed for the owners of Lox Around the Clock. Here, as in Lox, Lopata was taken with the conditions of the raw space, but the World Financial Center offered only a network of pipes hung from the ceiling and no layers of history and intervention. Lopata's design for Pipeline, deemed by one writer, "more Pop Art than Texas crude," kept the utility pipes exposed, covering them with thin plastic coating in bright colors.[118] Lopata exulted in the complexity of pipe patterns as well as the catwalks, ladders, and valves, and the bare walls, which he overlaid with bold patterns and graphics that, according to Barbara Pensoy, were like "the corporate logos you find looming on the industrial landscape."[119]

Adam Tihany

In contrast to Sam Lopata's flashy, media-friendly approach, Adam Tihany's was a model of restraint. As Marilyn Bethany, a journalist specializing in interior design, wrote, extending the "restaurants as theater" discussion of the 1980s: "If Sam Lopata is P.T. Barnum, then Adam Tihany is perhaps [the playwright] Neil Simon—a prescient and reliable maker of hits who manages enough flashes of brilliance to give pause to those who might otherwise dismiss him."[120] Tihany, like Lopata, was European. He was born in Transylvania but raised

in Israel. He went on to study architecture in Milan before coming to New York in 1974, where he began by designing showrooms and offices.

Tihany's first important restaurant was the New York branch of La Coupole (1982), the famous Paris brasserie, which was inserted into the ground-floor space of Ely Jacques Kahn's appropriately Art Deco Two Park Avenue (1926–27).[121] Occupying space on the building's south side, facing Thirty-second Street, the new restaurant seemed at first glance a shameless copy, although Tihany would claim that the design was "an adaptation, taken in the spirit of the original," in part necessitated by the dramatic difference in size and scale of the Paris and New York locations.[122] The New York version, despite the familiar terra-cotta color columns, dark red banquettes, and stylized glass lighting fixtures fabricated by the son of the craftsman who had made the originals in 1927, lacked the sweep and joyous brightness of the grand hall on the Boulevard Montparnasse.

Club A (1982), which Tihany designed in collaboration with Robert Couturier, was a restaurant plus a private membership nightclub.[123] Located in an industrial loft at 333 East Sixtieth Street, the project was most notable for the public restaurant, Tucano, which combined pear-wood paneling and a mirrored ceiling with brightly colored murals of tropical birds. Alo Alo (1985), 1030 Third Avenue, on the northwest corner of Sixty-first Street, in the Trump Plaza apartment building (see Upper East Side), was a glassy space of modest size, about 2,000 square feet, but soaring volume, with twenty-foot-high ceilings, which threatened to thwart Tihany's intention to create a grand café that was also intimate, although, in the end, he was able to come close to his goal, using supersized pyramidal lights hung from the ceiling at various heights.[124]

For the New York branch of Bice (1987), a long-established Milanese restaurant, Tihany not only designed the restaurant but also helped select the site, 7 East Fifty-fourth Street, an unprepossessing, 7,000-square-foot storefront in a former garage.[125] The acoustically bright and brightly lit room was tempered with extensive use of wood to trim an elaborately articulated ceiling suggesting tents. The bar area at the front, opening directly onto the sidewalk in the warm months, was

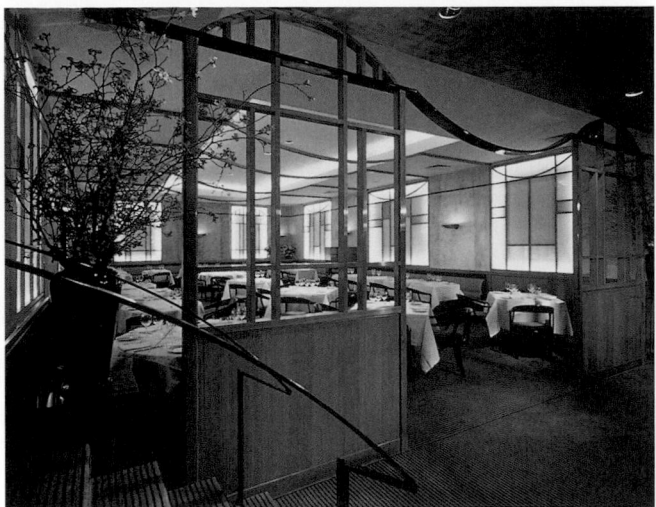

Huberts, 575 Park Avenue. Adam Tihany, 1988. Paige. ATD

especially intimate with paneling in curly sycamore.

Huberts marked a significant departure from the prevalent frenzied dining scene of the late 1980s. An established upscale restaurant known for its fine food, Huberts had been started in a Brooklyn townhouse by Len Allison and his wife, Karen Hubert, and then moved to Twenty-second Street in Manhattan before relocating to what would be its grandest, most elegant home (1988) in the space formerly belonging to the restaurant Le Perigord Park, 575 Park Avenue, on the southeast corner of Sixty-third Street. As Regina S. Baraban noted: "There is a very clear relationship between food and design, a relationship that feels appropriate and correct. The atmosphere recedes; it's a backdrop for dining rather than a vehicle for entertainment . . . [with] beautifully crafted spaces inspired by a sixteenth-century Japanese tea villa."[126] To retain the sense of intimacy that the restaurant was known for, Tihany employed level changes, screens, and sliding doors so that the space could be divided into three separate rooms that glowed with golden-toned Australian ash wood, polished brass, Murrano and sandblasted glass, and gold-flecked ochre-toned painted walls. Tihany's work was a success with the food critics. Seymour Britchky wrote that it was luxurious without any of the banality of "common denominator posh . . . upper-middle-class living rooms or three-hundred-dollar-night-hotel lobbies."[127] Tihany's design for Metro (1988), 23 East Seventy-fourth Street, was a perfect match for its very proper, Upper East Side clientele, with a softly lit, wood-paneled dining room and tables spaced far apart.[128] But even though the design as well as the food by Patrick Clarke was well received, Metro was forced to close its doors in two years' time.

Tihany's Remi, in which he was part owner, began in 1987 as a casual, Venetian-inspired bistro, at 323 East Seventy-ninth Street.[129] Remi was more notable for its details than for its overall ambiance. In 1990 Remi relocated to midtown where it became the principal retail tenant in Kohn Pedersen Fox's 1325 Sixth Avenue, which was actually a midblock structure at 145 West Fifty-third Street (see 6½ Avenue).[130] The move was not only a matter of geography but also of size and scale. What had been a neighborhood bistro seating seventy-five was now a midtown destination restaurant reminiscent of

the grand cafés of the 1980s, capable of serving 400 in the course of an evening. Moreover, the low-ceiling intimacy of the East Seventy-ninth Street location was replaced by a narrow, 120-foot-long, 27-foot-high space seating 160, with its narrow end facing Fifty-third Street and its east side lined with windows facing the building's glass-roofed galleria. The word "Remi," meaning "oars" in Italian, set the tone for the original restaurant where crisscrossed oars formed a canopy over the dining room. Oars played less of a part in the new Remi where, to articulate the huge ground-floor space of Kohn Pedersen Fox's building, Tihany created a relatively secluded bar area hung with glass chandeliers. Beyond lay the dining room where three flying beams springing from square columns combined with an eighteen-foot-high Renaissance-fresco-like mural by Paulin Paris, painted on a canted wall that ran above a continuous banquette, to at once modulate and open up the space so, as Tihany put it, "you feel you are dining in a courtyard outside the walls of a church."[131] The resulting sequence was truly memorable in a way that recalled the traditional arrival at Venice where, as Tihany noted, "you leave the train station for a *motoscafo* and suddenly the whole of the Grand Canal opens up."[132] A mirrored panel along the opposite wall reflected views of the mural for those who had their back to it. As well, it enabled them to enjoy the view of the galleria through the glass wall—in summer this midblock passage connecting Fifty-third and Fifty-fourth Streets served an additional eighty diners.

Remi was Tihany's most overtly themed restaurant, marrying architecture and cuisine. It marked the beginning of a more flamboyant series of projects including the eccentric and

Remi, 145 West Fifty-third Street. Adam Tihany, 1990. Paige. ATD

Le Cirque 2000, 455 Madison Avenue. Adam Tihany, 1997. Bar. Paige. ATD

witty Osteria del Circo (1996), 120 West Fifty-fifth Street, a moderately priced eatery based on a European circus with a proscenium-like treatment for the exhibition kitchen.[133] Osteria del Circo was a venture of the family of Sirio Maccioni, owner of the prestigious Le Cirque, where Tihany had done modest renovations over the years. In 1997 Tihany was given the job of reinventing Le Cirque as Le Cirque 2000, when the restaurant relocated from Park Avenue to the Villard Houses (McKim, Mead & White, 1882–85), 455 Madison Avenue, at Fiftieth Street.[134] Not permitted to modify the sumptuous, landmarked interiors, Tihany chose to contrast them with yet another zany, circus-inspired scheme. In the main dining room, he evoked clown costumes with tall, one-armed chairs with buttons down the back, arrayed against a multi-colored carpet replete with circus rings. The bar, with its giant torcheres, was the restaurant's crowning glory or coup de grace, depending on one's point of view. When asked to justify this color and light riot, Tihany said that what he had done was "like putting a Ferrari in an old palazzo."[135] Tihany saw himself as a portrait artist: "My restaurants are portraits of my clients." According to the designer, Le Cirque 2000 was the essence of Sirio Maccioni: "People ask, 'What drugs were you taking?' But what you see is who they [his clients] are."[136] In a way, Le Cirque 2000 was a throwback to the 1980s, confusing Holly Brubach, the New York Times's chief style writer, who tried to discern a trend. Assessing Le Cirque 2000, Brubach concluded that "the 80's notion of a restaurant as a great party, packed to the rafters, with the volume turned up to a raucous din" had given way in the 1990s "to the restaurant as theater—carefully orchestrated, antic and

zany. Like books, movies, art, fashion and even architecture, restaurants have begun to present themselves as entertainment, thereby relieving us of any responsibility to amuse one another."[137]

Ironically, at the same time that Tihany was planning his color blast for Le Cirque 2000, he was at work on one of his most understated designs, that of Jean Georges (1997) in the Trump International Hotel & Tower (see Columbus Circle).[138] Ruth Reichl thought the marriage of cuisine and interior design that Tihany achieved at Jean Georges was nothing short of revolutionary: "The austerity of the design . . . also puts the focus on food. The dining room, done in carefully neutral tones, is comfortable and expensive but so low-key it is easy to ignore. At lunch, with the sun pouring in, the walls seem to disappear and the trees of Central Park become the main focus. But as the day wanes, the fading light becomes the paramount design element: this is a magical place to watch day turn to night." But, she continued, "I am less taken with the dining room after dark; the designer . . . who is usually very good at lighting rooms, has allowed this one to seem cold when not bathed in natural light."[139]

David Rockwell

By the late 1990s, David Rockwell had transcended Morsa, Lopata, and Tihany to become, as Patricia Leigh Brown dubbed him, "architecture's Flo Ziegfeld, an unabashed proponent of what he calls 'the immersive experience' or sometimes just 'the Big Wow.'"[140] Rockwell's approach was somewhat different from the other three: "I believe in designing with a point of view so you have a restaurant design grow out of something special about the space, the location, the owner, the food. In the 1980s, you would be asked to design a generic restaurant before the owner even knew what kind of food he was going to serve. Restaurants were looked at as investment opportunities."[141] In 1983 Rockwell began his practice in partnership with Jay Haverson, who left to set up his own firm in 1993. Haverson was trained at Syracuse and Columbia Universities. Rockwell, also a Syracuse-trained architect, had strong ties to the theater, which began as a reflection of his mother's career as a musical theater choreographer. Rockwell saw restaurants "as theater. They're immersive, they're involving, they're active instead of passive."[142]

While Rockwell and Haverson did not set out to make a specialty of restaurant design, many of their early projects were bars and eateries, beginning with Sushi-Zen (1984), 57 West Forty-sixth Street, designed in a highly theatrical manner, with a generally dark interior and dramatic spotlighting inspired by "an operatic stage set," in effect a "runway leading to the stage itself—the sushi-bar."[143] Caffe Roma (1986), 3 West Eighteenth Street, was, at the client's request, more architectural than theatrical, evoking in a vague way a classical ruin.[144] Twenty:Twenty (1986), 20 West Twentieth Street, was bigger, seating 240 on six stagelike levels, each differentiated by their furnishings and by the servers' uniforms, ranging from jeans to black tie. Haverson/Rockwell's design was described by Regina S. Baraban as "intense." Twenty:Twenty was "not confined to one stylistic school. There are cool sweeps of turquoise and blasts of orangy red neon, black wicker armchairs, burnished-copper finish on column capitals and pipe rails, faux windows and fire escapes, black wrought-iron railings, and squares of a coffered ceiling with bands of red and turquoise," all contributing "to an eclectic, evocative

Sushi-Zen, 57 West Forty-sixth Street. Haverson/Rockwell Architects, 1984. Ross. RG

Le Bar Bat, 311 West Fifty-seventh Street. Haverson/Rockwell Architects, 1991. Warchol. RG

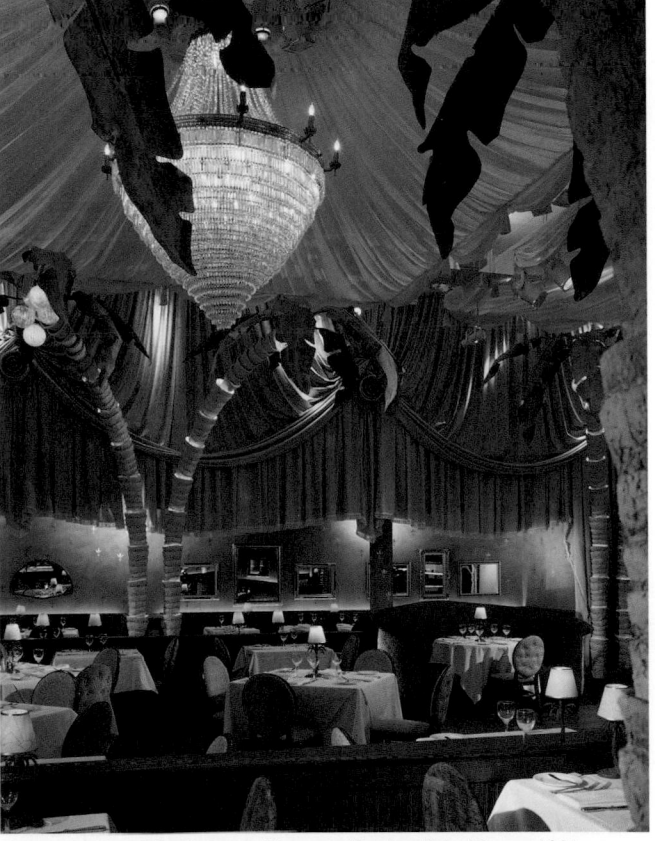

Tatou, 151 East Fiftieth Street. Haverson/Rockwell Architects, 1991. Warchol. RG

interior: it's a slick, southern-style cruise ship; an Italian hillside village; a futuristic opera house; a set for Miami Vice. It's hot and cold, loud and soft, angular and curvaceous."[145]

To overcome the cavernous scale of its space at the South Street Seaport, diners at Haverson/Rockwell's Ocean Reef (1987) sat beneath a meticulously restored collection of wooden boats suspended from the ceiling.[146] Other restaurants followed, but of no great importance, including Il Bianco (1988), 1265 Third Avenue,[147] and Mulholland Drive Café (1989), 1059 Third Avenue.[148] But in 1991, the firm's Le Bar Bat and Tatou heralded the new, overtly theatrical direction of the work that would become Rockwell's forte. Le Bar Bat (1991), 311 West Fifty-seventh Street, occupied what had once been the Manhattan Baptist Church, built as part of Rosario Candela's sixteen-story apartment building (1927), and had more recently been used as a recording studio. Though the church exterior was Gothic, only a few details in that style remained inside against which the architects played the main theme of bats amid the exotic decadence of Southeast Asia in the 1930s, forming, all in all, as Regina S. Baraban put it, "not a place for quiet dining [but] a Nineties version of the see-and-be-seen extravaganza—a place for you to become part of a dramatic, fantastical movie set."[149] The dark interior was brilliantly highlighted by spot-lit architectural features such as a copper-mesh arch over an upstairs bar, Gothic windows, Chinese characters carved into the columns, a vivid-red-painted kitchen glimpsed behind bamboo curtains and, above all others, the bats. The show did not end with the architecture. On most nights, according to Molly O'Neill, an "impassive waiter" stalked the balcony above the crowded bar, "pausing to open his order book, which immediately and invariably" burst into flames, making it possible, if only for a moment, for the usually unflappable "no hair or hemline out of place" crowd of drinkers seated below to experience enough surprise to enjoy "that surge of adrenaline, of wonder."[150] Because Tatou (1991), at 151 East Fiftieth Street, occupied a sixty-five-year-old space that had at various times functioned as a private club, a movie revival house, and a restaurant, many greeted Haverson/Rockwell's design as some sort of restoration of what was built in the 1920s as a mini-opera house and had later been home to the nightclub Versailles (Dorothy Draper, 1945). But much of Tatou was new, yielding what Baraban described as a "layered pastiche of opera house and vaudeville imagery that evokes both a real and an imagined past," incorporating some existing elements—a coved ceiling

Vong, 200 East Fifty-fourth Street. Haverson/Rockwell Architects, 1992. Warchol. RG

with scalloped wood moldings and a crystal chandelier—but adding to them peach brocade walls, tapestry upholstery, and a general aura of camp Victoriana.[151] Haverson/ Rockwell ended their partnership with Vong (1992), a French-Asian restaurant that transformed the peachy cool Toscana (see above) in the Lipstick Building into what Bryan Miller called a "raucous burnt-orange lair trimmed in gold leaf, with bold collages, romantic little booths and dramatic lighting."[152]

Hi-Life Restaurant and Lounge (1992), southeast corner of First Avenue and Seventy-second Street, credited to Haverson/Rockwell, was a reinvention of the neighborhood bar-and-grill of the 1930s and 1940s.[153] The 2,000-square-foot establishment's stainless-steel and baked-enamel panels were topped off by a neon sign flashing the bar's name, which book-ended a glamorous, giant martini glass. Two years later, Rockwell repeated the formula on his own at another location, southeast corner of Amsterdam Avenue and Eighty-third Street. In 1994 Rockwell redesigned the Monkey Bar, where he reinvented a long-established but somewhat moth-eaten bar and restaurant in the Hotel Elysée, at 60 East Fifty-fourth Street.[154] Rockwell prepared for the project by researching nightclubs and movies of the 1930s and 1940s. Ruth Reichl, after revisiting the room in 1998, wrote that it turned "every meal into a glamorous occasion." Rockwell's design made one "feel as if you had entered an earlier, more dangerous era. As Tyrone Power and his cronies smile down from the walls, men straighten their ties and women are tempted to see that their seams are straight."[155]

Rockwell's next important commission was Nobu (1994), 105 Hudson Street, the stylish, inventive restaurant featuring the inspired cooking of the Japanese chef Nobuyuki Matsuhisa. Rockwell was very clear about his intentions: to design a restaurant that looked "like no Japanese restaurant you've ever seen before."[156] With no shoji screens, tatami mats, or light wood cabinetry, the 2,800-square-foot restaurant was an abstract yet theatrical invocation of Japanese rural life, with diners seated amid stylized floor-to-ceiling treelike columns, birch-log sculptures in effect, that branched out over the space and dropped blossoms in the form of red dots

Monkey Bar, 60 East Fifty-fourth Street. Rockwell Group, 1994. Warchol. RG

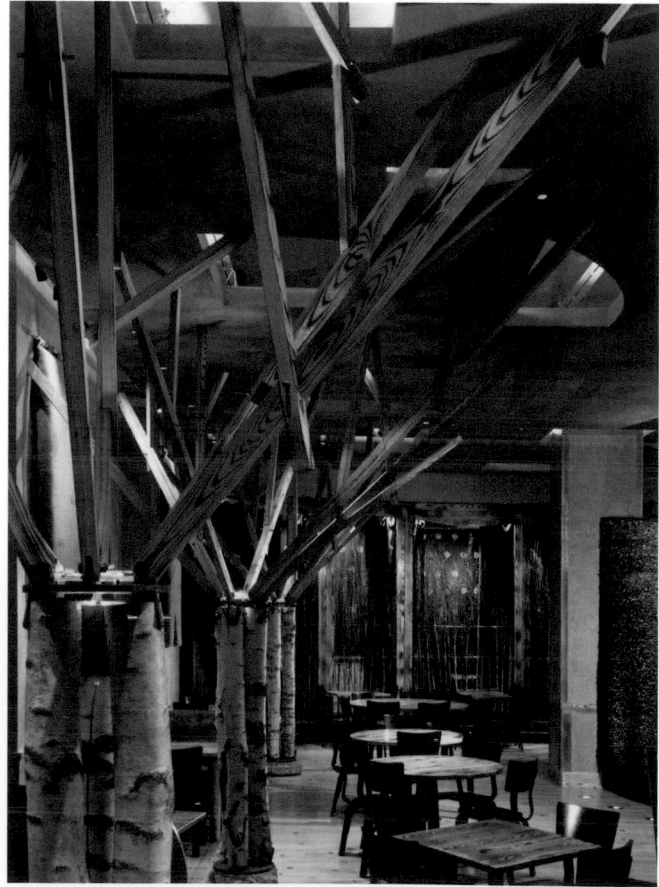

Nobu, 105 Hudson Street. Rockwell Group, 1994. Warchol. RG

Official All Star Café, 1540 Broadway. Rockwell Group, 1996. Warchol. RG

Torre di Pisa, 19 West Forty-fourth Street. Rockwell Group, 1995. Warchol. RG

painted on the floor. At the rear, a special dining room was separated from the main room by a screen of woven birch branches. Ruth Reichl described Nobu as "a cross between an enchanted forest and a set for the movie *Mishima*" locating the diner "firmly in that fantasy restaurant-land that recognizes no geographical boundaries."[157] In 1998 Matsuhisa opened a second restaurant adjacent to his original, Next Door Nobu, for which Rockwell took a different tack, designing a quirkily simple room with banquettes upholstered in fabric remnants, tables topped with scorched pine, a river-rock sushi bar, and walls hung with sisal runners to deaden the sound, all lit by suspended fixtures made from Indonesian market baskets.[158]

In the mid-1990s, Rockwell's name was virtually synonymous with themed restaurants, based on his design of a chain of Planet Hollywoods after the suicide of the designer of the New York location, as well as New York work including the Official All Star Café (1996), a 40,000-square-foot sports bar and restaurant located in the base of Skidmore, Owings & Merrill's Bertelsmann Building (see Times Square), 1540 Broadway, between Forty-fifth and Forty-sixth Streets.[159] The lively, stadium-like interior pulsated with the images of innumerable television sets broadcasting special selections from the various networks, although actual games were not broadcast in the main dining room. Not content with letting the sports create the excitement, or, wisely, the food, Rockwell sought a "stadium experience," opening up two floors of the building to create the main arena and slipping in a mezzanine to overlook the action. As Rockwell wryly put it: "We liked the 'modern stadium in a skyscraper' concept."[160]

Another Times Square theme restaurant by Rockwell was also in the works but this one, the presumably elaborate David Copperfield's Magic Underground on the northwest corner of Broadway and West Forty-ninth Street, had stopped when construction was nearly complete. In February 1998, Rockwell toured the construction site with Patricia Leigh Brown, who described it as a "preternatural fantasy . . . [a] building-as-performance, an edgy amalgam of magic, technology and theater . . . a strange fin-de-siècle catacomb—equal parts Piranesi, film noir, Steven Spielberg and the Kit Kat Club from 'Cabaret,'" a place where "rooms will drop, the bar will levitate, and diners will disappear."[161] The plans called for a 430-seat bar and restaurant in a 35,000-square-foot space. The exterior was to be covered with commercial signs in keeping

with its Times Square location, with the corner anchored by a large sculpture depicting a classically draped man flanked by two torches.

Rockwell returned to a more conventional restaurant type but not a more conventional design approach in his Torre di Pisa (1995), 19 West Forty-fourth Street, a 4,300-square-foot branch of a Milanese restaurant that did not take its Tuscan theming too seriously.[162] When the architect toured the just completed facility with *New York Times* reporter Suzanne Slesin, he remarked that "it looks like you could put on a performance of 'Rigoletto' here." To which Slesin replied in her column: "'Rigoletto' on an ocean liner in a storm is more like it."[163] In 1998, Holly Brubach saw Rockwell's restaurant as a symbol of distorted American values: "The large painted flats depicting buildings off kilter suggest a stage set for an earth quake That Torre di Pisa in New York, started by one of three brothers responsible for the popular trattoria of the same name in Milan, bears no resemblance whatsoever to the original is testimony to the difference these days between dining out abroad and dining out here. For Italians, good food and good conversation in a straight-forward atmosphere is enough. But not for us, it seems—we're looking for an experience."[164] Three years before, in 1995, Rockwell had made the very same point, but naturally without the negative spin: "People go to restaurants to get away from everyday life. Eating out is like a mini-vacation."[165]

Having sent-up Tuscany, Rockwell went on to China with

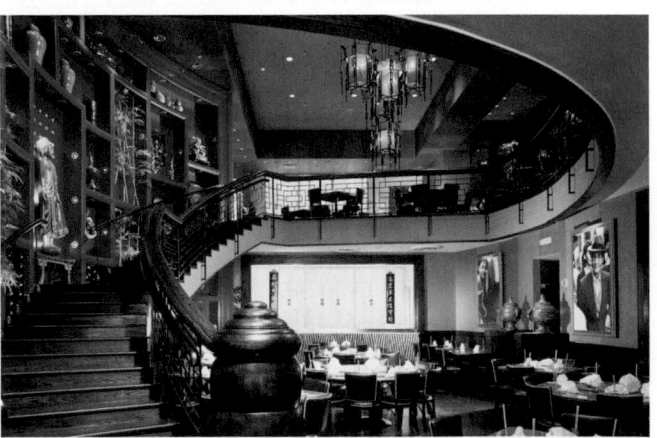

Ruby Foo's Dim Sum and Sushi Palace, 2182 Broadway. Rockwell Group, 1999. Warchol. RG

his zany, delightfully over-the-top Ruby Foo's Dim Sum and Sushi Palace (1999), 2182 Broadway, between Seventy-seventh and Seventy-eighth Streets, replacing Patricia Sapinsley's Sports (see above).[166] The focus of the design, an ornate, swooping staircase, was a practical solution to an age-old restaurant problem—to lure people to second-level dining. According to Ruth Reichl, Rockwell seemed "to have had Auntie Mame in mind when he created [the] sensational curved staircase" with the red lacquered niche-filled bento-box-like wall that lined it. "You can just see," Reichl wrote, Mame "floating down" that staircase, "crying 'Live, live live!' Mr. Rockwell's exciting design, a vibrant collage of mah-jongg tiles, gilded Buddhas and red-lacquered walls, sets the tone of the restaurant: Asia, the romantic East, seen through American eyes."[167]

Clubs

Studio 54 (1977), 254 West Fifty-fourth Street, between Broadway and Eighth Avenue, was the era's most famous and most notorious club, the setting of some of the most outrageous evenings New York had ever seen, famous for its celebrities and infamous for their alcohol-and-drug-stimulated behavior.[168] Designed by a group called Experience Space, a collaboration of Ron Doud, designer, Scott Bromley, architect, Brian Thompson, lighting designer, and Renny Reynolds, a florist, the club featured high-tech lighting effects by Thompson and the team of Jules Fisher and Paul Marantz and pulsating music to a disco beat made popular in the late 1970s by the singer Donna Summer. It was located in what had originally been the Gallo Theater (Eugene DeRosa, 1927), which had been refitted in the 1940s and 1950s as a broadcasting studio.[169] Covering over the sloping floor of the theater's orchestra seating area, Doud and Bromley created a dance floor around which rearrangeable seating units were grouped on a floor covered in black Astroturf. Virtually every other surface was painted black as well, although the remaining original plasterwork was cleaned and left untouched and original chandeliers were left in place in the lobby. Bookkeeping irregularities, detected by the federal government, led to the closing of Studio 54 on December 14, 1978, and jail sentences for Steve Rubell and Ian Schrager, who had conceived the project and were its principal owners.

Following upon the success of Studio 54, Xenon opened on June 8, 1978, inside what was once Henry Miller's Theater (Harry Creighton Ingalls, 1918), at 124 West Forty-third Street.[170] A rash of high-style discos followed, including the decorator Albert Pinto's superheated version of Art Deco for Regine's (1978), located inside the Delmonico Hotel (Goldner & Goldner, 1928), on the northwest corner of Park Avenue and Fifty-ninth Street. Regine's failed to impress Martin Filler, who called its "disco room a veritable citadel of sleaziness." Filler greeted Pinto's version of Art Deco with a "dumb astonishment" that gave "way to speechless horror" as the "specifics begin to emerge for the cacophonous whole Regine's bears about as much resemblance to the original [Art Deco] as Caesar's Palace does to Hadrian's Villa. To paraphrase Teddy Roosevelt on Duchamp's *Nude Descending a Staircase*, it looks like an explosion in a mirror factory."[171]

Located in the same space that had originally been designed in 1937 by Donald Deskey to serve as the International Casino, and later was renovated to meet the needs of the Bond's chain of men's clothing stores, Bond's

International Casino (1980) was an over-reaching entertainment venue that, like its namesake, closed in almost less time than it took to construct. The brainchild of John Addison, a reasonably well-known night-club entrepreneur, and Maurice Brahms, the new Bond's was to be "a whole entertainment complex that will appeal to all worlds."[172] It was to be open on a twenty-four-hour basis, but given its ability to hold from 3,000 to 5,000 people, the likelihood of filling it up was remote. The firm of Shelton, Stortz, Mindel & Associates, architects in charge of the renovation, made the most of what remained of Deskey's grand stair—it had been a bar as well in the original—which spiraled around a vast area intended to be the principal dance floor that, according to Lee Mindel, was treated "as a huge outdoor space . . . [with] pseudo building facades on its edges." By April 1980, the renovation had dragged on for a year, leading Mindel to refer to the place as "Bondage."[173]

A landmark in the history of good-time architecture, the Palladium (1985) was New York's most architecturally distinguished new night spot.[174] For some, carried away by the hype surrounding its opening, which was formidable, the Palladium was great architecture. It opened inside what had been the auditorium of the Academy of Music Theater (William Fried, 1926), 126 East Fourteenth Street, between Third and Fourth Avenues, which the Japanese Postmodernist architect, Arata Isozaki, working with Bloch Hesse & Shalat, transformed into a setting for the riotous dancing, drinking, and other attributes of the night culture just before the AIDS epidemic drastically curtailed its excesses.

Isozaki was arguably Japan's leading architect in the 1980s and he had not yet completed his first American building, the Museum of Contemporary Arts in Los Angeles, which in 1986 was to open to less publicity—and less acclaim—than the New York disco. He had been selected by Studio 54 partners Ian Schrager and Steve Rubell who, as Paul Goldberger observed, were "nothing if not pulse-takers of the moment . . . [who] correctly divined that architecture has a chic in the 1980's that it did not have in the 70's." That Isozaki accepted the commission, given the adverse effect that undertaking so seemingly trivial a building type could have on his reputation as a "serious" architect, did not go unnoticed. As Goldberger put it: "It is rare that a celebrated architect designs a discotheque at all, let alone decides to let this kind of project serve as his debut in a country in which he is beginning to achieve a major reputation. It is rather as if Philip Johnson were to go to Japan to design not a skyscraper, but just a geisha house."[175]

In addition to Isozaki's work, there were a raft of consultants, what Gini Alhadeff aptly labeled a "factory of entertainment," including Norma Kamali, who beautifully embellished the bar with swags of white fabric, and Robert Isabell and Dan Stewart, who, taking their inspiration from Jean Cocteau's film *La Belle et la bête*, created the ultra exclusive "back-stage" Mike Todd Room (named after the larger-than-life theatrical producer who once had offices in the building).[176] Keith Haring designed the mural-like stage backdrop, and Kenny Scharf transformed the lower lounge into a kaleidoscope of competing images ranging from comic-book icons to fake fur, mirrors, and toys. Paul Marantz's use of 2,400 individual lights set in round glass block transformed the fundamentally mundane metal stairs into a 1930s Hollywood musical dream set in real time.

Palladium, 126 East Fourteenth Street. Arata Isozaki and Bloch Hesse & Shalat. 1985. Hursley. TH

Palladium, 126 East Fourteenth Street. Arata Isozaki and Bloch Hesse & Shalat. 1985. Hursley. TH

For this modern dress version of London's Vauxhall and Ranelagh Gardens, Isozaki's bold move was to lift the dance floor to the level of what was the loge in the old theater, thereby making possible a stately procession from the street past an elegantly detailed, classical white hall and a chapel-like vestibule, with a vaulted ceiling painted by Francesco Clemente, up the spectacularly lit metal stair to the dance hall itself. Isozaki created a churchlike space within the theater volume, defined by a super-scale open-work grid and by two walls of twenty-five television screens that were among the first public demonstrations of the relatively new technology that could show either multiple images or be combined to produce a single image of colossal scale. The silver painted grid rose sixty-five feet, its precise geometry visually transforming the existing balcony seating into an amphitheater. "So high and grand" was the volume over head, Martin Filler observed, that it came as a surprise to learn that what seemed like "dimly glinting stars set into the dome are in fact the sprinklers required by fire regulations."[177]

Palladium brightened the scene with dazzling incandescence for a season or two, but the crash of the stock market and the consequences of the AIDS epidemic soon enough took its toll on the extravagant night scene of which it was so much a part. While its aesthetics were debatedly at the forefront of prevailing taste, there was nonetheless something déjà vu about it. As Gini Alhadeff put it: "We couldn't wait for it to open. It was going to be the most sophisticated club in New York: the one with space done by an architect and the decor done by artists. It was going to have more speakers, more video screens, more light, more DJs, more space than any other club in New York. It does But who has more than

one perfect body to take it all in? Who has more than one pair of eyes to see it all? Who has more than one pair of ears to hear it all? Who has more than one brain to sift through it all? . . . Who can talk to another in that kind of industrial noise? Who can find a friend in that dark smokey factory of entertainment?" Meditating on the scene of alienation the huge dance palace at one level seemed to embody, Alhadeff drew attention to the "people like confetti on the dance floor. Who are you here?" she asked and then answered: "A feverish molecule in a disco dictatorship trying to catch desire by the tail." The Palladium, she concluded, is "like a large department store: they have everything but you can't find what you're looking for. It's like an airport, or a train station (without planes or trains to take you places): a space so huge you become anonymous in it. It's like the first day at school, only at night, and in a class of 3,000. That's entertainment in the post-Orwell metropolis."[178]

BOUTIQUE HOTELS

In 1984 an important new trend emerged in New York's hotel industry with the opening of Morgans, 237 Madison Avenue, between Thirty-seventh and Thirty-eighth Streets, the city's first so-called boutique hotel.[1] Primarily small, fashionable facilities often located in older buildings, boutique hotels frequently featured high-style interiors. The movement was spearheaded by the team of Ian Schrager and Steve Rubell, best known for their Studio 54 nightclub (see above), working with developer Philip Pilevsky, who commissioned French designer Andrée Putman to convert the dilapidated, eighteen-story

Morgans, 237 Madison Avenue. Andrée Putman, 1984. Lobby. Warchol. PW

Royalton Hotel, 44 West Forty-fourth Street. Philippe Starck, 1988. Lobby. Mundy. PSN

Hotel Executive (originally Hotel Duane, Andrew J. Thomas, 1925) into a chic, 154-room hostelry. Putman first restored the building's limestone base with three prominent arches that had been covered over in a previous renovation dating back to the early 1960s. Inside, Putman decorated the small rooms in what Charles Gandee described as "quiet good taste," with her "signature shades-of-gray palette . . . happily enlivened by the multicolored pointillistic speckles of the pebbly paint washing not only the rooms but the public corridors." Gandee felt that the designer's "finest moment takes place in the bathroom, where black-and-white chessboard tile, bus-stop-shelter shower doors, and spindly-legged stainless-steel surgeons' sinks reinforce Madame Putman's reputation as grand

dame of high tech." Only the lobby mildly disappointed Gandee, who wrote that the "3-D harlequin floors with its *trompe l'oeil* play of granite and carpet and the shimmering pattern-glass walls with their shoji-like bronze mullions, like bickering spouses in an unhappy marriage, delight more alone than together."[2]

In 1988 Schrager, Rubell, and Pilevsky, working with another French designer, Philippe Starck, renovated the Royalton Hotel (C. E. Reid, 1897), 44 West Forty-fourth Street, a long run-down hotel located east of Times Square on the so-called Club Row block between Fifth and Sixth Avenues.[3] The high-profile Starck's second hotel—he had designed a hostelry in Beirut more than a decade earlier that was destroyed by the invading Syrian army on its opening day—and first work in New York was widely anticipated. It did not disappoint. The project was a total reworking of the former bachelors' residence, creating 171 new rooms, all designed by Starck, who worked in association with Gruzen Samton Steinglass. Planned as a "high style home away from home," Schrager stated that his goal "was to create this mansion in New York City. The idea behind it was to get closer and closer . . . to being like a residence rather than a hotel. When you walk in, it doesn't even look like a hotel lobby."[4] Well, maybe not a lobby—but then not exactly a living room either: the narrow, 180-foot-long space, done up in muted purples, grays, and off-whites and polished mahogany and dominated by a vivid cobalt blue carpet with its border of decorative white ghosts along one side, was clearly the highpoint of the design. Justin Henderson, writing in *Interiors*, asked, "Has there ever existed a hotel lobby with the sensual impact of the Royalton? Dream-like, inviting yet threatening, futuristic and yet richly redolent of the past, the hotel has its detractors, but no one disputes the fact that the Royalton is an absolute and utterly theatrical original."[5] Another feature of the hotel to draw attention was the design of its bathrooms. In fact, according to Schrager, Starck was hired on the strength of his design for the bathrooms at the Café Costes in Paris, which Schrager and Rubell had seen in a magazine article. And Starck himself declared that at the Royalton, "the architecture is in the bathrooms."[6] In the sparely decorated guestrooms, many equipped with fireplaces, the bathrooms featured circular tubs, multiple mirrored walls, built-in glass vanity tables, and stainless-steel sinks. But the bulk of attention focused on the men's room off the lobby, which included a striking stainless-steel waterfall of a urinal dubbed by John Skow, writing in *Time* magazine, a "Niagaral."[7]

Less than two years after the opening of the Royalton, in August 1990, this time in the heart of Times Square, the team of Schrager, Pilevsky, and Starck (Rubell had died of complications from AIDS in 1989) reinvented another hotel, the Paramount Hotel (Thomas W. Lamb, 1928), 235 West Forty-sixth Street, just east of Eighth Avenue.[8] Originally to have been renovated by Andrée Putman, after the success of the Royalton the job was turned over to Starck, who, working with the architect Anda Andrei, was challenged by the Paramount's much greater size—the twenty-two-story hotel contained 610 rooms—and by Schrager's request that it be a budget version of the Royalton. According to Karen Stein, to compensate for the very small, twelve-by-fourteen-foot single guestrooms, Starck "designed a series of elongated furnishings—a highback side chair and Brancusi-like overhead lamp—that manage to distort the proportions of the rooms,

creating a surreal quality overall."[9] Starck was also able to add his personal touch to the forty-square-foot bathrooms by including a conical-shaped stainless-steel sink. Every room also featured the same distinctive padded headboard: a framed, oversized silk-screened detail from Vermeer's *The Lacemaker*, which Starck had always admired in the Louvre and which the designer felt added an "aura of security."[10] Like the Royalton, the highlight of the renovation was the 4,000-square-foot, twenty-foot-tall lobby, which Suzanne Slesin deemed an impressive "indoor piazza": "New York has not had a grand hotel space quite like this since the Biltmore clock stopped ticking in 1981."[11] The roughly square space with polished gray plaster walls was entered via a vestibule detailed with lighted niches and whose marble walls were decorated with cut roses placed in narrow slots, a "decompression chamber,"

according to Edie Lee Cohen, "marking a transition from the chaotic streetscape to the elegance inside."[12] The lobby was dominated by the off-center, canted stucco and stone grand staircase framed on one side by a hand-applied white-gold-leaf wall while the other side featured a glass-panel rail. The stair led to a 3,500-square-foot mezzanine that featured additional seating as well as the hotel's bar. In contrast to the all-Starck-designed Royalton, the lobby of the Paramount featured an eclectic mix of furnishings, including a carved wood chair by Antonio Gaudi, an aluminum chaise by Mark Newson, as well as pairs of leather chairs and sofas by Jean-Michel Frank.

Schrager, no longer working with Pilevsky, also collaborated with Starck on the Hudson Hotel (1999), 353 West Fifty-seventh Street, between Eighth and Ninth Avenues, a reworking of the American Women's Association Building

Paramount Hotel, 235 West Forty-sixth Street. Philippe Starck, 1990. Lobby. Charles. FCP

Hudson Hotel, 353 West Fifty-seventh Street. Philippe Starck, 1999. View to the south. Ross. MS

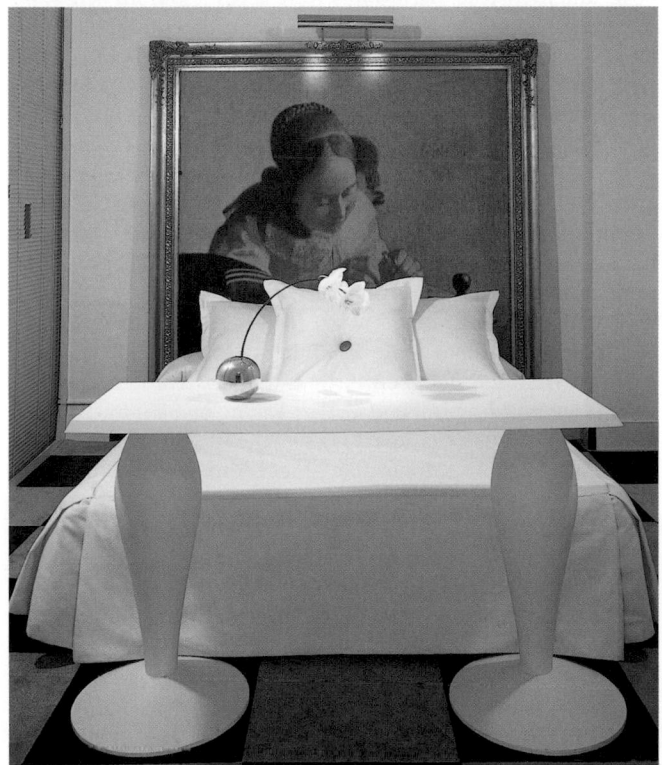

Paramount Hotel, 235 West Forty-sixth Street. Philippe Starck, 1990. Typical guest room. Warchol. PW

Hudson Hotel, 353 West Fifty-seventh Street. Philippe Starck, 1999. Bar. Ross. MS

(Benjamin Wistar Morris, 1929) to create a 1,000-room hotel geared toward young, hip travelers on a budget.[13] Financed in large part by Anne Morgan, the daughter of J.P. Morgan, the 475,000-square-foot, twenty-four-story American Women's Association Building was built as a women's residence with 1,250 rooms, a restaurant, basketball court, gym, and swimming pool. In 1941, a portion of it became the Henry Hudson Hotel and in 1973, WNET-TV/Channel Thirteen took over the second through ninth floors, while the eleventh through twenty-fourth floors, owned by St. Luke's-Roosevelt Hospital Center, were rented out as student housing. When Schrager purchased the building in 1997, he envisioned its transformation into a "modern Y.M.C.A., an urban spa in the middle of the city," where modish public spaces and an "in crowd" would compensate for tiny quarters.[14]

Starck again worked on the project with Anda Andrei as well as the Polshek Partnership, which served as architect of record. Leaving most of the brick exterior intact, the designers only modified a five-story section of the Fifty-eighth Street frontage, where they announced the entrance with a stucco panel. A torch was placed asymmetrically above and to the side of a pair of chartreuse glass doors, the color of which was repeated in two rows of windows above: a thin continuous strip at the second story and a row of eight small square openings punctuating the third story. Inside, the lower stories were gutted and redesigned as public spaces that were meant, according to Starck, to seem "as if you're a cyberkid and you go on holiday in the house of your English grandmother, who is a little strange because she takes acid."[15] Just inside the entrance, narrow escalators swept guests through a thirty-foot-high, tubelike, yellow-green illuminated glass-lined passageway to and from the second-floor main lobby, a thirty-six-foot-high space that James Gardner called a "nocturnal wonderland," covered by a glass ivy-adorned gable roof and featuring "some of the most tasteful brickwork of the past 10 years."[16] Under a Baccarat chandelier designed by the lighting designer Ingo Maurer, the effect of which was further enhanced by hologram images of candles placed around it, guests checked in at a forty-five-foot-long wooden reception desk carved with bas-reliefs of branches. Behind the reception desk, a tall arched window flanked by large square windows looked out to a terrace occupying the courtyard of the U-shaped building. Called Private Park and realized in association with the landscape designer Madison Cox, the courtyard, partially covered by a retractable glass roof, was decorated with overscaled gardening tools and foliage including a 500-gallon watering can and forty-five-foot-tall trees.

Low-lit hallways flanking the Private Park led to, on one side, the Library, a double-height clublike room, where the second story was ringed by a shallow, inaccessible balcony lined with shelves of fake books. But the Library's focal point was an antique purple baize billiard table illuminated by an enormous hemispherical metallic lampshade designed by Maurer. On the other side the Cafeteria, a college-dining-hall-like restaurant, was lit by twenty-foot-high windows. Long tables for communal dining were organized around a rectangular cooking area ringed by a dining counter. Far and away the Hudson's most glamorous and surreal environment was the bar, north of the lobby. It featured a translucent floor illuminated from below by 1,000 linear feet of white neon, upon which an eclectic smattering of chairs and tables were placed in typical Starck fashion, though they were atypically

Chambers Hotel, 15 West Fifty-sixth Street. Rockwell Group, 2000. View to the north. Joseph. RG

designed not by Starck but by an array of designers including Charles and Ray Eames and the Dutch firm, Droog Design. The ceiling was covered in a fresco by Francesco Clemente. Herbert Muschamp called the room "Kubrick territory," referring to the filmmaker's *2001: A Space Odyssey*, and felt that as a whole, the Hudson's eclectic public environments were appropriately bizarre: "For the city of strangers, they have proposed an aesthetic of strangeness. It's a match."[17]

The third floor accommodated 30,000 square feet of banquet rooms and meeting spaces, and guest rooms began on the fourth floor. The rooms were notoriously tiny—the majority occupying only 150 square feet—spare to the point of bare but nonetheless elegantly appointed with Makore wood-paneled walls and pristine white curtains, queen-sized beds, reading lamps with shades designed by Francisco Clemente, a small desk, and little else. Bathrooms were separated from bedrooms by a transparent glass wall with a curtain that could be drawn for privacy. Muschamp called the typical room "a perfect pillbox, your daily vitamin of space,"[18] while James Gardner felt the "overall effect of each room, together with the uniformity of all the rooms, recalls the cells of some monastic order."[19] After the events of September 11, 2001, Muschamp, whose apartment was located close to the disaster area in lower Manhattan, retreated to a room at the Hudson, which offered him "all a displaced person could ask for. . . . [I] possibly felt more at home than I do at home."[20]

David Rockwell, best known for his restaurant work (see Restaurants), designed the Chambers Hotel (2000), 15 West Fifty-sixth Street, between Fifth and Sixth Avenues, his first ground-up building in New York.[21] Rising on a 50-by-100-foot site previously used as a parking lot, the fifteen-story, vaguely classical, vaguely Modernist, Macedonian limestone-clad building was set back at the fifth and twelfth floors. Rockwell, working with architect of record Adams Soffes Wood Design, littered the public spaces and private rooms with over 400 pieces of art by 100 different artists—all "up and comers" because, as the hotelier Ira Drukier put it, "it wouldn't be interesting to buy established artists."[22] In addition, each of the hallways on the third through fourteenth floors was given over to a single artist who had free reign to transform the corridors, though the artists were required to sign contracts stating they would maintain the installations. Among those partaking were Jane Masters, Jovie Schnell, John Waters, John Newsom, Sheila Pepe, and Bob and Roberta

Smith. The art component added about 25 percent to the budget and nearly 50 percent to the construction timeline.

The hotel's seventy-seven guest rooms were conceived, according to Rockwell, with "the notion of an artist's studio"[23] in mind, though George Epaminondas quipped in *Wallpaper* magazine that "if the rooms are inspired by artists' lofts, they're the kinds of artists who had a sell-out show at the Mary Boone Gallery."[24] Each room had a minimum of three artworks and was finished with concrete walls and ceilings, wide-plank walnut floors, and exposed sprinkler pipes. Ten-foot ceilings were a luxury and each room featured brushed aluminum French doors opening in some cases onto terraces or, more often, steel balcony railings. If the rooms were meant to resemble artists' studios, the lobby, entered through twelve-and-a-half-foot-tall walnut doors carved in a basket-weave pattern, and outfitted with leather-covered columns, sumptuous furniture, a grand but modern fireplace, and a mezzanine wrapping three sides, was promoted as feeling like "the living room of a private art collector."[25] Adjacent to the lobby, a narrow bar led to Town, a 110-seat restaurant occupying a portion of the ground and basement levels designed by Rockwell with walls of gridded suede panels. All in all, Paul Goldberger deemed the hotel "very good," its interiors having the "quality that David Rockwell has exemplified again and again—the perfect pitch of a set designer." The details, he felt, were "exactly right" and the overall feel wasn't "too elegant, too raw, too uptown, too downtown, too retro, or too cutting edge. The proportions are right, and all the elements are skillfully wrought."[26]

Another hotel to feature art was the Gershwin, 7 East Twenty-seventh Street, occupying a portion of the former Layton Hotel (William H. Birkmire, 1905). Geared toward young, budget-minded tourists, the hostel-like Gershwin in 1997 installed Swedish artist Stefan Lindfurst's *Tongues and Flames*, a biomorphic sculpture appended to its facade.[27] Set against a backdrop of blood-red painted brick, Lindfurst's translucent fiberglass "tongues" doubled as entry canopies and "flames" rose up the facade, suggesting, as Lindfurst put it, that "this hotel is always on fire."[28] The sculpture intimated the importance of art to the hotel, which included an in-house cabaret and art gallery and offered an artist-in-residence program. The Hotel Giraffe, 365 Park Avenue South, northeast corner of Twenty-sixth Street, opened in 1999.[29] Designed by Stephen B. Jacobs and his wife, interior designer Andi Pepper, the twelve-story, ninety-five-room red brick with limestone trim hotel, despite its Juliet balconies with steel-finished aluminum railings and operable French doors, was ordinary. The hotel's whimsical name reflected the freewheeling capriciousness with which boutique hotels were churned out at the turn of the twenty-first century. As Henry Kallan, the developer, explained, "There is a hotel Elephant in Germany, so why not the Hotel Giraffe in New York?"[30]

Boutique hotels also returned and proliferated in the area where they first began in Murray Hill, including Rafael Viñoly's Roger Williams (1997), 131 Madison Avenue, southeast corner of Thirty-first Street, a renovation of a fifteen-story single-room-occupancy hotel (Jardine Murdock & Wright, 1931).[31] The highlight of the 190-room hostelry was the sleek, double-height lobby graced by three large structural columns clad in ribbed zinc. Stephen B. Jacobs's Library (2000), 299 Madison Avenue, northeast corner of Forty-first Street, was a reworking of a twelve-story, twenty-five-foot-

wide office building (Hill & Stout, 1912).[32] Andi Pepper's interior design included an imitation card catalogue placed behind the reception desk, a book-lined lobby, and individually themed floors identified according to the Dewey Decimal System. M. Castedo & Associates and Jeffery G. Beers's 107-room Dylan Hotel (2001), 52 East Forty-first Street, between Park and Madison Avenues, not only involved a near-gut renovation of York & Sawyer's Chemists' Club (1911) but also added four stories to the ten-story building, whose limestone and brick facade was restored.[33] A short distance to the west the 130-room Bryant Park Hotel (2001), designed by William B. Tabler Architects and the British minimalist architect David Chipperfield, was a renovation of Raymond Hood's landmark twenty-six-story black brick and gold-accented American Radiator Building (1924), located across the street from the park at 40 West Fortieth Street.[34] A Japanese company, Clio Biz, had purchased the building in 1988 during the wave of Japanese investment in New York real estate, intending to open a luxury hotel, but after years of vacancy the plan was changed to develop it as a residential condominium, though no progress was made. In 1997 Philip Pilevsky and Brian McNally bought the building from Clio Biz, announcing their plans to open a high-end hotel that would also house on its ground floor a 120-seat restaurant, Ilo, and a burgundy-leather-walled lobby and bar. A newly excavated forty-five-foot-deep subbasement contained a seventy-three-seat screening room and the so-called Cellar Bar, occupying a multi-tiered space covered by Guastavino-like groin vaults.

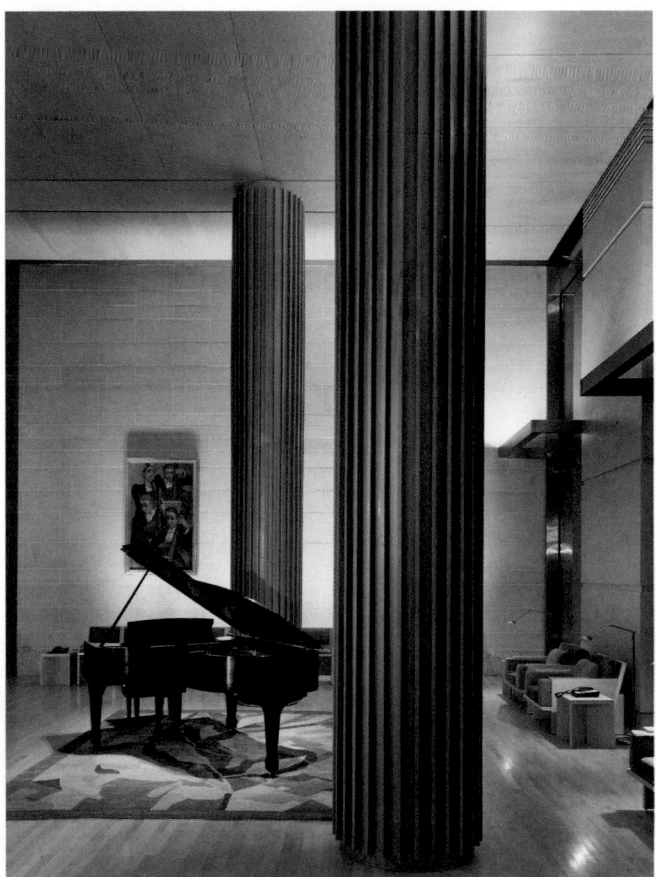

Roger Williams, 131 Madison Avenue. Rafael Viñoly, 1997. Lobby. Goldberg. ESTO

APARTMENTS

Throughout the 1960s and early 1970s, apartment after apartment in Manhattan's choicest residential neighborhoods was drastically reconfigured and redecorated largely to reflect the tastes of young families who had chosen to root themselves in city life. This trend continued as these families matured and others joined in the revival of urban living, transforming apartment interiors and, beginning in the mid-1980s, downtown lofts, into significant if highly ephemeral works of interior architecture.

In the late 1970s and early 1980s, Paul Segal made something of a specialty in fitting Le Corbusier–inspired interiors into high-ceilinged old New York apartment buildings. For the fashion photographer Hiro, Segal designed a studio and apartment (1976–77) in the exceptionally high-ceilinged and exceptionally public northeast corner of the Prasada (Charles W. Romeyn and Henry R. Wynne, 1906), 50 Central Park West, southwest corner of Sixty-fifth Street. According to Paul Goldberger, Hiro's duplex apartment, on the ground and second floors, looked "more like a SoHo loft than a West Side apartment. What Segal has done essentially is insert a well-crafted white object into the two-story space, letting its sleek and clean presence stand in deliberate contrast to the . . . Prasada. The vocabulary is one that is common these days, but its use here in juxtaposition with the old exterior gives this project its special quality."[1] Segal renovated at least three

apartments in the Dakota (Henry J. Hardenbergh, 1882–84), 1 West Seventy-second Street, including Goldberger's, which straddled the entrance arch facing Seventy-second Street and was originally intended as a suite for use by tenants' guests.

While Segal worked to break down the scale of high-ceilinged apartments, Joseph D'Urso was the savior for many Manhattanites who, intrigued by the views, leased space in the new so-called "luxury" towers, only to be disappointed by the low ceilings and generally mediocre appointments of the apartments. D'Urso first gained a reputation for this kind of work when he rescued a three-bedroom, forty-sixth-floor apartment (1975) in the Sovereign (Emery Roth & Sons, 1974), 425 East Fifty-eighth Street, for the fashion designer Calvin Klein.[2] In 1980 D'Urso's deft use of a raised platform turned a cramped studio apartment on a high floor in Gruzen & Partners's glass-sheathed 265 East Sixty-sixth Street (1978) (see Upper East Side) into a seemingly airborne platform suspended over the city.[3] In the same year, for Joel Pinsky, an associate of Calvin Klein's, D'Urso again used platforms to raise the floor with respect to the windows and thereby dramatize the view.[4] Unfortunately, the plan was overly complex.

Beginning with its apartment for Nan and Stephen Swid at 635 Park Avenue (J. E. R. Carpenter, 1912) in 1976–78, Gwathmey Siegel made a decisive move away from the rather hard-surface Modernism that had characterized its residential interiors in the 1960s and 1970s and that continued to characterize the firm's commercial interiors (see Offices).[5] As Charles Gandee wrote in 1981, "the chronicle that traces" the firm's work from 1970 to 1980 "can be viewed as a credible gauge for calibrating the distance architecture has traveled The length of that journey" can be seen in the "contrast between the pure, crisp, austerely honed *objet d'architecture* and the sensual materials, wash of color, and contextual richness" that the firm was currently exploring.[6] The 3,400-square-foot Swid apartment, occupying a full floor, was meticulously detailed with fine cabinetwork and lushly upholstered versions of classic Modernist furniture, but the extensive use of mirrors to expand the space and some highly contrived details compromised the work. Stanley Abercrombie, the architect and journalist, writing in 1981, found the apartment's forms "the most lyrical to appear in Gwathmey Siegel's work to date. Such a great number of curved niches and sweeping piano-shaped forms have been

ABOVE Swid apartment, 635 Park Avenue. Gwathmey Siegel & Associates, 1976–78. McGrath. NMcG

BELOW Swid apartment, 635 Park Avenue. Plans of apartment before renovation (left), after 1978 renovation (middle), and after 1985 renovation (right). GSAA

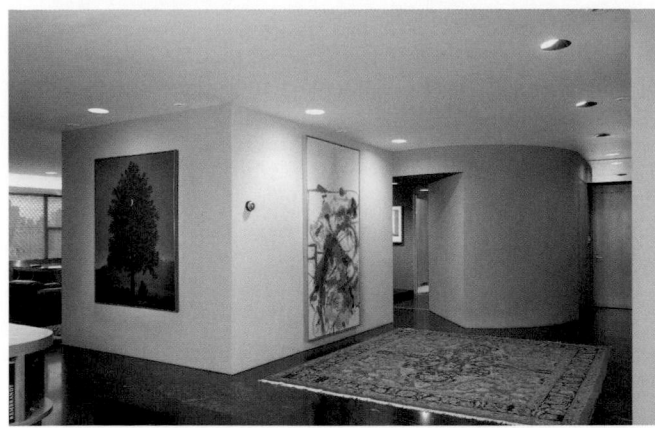

David Geffen apartment, 785 Fifth Avenue. Gwathmey Siegel & Associates, 1977–79. McGrath. GSAA

Swid apartment, 635 Park Avenue. Gwathmey Siegel & Associates, 1984–85. Warchol. GSAA

employed that the whole apartment, it seems, is caught up in an almost audible waltz."[7] However, Colin Rowe, in an essay written in 1987, reflected the disappointment of many in seeing that Carpenter's ingenious plan, "with its preliminary entrance, its circular foyer, its two or three living rooms, the seclusion of its bedrooms," constituting "almost a summary of the later phase of the American *belle époque*," was subjected to "what might be called extensive manipulation. . . . Presumably," Rowe opined, the plan "did not disclose a 'Modern' message, and, therefore" required it to "be either devastated or radically transformed. A manifesto on the part of the owners no doubt this was. For is it not a case of the *ricca borghesia* of New York City making protestations of apostolic poverty? But then, why did they select for this entirely gratuitous performance an apartment so exemplary and an outfit with the integrity of Gwathmey Siegel? But why eliminate the sophisticated entrance arrangements and the circular foyer? Or is this yet another manifesto injecting a situation in which it is of only the slightest relevance?"[8] The circular foyer was typical of all the building's apartments, although by the 1980s only a few of the original layouts remained intact. It had particular interest in that, in 1914, Wassily Kandinsky had made four paintings specifically for the hall foyer in the apartment of Edwin R. Campbell, a pioneer patron of Modernist art, on another floor of the building.[9]

Gwathmey Siegel's next apartment (1977–79) was a pied-à-terre for the Los Angeles–based media magnate David Geffen, for whom the firm had previously designed another apartment as well as an unrealized beach house in Malibu, California.[10] Charles Gandee admired Geffen's 1,700-square-foot apartment, located on the seventeenth floor of the decidedly banal but strategically located Park V (Emery Roth & Sons, 1963), 785 Fifth Avenue, between East Fifty-ninth and East Sixtieth Streets, citing the Geffen apartment for its combination of clear open plan and enriched palette, which Gwathmey agreed was the case.[11] Paul Goldberger was taken with "its great hospitality to art objects" and its "greater sense of separation between different living areas" than was previously typical in the firm's work.[12] The Arango apartment (1981) added to the richness of Geffen's apartment the spatial complexity of a living room dropped six feet below the rest of the apartment. Surprisingly, given the firm's typically high Modernist stance, classical language was invoked in abstractly re-imagined column capitals and bases and in the use of a continuous fascia-

like cornice. As Charles Gandee put it, "Gwathmey gambled his high-modern reputation with decidedly un-high-modern columns that could be, thanks to capitals and bases, the pride and joy of even the most hardened postmodernist." The columns were intended, according to Gwathmey, to not only "modulate the window wall 'facade,' but reinforce its density."[13]

The shift in the firm's work was so great in the 1980s—reflecting the general shift in taste as a whole—that in 1984–85 Gwathmey Siegel was asked by the Swids to renovate their apartment a second time. The normally anti-fashion Gwathmey, at some pains to explain this turn of events, observed that "historical periods don't die; they are just reinterpreted."[14] Part of the motivation for the new renovation lay in the fact that Stephen Swid was no longer head of Knoll, the Modernist furniture distributors, and therefore no longer obliged to showcase the company's products, leading to a much richer mix of twentieth-century pieces chosen by the architects with the help of Andrée Putman. As a result, the second Swid apartment represented the continuities of the Modern, including works of the so-called Art Deco as well as those of the International Style. The re-renovated apartment incorporated subtle changes to the plan, returning to it many of the rooms in almost the same configuration that J. E. R. Carpenter had intended for them, though the circular entry was still gone and many of the fireplaces were closed up to

Steinberg apartment, 944 Fifth Avenue. Gwathmey Siegel & Associates, 1987. Bryant. ARC

Rosen apartment, 911 Park Avenue. Robert A. M. Stern Architects, 1977. Perspective. RAMSA

Rosen apartment, 911 Park Avenue. Robert A. M. Stern Architects, 1977. RAMSA

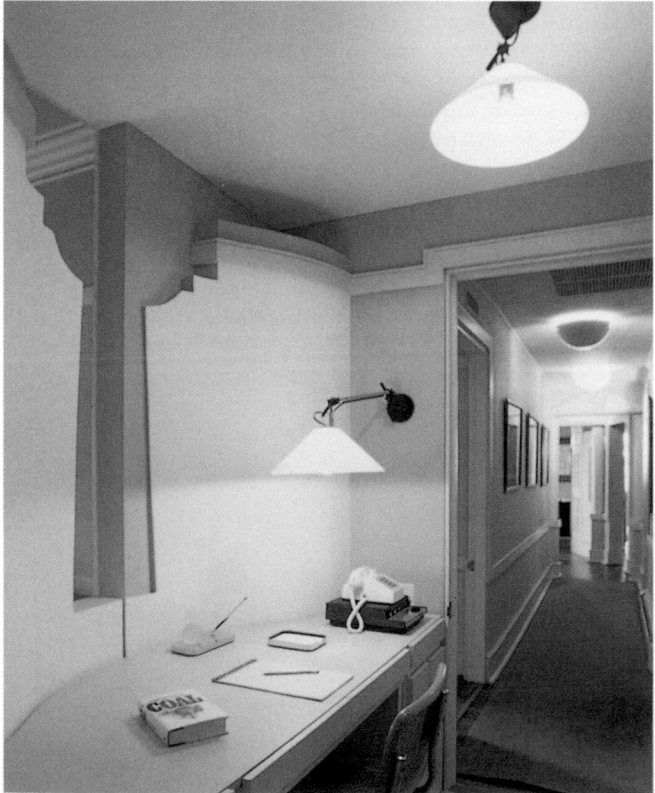

Hitzig apartment, 34 Gramercy Park East. Robert A. M. Stern Architects, 1979. Stocklein. RAMSA

create uninterrupted walls for the Swids' contemporary art. The Swid experience was so cathartic that Gwathmey—who was involved in all his firm's residential projects—was even willing to renovate, in a virtually traditional manner, Robert and Cathy Steinberg's American-antique-filled apartment, 944 Fifth Avenue, using a system of trimmed openings, baseboards, and moldings that visually tied the rooms together just as classical moldings would have but were a bit more abstract in profile.[15]

Though the Steinberg apartment marked an exception—it was a project undertaken for old friends and long-term clients—it, and the second Swid renovation, was symptomatic of Gwathmey's willingness to satisfy the need for luxury among the boom-year clients of the late 1980s and early 1990s. In writing about the splendidly detailed apartment (1994) for Charles Koppelman, a media executive, Paul Goldberger observed that Gwathmey Siegel, "known for its spareness, for its spatial complexity, for its commitment to the idea of abstraction," was willing to "design a Manhattan apartment that," sheathed "entirely in panelling, has as much intricacy of detail as a classical salon and is full of early twentieth-century French furniture."[16] The exquisitely proportioned panelling, combined with some spatial surprises including the mock skylight at the entry and above the long hall, went a considerable way toward lifting this project out of decorative scenography toward a convincing reinvigoration of tradition.

Although known for its residential work, Robert A. M. Stern Architects undertook comparatively few apartment renovations, a category of work that had helped earn its reputation in the early 1970s.[17] The firm's Rosen apartment (1977), 911 Park Avenue, was a minor effort with one significant feature, a freestanding screen-wall arcade linking the dining and living rooms, which were located at either end of a long, spacious, but otherwise dreary gallery.[18] Stern's Hitzig apartment (1979) was an important exemplar of the new Postmodern classicism. Located in George DaCunha's nine-story, red brick Gramercy (1883), 34 Gramercy Park East, northeast corner of Twentieth Street, it consisted principally of space-defining cabinets that made lighthearted play with the host building's Queen Anne classicism.[19] The Hitzig apartment was featured in a 1980 article by Suzanne Slesin, the New York Times's trend-chronicling writer on design best known for her advocacy of high-style high-tech minimalism, in which she cautioned readers to prepare for the Postmodern interior: "Just as we were getting used to the cool, empty expanse of the all-white modern interior, coming to terms with hospital hardware in the kitchen and learning to live with furniture-free, platformed spaces, we find ourselves confronted with crumbling arches, cut-out columns, fake neoclassical pediments and pastel-hued rooms full of puzzling architectural allusions." Slesin went on to observe that "it is the architect, rather than the interior designer, who is the main exponent of the postmodern style [which] . . . ranges from the serious intellectual approach to the fanciful."[20] According to Stern, the new approach differed dramatically from that of ten years before when "a typical renovation implied that one had to tear everything out and paint all the walls white. That's a destructive technique—most people have a sentimental attachment to the past and don't want to cut connections with it. Postmodernism is a physical expression of that past. It's avant-garde because it represents the latest thinking, and is a

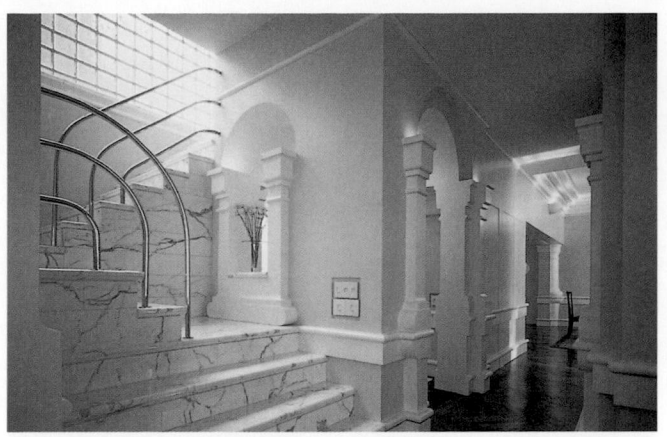

Capasso apartment, 990 Fifth Avenue. Robert A. M. Stern Architects, 1980–82. Ardiles-Arce. RAMSA

Reinhold apartment, 101 Central Park West. Michael Graves, 1980. Aaron. ESTO

reaction against the spare minimal look of the last 10 years. It's for people who have personal histories and are not trying to escape them. It's not a revival style, but it shows that the formal languages of the past can still be spoken."[21]

Stern's Capasso duplex apartment (1980–82) at 990 Fifth Avenue (Rosario Candela, 1926–27), northeast corner of Eightieth Street, tackled a condition almost exactly like one he had worked on for Peggy and Richard Danziger in 1973.[22] Here the stair was set against the party wall freeing up the long narrow plan for a three-room enfilade culminating in the living room. Most notable was the bold and inventive use of classical detailing, especially in the stair and in the vaulted vestibule. In 1981 Stern undertook an even more elaborate project for Jacob Rothschild that consisted of reclaiming the unused space surrounding the elevator machinery in the north tower of the San Remo (Emery Roth, 1930), 145–146 Central Park West, between Seventy-fourth and Seventy-fifth Streets, and attaching it to the apartment below to create a grand residence with spectacular views. The work was only partially completed, consisting of the introduction of new windows in the landmarked tower, when the apartment was sold to Steve Jobs, who retained I. M. Pei to continue with the project.[23] Stern completely reconfigured the Condon penthouse (1984–85) in the architecturally banal 535 East Eighty-sixth Street (Robert L. Bien, 1961), which enjoyed superb views of the East River.[24] Inspired by J. E. R. Carpenter's plan for 635 Park Avenue (see above), Stern introduced a round shallow-domed reception hall leading to the living room. To avoid the clash of a strictly classical interior with the realities of horizontal window openings and nine-foot-high ceilings, the woodwork and details were simplified and abstracted.

In 1980 Michael Graves reconfigured an apartment at 101 Central Park West that had been renovated in 1972 by Robert A. M. Stern and John S. Hagmann, transforming some back bedrooms into a suite for the young daughter of the new owners, Mr. and Mrs. Robert Reinhold.[25] Graves's suite, combining sleeping and dressing areas with a library, was completed at the height of his fame, when a survey of architecture students had ranked him the most influential of American architects. It was a textbook example of his approach, applying his characteristic deep-toned colors to a composition incorporating classical fragments, a ceiling washed by indirect illumination, and a site-specific collagelike wall construction, in this case depicting a stylized open book, all constituting what Martin

Filler praised as "his most highly developed residential essay yet in the mode that has been called, for want of a better term, Post Modern Classicism." Filler described the transformation of Stern and Hagmann's original "monochromatically neutral and spaciously open" scheme into its "polar opposite." Moreover, Graves was, according to Filler, responding to his art-collecting clients' request for "more than just a renovation; they wanted an innovative work of art." The design did not cater to the daughter's age but instead offered a mature essay that conveyed "the feeling . . . of a high-style Art Deco interior: opulent, formal, weighty, highly mannered, somewhat dark, and not particularly receptive to anything not intended as part of the designer's comprehensive scheme."[26] The deterministic splendor of the design was not lost on young Berkeley Reinhold, who wrote about it for the New York architecture newspaper, Express: "My cousin Henry [New York City Commissioner of Cultural Affairs Henry Geldzahler] said, 'It's a privilege to live in a room like this' and I agree with him."[27]

When the Reinholds sold the apartment and Diana Agrest and Mario Gandelsonas were called in by the new owners, they were faced with what Pilar Viladas described as "a veritable Postmodern archaeological dig." But while the main part of the apartment as designed by Stern and Hagmann remained more or less intact, Michael Graves's suite was no longer in place: it had been given to the Brooklyn Museum. Although the new owners had chosen the Central Park–facing apartment because its double-height living room and loftlike bedroom reminded them of their beach house on Long Island, they had Agrest and Gandelsonas transform it (1987–88) to create more defined living spaces and a more distinctly urban feel, leading Viladas to observe that "behind the imposing facades of venerable apartment buildings along . . . Central Park West, the style wars still rage." But for Viladas, Agrest and Gandelsonas's reconfiguration of the apartment serenely rose "above the fray," with an "almost minimalist leanness" that was "clearly contemporary," yet with a "spatial depth and richness of tone and texture" that suggested "strong Classical influences."[28] As Agrest and Gandelsonas put it, their work was far from a simplistic revival of traditional Modernism: "From a late twentieth century view, Modernist architecture is history."[29] While the design reflected the elegant details rendered principally in steel and granite for which the architects were known, its major interest was in the

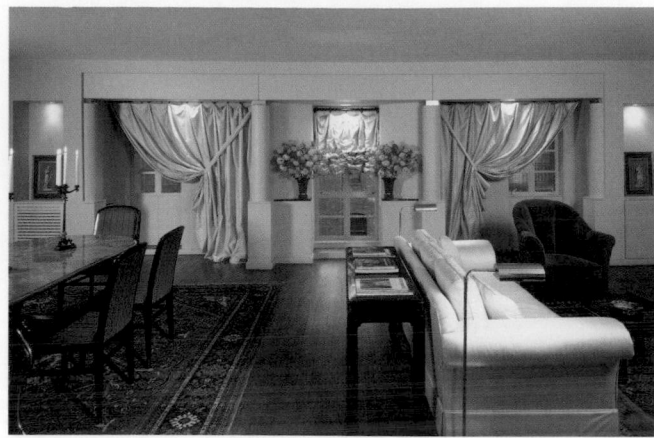

Oscar Kramer apartment. Machado & Silvetti Associates, 1982. McGrath. NMcG

Apartment, 101 Central Park West. Diana Agrest and Mario Gandelsonas, 1987–88. Warchol. PW

Nicola Bulgari apartment, Park Avenue and Sixty-first Street. Piero Sartogo and Michael Schwarting, 1978. McGrath. NMcG

Oscar Kramer apartment. Machado & Silvetti Associates, 1982. Interior elevations. MACH

reconfiguration of the double-height space facing the park, with the sweeping curve of Stern and Hagmann's sleeping balcony giving way to an oval oculus thereby regaining for the bedroom the status of a "room," and for the status of architecture, a resolution of the style wars through the work of Adolf Loos, whose work, according to the architects, "can be seen as a hinge in the Classical/Modernist opposition, being neither Classical nor Modernist."[30]

For the Italian jeweler Nicola Bulgari, the Italian architect Piero Sartogo and his American partner, Michael Schwarting, modified a pied-à-terre (1978) at Park Avenue and Sixty-first Street.[31] The renovation principally involved some new cabinetwork with delicately suggestive classically inspired details and an enfilade of white painted telescoping wood columns designed by Giulio Paolini, a sculptor. To enhance this effect, the apartment's plan was subtly rearranged and the wood floors replaced with terrazzo set in an intricately gridded pattern of aluminum bands. All in all, Paul Goldberger observed, there was a distinct specialness to the design: though "startlingly modern . . . the sensibility of a classical Italian palazzo" was very much there. "A feeling of classicism in the midst of experimentation is perhaps the finest quality——and

the most subtle of all the contradictions" Sartogo chose to explore.[32] The conceptual reference of the project was the Fibonacci sequence, represented geometrically by a spiral, with the columns placed at critical junctions of the grid. Though they were each the same height, no two of Paolini's columns were exactly the same, but the differences were systematic so that each was a part of the sequence.

For the apartment (1982) of Oscar Kramer, occupying the top two floors and the roof of a French neoclassical house on the Upper East Side, the Boston-based partnership of Rodolfo Machado and Jorge Silvetti designed an abstract, slightly heavy-handed salon and a blue-green painted lattice-enclosed roof terrace complete with false fireplace. As in the case of similar work at this time by Michael Graves, the drawings for the scheme conveyed a certain delicacy that the executed room seemed to lack, perhaps because the architects were so anxious to avoid the label of Postmodernism that, in their search for "architecture that effects its own clarification by resorting to principles that are beyond style," they were left with a grammar but insufficient vocabulary.[33]

From the earliest days of her practice, Margaret Helfand also struggled to resist Postmodernism, which she dismissed as a movement "generated by a desire to be stylish and fashionable."[34] Helfand's search for an appropriately modern language began with a 2,100-square-foot loft (1984) in Chelsea, a rather perfunctory version of 1960s work.[35] But by 1989 Helfand had found a distinct, if idiosyncratic, approach, with twisted grids and irregularly composed cabinets executed in varying kinds of glass, wood, and metal, which she first realized in the apartment she and Marti Cowan designed for Jay Adlersberg, a doctor and television personality.[36] Also known

as the "Apartment in Five Quadrants," the Adlersberg apartment, on Riverside Drive, was stylish and unique but not easily comprehensible. Adlersberg was already living in the apartment and thinking of moving to different quarters when Helfand proposed that the spaces could be made far more interesting not through a process of destruction but by maximizing its potential and creating new dynamics of movement through the introduction of custom-designed superscaled furniture. The impact on Adlersberg was transformative: "I used to think the way to see space was to keep it open. From Margaret I learned the way to see space is to fill it."[37] Helfand's apartment (1994) for Diane C. Bliss, also known as "Apartment for Art and Music," occupied an unusual trapezoidal corner of 33 East End Avenue.[38] In this apartment, which was stripped to its essentials, Helfand took the opposite approach from the Adlersberg project: "Rather than isolating functional elements as freestanding objects," she wrote, "the functional elements" became "the boundaries of the space and were developed as a flush rhythmic surface of wood doors, panels, and partially exposed recessed shelves," all contributing to "an interplay between the dual geometries defined by the trapezoidal floor plan."[39]

The work of Hariri & Hariri, coming on the scene in the late 1980s, was largely confined to small interventions in modest apartments which the firm pulled off with considerable aplomb, avoiding the good-taste Modernism that plagued so much interior renovation.[40] This was accomplished by concentrating on a few elements which, working with highly skilled artisans, the architects sculpted into arresting shapes, usually as chimneypieces or freestanding serving bars as in the Robertson (1987) and Buziak (1989) penthouses and the

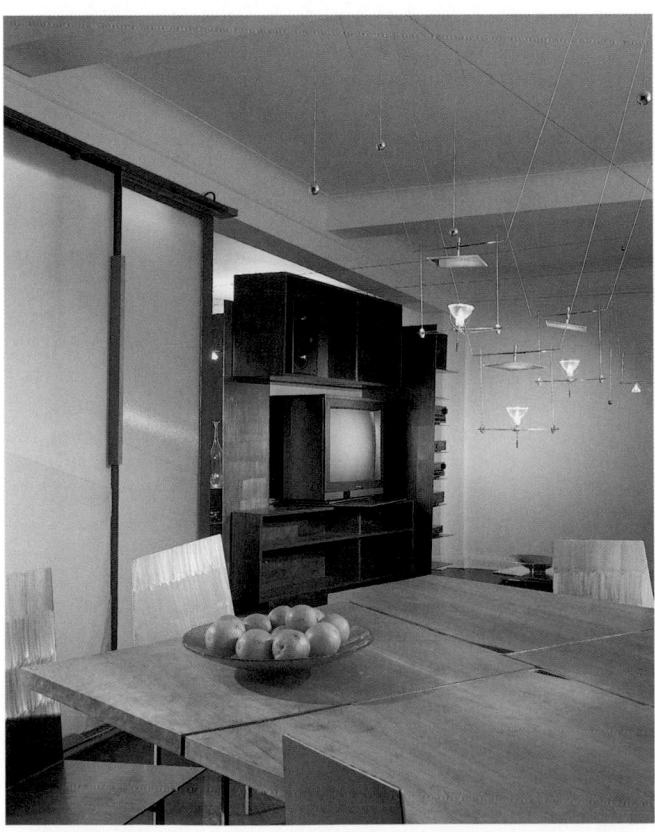

Apartment in Five Quadrants, Riverside Drive. Margaret Helfand, 1989. Warchol. PW

Apartment for Art and Music, 33 East End Avenue. Margaret Helfand, 1994. Warchol. PW

Wills apartment, Midtown. Hariri & Hariri, 1989. Lang. HAR

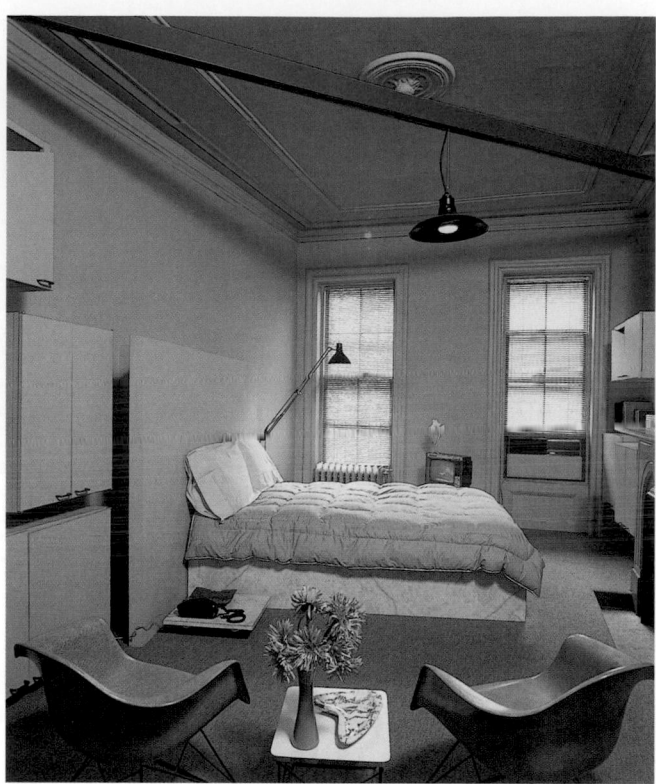

Barbara Jakobson townhouse, 167 East Seventy-fourth Street. Alan Buchsbaum, 1980. Nesbit. FS

Ruth Lande Shuman apartment, 1120 Park Avenue. Gaetano Pesce, 1993. PESCE

Silbermann apartment (1991).[41] Hariri & Hariri's Schiff apartment (1990), though, was more conventionally elegant and less interesting.[42] But their Wills apartment (1989), while executed with a much smaller budget and with few "moves," proved effective, as the architects put it, as "a testing ground for the dynamism of materials, textures, and colors brought together in one place." The apartment combined a rough-textured, mustard-colored stucco cylinder with a smooth, desert-red plaster wall and brushed steel slabs forming a chimneypiece, bringing together "old and new, essentially detached from one another" to create "a quiet, austere place that . . . maintains the energy and the edge of the city."[43]

The Italian artist-architect Gaetano Pesce, one of the era's original talents, known to New Yorkers for his Seaweed chair (1991) in the collection of the Museum of Modern Art, entered the local architecture scene in 1994 when he renovated the

offices of the advertising agency Chiat/Day (see Offices). But another New York project, an apartment at 1120 Park Avenue for Ruth Lande Shuman, had been a continuous work in progress for many years in the 1980s. Almost drowning in bright colors, filled with papier-maché cabinetry and extremely shaped custom furniture all set atop a 1,500-square-foot resin floor painting extending throughout most of the apartment, as well as extraordinary signage, graphics, and mural art, Shuman's apartment was like no other: "People either passionately embrace this place or they run for cover," the owner reported.[44] Pesce and Shuman enjoyed a close relationship so that the apartment, according to Marco Romanelli, was a "dual portrait: a portrait of the person living in it through a portrait of the person who designed it."[45]

Alan Buchsbaum's interiors were far and away the era's wittiest. Buchsbaum, as Martin Filler wrote shortly after the architect's death from AIDS in 1987, "was one of the first and most talented of his generation to recognize that interior design could be the worthy focus of an architectural career."[46] Buchsbaum's work in the late 1960s and early 1970s had a distinctly Pop character that he never quite overcame, although he added to it a sophisticated and knowing eye for the stylish Modernism of the 1930s and 1940s, which he did so much to incorporate in contemporary work.[47] Buchsbaum was willing to take on even the most modest sorts of problems, like kitchens, to which he almost always brought special drama.[48] His work could be straightforward to the point of invisibility, as in the Sanjurjo penthouse (1978), where he transformed what had been eight small rooms on the top floor of a Greenwich Village apartment building into a single, loftlike living space bathed in natural light, or the Restivo apartment (1979), where he managed, through the use of lighting and a

Diane Keaton apartment, 145–146 Central Park West. Alan Buchsbaum, 1982. Heinlein. DH

Billy Joel and Christie Brinkley penthouse, Central Park South. Alan Buchsbaum, 1985. Gili. FS

Alan and Patricia Dennis apartment, 45 Gramercy Park North. Alan Buchsbaum with Frederic Schwartz, 1986. Mundy. MMP

ABOVE Billy Joel and Christie Brinkley penthouse, Central Park South. Alan Buchsbaum, 1985. Plan. FS

specially designed pear-shaped dining table, to lend a sense of drama and playfulness to an inherently nondescript one-bedroom apartment.[49]

Buchsbaum's modest, self-effacing side could also be seen in his renovation (1984) of a four-story townhouse in SoHo for Anna Wintour, the high-profile fashion editor, and her husband, David Shaffer, a doctor. The architect viewed the project as one of "creative preservation," leading him to save many of the house's original details but then adding a few of his own, most notably an elegantly detailed slender steel column needed for support once the stair hall was opened to the dining room.[50] For Barbara Jakobson's townhouse, where a master suite had previously been designed by Emilio Ambasz and where Jakobson was herself to furnish the double-height living room with highly expressive pieces from the 1950s, Buchsbaum was willing to take on the problem of a teenage

daughter's bedroom (1980), using randomly placed cabinets hung on the wall at skewed angles to create what he described as a punk and strange effect.[51]

While Gwathmey tended to attract high-profile leaders in the entertainment and media business, Buchsbaum often found his clients among leading models and performers, including lofts for the actress Ellen Barkin and the singer Bette Midler (see below). Buchsbaum transformed the actress Diane Keaton's apartment (1982) in the San Remo into a light-filled loftlike space using industrial light fixtures and simple, over-scaled furniture.[52] He used a similar approach to the furniture, but did not transform the plan, for the apartment (1982) of the actor Bob Balaban and his wife, writer Lynn Grossman, in the Apthorp (Clinton & Russell, 1908), Seventy-eighth to Seventy-ninth Street, Broadway to West End Avenue.[53] For the twenty-foot-high studio-type living room of supermodel Christie Brinkley's Upper West Side apartment, Buchsbaum hand painted a green and yellow ceiling frieze and arranged the furniture as a still-life, combining a baby grand piano with a pink-chenille-upholstered La-Z-Boy lounger, a lavender slip-covered sofa, a specially designed hearthside rug, and an enormous coffee table, which he designed using plastic laminate in combination with natural stone, specially cut to appear to be as-found broken fragments.[54] When Brinkley married the songwriter and performer Billy Joel, they moved into a 2,500-square-foot apartment (1985) on Central Park South, to which Buchsbaum gave a loftlike feel, although it was the rakish positioning of the wittily selected and designed furniture that gave the place much of its character.[55]

Buchsbaum followed in this vein in his apartment (1986) for Alan and Patricia Dennis on Gramercy Park, his last residential project in New York, completed after his death with

Michael O'Keefe townhouse, Chelsea. Alan Buchsbaum, 1986. Aaron. ESTO

the assistance of Frederic Schwartz. There Buchsbaum achieved a much more dramatic effect by gutting the space and creating a strong visual axis between the living and dining rooms, punctuating the design with his characteristically inventive cabinetry as well as large-scale blue plaster tapered quatrefoil columns that suggested a new interest in the late work of Le Corbusier.[56] At the same time (1986), Buchsbaum was completing the renovation of the parlor floor of the actor Michael O'Keefe's Greek Revival townhouse in Chelsea, again combining the openness and informality of loft-style living with its historically reflective opposite, in this case a long sweep of cabinets suggesting a ruined wall.[57]

High-Concept Living

In some cases, apartment renovations provided a valuable outlet for architects whose highly conceptual work tended to confine their larger-scale projects to paper. Steven Holl's apartment (1983–84) for Andrew Cohen, 875 Fifth Avenue, northeast corner of Sixty-ninth Street (Emery Roth & Sons, 1939–40), one of his earliest realized works, had an unusual history.[58] Holl was teaching a first-semester studio at Columbia University's Graduate School of Architecture when Cohen, a student in the class, invited him to submit his credentials to a friend who was seeking to hire an architect for an apartment renovation. A week after receiving quantities of published material about Holl's work, Cohen revealed that the friend, "well, that was me."[59] Cohen, scion of a well-known New York real estate family, was not interested in a typical apartment but, as Holl put it, "an exploration in architecture."[60] The design was something of an intellectual puzzle: to counteract New York's insistent verticality, Holl introduced a 5/8-inch brass channel separating cream yellow finished plasterwork below from frescolike pale lavender colored plaster above, which also covered the ceiling. The channel became the literal tie binding the open plan together in what was otherwise sparse to the point of dryness, relieved only by meticulously crafted plasterwork, some custom-designed furniture including a drafting table for the student architect, specially woven rugs, and a sandblasted glass mural in the foyer. Behind the design lay complex proportioning systems and references to musical composition which would characterize his later work, leading Holl's Columbia colleague, Kenneth Frampton, to write in 1993 that the "particular spatial and chromatic

interactions . . . that are now the ultimate touchstone of his architecture" emerged in the Cohen apartment: a "fugual approach to the detailed ordering of space," a "preference for layered glass planes, particularly when obscured by sandblasted finish," and the "notion of the pivoting seam, that opens, or promises to open (either vertically or horizontally) to spatial sequences lying beyond the main volume."[61]

Holl's 1,500-square-foot apartment (1986–87) for the owner of the Giada boutique (see Shops) in Cesar Pelli's Museum Tower (see MoMALand) was inspired by the sense that the glassy, forty-second-floor aerie was cantilevered into the space of the city, encouraging him to make the city grid itself the basis for the design's organization, with rooms arranged as a domestic scaled block with intersecting avenues and streets.[62] The resulting composition of planes—with charcoal-gray walls running north-south representing avenues on the X axis, butter-yellow walls representing the crosstown streets on the

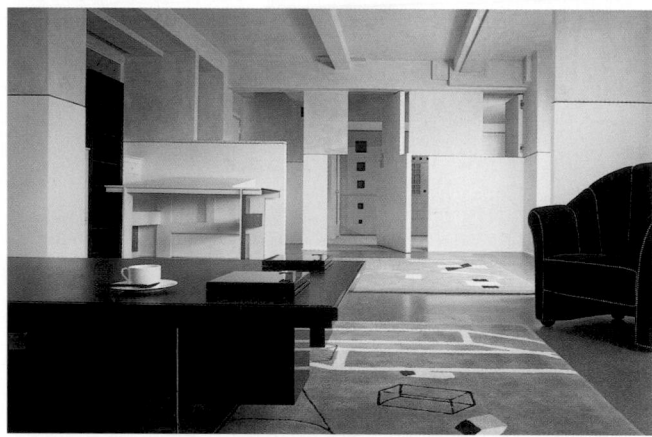

Andrew Cohen apartment, 875 Fifth Avenue. Steven Holl, 1983–84. Warchol. PW

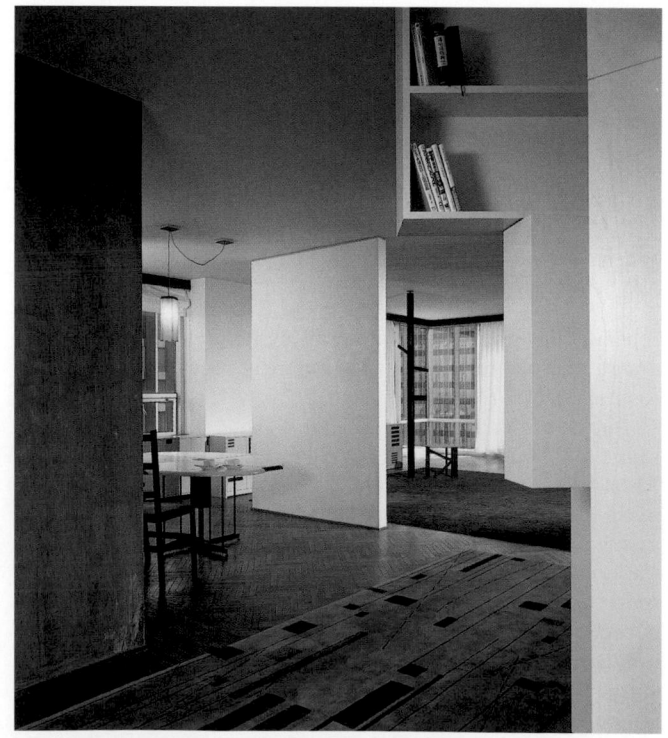

Museum Tower apartment, 15 West Fifty-third Street. Steven Holl, 1986–87. Warchol. PW

Y axis, and, for the Z dimension of the skyscraper, a series of vertical elements including polelike lighting columns—furthered Holl's pursuit of a sensuous, essentialized architectural vocabulary. This search was made easier than usual for Holl in this case because the clients had only the sketchiest program: "No chrome. No bright colors. No shiny materials."[63]

SITE's Laurie Mallet house (1985), a 160-year-old, three-and-one-half-story rowhouse on Barrow Street in the West Village, was commissioned by the owner of Williwear, the innovative clothing company for which the team of Alison Sky, Michelle Stone, and James Wines had already designed a showroom (see Shops).[64] The concept of the design was based "on a layering of narrative ideas drawn from the structure's history, its context, and the personal biography of its owner. This information was converted into a series of architectural and furniture artifacts that partially emerge from the walls, like ghosted memories that have been invaded by the later additions of several generations of inhabitants." While most of the ghosted objects were "consistent with the lifestyle of the 1820s," a few, like the riding hat, crop, and coat in the entry hall, related to Laurie Mallet's personal interests. Of course, only with the occupancy of the Mallet family, signs of which were scrupulously eliminated from the photographs of the interiors, would the "work of narrative architecture" become complete and the house and its garden become fully "invested with historical and psychological cross-referencing."[65]

Perhaps the most stylistically extreme interior, exceeding even Peter Eisenman's Toms loft (see below), was Joseph Giovannini's 3,300-square-foot Gramercy Park duplex (1989), which represented a bold stylistic confrontation between the existing classically detailed rooms that the co-op board insisted not be touched, and what Toshio Nakamura, editor of *A + U*, the influential Japanese journal, described as "a random deployment of diagonals, fragments, discontinuities and discordances . . . expressed and emphasized by means of the contraposition of lines and planes, acute and obtuse angles, dovetails and finials, continuities and interruptions . . . entirely divorced from representative or symbolic meanings, so [that] the materials deployed as their media are inevitably inorganic [and] any traces of free-hand work . . . meticulously erased."[66] The design, growing out of what Giovannini called an energy drawing allowing a "passive" pencil to sense key moments of intensity in the apartment, led to the revelation of a strong "desire line," which ran through walls between rooms that could not be violated. The desire line was represented in a system of built-in site-specific furniture, conceived as debris caught in a storm moving through the apartment, penetrating its two floors.

For his family's own use, in an apartment designed in 1989 but not built until 1993–94, Giovannini pursued the same degree of spatial manipulation in his ongoing search, as Paul Henninger wrote, "to form a history of unstable spaces with the experience of the home."[67] Through the use of fragmented planes and a floating vanishing point, Giovannini successfully "frustrates attempts to read any one system into the whole," producing "nothing less than a total disruption of the space." So pervasive was the effect that the architect's three-year-old daughter, when asked to make buildings from blocks in preschool, eschewed the typical right angular tower with cornice in favor of something "more akin to Eisenman, Gehry or Hadid than McKim, Mead & White"—*quelle surprise!*[68]

Laurie Mallet house, Barrow Street, West Village. SITE, 1985. Warchol. SITE

Gramercy Park apartment, 1 Lexington Avenue. Joseph Giovannini, 1989. JG

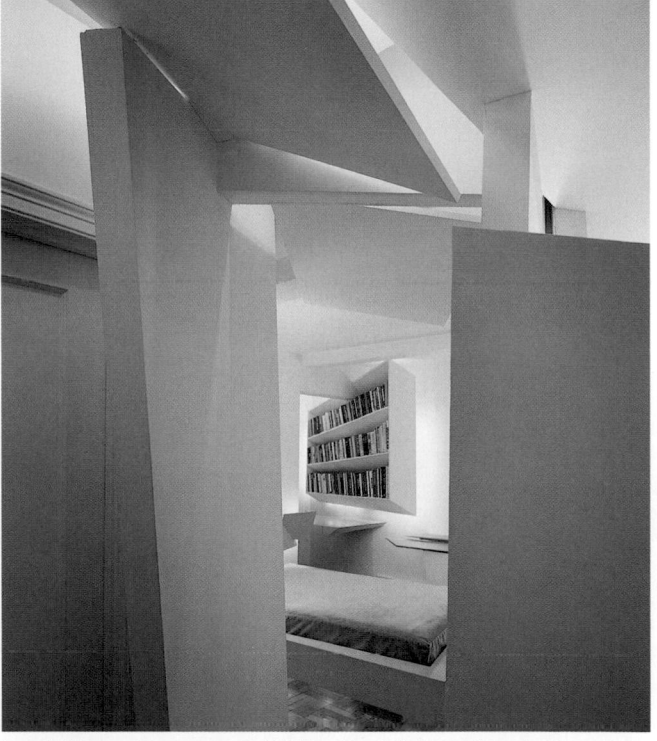
Joseph Giovannini apartment, 140 East Fortieth Street. Joseph Giovannini, 1994. Moran. MM

Richard Meier apartment, 19 East Seventy-second Street. Richard Meier, 1972. Stoller. ESTO

Ulrich Franzen apartment, 168 East Seventy-fourth Street. Ulrich Franzen, 1976. McGrath. NMcG

Steven K. Peterson and Barbara Littenberg apartment, 131 East Sixty-sixth Street. Peterson, Littenberg Architects, 1983. Aaron. ESTO

Peter Nelson loft, 305 Canal Street. Peter Nelson with Richard Haas, 1976. Mauss. ESTO

Architects' Own Apartments

Richard Meier, describing the place his own duplex apartment had within his evolving design philosophy, spoke for many architects who undertook to reconfigure typical accommodations for their own use. According to Meier "an architect's small works are at times his rubric."[69] Meier reconfigured a conventionally disposed duplex apartment (1972) at 19 East Seventy-second Street (Rosario Candela with Mott B. Schmidt, 1937), into "sculpted space for living, working, and studying," eliminating "any element which interrupted the spatial flow," including all moldings. "Beginning with pure volume, I made an open and expansive shape" and "then, in a more painterly fashion, I built and molded from within," using a freestanding wall-like cabinet that "defines and integrates the living zones."[70]

In 1976, Ulrich Franzen, who had made his reputation with elegant pavilion-like houses in the nearby suburbs but was now living and working in New York, took over a warrenlike penthouse at 168 East Seventy-fourth Street, between Lexington and Third Avenues. The apartment enjoyed an unspectacular north view across a broad terrace. Franzen opened up the space to loftlike proportions, screening off the skylit dining area and the raised library with low partitions and finishing the living area with modular Italian furniture.[71]

As a new generation of architects began to emerge in the 1980s, they too turned to devising their own domiciles as an aid to self-expression. But the roller-coaster economics of the eighties and early nineties, combined with the increasing popularity of the "downtown scene," altered the canvas from the rowhouse and apartment conversions that dominated the postwar era to one focused largely on lofts. There were notable exceptions to this, such as the maisonette apartment at 131 East Sixty-sixth Street that the husband-and-wife team of Steven K. Peterson and Barbara Littenberg recaptured from its recent function as doctors' offices, transforming it into a classically inspired suite (1983) of interconnecting rooms surrounding an implied courtyard, which they used alternately as a dining or conference room. The design, with its abstracted colonnades and implied vaults was, despite the designers' claims, distinctly Postmodern, but while there was nothing literal about its classicism, there was nothing jokey either.[72]

While Peterson and Littenberg were content to suggest a courtyard in Tuscany yet remain uptown, Peter Nelson, working with the artist Richard Haas, had used illusionistic murals in combination with a fairly free repertoire of classical elements in a loft (1975–76) at 305 Canal Street.[73] Fresh out of Cornell's architecture school, Nelson had been introduced to the monuments of the Renaissance by Colin Rowe, as well as Rowe's argument for a collagelike approach to counterpointing traditional and Modernist composition. The principal feature of the loft was the skylit atrium where Haas's illusionist painting opened the view to the exedra at the Villa Aldobrandini at Frascati, complete with two prelates strolling through the courtyard. Reflecting on the collaboration between Palladio and Paolo Veronese at the Villa Barbaro at Maser to create something steeped in antiquity yet distinctly of its own time, Martin Filler wrote that Nelson and Haas had created "a commentary on the fragmentation of the modern imagination (and modern architecture as part of that)" and with the loft made "an attempt to make that fragmentation whole again, a modest attempt at that, but one whose effect far exceeds the modesty of its means."[74]

Calvin Tsao and his partner Zack McKown, who had met when architecture students at Harvard and worked for I. M. Pei, renovated Tsao's 2,700-square-foot apartment (1983) at the San Remo. There the two set out the elements of the rather decorative Modernism that would be their hallmark: a gentrified irony, with knowing but archly delivered visual quotes from Ledoux and English country houses, mixed with references to the work of fashion designers such as Charles James. After three years' work on the apartment was over, the thirty-year-old Tsao invited his employer to dinner and a look-see. "So?" asked the young architect, to which Pei, looking out at Central Park replied, "It's hard to go wrong with a view like this."[75] Thomas Phifer and Jean Parker, both architects, practiced in different firms: Phifer as a partner of Richard Meier's; Parker as a partner in the firm of Buttrick White & Burtis, where she specialized in projects involving architectural preservation. In 1994, they drastically reconfigured their apartment to be more loftlike in appearance and to meet the needs of a family with young children.[76] Francois de Menil had commissioned an elaborate house from Charles Gwathmey before deciding to pursue a career in architecture on his own. In 1992, as one of his first independent projects, de Menil renovated an apartment for his family's use at 1021 Park Avenue (Rosario Candela, 1930), working in association with Bruce Nagel and Stephen Lesser, who had also recently left the Gwathmey office. The 3,900-square-foot duplex was extensively reconstructed and stripped of virtually all details, although the original plan was left pretty much intact. Aside from some cabinetwork, the principal interest lay in the collection of Secessionist and Prairie School furniture that joined a few pieces specially designed by the architect.[77]

Jane Siris and Peter Coombs, a husband wife team of architects, wishing to avoid conventional apartment living but not wanting to pioneer downtown loft neighborhoods, discovered yet another untapped resource, unused air rights of older apartment buildings that permitted the construction of reasonably elaborate penthouses. Siris/Coombs's 1,500-square-foot rooftop house, which grew out of a 400-square-foot studio penthouse, was awkwardly shaped to the point of whimsy yet not notably charming.[78]

David Rockwell, who would go on to an important career in what would come to be known as "entertainment architecture," (see Restaurants) also discovered rooftop living. In 1988, Rockwell, then in partnership with Jay Haverson, converted five maids' rooms into a 700-square-foot rooftop apartment. To relieve the meanness of the boxlike structure, Haverson/Rockwell enhanced the facade facing the roof terrace with a boldly scaled pediment carried on four square Doric columns.[79] Shelton, Mindel & Associates, working in association with Reed Morrison Architect, known for its good-taste Modernist interiors, extended their reach in Lee Mindel's beautifully detailed, low-pitched hipped-roof penthouse loft (1997), 143 West Twentieth Street, with a glazed barrel vault washing light over a skylight, an addition incorporating a graceful double-helix stair leading from a twelfth floor residence.[80]

Surprisingly, comparatively few architects undertook loft conversions for themselves. One exception was Malcolm Holzman, whose loft revealed an even zanier side to his personality than could be seen in his work as a partner in the firm of Hardy Holzman Pfeiffer.[81] The loft was designed with his wife, architect Andrea Landsman, who worked independently.

David Rockwell, 74 West Sixty-eighth Street. Haverson/Rockwell Architects, 1988. RG

Lee Mindel apartment, 143 West Twentieth Street. Shelton, Mindel & Associates in association with Reed Morrison Architect, 1997. Moran. MM

Malcolm Holzman and Andrea Landsman loft, 117 East Twenty-fourth Street. Malcolm Holzman and Andrea Landsman, 1990. McGrath. NMcG

"For our loft, Andy and I do what my clients won't let me," Holzman said.[82] Located at 117 East Twenty-fourth Street, nearer Gramercy Park than SoHo, the top-floor loft was pretty much left in its as-found condition. To achieve privacy, a series of more or less independent enclosures formed a master bedroom suite and a large storage area enclosed by roll-up garage doors. Reflected neon washed against metal walls stamped in brick patterns or kept in industrial corrugation. Calculated to shock by its raw brashness and the inclusion of aspects of the gritty realities of its industrial origins as well as of the modern urban condition, the loft was also receptive to an impressive collection of contemporary art and traditional crafts. Holzman apparently inspired his partner Hugh Hardy, and his wife, Tiziana, an architect who practiced separately, to abandon the comforts of a Greenwich Village townhouse for a top-floor 3,000-square-foot loft at 684 Broadway, which Mrs. Hardy fitted out with a series of modest rooms, some even wallpapered, grouped around an enormous 750-square-foot ballroom-salon intended for parties.[83]

Lofts

In June 1977, Paul Goldberger reported that converted loft, office, and hotel buildings had begun to rival, if not replace, "picturesque places" like Park Slope as the preferred setting for adventurous middle-class urbanity.[84] In part, Goldberger reported, the escalating availability of these new types of apartments was attributable to the 1976 Tax Reform Act offering benefits to developers reusing older structures, marking a complete reversal of previous policy that offered incentives for demolition and new construction. The trend was also the outgrowth of fresh planning ideas favoring mixed-use neighborhoods, as well as the recognition by developers that older buildings offered highly marketable opportunities for unusually configured apartments that the pressures for structural regularity made difficult in new construction.

Taking a broad view, Goldberger observed that "in a sense, the current trend represents a third phase of urban renewal growth—a phase that comes from a belief that cities depend enormously on their stock of older buildings for a sense of identity, and a lively physical environment to continue to attract and hold a middle class. Variety is a more important urban quality than order, exponents of this viewpoint feel." Goldberger went on to point out that New York, which had been "a leader in earlier phases of urban planning through its special incentive zoning districts and landmark preservation laws," was also the nation's leader in this new trend, with SoHo "the pioneering effort in commercial recycling."[85] But, Goldberger continued, though the recycling of older buildings helped retain and even expand the city's middle-class population, it did not address the needs of the poor. In so saying, like most commentators of the period, Goldberger, reflecting the social egalitarianism of the 1960s, was reluctant to come to terms with the fact that, to keep inner cities healthy, the needs of the middle class had to be met, so that by their presence jobs would be generated and taxes paid, thereby helping to provide for the less well off. This was confirmed in 1978 when a study prepared for the Citizens Housing and Planning Council by Rutgers University's Center for Urban Policy Research indicated that the city's policy favoring the conversion of outworn manufacturing and office buildings into residential lofts had resulted in providing housing for a population of well-

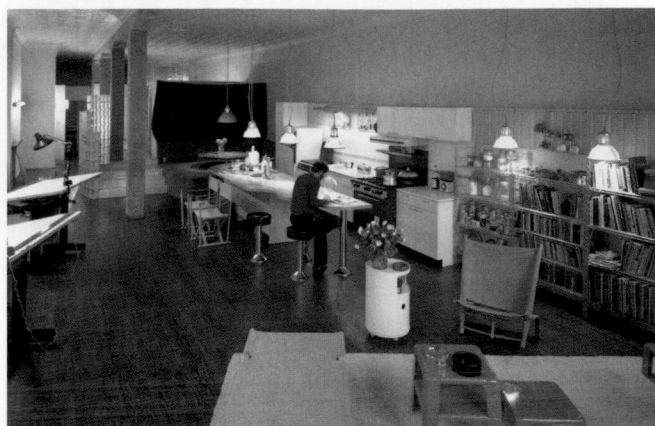

Alan Buchsbaum loft, 12 Greene Street. Alan Buchsbaum, 1976. McGrath. NMcG

Alan Buchsbaum loft, 12 Greene Street. Alan Buchsbaum, 1982. FS

educated and relatively affluent young people already strongly motivated to stay in Manhattan.[86]

Still, many of the city's lofts were illegally occupied as residences. While some that had long since outlived their usefulness as settings for manufacturing were ineligible for conversion, others that were eligible for conversion even though they still housed viable, if marginal, businesses were being emptied by landlords who anticipated changes in the law.[87] While city officials cracked down on illegal loft conversions in areas zoned exclusively for commerce and manufacturing, the pressure to make more loft space available for residential use continued to grow, leading to changes in the law and to the realization that, as Alan S. Oser, a *New York Times* real estate reporter, put it, "a whole new housing stock is in the making," not only in SoHo, NoHo, and Tribeca, but also other even more marginal manufacturing areas in Manhattan and beyond.[88] By 1980 there were more new housing units being created in lofts than in new structures.[89] The key to the new trend was the revision of the state's multiple dwelling law, a new provision of which, Article 7B, fostered the recycling of loft, commercial, and manufacturing buildings by providing developers with strategies that could be employed when the otherwise mandated thirty-foot-deep rear yards and 10 percent window-to-floor-area ratio for legally inhabited rooms could not be achieved. Article 7B permitted apartment windows to open either onto the street, a twenty-foot rear yard, or a twenty-foot interior light well. In place of the fixed 10 percent ratio of window to enclosed volume, it

introduced a sliding scale: 10 percent on rooms up to 500 square feet, declining to as little as 5 percent for rooms of 1,000 square feet or more.

To meet the increasing pressure for loft conversions, in 1981 the City Planning Commission proposed an extensive rezoning of midtown and lower Manhattan to protect certain manufacturing areas from residential conversion and establish certain mixed-use zones where the two uses could coexist, an idea that challenged the very heart of twentieth-century planning ideology and the very spirit that had motivated the introduction of land-use controls in New York in 1916. A large chunk of midtown above Fourteenth Street would fall into the new mixed-use category as would Tribeca, SoHo, and NoHo. The City Planning Commission approved this in February 1981, and the Board of Estimate followed suit in April.[90] In addition to clarifying the conversion rules, a fund was established to help relocate business tenants displaced by conversions, provided they remained in the city.

While the popular image of the loft was of a sprawling, largely open space punctuated by a row of ornamental cast-iron structural columns, many were relatively small and reasonably featureless units for one or two people—in essence a quirkier but in some ways less commodious form of the standard apartment. These were usually located in large buildings converted by one of a handful of large-scale developers who adapted the idea of loft living for a middle-class market, employing firms such as Bernard Rothzeid & Associates and Stephen B. Jacobs, which tended to preserve the exteriors of the buildings they tackled (though windows were sometimes less than sensitively replaced), while typically viewing the work inside as that of gut rehabilitation.[91]

The majority of attention regarding loft conversions was paid to those designed by prominent architects working for affluent or notable clients. As Mayer Rus noted in his 1998 book *Loft*, loft living, which had begun as an apparently radical, anti-bourgeois gesture, had become thoroughly domesticated "but by no means rendered bland or conventional." Moreover, Rus wrote, in the 1980s, lofts, "once typically the preserve of artists and other 'creative' types," had become "no less archetypally the sanctum of newly made plutocrats—a legacy, no doubt, of the reckless, booming 1980s economy of arbitrage, leveraged buyouts, and junk bonds." By the

Rosalind Krauss loft, 12 Greene Street. Alan Buchsbaum, 1976. McGrath. NMcG

century's end, the appeal of loft living was so broad that "no stereotypical profile" of the loft dweller applied.[92] Indeed, as Suzanne Slesin reported to readers of the *New York Times* in 1987, the pioneering era of loft living was over and "a new generation of settlers—young families—are taming and dividing up the raw open spaces of the loft frontier. Nowadays strollers are parked inside freight elevator entrances and highchairs dot newly installed kitchens. Once bohemian and casual, and often a design statement that was more glamorous than pragmatic, lofts are becoming established as convenient and spacious living spaces for children."[93]

Together with the co-op apartment—and by the late 1980s perhaps exceeding it—lofts became the city's principal showcase for young architectural talent. Loft living, with its loose-fit open spaces playing against the constraints of bounding walls and structural grid, depended principally upon and was, in its way, the fulfillment of the Modernist spatial revolution of the 1920s. Although there had been some stylish loft interiors designed by architects in the 1960s and early 1970s, the high-style residential loft really came into its own in the late 1970s and early 1980s when Alan Buchsbaum dominated the type.[94] The evolution of Buchsbaum's approach to loft design, leading from the casual, almost as-found approach of his own first loft to the high style of his work for the actress Ellen Barkin and the singer Bette Midler (see below), accurately mirrored the changing demography of "downtown." Buchsbaum's first lofts reflected the high-spirited version of "high tech" for which he was known. Buchsbaum's ad hoc approach could be seen in the loft (1976) he designed for himself in 12 Greene Street, a five-story, 25-by-90-foot building, that he bought the year before with two friends, the art critic Rosalind Krauss and the artist Robert Morris.[95] Buchsbaum's loft was casual, with curving glass-block partitions and extensive use of as-found industrial equipment that established a model widely imitated by the "average" loft-dweller. On the other hand, Buchsbaum's loft for Rosalind Krauss was so absolutely austere it led the art critic Robert Hughes, on his first visit, to proclaim: "The Bauhaus lives!"[96] In contrast to his own loft, Krauss's was unadorned, reflecting his client's taste. Only a core of utilities interrupted the white-painted, tin-ceilinged box of space. Critics found the restraint a welcome relief from the increasingly keyed-up aesthetics of Postmodernism. Janet Malcolm, in a profile of Krauss in the *New Yorker*, wrote that the beauty of the loft lay in its "dark, forceful, willful character. Each piece of furniture and every object of use or decoration has evidently had to pass a severe test before being admitted into this disdainfully interesting room. . . . But perhaps even stronger than the room's aura of commanding originality is its sense of absences, its evocation of all things that have been excluded. . . . No one can leave this loft without feeling a little rebuked: one's own house suddenly seems cluttered, inchoate, banal."[97]

In 1982 Buchsbaum moved his office and living space to the building's ground floor, where he doubled the usable area by slipping a steel-and-wood-supported mezzanine into the seventeen-foot-high space.[98] Here Buchsbaum moved away from both the austerity of the Krauss loft and the as-found quality of his own earlier loft toward a romantic elegance and stylistic eclecticism symbolized by the use of Postmodern pastel colors on the walls. The dining room and kitchen were on the mezzanine overlooking both the drafting room and a sunken hot tub shaped like a splash, which was part of a

Ellen Barkin loft, Chelsea. Alan Buchsbaum 1984. Gili. FS

George Ranalli apartment, 100 West Fifteenth Street. George Ranalli, 1984. Cserna. GR

22nd Street Loft, 21 East Twenty-second Street. George Ranalli, 1987. Cserna. GR

completely open suite that eliminated doors between bathroom and bedroom.

With the loft (1984) for Ellen Barkin, Buchsbaum entered into a much more romantic, even improvisational direction, which he went to some lengths to explain:

> I am the architect of this loft, and although it may sound fatuous to say that designing it and building it were an immense pleasure, they were. Much of the excitement came from working with my client, an American actress, who asked me to "fix" her place in Chelsea. It may also sound fatuous to say that I like my clients, but I do. They are primarily entertainers, and as the word implies, they are also entertaining. They are also adventurous and open to new experiences, so that suggesting the untried and daring is more interesting to them than copying a previously realized design. This particular actress was not a particularly easy client. She is capable of expressing everything an actress may be asked to express, and likes to practice her craft. I don't think we covered violence, but we did do crying, depression, hatred, and paranoia, as well as trust, love, enthusiasm, and laughing. We did a lot of laughing. . . . The furnishings are scattered in the areas we decided might be the best places to sit and eat. There are not formal axes, and the chairs and tables look as though they were set down by the movers and might be moved to some other spot, should the whim arise. The furnishings themselves are unrelated, except perhaps by color. They are meant to convey feelings of comfort and lack of pretension. The colors of the loft are purposely indecisive. They slide in both directions, toward the warm and the cool. The loft is lit by four tracks controlled from the entry. The various zones of the loft—living, dining, kitchen, sleeping—can, like a stage set, be lit or darkened according to the focus of attention.[99]

Bette Midler was one of the era's great and popular performers. Her 4,500-square-foot loft (1984) on the top floor of 451 Washington Street (1891) commanded sweeping views of the Hudson River.[100] Buchsbaum restored the space to its original state, "floating" within it a soundproofed music studio and treating bedrooms and bathrooms as modern insertions tucked away at the back. In the main room, Buchsbaum's hand was nearly invisible, except for some furniture.

By the early 1980s, the loft as a realization of the *plan libre* of 1920s Modernism, as can be seen in Mark Cigolle's Mercer Street loft (1980), began to give way to more complex and innovative interventions.[101] While Peix & Partner's loft (1980) for James Pepper, and even more so their Timothy Martin loft (1976), combined stylish finish and sophisticated plan-making to produce an effect more typical of uptown apartments, in the Chelsea loft (1980) designed for two art dealers who intended to use the space for daily living and business-related entertainment, they attempted a more complex and innovative approach with Postmodernist playfulness and boldly juxtaposed shapes.[102]

In keeping with the increased emphasis on theory-based composition in the early 1980s, a number of architects attempted to suggest a weightier, more profound architectural approach. Pe'era Goldman's Artist Loft (1982), in effect a modest subdivision of a square space, was freighted with analogies to the philosopher Ludwig Wittgenstein's Stonborough House.[103] Peter Wheelwright's Artist's Loft (1982), the principal feature of which was an elegantly detailed penthouse, incorporating a stair to the roof-garden, was also almost overwhelmed with high-minded rhetoric.[104]

Giuseppe Zambonini was also inclined to theorizing, but his tight-fit interiors were saved by a zesty inventiveness.[105]

K-Loft, 42 West Fifteenth Street. George Ranalli, 1993–95. Warchol. PW

Abramson-Zimmerman loft, 16 Hudson Street. Bentley LaRosa Salasky, 1983. Hursley. TH

His Chelsea loft (1979–80) for a musician and composer criss-crossed the narrow space with diagonal partitions screening kitchen and bedroom,[106] a strategy he also used for his own Tribeca loft (1977–80) with its fountain washing over hand-hewn slabs of Rossa di Verona marble found in a Brooklyn junkyard as well as other idiosyncratic fragments that gave the loft an almost bucolic character distinct from that of its warehouse setting.[107] Zambonini's Broadway loft (1979–80) was located in a light-splashed corner so that the principal walls followed the building's party wall, with individual "rooms" defined by airfoil-shaped wooden wedges.[108] While Zambonini, a former student of the Italian architect Carlo Scarpa, offered his work as a critique of the overt playfulness and formalism of Postmodernism, he did not completely resist the movement's storytelling impulses, insisting that his lofts reflect "the ambitions and memories of the designer, who tries to fill in with his own world of images the inevitable voids left in between the clients' desires and the potential of each space. It is the designer's responsibility to finally reach a discourse that not only follows from project to project, but reveals the urban nature of living in a loft and avoids romanticizing the industrial quality of these found spaces. Here is where an occasion for symbolism and rituality can exploit in full the theater of private and public spaces in New York City."[109]

But it was the American-educated George Ranalli rather than Zambonini who carried Scarpa's lessons forward in a new setting, beginning with his own one-room 325-square-foot studio apartment (1984), 100 West Fifteenth Street, southwest corner of Sixth Avenue. The apartment, located in a converted nineteenth-century warehouse, had the advantage of a ceiling high enough to permit Ranalli to shape a sleeping loft above the entry and kitchen as an elaborately modeled and articulated abstract sculpture inserted in the brick-walled space.[110] Ranalli's "22nd Street Loft" (1985), was intended as a response to what Anthony Vidler described as the "delicate problem" of loft design: "Should the space be left more or less as found, with the minimum of intervention, thus allowing the special qualities of openness, light and quasi-industrial fittings to be retained? Or should the raw space be entirely transformed into a replica of an apartment?" In response to this, Ranalli constructed what was almost literally a house within a house, leaving "the main space of the loft, like some small piazza," but "dramatically enhanced by the various 'windows,' balconies and stairways that look into it." The principal feature

of the loft was the reflective canopy over the bed, a folded plate of sheet brass that provided intimacy, "enclosing without entombing," suffusing the entire loft with a reflected golden light. According to Vidler, Ranalli's work, while reflecting that of Scarpa, was notable for its greater concern for "the relations of part to whole."[111]

Ranalli's K-Loft (1993–95) was commissioned by a husband and wife, both artists, who had lived with minimum comforts in the space for seventeen years until they became parents and required a more conventional arrangement.[112] Because the density and intense color of the brick walls and the brick vaulted ceiling had been a compelling part of their experience and its feeling had to remain despite the new work, Ranalli's response was to insert room-size enclosures within the 2,100 square feet of host space, wrapping them in carefully layered planes and assembling plywood and drywall in relationship to the structural brick to provide a rich vocabulary of abstract details.

The arrival of the money crowd brought with it an ever increasing demand for stylish loft interiors. Bentley LaRosa Salasky, a team of young, Columbia-trained architects (Ron Bentley and Sal LaRosa) and a decorator (Franklin Salasky), satisfied this demand while at the same time effectively contributing to the effort, encouraged most convincingly by Colin Rowe in his and Fred Koetter's book, *Collage City*, to achieve a synthesis between high-style Modernism and classicism.[113] As Bentley said: "Modern architecture has followed a minimalist path, but we prefer a Cubist-collage approach."[114] The firm addressed the problems of loft renovations in no significantly different way from the way they approached uptown apartments.[115] Their 1,500-square-foot Abramson-Zimmerman loft (1983), 16 Hudson Street, which Sal LaRosa characterized as "a cross between a Cubist collage and an English country house," was intended as a critique of Postmodernism's "'decorated' plans" that "look great," but lose "something in the translation to the elevations."[116] Instead, the team chose to decorate its elevations, providing a new traditional setting, with paneled walls, arched niches, and other time-honored details as a backdrop to contemporary furniture. The play with traditional styles was carried further back in time by Richard Gillette, a decorative painter who transformed his loft into a Pompeian villa overlaid by other historical references that reflected, as Herbert Muschamp reported, "not only . . . a succession of periods in the decorative arts but also . . . the enthusiasms Gillette has passed

David Salle loft, 9 White Street. Christian Hubert, 1984. Street-Porter. HUB

Toms loft, 644 Broadway. Peter Eisenman and Faruk Yorgancioglu, 1984–87. McGrath. NMcG

Ludwig/Fineman loft. Thomas Leeser, 1987. TL

through since he abandoned easel painting for decorative design."[117] In 1976, using period furniture, new pieces, and, most spectacularly, wall murals covering virtually every surface, including some ceilings, Gillette had transformed his brother Francis Gillette's apartment in 735 Park Avenue into a total Art Deco environment such as virtually no apartment had ever enjoyed, even in the style's heyday of the late 1920s and early 1930s.[118]

Christian Hubert, a young architect, transformed the very-successful-painter-of-the-moment David Salle's loft (1984) into a fantasia on the theme of Modernism, sheathing cast-iron Corinthian columns with tapered plaster shafts reminiscent of those Le Corbusier used at his Unité d'habitation in Marseilles of 1952, and, as a tribute to another aspect of Le Corbusier's work that had been suburbanized by Marcel Breuer in the 1940s, including a freestanding flagstone wall. Hubert's collagist approach mirrored Salle's, who, speaking of his own work, stated that it didn't matter "where the images are from . . . in terms of art history. When there is a reference, it isn't an art-historical one."[119] For Hubert, Salle's take on imagery was more than compatible: "David's paintings often extrapolate and recombine elements of America and the 1950s. . . . I adopted a similar recombinant imagery for the loft, placing special emphasis on the importance of surface materials." But the effect was somewhat campy. Accused of creating a "period piece," Hubert said that he "was just interested in using materials such as the aluminum and flagstone" and that the client's collection of postwar furniture "forced the 50s issue."[120] The Kathleen Schneider penthouse (1986–87) in SoHo by Hariri & Hariri, in effect a duplex loft, was lifted above the "good taste Modernism" of much of Bentley LaRosa Salasky's work and even that of Hubert's Salle loft by the limpid craftsmanship of its burnished steel spiral staircase and bar.[121]

At the opposite extreme to the intensely individualistic, even intuitive character of George Ranalli's approach lay Peter Eisenman's attempt to systematize the design process by basing his composition on the geometries of site, which, in the case of the Toms loft, were irregular enough to yield an interesting design. When asked by painter Emily Fuller and banker Newby Toms to renovate their 4,800-square-foot loft (1984–87), 644 Broadway (Steven D. Hatch, 1893), southeast corner of Bleecker Street, Eisenman, busy at work on large-scale projects, declined the job, but he was eventually persuaded to design the project and let his assistant Faruk Yorgancioglu carry it out. Currently at work on the Wexner Center for the Visual Arts, Ohio State University, Eisenman was intrigued by the prospect of adapting the strategy that had proved effective in Ohio to the more modest problem of a New York loft.[122] As at the Wexner Center, Eisenman based his design on the site, in this case using the building's chamfered corner to set up two separate planning grids and taking advantage of the building's skewed party wall to enliven a series of interconnected "rooms" that could be closed for privacy. Not content merely to latch on to such local conditions, Eisenman also claimed that his plan encapsulated the disjuncture between Broadway's canted axis and that of the Manhattan grid, which began only a mile or so to the north. A series of "stalactites" hanging from the ceiling further articulated the plan, which Eisenman confessed left him with "moments" when he felt "completely disoriented," referring to the private suite that took on its own geometry at the

corner.[123] According to Eisenman, "the intersection of the two geometries was used to produce a condition where neither geometry was dominant in either the vertical or horizontal dimension," producing the effect of displacement and destabilization the architect deemed an essential reflection of current conditions.[124] Cost prevented Eisenman from further dislocating the inhabitants' sense of place when he was unable to cover the ceiling in the same maple parquet used for the floors.

In 1987 Thomas Leeser, another key Eisenman collaborator, set four partly enclosed spaces at an angle in a single large space, creating a less wrought up but not necessarily less meaningful dialogue between the loft space and its subdivision. If, as Thomas Fisher suggested, the ideas behind Leeser's Ludwig/Fineman loft appeared "less visionary and more rational, less an evocation of power and more an essay about space" than Eisenman's did, it was because the design, as Leeser pointed out, was more grounded in traditional composition: "It is both a Modern space, without doors, and a Classical space, divided into four segments and a nine-square grid."[125] Michael McDonough's loft (1987) for Stephen and Marsha Berini, with its dramatically skewed and sinuously curved walls, was one of the period's more spatially inventive and formally eclectic, reflecting the witty and knowing McDonough's conviction that design should represent its moment and that "the 1980's in general are characterized by borrowing and recycling images from the culture, and doing it in a rough and discordant way."[126]

Tod Williams and Billie Tsien's 5,000-square-foot Quaindt loft (1988–90) in Greenwich Village helped to inaugurate the trend toward big, carefully crafted lofts with clearly defined spaces. In contrast to the spatial gyrations of Eisenman's work, or the theatricality of Buchsbaum, Williams and Tsien offered a symmetrical plan for the floor-through space, with the center reserved for a terrazzo-floored living room bounded by gently folded walls that slid past the structural columns. But the principal feature was what Clifford Pearson described as a "barrier-like" twelve-foot-long faceted plywood partition that rotated along a metal pole at the entrance to the loft.[127]

William MacDonald and Sulan Kolatan, a husband and wife team practicing as the Kolatan MacDonald Studio, were, like Eisenman, preoccupied with displacement—they quoted Paul Eluard's description of "Houses . . . turned inside-out like gloves"—but also with the reality of transiency, so that the design of their 2,500-square-foot M loft (1990), commissioned by an art-collecting couple and consisting of a panelized glazed aluminum wall, could be dismantled and relocated to another space.[128] Henry Smith-Miller and Laurie Hawkinson, another husband and wife partnership, were responsible for a number of significant lofts as well as high-style apartment interiors. The best of the firm's work effectively breached the chasm between obsessional asceticism and good-taste Modernism. For Murray Moss, the fashion designer and collector of design objects from the 1950s and 1960s, whose loft (1990) was in midtown, Smith-Miller + Hawkinson sought to preserve the original factory-like character although they so "idealized" and reproportioned the actual elements, regularizing the formerly casual arrangement of beams to reinforce the geometry of the reconfigured space, that the result was rather bland, with the exception of pivoting and sliding screen doors to shield the elevators from the living space, which provided a bit of dynamism.[129] Their Robert Greenberg and Corvova

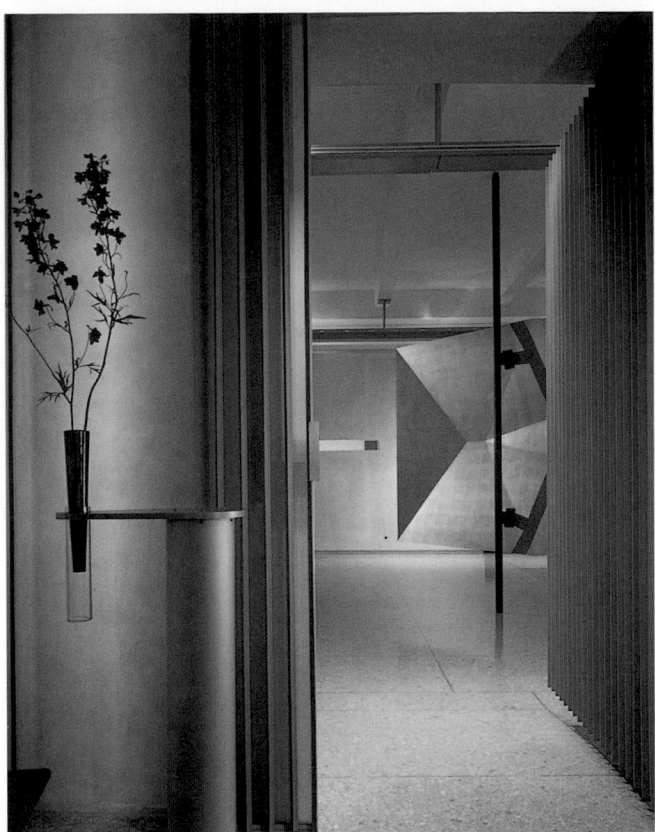

Quaindt loft, Greenwich Village. Tod Williams Billie Tsien & Associates, 1988–90. Paige. TWBTA

M loft. Kolatan MacDonald Studio, 1990. Moran. MM

Murray Moss loft, Midtown. Smith-Miller + Hawkinson, 1990. Piazza. SMHA

Howell loft, 140 Perry Street. Deborah Berke, 1997. Warchol. PW

Steven Holley loft, 832 Broadway. Hanrahan + Meyers Architects, 1994.
Aaron. ESTO

Urban Interface Loft, 40 Hudson Street. Dean/Wolf, 1997. Aaron. ESTO

Choy Lee loft (1997) sprawled across 7,500 square feet on the top floor of 348 West Thirty-eighth Street, with a steel and glass mezzanine adding another 2,500 square feet. Greenberg, a major figure in the emerging field of digital imaging, who was also a collector of outsider art, had begun with 3,000 square feet designed by Studio Morsa in the 1980s and renovated by David Roth in 1994.[130] Smith-Miller + Hawkinson "sutured" the interiors together, ending up with a bright, complex but not complicated mix of as-found and introduced structure defining clear, white painted rooms and areas.[131]

The passionately minimalist Deborah Berke, who was responsible for a number of lofts in the 1990s, dismayingly noted that "people don't want the lofts of the 1970s. They want bigger and bigger lofts with pantries, separate bedrooms, several bathrooms. And once you cut up the old 1,800 square foot loft, you lose the big, open loft feel. They really want the advantages of an apartment building in a loft—lobbies, a doorman . . . someone to take out the garbage. These people are not pioneers."[132] In 1997 Berke was at work on four lofts in 140 Perry Street, a four-story concrete building of 1909 once owned by the artist Joel Shapiro, and subsequently by the architect-developer Cary Tamarkin, who divided it up into eight 2,400-square-foot units. Berke had three clients for the four spaces, two artists and a lawyer (one client put two units together). "The building used to be a stable, but the aesthetic of the new spaces will be more industrial than agricultural,

with new bare concrete floors poured on top of the old."[133] Berke's loft (1997) for Jim Howell, a minimalist painter, and his wife, Joy, cleared half the 2,400-square-foot space for use as a gallery, confining the living room to one corner and the bedroom to the other. The rigorous gray-and-white color scheme deferred to the "unbelievably exacting and pure studies in gray" of Howell's paintings.[134]

Scott Marble and Karen Fairbanks's 4,500-square-foot loft (1995) for a family of four, the third loft for the same client, made ingenious use of a central spine of sliding screen walls separating the more formal from informal gathering space to allow the adults and children to enjoy the kind of privacy from each other that would be typical in a suburban house.[135] Tom Hanrahan and Victoria Meyers's loft (1994), 832 Broadway (Ralph Townsend, 1896), for Steven Holley, a lawyer who encouraged his architects in their struggle to redefine their practice along strictly Modernist lines, led to a design employing walls of clear and sandblasted glass to shape a quietly austere 3,800-square-foot environment that at first glance seemed little more than a redefinition of good-taste Modernism for a new generation.[136] But further consideration revealed a greater subtlety, which allowed the owner to enjoy the full extent of his space from virtually any part of it, with a variety of cabinets and partitions that could be moved as privacy required. Holley was in many ways a perfect client for a big open loft. According to Meyers, he left his work at the office and did not own a television.

The husband-and-wife team of Kathryn Dean and Charles Wolf were another young firm using loft conversions to push the limits of design. Their modest downtown studio apartment (c. 1994) was subdivided into "rooms" by five screens finished in canvas and steel, rough wood and polished cotton. Additionally, like so many other young architects at the century's end, they experimented with concrete casting and specially pigmented finishes.[137] In 1997 Dean/Wolf relocated to a five-story loft building (1857–58) in Tribeca at 40 Hudson Street where they occupied the top floor with a combined apartment and studio and, on the floor below, undertook the renovation of a 1,400-square-foot loft for a painter.[138] The principal feature of their own "urban interface loft," as they called it, was the reconfiguration of the usual bulkhead stair inside out, creating a sunken court within the volume of the house which Alexander Gorlin characterized as "a jewel-like cube of space," defined by copper-clad walls, clear and translucent glass, and traversed by a boldly configured stair with cast-concrete treads and risers leading to the roof. "Strangely enough," Gorlin continued, "although located on the top floor apartment, the space evokes a subterranean dwelling; the ground plane appears to be above, at the roof level. The inversion of the expected gives a mysterious quality to this downtown Manhattan space."[139] According to the architects, "dwelling below grade" was the motivating idea: "Conceptually, the horizon line was taken to be the level of the rooflines of this building and others surrounding Duane Park. The ceiling was then sliced open, and the landscape of the sky was revealed. When this new 'ground plan' dropped down into the center of the loft, a courtyard lined with copper was created."[140]

1100 Architect was begun in 1983 by Ines Elskop, David Piscuskas, Juergen Riehm, and Walter Chatham, who soon left to pursue work independently. Throughout the 1980s and 1990s, the firm was responsible for a succession of residential and commercial interiors, many undertaken for clients from the worlds of literature and the arts, that reexamined Modernism as a highly agreeable style while avoiding its more confrontational aspects, then represented by Deconstructivism.[141] For the actor Ron Rifkin and his wife Iva, 1100 Architect transformed a 3,000-square-foot, U-shaped loft (1996) as a backdrop for a collection of 1950s furniture, cabinets, and objects.[142] The firm's studio and residence for the painter Ross Bleckner (1990) exuded even more of the "good taste" that was such a surprise in Christian Hubert's loft for David Salle, especially the two top floors devoted to the artist's living quarters which were subdivided into beautifully shaped and proportioned rooms similar to those in its Greenwich Village townhouse (1991).[143]

Despite twenty years of stylistic experimentation—or at least high-style—some loft dwellers, preferring the comforts of "home," saw the lofts in terms of space waiting to be shaped into rooms. Some even, like, the banker turned photographer Henry Buhl, went even further, commissioning Judith Stockman to transform a 7,000-square-foot loft (1996) at 114 Greene Street into a rather elaborate version of a grand Tuscan village, obliterating virtually all traces of the space's factory origins.[144] William T. Georgis's 4,200-square-foot loft (1996) for Stephen Jay Gould, the paleontologist, and his wife, Rhonda Roland Shearer, an artist and writer, 62 Greene Street, managed to convey the feeling of a very spacious uptown apartment or, even more so, a country house in Westchester County.[145]

OFFICE INTERIORS

By the mid-1970s, the postwar era's concept of hierarchically regimented business interiors was being challenged on all sides. For one thing, the typical offices of the 1950s were ill-suited to the new dynamics of the workplace where electronic equipment was beginning to play a key role. For another, the post-1960s generation, the yuppies and baby boomers, representing a "me generation" with an enhanced sense of entitlement, were demanding more space, more light, more color, more drama, and more amenities such as better in-house food, exercise rooms, showering and changing facilities, and so on. In the 1960s, the so-called open-plan office landscape was offered up as an initial response to the new sensitivities of workers and the new management techniques of employers.[1] But its frequently zany plans and the general abolition of private offices that went with the approach were poorly received. As Ada Louise Huxtable, reporting in 1979 on an unidentified national sampling of corporate managers and employees, wrote: "New office systems simply regiment discontent. The workers want more, not less, privacy; better workspace, and easier access to essential equipment. They rate these things higher than raises or fringe-benefits. They agreed, almost to a man and a woman, that the relationship of surroundings to job satisfaction is extremely high. Their call is not for more stylish design, but for more considerate and comfortable design. . . . The business of 'space planning' cannot begin to cope with the deep-seated needs, inner defenses and libidinal responses that dictate the personal sense of space. Those who spend more time in offices than at home find the psyche continually assaulted. Gild not the lily, perfume not the air; when the designer comes in, let the workers beware."[2]

Gwathmey Siegel & Associates was one of the few leading architectural firms to consistently design office interiors. The firm developed this aspect of its work in order to stay afloat during the recession of the early 1970s. The rigorous geometry and solidity of form that was the trademark of its early houses proved remarkably adaptable to the kind of office interiors the firm took on which were typically for high-profile firms in finance, law, and advertising.[3] Its 2,500-square-foot executive

Reliance Group Holdings, 55 East Fifty-second Street. Gwathmey Siegel & Associates, 1979. Ardiles-Arce. GSAA

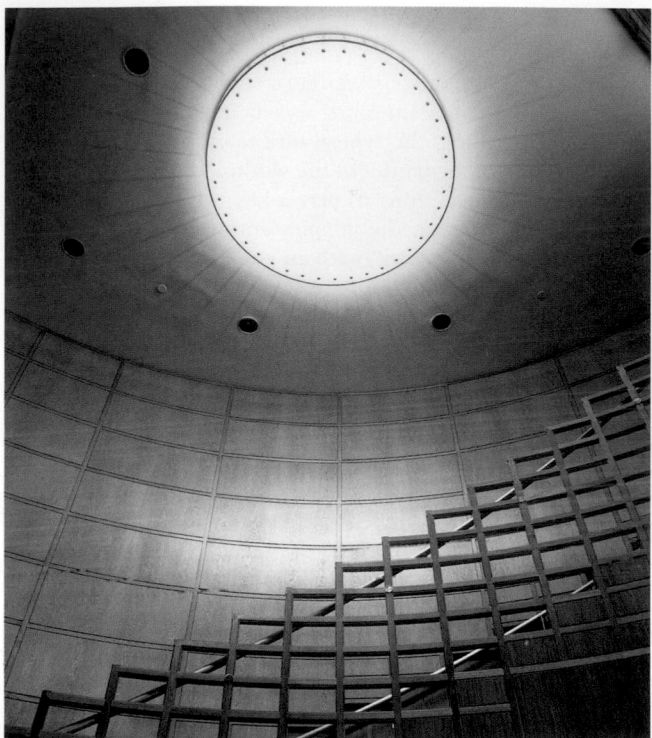

SBK Entertainment World, 1290 Sixth Avenue, Gwathmey Siegel & Associates, 1988. Kaufman. GSAA

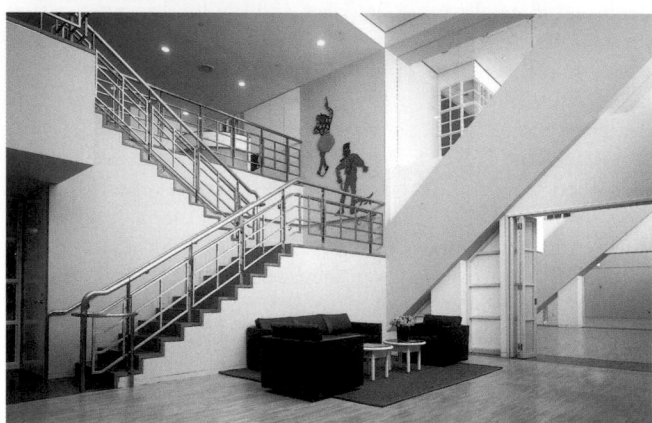

Offices of D'Arcy Masius Benton & Bowles, 1675 Broadway. Gwathmey Siegel & Associates, 1988. Entry lobby. Warchol. GSAA

offices for the Evans Partnership (1977), a real estate development company that also hired the firm to design a number of its suburban office buildings, featured glass-block walls that wrapped a small conference room.[4] A perhaps overly theatrical black glass mirrored wall helped resolve the awkward layout of the leased area as it tricked the space into seeming larger. The firm's offices for FDM Productions (1977), though half the size, were better situated, so that virtually all offices enjoyed outdoor light.[5] Again, mirrors were used to trick the space. Far from regarding them as a necessary evil, Charles Gwathmey relished the interior projects, which gave him and Robert Siegel "the opportunity to experiment on a smaller scale with the issues that we focus on in our buildings."[6] The 4,500-square-foot offices of Morton L. Janklow & Associates (1979), 598 Madison Avenue, were subtle and quite close in scale and ambiance to one of the firm's more luxurious houses. According to Siegel, Janklow, a lawyer and literary agent and

Offices of Ronald Lauder, 767 Fifth Avenue. Gwathmey Siegel & Associates, 1992. Warchol. GSAA

also a prominent art collector, believed "in working in a piece of art."[7] It was Siegel who more and more took on the responsibilities for the increasingly large-scale offices the firm was called upon to design. Among these were the two full floors of offices of the advertising firm Ally & Gargano (1979), 360 West Thirty-first Street, which featured a swank two-story reception area with mirrored aluminum ceiling tile and a pipe-railed open staircase as well as black laminate cabinetwork in the individual offices.[8]

Gwathmey Siegel's offices for Reliance Group Holdings (1979), located in Skidmore, Owings & Merrill's Park Avenue Plaza (see Park Avenue), 55 East Fifty-second Street, were larger and grander than its previous office interior work, totaling 75,000 square feet on three contiguous floors, leading the firm to pursue a design that would convey feelings of "permanence, quality and substance."[9] To combat the disorienting plan of SOM's building, with its huge floor areas and off-center location of the elevators, the three floors were linked by stairs rising through a vaulted lobby at the elevator core. The entire entry hall, including the vaulted ceiling as well as many other surfaces, and much of the furniture was finished in oak. Reliance was followed by the 42,000-square-foot offices for SBK Entertainment World (1988), 1290 Sixth Avenue, another large installation featuring vaulted ceilings, oak paneling, and a spectacularly detailed oak-lined stair hall suggesting a new influence on the firm's work, that of the gridded language of the Wiener Werkstätte. That group's decorative patterns in objects and furniture were also beginning to intrigue the architect Richard Meier and Nan Swid, the wife of SBK's chairman Stephen Swid and founder in the early 1980s, with Adie Powell, of the firm Swid Powell, for whom Gwathmey and Meier designed Wiener Werkstätte–influenced china and glassware.[10]

The 300,000 square feet of offices on fourteen floors for

D'Arcy Masius Benton & Bowles (1988) in Fox & Fowle's 1675 Broadway (see Times Square), on the northwest corner of Fifty-second Street, was not only the firm's largest and most complex interior to date, but also its most free-spirited. Because the offices were in a building that was cantilevered over a neighboring structure, Eugene De Rosa's Colony Theater (1924) (renamed the Broadway Theater), portions of the space leased by the advertising agency were interrupted by supporting trusses which, according to Robert Siegel, the firm regarded "as an asset," leading it to remove a floor in this area and expose the double-height entry lobby crisscrossed by a diagonal structure that complemented the diagonals of an open stair.[11] Gwathmey Siegel's design for McCann-Erickson, another large advertising firm, in 750 Third Avenue (Emery Roth & Sons, 1958), on the west blockfront from Forty-sixth to Forty-seventh Street, was less spectacular although just as big, with 300,000 square feet also on fourteen floors.[12] But the firm's 5,000-square-foot office (1988) for the Georgetown Group, 667 Madison Avenue (David Paul Helpern Associates, 1987), a real estate management firm, reasserted the mix of intimate, almost domestic scale with the corporate efficiency that characterized all its efforts.[13] Fitted out with soft, gently shaped upholstery and a mix of Wiener Werkstätte and contemporary chairs, the space was low key but still rigorous, with an especially elegant circular conference room.

Ronald Lauder, heir to a cosmetics fortune and former United States ambassador to Austria, gave Gwathmey Siegel an opportunity to fully explore its interest in early-twentieth-century Viennese furniture when he asked the firm to design his office (1992) on the forty-second floor of Edward Durell Stone's General Motors Building (1968), 767 Fifth Avenue, east blockfront from Fifty-eighth to Fifty-ninth Street. Lauder, who had acquired a group of Secessionist furnishings as well as a collection of early-twentieth-century German and Austrian Expressionist paintings, instructed his architects to create, as Gwathmey put it, an environment "whose palette and aesthetics would complement and present the collection in the best light."[14] Stimulated by the museum aspect of the commission, Gwathmey Siegel produced one of its most refined designs, with a spectacularly lit, gabled corridor-spine and a number of interestingly shaped rooms including a nearly circular dining room with a coffered ceiling, which was liberated from the constraints of standard lay-in acoustical tiling and articulated with a subtlety worthy of Otto Wagner whose light fixtures designed in 1906 for the Postal Savings Bank Building in Vienna were used.

Robert A. M. Stern Architects, which rarely took on corporate interior design commissions, renovated the thirty-sixth floor of Rockefeller Center's International Building (Associated Architects, 1935), 630 Fifth Avenue, for Capital Research (1987–89), an asset-management firm.[15] Stern sought to respond to the center's craftsmanship but, reflecting the contextualism of the 1980s and, especially, the wellspring of affection and respect for the complex that had grown up over those years, the design also attempted to extend the language of the building's public spaces into a suite of private offices.

Kohn Pedersen Fox Conway was the interior design subsidiary of the firm of Kohn Pedersen Fox, founded in 1976, becoming the leading corporate proponent of Postmodernist interior design. Like its parent architectural firm, KPFC began with rather conventional Modernist work: the 450,000-square-foot redesign of the offices of AT&T (1979), 195

Capital Research Company, 630 Fifth Avenue. Robert A. M. Stern Architects, 1987–89. Aaron. ESTO

MONY Financial Services, 1740 Broadway. Kohn Pedersen Fox Conway, 1984. Lobby. Warchol. PW

Broadway (William Welles Bosworth, 1914–17), only a portion of which was realized, was a competent but fundamentally conventional example of late International Style Modernism.[16] The Postmodern classicism of KPFC's interiors for the Equitable Life Assurance Company went much further toward an embrace of traditional detail than the tepid gestures of the building in which they were located, Edward Larrabee Barnes's Equitable Center (1986), 787 Seventh Avenue, between Fifty-first and Fifty-second Streets (see 6½ Avenue). The classicism of Equitable's offices, reflecting preferences of company management, was unusual in the firm's work. The firm's Postmodernism more typically focused on the revival of Modernist motifs from the 1920s and 1930s, as could be seen in one of its most convincing efforts, the renovations to the lobby and executive offices (1984) of MONY Financial Services. In its previous incarnation as Mutual of New York, the firm had commissioned its headquarters building, 1740

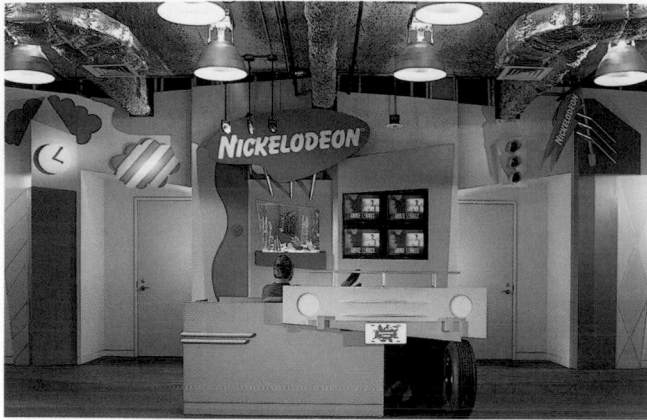

Viacom, Nickelodeon division, 1515 Broadway. Kohn Pedersen Fox Conway, 1991. Kaufman. EK

Broadway, east side between Fifty-fifth and Fifty-sixth Streets, from Shreve, Lamb & Harmon in 1939 but did not see it completed until 1950.[17] The design effort was led by Paul Rosen, an architect, who worked with J. Woodson Rainey, a leading design architect on the KPFC staff. Of principal interest was the redesign of the entrance to the MONY building, which the architects re-framed with a granite and brass door surround intended to strengthen what the journalist Paul Sachner characterized as the building's "feeble Art Deco roots," and the new lobby there. Stainless steel column enclosures and dramatically flared pendant light fixtures were set off against a black, white, gray, and reddish brown marble floor, whose

diagonal pattern echoed the diagonal geometry of Broadway.[18] On the twelfth floor, devoted to executive entertaining, the firm, responding to the interests of MONY's chairman, paid homage to Eliel Saarinen's modern classical work at Cranbrook, reproducing key pieces of furniture and commissioning more in the same spirit from craftsmen.

For Rosecliff, Inc., headed by Peter Joseph, a private investor who also ran a gallery specializing in the furniture of contemporary craftsmen such as Wendell Castle, KPFC's 12,000-square-foot offices (1988) on the thirty-second floor of KPF's 712 Fifth Avenue (see Fifth Avenue) were designed by J. Woodson Rainey, who once again, as in the Casual Quilted Giraffe (see Restaurants), revealed a meticulous, even obsessive, sense of detail, configuring the sleek glass, metal, and stone interior around a 160-inch dimensional module which he used as the radius for the segmentally arched spine that bisected the space and for the curved, marble-topped reception desk.[19] Rainey's *pièce de résistance* was Peter Joseph's desk, a steel plate resting on three idiosyncratically designed cones. In 1995, Joseph moved to new offices on the thirty-fourth floor of the same building, again commissioning Rainey and the KPFC team, which obliged with a suite of rooms that showcased the craftsman-designers represented in Joseph's gallery. Surprisingly, the normally controlling Rainey was willing to collaborate, observing with more enthusiasm than historical accuracy, "Not since the Wiener Werkstätte or the Bauhaus, has an architect had the chance to work with such a group of artists."[20] This time Rainey worked with a forty-inch module, providing limits for the size and placement of the work, which

Offices of William M. Mercer, Inc., 1166 Sixth Avenue. R. M. Kliment & Frances Halsband Architects, 1980. McGrath. KHA

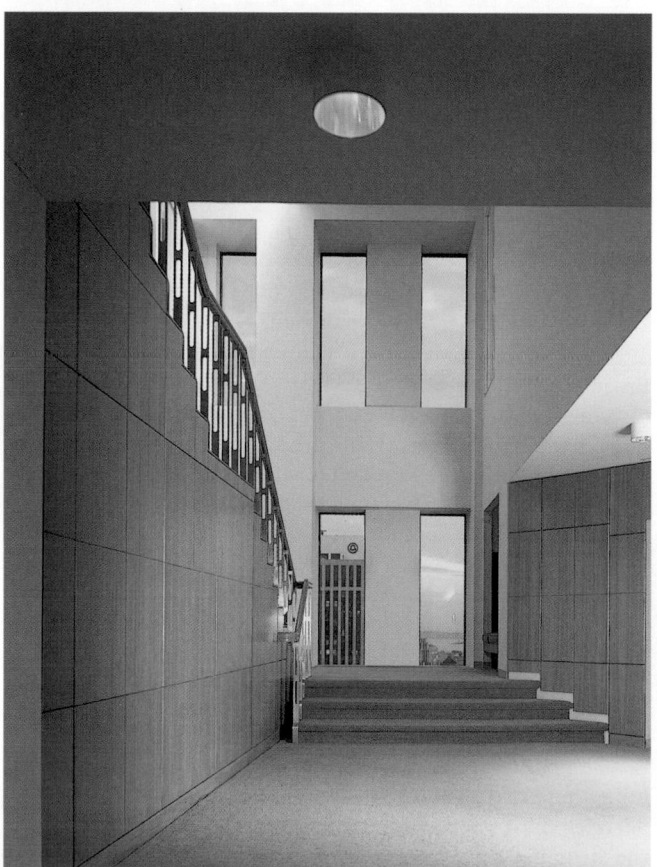

Offices of Levine, Huntley, Schmidt & Beaver, 355 Park Avenue South. R. M. Kliment & Frances Halsband Architects, 1986–88. McGrath. KHA

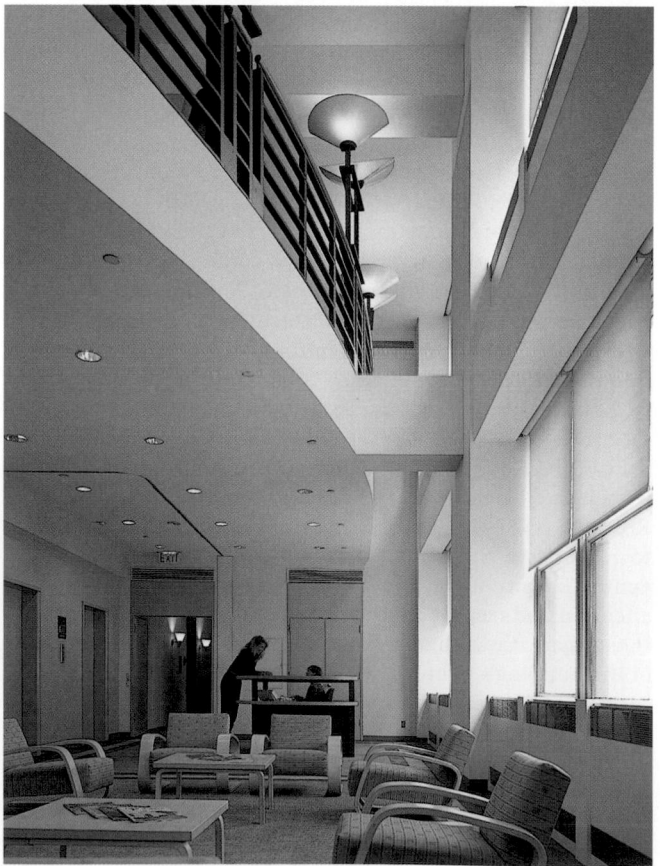

included a glass wall by James Carpenter consisting of dichroic panels casting rainbows of color on adjacent surfaces, a conference table *en pointe*, with feet in ballet slippers, designed by Gaetano Pesce, and door pulls by sculptor Albert Paley. Painted side panels and a reception desk were placed in the oak-lined lobby designed by Rainey.

True to Postmodernism's commitment to site- and program-specific design, the firm's next important interior was completely different, a suite of spaces for the various cable networks of the Viacom corporation, especially for its Nickelodeon division, an immensely popular channel catering to the young.[21] To convince the client that the firm could be child-friendly, Rainey developed a set of fantasy drawings suggesting how the project might develop, although none of the drawings was literally interpreted in the final work. But cartoonlike design was not Rainey's forte. In the 3,200-square-foot corner suite (1992) for the executives of Polygram Holding, the record company, in Skidmore, Owings & Merrill's Worldwide Plaza (see Clinton), he returned to his more characteristic mode, imposing on the space a tartan plaid of metal, stone, and glass that suggested a muted version of Constructivist sculpture from the 1920s.[22]

R. M. Kliment & Frances Halsband Architects was another firm shoring up its practice with corporate office interiors. The firm's reserved approach could be seen in the interiors for an unidentified law firm (1975–76)[23] and in the corporate headquarters and New York offices of William M. Mercer, Inc. (1980), located on the thirty-eighth, thirty-ninth, and forty-third floors of Skidmore, Owings & Merrill's 1166 Sixth Avenue (1974), east side of the avenue between Forty-fifth and Forty-sixth Streets.[24] The "style" of this early work was difficult to assess. As a sympathetic observer, Gerald Allen, put it: the offices were "reflections of Alvar Aalto and, more conceptually than visually, of Louis I. Kahn—perhaps through Mitchell/Giurgola, for whom [they] once worked. The results, though, are not very precise reflections of anything, and this may seem slightly weird and strange, and may raise eyebrows, bore, or even offend. This is perhaps to say only that the work . . . looks different."[25]

In the early 1980s, the firm dipped gingerly into the prevailing waters of Postmodern classicism, as seen in its offices for A. G. Becker Incorporated (1981), a venerable brokerage and banking firm occupying 157,000 square feet of space on the twenty-eighth through thirtieth floors of 55 Water Street (Emery Roth & Sons, 1972).[26] The vast floors were largely made up of businesslike office suites, mostly executed by specialists working under Kliment and Halsband's direction, but the circulation and especially the grand reception room, with its stepped octagonal ceiling, addressed the client's desire to convey a traditional image of stability. Still, the effect was somewhat standoffish, perhaps because as Charles Gandee wrote, "their work has been enriched by prevailing currents rather than swept away by popular trends."[27] Subsequent offices, such as the 54,000-square-foot space on three floors for the advertising agency Levine, Huntley, Schmidt & Beaver (1986–88) reflected a surer sense of form, more closely associated with the Modernist tradition.[28] Located in a loft building at 355 Park Avenue South, the offices were entered through a dramatic two-story reception area furnished with Alvar Aalto's low-slung bent-wood arm chairs, the curves of which complemented the curving arc of the second-level balcony above.

In 1976 Simon & Schuster, the book publishers, commis-

Simon & Schuster, 1230 Sixth Avenue. James Stewart Polshek & Associates, 1976. Stocklein. PPA

Simon & Schuster, 1230 Sixth Avenue. Allan Greenberg, 1986–87. Boardroom. Mauss. ESTO

sioned James Stewart Polshek & Associates, working with Pamela Babey, an associate for interior design, and John and Mary Condon, graphic designers, to redesign the eleventh through fourteenth floors of 1230 Sixth Avenue, originally the U.S. Rubber Company Building (Associated Architects, 1940), the last building of the original Rockefeller Center complex to be completed. This was to be the first of a number of large office interiors undertaken by Polshek, who clung to a straight Modernist approach in defiance of the prevailing Postmodernism. For Simon & Schuster, Polshek and his team created a suite of offices that was, according to Paul Goldberger, "soft, almost sensuous, but never theatrical." The use of a different color as a theme to help identify each floor and of mural-sized blow-ups of Diderot prints on bookmaking as wall decorations, as well as antique quilts and book stacks of the company's titles, "solves the problem of corporate art with inventiveness and style."[29] In 1986–87 Allan Greenberg designed a new suite of executive offices for Simon & Schuster, the centerpiece of which was the boardroom, which Greenberg modified in 1991–92 to accommodate interactive computer stations.[30] Greenberg's high classicism was in complete denial of Rockefeller Center's Modernist-influenced architecture. The traditional rooms rather surprisingly and incongruously mixed plexiglass illuminated ceilings to provide overhead light with elaborate moldings. Greenberg's offices for Brant Publications (1984–85) in the higher-ceilinged former Parke-Bernet Building (Walker & Poor, 1949), 980 Madison Avenue, between Seventy-sixth and Seventy-seventh Streets, were less compromised, with inventive, deliberately

Brant Publications, 980 Madison Avenue. Allan Greenberg, 1984–85. Mauss. ESTO

Offices of Altschiller Reitzfeld Davis Tracy-Locke, 1740 Broadway. Smith-Miller + Hawkinson, 1990. Warchol. PW

overscaled classical details employed in the important corridor and reception spaces.[31]

Polshek's offices for the advertising agency Backer & Spielvogel (1979), 11 West Forty-second Street, overlooked Bryant Park and the New York Public Library.[32] To maximize views for the majority of the employees and visitors, the architect persuaded his client to hold the executive offices back from the windows, leaving the choice view-facing space open for a long corridor and waiting areas. The Securities Groups' offices (1980), located on the tenth and eleventh floors of 500 Park Avenue (Skidmore, Owings & Merrill, 1956–60), were the most elegant of the architect's offices (see Park Avenue).

Paul Segal Associates' four floors of offices (1977) for *Rolling Stone* magazine were located in the Squibb Building (Ely Jacques Kahn, 1930), 745 Fifth Avenue, southeast corner Fifty-eighth Street. The design attracted a great deal of attention, not only for its combination of "a sort of New York sleekness with a pleasing informality," as Paul Goldberger put it, but also in light of the fact that the magazine's successful publisher, Jann Wenner, had made the decision to relocate to the city from San Francisco, a move widely touted as a good municipal omen. Perhaps attributing more to the somewhat bland design than he should have, Goldberger admired the use of glass block, the integration of old oak tables and other furniture brought from the San Francisco offices, the whimsical yellow window shades that "bring life to the view of 745 Fifth Avenue from the street," and, most of all, "the stair that cuts through from one floor to another at a 45-degree angle" revealing "two stories of windows and a sudden, dramatically angled

view down the side of the building to Fifth Avenue." Moreover, he liked the fact that there was "none of the funkiness one might expect from *Rolling Stone*, but then again this clearly isn't a bank or a law office, either. Rock music blaring from an art director's radio and writers in blue jeans seem not at all out of place, for all of the formality of what we might call the white esthetic. For this time, the modernist esthetic actually succeeds at doing what it always claimed it wanted to do—provide a calm, ordered background for the processes of life, however varied they might be."[33]

Just as Gwathmey Siegel and Kliment and Halsband had taken on office interior design to see themselves through the depressed economy of the late 1970s and early 1980s, a younger generation took on the same work after the business collapse of the late 1980s and the malaise of the early 1990s. This new generation was rather more anti-establishment than its predecessor, which was reflected in work that was not for bankers or lawyers, but companies involved in communications and entertainment. Henry Smith-Miller's interiors for Solomon Equities (1985), the developers of Skidmore, Owings & Merrill's Tower 49 (see Madison Avenue), 12 East Forty-ninth Street, provided the firm with 1,500 square feet on two floors of its building, linked by a stair rising through the double-height volume. While Smith-Miller contended that the design was divorced from "style" and merely an array of tectonic "fundamentals," it so very obviously gave off an impression of self-conscious Modernist revivalism that the architect felt obliged to observe that the design fell "neatly in the dialectic between postmodernism and what's to come. Our generation sees modernism as history; we take from it or we don't. I'm trying to stay out of the issue of style and deal with the fundamentals."[34]

During the late 1980s, after Smith-Miller entered into a partnership with Laurie Hawkinson, the work became freer and more visually challenging and less bogged down in abstruse theory. Smith-Miller + Hawkinson's offices (1990) for the ARDT-L (Altschiller Reitzfeld Davis Tracy-Locke) advertising agency, occupying 14,450 square feet at 1740 Broadway, deliberately fostered a sense of visual chaos by colliding elements such as cranked ceiling and wall planes against the orthogonal building structure and the regular pattern of office cubicles. This strategy, as Smith-Miller explained it, was intended to mirror that of advertising itself, where attitudes veer between reality and manufactured images of reality: "We wanted to initiate a visual discussion between real and artificial building, where forms and objects appear to slip and slide

New Line Cinema, 888 Seventh Avenue. Smith-Miller + Hawkinson, 1991. Warchol. PW

New Line Cinema, 888 Seventh Avenue. Smith-Miller + Hawkinson, 1991. Plan. SMHA

Gennaro Andreozzi, Inc., 118 East Twenty-fifth Street. Alan Buchsbaum, 1982. McGrath. NMcG

through each other."[35] The overlapping of systems was confined to the "public" parts of the plan and to the partners' offices—enclosed by scalloped glass partitions and sliding steel doors—that were organized on a diagonal grid echoing the ceiling, purportedly to capture better views of Central Park.

For New Line Cinema, an independent producer of more than typically provocative films, Smith-Miller + Hawkinson, which also designed the company's offices in Los Angeles, designed offices (1981) in New York at 575 Eighth Avenue, a former garment factory, where sandblasted concrete and unfinished drywall were the two materials. In 1991 they undertook the company's New York expansion into the nineteenth and twentieth floors of 888 Seventh Avenue (Emery Roth & Sons, 1972). Here skewed geometries were pursued, in part as the result of an observation of Michael Lynne, New Line's president, that "we made our name by taking a standard genre and giving it a twist."[36] The scheme was full of witty if somewhat arcane references to film-making, with the entrance seen by the architects as a "camera" catching views and cinematic images down the skewed geometry of long corridors that were relieved by off-center city views. According to the architects, the private offices were "composite shots," with exaggeratedly thick door and window frames recalling the work of Carlo Scarpa and Rudolf Schindler. All in all, as Smith-Miller remarked: "We're not breaking the mold of the office interior. We're just disturbing it."[37] The firm's much more modestly sized administrative offices for the Skowhegan School of Painting and Sculpture (1992), 200 Park Avenue South, was spatially straightforward, but it was not without its own dynamic largely coming from the skewed pattern of suspended overhead light troughs.[38]

While Alan Buchsbaum's free-wheeling Postmodernist reinterpretation of Modernist form found its most characteristic expression in residential interiors (see Apartments), he did undertake one inspired office interior (1982) for Gennaro Andreozzi, Inc., a commercial television production company located on the top floor of 118 East Twenty-fifth Street, an old printing press building. The multilevel, 3,500-square-foot suite sprinkled furnishings characteristic of residential work in a free-for-all plan with curving and angled walls that culminated in a roof-top greenhouse office. Asked about the madcap arrangement, Jerry Andreozzi said that the "place works and that's about as Bauhaus as it gets."[39] The high-spirited wackiness of the design led Buchsbaum to observe that "it may look thrown together, but it's really very worked out."[40]

Reach Networks. Anderson/Schwartz, 1991. Moran. MM

Chelsea Pictures, 122 Hudson Street. Anderson/Schwartz, 1993. Moran. MM

Reach Networks. Anderson/ Schwartz, 1991. Plan. FS

Anderson/Schwartz, a partnership of two young iconoclasts, Ross Anderson and Frederic Schwartz, could also be relied on to challenge but not break the mold of the office interior. But theirs was a more playful, far less abstract approach. This could be seen in the New York sales office (1988) of Finlandia Vodka, located on the forty-third floor of the RCA Building (Associated Architects, 1933) in Rockefeller Center, which needed not only to push the product but also to convey a special sense of its country of origin. Drawing inspiration from Finland's leading mid-century architect, Alvar Aalto, Frederic Schwartz, whose project this was, explored free-form shapes evocative of the master's own.[41] Ross Anderson's offices (1991) for Reach Networks, a software company occupying a loft in SoHo, inserted diagonally organized concrete partitions perforated like the punch cards of the early computer age as well as a particle-board-enclosed conference room into the otherwise largely untouched loft, leaving the grid of cast-iron Doric columns free to exercise their discipline and authority over the spatial near free-for-all.[42]

Anderson and Schwartz collaborated on the New York headquarters for Chelsea Pictures (1993), an independent production company specializing in television commercials that occupied 2,200 square feet on the top floor of the Bendheim Building (Julius Kastner, 1897–98), 122 Hudson Street, northeast corner of North Moore Street.[43] The soft, "low-tech" look of the details, to use Schwartz's phrase, combined with the use of exuberant patterning on walls and furniture, reflected the influence of Schwartz's mentor, Robert Venturi.

Anderson/Schwartz soon took on a larger project for another New York film company, SMA Video (1995), which described itself as the first high-end, full-service, on-line, film-to-digital-tape post-production house to settle in SoHo. The loosely organized plan featured two intricately shaped enclosures accommodating offices and screening and editing rooms set into the largely unremediated space of a former printing plant. "Mentally," Ross Anderson stated, "it's a place where people can walk through and feel some sense of dislocation. 'Where are we?' And we're making a connection with the larger landscape as well, so you don't feel you're locked in."[44]

For the booksellers Barnes & Noble, Anderson, now practicing on his own, designed website offices (1998) in the building that formerly served as headquarters for the Port Authority of New York and New Jersey (Abbott, Merkt & Co. with Aymar Embury II, 1932), on the full block bounded by Eighth and Ninth Avenues, Fifteenth and Sixteenth Streets. The offices occupied 65,000 square feet on what was one of the largest single floors in the city. The scale was daunting: the site "seemed like the state of Nevada," quipped Anderson.[45] Using a strategy previously developed for SMA Video, Anderson grouped offices in irregular freestanding enclosures that, owing to their plan shape, he called "worms," which, together with the executive offices scattered along the perimeter, helped break up the huge floor into identifiable portions. The first of the brightly painted worms, each "slithering between structural columns and marking individual departments," helped define amid the forest of work stations a major clearing that served as a forecourt to the conference rooms.[46]

Barnes & Noble, 111 Eighth Avenue. Ross Anderson, 1998. Moran. MM

Barnes & Noble, 111 Eighth Avenue. Ross Anderson, 1990. Plan. AA

Elektra Entertainment, 75 Rockefeller Plaza. Bausman Gill Associates, 1989. Conference room. Mauss. ESTO

Bausman Gill Associates, a firm founded by Karen Bausman and Leslie Gill, who met as students in the Cooper Union's School of Architecture, began to make its mark with the offices of Drenttel Doyle Partners (1987), an advertising agency, and Tagliarino Public Relations (1988), both modest undertakings that exhibited a high level of attention to detail.[47] The firm's offices for Elektra Entertainment (1989), 75 Rockefeller Plaza (Carson & Lundin, 1947), was a much bigger and much more visible commission. Elektra, occupying two floors, was a major record company specializing in pop music. The young firm was hired because it was felt that it represented the same kind of "risk-taking" that the company expected from its recording artists, although Bausman Gill's design proved to be fundamentally conservative though not traditional.[48] Echoing what the architects perceived as a characteristic of Rockefeller Center's historic architecture, they emphasized hand-craftsmanship in their work, concentrating on specific details including leather floors, stained birch ply panels bolted to the wall, metal tables, and a complexly modeled reception desk comprised of de Stijl–inspired interlocking planes. In a circular conference room, fresco panels rolled around on tracks to conceal or reveal shelves of tapes, while in a larger, oval conference room plaster panels were treated as "life size" frescoes suggesting Tuscany. Rich though the details were, what should have been the crowning feature of the plan, the open stair connecting the two floors, was narrow, boxlike, and too complicated, with overlapping struts, rails, and wall panels. By 1996, Bausman Gill's interiors had been largely demolished after Elektra was taken over by new management,

who hired the designer Clodagh to transform the company's image into one that was, according to the new chief executive, "warm, inviting, vibrant."[49] Bausman Gill's work with Elektra led to two floors of offices for Warner Bros. Records (1992) on the twentieth and twenty-first floors of the same building.[50] Here a much lighter palette of materials was used: plaster, steel, sisal, slate, cork, and stained wood paneling to give a more airy, open effect, although there were custom art installation pieces, most notably *Edison's Apparition*, a decorative screen interpreting the story of recorded sound that Bausman, working with Alison Berger, designed and executed.

Peter L. Gluck's Technimetrics Inc. (1984), 80 South Street, was one of the early high-tech "paperless" offices for a firm that specialized in developing and selling computerized databases for industry.[51] A sure sign of the impact of the usurping of traditional technology by electronics, Technimetrics occupied two buildings, one a 1906 five-story red brick warehouse, the other a 1956 six-story steel-framed building, both previously belonging to a commercial printer who had specialized in financial documents that could now be generated and reproduced electronically. The space was difficult to work with, especially that in the older building, which was supported by a veritable forest of massive timber columns. In keeping with the free-wheeling spirit associated with many of the new small technology-based businesses, the program called for a squash court, exercise room, and sauna. Though the interiors did not quite capture the excitement of the new electronic age, they did effectively showcase the owners' extensive collection of contemporary art.

J. S. M. Music Studios, 59 West Nineteenth Street. Hariri & Hariri, 1991. Warchol. PW

Offices of nickandpaul, 425 West Fifteenth Street. David Ling, 1998. Eberle. LING

Offices of nickandpaul, 425 West Fifteenth Street. David Ling, 1998. Plan. LING

Hariri & Hariri's J.S.M. Music Studios (1991), on the fifth and sixth floors of 59 West Nineteenth Street, wrapped offices and a lounge around a mass of recording studios, the irregular shape of which was determined by acoustical engineers.[52] As with so many other works of this kind, where the volume of the loft space tended to overwhelm the spatial arrangements of the designers, the details were all important. Specht Harpman's Good Machine (1997), 417 Canal Street, an independent film production company with a string of low-budget hits to its credit, occupied 10,000 square feet on the fourth floor of what had for a long time been a printing plant but had recently served as back offices for a financial corporation, the latter forming what Scott Specht described as "just about the grimmest office space you've ever seen."[53] In keeping with the client's reputation as a low-overhead operation, Specht Harpman stripped the space of its excrescences and installed a series of shojilike partitions finished in Homasote, Masonite, and acrylic, combining them with exposed duct-work and off-the-shelf fixtures, a familiar strategy that the designers interpreted in a fresh way, partially because, as Louise Harpman put it, "We're very choosy about the shelves we take the materials from."[54] In 2000 Specht Harpman completed four office interiors for companies located in the Starrett-Lehigh Building, which became a leading spot for new-media firms (see Chelsea). In 1997 Harpman's colleague at Yale, Steven Harris, inserted a metal scaffolding inside a former manufacturing building in SoHo, 443 Broadway (Griffith Thomas, 1860), to house the production offices of the author, monologist, and actor John Leguizamo. According to Harris, the search for an appropriate vocabulary was critical: "We definitely didn't want to do Disney. It needed to be scruffy, urban and edgy."[55]

David Ling's Cabana (1998), a post-production editing company, was located in 535 Fifth Avenue (H. Craig Severance, 1926), northeast corner of Forty-fourth Street, a midtown office building selected for business convenience. Because a SoHo loft would have otherwise been management's preference, Ling, who got the job in a competition, gutted three floors of the building and set out to pursue a policy he called "reverse gentrification," designing a place that would complement the "relentless creativity" of the round-the-clock operation that catered to the needs of ad agencies.[56] Inspired by German Expressionism, Ling sliced through the three floors with a skewed set of stairs, resulting in a narrow atrium bounded by folded planes of galvanized metal. More effective among Ling's work was the sprawling, 18,000-square-foot offices (1998) of nickandpaul, a branding agency, on the second floor of the Chelsea Market Building, 425 West Fifteenth Street, where a stupendously sized, elliptical translucent fiberglass-clad central arena-like core, housing a lounge, library, and conference room, was set askew inside the gridded plan, evoking the geometry and scale of Richard Serra's sculpture *Torqued Ellipses* (1997).[57]

Don Zivkovic, an Australian working in New York, also made a specialty of art-inspired offices, in his case the exploded geometries of Deconstructivism, which could be seen in the small suite designed for Roshak & Company (1990), a recruiting firm for graphic designers,[58] and for Elders Finance Group, an Australian bank (1991).[59] Zivkovic's offices for Omon New York Limited (1991), a branch of an Australian advertising agency, was less influenced by gallery art than by the movies, leading one observer to locate its design "somewhere between

Omon New York Limited, 23 Watts Street. Zivkovic Connolly Architects, 1991. Ranson. ZAA

Bladerunner and *Pee-wee's Playhouse*," using concrete, chipboard, and fabric to evoke Australian expansiveness within the confines of a SoHo loft building.[60] The principal features were the conference rooms, the aluminum frameworks of which were arranged on a distorted grid and infilled with a variety of transparent, translucent, and opaque panels.

The Office as Environmental Art

An important subset of office design consisted of boutique-sized facilities designed for specific clients who tolerated, or even encouraged, extremes of aesthetic speculation. Susana Torre's compact suite of law offices (1976) for Torczyner and Wiseman was the most intensely site specific of all such interiors. Harry Torczyner, the senior partner, had as his most famous client the estate of the Belgian Surrealist painter René Magritte. Located in the Fred F. French Building (H. Douglas Ives and John Sloan, 1927), 551 Fifth Avenue, northeast corner of Forty-fifth Street, the offices also served as a gallery for Torczyner's personal collection of contemporary art. Rather than obscure the architecture of the building, Torre chose to see the interior as an imposition on the building's structural frame, a decision which reflected the architect's conviction that the "spatial matrices" of any given site should "provide a reference for designating new architectural elements and their relative location with respect to the existing system of variables."[61] Every effort was made to increase the occupants' awareness of the host building's tectonics and of the intensely urban site. In addition to employing elaborate color-coding to highlight the structural cage including unseen beams in the floor, Torre lined the interior perimeter walls with off-white glazed brick to represent the inner face of the building's exterior brick cladding. Many elements in the plan, including a false door and angled mirrored planes, referred to specific works of art in Torczyner's collection, or at least to Torre's interpretation of them. According to Torre, the "primary associations and their architectural analogs are: The entrance door from the waiting room: Marcel Duchamp's door opening simultaneously into two different spaces. The black panel signifies a void. The 'window' between the painting gallery and the conference room: Magritte's painting 'Le Mois des Vendanges.' The mirrors placed at a 45-degree angle in the corners of the painting gallery: The surreal image of mirror as the boundary between *real* and *mysterious*. The mirrors, facing each other, unbend the ambulatory's corners, reflecting the

Offices of Torczyner and Wiseman, 551 Fifth Avenue. Susana Torre, 1976. McGrath. ST

Offices of Torczyner and Wiseman, 551 Fifth Avenue. Susana Torre, 1976. Axonometric. ST

illusory image of a long and straight corridor, the end of which is, in actuality, the wall contiguous to the beginning of the passage. These and other spatial metaphors are architectural embodiments of the occupant's intellectual, esthetic, and emotional affinities."[62] Torre's offices for Robert Panero Associates (1982) were much more modest.[63]

In contrast to Torre's intensely cerebral approach, Steven Holl's was highly visual, with a strong interest in the play of light and in details. Holl's only office interior (1991), for D. E. Shaw & Company, a sixty-five-person trading company

Banque Bruxelles Lambert, 630 Fifth Avenue. Emilio Ambasz, 1984. Warchol. AMB

Banque Bruxelles Lambert, 630 Fifth Avenue. Emilio Ambasz, 1984. Axonometric. AMB

D. E. Shaw & Company, 120 West Forty-fifth Street. Steven Holl, 1991. Warchol. PW

D. E. Shaw & Company, 120 West Forty-fifth Street. Steven Holl, 1991. Concept diagram. SHA

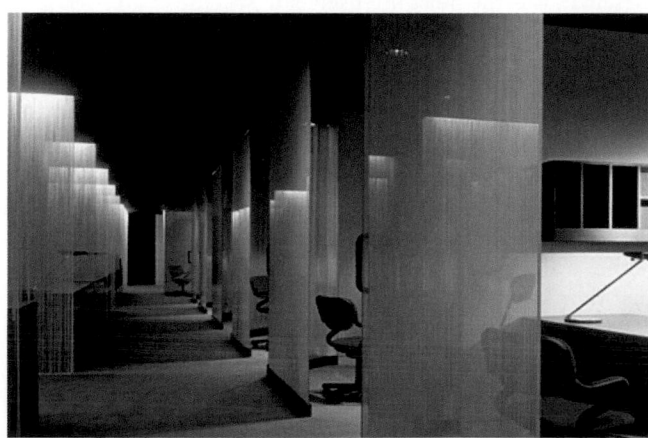

Financial Guaranty Insurance Company, 175 Water Street. Emilio Ambasz, 1985. Warchol. AMB

founded in 1988 by David Shaw, a former professor of computer science, located on the top two floors of the forty-story Tower 45 (Swanke Hayden Connell, 1989) (see Sixth Avenue), 120 West Forty-fifth Street, consisted mostly of private offices and semi-private workstations as well as a conference room and a small trading room, resulting in a plan the architect described as "unexceptional."[64] Given the banalities of the plan, Holl concentrated on the two-story thirty-one-foot cubical atrium-like reception area where, combining a sculptural handling of the wall in a manner recollective of the walls of Le Corbusier's chapel at Ronchamp (1950–55) with deep light-filled shadow boxes, he sought to capture the sense of the pulsating electronic communications that kept the

traders in contact with worldwide markets (the company's facilities manager, Michael Lehning, likened the effect to that of a computer chip). The atrium's light was tinted by painting the backs of the walls with vividly colored billboard paints that reflected onto the inner walls to give an eerily greenish glow, whether lit by daylight or, at night, by concealed fluorescents, which, when seen from the street below, easily identified the office in the otherwise uniform tower. The lighting idea was also extended to the conference room and executive office where the bands of unblinded windows produced unwanted glare.

Emilio Ambasz's 20,000-square-foot suite for Banque Bruxelles Lambert (1984), in Rockefeller Center's Inter-

national Building, containing executive and operational offices, trading, computer, conference, and board rooms, as well as his 15,000-square-foot offices for Financial Guaranty Insurance Company (1985), 175 Water Street (Fox & Fowle, 1983), were two of the most unusual and sensual corporate work environments the city had ever seen.[65] One of three suites designed by Ambasz for international outposts of Banque Bruxelles Lambert, each evoking its specific location, it was intended to be a quintessential exemplar of New York, however abstractly realized by the Surrealist-influenced New York- and Bologna-based architect who stated that "when one thinks of New York, especially Manhattan, one recalls vividly images of tall buildings. However, this landscape of mind rarely matches what we observe in reality. Tall buildings in New York hide in many cases other tall buildings. Seldom is there enough open space to provide a foreground for the contemplation of their facades. All this notwithstanding, their presence is pervasive, and though we cannot see them, they still directly permeate our conception of the city." Ambasz set out "to evoke these images of New York City within the bank's offices" in the hope "that those entering the bank would, for an ineffable instant, discover there that which they have always longed for but had, until then, rarely seen in its full splendor." For this reason, Ambasz conceived of a transparent environment for the bank's offices, "as a goodwill offering to its clients visiting from abroad, and as a friendly expression of its desire to become integrated as part of the city."[66]

Despite all this rhetoric, it was not the windows or the view of the city from them that was most interesting but the play against white lacquered walls of yard upon yard of floor-to-ceiling silk fringe hung in two layers about three inches apart surrounding the reception area as well as many of the interior offices. The effect was at once breathtaking and silly—and completely unlike any other office. Despite this, Ambasz was willing to repeat the strategy for Financial Guaranty Insurance Company, where some of the silken curtains hugged the wall to suggest an indeterminate depth of space and others formed planes that freely intersected toward the center of the plan to create the effect of an enclosure dematerializing in shimmering light.

Like the Banque Bruxelles Lambert offices, which were as much for promoting the bank's image as for working, the offices for Financial Guaranty, a firm specializing in municipal bonds, were also image-driven. But the product was more technically inventive, with six-by-eight-foot virtually self-sufficient work modules, the locations of which could be rearranged by lifting them onto a fork-lift, a feature that proved useful to the company whose business evolved dramatically in the volatile markets of the late 1980s. According to the client, Gerald L. Friedman, the reaction to Ambasz's offices was "mixed," but "whether clients like it or not, they never forget it."[67] And, as Ambasz wrote, the issue of image was all important: "As FGIC does not have a palpable product, the impression made by its physical quarters becomes very important The image takes as its central theme the dual aspects of richness of materials and mobility of form. The suggestion of richness, I believe, comes from that which cannot be measured. Intimations of ever expanding limits or horizons, of multilayered meanings, and of everchanging vistas, are far more effective than an obvious grand gesture." So the office was conceived as an unfolding sequence of "vignettes or landscapes" formed by silk curtains bathed in light from fiber optic sources hidden in the ceiling.[68] The British critic Peter Buchanan was dazzled and disturbed by Ambasz's design which he found "puzzlingly paradoxical: not least in compromising for aesthetic effect what seems an ultimate as a pragmatic and panoptic office system." Buchanan deemed Ambasz a master magician of effects, but wondered "whether such an unreal, almost night-clubbish, atmosphere is the best place to work in, day in day out, even if sealed in relative quiet in what seem paradoxically submerged goldfish bowls."[69] In 1993 the firm of Rogers Marvel Architects also explored the theme of curtained space, but this time using muslin curtains suspended from exposed piping to create cheap but surprisingly elegant, even theatrical, offices for Visiting Neighbors, a lower Manhattan non-profit organization caring for 1,500 elderly people.[70]

Gaetano Pesce's offices for Chiat/Day Advertising (1995) were not only visually arresting but also conceptually adventurous, a virtually complete reconstruction of the corporate office typology, reflecting Jay Chiat's sense that private offices and personally assigned desks were anachronisms in the computer age, inspiring political intrigue and thwarting cross-pollination of ideas. At Chiat/Day, employees stored their personal possessions in lockers, and relied on "study carrels" outfitted to accept the electronics that permitted them to communicate while in the office or on the road or at home. The idea was at once idealistic and practical. With so many staff members on the road, money could be saved by not providing fixed offices that would frequently be empty. A 25,000-square-foot upper floor of the Continental Center (Swanke Hayden Connell, 1983; see South Street Seaport), in the Financial District, was reconfigured to create a free arrangement of diverse spaces fitted out in visually arresting if overheated ways. The result proved less than ideal, with nomadlike workers roaming the office to find an available computer terminal or a quiet corner for a telephone conversation. The decision to hire Pesce seemed appropriate, given his belief that "the job of the architect [is] to give people the joy of discovering new ways to live, new ways to work," but the riotous omnipresent polychromy of the design proved challenging.[71] In 1999 Jay Chiat's ScreamingMedia, an Internet company, opened new offices in the Starrett-Lehigh Building (see Chelsea).

Chiat/Day Advertising, 180 Maiden Lane. Gaetano Pesce, 1995. PESCE

Architectural offices of Gwathmey Siegel & Associates, 475 Tenth Avenue. Gwathmey Siegel & Associates, 1982. Ardiles-Arce. GSAA

Architectural offices of Richard Meier & Partners, 475 Tenth Avenue. Richard Meier & Partners, 1985. Frances. ESTO

Architects' Offices

The practice of architecture is both labor intensive and space intensive. Though depictions of dramatically scaled workplaces in films and television and magazine articles might develop an expectation of high glamor, the reality was somewhat different; the work of many of the era's leading firms took place in comparatively anonymous spaces outfitted in a comparatively anonymous way. Part of this can no doubt be attributed to the desire of many architects to give clients an impression of a "business-like" and "down-to-earth" practice; part can also be assigned to the high cost of office space and to the large amount of space required by the typical practice which needed not only work areas for staff architects and those who supported them but also conference rooms and model-making areas as well as huge amounts of space for storage of models and drawings. Nonetheless, to the public, architectural offices conveyed a certain exoticism that added seasoning to the city's mix of interior working environments.

In the early 1980s architects were among the first important professionals to decamp midtown offices for formerly industrial lofts, usually on the West Side. Charles Gwathmey and Robert Siegel, who had first met while working for Edward Larrabee Barnes in the early 1960s when Barnes pioneered the reuse of industrial space by occupying a floor of a former commercial garage at 410 East Sixty-second Street, became partners in 1968 after Gwathmey's previous partnership with Richard Henderson was dissolved. In the 1970s the firm of Gwathmey Siegel & Associates occupied three studios in Carnegie Hall.[72] In 1982 it moved to 475 Tenth Avenue, northwest corner of Thirty-sixth Street, a fourteen-story, terra-cotta-clad loft building where the firm occupied a 17,000-square-foot floor.[73] The building's owners, led by Robert Liberman, were anxious to have the firm as a tenant who would attract other architects and designers and create a kind of updated version of the Architects Building (Ewing & Chappell and LaFarge & Morris, 1912), 101 Park Avenue, which had been torn down in 1979 to make way for Eli Attia's 101 Park Avenue (see Terminal City).[74] Richard Meier & Partners, Vignelli Associates, and Buttrick White & Burtis soon signed on for space at 475 Tenth Avenue as did a number of key suppliers of building products. Reflecting their approach to design and the details that support design, Gwathmey Siegel stripped its space to its essentials, meticulously organizing new air-handling and other systems in the

space between the ten-foot-high industrial sash and the fourteen-foot ceiling. Only the partners' offices, conference room, and reception area broke with the overall pattern of modular desks set behind six-foot-high partitions. According to Robert Siegel, the layout was "just like" that of a "self-sufficient city. You can stay here and have all the options. There's a sense of comfort, repose, ceremony and work—even a kitchen, sauna and shower." Charles Gwathmey, however, deemed it "more like a battleship, a dense, self-contained unit."[75]

Three years later, Richard Meier, previously located at 136 East Fifty-seventh Street, southeast corner of Lexington Avenue, joined Gwathmey Siegel in the Tenth Avenue building, also occupying an entire floor and exhibiting similar modularity in the layout of his studio space, but achieving a greater sense of openness with lower partitions.[76] Like Gwathmey Siegel's, Meier's working environment gave off a no-nonsense air; in fact, given the lyricism of his typical work, it seemed surprisingly generic. Meier's was planned much the same as Gwathmey Siegel's: private offices and conference rooms faced Tenth Avenue, with a broad concourse for receptionist and secretaries between the private offices and the open drafting room. One feature was a large room for exhibiting models, scaled no doubt to the model of Meier's key project at the time, the multi-building campus for the Getty Center in Los Angeles.

Massimo and Lella Vignelli had been located in the same East Sixty-second Street building that housed Edward Larrabee Barnes. They too relocated to 475 Tenth Avenue, occupying the top floor (1985) where sweeping views were supplemented by skylights. The Vignellis' design was less business-like and more imagistic than that of either of the architects, reflecting their work as graphic, interior, and furniture designers. "At the time," Massimo Vignelli stated, "our major interest was a representation of objectivity, a stripping down of whatever project we had in our hands in order to find the objective essence of that project. Now, we are allowing more room for subjectivity. We are allowing ourselves to play with symmetries, with ambiguities. The office is not in any form or shape post-modern. If anything, call it neo-modern—the basic language of the modern movement after the post-modernist phase."[77] The effect was complex, a "combination office and palazzo with a bit of the monastery," according to Vignelli.[78] Hinting at the work of the Italian architect Carlo Scarpa, the Vignelli offices were austere in a surreal and strangely sensuous sort of way, with lead-

Architectural offices of Robert A. M. Stern Architects, 211 West Sixty-first Street. Robert A.M. Stern Architects, 1985. View from library into drafting studio. Aaron. ESTO

Architectural offices of Robert A. M. Stern Architects, 460 West Thirty-fourth Street. Robert A.M. Stern Architects, 1995. Reception. Aaron. ESTO

paneled doors and sand-blasted glass partitions opening from high narrow halls contrasting with new and pre-existing exposed steel pipes and, for Massimo Vignelli's office, a wall of dark-gray lead panels sealed in beeswax and, as a desk, a square hot rolled steel table top carried on steel pipe still bearing the markings from the mill. Lella Vignelli's office was only slightly less brutal, with a slab of black granite carried on bronze legs to serve as a desk. Despite the use of as-found industrial materials, when all was said and done, the space seemed not at all generic but self-consciously arty, that is until one reached the studio where a refreshingly business-like order comparable to Gwathmey Siegel's and Meier's prevailed.

In 1985 the firms of Edward Larrabee Barnes Associates and James Stewart Polshek & Partners each moved to the same loft building in the West Village, at 320 West Thirteenth Street.[79] Barnes, like the Vignellis, was forced from East Sixty-second Street where the rents had become too high for architects and designers. Polshek, who in 1964 shared offices with Richard D. Kaplan, Michael Zimmer, and Walfredo Toscanini on the forty-seventh floor of 295 Madison Avenue in hitherto unused space next to the water tower, was relocating from 19 Union Square West.[80] Each of these architects' offices was relatively straightforward, with maximum effort devoted to capturing the light and views from the large industrial windows wrapping the studio space.

In 1985 Robert A.M. Stern Architects, previously located in a variety of small offices in what had been built as the Colonial Club (Henry F. Kilburn, 1894), 200 West Seventy-second Street, southwest corner of Broadway, moved to vastly expanded space at 211 West Sixty-first Street, a former goods distribution warehouse between Amsterdam and West End

Avenues.[81] The north- and west-facing studio with views over the Hudson River and into the gardens of Amsterdam Houses (Grosvenor Atterbury, Harvey Wiley Corbett, and Arthur C. Holden, 1947) was, according to Herbert Smith, writing in the *Architectural Record*, a "spirited mixture of neoclassic Postmodern and the unexpected . . . a very personal design image."[82] Two open drafting studios, lit at night by super-scaled table lamps as well as the usual Luxo "drafting" lamps, flanked a wide central hall forming a cross-axis like that of a central hall in a house, leading from reception area through the library—the heart of the plan reflecting the architect's interest in history as a design research tool—to Stern's office that could be imagined as a terrace overlooking the garden and river views beyond. In 1995 the firm moved again, to still larger space, occupying a 20,000-square-foot floor at the Master Printers Building (1927), 460 West Thirty-fourth Street, southeast corner of Tenth Avenue, where a new version of the previous plan was devised that, like its predecessor, reflected the architect's view that traditionalist and Modernist idioms were not mutually exclusive.[83]

The offices of SITE (1984), headed by James Wines, perhaps more than those of any other architect or designer, were the most personal and idiosyncratic. They were located in what had been a space devoted to light industrial use inside Louis Sullivan's only New York building, the Bayard Building (1898), 65 Bleecker Street, just east of Broadway.[84] In the hands of new owners, the Bayard Building was undergoing extensive restoration. Amazingly, SITE's second-floor space was the only one to retain Sullivan's original decorative details, many of which needed extensive restoration. In a tribute to Sullivan, while being characteristically if self-consciously irreverent and hip, Wines and his colleagues devised exposed wire lath and metal stud partitions capped by metal egg-and-dart cornices such as the great nineteenth-century architect might have used. The lacy new partitions were painted white to suggest "a ghost of the past."[85] Hardy Holzman Pfeiffer's offices (1986) on the eighteenth and nineteenth floors of 902 Broadway (Robert T. Lyons, 1912–13) were calculatedly irreverent, a highly theatrical, even deliberately slap-dash approach, reflecting the firm's approach to its work as a whole.[86]

Younger architecture and design firms, mostly located in SoHo and in the Flatiron district, reflected the revived interest in Modernist form that emerged in the late 1980s. M & Co., the graphic design firm, had begun life in a small workplace (1979)

Architectural offices of SITE, 65 Bleecker Street. SITE, 1984. SITE

Architectural offices of Karahan/Schwarting, 15–21 Park Row. Karahan/Schwarting, 1983. Charles. FCP

Architectural offices of Margaret Helfand, 32 East Thirty-eighth Street. Margaret Helfand, 1989. Warchol. PW

Offices of M & Co., 50 West Seventeenth Street. Tibor Kalman in association with Handler Rosenberg, 1984. LH

at 157 West Fifty-seventh Street, which Tibor Kalman, the firm's principal, recalled as a "goofy-looking office, with a goofy, triangular shaped table that fit into a goofy-shaped conference room." Reflecting the prevailing Postmodernism, the Fifty-seventh Street office was "very dressed up" although, with characteristic wit, Kalman treated the reception window as a hole smashed out of the wall with a sledge hammer. "You could bring a bank client or a rock group there for a meeting," Kalman

observed. "It sort of cut both ways."[87] Outgrowing the Fifty-seventh Street space, M & Co. led the way to the Flatiron district, where it occupied a small but image-packed loft (1984) at 50 West Seventeenth Street that reflected Kalman's Postmodernist sensibility as well as his Modernist tastes—"Everything we do is a contradiction between hip stuff and square stuff," he impishly stated. Designed by Kalman in association with industrial-designers-turned-interior-architects Handler Rosenberg, the result, as Larry Rosenberg developed it, was an office that looked almost undesigned: "The office doesn't have a postmodern look. It doesn't have a real retro look. It doesn't have an art deco look. It's a simple, honest office. It comes out of the factory aesthetic." Industrial-welded gridded metal frame windows were used to separate the various areas, emulating the loft's real windows and, according to Kalman, conveying "a sense of openness, a connection to outside."[88] But only some of the frames were glazed; some were open to foster a unity that, with the continually blaring pop music, brought the employees hipness to the point of distraction. Fancy or even "designed" fittings were eschewed in favor of "incredibly cheap" office chairs, used in the conference room, mockingly upholstered in a toilelike fabric bought on the Lower East Side.

Karahan/Schwarting, a young firm of architects—before setting up with Beyhan Karahan, his partner and wife, Michael Schwarting had been an associate at Richard

Meier's—occupied one of the city's remarkable but improbable spaces, the three-story, twenty-five-foot-wide tower atop R. H. Robertson's Park Row Building (1896–99), at 15–21 Park Row.[89] Not only was the space odd, but so was the location, which had not yet begun to return to prosperity as a home to high-tech media start-up companies. When the building was new, it was for a time the world's tallest, and the tower space had been an observation lookout.[90] Karahan/Schwarting took the 2,000-square-foot space over in 1983, stripping away layers of renovations to uncover its original geometries and details, including the inner side of the dome and the cast-iron gate of the cylindrical elevator. They painted the elevator core Pompeian red and the elaborate ironwork of the stair that wrapped it black, in bold contrast to the soft greens and whites selected for the three levels of surrounding drafting spaces where curving desks were hewn to the tower's outer walls.

Gregory Kiss, a former student of Schwarting's at Columbia, who had founded Kiss & Partners in 1983 with Colin Cathcart, another Columbia graduate, was impressed: "I loved that space and figured there must be more around like that."[91] Kiss discovered his dream space in another R. H. Robertson building, 150 Nassau Street (1895), the top three floors of which had been unused for years because they were above the reach of the building's elevators. After stripping away the layers, Kiss and Cathcart uncovered a treasure: 1,100 square feet of vaulted space with windows on three sides, which they furnished with simply partitioned work stations spray painted in a splatter pattern.

While the location of Margaret Helfand's office (1989) in a rehabilitated, 1,500-square-foot parlor floor of a Murray Hill brownstone, at 32 East Thirty-eighth Street, was by no means hip, in many ways the office itself was the most daring and also the most self-consciously arty of the small or boutique architectural firms. To the traditional mahogany-paneled former residential suite Helfand added a white marble fireplace and parquet floors left over from the set for the movie *Ragtime* (see Reel New York, Introduction). She then contrarily furnished the rooms with tables and cabinets of her own design which, according to Suzanne Stephens, seemed "to be inspired by 'The Cabinet of Dr. Caligari.'"[92] Reflecting the skewed geometries of Deconstructivism, the shot-blasted steel chairs that surrounded the segmented wafer board conference table carried on a base of corrugated concrete also revealed the growing interest of young architects in heavy, industrial materials: "We took basic everyday materials and let them be the expressive elements," Helfand stated. "But we don't impose this look on all our clients."[93]

One of the city's largest and oldest firms, Swanke Hayden Connell, founded as Walker & Gillette in 1906, riding the crest of late 1980s prosperity, decided to combine its search for new space with real estate development.[94] In 1989 the firm constructed for its own portfolio the Swanke Hayden Connell Building, the only structure in New York named for an architecture firm, a 100,000-square-foot, seven-story building on the southwest corner of Eighth Avenue and Fifty-eighth Street, facing Columbus Circle (see Columbus Circle). The Swanke firm occupied 60,000 square feet on the fifth, sixth, and seventh floors of its building as well as the penthouse. The seventh floor served as the principal reception area, with a double-height, skylit space that showcased presentation drawings suspended on a steel pulley system. An adjacent vitrine-lined gallery displayed a collection of rare architectural

books as well as archival documentation of early projects of the firm. On the penthouse level, a multi-use room that could serve as exhibition space, a presentation room, or an extra work area opened to a 2,500-square-foot terrace overlooking Central Park. Soon after the architects moved in the downturn in the economy almost proved the firm's complete undoing and they were forced to leave the building, which was taken over by the furniture makers Steelcase. Swanke Hayden Connell then decamped to far more modest quarters downtown at 295 Lafayette Street.

SHOPS

The 1980s and 1990s saw the proliferation of high-style shops, primarily located on Fifth and Madison Avenues. Fifth Avenue, between Forty-ninth and Sixtieth Streets, despite being "dumbed-down" by the arrival of national chains and theme shops, like stores for Coca-Cola, Disney, and Warner Bros. (see Fifth Avenue), still managed to maintain its status as a location for luxury retail, attracting a number of significant retailers who commissioned distinguished new stores, notably Michael Graves's Diane von Furstenberg boutique, Rafael Viñoly's Fendi shop, and Piero Sartogo and Nathalie Grenon's store for Bulgari, as well as an elegant new department store, Takashimaya (see Fifth Avenue). SoHo also emerged as an important setting for eye-catching stores, including the Dianne B. shop, Comme des Garçons, two stores for Helmut Lang, and Prada's New York Epicenter (see SoHo). In the newly emerging gallery district in Chelsea, Takao

Sointu: Harmony in Modern, 20 East Sixty-ninth Street. Tod Williams, 1980. View to the south. TWBTA

Pace Collection, 888 Madison Avenue. Steven Holl, 1986. View to the southeast. Warchol. PW

Giada, Inc., 904 Madison Avenue. Steven Holl, 1987. Darley. SHA

Pace Collection, 888 Madison Avenue. Steven Holl, 1986. Warchol. PW

Kawasaki spearheaded a design team on another shop for Comme des Garçons (see Chelsea) and in Tribeca, Frank Gehry and Gordon Kipping collaborated on a store for Issey Mikaye (see Tribeca). Still, Madison Avenue continued to prove the most durable location for high-style shops, with 50 percent of its businesses catering to European and South American customers.[1] The street's appeal lay in its scale and its access to the swank Upper East Side neighborhood and fashionable hotels where international visitors stopped.

Tod Williams's elegantly minimal Sointu: Harmony in Modern Design (1980), 20 East Sixty-ninth Street, a pastel-hued, 31-by-13 1/2-foot shop taking its name from the Finnish word for harmony or balance, specialized in small decorative and useful objects displayed as precious jewelry, many of them

under a pyramidal glass showcase that echoed the three steeply pitched gabled canopies which identified the premises on the outside.[2] The super-discreet shop facade was a modification and miniaturization of Williams's and Billie Tsien's submission to the "Chicago Tribune Competition: Late Entries" exhibition organized by Stanley Tigerman in 1980.[3] Bob Patino's similar but much bigger shop for the L.S. Collection (1989), 765 Madison Avenue, between Sixty-fifth and Sixty-sixth Streets, showcased modern objects for the home in a more open, less self-conscious way, greeting the street with two large windows and a recessed entrance niche behind a shiny copper-clad column.[4]

Steven Holl's minuscule, 364-square-foot shop (1986) for the Pace Collection, a high-end line of business and residential furniture, was located in a taxpayer built in the 1930s at the southwest corner of Madison Avenue and Seventy-second Street.[5] A rising star in the architectural firmament, Holl argued that architecture derived forms from specific local conditions, yet he wrapped the shop's two street-facing walls in glass, set in an intricately patterned metal frame that reminded some of the work of Piet Mondrian but seemed more likely to have been based on elegant Parisian shops fronts of the 1920s. The little shop was made to carry a heavy philosophical burden, with its designer claiming that the play of dominant horizontal mullions facing Seventy-second Street and the vertical pattern facing Madison Avenue, combined with the somewhat random use of sandblasted amber colored panels facing each street, reflected "the hyperactive view of alternating forces of movement" that occurred at the busy intersection.[6]

In 1987 Holl completed a second small shop, Giada, Inc., 904 Madison Avenue, between Seventy-second and Seventy-

Portantina, 866 Madison Avenue. Machado & Silvetti Associates, 1986. View to the west. Warchol. PW

Portantina, 866 Madison Avenue. Machado & Silvetti Associates, 1986. Warchol. PW

third Streets.[7] It was meticulously crafted and obsessively proportioned, with each element based on a set of proportions derived from the height and width of the space, which had been traced in a logarithmic spiral of rectangles proportional to the original one to supply the architect with a series of dimensions possessed of the same ratio, 1 to 1.618, the so-called golden section. Despite the geometric intensity, the overall effect was scattered, with the memorable part being the bits and details that formed parts of the cabinetwork and hardware. Peter Buchanan, the English critic, compared the fourteen-by-thirty-foot shop to the Pace boutique "that first brought . . . Holl to wide public attention" with a design drawing "inspiration in a particular interpretation of the context.

Ebel, 718 Madison Avenue. Andrée Putman, 1989. Mauss. ESTO

Though far less so than in the earlier shop, this has again resulted in an episodic composition infused by what looks like the insistent cross-rhythms of *Broadway Boogie-Woogie.*" Buchanan was willing to listen to "the architect's spiel—an example of the American tendency for the verbal to dominate the visual,"[8] but he was not willing to accept Holl's claim that the shop was his reaction to "the absolutely compressed condition of . . . a large building above bearing down with more than gravitational force, economic pressure and time pressure to act together like an invisible vise grip pressing the space in a psychological densification."[9] "But to many European eyes," Buchanan wrote, "it still looks like a fusion of De Stijl and Carlo Scarpa—but without the obvious discipline of the former and the sensual substantiality of material and craft of the latter."[10]

Diagonally across Seventy-second Street and Madison Avenue from the Pace shop and almost equidistant from the Giada shop, Rodolfo Machado and Jorge Silvetti's Portantina (1986), 866 Madison Avenue, a shop specializing in clothing, jewelry, and bibelots from the Veneto, consisted, according to its architects, of two important design moments: "the front and the main room. The front is made out of an impressive ogee stone frame (containing both the security screen and the canvas shade), a little space behind it (for protected viewing of the interior) and the glass front proper." They went on to explain that they made this "grand, very frontal and planar, intentionally overscaled architectural gesture . . . to assert the presence of the shop in a cool classical manner." The shop's main room, at first inspired by a particular kind of Venetian room, the *androne,* a hallway communicating between the street and canal entrances of Venetian palazzi, went on to find

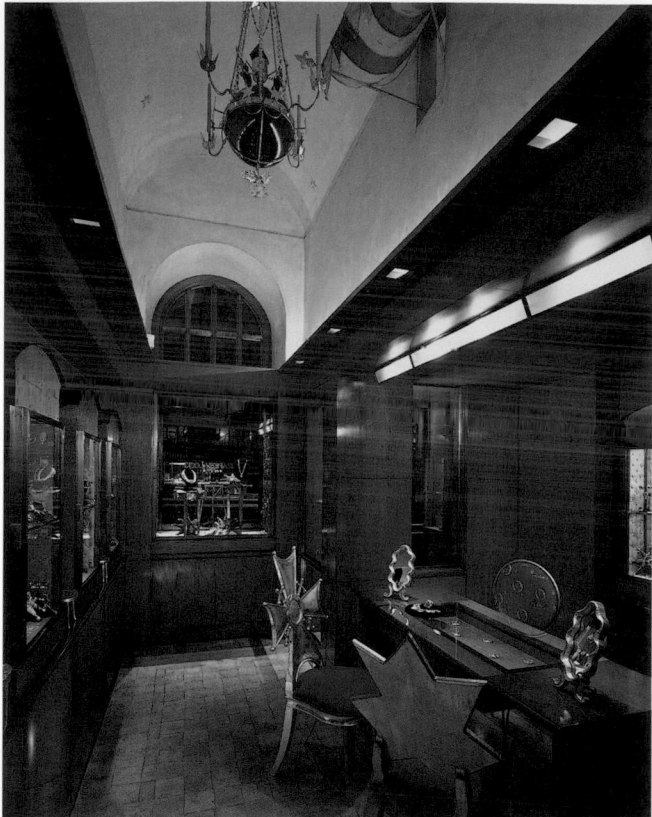

Elizabeth Locke, 968 Madison Avenue. Stover Jenkins, 1994. Mauss. ESTO

Fashion Boutiques

Toshiko Mori, working in collaboration with the Tokyo-based architect Siro Kuramata, carried minimalism to an almost theatrical level in her shop for Japanese fashion designer Issey Miyake at 992 Madison Avenue, between Seventy-sixth and Seventy-seventh Streets.[15] Kuramata had already designed the Miyake boutique inside Bergdorf Goodman (see Fifth Avenue), and Mori would go on to design the Issey Miyake Pleats Please store in SoHo (see SoHo). The Madison Avenue shop's design (1988) was also the brainchild of Tomio Mohri and Masao Nihei, a lighting designer, who proposed the strong blue light that would emanate from the basement storage level through a sharp incision in the main floor and suffuse the room with an eerie but not unfriendly glow, suggesting spatial infinity and ambiguity.

Romeo Gigli, perhaps the most unorthodox of the fashion boutiques (1990), was located in a five-story townhouse (Charles Buek, 1885–86; Sloan & Robertson, 1926–27), 21 East Sixty-ninth Street, which the Italian clothing designer, who trained as an architect, "essentially deconstructed," as Woody Hochswender wrote in the New York Times, stripping the ceilings to bare timbers and the walls to pipes and wiring before hanging Venetian glass chandeliers and pouring concrete floors embedded with glass shards.[16] Across the street, Tse (1994), 827 Madison Avenue, southeast corner of Sixty-ninth Street, designed by 1100 Architect, confronted the street with a double-height room clearly visible behind a wall of glass that wrapped around the corner to Sixty-ninth Street where the shop was entered.[17]

In 1992 even Charivari, the West Side's long-established counter-cultural emporium of high fashion, found Madison Avenue irresistible. Begun on upper Broadway, in 1978 the business expanded to a new location at the southeast corner of Columbus Avenue and Seventy-second Street, where a multi-level mazelike shop was planned by Alan Buchsbaum working with Stephen Tilly and Charles Thanhauser.[18] The idea for the design had come from Charivari's owner, Selma Weiser, who fell in love with a store she had stumbled on during a walk in Paris. As Weiser's son, Jon, who succeeded his mother in the business, recalled: "It had mezzanines and staircases, lots of different selling levels that you could see from the street. Mom thought the store was a visual kick."[19] In 1983 Charivari opened another branch, its fifth, Charivari Workshop, northeast corner of Columbus Avenue and Eighty-first Street,

its own character in the trapezoidal shape paralleling Madison Avenue. While, at the client's request, many of the details were based on familiar Venetian motifs, these were cleaned up to reveal their roots in geometry, while an operation of "shifting" led to the use of unorthodox materials, such as silk rather than wood door frames, and stone rather than plaster wainscoting, to ensure that the character was one where history was recalled with "a sense of *rigor* and *modernity*."[11]

Other jewelry shops on Madison Avenue were traditionally stylish but not necessarily representative of innovative aesthetic trends. For example, French designer Andrée Putman revived the chic Paris Modernism of the late 1920s and early 1930s in her shop for the watch maker Ebel (1989), 718 Madison Avenue, between Sixty-third and Sixty-fourth Streets.[12] Until 1985 Ebel had no brand of its own, preferring to manufacture for others. A short distance away at 675 Madison Avenue, between Sixty-first and Sixty-second Streets, Toshiko Mori's starkly minimalist Niessing (1990) evoked memories of the Wiener Werkstatte in its simple, if exaggeratedly gridded display cases.[13] For Stover Jenkins, classical space was a real possibility. His 200-square-foot Elizabeth Locke boutique (1994), 968 Madison Avenue, at Seventy-sixth Street, lined with mahogany and bronze display cabinets, was designed to showcase antique Italian micromosaics set in classically inspired hammered gold settings.[14] Jenkins's shop was exquisite, with a Minnesota limestone facade embellished by oiled statuary bronze plates and a black-and-cream fabric awning with hanging gold balls said to be influenced by Canaletto's Venetian scenes. Inside, dark mahogany paneled walls and silk-lined vitrines lined the space, which rose to a vaulted ceiling.

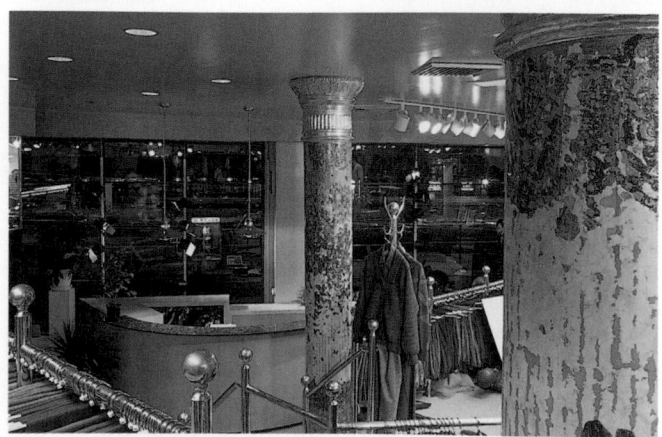

Charivari, 58 West Seventy-second Street. Alan Buchsbaum with Stephen Tilly and Charles Thanhauser, 1978. Nesbit. FS

turning this time to Bentley, LaRosa and Salasky, a young firm of architects and designers who received the commission on the recommendation of the minimalist interior designer Joseph D'Urso for whom LaRosa had worked. D'Urso's influence was obvious in the black-and-white design that divided the multilevel space along its length to segregate men's and women's clothing but used spidery stairs and bridges to encourage cross-overs.[20] In 1984 the chain expanded again, with a sixth shop, 16 West Fifty-seventh Street, designed by the Japanese designer Shigera Uchida, who was given far and away the largest construction budget the company had yet made available for a shop installation.[21] Uchida was selected on the strength of his work in Japan, where he had designed all the shops of Yohji Yamamoto, an important designer featured by Charivari. Originally, Uchida was commissioned to design a boutique in the store, but he took over the entire project when the relationship between the owners and Alan Buchsbaum, who was to have designed the rest of the store, soured. The series of stairs and platforms, however, were surely Buchsbaum's contribution to what was, all in all, a harsh and overly complicated interior. Charivari's Upper East Side store, replacing a coffee shop at 1001 Madison Avenue, between Seventy-seventh and Seventy-eighth Streets, designed by Agrest & Gandelsonas, was described by *New York Times* fashion reporter Anne-Marie Schiro as a "contemporary space of limestone, polished steel and mahogany where the neighborhood singles and young marrieds should feel at home."[22] The architects' boldest move was the insertion of a curving stair with a perforated metal balustrade that connected the two floors of the 5,000-square-foot space through an elliptical opening. But the store was plagued by the economic downturn as well as its location, failing to attract customers and draining the financial resources of the chain. As Jon Weiser put it, "If I had a magic wand, I would make the Madison Avenue store disappear."[23] Within five years after the opening of the Upper East Side location, Charivari had filed for bankruptcy protection and was down to just one store, its 8,000-square-foot shop on Fifty-seventh Street.

In 1993 Ralph Lauren pioneered the boutique as exemplar of a total lifestyle when he set up shop in the Gertrude Rhinelander Waldo mansion (Kimball & Thompson, 1897), southeast corner of Madison Avenue and Seventy-second Street, which had first been renovated to accommodate shops in 1921.[24] Significantly, as Paul Goldberger pointed out, at about the same time that department stores were reeling toward bankruptcy, in part because they could not keep up with fashion trends, Lauren was establishing his flagship store, and other leading catalog retailers like the Sharper Image and Franklin Mint were also opening stores of their own, restoring faith in the importance of real-time shopping that many felt would be replaced by catalogs or electronic media.[25]

Also in 1993, but on a much larger scale, Barney's, the venerable, seventy-year-old retailer located on Seventh Avenue between Sixteenth and Seventeenth Streets, which had begun life selling cut-rate men's clothing, opened an opulent, Peter Marino–designed store at 660 Madison Avenue, between Sixtieth and Sixty-first Streets, renovating a twenty-two-story office building (Emery Roth & Sons, 1958).[26] Marino, working with Kohn Pedersen Fox, stripped the Roth firm's anonymous glass-and-aluminum curtain wall and replaced it with one of French Luget limestone featuring large windows trimmed in black steel. Barney's occupied the first nine floors of the build-

Barney's, 660 Madison Avenue. Peter Marino, 1993. View to the west. Aaron. ESTO

Barney's, 660 Madison Avenue. Peter Marino, 1993. Mauss. ESTO

ing, its 230,000 square feet of space making it the largest new specialty store to be built in Manhattan since the Depression. The upper floors of the building were leased to office tenants. Inside the store, Marino, given few financial constraints, included custom-designed cabinetry and furniture finished in gray-stained laccwood, frosted sycamore, bleached anigre, cerused oak, and satinwood. He also designed new light fixtures and carpets for the store. Marino noted that "the spaces are deliberately open and loftlike, so you can see every corner of the floor. There are very few partitions. The architecture and the interior personality are deliberately the same. The store's columns, 27 inches in diameter, are always round and white. There is consistency and structural clarity."[27] The opening of Barney's in September 1993 was widely reported,

even by the international press, with Deyan Sudjic, in the British newspaper *The Guardian*, observing that "as a voice of architecture . . . [it] is uneventful in a suave, well-mannered kind of way [making it] hard to tell that it hasn't always been there. Which is the whole point."[28] But only three years later, the luxury chain was forced to declare bankruptcy, in part blamed on the expense of the Madison Avenue store as well as an ill-considered expansion campaign including stores outside the city. In 1997, reversing an earlier pledge, Barney's closed its Chelsea operation, although Marino's store remained open.

Of all the leading American fashion designers, Calvin Klein had been the most consistently supportive of Modernist design, beginning in 1975 when he gave the designer Joseph D'Urso his first major commission, the design of his apartment at the Sovereign, 425 East Fifty-eighth Street.[29] In 1995 Klein made one of his boldest business moves and far and away his boldest move as an architectural patron, when he opened his three-story-and-basement, 20,000-square-foot shop at 654 Madison Avenue, northwest corner of Sixtieth Street, next to Barney's, in what had formerly been home to the Guaranty Trust Company (William Rouse with Cross & Cross, 1927–28), putting the project's design in the hands of John Pawson, a not very well-known English minimalist.[30] Klein, introduced to Pawson's work by Ian Schrager, the

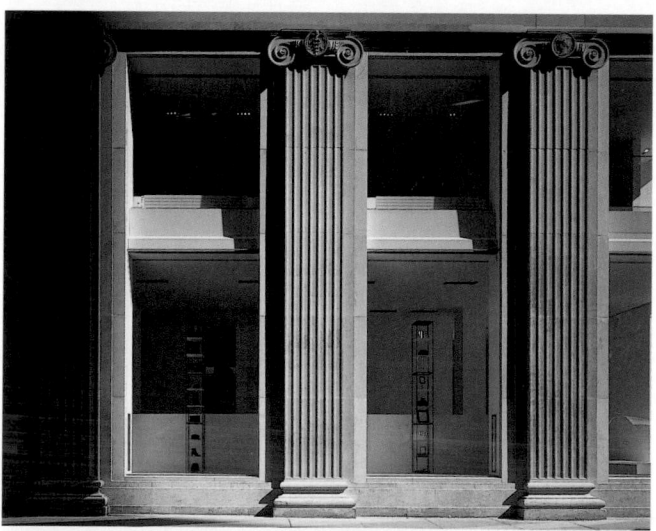

Calvin Klein, 654 Madison Avenue. John Pawson, 1995. View to the north. Warchol. PW

Calvin Klein, 654 Madison Avenue. John Pawson, 1995. Warchol. PW

Studio 54 entrepreneur turned hotelier, was attracted to the idea that the architect had not previously built anything of magnitude: "I've always been interested in people who haven't done it all before, so we can do the first big job together. Designers do get spoilt."[31] Pawson not only treated the facade with respect, but he also took advantage of the encoded message of its four Ionic soaring pilasters, which suggested a temple of consumerism, by inserting thirty-four-foot-high panes of glass—the largest ever used in New York—between them, slickly concealing the thick metal frames needed to hold them in place with polished granite facings. Inside, Pawson simplified the surfaces to the extreme, putting down stone paving from his native Yorkshire and breaking up the magnificence of the twenty-foot-high ground floor with a mezzanine covering one third of the space and, to the side, a not totally clarifying network of stairs to connect it all. Slots formed by holding back from the glass by one foot portions of the new floor and the one above opened up the space vertically to create some interesting vistas but the overall effect was one of distorted scale. At the same time, the deliberate absence of interior detailing, a reflection of Pawson's minimalism rather than a tight budget, was shoddy in its execution, so that every unavoidable detail, like air-conditioning vents, were a major visual intrusion. Despite the mellow beige of the Yorkshire stone and the three shades of white paint, there was a certain dumbing down of the aesthetic, as if minimalism was just simply the absence of effect. Caroline Roux, writing in the English newspaper *Blueprint*, seemed to understand this best. Klein felt his own work was "minimalist . . . about clean lines, not decorating a woman," as he put it, but to Roux, however, it seemed "to represent minimalism in its stylistic no-nonsense American form. Pawson's minimalism is of the European variety where what passes for austerity is actually a rich bag of slick moves that demand painstaking labour, craft, and a lot of understanding. An Armani suit is deceptively simple, a Klein suit really is simple—its structure is pared down to the least complicated lines, its construction is straightforward. That is not to say one is better than the other."[32]

Emporio Armani (1996), 601 Madison Avenue, between Fifty-seventh and Fifty-eighth Streets, occupied space that had been reconfigured for Georg Jensen by James Stewart Polshek in 1970.[33] The striped-wall Armani version was designed by Thomas O'Brien who, claiming inspiration from Eileen Gray's Parisian interiors of the 1920s, stated that "the world doesn't need another beige or white store," a rather startling observation given that just seven blocks away, at 760 Madison Avenue, northwest corner of Sixty-fifth Street, Peter Marino, working for the couture department of the same client, was putting the finishing touches on what was surely the blandest, beige-est building New York had ever seen.[34] Marino's claims for his boxlike ghosted palazzo were extravagant: "The architecture is as startling as when the Whitney [Marcel Breuer with Hamilton Smith, 1966] was built."[35] Marino's claim notwithstanding, his shop lacked the Whitney's sculptural power, but it did share the museum's anti-contextual bravura. Inside, the atmosphere of the display areas was far slicker than those at the Whitney but in their way also museum-like, with, according to Lucie Young, writing in the *New York Times*, men's suits hanging "on the walls like art, and evening dresses stand[ing] sculpturally in groupings" to provide an effect like "that of a post-guillotine cocktail party."[36] Aside from adhering

Giorgio Armani, 760 Madison Avenue. Peter Marino, 1996. View to the west. Aaron. ESTO

Valentino, 747 Madison Avenue. Peter Marino, 1996. Aaron. ESTO

Giorgio Armani, 760 Madison Avenue. Peter Marino, 1996. Aaron. ESTO

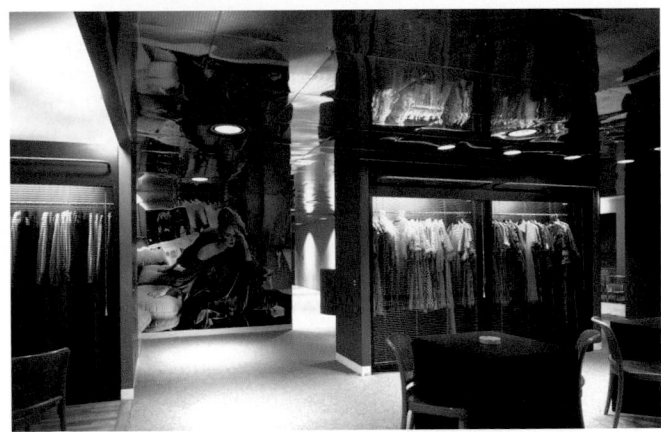

Swirl, Inc. showroom, 600 Fifth Avenue. Gwathmey Siegel & Associates, 1976. McGrath. NMcG

to the height requirements established by the Landmarks Preservation Commission, Marino made no attempt to fit in with the context. Moreover, stripped to bare surfaces, his design revealed, as Ned Cramer put it, "neglect of scale, proportion and hierarchy The Armani store's Madison Avenue facade . . . is a symmetrical, undifferentiated half-block-long surface In Marino's hands . . . the delicacy and restraint of the best Modernist work is lost. The suit may be made of silk, but the cut is all wrong."[37]

Completed at the same time (1996) as that of his arch-rival Armani diagonally across the street, and both designed by the same architect, Peter Marino, Valentino's boutique was brilliantly shoe-horned into what had been virtually counter-intuitive space that had begun as the Voisin restaurant when its host apartment building, the white brick–clad 30 East Sixty-fifth Street (Kokkins & Lyras), was completed in 1959. Valentino's was a shop and Armani's a stand-alone palazzo, but they had in common not only their architect but also a palette of materials. Nonetheless, as Elaine Louie observed in the *New York Times*, there was that "old intangible" difference: "sex appeal."[38] As Marino put it: "Armani's is tranquil and calm, but Valentino's is sexier and glamorous," owing, in part, to the bright red lacquered columns, red leather chairs, and gold-and-silver-leaf covered walls.[39] In order to create a space capable of attracting a retailer like Valentino, the two-bedroom cooperative apartment above the shop was purchased so that it could be incorporated into the retail space,

allowing ten additional feet in height to be added to what had been a mean space that was partly below street level.

In addition to stylish retail outlets, prominent fashion designers also commissioned distinguished showroom spaces. While the fashion industry represented the epitome of New York's obsession with style, it historically had taken few pains in the design of the showrooms in which the clothing was merchandised to buyers. But by the late 1970s, with the exponential increase of interest on the part of consumers in the brand identity of clothing and in the personalities of the designers themselves, architects were increasingly called upon to create distinct and expressive showrooms. These were typically to be found in leading Garment District office buildings but could also be found in more prominent buildings as well, as was the case with Gwathmey Siegel's 6,000-square-foot, sparely elegant offices and showroom for Swirl, Inc. (1976) in Rockefeller Center at 600 Fifth Avenue (Carson & Lundin, 1952).[40] Gwathmey Siegel's Garey Shirtmakers (1977), a much smaller showroom and office, was equally clean in its design and meticulous in its detailing.[41]

Calvin Klein set the trend for showroom design as a form of brand extension. For Klein's showroom (1977), 501 Seventh Avenue, Joseph D'Urso stripped the space down to the raw structure, coated the walls with white high-gloss enamel, used mirrored tile on the center portion of the ceiling to heighten the impact of the area beneath during runway shows, and lined the space with open buyers stations separated one

Calvin Klein Menswear showroom, 1211 Sixth Avenue. Joseph D'Urso, 1978. Aaron. ESTO

Williwear women's showroom, 209 West Thirty-eighth Street. SITE, 1982. Sterzing. SITE

Williwear men's showroom, 209 West Thirty-eighth Street. SITE, 1982. Sterzing. SITE

from the other by chain-link fencing.[42] A year later, D'Urso dramatically extended his vocabulary with the design of the Calvin Klein Menswear showroom, occupying 14,000 square feet of previously unoccupied space on the thirty-second floor of 1211 Sixth Avenue.[43] Inspired by shopping arcades, D'Urso set various individual specialty showrooms (for shirts, ties, etc.) behind horizontally gridded bay-window-like enclosures, transforming the unencumbered principal showroom into a grandly scaled promenade rising to eleven-and-a-half feet. The decision to confine his colors to black and white and pare down every surface to bare simplicity, D'Urso argued, would "activate and complement—by contrast—the clothing, with its continually evolving form, texture, and color. Indeed," he continued, "only when the clothing is introduced into the environment does the design intent become clear."[44] In 1980 D'Urso completed yet another showroom for the designer, Calvin Klein Jeans, 1400 Broadway, but the tricky programmatic requirements separating the men's and women's sales rooms, combined with the awkward plan of the small, 2,000-square-foot space, led to a less convincing design using curving walls to create the spatial division.[45]

Nothing could be further from the industrial chic of D'Urso's Calvin Klein showrooms, yet just as accurate a reflection of contemporary conditions, than SITE's showrooms for Williwear, the brand belonging to Willi Smith, the first significant African American designer. The showroom for women's clothes (1982), 209 West Thirty-eighth Street, in the heart of the Garment District, electrified the fashion community, encouraging the veteran journalist specializing in emerging style trends Marilyn Bethany to feature it in the *New York Times Magazine*, despite the fact that it was only open to buyers in the trade. "To appreciate just how aberrant the Williwear showroom is," Bethany wrote, "one must consider the norm for similarly ambitious ready-to-wear concerns. While varying in their particulars, fashion showrooms generally use the hush of carpeting and the flash of mirror and stainless steel to convey an image of brittle chic that is suggestive of a penthouse on Fifth Avenue. In contrast, the Williwear showroom has concrete floors, furniture that appears to be an ad hoc arrangement of loose bricks and building blocks, police barricade space dividers and backgrounds that are collages of urban textures—sidewalks, doorways, security gates, steel deck plates, sewer vents, standpipes—all arranged into a streetscape and painted putty gray. While undeniably chic, this showroom gives that exhausted value a friendly, energetic and intelligent new twist. But, above all, the Williwear showroom has wit. . . . While its imagery is clearly intended to shock, it manages to do so without appalling. And unlike much recent architectural wit, which is pitched so high that only the cognoscenti get the gag, SITE's barbs are aimed at the noninitiate—at his sense of humor, not at his expense."[46] Williwear for women was joined by a showroom (1982) for men in the same building, which was even more grittily urban, even more precisely a reflection of Smith's desire to present his clothes as an intrinsic part of street life. But, as with the women's showroom, the grim realities of street life were distilled and rendered palatable by wit with, as the designers stated, the gray paint creating an "homogenizing effect [that] destroys the anecdotal character of the industrial fragments. . . . In a psychological sense, the interior is like a memory or dream space."[47]

Before Tod Williams and Billie Tsien coalesced as a full-fledged partnership each was beginning to make a distinct independent mark on the city. Williams first came to prominence as designer of the Sointu shop (see above). In 1983 Tsien, then a member of the Williams office, completed a provocative, 2,500-square-foot suite combining office space and a showroom for L'Zinger International, 1441 Broadway.[48] To give expression to the fashion company's universal character—it was jointly owned by Americans and Japanese—Tsien combined traditional Japanese elements such as shoji with ones that represented current Japanese practice but were soon to

L'Zinger International, 1441 Broadway. Billie Tsien, 1983. Moran. TWBTA

Mexx showroom, 1410 Broadway. Robert A.M. Stern Architects, 1987. Derrick. RAMSA

become common in the United States, like stained concrete. With this basic palette, she created a composition of tilted planes that served as clothes racks set as objects in a Japanese garden.

Soon enough virtually all the important designers undertook to present their work in sophisticated showroom settings. In 1985 Wayne Berg, a rising young star on the local architectural scene, in collaboration with Richard Weinstein, an architect best known for his work as an urban designer, completed a showroom for Bill Blass that ingeniously set office cubicles afloat in a sea of continuous display space dazzlingly lit from two troughs that, in their opposition of diagonal and arc, turned the ceiling into a kind of abstract painting.[49] In the same year Berg, again in association with Weinstein, set out diagonal planes and twisted grids to transform the almost square windowless area of Anne Klein's showroom. Though Berg's showroom work was challenging, its statements were not made at the expense of the merchandise. As he observed: "A showroom should talk more about the attitude of the fashion designer and the collection, not about the person who designed it."[50]

In 1987 Margaret Helfand, another young architect on the way to prominence, went even further than Berg in attempting to de-construct the boxlike spatial enclosure in her Jennifer Reed showroom, 1441 Broadway, where, as the architect put it, "the freedom of [the] plan [was] designed to express the informality of the casual, natural fiber clothing. Plan and elevation are liberated from the humdrum regularity of orthogonal geometry and planes of natural materials are layered and leaned against each other [with] each double-sided display fixture [possessing] its own sculptural form and material identity: folded ground steel plate, layered planes of glass, and faceted wood volumes."[51] Andrée Putman's showroom (1986) for the European superstar Karl Lagerfeld at 333 Seventh Avenue was hardly architectural at all and rather disappointing as a work of the highly touted French decorator, who was much better represented by the Ebel shop (see above).[52]

Robert A. M. Stern Architects' showroom for Mexx (1987), one of three projects for the Dutch company purveying affordable street-smart clothing to young people, marked a further extension of that firm's work away from a specifically Postmodern vocabulary toward a more integrative approach. As Michael McDonough observed, the "showroom is inventive because unlike a lot of post-modern work, it doesn't just slap together traditional forms out of sheetrock."[53] Using bird's-eye maple and ebony wainscoting to solidify the principal spaces of the 10,000-square-foot showroom that occupied the second floor of 1410 Broadway (Ely Jacques Kahn, 1930), the design reflected the building's Art Moderne character, suggesting a kind of "cruise ship moderne," as Stern's project designer Graham Wyatt put it.[54]

Agrest & Gandelsonas's 5,000-square-foot showroom (1986) for the men's fashion designer Bill Robinson was the most visually disturbing of the various high-style fashion environments.[55] Located in a midtown office building, 575

Bill Robinson showroom, 575 Fifth Avenue. Agrest & Gandelsonas, 1986. Warchol. PW

Isaac Mizrahi showroom, 104 Wooster Street. Anderson/Schwartz, 1991. Moran. MM

Fifth Avenue, between Forty-sixth and Forty-seventh Streets, conspicuously outside the Garment District, the showroom reflected an unusual sympathetic relationship between the clothing designer, who liked to describe his approach as "classic and modern but not traditional," and the architectural designers, whom he felt shared a similar "thought process."[56] Robinson had been attracted to their work when he came upon some of their drawings in 1983 in the exhibition "Follies: Architecture for the Late-Twentieth-Century Landscape" at the Leo Castelli Gallery. Given that client-architect relationship and the fact that Agrest and Gandelsonas were better known for their words than their buildings—Roger Kimball pointed out that in 1977 the team, writing about a house they then had under design, assured their readers that a house is essentially "an exploration of the question of writing and architectural knowledge, a question of the problem of design as reading"—the architectural community awaited the Robinson showroom with a degree of anticipation, or as Kimball put it, "one was naturally curious . . . to see what sort of 'text' would emerge from this marriage of *haute couture* and *haute théorie*."[57] In anticipation of the actual task of designing, Agrest and Gandelsonas poured over hundreds of slides of Robinson's extensive travels, gravitating toward images from Egypt and Japan, which found their way into the design, especially in the mastaba-like pavilion realized in lattice that confronted visitors at the entrance beyond which lay the "complicated perspectival play" of the main selling area where, as Agrest put it, in an effort "to get out of

the commitment to 'sheetrock architecture,'"[58] pink limestone accented stucco was used for the walls, and columns and pilasters were formed out of bone-white brick, yielding a sense of solidity that was, as Kimball put it, "rugged, almost rustic [with a] solidity rare in the refined purlieus of fashion design."[59] Needless to say, Agrest and Gandelsonas had an elaborate explanation for their design, which they argued was "an architectural statement of various modes of framing: perspectival space (theater) versus 'accelerated' space (film), the contrast between the theatrical effect of suspense staged by the long 'silent' gallery versus the cinematographic (unresolved) tension produced by the accelerated space of the main area."[60] But, as Kimball pointed out, they "never specify exactly what semantic charge this 'theatric, even filmic' arrangement is intended to have, but I suspect that most of us will appreciate the space anyway— grateful that semiotics was not allowed to unbutton this elegant sartorial fantasy."[61]

When Isaac Mizrahi, seen by many to be American fashion's best new talent, opened his own studio in 1991, like a few industry leaders before him, he chose not to locate in the Garment District. Nor did he choose the fashionable precincts of midtown as had Bill Robinson, preferring instead a downtown location, leasing 12,000 square feet on two floors at 104 Wooster Street in SoHo. The space was selected for its natural light, which streamed in through windows and four skylights. As Mizrahi put it: "In New York, that's what luxury is."[62] As designed by Ross Anderson of Anderson/Schwartz, Mizrahi's showroom deftly complemented the loft's straightforward tectonics with a few elegant insertions—a maple-veneered, box-like enclosure for private fittings on the fourth floor entered through a rice paper and metal framed shojilike pivoting door, simple maple-veneered partitions and banquettes, and particle-board storage cubbies boldly shaped to establish an almost sculptural presence. Anderson's lighter, more casual showroom reflected the rising impact of urban street life on fashion but also the reduced budgets available for those designers who survived the economic fallout of the late 1980s and the changing tastes that came with the austerity of the early 1990s when generic clothes—tee shirts, khakis, and the like—dominated the marketplace.

FTL Associates' showroom and offices for Carmelo Pomodoro (1992), 525 Seventh Avenue, represented a high point of integration between the clothes being shown and the architect's design, to the point that Todd Dalland, an FTL principal, referring to a Pomodoro dress, jokingly asked, "Is it a dress or a building?"[63] Dalland and another of his partners, Nicholas Goldsmith, had for fifteen years been exploring the possibilities of stretched fabric: their firm was originally called Future Tents Ltd. In the 15,000-square-foot Pomodoro showroom, the tensilelike structure over which the fabric was stretched was largely confined to the showroom area where it floated a few feet below the ceiling in an effort to meet the client's request for "an industrial-loftlike environment, but one that has been softened around the edges."[64]

FTL's approach had earlier appealed to the designer Donna Karan whose very first showroom (1985) as an independent designer at 550 Seventh Avenue was decorated with cloudlike tents.[65] In 1992 Karan expanded into spacious offices at 240 West Fortieth Street, adding a steel-and-glass rooftop pavilion designed by Dalland and Goldsmith that, in keeping with her brand DKNY (Donna Karan New York), included a retractable stair inspired by those found on typical city fire escapes, as

Donna Karan showroom, 240 West Fortieth Street. FTL Associates, 1992. View to the southwest. Kaufman. EK

Donna Karan showroom, 240 West Fortieth Street. FTL Associates, 1992. Kaufman. EK

Go Silk showroom, 530 Seventh Avenue. Tod Williams Billie Tsien & Associates, 1993. Moran. MM

well as a spiral staircase enclosed in a cylindrical glass shaft. As Susanna Sirefman put it, the overall effect was that of the "reciprocal morphing of interior/exterior," yielding a "post-urban rooftop landscape . . . inside while the visitor has the distinct impression of floating outside over Manhattan's roofscape. This is a super-duper glam, desperately chic space."[66] The penthouse showroom's location was dramatically pinpointed on the skyline by the huge letters—DKNY—rising above the steel framed, thirty-foot-high glass wall, itself constructed like a three-dimensional billboard. Inside, in addition to the staircase that could be hoisted out of the way to make room for fashion shows, bleachers could unfold for additional seating. This was, as Forrest Wilson put it, "architecture for the young customers of DKNY . . . not designed for the exchange of ideas but for feeling the beat and being part of the scene. . . . It is here 'chaos dynamics' and the new sciences of complexity, the new flexible mentality of the electronic arts, and the mathematics of chaos swirl. The DKNY showroom mines the thrown-away space of New York City and elevates recycling to an architectural art form."[67] In comparison, 1100 Architect's showroom for Espirit (1992), 1407 Broadway, was far too tasteful and sweet despite the inventive details.[68]

Michael McDonough's 6,500-square-foot showroom for Sam & Libby (1993), footwear and apparel manufacturers, was a send-up of traditional styling for couture.[69] Using Homasote, a wallboard made of recycled newspapers, McDonough fashioned a stonelike rusticated enclosure populated by wittily shaped furniture purpose designed for the space. McDonough's

choice of materials, reflecting an environmental consciousness hitherto unusual in interior design, was also a guiding principal of Tod Williams Billie Tsien & Associates's Go Silk showroom (1993), a clothing company housed in 7,500 square feet of space at 530 Seventh Avenue. Go Silk was owned by L'Zinger International, for which Tsien had designed a showroom a decade earlier (see above). At its heart, the showroom featured a gently curved space treated as an oasis. With its sloping silver-leafed plywood walls floating two feet above the floor, this space was "all about being quiet," according to Billie Tsien.[70] Beyond the "decompression chamber" of the entry hall lay five showrooms connected by complexly detailed pairs of layered, maroon-stained plywood doors which, when open, permitted a seventy-five-foot-long, five-and-a-half-foot-wide runway to extend through to the main showroom.[71]

Shoe Shops

Shoe shops have traditionally been testing grounds for ideas in decoration and interior architecture. In the 1920s and 1930s for example, the various Modernist styles were introduced in elegant shops such as Richard Haviland Smythe's John Ward (1928), 555 Fifth Avenue, an exemplar of the French Moderne, or Vahan Hagopian's various London Character stores (1929), early interpretations of the International Style.[72] In the stylistically eclectic 1980s and 1990s, with the public virtually besieged by formal experimentation, some of the more genuinely inventive designers, like Alan Buchsbaum, approached the problem with calculated restraint, as for example in his

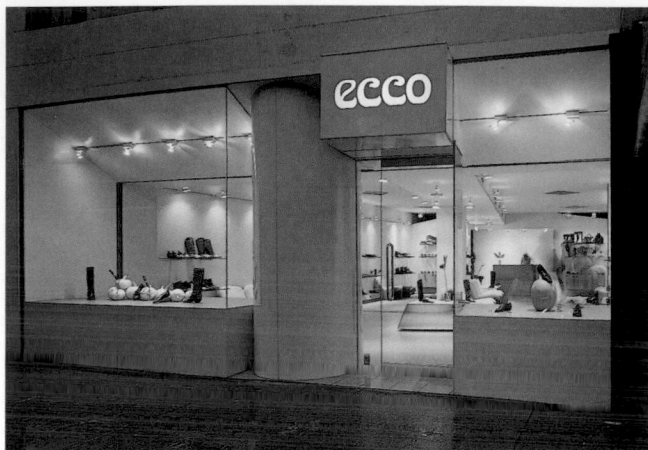

Ecco Shoes, 94 Seventh Avenue. Alan Buchsbaum, 1985. Kaufman. EK

Famolare, 767 Lexington Avenue. Piero Sartogo and Nathalie Grenon, 1985. SA

Ecco Shoes (1985), 94 Seventh Avenue, between Fifteenth and Sixteenth Streets, which combined two shops in Chelsea into a relatively anonymous, 1,400-square-foot box sliced on a diagonal by a display and seating area so located to help mitigate a pre-existing gigantic structural and utility column that the architect made a feature of by wrapping it in baked-enamel green-metal panels.[73]

Piero Sartogo and Nathalie Grenon's 1,600-square-foot Famolare (1985), 767 Lexington Avenue, intended as a prototype for a chain of retail shoe shops founded by a company formerly operating in the wholesale market, was decidedly more

architectural, although its frameless glass facade seemed more mall-like than street smart.[74] But a gabled canopy over the sidewalk that extended through the shop as a linear fluorescent lit skylight was more compelling. For the pricey Joan & David shoes, Eva Jiricna inserted simple casework and a spectacularly detailed perforated stainless steel stair into a shop (1990) at 104 Fifth Avenue, between Fifteenth and Sixteenth Streets.[75] The sixteen-and-a-half-foot-wide, seventy-foot-deep, sixteen-and-a-half-foot-high space was divided by a row of robust classical columns which Jiricna left exposed, winding sensuously shaped benches around and between them. Edward Mills's minuscule, eight-foot-wide, thirty-foot-deep store for Kenneth Cole, 95 Fifth Avenue, southeast corner of Seventeenth Street, typical of the architect's approach, was deliberately complex with intricately curving walls and soffits and richly finished surfaces, including natural rusting steel and plaster beaten with chains and painted with graphite, all in an effort to satisfy the client's desire to have "a juxtaposition of the old shell, and new, very modern fittings inside."[76]

Beauty Salons

Beauty salons were perhaps the most temporary of store interiors with new shops opening and older shops constantly remodeling in order to keep up with trends in hair as well as decorating fashion. Perhaps because of the promise of the young architects hired, a few of the shops were treated seriously in the professional press, including Henry Smith-Miller and Michael Rubin's Maurice Tidy Salon (1977), 631 Park Avenue, between Sixty-fifth and Sixty-sixth Streets, which transformed a former liquor store into "a supermodern" beauty salon sufficiently unusual to draw the attention of "anonymous people [who] walk in to find out what the shop does."[77] Scott Bromley, the architect, and Ron Doud, the designer, who were to achieve a moment of super-stardom as a result of their work at Studio 54, also tackled humbler assignments such as the Backer & Company hair salon (1977), 50 East Eighty-sixth Street, where, with a very limited budget, they updated a thirty-year-old establishment along Art Deco lines making dramatic and extensive use of black to create drama and understatement, as well as peach for flattery.[78]

Anderson/Schwartz's 16,800-square-foot Bumble & Bumble Hair Salon (1996), located in a nineteenth-century carriage house at 146 East Fifty-sixth Street, was, in terms of size, as well as artistic ambition, a cut above its rivals.[79] The project came to the architects after an April Fool's Day fire in 1995 virtually destroyed the owners' previous establishment in the same building. Ross Anderson had already worked for the owner who had been impressed with the architect's handling of the studio and showroom of the fashion designer Isaac Mizrahi (see above). Whereas the original salon had occupied only two floors, the new Bumble & Bumble was twice as big. Anderson rebuilt the carriage house's facade in a straightforward way but opened it up on the street level to reveal more than a glimpse of the sophisticated compilation of as-found industrial materials and fixtures that at once suggested a factory and the backstage of a Broadway theater. The factory image was exact: over 300 women visited the salon each day for hair cutting, hair coloring, and make-up services. As a talisman of the adventurous design inside, a pseudo-robot displaying photographs, video monitors, and metal objects d'art was attached to the show window with suction cups. As Anderson put it: "The salon places you on display while you

Maurice Tidy Salon, 631 Park Avenue. Henry Smith-Miller and Michael Rubin, 1977. McGrath. NMcG

Bumble & Bumble Hair Salon, 146 East Fifty-sixth Street. Anderson/Schwartz, 1996. Moran. MM

simultaneously view others. Transparency, translucency, opacity: spaces and objects are revealed through materials and shapes, creating anticipation. With unexpected combinations of architectural elements and reiterated materials, connections are formed that give the salon a coherence. Clients participating in their own transformation also participate in ours."[80]

Bookstores

In the late 1970s, there was a boom in midtown bookstores, which real estate interests, retailers, and planners welcomed as a stimulus to overall shopping traffic. The new shops tended to be larger and more shopper-friendly than in the past, with wider aisles for browsing and comfortably furnished sitting areas. B. Dalton Booksellers, a national chain claiming to be the world's largest retailer of hardcover books, introduced the trend to New York when it came to Fifth Avenue in 1977, leasing 25,000 square feet at 666 Fifth Avenue (Carson & Lundin, 1957), northwest corner of Fifty-second Street.[81] Doubleday, perhaps the city's most respected big chain, was also building new stores. Doubleday's pre- and post-war stores had been quite stylish, including Frank H. Holden's shop (1936) at Thirty-seventh Street and Fifth Avenue, and Arch Swank Associates' two-story store (1967) in the newly renovated Doubleday headquarters building on the northeast corner of Fifth Avenue and Fifty-third Street, but the renovation and expansion of 724 Fifth Avenue, between Fifty-sixth and Fifty-seventh Streets, designed by Weisberg & Castro (1978), resulted, according to Paul Goldberger, in "a supermarket . . . immense and shrill," with light bright enough "to make the store look like a television studio."[82]

The most innovative of the superscale bookstores was Barnes & Noble, a publisher of college texts and medical and scientific books that was transformed into a chain of superstores by Leonard Riggio, a New York University School of Commerce dropout who took the company over in 1971.[83] In 1977 Barnes & Noble opened its first big midtown store at 600 Fifth Avenue, between Forty-eighth and Forty-ninth Streets, replacing the venerable clothiers Rogers Peet.[84] To be one of the world's largest, and their first large-scale venture after their flagship store and annex at Fifth Avenue and Eighteenth Street, the new store was to have 8 percent of its 30,000 square feet devoted to customer amenities. Riggio was influenced by Rizzoli, the Italian publisher, which had established an elegant, well-lit bookstore (1964) at 712 Fifth Avenue, between Fifty-fifth and Fifty-sixth Streets, where classical music was played and coffee served.[85] After opening the midtown shop, Riggio and his partners embarked upon a massive campaign of expansion through buyouts and takeovers. In 1979 they purchased the Bookmasters chain, with its four midtown paperback outlets, and the same year they took over Marboro, the largest retailer of "remainder" books, which had five Manhattan stores.[86] After changing the franchise to that of Barnes & Noble, Riggio would organize the merchandise to cater to neighborhood interests, such as music at the Fifty-seventh Street and Seventh Avenue store. In 1986, with Barnes & Noble now controlling thirty-five stores, most in the New York metropolitan region, the company purchased the giant B. Dalton, and by the mid-1990s it would control Doubleday.[87]

In 1992 Barnes & Noble opened its first superstore at 1280 Lexington Avenue, northwest corner Eighty-sixth Street, an 8,000-square-foot facility.[88] Despite carpeting, soft music, and dark wood with ample seating for browsers, the design was relatively ordinary. Its next large store, which opened the following year in the heart of the Upper West Side on the west side of Broadway between Eighty-second and Eighty-third Streets, was more innovative.[89] The full-block, 32,000-square-foot, three-level store, with a capacity of 225,000 books and a fifty-seat café, caused a sensation and was immediately popular. In addition to the standard hunter-green color scheme and walnut shelves, the Broadway store included brass Deco-style light fixtures, mission-style tables, a listening booth for previewing audio books, and a 4,000-square-foot children's section. Most

Rizzoli, 31 West Fifty-seventh Street. Hardy Holzman Pfeiffer Associates, 1986. McGrath. NMcG

Archivia, 944 Madison Avenue. Michael Rubin, 1992. McGrath. NMcG

significantly, it featured a college library–like study hall with rows of tables overlooking Broadway attracting students and others. Barnes & Noble continued with the high amenity, superstore formula, opening a new 35,000-square-foot store (1994) on the west side of Sixth Avenue between Twenty-first and Twenty-second Streets in the former Adams & Company building (De Lemos & Cordes, 1902).[90] Also in 1994 Barnes & Noble took over the space formerly occupied by Conran's in Hugh Stubbins's Citicorp Center (1977), opening a 30,000-square-foot store.[91] In 1995 Barnes & Noble transformed the 100,000-square-foot Queen Anne–style Century Building (William Schickel, 1880–81), once home to a famous literary magazine, 33 East Seventeenth Street, facing Union Square.[92] Judith Saltzman of Li-Saltzman restored the facade, and James Cohen was charged with maintaining the character of the landmark interiors, which were listed on the National Register, while SBLM Architects/By 3 Group designed the bookstore itself in keeping with the bookseller's overall design standards. Taking advantage of the high ceilings and such architectural features as Corinthian capped cast-iron columns and considerable original woodwork, the effect was impressive, even though it lacked the intimacy and charm of many of the traditional bookstores such as Shakespeare & Company and Endicott that the superstores were rapidly driving out of business.[93] The soul-searching over the fate of the independent bookstores even reached the point of worrying whether the huge chains, and especially Barnes & Noble, would influence the quality and variety of books written in the increasingly homogenized book business. But the superstores had their defenders (as well as the business of the former customers of the independents). One unlikely ally, Victor Navasky, publisher of the liberal magazine *The Nation*, observed in 1995 in an op-ed article in the *New York Times*: "Twenty years ago, plagiarizing Rousseau, I lamented in print that 'books are born free but they are everywhere in chains.' As bookstore chains get more powerful, I argued, they will drive out independent bookstores and substitute commercial values for literary ones. Yet these days, while giving lip service to the idea of independent shops like Shakespeare & Company . . . I have been buying most of my books from Barnes & Noble. . . . This is partly because . . . too often Shakespeare . . . didn't have the book I needed . . . [and] then there are the superstore amenities: bigger discounts on just-published books, a cafeteria-cum-coffee bar, racks crammed with journals and newspapers from near and far. And there is no harassment about eating or peer pressure to shut up,

as there is in the public library. . . . But what really intrigues me . . . goes beyond yuppie trappings. . . . I am impressed by the fact that at a time when privatization is in the air . . . these chains seem intent on taking private space into the public sphere."[94] The success of Barnes & Noble spurred competition, and the Borders chain opened two large stores also filled with comfortable chairs and cafés, at Five World Trade Center and 461 Park Avenue, northeast corner of Fifty-seventh Street.[95] But perhaps the greatest threat to Barnes & Noble, and the whole superstore concept, was the dramatic growth of selling books over the internet, pioneered by Amazon.com but quickly imitated by Borders and Barnes & Noble themselves. By the late 1990s, the boom of large midtown bookstores was a thing of the past, especially on Fifth Avenue, where the only remaining store was Barnes & Noble's branch at 600 Fifth Avenue. Although the city's finest bookselling space in Ernest Flagg's Scribner Building (1913), 597 Fifth Avenue, was closed in 1996, the interior was lost only to books, as the space was reinvented as a retail outlet for the Italian clothing company Benetton (see Fifth Avenue).

A few brave entrepreneurs attempted to counter the superstore trend with smaller shops that offered exceptional levels of service in intimate and fundamentally traditional settings. One of these was the New York arm of the Italian publisher Rizzoli, which in 1985 was forced out of its elegant Fifth Avenue store after twenty-one years of service in order to make way for Kohn Pedersen Fox's 712 Fifth Avenue (see Fifth Avenue). Rizzoli relocated a short distance away at 31 West Fifty-seventh Street (1986) where Hardy Holzman Pfeiffer installed them in what

had originally been designed as the showroom for the Sohmer piano company (1928). Retained on Philip Johnson's recommendation, Hardy Holzman Pfeiffer was charged with recapturing the look and feel of the Fifth Avenue store that had become a mecca for booklovers, especially those interested in art, architecture, and design. According to Hugh Hardy, the project was "an essay in continuity."[96] To help preserve the mood, Hardy Holzman Pfeiffer relocated several important pieces of casework and four chandeliers from the Fifth Avenue store to Fifty-seventh Street. In addition, they reglazed the Adam-style plaster ceiling to make it seem more venerable. Despite a considerable increase in size, the new Rizzoli had the elegance and intimacy of its original store.

Founded by Jeannette Watson, Books & Company (1978), 939 Madison Avenue, between Seventy-fourth and Seventy-fifth Streets, was a new enterprise which, as designed by Stephen Sanders, succeeded in capturing, according to Paul Goldberger, "more of . . . [the] old-bookshop aura . . . than any new store in town has managed to do before." Burt Britton, the store's founding director, "wanted it to be like an English saloon or a French bookshop," but Goldberger felt that, although this was not quite achieved, Sanders had "skimmed off enough of the atmosphere of those places" to make it "a most surprising sort of store for New York." With its front window divided into multiple twelve-inch panes of glass set between wood mullions, and the dark-stained shelves, brown carpeting, and incandescent lighting fixtures within, the shop was a definite contrast to the typical high-style Madison Avenue boutique. "One could do without the exposed brick, which has become a cliché . . . but in general this is a warm and welcoming environment," Goldberger observed. "It is not cute, like most 'old-fashioned' shops, and it is not precious or delicate either."[97] The design philosophy was summed up by Britton, who said that "the architect kept telling me a metal stair would be much cheaper than a wooden one, but I said you don't understand, this is a *bookstore*," and a wood stair was built to connect the main floor to the second floor where there were more books and a cozy sofa on which from time to time some of the most important authors read from their work to an invited public.[98] Books & Company closed in 1997, not so much a victim of the superstores but the vagaries of its landlord, the Whitney Museum of American Art.[99]

Two other bookstores—each quite small—were notable additions to the local scene. The first, Archivia, occupying a mere nine-and-a-half-foot-wide, 700-square-foot space at 944 Madison Avenue, between Seventy-fourth and Seventy-fifth Streets, specialized in books about art, architecture, and decoration. As designed by Michael Rubin, the shop (1992) was a booklover's dream, lined with shelves reaching almost to the fifteen-foot-high ceiling (rolling ladders were installed to access the top shelves). The display of current titles was confined to slender center tables. At the rear of the store, a tiny mezzanine accommodating an office was both a practical and scale-giving device, as were the decorative wood louvers on the ceiling that baffled the overhead light while suggesting an elegant vault. "This is a space of small gestures," Rubin observed, "a very precise space."[100] Archivia closed after a dozen years in operation.

The second small bookstore was quite different, both in the subject matter it specialized in and in the design of the space: Zivkovic Connolly Architects's 2,500-square-foot St.

St. Mark's Bookshop, 31 Third Avenue. Zivkovic Connolly Architects, 1993. Ranson. ZAA

Mark's Bookshop (1993), 31 Third Avenue, at East Ninth Street, specialized in counter-cultural materials. Occupying an irregular but basically triangular space in NYU's Cooper Union Residence Hall (see Greenwich Village), the shop was deliberately designed to contrast with the coziness of a Books & Company or the luxe of Rizzoli. Taking advantage of the odd plan, Don Zivkovic located the service desk in the center from which the staff could survey the aisles of books that radiated in two directions from it, suggesting the Panopticon-inspired arrangements Frank Lloyd Wright and Alvar Aalto had devised for some of their library projects. Industrial metal scaffolding and traditional pine shelving were combined with a random pattern of terrazzo tiles on the floor and overhead canopies of light diffusing white plexiglass as well as a "natural" arrangement of flexible silver air-handling ducts to make for a cacophonous effect. One journalist described "surreal moments" in the design, including the contrast of the static shelving with the writhing, intestine-like shapes of the ductwork overhead, "which seem when viewed head on to possess their own power of locomotion," to create an effect that was "playful and rather mad" as if "alternative culture meets Alice in a '50s sci-fi Wonderland."[101] In their description, the architects put a different spin on the design, stating that the mix of elements and geometries "would bring together some of the raw aesthetics associated with the East Village neighborhood, collectively with the essential, basic requirements of the program . . . to form a cohesive whole growing, not out of a stylistic preference, but from a direct response to their limited needs."[102]

OUTER
BOROUGHS

BROOKLYN

By 1976 Brooklyn was beginning to emerge from a long and steady decline that for much of the twentieth century, despite tremendous physical growth and short periods of prosperity, kept it in the shadow not only of Manhattan but also of its stature at the end of the previous century. The borough's population still made it the fourth largest city in the nation, as it was in 1898, when the City of Brooklyn gave up its political independence to become part of Greater New York. But the populace was vastly different, having been transformed by successive waves of immigrating poor and lower-middle-class families beginning in 1903, when the completion of the Williamsburg Bridge provided a direct connection between the slums of the Lower East Side and the open, clean areas across the East River. This continued through the postwar era, by which time urban renewal struggled to rid Brooklyn of its own slums. A good deal of Brooklyn's decline could be attributed to the loss of jobs as industrial activity, especially along the once-bustling docks, slowed to a halt. By the close of the postwar era, Brooklyn had lost both its economic vitality and its cultural identity, as respected institutions such as the Brooklyn Academy of Music and the Brooklyn Museum declined and Coney Island deteriorated into an anemic version of the resort that had thrived as recently as the 1940s. Less tangible sources of civic pride were also lost, as when the *Brooklyn Eagle*, Brooklyn's nationally known newspaper, ceased publication in 1955 and the borough's baseball team, the Dodgers, moved to Los Angeles in 1957. By the 1970s most of the news that came out of Brooklyn concerned crime, poverty, arson, and racial tension. As evidenced by the fact that no major hotel was built in Brooklyn for nearly fifty years, no one, it seemed, had any reason to visit the borough.

But as the end of the century approached, Brooklyn staged a comeback, reviving not only as a center of culture and commerce but also as a collection of desirable residential neighborhoods, many remarkably intact as a result of their designation as historic districts and the influx of a new wave of immigrants—young professionals, artists, and families—who resuscitated neighborhoods one house at a time. Brooklyn's renaissance was apparent as early as 1980 to Randall Rothenberg, features editor of the *Brooklyn Heights Press*, who proclaimed on the op-ed page of the *New York Times*: "It's time to wake up to the fact that New York is a two-borough town again. . . . There is a sizable segment of the New Urban Gentry that has opted out of the East/West 95th Street Sweepstakes, preferring instead to renovate a brownstone in Cobble Hill. The only artists moving into SoHo and TriBeCa these days are those who can afford a $100,000 mortgage; the real paintbrush pioneers are braving Williamsburg. . . . Serious theater-goers nod knowingly about a cultural explosion called BAM—the Brooklyn Academy of Music."[1] Business was not far behind as plans to revive downtown Brooklyn's commercial and civic core moved forward in the 1980s and proved an unqualified success by the late 1990s.

Brooklyn Bridge

High spirits greeted the centennial of the Brooklyn Bridge in 1983.[2] Although the beloved landmark weathered its first century relatively well, in 1979 the engineering firm of Steinman

Boynton Gronquist & Birdsall determined that a major rehabilitation of most of its structural components was necessary. A plan was prepared to carry out the work over the following ten to fifteen years, but although cosmetic repairs such as the replacement of the pedestrian walkway took place in 1980, preparation for more significant work was slow to start. Then, on June 28, 1981, two of the bridge's 400 diagonal cable stays snapped, one slicing a gash through the pedestrian footpath and the other whipping out over the river before curling back to strike and kill Akira Aimi, a Japanese photographer.[3] The event added urgency to the repairs that began in 1983 and continued over the following two decades: the replacement of broken and rusted cables within the anchorage chambers, repairs to the roadway and the roadway truss, and the replacement of all of the 1,088 vertical suspender cables and 400 stays. In 1984 ramps were added to allow easier access for the handicapped as well as for bicyclists, who now had a demarcated bike lane.[4]

As had the opening of the bridge, its centennial received national attention. The U.S. Postal Service issued a commemorative stamp. All manner of merchandise was sold, ranging from T-shirts and umbrellas to souvenir splinters of wood from the walkway and even pieces of the cable that had snapped two years earlier. Andy Warhol was commissioned to design a poster that featured a historic photograph of the bridge, and Tobias Picker, a New York composer, wrote a concerto for piano and orchestra. The Brooklyn Museum launched "The Great East River Bridge," an exhibition of artwork, writings, and ephemera showcasing some of the 10,000 original engineering drawings that, thought to be lost, had been discovered in 1967 in a carpenter's shop under the Williamsburg Bridge.[5] The extravagant festivities on May 24 included a thirty-five-minute fireworks show kicked off by a blue starburst designed to resemble the one that opened the ceremonies 100 years earlier, and a computer-controlled sound-and-light show, "The Eighth Wonder," designed by Jules Fisher Associates to illuminate the caissons, cables, and towers in such a way as to depict events in the bridge's history, including lightning strikes, winter storms, and explosions that occurred during construction. A new permanent lighting system was also implemented during the celebration, designed by the Fisher firm to emphasize "a geometry of light appropriate to the geometry of the bridge," according to project manager Bob Davis.[6] In place of the former "necklace" lighting, new floodlights illuminated the towers above the road level as well as the radial fan of the cables. Original lighting stanchions along the pedestrian walkway were re-created in heavy-duty cast iron according to period photographs and sketches.[7]

The city hoped to channel the enthusiasm generated by the centennial into attracting public uses for the underutilized vaults and anchorages at each end of the bridge. Plans for the twenty-nine vaults supporting the roadway in Manhattan, ranging in size from one to three stories and from fifty-six to 10,074 square feet, had surfaced in the mid-1970s when, in the waning days of the Lindsay administration, the Brooklyn Bridge Plaza program was conceived to beautify the areas around the arches and thus help integrate the communities on the north and south sides of the structure.[8] The budget constraints of the late 1970s canceled this effort, but private groups also developed proposals. The 112 Workshop, represented by Jeffrey Lew and Alan Katzman working with Potter & Golder Associates, proposed linking three of the three-story archways by reopening the passageways between them to

Brooklyn Bridge Anchorage, Brooklyn side. Renovation by Smotrich & Platt; lighting design by Bonvini-Kondos, 1983. DSP

accommodate an arts center providing studio space, galleries, and living quarters. The plan did not move forward, hampered in part by two unresolved issues: the dampness of the vaults and the noise of the bridge traffic overhead. In 1987 a scheme prepared by Perkins Geddis Eastman called for 120,000 square feet of residential, office, and retail space, with the arches to be restored and the brick infill facades redesigned to resemble a row of nineteenth-century townhouses, but that plan also died and the spaces remained unused.[9]

Real progress was made on the Brooklyn side, however, where the cavernous anchorage, within which the main suspension cables were anchored to the earth, was renovated as an exhibition and performance space.[10] Borough President Howard Golden initiated the project in 1982, inviting Smotrich & Platt to examine the anchorage's two stone vaults and five additional brick transverse vaults that supported the roadway and determine whether the space could be used during the centennial celebration. By the following year, working with the structural engineer Robert Silman, Smotrich & Platt had converted the rooms, entered through a single doorway on Old Fulton Street, into what *New York Times* dance critic Jennifer Dunning called "one of the most atmospheric places in the city to see new art and performing."[11] The architects stabilized the walls and ceilings, blast-cleaning them with walnut shells to retain the texture and patina, added mechanical equipment, and poured new concrete floors that were paved with brick in some areas. Bonvini-Kondos, a lighting design firm, placed fluorescent tubes high on the walls to illuminate the barrel vaults and situated red neon fixtures on walls to indicate the presence of anchorage chains within. The inaugural exhibition, coordinated by Creative Time, included educational exhibits in addition to artworks and performances.[12] Creative Time continued to stage annual "Art in the Anchorage" events until 2001, when, after the attacks on the World Trade Center, the bridge came to be considered a target for terrorism, placing the anchorage off limits after nineteen seasons.

Old Brooklyn
From Fulton Ferry to Dumbo

In June 1977, after five years of research, hearings, and false starts, the Landmarks Preservation Commission created the Fulton Ferry Historic District, an irregularly shaped area roughly bounded to the north by the East River, to the south by Front and Doughty Streets, to the east by Main Street, and to the west by Furman Street.[13] Proximate to the site where Robert Fulton began steam-propelled ferry service to Manhattan in 1814, the area along Old Brooklyn's historic waterfront, once a commercial powerhouse, declined after the 1883 completion of the Brooklyn Bridge, which overshot it. The neighborhood lost virtually all momentum when ferry service to Manhattan was terminated in 1924. The construction of the Brooklyn-Queens Expressway in the 1950s isolated the area, freezing in place its legacy of masonry warehouses, mostly four and five-story Greek Revival, Italianate, or Romanesque Revival buildings. But the area's redevelopment potential was recognized by its principal property owner, Consolidated Edison, which had extensive holdings, including the Empire Stores (Nesmith & Sons, 1870; Thomas Stone, 1885), 53–83 Water Street, between Dock and Main Streets, a complex of seven four- and five-story brick warehouses totaling 340,000 square feet of space that looked like a single massive building.[14] Consolidated Edison, which led the opposition to the designation, had kept the buildings vacant in anticipation of constructing a power plant on the site, but after the historic district was created, the company sold the property to the state, which planned to restore the Empire Stores. In 1977, along the waterfront next to the buildings, the state created the 3.8-acre Empire Fulton Ferry State Park, a modest but welcome fenced-in area that contained a boardwalk and a few benches. Other signs of neighborhood renewal came in 1977, including the opening after more than a decade of effort of Michael (Buzzy) O'Keefe's River Café, a high-quality restaurant located on a barge moored at the foot of Old Fulton Street that had spectacular views of the lower Manhattan skyline.[15] Attracting a cosmopolitan crowd, the River Café proved to be a major marketing asset for the area. Just south, on a 102-foot-long former coffee barge tied to the Fulton Ferry Pier, Olga Bloom ran Bargemusic, a 150-seat wood-paneled floating concert hall dedicated to twice-weekly, year-round chamber concerts.[16] Also in 1977, in a clapboard firehouse built in 1926 to house the crew of a fireboat based at the Fulton Ferry Pier, the National Maritime Historical Society opened a small nautical museum.[17]

In 1980 the revival continued with Rothzeid, Kaiserman & Thomson's conversion of Frank Freeman's six-story brick

Richardsonian Romanesque Eagle Warehouse and Storage Company (1893; addition by Freeman, 1906), 28 Cadman Plaza West (formerly Old Fulton Street), southeast corner of Elizabeth Street, into eighty-five apartments, all with eleven-foot-high ceilings.[18] Developer Benjamin Fishbein was not pioneering new ground in his renovation, an honor that belonged to architect David Morton, who seven years earlier had converted the former Brooklyn City Railroad Company Building (1861), 8 Old Fulton Street, into apartments, but Fishbein's effort was better timed and proved a financial success.[19] As part of the renovation Rothzeid, Kaiserman & Thomson carved out a sixteen-foot-wide atrium in the center of the building to bring in additional light, and repaired the eleven-foot-diameter clock located on the parapet of the 1893 building, replacing its wood hands with lightweight aluminum.

Although the area was still largely derelict, by 1982 Paul Goldberger could report on a "revitalized Fulton Ferry" undergoing a "curious brand of gentrification," with "fashionable restau-

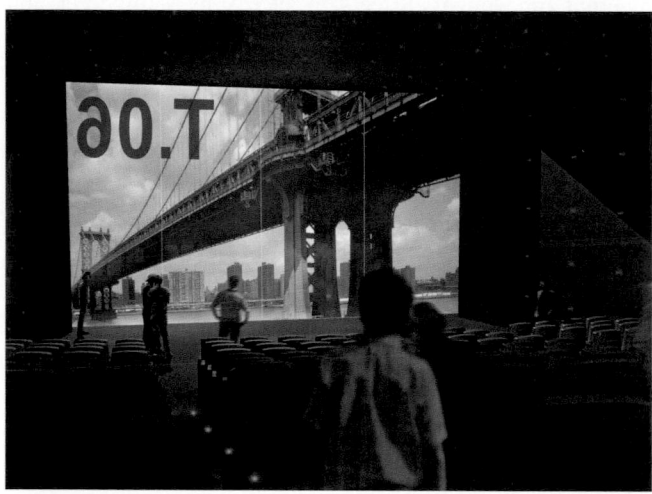

Proposed River Hotel, East River waterfront, between Brooklyn and Manhattan Bridges. Jean Nouvel, 1999. Rendering of theater. AJN

Proposed River Hotel, East River waterfront, between Brooklyn and Manhattan Bridges. Jean Nouvel, 1999. Photomontage, view to the northeast. AJN

rants, cultural facilities and living lofts but also dark factories as well, so the air of an old industrial neighborhood remains." Noting "a refreshing absence of boutiques," Goldberger compared the area to "SoHo a dozen years ago, with the addition of one of the most spectacular views in the world."[20] But this urban idyll was soon threatened when the city and state authorized the Urban Development Corporation to pick one or more developers to transform a fifteen-acre site between the two bridges, with hopes of creating a lively mixed-use neighborhood by adding retail, residential, and institutional tenants and a 500-room hotel to the light industrial businesses already there.[21]

In May 1982, the UDC chose David Walentas's Two Trees Management as "conditional developer" of the city- and state-owned site.[22] Walentas, who had cut his teeth renovating SoHo loft buildings for residential and commercial uses, and would remain the dominant player in the Fulton Ferry area for the next two decades, had recently purchased ten buildings next to the redevelopment site. Preliminary plans for Fulton Landing, as the mixed-use project was named, were drawn up by Beyer Blinder Belle and John T. Fifield Associates. The plan, in part resembling South Street Seaport, then nearing completion across the East River, proposed to expand the Empire Fulton Ferry State Park to six acres and include a pier pavilion containing restaurants and shops, a 300-foot-high observation tower, a 100-slip marina, two parking garages, and a farmers' market. The restored shell of the Empire Stores would possibly become home to factory outlets, and ferry service to lower Manhattan would be resumed. Walentas also planned to renovate his existing holdings—occupied mostly by light industry, including many in the garment trade—into high-end residential units and more lucrative office space. In January 1984, he announced an agreement to rent back-office space to the Wall Street firm Lehman Brothers, which would occupy at least two floors in the sixteen-story Gair Building (William Higginson, 1888), 1 Main Street, notable for its prominent clock tower.[23]

Opposition to Fulton Landing was immediate and vocal. Although many of its loft buildings were vacant, the Fulton Ferry area was still home to more than 145 companies employing almost 5,000 semiskilled and unskilled

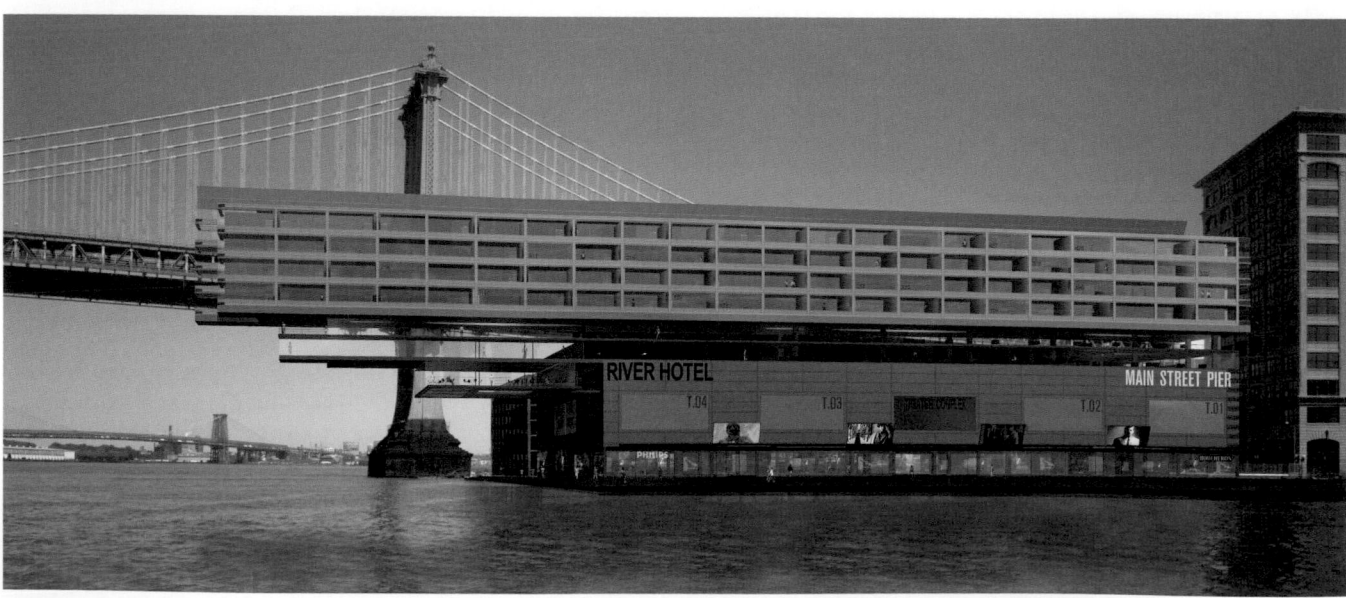

workers. Threatened manufacturers and labor unions joined forces to form the Save the Jobs Coalition. Also protesting Fulton Landing were the growing number of artists living and working in the area, who were attracted to the relatively spacious and inexpensive loft spaces as compared with those in Manhattan. Although supporters of the project derided the opposition as the Save Our Inexpensive Lofts Coalition, several local politicians took up the cause to save blue-collar jobs. In a controversial move that Walentas contended had more to do with a personal feud with Deputy Mayor Kenneth Lipper, the Koch administration decertified Two Trees as developer because of inadequate financing. Although the UDC did not recognize the city's authority to act unilaterally, the damage was done and Fulton Landing was abandoned in 1985. After Lehman Brothers withdrew its commitment to rent office space in the Gair Building, Governor Mario Cuomo brokered a compromise in which Walentas agreed to offer ten-year leases to manufacturers in four of his buildings, preserving 1,200 factory jobs, and the state agreed to transfer between 1,000 and 1,200 workers from the World Trade Center to renovated offices in Walentas-owned properties in Fulton Ferry.

Although he was unable to go forward with his ambitious plans for Fulton Landing, Walentas and Two Trees Management remained active in the Fulton Ferry area, which prospered in the late 1980s and 1990s as more historic buildings were renovated and the influx of artists and galleries continued.[24] By 1993 the neighborhood was sporting a popular new moniker, Dumbo, coined by artists and standing for "Down Under the Manhattan Bridge Overpass."[25] In 1996 another attempt was made to develop the Fulton Landing waterfront site, with Walentas redesignated as developer by the Giuliani administration.[26] Walentas again hired Beyer Blinder Belle as master planners for an entertainment, retail, and recreation center that would include a marina, a hotel, movie theaters, restaurants, and shops in the restored Empire Stores, and between eight and nine acres of parkland with a three-quarter-of-a-mile-long boardwalk. Before any specific plans were released, the project was assailed by many in the community, including artists worried that gentrification would force them out, and advocates for the Brooklyn Bridge Park (see below), who now wanted the Empire Fulton Ferry State Park to be part of their plans for the redevelopment of the piers beneath the Brooklyn Heights Esplanade.

In a bold move, perhaps intended to mute criticism of his project, Walentas selected innovative French architect Jean Nouvel to work with Beyer Blinder Belle on what would be his first building in the United States.[27] Nouvel's design, released in May 1999, called for a 377,000-square-foot, 245-room hotel clad in so-called white glass, in effect iron-free glass, and gray metal panels that dramatically cantilevered 134 feet out over the East River, constituting a 100-foot-high "bridge between bridges," in the words of the architect.[28] The building maintained a horizontal emphasis, with a four-story grid of hotel rooms sitting atop a five-story rectangular box that included ground-level shops and a sixteen-theater cinema with screens that could be raised to offer spectacular river views. The hotel complex also featured a health club that overlooked the Brooklyn Bridge and was connected to the main building by a glass bridge. Because mechanical equipment was housed in a separate facility, Nouvel was able

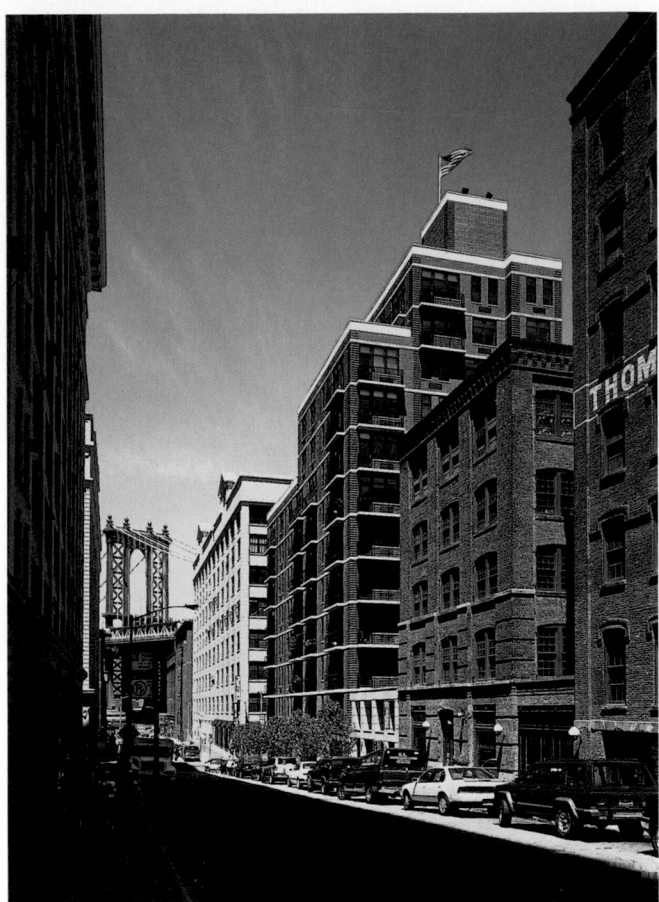

65 Washington Street, between York and Front Streets. Stephen B. Jacobs, 2001. View to the northwest. SBJG

to animate the highly visible roof with skylights and a landscaped patio. The hotel's three levels of public spaces were wrapped by seamless glass, and a square glass area on the floor of the lowest level permitted direct views of the river. Describing Nouvel as "the most original architect of his generation," Herbert Muschamp deemed this design to be one of his "most impressive works. New York has not seen a new building of its caliber in decades. This is architecture—the real thing. It is not a simulation, not corporate schlock, not yet another retro sigh. Viva la différence. And vive l'amour. Mr. Nouvel has clearly fallen in love with his site. . . . His design literally and figuratively reflects [its] wildly romantic context. And it plays on the narcissism of a city in thrall to its self-image as the center of the world."[29]

Despite the daring design from a star architect, which was appreciated by many, the committed and well-organized opposition continued its efforts. In December 1999, only seven months after its release, Walentas's redevelopment scheme was scrapped. Citing the belief that it would fundamentally alter the character of Dumbo by blocking views and generating too much automobile traffic, Joseph B. Rose, chairman of the City Planning Commission, stated that "the scale Walentas was pressing for, we felt, was beyond what was appropriate and sustainable. The revitalization of the waterfront in a way that creates a public amenity is the city's goal."[30]

Walentas and Two Trees were successful, however, in converting the Gair Building, recently vacated of state employees, into a high-end residential condominium, the 124-unit Clock

Proposed Light Bridges, 100 Jay Street, between York and Front Streets. SHoP/Sharples Holden Pasquarelli, 2001. Rendering of view to the southwest. SHOP

Tower (1999).[31] Beyer Blinder Belle was placed in charge of the renovation, the highlight of which was the top-floor, 3,500-square-foot loft complete with twenty-five-foot-high ceilings and four immense see-through clock faces, each fifteen feet in diameter. Walentas also built something that was rare for Dumbo, a new, twelve-story, fifty-four-unit red brick apartment building (Stephen B. Jacobs, 2001) at 65 Washington Street, between York and Front Streets.[32] The development team of Jeffrey M. Brown Associates and Cara Development were also attracted to Dumbo, commissioning SHoP/Sharples Holden Pasquarelli to design Light Bridges, a 385,000-square-foot mixed-use building on a 35,000-square-foot site at 100 Jay Street, between York and Front Streets, at the time home to a parking lot.[33] SHoP's design placed two dramatically modeled, twenty-story curving towers atop a four-story commercial and retail base and a 280-car underground garage. Although the 153-unit building, the highlight of which promised to be the glass corridors connecting the two towers, received city approval in February 2002, the developers were unable to proceed with their plans.

Brooklyn Bridge Park

In the late 1980s and early 1990s the Port Authority attempted to redevelop an eighty-seven-acre waterfront site south of Dumbo, stretching from the Brooklyn Bridge to Atlantic Avenue and encompassing Piers 1 through 6 at the foot of the Brooklyn Heights Esplanade.[34] Like other, similar facilities throughout the five boroughs, Piers 1–6, built in the 1950s to replace facilities from the turn of the century, had long ceased to be active, a victim of the container ship revolution in commercial cargo shipping, and they were officially closed to business in 1983. Their planned redevelopment resulted in even more volatile opposition than had

greeted David Walentas's Fulton Landing proposal. Although scenic view corridors established by the Board of Estimate in 1974 protected the views of the river and lower Manhattan skyline from the promenade, buildings as tall as fifteen stories were permitted at the northern and southern ends of the nearly mile-long site. Led by the Brooklyn Heights Association, the community aggressively challenged the Port Authority's expressed desire to create between 2,200 and 2,800 residential units amid twenty acres of parkland, along with a marina and retail venues. In 1991 the authority selected Larry A. Silverstein and Arthur G. Cohen to develop the dormant piers, but before any specific plans were released the project was dropped as too controversial. The following year the Port Authority, citing prohibitive upkeep costs, tried to sell the piers to a private developer, but Governor Cuomo blocked their sale. In 1993 Michael Sorkin, in a self-proclaimed attempt to propose something for the city's waterfront that did not follow the model of Battery Park City, produced a design for the site that included an "intensive mix of uses," calling for a conference center, a hotel located on a cruise ship, a barge-building yard, and an amphitheater facing Manhattan.[35] The failure of the Port Authority's proposal led to the creation of a new group, the Brooklyn Bridge Park Coalition, which advocated a waterfront park on the pier site, an idea supported by Cuomo. But the governor's defeat in the November 1994 election put plans for the new park on hold.

Momentum for Brooklyn Bridge Park was revived by the collapse in 1999 of Walentas's redevelopment plans for Dumbo. Its advocates now believed that in addition to the piers beneath the Brooklyn Heights Esplanade, the park should include the city- and state-owned area between the two bridges. The Downtown Brooklyn Waterfront Local Development Corporation, created by Brooklyn Borough President Howard Golden and funded by the state, was charged with coming up with a master plan and assembling a group of designers to be overseen by Hamilton, Rabinovitz & Alschuler, a real estate, economic, and public-finance consulting firm.[36] The team included Toronto-based architect Ken Greenberg of Urban Strategies, landscape architect Michael Van Valkenburgh, Vollmer Associates, and Ray Gindroz of the Pittsburgh firm Urban Design Associates. Gindroz served as a consultant to the Brooklyn Bridge Park Coalition, which remained an active force in the planning process. Fundamental to the undertaking was the practical realization that to some degree the park would need to be self-supporting to help pay for maintenance, necessitating the inclusion of revenue-producing elements.

Released in the spring of 2000, the master plan for the eighty-five-acre, 1.3-mile-long park running from Atlantic Avenue to just past the Manhattan Bridge envisioned a broad mix of uses. For the area between the Brooklyn and Manhattan Bridges, the proposal was at its least intrusive, calling for a grassy salt marsh opening up views to the restored Empire Stores, whose specific fate was not delineated. Pier 1 was to be the site of the most significant commercial activity, with plans for a hotel, restaurants, and cultural venues. Activity on Pier 2 would be modeled on the recreation center at Chelsea Piers, and Pier 3 would feature a large open space with a fountain and an amphitheater. A fishing dock and educational center were planned for Pier 4, with more intensive sports activities on Pier 5. The proposal

did not address Pier 6 at Atlantic Avenue, which remained under the control of the Port Authority. A two-and-a-half-mile walkway would be built to connect all the piers.

Local community groups were involved in the design process, but some Brooklyn Heights residents objected to the very idea of Brooklyn Bridge Park, fearing that it would draw too many people to the area, increasing automobile traffic and perhaps crime. But the critics failed to carry the day, and plans progressed, with Mayor Rudolph Giuliani committing $65 million in city funds in 2000. Governor George Pataki followed suit in January 2001, pledging $85 million in state aid. Despite budgetary cutbacks brought about by the attack on the World Trade Center, newly elected mayor Michael Bloomberg and Governor George Pataki remained strong supporters of the plan, announcing the creation in May 2002 of a new city and state agency empowered to build the park, the Brooklyn Bridge Park Development Corporation. Tangible progress, however, remained elusive, and plans for Brooklyn Bridge Park continued to be reworked. In 2005 a new master plan by Van Valkenburgh called for limited commercial development on only 8.2 acres, or less than 10 percent of the site, with construction estimated to begin in 2008 on a project expected to take five years to complete.[37]

ABOVE Proposed Brooklyn waterfront redevelopment, East River waterfront, between Brooklyn Bridge and Atlantic Avenue. Michael Sorkin Studio, 1993. Rendering of view to the northwest. MSS

BELOW Proposed Brooklyn Bridge Park, East River waterfront, from north of the Manhattan Bridge to Atlantic Avenue. Urban Strategies, Michael Van Valkenburgh, Vollmer Associates, and Urban Design Associates, 2005. Rendering of view to the northwest. MVVA

ABOVE Proposed 222 Columbia Heights, northwest corner of Pierrepont Street. Alfredo De Vido Associates, c. 1977. First scheme, rendering of view to the northwest. ADVA

ABOVE RIGHT Proposed 222 Columbia Heights, northwest corner of Pierrepont Street. Alfredo De Vido Associates, c. 1977. Second scheme, rendering of view to the northwest. ADVA

RIGHT 222 Columbia Heights, northwest corner of Pierrepont Street. Alfredo De Vido Associates, 1982. View to the northwest. Baitz. ADVA

Brooklyn Heights

In November 1965, Brooklyn Heights became the city's first historic district, ten months after being listed as a National Historic Landmark by the U.S. Department of the Interior.[38] Covering a significant portion of Brooklyn Heights roughly bounded by Atlantic Avenue and Fulton, Henry, Clinton, and Court Streets, the designated area encompassed nearly 1,300 buildings, primarily from the mid- to late nineteenth century and spanning the Federal, Greek Revival, Gothic Revival, and Anglo-Italianate styles. One of New York's most carefully monitored and well-tended neighborhoods, Brooklyn Heights was zealously guarded by the Brooklyn Heights Association, an advocacy group founded in 1910 and, after 1965, the Landmarks Preservation Commission, whose close scrutiny of renovations and proposed new construction frequently resulted in complex negotiations with owners and their architects. One of the early contests between the Landmarks Preservation Commission and an owner involved the Jehovah's Witnesses (officially known as the Watchtower Bible & Tract Society), a religious group that had established its headquarters in Brooklyn Heights in 1909 and was a major

property owner and developer in the area. The Witnesses' 1966 proposal for a dormitory and library (1970) on the southeast corner of Columbia Heights and Pineapple Street, prepared by A. L. Seiden, was redesigned five times before Ulrich Franzen & Associates was brought on board to revamp the scheme and gain the commission's approval.[39]

In another case, the commission sent Alfredo De Vido back to the drawing board twice before approving the design of a house for the lawyer-turned-developer Ian Bruce Eichner at 222 Columbia Heights, northwest corner of Pierrepont Street, a prominent, highly desirable 45-by-100-foot site bordering the promenade.[40] The house that previously occupied the site had burned down in the 1940s. De Vido's first scheme called for a "modular kind of building designed in a cubistic way" and was to be covered in stucco.[41] Setting it further at odds with its neighbor—an eclectic row of six four-story-with-basement houses (1852–60)—was its comparatively small size, providing two units in a two- to three-story building. The second plan called for a taller house with a stoop and more modulated fenestration, but it, too, was rejected, to the relief of local residents, who called for a strictly contextual design.

The architect's third proposal, prepared in 1978, was approved. Completed in 1982, the house rose five stories to include one residence for Eichner, two condominium units, and one rental apartment. Clad in eight-inch-square brown glazed brick with rounded belt courses, sills, and cornices, the design nodded respectfully to its neighbors while retaining its individuality. Window heights decreased toward the upper floors, and a single, prominently situated bay window jutted out above a garage door on Columbia Heights.

Eichner's attempt to renovate the ten-story Hotel Margaret (Frank Freeman, 1889), 97 Columbia Heights, northeast corner of Orange Street, the tallest building in Brooklyn Heights when it was built, brought into play the delicate issue of excessive height within the historic district.[42] The building, which was executed in copper, buff brick, red pressed brick, terra-cotta, and brownstone, was being used as a 220-room hotel when Eichner purchased it in 1977 and hired Harold Einhorn to renovate it as a forty-three-unit cooperative apartment house. On February 1, 1980, as the work was nearing completion, the building was destroyed by a five-alarm fire that raged for ten hours. The fire, whose cause remained undetermined, left no recourse but to raze the structure.

Though Eichner toyed with the idea of retaining the first five floors, matching the roofline of its neighbors, he quickly settled on a plan to build a fifteen-story apartment house that would be slightly shorter than the 128-foot-tall hotel it would replace. The plan drew severe criticism from the Brooklyn Heights Association because the established height limit of new construction in the area was fifty feet. The Landmarks Preservation Commission was sympathetic to the community

at first, denying the fifteen-story design and a subsequent thirteen-story version before approving an eleven-story tower. As realized in 1988, with Cooper Eckstut Associates taking over from Einhorn, the Margaret Apartments, a 106-foot-high, fifty-one-unit building, was a lamentable replacement of its namesake. Orange and red brick mixed uncomfortably with copper bay windows and green-glass spandrels, and the tower's stepped massing made for a visually noisy intrusion. The building was later purchased by the Jehovah's Witnesses for use as a dormitory.

Though largely built up with worthy historic buildings, there were some opportunities for new construction within the Heights. Alfredo De Vido Associates' 54 Willow Street (1987), between Orange and Cranberry Streets, was a staid eight-unit, four-story-with-basement brown brick apartment house built to the streetwall with regular fenestration, traditional lintels and sills, and a modest cornice.[43] In 1987 work was finished on the Bridge Harbor Heights Condominium Apartments, a mix of new construction and rehabilitation on the block bounded by Poplar Street, Cadman Plaza West, and Henry and Hicks Streets, at the northern edge of the historic district and also within the Cadman Plaza Urban Renewal Area, an eight-block swath whose redevelopment was completed by this project.[44] A total of 113 condominiums in fourteen buildings were provided in the project, which was organized as two separate entities: Condo I (Wids de la Cour and David Hirsch, 1987), which incorporated the renovated Children's Aid Society's Newsboys' Home (1884), 57 Poplar Street, and the newly built 55 Poplar Street, a five-story dark red brick building capped by a dormered mansard roof; and

Margaret Apartments, 97 Columbia Heights, northeast corner of Orange Street. Cooper Eckstut Associates, 1988. View to the northeast. Mauss. ESTO

54 Willow Street, between Orange and Cranberry Streets. Alfredo De Vido Associates, 1987. View to the southwest. Warchol. PW

Condo II, which included 65–75 Poplar Street (Kweller, Dubin, Baumgarten, with Charles A. Platt Partners, 1987), a row of four, four-story-with-basement townhouses whose bright red brick, green window frames, and minimal stone trim seemed insubstantial next to their more distinguished neighbors.

At the opposite end of the district, the editors of the *AIA Guide* singled out Stanley and Laurie Maurer's 105 Atlantic Avenue, between Henry and Hicks Streets, a two-story, red brick commercial building dominated by a large square window on the second floor below a Dutch gable, as being "modest, but handsome and articulate," although it was underscaled on its block.[45] More remarkable, in a way, was Joseph Stella's 125 Joralemon Street (1993), between Henry and Clinton Streets, a three-story, 1,700-square foot house that replaced a tiny, distinctly suburban one-story, red brick house from the early 1950s designed by Morris Rothstein.[46] With its red brick and stone-trim cladding, triplets of round arched windows, and a central gable, the new house was also intended to relate architecturally to C. P. H. Gilbert's Daniel Chauncey house (1891), next door at 129 Joralemon Street, for which it now resembled a carriage house. Stella's 21 Grace Court Alley (1994), a scaled-down version of 125 Joralemon Street, also resembled a carriage house, replacing a small, two-story, mid-nineteenth-century brick stable located at the terminus of a quiet mews that had once served houses on Remsen and Joralemon Streets.[47] In order to fit in with the scale of its neighbors, Stella cleverly designed the house to appear twice as wide and one story taller than its predecessor, a fiction necessitated by zoning that prevented additional square footage on the site. In fact, the new house was the same size as the one it replaced: half of the new facade was false. A garage door on the first floor led to an outdoor entrance court, and second-story window openings

TOP 125 Joralemon Street, between Henry and Clinton Streets. Joseph Stella, 1993. View to the northeast showing Daniel Chauncey house (C. P. H. Gilbert, 1891) on the right. JSA

ABOVE 21 Grace Court Alley. Joseph Stella, 1994. View to the east. JSA

RIGHT State House, 60 State Street, southwest corner of Hicks Street. Warman Pinkus Munoz Architects, 2002. View to the southwest. RAMSA

were left unglazed to offer views from an open-air terrace behind them. The third floor provided new attic space that did not count as floor area. Round arched windows and a gabled roof allowed the house to approach the charm of its setting. Warman Pinkus Munoz Architects' State House (2002), 60 State Street, southwest corner of Hicks Street, a five-story, eleven-unit salmon-pink brick apartment house built on a long-vacant site, was less traditional but not ingratiating.[48] Its lack of detail made it an awkward fit, despite the neighborly gesture of bays along the State Street facade.

The prosperity of Brooklyn Heights and the restrictions within the boundaries of the historic district made available sites outside of the district all the more attractive for highrise development. In 1984 the Jehovah's Witnesses proposed building a thirty-four-story dormitory just north of the district on the west side of Columbia Heights, extending west to Furman Street, to adjoin its headquarters to the west of the Brooklyn-Queens Expressway and south of the Brooklyn Bridge.[49] As initially proposed, the tower, set atop a six- to eight-story parking garage, would be Brooklyn's tallest building after the Williamsburgh Savings Bank. Although the site lay at a considerably lower elevation than the rest of the Heights, the building would nonetheless obstruct views of the Brooklyn Bridge from points within the neighborhood and along the promenade. The plan brought tensions between neighborhood residents and the Witnesses to a boil. In 1988 the City Planning Commission approved a revised design calling for a nineteen-story building, but six weeks later the Board of Estimate voted the project down.

High-rise development was more acceptable to the east of the historic district, where tall buildings had been introduced along Court Street during the 1920s and in the Cadman Plaza Urban Renewal Area during the 1960s and 1970s, and where the push to revitalize downtown Brooklyn as a business district overrode concerns about scale. Belonging more to the spirit of downtown Brooklyn but located within the boundaries of Brooklyn Heights was One Pierrepont Plaza (Haines Lundberg Waehler), a 650,000-square-foot office tower occupying a triangular site diagonally across from the Brooklyn Historical Society (George B. Post, 1881), on the block bounded by Pierrepont Street, Clinton Street, and Cadman Plaza West. At nineteen stories and 375 feet tall it was the largest office building to be built in Brooklyn at the time of its completion in 1988.[50]

The project was strongly supported by the city, previous owner of the site, which offered tax incentives and taxexempt financing and quick approvals needed to alter the site's zoning, which required a twenty-foot setback above eighty-five feet. HLW's plan called for sheer 110-foot walls rising to a barely noticeable five-foot setback. In his capacity as a member of the City Planning Commission, architect Max Bond convinced HLW to incorporate notched corners, slightly reducing the apparent bulk, while the Brooklyn Heights Association advocated a thinner tower to be set back on three of the four sides above eighty-five feet, in exchange for which they were willing to accept a taller building. When the community group was rebuffed, it filed suit demanding additional environmental impact studies, but just before the City Planning Commission's vote a compromise was reached in which fifteen-foot setbacks would occur at a height of ninety-five feet along Clinton and Pierrepont Streets, in exchange for two additional floors. As built, the banal red

One Pierrepont Plaza, block bounded by Pierrepont Street, Clinton Street, and Cadman Plaza West. Haines Lundberg Waehler, 1988. View to the northwest showing General Post Office (Mifflin E. Bell and William A. Freret, 1891) in right foreground. Paige. PPP

brick shaft of One Pierrepont Plaza rose from a limestone base to a limestone attic story beneath a copper mansard roof culminating in a pyramidal tower that echoed similar forms on the Brooklyn Historical Society and the nearby General Post Office (Mifflin E. Bell and William A. Freret, 1891).

Among the tower's ground-floor tenants was the Rotunda Gallery, founded in 1981 and so named to reference its original location in the rotunda of Brooklyn Borough Hall. In 1990 the gallery held a competition to design its new, 1,600-square-foot storefront space, entered at 33 Clinton Street. The firm of Smith-Miller + Hawkinson won with a proposal for what Henry Smith-Miller termed "an apparatus for

exhibitions."[51] Completed in 1993, the gallery's focal point was a broad two-story wall that could pivot along an arc traced into the floor. Opposite the entry, a flight of concrete stairs with translucent plexiglass railings led visitors to a viewing platform and accessed a mezzanine-level office. A thin strip of maple was set into the perimeter walls sixty-five inches above the floor, serving as a refined counterpoint to the space's raw concrete surfaces and identifying the ideal level at which to hang pictures, as prescribed by MoMA's founding director, Alfred H. Barr Jr. Susanna Sirefman lauded the "streamlined, clean atmosphere," finding "a light, floating quality to this lovely space, a serenity that lends itself well to the display of art."[52]

One Pierrepont Plaza's hulking form dwarfed the adjacent Brooklyn Heights branch of the Brooklyn Public Library, 280 Cadman Plaza West, casting it in perennial shadow. The two-story limestone, red granite, and aluminum library (Kealy and Patterson, 1961) was expanded in 1993 by David Prendergast, whose work included an interior renovation and new second-floor spaces added onto two existing single-story wings.[53] Prendergast clad the additions in materials similar to those of the original while giving the building a new civic presence in the form of a curved north facade in which a broken limestone arch emerged from a field of granite to frame a two-story opening that vaguely referenced the composition of the main library on Grand Army Plaza.

Another scale-defying building east of the historic district was Ian Bruce Eichner's spiritless thirty-two-story, 186-unit apartment tower at 180 Montague Street (2000), between Court and Clinton Streets, designed by H. Thomas O'Hara as a brick box enlivened only by sections of purple brick on the north and south facades.[54] Eichner employed the air rights of two adjacent buildings to allow twelve stories more than zoning permitted, foregoing the opportunity to buy additional air rights and build a fifty-story tower because thirty-two stories "made more sense on the block."[55] The polychrome 100 Court Street (2000), on the west blockfront between Schermerhorn and State Streets, designed by Hardy Holzman Pfeiffer Associates, incorporated a 22,000-square-foot Barnes & Noble bookstore in its forty-foot-high base and a twelve-screen movie theater (Furman & Furman) occupying a windowless 195-foot-tall tower above.[56] To disguise the tower's considerable bulk, Hugh Hardy decided to "create patterns, and a series of volumes instead of one great big box," peeling

away the mass with horizontal and vertical setbacks and decorating it with different colors and patterns of slate tile.[57] The red brick base, which incorporated a cornice and ornamental features evocative of nearby townhouses, gave way to a glassy corner at the entrance to the cinema.

Cobble Hill

To the south of Brooklyn Heights was Cobble Hill, roughly bounded by Atlantic Avenue on the north, Sackett Street on the south, Court Street on the east, and Hicks Street on the west, along which lay the sunken path of the Brooklyn-Queens Expressway. Cobble Hill's most significant institution, Long Island College Hospital, had dramatically boosted its presence in 1974 with Ferrenz & Taylor's twelve-story E. M. Fuller Pavilion, 70 Atlantic Avenue, southeast corner of

Hicks Street, and continued to expand with the construction of the Polak Pavilion (1984), a banal six-story, brown brick facility at the northeast corner of Hicks and Amity Streets that was designed by Ferrenz & Taylor to match the earlier building.[58] It was extended in 1988 by the same firm, now named Ferrenz, Taylor, Clark & Associates.

The hospital stirred up more than a bit of controversy when in 1993 it announced its decision to exercise an option the city had granted it in 1982 to purchase a .57-acre triangular site in the northeast corner of Van Vorhees Park, across Hicks Street, and build an eight-story, 430-car parking garage.[59] In exchange for removing land from the parks system, the institution promised to create and permanently maintain three small, landscaped parks on Henry Street between Atlantic and Amity Streets, though critics derided them as

100 Court Street, between Schermerhorn and State Streets. Hardy Holzman Pfeiffer Associates, 2000. View to the northwest. Choi. CCAP

"parklets . . . small, shadow-dominated and encircled by hospital structures."[60] Plans for the garage divided the community, with support coming from the borough president, the community board, and the Cobble Hill Association and bitter dissent voiced by the Brooklyn Heights Association, the Parks Council, the Neighborhood Open Space Coalition, the Municipal Art Society, and the Friends of Upper Van Voorhees Park. The latter, established in 1984, unsuccessfully sued to block the project and also invited architects and landscape designers to prepare designs that would show the small site's potential as recreational space. The proposals were displayed at the Urban Center in Manhattan in 1994 in an exhibition entitled "Visions for an Endangered Park." Among the firms to participate were Quennell Rothschild Associates, who incorporated overscaled stethoscopes and other medical equipment into the design, and Heintz/Ruddick Associates, who accommodated both the garage and a revitalized park. The garage went forward as planned, completed in 1996 with the same brown brick cladding as the rest of the hospital complex. In November 1996, the three replacement parks designed by the firm of Miceli Kulik Williams & Associates opened along Henry Street, two of them providing play equipment for youngsters and the third a quieter landscaped environment that included chess tables and benches.

The designation of the Cobble Hill Historic District in 1969 protected a broad swath of the neighborhood. New construction was rare within the historic district, one notable exception being Joseph and Mary Merz's 143 Kane Street

143 Kane Street, between Hicks and Henry Streets. Joseph and Mary Merz, 1997. View to the north. JMM

(1997), between Hicks and Henry Streets, a three-story single-family home replacing a two-car garage. To draw attention away from a garage door dominating the ground floor while referencing the stoops and raised entrances of the neighboring buildings, the architects "decided to make the opening on the second level the dominant opening," designing a large arched window with double doors accented with a modest balcony projecting over the garage.[61]

Far more common than new construction in Cobble Hill was the adaptive reuse of outmoded buildings. Reporting in the *New York Times* in 1985, Shawn G. Kennedy could find "perhaps no more telling symbol of the transformation" of Cobble Hill than the conversion of the four-and-a-half-story Sacred Heart and St. Stephen's School (1922) on Hicks Street, between Degraw and Kane Streets, into condominiums.[62] The renovation by Interdesign retained much of the existing layout, fitting some of the thirty-four apartments into former classrooms and other duplex and triplex units into the auditorium. In 1991 Alfred Menziuso converted the attached four-story convent into eight apartments.[63] Kirshenbaum & Tambasco's renovation in 1986 of a five-story industrial building (1890s), south blockfront of Kane Street between Tiffany Place and Hicks Street, into One Tiffany Place, a seventy-unit residential condominium, marked the first significant conversion of a manufacturing building west of the Brooklyn-Queens Expressway, blurring the perceived western boundary of Cobble Hill.[64] Five years later Kirshenbaum & Tambasco also renovated the nine-story Mullins furniture warehouse as Tiffany Mews, 63 Tiffany Place, between Degraw and Hicks Streets, another seventy-unit apartment complex.[65]

Carroll Gardens

To the south of Cobble Hill was the sixty-block area called Carroll Gardens, historically considered part of Red Hook but rechristened in the mid-1960s in an attempt to improve its fortunes. As in Cobble Hill, adaptive reuse, including the conversion of several ecclesiastical buildings, outstripped new construction. Miele Associates's 1984 renovation of the immense South Congregational Church (1857), 358–366 Court Street, a Romanesque Revival landmark with Gothic interiors, yielded twenty-six apartments, some with fifteen-foot vaulted ceilings and stained-glass windows.[66] In 1986 the equally large Norwegian Sailors Church (1855), northwest corner of Clinton Avenue and First Place, was remodeled to provide thirty-five duplex and triplex co-ops, many with dazzling features like groin vaults and large oak beams.[67] Original stained-glass windows were replaced with clear glass. In 1990 the Calvary Baptist Church of Red Hook (1876), 118 Fourth Place, between Court and Smith Streets, was renovated by Van Brody to contain eleven condominiums, each different from the other.[68]

Among the few examples of new construction in Carroll Gardens was a row of three identical houses, 297–299a Carroll Street (1986), built within the Carroll Gardens Historic District, a small swath containing over 160 buildings, mainly houses situated on unusually deep blocks along President and Carroll Streets.[69] Replacing the South Brooklyn Christian Assembly church (originally the Carroll Park Methodist Episcopal Church, 1872), which had been destroyed by fire, the three-story-with-basement red-concrete-block houses featured terraces set into metal mansard roofs that mediated between the two- and four-story houses on either side.[70]

West of the Brooklyn-Queens Expressway, along Columbia

362 Pacific Street, between Hoyt and Bond Streets. John Gillis, 1998. View to the south. Zimmerman. JGA

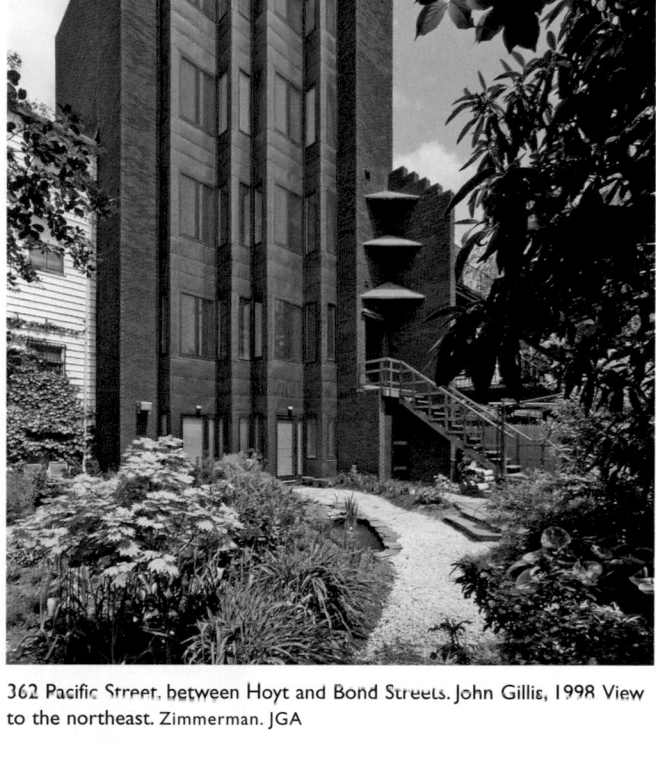

362 Pacific Street, between Hoyt and Bond Streets. John Gillis, 1998 View to the northeast. Zimmerman. JGA

Street, between Union and Summit Streets and extending west toward Van Brunt Street, where thirty-three buildings had been demolished in 1975 after nearby sewer construction caused two of the structures to collapse and undermined the foundations of the others, a new housing development, Columbia Terrace, was completed in five phases between 1984 and 1991.[71] Designed by Wids de la Cour and Hirsch & Danois Partnership, the project's 212 units occupied monotonous strips of three-story red brick rowhouses with metal stoops and deeper-than-usual front yards that tried to relate to the historic fabric to the east.

East of Cobble Hill and Carroll Gardens, the Boerum Hill Historic District, designated in 1973, was graced by an accomplished new house at 362 Pacific Street (1998), between Hoyt and Bond Streets.[72] Designed by John Gillis, the two-family, four-story-with-basement, red orange brick building featured an elegantly detailed facade with corbelled bay windows and ornamental sills that aligned with its eastern neighbor close to the sidewalk and stepped back for one bay to meet the line of the set-back clapboard house to the west. The rear facade, clad in brick with an extensive amount of copper, was shaped by vertical setbacks that better positioned it for views of a lush garden that also incorporated the rear yard next door.

Red Hook

A peninsula surrounded by Gowanus Bay, Erie Basin, and Buttermilk Channel, Red Hook, a busy working-class waterfront community at the beginning of the twentieth century, began its decline into an economically marginal area in the 1930s with the construction of the forbidding Red Hook

Houses (Electus D. Litchfield, 1937), located on a thirty-three-acre site bounded by Dwight, Clinton, West Ninth, and Lorraine Streets, the country's first high-density public housing project and Brooklyn's largest, accommodating more than 5,500 people in 2,545 apartments in twenty-seven two- and six-story, red brick buildings.[73] The neighborhood's fortunes plummeted considerably after World War II when the area was virtually cut off from the upland by the building of the Gowanus Expressway, the Brooklyn-Battery Tunnel, and the Brooklyn-Queens Expressway. With isolation and the decline in Brooklyn's port activity came a loss in population beginning in the 1960s, accelerating the downward spiral that only served to further marginalize Red Hook.

In 1981, to revitalize Red Hook's once-busy piers, the Port Authority realized an ambition that dated back to the 1960s, opening the Red Hook Container Terminal on an eighty-acre site between Pioneer and Congress Streets, which encompassed Piers 8 through 12, creating a two-crane facility capable of handling more than 30,000 containers a year, or more than one million tons of cargo.[74] Though in no way a challenge to the hegemony of the Eastern Seaboard's leading container operation, the Port Newark/Elizabeth Marine Terminal on Newark Bay, Red Hook's modest new facility helped keep commercial activity alive, bringing some measure of prosperity to Brooklyn's ailing waterfront. By the late 1980s, the expanded facility was unloading more than 50,000 containers a year, and in 1994 a 70-ton, 120-foot-high refurbished crane that sat idle two miles to the south on the Thirty-ninth Street Pier in Sunset Park was moved to the terminal, further increasing capacity.

Another initiative along Red Hook's waterfront was not as successful. In 1988, after a five-year-long effort, the Port Authority opened the Fishport, a boat-docking and fish-processing center located at the Erie Basin.[75] Although the complex included state-of-the-art facilities, including 12,000 square feet of refrigerated storage and display space, a 40-ton-a-day ice-making machine, new loading docks, and refurbished piers, the Fishport was unable to draw buyers away from the wholesale markets at the Fulton Fish Market in lower Manhattan, and after little more than a year in operation the Port Authority closed it down.

When some artists began moving into Red Hook in the late 1980s, the *New York Times* was prompted to ask if it was possible for the "square mile of urban blight on the southwestern elbow of Brooklyn [to] turn into the next neighborhood for the black-clad bohemian set," facetiously suggesting the nickname "RedHo."[76] But Red Hook resisted gentrification. In the late 1990s, however, it became home to several modest structures with aesthetic ambitions. Near the abandoned Fishport, Alfredo De Vido's fundamentally utilitarian, 7,200-square-foot administration building (1996) for the Police Department's Erie Basin Evidence Vehicle Facility was livened up with textured concrete block and glazed concrete

block in a variety of colors.[77] De Vido also renovated a 54,000-square-foot warehouse intended for vehicles involved in major crimes, adding a continuous roof monitor to bring in natural light. The waterfront at the end of Coffey Street was transformed in 1998 by Di Domenico & Partners into the Louis Valentino Jr. Park and Pier, named for a firefighter from Red Hook who died in 1996 in the line of duty.[78] Even more stylish, Hanrahan + Meyers's tightly budgeted, versatile Red Hook Center for the Arts (2000), 110 West Ninth Street, southwest corner of Clinton Street, commissioned by the New York City Housing Authority and built at the northeastern edge of Red Hook Houses, consisted of a renovation of an existing 24,000-square-foot brick community center and the construction of a new 3,000-square-foot limestone-and-glass entrance pavilion that included a skylit art gallery.[79] Designed in collaboration with Castro-Blanco, Piscioneri & Associates, the lower level of the reconstituted facility became home to an alternative high school for the arts, complete with classrooms, library, dance studio, and radio station. The highlight of the design was the flexible theater and athletic space featuring a deep-blue painted proscenium that opened to the rear, facing a newly landscaped area, permitting both indoor and outdoor performances.

New York Police Department Erie Basin Evidence Vehicle Facility, Erie Basin. Alfredo De Vido, 1996. View to the northwest. McGrath. NMcG

Red Hook Center for the Arts, 110 West Ninth Street, southwest corner of Clinton Street. Hanrahan + Meyers, 2000. View to the south. Hueber. HMA

View to the northeast showing, in foreground, General Post Office (Mifflin E. Bell and William A. Freret, 1891; annex, James Wetmore, 1933; renovation by R. M. Kliment & Frances Halsband Architects, 2006) and, in background, United States Eastern District Courthouse (Cesar Pelli and Haines Lundberg Waehler, 2006). KHA

Downtown Brooklyn
Civic Center

Despite the grand ambitions and enormous scale of the city's 1944 master plan for Brooklyn's Civic Center (Lorimer Rich, Gilmore D. Clarke, and W. Earle Andrews), the largest such project in postwar America involving the reconstruction of over forty-five acres, the demolition of 304 buildings, and the acquisition of 426 parcels of land, the effort, as realized over the next two decades, ultimately failed in its stated goal of addressing the government's long-term need for space and revitalizing the downtown business district.[80] The centerpiece of the master plan was the landscaped eight-acre, mall-like S. Parkes Cadman Plaza, which revealed itself more as a voided center than a focus of civic life. Even though several substantial buildings were built, albeit of limited architectural interest—including Shreve, Lamb & Harmon's New York State Supreme Court Building (1958) and Carson & Lundin and Lorimer Rich & Associates's Federal Building and Courthouse (1962)—by the 1980s the city, state, and federal governments' need for additional facilities was again acute.[81] In addition, the remaining distinguished historic buildings in the Civic Center, including Gamaliel King's Borough Hall (1846–51), Mifflin E. Bell and William A. Freret's General Post Office (1891), and McKenzie, Voorhees & Gmelin's Municipal Building (1927), were for the most part in poor shape and in need of serious renovation.[82]

In 1981 plans were announced for the rehabilitation of Brooklyn's oldest public building, Borough Hall, 209 Joralemon Street, northeast corner of Court Street, an imposing Greek Revival design in Tuckahoe marble distinguished by its north-facing pedimented portico of six fluted Ionic columns reached by a flight of steep steps.[83] Serving as Brooklyn's City Hall until consolidation in 1898, the building had deteriorated since its last significant alteration, a new cast-iron cupola (Vincent C. Griffith and Stoughton & Stoughton) installed in 1898 following the destruction by fire in 1895 of King's wood original. Conklin Rossant was put in charge of the restoration of the four-story landmark, including the repair and cleaning of the exterior stonework and a total overhaul of the interior. Delays and cost overruns quickly set in as the condition of the historic building proved worse than expected. City officials at the General Services Department blamed poor work by contractors picked under the constraints of the Wicks Law, which required that at least four contractors instead of a prime contractor be used and that they be selected on the basis of a low bid. But the time and money spent seemed well worth it when a refurbished Borough Hall at last reopened in June 1989, sporting Alex Generalis's thirteen-foot-high bronze statue *Justice* atop the restored cupola, a replica of the original statue destroyed in the 1895 fire. Paul Goldberger praised Conklin's work, writing that "New York City is not always an architectural client with the vision and the commitment to give difficult projects their due, but this time it could not have done better." Goldberger

called particular attention to the "radical surgery" done to the rotunda, which was widened and given two new marble staircases, noting that "all of this has the effect not of compromising the integrity of this building but of enhancing it."[84]

By the late 1980s, the shortage of available court space in the Civic Center had reached crisis proportions. In 1989 the Judicial Conference of the United States, the principal policy-making body concerned with the administration of federal courts, declared a "space emergency" in Brooklyn.[85] In August 1992, in an attempt to alleviate the problem, the federal government announced plans for both new and renovated court space in a twenty-two-story, 415-foot-tower as well as in the General Post Office and its annex (James Wetmore, 1933), located on the full block bounded by Adams, Johnson, and Tillary Streets and Cadman Plaza East. The new space would allow the government to consolidate operations that were scattered in five different buildings. In contrast to the swift progress then being realized on the ten-block site just to the east of the Civic Center, where the Polytechnic Institute and Forest City Ratner were successfully collaborating on an office, academic, and research complex called MetroTech (see below), the plans for new court space proved hard to complete.

The original idea to build a tower above the General Post Office annex was dropped in 1994 after Senator Daniel Patrick

General Post Office, north side of Johnson Street, between Cadman Plaza East and Adams Streets. Renovation by R. M. Kliment & Frances Halsband Architects, 2006. Robinson. KHA

Moynihan stepped in, responding to complaints from the community.[86] In 1996 plans were released for an eighteen-story, 750,000-square-foot, 300-foot-high building designed by Cesar Pelli in association with Haines Lundberg Waehler.[87] To be located across Tillary Street from the General Post Office complex on a site bounded by Cadman Plaza East and Adams Street, the building would replace the four-story wing of Carson & Lundin and Lorimer Rich & Associates's Federal Building and Courthouse and be connected to the six-story section of the 1962 building that would remain. Strong opposition continued, and in November 1998, a compromise was reached for a fourteen-story, 650,000-square-foot, 260-foot-high version. Carson & Lundin's four story wing was demolished in 1998, and construction on Pelli's limestone and glass bow-shaped tower rising from a four-story base was completed in 2006.

At the General Post Office site R. M. Kliment & Frances Halsband Architects were put in charge of the renovation (2006) to provide space for the U.S. Bankruptcy Court, the U.S. Attorney for the Eastern District, and the Postal Service. According to the architects, the adaptive reuse was "designed to reinstate the existing building as a significant formal and functional presence in the civic life of Brooklyn."[88] Except for a local branch of the Post Office, the original building and its annex had been vacant for the previous decade. Although the bulk of the work involved faithful restoration, Kliment and Halsband added a 45,000-square-foot mezzanine built over the first floor of the annex and a new flight of granite steps along the Cadman Plaza facade. The highlight of the design was the 120-by-40-foot steel-and-glass skylight atop the four-story atrium of the original building, blacked out since World War II.

The shortage of city and state court space was addressed in 1999 with the announcement of plans for the thirty-two-story Brooklyn Supreme and Family Courthouse, 330 Jay Street, southwest corner of Johnson Street, a few blocks southwest of the new federal facilities.[89] Forest City Ratner, the developer of MetroTech, was the developer of the new courthouse tower, over the objections of some of the firm's commercial tenants, including Chase Manhattan, which objected to the courthouse on the grounds that it would dilute MetroTech's image as a business center. Plans went forward, however, and construction began in June 2001 on Perkins Eastman's 1.1-million-square-foot, 473-foot-high building (2005) rising from a granite base and clad in beige brick with precast concrete accents and a green-glass curtain wall with aluminum mullions. In addition to seventy-four courtrooms, a 750-person jury assembly room, and a detention facility accommodating 300 prisoners, the top five floors of the building were reserved for speculative office space.

On a site directly south stood William B. Tabler's massive, thirty-story Renaissance Plaza (1999), on Jay Street between Johnson and Willoughby Streets.[90] The building took sixteen years to realize, delayed not by community opposition but by difficulties in finding tenants and financing as well as stalled progress during the recession of the early 1990s. But eventually, prospective tenants materialized, including the Brooklyn District Attorney's office. The building also incorporated a 384-room Marriott Hotel occupying 810,000 square feet in its broad seven-story, courtyard-enclosing base, the first full-service hotel built in Brooklyn in nearly seventy years. Among the Marriott's facilities was a conference center, a health club, a restaurant, and an 18,000-square-foot ballroom, the largest

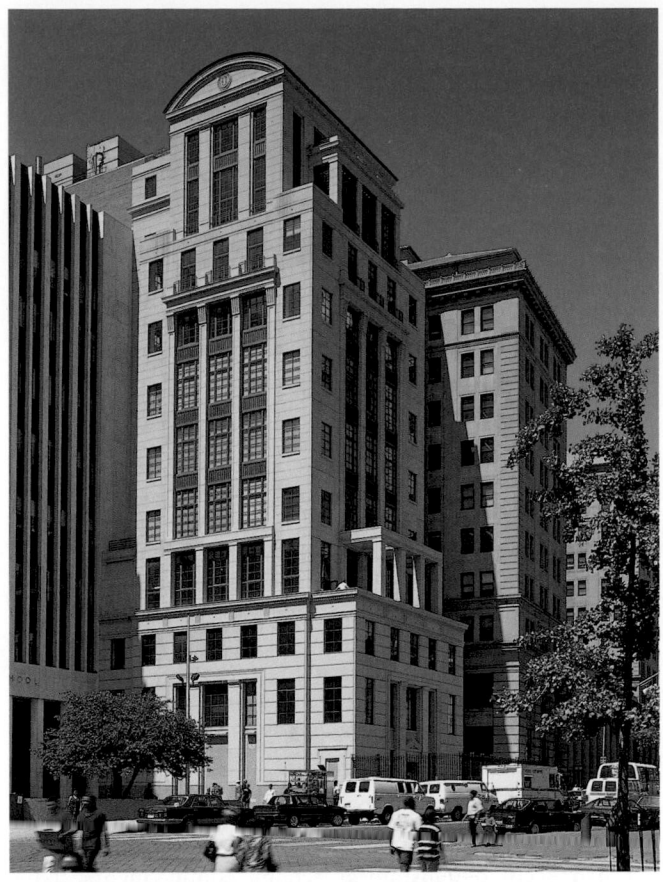

Brooklyn Law School, 250 Joralemon Street. Robert A. M. Stern Architects in association with Wank Adams Slavin Associates, 1994. View to the southwest. Aaron. ESTO

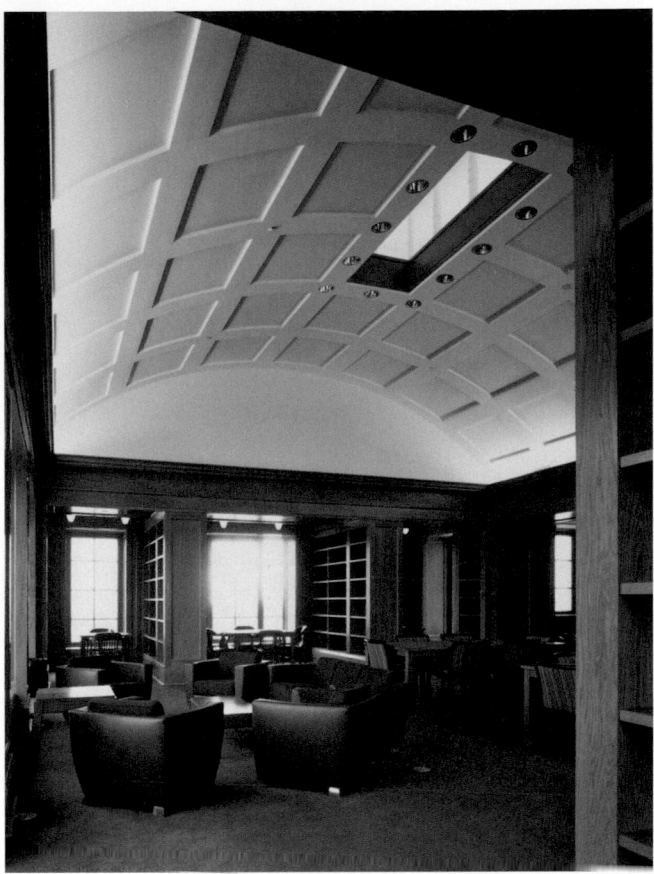

Brooklyn Law School, 250 Joralemon Street. Robert A. M. Stern Architects in association with Wank Adams Slavin Associates, 1994. Faculty library. Aaron. ESTO

in the borough and the fourth largest in the city. Despite initial concern for the hotel's viability, the Marriott proved very successful. Plans for an expansion were already being considered before the hotel opened but not officially announced until 2002. They called for a freestanding twenty-three-story annex (William B. Tabler Architects and SB Architects) containing 280 rooms, on the site of an adjacent city-owned parking garage. The entrance to the building, construction of which began in January 2005, was to be through the existing hotel lobby, to which it was connected by a two-story bridge.

In 1991 Brooklyn Law School, headquartered in a banal, nine-story, white-marble-clad building (Praeger-Kavanagh-Waterbury, 1968) set behind a windswept plaza at 250 Joralemon Street, between Court Street and Boerum Place, released plans for an eleven-story addition to be designed by Robert A. M. Stern Architects in association with Wank Adams Slavin Associates on an adjacent, 7,500-square-foot site that the school had acquired in 1984.[91] Located in the heart of the Civic Center, across the street from Borough Hall and next to the Municipal Building, Stern's precast-concrete campanile-like tower (1994) rose from a three-story-high polished granite base and was inspired by its classical neighbors. The first nine floors of the tower were connected to the original building, which was also renovated. A formal dining room was on the tenth floor and a faculty library on the eleventh.

Herbert Muschamp had some kind words for the building, particularly the tripartite massing, which he found "excep-

tionally fine," and the "sumptuous rooms, paneled in warm cherry wood and tawny maple." Although "straightforward skill substitutes for post-modern irony here," Muschamp contended that "Stern has stifled the design with an excess of literal period detail. Pediments, medallions, ornamental lanterns, triglyphs, dentils: not even the Parthenon could survive this suffocating blanket of well-bred style. And this is tragic, because beneath the classical dressing this building has good bones."[92] In a letter to the New York Times, Carolyn Konheim took strong exception to Muschamp's review, writing, "Every time I pass the building, I feel Brooklyn is blessed by having a building of such elegance and fine workmanship. In contrast to Mr. Muschamp's expectation of less literal classicism in new buildings, we brownstone Brooklynites like our history unadulterated."[93] In his survey of the borough's architecture, Francis Morrone deemed Stern's Brooklyn Law School addition "hands down the best building erected in Brooklyn since World War II."[94]

Three blocks to the south at 205 State Street, on the northwest corner of Boerum Place, on a site formerly home to a parking lot and garage, Stern was commissioned in 2001 to design another building for Brooklyn Law School, a 265-foot-high, twenty-two-story, red brick residence for 407 students.[95] Although, in August 2001, the City Planning Commission had placed a cap of 120 feet on building height for Boerum Place, only eleven months later the commission unanimously approved plans for the building over the objections of some neighborhood residents and politicians. As Assemblywoman

Feil Hall, Brooklyn Law School, 205 State Street, northwest corner of Boerum Place. Robert A. M. Stern Architects in association with Schuman, Lichtenstein, Claman & Efron, 2005. View to the northwest. Aaron. ESTO

Joan L. Millman asked, "What is the point of empowering residents to recommend regulations if variances are granted that are antithetical to the ideal that the zoning restrictions were based on?"[96] Despite receiving the variance, a modest compromise was arrived at, and the building's height was reduced to 216 feet, providing living space for 360 students. Feil Hall (2005), designed to complement Stern's earlier effort for Brooklyn Law School, included a mix of studios and one-to four-bedroom apartments with full kitchens, a ground-floor social area for the residents, and a top-floor conference center.

MetroTech Center

At a City Hall press conference in December 1984, Mayor Ed Koch announced plans for a 1.7-million-square-foot office, retail, academic, and research complex on a sixteen-acre site in downtown Brooklyn roughly bounded on the north by Tillary Street, on the south by Willoughby Street, on the east by Flatbush Avenue Extension, and on the west by Jay Street.[97] First called the Metropolitan Technology Center but quickly shortened to MetroTech, the $340 million mixed-use project was the result of a collaboration between the city's Public Development Corporation, Forest City Enterprises, and the Polytechnic Institute of New York, an engineering college founded in Brooklyn in 1854. Polytechnic was located in scattered renovated facilities on the redevelopment site as well as in buildings in Farmingdale, Long Island, and White Plains. The complex was the brainchild of George Bugliarello, Polytechnic's president, who in the mid-1970s first proposed a

research park along the lines of those created in California's Silicon Valley, but it was not until 1982 that he entered into specific discussions with the city. Not only would high-tech companies be encouraged to open research and development operations in Brooklyn, Polytechnic would use the opportunity to create a more coherent campus setting. MetroTech was also seen as a way to revive Brooklyn's flagging downtown while staunching the flow of jobs out of the city to cheaper suburban office park locations, often in New Jersey. Deputy Mayor Kenneth Lipper predicted that with the successful completion of MetroTech, downtown Brooklyn would become the city's third major business district, after midtown and the financial district in Manhattan.

Opposing the project was a group composed of local property owners and residential and commercial tenants who banded together as STAND (Stand Against Neighborhood Destruction). STAND pledged to block MetroTech, arguing that it was an inappropriate use of the city's condemnation powers and reminiscent of massive failed urban renewal projects from the 1950s and 1960s, pressing instead for an incremental approach that the city, Forest City, and Polytechnic rejected as impractical. Protests were also raised by those who claimed that the project represented a serious conflict of interest: Forest City's principal, Bruce Ratner, had served in the Koch administration as Commissioner of Consumer Affairs from 1978 to 1982.

Despite the opposition, plans moved forward and a master plan drawn up by Haines Lundberg Waehler and Ehrenkrantz & Eckstut was completed in 1986, by which time the developers had secured substantial tenant commitments. Now swelled to 4.2 million square feet of space, the master plan called for eight new and three renovated buildings on the ten-square-block site and a central, 3.3-acre landscaped public space. In July 1987, the Board of Estimate approved plans for MetroTech, and sixteen months later, in November 1988, the project was given an additional boost when Chase Manhattan Bank, which had been threatening to move its back-office operations to New Jersey, agreed to move its computer facilities and at least 5,000 employees to the complex after the city and state put together an incentive package of tax breaks and energy subsidies that some criticized as too generous.

From the start, MetroTech had a catalytic effect on downtown Brooklyn's revival. A four-block stretch of Myrtle Avenue between Flatbush Avenue Extension and Jay Street was closed to traffic and converted into a pedestrian walkway named Myrtle Promenade. In an attempt to promote a lively atmosphere, new buildings along the south side of Myrtle Promenade featured pedestrian arcades containing stores and restaurants. About fifty mostly three- and four-story buildings were demolished to make way for the new construction. In deference to their age and historic importance, four houses from the 1840s at 100, 106, 108, and 110 Johnson Street, between Lawrence and Bridge Streets, were moved three blocks away by flatbed truck to a site at 182–188 Duffield Street, north of Willoughby Street. In 2001 the houses were designated landmarks.[98] Another building on the redevelopment site given special treatment was Frank Freeman's Fire Headquarters (1892),

FACING PAGE Aerial view to the northwest of downtown Brooklyn, c. 1999, showing Long Island University in foreground right, MetroTech Center in middle, Civic Center in middle distance, and Fulton Street Mall on far left. Ries. SRP

View to the southwest showing, from left to right, Four MetroTech Center (Skidmore, Owings & Merrill, 1993), Three MetroTech Center (Skidmore, Owings & Merrill, 1992), Two MetroTech Center (Swanke Hayden Connell, 1990), and One MetroTech Center (Swanke Hayden Connell, 1991). Mauss. ESTO

365 Jay Street, between Myrtle Avenue and Willoughby Street, a remarkably inventive Richardsonian Romanesque design that the city landmarked in 1966.[99] Owned by the Polytechnic Institute, the building was converted into eighteen units of subsidized apartments for elderly and low-income residents displaced by the new construction.

On June 26, 1989, construction officially began at MetroTech with a groundbreaking ceremony for its first two buildings. Although the architecture of MetroTech, which began to take shape in the early 1990s, failed to impress, the pace of construction and the swift and orderly completion of the master plan was remarkable, considering the scope of the complex and the city's seeming inability to realize large-scale projects. Swanke Hayden Connell designed three buildings at MetroTech, including the first to be completed, Two MetroTech Center (1990), south side of Myrtle Promenade between Lawrence and Bridge Streets, a ten-story, 550,000-square-foot red brick building for the Securities Industry Automation Corporation.[100] Equally bland but much larger was the firm's 950,000-square-foot, twenty-four-story One MetroTech Center (1991), located just to the west on a site bounded by Jay and Lawrence Streets.[101] Built for Brooklyn Union Gas, which occupied a little less than half of the rentable space, the building also became home, after the city intervened with substantial tax breaks, to back-office operations for Wall Street firm Bear Stearns, which relocated 1,500 employees there. Swanke Hayden Connell's best effort at MetroTech was an eight-story, 350,000-square-foot red brick headquarters

(1997) for the Fire Department, Nine MetroTech Center, on Johnson Street (now also known as Tech Place) between Flatbush Avenue Extension and Bridge Street, a Postmodern interpretation of the Georgian.[102]

Skidmore, Owings & Merrill's two-building, 1.8-million-square-foot data processing and operations center for Chase Manhattan, located on a 151,000-square-foot site bounded by Myrtle Promenade and Gold, Willoughby, and Bridge Streets, formed an L around one of the redevelopment area's underappreciated landmarks, Ralph Walker's twenty-seven-story Long Island Area Headquarters for New York Telephone (1929), northeast corner of Bridge and Willoughby Streets.[103] The orange brick buildings—the eight-story Three MetroTech Center (1992) and the twenty-three-story Four MetroTech Center (1993)—were connected by a basement tunnel and a second-story bridge across Duffield Street. Because it was locked into a necessarily bulky massing, SOM's design was no match for Walker's refined composition of complex setbacks and slender tower, despite similar details and brick color. More successful, perhaps because it was less self-consciously deferential, was the nineteen-story, deftly fenestrated, orange brick tower of 15 MetroTech Center (2003), north side of Myrtle Promenade between Flatbush Avenue Extension and Bridge Street, designed by Cesar Pelli in collaboration with Swanke Hayden Connell.[104]

Davis Brody Bond designed three new buildings for the Polytechnic Institute, beginning in 1992 with the 135,000-square-foot Bern Dibner Library, Five MetroTech Center, on Johnson Street between Bridge and Lawrence Streets, a

four-story building that was also home to the Center for Advanced Technology in Telecommunications, a research and education group dedicated to attracting high-tech companies to MetroTech.[105] The warehouselike structure confronted MetroTech's public plaza with a loggia that revealed the building's structural grid, leading the editors of the *AIA Guide* to praise the building for its "industrial elegance in precast concrete, articulated and connected with great panache."[106] Just southeast of the library, at 311 Bridge Street, stood the three-story Greek Revival Bridge Street Church (1846), which had served Brooklyn's first black congregation and was also a stop on the Underground Railroad. In 1996, after a four-year renovation of the landmark overseen by Daniel Hopping and George Cooper Rudolph III, the church reopened as Wunsch Hall, a student center.[107] In fall 1999, after the school, now known as Polytechnic University, received a $175 million gift, plans were announced for two new buildings.[108] Located on Jay Street between Myrtle Promenade and Johnson Street, Davis Brody Bond's mixed-use, eight-story Jacobs Building (2002) was built as an addition to Rogers Hall, the former American Safety Razor Company Building, which the school had taken over in 1954 and also planned to renovate. Distinguished by a three-story-high glassy entrance, the L-shaped Jacobs Building included a 30,000-square-foot gymnasium and six academic floors, with two ninety-seat lecture halls, classrooms, and laboratories. In a move to end its status as a commuter school, Davis Brody Bond also completed Polytechnic's first dormitory, the eighteen-story, 400-room Othmer Residence Hall

Livingston Plaza, block bounded by Boerum Place and Smith, Livingston, and Schermerhorn Streets. Murphy/Jahn, 1991. View to the southwest. MJ

(2002), 101 Johnson Street, between Jay and Lawrence Streets, a stylish recall of 1950s Modernism with the mass articulated to read as two parallel slabs, one clad in precast concrete and horizontal strip windows, the other, taller and behind it, sheathed in a glass curtain wall.

Beyond MetroTech

More distinguished than the office buildings at MetroTech was Murphy/Jahn's twelve-story Livingston Plaza (1991), occupying the full block bounded by Boerum Place and Smith, Livingston, and Schermerhorn Streets.[109] It was also the firm's most understated New York project, despite striated dark and light gray masonry facades framed by bold cylindrical corner towers that gave it a fortresslike appearance. Original plans for the building to accommodate back-office functions for Wall Street unraveled after the stock market crash of October 1987, but fortunately for the developers, the New York City Transit Authority, seeking to consolidate its scattered Brooklyn offices into a single location near its headquarters at 370 Jay Street, decided not only to take all of the building's 500,000 square feet but also to purchase the building outright.

Long Island University, founded in 1926 on a compact campus bounded by De Kalb Avenue, Flatbush Avenue, Willoughby Street, and Ashland Place, lacked a formal campus entry until the dedication on June 4, 1985, of a fifty-foot-high steel arch set on a tiered red brick paved plaza designed by Nicholas Quennell of Quennell Rothschild Associates. The brightly colored arch, inspired by the Soldiers' and Sailors' Memorial Arch on Grand Army Plaza, was aimed toward the Manhattan Bridge.[110] In

1995 Mitchell/Giurgola Architects overhauled the university's most historically significant building, the former 4,124-seat Brooklyn Paramount Theater (Rapp & Rapp, 1928), southeast corner of Flatbush and De Kalb Avenues. Once the borough's leading movie palace, the Paramount and its adjacent eleven-story office building had been taken over by the institution beginning in 1950 with the office building and continuing in 1962, when Lionel K. Levy adapted the Austrian Rococo-style theater for use as a basketball gymnasium.[111] Mitchell/Giurgola retained the athletic functions while adding facilities for a new student union by inserting clubrooms into mezzanine hallways and transforming the theater's ticketing and entry hall into a cafeteria, lounge, and "grand ceremonial space."[112]

The renovation was carried out in conjunction with the construction of Mitchell/Giurgola's six-story William Zeckendorf Health Sciences Center (1995), 75 De Kalb Avenue, between Flatbush Avenue and Ashland Place, which was erected on a vacant site across the street from the former Paramount Theater, to which it was linked by a third-story bridge.[113] Providing laboratories, classrooms, offices, and lounges, the 100,000-square-foot salmon-colored brick and cast-stone facility featured a prominent clock tower that helped give new definition to the campus's southern edge. In 2001 Mitchell/Giurgola completed a third project for the university, the Jeanette & Edmund T. Pratt Jr. Center for Academic Studies, a 68,150-square-foot classroom, library, laboratory, and administrative building replacing an abandoned subway substation that had long been a blight in the heart of the campus.[114] With three of its sides hemmed in by

neighboring structures, the architects introduced as much natural light as possible through the exposed east facade, sheathing it with a green-tinted glass curtain wall incorporating green-metal panels above a recessed base. A 100-foot-high vertical orange brick plane intersected the facade, marking the building's entrance.

Attempts to breathe new life into downtown Brooklyn's once vital shopping district were disheartening, beginning with the opening between 1977 and 1984 of Fulton Mall (Pomeroy, Lebduska Associates with Seelye, Stevenson, Value & Knecht, engineers), an eight-block stretch of Fulton Street between Adams Street and Flatbush Avenue that pioneered a new type of pedestrian mall by combining two bus lanes with vastly widened sidewalks.[115] While new red brick sidewalks, benches, trees, bus shelters, and information kiosks contributed to a pleasant and well-patronized shopping district, changing demographics could not support the high-end retailers that had been envisioned, and the mall became a decidedly down-market venue dominated by discount stores, brand-name outlets, and fast-food eateries.

At the eastern end of Fulton Mall, on the block bounded by Fulton Street, Flatbush Avenue, and Willoughby, Fleet, and Gold Streets, was the Albee Square Mall (Gruen Associates, 1980), a vast, three-story indoor shopping center featuring a full-height atrium capped by a peaked translucent roof. Initially approved in 1976, the eighty-store mall and its adjoining four-level 500-car parking garage to the north replaced the 2,200-seat RKO Albee Theater (Thomas W. Lamb, 1925), which closed on September 21, 1976, and was demolished the following year.[116] Some of the theater's fittings were saved, although the famous marble stairways were smashed and used as landfill. The Albee Square Mall failed to attract an anchor tenant and was soon overrun by hoards of teenagers who reportedly went on shoplifting sprees and loitered endlessly, scaring away potential customers. Forest City Ratner purchased the mall in 1990 and renamed it the Gallery at MetroTech, promising upscale stores that would be patronized by the area's new office workers, but the attempt was broad-

Long Island University arch and plaza, east side of Flatbush Avenue, between Fleet Street and De Kalb Avenue. Quennell Rothschild Associates, 1985. View to the northwest. Rosen. QRP

William Zeckendorf Health Sciences Center, Long Island University, 75 De Kalb Avenue, between Flatbush Avenue and Ashland Place. Mitchell/Giurgola Architects, 1995. View to the northeast. Goldberg. ESTO

Jeanette & Edmund T. Pratt Jr. Center for Academic Studies, Long Island University. Mitchell/Giurgola Architects, 2001. View to the northwest. Goldberg. ESTO

Fulton Mall, Fulton Street, between Adams Street and Flatbush Avenue. Pomeroy, Lebduska Associates with Seelye, Stevenson, Value & Knecht, 1977–84. View to the northwest. LHP

sided by the difficulty of overcoming the mall's bad reputation.[117] In 1993 a 45,000-square-foot Toys 'R' Us store became the first anchor tenant, but the mall continued to struggle.

Atlantic Center

The Atlantic Terminal Urban Renewal Area, created in 1968, encompassed 104 acres roughly bounded by Vanderbilt and Greene Avenues, Hanson Place, Lafayette, Flatbush and Third Avenues, and Pacific Street.[118] At the heart of the site was Atlantic Terminal, Brooklyn's busiest transportation hub, which combined a terminus of the Long Island Rail Road with a confluence of subway stations. Much of the area consisted of railroad marshaling yards that were to be covered with a platform supporting plazas and buildings. But plans did not move forward, nor did a plan to build a new campus for Baruch College, approved in 1975 but abandoned during the fiscal crisis. Some new housing was realized on scattered sites in the district, including several buildings designed by Bond Ryder Associates and James Stewart Polshek & Associates' Atlantic Terminal Houses (1976), 487–495 Carlton Avenue, northeast corner of Atlantic Avenue. Nevertheless, the area remained essentially derelict, and the redevelopment plan languished until January 16, 1985, when Mayor Koch announced the selection of Rose Associates to develop Atlantic Center, an ambitious housing, office, and retail complex to be built on an almost completely cleared twenty-six-acre tract bounded by Flatbush Avenue on the west, Hanson and Fulton Streets on the north, Carlton Avenue on the east, and Atlantic Avenue on the south.[119]

To be realized in two stages, Atlantic Center called for nearly three million square feet of new construction. While it was hard to imagine that such a project could succeed within an area that for twenty years had been, as the editors of the *New York Times* phrased it, "the home of rundown bars and fast-food joints, a hangout for prostitutes and low-lifes,"[120] the fact that the site was so well served by public transportation and visited by so many subway and Long Island Rail Road commuters gave heart to Frederick Rose, chairman of Rose Associates, who proclaimed: "We have never announced a job that we haven't built. In Brooklyn we can produce just as good buildings as in downtown Manhattan but at a fraction of the price."[121]

The developers also had a strong ally in the city. Aside from providing tax incentives and a major tenant (the city's Health and Hospitals Corporation), the city promised funds for new streets, two small parks, and a multilevel 1,000-car parking garage that would make the complex even more accessible. Several firms were hired to collaborate on the design, with Skidmore, Owings & Merrill handling the commercial portion, the California-based Peter Calthorpe Associates designing the residential master plan, the Brooklyn-based architect Harry Simmons Jr. designing the houses, and the firm of Weintraub & di Domenico preparing the landscape designs.

The plan was released to the public on July 30, 1985. SOM situated a pair of twenty-four-story yellow brick and limestone towers at the northwest corner of the site, where their hulking masses would be overshadowed by the graceful silhouette of Brooklyn's landmark skyscraper, the Williamsburgh Savings Bank (Halsey, McCormick & Helmer, 1929) across Hanson Place.[122] The towers' bulk, reflecting the need to provide large floor plates for back-office tenants, was to be somewhat mitigated by numerous setbacks at the top.

Proposed Atlantic Center, blocks bounded by Flatbush, Carlton, and Atlantic Avenues and Hanson and Fulton Streets. Skidmore, Owings & Merrill, Peter Calthorpe Associates, Harry Simmons Jr., and Weintraub & di Domenico, 1985. Rendering of view to the northeast. SOM

Abutting the towers were lower site-filling office buildings that enclosed a courtyard. The complex's massive garage, accommodating a vast supermarket on its first floor and helping to frame the courtyard, stretched east along Atlantic Avenue from Fort Greene Place to South Portland Avenue, while a row of three more low lying office buildings were to continue along the blockfronts of Atlantic Avenue to Carlton Avenue, providing a buffer between the open rail yards to the south and the planned residential neighborhood to the north.

Calthorpe's work, spread across the blocks bounded by South Portland Avenue, Carlton Avenue, Fulton Street, and Atlantic Avenue, was more compelling. Calthorpe, a leading theorist and practitioner of the "new urbanism," situated 688 apartments in eight clusters of four-story rowhouses laid out to enclose private courtyards. Individual houses were to feature occasional bay windows and traditional stoops. At the center of the neighborhood, a one-and-a-half-acre horseshoe-shaped park was bordered along its curved edge by a line of crescent-shaped houses. Day care centers, small shops, and grocery stores were to be placed throughout the neighborhood, particularly along Fulton Street. For Calthorpe, the goal was to "reestablish the lost fabric of a neighborhood decimated by 1960s redevelopment"[123] by creating one whose "dominant forms will be the shared spaces, as in the old brownstone streets, where the street and the stoop were habited [sic] as part of the public realm."[124]

The editors of the New York Times advocated "enthusiastic support" for Atlantic Center and the Board of Estimate approved the plan on October 9, 1986, setting off a firestorm of opposition.[125] Fifty neighborhood groups voiced concerns, and four separate lawsuits were filed, two by organizations worried about the development's impact on air pollution and traffic congestion, and two claiming that not enough low-income housing was included in the plan, which would result in significant displacement of low-income residents in neighboring areas. The litigation virtually crippled the project. In December 1988, the New York State Court of Appeals officially halted the development. In addition, the lingering effects of the stock market crash in October 1987 had soured the prospect of luring Wall Street businesses to Atlantic

Atlantic Terminal Mall, northeast corner of Atlantic and Flatbush Avenues. Hardy Holzman Pfeiffer Associates, 2004. View to the northwest. McGrath. H3

Center. In 1990 Rose Associates warned that the development might look vastly different from the original plan, and a year after that, in February 1991, the developers announced that they had agreed to partner with Forest City Ratner, whose MetroTech development was proceeding smoothly, in hopes of making better progress.

Forest City Ratner ultimately took complete control of the development, abandoning the SOM/Calthorpe plan and embarking on a new one that retained a significant housing component but shifted the focus of the commercial section from office development to retail space. Ehrenkrantz & Eckstut replaced SOM as the master planner and architect of the commercial area, while Swanke Hayden Connell, working with DeLaCore & Ferrara, prepared new designs for the residential portion that broke ground in 1994 and was realized in several phases over the following five years as the Village at

Village at Atlantic Center, site bounded by South Portland, Carlton, and Atlantic Avenues, and Fulton Street. Swanke Hayden Connell, 1995. SHCA

Atlantic Center, providing 417 units in 3,600-square-foot, three-story-with-basement multifamily rowhouses lined up parallel to one another. Though the development lacked the sense of place or coherence that Calthorpe's plan promised, the houses themselves were relatively well executed, with bay-windowed red brick fronts trimmed with precast concrete, fiberglass cornices, and bracketed hoods over the doorways.

The far less interesting retail component of Atlantic Center, also built in several phases, was inauspiciously kicked off with Ehrenkrantz & Eckstut's Atlantic Center Mall, between Atlantic Avenue and South Portland Avenues and Fort Greene, Hanson, and South Elliot Places, a vast three-story, 380,000-square-foot beige and blue box ornamented with paper-thin full-height arches running along the facades and spindly flagpoles rising above the roofline. While the brisk business that followed its November 7, 1996, opening validated the general perception that Brooklynites were underserved by retail outlets, the mall quickly gained a reputation for being an inhospitable environment in which to shop. In a misguided attempt to build a store that was "sympathetic to its urban environment, not just a suburban store plopped down on a city street," as Paul A. Travis, executive vice president of Forest City Ratner put it, the stores were accessed mainly from the street, whereas the mall's interior circulation was a confusing network of narrow hallways without the signage, seating, or central atrium that suburban shoppers were accustomed to.[126] As objectionable as it was on the inside, the building was worse on the outside, earning the nickname "the big ugly,"[127] and being singled out by Francis Morrone as "the ugliest building in Brooklyn."[128] In 2004 the mall was given a makeover that improved its signage and added patches of dark red and brown to the exterior.

Two years after the Atlantic Center Mall opened, plans were announced for the Atlantic Terminal Mall (2004) across the street to the west, a 375,000-square-foot, four-story, seventy-five-foot-tall shopping center constructed over the transit hub.[129] In the 1950s, the 3.6-acre site on the northeast corner of Atlantic and Flatbush Avenues had been considered for a new stadium for the Brooklyn Dodgers. According to Hardy Holzman Pfieffer Associates, which designed the exterior (the Ives Group planned the retail spaces), each facade responded "to the character of its immediate streetscape. Portions of the building facing residential neighborhoods are more modest in scale, while the prominent curved facade along Flatbush Avenue emphatically embraces the streetwall. . . . The predominantly masonry mass defers to neighboring brownstones. Precast concrete details relate to the buff-colored limestone of the [Williamsburgh Savings] bank, directly opposite. A green metal cornice delineates the building's upper story, which is sheathed in a combination of corrugated and flat metal panels."[130] Inside, a full-height atrium and lobby designed by Alexandra Champalimaud & Associates featured domed and vaulted ceilings formed by acrylic scrims splashed with images of Brooklyn landmarks and enlarged Sanborn tax maps of the area.

Though office space had not been a priority in Forest City Ratner's plans, the attack on the World Trade Center resulted in the construction of a ten-story mixed-use building for the displaced Bank of New York.[131] Rising from the eastern edge of Atlantic Terminal Mall, at 2 Hanson Place, Swanke Hayden Connell Associates's 396,000-square-foot tower (2004) featured a facade of masonry, green-tinted glass windows and panels, and red-terra-cotta panels culminating in a broad, sloping parapet. A glass band at the fifth floor indicated the location of a sky lobby and visually separated the tower from the retail base below.

Brooklyn Academy of Music

The Brooklyn Academy of Music, the oldest performing arts organization in the United States, was established in 1861 in Leopold Eidlitz's severe, pavilionated German Romanesque–inspired building on Montague Street.[132] When fire destroyed Eidlitz's building in 1903, the Academy moved to a more spacious block-long site on Lafayette Avenue between Ashland Place and St. Felix Street, commissioning Herts & Tallant to design a new home (1908) that included a 2,100-seat opera house, a 1,400-seat music hall, a ballroom, lecture halls, offices, and a 5,000-square-foot lobby running the entire length of the building.[133] The incorporation of Brooklyn into the consolidated city in 1898 and the opening up of the subway under the East River in 1908 made Manhattan's attractions easily accessible to Brooklynites, leading the Academy into a period of slow decline and, after World War II, decrepitude. It was rescued from this state in 1967, when Harvey Lichtenstein assumed the position of president and executive producer, transforming the organization into an internationally recognized center for contemporary performances in opera, music, theater, and dance.

In 1986 Lichtenstein expanded the reach of his programs by taking over the Majestic Theater (1903), 651 Fulton Street, between Rockwell Place and Ashland Place, for the ongoing use of Peter Brook, the provocative director.[134] The theater, originally built for live performances, was used as a movie house until it closed in 1968. When BAM took it over, the Majestic was in an advanced state of dereliction. With only modest funds

Majestic Theater (renamed the Harvey Lichtenstein Theater), Brooklyn Academy of Music, 651 Fulton Street, between Rockwell Place and Ashland Place. Renovation by Hardy Holzman Pfeiffer Associates, 1987. Saylor. H3

BAM Café, Brooklyn Academy of Music, 30 Lafayette Avenue, between Ashland Place and St. Felix Street. Renovation by Hardy Holzman Pfeiffer Associates, 1997. Kaufman. H3

Rose Cinemas, Brooklyn Academy of Music, 30 Lafayette Avenue, between Ashland Place and St. Felix Street. Renovation by Hardy Holzman Pfeiffer Associates, 1998. Lovi. H3

RIGHT Proposed New York Experimental Glass Workshop, 647 Fulton Street, northeast corner of Rockwell Place. Steven Holl, 1990. Rendering of view to the north. SHA

BELOW Mark Morris Dance Center, 3 Lafayette Avenue, northeast corner of Rockwell Place. Beyer Blinder Belle, 2001. View to the northeast. Felicella. EF

at their disposal, Lichtenstein and Hardy Holzman Pfeiffer Associates elected to treat it as a stabilized ruin. The project was done not only relatively cheaply but quickly, with improvements to and reconstruction of stage, lobby, mechanical systems, and back-of-house area squeezed into only thirty-two weeks of construction time. The first scheduled performance was Brook's presentation of the nine-hour epic *The Mahabharata*, which reopened the house on October 13, 1987.

The "restored" Majestic (renamed the Harvey Lichtenstein Theater in 1999) reduced the original seating capacity of 1,800 by half, largely by eliminating the first rows of the balcony, thrusting the stage forward well past the proscenium, and filling in missing orchestra level seats with benches. All in all, this gave the room a considerable feeling of openness and informality well-suited to the experimental work of Brook

who, as *New York Times* critic Michael Kimmelman reported, "sought to break down the stodgy ritualistic overtones he thinks characterize traditional theaters." While Kimmelman found the informality "appealing," he felt that the finished work was fraught with "major . . . practical and conceptual" problems, ranging from the uncomfortable padded benches in the orchestra to the stools in the balcony, which were said to be uncomfortable because Brook wanted the audience's suffering to be commensurate to his actors' hard work.[135]

In 1994 Hardy Holzman Pfeiffer was asked to convert the Lepercq Space, a former ballroom in BAM's main building that Alfredo De Vido transformed into a 500-seat venue in 1973, into a new café.[136] The architects overcame the disadvantage of the room's second-floor location by introducing escalators that enabled it to function easily during intermissions. To overcome its grand scale, deep red openwork steel arches inset with corrugated perforated metal were introduced to recall the original decorative plaster vaults, but they actually conjured up images of the train room at the former Pennsylvania Station. Shortly afterward, BAM opened Hardy Holzman Pfeiffer's Rose Cinemas, a four-screen complex inserted into the richly plastered Helen Carey Playhouse, the former music hall that James Stewart Polshek had renovated in the early 1970s. While the fit between the new and historic elements was handled skillfully, it could be said that the grand old room and its foyer had been lost in a process alarmingly similar to that of the "twinning" and "quadding" which in the 1970s befell so many of the remaining grand movie palaces from the 1920s. In 2002 Herts & Tallant's building was renamed for Peter Jay Sharp after a careful restoration by Hardy Holzman Pfeiffer, which worked with Building Conservation Associates to identify lost elements of the colorful facade by examining old photographs and postcards.[137] Notable was the replacement of the long-since-demolished parapet and cornice featuring twenty-two full-sized lions' heads and the addition of a 130-foot-long undulating glass entrance canopy, a new element.

Far more than virtually any other attempt to rejuvenate downtown Brooklyn, BAM's resurgence did the trick, inspiring

other cultural institutions and arts groups to settle nearby and bring with them the young audiences who also ate in restaurants and eventually chose the area as a place to live. In 1985 the city's Public Development Corporation attempted to renovate the Strand Theater (1919), 647 Fulton Street, northeast corner of Rockwell Place, a former vaudeville house that was converted into a fifty-two-lane bowling alley in the 1960s, as the Strand Performing Arts Studio, providing studio space for music and dance organizations.[138] The project did not take off, but in 1991 the New York Experimental Glass Workshop (later renamed Urban Glass), a glass artists' cooperative open to the public, relocated to the building from its quarters on Mulberry Street in Manhattan, retrofitting the upper balcony to accommodate furnaces and crossing the space with a tangle of air ducts and catwalks. The exterior component of the renovation, a new facade designed by Steven Holl (1990), did not materialize.[139] Holl planned to frame the building's two entrances with aluminum panels, cast-glass prisms, a colorful pattern of painted rectangles inset with glittering glass beads, and display cases for showing objects made in the workshop.

In 2001 the Mark Morris Dance Center (Beyer Blinder Belle), northeast corner of Lafayette Street and Rockwell Place, opened one block west of BAM to provide a permanent home for the dance group, which had been founded in 1980.[140] The center rose on the site of a state-owned building, recently used as a hotel and mental health center, that Harvey Lichtenstein had negotiated for BAM to purchase and in turn sell to the dance group. Beyer Blinder Belle retained only the steelwork of the building's first floor when designing the new five-story facility, which provided two small dance studios, a huge, sixty-by-sixty-foot top-floor main studio beneath a twenty-six-foot-high vaulted ceiling that could be transformed into a 150-seat theater, two kitchens, an archive room, a video library, dressing rooms, warm-up rooms, two pergola-shaded terraces, administrative offices, and rooms for classes and workshops. The bright facade incorporated translucent wall panels that glowed from within at night and were meant to evoke, according to Fred Bland, a partner at Beyer Blinder Belle, "a phoenix rising, a light, almost white building signifying the rebirth of this part of Brooklyn and of the arts."[141]

Fort Greene and Clinton Hill

Fort Greene first blossomed as a middle-class neighborhood after 1867, when Frederick Law Olmsted and Calvert Vaux's redesign of Washington Park (later Fort Greene Park) catalyzed the development of block upon block of brownstone rowhouses mostly executed in the French Second Empire, neo-Grec, and Italianate styles, as well as single-family homes and some multifamily apartment buildings.[142] While portions of the neighborhood, including a thirty-eight-acre swath to its north, were lost to urban renewal during the 1940s, Fort Greene's southern quarter retained sufficient historic building stock to warrant the designation on September 26, 1978, of the Fort Greene Historic District, including Fort Greene Park and all or part of nineteen blocks extending south and east to Fulton Street and Vanderbilt Avenue.[143] The designation proved to be an important step in a revitalization that was unlike the gentrification of so many other neighborhoods where existing, often nonwhite, residents were displaced. Remarkably, Fort Greene retained a vibrant mix, in part because the area's longtime black residents were predominantly middle-class homeowners. While "brownstoners" were

instrumental in revitalizing Fort Greene's individual properties, developers also played a crucial role, among them the architect and builder Stephen B. Jacobs, who between 1982 and 1986 renovated more than twenty brownstones and townhouses, many of them in advanced states of decay. "Part of our plan," explained Jacobs, "was to take the buildings that were beyond the capabilities of the brownstoners."[144] New residential construction was uncommon, though Warren Gran & Associates realized a seven-story residence for senior citizens at 80 Greene Avenue (1986), southeast corner of Clermont Avenue, a bulky, light-red brick building that featured a chamfered and glazed corner from which a triangular stack of terraces emerged to imply a continuation of the streetwall.[145]

To the east of Fort Greene, more than twenty blocks of Clinton Hill were designated as a historic district on November 10, 1981, at which point Andrew S. Dolkart noted that the neighborhood had "again begun to attract investment. The new owners have been more interested in restoring the old houses than in building . . . new ones. Mansions that had been neglected for decades have taken on a new life and owners have begun to show renewed pride in their well-preserved rowhouses."[146]

The Vendome (Halstead P. Fowler, 1887), 363 Grand Avenue, northeast corner of Gates Avenue, a five-and-a-half-story Romanesque Revival apartment house, was nearly demolished by the city despite its location within the historic district.[147] A fire had gutted the building in 1980, and the city, having taken it over in 1982, decided to raze it five years later to allow progress to begin on twenty-four four-story rowhouses that Stephen B. Jacobs wanted to build on vacant land flanking the building along Grand and Gates Avenues. Jacobs claimed that he could not go forward with his project without knowing the future of the derelict Vendome. When it became

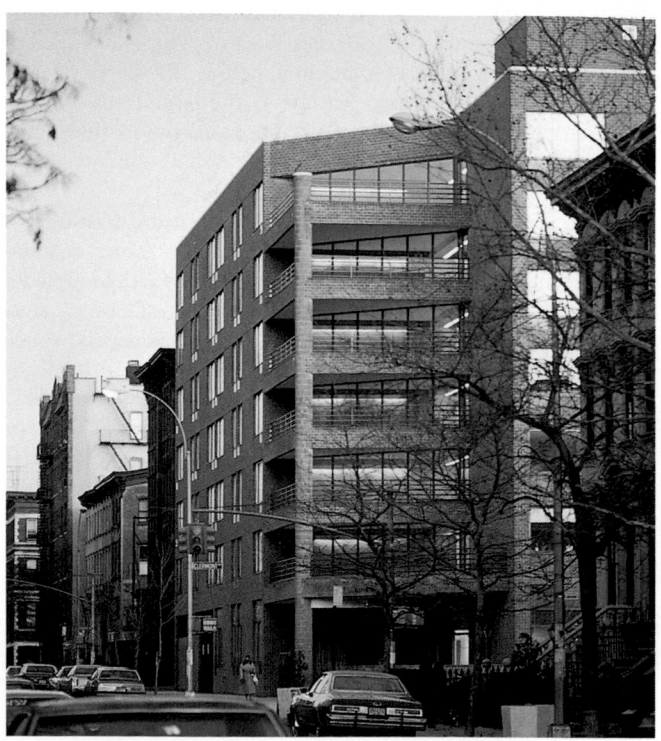

80 Greene Avenue, southeast corner of Clermont Avenue. Warren Gran & Associates, 1986. View to the southeast. GAAP

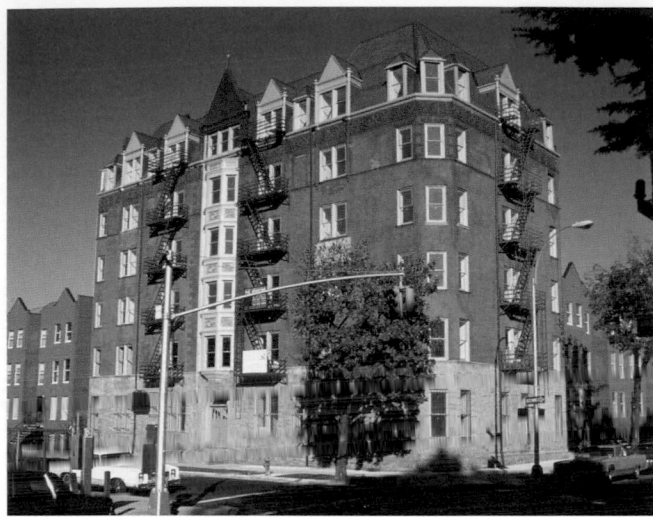

Vendome (Halstead P. Fowler, 1887), 363 Grand Avenue, northeast corner of Gates Avenue. Renovation by Stephen B. Jacobs, 1990. View to the northeast showing Clinton Hill Houses (Stephen B. Jacobs, 1989) on right and left. SBJG

clear that a sizable grant would be needed to help finance the restoration if it were to remain affordable to middle-income tenants, the city gave up hope, but it was persuaded by the Landmarks Preservation Commission to partner with the New York Landmarks Conservancy in offering a challenge grant to raise the cash, most of the remainder of which was contributed by the state. Jacobs was able to restore the Vendome in 1990 to contain twenty-four apartments. The adjacent townhouses, known as the Clinton Hill Houses (1989), were broken up so that every third bay was recessed and capped by a curved parapet to contrast with pointed gables on the protruding bays that made reference to the Vendome's gabled dormers. A better example of new housing within the historic district was the block-long St. James Terrace (Bricolage Design, 1990), 163–185 Greene Avenue, between Washington Avenue and St. James Place.[148] The eleven three-and-a-half-story rowhouses, planned before the district's designation, were redesigned to meet the standards of the Landmarks Preservation Commission, resulting in the incorporation of ornamental brickwork, rounded windows, and wrought-iron fencing along the sidewalk.

Clinton Hill was anchored by Pratt Institute, founded in 1887 by Charles Pratt and growing over the years to become one of the country's leading art and design schools. Pratt occupied a superblock campus bounded by De Kalb, Classon, and Willoughby Avenues, and Hall Street, as well as several other buildings nearby.[149] At the heart of the campus were Lamb & Rich's Main Building (1887; addition by William B. Tubby, 1891), Pratt's first structure, and the Pratt Free Library (William B. Tubby, 1896; north porch, John Mead Howells, 1936), Hall Street between Willoughby and De Kalb Avenues, Brooklyn's first public library. During their 1982 renovation of the library, Giorgio Cavaglieri and Warren Gran & Associates added a large terrace to its south side that sat above a band of windows, admitting light to a newly excavated wing of stacks below.[150]

While much of Pratt's growth had involved the acquisition and conversion of existing buildings, in 1975 a sizable parcel near the east edge of the campus became home to the purpose-built 110,000-square-foot Pratt Activity/Resource Center, an

athletic facility designed by Daniel F. Tully Associates and Ezra D. Ehrenkrantz & Associates.[151] The center's facades were composed of rows of low, gabled concrete walls and made few if any gestures to campus architecture. It was not without interest, however. A tentlike hyperbolic paraboloid roof peaked in a series of five, forty-nine-foot-high points to cover a column-free 390-by-130-foot room–the largest enclosed clear-span space in Brooklyn. Inside, tennis courts and a running track occupied the main level, and a mezzanine level contained dance studios and offices. The energy crisis of the mid-1970s prompted the incorporation of a cooling system that drew fifty four-degree water from an underground aquifer and circulated it in pipes throughout the center.

Pratt's next major expansion was Pasanella + Klein Stolzman + Berg's Vincent A. Stabile Hall, a 128-room dormitory for freshman art and architecture students.[152] The architects, led by partner Wayne Berg, had been selected in 1997 during Pratt's first-ever design competition, besting entries from Gwathmey Siegel & Associates, Hardy Holzman Pfeiffer Associates, and James Stewart Polshek & Partners. Ehrenkrantz & Eckstut, master planners for the campus, administered the competition and selected the building's site: a nearly eight-acre parking lot at the eastern end of the campus past the athletic center and, to the north of that, the three-story Pratt Row faculty houses (Hobart A. Walker, 1907).[153] The architects were asked to give strong definition to the northeast campus boundary while providing space for the construction of future buildings nearby and, in the dormitory itself, to encourage interaction among students through the inclusion of studio and work spaces as well as living quarters.

The positioning of the building became a deciding factor. The Polshek and Hardy firms hugged the site's north and east boundaries to create a presence along Classon and Willoughby Avenues, though Polshek's scaleless five-story facade seemed intimidating. Berg's and Gwathmey's schemes both reserved the site's edge for future development while pulling their buildings closer to the existing campus buildings, a strategy that was more in line with Pratt's current needs. Both Berg and Gwathmey proposed a north–south multipurpose spine with residential wings extending to the east. According to Thomas Hanrahan, dean of the architecture school, Berg's design was the clear winner: "It unfolded as you walked through it. It had a real vision of campus life and spaces for students."[154] As completed in 2000, residents entered at the southern terminus of the north–south wing, where they passed through a five-story cube containing lounges and a gallery. On their way to the dorm rooms, they passed by double-height "homework rooms" situated at the juncture of the circulation spine and the three residential wings, each of which terminated in a five-story brick tower overlooking interstitial courtyards landscaped by Signe Nielsen. The contextually sensitive design related in scale to the faculty houses across the way. Above an aluminum brise soleil, a set-back aluminum-and-glass volume referred to the industrial buildings east of the campus while giving the building an appropriately contemporary look.

While architecture students had a home on campus, the architecture school itself was located a block to the south in the fading grandeur of Higgins Hall, on the east blockfront of St. James Place between Clifton Place and Lafayette Avenue. The building, actually a complex of structures, had been built for Adelphi Academy, a private high school, and consisted of a four-story north wing (Mundell & Teckritz, 1867), a four-and-

a-half-story south wing (Charles C. Haight, 1888), and a two-story central connecting wing that had housed a 1,000-seat chapel.[155] Pratt acquired the buildings in 1965 and moved the architecture school there in 1970. Gwathmey Siegel & Associates was hired in 1989 to renovate and expand Higgins Hall, but the project did not go forward.[156] Gwathmey's plan would have brought the center wing's height up to that of the north and south wings by adding a gridded box whose muted Modernism recalled the firm's addition to the Guggenheim Museum. A multistory rectangular window was to expose the sloping floor plate required to link the varied floor heights of the north and south wings.

Modest renovations to Higgins Hall were carried out during the mid-1990s, until July 21, 1996, when an early-morning fire began in the basement of the center wing and tore through the structure, destroying irreplaceable video and film archives and causing extensive damage to the entire building.[157] The center wing was unsalvageable, the north wing was left roofless and essentially gutted, but the southern wing was in relatively good shape. The rebuilding of Higgins Hall went forward in stages, beginning with the north wing's renovation (1999), carried out by Rogers Marvel Architects working with Ehrenkrantz & Eckstut as preservation consultant. Impressed by the fire's uncovering of architectural elements like arched openings, iron columns, rubble-filled concrete and masonry walls, and timber lintels, the architects decided to "reveal the poetic within the ruin,"[158] letting, according to Robert Rogers, "the layers become the material quality of the building" while

FAR LEFT Proposed dormitory, Pratt Institute, west of Classon Avenue, between Willoughby and De Kalb Avenues. James Stewart Polshek & Partners, 1997. Cutaway axonometric, view to the northeast. PPA

LEFT Proposed dormitory, Pratt Institute, west of Classon Avenue, between Willoughby and De Kalb Avenues. Gwathmey Siegel & Associates, 1997. Site plan. GSAA

BELOW Vincent A. Stabile Hall, Pratt Institute, west of Classon Avenue, between Willoughby and De Kalb Avenues. Pasanella + Klein Stolzman + Berg, 2000. View to the southwest. Warchol. PW

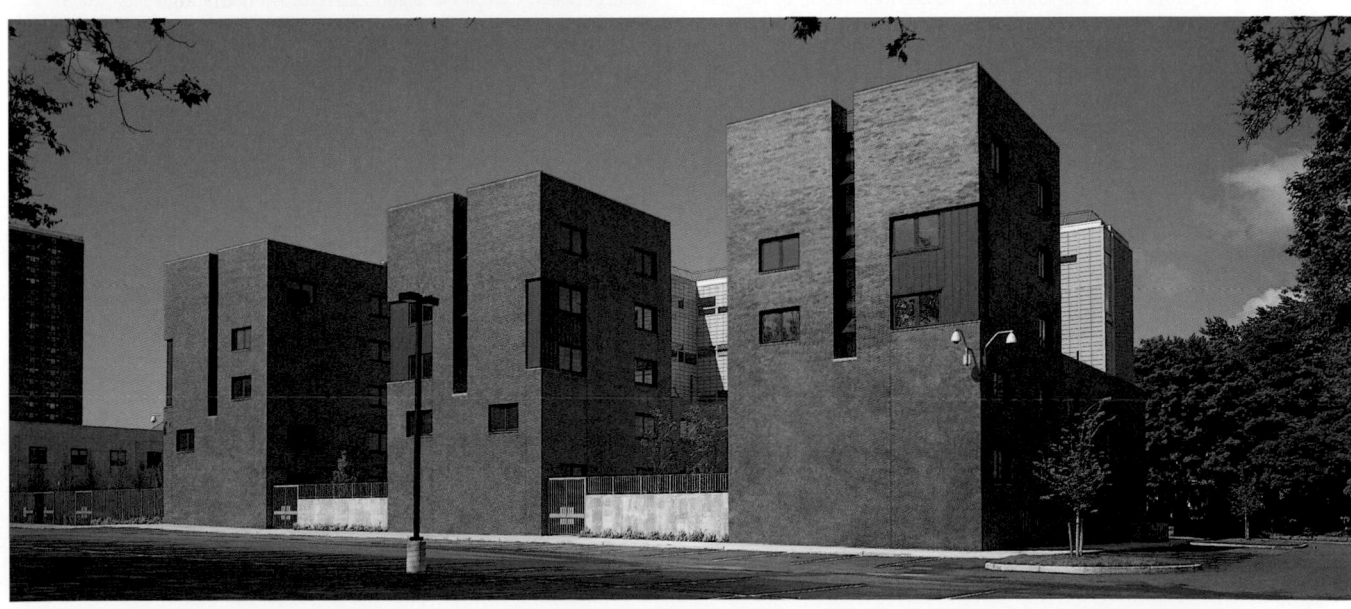

selectively inserting the "things you need in a school, like studios and pin-up space."[159] The rebuilt structure's use of exposed brick walls and disembodied brick archways displayed like archaeological artifacts throughout the design studios impressed Ralph Lerner, who lauded the "clean, well-crafted spirit of the project," especially the incorporation of the historic elements into their new context, which he found "really quite wonderful."[160]

As renovation of the north wing proceeded, funds were raised to build Steven Holl's center wing, a 22,500-square-foot, four-story link containing a gallery, auditorium, workshops, and design studios.[161] Holl also recognized the destructive impact of the fire, memorializing the lost building by placing his wing on a plinth of concrete and salvaged charred bricks. But the driving force of Holl's design became the reconciliation

of the unaligned floors in the north and south wings. The variance between the levels increased from one-half inch on the first floor to six-feet-seven-inches on the fourth floor, a "dissonance" as the architect put it, that "moves from the detail thickness of a finger to human scale."[162] Holl wrapped the concrete column-and-slab structure in panels of white translucent structural glass that would allow light to enter during the day and be emitted at night. The floor plates were expressed on the facade with brass strips and, at the point where steps and ramps connected the divergent levels within, Holl replaced the structural glass with a geometric composition of brass-framed clear-glass windows that exposed the juncture inside. The design, deemed by the Landmarks Preservation Commission to be "brilliant" and "very brave," was completed in 2005.[163]

Proposed Higgins Hall, Pratt Institute, east blockfront of St. James Place, between Clifton Place and Lafayette Avenue. Gwathmey Siegel & Associates, 1989. Rendering of view to the east. GSAA

North Wing (Mundell & Teckritz, 1867), Higgins Hall, Pratt Institute, southeast corner of St. James Place and Lafayette Avenue. Renovation by Rogers Marvel Architects with Ehrenkrantz & Eckstut, 1999. Sundberg. ESTO

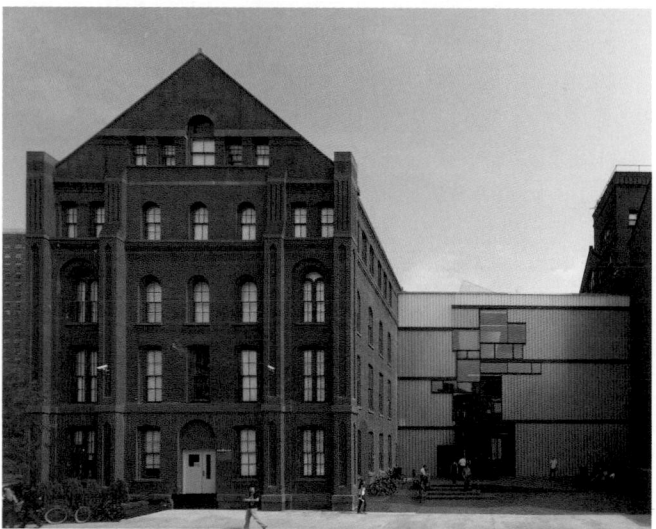

Center Wing, Higgins Hall, Pratt Institute, east blockfront of St. James Place, between Clifton Place and Lafayette Avenue. Steven Holl, 2005. View to the east. Sundberg. ESTO

Center Wing, Higgins Hall, Pratt Institute, east blockfront of St. James Place, between Clifton Place and Lafayette Avenue. Steven Holl, 2005. Sundberg. ESTO

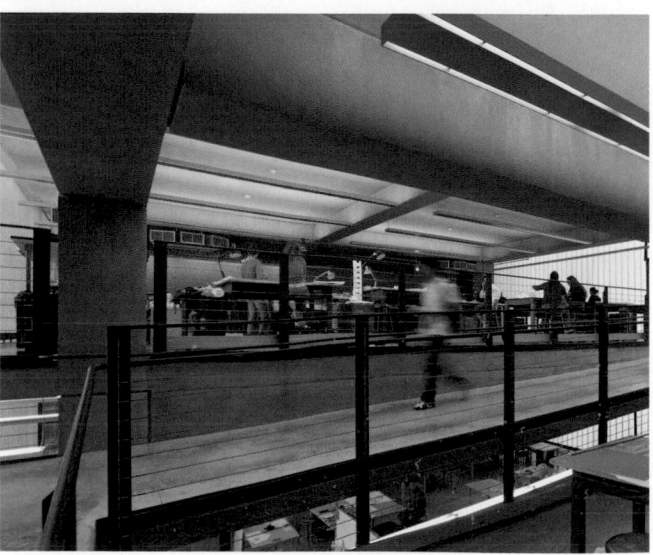

Park Slope

Park Slope developed into an architecturally distinguished neighborhood of homes, clubs, and, later, apartment houses after the completion in 1874 of Prospect Park, the neighborhood's eastern border and highest point, from which it descended both in elevation and prestige westward to Fourth Avenue.[164] Like many once-prestigious Brooklyn neighborhoods, Park Slope suffered from an accelerated departure of upper-middle-class residents to the suburbs after World War II, leading to the decay of many rowhouses and townhouses and the subdivision of others into rooming houses. However, the neighborhood began to regain its lost prestige relatively quickly as an influx of brownstoners began in the 1960s to fix up houses one by one. In 1973 the Park Slope Historic District was designated, protecting more than 1,600 buildings.[165] By 1978, according to Denis Hamill, while the area was still a multifaceted community of "luxury homes, slums, commercial strips, heroin supermarkets, working-class enclaves, ethnic hamlets, and pockets of successful—and unsuccessful—integration," in certain sections, especially in the northeast where brownstoners had settled en masse, the newcomers had "brought their culture, money, pedigreed dogs, and civic pride." The commercial portion of Seventh Avenue from Flatbush Avenue to Third Street, he noted, had begun "to flourish with the kinds of businesses Park Slope never had before: bookstores and craft shops, home bakeries and coffeehouses, plant stores and spice emporiums, fancy saloons and restaurants, boutiques and hairdressers and art galleries." Above all, Hamill stressed, "the fastest-growing business in the area is real-estate agencies."[166] In 1981, as Park Slope's desirability continued to skyrocket, Michael Winkleman marveled in *Metropolis* about how "little evidence" existed of the area's former decline: "twenty years of brownstoning and reinvestment have turned it around."[167]

The conversion in 1982 of the Ansonia Clock Factory, occupying the full block bounded by Twelfth and Thirteenth Streets, Seventh and Eighth Avenues, into Ansonia Court (Hurley & Farinella; garden courtyard landscaped by Zion & Breen), a cooperative apartment building, was a pioneering renovation in Park Slope's southernmost reaches.[168] The otherwise nondescript four-story, red brick factory, which enclosed a central courtyard, was built in 1880 but destroyed by fire as it neared completion and rebuilt the following year to become the largest clock factory in the country. In more recent years it had produced rubber, textiles, and fluorescent lights, employing some of the neighborhood's residents before closing in the late 1970s. In a marketing campaign that fully acknowledged the project's role in the changing area, advertisements proclaimed: "Now is the time to buy into the future . . . before prices rise, before space evaporates, before you have to take what you can get to locate in a good neighborhood."[169]

New construction in Park Slope did not begin to pick up until the late 1980s and was limited primarily to the neighborhood's western and southern fringes, outside of the historic district. This part of Park Slope was home to its least distinguished architecture, and the new buildings were uneven in quality. Stephen B. Jacobs's awkwardly massed red brick and cast-stone-trimmed 305 Fifth Avenue (1990), between Second and Third Streets, consisted of a five-story central portion flanked by two four-story wings, each section capped by a pediment.[170] Victor Caliandro's Sterling Court (1991), 100 Sterling Place, between Sixth and Seventh Avenues, a thirty-eight-unit

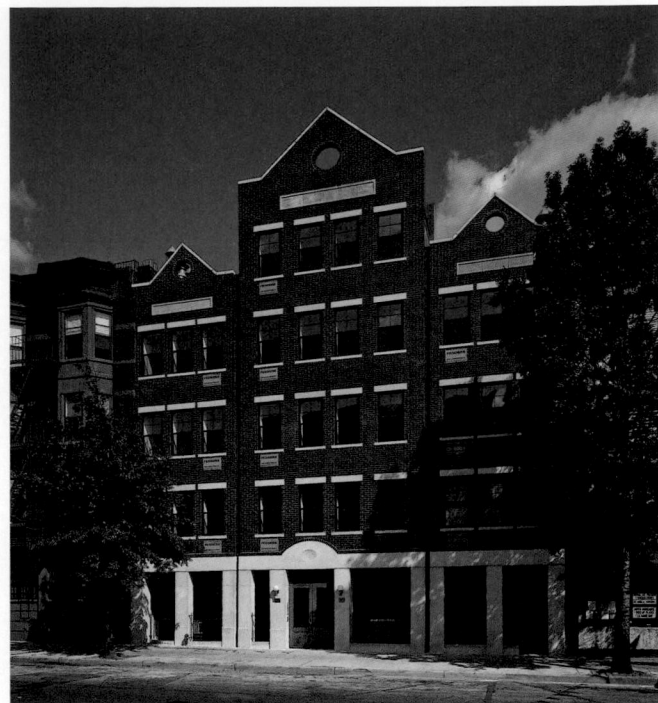

305 Fifth Avenue, between Second and Third Streets. Stephen B. Jacobs, 1990. View to the northeast. SBJG

apartment house built on a vacant parcel, was more interesting.[171] Although zoning would have permitted a ten-story building with what would surely have been breathtaking views, Caliandro chose a more urbanistically responsible strategy. He situated the project's 46,000 square feet in four stories spread across the 200-foot-wide-by-100-foot-deep site and broke up the building's long facade into an asymmetrical composition of red brick sections alternating with recessed glass bays that introduced light into the elevator lobbies and halls. The five-story Victoria (1992), 297 First Street, between Fourth and Fifth Avenues, held out the promise of even greater distinction, given that it was designed by Rafael Viñoly.[172] But when the twenty-unit apartment building was completed, it was what project manager Michael Dobbs described as "an abstraction of styles" that failed to deliver.[173] The essentially flat 100-foot-long facade featured a series of vertical slots occupied by the building's downspouts, and a parapet doubling as a railing for two penthouse terraces was notched almost to the point of crenellation.

Park Slope's most prestigious private school, the Berkeley Carroll School, 181 Lincoln Place, between Seventh and Eighth Avenues, was formed in 1983, when the all-girls Berkeley Institute, established in 1887, merged with the Carroll Street School, founded by brownstoners in 1967. In 1992, to meet the needs of a student body that had grown with the area's burgeoning population of young families, Fox & Fowle's four-story, 16,000-square-foot annex was added to the upper and middle school buildings, providing administrative offices, lounges, classrooms, and skylit art studios.[174] The expansion gave new unity to the institution by linking Walker & Morris's original Berkeley Institute (1896; expanded by the same firm, 1899), a modified neo-Jacobean red brick structure with bold limestone quoins and bandcourses, to two subsequent, haphazardly planned additions: a one-story gymnasium

Addition, Berkeley Carroll School, 181 Lincoln Place, between Seventh and Eighth Avenues. Fox & Fowle, 1992. View to the north showing Berkeley Institute (Walker & Morris, 1896; expanded by the same firm, 1899) on left. FXF

(John Burke, 1936) and a four-story addition (1958). Deemed "superb" by Francis Morrone, Fox & Fowle's red brick and cast-concrete-trimmed, bay-windowed facade was set back from the street to provide a gated forecourt to a new main entrance.[175] Andrew S. Dolkart and Judith Saltzman considered the "handsome" building's gabled roof, tripartite windows, and multipaned sash to be a "rare example of the creative use of historic forms for new construction in a historic district."[176]

Berkeley Carroll's elementary school, located at 701 Carroll Street, also expanded with the construction of a new gymnasium and swimming pool at 762 President Street (2001), between Sixth and Seventh Avenues, rising on the site of a rear playground.[177] Richard Dattner shaped the 100-foot-long facade to resemble a row of three, three-story houses, but square windows—some of them bricked in—and simple bandcourses and cornices rendered the whole somehow unimpressive, although the scale of the building was nicely tricked by extending the wall to form a parapet shielding a rooftop playground.

Prospect Park and Institute Park

Considered by its creators the more successful design, Frederick Law Olmsted and Calvert Vaux's Prospect Park (1866–73), roughly bounded by Eastern Parkway to the north, Flatbush and Ocean Avenues to the east, Parkside Avenue to the south, and Prospect Park West and Prospect Park Southwest to the west, was forced to play second fiddle to Central Park from the time of its opening.[178] During the Lindsay administration Central Park seemed to receive the lion's share of public attention and funding, but Brooklyn's 526-acre green lung was nonetheless the beneficiary of some much-needed maintenance. In 1980, at a time when the park's reputation was at a low point, feared as a haunt of muggers

and vandals, Mayor Koch announced plans for the restoration of a number of its buildings, bridges, and major landscape features, as well as the appointment of Tupper Thomas as park administrator to oversee the revitalization.[179] At the same time, a campaign was begun to draw more people into Prospect Park by increasing security, and the 1983 park census showed that attendance had risen 150 percent since 1979.

In 1984 the Parks Department's staff undertook the rehabilitation of the brick-and-glass Picnic House (Jay Sarsfield Kennedy, 1928) overlooking the Long Meadow near the Third Street entrance, a replacement for the 1876 wood-and-brick original that had burned down.[180] Three years later work was completed on the reconstruction of the Concert Grove Pavilion (Calvert Vaux, 1874), also known as the Oriental Pavilion, which had been nearly destroyed by a fire set by vandals in 1974.[181] Only the eight cast-iron pillars that supported the massive roof remained. As designed by James Lamantia, in collaboration with Parks Department architects Joseph and Adrienne Bresnan, the goal was to reproduce the original, although Lamantia conceded that "the brio and elegance of some of the carving just can't be bought today."[182] The task was complicated by the fact that no original plans remained, forcing the architects to work from drawings based on historic photographs. Before arriving at a palette of grays, greens, and mauves for the roof's terne-coated, stainless-steel shingles and stained-glass skylight, Lamantia studied another Vaux design of similar vintage, his Samuel J. Tilden house (1884), 14–15 Gramercy Park South, now serving as home to the National Arts Club.

In 1987 the effort to revitalize the park was given a significant boost with the creation of the Prospect Park Alliance, a nonprofit group patterned on the Central Park Conservancy.[183] Dedicated to raising the park's profile and to fund-raising, the Alliance undertook a succession of renovation projects,

including the 1990 restoration of the Carousel (Charles Carmel, 1912), located in the Children's Corner just inside the Willink Entrance, and the 1993 rehabilitation of the Tennis House (Helmle, Huberty & Hudswell, 1910) overlooking the Long Meadow.[184] Between 1989 and 1993 Goldstone & Hinz reworked Aymar Embury's Zoo (1935), located in the Children's Corner.[185] In the late 1990s, important parts of the park's landscape were improved, including the paths along the Long Meadow and the wooded area known as the Ravine, located between the Long Meadow and the Nethermead and noted for three waterfalls, which were painstakingly restored.[186] In 1999 the Prospect Park Alliance Design and Construction team, led by architect Ralph Carmosino, began a restoration of the Boathouse (Helmle & Huberty, 1905) that included a new terra-cotta facade, the replacement of wood window frames, upgraded mechanical and electrical systems, and a boat dock.[187] In April 2002, the building was reopened as the home of the National Audubon Society's first urban center, one of 1,000 nature education facilities that the society planned to open over the next twenty years.

More significant planning and building activity occurred at Prospect Park's northern edge, in Institute Park, a triangular parcel bounded by Eastern Parkway and Flatbush and Washington Avenues that Olmsted and Vaux had recommended be set aside for monumental buildings and which became home to the Brooklyn Museum, the Brooklyn Botanic Garden, and the main branch of the Brooklyn Public Library. On March 4, 1986, the Board of Trustees of the Brooklyn Museum, at a special session, elected to sponsor an international invitational competition to produce a master plan that would guide the troubled institution's growth into the twenty-first century.[188] The trustees had high hopes, emboldened by those of the museum's founders, who in 1893 sponsored an architectural competition for what was intended to become one of the world's largest museums and a glorious symbol of civic pride. That competition was awarded to the firm of McKim, Mead & White, who saw only about one-quarter of their building realized by the time they completed their work in 1926.[189] In 1934 the museum undertook one more significant building campaign, one not of expansion but of renovation and retrenchment in the name of functional modernization and stylistic Modernism. Significant changes resulted—most notably the removal of the monumental steps leading up to the entrance on the *piano nobile* and their replacement by ground-level access through what had formerly been the auditorium.[190] Aside from whatever symbolic value it may have had, this act of vandalism, as well as subsequent lesser "improvements," rendered the museum's once-clear plan incoherent, and by the 1980s the museum was a chaotic jumble of poorly arranged, inadequately ventilated galleries.

Plans for new wings were produced periodically in the 1940s and 1950s, but funds were never found except for the stripping of some classical interiors and their redesign in the Modernist style. In 1980 Prentice & Chan, Ohlhausen completed one further addition to the museum: the service extension of the East Wing.[191] Built with federal funds secured in 1977, it housed a new boiler plant, offices, workrooms, classrooms, and two new elevators, as well as space for future environmental-control equipment and a new auditorium. The addition was bland and not a little brutal, reduced by severe budgetary constraints to what Joan Darragh, the Brooklyn Museum's vice director for planning, described in 1988 as "a mundane, Modernist wing."[192]

Terrance R. Williams, an architect who had served as deputy director of the Mayor's Office of Lower Manhattan Development in the 1970s, was hired as a professional adviser to the competition, and a jury—consisting of museum director Robert Buck, three trustees, and Phyllis Lambert, James Stirling, and Klaus Herdeg, who served as chairman—was assembled. Reyner Banham, an architectural historian, served on the selection committee, which culled five firms as competitors from a group of ten initially screened. The five firms who made the final cut were the Philadelphia firm of Atkin, Voith & Associates with the New York firm of Rothzeid Kaiserman Thomson & Bee; the New York firms of Kohn Pedersen Fox; Skidmore Owings & Merrill with the Vitetta Group/Studio Four; Voorsanger & Mills Associates; and the team of Arata Isozaki & Associates and James Stewart Polshek, whose scheme was selected. Isozaki, a Japanese architect, was then at the peak of his international fame.

The final selection occurred in October 1986, but it was not until March 1988 that an exhibition of the five competition entries was held at the museum. The five schemes were quite varied, ranging from Voorsanger & Mills's engagingly low-key Modernist scheme that seemed strongest in its integration with the landscape, to Atkin, Voith's confidently classical but less than clearly planned proposal. The plan designed by David Childs of SOM was thinly classical, as was KPF's proposal, although its composition was open and dynamic in ways that were carried out further in the winning submission of Isozaki and Polshek, which projected a boldly contemporary image rooted in the late-eighteenth-century classicism of C. N. Ledoux, with a 150-foot-high, skylit, truncated obelisk that recalled the colossal dome originally proposed by McKim.

In his thoughtful assessment of the competition, sadly buried away in the book review section of the *Winterthur Portfolio*, Patrick Pinnell, a young architect and Yale professor, noted that Atkin, Voith's scheme, the "only design to rely throughout on literal, nonironic classicism for its stylistic language," was complimented by the jury for its "repose" but then chastised because its pieces "would not make a coherent whole," despite the fact that the winning scheme "purposefully aimed at fragmentation." Pinnell went on to suggest that KPF's scheme, the only one presented in black-and-white drawings rather than color renderings, seemed to lack "passion." He was even less charitable to Childs's proposal, with its "banal" facades: "The mindset at work seems more commercial or bureaucratic than civic; at best, this scheme would have been a sort of Rayburn Building [Harbeson, Hough, Livingston & Larson, 1962–65, Washington, D.C.] for art." He praised Voorsanger's as "the most original and realistic design of the lot" but pointed out that "the Jury did not believe in the looping circulation systems inevitably produced by the radical phasability of the scheme." Pinnell, like virtually all observers, was impressed by the winning design, which he found "breathtaking in its sweep. Somehow site, program, and everything else were made to move in the service of the design."[193]

In 1988 Polshek, in response to the considerable speculation over his contribution to what many regarded as Isozaki's scheme, offered the following:

Isozaki, [Polshek partner] Jim Garrison, and I met in early July in London, and . . . developed a parti that became the basis of the final design that ultimately won the competition. This design had as its starting point our conviction that: 1) the original McKim, Mead & White 500-foot-square plan must be expressed in the final master

ABOVE Proposed Brooklyn Museum expansion, 200 Eastern Parkway, south-west corner of Washington Avenue. Atkin, Voith & Associates and Rothzeid, Kaiserman, Thomson & Bee, 1986. Model, view to the north. RKTB

BELOW Proposed Brooklyn Museum expansion, 200 Eastern Parkway, southwest corner of Washington Avenue. Voorsanger & Mills Associates, 1986. Model, view to the northeast. VA

ABOVE Proposed Brooklyn Museum expansion, 200 Eastern Parkway, southwest corner of Washington Avenue. Skidmore, Owings & Merrill with the Vitetta Group/Studio Four, 1986. Rendering of view to the north. SOM

ABOVE Proposed Brooklyn Museum expansion, 200 Eastern Parkway, southwest corner of Washington Avenue. Arata Isozaki & Associates and James Stewart Polshek, 1986. Site plan. PPA

LEFT Proposed Brooklyn Museum expansion, 200 Eastern Parkway, southwest corner of Washington Avenue. Arata Isozaki & Associates and James Stewart Polshek, 1986. Model, view to the northeast. Lieberman. PPA

West Wing, Brooklyn Museum, 200 Eastern Parkway, southwest corner of Washington Avenue. James Stewart Polshek, 1993. Bazelon. CBM

plan concept; 2) that the original center of the plan be clearly identified; 3) that the master plan delineate a new south facade facing the New York Botanical Gardens [sic]; and 4) that the additions not replicate the classical style of the original design, with the exception of one corner pavilion. The preponderant part of the added space program was to be housed in a single new building completing the western facade. The roles that Isozaki and I played were very clear. They represented our philosophical interests regarding the art of building. Isozaki's were in the iconographic, monumental, and representational aspects of the projects. Mine were in the issues of "connections"—both those that were external and urbanistic (the relationship of the new museum to its neighborhood and to the Botanical Gardens), and internal (the relationships of circulation areas to dedicated spaces, both as functional pathways and volumetric transitions). One other "connection" that I focused on was that between the museum plan as originally conceived by McKim, Mead & White and the new master plan configuration that resulted in the cranked plan at the *piano nobile* level. The museum's original entry from Eastern Parkway will be restored, including the replacement of the original stairs and the addition of new ramps. An eighty-foot-high vaulted gallery space will connect the two entries. From the obelisk two bridges will splay out to connect to the new west wing at third points. The bridges will also form the two sides of the new glass-roofed Rodin Court. The urban design plan extends the angles of these bridges out onto the landscape as open-air promenades, enclosing a major reflecting pool (where, in the nineteenth century, a reservoir had existed) and an amphitheater facing the new west facade.[194]

While the critics were largely pleased by the master plan and the public seemed duly impressed, one major obstacle blocked the way: lack of money. Not only was the Brooklyn Museum underattended and undersupported financially by the city, it was underendowed as compared with its rival, the Metropolitan. Moreover, the museum had not raised one cent toward the proposed construction project. Soon enough, however, some funds were made available by Iris and B. Gerald Cantor, leading to the realization of a 460-seat auditorium (1991) in a previously vacant concrete shell within the museum's service wing, new storage facilities, and the renovation of the West Wing. The stainless-steel gridded, bleached white oak paneled Cantor Auditorium, with its undulating white plaster ceiling of intersecting hyperbolic parabaloids, was a distinct reflection of Polshek's antipathy to both "a pastiche of the Beaux-Arts style" and "post-modern gimmickery."[195] The ceiling's design, deemed the room's "one monumental gesture" by Peter D. Slatin, was attributed to Isozaki, who had used the motif before in Japan.[196] According to Isozaki, it was intended to suggest that the audience was "beneath the surface of the sea."[197]

The West Wing, renovated as display space and offices, was reopened in stages in 1992 and 1993. Roberta Smith, the *New York Times* art critic, found the galleries to be "among the most handsome and viewer-friendly in the country."[198] The 100-foot-long navelike galleries bracketed at either end by small

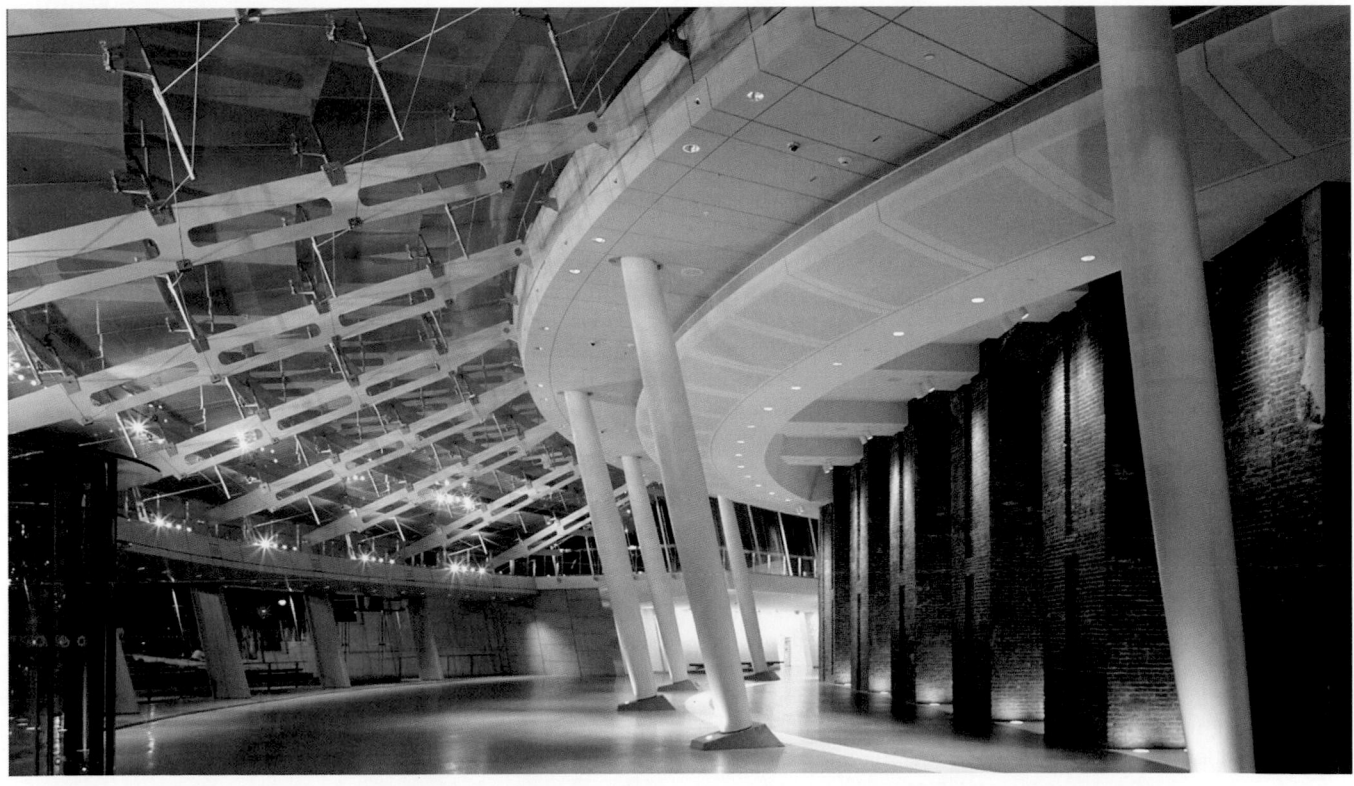

ABOVE Entry Pavilion and Plaza, Brooklyn Museum, 200 Eastern Parkway, southwest corner of Washington Avenue. Polshek Partnership Architects, 2004. View to the south. Barnes. RB

BELOW Entry Pavilion, Brooklyn Museum, 200 Eastern Parkway, southwest corner of Washington Avenue. Polshek Partnership Architects, 2004. Barnes. RB

Steinhardt Conservatory, Brooklyn Botanic Garden, 1000 Washington Avenue.
Davis, Brody & Associates, 1988. View to the southwest. Warchol. PW

antechamber-like spaces, and some other ancillary gallery rooms, were essentially new, except for a carefully restored cast-iron and slate staircase connecting the three floors.

The Cantor Auditorium and the renovated West Wing promised new life for the museum, but by the early 1990s, the city's sour economy and the need to renovate the existing plant before taking on new expansion projects led Robert Buck to temporarily shelve the master plan as a "plan for another century."[199] The next major plans for the museum, developed under Buck's successor, Arnold Lehman, did not call for the replacement of the main stairs, which had been an admired feature of the Isozaki/Polshek plan.[200] As released in September 2000, the new plans, designed by Polshek alone, called for a 17,000-square-foot semicircular glass-and-steel entrance pavilion and substantial landscaped public plaza facing Eastern Parkway. The bold Modernist addition, containing a lobby twice the size of the current facility, was topped by a clear glass roof held in place by metal plates and cables and arranged as a series of stepped arcs, allowing views to the museum's restored limestone facade. At the east end of the pavilion, a broad staircase led to an elevated promenade. The plaza included reflecting pools, fountains, locations for sculpture, an amphitheater with bleacher-like seating, and a stage area for outdoor concerts. According to Lehman, the intent of

the addition was to make the museum more inviting and appeal to a broader audience by creating "Brooklyn's new front stoop." "It's very much about creating new generations of museum visitors who need to feel a relevance to their lives," Lehman stated. "It's very important that we do everything we can to break down barriers. Before, this was a building that was really unfriendly. We wanted to open it up. Now, you'll have a sense of seeing into and out of the building."[201]

Polshek attributed his about-face over the steps to an "analysis of the approach, entry sequence, urban context, and institutional goals," concluding that a "reconstruction of the original stair was neither feasible, given its extraordinary height and its inherent contradiction with contemporary sensibilities and federal requirements for disabled access, nor appropriate, given the museum's democratic vision of itself." Polshek further noted that his design was inspired by McKim, Mead & White's unrealized eastern entry and that it was "deeply rooted in the formal and organizational strategies of the historic structure. . . . Its asymmetry, permeability, and minimalism are counterpoints to the rigorous symmetry, opacity, and decorative quality of the original, and its stepped forms—amphitheater, glazed roof sections, and elevated promenade, or passerelle, at the second-floor landing level—reference the original monumental entry stair."[202]

Joseph Giovannini had high hopes for the design, which he believed would help ease the museum's

forbidding formality. What looks like an afterimage of the staircase is fragmented into several asymmetrical sections that step, slide, circle, and radiate in semicircular orbits. A glass roof forms an ephemeral podium rippling under the heavy limestone colonnade. The designers have played against symmetry, creating a foreground that breaks the rigid ideal to offer visitors a front yard that acts as amphitheater, park, passerelle, lobby, exploratorium. As though operating on the classical ideal with a can opener, Polshek released the teeming variety suppressed by the overregulated facade, shifting it from certainty to uncertainty.[203]

There were, however, several voices raised in protest by those who Polshek labeled "knee-jerk" preservationists.[204] Christabel Gough, secretary of the Society for the Architecture of the City, stated that "the entire scheme represents failure in the governance of an institution which is making an unfortunate programmatic demand to put out front an expensive glass signifier of the newly minted fun fair that is supposed to be spinning the turnstiles inside." But Roger Lang of the New York Landmarks Conservancy endorsed the museum's provocative plans: "In our view, their architects have sent a wake-up call that is both appropriate and invigorating. To be sure, this solution is not our grandfather's Beaux-Arts."[205] In February 2001, the Landmarks Preservation Commission gave Polshek the go-ahead for his entrance pavilion and plaza.

Herbert Muschamp declared the addition, as completed in April 2004, "one of the most attractive public spaces to be found anywhere in town." Although Polshek's design was "not flawless . . . [as] the brushed satin finish of the addition's steel framework dulls the impact of a structure that ought to pop you in the eye," Muschamp enthused over the pavilion's interior: "In effect a winter garden, or orangerie, this is crystal palace architecture. It descends from the same Victorian moment that produced the recycling of period styles. A trick of scale helps account for the delight. From the outside, seen in relationship to the facade, the pavilion appears to hug the ground. Inside, it soars. And the semicircular shape gives the space a dynamic horizontal sweep."[206] Hilton Kramer could not have disagreed more, blasting "Operation Face Lift: the museum's glitzy new entrance, a costly postmodern extravaganza of glass and steel that effectively destroys the classical elegance of the building's original design by McKim, Mead and White."[207] Francis Morrone somewhat reluctantly praised Polshek's effort, writing that "when I first saw his plans for the Brooklyn Museum, I pretty much thought civilization as we have known it had come to an end. Faced with the reality, I have tempered my views. Judged on its own standard, the glass pavilion is superior work and the pavilion clearly makes programmatic sense."[208]

The neighboring Brooklyn Botanic Garden, located on a fifty-acre site, was founded by the Brooklyn Institute of Arts and Sciences in 1910. Its original grounds, designed by Harold Caparn, were soon enriched by thematic gardens, including a Japanese garden (Takeo Shiota, 1915), a rock garden (1916), the Cherry Esplanade (1918), and a rose garden (1927), while administrative functions as well as lecture rooms, laboratories, and a library were housed in an Italianate building designed by McKim, Mead & White in 1918.[209] In 1984, in response to a long-felt need for more space for its nonhardy, indoor collec-

tions, the Brooklyn Botanic Garden announced plans for four new linked buildings designed by Davis, Brody & Associates: three octagonal glass pavilions, each framed in tubular steel and crowned by a central cupola, and one gabled rectangular greenhouse facing Washington Avenue, which would be the point of entry.[210] Davis, Brody would also be responsible for renovations of the administration building and of McKim, Mead & White's glass conservatory (1914), popularly known as the Palm House. The project would more than double the garden's current display space, and the oval-shaped Palm House would be converted for use as a special events and education center. The four-building complex, collectively named the Steinhardt Conservatory for a major donor, was completed in 1988, with the Palm House renovations finished the following year. Paul Goldberger found the Steinhardt Conservatory a "superb display area for plants and a handsome architectural object in itself," describing the three pavilions as being "not unlike great glass tents," with a "relaxed, comfortable air."[211]

Institute Park's third and last component to be finished, Githens & Keally's modern classical main branch (1941) of the Brooklyn Public Library, Grand Army Plaza at the intersection of Flatbush Avenue and Eastern Parkway, renovated its cramped and technologically outmoded children's wing in 2000.[212] In order to create more usable space, Pasanella + Klein Stolzman + Berg inserted a 120-foot-long, freestanding "technology" loft that included forty-one computer stations. In the 1960s the ceilings of the 10,500-square-foot wing had been dropped three feet to permit the introduction of air conditioning. To accommodate the new structure, the original ceilings were restored, which fortuitously allowed the windows to be completely uncovered, bringing in more natural light. New furniture, lighting, and a blue-and-turquoise linoleum floor were also installed, and the existing mezzanine above the entrance was renovated to serve education programs.

Eastern District

The neighborhoods of Williamsburg, Greenpoint, and Bushwick, collectively known since they were annexed to the City of Brooklyn in 1855 as the Eastern District to distinguish them from Brooklyn's historic focus, the village of Breukelen, constituted the northern part of the borough.[213] Roughly bounded by North Seventh Street and Newtown Creek to the north, the Queens County line to the east, Flushing Avenue to the south, and the East River to the west, Williamsburg was forever changed by the completion in 1903 of the Williamsburg Bridge (Leffert L. Buck), which provided a direct connection with the overcrowded slums of Manhattan's Lower East Side.[214] The largely Irish population already settled there was soon joined and eventually dominated by Eastern European Jews, and, after World War II, the neighborhood, especially its southern portion, became the almost exclusive enclave of Hasidic Jews who for the most part had immigrated from Central Europe. Although the predominant building stock consisted of rowhouses and tenements, interspersed among these were important commercial buildings such as George B. Post's imposing Williamsburgh Savings Bank (1868–75), northwest corner of Broadway and Driggs Avenue.[215] In the interwar and postwar periods comparatively few new buildings of interest were completed. Exceptions were an early and innovative public housing project, Williamsburg Houses (Richmond H. Shreve and William Lescaze, 1934–38), Maujer to Scholes Street and Leonard Street to Bushwick Avenue, and a mammoth,

Proposed office building, southeast corner of Marcy Avenue and South Ninth Street. SITE, 1983. Model, view to the northwest. SITE

Northside Terraces Condominiums, site bounded by North Third and Berry Streets and Bedford and Metropolitan Avenues. James McCullar & Associates, 1992. View to the southwest. Zimmerman. WZ

long-delayed, and controversial project, Woodhull Hospital (Kallman & McKinnell, 1968–78; opened, 1982), located on a twelve-acre superblock at the southwest corner of Broadway and Flushing Avenue.[216]

The dominant story in Williamsburg for the last twenty years of the twentieth century was ethnographic rather than architectural. Large numbers of Hispanics, many from the Dominican Republic, moved into the neighborhood, especially its eastern portion, so that by 1990 the population was almost evenly divided between Hasidim and more recent immigrants from Latin America.[217] Even more consequential to the fate and character of the neighborhood was its colonization by artists seeking affordable places to live and work, a trend that began in the late 1970s, burgeoned in the late 1980s and early 1990s, and by century's end had transformed the long-dowdy area into a popular, hip destination for young people.[218]

Artists first settled in the northwest section of Williamsburg—an area known as Northside about six blocks north of the Williamsburg Bridge and separated from Southside by Grand Street—and, to a lesser extent, in Greenpoint. Throughout the 1980s the number of artists moving to the area continued to rise, but only a few galleries were established and, as Lisa Foderaro noted in the New York Times in 1987, "not a single café or restaurant geared toward that clientele has opened."[219] But five years later things had begun to change. In 1992 a New York magazine cover story touted Williamsburg as "the new bohemia," with the literary biographer Brad Gooch estimating that more than 2,000 artists had settled there, noting that the "invasion has been a peaceful and subtle one. It takes a trained eye to pick out Earwax, the record boutique wedged between a pet-food store and a brown-shingle house on Bedford Avenue, where club D.J.'s from the neighborhood go to find unusual spins. Or to spot the 'Art Salad' listed on the menu of Kasia's Polish restaurant. . . . The artists prefer the obscurity, and so far they've been successful at keeping their secret."[220]

Inevitably, gentrification pressures began to be felt as the neighborhood's popularity soared in the mid-1990s and continued to accelerate. In addition to rising rents charged by owners who had renovated the area's existing building stock, the neighborhood, especially in the Northside area along Bedford Avenue, became home to fashionable bars and night-clubs, cafés and restaurants, clothing boutiques, arts and crafts stores, and art galleries. In 1997 Williamsburg's reputation was such that the Utne Reader, a Minneapolis-based national magazine, declared it the third hippest place to live in the United States, surpassed only by San Francisco's Inner Mission area and the Lower Garden District of New Orleans. But four years later Leslie Downer reported in the Financial Times of London that the neighborhood "had crossed the line from hip to gentrified."[221] Francis Morrone noted in 2001 that "it may be the first time since the heyday of Brooklyn Heights roof gardens that it has been trendy for Manhattanites to cross the river for nightlife."[222]

Williamsburg did not attract much new construction, although one unrealized project was notably ambitious. In 1983 an unusual collaboration was announced between the Paz Holding Corporation, a development group headed by two local Hasidic residents, and SITE for the first major new office building in the neighborhood in twenty-five years.[223] To be located at the southeast corner of Marcy Avenue and South Ninth Street, the project would incorporate the existing structure on the site, a 55,000-square-foot, six-story building designed by Boring & Tilton in 1904 for the YMCA that had stood vacant for more than a decade. The developers had originally intended to renovate and reclad the building in glass, but SITE, taking a page from their work for the Best Products Company, offered a more radical proposal: a gut renovation, the restoration of the two facades facing Marcy Avenue and South Ninth Street, and a 20,000-square-foot glass addition at the rear of the building, facing the Brooklyn-Queens Expressway. According to James Wines, SITE's principal, the building was "designed to emerge from the old YMCA center as if by some miraculous resurrection."[224] As Douglas Brenner noted in Architectural Record, "The contrast of a seemingly ruinous shell and a sleek terrarium within the Janus-like

exterior is a vivid emblem for the reconciliation of dualities that shape Williamsburg's cultural identity: old and new, decay and rebirth, worldly and religious, parochial and ecumenical."[225] The building was to include office space, a bank, a Kosher restaurant, and a health club but the project fell victim to the depressed real estate market following the stock market crash in October 1987.

In addition to renovations of existing housing stock, in 1992 the northern part of Williamsburg gained affordable new housing with the completion of James McCullar & Associates's Northside Terraces Condominiums, nineteen three-story red brick rowhouses located on a site bounded by North Third and Berry Streets and Bedford and Metropolitan Avenues.[226] The vacant, rubble-strewn lot, a hangout for prostitutes, had been cleared by the city in 1973 to make way for an industrial park that never materialized. The design of the twenty-four-foot-wide houses, with their spare cast-stone details and steep metal stoops, was intended to recall the scale of neighboring houses as well as the twenty-two two- and three-story buildings torn down nineteen years earlier. Developed by the Hudson Companies under the city's New Homes Program, the fifty-seven-unit Northside Terraces Condominiums featured two-bedroom apartments geared toward first-time buyers with modest incomes.

Hirsch/Danois's 1994 renovation of the Moore Street Market, 108 Moore Street, between Graham and Humboldt Avenues, provided a modest but welcome upgrade in the heart of the predominantly Hispanic section of East Williamsburg.[227] Built in 1940 by the city's Department of Public Works in an effort by Mayor Fiorello La Guardia to reduce the number of peddlers selling from pushcarts, the bland brick box was enlivened to attract more merchants and customers. In addition to a ceramic-tile mural on the exterior and bold graphics and improved lighting inside, Hirsch/Danois animated the space with a new triangular skylight.

In 1997, as part of a campaign to improve community centers, the New York City Housing Authority commissioned Pasanella + Klein Stolzman + Berg to design a new facility to serve Williamsburg Houses, acknowledged as the city's best public housing project.[228] The firm was selected over competing entries from Margaret Helfand, who proposed three wedged-shaped blocks, and Jambhekar Strauss Architects, whose design featured a glazed, column-free space facing a large plaza. Completed in 2003, the 31,000-square-foot freestanding steel-framed Williamsburg Community Center, 195 Graham Avenue, between Meserole and Scholes Streets, was a stylish two-story multiuse facility organized as a series of small pavilions grouped around a large, central space housing a gym, dance studio, performance stage, and mezzanine-level exercise room. Occupying part of a former playground area, the design was inspired, according to project architect Lawrence Zeroth, by the "beautiful wave of the chain link fences that surrounded the site." The choice of materials, including glass, glass block, and translucent Kalwall panels, was intended to render the design as "transparent" as possible.[229] The glass walls of the main gymnasium were protected by a perforated aluminum screen, and movable partitions made of reinforced-glass garage and airplane-hangar doors rendered the interior space extremely flexible. Jim O'Grady, writing in the *New York Times*, felt that, with its translucent walls and bird's-eye maple cabinetry, the "center looks like the sleek gym one might find at a wealthy college" instead of a building designed to serve 3,000 residents of public housing.[230]

North of Williamsburg lay Greenpoint, which also attracted its fair share of artists seeking affordable lofts but remained primarily a working-class neighborhood with nearly 80 percent of those arriving between 1990 and 1996 of Polish origin, according to the City Planning Department.[231] The neighborhood's major recreational amenity was Aymar Embury II's McCarren Park Pool and Bathhouse, built as a project of the Works Progress Administration.[232] One of ten large pools opened in the summer of 1936 and located within the thirty-six-acre McCarren Park, at Lorimer Street between Bayard Street and Driggs Avenue, the facility had been allowed to seriously deteriorate before it was finally closed in September 1983. Six years later, in 1989, the city announced plans to replace the 165-by-330-foot pool with a 65-by-165-foot main pool and a 35-by-45-foot wading pool. Although the Parks Department pledged to restore the monumental entrance arch, the two flanking bathhouse wings would be replaced by new locker rooms and an enclosed gymnasium. Opposition from preservationists quickly surfaced, and a new advocacy group, Independent Friends of McCarren Park, led by Phyllis Yampolsky, rallied to save the pool and bathhouse. Robert A. M. Stern stated that "these buildings are notable. They are of landmark quality. This was a social vision that was, for once, married to a great architectural statement."[233] But Henry J. Stern, commissioner of the Parks Department, strongly disagreed, noting, "It's a rectangular brick shed built for people to get undressed in. Does it deserve immortality because it was built by the master? If Moses were commissioner today, the bathhouse would have been long gone and replaced by something more useful."[234]

No progress was made as the city and community and preservation groups continued to feud over the pool complex's fate. In the late 1990s, Yampolsky's group, now known as the McCarren Park Conservancy, commissioned Robert A. M. Stern Architects to draw up plans for the site.[235] The scheme called for the restoration of the bathhouse wings and entrance arch but reduced the size of the pool, creating room for an in-line skating area. The plan also included a central plaza, an amphitheater, community rooms, exhibition space, a restaurant

Williamsburg Community Center, 195 Graham Avenue, between Meserole and Scholes Streets. Pasanella + Klein Stolzman + Berg, 2003. View to the northwest. Warchol. PKSB

Metropolitan Pool and Bathhouse (Henry Bacon, 1922), 261 Bedford Avenue, southeast corner of Metropolitan Avenue. Renovation by Medhat Salam, 1997. Thompson. MSA

and café, and a health club. Frustrated by the lack of progress, the local community board created the McCarren Park Pool Task Force, headed by Robert Bratko and composed of representatives from a dozen community groups. In April 2001, the task force released a compromise plan designed by Vollmer Associates that was unanimously endorsed by the community board and received the tentative support of the Parks Department.[236] Vollmer's less ambitious plan also restored the entrance arch and bathhouse wings as well as reduced the size of the pool. But funding problems, soon exacerbated by budget cutbacks brought about by the Trade Center attack, stymied hope for McCarren Park's renewal, and the facility remained a shuttered, deteriorating eyesore.

A much happier fate befell another Parks Department facility in the Eastern District, Henry Bacon's Metropolitan Pool and Bathhouse (1922), 261 Bedford Avenue, southeast corner of Metropolitan Avenue.[237] Although the Parks Department came close to closing the badly deteriorated building in the 1980s, the department instead hired Medhat Salam in 1992 to renovate this "tarnished jewel," as the architect called it.[238] Completed between 1995 and 1997, work included a restoration of the spare, elegantly detailed, red brick, granite, and limestone classical facade and repairs to the plumbing, electrical, ventilation, and pool filtration systems, as well as new locker rooms and a community meeting room. The highlight of the renovation was the restoration of the embossed copper ceiling and skylight over the thirty-by-seventy-five-foot pool. Salam also refurbished three eighteen-foot-high arched windows

located between the entrance hall and the natatorium and added modern pendant fixtures that cast indirect light over the water, a special request of swimming enthusiast Henry J. Stern, who supposedly preferred the back stroke.

Bedford-Stuyvesant and Crown Heights

Roughly bounded by Flushing Avenue on the north, Broadway on the East, Atlantic Avenue on the south, and Washington Avenue on the west, the neighborhood of Bedford-Stuyvesant, a postwar term bringing together two communities of the old City of Brooklyn, Bedford on the west and Stuyvesant Heights on the east, became, after Harlem, the city's leading African American enclave following World War II.[239] In 1950, 33 percent of the neighborhood was black, and by 1968 the number had increased to 85 percent as the area became a dumping ground for families displaced by large-scale urban renewal projects in Harlem. Although the formerly white, middle-class area had the city's highest infant mortality rate in the mid-1960s, physically the neighborhood was far from a slum, with handsome tree-lined streets of distinguished rowhouses, apartment buildings, churches, and other institutional buildings such as schools and clubs dating largely from the last three decades of the nineteenth century. The neighborhood was the scene of intense planning activity and publicity after Senator Robert Kennedy visited in 1966 and helped to set up the Bedford-Stuyvesant Restoration Corporation, the first nonprofit community development corporation in the United States.[240]

The Restoration Corporation achieved success in promoting the rehabilitation of the neighborhood's rich building stock, and in the 1980s and 1990s the most significant activity in Bed-Stuy, as the neighborhood was popularly referred to, was again centered around the renovation of rowhouses and apartment buildings to serve low- and moderate-income tenants.[241] One of the neighborhood's best apartment buildings, Montrose W. Morris's five-story Alhambra (1890), 500–518 Nostrand Avenue, between Halsey and Macon Streets, a superb example of the architect's ability to synthesize elements from the Romanesque Revival and Queen Anne styles, was renovated in 1998 by Anderson Associates, creating forty-

Sojourner Truth Houses, scattered sites on Hart, Pulaski, and Kosciusko Streets and De Kalb Avenue, between Malcolm X Boulevard and Stuyvesant Avenue. Harden Van Arnam Architects, 1992. HVA

ABOVE Engine Company 233, Ladder Company 176, northeast corner of Rockaway Avenue and Chauncey Street. Eisenman/Robertson, 1987. View to the east. Hoyt. ESTO

BELOW Engine Company 233, Ladder Company 176, northeast corner of Rockaway Avenue and Chauncey Street. Eisenman/Robertson, 1987. View to the north. Hoyt. ESTO

six subsidized one-, two-, and three-bedroom apartments.[242] Although designated a landmark by the city in 1986, the building, already in poor condition, had continued to deteriorate, and in February 1994, a fire destroyed parts of the roof and interior, rendering the structure uninhabitable. The exterior was completely restored, but the decision to include 7,000 square feet of retail at the base of the former luxury apartment house, although understandable from an economic point of view, compromised the appearance of the building.

Morris was one of the area's most prolific and gifted designers, and just one block to the north, Anderson Associates was also responsible for the renovation in the 1990s of his five-story châteauesque Renaissance Apartments (1892), southwest corner of Nostrand Avenue and Hancock Street.[243] Also designated a landmark in 1986, the Renaissance Apartments was dilapidated and vacant before Anderson Associates repaired and cleaned the facade and gutted the interior to create housing units for low-income residents. A building of even greater vintage, the French Second Empire–style Gibb Mansion (unattributed, c. 1850), 218 Gates Avenue, between Classon and Franklin Avenues, was renovated by architect Beth Cooper Lawrence in a project sponsored by the Pratt Area Community Council.[244] By the 1980s the thirty-nine-room mansion had devolved into a short-stay hotel notorious as a haunt for drug users and prostitutes. In 1996 the hotel closed down, and two years later the council purchased the building and converted it into seventy-one efficiency apartments, fifty of which were reserved for single formerly homeless persons

Jewish Children's Museum, southeast corner of Eastern Parkway and Kingston Avenue. Gwathmey Siegel & Associates, 2004. View to the south. Sundberg. ESTO

living with HIV/AIDS, and the remainder intended for low-income single adults already living in Bed-Stuy. Not intended to be an exact replica of the 1850s building, Cooper Lawrence described the effort, completed in 2002, as a "gesture toward the original."[245] Besides completely gutting and renovating the interior, she added an elevator and a four-story addition at the rear of the building.

Several new low-rise housing projects were completed in Bed-Stuy with the goal of promoting home ownership among moderate-income neighborhood residents. In 1984, on land cleared in the late 1960s as part of the Bedford-Stuyvesant Urban Renewal Area, seventy-four single-family two-story red brick rowhouses designed by Saltini Ferrara were completed in the Fulton Park area on a site bounded by Herkimer Street, and Schenectady, Atlantic, and Troy Avenues.[246] Sponsored by the city's Department of Housing Preservation and Development, the twenty-two-foot-wide houses were set back from the street, had parking pads in place of garages, and chain-link fencing enclosing the forty-foot-deep backyards. Alan S. Oser put it kindly when he wrote that "there has been no attempt at architectural nuance by a builder striving to hold down costs in an untested market."[247] More attractive were Harden Van Arnam Architects' two-and-a-half-story red brick Sojourner Truth Houses (1992), sixty-eight two-family houses with prominent stoops located on scattered sites on Hart, Pulaski, and Kosciusko Streets and De Kalb Avenue between Malcolm X Boulevard and Stuyvesant Avenue.[248] In fall 2000, work was completed on Maple Gardens, a public-private initiative developed by L & M Equity Participants and

Loewen Development under the city's New Homes Program, consisting of forty-five three-story, three-family attached houses located mostly on previously vacant sites scattered along MacDougal, Hull, and Fulton Streets between Saratoga and Howard Avenues.[249] Danois Architects's design for Maple Gardens, with its brown brick facades, bay windows, and cast-stone details, took its stylistic cues from nearby rowhouses.

The most interesting new building in Bedford-Stuyvesant was Eisenman/Robertson's firehouse (1987) for Engine Company 233, Ladder Company 176, on the northeast corner of Rockaway Avenue and Chauncey Street.[250] Intended by its designer, Peter Eisenman, as a "public marker, a literal beacon of unity" for a run-down area at the eastern end of Bed-Stuy, the composition of the two-story firehouse responded to two competing elements of the challenging site: the immediate flanking streets composed of rowhouses and modest apartment houses, and the elevated rail line running along Broadway just to the east.[251] To relate to neighboring masonry buildings, square concrete block was used to clad the first floor. The more abstract upper floor was composed of a stainless-steel-clad structural frame and white concrete-block walls turned forty-five degrees to relate to the elevated and the street grid beyond. Connecting the two elements was an angular stainless-steel-clad bay accommodating the firehouse's control rooms. According to Herbert L. Smith Jr., writing in *Architectural Record*, "Eisenman . . . achieved a subtle, Mondrian-like patterning by emphasizing insets and window, door, or ventilation openings, with quiet color differences—and added an associative spark of fire-engine-red truck-bay doors." Smith observed that the "shimmering metal frame projects beyond the upper walls, in a sort of cut-away, decon-structivist manner, to tie back to the ground-floor structure."[252] Susanna Sirefman praised the "intellectual design" as "sculptural and evocative,"[253] while Herbert Muschamp noted in 1997 that the firehouse "attracted little notice on its completion 10 years ago. The station dates from a period when Eisenman . . . was trying to make the transition from paper architect to builder. In the process, his ideas were often watered down into decorative surface effects. The fire station's most distinctive feature, in fact, is an arrangement of red neon tubes, conceived in collaboration with Robert Slutzky, that flash when the firefighters are on call."[254]

In 1999 David Burney, the Housing Authority's director of Design and Capital Improvements, hired George Ranalli to renovate an existing 1,500-square-foot facility at 940 Hancock Street, between Broadway and Saratoga Avenue, serving the residents of the sixteen-story Saratoga Village (1966), as well as to design a 3,500-square-foot addition.[255] Recalling Frank Lloyd Wright's Prairie School work in its horizontal massing and geometric detailing, Ranalli's building (2006) featured a facade of red iron-spot brick with prominent glass-fiber-reinforced-concrete lintels and copestones. The addition included offices, a large multipurpose community room, game and reading rooms, and a kitchen. A large outdoor terrace featured an eighteen-by-nineteen-foot concrete wall to serve as a screen for showing movies in good weather.

South of Bedford-Stuyvesant lay Crown Heights, roughly bounded by Atlantic Avenue to the north, Ralph Avenue to the east, Empire Boulevard to the south, and Washington Avenue to the west. The Brooklyn Children's Museum, founded in 1899 as the world's first such facility, was the neighborhood's most prominent civic institution, headquartered since 1977 in

a two-story "bunker" building designed by Hardy Holzman Pfeiffer.[256] Located in the northwest corner of Brower Park, only one level of the 51,000-square-foot museum was above grade, and that portion was covered by planted earth berms rising to the roof, all in an attempt to minimize disruption of the park. In 1989 the museum expressed interest in renovating its facility, but it was not until a decade later, as the institution's centennial approached, that plans for an extensive addition were seriously contemplated.[257] Although Demetri Sarantitis and Susana Torre were initially named as the architects for the new work, in 2001 the job went to Rafael Viñoly.[258] In a striking reversal of the previous building's relative anonymity, Viñoly's undulating, two-story, L-shaped addition wrapped Hardy's building, which would also be renovated, with a blazing yellow mass that would nearly double the amount of available exhibition space. Construction began on the building in October 2003, with completion expected in 2007.

In 1999 plans were announced for another children's museum in Crown Heights, sponsored by Tzivos Hashem, a nonprofit children's organization, to be dedicated to Jewish culture and history.[259] As completed in December 2004, Gwathmey Siegel's six-story, 50,000-square-foot Jewish Children's Museum, southeast corner of Eastern Parkway and Kingston Avenue, clad in glass, silver and white aluminum panels, and a purplish black iron-spot brick, featured a sculptural corrugated steel rooftop enclosure concealing mechanical equipment, a sharply angular bay window, a boldly projecting balcony, and a twenty-by-thirty-foot photomosaic of a child, created from more than 1,400 separate images. The bold Modernist composition stood in stunning contrast to the relatively sedate neighborhood mostly comprising three- and four-story rowhouses and modest apartment houses. Inside, the facility included 12,000 square feet of exhibition space, a 2,700-square-foot concert hall and banquet room, a 75-seat movie theater, a synagogue, and administrative offices and conference rooms on the top two floors.

Brownsville and East New York

By the late 1970s, the neighborhoods of Brownsville, occupying the roughly triangular area between Remsen and East New York Avenues and the right-of-way of the Long Island Rail Road, and East New York, extending from those tracks east to the Queens line, between Atlantic Avenue and Jamaica Bay, since the late nineteenth century working-class sections, had reached a nadir.[260] The decline was not sudden. It began in the late 1930s, when demographic changes started to eat away at the area's social and physical fabric. After World War II, wholesale clearance of blighted blocks and their replacement with residential towers set amid greenery and parking lots, intended to stem the decay, had the opposite effect. Efforts to build more appropriately scaled housing during the 1960s and early 1970s, including projects carried out under the Model Cities program, failed to turn the tide, and the cycles of deterioration, abandonment, and exodus continued. Between 1970 and 1980, Brownsville's population dropped from 122,000 to 74,000, and East New York lost one-sixth of its population, or 5,000 households.[261] Nowhere in the city was evidence of neglect and decay more visible: even lighting and signage were somehow missing. In the early 1980s, according to the Reverend Johnny Ray Youngblood, 85 percent of East New York's street corners were without signs: "Ambulances, the police and, of course, visitors could hardly find their way."[262]

Camilo José Vergara, a photographer who documented changes in the city's most blighted areas, monitored a portion of East New York's Sutter Avenue along the elevated L train subway line in the late 1970s, at which time he witnessed the "last remnants of a crumbling neighborhood, once called Little Pittsburgh, where Russians, Poles, and Germans had lived, [and which was] the birthplace of George Gershwin and Danny Kaye." Writing in 1996, he noted that "the Premiere Theater, the largest structure in the area, was demolished. Atkins Flowers moved next door to the theater, then closed, then was leveled. Two blocks to the east, a defiant homeowner painted his brick row house green and white, a banner of hope. In the distance, to the east of Sutter Avenue, is Unity Plaza, one of the worst housing projects in the city. . . . For a couple of years the empty land of the area was used as a ball field, but it then became vacant again."[263]

The neighborhood's physical deterioration was matched by social decay. Crime, especially violent crime, was rampant as East New York became known as the "murder capital of New York City."[264] Popular culture latched on to the image. The 1985 film *Death Wish 3*, starring Charles Bronson as a vigilante architect, was set in East New York, and abounded with killings, explosions, fires, and shootings.[265] Life seemed to imitate cinematic fiction. In November 1991, three police officers were shot in four days in Brownsville and East New York.[266] Later that month a student at Thomas Jefferson High School was shot to death by a fourteen-year-old peer in a school hallway.[267] Only three months later, on February 27, 1992, two students were killed at the school about an hour before Mayor David Dinkins was scheduled to visit, and only fifteen feet away from two New York City police officers who were on duty as part of the regular security detail.[268] The school, at 400 Pennsylvania Avenue, between Dumont and Blake Avenues, was in the heart of an area referred to by local police as the "dead zone."[269]

Massive disinvestment seemed to be the prevailing policy. The only notable example of institutional construction during the 1980s was the police department's 73rd Precinct Station House and Service Station No. 3 (Swanke Hayden Connell, 1984), 1470 East New York Avenue, between Bristol Street and Hopkinson Avenue. According to the architects, the distinctive sawtooth facade "was intended to reflect the scale and module of row houses typical" of Brooklyn while providing space for a colorfully paved pedestrian plaza that signified "a further attempt to integrate the police department into the community."[270] One tentative sign of renewal was the establishment of the East Brooklyn Industrial Park in 1982, 100 acres bounded by Sheffield Avenue, Van Sinderen Avenue, Powell Street, and Liberty Avenue, straddling Brownsville and East New York.[271] Home to forty-two businesses when the city began to offer incentive packages for companies to settle there, by 1986 half of the park's tenants had expanded and twenty-two new companies had established operations. Taking advantage of a "foundation and slab" program in which the city delivered a site with its foundation in place, the Faden Bayes Corporation, a distributor of paper and grocery products, built the first new structure in 1986, a 60,000-square-foot building on Pitkin Avenue, locally renamed Industrial Park Road.

Grim as the situation was, one substantial step toward economic and social stability came with the so-called Nehemiah Plan, which, beginning in 1982, facilitated the construction of more than 1,500 two-story two- and three-bedroom houses

ABOVE 73rd Precinct Station House and Service Station No. 3, 1470 East New York Avenue, between Bristol Street and Hopkinson Avenue. Swanke Hayden Connell, 1984. View to the south. Wasserman. SHCA

BELOW View to the southeast from Mother Gaston Boulevard and Livonia Avenue of Nehemiah Homes, 2002. Vergara. CV

purchased by low-income first-time homeowners, many of whom were from nearby projects. Although the plan's contribution toward the area's resuscitation was crucial, the strategy of building single-family and not multifamily housing came under fire as a wasteful use of land once the immense cleared tracts that Nehemiah demanded became scarce.

One of the only projects to buck the Nehemiah trend was Spring Creek Gardens (1990), a 585-unit low-rise apartment complex built on a vacant 7.8-acre site bounded by Loring

Avenue, Forbell Street, Emerald Street, and a mapped but unbuilt extension of Stanley Avenue, close to the Queens border.[272] Designed by the Liebman Melting Partnership working with Costas Kondylis of Philip Birnbaum & Associates and developed by the General Atlantic Realty Corporation and the Related Companies, the project was intended to achieve the density of high-rise construction in low-rise buildings, a challenge that had also been attempted in the 1970s by, among others, Theodore Liebman, who collaborated on the similarly

charged but anticlimactic and only partially completed Marcus Garvey Village (1976) in Brownsville.[273] To meet the zoning requirement that seven parking spaces be provided for every ten units, the architects elevated the complex on a concrete deck ten feet above grade over a 535-car garage. Apartments were organized into three groups of attached five-story walk-up buildings. Each building housed eight families, and each group, roughly G-shaped in plan, was situated at the block perimeter and curled inward to enclose two-and-a-half acres of courtyards laid out by the Schnadelbach Partnership. The thinness of the buildings allowed each unit to be a floor-through and thus to enjoy both street and courtyard views. Automobiles entered the complex through a gated driveway leading to a pedestrian-scaled traffic circle. Absent from the complex were potentially dangerous interior stairwells, corridors, and elevators (save one for elderly tenants). Instead, external stairways accessed each apartment, in keeping with Liebman's assertion that "if you provide individual front doors, you're giving people homes rather than a housing project."[274] A lightweight prefabricated panel system of steel studs, synthetic stucco cladding, preinstalled windows, and plumbing and utilities that could be connected easily on-site sped the construction process and lowered financing costs for the developer.

Spring Creek Gardens' first phase of 280 units was completed in 1989, and a second phase of 305 units the following year. But a final phase that would have brought the total number of apartments to 765 was canceled after opponents, demanding more moderate-income units (low-income units, eligible for federal tax credits, were more profitable), successfully lobbied to have the tax laws changed but in so doing made it unprofitable to continue development. The western two-thirds of the project, at least, redeemed the idea that, by returning to the walk-up model, which developers and architects had propounded in

the early twentieth century, decent high-density low-rise housing could be built for low-income families. Paul Goldberger wrote: "Few sites could offer a drearier context to work with, and yet the architects have managed to achieve a real sense of urbanity nonetheless." The buildings "come together to create a surprisingly amiable and potent sense of place. This is the real accomplishment here: these buildings are arranged along small streets, and there is a central public square as well as the smaller private courtyards for each cluster of apartments. Even out in the Spring Creek marshland, the feeling is of an urban place—a town or village, not a 'project.'"[275]

Some projects built to provide shelter for society's very bottom strata were located in Brownsville and East New York because land was available and essentially worthless and because there were virtually no established citizen groups to organize the so-called NIMBY ("not in my backyard") objections such accommodations frequently encountered. These included Skidmore, Owings & Merrill's 381 East New York Avenue (1990), the Pratt Institute Planning and Architectural Collaborative's 2626 Pitkin Avenue (1998), and Cooper, Robertson & Partners' two projects for Housing Enterprise for the Less Privileged (HELP): HELP I (1988) and HELP Homes (1992). In 2002 Amie Gross Architects' Genesis Neighborhood Plaza (2002), 360 Snediker Avenue, also part of the HELP network, was completed as a six-story, red brick building comprising fifty-two units of homeless housing, a health clinic, and a job-training facility.[276] Its most remarkable feature, signaling that the area's crime rate had finally dropped off, was an adjacent two-story entry pavilion with full-height glass walls that remained unbarred.

In the mid-1990s, Michael Sorkin called East New York "a museum of virtually every failed social housing typology in the American experience" and proposed two strategies for

LEFT Spring Creek Gardens, site bounded by Loring Avenue, Forbell and Emerald Streets, and a mapped but unbuilt extension of Stanley Avenue. Liebman Melting Partnership and Costas Kondylis of Philip Birnbaum & Associates, 1990. View to the northeast. Goldberg. ESTO

BELOW Spring Creek Gardens, site bounded by Loring Avenue, Forbell and Emerald Streets, and a mapped but unbuilt extension of Stanley Avenue. Liebman Melting Partnership and Philip Birnbaum & Associates, 1990. Site plan. LMP

changing its fortunes.[277] In 1994, "looking at the empty lots not as blight but as a community resource," he proposed "Shrooms," a plan inspired by his competition entry earlier in the year to rebuild the souks of Beirut with a series of "large, champignon-like structures" whose canopies, linked by bridges, would shade public spaces.[278] The Shrooms of East New York, "flowing through the middle of the blocks" and occupying "the spaces of abandonment as they are found," would house programmable loft spaces in the would-be mushroom stems while the caps would overlap with one another to define indoor "green rooms" for collective use. Gardens would sit atop the structures. In time, Sorkin wrote, the "growing garlands of Shrooms might help in both greening and rebuilding," adding a new "pattern of movement through the neighborhood, a greenway that operates not as a replacement for the street but as a supplement to it."[279]

In 1995–96 Sorkin again turned his attention to East New York, offering an even more organic and conceptual proposal. Wondering how the area could be affected not by "urban-renewal-esque demolition or by historicist completion" but by "the addition of new layers of circulation, of use, of green space, and of form," Sorkin proposed to plant a tree in the middle of an intersection as a kind of "acupuncture" that would at once decrease automobile traffic (and what he felt to be the "excess of public space" devoted to it), while forcing the "invention of a new green system for the neighborhood" by requiring alternate routes of circulation to be created around the tree, "creating neighborhood-scaled commercial and social centers that would restore legibility, convenience, and conviviality to a precinct ragged and overlarge."[280]

Shrooms of East New York. Michael Sorkin Studio, 1994. Site plan. MSS

East New York Acupuncture. Michael Sorkin Studio, 1995–96. Site plan. MSS

In 1995 the Architectural League of New York hoped to jump-start a community-based plan for the area by sponsoring "Envisioning East New York," a competition in which architects were asked to consider various local sites.[281] The fact that only twenty-five teams entered submissions was disappointing. Even more disheartening was the prevalence of symbolic and artistic proposals over practical studies. According to one participant, Denise Bekaert, "Our profession should be called on the carpet. It was pitiful."[282] The most serious-minded scheme was that of the Pratt Institute Planning and Architectural Collaborative, which prepared seven housing prototype designs, matching specific types with existing sites.

As the area slowly crept back to life, several modest but architecturally distinguished religious, educational, and health-care facilities were built. Theo. David & Associates infused two churches with artistry despite meager budgets. The Bethelite Institutional Baptist Church (1989), 446 Elton Street, between Belmont and Sutter Avenues, called for the expansion of an existing brick box located on a forty-by-ninety-foot midblock site.[283] Despite its small size, the church presented a dignified facade to the street, with a recessed porch set beneath an overscaled Dutch stepped gable rising to an extruded cross. The gable's form was also extruded backwards to shape the roof of the sanctuary, with portions of each vertical rise glazed to serve as clerestory windows. Completed two years later, David's New Life Baptist Church, 931 Dumont Avenue, between Warwick and Ashford Streets, consisting of a twenty-five-foot-wide sanctuary addition to the congregation's existing converted two-

story rowhouse, featured a minimalist exterior of red brick punctuated by a fifteen-foot-high painted steel cross placed off-center above a recessed entrance and shadowed by a series of additional crosses behind it.[284] The twenty-seven-foot-high worship space was illuminated by a skewed cruciform skylight whose crossing was positioned directly over the pulpit. An undulating glass-block wall separated the sanctuary from a rear yard, and a cylindrical skylight illuminated a six-foot circular baptismal pool. Jayne Merkel and Philip Nobel called the design "stunning."[285]

Richard Dattner's modest one-story Cypress Hills Branch Library (1995), 1197 Sutter Avenue, northwest corner of Crystal Street, replaced an earlier branch located in the Cypress Hills Houses (Carson & Lundin, 1954) across the street. Though he conceived the building as a "beacon of civility and hope in one of New York's most troubled neighborhoods," Dattner also envisioned it as a fortress, focusing the plan "inward" around a square double-height clerestory windowed reading room that was rotated at a forty-five-degree angle to its corner site, "adding to the contrast between the somewhat cloistered, peaceful interior and the protective masonry exterior."[286] The entrance, set back in a skylight-covered courtyard, was shielded from the street by metal gates decorated by Rolando Briseño, a Brooklyn-based artist.

Davis Brody Bond, in a joint venture with Larsen Shein Ginsberg + Magnusson, designed four distinctive satellite Family Care Centers for Brookdale Hospital at 2554 Linden Boulevard, 1883 Eastern Parkway, 1095 Flatbush Avenue, and 465 New Lots Avenue.[287] Completed in 1996, the buildings ranged in size from 6,550 to 12,000 square feet, each a

Bethelite Institutional Baptist Church, 446 Elton Street, between Belmont and Sutter Avenues. Theo. David & Associates 1989 View to the southwest. Vascimini. TDA

Bethelite Institutional Baptist Church, 446 Elton Street, between and Sutter Avenues. Theo. David & Associates 1989. Vascimini. TDA

New Life Baptist Church, 931 Dumont Avenue, between Warwick and Ashford Streets. Theo. David & Associates 1991. View to the north. Vascimini. TDA

New Life Baptist Church, 931 Dumont Avenue, between Warwick and Ashford Streets. Theo. David & Associates 1991. Plan. TDA

New Life Baptist Church, 931 Dumont Avenue, between Warwick and Ashford Streets. Theo. David & Associates 1991. Vascimini. TDA

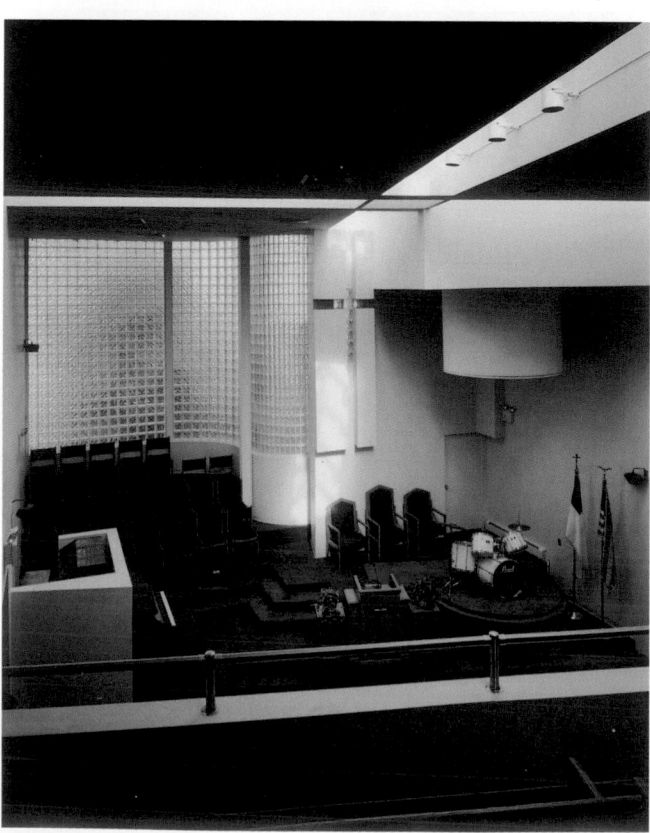

stylish configuration of glass-block walls, concrete block, striated brick, and steel. Also affiliated with Brookdale Hospital was Schuman, Lichtenstein, Claman & Efron's six-story, two-tone red brick Arlene and David Schlang Pavilion (1998), an eighty-seven-unit apartment house for the low-income elderly at 568 Rockaway Parkway, between Linden Boulevard and Church Avenue.[288]

Mitchell/Giurgola Architects and John Ciardullo Associates' five-story P.S. 156/I.S. 293 (2002), also known as the Waverly School for the Arts, occupying most of the block bounded by Sutter Avenue, Legion Street, Blake Avenue, and Grafton Street, gave an important lift to Brownsville, replacing a 1908 school that had been abandoned, vandalized, and then demolished in 1993 after it was determined to be unsuitable for renovation because of high levels of asbestos and lead.[289] Playing a dual role as school and community center, a wing of classrooms and labs could be closed off after hours, while a second wing containing the gymnasium, cafeteria, library, and 416-seat auditorium remained open. Glass-and-aluminum-panel curtain walls were incorporated into the tan brick facade and, to make the building more inviting, its main stairway rose alongside a two-story wall tiled with colored glass, designed by the sculptor Ned Smyth, and was exposed behind a glazed wall that allowed views inside from Sutter Avenue. The architects also eliminated the expanded wire mesh that typically covered the first-floor windows of urban schools—and contributed to what Paul Broches of Mitchell/Giurgola called "a somewhat prisonlike association"—in favor of a perforated metal panel system that provided "an equivalent measure of protection, if not more, and is much more attractive both looking from the inside and outside."[290]

TOP Cypress Hills Branch Library, 1197 Sutter Avenue, northwest corner of Crystal Street. Richard Dattner, 1995. View to the north. RDPA

ABOVE Brookdale Hospital Family Care Center, 1883 Eastern Parkway, between Atlantic Avenue and Herkimer Street. Davis Brody Bond with Larsen Shein Ginsberg + Magnusson, 1996. View to the northwest. DBB

RIGHT Brookdale Hospital Family Care Center, 465 New Lots Avenue, northeast corner of Wyona Street. Davis Brody Bond with Larsen Shein Ginsberg + Magnusson, 1996. View to the northeast. DBB

P.S. 156/I.S. 293 (Waverly School for the Arts), site bounded by Sutter and Blake Avenues and Legion and Grafton Streets. Mitchell/Giurgola Architects and John Ciardullo Associates, 2002. View to the west. Chu. KCJP

P.S. 156/I.S. 293 (Waverly School for the Arts), site bounded Sutter and Blake Avenues and Legion and Grafton Streets. Mitchell/Giurgola Architects and John Ciardullo Associates, 2002. View to the south showing *Destination* by Ned Smyth. Chu. KCJP

Olhausen DuBois's Van Dyke Community Center (2000), 392 Blake Avenue, between Gaston Boulevard and Powell Street, in the Van Dyke Houses (Isadore and Zachary Rosenfield, 1955), featured a distinctive curving roof over a basketball court that the architects understood to be the building's most popular amenity. In light of what they perceived as a "long-term goal . . . to expose kids to what's going on in the activity rooms," they lined a broad, tiered common area with curving glass walls, allowing views into a computer lab, library, game room, wood shop, and music, dance, and fitness studios.[291] As designed by Caples Jefferson Architects, the

Marcus Garvey Houses Community Center, 20 Amboy Street, completed in 2005, comprised "small protected landscapes for children and adults" in a "meandering" plan formed by two "opaque irregular glazed brick masses of heavy construction" linked by "strict orthogonal corridors of light construction" enclosing a central courtyard.[292] The building's free-form shape and sloping silhouettes were intended to "reinforce the center's programmatic position as a dominant element in the complex, even though it is low in scale."[293]

To the south of East New York but increasingly associated with it, the area on Jamaica Bay known as Spring Creek was

ABOVE Marcus Garvey Houses Community Center, 20 Amboy Street, between Pitkin and East New York Avenues. Caples Jefferson Architects, 2005. Aerial view to the north. Olivas. CJA

BELOW Landings at Fresh Creek, Louisiana Avenue, between Twin Pines Drive and Vandalia Avenue. Herbert L. Mandel, 1995. View to the west. Mandel. HLM

dominated by Starrett City (Herman Jessor, 1976), a forty-six-building, 5,881-unit middle-income housing development covering 153 acres.[294] In 1989 the Board of Estimate designated the Starrett Housing Corporation as developer of three vacant sites to the west, north, and east of Starrett City. In expectation of a bustling new mixed-use district, Starrett City was renamed Starrett at Spring Creek. To the west of Starrett City, on a fourteen-acre strip of land adjacent to wetlands protecting the Fresh Creek Basin along Louisiana Avenue, Starrett built the Landings at Fresh Creek (site plan, Gruzen Samton; townhouses, Herbert L. Mandel, 1990–95), a 282-unit develop-

ment of three-story townhouses with salmon-colored brick, stone trim, faceted facades, and geometric parapets.[295] Initially planned to include five clusters built in five stages, only two were realized because of slow sales attributable in part to a smaller than expected response from Starrett City tenants.

The most ambitious development at Spring Creek was scheduled to rise to the east of Starrett City and west of the Brooklyn Developmental Center (Katz, Waisman, Weber, Strauss, 1974) on 230 acres of city- and state-owned landfill once used as a dump for construction debris.[296] According to a master plan prepared by Cooper, Robertson & Partners in 1989, Gateway Estates (origi-

ABOVE Proposed Nehemiah Spring Creek, site bounded by Flatlands, Vandalia, Schenck, and Fountain Avenues. Alexander Gorlin, 2004. Typical two- and three-story front elevations. AGA

LEFT Proposed Nehemiah Spring Creek, site bounded by Flatlands, Vandalia, Schenck, and Fountain Avenues. Alexander Gorlin, 2004. Rendering of typical streetscape. AGA

nally called Spring Creek Estates) called for a wide mix of uses including 4,700 owner-occupied residential units in low-rise townhouses, three schools, sixty-five acres of open space, significant retail and office components, a community facility, areas for religious and institutional use, and a 60,000-square-foot industrial site. Progress was delayed when Mayor Dinkins took office and deferred the city's funding until 1993. In the interim, East Brooklyn Churches identified the site as being suitable for 2,000 Nehemiah houses and waged a fierce battle to gain control over it.

In October 1992, an agreement was reached to incorporate 500 Nehemiah houses in the northeast corner of Gateway Estates between Flatlands, Vandalia, Schenck, and Fountain Avenues. Cooper, Robertson's amended plan (1994) called for the Nehemiah houses, 2,300 Starrett houses, and two schools to be organized on a grid of streets bounded by low-rise structures and avenues hosting mid-rise buildings ringed by thirty-eight acres of parkland. To pay for infrastructural work, the

site's southern forty-eight acres were to be developed first, with a larger than originally planned 640,000-square-foot retail component of big-box stores accessed from a new exit ramp off of the Belt Parkway. The City Council approved the project unanimously in June 1996, and after several years of political wrangling and a change in ownership of the publicly traded Starrett Housing Corporation, ground was broken in November 2000 on Gateway Center (Greenberg Farrow Architecture, 2002), a red brick, suburban-style strip mall with parking for 2,891 cars that attracted national retailers like Target, Home Depot, and Marshalls, and eschewed a food court in favor of dine-in restaurants.[297]

Construction began in 2004 on Nehemiah Spring Creek. As designed by Alexander Gorlin, the neighborhood of 844 two- and three-family, 1,600-square-foot modular houses promised to be a notch above any previously built under the program. Street life would be fostered by the relegation of car parking to

the rear of the houses and the inclusion of front stoops, while streetscapes would vary with alternating groups of two- and three-story houses to create an undulating roofline. The neighborhood's overall look would be determined in part by buyers, who could individualize their homes by choosing among a selection of materials, finishes, and colors intended to complement one another. Facades were enlivened by the incorporation of bay windows and vertical recesses as well as ribbon windows on some houses and rectangular windows in a gridded or staggered formation on others. At the individual level, the houses were also more appealing: two feet wider than their predecessors and laid out with open loft spaces that could be partitioned according to the changing needs of families over time. Construction of the remaining houses of Gateway Estates, and of a seventeen-acre park that included New York's first regulation cricket fields, began in 2005.

Flatbush

Founded in 1652 and annexed to the City of Brooklyn in 1894, Flatbush, located in the center of the borough, remained rural until the 1880s, when the opening of the Brooklyn, Flatbush and Coney Island Railroad helped to transform the area into a prosperous middle-class suburb containing houses in a wide variety of styles.[298] After World War I, six- and seven-story apartment houses filled in vacant sites and replaced older houses. Ocean Parkway and Ocean and Bedford Avenues were among the area's leading streets, and the neighborhoods lying between them constituted a highly desirable urban suburbia that attracted affluent Jews leaving the Lower East Side. In the 1950s and afterward, East Flatbush, roughly bounded by Empire Boulevard, Remsen Avenue, Avenue H, and New York Avenue, became home to black immigrants from the Caribbean, while central Flatbush, especially the Midwood section, retained its caché with Central European Jews, giving way to the largest enclave of Syrian Jews in the world.

In 1975 Ocean Parkway, the five-and-a-half-mile-long, 210-foot-wide landscaped boulevard designed by Frederick Law Olmsted and Calvert Vaux in 1874–76, was declared a city landmark over the objections of some officials in the City Planning Department, who feared that designation might jeopardize much-needed federal funds earmarked for its renovation.[299] But preservationists and community groups strongly supported the move as a way to prevent the city's Department of Highways from widening the road by chipping away at its spacious flanking malls that featured pedestrian, equestrian, and bicycle paths. The city's renovation, completed in 1980, preserved the malls while providing for a new drainage system, refurbished curbs, and the planting of more than 600 trees along the right of way.[300] In 1977 the City Planning Commission created the Special Ocean Parkway District, a large area bounded by Fort Hamilton Parkway and Coney Island, Brighton Beach, and McDonald Avenues, with the goal of maintaining the neighborhood's existing scale and character, including the requirement that buildings facing Ocean Parkway include a thirty-foot landscaped "front yard." The creation of the special district, the landmark designation, and the renovation of Ocean Parkway seemed to trigger a rebirth in the middle-class neighborhoods that defined its length from Prospect Park to Coney Island, resulting in a huge influx of Orthodox Jews, mostly young people with large families.[301]

Prosperity was accompanied by the replacement of relatively modest single-family homes on modest-sized lots,

1996 East Fifth Street, between Avenues S and T. Robert A. M. Stern Architects, 1986. View to the southwest. RAMSA

1990 East Fourth Street, between Avenues S and T. Anthony Cohn, 1996. View to the southwest. Krogh. AC

mostly built around the time of World War I, with larger and far more lavish houses. One of the most elaborate, designed by Robert A. M. Stern Architects (1983–86), was built on a hitherto undeveloped lot at 1996 East Fifth Street between Avenues S and T.[302] An attempt to refine the architectural themes that typified neighboring houses, the design also established a unique identity through the quality and character of its detailing and the rich mixture of its materials. The rusticated, alternating bands of red brick and granite formed a high base, surmounted by cream-colored stucco and capped by a hipped roof of green-glazed tile. Inside, rooms with twelve-foot-high ceilings were gathered about an entry hall that rose two stories and culminated in a gilded dome.

Across the street, Anthony Cohn, who had worked in Stern's office on the East Fifth Street project, echoed its vocabulary in a tightly massed composition (1989–93), 2007 East Fifth Street, that combined a high red brick base with a stucco

506 Avenue S, southeast corner of East Fifth Street. Ike Kligerman Barkley, 2000. View to the southeast. Aaron. ESTO

Residence, northwest corner of Seventeenth Avenue and Fifty-fourth Street. Peter Gluck, 1998. View to the northwest. Dischinger. PLG

Mesivta Yeshiva Rabbi Chaim Berlin, 1605 Coney Island Avenue, between Avenue L and Locust Avenue. Fox & Fowle, 1988. View to the northeast. Lai. FXF

superstructure also topped by a green-tile roof. A block away, at 1990 East Fourth Street, between Avenues S and T, Cohn had the advantage of an unusually large, sixty-foot-wide lot for a house (1996) that was distinguished by a two-story porch carried by paired Tuscan columns at the base and Ionic columns at the second story. Again, Cohn employed a similar palette of red brick, cream-colored stucco, and a green-tile roof finished in both matte and high-gloss glaze. The exterior also featured Euville limestone from Nancy, France. The rooms were arranged around a stair hall topped by a dome elaborately detailed in bronze and colored glass. The firm of Ike Kligerman Barkley, whose principals had also worked in Stern's office, built in Midwood as well, including a brick, limestone, and stucco house (2000) at 506 Avenue S, southeast corner of East Fifth Street. Combining Mediterranean and classical elements, the house, topped by a red tile roof, featured a gabled entrance portico carried on brick columns and a prominent central pediment above the second story.

In Borough Park, another heavily Orthodox Jewish neighborhood west of Flatbush, Peter Gluck broke with the area's traditional architecture in a three-and-a-half-story Modernist house (1998) on the northwest corner of Seventeenth Avenue and Fifty-fourth Street.[303] Although he eschewed any direct historical references in his design, Gluck was still sensitive about the potential of the 13,000-square-foot house to overwhelm its more modest neighbors. To minimize its presence, Gluck broke the mass of the cubelike structure into three parts, "almost mini-houses in themselves," according to the architect.[304] The rooms were organized around a central skylit stairway that allowed natural light into the middle of the house. Built for a scholar whose students visited on a regular basis, Gluck maintained the privacy of other family members by inserting a two-story wall of wood and glass to screen the staircase from the entrance hall. Elizabeth Pochoda, writing in *House & Garden*, described Gluck's design as an example of the architect's "mastery of contextual modernism. . . . Without casting a backward glance or bearing quaint historic elements like a decorative cornice or a traditional stoop, his house addresses its neighbors in assertive but accommodating language." She called particular attention to the entry, noting that "instead of being a grand statement for a grand house, the entrance is strong and quiet. And like a traditional exterior, this one has identifiable windows and a design open enough to acknowledge the importance of the city corner, instead of throwing up a wall and ignoring it. Even the materials, stucco and stone, are traditional city materials."[305]

To help serve the increasing number of religious Jews settling in the area, several institutions expanded or commissioned new facilities. Among these was Mesivta Yeshiva Rabbi Chaim Berlin, for which Fox & Fowle designed a substantial three-story building (1988) clad in granite and polychromatic brick in shades of red and purple, at 1605 Coney Island Avenue, between Avenue L and Locust Avenue.[306] In 1989 Robert A. M. Stern Architects completed work on the 12,000-square-foot Kol Israel Synagogue, northeast corner of Bedford Avenue and Avenue K, built for an Orthodox Sephardic congregation.[307] Built under restrictions established by the City Planning Commission, which sought to protect the area's residential fabric by requiring that new religious buildings replace no more than one existing building, the massing of the banded red brick and stone building, topped by a red-tile roof, was arranged to present a civic scale along the major avenue and a more intimate entrance facing the residen-

tial cross street. Strict height and setback requirements led to an unusual arrangement whereby the entire site was excavated to create a below-grade sanctuary of the largest possible area but one that was light-filled, because at its center the space rose up past the entry level and women's balconies to achieve a height of thirty-four feet. Laura Felleman Fattal wrote that "the ambience of the synagogue . . . recalls communities around the Mediterranean. The wrought-iron accents, wooden seats, ark and reader's platform, decoratively painted wooden beams, the small window on the frontal facade and the patterned brick of the exterior of the building, concurrently create a symbolic and tangible Sephardi presence."[308]

Flatbush's leading secular institution, Brooklyn College, founded in downtown Brooklyn in 1910, moved in 1937 to a twenty-eight-acre Georgian-style campus roughly bounded by Glenwood Road, Nostrand Avenue, the tracks of the Long Island Rail Road, and Ocean Avenue.[309] In 1984 SITE was asked to create quarters on the ground floor of the campus's most prominent building, Randolph Evans's red brick Georgian library (1937), for the recently founded Museum of the Borough of Brooklyn.[310] Opened in 1987, the modest, short-lived museum was dedicated to the visual and cultural history of the borough. In order to accommodate a wide range of exhibition materials, SITE's design was intended to be as flexible as possible. Objects were displayed on moveable steel-framed perforated metal panels measuring four feet by eight and a half feet and suspended from an overhead grid system. To add visual interest, as well as to relate the design to Evans's building, now known as La Guardia Hall, SITE decorated the floating exhibition panels with classical cornices and base moldings. Although the museum was disbanded after a few years of operation, the space continued to be used by art students and others for temporary exhibitions.

In the mid-1990s, after a room-by-room survey of Brooklyn College's existing facilities, R. M. Kliment & Frances Halsband Architects drafted a master plan for the campus that called for new academic and research space as well as the recapturing of underutilized existing space.[311] The plan's goals also included the creation of a more student-friendly environment, better links between the institution and the surrounding community, and the construction of a new quadrangle. In October 2002, Buttrick White & Burtis, in collaboration with Shepley Bulfinch Richardson & Abbott, completed the first phase of the master plan with the restoration of the main library building's facade and its complete interior renovation.[312] Their work also included a four-story, red brick addition designed to complement Evans's building. Although the renovation and addition provided state-of-the-art facilities, it also resulted, unfortunately, in the loss of SITE's handsome exhibition space.

Sunset Park

Sunset Park, bounded by Fifteenth Street, Sixty-fifth Street, Eighth Avenue, and the harbor, was divided roughly in half by an elevated rail line along Third Avenue and then by the elevated six-lane Gowanus Expressway (1941) that replaced it, so that the industrial area to the west was quite distinct from the residential neighborhood on the gradually sloping land rising to the east. The area's most notable industrial complex was Cass Gilbert's powerfully monumental, reinforced-concrete Brooklyn Army Terminal (1919), west of Second Avenue from Fifty-eighth to Sixty-sixth Street, occupying fifty-five acres of land and forty-two acres below the water with two, roughly

Kol Israel Synagogue, northeast corner of Bedford Avenue and Avenue K. Robert A. M. Stern Architects, 1989. View to the northeast. RAMSA

Kol Israel Synagogue, northeast corner of Bedford Avenue and Avenue K. Robert A. M. Stern Architects, 1989. RAMSA

two-million-square-foot, nine-story buildings and three shed-covered piers. The terminal had been a primary point of embarkation for military personnel and cargo during World Wars I and II but was left vacant when the Department of Defense moved its cargo functions to Bayonne, New Jersey, in 1966 and relocated remaining personnel in 1975. In 1979 the city began a lengthy process leading to the purchase of the land from the federal government in 1981.[313] As negotiations

moved along, the city issued a request for proposals for the terminal's redevelopment, garnering three schemes that called for industrial uses and two that combined industry with housing and retail businesses.[314] Perkins & Will's scheme, prepared for the Brooklyn Terminal Development Corporation, called for gutting the pier sheds and rebuilding them with terraced housing, 1,300 apartments to be accommodated in one of the factory buildings, and new residential construction to be sited elsewhere on the property. Richard Dattner prepared three schemes for Grayco Builders to convert the more inland of the two Gilbert structures, known as Building B, into the world's biggest residential building, with 1,440 units. The first option called for the removal of portions of the exterior to create bays providing better light and views, the second widened the interior courtyard to introduce more natural light, and the third called for the removal of the building's ends to create two parallel slabs. In each case, additional low-rise housing would be built inland from the factory.

In September 1980, the city chose a proposal by Helmsley-Spear Inc. to redevelop the property for industrial purposes, but a year later Harry B. Helmsley withdrew from the deal, stating, "The city made the terms more and more onerous, and at the same time mortgage money got more difficult, interest rates got higher and there's a lot of talk about recession."[315] Further progress proved elusive until 1985, when the city announced that it would renovate the terminal for printing businesses, which were being priced out of Manhattan. To ensure that this plan would go forward, the Public Development Corporation, which controlled the site, would for the first time act as the developer of one of its own projects. Beyer Blinder Belle prepared designs for the multiphased

Federal Detention Center, 80 Twenty-ninth Street, between Third and Second Avenues. Urbahn Associates, 1996. View to the southwest. Zucker. UA

Proposed conversion of Building B, Brooklyn Army Terminal. Richard Dattner, 1981. Rendering. RDPA

renovation, which began with one million square feet in Building B. Completed in October 1987, the work included new mechanical systems, doors, canopies over the loading docks, passenger and freight elevators, landscaped parking lots, a new entrance, and a gray, pink, and black terrazzo-floored, glass-walled lobby overlooking the internal courtyard. The space had originally been covered by corrugated glass but was now left open to the elements, although the skeletal steel trusses that had been used to support the skylight remained intact. With the help of city-offered incentives like relocation grants, tax reductions, and discounted electricity, the project was a success, attracting more than twenty print shops, as well as costume jewelers and garment makers. In 1988 the project's second phase was announced, and it called for the renovation of the remaining million square feet in Building B. For this stage, Beyer Blinder Belle inserted a two-story shop-lined lobby into the southern end of the building and in the courtyard built a metal-roofed walkway that Herbert Muschamp felt "marred" the overall renovation.[316]

In 1993 BATKids, a day care center serving fifty-five children, was established as the first such facility in the city to be built in an industrial park.[317] The firm of Architrope renovated a 5,200-square-foot space in Building B into three classrooms and an indoor play area, the walls of which were painted to resemble an underwater landscape. A 3,200-square-foot outdoor playground was also provided. The terminal's second structure, Building A, was renovated in several stages between 1994 and 2003 according to designs by Arthur L. Spaet & Associates and LZA Associates.[318]

To the north of the Brooklyn Army Terminal was the sprawling Bush Terminal (William Higginson, 1910–26), a complex of nineteen industrial buildings on a site between Twenty-eighth and Fiftieth Streets. It remained active as an industrial complex and during the first half of the 1980s attracted the largest concentration of garment companies—two million square feet's worth—outside of Manhattan.[319] In 1991 the Federal Bureau of Prisons announced plans to establish a Federal Detention Center in two Bush Terminal buildings

on the block bounded by Second and Third Avenues and Twenty-ninth and Thirtieth Streets, eventually replacing one with a purpose-built prison wing.[320] Because the federal government owned the buildings and was not required to undergo community review, neighbors and elected officials who opposed the plans were powerless, and the project went forward. In 1995 work began on the phase of new construction that retained the eastern structure as a 500-bed facility and replaced the western one with a 425,000-square-foot 1,000-cell jail designed by Urbahn Associates. The wings were separated from each other by a parking lot and a one-story link building. Completed in 1996, Urbahn's building was a compatible addition to the industrial complex, its thirteen-story concrete frame clad in reinforced-concrete panels with infill sections of orange brick tile and punch-out steel sectional windows. Decorative grills on the north and south facades allowed light and air to enter—but not prisoners to escape from—outdoor recreational areas that each served two floors of cells.

Sunset Park's residential neighborhood was centered around the twenty-five-acre Sunset Park. In 2000 the Southwest Brooklyn Industrial Development Corporation sponsored an ideas competition, "Sunset Park: Beyond the Gowanus Expressway," in which architects and community groups, each judged separately, were asked to contemplate how the area could be reunited if the expressway was not elevated above Third Avenue but instead channeled through a tunnel beneath it: one of several options considered but not adopted in the previous decade by the Department of Transportation as a way of increasing the capacity of the highly congested traffic artery.[321] The competition drew twenty-eight entries, and Bruce A. Silverberg's proposal for La Plaza Mayor de

Sunset Park was chosen as the professional group's winner. Silverberg remade Third Avenue as a lighter-volume, four-lane thoroughfare incorporating a tree-lined bike path down the center. A landscaped "green corridor" on Forty-third Street would connect Sunset Park with the water. At the intersection of the two new axes, Third Avenue would be widened significantly between Fortieth and Forty-fourth Streets to create Plaza Mayor, a public space with a fountain, café, and greenmarket whose canopy would incorporate a section of the former elevated road, an idea that the jury called "ingenious."[322]

Sheepshead Bay

Sheepshead Bay, bordered on the south by the ocean inlet for which it was named, on the west and north by the neighborhoods of Gravesend and Marine Park, and on the east by Shell Bank Creek, was best known for the fishing village atmosphere of its waterfront district, where a charter boat business thrived alongside destination restaurants and small-scale shops on Emmons Avenue, the main commercial strip paralleling the north shore of the bay. The area had already slipped into decline when in 1979 its most famous restaurant and leading tourist attraction, F.W.I.L. Lundy Brothers (better known as Lundy's), 1901 Emmons Avenue, between Ocean Avenue and East Nineteenth Street, closed two years after the death of its owner, Irving Lundy. In addition to the restaurant, the Lundy family had owned about ten blocks along Emmons Avenue, many of the properties used as parking for patrons of the fishing boats berthed among ten piers in the bay. Without Lundy's as a tourist magnet and economic engine, and with the fate of the Lundy properties tied up in disputes, Emmons Avenue stumbled, giving way to down-market retailers. At

Sunrise on the Bay, 2211 Emmons Avenue, between Dooley and East Twenty-first Streets. Gruzen Samton, 1999. View to the northwest. GS

the same time, the fishing business suffered as costs escalated and interest in recreational fishing dwindled.

In 1984, to restore vitality to the waterfront, the city offered up for development two underwater sites on either side of the fishing-boat piers. The following year brought the announcement of a plan for the Wharf at Sheepshead Bay, calling for the renovation of the existing piers and the construction of a new 500-foot pier that would contain restaurants and shops. The plan was canceled in 1986 when its developer, Michael J. Lazar, was indicted (and later convicted of bribery) in a scandal involving the city's Parking Violations Bureau.[323] In 1987 a new plan, prepared by Alexander Cooper & Partners, proposed a floating restaurant, museum, and ferry terminal to be built on either side of the piers, an esplanade, and sixty-three condominiums to be built on the site of Lundy's, but that proposal, too, failed to materialize.[324] In the meantime a Queens-based developer who had acquired several of the Lundy family properties moved forward with Waterview Village (DiFiorri & Giacobbe), a 139-unit apartment complex on a 1.8-acre site extending from Emmons Avenue to Shore Parkway between East Twenty-sixth and East Twenty-seventh Streets.[325] Three three-story bay windowed and balconied buildings were completed in stages between 1985 and 1987, one along the avenue and two extending north along the side streets. The group enclosed a landscaped courtyard, playground, and swimming pool.

In 1993 plans were announced to build a Loehmann's discount women's clothing store on another Emmons Avenue blockfront, between Twenty-first Street and Poole Lane, stirring up more than a bit of controversy as the community found itself divided between those who hailed it as a viable antidote to the many failed attempts at sparking a local

Holocaust Memorial Park, Shore Boulevard and Emmons Avenue. George Vellonakis, 1997. View to the south. Vellonakis. VELL

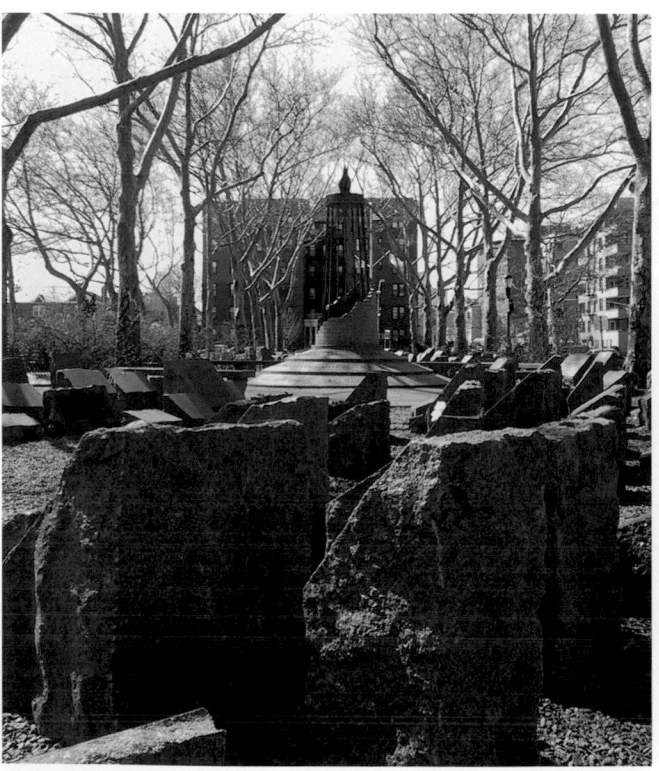

rebirth and those who argued that its faceless commercial character would sound the death knell for Sheepshead Bay's already waning charm.[326] Even before completion in 1996 the store proved pivotal in catalyzing the long-awaited resuscitation of Lundy's, giving lenders who had been reluctant to invest in earlier attempts to revive the eatery the confidence in the area that they needed.[327] The renovation came just in time to rescue Lundy's Spanish Colonial Revival–style building (Bloch & Hesse, 1934), which had been designated a landmark in 1992 but had continued to waste away at the hands of vandals and nature.[328] When it reopened in 1995, Van Brody's redesign had reduced the size of the restaurant significantly—seating 800 instead of 1,700—and a sizable portion had been converted to the Lundy's Landing Mall, a retail center. But the importance of the event was not to be underestimated. As City Councilman Anthony Weiner put it, "Since 1979, there's been an old joke around here that Lundy's is about to reopen. Developers have come here in fits and starts, so this is close to a religious experience."[329]

In 1999 another Emmons Avenue blockfront, a two-acre parking lot between Dooley and East Twenty-first Streets, was developed as Sunrise on the Bay, 2211 Emmons Avenue, a four-story 104-unit apartment building for the elderly with 10,000 square feet of medical offices and a 5,000-square-foot Kosher restaurant on the ground floor.[330] As designed by Gruzen Samton, the courtyard-enclosing complex featured lively red brick facades, protruding buff brick bays, and, at the top of the southeast corner, a "lighthouse inspired" porch set within a peaked octagonal enclosure.[331]

In 1997 Sheepshead Bay became home to the state's first publicly funded Holocaust memorial.[332] Situated on Shore Boulevard at the western edge of the bay, Holocaust Memorial Park, designed by George Vellonakis, a Parks Department architect, was a 450-by-110-foot waterfront park in which three walkways led to a central fourteen-and-a-half-foot-tall monument. Rising from three circular tiers of Jerusalem Stone inscribed with the names of victimized nations, the sculpture peeled away to expose a framework of steel and barbed wire intended to evoke the smokestack of a concentration camp furnace. An eternal flame was enclosed within. Throughout the surrounding park, forty inscribed granite blocks gave descriptions of historical events and figures, and more than a hundred additional markers were inscribed with the names of Holocaust victims, including survivors.

To the east of Sheepshead Bay across the Shell Bank Creek, the cloistered community of Gerritsen Beach received one notable public building during the 1990s, John Ciardullo Associates' red brick and cast-stone Gerritsen Beach Branch Library (1997), 2808 Gerritsen Avenue, sited at the east end of the Shell Bank Canal.[333] A modified Romanesque brick archway was placed off center on a broad gabled facade whose south end was marked by a clock tower with corbeled brickwork. The library's entrance, leading directly into the main reading room, sat on axis with a full-height rectangular window wall overlooking the canal. The reading room was spacious and featured exposed timber trusses carried on steel columns rising from brick-and-cast-stone bases. David W. Dunlap was impressed by the building, which, aside from its "almost pastoral seaside setting . . . has an undeniable dignity of its own."[334]

Just inside the northern boundary of the barely developed 798-acre Marine Park was the 5,400-square-foot Salt Marsh Nature Center (2000), designed by Kevin Wolfe, a Parks

ABOVE Gerritsen Beach Branch Library, 2808 Gerritsen Avenue. John Ciardullo Associates, 1997. View to the northeast. Wright. JCA

LEFT Gerritsen Beach Branch Library, 2808 Gerritsen Avenue. John Ciardullo Associates, 1997. View to the southwest. Wright. JCA

BELOW Gerritsen Beach Branch Library, 2808 Gerritsen Avenue. John Ciardullo Associates, 1997. Wright. JCA

Department architect. The project had initially been proposed in 1993 according to designs prepared by Lee Skolnick, whose two-story, 8,000-square-foot scheme, to be built half on land and half on a floating dock in Gerritsen Creek, would have featured a sod-covered monopitch roof carried on skewed pilinglike columns.[335] Wolfe's single-story, U-shaped building with splayed arms embracing a courtyard was set back from the shoreline on a landfill site, positioned to optimize views of the creek and wetlands. Wolfe conceived the nature center as "a stylized Adirondack camp building" stretching "out horizontally across its site, embracing the larger landscape and connecting the inside spaces to the outdoors" while being a "minimal visual intrusion on the site" and a "boundary between the natural wetlands of the park and urban Brooklyn."[336] Visitors entered through a broad, cylindrical

ABOVE Proposed Salt Marsh Nature Center, Marine Park, south of Avenue U. Lee Skolnick, 1993. Model, view to the northwest. LHS

BELOW Marine Park Environmental Center, Marine Park, south of Avenue U. Kevin Wolfe, 2000. View to the east. Kaufman. EK

stone tower ringed by clerestory windows, which allowed light to enter a two-story rotunda, where terrazzo floors were decorated with the names of famous naturalists as well as renderings of snakes, dragonflies, and other local animals. The building's two arms—one containing a ranger station and the other a caretaker's apartment—were joined by a long classroom with educational displays and full-height French doors that opened to the courtyard, where shallow-pitched, deeply overhanging roofs and wooden pergolas shaded the building's red brick, bluestone, and granite facades.

Coney Island

A popular seaside pleasure ground since the 1870s, when vast Stick Style wooden hotels were reached by six railway lines, the peninsula of Coney Island, including Manhattan and Brighton Beaches, became a one-day destination resort in the first decades of the twentieth century.[337] After World War I, with the commencement of direct subway service to Manhattan, Coney Island also became the permanent home for many lower-middle-class New Yorkers, but swelled in summer, when people flocked to its amusements and beaches. The area

reached its apogee of popularity during World War II, when gasoline rationing severely restricted long-distance travel. After the war, however, the general prosperity made automobile travel widely affordable, precipitating the area's decline as many chose to visit more exclusive shore points farther from the city and Coney Island frequently became a destination of last choice. This decline was exacerbated by rising racial tensions in the city and by the decision to build a large number of public housing projects that cast a fortresslike pall over the neighborhood. In the late 1960s the New York State Urban Development Corporation sponsored several vest-pocket and medium-sized projects that promised a rebirth. The neighborhood remained depressed, however, seemingly locked in a downward trend.

The attempts to revive Coney Island that began in the late 1970s centered on restoring its historic reputation as a popular recreation destination. In June 1977 Parks Commissioner Martin Lang announced the city's intention to build an amusement park on the twelve-acre site formerly home to George Tilyou's Steeplechase Park (1897; burned and rebuilt, 1907), West Sixteenth to West Nineteenth Street between Surf Avenue and the Boardwalk.[338] In a major blow to the resort, Steeplechase Park had been closed in 1965, and the city's subsequent attempts to build an "open space" park on the site failed, leaving the area an eyesore littered with abandoned cars and trailers.

The only remnant of Steeplechase Park was the framework of the 262-foot-high Parachute Jump ride (James H. Strong, 1939), originally built for the New York World's Fair and moved to Coney Island in 1940.[339] In July 1977, the Landmarks Preservation Commission designated the Parachute Jump a city landmark, but three months later, despite testimony by commission chairperson Beverly Moss Spatt that it was the "Eiffel Tower" of Brooklyn, the Board of Estimate unanimously refused to approve the designation, citing claims from the Parks Department that it would cost $10,000 a year to maintain the structure.[340] After the board's vote, a Parks Department official said the city would "move to demolish it" but the threat proved hollow and the derelict hulk was left to rust.[341] (A dozen years following its first failed attempt, the commission was able to successfully designate the Parachute Jump after the Parks Department withdrew its objection.)[342] The Parks Department's plans for an amusement park failed to move forward and the Steeplechase Park site remained a highly visible symbol of Coney Island's failure to rebound.

In August 1985, developer Horace Bullard, after signing a twenty-year lease agreement with the city, announced his intention to build a new amusement park on the Steeplechase Park site.[343] To be designed by Silverman & Cika in conjunction with theme park specialists Battaglia Associates, the new facility was planned to include sixty new rides and attractions, an elevated trolley system, and a renovated Parachute Jump. Plans for the amusement park soon stalled but were not officially dropped until 1994, when the city became convinced that Bullard could not raise enough money to finance the project.

Despite the failure to redevelop the Steeplechase Park site, there were some encouraging signs of renewal on and around Coney Island's Boardwalk. In 1985 Coney Island U.S.A., a newly founded nonprofit arts group dedicated to reviving the area's fortunes, sponsored the opening of Sideshows by the Seashore, located in a former pinball arcade and featuring musicals and plays, as well as a small museum dedicated to memorabilia.[344] That same year, another group, the Coney

Island Hysterical Society, renovated the Spookhouse. In 1987 the Boardwalk itself was spruced up with the replacement of its worn Douglas fir planks with new greenheart planks from South America, and the Steeplechase Pier, a 1,000-foot walkway over the ocean at West Seventeenth Street, underwent a thorough restoration.[345] The resort's historic past got a boost when the Landmarks Preservation Commission designated two more of Coney Island's best-known amusements in 1988 and 1989: the wooden-track Cyclone roller coaster (Harry C. Baker and Vernon Keenan, 1927), 834 Surf Avenue, and the 150-foot-high Wonder Wheel Ferris wheel (Charles Herman, 1920), 3059 West Twelfth Street.[346] Another optimistic sign for Coney Island was the decision of the area's most notable public institution, the New York Aquarium, located on a fourteen-acre site at the Boardwalk and West Eighth Street in buildings designed by Harrison & Abramovitz (1957) and Goldstone & Dearborn (1966), to renovate in the late 1980s and early 1990s. The new work included Goldstone & Hinz's Sea Cliffs exhibition (1993), a 350-foot-long simulation of a rocky coastline in the North Pacific offering above and below water views of penguins, sea lions, and walruses.[347]

In the mid-1990s, with Bullard's scheme for a new amusement park no longer on the table, local government and business leaders began to lobby for a sports stadium on the Steeplechase Park site, an idea that appealed to Mayor Giuliani, a baseball enthusiast.[348] Planned in collaboration with a new minor league ballpark for the New York Yankees on Staten Island, the Brooklyn stadium would be affiliated with the New York Mets. As designed by Jack L. Gordon Architects and completed in 2001, the 7,500-seat KeySpan Park proved a fitting complement to the honky-tonk of the Boardwalk, with a scoreboard topped by a replica of the famed roller coaster, bold graphics, and bright and colorful exterior lighting that animated the structure at night. The state-of-the-art facility, home of the Single A farm team Brooklyn Cyclones and named for the utility company that purchased the rights, included twelve luxury suites and provided parking for 1,243 cars. The stadium, which was also intended to host concerts and other entertainment events, proved an immediate hit, quickly selling out a season's worth of home games and renting all of the street-level retail space.

East of Coney Island lay Brighton and Manhattan Beaches, two communities that, in marked contrast, remained relatively prosperous and, beginning in the 1970s, became home to large numbers of Jews emigrating from the former Soviet Union.[349] In 1986 the developer Stephen Muss, president of Alexander Muss & Sons, announced plans to build a 2.9-million-square-foot luxury apartment complex on the fifteen-acre oceanfront site of the Brighton Beach Bath and Racquet Club, bounded by Coney Island and Brighton Beach Avenues and Seacoast Terrace.[350] The private social and athletic club founded by Joseph Day in 1907 as the Brighton Beach Baths had, by the 1970s, begun to lose members. The Muss firm, which had owned the facility since 1955, hired Beyer Blinder Belle to design Brighton-by-the-Sea, a 2,200-unit complex that included six towers ranging in height from twenty-two to forty-four stories, two townhouse wings, 32,000 square feet of ground-floor retail and office space, and parking for 1,850 cars.

Before the proposal went through the approvals process, the developers, reacting to concern raised by some in the community that it was too large and tall, revised their plans.[351] Released in 1989, the similar, scaled-back scheme, designed

ABOVE Oceana, site bounded by Coney Island and Brighton Beach Avenues and Seacoast Terrace. Sandy & Babcock with Schuman, Lichtenstein, Claman & Efron, 2004. View to the southwest. Sundberg. ESTO

LEFT KeySpan Park, 1904 Surf Avenue, between West Seventeenth and West Nineteenth Streets. Jack L. Gordon Architects, 2001. View to the southeast. JLGA

by Costas Kondylis, called for 1,730 apartments in five buildings, the tallest of which was twenty-nine stories. The reworked scheme was still opposed, with Linda Davidoff, of the Parks Council, protesting it for creating a "barrier between the community and the waterfront."[352] Before the apartment complex was approved by the City Planning Commission in July 1992, Muss had Kondylis reduce it again to accommodate 1,500 units in four buildings, although the tallest still rose to twenty-nine stories. In March 1994 the final hurdle was overcome when a lawsuit filed by the Committee to Preserve Brighton Beach and Manhattan Beach was dismissed.

Despite receiving the go-ahead, Muss instead sold the site to his cousin Joshua L. Muss, head of the Muss Development Company, in 1997, the same year that the Brighton Beach Bath and Racquet Club was finally shuttered.[353] Joshua Muss hired new architects to produce a more modest scheme. As designed by Sandy & Babcock, in collaboration with Schuman, Lichtenstein, Claman & Efron, the Oceana, as the gated, 850-unit condominium complex was now called, consisted of sixteen five- to twelve-story buildings clad in red brick and prefabricated stucco panels with gabled roofs and balconies. The project included two acres of landscaped space, a 12,000-square-foot clubhouse, indoor and outdoor pools, and parking for 1,200 cars. Construction began on the Oceana in the summer of 1999 and by December 2001 five buildings had been completed, with another six finished in the following three years.

Morrisania Air Rights Houses, platform over Penn Central railroad cut between East 158th and East 163rd Streets. Jarmul & Brizee, 1980. View to the west. Vergara. CV

THE BRONX

Out of the Ashes: South Bronx Revival

Despite pockets of relative stability, such as the lower-middle- and working-class neighborhoods east of the Bronx River Parkway, as well as areas of middle-class prosperity and even affluence, such as Riverdale in its northwest corner, the dominant story of the Bronx over the past thirty years has revolved around the fortunes of the South Bronx, its most troubled section and the site of the borough's most intense planning and building activity. By the late 1970s, the South Bronx, encompassing Mott Haven, Port Morris, Melrose, Longwood, Hunts Point, Morrisania, and Crotona Park, had become a national symbol for what was wrong with urban America. The area had been devastated by the combined effects of the white flight of the 1960s, leaving an overwhelmingly poor black and Hispanic population, high crime rates largely attributable to the illicit drug trade, and the widespread neglect, abandonment, and frequent arson of its building stock.[1]

The first substantial new project to be completed in the area, Morrisania Air Rights Houses (Jarmul & Brizee, 1980), built on a platform over the four-track Penn Central railroad cut west of Park Avenue between East 158th and East 163rd Streets, a low-income, 843-unit housing complex, was a holdover from the early 1970s, representing the last high-density high-rise public housing complex to be built in the neighborhood and one of the last built in the entire city.[2] The

project, financed by the Federal Department of Housing and Urban Development, originally called for 1,034 apartments in three eleven- to twenty-nine story buildings to be designed by the Eggers Partnership.[3] The 1971 design called for the use of steel trusses to allow construction to take place without interfering with the normal operation of the railroad line, the tracks of which were sunk in an open cut twenty feet below street level. The embankment flanking the railroad would be used for elevator pits, utility lines, and boiler plants, and provisions for ventilation, lighting, and fire exits would be built into the platform covering the tracks. The project was stalled by the city's inability to find a contractor able to build the complex within the $39 million budget provided by HUD.

Six years later the project was revived when the recession-driven depressed state of the construction industry resulted in lower building costs. But with the passage of time, there were over 1,000 acres of vacant land available in the South Bronx and an idea that seemed, as *New York Times* reporter Charles Kaiser put it, "novel, but defensible" in 1971 when there was little or no vacant land available in the neighborhood now appeared almost ludicrous for an area that "has been devastated by fires and building abandonments."[4] City officials publicly acknowledged that the project no longer made sense but complained that there was nothing they could do because federal rules required that the housing complex go forward above the railroad tracks as an air-rights demonstration project.

Construction on the three-building Morrisania Air Rights Houses began in the summer of 1977 and was completed by 1980. Designed by Jarmul & Brizee, who replaced the Eggers Partnership in the late 1970s, the imposing project loomed over the bleak landscape surrounding its 5.38-acre site. The nineteen-, twenty-three-, and twenty-nine-story tan brick buildings had highly prominent exposed-concrete buttresses flaring out at the base, a poor man's version of Philip Johnson's unrealized Chelsea Walk (1967), another high-density high-rise apartment complex planned above railroad tracks, in this case the open-air yards between Ninth and Tenth Avenues and West Thirty-first and West Thirty-third Streets, which Seymour Jarmul had worked on with Johnson and Samuel Paul.[5]

Eighteen years after their completion, in 1998, by which time highly praised, socially successful low-rise housing projects had proliferated throughout the South Bronx (see below), the New York City Housing Authority hired Curtis + Ginsberg Architects to come up with ways to improve Morrisania Air Rights Houses.[6] As the architects explained, the problem with the "original design" was that it created "a wall, emphasizing the division created by the train cut. This insensitive and outmoded design has had a negative impact on the community." Curtis + Ginsberg's master plan, prepared in association with landscape architect Mark K. Morrison, pointed to the "site design" and the project's "lack of integration into the neighborhood" as "major failings," proposing a new landscaped "internal street" that would provide a direct path to the Metro-North station at East 162nd Street and open space created around a pedestrian plaza at East 161st Street. According to the architects, the new plaza would include a water feature and a shaded sitting area with a canopy equipped with lights for nighttime use to reengage "the surrounding neighborhood by providing a physical and visual connection" to its "commercial spine" on 161st Street. The plan also called for additional open space in the form of a "passive park with rolling lawns, shade trees, community gardens, picnic area and play spray," as well as a new management and maintenance building, freeing up space in one of the existing towers to create eight two-bedroom garden apartments for tenants with physical disabilities.[7] As a result of Curtis + Ginsberg's study, several small-scale improvements were realized, including modestly expanded recreational areas and renovated lobbies connected to the sidewalk by large glass guard pavilions intended to reduce crime and vandalism exacerbated by the presence of the concrete buttresses, which trespassers used as hiding places.[8]

From Charlotte Street to Charlotte Gardens

While the entire ravaged landscape of the South Bronx was of grave concern, one particularly stricken part of it, Charlotte Street, in the Crotona Park section, became the focus of attention, becoming a virtual soapbox for both local and national politicians seeking a forum on urban issues. In March 1976, Arizona congressman and candidate in the Democratic presidential primary Morris K. Udall visited Charlotte Street. He was joined by Representative Herman Badillo, whose district included the area, and other local politicians and community leaders, as one photographer in a swarm of others directed "over here, over here, the rubble looks good over here."[9]

Jimmy Carter, who won the Democratic nomination and the presidency, had been criticized for not traveling to the South Bronx after the riots that followed the July 1977 blackout. Nine months into his term, Carter finally visited the neighborhood. On October 5, 1977, during a trip to the city on United Nations business, he made what *New York Times* reporter Lee Dembart described as a "sudden and dramatic trip . . . where he viewed some of the country's worst urban blight" accompanied by Mayor Abraham Beame and Patricia Roberts Harris, secretary of Housing and Urban Development.[10] As the presidential motorcade passed through the burned-out and rubble-strewn area, people shouted "Give us money!" and "We want jobs!" Twice Carter got out of his limousine to walk around and talk with local residents. The first of the two stops was at 1186 Washington Avenue, between East 167th and East 168th Streets, a renovation project where

Proposed master plan, Morrisania Air Rights Houses, platform over Penn Central railroad cut between East 158th and East 163rd Streets. Curtis + Ginsberg Architects, 1998. CGA

forty people had converted a six-story tenement into a twenty-eight-unit apartment house. The second stop was on Charlotte Street itself, where the caravan stopped in the middle of a block in which all the buildings on both sides of the street had been demolished and the bricks heaped into mounds, some as high as eight feet. After covering two decimated blocks on foot, Carter, who later described the visit as "very sobering," turned to Secretary Harris and asked whether what they were seeing had happened in the past five years, "after Nixon cut off the urban renewal funds?" The answer was yes, whereupon President Carter asked for a report on "which areas can still be salvaged. Maybe we can create a recreation area and turn it around. Get a map of the whole area and show me what could be done."[11]

The editors of the *New York Times* deemed the president's visit to the South Bronx "as crucial to an understanding of American urban life as a visit to Auschwitz is crucial to an understanding of Nazism." But the editors felt that his priorities were somewhat off the mark: "The vistas of destruction and despair that stretched before the President prompted him to wish them out of existence. . . . Alas, like many predecessors, the President responded to the symptom, not the cause; a reconstruction of housing that provides only the short-term work of rehabilitation leaves untouched the basic cause of the present distress of the Bronx. . . . The people of the Bronx . . . need places to work; playgrounds are no substitute for them."[12]

By the time of Carter's visit, some small first steps had been taken to rebuild the South Bronx, including rehabilitation efforts along Fox Street between Longwood Avenue and Avenue St. John in the Longwood section, an area notorious as the center of violent gang activity.[13] With the help of special federal subsidies announced in the waning days of the Ford administration and largely because of the efforts of a local entrepreneur and builder, Tom Cuevas, by 1977 fifteen buildings, with a total of 380 apartments, were renovated. But city officials and community activists realized that the key to any significant improvement would require a more comprehensive effort in order to create a coherent neighborhood that would be able to sustain itself over time.

In December 1977, in the final days of Mayor Beame's administration, a five-year, $870 million plan was released that targeted specific areas using what was for postwar New York an innovative approach, promising new town-like enclaves in the most devastated areas around Charlotte Street and the Bathgate section, industrial parks, 10,000 new jobs, a greenbelt, gardens and farms, and 22,000 new housing units.[14] The plan, which extended the boundaries of the South Bronx to include the area west to the Harlem River and north past the Cross-Bronx Expressway to Fordham Road, relied on between $658 million and $738 million in federal assistance. When shown the plan, Bruce Kirschenbaum, an assistant to President Carter, was cautiously optimistic about its chances in Washington. Mayor-elect Ed Koch admitted to being merely cautious. The plan was governed by three principles: economic development, the need for new, low-density housing, and the importance of rehabilitating the areas that had survived. Pushing the plan forward, the Koch administration set up a task force to coordinate the efforts of the City Planning Commission, the Office of Economic Development, and the Housing Preservation and Development Administration. Mayor Koch's caution was well founded not only because Washington was not yet prepared to release funds into the area

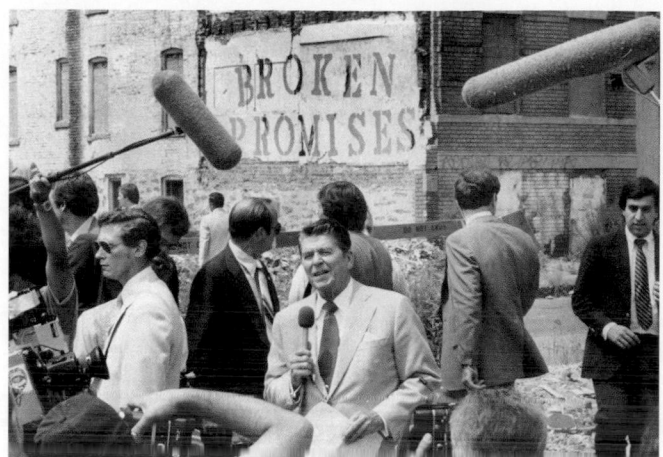

Presidential candidate Ronald Reagan visiting Charlotte Street, August 5, 1980. In background is the mural *Broken Promises* (John Fekner, 1980). Smith/NYDN. NYDN

but also because it was becoming clear that neither rehabilitation nor new construction was enough. Building activity needed to be accompanied by social programs, largely in the form of job training. For example, the Mott Haven Housing Development Fund's ten-year-old renovation of twenty apartment buildings on East 139th and East 140th Streets between St. Ann's and Cypress Avenues had become, according to *New York Times* reporter Joseph P. Fried, "a nightmare of dashed hopes and redevastated buildings, of apartment houses once more abandoned or again housing people amid dilapidation."[15] Half of the buildings were entirely empty and ravaged and the others only partly filled: tenants blamed poor workmanship, exploitive management, and poor government supervision, and the community-based development fund said rents were in arrears and accused tenants and other neighborhood people of vandalism and destructive thievery.

In order to help get the redevelopment of the South Bronx on track, in 1978, acting on the advice of Herman Badillo, now deputy mayor, Mayor Koch selected veteran planner Edward J. Logue to head the South Bronx Development Organization. Logue, the most effective city rebuilder in recent history, was often compared to Robert Moses. Logue had directed the redevelopment authorities of New Haven and Boston before serving as head of the New York State Urban Development Corporation from 1968 to 1975.[16] His record in that job was uneven, at best, but the failure to implement his plans was attributed not to his lack of vision but to the near-collapse of the agency in the fiscal crisis of 1975.[17] Logue approached this new job with seemingly boundless optimism, pronouncing that by 1985 the Grand Concourse would "be blooming. It is a broad, Parisian-style boulevard with the best housing stock in the area. We have a billion-and-a-half-dollar asset, and 30,000 units, in those buildings and we can't afford to lose that." Logue went on to note that most people, especially residents of Manhattan, had been unduly influenced by all the bad publicity and had the "wrong idea about the South Bronx. They think it's all wasteland up there. That's wrong. There are a lot of assets, both physical and human, to build on." Still, Logue was realistic: "We can't just do physical development up there. . . . We'll need to do economic and social development as well. But we do have to do housing and physical development because of all the physical decay."[18]

The first part of the redevelopment plan called for 732 apartments in two- and three-story buildings to be located on Charlotte Street. By this time, to most Americans, the words Charlotte Street had become synonymous with urban blight, but many old-time Bronx residents remembered it as a once-fine neighborhood. The area had marked a significant stepping stone in the rise of working-class families into the middle class when Charlotte Street and its companion blocks, Wilkins Avenue and East 172nd Street, had been home to fifty-one apartment buildings accommodating more than 3,000 people. By 1977 only nine of those buildings were left standing—six of them abandoned, their entrances and windows boarded up, and two others completely burned out. The one remaining inhabited building, at Boston Road between Charlotte Street and Wilkins Avenue, contained thirty-seven apartments serving approximately 100 people.

In February 1979, the Board of Estimate voted 7 to 4 against the first stage of the redevelopment plan, with those opposed making the argument that it disproportionately favored the Bronx at the expense of the other boroughs. As Brooklyn Borough President and board member Howard Golden bluntly put it: "If President Carter's chauffeur had taken a right turn instead of a left turn, we'd have all the money going to Bushwick now."[19] The vote stunned White House officials who had been working on securing federal funds for the South Bronx, and Mayor Koch angrily declared that the negative vote on the low-rise housing plan threatened to scuttle the entire plan to renew the neighborhood. Koch sent Logue back to the drawing board, and in August he came up with a much-reduced, $375 million rehabilitation plan that emphasized renovating existing housing stock and job creation. The slimmed down plan also called for a new industrial park in the Bathgate area but noted that Charlotte Street might better serve as a place for "greening and clean-

ing" rather than development.[20] Although Herman Badillo labeled the new plan "the most cowardly kind of retreat a Mayor could indulge in" and resigned as deputy mayor,[21] the *New York Times* supported the scheme: "It is less sweeping than the plan that started with Charlotte Street. It also appears much sounder. . . . Mr. Logue . . . urges plans that would consolidate rather than expand the borough's population and economic activity; it would be futile to rebuild for a population as large as that of the 1940's."[22]

But even the reduced South Bronx plan faced substantial obstacles in Washington. Once again the area became enmeshed in national politics as presidential candidates in the 1980 election visited Charlotte Street, with Ted Kennedy, who was challenging President Carter for the Democratic nomination, visiting in March, and Republican Ronald Reagan in August. Reagan, shading the truth, blasted Carter for reneging on his promises to revive the area, while declaring that the key to rebuilding the blighted neighborhood was not large federal subsidies but tax incentives and the participation of private industry. With Reagan's victory, the renewal plan's chances seemed even less likely. In 1981 the South Bronx's notorious reputation was dealt an additional blow with the release of Daniel Petrie's *Fort Apache, the Bronx*, a movie that portrayed the area as an excessively violent and out-of-control urban battleground.[23]

Although Logue's initial plan for the South Bronx had shied away from development on Charlotte Street, it was in fact on that street that dramatic renewal first took place in the spirit of his plan, with the construction of Charlotte Gardens (1982–87) along Charlotte Street and Wilkins Avenue, radiating out toward Crotona Park, Minford Place, and East 170th Street.[24] Consisting of eighty-nine prefabricated one-and-a-half-story ranch houses with three bedrooms, one-and-a-half baths, white picket fences, and aluminum siding, the development

View east along Charlotte Street from Boston Road, 1981. Vergara. CV

Charlotte Gardens, along Charlotte Street and Wilkins Avenue.
Prefabricated houses built by the South Bronx Development Organization,
1982–87. View east along Charlotte Street, 1989. Vergara. CV

represented an improbable transformation of a fifteen-acre inner-city site, sparking enormous publicity and strong critical reaction.

These moderately priced houses were built by the South Bronx Development Organization with the aid of grants and loans from the Local Initiatives Support Corporation, an organization set up by the Ford Foundation to encourage redevelopment in America's inner cities, as well as a small amount of federal funds secured by Senator Alfonse D'Amato. Mortgages were state subsidized to attract local buyers. Logue carefully chose the suburban model, explaining, "The suburban look is helpful. Where did you think people went when they got enough money to leave the South Bronx? To the suburbs." (Logue seemed oblivious to the fact that very many went to Co-op City [Herman Jessor, 1965–70], the immense complex of towers and slabs built in the Northeast Bronx on the site of the failed Freedomland theme-park development.) Speaking to reporters after the completion of the first two ranch houses in 1983, Logue recalled that a landscape architect on the staff of the development organization had warned about the white picket fences, fearing they would be attractive targets for graffiti artists. Logue dismissed the concern, asking, "What is the American dream? A home of your own with a white picket fence. I want white."[25] Logue's decision was also informed by the widespread belief that it was the construction of so many large-scale public housing projects in the

1950s and 1960s that had helped sow the seeds of the South Bronx's present blight.[26]

From the outset, Charlotte Gardens's single-family, 2,100-square-foot houses, sitting on 68-by-100-foot lots, were popular with the public, with more than 2,500 people visiting the two model homes within a month of their opening and 507 completed applications received for the eighty-nine available houses. Many observers considered the factory-built houses a gimmick, but Eric Marcus, writing in Metropolis, defended the "controversial Levittown-style housing development" as a welcome, tangible upgrade for the neighborhood, although he admitted that Charlotte Gardens could also be seen as a "publicity stunt, well-intentioned, but a publicity stunt nonetheless. The presence of middle-class homes bought by middle-class families in the most infamous urban disaster area said something to the outside world. The startling contrast of white picket fences and burned-out buildings guaranteed that message would be carried in newspapers and on the evening news all across the country. And it was."[27] Architectural historian Gwendolyn Wright, in a 1986 interview conducted by Robert A. M. Stern at Charlotte Gardens as part of the public television series Pride of Place: Building the American Dream, observed that "what is very striking is the belief that this housing is going to take care of these [inner city] problems—that the image of suburbia is the solution to the problems of American family life, to problems of the

American economy." Although Wright believed that Charlotte Gardens "will in fact help the South Bronx" and have a "very positive social effect," she expressed disappointment that "architecturally . . . it wasn't a more beautiful and more compelling and a more positive image."[28]

In addition to the image of rubble-strewn Charlotte Street, the South Bronx produced another symbol of inner-city blight. On November 7, 1983, the *New York Times* reported in a front-page story that the city's Department of Housing Preservation and Development had plans to place decorative vinyl decals depicting curtains, shades, shutters, and flowerpots over the boarded-up windows of abandoned, city-owned buildings along the Cross-Bronx Expressway between the Harlem River and the Bronx River Parkway.[29] As Anthony B. Gliedman, commissioner of the department, explained: "We want to brighten up the face of the neighborhood while waiting for new Federal programs to rebuild the neighborhood. I recognize that this is superficial. We don't want anybody to think we're doing this instead of rebuilding. But that will take years and require tens of millions or hundreds of millions of dollars. And while we're waiting, we want people to know that we still care." Gliedman defended the plan by stating, "Morale is very real. Perception is reality."[30] With little fanfare three years earlier, in October 1980, the city had placed colorful decals just like these in two derelict buildings in the Greenpoint section of Brooklyn and in the interim had put up others around the five boroughs, mostly at the request of local community boards, but the plan for the South Bronx was unprecedented in its scope. The funding for the decals, which cost about six dollars each, came from the federal government in the form of a $300,000 community development block grant administered by HUD and specifically earmarked for rehabilitation work. Gliedman pointed out that if the money were used for the actual renovation of apartments only about a half dozen buildings could be rehabilitated. He also made it clear, although few would take notice of the fact, that only a third of the grant dollars would be spent on the decals, with the remaining funds used for demolition expenses, masonry repairs, and other minor improvements.

Neighborhood residents were among the first to react to Gliedman's plan, with most expressing disbelief that this was the best the city could do. *New York Times* reporter William Geist interviewed residents of the Crotona Park section and found a pervasive cynicism, with some suggesting that "while the city was at it, why not expand the program to provide designer clothing decals to place over the tattered apparel of impoverished residents, large Mercedes-Benz decals to strap to their [cars] and decals of strip sirloins for them to eat."[31] Wilmer Cintron spoke for many when he declared the program "dumb. They should fix up the buildings, and have people living here, not decals." Still, a few locals expressed tentative support, with Jose Ceballos stating, "I grew up here and saw it go down. Now we're moving up. Anything to make us look better, I appreciate. I think it lets people know the city at least hasn't forgotten us."[32]

The editors of the *New York Times* roundly condemned the decal proposal. Although they supported the "sparing use of colorful decals on boarded up windows to give a lived-in look to a few deserted buildings," they felt that "this practice becomes ugly and destructive when officialdom sets out to pretend that a large deceased section of the city still hums with life."[33] Mayor Koch quickly responded to the *Times's*

attack, noting that he had first suggested the idea of the decals four years earlier as a way of putting these unsightly buildings "in cold storage. During that time we want to bind them, as we would a wound, with a dressing until we have the dollars to repair them or demolish them." Koch reiterated that only one-third of the federal grant would be used for decals, before ending his letter on a sarcastic note, writing that he had hoped the editors would "understand what we are trying to do, but then I thought to myself we made an error. We chose to call the dressing for these wounds 'decals.' Perhaps if we had called them 'trompes l'oeil,' The Times would have put us on the art page and applauded. How easy it is to ridicule. How hard it is to get anything done."[34]

It was not long before the story spread to the national press. In December 1983, the program received the unlikely, albeit reluctant, support of conservative syndicated columnist George Will who, citing the theories of political scientist James Q. Wilson, wrote that "if a window in a building is broken and left unrepaired, all the rest of the windows will soon be broken. This is because one unrepaired window is a signal that no one cares, so breaking windows, which is always fun, is cost-free." Will concluded that "in the lunar landscape of the South Bronx, decals, as a sign that indifference is not complete, are better, if just barely, than nothing."[35] Former Parks Commissioner August Heckscher, writing in the *Christian Science Monitor*, strongly disagreed, believing that the "odd experiment" set a dangerous precedent.[36] Although most city officials continued to gamely defend the decal program, in an August 1984 interview Edward Logue criticized the measure as one "that offends. It's pure Potemkin village, just for the benefit of the people passing on the highway."[37]

As the South Bronx's fortunes began to improve in the late 1980s, the decal saga had a somewhat happy ending when the nonprofit Phipps Houses commissioned Meltzer/Mandl Architects and Castro-Blanco, Piscioneri & Associates to renovate twenty abandoned five- and six-story buildings that formerly sported the decorative decals.[38] The development, Crotona Park West (1994), on a site bounded by the Cross-Bronx Expressway and Claremont Parkway, Fulton and Third Avenues, provided 563 new apartments for 2,200 low- and moderate-income tenants.

The superficial improvements of the decal program notwithstanding, early signs of a genuine renewal were seen not only in Charlotte Street's suburbia but also in the construction of several new projects in the early 1980s, including buildings for industrial and cultural uses as well as the creation of sophisticated new recreational spaces. In December 1979, the Bathgate Industrial Park, an industrial complex on an eight-block twenty-one-acre site bordered by Washington Avenue, the Cross-Bronx Expressway, Third Avenue, and Claremont Parkway, got under way.[39] Bathgate Avenue, running north–south, bisected the site, 65 percent of which was vacant and 81 percent of which was city owned. The complex was intended to contain simple buildings that could be parceled out to small manufacturers, providing a total of 575,000 square feet of industrial space and generating 1,100 jobs.

The first building, Bathgate I, built by the New York City Public Development Corporation in partnership with the South Bronx Development Organization, was a one-story 58,000-square-foot solid-masonry factory occupying two acres at the northwest corner of the industrial park. Completed in 1982, it constituted, according to Mayor Koch,

View to the west of Fulton Avenue showing decorative decals (1986), above, and after renovation as Crotona Park West (Meltzer/Mandl Architects and Castro-Blanco Piscioneri & Associates, 1994), below. Vergara. CV

"the first speculative industrial construction financed by the city."[40] As it neared completion in December 1981, city officials were relieved when two companies, a maker of airplane parts and a manufacturer of garment padding, signed twenty-year leases for the space. A further vote of confidence in the project came in 1981 when the Port Authority of New York and New Jersey announced its intention to develop three of the park's eight blocks. The Port Authority's Technical Center, designed by its in-house staff and completed in 1987, was a two-story factory that the editors of the *AIA Guide* deemed the "handsomest" of Bathgate's buildings, built with "striped block and an arch" that "make a humble but effective effort."[41] By 1994 occupancy at the park was poised to reach 100 percent with the construction of the tenth building, a two-story, 140,000-square-foot plant for Clay Park Labs, a generic drug manufacturer that already operated out of two buildings at Bathgate. By this time, the project was successful beyond initial expectations, employing 1,300 workers, approximately 70 percent of whom were residents of the Bronx and Upper Manhattan.

Landscape architect Lee Weintraub and architect John di Domenico were responsible for three much-needed and enthusiastically received park projects as part of the city's Bureau of Open Space Design, a six-member team within the Department of Housing Preservation and Development. The three projects were funded with the aid of HUD and sponsored by the Southeast Bronx Community Organization, which was headed by Father Louis R. Gigante, a prominent local cleric who represented the area in the City Council. The first to go forward was Tiffany Plaza (1981), a multiuse public space on the southeast corner of Tiffany and Fox Streets, across the street from Gigante's church, St. Athanasius, in the Longwood section.[42] Weintraub and di Domenico's vaguely Pop, vaguely Surrealist design, which also owed a debt to the work of the Mexican architect-urbanist Luis Barragán, included a free-standing white-and-pink stucco and glass-block wall, large lion's-head fountains made of stone, thirty honey locust trees, and patterned paving blocks. Robert Jensen, writing in *Progressive Architecture*, believed that the design created "a vision of summer sun and resort-town luxury in defiance of [the] South Bronx's image."[43] Charles Gandee, in *Architectural Record*, was also impressed by the "more-than-slightly-surreal oasis," adding that one would have to visit the devastated neighborhood to "appreciate the exhilaration one feels at first sight of [the park]. . . . It's an open window in a smoke-filled room. It's hope."[44]

In 1982 Weintraub and di Domenico completed a renovation of Charlton Park, located on East 164th Street between Boston Road and Cauldwell Avenue in Morrisania.[45] The gated park, sponsored by the neighboring Grace Gospel Family Church, featured an elaborately carved pergola composed of scalloped timber joists and beams resting on concrete columns decorated with caryatids "reminiscent," according to South Bronx native Weintraub, "of the south porch of the Erechtheum" from fifth-century B.C. Athens.[46] The last of Weintraub and di Domenico's South Bronx collaborations was Longfellow Garden (1983), Longfellow Avenue between East 165th Street and Lowell Place.[47] Also sponsored by Father Gigante's community organization, this Hunts Point park was sheltered from its surrounding neighborhood of five- and six-story apartment buildings by an interior border of linden trees that also provided shade for azaleas and rhododendrons.

Tiffany Plaza, southeast corner of Tiffany and Fox Streets. Weintraub & di Domenico, 1981. View to the southeast. LWLA

Charlton Park, East 164th Street, between Boston Road and Cauldwell Avenue. Weintraub & di Domenico, 1982. View to the northwest. LWLA

Surrounded by a wrought-iron fence, Longfellow Garden was further shaped by three brick terraces linked by stairs and a central pergola. Spray jets were added for the benefit of children, while adults could take advantage of nine planting beds set aside for local gardeners.

In 1983, the twelve-year-old Bronx Museum of the Arts, previously forced to make do with cramped, makeshift space in the Bronx County Building (Freedlander & Hausle, 1934), 851 Grand Concourse, southwest corner of East 161st Street, moved into its own building, taking over Simon Zelnik's deconsecrated Young Israel Synagogue (1961), 1040 Grand Concourse, northeast corner of East 165th Street, which had been sold to the city the previous year by its dwindling congregation.[48] The museum, founded with the help of the Metropolitan Museum of Art in an effort to bring contemporary art to the Bronx, not surprisingly placed a strong emphasis on local artists. Castro-Blanco, Piscioneri & Feder was hired to convert the synagogue's former sanctuary into a large exhibition space and create an additional five galleries out of former classroom and office space. The highlight of the

Bronx Museum of the Arts, 1040 Grand Concourse, northeast corner of East 165th Street. Castro-Blanco, Piscioneri & Feder, 1988. View to the northeast. Vergara. CV

renovation, which was completed in 1988, was a three-story glass atrium that served as the museum's lobby. Hugo Lindgren was pleased with the transformation, writing in *Metropolis* that the "Modernist synagogue . . . works quite nicely as an art museum, with high ceilings and wood floors that make for excellent galleries."[49]

After Charlotte Gardens: A New Housing Model

Although it generated enormous attention and publicity for the neighborhood, the Charlotte Gardens experiment initiated by Logue, who left the South Bronx Development Organization in 1985, did not serve as the model for future development. But neither was there a return to the failed policy of large-scale public housing as represented by Morrisania Air Rights Houses. Instead, a compromise between the two approaches was achieved, with new residential construction in the South Bronx typified by relatively low-density rowhouse-scaled enclaves and modestly sized apartment buildings. This new construction more often than not required the active participation of a sponsoring, nonprofit organization, but progress could not have been made without the strong commitment of the Koch administration, which in April 1986 announced its decision to invest more than $4 billion over the next ten years to improve housing throughout the five boroughs, although the vast majority of the funding was earmarked for the rehabilitation of existing housing stock.

A few blocks south of Charlotte Gardens, on an Intervale Avenue site between Freeman and Home Streets, a row of 125 single-family homes called Salters Square, completed in two stages between 1988 and 1989, was seen by Alan S. Oser as a more realistic "successor" to Charlotte Gardens, where the "extreme low density of . . . development made it unlikely that the concept would be replicated on additional city sites nearby."[50] Sponsored by the New York City Housing Partnership—which worked with the Mid-Bronx Desperados Community Housing Corporation, a group that had helped with the marketing of Charlotte Gardens—the moderately priced, three bedroom, one-and-a-half bath houses were built on-site by a local developer, the Procida Realty and Construction Corporation, and designed by Wechsler, Grasso & Menziuso. The first project built under a new state-sponsored program dedicated to affordable home ownership, Salters Square consisted of two-story, boxlike pale gray concrete and synthetic stucco houses, with prominent brightly colored metal awnings, set back behind a fenced-in front yard with room for a parking pad. Despite the fundamental anti-urbanism of a streetscape defined by cars parked in a front yard behind pen-like fencing, the development met with success on many levels. Genevieve S. Brooks, executive director of the Mid-Bronx Desperados, was pleased with the design of the 1,150-square-foot, 18-by-32-foot houses, noting that "we like this new house—it's a tight house, it's efficient."[51] Salters Square also proved popular with its intended audience of low- and moderate-income home buyers, selling out after only three weeks on the market. In 1990 the same developer and group of sponsors built Thurston Plaza, a development of fifty two-family, three-story rowhouses grouped around a courtyard on a site bounded by Intervale Avenue, East 169th Street, Rev. James A. Polite Avenue, and Chisholm Street.[52] Castro-Blanco, Piscioneri & Associates's design was somewhat better detailed but also featured prominent brightly colored awnings and set the houses back behind a fenced-in front yard and parking space.

Other rowhouse-scaled development included Magnusson Architects's Melrose North (1991), southeast corner of Melrose Avenue and East 155th Street, twenty-six three-story, two-family houses located on a previously vacant site.[53] In order to hold down costs for the fifty-two units, which were subsidized by the New York City Housing Partnership, the 2,350-square-foot buildings were constructed using a steel and aluminum modular frame made by DeLuxe Homes, Inc., a Pennsylvania-based home builder, and featured synthetic stucco facades, aluminum-framed windows, and single-ply membrane roofs. DeLuxe Homes also provided the prefabricated wood-framed modules for Rivercourt Homes (1991), a development of thirty-three three-story, two-family homes on a site between East 178th and East 179th Streets and Vyse and Daly Avenues.[54] The project was sponsored by the Catholic Charities of the Archdiocese of New York.

ABOVE Thurston Plaza, site bounded by Intervale and Rev. James A. Polite Avenues and East 169th and Chisholm Streets. Castro-Blanco, Piscioneri & Associates, 1990. Courtyard. Vergara. CV

LEFT Thurston Plaza, site bounded by Intervale Avenue and Rev. James A. Polite Avenue and East 169th and Chisholm Streets. Castro-Blanco, Piscioneri & Associates, 1990. Moran. MM

BELOW Melrose North, southeast corner of Melrose Avenue and East 155th Street. Magnusson Architects, 1991. View to the south. Brizzi. MAP

Crotona Terrace, 1714 Crotona Park East, between East 173rd and East 174th Streets. Liebman Melting Partnership, 1994. View to the southwest. Moran. MM

Casella Plaza, 961 East 180th Street, northeast corner of Vyse Avenue. Michael Avramides, 1999. View to the northeast. Shanks. MV

Architect Stephen B. Jacobs, an adviser to the project's community sponsor, Phipps Houses, was able to provide a measure of visual interest by staggering the twenty-two-by-forty-foot aluminum-sided houses and including bold, colorful decorative details above the entrances and third-story windows. Jacobs was also responsible for the neighboring Archdiocese Houses (1998), a plainer development of fifty-two two-story, two-family houses most notable for the fact that photographer Camilo José Vergara, who specialized in capturing inner-city decay, had documented the site since 1980, chronicling the progression from occupied apartment house to abandonment and demolition and, finally, construction of the new project.[55]

The neighborhood's new apartment houses were more interesting architecturally. The Liebman Melting Partnership designed two modest-size low-income apartment buildings in the early 1990s for the Mid-Bronx Desperados, beginning with the six-story, seventy-six-unit, red brick Eae J. Mitchell Terrace (1991), 945 East 174th Street, between Hoe and Vyse Avenues, in the Crotona Park section.[56] Three years later Liebman Melting's design of orange and purple brick for the eight-story, fifty-two-unit Crotona Terrace, 1714 Crotona Park East, between East 173rd and East 174th Streets, animated by decorative brick bands and precast concrete lintels, was praised by the editors of the *AIA Guide* as "polychromatic neo-Art Deco. A handsome reminiscence that fits in well with its venerable Art Deco neighbors."[57] Another apartment building that more literally took its stylistic cues from the area's interwar architecture was Michael Avramides's seven-story Casella Plaza (1999), 961 East 180th Street, northeast corner of Vyse Avenue, a ninety-eight-unit facility for low- and moderate-income senior citizens sponsored by the Aquinas Housing Corporation.[58] The L-shaped iron-spot red brick building had a corner entrance set back from a plaza and featured a base and decorative details fashioned from buff-colored precast concrete, a nod to the stonework and terra-cotta ornament of nearby buildings.

Meltzer/Mandl Architects's Melrose Court (1994) was a 265-unit development of seventy-three three- and four-story buildings on a 4.5-acre site bounded by St. Ann's and Brook Avenues and East 156th and East 159th Streets.[59] The subsi-

dized two- and three-bedroom condominium apartments, which ranged in size from 1,050 to 1,200 square feet, were sponsored by the New York City Housing Partnership and built by the Procida Realty and Construction Corporation. Marvin H. Meltzer made the surprising claim that his design did not look like a composition of individual townhouses but like "a megastructure."[60] Though a low-rise project, it was developed at a relatively high density of sixty units per acre, with each group of buildings organized around a gated, landscaped courtyard that contained, according to Bradford McKee, "strikingly articulated staircases rising to individual residences." Although McKee was pleased with the "inner spaces [which] offer intimacy," he felt that the "outer face of the complex addresses the South Bronx streets as terra incognita."[61] Meltzer explained that at the request of the New York City Housing Partnership, the design was "purposefully contradictory in its street and courtyard treatments. The courtyards and their facades are rich and textural, with entrances that recall New York City stoops. Colorful masonry, canopies and a variety of light fixtures all face a landscaped green space with an attractive pattern of walkways and furniture. The street facade, in contrast, takes a minimal approach, using a simple change in the color of the aluminum siding and masonry at the first floor to create interest."[62]

Throughout the 1990s Meltzer/Mandl was active in the South Bronx, completing several apartment buildings, including Gerard Court (2000), another courtyard complex on a long-vacant sloping site four blocks north of Yankee Stadium between Gerard and River Avenues and East 164th and East 165th Streets.[63] The low-income rental project comprised three brick buildings: a seven-story, 126-unit building and two three-story rows. Meltzer/Mandl's six-story 950 Jennings Street (2000), between Vyse and Hoe Avenues, and nine-story Crotona Avenue Apartments (2000), 2130 Crotona Avenue, between East 181st and East 182nd Streets, were both clad with brick and synthetic stucco patterned in a wide array of colors.[64] Even more boldly patterned was the firm's seven-story Intervale Houses (2000), 1118 Intervale Avenue, northeast corner of 167th Street, another brick and synthetic stucco design finished in shades of blue, yellow, orange, and red. Meltzer noted that the bright colors were chosen in order to

give "affordable housing a distinctive look that tenants can take pride in. We want the colors to be attractive, not too gaudy, that we can fit into a fairly tight budget."[65]

Melrose Commons

In January 1989, in the same State of the City address that called for a new Police Academy (see below) to be built in the South Bronx, Mayor Koch proposed Melrose Commons, an ambitious twelve-year urban-renewal project.[66] The intent was to transform the blighted forty-acre thirty-block area roughly bounded by Park and St. Ann's Avenues and East 156th and East 163rd Streets—once an important center for the Bronx but now a wasteland of dilapidated and burned-out buildings as well as a plethora of city-owned vacant lots. The principal component of the plan was to be 3,000 new apartments in two-, three-, and six-story buildings to be built by private and nonprofit developers working with the city's Department of Housing Preservation and Development. In addition to the new apartments—primarily condominiums geared for moderate- and middle-income buyers—the plan called for the renovation of 750 units in existing apartment houses, 250,000 square feet of new commercial space, and six new parks, including a central one of four acres. Mayor Koch enthused, "Melrose Commons will be the largest new housing development in the Bronx in over two decades and is a welcome addition to the ambitious rebuilding of the borough's housing stock already under way." With some exaggeration as well as

a healthy dose of optimism, he declared the plan "another sign that the Bronx isn't just back. It's arrived."[67]

Progress on Melrose Commons soon stalled, even though it received the support of the new mayor, David Dinkins. In November 1990, Bronx Borough President Fernando Ferrer's office included both the Police Academy and Melrose Commons in their far larger Bronx Center Plan, which encompassed an approximately 300-square-block area surrounding the East 161st Street corridor. This plan called for new educational facilities, a large retail complex for the Hub, the neighborhood's traditional retail center around East 149th Street and Third Avenue, and new and upgraded law courts near Yankee Stadium. As reporter Tim Golden explained in the *New York Times*, many felt that of all the proposals in the Bronx Center Plan, Melrose Commons was the most challenging: "To build an entire neighborhood where there are now mostly vacant lots and abandoned buildings would cost more than $400 million over 12 years. City housing subsidies alone are estimated at $100 million, and some officials are skeptical about developers' chances of drawing better-off home buyers into an area ringed by housing projects."[68]

Melrose Commons was further stymied by the city's economic downturn and by well-organized protests from local groups who argued that it was unfair to spend severely limited public funds on a project that did not serve the current residents of the area, who were among the poorest in the city, with a median income below $10,000 a year. Although the proj-

Melrose Court, site bounded by St. Ann's and Brook Avenues and East 156th and East 159th Streets. Meltzer/Mandl Architects, 1994. View to the north. Vergara. CV

Intervale Houses, 1118 Intervale Avenue, northeast corner of East 167th Street. Meltzer/Mandl Architects, 2000. View to the northeast. MMA

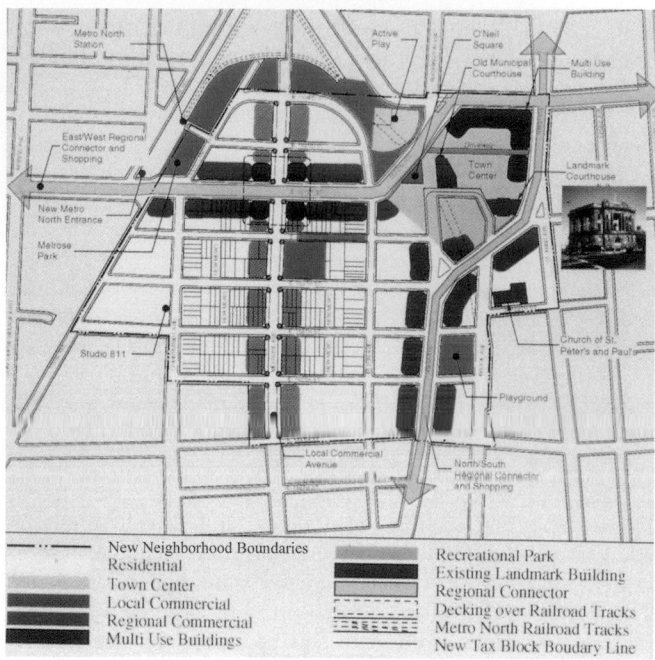

Proposed Melrose Commons, site bounded by Park and St. Ann's Avenues and East 156th and East 163rd Streets. Magnusson Architects and Weintraub & di Domenico, 1994. Plan. MAP

ect was still in the planning stages, preliminary drawings released by the Bronx borough president's office showed low-rise apartment blocks surrounding private courtyards, a design move that infuriated Blanca Ramirez, executive director of South Bronx People for Change: "The buildings are going to be enclosed—that protects them from 'those people' in the rest of the neighborhood. But they're not only locking themselves in, they're also locking everyone else out. What kind of message is being sent to the rest of the neighborhood?"[69]

City officials defended the plan, noting that there would be only minimal displacement of the 950 households on the site, with more than two-thirds of these families offered housing in buildings slated for renovation. The city also pledged to help relocate the eighty local businesses with nearly 500 employees. Bernd Zimmermann, planning director in the borough president's office, believed that the success of Melrose Commons was crucial to the larger renewal of the South Bronx: "We have a community of poverty. This could bring a better income group, a better socio-economic balance It's going to be the keystone for redevelopment."[70]

In 1993, with Melrose Commons still in limbo, the city withdrew its 3,000-unit proposal, enlisting the support of a community-based group, Nos Quedamos (We Stay), which had previously opposed the project, to work with the Department of City Planning, the Department of Housing Preservation and Development, and the Bronx borough president's office to redesign Melrose Commons.[71] The newly formed community group had the help of two architects who donated their time, Petr Stand of Magnusson Architects and Lee Weintraub of Weintraub & di Domenico. Although Nos Quedamos was opposed to any displacement of existing residents or businesses, over the course of nearly a year of negotiations a compromise on this issue was reached. The new Melrose Commons plan, approved by the City Council in June 1994, called for a dramatic reduction in the number of

new units, nearly halving the number to 1,700 apartments to be located primarily in attached rows of two- and three-story buildings although six- to eight-story apartment buildings, some with retail bases, would be included as well. There was also a change in income mix—some lower-income units would be made available—though the majority still remained in the moderate to middle-class range. In addition to the new housing, plans remained as before for renovated apartments and improved retail facilities. A one-acre park was substituted for the central four-acre park proposed earlier, which local residents criticized as too big to be adequately maintained and which they feared would become a potential magnet for drug dealers and vagrants. The new, reduced Melrose Commons plan resulted in significantly less displacement of both residents and businesses, with 60 percent of the existing buildings on the site to be retained and renovated. Although Melrose Commons received the enthusiastic support of the community, city officials, and even the federal government, there was still concern over whether developers could be found and funds secured to move forward, with some estimates pegging the redevelopment costs at $15 million a block.[72] Nonetheless, cautious optimism remained the mood of the day. As Kent Barwick, president of the Municipal Art Society and a strong supporter of the new plan, put it, "Do I think it will be built tomorrow? No. But do I think it will be built? Yes. And when it is built do I think it will last? Yes."[73]

In December 1998, after more than four years of delays, tangible progress was made on Melrose Commons: groundbreaking occurred for its first component, the Plaza de los Angeles—named for its proximity to two churches—thirty-five three-family homes on five vacant sites on the east and west sides of Elton Avenue between East 156th and East 159th Streets.[74] This phase was developed as part of the New York City Housing Partnership's moderate-income New Homes

La Puerta de Vitalidad, west side of Third Avenue, between East 158th and East 159th Streets. Larsen Shein Ginsberg + Magnusson, 2002. View to the northwest. Brizzi. MAP

Program and built by the Procida Realty and Construction Company. The houses of concrete block, red and beige brick, and sand-colored cast stone, completed in September 2000, were designed by Magnus Magnusson of Larsen Shein Ginsberg + Magnusson in consultation with Nos Quedamos. The new rowhouses contained an owner's 1,355-square-foot, two-bedroom duplex and two rental units, one an 875-square-foot, two-bedroom apartment and the other a 455-square-foot one-bedroom apartment. In a welcome move, parking spaces were placed at the rear of the houses. The editors of the *AIA Guide* were pleased with the results, writing that the Plaza de los Angeles addressed "the urban problem more elegantly than the sprawl of Charlotte Gardens or the banality of endless new blocks of two-story vinylized units with their wrought-iron-gated parking bays."[75]

Larsen Shein Ginsberg + Magnusson was also responsible for the next completed project at Melrose Commons, the mixed-use, seven-story La Puerta de Vitalidad ("the door to vitality"), just west of the Plaza de los Angeles on Third Avenue between East 158th and East 159th Streets.[76] Sponsored by Phipps Houses and designed by Magnusson in consultation with Nos Quedamos, the sixty-one-unit, multi-hued brick building (2002) for low-income residents reserved 51 percent of its one- to three-bedroom apartments for formerly homeless families and included a retail store and a community health-care facility on the ground floor. In August 2002, the third housing project was completed at Melrose Commons: thirty three-story, three-family houses forming a gated interior courtyard on a formerly vacant site bounded by Melrose and Elton Avenues and East 158th and East 159th Streets.[77] Called Sunflower Way, the project was developed through the New York City Housing Partnership's New Homes Program and designed by Danois Architects as precast-concrete and red brick buildings featuring prominent front stoops and cornices.

Rebuilding the Community

In addition to success on the housing front, the renewal of the South Bronx was broad based, with a new wave of public projects proposed beginning in the late 1980s reflecting a new perception of the neighborhood as a viable setting for architecturally distinguished buildings serving vital institutions. The impact of these on the community was positive; and the quality of the architecture was as high and in some cases higher than anything New York had undertaken in the civic realm since the 1930s. Because they were in the South Bronx, however, these projects were little known by the general public and largely ignored by the profession as a whole.

Several new community facilities were built to meet the needs of the area's troubled and disadvantaged residents as well as the long-underserved, overwhelmingly low-income population at large. In 1992, on a site just west of Claremont Park bounded by Morris and College Avenues and East 171st and East 172nd Streets, the Housing Enterprise for the Less Privileged (HELP), a nonprofit group assisting the homeless, opened a new on-site facility providing a full spectrum of social services, including drug and alcohol rehabilitation programs, child care, medical care, job training and placement services, in addition to 212 units of transitional housing for the homeless.[78] HELP was founded six years earlier by Andrew Cuomo, the son of Mario Cuomo, who at the time was the state's governor. The group had opened other facilities in Brooklyn as well as outside the city in New York's Westchester and Suffolk counties, but this was its most extensive effort to date. Designed by Castro-Blanco, Piscioneri & Associates, the beige brick HELP Bronx Morris consisted of a two-story community center and a four-story apartment wing that enclosed a landscaped courtyard which also served as a

Police Athletic League, South Bronx Community Center, 991 Longwood Avenue, between Fox and Beck Streets. Kevin Hom + Andrew Goldman Architects, 1996. View to the northeast. Mauss. ESTO

BELOW Hunts Point Youth Center, 765 Manida Street, between Spofford and Lafayette Avenues. Hanrahan + Meyers Architects, 2001. Aaron. ESTO

ABOVE Hunts Point Youth Center, 765 Manida Street, between Spofford and Lafayette Avenues. Hanrahan + Meyers Architects, 2001. View to the west. Aaron. ESTO

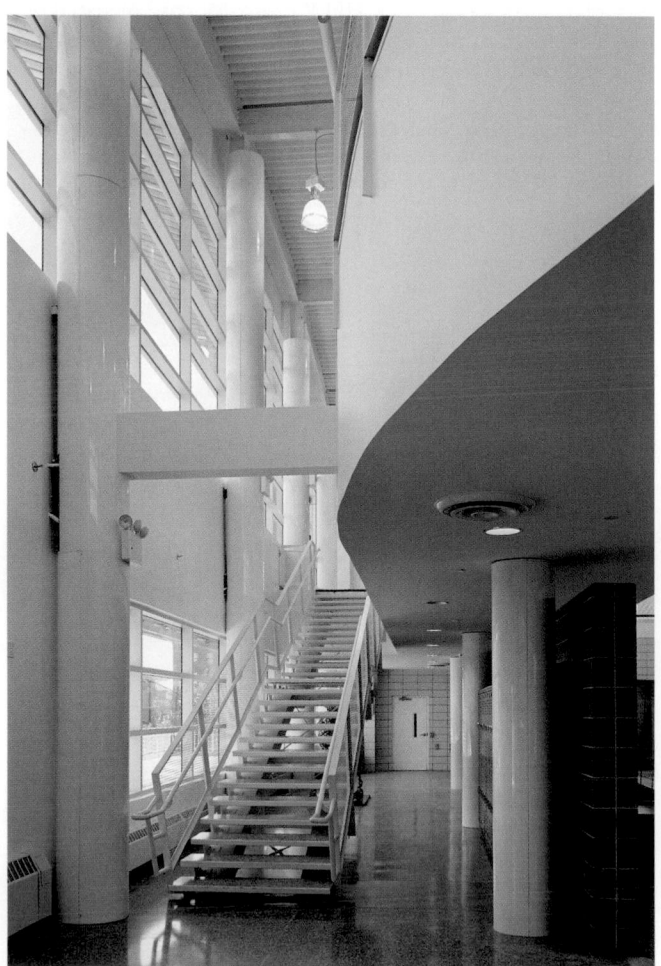

children's playground. The architects placed the corridors to the housing block on the outside, facing the courtyard, in order to provide residents with a safe, easily monitored space away from the street. A prominent clock tower gave the complex a distinctive institutional identity.

Four years later, in 1996, Kevin Hom + Andrew Goldman Architects completed work on the 38,000-square-foot South Bronx Community Center, 991 Longwood Avenue, between Fox and Beck Streets, built for the Police Athletic League, which maintained operations in all five boroughs.[79] Designed to provide job training as well as educational, cultural, and recreational programs for 3,000 neighborhood youngsters, it was the first new youth center in the neighborhood in close to twenty years and a visible symbol of the community's struggle for stability. Planning for the project began in 1990 after the Police Athletic League closed its dilapidated South Bronx center and was forced to run its outreach operations out of local schools. In addition to such standard fare as a gymnasium, basketball courts, arts and crafts rooms, and lounges, the four-level South Bronx Community Center included a radio station and an outdoor terrace classroom and amphitheater. Hom and Goldman animated their brick and glass design with bright colors, employing blue, yellow, white, and red on the exterior. The vivid color scheme was extended to the interior as well, where a three-level atrium and a second-floor lounge were contained within a red drum that extended beyond the dark glass front facade.

In January 1999, Mayor Giuliani announced plans for a new youth center to be built in an as yet undecided location in the Hunts Point section of the South Bronx.[80] Originally envisioned as a very modest facility with a small gym and a place for kids to do their homework after school,

as designed by Hanrahan + Meyers Architects (2001), the Hunts Point Youth Center proved to be something far more substantial: a sophisticated design providing, in addition to recreational and classroom space, facilities for theater and dance as well as an art gallery and art education center. Located on a 100-foot-square site—the same site intended for Aldo Rossi's proposed South Bronx Academy of Art (see below), within a city park that also included several baseball fields, the 18,625-square-foot facility, 765 Manida Street, between Spofford and Lafayette Avenues, was a steel-frame building with walls of weathered concrete-block and glass. The most prominent feature was the standing-seam vaulted metal roof punctuated by two prominent sculptural skylights. To help shade the glass wall from the morning sun, the east-facing entrance facade was recessed five feet beneath the roof. Inside, the main floor housed most of the activities, while the second level, reached by what the architects called a "waterfall" stair, featured a running track that ringed the gym space below. Victoria Meyers, noting the desire to create a welcoming presence, stated that "we wanted to give the building a soft, sculptural character. We even looked at Ronchamp," referring to Le Corbusier's pilgrimage church near Belfort, France.[81] On a more practical level necessitated by a tight budget and time constraints, the architects decided to keep the detailing

simple, or, as Tom Hanrahan put it, "You need to make your moves big and keep things fairly loose."[82] For example, when security-conscious city officials balked at the large amount of ground-floor glass, the architects responded with a relatively inexpensive solution, proposing bi-folding perforated metal airplane-hangar doors which could be closed at night or opened during the day, doing double duty as a window canopy.

Agrest & Gandelsonas's Melrose Community Center (2001), 286 East 156th Street, was one of the first, and surely the most stylistically sophisticated, of the new community centers realized as part of the New York City Housing Authority's program to improve such facilities within large-scale housing projects.[83] Located in the northeast corner of Melrose Houses (Louis E. Jallade and William T. Koch, 1952), a bleak environment consisting of eight fourteen-story red brick buildings on a twelve-acre site bounded by Morris and Courtlandt Avenues and East 153rd and East 156th Streets, the 20,000-square-foot complex, designed in association with Wank Adams Slavin Associates, consisted of an elliptical steel-frame gymnasium, clad in aluminum panels and concrete block, anchoring the corner of the 1.78-acre site, a glassy, two-story, 168-foot-long rectangular building housing classrooms placed at an angle to the gymnasium, and a thin one-story concrete-block and glass wing serving as a common

Melrose Community Center, 286 East 156th Street. Agrest & Gandelsonas in association with Wank Adams Slavin Associates, 2001. View to the northeast. Sundberg. ESTO

Proposed police academy, site bounded by East 153rd and East 156th Streets and Concourse Village East and West. Rafael Viñoly, 1992. Exploded axonometric. RVAPC

entrance as well as exhibition space. Describing the glassy classroom building, Diana Agrest explained: "The idea was that instead of creating a fortress, the best thing against paranoia and fear was to see. People can see what's going on in there."[84] To further this sense of openness, glass walls inside the building divided classrooms from the double-height circulation spine.

The Melrose Community Center was enthusiastically welcomed by the neighborhood, and early concerns that so much glass would be too tempting for vandals proved unfounded. David Burney, director of the Design and Capital Improvements Department of the Housing Authority, believed that if you cared about the details and gave the people something beside the drab product they were used to they would respect it. As he put it: "It's the opposite of the broken window theory."[85] Suzanne Stephens was impressed with the "striking new center," finding that "the clarity of the forms, even though they are low-rise objects amid high-rise brick buildings, turns the center into an instant landmark. The use of gleaming aluminum and glass, along with colored glazed block and metal panels, jazzes up the place in an elegant manner. On top of that, the lucid separation of the program into distinct, simple forms, and the contrast of opaque and transparent materials effectively signal the different functions. Since the budget was tight, it is remarkable that the translation of design into built form has been achieved so successfully."[86]

On March 10, 1987, the editors of the *New York Times*, responding to a recommendation by Mayor Koch's Advisory Committee on Police Management and Personnel Policy that the city's 260,000-square-foot police academy at 235 East Twentieth Street (1964) be replaced by a new one in "an under-utilized section of the city," suggested a South Bronx location. The abundance of city-owned land would allow space for the police department's many needs, but "as important," the editors argued, "the facility would guarantee continued police

interest in the area, thus enhancing prospects for housing and commercial development. A modern police academy in the South Bronx would make for better police officers and commanders, a healthier South Bronx and a safer city."[87] On January 25, 1989, Mayor Koch, in his State of the City address, announced that a new police academy would be built in the South Bronx on an 8.35-acre city-owned site bounded by East 153rd Street, East 156th Street, and Concourse Village East and West.[88] The site was part of the former Penn Central Mott Haven train yards, which had been built at an elevation twenty-five feet below street level. An international competition was held to choose the design, and a Request for Expression of Interest issued in November 1989 garnered roughly twenty responses. By the time the competition program was released, the project had grown in scope to the extent that estimates brought its cost to three times what was originally envisioned. Architects were to design a 475,000-square-foot academy for 2,300 students incorporating, among other elements, classrooms, administrative offices, a police museum, athletic facilities, an auditorium, an eight-lane quarter-mile running track, a firing range, and parking for over 700 cars.

In April 1990, seven finalists were announced: Edward I. Mills with Perkins & Will; Venturi Scott Brown & Associates, working with Anderson/Schwartz Architects and the Grad Partnership; Rafael Viñoly; Richard Dattner with Davis, Brody; John M. Y. Lee and Edward Larrabee Barnes; Warren W. Gran with Foster Associates of London; and Ellerbe Becket with Michael Fieldman & Partners. But only a month later, Mayor Dinkins, having recently taken office, halted the expensive project pending a reevaluation of its scope. The mayor's no-growth capital-spending plan delayed construction of the academy from 1992 to 1995 but did allocate limited funds for developing the design. Even so, the process was postponed twice during the following two years. However, on June 1, 1992, the seven teams previously chosen to compete agreed to resume their work as originally planned and were given five months to prepare their proposals.

On November 18, 1992, Ellerbe Becket and Michael Fieldman's design was selected. Peter Pran, the Norwegian-born design principal of Ellerbe Becket, led the team. Second place was awarded to Dattner and Davis, Brody; third place to Venturi, Anderson/Schwartz, and the Grad Partnership; and an honorable mention to Viñoly. All but one of the schemes situated buildings along the south and west edges of the site, placing the running track and playing field behind the buildings to face the rail yards that bordered the site to the east. A number of schemes called for semicircular buildings embracing the curve of the running track. Viñoly's was the only proposal that would spread the building over most of the site, with the track and field sitting "atop a single giant roof spanning a loose configuration of volumes" housing most of the program components. These volumes would surround the master deck—"the ceremonial heart of the facility"—where students would gather each morning.[89] The jury reportedly considered the idea technically brilliant but too expensive. The Venturi team proposed long, thin buildings that minimized the number of floors and were massed to allow as much natural light inside as possible. A long curving building bordering the running track occupied the southwest corner of the site, set back from the street on a plaza and featuring a protruding cylindrical volume indicating the main entrance. A narrow rectilinear wing extended to the north. Dattner and Davis, Brody's

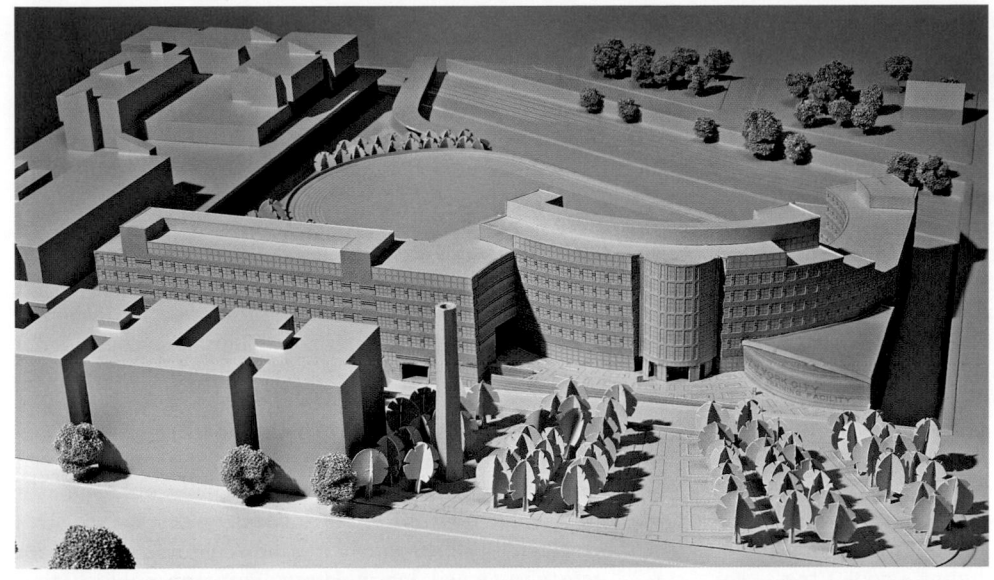

Proposed police academy, site bounded by East 153rd and East 156th Streets and Concourse Village East and West. Venturi, Scott Brown & Associates with Anderson/Schwartz Architects and the Grad Partnership, 1992. Model, view to the east. VSBA

Proposed police academy, site bounded by East 153rd and East 156th Streets and Concourse Village East and West. Richard Dattner with Davis, Body & Associates, 1992. Model, view to the east. RDPA

Proposed police academy, site bounded by East 153rd and East 156th Streets and Concourse Village East and West. Ellerbe Becket with Michael Fieldman & Partners, 1992. Model, view to the southwest. PP

scheme was somewhat contradictorily designed to be "an open, permeable fortress, recalling familiar historic precedents such as armories, urban college campuses, and parade grounds," according to Dattner.[90] A cylindrical four-story entrance tower anchored the southwest corner and housed public elements of the program like the auditorium and police museum while offering direct access to the parade grounds and running track as well as a rooftop observation platform topped by the crownlike framework of a communications mast, satellite dishes, and antennae.

Ellerbe Becket's winning proposal was unabashedly timely in its aesthetics: a daring exemplar of Deconstructivism. Its swooping form, composed of an eight-story curved administrative wing attached to a 400-foot-long, six-story academic wing extending to the north, was to be sheathed in a glass and steel curtain wall along the street and glass and concrete on the rear facade facing the running track. The library, museum, auditorium, and other facilities open to the public were located at the juncture of the two wings, while many of the additional athletic facilities, including a pool, fitness center, and par course, were located adjacent to the running track, which itself would cover a subterranean firing range and 784-car parking garage. Herbert Muschamp was enthusiastic about the design: "In model form, it is a beautiful piece of architectural sculpture, at once muscular and lyrical, formally assertive but not visually overbearing, its airy translucence a deliberate attempt to avoid a fortresslike impression." He compared the "gleaming" proposal to a "marathon runner dashing toward the ribbon . . . a modern athletic thoroughbred of a building."[91]

In February 1994, the newly elected mayor, Rudolph Giuliani, announced that to help close the city's budget gap, plans for the police academy would be scrapped completely and the existing academy building would undergo a modest renovation. Proponents of the new building formed the Committee to Keep the Police Academy in the Bronx, organizing protests at City Hall and in Albany. Bartholomew Voorsanger, president of the New York Chapter of the American Institute of Architects, stated, "It sends a very difficult signal that the first thing that's cut [from the city budget]

is a building of such design distinction. There has been a long, long policy of make-do in the city. The inventory of our public buildings is in a deplorable state which needs a huge capital investment. What was extraordinary was the possibility of lifting everyone's vision."[92] In June 1994, Giuliani ceded under the pressure, but only marginally, allotting limited funds for the continued development of the plans, but none for actual construction. By May 1995, reportedly none of the money had been spent and Giuliani cut the Police Academy entirely from the new budget and the project died.

Much smaller in scale but sharing the same fate was the Italian architect Aldo Rossi's proposed South Bronx Academy of Art, a tuition-free alternative private high school for fifty pupils.[93] It was commissioned in 1991 by Tim Rollins, a teacher and founder of the Art and Knowledge Workshop, which offered after-school arts programs for learning-disabled teenagers and students in danger of dropping out, some of whom collaborated with Rollins under the name K.O.S. (Kids of Survival). The 30,000-square-foot building was planned for a 2.7-acre city-owned lot in Hunts Point on a block that housed two walled-in institutions: the Corpus Christi Monastery and the Spofford Juvenile House of Detention. Rossi's academy would also sit within the fortifications of a concrete wall that existed as a remnant of an orphanage previously on the site, occupying approximately a quarter of the lot, with the remainder used as a park and a baseball field. The design called for a rectangular five-story red brick central tower, the front of which would be covered by a mural by Tim Rollins and K.O.S., flanked by two classroom and studio wings, each shaped with three projecting rowhouse-like elements. Attached to the rear of the tower, which was intended to house galleries and a second-story auditorium, was a cylindrical library. A tall, conical lighthouse sat apart from the building opposite the front entrance. The bold geometric volumes were to be brilliantly polychromed; the main block would be red brick, the flanking wings would be painted yellow, the window frames blue, the doors and cornices green, and the library and lighthouse white. According to his design partner, Morris Adjmi, Rossi viewed the project as an "urban rescue operation" capable of catalyzing "the physical redemption of the neighborhood."[94] But the financial and political support necessary to build the school did not materialize.

Opened in 1970, Eugenio Maria de Hostos Community College, the most important educational institution in the South Bronx, struggled in temporary quarters for over twenty years before getting its first purpose-built building. Named for a Puerto Rican educator and patriot, Hostos was a junior college of the City University of New York geared toward preparing its students for jobs in the health-care industry, and was the only college in the City University system offering bilingual education, as well as the first to be deliberately situated in an economically depressed area. The school had initially been promised a twelve-acre campus just east of the Hub, the South Bronx's traditional business heart, but when the fiscal crisis eliminated funds for city buildings, that site was repackaged for a new shopping center whose tenants were to pay rent to the college, which planned to use the income to build on part of the site.[95] In the meantime, Hostos established what were meant to be temporary quarters a few blocks to the west, cramming its programs into a six-story former tire factory, 475 Grand Concourse, southwest corner of 149th Street.[96] The result was an institution that was not only overcrowded but

Proposed South Bronx Academy of Art, site bounded by Manida and Tiffany Streets and Spofford and Lafayette Avenues. Aldo Rossi, 1991. Model. MAA

ABOVE Allied Health and Science Building, Eugenio Maria de Hostos Community College, 475 Grand Concourse. Voorsanger & Mills Associates, 1991. View to the southwest. Warchol. PW

BELOW Allied Health and Science Building, Eugenio Maria de Hostos Community College, 475 Grand Concourse. Voorsanger & Mills, 1991. Library. Warchol. PW

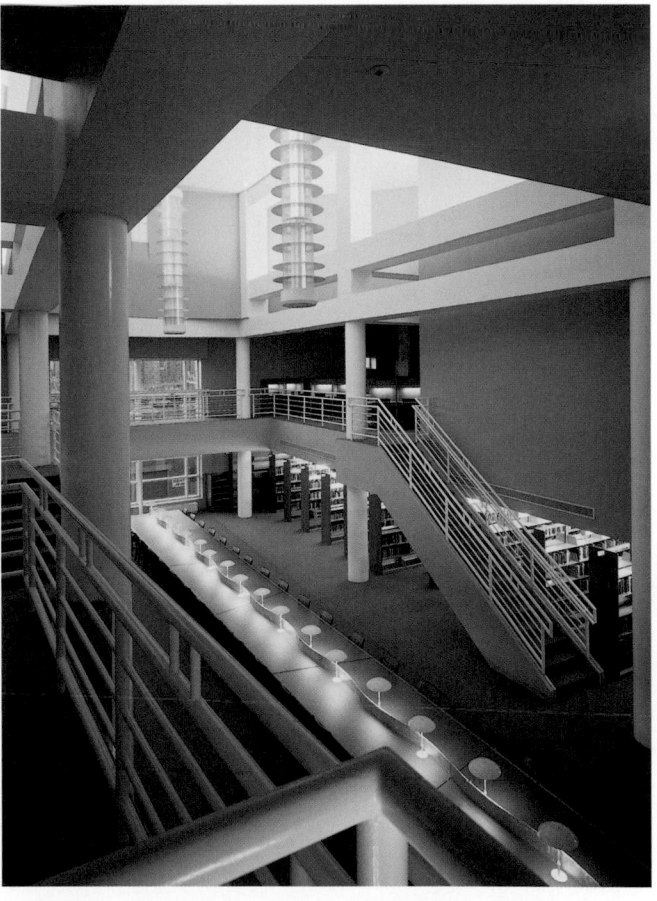

also without adequate support facilities, such as an auditorium, gymnasium, library, or cafeteria. In 1974 Hostos bought a brown brick and glass office building across the street, the former Security Mutual Insurance Company (Horace Ginsbern & Associates, 1965), 500 Grand Concourse, southeast corner of 149th Street, but the building was not renovated for school use until 1980.[97]

By the mid-1980s enrollment in the college had grown to the extent that the failure to provide it with a larger, permanent campus became a political embarrassment. In August 1985, plans were announced for a new city- and state-funded complex, and in 1987 the New York State Dormitory Authority and the City University Construction Fund hired Gwathmey Siegel & Associates, working with Sanchez and Figueroa Architects, to serve as master planner for the school's expansion.[98] Their plan called for a pair of new buildings facing each other across the Grand Concourse and linked by a pedestrian bridge. The Gwathmey and Sanchez team designed the East Academic Complex (1994), 460 Grand Concourse, and the firm of Voorsanger & Mills Associates, working with the Hirsch/Danois Partnership, was commissioned to design the Shirley J. Hinds Allied Health and Science Building (1991), 475 Grand Concourse.[99]

Voorsanger & Mills's Allied Health and Science Building, a five-story, 101,500-square-foot facility with iron-spot brick, corrugated metal, and square punched windows, was organized around a principal north–south circulation spine on the third floor. The spine, or "campus street," as the architects termed it, paved in terrazzo and lined with benches, was conceived as a "filter [with] uses and circulation vertically and horizontally

BELOW East Academic Complex, Eugenio Maria de Hostos Community College, 460 Grand Concourse. Gwathmey Siegel & Associates, 1994. Goldberg. ESTO

ABOVE East Academic Complex, Eugenio Maria de Hostos Community College, 460 Grand Concourse. Gwathmey Siegel & Associates, 1994. View to the southeast. Goldberg. ESTO

attached." At its southern end, the axis terminated in a three-story, glass-enclosed, cube-shaped "porch" that served as the entry and exit point to the pedestrian bridge.[100] The northern end culminated in a protruding, glass stair tower that rose the full height of the building, marking a ground-level entry from which a long staircase angled through the building for two stories to intersect with the third-floor campus street. The library was the most dramatic of the interior spaces, entered on the third floor but primarily situated on the second floor, where a communal, seventy-foot-long reading table sat in a triple-height space crowned by a cylindrical drum. Voorsanger's building wrapped around the college's original facility, which was renovated as laboratories and a remedial learning center and incorporated into the new complex.

Gwathmey Siegel's East Academic Complex was a 240,000-square-foot, four-story, brick- and glass-clad structure providing, in addition to classrooms and offices, a gymnasium, a twenty-five-meter swimming pool, a cafeteria, numerous multipurpose rooms, and a bookstore.[101] It also contained the Hostos Center for the Arts & Culture, comprising a 906-seat theater, a 350-seat repertory theater, art, music, dance, and photo studios, and an art gallery. An outdoor plaza and stage was situated between the building and the 500 Grand Concourse building to the north. Inside, a five-story, skylit atrium ringed by three stories of balconies constituted, according to the architects, "an interior cloister . . . the major public space on the campus and the primary internal circulation volume." It was also the point of access to the barrel-vaulted skylit pedestrian bridge that, with its blue-flecked

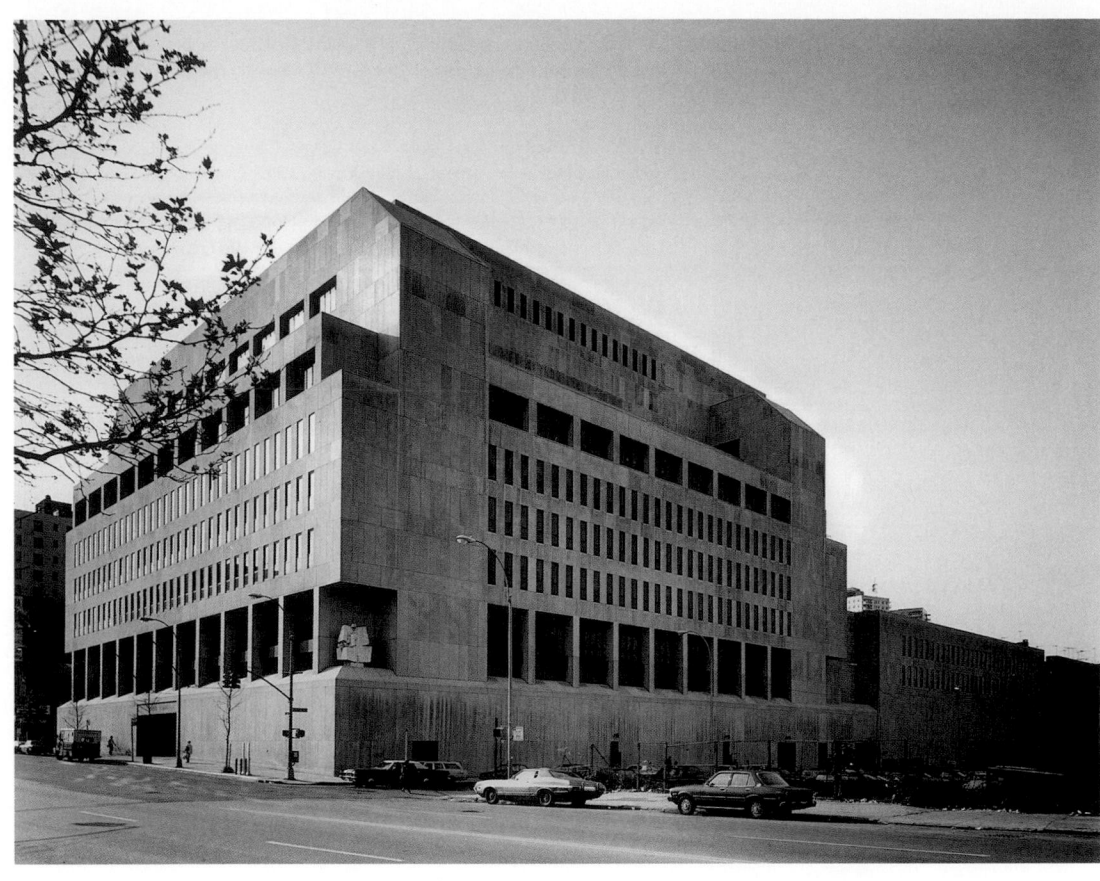

Criminal/Family Courts Building, 215 East 161st Street, between Sheridan and Sherman Avenues. Harrison & Abramovitz, 1977. View to the northwest. McGrath. NMcG

white terrazzo benches, became a de facto quad twenty-three feet above the Grand Concourse. The northern portion of Gwathmey's facade stepped back incrementally from the street wall, bringing attention to a small corner tower that combined with the pedestrian bridge to serve, according to the architects, as a pair of "visual icons, establishing a sense of place and a new image for the campus in the community."[102] The effect was lost on Susanna Sirefman, who felt that the exterior was "not remarkable: its contextual massing, materials and color make it disappear into its urban setting."[103]

Though long well served by such distinguished buildings as Michael J. Garvin's Bronx Borough Courthouse (1905–14), East 161st Street between Brook and Third Avenues, and Freedlander & Hausle's Bronx County Building (1934), 851 Grand Concourse, southwest corner of East 161st Street, by the 1970s the Bronx was in desperate need of modern court facilities, a pent-up demand only partially satisfied by Harrison & Abramovitz's Criminal/Family Courts Building (1977), 215 East 161st Street, between Sheridan and Sherman Avenues, a domineering twelve-story edifice, of which the editors of the *AIA Guide* wrote: "If architecture is expressive of the social order, then this bulky structure tells us that justice must be ponderous, rigid, and self-righteous."[104] Following the completion of Harrison & Abramovitz's facility, the Bronx Borough Courthouse was shuttered. It would take another twenty years before the next courthouse was completed. Rafael Viñoly's Bronx Housing Court (1997), 1118 Grand Concourse, between East 166th and McClellan Streets, provided a new home for a function that since 1973 had been located in cramped quarters in the basement of the Bronx County Building.[105] Viñoly's 92,000-square-foot building rose ten stories, the first five of which accommodated thirteen courtrooms. The upper floors, in a narrow setback tower, were occupied by staff rooms, a press room, conference rooms, judges' and clerks' offices, and a two-story library. The northern edge of the plan contained a vertical circulation core with stairs carried on truss-like stringers rising behind sleek glass walls. The courthouse, clad in a combination of sandstone and gray Roman brick, featured gridded aluminum and glass curtain walls that Viñoly situated to "create monumental openings into the public areas." The ninth- and tenth-floor judges' library was expressed on the exterior by a canted glass volume jutting out from the facade "to be visible to surface traffic crossing the Harlem River from Manhattan into the Bronx."[106]

The new Bronx Criminal Courthouse, also designed by Viñoly, was much more ambitious, a one-million-square-foot superblock to be constructed in three phases on a three-block site between East 161st and 163rd Streets and Sherman and Grant Avenues.[107] At the time of its anticipated completion in 2010, the Bronx Criminal Courthouse was expected to provide seventy-two courtrooms for the Supreme and Criminal Courts as well as facilities for the Department of Corrections, the Police Department, the Department of Probation, the Bronx District Attorney, and other agencies. Retail space and a day care facility were included in the plan early on but, after the bombing of the Alfred P. Murrah Federal Building in Oklahoma City in 1995, in which eighteen children enrolled in the day care center were killed, this feature was dropped.

Also, concerns about terrorist attacks from vehicles led to the decision to close Grand Street, which was originally to cut through the complex, and in 2000 bullet-resistant glass and blast-resistant walls were incorporated into the design.

Viñoly's L-shaped plan situated the bulk of the structure along 161st Street; a civic plaza occupied much of the rest of the site, which faced a lower-scale residential neighborhood. Set within the landscaped plaza would be a two-story cylindrical building intended to function as a jury assembly area. Inside, public corridors and a system of stairs and ramps ran along the plaza facade, while separate circulation for judges and staff was situated on the 161st Street side. An innovative folded-glass facade, arranged in five-foot-wide bays, incorporated three types of glass at each floor level, ranging from panels of low-transparency frit glass on the bottom to high-transparency glass on the top. Reflective ceiling surfaces would allow sunlight to bounce deep into the building. In 2001 ground was broken for the first phase of construction, comprising forty-seven courtrooms.

Just a few blocks west of the group of courthouses was a venerable Bronx institution, Yankee Stadium (Osborn Engineering Company, 1923; renovation, Praeger-Kavanagh-Waterbury, 1976), bounded by Rupert Place, River Avenue, and East 157th and East 161st Streets, where, on the afternoon of April 13, 1998, when fortunately no one was sitting in the stands, a 500-pound concrete and steel beam fell from the upper deck.[108] The accident, caused by an isolated fault, closed the stadium for only eleven days but helped to revive, if not ignite, the long-running, heated debate over the future in the Bronx of America's most profitable baseball team. Although the 1976 renovation had addressed many pressing problems, it

did not fulfill the expectations of principal owner George Steinbrenner who, beginning in the late 1980s, embarked on a campaign aimed at getting the city and state to build a new stadium, threatening, at various times, to leave New York for New Jersey's Meadowlands. In an attempt to keep the Yankees in the city, several schemes were offered up, including a 1990 proposal supported by Bronx Borough President Fernando Ferrer for a 75,000-seat domed stadium on a 414-acre site at Ferry Point Park, at the north end of the Bronx-Whitestone Bridge.[109] Far more controversial was the idea, first announced in 1993 by Governor Cuomo and later taken up by Mayor Giuliani, for a new 50,000-seat Yankee Stadium in Manhattan, to be located in the West Side Railyards in the West Thirties south of the Javits Center.[110] A more comprehensive plan, also promoted by Ferrer, was for Yankee Village (1998), a scheme designed by Beyer Blinder Belle to improve not only the stadium but also the entire immediate neighborhood, calling for enhanced green spaces, major transportation infrastructure improvements, and a new, 450,000-square-foot shopping center.[111] But none of the proposals to rework or replace Yankee Stadium found the necessary political and financial support.

North of Yankee Stadium, in Morris Heights, David Prendergast's modest but stylish Sedgwick Branch of the New York Public Library (1993), 1701 University Avenue, northwest corner of West 176th Street, brightened up a small, triangular, litter-strewn site on a reviving commercial thoroughfare.[112] Prendergast, who initially envisioned a site-filling building with an internal courtyard, decided that

Bronx Criminal Courthouse, site bounded by East 161st and East 163rd Streets and Sherman and Grant Avenues. Rafael Viñoly, 2001. Model, view to the southeast. RVAPC

Sedgwick Branch, New York Public Library, 1701 University Avenue, northwest corner of West 176th Street. David Prendergast, 1993. View to the north. Cox. PLA

Proposed Gymnasium Bridge, Harlem River Yard, ninety-six-acre site bounded by Bronx Kill, Harlem River, and East 132nd Street. Steven Holl, 1978. Site plan. SHA

Proposed Gymnasium Bridge, Harlem River Yard, ninety-six-acre site bounded by Bronx Kill, Harlem River, and East 132nd Street. Steven Holl, 1978. Plan and axonometric. SHA

approach would seem inappropriately aloof from the community and instead fitted the program into a one-story, 3,900-square-foot, L-shaped building bordering a 2,000-square-foot plaza on the corner. The bulk of the library was housed in a narrow concrete-block bearing-wall structure stretching along the north edge of the site, but the building's defining feature was a fifteen-foot-tall truncated cone clad in mill-finished stainless steel at the west edge of the site, housing a community room that Prendergast referred to as a "giant teepee" symbolizing community togetherness.[113] The artist Sandy Gellis shaped the plaza with a landscape of contoured concrete steps punctuated by large mica rocks and carbon-steel bollards capped with phosphorescent tops arranged in a pattern based on the Cygnus A galaxy.

Harlem River Yard

The South Bronx's single largest developable tract, the Harlem River Yard, was a decommissioned ninety-six-acre rail yard stretching a mile and a half along the borough's southern edge and separated from Randalls Island to the south by the Bronx Kill, a narrow waterway shallow enough at points to be crossed on foot. In 1978 the Wave Hill Center for Environmental Studies sponsored a design competition to generate ideas for

guiding the site's future, in response to reports that the Economic Development Corporation, which had taken control of the yard after its owner, the Penn Central Railroad, went into receivership in 1972, was in negotiations with a European developer who planned to build an industrial park.[114] Although those plans fell through, the Wave Hill Center, concerned that no details had been provided about the industrial park's integration into the South Bronx, went forward with its study, aiming "to explore ways in which future development of this property—either as an industrial park or some similar revenue-producing enterprise—might enhance not only the immediate surrounding community's economic life but also its environmental and social quality." The Center invited six architects and planners—Steven Holl, Andrew McNair, Livio Dimitriu, Jeffrey Clark, Robert Livesey, and Patrick Ping Tse Too—to consider the site from a master planner's perspective, giving careful consideration to its potential role as "an environmental bridge to Randalls Island," where ball fields, picnic areas, and Downing Stadium were popular—but not easily accessible—attractions for South Bronx residents.[115]

Each of the proposals called for the South Bronx street grid to be extended over the site. Most of the designers also envisioned a subway stop on the proposed Second Avenue subway line to be built either on Randalls Island or at the northern edge of the rail yard at East 132nd Street. Livio Dimitriu's Randalls Island subway station took the form of an enormous cylinder emerging from the ground with a north-facing entrance, situated so as to infuse the area with vitality through "the reorientation of activity on a north–south axis, between 138th Street and Randalls Island, across and through the rifts which stratify the neighborhood."[116] Andrew McNair established a link between the site and Randalls Island with a tree-lined viaduct over the Bronx Kill, while Patrick Ping Tse Too proposed a simple pedestrian bridge that took a backseat to his vision of the rail yard as a mix of open spaces, industrial uses, community facilities, a business district, and a solar power plant.

Steven Holl's proposal, by far the most inventive, was crucial in establishing its young designer as a significant artistic voice. Holl covered the rail yard in a grid of blocks that were "small and proportioned to city scale to discourage the tendency toward sprawling industrial structures." Black ash from burned-out buildings throughout the South Bronx was to be spread across every other block, alternating with blocks of freshly seeded lawns, so that airplanes passing over the site on

their way to and from La Guardia Airport would see a checker-board pattern representing what Holl called "a pessimistic-optimistic collision of squares." The boldest gesture of Holl's plan was the Gymnasium Bridge, a "series of bridges over bridges" that at once provided the environmental link between the rail yard and Randalls Island and offered a multipurpose community facility. The hybrid bridge-building was formed by two small "entry bridges" located on either side of the Bronx Kill that in turn supported a long span forming a third bridge, which comprised a two-story steel-truss building that was to be clad in translucent white panels wrapping a full range of athletic facilities, with quiet activities like billiards and checkers on the first level and strenuous activities like weight training, handball, and boxing on the second level. A taller, fourth bridge, dotted with square punched windows and topped by an observation deck, was to be, as Holl put it, "in water rather than over water."[117] It would accommodate water-related elements of the program, such as a rowboat launch at the base and steam rooms and showers above, as well as an ice-skating rink surrounding a circular stair core that connected the two main bridges at the point of their crossing.

In 1978 plans were initiated by the New York State Department of Transportation and the Port Authority of New York and New Jersey to convert the Harlem River Yard into an intermodal freight terminal, where goods delivered by rail to the city would be transferred to trucks.[118] A great amount of time and money was spent on building—though not quite completing—the Oak Point Link, a 1.7-mile stretch of bridge and trestle connecting the Oak Point and Harlem River rail yards. But in 1989 the transportation department decided to cancel the project after representatives of one company hired to build the link were indicted for fraud and a second company sank pilings into the river bed only to find crumbling rock caused by an earthquake fault. The link was finally completed in 1998, twenty years after its conception, paving the way for an operable intermodal rail yard. But the twenty-eight-acre size

of the freight yard—reduced from the eighty-eight acres originally planned—led Jerrold Nadler, once one of its greatest advocates, to predict troublesome bottlenecks and bemoan that "New York is not going to have a proper rail freight system unless we get the entire Harlem River Yard back."[119] That would be impossible. In 1999 the company Waste Management opened a waste transfer station in the western portion of the rail yard and on September 11, 2001, the *New York Post* opened a 430,000-square-foot printing plant on a seventeen-acre tract at the eastern end.[120] The opening was ahead of schedule, understandably so as a result of the terrorist attacks earlier in the day that derailed production at 210 South Street, the newspaper's lower Manhattan plant, which did not reopen.

In May 1994, after two years of quiet planning, the National Resources Defense Council, in partnership with a Bronx community group called the Banana Kelly Community Improvement Association, announced plans to build a paper recycling plant on a twenty-two-acre portion of the Harlem River Yard bisected by the elevated northern arm of the Triborough Bridge.[121] The proposed plant, to be the first of its kind in the city, promised numerous ecological benefits, the most significant being the recycling of 280,000 metric tons of paper discarded each year by city offices into 220,000 tons of newsprint, roughly half the amount consumed annually. The idea of creating paper not from trees in a forest but from what was referred to as the "urban forest" meant saving over 3.4 million trees each year. It would also decrease the amount of waste going into the Fresh Kills landfill. Gray water from the nearby Ward's Island sewage treatment plant would be used at the factory, rather than the 3 million gallons of fresh water each day that would otherwise have been consumed. In addition, the plant would generate 300 permanent new jobs—not to mention innumerable jobs during construction—and offer housing, training, day care, and health care for the workers.

The project's presumed benefits notwithstanding, it was greeted with intense opposition, primarily emanating from the

Proposed Bronx Community Paper Company plant, Harlem River Yard, twenty-two-acre site flanking the northern arm of the Triborough Bridge.

Maya Lin and Haines Lundberg Waehler, 1994. Rendering of view to the south. HLW

South Bronx Clean Air Coalition, a group of fifty organizations claiming that the plant would further pollute the air in a district whose residents were commonly plagued by respiratory ailments. Even more important, they still wanted the yard to become an intermodal rail hub. Despite the opposition, plans for the paper mill moved forward. In 1992 the Bronx Community Paper Company, a for-profit company created to operate the proposed mill, hired Haines Lundberg Waehler to design the complex, which would comprise four buildings: two each on either side of the Triborough Bridge. To the west of the bridge would be a 100,000-square-foot wastepaper storage building and a 53,000-square-foot de-inking plant. On the other side of the Triborough the de-inked paper would enter a 111,000-square-foot papermaking facility and then be transported to an 86,000-square-foot paper-storage building.

A year into the design process, the architect Maya Lin was brought on to design the plant's exterior and landscape, an effort, as Raymond Gastil put it, "to build a plant that had symbolic as well as functional value."[122] According to Lin, the design interventions were intended "to expose the processes. We want to show people what's going on within."[123] To that end, the complex's corrugated aluminum cladding gave way to broad glass panels at points where the different buildings were joined and where materials were transferred from one part of the recycling process to another. Thirty-foot-tall clerestory windows wrapped the structures to allow natural light within but also to afford views of the machinery from traffic on the bridge. Lin also planned to transform some of the plant's raw materials and by-products into positive elements of the factory landscape, and she designed a 200-foot-tall transparent smokestack offering views of the steam rising within as well as, at the entrance, a glass-enclosed water wall that used the factory's gray water. To the south of the buildings, Lin proposed to dress up what was to have been a stark asphalt parking lot with a grove of trees planted on a grid mirroring that of the buildings' columns. In December 1997 the project took the spotlight when Lin's designs were displayed by the Municipal Art Society. But staunch opposition continued, and the multitude of major and minor setbacks that had plagued it all along eventually combined to spell disaster for the proposed paper plant, which was officially called off in July 2000.

North Bronx

Two of the city's finest outdoor public attractions, the Bronx Zoo and the New York Botanical Garden—both in the 718-acre Bronx Park—undertook significant construction projects during the last quarter of the twentieth century. The Bronx Zoo, occupying the southern 250 acres of the park, opened in 1899 as the New York Zoological Park. Its coherent campus of buildings designed by Heins & LaFarge (1899–1911) represented—both in their individual design and as a planned ensemble—the sensitive adaptation of formal classicism to a picturesque arcadian setting.[124] Following the completion of Charles Platt and Paul Manship's Paul J. Rainey Memorial Gate in 1934, the architectural additions to the zoo were designed to be less visually conspicuous, coinciding with a general reform in zoo design that stressed placing animals in natural-seeming habitats rather than cages.

The Carter Giraffe Building (1982), designed by Harold Buttrick & Associates, was described by the zoo's general curator, James G. Doherty, as "inconspicuous. . . . We were

not looking to build a monument, like the old building" of 1908 that it replaced.[125] The former building, designed by Heins & LaFarge and located on the same site, was only nineteen feet tall and had acquired what the giraffe keeper described as "little horn holes" in the ceiling.[126] Buttrick's building, part of a five-acre indoor and outdoor complex, featured twenty-one-foot ceilings but was nestled into the side of a hill to disguise its height. Inside, according to the New York Times's Ari Goldman, it looked "more like a Columbus Avenue bar than a zoo space. There are skylights, butcher-block counters, polished red brick floors and a colorful African mural" by Christian White.[127]

Wild Asia, a thirty-eight-acre exhibit situated at the southeast corner of the zoo, could be viewed from the city's only monorail, called the Bengali Express, which had been installed for the exhibit's opening in 1977.[128] Wild Asia was not fully completed, however, until the opening on June 22, 1985, of Jungle World (Herbert W. Reimer), a skylit building encompassing about an acre and rising to a height of fifty-five feet to become the zoo's largest structure.[129] Jungle World incorporated elements like a forty-foot-high waterfall, heated rocks for reptiles, over thirty species of tropical trees, and a huge but fake seven-foot-diameter strangler fig tree made of steel, fiberglass, and epoxy that served as a framework to support real plants and vines.

The Russell B. Aitken Seabird Aviary (FTL/Happold) replaced the zoo's original aviary, which had collapsed under the weight of snow in February 1995.[130] Built on the same site and opened in March 1997, the 32,000-square-foot Aitken aviary, thirty percent larger than its predecessor, was formed by a series of steel arches rising from an undulating concrete wall that was submerged below grade at some points but rose above the ground at others to accommodate cavelike entrances. The arches were covered by a roof membrane of one-millimeter-diameter stainless-steel wire-mesh fabric that was thin enough to be invisible from a distance yet strong enough to sustain snow and wind loads.

The Congo Gorilla Forest and Environmental Education Center (1999), sited along the southwest edge of the zoo, was designed by Helpern Architects in conjunction with the exhibition and graphic arts department of the Wildlife Conservation Society, which operated the Bronx Zoo.[131] An elaborate simulacrum of a central African rainforest, the 6.5-acre exhibit was the most expensive in the Bronx Zoo's history and home to a total of 300 animals and seventy-five species, including twenty lowland gorillas who were the guests of honor. The new indoor-outdoor habitat incorporated eleven waterfalls, misting machines, fifty-five artificial rainforest trees—some with radiant-heated concrete bases and air-conditioned breezes emanating from vents at the top—and even a jungle soundtrack piped through loudspeakers. Visitors entered the exhibit along a 600-foot-long path through the rainforest that led to a two-story steel-and-concrete building well hidden by rocks and vegetation. Galleries and educational exhibits dotted the path to a seventy-seat theater whose projection screen would, after each showing of a short film about gorillas and their habitat, peel away to reveal the Congo Gorilla Forest exhibit. The large glass wall between the areas was designed in consultation with a squash-court specialist to withstand the pressure of a 600-pound gorilla. A glass tunnel leading out of the building allowed visitors to see gorilla activity above them.

By the mid-1970s the 250-acre New York Botanical

Carter Giraffe Building, Bronx Zoo, Bronx Park. Harold Buttrick & Associates, 1982. View to the north. MBBA

Congo Gorilla Forest and Environmental Education Center, Bronx Zoo, Bronx Park. Helpern Architects, 1999. Theater. Mauss. ESTO

Congo Gorilla Forest and Environmental Education Center, Bronx Zoo, Bronx Park. Helpern Architects, 1999. Mauss. ESTO

Garden, incorporated in 1891 as an educational facility and museum for the public modeled on the Royal Botanical Gardens at Kew, England, was in a sorry state.[132] Edward Larrabee Barnes was at work on a master plan that included proposals for a new Plants and Man Building and for the restoration of the Garden's architectural centerpiece, the Conservatory Range, designed in 1902 by William R. Cobb for the Lord and Burnham Company. But any sense of optimism was wiped away by the city's fiscal crisis, and were it not for a gift from philanthropist Enid Annenberg Haupt, the badly deteriorating Conservatory, declared a National Historic Landmark by the National Park Service in 1967 and a New York City landmark in 1973, would likely have been demolished. Barnes's work was put on hold indefinitely, but Haupt's gift enabled a low-budget but crucial renovation of the glass house, which was reopened in 1978 as the Enid A. Haupt Conservatory.[133] The renovation was carried out by Barnes and

involved the replacement of cast-iron framing members with ones formed in aluminum and the installation of 17,000 new panes of glass. Unfortunately, as restored, the Haupt Conservatory was forced to accommodate educational exhibits originally intended for some of the facilities that had been canceled, a fact that left Barnes "regretful that this building had to become a large-scale teaching facility." To accommodate the groups of schoolchildren who would tour the building, Barnes reorganized circulation so visitors no longer entered at the midpoint of the roughly C-shaped greenhouse, visited one wing and then doubled back to view the other. Instead, he created a full loop by connecting the two wings with a newly excavated galvanized steel tunnel beneath the courtyard, an intervention that Barnes deemed "severely damaging [to] the architectural experience of the building."[134]

Work on the Conservatory, important as it was, sapped both energy and funds from other parts of the institution, and

ABOVE Garden Café and Terrace Room, New York Botanical Garden, Bronx Park. Cooper, Robertson & Partners, 1997. View to the southeast. Aaron. ESTO

BELOW Janet and Arthur Ross Lecture Hall, Museum Building (Robert W. Gibson, 1902), New York Botanical Garden, Bronx Park. Renovation by Hardy Holzman Pfeiffer Associates, 1993. Kaufman. H3

during the early 1980s, as flower gardens were removed and planting initiatives halted, the Botanical Garden was, for the public, little more than a large park. Conditions began to improve by the mid-1980s, with the restoration by Robert Meadows of a triangular rose garden originally designed by Beatrix Farrand during the early 1900s and dismantled in the 1960s.[135] The garden had never been fully completed, and Meadows was forced to work from only a few sketches, leading to a design that Ellen Posner deemed "rigid . . . with its large radiating pathways, central seven-sided gazebo and thick metal fencing at the periphery" seeming "far too monumental for a relatively small space."[136]

Improvements to the Garden took a notable step forward in 1989, when Gregory Long, an art historian previously serving as vice president of the New York Public Library and, before that, the American Museum of Natural History and the New York Zoological Society, became president of the Botanical

Garden. Long quickly began to turn things around, hiring Hardy Holzman Pfeiffer Associates to undertake a series of small-scaled but important scenic improvements, carried out in 1990, that included the establishment of a nonvehicular entrance, the construction of prominent pylons to help orient visitors, and the installation, near Robert W. Gibson's Museum Building (1902), of two lattice pavilions serving as a temporary visitor center and a series of similar pavilions scattered throughout the garden grounds, which provided, according to Hugh Hardy, "orientation and shelter in a lighthearted and ephemeral way that more permanent-seeming architecture could not achieve" while at the same time conveying "the illusion that this vast . . . garden had somehow been changed and made more friendly, less remote and confusing."[137] In 1993 Hardy Holzman Pfeiffer Associates renovated the Museum Building's Janet and Arthur Ross Lecture Hall, transforming it from what Hardy described as "the ugliest, most vapid space you can imagine" into a brightly colored 428-seat auditorium that mixed original elements such as wooden seats with contemporary light fixtures and a newly sloping back wall.[138]

In 1993, according to a master plan developed by R. G. Roesch Architecture & Landscape Architecture, the Botanical Garden embarked on a seven-year campaign of construction and renovation intended to renew the institution both physically and philosophically as it reimagined itself not as a mere garden but, as Long put it, a "museum of plants."[139] Between 1993 and 1997 the Haupt Conservatory was treated to another renovation under the direction of Beyer Blinder Belle.[140] With new glazing and computerized systems controlling temperature, humidity, and ventilation, the Conservatory was once again able to serve the sole purpose of showcasing the Botanical Garden's plant collection, now exhibited in eleven galleries divided into four biomes, or environments, and comprising over 3,000 plants.

Cooper, Robertson & Partners' Garden Café and Terrace Room (1997) opened the same week as the restored Haupt

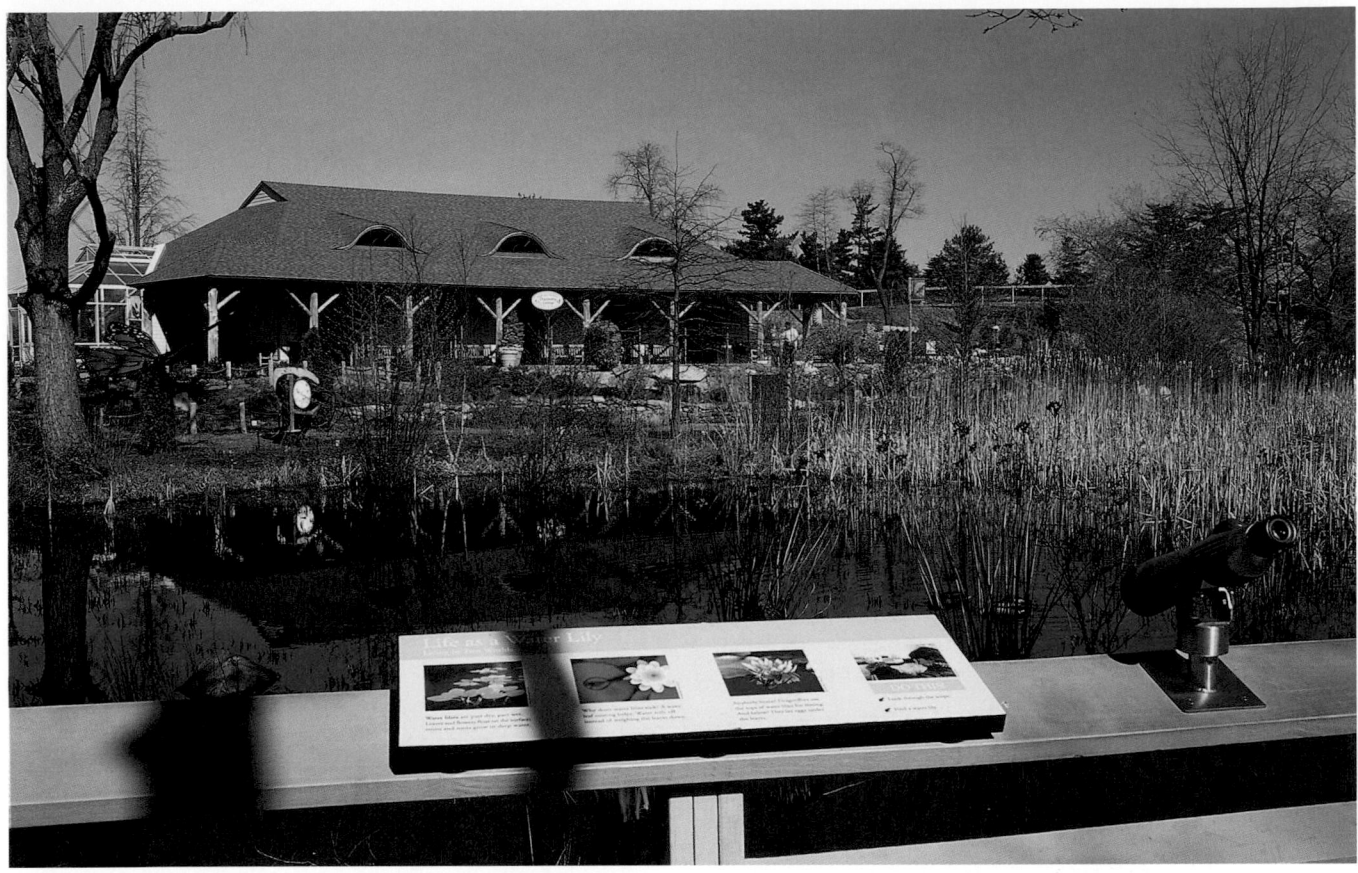

William and Linda Steere Plant Discovery Center, New York Botanical Garden, Bronx Park. Richard Dattner, 1998. View to the northwest. RDPA

International Plant Science Center, New York Botanical Garden, Bronx Park. Polshek Partnership, 2002. View to the south showing Museum Building (Robert W. Gibson, 1902) on right. Benson. RBP

International Plant Science Center, New York Botanical Garden, Bronx Park. Polshek Partnership, 2002. Site plan. PPA

Leon Levy Visitor Center, New York Botanical Garden, Bronx Park. Hardy Holzman Pfeiffer Associates, 2004. View to the southwest. Benson. RBP

Conservatory.[141] The 16,400-square-foot pale pink Virginia brick building, inspired by eighteenth-century English orangeries, featured oversized arched windows and two octagonal rooftop lanterns and provided a 200-seat café and a room for private events. In 1998 the Botanical Garden opened the Everett Children's Adventure Garden, designed by landscape architects Miceli, Kulik, Williams & Associates, who worked from a conceptual plan by CLR Design.[142] The twelve-acre garden was organized as a series of outdoor "galleries," each designed by Van Sickle & Rolleri to provide hands-on activities and games dealing with subjects such as photosynthesis and plant pollenation. Other attractions at the Adventure Garden included whimsically shaped topiaries, mazes fashioned from hedges and boulders, interactive elements like water jets that could be activated by stepping on faux lily pads set into walkways, and Richard Dattner's William and Linda Steere Plant Discovery Center (1998), set at the edge of a two-acre wetland. The Discovery Center provided additional exhibits, a children's herbarium and laboratory, and a greenhouse in a gently curving 4,400-square-foot, timber-framed, Shingle Style building wrapped by a porch on the south side.

The Polshek Partnership's International Plant Science Center (2002), a 70,000-square-foot addition to the Museum Building, was the most physically imposing improvement to the Botanical Garden, providing a much-needed, modernized facility for the William and Lynda Steere Herbarium, the largest collection of preserved plant specimens in the Western Hemisphere.[143] Polshek's six-story addition, extending northward from the building's west wing, confronted Mosholu Parkway with an almost windowless seventy-eight-foot-long buff-colored precast-concrete facade that Polshek envisioned as a "vertical garden wall" symbolically expressing "the programmatic content of the building" and announcing "the Garden to the City beyond" while blocking from public view smaller incremental rear additions to the Museum Building.[144] A framework of vertical painted-steel fins crossed by horizontal rods, applied to the otherwise featureless facade, was

intended to create a "play of light and shadow" that expressed the "proportions and rhythms of the historic building's neoclassical order" while providing a framework for Virginia Creeper that would emerge from planters situated at the second-story level and spread across the building.[145] As Bradford McKee commented, Polshek's design suggested "a hard modern squint" at the Museum Building's exterior, resulting in an abstraction of its tripartite organization formed by the addition's rusticated base, vertical fins, and thin, blank attic-level frieze below a copper cornice.[146] Polshek further related his wing to the main building by providing two copper-clad bays—one on the west facade with strip windows built into it and the other on the narrow south facade—that made reference to the Museum Building's copper dome. Polshek also renovated portions of the Museum Building's interior, including the 2,600-square-foot entry hall and, most notably, the 18,500-square-foot LuEsther T. Mertz Library, which was in such bad shape, according to the architect, as to warrant "a work of unambiguously modern architecture."[147] Some elements of the old were retained, most notably the building's central thirty-six-foot-high rotunda, which was restored to provide a fourth-floor entrance to the library.

In 2004 Hardy Holzman Pfeiffer Associates completed the Leon Levy Visitor Center just inside the Conservatory Gate.[148] It contained a café, bookstore, garden shop, ticket desk, and orientation center in four buildings spread across a three-and-a-half-acre site and connected by bluestone pathways. Covered by gull-wing roofs of Western red cedar intended to evoke the Garden's rolling hills, the glass, steel, and stone structures were carefully situated so as not to disturb the root systems of the site's trees, some of which were exceptionally rare and old. When it was completed, Joseph Giovannini deemed the Visitor Center "the best structure" among the Garden's recent additions, helping to transform it from "a sorry, scraggly park . . . suburbanized with cars, parking lots, and dogs chasing Frisbees" into "what God would have done given the cash and a database." Giovannini was further pleased that, "rather than

imitate the Beaux-Arts arboretum in the estate, Hardy . . . modeled his structure after the long tradition of pavilions in the garden." The overall result, he concluded, was a building that "treads lightly in the landscape, delivering visitors with gentle persuasion into the garden it introduces."[149]

Just west of the New York Botanical Garden was Fordham University's eighty-five-acre Rose Hill campus, bordered by Southern Boulevard, East Fordham Road, and Webster Avenue. In 1994 the two institutions found themselves enmeshed in a serious disagreement over the future of Fordham's campus radio tower. Responding to Federal Communications Commission regulations seeking to reduce public exposure to radio frequencies, Fordham proceeded with plans to replace the antenna atop Keating Hall that had served its popular radio station, WFUV-FM, since 1947, with a freestanding, three-sided, 480-foot-tall, galvanized-steel tower elsewhere on campus.[150] Fordham determined that the best location would be the highest point on its own campus, a spot just across Southern Boulevard from the Botanical Garden's architectural pride and joy, the Enid A. Haupt Conservatory.

The New York City Buildings Department granted a permit for the tower in May 1994, and construction began shortly thereafter. But in July, by which time the structure had reached 260 feet and loomed all too visibly over the Conservatory, the Garden successfully petitioned the Buildings Department to force a halt in construction on grounds that the tower was more substantial than the aerial

the department had envisioned and was therefore subject to zoning regulations, which would allow a maximum height of 380 feet. The Botanical Garden argued against the height allowance, and a process of rulings and appeals, including a June 1996 decision by the New York State Supreme Court that the Garden would not suffer significant economic hardship were the tower to be completed, ensued. The most significant determination was to be made by the FCC, which, previously unaware of its requirement to do so, was belatedly performing an environmental review of the tower's impact on the Garden. Were it deemed harmless, work could proceed.

In October 1996, as Fordham awaited the FCC's decision, the Botanical Garden presented the university with an alternative radio tower design, commissioned from the Polshek Partnership, which worked with a Botanical Garden–hired broadcast engineer in determining WFUV's transmission requirements. Proposed for the same site, the tower took the form of a pair of 185-foot-tall telescopically tapering steel poles supporting a plaster cylinder containing the antenna. In the increasingly acrimonious debate, Fordham officials, awaiting the FCC ruling, called the proposal a stalling technique, while the Botanical Garden retorted that Fordham, which would be able to lease the radio tower to other broadcasters, was primarily interested in financial gain.

In 1997 the FCC ruled that the tower would have a negative impact on the Garden by "introducing an obtrusive visual element" to its landscape and suggested that the two

Enid A. Haupt Conservatory, New York Botanical Garden, Bronx Park. Renovation by Beyer Blinder Belle, 1997. View to the southwest showing Fordham University radio tower in background. McGrath. ESTO

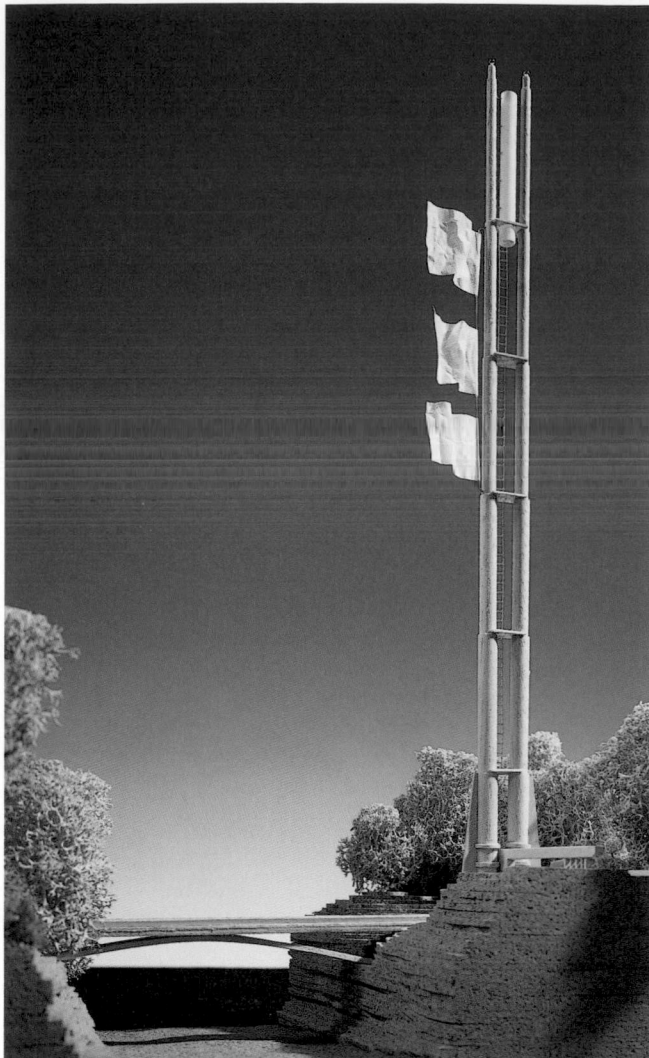

Proposed radio tower, Fordham University. Polshek Partnership, 1996. Model. Pottle. ESTO

parties negotiate a compromise.[151] But seven years of bickering ensued and no resolution was reached. At long last, in May 2004, as the unfinished tower marked its tenth anniversary at its highly contested location, officials of Montefiore Medical Center offered to accommodate a new radio tower on the roof of Montefiore II (Schuman, Lichtenstein & Claman, 1972), a twenty-eight-story staff residence hall at 3450 Wayne Avenue, between East Gun Hill Road and East 210th Street, a mile-and-a-half north of the Fordham campus in Norwood.[152] The offer was accepted by all parties, with the Botanical Garden agreeing to contribute funds for the uncompleted tower's dismantling and the preparation of the new site, requiring the relocation of the building's rooftop cooling system. The exceptionally slim 161-foot-tall antenna, allowing the station's signal to reach more than double the current population, was placed atop Montefiore II in September 2005, and seven months later the controversial tower was dismantled.

Fordham had a much easier time building the William D. Walsh Family Library (Shepley Bulfinch Richardson & Abbott and Buttrick White & Burtis, 1997), a significant addition anchoring the southwest corner of the campus at East Fordham Road and Third Avenue.[153] Named for an alumnus

donor, the five-story, 130-foot-tall facility housed roughly one million volumes and seating for 1,500 students behind its facade of randomly coursed fieldstone and limestone trim, which rose with numerous setbacks to a fifty-one-foot tower adorned with buttresses and finials in keeping with the historic campus architecture.

Just across the street from Fordham University, a prominently located, city-owned, 5.5-acre full-block site bounded by East Fordham Road, Washington Avenue, East 189th Street, and Third Avenue, had for decades sat vacant and strewn with litter. In 1980 Chase Enterprises, a Hartford-based developer, was chosen to build Fordham Plaza, a mixed-use building comprising 350,000 square feet of offices, 52,000 square feet of retail space, and a 500-car parking garage.[154] The largest speculative office building to date to be built in the Bronx and the first major office building to come to the borough since World War II, it was funded with the assistance of city, state, and federal grants and loans. Completed in 1986 to the designs of Skidmore, Owings & Merrill's Raul de Armas, Fordham Plaza, a thirteen-story cylindrical corner tower with two flanking wings that stepped back in two-story increments, was clad in yellow brick with black glazed brick accents and polished chrome trim above a two-story green marble base. The garage occupied a separate three-story structure behind the building. Although Fordham Plaza offered a caliber of office space unparalleled in the Bronx, including top-floor offices that commanded spectacular 360-degree views, the asking rents were double to triple the existing rents nearby, leaving half the office space vacant two years after the building's completion. It did however, succeed in revitalizing the retail scene around it.

Three blocks north, R. M. Kliment & Frances Halsband Architects' Primary School 54 (1999), 2703 Webster Avenue, between East 195th and East 197th Streets, served 622 prekindergarten through fifth grade students in a carefully proportioned and detailed rectilinear reddish brown brick and cast-stone building accommodating twenty-five classrooms and other typical school spaces.[155] Two entrances were provided—a main student entrance accessed by a through-block landscaped garden on the west side of the school facing a residential neighborhood, and a community entrance on the east side, off busy Webster Avenue. A large playground was located to the south of the building and a smaller one for the youngest children adjoined their classrooms on the west side of the school. Inside, each floor was treated with a different color palette rendered in patterned vinyl on the floor and structural glazed facing tiles on the walls.

This area of the Bronx was also home to four public schools built under the city's prototype school initiative: three by the firm of Perkins & Will and one by the Ehrenkrantz Group & Eckstut.[156] The latter firm, led by Ezra Ehrenkrantz, who had been an important contributor to California's School Construction Systems Development (SCSD) project, a similar effort to devise prototype schools in the early 1960s, situated gabled rowhouse-scaled buildings around enclosed courtyards to evoke collegiate quads. Each of the firm's three schools—P.S. 20 (1996), 3050 Webster Avenue, in the Bronx, P.S. 7 (1994), 80–55 Cornish Avenue, in Queens, and P.S. 43 (1995), Beach 29th Street and Seagirt Avenue, in Queens—consisted of two identical four-story, 550-student classroom wings flanking an administrative block providing a main entrance. A separate two-story special education module accommodated 100 disabled students, and

William D. Walsh Family Library, Fordham University, northeast corner of East Fordham Road and Third Avenue. Shepley Bulfinch Richardson & Abbott and Buttrick White & Burtis, 1997. View to the north. Goldberg. ESTO

Fordham Plaza, site bounded by East Fordham Road, Washington Avenue, East 189th Street, and Third Avenue. Skidmore, Owings & Merrill, 1986. View to the southeast. MDA

Primary School 54, 2703 Webster Avenue, between East 195th and East 197th Streets. R. M. Kliment & Frances Halsband Architects, 1999. View to the north. Aaron. ESTO

a fourth component housed a gymnasium and auditorium. Inside, classrooms were fitted out with gridded trellises suspended from the ceiling that allowed the spaces to be subdivided with curtains or decorated with banners and flags.

Perkins & Will's schools similarly incorporated four modules: a 300-student classroom building; a two-story lunchroom and auditorium building; a one-story gymnasium block; and a four-story "administrative/resource" building accommodating a library, offices, art, science, and computer labs as well as the main entrance marked by a protruding bay that rose above the roofline to form an operable bell tower. But in an implicit criticism of Ehrenkrantz's residential-scale approach, Aaron Schwarz, the partner in charge at Perkins & Will, purposefully decided not to design "a bunch of townhouses."[157] Instead, despite a vague bid to emulate Art Deco apartment houses, the Perkins & Will prototype seemed to Paul Goldberger like "a slightly taller version of 1940's or 1950's suburban schools. . . . While its suburban modernity

has a certain quaintness today, and is surely far better than a lot of the modern school design New York has seen, it is hardly the serious civic building" that the prototype school program's "partisans envision."[158] Of Perkins & Will's schools, including P.S. 23 (1992), 2151 Washington Avenue, and P.S. 279 (1992), 2100 Walton Avenue, P.S. 3 (1995), 2100 La Fontaine Avenue, was the most notable because of the unique treatment given to its entrance by artist Vito Acconci, who created an environmental artwork in which certain architectural components of the design were "visually folded down and reflected in the courtyard." As Acconci put it, "The walls that enclose the children inside become the ground that children walk over and play on outside."[159]

Norwood, an ethnically diverse and economically stable neighborhood in the northern portion of the Central Bronx, was the location of two important health care institutions: North Central Bronx Hospital and the Montefiore Medical Center, the latter expanding in 2001 with the completion of

LEFT Primary School 20, 3050 Webster Avenue, between East 202nd Street and Moshulu Parkway. Ehrenkrantz Group & Eckstut, 1996. View to the southwest. Ries. SRP

BELOW Primary School 23, 2151 Washington Avenue, between East 181st and East 182nd Streets. Perkins & Will, 1992. View to the northwest. Choi. CCAP

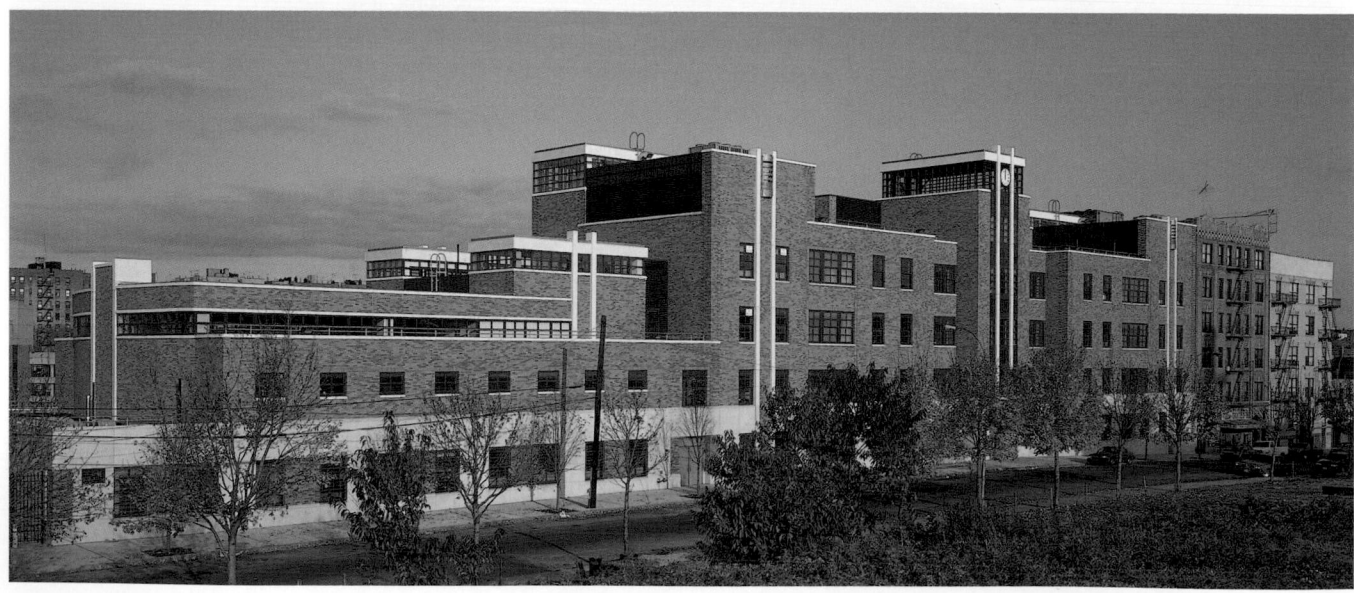

the Children's Hospital at Montefiore (Moed de Armas & Shannon, exterior; Rockwell Group, interiors), 3415 Bainbridge Avenue, a ten-story 155,000-square-foot facility offering among its many services a children's emergency room and trauma center and facilities for cancer treatment and organ transplants.[160] Moed de Armas & Shannon's sleek glass and aluminum curtain-walled building was composed of a five-story base, a deeply recessed sixth floor, and a more boldly detailed upper portion cantilevering back out over the base.

Intended to entertain and educate its patients while healing them, the hospital interior was designed according to the concept of family-centered care, which held that the presence of families—both physically in the hospital (patient rooms had pull-out sleeper couches) and as partners in the healing process—helped speed a child's recovery. The design was also inspired by the teachings of Carl Sagan, the astronomer and television personality who died in 1996. Sagan, who encouraged people to understand their place in the cosmos, was a close friend of the hospital's president, Irwin Redlener, whose original plans to include a Carl Sagan Discovery Center in the new facility, "evolved," according to the doctor, "to characterize the hospital itself."[161] David Rockwell, an architect specializing in entertainment venues, envisioned the young patients as "explorers on a journey to healing," with each child admitted issued an "explorer's passport," a wristband, trading cards featuring his or her picture, and an "explorer's kit" containing a compass, a kaleidoscope, and a periscope.[162] A large painted glass "galaxy wall" depicting a mural of the Milky Way with a *You Are Here* label identifying Earth was placed just inside the lobby, which included a second level downstairs. A bridge crossing over the lower lobby floor, curved to correspond with the circumference of the sun, was paved with floor panels inspired by Charles and Ray Eames's film *Powers of Ten* (1968). The panels depicted an increasingly magnified view of a child's world, from the first panel, which showed the entire planet, to the last one, showing a strand of DNA of a child's hand. The lower lobby's centerpiece was a Foucault pendulum designed by the sculptor Tom Otterness. The patient floors were decorated with specially commissioned artworks, each addressing a different theme. Patients were situated on floors according to age, not ailment, and rooms, instead of having numbers, were identified by a bumblebee or the Big Dipper, to name two examples. Each room featured window shades that, when lowered, depicted the Bronx during different time periods extending back to the dinosaurs.

Lehman College
Lehman College, opened in 1932 as the uptown campus of Hunter College and renamed in 1967 to honor Herbert H. Lehman, former governor of New York, occupied a thirty-seven-acre campus originally planned by Thompson, Holmes & Converse and Charles B. Meyers (1928), with four Gothic-style buildings and sprawling green lawns.[163] Conspicuously absent was a main building that would have been the college's focal point, and in 1959 Marcel Breuer & Associates' Shuster Hall was completed as a bland addition to its western edge.

In 1968 the college hired David Todd & Associates and Jan Hird Pokorny to collaboratively prepare a master plan, leading to the architects' design of two new buildings housing a library, concert hall, and speech and theater facility, as well

Children's Hospital at Montefiore, Montefiore Medical Center, 3415 Bainbridge Avenue, between East Gun Hill Road and East 210th Street. Moed de Armas & Shannon, exterior; Rockwell Group, interiors, 2001. View to the northwest. de Armas. MDA

Children's Hospital at Montefiore, Montefiore Medical Center, 3415 Bainbridge Avenue, between East Gun Hill Road and East 210th Street. Moed de Armas & Shannon, exterior; Rockwell Group, interiors, 2001. Lobby. de Armas. MDA

as the renovation of a third.[164] Construction began in 1973, was halted in 1975 during the fiscal crisis, resumed in 1977 with the help of a loan from the New York State Dormitory Authority, and was completed in 1980. Todd and Pokorny strategically situated the new library and concert hall in a single, elongated building that stretched along the eastern edge of the campus on Paul Avenue to effectively close it off from adjacent train yards and at the same time define a campus quad. The skylit library wing, banded in dark tinted glass and limestone, occupied the southern half of the structure, and the three-story-high concert hall, containing a 2,318-seat asymmetrical performance space, occupied the northern half, a fan-shaped volume that funneled people onto the campus. Todd and Pokorny converted the largest of the original structures, the former student union, to use as a music building, adding on the north side a new Speech and Theater Building that contained additional performing arts facilities, among them an experimental theater seating 200 and a 500-seat theater with steeply raked floors.

Architecturally, the most significant addition to the Lehman campus, and one of the boldest buildings completed in New York in many years, was Rafael Viñoly's Herbert H. Lehman Physical Education Facility (1994).[165] At Viñoly's insistence, the college reconsidered the building's site, a small parcel at the northeast corner of the campus once slated for a partially subterranean gymnasium designed by Conklin Rossant, because according to Viñoly partner Jay Bargmann, it "would have forced a high-rise solution."[166] Instead, Viñoly called for the opposite: a low-lying, 608-foot-long building that spanned the entire north end of the campus, forming a gateway from Bedford Park Boulevard West, where many students arrived by subway and car. The 165,000-square-foot building contained a 1,300-seat gymnasium for basketball, an Olympic-size swimming pool, a secondary gymnasium with a mezzanine running track, racquetball courts, gymnastics rooms, dance studios, fitness and locker rooms, classrooms, and offices.

The building's defining feature was its roof—carapace-like, curving, supported by steel trusses, clad in mill-finished stainless steel, and segmented into three sections to allow light in through clerestory windows. At 101 feet wide, the roof made the building seem "more like geography than architecture," according to Viñoly.[167] The underside of the roof was painted white and left exposed inside, supported by

View to the north of Lehman College, campus bounded by West 195th Street, Reservoir and Goulden Avenues, Bedford Park Boulevard West, and Paul and Jerome Avenues. View to the northeast showing library and concert hall (David Todd & Associates and Jan Hird Pokorny, 1980) on the right and Herbert H. Lehman Physical Education Facility (Rafael Viñoly, 1994) in middle distance. Goldberg. ESTO

Speech and Theater Building, Lehman College. David Todd & Associates and Jan Hird Pokorny, 1980. View to the east. Motzkin. JHPA

Herbert H. Lehman Physical Education Facility, Lehman College. Rafael Viñoly, 1994. View to the northwest. Goldberg. ESTO

Herbert H. Lehman Physical Education Facility, Lehman College. Rafael Viñoly, 1994. Swimming pool. Goldberg. ESTO

thin reinforced-concrete columns that, for Herbert Muschamp, created an "archaic" effect: "Like a Corinthian colonnade, it evokes the canopy of foliage spreading from a tree trunk."[168] On the campus side of the building, the roof cantilevered ten feet past the exterior wall and arced toward the ground, providing a sun screen.

The Lehman gym was pierced by College Walk, the campus's tree-lined longitudinal axis, which Viñoly's design acknowledged by cutting away a portion of the roof. The architect called the resulting plaza below the "mouth piece."[169] The rather severe precast concrete and glass north facade, described by Muschamp as being "as glum as the

front is radiant," featured four flagpoles flanking the entry point. A second-story glass-walled trophy hall spanned the entrance to connect the building's two wings, which were also linked underground. Despite some reservations, Muschamp praised Viñoly's "ravishingly fluid design"[170] whose "point" seemed to be "the classical belief that the human form lies at the root of the idea of beauty. Mr. Viñoly employs no caryatids or Ionic orders to render this ancient concept. Rather, he integrates engineering and esthetics into one impeccably toned physique. . . . While it contains no overtly symbolic forms, the entire building displays athletic poise under gravity's pressure."[171]

Riverdale

Purchased as a summer retreat in 1852 by five wealthy businessmen but developed soon thereafter as a suburban enclave featuring a street plan by Frederick Law Olmsted adopted in 1877, Riverdale was best known for the stylistically eclectic detached single-family homes that proliferated immediately before and after World War I.[172] The construction of large apartment buildings, beginning in the 1920s but dramatically escalating in the period following World War II, threatened Riverdale's suburban character. Although high-density apartment construction slowed considerably in the 1970s and after because few sites remained, what was built was largely undistinguished, even when the aim was to produce luxury accommodations. Replacing the threat posed by high-rise apartment houses was the specter of proliferating single-family houses built on lots created by parceling the remaining estates.

In 1977 Columbia University announced its intention to sell the Edward C. Delafield residence, a nineteenth-century mansion built as Fieldston Hall (renovated and expanded by Dwight James Baum, 1916), and the eleven lushly landscaped acres it sat on, bounded by Hadley Avenue, West 240th Street, Douglas Avenue, and West 247th Street.[173] The property had been bequeathed to Columbia in 1965 with the intention that the university would establish an arboretum, but the project was beyond the university's financial capabilities. The sale was subject to the purchasers, a firm of developers, getting community approval for their plan to use the house as a club and surround it with seventy-two low-rise condominiums. Twice before, the university had tried to sell the property, but developers' plans for high-rise structures failed to gain community support. The neighbors were not very happy with the new plan either. The real issues were environmentalism and, of course, growth, with many neighboring residents demanding the estate's preservation as a park. On December 27, 1977, the City Planning Commission, in a surprise vote, rejected the plan for seventy-two houses, basing its action on a belief that it was too damaging to natural features of the site.

In April 1980, a sale of the land to a subsidiary of the Miller Buckley group, a London-based investment and development company, was reported, and a plan for thirty-two condominiums, three of which were to be in the mansion, was filed with the City Planning Commission.[174] James Stewart Polshek and his partner, Peter Gluck, of the newly formed but short-lived firm of Polshek, Gluck & Associates, were chosen to design the houses. According to Gluck, they would have "traditional faces, facing the road, evocative of the shingle style of American architecture of the late nineteenth century," but the rear elevations would be "more contemporary."[175] The plan won the support of many environmentalists, including some of the leaders of the Friends of the Greenbelt, a group founded in 1977 to oppose the earlier plan. City officials credited the low density of the proposal as a key selling point to the community. In 1981 the developer successfully acquired the property from Columbia and by 1984, as construction was proceeding on the first phase of eleven houses, Delafield Estates, as the project was named, was being promoted as an "ultra-exclusive residential enclave."[176] The single and attached homes, ranging in size from 3,900 to 5,000 square feet, were situated to preserve as much as possible of the site's topography and natural features, including many of its 256 trees. The City Planning Commission demanded that the Belvedere lawn,

to the north of the mansion, be preserved, leading to a plan to excavate a parking garage beneath it. Houses adjacent to the lawn would feature elevators providing direct access to the parking spaces. Polshek grouped the houses in "clusters to give them a sense of identity with their immediately adjacent landscape features." Seeking a "formal expression that would feel natural in Riverdale," he called for a "community of 'stage set' half-timber and stucco Tudor mansions" with long vertical windows that, "while relating to one another, [were] able to express an individualism that would certainly be desired by their owners."[177] Although the carriage house was renovated, a prototype house completed, and four other houses built—two of which were inspired by the Polshek unit but not designed by the architect—the development was never fully realized. In 1994 the mansion was destroyed by fire.

The future of the mansion at 640 West 249th Street, on the corner of Independence Avenue, a 24,000-square-foot Tuscan villa designed by Dwight James Baum (1922) for the luxury apartment house developer Anthony Campagna and singled out in 1939 by the Federal Writers' Project as "one of the finest villas in the East," was called into question in 1988 when Daymon Associates, a Manhattan-based food brokerage company, proposed to convert it for use as its corporate headquarters.[178] Sixty employees were to work at the site, and a thirty-eight-car gravel parking lot—not visible from the street—was to be built somewhere on the three-and-a-half-acre property. Opponents waged an intense campaign to derail the project and, coinciding with the designation on October 16, 1990, of the Riverdale Historic District, encompassing either side of Sycamore Avenue between 252nd and 254th Streets, they began to lobby for the Campagna estate's designation, which was granted on November 16, 1993.[179]

Daymon Associates withdrew their plan and in 1993 the mansion was sold to the Yeshiva of Telshe Alumni, an Orthodox Jewish boarding school that already occupied a Tudor mansion across the street on Independence Avenue and planned to consolidate its facilities in that and the Campagna estate, which was intended to provide space for dormitories, classrooms, and a prayer room.[180] The school hired Beyer Blinder Belle to design a combination of new buildings and renovations. The firm presented its scheme in May 1994, calling for two new stylistically complementary buildings running parallel to each other on either side of a sunken garden at the rear of the villa and rising to a height eighteen feet below the villa's roofline. The eastern wing featured a slightly higher roof than the western one, as well as a cupola with a spire extending to the height of the mansion's roof. The wings would be connected to the mansion by a subterranean passage, and the sunken garden itself would remain untouched. Opponents were plentiful, including the Municipal Art Society, the Riverdale Nature Preservancy, and the neighboring Wave Hill, whose chairman, David Beim, was "alarmed at the massive scale" of the proposed additions.[181] Beyer Blinder Belle revised the scheme to address the community's concerns, and the new proposal, calling for a one-story wing on the west edge of the sunken garden, a two-story wing on the eastern edge, and a two-and-a-half-story building to the east of the mansion, was approved in July 1994 by the landmarks commission, with the Municipal Art Society calling it "a distinguished solution to a demanding problem."[182] The Riverdale Nature Preservancy remained "disappointed."[183]

The project was delayed, however, and changes to the plan eventually saw to the cancellation of all but the low building on the east side of the sunken garden.

At Wave Hill, an estate and public garden occupying twenty-eight acres along the Hudson River at West 252nd Street, Robert A. M. Stern Architects' Perkins Visitors Center (2004), providing a garden interpretation center, a gift shop, and visitor amenities, was built on the site of a turn-of-the-century garage attributed to Heins & LaFarge, located between the 1843 Wave Hill House and the 1927 Glyndor House.[184] The garage, damaged by fire, was incorporated into the new center, which provided the first such facility for Wave Hill since its opening to the public in 1970. The garage's brick exterior was exposed, cleaned, and repointed, and a new entry pergola was added along with a slate hipped roof with a copper-clad skylight. Stern replaced a banal 1930s addition to the garage with a board-and-batten building for the horticultural staff that wrapped around a service yard to shield service vehicles from visitors' view.

Riverdale's private institutions continued to grow during the late twentieth century. Among them was the Hebrew Home for the Aged, 5901 Palisade Avenue, south of West 261st Street, which added to its nineteen-acre campus of Gruzen Samton–designed buildings begun in 1968 with the Goldfine Pavilion and continued in 1975 with the Palisade Nursing Home.[185] Gruzen's Alma & Milton Gilbert Pavilion (1987), a rather severe three-story red brick building, provided 30,000 square feet of space for new dining rooms and recreational facilities. The same firm's Resnick Stolz Link Pavilion, completed in 1999, served a similar purpose in a more playfully historicist gabled, belvedere-topped, red brick structure whose massing falsely implied a Greek cross plan.

Riverdale Terrace (2000), also designed by the Gruzen firm for the same organization, was a seven-story red brick building with fifty-eight 540-square-foot residences rising on a 125-by-100-foot lot at 3247 Johnson Avenue, near West 235th Street, close to the heart of Riverdale's commercial district.[186]

Gruzen Samton also designed a major addition to the Horace Mann School, 231 West 246th Street.[187] The firm prepared a master plan for the eighteen-acre campus and in 1999 completed two new buildings that echoed the Collegiate Gothic style of the school's principal building, Tillinghast Hall (Edgar A. Josselyn, 1913). The 55,000-square-foot Fisher Hall housed music and performance facilities, a 225-seat recital hall, a choral room, art studios, and student and faculty dining halls. The fan-shaped building featured a clock tower and was positioned at the top of its hillside site at the northeast corner of the campus quad. To the rear, the building stepped down the steep hill with a long glass-enclosed staircase running along the outside wall of the building, taking advantage of sweeping views. The new 36,000-square-foot, red brick middle school building, Rose Hall, was linked to the renovated Pforzheimer/Gratwick Hall (Victor Christ-Janer, 1956; renovation and expansion, Frost Associates, 1975), providing classrooms and an atrium lounge lit by large clerestory windows. A gabled roof rose at the center of the building's two-story facade.

Bronx Developmental Center

Despite the optimism generated by the rejuvenation of the Bronx, fueled in large part not just by an increase in building activity but by the impressive quality of the new buildings, there was one new piece of construction that was decidedly not welcomed by all, one that would lead to the loss of the borough's most celebrated example of Modernist architecture:

Richard Meier's Bronx Developmental Center (1970–77), located on a featureless, 18.5-acre site in the Pelham Bay section at 1200 Waters Place, between the Penn Central Railroad right-of-way and the Hutchinson River Parkway.[188] At the time of its completion, Ada Louise Huxtable had declared the complex, planned as a total-care residential facility for 750 children with physical and mental disabilities, "the cynosure of the architectural world,"[189] and the editors of the *AIA Guide* praised it as "a consummate work of architecture . . . sure to be ranked among the great buildings of its time."[190] Still, the controversial, dauntingly abstract design was criticized by many as too severe, with an obsessive purism inappropriate for a facility designed to serve mentally disturbed children and their families. Several features of the complex, such as open-tread stairs, open railings, and an open bridge, were regarded by mental health professionals as ill suited to the institution's program.

In November 1999, the state-run facility was put up for sale by the Empire State Development Corporation. Closed since 1992, the complex had been allowed to seriously deteriorate over the years, particularly when maintenance budgets

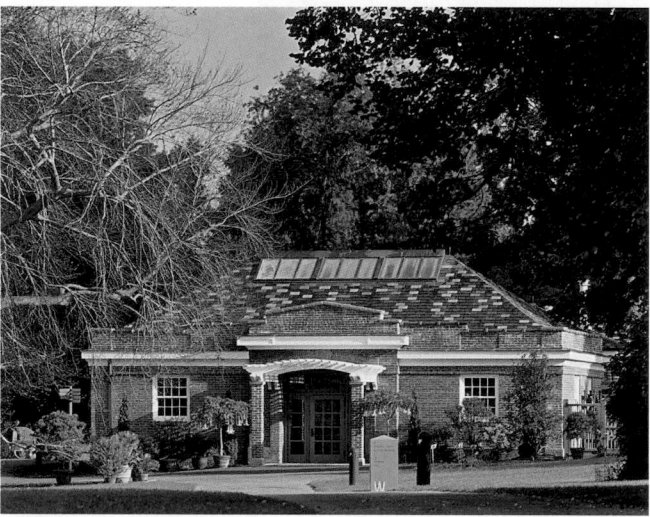

Perkins Visitors Center, Wave Hill, Hudson River at West 252nd Street. Robert A. M. Stern Architects, 2004. View to the north. Aaron. ESTO

Resnick Stolz Link Pavilion, Hebrew Home for the Aged, 5901 Palisade Avenue. Gruzen Samton, 1999. View to the northwest. Ries. SRP

were slashed as the patient population dramatically declined beginning in the mid-1980s. In 1990, in an attempt to revitalize the underutilized center, which by that time served only 125 patients, the Urban Development Corporation commissioned the Stein Partnership to study alternate uses, including the possibility of converting it into housing for health workers in nearby medical complexes.[191] Nothing came of the Stein Partnership's report, nor did anything result from Bronx Borough President Fernando Ferrer's recommendation, delivered in a January 1998 speech, that the complex be turned into a biomedical science park.[192]

In May 2000, six months after the Bronx Developmental Center was put up for sale, the state accepted the $3.7 million bid of the New Rochelle–based Simone Development Companies to radically alter Meier's complex, converting the facility into Class A office space.[193] The sale, which went unreported in the press, was completed a year later, on May 23, 2001. By the time the story first hit the papers in February 2002, work had already begun on the Newman Design Group's redesign, which called for the retention and restoration of a large landscaped courtyard and the glassy bridge that crossed it, but the complete gutting of the interiors, and on the exterior, the replacement of the "natural"-finish aluminum cladding by white aluminum panels with conventional office windows. The complex was also significantly expanded because, as developer Joseph Simone explained: "The floor plates do not work for anything except maybe a dormitory and psychiatric center."[194] Plans for the Hutchinson Metro Center, as the new complex was called, also included a second phase with three new buildings, culminating in a 1.2-million-square-foot office park, which would make it the largest such facility in the Bronx.

Reaction in the architectural community was mostly one of amazement. According to Theo Prudon, president of DOCO-MOMO, a group committed to the preservation of modern buildings: "It slipped by everyone's radar screen."[195] Robert Stern called the news "a shocker." Referring to the tragic loss of the World Trade Center five months earlier, he observed that "this is a monument of exactly the same period. This is serious."[196] But there was very little that anyone could do—the Landmarks Preservation Commission was stymied by the fact that the building was too young to be considered for designation. Richard Meier, also caught off guard, was irritated that both the developer and the architect had failed to consult him before beginning work, stating that "it's interesting to me that they never come back to the original architect."[197]

Faced with such criticism, a spokesperson for the developers responded: "A small but vocal group of critics has come out against the plan. Where were these people over the past three decades while the state of New York allowed this architectural gem to deteriorate before their eyes?"[198] Government officials were not so apologetic, with Governor Pataki applauding the Simone Development Companies's proposal, which would create an estimated 300 construction jobs. In July 2003, Edwin McDowell reported in the *New York Times* on "a gleaming white Class A office building . . . nearing completion," with the first tenants moving in within a month.[199] While waiting for additional tenants before proceeding with the three new office buildings of phase two, Simone Development also announced plans for a 150-room hotel and conference center on the site, uses that might well have been accommodated by Meier's now-destroyed building.

ABOVE Horace Mann School, 231 West 246th Street. View to the northeast showing Rose Hall (Gruzen Samton, 1999) on the right and Fisher Hall (Gruzen Samton, 1999) on the left. Mauss. ESTO

LEFT Fisher Hall, Horace Mann School, 231 West 246th Street. Gruzen Samton, 1999. View to the northwest. Mauss. ESTO

STATEN ISLAND

Encompassing sixty square miles, or roughly two-and-a-half times the size of Manhattan, Staten Island was the least populous of the city's boroughs. The construction of the Verrazano-Narrows Bridge (Othmar Hermann Ammann, 1964)—which connected Bay Ridge, Brooklyn, with Fort Wadsworth, on the northeastern side of the island—radically transformed Staten Island almost overnight.[1] The semirural backwater became the scene of intense development activity as speculation dramatically raised land values, and acre after acre of the borough's still-open countryside was subdivided to make way for ill-planned, ill-designed, but distinctly affordable one-, two-, and three-family houses located on small lots. Although the city seemed to turn a blind eye to the frenzied building boom, nearly 1,800 acres of the so-called greenbelt—a chain of contiguous parks, private camps, and a country club that ran roughly north–south along the island's central wooded ridge—were saved from development pressures as well as from a plan for a high-speed roadway, Richmond Parkway.

The residential building boom that began with the opening of the Verrazano-Narrows Bridge continued unabated in the late 1970s and 1980s as innumerable townhouse developments and modest apartment houses were added to the mix of housing types built on the island. James Barron reported in the *New York Times* that in 1978 Staten Island led the state in the construction of new single-family houses and condominiums, with the majority of the activity concentrated in small-tract developments in the center of the island. At an economically sluggish time, as Robert Wieboldt, executive vice president of the New York State Builders' Association, put it, "Staten Island is the only place that's really going gung ho."[2] In 1982 Staten Island accounted for 10 percent of all homes being built in the state, and 65 percent of the new units were so-called mother-daughter houses, typically three-story buildings with an extra room and bathroom that could be rented out.[3] Four years later, Alan S. Oser could see no end to the boom, writing that "the pace of development is as swift as it was in the 1960's."[4] At the end of the decade, even with the collapse of the real estate market following the October 1987 stock market crash, the pace of new construction on Staten Island remained strong, expanding beyond the center of the borough, especially along the South Shore.

Although the net growth of 22,000 housing units between 1980 and 1990 made it the city's leader in the percentage of new residents, Staten Island still accounted for only 5 percent of New York's overall population. Moreover, as the city's population became increasingly nonwhite, and despite a jump in the number of blacks, Hispanics, Asians, and other minorities moving to Staten Island, the borough was still nearly 80 percent white, according to the 1990 census. Many of its predominantly lower-middle-class and middle-class residents felt little connection to their fellow New Yorkers, believing they had more in common with those living in nearby suburban communities in New Jersey or on Long Island. This alienation found its expression in the November 1993 election, when a nonbinding resolution calling for the borough's secession from the city was approved by 65 percent of the borough's voters.[5] Nothing, however, came of the referendum.

In the building boom of the 1980s, the vast majority of new housing projects were as undistinguished as those that

Port Regalle, overlooking Great Kills Harbor, between Wiman and Nelson Avenues. John Ciardullo Associates, 1988. Site plan. JCA

had followed the completion of the Verrazano-Narrows Bridge. There were, however, a few exceptions, including John Ciardullo Associates's 340-unit Port Regalle (1988), a townhouse development located in the Great Kills section on a thirty-eight-acre waterfront site overlooking Great Kills Harbor between Wiman and Nelson Avenues.[6] Less than a mile from the federally protected Gateway National Recreation Area, the South Shore site was previously home to two marinas, a handful of vacant lots, and eighteen summer cottages. Ciardullo's design, with its red-tile roofs and exterior walls finished in peach-colored stucco, was massed to resemble a Mediterranean hillside fishing village. The upscale development of attached three-story buildings included terraces, private and community gardens, and a waterfront esplanade. Port Regalle also provided a 300-slip marina for condominium owners, a particularly welcome amenity, since there was a long waiting list to obtain one of the existing, 1,000 boat slips on Great Kills Harbor.

At the other end of the economic spectrum, there were few projects on Staten Island, at least compared with the rest of the city, that participated in one of the many public-private

Port Regalle, overlooking Great Kills Harbor, between Wiman and Nelson Avenues. John Ciardullo Associates, 1988. View to the southeast. Lieberman. JCA

initiatives designed to promote first-time home ownership among moderate-income citizens. Stephen B. Jacobs acted as both architect and developer for one of these, the 190-unit Heron Pond (1988), located on a twelve-and-a-half-acre North Shore site in the Arlington section, just west of Arlington Avenue and near the Goethals Bridge.[7] Planned in collaboration with the nonprofit New York City Housing Partnership, whose aid helped to keep down the cost of acquiring the site, the two-and-a-half-story attached townhouses featured clapboard siding and wooden porches.

Staten Island boasted the city's highest percentage of single-family houses, which continued to be built in significant numbers, averaging more than 100 custom-designed houses a year throughout the 1980s.[8] Although many, especially in the affluent areas of Grymes Hill and Todt Hill, were quite large and sometimes in questionable taste—like Mafia kingpin Paul Castellano's 16,000-square-foot version of the White House on Benedict Road in Todt Hill—Alfredo De Vido's 6,500-square-foot wood-frame brick house (1988) on a quarter-acre lot was a cut above the typical product, an inward-looking design with rooms grouped around a central toplit space to provide privacy.[9]

The most significant development of detached single-family homes was built on a portion of the former 300-acre Todt Hill estate of architect Ernest Flagg.[10] Known as Stone Court, Flagg's property, which was divided after his death in 1947, included a Dutch Colonial main house (1898) surrounded by French Norman outbuildings built between 1898 and 1917. Also on the property were a number of small suburban houses, or "cottages," designed and built by Flagg at his own expense in the late teens and 1920s. He intended these to be exemplars of a standardized system of construction that would become a model for future developers, publishing his ideas in his 1922 book *Small Houses: Their Economical Design and Construction*.[11] In 1982 Sanford Nalitt, a developer born and raised on Staten Island, purchased eight acres of the Flagg estate from its owner, St. Charles Seminary, with the intention of dividing the property into twenty-eight building lots. The religious order would remain headquartered in Flagg's mansion, which had been designated a landmark in 1967. A year after purchasing the property Nalitt was forced to adjust course when the Landmarks Preservation Commission extended the designation to include a total of

Copperflagg Estates, site bounded by Richmond, Four Corners, and Todt Hill Roads. Robert A. M. Stern Architects, 1983–89. Site plan. RAMSA

Copperflagg Estates, site bounded by Richmond, Four Corners, and Todt Hill Roads. Robert A. M. Stern Architects, 1983–89. View to the southeast. RAMSA

nine-and-a-half acres surrounding the main house. Nalitt hired Robert A. M. Stern Architects to prepare a master plan for Copperflagg Estates (1983–89), a twenty-two-house development that would include buildings both within and outside the landmarked area. By focusing beyond the design of the individual house, Stern believed he could create "a sense of place where individuality, community and the natural landscape coexist." Noting that planned suburban design was a field largely abandoned by architects to speculative developers, the architect felt it was still possible "to produce that rich diversity within order that has always been the glory of America's suburbs."[12]

Along the approach to Flagg's mansion and within the confines of the landmarked area, Stern designed seven houses in the spirit of Flagg's French Norman buildings. They surrounded a formal garden providing a communal focus that was created in the basin of an abandoned swimming pool. On the remainder of the site, Stern drew up design guidelines for houses on quarter-acre lots, suggesting a rich variety of possible styles, including Georgian, Arts and Crafts, Dutch Colonial, Federal, and Regency. The first building to be completed was a model house at 16 Flagg Court (1984), a fieldstone-and-stucco design intended to evoke the rustic sophistication and picturesque character of Flagg's cottage-style work. In the 1980s nine houses abutting the landmark area were built, five of which were designed by Stern and the remainder realized by Calvanico Associates, Charles M. Aquavella, Di Fiore & Giacobbe Architects, and Joseph Morace.

Steven Holl produced two unrealized residential schemes for Staten Island sites, beginning in 1980 with a 2,154-square-foot house designed for the Metz family, a young couple who were artists and their teenage daughter.[13] Located on a thickly wooded half-acre site near a forested ravine, Holl adopted a U-

shaped plan for a program that was organized around an inner courtyard. The front facade was composed of colored concrete blocks, the courtyard was painted white to maximize light, and the sidewalls were painted black for the clients, who expressed a distaste for the surrounding suburban imagery. Although David Childs, sitting on a jury convened by *Progressive Architecture*, conceded that the scheme "may be literary and poetic," he failed to "see it as a strong piece of architectural design. It's unattractive. I don't think it's real. It's full of witticism and conceit." But Thomas Beeby found the design's "awkwardness . . . quite beautiful" and Michael Graves added that "it's homely and bizarre and quite masterful."[14] Holl's more ambitious Autonomous Artisans' Houses (1980–84) was intended to provide both living and work space for craftsmen in a variety of disciplines.[15] An existing warehouse would be converted to shared studio space, with seven houses lined up in a row against the warehouse wall and separated from each other by gardens. The long, narrow houses were each given a unique treatment based on the occupant's speciality; for example, a brick barrel-vault roof for the mason, an etched-glass roof for the artist who worked with glass, a tin pyramid topping the tinbender's home, and a boatlike structure on the second level of the woodworker's house.

In addition to new housing, there was one significant residential adaptive reuse project completed in Tompkinsville, about a ten-minute walk south of the St. George ferry terminal, which provided service to lower Manhattan. Bay Street Landing (1982), located on a thirty-five-acre waterfront parcel at the foot of a fifty-foot cliff beneath Bay Street, involved the renovation by architect Albert Melniker of six- and seven-story former cocoa and coffee warehouses, built between the 1880s and 1920s and empty for more than a decade, to create 134 loft apartments.[16] Five years after the first apartments opened, the complex expanded when David Kenneth Specter & Associates completed work on 131 lofts. In addition to the new housing, the Bay Street Landing project included the reconstruction of four dilapidated 1,000-foot-long piers for use as a 600-boat marina.

Despite the success of Bay Street Landing, the St. George waterfront remained a comparatively sleepy place well into the 1990s. More often than not, tourists and Manhattan day-trippers who decided to enjoy a boat trip on the Staten Island Ferry to take in the spectacular views of the harbor, lower Manhattan skyline, and Statue of Liberty, found little reason to disembark and explore the immediate neighborhood. Staten Islanders also failed to linger, quickly hustling from the ferry terminal and its bus and rail connections to homes across the island. The Department of Transportation attempted to improve the area in 1996, commissioning under the Percent for Art Program artist Siah Armajani's lighthouse and bridge south of the ferry terminal in a new public plaza, the North Shore Esplanade, designed by landscape architects Johansson & Walcavage.[17] The Iranian-born Armajani fashioned a sixty-five-foot-tall openwork lighthouse out of steel and wood painted gray, with accents of green and orange, topped by a reddish-gold glass lamp equipped with a 1,000-watt light. The sixty-five-foot-long bridge, which incorporated excerpts from Wallace Stevens's poetry in small brass letters placed on the framework, provided pedestrian access from the upper-level bus ramp to the esplanade. Johansson &

ABOVE Proposed Metz house, Staten Island. Steven Holl, 1980. Sectional perspective. SHA

BELOW Proposed Autonomous Artisans' Houses, Staten Island. Steven Holl, 1980–84. Rendering. SHA

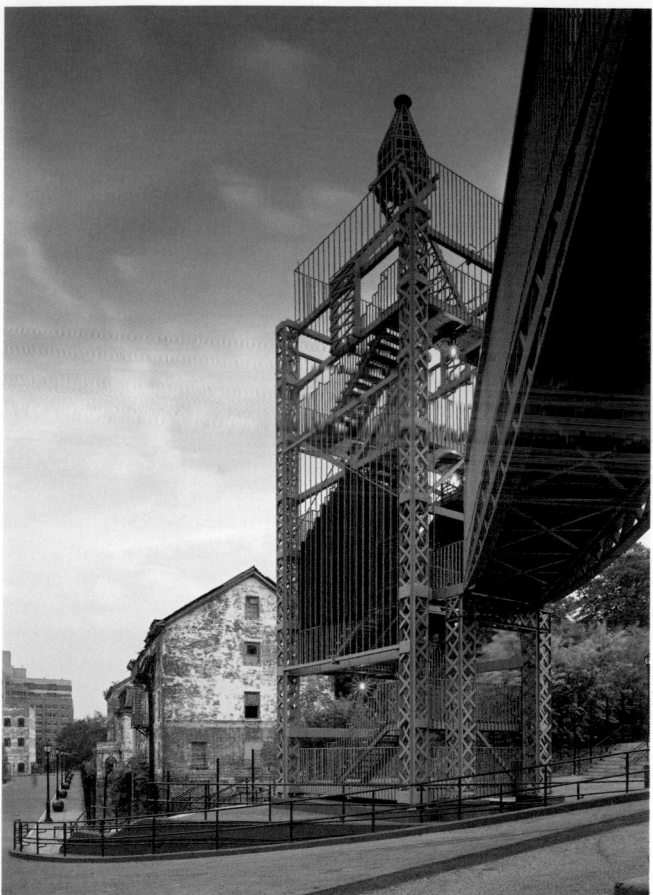

Lighthouse and bridge, North Shore Esplanade. Siah Armajani, 1996.
View to the south. Heinrich. HP

Walcavage's half-mile-long North Shore Esplanade, varying in width from sixteen to 130 feet, incorporated into its plan three dozen honey locust trees, benches, granite tables topped with chess boards, decorative red buoys, and planting beds bordered by pale pink granite slabs that provided additional seating.

In February 1997, the city announced more extensive plans for the St. George waterfront, releasing a striking scheme of twisted, folded planes designed by Peter Eisenman for a combined new ferry terminal and home for the Staten Island Institute of Arts & Sciences, replacing the existing rundown, red brick terminal (Madigan-Hyland, 1951).[18] Eisenman's challenging design, developed in collaboration with Hellmuth, Obata & Kassabaum, placed the ferry terminal beneath a 170,000-square-foot museum that would provide new facilities for the 116-year-old Institute of Arts & Sciences, currently headquartered in a two-story Georgian building (Robert W. Gardner, 1918) located a few blocks away at 75 Stuyvesant Place, northeast corner of Wall Street. Eisenman's avant-garde, computer-generated design, described by the *Washington Post*'s art and architecture critic, Benjamin Forgey, as "a brilliant concatenation of curved and angled slices of metal and concrete,"[19] was strongly promoted by Staten Island Borough President Guy Molinari, who stated, "This is probably one of the most exciting proposals that I have ever been involved with. This is going to be a showcase for us, the gateway to Staten Island."[20] Ironically, it was to a considerable extent Molinari's strenuous objections to the provocative nature of Venturi, Scott Brown & Associates's design for a new ferry ter-

minal on the Manhattan side that had scuttled that project.

Herbert Muschamp strongly supported the Eisenman/HOK ferry terminal and museum as a way to expand development beyond Manhattan, noting that in other cities, particularly Paris and Barcelona, "planners understand that new buildings can play a critical role in stretching the urban horizon beyond the dense central core." Declaring the effort the "most innovative civic project to go forward in New York in more than a generation," Muschamp also believed it was Eisenman's "most buoyant" design. The critic was particularly impressed with the "large, translucent roof of faceted, whirling contour. Viewed from the water, the roof recalls the weatherman's pinwheel sign for a hurricane. Formally, it recalls the sinuous metal roof of the convention center Eisenman designed for Columbus, Ohio." The roof would be composed of Kevlar, a light but very strong synthetic compound that would also clad the ferry terminal. Muschamp also praised the open, undulating interior spaces, writing that they "should be a marvel, comparable in sculptural strength to the great vaulted spaces of Eero Saarinen's T.W.A. Terminal at Kennedy International Airport."[21]

Progress on the combined terminal and museum soon stalled. In 1999, two years after it was first announced, the city decided to separate and reduce the projects, proposing that a slightly smaller home for the Institute of Arts & Sciences, still to be designed by Eisenman, be built adjacent to the existing St. George Ferry Terminal, which would be extensively renovated by HOK. Adding to the mix planned for the waterfront, HOK would also be responsible for a new minor league ballpark affiliated with the New York Yankees to be located north of the reworked ferry terminal. Although Eisenman's museum project failed to move forward, HOK's renovation of the ferry terminal did progress after groundbreaking on September 6, 2001, although it was subject to delays associated with budget cutbacks following the Trade Center attack five days later.[22] HOK's plans for the 190,000-square-foot ferry terminal (2005), about 20,000 square feet larger than the previous facility, provided a more open, glassier design with extensive use of outdoor spaces, including 100,000 square feet of new terraces on a two-level plaza. HOK was prevented from increasing the size of the 161-by-98-foot main waiting room but raised the roof five feet on the land side and twenty feet facing the harbor where a new aluminum and glass curtain wall took better advantage of the water views and brought in abundant natural light.

Much quicker progress was achieved on the new baseball stadium for the New York Yankees Single A farm team.[23] The project was championed by Mayor Giuliani, a committed fan whose efforts also led to the construction at the same time of a minor league ballpark affiliated with the New York Mets on Coney Island. As realized by the sport, venue, and event division of HOK, the spare design of the 7,170-seat Richmond County Bank Ballpark at St. George (2001), memorializing a local bank that purchased the naming rights, deferred to its dramatic waterfront setting and views of the lower Manhattan skyline. The stadium included nineteen luxury suites accommodating sixty fans, a souvenir shop, and a 1,100-car parking lot, and was also intended to host concerts and other events during the off-season.

Although the Staten Island Institute of Arts & Sciences remained headquartered in its modest facilities in St. George, other arts institutions sharing the same central administration

ABOVE Proposed Staten Island Institute of Arts & Sciences and Ferry Terminal, St. George waterfront. Peter Eisenman and Hellmuth, Obata & Kassabaum, 1997. Rendering of view to the northeast. EA

MIDDLE LEFT Proposed Staten Island Institute of Arts & Sciences and Ferry Terminal, St. George waterfront. Peter Eisenman and Hellmuth, Obata & Kassabaum, 1997. Site plan. EA

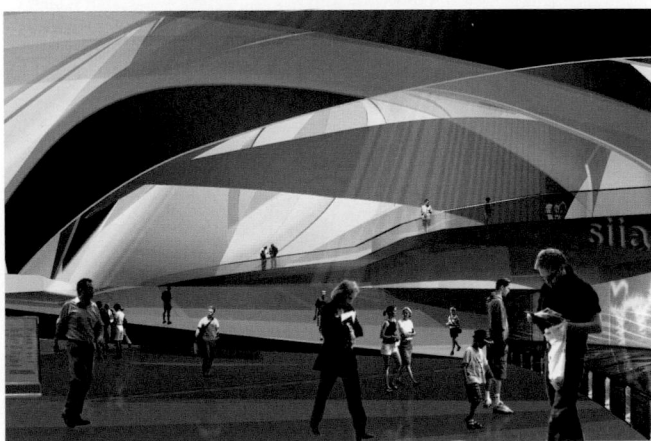

ABOVE Proposed Staten Island Institute of Arts & Sciences and Ferry Terminal, St. George waterfront. Peter Eisenman and Hellmuth, Obata & Kassabaum, 1997. EA

ABOVE St. George Ferry Terminal, 1 Bay Street. Hellmuth, Obata & Kassabaum, 2005. HOK

ABOVE Richmond County Bank Ballpark at St. George, 75 Richmond Terrace. HOK Sport + Venue + Event, 2001. Entrance. MacKenzie. HOKSVE

RIGHT Richmond County Bank Ballpark at St. George, 75 Richmond Terrace. HOK Sport + Venue + Event, 2001. View to the northeast. MacKenzie. HOKSVE

and located two miles to the west on the eighty-three-acre North Shore site of the Snug Harbor Cultural Center were able to move forward with improvement plans. Founded in 1833 as a retirement home for seamen, Sailors' Snug Harbor, an assemblage of twenty-six buildings including some of the finest examples in the country of the Greek Revival style, was converted into an arts center in the 1970s after the city purchased the property from the maritime organization, which relocated to North Carolina.[24] In 1985 the Staten Island Children's Museum left makeshift facilities at 15 Beach Street in the Stapleton section for a new home at Snug Harbor.[25] Architects David Prendergast, Jeffrey Hannigan, and James Sawyer, working with graphic designer Keith Goddard, transformed a 20,000-square-foot former maintenance building (1913) into a flexible exhibition space organized around a central four-story atrium situated under one of the Italianate brick building's original skylights. In addition to the gut renovation of the interior, which included a children's theater, a gift shop, workshop rooms, and office space, the project involved the restoration of the facade and roof as well as the creation of an entrance terrace. Paul Goldberger was impressed with the effort, writing that the architects "managed to work a considerable degree of architectural energy into a tight space and tighter budget. The tone might be called warm high-tech, with a gentle dash of post-modernism; the sales shop has a mock classical temple facade, a gracious bow to the main Snug Harbor buildings, while the exhibition areas are lively and efficient."[26] In 2001 Prendergast Laurel Architects completed additional work at the Children's Museum, renovating a fifty-by-eighty-foot brick barn (1890) for use as event space.[27] The following year they designed a 100-foot-long, eighteen-foot-wide, steel-framed glass breezeway with a curved, lead-coated copper roof that connected the barn to the museum's main building.

In 1987 the Snug Harbor Cultural Center sponsored a competition to restore and expand the severely deteriorated 900-seat

Staten Island Children's Museum, Snug Harbor Cultural Center site bounded by Kissel Avenue, Henderson and Tysen Streets, and Richmond Terrace. Prendergast Laurel Architects, 2002. View to the southwest showing 2001 renovation on left. Cox. PLA

Proposed Music Hall expansion and restoration, Snug Harbor Cultural Center, site bounded by Kissel Avenue, Henderson and Tysen Streets, and Richmond Terrace. Allan Greenberg, 1987. Rendering of view to the southwest. AG

Proposed Music Hall expansion and restoration, Snug Harbor Cultural Center, site bounded by Kissel Avenue, Henderson and Tysen Streets, and Richmond Terrace. Jan Hird Pokorny, 1987. Rendering of view to the southwest. JHPA

Proposed Music Hall expansion and restoration, Snug Harbor Cultural Center, site bounded by Kissel Avenue, Henderson and Tysen Streets, and Richmond Terrace. Robert A. M. Stern Architects and Robert Meadows, 1987. Rendering of view to the southwest. RAMSA

temple-fronted Music Hall (Robert W. Gibson, 1892) located at the eastern end of the complex's second row of buildings, behind the original grouping of Greek Revival structures.[28] Six firms were selected as finalists from forty-five entries: Allan Greenberg; Robert A. M. Stern Architects and Robert Meadows; Notter, Finegold & Alexander; Jan Hird Pokorny; James Stewart Polshek & Partners; and Rafael Viñoly Architects. Pokorny proposed a modest templelike addition linked to the original hall by a glass "hyphen," while Greenberg's submission featured a sunken plaza, a scheme that Paul Goldberger described as "a strangely modern design in classical garb . . . [that] while full of classical decoration, seemed oddly reminiscent of a 1960's office tower."[29] Stern

and Meadows's plan called for a second, stylistically complementary 1,200-seat opera theater to be built adjacent to the Music Hall. Mark A. Hewitt, who served as a professional advisor to the competition, described Notter, Finegold & Alexander's third-place scheme as a "frank 'saddlebag' addition to the east of the building."[30] Polshek, who was awarded second prize, relied on an underground addition to provide the majority of new space, an approach also taken by Viñoly in his winning scheme, which called for a small addition at the rear for expanded backstage space as well as a modest tower topped by a sculpture of Aeolus, the keeper of the winds in Greek mythology. Viñoly also proposed a new terrace with a semicircular amphitheater and a glass-enclosed

ABOVE Proposed Music Hall expansion and restoration, Snug Harbor Cultural Center, site bounded by Kissel Avenue, Henderson and Tysen Streets, and Richmond Terrace. Rafael Viñoly, 1987. Rendering of aerial view to the southwest. RVAPC

BELOW Proposed Music Hall expansion and restoration, Snug Harbor Cultural Center, site bounded by Kissel Avenue, Henderson and Tysen Streets, and Richmond Terrace. Rafael Viñoly, 1987. Section. RVAPC

lobby. Goldberger praised the design as "crisp and self-assured," writing that it "respects the older building without engaging in fawning homage."[31]

Although Viñoly's firm was awarded the commission in June 1987, budgetary constraints quickly stalled the project, and when the architect finally began work nine years later, in 1996, the ambitious program was severely curtailed and consisted only of renovations to the Music Hall. Completed in October 1997, the first phase of work allowed for a 400-seat concert hall and a partial restoration of the balcony. In January 2004, a second round of renovations added a new box office, increased the seating capacity to 700, and completed the restoration of the balcony.

To the south of St. George, a thirty-six-acre site on the Stapleton waterfront was selected by the U.S. Navy in 1983 for development as Naval Station, New York, one of thirteen so-called home ports to be built around the country as part of a Reagan administration plan to increase the Navy's fleet to 600 ships while dispersing it to make it less vulnerable to attack.[32] Staten Island's home port was to accommodate the battleship *Iowa* and six support ships. According to testimonies by Department of Defense officials before Congress, the *Iowa* was known to carry Tomahawk missiles equipped with nuclear warheads, raising concerns about the wisdom of a site so close to a major population center. The mayor and other public officials, however, strongly advocated for the base

on the grounds that it would provide hundreds of jobs during construction and a significant boost to the local economy upon completion. Despite protests, construction went forward on a series of large, bare-bones maintenance, utility, communications, and supply buildings as well as on Pier 1 (Frederic R. Harris Inc., 1989), a ninety-foot-wide, highly engineered dock jutting 1,400 feet out into the Narrows.

The Navy commenced operations at the port in 1990 but only four years later it was closed, after the disbanding of the Soviet Union in 1991 signaled an end to the cold war and undermined the very basis for an expanded fleet and the overall home-port strategy. The site sat vacant and neglected for more than a decade, during which time various proposals for its reuse came and went, including plans for a movie, entertainment, marine, and retail complex, a Formula One car racetrack, a berth for gambling boats or luxury liners, and a neighborhood of apartment buildings, townhouses, and parks designed by Hellmuth, Obata & Kassabaum.[33] In late 2001, the city agreed to allow Stapleton Studios, a start-up film studio, to convert one of the smaller structures into a sound stage, but the Bloomberg administration rescinded the city's support in 2004, instead envisioning the demolition of the Navy buildings and their replacement with a mixed-use community of housing, stores, restaurants, a sports complex, and eighteen acres of open space to be built by 2009 according to designs by the Philadelphia-based firm of Wallace Roberts & Todd and landscape architect Margie Ruddick.[34]

Staten Island's educational and health-care institutions realized several notable new buildings. The College of Staten Island was formed in 1976 from the merger of Richmond College in St. George and Staten Island Community College, in Sunnyside. (In 1972 Paul Rudolph, in collaboration with John Johansen, Max Urbahn, and Alexander Kouzmanoff, devised a master plan for Staten Island Community College,

but nothing came of the proposal.) The College of Staten Island operated in the two locations until 1993, when it established the largest college campus in the city on 204 acres of the former Willowbrook State School (William E. Haugaard, 1941), bounded by Victory Boulevard, Forest Hill and Willowbrook Roads, and a right-of-way of Willowbrook Parkway, in the highlands near the island's center.[35] Willowbrook, a former hospital for the mentally disabled, had gained infamy in 1972 when its egregious mistreatment of patients was publicly exposed, leading to years of litigation and the institution's demise in 1987.

In 1989 the College of Staten Island unveiled Edward Durell Stone Associates' master plan. It incorporated fourteen of the original Neo-Georgian Willowbrook buildings and added five new ones. Roads that had previously cut across the Willowbrook campus were eliminated in favor of an exterior loop road connecting five perimeter parking lots for 2,100 cars. The campus interior, featuring a dominant north–south axis that bisected two quadrangles and was crossed by several minor axes, was reserved for foot traffic. Stone Associates also was responsible for gutting and renovating the Willowbrook buildings—mainly two-story dormitories in the north and south quads—to serve as classrooms, laboratories, and faculty offices, adding new front entrances and red brick and glass-enclosed stair towers. The architects also designed the campus's largest building, the 143,000-square-foot Center for the Arts (1996), containing a 430-seat proscenium theater, an 893-seat concert hall, a black-box theater, a 150-seat recital hall, a 150-seat lecture hall, a 1,900-square-foot art gallery, and 44,000 square feet of classrooms within a three-story red brick and precast-concrete exterior. A two-story brick-paved lobby extended through the building, covered by a skylight of dark tinted glass set into a peaked copper roof.

Conklin Rossant's Sports and Recreation Facility (1994) responded to its location at the northern terminus of the College

Master plan, College of Staten Island, site bounded by Willowbrook and Forest Hill Roads, Campus Drive, and Victory Boulevard. Edward Durell Stone Associates, 1989. RGAAP

ABOVE Sports and Recreation Facility, College of Staten Island, site bounded by Willowbrook and Forest Hill Roads, Campus Drive, and Victory Boulevard. Conklin Rossant, 1994. View to the southeast. Zimmerman. WZ

BELOW Student Center, College of Staten Island, site bounded by Willowbrook and Forest Hill Roads, Campus Drive, and Victory Boulevard. Mayers & Schiff, 1992. View to the northwest. Warchol. PW

of Staten Island's main axis with a symmetrical entry facade whose two faceted red brick towers framed a broad, gridded glass window. Inside, naturally lit corridors enlivened by curving glass-block walls led to the gymnasium, day care center, ball courts, and skylit swimming pool. An east wing included classrooms built around an enclosed courtyard. At the southwest corner of the campus, Mitchell/Giurgola Architects' Laboratory Science Building (1995), clad in orange brick with cast-stone trim, consisted of a four-story research wing and a three-story classroom wing forming a U to embrace a courtyard. The wings were connected on the second story to allow passage at ground level between a parking lot to the west and the campus to the east. The most notable feature was its curved southwest corner

with a glazed upper story capped by a pointed skylight intended to indicate the presence of a greenhouse within.

Perry Dean Rogers & Partners and Mayers & Schiff Associates worked together on a design for the campus's two most distinctive buildings: the student center and the library. The concept called for low, H-shaped structures of red brick and glass block situated around high rotundas that would glow at night, creating an iconic identity for the college. Mayers & Schiff handled the design of the student center (1992), which focused on an impressively scaled, broad glass-block cylinder rising to a conical, cupola-topped copper roof. Perry Dean Rogers's library (1992) rose three stories to a conical copper roof covering a four-story-high marble-floored rotunda inside. The library was entered through a

ABOVE Library, College of Staten Island, site bounded by Willowbrook and Forest Hill Roads, Campus Drive, and Victory Boulevard. Perry Dean Rogers, 1992. View to the south. Warchol. PW

RIGHT P.S. 56, 250 Kramer Avenue. Mitchell/Giurgola Architects, 1998. Auditorium. Goldberg. ESTO

three-story glass-block cylinder nestled between orthogonal red brick wings. "As icons go . . . they're fairly timid," wrote Hugo Lindgren in *Metropolis*, "and while the buildings do break up the campus's boxy Georgian uniformity to some extent, they don't go far enough." Lindgren found the interiors to be "much more appealing . . . particularly" those of the library, where study carrels were "positioned around the upper levels of the rotunda, filled with natural light from the glass top."[36]

In addition to their work at the College of Staten Island, Mitchell/Giurgola Architects designed two public elementary schools in the borough, beginning with the four-story, 98,000-square-foot P.S. 56 (1998), 250 Kramer Avenue, in Rossville.[37] The L-shaped buff and red brick building was pulled to the northern edge of its sloping site to open up a large playground

to southern exposure. The building contained fiber-optic cables for Internet access—the city's first school with such a feature—floor-to-ceiling windows that flooded classrooms and colorful corridors with natural light, and hallways with softly curving walls. Another notable amenity was a 450-seat auditorium that had windows behind the stage, affording views of a verdant backdrop of trees. A nearly identical version of the design was built in 2000 as P.S. 6, 555 Page Avenue, in nearby Richmond Valley, adapted moderately to fit its flat site.[38]

In 1979 Staten Island Hospital (renamed Staten Island University Hospital in 1989, after a merger with Richmond Memorial Hospital) relocated from the seventeen-building campus in New Brighton that it had occupied since 1890 to a state-of-the-art, 441-bed facility, 475 Seaview Avenue, in

ABOVE Sewage Pumping Station, south of Hannah Street, Tompkinsville. Warren W. Gran, 1979. View to the southeast. GAAP

BELOW Oakwood Beach Sludge Treatment Facility, adjacent to Gateway National Recreation Area. Richard Dattner, 1992. View to the southeast. Sprung. RDPA

Ocean Breeze, designed by Rogers, Butler, Burgun & Shahine as a series of two- and four-story precast-concrete-clad wings pinwheeled around a central core.[39] By the mid-1990s the hospital had again outgrown its quarters and hired Norman Rosenfeld Architects to prepare a master plan and undertake a series of improvements, the most significant of which was the six-story, 103,000-square-foot Tower Pavilion (2000).[40] Rosenfeld's building, by alternating precast-concrete panels with bands of green tinted glass shaded at the corners by brise-soleils, was stylish in a clinical sort of way. A double-height glassed-in lobby sat within a framework of white painted tubular seismic structural braces.

Two notable works of civic infrastructure were also built on Staten Island. Warren W. Gran's diminutive but distinguished Sewage Pumping Station, completed in 1979, sat on a marginal Tompkinsville site sandwiched between railroad tracks and the waterfront.[41] It was a pristine white reinforced-concrete beach-house-like structure whose sloping roof, skylights, and porthole- and smokestack-like vents gave it a nautical theme while disguising its gritty function. Richard Dattner's Oakwood Beach Sludge Treatment Facility (1992), adjacent to the Gateway National Recreation Area, also had a measure of élan—its alternating bands of off-white and gray precast concrete, horizontal windows, and aluminum brise-soleils dressed up four otherwise bland structures to resemble, according to the architect, "over-scaled beach cabanas lost among the dunes."[42]

Fresh Kills

On March 22, 2001, the Fresh Kills landfill, the largest garbage dump in the world, occupying 3,000 acres on the western shore of central Staten Island along the Arthur Kill, accepted, with much fanfare, its last shipment of waste.[43] Fresh Kills' closing ended an unpleasant chapter in Staten Island's history

that began in 1948, when Robert Moses called for the salt marsh, which like many other wetlands areas had not yet been recognized as an ecological asset, to be used as a dumping grounds. Though initially intended to close after three years, the site was expanded by 1,700 acres in 1953, and eventually 108 million tons of garbage were deposited there at four discrete areas, three of which had been closed and sealed by the late 1980s, leaving only one "open face," known as 1/9, in the southwest corner of the site. By 1989 sector 1/9 was on schedule to be built out as a 505-foot-high pyramid of garbage that would be the highest point on the Atlantic seaboard south of Maine and taller than the Great Pyramid of Khufu at Giza.[44]

Staten Islanders who had long wanted to have Fresh Kills closed endured numerous broken mayoral promises to do so.

Competition entry, "Fresh Kills: From Landfill to Landscape." JMP Landscape and John McAslan + Partners, 2001. Plan. JMP

Aside from the fact that the dump sullied the borough's reputation in New York and beyond, making Staten Island virtually synonymous with garbage, it was an environmental disaster wrought with essentially unsolvable problems. Fresh Kills' environmental shortcomings were well known. It had been started before the enactment of regulations requiring, as one of many examples, that a barrier be placed at the bottom of the fill to prevent the outflow of leachate, the contaminated liquid produced as water filters through refuse.

The single, vexing obstacle to closing the landfill was how to dispose of the almost incomprehensible amount of garbage being sent there on a daily basis. During the 1980s the city had hoped to build up to eight incinerators throughout the five boroughs, beginning with one in the Brooklyn Navy Yard, but officials underestimated the amount of public opposition that would be raised against the plan. In the mid-1990s, the incinerator idea, long postponed, was officially abandoned.[45] Then, in an unexpected move, on May 29, 1996, Mayor Giuliani and Governor Pataki announced that Fresh Kills would be closed by December 31, 2001. In late 1996, a task force of city, state, and federal officials reported that after the landfill's closing, all residential garbage that was not recycled would, like commercial garbage, be exported, marking the first time since the 1930s that household garbage would be carted out of the city. In the short term, trucks would be relied upon to carry away the trash, while long-term plans would seek to make more use of trains and barges. On December 2, 1998, Giuliani announced a plan to export all of the residential garbage from Manhattan and Queens to two transfer stations it envisioned for the New Jersey waterfront, from which point it would be carried to landfills primarily in Virginia, Ohio, and

Pennsylvania. By early 2000, the transition to exporting was well under way. Trash trucks were making roughly 425,000 extra trips across the bridges and tunnels during the course of a year, a solution that was taking its toll locally: air pollution on Canal Street, where traffic entered the Holland Tunnel, jumped 16 percent. When Fresh Kills closed in March 2001, nine months ahead of schedule, the city had yet to formulate a long-term solution for managing its waste. In 2004 the Bloomberg administration presented a twenty-year plan to dispose of garbage via four new marine transfer stations—two in Brooklyn, one in Queens, and one in Manhattan—and rail transfer stations in the Bronx and on Staten Island.[46] But the fate of that plan remained in limbo as local communities spoke out in opposition.

Although Fresh Kills closed (it was temporarily reopened on September 13, 2001, to receive wreckage from the World Trade Center for sorting and examination), the issue of the site's long-term future remained unresolved. In 2001, to generate new ideas, the Municipal Art Society, the Staten Island Borough President's Office, and the New York City Departments of City Planning, Sanitation, Parks and Recreation, and Cultural Affairs cosponsored a two-stage international design competition, "Fresh Kills: From Landfill to Landscape."[47] New York's Department of State provided financial support, and the National Endowment of the Arts gave a matching grant to help fund the competition, whose winner would have the opportunity to contract with the city to prepare a master plan. Three panel discussions and numerous community meetings preceded the competition. No specific program was prescribed for the affected 2,200 acres, but the competition called for a flexible plan that could be implemented in phases as well as the inclusion of some revenue-generating elements to help fund the plan's overall realization and maintenance. In August 2001, six teams, chosen from forty-eight would-be competitors, were asked to prepare conceptual designs: Field Operations, of Philadelphia; JMP Landscape and John McAslan + Partners, of London; Rios Associates, of Los Angeles; Hargreaves Associates, of Cambridge, Massachusetts; Tom Leader Studio, of Berkeley, California; and Sasaki Associates, of Watertown, Massachusetts. Just before submitting their schemes in October, each participant added a September 11 memorial at the peak of mound 1/9, where debris from the World Trade Center site had been deposited.

The McAslan team's second-place proposal called for a heavily forested site centered around three parks and three buildings. The parks, located at the perimeter of the landfill to help integrate neighboring communities, included a Migration Center that would bring "the spectacle of animal migration to a broad audience," an Earth Center in which native plants would be grown and soil created through composting, and an Energy Center that would explore "emerging technologies and renewable energy sources."[48] The third-place scheme, "RePark," from Rios Associates, was the most whimsical, providing an outdoor movie theater, equestrian trails, ballfields, a golf course, a water park in which disused barges could accommodate swimming and kayaking, and most memorably, a five-kilometer-long U-shaped picnic table made from recycled detergent bottles. Of the six finalists, Hargreaves Associates was the only one to propose an alteration of the landfill mounds themselves, calling for the recirculation instead of the removal of leachate, which would speed the decomposition process.

TOP Competition entry, "Fresh Kills: From Landfill to Landscape." Rios Associates, 2001. Rendering of view to the southwest. RCHS

ABOVE Competition entry, "Fresh Kills: From Landfill to Landscape." Field Operations, 2001. Rendering of view to the northwest. FO

The winning scheme, "Lifescape," by Field Operations, led by James Corner and Stan Allen working with a host of ecological, engineering, and economic consultants, sought to transform Staten Island from a "backyard bypass in a larger and more vital metropolis" into "an expansive network of greenways, recreational open spaces, and restored habitat reserves—a new nature-lifestyle island, both destination and envy of the surrounding urbanites." One of the plan's strong points was its three-stage, thirty-year development strategy, beginning with a short-term reclamation of the site referred to as "seeding," including the "restoration of native habitat and creating some landscapes of recreational amenity for the immediate neighborhoods." The second phase called for the installation of transportation and utility infrastructure, and the third phase would establish programmatic uses, including a farmer's market, a large multiuse stadium, a bird-nesting island, and athletic fields. These and other active and passive recreational areas and natural habitats would be organized within a system of what the designers labeled "threads–lines that circulate, distribute, link," "mats—surface conditions," and "islands—distinctive reserves and masses."[49]

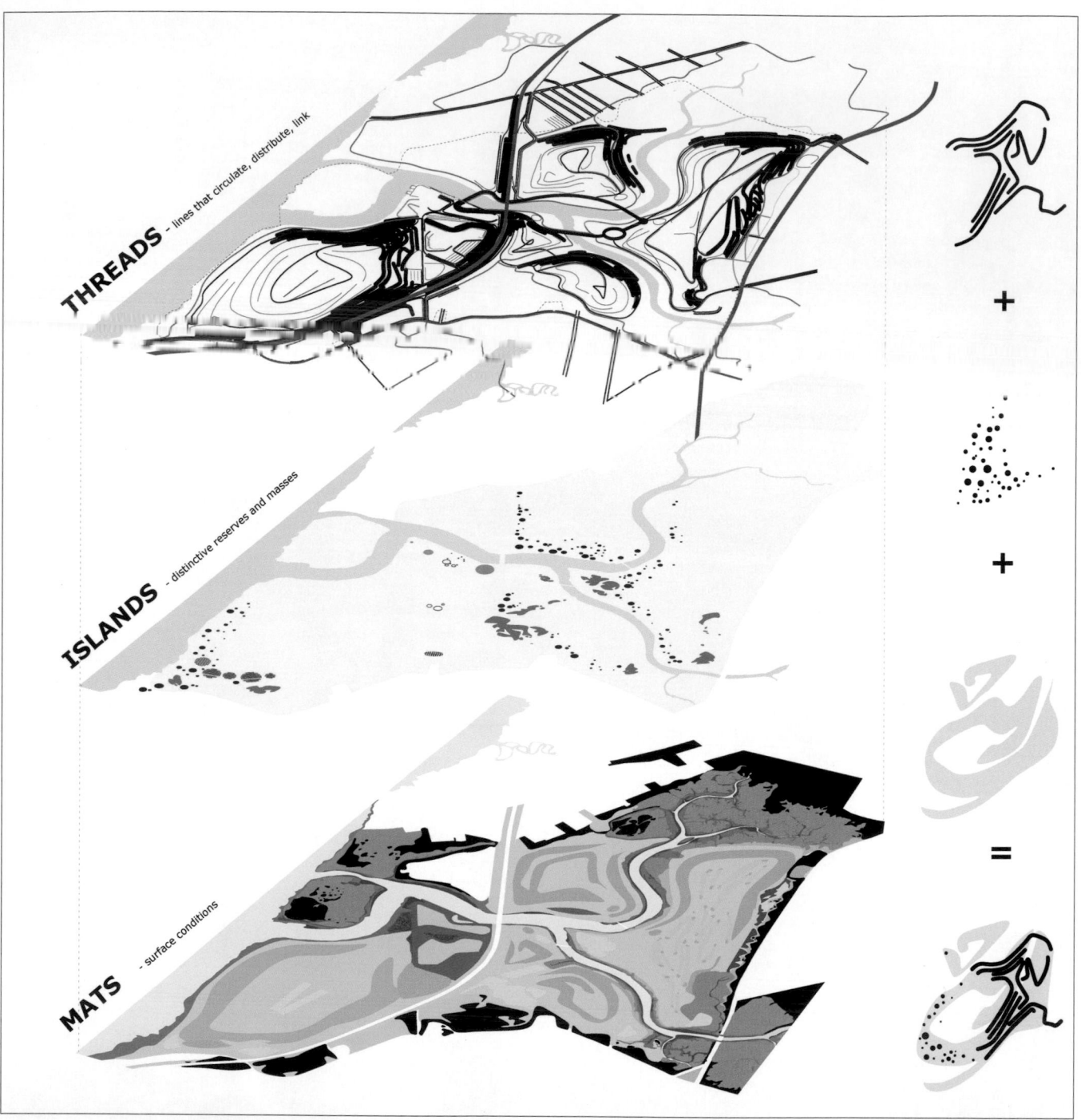

Competition entry, "Fresh Kills: From Landfill to Landscape." Field
Operations, 2001. Threads, islands, and mats diagram. FO

A common focus of the premiated schemes was the bolstering of existing ecologies and the creation of new natural environments. But as some observers, like Rebecca Krinke, writing in *Landscape Architecture*, pointed out, the use of ecology "primarily as amusement and commodity" approached an uncomfortable threshold at which the site's own natural history was misrepresented: "There seems to have been a self-conscious attempt to create sensational parks for the 21st century through the vehicle of ecology," in which "the visitor consumes an artificial display and entertainment of 'ecology.' As the schemes move farther away from the site itself by importing so much new program . . . the power of the projects

diminishes."[50] Writing in *Praxis*, Linda Pollak criticized the group of winning entries for not adequately acknowledging the site's life as a garbage dump, though she perhaps overlooked the fact that Staten Islanders were ready to see that history permanently buried.

In September 2003, the process of developing Field Operations' master plan was initiated with a two-year public outreach program with the expectation that portions of the landfill could become available for public use by 2008. Two years later, in August 2005, Mayor Bloomberg announced that work had begun on the first phase of the new park, Owl Hollow Fields, a soccer complex located at the southern end of the site.

QUEENS

The erosion of the almost rural character of the city's largest borough had begun in the 1930s and accelerated after the end of World War II, when its population dramatically increased. Nonetheless, Queens remained a combination of identifiable, separate villages and neighborhoods. Development stalled in the 1970s, but with the economy's resurgence in the 1980s, pressures for growth resurfaced, especially in Long Island City, where ambitious plans for large-scale mixed-use projects were joined by the creation of an incipient cultural and arts district. Significant new construction also occurred at the borough's two airports and at its increasing number of colleges and universities, while a civic focus began to emerge with the construction of new courthouses and governmental buildings in Jamaica.

The most significant development in Queens, however, involved the dramatic transformation not of its physical but of its social fabric, as immigrants, many from Asia, poured in. By the end of the twentieth century, Queens led the city in the number of foreign-born residents, who represented nearly 40 percent of the borough's population in 1990 and over 50 percent by 2000. By 1992 more than 40 percent of the borough's businesses were owned by ethnic minorities, nearly double the percentage in Manhattan. At century's end, Queens was the most ethnically diverse county in the country. As a consequence, entire neighborhoods were recast. Flushing, a predominantly white, middle-class area, became the city's largest and most diverse Asian community, with significant numbers of Chinese and Korean immigrants, as well as people from the Indian subcontinent. In the prosperous neighborhoods of Douglaston and Little Neck, the Asian population doubled between 1990 and 2000, by which point 23 percent of the residents were Asian. During the same ten years, the borough's Indian population nearly doubled from 56,601 to 109,114. Immigrants from Guyana settled in Jamaica and South Ozone Park, and Dominicans and Colombians moved into Jackson Heights, Elmhurst, and Corona. In 2003 Joseph Salvo, director of the population division at the City Planning Department, characterized the situation as "probably the greatest social experiment in history."[1]

Long Island City

Existing as an independent city from 1870 until Greater New York's consolidation twenty-eight years later, historic Long Island City, an industrial and residential area in the western section of the borough and including the communities of Hunters Point, Long Island City, Ravenswood, Astoria, Steinway, and Sunnyside, was the scene of the most dramatic planning and building activity in Queens during the 1980s. In March 1983, the Port Authority of New York and New Jersey announced its interest in developing seventy-four acres of mostly rundown waterfront property in the Hunters Point section, a site bounded by the Anable Basin at Forty-fifth Road on the north, Newtown Creek on the south, and Fifth and Second Streets on the east, into a mixed-use community with thousands of apartments and millions of square feet of office space.[2] As with efforts then afoot in Hoboken, New Jersey, the Port Authority planned to issue bonds but obtain the majority of the funding from private developers. The Port Authority reported that it had spoken with the site's two largest landholders—the Tribune Company, which owned the *Daily News* printing plant (Harrison & Abramovitz, 1972), 55–02

Second Street, and Pepsico, which owned a bottling plant (Harrison, Fouilhoux & Abramovitz, 1943), 46–00 Fifth Street—and both expressed a willingness to relocate.[3] Another significant presence on the site was Frederick Botour's Tennisport Club, located on a seven-acre parcel bounded by Fiftieth Avenue, Second Street, Borden Avenue, and the East River, which included indoor and outdoor courts as well as a one-story clubhouse and restaurant. Botour had expressed interest in building a seventeen-story, 153-unit luxury apartment house, but his efforts were rebuffed by the city.

Complicating the site's potential redevelopment were the three tunnel systems that ran underneath it for the subway, the Long Island Rail Road, and the Queens Midtown Tunnel. The city and state expressed tentative support for the plan, but both emphasized that they would not cede total control to the agency. One early and rare note of opposition came from Assemblyman Jerrold Nadler, who expressed concern over the loss of industrial jobs: "It is predictable that within five years of completion of the project, almost all of those 25,000 jobs will be displaced by residential conversion resulting directly from this project."[4] Officials at the Port Authority rebutted that Nadler's numbers referred to jobs in all of Long Island City and that the site under consideration currently provided work for only 700 people.

In November 1983, the city and state reached an agreement with the Port Authority, which pledged to spend up to $125 million on infrastructure improvements to the site to prepare it for private development. The authority would hire architects to prepare plans, subject to the city's approval, with the expectation that construction would begin in May 1986. The editors of the *New York Times* applauded the deal but voiced concern that revenues to the city from the project would be limited because of the Port Authority's tax-exempt status. Although State Senator John J. Marchi, of Staten Island, temporarily held up approval of the necessary legislation, believing that the site might be better suited to a sports complex, in July 1984 the state senate passed a bill allowing the Port Authority to move forward.

The Gruzen Partnership, in association with Beyer Blinder Belle, was selected to develop a master plan in consultation with the Queens office of the City Planning Department, headed by Peter Magnani. Noting concerns that the Hunters Point site would be transformed into an enclave of luxury apartment buildings, Peter C. Goldmark Jr., executive director of the Port Authority, made clear that he wanted the development "to be part of Queens. If all we succeed in doing is transporting part of Manhattan to a new Gold Coast in Queens, we will have failed."[5] The plan, released in October 1986, called for ten million square feet of new development, including five million square feet of residential construction, four million square feet of office space, and one million square feet for retail and hotel space. Parking for 6,400 cars would be provided in an underground facility. The housing component of the plan would be fulfilled with a total of 5,000 units in high-rise buildings at the northern and southern ends of the site, and townhouses and garden apartments along the water's edge. The office space would be divided equally between high-rise Class A space and low-rise buildings for back-office operations. The plan also included between seven and ten acres of public space to be built on decks over the river, an expensive move that the architects deemed necessary because it "permitted regularization and reformation of the existing shoreline and also created more regularized

development parcels. The inclusion of decking was crucial for overcoming the narrowness of the site at certain points by providing a large and continuous public waterfront esplanade and a small roadway for improved site circulation."[6] Calling for the extension of the Queens street grid onto the development area, the plan also provided for a 1.25-mile-long, twenty-five-foot-wide paved riverfront walk, a large landscaped plaza at the center of the site, a park at the site's northern tip, and a circular park at its south end at the confluence of Newtown Creek and the East River, all in all creating more than fourteen acres of landscaped open space. This preliminary plan was largely ignored by the press, perhaps because it seemed so much a rehash of themes from Battery Park City. A year after its release, in October 1987, the stock market crash and ensuing collapse of the real estate market halted progress, a fate that also befell other ambitious waterfront schemes, including three in Manhattan: South Ferry, Riverwalk, and the Hudson River Center.

Unlike the high-profile Manhattan waterfront projects that were never revived after their troubles in the late 1980s, a plan for the Hunters Point site moved forward in the 1990s.[7] The redevelopment had new sponsorship from all three of New York's major development authorities: the Port Authority, the city's Public Development Corporation, and the New York State Urban Development Corporation (UDC), which, because of its powers of condemnation and ability to speed through various environmental reviews, assumed the lead role in implementing the project. By 1990 the Port Authority controlled roughly one-third of the site, but in the years since planning

first began, a private development group headed by William Zeckendorf Jr. and Martin J. Raynes had either purchased land or entered into agreements to buy land for separate parcels that amounted to almost 25 percent of the site. The three government agencies agreed that developers for the site would not be chosen until a detailed master plan was approved.

The Gruzen firm, now known as Gruzen Samton Steinglass, along with Beyer Blinder Belle, modified their original plan to include nine million square feet of development, with three thirty-eight-story residential towers, 2.25 million square feet of commercial space in three office buildings, and a 350-room hotel. The architects placed the commercial core at the center of the site because of its convenient subway access, and the majority of residential construction at the northern and southern ends. Of the 6,385 apartments planned, 10 percent would be set aside as below-market units, with half reserved for senior citizens and half to go to residents already living within the boundaries of the local community board. Twenty acres of new parks and open space would be created, including a continuous waterfront esplanade. Parking garages, their rooftops planted with gardens, would accommodate more than 5,000 cars. After consultation with community representatives, the plan was altered to include a 650-student elementary school, a community center with a swimming pool, and a reduction of the street wall at the easternmost edge of the site, with a maximum height of fifty feet specified. The plan also included a new north–south boulevard, which, according to John Beyer, would "twist around to generate a

series of angles that would relate to the views, somewhat like Broadway. The angles and scale of the ensemble should create interest and excitement along the boulevard."[8]

Although the Board of Estimate formally approved plans for the project in August 1990 at its last session before being dissolved, the proposal languished. In October 1991, in a move aimed at expediting the plan, Governor Mario Cuomo announced the creation of the Queens West Development Corporation, a subsidiary of the UDC that would oversee the development of the site, which hereafter would be officially referred to by its new name instead of Hunters Point. In contrast to the relative apathy that greeted the initial release of plans in 1986, community opposition to the new plan was vocal, mostly centered on the belief that Queens West would displace local residents and businesses and lead to the gentrification of the surrounding area, while also straining already overburdened city services like sewage and transportation. The effort was led by the Hunters Point Community Coalition, which hired Harken Architects to prepare an alternative plan for the site. Bonnie Harken, who had worked on Battery Park City's north residential area for Cooper, Robertson in the late 1980s and early 1990s, produced a proposal that reduced the built square footage from nine million square feet to 4.1 million, with almost three million square feet reserved for 3,000 apartments and only about 560,000 square feet for commercial space. Her plan emphasized low- and mid-rise construction, with a majority of the new buildings between two and six stories, although it provided for two

pairs of twenty-story residential towers placed atop office and retail bases as well as one twenty-story apartment building at the north end of the site. Parkland would be increased to between twenty-six and twenty-eight acres, and the *Daily News* plant renovated for use as either a museum or a nature center. Harken's plan extended the existing street grid west all the way to the waterfront, where a new curving road, Hunters Point Drive, flanked by a twenty-five-foot-wide walkway and a waterfront esplanade, would be created. Harken's plan was published in *Oculus* in April 1993, and two months later Jordan Gruzen and John Beyer vigorously defended their proposal in the same publication, noting that the nine million square feet of development was required "to create the critical mass and financial resources necessary for public amenities and to generate the activities and ambiance for a cohesive and safe neighborhood. The density was determined after years of extensive analysis, and is deemed sufficient to attract the substantial private sector investment necessary."[9]

Queens West finally began to show signs of life with the announcement that infrastructure improvements, backed by $30 million in city capital funds, would begin in June 1994. At the same time, the Queens West Development Corporation declared that Manhattan Overlook Associates, a development team that owned land on the site and included William Zeckendorf Jr., the Trotwood Corporation, and two Tokyo-based companies, would develop the project's first building, a forty-two-story apartment tower to be designed by Cesar Pelli, with construction expected to begin before the end of the year.

In addition, plans were announced for a substantial new waterfront park, Gantry State Plaza Park, opposite the new apartment building.

Groundbreaking for Queens West began in September 1994 with the construction of the modest, 60-by-600-foot Hunters Point Community Park located two blocks from the water's edge on the south side of Forty-eighth Avenue between Vernon Boulevard and Fifth Street, the site of an abandoned railway cut.[10] Even before infrastructure work began, plans for the park went forward in order to convince officials from the U.S. Department of Housing and Urban Development (HUD), whose mortgage insurance was needed to permit construction to advance, that the planned residential tower just to the west would not be an isolated addition to the largely industrial site. Another motivation for building the park was to mollify local residents. Originally the Long Island Rail Road's abandoned railway cut was to be turned into a below-grade roadway leading into the new development, but community opposition, led by Councilman Walter L. McCaffrey, who believed that the road would isolate Queens West from the rest of the neighborhood, convinced the development corporation to instead build a community park.

Designed by Weintraub & di Domenico, working in association with Thomas Balsley Associates, Hunters Point Community Park, completed in August 1995, was built on top of 30,000 cubic yards of soil, sand, and broken-up concrete brought to the site. Requiring the removal of the Vernon Boulevard Bridge, a modest truss span that had only recently been renovated by the city, the stark design included six large concrete spheres marking the entrance, as well as three basketball courts, two handball courts, shaded seating, and concrete walls animated by colored glass bricks. Seven months after its opening, in March 1996, *New York Times* reporter Douglas Martin described the park as a "virtual wonderland of concrete," sarcastically noting that the project was "so distinguished and lavish in its use" of the material "that it won a merit award last November from the Concrete Industry

Board."[11] He also noted the disappointment of several local residents. Although Lee Weintraub dismissed the criticism as the "selfish banterings" of those neighborhood residents opposed to the larger plans for Queens West, Parks Commissioner Henry J. Stern, who had no role in planning the park, agreed with many in the community when he said, "I think they forgot what the word 'park' meant."[12]

In 1996 construction began on the first building at Queens West, Cesar Pelli's forty-two-story, 721,000-square-foot Citylights (1998), a 522-unit middle-class cooperative located on a 143,000-square-foot site bounded by Forty-eighth and Forty-ninth Avenues, Fifth Street, and Center Boulevard.[13] Rising from a five-story base containing retail space, a 527-car garage, and a public school, Pelli's bow-fronted, balconied tower, designed in association with Schuman, Lichtenstein, Claman & Efron, was clad in a lively mix of red, orange, and yellow brick. Herbert Muschamp, despite his quarrel with the conservative nature of the master plan, praised Pelli's design as a "sophisticated echo of Rockefeller Center. Shallow vertical setbacks terminating in balconies evoke" the RCA Building's "sleekly modulated wings."[14] In 2002 the Citylights cooperative was joined by Queens West's second building, Perkins Eastman Architects' thirty-two-story, 426,000-square-foot Avalon Riverview, located directly to the south on a site bounded by Forty-ninth and Fiftieth Avenues, Center Boulevard, and Second Street, a similarly massed but much less compelling design clad in red and tan brick that rose from a four-story base containing 9,000 square feet of retail space and a 141-car three-level parking garage.[15]

Gantry State Plaza Park, designed by Weintraub & di Domenico in association with Sowinski Sullivan Architects and Thomas Balsley Associates, opened in 1998 to both wide public and critical acclaim, in stark contrast to the tepid if not hostile reception that greeted the Hunters Point Community Park.[16] Located opposite the Citylights apartment building on a 2.5-acre site, Gantry Park was centered on two prominent

Hunters Point Community Park, south side of Forty-eighth Avenue, between Vernon Boulevard and Fifth Street. Weintraub & di Domenico in association with Thomas Balsley Associates, 1995. View to the east. TBA

Citylights, site bounded by Forty-eighth and Forty-ninth Avenues, Fifth Street, and Center Boulevard. Cesar Pelli & Associates in association with Schuman, Lichtenstein, Claman & Efron, 1998. View to the northeast. Pelli. CPA

Avalon Riverview, site bounded by Forty-ninth and Fiftieth Avenues, Center Boulevard, and Second Street. Perkins Eastman Architects, 2002. View to the southeast. Woodruff/Brown. PE

Proposed apartment buildings, Queens West, site flanking Center Boulevard, between Forty-fifth and Forty-seventh Roads. Arquitectonica, 2001. West elevation. ARQ

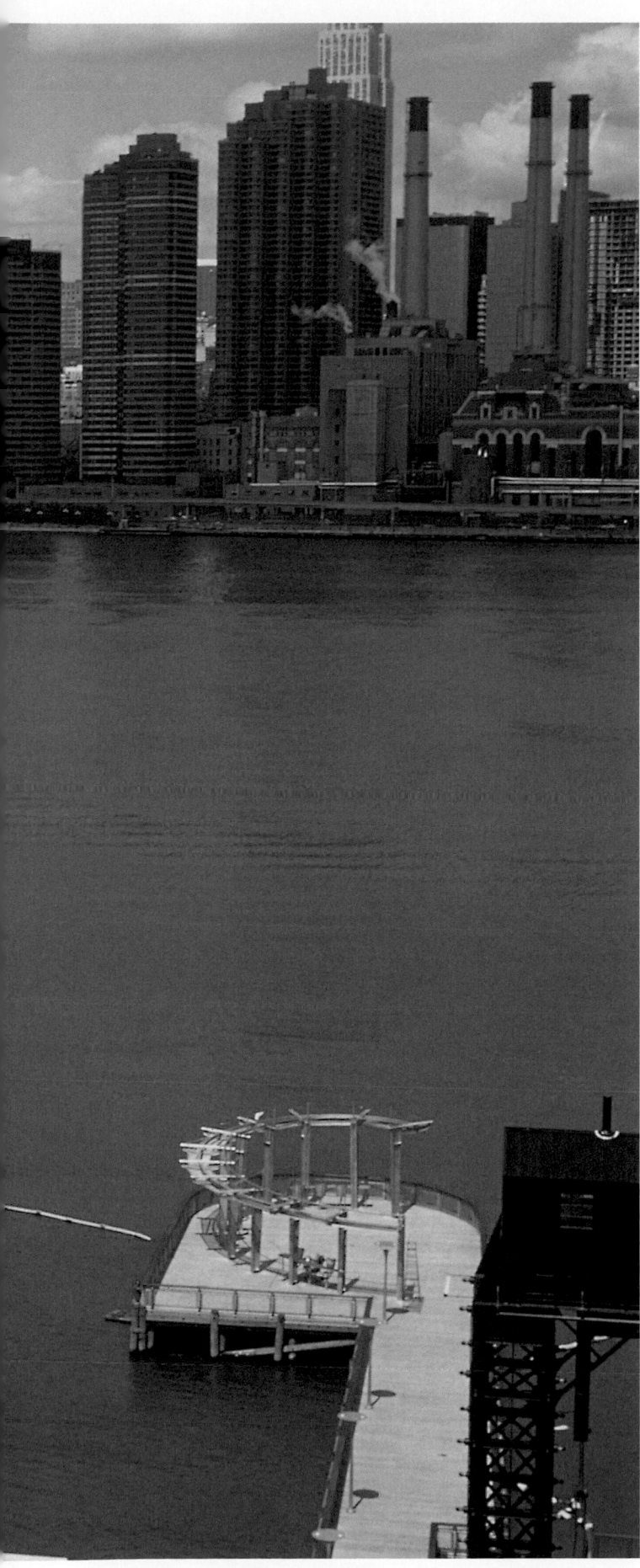

black steel gantries that had once transferred freight cars from river barges onto the tracks of the Long Island Rail Road. Although Michael Wise derided the restored gantries as a "disingenuous" gesture given "Queens West's scale and decidedly postindustrial character," the great majority of observers applauded their retention as symbols of the area's industrial past.[17] The entrance area to the park was marked by a circular paved plaza enclosing a mist fountain. At the southern end of the park, a garden space was formed by two paths, one paved with gravel, the other with stone, that led down to the water's edge. Phase one of the park also included the renovation of four piers. One devoted to fishing had a long, undulating wooden bench and a steel fish-cleaning table with running water. The "star gazing" pier featured sculptural wooden chaise lounges. Another pier included a curving bar-height counter with stools, topped by a metal canopy, and the northernmost pier was planned to accommodate ferries and included a serpentine bench. In his book on waterfront development, Raymond Gastil described Gantry Park as a "memorable urban place" that "incorporated history, even as it defined itself as a contemporary park in the selection of its materials, its crisp geometries, and its focus on providing its visitors with as direct an experience of the water and the waterfront as possible."[18]

In February 2001, plans were announced for the next stage of Queens West's development, with the Rockrose Development Corporation gaining the right to develop the northern portion of the site, a twenty-one-acre parcel occupied by the Pepsi-Cola bottling plant that had closed two years earlier.[19] Although Pepsico agreed to sell the site, the company insisted that the 60-by-100-foot red neon *Pepsi-Cola* sign by Artkraft Strauss, which had been a prominent fixture on the East River waterfront since 1936, remain. It would be re-erected on a new parking garage. In a somewhat surprising move, Rockrose hired Arquitectonica, best known for their flashy, colorful buildings in Miami and their equally flashy Westin Hotel on Forty-second Street and Eighth Avenue, to design the seven-building residential development, which would range in height from seven to thirty-five stories, contain 3,000 apartments, and include retail space at the base of the buildings. The preliminary plans placed the apartment buildings on both sides of Center Boulevard and called for more than thirteen acres of landscaped space, including a waterfront park to be designed by Abel Bainnson Butz. The architects claimed that "this new neighborhood will appear as an assemblage of thin glass towers of different heights, each intersecting a corresponding elongated slab. . . . The overall composition constitutes a collage of abstract, rigorously orthogonal geometries, emphasized by the contrasting materials of the city—glass, steel and masonry." Put succinctly, the architects claimed that their "building is no longer simply a building, it is an abstract urban landscape."[20]

As Rockrose and Arquitectonica developed their plans, there was some progress on other parts of Queens West, including the designation of LCOR as developers of the

American Museum of the Moving Image, Thirty-fifth Avenue, between
Thirty-sixth and Thirty-seventh Streets. Gwathmey Siegel & Associates,
1988. View to the east. Goldberg. ESTO

commercial center.[21] In the aftermath of the September 11, 2001, attacks, LCOR directed its architects, Kohn Pedersen Fox, to prepare energy-efficient plans to help reduce dependence on foreign oil. No developers were selected for the planned southern residential area of Queens West, but the site did attract the interest of those advocating for New York as the site of the 2012 Olympics who believed it represented an excellent location for an Olympic Village, which could be subsequently converted to housing.[22] A five-firm competition for the design of the Olympic Village in 2004 was won by Morphosis, but New York was not picked to host the event.[23]

Kaufman Astoria Studios

In 1976, after years of inactivity, the Astoria Studio (1920), on the block bounded by Thirty-fifth and Thirty-sixth Streets, Thirty-fourth and Thirty-fifth Avenues, was revived for filmmaking. Designed and engineered by the Fleishmann Construction Company, the main studio building occupying the southern half of the block, a large industrial structure dressed up with a modern classical entrance facing Thirty-fifth Avenue with a grand porte cochere recessed behind a colonnade, contained the 120-by-228-foot Studio E, nicknamed the "Big House," the largest sound studio east of Los Angeles.[24] Originally built for the Famous Players-Lasky Company (renamed Paramount Pictures in 1927), the studio had been used well into the 1930s. In 1939 it was taken over by the U.S.

Army for use as the Army Pictorial Center, where training films and a television series were made. Paramount sold the studio to the Army in 1952, and three years later it was turned over to the U.S. Department of Health, Education and Welfare (HEW), which made roughly 300 films per year until 1970, when the building was boarded up. In 1972 HEW encouraged La Guardia Community College to use the studio for educational purposes, but the college was unable to afford the facility for its own programs or to find commercial tenants, leading Walter J. Wood, director of the Mayor's Office for Motion Pictures and Television, to try to lure filmmakers back to it.

Two major productions resuscitated the studio in 1976: Herb Gardner's *Thieves* and Richard Sarafian's *The Next Man*.[25] Capitalizing on the momentum generated by these films, in 1977 Glenn Ralston, a local planner, along with five friends, including Sam Robert, executive coordinator of the Council of Motion Picture and Television Unions, and John McGuire, executive secretary of the Screen Actors Guild, with the political support of Queens Deputy Borough President Claire Shulman, formed the nonprofit Astoria Motion Picture and Television Foundation to operate and renovate the studio.[26] They also planned to create a museum, a workshop, and a lab for film students. The newly named Astoria Motion Picture and Television Production Center benefitted immeasurably when in 1977 Sidney Lumet, the director and self-described "New York freak," decided to use it for making his

film *The Wiz*. Starring Diana Ross, it was reportedly the largest and most complicated film ever shot in New York. During filming of *The Wiz*, the building was outfitted with new plumbing, renovated dressing rooms, and new seats in the screening rooms.

On March 14, 1978, the main studio building was designated a New York City landmark, and in April Lumet took his support one step further when he testified at a state senate subcommittee hearing that the Astoria studio could be become a more formidable competitor to Hollywood—and more important, a better generator of revenue for New York—if funds were secured for improvements such as upgraded wiring, a new projection room, and a new generator.[27] The hearing had been held specifically to discuss the establishment of the State Office for Motion Picture and Television Development, an agency founded the following year with the power to finance not only films made in New York State but also the construction of production, recording, editing, and other film-related facilities in New York. The agency proposed to remodel the Astoria studio to accommodate pre- and postproduction facilities as well as two additional sound stages.

On September 5, 1980, Mayor Ed Koch announced that George S. Kaufman, a prominent real estate developer, had been awarded the rights to redevelop the site, which included twelve buildings in addition to the main studio.[28] The federal government transferred ownership of the site to the city for one dollar, and the city in turn leased the complex to the Public Development Corporation, which then leased the property to Kaufman. In November 1981, leading entertainers Johnny Carson and Alan King, the theater owner James M. Nederlander, and the playwright Neil Simon joined Kaufman as investors. The plan grew to call for the renovation of Studio E, the creation of seven additional film and TV stages, topnotch makeup, wardrobe, and dressing rooms, new carpentry and art shops, new screening rooms, and a new sound-recording stage large enough to accommodate an orchestra. For the first time, the complex would include postproduction facilities, and a satellite link would facilitate the broadcasting of live or prerecorded programs anywhere in the world. In addition, 300,000 square feet of office space, available for a fraction of the cost of midtown Manhattan office space, would allow companies related to the entertainment industry to establish a base in the complex.

Renovations were begun on December 13, 1982, and by 1986, the Kaufman Astoria Studios comprised nineteen buildings on seven blocks along Thirty-fifth Avenue between Thirty-fourth and Thirty-eighth Streets, encompassing one million square feet and serving as a home to eighty businesses with 800 employees. The area, as one *New York Times* reporter described it, had "an almost palpable sense of dynamism and a sort of easygoing friendliness."[29] Woody Allen gave the studio his seal of approval by stating "it's clean, everything works, the dressing rooms are nice, and there's no other studio of comparable size in New York."[30] While it was regularly booked with movie productions, Kaufman Astoria was also increasingly used to shoot commercials and music videos, and to record music. In July 1986, two radio stations, WHN-AM and WQHT-FM, joined the mix and went on the air from the Kaufman studios. Then, in 1987 the studios entered a new phase when the very popular television series *The Cosby Show* took up occupancy after Bill Cosby refused to cross a picket line outside the show's existing studio in Brooklyn.

American Museum of the Moving Image, Thirty-fifth Avenue, between Thirty-sixth and Thirty-seventh Streets. Gwathmey Siegel & Associates, 1988. View to the east of stair tower. Goldberg. ESTO

The same year, Lifetime Television announced plans to consolidate its California and East Coast operations at Kaufman Astoria, moving 200 employees into roughly 125,000 square feet of space. In 1988 Kaufman announced, "We have the nucleus now. Trouble is, there is a limit to that nucleus. This is the largest studio on the East Coast now, but it's completed. We're 100 percent occupied."[31]

On September 10, 1988, the American Museum of the Moving Image—the first museum in the country devoted to the art, history, and technology of film, television, and video—opened in Building 13, a 45,000-square-foot, three-story industrial structure occupying the full blockfront across the street from the main studio building, on Thirty-fifth Avenue between Thirty-sixth and Thirty-seventh Streets.[32] The idea for the museum was hatched about a decade earlier by the founders of the Astoria Motion Picture and Television Foundation, who began to collect memorabilia and artifacts and occasionally mounted small-scale exhibitions and offered film screenings in temporary quarters. The museum was intended to demystify the process of making films and television programs by exposing and explaining behind-the-scenes aspects like special effects, sound, and overall costs, as well as exploring the effects of the moving image on society. When Kaufman became the site's developer in 1981, plans for a new facility got under way; in 1983 Gwathmey Siegel & Associates was hired to prepare designs.

American Museum of the Moving Image, Thirty-fifth Avenue, between Thirty-sixth and Thirty-seventh Streets. Gwathmey Siegel & Associates, 1988. View showing exterior of *Tut's Fever* (Red Grooms and Lysiane Luong, 1988). Aaron. ESTO

Gwathmey Siegel treated the exterior delicately, reglazing it and repairing the stucco facades. The museum entrance, originally designed to face west toward the rest of the studio complex, was ultimately relocated to the south facade, along Thirty-fifth Avenue. On axis with the entrance, a yellow and red circulation core extended out from the north facade, wrapped by a cantilevered stair encased in a curtain wall of tinted laminated glass and white steel. The architects identified this as the "iconic object of the design and the orientation element for the entire complex."[33] Susanna Sirefman described the stair tower's color as "jazzy sunshine" and its form, she felt, created "a graceful and transparent counter-point to the symmetrical gridded masonry street facade."[34] Elena Marcheso Moreno, writing in *Architecture*, was impressed by the architects' differentiation between the existing building and the new additions, noticing, for instance, that the sinuous soffits that Gwathmey designed "to conceal massive air ducts are dropped nearly five feet but are kept away from the building perimeter so that the full height of the existing structure remains evident."[35] Paul Goldberger remarked that as bright as the stair tower was, "even this bit of flash is rather low key; the mood here is always industrial not luxurious." Nonetheless, Goldberger continued, the architects' "restraint did not serve the museum in such good stead in

some of the public areas, such as the entry lobby, which is so understated as to make one wonder whether anything worthwhile lies ahead, and at the front door, which has a few red details that are more of an abstract hint of a marquee than anything potent enough to be noticeable."[36]

The ground floor accommodated a museum store, a café, a meeting room, an 1,800-square-foot exhibition space, and a sixty-seat screening room, all surrounding a 190-seat theater that cleverly occupied the sloping footprint of a former loading ramp. The second floor featured an open central space containing the permanent exhibition "Behind the Screen: Producing, Promoting and Exhibiting Motion Pictures and Television," the centerpiece of which was Red Grooms and Lysiane Luong's parodic *Tut's Fever*, a miniature movie palace inspired by the Egyptian-themed theaters of the 1920s. Visitors entering the theater were met by a blond papiermâché Mae West concessionaire standing behind a popcorn counter. Inside the forty-seat auditorium, where a sculpture of Mickey Rooney stood dressed in an usher's costume and each seat featured an image of Rita Hayworth on its slipcover, a pattern of Grooms-conceived, movie-inspired hieroglyphics depicting palm trees, cacti, movie reels, and dollar signs covered the floor, walls, and ceiling, all adding up to what Stephen Holden described as a "winding Pop Art crypt."[37]

Riding on his success, George S. Kaufman envisioned a wider range of uses for the Kaufman Astoria Studios, proposing it as a suitable location for back-office space for large corporations. This did not happen, although in 1989 the Atlantic Bank of New York announced plans for 34–11 Thirty-fifth Avenue, an eight-story, 100,000-square-foot building on the northwest corner of Thirty-fifth Street across the street from the studio.[38] As completed by Kontokosta Associates Engineers/Architects, the somewhat diagrammatic caststone-clad building, which became the headquarters for Laborers' Local Union No. 731, was downsized to four stories.

In 1999 Kaufman announced plans for a new 40,000-square-foot studio building, 34–12 Thirty-sixth Street (Janson Design Group), between Thirty-fourth and Thirty-fifth Avenues, that was to include an 18,000-square-foot sound stage—the complex's seventh—and spaces for all stages of film production, from set design and construction to editing. The project was held up by rising construction costs. In September 1999, Forest City Ratner developed a 112,000-square-foot, single-story gray-and-beige masonry-block building (Furman & Furman) incorporating a fourteen-screen movie theater with 400 spaces of rooftop parking, occupying almost the entire block bounded by Thirty-fourth and Thirty-fifth Avenues and Thirty-seventh and Thirty-eighth Streets, two blocks away from the main studio building.[39]

International Design Center

On April 13, 1983, Lazard Realty invited 500 members of the interior design community to the Rainbow Room, on the sixty-fifth floor of 30 Rockefeller Plaza, to unveil the International Design Center, New York (IDCNY), a headquarters for the wholesale, to-the-trade interior design industry that would offer one-stop shopping for designers and architects in search of furniture, textiles, lighting, and accessories, along the lines of facilities like the Merchandise Mart in Chicago and the Pacific Design Center in Los Angeles.[40] As guests at the Rainbow Room looked out of the east-facing windows, a cluster of four former industrial buildings in Long Island City, a mile and a half away across the East River, were illuminated on cue by a dozen arc lights brought in from three states for the occasion.

Lazard had purchased the buildings the previous year, beginning with the five-story, 550,000-square-foot American Chicle Company factory, originally the Adams Chewing Gum Factory (Ballinger & Perot, 1919), 30–20 Thomson Avenue, between Thirtieth Place and Thirty-first Street, and the

Proposed International Design Center, New York (IDCNY), site bounded by Skillman, Thomson, and Forty-seventh Avenues and Thirty-first Street. I. M. Pei & Partners, 1983. Axonometric of master plan, view to the northwest. PCFP

RIGHT International Design Center, New York (IDCNY), site bounded by Skillman, Thomson, and Forty-seventh Avenues and Thirty-first Street. Renovation by Gwathmey Siegel & Associates. View to the north showing Center Two (1985) on left and Center One (1986) on right. Bryant. ARC

BELOW Center Two, International Design Center, New York (IDCNY), site bounded by Thirtieth Street, Thomson Avenue, Thirtieth Place, and Forty-seventh Avenue. Renovation by Gwathmey Siegel & Associates, 1985. Atrium. GSAA

neighboring eight-story, 460,000-square-foot Bucilla Building, originally the American Ever Ready Building (Maynicke & Franke, 1914), 30–30 Thomson Avenue, between Thirtieth Place and Thirtieth Street.[41] Fox & Fowle Architects, working with Stephen Lepp Associates, were hired to convert the two structures into Thomson Place, a complex of back-office space to be marketed to Manhattan companies. As plans progressed, Lazard also purchased the neighboring Executone Building, originally the Loose-Wiles Sunshine Biscuit Company (William Higginson, 1914), Skillman Avenue between Twenty-ninth and Thirtieth Streets, which at 900,000 square feet was the largest industrial plant in Queens when built.

Lazard's interest in investing in Long Island City was considered an important step forward for the area, so much so that when plans for Thomson Place fell apart in 1982, city officials stepped in and convinced Lazard to develop the IDCNY, which they believed could help counter the fragmentation of New York's 450-firm, 30,000-employee interior design industry, which was dispersed throughout Manhattan's East Side. As rents soared during the early 1980s, the industry, dependent on the proximity of shops and showrooms to one another, had begun to scatter as smaller firms were priced out of Manhattan, thereby drastically compromising its appeal to busy out-of-town buyers, who increasingly took their business to Chicago, Atlanta, and other concentrated regional marts.

On paper, at least, the idea of IDCNY seemed promising, but there was an overriding concern that Long Island City was simply too far from midtown—psychologically, if not geographically. As Robin Roberts, owner of Clarence House, the luxury fabric purveyor, stated: "We're selling fabrics at

$100, $200, $3,000 a yard. You can't expect someone to go on a subway to buy something like that. I mean, Mrs. Onassis on a bus?"[42] In order to add cachet to the project if not allay some of these concerns, Lazard replaced Fox & Fowle with higher-profile architects who would appeal to the design-sensitive tenants they sought, hiring I. M. Pei & Partners to prepare a master plan and Gwathmey Siegel & Associates and D'Urso Design to renovate the individual buildings (Gwathmey Siegel would later take over D'Urso's responsibilities). Stephen Lepp Associates stayed on as associate architect and Vignelli Associates was asked to design graphics, signage, and marketing materials.

Pei's master plan envisioned several phases of development, eventually leading to the creation of 4.5 million square feet of space in the four existing buildings and in newly constructed showrooms, exhibition spaces, retail shops, and a hotel. The entire complex was to surround a 60,000-square-foot pedestrian-friendly "arrivals plaza" atop a two-level parking garage for 450 cars, to the south of the Bucilla Building, which was renamed Center Two. Because of its central location, Center Two was to be renovated first, followed by the American Chicle building, renamed Center One.

By May 1984, when Mayor Koch presided over a ribbon-cutting ceremony for the beginning of renovations, more than twenty-five companies had signed leases for 400,000 square feet of space. It had become apparent that firms specializing in residential interiors were not attracted to the center, so the developers shifted their strategy to market the showroom spaces to so-called contract firms catering to institutional and corporate clients. On June 3, 1985, by which point forty-four companies had signed leases, a milestone was reached with the illumination of a huge red *IDCNY* sign on the roof of Center Two, lending the complex a sense of reality and permanence that helped it gain, within three months, an additional thirty tenants.

Center Two opened on October 10, 1985, impressing the 900 guests who followed a trail of red glitter across construction-site sidewalks to attend festivities that included a symposium in which Charles Gwathmey, Robert Siegel, and Massimo Vignelli discussed the project. Gwathmey Siegel treated the former factory with a light touch, cleaning up the gritty building while retaining its industrial character, closing the factory's south-facing U-shaped plan with the insertion of an elevator core that became the fourth wall of an interior courtyard to its north and, to the south, creating a recessed entryway and lobby covered by a barrel-vaulted glass canopy extending out toward Pei's planned arrivals plaza. Sadly, the plaza was realized as a parking lot, described by Charles K. Gandee as an "unwelcome mat."[43]

The newly defined interior courtyard, once a loading area for trains that pulled into the building to receive their cargo, was covered over with a skylight to create a soaring, 120-foot-high terrazzo-floored atrium. A series of metal catwalks crossed the space at the fourth floor, also serving as a support for lights and banners. According to Gwathmey, the catwalks were meant to "imply a lowered ceiling plane" and thus a "human-scale room" within the high space.[44] Across the courtyard from the elevators, a stair tower modeled with strong diagonal lines lent a sense of dynamism to what Paul Goldberger called "one of the more grandly scaled enclosed public spaces made in New York in our time," an impression especially apparent during the parties that were frequently

Center One, International Design Center, New York (IDCNY), site bounded by Thirty-first Street, Thomson Avenue, Thirtieth Place, and Forty-seventh Avenue. Renovation by Gwathmey Siegel & Associates; graphics and signage by Vignelli Associates, 1986. Atrium. Bryant. ARC

held there, though he found the space "slightly static . . . somewhat chilling" when it was not active.[45] The showrooms were situated at the building's perimeter, accessed from a ten-foot-wide promenade that wrapped around and overlooked the atrium at each level, allowing natural light to fill the circulation spaces, a rarity in such facilities.

Center One opened a year later, on October 9, 1986. Again the architects covered over an existing courtyard, this time with a glass barrel vault. To break down the scale of the central space, which was significantly longer and narrower than that in Center Two, the architects divided it into two 8,000-square-foot halves, installing an elevator core at its midpoint. The elevator core was bright red-orange in color and along with yellow banners designed by Vignelli introduced a splash of vibrancy into the otherwise cool white-and-gray space. In each half of the atrium, a staircase was suspended from the long wall, cascading down from the center. Centers One and Two were connected by a three-story enclosed bridge clad in red orange corrugated metal with an almost full-height circular window that created, for Goldberger, a "spectacular" effect, like a "piece of geometric sculpture."[46]

Though Goldberger considered the overall design to be a success, he was disappointed with the showrooms themselves. While many of the more than 100 showrooms that opened in IDCNY were nonevents, some were certainly better than others.[47] In their 21,000-square-foot showroom for

Atelier International showroom, IDCNY. Richard Penney, 1987. McGrath. NMcG

ICF showroom, IDCNY. Mario Botta, 1986. Kaufman. EK

ICF showroom, IDCNY. Mario Botta, 1986. Plan. MBA

Herman Miller, Gwathmey Siegel used the building's twenty-foot-on-center columns as the basis for a ten-foot-square lighting grid suspended ten feet above the floor.[48] Like their catwalks in Center Two, the grid was to act as an implied ceiling plane and support fabrics and panels used to reconfigure the space. Exposed pipes and mechanical systems and sandblasted concrete columns were countervailed by smooth materials like clear and etched glass, white neoparium, and painted drywall.

Thad Hayes conceived Edward Pashayan & Co.'s 11,000-square-foot showroom as a "great open landscape."[49] The vast room was broken up by low concrete-block partitions, a folding screen, and most dramatically, two ten-foot-high, nineteen-foot-diameter open-wire corn cribs lined with cotton scrims, inside of which featured items were put on display. For Atelier International's showroom, Richard Penney worked with the company's head, Stephen Kiviat, also an architect, to create a symmetrical plan providing distinct areas for the company's three categories of products: lighting, contract, and residential furniture. Visitors to the three-story showroom were brought from a first-level reception area to upper-level galleries via a barrel-vaulted, skylit staircase offering, according to Joseph Giovannini, "the suspense of a Hitchcock thriller."[50]

Several of the smaller showrooms were quite distinctive. The Swiss-based architect Mario Botta designed ICF's 10,000-square-foot showroom showcasing its line of high-style, architect-designed Modernist furniture in a series of semicircular alcoves formed out of bands of white-painted concrete brick walls suggesting the strong masonry forms that were his architectural signature. The idea, according to Botta, was "to

create surprises by hiding and then discovering the furniture . . . to make architecture more than an expository space for products. Furniture changes; architecture remains."[51] While Goldberger called the design, Botta's first in America, "a surprisingly harsh essay in brick, lacking both the brooding power and the tensile energy of his other work,"[52] most other observers lauded the architect's antidote to the typically ephemeral character of showroom design, including Giovannini, who termed it an "in-house Stonehenge—an orderly landscape of monumental circular brick walls, with a sense of great permanence and purpose."[53]

The bathroom-fixture company American Standard hired the Chicago-based firm of Tigerman McCurry Architects to design both its 6,000-square-foot showroom and, while that was under construction, a temporary showroom. In the temporary space, the architects toyed with the paradox of putting the

ABOVE Temporary American Standard showroom, IDCNY. Tigerman
McCurry Architects, 1988. TMA

ABOVE American Standard showroom, IDCNY. Tigerman McCurry
Architects, 1989. Diagram of black and white cubes. TMA

LEFT American Standard showroom, IDCNY. Tigerman McCurry
Architects, 1989. Hursley. TH

ABOVE Allsteel showroom, IDCNY. SITE, 1986. Sterzing. SITE

RIGHT Citicorp at Court Square, site bounded by Forty-fourth Drive, Forty-fifth Avenue, Twenty-third Street, and Jackson Avenue. Skidmore, Owings & Merrill, 1989. View to the west. Lieberman. NL

most private of household furnishings on display for all to see, establishing an informal feel by using pried-open packing crates as pedestals for sinks and toilets and, in an area separated by shower curtains hung from metal frames, situating toilets around glass tabletops supported by wooden sawhorses to approximate a conference room setting.[54] The permanent showroom, surrounded by a ten-inch-deep pool of water fed by wall-mounted faucets that ran throughout the day, was divided into twenty-four ten-foot cubes alternately finished in black and white metal, plaster, tile, and marble to resemble "a three-dimensional structural-steel checkerboard," as Paul M. Sachner described it.[55]

Perhaps the most inventive showroom was designed by SITE for the company Allsteel.[56] Led by James Wines, SITE emphasized the design and construction of Allsteel's line of office furniture by suspending upside-down from the ceiling a stripped-to-the-bones version of each piece of furniture on the showroom floor. The effect was otherworldly, with not only chairs, desks, and partitions, but also typewriters, hole-punchers, and briefcases uncannily suspended above. In addition—and back on the floor—Wines conceived glass partition walls as "invisible bisectors" slicing through pieces of furniture that were upholstered and finished on one side of the glass and stripped down on the other side.[57]

Despite auspicious beginnings, IDCNY was not a success, hampered by its Queens location and plagued by high construction costs. The stock market crash of October 1987 and

the recession that followed took the bottom out of the office furniture market at the same time that showroom space in Manhattan, once precious, was becoming increasingly available and considerably less expensive. By 1991 Suzanne Slesin could describe the corridors of IDCNY as "virtually empty."[58] Two years later the Bank of New York took control over the complex and repositioned it in the market by leasing roughly half of it as office space.[59] The showrooms were consolidated into Center Two, and Center One became home primarily to governmental offices. By 1998 Center Two had also gone bust and the complex was renamed the Queens Atrium Corporate Center, a far more successful venture that was nearly 100 percent leased by the year 2000.

Citicorp at Court Square

In the spring of 1985, rumors began to circulate that Citicorp, the nation's biggest bank, was planning a large new office building on a recently acquired Long Island City site to complement its major holdings in Manhattan, consisting of Citicorp Center (Hugh Stubbins & Associates, 1977), Lexington to Third Avenue, Fifty-third to Fifty-fourth Street, as well as an earlier headquarters building they still controlled at 399 Park Avenue (Carson & Lundin in association with Kahn & Jacobs, 1961), between Fifty-third and Fifty-fourth Streets.[60] In July Citicorp confirmed the rumors when a spokesman for the company told the *New York Times* that it was considering a forty- to fifty-story tower on the 80,000-square-foot lot bounded by Forty-fourth Drive, Forty-fifth Avenue, Twenty-third Street, and Jackson Avenue, only a four-minute subway ride from its Lexington Avenue headquarters.[61] The spokesman noted that a decision about whether to go ahead with the project was expected before the end of the year and that Skidmore, Owings & Merrill would be responsible for the building's design, 50 percent of which was to be occupied by the bank and the remainder leased to outside tenants.

In December 1985, Citicorp definitively declared its intention to go forward with the project, which would top out at over 600 feet, making it not only the highest building in the outer boroughs but also the tallest tower outside Manhattan between Boston and Baltimore.[62] In contrast to the typical practice of shifting back-office-type operations to the outer boroughs, Citicorp envisioned this new facility as a way to decentralize some of its major operations, moving some 2,000 employees, including many executives. The two-acre site, home to a parking lot, was located in a low-rise neighborhood of lower-middle-class residences and light industry. The immediate vicinity was also home to two landmarks. Just to the east, across Jackson Avenue, was the Long Island City Branch of the New York State Supreme Court (George Hathorne, 1874; rebuilt, Peter M. Coco, 1908), 25–10 Court Square, and a block to the west was the Hunters Point Historic District, bounded by Twenty-first and Twenty-third Streets, Forty-fifth Road, and Forty-fourth Drive, an enclave of forty-seven largely intact rowhouses built by Spencer B. Root and John P. Rust between 1871 and 1890.[63] The bank was attracted to the site not only because of its proximity to stations on three subway lines and to the Hunters Point station of the Long Island Rail Road, but also because of its relative low cost as compared with Manhattan. Moreover, the site promised that the proposed new building would be highly visible from Citicorp's headquarters in Manhattan, in fact concluding the axis of East Fifty-third Street.

Citicorp at Court Square, site bounded by Forty-fourth Drive, Forty-fifth Avenue, Twenty-third Street, and Jackson Avenue. Skidmore, Owings & Merrill, 1989. Rotunda. Lieberman. SOM

As designed by Raul de Armas of SOM, the 1,375,000-square-foot, 633-foot-tall office building would rise fifty stories with a curtain wall of glass and blue-green metal panels. Near the top, the otherwise unbroken tower mass was set back at its corners, giving the building its principal distinction. In exchange for generous zoning concessions that permitted a building seven times larger than normally allowed, as well as a $23 million tax abatement for building outside of Manhattan's business districts, Citicorp agreed to contribute some public amenities: a seven-story glass rotunda accessible from the subway, renovations for nearby subway stations, a 350-foot-long underground pedestrian link between separate subway lines that connected the Court Square station and the Twenty-third Street station, 2,500 square feet of donated space in the company's new four-story computer annex to serve as a public library branch, and a 16,000-square-foot triangular public plaza densely planted with Cutleaf European birch trees.

The editors of the *New York Times* quickly embraced the bank's plan, writing on December 31, 1985, that the "decision of Citicorp to leap across the East River and plant a new . . . headquarters building in Queens should enhance New York's future as an office center. It will also hearten New Yorkers outside Manhattan, who would finally benefit directly from the office explosion." The editors also supported the decision of the City Planning Commission to allow a building far larger than what the current zoning allowed, believing that the move "seems fully justified" because the area was well served by mass transit and because "when the present zoning was adopted in 1961," it favored the needs of "Long Island City's manufacturing businesses . . . , and office densities that force up land values were unwelcome. Now there is no demand for

more manufacturing space."[64] In a letter to the paper, Stanley S. Litow and David Gallagher, of the New York Interface Development Project, a nonprofit research group specializing in urban issues, strongly disagreed, asserting that "there is a dearth of available manufacturing space in Long Island City, and it is very much in demand." Noting that "Long Island City is a well-established relocation site for manufacturers forced out of Manhattan by rising rents and building conversions," they worried that "this neighborhood concentration of more than 32,000 industrial jobs, the largest in the city, is imperiled by the very type of office development you applaud. New York needs its manufacturing jobs because not all city residents want or are trained for office employment."[65] This point of view was in the decided minority and almost every public official strongly supported Citicorp's move, perhaps motivated by the fear that the bank might leave the city entirely if permission were denied.

Construction on Citicorp's building began early in 1987, and by the summer of 1988 the steel superstructure was complete. Anthony DePalma reported in the *New York Times* on its dramatic impact on the skyline: "Face due east from the corner of 53d Street and Lexington Avenue in midtown Manhattan, and the huge new skyscraper taking up almost the entire plane of view appears to be just a few blocks away. But walk a few blocks in that direction and it becomes clear that the building is farther away than it seems—that it is, in fact, a Manhattan-sized tower sprouting up across the East River in Queens." DePalma further noted that the tower "dominates the Queens skyline like a sequoia in the desert, and the difference is even more striking on the ground. The new giant's neighbors are three-story rowhouses and 15-foot-high commercial buildings whose primary architectural features are steel garage doors."[66]

In October 1988, Paul Goldberger offered his first comments on SOM's new building, officially named Citicorp at Court Square (1989), writing that "there is nearly complete in New York City a skyscraper that is having an impact on the skyline as profound, in its own way, as the World Trade Center," one that is "rapidly becoming one of the most conspicuous structures in the entire city. . . . It is a very unlikely thing, this building—no other skyscraper in New York is remotely like the Citicorp tower, not so much for its design as for the fact that it stands free, alone in this landscape of gas stations, warehouses and row houses." Goldberger noted that "we perceive this tower with greater intensity than almost any other skyscraper in the city" because "we are completely unaccustomed in New York to viewing towers that stand by themselves." Although Goldberger claimed that the "real issue is not the esthetics of this building but the simple fact of its existence," he was nonetheless sympathetic to its design: "Handsome, even somewhat refined; its pale blue-green glass and transparent windows are obviously intended to reduce the impact of the vast tower on Long Island City, and to a considerable extent they succeed. . . . And the shape—a tower with stepped-back height, with small setbacks at the very top to create a hint of a pyramid where the building meets the sky—helps a bit more in reducing the apparent bulk."[67]

Still, Goldberger could not overlook some negative consequences of the huge tower, conceding that "this building does, after all, transform the landscape of New York. No longer does Manhattan virtually by itself control the skyline. And the placement of this building has a particularly harsh effect from

midtown: it directly blocks the vista eastward on 53d Street, quashing that sense of open space at the end of canyons of buildings that is so vital a part of the Manhattan cityscape." But Goldberger waffled, arguing that though "these effects are all saddening . . . they don't, in themselves, add up to a sense that the city made a mistake here. For it is imperative that there be some large-scale growth in the boroughs, and this is as logical a place as any for it to happen." Goldberger concluded his assessment by comparing Citicorp at Court Square to its only "real peer" in the city, the 512-foot-tall Williamsburgh Savings Bank (Halsey, McCormick & Helmer, 1929), another "skyscraper that rises in such splendid and startling solitude," completed "in the hope that the business center of Brooklyn would move in its direction, which never happened. For 60 years the building has stood by itself . . . and the cityscape has never suffered from this tower's isolated position. Skyscrapers built at random all over New York would be devastating, but an occasional exclamation point, well designed and carefully placed, will do the skyline no grievous harm."[68]

In sharp contrast to Goldberger, architect James S. Rossant feared that Citicorp at Court Square represented the death of planning in New York, writing in a letter to the *Times* that the new building "has risen like a giant weed in a garden: silently, overnight, it has grown to loom over Manhattan." Although Rossant acknowledged that the building went through all the proper approvals processes, he felt there "has been no real citywide debate about this most devastating change in New York City. . . . The grand design of midtown Manhattan—that intense forest bastion of skyscrapers surrounded by a kind of moat on the east, with the vast, unbroken field of low buildings of Queens beyond it—as famous an image of a city as exists in the 20th century, is now changed forever. . . . We cannot afford to allow projects of [this] significance . . . to go ahead without careful review. More important, this review must take place when it can still have effect."[69]

By the time of the building's completion in 1989, Citicorp had decided against leasing half of the space to outside tenants and instead took control of the entire building, transferring more than 4,000 employees there and simultaneously selling off some of its Manhattan real estate. Despite the tower's dominating presence, only seven years after its completion Citicorp felt the need to add illuminated, one-story-high letters spelling out the name "Citibank" at the top of all four sides of the building because, as spokesman John M. Morris explained, "it's an anonymous building . . . people don't recognize that as the Citibank building," testament perhaps to a certain blandness in its design, especially when compared to the ski-slope top of Stubbins's building, widely identified with the corporation. George Armstrong, a neighborhood resident and member of the Long Island City Interblock Association, declared the sign a "disgrace," pointing to its "big block letters, with a rather ugly font," although he added that the building itself "has a certain amount of grace."[70]

Churches

Two notable churches were constructed to serve Long Island City's repopulating community. Alfredo De Vido Associates' Community Church of Astoria (1987), 14–42 Broadway, between Fourteenth Place and Twenty-first Street, enveloped an existing 1952 church building, doubling its size to 4,000 square feet to include a new second-floor fellowship hall,

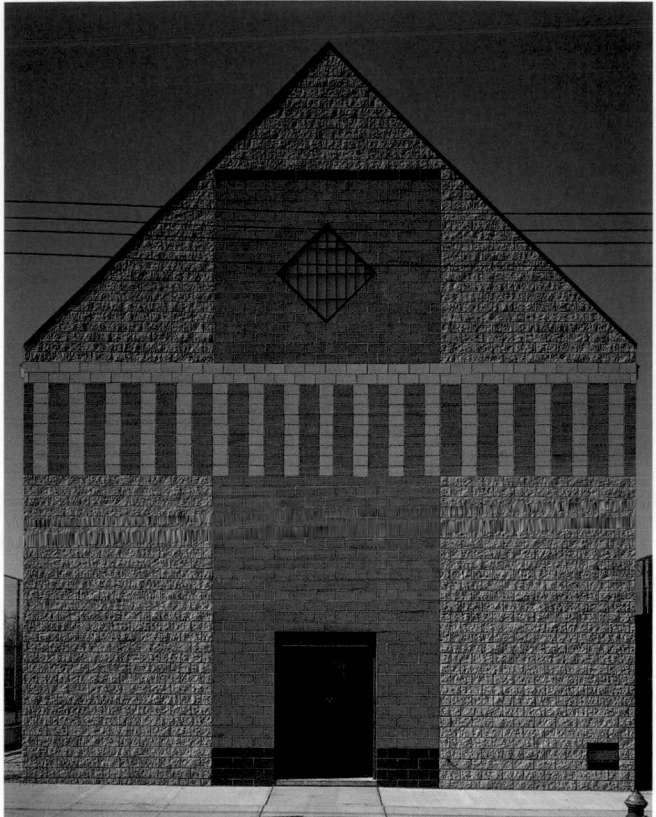

Community Church of Astoria, 14–42 Broadway, between Fourteenth Place and Twenty-first Street. Alfredo De Vido Associates, 1987. View to the southwest. Warchol. PW

meeting room, and kitchen. De Vido's rather diagrammatic combination of textured and glazed concrete block in several shades of gray with red accents to depict a cross on the front facade impressed the editors of the *AIA Guide*, who remarked that it was "amazing what concrete block can be made to do."[71]

Far more provocative was Greg Lynn, Michael McInturf, and Douglas Garofalo's New York Presbyterian Church (1999), 42–23 Thirty-seventh Avenue (the former Dreyer Avenue), in Sunnyside, one of the most talked about buildings of the late 1990s.[72] The church was a dramatic reconstruction of and addition to an 88,000-square-foot minor masterpiece of the Art Moderne, Irving M. Fenichel's Knickerbocker Laundry (1932). Fenichel's building was important enough to attract the attention of Lewis Mumford, who in 1932 wrote disapprovingly about its "misplaced monumentality," but since 1986, when its last tenant, the perfumer Naarden-UOP Fragrances, abandoned it, the building had become a notable symbol of the city's declining fortunes, especially visible to suburban passengers on the Long Island Rail Road, the main line of which bordered the site on the south.[73]

Overblown though the facade may have been, it remained for fifty years a de facto landmark amid a bleak industrial landscape, though its status was never officially recognized by the Landmarks Preservation Commission. In August 1989, plans were announced by the developer Richard Zirinsky for the redevelopment of the building and adjoining property as the Sunnyside Mall, intended to cater to home-related and electronic stores.[74] But the decline in the real estate market undid the plan and Zirinsky lost the property to a bank, which left the building largely unprotected and allowed its appear-

ance to precipitously decline. In 1993 Fenichel's building was acquired by the Korean Presbyterian Church of New York, which had outgrown its home in a former catering hall at Broadway and Roosevelt Avenue. Initial plans for conversion into a church and community center, with a chapel, offices, nursery, classrooms, and gymnasium, were prepared by Young Sang Cho, an architect practicing in Elmhurst. Cho's plans called for significant alterations to the original design, including a bold reconfiguration of the entrance to form a navelike mass surmounted by a large crucifix.

While community groups began to argue for a design more sensitive to the building's character, the project's cost escalated dramatically and Cho was replaced by Greg Lynn and his team, practicing as Form, Inc. The new design, which was innovative in many ways, not least because it was among the first to be predominantly computer generated, provided for a sanctuary capable of holding 2,500 worshipers—more than could be seated in St. Patrick's Cathedral in Manhattan—a 600-person wedding chapel, an 800-seat cafeteria, eighty classrooms, five multipurpose meeting rooms, a library, exhibition hall, and support facilities. The design process was almost as interesting as the building itself. Through Internet connection the three architects and four assistants working in their different offices in New York, Chicago, and Cincinnati could exchange CAD files, model photographs, and other information throughout the typical work day, distributing the workload among the offices and thereby pooling the insights and experiences of the comparatively young and inexperienced team.

The floor of the new sanctuary was located on the roof of the existing factory, which had originally been designed to allow for the building's vertical expansion. Though the laundry's structure could support the loads generated by the sanctuary, the roof covering that space would have to be carried on a separate structure, leading to the brilliantly eccentric, seemingly kinetic, aesthetically challenging, armadillo-like canopy structure liberated from the conventional structure below. To achieve the roof design the architects worked with what they

New York Presbyterian Church, 42–23 Thirty-seventh Avenue, east of Forty-third Street. Greg Lynn, Michael McInturf, and Douglas Garofalo, 1999. Sanctuary plan. GLF

ABOVE New York Presbyterian Church, 42–23 Thirty-seventh Avenue, east of Forty-third Street. Greg Lynn, Michael McInturf, and Douglas Garofalo, 1999. View to the north. Staller. SI

BELOW New York Presbyterian Church, 42–23 Thirty-seventh Avenue, east of Forty-third Street. Greg Lynn, Michael McInturf, and Douglas Garofalo, 1999. View to the southeast. Staller. SI

BELOW New York Presbyterian Church, 42–23 Thirty-seventh Avenue, east of Forty-third Street. Greg Lynn, Michael McInturf, and Douglas Garofalo, 1999. View to the west from within stair passageway. Staller. SI

BELOW New York Presbyterian Church, 42–23 Thirty-seventh Avenue, east of Forty-third Street. Greg Lynn, Michael McInturf, and Douglas Garofalo, 1999. Staller. SI

called "blob modeler" software developed for automobile designers who need to be able to change portions of a car's design without changing its entirety. The software enabled the architects to shape the design rather as a sculptor models a mass of clay, allowing them to evolve what Joseph Giovannini characterized as the "vague, drifting orientation toward the front of the sanctuary."[75]

Using affordable but durable materials, especially standing-seam metal cladding and metal panels, the new building challenged its host structure. Though the church presented an important facade to the railroad, such was now in actuality a secondary facade. Parishioners arrived by car, so that the church's real entrance was on the west side, facing a large parking lot. Although the sanctuary roof was notably bold, the really interesting part of the design was the arrangement of stairs and passageways that helped turn the story-and-one-half climb from parking lot to the worship space into a dramatic sequence. Though senior parishioners were scandalized by Fenichel's design, many younger members of the congregation seemed almost pleased with its spaceshiplike shape rising behind Fenichel's preserved monumental facade, which the architects painted black and nicknamed the "shroud."

Despite its preopening hype, the final results were mixed. Nicolai Ouroussoff, architecture critic of the *Los Angeles Times*, dismissed the church as "a static, brooding building that breaks few conventions [and] tells us more about the computer's limits than its potential." Ouroussoff was most impressed by the paths through the building taking worshipers to the elevator tower, the sanctuary, or to the chapel and cafeteria but found that "the flat, open floor, with its endless rows of pews, adds to that feeling of a quickly assembled, staged event." Acknowledging the restraints of the tight budget, Ouroussoff also suspected that "a more fundamental problem . . . may stem from the architect's unwillingness to leave the abstract world of the computer to dig into the realities of life in the world of humans. . . . In the end, the building captures the computer's lifelessness without its slick, erotic charge."[76]

Herbert Muschamp's enthusiasm contrasted with Ouroussoff's disappointment. The *New York Times*'s critic saw the church as a reflection of Peter Eisenman's influence (Lynn and McInturf had worked for Eisenman): "The younger architects give us Eisenmanesque forms without the Hate me! Hate me! provocation. That loss is a gain all around." Muschamp was particularly taken with the sanctuary, declaring it "the most impressive interior to be built in New York in many years." But Muschamp's appreciation lay more with the building as a symbol of an idea and a moment than as a work of architectural art in and of itself:

> The church is a natural extension of the process the architects used to design it. That process caused three architects to reconfigure the spatial relationships between them. The church amplifies those relationships in architectural terms. It would be odd if the computer did not set off a spatial revision comparable to that sparked by Brunelleschi's development of linear perspective in 15th century Florence. Indeed, blob architecture undermines the enduring authority of perspectival space. While blob architecture has its Baroque aspects, its twists on axis, symmetry and procession violate classical norms. In Queens, the classically symmetrical Deco facade accentuates the anti-classicism of the addition.[77]

Joseph Giovannini found the church to have an almost desiccated quality, particularly in the interior, which he suggested may have been a result of the limitations of the design methodology: "One of the potential blind spots of the computer is the sense of materiality; even with texture-mapping buttons, the machine tends to produce airless, immaterial visions. Here the computer confirmed the material austerity set up by the budget and the asceticism of the church. The sum of generic materials, even if used unconventionally, connotes office blocks and factories. In an otherwise rich composition full of spatial complexities, the materials make the church seem diagrammatic."[78]

Architects were mixed in their reactions to the building. Not everyone agreed with Antoine Predock, who admired the challenge, saying that it had "a nice Godzilla meets Bambi quality—there is a feeling that an alien has come from without and invaded the building."[79] Alexander Gorlin, once Douglas Garofalo's studio critic at Yale, saw it as "a kind of religion factory attacked by a giant armadillo" that suggested "a completely new idea in adaptive reuse (unlikely to win accolades from the preservation community) which could be called adaptive S & M" with the original building "victimized: masked, bound, strapped by the railroad tracks, painted black, mounted, and submerged beneath the curving leviathan of the roof above." Like almost every other visitor, Gorlin was impressed with the stairs leading to the sanctuary but felt that the "anticipation" set up was not fulfilled by the sanctuary itself, which did not "compare with the toughness of the facade's metallic and translucent materials" and was, instead, "a sweet, soft space, with the languid, dead fluorescent glow of a Holiday Inn meeting hall."[80]

When all was said and done, the New York Presbyterian Church, though startling in the manner of its realization, had strong connections to work of the 1950s and 1960s, when architects like Eero Saarinen explored the expressive possibilities of thin-shelled, ribbed construction. What was the most provocative part of the design was not the sanctuary or its enclosing structure, or the use of fiberglass to clad a major facade or even the contrapuntal juxtaposition of resolved, almost platonic forms with the unresolved tubes and stairways of the circulation system–this had been explored by architects in the 1960s such as John Johansen–but the fact that the building had been created by the computer used as a conceptual tool and not merely an instrumental one.

Art Outpost

By the late 1990s, the largely industrial confines of Long Island City were home to an art district specializing in contemporary work. Although it lacked the vitality and density of Greenpoint and Williamsburg, which were fast developing as residential neighborhoods populated by artists driven from SoHo, Tribeca, and Alphabet City by rising real estate values, Long Island City was more important for venues for the display of contemporary art. Long Island City's renewal as an outpost of Manhattan's museum scene began in 1976 with the opening of an exhibition and studio center for the Institute of Art and Urban Resources in the former Public School 1 (1893; north wing, C. B. J. Snyder, 1906), 46–01 Twenty-first Street between Forty-sixth Road and Forty-sixth Avenue, in the Hunters Point section.[81] Shuttered since 1963, the Romanesque Revival building, the victim of neglect and vandalism, was transformed into an arts complex intended for some of the nation's most avant-garde artists. Working with an extremely limited budget whose funds were provided by a combination of city, state, and federal agencies, architect Shael Shapiro's

Isamu Noguchi Garden Museum, 32–37 Vernon Boulevard, northeast corner of Thirty-third Road. Restoration by Sage and Coombe Architects, 2004. Aaron. ESTO

"minimal" reconstruction was confined to such basic interventions as roof and floor repairs, rewiring, plumbing, and climate control. Shapiro converted the three classroom floors into thirty-five artists' studios and reserved the sixty-by-seventy-foot auditorium as a performance area. Hallways became galleries. As Shapiro put it, "We're really only cleaning up the building. Wherever we can do nothing, we're doing it."[82] The bare-bones approach to the space, originally called Project Studios One but quickly dubbed P.S. 1, seemed to match the aesthetic aspirations of the young artists intended to occupy it. As Alanna Heiss, president of the four-year-old arts organization that she helped found, noted, "Most of our artists like to work with and transform spaces as they are." Directed to the abandoned school by Queens Borough President Donald Manes, Heiss stated, "The industrial location was ideal, because of supplies, and it's so big that artists can afford to experiment there."[83]

Although the area had been home to the sculptors Isamu Noguchi and Roy Gussow, who arrived in 1961 and 1964, respectively, P.S. 1 was the catalyst for Long Island City's emergence as an arts community. In 1978 P.S. 1 was joined by

Independent Studios One, or I.S. 1, which provided studio and exhibition space in a nearby former furniture factory at 10–27 Forty-sixth Avenue. Artist Stephanie Brody Lederman explained the area's growing appeal by noting that it was "very close to Manhattan. If you are doing things at galleries or at museums, it's on the way, or if someone wants to come see you, you just tell them it's two subway stops past the Museum of Modern Art."[84] The trend continued, leading Philip Shenon, a *New York Times* reporter, to declare Long Island City a "new artists' haven" and an important "proving ground for young artists."[85]

Long Island City's artistic profile was further lifted in 1985 when eighty-year-old Isamu Noguchi, working with architect Shoji Sadao, created a museum dedicated exclusively to his own work, located across the street from his studio in a former photo-engraving plant (1928) at 32–37 Vernon Boulevard, northeast corner of Thirty-third Road, an isolated site in the Ravenswood section.[86] Noguchi acquired the two-story red brick factory in 1974 and in the early 1980s began work on the museum, first adding an adjacent two-story cement-block structure (1982) that, along with the 8,500-square-foot garden,

P.S. 1, 46-01 Twenty-first Street, between Forty-sixth Road and Forty-sixth Avenue. Frederick Fisher in association with David Prendergast, 1997. Moran. MM

RIGHT P.S. 1, 46–01 Twenty-first Street, between Forty-sixth Road and Forty-sixth Avenue. Frederick Fisher in association with David Prendergast, 1997. View to the west showing Citylights (Cesar Pelli & Associates, 1998) in background left. Moran. MM

filled out the triangular 38,000-square-foot site. The Isamu Noguchi Garden Museum contained fourteen separate gallery areas displaying about 500 works of art from every period of the sculptor's sixty-year-long career. The 11,000-square-foot facility was entered through a roofless gallery containing Noguchi's most recent designs, with the remainder of the work arranged along an indoor walking path in roughly reverse chronological order. The gallery spaces were spare, with large windows cut out to provide views of the garden. No heating or air-conditioning had been installed, and the facility was only open from April to October. The garden contained trees and plants native to Japan and the United States, as well as large stone sculptures on a bed of manicured gravel and one of Noguchi's signature slow-moving water fountains. After Noguchi's death in 1988, Shoji Sadao designed a twelve-inch-wide, six-inch-high basalt grave-stone, partly polished and partly rough, to mark the location in an inconspicuous corner of the garden of half of the sculptor's ashes, the other half of which had been buried in the garden of his studio in Japan. In 2001 it was discovered that the former factory had settled unevenly, putting stress on the brick walls. Although the Noguchi Foundation expressed interest in a more significant renovation, with Tod Williams and Billie Tsien initially tapped to do the work, budget constraints led to a more modest restoration (2004) executed by Sage and Coombe Architects that included facade repair, new windows, renovation of administrative offices, a new design shop and café, and the installation of a heating and cooling system, allowing the museum to be open year-round.[87]

Isamu Noguchi was also partly responsible for the Socrates Sculpture Park, located only a few blocks from his studio and museum.[88] In 1986 Noguchi and sculptor Mark di Suvero, who also had a studio in the area, helped found the park, an outdoor exhibition space dedicated to a changing display of large-scale sculpture located on four-and-a-half vacant acres, previously used as an illegal dumping ground, bounded by

Dance pavilion and disk jockey booth, P.S. 1 courtyard. Philip Johnson in collaboration with Robert Isabell and Donald and Taffy Kaufman, 1999. View to the north. McGrath. NMcG

Vernon Boulevard and the East River, Broadway and Thirty-first Avenue. With a shoestring budget and a slew of volunteers, the litter-strewn riverfront lot was transformed into a suitable location for monumental sculptural works with the addition of winding gravel paths, wildflower gardens, and large stretches of open space with newly planted grass. As di Suvero, the driving force behind the park's creation, noted: "To be outdoors is an essential thing for living sculpture, and we have that here. There should be a place in Manhattan but there isn't and they're not about to sacrifice four acres of space in Manhattan for sculpture."[89] Although the city gave the Socrates Sculpture Park a five-year lease, the success of the venture drew attention to the site from developers who lobbied for its redevelopment as luxury waterfront housing, threatening its future until 1998, when it was officially declared a permanent city park.[90]

Long Island City's status as an art enclave was given an additional boost in 1987 when Creative Time relocated its Art on the Beach series, a summer-long exhibition of sculpture combined with dance, music, and conceptual art performances, initially staged at Battery Park City, to a six-acre landfill site donated by the Port Authority along the Hunters Point waterfront, at Second Street south of Fifty-fourth Avenue.[91] The 1988 opening of the American Museum of the Moving Image at the nearby Kaufman Astoria Studios com-

plex (see above) further strengthened the area's claim as an arts neighborhood. By 1990 there were an estimated 500 artists either living or working in an area that had been transformed over the past fifteen years, according to Linda Bradford, writing in *Metropolis*, "into a center of art . . . with international significance."[92]

In 1995, close to two decades after its founding, P.S. 1 announced plans for an extensive renovation to its building that would increase the usable space from 50,000 square feet to 84,000 square feet and add a 20,000-square-foot sculpture garden on land currently home to a parking lot and sometimes used by the museum to display sculpture.[93] Frederick Fisher, a Los Angeles–based architect with extensive experience in designing exhibition spaces for contemporary art, received the commission, charged with the goal of creating a "legitimate museum, not just an ad hoc space," while retaining the rough-and-tumble character of the 1976 renovation.[94] A significant portion of the three-year $8.5-million renovation, executed in association with New York architect David Prendergast, 85 percent of which was funded by the city, involved bringing the building up to code, removing asbestos, adding an elevator, installing a loading dock, fixing the leaky roof, and performing other needed structural repairs. Fisher consolidated the artists' studios in the south wing of the building and created thirty-six new galleries in a variety of

styles, sometimes working with original features, like tin ceilings and an exposed-brick vaulted ceiling, but also tearing down walls to create larger spaces with smooth white-painted walls. To enable the display of taller pieces, Fisher carved a two-story, brick-walled gallery out of the former boiler room. In addition to a new café and bookstore, decorated with hanging slide viewers equipped with images of more than 100 works of art, Fisher also included a basement-level space for an art education center as well as a new performance and film theater. Stairwells were painted by artists, and even the bathrooms included art installations.

The sculpture garden, surrounded by high gray concrete walls and filled with a crushed-gravel floor, was divided by concrete walls into three distinct galleries. Previously entered from Twenty-first Street, visitors to P.S. 1 now entered what was once the back of the school, arriving from Jackson Avenue through the courtyard. A concrete staircase, broad enough to serve as seating, led to a deep terrace and glass entrance doors, an arrangement that impressed *New York Times* art critic Roberta Smith, who deemed it "one of the best front doors in the city," while also noting that it "puns gently on the Metropolitan Museum of Art's grand staircase, and provides a space for outdoor performances." To help animate the back of the building, three-story-high letters spelling out "P.S.1" were added, a motif repeated at reduced scale at the courtyard entrance. Smith also praised the rest of Fisher's renovation, writing that it "retains quite a bit of [P.S.1's] signature funkiness" but makes the facility "more accommodating and more stylish."[95]

In February 1999, sixteen months after its reopening, P.S. 1 announced that it was merging with the Museum of Modern Art, gaining the seventy-year-old Manhattan-based institution a foothold in an outer borough as well as exposure to the most contemporary work and trends, and P.S. 1 access to MoMA's considerable resources for fund-raising and publicity.[96] The first collaborative project of the union was a temporary dance pavilion and disk jockey booth (1999) designed by Philip

Johnson for P.S. 1's summer dance and music series held on Saturdays in the courtyard.[97] Johnson designed what he described as "a disco for the 21st century. It's a medieval amphitheater with a science-fiction feeling."[98] The angular roofless pavilion had bleacher-style benches and a deejay booth suspended over the bandstand and was surrounded by towers as high as forty-eight feet and constructed of off-the-shelf galvanized steel scaffolding and white construction mesh. Johnson collaborated on the project with party designer Robert Isabell and color specialists Donald and Taffy Kaufman, who were responsible for the chartreuse, chocolate, ultramarine, deep violet, acid green, and emerald green dance floor. Philip Nobel, who regretted that "a younger, hipper architect" had not been hired to inaugurate the merger, was not impressed, describing the effort as "a pared-down version of one of Johnson's clunky Eighties skyscrapers: It is totally overscaled, thoroughly underwhelming."[99]

The following summer MoMA and P.S. 1 sponsored the first of what would become a series of competitions inviting young architects to design a temporary project intended for the courtyard. SHoP/Sharples Holden Pasquarelli won with Dunescape (2000), an inventive design centered on five elements you would find at the beach: cabana, beach chair, umbrella, boogie board, and surf.[100] SHoP used 6,000 2-by-2 cedar planks ranging in length from eight to twelve feet to create an urban beach, with the boards arranged in undulating waves shaped to accommodate a variety of uses, rising to provide shade, bending down for seating, or twisting on the ground to give privacy for changing clothes. Dunescape also included a wading pool, beach chairs, umbrellas, and four steel poles spraying a cooling mist. Foregoing traditional plans and elevations, the architects created large 3-D computer drawings that they brought to the site and used as construction documents. Limited to a budget of $50,000, they relied on a crew of volunteers to cut and bolt the slats. "If there is any problem with this project," Paul Goldberger wrote, "it is that it is not going to be easy to see it disappear at the end of the

LEFT Dunescape, P.S. 1 courtyard. SHoP/Sharples Holden Pasquarelli, 2000. Joseph. SHOP

BELOW Dunescape, P.S. 1 courtyard. SHoP/Sharples Holden Pasquarelli, 2000. View to the west. Joseph. SHOP

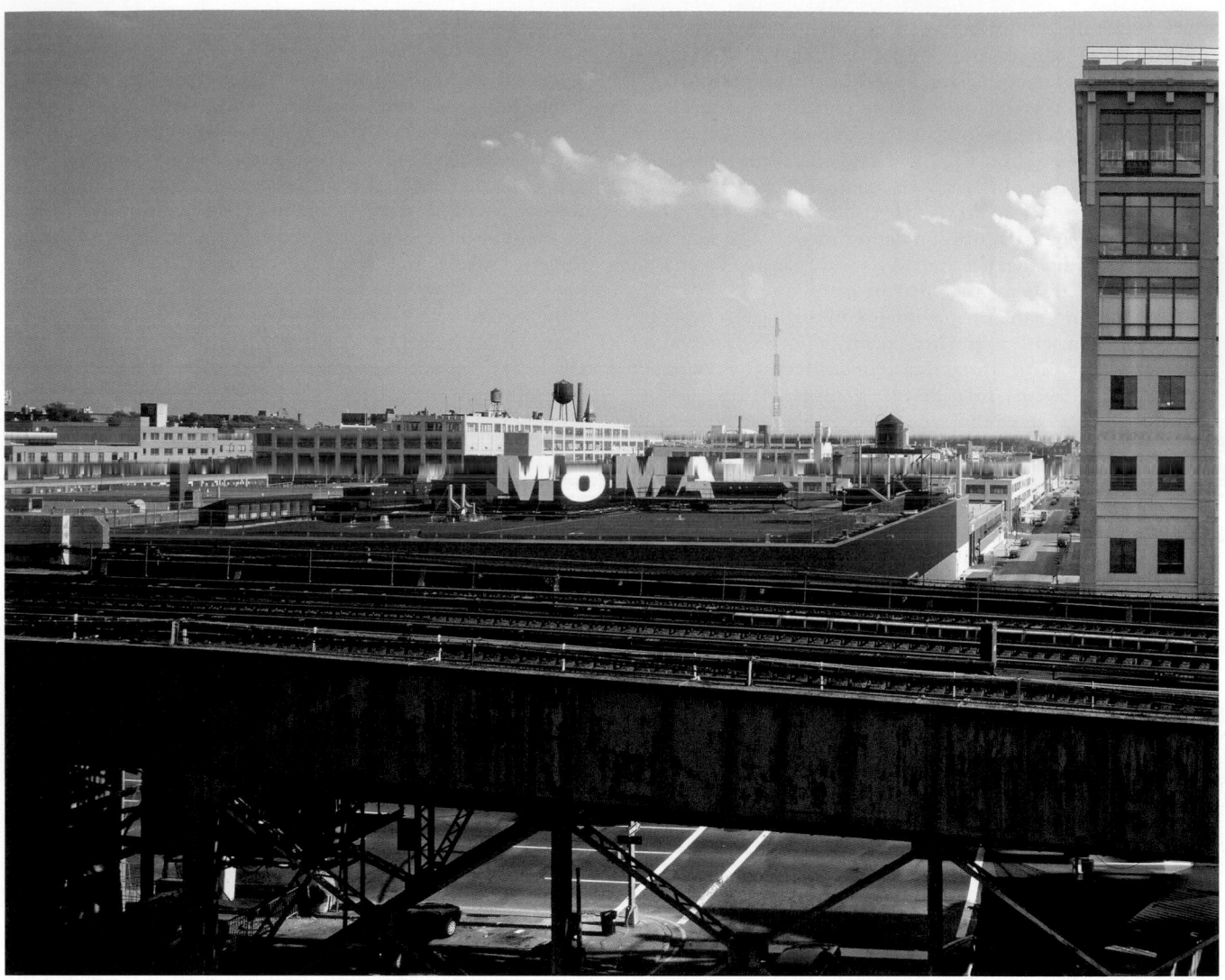

MoMA QNS, 45–20 Thirty-third Street, between Queens Boulevard and Forty-seventh Avenue. Michael Maltzan and Cooper, Robertson & Partners, 2002. View to the south. Richters. CRP

summer. This is one of the few instances of computer-enhanced design in which the result is warmer, livelier, and more exciting than the renderings that preceded it."[101]

In January 2000, MoMA announced its intention to renovate the two-story, 140,000-square-foot Swingline staple factory (1947), 45–20 Thirty-third Street, just off Queens Boulevard and not far from P.S. 1, for use as a temporary art center during construction of Yoshio Taniguchi's addition, which necessitated the closing of the Manhattan museum.[102] The factory had been vacant since February 1999, when Swingline moved its operations to Mexico, resulting in the loss of 450 jobs. To give the new facility a distinct identity, Base, a Belgian-based image-development company, came up with a new logo, MoMA QNS. News of MoMA's expansion into Queens was greeted as yet another sign of the health of the growing arts district, bolstered in 2001 by the introduction of free weekend shuttle-bus service from MoMA's Fifty-third Street building to P.S. 1, the Noguchi Museum, Socrates Sculpture Park, and the American Museum of the Moving Image.

Michael Maltzan, a Los Angeles–based architect who had worked in Frank Gehry's office, collaborated with Cooper, Robertson & Partners on the renovation (2002) of the former factory building. Maltzan was responsible for the most dramatic changes to the exterior, painting the building a bright blue that was accented at night by a 150-foot-long bar of fluorescent lights projecting six feet from the building, adding sliding glass entrance doors sandblasted with the museum's logo, and creating a supersized mural on the roof spelling out "MoMA." For the latter Maltzan placed fragmented white letters on black-painted plywood boxes concealing rooftop mechanical equipment. From a distance the letters appeared disconnected but when viewed from the elevated subway train as it approached the station near the museum, they came together to be easily read. Nicolai Ouroussoff found "the overall effect . . . mesmerizing. Maltzan has created the museum's identity out of almost nothing—some paint, some boxes, a few fluorescent lamps. But these elements are delicately woven through the city's existing texture. As they dissolve in and out of view, they act as a subtle commentary on the museum's temporary status."[103] Inside, the 12,500-square-foot lobby, which Maltzan said was inspired by Alvar Aalto's Finnish exhibit at the 1939 New York World's Fair, was dominated by an imposing, twisting ramp leading to a mezzanine

ABOVE MoMA QNS,
45–20 Thirty-third Street,
between Queens Boulevard
and Forty-seventh Avenue.
Michael Maltzan and
Cooper, Robertson &
Partners, 2002. View to the
west. Richters. CRP

LEFT MoMA QNS,
45–20 Thirty-third Street,
between Queens Boulevard
and Forty-seventh Avenue.
Michael Maltzan and
Cooper, Robertson &
Partners, 2002. Richters.
CRP

space occupied by a bookstore and café.[104] Cooper, Robertson designed the main exhibition space, the 180,000-volume library, storage areas, and staff offices and oversaw the installation of state-of-the-art mechanical and air systems required to protect the collection. Although Joseph Giovannini dismissed the galleries as "the same old white, Mies-inspired interiors,"[105] Paul Goldberger praised them as "understated and deferential to the art, but you never quite lose the sense that you are in a converted factory—there are polished concrete floors, white walls, and a black-painted ceiling."[106] In September 2004, in anticipation of the November reopening of MoMA's Manhattan headquarters following completion of Taniguchi's addition, MoMA QNS closed its doors as an exhibition space, but the museum retained the building for use as a storage, conservation, and research facility.

Central Queens

The town of Newtown, first settled in 1642, incorporated most of central Queens, including the neighborhoods of Jackson Heights, Corona, Elmhurst, Rego Park, Forest Hills, and Kew Gardens. Once separate villages with distinct identities, the explosion of development in Queens that followed the construction of the subway lines and continued during the postwar boom did much to blur the boundaries between them. From the 1970s to the 1990s the landscape and built environment of central Queens remained relatively unchanged, but the area's demographic makeup was transformed by a massive influx of immigrants, predominantly Hispanic and Asian.

Jackson Heights, bounded by Astoria Boulevard on the north, Ninety-fourth Street and Junction Boulevard on the

82–13 Thirty-seventh Avenue, between Eighty-second and Eighty-third Streets. Fakler & Eliason, 1994. View to the northwest. FEA

east, Roosevelt Avenue on the south, and the Brooklyn Queens Expressway on the west, was a mostly residential neighborhood of apartment houses, garden apartments, and two-family houses with a bustling commercial district centered around Thirty-seventh Avenue and Eighty-second Street. It had been developed primarily by the Queensboro Corporation in the years before World War I and continuing into the 1950s, during which time it was transformed from an experiment in high-density suburban-style living to an almost completely built-out neighborhood whose once-generous open spaces had been replaced by block after block of apartment buildings.[107]

On October 19, 1993, the Landmarks Preservation Commission adopted the Jackson Heights Historic District, a thirty-eight-block area roughly bounded by Northern and Roosevelt Boulevards and Seventy-sixth and Eighty-eighth Streets, consisting of more than 500 apartment buildings and houses, the majority built by the Queensboro Corporation between 1911 and 1950.[108] It was only the second historic district in Queens (the first was the Hunters Point Historic District, designated in 1968). The enactment of the historic district prompted the redesign of a 130,000-square-foot office building planned for 82–13 Thirty-seventh Avenue, between Eighty-second and Eighty-third Streets. The Fresh Meadows–based architects Fakler & Eliason, having originally called for a glass-walled building that proved unpopular among local residents, proposed a new design intended to fit in with its Georgian- and Tudor-style neighbors.[109] The building's two-story, sidewalk-hugging base was topped by a steeply pitched slate roof, and each corner featured a small clock tower with a pyramidal roof. On the second floor, red brown brick piers and a stone balustrade implied a loggia but cleverly disguised a parking garage (parking was also provided on the third floor). The office tower, set back to rise six stories above the base, featured a projecting central bay topped by a pediment and flanked by unusual concrete, limestone, and brick bay windows. If a bit overwrought, the building, completed in 1994, was inoffensive, and its massing and ornament went a long way toward hiding its considerable bulk.

On a smaller site to the west, also within the historic district, ground was broken in March 2000 for the Jewish Center of Jackson Heights, southwest corner of Thirty-Seventh Avenue and Seventy-seventh Street, replacing a restaurant.[110] Designed by Herbert Mandel, the 6,000-square-foot, one-story red brick building featured rounded corners and perimeter skylights. The synagogue's 200-seat sanctuary was lit by a series of stained glass windows facing the corner.

The Regal Heights Rehabilitation and Health Care Center (Breger Terjesen Associates Architects, 2000), 70–05 Thirty-fifth Avenue, north blockfront between Seventieth and Seventy-first Streets, a 280-bed nursing home, replaced a car dealership on the western edge of Jackson Heights. In the mid-1980s the firm of Harman Jablin Architects had been asked to design residences for the 25,000-square-foot site, first proposing three townhouses and later a four-story apartment building before seeking a variance in 1987 for a seven-story orange brick building that would rise to the same height as its neighbors.[111] Though it failed to go forward, the project set the stage for the nursing home, which, when completed as an eight-story red brick building with beige brick bands above the base and at the top floor, might have sat well on the street were it not for two ominous recessed and pedimented dark-tinted glass bays on the south and west facades.

At the northern border of Jackson Heights, Leonard Colchamiro Architects and Planners, based in Brooklyn, renovated the 385,000-square-foot Bulova Watch Company building (Alexander D. Crosett & Associates, 1953), a three-story, 450-by-350-foot limestone-clad stripped classical factory situated on a twenty-three-acre site at the intersection of Astoria Boulevard, Grand Central Parkway, and Boody Street, to become the Bulova Corporate Center (1986), remodeling the north and south-facing entrances and adding a new west entrance and 100,000 square feet of space to the third floor.[112] The building was well suited for corporate offices both because of its location—less than a mile from La Guardia Airport and just off major expressways—and because its newly added conference center, 150-seat auditorium, restaurant, and health club were unrivaled amenities in the Queens office market. In 1986 British Airways became the first tenant, moving their American headquarters from 245 Park Avenue into 185,000 square feet on the second floor. The Kurland Group designed the interior, breaking down the sprawling floor plate by installing a series of portals inspired by the Bulova building's entrance.[113] Jean-Pierre Heim was responsible for the British Airways lobby as well as the corporate center's 350-seat restaurant, 10:10 (1989), designed in consultation with Tyrone Rober and Susan Blumenfeld.[114] The restaurant was laid out so that its plan resembled a wristwatch, the centerpiece being a circular bar beneath a thirty-foot-diameter circular soffit with backlit Roman numerals. The tables, stools, handrails, and trim were all designed to evoke clock components.

To the east of Jackson Heights were the long-established residential communities of Elmhurst and Corona, both of

10:10, Bulova Corporate Center. Jean-Pierre Heim, 1989. JPH

P. S. 228, 32–65 Ninety-third Street, northeast corner of Northern Boulevard. Richard Dattner, 2001. View to the northeast. RDPA

which underwent significant demographic transformations during the 1980s. Immigrants from 112 countries settled in Elmhurst and, in Corona, Dominicans accounted for almost half of all new settlers and Chinese and Colombians about a tenth each.[115] In 1984 Gruen Associates completed work on the 115th Precinct, 92–15 Northern Boulevard, between Ninety-second and Ninety-third Streets.[116] It was the city's first station house to be built for a newly created police precinct in thirteen years. The architects designed the 32,500-square-foot building to be low and broad, cladding it in dark brown brick and terra-cotta and keeping it to two stories in order to fit in with its surroundings. The final effect was, however, anything but neighborly, with the building's main gesture to the community a foreboding arched entryway.

Across the street, Richard Dattner's P.S. 228 (2001), 32–65 Ninety-third Street, northeast corner of Northern Boulevard, was a modest but distinctive 45,000-square-foot, three-story box clad in two shades of red brick, striated along the base and in a diaper pattern at the corner, where a flagpole and a bell tower provided a measure of monumentality, as did a two-story recessed entry featuring a large, colorful float-glass painting by Skowman Hastanan.[117] Dattner's Louis Armstrong Cultural Center (1993), located just south of Northern Boulevard on 107th Street, provided athletic facilities for North Corona, including handball and raquetball courts, a basketball gymnasium situated partially below grade, and a rooftop recreation area.[118] The bland 35,000-square-foot brick box was moderately enlivened by oculi, orange brick highlights, and a subtle blue brick diaper pattern. The two-story red brick Langston Hughes Community Library and Cultural Center (2000), 100–01 Northern Boulevard, northeast corner of 100th Street, was designed by Davis Brody Bond and Garrison McNeil & Associates.[119] This branch of the Queens Borough Public Library, which provided standard library

facilities as well as an art gallery, a multipurpose hall for concerts and classes, and a Black Heritage Reference Room, escaped banality by incorporating a long, sloping parapet, two angular rust-colored metal volumes protruding from the facade, and an irregular pattern of fenestration.

In 2003 the home of Corona's most famous resident, Louis Armstrong, was renovated and opened as a museum. Armstrong and his wife, Lucille, had lived in the small brick house at 34–56 107th Street (Robert Johnson, 1910) from 1943 until his death in 1971, during which time Corona's population was largely Italian and Jewish. After Lucille died in 1983, the house, listed on the National Register of Historic Places in 1977 and declared a New York City landmark in 1988, was bequeathed to the New York City Department of Cultural Affairs, which in turn asked Queens College to administer it. Rogers Marvel Architects prepared a master plan for the house's transformation into a museum while Platt Byard Dovell White designed the renovation, inserting a visitors center in the former garage, removing a third-floor addition that Lucille added after her husband's death, and restoring rooms, including a completely mirrored bathroom and a pristine 1960s-era kitchen with aquamarine Formica cabinetry.[120]

In 1983 the Samuel and Lucille Lemberg Building of the Central Queens Young Men's and Young Women's Hebrew Association was built on the 200-foot-long sloping east blockfront of 108th Street, between Sixty-seventh Road and Sixty-seventh Avenue.[121] Johansen & Bhavnani kept the 35,000-square-foot building to two stories at the edges while stepping the mass up to four stories in the rear center of the site. The building's white siding, concrete-block walls, fenced-in rooftop playground, and opaque glass panels enclosing mechanical equipment created an incongruous industrial presence in the residential neighborhood. Far more satisfying was Gran Sultan Associates' distinctive 1996 addition to P.S. 14, 107–01 Otis Avenue, west side of 108th Street.[122] The three-story, 35,000-square-foot cafeteria and classroom wing's sawtooth plan, which allowed the rooms to have two walls of windows, was turned on point with the sidewalk, where the corners poked out beyond a paneled stone wall to form a dynamic series of angular brick piers along the sidewalk. The artist Elizabeth Grajales created a series of landscapes and animal portraits rendered in tile and carved brick for exterior walls and interior floors and corridors.

The largest-scale additions to central Queens occurred along Queens Boulevard, one of the borough's most important thoroughfares, running southeast from Bridge Plaza to

LEFT Langston Hughes Community Library and Cultural Center, 100–01 Northern Boulevard, northeast corner of 100th Street. Davis Brody Bond and Garrison McNeil & Associates, 2000. View to the northeast. Sundberg. ESTO

BELOW Samuel and Lucille Lemberg Building, Central Queens YMHA, 108th Street, between Sixty-seventh Road and Sixty-seventh Avenue. Johansen & Bhavnani, 1983. View to the southeast. Aaron. ESTO

138th Place and Hillside Avenue. Costas Kondylis's twenty-seven-story apartment house, the Embassy (1990), 112–01 Queens Boulevard, north side at Seventy-fifth Avenue, was the first major residential project to be built in Forest Hills in nearly two decades and the last exceptionally tall tower to rise before the expiration of the Housing Quality Program, which allowed it to receive bonus square footage in return for recreational amenities and open space.[123] Samuel and David J. Paul had prepared initial designs for the building, but when the owner abruptly sold the 1.1-acre site in 1988, Kondylis was hired by the new owners to rework the design, keeping its shape but refining the details, altering apartment layouts, and adding glass corners and more balconies. In addition, Kondylis created more room for penthouses by relocating the health club from the twenty-seventh to the third floor. At that level the building set back, allowing the club to provide a running track that circled it on an eighteen-foot-wide terrace designed by the landscape firm of Coe Lee Robinson & Roesch.

Plans were announced in 1986 to convert the Muller Brothers Moving and Storage Building (1926), 101–20 Queens Boulevard, southwest corner of Sixty-seventh Drive, a vacant, six-story fifty-by-fifty-foot furniture warehouse, into the Forest Hills Professional Center, with a new glass facade to be installed over the worn-out brick. That project did not go forward, but in 1999 new owners successfully renovated the building as the Viscaya, a thirty-one-unit apartment house.[124] Peter Casini, a Queens-based architect, added three floors and a six-story rear extension—both topped by broad arched roofs—and installed a skin of bright blue resin-based synthetic stucco on the original structure, covering the new steel-and-concrete-framed additions with the same material in beige.

Farther east along Queens Boulevard, the "downtown" district of Kew Gardens was dominated by civic buildings such as Queens Borough Hall (William Gehron and Andrew J.

ABOVE P.S. 14, 107–01 Otis Avenue, northwest corner of 108th Street. Gran Sultan Associates, 1996. View to the northwest. GAAP

BELOW Embassy, 112–01 Queens Boulevard, southeast of Seventy-fifth Avenue. Costas Kondylis, 1990. View to the northeast. RAMSA

Thomas, 1941) and the Queens County Criminal Courthouse (see below), but Ulrich Franzen's sixteen-story Forest Hills Tower (1981), 118–35 Queens Boulevard, northwest corner Seventy-eighth Crescent, rose as a new commercial landmark.[125] When, in 1986, construction was derailed on a twenty-story office building designed by Fox & Fowle to rise above a garage behind Queens Borough Hall, developer Sidney Esikoff proposed a mixed-use eighteen-story building designed by Eli Attia.[126] Foundations were begun in 1987, but before the structure began to rise, Esikoff sold the project to another developer who could not successfully find a "community use" for five floors of the tower, forcing the height to be reduced to thirteen stories. As completed in 1989, Eli Attia's 500,000-square-foot Queens Tower was sheathed in a combination of gray tinted glass and mullionless mirrored glass, the latter covering the western and southern "ends" of the building as well as the prominent northeast-facing corner entry, whose faceted chamfers widened as the building rose to culminate in a broken arch.

In 1993 construction was completed on a new entry plaza and east wing for the Queens County Criminal Courthouse, 125–01 Queens Boulevard, situated on 5.4 acres bounded by Queens Boulevard, Hoover Avenue, 132nd Street, and 82nd Avenue.[127] The original building, designed by Alfred Easton Poor and Gehron & Seltzer and built in phases between 1956 and 1961, was H-shaped in plan and included a ten-story

LEFT Queens Tower, 80–02 Kew Gardens Road, between Union Turnpike and Eightieth Road. Eli Attia, 1989. View to the west. EAA

BELOW Queens County Criminal Courthouse, 125–01 Queens Boulevard. New entry plaza and east wing by Ehrenkrantz & Eckstut, 1993. View to the southwest. Warchol. PW

Shaare Tova Synagogue, 82–33 Lefferts Boulevard, southeast corner of Abingdon Road. Richard Foster Associates, 1983. View to the southwest. RAMSA

courthouse wing, an eleven-story prison wing, and a four-story district attorney's office.[128] Ehrenkrantz & Eckstut's multiphase master plan called not only for the renovation of existing facilities but for the addition of new east and west wings that would enclose the open portions of the H, creating landscaped interior courtyards. The east wing, clad in brick, limestone, and stainless steel to match the original building, was a five-story 159,000-square-foot annex that added eleven courtrooms, a central booking area, and new probation offices. The new east facade featured sweeping, curved glass enclosing a grandly scaled gallery inside. On the south facade, along Queens Boulevard, the architects enhanced the entry with a landscaped plaza leading to an expanded lobby intended by the architects to be an "inviting gesture" and to restore Queens Boulevard to "its intended status in the community."[129] In the plaza, Japanese sculptor Susumu Shingu's thirty-foot-high *Dialogue with the Sun* featured polished stainless-steel parts carefully balanced to move with even slight breezes. For Susanna Sirefman, the east wing was a "sombre, but smart edifice . . . a decidedly decent building—contemporary and tasteful—with a surprisingly friendly character." The old and new buildings were so "successfully integrated," according to Sirefman, that it was "almost impossible to tell where the two meet."[130]

The chaos of downtown Kew Gardens was offset by the quiet, leafy village just blocks to the south, where Lefferts Boulevard and Metropolitan Avenue were lined with small-scaled Tudor Revival buildings mostly from the 1910 or 1920s. The Shaare Tova Synagogue (1983), 82–33 Lefferts Boulevard, southeast corner of Abingdon Road, designed by Richard Foster Associates, was an appropriately understated if stylistically divergent addition to the neighborhood, serving a local population of Iranian Jews, many of whom immigrated to Kew Gardens after the Iranian revolution in 1979.[131] Foster set the sanctuary back from the corner behind an open forecourt and a one-story entrance wing, where its red brick form, above a recessed base, was punctuated by alternating circular and narrow rectangular stained glass windows. Nearby, Peter Casini designed a pair of four-story-and-basement balconied apartment buildings at 84–62 Austin Street (1981), notable for the large top-floor arched windows and notched parapets that led the editors of the *AIA Guide* to describe them as "unusually radical."[132]

La Guardia Airport

La Guardia Airport, occupying 650 acres hemmed in by Bowery Bay, Flushing Bay, the Grand Central Parkway, and the neighborhood of Jackson Heights, was built by the city and the Federal Works Progress Administration on the site of a private airfield that had replaced the Gala Amusement Park.[133] Officially dedicated on October 15, 1939, as the North Beach Airport (Delano & Aldrich), it was renamed for the former mayor when the Port of New York Authority took over operations in 1947. After international and transcontinental air traffic was shifted to the much larger Idlewild Airport in 1948, La Guardia settled into its role as New York's domestic gateway (also providing service to Canada). Its numerous shortcomings, however, led to the announcement in 1957 of a major reconstruction plan resulting in the realization over the following decade of Harrison & Abramovitz's portholed control tower (1963) and curving Central Terminal Building (1964).[134] In 1976 the last element of the reconstruction plan was completed: the Central Garage, a five-level, 3,000-car parking garage situated across from the Central Terminal Building, to which it was attached by two covered bridges.[135] As designed by the Port Authority's in-house staff, the garage was built of concrete and exposed steel and distinguished by two pairs of helical ramps, one each for incoming and outgoing traffic.

Although the reconstruction demolished Delano & Aldrich's central building, it retained several hangars designed by that firm as well as their Marine Air Terminal (1940), La Guardia's most distinguished building, which was designated an interior and exterior landmark on November 25, 1980.[136] Pan Am erected a prefabricated building adjacent to the terminal in 1986 to provide six additional gates.[137] In 1995, by which point Delta had taken over the facility, the terminal was treated to a major rehabilitation carried out by Beyer Blinder Belle, which restored the stainless-steel canopy, refabricated historic light fixtures, and returned the three-story main stairway that had been boxed in over the years to its original configuration.

East of the Central Terminal Building, Eastern Airlines built a new facility for its increasingly popular hourly flights to Boston and Washington.[138] The new 95,000-square-foot terminal, designed by the Port Authority's architectural staff,

BELOW Brooklyn National Hot Dog restaurant, Central Terminal, La Guardia Airport. Theo. David & Associates, 1997. Vascimini. TDA

ABOVE Delta Airlines Terminal, La Guardia Airport. Leibowitz Bodouva & Associates, 1983. View to the north. Goldberg. ESTO

was announced in 1977 and opened in March 1981. In 1983 Delta Airlines opened a new terminal at the far eastern edge of the airport grounds on eleven acres of land formerly used for parking.[139] Designed by Leibowitz Bodouva & Associates, the 270,000-square-foot facility took the form of a long, low rectilinear departure hall leading to a single concourse providing ten gates.

By the mid-1980s the Central Terminal Building, designed to accommodate eight million annual passengers, was handling double that amount, and the numbers kept increasing.[140] Between 1987 and 1992, the Central Terminal Building was expanded and modernized according to designs by William Nicholas Bodouva + Associates, working with TAMS Consultants, which unified separate airline facilities within the building by creating a single ticket lobby and, more significantly, extended the lower level fifty-five feet toward the central parking garage to provide more space for the baggage-claim area and arrivals.[141] Atop the arrivals addition was a new six-lane departure roadway, double the width of the previous traffic-snarled road. Additional retail spaces were also created but were overshadowed in 1997 when a forty-five-foot-high atrium was carved into the central portion of the terminal, providing space for shops and fast food restaurants, including a neon-lit Brooklyn National hot dog stand designed by Theo. David & Associates.[142]

The most sizable addition was a new terminal completed in 1992 for US Airways, replacing two hangars to the east of the main terminal.[143] Also designed by the Bodouva firm, the 300,000-square-foot building of white porcelain panels and aqua-tinted glass consisted of a skylit sixty-five-foot-tall

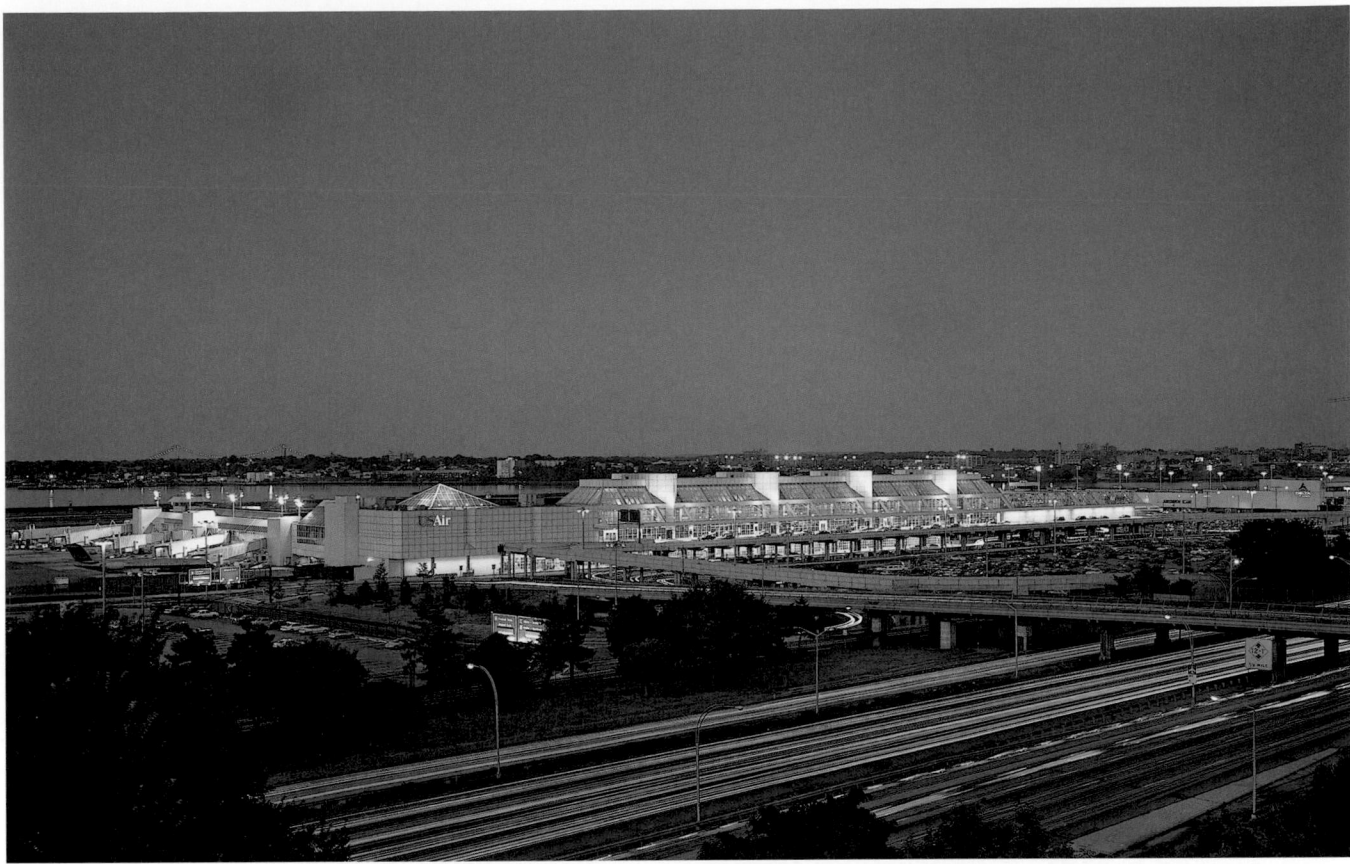

ABOVE US Airways Terminal, La Guardia Airport. William Nicholas Bodouva + Associates, 1992. View to the east. Goldberg. ESTO

departure hall that connected its lobby and check-in areas with those of the Eastern Shuttles terminal next door, which US Airways also took over in 1992. The most notable feature of the twelve-gate facility was a canopy extending over the ticketing counters, designed by Smith-Miller + Hawkinson with Guy Nordenson of Ove Arup & Partners. A lightweight composite material was used for the thin, gently curving canopy itself, while triangular glass plates, stainless-steel cables, and strips of LED signage helped produce a high-tech aesthetic.

Flushing Meadows-Corona Park

When, two years after the conclusion of the 1964–65 World's Fair, Robert Moses turned over the fairgrounds and adjacent parklands to the city for development of the 1,258-acre Flushing Meadows-Corona Park—New York's second largest park surpassed only by the 1,454-acre Great Kills Park on Staten Island—it was nowhere near the pleasure grounds Moses had been promising since the 1930s.[144] Once the "valley of ashes" described so eloquently by F. Scott Fitzgerald in *The Great Gatsby*, the vast marsh and dumping grounds had been reclaimed to host the 1939–40 and 1964–65 World's Fairs and were sparsely planted and ringed and bisected by high-speed traffic arteries.[145] The basic plan of the park was classical, peppered by buildings left over from the 1939–40 fair (the New York City Building, Aymar Embury II, 1939; and the Gertrude Ederle Pool and Amphitheater, Sloan & Robertson, 1939) and from the 1964–65 fair (the Hall of Science, Harrison & Abramovitz, 1964; and the New York State Pavilion, Philip

USTA National Tennis Center, Flushing Meadows-Corona Park. David
Kenneth Specter & Associates, 1978. Aerial view to the southwest. SDA

Johnson and Richard Foster, 1964). The most beloved of the
structures was the Unisphere, built on the site of the Trylon
and Perisphere from the 1939–40 World's Fair. It was a shining
globe designed for the U.S. Steel Corporation by Peter Müller-
Monk Associates and Gilmore D. Clarke, who also landscaped
the park plan, which included radiating pathways and a 600-
yard-long east–west mall.[146]

Additionally, the park was home to two stadiums, Shea
Stadium (Praeger-Kavanagh-Waterbury,1964) and the Singer
Bowl (Architectural Enterprises, 1964).[147] In 1967, in an
uncharacteristically bold move, the city commissioned an
international design team consisting of two architects, Marcel
Breuer and Kenzo Tange, and the landscape architect
Lawrence Halprin to prepare a master plan for the fairground's
transformation into a vast sports park and arts complex. The
plans were not carried out, and few improvements were made
to the park until 1977, when the U.S. Tennis Association
began talks with city officials about shifting the U.S. Open
from the 8,000-seat stadium of the West Side Tennis Club in
Forest Hills Gardens, where it had been held since 1924, to the
Singer Bowl, which had been renamed Louis Armstrong
Stadium.[148] According to the plan, a sixteen-acre National
Tennis Center would be built around the renovated stadium.
Despite a snowy winter, a wet spring, considerable labor prob-
lems, and cost overruns attributable not only to a fast-track
construction schedule but also to unforeseen obstacles such as

long-forgotten buried foundations from previous fair buildings
that had to be removed, the new stadium was completed in
time for the 1978 U.S. Open. Designed by David Kenneth
Specter & Associates, in collaboration with the Philadelphia-
based landscape architects Schnadelbach-Braun Partnership,
the National Tennis Center offered incomparable amenities:
twenty-five outdoor courts, nine indoor courts housed in two
nondescript adjoined metal sheds, a clubhouse with locker
rooms, lounges, restaurants, offices, a bank, and a post office.
To transform the Armstrong stadium into a much bigger facil-
ity, Specter superimposed an octagonal ring of steeply pitched
bleachers over the stadium's western half, creating a main
court seating 19,500. In the other half of the bowl, nestled
under a portion of the new octagonal stands, he created a
smaller arena known as the Grandstand, seating 6,200. The
increased capacity of the new facility and the availability of
8,000 parking spaces at nearby Shea Stadium vastly out-
weighed the loss of intimacy and the inherent charm of the
Forest Hills stadium and its setting. Most observers, like John
Duka, writing in *New York* magazine, were impressed by the
scope of the new facilities but not thrilled by their aesthetics:
"It is not pretty. In fact, the stadium with its exposed steel
superstructure and the nearby corrugated-steel buildings that
will house indoor tennis courts are downright ugly."[149]

By 1990 the U.S. Open had become so popular that it was
outgrowing the National Tennis Center. The U.S. Tennis

Association was dissatisfied with both the amount of seating provided and the poor circulation between the various tennis venues, which resulted in overall inefficiency and slow-moving, confused crowds of people. With the lease set to expire in 1994, on February 19, 1991, Mayor David Dinkins announced a plan, designed by Rossetti Associates Architects, to expand the center by building three new stadiums for 41,000 spectators directly to the east of the current complex.[150] Upon completion of the new facilities the existing site, including Louis Armstrong Stadium, would be cleared and reused for parking and practice courts. Thirty-one additional acres of Flushing Meadows-Corona Park would be used, requiring the relocation of a popular pitch and putt golf course. To sweeten the deal, twenty new acres of park were to be created by converting nearby property owned by the Long Island Rail Road, and funds were promised for general upgrades to the park. But these offers were not enough to appease the plan's many opponents, who called it a "giveaway" of cherished parkland to "special interests."[151]

In late 1992, the U.S. Tennis Association scaled back its proposal, calling for the renovation of the existing stadiums and the construction of only one new stadium. The new plan, also designed by Rossetti Associates Architects, reduced the amount of parkland needed to twenty-five acres and would spare the pitch and putt golf course. The new facilities would rise on the site of the United States Pavilion (Charles Luckman, 1964), which had been razed in 1976.[152] The new plan gained critical approvals by the end of 1993, and as one of his later acts in office, Mayor Dinkins signed a long-term lease for the land, over the objections of Mayor-elect Rudolph Giuliani. Although Giuliani did not contest the lease, he nonetheless boycotted the U.S. Open for several years and, in a very public fashion, refused to speak at the August 1997 dedication of the new Arthur Ashe Stadium.

The new complex passed muster with athletes who had been vocal in criticizing the old facilities. The Rossetti firm stripped the Louis Armstrong Stadium of its upper ring of seating, bringing its capacity down to 10,000, provided a bigger food court with seating for 1,600, and rebuilt the outdoor courts with more interstitial space and bleachers for 9,800. The courts were also repositioned from their diagonal arrangement that followed the radial World's Fair plan to instead face north–south, on axis with the Unisphere, which was now seemingly integrated into the tennis complex. Herbert Muschamp was impressed with the 23,000-seat Arthur Ashe Stadium, though he found the red brick base "ungainly." Inside, however, the stadium itself was "a gem. A sapphire, to be precise," Muschamp added, referring to its octagonal shape (which felt like "sitting inside a sharply cut jewel") and the blue color of the seating and signage. "At night, when the lighting pours down onto the court from all sides, the place sparkles." But the stadium was criticized as elitist, because fewer lower-priced seats were offered than in the old stadium despite greater seating capacity, and because its eighty-nine luxury suites, featuring amenities such as wet bars, phones, refrigerators, couches, and private bathrooms, were located close to the court, forcing everyday fans and longtime season ticket holders alike to sit significantly higher in the stands than ever before. In the end, though, the center was accepted by the public, with Muschamp praising its "sense of occasion" and writing that "New York has not produced as energized a public space since Lincoln Center. What we have here in Queens, in fact, is a Lincoln Center for jocks."[153]

Arthur Ashe Stadium, National Tennis Center, Flushing Meadows-Corona Park. Rossetti Associates Architects, 1997. Sundberg. ESTO

In 1988, frustrated by the park's lack of a coherent identity, confused circulation, poor signage, and general state of neglect, the Flushing Meadows-Corona Park Corporation, a nonprofit civic group, commissioned a group of architects and planners to prepare a master plan.[154] Collectively known as the FMCP Task Force and chaired by Alan Plattus, of Yale University's School of Architecture, the overall design was conceived by Bernard Tschumi, newly appointed dean of Columbia's architecture school, whose competition design for the Parc de la Villette in Paris was highly acclaimed.[155] Plattus and Tschumi worked with Karen B. Alschuler, an urban planner and partner at Skidmore, Owings & Merrill, her husband William R. Alschuler, an environmental scientist and museum consultant, and Nicholas Quennell, a landscape architect. The proposal called for a radical reorganization of the park, transforming rather than restoring the World's Fair's site plan. The scheme nearly obliterated the existing east–west axis of the mall, replacing it with a bold 1,000-foot-wide-by-three-mile-long rectangular mall running south from Flushing Bay to Queens Borough Hall, in Kew Gardens, its borders marked by planted walkways and bright red pylons that, in the spirit of a World's Fair, could shoot beams of light high into the air. The proposed mall would provide an array of active recreational areas, including athletic fields, some of which were laid directly over the Fountains of the Fair that extended east from the Unisphere. A meandering landscaped pedestrian and bike path would crisscross the mall, leading

Proposed master plan, Flushing Meadows-Corona Park. FMCP Task Force, 1988. Rendering of view to the southeast. BTA

from one public attraction to another, and the Flushing River, currently flowing in underground pipes, was to be brought back to the surface, reconnecting Flushing Bay to Willow Lake. The unimplemented plan also provided clearer entry points to the park, a new ring road for circulation, and additional parking.

Despite Flushing Meadows-Corona Park's shortcomings as a work of landscape architecture, it was the city's most intensely used recreational space and was generally perceived as the cultural center of Queens. Its principal museum attraction was Harrison & Abramovitz's New York Hall of Science, a sculptural eighty-foot-high building with undulating concrete walls inset with cobalt-colored cast glass, originally housing exhibitions devoted to space exploration and retained as a science museum after the 1964–65 fair closed.[156] For five years, beginning in 1981, the museum was closed for modest renovations that were intended to make the science and technology more accessible, with interactive "please-touch" exhibits, but these were determined by an independent committee to be inadequate.[157]

To get the museum back on track, Beyer Blinder Belle was hired in 1990 to prepare a master plan, which called for its floor area to be quadrupled over ten years.[158] The architects also renovated the existing 65,000-square-foot building and added 28,000 square feet to its west side that included a new entry rotunda and a second, oval-shaped building housing an auditorium, cafeteria, museum shop, new galleries, and support facilities. Work was completed in 1996. Adjacent to the entry, Joan Krevlin of BKSK Architects, working with landscape architect Lee Weintraub, designed the 30,000-square-foot New York Hall of Science Playground (1999), a "teaching park" realized as a multicolor environment intended to help children learn physics through interactive exhibitions.[159] Extending over the playground was a four-hundred-foot-long blue tube suspended from pylons that also supported an

elevated walkway with exhibits and activities along its length. Countering this rigid organizing spine was an undulating boardwalk at the edge of the park that recalled the form of the Hall of Science.

In 2004 the museum completed a second expansion, carried out by the Polshek Partnership, with Todd H. Schliemann leading the design effort. The architects created a continuous circulation loop while expanding the institution with 55,000 square feet of new exhibition space in a long, low angled volume intended as a "horizontal counterpoint" to the original building, from which it extended to the north.[160] In contrast to the dark interiors of the original building, the Polshek firm created a Hall of Light, an airy structure naturally lit through a skin of translucent fiberglass panels that gave way to clear glass at the extension's northern tip, where the base was also transparent to allow passersby a view inside. The north end also featured a light wall—a sixteen-foot-square tilted glass plane dotted by small circular mirrors—designed by James Carpenter Design Associates. Next to the addition was an oval-shaped exhibition hall that complemented the forms added by Beyer Blinder Belle and helped give shape to Rocket Park, whose space rockets and capsules, first displayed in the 1964–65 World's Fair, were renovated and supplemented with new rockets in a redesign by Buck/Cane Architects.

The park's second major public institution was the Queens Museum, occupying the New York City Building built for the 1939–40 World's Fair, which also served as the temporary headquarters of the United Nations General Assembly after World War II and was resuscitated for the 1964–65 fair.[161] In 1972 the building became home to the Queens Museum, whose 20,000 square feet of exhibition space made it the borough's largest museum even though it shared the facility with the New York City Skating Rink, which occupied the southern wing. The main east-facing entrance was eliminated in favor of entrances on the north and south facades for these

ABOVE New York Hall of Science, Flushing Meadows-Corona Park. View to the northeast showing Playground (BKSK Architects and Lee Weintraub, 1999) on right, Hall of Science (Harrison & Abramovitz, 1964) in center, and addition (Beyer Blinder Belle, 1996) on left. Mauss. ESTO

LEFT Hall of Light, New York Hall of Science, Flushing Meadows-Corona Park. Polshek Partnership, 2004. View to the southeast. Goldberg. ESTO

BELOW Hall of Light, New York Hall of Science, Flushing Meadows-Corona Park. Polshek Partnership, 2004. View showing light wall by James Carpenter. Goldberg. ESTO

dual uses. The museum's most famous exhibit was the Panorama of the City of New York, a 9,335-square-foot, 835,000-building model of New York City built for the 1964–65 World's Fair by Lester Associates at a scale of one inch to 100 feet. The model was updated in 1974, but by 1989 the museum's curator estimated that despite piecemeal additions donated by architectural firms, the model was about twenty thousand buildings behind the real city, lacking prominent works like the Javits Center, Cityspire, and all of Battery Park City.[162] In 1990 corporate sponsorships and additional donations from architectural firms added about 125 major projects, including Battery Park City.

The following year Rafael Viñoly Architects began a substantial renovation of the museum, rationalizing its circulation,

Queens Museum of Art, Flushing Meadows-Corona Park. Renovation by
Rafael Viñoly Architects, 1994. View to the southwest. Goldberg. ESTO

renovating galleries, and adding a new auditorium.[163] The renovation was meant to give the institution, which simultaneously changed its name to the Queens Museum of Art, a fresh identity. When work was completed in 1994, Viñoly had reestablished the east facade as the main entry, creating a double-height atrium by filling in the existing open colonnade with a thirty-foot-high aluminum-and-glass curtain wall, and marking the entry with a skylit revolving door on axis with the Unisphere. Inside the entrance, a long switchback ramp connected the first and second floors. A secondary entrance was retained on the north facade, now reclad in precast-concrete panels matching the existing limestone and given a new glass-and-steel canopy. The rest of the exterior was left intact.

The Panorama was given its due, updated and restored by Lester Associates. Existing buildings were cleaned, and the model was coated with ultraviolet paint to make it glow in the dark. When it emerged from the renovation, the new Panorama had about 95,000 more buildings than when unveiled thirty years earlier. While the original means of viewing the model—an "indoor helicopter ride" in which pod-shaped cars ran on a track around the gallery—still functioned into the 1980s, the system was removed and replaced by a ring of glass-floored ramps, allowing visitors to move at their own pace. For Herbert Muschamp, Viñoly's "ravishing sense of open, flowing space" helped transform the museum into "one of the city's handsomest places for viewing art."[164]

In 2001 when the opportunity came to relocate the ice-skating rink to another facility and double the museum's size, the city's Design and Construction Department held its first design competition to select an architect.[165] The winner, Eric Owen Moss Architects, planned to transform the museum into a 100,000-square-foot visual and performing arts center and strip the entire middle third of the building down to its steel roof trusses, replacing the skin with a folded and faceted glass membrane capable of changing from clear to opaque at the flip of a switch. The flashy new enclosure covered a space that Moss called the Main Event, an amphitheater with tiered seating that stepped down to a stage nestled against the outside wall of the Panorama gallery, whose amoeba-shaped envelope would be given new prominence as part of a continuous room that included the space formerly occupied by the ice-skating rink, now reinvented as a temporary exhibition hall capable of showcasing large works of contemporary art. Moss proposed to relocate the earth excavated from the new amphitheater to the west side of the museum where a berm, dubbed the Magic Mountain, would present a retaining wall to Grand Central Parkway and a planted grass slope and sculpture garden to the museum. Though scheduled to break ground in 2003, Moss's expansion was delayed by budget cuts made in the wake of the terrorist attacks on September 11, 2001. In 2005 the museum abandoned Moss's scheme, hiring the English firm Grimshaw to plan its expansion.

Although the fate of the park's fair buildings varied, the future of the 1964–65 World's Fair's most whimsical structure, the New York State Pavilion, hung in the balance. Designed by Philip Johnson and Richard Foster with the structural engineer Lev Zetlin, it consisted of a theater, three towers, and the huge oval Tent of Tomorrow, famous for its giant mosaic floor map of New York State. In 1993 the Theaterama, a 40-foot-high-by-100-foot-diameter concrete cylinder originally adorned with ten works of contemporary art, found a new use when it was renovated and expanded by Alfredo De Vido to

TOP Panorama, Queens Museum of Art, Flushing Meadows-Corona Park. Museum renovation by Rafael Viñoly Architects; panorama renovation by Lester Associates, 1994. Goldberg. ESTO

ABOVE Proposed Queens Museum of Art renovation, Flushing Meadows-Corona Park. Eric Owen Moss Architects, 2001. East elevation. EOMA

LEFT Proposed Queens Museum of Art renovation, Flushing Meadows-Corona Park. Eric Owen Moss Architects, 2001. Rendering of Main Event. EOMA

Queens Theatre in the Park, Flushing Meadows-Corona Park. Renovation by Alfredo De Vido, 1993. View to the east. McGrath. NMcG

become the Queens Theatre in the Park, a performing arts center providing a 500-seat main theater with theatrical rigging and lighting and a 100-seat reconfigurable cabaret theater on a lower level.[166] De Vido added to the west side of the building a glass-block-enclosed lobby that rose to the full height of the facade and was flanked by cylindrical concrete stair and elevator towers capped by fiberglass discs intended to reference the adjacent pavilion. De Vido also covered over the building's original wood dome with an aluminum geodesic dome.

The rest of the New York State Pavilion was left to decay, its multicolored plastic roof removed in the 1970s and the three observation towers closed to the public.[167] At ground level the vast enclosure was used as a storage area for pesticides and dangerous chemicals during the 1970s and then left unused through the 1980s and 1990s. Despite some proposals over the years to reuse the complex, a tenable new function could not be found and, in 2001, Parks Commissioner Henry J. Stern stated: "It's too good to tear down but not good enough to spend $20 million on to restore. So it remains."[168]

Flushing

Located in the northeast section of the borough and roughly bounded by the Van Wyck Expressway on the west, Francis Lewis Boulevard on the east, Twenty-fifth Avenue on the north, and Kissena Park on the south, the historic village of Flushing began to lose its small-town feel after the end of World War II.[169] It was then that the population dramatically increased as detached and attached three- and four-story two-family townhouses and six- and eight-story apartment buildings joined the mix of modest apartment buildings built between 1920 and 1940 and single-family wooden houses from the 1880s and 1890s. At Flushing's heart was a sizable and busy retail and commercial downtown area clustered on and around Main Street, Roosevelt Avenue, and Kissena and Northern Boulevards. Flushing's post-1970s population swelled along with the rest of Queens, but even more than its host borough, its composition dramatically changed as middle-class whites gave way to Chinese and Korean immigrants, as well as people from the Indian subcontinent, leading wags to label its principal connection to Manhattan, the Number 7 train, the "Orient Express."[170] Stores, markets, and restaurants catered to Flushing's wide range of ethnicities, while new and exotic houses of worship sprung up—sometimes incongruously—in the sleepy sections composed primarily of single-family homes. Barun Basu Associates's dark gray brick and granite Hindu Temple of New York (1977), 45–57 Bowne Street, between Forty-fifth and Holly Avenues, was, according to C. Srinivasacharya, the priest who had flown to New York from Hyderabad, India, for the dedication ceremony, "just like in India."[171] Writing in the New York Times, Pranay Gupte noted that the ornately detailed temple, with its domes, carved figures of monkeys, peacocks, and eagles, was "easily the most striking building in a neighborhood that consists mainly of clapboard one-family houses."[172] In 1991 the temple added a large gymnasium-like structure next door in the same materials and color. Facing Holly Avenue and Smart Street with a curved entrance bay and glassy facades, the building served as a wedding hall, auditorium, and banquet room for the growing congregation.

On the southwest corner of Parsons Boulevard and Ash Avenue, Ashihara Associates's Nichiren Shoshu Temple (1984) was built for the followers of a thirteenth-century form of Japanese Buddhism. A low-slung abstract composition of white-painted stacked horizontal forms, it attracted the attention of the editors of the AIA Guide, who in 1988 praised the building, with its minimalist interiors, as "serenity without dullness: a testament to the expressive possibilities of thoughtful architecture, even when rendered in ribbed concrete block," although in the next edition of their guidebook published a dozen years later they added that the temple "might be equally contextual on Mars."[173] Two blocks away, the distinctly Postmodern Won Buddhist Temple (Bo Yoon & Associates, 1986), southwest corner of Cherry Avenue and Burling Street, serving a Korean congregation, was a two-story, white stucco, houselike structure with square windows.[174] Its central portion rose to a peaked roof bisected by a glass-block bay topped by a circle motif common in Buddhist temples.

The success of Flushing's economically thriving downtown—primarily a motley collection of low-rise buildings with unsightly storefronts and merchandise often spilling out onto the crowded sidewalks—was universally credited to the influx of Asian merchants and residents. In the late 1940s, an

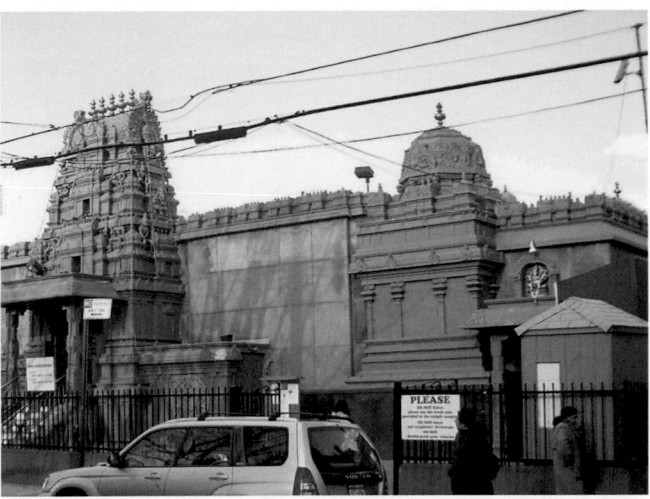

Hindu Temple, 45–57 Bowne Street, between Forty-fifth and Holly Avenues. Barun Basu Associates, 1977. View to the northeast. RAMSA

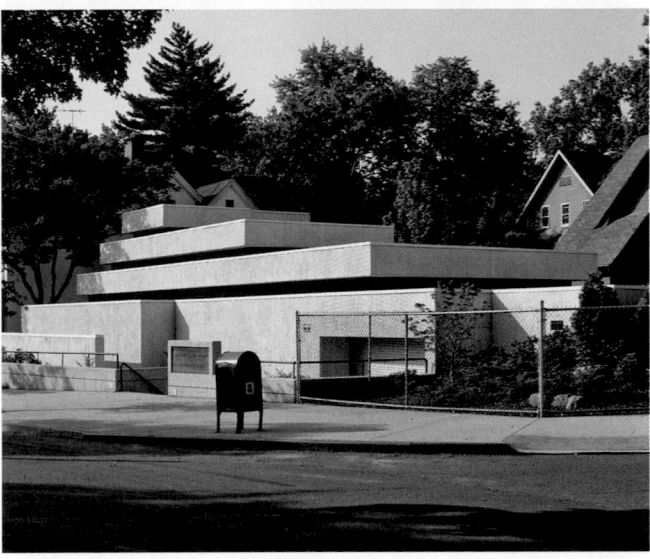

Nichiren Shoshu Temple, southwest corner of Parsons Boulevard and Ash Avenue. Ashihara Associates, 1984. View to the southwest. NAA

Nichiren Shoshu Temple, southwest corner of Parsons Boulevard and Ash Avenue. Ashihara Associates, 1984. NAA

Main Street Tower, southeast corner of Main Street and Flushing Boulevard. Leo Fakler, 1987. View to the southeast. RAMSA

ambitious but unrealized proposal for large-scale development was made by William Zeckendorf, who called for a futuristic, International Style mixed-use commercial center containing department stores, offices, an entertainment center, and moving sidewalks on twenty acres in the heart of downtown.[175] Four decades later, in 1986, Zeckendorf's son, William Jr., won the right to build a mixed-use commercial and residential complex on a city-owned 240,000-square-foot site serving since 1954 as a parking lot and bounded by Union and 138th Streets and Thirty-seventh and Thirty-ninth Avenues, a block away from the Main Street shopping corridor.[176] Plans for the 1,226,000-square-foot Flushing Center, designed by Gruzen Samton Steinglass in association with Prentice & Chan, Ohlhausen, called for a three-story steel-framed shopping mall, with a central, forty-eight-foot-high skylight, to accommodate ninety retail stores and a ten-screen movie complex, as well as a six-story red brick office building placed on top of an eight-level, 1,100-car parking complex, six levels of which would be above ground. Additionally, two sixteen-story concrete-framed apartment buildings, clad in red brick with white brick accents, would each contain 199 apartments and include parking for ninety-nine cars in below-ground garages. Flushing Center was hotly debated, pitting recently arrived Asian entrepreneurs and residents against white, middle-class longtime owners of single-family homes. At stake, many argued, was what was left of Flushing's small-town character. Zeckendorf's plan met the same fate as his father's. Its abandonment in August 1991 was attributed to the real estate collapse of the late 1980s and the developer's own financial difficulties.

In 1987 one substantial project was completed in downtown Flushing, Leo Fakler's tan brick and mirror-glass–clad

Main Street Tower, southeast corner of Main Street and Northern Boulevard, a brutally scaled nine-story office building rising from a two-story retail base.[177] The ungainly massing of Fakler's design for the Huang Development Corporation, with its sloping base, filled out the zoning envelope in a manner that recalled two buildings in Manhattan, Davis, Brody's Westyard Distribution Center (1970), east side of Tenth Avenue between Thirty-first and Thirty-third Streets, and Der Scutt's 1982 Continental Illinois Center at 520 Madison Avenue.[178] Downtown Flushing also became home to two new hotels, beginning with the eight-story, twenty-four-room Garden Hotel (1989), 136–36 Thirty-ninth Avenue, just east of Main Street, another project of the Huang Development Corporation.[179] Howard Graf and Raymond Chan's spare design in red brick primarily confined ornament to a one-story stone base, canopied entrance, and light-colored brickwork used to accent the metal framed windows. A block away, Hong Kong–born architect Daniel Pang's Sheraton La Guardia East (1991), 135–20 Thirty-ninth Avenue, was equally bland but much larger: fourteen stories of red and tan brick and reflective-glass windows.[180] The 175-room hotel, with its 185-car underground garage and banquet hall accommodating 400 people, was marketed to Asian visitors by Taiwanese developers who acquired a Sheraton franchise.

To serve the burgeoning polyglot population, a number of community facilities were realized. Bennett Metzner Sowinski's unprepossessing, four-story, white stucco block Community Outreach Center (1993) for the Flushing branch of the YWCA, 42–07 Parsons Boulevard, was the organization's first new building in the city since 1917.[181] The 10,000-square-foot building allowed the group, which had hitherto relied on scattered donated space in churches and community centers throughout the neighborhood, to put all its social programs under one roof. Far more interesting was Platt Byard Dovell's transformation beginning in 1994 of the Romanesque Revival Flushing Town Hall (sometimes attributed to William Post, 1862), northeast corner of Northern Boulevard and Linden Place, into headquarters for the Flushing Council on Culture and the Arts.[182] The two-story beige brick building, which had served as a municipal courthouse after Queens became part of New York City in 1898, was declared a landmark in 1968, but it had deteriorated significantly over the next twenty years while accommodating, at various times, a theater, a restaurant, and office space. By 1989 the building was vacant and its litter-strewn backyard a gathering place for drug users. Over the next five years, the architects restored the exterior, added exhibition galleries, a visitors center, and administrative offices, and transformed the second-story Great Hall into a performance space with perimeter box seating.

Far and away the most distinguished civic addition to the neighborhood was the Polshek Partnership's Flushing Regional Branch Library (1998), located in the heart of downtown on a triangular site formed by the intersection of Main Street and Kissena Boulevard.[183] Replacing an outmoded facility on the same site built in 1957, the four-story building featured a curving green-glass facade along Main Street whose transparency was intended, according to the architects, to "metaphorically" advertise learning. David Dunlap was impressed with the "diaphanous glass wall [that] flows coolly along Main Street, bending gently as it approaches the oblique intersection with Kissena Boulevard. The curving curtain wall

actually extends a few feet beyond the masonry shell of the building, which heightens the sense of transparency."[184] The facade along Kissena Boulevard was stone, "its articulation," according to the architects, "alluding to the book stacks within and its opacity allowing perimeter shelving to be maximized" as well as granting privacy to staff offices.[185] Inside, to take advantage of the light, reading areas and the main stairs were placed just inside the glass wall. An open-work plan was repeated on the three main floors, with the top floor serving as exhibition space and a resource center dedicated to international studies, and the basement home to a 227-seat auditorium, a 150-seat conference room, and an adult learning center. The 76,000-square-foot library was the largest in the borough's sixty-two-branch system.

Fresh Meadows

The large area bounded by Kissena Park Corridor, Cunningham Park, Union Turnpike, and Flushing Meadows-Corona Park included on its eastern flank the Fresh Meadows housing development, designed by Voorhees, Walker, Foley & Smith in 1946–49 for the New York Life Insurance Company as a suburban-scale neighborhood of predominantly two- and three-story red brick flat-roofed buildings grouped in quadrangles around a twenty-acre central open area.[186] In 2000 Audrey Matlock Architect renovated and expanded the 1957 Fresh

ABOVE Fresh Meadows Branch Library, 193-20 Horace Harding Expressway, between 193rd and 194th Streets. Renovation and expansion of branch (Charles B. Ferris Associates and G. Harmon Gurney, 1957) by Audrey Matlock Architect, 2000. View to the southwest. AMA

LEFT 107th Precinct Station House, 71–01 Parsons Boulevard, southeast corner of Seventy-first Avenue. Perkins Eastman, 1993. View to the east. Choi. PE

Meadows Branch Library (Charles B. Ferris Associates and G. Harmon Gurney), 193–20 Horace Harding Expressway, on the northern edge of the development, which had been recognized as an "outstanding example of functional architecture" by the Queens Chamber of Commerce upon its completion.[187] But Matlock did not quite see its modernity, and undertook to "transform the 'modernist' aesthetic" of the original flat-roofed steel and glass library "into a truly modern building" by replacing its exterior walls with a translucent- and clear-glass and aluminum glazing system that would "filter out heat, add insulation, prevent infiltration, regulate shading and diffuse light."[188] In addition to renovating the original library, Matlock included in her modernization a new volume at the building's corner whose aluminum and structural glass surfaces differentiated it from the original architecture.

Nearby, Perkins Eastman's 107th Precinct Station House (1993), 71–01 Parsons Boulevard, southeast corner of Seventy-first Avenue, also attempted a kind of updated Modernism in an effort to relate to its surroundings, which consisted of a shopping center and brick rowhouses.[189] Project architect Lucian Andrei explained that the architects "looked around and used what was there" when conceiving the three-story building's

exterior of anodized aluminum panels and iron-spot brick.[190] Numerous patterns of fenestration suggested the various programmatic elements within, including offices, cells, a briefing room, and a garage on the first floor, clerical areas, a locker room, and dormitories on the second floor, and, on the third floor, a command center to be used by leaders from each precinct in times of emergency. On the roof, an assembly of painted gray steel approximating the look of a satellite dish and other technological equipment was meant, according to its sculptor, Alice Aycock, "to represent communication—always an important part of the role of police in any community."[191]

To the west of Fresh Meadows, Queens College, founded in 1937, occupied a campus roughly bounded by Reeves Avenue, Kissena Boulevard, Melbourne Avenue, and Main Street.[192] Built in 1908 for the New York Parental School, its original Spanish Mission–style buildings had slowly been replaced by stylistically incoherent structures until only four remained, along with the grassy mall that established an east–west axis across the southern half of the campus. The college continued to expand during the 1980s and 1990s, with two notable additions sitting across from one another on the western end of the mall. Davis, Brody & Associates' 225,000-square-foot

Science Facility (1986) was a massive, low-lying structure consisting of four identical three-story terra-cotta-block and concrete wings situated in a pinwheel plan around a core of lecture halls.[193] The Gruzen Partnership's Benjamin S. Rosenthal Library (1988) featured a prominent brick and metal openwork clock tower positioned near its entrance, echoing, according to the architects, a feature of a former campus building.[194] The six-story library, clad in precast-concrete panels and alternating bands of pink and gray granite, was organized as two hip-roofed wings containing stacks and offices extending perpendicularly from a two-story glassed-in entrance atrium that led to a conical skylit rotunda housing the library's main circulation desk. The Gruzen Partnership also designed a tiered semicircular plaza located to the south of the Rosenthal Library that provided a suitably ceremonial western terminus for the campus mall. Another addition to the college was the Aaron Copland School of Music (Robert B. Marquis with Wank Adams Slavin Associates, 1992), situated at the northen edge of the campus, where it would be accessible to the surrounding community and close to the school's existing performing arts facility in the Colden Center.[195] But the location also meant that the building sat close to the Long Island Expressway, requiring its outer walls to be thicker than usual and its windows to be double and triple glazed. In addition, classrooms, practice rooms, and rehearsal halls were all situated at the perimeter of the plan to provide a buffer for the central 491-seat concert hall, an octagonal space walled in red oak whose eight wooden sound-diffusion panels suspended above the side boxes helped garner excellent reviews for its acoustical designer, Peter George Associates.

Northeastern Queens
Along the East River shore north of historic Flushing were the communities of College Point, Malba, Whitestone, Beechhurst, and Bayside, developed before World War I as summer resorts. Following World War II, the modest single-family houses that predominated in the area were joined by significant garden apartment developments, and by the early 1970s by some larger apartment buildings.[196] The College Point waterfront, cut off from the neighborhood itself by the Whitestone Expressway, was principally home to new commercial and industrial buildings, beginning in 1983 with Stephen B.

New York Times Printing Plant, College Point Industrial Park, 26–50
Whitestone Expressway, between Twentieth Avenue and Linden Place.
Polshek Partnership, 1997. View to the southwest. Goldberg. ESTO

Rabinoff & Associates's two-story building for the EDO Corporation.[197] Located near the East River on the north side of Fourteenth Avenue between 110th and 111th Streets, the building's uninviting, almost windowless, aluminum-clad facade seemed all too expressive of its purpose as home to a government contractor specializing in minesweeping systems, sonar equipment to track nuclear submarines, and other military equipment. In 1986 Werfel and Associates completed work on a 19,000-square-foot headquarters for the nonprofit Greater New York Auto Dealers Association, 18–20 Whitestone Expressway, just north of Twentieth Avenue.[198] The three-story building, also planned to provide office space for small companies in the automobile industry, was located in the College Point Industrial Park, a 550-acre tract established in 1969 by the city to aid light industry and encourage office and retail development. According to Laurence Werfel, the curving forms of the aluminum-clad, structural-steel-frame building with horizontal strips of dark tinted glass windows were intended to allow the building to be easily grasped by motorists moving at highway speeds.

In December 1993, the *New York Times* and the city reached an agreement permitting the newspaper to build a massive printing plant on a thirty-two-acre site in the College Point Industrial Park, just off the Whitestone Expressway between Twentieth Avenue and Linden Place.[199] A year before, the *Times* had opened a new printing plant in Edison, New Jersey, and also seriously considered locating its proposed facility, intended to allow the paper to produce its first color daily edition, outside the city's boundaries. The city responded with a package of tax incentives and discounted energy costs, a move that was criticized by some as too generous considering that the new plant would employee only 500 people, far fewer than other major corporations who received similar incentive offers. The Polshek Partnership received the commission for the job, which came with significant budget constraints because, as David A. Thurm, vice president for real estate development at the *Times*, put it, "we intended to use as much of the budget as possible for the very best printing equipment." Thurm also noted that the *Times* "didn't want to house the newspaper print process in an almost

New York Times Printing Plant, College Point Industrial Park, 26–50
Whitestone Expressway, between Twentieth Avenue and Linden Place.
Polshek Partnership, 1997. Goldberg. ESTO

windowless factory-like box." In order to take advantage of
the highly visible site just fifty feet from a six-lane highway
typically traveled by one million cars each week, the *Times*
wanted its "new plant to be a work of architecture that would
clearly express from the exterior what goes on within."[200]

Polshek's design for the 515,000-square-foot Galvalume-
clad *New York Times* Printing Plant (1997), realized in close
collaboration with the client and Parsons Main, Inc., a firm
specializing in printing plants, consisted of several different
functional components. The centerpiece of the design was a
650-foot-long, three-story, skylit hall accommodating five
sixty-foot-high four-color printing presses, with room remain-
ing for an additional press if needed. An enormous expanse of
glass on the front facade brought additional light into the
building and allowed motorists passing by to view the presses
at work. Thirty-foot-high black-painted steel-mesh letters in
the *Times'* familiar font spelled out the paper's name on an
angle and spilled over the flat roof. Jutting out from the
Whitestone Expressway facade were bright yellow painted
boxes containing filters used to remove ink mist. Also adding

interest to the long narrow building were "a few Decon-
structivist tweaks," according to project architect Richard M.
Olcott, including a facade that tilted slightly and extended
beyond the roof line to conceal mechanical equipment.[201]
Directly behind the press hall was a three-story circulation
spine that included an employee entrance, lockers, lounges,
workshops, and computer facilities. The circulation spine also
separated the press hall from the mail room and loading docks
located at the back of the building. Just south of the press hall
was a relatively small volume with an angled mirror-glass
facade that contained the facility's public entrance and lobby
as well as administrative offices. At the southern end of the
site was the massive, loftlike automated storage and distribu-
tion facility, which was painted a bright blue.

Critical reaction to Polshek's printing plant, a state-of-the-
art operation capable of producing 500,000 copies of the daily
edition, was positive. For Catherine Slessor, writing in
Architectural Review, the plant "stands out as a bold and con-
fident new urban landmark . . . articulated with tough, simple
textures, vivid colors and superscale graphics. The result is an

Wildflower Estate Condominiums, site bounded by Ninth Avenue, Totten Street, and the East River. Faruk Yorgancioglu and Beyhan Karahan & Associates, 1999. Site plan. BKAA

arresting, animated building-as-billboard that both affirms and dramatizes its function on the edge of the expressway."[202]

In Beechhurst, on Cryder's Point overlooking the Long Island Sound, Dwight James Baum's Wildflower (1924), 168–11 Powells Cove Boulevard, a two-and-a-half-story Neo-Tudor house built for Arthur Hammerstein and named for the theatrical producer's musical comedy hit of 1923, occupied a thirty-acre site that also included four other estates which in the 1950s were sold to Alfred Levitt, who built Levitt House (George G. Miller, 1958), a collection of thirty handsome eight-story apartment buildings raised on pilotis with corner balconies and continuous horizontal glazing.[203] Hammerstein's house was

retained for use as a clubhouse. In subsequent years Wildflower changed owners and served as a restaurant. In 1982, after the house was already in fairly poor condition and development pressures had raised concerns among local residents for its survival, the Landmarks Preservation Commission designated it a landmark, putting an end to plans by Long Island developer Edward Flax to build garden apartments on the five-acre site.[204]

In 1988 new owners, Kiska Developers, expressed interest in restoring the Hammerstein house, vacant since designation, as well as building a combination of two- and three-story townhouses and either one high-rise or two mid-rise apartment buildings, but plans stalled for the next decade.[205] Kiska sold

Wildflower Estate Condominiums, site bounded by Ninth Avenue, Totten Street, and the East River. Faruk Yorgancioglu and Beyhan Karahan & Associates, 1999. View to the northwest showing renovated Wildflower (Dwight James Baum, 1924). BKAA

Wildflower Estate Condominiums, site bounded by Ninth Avenue, Totten Street, and the East River. Faruk Yorgancioglu and Beyhan Karahan & Associates, 1999. BKAA

the house to the Enar Development Corporation in 1993, but two years later, in February and March 1995, two cases of arson severely damaged the building. After inspecting Wildflower, the Buildings Department determined that the structure was still sound and did not need to be demolished.[206] In October 1997, Kiska repurchased the property, and five months later, after approval from the commission, released plans for its redevelopment.[207] Faruk Yorgancioglu and Beyhan Karahan & Associates's plan for Wildflower Estate Condominiums (1999) called for the restoration of the Hammerstein house's facade and its conversion into six duplex apartments and, subsequently, the construction of twenty-four two- and three-story balconied townhouses closely surrounding it. In 2001 twenty-seven additional triplex townhouses with individual garages were completed in the gated community. Although the architects made an effort to preserve the waterfront views and retain the character of the original landscaping, it was difficult to conclude that they had achieved their goal of creating a "village-like setting" around the Hammerstein house and that the new buildings looked like they had "been there from the start."[208]

In Bayside the Glick Organization completed Baybridge, a development of 600 floor-through and duplex apartments built between 1981 and 1985 on a thirty-acre site bounded by the Clearview Expressway, 212th Street, the Cross Island Parkway, Bell Boulevard, and Fifteenth Drive.[209] Designed by Liebman Liebman Associates in a parodistic version of the Georgian style intended to recall suburban developments outside of Washington, D.C., the three-story townhouses were clad in three shades of jumbo-sized beige and red brick and featured bay windows, recessed dormer windows, mansard roofs, shutters, arched entryways, garages, and continuous balconies at the rear of the clustered buildings at the second-floor level. Adjacent to the gated development, along the Cross Island Parkway, Glick built the cupola-crowned Baybridge Commons (1986), a modest two-level, 30,000-square-foot shopping center designed by Liebman Liebman.[210] Also in the immediate vicin-

Scheuer House, 208–11 Twenty-sixth Avenue, east of the Clearview Expressway. Gruzen & Partners, 1981. Courtyard. GS

ity was Gruzen & Partners's Scheuer House (1981), 208–11 Twenty-sixth Avenue, east of the Clearview Expressway, a four-story, red brick, 149-unit apartment complex for the elderly. Pointing to such features as a central garden courtyard with a fountain and a recessed glassed-in entry and lounge area, Suzanne Slesin concluded that the "understated apartment house is more a triumph of small design considerations than a major architectural statement."[211]

The compact Bayside campus of Queensborough Community College (master plan and first buildings, Frederick Wiedersum & Associates and Holden, Egan, Wilson & Corser, 1967–75), bounded by Fifty-sixth Avenue, Cloverdale Boulevard,

Baybridge, site bounded by the Clearview Expressway, 212th Street, the Cross Island Parkway, Bell Boulevard, and Fifteenth Drive. Liebman Liebman Associates, 1981–85. RAMSA

Administration Building, Queensborough Community College, site bounded by Fifty-sixth Avenue, Cloverdale Boulevard, Garland Drive, and Alley Pond Park. Percival Goodman, 1977. View to the southeast. RAMSA

Schneider Children's Hospital, Long Island Jewish Hospital-Hillside Medical Center, 269–01 Seventy-sixth Avenue. Architects Collaborative, 1983. View to the northwest. Anon. ESTO

Garland Drive, and Alley Pond Park, formerly the site of the Oakland Golf Course, added two similar tan brick buildings in 1977: Percival Goodman's Administration Building and Armand Bartos's Medical Arts Building, a pair that the editors of the *AIA Guide* deemed "examples of stylish form-making for its own sake."[212] East of the college at the Queens-Nassau border in Glen Oaks, another institution, the Long Island Jewish Hospital-Hillside Medical Center, added two new buildings in the 1980s, beginning with the Schneider Children's Hospital (1983), 269–01 Seventy-sixth Avenue, opposite 269th Street, a Brutalist, gray concrete, five-story, 150-bed facility

Ronald McDonald House, Long Island Jewish Hospital-Hillside Medical Center, 267–07 Seventy-sixth Avenue. Lee Harris Pomeroy, 1986. View to the northeast. McGrath. LHP

designed by the Architects Collaborative.[213] Far more successful was Lee Harris Pomeroy's 20,000-square-foot Ronald McDonald House (1986), 267–07 Seventy-sixth Avenue, opposite 267th Street, built to temporarily house families whose children were being treated for cancer at the medical facility two blocks away.[214] The inviting design consisted of two dominant elements: a gently curving two-story section containing the main entrance that opened onto a landscaped garden and included a playroom, library, and dining facilities, and a four-story curvilinear wing raised on pilotis that accommodated eighteen guest rooms.

Jamaica

By the mid-1970s, downtown Jamaica, also known as Jamaica Center, bounded by Hillside and Liberty Avenues on the north and south and 175th Street and Sutphin Boulevard on the east and west, was in a perilous state.[215] During the 1940s and 1950s, it had been the city's third largest shopping district, but drastic demographic and economic transformation in the 1960s saw its white, middle-class residents lured to the suburbs of Long Island, leaving the neighborhood to a much less affluent African American population and immigrants from Latin America, China, India, and other countries. Along Jamaica Avenue, the main retail thoroughfare, small shops selling cheap goods at high prices became typical. The area's seven movie theaters were all closed by the mid-1970s, banks moved their headquarters elsewhere, and the local newspaper, the *Long Island Press*, ceased publication in 1977 after 157 years.[216] In 1965 the Regional Plan Association had suggested the redevelopment of Jamaica Center into a regional subcenter for the metropolitan area, but that vision, while vigorously supported, was halted by the fiscal crisis. When the economy picked up again, the Greater Jamaica Development Corporation, founded in 1967 and headed by F. Carlisle Towery, an architect and urban designer who had been active in the Regional Plan Association, continued to work toward the vision of a renewed Jamaica Center, proving fundamental in the long and arduous comeback that Jamaica staged during the 1980s and 1990s as it regained its vitality as a center not only of retailing but of education, commerce, and government.[217]

In 1975 a group of seventy-five local merchants, attempting to stem the decline of the shopping district, proposed an 800-foot-long pedestrian mall on 165th Street between Jamaica

ABOVE Joseph P. Addabbo Federal Building, block bounded by Jamaica and Archer Avenues, 153rd Street, and Parsons Boulevard. Gruzen & Partners and the Ehrenkrantz Group, 1988. View to the southeast. Robinson. GS

RIGHT Joseph P. Addabbo Federal Building, block bounded by Jamaica and Archer Avenues, 153rd Street, and Parsons Boulevard. Gruzen & Partners and the Ehrenkrantz Group, 1988. View of lobby showing *Community* by Jacob Lawrence on left and *Family* by Romare Bearden on right. Robinson. GS

and Eighty-ninth Avenues.[218] Macy's would anchor the northern end of the mall and the J. W. Mays and Gertz department stores would be within a few blocks on Jamaica Avenue. As realized in 1978, the 165th Street Mall was closed to all but emergency and delivery vehicles.[219] The street, repaved in red and brown brick, featured new oak trees and light standards and a series of metal sculptures by William King successively depicting a figure raising its arms in triumph. But hopes for a new breath of life outstripped reality. In October 1977, the same week that construction began on the mall, Macy's announced it would close its Jamaica store. Three years later, Gertz's, once the biggest department store in Queens and only two blocks from the pedestrian mall, closed after years of poor sales. In February 1982, a fire that was later determined to have been an act of arson destroyed a quarter of the stores on the mall, leaving them vacant until they were renovated in 1985. At the end of 1988 Mays, Jamaica's last department store, also closed, signaling the end of an era.

At the same time, several infrastructure improvements pointed to possible revitalization. In 1979 the Jamaica Avenue elevated—4,600 feet of track between Sutphin Boulevard and 168th Street—was finally torn down (its removal had been postponed since the early 1960s). With the el gone, Jamaica Avenue was completely rebuilt, reemerging in 1985 with red brick sidewalks, granite curbs, trees, new traffic signals, and street furniture. El service was replaced by a subway extension that brought the IND and BMT lines along Archer Avenue one block south.[220] Begun in 1972, the subway extension's rainmaking potential made it all the more maddening when delays brought on by the fiscal crisis and innumerable construction problems delayed its completion until December 1988.

Although the closing of the Gertz store in 1980 had been damaging, the building that had housed it was reopened in 1985 as Gertz Plaza Mall, providing 300,000 square feet of office space on the upper six floors for 1,500 state agency workers relocated from the World Trade Center. In 1988, 100,000 square feet in the basement and first floors were renovated by the Cedarhurst, Long Island–based firm of Wax Bryman Ferraro to accommodate shops and restaurants.[221] The architects refurbished portions of the building's granite-and-brick facade but hung a large, crass marquee above the entry. The architecture was banal, but the injection of new retail activity proved a catalyst to the area's resurgence.

More instrumental to the area's rebirth was the construction of the Joseph P. Addabbo Federal Building, a regional headquarters for the Social Security Administration that brought 3,000 workers to the centrally located site on the west side of Parsons Boulevard between Jamaica and Archer Avenues.[222] In May 1981, a team of two firms—Gruzen & Partners and the Ehrenkrantz Group—were chosen from among nineteen candidates who submitted initial proposals and six finalists who developed them in a compensated competition, the first ever sponsored by the federal government's General Services Administration. Completed in 1988, the eleven-story, 964,000-square-foot Addabbo Federal Building was the largest office building in Queens, which the editors of the *AIA Guide* dismissed as a "big, bulky, brick, bureaucratic block."[223] The main entrance was set into a three-story-high cutaway in the base of the northeast corner. At the top, two sixteen-foot-diameter vertical sundials faced east and west, respectively, to display the morning and afternoon hours, but they were so cryptic that their function if not their very presence was hard to discern. Of greater artistic merit was the

series of specially commissioned paintings and sculptures that brought the work of eight artists, all black, to grace the two main entrances and one wall of the block-long lobby. According to *New York Times* art critic Michael Brenson, the most satisfying piece was Houston Conwill's "wonderful . . . strong and elegant" sculpture, *Poet's Rise*, situated outside the building's northwest entrance on Jamaica Avenue and consisting of a lectern and an octagonal well that referenced one which was once on the site and had been a gathering place for early residents.[224] Inside, the lobby was lined by six approximately ten-by-twelve-foot mosaic, ceramic tile, and painted murals, the two in the center by the most prominent of the artists, Jacob Lawrence and Romare Bearden, and those on either side by Frank Smith, Richard Yarde, Edgar H. Sorrells-Adewale, and Howardena Pindell.

Just as important to Jamaica's resurrection was the long-awaited construction of a permanent campus for York College, the City University of New York's youngest college, on a fifty-acre site bordered by the Long Island Rail Road tracks on the north, South Road on the south, and 158th and 165th Streets on the west and east. Since its founding in 1967, York College had been housed in scattered facilities around downtown Jamaica, including a vacant Montgomery Ward department store at 150–18 Jamaica Avenue. Plans for the permanent campus had been prepared by Gruzen & Partners in 1973, but progress was delayed by the city's fiscal crisis until 1980, when ground was broken for the York College Academic Core Building (1986), a five-story, red terra-cotta-block megastructure.[225] U-shaped in plan, the building hugged a multilevel outdoor plaza, with administrative offices and a library situated in one wing, and classrooms, lecture halls, laboratories, art studios, and other academic spaces occupying a second, terraced wing. The two were joined by an "indoor academic

ABOVE Jamaica Market, 160th Street, between Jamaica and 90th Avenues. James McCullar & Associates, 1992. View to the northwest. Zimmerman. WZ

RIGHT Jamaica Market, 160th Street, between Jamaica and 90th Avenues. James McCullar & Associates, 1992. Zimmerman. WZ

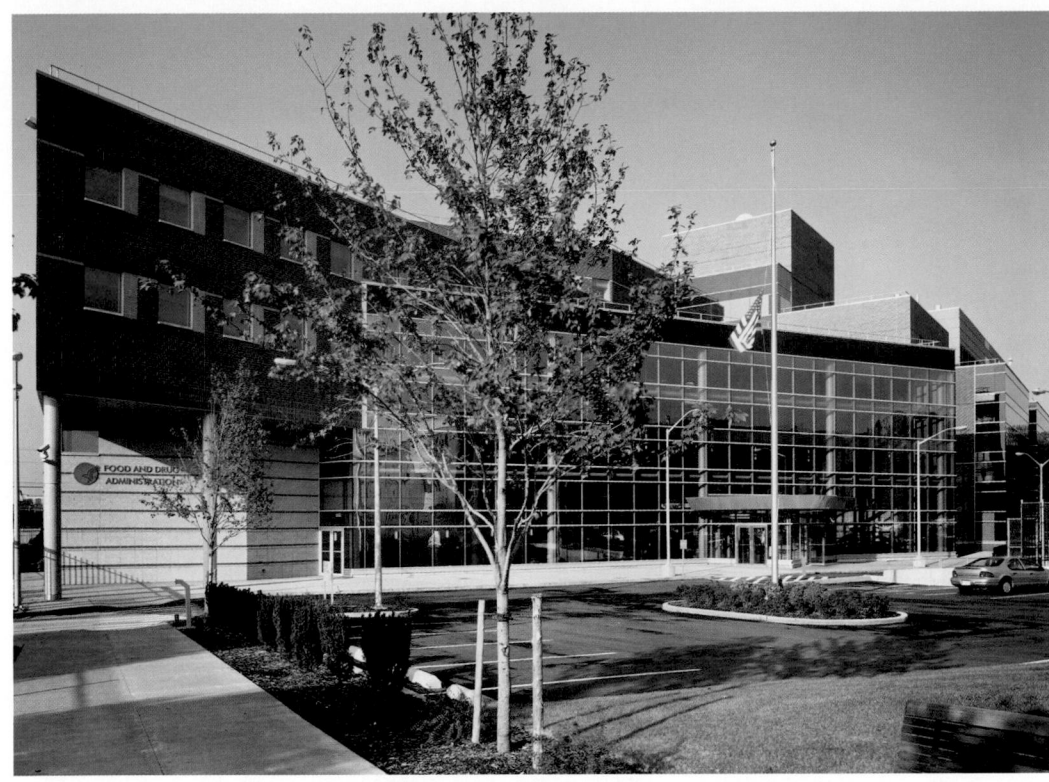

United States Food and Drug Administration Field Laboratory and Regional Office Building, 158–15 Liberty Avenue, northeast corner of 158th Street. Gruzen Samton, 2000. View to the northwest. Morse. GS

street," as Jordan Gruzen termed it, a full-height, skylit mall crossed by bridges, stairs, and escalators that served "as an all-weather gathering place."[226]

York College grew with the completion of the Health and Physical Education Complex (Cain, Farrell & Bell, 1987), a red brick building consisting of a low rectangular volume housing an Olympic-size swimming pool and a windowless cylindrical drum set upon a recessed base containing basketball courts. The Polshek Partnership's York College Performing Arts Center (1990) provided a 1,500-seat theater with a full fly and orchestra pit, a 150-seat experimental theater, and a prop and scenery shop within a red and purple brick building with a glass entry facade. While the presence of the college had a beneficial effect on the area, the campus had little to offer in the way of coherent urbanism or architectural distinction.

By the late 1980s, few vacant storefronts could be found along Jamaica Avenue, though the discount clothing and electronics shops and restaurants were not as upscale as those that had been there in the 1940s and 1950s. In 1992 work was completed on James McCullar & Associates' Jamaica Market, west side of 160th Street, north of Jamaica Avenue, a permanent home for the open-air produce market founded by the Greater Jamaica Development Corporation in 1976 as a temporary use for vacant downtown sites.[227] The two-story market building provided 6,000 square feet of space for food sellers behind metal roll-down gates that could be left open in good weather. The main entrance was set beneath a forty-foot-high, cupola-topped, glass-and-steel portico leading to a skylit food court. The not innovative but nonetheless distinctly stylish building was finished in a palette of green, yellow, pink, and purple derived, according to Mark Alden Branch, writing in *Progressive Architecture*, "from the tastes of the community's Caribbean population."[228] To give the market a presence on

Jamaica Avenue, a 140-foot-long brick-paved "farmers lane"— a prettified alleyway—served as a secondary entrance and provided additional selling space.

In 1994 the U.S. Food and Drug Administration announced that it would build its new Field Laboratory and Regional Office Building (2000) on the northwestern edge of the York College campus, near the northeast corner of Liberty Avenue and 158th Street.[229] The FDA had previously been headquartered in Sunset Park, Brooklyn, at a waterfront location that kept it close to the food, drugs, and other goods under its scrutiny, which historically came in by boat. The Jamaica facility would put it closer to Kennedy Airport, where the majority of goods now arrived. Its exterior, offices, and atrium were designed by Gruzen Samton, and its laboratories by Haines Lundberg Waehler. The less than inspiring red, purple, and beige brick building incorporating black- and clear-glass facades was separated into three components: a five-story office block, a three-story lab block, and a three-story-high east-facing glass-walled atrium featuring tables and chairs for 200 employees.

Jamaica Center was further bolstered by the construction of two new courthouses. In 1997 Perkins Eastman's Queens Civil Courthouse opened at 89–17 Sutphin Boulevard, between Eighty-ninth and Ninetieth Avenues.[230] The architects organized the 315,000-square-foot limestone, granite, and glass building into two wings. At the north end of the site a four-story cube housing jury selection facilities for both the civil and supreme courts was set back on a plaza to align with the Queens Supreme Courthouse (Alfred H. Eccles and William W. Knowles, 1938) located across the street. At the southern end a long, five-story wing, tilted seven degrees off axis from the northern building to meet the angle of Ninetieth Avenue, contained twenty courtrooms for the civil and housing

Queens Civil Courthouse, 89–17 Sutphin Boulevard, between Eighty-ninth and Ninetieth Avenues. Perkins Eastman, 1997. View to the southeast. Choi, PE

courts on the first four floors and judges' chambers, conference rooms, and a law library on the fifth floor. A five-story glassed-in atrium provided the court wing with what the editors of the *AIA Guide* called "a grand spatial adventure," while the exterior's gridded curtain wall formed the southern edge of a public plaza leading to the building's recessed entry, inside of which a 3,500-square-foot lobby featured Ed Carpenter's *Ojo*, an aluminum, stainless steel, and dichromatic glass sculpture suspended from the ceiling.[231]

Two years after the completion of the Civil Courthouse, construction began on the Queens Family Courthouse and City Agency Facility (2003), 151–20 Jamaica Avenue, between 151st and 153rd Streets, across the street from the Addabbo Federal Building.[232] Designed by Pei Cobb Freed & Partners working with Gruzen Samton as associate architects, the buff brick and glass building featured granite plaques inscribed with quotes from Thurgood Marshall. As with the Civil Courthouse, the Family Courthouse complex was separated into two wings, in this case connected by a 2,700-square-foot, one-story glass entrance pavilion. The smaller wing, the City Agency Facility, accommodated the Department of Probation, Victims Services, Office of Mental Health, and other city and state agencies within a four-story, 100,000-square-foot volume with a curved facade facing an entrance plaza. The second wing, rising four stories with a set-back fifth floor and containing 175,000 square feet, housed sixteen court parts and seven hearing rooms as well as other facilities.

Natural light and views were a priority for both the Family Courthouse's courtrooms, which were given seven-and-a-half-foot-tall windows, and the waiting areas, which were positioned at the building's perimeter and expressed on the exterior by twenty three-story glass bays protruding two feet from the facade (ten bays each faced Jamaica and Archer Avenues). At the heart of the facility was a forty-by-forty-foot cylindrical skylit atrium crossed by escalators that, according to Ian Bader, of Pei Cobb Freed, "provide a continuum of spatial experience so you always see where you are in the building. The idea of the courthouse as a labyrinth is one of the most terrifying images one can imagine."[233] *Katul Katul*, a translucent plastic and aluminum sculpture by Ursula von

Rydingsvard, was suspended from the atrium, its two tentacle-like appendages dangling down on either side of the escalators.

Two blocks away, east of the Addabbo Federal Building, a two-acre site bounded by Jamaica and Archer Avenues, Parsons Boulevard, and 160th Street was developed in 2002 as the 411,000-square-foot One Jamaica Center (Schuman, Lichtenstein, Claman & Efron).[234] The building contained 135,000 square feet of retail space on its first two floors (leased to national chains), a fifteen-screen, 3,200-seat movie theater on the third floor (the first movie theaters to be built in Jamaica in more than fifty years), and two levels of underground parking, signifying at once the largest private development in Jamaica in decades and the onset of a new stage of prosperity.

About a mile south of Jamaica Center, work was completed in 1997 on Harry Simmons Jr.'s Allen African Methodist Episcopal Cathedral, 110–31 Merrick Boulevard, southeast corner of 110th Avenue.[235] The 93,000-square-foot, 2,500-seat cathedral for the rapidly growing 8,600-member congregation led by Congressman Floyd H. Flake, its pastor since 1976, was according to church officials the largest church built in the city in fifty years. The building faced Merrick Boulevard with a monumental, angular corner entrance facade whose triangular, sloping roof and eighty-four-foot-high knife-edged steeple rising from the ground were so shaped to reference the Trinity. Inside, the "glu-lam structure" of the main sanctuary "was designed to mimic a grand piano, given the importance of music in the African American religious tradition," according to Kandace Simmons, who took over her father's architectural firm after his death in an airplane crash in 1994.[236] The facility also included an 8,500-square-foot fellowship hall, church offices, and a 150-seat chapel.

Stein White Nelligan Architects' 13,800-square-foot South Jamaica branch (1999) of the Queens Borough Public Library, 108–41 Guy R. Brewer Boulevard, between 108th and 109th Streets, was the first building to be constructed under the NYC Department of Design and Construction's Sustainable Design Program and was expected to drastically reduce energy costs by incorporating "green" elements like clerestory windows and artificial lighting that adjusted automatically to

changing levels of daylight. On a sunny day, two-thirds of the library's lighting would be natural, a benefit that, aside from being environmentally sound, produced what Michael J. Crosbie called a "dynamic interior environment with soft, diffused sunlight that is brighter and warmer in the winter and more subdued and sheltered in the summer."[237] The library hugged the property line of its midblock site on all sides except for along the street, where it was set back to provide a welcoming presence. The architects kept decorative finishes to a minimum, allowing the building's brick, glass, and concrete surfaces and its exposed mechanical systems to set the mood inside. During its first year of operation, the South Jamaica library used 30 percent less energy than comparably sized libraries.

North of Jamaica Center was St. John's University, which by the mid-1990s, with more than 21,000 students, had the largest enrollment of any Roman Catholic university in the United

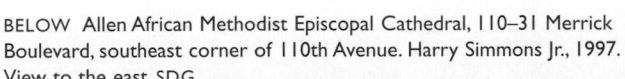

BELOW Allen African Methodist Episcopal Cathedral, 110–31 Merrick Boulevard, southeast corner of 110th Avenue. Harry Simmons Jr., 1997. View to the east. SDG

BELOW Allen African Methodist Episcopal Cathedral, 110–31 Merrick Boulevard, southeast corner of 110th Avenue. Harry Simmons Jr., 1997. SDG

States.[238] The school, opened in 1870 and for many years located in Brooklyn, built a new campus in 1956 on the 100-acre former Hillcrest Golf Course, bounded by Union Turnpike, Utopia Parkway, Grand Central Parkway, and 168th Street. The campus, incrementally developed over the years with bland buildings, continued to grow during the 1990s with additions like Chiang-Ching Kuo Memorial Hall (Taylor Clark Architects, 1993), a single-story, 5,500-square-foot speech and hearing center,[239] and Finley Hall (1994), an eight-story expansion to Fromkes Hall (1972) that nearly doubled the size of St. John's law school and was designed by Carson, Lundin & Thorson to match the original building, which they had also designed.[240]

In 1998 St. John's embarked on an ambitious and orderly expansion, guided by a ten-year master plan prepared by Haines Lundberg Waehler that called for a new conference center, student center, administration building, multimedia facility, and new athletic fields. But the most notable aspect of the plan was the scheduled construction of a residential quadrangle consisting of up to twelve dormitories housing 2,800 students.[241] Not only would the dormitories be the first housing offered by St. John's since it was founded, they would be the first on-campus student housing provided by any college or university in Queens. Along with the residential quad, which would be located in an area known as "the pits" near the Grand Central Parkway in the southwestern corner of the campus, would be a new church to replace the school's small basement chapel, and a dining hall. The first three dormitories—Century, Millennium (renamed John Cardinal O'Connor Hall), and Hillcrest Halls—opened in fall 1999. Designed by

Einhorn Yaffee Prescott, they provided 800 beds in one six-story and two five-story bay-windowed salmon-colored brick buildings with zinc-colored metal roofs and protruding towers clad in precast stone. Two additional dormitories opened in 2000, the five-story, L-shaped Hollis and Briarwood Halls, designed by Adamson Associates Architects.[242] The architects adopted a similar palette of materials for more simply massed buildings, which provided 650 beds. Just north of the residential quad was the 45,000-square-foot Montgoris Dining Hall (2000), also designed by Einhorn Yaffee Prescott.[243] Clad in salmon-colored brick with precast stone detailing but standing out because of its soaring glass-walled, arc-roofed dining room, it could seat 600 students.

Located on a prominent site nearby on the main quad was Martin A. DeSapio's St. Thomas More Church (2004).[244] Originally to be designed by Cesar Pelli, the university's first freestanding church was organized around a central triple-height worship space occupying an octagonal drum that rose with a pitched roof to a tall cupola with stained-glass windows. A small limestone-clad side chapel appended to the church's west facade occupied a distinct telescoping octagonal volume. Three separate shrines within the church honored St. Thomas More, the Blessed Mother, and the victims of the September 11, 2001, terrorist attacks.[245]

The master plan also called for new athletic facilities for St. John's successful sports teams and their zealous fans. Rafael Viñoly Associates was originally retained to lay out new soccer and softball fields and other related facilities, proposing to erect a campanile that would have brought a sense

South Jamaica branch, Queens Borough Public Library, 108–41 Guy R. Brewer Boulevard, between 108th and 109th Streets. Stein White Nelligan Architects, 1999. View to the southeast. Sundberg. ESTO

Century (left) and Millennium (right) Halls, St. John's University. Einhorn Yaffee Prescott, 1999. View to the northwest. Mauss. ESTO

Montgoris Dining Hall, St. John's University. Einhorn Yaffee Prescott, 2000. View to the southwest. Warchol. PW

of grandeur to the complex. But the firm of Urbitran Associates, working with Arquitectonica as design architects, ultimately designed the Belson Soccer Stadium—opened in September 2002 as a turf field with seating for 2,300 spectators, all built on top of a parking deck—and the St. John's University Softball Field, also completed in 2002.[246]

Kennedy Airport

Located on 4,930 acres of reclaimed land in southeastern Queens along Jamaica Bay, fifteen miles from Manhattan, John F. Kennedy International Airport, run by the Port Authority of New York and New Jersey, was by far the metro-politan region's largest and busiest airport, serving national and international air passengers as well as a significant amount of cargo service. Opened as Idlewild International Airport in 1947 and renamed in honor of the slain president in 1963, the centerpiece of Kennedy Airport was Terminal City, its main area of passenger terminals built under a master plan devised in 1955 by Wallace K. Harrison who rejected the idea of a single terminal as impractical for so vast and complicated an operation in favor of an innovative arrangement of decentralized facilities with individual terminals for each important carrier connected to each other by surface roads.[247] The majority of Terminal City was built between the late 1950s and

early 1960s, beginning with Skidmore, Owings & Merrill's International Arrivals Building (1957) and including the airport's most talked about design, Eero Saarinen & Associates's TWA Terminal (1962). Although the original planners had always envisioned it as the world's largest airport, the tremendous growth of air travel far outstripped their expectations, and by the 1970s Kennedy's overtaxed facilities and hopelessly congested roadways were deemed inadequate.

In 1981, in an effort to ease overcrowding and increase efficiency, the Port Authority announced plans to spend $500 million over the next fifteen years to improve both Kennedy and La Guardia by renovating runways and taxiways, expanding passenger terminals and air cargo facilities, and reconstructing the airports' roadway systems.[248] At Kennedy, where more than 40,000 people worked, 250,000 passed through each typical day, and 4,500 cars arrived and departed each peak hour, congestion was exacerbated by the lack of a direct mass-transit link to the city and to suburban train lines. The Metropolitan Transportation Authority's "train to the plane" program implemented in 1978 and consisting of subway service to Howard Beach followed by a shuttle bus connection to the airport, barely made a dent in the problem.

Progress on Kennedy's expansion and renovation was stalled throughout the early and mid-1980s. But a hotel was announced in 1986, the first new hostelry at the airport in fifteen years, located off site at 144–02 135th Avenue, immediately east of the Van Wyck Expressway where it crossed the Belt Parkway, and a quarter of a mile north of the airport.[249] Developed by Field Hotel Associates with tax-exempt financing provided by the city, Alesker, Reiff & Dundon's twelve-story 360-room Holiday Inn (1987) featured a light gray facade of precast concrete and a prominent glass-vaulted porte cochere.

In 1987 expansion plans for Kennedy were renewed with the announcement of JFK 2000, a master plan for the airport designed by I. M. Pei & Partners, architects of the National Airlines Terminal (1971), one of Terminal City's better

buildings.[250] According to Paul Karas of the Port Authority, the need for the revamping was now acute: "Kennedy is being avoided. We have to change that and make it a convenient and exciting experience for the traveler."[251] The heart of the plan, designed by Henry N. Cobb, a partner in the Pei firm, was the five-story, 1.3-million-square-foot Central Terminal Complex to be located inside Terminal City's existing ring of buildings, near the International Arrivals Building, replacing a parking lot and the Tri-Faith Chapels Plaza (1966), a collection of three freestanding houses of worship designed by Bloch & Hesse, Edgar Tafel, and George J. Sole.[252] Instead of proceeding to an individual airline terminal, passengers would go directly to the Central Terminal Complex, drop off their luggage at a centralized baggage-sorting area, and then be efficiently whisked by an automated people-mover system to their particular terminal. The Central Terminal was to include a 115-foot-high, domed, skylit entrance hall as well as baggage-claim areas, ticket counters, restaurants, retail shops, and chapels. The elevated twin-track rail system, devised to avoid the airport's congested inner roadways, could carry 2,000 passengers an hour in cars accommodating seventy-six people, with an estimated average travel time of two minutes to each of the terminals. In addition to the central terminal and elevated rail system, JFK 2000 also included a reconfiguration of the internal roadway network, a hotel, expanded office space, a 2,000-car underground garage, a new control tower, and needed infrastructure improvements.

The most vocal criticism of the master plan centered on its failure to include a direct mass-transit connection to the airport, instead relying on the shuttle-bus service from the Howard Beach subway station. As one anonymous airline company chief executive put it: "The whole thing is absurd. It's going to improve people's mobility once they get out to Kennedy, but it doesn't do anything to help speed up the task of getting there."[253] The fate of the JFK 2000 plan, however, was ultimately tied to the diminishing fortunes of the airline industry. Although the Port Authority planned to pay for the

expansion by issuing bonds, it still required the financial assistance of the airlines themselves in the form of substantially higher user fees. The precarious state of the airlines in the late 1980s prevented the companies from supporting the authority's plan, and in May 1990, just one month after the Metropolitan Transportation Authority ended its "train to the plane" program after a dozen years, the Port Authority announced that it had indefinitely postponed the most ambitious aspects of its initiative, the Central Terminal Complex and the automated people mover.

Some parts of the master plan did move forward, however, including the construction of the JFK Expressway (1991), a four-lane highway that connected the airport to the Belt Parkway and the Nassau Expressway and was expected to ease congestion on the Van Wyck Expressway.[254] The airport's internal roadway system was improved by dividing it into quadrants, allowing motorists to reach terminals more directly rather than having to circle the entire Terminal City area. A 321-foot-high replacement for the 1952 control tower was designed by Leo A. Daly in collaboration with the Pei firm and completed in 1994.[255] Located on the runway side of the International Arrivals Building, the thirty-four-foot-square, white, reinforced-concrete shaft was double the height of the previous facility. At its top, the control tower featured a three-level cantilevered glass section housing electronic equipment and air-traffic controllers. A second cantilevered glass portion was used by employees involved with ramp control and gate assignments, and the two-story base contained administrative offices for the Federal Aviation Administration.

In 1995 the Eggers Group (succeeded by the Hillier Group) completed a renovation of the airport's 30,000-square-foot

Control Tower, Kennedy Airport. Leo A. Daly in collaboration with I. M. Pei & Partners, 1994. View to the northeast. Thompson. PCFP

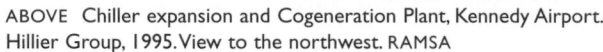

ABOVE Chiller expansion and Cogeneration Plant, Kennedy Airport. Hillier Group, 1995. View to the northwest. RAMSA

BELOW Proposed Consolidated Terminal for American and Northwestern Airlines, Kennedy Airport. Ellerbe Becket in association with David E. Leibowitz, 1989. Model, view to the southeast. PP

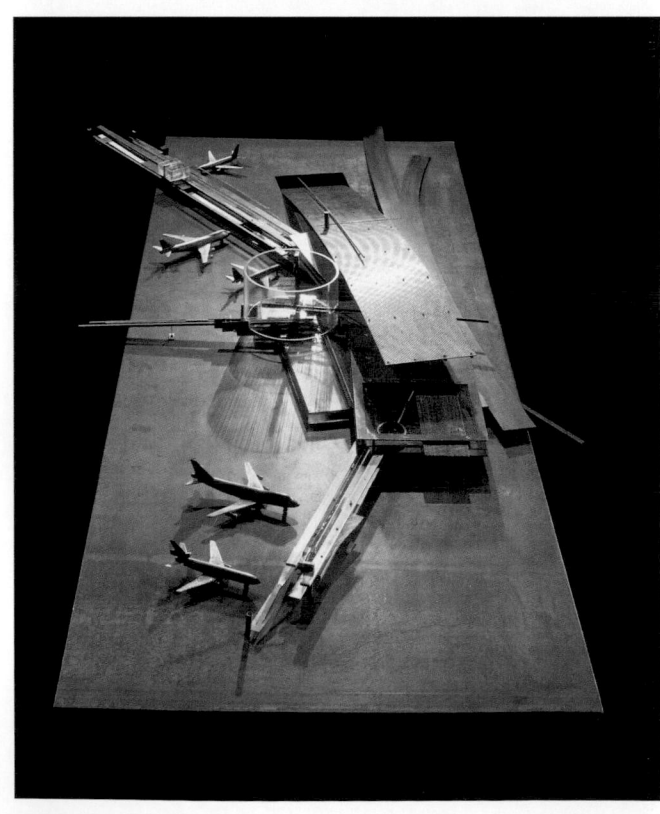

Central Heating and Cooling Plant (Skidmore, Owings & Merrill, 1957) and the construction of a 12,000-square-foot Chiller expansion and a 45,000-square-foot Cogeneration Plant.[256] Cognizant that the facility, which would now provide greater quantities of electrical power and hot and cold water to the airport, was "a nonpublic building in a very public setting," as Robert Davidson, chief architect in the Port Authority's engineering department, put it, the authority wanted "the level of design" to be "consistent with the existing and future design at the airport."[257] The Port Authority and the architects agreed that the plant's impressive machinery should be neither totally exposed nor enclosed. The most prominent components, a pair of boilers with 120-foot-high exhaust stacks, became the centerpiece of the visually overwrought complex, their lower portions wrapped in a metal space-frame painted bright red. The rest of the buildings were covered by shallow arched roofs and wrapped in green-tinted glass to allow views of the color-coded tangle of pipes within. Each building's south-facing facade was canted at a sixty-degree angle, leaning out from bottom to top to "reflect the geometries of the surrounding terminals."[258]

In 1988, as the master plan was being developed, American and Northwestern Airlines announced their intention to replace their neighboring facilities (American, Kahn & Jacobs, 1960; Northwestern, originally United, Skidmore, Owings & Merrill, 1961) with a consolidated terminal,

sponsoring a competition in conjunction with the Port Authority for what would be the first new terminal built at Kennedy in two decades.[259] Second place was awarded to Ellerbe Becket working in association with David E. Leibowitz. According to project architect Peter Pran, the design's curved steel canopy, which seemed to float over the entire length of the main terminal structure, was intended, like Saarinen's TWA Terminal, to convey "flying before you fly."[260] To accommodate the forty-four required gates, the architects added a satellite facility accessible by monorail. Adjacent to the main terminal was a glass cylinder containing stations for the satellite monorail as well as the people mover proposed in the Pei master plan. On the cylinder's upper levels a bar and restaurant would be dramatically cantilevered into the spacious round atrium space, affording excellent views of arriving and departing planes.

American, Northwest, and the Port Authority selected a more conventional scheme designed by Murphy/Jahn, similar to one the firm had completed for United Airlines the previous year at Chicago's O'Hare Airport.[261] Helmut Jahn's design called for a four-level, gently curving main terminal, with a three-level gate facility directly behind it. Additional gates would be provided in a satellite structure connected to the main terminal by moving walkways. But with the failure of the most significant components of the master plan to go forward, the airlines and the Port Authority balked at the ambitious undertaking and canceled the plans for the consolidated terminal. In the early 1990s, American instead built a connecting finger between the two terminals, which were also renovated under the supervision of Murphy/Jahn in collaboration with the engineers Ove Arup & Partners.[262]

In 1991 Lufthansa German Airlines, Japan Air Lines, and Air France, fed up with sharing space with fifty other airlines in the chaotic International Arrivals Building, jointly proposed to build their own terminal on the twenty-five-acre site of Terminal 1 (Chester L. Churchill, 1959), originally built for Eastern Airlines.[263] Two additional airlines soon joined the team, and in 1992 Kohn Pedersen Fox prepared a design in which an "inclined aluminum drum" served as an identifying icon along the roadway as well as a hinge between a long glass-wrapped departure hall with sharply angled aluminum piers supporting a metal roof, situated parallel to the road, and a winglike main concourse enclosed by horizontal bands of glass that made it seem to "hover above the tarmac," according to the architects.[264]

KPF was replaced by William Nicholas Bodouva + Associates, specialists in airport design, who prepared a new scheme. The Eastern terminal was demolished by 1995, and its replacement, built on a fast-track schedule, opened on May 28, 1998, becoming the airport's first new terminal in more than twenty-five years.[265] The 675,000-square-foot Terminal 1 was the first at Kennedy to incorporate design elements that had become standard in airports around the world: it was flooded with natural light, incorporated a central retail and restaurant area, and featured a large departure hall with an open plan in which ticketing "islands" were positioned perpendicular to the entrance rather than parallel, allowing for more transparency and easier orientation.

Terminal 1's plan was complex. "Swooping rooflines," as Bodouva described them, became the building's signature element, with a twenty-two-degree sloped curtain-wall skylight above the entry whose curved lower edge earned it the

Proposed Consolidated Terminal for American and Northwestern Airlines, Kennedy Airport. Murphy/Jahn, 1989. Model, view to the northwest. MJ

ABOVE Terminal 1, Kennedy Airport. William Nicholas Bodouva + Associates, 1998. Departures hall. Warchol. PW

LEFT Terminal 1, Kennedy Airport. William Nicholas Bodouva + Associates, 1998. View to the southwest. Warchol. PW

nickname "the smile."[266] In plan, the terminal resembled a pair of concentric arcs, the first housing the 90-foot-wide, 750-foot-long departures hall, a bright room whose steel armature was exposed and painted white. Stainless-steel canopies covered the four ticket islands that served Air France, Japan Airlines, Korean Air, Lufthansa, and seven other airlines who had joined them by 2000. Beyond the ticketing hall, escalators rose above a black-granite waterwall to a mezzanine that provided a food court and retail rotunda overlooking the arrivals area below. The customs and passport inspection room became the terminal's most improbably hospitable area, its skylights and carpeting meant to "provide a welcoming atmosphere," according to Bodouva.[267] With characteristic exaggeration, Herbert Muschamp commented that it was "deeply shocking to enter an area like this without feeling that you should sink to your knees and apologize for being alive. But this space actually communicates the thought you want to hear: welcome home." When it opened, Muschamp hailed the terminal as "a return to the glamour of flying," a "small oasis in Kennedy's desert of decrepitude," and "an excellent building, at once muscular and calm and, above all, lucid."[268] Two years later, however, the critic seemed to have lost his zeal when, commenting on Bodouva's plans for an expansion of the TWA terminal (see below), he wrote that the architects had "no proven aptitude for visionary design" and that Terminal 1 was "your basic box of space with a few slants and curves thrown in."[269]

While Terminal 1 was under construction, work began on Terminal 4, also known as the International Air Terminal, Skidmore, Owings & Merrill's replacement of their own International Arrivals Building (1957), the airport's first terminal and its primary international gateway.[270] Plans to upgrade the building had first been announced in 1994 in an effort to stem the loss of international travelers to competing

ABOVE Terminal 4, Kennedy Airport. Skidmore, Owings & Merrill, 2001. View to the south. Goldberg. ESTO

FACING PAGE Terminal 4, Kennedy Airport. Skidmore, Owings & Merrill, 2001. Departures hall. Spranger. SOM

airports. The International Arrivals Building had been expanded from 600,000 to 1.4 million square feet over the years to help deal with what had grown from 2,500 to 20,000 passengers each day. But it was nonetheless outmoded and inefficient, essentially operated as six separate terminals, each with its own check-in, baggage, ticketing, security, and waiting areas. As well, its gates were ill equipped to handle increasingly large jumbo jets.

But when the Port Authority, considering how to upgrade the building, concluded that a total replacement was the best option, it also determined that a newly built terminal could be profitable to private operators. After soliciting and receiving several bids, on May 13, 1997, the Port Authority turned over operations to JFK International Air Terminal LLC, a private consortium of Schipol U.S.A., a subsidiary of the Dutch company that ran the highly regarded Schipol airport in Amsterdam; LCOR, the New York–based development company; and Lehman Brothers, the investment banking firm. As a public-private partnership, the Port Authority and the consortium hired Skidmore, Owings & Merrill to work with TAMS Consultants and Ove Arup & Partners on the design of the new terminal.

David W. Dunlap compared the construction effort to "performing open-heart surgery on a patient who is simultaneously running a marathon."[271] The work, begun in 1997, was carried out in numerous phases over a six-year period during which the new 1.5-million-square-foot terminal was constructed around the old one. Ten gates remained operational at all times during the process. Because the old and new footprints overlapped, as portions of the new building were completed the old terminal was demolished and the site rebuilt. Terminal 4 officially opened on May 24, 2001, and the project was completely wrapped up in January 2003.

Passengers arriving by car were dropped off on a new elevated roadway that led to a soaring departures hall, a 55-by-400-foot room covered by an arced 235-foot clear-span roof designed to resemble an aircraft wing and supported by a modular braced-frame structure with exposed steel columns in an angled wishbone configuration. Nancy Hamilton, a senior associate at Ove Arup, explained: "We wanted to create a look similar to the great transportation centers of the 1800s. By using sloping columns to provide the stability of the structure, it creates a very open framework, eliminating many walls."[272] Dramatic as the space may have been, Karrie Jacobs also found it to be "clean and functional to the point of being generic. . . . a glass shed with a skyward tilt to the roof line."[273] Alexander Calder's mobile *Flight* (1957), having presided over the arrivals hall of the International Arrivals Building, was reinstalled in the new departures hall but now seemed hopelessly underscaled. Both the land-side and air-side facades were of glass, allowing departing passengers to see directly through the entry facade into the ticketing area and to the airfields beyond.

As a private operation the terminal had to be profitable, so on their way to the gates passengers were required to traverse a 150-foot-wide, 1,000-foot-long retail area, a multilevel space containing a food court ringed by forty upscale shops adorned by a clock tower, topiary, and a series of "view parks" that offered glimpses of activity on the tarmac. A mezzanine level provided access to four chapels (Muslim, Protestant, Catholic, and Jewish) that incorporated elements from the freestanding chapels they replaced. Karrie Jacobs lamented that "the dream of a bold, awe-inspiring civic monument" seemed to have "been scrapped in favor of a pragmatic vision, a kaleidoscopic commercial hub that comforts travelers by immersing them in a familiar environment, a shopping mall."[274]

Travelogues, Terminal 4, Kennedy
Airport. Diller + Scofidio, 2001. DSR

Three artworks were specially commissioned to brighten up the arrival sequence. Harry Roseman's *Curtain Wall* decorated the two roughly thirty-foot-long concourses with a series of trompe l'oeil curtains made from modified gypsum that seemed to have been blown by the wind and frozen in midgust. Diller + Scofidio enlivened the corridors that led to the customs and immigrations area with *Travelogues*, a series of backlit screens with X-ray-like images of briefcase contents that intimated narrative vignettes. Upon reaching the customs and immigration hall, arriving passengers were greeted by Deborah Masters's *New York Streets*, a series of twenty-eight paintings stretching 100 yards above the inspections counters depicting glimpses of New York life, intended, according to the artist, "to get across the idea that New York is lively and energetic but that it is also an extremely fatiguing city."[275]

Perhaps the most sophisticated element of the new terminal, however, was the presence on an intermediary level between arrivals and departures of a station for the light rail AirTrain JFK, the long-desired mass-transit connection between Manhattan and the airport that opened in December 2003. While each of Kennedy's terminals was served by its own AirTrain station, Terminal 4 was the only one to incorporate the station within the building itself.

With the International Air Terminal under construction, JFK's major individual carriers began to plan for the renovation or replacement of their own terminals. On January 25, 1999, American Airlines, Kennedy's largest carrier, occupying both Terminal 8, which it had originally constructed, and Terminal 9, originally the United Airlines Terminal, unveiled designs prepared by TAMS Consultants and Daniel, Mann, Johnson & Mendenhall to replace both terminals with a colossal new one.[276] The airline hoped to salvage in some form Terminal 8's 317-foot-long stained-glass facade by Robert Sowers. Like Terminal 4, which it promised to dwarf, the new Terminal 8 would be built in stages to eventually comprise 2.2 million square feet, with fifty-six gates (compared with twenty-six current gates), a 220-counter check-in area, and three concourses, two of which would be arranged in an H-

shape plan parallel to the roadway, and the third of which would become the airport's first midfield concourse, a separate building to the north of the main terminal accessible via a 420-foot-long tunnel. Construction got under way, but the scheduled completion date of 2006 was pushed back by at least a year after the economic slowdown resulting from the September 11, 2001, terrorist attacks.

Delta Airlines also announced plans in 1999 to add ten gates to Terminal 2 (White & Mariani, 1961), originally the Braniff, Northeast and Northwest Orient terminal, and to add twenty-six gates to Terminal 4's western concourse, which had been designed to accommodate such an expansion.[277] Unfortunately, the plan, prepared by HOK, also called for the replacement of the daringly engineered Terminal 3 (Tippets-Abbett-McCarthy-Stratton, 1960), originally the Pan American terminal, with a bridge connecting Terminals 2 and 4.[278] While the Terminal 2 addition went forward as planned, the Pan American terminal was given a reprieve in the wake of September 11, though its ultimate fate remains uncertain.

TWA Terminal

Despite the legion of complaints lodged against Kennedy Airport expressing frustration at the lack of clarity of its overall plan or criticism of individual buildings, there was general agreement that the airport possessed at least one architectural masterpiece, Eero Saarinen & Associates's TWA Terminal (1962), praised as one of a handful of post–World War II buildings in New York to be viewed as an international landmark, a total work of architecture in which the exterior expression and interior space formed a seamless continuity.[279] Designed, in Saarinen's words, "to express the excitement of air travel," the brilliantly conceived and grandly articulated building dramatically elevated the humdrum realities of air travel to a rite of passage as travelers became part of the drama of flight itself.[280] For the first time in a modern air terminal, as travelers waited, they were treated to a continuous ballet of planes taxiing across the tarmac. Opened eight months after Saarinen's death in September 1961, the terminal was

expanded in 1970 by Kevin Roche John Dinkeloo and Associates, the Saarinen successor firm, which added the second flight wing called for in the original design.[281]

In 1978 Witthoefft & Rudolph designed a modest yet sympathetic companion to the TWA Terminal, a 330-foot-long, 22-foot-wide pedestrian shelter located in the roadway island in front of the terminal and constructed of precast-concrete columns and reinforced-concrete edge beams supporting a clear-acrylic barrel-vault canopy. Paul Goldberger found much to praise, noting that the structure represented "an unusually delicate design problem, since the architects were required to create a structure that could blend comfortably with the TWA terminal itself. . . . To design something too plain would have insulted the famous original building, to design something too elaborate would have upstaged it; it is to the credit of Witthoefft & Rudolph that they created a handsome, curving structure that takes its inspiration from the original but is in no way directly imitative."[282]

A dozen years later, in March 1990, as the Pei firm's master plan as well as Helmut Jahn's consolidated terminal for American and Northwestern Airlines were still in the works, Trans World Airlines commissioned Perkins & Will to prepare schematic designs for a multiphased expansion of the airline's facilities, combining Saarinen's building with I. M. Pei's neighboring National Airlines Terminal.[283] The ambitious plan would have doubled the size of the TWA complex. But with the failure of the major components of the master plan as well as Jahn's new terminal to move forward, TWA also got cold feet and soon canceled the expansion before any designs were published.

Although the Perkins & Will addition was abandoned, the potential threat it raised to Saarinen's building brought renewed attention to the terminal and concern for its survival, a fear heightened by TWA's financial instability and its filing for Chapter 11 bankruptcy in 1992. A move to have Saarinen's iconic structure designated a landmark was launched in 1992, the first year that the thirty-year-old building was eligible for consideration. Stanley Brezenoff, executive director of the Port Authority, which owned the terminal and leased it to TWA, acknowledged the consider-

able merits of Saarinen's design in a letter to the Landmarks Preservation Commission: "We agree that the terminal building represents a significant architectural achievement." But he also pointed out that it was "obsolete from an operational standpoint" and needed to be "modernized in order to keep pace with the changing needs of air travelers."[284] On July 19, 1994, the Landmarks Preservation Commission designated both the exterior and interior of Saarinen's terminal a landmark, with Trans World Airlines objecting to the interior designation.[285] As Marvin B. Mitzner, a lawyer representing the airline, which had recently emerged from bankruptcy protection and rented the facility on a month-to-month basis, stated, "By extending the designation to all interiors and the wings of the terminal, it really prevents us from modernizing the terminal in a way we believe is necessary."[286] The Port Authority stated that it welcomed the commission's decision, and Brezenoff noted that his agency would cooperate "to the maximum extent possible," although he also made clear that because the building's owner was a government agency they were not legally bound by the constraints of designation and could still alter the terminal at their own discretion.[287]

In 2001 the integrity of the TWA Terminal was again threatened, with plans announced by the Port Authority for a 1.5-million-square-foot terminal for United Airlines that would be built directly behind Saarinen's 374,000-square-foot building.[288] As designed by William Nicholas Bodouva + Associates in collaboration with Beyer Blinder Belle, the massive C-shaped terminal surrounding the air side of Saarinen's building would require the demolition of the two satellite gate structures, the eastern one designed by Saarinen and the western one added by Roche in 1970. Without gate facilities, the terminal could no longer serve its original function, a situation that the Port Authority endorsed, believing that the TWA Terminal was hopelessly outmoded for current demands. As Ted D. Kleiner, assistant director for capital programs at the Port Authority, stated, "This is no longer a good terminal, and I think most people who have traveled through it would probably recognize this. My sense is that saving the entire terminal will not advance the plan of building the airport we need to

Proposed United Airlines Terminal, Kennedy Airport. William Nicholas Bodouva + Associates in collaboration with Beyer Blinder Belle, 2001. Model. WNBA

Alternative design for new terminal next to TWA Terminal, sponsored by Municipal Art Society, Kennedy Airport. Hal Hayes, 2002. HH

build."[289] The authority also defended its decision by noting that the "umbilical" tubes leading to the satellite pods would be saved, rather than demolished as first contemplated, and would connect to the new terminal. No specific future use for Saarinen's building was given by the agency, although plans to convert it under the direction of Beyer Blinder Belle into a museum of aviation, a conference center, or restaurants and shops were variously mentioned.

Reaction in the preservation community was swift and vocal. Led in large part by the Municipal Art Society, objection to the authority's plans not only centered on the mutilation of Saarinen's building but on the potential damage inflicted by Bodouva's semicircular United Airlines Terminal. Despite its sculptural bravura, Saarinen's building was quite modest in size, and many believed its soaring form suggesting a vivid sense of flight would be aesthetically crushed by too large and insensitive a neighbor. In a statement issued by the Municipal Art Society, Philip Johnson noted that the "best part of the building will be totally lost in this new scheme. You can't remove the satellite gates. You can't take away any of it. And you can't destroy the observer's view of the elevation. The more I think about it, the more maddening it gets. This building represents a new idea in twentieth-century architecture, and yet we are willing to strangle it by enclosing it within another building. Imagine, tying a bird's wings up. This will make the building invisible. If you're going to strangle a building to death, you might as well tear it down."[290]

In the wake of the events of September 11, 2001, the plans for the new terminal were put on hold. One month later the TWA Terminal was shuttered when American Airlines, whose parent company had taken control of TWA earlier in the year, decided to consolidate operations. But, sensing that the airline business would rebound, the Municipal Art Society continued to explore ways to preserve TWA's building, sponsoring an alternative design (2002) by Hal Hayes that would keep the Saarinen building as a financially viable air terminal with fifty-two gates, as opposed to the fifty-one provided in the Port Authority-sponsored plan. Hayes's design, also requiring the demolition of Pei's National Airlines Terminal, would shift new construction off to the side of Saarinen's building as well as next to the two

satellite gate structures, thus retaining the views of the airfield from the TWA Terminal.

The Port Authority, however, remained committed to its gigantic new terminal, although instead of United Airlines it was now intended for a newly founded carrier, JetBlue Airways. Additional pressure to save Saarinen's terminal was generated by the decision of the National Trust for Historic Preservation to place the building on its 2003 list of the nation's eleven most endangered places. In October 2003, after a series of meetings between the Port Authority, JetBlue, and the Municipal Art Society, a compromise was reached. A new facility would still be built behind the TWA terminal, blocking views, but Saarinen's building would retain a measure of its original function, serving as an entrance to the new terminal with ticketing facilities and information kiosks placed in its main hall. The tube-shaped passageways, one of which would be rebuilt to accommodate a moving walkway, would connect to the new terminal. Also saved was the satellite gate structure designed by Saarinen, which would be relocated to the end of a new concourse, although the one added by Roche would be demolished. Beyer Blinder Belle was retained to oversee the restoration of Saarinen's terminal, which would also include restaurants and shops. In August 2004, Gensler was named the architect for the 26-gate, 625,000-square-foot terminal to be built on a 70-acre tract behind the TWA Terminal, with a groundbreaking ceremony held in December 2005 and completion expected in 2009. A spokesman for the firm stated that "the new structure's trim, low profile creates a respectful background to the former TWA terminal just opposite. However, the new design is also distinguished from the soaring concrete curves of the old terminal with geometric lines and a taut metal and glass enclosure that create a contemporary feel."[291]

Arverne

At the end of the nineteenth century and beginning of the twentieth, Arverne was a popular oceanfront resort area in the Rockaways. But the area degenerated into a blighted slum as unheated summer dwellings were converted into year-round housing for the poor, and in the 1960s the Lindsay administration cleared more than 4,000 dilapidated wooden bungalows

Proposed JetBlue Airways Terminal, Kennedy Airport. Gensler, 2004. Rendering of view to the southeast. GEN

and cottages in anticipation of redeveloping the 308-acre Arverne Urban Renewal Area, bounded on the north by the Rockaway Freeway, on the south by the Boardwalk, on the east by Beach Thirty-second Street, and irregularly on the west by Beach Seventy-fourth and Beach Eighty-first Streets.[292] Throughout the late 1960s and early 1970s, however, the waterfront site, which was more than an hour by subway from midtown Manhattan and the largest single tract of undeveloped city-owned land in New York, remained a largely litter-strewn, weed-filled eyesore. The only significant development was Carl Koch & Associates's Ocean Village (1975), Rockaway Beach Boulevard to the Boardwalk, between Beach Fifty-sixth and Beach Fifty-ninth Streets, an eleven-building, 1,110-unit, high-rise complex on a twenty-acre site that stood, as *New York Times* reporter Joseph P. Fried put it, "like an oasis."[293] Longtime Rockaway Park resident Karl Butigian expressed the frustration of many when he stated that "for 20 years nothing has been done. This is oceanfront property. Two miles of prime oceanfront property."[294]

In 1986 the Starrett Housing Corporation expressed interest in developing half of the urban renewal area with a complex of townhouses and twelve-story apartment buildings stretching for roughly a mile along the ocean at the eastern end of the site.[295] Under consideration was a combination of condominiums and rental apartments accommodating between 4,000 and 6,000 middle- or upper-middle-class families, though 20 percent of the rental units would be set aside for subsidized low- and moderate-income tenants. Starrett's offer stalled, however, before any progress was made or plans were released, a fate that also befell a proposal the following year to build 3,200 so-called Nehemiah Homes, low- and moderate-income single- and two-family townhouses co-sponsored by the East Brooklyn Churches and the nonprofit Queens Citizens Organization.[296]

In October 1988, the Koch administration announced a plan for the site involving no public subsidies, calling for the construction over the next ten years of between 7,000 and 10,000 market-rate housing units by a private developer who would purchase the site from the city for a minimum of $25 million and also be responsible for at least $300 million in infrastructure improvements, including roads, sewers, a fire-house, two public schools, and forty-five acres of parkland.[297] The city's request for proposals also specified that no building be taller than 125 feet and any structure within 250 feet of the beach be limited to 60 feet. A maximum of 300,000 square feet of retail and commercial space was allowed, with the provision of one parking space for every housing unit, along with 500 public spaces. The developer would also have to provide fifteen north–south streets and a new east–west six-lane land-scaped road "like Eastern Parkway or Ocean Boulevard," according to Abraham Biderman, Commissioner of Housing, Preservation and Development.[298] Although proceeds from the sale of the land would pay for at least 800 new units of subsidized housing on a site north of Arverne, in Edgemere, advocates of affordable housing like the Queens Citizens Organization strongly objected to the city's approach. The city defended the reliance on market-rate units, with Mayor Koch arguing that the Arverne neighborhood, one of the poorest in the city, needed a greater economic mix. Despite the record of failed redevelopment attempts, Parks Commissioner Henry J. Stern was optimistic, describing the site as "the Riviera of New York City. It's Florida without sharks."[299]

Although nine groups expressed interest in redeveloping the two-mile-long site, only three teams of developers and architects met the city's April 10, 1989, deadline for submitting proposals. The New Arverne Partnership, a joint venture of Milstein Properties and the Lefrak Organization, submitted a plan designed by Raquel Ramati and Frank Repas that was focused on a promenade running through the middle of the site, reinforcing the pedestrian nature of the beach community, a feature that was somewhat "handicapped," in the opinion of Alex Cohen, writing in *Oculus*, by the provision of "above-ground street parking at each of the housing blocks," although "the variety of housing heights in each block does add visual interest to the design." Cohen was more critical of Carr, Lynch, Hack & Sandell's design for Hovnanian Enterprises, the Related Companies, and the Briarwood Organization, writing that it "protects unobstructed ocean views but does little else for Arverne. While upgrading an out-of-favor housing type (Zeilenbau) and specifying informal pedestrian paths, the plan fails to consider the design issues of

Proposal for Arverne Urban Renewal Area, site bounded by Rockaway Freeway, the Boardwalk, Beach Thirty-second, Beach Seventy-fourth, and Beach Eighty-first Streets. Carr, Lynch, Hack & Sandell, 1989. Site plan. CLS

a hierarchy in the width and types of streets, the creation of open space pockets, and the relationship of the housing to the new infrastructure. All of these issues are central to creating a new community, particularly one of 10,000 people thickly concentrated on slightly more than 300 acres."[300]

On May 15, 1989, the city selected the proposal submitted by Oceanview Associates, a collaboration of Forest City Development, Park Tower Estates, and the Ratner Group, who offered a high bid of $90 million for the site and proposed to build 10,000 apartments over the next decade in four phases, with infrastructure work to begin early in 1990 and the first units to be completed before the end of 1991. As designed by Ehrenkrantz, Eckstut & Whitelaw and the Liebman Melting Partnership, 7,300 of the one-, two-, and three-bedroom apartments would be provided in three- and four-story townhouses with stoops and bay windows that opened both to the street and landscaped courtyards that were raised one level to conceal parking below. The remainder of the units would be placed in mid-rise buildings as high as twelve stories located on wider streets that also included the commercial components of the plan. The required park space would be used to divide the site into distinct, blocklike neighborhoods, with an emphasis placed on preserving views to the water and promoting public access to the beach. In an attempt to keep down costs, the architects considered the use of modular units constructed off site. Although Paul Goldberger cautioned that the proposal could "only be judged as a plan, and a very preliminary one at that," he believed that "the Arverne design has great importance for all cities around this country, for it stands as one of the most sweeping attempts anywhere to prove that the old way of making cities did not fail—and that the best way to make dense urban housing is to build low buildings and weave them close together in patterns that resemble traditional city streets."[301]

Although the Board of Estimate approved Oceanview Associates' plan in August 1990, the developer, citing a poor economy, backed out of the project at the end of 1991.[302] Over the next several years, the city rethought its approach for the long-stalled site and deemed it more practical to continue with development on a piecemeal basis.[303] In February 1997, the city awarded the Briarwood Organization the right to build up to 161 two-family houses on fifteen vacant acres at roughly the middle of the urban renewal site.[304] The first phase of the project, completed in 2000 and named Waters Edge, included forty unsubsidized middle-income houses for a site bounded by Rockaway Beach Boulevard, Larkin Avenue, Beach Fifty-ninth, and Beach Sixty-first Streets, representing the first new construction in the urban renewal area in twenty-five years. Designed by Fakler & Eliason, the two-story, red brick, two-family houses with steeply pitched roofs and overhanging eaves featured shutters, balconies, modest front lawns, driveways, and garage space for two cars.

In December 2000 the Department of Housing Preservation and Development issued another request for proposals, this time for a residential community of approximately 1,000 market-rate homes for a 100-acre site at the western end of the urban renewal area between Beach Fifty-ninth and Beach Eighty-first Streets.[305] The Architectural League of New York took the occasion to sponsor a symposium and exhibition, "Arverne: Housing on the Edge," inviting four teams of architects associated with academic or research institutions—including CASE, a Dutch research foundation, Yale, Columbia, and City College—to investigate additional possibilities for the site.[306] Rosalie Genevro, executive director of the Architectural League, explained the motivation behind the exhibition: "It is very difficult to change a system as complex as housing production, influenced as it is by financial structures, perceptions of the

market, construction practices, government regulations, and cultural values. Every so often, a shock to the system, in the form of ideas that are radically different than accepted practice, can provide a useful jolt that opens up awareness of the enormous number of other ways of doing things."[307]

CASE, formed in 2000 by architects John Bosch, Bruce Fisher, Reinier de Graaf, and Beth Margulis, came up with a scheme that Jayne Merkel described as "a kind of moonscape on the dunes," proposing a combination of very low and high density development on the site.[308] Envisioning Arverne's long-term future as "a respectable adjunct of Kennedy Airport," CASE's plan would "capitalize on [the site's] prevailing emptiness by injecting it with new meaning," returning to landscape any roads that no longer served buildings and providing new "soft roads" along topographical lines to support clustered housing.[309] The Yale team, led by Diana Balmori, Deborah Berke, Peggy Deamer, and Keller Easterling, focused primarily on environmental concerns, proposing the addition of a second line of dunes and the replacement of "hard" drainage and sewer systems with a "natural" system using swales, porous paving, and plants, bacteria, and sunlight to treat effluent. In order to save money as well as expedite production, the plan called for modular housing units that could be stacked in different configurations. Raised above flood height, which would allow parking underneath, the energy-efficient buildings could be placed in a variety of densities throughout the site.

Michael Bell Architecture, Marble/Fairbanks Architects, and the Mark Rakatansky Studio represented Columbia. They divided the site into three sections with a mix of housing types and sizes aimed at creating appropriate transitions to the closest existing construction, including a few remaining bungalows, large-scale public housing projects, and the recent two-family homes built by the Briarwood Organization. Michael Bell designed glass-walled houses raised on stilts; Marble/Fairbanks contributed rowhouses clustered around courtyards; and Rakatansky's design, including hotel and motel units, took inspiration "from attributes of the slab housing and the older vernacular houses."[310] The submission of the City College team, headed by Michael Sorkin and

ABOVE Proposal for Arverne Urban Renewal Area, site bounded by Rockaway Freeway, the Boardwalk, Beach Thirty-second, Beach Seventy-fourth, and Beach Eighty-first Streets. Ehrenkrantz, Eckstut & Whitelaw and Liebman Melting Partnership, 1989. Site plan. EEKA

RIGHT Proposal for Arverne Urban Renewal Area, site bounded by Rockaway Freeway, the Boardwalk, Beach Thirty-second Street, Beach Seventy-fourth, and Beach Eighty-first Streets. Ehrenkrantz, Eckstut & Whitelaw and Liebman Melting Partnership, 1989. Rendering of view to the east. EEKA

ABOVE Competition entry, "Arverne: Housing on the Edge." CASE, 2001. Model, view to the west. BOSCH

RIGHT Competition entry, "Arverne: Housing on the Edge." Yale team, led by Diana Balmori, Deborah Berke, Peggy Deamer, and Keller Easterling, 2001. Model. Pottle. ESTO

BELOW Competition entry, "Arverne: Housing on the Edge." Yale team, led by Diana Balmori, Deborah Berke, Peggy Deamer, and Keller Easterling, 2001. Sections through water swales. BA

Competition entry, "Arverne: Housing on the Edge." Columbia team, led by Michael Bell Architecture, Marble/Fairbanks Architects, and Mark Rakatansky Studio, 2001. Site plan. BELL

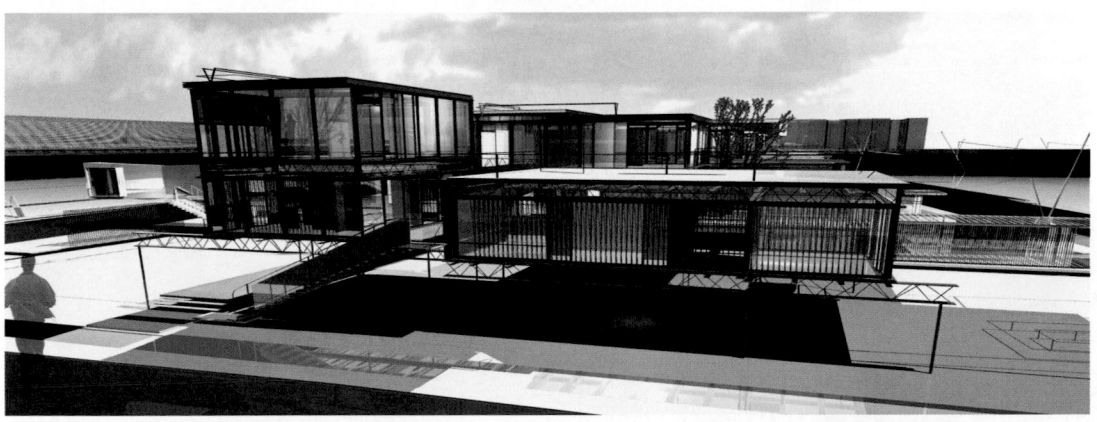

LEFT Competition entry, "Arverne: Housing on the Edge." Columbia team, Michael Bell Architecture, 2001. Rendering of triplex units. BELL

BELOW Competition entry, "Arverne: Housing on the Edge." Columbia team, Mark Rakatansky Studio, 2001. Rendering of duplex units with hotel-motel units behind. BELL

including SHoP and SYSTEMarchitects, was a celebration of the beach, highlighted by a wide landscaped path leading from the elevated subway station at Beach Sixty-seventh Street directly to the Boardwalk. As Sorkin put it: "The alpha and omega of Arverne is the beach, a New York City beach. How to design for such an environment? An extreme low-density approach—the Hamptons in town—seems wrong. A city-owned site in one of the most fabulous situations on the east coast should not be squandered on the happiness of the few." Sorkin hoped to recapture the heyday of the Rockaways as a resort with "relaxed, dense, and accessible architecture, by extensive beachfront commercial activity and circulation, and by a mix of uses—including restaurants, hotels, shops, and sports."[311] The plan provided 2,500 apartments in modular housing units and was sensitive to the environment: photovoltaic cells and windmills provided some power, and a "slow-mo" boulevard was added for pedestrians and "clean" vehicles that traveled at a maximum of fifteen miles per hour and emitted no exhaust.

In December 2001, the city announced the selection of the Benjamin Development Company and the Beechwood Organization to develop over a ten-year period the 100-acre site

ABOVE Competition entry, "Arverne: Housing on the Edge." City College team, led by Michael Sorkin and including SHoP and SYSTEMarchitects, 2001. Site plan. MSS

BELOW Competition entry, "Arverne: Housing on the Edge." City College team, led by Michael Sorkin and including SHoP and SYSTEMarchitects, 2001. Rendering of view to the south. MSS

at the western end of the urban renewal area as Arverne-by-the-Sea, consisting of 2,300 residential units, 250,000 square feet of commercial and retail space, a 30,000-square-foot community recreation center, ten acres of parkland, and a charter school for 800 students.[312] Ehrenkrantz Eckstut & Kuhn Architects's master plan called for a mix of housing types, including three-story two-family houses, mid-rise buildings with apartments above retail spaces, single-family detached houses, and smaller-scale two-family houses. The architects had a long association with the site, having codesigned Oceanview Associates's aborted proposal in the late 1980s. The centerpiece of the design was the Village Square Transit Plaza, which included a clock tower rising above the elevated tracks of the Beach Sixty-seventh Street subway station. A new retail street, Ocean Way, led from the renovated subway station to the Boardwalk and connected with two parks. Distinct, pedestrian-friendly neighborhoods, each with their own focus and public spaces and facilities, would be established throughout the site. Despite the skepticism of many local residents that Arverne-by-the-Sea would meet the same fate as previous ambitious proposals for the urban renewal site, construction began in the summer of 2002, and on May 25, 2004, Mayor Michael Bloomberg attended a ribbon-cutting ceremony marking the completion of the first twenty-seven two-family houses, the thoughtful planning and playfully vernacular design of which held great promise for a fresh start.

TOP Arverne-by-the-Sea, between Beach Fifty-ninth and Beach Eighty-first Streets. Ehrenkrantz Eckstut & Kuhn, 2001. Site plan. EEKA

ABOVE Arverne-by-the-Sea, between Beach Fifty-ninth and Beach Eighty-first Streets. Ehrenkrantz Eckstut & Kuhn, 2001. Rendering of view to the north. EEKA

LEFT Arverne-by-the-Sea, between Beach Fifty-ninth and Beach Eighty-first Streets. Ehrenkrantz Eckstut & Kuhn, 2004. View to the south. Taylor. EEKA

AFTERWORD

At the outset of this series, we thought the millennium would be a logical or at least convenient conclusion to a narrative that begins with the Civil War in *New York 1880*. The millennium, no surprise, proved to be a nonevent—more commercial hype than a real marker.

The end of this chapter for New York and perhaps the United States did not occur at midnight, December 31, 1999, but on the morning of September 11, 2001, when disaster struck as two hijacked commercial airliners attacked the twin towers of the World Trade Center, causing their total collapse and the loss of more than 2,700 lives. The repercussions of this coordinated attack on the United States—another plane hit the Pentagon in Washington, D.C., and a fourth reportedly aimed for the White House or the U.S. Capitol crashed in Pennsylvania—were enormous for the country as a whole but were most keenly felt in New York, where the process of rescue, the search for bodies, and the cleanup of the site drew volunteers from all over the country.

As we complete this book in the early months of 2006, the plans developed, reviewed, and revised for the reconstruction of the Trade Center site, calling for a memorial, new offices, an arts complex, a transportation hub, and a shopping mall, are not only mired in the complexities of local politics but also caught up in the emotionalism caused by so many lives lost, so many families torn apart. After the attack on the Trade Center, the grieving city stumbled, but soon enough began to rebuild itself and move on. That story of the city's rebirth is for others to tell.

FACING PAGE *Tribute in Light.* John Bennett and Gustavo Bonevardi, Julian LaVerdiere and Paul Myoda, Richard Nash Gould, and Paul Marantz, 2002. View to the east. Totaro. ESTO

PHOTOGRAPHIC SOURCES

PHOTOGRAPHERS

Aaron: © Peter Aaron/Esto
Abbott: James B. Abbott
Albarello: Joseph Albarello
Ali: Raza Ali
Allison: David Allison
Amiaga: Amiaga Photographers
Anderson: David Anderson
Ardiles-Arce: Jaime Ardiles-Arce
Aschkenas: David Aschkenas
Baitz: Otto Baitz
Barnes: Richard Barnes
Bartelstone: John Bartelstone
Baz: Doug Baz
Bazelon: Patricia L. Bazelon
Benson: Robert Benson
Bessler: Lydia Gould Bessler
Blumb: Jon Blumb
Boenzi: Neal Boenzi
Bordes: David Bordes
Borel: Nicolas Borel
Bosselman/Webb: Bosselman/Webb
Brandt: Peter Brandt
Brizzi: Andrea Brizzi
Bryant: Richard Bryant/arcaid.co.uk
Carvalho: Philip J. Carvalho
Cathcart: James Cathcart
Cedar-Miller: Sara Cedar-Miller
Champlin: Kenneth Champlin
Charles: © Frederick Charles
Chauvet: Anne Chauvet
Checkman: Louis Checkman
Choi: Chuck Choi
Chu: Kevin Chu/KCJP
Cornish: © Dan Cornish/Esto
Cox: Whitney Cox
Crawford: Richard Crawford
Cserna: George Cserna
Cullen: Libby Cullen
D'Addio: Jim D'Addio
Dallal: Thomas Dallal
Darley: Mark C. Darley
Davies: Richard Davies
Davis: © Robert Davis
dbox: dbox
de Armas: David de Armas
Denance: Michael Denance
Denes: Agnes Denes
Derrick: Derrick & Love
Dersin: Michael Dersin
Didomenico: Philip Didomenico
Dischinger: François Dischinger
Dong: Roger Dong
Dukos: Tyrone Dukos
Eberle: Todd Eberle
Evans: Steven Evans
Feinknopf: Brad Feinknopf
Fekner: John Fekner
Felicella: Elizabeth Felicella
Ferrino: Paul Ferrino Photographer
Floto Warner: Floto & Warner Photographers
Frances: © Scott Frances/Esto
Franco: Angel Franco
Frank: Dick Frank Studio
Freeman: Don Freeman
Friedberg: Adam Friedberg
Gallery: Wyatt Gallery
George: Fred George
Gili: Oberto Gili
Goldberg: © Jeff Goldberg/Esto
Gordon: Andrew Gordon
Gordon/NYDN: Chet Gordon/New York Daily News

H. Benson: Harry Benson
Hahm: Sedge Hahm/Hillier Architecture
Hambourg: Serge Hambourg
Hartman: Harry Hartman
Hausner: Edward Hausner
Heald: David Heald
Heatley: Jeff Heatley
Heinlein: David Heinlein
Heinrich: George Heinrich
Higgins: Chester Higgins Jr.
Himmel: Lizzie Himmel
Hogan Charles: Dan Hogan Charles
Holm: Alvin Holm
Holzherr: Florian Holzherr
Hoyt: © Wolfgang Hoyt/Esto
Hueber: Eduard Hueber
Hultberg: Carl Hultberg
Hursley: Timothy Hursley
Joseph: David Joseph
Kaiserman: Carl Kaiserman
Kaufman: Elliott Kaufman
Kleinberg: Michael Kleinberg
Koch: Raimund Koch
Kontzias: Bill Kontzias
Koontz: Michael Koontz
Kornfeld: Andreas Kornfeld Photography
Kotter: Jennifer Kotter
Krogh: Jennifer Krogh
Kroll: © Tracy Kroll/Esto
Krulwich: Sara Krulwich
Kwon: © Seong Kwon for Richard Cook & Associates,
 Architects
Lai: Chun Lai Photography
Lang: George Lang
Lieberman: Nathaniel Lieberman
Little: Christopher Little
Loo: Keith Loo
Lovi: Christopher Lovi
Lubarsky: David Lubarsky
Luckenbill: Donald Luckenbill
MacKenzie: Maxwell MacKenzie
Maisel: Todd Maisel
Mandel: Herbert L. Mandel
Manning: Jack Manning
Markese: Anthony Markese
Mauss: © Peter Mauss/Esto
McDonald: Scott McDonald
McGrath: ©Norman McGrath
Meinhardt: Carl Meinhardt
Milford: Kate Milford
Miller: Bill Miller
Milroy & McAleer: Milroy & McAleer
Molitor: Joseph W. Molitor
Moore: Peter Moore
Moran: Michael Moran
Morris: Larry Morris
Morrison: © Mark K. Morrison, FASLA
Morse: © James R. Morse NYC
Motzkin: Robert Motzkin
Mundy: Michael Mundy
Naar: Jon Naar
Neoscape: neoscape
Nesbit: Charles Nesbit
Nolan: Brian Nolan
Olivas: Julian Olivas
Oristaglio: © Susan Oristaglio/Esto
Orlewicz: Victor Zbigniew Orlewicz
O'Shields: Stewart O'Shields
Paige: Peter Paige
Parker: Bo Parker
Paschall: Paschall/Taylor
Payne: Richard Payne

Pelli: Enrique Pelli
Penny: Donald Penny
Perkell: Jeff Perkell
Piazza: Matteo Piazza
Pickman: David Pickman
Pinover Schiff: Betsy Pinover Schiff
Polidori: Robert Polidori
Pottle: © Jock Pottle/Esto
Powell: Tom Powell
Preston: Whit Preston
Rahman: Ram Rahman
Ransick: Robert Ransick
Ranson: Ashley Ranson, Ranson Black Ltd.
Reck: Robert Reck
Richards: Matt Richards
Richters: Christian Richters
Ries: Stan Ries
Robinson: Cervin Robinson
Roca/NYDN: John Roca/New York Daily News
Roesch: Geoffrey Roesch
Rogers: Dub Rogers Photography Company
Rosen: Laura Rosen
Rosenthal: Steve Rosenthal
Ross: Mark Ross
Rothschild: Bill Rothschild
Saylor: Durston Saylor
Schiller: Eric Schiller
Schulman: Richard Schulman
Scream!Point: © Scream!Point
Shanks: James Shanks
Shapiro: Liz Shapiro
Smith: Georgia Glynn Smith
Smith/NYDN: Jack Smith/New York Daily News
Spranger: Douglas Spranger
Sprung: Pete Sprung
Staller: Jan Staller
Sternfeld: Joel Sternfeld
Sterzing: Andreas Sterzing
Stocklein: Edmund Stocklein
Stoller: Ezra Stoller © Esto
Street-Porter: Timothy Street-Porter
Sundberg: © David Sundberg/Esto
Tannenbaum: Allan Tannenbaum
Taylor: Taylor Photography
Thompson: Addison Thompson
Totaro: © Jeffrey Totaro/Esto
Tupu: Steven Tupu
Vascimini: Donald Vascimini
Vecerka: © Albert Vecerka/Esto
Vellonakis: George Vellonakis
Vergara: Camilo Vergara
Volz: A. Perkovic/W. Volz
Walker: Robert Walker
Wallen: Jonathan Wallen
Warchol: © Paul Warchol
Ward: Alan Ward
Wargo: Matt Wargo
Wasserman: Robert Wasserman
Wheeler: Nick Wheeler
Williams: David Williams
Wilson: Jim Wilson
Woodruff/Brown: Woodruff/Brown Architectural Photography
Wright: Roy Wright
Wyner: Isaiah Wyner
Zankovic: Aker Zankovic
Zimmerman: Wade Zimmerman
Zimmermann: Frank Zimmermann
Zucker: Bob Zucker

COLLECTIONS

AA: Anderson Architects
AAGA: Agrest and Gandelsonas Architects
AARRIS: AARRIS Architects
ABA: Andrew Bartle Architects
AC: Anthony Cohn
ACC: Acconci Studio
AD: Agnes Denes
ADSHEL: Clear Channel Adshel
ADVA: Alfredo De Vido Associates
AG: Allan Greenberg Architect
AGA: Alexander Gorlin Architects
AH: Atelier Hollein
AHA: Alvin Holm A.I.A. Architects
AI: Arata Isozaki & Associates
AJN: Ateliers Jean Nouvel
AK: Aleksandra Kasuba
AKS: Abramovitz, Kingsland & Schiff
AMA: Audrey Matlock Architect
AMB: Emilio Ambasz & Associates
AMNH: American Museum of Natural History
ANS: Adele Naude Santos Architects
AP: Amiaga Photographers
API: Arch Photo Inc.
ARC: Arcaid
ARCH: *Architecture*
ARIEL: Ariel—The Art of Building, LLC
ARO: Architecture Research Office
ARQ: Arquitectonica
AS: Asia Society
ASY: Asymptote
AT: Allan Tannenbaum
ATD: Tihany Design
AWA: Alan Wanzenberg Architect
AWWP: AP/Wide World Photos
AXA: AXA Equitable
BA: Balmori Associates
BAC: Brooklyn Architects Collective
BBB: Beyer Blinder Belle
BBG: BBG-BBGM
BELL: Michael Bell Architecture
BEN: Harry Benson
BIS: Sergei Bischak
BKAA: Beyhan Karahan & Associates, Architects
BKSK: BKSK Architects
BLVD: *Boulevard/Manhattan* (New York: Columbia Architecture, Planning, Preservation, 1991)
BM: Brian McGrath
BOSCH: Bosch Architects
BPA: Bogdanow Partners Architects
BPCA: Hugh L. Carey Battery Park City Authority
BPS: Betsy Pinover Schiff
BTA: Bernard Tschumi Architects
CBM: Courtesy of the Brooklyn Museum
CC: Charles Correa
CCA: Collection Centre Canadien d'Architecture/Canadian Centre for Architecture, Montréal
CCAP: Chuck Choi Architectural Photography
CCNY: Archives, the City College of New York, CUNY
CDG: Comme des Garçons
CDP: Christian de Portzamparc
CFA: Cook + Fox Architects
CGA: Curtis + Ginsberg Architects
CGS: Chermayeff & Geismar Studio
CH: Carl Hultberg
CIV: CIVITAS
CJA: Caples Jefferson Architects
CLS: Carr, Lynch and Sandell
CN: Condé Nast
CPA: Cesar Pelli & Associates
CR: Cervin Robinson

CRA: Christoph Riedner Architect
CRP: Cooper, Robertson & Partners
CT: Creative Time
CU: Columbia University, Collection of the Avery Architectural and Fine Arts Library, including the Drawings Collection
CV: Camilo Vergara
DA: Danois Architects
DBA: David Bergman
DBB: Davis Brody Bond
DCA: Davis Crossfield Associates
DCP: Department of City Planning, City of New York
DDP: di Domenico + Partners
DH: David Heinlein
DL: Donald Luckenbill Architect
DLA: Diane Lewis Architects
DP: David Pickman
DRA: Daniel Rowen Architects
DRPC: Dub Rogers Photography Company
DS: Diamond + Schmitt Architects
DSA: Der Scutt Architect
DSP: David Smotrich & Partners
DSR: Diller Scofidio + Renfro
DW: Donna Walcavage
EA: Eisenman Architects
EAA: Eli Attia Architects
ED: Eric Drooker www.drooker.com
EEKA: Ehrenkrantz Eckstut & Kuhn Architects
EF: Elizabeth Felicella
EK: Elliott Kaufman
EKH: © The Estate of Keith Haring
EM: Ed Mills
EOMA: Eric Owen Moss Architects
ERC: © Estate of Roy Lichtenstein
ESKW: Edelman Sultan Knox Wood
ESP: Eldridge Street Project
ESTO: www.esto.com
FAP: Foster and Partners
FBA: Françoise Bollack Architects
FCP: F. Charles Photography, fcharles.com
FDI: *Franklin D. Israel* (New York: Rizzoli International Publications, 1992)
FEA: Fakler Eliason and Associates
FGCA: Franke, Gottsegen, Cox Architects
FGP: Fred George Photography
FHL: Friends of the High Line, Courtesy of the City of New York
FLL: Courtesy of Francis Loeb Library, Harvard Design School
FLM: Franck Lohsen McCrery, Architects
FO: Field Operations
42DP: 42nd Street Development Project
42SF: The 42nd Street Fund
FOT: Foton Photography
FS: Frederic Schwartz Architects
FSA: Feder & Stia Architects, LLP
FWP: Floto & Warner Photographers
FWPA: Frank Williams & Partners, Architects
FXF: FXFOWLE Architects
GA: Gabellini Associates
GAAP: Gran Associates Architects and Planners
GCR: George Cooper Rudolph III
GEN: Gensler
GFA: Greenberg Farrow Architecture
GF55: GF55 Architects
GK: Gordon Kipping
GLF: Greg Lynn FORM
GMA: Gluckman Mayner Architects
GMFA: Gracie Mansion Fine Art
GP: Gehry Partners
GR: George Ranalli
GRV: Michael Graves & Associates

GS: Gruzen Samton LLP Architects Planners & Interior Designers
GSAA: Gwathmey Siegel & Associates Architects
GV: Pierre-Alain Croset, *Gino Valle* (Milan: Electa, 1989)
HA: Handel Architects
HAR: Hariri & Hariri Architecture
HB: Hedrich Blessing, Ltd.
HC: Harvard Club
HDM: Herzog & de Meuron
HH: Hal Hayes
HIL: Hillier Architecture
HLM: Herbert L. Mandel, P.C.
HLW: HLW International
HMA: Hanrahan Meyers Architects
HO: Herbert Oppenheimer
HOK: Hellmuth, Obata & Kassabaum
HOKSVE: HOK Sport + Venue + Event
HP: Heinrich Photography
HPDC: Housing Partnership Development Corporation
H3: H3 Hardy Collaboration Architecture
HUB: Christian Hubert
HVA: Harden Van Arnam Architects
IAUS: *Philip Johnson: Processes*, exhibition catalogue (New York: Institute for Architecture and Urban Studies, 1978)
I-BEAM: I-BEAM
IC: Instituto Cervantes
IW: Isaiah Wyner
JB: Jon Blumb
JCA: John Ciardullo Associates
JCD: JCDecaux
JCDD: James Carpenter Design Associates
JF: © Estate of John Fekner
JG: Joseph Giovannini
JGA: John Gillis/Architects
JGWA: John G. Waite Associates
JHA: James Harb Architects
JHP: Jeff Heatley Photography
JHPA: Jan Hird Pokorny Associates
JKA: Jonathan Kirschenfeld Associates
JLGA: Jack L. Gordon Architect
JMM: Joseph and Mary Merz
JMP: John McAslan + Partners
JNP: Jon Naar Photography
JP: Jerde Partnership
JPA: John Portman & Associates
JPH: Jean-Pierre Heim and Associates
JPL: Joseph Pell Lombardi
JSA: Joseph Stella Architect
KBJC: Karen Bermann and Jeanine Centuori
KCA: Kiss + Cathcart, Architects
KCJP: Kevin Chu + Jessica Paul
KGA: Kostow Greenwood Architects
KHA: R.M. Kliment & Frances Halsband Architects
KMS: Kolatan/MacDonald Studio
KPF: Kohn Pedersen Fox
KRJDA: Kevin Roche John Dinkeloo and Associates
LCAP: Leonard Colchamiro Architects and Planners
LGB: Lydia Gould Bessler
LH: Laura Handler
LHP: Lee Harris Pomeroy
LHS: Lee H. Skolnick Architecture + Design Partnership
LING: David Ling
LMP: The Liebman Melting Partnership
LS: Lynne B. Sagalyn
LWLA: Lee Weintraub Landscape Architecture Community Design
LYY: Lester Y. Yuen
MAA: Morris Adjmi Architects
MACH: Machado and Silvetti Associates
MAP: Magnusson Architecture and Planning
MAS: Courtesy of Municipal Art Society

MB: Meta Brunzema Architects
MBA: Mario Botta Architetto
MBBA: Murphy Burnham & Buttrick Architects
MCK: McKissack & McKissack
MDA: Moed de Armas & Shannon
MFA: Michael Fieldman, Architect
MG: Meter Gallery
MGA: Mitchell/Giurgola Architects
MGI: Milton Glaser, Inc.
MJ: Murphy/Jahn
MKM: Mark K. Morrison Associates Ltd.
MLS: Maya Lin Studio
MM: Michael Moran
MMA: Meltzer/Mandl Architects
MMC: MilroyandMcAleer.com
MMP: Michael Mundy Photographer
MN: Mathews Nielsen
MNRR: Metro-North Railroad
MOHG: Mandarin Oriental Hotel Group
MP: Macklowe Properties
MPC: Milstein Properties Corp.
MR: Mark Ross
MS: Martha Schwartz
MSA: Medhat Salam Associates
MSS: Michael Sorkin Studio
MV: Michael Avramides
MVVA: Michael Van Valkenburgh Associates
NAA: Nobutaka Ashihara Associates
NIDC: Nautilus International Development Consulting
NL: Nathaniel Lieberman
NMcG: Norman McGrath
NYDN: *New York Daily News*
NYP: *New York Post*
NYSDED: New York State Department of Economic
 Development. "I Love New York" is a registered trademark
 and service mark of the New York State Department of
 Economic Development; used with permission.
NYT: *New York Times*
ODA: Ohlhausen DuBois Architects
OMA: Office for Metropolitan Architecture
OP: Olin Partnership
PA: Pyatok Associates
PANY: Port Authority of New York and New Jersey
PAY: Payette
PB: Peter Brandt
PBDW: Platt Byard Dovell White
PCFP: Pei Cobb Freed & Partners
PE: Perkins Eastman
PEN: Peter Pennoyer Architects
PESCE: Gaetano Pesce
PJAR: Philip Johnson Alan Ritchie Architects
PKSB: Pasanella + Klein Stolzman + Berg
PL: Peterson/Littenberg Architecture and Urban Design
PLA: Prendergast Laurel Architects
PLG: Peter L. Gluck & Partners, Architects
PP: Peter Pran
PPA: Polshek Partnership Architects
PPP: Peter Paige Photography
PR: Pleskow + Rael
PRE: Precis
PRF: Paul Rudolph Foundation
PS: Patricia Sapinsley
PSN: Philippe Starck Network
PTG: Park Tower Group
PW: Paul Warchol Photography
QFT: Quinlan & Francis Terry Architects
QRP: Quennell Rothschild & Partners
RA: Robert Adam Architects
RAA: Raimund Abraham Architect
RAM: Ramaz School
RAMSA: Robert A. M. Stern Architects
RB: Richard Barnes
RBP: Robert Benson Photography
RBSD: RBSD Architects
RBTA: Ricardo Bofill Taller de Arquitectura
RCA: Robert Cane Architects
RCHS: Rios Clementi Hale Studios
RD: Richard Davies
RDPA: Richard Dattner & Partners Architects
REDUX: A. Perkovic/W. Volz/Laif/Redux
RG: Rockwell Group
RGAAP: RGA Architects and Planners
RGRA: R. G. Roesch Architecture
RGS: The Rose + Guggenheimer Studio
RH: Richard Haas
RK: Raimund Koch
RKA: Rod Knox Architect
RKTB: Rothzeid, Kaiserman, Thomson & Bee
RL: Richard Levitz
RMPA: Richard Meier & Partners Architects
RNGA: Richard Nash Gould Architects
RP: Richard Payne
RPA: Regional Plan Association
RPBW: Renzo Piano Building Workshop
RR: Robert Reck
RRA: Raquel Ramati Associates
RS: Richard Serra
RTUF: *Reweaving the Urban Fabric: Approaches to Infill
 Housing* (New York: New York State Council on the Arts,
 1988)
RU: Reiser + Umemoto
RVAPC: Rafael Viñoly Architects, P.C.
RW: Robert Walker
RWA: Roberta Washington Architects
RWP: Roy Wright Photography Inc.
SA: Sartogo Architetti Associati

SAA: Storefront for Art and Architecture
SB: Steve Brosnahan Collection of the Lower East Side
 Tenement Museum
SBC: St. Bartholomew's Church
SBJG: Stephen B. Jacobs Group
SBLM: SBLM Architects
SC: Santiago Calatrava
SCA: Sellers and Company Architects
SCAA: Scarano and Associates
SCM: Sara Cedar-Miller
SDA: Specter DeSouza Architects
SDG: Simmons Design Group
SG: Steve Gottlieb
SH: Specht Harpman
SHA: Steven Holl Architects
SHCA: Swanke Hayden Connell Architects
SHOP: SHoP Architects
SI: Staller Industries
SITE: SITE
SITES: "Storefront for Art and Architecture," *Sites* 19 (1987)
SKY: Skyviews Survey
SLCE: Schuman, Lichtenstein, Claman & Efron
SM: Studio Morsa
SMHA: Smith Miller + Hawkinson Architects
SMM: Sun and Moon Marketing
SOM: Skidmore, Owings & Merrill
SR: Steve Rosenthal
SRGM: Solomon R. Guggenheim Museum
SRP: Stan Ries Photography
SS: Steiner Studios
SST: Second Stage Theatre
ST: Susana Torre
STA: Smith & Thompson Architects
STAD: Sawicki Tarella Architecture + Design
SWN: Stein White Nelligan Architects
SYND: Syndicate
TA: Tamarkin Architecture
TBA: Thomas Balsley Associates
TCA: Turett Collaborative Architects
TD: Thomas Dallal
TDA: Theo. David Architects
TEC: tec ARCHITECTURE
TEK: TEK Architects PC
TERR: Terrain Landscape Architecture + Constructed Ecology
TH: Timothy Hursley
TIME: TIME Magazine © 1979 Time Inc. Reprinted by per-
 mission
TL: Thomas Leeser
TLA: Todd Lee Architect
TLAP: Thoreson and Linard Architecture, Planning
TMA: Tigerman McCurry Architects
TPP: Thomas Phifer and Partners
TR: Terence Riley
TS: Tishman Speyer
TWBTA: Tod Williams Billie Tsien & Associates
UA: Urbahn Associates
ULI: Urban Land Institute
VA: Voorsanger Architects
VAI: Van Alen Institute
VBL: Victor Body-Lawson
VELL: George Vellonakis
VG: The Vendome Group
VIG: Vignelli Associates
VL: Carol Willis and Rosalie Genevro, eds., *Vacant Lots* (New
 York: Architectural League; New York: Princeton
 Architectural Press, 1989)
VP: Vincent Polsinelli
VSBA: Venturi, Scott Brown and Associates
WA: W Architecture
WAA: Wormser + Associates Architects
WBAP: Woodruff/Brown Architectural Photography
WBT: William B. Tabler Architects
WC: Whitney Cox
WEJA: Wendy Evans Joseph Architecture
WG: Walker Group
WILL: Paul Willen
WJ: Wes Jones
WJC: William J. Conklin
WNBA: William Nicholas Bodouva + Associates
WZ: Wade Zimmerman
ZAA: Zivkovic Associates Architects
ZGFP: Zimmer Gunsul Frasca Partnership
ZH: Zaha Hadid

NOTES

PREFACE

1. Robert A. M. Stern, Gregory Gilmartin, and John Montague Massengale, *New York 1900: Metropolitan Architecture and Urbanism 1890-1915* (New York: Rizzoli International Publications, 1983); Robert A. M. Stern, Gregory Gilmartin, and Thomas Mellins, assisted by David Fishman and Raymond W. Gastil, *New York 1930: Architecture and Urbanism Between the Two World Wars* (New York: Rizzoli International Publications, 1987); Robert A. M. Stern, Thomas Mellins, and David Fishman, *New York 1960: Architecture and Urbanism Between the Second World War and the Bicentennial* (New York: Monacelli Press, 1995); Robert A. M. Stern, Thomas Mellins, and David Fishman, *New York 1880: Architecture and Urbanism in the Gilded Age* (New York: Monacelli Press, 1999).

2. Susan Sachs, "The Census: New York," *New York Times* (March 16, 2001): 1, B: 7. Also see Ira Rosenwaike, *Population History of New York City* (Syracuse, N.Y.: Syracuse University Press, 1972).

INTRODUCTION

THE FALL AND RISE OF THE PUBLIC REALM

1. Robert D. McFadden, "Power Failure Blacks Out New York; Thousands Trapped in the Subways; Looters and Vandals Hit Some Areas," *New York Times* (July 14, 1977): 1, B: 2; Lawrence Van Gelder, "State Troopers Sent into City as Crime Rises," *New York Times* (July 14, 1977): 1, B: 2; "Wednesday the Thirteenth," editorial, *New York Times* (July 15, 1977): 22; Robert D. McFadden, "New York Power Restored Slowly; Looting Widespread, 3,300 Seized; Blackout Results in Heavy Losses," *New York Times* (July 15, 1977): 1–2; Thomas Plate, "Why the Cops Didn't Shoot," *New York* 10 (August 1, 1977): 28–31; John Kifner, "The Bushwick Area Is Struggling to Avoid Becoming a South Bronx," *New York Times* (October 24, 1977): 1, 49; Pranay Gupte, "Vivid Scars of '77 Blackout Remain in City," *New York Times* (July 13, 1978): 1, 18; Robert Curvin and Bruce Porter, *Blackout Looting!: New York City, July 13, 1977* (New York: Gardner Press, 1979); Anthony Ramirez, "The Darkest Hours of a Dark Time: 20 Years Ago, a Blackout Brought out Much of the City's Worst," *New York Times* (July 13, 1997), XIII: 3.

2. Van Gelder, "State Troopers Sent into City as Crime Rises": 1. For the 1965 blackout, see Stern, Mellins, and Fishman, *New York 1960*, 100–102.

3. For the celebration of the bicentennial and the Democratic National Convention, see Stern, Mellins, and Fishman, *New York 1960*, 1212–13.

4. For the fiscal crisis, see Stern, Mellins, and Fishman, *New York 1960*, 34–36.

5. "Wednesday the Thirteenth": 22.

6. Wolfgang Saxon, "Two Skyscrapers, Damaged by Bombs in Mid-Manhattan," *New York Times* (February 19, 1977): 1, 27; Peter Kihss, "Bomb Notes Asks End to U.S. Investigation," *New York Times* (February 20, 1977): 1, 32.

7. Mary Breasted, "100,000 Leave New York Offices as Bomb Threats Disrupt City; Blasts Kill One and Hurt Seven," *New York Times* (August 4, 1977): 1, B: 7; Michael C. Jensen, "Cost of Building Evacuations Estimated at Millions in Lost Time," *New York Times* (August 5, 1977): 11. Also see Peter Kihss, "F.A.L.N. Takes Blame for Bombs in Stores," *New York Times* (April 12, 1977): 23; Mary Breasted, "3-Year Inquiry Threads Together Evidence on F.A.L.N. Terrorism," *New York Times* (April 17, 1977): 1, 49; Mary Breasted, "Police Plagued by Bomb Threats as Park Ave. Building Is Vacated," *New York Times* (August 10, 1977): 77; Charles Kaiser, "Bomb Threat Closes La Guardia an Hour," *New York Times* (August 15, 1977): 60.

8. Charles Kaiser, "Helicopter Flights Approved by Board," *New York Times* (January 21, 1977): 82; Kevin L. Goldman, "Copters Join Midtown Cacophony," *New York Times* (March 27, 1977), VIII: 1, 7; Robert D. McFadden, "5 Killed as Copter on Pan Am Building Throws Rotor Blade," *New York Times* (May 17, 1977): 1, 20; Wolfgang Saxon, "Copter Pad Born in Controversy," *New York Times* (May 17, 1977): 20; "Hundreds of Commuters Throng Barriers at Grim Accident Scene," *New York Times* (May 17, 1977): 20; Richard Witkin, "Helicopter Landing-Gear Blamed; U.S. Inspection of All S-61's Urged," *New York Times* (May 18, 1977): 1, B: 9; "Helicopter Accident Laid to Landing Gear," *New York Times* (October 14, 1977): 25.

9. Robert D. McFadden, "Suspect in 'Son of Sam' Murders Arrested in Yonkers; Police Say .44-Caliber Weapon Is Recovered," *New York Times* (August 11, 1977): 1, D: 17; Leonard Buder, "Berkowitz Is Described as 'Quiet' and as a 'Loner,'" *New York Times* (August 12, 1977): 10; Jimmy Breslin and Dick Schaap, *.44* (New York: Viking Press, 1978); David Abrahamsen, *Confessions of Son of Sam* (New York: Columbia University Press, 1985).

10. Frank Lynn, "Beame Finishes Third," *New York Times* (September 9, 1977): 1, B: 7; Frank Lynn, "Democrat Is Mayor," *New York Times* (November 9, 1977): 1, B: 4; Douglas E. Schoen and Mark J. Penn, "Koch's Narrowed Win," *New York Times* (November 11, 1977): 26; George J. Lankevich, *American Metropolis: History of New York City* (New York: New York University Press, 1998), 222–29.

11. Lynn, "Democrat Is Mayor": 4. Also see Joseph P. Fried, "Construction of Housing Below 1932 Level Here," *New York Times* (March 5, 1976): 61; Steven R. Weisman, "Indications of Deterioration Abound in New York Crisis," *New York Times* (December 5, 1976): 1, 77; Fred Ferretti, "Financial Crisis Crippling New York's Public Schools," *New York Times* (December 12, 1976): 1, 80; Michael Sterne, "A Plan to Revitalize New York's Economy Is Offered by Beame," *New York Times* (December 21, 1976): 1, 68; Peter Kihss, "Planners Say Region Lost Population and Is Lagging in Economic Recovery," *New York Times* (November 28, 1977): 35; "City Population Is at Its Lowest Since the 1930's," *New York Times* (December 18, 1978), B: 3.

12. Fred Ferretti, "New York Will Be Forced to Be a Much Smaller Apple," *New York Times* (February 15, 1976), IV: 6. Also see Roger Starr, "Making New York Smaller," *New York Times* (November 14, 1976), VI: 32–33, 99–106.

13. Edward C. Burks, "Carter Acts to Back $2 Billion in Bonds for New York City," *New York Times* (March 3, 1978): 1, D: 12; Felix G. Rohatyn, "The Rescue (Maybe) of New York City," *New York Times* (March 5, 1978), IV: 19; "What New York Asks," editorial, *New York Times* (June 6, 1978): 16; Edward C. Burks, "House, 247 156, Supports New York with $2 Billion Bond Guarantee; Koch Calls Vote 'Overwhelming,'" *New York Times* (June 9, 1978): 1, 15; "A Lifeboat for New York," editorial, *New York Times* (June 11, 1978), IV: 20; Lee Dembart, "Carter Signs Aid Bill for New York at a Gala Celebration at City Hall," *New York Times* (August 9, 1978): 1, B: 2; "An Update on the Fiscal Crisis of New York City," *New York Times* (August 9, 1978), B: 2; "New York's Crucial Moment," editorial, *New York Times* (December 5, 1978): 22; Steven R. Weisman, "Koch Warns Carter About Need for Aid," *New York Times* (December 28, 1978): 1, B: 5.

14. Damon Stetson, "Transit Workers Strike Subways and Buses as Wage Talks Fail," *New York Times* (April 1, 1980): 1, B: 8; Clyde Haberman, "The Transit Strike: City Meets First Day with Aplomb," *New York Times* (April 2, 1980): B: 1, 6; David A. Andelman, "Transit System Rolls amid Debate on Contract and Fate of 50 Cent Fare," *New York Times* (April 13, 1980): 1, 35; Joyce Purnick, "Koch Warns Unions on Hopes for Raises," *New York Times* (April 13, 1980): 1, 37; Joseph P. Fried, "Transit Unions Told Penalty Will Stand," *New York Times* (May 20, 1980), D: 23. For the 1966 transit strike, see Stern, Mellins, and Fishman, *New York 1960*, 31.

15. Edward I. Koch, quoted in Purnick, "Koch Warns Unions on Hopes for Raises": 1.

16. "The Once and Future City," editorial, *New York Times* (December 11, 1980): 34.

17. Clyde Haberman, "Key Fiscal Goal Reached by City in Big Note Sale," *New York Times* (February 18, 1981): 1, 29; Clyde Haberman, "Rating on Bonds Offered by City Now Favorable," *New York Times* (March 6, 1981): 1, B: 5; Clyde Haberman, "Who Cured Fiscal Crisis in the City?" *New York Times* (March 7, 1981): 25, 27; "Topics of the Times: Triple-B'd," *New York Times* (March 8, 1981), IV: 18; Michael Quint, "New York's New Credit Rating," *New York Times* (March 9, 1981), D: 7.

18. Clyde Haberman, "$14.7 Billion Budget," *New York Times* (May 13, 1981), B: 2; "The City Budget: It's Balanced, It's Provident," *New York Times* (May 17, 1981), IV: 7; Clyde Haberman, "A City Budget Surplus," *New York Times* (June 14, 1981), IV: 6.

19. "Dog Clean-Up Law Begins Today," *New York Times* (August 1, 1978), B: 7. Also see Dena Kleiman, "Owners of Dogs Face Orders to Clean Up," *New York Times* (July 23, 1978): 1, 37; Fred Ferretti, "Dog Owners Cope with Cleanup Law," *New York Times* (August 2, 1978), B: 1, 4.

20. Philip H. Dougherty, "Selling New York as the Place to Be," *New York Times* (June 28, 1977): 55; Michael Sterne, "A Sales Pitch for New York," *New York Times* (December 11, 1977), III: 1, 4; James P. Sterba, "New York Sees Record Tourism," *New York Times* (May 12, 1978), D: 12; James P. Sterba, "'I Love New York' Campaign Going National," *New York Times* (July 7, 1978), B: 1; "Notes on People," *New York Times* (July 28, 1978): 13; Fred Ferretti, "Occupancy in Hotels Is Running at 90%," *New York Times* (November 14, 1978), B: 1; Philip H. Dougherty, "New York Loves 'I Love New York,'" *New York Times* (December 14, 1978), D: 17; "State Reports $400 Million Rise in Tourism Since New Promotion," *New York Times* (January 17, 1979), B: 8; Sheila Rule, "Carey Praises 'I Love New York,'" *New York Times* (April 18, 1979), B: 2; Philip H. Dougherty, "How to Polish an Image," *New York Times* (May 21, 1979), D: 8; Joseph P. Fried, "Tourism, Nearing a Record, Fills New York Hotels," *New York Times* (June 5, 1979): 1, B: 7; Sheila Rule, "A Plan to Aid South Harlem Is Announced," *New York Times* (August 14, 1979), B: 1; Edward Schumacher, "1979 Is Reported a Record Year for Tourism in New York City," *New York Times* (December 27, 1979), B: 3; "City Gets Fewer Tourists, but Just as Many Dollars," *New York Times* (November 9, 1980), part 2: 71.

21. Albert Formicola, quoted in Ferretti, "Occupancy in Hotels Is Running at 90%": 1.

22. Michael Sterne, "New York Is Attracting Foreign Businesses," *New York Times* (April 17, 1977): 1, 18; Michael C. Jensen, "Europeans, Wary About Future, Step Up Pace of Investing in U.S.," *New York Times* (July 22, 1977): 1, D: 3; James P. Sterba, "New York Is Intensifying Efforts to Draw More Foreign Business," *New York Times* (December 31, 1978): 1, 18; "Japan Business Mission to U.S.," *New York Times* (September 14, 1979), D: 3; Alan S. Oser, "A Foreign Interest in Manhattan," *New York Times* (October 10, 1979), D: 18; Edward Schumacher, "City Hall Attempts to Lure Foreign Plants," *New York Times* (October 12, 1979), B: 1–2.

23. Frank J. Prial, "Merchants Applaud Self-Taxation Law as Boon to the City," *New York Times* (February 19, 1982): 1, B: 4; C. Kenneth Orski, "Urban Amenity Zones," *New York Times* (March 13, 1982): 25; John C. Dearie, "Business Self-Help Plan Fighting for Its Life," letter to the editor, *New York Times* (October 13, 1983): 18; Sam Roberts, "Merchants Taxing Themselves to Offer More Services in Special Districts," *New York Times* (October 11, 1983), B: 1, 20; "To the City," editorial, *New York Times* (June 23, 1984): 22; "From Rags to Hitches: Taxing Themselves," editorial, *New York Times* (July 24, 1985): 18; Deirdre Carmody, "Union Square Park Reopens with a Lush Grandeur," *New York Times* (May 23, 1985), B: 1, 10; Richard D. Lyons, "Business Aid for Districts in 5 Boroughs," *New York Times* (November 8, 1989): 20; "When City Hall Fails, Do It Yourself," editorial, *New York Times* (January 13, 1991), IV: 18; David Gallagher, "Business Improvement District Concept Can Work Citywide," letter to the editor, *New York Times* (January 31, 1991): 22; Alan S. Oser, "Perspectives: Business Improvement Districts," *New York Times* (February 10, 1991), X: 5; "Public Needs, Answered Privately," editorial, *New York Times* (July 26, 1991): 26; "New York Bets on Bids," *Metropolis* 11 (April 1992): 15, 21; Alan S. Oser, "Spreading the Gospel of Improvement Districts," *New York Times* (October 31, 1993), X: 8; Douglas Martin, "Districts to Improve Business Proliferate," *New York Times* (March 23, 1994), B: 3.

24. "Underground Angels," *The Economist* (February 7, 1981): 28; "Angels and Other Guardians," *Newsweek* 97 (March 23, 1981): 48; William Robbins, "Effectiveness of Guardian Angels Called Uncertain," *New York Times* (August 7, 1981): 1; Curtis Sliwa and Murray Schwartz, *Street Smart: The Guardian Angel Guide to Safe Living* (Boston: Pearson Addison Wesley, 1982); James Haskins, *The Guardian Angels* (Berkeley Heights, N.J.: Enslow Publishers, 1983).

25. "Victims of Urban Revival," editorial, *New York Times* (November 18, 1978): 20. Also see "New York Still Beckons the Nation's Young," *New York Times* (May 11, 1982): 1, B: 5.

26. Charles Kaiser, "Blacks and Puerto Ricans a Bronx Majority," *New York Times* (April 19, 1976): 1, 23; Thomas A. Johnson, "Racial Change: Two Queens Areas," *New York Times* (May 9, 1976), VIII: 1, 6; Michael Goodwin, "The Japanese Presence Unobtrusively Makes Itself Felt," *New York Times* (November 27, 1977), VIII: 1, 4; David Vidal, "Hispanic Newcomers in City Cling to Values of Homeland," *New York Times* (May 11, 1980): 1, 52; Anna Quindlen, "New Asian Immigrants Shape a Life in New York," *New York Times* (August 25, 1980), B: 1, 7; Irvin Molotsky, "Census Shows Major Shift in Region's Demographics," *New York Times* (April 12, 1981), IV: 6; Irvin Molotsky, "Census Indicates a Sharp Decline in White in City," *New York Times* (April 6, 1981): 1, B: 6; John Herbers, "Census Finds That New York's Pot Is Still Melting," *New York Times* (April 25, 1982): 38; Dena Kleiman, "A Surge of Immigrants Alters New York's Face," *New York Times* (September 27, 1982): 1, B: 4; Philip Kasinitz, "City's 'New Immigrants,'" *Dissent* 34 (Fall 1987): 496–506; Nathan Glazer, "The New New Yorkers," in Peter D. Salins, ed., *New York Unbound* (New York: Basel Blackwell, 1988), 54–72.

27. Ada Louise Huxtable, "'Bigger–And Maybe Better,'" *New York Times* (August 26, 1979), II: 25–26. Also see Rem Koolhaas, *Delirious New York* (New York: Oxford University Press, 1978; New York: Monacelli Press, 1994), portions excerpted in *Progressive Architecture* 59 (December 1978): 70–75, *Architecture + Urbanism* (October 1988): 135–51, and *Arch Plus* (October 1990): 58–67; Gilbert Millstein, "Architectural Extravaganza," *New York Times* (December 24, 1978), VII: 15; "Rem Koolhaas: Why I Wrote Delirious New York and Other Textual Strategies," interview with Cynthia Davidson, *ANY* 1 (May-June 1993): 42–43; Martin Filler, "The Rem Cycle," *Harper's Bazaar* (November 1994): 194–99; Herbert Muschamp, "Rem Koolhaas's New York State of Mind," *New York Times* (November 4, 1994), C: 1, 34; Peter Plagens, "Cool Hand Koolhaas," *Newsweek* 125 (January 16, 1995): 68; "A Manifesto for Manhattan," *L'Arca* (April 1995): 105; Ursula Daus, "Delirious New York," *Baumeister* 92 (July 1995): 58; Val Rynnimeri, "Delirious New York," *Canadian Architect* 40 (November 1995): 17; Belinda Luscombe, "Making a Splash," *Time* 147 (April 8, 1996): 62–64; Karrie Jacobs, "Fun City," *New York* 29 (December 2, 1996): 36.

28. Muschamp, "Rem Koolhaas's New York State of Mind": 1.

29. Bernard Tschumi, *The Manhattan Transcripts* (London: Academy Editions; New York: St. Martin's Press, 1981).

30. Ada Louise Huxtable, "Today the Cards Are All in the Builders' Hands," *New York Times* (March 26, 1978), II: 29.

31. For the J-51 program, see Alexander Garvin, *The American City: What Works, What Doesn't* (New York: McGraw-Hill, 1996), 7–8, 192–93.

32. Paul Goldberger, "Midtown Construction: Problem of Prosperity," *New York Times* (July 30, 1979), B: 1, 4.

33. Ada Louise Huxtable, "'Bigger–And Maybe Better,'" *New York Times* (August 26, 1979), II: 25–26.

34. Goldberger, "Midtown Construction: Problem of Prosperity": 4.

35. Robert F. Wagner Jr., quoted in Goldberger, "Midtown Construction: Problem of Prosperity": 4.

36. Carter B. Horsley, "It's an Owner's Market, but Office Builders Hesitate," *New York Times* (January 27, 1980), VIII: 1, 4. Also see Richard Higgins, "Key Office Plans Still on Track," *New York Times* (October 28, 1979), VIII: 1, 7; "Highrise Spurt in Midtown Raises Manhattan Opposition," *Journal of the American Institute of Architects* 69 (January 1980): 104–6; Carter B. Horsley, "Office Construction Surging in Manhattan," *New York Times* (February 23, 1981): 1, D: 11; Carter B. Horsley, "Office Market Adjusting to Inflation," *New York Times* (March 1, 1981), VIII: 1, 4; Ari L. Goldman, "Surge in Building of Offices Brings 'Mixed Blessing,'" *New York Times* (April 6, 1981), B: 1, 8; N. R. Kleinfield, "Boom Times for the Builders of New York," *New York Times* (July 26, 1981), III: 1, 6; Damon Stetson, "City Building Boom Generates New Jobs," *New York Times* (September 6, 1981): 52.

37. Paul Goldberger, "6 Architects Ponder Design Rationale Behind New Manhattan Skyscrapers," *New York Times* (February 21, 1981): 14; Janet Nairn, "Seven Architects Convene at the Museum of Modern Art to Discuss 'Super-Building,'" *Architectural Record* 169 (April 1981): 35; Aaron A. Betsky, "Beauty Only Skin Deep," *Metropolis* 1 (August/September 1981): 5–6.

38. Martin Gallent, quoted in Jim Sleeper, "Boom and Bust with Ed Koch," *Dissent* 34 (Fall 1987): 437–52.

39. Irving Minkin, quoted in Carter B. Horsley, "The Urban Rock Fall: A Peril of Spring," *New York Times* (April 23, 1978), VIII: 1, 4.

40. "Falling Masonry Fatally Injures Barnard Student," *New York Times* (May 17, 1979), B: 3; Pranay B. Gupte, "City Is Studying Why Lintel Fell, Killing Student," *New York Times* (May 18, 1979), B: 1, 3; "Columbia to Fix Retaining Wall," *New York Times* (May 31, 1979), B: 4; Richard Higgins, "Tragedy Puts Columbia to Test as Landlord," *New York Times* (August 5, 1979), VIII: 1, 4.

41. "Falling Object Hurts Girl on East 86th St.," *New York Times* (June 26, 1979), B: 5; "Part of 86th St. Shut as New Debris Falls," *New York Times* (July 2, 1979), B: 4; "Wall Inspection Bill," *New York Times* (January 11, 1980), B: 3; "New York's Local Law 10," *Architectural Record* 169 (July 1981): 57; Samuel Weiss, "Deadline Nears on Facade Law," *New York Times* (December 27, 1981), VIII: 1–2; Edward A. Gargan, "The Falling-Masonry Peril," *New York Times* (August 8, 1982), VIII: 7; Michael Goodwin, "Law Governing Facade Checks Is Found Weak," *New York Times* (August 11, 1982), B: 1; Rita Caviglia, "Local Law No. 10 and the Disappearing Cornice," *Progressive Architecture* 63 (November 1982): 29–30; James Marston Fitch, "Local Law 10," *Oculus* 44 (January 1983): 3, 6–7, 10; Charles K. Hoyt, "Local Law 10," *Oculus* 44 (January 1983): 3–5; Paul Goldberger, "What a Law Can Do to Architecture," *New York Times* (January 18, 1983), C: 11; Adam Derrick, "Losing the Past," letter to the editor, *New York Times* (February 6, 1983), VIII: 12; Irwin Fruchtman, "A Law That Helps Save Historic Facades," letter to the editor, *New York Times* (February 12, 1983): 22; Sam Pinkwas, "Local Law 10, Facades 0," *Metropolis* 3 (July-August 1983): 8; David W. Dunlap, "Building-Safety Crackdown in New York Shows Results," *New York Times* (September 11, 1983), B: 3; Lee A. Daniels, "Facade Law Achieving Its Goals," *New York Times* (January 8, 1984), VIII: 1; William G. Blair, "Assessing the 10-Year-Old Facade Law," *New York Times* (June 10, 1990), X: 9.

42. Goldberger, "What a Law Can Do to Architecture": 11.

43. George W. Goodman, "Owners Stripping Facades of Ornament," *New York Times* (December 12, 1982), VIII: 1, 14.

44. Leslie Wayne, "5-Year Stock Rally: The Far-Reaching Impact," *New York Times* (August 3, 1987): 1, D: 4.

45. Marshall Berman, "Eternal City," *Voice Literary Supplement* (November 1989): 9.

46. Joelle Attinger, "The Decline of New York," *Time* 136 (September 17, 1990): 38.

47. Marjorie Hunter, "$209,508 China Purchase Is Defended by President," *New York Times* (October 2, 1981): 27.

48. Gus Tyler, "A Tale of Three Cities," *Dissent* 34 (Fall 1987): 463–70.

49. Kenneth Lipper, "What Needs to Be Done?" *New York Times* (December 31, 1989), VI: 28, 45–46.

50. Robert Price, "The Good News About New York City," *New York Times* (September 28, 1986), VI: 30–32, 49–50, 54, 58–60.

51. Blake Fleetwood, "The New Elite and an Urban Renaissance," *New York Times* (January 14, 1979), VI: 16–20, 22, 26, 34–35.

52. Roger Starr, quoted in Fleetwood, "The New Elite and an Urban Renaissance": 19–20.

53. Steven V. Roberts, "Hart Taps a Generation of Young Professionals," *New York Times* (March 18, 1984): 26; William Safire, "On Language: Away with You, Nosy Parker," *New York Times* (March 25, 1984), VI: 18; "Hippies, Yippies, Yuppies," editorial, *New York Times* (June 28, 1984): 26.

54. Tom Wolfe, *Bonfire of the Vanities* (New York: Farrar, Straus and Giroux, 1987; New York: Bantam Books, 1988), 12. Also see Frank Conroy, "Urban Rats in Fashion's Maze," *New York Times* (November 1, 1987), VII: 1, 46; James Andrews, "What the Dickens! Tom Wolfe Has Written a New York Novel," *Christian Science Monitor* (November 3, 1987): 20; George F. Will, "New(s) from Tom Wolfe," *Washington Post* (November 22, 1987), C: 7.

55. Jane Amsterdam, "Letter from the Editor," *Manhattan, inc.* 1 (September 1984): 6.

56. Donald J. Trump with Tony Schwartz, *Trump: The Art of the Deal* (New York: Random House, 1987). Also see Donald J. Trump with Charles Leerhsen, *Trump: Surviving at the Top* (New York: Random House, 1990); Donald J. Trump with Kate Bohner, *Trump: The Art of the Comeback* (New York: Random House, 1997).

57. Fox Butterfield, "Trump Hints of Dreams Beyond Building," *New York Times* (October 5, 1987), B: 1, 6.

58. Ivan F. Boesky, quoted in William Glaberson, "The Plunge: A Stunning Blow to a Gilded, Impudent Age," *New York Times* (December 13, 1987): 1, 44.

59. Quoted from *Wall Street* (20th Century Fox, 1987), written by Oliver Stone and Stanley Weiser, directed by Oliver Stone, produced by Edward R. Pressman.

60. James Sterngold, "On Wall Street, a Greedy New Breed," *New York Times* (July 27, 1986), IV: 24.

61. Pete Hamill, "Our Times," *New York* 21 (April 4, 1988): 52–56, 59.

62. Jay McInerney, *Bright Lights, Big City: A Novel* (New York: Vintage Contemporaries, 1984). Also see Stephen Dobyns, "Hero Without a Name: Bright Lights, Big City," *Washington Post* (November 6, 1984), B: 2; William Kotzwinkle, "You're Fired, So You Buy a Ferret," *New York Times* (November 25, 1984), VII: 9.

63. Tyler, "A Tale of Three Cities": 467.

64. Tyler, "A Tale of Three Cities": 463, 468–70.

65. Sydney H. Schanberg, "Gentrifiers: The Guns," *New York Times* (May 15, 1982): 27. Also see Sydney H. Schanberg, "Gentrifiers: The Greed," *New York Times* (May 8, 1982): 23; Sydney H. Schanberg, "Gentrifiers: The Lawyers," *New York Times* (May 11, 1982): 19; Sydney H. Schanberg, "Gentrifiers: The Police," *New York Times* (May 18, 1982): 23; Sydney H. Schanberg, "Gentrifiers: The Policy," *New York Times* (May 22, 1982): 27; Lee A. Daniels, "'Gentrification' of 2 Neighborhoods Found Beneficial," *New York Times* (March 23, 1984), B: 5.

66. Schanberg, "Gentrifiers: The Greed": 23.

67. Daniels, "'Gentrification' of 2 Neighborhoods Found Beneficial": 5.

68. Ethan Schwartz, "City Starts Cross-Subsidy Sale of East Village Parcels," *New York Times* (November 10, 1985), VIII: 7.

69. Peter Salins, quoted in Fleetwood, "The New Elite and an Urban Renaissance": 35.

70. Bryce Nelson, "Nation's Psychiatrists Give 'High Priority' to the Homeless," *New York Times* (May 10, 1983), C: 1, 2; Deirdre Carmody, "The City Sees No Solution for Homeless," *New York Times* (October 10, 1984): 1, B: 4.

71. Norman Podhoretz, "Tap the Disgust," *New York 23* (November 26, 1990): 38–39.

72. Mortimer B. Zuckerman, "Power Points," *New York 23* (November 26, 1990): 49.

73. Dena Kleiman, "Hobo Colony Lives Mole-like in an Inferno of Pipes Under Park Avenue," *New York Times* (November 29, 1977): 39; David Bird, "Maze of Tunnels Remains Refuge of the Homeless," *New York Times* (March 17, 1980), B: 1, 11.

74. Barbara Basler, "Officials Debate the Number of the Mentally Ill Homeless," *New York Times* (November 14, 1985), B: 11.

75. David Bird, "Help Is Urged for 36,000 Homeless in City's Streets," *New York Times* (March 8, 1981): 1, 44. Also see Laurie Johnston, "A Journey into the City's Netherworld," *New York Times* (March 11, 1981), B: 3.

76. Edward I. Koch, quoted in A. O. Sulzberger Jr., "Mayor Defends City's Handling of Its Homeless," *New York Times* (November 20, 1981), B: 1.

77. Robin Herman, "Pact Requires City to Shelter Homeless Men," *New York Times* (August 27, 1981): 1, B: 11; Robin Herman, "Providing Shelter for New York City's Homeless," *New York Times* (September 18, 1981), B: 4; Carmody, "The City Sees No Solution for Homeless": 1, B: 4.

78. Crystal Nix, "New York's Mentally Ill Fear Homeless Shelters," *New York Times* (November 10, 1985): 52.

79. Anthony Borden, "AIDS Crisis: The Sorrow of the City," *Dissent 34* (Fall 1987): 561–64; Robert F. Wagner Jr., *New York Ascendant: The Report of the Commission on the Year 2000* (New York: Harper & Row, 1988), 99–101.

80. www.usdoj.gov/dea/deamuseum. Also see Jane Gross, "A New, Purified Form of Cocaine Causes Alarm as Abuse Increases," *New York Times* (November 29, 1985): 1, B: 6; Peter Kerr, "Drug Treatment in City Is Strained by Crack, a Potent New Cocaine," *New York Times* (May 16, 1986): 1, 18; William F. Blair, "New Police Drug Task Force Arrests 183 in Daylong Sweep," *New York Times* (September 12, 1986): 19; Arnold H. Lubasch, "New York's Biggest Crack Ring Is Broken, U.S. Officials Say," *New York Times* (July 31, 1987), B: 1, 5; Josh Barbanel, "Crack Use Pervades Life in a Shelter," *New York Times* (February 18, 1988): 1, B: 3; Peter Kerr, "Young Crack Addicts Find There's No Help for Them," *New York Times* (May 2, 1988), B: 1, 4; Michel Marriott, "After 3 Years, Crack Plague in New York Only Gets Worse," *New York Times* (February 20, 1989): 1, 4; Gina Kolata, "Old, Weak and a Loser: Crack User's Image Falls," *New York Times* (July 23, 1990): 1, B: 4; Daniel Patrick Moynihan, "Crack Epidemic Deserves as Much of Our Attention as AIDS," letter to the editor, *New York Times* (July 2, 1991): 16; "Crack May Be Cracking," *New York Times* (August 10, 1991): 18.

81. Hamill, "Our Times": 52–56, 59.

82. Irving Howe, "Social Retreat and the *Tumler*," *Dissent 34* (Fall 1987): 406–11.

83. James LeMoyne, "Panel Formed to Study Goals for City," *New York Times* (February 18, 1984): 27; Suzanne Daley, "Profile of New York in the Year 2000: More Jobs, but a Needier Population," *New York Times* (February 25, 1986), B: 1; Sam Roberts, "A Koch Agenda May Be Born from Study of Ills," *New York Times* (June 29, 1987), B: 1; Alan Finder, "Guide to New York City's Future Recommends Sweeping Changes," *New York Times* (July 1, 1987): 1, B: 4; "New York's Hard Climb Ahead," editorial, *New York Times* (July 2, 1987): 26; Alan Finder, "Can Top New York Officials Implement the Proposals of Commission on Year 2000?" *New York Times* (July 4, 1987): 29; Joseph Giovannini, "A Vision of New York as It Reaches for the Next Millennium," *New York Times* (July 5, 1987), IV: 6; "Schools, Jobs and the Year 2000," editorial, *New York Times* (July 13, 1987): 16; Ada Louise Huxtable, "Stumbling Toward Tomorrow: The Decline and Fall of the New York Vision," *Dissent* (Fall 1987): 453–61; Howard W. French, "Dinkins Says Report Ignores Effect of Racism on New York," *New York Times* (November 29, 1987): 70; Wagner, *New York Ascendant: The Report of the Commission on the Year 2000*; Sam Roberts, "Decade's Misery and Strengths Greet the Mayor," *New York Times* (January 1, 1990): 27.

84. Stern, McIlins, and Fishman, *New York 1960*, 133.

85. "New York's Hard Climb Ahead": 26.

86. Huxtable, "Stumbling Toward Tomorrow: The Decline and Fall of the New York Vision": 453–61.

87. Wagner, *New York Ascendant: The Report of the Commission on the Year 2000*, 4.

88. Richard Levine, "As Towers Top Off, Construction Boom Fades in New York," *New York Times* (July 2, 1990): 1, B: 3.

89. Anthony DePalma, "Construction of Apartments in Manhattan Falls Sharply," *New York Times* (April 3, 1988), X: 1, 11.

90. Ian Bruce Eichner, quoted in "Condo Buys Air to Sell Space," *Manhattan, inc.* 4 (April 1987): 21.

91. David W. Dunlap, "The Downfall of Drexel Weakens a Soft Market," *New York Times* (May 20, 1990), XA: 29.

92. Mark McCain, "With Vacancies Rising, Watchword Is Caution," *New York Times* (May 15, 1988), XIII: 40–43.

93. Quoted in McCain, "With Vacancies Rising, Watchword Is Caution": 41.

94. Levine, "As Towers Top Off, Construction Boom Fades in New York": 1, B: 3.

95. David W. Dunlap, "Developers End a Legal Tussle on a Skyscraper," *New York Times* (December 29, 1990): 28.

96. Ada Louise Huxtable, "Creeping Gigantism in Manhattan," *New York Times* (March 22, 1987), II: 1, 36.

97. Huxtable, "Creeping Gigantism in Manhattan": 36.

98. Paul Goldberger, "The City's Birthright Sold for Air Rights," *New York Times* (May 31, 1987), II: 1, 27.

99. Huxtable, "Creeping Gigantism in Manhattan": 1, 36.

100. Rem Koolhaas, "Delirious No More," *Wired* (June 2003): 167–68.

101. Paul Byard, "Disquieting Times for New York Architects," *New York Times* (February 7, 1987): 27.

102. Herbert Muschamp, "The Breached Wall," *New Republic* 198 (April 11, 1998): 27–30.

103. Joyce Purnick, "Manes Is Found Bleeding in Car Halted by Police," *New York Times* (January 11, 1986): 1, 28; "The Manes Nightmare," editorial, *New York Times* (January 16, 1986): 22; "What to Assume About Donald Manes," editorial, *New York Times* (January 23, 1986): 26; "Manes Case: Chronology of Revelations and Resignations," *New York Times* (February 2, 1986), IV: 22; Robert D. McFadden, "Manes Is a Suicide, Stabbing Himself at Home in Queens," *New York Times* (March 14, 1986): 1, B: 20; Richard J. Meislin, "Political Power and Influence Lost in a Swirling City Scandal," *New York Times* (March 15, 1986), B: 1, 20; Jim Sleeper, "Boodling, Bigotry, and Cosmopolitanism," *Dissent 34* (Fall 1987): 413.

104. Jack Newfield and Wayne Barrett, *City for Sale: Ed Koch and the Betrayal of New York* (New York: Harper & Row, 1988). Also see Christopher Lehmann-Haupt, "Books of The Times: A Mayor, a City and a Tangled Skein of Scandal," *New York Times* (December 22, 1988), C: 17; Doug Ireland, "'City for Sale': A Critical View of Koch's Time," *New York Observer* (December 26, 1988-January 2, 1989): 3.

105. Robert D. McFadden, "Black Man Dies After Beating by Whites in Queens," *New York Times* (December 21, 1986): 1, 44; Ronald Smothers, "Black Leaders Say Queens Attack Is Evidence of 'Pervasive Problem,'" *New York Times* (December 23, 1986): 1, B: 4; Ronald Smothers, "1,200 Protesters of Racial Attack March in Queens," *New York Times* (December 28, 1986): 1, 26; Nicolaus Mills, "Howard Beach-Anatomy of a Lynching," *Dissent 34* (Fall 1987): 479–85; Charles J. Hynes and Bob Drury, *Incident at Howard Beach: The Case for Murder* (New York: Putnam, 1990).

106. Ralph Blumenthal, "Black Youth Is Killed by Whites," *New York Times* (August 25, 1989): 1, B: 2; Kirk Johnson, "A New Generation of Racism Is Seen," *New York Times* (August 27, 1989): 32; John Kifner, "Bensonhurst: A Tough Code in Defense of a Closed World," *New York Times* (September 1, 1989): 1, B: 4.

107. Howard Kurtz, "Rotting Apple: The Diminishing Joys of Living in New York," *New Republic* 198 (April 11, 1988): 19–23. Also see Irving Kristol, "Why I Left," *New Republic* 198 (April 11, 1988): 24–25; William Tucker, "Then There's Rent Control," *New Republic* 198 (April 11, 1988): 22; L. J. Davis, "New York's Decay Exposed!" *New Republic* 198 (April 7, 1988): 27; Blake Fleetwood, "Big, Bad Apple," letter to the editor, *New Republic* 198 (May 23, 1988): 6.

108. William H. Whyte, *City: Rediscovering the Center* (New York: Doubleday, 1988), 7, 25. Also see Edward A. Schwartz, "City," *New Republic* (February 26, 1989), VII: 15–16; Brendan Gill, "The Sky Line: City," *New Yorker* 65 (March 6, 1989): 99–104; David Lewis, "City," *Architecture* 79 (April 1990): 137.

109. Marshall Berman, "Eternal City," *Village Voice Literary Supplement* (November 1989): 9.

110. Michael Oreskes, "Dinkins Defeats Giuliani in a Close Race," *New York Times* (November 8, 1989): 1, B: 11; Howard Fineman, "The New Black Politics," *Newsweek* 114 (November 20, 1989): 52; Todd S. Purdum, "Dinkins Will Delay Hiring of Recruits for Police Force," *New York Times* (January 4, 1990): 1, B: 2; "The Mayor's Signal: Blunt, but Brave," editorial, *New York Times* (January 6, 1990): 24; Todd S. Purdum, "To Start, Dinkins Sits Down and Serves Up Bad News for All," *New York Times* (January 7, 1990), IV: 5; Todd S. Purdum, "Dinkins to Cut Spending More Than $200 Million," *New York Times* (January 9, 1990), B: 3.

111. Robert D. McFadden, "New York Sees Sharp Rise in Murders and Robberies," *New York Times* (September 15, 1990): 25, 27; "Subway Crime Statistics Rise," *New York Times* (September 25, 1990), B: 2; George James, "New York Killings Set a Record," *New York Times* (April 23, 1991): 1, B: 4; Robert D. McFadden, "New York Leads Big Cities in Robbery Rate," *New York Times* (August 11, 1991): 28.

112. Jack Curry, "Tourist Slain in a Subway in Manhattan," *New York Times* (September 4, 1990), B: 1; James Barron, "Tourist-Slaying Suspects Are Tied to a Gang of Ritualistic Muggers," *New York Times* (September 5, 1990): 1, B: 4; Michael Specter, "Even in New York, Some Crimes Still Horrify," *Washington Post* (September 6, 1990): 5; Sam Roberts, "Dinkins's Style and the Pressure to Sound Tough," *New York Times* (September 10, 1990), B: 1; "New York's Nightmare," *Newsweek* 116 (September 17, 1990): 35; Joelle Attinger, "The Decline of New York," *Time* 136 (September 17, 1990): 36–41; Joyce Wadler, "Death of an Out-of-Towner," *People* 34 (September 24, 1990): cover, 74–77.

113. "Dave, Do Something!" *New York Post* (September 7, 1990): 1.

114. Morganthau, "New York's Nightmare": 35.

115. Attinger, "The Decline of New York": 39.

116. M. A. Farber, "Black-Korean Who-Pushed-Whom Festers," *New York Times* (May 7, 1990), B: 1, 10; Todd S. Purdum, "Angry Dinkins Defends Role in Race Cases," *New York Times* (May 9, 1990), B: 1, 4; Todd S. Purdum, "Dinkins Asks for Racial Unity and Offers to Mediate Boycott," *New York Times* (May 12, 1990): 1, 27; Eric Pooley, "The Koreans: Caught in the Furor," *New York 23* (May 28, 1990): 38–40; Andy Logan, "City Games," *New Yorker* 66 (May 28, 1990): 19–20; Jonathan Rieder, "Trouble in Store," *New Republic* 203 (July 2, 1990): cover, 16–17; Pete Hamill, "The New Race Hustle," *Esquire* 114 (September 1990): 77–78; David Gonzalez, "8 Arrested in Boycott of Brooklyn Store," *New York Times* (September 23, 1990): 34; Andrew Hacker, "Blacks' Silence on Blacks," *New York Times* (December 13, 1990): 31; Arnold H. Lubasch, "Woman Who Touched Off Boycott Describes Attack," *New York Times* (January 5, 1991): 25.

117. John T. McQuiston, "Fatal Crash Starts Melee with Police in Brooklyn," *New York Times* (August 20, 1991), B: 1, 3; John Kifner, "A Boy's Death Ignites Clashes in Crown Heights," *New York Times* (August 21, 1991), B: 1, 4; James Barron, "Tension in Brooklyn: Fear, Loss and Rage Tear Area," *New York Times* (August 22, 1991), B: 3; Ari L. Goldman, "As Blacks Clash with Hasidic Jews in Crown Heights, Who's in Control?" *New York Times* (August 25, 1991), IV: 6; Todd S. Purdum, "Dinkins Calls for Healing in Brooklyn," *New York Times* (August 26, 1991), B: 1, 3; Martin Gottlieb, "Bubble and Trouble in New York's Venerable Melting Pot," *New York Times* (August 29, 1991), B: 1–2; A. M. Rosenthal, "On My Mind: Pogrom in Brooklyn," *New York Times* (September 3, 1991): 23; Melinda Beck, "Bonfire in Crowns Heights," *Newsweek* 118 (September 9, 1991): 48; Joe Klein, "Deadly Metaphors," *New York 24* (September 9, 1991): 26–29; Sam Allis, "An Eye for an Eye," *Time* 138 (September 9, 1991): 20; James C. McKinley Jr., "Dinkins Describes Killing of Jew in Crown Heights as a 'Lynching,'" *New York Times* (September 10, 1991), B: 3; Andy Logan, "Syzygy," *New Yorker* 67 (September 23, 1991): 102–8; David Evanier, "Invisible Man," *New Republic* 205 (October 14, 1991): cover, 21–26; Richard H. Girgenti, *A Report to the Governor on the Disturbances in Crown Heights* (Albany, N.Y.: New York State Division of Criminal Justice Services, 1993).

118. Don Terry, "Dinkins Proposes 'Painful' Budget of $27.8 Billion," *New York Times* (February 2, 1990): 1, B: 2; Todd S. Purdum, "Dinkins's First Budget Has Some Hard Edges," *New York Times* (February 4, 1990), IV: 5; Todd S. Purdum, "Bumpy Road Ends at Budget for New York City," *New York Times* (July 1, 1990): 30; Josh Barbanel, "Fiscal Reality: Bumpy Streets, Library Cuts and Tuition Rise," *New York Times* (February 4, 1991): 1, B: 5; Michael Specter, "Dinkins's Role in Sanitation Is Faulted," *New York Times* (January 18, 1992): 25.

119. "How to Save New York," *New York 23* (November 26, 1990): cover, 33–67.

120. "To Restore New York City: First, Reclaim the Streets," editorial, *New York Times* (December 30, 1990), IV: 10; "To Restore New York City: Billions for the Homeless: Snatched," editorial, *New York Times* (January 1, 1991): 28; "To Restore New York City: Fighting for Fairness: I," editorial, *New York Times* (January 6, 1991), IV: 18; "To Restore New York City: Fighting for Fairness: II," editorial, *New York Times* (January 7, 1991): 16; "To Restore New York City: No Time to Give Up on Crime," editorial, *New York Times* (January 8, 1991), 20; "To Restore New York City: When City Hall Fails, Do It Yourself," editorial, *New York Times* (January 13, 1991), IV: 18; "To Restore New York City: Urban Disarmament and Uncle Sam," editorial, *New York Times* (January 20, 1991), IV: 18; "To Restore New York City: A Union Lock on Litter," editorial, *New York Times* (January 24, 1991): 22; "To Restore New York City: Collapsing the Mental Health Featherbed," editorial, *New York Times* (February 5, 1991): 22; "To Restore New York City: The Police Plan's Ambitious Promise," editorial, *New York Times* (February 9, 1991): 22; "To Restore New York City: Mining Dead Cars for Money," editorial, *New York Times* (February 19, 1991): 16.

121. Edward I. Koch, quoted in Alex Witchel, "How's He Doing? Fine. Just Ask Him," *New York Times* (January 26, 1994), C: 1, 8. For another explanation of the city's woes, see Robert Fitch's book, *The Assassination of New York* (London: Verso, 1993), which puts the blame squarely on the shoulders of the city's financial and real estate elites, singling out for particular rebuke the Rockefeller family. Also see Joshua B. Freeman, "We Own New York," *Nation* 257 (November 22, 1993): 626; Deyan Sudjic, "Books: Rotten to the Core," *The Guardian* (London) (December 28, 1993): 10; Geordie Greig, "A Tale of Two Cities Divided by Cash," *Times* (London) (January 16, 1994): 18; "The Rockefellers Did It," *Planning* 60 (May 1994): 37; John Mollenkopf, "Planning and History," *Journal of the American Planning Association* 61 (Winter 1995): 123.

122. Kent Barwick, quoted in Sarah Bartlett, "Beyond Just Complaining," *New York Times* (December 27, 1991): B: 1–2.

123. Linda Greenhouse, "Justices Void New York City's Government," *New York Times* (March 23, 1989): 1, B: 5; "The Right Way to Rule New York," editorial, *New York Times* (March 23, 1989): 28; Todd S. Purdum, "On Estimate Board's Agenda, Last Item Is Its Own Demise," *New York Times* (August 16, 1990): 1, B: 4; "The Board of Estimate's Upbeat End," editorial, *New York Times* (August 27, 1990): 16; Felicia R. Lee, "End Comes with Hisses for Board of Estimate," *New York Times* (August 28, 1990), B: 1, 3; Todd S. Purdum, "At Its Last Hurrah, a Municipal Frog Seems Almost Princely," *New York Times* (August 19, 1990), IV: 20.

124. Robert D. McFadden, "Explosion at the Twin Towers," *New York Times* (February 27, 1993): 1, 22–23; Malcolm

Gladwell, "At Least 5 Die, 500 Hurt as Explosion Rips Garage Under World Trade Center," *Washington Post* (February 27, 1993): 1; James Bennet, "Crisis at the Twin Towers," *New York Times* (March 1, 1993), B: 5; Robert D. McFadden, "Crisis at the Twin Towers: The Explosion," *New York Times* (March 1, 1993): 1, B: 4; Joseph B. Treaster, "Leading Bomb Specialists Sift Explosion Aftermath," *New York Times* (March 4, 1993), B: 4; Alison Mitchell, "Suspect in Bombing Is Linked to Sect with a Violent Voice," *New York Times* (March 5, 1993): 1, B: 3; N. R. Kleinfield, "The Suspect: More Light Is Shed on a Shadowy Life," *New York Times* (March 6, 1993): 25; Steven Prokesch with Barry Meier, "The Twin Towers: The Cost," *New York Times* (March 7, 1993): 1, 40; Nadine M. Post et al., "Anatomy of a Building Disaster," *Engineering News-Record* 230 (March 8, 1993): 8; Douglas Waller with Tom Morganthau, "Hitting Home," *Newsweek* 121 (March 8, 1993): cover, 18–29; Richard Lacayho, "Tower Terror," *Time* 141 (March 8, 1993): 24–28; Nadine M. Post with Judy Schriener, "Trade Center Digs Out After Blast," *Engineering News-Record* 230 (March 15, 1993): 9; Eric Pooley, "The Arab Connection," *New York* 26 (March 15, 1993): 30–33; Andy Logan, "Don't Look Back," *New Yorker* 69 (March 15, 1993): 56–60; Lance Morrow, "In the Name of God," *Time* 141 (March 15, 1993): cover, 24–25; Brian Duffy, "A Towering Mystery: With Suspects in Custody, the Motive for the Bombing Remains Elusive," *U.S. News & World Report* 114 (March 15, 1993): 27; Thomas J. Lueck, "One Tower Is to Reopen After Blast," *New York Times* (March 18, 1993), B: 1, 4; Jill Smolowe, "The $400 Bomb," *Time* 141 (March 22, 1993): 40; James S. Russell, "Systems Failed in Attack," *Architectural Record* 181 (April 1993): 31; William D. Harrel and John S. DeMott, "Business Lessons from a Disaster: World Trade Center Bombing," *Nation's Business* 81 (May 1993): 38–40; "Abandoned Car Is Seized in Bomb Inquiry," *New York Times* (May 28, 1993), B: 4; Robert D. McFadden, "8 Seized as Suspects in Plot to Bomb New York Targets and Kill Political Figures," *New York Times* (June 25, 1993): 1, B: 2; Richard Perez-Pena, "Parking Garage at Trade Center to Reopen for Some Vehicles," *New York Times* (July 29, 1993), B: 4; "Garage Damaged in Bombing Reopens at the World Trade Center," *New York Times* (September 3, 1993), B: 2; *World Trade Center Bombing: Terror Hits Home: Hearing before the Subcommittee on Crime and Criminal Justice of the Committee on the Judiciary, House of Representatives* (Washington, D.C.: GPO, 1994); Jim Dwyer et al., *Two Seconds Under the World: Terror Comes to America* (New York: Crown Publishers, 1994); N. R. Kleinfield, "Legacy of Tower Explosion: Security Improved, and Lost," *New York Times* (February 20, 1994): 1, 42; Richard Bernstein, "4 Are Convicted in Bombing," *New York Times* (March 5, 1994): 1, 28; N. R. Kleinfield, "Convictions Greeted with Jubilation and Big Sighs," *New York Times* (March 5, 1994): 29; "A Verdict Against Terror," editorial, *New York Times* (March 5, 1994): 22; James McKinley Jr., "Mountains of Evidence, but Questions Remain," *New York Times* (October 2, 1995), B: 5; Phil Rubin, "The Action Begins in 187 Civil Suits Over 1993 Bombing," *New York Observer* (February 19, 1996): 1, 8; Joe Mysak, *Perpetual Motion: The Illustrated History of the Port Authority* (Santa Monica: General Publishing, 1997), 237–47; Benjamin Weiser, "As Trade Center Smoldered, Suspect Watched, Jury Hears," *New York Times* (October 23, 1997): 1, B: 11; Angus Kress Gillespie, *Twin Towers* (New Brunswick, N.J.: Rutgers University Press, 1999), 3–8.

125. McFadden, "Explosion at the Twin Towers": 1.

126. Mysak, *Perpetual Motion*, 239.

127. Jerry Gray, "The 1993 Elections: Giuliani Ousts Dinkins by a Thin Margin," *New York Times* (November 3, 1993): 1, B: 6; Felicia R. Lee, "Viewing a Verdict Based on Race," *New York Times* (November 3, 1993), B: 2; Todd S. Purdum, "The 1993 Elections: Mayor," *New York Times* (November 3, 1993): 1, B: 3; Peter Applebome, "Results Hint at Secondary Role for Race," *New York Times* (November 4, 1993): 24; Todd S. Purdum, "Giuliani: Overcoming Early Negative Image to Pull Ahead in Voters' Perception," *New York Times* (November 4, 1993), B: 5; Alison Mitchell, "Giuliani Urges Dream of Better City and End to Fear," (January 3, 1994): 1, 16; Sam Roberts, "Giuliani's No-Frills Speech Evokes an Earlier Era," *New York Times* (January 3, 1994): 17; "The New Mayor: Transcript of Inaugural Speech," *New York Times* (January 3, 1994): 18; David Firestone, "A Get-Tough Mayor? Tell That to Andrew," *New York Times* (January 4, 1994): 1, B: 4; Andrew Kirtzman, *Rudy Giuliani: Emperor of the City* (New York: William Morrow, 2000), 42–44.

128. Todd S. Purdum, "Quietly, Term-Limit Measure Seems Likely to Pass," *New York Times* (October 10, 1993): 45; Sam Roberts, "Term-Limit Backers to Begin Ad Campaign," *New York Times* (October 21, 1993), B: 12; "Term Limits Limit Voters' Rights," editorial, *New York Times* (October 21, 1993): 26; Jerry H. Goldfeder, "New York Term Limits Make for False Reform," letter to the editor, *New York Times* (October 26, 1993): 20; "Beware Term Limits," editorial, *New York Times* (November 1, 1993): 18; Steven Lee Myers, "New Yorkers Approve Limit of 2 Terms for City Officials," *New York Times* (November 3, 1993), B: 1; Steven Lee Myers, "Vallone Says Term Limits Issue Is 'Not Dead,'" *New York Times* (November 4, 1993), B: 2.

129. "Beware Term Limits": 18.

130. Kirtzman, *Rudy Giuliani*, 62.

131. Rudolph W. Giuliani, quoted in "The New Mayor: Transcript of Inaugural Speech": 18.

132. Fred Siegel, "The Prince of New York: Rudolph Giuliani's Legacy," *Weekly Standard* (August 21, 2000): 38.

133. Alison Mitchell, "Giuliani Plan Seeks to Raise Productivity," *New York Times* (February 2, 1994), B: 1–2; James C. McKinley Jr., "Fiscal Plan Could Curb Services, as Well as Deficit," *New York Times* (February 3, 1994), B: 2; Steven Lee Myers, "Giuliani Outlines a Budget to Cut Government Size," *New York Times* (February 3, 1994): 1, B: 2;

James C. McKinley Jr., "Giuliani's Budget Proposes Cuts for Spending and Work Force," *New York Times* (May 11, 1994): 1, B: 4; Steven Lee Myers, "Giuliani's Spending Plan: The Overview," *New York Times* (April 28, 1995): 1, B: 5; Thomas J. Lueck, "Commercial Renters to Get a Break," *New York Times* (June 15, 1995), B: 8; Rebecca Johnson, "New York City Can't Afford This Tax," *New York Times* (April 13, 1996): 21; Kirk Johnson, "What Saved the Hotels? Not Just Tax Cuts," *New York Times* (July 30, 1997), B: 1, 6.

134. Esther B. Fein, "Workfare Not Just a Program to Save Money, Adviser Says," *New York Times* (January 13, 1995), B: 3; "A Better Welfare Reform Plan," editorial, *New York Times* (April 21, 1995): 30; "Welfare Reform in Action," editorial, *New York Daily News* (April 24, 1995): 20; William F. Buckley, "New York's Welfare Struggle," *National Review* 47 (June 12, 1995): 78–79; "A Sweeping Change," editorial, *New York Daily News* (July 31, 1995): 22; Dave Saltonstall, "Working on Welfare," *New York Daily News* (August 13, 1995): 19; Kimberly J. McLarin, "Welfare Fingerprinting Finds Most People Are Telling the Truth," *New York Times* (September 29, 1995), B: 1, 4; Irwin M. Stelzer, "Can Giuliani Save New York?" Commentary 100 (December 1995): 31–37; Kimberly J. McLarin, "City Sued Over Program to Curb Welfare Fraud," *New York Times* (December 30, 1995): 31; Bob Liff and Russ Buettner, "City Expanding Workfare for Single Parents," *New York Daily News* (March 19, 1996): 52; Karen W. Arenson, "Workfare Rules Cause Enrollment to Fall, CUNY Says," *New York Times* (June 1, 1996): 1, 25; David Firestone, "Debating Workfare: Mayor's Effort Raises Questions Over Impact on Poor," *New York Times* (August 21, 1996), B: 4; David Firestone, "Workfare Cuts Costs but Tracking New Jobs Poses Problems," *New York Times* (September 9, 1996), B: 1, 7; Lizette Alvarez, "Giuliani and Union Praise Successes of Workfare," *New York Daily News* (December 15, 1996): 51; Kirtzman, *Rudy Giuliani*, 171–74.

135. "A Sweeping Change": 22.

136. George James, "Bratton Puts Focus on Beat for Shake-Up," *New York Times* (January 24, 1994), B: 1–2; Clifford Krauss, "Giuliani and Bratton Begin Push to Shift Police Aims and Leaders," *New York Times* (January 26, 1994), B: 3. Also see William Bratton with Peter Knobler, *Turnaround: How America's Top Cop Reversed the Crime Epidemic* (New York: Random House, 1998); Richard Bernstein, "A Thinker Attuned to Doing: James Q. Wilson Has Insights, Like Those on Cutting Crime, That Tend to Prove Out," *New York Times* (August 22, 1998), B: 7, 9; Eli B. Silverman, *NYPD Battles Crime: Innovative Strategies in Policing* (Boston: Northeastern University Press, 1999); William J. Bratton and William Andrews, "What We've Learned About Policing," *City Journal* 9 (Spring 1999): 14–27; Jack Maple and Chris Mitchell, *The Crime Fighter* (New York: Broadway Books, 2000); Vincent E. Henry and William J. Bratton, *The Compstat Paradigm: Management Accountability in Policing, Business and the Public Sector* (New York: Looseleaf Law Publications, 2002).

137. David A. Kaplan, "These Guys Do Windows," *Newsweek* 123 (January 17, 1994): 48; Clifford Krauss, "Study Suggests It Is Easy to Banish Squeegee Men," *New York Times* (February 7, 1994), B: 3; Alison Mitchell, "An Apron for a Squeegee," *New York Times* (February 16, 1994), B: 2; Michael Barone, "Seeking Civility in America's Cities," *U.S. News & World Report* 116 (April 4, 1994): 26; John Leo, "America's Retreat from Disorder," *U.S. News & World Report* 116 (April 25, 1994): 25; David Brooks, "Giuliani: Start Spreading the News," *The Weekly Standard* 1 (November 13, 1995): 23; Michael Daly, "Squeegee Man Springs Anew," *New York Daily News* (May 19, 1996): 8; "'No' to Aggressive Panhandlers," editorial, *New York Times* (July 5, 1996): 22; Barbara Ross and Jane Furse, "200 Suspects Locked in Legal Limbo," *New York Daily News* (July 11, 1996): 40; "It's a Quality, Quality Life," *New York Times* (July 14, 1996), VI: 8; Bob Kappstatter, "Guy Can Really Squeeqee a Buck," *New York Daily News* (July 28, 1996): 13; "Council Looks to Scrub Squeegees, Beggars," *New York Daily News* (September 11, 1996): 29; Clifford J. Levy, "Council Approves Restrictions on Beggars," *New York Times* (September 12, 1996), B: 4; Denis Hamill, "Law Gives Them Bum's Rush," *New York Daily News* (September 13, 1996), Metro: 4; Joel Siegel, "Pushy Pests Face Jail," *New York Daily News* (September 26, 1996): 20.

138. Daly, "Squeegee Man Springs Anew": 8.

139. Steven Lee Myers, "Mayor Says Crime Data Affirm Strategies," *New York Times* (January 8, 1995): 1, 26; John Moody, "Safe? You Bet Your Life," *Time* 146 (July 24, 1995): 35; Craig Horowitz, "The Suddenly Safer City," *New York* 28 (August 14, 1995): 20–25; Vince Beiser, "Why the Big Apple Feels Safer," *Maclean's* (September 11, 1995): 39; Elizabeth Lesly, "A Safer New York City," *Business Week* (December 11, 1995): 81; "Crime Is Down, Again," editorial, *New York Times* (December 23, 1995): 26; Lars-Erik Nelson, "The Big Apple Teaches U.S. How to Fight Crime," *New York Daily News* (January 8, 1996): 31; Clifford Krauss, "City Is Safer, Rising Number of People Say," *New York Times* (January 14, 1996): 27–28; Eric Pooley and Elaine Rivera, "One Good Apple," *Time* 147 (January 15, 1996): cover, 54–56; Bob Liff, "City Crime Drop Bests U.S.," *New York Daily News* (January 6, 1997): 10; Michael Cooper, "Murder Rate Is Continuing to Decrease," *New York Times* (July 1, 1997): 1, B: 3; Gene Mustain and Lawrence Goodman, "Fuller Life in a Safer City: Crime Drop Sparks Quiet Revolution," *New York Daily News* (December 15, 1997): 6; John Marzulli, "Gun Slayings Plunge: Dramatic Reduction Part of Banner Year," *New York Daily News* (December 31, 1998): 7.

140. Siegel, "The Prince of New York: Rudolph Giuliani's Legacy": 38.

141. David Firestone, "A Helpful Giuliani Is Drawing Bratton a Map to the Door," *New York Times* (March 26, 1996), B: 1, 5; Michael Daly, "He Couldn't Last If Rudy Comes 1st,"

New York Daily News (March 27, 1996): 2; David Firestone, "Bratton Quits Police Post," *New York Times* (March 27, 1996): 1, B: 5; Clifford Krauss, "Bratton Hailed as Pioneer of New Style of Policing," *New York Times* (March 27, 1996), B: 5; Steven Lee Myers, "Squabbling Behind the Amicable Departure," *New York Times* (March 27, 1996), B: 4; "Brain Drain at the NYPD," editorial, *New York Daily News* (April 3, 1996): 26; Gregory Beals and Evan Thomas, "A Crimebuster's Fall," *Newsweek* 127 (April 8, 1996): 42.

142. Shawn G. Kennedy, "Giuliani's Spending Plan: The Agencies," *New York Times* (February 15, 1995), B: 5; James Trager, *The New York Chronology* (New York: Harper Resource, 2003), 826.

143. Nick Ravo, "Zoning Out Sex-Oriented Businesses," *New York Times* (March 6, 1994), X: 1, 16; Steven Lee Myers, "Giuliani Proposes Toughening Laws on X-Rated Shops," *New York Times* (September 11, 1994): 1, 39; Joseph J. Sanow, "Must the Sex Shops Blare Their Presence?" letter to the editor, *New York Times* (September 17, 1994): 22; "Mayor Versus Peep Shows," editorial, *New York Observer* (September 19, 1994): 4; Steven Lee Myers, "Many Not in the Mood These Days for Sex-Oriented Establishments," *New York Times* (September 25, 1994): 41; Michael Lewis, "Titillation: Rudy Giuliani's Victorian Crusade," *New Republic* 211 (October 24, 1994): 16, 10, 20; Sarah Kershaw, "Against Pornophobia," *New York Times* (January 16, 1995): 20; Vivian S. Toy, "Panel Votes Zoning Rule on Sex Shop," *New York Times* (October 25, 1995), B: 4; "Limiting Sex Shops, Responsibly," editorial, *New York Times* (October 27, 1995): 30; Robin Pogrebin, "The Year in Sex Zones," *New York Times* (December 31, 1995), XIII: 7; Jayne Merkel, "Queer Theorist and Feminist Debate New York's Sex-Related Business Zoning," *Oculus* 58 (February 1996): 17; Thomas J. Lueck, "Sex Shops and Patrons Join in Suits Challenging Zoning," *New York Times* (February 28, 1996), B: 2; Vivian S. Toy, "Sex Shops Greet Law with Wink, Nod and Lawsuit," *New York Times* (October 16, 1996), B: 1, 4; Vivian S. Toy, "New York Zoning Against Sex Shops Is Upheld as Fair," *New York Times* (October 24, 1996): 1, B: 4; Vivian S. Toy, "First Store Is Padlocked Under Sex-Shop Law," *New York Times* (September 20, 1997), B: 3; Raymond Hernandez, "Court, 6–0, Backs New York Statute Limiting Sex Shops," *New York Times* (February 25, 1998): 1, B: 5; Dan Barry, "Federal Court Upholds City Zoning Law to Curb Sex Shops," *New York Times* (June 4, 1998), B:1, 5; David Rohde, "Sex Shops Try to Obey Law, as Written," *New York Times* (August 6, 1998), B: 3; Dan Barry and David Rohde, "Giuliani Begins to See Results in Battle Against Sex Shops," *New York Times* (August 9, 1998): 29, 32; David Rohde, "Courts Allow City to Shutter 5 Strip Clubs," *New York Times* (August 13, 1998), B: 7; "Controlling Sex Shops," editorial, *New York Times* (September 27, 1998): 24; "New York Law That Curbs Topless Dancing Is Upheld," *New York Times* (October 6, 1998), B: 3; David Rohde, "Supreme Court Denies Appeal by Sex Shops," *New York Times* (January 12, 1999), B: 1, 6; Dan Barry, "With John Wayne and Sushi, Sex Shops Survive a Cleanup," *New York Times* (January 1, 2001): 1, B: 5.

144. "Limiting Sex Shops, Responsibly": 30.

145. Clifford J. Levy, "Wall St. Profits Lead a Recovery in New York City," *New York Times* (October 21, 1996): 1, B: 6.

146. Joseph Rose, quoted in Douglas Feiden, "Magnet for Young Magnates," *New York Daily News* (September 29, 1996): 18.

147. Bob Kappstatter, "South Bronx Area on the Way Back," *New York Daily News* (September 29, 1996): 20.

148. Andrew Jacobs, "After Years of Sleaze and Decay, the Great White Way Suddenly Looked Hot," *New York Times* (December 29, 1996), XIV: 6.

149. James Traub, "Giuliani Internalized," *New York Times* (February 11, 2001), VI: 62. Also see James Traub, *The Devil's Playground: A Century of Pleasure and Profit in Times Square* (New York: Random House, 2004).

150. Surabhi Avasthi, "A Nicer Place to Visit," *New York Times* (September 29, 1996): 19; Thomas J. Lueck, "A Rise in Visitors, a Shortage of Rooms," *New York Times* (October 21, 1996), B: 6.

151. Richard Parsons, quoted in Robin Kamen, "It Was a Very Good Year," *Crain's New York Business* (December 22–28, 1997): 4, 17.

152. Peter Grant, "Rooms with a View–& a Price," *New York Daily News* (September 29, 1996): 18.

153. Peter Grant, "Empire of Emporiums," *New York Daily News* (September 29, 1996): 19.

154. Mark Tran, "American Notebook: Big Apple Gains Electronic Core," *Guardian* (London) (June 19, 1995): 16; Janet Allon, "The Buzz in Silicon Alley," *New York Times* (September 10, 1995), XIII: 4; David Michael, "Behind Downtown 'Scene,' Real Work Is Getting Done," letter to the editor, *New York Times* (September 24, 1995), XIII: 25; Paula Span, "A Geek into the Future: Young Web Wizards Spin a New World in New York's Silicon Alley," *Washington Post* (April 5, 1996), F: 1; "Where the High-Tech Jobs Are," *New York Times* (January 1, 1996): 47; Carl Weisbrod, "Wall Street Looks to Information Revolution," letter to the editor, *New York Times* (January 17, 1996): 18; Steve Lohr, "New York Area Is Forging Ahead in New Media," *New York Times* (April 15, 1990), D: 1, 4; "New York's Dynamic New Media," editorial, *New York Times* (April 16, 1996): 20; Kirk Johnson, "Where a Zoning Law Failed, Seeds of a New York Revival," *New York Times* (April 21, 1996): 1, 42; Eric Asimov, "Content's Fine. But Profits?" *New York Times* (August 11, 1996), XIII: 8; Eric Asimov, "Give Me Your Wired," *New York Times* (August 11, 1996), XIII: 1, 8–9; Thomas P. Hirschfeld, "The Coming Showdown in Media City," *City Journal* 7 (Winter 1997): 66–73; Edward Wong, "The Streets Are Paved with PC's: Wall Street and Silicon Alley Lure a New Breed of High-Tech Immigrants," *New York Times* (August 16, 1998), XIV: 1, 10–11; Amy Harmon, "Beyond

Boosterism in the Alley; New York's Web Industry May Be Outgrowing Its Image," *New York Times* (August 17, 1998), D: 1, 6; John Holusha, "Silicon Alley's Byways and Boulevards," *New York Times* (December 13, 1998), XI: 1, 6; Carl Weisbrod, "Silicon Alley's Boulevards," letter to the editor, *New York Times* (December 27, 1998), XI: 9; John Holusha, "High-Tech Growth Filling Financial District Offices," *New York Times* (November 28, 1999), XI: 9; "Millionaires of Silicon Alley," *Crain's New York Business* (November 29–December 5, 1999): 46–57; John Holusha, "Web Companies Can See Expanding Downtown," *New York Times* (January 12, 2000), B: 8; Mark Walsh, "Cool Market Threatens Alley Firms," *Crain's New York Business* (February 7, 2000): 1, 51; Rachel Sheier, "Dot-Com Dive Stuns Alley Cats," *New York Daily News* (April 16, 2000): 3; Steven Malanga, "The Triumph of Silicon Alley," *City Journal* 10 (Summer 2000): 42–51; Terry Pristin, "Stock Market Fears Are Stalling Silicon Alley's Gold Rush," *New York Times* (July 4, 2000), B: 1–2; Leslie Eaton and Jayson Blair, "Dot-Com Fever Followed by Bout of Dot-Com Chill," *New York Times* (October 27, 2000), B: 1, 10; Charlie LeDuff, "What a Long, Strange Trip: Pseudo.Com to Dot.Nowhere," *New York Times* (October 27, 2000), B: 1, 10; Jayson Blair, "Silicon Alley's Revenues Fall, and More Layoffs Are Planned," *New York Times* (November 11, 2000), B: 2; Jayson Blair, "Silicon Alley Rentals Are Hot as Dot-Coms Suddenly Aren't," *New York Times* (November 14, 2000), B: 5; Jayson Blair, "Layoffs Galore in Silicon Alley, but Many Find a Traditional Net," *New York Times* (February 9, 2001), B: 3.

155. Quoted in David W. Chen, "In Fast-Changing Silicon Alley, Companies Adapt or Abort," *New York Times* (February 7, 1997), B: 7.

156. Ian Fisher, "The Human Face of New York's World Wide Web," *New York Times* (August 8, 1996), B: 1, 6.

157. Jacques Steinberg, "Manhattan Emerging Hub of Multimedia," *New York Times* (June 3, 1995): 21.

158. Allon, "The Buzz in Silicon Alley": 6.

159. Clay Lifflander, quoted in Dave Saltonstall, "New Boom Town for All Things Cutting-Edge," *New York Daily News* (July 9, 1995): 32.

160. Quoted in Chen, "In Fast-Changing Silicon Alley, Companies Adapt or Abort": 7.

161. Tom Standage, "We Don't Surf, We Walk the Net," *Independent* (London) (January 15, 1996): 14.

162. Fisher, "The Human Face of New York's World Wide Web": 1, 6.

163. Weisbrod, "Wall Street Looks to Information Revolution": 18.

164. Mervyn Rothstein, "Real Estate/High-Tech Features Bring a Turnaround to a Downtown Building, After Five Vacant Years," *New York Times* (September 11, 1996), D: 5; Mervyn Rothstein, "New Tenants for a Popular Silicon Alley Building," *New York Times* (February 26, 1997), B: 7.

165. Peter Grant, "Millions for Silicon Alley," *New York Daily News* (February 12, 1997): 53; Thomas J. Lueck, "Offering Low Rent to Lure High Tech," *New York Times* (February 12, 1997), B: 7; "Oversupply of Office Space Is Starting to Dwindle," *New York Times* (May 4, 1997), IX: 9; Mervyn Rothstein, "Offices Plugged In and Ready to Go," *New York Times* (February 4, 1998), B: 6; Nick Ravo, "New York Recruiter Lands 7 Businesses," *New York Times* (August 27, 1998), B: 6; John Holusha, "Luring High Technology Downtown," *New York Times* (February 10, 1999), B: 11; Andrew Friedman, "Gone.com," *New York Times* (March 4, 2001), XIV: 1, 11.

166. Carl Weisbrod, quoted in "Oversupply of Office Space Is Starting to Dwindle": 9.

167. Edward Lewine, "Putting a Funky Face on Wall Street," *New York Times* (September 23, 1998), G: 4.

168. John Holusha, "Turning Buildings into Telecommunications Hubs," *New York Times* (October 10, 1999), XI: 1.

169. David W. Dunlap, "Once and Future Telecommunications Crossroads," *New York Times* (January 19, 2000), B: 8.

170. David W. Chen, "Venture Capital Discovers New York's New Technology," *New York Times* (February 5, 1997), B: 7; Chen, "In Fast-Changing Silicon Alley, Companies Adapt or Abort"; Nick Ravo, "Silicon Alley Seeing More Deals and Cash," *New York Times* (February 12, 1998), B: 9.

171. Fred Wilson, quoted in Saul Hansell, "Gold Rush in Silicon Alley: Venture Capital Moves East," *New York Times* (February 7, 2000), C: 1, 13.

172. Lisa Napoli and Saul Hansell, "For Silicon Alley, a Time to Rise and Shine," *New York Times* (March 29, 1999), C: 1, 4.

173. Denny Lee, "A Once-Evocative Name Falls Victim to the Bursting of the High-Tech Bubble," *New York Times* (March 24, 2002), XIII: 4.

174. Bill Lessard, quoted in Lee, "A Once-Evocative Name Falls Victim to the Bursting of the High-Tech Bubble": 4.

175. Mark Madell, quoted in Lee, "A Once-Evocative Name Falls Victim to the Bursting of the High-Tech Bubble": 4.

176. Adam Nagourney, "Giuliani Sweeps to Second Term as Mayor," *New York Times* (November 5, 1997): 1, B: 3.

177. Jane H. Lii, "Fireworks Ban May Send the Ox in Quietly," *New York Times* (February 2, 1997), XIII: 8; Jane H. Lii, "Chinatown Groups Ask Mayor to Rethink Fireworks Ban," *New York Times* (February 15, 1997): 27; Michael O. Allen, "Chinatown Fireworks Off Menu," *New York Daily News* (June 29, 1997): 4; David M. Herszenhorn, "Police Ban on Firecrackers Makes for Quieter Holiday," *New York Times* (July 5, 1997): 26; David W. Chen, "No-Walking Zones Tested to Fight Midtown Gridlock," *New York Times* (December 25, 1997): 1, B: 2; Alan Finder, "Footloose Pedestrians Are Just About in Lock Step: They Hate Traffic Plan," *New York Times* (December 27, 1997), B: 3; David Seifman and Gersh Kuntzman, "Rudy's Set to Step Up His War on Jaywalkers," *New York Post* (January 1, 1998): 6; Norimitsu Onishi, "With Higher Fines, Giuliani Hopes to Hobble Jaywalkers," *New York*

Times (January 13, 1998), B: 2; Lenore Skenazy, "Rudy of Mayberry Is Missing the Mark," *New York Daily News* (January 13, 1998): 5; Karen Zautyk, "Jaywalking on Mayor's Wild Side," *New York Daily News* (January 16, 1998): 41; Kit R. Roane, "Police Balk at Crackdown on Jaywalkers by Giuliani," *New York Times* (February 8, 1998): 35; David Rohde, "Officer Apprehends a Perpetrator: The Charge Is Jaywalking," *New York Times* (February 9, 1998), B: 1; Frank Lombardi, "Blizzard of Summonses Blankets City," *New York Daily News* (May 20, 1998): 4.

178. Siegel, "The Prince of New York: Rudolph Giuliani's Legacy": 38.

179. Tom Topousis and Neil Graves, "Rudy Launches Art Attack on Museum's 'Sick Stuff,'" *New York Post* (September 23, 1999): 3; Dan Barry and Carol Vogel, "Giuliani Vows to Cut Subsidy Over 'Sick' Art," *New York Times* (September 23, 1999): 1, B: 12; "The Mayor as Art Censor," editorial, *New York Times* (September 24, 1999): 26; Peter Plagens, "Holy Elephant Dung!" *Newsweek* 134 (October 4, 1999): 71; John Cloud, "New York's Art Attack," *Time* 154 (October 4, 1999): 64; Michael Tomasky, "R. Giuliani vs. Sensation Exhibit," *New York* 32 (October 11, 1999): 26; Robin Cembalest, "Battle in Brooklyn," *Art News* 98 (November 1999): 61–62.

180. Elisabeth Bumiller, "In the Wake of Attack, Giuliani Cracks Down on Homeless," *New York Times* (November 20, 1999): 1, B: 3; David M. Herszenhorn, "Seeking Common Ground in the Debate on the Homeless," *New York Times* (November 23, 1999), B: 10; Nina Bernstein, "Lawyers for Homeless Seeking to Block New Rules on Shelters," *New York Times* (November 27, 1999), B: 1, 3; David M. Herszenhorn, "1,000 in Park Denounce Giuliani on Homeless Arrest Policy," *New York Times* (December 6, 1999), B: 1, 5; "The Law on Homeless Shelters," editorial, *New York Times* (December 11, 1999): 18; Nina Bernstein, "City's Rules for Shelters Held Illegal," *New York Times* (February 23, 2000), B:1, 5.

181. K. C. Baker, "2 Cops Eyed in Sex Attack," *New York Daily News* (August 13, 1997): 3; Dan Barry, "Charges of Brutality," *New York Times* (August 14, 1997): 1, B: 3; David Hinckley, "The Talk Is All About Louima," *New York Daily News* (August 21, 1997): 110; "Assault Case Brings Call for a Nationwide Inquiry," *New York Times* (September 13, 1997): 29; Anthony V. Bouza, *Police Unbound* (Amherst, N.Y.: Prometheus Books, 2001), 65–66, 118, 151, 207–8, 262.

182. Rafael A. Olmeda, "Cops Blast Unarmed Man," *New York Daily News* (February 5, 1999): 4; Michael Cooper, "Officers in Bronx Fire 41 Shots, and an Unarmed Man Is Killed," *New York Times* (February 5, 1999): 1, B: 5; Amy Waldman, "In a Quest for Peace and Opportunity, West Africans Find Anger," *New York Times* (February 6, 1999), B: 6; Bryna J. Fireside, *The Trial of the Police Officers in the Shooting Death of Amadou Diallo* (Berkeley Heights, N.J.: Enslow Publishers, 2004).

183. C. J. Chivers, "Death Sets Off Spasms of Sorrow and Outrage," *New York Times* (March 17, 2000), B: 5; William K. Rashbaum, "Undercover Police in Manhattan Kill an Unarmed Man in a Scuffle," *New York Times* (March 17, 2000): 1, B: 5.

184. David M. Halbfinger, "High-Rise Wall Breaks Loose, Raining Debris on Shoppers," *New York Times* (December 8, 1997), B: 3; Maureen Fan and Corky Siemaszko, "Terror Pelts Mad. Ave.," *New York Daily News* (December 8, 1997): 5; David W. Chen, "Blocks Still Closed After Wall Peels Off," *New York Times* (December 9, 1997), B: 3; David W. Chen, "On Madison, a Crumbling Wall Is Scrambling Lives," *New York Times* (December 10, 1997), B: 1, 6; David W. Chen, "Reopening of Avenue Is Nearer, but Delayed," *New York Times* (December 11, 1997), B: 3; "Madison Avenue Reopens," *New York Times* (December 13, 1997): 1; Robert D. McFadden, "Major New Flaws Are Found on Shaky Madison Ave. Wall," *New York Times* (December 15, 1997). B: 3; "Looking Upward, with Anxiety," editorial, *New York Times* (December 17, 1997): 30; Glenn Collins, "Behind Facade of Calamity, Life Goes On," *New York Times* (December 18, 1997), B: 3; Charles V. Bagli, "Owner to Dismantle Flawed Madison Ave. Facade," *New York Times* (December 20, 1997), B: 1, 4; Robert A. Ivy, "A Building Lasts a Lifetime," editorial, *Architectural Record* 186 (February 1998): 13; David W. Chen, "Picking Up the Pieces on Madison Avenue," *New York Times* (August 5, 1998), B: 1, 7. For 540 Madison Avenue, see Stern, Mellins, and Fishman, *New York 1960*, 419–20.

185. See Kirtzman, *Rudy Giuliani*, 254–88.

186. Alice McQuillan, "Madness on Videotape," *New York Daily News* (June 13, 2000): 3; C. J. Chivers and Kevin Flynn, "35 Scary Minutes: Women Tell Police of Assaults in Park," *New York Times* (June 13, 2000): 1, B: 14; C. J. Chivers and William K. Rashbaum, "Inquiry Focuses on Officers' Responses to Violence in Park After Parade," *New York Times* (June 14, 2000), B: 1, 13; "Has Giuliani Given Up On Keeping Order," editorial, *Newsday* (June 15, 2000): 48.

187. Clyde Haberman, "Fighting City Hall," *New York Times* (July 30, 2000), VII: 16.

188. James Traub, "Giuliani Internalized," *New York Times* (February 11, 2001), VI: 62.

TOWARD A LIVABLE CITY

1. Quoted in Lee A. Daniels, "Lots Are Drawn for New Middle-Income Homes," *New York Times* (December 9, 1983), B: 3. Also see Michael Goodwin, "As Housing Problems Increase, Experts See Little Hope for Future," *New York Times* (January 23, 1980), B: 1, 4.

2. Lewis Mumford, "The Sky Line: The Red-Brick Beehives," *New Yorker* 26 (May 6, 1950): 79–83.

3. Lewis Mumford, "Mass Production and the Modern House," *Architectural Record* 67 (January 1930): 13–20; Lewis Mumford, "The Sky Line: The Regional Plan," *New Yorker* 8 (May 21, 1932); Lewis Mumford, "The Plan of New York I," *New Republic* 71 (June 15, 1932): 121–26; Lewis Mumford,

"The Plan of New York II," *New Republic* 71 (June 22, 1932): 146–54; Clarence S. Stein, *Toward New Towns for America* (Liverpool: Liverpool University, 1951).

4. Alan S. Oser, "Section 235: New York Bid to Spur Low-Rise Housing," *New York Times* (July 11, 1980): 13.

5. Michael Goodwin, "A Home Ownership Aid Program Is Planned for City," *New York Times* (February 22, 1980), B: 3; Lee A. Daniels, "City Is Sponsoring 2,200 Small Houses," *New York Times* (February 13, 1981): 1, B: 3; Richard Higgins, "2,000-House Plan Will Test Market in Renewal Areas," *New York Times* (February 22, 1981); Alan S. Oser, "How Sharp Cuts in Federal Help Will Affect Housing," *New York Times* (October 2, 1981): 31; "New Middle-Income Housing Is Being Constructed in New York City Under the Federal 235 Program," *Architectural Record* 169 (December 1981): 33; I. D. Robbins, "Wanted: Leadership in Housing," *New York Times* (December 6, 1981), VIII: 1; Ronald Smothers, "Koch Plan for 2,200 New Houses in Jeopardy, Builders Say," *New York Times* (December 13, 1981), VIII: 4; Martin Gottlieb, "Small Homes at Low Cost," *New York Times* (February 18, 1985), B: 1, 4.

6. Edward I. Koch, quoted in Michael Goodwin, "Koch Outlines Problems of Housing Facing City," *New York Times* (August 26, 1981), B: 1, 4.

7. "Postings/Housing Reprieve," *New York Times* (June 10, 1984), VIII: 1; "Coney I. Residents Fault New Homes," *New York Times* (July 6, 1984), B: 3; Matthew L. Wald, "New Coney I. Homes Called Flawed," *New York Times* (July 16, 1984), B: 2.

8. For Twin Parks Northeast, see Stern, Mellins, and Fishman, *New York 1960*, 958, 960–61.

9. Richard Plunz, *A History of Housing in New York City* (New York: Columbia University Press, 1990), 330.

10. Lee A Daniels, "The Rockefeller Proposal for Middle-Class Homes," *New York Times* (January 22, 1982): 20; Lee A. Daniels, "Lots Are Drawn for New Middle-Income Homes," *New York Times* (December 9, 1983), B: 3; Alan S. Oser, "New Tack in Getting Homes Built," *New York Times* (December 18, 1983), VIII: 6; Matthew L. Wald, "U.S. Grants $15 Million for Housing in the City," *New York Times* (December 23, 1983), B: 3; Lee A. Daniels, "Housing Partnership Begins in the Middle," *New York Times* (January 29, 1984), IV: 7; Michael deCourcy Hinds, "Lenders in City Advised It Pays to Back Housing," *New York Times* (October 16, 1984), B: 3; Alan S. Oser, "Brownstone Look Returning to Fort Greene Project," *New York Times* (November 9, 1984), B: 7; Carter B. Horsley, "Study Gives Not to 3-Family Houses," *New York Post* (August 11, 1988): 50.

11. Lee A. Daniels, "36 Churches in Brooklyn Plan to Build 5,000 Homes," *New York Times* (June 30, 1982), B: 1, 7; Lee A. Daniels, "City Agrees to Brooklyn Home Loans," *New York Times* (July 28, 1982), B: 2; Lee A. Daniels, "Brooklyn Churches Gain City Help for New Homes," *New York Times* (July 30, 1982), B: 7; Deirdre Carmody and Laurie Johnston, "Rebuilding in Brownsville," *New York Times* (November 1, 1982), B: 2; Alan S. Oser, "In Brownsville, Churches Joining to Build Homes . . . ," *New York Times* (May 1, 1983), VIII: 7; Richard D. Lyons, "What's the Shape of City's Housing?" *New York Times* (June 19, 1983), VIII: 6; "Cuomo and Church Leaders Meet in Brooklyn on Housing," *New York Times* (July 20, 1983), B: 6; "Koch Praises Start on New Housing," *New York Times* (November 3, 1983), B: 7; George W. Goodman, "Housing in Brownsville Progresses," *New York Times* (November 6, 1983), VIII: 6; Sydney H. Schanberg, "Bricks and Local Power," *New York Times* (February 21, 1984): 23; Sheila Rule, "Beyond Scars, Brownsville Shows Signs of New Hope," *New York Times* (September 20, 1984): B: 1, 7; Michael deCourcy Hinds, "Facing Up to the Housing-Supply Issue," *New York Times* (December 29, 1985), VIII: 1, 6–7; "Churches in Brooklyn Agree to a Modified Housing Plan," *New York Times* (March 26, 1986), B: 3; Michael deCourcy Hinds, "Affordability vs. the Building Code," *New York Times* (September 7, 1986), VIII: 6; I. D. Robbins, "Affordable Housing Today Means Tracts of Single-Family Homes," letter to the editor, *New York Times* (October 2, 1987): 34; Alan Finder, "Plan for Row Houses, Praised Nationally, Debated at Home," (December 13, 1988), B: 1, 10; Deborah S. Gardner, "New Housing," in Carol Willis and Rosalie Genevro, eds., *Vacant Lots* (New York: Architectural League; New York: Princeton Architectural Press, 1989), 9–14; Frank J. Prial, "Developer Hopes to Build Housing on Land Owned by New York City," *New York Times* (November 17, 1989), B: 4; Alan S. Oser, "Perspectives: The Nehemiah Plan; A High-Volume Builder Yearns for Land," *New York Times* (April 16, 1989), X: 9, 16; Mildred Antenor, "Nehemiah Homes: A Dream Turned Nightmare," *Village Voice* (February 20, 1990): 10, 14; Philip Arcidi, "Affordable Housing: Essays," *Progressive Architecture* 72 (June 1991): 110–11; James Thomas Martino, "A Housing Program That Builds for Less," letter to the editor, *New York Times* (May 5, 1992): 30; Steven Prokesch, "Housing Pact Is Reached for Brooklyn," *New York Times* (October 6, 1992), B: 1, 4; Hugo Lindgren, "Life in the Dead Zone," *Metropolis* 13 (March 1994): 15, 18–19; Robert Neuwirth, "Visible City/I. D. Robbins," *Metropolis* 14 (March 1995): 27–31, 33; Lawrence Van Gelder, "I. D. Robbins Is Dead at 86: Pioneer in Low-Cost Homes," *New York Times* (July 4, 1996), B: 8; Samuel G. Freedman, "From the Ground Up in East New York," *New York Times* (April 4, 1998): 13.

12. I. D. Robbins, "For the $12,000-a-Year Income: Blueprint for a One-Family House," *New York Daily News* (October 7, 1979), magazine: 10–12. Also see I. D. Robbins, "Anybody Here Want Decent, Low-Cost Housing?" *New York Daily News* (October 16, 1979): 32; I. D. Robbins, "We're Hearing It for the Low-Row House Idea," *New York Daily News* (October 23, 1979): 34; I. D. Robbins, "Affordable One-Family Homes by the Thousands," *New York Daily News* (November 13, 1979): 32.

13. Robbins, "For the $12,000-a-Year Income: Blueprint for a One-Family House": 10–12.

14. Robbins, "For the $12,000-a-Year Income: Blueprint for a One-Family House": 10–12.

15. For the Van Dyke Houses, see Stern, Mellins, and Fishman, *New York 1960*, 922–23.

16. Daniels, "City Agrees to Brooklyn Home Loans": 2.

17. Plunz, *A History of Housing in New York City*, 332. For Otto Haesler's project, see *Modern Architecture: International Exhibition, New York Feb. 10 to March 23, 1932, Museum of Modern Art* (New York: Museum of Modern Art, 1932).

18. I. D. Robbins, quoted in Robert Neuwirth, "Housing After Koch," *Village Voice* (November 7, 1989): 22–24.

19. Robbins, "Affordable Housing Today Means Tracts of Single-Family Homes": 34.

20. Alan S. Oser, "A Struggle Over Sites in the South Bronx," *New York Times* (October 22, 1989), X: 9; Bruce Lambert, "Way Cleared for Long-Delayed Housing," *New York Times* (April 14, 1991), X: 1, 8; "Housing Development Dedicated in the Bronx," *New York Times* (May 8, 1992), B: 3; Lynette Holloway, "Little Slices of Suburbia, a la South Bronx," *New York Times* (May 8, 1994), XIV: 9; Bradford McKee, "South Bronx," *Architecture* 84 (April 1995): 86–95; Jane H. Lii, "South Bronx Churches Will Expand Affordable Housing," *New York Times* (December 4, 1997), B: 4.

21. McKee, "South Bronx": 88.

22. I.D. Robbins, quoted in Neuwirth, "I. D. Robbins": 28.

23. Neuwirth, "I. D. Robbins": 31.

24. Rachelle Garbarine, "645 Modular Houses Going Up in Brooklyn," *New York Times* (July 4, 1997), B: 5; Alan S. Oser, "A Housing Program's Next Generation," *New York Times* (December 21, 1997), XI: 1; Josh Barbanel, "Steady Focus, Evolving Vision," *New York Times* (May 16, 2004), XI: 1, 6.

25. Peter Marcuse, "Introduction," in *Reweaving the Urban Fabric: Approaches to Infill Housing* (New York: New York State Council on the Arts, 1988), 9–10.

26. Community Design Workshop, *A Housing Platform for Harlem* (New York: Columbia University Graduate School of Architecture and Planning, June 1985), 9.

27. Community Design Workshop, *A Housing Platform for Harlem*, 23–25, 33.

28. Deborah Norden, "Preface," in *Reweaving the Urban Fabric: Approaches to Infill Housing*, 7. Also see *Inner City Infill: A Housing Competition for Harlem* (New York: New York State Council on the Arts, 1985), 13; "Pencil Points," *Progressive Architecture* 66 (July 1985): 12; "Names and News," *Oculus* 47 (September 1985): 10; Joanna Wissinger, "Inner City Infill: Housing for Harlem," *Progressive Architecture* 67 (February 1986): 23–24; "Names and News," *Oculus* 48 (March 1986): 10; "Names and News," *Oculus* 48 (June 1986): 7; Joanna Wissinger, "Harlem Infill Finalists," *Progressive Architecture* 67 (July 1986): 28; "Inner-City Infill Housing Competition for Harlem," *Architectural Record* 174 (August 1986): 66–67; Victoria Geibel, "New Hopes for Harlem," *Metropolis* 6 (November 1986): 26–27; "Affordable Housing in Harlem," *Architecture California* 8 (November /December 1986): 9–10; Ghislaine Hermanuz, "Infill Housing: A Remedy to Harlem's Deterioration," in *Reweaving the Urban Fabric: Approaches to Infill Housing*, 13–36; Roy Strickland, "Low-Income Infill Housing," *Progressive Architecture* 69 (June 1988): 32; Michael Pyatok, "Housing as a Social Enterprise: The Ambivalent Role of Design Competitions," *Journal of Architectural Education* 46 (February 1993): 147–61.

29. *Inner City Infill: A Housing Competition for Harlem*, 37–38.

30. See Stern, Gilmartin, and Massengale, *New York 1900*, 290–91, 295.

31. *Inner City Infill: A Housing Competition for Harlem*, 37–38.

32. *Inner City Infill: A Housing Competition for Harlem*, 31.

33. Wissinger, "Inner City Infill: Housing for Harlem": 24.

34. Richard Plunz, "Strange Fruit: The Legacy of the Design Competition in New York Housing," in *Reweaving the Urban Fabric: Approaches to Infill Housing*, 116.

35. Anemona Hartocollis, "Religious Leaders Plan Schools with Public Funds in New York," *New York Times* (December 29, 1998): 1, B: 5; Anemona Hartocollis, "8 Charter Schools, 4 with Profit Goal, Are Picked by State," *New York Times* (June 16, 1999): 1, B: 5.

36. Paul Goldberger, "Designs That Reach High for People with Low Incomes," *New York Times* (November 8, 1987), II: 38, 43; Roy Strickland, "Infill Housing in New York," *Progressive Architecture* 69 (January 1988): 37–38, 40, 43; Karen D. Stein, "Filling Vacancies: Proposals for Low- and Moderate-Income Housing," *Architectural Record* 176 (February 1988): 71; David Masello, "Designs for Vacant Lots," *Metropolis* 7 (March 1988): 24; "Infill Housing Correction," *Progressive Architecture* 69 (March 1988): 11; Herbert Muschamp, "The Breached Wall," *New Republic* 198 (April 11, 1998): 27–30; Willis and Genevro, eds., *Vacant Lots*; Hadley Arnold, ed., *Work Life: Tod Williams Billie Tsien* (New York: Monacelli Press, 2000), 237–39.

37. Strickland, "Infill Housing in New York": 37.

38. Stern, Mellins, and Fishman, *New York 1960*, 883–84.

39. Goldberger, "Designs That Reach High for People with Low Incomes": 43.

40. Strickland, "Infill Housing in New York": 40.

41. Quoted in Willis and Genevro, eds., *Vacant Lots*, 136.

42. Strickland, "Infill Housing in New York": 43.

43. James Tice, quoted in Willis and Genevro, eds., *Vacant Lots*, 184.

44. Goldberger, "Design That Reach High for People with Low Incomes": 38.

45. Paul Rosenblatt, quoted in Willis and Genevro, eds., *Vacant Lots*, 58.

46. Goldberger, "Design That Reach High for People with Low Incomes": 38.

47. Gustavo Bonevardi and Lee Ledbetter, quoted in Willis and Genevro, eds., *Vacant Lots*, 43.

48. Muschamp, "The Breached Wall": 30.

49. Sydney H. Schanberg, "No Room in the City," *New York Times* (December 25, 1984): 27; William Sloane Coffin, "New York's Housing Disaster," *New York Times* (February 2, 1985): 21; Michael deCourcy Hinds, "Adapting to the High Cost of Housing," *New York Times* (February 3, 1985), VIII: 1, 14; Michael deCourcy Hinds, "Deterioration Threatens City's Housing," *New York Times* (February 17, 1985), VIII: 1; Joseph Berger, "Failure of Plan for Homeless Reflects City Housing Crisis," *New York Times* (February 19, 1985): 1, B: 5; Josh Barbanel, "City Has Fewer Rental Apartments, Survey Finds," *New York Times* (March 6, 1985): B: 7; Alan S. Oser, "Housing Study Finds Shift to Ownership," *New York Times* (March 10, 1985), VIII: 7; "First Save Public Housing," editorial, *New York Times* (April 20, 1985): 22; deCourcy Hinds, "Facing Up to the Housing-Supply Issue": 1, 6; "Unjam New York's Housing," editorial, *New York Times* (September 27, 1986); William A. Moses, "Existing Buildings Are the Best Bet," letter to the editor, *New York Times* (October 14, 1986): 34; "Reversing a Trend, Housing Increases in New York City," *New York Times* (December 27, 1987): 59; Alan Finder, "Moderate-Priced Housing: Must City Be Forever Short of Affordable Living Space?" *New York Times* (May 1, 1988), IV: 6; "Housing Crisis, Housing Emergency," editorial, *New York Times* (May 10, 1988): 30; Nora Richter Greer, "Housing: Deepening Crisis and Stirrings of Response," *Architecture* 77 (July 1988): 58–63.

50. Alan S. Oser, "Perspectives: Inclusionary Zoning; New Bonuses Spur Low-Income Units," *New York Times* (March 20, 1988), VIII: 9, 22; Alan S. Oser, "Perspectives: Low-Income Housing; Manhattan 421a Carrot Bitten in Brooklyn," *New York Times* (April 17, 1988), X: 9; Alan S. Oser, "Swapping Tax Credits for Housing," *New York Times* (June 21, 1988), B: 1, 5; Raymond W. Gastil, "Designing Public Housing," *Metropolis* 8 (December 1988): 23–25; Alan S. Oser, "Perspectives: Providing for Parking; The 'San Francisco Solution' Comes East," *New York Times* (December 4, 1988), X: 9; Paul Goldberger, "On a Desolate Beach in Queens, a Point of Departure," *New York Times* (July 23, 1989), II: 29; Iver Peterson, "Linking 421a to Low-Income Housing," *New York Times* (December 17, 1989), X: 1, 7; "Spring Creek; Brooklyn, New York," *Architecture* 79 (July 1990): 52–53; Philip Arcidi, "Affordable Housing: Essays," *Progressive Architecture* 72 (June 1991): 110–11; "A Secure Rental Oasis for East New York," *New York Times* (January 9, 1994), X: 1, 10; Alan Melting, "'Secure Rental Oasis for East New York,'" letter to the editor, *New York Times* (January 30, 1994), X: 12; Theresa Braine, "High Wire Act: Affordable Housing Design," *Grid* 2 (January + February 2000): 90–92.

51. Peterson, "Linking 421a to Low-Income Housing": 1, 7.

52. Edward I. Koch, quoted in Arthur Brown, Dan Collins, and Michael Goodwin, *I Koch* (New York: Dodd, Mead, 1985), 290. Also quoted in Plunz, *A History of Housing in New York City*, 371 (n.71).

53. Alan S. Oser, "A New Way of Creating Mixed-Income Developments," *New York Times* (March 17, 1985), VIII: 7.

54. Josh Barbanel, "Koch to Propose $4 Billion Plan to Add Housing," *New York Times* (January 3, 1985), B: 3; Maurice Carroll, "Cuomo to Offer $3.5 Million Plan to Aid Housing," *New York Times* (January 9, 1985), B: 1, 3; Maurice Carroll, "Key Housing Issues Confront Three State Legislatures," *New York Times* (January 13, 1985), VIII: 7; "Koch Offers Innovations, but Few Price Tags," *New York Times* (February 3, 1985), IV: 7; Alan Finder and Alan Scardino, "High Hopes for Housing," *New York Times* (May 26, 1985), IV: 6; deCourcy Hinds, "Facing Up to the Housing-Supply Issue": 1, 6; "More Housing on the Way," *New York Times* (March 23, 1986), IV: 6; "Battery Park City Authority in $180 Million Issue," *New York Times* (August 19, 1986), D: 19; Michael Quint, "Battery Park Revenues to Back Housing Bonds," *New York Times* (October 1, 1987), D: 1; Alan S. Oser, "Perspectives: Rehabilitation; 'Public Housing' in Abandoned Buildings," *New York Times* (October 4, 1987), VIII: 9, 22; Michael Quint, "Battery Park Pays More Than Its Way," *New York Times* (October 25, 1987), IV: 7; Jeffery Schmalz, "New York Reaches Accord on Housing," *New York Times* (December 27, 1987): 1, 38; Jeffrey Schmalz, "Cuomo Figures for New Housing Found Overstated by 500%," *New York Times* (March 24, 1988), B: 1–2.

55. "Housing Needs More Than Capital," editorial, *New York Times* (February 27, 1985): 22.

56. Edward I. Koch and Mario Cuomo, "How New York Designs a Housing Program," letter to the editor, *New York Times* (March 11, 1985): 18.

57. Alan S. Oser, "Perpectives: Affordability; Organizing to Build More Housing," *New York Times* (January 5, 1986), VIII: 6; Alan S. Oser, "Grappling with the Housing Issue," *New York Times* (April 27, 1986), VIII: 6.

58. David W. Dunlap, "Koch Urges Major Rezoning in 4 Boroughs to Add Housing," *New York Times* (April 17, 1986), B: 1, 4; "A Boldly Ordinary Housing Plan," editorial, *New York Times* (May 3, 1986): 26; William G. Blair, "Queens Fears Impact of New Multifamily Dwellings," *New York Times* (May 11, 1986), VIII: 7; Michael deCourcy Hinds, "Delays Beset 255-Unit Modular Project in Brownsville," *New York Times* (June 29, 1986), VIII: 7; Michael deCourcy Hinds, "Affordability vs. the Building Code," *New York Times* (September 7, 1986), VIII: 6; Alan Finder, "Plan to Build Basic Housing Hits Cost Snag," *New York Times* (January 10, 1987): 29; Jesus Rangel, "Group Proposes 3 Programs to Meet Increase in the Homeless," *New York Times* (January 25, 1987): 25.

59. Robert Esnard, quoted in Hinds, "Affordability vs. the Building Code": 6.

60. Quoted in Hinds, "Affordability vs. the Building Code": 6. Also see Dennis Hevesi, "When Builders Are Inspectors," *New York Times* (December 3, 2000), XI: 1, 6.

61. "A Boldly Ordinary Housing Plan": 26.

62. Joyce Purnick, "Koch to Announce Plan for 250,000 Apartments," *New York Times* (April 30, 1986), B: 3; Michael deCoursy Hinds, "A $3 Billion City Housing Proposal," *New York Times* (May 18, 1986), VIII: 6; Alan Finder, "10-Year Plan for Housing Under Attack," *New York Times* (December 4, 1986), B: 1, 15; Alan Finder, "City Increases Income Limits in Rental Plan," *New York Times* (April 2, 1987), B: 1, 8; Alan Finder, "$4.2 Billion Housing Program Moves off Ground Floor," *New York Times* (April 28, 1988), B: 1, 6; Alan Finder, "Koch Proposes Larger Plan to Renovate City Dwellings," *New York Times* (May 5, 1988), B: 3; Alan S. Oser, "Perspectives: The 10-Year Plan; Broadening the City's Housing Agenda," *New York Times* (May 15, 1988), X: 9; Sam Roberts, "Deserted Houses Slowly Becoming Homes Again," *New York Times* (October 17, 1988), B: 1; James Barron, "$5 Billion Plan for Apartment Pushed in Bronx," *New York Times* (February 28, 1989), B: 4; Thomas J. Lueck, "Sponsors of Rebuilt Housing Foresee 1,000 More Units," *New York Times* (May 15, 1989), B: 3; Alan Finder, "Bronx Housing Impresses Rockefeller and Builders," *New York Times* (June 15, 1989), B: 1; Camilo José Vergara, "Lessons Learned, Lessons Forgotten: Rebuilding New York City's Poor Communities," *Livable City* 15 (March 1991): 3–9; Jayne Merkel, "Hard Times for Housing," *Oculus* 57 (June 1995): 10–14, 17; Gregg G. Van Ryzin and Andrew Genn, "The Neighborhood Impacts of New York City's Ten Year Housing Plan," *Properties: The Review of the Steven L. Newman Real Estate Institute* 3 (Spring 2000): 109–21.

63. Jack Rosenthal, "The Pyramids of New York," *New York Times* (January 29, 1989), IV: 22.

64. Roger Starr, "Editorial Notebook; Low-Income Housing That Works," *New York Times* (August 25, 1991): 14.

65. Vergara, "Lessons Learned, Lessons Forgotten": 3, 9.

66. Iver Peterson, "New Housing Outlook for New York Is Gloomy," *New York Times* (September 30, 1990), X: 1, 9; Alan Finder, "After Decades of Rises, Rents Sag in Much of New York City," *New York Times* (November 29, 1990): 1, D: 20; Thomas J. Lueck, "Bottom of the Housing Slump Is Seen in the New York Area," *New York Times* (March 1, 1991): 1, D: 5; Nick Ravo, "New Housing at Lowest Since '85," *New York Times* (August 30, 1992), X: 1, 4.

67. Peter Marcuse, quoted in Alan Finder, "Apartment Doubling-Up Hits the Working Class," *New York Times* (September 25, 1990): 1, B: 6. Also see Andrew White, "Overcrowded Masses," *City Limits* 17 (October 1992): 20–21.

68. Jane Fritsch, "New York Agency Cuts Apartments for the Homeless," *New York Times* (August 19, 1992): 1, B: 2; James Bennet, "Dinkins Pact Cuts Homeless in the Projects," *New York Times* (August 21, 1992), B: 1, 4; "A Halfhearted Homeless Policy," editorial, *New York Times* (August 24, 1992): 14; Celia W. Dugger, "Tough Help for Homeless," *New York Times* (September 25, 1992): 1, B: 4; Celia W. Dugger, "Limits Sought on Shelters for Homeless," *New York Times* (September 19, 1992): 21–22.

69. Thomas J. Lueck, "Breaking New Ground in Housing Policy," *New York Times* (April 30, 1989), X: 1, 18; Jeannette Walls, "'Tier II': An SRO by Any Other Name?" *New York* 24 (January 21, 1991): 11; Susan Gilman, "Board 7/Temporary Residence for Homeless Is Debated," *New York Observer* (January 21, 1991): 6; "The Welfare Hotel That Isn't," editorial, *New York Times* (February 4, 1991): 16; Catherine S. Manegold, "A Conflict Over Havens That Advise and Shelter," *New York Times* (September 20, 1992): 43.

70. Peter Salins, quoted in Peterson, "New Housing Outlook for New York Is Gloomy": 9.

71. Ravo, "New Housing at Lowest Since '85": 4.

72. Alan Finder, "Homes for Middle Class Rise on Blighted Blocks," *New York Times* (April 9, 1991), B: 3.

73. Margaret Mittlebach, "Suburbs in the City," *City Limits* 16 (May 1991): cover, 12–16.

74. Alan Finder, "New York Pledge to House Poor Works a Rare, Quiet Revolution," *New York Times* (April 30, 1995): 1, 40; Alan Finder, "Success of Housing Program Rests on Economy," *New York Times* (May 2, 1995), B: 3.

75. Van Ryzin and Genn, "The Neighborhood Impacts of New York City's Ten Year Housing Plan": 111.

76. "A Way Out of the Homeless Hotels," editorial, *New York Times* (December 25, 1985): 30; Irving Lepselter, "Housing the Homeless," letter to the editor, *New York Times* (January 15, 1986): 22; "An Alternative to Welfare Hotels for the Homeless," *New York Times* (February 23, 1986), IV: 6; "Spartan Help for the Homeless," editorial, *New York Times* (February 25, 1986): 30; "What $70,000 Buys for the Homeless," editorial, *New York Times* (March 25, 1986): 30; Barbara Basler, "Private Group Prepares Housing for Homeless," *New York Times* (July 3, 1986), B: 5; "At Last, a Little Help for the Homeless," *New York Times* (February 20, 1987): 30; Paul Goldberger, "Designing a Decent Alternative for the Homeless," *New York Times* (March 27, 1988), II: 39, 44; "HELP I," *Progressive Architecture* 69 (October 1988): 76–77; Sam Howe Vanderhovek, "Cuomo Son Plans Units for Homeless," *New York Times* (October 31, 1988), B: 3; Paul M. Sachner, "Heroes in Our Own Backyard," *Architectural Record* 176 (November 1988): 82–85; Paul Goldberger, "Fashions in Bricks and Mortar Make Room for Conscience," *New York Times* (December 25, 1988), II: 32; Michael Mostoller with Victoria Geibel, "A Refuge from the Street," *Metropolis* 8 (March 1989): 54–59, 79, 81, 83–84; Paul Goldberger, "Why Design Can't Transform Cities," *New York Times* (June 25, 1989), II: 1, 30; Eve M. Kahn, "SOM's Sensible Shelters," *Wall Street Journal* (August 31, 1992): 8.

77. Basler, "Private Group Prepares Housing for Homeless": 5; "At Last, a Little Help for the Homeless": 30; Goldberger, "Designing a Decent Alternative for the Homeless": 39, 44; Sachner, "Heroes in Our Own Backyard": 82–85; Goldberger, "Fashions in Bricks and Mortar Make Room for Conscience": 32; Mostoller and Geibel, "A Refuge from the Street": 59.

78. Goldberger, "Designing a Decent Alternative for the Homeless": 39, 44.

79. Verhovek, "Cuomo Son Plans Units for Homeless": 3; McKee, "South Bronx": 86–95.

80. Verhovek, "Cuomo Son Plans Units for Homeless": 3; Sam Roberts, "Beyond Theories to What Works for the Homeless," *New York Times* (February 4, 1991), B: 1; "Metropolitan Desk," *New York Times* (December 18, 1993): 27; McKee, "South Bronx": 86–95; Rafael A. Olmeda, "Helping Homeless Kids Scout Out Their Future," *New York Daily News* (May 9, 1995), Metro: 3.

81. Clifford A. Pearson, "Chapter Two," *Architectural Record* 180 (July 1992): 108–13; Kahn, "SOM's Sensible Shelters": 8; "1993 Design Awards," *AIA New York State News* (November 1993): 10.

82. Kahn, "SOM's Sensible Shelters": 8.

83. Conrad Levenson and Tony Schuman, quoted in Kahn, "SOM's Sensible Shelters": 8.

84. George James, "Budget Agreement Postpones Showdown on Koch Shelter Plan," *New York Times* (June 18, 1987): B: 1, 8; Goldberger, "Designing a Decent Alternative for the Homeless": 39, 44; Paul Goldberger, "What's at Stake Is Control Over the Building Process," *New York Times* (May 15, 1988), II: 48; Goldberger, "Fashions in Bricks and Mortar Make Room for Conscience": 32; Goldberger, "Why Design Can't Transform Cities": 1, 30; Alan S. Oser, "The New Shelters for Homeless Families," *New York Times* (April 8, 1990), X: 7, 10; Clifford A. Pearson, "Beyond Shelters," *Architectural Record* 180 (July 1992): 84–91; Kahn, "SOM's Sensible Shelters": 8; "1993 Design Awards": 10.

85. Conrad Levenson, quoted in Kahn, "SOM's Sensible Shelters": 8.

86. Kahn, "SOM's Sensible Shelters": 8.

87. Goldberger, "Designing a Decent Alternative for the Homeless": 44.

88. Larry Conklin, quoted in Jennifer Stern, "Serious Neglect: Housing for Homeless People with AIDS," *City Limits* 14 (April 1989): 12–15. Also see Beverly Cheuvront, "Double Jeopardy: Facing AIDS and Homelessness," *City Limits* 13 (February 1988): 12–15.

89. Michel Marriott, "Koch Picks 8 Sites in 3 Boroughs to House Homeless AIDS Patients," *New York Times* (October 31, 1988): 1, 3; Robert D. McFadden, "Koch Criticized on Plan to Open AIDS Shelters," *New York Times* (November 1, 1988): B: 1–2; David W. Dunlap, "AIDS Plan for Center Is Rejected," *New York Times* (September 29, 1989): B: 3.

90. Cheuvront, "Double Jeopardy: Facing AIDS and Homelessness": 12–15; Eve Kahn, "A Place of Refuge," *Metropolis* 7 (May 1988): 30–31; Stern, "Serious Neglect: Housing for Homeless People with AIDS": 12–15; Alexander Farnsworth, "AIDS and Architecture," *Metropolis* 10 (December 1990): 21–23.

91. Marriot, "Koch Picks 8 Sites in 3 Boroughs to House Homeless AIDS Patients": 1; Christopher Gray, "Streetscapes /Woodycrest Children's Home," *New York Times* (January 8, 1989), X: 6; Stern, "Serious Neglect: Housing for Homeless People with AIDS": 12–15; Farnsworth, "AIDS and Architecture": 22; Mireya Navarro, "AIDS Residence Housing Families Faces Review," *New York Times* (October 20, 1991): 26; Karin Tetlow, "Family Value," *Interiors* 151 (December 1992): 40–41; Norval White and Elliot Willensky, *AIA Guide to New York City*, 4th ed. (New York: Crown Publishers, 2000), 590.

92. "Speyer School Building," *New York Times* (January 6, 1991), X: 1; White and Willensky, *AIA Guide* (2000), 478.

93. Steven Bodow, "Design for AIDS Care," *Architecture* 80 (July 1991): 73; Bruce Lambert, "A Rare Welcome for an AIDS Project," *New York Times* (December 26, 1993), XIII: 6; Karin Tetlow, "Treatment Center," *Interiors* 154 (November 1995): 60–63; David W. Dunlap, "Building Blocks in the Battle on AIDS," *New York Times* (March 20, 1997), IX: 1, 6.

94. David W. Dunlap, "AIDS and the Practice of Architecture," *New York Times* (April 3, 1994), X: 1, 6; "AIDS Housing: An Integrated Approach," *Architecture* 85 (March 1996): 149; Dunlap, "Building Blocks in the Battle on AIDS": 1; Julie V. Iovine, "For AIDS Housing; Quality Where It Counts," *New York Times* (April 10, 1997), C: 1, 6.

95. Dunlap, "AIDS and the Practice of Architecture": 1, 6; Dunlap, "Building Blocks in the Battle on AIDS": 1.

96. Michael J. Crosbie, "Pro Bono Architecture," *Architecture* 81 (September 1992): 91–96; "Claremont Park Family Care Center," *Progressive Architecture* 74 (January 1993): 54–55.

97. Shawn G. Kennedy, "Defaults Rise, Posing Peril for Housing," *New York Times* (May 31, 1994), B: 1–2; Jesse Drucker, "Rudy's Housing Sale Has Tenants Bristling," *New York Observer* (September 19, 1994): 1, 17; Shawn G. Kennedy, "Working to End Landlord Role, New York Faces Hurdles," *New York Times* (September 24, 1994): 21–22; "New York's New Housing Plan," editorial, *New York Times* (November 4, 1995): 22; Alan S. Oser, "New York City Shifts Tactics on Troubled Housing," *New York Times* (June 6, 1996), IX: 7.

98. "New York's New Housing Plan," editorial, *New York Times* (November 4, 1995): 22.

99. Kennedy, "Working to End Landlord Role, New York Faces Hurdles": 21–22.

100. David W. Chen, "One Housing Woe Gives Way to Another," *New York Times* (December 21, 2003): 49, 52.

101. Tom Fox, quoted in Anne Raver, "Is This City Big Enough for Gardens and Houses?" *New York Times* (March 27, 1997), C: 1, 8.

102. Anne Raver, "Houses Before Gardens, the City Decides," *New York Times* (January 9, 1997), C: 1, 4; Chrisena Coleman, "Rudy Urged to Leaf Gardens," *New York Daily News* (January 31, 1997): 1; Cathleen McGuire, "Room for Gardens," letter to the editor, *New York Times* (February 6, 1997), C: 7; Raver, "Is This City Big Enough for Gardens and

Houses?": 1, 8; Douglas Martin, "City Takeover Looms for Gardens on Vacant Lots," *New York Times* (May 1, 1998), B: 1, 10; Cody Lyon, "Urban Oases Imperiled," letter to the editor, *New York Times* (May 4, 1998): 18; Douglas Martin, "A Garden Caught in a Housing Squeeze," *New York Times* (May 18, 1998), B: 4; Anthony R. Smith, "Gardens and Housing," letter to the editor, *New York Times* (May 19, 1998): 20; Chrisena Coleman, "City Bugs Gardeners; Plan to Reclaim Lots Stirs Anger and Opposition," *New York Daily News* (May 21, 1998): 10; Jodi Wilgoren, "Bulldozers Raze a Student Garden in Harlem," *New York Times* (November 3, 1998), B: 3; Paul Winkeller, "Bulldoze a Garden? Only in New York," letter to the editor, *New York Times* (November 5, 1998): 28; Anne Raver, "Auction Plan for Gardens Stirs Tensions," *New York Times* (January 11, 1999), B: 1, 7; "For Sale: The Garden of Eden," editorial, *New York Times* (January 14, 1999): 20; Leslie H. Lowe, "Garden Auction Is Slap at Civility," letter to the editor, *New York Times* (January 16, 1999): 16; Joan Ewing and Audrey Tumbarello, "Garden Auction Is Slap at Civility," letter to the editor, *New York Times* (January 16, 1999): 16; Albor Ruiz, "Garden-Lot Sell-Off Is One Bad Harvest," *New York Daily News* (January 25, 1999): 4; David Lefer, "Garden Flap Growing; Giuliani to Auction 126 Lots," *New York Daily News* (February 21, 1999): 26; Dan Barry, "Garden-Lovers Arrested at City Hall Sit-In," *New York Times* (February 25, 1999), B: 8; Jennifer Kalb, "Saving City Gardens," letter to the editor, *New York Times* (March 3, 1999): 16; David M. Herszenhorn, "A Community Garden in Brooklyn Wins Reprieve," *New York Times* (March 19, 1999), B: 4; Anne Raver, "Hundreds Gather to Protest City's Auction of Garden Lots," *New York Times* (April 11, 1999): 33; "Hundreds Rally to Save Community Gardens," *New York Times* (April 12, 1999), B: 6; Anne Raver, "City Rejects $2 Million Offer for Gardens" *New York Times* (April 23, 1999), B: 3; Gregory Heller, Richard Kassel, and Jane Weissman, "New York's Vital Patches of Green," letters to the editor, *New York Times* (April 27, 1999): 22; A. Carleton Dukess, "City Gardens Endure," letter to the editor, *New York Times* (April 28, 1999): 28; "Selling the People's Gardens," editorial, *New York Times* (May 3, 1999): 28; Abby Goodnough, "Groups Sue to Stop Sale of Gardens Owned by City," *New York Times* (May 4, 1999), B: 11; David M. Herszenhorn, "Protestors Fight Auctioning of Community Gardens," *New York Times* (May 6, 1999), B: 6; David M. Herszenhorn, "Two More Suits Seek to Stop Sale of Gardens," *New York Times* (May 8, 1999), B: 2; Howard Golden, "To Enjoy the Park, You Must Get Out of the Car; Put Gardens to Good Use," letter to the editor, *New York Times* (May 10, 1999): 22; "Spitzer Sues to Block Auction of Garden Sites," *New York Times* (May 11, 1999), B: 4; Dan Barry, "Giuliani Seeks Deal to Sell 63 Gardens to Land Group and End Suits," *New York Times* (May 12, 1999), B: 1, 4; Michael Grunwald, "Mayor Giuliani Holds a Garden Sale: As New York's Hot Housing Market Engulfs Community Oases, Protests Grow," *Washington Post* (May 12, 1999): 1.

103. Fran Reiter, quoted in Raver, "Houses Before Gardens, the City Decides": 1.

104. Andrew Stone, quoted in Raver, "Auction Plan for Gardens Stirs Tensions": 1.

105. "For Sale: The Garden of Eden": 20.

106. Rudolph W. Giuliani, quoted in Grunwald, "Mayor Giuliani Holds a Garden Sale": 1.

107. Quoted in Herszenhorn, "Two More Suits Seek to Stop Sale of Gardens": 2.

108. Quoted in Barry, "Giuliani Seeks Deal to Sell 63 Gardens to Land Group and End Suits": 1.

109. "Bette Midler Chips In to Rescue Gardens," *New York Times* (May 13, 1999): 1; Dan Barry, "Sudden Deal Saves Gardens Set for Auction," *New York Times* (May 13, 1999), B: 1, 6; Michael Grunwald, "Plot Twist: $4.2 Million Saves New York Gardens; Better Midler Joins in Rescuing Community Oases," *Washington Post* (May 13, 1999): 2; "Miss M's Divine Intervention," editorial, *New York Times* (May 14, 1999): 26; John D. Echeverria, "Saving City Gardens," letter to the editor, *New York Times* (May 18, 1999): 22.

110. Echeverria, "Saving City Gardens": 22.

111. Lisa L. Colangelo, "Judge Lets Gardens Grow, Denies City Bid to Lift Ban on Development," *New York Daily News* (July 26, 2001), Metro: 1; Laura Mansnerus, "Judge Upholds Court Order Protecting Gardens on City Properties," *New York Times* (July 26, 2001), B: 2.

112. Anne Raver and Jennifer Steinhauer, "City in Talks to End Lawsuit Over Community Gardens," *New York Times* (April 26, 2002), B: 4; "Corrections," *New York Times* (May 2, 2002): 2; Michael Saul, "500 Gardens Saved in City Housing Deal," *New York Daily News* (September 19, 2002): 6; Jennifer Steinhauer, "Ending a Long Battle, New York Lets Housing and Gardens Grow," *New York Times* (September 19, 2002): 1, B: 8; "Houses or Gardens in New York City," editorial, *New York Times* (September 20, 2002): 26.

113. Michael Bloomberg, quoted in Saul, "500 Gardens Saved in City Housing Deal": 6.

114. "Houses or Gardens in New York City": 26.

DIGGING IN

1. Glenn Fowler, "Major Rebuilding of City Property Asked by New York Planning Unit," *New York Times* (March 13, 1978): 1; D: 6.

2. Edward M. Kresky, "Building New York City, and Non-Building," *New York Times* (December 29, 1979): 21. Also see "Before New York's Roof Collapses," editorial, *New York Times* (January 19, 1980): 22.

3. Glenn Fowler, "Work to Resume on Water Tunnel," *New York Times* (April 28, 1976): 29; Steven R. Weisman, "Beame Offers Budget Totaling $13.9 Billion," *New York Times* (April 23, 1977): 1, 24; "Fire Kills 1, Injures 3," *New York Times* (October 14, 1977): 86; "Pulling the Plug on New York's Water," editorial, *New York Times* (June 28, 1978): 22; David

Bird, "U.S. Aides Tour Third Water Tunnel," *New York Times* (December 1, 1978), B: 4; "Stalled Water Tunnel to Receive Some Work," *New York Times* (December 15, 1978), B: 2; Anna Quindlen, "$35 Million Loan Is Asked for 3d Tunnel," *New York Times* (May 1, 1979), B: 1; Roger Starr, "Fight to Save the City's Fine Water," *New York Times* (November 25, 1979), VI: 32; Clyde Haberman, "A Water Tunnel Is Badly Needed, Goldin Cautions," *New York Times* (January 5, 1981), B: 1, 5; Peter Kihss, "Offer Made to Finish Water Tunnel," *New York Times* (February 25, 1981), B: 1, 16; Joyce Purnick, "New York Has Reason to Pour $2.7 Billion into a Hole in the Ground," *New York Times* (April 26, 1981), IV: 8; "State Utility Proposes Funding N.Y.C. Water Job," *Engineering News-Record* 206 (March 5, 1981): 26; "New York: Symptoms of Decay," *The Economist* (August 1, 1981): 33; Richard J. Meislin, "City Is Urged to Reconsider Building 3d Water Tunnel," *New York Times* (August 2, 1981): 26; A. O. Sulzberger Jr., "New York Area Fights Complex Water Woes," *New York Times* (August 10, 1981): 1, B: 6; "N.Y.C. Trudges Along on Third Water Tunnel," *Engineering News-Record* 208 (June 24, 1982): 30; Martin Gottlieb, "City Accepts Bid on Part of 3d Water Tunnel," *New York Times* (February 25, 1983): 1, B: 4; "N.Y.C. Water Tunnel Revived," *Engineering News-Record* 210 (March 3, 1983): 14; "Innovators Mold N.Y. Tunnel," *Engineering News-Record* 213 (August 16, 1984): 27; "The Worm and the Apple: Tunnel Triumph," *New York Times* (February 14, 1985): 30; Bruce A. Silberblatt, "Tunnel Falls Short of a Triumph," letter to the editor, *New York Times* (February 27, 1985): 22; Joseph T. McGough Jr., "The Long-Range Plans for New York City's Water Supply," letter to the editor, *New York Times* (May 17, 1985): 30; Alexander Reid, "Tunnel No. 3 to Aid Distribution Lines Starting in the 90's," *New York Times* (July 25, 1985), B: 1, 4; George James, "Blaze Traps 90 at Tunnel Site," *New York Times* (September 5, 1985), B: 2; Martin Gottlieb, "City's Biggest Construction Boom: Public Projects," *New York Times* (January 13, 1986), B: 3; Crystal Nix, "Insurance Woes Delay Progress on New Tunnel," *New York Times* (April 11, 1986), B: 2; "Waterways and Airways: Invisible Monument," *New York Times* (October 5, 1986): 20; Roger Starr, "Now, to Get New Yorkers to Turn off the Faucet . . . ," *New York Times* (May 8, 1988), IV: 6; Daniel S. Levy, "Water," *Metropolis* 9 (June 1990): 78–84; Irwin Fruchtman, "System Needs Study," letter to the editor, *New York Times* (September 22, 1990): 22; "Third Water Tunnel," *Engineering News-Record* 225 (December 17, 1990): 17; Allen Soast, "Water Supply Project Now into Second Stage," *Engineering News-Record* 227 (August 5, 1991): 26; "New York Water Tunnel Work Increased," *New York Times* (March 6, 1992), B: 3; "Water Tunnel III," *Livable City* 16 (Fall 1992); Dennis Hevesi, "Tunnel Likened to Brooklyn Bridge in Complexity and Scale," *New York Times* (November 25, 1993), B: 3; Robert D. McFadden, "Body of Man Is Recovered from Tunnel," *New York Times* (November 26, 1993), B: 1, 13; Robert D. McFadden, "Investigators Start Inquiry at Tunnel," *New York Times* (November 27, 1993): 23; Ian Fisher, "Tunneling into a World of Danger," *New York Times* (November 28, 1993): 45; Marvine Howe, "Street-Level Fallout from a Tunnel," *New York Times* (December 5, 1993), XIV: 6; David W. Dunlap, "Construction Below, Opposition Above," *New York Times* (May 15, 1994), X: 1, 7; "Change of Location for Water-Tunnel Shaft," *New York Times* (June 19, 1994), X: 1; Lynette Holloway, "No Tunnel Vision: Anatomy of a Decision," *New York Times* (June 19, 1994), XIV: 10; Jonathan P. Hicks, "Audit Cites Mismanagement in Water Tunnel Project," *New York Times* (February 24, 1995), B: 3; Randy Kennedy, "Brooklyn-Queens Link Is Achieved in New Water Tunnel," *New York Times* (February 10, 1997), B: 1, 3; Stanley Greenberg, *Invisible New York: The Hidden Infrastructure of the City* (Baltimore and London: Johns Hopkins University Press, 1998), 72–73, plates 2–7; Thomas Kelly, "A Man a Mile," *Esquire* (October 1997): 54–59; Elizabeth Kolbert, "Far from Sky, Sandhogs Face Grit and Risk," *New York Times* (February 16, 1998): B: 1; Douglas Martin, "Decades After Its Conception, 3d Water Tunnel Set to Open," *New York Times* (August 6, 1998), B: 1, 8; Douglas Martin, "A Taste of Water from the Third Tunnel," *New York Times* (August 14, 1998), B: 3; James Sanders, "In New York, Seeking a Grand Vision of Public Works," *New York Times* (September 1, 2002), IV: 5; Denny Lee, "New York's Big Dig Heads for Midtown," *New York Times* (September 22, 2002), XIV: 6; Stanley Greenberg, *Waterworks* (New York: Princeton Architectural Press, 2003), 3–4, 150–51, plates 68–80; Adam Fifield, "The Underground Men," *New York Times* (January 12, 2003), XIV: 1, 7; David Grann, "City of Water," *New Yorker* 79 (September 1, 2003): 88–98; Winnie Hu, "Mayor Goes 550 Feet Below to Note Start of Tunnel Construction," *New York Times* (October 9, 2003), B: 4; Greg Gittrich, "City's Tunnel Vision," *New York Daily News* (October 7, 2003): 24–25; "New York's Big Dig," editorial, *New York Daily News* (October 14, 2003): 38; David Owen, "Concrete Jungle," *New Yorker* 79 (November 10, 2003): 62.

4. Grace Lichtenstein, "New York Bridges Aren't Falling, but Some Are Crumbling," *New York Times* (March 27, 1978), B: 1, 8. Also see Steve Ross, "Troubled Bridges," *New York 10* (November 14, 1977): 52–54, 56–57; Anna Quindlen, "A Federal Grant to Help Rebuild 126 City Bridges," *New York Times* (March 20, 1979): B: 1.

5. Josh Barbanel, "Shaky Bridges in New York," *New York Times* (November 28, 1982), IV: 6.

6. Calvin Sims, "New York's Shaky Bridges Facing New Cuts," *New York Times* (December 20, 1990), 1, B: 6. Also see Martin Gottlieb, "City's Biggest Construction Boom: Public Projects," *New York Times* (January 13, 1986), B: 3; "Feeding Time for Starved Bridges," editorial, *New York Times* (May 3, 1988): 34; Dennis Hevesi, "New York City Needs to Find Funds to Repair 600 Bridges," *New York Times* (April 18, 1988), B: 1, 4; Richard Levine, "Koch Budget Provides More for Bridges,"

New York Times (April 29, 1988), B: 1, 3; Richard Levine, "Koch to Seek New Agency for Bridges," New York Times (May 7, 1988): 29; Howard Golden, "Bridge Repair Work Needs the Safeguard of Public Review," letter to the editor, New York Times (August 23, 1988): 22; Michel Marriott, "A List of Repairs for New York City," New York Times (March 12, 1989), IV: 8; Michel Marriott, "Goldin Faults New York City for 'Deficiencies' in Bridges," New York Times (May 22, 1989), B: 4; "Bringing Back the Bridges," editorial, New York Times (September 29, 1989): 34; Calvin Sims, "Deterioration of Bridges Is Far Worse Than Feared," New York Times (September 15, 1990): 25, 27; Robin Pogrebin, "New York City's Bridges," New York Observer (September 24, 1990): 6; Calvin Sims, "Budget Threat to New York Bridges," New York Times (November 20, 1990), B: 4; Calvin Sims, "Corrosion's Rise Imperils Bridges over East River," New York Times (December 17, 1990), B: 5; "A Red Flag for New York's Bridges," editorial, New York Times (December 27, 1990): 18; Calvin Sims, "Chief of Bridges to Seek Advice on Repair Plan," New York Times (January 14, 1991), B: 5; Calvin Sims, "Procedures on Bridge Repairs Satisfy U.S. Road Engineers," New York Times (February 21, 1991), B: 4; "A Spotlight on New York's Bridge Mess," editorial, New York Times (February 28, 1991): 24; Martin Tolchin, "Most New York City Bridges Are Failing, a Study Finds," New York Times (April 2, 1991), B: 3; Josh Barbanel, "Bond Plan for Bridges Is Thwarted: Maintenance Work Thrown into Doubt," New York Times (July 13, 1991): 23; Calvin Sims, "Increase in Bridge Upkeep Is Planned," New York Times (August 10, 1991): 23.

7. Stern, Gilmartin, and Massengale, New York 1900, 50–51.

8. "Roadway Is Shut on the Williamsburg," New York Times (April 11, 1988), B: 5; "Problem Beams Halt 2 Subways Crossing Bridge," New York Times (April 12, 1988), B: 3; Sarah Lyall, "The Williamsburg Bridge Is Shut for 2 Weeks as Cracks Are Found," New York Times (April 13, 1988): 1, B: 3; Don Terry, "For Commuters and Shopkeepers, a Trying Day Without the Williamsburg," New York Times (April 14, 1988), B: 2; Mark A. Uhlig, "Bridge Closing Puts New Emphasis on Inspections," New York Times (April 14, 1988), B: 2; "Gulliver's Cables," editorials, New York Times (April 17, 1988), IV: 26; Calvin Sims, "Bridge Troubles Provide a Case Study of Neglect," New York Times (April 17, 1988): 40; "City News Digest," New York Observer (April 18, 1988): 6; Kirk Johnson, "U.S. Aide Urges Private Industry to Help Bridge," New York Times (April 22, 1988), B: 3; Robert W. Selsam, "Forget About Fixing the Williamsburg Bridge," New York Times (April 23, 1988): 31; W. Miller, "The Vehicapult," cartoon, New Yorker 64 (April 25, 1988): 29; "Falling Down, Falling Down," editorial, New York Observer (April 25, 1988): 4; Kirk Johnson, "Agency Seeks Assurances Over Bridge," New York Times (April 25, 1988), B: 1, 4; Kirk Johnson, "Engineers Bash Away at Bridge to Get to the Roots of Its Rust," New York Times (April 30, 1988): 33, 35; Sam Roberts, "A Rotting Bridge and Who Takes the Blame for It," New York Times (May 9, 1988), B: 1; Kirk Johnson, "Corrosion on the Williamsburg Is Mainly on Approach Roads," New York Times (May 10, 1988), B: 1, 4; Lydia Chavez, "Stores Suffer Without the Williamsburg," New York Times (May 12, 1988), B: 1, 5; Kirk Johnson, "Williamsburg Bridge to Reopen in 3 Phases Starting in 3 Weeks," New York Times (May 14, 1988): 1, 34; Kirk Johnson, "Williamsburg Is Reopened for Cars Only," New York Times (May 27, 1988), B: 1, 3; Daralice D. Boles, "A Bridge Too Far?" Progressive Architecture 69 (June 1988): 28; "Williamsburg Bridge Replacement Competition," Architectural Record 176 (July 1988): 62–63; "All Lanes Reopened on the Williamsburg," New York Times (July 27, 1988), B: 4; "Creating a Lobby for Bridges," editorial, New York Post (July 29, 1988): 20; "Topics of The Times: Good Bridgework," New York Times (August 9, 1988): 18; Kirk Johnson, "Management 101: Finding Ways to Save Bridges," New York Times (September 18, 1988), IV: 6. Also see Robert D. McFadden, "Replacing of Williamsburg Bridge Is Studied," New York Times (October 16, 1983): 39; Robert O. Boorsin, "A Critical Point for Bridge Repair Plan," New York Times (January 26, 1987), B: 1, 7; Howard W. French, "Two Steel Support Bars Fall from Williamsburg Bridge," New York Times (May 10, 1987): 28; Thomas Morgan, "Corrosion of Bridge's Cables Is Called Limited," New York Times (January 17, 1988): 30; Jesus Rangel, "Flights of Fancy Over the Williamsburg," New York Times (March 22, 1988), B: 1, 9.

9. "Gulliver's Cables": 26.

10. "Topics of The Times: Good Bridgework": 18.

11. "Saved: Historic Williamsburg Bridge," Architectural Record 183 (February 1995): 14; "Sheathing a Bridge," New York Times (January 23, 1996), B: 3; Somini Sengupta, "Sandblasting Safety Tent Draws Critics," New York Times (February 25, 1996), XIII: 8; "The Williamsburg," New York Observer (February 26, 1996): 2; "Calling It a Day," New York Times (February 28, 1996), B: 2; Dean Chang, "Roadwork Drives Commuters Nuts," New York Daily News (May 19, 1996): 26; Karen Zautyk, "The Road to Hell Is Paved . . . ," New York Daily News (July 15, 1996): 27; Mark Francis Cohen, "Bridge Goes from Woe to Woe," New York Times (July 21, 1996), XIII: 8; Alex Michelini, "It's Too Close for Comfort," New York Daily News (August 11, 1997): 5; David W. Dunlap, "The Preservation Band That Sets the Tone," New York Times (June 7, 1998), XI: 1, 22; John Sullivan, "Study Puts High Price on Fixing a Crumbling City," New York Times (August 25, 1998): 1, B: 4; Tara Bahrampour, "Williamsburg Bridge," New York Times (December 29, 2002), XIV: 7; Joseph Berger, "The Other Bridge, but All Brooklyn," New York Times (June 22, 2003): 25.

12. "Crack on Bridge Halts Train Service," New York Times (May 26, 1982), B: 3; Ari L. Goldman, "Brooklyn Trains Will Be Delayed in Bridge Repair," New York Times (August 4, 1983), B: 1; "Repairs to Divert 2 IND Runs," New York Times (August 4, 1985): 35; "$60 Million Given for Bridge Repairs," New York Times (October 7, 1985), B: 3; Robert O. Boorstin, "Manhattan

Bridge's Problems Drag On," New York Times (November 8, 1986): 33–34; Kirk Johnson, "Halt Is Planned in Bridge Work over East River," New York Times (August 18, 1988), B: 3; "One Fewer Traffic Obstacle," New York Times (December 10, 1988), B: 1; Dennis Hevesi, "Hazards Halt Manhattan Bridge Subway Line," New York Times (December 28, 1990): 1, B: 3; Calvin Sims, "New York Reopened Bridge Subway Line in Spite of Warnings," New York Times (January 8, 1991): 1, B: 4; Calvin Sims, "Engineers Cite Design Flaw in Bridge Woes," New York Times (February 11, 1991), B: 1, 4; Garry Pierre-Pierre, "Neglect of Manhattan Bridge Takes Toll in Time and Money," New York Times (April 10, 1996), B: 1, 4; Garry Pierre-Pierre, "After 3 Years of Repairs, Deck of Bridge Set to Reopen," New York Times (August 30, 1996), B: 3; Randy Kennedy, "On the East River, a Big Fixer-Upper," New York Times (December 3, 2001), F: 1, 4. For the Manhattan Bridge, see Stern, Gilmartin, and Massengale, New York 1900, 51–53.

13. Lindsey Gruson, "Long Unlucky, Rail Bridge Hits $55 Million Repair Jackpot," New York Times (November 30, 1991): 21–22; "The Talk of the Town: Junket," New Yorker 68 (April 27, 1992): 30–32; "Hell Gate Bridge Repainted," Municipal Art Society Newsletter (May/June 1992): 1; Michael T. Kaufman, "When Made Over, Hell Gate Bridge Won't Clash with East River," New York Times (December 26, 1992): 24; I. Donald Weston, "Oh, Please Don't Paint That Bridge Bright Red," letter to the editor, New York Times (January 9, 1993): 24; Janet Heller, "More Colorful Bridges," letter to the editor, New York Times (January 27, 1993): 22. For the Hell Gate Bridge, see Stern, Gilmartin, and Massengale, New York 1900, 54–56.

14. Quoted in "Hell Gate Bridge Repainted": 1.

15. Donald Kaufman, quoted in "The Talk of the Town: Junket": 31–32.

16. Daniel B. Schneider, "F.Y.I.: New Lighting for George," New York Times (September 24, 2000), XIV: 2; Margo Nash, "In the Dark with George," New York Times (November 3, 2002), XIV: 3; Mark Maddaloni, "Nice Bridge! But Pricey," letter to the editor, New York Times (December 1, 2000): 36; Hendrik Hertzberg, "Gorgeous George," New Yorker 77 (March 26, 2001): 76–77; Nayana Currimbhoy, "New Uplighting Captures the Engineering Beauty of Manhattan's George Washington Bridge," Architectural Record 189 (May 2001): 320–23; Ellen Lampert-Graux, "Domingo Gonzalez Associates Circles the City with Light," Lighting Dimensions (May 2001): 25; Martin C. Pedersen, "City High Lights," Metropolis 21 (May 2002): 88–89. For the George Washington Bridge, see Stern, Gilmartin, and Mellins, New York 1930, 676–82.

17. Nash, "In the Dark with George": 3.

18. Hertzberg, "Gorgeous George": 77.

19. Lisa Foderaro, "Trinity's Bridge," New York Times (April 1987), VIII: 1; "Taking on a Small Challenge," Engineering News-Record 219 (August 20, 1987): 12; Sam Roberts, "Metro Matters," New York Times (December 28, 1987), B: 1; Elaine Louie, "A Footbridge from Another Era," New York Times (April 27, 1989), C: 3; White and Willensky, AIA Guide (2000), 23.

20. For the Loew Bridge, see Stern, Mellins, and Fishman, New York 1880, 61, 63.

21. See Robert Caro, The Power Broker: Robert Moses and the Fall of New York (New York: Random House, 1974), 904–8.

22. Richard Haitch, "Rail Promises," New York Times (April 4, 1976): 37; Edward C. Burks, "Airport Rail Link Pushed," New York Times (August 22, 1976), XI: 10; Ralph Blumenthal, "Port Agency Plans to Put $240 Million into Bus Programs," New York Times (June 10, 1977): 1, B: 2. Also see Will Lissner, "Midtown to Be Linked to Kennedy Airport by Rail," New York Times (February 29, 1968): 1; Frank J. Prial, "Go-Ahead on Rail Links to 2 Airports Announced," New York Times (May 16, 1971): 1, 69.

23. Grace Lichtenstein, "Experimental Bus-Subway Route to Kennedy Planned," New York Times (June 27, 1978), B: 2; Grace Lichtenstein, "Carey Announces Express Service to Kennedy by Bus and Subway," New York Times (June 28, 1978), B: 3; Larry Kardish, "By M.T.A. from Kennedy: A Bus in Blue, a Subway Train with Luggage Racks," New York Times (December 17, 1978), X: 15; Francis X. Clines, "The Subway Route to the Sun," New York Times (January 13, 1979): 26; Maria Torres de Sanchez, Kenneth R. Anderson, and Robert Berke, "M.T.A. to J.F.K.," letters to the editor, New York Times (January 21, 1979), X: 11; Ari L. Goldman, "JFK Train: Wasteful or Wonderful," New York Times (June 5, 1980), B: 1, 13.

24. David E. Pitt, "Transit Agency Wants to End Airport Express," New York Times (October 22, 1989): 40; Brendan B. Read, "A Commuter Rail Link to Kennedy Airport Still Makes Sense," letter to the editor, New York Times (January 25, 1990): 22; Jack Permut, "Rail Link to Airport," letter to the editor, New York Times (February 17, 1990): 22; Calvin Sims, "M.T.A. Proposes Rail Line to Link Major Airports," New York Times (March 18, 1990): 20; Steven Saltzman, "'Take the Train to the Plane," Metropolis 9 (June 1990): 22; Barbara Crossette, "Proposed Trains Between Planes in New York," New York Times (October 6, 1991), V: 3; "The City and Its Environs," Oculus 54 (November 1991): 3; "Airport Light Rail Connector," Oculus 54 (February 1992): 12; Janette Sadik-Khan, "Airport Access," Livable City 16 (Spring 1992): 2.

25. James Dao, "Dream Train to Airports Takes Step Nearer Reality," New York Times (December 21, 1992), B: 1, 10; "It Takes Years to Get to J.F.K.," New York Times (December 26, 1992): 20; Stanley Brezenoff, "Light-Rail Link Between Manhattan and Airports Makes Sense," letter to the editor, New York Times (January 9, 1993): 22; Robert S. Leonard, "Extend the Subway," letter to the editor, New York Times (January 9, 1993): 22; Lisa W. Foderaro, "Train to the Plane: Will It Ever Fly?" New York Times (October 31, 1993): 39; Stephen A. Bauman, "Why Light-Rail Train to the Plane Won't Work," letter to the editor, New York Times (November 13, 1993): 22; Bruce Lambert, "Site for Airport Link Is Disputed," New York Times (June 19, 1994), XIV: 8; David S. Chartock, "$2B Light

Rail Could Provide Over 9,000 Jobs," New York Construction News 42 (June 27, 1994): 1, 3; Lynette Holloway, "That Other Train to the Plane," New York Times (July 10, 1994), XIV: 8; David Firestone, "Queens Residents Criticize Plan for an Airport Rail Link," New York Times (July 27, 1994), B: 1, 3; Bruce Kanin, "Proposed Rail Link to Airports Ignores Needs of New Yorkers," letter to the editor, New York Times (August 9, 1994): 22; "Speed the Train to the Plane," editorial, New York Times (August 11, 1994): 22; James E. Landry, "Airport-Rail Plan Makes Very Little Sense," letter to the editor, New York Times (August 19, 1994): 26; Richard Eyen, "Midtown Traffic Horrors Would Worsen with Airport Rail Link," letter to the editor, New York Times (August 26, 1994): 28; "The Link for La Guardia and JFK," Access New York: A Publication of the Port Authority of NY & NJ 1 (Summer 1994): 1–5; Richard Lynn, "Extend Airport Link Plan to Columbus Circle," letter to the editor, New York Times (September 26, 1994): 16; "Air Rail Link: Only Connect," editorial, New York Observer (October 17, 1994): 4; Carleen Hawn, "Train to the Plane Gets Some Support, with Reservations: Opposition to Proposed Route," New York Observer (October 24, 1994): 8; Clifford J. Levy, "Citing Rising Costs, Port Authority Kills Airport Rail Plan," New York Times (June 1, 1995): 1, B: 4; Randy Kennedy, "Stopping the Airport Rail Plan Is a 'Big Mistake,' Giuliani Says," New York Times (June 2, 1995), B: 5; "Keep the Train to the Plane Alive," editorial, New York Times (June 3, 1995): 18; Joyce Purnick, "The Train to the Plane Turns to Pie in the Sky," New York Times (June 5, 1995), B: 3; Daniel Patrick Moynihan, "History Will Judge New York City by Its Airport Rail Link," letter to the editor, New York Times (June 8, 1995): 28.

26. "It Takes Years to Get to J.F.K.": 20.

27. Moynihan, "History Will Judge New York City by Its Airport Rail Link": 28.

28. Gary Pierre-Pierre, "The A Train to the Airport Is a Bargain," New York Times (December 9, 1995): 25.

29. John Sullivan, "Rail Link Proposed from Penn Station to Kennedy Airport," New York Times (April 19, 1996), B: 1, 5; "Airport Access: From Dead to Deliverable," Municipal Art Society Newsletter (July-August 1996): 6; Neil MacFarquhar, "Agency Says J.F.K. Rail Plan Is Ready, but Mayor Balks," New York Times (March 13, 1997), B: 7; Alan Gotthelf, "New Train to the Plane," letter to the editor, New York Times (March 18, 1997): 20; Andy Newman, "Airport Fight Holds Up $23 Billion," New York Times (September 25, 1997), B: 1, 3; Andy Newman, "Officials Agree on Modest Plan for a Rail Link to One Airport," New York Times (October 2, 1997), B: 1, 3; "Approving the Rail Link to Kennedy," editorial, New York Times (November 18, 1997): 26; Andy Newman, "Lots of Lobbying, but No Decision on Rail Line to Kennedy Airport," New York Times (November 27, 1997), B: 10; Robert A. Olmsted, "Trains to the Airport," letter to the editor, New York Times (November 29, 1997): 14; Karrie Jacobs, "Train in Vain," New York 30 (December 8, 1997): 17–18; Robert Olmsted, "Off Track," letter to the editor, New York 30 (December 22–29, 1997): 20; Matthew L. Wald, "Plan Approved for a Kennedy Rail Link," New York Times (February 10, 1998), B: 5; David Rohde, "Giuliani Threatens to Oppose Kennedy Rail Link," New York Times (April 17, 1998): 1, B; 2; Norman Scott, "Better Airport Link," letter to the editor, New York Times (April 18, 1998): 12; Kira L. Gould, "Getting to the Airport," Oculus 60 (June 1998): 20–21; Neil MacFarquhar, "Disagreement Over Rent Stalls Airport Rail Project," New York Times (June 14, 1998): 25; "Quietly, New York City Backs Kennedy Rail Line," New York Times (July 24, 1998), B: 6; Clyde Haberman, "Train to Plane Is Seen Mainly as a Pain," New York Times (January 22, 1999), B: 1; David M. Herszenhorn, "Still Opposed, Planners Let Airport Link Go Ahead," New York Times (May 4, 1999), B: 8; "Train to the Plane," New York 32 (May 17, 1999): 45; Clyde Haberman, "Despite Holes, Good Enough for a City Plan," New York Times (May 28, 1999), B: 1; Vivian S. Toy, "Rail Link from Midtown to Kennedy Wins Pivotal Approval," New York Times (June 3, 1999), B: 1, 10; Dan Barry, "Port Authority Won Uphill Battle to Build Train to the Plane," New York Times (June 6, 1999): 41, 43; Robert A. Myers, "Train (and Taxi) to Plane," letter to the editor, New York Times (June 10, 1999): 30; "Airtrain," New York Construction News 48 (August 1999): 82; Matthew L. Wald, "F.A.A. Clears Way for Kennedy Train Project, Officials Say," New York Times (August 17, 1999), B: 2; Maki Becker, "Laying AirTrain Track," New York Daily News (December 13, 1999), Metro: 1; David S. Chartock, "Airtrain Profile," New York Construction News 48 (March 2000): 23, 31, 35–38, 40–44, 46; Aileen Cho, "Long-Awaited Light Rail System Snakes Toward New York's JFK," Engineering News-Record 245 (August 21, 2000): 74; "First Test Nears for AirTrain," New York Times (September 17, 2000), XI: 1; Andrés Martinez, "Now Boarding, the Overdue Train to the Plane," New York Times (December 18, 2001): 22; David S. Chartock, "Howard Beach Station Challenges Are Similar to Those for Jamaica," New York Construction News 49 (May 2002): 27; Ruth Bashinsky, "AirTrain Service Right on Track," New York Daily News (August 19, 2002): 3; Robert D. McFadden and Lydia Polgreen, "Train to Kennedy Derails in a Test," New York Times (September 28, 2002): 1, B: 4; Aileen Cho, "Accidents," Engineering News-Record 249 (October 7, 2002): 11; "Investigation," Engineering News-Record 249 (October 14, 2002): 7; "Airtrain at John F. Kennedy International Airport," New York Construction News 50 (December 2002): 83; Kristen Richards, "History as Prelude: Modern Interventions in Historic Context," Oculus (Spring 2003): 24–26; Clemente Lisi, "JFK AirTrain Testing Back on Track Today," New York Post (April 16, 2003): 2; David W. Dunlap, "Change at Jamaica," New York Times (July 6, 2003): 2; Aileen Cho, "An 'Airport Station' Marks Homestretch for Megaproject," Engineering News-Record 251 (August 18, 2003): 17; Corey Kilgannon, "A Possible Holiday Bonus: The AirTrain to Kennedy Airport May Soon Be Running," New York Times

(November 30, 2003): 42; Hugo Lindgren, "The Beast of Queens," *New York Times* (November 30, 2003), VI: 31; Susan Stellin, "A Train to the Plane, at Long Last," *New York Times* (December 14, 2003), V: 3; Warren Woodberry Jr., "AirTrain Rollin," *New York Daily News* (December 18, 2003): 12; Clemente Lisi, "New Train to the Plane," *New York Post* (December 18, 2003): 6–7; Julia Levy and Lisa Scherzer, "Racing to JFK," *New York Sun* (December 18, 2003): 1, 10; James Barron, "The Best Way to the Airport? It's a Race," *New York Times* (December 18, 2003), B: 6; Michael Luo, "Century After Wright Brothers, a Train to J.F.K.," *New York Times* (December 18, 2003): 1, B: 6; Joyce Purnick, "Pack Light. Not for Trip, but for AirTrain" *New York Times* (December 18, 2003), B: 1; Brian Harmon, "AirTrain a Great, Yet Still Rare, Find," *New York Daily News* (December 19, 2003): 27; Michael Luo, "Faulty Doors at Kennedy Airport Mar Start of AirTrain," *New York Times* (December 20, 2003), B: 3; Susan Saulny, "Finding J.F.K. Is Easy: First, Find the AirTrain," *New York Times* (January 20, 2004), B: 3; Susan Stellin, "J.F.K. by AirTrain: Bag the Bus," *New York Times* (April 4, 2004), V: 10.

30. Michael R. Bloomberg, quoted in Luo, "Century After Wright Brothers, a Train to J.F.K.": 1.

31. Ethan C. Eldon, "Our Subways: Worthy of a Second Dante," *New York Times* (July 2, 1976): 22.

32. Edward C. Burks, "215 More Daily Subway Runs Will Be Eliminated by Aug. 30," *New York Times* (August 14, 1976): 1, 22.

33. Stanley Turkel, "Subway System: To Destroy or to Save," letter to the editor, *New York Times* (December 4, 1976): 24.

34. Quoted in Ralph Blumenthal, "A 'Village' Artist Designs His Own Subway Map," *New York Times* (May 28, 1977): 17.

35. "Realism Gained in Subway Map," *New York Times* (February 1, 1978), B: 3; Ellen Stern, "Routes," *New York* 11 (February 6, 1978): 61; Paul Goldberger, "Design Notebook," *New York Times* (February 9, 1978), C: 10; "A New Subway Map That Goes Back to the Basics," *New York Times* (May 25, 1979), B: 3; "The Best Subway Map in Years," editorial, *New York Times* (July 1, 1979): 20; Paul Goldberger, "At Last, a Usable Subway Map," *New York Times* (August 2, 1979), C: 1, 11; Sam Allis, "Underground Artistry in New York," *Washington Post* (August 5, 1979), G: 3; Ben Yagoda, "How to Review a Subway Map," *New York Times* (February 24, 1980), VII: 22; Marc Eichen, "Subway Maps: Getting from A to D," *Focus* 41 (Winter 1991): 30–34. For Vignelli's map, see "New Subway Maps Introduced; To Be Distributed Next Monday," *New York Times* (August 5, 1972): 32.

36. Goldberger, "At Last, a Usable Subway Map": 1, 11.

37. Massimo Vignelli, quoted in Allis, "Underground Artistry in New York": 3.

38. Andy Newman, "After 2 Decades, a New Transit System Map," *New York Times* (January 21, 1998), B: 1, 4; Peter Joseph, "A Subway Map for All," letter to the editor, *New York Times* (January 26, 1998): 20; "The New Subway," editorial, *New York Times* (January 28, 1998): 24; Michael Taglieri, "New Subway Map Still Leaves Us Guessing," letter to the editor, *New York Times* (January 28, 1998): 24; Philip Nobel, "Which Way Now?" *Creative Review* (May 1, 1998): 51–54; Betsy Wade, "Some New Maps Worth Unfolding," *New York Times* (September 27, 1998), V: 4.

39. Nobel, "Which Way Now?": 53.

40. Paul Goldberger, "Operation Facelift Is Upgrading Old Subway Stations with Encouraging Results," *New York Times* (May 3, 1979), C: 6; Leslie Maitland, "Subway Inspections Cut for Redecoration, Report Says," *New York Times* (June 27, 1979), B: 3; White and Willensky, *AIA Guide* (2000), 22.

41. Goldberger, "Operation Facelift Is Upgrading Old Subway Stations with Encouraging Results": 6.

42. Glenn Fowler, "Capital Budget of 1 Billion Has Renewal as Aim," *New York Times* (April 27, 1979), B: 3; Ada Louise Huxtable, "Remodel the Subway Remodeling Plan," *New York Times* (May 4, 1979): 32; Leslie Maitland, "City to Get U.S. Aid on Subway Stations," *New York Times* (August 8, 1979): 1, B: 3.

43. Huxtable, "Remodel the Subway Remodeling Plan": 32.

44. Leslie Maitland, "Problems of Defective Subway Cars Stir Conflicts Among City Officials," *New York Times* (June 12, 1979): 1, B: 7; Leslie Maitland, "Transit Aides Found Manufacturer Misrepresented Subway-Car Tests," *New York Times* (June 13, 1979): 1, B: 12; Leslie Maitland, "Proposed Repair of Subway Cars Called a Hazard," *New York Times* (June 14, 1979), B: 1, 9; Leslie Maitland, "City Takes 109 Cars off Subway Service as 'Unsatisfactory,'" *New York Times* (June 15, 1979): 1, B: 4; Leslie Maitland, "Transit Executive Rejected a Call to Refuse Flawed Subway Cars," *New York Times* (June 16, 1979): 1, 25; Maitland, "Subway Inspections Cut for Redecoration, Report Says": 3; Maurice Carroll, "Graffiti as a Mixed Blessing: It Hides Other Transit Woes," *New York Times* (July 1, 1979), IV: 6.

45. David A. Andelman, "60-Cent Transit Fare Takes Effect," *New York Times* (June 28, 1980): 1, 25; Judith Cummings, "January Subway Service Assailed as the Worst in the Lines' History," *New York Times* (February 9, 1981): 1, D: 11; Richard J. Meislin, "Mass-Transit Fares Expected to Climb by up to 15 Cents in City," *New York Times* (February 28, 1981): 1, 27; Richard J. Meislin, "M.T.A. Improvements Totaling $5 Billion Proposed by Carey," *New York Times* (March 3, 1981): 1, B: 4; "To Put Transit Together Again," editorial, *New York Times* (March 4, 1981): 26; Richard J. Meislin, "Carey's Plan to Aid M.T.A.," *New York Times* (March 5, 1981), B: 3; Richard J. Meislin, "Accord on M.T.A. Plan Set by Carey, Koch and Others," *New York Times* (March 6, 1981), B: 3; Richard J. Meislin, "Koch Proposes New Taxes as Alternative to Fare Rise," *New York Times* (March 17, 1981), B: 1; Frank Lynn, "Politics and Transit Fares in New York," *New York Times* (March 25, 1981), B: 3; Richard J. Meislin, "Legislature Asked by Carey to Take Up Plan to Aid Transit," *New York Times* (April 5, 1981): 1, 34; Clyde Haberman, "Koch Sees Transit Fare Rise Even with No Better Service," *New York Times* (April 7,

1981), B: 3; "Running the M.T.A. into the Ground," editorial, *New York Times* (April 8, 1981): 26; Russell Baker, "And Only Sixty Cents," *New York Times* (April 29, 1981): 27; Edward A. Gargan, "Agency Lists Its 69 Most Deteriorated Subway Stations," *New York Times* (June 11, 1981), B: 5; Robin Herman, "Assembly Passes $5.6 Billion Plan for M.T.A. Aid," *New York Times* (June 23, 1981), B: 2; Judith Cummings, "Ravitch Says Fare Will Go up to 75 Cents by This Weekend," *New York Times* (July 1, 1981), B: 3; "Transit Battle, Transit War," editorial, *New York Times* (July 11, 1981): 22; Judith Cummings, "6-Hour Nightly Shutdown of Subways Is Proposed," *New York Times* (July 16, 1981), B: 3; Ari L. Goldman, "M.T.A. Drafts $6.7 Billion Plan," *New York Times* (July 17, 1981): 1, B: 3; Shawn G. Kennedy, "Transit Projects Called Imperiled," *New York Times* (September 6, 1981): 1, 37; Josh Barbanel, "City's Subways Still Declining, a Survey Finds," *New York Times* (October 15, 1981): 1, B: 2; Michael Oreskes, "Analysts Expect M.T.A.'s Projects to Aid Economy," *New York Times* (November 28, 1982): 1, 43.

46. Clyde Haberman and Laurie Johnston, "Next Stop, Culture St.," *New York Times* (July 13, 1982), B: 3; Susan Heller Anderson, "How Culture in the Subways May Look," *New York Times* (August 9, 1982), C: 13; "Underground Culture," *New York Times* (August 12, 1982): 26; Jon Wiener, "Please Don't Copy," letter to the editor, *New York Times* (August 17, 1982): 26; "Culture Stations Exhibition," *Oculus* 44 (October 1982): 6; "Culture Stations," *Progressive Architecture* 63 (October 1982): 55; Stan Pinkwas, "Cultural Cosmetics," *Metropolis* 2 (November 1982): 5; James Brooke, "In Subway, an Accent on Culture," *New York Times* (June 20, 1986), B: 4.

47. Anderson, "How Culture in the Subways May Look": 13; "Underground Culture": 26; "Culture Stations": 55; Pinkwas, "Cultural Cosmetics": 5; Brooke, "In Subway, an Accent on Culture": 4.

48. Anderson, "How Culture in the Subways May Look": 13; "Underground Culture": 26; "Culture Stations": 55; Pinkwas, "Cultural Cosmetics": 5; Brooke, "In Subway, an Accent on Culture": 4.

49. Haberman and Johnston, "Next Stop, Culture St.": 3; Anderson, "How Culture in the Subways May Look": 13; "Underground Culture": 26; "Culture Stations": 55; Pinkwas, "Cultural Cosmetics": 5; Peter Lemos, "Scene & Heard," *Metropolis* 6 (January-February 1986): 16; Brooke, "In Subway, an Accent on Culture": 4; Victoria Geibel, "Taming the Subterranean Beast," *Metropolis* 6 (October 1986): 26; James Brooke, "Transit System Repairs Produce Mixed Results," *New York Times* (November 23, 1986): 51.

50. Haberman and Johnston, "Next Stop, Culture St.": 3; Anderson, "How Culture in the Subways May Look": 13; "Underground Culture": 26; "Culture Stations": 55; Pinkwas, "Cultural Cosmetics": 5; "On the Sidewalks of New York: East Side . . . ," *Architectural Record* 172 (March 1984): 57; "Subway Kiosk Installed at Astor Place," *New York Times* (March 2, 1986): 42; "Subway Schemes: Beaver Pride," *New York Times* (May 26, 1986): 18; Brooke, "In Subway, an Accent on Culture": 4; Geibel, "Taming the Subterranean Beast": 26; Paul Goldberger, "2 Subway Projects, 2 Outcomes," *New York Times* (October 18, 1986): 29–30; Tom Cross and Lenore Gladstone, "Appearance Meets Reality at the Astor Place Subway Station," letters to the editor, *New York Times* (November 10, 1986): 22; Grace M. Anderson, "Eager Beaver," *Architectural Record* 175 (January 1987): cover, 80–83; Bill N. Lacy, "Letters," *Architectural Record* 175 (May 1987): 4; "Astor Place Station," *Oculus* 48 (May 1987): 9, 14; Norval White and Elliot Willensky, *AIA Guide to New York City*, 3rd ed. (New York: Macmillan, 1988), 155; "AIA Component Awards," *Architecture* 77 (May 1988): 111. Also see Landmarks Preservation Commission of the City of New York, LP-1096 (October 23, 1979); Barbaralee Diamonstein, *The Landmarks of New York III* (New York: Harry N. Abrams, 1998), 258.

51. James Brooke, "Transit System Repairs Produce Mixed Results," *New York Times* (November 23, 1986): 51. Also see M. A. Farber, "Inefficient Ways of the Past Still Hamper Transit System," *New York Times* (July 31, 1984): 1, B: 4; Suzanne Daley, "Transit Authority Plans Major Spending Shift," *New York Times* (November 27, 1984): 1, B: 4; Suzanne Daley, "Year of Delays Plague Renovation of a Brooklyn IRT Station," *New York Times* (March 8, 1985), B: 1, 7; Marilyn Webb, "Paradise Postponed: Are the Subways Improving Fast Enough?" *New York* 19 (November 17, 1986): 44–50; "Transfusion for New York's Lifeline," editorial, *New York Times* (November 26, 1986): 26; "NYC Transit Authority," *Oculus* 48 (December 1986): 20; Richard Levine, "42d Street Shuttle: Cars for Reviled Line," *New York Times* (October 3, 1987): 29, 33; Richard Levine, "Seeking Bearable Subway Discomfort," *New York Times* (October 10, 1987): 33, 36; "Myths About the Metropolis: Transit," editorial, *New York Times* (October 11, 1987), IV: 26; Kirk Johnson, "Reliability of New York Subway Cars Showing Gains," *New York Times* (April 11, 1988), B: 1–2; Peter A. Quinn, "A Paean to New York's Fetid Subways," *New York Times* (May 7, 1988): 27; Kirk Johnson, "Survey Finds More Delays on Subways," *New York Times* (July 22, 1988), B: 1–2; Daniel Machalaba, "Transit Manager Shows New York Subway Isn't Beyond Redemption," *Wall Street Journal* (October 14, 1988): 1, 9; Craig Wolff, "Subways Later but Cleaner, Group Asserts," *New York Times* (March 30, 1989), B: 1, 4; Roger Starr, "Subway Repair, Repaired," *New York Times* (April 8, 1989): 26; Hugh A. Dunne, "Ravitch's Role in the Subways Remembered," letter to the editor, *New York Times* (April 29, 1989): 26; Constance L. Hays, "Transit Agency Says New York Subways Are Free of Graffiti," *New York Times* (May 10, 1989): 1, B: 3; Martha A. Miles, "In the Subway, a Measure of Control Is Up," *New York Times* (May 14, 1989), IV: 24; Peter Hellman, "What's Better Now?" *New York* 22 (May 22, 1989): 36; Sam Roberts, "Subway Service: Is It Any Better? Or Worth More?" *New York Times* (November 20, 1989), B: 1;

"The Man Who Saved the Subways," editorial, *New York Times* (January 8, 1990): 16.

52. Gene Russianoff, quoted in Hays, "Transit Agency Says New York Subways Are Free of Graffiti": 3.

53. Calvin Sims, "Transit Agency Plans Improvements," *New York Times* (January 17, 1991), B: 3; Karrie Jacobs, "The City Below the City," *Metropolis* 9 (May 1991): 96–101, 103, 105, 107; Alan Finder, "Transit Authority Switches Tracks," *New York Times* (March 16, 1992), B: 1, 4; James C. McKinley Jr., "City to Delay Subway Work at 6 Stations," *New York Times* (October 15, 1994): 21–22; "Subway Stations Are Undergoing Massive Rehabilitation Program," *New York Construction News* 43 (November 13, 1995): 6; Constance L. Hays, "Notes from the Underground: Stations Renovations Continue," *New York Times* (December 29, 1996), XIII: 7; Thomas Hudson, "New York Raw," *New York Observer* (March 17, 1997): 2; Thomas J. Lueck, "Satellite Tracking System Planned for Buses, but Subway Renovations Drag On," *New York Times* (June 15, 1999), B: 5.

54. Brooke, "In Subway, an Accent on Culture": 4; Geibel, "Taming the Subterranean Beast": 26; Andrew L. Yarrow, "Adventurous Performers in Unexpected Stages," *New York Times* (October 9, 1987), C: 1, 36; John Rockwell, "Beneath a Street, Art Soothes," *New York Times* (November 10, 1987), B: 1; Ron Alexander, "Style Makers," *New York Times* (May 7, 1989), part 2: 50; "Transit Agency Creates Art Havens in Subways," *New York Times* (November 6, 1989), B: 3; Deirdre van Dyk, "'A Bit at a Time,' Underground Art," *New York Observer* (May 7, 1990): 6; Patrick Kernan, "Wopo's World," *New York* 23 (August 6, 1990): 16; Elaine Louie, "Where Art Is Blowin' in the Wind," *New York Times* (November 22, 1990), C: 3; Akiko Busch, "The Mosaic," *Metropolis* 10 (April 1991): 44–46; Dennis Wepman, "Subway Survivors," *Metropolis* 10 (April 1991): 47; Calvin Sims, "Subways (and Away We Go) Plan a Lot of Traveling Music," *New York Times* (September 10, 1991): 1, B: 3; "Underground Sound," editorial, *New York Times* (September 11, 1991): 26; Alan Finder, "M.T.A. Ends Exhibit and Artist Cries Foul," *New York Times* (December 19, 1991), B: 3; "Underground Art Scene," *New York Times* (April 30, 1992), C: 3; Peter E. Stangl, "The Once and Future Subway," *Livable City* 16 (Fall 1992): 6; Kevin Haynes, "Tunnel Vision," *New York* 25 (December 7, 1992): 30; "Topics of The Times: Poetry in the Subways," *New York Times* (December 18, 1992): 38; Robin Raisfeld, "Rainbow Coalition," *New York* 26 (November 22, 1993): 29; Dulcie Leimbach, "Luminous Art That Softens a Subway," *New York Times* (January 20, 1994), C: 3; William Grimes, "Raising Artistic Sights of Riders in Nether and Upper Regions," *New York Times* (August 22, 1994), C: 9; Carol Vogel, "Beyond Museum Precincts, the City as Gallery," *New York Times* (January 22, 1996), C: 11; "Underground Gallery-Going," editorial, *New York Times* (January 28, 1996), IV: 12; "'O Sole Mio' on a Faux Canal (Street)," *New York Times* (December 4, 1996), B: 3; David W. Dunlap, "New Stop, Murals: Change Here for Uptown Sculpture," *New York Times* (May 1, 1998), E, part 2: 37, 52; Elsie Hseih, "Animal Tracks," *Print* 54 (November-December 2000): 14; David W. Dunlap, "For Terra Cotta, Terra Firma," *New York Times* (April 29, 2001), XI: 1; John Rockwell, "That Rumbling Underfoot? It's Not a Subway, It's Art," *New York Times* (May 22, 2002), E: 1, 8; Roberta Smith, "The Rush-Hour Revelations of an Underground Museum," *New York Times* (January 2, 2004), E, part 2: 39–40.

55. Mike Reiner and Michelle Greene, quoted in Eleanor Blau, "Subterranean Throne: A Seat Worth Tussling For," *New York Times* (October 28, 1991), B: 3.

56. Dunlap, "New Stop, Murals: Change Here for Uptown Sculpture": 52; Robert O'Harrow Jr., "Tunnel Visions," *Washington Post* (February 16, 2003), E: 1; Smith, "The Rush-Hour Revelations of an Underground Museum": 39–40.

57. Philip Nobel, "As Always, Please Touch," *New York Times* (April 8, 1999), F: 1, 13; "161st Street/Yankee Stadium Station," *New York Construction News* 50 (December 2002): 93; David W. Dunlap, "New Look for Bronx Civic Crossroads," *New York Times* (May 25, 2003), XI: 1, 6; "161 Street Station/Yankee Stadium," *New York Construction News* 50 (June 2003): 63.

58. Marvine Howe, "Revamping an Old Subway Station," *New York Times* (January 2, 1994), XIII: 5; "Manhattan Update: Union Square," *New York Times* (March 13, 1994), XIII: 6; "$40 Million Construction Contract Is Signed; Colorful Renovation for Union Sq. Station," *New York Times* (March 12, 1995), IX: 1; John Culhane, "Union Square Station Rehabilitation: An Important Piece of Civic Architecture," *New York Construction News* 43 (March 18, 1996): 6; "Speeding up Union Square," *New York Observer* 10 (September 5, 1996): 10; Karrie Jacobs, "Notes from Underground," *New York* 29 (December 23–30, 1996): 34; Daniel B. Schneider, "F.Y.I.: Once and Future Station," *New York Times* (April 18, 1999), XIV: 2; Joseph P. Fried, "Untangling Knots in the Subway," *New York Times* (February 3, 2000), B: 1, 4; "14th Street/Union Square Subway Station," *New York Construction News* 48 (December 2000): 45; Alan Balfour, *World Cities: New York* (New York: Wiley Academy, 2001), 188; "Revealing Architecture," *Architectural Record* 189 (April 2001): 202; Smith, "The Rush-Hour Revelations of an Underground Museum": 39–40.

59. Jacobs, "Notes from Underground": 34.

60. Goldberger, "2 Subway Projects, 2 Outcomes": 29–30.

61. David W. Dunlap, "Rethinking 42d St. for Next Decade," *New York Times* (June 27, 1993), X: 1, 6; "Subway Stations Are Undergoing Massive Rehabilitation Program": 6; Anthony Ramirez, "Subway Plan for Times Sq. Reduces Exits," *New York Times* (April 28, 1996), XIII: 9; April DiComo, "Times Square Subway Rehab Begins," *New York Construction News* 45 (January 13, 1997): 1, 7; Charles V. Bagli, "Retreat on Times Square Subway Plan," *New York Times* (May 14, 1998), B: 3; David Firestone, "Subway Station to Be Renovated, Keeping Pace with Times Square," *New York Times* (July 16, 1998): 1, B: 6; David Firestone, "Times Sq. Cleanup Missed Underbelly,"

New York Times (July 19, 1998), 1, 23; Eric Marcus, Robert F. Drake, and Anthony Feldmesser, "Times Square Station Is No Gift to Riders," letters to the editor, *New York Times* (July 21, 1998), E: 7; Thomas J. Lueck, "Bid Is Awarded for Times Sq. Subway Project," *New York Times* (January 9, 1999), B: 4; William B. Sagalyn, *Times Square Roulette: Remaking the City Icon* (Cambridge, Mass., and London: MIT Press, 2001), 388–402; Aileen Cho, "New York City Subway Station Face Lifts Vie with Busy System," *Engineering News-Record* 246 (February 26, 2001): 15; "The Reconstruction of the Times Square Station Complex," *New York Construction News* 50 (December 2002): 85; Richard Staub, "Subway Series: Transit Pride," *Oculus* (Spring 2003): 28–32; David W. Dunlap, "Crossroads of the Whirl," *New York Times* (March 28, 2004), XIV: 13.

62. Sagalyn, *Times Square Roulette*, 397.

63. Christine Bodouva, quoted in DiComo, "Times Square Subway Rehab Begins": 7.

64. Firestone, "Subway Station to Be Renovated, Keeping Pace with Times Square": 6; Holland Cotter, "Jacob Lawrence Is Dead at 82," *New York Times* (June 10, 2000): 13; Lawrence Van Gelder, "For Jacob Lawrence, a Subway Showcase," *New York Times* (November 6, 2001), E: 1; William Zimmer, "Seeing Messages, Some Subtle, in a Door," *New York Times* (May 5, 2002), XIV: 16; Avis Berman, "In a New Times Square, a Wink at Futures Past," *New York Times* (September 1, 2002), II: 1, 25; O'Harrow, "Tunnel Visions": 1; Smith, "The Rush-Hour Revelations of an Underground Museum": 40.

65. Van Gelder, "For Jacob Lawrence, a Subway Showcase": 1; *Roy Lichtenstein: Times Square Mural*, exhibition catalog (New York: Roy Lichtenstein Foundation; New York: Mitchell-Innes & Nash, 2002); Carol Vogel, "Next Stop, Times Square," *New York Times* (July 5, 2002), E: 32; Berman, "In a New Times Square, a Wink at Futures Past": 1, 25; "Underground Art," *New York Times* (September 6, 2002), B: 8; Rick Moody, "A Metropolis as Small as a Playing Card," *New York Times* (September 8, 2002), XIV: 13.

66. Janet Allon, "Test for Non-Genteel Group: Fight Over 72d Street Station," *New York Times* (January 21, 1996), XIII: 8; Anthony Ramirez, "New Station, Less Pavement at West 72d St.," *New York Times* (April 5, 1998), XIV: 6; Richard Dattner (Mulgrave, Australia: Images Publishing, 2000), 220–23; Tom Loftus, "Work on 72nd Street Subway Leaves Greenmarket Homeless," *New York Observer* (February 14, 2000): 8; Corey Kilgannon, "Neighborhood Report: Upper West Side," *New York Times* (February 27, 2000), XIV: 7; Edward Wong, "72nd St. Station Renovation Should Do More, Critics Say," *New York Times* (June 7, 2000), B: 3; Randy Kennedy, "Trouble down the Line in Rerouting Train," *New York Times* (June 17, 2000), B: 2; Sherri Day, "Are Renovations in Subway a Threat to Life Upstairs?" *New York Times* (June 18, 2000), XIV: 8; Denny Lee, "A Messy Construction Project Grows Even More Tangled," *New York Times* (February 4, 2001), XIV: 6; Randy Kennedy, "72nd St. Station Project Has Riders Feeling Squeezed," *New York Times* (April 10, 2001), B: 4; Randy Kennedy, "Hunting for a Thief with Underground Connections," *New York Times* (May 14, 2002), B: 3; Christopher Gray, "Streetscapes/Subway Platforms," *New York Times* (May 19, 2002), XI: 7; "A Hot Day's Work on a Hot Roof," *New York Times* (August 17, 2002), B: 3; "New 72nd St. Station Opens," *New York Post* (October 30, 2002): 6; Regan Wilcox, "Shiny and New at 72nd Street," *New York Sun* (October 30, 2002): 1, 3; "Improvements for Riders 'in a Hole in the Ground,'" *New York Times* (October 30, 2002), B: 3; James Gardner, "Why Must New York Have a Mediocre Underground," *New York Sun* (November 4, 2002): 10.

67. *Richard Dattner*, 220.

68. Gardner, "Why Must New York Have a Mediocre Underground": 10.

69. Bob Liff, "Fear of Biz Derail," *New York Daily News* (March 21, 2001), Metro: 1; Alex Marshall, "Play Ball," *Metropolis* 21 (August-September 2001): 70–74, 105, 107; Elizabeth Hays, "Subway Repair May Impair Coney Biz," *New York Daily News* (August 7, 2001), Metro: 1; Tara Bahrampour, "Trek to Beach Will Get Harder as Station Gets a Face-Lift," *New York Times* (August 25, 2002), XIV: 7; Clemente Lisi, "New Solar System Will Power Coney I. Subway Station," *New York Post* (November 24, 2003): 19; Aileen Cho, "Transit," *Engineering News-Record* 252 (April 12, 2004): 26; Clemente Lisi, "Shining-Time Station," *New York Post* (April 16, 2004): 28; Clemente Lisi, "Shore Shot," *New York Post* (May 23, 2004): 2; Soni Sangha, "El of a View! Coney Terminal Reopens," *New York Daily News* (May 24, 2004): 14.

70. Mozell Hill, quoted in Sangha, "El of a View! Coney Terminal Reopens": 14.

71. Randy Kennedy, "Bearing Stunned Commuters, the Subway of the Future Begins 30-Day Test Run," *New York Times* (July 11, 2000), B: 3; Janet Abrams, "Notes from the Underground," *New York Times* (October 1, 2000), VI: 2; Julien Devereux, "All Aboard!" *Metropolis* 20 (November 2000): 44; Robert Sullivan, "The Talk of the Town: Dept. of Transportation," *New Yorker* 77 (January 15, 2001): 34–35; Randy Kennedy, "New Subway Cars Show Flaws and Are Removed for Repairs," *New York Times* (March 17, 2001), B: 4; Stan Fischler, "Blind Spot," *New York Times* (March 18, 2001), XIV: 11; Randy Kennedy, "The Subway Voice of the Future Is a Recording," *New York Times* (March 20, 2001), B: 3.

72. Fischler, "Blind Spot": 11.

73. Edward Barrera, "Subway Token Dies at 50," *New York Daily News* (April 13, 2003): 2; Elissa Gootman, "Suddenly, It's a Token Booth in Name Only," *New York Times* (April 14, 2003), F: 5; "Subway Token: Currency of the Past," *New York Times* (May 5, 2003), B: 6; Paula Span, "A Small Token of Our Affection," *Washington Post* (May 5, 2003), C: 1.

74. Lisa W. Foderaro, "Fare Cards Make Debut in Subways," *New York Times* (January 6, 1994), B: 1, 4; "A New Entry in the Transit Fare System," *New York Times* (January 7, 1994), B: 1; Douglas Martin, "Fare Cards: A Glimpse of the Future

Underground," *New York Times* (January 7, 1994), B:3; "When It Isn't in the Cards," *New York Times* (February 13, 1994), VI: 19; Matthew L. Wald, "Fare Card Plan in the Subways Exceeds Goals," *New York Times* (February 20, 1994), 39, 44; Charles R. Broshous, Marsha S. Dennis, Bert Rosenheck, Tobias Guggenheimer, and Jozef Paulik, "Don't Judge New York Subway Fare Card After Only 3 Months," letters to the editor, *New York Times* (August 30, 1994): 20; Gary Pierre-Pierre, "The Faltering Metrocard Sets Transit Officials Scampering," *New York Times* (July 30, 1996), B: 1, 3; "Fear of Fare Cards," editorial, *New York Times* (August 2, 1996): 26; Amy Harmon, "What Galls a Hacker Most? The Metrocard," *New York Times* (August 11, 1997): 1, B: 4; Somini Sengupta, "Fear That Automation Will Replace Clerks," *New York Times* (August 23, 1997): 27.

75. Carter B. Horsley, "Developers Debating Amenities for Public," *New York Times* (May 24, 1978), D: 20; "The Worm and the Apple: Public Discomfort," *New York Times* (May 29, 1983), IV: 14; "The Worm and the Apple: Rest Stops," *New York Times* (August 4, 1983): 18.

76. "A Problem of Public Comfort," editorial, *New York Times* (November 23, 1986), IV: 24. Also see Nick Ravo, "Perplexing Problem: When Streets Become Public Urinals," *New York Times* (December 29, 1986), B: 1, 4; Louis Marck, "Public Toilets," letter to the editor, *New York Times* (January 12, 1987): 20.

77. "A Modest Proposal," editorial, *New York Times* (November 5, 1990): 20. Also see Felicia R. Lee, "The Homeless Sue for Toilets in New York," *New York Times* (November 1, 1990), B: 1; Arthur J. Weiss, "In France, They Do Public Toilets with Style," letter to the editor, *New York Times* (November 17, 1990): 22; Peter F. Guida, "Incentive Plan," letter to the editor, *New York Times* (November 26, 1990): 18.

78. Celia W. Dugger, "In New York, Few Public Toilets and Many Rules," *New York Times* (May 21, 1991): 1, B: 3; "Public Restrooms, Within Reach," editorial, *New York Times* (May 28, 1991): 20; Barbara J. Fife, "Working On It," letter to the editor, *New York Times* (June 3, 1991): 16; Ruth Lowenkron, "Don't Blame Disabled for the Delay in Building Public Toilets," letter to the editor, *New York Times* (June 3, 1991): 16; Lawrence Kurtzberg, "Public Toilets for OTB," letter to the editor, *New York Times* (June 10, 1991): 16; Celia W. Dugger, "Yes, New York City Plans Sidewalk Toilets," *New York Times* (June 27, 1991), B: 1, 6; "Sound Compromise on Public Toilets," editorial, *New York Times* (July 6, 1991): 20; Joan K. Davidson, "Free Test for Toilets," letter to the editor, *New York Times* (July 27, 1991): 22; "Public Privies Open, and None Too Soon," *New York Times* (July 1, 1992), B: 3; "Not-So-Mean Streets," editorial, *New York Times* (July 2, 1992): 18; James C. McKinley Jr., "European Conveniences," letter to the editor, *New York Times* (July 5, 1992), IV: 2; Suzanne Davis, "Public Toilets," letter to the editor, *New York Times* (April 24, 1992): 34; "Gift May Put Lid on Self-Cleaning Toilets," *New York Times* (June 5, 1992), B: 3; "The Talk of the Town: Experiment," *New Yorker* 68 (July 13, 1992): 24–25; Amy Gamerman, "Commode a la Mode Is a Clean Machine from France," *Wall Street Journal* (August 18, 1992): 14.

79. "The Talk of the Town: Experiment": 24.

80. "Not-So-Mean Streets": 18.

81. Steven Lee Myers, "Pay Toilets a Success, but They're Still Closing," *New York Times* (October 30, 1992), B: 1, 7; "Pay Toilets, an Unqualified Success," editorial, *New York Times* (November 13, 1992): 28; James C. McKinley Jr., "Bids to Build Public Toilets Facing Limits," *New York Times* (January 27, 1993), B: 1, 4; Charles Mahtesian, "Desperate in New York?" *Governing* 6 (February 1993): 15–16; "Down the Drain," editorial, *Wall Street Journal* (February 4, 1993): 16; "Vote on Pay-Toilet Bids," *New York Times* (February 5, 1993), B: 3; Ruth Lowenkron, "Street Toilet Equality for Disabled Is the Law," letter to the editor, *New York Times* (February 9, 1993): 20; Patricia Cohen, "Hot Seats," *New Republic* 208 (February 22, 1993): 11–12; Peter Hellman, "Toilet Wars," *New York* 26 (May 3, 1993): 38–43; Marvine Howe, "Supporters of Public Toilet Plan Dismayed by Advertising Kiosks," *New York Times* (August 29, 1993): 37; David W. Dunlap, "Manufacturers Quit a Project for Pay Toilets," *New York Times* (October 1, 1993), B: 3; Betsy Gotbaum, "Advertising Was Always Part of Public Toilet Deal," letter to the editor, *New York Times* (October 10, 1993), XIII: 17; Thomas J. Lueck, "Berlin Concern Agrees to Build Public Toilets," *New York Times* (October 30, 1993): 24; "City Hall: Test the Toilets," editorial, *New York Times* (February 26, 1994): 22; Jonathan P. Hicks, "City Council Vote Delays a Public Toilet Contract," *New York Times* (March 1, 1994), B: 3; James Munves, "What About the Public Toilets We Have?" letter to the editor, *New York Times* (March 8, 1994): 20; Douglas Lasdon, "Why Can Those Other Cities Put Public Toilets on the Streets?" letter to the editor, *New York Times* (March 15, 1994): 22; "News," *Municipal Art Society Newsletter* (April 1994): 1–2; "Holding It In (for Two Years)," editorial, *New York Observer* (April 11, 1994): 4; "Automatic Toilets Planned for Parks," *New York Times* (July 21, 1994), C: 3; David Siff, "Still No Public Toilets," letter to the editor, *New York Times* (July 23, 1994): 18; Celia W. Dugger, "Public Toilets in New York: Maybe This Time," *New York Times* (August 20, 1994): 1, 26.

82. Jonathan P. Hicks, "Street Newsstands and Bus Stops Are Giuliani's Latest Concern," *New York Times* (April 14, 1995), B: 1, 4; Jonathan P. Hicks, "Papers Fight Giuliani Newsstand Overhaul," *New York Times* (June 7, 1995), B: 4; "Hailing the Cab Plan," editorial, *New York Times* (December 30, 1995): 25; Fran Reiter, "New York Acts to Franchise Pay Toilets," letter to the editor, *New York Times* (January 5, 1996): 12; "Welcome All Bidders for Street Toilets," editorial, *New York Times* (January 28, 1996): 20; "Street Smart," *New York Times* (February 25, 1996), VI, part II: 92; "Public Relief," *New York Times* (April 28, 1996), XIII: 2; "Streets and Sidewalks," *Municipal Art Society Newsletter* (June 1996): 4; David W. Dunlap, "City Seeking an Exterior Decorator," *New York Times* (June 2, 1996), IX: 1, 8; Timothy Mennel, "City Seeking Exterior Decorator," letter to the editor, *New York Times* (June 23, 1996), IX: 1; Anthony

Ramirez, "'Street Furniture' Irks Some Tastes," *New York Times* (August 4, 1996), XIII: 5; Clifford J. Levy, "New 'Furniture' and, Finally, Toilets Planned for City Streets," *New York Times* (December 4, 1996), B: 1, 7; Jesus Escobar, "Redecorating the City," letter to the editor, *New York Times* (December 7, 1996): 22; Paul Goldberger, "Bus Shelters with Panache and Other Idées," *New York Times* (December 8, 1996): 49, 54; Peter Slatin, "A Public Toilet Is Headed Your Way," *New York Post* (January 16, 1997): 34, 38; Clifford J. Levy, "2 Giuliani Advisers Prosper from City Lobbying," *New York Times* (February 9, 1997): 1, 44; Clifford J. Levy, "Criticism of Lobbying Is False Issue, Mayor Says," *New York Times* (February 15, 1997): 27; Douglas Feiden, "Head Rolls Over Kiosk Contract," *New York Daily News* (April 9, 1997): 18; "Future Street Furniture and Current Examples," *New York Times* (April 27, 1997), XIII: 14; David Gonzalez, "News Vendors Face Prospect of Last Stand," *New York Times* (May 17, 1997): 21; Barbara Nadel, "Record News," *Architectural Record* 185 (June 1997): 34; Todd W. Bressi, "A Stealth Streetscape?" *Oculus* 60 (October 1997): 5; *Richard Meier Architect: 1992/1999* (New York: Rizzoli International Publications, 1998), 434–35; David W. Dunlap, "A Mayor's Prerogative: Rethinking the City Street Furniture," *New York Times* (January 28, 1998): B: 6; Elizabeth Kolbert, "Public Toilets: Finding Relief Is Still a Quest," *New York Times* (March 16, 1998), B: 1; "City to Seek Bids for Bus Shelters," *New York Times* (June 27, 1998), B: 3; David W. Dunlap, "Commercial Real Estate," *New York Times* (July 1, 1998), B: 7; David W. Dunlap, "Street Furniture Design Stuck in Gridlock," *New York Times* (August 9, 1998), XI: 1, 24; Robert S. Bookman, "'Street Furniture Stuck in Gricklock,'" letter to the editor, *New York Times* (August 23, 1998), XI: 9; Lisa Green, ed., *Richard Meier: Architect* (New York: Monacelli Press, 1999), 299; Marie Redding, "Nowhere to Go!" *New York Daily News* (January 10, 1999): 22; Frank Lombardi, "Rudy: Don't Flush Pay Toilets," *New York Times* (February 10, 2000): 4; Clyde Haberman, "City Hall Can't Answer Nature's Call," *New York Times* (February 11, 2000), B: 1; "New York's Missing Facilities," editorial, *New York Times* (February 14, 2000): 20; Tina Kelly, "Following Up," *New York Times* (May 7, 2000): 45; Peter Morris Dixon, ed., *Robert A. M. Stern: Buildings and Projects, 1999–2003* (New York: Monacelli Press, 2003), 276–77; Philip Nobel, "Richard & Me," *Metropolis* 22 (April 2003): 66, 68.

83. Kent L. Barwick, quoted in Hicks, "Street Newsstands and Bus Stops Are Giuliani's Latest Concern": 4.

84. Mennel, "City Seeking Exterior Decorator": 11.

85. Nobel, "Richard & Me": 66.

86. Quoted in *Richard Meier Architect: 1992/1999*, 435.

87. For Polshek's 1971 design, see Stern, Mellins, and Fishman, *New York 1960*, 92.

88. Peter Eisenman, quoted in Dunlap, "Street Furniture Designs Stuck in Gridlock": 24.

89. Rudolph W. Giuliani, quoted in Lombardi, "Rudy: Don't Flush Pay Toilets": 4.

90. Barbara Stewart, "At Last, 2 Public Pay Toilets in Midtown," *New York Times* (January 18, 2001), B: 4; Felicia R. Lee, "Public Toilets: The Orphan Issue," *New York Times* (January 28, 2001), XIV: 1.

91. Jesse McKinley, "Fitting a Little Show into a Big House," *New York Times* (September 2, 2001), II: 3.

92. Diane Cardwell, "Mayor Says Pay Toilets Would Help City's Budget," *New York Times* (August 10, 2002), B: 3; Frank Lombardi, "400M Bid Links Toilets, Newsstands, Bus Stops," *New York Daily News* (September 18, 2002): 4.

93. White and Willensky, *AIA Guide* (2000), 314–15. Also see ". . . West Side," *Architectural Record* 172 (March 1984): 57; Susan Heller Anderson and David W. Dunlap, "An Upscale Newsstand," *New York Times* (April 17, 1985), B: 3; Anthony Ramirez, "Upper West Side," *New York Times* (January 19, 1997), XIII: 6.

94. Wayne Turett, quoted in Anderson and Dunlap, "An Upscale Newsstand": 3.

95. Patricia Leigh Brown, "A Streamlined Design for City Newsstands," *New York Times* (September 8, 1988), C: 3; "Designs for City Newsstands," *Storefront for Art & Architecture Newsletter* (April 1990): 1–3; John Pierson, "New York Is Getting New Displays for News," *Wall Street Journal* (August 31, 1992), B: 1; "All the Prints in Newsstands That Fit," *New York Times* (September 10, 1992), C: 3; Marvine Howe, "What's Pink and Sells Papers?" *New York Times* (January 9, 1994), XIII: 5.

96. Frances Halsband, quoted in "All the Prints in Newsstands That Fit": 3.

ON THE WATERFRONT

1. Stern, Mellins, and Fishman, *New York 1960*, 112–19. Also see Michael Z. Wise, Wilbur Woods, and Eugenia Bone, "Evolving Purposes," in Kevin Bone, ed., *The New York Waterfront: Evolution and Building Culture of the Port and Harbor* (New York: Monacelli Press, 1997), 210, 217–19; Ann L. Buttenwieser, *Manhattan Water-Bound*, 2nd. ed. (Syracuse, N.Y.: Syracuse University Press, 1999), 209–17.

2. Jane Jacobs, *The Death and Life of Great American Cities* (New York: Random House, 1961).

3. Robert Caro, *The Power Broker: Robert Moses and the Fall of New York* (New York: Alfred A. Knopf, 1974).

4. Edward C. Burks, "Demolition of Part of West Side Highway May Start in September," *New York Times* (May 25, 1976): 39; "The West Side Highway Project," *New York Times* (May 30, 1976), IV: 6; "West Side Road Is Moving Ahead," *New York Times* (August 29, 1976): 40.

5. Ralph Blumenthal, "Westway Plan Wins Final U.S. Approval; Boon to City Is Seen," *New York Times* (January 5, 1977): 1, 10; "An O.K. on Westway," *New York Times* (January 9, 1977), IV: 9.

6. Paul Goldberger, "Uncertainty Clouds Westway's Amenities," *New York Times* (January 13, 1977): 37.

7. Ada Louise Huxtable, "Will Westway Turn into the Opportunity of a Century?" *New York Times* (January 23, 1977), II: 25, 29.

8. Huxtable, "Will Westway Turn into the Opportunity of a Century?": 25, 29.

9. Barry Benepe, "Let's Not Be Optimistic About Westway," letter to the editor, *New York Times* (March 6, 1977), II: 23–24.

10. Peter Kihss, "Federal Agency Finds Westway Pollution Peril," *New York Times* (February 17, 1977): 1, 33.

11. Edward I. Koch, quoted in Steven R. Weisman, "Koch Calls Westway a 'Disaster' and Vows It 'Will Never Be Built,'" *New York Times* (October 28, 1977): 1, 16.

12. Richard J. Meislin, "The Westway Loses First Round as State Faults Air Pollution," *New York Times* (December 17, 1977): 51. Also see John B. Oakes, "Westway Trade-In," *New York Times* (January 10, 1978): 33.

13. "How Westway Will Destroy New York," an interview with Jane Jacobs by Roberta Grandes Gratz, *New York* 11 (February 6, 1978): 30–34.

14. Paul Goldberger, "Westway Architects Selected by State," *New York Times* (February 24, 1978): 16; "Major Projects for Venturi & Rauch," *Progressive Architecture* 59 (March 1978): 22–23.

15. Robert Venturi, quoted in Goldberger, "Westway Architects Selected by State": 16. For Venturi and Scott Brown's's anti-highway work, see David B. Brownlee, "Form and Content," in David B. Brownlee, David G. De Long, and Kathryn B. Hiesinger, *Out of the Ordinary: Robert Venturi Denise Scott Brown and Associates* (Philadelphia: Philadelphia Museum of Art in association with Yale University Press, 2001), 47–49.

16. Tri-State Regional Planning Commission, *Economic Implications of Westway* (November 1978); "Take the Subway," editorial, *Washington Post* (September 4, 1980): 16; Marcy Benstock, "For a Westway Trade-In," *New York Times* (November 8, 1980): 23.

17. Clyde Haberman, "Koch Revises Support of Westway; Will Offer a Cheaper Plan Today," *New York Times* (December 16, 1980): 1, B: 6; Ari L. Goldman, "A Koch Plan and Westway," *New York Times* (December 22, 1980), B: 3; Arthur P. Stoliar, Jennings Randolph, Daniel Patrick Moynihan, and Lois Katz, "Toward a Decision in the Westway Controversy," letters to the editor, *New York Times* (January 1, 1981): 18.

18. Edward I. Koch, quoted in Goldman, "A Koch Plan and Westway": 3.

19. Ari L. Goldman, "Plan for Westway Gains Endorsement from U.S. Secretary," *New York Times* (February 10, 1981): 1, B: 3.

20. Paul Goldberger, "Debate on Westway Concerns Concepts of City's Future," *New York Times* (February 10, 1981), B: 3; Richard J. Meislin, "2 Democratic Leaders Ask Carey to Explore Trade-In on Westway," *New York Times* (March 4, 1981): 1, B: 8; Irvin Molotsky, "House Hearing Told a Westway Trade-In Might Be Difficult," *New York Times* (March 6, 1981): 1, B: 3; Richard J. Meislin, "Decisions May Shape Future of Transit in New York Area," *New York Times* (March 9, 1981), B: 3; John B. Oakes, "Mr. Carey, Westway Is the Wrong Way," *New York Times* (March 10, 1981): 19; "Three U.S. Agencies Said to Drop Their Objections to Westway Plan," *New York Times* (March 11, 1981), B: 7; Ari L. Goldman, "Federal Permits In, Carey Now Presses for Westway Start," *New York Times* (March 12, 1981): 1, B: 2; Steven R. Weisman, "Reagan, Visiting City, Plans Westway Talks with Koch," *New York Times* (March 14, 1981): 1; Paul L. Montgomery, "President, Visiting New York, Frees Aid for 2 City Projects," *New York Times* (March 15, 1981): 1, 26.

21. "Carey Gives Notice on Westway Buying," *New York Times* (March 19, 1981), B: 6.

22. George F. Will, "Getting Big Things Done," *Newsweek* 97 (March 30, 1981): 90.

23. Sheldon Pollack, "A Westway Trade-In Is No Way to Help Mass Transit," letter to the editor, *New York Times* (April 23, 1981): 22; Richard N. Gottfried, "Westway Proponents' Distorted View of the 'Trade-In' Alternative," letter to the editor, *New York Times* (May 7, 1981): 34.

24. "Suit Filed to Stop Westway Project," *New York Times* (May 19, 1981), B: 4.

25. Sydney H. Schanberg, "Time to Put Westway Away," *New York Times* (June 6, 1981): 23; Sydney H. Schanberg, "The Risks of Westway," *New York Times* (July 21, 1981): 15; Sydney H. Schanberg, "Pulling Westway's Plug," *New York Times* (March 20, 1982): 27; Sydney H. Schanberg, "Westway: Third Rate Cover Up," *New York Times* (April 20, 1982): 27; Sydney H. Schanberg, "Westway Deceit (1)," *New York Times* (June 26, 1982): 25; Sydney H. Schanberg, "Westway Deceit (2)," *New York Times* (June 29, 1982): 23; Sydney H. Schanberg, "Westway's Price List," *New York Times* (December 14, 1982): 31; Sydney H. Schanberg, "A Wake for Westway," *New York Times* (March 22, 1983): 25; Sydney H. Schanberg, "Cuomo's Impasse Arrives," *New York Times* (May 3, 1983): 27; Sydney H. Schanberg, "The Same Old Scandal," *New York Times* (May 10, 1983): 25; Sydney H. Schanberg, "Beyond Contempt," *New York Times* (June 28, 1983): 27; Sydney H. Schanberg, "Corruption Ignored," *New York Times* (June 9, 1984): 23; Sydney H. Schanberg, "Corruption Ignored (2)," *New York Times* (June 12, 1984): 27; Sydney H. Schanberg, "Westway's Sleaze Factor," *New York Times* (October 9, 1984): 33; Sydney H. Schanberg, "New Westway Dictionary," *New York Times* (October 27, 1984): 25; Sydney H. Schanberg, "Pyramids That Cloud the Mind," *New York Times* (January 26, 1985): 21; Sydney H. Schanberg, "Boondoggle by Local Choice," *New York Times* (March 5, 1985): 27; Sydney H. Schanberg, "Merits and Misconduct," *New York Times* (June 11, 1985): 27; Sydney H. Schanberg, "Getting 'the Message,'" *New York Times* (July 2, 1985): 19; Sydney H. Schanberg, "The Testimony Doesn't Wash," *New York Times* (July 6, 1985): 21; Sydney H. Schanberg, "Cajun Flies and Westway," *New York Times* (July 27, 1985): 23.

26. Schanberg, "Time to Put Westway Away," (June 6, 1981): 23. Also see Schanberg, "The Risks of Westway," (July 21, 1981): 15.

27. Edward A. Gargan, "Koch and Carey Sign a Pact for Westway Construction Unless U.S. Cuts 'Amenities,'" *New York Times* (August 1, 1981): 1, 30. Also see Ari L. Goldman, "Koch Asks New Agency on Funds for Westway," *New York Times* (July 28, 1981), B: 1, 6; "Text of the Agreement Between the State and City on the Westway Project," *New York Times* (August 1, 1981): 1, 30; "The Westway Project: Its History and Future," *New York Times* (August 1, 1981): 30.

28. Edward A. Gargan, "Building Westway, Now That It's Real," *New York Times* (August 2, 1981), IV: 9.

29. "New Demolition Set for Westway," *New York Times* (August 31, 1981), B: 3.

30. "West Side Highway Collapse Injures 3 Workers," *New York Times* (February 3, 1982): 8. Also see "Canal Street Bridge to Be Sold for Scrap," *New York Times* (November 21, 1982): 38.

31. Clyde Haberman, "Reagan Visits City to Present Check for the Westway," *New York Times* (September 8, 1981): 1, B: 6. Also see Michael Oreskes, "Reagan Will Bring Westway Payment to New York City," *New York Times* (September 8, 1981): 1, D: 23.

32. Ian Fletcher, quoted in Arnold H. Lubasch, "Sierra Club Suit Terms Westway Perilous to Fish," *New York Times* (October 6, 1981), B: 7.

33. John Marino, quoted in Robin Herman, "Judge Reduces Westway Suits to Single Issue," *New York Times* (December 14, 1981): 1, B: 10.

34. John B. Oakes, "The Carey-Koch 2d Ave. Westway," *New York Times* (March 5, 1982): 27; Schanberg, "Pulling Westway's Plug," (March 20, 1982): 27. Also see Walter H. Beebe and Charles Bell, "Mass Transit, Not Westway, Is the New York City Priority," letter to the editor, April 6, 1982): 18.

35. Michael Goodwin, "Five Members of Board of Estimate Sue Koch Over Westway," *New York Times* (November 26, 1981), B: 5.

36. "For Westway, Yet Again," editorial, *New York Times* (March 26, 1982): 26; Josh Barbanel, "Legislature's Leaders Agree to Halt Westway Financing," *New York Times* (March 27, 1982): 27.

37. Thomas P. Griesa, quoted in Arnold H. Lubasch, "U.S. Judge Blocks Westway Landfill as Threat to Fish," *New York Times* (April 1, 1982): 1, B: 8.

38. Quoted in Arnold H. Lubasch, "U.S. Judge Bars Landfill Project for the Westway," *New York Times* (April 15, 1982), B: 1.

39. Schanberg, "Westway: Third Rate Cover Up," (April 20, 1982): 27. Also see Richard Severo, "Pier Area on West Side Called Vital to Survival of Striped Bass," *New York Times* (April 25, 1982): 50.

40. Schanberg, "Westway Deceit (1)," (June 26, 1982): 25.

41. Arnold H. Lubasch, "A Judge Blocks All U.S. Money for the Westway," *New York Times* (July 1, 1982): 1, B: 6; Michael Oreskes, "Westway Court Actions Seen as Costly Setback," *New York Times* (July 2, 1982), B: 3.

42. "No More Westway Fish Stories," editorial, *New York Times* (July 5, 1982): 18. Also see W. C. Hennessy, "Westway Will Again Prevail," letter to the editor, *New York Times* (July 17, 1982): 18; Ted Weiss, "Of Fish and Men and the Fate of the Westway Project," letter to the editor, *New York Times* (July 24, 1982): 22.

43. Arnold H. Lubasch, "U.S. Judge to Name a Master to Monitor Reports on Westway," *New York Times* (July 23, 1982): 1, B: 2; Arnold H. Lubasch, "Westway Master Gets Judge's Orders," *New York Times* (July 24, 1982): 27; "Hang on to Westway," editorial, *New York Times* (September 12, 1982): 20; Michael J. Cuddy, "Westway's Well-Spent $75 Million," letter to the editor, *New York Times* (December 22, 1982): 22.

44. Schanberg, "A Wake for Westway," (March 22, 1983): 25.

45. Quoted in Michael Oreskes, "Cuomo Adviser Urges Scrapping of the Westway," *New York Times* (May 3, 1983), B: 1, 4.

46. "The Westway 'Luxury' Is a Bargain," editorial, *New York Times* (May 4, 1983): 26. Also see James L. Larocca, "Westway Progress," letter to the editor, *New York Times* (May 10, 1983): 24; Schanberg, "The Same Old Scandal," (May 10, 1983): 25.

47. Schanberg, "Beyond Contempt," (June 28, 1983): 27; Peter Freiberg, "Westway Update," *Metropolis* 3 (September 1983): 10.

48. Deirdre Carmody, "3 Designs for Proposed Westway Park Displayed by State," *New York Times* (December 23, 1983), B: 1, 7; "A Riverfront Park for New York Is Proposed," *Architectural Record* 172 (February 1984): 51; "Names and News," *Oculus* 45 (February 1984): 7; Daralice D. Boles, "Westway Wonderland," *Progressive Architecture* 65 (February 1984): 34; Paul Goldberger, "3 Design Plans Being Considered for Proposed Park over the Westway," *New York Times* (March 28, 1984), B: 1, 4; George Lewis, "Chapter Reports," *Oculus* 45 (April 1984): 7; George Lewis, "Notes on the Year," *Oculus* 45 (June 1984): 17; Deirdre Carmody, "Westway Park Design Goes Public," *New York Times* (June 21, 1984), B: 1; Douglas Davis, "Mr. Post-Postmodern," *Newsweek* 104 (July 9, 1984): 78; "Behold the Westway Park," editorial, *New York Times* (July 14, 1984): 22; Susan Heller Anderson and Maurice Carroll, "Countdown on Westway," *New York Times* (October 2, 1984), B: 3; "Westway Park," *Princeton Journal* 2 (1985): 196–99; Grace Anderson, "Big Park for the Big Apple," *Architectural Record* 173 (January 1985): 124–31; Susan Heller Anderson and David W. Dunlap, "Model Compromise," *New York Times* (February 16, 1985): 27; Craig Whitaker, "Design Arguments for an Urban Highway," *Urbanismo Revista* 3 (September 1985): 39–48; A. Sanmartín, *Venturi, Rauch and Scott Brown* (London: Academy Editions, 1986), 132–35; Stanislaus von Moos, *Venturi, Rauch & Scott Brown: Buildings and Projects* (New York: Rizzoli International Publications, 1987), 128–33; Vincent Scully, "Robert Venturi's Gentle Architecture," in Christopher Mead, ed., *The Architecture of Robert Venturi* (Albuquerque: University of New Mexico Press, 1989), 28; Frederic Schwartz and Carolina Vaccaro, *Venturi Scott Brown and Associates* (Barcelona: Editorial Gustavo Gili, 1995),

132–33; Buttenwieser, *Manhattan Water-Bound*, 219–25; David G. De Long, "Seeking a Rational Mannerism," in Brownlee, De Long, and Hiesinger, *Out of the Ordinary: Robert Venturi Denise Scott Brown and Associates*, 147.

49. Buttenwieser, *Manhattan Water-Bound*, 222.

50. Boles, "Westway Wonderland": 34.

51. Goldberger, "3 Design Plans Being Considered for Proposed Park over the Westway": 1, 4.

52. "Behold the Westway Park": 22.

53. Quoted in "Westway Park": 196.

54. "Partial Reprieve: Court Says New York State Can Continue Westway Work," *Engineering News-Record* 212 (March 15, 1984): 12.

55. Quoted in Sam Roberts, "Army Determines Building Westway Could Harm Bass," *New York Times* (November 28, 1984): 1, B: 6. Also see Ellen Posner, "Waffling on Westway's Architectural Cost," *Wall Street Journal* (August 14, 1984): 1.

56. "The Last Westway Hurdle," editorial, *New York Times* (December 1, 1984): 22. Also see Maurice Carroll, "Reagan Aid Requested on Westway," *New York Times* (December 23, 1984): 20; Sam Roberts, "Westway Project Expected to Win a Crucial Ruling," *New York Times* (January 17, 1985): 1, B: 5; Alan Finder, "Favorable Wind for Westway," *New York Times* (January 20, 1985), IV: 6.

57. Sam Roberts, "Westway Landfill Wins the Support of Army Engineer," *New York Times* (January 24, 1985): 1, B: 3; "Westway's Endless Last Mile," editorial, *New York Times* (January 26, 1985): 20; Schanberg, "Pyramids That Cloud the Mind," (January 26, 1985): 21.

58. John B. Oakes, "Hell-for-Broke on Westway," *New York Times* (February 16, 1985): 23.

59. Sam Roberts, "E.P.A. Withdraws as a Challenger of Westway Plan," *New York Times* (February 20, 1985): 1, B: 4.

60. "The Promise of Westway at Last," editorial, *New York Times* (February 21, 1985): 22. Also see Schanberg, "Boondoggle by Local Choice," (March 5, 1985): 27.

61. "Final Stretch for Westway," editorial, *Engineering News-Record* 214 (March 7, 1985): 72; "Manhattan's Westway Wins Its Final Permit," *Engineering News-Record* 214 (March 7, 1985): 10.

62. Robert D. McFadden, "Westway Foes Spar Across Hudson," *New York Times* (April 15, 1985), B: 5; "Forgotten Facts in the Hudson War," editorial, *New York Times* (May 14, 1985): 26; Josh Barbanel, "Koch Threatens Jersey for Opposing Westway," *New York Times* (May 21, 1985), B: 3; Rep. James J. Howard, "New York City Landfill Is Not a Federal Transportation Project," letter to the editor, *New York Times* (May 28, 1985): 18.

63. Sam Roberts, "Judge to Rehear Westway Dispute," *New York Times* (May 19, 1985), 35; Arnold H. Lubasch, "Striped-Bass Study Debated as Trial on Westway Starts," *New York Times* (May 21, 1985), B: 3.

64. Thomas P. Griesa, quoted in "Griesa Assails Westway Records," *New York Times* (May 30, 1985), B: 2. Also see Schanberg, "Merits and Misconduct," (June 11, 1985): 27.

65. Arnold H. Lubasch, "Judge Hears Closing Arguments on Westway Ban," *New York Times* (July 23, 1985), B: 3.

66. Schanberg, "Cajun Flies and Westway," (July 27, 1985): 23. Also see W. H. James, "The Spur That Westway Would Give to New York's Regeneration," letter to the editor, *New York Times* (August 6, 1985): 22.

67. Chuck Conconi, "Personalities," *Washington Post* (September 26, 1985), D: 3.

68. Thomas P. Griesa, quoted in Arnold H. Lubasch, "Westway Project Is Blocked Again by Federal Judge," *New York Times* (August 8, 1985): 1, B: 3.

69. "Milestones for Westway Plan," *New York Times* (August 8, 1985), B: 3; Sam Roberts, "Westway Is at the Crossroads Again," *New York Times* (August 8, 1985), B: 3.

70. Tom Morganthau with Martin Kasindorf, Lynda Wright and Mary Hager, "The Death of a 'Boondoggle'?" *Newsweek* 106 (August 19, 1985): 28. Also see "Down to the Wire: Westway May Not Be Able to Survive Latest Court Ruling," *Engineering News-Record* 215 (August 15, 1985): 15; Peter Lemos, "The Great Fish Trial," *Metropolis* 5 (September 1985): 16; "Construction of Westway," *Progressive Architecture* 66 (September 1985): 24.

71. Arnold H. Lubasch, "U.S. Appeals Court Upholds Decision to Halt Westway," *New York Times* (September 12, 1985): 1, B: 4.

72. Michael Oreskes, "House Votes by Big Margin to Bar Funds for Westway," *New York Times* (September 12, 1985), B: 8; David Rogers, "House Blocks Funds for Crucial Part of Westway Plan," *Wall Street Journal* (September 12, 1985): 1.

73. "Westway at the Brink," editorial, *New York Times* (September 13, 1985): 26; Sam Roberts, "The Future of Westway," *New York Times* (September 13, 1985): 1, B: 2.

74. Michael Oreskes, "Supporters of Westway Plan a Possible Trade-In," *New York Times* (September 13, 1985): 1, B: 3; Sam Roberts, "Complications Over Trade-In for Westway," *New York Times* (September 19, 1985), B: 1, 9.

75. Michael Oreskes, "Moynihan Sees No Way to Win a Westway Vote," *New York Times* (September 19, 1985), B: 9; "The Next-Best Way," editorial, *New York Times* (September 20, 1985): 30; Governor Cuomo and Mayor Koch, "Joint Statement on Westway," *New York Times* (September 20, 1985), B: 2; Michael Oreskes, "New York Leaders Give Up Westway and Seek Trade-In," *New York Times* (September 20, 1985): 1, B: 2; "$15,000-an-Inch Highway," editorial, *Washington Post* (September 21, 1985): 22; Alan Finder, "Westway, a Road That Was Paved with Mixed Intentions," *New York Times* (September 22, 1985), IV: 6.

76. Sam Roberts, "Trade-In Plan: Half May Go for Transit," *New York Times* (September 24, 1985): B: 1, 4; Sam Roberts, "Koch and Cuomo Slice Westway Pie in Plan for a Federal Funds Trade-In," *New York Times* (September 27, 1985), B: 1, 10.

77. "Death of a Highway," *New York Times* (September 27, 1985): 30. Also see Michael Oreskes, "Reporter's Notebook:

Finale of Westway Debate," *New York Times* (September 30, 1985), B: 3.

78. Robert F Wagner Jr., and Mario Cuomo, quoted in Sam Roberts, "The Legacy of Westway: Lessons from Its Demise," *New York Times* (October 7, 1985): 1, B: 8.

79. Russell Baker, "Big One Gets Away," *New York Times* (October 9, 1985): 23.

80. Robert Moses, quoted in Carter Wiseman, "Where Westway Went: A Case Study in Changing Urban Priorities," *Architectural Record* 174 (February 1986): 81–82. Also see Patrick Phillips, "Whither Westway?" *Urban Land* 45 (February 1986): 36–37; Jim Burns, letter to the editor, *Architectural Record* 174 (April 1986): 4.

81. Wiseman, "Where Westway Went: A Case Study in Changing Urban Priorities": 81.

82. George Haikalis, "Westway II: Shaping an 'Inboard' Alternative to Westway," *New York Affairs* 9 (No. 2, 1985): 89–94; Michael Oreskes, "Westway Funds Trade-In Wins Federal Approval," *New York Times* (October 1, 1985), B: 3; Ross Sandler, "Planning the Best Way for the Former Westway Stretch," *New York Times* (October 19, 1985): 27; "Westway Is Dead," *Progressive Architecture* 66 (November 1985): 24; "Concern to Study West Side Traffic," *New York Times* (January 23, 1986): 31; "Pride of Westway," *Metropolis* 5 (May 1986): 10; *New York City's Waterfront: A Plan for Development* (New York, July 1986), 40–41; "Conceiving a Son of Westway," editorial, *New York Times* (July 31, 1986): 20; James Brooke, "State Offers 4 Versions of Boulevard to Replace Defunct Westway Project," *New York Times* (August 7, 1986): B: 1, 3; Michael Sorkin, "Ten Rules for Rebuilding the West Side," *Village Voice* (August 26, 1986): 83, 92; Robert O. Boorstin, "A 6-Lane Road Would Replace Westway Plan," *New York Times* (November 17, 1986): 1, B: 2; Robert O. Boorstin, "Panel Agrees on Parts of West Side Road Plan," *New York Times* (November 27, 1986): B: 9; "At Last, a Westway Truce," editorial, *New York Times* (November 29, 1986): 30; Robert O. Boorstin, "Panel Presents Roadway Plan for West Side," *New York Times* (December 9, 1986): 1, 12; Robert O. Boorstin, "West Side Road Panel Disagrees on Esplanade," *New York Times* (January 8, 1987): 31; Arthur Levitt Jr., "Let's End the Westway War," *New York Times* (February 4, 1987): 27; "Putting This Stock in the Waterfront," *Avenue* (May 1987): 122; Sam Roberts, "Westway II: A Delay Costing $90,000 a Day," *New York Times* (July 16, 1987): B:1.

83. Mark A. Uhlig, "Officials Agree on a New Road at Westway Site," *New York Times* (August 23, 1987): 1, 42; "Artful Compromise on Westway," editorial, *New York Times* (August 25, 1987): 20; Joseph Giovannini, "West Side's New Road to Ornament Manhattan?" *New York Times* (August 30, 1987), IV: 28; Richard N. Gottfried, "Add Park to the West Side Highway," letter to the editor, *New York Times* (September 7, 1987): 18; Gene Russianoff, Marcy Benstock, John Mylod, and Larry Shapiro, "Westway Proposal Is Good for Developers, Bad for New Yorkers," letter to the editor, *New York Times* (September 15, 1987): 34.

84. Ginger Danto, "Plans for West Side Esplanade Moving Slowly," *New York Observer* (January 11, 1988): 7; Peg Tyre and Jeannette Walls, "West Side Drive Back on Track," *New York* 21 (April 18, 1988): 17–18; Joyce Purnick, "Westway Substitute on Map for 10 Years," *New York Times* (May 30, 1988): 25–26.

85. Richard Levine, "Highway's Demise: Nightmare for Drivers," *New York Times* (January 6, 1989), B: 1, 3; Lou Chapman, "The End of the Road," *New York Observer* (January 30, 1989): 8; Michael T. Kaufman, "Death of an Old Highway and a Home for the Homeless," *New York Times* (May 25, 1989), B: 1, 14.

86. Elizabeth Kolbert, "Cuomo Delays Esplanade Plan for the Hudson," *New York Times* (January 17, 1989), B: 7; Michael Tomasky, "City News Digest," *New York Observer* (January 23, 1989): 6; "Stalled for Good," editorial, *New York Observer* (January 30, 1989): 4.

87. "Westway's Nihilists," editorial, *New York Times* (April 15, 1989): 26.

88. Bridget Barclay et al., "Would-Be West Side Developers Still Target Striped Bass Habitat," letter to the editor, *New York Times* (May 5, 1989): 34.

89. Audrey Farolino and Chris McKenna, "Waterfront Panel Back in Business," *New York Post* (June 22, 1989): 40.

90. "Calendar: Festivals on Sea and Land," *New York Times* (June 8, 1989), C: 5; David W. Dunlap, "Banners to Wave Again for Hudson Park," *New York Times* (July 7, 1989): B: 2.

91. David W. Dunlap, "Post-Westway Plan Offered by Panel for Hudson Shore," *New York Times* (November 1, 1989), B: 3.

92. Gary Hack, quoted in Dunlap, "Post-Westway Plan Offered by Panel for Hudson Shore": 3.

93. "Cuomo and Dinkins Back Hudson Park," *New York Times* (February 16, 1990): B: 2.

94. Constance L. Hays, "Funds May Fall Short in West Side Park Plan," *New York Times* (March 4, 1990): 32.

95. Sam Howe Verhovek, "Accord Near on Preserving Westway Site," *New York Times* (May 15, 1990), B: 1–2; "A Correction: Hudson Building Ban," *New York Times* (May 16, 1990), B: 4.

96. Quoted in West Side Waterfront Panel, *A Vision for the Hudson River Waterfront Park* (New York, September 17, 1990), 1. Also see Constance L. Hays, "Panel Unveils Plan for Park Along Hudson Waterfront," *New York Times* (September 18, 1990), B: 3; Constance L. Hays, "Hudson River Park Plan Draws Critics," *New York Times* (September 29, 1990): 25, 28; Michael Tomasky, "How Do You Build a Park?" *New York Observer* (October 8, 1990): 3; Sam Roberts, "Westway's Ghost Pays Off, Proving Skeptics Wrong," *New York Times* (November 26, 1990), B: 1.

97. Allan R. Gold, "Defeat of the Environmental Bond Act May Mean Higher Taxes in New York," *New York Times* (November 8, 1990): 1, B: 12; Bill Hine, "We Can't Afford More Delay on Hudson River Waterfront Park," letter to the editor,

New York Times (November 28, 1990): 20; Alexander Denega, "'Why I Voted No,'" letter to the editor, *New York Times* (November 28, 1990): 20.

98. "Project Citation," *Annals of the New York Chapter of the American Institute of Architects, 1995–96* (1996): 33; Hanrahan + Meyers Architects: *The Four States of Architecture* (West Sussex, England: Wiley-Academy, 2002), 84–91.

99. Sam Roberts, "Cuomo and Dinkins Offer a New Plan for the West Side," *New York Times* (May 20, 1992): 1, B: 3; "Wisdom on the Waterfront," editorial, *New York Times* (May 21, 1992): 28; Sam Roberts, "Consensus Means Waterfront Project for West Side May Actually Get Built," *New York Times* (May 21, 1992), B: 2; David W. Dunlap, "A Blueprint of the Future Along the Hudson River," *New York Times* (May 24, 1992): 37; Michael Specter, "With Park and Path, New York Tries to Link Asphalt to Water," *New York Times* (June 9, 1992), B: 1, 6; Marta Mestrovic, "All Quiet on the Western Waterfront?" *Metropolis* 12 (September 1992): 15, 18; David W. Dunlap, "Charting the Future of the Waterfront," *New York Times* (November 15, 1992), X: 1, 8.

100. Sam Roberts, "Details Offered on Alternative to Westway," *New York Times* (May 13, 1993), B: 11.

101. David W. Dunlap, "Jostling for Position on the Riverfront," *New York Times* (July 11, 1993), X: 1, 6.

102. Bruce Lambert, "A New Bike Path: Recreation with a River View," *New York Times* (October 31, 1993), XIII: 6; "Down by the Riverside," editorial, *New York Times* (June 5, 1994), IV: 16; Stuart Waldman, "Why Can't We Have a True Waterfront Park on the Hudson?" *New York Times* (June 16, 1994): 26; David W. Dunlap, "The Hudson Waterfront: What's Next?" *New York Times* (June 26, 1994), IX: 1, 8.

103. David W. Dunlap, "Officials Approve Plans to Rebuild West Side Artery," *New York Times* (August 2, 1994): 1, B: 3; "Tortuous History of a Highway," *New York Times* (August 2, 1994): 3; Anna Shapiro, "Rebuilt West Side Highway Is a Trojan Horse," letter to the editor, *New York Times* (August 18, 1994): 22; Marvine Howe, "Fear of West Side Plans: Park or K-Mart-on-the-Hudson? *New York Times* (August 21, 1994), XIII: 1.

104. *Hudson River Park: Concept and Financial Plan* (New York: Hudson River Park Conservancy, 1995); Buttenwieser, *Manhattan Water-Bound*, 253–54; Raymond W. Gastil, *Beyond the Edge: New York's New Waterfront* (New York: Princeton Architectural Press, 2002), 126–30; Ian Luna, ed., *New New York: Architecture of a City* (New York: Rizzoli International Publications, 2003), 34–35.

105. Thomas J. Lueck, "Ruling May Delay Decisions on Hudson Riverfront Plans," *New York Times* (January 14, 1995): 27; Bruce Lambert, "Park Panel at Center of War over Waterfront," *New York Times* (February 19, 1995), XIII: 6; Andrew C. Revkin, "Chief of Hudson River Conservancy Ousted," *New York Times* (April 26, 1995), B: 2.

106. Andrew Jacobs, "Pier Group: 3 Bring Sand and Ideas," *New York Times* (August 13, 1995), XIII: 7.

107. Randy M. Mastro, "The Road Not Taken," *New York Times* (August 26, 1995): 19; Gene Russianoff, "Don't Ponder New Westways when Subways Are Crumbling," letter to the editor, *New York Times* (September 4, 1995): 18; Anna Shapiro, "Bring On the Green," letter to the editor, *New York Times* (September 4, 1995): 18; Bruce Lambert, "Deadline Nears on Fund Waiver for Westway," *New York Times* (September 24, 1995), XIII: 6.

108. Bruce Lambert, "Pataki About to Remove Waterfront Park Plan from Limbo," *New York Times* (January 28, 1996), XIII: 8; Gary Pierre-Pierre, "After Two Decades, Work Begins on Far Less Ambitious Westway," *New York Times* (April 2, 1996), B: 1, 4.

109. Joyce Purnick, "Slowly Moving Down a Road to a Roadway," *New York Times* (April 4, 1996), B: 1. Also see Gene Russianoff, "Westway's Defeat Yielded Tangible Benefits," letter to the editor, *New York Times* (April 10, 1996): 18; Richard T. Anderson, "Westway's Promise," letter to the editor, *New York Times* (April 15, 1996): 14; Tom Fox, "Let's Begin Work on the Hudson River Park," letter to the editor, *New York Times* (April 20, 1996): 20.

110. Douglas Martin, "Park on West Side Takes Big Step Ahead," *New York Times* (June 6, 1996), B: 1, 3; "A Park on the Hudson River," editorial, *New York Times* (June 21, 1996): 26; Douglas Martin, "Immutable Principle vs. Adaptable Park Plan," *New York Times* (June 30, 1996): 25; John Mylod, "River Park Fighter," letter to the editor, *New York Times* (July 7, 1996): 8; "Marcy Benstock: The News Fit to Print," *Wall Street Journal* (July 10, 1996): 13; "Hudson River Park Debate (Continued)," *Wall Street Journal* (July 18, 1996): 11; Devin Leonard, "Ghosts of Westway Haunt Pataki Plan for Park on Hudson," *New York Observer* (June 9, 1997): 1, 8; Bunny Gabel, "Anti-Authority," letter to the editor, *New York Observer* (June 23, 1997): 4.

111. Andrew Jacobs, "Hudson Waterfront: Pier 40's Unified Front Breaks," *New York Times* (August 11, 1996), XIII: 6; Janet Allon, "Coalition Fights Plan for Parking Instead of a Park," *New York Times* (March 16, 1997), XIII: 6; Andrew C. Revkin, "Civic Groups Warn State Over Pier on Houston Street," *New York Times* (April 4, 1997): B: 2; Devin Leonard, "Gargano Power Grab Could Delay Plans for Park on Hudson," *New York Observer* (June 30-July 7, 1997): 1, 12; Janet Allon, "Piers Plan for Leagues Hits a Shoal," *New York Times* (November 30, 1997), XIV: 7.

112. Andrew Jacobs, "Hudson Waterfront: A Glimpse of River Park in Limbo," *New York Times* (December 1, 1996), XIII: 6; Andrew Jacobs, "Waterfront: Down by the River: Park Solution?" *New York Times* (December 29, 1996), XIII: 6; "The Ebbing Hudson River Park," editorial, *New York Times* (February 13, 1997): 32.

113. Andrew C. Revkin, "Pataki to Commit $100 Million Share to a Hudson Park," *New York Times* (April 3, 1997): 1, B: 4; "A Boost for the Hudson River Park," editorial, *New York Times* (April 4, 1997): 34; "The Hudson! Of Course!" *New York Times* (April 6, 1997), F: 2.

114. Douglas Martin, "Planners Foresee Beaches on Banks of a Clean Hudson," *New York Times* (August 11, 1997), B: 2.

115. David M. Halbfinger, "Hudson Park's Beginning," *New York Times* (August 21, 1997), B: 5; "The Mayor and the River," editorial, *New York Times* (November 24, 1997): 22; Douglas Martin, "Hudson River Park Plan Moves Closer to Reality," *New York Times* (February 16, 1998): 1, B: 4; "Dream and Reality on the Hudson," editorial, *New York Times* (February 21, 1998): 10; Kemba Johnson, "No Shore Thing," *City Limits* 23 (March 1998): 10–12; Douglas Martin, "Hudson Park Plan Turns Friends into Foes," *New York Times* (March 9, 1998), B: 6; "The Hudson Needs the Mayor," editorial, *New York Times* (March 10, 1998): 18.

116. Douglas Martin, "City and State Agree on Plan for Oversight of River Park," *New York Times* (June 14, 1998): 40; Abby Goodnough, "Albany Passes a Bill to Speed School Voting," *New York Times* (June 20, 1998), B: 1–2; "A River Park Grows in Manhattan," editorial, *New York Times* (July 30, 1998), 18; Douglas Martin, "Hudson Park Draws Closer to Reality," *New York Times* (July 30, 1998), B: 1, 8.

117. Bernard Stamler, "Route 9A: Long Overdue but Ahead of Schedule," *New York Times* (June 21, 1998), XIV: 5; David S. Chartock, "Communities Play Key Role in the Evolution of Route 9A," *New York Construction News* 46 (August 1998): 30–36.

118. Douglas Martin, "Pataki Signs Law Creating Hudson Park," *New York Times* (September 9, 1998), B: 3; Douglas Martin, "Plan for Park on Hudson River Hits Snag in City Council," *New York Times* (October 16, 1998), B: 4; "Hudson River Park Wins Council Backing," *New York Times* (October 23, 1998), B: 10.

119. Douglas Martin, "Work on Hudson Park Is Stalled as Officials Lag in Naming Board," *New York Times* (March 1, 1999), B: 1, 7; Douglas Martin, "Pataki and Giuliani Pick Hudson River Park Board Members," *New York Times* (March 5, 1999), B: 3; "Keep Moving on the Hudson River Park," editorial, *New York Times* (March 7, 1999): 14; Douglas Martin, "Be It Ever So Humble: Hudson Park Has New Office," *New York Times* (March 16, 1999), B: 3; Josh Benson, "Scholarly Beef Boss James Ortenzio Works on $400 Million Hudson Park," *New York Observer* (April 26, 1999): 1, 8; Michael Tomasky, "The Next Big Things," *New York* 32 (May 17, 1999): 40–47.

120. Bernard Stamler, "Park Fans Win Tug of War Over Gansevoort Peninsula," *New York Times* (April 4, 1999), XIV: 7.

121. Paul Bennett, "Wayfinding and Identity," *Landscape Architecture* 89 (July 1999): 22; Paul Bennett, "An Island Unto Itself," *Landscape Architecture* 89 (July 1999): 68–75, 94–95.

122. Corey Kilgannon, "Anchoring a Cruise Ship Pier for Earthly Pleasures," *New York Times* (July 25, 1999), XIV: 6.

123. Douglas Martin, "City Opens 1st Section of New Park on Hudson," *New York Times* (September 27, 1999), B: 5; Eleanor Randolph, "A Park Along the River," *New York Times* (October 23, 1999): 16.

124. Josh Benson, "A Fierce Coalition Prepares Last Stand Against Hudson Park," *New York Observer* (January 10, 2000): 1, 7; "Nadler, Kennedy and Kerry Sabotage New York Park," editorial, *New York Observer* (January 17, 2000): 4.

125. Barbara Stewart, "Hudson River Park on Restored Piers Approved by U.S.," *New York Times* (June 1, 2000): 1, B: 6; "The Hudson River Park, on Track," editorial, *New York Times* (June 4, 2000): IV: 18; "A West Side Winner," editorial, *New York Observer* (June 12, 2000): 4; Terry Golway, "A Test of Leadership: Saving the Watershed," *New York Observer* (June 12, 2000): 5.

126. *New York City Waterfront Revitalization Program* (New York: Department of City Planning, 1982), 3, 70, 81.

127. Martin Gottlieb, "Experts Seek Ways to Reclaim City Waterfront," *New York Times* (April 28, 1984): 26; *578 Miles of Opportunity: New York City's Waterfront* (New York: Parks Council and Regional Plan Association, 1985).

128. Quoted in *578 Miles of Opportunity: New York City's Waterfront*, 1, 3–4.

129. *New York City's Waterfront: A Plan for Development* (New York: New York City Public Development Corporation, 1986). Also see Philip S. Gutis, "P.D.C.'s Agenda," *New York Times* (July 20, 1986), VIII: 1.

130. Joseph Giovannini, "New York Harbor Being Redesigned," *New York Times* (November 11, 1986), B: 1–2.

131. Douglas Martin, "Prison Barge Arrives at East River Pier," *New York Times* (October 27, 1987), B: 24; Douglas Martin, "Oversight Groups Assail Prison Barge as Poorly Constructed and Dangerous Maze," *New York Times* (November 10, 1987), B: 3; "Proposed Prison Barge Undergoes an Inspection," *New York Times* (November 11, 1987), B: 2; Kirk Johnson, "Ruling Allows Immediate Use of Barge as Jail," *New York Times* (February 27, 1988): 35; "Man Is First to Escape from Prison Barge," *New York Times* (May 1, 1988): 44; Douglas Martin, "Jail Barge to Change Rivers," *New York Times* (May 17, 1988), B: 2; Douglas Martin, "A Prison Barge on Hudson: 'Folly' or 'Ideal,'" *New York Times* (June 16, 1988), B: 1, 8; David W. Dunlap, "Review of a Plan for a Jail Barge Is Drawing Fire," *New York Times* (August 25, 1988), B: 3; "Estimate Board Votes Second Prison Barge," *New York Times* (October 15, 1988): 35; Celestine Bohlen, "Board Backs Prison Barge Near Pier 40," *New York Times* (October 28, 1988), B: 1–2; Ted Gest, "The Far Shore of America's Bulging Prisons," *U.S. News & World Report* 105 (November 14, 1988): 11; Celestine Bohlen, "Jail Influx Brings Change for 2 Barges," *New York Times* (March 3, 1989), B: 1, 4; "First Group of Inmates Moves to Prison Barge," *New York Times* (March 7, 1989), B: 3; "Prison Barge, at Lower East Side Berth, Is Prepared for Inmates," *New York Times* (May 28, 1989), B: 2; Celestine Bohlen, "For Inmates, the Living Is Easier on 'Love Boat,'" *New York Times* (May 30, 1989), B: 3; Michel Marriott, "On Prison Barge, All Hands Battle Drugs," *New York Times* (September 25, 1989), B: 1, 5; Selwyn Raab, "Late Docking of a Prison Barge Saves Cash, but Cells Are Needed," *New York Times* (July 8, 1991), B: 3; Selwyn Raab, "Bronx Jail Barge to Open, Though the Cost Is Steep," *New York*

Times (January 27, 1992), B: 3; Esther B. Fein, "A $1.8 Million Bid Wins 2 Empty Prison Barges," *New York Times* (July 29, 1994), B: 3; Gastil, *Beyond the Edge*, 47–48.

132. Richard J. Koehler, quoted in Martin, "Prison Barge Arrives at East River Pier": 24.

133. Gastil, *Beyond the Edge*, 47–48.

134. Buttenwieser, *Manhattan Water-Bound*, 249.

135. Buttenwieser, *Manhattan Water-Bound*, 250–51.

136. *New York City Comprehensive Waterfront Plan: Reclaiming the City's Edge* (New York: Department of City Planning, 1992). Also see David W. Dunlap, "For New York, the Time Is Right, but Is the Task Just Too Nightmarish?" *New York Times* (April 12, 1992), X: 1, 9; "Waterfront Improvements Urged," *Municipal Art Society Newsletter* (May-June 1992): 2; Michael Specter, "With Park and Path, New York Tries to Link Asphalt to Water," *New York Times* (June 9, 1992), B: 1, 6; James C. McKinley Jr., "Proposal to Double Park Area on the Shore," *New York Times* (August 12, 1992), B: 3; Marta Mestrovic, "All Quiet on the Western Waterfront?" *Metropolis* 12 (September 1992): 15, 18; Peter Slatin, "New Plans for New York," *Architecture* 81 (October 1992): 25; "We Covet the Waterfront," *Oculus* 55 (October 1992): 10; David W. Dunlap, "Charting the Future of the Waterfront," *New York Times* (November 15, 1992), X: 1, 8; Herbert Muschamp, "The Year in the Arts: Architecture/1992," *New York Times* (December 27, 1992), II: 37; Peter Slatin, "Waterfront Plan," *Oculus* 55 (January 1993): 9–10; Craig Whitaker, "Waterfront Plan: Learning from New Jersey," *Oculus* 55 (January 1993): 10–11; Jennifer Downey, "The Waterfront," letter to the editor, *New York Times* (January 10, 1993), X: 13; Richard L. Schaffer, "New York City Comprehensive Waterfront Plan," *Livable City* 17 (Spring 1993): 2–3; Brian McGrath and Mary Elizabeth Rusz, "Perspectives on the New York Waterfront: Introduction," *Livable City* 17 (Spring 1993): 3; Elliott D. Sclar, "Perspectives on the New York Waterfront: Industry," *Livable City* 17 (Spring 1993): 4; Paul Buckhurst, "Perspectives on the New York Waterfront: Development," *Livable City* 17 (Spring 1993): 4–5; George Haikalis, "Perspectives on the New York Waterfront: Transportation," *Livable City* 17 (Spring 1993): 5; Marcia Reiss, "Perspectives on the New York Waterfront: Parks & Open Space," *Livable City* 17 (Spring 1993): 6; David F. M. Todd, "Perspectives on the New York Waterfront: Preservation," *Livable City* 17 (Spring 1993): 6; John Gardner, "Perspectives on the New York Waterfront: Environment," *Livable City* 17 (Spring 1993): 7; Richard L. Schaffer, "City Planning's Waterfront Plan," *Oculus* 55 (April 1993): 10; David W. Dunlap, "Jostling for Position on the Riverfront," *New York Times* (July 11, 1993), X: 1, 6; David W. Dunlap, "A Shift in Rules Guiding Growth Along the Water," *New York Times* (October 3, 1993), X: 1, 7; David W. Dunlap, "Panel Passes Council Plan for Building on Shoreline," *New York Times* (October 7, 1993), B: 2; "Progress on the Waterfront," editorial, *New York Times* (October 14, 1993): 22; Herbert W. Muschamp, "Fear, Hope and the Changing of the Guard," *New York Times* (November 14, 1993), II: 37; Richard L. Schaffer, "Waterfront Vision," letter to the editor, *New York Times* (December 12, 1993), II: 4; Wise, Woods, and Bone, "Evolving Purposes," in Bone, ed., *The New York Waterfront*, 227–33; Michael Z. Wise, "Modest Endeavors," in Bone, ed., *The New York Waterfront*, 237–38; Nina Rappaport, "On the Waterfront," *Oculus* 61 (October 1998): 8–15; Buttenwieser, *Manhattan Water-Bound*, 248–51; Gastil, *Beyond the Edge*, 52–53.

137. Richard L. Schaffer, quoted in Dunlap, "Charting the Future of the Waterfront": 8.

138. *New York City Comprehensive Waterfront Plan: Plan for the Bronx Waterfront* (New York: Department of City Planning, 1993); *New York City Comprehensive Waterfront Plan: Plan for the Manhattan Waterfront* (New York: Department of City Planning, 1993); *New York City Comprehensive Waterfront Plan: Plan for the Queens Waterfront* (New York: Department of City Planning, 1993); *New York City Comprehensive Waterfront Plan: Plan for the Brooklyn Waterfront* (New York: Department of City Planning, 1994); *New York City Comprehensive Waterfront Plan: Plan for the Staten Island Waterfront* (New York: Department of City Planning, 1994).

139. Specter, "With Park and Path, New York Tries to Link Asphalt to Water": 6.

140. Ruth Messinger, quoted in McKinley, "Proposal to Double Park Area on the Shore": 3.

141. Ron Hine, quoted in Slatin, "Waterfront Plan": 9.

142. Mestrovic, "All Quiet on the Western Waterfront?": 15, 18.

143. Michael Slattery, quoted in Dunlap, "Charting the Future of the Waterfront": 8.

144. Whitaker, "Waterfront Plan: Learning from New Jersey": 10–11.

145. "Progress on the Waterfront": 22.

146. Muschamp, "Fear, Hope and the Changing of the Guard": 37.

147. "The Waterfront: A Historical Portrait," *New York Times* (February 13, 1994), XIII: 12; Sarah Amelar, "The Essential City: New York Waterfront Survey," *Newsline* 6 (March-April 1994): 6.

148. Amelar, "The Essential City: New York Waterfront Survey": 6.

149. Quoted in Amelar, "The Essential City: New York Waterfront Survey": 6.

150. "New York City Waterfront," *New York Times* (December 5, 1996), C: 5; Kira L. Gould, "Eyes on the Waterfront," *Oculus* 59 (February 1997): 5; "Waterfront Portrait," *New York Times* (February 13, 1997), C: 9; "A Pier, Once Ignored, Is Suddenly a Favorite," *New York Times* (December 10, 1998), F: 16; "Calendar: Topics," *New York Times* (May 27, 1999), F: 4; Hugh Son, "Kid Stuff," *New York Daily News* (July 10, 1999): 33; "Calendar: Thoughts on the Waterfront," *New York Times* (August 30, 2001), F: 8.

151. Quoted in http://www.vanalen.org/competitions/east_river. Also see *Design Ideas for New York's East River*

(New York: Van Alen Institute, 1998); "East River Dreams," *New York Times* (March 19, 1998), F: 5; "Seeking Entries," *Metropolis* 17 (April 1998): 25, 58; Allen Salkin, "N.Y. Waterfront Gets a Face Lift," *New York Post* (May 26, 1998): 24; "Design Ideas for New York's East River," *Oculus* 61 (October 1998): 3; "East River Projects," *Van Alen Report* 4 (October 1998): 5–6; "Some Stylish Suggestions for the East River," *New York Times* (November 1, 1998), XIV: 15; "Ideas for the East River," *Oculus* 61 (January 1999): 5; Gastil, *Beyond the Edge*, 139–41.

152. Quoted in *Design Ideas for New York's East River*, 3.

153. Quoted in http://www.vanalen.org/competitions/east_river.

154. Gastil, *Beyond the Edge*, 142–43.

155. Allan R. Gold, "New York's Waters Cleaner, but Pollution Is Still Daunting," *New York Times* (April 19, 1990), 1, B: 4; Allan R. Gold, "New York City Expanding Monitoring of Toxic Wastes," *New York Times* (July 29, 1991), B: 3; Matthew L. Wald, "A New 10-Year Plan to Prevent Water Pollution," *New York Times* (September 12, 1993): 57; Andrew C. Revkin, "Harbor Is Cleaner," *New York Times* (June 15, 1995), B: 3; William K. Stevens, "Shaking Off Man's Taint, Hudson Pulses with Life," *New York Times* (June 9, 1996): 1, 46; John H. Cushman Jr., "Plan Developed by White House to Clear Harbor in New York," *New York Times* (July 24, 1996), B: 1, 3; Andrew C. Revkin, "2 Governors Plan Cleanup for Harbor," *New York Times* (October 6, 1996): 37–38; "Saving New York Harbor," editorial, *New York Times* (October 8, 1996): 24; Wise, "Modest Endeavors," in Bone, ed., *The New York Waterfront*, 239; Bernard Stamler, "A River Rising," *New York Times* (August 24, 1997), XIII: 3, 10; Andrew C. Revkin, "Making Up Their Beds and Hoping the Oysters Will Move In," *New York Times* (June 24, 1999), B: 1, 5; Andy Newman, "Life Returns to Fouled Creek," *New York Times* (November 12, 1999), B:1, 6; Barbara Stewart, "In Bronx, a Plan for Reeling in Fish, Not Cars," *New York Times* (November 20, 1999), B: 1–2; Gastil, *Beyond the Edge*, 21, 50.

156. Stephanie Strom, "Yes, Francesca, There Are Fish, Real Fish, in the Hudson," *New York Times* (October 15, 1990), B: 14; "Casting Lines, and Faith, in the Harbor," *New York Times* (September 21, 1991): 23, 25; John C. Dearie, "Don't Eat Fish of New York City Waters," letter to the editor, *New York Times* (October 15, 1991): 24; Dulcie Leimbach, "For Children," *New York Times* (May 13, 1994), C: 29; Jennifer Kingson Bloom, "Rebirth Seen for Decaying Pier," *New York Times* (January 29, 1995), XIII: 7; Robert H. Boyle, "Outdoors: Fishing," *New York Times* (May 26, 1996), VIII: 9; Andrew Jacobs, "On New Pier, a Necessity Brings Amenity," *New York Times* (October 20, 1996), XIII: 6; Alexandra McGinley, "Playing Catch with Ishmael," *New York Times* (July 5, 1998), XIV: 10; Corey Kilgannon, "Hook, Line and Sinker," *New York Times* (June 6, 1999), XIV: 1, 12.

157. Tom Sawyer, "Beyond the Waterfront, and into the Water," *New York Times* (September 17, 1995), XIII: 1; Douglas Colligan, "Around New York the Hard Way," *New York Times* (May 19, 1996), V: 37; Ingrid Abramovitch, "Radical! New York Is Adventure-Sport City," *New York Times* (June 28, 1998), IX: 1; Bernard Stamler, "Kayaks Off Chelsea?" *New York Times* (July 26, 1998), XIV: 6; Andrew C. Revkin, "On the Water, an Uneasy Mix," *New York Times* (September 6, 1998): 35; Andy Newman, "Circumnavigator in a Kayak Discovers a New World," *New York Times* (June 11, 2000), XIV: 6; Edward Wong, "Kayaking," *New York Times* (October 4, 2001), D: 15; Gastil, *Beyond the Edge*, 54; Corey Kilgannon, "Going Near the Water," *New York Times* (August 18, 2003), B: 3; Richard J. Newman, "Bobbing in the Big Apple," *U.S. News & World Report* 136 (April 26, 2004): 2.

158. Maureen C. Muenster, "Swimming and Floating in New York's Waterways," *New York Times* (April 11, 1999), XIV: 11; Kimberly Stevens, "Splash! Swimming Pools Proposed for City Rivers," *New York Times* (July 18, 1999), XIV: 3; Buttenwieser, *Manhattan Water-Bound*, 4, 108–9.

159. Raymond Gastil, quoted in Stevens, "Splash! Swimming Pools Proposed for City Rivers": 3.

160. Lindsey Gruson, "In a Cleaner Harbor, Creatures Eat the Waterfront," *New York Times* (June 27, 1993): 1, 32; David Rohde, "Burrowing Crustaceans Cause Closing of Pier," *New York Times* (April 28, 1998), B: 3; David M. Herszenhorn, "Pest Is Eating at City's Edges," *New York Times* (July 28, 1999), B: 1, 7.

161. Martin Gottlieb, "Jersey Developer Proposes to Restore Ferry Service," *New York Times* (February 7, 1984), B: 1, 20; Martin Gottlieb, "Koch, Joining Kean, Suggests Reviving Ferry Service Across Hudson," *New York Times* (February 8, 1984), B: 3; Sam Roberts, "Port Agency to Rule on Resuming Ferry Service Across the Hudson," *New York Times* (November 24, 1984): 1, 27; Susan Heller Anderson and David W. Dunlap, "Ferry Across the Hudson," *New York Times* (November 28, 1984), B: 4; Joseph F. Sullivan, "Ferry Is to Start Runs Tomorrow Across Hudson," *New York Times* (December 3, 1986), B: 11; Joseph F. Sullivan, "Swift Ride to Liberty: The Ferry," *New York Times* (December 5, 1986), B: 3; "Bridging the Hudson," *Avenue* (May 1987): 115; Joseph F. Sullivan, "The Commuter Ferry Begins to Take Hold," *New York Times* (September 30, 1987): 13; Daniel Machalaba, "In Waterfront Cities, Ferries Are Making a Comeback as an Option for Commuters," *Wall Street Journal* (March 16, 1988): 34; Constance L. Hays, "In Lieu of Williamsburg: Slow Day for New Ferry," *New York Times* (April 19, 1988), B: 4; "The Talk of the Town: Crossings," *New Yorker* 64 (May 23, 1988): 20; Lou Chapman, "The Ferries Are Back," *New York Observer* (May 22, 1989): 12; Steven Saltzman, "Ferry Service," *Metropolis* 9 (January-February 1990): 18; Mary B. W. Tabor, "The Newest Fashion in Urban Transportation: Ferryboats," *New York Times* (October 22, 1991), B: 1, 4; Arthur E. Imperatore, "Ferries Belong to Our Transportation Future," letter to the editor, *New York Times* (March 31, 1992): 20; Thomas J. Lueck, "Officials Seek More Ferries to Manhattan," *New York Times* (September 4, 1992), B: 1, 5; Peter Slatin, "Ferries for the Future," *Metropolis* 12

(March 1993): 15, 19–20; Hugo Lindgren, "Coast Is Clear," *Metropolis* 13 (December 1993): 11; Garry Pierre-Pierre, "Wall Streeters Test Water Future," *New York Times* (September 17, 1996), B: 3; Garry Pierre-Pierre, "Traveling by Ferry, Once Common in New York Harbor, May Be Again," *New York Times* (September 22, 1996): 42; Wise, "Modest Endeavors," in Bone, ed., *The New York Waterfront*, 239, 242–43; Andy Newman, "Ferry Company Adds Two Manhattan Routes," *New York Times* (June 14, 1998), B: 5; Garry Pierre-Pierre, "New Ferry Service to Ply the Harbor," *New York Times* (May 9, 1997), B: 10; Andy Newman, "Jersey City-to-Midtown Ferry Will Be the First in Decades," *New York Times* (August 25, 1998), B: 5; Buttenwieser, *Manhattan Water-Bound*, 83, 276; Thomas J. Lueck, "Big Ferry Operator to Enter New York Market," *New York Times* (January 30, 1999), B: 5; Andrew Jacobs, "A Ferry Loop Plan to Connect the Dots for New York Bay," *New York Times* (February 10, 1991): 1, B: 4; Erika Kinetz, "Envisioning a Day When Ferries Abound on City Waters," *New York Times* (July 22, 2001), XIV: 6; Lynda Richardson, "On the Busy Ferries, It's Steady as He Goes," *New York Times* (December 19, 2001), D: 2; Gastil, *Beyond the Edge*, 54.

IN THE HARBOR

1. Josh Barbanel, "Statue of Liberty Damaged in Climb by Two Protesters," *New York Times* (May 11, 1980): 1, 32; "2 Statue Climbers Charged with Trespass and Damage," *New York Times* (May 12, 1980), B: 3; "Scaffolding Ordered for Survey of Statue," *New York Times* (May 14, 1980), B: 3. For the Statue of Liberty, see Stern, Mellins, and Fishman, *New York 1880*, 371–82.

2. "Inspectors Find Statue Is Corroded," *New York Times* (May 19, 1980), B: 1, D: 9.

3. Charles Strum, "Threat to Liberty," *New York Times* (November 15, 1981): 49.

4. Paul L. Montgomery, "Statue of Liberty Is Site of a Blast in Exhibit Room," *New York Times* (June 4, 1980), B: 2.

5. "Iacocca to Head Drive to Restore Landmarks," *New York Times* (May 19, 1982), C: 20; "Statue of Liberty Restoration Drive," *Progressive Architecture* 63 (August 1982): 40; "Statue of Liberty Will Be Closed for Restoration in 1984 for as Long as a Year," *New York Times* (November 7, 1982): 50; Laurie Johnston and Susan Heller Anderson, "A Gift for Liberty," *New York Times* (April 9, 1983): 26; "Statue of Liberty Centennial," *Progressive Architecture* 64 (June 1983): 25; Elliot Willensky, "A Nation Finally Remembers," *Historic Preservation* 35 (July-August 1983): 14–19; Philip Shenon, "Statue of Liberty to Be Repaired Starting in Fall," *New York Times* (July 5, 1983), B: 1–2; "From Torch to Toes, New Life for Miss Liberty," *New York Times* (July 20, 1983): 1; Jane Perlez, "Statue of Liberty's Restoration Will Focus on 13 Trouble Spots," *New York Times* (July 20, 1983), B: 1; "Aid for the Disabled," *New York Times* (July 30, 1983): 26; "Preservation Plans Set for Statue of Liberty, Ellis Island," *Architecture* 72 (September 1983): 16–17; Thomas Vonier, "Give Me Your Corroded, Your Cracked," *Progressive Architecture* 64 (September 1983): 41, 44; "Names and News," *Oculus* 45 (October 1983): 10; "Putting the Arm on Miss Liberty," editorial, *New York Times* (December 18, 1983), IV: 18; "If You Still Believe in Me, Save Me," *Architectural Record* 172 (January 1984): 162; "Renovation Begun on Miss Liberty," *New York Times* (January 24, 1984), B: 3; Susan Heller Anderson and David Bird, "Slang and the Statue," *New York Times* (January 31, 1984), B: 3; William Koehling, "History of the Statue of Liberty," *Oculus* 45 (February 1984): 10; Jane Perlez, "Interior Restoration Set at the Statue of Liberty," *New York Times* (February 8, 1984), B: 3; William G. Blair, "$67 Million Pledged to Statue of Liberty Drive," *New York Times* (February 19, 1984): 55; Susan Heller Anderson and David Bird, "Souvenirs from the Statue," *New York Times* (March 28, 1984), B: 5; "Statue of Liberty Shut for Facelift," *New York Times* (May 30, 1984), B: 4; Grace Anderson, "Restoring the Statue of Liberty," *Architectural Record* 172 (July 1984): 128–35; "Beacon of Freedom Is Retired," *New York Times* (July 5, 1984): 1; Nicole Simmons, "Pictures of Liberty Mark Centennial," *New York Times* (July 6, 1984), C: 20; "Liberty Finds Herself Behind Bars," *Building* 246 (July 13, 1984): 11; "Statue of Liberty Is License Problem," *New York Times* (July 30, 1984), D: 4; "Drive for Statue of Liberty Nears $100 Million," *New York Times* (August 19, 1984): 51; "Statue of Liberty," *Metals in Construction* (Fall 1984): cover, 2–7, 12; "From Harbor Perch to Workroom Floor," *New York Times* (November 30, 1984), B: 4; Stuart Diamond, "Statue's Repair Aids Research," *New York Times* (February 14, 1985), D: 2; "New Torch of Liberty to Be Built by French," *New York Times* (October 8, 1984), B: 2; "Disabled to Help Statue of Liberty," *New York Times* (December 9, 1984): 74; "I Think She'll Stand Now for Another Hundred Years," cartoon, *Architectural Record* 173 (March 1985): 75; Thomas Fisher, "Liberty Update," *Progressive Architecture* 66 (March 1985): 95–99; "Shining New Torch for Miss Liberty," *New York Times* (March 22, 1985), B: 1; Paul Lewis, "French Seek Funds for Miss Liberty," *New York Times* (April 16, 1985), B: 4; William E. Geist, "Frenchman Renew Old Roles at Statue of Liberty," *New York Times* (April 20, 1985): 27; "Hustling: New York," editorial, *New York Times* (May 28, 1985): 18; Susan Heller Anderson and David W. Dunlap, "New Beacon," *New York Times* (May 28, 1985), B: 3; Bernard A. Weisberger, "She's a New Yorker," letter to the editor, *New York Times* (June 15, 1985): 22; "Iacocca Makes Appeal for Ellis Island Funds," *New York Times* (June 27, 1985), B: 2; Maurice Carroll, "Court to Determine if Miss Liberty Is a Jerseyan," *New York Times* (August 19, 1985), B: 2; "Liberty I. Suit Sent to a Jersey Court," *New York Times* (August 20, 1985), B: 2; Robert Abrams, "$80 Million Is a Lot of Miss Liberty Statuettes," letter to the editor, *New York Times* (September 8, 1985), IV: 24; Robert D. McFadden, "New Torch Shines Atop Miss Liberty," *New York Times* (November 26, 1985), B: 3; Peter Lemos, "Give Me Your Tired," *Metropolis* 5 (December 1985): 12; Calvin Sims, "Engineers Fix Original Defects in the Statue," *New York Times* (December 17, 1985),

C: 1, 4; "'Every Hundred Years, a Lady Needs a Lift,'" *Metals in Construction* (Winter 1985/86): 7–13; Richard Seth Hayden and Thierry W. Despont, *Restoring the Statue of Liberty: Sculpture, Structure, Symbol* (New York: McGraw-Hill, 1986), 44–89; Michael John Weber, "A Day with Miss Liberty," *Connoisseur* 216 (January 1986): 14, 16; "Miss Liberty Losing Her Shield of Metal," *New York Times* (February 7, 1986), B: 4; Richard Haitch, "Staking a Claim to Miss Liberty," *New York Times* (February 16, 1986): 60; Robert Pear, "U.S. Ousts Iacocca as Chairman of Advisers on Statue of Liberty," *New York Times* (February 13, 1986), B: 1, 13; Robert Pear, "Iacocca and Secretary of Interior Clash Over Statue Panel Ouster," *New York Times* (February 14, 1986): 1, 25; "Emma Lazarus or Elizabeth Arden?" editorial, *New York Times* (February 16, 1986), IV: 16; "The Statue of Liberty Wins the AIA's Henry Bacon Medal for Memorial Architecture," *New Mexico Architect* 27 (March-April 1986): 7, 9; David Bird, "For Miss Liberty's 100th, Tickets by Lottery," *New York Times* (March 19, 1986): 1, B: 11; "AIA's Henry Bacon Award Honors Statue of Liberty," *Architecture* 75 (April 1986): 23; Deirdre Carmody, "22 Tall Ships Accept Bid to Lead Parade on July 4," *New York Times* (April 8, 1986), B: 4; Peter Lemos, "Liberty Gridlock," *Metropolis* 5 (May 1986): 12–13; Nicolas Monti, "Liberty Restored," *Modo* 10 (May 1986): 50–53; Georgia Dullea, "In Miss Liberty's Shadow, a Tiny Village of Families," *New York Times* (May 2, 1986), B: 1, 4; Julian H. Salomon, "Liberty's Landscape," letter to the editor, *New York Times* (May 9, 1986): 34; Richard Haitch, "Threat to Dun Liberty Island," *New York Times* May 18, 1986): 55; Samuel G. Freedman, "Better than New," *New York Times* (May 18, 1986), VI: 28–31, 72–73, 75; William E. Geist, "The Iacocca Touch," *New York Times* (May 18, 1986), VI: 32–33, 50, 54, 56; Susan Heller Anderson and David W. Dunlap, "Another French Connection for the Statue of Liberty," *New York Times* (May 26, 1986): 23; Samuel G. Freedman, "Project Manager Battles Deadline," *New York Times* (May 27, 1986), B: 1, 20; Paul Goldberger, "For Miss Liberty, a New Grandeur," *New York Times* (May 27, 1986), B: 1, 20; Jeremy Lebensohn, "I Lift My Lamp . . . ,'" *American Craft* 46 (June-July 1986): 20–27, 65–66; "Crowning Glory of Renovated Miss Liberty Shines with New Windows," *Commercial Renovation* 8 (June 1986): 28; "The Statue of Liberty," *Progressive Architecture* 67 (June 1986): 34; "La Liberté à Cent Ans," *Connaissance des Arts* 413/414 (July-August 1986): 76–81; Justin Henderson, "Lighting Liberty Inside and Out," *Interiors* 145 (July 1986): 34, 36, 41; Peter Lemos, "Citing the Obvious," *Metropolis* 6 (July-August 1986): 15; Martin Gottlieb, "Iacocca Says Liberty Fund Surpassed Its Goal by $12 Million," *New York Times* (July 2, 1986), B: 5; Paul Goldberger, "The Statue of Liberty: Transcending the Trivial," *New York Times* (July 17, 1986), C: 18; Bertrand Lemoine, "La Statue de la Liberté New York," *L'Architecture d'Aujourd'hui* 246 (September 1986): 39–47; Mike Wallace, "Hijacking History: Ronald Reagan and the Statue of Liberty," *Radical History Review* 37 (1987): 118–30; Grace Anderson, "A Colossus Remodeled," *Architectural Record* 175 (April 1987): 98–103; Rita Robison, "Liberty Restored," *Civil Engineering* 57 (July 1987): 42–44; "Bartholdi's Liberty," *Blueprints* 5 (Summer 1987): 4; "Liberty Restored," *Building Research and Practice* 15 (November-December 1987): 388; "Stairs and Elevator of the Statue of Liberty," *Detail* 28 (March-April 1988): 174–83; Jo Brisbane, "The Making of Liberty," *Blueprints* 6 (Winter 1988): 6–7; Robert Baboian, E. Blaine Cliver, and E. Lawrence Bellante, eds., *The Statue of Liberty Restoration* (Houston: National Association of Corrosion Engineers, 1990); "Statue of Liberty," *Process Architecture* 94 (February 1991): 68–69; Allan R. Gold, "New Theory: Salt Tainting Lady Liberty's Complexion," *New York Times* (August 23, 1991), B: 1, 5; David Hannaford Mitchell, "The Ideal City," *Preservation* 48 (November-December 1996): 38–41; White and Willensky, *AIA Guide* (2000), 532–33.

6. Jeffrey Schmalz, "On Shore," *New York Times* (May 18, 1986), VI: 64–65, 78–79, 84; Robert D. McFadden, "Light from Lasers," *New York Times* (July 4, 1986): 1, B: 2; Sara Rimer, "Across U.S., a Ceremony for History," *New York Times* (July 4, 1986): 1, B: 6; Robert D. McFadden, "A Very Special Day: Millions Watch Festive Harbor Salute to Liberty," *New York Times* (July 5, 1986): 1, 30; Robert D. McFadden, "Miss Liberty Reopens Amid Gaiety in the Harbor," *New York Times* (July 6, 1986): 1, 16; Deirdre Carmody, "Huge Cleanup Is Added to List of Superlatives," *New York Times* (July 8, 1986): B: 4.

7. "Port of Entry," editorial, *New York Times* (May 28, 1976): 24. For Ellis Island's Main Building, see Stern, Gilmartin, and Massengale, *New York 1900*, 75, 78.

8. Robert D. McFadden, "Tourist Boats Due at Ellis I." *New York Times* (May 28, 1976), C: 1, 13; Murray Schumach, "Ellis Island Reopened, Evoking Memories," *New York Times* (May 29, 1976): 1, 13; Murray Schumach, "Reopened Ellis Island Proves Sellout Attraction for Tourists," *New York Times* (May 30, 1976): 28; Milton Leebaw and Harriet Heyman, "The Reopening of Ellis Island," *New York Times* (May 30, 1976), IV: 6; Francis X. Clines, "A Return to the Ghosts of Ellis Island," *New York Times* (June 21, 1977): 30; Paul Goldberger, "Design Notebook/Bringing New Life to the Queensboro Bridge," *New York Times* (August 4, 1977), C: 1; Michael Sorkin, "The Odd Couples," *Village Voice* (March 18, 1981): 78; Sydney H. Schanberg, "Ellis Island Is Crumbling," *New York Times* (July 25, 1981): 23; Robert D. McFadden, "Private Help Sought for Restoring Ellis Island," *New York Times* (December 12, 1981): 1, 31; Peter Sammartino, "Ellis Island Is a Monument, Not a Marketplace," letter to the editor, *New York Times* (January 11, 1982): 18.

9. Leebaw and Heyman, "The Reopening of Ellis Island": 6.

10. Susana Torre, "Rehabilitation of Ellis Island as a Public Park and Museum," *Oz* 4 (1982): 42–47; Kevin Wolfe, "Island of the Dreams," *Metropolis* 4 (January/February 1985): 26–29, 40; Jonathan Barnett, "Beyond Revivalism and the Bauhaus: A New Partnership in the Arts," in *Collaboration, Artists and Architects: In Celebration of the Centennial of the*

Architectural League (New York: Whitney Library of Design, 1981), 90–95; Susana Torre and Charles Simonds, "Ellis Island Gateway to America," in *Collaboration, Artists and Architects: In Celebration of the Centennial of the Architectural League*, 144–51.

11. See Stern, Mellins, and Fishman, *New York 1960*, 1136–38.

12. "Iacocca to Head Drive to Restore Landmarks," *New York Times* (May 19, 1982), C: 20; "Iacocca Outlines Ellis Island Plan," *New York Times* (June 21, 1982), B: 3; Richard Bernstein, "For Ellis Island, a Reborn Role as a Monument," *New York Times* (December 9, 1982), B: 1, 11; Elliot Willensky, "A Nation Finally Remembers," *Historic Preservation* 35 (July-August, 1983): 14–19; Martta Rose, "Ellis Island: The Memories Linger On," *New York Times* (July 3, 1983), XI: 19; "U.S. Seeking Relics of Ellis Island's Past," *New York Times* (July 31, 1983): 44; "Preservation Plans Set for Statue of Liberty, Ellis Island," *Architecture* 72 (September 1983): 16–17; "Ellis Island Tour Open to All," *Oculus* 45 (September 1983): 12; "Names and News," *Oculus* 45 (September 1983): 9; Mary Anne Ramer, "Don't Let Restoration Stop at Miss Liberty," letter to the editor, *New York Times* (December 31, 1983): 22; Lee Iacocca with William Novak, *Iacocca: An Autobiography* (New York: Bantam Books, 1984), 339–41; Herbert Barchoff, "$160 Million Project," letter to the editor, *New York Times* (January 11, 1984): 20; Arnold H. Vollmer, "Ellis Island: A Symbol 'Best Forgotten,'" letter to the editor, *New York Times* (January 14, 1984): 20; Daralice D. Boles, "Restoring the Isle of Tears," *Progressive Architecture* 65 (February 1984): 27–28; Beyer Blinder Belle and Notter Finegold Alexander, *Ellis Island Historic Structures Report* (Washington, D.C.: United States Department of Interior/National Park Service, February 1, 1984); Jesus Rangel, "Renovation for Ellis I. Is Outlined," *New York Times* (May 24, 1984), B: 8; "Plans Unveiled for Ellis Island Restoration," *Architectural Record* 172 (July 1984): 51; "Ellis Island Restoration Will Blend Living History with New Learning Aids," *Building Design Journal* 2 (1984): 9; David Carr, "Ellis Island a Recreation Center?" *New York Times* (August 25, 1984): 23; Harlan D. Unrau, *Historic Resource Study: Ellis Island*, vol. 3 (Denver: United States Department of Interior/National Park Service, September 1984); Wolfe, "Island of the Dreams": 26–29, 40; "Approval Is Sought for Ellis I. Bridge," *New York Times* (January 14, 1985), B: 5; "Ellis Island Restoration Plans Detailed," *Building Design & Construction* 25 (February 1985): 21; "Renovation Continues at Ellis Island Center," *New York Times* (April 9, 1985), B: 2; "Iacocca Makes Appeal for Ellis Island Funds," *New York Times* (June 27, 1985), B: 2; Albert J. Parisi, "Ellis Island: Welcome of Old Being Dusted Off," *New York Times* (July 7, 1985), XI: 1, 5; "Ellis Island, the Other Restoration Project in the Harbor," *New York Times* (July 20, 1985): 27; Roberta Brandes Gratz and Eric Fettman, "Iacocca's Golden Door: The Selling of Miss Liberty," *Nation* 241 (November 9, 1985): 465–66, 468–76; Roberta Brandes Gratz and Eric Fettman, "The Battle for Ellis Island," *Nation* 241 (November 30, 1985): 579–82; Martin Gottlieb, "Iacocca Disputed on Criticism of Ellis I. Plan," *New York Times* (February 15, 1986): 31; Martin Gottlieb, "Restoring Ellis Island: Bitter Dispute over the Future of a National Shrine," *New York Times* February 23, 1986): 39; Herb Rosenthal, "Should Ellis Island Be for the Few or the Many?" letter to the editor, *New York Times* (March 2, 1986), IV: 22; Walter E. Staab, "Put Museum on Ferry," letter to the editor, *New York Times* (March 2, 1986), IV: 22; Rafael L. Urquidi, "Music Festival Site," letter to the editor, *New York Times* (March 2, 1986), IV: 22; James S. Rossant, "Ellis Island Conference Center, for New Ideas for the Future," letter to the editor, *New York Times* (March 14, 1986): 34; Peter Hoffmann, "What Future for Ellis Island?" *Architectural Record* 174 (April 1986): 33; Michael Adlerstein, "A Monument to Immigration Takes Form in New York Harbor," letter to the editor, *New York Times* (April 17, 1986): 30; Manuela Hoelterhoff, "Bickering and Dickering: The Storm over Ellis Island," *Wall Street Journal* (April 17, 1986): 26; Michael Norman, "Linking Jersey City to Ellis I., Bridge with a Brief Life Span," *New York Times* (April 29, 1986), B: 1; Mildred F. Schmertz, "Preserving the Architecture of Ellis Island," *Architectural Record* 174 (May 1986): 15; Martin Gottlieb, "Ellis I. Proposal Is Seen as Faulty," *New York Times* (May 11, 1986): 30; Martin Gottlieb, "Battle of Ellis I.: A Peace Plan from Iacocca," *New York Times* (May 15, 1986), B: 1–2; John Burgee and James S. Rossant, "Ellis Island," letters to the editor, *Wall Street Journal* (May 15, 1986): 29; "The Other Ellis Island," editorial, *New York Times* (May 18, 1986), IV: 24; Martin Gottlieb, "Panel Requests Ideas of Public on Ellis I. Plan," *New York Times* (May 21, 1986), B: 5; Martin Gottlieb, "Plan for Ellis Island Development Still in Question," *New York Times* (July 8, 1986), B: 4; Michael Sorkin, "Immigrant Savings," *Village Voice* (July 8, 1986): 90; Roberta Brandes Gratz, "Letters," letter to the editor, *Architectural Record* 174 (August 1986): 4; Martin Gottlieb, "U.S. Backs Broad Ellis I. Plan," *New York Times* (September 27, 1986): 33, 36; "Names and News," *Oculus* 48 (October 1986): 7; Wallace, "Hijacking History: Ronald Reagan and the Statue of Liberty": 119–30; Peter Wyden, *The Unknown Iacocca* (New York: William Morrow, 1987), 256–60; David W. Dunlap, "At Ellis Island, Gloomy Ruin Starts to Shine," *New York Times* (February 25, 1987), B: 1; Robert E. Taylor, "Ellis Island Plans of Iacocca, Hodel Fail to Find Berth—Finance Panel Rejects Ideas That Sparked Bitter Rift, but the Debate Isn't Over," *Wall Street Journal* (March 25, 1987): 18; "Main Building, Ellis Island National Monument, New York City," *Architectural Record* 175 (June 1987): 156–57; "Power House, Ellis Island National Monument, New York City," *Architectural Record* 175 (June 1987): 158–59; Edward Sussman, "Ellis Island Hotel is Backed by Panel but Is Called 'Economically' Flawed," *Wall Street Journal* (June 25, 1987): 28; Mark A. Uhlig, "Plan for Ellis Island by Group Is Backed by Interior Secretary," *New York Times* (September 16, 1987), B: 4;

"Plan for Conference Center on Ellis Island Is Cleared," *Wall Street Journal* (September 16, 1987): 57; Lee Iacocca with Sonny Kleinfeld, *Talking Straight* (New York: Bantam Books, 1988; Boston: G. K. Hall, 1989), 3–8; Bruce Weber, "Welcome Back," *New York Times* (June 5, 1988), VI: 102; Fox Butterfield, "At Ellis I., Tracking 17 Million Names," *New York Times* (June 9, 1988), B: 17; Albert J. Parisi, "Tracing Families through Ellis I.," *New York Times* (November 13, 1988), XIII: 12; Miriam Horn, "The Return to Ellis Island," *U.S. News & World Report* 105 (November 21, 1988): 63–65; Cynthia Owen Philip, "A Time Remembered . . . and Restored," *Mechanical Engineering* 111 (January 1989): 36–43; Marvin Howe, "Once Again, Ellis Island Will Open Its Arms in Welcome," *New York Times* (June 9, 1989), B: 1, 4; Jere Hester, "No Fall Debut for Ellis Island," *On the Avenue* 6 (October 7, 1989): 39; Wilton S. Tifft, *Ellis Island* (Chicago: Contemporary Books, 1990); F. Ross Holland Jr., "The Government, the Commission, and the Foundation: Public/Private Cooperation in the Restoration of the Statue of Liberty and Ellis Island," in Baboian, Cliver, and Bellante, eds., *The Statue of Liberty Restoration*, 9–13; Laura Costello, "Gateway to America," *Blueprints* 8 (Spring 1990): 1, 6; "Grand," *New Yorker* 66 (April 9, 1990): 29–31; Clifford A. Pearson, "Reopening America's Gates," *Architectural Record* 178 (July 1990): 46–57; "Brick in Architecture: Brick Makes History: The Renovation of Ellis Island," *Architecture* 79 (July 1990): 17; Matt Carroll, "Boston Architectural Firm Helps Restore Ellis Island," *Boston Globe* (July 21, 1990): 37; Barbara Flanagan, "Coming Home: Ellis Island, the Museum," *Metropolitan Home* 22 (August 1990): 82, 84, 86; "Ellis Island Undergoes Architectural Transformation," *New York Times* (August 14, 1990): 1; Paul Goldberger, "Gateway to America Is Once Again Ready to Greet the Masses," *New York Times* (August 14, 1990), C: 13, 18; Dinitia Smith, "The Golden Door: Ellis Island Reopens to Tell America's Epic Story," *New York* 23 (August 27, 1990): 28–34, 42–44; Cynthia Owen Philip, "Celebrating an Island Artifact," *Archaeology* 43 (September/October 1990): 45–51; Allen Freeman, "Ellis Island Revisited," *Historic Preservation* 42 (September-October 1990): 32–37, 82; Jeffrey Hoff and Steven Saltzman, "Immigration Returns to Ellis Island," *Metropolis* 10 (September 1990): 19–20; Alessandra Stanley, "Redone Ellis Island: Burnished but not Brash," *New York Times* (September 2, 1990): 1, 32; Paul Goldberger, "At Ellis Island, Embracing the Past and the Future," *New York Times* (September 7, 1990), C: 1, 23; Richard F. Shepard, "Inside, Reliving the Immigrant's Experience," *New York Times* (September 7, 1990), C: 2; "The Golden Door, Re-Opened," editorial, *New York Times* (September 9, 1990), IV: 24; Tom Mathews with Anne Underwood and Clara Bingham, "America's Changing Face," *Newsweek* 116 (September 10, 1990): 46–50; Mary Lord, "Ellis Island, N.Y.," *U.S. News & World Report* 109 (September 10, 1990): 21; Edward Ball, "Ellis Island Revisited: Museum of Tears," *Village Voice* (September 11, 1990): 59, 87; Richard Lacayo, "Reopening the Gates of America," *Time* 136 (September 17, 1990): 68; William Roberts, "Give Peter Sammartino Ellis Island Credit," letter to the editor, *New York Times* (September 26, 1990): 24; Alfred H. Horowitz, "In Self-Defense," letter to the editor, *New York* 23 (October 1, 1990): 8; John Morris Dixon, "Ellis Island, 1980s Shrine," *Progressive Architecture* 71 (November 1990): 23–24; Jane Holtz Kay, "Ellis Island Reopens as Museum," *Architecture* 79 (November 1990): 21, 24; Pamela Reeves, *Ellis Island* (New York: Dorset Press, 1991); Graham Vickers, "Manhattan Transfer," *World Architecture* 10 (1991): 62–67; "1 Million Visitors and (Not) Counting," *New York* 24 (May 27, 1991): 10; Patricia Leigh Brown, "Ellis Island: All Too Like the Old Days," *New York Times* (July 5, 1991), C: 1, 18; Lynne Tillman, "Reports from Ellis Island: The Museum of Hyphenated Americans," *Art in America* 79 (September 1991): 55–57, 59, 61; "September 1990," editorial, *Metropolis* 11 (September 1991): 10; Robert Hanley, "Park Service Backs Demolition on Ellis Island," *New York Times* (November 23, 1991): 25–26; Roberta Brandes Gratz, "Malling History," *Nation* 253 (November 25, 1991): 656; Mike Wallace, "Exhibition Reviews: The Ellis Island Immigration Museum," *Journal of American History* 78 (December 1991): 1032; "Wall of Fame," *New York* 24 (December 16, 1991): 18; "Save Ellis Island's Ghosts," editorial, *New York Times* (December 27, 1991): 32; "Pencil Points," *Progressive Architecture* 73 (January 1992): 22; Toby Axelrod, "Board vs. Ellis I. Development," *New York Observer* (January 27, 1992): 8; Orin Lehman, "Striking a Balance," letter to the editor, *New York Times* (January 25, 1992): 22; James S. Rossant, "To Keep Memories, Keep Ellis Island Buildings," letter to the editor, *New York Times* (January 25, 1992): 22; Jerome L. Wilson, "For Conference Center," letter to the editor, *New York Times* (January 25, 1992): 22; "On Ellis Island," *Municipal Art Society Newsletter* (February 1992): 3; "RE: Ellis Island—Pro and Con," *Oculus* 54 (February 1992): 11; Deborah K. Dietsch, "Island of Hope, Island of Tears," *Architecture* 81 (March 1992): 15; Schuyler Warmflash, "The Other Side of Ellis Island Tells a Story That Needs to Be Heard," *Preservation Perspective New Jersey* 11 (Spring 1992): 1–2; Suzanne Stephens, "A Critique," *Oculus* 54 (May 1992): 4–5; Jules G. Horton and Graham S. Wyatt, "Preserving Ellis Island," letters to the editor, *Architecture* 81 (June 1992): 18; "Details," *Architecture* 81 (August 1992): 24; "Ellis Island Update," *Oculus* 55 (October 1992): 3; James Rossant, "Response," *Oculus* 55 (October 1992): 3; Jules G. Horton, "Power of the Pen," letter to the editor, *Architecture* 81 (December 1992): 14; Deborah Sontag, "Immigrants Find Immortality, at a Price," *New York Times* (January 14, 1993), B: 3; "Progress in Fight to Preserve Ellis Island," *Municipal Art Society Newsletter* (March 2, 1994): 3; Doron P. Levin, *Behind the Wheel at Chrysler: The Iacocca Legacy* (New York: Harcourt Brace & Co., 1995), 28–29, 93–96; Myra Vanderpool Gormley, "Ellis Island: A Link to the Past," *Colonial Homes* 21 (August 1995): 20; Mike Wallace, "Boat People: Immigration

History at the Statue of Liberty and Ellis Island," in *Mickey Mouse History and Other Essays on American Memory* (Philadelphia: Temple University Press, 1996), 55–73; *Beyer Blinder Belle Architects & Planners* (New York: Beyer Blinder Belle Architects, 1997), unpaginated; Susanna Sirefman, *New York: A Guide to Recent Architecture* (London: Ellipsis, 1997), 18–21; David W. Dunlap, "The Preservation Band That Sets the Tone," *New York Times* (June 7, 1998), XI: 1, 22; White and Willensky, *AIA Guide* (2000), 533.

13. Quoted in Gratz and Fettman, "The Battle for Ellis Island": 580.

14. John Burgee, quoted in Gratz and Fettman, "The Battle for Ellis Island": 580.

15. Russell Dickenson, quoted in Gratz and Fettman, "The Battle for Ellis Island": 581.

16. Gratz and Fettmann, "The Battle for Ellis Island": 579.

17. Vollmer, "Ellis Island: A Symbol 'Best Forgotten'": 20.

18. John Belle, quoted in "Plans Unveiled for Ellis Island Restoration": 51.

19. John Belle, quoted in "Ellis Island Restoration Will Blend Living History with New Learning Aids": 9.

20. Lee Iacocca, quoted in Gratz and Fettman, ""The Battle for Ellis Island": 580.

21. Quoted in Gottlieb, "Restoring Ellis Island: Bitter Dispute over Future of a National Shrine": 39.

22. "Emma Lazarus or Elizabeth Arden?": 16.

23. Rossant, "Ellis Island Conference Center, for New Ideas for the Future": 34.

24. Hoelterhoff, "Bickering and Dickering: The Storm over Ellis Island": 26.

25. Goldberger, "At Ellis Island, Embracing the Past and the Future": 23.

26. Kay, "Ellis Island Reopens as Museum": 24.

27. Orin Lehman, quoted in Hanley, "Park Service Backs Demolition on Ellis Island": 25.

28. "A Bridge and a Budget," editorial, *New York Times* (July 29, 1992): 20; "Ellis Island Bridge Is Opposed by Cuomo," *New York Times* (November 16, 1993), B: 4; Todd S. Purdum, "Lowey and Lautenberg Lock Horns over a Bridge," *New York Times* (June 26, 1994): 28; Neil MacFarquhar, "For Ellis Island, New Talk of a Hotel, a Bridge and Masses Yearning to Get in Free," *New York Times* (April 3, 1997), B: 6.

29. Stephens, "A Critique": 4. For Philip Johnson's Ellis Island scheme, see Stern, Mellins, and Fishman, *New York 1960*, 1136–38.

30. James C. McKinley Jr., "Council Joins 2-State Fight over Ellis Island," *New York Times* (February 9, 1994), B: 1, 3. Also see "Islands Make New York New York," editorial, *New York Times* (March 2, 1994): 20; James Barron, "Ellis Island, Gateway to a State That Starts with 'New,'" *New York Times* (May 17, 1994), B: 4; "Ellis Island, N.J.?" editorial, *New York Times* (June 12, 1994), IV: 16; Neil MacFarquhar, "Ellis Island May Have Been Made for You and Me, but Who Owns It?" *New York Times* (December 31, 1995): 27, 30; Neil MacFarquhar, "Court Hears 2 States Claim a Piece of History," *New York Times* (April 12, 1996), B: 1, 6; Adam Nossiter, "Ellis Island Becomes Courtroom for a Day," *New York Times* (July 16, 1996), B: 3; Clyde Haberman, "Who Owns Ellis: Stirring the Melting Pot," *New York Times* (July 23, 1996), B: 1; Peter Verniero, "Ellis Island, N.J.," *New York Times* (August 21, 1996): 17; Clyde Haberman, "Ellis Island Still Vexes Its Neighbors," *New York Times* (January 10, 1997), B: 1; Neil MacFarquhar, "Solomonic Ruling Would Divide Ellis Island," *New York Times* (April 2, 1997): 1, B: 4; "Dividing Ellis Island," editorial, *New York Times* (April 3, 1997): 20; Bruce C. Haxthausen, "N.Y. Island Swapping," letter to the editor, *New York Times* (April 6, 1997): 18; "'O Say Can You See the State Line?'" *New York Times* (April 15, 1997): 1; Neil MacFarquhar, "Carving Ellis Island: A Fine Line," *New York Times* (April 15, 1997), B: 6; Linda Greenhouse, "Fight Heats Up as High Court Considers Fate of Ellis Island," *New York Times* (September 30, 1997), B: 1, 4; "New York's Title to Ellis Island," editorial, *New York Times* (January 13, 1998): 18; Drew DeCourcey, Donald J. Gehan Jr., and Peter Verniero, "N.J. Deserves a Share of Ellis Island," letters to the editor, *New York Times* (January 19, 1998): 16; "Excerpts from the Supreme Court's Decision on Ellis Island," *New York Times* (May 27, 1998), B: 7; Linda Greenhouse, "High Court Gives New Jersey Most of Ellis Island," *New York Times* (May 27, 1998), B: 7; David M. Herszenhorn, "New Jersey Officials Move to Put Ellis Island on Map," *New York Times* (May 28, 1998), B: 5; Robert Sullivan, "The War Between the States," *New York Times* (May 28, 1998): 29; Joe Sharkey, "Pride, Prejudice and Border War Bluster," *New York Times* (May 31, 1998), IV: 3; David M. Herszenhorn, "New Jersey, Proud Owner, to Raise Flag on Ellis Island," *New York Times* (July 4, 1998), B: 2.

31. David M. Halbfinger, "Trying to Save Ellis Island, the Neglected 'Sad Side,'" *New York Times* (June 16, 1997): 1, B: 3; David Anthone, Dona Fowler, William N. Hubbard, Gersil N. Kay, Ira M. Rutkow, "Ellis Island's Ruins Are Far from Romantic," letters to the editor, *New York Times* (June 21, 1997): 20; "Saving the Forgotten Side of Ellis Island," *New York Landmarks Conservancy Newsletter* (Fall 1997): 3–6; "New Hope for Ellis Island," *Municipal Art Society Newsletter* (August-September 1997): 1; David M. Halbfinger, "Rescue Plan for Neglected South Side of Ellis Island," *New York Times* (October 29, 1997), B: 3; Clyde Haberman, "The Other Ellis Island," *New York Times* (March 22, 1998), VI: 42–46; James Dao, "$6.6 Million Is Urged for Urgent Repairs on Ellis I.," *New York Times* (April 23, 1998), B: 8; "Ellis Island's Other Side," editorial, *New York Times* (May 3, 1998), IV: 16; "Clyde Haberman, "Tarnished Golden Door: The Hidden Side of Ellis I.," *New York Times* (May 26, 1998), B: 1; Roger P. Lang, "The Abandoned Buildings of Ellis Island," *Blueprints* 16 (Fall 1998): 4–5; "Saving an American Treasure: New Jersey's Ellis Island May Have a Future," *Preservation Perspective NJ* 18

(Summer/Fall 1999): 4; Ada Louise Huxtable and Howard Markel, "Ghosts of Hope and Despair," *Wall Street Journal* (December 9, 1999): 24; David M. Halbfinger, "New Jersey Plans Grand Makeover for Ellis Island," *New York Times* (January 21, 2000), B: 1, 6; William F. May and (Rev.) Thomas L. Sheridan, "Ellis Island, Restored Bit by Bit," letters to the editor, *New York Times* (January 28, 2000): 22; "Ellis Island Rescue Funding Plan Announced," *Engineering News-Record* 244 (January 31, 2000): 11; "Stabilization Work Begins on Ellis Island While Photo Exhibit Portrays *Forgotten Gateway*," *New York Landmarks Conservancy Newsletter* (Winter 2000): 11–12; "The Next Phase for Ellis Island," *New York Times* (December 3, 2000), XI: 1; Maria Newman, "The Rust Must Go, but the Ghosts Linger; Restoring Ellis Island's Forgotten Side," *New York Times* (August 13, 2001), B: 1, 3; "Ghosts of Ellis Island," editorial, *New York Times* (September 8, 2001): 12.

32. Quoted in Greenhouse, "High Court Gives New Jersey Most of Ellis Island": 1.

33. Melinda Henneberger, "Coast Guard May Close Base on Governors Island Within Three Years," *New York Times* (February 4, 1995): 21; Rosemary Metzler Lavan, "Governors Island Eyed Site Could Be Home of Casinos, High-Rises," *New York Daily News* (October 8, 1995): 14; "To Protect a New York Island," editorial, *New York Times* (October 11, 1995): 22; Don Van Natta Jr., "Coast Guard Plans to Leave Governors I.," *New York Times* (October 17, 1995), B: 1, 3; Thomas J. Lueck, "Voices/Ideas for an Island," *New York Times* (October 18, 1995), B: 3; Denis Hamill, "C'mon, Let's Roll Dice and Governors Island Is the Place to Do It," *New York Daily News* (October 18, 1995): 8; Randy Kennedy, "On an Oasis in New York Harbor, a Bittersweet Salute," *New York Times* (October 18, 1995), B: 3; "And the Real Estate!" *New Yorker* 71 (October 23, 1995): 37–38; Stephen Jones, "Governors I. History Must Be Accessible to All," letter to the editor, *New York Times* (October 24, 1995): 26; "What to Do with Governors Island?" *New York Times* (October 28, 1995): 21; David W. Dunlap, "New York City's Many Islands Lapped by Tides of Change," *New York Times* (November 12, 1995), IX: 1, 8; John McGinnis, "A Modest Proposal for a New Magic Kingdom," *Wall Street Journal* (January 30, 1996): 12; Stefan Fatsis, "Big-City Plans for a Tiny Island Village," *Wall Street Journal* (March 29, 1996), B: 12; Thomas J. Lueck, "Clinton Offer of Governors Island to New York Mired in Indecision," *New York Times* (March 27, 1997): 1, B: 10; "A Bargain in the Harbor," editorial, *New York Times* (March 30, 1997), IV: 10; "Governors Island: A Gift That Bears a Close Look," *New York Times* (April 1, 1997), B: 8; "Golf Makes Attractive Use of Governors Island," letter to the editor, *New York Times* (April 4, 1997): 34; David M. Halbfinger, "Lacking Space, N.Y.U. Seeks Governors Island Expansion," *New York Times* (April 19, 1997): 22; Devin Leonard, "City Pursues Turning Governors Island into Ye Olde Tourist Trap," *New York Observer* (May 12, 1997): 1, 34; "Marooned on a Deserted Island," *New York Times* (June 19, 1997), B: 3; Brendan Gill, "Governors Island–For Sale?" *Architectural Digest* 54 (July 1997): 50, 52, 54, 56–57; "Governors' Opportunity," *Landscape Architecture* 87 (July 1997): 28; Thomas J. Lueck, "Governors Island Is No Lure for Developers, Panel Hears," *New York Times* (July 15, 1997), B: 7; Gian-Claudia Sciara, "Isle Fly Away," *City Limits* 22 (August/September 1997): 14–15; Greg Sargent, "What's the Maintenance? No Buyers on Horizon for Governors Island," *New York Observer* (November 24, 1997): 1, 29; Elizabeth Kolbert, "Island Needs a Dollar and a Dream," *New York Times* (December 1, 1997), B: 1; Thomas J. Lueck, "Governors Island Hearings," *New York Times* (December 3, 1997), B: 11; Raymond W. Gastil, *Beyond the Edge: New York's New Waterfront* (New York: Princeton Architectural Press, 2002), 188–89.

34. Gerard R. Wolfe, "Governors Island," in Kenneth T. Jackson, ed., *The Encyclopedia of New York City* (New Haven, Conn.: Yale University Press; New York: New-York Historical Society, 1995), 493.

35. Landmarks Preservation Commission of the City of New York, LP-0542–46, (September 19, 1967); "Interior Dept. Names 11 Historic Landmarks," *New York Times* (May 6, 1985), B: 9; Barbaralee Diamonstein, *The Landmarks of New York III* (New York: Harry N. Abrams, 1998), 32.

36. Raquel Ramati, quoted in Lavan, "Governors Island Eyed Site Could Be Home of Casinos, High-Rises": 14.

37. Donald J. Trump, quoted in Lueck, "Voices/Ideas for an Island": 3.

38. Lewis Rudin, quoted in Lavan, "Governors Island Eyed Site Could Be Home of Casinos, High-Rises": 14.

39. Phillip Lopate, quoted in "What to Do with Governors Island?": 21.

40. Marcia Reiss, quoted in Lueck, "Voices/Ideas for an Island": 3.

41. Ned Kaufman, "Landmarks Downtown; Planetarium Uptown; New Zoo Too?" *Municipal Art Society Newsletter* (January-February 1996): 2; "Advocacy," *Municipal Art Society Annual Report, 1995–1996* (June 18, 1996): 2.

42. Landmarks Preservation Commission of the City of New York, *Governors Island Historic District Designation Report* (New York, 1996); David Stout, "Governors Island Historic District Created," *New York Times* (June 19, 1996), B: 2; "Preservation Projects," *Oculus* 59 (September 1996): 4; Diamonstein, *The Landmarks of New York III*, 525.

43. "Governors Island, Morningside Heights and Historic Districts; Meetings and a Conference on Preservation Issues," *New York Times* (January 19, 1997), IX: 1.

44. McGinnis, "A Modest Proposal for a New Magic Kingdom": 12.

45. Quoted in Michael Sorkin, *Michael Sorkin Studio: Wiggle* (New York: Monacelli Press, 1998), 38–45. Also see "Michael Sorkin Studio: Trip," *Architectural Design* 66 (September-October 1996): 12–15; "Michael Sorkin: West Side Waterfront, Brooklyn Waterfront, Governors Island," *Abitare* (May 1999): 162–65.

46. Quoted in Raymond W. Gastil, "Public Property: A Competition for Governors Island in New York Harbor," *Competitions* 6 (Fall 1996): 42–49. Also see "Competition," *Architectural Record* 184 (March 1996): 11; "Competitions: Civic Art," *Classicist* 4 (1997–1998): 74–81; Anuradha Mathur and Dilip da Cunha, "Soil That New York Rejected and Re-collects," *Landscape Journal*, special issue (1998): 31–34.

47. Gastil, "Public Property: A Competition for Governors Island in New York Harbor": 49.

48. Urban Land Institute, *Governors Island, New York, New York: An Evaluation of the Island's Potential and a Strategy for Its Redevelopment* (Washington, D.C.: Urban Land Institute, 1996).

49. Urban Land Institute, *Governors Island, New York, New York: An Evaluation of the Island's Potential and a Strategy for Its Redevelopment*, 10, 21.

50. Eric McGee, "The RPA Proposal for Governors Island," *Oculus* 61 (November 1998): 17–18.

51. Daniel Patrick Moynihan, quoted in Lueck, "Clinton Offer of Governors Island to New York Mired in Indecision": 1.

52. Douglas Durst, quoted in Lueck, "Governors Island Is No Lure for Developers, Panel Hears": 7.

53. Quoted in Thomas J. Lueck, "Governors I. Urged as Site for a Casino," *New York Times* (December 5, 1997), B: 1, 12. Also see "Chips Ahoy," *New York Post* (December 6, 1997): 1; Robert Hardt Jr., "Rudy Wagers on Governors Is. Casino," *New York Post* (December 6, 1997): 2–3; David Firestone, "Giuliani Says City Must Plan for Gambling," *New York Times* (December 6, 1997): 1, B: 2; Elizabeth Kolbert, "Island Fantasy That Rivals Fantasy Island," *New York Times* (December 8, 1997): 1; "Don't Gamble with Governor's Island," editorial, *New York Times* (December 9, 1997): 28; Matthew Berman, "Two Axe Heads," *ANY* 22 (1998): 10–11; Joseph Dolman, "New York Harbor's Deserted Island," *Preservation* 50 (January-February 1998): 16–17; Kirk Johnson, "Gambling Industry Scoffs at Mayor's Plan for Governor's Island," *New York Times* (January 7, 1998), B: 5; Kate Coyne, "Rolling the Bones on Governor's Island," *New York* 31 (January 19, 1998): 15; Bruce Handy, "Manhattan Monaco: The Early Years," *New York Times* (February 1, 1998), VI: 36–37; James Dao, "Many in Congress Oppose Mayor's Casino Plan for Governors Island," *New York Times* (May 10, 1998): 29, 34; Hugo Lindgren, "Dealing Rudy Out," *New York* 31 (May 18, 1998): 13–14; Peter Slatin, "Casino Owners in Atlantic City Betting on N.Y.," *New York Post* (May 27, 1998): 32; Douglas Martin, "City's Plans for Governors I. Include Housing and Casino," *New York Times* (June 13, 1998), B: 3; Douglas Martin, "Study Sees High Revenue in a Governors Island Casino," *New York Times* (June 18, 1998): B: 3.

54. "Don't Gamble with Governors Island": 28.

55. Donald J. Trump, quoted in Johnson, "Gambling Industry Scoffs at Mayor's Plan for Governors Island": 5.

56. "Governors Island Named Most Endangered by National Trust," *Municipal Art Society Newsletter* (July/August 1998): 1.

57. "City Seeks Proposals for Governors Island," *New York Times* (July 29, 1998), B: 3; Thomas J. Lueck, "City Hall Gets First Plans for Governors I.," *New York Times* (September 15, 1998), B: 3; Richard E. Mooney, "Governors Island: Many Proposals, No Consensus," *New York Times* (January 31, 1999), XI: 7.

58. James Dao, "Giuliani Names Panel for Governors Island," *New York Times* (January 22, 1999), B: 2; Mooney, "Governors Island: Many Proposals, No Consensus": 7; James Dao, "Looking for a Quick $500 Million from Governors Island," *New York Times* (March 20, 1999), B: 5; Devin Leonard, "New Trouble in Paradise: Giuliani-Pataki Storm Hits Governors Island," *New York Observer* (April 12, 1999): 1, 11; Devin Leonard, "Governors Island Deal on Ropes After Feds Withdraw $1 Offer," *New York Observer* (June 7, 1999): 1, 8; Douglas Martin, "Governors Island Attracts Various Development Ideas," *New York Times* (June 13, 1999): 50; Devin Leonard, "Danish Amusement Park on Governors Island? Rudy Thinks About It," *New York Observer* (September 6, 1999): 1, 6; Thomas J. Lueck, "Mayoral Group Agrees on Plan to Redevelop Governors I.," *New York Times* (September 2, 1999), B: 1, 7; "www.harbor.org," *Architecture* 89 (January 2000): 33.

59. Raymond Hernandez, "Accord on a Plan for Governors I.," *New York Times* (January 3, 2000): 1, B: 5; Thomas J. Lueck, "Accord in Hand, Officials May Take on Congress Next," *New York Times* (January 7, 2000), B: 4; Barbara Stewart, "Spurring Profit to Protect History," *New York Times* (January 7, 2000), B: 1, 4; "A Plan for Governors Island," editorial, *New York Times* (January 8, 2000): 12; Betty Heller and Gerard W. Gentile, "Imagining the Uses of Governors Island," letters to the editor, *New York Times* (January 11, 2000): 24; Peter Slatin, "Governors Island," *Grid* 2 (January + February 2000): 25; Philip Nobel, "A Diplomatic Solution for the U.N.," *Architecture* 89 (February 2000): 166; Soren Larsen, "Governors Island: A Plan at Last?" *Architectural Record* 189 (February 2000): 32; "Island of Opportunity," *World Architecture* 84 (March 2000): 27; Joseph Giovannini, "Just Add Water," *New York* 33 (April 3, 2000): 24–25; Peter Grant, "A Real Steal," *Wall Street Journal* (May 10, 2000), B: 14; Jayne Merkel, "What's Next in the Harbor?" *Oculus* 62 (May 2000): 13; "Supporting the Governors Island Preservation Act," *New York Landmarks Conservancy Newsletter* (Autumn 2000): 16; Andrew Rice, "September Deadlock on Governors Island Between City, State," *New York Observer* (September 18, 2000): 1, 9; "Dithering Over Governors Island," editorial, *New York Times* (September 25, 2000): 26; Richard Brookhiser, "A Plan for Governors Island: Make It a High-Tech Campus," *New York Observer* (October 9, 2000): 4; Barbara Stewart, "Window Closing on Governors Island Plan," *New York Times* (December 6, 2000), B: 3.

60. Giovannini, "Just Add Water": 24–25.

61. Stewart, "Window Closing on Governors Island Plan": 3.

62. Raymond Hernandez with Barbara Stewart, "Clinton, with Time Running Out, Protects Part of Governors I.," *New York Times* (January 21, 2001): 29, 31.

63. Barbara Stewart, "Governors I. Must Be Sold, a Justice Dept. Memo Says," *New York Times* (May 16, 2001), B: 3; Josh Benson, "Bush May Void Deal Stuck By Clinton for $1 Island Sale," *New York Observer* (May 21, 2001): 1, 7; Alice Lipowicz, "Shift in Senate Could Rescue N.Y.'s Governors Island Plan," *Crain's New York Business* (June 4, 2001): 14; "Governors Is. Impasse Brings Sniping," *Crain's New York Business* (August 6–12, 2001): 19; Alice Lipowicz, "Pataki Digs In on Governors Island," *Crain's New York Business* (August 13, 2001): 3; Barbara Stewart, "As Deadline Draws Near, the Future of Governors Island Remains Uncertain," *New York Times* (August 25, 2001): B: 6.

64. "W to Hand Over Govs Isle," *New York Daily News* (April 2, 2002): 3; "New Hope for Governors Island," editorial, *New York Times* (April 2, 2002): 22; Raymond Hernandez, "Governors Island Deal May Yield Offshore CUNY Campus," *New York Times* (April 2, 2002): B: 1–2; Michael Cooper and Karen W. Arenson, "CUNY Plan: Visions High, Details Few," *New York Times* (April 3, 2002): B: 1, 4; Barry Rosenberg, "The Campus That Jutted into the Harbor," letter to the editor, *New York Times* (April 6, 2002): 14; "Island Could Sink in CUNY Swamp," editorial, *New York Daily News* (April 8, 2002): 34; Diane Cardwell, "Offer of Governors Island Inspires a Host of Ideas for City," *New York Times* (April 10, 2002): B: 6; Robert Yaro and Robert Pirani, "Relaunching Governors Island," *New York Times* (April 11, 2002): 33; John E. Czarnecki, "Feds Turn Over Governors Island to New York for a CUNY Campus," *Architectural Record* 190 (May 2002): 44; Michael Saul, "City Set to Acquire Governors Island," *New York Daily News* (January 31, 2003): 10; Terry Pristin, "White House to Hand Over Governors Island to New York," *New York Times* (January 31, 2003): B: 5.

65. Jayson Blair, "Broadcast Tower Is Urged for Governors I.," *New York Times* (May 1, 2002): B: 3; Diane Cardwell, "Governors I. Is Unlikely to Get Tower, Mayor Says," *New York Times* (May 4, 2002): B: 4; Frank Lombardi, "Mike's Not Receptive to Antenna Plan," *New York Daily News* (May 4, 2002): 7; Jayson Blair, "Chief of Effort for TV Tower Is Dismissed, Signaling Shift," *New York Times* (May 30, 2002), B: 7; Jayson Blair, "Lawmakers Seeking Site for Antenna in New York," *New York Times* (June 29, 2002), B: 2.

REEL NEW YORK: THE CITY AND CINEMA

1. See Stern, Mellins, and Fishman, *New York 1960*, 1177–78.

2. Mark Jacobson, "New York, You Oughta Be in Pictures," *New York* 8 (December 28, 1975/January 5, 1976): 34–44; Michael Korda, "Memoirs of a Movie Brat," *New York* 8 (December 28, 1975/January 5, 1976): 45–46; Edward Sorel, "Preview of Coming Attractions," *New York* 8 (December 28, 1975/January 5, 1976): 68–71; Ellen Stern, "How to Make a Movie in New York," *New York* 8 (December 28, 1975/January 5, 1976): 55–60; John Corry, "Hollywood's Biggest New Star Is Little Old New York," *New York Times* (January 29, 1978), II: 1, 32.

3. Corry, "Hollywood's Biggest New Star Is Little Old New York": 32.

4. Edward I. Koch, quoted in Corry, "Hollywood's Biggest New Star Is Little Old New York": 32.

5. Sidney Lumet, quoted in Corry, "Hollywood's Biggest New Star Is Little Old New York": 32.

6. Ellen Pall, "Free Outdoor Fun: Watching Movies Being Made," *New York Times* (September 28, 1990), C: 5.

7. James Barron, "Settlement Defeat Speeds Film Exodus from New York," *New York Times* (April 17, 1991), B: 1, 3; Glenn Collins, "New York Workers Reach a Film Pact, Ending a Shutdown," *New York Times* (May 17, 1991): 1; Glenn Collins, "Back in the Maelstrom; Filming Resumes," *New York Times* (May 23, 1991), C: 17; Glenn Collins, "Lights, Cameras and a Sudden Surge in Action," *New York Times* (October 1, 1991), C: 11; William Grimes, "New York Has a Full-Time Fan Promoting It as a Film Capital," *New York Times* (March 12, 1992), C: 17; William Grimes, "With Films Scarce, New York Still Feels Impact of Boycott," *New York Times* (May 28, 1992), C: 1, 15; William Grimes, "To Gauge the Film Industry, Start with a Magic Number," *New York Times* (May 28, 1992), C: 15; Alessandra Stanley, "To the Finalists: Don't Call Us . . . ," *New York Times* (June 21, 1992): 25, 28; Paula Span, "Bonfire of the Movie Biz? Filmmakers Flee the Big Apple, Citing Union Demands and the Economy," *Washington Post* (December 14, 1992), B: 1.

8. Matthew Purdy, "Hollywood Is Casting; New York Stays Home," *New York Times* (February 27, 1994): 30; "The $3 Billion Balloon," editorial, *New York Observer* (April 18, 1994): 4; Bruce Weber, "Giuliani Says 1996 Film Making in City Set Records," *New York Times* (February 5, 1997), B: 7; Clyde Haberman, "Celluloid City: Godfather of Locations," *New York Times* (June 23, 1998), B: 1; David Colman, "Welcome to the New Los Angeles: It's on the Hudson," *New York Times* (November 15, 1998), IX: 1, 4.

9. "Soho Losing Sleep Over Hollywood," *New York* 29 (December 16, 1996): 14. Also see William Grimes, "Disrupting Film Sites in a Drive for Minority Jobs," *New York Times* (December 11, 1991), C: 17; Krystyna Piorkowska, "A Landlord's Pan of Local Filming," letter to the editor, *New York Times* (January 7, 1996), XIII: 15; David Kirby, "Where Films Are Noir and Parking Is Dire," *New York Times* (August 9, 1998), XIV: 7; Colin Moynihan, "A Private Enemy Tries to Sabotage Public Filming," *New York Times* (August 23, 1998), XIII: 6; Bernard Stamler, "A Hollywood Film Crew Departs; Duane St. Says Good Riddance," *New York Times* (October 31, 1999), XIII: 6.

10. For Forest City Ratner's plan, see Devin Leonard, "Rudy Is Keeping Mum on Movie-Mad Donor's Film Studio Fantasy," *New York Observer* (April 7, 1997): 1, 25. For Hudson River Studios, see Thomas J. Lueck, "$120 Million Movie Studio Hub Is Planned for Lower Manhattan," *New York Times* (July 11, 1998): 1, B: 2; Terry Pristin, "Tinseltown Dreams Face Reality," *New York Times* (December 9, 1998), B: 17; Terry Pristin, "TV

and Movie Soundstage Project Is Dropped," *New York Times* (November 4, 1999), B: 8.

11. Thomas J. Lueck, "A Film Studio Is Proposed for the Brooklyn Navy Yard," *New York Times* (June 19, 1998), B: 9; Pristin, "Tinseltown Dreams Face Reality": 17; Glenn Collins, "Plan to Boost Film Industry in New York," *New York Times* (August 17, 2004): B: 5.

12. Geraldine Fabrikant, "Wall Street Reviews 'Wall Street,'" *New York Times* (December 10, 1987), D: 1, 5; Vincent Canby, "Film: Stone's 'Wall Street,'" *New York Times* (December 11, 1987), C: 3.

13. Tim Golden, "Filming Puts Bronx Vanities Out of Joint," *New York Times* (April 24, 1990), B: 1, 2; "'Vanities' Foul Weather," *New York Observer* (May 7, 1990): 5; Jeannette Walls, "*Bonfire* Brightens Lobby at 800 Park," *New York* 23 (December 17, 1990): 11; Edward I. Koch, "Film: Hizzoner Puts Torch to 'Bonfire' . . . ," *Wall Street Journal* (December 20, 1990): 14; "Vanities, on the Bench," editorial, *New York Times* (December 24, 1990): 22; Fernando Ferrer, "Bronx Didn't Hamper 'Bonfire' (Just Hates It)," letter to the editor, *New York Times* (January 11, 1991): 28; Pauline Kael, "The Current Cinema: Vanity, Vanities," *New Yorker* 67 (January 14, 1991): 76–79; Joseph F. Sullivan, "Din Still Echoes from Scripted 'Bonfire' Riot," *New York Times* (October 1, 1991); Christopher Lehmann-Haupt, "How Hollywood's 'Bonfire' Crashed and Burned," *New York Times* (November 18, 1991), C: 16; Steven Bach, "Burning Money," *New York Times* (November 24, 1991), VII: 14; Jeannette Walls, "Salamon Fibbed for Better *Bonfire* Book," *New York* 24 (December 2, 1991): 27; William Grimes, "New York Has a Full-Time Fan Promoting It as a Film Capital," *New York Times* (March 12, 1992), C: 17; Bernard Weinraub, "With New Film, De Palma Tries to Rise from Ashes of 'Bonfire,'" *New York Times* (July 2, 1992), C: 13.

14. Koch, "Film: Hizzoner Puts Torch to 'Bonfire' . . . ": 14.

15. Janet Maslin, "The Dress-for-Success Story of a Secretary from Staten Island," *New York Times* (December 21, 1988), C: 22; Vincent Canby, "New York City's Problems Are in the Picture," *New York Times* (July 2, 1989), II: 9; James Sanders, *Celluloid Skyline: New York and the Movies* (New York: Alfred A. Knopf, 2001), 92, 136–38, 280.

16. Canby, "New York City's Problems Are in the Picture": 9.

17. Vincent Canby, "'The Secret of My Success,'" *New York Times* (April 10, 1987), C: 4; Janet Maslin, "Business on the Big Screen," *New York Times* (April 12, 1987), II: 17. For *How to Succeed in Business Without Really Trying*, see Stern, Mellins, and Fishman, *New York 1960*, 1177–78, 1201.

18. Canby, "The Secret of My Success": 14.

19. Maslin, "Business on the Big Screen": 17.

20. Jeannie Park, "Michael Caine Turns Homicidal," *New York Times* (October 1, 1989), II: 17; Vincent Canby, "Climbing the Ladder to Success in 'Shock,'" *New York Times* (March 23, 1990), C: 17.

21. Park, "Michael Caine Turns Homicidal": 17.

22. Janet Maslin, "Film: 'Fame' Opens, Bubbling with Life," *New York Times* (May 16, 1980), C: 14; Annette Insdorf, "Alan Parker: Finding 'Fame' on the Streets of New York," *New York Times* (May 25, 1980), D: 15, 20.

23. Alan Parker, quoted in Insdorf, "Alan Parker: Finding 'Fame' on the Streets of New York": 15.

24. Janet Maslin, "'Tootsie': A Woman Who Is Dustin Hoffman," *New York Times* (July 13, 1982), C: 7; Vincent Canby, "Film: 'Tootsie,' Comedy," *New York Times* (December 17, 1982), C: 12; Stephen Farber, "How Conflict Gave Shape to 'Tootsie,'" *New York Times* (December 19, 1982), H: 1.

25. Edward Lewine, "The Dow Is Up: Greed Revisited," *New York Times* (November 10, 1996), XIII: 3.

26. Maureen Dowd, "'The Paper' Replates 'The Front Page' for the 90's," *New York Times* (March 13, 1994), II: 15; Roger Ebert, "Stop the Presses! They Got It Right!" *Chicago Sun-Times* (March 18, 1994): 40; Janet Maslin, "A Day with the People Who Make the News," *New York Times* (March 18, 1994), C: 19; Pete Hamill, "A Media Event," *New York* 27 (March 21, 1994): 26–29, 32; John Powers, "John Powers Reviews *The Paper*," *New York* 27 (March 21, 1994): 32–33; Martin Kihn, "Simulating the *Times*," *New York* 27 (March 21, 1994): 28.

27. Paul Goldberger, quoted in Kihn, "Simulating the *Times*": 28.

28. James Barron, "'City Hall' Passes Muster With Real-Life Officials," *New York Times* (February 6, 1996), B: 5; Bruce Weber, "Into the Municipal Maelstrom," *New York Times* (February 11, 1996), II: 11, 23; Janet Maslin, "Dangerous Dealings in the Heart of New York," *New York Times* (February 16, 1996), C: 3; Joyce Purnick, "Inside 'City Hall,'" *New York Times* (February 18, 1996): 39; Steven R. Weisman, "Shades of 'City Hall,'" *New York Times* (February 19, 1996): 14; Andrew Sarris, "*City Hall*: After the Grit, It's Down to 'I Love New York,'" *New York Observer* (February 19, 1996): 23.

29. Janet Maslin, "Screen: The Prince of Bay Ridge," *New York Times* (December 16, 1977): 66.

30. Vincent Canby, "Film: 'Annie Hall,' Allen at His Best," *New York Times* (April 21, 1977): 77; Vincent Canby, "Woody Allen Is the American Ingmar Bergman–No Kidding," *New York Times* (April 24, 1977), D: 19; Vincent Canby, "This Was the Year Comedy Was King," *New York Times* (December 25, 1977): 49; Sanders, *Celluloid Skyline: New York and the Movies*, 250–51, 406–7, 409.

31. Sanders, *Celluloid Skyline: New York and the Movies*, 407.

32. Judy Klemesrud, "Woody Allen's Friends Were All There," *New York Times* (April 20, 1977): 18; "Woody Allen Shoots at Elaine's," *New York Times* (July 21, 1978): C: 18; Natalie Grittelson, "The Maturing of Woody Allen," *New York Times* (April 22, 1979), VI: 30–32, 102, 104–7; Vincent Canby, "Woody Allen's Manhattan," *New York Times* (April 25, 1979): C: 17; Canby, "New York City's Problems Are in the Picture": 9.

33. Woody Allen, quoted in Gittelson, "The Maturing of Woody Allen": 32.

34. Canby, "New York City's Problems Are in the Picture": 9.

35. Canby, "New York City's Problems Are in the Picture": 9.

36. Vincent Canby, "Screen: Dudley Moore Stars as a Screwball in 'Arthur,'" *New York Times* (July 17, 1981), C: 10.

37. Vincent Canby, "Screen: De Niro, Streep Star in 'Falling in Love,'" *New York Times* (November 21, 1984), C: 11. Also see Seth Cagin, "Location Puts the Cliff in a Cliffhanger and the Glow in Romance," *New York Times* (July 29, 1984), II: 15, 23; Glenn Collins, "Love Makes a Movie Comeback," *New York Times* (November 25, 1984), II: 1, 28; Janet Maslin, "Film View; 'Falling in Love' Makes the Most of the Mundane," *New York Times* (December 9, 1984), II: 2.

38. Janet Maslin, "Film: 'Moonstruck,' with Italians in Love,'" *New York Times* (December 16, 1987), C: 22; Carol Lawson, "The Best Supporting Baker?" *New York Times* (March 30, 1988), C: 14; Joseph P. Fried, "Restaurant Retains a Flavor of the Past," *New York Times* (May 12, 2002): 27.

39. Vincent Canby, "'Jungle Fever' Sweeps Cannes," *New York Times* (May 17, 1991), C: 1, 17. Also see Patricia Leigh Brown, "A Film-in-Progress on a Black Architect," *New York Times* (November 15, 1990), C: 3; Vincent Canby, "Spike Lee's Comedy of Sorrow," *New York Times* (June 7, 1991), C: 1, 10; Nicolai Ouroussoff, "After a Moment in the Sun, Eclipsed Again," *New York Times* (October 6, 1991), II: 42–43.

40. Canby, "'Jungle Fever' Sweeps Cannes": 17.

41. Ouroussoff, "After a Moment in the Sun, Eclipsed Again": 42.

42. Bruce Weber, "Can Men and Women Be Friends?" *New York Times* (July 9, 1989), H: 11; Caryn James, "It's Harry Loves Sally in a Romance of New Yorkers and Neuroses," *New York Times* (July 12, 1989), C: 15.

43. James, "It's Harry Loves Sally in a Romance of New Yorkers and Neuroses": 15.

44. Vincent Canby, "When Sam Met Annie, or When Two Meet Cute," *New York Times* (June 25, 1993), C: 10.

45. Janet Maslin, "Meet. Fight. Fall in Love. What a Day!" *New York Times* (December 20, 1996), C: 12.

46. Also see Stephen Holden, "Looking at the Same Old Song," *New York Times* (December 1, 1996), II: 13, 18; Beth Landman and Deborah Mitchell, "Streisand Turns Over a New Leaf," *New York* 29 (April 8, 1996): 9; Michael Cooper, "The Occupation of West 84th," *New York Times* (May 12, 1996), XIII: 4; Janet Maslin, "Streisand on Top A, with 2 Pet Men in Orbit," *New York Times* (November 15, 1996), C: 14.

47. Gary van der Meer, quoted in Cooper, "The Occupation of West 84th": 4.

48. Henry Urbach, "Losing Barneys," *ANY* 22 (1998): 47; "Tempting Fruit Is Only for the Eye," *New York Times* (May 14, 1998), B: 2; Patricia Leigh Brown, "The Built Environment; Take Broadway to the Center of the Universe," *New York Times* (December 17, 1998), F: 3; Janet Maslin, "hanks&ryan@romance.com," *New York Times* (December 18, 1998), E: 1, 20.

49. Milton Glaser, quoted in Brown, "The Built Environment; Take Broadway to the Center of the Universe": 3.

50. Maslin, "hanks&ryan@romance.com": 1.

51. For *Mean Streets*, see Stern, Mellins, and Fishman, *New York 1960*, 1190.

52. Richard F. Shepard, "Making Illusion and Reality Inseparable," *New York Times* (August 3, 1978), B: 3; Janet Maslin, "Movie: 'Warriors' Creates Visual Style That Is Stark," *New York Times* (February 10, 1979): 10; Vincent Canby, "When a Tame Film Inspires Violence," *New York Times* (March 4, 1979), D: 19; Sanders, *Celluloid Skyline: New York and the Movies*, 385.

53. Maslin, "Movie: 'Warriors' Creates Visual Style That Is Stark": 10.

54. Vincent Canby, "Film: 'Escape From New York,'" *New York Times* (July 10, 1981), C: 6.

55. Vincent Canby, "'Fort Apache, the Bronx,' with Paul Newman," *New York Times* (February 6, 1981), C: 6. Also see Selwyn Raab, "Film Image Provokes Outcry in South Bronx," *New York Times* (February 6, 1981), C: 6; "'Apache' Film's Debut Protested," *New York Times* (February 7, 1981): 9; Lee A. Daniels, "The Talk of the South Bronx," *New York Times* (April 11, 1981), II: 25.

56. Lawrence Van Gelder, "East Side, West Side, the Cameras Are Rolling All Around the Town," *New York Times* (April 13, 1980), II: 1, 10; John Corry, "'Prince of the City' Explores a Cop's Anguish," *New York Times* (August 9, 1981), II: 1; Janet Maslin, "Screen: Lumet's 'Prince of the City,'" *New York Times* (August 19, 1981), C: 17; John Lombardi, "Lumet: The City Is His Sound Stage," *New York Times* (June 6, 1982), VI: 26–30, 78–81.

57. Vincent Canby, "Film: 'Goodbar' Turns Sour," *New York Times* (October 20, 1977): 27.

58. Janet Maslin, "Film: Sinatra in 'First Deadly Sin,'" *New York Times* (October 24, 1980), C: 10.

59. Chris Chase, "At the Movies," *New York Times* (March 27, 1981), C: 8.

60. Matthew Purdy, "Officials Say 'Cut!' to Subway Violence on Film," *New York Times* (February 24, 1994), B: 1–2; "New York: The Movie Set," editorial, *New York Times* (February 25, 1994): 28; Gretchen Dykstra, "When Arnold Schwarzenegger Made a Movie in Times Square," letter to the editor, *New York Times* (March 4, 1994): 26; Steve Kesten, "The Hijacked Train," letter to the editor, *New York Times* (March 4, 1994): 26; Nancy Littlefield, "No Censorship for Koch," letter to the editor, *New York Times* (March 4, 1994): 26.

61. Josh Young, "Cops, Robbers and the N.Y. Subway System," *New York Times* (November 19, 1995), II: 20; Stephen Holden, "Underground Fun House with the Basketball Duo," *New York Times* (November 22, 1995): C: 12; Sanders, *Celluloid Skyline: New York and the Movies*, 386.

62. Robert D. McFadden, "Subway Fire Attack Prompts an Uproar Over Action Movie," *New York Times* (November 28, 1995): 1, B: 4; Richard Perez-Peña, "A Horror Scene Made Real," *New York Times* (December 3, 1995), IV: 2; John Leland, "Violence, Reel to Real," *Newsweek* 126 (December 11, 1995): 46–48; Alan F. Kiepper, "What Does Hollywood Say Now?" *New York Times* (December 12, 1995): 27; Lynette Holloway, "Token Booth Fire Attack Seems Unrelated to Movie," *New York Times* (December 16, 1995): 26.

63. Paul Goldberger, "New York as Film Setting and as Star," *New York Times* (July 11, 1989), C: 12.

64. Vincent Canby, "Spike Lee Stirs Things Up at Cannes," *New York Times* (May 20, 1989): 11; Vincent Canby, "Spike Lee Raises the Movies' Black Voice," *New York Times* (May 28, 1989), II: 11; Vincent Canby, "Spike Lee Tackles Racism in 'Do the Right Thing,'" *New York Times* (June 30, 1989), C: 16; Canby, "New York City's Problems Are in the Picture": 9; Goldberger, "New York as Film Setting and as Star": 12; Sanders, *Celluloid Skyline: New York and the Movies*, 179–82.

65. Sanders, *Celluloid Skyline: New York and the Movies*, 181.

66. Janet Maslin, "Film Festival/Two Portraits: One of Romance in France, One of Crime in New York," *New York Times* (September 22, 1990): 13; Hal Hinson, "Faith, Dope and Charity; 'King of New York': Overdone Wackiness," *New York Times* (November 20, 1990), E: 2.

67. Sanders, *Celluloid Skyline: New York and the Movies*, 170. Also see Stephen Holden, "Where the Streets Are Mean and People Are Even Meaner," *New York Times* (May 22, 1991), C: 11; John Leland, "Black to the Future," *Newsweek* 117 (May 27, 1991): 58; Richard Bernstein, "The Film and the Dream: A Brooklyn Story," *New York Times* (May 28, 1991), C: 1; Sanders, *Celluloid Skyline: New York and the Movies*, 170–72.

68. For Red Hook Houses, see Stern, Gilmartin, and Mellins, *New York 1930*, 496, 498–99.

69. Janet Maslin, "Too Much to Prove, and No Reason to Prove It," *New York Times* (January 17, 1992), C: 10. Also see Kenneth M. Chanko, "Keeping Juice Fresh," *New York* (May 13, 1991): 30; Janet Maslin, "Making a Movie Take the Rap for the Violence It Attracts," *New York Times* (January 22, 1992), C: 13.

70. Janet Maslin, "Cops-vs.-Crack Formula by Mario Van Peebles," *New York Times* (March 8, 1991), C: 15. Also see Hal Hinson, "'New Jack City': Into the Heat," *Washington Post* (March 8, 1991), D: 1.

71. David Gonzalez, "Harlem Was on Their Mind," *New York Times* (February 20, 1994), II: 11, 19; William McDonald, "Thicker Than Water, and Spilled by the Mob," *New York Times* (May 21, 1995), II: 11, 20.

72. Leon Ichaso, quoted in Gonzalez, "Harlem Was on Their Mind": 11.

73. Roger Ebert, "Timely Questions; Spike's 'Clockers' Gripping," *Chicago Sun-Times* (September 13, 1995): 39. Also see Janet Maslin, "In a Hell of Drugs and Despair," *New York Times* (September 13, 1995), C: 11; Sanders, *Celluloid Skyline: New York and the Movies*, 172–74.

74. Sanders, *Celluloid Skyline: New York and the Movies*, 183. Also see Jon Pareles, "They're Rebels Without a Cause, and Couldn't Care Less," *New York Times* (July 16, 1995), II: 1.

75. Stephen Holden, "Dead End Kids, in Modern Dress," *New York Times* (February 13, 1998), E: 28.

76. David Kamp, "Three on a Match," *Vanity Fair* (October 1999): 274–75; Roger Ebert, "Bringing Out Cage's Best; Scorsese Film Goes on an Intense Ride," *Chicago Sun-Times* (October 22, 1999): 25; Janet Maslin, "A Scorsese Devil Hunt," *New York Times* (October 22, 1999), E: 1, 31; Graham Fuller, "When the Charisma of the City Steals the Limelight," *New York Times* (November 14, 1999), II: 3, 18.

77. Kamp, "Three on a Match": 274–75.

78. Janet Maslin, "Chaplinesque Artist and Waif Among the Homeless," *New York Times* (November 3, 1989), C: 14; Edward Guthmann, "Homeless Inspire Intimate Tale of Street Life," *San Francisco Chronicle* (November 12, 1989): 25; Michael E. Ross, "The Serious Ends of Comedy," *New York Times* (November 18, 1989): 15.

79. Richard Bernstein, "Battling Crack Dealers on Rooftops of New York," *New York Times* (March 18, 1989): 16. Also see Joel Rose, "Lower East Side: Directors Love It to a Fault," *New York Times* (May 7, 1989): 22.

80. Rose, "Lower East Side: Directors Love It to a Fault": 22.

81. Jan Hoffman, "Matt Dillon May Look Tough, but Don't Get Him Wrong," *New York Times* (October 31, 1993), II: 15; Janet Maslin, "The Saint of Fort Washington; Homeless, Helpless and Holy, in One Kind of Hell," *New York Times* (November 17, 1993), C: 19. For the Fort Washington Armory, see "Plans Completed for 22d's New Armory," *New York Times* (August 22, 1909): 12.

82. Maslin, "The Saint of Fort Washington; Homeless, Helpless and Holy, in One Kind of Hell": 19.

83. Roger Ebert, "Emptiness Theme Is Forever in 'Sunday,'" *Chicago Sun-Times* (September 26, 1997): 39.

84. Julie Salamon, "Film: Medieval Fantasy in Modern Manhattan," *Wall Street Journal* (September 19, 1991): 12; Janet Maslin, "A Cynic's Quest for Forgiveness," *New York Times* (September 20, 1991), C: 10; David Morgan, "Gilliam," *Metropolis* 10 (September 1991), 38–43, 56–57, 59.

85. Terry Gilliam, quoted in Morgan, "Gilliam": 59.

86. Salamon, "Film: Medieval Fantasy in Modern Manhattan": 12.

87. Rose, "Lower East Side: Directors Love It to a Fault": 22. Also see Janet Maslin, "Learning to Appreciate a Mr. Right Who Sells Pickles and Tells Jokes," *New York Times* (August 24, 1988), C: 15; Jerry Tallmer, "Fancy 'Delancey,'" *New York Post* (August 24, 1988): 23; Alvin Klein, "Crossing Obstacles of 'Delancey,'" *New York Times* (October 2, 1988), XII: 21, Sanders, *Celluloid Skyline: New York and the Movies*, 358. For Hester Street, see Stern, Mellins, and Fishman, *New York 1960*, 1175.

88. Arthur Lubow, "The 'Little Odessa' File," *New Yorker* 70

[March 21, 1994]: 188–92, 195–202; Caryn James, "Russian Emigre Family with a Son in the Mob," *New York Times* (May 19, 1995), C: 12; McDonald, "Thicker Than Water, and Spilled by the Mob": 11, 20; Caryn James, "Do the Movies Get New York Right?" *New York Times* (July 9, 1995), XIII: 1.

89. James, "Russian Emigre Family with a Son in the Mob": 12.

90. Mirta Ojito, "In Polish Film, Brooklyn Isn't Paved with Zlotys," *New York Times* (December 17, 1996), B: 3.

91. Vincent Canby, ". . . And So Does the Screen," *New York Times* (July 1, 1979), D: 1, 17. Also see Vincent Canby, "Immigrants Define America on Screen," *New York Times* (May 27, 1984), II: 15; Vincent Canby, "How to Tour the World for $4," *New York Times* (July 8, 1979), D: 17; James Trager, *The New York Chronology* (New York: HarperCollins, 2003), 749.

92. Vincent Canby, "Screen: 'Worlds of Angelita,'" *New York Times* (October 28, 1983), C: 4.

93. Stephen Holden, "Goodbye Santo Domingo, Hello Manhattan," *New York Times* (February 14, 1996), C: 12.

94. Stephen Holden, "Citizens of Poverty Yearning to Be Free," *New York Times* (October 22, 1999), E: 12; Amy Waldman, "In Film, Immigrants Bring Real Life to Acting Jobs," *New York Times* (October 25, 1999), B: 3; Cathy Lang Ho, "Corner Market," *Metropolis* 18 (November 1999): 68; Roger Ebert, "'City' Enriched by Real Lives," *Chicago Sun-Times* (January 7, 2000): 23.

95. Holden, "Citizens of Poverty Yearning to Be Free": 12.

96. Vincent Canby, "Sayles's 'Brother,'" *New York Times* (September 14, 1984), C: 5; Lawrence Van Gelder, "At the Movies," *New York Times* (September 14, 1984), C: 6.

97. "Muppet Crew Celebrates a Film and a Birthday," *New York Times* (September 26, 1983), B: 2; Vincent Canby, "Film: Broadway Setting for 3d Muppet Romp," *New York Times* (July 13, 1984), C: 10; Gary Arnold, "The Muppet Mope," *Washington Post* (July 14, 1984), C: 7.

98. Vincent Canby, "Film: Paul Mazursky's 'Moscow on the Hudson,'" *New York Times* (April 6, 1984), C: 12; Janet Maslin, "At the Movies," *New York Times* (April 6, 1984), C: 12; Judy Klemesrud, "Robin Williams Dons an Emigre's Guise," *New York Times* (April 15, 1984), II: 21; Eleanor Blau, "The Ethnic Authenticity of 'Moscow,'" *New York Times* (May 22, 1984), C: 11.

99. Vincent Canby, "Review/Film; African Prince in Queens," *New York Times* (June 29, 1988), C: 19.

100. Janet Maslin, "Review/Film; Alone Again: Holiday Mischief in Manhattan," *New York Times* (November 20, 1992), C: 1, 6; Julie Salamon, "Film: Eddie Murphy as Capitol Hill Con Man," *Wall Street Journal* (December 3, 1992): 11; Janet Maslin, "The Plaza Off Screen: A Real-Life Adventure," *New York Times* (December 4, 1992), C: 1, 25.

101. "High Noon on the Lower Level," *New York Times* (November 14, 1993): 39; Douglas Martin, "A Film's Regards to Old Broadway," *New York Times* (December 12, 1993), XIII: 6; Caryn James, "Midday Cowboys in the City, with Horses," *New York Times* (June 3, 1994), C: 21.

102. Richard F. Shepard, "Film of 'Wiz' Will Be Made at Queens Site," *New York Times* (April 9, 1977): 10; Dee Wedemeyer, "The Emerald City Comes to New York City," *New York Times* (September 23, 1977): 29; Carrie Donovan, "'Wiz Biz," *New York Times* (August 6, 1978), VI: 13; Vincent Canby, "When Budgets Soar over the Rainbow," *New York Times* (November 26, 1978), D: 13; John Lombardi; "Lumet: The City Is His Sound Stage," *New York Times* (June 6, 1982), VI: 26–30, 78–81.

103. Rob Cohen, quoted in Wedemeyer, "The Emerald City Comes to New York City": 29.

104. Janet Maslin, "Film 'Ghostbusters,' with Murray and Akroyd," *New York Times* (June 8, 1984), C: 5; Sanders, *Celluloid Skyline: New York and the Movies*, 115–18.

105. Paul Goldberger, "Glassy Skyscrapers and Other Villains of the Movies," *New York Times* (July 15, 1990), II: 27.

106. Vincent Canby, "Citywide Bad Temper: Better Call in Ghostbusters!" *New York Times* (June 16, 1989), C: 5; Goldberger, "New York as Film Setting and as Star": 12.

107. Goldberger, "New York as Film Setting and as Star": 12.

108. Julie Salamon, "Gizmo et al. in the Big Apple," *Wall Street Journal* (June 21, 1990): 12; Paul Goldberger, "Glassy Skyscrapers and Other Villains of the Movies," *New York Times* (July 15, 1990), II: 27; Sanders, *Celluloid Skyline: New York and the Movies*, 139–40.

109. Goldberger, "Glassy Skyscrapers and Other Villains of the Movies": 27.

110. Janet Maslin, "Men in Black," *New York Times* (July 1, 1997), C: 9; Sanders, *Celluloid Skyline: New York and the Movies*, 438–39.

111. Sanders, *Celluloid Skyline: New York and the Movies*, 439.

112. Michael Specter, "New York, N.Y., It's Another Town," *New York Times* (August 16, 1992), II: 7.

113. David L. Snyder, quoted in Specter, "New York, N.Y., It's Another Town": 7.

114. Su Avasthi, "New York in 2259," *New York Post* (May 7, 1997): 38–39; Michael Sorkin, "Remembering the Future," *Architectural Record* 187 (June 1999): 96–101; Sanders, *Celluloid Skyline: New York and the Movies*, 111–14.

115. Sanders, *Celluloid Skyline: New York and the Movies*, 113.

116. Susan Heller Anderson, "It's a Bird! It's a Plane! It's a Movie!" *New York Times* (June 26, 1977): 61; Vincent Canby, "Screen: It's a Bird! It's a Plane! It's a Movie!" *New York Times* (December 15, 1978), C: 15; Sanders, *Celluloid Skyline: New York and the Movies*, 102–3.

117. Richard Donner, quoted in Anderson, "It's a Bird! It's a Plane! It's a Movie!": 61.

118. Hilary de Vries, "'Batman' Battles for Big Money," *New York Times* (February 5, 1989), II: 11; Benedict Nightingale, "Batman Prowls a Gotham Drawn from the Absurd," *New York Times* (June 18, 1989), II: 1, 16; Canby, "New York City's Problems Are in the Picture": 9; Goldberger, "New York as Film Setting and as Star": 12; Pilar Vilades, "Batman: Design

for the Bad Guys," *Progressive Architecture* 70 (September 1989): 21–22; Betsey Sharkey, "Anton Furst: Lost in the Dream Factory," *New York Times* (February 16, 1992), II: 1, 18–19; Dietrich Neumann, ed., *Film Architecture: Set Designs from Metropolis to Blade Runner* (Munich: Prestel, 1999), 160–69; Sanders, *Celluloid Skyline: New York and the Movies*, 103–5; Dana Jennings, "New York Action Hero," *New York Times* (November 23, 2003), XIV: 3.

119. Anton Furst, quoted in de Vries, "'Batman' Battles for Big Money": 11.

120. Anton Furst, quoted in Neumann, ed., *Film Architecture: Set Designs from Metropolis to Blade Runner*, 163.

121. Goldberger, "New York as Film Setting and as Star": 12.

122. David Ansen, "A Gotham Gothic," *Newsweek* 119 (June 22, 1992): 50–51. Also see Betsey Sharkey, "Batman's City Gets a New Dose of Urban Blight," *New York Times* (June 14, 1992), II: 13–14.

123. Neumann, *Film Architecture: Set Designs from Metropolis to Blade Runner*, 172.

124. Joe Quesada, quoted in Dana Jennings, "New York Action Hero," *New York Times* (November 23, 2003), XIV: 3.

125. Peter M. Nichols, "Did the Spider Also Supply the Red Leather Couture?" *New York Times* (February 28, 2003), E: 1; Elvis Mitchell, "Blind Lawyer as Hero in Red," *New York Times* (February 14, 2003), E: 1, 19.

126. Chip Kidd, "A Tale of Three Cities," *New York Times* (May 19, 2002), XIV: 3; Corey Kilgannon, "So, Spider-Man! Brilliant Disguise!" *New York Times* (May 8, 2002), B: 1, 7; A. O. Scott, "Muscles Ripple, Webs Unfurl, Hormones Race," *New York Times* (May 3, 2002), E: 1, 15.

127. Scott, "Muscles Ripple, Webs Unfurl, Hormones Race": 15.

128. Anthony Ramirez, "The Beast That Ate 23d Street?" *New York Times* (April 27, 1997), XIII: 6; Rick Lyman, "Rains Come to Wall Street and with Them, Godzilla," *New York Times* (May 19, 1997), C: 11, 14; Stephen Holden, "So, How Big Is It Again? Sizing Up the Lizard King," *New York Times* (May 19, 1998), E: 1, 8.

129. Bruce Orwall and John Lippman, "Collision or Not, Hollywood Is Ready," *Wall Street Journal* (March 13, 1998), B: 1, 6; Joe Morgenstern, "Film: Cosmic Crashes; Comic Cons," *Wall Street Journal* (July 1, 1998): 16; Janet Maslin, "Henny Penny Gets the President's Ear," *New York Times* (July 1, 1998), E: 1, 6.

130. Orwall and Lippman, "Collision or Not, Hollywood Is Ready": 1, 6.

131. Janet Maslin, "The Cold War Is Back, Nuclear Bombs and All," *New York Times* (September 26, 1997), E: 10.

132. *The Siege* (Edward Zwick, 1998). Also see Laurie Goodstein, "Arab-Americans Fear a Terrorism Film Will Deepen Hatred," *New York Times* (August 24, 1998), E: 1, 5; Laurie Goodstein, "Hollywood Now Plays Cowboys and Arabs," *New York Times* (November 1, 1998), II: 17, 20; Janet Maslin, "New York as Battleground of Terrorists and Troops," *New York Times* (November 6, 1998), E: 15; Joe Morgenstern, "Terrorists and Tanks Invade New York in Chilling 'The Siege,'" *Wall Street Journal* (November 6, 1998), W: 1–2; Julian E. Barnes, "Protesters Say a New Movie Likens Islam to Terrorism," *New York Times* (November 7, 1998), B: 3; Ibrahim Hooper, "Again, Islam Is an Easy Villain," *New York Times* (November 10, 1998): 29; Edward Zwick, "In the Hurt Game, Honesty Loses," *New York Times* (November 10, 1998): 29.

133. Maslin, "New York as Battleground of Terrorists and Troops": 15.

134. Vincent Canby, "Film: 'New York' in a Tuneful Era," *New York Times* (June 23, 1977): 61.

135. For *Gangs of New York*, see A. O. Scott, "Film Review: To Feel a City Seethe," *New York Times* (December 20, 2002), E: 1, 35. For *The Age of Innocence*, see Christopher Gray, "Recreating 'The Age of Innocence' in Brick and Paint," *New York Times* (October 24, 1993), II: 11.

136. Richard F. Shepard, "Filming of 'Ragtime' Restores 1906 to Block on E.11th Street," *New York Times* (July 28, 1980), C: 12; "O'Brien and Cagney Reunite for 'Ragtime,'" *New York Times* (September 19, 1980), C: 3; William Borders, "Mailer, Dying for a Part in 'Ragtime,'" *New York Times* (December 17, 1980), C: 25; Tom Buckley, "The Forman Formula," *New York Times* (March 1, 1981), VI: 28–31, 42, 44, 50–53; Vincent Canby, "'Ragtime' Evokes Real and Fictional Pasts," *New York Times* (November 20, 1981), C: 10.

137. "Compare and Contrast: A New York Adventure," *New York Times* (October 22, 1995): 37; Joe Morgenstern, "IMAX: New York on the Really Big Screen," *Wall Street Journal* (August 30, 1996): 7; Herbert Muschamp, "New York Is Reaching Backward to Find Itself," *New York Times* (October 29, 1995), II: 1, 46.

138. Robert Evans, quoted in Aljean Harmetz, "Puzo Writing Film on Cotton Club," *New York Times* (September 17, 1981), C: 27. Also see Aljean Harmetz, "Stallone in Dispute on 'Cotton Club,'" *New York Times* (June 1, 1982), C: 14; Harold Faber, "'Cotton Club' Goes to Albany for Its Premier," *New York Times* (December 2, 1984): 46; Sandra Salmans, "'Cotton Club' Is Neither a Smash nor a Disaster," *New York Times* (December 20, 1984), C: 13; Vincent Canby, "Coppola's 'Cotton Club,'" *New York Times* (December 14, 1984), C: 3.

139. Janet Maslin, "Screen: 'Brighton Beach Memoirs,'" *New York Times* (December 25, 1986): 23; Avery Corman, "Woody Allen and Neil Simon Conjure a Compelling Era," *New York Times* (January 25, 1987), II: 1, 14; Vincent Canby, "Woody Allen's Fond Remembrances of 'Radio Days,'" *New York Times* (January 20, 1987), C: 1, 10.

140. Stuart Wurtzel, quoted in Susan Chumsky, "The Reality of the Unreal," *Metropolis* 6 (January/February 1987): 44–47, 65, 67; "The Village Lives," *New York Times* (March 18, 1988): 34.

141. Roger Ebert, "Last Exit to Brooklyn," *Chicago Sun-Times* (May 11, 1990): 47. Also see Leslie Bennetts, "'Last Exit' Brings Pleasant Moments at Last," *New York Times* (August 4,

1988), C: 19; Vincent Canby, "Review/Film: A Brutal, Elegiac 'Last Exit,' Unrelieved by Hope," *New York Times* (May 2, 1990), C: 15.

142. Herbert Mitgang, "On Broadway, the Clock Read 1954," *New York Times* (September 24, 1981), C: 26; Janet Maslin, "'Favorite Year' with Peter O'Toole," *New York Times* (October 1, 1982), C: 10.

143. Caryn James, "Sniffing Out the Truth About Instant Success," *New York Times* (March 11, 1994), C: 8. Also see Diana Charnley, "Production Design as Process," in Francois Penz and Maureen Thomas, eds., *Cinema & Architecture* (London: British Film Institute, 1997), 154–55; Sanders, *Celluloid Skyline: New York and the Movies*, 121–22, 248, 436.

144. Vincent Canby, "Film: 'Once Upon a Time in America,'" *New York Times* (June 1, 1984), C: 8.

145. Vincent Canby, "Review/Film: A Cold-Eyed Look at the Mob's Inner Workings," *New York Times* (September 19, 1990), C: 11, 15.

146. Janet Maslin, "Screen: 'The Wanderers,' a Bronx Gangs Story," *New York Times* (July 13, 1979), C: 12.

147. Janet Maslin, "Review/Film: A Bronx Tale," *New York Times* (September 29, 1993), C: 13.

148. Michael Goodwin, "Thousands Dance and Others Fume [illegible] in Central Park," *New York Times* (May 1, 1978), B: 3; Vincent [illegible], "The Age of Affluence Lives 'Twist' In 'Stylish, Satisfying," *New York Times* (March 25, 1979), D: 11.

149. Janet Maslin, "Red Hot Buttons in Lee's Steaming 'Sam,'" *New York Times* (July 2, 1999), E: 1, 27; Kit R. Roane, "Filmgoers Revisit a Summer They Couldn't Forget," *New York Times* (July 3, 1999), B: 2.

150. William L. Hamilton, "Studio 54 Reawakens, and No Hangover," *New York Times* (November 27, 1997), F: 9. Also see Bernard Weinraub, "Disco Nights of Studio 54," *New York Times* (May 8, 1998), E: 10; Stephen Holden, "Sex, Drugs and Disco as a Hustler Gains a Suspect Celebrity," *New York Times* (August 28, 1998), E: 10.

151. Weinraub, "Disco Nights of Studio 54": 10; Janet Maslin, "Night Life of the Young, Urban and Genteel," *New York Times* (May 29, 1998), E: 12.

152. Caryn James, "In a Change-of-Pace Production, Merchant and Ivory Film on Mott St.," *New York Times* (April 5, 1988), C: 13; Hal Lipper, "Making a Movie by the Book," *St. Petersburg Times* (May 31, 1988), D: 1; David Lida, "Slaves of New York Author Lives a Dream on Film Set," *Toronto Star* (June 6, 1988), C: 4; Erica Abeel, "Merchant and Ivory Traffic in 'Slaves of New York,'" *New York Times* (March 12, 1989), II: 13; Janet Maslin, "James Ivory's Version of Janowitz's 'Slaves,'" *New York Times* (March 17, 1989), C: 8; Roberta Smith, "The Art World Painted in Films," *New York Times* (April 5, 1989), C: 19; Jay Carr, "Movie Review/Slaves of New York," *Boston Globe* (March 24, 1989): 41; Rose, "Lower East Side: Directors Love It to a Fault": 22; Steve Garbarino, "Fashion Verite," *New York Times* (February 24, 2002), VI: 2.

153. James Ivory, quoted in Abeel, "Merchant and Ivory Traffic in 'Slaves of New York'": 13.

NEW YORK ON THE SMALL SCREEN

1. Gary David Goldberg, quoted in Caryn James, "The Big City, with an Even Bigger Cast: A Great Place to Visit (At Least on Television)," *New York Times* (October 23, 1997), E: 1, 8.

2. John J. O'Connor "TV: Two Late-Night Arrivals," *New York Times* (January 7, 1980), C: 17; John J. O'Connor "Casting a Wider Net for Talent," *New York Times* (July 6, 1980), D: 23; Tony Schwartz, "Television Week," *New York Times* (November 23, 1980), II: 2; John J. O'Connor "TV: 'Park Place,' New CBS Comedy," *New York Times* (April 9, 1981), C: 24.

3. Leslie Bennetts, "Bill Cosby Begins Taping NBC Series," *New York Times* (August 6, 1984), C: 20; Arthur Unger, "'Bill Cosby Show,'" *Christian Science Monitor* (September 24, 1984): 27; William Raspberry, "Cosby Show: Black or White?" *Washington Post* (November 5, 1984): 27; Bruce Weber, "Eventually, All Things End, Even a Big Hit Like 'Cosby,'" *New York Times* (March 7, 1992): 1, 30; Michael Winship, "Cosby's Brooklyn," letter to the editor, *New York Times* (March 24, 1992): 20; Bill Carter, "In the Huxtable World, Parents Knew Best," *New York Times* (April 26, 1992), II: 1, 33.

4. John J. O'Connor, "'Kate & Allie,' About 2 Divorced Women, on CBS," *New York Times* (March 19, 1984), C: 15; Tom Shales, "Comedy with Class," *Washington Post* (March 19, 1984), C: 1.

5. John J. O'Connor, "New CBS Wednesday Night Lineup," *New York Times* (September 18, 1985), C: 26; Sally Bedell Smith, "Edward Woodward, New TV Hero," *New York Times* (September 19, 1985), C: 34; Lisa Belkin, "All New York Auditions as a Set for TV's 'Equalizer,'" *New York Times* (July 9, 1987), C: 1, 8; John J. O'Connor, "Family Life in a Welfare Hotel on 'The Equalizer,'" *New York Times* (March 16, 1988), C: 26.

6. John J. O'Connor, "'Seinfeld,' a Comic as a Comic," *New York Times* (June 7, 1990), C: 22; John Tierney, "With Help of 'Seinfeld,' Legend in His Own Time," *New York Times* (January 18, 1996), B: 1, 5; John J. O'Connor, "'Seinfeld,' a Short Kvetch from Bizarre to Bizarro," *New York Times* (October 31, 1996), C: 20; Esther B. Fein, "Nada, Nada, Nada," *New York Times* (December 27, 1997), B: 1, 5; "The Seinfeldian Universe," editorial, *New York Times* (December 28, 1997), IV: 8; Anthony Ramirez, "Goodbye to 'Seinfeld,' or Good Riddance," *New York Times* (January 4, 1998), XIV: 5; David W. Chen, "City Will Mark End of a Show About Nothing by Doing Nothing," *New York Times* (May 6, 1998), B: 3; Caryn James, "'Seinfeld' Serves Out Its Sitcom Sentence," *New York Times* (May 15, 1998), B: 1, 5.

7. Quoted in Anita Gates, "Room Enough to Stretch the Imagination," *New York Times* (March 3, 1996), II: 31, 38. Also see John J. O'Connor, "Trying to Succeed at a 90's Marriage," *New York Times* (September 23, 1992): C: 20; John J. O'Connor, "Yes, More Friends Sitting Around," *New York Times*

(September 29, 1994), C: 18.

8. Gail Collins, "The Spin on 'Spin City,'" *New York Times* (September 20, 1996): 30. Also see Lawrie Mifflin, "New York Re-enters the Sitcom Universe, Wryly," *New York Times* (September 5, 1996), C : 17, 22; Joyce Purnick, "TV City Hall: More Laughs Than Issues," *New York Times* (September 26, 1996), B: 1; Clyde Haberman, "Dramatic License in the Corridors of Power," *New York Times* (October 6, 1996), II: 48, 54.

9. Eleanor Blau, "Only 'Law and Order' Is Filming for TV on New York's Streets," *New York Times* (September 2, 1991): 11. Also see John J. O'Connor, "New Series Has 2 Tiers, the Chase and the Trial," *New York Times* (September 13, 1990), C: 26; Bruce Weber, "In Prime Time, the N.Y.P.D. Rules," *New York Times* (October 28, 1994), B: 1; Bruce Weber, "Authority Bars Subway Use for Filming a TV Scene," *New York Times* (December 16, 1995): 25–26; Caryn James, "'Law and Order' Meets 'Homicide,'" *New York Times* (February 7, 1996), C: 11, 16; Glenn Collins, "A Tough Town, on Screen Anyway," *New York Times* (March 17, 1998), B: 1, 8; Molly Haskell, "A 'Law and Order' Addict Tells All," *New York Times* (April 7, 2002), XIV: 1, 14.

10. John J. O'Connor, "The Hourlong Drama Is Alive and Resurgent," *New York Times* (September 21, 1994): C: 18; Weber, "In Prime Time, the N.Y.P.D. Rules": 1–2; Caryn James, "A Rapper Caught Up in Violence. Sound Familiar?" *New York Times* (October 21, 1996): 9, 00.

11. Andy Meisler, "A Which Hunt Turned the Nation of Demons," *New York Times* (October 26, 1993), C: 15; Clifford Krauss, "N.Y.P.D. Blues Praise TV Version," *New York Times* (March 25, 1994), B: 1–2; Weber, "In Prime Time, the N.Y.P.D. Rules": 1–2.

12. John J. O'Connor, "'The Real World,' According to MTV," *New York Times* (July 9, 1992), C: 15, 22; N. R. Kleinfeld, "Barefoot in the Loft: A Real New York Story," *New York Times* (March 22, 1992), II: 33.

13. John J. O'Connor, "SJF, 40ish, Pressured in TriBeCa," *New York Times* (May 4, 1993), C: 20; Eric Mink, "New York Primo for New Season's Prime Time," *New York Daily News* (July 25, 1995): 61; James Barron, "New York City Soaps as Eyewash," *New York Times* (October 22, 1995): 37.

14. James, "The Big City, with an Even Bigger Cast: A Great Place to Visit (At Least on Television)": 1, 8. Also see Bill Carter, "If They Can Make It There," *New York Times* (July 9, 1997), C: 16.

15. Gini Sikes, "Sex and the Cynical Girl: A Gentler Approach," *New York Times* (April 5, 1998), II: 37; Caryn James, "In Pursuit of Love, Romantically or Not," *New York Times* (June 5, 1998), E: 32; Nancy Franklin, "Sex and the City," *New Yorker* 74 (July 6, 1998): 74–77; Elizabeth Busmiller, "Sex and the City's Tiny, Tiny Apartments," *New York Times* (July 31, 1998), B: 2; John Tierney, "TV Gives Sex in New York a Bad Name," *New York Times* (July 15, 1999), B: 1; Yahlin Chang, "Sex and the City," *Newsweek* 134 (August 2, 1999): 60–61; Wendy Shalit, "Sex, Sadness, and the City," *City Journal* 9 (Autumn 1999): 89–95; Sarah Bernard, "Sex Maniacs," *New York* 32 (October 4, 1999): 13; Nancy Hass, "The Small-Screen City," *New York Times* (December 5, 1999), XIV: 1, 16; Maryellen Gordon, "Sex and the City: Sin-spiration," *Glamour* 98 (June 2000): 209; James Poniewozik, "Waiting for Prince Charming," *Time* 156 (August 28, 2000): 50–51; Lynn Snowden Picket, "Is Sex and the City Ruining Your Sex Life?" *Mademoiselle* 107 (July 2001): 64–67; Robert Sullivan, "Best Dressed Television Show," *Vogue* 191 (November 2001): 195–96.

16. Hass, "The Small-Screen City": 16.

FALLING IN LOVE AGAIN: NARCISSISTIC NEW YORK

1. Washington Irving, *A History of New-York from the Beginning of the World to the End of the Dutch Dynasty* (Chicago: W. B. Conkey Company, 1809).

2. Robert Caro, quoted in David W. Chen, "New York Bound Bookshop Is Closing at End of Summer," *New York Times* (June 24, 1997), B: 7. Also see Anna Quindlen, "About New York: Déjà Vu in a Cluttered Bookshop," *New York Times* (November 21, 1981): 31; Ann Barry, "A Haven for Lovers of Early New York," *New York Times* (December 12, 1982), II: 39; Clyde Haberman, "A Bookstore That Knew New York," *New York Times* (July 15, 1997), B: 1.

3. Robin Herman and Laurie Johnston, "Subway 'Solutions,'" *New York Times* (November 22, 1982), B: 3.

4. Carol Willis, ed., *Building the Empire State* (New York: W. W. Norton, in association with the Skyscraper Museum, 1998); *Lower Manhattan Plan: The 1966 Vision for Downtown New York* (New York: Princeton Architectural Press, in association with the Skyscraper Museum, 2002).

5. Samuel L. Mitchill, *The Picture of New-York: or, The Traveller's Guide Through the Commercial Metropolis of the United States. By a Gentleman Residing in this City* (New York: I. Riley & Co., 1807).

6. I. N. Phelps Stokes, *The Iconography of Manhattan Island, 1498–1909*, 6 vols. (New York: Robert H. Dodd, 1915–1928); Federal Writers' Project, *New York Panorama* (New York: Random House, 1938); Federal Writers' Project, *The WPA Guide to New York City* (New York: Random House, 1939).

7. E. B. White, "Here is New York," *Holiday* 5 (April 1949): 34–43; E. B. White, *Here is New York* (New York: Harper, 1949); John Steinbeck, "Autobiography: Making of a New Yorker," *New York Times* (February 1, 1953), VI: 26–27, 66–67.

8. Norval White and Elliot Willensky, *AIA Guide to New York City* (New York: New York Chapter, American Institute of Architects, 1967); Norval White and Elliot Willensky, *AIA Guide to New York City* (New York: Macmillan, 1968).

9. Norval White and Elliot Willensky, *AIA Guide to New York City*, rev. ed. (New York: Macmillan, 1978); Norval White and Elliot Willensky, *AIA Guide to New York City*, 3rd ed. (New York: Macmillan, 1988); Norval White and Elliot

Willensky, *AIA Guide to New York City*, 4th ed. (New York: Crown Publishers, 2000).

10. For architectural guidebooks, see John Tauranac, *Essential New York: A Guide to the History and Architecture of Manhattan's Important Buildings, Parks and Bridges* (New York: Holt, Rinehart & Winston, 1979); Carol von Pressentin Wright, *New York* (London: A. & C. Black; New York: W. W. Norton, 1983); Andrew S. Dolkart, *Forging a Metropolis: Walking Tours of Lower Manhattan Architecture* (New York: Whitney Museum of American Art, 1990); Andrew S. Dolkart, *This Is Brooklyn: A Guide to the Borough's Historic Districts and Landmarks* (Brooklyn: The Fund for the Borough of Brooklyn, 1990); Gerard R. Wolfe, *New York: A Guide to the Metropolis* (New York: McGraw-Hill, 1993); Donald Martin Reynolds, *The Architecture of New York City: History and Views of Important Structures, Sites, and Symbols* (New York: John Wiley & Sons, 1994); Andrew S. Dolkart, *Touring the Upper East Side: Walks in Five Historic Districts* (New York: New York Landmarks Conservancy, 1995); Andrew S. Dolkart and Gretchen S. Sorin, *Touring Historic Harlem: Four Walks in Northern Manhattan* (New York: New York Landmarks Conservancy, 1997); Francis Morrone, *The Architectural Guidebook to Brooklyn* (Salt Lake City: Gibbs Smith, 2001); Francis Morrone, *The Architectural Guidebook to New York City* (Salt Lake City: Gibbs Smith, 2002).

11. Paul Goldberger, *The City Observed: New York* (New York: Random House, 1979). Also see David McCullough, [illegible] *New York Times* (July 2, 1979) VII: 3; Bernard P. Spring, "'Big Apple' Is Cut Open in Two Books," *Journal of the American Institute of Architects* 69 (April 1980): 78, 80, 82; Andrew Alpern, "A Guide to Guidebooks," *Metropolis* 5 (July/August 1985): 21–22.

12. Barbaralee Diamonstein, *The Landmarks of New York* (New York: Harry N. Abrams, 1988); Barbaralee Diamonstein, *The Landmarks of New York II* (New York: Harry N. Abrams, 1993); Barbaralee Diamonstein, *The Landmarks of New York III* (New York: Harry N. Abrams, 1998); Barbaralee Diamonstein-Spielvogel, *The Landmarks of New York: An Illustrated Record of the City's Historic Buildings* (New York: Monacelli Press, 2005).

13. Landmarks Preservation Commission, *A Guide to New York City Landmarks* (New York: Landmarks Preservation Commission, 1979); Andrew Dolkart, *Guide to New York City Landmarks* (Washington, D.C.: Preservation Press, 1992); Andrew Dolkart, *Guide to New York City Landmarks* (Washington, D.C.: Preservation Press; New York: John Wiley & Sons, 1998); Andrew Dolkart and Matthew Postal, *A Guide to New York City Landmarks* (New York: John Wiley & Sons, 2000).

14. Christopher Gray, *New York Streetscapes: Tales of Manhattan's Significant Buildings and Landmarks* (New York: Harry N. Abrams, 2003).

15. Margot Gayle and Michele Cohen, *The Art Commission and the Municipal Art Society Guide to Manhattan's Outdoor Sculpture* (New York: Prentice Hall Press, 1988).

16. Margot Gayle, *Cast-Iron Architecture in New York: A Photographic Survey* (New York: Dover, 1974); John Yang, *Over the Door: The Ornamental Stonework of New York* (New York: Princeton Architectural Press, 1995); Susan Tunick, *Terra-Cotta Skyline: New York's Architectural Ornament* (New York: Princeton Architectural Press, 1997). Also see Yumiko Kobayashi and Ryo Watanabe, *New York Detail: A Treasury of Ornamental Splendor* (San Francisco: Chronicle Books, 1995).

17. Edward K. Spann, *The New Metropolis: New York City, 1840–1857* (New York: Columbia University, 1981); Roger Starr, *The Rise and Fall of New York City* (New York: Basic Books, 1985); Thomas Bender, *New York Intellect: A History of Intellectual Life in New York City from 1750 to the Beginnings of Our Own Time* (New York: Knopf, 1987); Elizabeth Blackmar, *Manhattan for Rent: 1785–1850* (Ithaca, N.Y.: Cornell University Press, 1989); Jeff Kisseloff, *You Must Remember This: An Oral History of Manhattan from the 1890s to World War II* (San Diego: Harcourt Brace Jovanovich, 1989); Oliver E. Allen, *New York, New York: A History of the World's Most Exhilarating and Challenging City* (New York: Atheneum, 1990); Luc Sante, *Low Life: Lures and Snares of Old New York* (New York: Farrar Straus Giroux, 1991); Michael Pye, *Maximum City: The Biography of New York* (London: Sinclair-Stevenson, 1991); Eric Homberger, *The Historical Atlas of New York City: A Visual Celebration of Nearly 400 Years of New York City's History* (New York: H. Holt and Co., 1994); George J. Lankevich, *American Metropolis: A History of New York City* (New York: New York University, 1998); Bill Harris, *The Sidewalks of New York: A Celebration of New York History* (Carlsbad, Calif.: Heritage Media Corp., 1999); M. H. Dunlop, *Gilded City: Scandal and Sensation in Turn-of-the-Century New York* (New York: William Morrow, 2000); Hasia R. Diner, *Lower East Side Memories: A Jewish Place in America* (Princeton, N.J.: Princeton University Press, 2000); Jeffrey A. Kroessler, *New York: Year by Year: A Chronology of the Great Metropolis* (New York: New York University Press, 2002); James Trager, *The New York Chronology: The Ultimate Compendium of Events, People, and Anecdotes from the Dutch to the Present* (New York: HarperResource, 2003).

18. Jerold S. Kayden, *Privately Owned Public Space: The New York Experience* (New York: John Wiley, 2000), 1–2.

19. Michael Kimmelman, "What Really Makes New York Work: The Infrastructure; The Body and Soul of the City Machine," *New York Times* (April 8, 1990), VI: 20–23.

20. David W. Dunlap, "High-Powered Hot Dogs and Other Monuments," *New York Times* (January 17, 1988), VII: 24. Also see Norval White, *New York: A Physical History* (New York: Atheneum, 1987); Richard Guy Wilson, "Two on New York, as Through a Glass Romantically," *Architecture* 77 (April 1988): 49, 52–53.

21. David W. Dunlap, "The World on a Strap," *New York Times* (October 3, 1993), VII: 33. For the subway, see Stan Fischler,

Uptown, Downtown: A Trip Through Time on New York's Subways (New York: Hawthorn Books, 1976); Brian J. Cudahy, *Under the Sidewalks of New York: The Story of the Greatest Subway System in the World* (Brattleboro, Vt.: S. Greene Press, 1979); Clifton Hood, *722 Miles: The Building of the Subways and How They Transformed New York* (New York: Simon & Schuster, 1993); Michael W. Brooks, *Subway City: Riding the Trains, Reading New York* (New Brunswick, N. J.: Rutgers University Press, 1997); Peter Derrick, *Tunneling to the Future: The Story of the Great Subway Expansion That Saved New York* (New York and London: New York University Press, 2001).

22. Sharon Reier, *The Bridges of New York* (New York: Quadrant Press, 1977); JoAnne Abel Goldman, *Building New York's Sewers: Developing Mechanisms of Urban Management* (West Lafayette, Ind.: Purdue University Press, 1997). Also see "Three Different Pathways to the City's Waterfront," *New York Times* (October 5, 1997), XIII: 9.

23. Harry Granick, *Underneath New York* (New York: Rhinehart & Company, 1947; New York: Fordham University Press, 1991).

24. Stanley Greenberg, *Invisible New York: The Hidden Infrastructure of the City* (Baltimore, Md.: Johns Hopkins University Press, 1998).

25. Rebecca Read Shanor, *The City That Never Was* (New York: Viking Penguin, 1988). Also see Michiko Kakutani, "Unfulfilled Dreams for New York," *New York Times* (September 10, 1988): 16; Robert Campbell, "Those Giant Cheese Graters in the Sky," *New York Times* (January 8, 1989), VII: 11; Percival Goodman, "The City That Never Was," *Architecture* 78 (July 1989): 39, 41, 43.

26. For the waterfront, see Kevin Bone, ed., *The New York Waterfront: Evolution and Building Culture of the Port and Harbor* (New York: Monacelli Press, 1997); Ann L. Buttenwieser, *Manhattan Water-Bound: Manhattan's Waterfront from the Seventeenth Century to the Present*, 2nd ed. (Syracuse, N.Y.: Syracuse University Press, 1999); Raymond W. Gastil, *Beyond the Edge: New York's New Waterfront* (New York: Van Alen Institute; Princeton Architectural Press, 2002).

27. For an example of books on the outer boroughs, see *Building a Borough: Architecture and Planning in the Bronx, 1890–1940* (Bronx, N.Y.: Bronx Museum of the Arts, 1986); Jill Jonnes, *We're Still Here: The Rise, Fall, and Resurrection of an American City* (Boston: Atlantic Monthly Press, 1986); Elliot Willensky, *When Brooklyn Was the World, 1920–1957* (New York: Harmony Books, 1986); Grace Glueck and Paul Gardner, *Brooklyn: People and Places, Past and Present* (New York: Harry N. Abrams, 1991); Ellen M. Snyder-Grenier, *Brooklyn! An Illustrated History* (Philadelphia: Temple University Press, 1996); Barry Lewis, *Kew Gardens: Urban Village in the Big City* (Kew Gardens, N.Y.: Kew Gardens Council for Recreation and the Arts, 1999); Marc Linder and Lawrence S. Zacharias, *Of Cabbages and Kings County: Agriculture and the Formation of Modern Brooklyn* (Iowa City: University of Iowa Press, 1999); Lloyd Ultan and Barbara Unger, *Bronx Accent: A Literary and Pictorial History of the Borough* (New Brunswick, N.J.: Rutgers University Press, 2000).

28. For an example of books on specific neighborhoods and parks, see Stephen Garmey, *Gramercy Park: An Illustrated History of a New York Neighborhood* (New York: Balsam Press, 1984); M. M. Graff, *Central Park, Prospect Park: A New Perspective* (New York: Greensward Foundation, 1985); Carole Klein, *Gramercy Park: An American Bloomsbury* (Boston: Houghton Mifflin, 1987); James Trager, *West of Fifth: The Rise and Fall and Rise of Manhattan's West Side* (New York: Atheneum, 1987); Andrew Scott Dolkart, *The Texture of TriBeCa* (New York: TriBeCa Community Association, 1989); Peter Salwen, *Upper West Side Story: A History and Guide* (New York: Abbeville Press, 1989); Eugene Kinkead, *Central Park, 1857–1995: The Birth, Decline, and Renewal of a National Treasure* (New York: W. W. Norton, 1990); Terry Miller, *Greenwich Village and How It Got That Way* (New York: Crown, 1990); Henry Hope Reed, Robert M. McGee, and Esther Mipaas, *Bridges of Central Park* (New York: Greensward Foundation, 1990); Roy Rosenzweig and Elizabeth Blackmar, *The Park and the People: A History of Central Park* (Ithaca, N.Y.: Cornell University Press, 1992); Andrew Scott Dolkart, *Gramercy: Its Architectural Surroundings* (New York: Gramercy Neighborhood Associates, 1997); David L. A. Gordon, *Battery Park City: Politics and Planning on the New York Waterfront* (Amsterdam: Gordon and Breach, 1997); Andrew Scott Dolkart, *Morningside Heights: A History of Its Architecture and Development* (New York: Columbia University Press, 1998); Christopher Mele, *Selling the Lower East Side* (Minneapolis: University of Minnesota Press, 2000); Michael Henry Adams, *Harlem, Lost and Found: An Architectural and Social History, 1765–1915* (New York: Monacelli Press, 2002).

29. David W. Dunlap, *On Broadway: A Journey Uptown Over Time* (New York: Rizzoli International Publications, 1990); Tony Hiss, "Street of Dreams," *New York Times* (December 2, 1990), VII: 11, 72; John Tauranac, "Glorious, Squalid Broadway's Lore and Lure," *New York Times* (December 20, 1990), C: 18.

30. James Trager, *Park Avenue: Street of Dreams* (New York: Atheneum, 1990); Jerry E. Patterson, *Fifth Avenue: The Best Address* (New York: Rizzoli International Publications, 1998).

31. William R. Taylor, ed., *Inventing Times Square: Commerce and Culture at the Crossroads of the World* (New York: Russell Sage Foundation, 1991); Samuel R. Delaney, *Times Square Red, Times Square Blue* (New York: New York University Press, 1999); Lynne B. Sagalyn, *Times Square Roulette: Remaking the City Icon* (Cambridge, Mass.: MIT Press, 2001). Also see Alexander J. Reichl, *Reconstructing Times Square: Politics & Culture in Urban Development* (Lawrence: University Press of Kansas, 1999); Anthony Bianco, *Ghosts of 42nd Street: A History of America's Most Famous Block* (New York: HarperCollins, 2004); James Traub, *The Devil's Playground: A Century of Pleasure and Profit in Times Square* (New York: Random House, 2004).

32. For books on specific buildings and building types, see William D. Middleton, *Grand Central, the World's Greatest Railway Terminal* (San Marino, Calif.: Golden West Books, 1977); Mosette Glaser Broderick and William C. Shopsin, *The Villard Houses: Life Story of a Landmark* (New York: Viking Press, 1980); Deborah Nevins, ed., *Grand Central Terminal: City Within the City* (New York: Municipal Art Society, 1982); Mary Black, *New York City's Gracie Mansion: A History of the Mayor's House* (New York: Published for the Gracie Mansion Conservancy by the J. M. Kaplan Fund, 1984); Jonathan Mandell, *Trump Tower* (Secaucus, N.J.: Lyle Stuart, 1984); Lorraine B. Diehl, *The Late, Great Pennsylvania Station* (New York: American Heritage, 1985); Henry Hope Reed, *The New York Public Library: Its Architecture and Decoration* (New York: W. W. Norton, 1986); Christine Smith, *St. Bartholomew's Church in the City of New York* (New York: Oxford University Press, 1988); Nicholas van Hoogstraten, *Lost Broadway Theatres* (New York: Princeton Architectural Press, 1991); Jerry Adler, *High Rise: How 1,000 Men and Women Worked Around the Clock for Five Years and Lost $200 Million Building a Skyscraper* (New York: Harper Collins, 1993); John Tauranac, *Empire State Building: The Making of a Landmark* (New York: Scribner, 1995); Mary B. Dierickx, *The Architecture of Literacy: The Carnegie Libraries of New York City* (New York: New York City Dept. of General Services, 1996); Sarah Bradford Landau and Carl W. Condit, *Rise of the New York Skyscraper, 1865–1913* (New Haven: Yale University Press, 1996); William D. Middleton, *Manhattan Gateway: New York's Pennsylvania Station* (Waukesha, Wis.: Kalmbach Books, 1996); Mary C. Henderson, *The New Amsterdam: The Biography of a Broadway Theater* (New York: Hyperion, 1997); Willis, ed., *Building the Empire State*; Eric Darton, *Divided We Stand: A Biography of New York's World Trade Center* (New York: Basic Books, 1999); Angus Kress Gillespie, *Twin Towers: The Life of New York City's World Trade Center* (New Brunswick, N.J.: Rutgers University Press, 1999); William Morrison, *Broadway Theaters: History & Architecture* (New York: Dover, 1999); John Belle and Maxinne R. Leighton, *Grand Central: Gateway to a Million Lives* (New York: W. W. Norton, 2000); Daniel M. Abramson, *Skyscraper Rivals: The AIG Building and the Architecture of Wall Street* (New York: Princeton Architectural Press, 2001); Mitchell Pacelle, *Empire: A Tale of Obsession, Betrayal, and the Battle for an American Icon* (New York: John Wiley & Sons, 2001).

33. Tom Shachtman, *Skyscraper Dreams: The Great Real Estate Dynasties of New York* (Boston: Little, Brown, 1991). Also see John Tauranac, *Elegant New York: The Builders and the Buildings* (New York: Abbeville Press, 1985); Jim Powell, *Risk, Ruin & Riches, Inside the World of Big-Time Real Estate* (New York: Macmillan, 1986); Anthony Bianco, *The Reichmanns: Family, Faith, Fortune, and the Empire of Olympia & York* (New York: Times Books, 1997).

34. Richard Plunz, *A History of Housing in New York City* (New York: Columbia University Press, 1990). Also see Anthony Jackson, *A Place Called Home: A History of Low-Cost Housing in Manhattan* (Cambridge, Mass.: MIT Press, 1976); Andrew Alpern, *New York's Fabulous Luxury Apartments* (New York: Dover, 1987); Andrew Alpern, *Luxury Apartment Houses of Manhattan: An Illustrated History* (New York: Dover, 1992); Elizabeth Hawes, *New York, New York: How the Apartment House Transformed the Life of the City* (New York: Knopf, 1993); Andrew Alpern, *Historic Manhattan Apartment Houses* (New York: Dover, 1996); Andrew Alpern, *The New York Apartment Houses of Rosario Candela and James Carpenter* (New York: Acanthus Press, 2001).

35. Richard Oliver, ed., *The Making of an Architect, 1881–1981: Columbia University in the City of New York* (New York: Rizzoli International Publications, 1981); Robert A. M. Stern, Gregory Gilmartin, and John Montague Massengale, *New York 1900: Metropolitan Architecture and Urbanism, 1890–1915* (New York: Rizzoli International Publications, 1983); Robert A. M. Stern, Gregory Gilmartin, and Thomas Mellins, *New York 1930: Architecture and Urbanism Between the Two World Wars* (New York: Rizzoli International Publications, 1987); Robert A. M. Stern, Thomas Mellins, and David Fishman, *New York 1960: Architecture and Urbanism Between the Second World War and the Bicentennial* (New York: Monacelli Press, 1995); Robert A. M. Stern, Thomas Mellins, and David Fishman, *New York 1880: Architecture and Urbanism in the Gilded Age* (New York: Monacelli Press, 1999).

36. Paul Goldberger, "A Noble Vision in Stone," *New York Times* (March 18, 1984), VII: 11. Also see Warren A. James, "New York 1900: Metropolitan Architecture and Urbanism, 1890–1915," *Architectural Record* 172 (November 1984): 75.

37. Paul Goldberger, "Wasn't It Romantic?" *New York Times* (May 31, 1987), VII: 3.

38. Wilson, "Two on New York, as Through a Glass Romantically": 49, 52–53. Also see Thomas S. Hines, "A Star Is Built," *New York Times* (March 19, 1995), VII: 1, 12, 14–16; Jeffrey Kroessler, "The Life and Near Death of a Great American City," *Architectural Record* 183 (November 1995): 21; Ed Robbins, "New York, New York," *Architectural Review* 200 (July 1996): 88.

39. James F. O'Gorman, "Raising Gotham," *New York Times* (December 19, 1999), VII: 16–17. Also see Henry Urbach, "Slices of the Apple," *Architecture* 88 (July 1999): 61–63.

40. Edwin G. Burrows and Mike Wallace, *Gotham: A History of New York City to 1898* (New York: Oxford University Press, 1999); Denis Hamill, "Streetwise 'Gotham' Guy a Prize," *New York Daily News* (April 18, 1999): 8.

41. "Group to Profile New York's History," *New York Times* (January 10, 1988): 40; Kenneth T. Jackson, ed., *The Encyclopedia of New York* (New Haven: Yale University Press; New York: New-York Historical Society, 1995); Terry Golway, "Encyclopedia Urbanica," *New York Observer* (September 18, 1995): 21; William Grimes, "You Could Look It Up," *New York Times* (October 8, 1995), VII: 9; Jason Epstein, "Metropolitan Life," *New York Review of Books* (November 16, 1995): 4–6.

42. Heinrich Klotz, ed., *New York Architecture: 1970–1990* (Munich: Prestel-Verlag, 1989). Also see Paul Goldberger, "Architecture," *New York Times* (December 3, 1989): 21, 38.

43. Alan Balfour, *World Cities: New York* (New York: Wiley Academy, 2001).

44. Susanna Sirefman, *New York: A Guide to Recent Architecture* (London: Ellipsis, 1997); Susanna Sirefman, *New York: A Guide to Recent Architecture* (London: Ellipsis, 2001).

45. Jonathan Mandell, "Admiring Itself in a Thousand Mirrors," *New York Times* (December 10, 2000), II: 1, 38.

46. Art Spiegelman, "Gloomy Toons," *New York Times* (December 27, 1992), VII: 9. Also see Eric Drooker, *Flood! A Novel in Pictures* (New York: Four Walls Eight Windows, 1992).

47. Kathy Jakobsen, *My New York* (Boston: Little, Brown, 1993); Frank Rich, "Broadway Baby," *New York Times* (November 14, 1993), VII: 15, 45.

48. Matteo Pericoli, *Manhattan Unfurled* (New York: Random House, 2001); Matteo Pericoli, *Manhattan Within* (New York: Random House, 2003).

49. Camilo José Vergara, *The New American Ghetto* (New Brunswick, N.J.: Rutgers University Press, 1995); Camilo José Vergara, *American Ruins* (New York: Monacelli Press, 1999).

50. Colin Moynihan, "Lens on the Lower East Side," *New York Times* (August 8, 1999), XIV: 1, 10–11.

51. For pictorial books, see *Manhattan*, introduced by Jean-Claude Suarès (New York: Harry N. Abrams, 1981); Richard Berenholtz, *Manhattan Architecture* (New York: Prentice Hall, 1988); Robert Cameron, *Above New York: A Collection of Historical and Original Aerial Photographs of New York City* (San Francisco: Cameron and Company, 1988); Jean Gardner, *Urban Wilderness: Nature in New York City* (New York: Earth Environmental Group, 1988); Jan Staller, *Frontier New York* (New York: Hudson Hills Press, 1988); Nathaniel Lieberman, *Manhattan Lightscape* (New York: Abbeville Press, 1990); Horst Hamann, *New York Vertical* (New York: Te Neues Publishing, 1997); Greenberg, *Invisible New York*; Laura Rosen, *Manhattan Shores: An Expedition Around the Island's Edge* (London: Thames and Hudson, 1998); John Tauranac and Yann Arthus-Bertrand, *New York from the Air* (New York: Harry N. Abrams, 1998); Eric Peter Nash, *Manhattan Skyscrapers* (New York: Princeton Architectural Press, 1999).

52. *Manhattan*, 48.

53. Ellen Posner, "Introduction," in Berenholtz, *Manhattan Architecture*, 6.

54. Caryn James, "For a City Driven by a Dream," *New York Times* (November 12, 1999): 30, 32; John Leonard, "New York Times," *New York Times* 32 (November 15, 1999): 78, 80; Dan Barry, "A Metropolis Made Great by Greed," *New York Times* (November 21, 1999): 45, 52.

55. Ric Burns, James Sanders, and Lisa Ades, *New York: An Illustrated History* (New York: Knopf, 1999); Ric Burns, James Sanders, and Lisa Ades, *New York: An Illustrated History* (New York: Knopf, 2003).

STYLES

1. See Stern, Gilmartin, and Mellins, *New York 1930*, 26–29, 344. For a recent discussion, see Michael J. Lewis, "'All Sail, No Anchor': Architecture After Modernism," *New Criterion* 22 (December 2003): 4–16.

2. Robert A. M. Stern, *New Directions in American Architecture*, rev. ed. (New York: George Braziller, 1969, 1977), 30–49.

3. Alan Chimacoff, "'The Emperor's Postmodernism: Clothes but No Emperor,'" *Progressive Architecture* 67 (Mid-May 19/8): 161–62. Also see Colin Rowe, "The Mathematics of the Ideal Villa," *Architectural Review* 101 (March 1947): 101–4; Colin Rowe, "Mannerism and Modern Architecture," *Architectural Review* 107 (May 1950): 289–99; Vincent J. Scully Jr., *The Shingle Style and the Stick Style: Architectural Theory and Design from Richardson to the Origins of Wright* (New Haven, Conn.: Yale University Press, 1955).

4. Henry Hope Reed, *The Golden City* (Garden City, N.Y.: Doubleday, 1959).

5. Jane Jacobs, *The Death and Life of Great American Cities* (New York: Random House, 1961).

6. Robert Venturi, *Complexity and Contradiction in Architecture* (New York: Museum of Modern Art; Garden City, N.Y.: Doubleday, 1966). For his declaration that "I am not now and never have been a Postmodernist," see Robert Venturi, "A Bas Postmodernism, Of Course," *Architecture* 90 (May 2001): cover, 154–57.

7. Aldo Rossi, *The Architecture of the City*, trans. by Diane Ghirardo and Joan Ockman (Padova: Marsilio, 1966; Cambridge, Mass.: MIT Press, 1982).

8. Charles Moore, "As at Disneyland, 'We Already Had the Future; It Was the '50s,'" *Progressive Architecture* 67 (Mid-May 1978): 161.

9. Robert Jensen, "'The Discrepancy Is Between What Is and What Ought to Be,'" *Progressive Architecture* 67 (Mid-May 1978): 160. Also see Robert Jensen and Patricia Conway, *Ornamentalism: The New Decorativeness in Architecture & Design* (New York: Clarkson N. Potter, 1982).

10. Philip Johnson, quoted in Andrea O. Dean, "Conversations: Philip Johnson," *Journal of the American Institute of Architects* 168 (June 1979): 50.

11. "Design Directions: Other Voices," *Progressive Architecture* 67 (Mid-May 1978): 160–65, 228. Also see Nory Miller, "Design Directions: Looking for What Is Missing," *Journal of the American Institute of Architects* 67 (Mid-May 1978): 152–59; Robert A. M. Stern, "The Doubles of Post-

Modern," *Harvard Architectural Review* 1 (Spring 1980): 75–87.

12. James Marston Fitch, "A Funny Thing Happened . . . ," *Journal of the American Institute of Architects* 67 (January 1980): 66.

13. Fitch, "A Funny Thing Happened . . . ": 66–67.

14. Stern, "The Doubles of Post-Modern": 75–87. Also see Paul Goldberger, "Legacies of an Era at Columbia," *New York Times* (April 29, 1980), C: 6; Stern, Mellins, and Fishman, *New York 1960*, 42, 743–45.

15. Stern, "The Doubles of Post-Modern": 87.

16. Paul Goldberger, "Architects Meet to Note Failures of Modernism," *New York Times* (December 11, 1980), C: 19. Also see Janet Nairn, "Skidmore, Owings & Merrill's New Directions in High-Rise Design," *Architectural Record* 169 (March 1981): 114.

17. Goldberger, "Architects Meet to Note Failures of Modernism": 19.

18. Robert A. M. Stern, quoted in Goldberger, "Architects Meet to Note Failures of Modernism": 19.

19. Raul de Armas, quoted in Goldberger, "Architects Meet to Note Failures of Modernism": 19.

20. Goldberger, "Architects Meet to Note Failures of Modernism": 19.

21. Ada Louise Huxtable, "The Boom in Bigness Goes On," *New York Times* (December 28, 1980), D: 25–26.

22. Michael Sorkin, "American Architecture Since 1960: Quo Vadis," *Architecture + Urbanism*, extra edition (March 1981): 15, 24–28.

23. Sorkin, "American Architecture Since 1960: Quo Vadis": 27.

24. Hilton Kramer, "When Modernism Became Orthodoxy," *New York Times* (March 28, 1982), II: 1, 32.

25. Hilton Kramer, "Postmodern: Art and Culture in the 1980s," *New Criterion* 2 (September 1982): 36–42.

26. Ada Louise Huxtable, "The Troubled State of Modern Architecture," *New York Review of Books* 27 (May 1, 1980): 23–30, reprinted in *Architectural Record* 169 (January 1981): 72–79; Ada Louise Huxtable, "Is Modern Architecture Dead?" *New York Review of Books* 28 (July 16, 1981): 17–20, reprinted in *Architectural Record* 169 (October 1981): 100–105.

27. Huxtable, "The Troubled State of Modern Architecture," *Architectural Record*: 74, 79.

28. Stanley Abercrombie, "Obituary: Postmodernism, 1972–1986," editorial, *Interior Design* 57 (December 1986): 148. Also see Douglas Davis, "Late Postmodern: The End of Style," *Art in America* 75 (June 1987): 14–23.

29. Charles Jencks, *The Language of Post-Modern Architecture* (New York: Rizzoli International Publications, 1977), 9.

30. K. Michael Hays, ed., *Architecture Theory Since 1968* (Cambridge, Mass.: MIT Press, 1998), 679.

31. For MoMA's "Deconstructivist Architecture" exhibition, see Philip Johnson and Mark Wigley, *Deconstructivist Architecture* (New York: Museum of Modern Art; Boston: Little, Brown and Company, 1988); Michael Sorkin, "Philip Johnson's MOMA Hustle," *Interiors* 147 (April 1988): 28, 30, 32; Paul Goldberger, "Architecture: Cycles of Invention," *New York Times* (April 10, 1988), VI: 74; Charles Gandee, "The Revolution of '88!" *House & Garden* 160 (May 1988): 37; Lynn Nesmith, "Deconstructivist Architecture Show to Open at MoMA Late This Month," *Architecture* 77 (June 1988): 26; Diane Ghirardo, "Desperately Seeking Decentering," *Architectural Review* 183 (June 1988): 4–6; Paolo Rizzoli, "Deconstructivist Architecture," *L'Arca* 21 (June 1988): 1–2; Sylvia Lavin, "On the MOMA Show: Is Deconstruction a New Style, or Does It Need Deconstructing?" *Interiors* 147 (June 1988): 16, 20, 25, 28; Victoria Geibel, "'The Unbearable Lightness' of Philip Johnson," *Metropolis* 7 (June 1988): 24, 27; Carter B. Horsley, "Break-Up at the Modern," *New York Post* (June 23, 1988): 49; Paul Goldberger, "Theories as the Building Blocks for a New Style," *New York Times* (June 26, 1988), II: 29; Nancy Goldring, "Reading Between the Lines," *Building Design* 892 (July 1, 1988): 2; Michael Sorkin, "Decon Job," *Village Voice* (July 5, 1988): 81, 83; Roger Kimball, "Philip Johnson's Revenge," *Architectural Record* 176 (August 1988): 53, 55, 57; Michael J. Crosbie, "Decon Show Opens, Generates Unheated Summer Symposium," *Architecture* 77 (August 1988): 28, 30; Peter Blake, "Star Wars at the MOMA," *Interior Design* 59 (August 1988): 221–23; Ziva Freiman, "What is Deconstructivist? And Why Is Everyone Saying Such Terrible Things About It?" *Metropolitan Home* 20 (August 1988): 48, 50, 99; Daralice D. Boles, "The Decon Seven: Dismantling a 'Movement,'" *Progressive Architecture* 69 (August 1988): 25, 27; Peter Buchanan, "Decon Tricks," *Architects' Journal* 187 (August 17, 1988): 60–61; Ken Brozan, "Performing Architecture," *Blueprint* 50 (September 1988): 73–74; Raymond Gastil, "The Agents of Instability," *Blueprint* 50 (September 1988): 74–75; Catherine Ingraham, "Milking Deconstruction or Cow Was the Show?" *Inland Architect* 32 (September/October 1988): 61–65; Brendan Gill, "The Sky Line: Deconstructivism," *New Yorker* 64 (September 5, 1988): 90–92, 95–96; Raymond W. Gastil, "Function Follows Deformation," book review, *Design Book Review* (Fall 1988): 65–66; Diane Ghirardo, "Mind the Gap," *Architectural Review* 185 (October 1988): 4, 9; Charles Wheatley, "Deconstructivism at MoMA," *L.A. Architect* (December 1988): 9; David Evans, "Deconstructivist Architecture," *Sites* 21–22 (1989): 106–8; Douglas Davis, "Slaying the Neo-Modern Dragon," *Art in America* 77 (January 1989): 43–45, 47, 49; Mary McLeod, "Architecture and Politics in the Reagan Era: From Postmodernism to Deconstructivism," *Assemblage* 8 (February 1989): 22–59, reprinted in Hays, ed., *Architecture Theory Since 1968*, 680–702; Regina Cornwall, "MoMA's Ego Builder," *New Art Examiner* 16 (February 1989): 36–41; "Deconstructivist Thoughtlessness," *Architettura* 38 (February 1992): 82–83. For Deconstructivism, see Joseph Giovannini, "The Limit of Chaos Tempts a New School of Architects," *New York Times* (February 4, 1988), C: 1, 12; Mrs. John C. Shalvoy, "Tilting Skyscrapers," letter to the editor,

New York Times (February 11, 1988), C: 7; Joseph Giovannini, "Breaking All the Rules," *New York Times* (June 12, 1988), VI: 40–43, 126, 130.

32. Bernard Tschumi, quoted in Giovannini, "The Limit of Chaos Tempts a New School of Architects": 12.

33. Philip Johnson, "Preface," in Johnson and Wigley, *Deconstructivist Architecture*, 8.

34. Mark Wigley, "Deconstructivist Architecture," in Johnson and Wigley, *Deconstructivist Architecture*, 10, 19.

35. McLeod, "Architecture and Politics in the Reagan Era: From Postmodernism to Deconstructivism," in Hays, ed., *Architecture Theory Since 1968*, 691.

36. McLeod, "Architecture and Politics in the Reagan Era: From Postmodernism to Deconstructivism," in Hays, ed., *Architecture Theory Since 1968*, 693.

37. McLeod, "Architecture and Politics in the Reagan Era: From Postmodernism to Deconstructivism," in Hays, ed., *Architecture Theory Since 1968*, 693.

38. Shalvoy, "Tilting Skyscrapers": 7.

39. Paul Goldberger, "Fashions in Bricks and Mortar Make Room for Conscience," *New York Times* (December 25, 1988), II: 32.

CRITICS

1. Ada Louise Huxtable, "The Art We Cannot Afford to Ignore (but Do)," *New York Times* (May 4, 1958), VI: 14–15, 86. For a discussion of Huxtable's early career, see Stern, Mellins, and Fishman, *New York 1960*, 1210–11.

2. Francis Morrone, "Do Architecture Critics Matter?" *New Criterion* 21 (April 2002): 31–36.

3. Stephen Grover, "Heeded Words: Ada Louise Huxtable Has Formidable Power as Architecture Critic," *Wall Street Journal* (November 7, 1972): 1, 12.

4. "Huxtable Was Here," editorial, *New York Times* (December 30, 1981): 14.

5. Ada Louise Huxtable, *Architecture Anyone? Cautionary Tales of the Building Art* (New York: Random House, 1986).

6. Ada Louise Huxtable, *The Tall Building Artistically Reconsidered: The Search for a Skyscraper Style* (New York: Pantheon Books, 1984). Also see Margaret Muther D'Evelyn, "The Tall Building Artistically Reconsidered," book review, *Christian Science Monitor* (April 16, 1985), B: 3; Charles W. Moore, "From the Ground Up, and Up," book review, *New York Times* (June 23, 1985), VII: 22; Martin Filler, "The Tall Building Artistically Reconsidered," book review, *New York Review of Books* 32 (December 5, 1985): 11.

7. Witold Rybczynski, "The Pasteboard Past," *New York Times* (April 6, 1997), VII: 13.

8. Diane Ghirardo, "Unrealistic Expectations," *Architecture* 86 (May 1997): 71, 73.

9. Paul Goldberger, "'No Longer a Belief That Dogma Will Do Our Work for Us,'" *Progressive Architecture* 67 (Mid-May 1978): 162. For further discussion of Postmodernism, see Paul Goldberger, *On the Rise: Architecture and Design in the Postmodern Age* (New York: Times Books, 1983), 3–6.

10. Goldberger, "'No Longer a Belief That Dogma Will Do Our Work for Us'": 162.

11. Stern, Mellins, and Fishman, *New York 1960*, 121.

12. Paul Golberger, quoted in Daralice Donkervoet, "An Interview with Paul Goldberger," *CRIT/ASJ* (Spring 1981): 14–16.

13. Richard Plunz and Kenneth L. Kaplan, "On 'Style,'" *Forum Voor Architectur en Daarme Verbonden Kunsten* 29 (1984–85): 78–86.

14. Michael Sorkin, "Why Goldberger Is So Bad," *Village Voice* (April 2, 1985): 90–91, reprinted in Michael Sorkin, *Exquisite Corpse* (London and New York: Verso, 1991), 101–7. Also see Kaplan and Plunz, "On 'Style'": 78–86.

15. Lorne Manley, "Off the Record," *New York Observer* 11 (May 26, 1997): 6.

16. "Architecture Critic Named," *New York Times* (June 3, 1992), C: 19; "Herbert Muschamp," *Progressive Architecture* 73 (July 1992): 18.

17. Herbert Muschamp, *File Under Architecture* (Cambridge, Mass.: MIT Press, 1974).

18. H. Ward Jandl, "Architecture/Muschamp, Herbert. File Under Architecture," *Library Journal* 100 (July 15, 1975): 1205.

19. Paul Goldberger, "Frank Lloyd Wright Is Clearly the Man of the Year," *New York Times* (September 11, 1983), II: 39. Also see Herbert Muschamp, *Man About Town: Frank Lloyd Wright in New York City* (Cambridge, Mass.: MIT Press, 1983).

20. Herbert Muschamp, quoted in Norris Kelly Smith, "Man About Town: Herbert Muschamp," *Design Book Review* 3 (Winter 1984): 6–8. For other reviews, see Dennis L. Dollens, "Architecture/Muschamp, Herbert. Man About Town: Frank Lloyd Wright in New York City," *Library Journal* 108 (November 1, 1983): 2076–77; J. Schaire, "Brief Reviews/Man About Town: Frank Lloyd Wright in New York City," *Harper's* 267 (December 1983): 75–76; Keith Bell, "Book and Exhibition Reviews/Man About Town: Frank Lloyd Wright in New York City," *Structurist* 25/26 (1985/1986): 133–39.

21. Herbert Muschamp, "Ground Up," *Artforum* 24 (November 1985): 6; Herbert Muschamp, "Ground Up," *Artforum* 24 (December 1985): 8; Herbert Muschamp, "Ground Up," *Artforum* 24 (January 1986): 9; Herbert Muschamp, "Ground Up," *Artforum* 24 (March 1986): 10; Herbert Muschamp, "Ground Up," *Artforum* 24 (April 1986): 9; Herbert Muschamp, "Ground Up," *Artforum* 24 (Summer 1986): 14; Herbert Muschamp, "What in the World," *Artforum* 25 (October 1986): 12–13; Herbert Muschamp, "Ground Up," *Artforum* 25 (December 1986): 2–4; Herbert Muschamp, "Ground Up," *Artforum* 25 (April 1987): 10–11; Herbert Muschamp, "Ground Up," *Artforum* 25 (Summer 1987): 5; Herbert Muschamp, "Ground Up," *Artforum* 26 (September 1987): 8–9; Herbert Muschamp, "Ground Up," *Artforum* 26 (November 1987): 15–16; Herbert Muschamp, "Labyrinth," *Artforum* 26 (November 1987): 12; Herbert Muschamp,

"Ground Up," *Artforum* 26 (April 1988): 12; Herbert Muschamp, "Ground Up," *Artforum* 26 (May 1988): 9; Herbert Muschamp, "Ground Up," *Artforum* 27 (October 1988): 18–20.

22. Smith, "Man About Town: Herbert Muschamp": 8.

23. "Last Romance: Herbert Muschamp Interviews Anonymous Source," *Express* 2 (Winter 1982): 18–19, 22; Herbert Muschamp, "Fashion in Architecture," *Express* 2 (Spring 1982): 8; Herbert Muschamp, "The Scene of the Crime; Mrs. Harris and the American Home," *Express* 2 (Spring 1982): 18; Herbert Muschamp, "S.S. Normandie," *Express* 2 (Spring 1983): 12; Herbert Muschamp, "Wright in a Cabin," *Express* 2 (Spring 1983): 22; Herbert Muschamp, "The Portable Room," *Arts & Antiques* (June 1984): 76–88; Herbert Muschamp, "Unnatural Positions in the Natural House," *Arts & Antiques* (September 1984): 62–65; Herbert Muschamp, "Chez Muse: The American Museum Scene," *Lotus International* 53 (1987): 10–15; Herbert Muschamp, "Andy Before the Soup Can," *Vogue* 178 (December 1988): 218; Herbert Muschamp, "A Big Influence," *Vogue* 179 (January 1989): 98; Herbert Muschamp, "The Good Side of Bad Taste," *House & Garden* 161 (January 1989): 50; Herbert Muschamp, "Sacred Arts," *Vogue* 179 (April 1989): 420; Herbert Muschamp, "Angels!" *Vogue* 179 (December 1989): 278; Herbert Muschamp, "Trading Places," *House & Garden* 162 (May 1990): 56, 60, 62; Herbert Muschamp, "Oil and Water," *Vogue* 180 (July 1990): 200; Herbert Muschamp, "Don't Look Now," *Vogue* 181 (February 1991): 318; Herbert Muschamp, "Books–A Life of Picasso, 1881 1906 by John Richardson," *Vogue* 181 (March 1991): 243; Herbert Muschamp, "Main Drag," *Vogue* 181 (December 1991): 130.

24. Herbert Muschamp, quoted in Lenore Lucey, "The Critic Speaks: Herbert Muschamp," *Oculus* 57 (September 1994): 13.

25. Herbert Muschamp, "Critical Reflections," *Artforum* 33 (May 1995): 72–73, 117, 124. Also see Frank Gehry, "Herbert Muschamp," *Artforum* 33 (May 1995): 72.

26. For Muschamp's fashion pieces, see Herbert Muschamp, "In a Ring, Love's Paradoxes Unfold," *New York Times* (March 2, 1997): 39; Herbert Muschamp, "Searching for Yourself in Versace's Mirror," *New York Times* (July 27, 1997): 33; Herbert Muschamp, "Versace's Styles: Telling Tales of Hedonists," *New York Times* (December 12, 1997), E: 37; Herbert Muschamp, "A Star to Swing On," *New York Times* (March 19, 1998), F: 1, 8; Herbert Muschamp, "Liberty, Equality, Sorority," *New York Times* (April 3, 1998), E: 39; Herbert Muschamp, "Easy to Pack, Harder to Understand," *New York Times* (December 27, 1998), II: 1, 37; Herbert Muschamp, "Beefcake for the Masses," *New York Times* (November 14, 1999), VI: 120; Herbert Muschamp, "From Olympus, Divine Dresses," *New York Times* (May 2, 2003), E: 31, 33; Herbert Muschamp, "In the Land of the Free, Who Wears the Skirts?" *New York Times* (November 7, 2003), E: 27, 35.

27. "A 'Miracle' of the Times," editorial, *New Criterion* 16 (October 1997): 1–3.

28. Suzanne Stephens, "Assessing the State of Architectural Criticism in Today's Press," *Architectural Record* 186 (March 1998): 64–69, 194.

29. Judith Shulevitz, "The Muschamp Chronicles, Part 1," *Slate* (November 2, 2000). Also see Herbert Muschamp, "A Rare Opportunity for Real Architecture Where It's Needed," *New York Times* (October 22, 2000), II: 1, 39; William Powers, "Insane Honesty," *National Journal* 33 (May 26, 2001): 1589; Ira Stoll, "Times Tower," in smartertimes.com.

30. Judith Shulevitz, "The Muschamp Chronicles, Part 2," *Slate* (November 3, 2000). Also see Judith Shulevitz, "The Muschamp Chronicles, Part 3," *Slate* (November 7, 2000).

31. Vincent Scully, quoted in Shulevitz, "The Muschamp Chronicles, Part 2."

32. Herbert Muschamp, "Filling the Void: A Chance to Soar," *New York Times* (September 20, 2001), II: 1, 36. Also see Leon Wieseltier, "Washington Diarist/Ruins," *New Republic* 225 (November 26, 2001): 46; Morrone, "Do Architecture Critics Matter?": 31–36.

33. Robert A. Ivy, "Another Pair of Eyes," *Architectural Record* 190 (December 2002): 17–18. Also see Reed Kroloff, "Architecture Needs More Critics. Trust Me," editorial, *Architecture* 90 (June 2001): 23. In the same issue Kroloff published a chart that statistically analyzed the critic's preferences among architects and topics. See Michael Sorkin, "Herb's Content," *Architecture* 90 (June 2001): 64–65.

34. "Just As I Expected, These Plans Suck," parody of Herbert Muschamp purportedly written by Michael Bierut (2002).

35. "Last Romance: Herbert Muschamp Interviews Anonymous Source": 22.

36. Clay Risen, "As Muschamp Goes, Angry Adversaries Ready for Revenge," *New York Observer* (June 28–July 5, 2004): 1, 31.

37. Martin Pawley, "Going Guerrilla in the Reagan Years," *Blueprint* 97 (May 1993): 14.

38. Sorkin, *Exquisite Corpse*, 1.

39. Michael Sorkin, quoted in "Critics on Criticism," *Metropolis* 5 (November 1985): 28–31, 39–41.

40. Sorkin, *Exquisite Corpse*, 4. Sorkin's notable diatribes against Johnson include Michael Sorkin, "Philip Johnson: The Master Builder as a Self-Made Man," *Village Voice* (October 20, 1978): 61–62, reprinted in Sorkin, *Exquisite Corpse*, 7–14; Michael Sorkin, "The Real Thing," *Architectural Record* 174 (September 1986): 78, reprinted in Sorkin, *Exquisite Corpse*, 171–77; Michael Sorkin, "Canon Fodder," *Village Voice* (December 1, 1987): 60, reprinted in Sorkin, *Exquisite Corpse*, 254–59; Michael Sorkin, "Where Was Philip?" *Spy* (October 1988): 32, reprinted in Sorkin, *Exquisite Corpse*, 307–11.

41. Peter Kaufman, "Sorkin, Michael. Exquisite Corpse: Writing on Buildings, 1979–1989," book review, *Library Journal* (September 15, 1991): 74. Also see Sorkin, *Exquisite Corpse*; Ross Miller, "Monuments of Evasion," book review, *Wilson Quarterly* 16 (Spring 1992): 88; Kurt Andersen, "The '80s as Spectacle," book review, *Architectural Record* 180 (May

1992): 50; Charles Jencks, "Exquisite Corpse," book review, *Architectural Design* 62 (May/June 1992): XXIV–XXV; David Dunster, "Real Architectural Criticism," book review, *RIBA Journal* 99 (August 1992): 23; Nayana Currimbhoy, "Taking Aim: Michael Sorkin Sets Out to Prove That the Pen Is Sharper Than the Sword," book review, *Interiors* 152 (January 1993): 12; Jayne Merkel, "In Defense of Modern Architecture," book review, *Art in America* 81 (February 1993): 37, 39.

42. Andersen, "The '80s as Spectacle": 50.

43. Jencks, "Exquisite Corpse": XXIV–XXV.

44. "News Briefs," *Architectural Record* 175 (May 1987): 71; Herbert Muschamp, "Brendan Gill Dies at 83: Author and Preservationist," *New York Times* (December 29, 1997), B: 8; "In a Final Interview, Writer Brendan Gill Spoke of Critic's Role," *Architectural Record* 186 (February 1998): 31.

45. Brendan Gill, "The Sky Line: Revival of Column," *New Yorker* 63 (February 23, 1987): 106–9; Brendan Gill, "The Sky Line: On the Brink," *New Yorker* 63 (November 9, 1987): 113–25; Brendan Gill, "The Sky Line: Above/Below," *New Yorker* 63 (February 8, 1988): 90–92; Brendan Gill, "The Sky Line: Deconstructivism," *New Yorker* 64 (September 5, 1988): 90–92; Brendan Gill, "The Sky Line: A Malady of Gigantism," *New Yorker* 64 (January 9, 1989): 73–77; Brendan Gill, "The Sky Line: Holding the Center," *New Yorker* 65 (March 6, 1989): 99–104; Brendan Gill, "The Sky Line: In the Classic Vein," *New Yorker* 65 (August 14, 1989): 80–84; Brendan Gill, "The Sky Line: Battery Park City," *New Yorker* 66 (August 20, 1990): 69–78; Brendan Gill, "The Sky Line: Worldwide Plaza," *New Yorker* 66 (December 24, 1990): 86–90; Brendan Gill, "The Sky Line: The Death of the Skyscraper," *New Yorker* 67 (March 4, 1991): 90–94; Brendan Gill, "The Sky Line: 712 Fifth," *New Yorker* 67 (June 10, 1991): 97–102; Brendan Gill, "The Sky Line: 1932," *New Yorker* 68 (April 27, 1992): 94; Brendan Gill, "The Sky Line: Pure Wright," *New Yorker* 68 (July 27, 1992): 67–71; Brendan Gill, "The Sky Line: Hazards of Bigness," *New Yorker* 68 (August 31, 1992): 69–75; Brendan Gill, "The Sky Line: Endangered Species," *New Yorker* 68 (October 12, 1992): 57–58; Brendan Gill, "The Sky Line: On Astor Row," *New Yorker* 68 (November 2, 1992): 51–54; Brendan Gill, "The Sky Line: Opening the Gates," *New Yorker* 68 (February 15, 1993): 90–91; Brendan Gill, "The Sky Line: Knight in Glass Armor," *New Yorker* 69 (November 22, 1993): 108–11; Brendan Gill, "The Sky Line: The Suburbanite," *New Yorker* 70 (March 7, 1994): 84–87; Brendan Gill, "The Sky Line: The American in Paris," *New Yorker* 70 (October 10, 1994): 91–94; Brendan Gill, "The Sky Line: Martha's Retreat," *New Yorker* 71 (October 16, 1995): 108–12; Brendan Gill, "The Sky Line: The One-Man City," *New Yorker* 72 (December 9, 1996): 124–27; Brendan Gill, "The Sky Line: A Party for Brooke," *New Yorker* 73 (April 21, 1997): 72–77.

46. Brendan Gill, quoted in "In a Final Interview, Writer Brendan Gill Spoke of Critic's Role": 31.

47. Manuela Hoelterhoff, "The Met's New Wing of 19th Century Art," *Wall Street Journal* (May 13, 1980): 24; Manuela Hoelterhoff, "Death by Design: How to Murder a Monument," *Wall Street Journal* (March 18, 1986): 26; Manuela Hoelterhoff, "Bickering and Dickering: The Storm Over Ellis Island," *Wall Street Journal* (April 17, 1986): 26; Manuela Hoelterhoff, "The Wrong Way to Expand Wright's Museum," *Wall Street Journal* (June 17, 1986): 26; Manuela Hoelterhoff, "Vast New Wallace Wing Opens at Met Museum," *Wall Street Journal* (March 17, 1987): 30; Manuela Hoelterhoff, "Guggenheim Plan Is Wrong for Wright," *Wall Street Journal* (March 23, 1987): 29; Manuela Hoelterhoff, "Bringing the Stroller Set to Battery Park City," *Wall Street Journal* (July 14, 1987): 24.

48. Carter Wiseman, quoted in "Critics on Criticism": 29–30.

49. Karrie Jacobs, e-mail to author (January 15, 2004).

50. Joseph Giovannini, "How Design Was Decided for Central Park's Lamps," *New York Times* (August 28, 1983): 52; Joseph Giovannini, "At Home Downtown with Light and Views," *New York Times* (September 1, 1983): C: 1, 6; Joseph Giovannini, "Philip Johnson Designs for a Pluralistic Age," *New York Times* (January 8, 1984), II: 29, 36; Joseph Giovannini, "Museums Make Room for the Art of Architecture," *New York Times* (May 20, 1984), II: 33; Joseph Giovannini, "Dramatic Effects in Restaurant Design," *New York Times* (June 14, 1984), C: 1, 6; Joseph Giovannini, "A Grave Situation for Marcel Breuer's Whitney," *Artforum* 24 (November 1985): 84–86; Joseph Giovannini, "Museum's Design Is Based on Promising Concept," *New York Times* (September 5, 1986), B: 4; Joseph Giovannini, "Offices Move Boldly Backward or Playfully Forward," *New York Times* (January 19, 1986), III: 8; Joseph Giovannini, "Architect Puts His Mark on Skyline," *New York Times* (September 8, 1986), C: 17; Joseph Giovannini, "Apartment Builders Return to Prewar Design," *New York Times* (October 13, 1986): 1, B: 4; Joseph Giovannini, "Brooklyn Museum Design Selected," *New York Times* (October 17, 1986), C: 40; Joseph Giovannini, "For 5th Ave.: Offices or Stores?" *New York Times* (October 20, 1986), B: 1, 16; Joseph Giovannini, "Guggenheim Hearings to Reopen," *New York Times* (October 30, 1986), C: 28; Joseph Giovannini, "Design Notebook," *New York Times* (January 29, 1987), C: 12; Joseph Giovannini, "Design Notebook," *New York Times* (March 12, 1987), C: 12; Joseph Giovannini, "Museum Piece," *Artforum* 25 (April 1987): 8–9; Joseph Giovannini, "Museum Piece," *Artforum* 25 (May 1987): 2–5; Joseph Giovannini, "West Side's New Road to Ornament Manhattan," *New York Times* (August 30, 1987), IV: 28; Joseph Giovannini, "Young Voices Soar at the New St. Thomas Choir School," *New York Times* (September 17, 1987), C: 1, 12; Joseph Giovannini, "From Far and Near, Designers Flock to a New York 'Saturday,'" *New York Times* (October 15, 1987), C: 10; Joseph Giovannini, "International Antiques Center Opens Its Doors with a Gala," *New York Times* (November 19, 1987), C: 3; Joseph Giovannini, "429 Thoughts on What Can Fill the Space of Westway," *New York Times* (January 17, 1988), IV: 28; Joseph Giovannini, "Frank Gehry

Really Loves Fish," *New York Times* (January 21, 1988), C: 3; Joseph Giovannini, "More Than a Club: It's Open House," *New York Times* (April 7, 1988), C: 12; Joseph Giovannini, "Making Room for Art," *House & Garden* 161 (December 1989): 132–39; Joseph Giovannini, "Breaking the Institutional Envelope," *Progressive Architecture* 73 (October 1992): 116–17; Joseph Giovannini, "The Great White Way," *Avenue* (December 1992): 46–51; Joseph Giovannini, "Exhibition Review: Arata Isozaki: Works in Architecture," *Architecture + Urbanism* (April 1994): 2–3; Joseph Giovannini, "Science Library Opens in New York City," *Architecture* 85 (June 1996): 54–55; Joseph Giovannini, "Finalists Announced for MoMA Expansion," *Architecture* 86 (May 1997): 46–47; Joseph Giovannini, "Back to the Box," *New Yorker* 73 (May 12, 1997): 38–39; Joseph Giovannini, "If There's Heaven, It Should Expect Changes," *New York Times* (August 14, 1997), C: 1, 10; Joseph Giovannini, "Computer Worship," *Architecture* 88 (October 1999): 88–99; Joseph Giovannini, "New York State of Mind," *World Architecture* (February 2000): 48–55; Joseph Giovannini, "Best Bytes," *New York* 33 (March 27, 2000): 32; Joseph Giovannini, "Just Add Water," *New York* 33 (April 3, 2000): 24–25; Joseph Giovannini, "Time of the Signs," *New York* 33 (June 26-July 3, 2000): 148–49; Joseph Giovannini, "The Inn Crowd," *New York* 33 (August 21, 2000): 58; Joseph Giovannini, "Lost in Space," *New York* 33 (November 27, 2000): 146, 148; Joseph Giovannini, "Working the Angles," *New York* 34 (August 6, 2001): 58–59; Joseph Giovannini, "Architecture," *New York* 34 (December 24–31, 2001): 115; Joseph Giovannini, "Acing the Deuce," *New York* 35 (January 21, 2002): 77–78; Joseph Giovannini, "Bearish on Madison Ave.," *New York* 35 (March 25, 2002): 137–38; Joseph Giovannini, "Finally, Prada," *Interior Design* 73 (April 2002): 222–25; Joseph Giovannini, "Forum and Function," *New York* 35 (April 29, 2002): 55; Joseph Giovannini, "Site Unseen," *New York* 35 (July 8, 2002): 48–49; Joseph Giovannini, "Introduction," in Ian Luna, ed., *New New York: Architecture of a City* (New York: Rizzoli International Publications, 2003), 9, 60–65.

RESURFACING MODERNISM

1. Paul Goldberger, "A New Touch of Glass Due on Park Ave.," *New York Times* (November 17, 1980), B: 1, 6; "A Public Park Under Glass on Park Avenue for Chemical Bank," *Architectural Record* 169 (Mid-August 1981): 23; Paul Goldberger, "The New American Skyscraper," *New York Times* (November 8, 1981), VI: 68–73, 76, 78, 86, 88, 90, 92, 94, 96; Joan Lee Faust, "Bank's Greenhouse Opens to the Public," *New York Times* (April 29, 1982), C: 3; Paul Goldberger, "Aspirations of a Park Avenue Atrium," *New York Times* (April 29, 1982), B: 2; Janet Nairn, "Urban Botanical Park Glassed In at ChemCourt," *Architectural Record* 170 (December 1982): 20–21; David L. Shirey, "There's Poetry in the Newest Office Portals," *New York Times* (December 5, 1982), VIII: 1, 14; Paul Goldberger, "Lobbies Coming Back into Their Own," *New York Times* (May 13, 1984), XII: 12; Paul Goldberger, "The Sidewalks of New York–Indoors," *New York Times* (March 24, 1985), X: 21; Andrea Israel, "Sampling the Atriums," *New York Times* (March 24, 1985), X: 20; Dan Graham and Robin Hurst, "Corporate Arcadias," *Artforum* 26 (December 1987): 68–74; White and Willensky, *AIA Guide* (1988), 246; Dan Graham and Robin Hurst, "Odysseys in Space," *Building Design* 907 (October 21, 1988): 38–43; Kay Lazar, "IBM, Trump, A.T.&T., How Do Your Gardens Grow?" *New York Observer* (November 28, 1988): 1, 8. For 277 Park Avenue, see Stern, Mellins, and Fishman, *New York 1960*, 354–56.

2. For Citicorp Center, see Stern, Mellins, and Fishman, *New York 1960*, 490–97.

3. Michael Maas, quoted in Goldberger, "Aspirations of a Park Avenue Atrium": 2.

4. Goldberger, "Aspirations of a Park Avenue Atrium": 2.

5. Goldberger, "The New American Skyscraper": 88.

6. Goldberger, "Aspirations of a Park Avenue Atrium": 2.

7. Alan S. Oser, "Perspectives: Chemical's Consolidation," *New York Times* (February 7, 1993), X: 5; "Departing Tenant May Be Required to Remove Asbestos, Fireproofing; Chemical Bank v. Stahl, Supreme Court IA Part 3, Justice W. Davis," *New York Law Journal* (June 28, 1995): 25.

8. Frances Cerra, "Pink Terrazzo Out, Black Granite In," *New York Times* (March 27, 1983), VIII: 1; Richard Rush, "Play It Again, SOM," *Architectural Record* 172 (November 1984): 150–51, 156–57; George W. Goodman, "Manufacturers Hanover Remodels Its Skyscraper," *New York Times* (October 30, 1987), VIII: 7; White and Willensky, *AIA Guide* (1988), 246; White and Willensky, *AIA Guide* (2000), 278. For the Union Carbide Building, see Stern, Mellins, and Fishman, *New York 1960*, 352–54.

9. Anthony DePalma, "Pan Am Lobby Is Upgraded in Effort to Raise Rents," *New York Times* (February 27, 1985): 20; "A Grand Staircase Is Focal Point in Pan Am Renovation," *Metals in Construction* (Winter 1985/86): 16–17; Paul Goldberger, "A Change of Makeup for Pan Am Building Lobby," *New York Times* (December 11, 1986): C: 24; Suzanne Stephens, "Learning from Las Vegas–and Cairo?" *Manhattan, inc.* 3 (December 1986): 199; "Pan Am Building: Seven Reactions," *Interior Design* 58 (September 1987): 262–63, 317; Jerry Cooper, "Pan Am Building Lobby: A Report on the Recent Redesign of the Landmark Manhattan Tower's Public Spaces by Warren Platner Associates," *Interior Design* 58 (September 1987): 256–63; White and Willensky, *AIA Guide* (1988), 244; Herbert Muschamp, "Crystal Corridor in the City of Glass," *New York Times* (December 24, 1999), E: 47, 49. For the Pan Am Building, see Stern, Mellins, and Fishman, *New York 1960*, 357–69.

10. Warren Platner, quoted in Cooper, "Pan Am Building Lobby": 261.

11. Warren Platner, quoted in "A Grand Staircase Is Focal Point in Pan Am Building Renovation": 16.

12. Stephens, "Learning from Las Vegas–and Cairo?" 199.

13. Goldberger, "A Change of Makeup for Pan Am Building Lobby": 24.

14. Carter Wiseman, quoted in "Pan Am: Seven Reactions": 262.

15. "Bye-bye Pan Am," *Oculus* 54 (February 1992): 5. For Metropolitan Life's 1909 building, see Stern, Gilmartin, and Massengale, *New York 1900*, 171–73; Stern, Mellins, and Fishman, *New York 1960*, 1108. For Metropolitan Life's 1923 building, see Stern, Gilmartin, and Mellins, *New York 1930*, 506, 535–37. For Metropolitan Life's 1964 building, see Stern, Mellins, and Fishman, *New York 1960*, 1108.

16. Robert A. M. Stern, quoted in Dunlap, "Final Pan Am Departure": 3.

17. Christopher McLaughlin, "Keep Pan Am Sign as Memorial to Air Pioneer," letter to the editor, *New York Times* (February 8, 1992): 20; Daniel Cohen, "Pan Am Doesn't Deserve Any Sort of Memorial," letter to the editor, *New York Times* (February 29, 1992): 22; Eric L. Ploen, "Keep Only the Globes," letter to the editor, *New York Times* (February 29, 1992): 22; David W. Dunlap, "Final Pan Am Departure," *New York Times* (September 4, 1992), B: 3; "'P' as in Passing," *New York Times* (September 15, 1992), B: 4; "Replacing 'Pan Am': Lighting Up 'MetLife' at 200 Park," *New York Times* (January 10, 1993), X: 1.

18. Quoted in Steve Cuozzo, "$50M Makeover for Met Life," *New York Post* (August 14, 2001): 32. Also see Carol Vogel, "A Familiar Mural Finds Itself Without a Wall," *New York Times* (July 9, 2001): 1, B: 4; Abby Bussel, "Help Wanted," *Interior Design* 72 (September 2001): 304–7; Christopher Gray, "Streetscapes/The MetLife Building, Originally the Pan Am Building," *New York Times* (October 7, 2001), XI: 1; Carol Vogel, "Inside Art," *New York Times* (February 21, 2003), E: 39.

19. Eugene Kohn, quoted in Vogel, "A Familiar Mural Finds Itself Without a Wall": 4.

20. "505 Park: New Face by Scutt," *New York Times* (January 27, 1985), VIII: 1; John Sailer, *The Great Stone Architects* (Oradell, N.J.: Tradelink Publishing Co., 1991), 94–107; Robert P. Metzger, *Der Scutt Retrospective* (Reading, Pa.: Reading Public Museum, 1996), 56–57; White and Willensky, *AIA Guide* (2000), 285. For 505 Park Avenue, see Stern, Mellins, and Fishman, *New York 1960*, 333–34.

21. "Granite and Glass: New Face on 59th," *New York Times* (October 30, 1983), VIII: 1; White and Willensky, *AIA Guide* (1988), 281; Metzger, *Der Scutt Retrospective*, 32; White and Willensky, *AIA Guide* (2000), 300. For the Playboy Club, see Stern, Mellins, and Fishman, *New York 1960*, 499–500.

22. William G. Blair, "$17 Million Surgery: Madison Facelift," *New York Times* (January 25, 1987), VIII: 1; White and Willensky, *AIA Guide* (1988), 282; Sailer, *The Great Stone Architects*, 94–107; Metzger, *Der Scutt Retrospective*, 60–61. For 625 Madison Avenue, see Stern, Mellins, and Fishman, *New York 1960*, 419.

23. "RCA Unit's Offices Sold to Prudential; Price Is $90 Million," *Wall Street Journal* (September 15, 1981): 20; Michael deCourcy Hinds, "The Asking Price: $3,868 a Sq. Ft.," *New York Times* (May 6, 1984), VIII: 6, 14; "Madison Piggyback: Base Plus 27," *New York Times* (May 26, 1985), VIII: 1; Paul Goldberger, "Trump: Symbol of a Gaudy, Impatient Time," *New York Times* (January 31, 1988), II: 32, 35; William E. Geist, "Trump Expanding," *New York Times* (April 14, 1996), VI: 142; Mervyn Rothstein, "Turning One Floor into Almost Two in an Office Deal," *New York Times* (March 12, 1997), B: 5; White and Willensky, *AIA Guide* (2000), 300. For the CIT Building, see Stern, Mellins, and Fishman, *New York 1960*, 498–99.

24. William E. Geist, "The Expanding Empire of Donald Trump," *New York Times* (April 8, 1984), VI: 142; Ada Louise Huxtable, "Donald Trump's Tower," *New York Times* (May 6, 1984), VI: 134; "The Asking Price: $3,868 a Sq. Ft.": 6, 14; Michael A. Hiltzik, "Towering Presence in New York; Donald Trump Stirs Controversy with Grandiose Structures," *Los Angeles Times* (April 7, 1985), V: 1; "Madison Piggyback: Base Plus 27": 1; Goldberger, "Trump: Symbol of a Gaudy, Impatient Time": 32, 35.

25. Philip Johnson, quoted in Geist, "The Expanding Empire of Donald Trump": 142.

26. "Facelift on Lex: Gold That Faded," *New York Times* (January 29, 1989), X: 1; Metzger, *Der Scutt Retrospective*, 52–53.

27. For the Ritz-Carlton Hotel, see Stern, Gilmartin, and Massengale, *New York 1900*, 262–63. For 380 Madison Avenue, see Stern, Mellins, and Fishman, *New York 1960*, 417.

28. See Stern, Mellins, and Fishman, *New York 1960*, 335.

29. Mark McCain, "Cachet of an Address Fades in the Face of Modern Needs," *New York Times* (November 6, 1988), X: 27; Rachelle Garbarine, "Sweeteners for Offices in Manhattan," *New York Times* (August 15, 1990), D: 19; David W. Dunlap, "New, Improved Face for the Colgate Headquarters," *New York Times* (October 20, 1999), B: 8.

30. David Dinkins, quoted in Leonard Buder, "An Office Tower on Park Ave. Will Be Rebuilt," *New York Times* (January 11, 1990), B: 3. Also see "Penn Central Seeks to Sell Real Estate for $40.3 Million," *Wall Street Journal* (February 10, 1978): 4; Barbara Selvin, "O&Y to Rebuild Park Ave. Building," *Newsday* (January 11, 1990): 51; David W. Dunlap, "From Dowdy to Sleekly Handsome on Park Avenue," *New York Times* (February 4, 1990): 17; Alison Leigh Cowan, "Insurer to Buy Olympia Office Tower," *New York Times* (September 16, 1992), D: 5; Charles V. Bagli, "Mutual of America: $200 Million Ante," *New York Observer* (October 5, 1992): 1, 18; "Mutual of America Will Move Its Headquarters," *New York Times* (October 22, 1992), D: 4; Rachelle Garbarine, "A Park Avenue Building Is Going from Wedding Cake to Sleek Modern," *New York Times* (February 24, 1993), D: 19; "320 Park Avenue," *Architecture + Urbanism*, special issue (September 1993): 26–27, 52–61; David W. Dunlap, "Building's New Look Shaped by Old Zoning," *New York Times* (November 14, 1993), X: 1,

10; "New York," *Engineering News-Record* 231 (December 13, 1993): 39; "Corrections," *New York Times* (December 26, 1993), X: 3; Peter Slatin, "Park Avenue Makeover," *Architectural Record* 183 (February 1995): 34; Paul Goldberger, "A 30-Something Tower Tries So Hard for a 90's Look," *New York Times* (July 9, 1995), II: 31; Kevin E. Vitting, "Go Easy on the Purism," letter to the editor, *New York Times* (August 6, 1995), II: 2, 4; "Structural Upgrade," *Architecture* 84 (November 1995): 124–25; White and Willensky, *AIA Guide* (2000), 279. For 320 Park Avenue, see Stern, Mellins, and Fishman, *New York 1900*, 336.

31. Goldberger, "A 30-Something Tower Tries So Hard for a 90's Look": 31.

32. "430 Park: The Future of Park Avenue," advertisement, *Crain's New York Business* (March 6, 2000): 47; John Holusha, "Redesigning and Upgrading a Faded Office Building," *New York Times* (July 22, 2001), XI: 8; "Corrections," *New York Times* (August 12, 2001), XI: 7; Andrew Alpern, "The History of 420–430 Park Ave.," letter to the editor, *New York Times* (August 26, 2001), XI: 10; David S. Chartock, "430 Park Avenue Renovation Creates Class A Office Building," *New York Construction News* 49 (February 2002): 17–23. For the 1954 renovation, see Stern, Mellins, and Fishman, *New York 1960*, 334.

33. Rachelle Garbarine, "Facelift for Madison Ave. Block," *New York Times* (November 11, 2001), XI: 7; Peter Slatin, "Macklowe's Madison Avenue Remake," *Grid* 4 (January-February 2002): 38–39; Chhandasi Pandya, "Caisse Buys Another Piece of Manhattan," *Montreal Gazette* (June 20, 2002), F: 2.

34. Robert Hanley, "Abercrombie & Fitch Put Up for Sale," *New York Times* (July 20, 1976): 37; Isadore Barmash, "Abercrombie & Fitch in Bankruptcy Step," *New York Times* (August 7, 1976): 1, 27; Robert McG. Thomas Jr., "An Old Sport, Abercrombie & Fitch Says It Must Close Historic Doors," *New York Times* (November 14, 1977): 37; Isadore Barmash, "Hundreds Stalk Bargains at Abercrombie Close-Out," *New York Times* (November 18, 1977): 33; "The Glory That Was Abercrombie, the Grandeur That Was Fitch," *New York Times* (December 23, 1977), D: 29; Carter B. Horsley, "Office Market Jumping Again," *New York Times* (January 8, 1978), VIII: 1, 4; Isadore Barmash, "Abercrombie Shell Getting a New Skin," *New York Times* (May 17, 1978), D: 1, 16; "Realty News," *New York Times* (October 14, 1979), VIII: 8; Alan S. Oser, "A Midtown Building's New Life," *New York Times* (February 20, 1980), D: 17. For Abercrombie & Fitch, see Stern, Gilmartin, and Massengale, *New York 1900*, 196.

35. Edwin McDowell, "Commercial Real Estate," *New York Times* (January 26, 2000), B: 6; Christopher Gray, "Streetscapes/The 1906 Home Club Co-op," *New York Times* (February 6, 2000), XI: 7; "Office Tower Planned," *New York Times* (July 25, 2000), B: 7; David S. Chartock, "Critical Blend of Steel & Concrete Right Recipe for 360 Madison Ave.," *New York Construction News* 48 (September 2001): 31–34, 36; Slatin, "Macklowe's Madison Avenue Remake": 38; "360 Madison Avenue," *New York Construction News* 49 (June 2002): 41; "2002 Award of Merit: Office Project," *New York Construction News* 50 (December 2002): 47; "2002 Top Projects: 360 Madison Avenue," *New York Construction News* 50 (June 2003): 55; James Gardner, "The Best Building in Years," *New York Sun* (June 23, 2003): 14. For the Home Club building, see Stern, Gilmartin, and Massengale, *New York 1900*, 301, 303.

36. Serge Appel, quoted in Chartock, "Critical Blend of Steel & Concrete Right Recipe for 360 Madison Ave.": 34, 36.

37. Gardner, "The Best Building in Years": 14.

38. Charles Luckman, "Lever House–The Client's View," letter to the editor, *Journal of the American Institute of Architects* 69 (August 1980): 8, 66, 70; David W. Dunlap, "Lever House Office Tower Declared a City Landmark," *New York Times* (November 10, 1982), B: 2; Richard Levine, "Lever House: Too Nice to Die?" *New York Times* (November 14, 1982), IV: 7; Diane Henry, "Lever House Mystery: Proposals for a New Building," *New York Times* (November 17, 1982), B: 8; Paul Goldberger, "Lever House Awaits the Decision on Its Future," *New York Times* (November 21, 1982), II: 29; "Lever Landmarked," *Progressive Architecture* 63 (December 1982): 21; "Lever Becomes a Landmark, Demolition Threats Continue," *Journal of the American Institute of Architects* 72 (January 1983): 30, 92; "Lever's Glass House Named a Landmark," *Architectural Record* 171 (January 1983): 61; David W. Dunlap, "Lever House Landmark Up for a Vote," *New York Times* (January 26, 1983), B: 3; C. Ray Smith, "Editorial," *Oculus* 44 (February 1983): 2, 6; Swanke Hayden Connell, "White Paper on Lever House," *Oculus* 44 (February 1983): 3–6; "Let Lever House Stand," editorial, *New York Times* (February 5, 1983): 22; Henry N. Cobb, Arthur Drexler, Kenneth Frampton, I. M. Pei, Philip Johnson, Cesar Pelli, Henry-Russell Hitchcock, and James Stewart Polshek, "Lever House Is Indisputably a Landmark," letter to the editor, *New York Times* (February 9, 1983): 30; Paul Goldberger, "Tower Plan for Lever House: Three-Way Struggle," *New York Times* (February 10, 1983), B: 2; David W. Dunlap, "Landmarks, Too, Often Change with the Times," *New York Times* (February 13, 1983), IV: 8; Robin Herman and Laurie Johnston, "Lobbying for Lever House," *New York Times* (February 23, 1983), B: 3; "Save the Lever Landmark," editorial, *Christian Science Monitor* (February 24, 1983): 24; "Architecture Historians Quoted as Witnesses Against Lever House and Their Comments on How They are Quoted," *Oculus* 44 (March 1983): 3–4, 14; Henry H. Brennan, "Letters," letter to the editor, *Oculus* 44 (March 1983): 5; George Lewis, "Lever House," *Oculus* 44 (March 1983): 5; "Exercise in Lever-age," *Metropolis* 2 (March 1983): 4; Daralice Donkervoet Boles, "Will Lever House Be Saved?" *Progressive Architecture* 64 (March 1983): 25–26; Janet Heller, "Save Lever House," *New York Times* (March 12, 1983): 23; Jamie Malanowski, "The Planners of New York City, by Default," letter to the editor,

New York Times (March 26, 1983): 22; David W. Dunlap, "Board Sustains Lever Building as a Landmark," *New York Times* (March 19, 1983): 25; Ward Morehouse III, "Tug of War over New York Skyscraper," *Christian Science Monitor* (March 29, 1983): 6; John Durant Cooke and Roy Harlow, "RE: Lever House," letters to the editor, *Oculus* 44 (April 1983): 10; "Lever's Landmark Status Upheld; Demolition Threats Defeated," *Journal of the American Institute of Architects* 72 (April 1983): 17–18; Alan S. Oser, "Action on Landmarking Clears the Way for Talks," *New York Times* (April 3, 1983), VIII: 7; Isaiah Ehrlich, "RE: White Paper," *Oculus* 44 (May 1983): 10; Halina Rosenthal, "Letters," *Oculus* 44 (June 1983): 12; Nora Richter Greer, "'83: A Very Good Year Despite Some Unresolved Controversies," *Architecture* 73 (March 1984): 70, 74, 82; Anne-Marie Schiro, "At Lever House, a Benefit Party," *New York Times* (October 5, 1984), B: 8.

39. Henry, "Lever House Mystery: Proposals for a New Building": 8.

40. Goldberger, "Tower Plan for Lever House: Three-Way Struggle": 2.

41. Goldberger, "Tower Plan for Lever House: Three-Way Struggle": 2.

42. Harrison J. Goldin, quoted in "Lobbying for Lever House": 3.

43. "Sears Resurrected," *Progressive Architecture* 67 (May 1986): 39–40; James S. Russell, "Icons of Modernism or Machine-Age Dinosaurs?" *Architectural Record* 177 (June 1989): 142–47; "Bunshaft Remembered," *Architecture* 79 (September 1990): 35; Theodore H. M. Prudon, "Saving Face," *Architecture* 79 (November 1990): 105–10, 114; "Aging Lever House May Get a New Skin," *New York Times* (October 22, 1995), IX: 1; Ann C. Sullivan, "Recladding Modern Buildings," *Architecture* 84 (November 1995): 119–21; Christopher Gray, "Streetscapes/Lever House," *New York Times* (July 28, 1996), IX: 7; "New Commissions," *Architecture* 85 (September 1996): 49; "David Childs and His Colleagues," *Oculus* 59 (September 1996): 4; Karrie Jacobs, "Faulty Towers," *New York* 31 (March 16, 1998): 33, 78; "The Buzz," *Architecture* '87 (May 1998): 41; Peter Grant, "Lever House Sold: Germans Win Landmark," *New York Daily News* (October 27, 1998): 33; David W. Dunlap, "After One-Tenant History, Lever House Opens Up," *New York Times* (January 27, 1999), B: 7; Christopher Gray, "Streetscapes/Henry Hope Reed," *New York Times* (September 19, 1999), XI: 7; Florence Fabricant, "Seeking a Spot," *New York Times* (December 22, 1999), F: 10; David W. Dunlap, "Designing a Restoration, and Words to Describe It," *New York Times* (December 29, 1999), B: 7; Herbert Muschamp, "How Modern Design Remains Faithful to Its Context," *New York Times* (August 6, 2000), II: 34; Wilton S. Dillon, "Lever House: A Dancing Lantern," letter to the editor, *New York Times* (August 20, 2000): 4; Donald Albrecht, "House of the Rising SOM," *Interiors* 159 (December 2000): 58–63; Eric Gibson, "Orphans of Time," *Wall Street Journal* (April 13, 2001), W: 17; Anne Raver, "The Places He'll Go to Green the City," *New York Times* (November 14, 2002), F: 1, 11; John Morris Dixon, "Lever House," *Architecture* 190 (December 2002): 60–67; Carl Hauser and Bradley Walters, "Lever House," *Oculus* (Spring 2003): 34–37; "Lever House Curtain-Wall Replacement," *Architectural Record* 191 (May 2003): 151; Craig Kellogg, "Lounging About at Lever House," *New York Times* (May 22, 2003), F: 3.

44. Vincent Stramandinoli, quoted in "Aging Lever House May Get a New Skin": 1.

45. For the Lever House garden proposal, see Bruce Altshuler, *Isamu Noguchi* (New York: Abbeville Press, 1994), 70; Ana Maria Torres, *Isamu Noguchi: A Study of Space* (New York: Monacelli Press, 2000), 80–87.

46. "Lever House Garden Party," *Grid* 2 (March + April 2000): 32.

47. David W. Dunlap, "New Restaurant to Add Zing to Lever House," *New York Times* (July 11, 2003), B: 6; William L. Hamilton, "Tonight's Special: Lever House," *New York Times* (August 17, 2003), IX: 1, 8.

48. "Madrid Bank Starts Work on 20-Story East Side Tower," *New York Construction News* 38 (September 10, 1990): 1, 12; "Lever House Neighbor: A 20-Story Bank Tower," *New York Times* (April 14, 1991), X: 1; Karen Salmon, "Banco Santander U. S. Headquarters," *Architecture* 80 (June 1991): 51; White and Willensky, *AIA Guide* (2000), 281.

49. White and Willensky, *AIA Guide* (2000), 281.

LOWER MANHATTAN

BATTERY PARK CITY

1. Linda Greenhouse, "Battery Park City's Future Questioned by Levitt Audit," *New York Times* (March 1, 1976): 1, 16.

2. See Stern, Mellins, and Fishman, *New York 1960*, 206–12.

3. See Stern, Mellins, and Fishman, *New York 1960*, 198–206.

4. Lee Dembart, "Unions Vow Peace for Battery Housing," *New York Times* (March 9, 1976): 1, 31; Ada Louise Huxtable, "Splendor Overcomes Snafu in Battery Park City," *New York Times* (July 25, 1976), II: 24; Alan S. Oser, "Builders Get New Impetus in U.S. Mortgage Backing," *New York Times* (October 15, 1976): 15; Alan S. Oser, "Federal Mortgage Insurance a Key to Fate of Battery Park City," *New York Times* (November 26, 1976), B: 22; Joseph P. Fried, "Construction Projects Running out of Financial Mortar," *New York Times* (February 11, 1977), B: 1, 5; Peter Koenig, "Rocky Premises: Battery Park City Is an $80 Million Hole in the Ground," *Barron's* (April 18, 1977): 5, 21–23; Joseph P. Fried, "Preliminary Federal Backing Given on Long-Delayed Battery Park City," *New York Times* (July 29, 1977), B: 3; Joseph P. Fried, "Will Battery Park City Ever Rise?" *New York Times* (October 30, 1977), VIII: 1, 3; Justin J. Murphy, "On Battery Park City," letter to the editor, *New York Times* (November

13, 1977), VIII: 8; Joseph P. Fried, "U.S. Decision Is Expected Soon on Battery Park City Mortgage Insurance," *New York Times* (February 12, 1978): 38; "Battery Park City Delay," *New York Times* (February 25, 1978): 25; Joseph P. Fried, "Construction Workers Take Over at a Hearing," *New York Times* (March 24, 1978), B: 3; Joseph P. Fried, "U.S. Doubts Intensify About Battery Park City," *New York Times* (April 22, 1978): 23; Joseph P. Fried, "Battery Park Housing Plan Wins Tentative Backing of Washington," *New York Times* (May 13, 1978): 1, 11; Milton Leebaw and Daniel Lewis, "Battery Park Gets Recharged," *New York Times* (May 14, 1978), IV: 5; "Battery Park City Work," *New York Times* (May 17, 1978), B: 3; Joseph P. Fried, "Battery Project Is Resumed as U.S. Approval Is Awaited," *New York Times* (November 22, 1978), B: 3; "Project Still Accepting Applications for Rental," *New York Times* (November 22, 1978), B: 3; Byron Klapper, "New York's Battery Park City Authority in Lower Manhattan Is Facing Cash Woes," *Wall Street Journal* (December 4, 1978): 37; Stern, Mellins, and Fishman, *New York 1960*, 212.

5. For Lefrak's most prominent development, Lefrak City (Jack Brown, 1960–67), located in Elmhurst, Queens, see Stern, Mellins, and Fishman, *New York 1960*, 994–96.

6. "Environmental Enhancement," *Design and Environment* 6 (Summer 1975): 15–16; "Lawrence Halprin," *Process Architecture* 4 (1978): 260. Also see Lawrence Halprin & Associates, *New York, New York* (New York: City of New York, 1968); Stern, Mellins, and Fishman, *New York 1960*, 132.

7. Lawrence Halprin, quoted in Huxtable, "Splendor Overcomes Snafu in Battery Park City": 24.

8. Vollmer Associates, *Evaluation of New York City Convention and Exhibition Center at Battery Park City* (New York, 1977); "Study Says Battery Park Is Best Convention Site," *New York Times* (May 6, 1977), D: 13.

9. Peter J. Solomon, quoted in Edward Schumacher, "13 Years Later, Battery Park City's an Empty Dream," *New York Times* (October 26, 1979), B: 3.

10. Leonard Sloane, "Amex Opens '78 with New Chief and Mayor–But Old Site Issue," *New York Times* (January 4, 1978): 1, 16; "Amex: New Chief, New Indictments," *New York Times* (January 8, 1978), III: 17; Walter H. Waggoner, "Amex Chief Sees a 'Chance' of Moving to Jersey," *New York Times* (January 14, 1978): 49; Leonard Sloane, "Wall Street Could Be Anywhere, U.S.A.," *New York Times* (February 5, 1978), IV: 6; "Koch, Carey Visit Amex," *New York Times* (July 6, 1978), D: 6; James P. Sterba, "How New York Almost Lost the Amex," *New York Times* (November 27, 1978), B: 1, 10; "Amex Headquarters," *New York Times* (March 18, 1979), VIII: 6; Richard J. Meislin, "Attempt to Revive Battery Park Plan Is Readied by Carey," *New York Times* (October 28, 1979): 1, 35; "Keeping the Amex in New York City," editorial, *New York Times* (October 30, 1979): 18; Edward Schumacher, "State Aid for New Amex Building Criticized at Legislative Hearing," *New York Times* (October 31, 1979): 3; Richard J. Meislin, "Albany Legislators Nearing Accord on Financing for New Amex Home," *New York Times* (November 1, 1979), B: 1; Ari L. Goldman, "American Exchange Wins State Backing to Build New Home," *New York Times* (November 3, 1979): 1, 24; "A New Home for the Amex?" *New York Times* (November 4, 1979), III: 19; Ronald Smothers, "City Receives Federal Funds to Assist Commercial Construction Projects," *New York Times* (December 9, 1979): 25.

11. Richard W. Gottfried, quoted in Goldman, "American Exchange Wins State Backing to Build New Home": 1, 24.

12. Alexander Cooper Associates, *Battery Park City Draft Summary Report and 1979 Master Plan* (New York, October 1979); "Last Chance for Battery Park City," editorial, *New York Times* (November 7, 1979): 22; Paul Goldberger, "A Realist's Battery Park City," *New York Times* (November 9, 1979), B: 4; Edward Schumacher, "Carey and Koch, Accept New Battery Park City Plan," *New York Times* (November 9, 1979), B: 1, 4; Ada Louise Huxtable, "Is This the Last Chance for Battery Park City?" *New York Times* (December 9, 1979), VIII: 39; Jon Michael Schwarting, "Paradise Lost?: The Future Development of Battery Park," *Precis* 3 (1981): 19–21; Jon Michael Schwarting, "Battery Park City Will Rise," *Progressive Architecture* 62 (February 1981): 32, 36, 40; Cooper Eckstut Associates, *Battery Park City South Residential Area Design Guidelines* (New York, April 1981); H. Alan Hoagland, "City Form and Policy," letter to the editor, *Progressive Architecture* 62 (April 1981): 10; Carter B. Horsley, "Young Firm Shaping Future of Two Areas," *New York Times* (June 28, 1981), VIII: 1; Herbert Muschamp, "Learning from New York," *Express* 1 (Fall 1981): 4–5; "Battery Park City Master Plan and Guidelines," *Progressive Architecture* 65 (January 1984): 136–37; Alexander Cooper and Stanton Eckstut, "A Viable Vision: Battery Park City Markets Large-Scale Development," *Urban Land* 43 (October 1984): 2–6; Sandro Marpillero, "Rinascenza e illusione: Battery Park City," *Casabella* 48 (November 1984): 16–29; "The Master Plan," *Oculus* 46 (February 1985): 3; Agata Bazzi, "Battery Park City," *Abitare* 235 (June 1985): 64–73; Robin Karson, "Battery Park City Takes Manhattan," *Landscape Architecture* 75 (July-August 1985): 64–69; Michael Sorkin, "Dump the Trump," *Village Voice* 31 (December 24, 1985), 112–13, reprinted in Michael Sorkin, *Exquisite Corpse* (London and New York: Verso, 1991), 141–47; Leo Koonmen, "Vision of the New Urban Context: The Development of Battery Park City," *Columbia Art Review* (Spring 1986): 22–25; Carter Wiseman, "The Next Great Place: The Triumph of Battery Park City," *New York* 19 (June 16, 1986): 34–41; Susan Doubilet, "Cooper, Eckstut Associates," *Progressive Architecture* 67 (July 1986): 98–105; Daniel Beekman, "Cooper, Eckstut Cityscape," letter to the editor, *Progressive Architecture* 67 (October 1986): 11; Alexander Cooper, "Hudson Progress," letter to the editor, *New York Times* (March 8, 1987), VIII: 9; "Together and Separately, Creating the New Waterfront," *Avenue* (May 1987):

138; Brendan Gill, "The Sky Line: Battery Park City," *New Yorker* 66 (August 20, 1990): 69–78; Paul Goldberger, "Battery Park City's Brave New World," *Architectural Digest* 47 (November 1990): 142, 144, 146, 148; "Battery Park City Master Plan, New York," *Progressive Architecture* 74 (January 1993): 102; Roger Starr, "A Stroll Through Battery Park City," *City Journal* 3 (Autumn 1993): 110–15; Ann Breen and Dick Rigby, *Waterfronts: Cities Reclaim Their Edge* (New York: McGraw-Hill, 1994), 278–82; Susan S. Fainstein, *The City Builders* (Oxford and Cambridge, Mass.: Blackwell, 1994), 175–77; Eric Uhlfelder, "Revenue Sharing," *Urban Land* 54 (March 1995): 25–31; George H. Douglas, *Skyscrapers: A Social History of the Very Tall Building in America* (Jefferson, N.C., and London: McFarland & Co., 1996), 193; Sylvia Lewis, "Mr. Precedent," *Planning* 62 (August 1996): 10–15; David L. A. Gordon, *Battery Park City: Politics and Planning on the New York Waterfront* (Amsterdam: Gordon and Breach, 1997), especially chapters 3–7.

13. Alexander Cooper Associates, *Battery Park City Summary Report and 1979 Master Plan*, 1, 4.

14. Quoted in "The Master Plan," *Oculus*: 3.

15. Alexander Cooper Associates, *Battery Park City Draft Summary Report and 1979 Master Plan*, 13, 42, 44, 46–47, 49, 64.

16. Alexander Cooper Associates, *Battery Park City Draft Summary Report and 1979 Master Plan*, 15–16.

17. Goldberger, "A Realist's Battery Park City": 4.

18. Huxtable, "Is This the Last Chance for Battery Park City?" 39.

19. J. Michael Kirkland, quoted in "Battery Park City Master Plan and Guidelines": 137.

20. Muschamp, "Learning from New York": 4.

21. Schwarting, "Paradise Lost?: The Future Development of Battery Park": 20.

22. Sorkin, "Dump the Trump": 112.

23. "State Plan to Aid Amex Faces Court Challenge," *New York Times* (April 17, 1980), D: 7; Maurice Carroll, "Snags Put Off Amex Ground Breaking," *New York Times* (June 14, 1980): 28; Joyce Purnick, "Carey, Koch Join Forces to Celebrate New Center," *New York Times* (June 18, 1980), B: 1; Frank Lynn, "Judge Charges Pressure by Albany in Amex Case," *New York Times* (June 24, 1980), B: 3; Selwyn Raab, "Subsidy to Amex for a New Home Upheld by Court," *New York Times* (July 3, 1980), B: 1; Carter B. Horsley, "A Lift for Major Projects," *New York Times* (July 9, 1980), D: 15; "American Stock Exchange," *Wall Street Journal* (September 23, 1980): 1; Richard J. Meislin, "State Plan for New Amex Building May Be Dropped," *New York Times* (October 9, 1980): 1; Richard J. Meislin, "Amex Votes Down Plans for a New Headquarters," *New York Times* (October 10, 1980), D: 1; "Rabbit Feet and the American Exchange," editorial, *New York Times* (October 17, 1980): 30.

24. Michael Goodwin, "Construction of Battery Park City Is Now Scheduled to Begin in June," *New York Times* (May 16, 1980), B: 4; Michael Goodwin, "U.S. Vow on Bonds Aided Rating for Battery Project," *New York Times* (May 17, 1980): 1; Glenn Fowler, "Rentals Starting for Apartments Near the Battery," *New York Times* (March 17, 1981), B: 3; "Gateway Plaza at Battery Park City: A Major Housing Development in Lower Manhattan," *Architectural Record* 169 (May 1981): 37; "Residential Towers Being Rented at Battery Park City," *New York Times* (January 20, 1982), B: 1; "Irving E. Gershon, Architect, a Designer of Gateway Plaza," *New York Times* (February 24, 1982): 18; Selwyn Raab, "Irregularities in Concrete Industry Inflate Building Costs, Experts Say," *New York Times* (April 26, 1982): 1; George W. Goodman, "At Battery Park City, a Rent Strike," *New York Times* (January 16, 1983), VIII: 6; David W. Dunlap, "At Battery Park City, 'Pioneers' Like Life," *New York Times* (July 22, 1983), B: 1, 4; Shawn G. Kennedy, "Food for Gateway," *New York Times* (November 3, 1983), VIII: 1; "Gateway Plaza," *Oculus* 46 (February 1985):14; White and Willensky, *AIA Guide* (2000), 49.

25. Stanton Eckstut, quoted in Koonmen, "Vision of the New Urban Context: The Development of Battery Park City": 24.

26. Gill, "The Sky Line: Battery Park City": 74.

27. "Gateway Plaza": 14.

28. Quoted in Carter B. Horsley, "A Life for Major Projects," *New York Times* (July 9, 1980), D: 15.

29. Joyce Purnick, "Battery Park City Tax Plan Accepted," *New York Times* (October 16, 1980), B: 3.

30. Alan S. Oser, "Canadian Company Becomes a Big City Landlord," *New York Times* (October 26, 1977), D: 11; Robert D. McFadden, "Battery Park City Builder Picked," *New York Times* (November 14, 1980), B: 3; Alan S. Oser, "Office Tower on 42nd Street Revitalized by New Owner," *New York Times* (November 19, 1980): 33; Carter B. Horsley, "Battery Park City Bidding Faulted," *New York Times* (November 30, 1980), VIII: 1; Alan S. Oser, "Canadian Developer's U.S. Role," *New York Times* (December 10, 1980), D: 21. Also see Anthony Bianco, *The Reichmanns: Family, Faith, Fortune, and the Empire of Olympia & York* (New York: Times Books, 1997), especially pages 402–9, 440–51, 460–63, 533.

31. Paul Goldberger, "A Dramatic Counter-Point for Trade Center," *New York Times* (May 14, 1981), B: 1, 13; Joyce Purnick, "Plans Disclosed for Office Core at Battery Park," *New York Times* (May 14, 1981), B: 1, 12; Ada Louise Huxtable, "A New 'Rockefeller Center' Planned for Battery Park," *New York Times* (May 24, 1981), II: 25, 35; "A Glittering Prize for the Battery," editorial, *New York Times* (May 27, 1981): 26; Laurence A. Michaels, "A Missing Equation in Battery Park City," letter to the editor, *New York Times* (May 30, 1981): 22; "Cesar Pelli's Winning Design for 'Commercial Core' of Battery Park City," *Architectural Record* 169 (July 1981): 41; John Pastier, "The Sophisticated Skins of Cesar Pelli," *Journal of the American Institute of Architects* 70 (October 1981): 75–83; Muschamp, "Learning from New York": 4; "Battery Park City Commercial Development, New York," *Progressive Architecture* 62 (October 1981): 69; Cesar Pelli, "Skyscrapers,"

Perspecta 18 (1982): 134–69; Paul Goldberger, *The Skyscraper* (New York: Alfred A. Knopf, 1982), 158–61; "Battery Park City Commercial Core," *Architecture + Urbanism* 135 (January 1982): 83–85; Timothy Gregory Quigley, "Battery Park City: World Financial Center" (Masters thesis, University of Minnesota, 1983); "Megajob Takes Foothold in Fill," *Engineering News-Record* 210 (April 14, 1983): 28; Alan S. Oser, "American Express Completes Deal to Move to Battery Park," *New York Times* (June 17, 1983), B: 7; Douglas Brenner, "New Layers of Meaning: Works in Progress by Cesar Pelli," *Architectural Record* 171 (July 1983): 104–5; "Giant Walkways Built like Bridges," *Engineering News-Record* 212 (March 29, 1984): 60; "Building D at Battery Park City," *Metals in Construction* (Fall 1984): 8–30; Marpillero, "Rinascenza e illusione: Battery Park City": 16–29; "Cesar Pelli," *Architectural Design* 55 (Nos. 1–2, 1985): 32–37; "World Financial Center," *GA Document* 12 (January 1985): 50–51; C. Ray Smith, "The World Financial Center," *Oculus* 46 (March 1985): 2–6; "Changing Plans Make Macrojob Moving Target," *Engineering News-Record* 214 (March 7, 1985): 28; Bazzi, "Battery Park City": 64–73; Karson, "Battery Park City Takes Manhattan": 64–69; Susan Doubilet, "Big City Builders Olympia & York," *Progressive Architecture* 66 (July 1985): 79–86; "World Financial Center," *Architecture + Urbanism*, extra edition (July 1985): 176–99; Gavin Macrae-Gibson, "Cesar Pelli: Heir of Mies," *Architecture + Urbanism*, extra edition (July 1985): 224–27; John Pastier, "Cesar Pelli: The Architect as Servant," *Architecture + Urbanism*, extra edition (July 1985): 85–88; Cesar Pelli, "Architectural Form and the Tradition of Building," *Architecture + Urbanism*, extra edition (July 1985): 26–32; Winston William, "Finally, the Debut of Wall Street West," *New York Times* (August 25, 1985), III: 1, 6; S. L. Fordsham, "World Financial Center," *Urban Land* 44 (September 1985): 22–26; "World Financial Center," *Oculus* 47 (November 1985): cover, 2–5; "Credits to Battery Park City," *Oculus* 47 (December 1985): 12; Robert A. M. Stern, *Pride of Place: Building the American Dream* (Boston: Houghton Mifflin; New York: American Heritage, 1986), 241–42, 247; "World Financial Center: Newest Jewel in Manhattan's Crown," *Metals in Construction* 4 (No. 1, 1986): 8–13; Koonmen, "Vision of the New Urban Context: The Development of Battery Park City": 22–25; Karin Tetlow, "Expressing an Image: Part 1," *Interiors* 145 (June 1986): 133–49; Wiseman, "The Next Great Place": 34–41; "World Financial Center," *Process Architecture* 69 (July 1986): 96–103; Karin Tetlow, "Expressing an Image: Part 2," *Interiors* 145 (August 1986): 198–207; Douglas Davis, "The New Master Builder," *Newsweek* 108 (August 4, 1986): 61; Karin Tetlow, "Expressing an Image: Part 3," *Interiors* 145 (October 1986): 154–61; Andrea Oppenheimer Dean and Allen Freeman, "The Rockefeller Center of the '80s?" *Architecture* 75 (December 1986): 36–43; Sonia R. Chao and Trevor B. Abramson, eds., *Kohn Pedersen Fox: Buildings and Projects, 1976–1986* (New York: Rizzoli International Publications, 1987), 326; Carter Wiseman, "A Vision with a Message," *Architectural Record* 175 (March 1987): 112–21; Mark McCain, "Two Behemoths with 3 Million Square Feet to Let," *New York Times* (March 22, 1987), VIII: 41; "New Construction Around Town," *Oculus* 48 (May 1987): 28–29; Albert Scardino, "Cities in the Sky, Skyscrapers by the Acre," *New York Times* (May 17, 1987): 28; Colin Amery, "Exemplary Development in Lower Manhattan," *Financial Times* (London) (May 18, 1987): 23; Nathalie Grenon, "On the Hudson, at Battery Park City," *Arca* 62 (July-August 1987): 58–65; Thomas J. Lueck, "From California, an Indoor Palm Grove," *New York Times* (September 15, 1987), B: 1, 4; "Live on Stage at Battery Park City," *New York Times* (January 7, 1988), C: 3; Karin Tetlow, "Trading Up," *Interiors* 147 (March 1988): 153–88; Abraham Gutman, Leonid Zbrovosky, and Lee Petrella, "World Financial Center: Steel Comes Out on Top!" *Modern Steel Construction* 28 (March-April 1988): 23–26; "World Financial Center," *Architecture + Urbanism*, extra edition (April 1988): 48–60; Nadine M. Post, "Data-Hungry Traders Put Technological Twist in Wall Street in New York City Towers," *Engineering News-Record* 221 (September 29, 1988): 24; Paul Goldberger, "Winter Garden at Battery Park City," *New York Times* (October 12, 1988), C: 15–16; Carter B. Horlsey, "A Boss for All Seasons," *New York Post* (October 13, 1988): 53, 68; "New York as Window," editorial, *New York Times* (October 16, 1988): 20; Ann Walmsey and D'Arcy Jenish, "A Family's Way to Wealth," *Maclean's* (October 24, 1988): 46; Silvano Stucchi, "Il World Financial Center a Manhattan," *Industria delle costruzioni* 22 (November 1988): 38–49; Robert Campbell, "New York's Most Ambitious–and Controversial–Office Development," *Boston Globe* (November 13, 1988): 2; Robert Campbell, "Tented City," *Architects' Journal* 188 (November 16, 1988): 24–25, 27; Paul Goldberger, "To the Heights of Simplicity," *New York Times* (November 20, 1988), VI: 21, 54–56, 58; Jean Elson Nathan, "Agency's New Head Planning to Modify Battery Park City," *New York Observer* (December 19, 1988): 1, 7; Michael Sorkin, "Ciao Manhattan," in Heinrich Klotz, *New York Architektur* (Munich: Prestel-Verlag, 1989), 192–93, reprinted in Sorkin, *Exquisite Corpse*, 357–65; Victoria Geibel, "The New Urban Landscape," *Metropolis* 8 (January-February 1989): 35; Sylvia Lavin, "Interiors Platform," *Interiors* 148 (February 1989): 16, 20, 22, 24; "Battery Park City: World Financial Center," *Process Architecture* 82 (May 1989): 116–21; Richard F. Shepard, "Exploring Battery Park City," *New York Times* (May 19, 1989), C: 1, 19; Peter Hellman, "What's Better Now," *New York* 22 (May 22, 1989): 34; Tony Diaz, "La construccion del 'skyline,'" *Arquitectura viva* 6 (June 1989): 22–26; Dayan Dudjic, "War of the Cities," *Blueprint* 58 (June 1989): 36–38; *Cesar Pelli: Buildings and Projects, 1965–1990* (New York: Rizzoli International Publications, 1990), 92–119; Mario Gandelsonas, "Conditions for a Colossal Architecture," in *Cesar Pelli: Buildings and Projects, 1965–1990*, 9–12; Paul Goldberger, "Introduction," in *Cesar Pelli: Buildings and*

Projects, 1965–1990, 6–8; John Pastier, "The Evolution of an Architect," in *Cesar Pelli: Buildings and Projects, 1965–1990*, 13–19; Fulvio Irace, *Emerging Skylines* (New York: Whitney Library of Design, 1990), 110–13; "Cesar Pelli," *Architecture + Urbanism* (February 1990): 65–89; Gill, "The Sky Line: Battery Park City": 69–78; Starr, "A Stroll Through Battery Park City": 110–15; Goldberger, "Battery Park City's Brave New World": 142, 144, 146, 148; Sigurd Grava, "Battery Park City in the Last Decade of the Twentieth Century," in *Between Edge and Fabric: Battery Park City* (New York: Columbia University Graduate School of Architecture, Planning and Preservation, 1991), 8–13; Susan S. Fainstein, "Promoting Economic Development: Urban Planning in the United States and Great Britain," *Journal of the American Planning Association* 57 (Winter 1991): 22–33; "World Financial Center Has Been Assimilated into the Wall Street Landscape," *Process Architecture* 104 (June 1992): 151; *Cesar Pelli: Selected and Current Works* (Mulgrave, Australia: Images Publishing, 1993), 54–63; Fainstein, *The City Builders*, 177–85; Francis Morrone, *The Architectural Guidebook to New York City* (Salt Lake City: Gibbs-Smith, 1994), 52–56; "Cesar Pelli Wins AIA Gold Medal," *Progressive Architecture* 76 (February 1995): 31; Uhlfelder, "Revenue Sharing": 25–31; Lewis, "Mr. Precedent": 10–15; Gordon, *Battery Park City: Politics and Planning on the New York Waterfront*, 77–83; Susanna Sirefman, *New York: A Guide to Recent Architecture* (London: Ellipsis, 1997), 32–35; Eric P. Nash, *Manhattan Skyscrapers* (New York: Princeton Architectural Press, 1999), 163–66; Vincent Scully, "On Cesar Pelli," in *Cesar Pelli: Building Designs, 1965–2000* (New Haven, Conn.: Yale University School of Architecture, 2000); White and Willensky, *AIA Guide* (2000), 49–51; Guy Trebay, "World Class Setting for Wedding Albums," *New York Times* (July 9, 2000), IX: 1, 6.

32. Ron Soskolne, quoted in Bianco, *The Reichmanns*, 407.

33. Cesar Pelli, quoted in "World Financial Center," *Architecture + Urbanism*: 184.

34. Goldberger, "A Dramatic Counter-Point for Trade Center": 1, 13.

35. Goldberger, "A Dramatic Counter-Point for Trade Center": 1, 13.

36. For the Barclay-Vesey Building, see Stern, Gilmartin, and Mellins, *New York 1930*, 565–67, 569–70.

37. Sirefman, *New York*, 32.

38. Goldberger, "Winter Garden at Battery Park City": 15–16.

39. Wiseman, "A Vision with a Message": 114–15.

40. Scully, "On Cesar Pelli," in *Cesar Pelli: Buildings and Designs, 1965–2000*, no pagination.

41. Campbell, "New York's Most Ambitious–and Controversial–Office Development": 2.

42. Campbell, "Tented City": 24.

43. Carter B. Horsley, "Builders Compete for Big Projects," *New York Times* (April 12, 1981), VIII: 1, 6; "Designer Consortium," *New York Times* (July 5, 1981), VIII: 1, 6; Paul Goldberger, "6 Builders Chosen for Housing at Battery Park City," *New York Times* (August 19, 1981): 1, B: 8; Richard Levine and Carlyle L. Douglas, "Battery Park–Less Awesome, More Feasible," *New York Times* (August 23, 1981), IV: 6E; "Battery Park City Ground Lease Terms Are Concluded and Developers Are Chosen," *Architectural Record* 169 (October 1981): 35; Alan S. Oser, "Battery Park City: The Newest Prestige Address," *New York Times* (April 18, 1982), VIII: 7; "Battery Park Potpourri," *Progressive Architecture* 64 (March 1983): 52; Paul Goldberger, "Signs of Better Building," *New York Times* (November 10, 1983), C: 22; David W. Dunlap, "Battery Park City's Next Endeavor Evokes a Remembrance of Things Past," *New York Times* (November 16, 1983), B: 1, 4; "Battery Park City: A New Residential Skyline for Downtown New York," *Architectural Record* 171 (December 1983): 28–29; "Residential Building Designs for Battery Park City," *Oculus* 45 (December 1983): 10; Daralice Donkervoet Boles, "Battery Park's Grand Design," *Progressive Architecture* 64 (December 1983): 25; Paul Goldberger, "The Intent Was Not to Shock but to Please," *New York Times* (December 25, 1993), II: 23; Elliot Vilkas, letter to the editor, *Oculus* 45 (January 1984): 10; George W. Goodman, "Battery Park City Work Advances," *New York Times* (May 13, 1984): 6; "Ulrich Franzen," *Architecture + Urbanism* (October 1984): 106; Alan S. Oser, "Rector Place Residential Phase Ready for Building," *New York Times* (November 11, 1984), VIII: 7; "Rector Place," *Oculus* 46 (February 1985): 4–7, 13; Amanda Burden, "Battery Park City," *Oculus* 46 (February 1985): 8; "Davis Brody," *Oculus* 47 (September 1985): 10; Alan S. Oser, "Pace Quickens in Battery Park City," *New York Times* (November 24, 1985), VIII: 6; Shawn G. Kennedy, "Living on a Landfill," *New York Times* (December 22, 1985), VIII: 1; "Battery Park City, Site 5B," *Process Architecture* 64 (January 1986): 152–53; "James Stewart Polshek," *Process: Architecture* 64 (January 1986): 134; "Mariner's Cove," *Process Architecture* 64 (January 1986): 140–44; "Rector Pl. Rentals," *New York Times* (March 9, 1986), VIII: 1; Michael deCourcy Hinds, "Shaping a Landfill into a Neighborhood," *New York Times* (March 23, 1986), VIII: 1, 18; "Next-to-the-Last for Rector Place," *New York Times* (May 4, 1986), VIII: 1; Ellen Rosen, "2 More Rentals at Rector Place," letter to the editor, *New York Times* (May 18, 1986), VIII: 12; Peter Lemos, "Battery Park City Update," *Progressive Architecture* 67 (June 1986): 37–38; Paul Goldberger, "Battery Park City Is a Triumph of Urban Design," *New York Times* (August 31, 1986), II: 1, 23; Paul Goldberger, "A Baker's Dozen of New York City's Urban Masterpieces," *New York Times* (July 31, 1987), C: 1; Michele Herman, "Battery Park City from the Inside," *Metropolis* 7 (September 1987): 20–21; White and Willensky, *AIA Guide* (1988), 44; James Stewart Polshek: Context and Responsibility (New York: Rizzoli International Publications, 1988), 48–49, 176–77; Grace M. Anderson, "Hudson Tower, Battery Park City," *Architectural Record* (February 1988): 132–33; Thomas Fisher, "Building the New City," *Progressive Architecture* 69 (March

1988): 86–93; "Urban Design Credits," *Progressive Architecture* 69 (May 1988): 11; Carol Lawson, "Housing Plan That Forgot the Children," *New York Times* (July 21, 1988), C: 1; Manuela Hoelterhoff, "Bringing the Stroller Set to Battery Park City," *Wall Street Journal* (July 14, 1988): 24; Paul Goldberger, "Battery Park City Looks Inward for Innovation," *New York Times* (July 24, 1988), II: 28; Benjamin Forgey, "The Recharged Battery: New York's Newest Neighborhood," *Urban Land* 48 (October 1989): 9–11; Stephen Dobney, ed., *Mitchell/Giurgola Architects: Selected and Current Works* (Mulgrave, Australia: Images Publishing, 1996), 210–13; Gary R. Hilderbrand, ed., *Making a Landscape of Continuity: The Practice of Innocenti & Webel* (Cambridge, Mass.: Harvard University Graduate School of Design, 1997), 94–95; White and Willensky, *AIA Guide* (2000), 47–48.

44. Burden, "Battery Park City": 8.

45. Cooper Eckstut Associates, *Battery Park City South Residential Area Design Guidelines*, 5, 14.

46. Cooper Eckstut Associates, *Battery Park City South Residential Area Design Guidelines*, 4.

47. Cooper Eckstut Associates, *Battery Park City South Residential Area Design Guidelines*, 34–35, 38, 40.

48. Peter Eisenman, quoted in "Designer Consortium": 6.

49. Oser, "Rector Place Residential Phase Ready for Building": 7.

50. Goldberger, "Tradition in Housing": 3. For East Midtown Plaza, see Stern, Mellins, and Fishman, *New York 1960*, 289–90. For the Roosevelt Island proposal, see Stern, Mellins, and Fishman, *New York 1960*, 645–47.

51. Dunlap, "Battery Park City's Next Endeavor Evokes a Remembrance of Things Past": 1.

52. Richard Kahan, quoted in Dunlap, "Battery Park City's Next Endeavor Evokes a Remembrance of Things Past": 1.

53. Meyer S. Frucher, quoted in Wiseman, "The Next Great Place": 41.

54. Uhlfelder, "Revenue Sharing": 30.

55. Oser, "Pace Quickens in Battery Park City": 6.

56. Wiseman, "The Next Great Place": 40

57. Hilderbrand, ed., *Making a Landscape of Continuity: The Practice of Innocenti & Webel*, 94.

58. Goldberger, "Battery Park City Is a Triumph of Urban Design": 1.

59. Wiseman, "The Next Great Place": 39.

60. Forgey, "The Recharged Battery: New York's Newest Neighborhood": 10.

61. Wiseman, "The Next Great Place": 39.

62. *James Stewart Polshek: Context and Responsibility*, 48–49.

63. Fisher, "Building the New City": 88.

64. Boles, "Battery Park's Grand Design": 5.

65. White and Willensky, *AIA Guide* (1988), 45.

66. Anderson, "Hudson Tower, Battery Park City": 132.

67. White and Willensky, *AIA Guide* (2000), 48.

68. Forgey, "The Recharged Battery: New York's Newest Neighborhood": 10.

69. Goldberger, "To the Heights of Simplicity": 58.

70. White and Willensky, *AIA Guide* (1988), 44.

71. Fisher, "Building the New City": 91.

72. Wiseman, "The Next Great Place": 37.

73. Doubilet, "Cooper, Eckstut Associates": 98.

74. Goldberger, "Battery Park Is a Triumph of Urban Design": 1.

75. James Stewart Polshek, quoted in Fisher, "Building the New City": 92.

76. Stanton Eckstut, quoted in Doubilet, "Cooper, Eckstut Associates": 98.

77. Hoelterhoff, "Bringing the Stroller Set to Battery Park City": 24.

78. Goody, Clancy and Associates, *Family Housing at Battery Park City* (New York, 1988); Bond, Ryder and Associates, *Choice and Flexibility in Housing: Innovative Housing Study for Battery Park City Authority* (New York, April 1988); Ricardo Bofill, *Affordable Family Housing Proposal for Battery Park City Authority* (New York, June 1988); Ehrenkrantz Group & Eckstut, *Innovative Housing Design Study for Battery Park City Authority* (New York, June 9, 1988); Goldberger, "Battery Park City Looks Inward for Innovation": 28.

79. Goldberger, "Battery Park City Looks Inward for Innovation": 35. For Eastwood Apartments, see Stern, Mellins, and Fishman, *New York 1960*, 650–52.

80. Cooper Eckstut Associates, *Battery Place Residential Area Design Guidelines* (New York, May 1985); Oser, "Pace Quickens in Battery Park City": 6; Lemos, "Battery Park City Update": 38; Lisa W. Foderado, "Battery Park City Getting 3 More Housing Projects," *New York Times* (November 14, 1986): 28; Alan S. Oser, "Breaking Ground as a New Developer," *New York Times* (December 21, 1986), VIII: 6; Fisher, "Building the New City": 93; Peterson, "Battery Park City: A New Phase Begins": 1; "New Condo at Battery Park City," *New York Post* (November 11, 1988): 66; Heinrich Klotz and Luminita Sabau, eds., *New York Achitektur* (Munich: Prestel-Verlag, 1989), 100–101; Ehrenkrantz Group & Eckstut, Architects, *Battery Place Residential Area Design Guidelines, Amended February, 1989* (New York, February 1989); Andree Brooks, "Battery Park City Grows Despite '87 Wall St. Crash," *New York Times* (February 24, 1989): 15; Alan S. Oser, "Shaping the Pattern of Future Housing," *New York Times* (July 9, 1989), X: 3; "At Battery Park City," *Oculus* 52 (October 1989): 5; Susan Chira, "Battery Park City Rousing from a 2-Year Fiscal Sleep," *New York Times* (November 7, 1989), B: 1, 6; Richard D. Lyons, "Blueprint' Sales," *New York Times* (December 3, 1989), X: 1; "Architect Abuse: When Credit Is Overextended," *Oculus* 52 (January 1990): 5; Rachelle Garbarine, "2 New Projects Test a Sluggish Market," *New York Times* (August 10, 1990): 16; Stephanie Strom, "83 Brand-New Condos and a Harbor View: What Am I Bid?" *New York*

Times (May 20, 1991), B: 1–2; Birgit Jeppesen, "Battery Park City," *Arkitekten* 94 (October 1992): 434–37; Tracie Rozhon, "Just a Little Home for 2," *New York Times* (March 20, 1994), X: 6; Andrew Jacobs, "Multiplex Dreams at Battery Park City," *New York Times* (December 24, 1995), XIII: 6; White and Willensky, *AIA Guide* (2000), 47.

81. Cooper Eckstut Associates, *Battery Place Residential Area Design Guidelines*, 5, 8–10, 26–28.

82. Jacobs, "Multiplex Dreams at Battery Park City": 6; Jayne Merkel, "Expanding Battery Park City," *Oculus* 58 (June 1996): 11–12; Henry Urbach, "Basic Instincts," *Interior Design* 68 (September 1997): 156–59; "Deborah Berke: Battery Park City Parks Corporation Facility, Battery Park City, New York City," *Architectural Design* 69 (May–June 1999): 34–37; www.dberke.com/architecture/bpc/t.htm.

83. www.dberke.com/architecture/bpc/t.htm.

84. David Emil, quoted in Garbarine, "2 New Projects Test a Sluggish Market": 16.

85. Jane Perlez, "Stuyvesant High May Relocate," *New York Times* (July 16, 1986), B: 2; Jane Perlez, "A New School for Stuyvesant to Be Speeded," *New York Times* (October 2, 1987), B: 1, 9; "News Briefs," *Architectural Record* 176 (March 1988): 63; Meyer S. Frucher, "Let the Possibilities for the West Side Waterfront Be Explored," letter to the editor, *New York Times* (August 5, 1988): 24; Bill Hine, "Building a High School Across a Highway Is Dangerous Planning," letter to the editor, *New York Times* (September 3, 1988): 22; Robert D. McFadden with Eben Shapiro, "Finally, a Facade to Fit Stuyvesant," *New York Times* (September 8, 1992), B: 1, 6; Hugo Lindgren, "Learning from Tribeca," *Metropolis* 12 (November 1992): 13, 17; Peter Slatin, "Stuyvesant High School of Science," *Oculus* 55 (November 1992): 6–9; Alex Cooper and Ralph Steinglass, "Stuyvesant High School Criticism: Response," *Oculus* 55 (January 1993): 3; Renee Levine, "Another Response," *Oculus* 55 (January 1993): 3; Elizabeth D. Andrzejewicz, "New Stuyvesant High School Designed as 'Vertical Campus' in Manhattan," *New York Construction News* (January 18, 1993), II: 7; Sam Dillon, "Building Flaws Tarnish Stuyvesant's Showcase," *New York Times* (January 28, 1993), B: 1, 2; Terry Golway, "Marked for Death," *New York Observer* (February 8, 1993): 5; Robin Fields, "A+," *Metropolis* 12 (May 1993): 68–71, 97; Herbert Muschamp, "On the Hudson, Launching Minds Instead of Ships," *New York Times* (June 6, 1993), II: 40; Bruce Lambert, "A Deal to Open Stuyvesant's Doors (and Pool)," *New York Times* (September 19, 1993), B: 3; Herbert Muschamp, "Enlightenment on the Harbor," *New York Times* (November 7, 1993), IV: 18; Sirefman, *New York*, 36–39; White and Willensky, *AIA Guide* (2000), 52; Alan Balfour, *World Cities: New York* (New York: Wiley Academy, 2001), 144.

86. For the original Stuyvesant High School, see Stern, Gilmartin, and Massengale, *New York 1900*, 85–86.

87. Slatin, "Stuyvesant High School of Science": 7.

88. Muschamp, "On the Hudson, Launching Minds Instead of Ships": 40.

89. Slatin, "Stuyvesant High School of Science": 7.

90. Constance L. Hays, "Highway Bridge Plan Roiling TriBeCa," *New York Times* (August 6, 1990), B: 4; Joseph Berger, "School Bridge Plan Ends Up in Hot Water in City Council," *New York Times* (June 5, 1991), B: 3; "A New High School Gets a New Bridge," *New York Times* (March 1, 1992): 26; *Skidmore, Owings & Merrill: Selected and Current Work* (Mulgrave, Australia: Images Publishing, 1995), 216–17; "The Tribeca Pedestrian Bridge," *Architecture + Urbanism*, special edition (August–September 1993): 82–91; White and Willensky, *AIA Guide* (2000), 52.

91. *Skidmore, Owings & Merrill: Selected and Current Work*, 216.

92. Fisher, "Building the New City": 86–91; Battery Park City Authority, *Annual Report for 1989/1990* (New York: Battery Park City Authority, 1990); "Waterfront Neighborhood," *Progressive Architecture* 71 (January 1990): 120–21.

93. "New Players at Battery Park City," *Oculus* 54 (February 1992): 10; Stanislaus von Moos, *Venturi, Scott Brown & Associates: Buildings and Projects, 1986–1998* (New York: Monacelli Press, 1999), 84–85.

94. Ralph Lerner Architect, *Battery Park City: Design Guidelines for the North Residential Neighborhood* (New York: Battery Park City Authority, 1994); David W. Dunlap, "Opening New Fronts at Battery Park City," *New York Times* (September 4, 1994), IX: 1, 7; Susan Doubilet, "Battery Park City: The Future Is Now," *Oculus* 57 (October 1994): 6–7.

95. "Alexander Gorlin," *GA Houses* 45 (March 1995): 58–59; *Alexander Gorlin: Buildings and Projects* (New York: Rizzoli International Publications, 1997), 140.

96. *Alexander Gorlin: Buildings and Projects*, 140.

97. Suzanne Stephens, "Avant-Garde Information Booths," *New York Times* (July 28, 1994), C: 3; "Alexander Gorlin," *GA Houses* 45 (March 1995): 60; Jayne Merkel, "Expanding Battery Park City," *Oculus* 58 (June 1996): 11–12; *Alexander Gorlin: Buildings and Projects*, 9, 144; Charles Linn, "Small Projects," *Architectural Record* 186 (June 1998): 108–9; Andrea Truppin, "Whimsical Booths Stand Guard over Battery Park City," *Architectural Record* 186 (June 1998): 109; White and Willensky, *AIA Guide* (2000), 48.

98. Alexander Gorlin, quoted in Stephens, "Avant-Garde Information Booths": 3.

99. Josh Barbanel, "3 Exchanges Plan Move to Battery," *New York Times* (November 13, 1985): 1, D: 23; "The Exchange Project," *Architecture + Urbanism* 211 (April 1988): 136–39; Richard Levine, "4 Exchanges Spurn Moving to New Jersey," *New York Times* (November 7, 1990), B: 11–12; David W. Dunlap, "Commercial Property/Exchanges Headquarters," *New York Times* (August 25, 1991), VIII: 13; Judith Warner, "Board 1/ 'Unnecessary' Commodities Building Opposed," *New York Observer* (October 28, 1991): 8; "Tribeca Development," *Oculus* 54 (November 1991): 11; Charles V.

Bagli, "TriBeCa NIMBY II; Commodity Traders Still Need Home," *New York Observer* (December 2, 1991): 1, 19; Stanley W. Angrist and Neil Barsky, "New York Merc Is out of Plan for New Facility," *Wall Street Journal* (January 9, 1992), C: 12; James Bennet, "Big Exchange Withdraws from Joint Futures Project," *New York Times* (January 10, 1992), B: 3; Suzanne Stephens, "The Changing Exchanges," *Oculus* 54 (February 1992): 8–10; Suzanne Stephens, "Exchanges Update," *Oculus* 54 (March 1992): 7; James C. McKinley Jr., "Exchanges in TriBeCa Approved," *New York Times* (March 6, 1992), B: 2; Charles V. Bagli, "Will Industry Close Book on TriBeCa Comex H.Q.?" *New York Observer* (March 23, 1992): 1, 16; Calvin Sims, "3 Exchanges Agree to Stay, and New York City to Pay Half," *New York Times* (August 14, 1992), B: 1–2; Calvin Sims, "New Jersey Still Beckons to Exchange in New York," *New York Times* (August 15, 1992): 23; Suzanne Stephens, "Status," *Oculus* 55 (October 1992): 7; Adam Bryant, "Memberships Vote to Merge 2 New York Futures Markets," *New York Times* (April 26, 1994), D: 1; "Commodities Exchanges Plan to Move to New Headquarters," *Wall Street Journal* (August 5, 1994), C: 19; Steven Lee Myers, "Exchange to Build and Stay in Manhattan," *New York Times* (August 5, 1994), B: 3; David W. Dunlap, "Opening New Fronts at Battery Park City," *New York Times* (September 4, 1994), IX: 1, 7; Susan Doubilet, "NYMEX to BPCA: Yes," *Oculus* 57 (October 1994): 8; "Pulse; Plans," *Engineering News-Record* 234 (March 27, 1995): 92; "Two Exchanges Plan a Move Across the Hudson," *New York Times* (July 13, 1995), D: 6; "Work Starts on a New $90M Home for the N.Y. Mercantile Exchange," *New York Construction News* 43 (October 23, 1995): 1, 5; "New York Mercantile Exchange Building," *Oculus* 58 (November 1995): 4; Charles V. Bagli, "Coffee, Sugar, Amex Greedy for Last Site Down in Battery Park," *New York Observer* (June 10, 1996): 1, 24; "Tax Abatements and Exemptions Help Manhattan's Battery Park City Rise Again," *Architectural Record* 184 (August 1996): 48–49; John Holusha, "For the Mercantile Exchange, the Futures Is Now," *New York Times* (April 20, 1997), IX: 7; Peter Grant, "Merc's First Day in New Home," *New York Daily News* (July 8, 1997): 47; David M. Halbfinger, "Show Them the Money; New York's Financial District Is a Must-See Tourist Destination," *New York Times* (August 27, 1997), B: 1, 6; Charles Lockwood, "Battery Park City," *Urban Land* 56 (October 1997): 97–98, 122; David W. Dunlap, "Filling in the Blanks at Battery Park City," *New York Times* (February 7, 1999), XI: 1, 22; White and Willensky, *AIA Guide* (2000), 51.

100. Stephens, "The Changing Exchanges": 8.

101. Michael Sorkin, quoted in Stephens, "The Changing Exchanges": 9.

102. "Wooing Foreigners," *The Economist* 323 (June 6, 1992): 26; Douglas Feiden, Alan Mirabella, and Marcia Parker, "Battery Park Joining Fray to Lure Unicef," *Crain's New York Business* (August 10, 1992): 6; Nick Ravo, "2 Finalists Battle for an Expanded Unicef," *New York Times* (July 18, 1993), X: 1.

103. David Childs, quoted in Lockwood, "Battery Park City": 98.

104. www.som.com/html/new_york_mercantile_exhange. html.

105. Battery Park City Authority, *Annual Review* (New York: Battery Park City Authority, 1994); David W. Dunlap, "Opening New Fronts at Battery Park City," *New York Times* (September 4, 1994), IX: 1, 7; Tracie Rozhon, "What's Up–And What's Going Up," *New York Times* (January 15, 1995), X: 1; "New York," *Engineering News-Record* 234 (June 5, 1995): 72; Jayne Merkel, "Expanding Battery Park City," *Oculus* 55 (June 1996): 11–13; "Tax Abatements and Exemptions Help Manhattan's Battery Park City Rise Again," *Architectural Record* 184 (August 1996): 48; Rachelle Garbarine, "Battery Park City Plans Apartments and a School," *New York Times* (July 25, 1997), B: 5; Jayne Merkel, "Children's Architecture," *Oculus* 60 (March 1998): 11–15; Terry Pristin, "Battery Park City to Give Middle-Income Renters a Break," *New York Times* (March 24, 1998): 8; *Pasanella + Klein Stolzman + Berg* (Gloucester, Mass.: Rockport Publishers, 1999), 54–57; Kira L. Gould, "P.S./I.S. 89: A New School Downtown," *Oculus* 61 (February 1999): 18; Dunlap, "Filling in the Blanks at Battery Park City": 1, 22; White and Willensky, *AIA Guide* (2000), 51; "Brick in Architecture: The 2000 Residential Issue: Tribeca Bridge Tower and P.S./I.S. 89," *Architecture* 89 (November 2000):17–24.

106. Battery Park City Authority, *Annual Review* (1994), 3.

107. White and Willensky, *AIA Guide* (2000), 51.

108. *Pasanella + Klein Stolzman + Berg*, 54.

109. Dunlap, "Opening New Fronts at Battery Park City": 1; Merkel, "Expanding Battery Park City": 11–13; "Tax Abatements and Exemptions Help Manhattan's Battery Park City Rise Again": 48; Rachelle Garbarine, "Financing Is Ready for 3 Mixed-Income Buildings," *New York Times* (September 5, 1997), B: 6; David S. Chartock, "Tribeca Pointe Rising," *New York Construction News* 45 (January 1998): 12–13, 15–16, 18; "HRH Building Tribeca Park," *New York Construction News* 45 (June 1998): 13; Nina Rappaport, "On the Waterfront," *Oculus* 61 (October 1998): 8–15; Rachelle Garbarine, "42-Story Apartment Tower for Battery Park City," *New York Times* (October 2, 1998), B: 8; Battery Park City Authority, *Annual Report* (New York: Battery Park City Authority, 1999); Nina Rappaport, "Winners!" *Oculus* 61 (January 1999): 4; Kate Kelly, "Building Boom of 1999: Will Manhattan Change into Tacky Condo Town?" *New York Observer* (February 1, 1999): 1, 11; Dunlap, "Filling in the Blanks at Battery Park City": 1, 22; Trish Hall, "Choosing an Apartment from the Office Window," *New York Times* (March 21, 1999), XI: 4; Jo B. Hoffman, "Financial District," *New York* 32 (April 12, 1999): 60, 62–63; Alexandra Lange, "The Towers That Be," *New York* 32 (April 12, 1999): 42–44; Jayne Merkel, "Home, Sweet Home?" *Oculus* 62 (September 1999): 12–13; Trish Hall, "Former Navy Man Finds a Home by the River," *New York Times* (October 31, 1999), XI: 2; White and Willensky, *AIA Guide* (2000), 51–52;

Georges Binder, ed., *Sky High Living: Contemporary High-Rise Apartment and Mixed-Use Buildings* (Mulgrave, Australia: Images Publishing, 2002), 112–13; Francis Morrone, "Abroad in New York," *New York Sun* (August 16–18, 2002): 11; Jayne Merkel, "Architecture in Developer Land," *Architectural Design* 74 (January/February 2004): 6–15.

110. Scott Keller, quoted in Garbarine, "42-Story Apartment Tower for Battery Park City": 8.

111. Merkel, "Home, Sweet Home?": 13.

112. Morrone, "Abroad in New York": 11.

113. Andrew Jacobs, "Why the Time Might Be Right for a Hotel," *New York Times* (December 24, 1995), XIII: 6; "$110 Million Development for Battery Park City," *New York Times* (August 18, 1996), IX: 1; "New Battery Park City Complex," *Architectural Record* 184 (October 1996): 17; Thomas J. Lueck, "Battery Park City Authority Chooses Builder for First Hotel," *New York Times* (May 13, 1997), B: 6; Bernard Stamler, "For the Cinematically Deprived," *New York Times* (September 21, 1997), XIII: 8; Charles V. Bagli, "Hotel Business Is Growing Bigger, Busier and Faster," *New York Times* (November 23, 1997): 39; Alan S. Oser, "All Over Town, Movie Screens Are Popping Up," *New York Times* (December 30, 1998), B: 6; *Hugh L. Carey Battery Park City Authority Annual Review 1999* (New York: Hugh L. Carey Battery Park City Authority, 1999), 19; Dunlap, "Filling in the Blanks at Battery Park City": 1, 22; White and Willensky, *AIA Guide* (2000), 51; Abby Bussel, "Room Boom," *Grid* 2 (March + April 2000): 94, 96; Jayne Merkel, "Gotham Hospitality," *Oculus* 62 (March 7, 2000): 12–17; Abby Bussel, "Traveling Show," *Grid* 2 (May + June 2000): 98–101; Joseph Giovannini, "The Inn Crowd," *New York* 33 (August 21, 2000): 58; "On the Drawing Boards," *Oculus* 63 (November 2000): 6.

114. Giovannini, "The Inn Crowd": 58.

115. Jayne Merkel, "Aging in Place in New York: Senior Housing," *Oculus* 61 (September 1998): 12–15; *Hugh L. Carey Battery Park City Authority Annual Review 1999*, 19; Dunlap, "Filling in the Blanks at Battery Park City": 1, 22; White and Willensky, *AIA Guide* (2000), 51; Alan S. Oser, "More Elderly Living Options, at a Price," *New York Times* (October 8, 2000), XI: 1, 6; Terry Pristin, "Luxury Building," *New York Times* (October 19, 2000), B: 12.

116. *Hugh L. Carey Battery Park City Authority Residential Environmental Guidelines* (New York, January 26, 2000).

117. David W. Dunlap, "Streets Vanish from Master Plans," *New York Times* (June 6, 2002), B: 3.

118. Michael Van Valkenburgh, "Faculty Project; Teardrop Park, Battery Park City," *Harvard Design Magazine* 12 (Fall 2000): 92–93; Rachelle Garbarine, "Enclave Turns Green, Inside and Out," *New York Times* (March 23, 2001), B: 7; http://www.mvvainc.com.

119. http://www.mvvainc.com.

120. Terry Pristin, "Battery Park City Plans New Building," *New York Times* (June 9, 1998), B: 8; Peter Grant, "It's Rockrose Solid; Developer Lands Site down by the Riverside," *New York Daily News* (December 14, 1998): 29; Garbarine, "Enclave Turns Green, Inside and Out": 7.

121. Julie V. Iovine, "At Battery Park City, Developers Seek a New Kind of Green," *New York Times* (February 10, 2000), F: 7; "Green Building Planned for Battery Park City," *New York Construction News* 48 (April 2000): 7; Nadine M. Post with Joann Gonchar, "'Sustainable' Living on the Rise," *Engineering News-Record* 245 (July 3, 2000): 12–13; David Caplan, "Clean Living," *Wallpaper* (September 2000): 108; "Green Apartment Bldg. to Start in Battery Park," *New York Construction News* 48 (November 2000): 7; Rachelle Garbarine, "'Green' Tower at Battery Park City," *New York Times* (November 3, 2000), B: 12; Garbarine, "Enclave Turns Green, Inside and Out": 7; Alec Appelbaum, "Green Giant," *Metropolis* 21 (October 2001): 58, 60, 62; David Gissen, ed., *Big & Green: Toward Sustainable Architecture in the 21st Century* (New York: Princeton Architectural Press; Washington, D.C.: National Building Museum, 2002), 156–57; Jessica Fein, "Happy Endings," *Metropolis* 22 (November 2002): 18; Rafael Pelli, "A Lesson in Green City Building," *Metropolis* 22 (November 2002): 17; Douglas R. Porter, Edward J. Blakely, and Alexander E. Kalamaros, "Sustainable Infill," *Urban Land* 62 (May 2003): 60–69; James Gardner, "These Days, It's Hip to Be Green," *New York Sun* (November 10, 2003): 17; Motoko Rich, "Aiming to Be the Next Big Amenity," *New York Times* (November 13, 2003), D: 1, 6.

122. Garbarine, "Enclave Turns Green, Inside and Out": 7; Garbarine, "'Green' Tower at Battery Park City": 12.

123. Stern, Mellins, and Fishman, *New York 1960*, 758–60.

124. For Goodman's scheme, see Kimberly J. Elman and Angela Giral, eds., *Percival Goodman: Architect, Planner, Teacher, Painter* (New York: Miriam and Ira D. Wallach Art Gallery, Columbia University in the City of New York, 2001), 41–42, 187. For Mendelsohn's scheme, see Bruno Zevi, *Erich Mendelsohn: The Complete Works* (Basel: Birkhäuser, 1999), 394–407.

125. Stern, Mellins, and Fishman, *New York 1960*, 759.

126. Stern, Mellins, and Fishman, *New York 1960*, 196–97; Kent Larsen, *Louis I. Kahn: Unbuilt Masterworks* (New York: Monacelli Press, 2000), 110–23.

127. "Panel Is Named to Plan a Holocaust Memorial," *New York Times* (May 3, 1981): 39.

128. Deirdre Carmody and Clyde Haberman, "Commission Seeking Site for Holocaust Memorial," *New York Times* (September 17, 1982), B: 3; Lawrence Van Gelder, "One Man's Mission for Six Million," *New York Times* (September 5, 1983), XXI: 2. For the Ethical Culture Society, see Stern, Gilmartin, and Massengale, *New York 1900*, 392–93. For the Gallery of Modern Art, see Stern, Mellins, and Fishman, *New York 1960*, 671–72. For the Custom House, see Stern, Gilmartin, and Massengale, *New York 1900*, 74–77.

129. Michael Oreskes, "Battery Park City Offers Holocaust

Museum a Site," *New York Times* (April 5, 1985): 1, B: 3; Robert Morgenthau, "A Way to Illuminate the Holocaust," *New York Times* (May 2, 1985): 27; Joseph Berger, "Holocaust Memorial to Rise near Battery Park," *New York Times* (September 5, 1986): 1, B: 4; Joseph Giovannini, "Museum's Design Is Based on Promising Concept," *New York Times* (September 5, 1986), B: 4; Lisa W. Foderaro, "About Real Estate," *New York Times* (November 14, 1986): 28; "New York," *Engineering News-Record* 218 (April 23, 1987): 28; Michael Sorkin, "Reconstructing the Holocaust," *Village Voice* 32 (June 23, 1987): 94, reprinted in Sorkin, *Exquisite Corpse*, 223–27; "Plum Jobs," *Interiors* 147 (August 1987): 196; "Director Is Named for Holocaust Museum," *New York Times* (November 7, 1987): 11; *James Stewart Polshek: Context and Responsibility*, 54–55, 221–23; Douglas C. McGill, "A Museum Taking Shape to Tell the Holocaust Story," *New York Times* (March 7, 1988), B: 1–2; Douglas C. McGill, "Holocaust Museum Seeks the Artifacts of Suffering," *New York Times* (April 11, 1988), B: 1, 4; Jean Nathan, "Holocaust Panel Still Hopes for a June Groundbreaking on Its $70 Million Museum," *New York Observer* (March 14, 1988): 6; Sam Roberts, "Bloody Steps Take a Liberator On to a Museum," *New York Times* (June 13, 1988), B: 1; Thomas J. Lueck, "City and State at Odds on Battery Park Hotel Plan," *New York Times* (September 25, 1988): 36; "Holocaust Museum Getting New Help," *New York* 21 (November 28, 1988): 21; Edward A. Adams, "Museum Jinxed Again," *New York Post* (December 8, 1988): 73, 86; Thomas J. Lueck, "Agency Revises a Museum Plan at Battery Park," *New York Times* (February 24, 1989), B: 3; Martin Weyl, "How Do Museums Speak the Unspeakable?" *New York Times* (June 11, 1989), II: 38; Susan Chira, "Waterfront Developer Picked," *New York Times* (September 24, 1989): 43; Joseph P. Griffith, "Living Memorial to Go up Downtown," *Metropolis* 9 (October 1989): 27–28; "Agreement Is Reached on Holocaust Museum," *New York Times* (July 27, 1991): 26; Fran Rensbarger, "Two Memorials to Holocaust," *New York Times* (July 12, 1992), X: 13.

130. James Stewart Polshek, "Notes on My Life and Work," in *James Stewart Polshek: Context and Responsibility*, 55.

131. Giovannini, "Museum's Design Is Based on Promising Concept": 4.

132. Allan Greenberg, "Statement," in David G. De Long, Helen Searing, and Robert A. M. Stern, eds., *American Architecture: Innovation and Tradition* (New York: Rizzoli International Publications, 1986), 216–17; Sorkin, "Reconstructing the Holocaust": 94; *Allan Greenberg: Selected Works* (London: Academy Editions, 1995), 124.

133. Allan Greenberg, letter to author (November 25, 2003).

134. Sorkin, "Reconstructing the Holocaust": 94.

135. Diana Jean Schemo, "New York Is Still Waiting for Its Own Holocaust Museum," *New York Times* (December 12, 1993): 45; "Holocaust Memorial to Become Reality," *New York Times* (August 19, 1994): 1; David W. Dunlap, "Holocaust Memorial Museum to Rise in Battery Park City," *New York Times* (August 19, 1994), B: 1–2; David W. Dunlap, "A Holocaust Memorial for New York," *New York Times* (August 21, 1994), IV: 1; Sue Fishkoff, "Lease Signed for New York Holocaust Memorial Museum," *Jerusalem Post* (August 21, 1994): 12; David W. Dunlap, "Opening New Fronts at Battery Park City," *New York Times* (September 4, 1994), IX: 1, 7; Ann C. Sullivan, "Construction Begins on NYC Holocaust Museum," *Architecture* 83 (October 1994): 33; Susan Doubilet, "Battery Park City: The Holocaust Memorial Museum: Agonies and Ironies," *Oculus* 57 (October 1994): 6–7; Marilyn Henry, "Jewish Vote Wooed at Ceremony for New York Holocaust Museum," *Jerusalem Post* (October 17, 1994): 2; Vince Beiser, "New York's Holocaust Dilemma," *Jerusalem Post* (October 24, 1994): 35; Clyde Haberman, "Memories of Holocaust, and Debate," *New York Times* (April 16, 1996), B: 1; Jayne Merkel, "Expanding Battery Park City," *Oculus* 58 (June 1996): 11–12; Nadine Brozan, "Chronicle," *New York Times* (June 6, 1997), D: 22; "Rabbis Sue to Block New Holocaust Museum," *New York Times* (September 6, 1997): 26; Julie Salamon, "Walls That Echo of the Unspeakable," *New York Times* (September 7, 1997), II: 84, 86; Karrie Jacobs, "Never Forget," *New York* 30 (September 8, 1997): 118–20; Esther B. Fein, "Survivors of Evil Dedicate Reminder for the Future," *New York Times* (September 12, 1997): 1, B: 3; Michael Kimmelman, "In the Faces of the Living, Honor for the Dead," *New York Times* (September 12, 1997), C: 1, 26; A. M. Rosenthal, "On My Mind: Look, See Us Alive," *New York Times* (September 12, 1997): 35; Gene Sloan, "Headline Captures Rich Jewish Heritage," *USA Today* (September 12, 1997): 9D; David Gonzalez, "Simple Dress in Spotlight, Triumphantly," *New York Times* (September 13, 1997): 25; Elisabeth Bumiller, "After 50 Years of Struggle, Redemption," *New York Times* (September 15, 1997): 37, 43; Herbert Muschamp, "Museum Tells a Tale of Resilience, Tuned to the Key of Life," *New York Times* (September 15, 1997), E: 1–2; Virginia Breen, "Museum Opens Eyes to Holocaust," *New York Daily News* (September 16, 1997): 17; "Opening Day at Holocaust Museum," *New York Times* (September 16, 1997), B: 6; Amy Gamerman, "New Museum of Jewish Heritage," *Wall Street Journal* (September 18, 1997): 12; Frank A. Folisi, "Memorial to Whom?" letter to the editor, *New York Times* (September 19, 1997): 30; "New York's Holocaust Museum," *New York Observer* (September 29, 1997): 4; Clyde Haberman, "In Memorial on Holocaust, Message Is Life," *New York Times* (October 3, 1997), B: 1; Aaron Betsky, "Building Absence," *Archis* (July 1998): 40–47; Paul Goldberger, "The Wrecking Ball: The Little Pavilion That Could," *New Yorker* (January 21, 2002): 26. For Freed's building, see Adrian Dannatt, *United States Holocaust Memorial Museum: James Ingo Freed* (London: Phaidon Press, 1995).

136. Muschamp, "Museum Tells a Tale of Resilience, Tuned to the Key of Life": 1–2.

137. Dan Barry, "Museum-Financing Dispute Underscores Giuliani-Pataki Rift," *New York Times* (February 4, 1999), B: 1, 8; Abby Goodnough, "Mayor 'Baffled' by Dispute on Museum Funds," *New York Times* (February 5, 1999), B: 8; Dunlap, "Filling in the Blanks at Battery Park City": 1, 22; Amy Waldman, "City Pledges $22 Million to Expand a Museum," *New York Times* (April 19, 1999), B: 6; Ralph Blumenthal, "A Museum Wing to Bear Witness to Jewish Life," *New York Times* (October 26, 2000), E: 1, 6; "Holocaust Museum Begins Expansion," *New York Times* (October 27, 2000), B: 8; Peter Reina and Nadine M. Post, "Monuments in Three Cities to Tell Tales of the Holocaust," *Engineering News-Record* 245 (November 6, 2000): 15; Suzanne Stephens, "Roche Adds to His NYC Jewish Museum," *Architectural Record* 188 (December 2000): 36; Ralph Blumenthal, "Museum of Jewish Heritage Names New Director," *New York Times* (December 8, 2000), E: 53; Balfour, *World Cities: New York*, 141; "Holocaust Memorial to Add East Wing," *New York Construction News* 49 (March 2001): 13; Robert M. Morgenthau, "Museum Does Its Part," letter to the editor, *New York Times* (January 12, 2002): 14; Eric Herman, "Holocaust Museum to Grow Four Times Its Size," *New York Daily News* (October 8, 2002): 53; David W. Dunlap, "A Monument to Survival Casts Its Resolve in Stone," *New York Times* (September 12, 2003), E: 2; Jason Edward Kaufman, "Stones Full of Life and Memory," *New York Times* (September 14, 2003), II: 35; Justin Davidson, "New, Tangential Wing Recasts a Museum," *New York Newsday* (September 18, 2003), B: 2; "Remembering the Dead with New Life," *New York Times* (September 20, 2003), B: 6; Simon Schama, "The Stone Gardener: A Land Artist Comes to Lower Manhattan," *New Yorker* 36 (September 22, 2003): 126.

138. Schama, "The Stone Gardner: A Land Artist Comes to Lower Manhattan": 126.

139. Davidson, "New, Tangential Wing Recasts a Museum": 2.

140. Goldberger, "The Wrecking Ball: The Little Pavilion That Could": 26. Also see White and Willensky, *AIA Guide* (2000), 47.

141. *Hugh L. Carey Battery Park City Authority Annual Review 1999*, 16; Dunlap, "Filling in the Blanks at Battery Park City": 1, 22; White and Willensky, *AIA Guide* (2000), 47.

142. Peter Grant, "Going Upscale with Downtown Hotel," *New York Daily News* (February 3, 1988): 23; David W. Dunlap, "Ritz-Carlton Luxury Hotel Planned at Manhattan's Tip," *New York Times* (January 22, 1999), B: 3; "5-Star Hotel Planned for Battery Park City," *New York Construction News* 47 (April 1999): 13; Deborah Schoeneman, "Putting on the Gated Ritz," *New York Observer* (April 10, 2000): 25–26; David W. Dunlap, "Skyscraper Museum Gets a Suitable Home," *New York Times* (September 20, 2000), B: 1, 6; Craig Kellogg, "In Battery Park City," *Oculus* 63 (November 2000): 5–6; Louise Kramer, "Ritz Fights Blitz," *Crain's New York Business* (October 8, 2001): 3, 34; Terry Pristin, "Trying to Forget Disaster Around the Corner," *New York Times* (October 14, 2001): 34; Binder, ed., *Sky High Living*, 186–87; Ray Cormier, "Lady Liberty's Newest Neighbor Is a Ritz-Carlton," *New York Times* (January 27, 2002), V: 3; Susan Saulny, "Hotel Plans a Defiant Debut near Ground Zero," *New York Times* (January 28, 2002), B: 4; John E. Czarnecki, "First Downtown N.Y.C. Building Completed Post 9/11 Opens," *Architectural Record* 190 (January 2002): 28; Jen Renzi, "Standing Tall in New York," *Interior Design* 73 (March 2002): S16-S21; "Ritzy Digs," *Oculus* 64 (April 2002): 6–7; "Ritz Carlton Hotel & Residences, Downtown New York," *New York Construction News* 49 (June 2002): 27; Fred Bruning, "Onward, Upward: Skyscraper Museum Is Almost Home Free," *Newsday* (August 13, 2002), B: 3; "Ritz Carlton Hotel & Residences, Battery Park," *New York Construction News* 50 (June 2003): 37.

143. "Battery Park City Holds Hotel Key," *New York* 21 (August 22, 1988): 15; "BPCA to Issue Nov. RFP for New Hotel," *New York Construction News* (September 25, 1989): 1, 19.

144. Frank Nicholson, quoted in Renzi, "Standing Tall in New York": S20.

145. Carol Willis, quoted in Bruning, "Onward, Upward": 3.

146. Roger Duffy, quoted in Dunlap, "Skyscraper Museum Gets a Suitable Home": 6.

147. Grace Glueck, "Art People," *New York Times* (May 16, 1980), C: 24; Jennifer Dunning, "Dance: 'Art on the Beach,'" *New York Times* (August 6, 1980), C: 16; Jennifer Dunning, "The People Behind the Scenes at Battery Park City," *New York Times* (August 1, 1981): 9; Grace Glueck, "Sculpture: On the Beach," *New York Times* (June 25, 1982), C: 27; Grace Glueck, "Engaging Experiments Transform a Sandy Site," *New York Times* (July 31, 1983), II: 25; Jennifer Dunning, "Dance: A Collaboration in the Sand," *New York Times* (August 23, 1983), C: 13; Jennifer Dunning, "15 Reasons Why New York Is Always New," *New York Times* (September 7, 1984), C: 1, 22; Grace Glueck, "Art: 'Art on the Beach,' Works and Performance," *New York Times* (July 5, 1985), C: 14; Ian T. Macauley, "Public Art Group Is Established," *New York Times* (October 27, 1985), XIII: 4; Eric Darton, *Divided We Stand* (New York: Basic Books, 1999), 176–77; Herbert Muschamp, "The New Ground Zero," *New York Times* (August 31, 2003), II: 1, 21.

148. Glueck, "Engaging Experiments Transform a Sandy Site": 25.

149. Quoted in Muschamp, "The New Ground Zero": 21.

150. Grace Glueck, "A Critic's Guide to the Outdoor Sculpture Shows," *New York Times* (June 11, 1982), C: 1, 21; Jill Hartz, ed., *Agnes Denes* (Ithaca, N.Y.: Herbert F. Johnson Museum of Art, Cornell University, 1992), 118–20; Agnes Denes, *Agnes Denes: Projects for Public Space: A Retrospective* (Lewisburg, Penn.: Samek Art Gallery, Bucknell University, 2003), 29.

151. Agnes Denes, "Wheatfield–A Confrontation: The Philosophy," in Hartz, ed., *Agnes Denes*, 118.

152. Glueck, "A Critic's Guide to the Outdoor Sculpture Shows": 21.

153. Michael Brenson, "Battery Park Plaza Design Unveiled," *New York Times* (December 1, 1983), C: 28; John Russell, "Where City Meets Sea to Become Art," *New York Times* (December 11, 1983), II: 1; Battery Park City Authority, *Annual Report 1984* (New York: Battery Park City Authority, 1984); "Names and News," *Oculus* 45 (January 1984): 10; Benjamin Forgey, "Battery Park City: Building an Example," *Washington Post* (October 13, 1984), B: 1; Douglas C. McGill, "Architect and Artists Collaborate on Battery Park City Plaza," *New York Times* (January 31, 1985), C: 17; "The World Financial Center," *Oculus* 46 (March 1985): 2–15; Karson, "Battery Park City Takes Manhattan": 64–69; Victoria Geibel, "The Act of Engagement," *Metropolis* 6 (July-August 1986): 32–33, 43, 46–47; Dean and Freeman, "The Rockefeller Center of the '80s?": 36–43; Wiseman, "A Vision with a Message": 112–21; Kay Kaiser, "Battery Park Commits No Assault," *San Diego Union-Tribune* (November 29, 1987), F: 1; *Architectural Art: A Discourse* (New York: American Craft Museum, 1988), 48–49; Paul Goldberger, "Public Space Gets a New Cachet in New York," *New York Times* (May 22, 1988), II: 35; Michael Kimmelman, "The Integration of Art and Public Architecture," *New York Times* (May 27, 1988), C: 24; Goldberger, "Winter Garden at Battery Park City": 15; Carter B. Horsley, "The Garden of Plenty," *New York Post* (October 13, 1988): 53; Campbell, "Tented City": 24–25, 27; Catherine Howett, "Battery Park City," *Landscape Architecture* 79 (May 1989): 51–57; Michael Brenson, "Big Sculpture for Wide-Open Spaces," *New York Times* (July 21, 1989), C: 1; Paola Antonelli, "Opere Pubbliche e Private dal 1968 al 1989: Siah Armajani," *Domus* 713 (February 1990): 48–57; Ken Johnson, "Poetry and Public Service," *Art in America* 78 (March 1990): 160–63, 219; Gill, "The Sky Line: Battery Park City": 69–78; Goldberger, "Battery Park City's Brave New World": 142, 144, 146, 148; *Siah Armajani: Elements* (New York: Max Protetch Gallery, 1991), no pagination; Paola Antonelli, "Public Art a Battery Park City, NY, 1982/90," *Domus* 723 (January 1991): 78–89; Marc Treib, "Arte Pubblica e Spazi Pubblici," *Casabella* 56 (January/February 1992): 94–99; *Siah Armajani: Contributions Anarchistes, 1962–1994* (Nice: Centre National d'Art Contemporain, 1994), 116–17, 153; Breen and Rigby, *Waterfronts: Cities Reclaim Their Edge*, 219–22, 278–82; Deyan Sudjic, "Some Sign that People Do Not Totally Regret Life," *Blueprint* 113 (December/January 1995): 44–45; White and Willensky, *AIA Guide* (2000), 50.

154. Scott Burton, quoted in Geibel, "The Act of Engagement": 43.

155. Armajani, quoted in *Siah Armajani: Contributions Anarchistes, 1962–1994*, 153.

156. Cesar Pelli, quoted in McGill, "Architect and Artists Collaborate on Battery Park City Plaza": 17.

157. Johnson, "Poetry and Public Service": 219.

158. Johnson, "Poetry and Public Service": 219.

159. Goldberger, "Winter Garden at Battery Park City": 15.

160. Johnson, "Poetry and Public Service": 163.

161. Antonelli, "Public Art a Battery Park City, NY, 1982/90": 84.

162. Kaiser, "Battery Park Commits No Assault": 1.

163. "Un Port Couvert," *L'Architecture d'Aujourd'hui* 243 (February 1986): 13; Bernard McCormick, "Giving Berth to the Super-Yachts," *Avenue* (May 1987): 152–54, 156, 158; Lisa W. Foderado, "At Battery Park City, Opulent Marina," *New York Times* (July 5, 1987), VIII: 1; Donna Cornachio, "Saint-Tropez on the Hudson," *Metropolis* 8 (January-February 1989): 19–20; "Shipshape Life Style," *Los Angeles Times* (April 2, 1989), VIII: 14; Joanna Molloy, "The Haute Harbor," *New York* 22 (April 17, 1989): 28; David W. Dunlap, "Parking That Yacht—for $2.50 Million," *New York Times* (June 19, 1989), B: 3; "Fancy Gardens and Yachts," editorial, *New York Observer* (May 7, 1990): 4; Laurie Goodstein, "Traveling Yacht Owners Giving Pricey Harbor Basins the Slip," *Los Angeles Times* (October 7, 1990): 18; "Wave of the Future Recedes," *New York Times* (January 19, 1992), X: 1; Philip Jodidio, *Sir Norman Foster* (Cologne: Taschen, 1997), 162.

164. "Governor Pataki Unveils New York City Police Officers Memorial," press release (October 20, 1997); White and Willensky, *AIA Guide* (2000), 50.

165. White and Willensky, *AIA Guide* (1988), 47; Mark A. Uhlig, "Site in Manhattan Is Chosen for a New Ferry Terminal," *New York Times* (May 8, 1988): 27; "First Ferries for New Commuter Service Arrive in Harbor," *New York Times* (September 19, 1989), B: 4; "After 22 Years, Manhattan-Hoboken Ferry Service Is Back," *New York Times* (October 17, 1989), B: 1; "Ferris vs. Gridlock," editorial, *New York Times* (October 17, 1989): 26; "A New Ferryboat's Maiden Voyage Between Hoboken and New York," *New York Times* (February 6, 1993): 26.

166. "Down at Battery Park City," *Oculus* 56 (May 1994): 5; Douglas P. Reed, "Der Park als Ort des Wandels," *Garten + Landschaft* 105 (March 1995): 9–15, 36; Heidi Landecker, "Waterfront Connection," *Architecture* 84 (August 1995): 56–61; American Institute of Architects: New York Chapter, *Annals* (New York: American Institute of Architects, 1996–97), 28; Dobney, ed., *Mitchell/Giurgola Architects: Selected and Current Works*, 12–14, 122–29, 245; "Arquitectura de Hoy en Movilidad Urbana," *Escala* 30 (1997): 87–91; Martin Puryear (Barcelona: Fundción "La Caixa," 1997), 126; Carles Broto, *Urbanism* (Barcelona: LINKS International, 1998), 144–51.

167. For Endless Column, see Friedrich Tejn Bach, Margit Rowell, and Ann Temkin, *Constantin Brancusi: 1876–1957* (Cambridge, Mass.: MIT Press, 1995).

168. Martin Puryear, quoted in Landecker, "Waterfront Connection": 60.

169. Mildred F. Schmertz, "The Aesthetic Dimension," in Dobney, ed., *Mitchell/Giurgola Architects: Selected and Current Works*, 8–15.

170. Alexander Cooper Associates, *Battery Park City Draft Summary Report and 1979 Master Plan* (New York, October

1979); Muschamp, "Learning from New York": 4–5; Paul Goldberger, "Landscape as Design: 2 Shows Focus on Olmsted," *New York Times* (October 13, 1981), C: 21; "Behold, A Battery Park," editorial, *New York Times* (October 31, 1981): 26; Philip Shenon, "Along the Battery Esplanade, Salt Air, Greenery and Peace," *New York Times* (June 26, 1983): 29; Karson, "Battery Park City Takes Manhattan": 64–69; Daralice Donkorvoet Boles, "Not Since Robert Moses: The Battery Park Esplanade," *Progressive Architecture* 64 (July 1983): 24; "Names and News," *Oculus* 45 (September 1983): 9; "On the Waterfront…," *Architectural Record* 171 (September 1983): 41; "The Esplanade," *Oculus* 46 (February 1985): 16; "Battery Park City, New York," *Progressive Architecture* 67 (January 1986): 149; Peter Lemos, "Battery Park City Update," *Progressive Architecture* 67 (June 1986): 37–38; Iver Peterson, "Battery Park City: A New Phase Begins," *New York Times* (June 19, 1988), X: 1, 18; "Esplanade Recalls Old New York," *New York Times* (July 3, 1986), C: 3; "Battery Park City Esplanades I and II," *Landscape Architecture* 78 (November 1988): 42–43; Goldberger, "To the Heights of Simplicity": 21, 54–56, 58; Norbert Schindler, "Battery Park on New York's New River Front," *Garten + Landschaft* 98 (December 1988): 43–48; Peter Hellman, "The Esplanade at Battery Park City," *New York* 22 (May 22, 1989): 33; Gill, "The Sky Line: Battery Park City": 69–78; Sylvia Lewis, "Mr. Precedent," *Planning* 62 (August 1996): 10–15.

171. Muschamp, "Learning from New York": 4.

172. Goldberger, "Landscape as Design: 2 Shows Focus on Olmsted": 21.

173. Goldberger, "The Intent Was Not to Shock but to Please": 23–24.

174. Meyer S. Frucher, quoted in Albert Scardino, "Marketing Real Estate with Art," *New York Times* (February 1, 1987), III: 23.

175. Brenson, "Battery Park Plaza Design Unveiled": 28; Russell, "Where City Meets Sea to Become Art": 1; Kay Larson, "Combat Zone," *New York* 18 (May 13, 1985): 117–18; Douglas C. McGill, "Battery to Get Four More Artworks," *New York Times* (April 25, 1985), C: 21; Patricia C. Phillips, "Battery Park City Fine Arts Program," *Artforum* 24 (September 1985): 126–27; Scardino, "Marketing Real Estate with Art": 23; Nancy Princenthal, "On the Waterfront," *Art in America* 75 (April 1987): 210–11, 239; Michael Brenson, "Art: Public Sculpture as City Companion," *New York Times* (August 7, 1987), C: 28; Goldberger, "To the Heights of Simplicity": 21, 54–56, 58; Howett, "Battery Park City": 51–57; Goldberger, "Battery Park City's Brave New World": 142, 144, 146, 148; Herbert Muschamp, "Between Art and Cars," in *Richard Artschwager: Public (public)* (Madison, Wisc.: Elvehjem Museum of Art, 1991), 74–80; Antonelli, "Public Art a Battery Park City, NY, 1982/90": 78–84; Sirefman, *New York*, 28–31.

176. Robin Karson, "Battery Park City, South Cove," *Landscape Architecture* 76 (May/June 1986): 48–53; Victoria Geibel, "The Act of Engagement," *Metropolis* 6 (July/August 1986): 32–33, 43, 46–47; Alvin Boyarsky, "Conversation," in *Mary Miss: Projects, 1966–1987* (London: Architectural Association, 1987), 88–91; White and Willensky, *AIA Guide* (1988), 43; Kay Larson, "Pier Pressure," *New York* 21 (August 1, 1988): 46–47; Raymond W. Gastil, "On the Waterfront: Art/Architecture," *Progressive Architecture* 69 (September 1988): 24–25; Nancy Princenthal, "On the Lookout," *Art in America* 76 (October 1988): 158–61; Catherine Howett, "Battery Park City," *Landscape Architecture* 79 (May 1989): 51–57; "AIA Honors Achievements in Design," *Architecture* 79 (May 1990): 40; Antonelli, "Public Art a Battery Park City, NY, 1982/90": 78–84; Reed, "Der Park als Ort des Wandels": 9–15, 36; Sandro Marpillero, "Four Projects by Mary Miss," *Architecture + Urbanism* 315 (December 1996): 104–7; *Mary Miss: Making Place* (New York: Whitney Library of Design, 1997), 84–87; White and Willensky, *AIA Guide* (2000): 47.

177. Princenthal, "On the Waterfront": 211.

178. Brenson, "Art: Public Sculpture as City Companion": 28.

179. Larson, "Combat Zone": 117.

180. Princenthal, "On the Lookout": 160.

181. Muschamp, "Between Art and Cars," *Richard Artschwager: Public (public)*, 77.

182. Stanton Eckstut, quoted in Karson, "South Cove": 50.

183. Mary Miss, quoted in Marpillero, "Four Projects by Mary Miss": 106.

184. Mary Miss, quoted in Marpillero, "Four Projects by Mary Miss": 106.

185. Gill, "The Sky Line: Battery Park City": 76.

186. Antonelli, "Public Art a Battery Park City, NY, 1982/90": 78–84.

187. Larson, "Combat Zone": 118.

188. Goldberger, "Public Space Gets a New Cachet in New York": 35; Herbert Muschamp, "Manhattan Samples Suburbia," *New York Times* (August 28, 1992), C: 1, 16; Karrie Jacobs, "Little Utopias (or Another Visit to Battery Park City)," *Metropolis* 12 (September 1992): 86; Mac Griswold, "BPC's Latest: Hudson River Park," *Landscape Architecture* 82 (December 1992): 62–64; Jane Holtz Kay, "The New/Renewed Urban Parks: Over-Design by Committee?" *Landscape Architecture* 82 (December 1992): 38–39; "Hudson River Park," *Process: Architecture* 130 (July 1996): 13–19; White and Willensky, *AIA Guide* (2000), 52.

189. Goldberger, "Public Space Gets a New Cachet in New York": 35.

190. Muschamp, "Manhattan Samples Suburbia": 16.

191. von Moos, *Venturi, Scott Brown & Associates: 1986–1998*, 188–89.

192. von Moos, *Venturi, Scott Brown & Associates: 1986–98*, 188–89.

193. For Venturi's Chippendale Chair, see Frederic Schwartz and Carolina Vaccaro, *Venturi Scott Brown and Associates: Works and Projects* (Barcelona: Editorial Gustavo Gili, 1995), 128–29.

194. Demetri Porphyrios, "North End Pavilion in Battery Park City, New York," *Composicion Arquitectonica, Art & Architecture* 6 (June 1990): 61–70. Also see Suzanne Stephens, "A Classical View of the Hudson," *New York Times* (June 18, 1992), C: 3; *Demetri Porphyrios: Buildings and Writings* (London: Academy Editions, 1993), 58–61.

195. Porphyrios, "North End Pavilion in Battery Park City, New York": 63.

196. Peg Tyre and Jeannette Walls, "Battery Park City's Sky-High Sculpture," *New York* 22 (January 30, 1989): 8; Judd Tully, "The Disenchanted Garden," *Artnews* 89 (May 1990): 78; Antonelli, "Public Art a Battery Park City, NY, 1982/90": 78–84.

197. *Tom Otterness* (New York: Brooke Alexander; Santa Monica: James Corcoran Gallery, 1990); Michael Brenson, "Tom Otterness's Wicked World of Human and Beastly Folly," *New York Times* (November 23, 1990), C: 4; Jacobs, "Little Utopias (or Another Visit to Battery Park City)": 86.

198. Jacobs, "Little Utopias (or Another Visit to Battery Park City)": 86.

199. Muschamp, "Manhattan Samples Suburbia": 16.

200. Kay, "The New/Renewed Urban Parks: Over-Design by Committee?": 39.

201. Griswold, "BPC's Latest: Hudson River Park": 64.

202. Muschamp, "Manhattan Samples Suburbia": 16.

203. Mary Sherman, "The Vesey Turnaround Competition: Public Art in Battery Park City," *Competitions* 6 (Summer 1996): 6–15; *Hodgetts + Fung: Scenarios and Spaces* (New York: Rizzoli International Publications, 1997), 88–89; Brad Collins and Elizabeth Zimmerman, eds., *Eric Owen Moss: Buildings and Projects 2* (New York: Rizzoli International Publications 1996), 202–7.

204. Sherman, "The Vesey Turnaround Competition: Public Art in Battery Park City": 7.

205. Francesco Venezia, quoted in Sherman, "The Vesey Turnaround Competition: Public Art in Battery Park City": 7.

206. *Hodgetts + Fung: Scenarios and Spaces*, 88.

207. David W. Dunlap, "Memorial to the Hunger, Complete with Old Sod," *New York Times* (March 15, 2001), E: 1, 8; "A Wee Bit of Irish Countryside for New York," *Architectural Record* 189 (May 2001): 53; David W. Dunlap, "Worn Down and Irish, and Moving Over Here," *New York Times* (May 30, 2001), B: 3; Heather Hammatt, "In Living Memory: Landscape Becomes a Living Memorial as Post-Famine Ireland Is Recreated in New York City," *Landscape Architecture* 91 (August 2001): 20; Roberta Smith, "A Memorial Remembers the Hungry," *New York Times* (July 16, 2002), E: 1, 3; Verlyn Klinkenborg, "The Great Irish Hunger and the Art of Honoring Memory," *New York Times* (July 21, 2002), IV: 12; Diana Balmori, "Review: Irish Hunger Memorial," *E-Oculus* (August 15, 2002); David Frankel, "Hunger Artist," *Artforum International* 40 (Summer 2002): 35; Philip Nobel, "Going Hungry," *Metropolis* 22 (November 22, 2002): 82, 84; "1100 Architect: The Irish Hunger Memorial," *Architecture + Urbanism* (March 2003): 98–101; Jane Holtz Kay, "A Hunger for Memorials: Feeding the Famine of Myth and Memory in New York and Elsewhere," *Landscape Architecture* 93 (March 2003): 114–16; Conor O'Clery, "Major Renovation at New York Famine Memorial," *Irish Times* (April 21, 2003): 7; David Ebony, "On Site: An Irish Lament," *Art in America* 91 (May 2003): 54–55, 57; Jim Dwyer, "Memorial to Irish Fortitude Comes Undone in New York," *New York Times* (May 7, 2003): 1, B: 7; Lynda Richardson, "Like Potato Fields, His Memorial Lies Fallow," *New York Times* (May 14, 2003), B: 2; "Brian Tolle; Irish Hunger Memorial, Battery Park City, New York," *Sculpture* 22 (June 2003): 26; Cynthia Davidson, "The Artist Brian Tolle, with 1100 Architect, Gives a Twist to Known and Nostalgic Elements in the Design for the Irish Hunger Memorial in Lower Manhattan," *Architectural Record* 191 (July 2003): 102–5.

208. Smith, "A Memorial Remembers the Hungry": 3.

209. Paul Goldberger, "Reinventing the City," *New York Times* (April 26, 1987), VI: 19; White and Willensky, *AIA Guide* (1988), 43; Rosamond Bernier, "A Battery of Gardens," *House & Garden* 160 (April 1988): 146–53, 206; Douglas C. McGill, "New Plans for Parks at Battery," *New York Times* (May 5, 1988), B: 1, 9; Goldberger, "Public Space Gets a New Cachet in New York": 35; Douglas C. McGill, "An Artful Garden for Battery Park, Created by a Painter and an Architect," *New York Times* (August 20, 1988): 11; Raymond W. Gastil, "The Garden Wall," *Metropolis* 8 (September 1988): 28–29; Ellen Posner, "Harmony Not Uniqueness," *Landscape Architecture* 79 (May 1989): 42–57; Patti Hagan, "Jennifer Bartlett's Walled Garden: 24 Rms, No Rv Vu," *Wall Street Journal* (October 26, 1989): 14; Rupert C. Barneby, Sarah Mann, Pamela Nankey, and Ray Bright, "Jenny, How Does Your Garden Grow," letters to the editor, *Wall Street Journal* (November 21, 1989): 19; "Inside Media," *Oculus* 52 (December 1989): 3–4; John Russell, "Heady and Hectic Works from Jennifer Bartlett," *New York Times* (January 12, 1990), C: 27; Barbara Britton, "Battery Park Garden Meets with Less than Universal Appeal," letter to the editor, *New York Times* (February 3, 1990): 26; Constance L. Hays, "Art and Realism Collide in the Plans for a Battery Park Garden," *New York Times* (February 13, 1990), B: 4; Paul Goldberger, "Exclamation Point for Battery Park City," *New York Times* (March 11, 1990), II: 41; Nicholas Quennell, "Battery Park City; Team Approach to a Garden," letter to the editor, *New York Times* (April 1, 1990), II: 3; Terry Golway, "At Battery Park City, How Does That Garden Grow?" *New York Observer* (April 30, 1990): 1, 8; Judd Tully, "The Disenchanted Garden," *Artnews* 89 (May 1990): 78; Gill, "The Sky Line: Battery Park City": 69–78; Eric Gibson, "Jennifer Bartlett and the Crisis of Public Art," *New Criterion* 9 (September 1990): 62–64; Antonelli, "Public Art a Battery Park City, NY, 1982/90": 78–84; Nicholas Quennell, "The Expanding Role of Landscape Architects," *Competitions* 1 (Summer 1991): 57–60; Peter D. Slatin, "Joint-Venture Garden for Battery Park City,"

Architectural Record 179 (August 1991): 25; Suzanne Stephens, "Follow-Up," *Oculus* 54 (September 1991): 5; Raymond Sokolov, "South Gardens: Free at Last," *Wall Street Journal* (October 16, 1991): 14; Clare McHugh, "At Battery Park City, Brave New Garden Design Is Uprooted," *New York Observer* (October 21, 1991), 1, 16; "No Grow for Battery Garden," *Art in America* 80 (January 1992): 27; Herbert Muschamp, "A Park as Not Just Another Pretty Space," *New York Times* (February 23, 1992), II: 38; Patti Hagan, "Books for Gardeners Naughty and Nice," *Wall Street Journal* (December 21, 1993): 10.

210. Jennifer Bartlett, quoted in Bernier, "A Battery of Gardens": 149.

211. Quoted in Hagan, "Jennifer Bartlett's Garden: 24 Rms, No Rv Vu'": 14.

212. Gastil, "The Garden Wall": 28.

213. Hagan, "Jennifer Bartlett's Garden: 24 Rms, No Rv Vu'": 14.

214. Lynden B. Miller, quoted in Hagan, "Jennifer Bartlett's Garden: 24 Rms, No Rv Vu'": 14.

215. Barneby, "Jenny, How Does Your Garden Grow?": 19.

216. Bruce Kelly, quoted in Posner, "Harmony Not Uniqueness": 49.

217. Quoted in Hagan, "Jennifer Bartlett's Walled Garden: 24 Rms, No Rv Vu'": 14.

218. Goldberger, "Exclamation Point for Battery Park City": 41.

219. Carol Vogel, "New Plans for South Garden at Battery Park City," *New York Times* (February 14, 1992), C: 17; "South Gardens Choices," *Oculus* 54 (April 1992): 4; "Projects," *Architectural Record* 180 (May 1992): 23; Herbert Muschamp, "Sprucing Up the Site of a Collective National Drama," *New York Times* (January 17, 1993), II: 32; Nancy Wartik, "Board 1/New Park for Battery Park City Presented," *New York Observer* (February 1, 1993): 8; Heidi Landecker, "Battery Park City's Final Park Takes Advantage of Spectacular Harbor Views," *Architecture* 84 (August 1995): 31; John Morris Dixon, "View Point," *Progressive Architecture* 76 (August 1995): 90–97; Paul Goldberger, "A Small Park Proves That Size Isn't Everything," *New York Times* (November 24, 1996), II: 46; Sirefman, *New York*, 28–31; Michael Maynard, "A Park with a View," *Landscape Architecture* 87 (January 1997): 26, 28–31; Clifford A. Pearson, "Wagner Park," *Architectural Record* 185 (February 1997): 64–69; Ada Louise Huxtable, "And a Park in Manhattan," *Wall Street Journal* (August 28, 1997): 12; Charles Lockwood, "Battery Park City: Act II," *Urban Land* 56 (October 1997): 97–98, 122; James S. Russell, "Where Does Architecture Fit in the Big Apple?" *Urban Land* 56 (October 1997): 76–78, 120; "Assault in the Battery," *Architecture New York* 22 (1998): 8–9; Broto, *Urbanism*, 178–87; "Robert F. Wagner, Jr., Park," *Architectural Record* 186 (June 1998): 125; Anita Berrizbeitia and Linda Pollak, *Inside/Outside: Between Architecture and Landscape* (Gloucester, Mass.: Rockport Publishers, 1999), 120–25; Laurie Olin, "What I Do When I Can Do It: Representation in Recent Work," *Studies in the History of Gardens and Designed Landscapes* 19 (January-March 1999): 102–21; White and Willensky, *AIA Guide* (2000), 47; Balfour, *World Cities: New York*, 201; Luca Molinari, *Atlas: North American Architecture Trends, 1990–2000* (Milan: Marazzi Gruppo Ceramiche, 2001), 48–53.

220. Olin, "What I Can Do When I Can Do It: Representation in Recent Work": 112.

221. www.machado-silvetti.com/projects/main_41_wagner.html.

222. Rodolfo Machado, quoted in Pearson, "Wagner Park": 66.

223. www.machado-silvetti.com/projects/main_41_wagner.html.

224. Olin, "What I Do When I Can Do It: Representation in Recent Work": 112–14.

225. Goldberger, "A Small Park Proves That Size Isn't Everything": 46.

SOUTH FERRY

1. "N.Y. City Contest," *Progressive Architecture* 66 (July 1985): 74; Paul M. Sachner, "South Ferry Plaza: More High-Density Development at Manhattan's Gateway," *Architectural Record* 173 (October 1985): 95; Peter Lemos, "Assault on the Battery," *Metropolis* 5 (October 1985): 10; Daralice D. Boles, "South Ferry Plaza: Jury Still Out," *Progressive Architecture* 66 (December 1985): 21–22; Heinrich Klotz, *Vision der Moderne: Das Prinzip Konstruktion* (Munich: Prestel Verlag, 1986), 442–43; Nory Miller, *Helmut Jahn* (New York: Rizzoli International Publications, 1986), 246–47; "Chapter Reports," *Oculus* 47 (January 1986): 18; "South Ferry Plaza," *Process Architecture* 65 (February 1986): 112–19; "Pencil Points," *Progressive Architecture* 67 (March 1986): 22; "Pencil Points," *Progressive Architecture* 67 (April 1986): 26; "South Ferry Plaza," *Architecture + Urbanism*, extra edition (June 1986): 252–53; "Notes on the Year," *Oculus* 47 (June 1986): 4; Anthony DePalma, "The City's Thorny Review Process," *New York Times* (July 27, 1986), VIII: 6, 16; "Colossal 'Lighthouse' Is South Ferry Winner," *The Architects' Journal* (July 30, 1986): 12; Deirdre Carmody, "Manhattan's Southern Tip to Get 60-Story Tower," *New York Times* (July 18, 1986): 1, 10; Paul Goldberger, "Tower at Ferry Terminal: A Lively but Large Design," *New York Times* (July 18, 1986): 10; Jeanie Kasindorf, "Intelligencer: Design Experts Speak. Will the City Pay Attention," *New York* 19 (July 21, 1986): 11; Anthony De Palma, "The City's Thorny Review Process," *New York Times* (July 27, 1986), VIII: 6, 16; Michael Wagner, "Bringing Life Back to South Ferry Plaza," *Interiors* 146 (November 1986): 40; "NYC Public Development Corporation," *Oculus* 48 (December 1986): 17; Albert Scardino, "They'll Take Manhattan," *New York Times* (December 7, 1986), VI, part 2: 34–37, 112, 114, 116–17; *Kohn Pedersen Fox: Buildings and Projects, 1976–1986* (New York: Rizzoli International Publications, 1987), 258–65; "Awards," *Oculus* 48 (February 1987): 6; "Names and News," *Oculus* 48 (March 1987): 11; "Ferry Godmother," *Avenue* (May 1987): 126; White and

Willensky, *AIA Guide* (1988), 24–25; Thomas G. Patterson, "Don't Cast a Giant Shadow over the Battery," letter to the editor, *New York Times* (March 14, 1988): 18; William H. Honan, "2 Arts Groups to Use Old Ferry House," *New York Times* (October 28, 1988), C: 3; Karen Cook, "Waterfront Projects," *New York Post* (January 12, 1989): 50–51; Beth Dunlop, *Arquitectonica* (Washington, D.C.: AIA Press, 1991), 96–97; *Hardy Holzman Pfeiffer Associates: Buildings and Projects 1967–1992* (New York: Rizzoli International Publications, 1992), 263; *Peter Pran of Ellerbe Becket: Recent Works* (London: Academy Editions, 1992), 16–19; *Murphy/Jahn: Selected and Current Works* (Victoria, Australia: Images Publishing, 1995), 118; Michael J. Crosbie, *The Architecture of Frank Williams* (Rockport, Mass.: Rockport Publishers, 1997), 114–21; Alan Balfour, *World Cities: New York* (New York: Wiley Academy, 2001), 314–17; Raymond W. Gastil, *Beyond the Edge: New York's New Waterfront* (New York: Princeton Architectural Press, 2002), 43.

2. For the Whitehall Ferry Terminal, see Stern, Gilmartin, and Massengale, *New York 1900*, 48–49. For the Staten Island Ferry Terminal, see Stern, Mellins, and Fishman, *New York 1960*, 197.

3. Lemos, "Assault on the Battery": 10.

4. See Stern, Gilmartin, and Mellins, *New York 1930*, 557, 561.

5. For the Bank of the Manhattan Company Building, see Stern, Gilmartin, and Mellins, *New York 1930*, 602–3, 605.

6. Goldberger, "Tower at Ferry Terminal: A Lively but Large Design": 10.

7. Goldberger, "Tower at Ferry Terminal: A Lively but Large Design": 10.

8. Miguel Garcilazo, Peter Moses, and Mary Papenfuss, "Fire Ravages: 'Suspicious' Blaze Leaves 15 Injured," *New York Post* (September 9, 1991): 4–5; Miguel Garcilazo and Peter Moses, "Homeless Saved from Fiery Death as Roof Falls," *New York Post* (September 9, 1991): 5; Miguel Garcilazo and Peter Moses, "Riders: Workers Ignored Smell of Smoke," *New York Post* (September 9, 1991): 5; Robert D. McFadden, "Big Fire Destroys Terminal of Ferry to Staten Island," *New York Times* (September 9, 1991): 1, B: 2; Steven Lee Myers, "Ferry Terminal a 'Banal Portal to Joy,'" *New York Times* (September 9, 1991), B: 2; Mike Koleniak and Miguel Garcilazo, "Ferry Riders Up the Creek," *New York Post* (September 10, 1991): 20; Robert D. McFadden, "Commuters Face Woes on S.I. Ferry," *New York Times* (September 10, 1991), B: 1, 4; "Staten Island Ferry Terminal Set to Reopen," *New York Times* (September 14, 1991): 25.

9. "$100 Million Rebuilding: Ferry Terminal Contest," *New York Times* (May 3, 1992), X: 1; "Ferry Terminal Design: 6 Chosen for Competition," *New York Times* (August 30, 1992), X: 1; Herbert Muschamp, "6 Visions of a New Ferry Terminal," *New York Times* (November 5, 1992), C: 17, 22; "Corrections," *New York Times* (November 6, 1992): 2; Richard Steier, "New Ferry-Terminal Plan Hits the Big Time," *New York Post* (November 7, 1992): 3; David W. Dunlap, "Face of Future at Ferry Dock Is 120 Feet Tall," *New York Times* (November 7, 1992): 1, 24; Raymond Hernandez, "Fuss Churns over Clock for the Staten Island Ferry Terminal," *New York Times* (November 9, 1992), B: 3; David W. Dunlap, "Chartering the Future of the Waterfront," *New York Times* (November 15, 1992), X: 1, 8; Herbert Muschamp, "For Staten Island, a Ferry Terminal Rooted in the Past," *New York Times* (November 22, 1992), II: 32; "The Big Clock," editorial, *New York Times* (November 23, 1992): 16; "Terminal Clock Is New Beacon for the Battery," *Architectural Record* 190 (December 1992): 12; "Details," *Architecture* 81 (December 1992): 20; "Pencil Points," *Progressive Architecture* 73 (December 1992): 14; Carl Weisbrod and Lucius Riccio, "Ferry Terminal: A Timely Civic Symbol," letter to the editor, *New York Times* (December 27, 1992), II: 4; Suzanne Stephens, "Competition Comebacks," *Oculus* 55 (January 1993): 6–7; "The Big Time: VSBA Wins Ferry Terminal," *Progressive Architecture* 74 (January 1993): 16; Stephen A. Kliment, "Flawed Signal," *Architectural Record* 181 (February 1993): 9; Mildred F. Schmertz, "Giant Timepiece Alarms Manhattan," *Architecture* 82 (February 1993): 24–25; "Drawing Credit," *Progressive Architecture* 74 (February 1993): 9; Jayne Merkel, "Whitehall Ferry Terminal: The Art of Moving People the Old-Fashioned Way," *Competitions* 3 (Spring 1993): 52–61; "Skidmore, Owings & Merrill," *Architecture + Urbanism*, special issue (September 1993): 166–67; Robert Venturi and Denise Scott Brown, "The Whitehall Ferry Terminal in Lower Manhattan," *The New City* 2 (Winter 1993–94): 96–105; "Whitehall Ferry Terminal, New York," *Domus* 756 (January 1994): 28–31; Michael McDonough, "Currents: Design's Future," *New York Times* (June 9, 1994), C: 3; Frederic Schwartz and Carolina Vaccaro, *Venturi Scott Brown and Associates* (Barcelona: Editorial Gustavo Gili, 1995), 248–51; "Whitehall Ferry Terminal, New York, 1992," *Archithese* 25 (June 1995): 32–33; William Goldschlag, "Budget: A Penn Pal, S.I. Ferry Terminal Also Gets Fed Boost," *New York Daily News* (November 16, 1995): 40; Alberto Ferlenga, *Aldo Rossi: Opera Completa 1993–1996* (Milan: Electa, 1996), 80–83; Robert Venturi, *Iconography and Electronics upon a Generic Architecture: A View from the Drafting Room* (Cambridge, Mass., and London: MIT Press, 1996), 35–36, 213–17; Venturi, Scott Brown and Associates, "Whitehall Ferry Terminal: Return to New York (via Las Vegas)," *Casabella* 62 (July-August 1998): 12; Alberto Ferlenga, *Aldo Rossi: Tutte le Opere* (Milan: Electa, 1999), 320–21; *Venturi, Scott Brown & Associates: Buildings and Projects, 1986–1998* (New York: Monacelli Press, 1999), 180–83; David G. De Long, "Seeking a Rational Mannerism," in David B. Brownlee, David G. De Long, and Kathryn B. Hiesinger, *Out of the Ordinary: Robert Venturi Denise Scott Brown and Associates* (Philadelphia: Philadelphia Museum of Art in association with Yale University Press, 2001), 144–45, 147; Alberto Ferlenga, ed., *Aldo Rossi: The Life and Works of*

an Architect (Cologne: Könemann, 2001), 320–21; *The Architecture of Rafael Viñoly* (New York: Princeton Architectural Press, 2002), no pagination; Gastil, *Beyond the Edge: New York's New Waterfront*, 43–44.

10. Muschamp, "6 Visions of a New Ferry Terminal": 17.

11. Muschamp, "6 Visions of a New Ferry Terminal": 17, 22.

12. Muschamp, "6 Visions of a New Ferry Terminal": 22.

13. Venturi and Scott Brown, "The Whitehall Ferry Terminal in Lower Manhattan": 97.

14. Guy Molinari, quoted in Dunlap, "Face of Future at Ferry Dock Is 120 Feet Tall": 24.

15. "The Big Clock": 16.

16. Muschamp, "For Staten Island, a Ferry Terminal Rooted in the Past": 32. Also see Robert Venturi, *Complexity and Contradiction in Architecture* (New York: Museum of Modern Art; Garden City, N.Y.: Doubleday, 1966).

17. Stephens, "Competition Comebacks": 7.

18. James S. Russell, "A Less-Decorated Shed for Staten Island Ferry," *Architectural Record* 184 (February 1996): 11; Tracie Rozhon, "80's Giant Dreams Facing 90's Economic Realities," *New York Times* (June 9, 1996), IX: 1, 10; "Project for the Whitehall Ferry Terminal," *Space Design* 8 (August 1997): 72–77; "Terminal Traghetti Whitehall," *Casabella* 62 (July-August 1998): 12–19; *Venturi, Scott Brown & Associates: Buildings and Projects, 1986–1998*, 184–87; De Long, "Seeking a Rational Mannerism," in Brownlee, De Long, and Hiesinger, *Out of the Ordinary: Robert Venturi Denise Scott Brown and Associates*, 144–45, 147.

19. Guy Molinari, quoted in Russell, "A Less-Decorated Shed for Staten Island Ferry": 11.

20. Peter Grant, "1 Ferry Plan Sunk; Architect Walks," *New York Daily News* (October 28, 1996): 4.

21. David W. Chen, "Sleeker Design for Staten Island Ferry Terminal Is Unveiled," *New York Times* (March 20, 1997), B: 8; "Whitehall Ferry Terminal Reconstruction," *New York Construction News* 47 (March 1999): 56; "Whitehall Ferry Terminal: Hope Wanes for Majestic Gateway," *Municipal Art Society Newsletter* (May-June 1999): 1, 3; Peter Grant with Salvatore Arena, "Ferry Funding May Be Terminal," *New York Daily News* (June 24, 1999): 44; Frank Lombardi, "New Terminals, Boats for Ferry," *New York Daily News* (September 26, 2000): 35; "Coming Up: One Ferry Terminal, Hold the Clock," *New York Times* (November 12, 2000), XI: 1; Jayne Merkel, "At the Water's Edge," *Oculus* 64 (November 2001): 10–11; Gastil, *Beyond the Edge: New York's New Waterfront*, 187; David W. Dunlap, "Launching a Flotilla of Ferry Terminals," *New York Times* (April 7, 2002), XI: 1, 6; Jason Feldman, "Complex Construction Challenges Whitehall Ferry Terminal Team," *New York Construction News* 49 (May 2002): 35; Alastair Gordon, "At Home With: Frederic Schwartz," *New York Times* (September 19, 2002), F: 1, 4; "Ferry Construction Steams Ahead," *New York Construction News* 51 (August 2003): 35; Herbert Muschamp, "The New Season/Architecture," *New York Times* (September 7, 2003), II: 103; Ian Luna, ed., *New New York: Architecture of a City* (New York: Rizzoli International Publications, 2003), 14–17.

22. Carter B. Horsley, "Ferry Portals," in http://www.thecityreview.com/ferry.htm.

23. Guy Molinari, quoted in Chen, "Sleeker Design for Staten Island Ferry Terminal Is Unveiled": 8.

24. Nina Rappaport, "Restoration Rebounds," *Oculus* 60 (March 1998): 4; *Between Spaces: Smith-Miller + Hawkinson Architecture* (New York: Princeton Architectural Press, 2000), 28–47; Balfour, *World Cities: New York*, 190; "New Buildings of Merit," *New York Times* (January 21, 2001), XI: 1; "Calendar: New Architecture," *New York Times* (January 25, 2001), F: 12; Amanda May, "New York on Display," *Grid* 3 (March 2001): 30–31; Jayne Merkel, "New New York 2," *Oculus* 63 (March 2001): 17; Suzanne Stephens, "Smith-Miller + Hawkinson Architects Brings Architecture to the Public Realm with a Small Ferry Terminal on Pier 11 Near Wall Street," *Architectural Record* 184 (May 2001): 220–23; Paul Goldberger, "Gateway to Gotham," *New York* 76 (May 28, 2001): 114–15; Merkel, "At the Water's Edge": 10–11; "Architecture Award," *Oculus* 64 (December 2001): 28; Gastil, *Beyond the Edge: New York's New Waterfront*, 27–28, 54; "Smith-Miller + Hawkinson: Pier 11," *Quaderns d'arquitectura i urbanisme* 232 (2002): 146–57; Luna, ed., *New New York*, 18–21.

25. Quoted in www.smharch.com/projects-htm/pier.htm.

26. Goldberger, "Gateway to Gotham": 114.

SOUTH STREET SEAPORT

1. Landmarks Preservation Commission of the City of New York, *South Street Seaport Historic District Designation Report* (New York, 1977); Edward Ranzal, "$23 Million Plan to Restore Museum Area," *New York Times* (July 29, 1977), B: 3; Karen Rothmyer, "Seaport the Focus of Push for Development," *New York Times* (February 12, 1978), VII: 1, 4; James P. Sterba, "City to Seek Grant for South Street Area," *New York Times* (July 23, 1978): 19; Ada Louise Huxtable, "'Development' at the Seaport," *New York Times* (February 25, 1979), II: 31–32; Anna Quindlen, "$210 Million Marketplace for South Street Planned," *New York Times* (September 28, 1979), B: 3; "South Street's Ship Is Coming In," *New York Times* (September 30, 1979), IV: 6; Ada Louise Huxtable, "The Editorial Notebook: A Squint at South Street," *New York Times* (October 17, 1979): 26; Laurie Johnston, "Plan for South Street Market Leaves a Wake of Dissension," *New York Times* (November 28, 1979), B: 1, 20; Eleni Constantine, "South Street Seaport: Son of Quincy Market," *Progressive Architecture* 60 (December 1979): 26, 30; Claudia Lorber, "The Seaport Development Plan 1980," *Seaport* 14 (Spring 1980): 26–33; Carter B. Horsley, "South Street Seaport Development Moving Ahead," *New York Times* (June 25, 1980): 25; Howard Burkat, "Whither the South Street Seaport,"

letter to the editor, *New York Times* (July 4, 1980): 16; Ada Louise Huxtable, "The Sell-Off at St. Bartholomew's," *New York Times* (October 26, 1980), II: 33; "Seaport Plan Stirs New Uncertainty at Fish Market," *New York Times* (November 8, 1980): 27; Clyde Haberman, "City Approves $23 Million South Street Seaport Plan," *New York Times* (November 14, 1980): 1, B: 4; Elena Phipps and Lawson Moyer, "Wrong Development for a Seaport," letters to the editor, *New York Times* (November 29, 1980): 22; John B. Hightower, "Toward a Bustling Seaport Steeped in History," letter to the editor, *New York Times* (December 20, 1980): 24; Clyde Haberman, "South St. Seaport Gets Key Grant," *New York Times* (December 25, 1980): 1, 44; Ada Louise Huxtable, "The Boom in Bigness Goes On," *New York Times* (December 28, 1980), II: 25–26; "Selling the Seaport," editorial *New York Times* (January 8, 1981): 22; "New York's Seaport Plan Is Approved," *Progressive Architecture* 62 (March 1981): 42; "Roundtable on Rouse," *Progressive Architecture* 62 (July 1981): 100–106; Sharon Lee Ryder, "The Big Boys from the Big Time," *Metropolis* 1 (October 1981): 7; A. O. Sulzberger Jr., "Board Approves Leases for South Street Seaport Plan," *New York Times* (October 23, 1981), B: 3; "A Landlubber's Winter Guide to the Seaport," *New York Times* (February 5, 1982), C: 1, 20; Michael Winkelman, "Some Edifices down on South Street," *Metropolis* 1 (March 1982): 20–22; "The South Street Seaport," *Oculus* 44 (September 1982): 6; Sandro Marpillero, "South Street Seaport, New York," *Lotus International* 46 (1985), 62–71; Landmarks Preservation Commission of the City of New York, LP-1646 (July 11, 1989); David W. Dunlap, "Board of Estimate Extends Seaport Historic District by One Block," *New York Times* (October 14, 1989): 27, 29; M. Christine Boyer, "Cities for Sale: Merchandising History at South Street Seaport," in Michael Sorkin, ed., *Variations on a Theme Park* (New York: Hill and Wang, 1992), 181–204; Barbaralee Diamonstein, *The Landmarks of New York III* (New York: Harry N. Abrams, 1998), 502, 514; Ann L. Buttenwieser, *Manhattan Waterbound*, 2nd. ed. (Syracuse, N.Y.: Syracuse University Press, 1999), 6, 225–27, 252–53; Raymond W. Gastil, *Beyond the Edge: New York's New Waterfront* (New York: Princeton Architectural Press, 2002), 48–49.

2. See Stern, Mellins, and Fishman, *New York 1960*, 1149–50.

3. "Exxon Giving $200,000 for South St. Seaport Park," *New York Times* (September 23, 1975): 41; White and Willensky, *AIA Guide* (2000), 301.

4. For Quincy Market, see Donlyn Lyndon, *The City Observed: Boston* (New York: Random House, 1982), 43–44, 48–50.

5. John Hightower, quoted in Rothmyer, "Seaport the Focus of Push for Development": 4.

6. Peter Stanford, quoted in Rothmyer, "Seaport the Focus of Push for Development": 4.

7. John Morris Dixon, quoted in "Roundtable on Rouse": 100.

8. Huxtable, "'Development' at the Seaport": 31–32. Also see Paul Goldberger, "The Lesson of Peck Slip," *Seaport* 12 (Winter 1979): 4–10; Richard Haas, *An Architecture of Illusion* (New York: Rizzoli International Publications, 1981), 80–85, 88, 92–93; White and Willensky, *AIA Guide* (1988), 535.

9. Huxtable, "The Editorial Notebook: A Squint at South Street": 26.

10. Huxtable, "The Boom in Bigness Goes On": 26.

11. *Schermerhorn Row Block* (Albany, N.Y.: Preservation and Restoration Bureau, Division for Historic Preservation, 1975); John D. Stewart et al., *The Schermerhorn Row Block: A Study in Nineteenth-Century Building Technology in New York City* (Waterford, N.Y.: New York State Bureau of Parks, Recreation, and Historic Preservation, October 1981); Erin Drake Gray, "The Schermerhorn Row Block Preservation Project: It's Begun!" *Seaport* 15 (Winter 1982): 10–17; Ellen Fletcher Rosebrock, "Sweet's Refectory," *Seaport* 15 (Winter 1982): 18–21; "Progress into the 19th Century," *New York Times* (November 30, 1982), B: 3; George W. Goodman, "Schermerhorn Row's Resurrection Close at Hand," *New York Times* (January 9, 1983), VIII: 7; Deirdre Carmody, "Rejuvenated Seaport Is Due to Open July 28," *New York Times* (July 15, 1983), B: 1, 3; Paul Goldberger, "At Seaport, Old New York with a New Look," *New York Times* (July 29, 1983), C: 1, 17; "The Restoration of the Schermerhorn Row Block," *Oculus* 45 (September 1983): 7, 14–16; Douglas Brenner, "Profiting from the Past," *Architectural Record* 172 (January 1984): 97–107; Marpillero, "South Street Seaport, New York": 63–66.

12. John F. Burns, "Seaport Building Dating to 1777 Burns," *New York Times* (February 4, 1976): 1, 25.

13. Goldberger, "At Seaport, Old New York with a New Look": 17.

14. Brenner, "Profiting from the Past": 99.

15. Jan Hird Pokorny, quoted in "The Restoration of the Schermerhorn Row Block": 14.

16. "Restoration of the Museum Block," *Oculus* 45 (September 1983): 7, 16–17; James Marston Fitch, "The Case of the Purloined Building," *Architectural Record* 172 (January 1984): 114–17; "Awards," *Oculus* 45 (May 1984): 8; Marpillero, "South Street Seaport, New York": 67–69; Nora Rubinstein, "Timeless Shopping," *Interiors* 144 (January 1985): 180–81; "Design Awards," *Architectural Record* 173 (October 1985): 107; *Beyer Blinder Belle, Architects & Planners* (New York: Beyer Blinder Belle, 1997), no pagination; Margot and Carol Gayle, *Cast-Iron Architecture in America: The Significance of James Bogardus* (New York: W. W. Norton, 1998), 229–33.

17. Stern, Mellins, and Fishman, *New York 1960*, 1151; Stern, Mellins, and Fishman, *New York 1880*, 26.

18. Ada Louise Huxtable, "The Case of the Stolen Landmarks," *New York Times* (January 11, 1977): 24.

19. John L. Belle, quoted in "Restoration of the Museum Block": 16.

20. "Names and News," *Oculus* 44 (December 1982): 2; Alan S. Oser, "Weighing Anchor for a Major Downtown Attraction," *New York Times* (February 6, 1983), VIII: 7; "Names and News," *Oculus* 44 (May 1983): 7; Goldberger, "At Seaport, Old New York with a New Look": 17; Brenner, "Profiting from the Past": 104–7; "Boston Society of Architects Export Awards," *Architecture* 73 (May 1984): 345; John G. Tucker, "Coho by the Sea," *Interior Design* 55 (May 1984): 262–63; "Names and News," *Oculus* 45 (June 1984): 13; "South Street Seaport," *Building Design & Construction* 25 (September 1984): 75; Marpillero, "South Street Seaport, New York": 67–69; Josh Barbanel, "Pavilion Rising at Seaport Draws Opposition," *New York Times* (March 11, 1985), B: 1, 3; C. Ray Smith, "Pier 17 Pavilion Completes New York's South Street Seaport," *Architecture* 74 (November 1985): 20; Craig Whitaker, "Rousing Up the Waterfront," *Architectural Record* 174 (April 1986): 67, 69, 71; Jerry Cooper, "Liberty Café," *Interior Design* 57 (May 1986): 292–93; "Boston Society of Architects 1986 Boston Export Awards," *Architectural Record* 174 (September 1986): 73; "Pier Group," *Architectural Review* 180 (September 1986): 42–45; "Design Awards/Competition: American Institute of Steel Construction 1987 Architectural Awards of Excellence," *Architectural Record* 175 (September 1987): 66–67; Jerry Cooper, "Ocean Reef Grille," *Interior Design* 59 (February 1988): 304–7; Mildred F. Schmertz, "Designing the Urban Marketplace," *Architectural Record* 176 (June 1988): 140–45; "South Street Seaport," *Colonial Homes* 15 (December 1989): 32–34, 36, 38, 40, 42–43, 60; "South Street Seaport," *Process Architecture* 89 (June 1990): 106–9; William Grimes, "As Museum and Mall, a Seaport Lives On," *New York Times* (May 1, 1992), C: 1, 6; "South Street Seaport," *Process Architecture* 113 (October 1993): 12–15.

21. Goldberger, "At Seaport, Old New York with a New Look": 17.

22. "Names and News": 13.

23. Quoted in Brenner, "Profiting from the Past": 104.

24. Deirdre Carmody, "Rejuvenated Seaport Is Due to Open July 28," *New York Times* (July 15, 1983), B: 1, 3; Chris Oliver and Arthur Greenspan, "South Street Seaport: Anchors Away!" *New York Post* (July 28, 1983): 13; Richard F. Shepard, "Seaport Site Opens Today with a Fanfare," *New York Times* (July 28, 1983), B: 1, 8; "A Sea of Cheers Marks the Opening of South Street Seaport," *New York Times* (July 29, 1983): 1; Goldberger, "At Seaport, Old New York with a New Look": 1, 17; Marian Burros, "A Sampler of Foods from Shops at Seaport," *New York Times* (July 29, 1983), C: 17; Deirdre Carmody, "Cheering Throng Jams Fulton Street for Opening," *New York Times* (July 29, 1983), C: 17; "A Hot Time at the New Old Seaport," *New York Times* (July 31, 1983): 1; Iris Alex, "The Community View," *Oculus* 45 (September 1983): 7, 14; Daralice D. Boles, "South Street Seaport Sets Sail," *Progressive Architecture* 64 (September 1983): 29; Deirdre Carmody, "Seaport Neighbors Aren't Sharing," *New York Times* (October 21, 1983), B: 1, 4; Anne-Marie Schiro, "A Tour of the Shops at South Street Seaport," *New York Times* (October 29, 1983): 33; Brenner, "Profiting from the Past": 97–107.

25. Goldberger, "At Seaport, Old New York with a New Look": 17.

26. Kurt Andersen, "Americanizing the Singular City," *Architectural Digest* 45 (November 1988): 76, 82, 86–87, 90.

27. Martin Gottlieb, "Some Shops at Seaport Say It's a Struggle to Survive," *New York Times* (January 6, 1984), B: 1, 5.

28. Lisa V. Foderaro, "At South Street Seaport, the Other Half Beckons," *New York Times* (November 28, 1986), B: 31; David W. Dunlap, "At Seaport: New Wine for Old Skins," *New York Times* (September 7, 1987): 21; Mark McCain, "Commercial Property: A Troubled Urban Mall," *New York Times* (March 13, 1988), X: 27; "Sleepy Seaport Mulls New Tack," *New York* 21 (April 11, 1988): 22; Peter Weatherhead, "No Rousing Welcome in New York," *Building* 253 (May 27, 1988): 42–44; Carter B. Horsley, "Full Speed Ahead at Seaport," *New York Post* (January 19, 1989): 65; Dunlap, "Wave of Growth Planned at South Street Seaport": 1–2; Jeannette Walls, "Seaport Seeks Sexier City Image," *New York* 24 (January 28, 1991): 9–10; Douglas Martin, "South Street Seaport: Just Another Mall?" *New York Times* (October 17, 1993), VIII: 4; David M. Halbfinger, "South Street Seaport to Get Skating Rink," *New York Times* (November 5, 1997), B: 13; "For the Hans Brinker in Us," *New York Times* (December 28, 1997): 1; Bernard Stamler, "Rough Sailing for South Street Seaport," *New York Times* (March 29, 1998), XIV: 1, 12.

29. Stamler, "Rough Sailing for South Street Seaport": 1.

30. Louise Kramer, "Rouse Finally Fills Seaport Building; Sees Better Sailing," *Crain's New York Business* (January 22, 2001): 4, 39.

31. "Condominium Abeam South St. Seaport," *New York Times* (October 2, 1983), B: 1; Anthony DePalma, "About Real Estate," *New York Times* (January 6, 1984), B: 7; White and Willensky, *AIA Guide* (2000), 37; *The Architecture of Rafael Viñoly* (New York: Princeton Architectural Press, 2002), no pagination. For the Volunteer Hospital, see *South Street Seaport Historic District*, 8.

32. White and Willensky, *AIA Guide* (2000), 37.

33. Quoted in "Announcing New York's First Contextual Office Building: Seaport Plaza," advertisement, *New York Times* (April 18, 1982), XII: 2. Also see Carter B. Horsley, "Lower Manhattan Luring Office Developers," *New York Times* (October 23, 1981), VIII: 1, 10; "Lloyds Bank Leases Seaport Tower," *New York Times* (April 6, 1982), B: 10; "Pencil Points," *Progressive Architecture* 63 (May 1982): 44; Alan S. Oser, "Development Returns to Wall Street Area," *New York Times* (August 8, 1982), VIII: 1, 13; Shawn G. Kennedy, "Seaport Plaza Gets Blue Chip Tenants," *New York Times* (December 7, 1983), B: 6; Dee Wedemeyer, "Lobbies with Stellas: The Developers' Choice," *New York Times* (May 12, 1985), XII: 71; "Seaport Plaza," *Building Stone Magazine* (March-April 1987): 10–15; White and Willensky, *AIA Guide* (2000), 29.

34. Carter B. Horsley, "Continental Corp. Plans to Build 35-Story Skyscraper Downtown," *New York Times* (January 25, 1979): 1, B: 11; "A New Skyscraper for Manhattan," *New York Times* (January 28, 1979), III: 15; Eleni Constantine, "Continental Corp. Headquarters," *Progressive Architecture* 60 (June 1979): 50; Alan S. Oser, "A 38-Story Office Building," *New York Times* (March 12, 1980), B: 5; "Two Towers Set for Downtown," *New York Times* (December 14, 1980), VIII: 1–2; Horsley, "Lower Manhattan Luring Office Developers": 1, 10; "Faceted Tower for Lower New York City," *Architectural Record* 170 (April 1982): 38; Oser, "Development Returns to Wall Street Area": 1, 13; "The Continental Center," *Architecure + Urbanism* (July 1984): 84–87; Jerold S. Kayden, *Privately Owned Public Space: The New York City Experience* (New York: John Wiley & Sons, 2000), 89–90; White and Willensky, *AIA Guide* (2000), 29.

35. Edward I. Koch, quoted in Horsley, "Continental Corp. Plans to Build 35-Story Skyscraper Downtown": 11.

36. Horsley, "Lower Manhattan Luring Office Developers": 1, 10; Oser, "Development Returns to Wall Street Area": 1, 13; G. Bruce Knecht, "Manhattan's Newest Land Baron," *New York Times* (September 25, 1983), III: 4; White and Willensky, *AIA Guide* (2000), 29.

37. White and Willensky, *AIA Guide* (2000), 29.

38. Shawn G. Kennedy, "Seaport Link for a Tower in Manhattan," *New York Times* (October 26, 1988), D: 24; "40 Fulton St.," *Office Buildings* (April 1988): 108; White and Willensky, *AIA Guide* (2000), 29.

39. Robert Fox, quoted in Kennedy, "Seaport Link for a Tower in Manhattan": 24.

40. David W. Dunlap, "Apartment Tower Is Proposed in Seaport District," *New York Times* (July 25, 1984), B: 4; "Panel Rejects Plan for Seaport Tower," *New York Times* (November 15, 1984), B: 3; David W. Dunlap, "Landmarks Panel Turns Down Tower for Seaport District," *New York Times* (August 27, 1986), B: 2; "Seaporters Fight Wave of Future," *New York* 20 (April 20, 1987): 14; David W. Dunlap, "Seaport Project Again Opposed by Neighbors," *New York Times* (March 1, 1989), B: 3; Carter B. Horsley, "All Wet on Water Street," *New York Post* (March 16, 1989): 57; Alan S. Oser, "The Search for an 'Appropriate' Design," *New York Times* (April 23, 1989), X: 9, 16; David W. Dunlap, "After 4 Setbacks, Developers Hire Critic to Design Seaport Building," *New York Times* (October 23, 1989), B: 2; David W. Dunlap, "Seaport Story," *New York Times* (December 10, 1989): 59; "The Milsteins Grind Slowly," *New York Observer* (January 22, 1990): 4; David W. Dunlap, "South Street Seaport," *New York Times* (February 11, 1990), X: 17; "Building at 250 Water Street Wins Approval after 8 Years," *New York Times* (May 29, 1991), B: 3; David W. Dunlap, "South Street Seaport: At Last, a Plan Wins in Landmark District," *New York Times* (June 9, 1991), X: 1, 17; Susan Gilman, "New Milstein Plan for Water Street Is Opposed," *New York Observer* (January 22, 1996): 6; Tracie Rozhon, "80's Giant Dreams Facing 90's Economic Realities," *New York Times* (June 9, 1996), IX: 1, 10; Karrie Jacobs, "New Style: No Style," *New York* 29 (September 23, 1996): 30–31, 115; Andrew Jacobs, "Plan for Apartment Towers Returns: So Do Protests," *New York Times* (March 23, 1997), XIII: 7; Bernard Stamler, "Latest Plan Joined by Counterplan in Landmarks Fight at 250 Water St.," *New York Times* (June 8, 1997), XIII: 24; Greg Sargent, "Ye Olde Seaport Mulls a Mews," *New York Observer* (June 2, 1997): 12; "A New Design Concept for 250 Water Street," *Municipal Art Society Newsletter* (November/December 1997): no pagination; Paul Spencer Byard, *The Architecture of Additions: Design and Regulation* (New York: W. W. Norton, 1998), 33–34; Rachelle Garbarine, "Residential Real Estate," *New York Times* (March 20, 1998), B: 9; Charles V. Bagli, "Battle Nears over Rezoning near Seaport," *New York Times* (January 22, 2003), B: 1, 4; Eric Herman, "Bldg. Limits for South St. Seaport," *New York Daily News* (March 6, 2003): 38; Motoko Rich, "Neighbors Think Outside the Block," *New York Times* (September 18, 2003), F: 1, 10.

41. Ulrich Franzen, quoted in Dunlap, "Apartment Tower Is Proposed in Seaport District": 4.

42. Quoted in Dunlap, "Landmarks Panel Turns Down Tower for Seaport District": 2.

43. Horsley, "All Wet on Water Street": 57.

44. David W. Dunlap, "Wave of Growth Planned at South Street Seaport," *New York Times* (January 19, 1989), B: 1–2; Richard D. Lyons, "Commercial Property," *New York Times* (July 30, 1989), X: 17; "Projects Within the City," *Oculus* 52 (February 1990): 4; Dunlap, "South Street Seaport": 17; David W. Dunlap, "Commercial Property," *New York Times* (June 30, 1991), X: 19; Monte Williams, "Seaport's Blemish: Old, Not Quaint," *New York Times* (February 12, 1995), XIII: 6; *The Architecture of Rafael Viñoly*, no pagination.

45. "Marine Group Sailing Away?" *New York* 21 (May 2, 1988): 12; David W. Dunlap, "Seamen Institute Finds a Haven On Water Street," *New York Times* (October 31, 1988), B: 1; "The Seamen's Church Institute," *Architectural Record* 177 (January 1989): 47; "Seamen's Church Institute," *Architecture + Urbanism* (November 1990): 110–13; "News Notes," *Oculus* 53 (December 1990): 3–4; Richard F. Shepard, "Ahoy, Mates, the Institute's Back at the Seaport," *New York Times* (May 6, 1991), B: 3; Elaine Louie, "With Light from Above," *New York Times* (August 1, 1991), C: 3; Barry Bergdoll, "Sailor's Delight," *Architecture* 80 (November 1991): cover, 66–73; Amy Dana, "Home Port," *Interiors* 151 (January 1992): 66–67; "Seamen's Church Institute Headquarters," *Bauwelt* 83 (February 14, 1992): 276–79; "AIA Picks 18 for Honor Awards," *Progressive Architecture* 74 (February 1993): 17–18; Marisa Bartolucci, "Citizen Architect," *Metropolis* 14 (June 1995): 62–67, 74–79; Susanna Sirefman, *New York* (London: Ellipsis, 1997), 22–23; Byard, *The Architecture of Additions*, 147–51; White and Willensky, *AIA Guide* (2000), 37; Susan Strauss and Sean Sawyer, eds., *Polshek Partnership Architects* (New York:

Princeton Architectural Press, 2005], 12–21.
46. Stern, Mellins, and Fishman, *New York 1960*, 183–85.
47. Stern, Mellins, and Fishman, *New York 1960*, 182–83.
48. Bergdoll, "Sailor's Delight": 68.

FINANCIAL DISTRICT
1. Carter B. Horsley, "Development Activity Astir in the Financial District," *New York Times* (September 23, 1979), VIII: 1, 6; Carter B. Horsley, "Lower Manhattan Luring Office Developers," *New York Times* (October 25, 1981), VIII: 1, 10; "A Lot for a Lot," *New York Times* (September 12, 1982), VIII: 1. For One Chase Manhattan Plaza, see Stern, Mellins, and Fishman, *New York 1960*, 172–76.
2. For Clinton & Russell's building, see W. Parker Chase, *New York: The Wonder City* (New York: Wonder City Publishing, 1932; New York: New York Bound, 1983), 156. For the Bank of New York and National City Company buildings, see Stern, Gilmartin, and Mellins, *New York 1930*, 534, 548, 586, 602.
3. Austen Gray, quoted in Horsley, "Development Activity Astir in the Financial District": 6.
4. Diane Henry, "About Real Estate: Major New Skyscraper Expected for Wall Street Site," *New York Times* (April 13, 1983), B: 4; Shawn G. Kennedy, "About Real Estate: Plans Progressing for a 60-Story Wall Street Tower," *New York Times* (September 14, 1983): 24.
5. For 55 Wall Street, see Stern, Gilmartin, and Massengale, *New York 1900*, 185; Barbaralee Diamonstein, *The Landmarks of New York III* (New York: Harry N. Abrams, 1998), 85.
6. Neil Klarfeld, quoted in Kennedy, "About Real Estate: Plans Progressing for a 60-Story Wall Street Tower": 24.
7. Ada Louise Huxtable, *The Tall Building Artistically Reconsidered* (New York: Pantheon Books, 1984), 71–72; "Landmarks Panel Backs Tower Plan," *New York Times* (March 29, 1984), B: 6; Paul Goldberger, "Manhattan's New Skyscrapers Pay Homage to the 20's," *New York Times* (June 17, 1984), II: 31; Francesco Dal Co, *Kevin Roche* (New York: Rizzoli International Publications, 1985), 252–53; "Kevin Roche John Dinkeloo and Associates," *GA Document* 12 (January 1985): 54–56; Carter Wiseman, "High Rise, Hard Sell," *New York* 18 (March 11, 1985): 42–46; Alan S. Oser, "Perspectives: Planning Policy; A Dissenting Voice on Transferring Air Rights," *New York Times* (June 16, 1985), VIII: 7; Josh Barbanel, "Instead of Leaving, Morgan Bank to Buy a Tower on Wall St.," *New York Times* (September 10, 1985): 1, B: 7; "Morgan Guaranty to Build $550 Million Headquarters," *Wall Street Journal* (September 10, 1985): 26; "The Bank Kept From a Run," *New York Times* (September 14, 1985): 22; Mark McCain, "Commercial Property: Building Crowns; Bold New Flourishes Embellish the Tops of Towers," *New York Times* (November 22, 1987), VIII: 35; Robert A. M. Stern with Raymond Gastil, *Modern Classicism* (New York: Rizzoli International Publications, 1988), 204–7; "Morgan Guaranty Trust Company Headquarters," *Architecture + Urbanism* (April 1988): 128–31; "J. P. Morgan Gets Financing," *New York Times* (May 3, 1988), D: 28; Heinrich Klotz, ed., *New York Architecture. 1970–1990* (Munich: Prestel-Verlag, 1989), 212–13; Karin Tetlow, "Counting Assets," *Interiors* 148 (April 1989): 146–51; "Billion Dollar Building at 60 Wall Street," *Stone World* 7 (April 1990): 49; Paul Goldberger, "A Tower Competes with Wall Street's Last Golden Age," *New York Times* (March 4, 1990), II: 35; Thomas J. Lueck, "Corporations Demand Flexibility in New Offices," *New York Times* (May 20, 1990), X: 11; *Park Tower Group*, brochure (New York, 1992), no pagination; Jerold S. Kayden, *Privately Owned Public Space: The New York City Experience* (New York: John Wiley & Sons, 2000), 93–94; White and Willensky, *AIA Guide* (2000), 18.
8. Nory Miller, *Helmut Jahn* (New York: Rizzoli International Publications, 1986), 222–23. Also see Ante Glibota, *Helmut Jahn* (Paris: Paris Art Center, 1987), 448–49. For Loos's Chicago Tribune competition entry, see *The International Competition for a New Administration Building for the Chicago Tribune* (Chicago, 1923), plate 196; Robert Bruegmann, "When Worlds Collided: European and American Entries to the Chicago Tribune Competition of 1922," in John Zukowsky, ed., *Chicago Architecture, 1872–1922: Birth of a Metropolis* (Munich: Prestel-Verlag; Chicago: The Art Institute of Chicago, 1987), 302–17.
9. Kevin Roche, quoted in "Morgan Guaranty Trust Company Headquarters": 131.
10. For Roche's hotel, see Stern, Mellins, and Fishman, *New York 1960*, 636–39.
11. Kevin Roche, quoted in "Kevin Roche John Dinkeloo and Associates": 54.
12. Goldberger, "Manhattan's New Skyscrapers Pay Homage to the 20's": 31.
13. Wiseman, "High Rise, Hard Sell": 45.
14. For 23 Wall Street, see Stern, Gilmartin, and Massengale, *New York 1900*, 183. For 15 Broad Street, see Stern, Gilmartin and Mellins, *New York 1930*, 535.
15. Goldberger, "A Tower Competes with Wall Street's Last Golden Age": 35. For the Bank of the Manhattan Company Building and Cities Service Building, see Stern, Gilmartin, and Mellins, *New York 1930*, 586, 600–603, 605.
16. Peter T. Kilborn, "Indecisive Fed Keeps Lot Empty 10 Years," *New York Times* (March 9, 1979), D: 1, 6; "Two Towers Set for Downtown," *New York Times* (December 14, 1980), VIII: 1–2; Paul Goldberger, "6 Architects Ponder Design Rationale Behind New Manhattan Skyscrapers," *New York Times* (February 21, 1981): 14; Diane Henry, "Major New Skyscraper Expected for Wall Street Site," *New York Times* (April 13, 1981), B: 4; Carter B. Horsley, "Lower Manhattan Luring Office Developers," *New York Times* (October 25, 1981), VIII: 1, 10; Paul Goldberger, "The New American Skyscraper," *New York Times* (November 8, 1981) VI: 68–73, 76, 78, 86, 88, 90, 92, 94, 96; "33 Maiden Lane," *Architecture + Urbanism* (January 1983): 63; *Philip Johnson/John Burgee: Architecture*

1979–1985 (New York: Rizzoli International Publications, 1985), 7, 124–29; "High-Rise Buildings & Projects," *GA Document* 12 (January 1985): 23; Paul Goldberger, "Philip Johnson, at 80 Is Dean and Gadfly of the Profession," *New York Times* (June 29, 1986), II: 29; "2 Federal Plaza, New York," *Architecture + Urbanism*, extra edition (April 1988): 217; "Federal Reserve Plaza, 33 Maiden Lane, New York, New York," in *Park Tower Group*, brochure (New York, 1992), no pagination; "Federal Reserve Bank Signs Lease to Expand," *New York Times* (August 23, 1997): 26; David W. Dunlap, "Reserve Bank to Make Building Fit Its Name," *New York Times* (August 27, 1997), B: 6; Herbert Muschamp, "Regent and King in a Procession of New Forms," *New York Times* (November 29, 1998), II: 44; Kayden, *Privately Owned Public Space*, 102; White and Willensky, *AIA Guide* (2000), 40–41; Stephen Fox, *The Architecture of Philip Johnson* (Boston: Bulfinch Press, 2002), 258.
17. For York & Sawyer's building, see Stern, Gilmartin, and Mellins, *New York 1930*, 174–75.
18. For Roche's design, see Stern, Mellins, and Fishman, *New York 1960*, 190–91.
19. Philip Johnson, quoted in "Two Towers Set for Downtown": 2.
20. Dunlap, "Reserve Bank to Make Building Fit Its Name": 6.
21. Goldberger, "Philip Johnson, at 80 Is Dean and Gadfly of the Profession": 29.
22. Grace Glueck, "Art People," *New York Times* (April 6, 1979), C: 25; "Paying the Cultural Rent," editorial, *New York Times* (July 21, 1980): 16; "Downtown Whitney Museum to Move Oct. 1," *New York Times* (September 1, 1980), III: 11; Richard F. Shepard, "New Precincts," *New York Times* (October 30, 1980), C: 17; "Whitney Museum to Open Branch in Stamford in May," *New York Times* (January 2, 1981), C: 24; Michael Brenson, "Whitney at Philip Morris Set to Open," *New York Times* (April 4, 1983), C: 11; Grace Glueck, "Are the Whitney's Satellite Museums on the Right Course?" *New York Times* (June 9, 1985), II: 31; "Names and News," *Oculus* 47 (September 1985): 10; Andrew L. Yarrow, "The Whitney Returns to Downtown," *New York Times* (April 16, 1988): 12; Peter Blake, "Art Pit," *Interior Design* 59 (August 1988): 156–61; Julie Iovine, "Artistic Liaisons," *Architectural Record* 176 (Mid-September 1988): 106, 114–17; "Tod Williams, Billie Tsien Honored by NYC/AIA," *Interior Design* 60 (December 1989): 39; Patricia Phillips, "Domestic Arrangements," *Ottagono* 97 (December 1990): 17–23; "Federal Reserve Plaza, 33 Maiden Lane, New York, New York," in *Park Tower Group*, no pagination; Carol Vogel, "The Art Market," *New York Times* (January 31, 1992), C: 28; "Whitney Museum of American Art Downtown Branch," *Bauwelt* 83 (February 14, 1992): 284–85; "Whitney Out at Equitable and Downtown Branches," *Art in America* 80 (March 1992): 33; "IBM to Turn Whitney Downtown Gallery Into Marketing Center," *Corporate Art News* 8 (March 1992): 1–2; David W. Dunlap, "Commercial Real Estate," *New York Times* (August 27, 1997), B: 6; Tod Williams and Billie Tsien, *WorkLife: Tod Williams, Billie Tsien* (New York: Monacelli Press, 2000), 237.
23. For 55 Water Street and the first downtown Whitney branch, see Stern, Mellins, and Fishman, *New York 1960*, 183–85.
24. For the First Police Precinct Station, see Stern, Gilmartin, and Massengale, *New York 1900*, 73–74.
25. David W. Dunlap, "Old Police Station to Be Home to Landmarks Commission," *New York Times* (October 8, 1992), B: 21; "A Landmark for Landmarks," *New York Times* (January 16, 1994), XIII: 6.
26. Glueck, "Are the Whitney's Satellite Museums on the Right Course?": 31.
27. Williams and Tsien, *WorkLife: Tod Williams, Billie Tsien*, 237.
28. Blake, "Art Pit": 156, 159, 161.
29. Horsley, "Development Activity Astir in the Financial District": 1, 6; Jennifer Dunning, "A Downside-Up Look at How New York Ticks," *New York Times* (May 29, 1981), C: 11; Horsley, "Lower Manhattan Luring Office Developers": 1; Alan S. Oser, "Development Returns to Wall Street Area," *New York Times* (August 9, 1982), VIII: 1, 13; Diane Henry, "Downtown Building's Park Vista," *New York Times* (August 11, 1982), D: 18; David W. Dunlap, "Building's Altered Plan Imperils Its Tax Break," *New York Times* (November 28, 1983), B: 3; "Late Paperwork Costs Builders $2.4 Million," *New York Times* (December 29, 1983), B: 20; Oser, "Perspectives: Planning Policy; A Dissenting Voice on Transferring Air Rights": 7; "7 Hanover Square," *Office Buildings* (June 1997): 108; Kayden, *Privately Owned Public Space*, 80; White and Willensky, *AIA Guide* (2000), 16; Alastair Gordon, *Romantic Modernist: The Life and Work of Norman Jaffe, Architect* (New York: Monacelli Press, 2005), 215.
30. For India House, see Landmarks Preservation Commission of the City of New York, LP-0042 (December 23, 1965); Diamonstein, *The Landmarks of New York III*, 111. For Richard F. Carman's suburban village in Upper Manhattan, Carmansville, see Stern, Mellins, and Fishman, *New York 1880*, 829–33.
31. Norman Jaffe, quoted in Henry, "Downtown Building's Park Vista": 18.
32. White and Willensky, *AIA Guide* (2000), 16. For Midway Gardens, see Bruce Brooks Pfeiffer, *Frank Lloyd Wright, vol. 3: Monograph 1907–1913* (Tokyo: A.D.A. Edita, 1987), 238–65.
33. Dunlap, "Building's Altered Plan Imperils Its Tax Break": 3.
34. Horsley, "Development Activity Astir in the Financial District": 1, 6; Glenn Fowler, "Archeologists Hard at Work at Site of the First City Hall," *New York Times* (October 25, 1979), B: 3; Karen W. Arenson, "Goldman Plans New Building," *New York Times* (October 15, 1980), D: 1, 21; "Two Towers Set for Downtown," *New York Times* (December 14, 1980), VIII: 1–2; Alan S. Oser, "Manhattan Developer's Headaches," *New York Times* (January 21, 1981), D: 17;

Horsley, "Lower Manhattan Luring Office Developers": 1; Oser, "Development Returns to Wall Street Area": 1, 13; Jonathan P. Hicks, "Goldman, Sachs to Sell Building," *New York Times* (May 18, 1985): 36; "85 Broad Street," *Office Buildings* (June 1997): 69; Kayden, *Privately Owned Public Space*, 78–80; White and Willensky, *AIA Guide* (2000), 14.
35. For Fraunces Tavern and the Fraunces Tavern Historic District, see Landmarks Preservation Commission of the City of New York, LP-0030 (November 23, 1965); Landmarks Preservation Commission of the City of New York, LP-0994 (November 14, 1978); Diamonstein, *The Landmarks of New York III*, 34, 505.
36. Stern, Mellins, and Fishman, *New York 1960*, 190.
37. White and Willensky, *AIA Guide* (2000), 14.
38. Steven Rattner, "British Funds Turning to America," *New York Times* (September 13, 1981), VIII: 1; Horsley, "Lower Manhattan Luring Office Developers": 1, 10; Oser, "Development Returns to Wall Street Area": 1, 13; White and Willensky, *AIA Guide* (1988), 19; "40 Broad Street," *Office Buildings* (June 1997): 64; Kayden, *Privately Owned Public Space*, 95.
39. Agis Salpukas, "Barclays Will Build a Headquarters on Wall St.," *New York Times* (April 12, 1984), D: 3; "We're Digging In," advertisement, *New York Times* (January 7, 1985), D: 3; "Introducing Wall Street's Majestic New Presence: Barclays Bank Building," advertisement, *New York Times* (January 27, 1985), III: 25; Shawn G. Kennedy, "Wall St. Is Getting Its First New Building in 15 Years," *New York Times* (February 6, 1985), B: 6; "75 Wall Street," *Office Buildings* (June 1997): 142; Kayden, *Privately Owned Public Space*, 85–86; White and Willensky, *AIA Guide* (2000), 28. For the Irving Trust and Barclay-Vesey buildings, see Stern, Gilmartin, and Mellins, *New York 1930*, 564–73.
40. "Two Towers Set for Downtown": 1–2; Carter B. Horsley, "Howard Ronson Begins Work on One Tower, Sells Another," *New York Times* (September 20, 1981): 1; Horsley, "Lower Manhattan Luring Office Developers": 1; Oser, "Development Returns to Wall Street Area": 1, 13; G. Bruce Knecht, "Manhattan's Newest Land Baron," *New York Times* (September 25, 1983), III: 4; Alan S. Oser, "A British Flurry Downtown," *New York Times* (June 10, 1984), VI: 14; David W. Dunlap, *On Broadway: A Journey Uptown Over Time* (New York: Rizzoli International Publications, 1990), 19–20; "45 Broadway Atrium," *Office Buildings* (June 1997): 78; "One Exchange Plaza," *Office Buildings* (June 1997): 81; Kayden, *Privately Owned Public Space*, 96–97; White and Willensky, *AIA Guide* (2000), 22–23.
41. Robert Fox, quoted in Horsley, "Howard Ronson Begins Work on One Tower, Sells Another": 2.
42. Knecht, "Manhattan's Newest Land Baron": 4; Oser, "A British Flurry Downtown": 6; Shawn G. Kennedy, "A 'Smart' Building Rises for Small Tenants," *New York Times* (May 21, 1986), B: 9; William Cochrane, "Property Market," *Financial Times* (London) (July 26, 1986): 14; Mark McCain, "Commercial Property: Downtown Offices," *New York Times* (February 21, 1988), VIII: 27; White and Willensky, *AIA Guide* (2000), 13; "Broad Financial Center," *Office Buildings* (June 2000): 78. For the New York Clearing House Association, see White and Willensky, *AIA Guide* (2000), 13.
43. Philip Shenon, "U.S. Assay Site Sold Downtown for $27 Million," *New York Times* (July 21, 1983), B: 9; Oser, "A British Flurry Downtown": 6, 14; David W. Dunlap, "Zoning Trade-Off Is Gaining Support," *New York Times* (August 5, 1984): 43; David W. Dunlap, "City's Plan to Sell Air Rights at Landmarks Draws Critics," *New York Times* (August 26, 1984): 51; Richard D. Lyons, "Real Estate," *New York Times* (September 11, 1985), D: 24; Alan S. Oser, "Perspectives: Downtown Leasing," *New York Times* (December 29, 1985), VIII: 4; "Intelligence and Clear Spans," *Metals in Construction* 4 (1986): 17–20; Shawn G. Kennedy, "A 'Smart' Building Rises for Small-Office Tenants," *New York Times* (May 21, 1986), B: 9; Shawn G. Kennedy, "Building Is Geared to Wall St.," *New York Times* (October 29, 1986): D: 26; Richard D. Lyons, "How Builders Invent Vanity Addresses," *New York Times* (May 22, 1988), X: 9; Kayden, *Privately Owned Public Space*, 83–84; White and Willensky, *AIA Guide* (2000), 27–28. For the U.S. Assay Building, see "Mellon Obtains New Assay Office Site on East Side of Old Slip at Front Street," *New York Times* (November 28, 1929): 32; "Mills Lays Stone of Assay Building," *New York Times* (August 1, 1931): 15; "New Assay Building Nearing Completion," *New York Times* (May 24, 1932): 37.
44. Margot Jacqz, "Gino Valle's New York Bank," *Skyline* (November 1982): 26; "Continuità e distanza critica: ultimato l'edificio di Gino Valle a New York," *Casabella* 51 (May 1987): 38–39; Kenneth Frampton, "Gino Valle: Edificio per uffici, New York," *Domus* 683 (May 1987): 25–37; "Architecture Awards," *New York Times* (May 30, 1988): 17; Pierre-Alain Croset, *Gino Valle* (Milan: Electa, 1989), 226–29; Landmarks Preservation Commission of the City of New York, LP-1943 (February 13, 1996); Diamonstein, *The Landmarks of New York III*, 464; White and Willensky, *AIA Guide* (2000), 16. For the Seligman Building, see Stern, Gilmartin, and Massengale, *New York 1900*, 161.
45. Jacqz, "Gino Valle's New York Bank": 26.
46. Frampton, "Gino Valle: Edificio per uffici, New York": 32–33, 36.
47. Oser, "A British Flurry Downtown": 14; Anthony DePalma, "Replacing Seamen's Institute," *New York Times* (September 18, 1985), D: 24; Anthony DePalma, "Building Offices Without a Prime Tenant," *New York Times* (July 27, 1986), VIII: 1, Iver Peterson, "A New Manhattan Office Tower Awaits First Tenant," *New York Times* (June 22, 1988): 24; Carlos Dobryn, "Seventeen State Street," *Modern Steel Construction* 28 (July-August 1988): 6–7; Paul Goldberger, "At 17 State Street, High Tech Passes Into the Vernacular," *New*

York Times (July 17, 1988), II: 31; Robert Sobel, "Manhattan's Glowing Tower," *Arca* 26 (April 1989): 29; Mark McCain, "The New Watchmen: TV Monitors and Computers," *New York Times* (July 9, 1989), X: 19; David W. Dunlap, "State Street Penitent: A Taste of the Past to Emend a Builder's Blunder," *New York Times* (May 6, 1990), X: 25; Kayden, *Privately Owned Public Space*, 75–76; White and Willensky, *AIA Guide* (2000), 10. For Kaufman's developments in lower Manhattan in the early 1970s, see Stern, Mellins, and Fishman, *New York 1960*, 185–88.

48. For Eggers & Higgins's building, see Stern, Mellins, and Fishman, *New York 1960*, 182–83.

49. Melvyn Kaufman, quoted in DePalma, "Replacing Seamen's Institute": 24.

50. Joyce Purnick, "Plan Is Disclosed for Office Tower at Trade Center," *New York Times* (May 27, 1981), B: 3; Carter B. Horsley, "Lower Manhattan Luring Office Developers," *New York Times* (October 25, 1981), VIII: 1, 10; Joseph Berger, "Work Set on Last Trade Center Unit," *New York Times* (October 1, 1984), B: 16; Anthony DePalma, "Expansion at Trade Center," *New York Times* (October 31, 1984), D: 26; Anthony DePalma, "Office Development Surges in Suburbs," *New York Times* (May 25, 1986), VIII: 1, 16; "Drexel Expects Building Deal," *New York Times* (June 18, 1986), D: 4; "Company Briefs," *New York Times* (June 20, 1986), D: 3; *New York Times* (June 20, 1986), D: 3; "A Realty Gambler's Big Coup," *New York Times* (July 11, 1986), D: 1; Anthony DePalma, "Building Offices Without a Prime Tenant," *New York Times* (July 27, 1986), VIII: 1; Albert Scardino, "$3 Billion Office Pact Canceled by Drexel," *New York Times* (December 3, 1986), D: 1; Mark McCain, "Commercial Property: The Downtown 'Empty States'; Two Behemoths with 3 Million Square Feet to Let," *New York Times* (March 22, 1987), VIII: 43; "Shearson Won't Rent Space in New Manhattan Tower," *Wall Street Journal* (May 8, 1987): 6; "Company News," *New York Times* (June 9, 1987), D: 11; Eric N. Berg, "Talking Deals: Developer Plays a Waiting Game," *New York Times* (April 7, 1988), D: 2; Peg Tyre and Jeannette Walls, "New York Intelligencer: Salomon Moving in on Drexel Space," *New York* 21 (April 18, 1988): 17; Thomas J. Lueck, "Salomon Will Move to Trade Center," *New York Times* (November 29, 1988), B: 3; Mark McCain, "Commercial Property: The Salomon Solution; A Building Within a Building, at a Cost of $200 Million," *New York Times* (February 19, 1989), X: 27; Jeannette Walls, "New York Intelligencer: Developer Makes Room for Groom," *New York* 22 (March 20, 1989): 11; White and Willensky, *AIA Guide* (2000), 54.

51. For the original World Trade Center buildings, see Stern, Mellins, and Fishman, *New York 1960*, 198–206.

52. McCain, "Commercial Property: The Downtown 'Empty States'; Two Behemoths with 3 Million Square Feet to Let": 43.

53. Larry A. Silverstein, quoted in McCain, "Commercial Property: The Salomon Solution; A Building Within a Building, at a Cost of $200 Million": 27.

54. "Irving Trust Plans $85 Million Building," *New York Times* (May 28, 1980), B: 3; Alan S. Oser, "New Center for Irving Trust," *New York Times* (May 28, 1980), D: 18; "In Progress: Irving Trust Company Operations Center, New York, N.Y.," *Progressive Architecture* 61 (October 1980): 42, 44; Janet Nairn, "Skidmore, Owings & Merrill's New Directions in High-Rise Design," *Architectural Record* 169 (March 1981): 114, 124–25; Alan S. Oser, "Development Returns to Wall Street Area," *New York Times* (August 8, 1982), VIII: 1, 13; *Skidmore, Owings & Merrill: Architecture and Urbanism, 1973–1983* (Stuttgart: Verlag Gerd Hatje; New York: Van Nostrand Reinhold, 1983), 240–43; "Irving Trust Operations Center," *Architecture + Urbanism* (March 1983): 56; Shawn G. Kennedy, "Real Estate: Helping Banks Add Locations," *New York Times* (December 21, 1983), D: 21; "Design Awards/Competitions: New York Chapter/AIA: 1986 Distinguished Architecture Awards," *Architectural Record* 174 (October 1986): 67; Kayden, *Privately Owned Public Space*, 103–4; White and Willensky, *AIA Guide* (2000), 56. For Ralph Walker's Irving Trust Building, see Stern, Gilmartin, and Mellins, *New York 1930*, 564, 567–69, 572–73.

55. "Built-In High Tech," *New York Times* (March 24, 1985), VIII: 1; Shawn G. Kennedy, "About Real Estate: Tribeca Building Begun with Help from the City," *New York Times* (January 14, 1986), B: 6; "Shearson Adds to Office Space," *New York Times* (May 19, 1987), D: 10; "Briefs," *New York Times* (October 1, 1987), D: 3; Alan S. Oser, "Slowly, Vacant Manhattan Land Is Rezoned," *New York Times* (November 27, 1988), VIII: 3, 8; "75 Park Place," *Office Buildings* (May 1999): 129; White and Willensky, *AIA Guide* (2000), 56.

56. Howard Blum, "Shearson Picks Manhattan Site for New Center," *New York Times* (January 16, 1984), I, D: 12; Michael Goodwin, "Private Developers Dispute City on Shearson Deal," *New York Times* (January 19, 1984), B: 5; Michael Goodwin, "A Broker Backs Report of a Deal with Shearson," *New York Times* (January 21, 1984): 25; Shawn G. Kennedy, "About Real Estate: Keeping Businesses in New York City," *New York Times* (February 1, 1984), B: 8; "2 Developers Sue on Shearson Deal," *New York Times* (February 2, 1984), B: 4; Robert J. Cole, "Shearson to Pay $360 Million to Acquire Lehman Brothers," *New York Times* (April 11, 1984): 1; David W. Dunlap, "City Deal with Shearson Draws Fire," *New York Times* (April 26, 1984), B: 3; "Shearson Tower Is Opposed in Suit," *New York Times* (August 23, 1984), B: 12; "On Kicking Away 3,400 Jobs," editorial, *New York Times* (September 4, 1984): 20; "Officials Withdraw from Tribeca Suit," *New York Times* (September 5, 1984), B: 5; Peter Lushing, "Power to Sue Confers No Power to Delay," letter to the editor, *New York Times* (September 15, 1984): 22; Ruth W. Messinger, Franz Leichter, Frank Domurad, "Downtown Deals at Public Expense," letter to the editor, *New York Times* (September 15, 1984): 22; "Suit Over a Tower in Tribeca Killed," *New York Times* (November 10, 1984): 27; Josh Barbanel, "Trial Ordered in Office Tower Dispute," *New York Times* (January 4, 1985), B: 5; Peter Kaufman, "Tribeca Offices," *New York Times* (August

18, 1985): 50; Sandra Salmans, "At Least, Shearson Makes Its Move," *New York Times* (October 19, 1985): 33; Alan S. Oser, "Hudson St. Lofts Draw Offices," *New York Times* (March 9, 1986), VIII: 7; *Kohn Pedersen Fox: Buildings and Projects, 1976–1986* (New York: Rizzoli International Publications, 1987), 248–53; David E. Pitt, "Protest in Tribeca: Trying to Save Greenery," *New York Times* (June 26, 1987), B: 3; "Demise of a Temporary Park in Tribeca Sparks a Protest," *New York Times* (June 26, 1987), B: 1; David W. Dunlap, "250,000 Glimpses of 18th-Century New York," *New York Times* (April 7, 1988), B: 1, 5; David W. Dunlap, "For Tribeca, Delicate Diversity or Wall Street North?" *New York Times* (June 13, 1989), B: 1, 4; Kayden, *Privately Owned Public Space*, 105; White and Willensky, *AIA Guide* (2000), 58.

57. For Independence Plaza, see Stern, Mellins, and Fishman, *New York 1960*, 1149, 1151.

58. Quoted in *Kohn Pedersen Fox: Buildings and Projects, 1976–1986*, 248.

59. David Gonzalez, "About New York: Criticism Never Rains But It Pours," *New York Times* (May 24, 1997): 21; Tibor Kalman, "Op-Art," *New York Times* (August 10, 1997), IV: 15; Mark Schweber, "For a Skyline in Neon," letter to the editor, *New York Times* (August 13, 1997): 22; Greg Sargent, "More Stormclouds Gather Over TriBeCa's Neon Umbrella," *New York Observer* (October 13, 1997): 10; James McKinley, "Storm Brewing for Umbrella," *New York Times* (November 30, 1997), XIV: 7; "City Scene Setters," *New York Times* (December 28, 1997), XIV: 5; "Something to Grouse About," *Newsweek* 131 (January 12, 1998): 6; James Bradley, "Umbrella Woes," *Village Voice* (January 13, 1998): 27; Claudia H. Deutsch, "In the Glow of a Merger, a Fight Over a Neon Sign," *New York Times* (April 9, 1998), B: 9; Clyde Haberman, "Merger or No, the Umbrella Still Glows," *New York Times* (April 10, 1998), B: 1; "Fold the Umbrella," editorial, *New York Times* (April 15, 1998): 24; Clyde Haberman, "Drying Out the Red Neon Umbrella," *New York Times* (May 19, 1998), B: 1; James Loney, "Best N.Y. Buildings Don't Need Signs to Advertise," letter to the editor, *New York Times* (May 23, 1998): 14; James Bradley, "Umbrella Folds," *Village Voice* (July 14, 1998): 22; White and Willensky, *AIA Guide* (2000), 58; David W. Dunlap, "For Once-Gritty Tribeca, a Golden Glow," *New York Times* (July 30, 2000), XI: 1, 7; David Koch, "Apply New Rules to the Big Umbrella," letter to the editor, *New York Times* (September 17, 2000), XIV: 15.

60. Kalman, "Op-Art": 15.

61. For Stubbins's Citicorp Center, see Stern, Mellins, and Fishman, *New York 1960*, 490–96.

62. "Fold the Umbrella": 24.

NEW YORK STOCK EXCHANGE

1. For Post's New York Stock Exchange, see Stern, Gilmartin, and Massengale, *New York 1900*, 144, 155, 187, 189.

2. For Trowbridge & Livingston's building, see Stern, Gilmartin, and Mellins, *New York 1930*, 535.

3. For Skidmore, Owings & Merrill's, Richard W. Adler's, O'Connor & Kilham's, I. M. Pei's, and Gordon Bunshaft's schemes, see Stern, Mellins, and Fishman, *New York 1960*, 198–200, 216–19.

4. For Kahn & Jacobs and Sidney Goldstone's building, see Stern, Mellins, and Fishman, *New York 1960*, 170–71. For the Commercial Cable Building and the Blair Building, see Stern, Gilmartin, and Massengale, *New York 1900*, 152, 155–56.

5. Robert J. Cole, "Big Board and Amex Termed Very Close to Merger Formula," *New York Times* (February 22, 1977): 45–46; "Wedding Bells on Wall Street for the Exchanges," *New York Times* (February 27, 1977), III: 17; Leonard Sloane, "Exchange Puts Off Action on Plan for Amex Merger," *New York Times* (May 20, 1977), D: 1, 5. For Starrett & Van Vleck's building, see Stern, Gilmartin, and Mellins, *New York 1930*, 178–79, 183.

6. Edward I. Koch, quoted in "The Koch System," *New York Times* (June 26, 1979), C: 6. Also see "Big Board, Comex Halt Merger Talks," *New York Times* (March 16, 1979), D: 4.

7. "Broadway Lease," *New York Times* (January 27, 1980), VIII: 4. For 100 Broadway, see Stern, Gilmartin, and Massengale, *New York 1900*, 158–59; Stern, Mellins, and Fishman, *New York 1960*, 1133–34.

8. John Crudele, "Larger Floor for Big Board," *New York Times* (November 13, 1985), D: 1; "Big Board Expanding," *New York Times* (January 15, 1988), D: 3. Also see Joseph Berger, "New York Stock Exchange Among 6 Buildings Gaining Landmark Status," *New York Times* (July 11, 1985), B: 1; Barbaralee Diamonstein, *The Landmarks of New York III* (New York: Harry N. Abrams, 1998), 256–57.

9. Neil Barsky, "Big Board, Amex Discuss Sharing a New Home," *Wall Street Journal* (June 12, 1992), C: 1, 11; Martin Dickson, "Stock Exchanges May Share NY Building," *Financial Times* (June 13, 1992): 10; Thomas J. Lueck, "7 Giants of Finance May Share Quarters," *New York Times* (June 13, 1992): 27; Charles V. Bagli, "Financial District's $1 Billion Cure-All: Mega-Stock Market," *New York Observer* (December 14, 1992): 1, 16; David W. Dunlap, "Two Stock Exchanges Drop Plans to Build Complex," *New York Times* (September 25, 1993): 27.

10. For 23 Wall Street, see Stern, Gilmartin, and Massengale, *New York 1900*, 183. For 15 Broad Street, see Stern, Gilmartin and Mellins, *New York 1930*, 535. For 37 Wall Street, see W. Parker Chase, *New York: The Wonder City* (New York: Wonder City Publishing Co., 1932; New York: New York Bound, 1983), 161.

11. Peter Slatin, "Give My Regards to Broad Street," *New York Post* (August 12, 1996): 22; Thomas S. Mulligan, "Lock, Stock & Farewell? NYSE May Be Leaving Its Historic Hq," *Los Angeles Times* (August 13, 1996): 1; Bob Liff and Peter Grant, "NYSE May Abandon Wall Street," *New York Daily News* (August 13, 1996): 47; Peter Slatin, "Donald's Dream!" *New York Post* (August 13, 1996): 24, 26; Alan Finder, "New York Stock Exchange Considers a Move, but Not from Manhattan,"

New York Times (August 13, 1996), B: 1, 3; Haya El Nasser, "NYC Sky Again the Limit for Trump Proposes to Build to Record Heights," *USA Today* (August 14, 1996): 3A; Dan Beucke, "New York Stock Exchange," *New York Newsday* (August 18, 1996), F: 2; Ann C. Sullivan, "Trump Proposes Record-Breaking Tower," *Architecture* 85 (October 1996): 45; Jesus Sanchez, "In the U.S., Skyscrapers Are Being Downsized by History," *Los Angeles Times* (November 12, 1996): 1.

12. For the Petronas Towers, see Michael J. Crosbie, *Cesar Pelli: Recent Themes* (Basel, Berlin, and Boston: Birkhäuser, 1998), 98–109.

13. Jeffrey A. Trachtenberg, "Big Board Ponders a Radical Redesign," *Wall Street Journal* (October 28, 1996), C: 1; Peter Grant, "Hard Sell for NYSE Plan: Landmark Groups Plan to Fight Broad St. Expansion Proposal," *New York Daily News* (October 29, 1996): 46; Thomas J. Lueck, "An Atrium for the Citadel of Capitalism," *New York Times* (October 29, 1996), B: 11; Hubert B. Herring, "Diary: Stock Market," *New York Times* (November 3, 1996), III: 2; Randy Wade, "Don't Block Broad St.," letter to the editor, *New York Times* (November 3, 1996), IV: 14; Brendan Sexton, "Keep Public Space Open," letter to the editor, *New York Times* (November 9, 1996): 22; "On the Drawing Boards," *Oculus* 59 (December 1996): 3.

14. Sexton, "Keep Public Space Open": 22.

15. Peter Slatin, "Two Added to NYSE Expansion Team," *New York Post* (December 18, 1996): 27; *Hardy Holzman Pfeiffer Associates: Buildings and Projects, 1992–1998* (New York: Rizzoli International Publications 1999), 217.

16. Peter Slatin, "NYSE Talks with City About Headquarters," *New York Post* (February 6, 1998): 30; "Stock Exchange Nears Move of Trading Floor," *New York Times* (February 20, 1998), B: 10; Thomas J. Lueck, "Stock Exchange Weighs Move to Battery Park City," *New York Times* (April 22, 1998), B: 1, 7; Susan Harrigan and Dan Janison, "Off the Wall? NYSE Ponders Move," *New York Newsday* (April 23, 1998): 5; Mike Allen, "Stock Exchange on Wall Street Offered a Home in New Jersey," *New York Times* (May 8, 1998), B: 1, 8; Devin Leonard, "NYSE, Nasdaq Try to Shake Down City for Big Tax Breaks," *New York Observer* (May 11, 1998): 1, 20; Charles V. Bagli, "New Broad Street Site Is Proposed to Keep Stock Exchange in Area," *New York Times* (May 20, 1998), B: 1, 6; John Labate, "New York SE May Be Trading Places," *Financial Times* (May 21, 1998): 6; Devin Leonard, "An Antique Skyscraper Stands in Way of Plan to Expand Stock Market," *New York Observer* (June 8, 1998): 1, 25; Devin Leonard, "Giuliani and Levine Scrambling to Keep NY Stock Exchange," *New York Observer* (July 20, 1998): 1, 11; Charles V. Bagli, "Deals Near on Manhattan Sites for 3 Stock Markets," *New York Times* (October 9, 1998), B: 1, 12; Charles V. Bagli, "New Stock Exchange Site Under Discussion," *New York Times* (October 17, 1998), B: 1, 3; David W. Chen, "New Offer to Big Board," *New York Times* (October 23, 1998), B: 12; Gordon Stott, "Save Wall Street," letter to the editor, *New York Times* (November 5, 1998): 28; Charles V. Bagli, "Wall Street Plays Relocation Card, and City Pays," *New York Times* (November 8, 1998): 39, 41; Charles V. Bagli, "Deal Is Near on New Home for Big Board," *New York Times* (November 21, 1998), B: 3; "Subsidy for the Stock Exchange," editorial, *New York Times* (November 30, 1998): 22; Charles V. Bagli, "11th-Hour Tinkering Keeps Big Board Plan in Business," *New York Times* (December 4, 1998), B: 14; Shane Keats, "Stock Exchange Bullies," letter to the editor, *New York Times* (December 4, 1998): 30; Charles V. Bagli, "Masters of Jersey: Wall Street Shudders at Life Across the River," *New York Times* (December 6, 1998), IV: 4; "Exchange Studies Move," *New York Times* (December 22, 1998), B: 8; Charles V. Bagli, "City and State Agree to $900 Million Deal to Keep New York Stock Exchange," *New York Times* (December 23, 1998), B: 3; John Labate, "NYSE Agrees to Stay on Wall Street," *USA Today* (December 23, 1998): 1; "Big Board," *Grid* 1 (Winter 1999): 22; Elisabeth Bumiller, "Drawing Plans for Tomorrow's Landmarks," *New York Times* (June 1, 1999), B: 2; Jon Birger, "NYSE Rethinks Its New Building, Big Trading Floor," *Crain's New York Business* (August 2–8, 1999): 1, 47; Joan Warner, "Trading Places," *Grid* 1 (Fall 1999): 78–81; Charles V. Bagli, "City's Expense in Keeping Stock Exchange Here Goes Up," *New York Times* (February 1, 2000), B: 6; Elizabeth Harrison Kubany, "SOM Takes Manhattan," *Architectural Record* 188 (March 2000): 63–64, 204; Charles V. Bagli, "Doubts Rise on New Site for Big Board," *New York Times* (June 6, 2000), B: 3; Joe Mahoney, "Silver, Bruno Strike Deal to Keep NYSE in New York," *New York Times* (June 23, 2000): 8; Kristi Cameron, "What's in an Address?" *Metropolis* 19 (July 2000): 52; "Stock Exchange Plan Wins First Approval," *New York Times* (July 21, 2000), B: 7; Charles V. Bagli, "Only 2 Developers Express Interest in Building Trading Complex for Stock Exchange," *New York Times* (August 24, 2000), B: 7; Denny Lee, "Residents Wish Stock Exchange Was Bearish About a New Office," *New York Times* (September 10, 2000), XIV: 6; Matthew Creamer, "Stock Exchange Bought: Neighbors Cringe," *New York Observer* (October 2, 2000): 9; Eric Herman, "Architect's Building Big Legacy," *New York Daily News* (October 23, 2000): 32; "Trading Tower," *Wall Street Journal* (November 1, 2000), B: 14; Andrew Rice, "Without a Developer, City May Go It Alone on New NYSE Building," *New York Observer* (December 11, 2000): 1; Charles V. Bagli, "Stock Exchange Signs Deal for New Site in Financial District," *New York Times* (December 21, 2000), B: 8; Eric Herman, "NYSE Building Site May Cost City More," *New York Daily News* (December 22, 2000): 93; "NYC Eyes Stock Exchange Tower," *Building Design and Construction* (January 1, 2001): 8; Eric Herman, "New Day for Two NYC Landmarks: NYSE Land Deal Struck," *New York Daily News* (March 16, 2001): 44; "Bank Sale Advances Plan for New Big Board Base," *New York Times* (March 16, 2001), C: 14; David W. Dunlap, "A Downtown Flagship Strikes Its Colors," *New York Times* (March 25, 2001), XI: 1, 4; Shonquis Moreno,

"New York City Begs Stock Exchange, 'Don't Go!'" *Architecture* 90 (April 2001): 43; Eric Herman, "New Digs for NYSE on Shaky Ground," *New York Daily News* (November 12, 2001): 58; Lois Weiss, "Grasso Eyes Glass Tower Again," *New York Post* (November 28, 2001): 40; Andrew Rice, "Back to the Drawing Board," *Architecture* 91 (January 2002): 44–45, 47–49, Charles V. Bagli, "Deal to Build New Complex Eludes Mayer and Wall St.," *New York Times* (January 1, 2002), B: 5; Peter Slatin, "If You Built It, It Will Get Built," *Grid* 4 (March 2002): 64; Alair Townsend, "NYSE's Wants vs. Its Needs," *Crain's New York Business* (May 20, 2002): 9; Eric Herman, "Costly Tab for NYSE Deal That Has Been Canceled," *New York Daily News* (August 3, 2002): 15; Charles V. Bagli, "45 Wall St. Is Renting Again Where Tower Deal Failed," *New York Times* (February 8, 2003), B: 3.

17. Richard A. Grasso, quoted in Harrigan and Janison, "Off the Wall? NYSE Ponders Move": 5.

18. Ray Fleischhacker, quoted in Herman, "Costly Tab for NYSE Deal That Has Been Canceled": 15.

19. Junius Peake, quoted in Birger, "NYSE Rethinks Its New Building, Big Trading Floor": 47.

20. *Skidmore, Owings & Merrill: Architecture and Urbanism, 1995–2000* (Mulgrave, Australia: Images Publishing, 2000), 73–74; Kristi Cameron, "What's in an Address?" *Metropolis* 19 (July 2000): 52; "A Quantum Leap in Trading Technology," *The Exchange* 7 (September 2000): 1–3; "New York Stock Exchange Trading Floor Expansion," *New York Construction News* 49 (December 2000): 25; "Postings: American Institute of Architects Announce Awards," *New York Times* (January 7, 2001), XI: 1; "Honor Awards: Interiors," *Architectural Record* 189 (May 2001): 141.

21. Nina Rappaport, "Grab Bag of Commissions and Completions," *Oculus* 61 (November 1998): 3; Jaikumar Vijayan, "Virtual Reality Trading Floor Adds New Dimension," *Computerworld* 33 (March 28, 1999): 67; "Asymptote: Rashid = Couture," *Architecture + Urbanism* (May 1999): 22–31; "Asymptote Architecture," *Domus* (June 1999): 39–46; Pilar Guzman, "Wall-Less Street," *Metropolis* 18 (June 1999): 56; Sarah Amelar, "Asymptote's Dual Projects for the New York Stock Exchange Span Both Real and Virtual Realms," *Architectural Record* 187 (June 1999): 140–45; "Asymptote," *Oculus* 62 (October 1999): 16–17; "Asymptote Architecture," *Casabella* (December 1999-January 2000): 107–13; *10 x 10*, eds. Vivian Constantinopoulos and Iona Baird (London: Phaidon, 2000), 60–63; White and Willensky, *AIA Guide* (2000), 20; Dan Fox, "Imaging All the People," *World Architecture* 90 (October 2000): 110–13; Luca Molinari, *Atlas: North American Architecture Trends, 1990–2000* (Milan: Marazzi Gruppo Ceramiche, 2001), 128–35; Ian Luna, ed., *New New York: Architecture of a City* (New York: Rizzoli International Publications, 2003), 24–27.

22. Hani Rashid, quoted in Amelar, "Asymptote's Dual Projects for the New York Stock Exchange Span Both Real and Virtual Realms": 141.

WALL STREET 24/7

1. Joseph Pell Lombardi, *Liberty Tower*, marketing brochure (1979); "The Liberty Tower," advertisement, *New York Times* (July 11, 1979), D: 15; Carter B. Horsley, "Wall St. Image Facing Change as Apartments Replace Offices," *New York Times* (July 29, 1979), VIII: 1–2; Joseph Giovannini, "At Home Downtown with Light and Views," *New York Times* (September 1, 1983), C: 1, 6; Michael Cooper, "The Ghosts of Teapot Dome," *New York Times* (January 28, 1996), XIII: 4; White and Willensky, *AIA Guide* (2000), 41. For Cobb's 55 Liberty Street, see Landmarks Preservation Commission of New York, LP-1243 (August 24, 1982); Barbaralee Diamonstein, *The Landmarks of New York III* (New York: Harry N. Abrams, 1998), 297.

2. Joseph Pell Lombardi, quoted in Giovannini, "At Home Downtown with Light and Views": 6.

3. Charles K. Gandee, "Gillette Studio," *Architectural Record* 173 (Mid-September 1985): 86–95; Suzanne Stephens, "More Than Skin Deep," *House & Garden* 158 (January 1986): 80–89, 177; "Gillette Studio, N.Y.," *Lotus International* 66 (1990): 46–51; *Franklin D. Israel: Buildings and Projects* (New York: Rizzoli International Publications, 1992), 28–37; Lorenzo Spagnoli, *Franklin D. Israel: La creazione del disordine* (Torino, Italy: Testo & Immagine, 1998), 32–33.

4. Franklin D. Israel, quoted in *Franklin D. Israel: Buildings and Projects*, 29.

5. Stephens, "More Than Skin Deep": 177.

6. For the Excelsior Power Company conversion, see Horsley, "Wall St. Image Facing Change as Apartments Replace Offices"; Selwyn Raab, "Downtown: The Original Place to Live," *New York Times* (January 2, 1983), VIII: 1; White and Willensky, *AIA Guide* (2000), 44; Daniel B. Schneider, "An Edison Competitor," *New York Times* (April 1, 2001), XIV: 2. For Grinnell's building, see Stern, Mellins, and Fishman, *New York 1880*, 493. For the New York Cotton Exchange conversion, see Alan S. Oser, "Housing on the Way in Financial District," *New York Times* (July 16, 1976), B: 6; Horsley, "Wall St. Image Facing Change as Apartments Replace Offices": 2; Lee A. Daniels, "About Real Estate," *New York Times* (August 13, 1982): 15; Nancy J. Albaugh, "If You're Thinking of Living In: Lower Manhattan," *New York Times* (November 4, 1984), VIII: 9. For Barber's building, see W. Parker Chase, *New York: The Wonder City* (New York: Wonder City Publishing, 1932; New York: New York Bound, 1983), 148.

7. Ted Cohen, "At Home on Wall Street," *Metropolis* 12 (October 1992): 9, 20. For the Lower Manhattan Plan, see Stern, Mellins, and Fishman, *New York 1960*, 210–11.

8. New York City Planning Commission, *Plan for Lower Manhattan* (New York, October 1993), 39. Also see Claudia H. Deutsch, "Plan Seeks Improvement Package for Financial District," *New York Times* (October 20, 1993), B: 3; Hugo Lindgren, "Planned Shrinkage for Wall Street?" *Metropolis* 13

(January-February 1994): 18, 22; Tom Redburn, "The Soul-Searching Downtown," *New York Times* (May 15, 1994), XIV: 4; Tom Stevenson, "View from New York: Skyscrapers Turn to Empty Boasts for Manhattan," *The Independent* (London) (November 14, 1994): 29.

9. Thomas J. Lueck, "Giuliani Plans Inducements to Revive Wall Street Area," *New York Times* (December 16, 1994): 1, B: 8; Richard Waters, "A New Life for Old Manhattan," *Financial Times* (December 17, 1994): 3; Peter Slatin, "Housing Pioneers Scout the Downtown Frontier," *New York Times* (July 30, 1995), IX: 7; Michael Finnegan, "Wall Street Tax Break Eyed," *New York Daily News* (October 10, 1995): 10; Thomas J. Lueck, "Tax Breaks Approved to Spur Growth in Lower Manhattan," *New York Times* (October 13, 1995), B: 3; "Downtown Is Boomtown," *New York Construction News* (March 18, 1996): 1; Derek H. Trelstad, "A Right-Sized Future for Living in Lower Manhattan," *Architectural Record* 184 (June 1996): 15; Ellen Kirschner Popper, "Developers Are Bullish on Wall Street," *New York Times* (June 30, 1996), IX: 1, 8; Jonathan Hale, "Living High in Lower Manhattan?" *Preservation* 48 (September-October 1996): 22–23; Tom Vanderbilt, "Can a Residential Neighborhood Be Carved Out of the Financial District?" *Metropolis* 16 (November 1996): 22, 26; Joe Mathews, "Wall Street Recycles Itself," *Baltimore Sun* (October 17, 1997): 2A; Kevin McCoy, "New Homes Where Bulls Roam," *New York Daily News* (December 18, 1997): 26; Karrie Jacobs, "Lower Manhattan's Bull Market," *Architecture* 87 (January 1998): 38–39, 41–43; Lawrence O. Houstoun Jr., "Urban Awakening," *Urban Land* 57 (October 1998): 34–41.

10. Carol Willis, quoted in Popper, "Developers Are Bullish on Wall Street": 1.

11. Slatin, "Housing Pioneers Scout the Downtown Frontier": 7; "Office Building Going Residential," *New York Times* (December 17, 1995), IX: 1; Phoebe Eaton, "Virtual Realty," *New York* 29 (March 25, 1996): 78–83; Popper, "Developers Are Bullish on Wall Street": 1, 8; Hale, "Living High in Lower Manhattan?": 22; Vanderbilt, "Can a Residential Neighborhood Be Carved Out of the Financial District?": 22, Rachelle Garbarine, "From Offices to Apartments in Lower Manhattan," *New York Times* (April 4, 1997), B: 5; Jacobs, "Lower Manhattan's Bull Market": 38; Karrie Jacobs, "Rudy's Secret Plans," *New York* 31 (May 4, 1998): 34, 36–37; White and Willensky, *AIA Guide* (2000), 20. For Clinton & Russell's building, see Chase, *New York: The Wonder City*, 162.

12. Eaton, "Virtual Realty": 81.

13. Peter Grant, "Brothers Buy Bldg. for Downtown Apts.," *New York Daily News* (May 27, 1996): 20; "A New Life for 45 Wall," *New York Times* (July 21, 1996), IX: 1; Anne Spackman, "Downtown on the Up," *Financial Times* (December 7, 1996): 12; Garbarine, "From Offices to Apartments in Lower Manhattan": 5; "Tenants at 45 Wall St.: Just Folks, Not Firms," *New York Times* (August 17, 1997), IX: 1; Richard Tomkins, "Sleeping at the Office on Wall Street," *Financial Times* (September 25, 1997): 6; Mathews, "Wall Street Recycles Itself": 2A; Jennifer Lee, "Roomies on Wall Street," *New York Times* (August 22, 1999), IX: 1; White and Willensky, *AIA Guide* (2000), 19; Denny Lee, "Residents Wish Stock Exchange Was Bearish About a New Office," *New York Times* (September 10, 2000), XIV: 6; David W. Dunlap, "A Downtown Flagship Strikes Its Colors," *New York Times* (March 25, 2001), XI: 1, 4; *Marvin H. Meltzer: City as Poetry* (Milan: l'Arca Edizioni, 2002), 96.

14. Lee, "Roomies on Wall Street": 1.

15. For the Delmonico's conversion, see Mervyn Rothstein, "The Office Building in Lower Manhattan That Housed Delmonico's Changes Hands for $3 Million," *New York Times* (December 6, 1995), D: 19; Christopher Gray, "Streetscapes/56 Beaver Street," *New York Times* (April 14, 1996), IX: 7; Popper, "Developers Are Bullish on Wall Street": 8; Houstoun, "Urban Awakening": 36; White and Willensky, *AIA Guide* (2000), 16–17. For Lord's building, see Stern, Mellins, and Fishman, *New York 1880*, 733–35. For the Empire Building's conversion, see Hale, "Living High in Lower Manhattan?": 22; Rachelle Garbarine, "At 100, Skyscraper Becomes Housing," *New York Times* (September 12, 1997), B: 6; Popper, "Developers Are Bullish on Wall Street": 8; Houstoun, "Urban Awakening": 34; White and Willensky, *AIA Guide* (2000), 22. For Kimball's building, see Landmarks Preservation Commission of the City of New York, LP-1933 (June 25, 1996); Diamonstein, *The Landmarks of New York III*, 456.

16. Hale, "Living High in Lower Manhattan?": 22; Rachelle Garbarine, "Rose Associates Enters the Conversion Market," *New York Times* (July 11, 1997), B: 5; Leslie Eaton, "Tottering into the Spandex Era," *New York Times* (October 4, 1998): 41, 44; Debra Waters, *Hardy Holzman Pfeiffer Associates: Buildings and Projects, 1992–1998* (New York: Rizzoli International Publications, 1999), 214; Alan S. Oser, "As Buildings Rise, So Do Their Rents," *New York Times* (June 6, 1999), XI: 1; Trish Hall, "Habitats/21 West Street in Lower Manhattan," *New York Times* (August 8, 1999), XI: 6; White and Willensky, *AIA Guide* (2000), 8; Dean E. Murphy, "Condos to Rise Above the Heisman Trophy," *New York Times* (August 24, 2000), B: 7; Mitchell Belitz, "Club Building Is Named Landmark," *New York Times* (November 15, 2000), B: 12; Dick Weiss, "Heisman Ceremony May Be Forced to Move," *New York Daily News* (September 26, 2001): 95; Trish Hall, "Habitats/21 West Street, Downtown Manhattan," *New York Times* (March 24, 2002), XI: 8; Ian Blecher, "Downtown Athletic, Once on the Ropes, Seeks Tower Money," *New York Observer* (March 25, 2002): 1, 28; John Henderson, "Downed Athletic Club: Boarded-Up Home of the Heisman Remains Closed, Two Years After 9/11," *Denver Post* (September 11, 2003), D: 1. For Starrett & Van Vleck's buildings, see Stern, Gilmartin, and Mellins, *New York 1930*, 194–96, 535, 538.

17. Popper, "Developers Are Bullish on Wall Street": 1, 8; Hale, "Living High in Lower Manhattan?": 22; Michael Cooper, "Artists Muster in Defense of Their 'Happy

Nonsense,'" *New York Times* (November 10, 1996), XIII: 8; Alan S. Oser, "A Glass Tower Rides Downtown's Residential Wave," *New York Times* (April 6, 1997), IX: 5; Rachelle Garbarine, "On John St., from Offices to Housing," *New York Times* (December 19, 1997), B: 12; Houstoun, "Urban Awakening": 37. For Emery Roth & Sons's building, see Stern, Mellins, and Fishman, *New York 1960*, 185, 188.

18. Garbarine, "On John St., from Offices to Housing": 12; Rachelle Garbarine, "Another Building in Wall St. Area Becomes Housing," *New York Times* (May 7, 1999), B: 10; Rachelle Garbarine, "Transforming Another Office Tower," *New York Times* (August 20, 1999), B: 6. For Shreve, Lamb & Harmon's building, see Stern, Gilmartin, and Mellins, *New York 1930*, 537.

19. Glenn Fowler, "Landmarks at 40 Wall Is Sold," *New York Times* (January 5, 1983), D: 2; "Building Sale Contract in Place, Report Says," *New York Times* (March 2, 1986): 15; Eric Pace, "Marcos Holdings Frozen by Judge," *New York Times* (March 4, 1986): 12; "Marcos Holdings Shedding Web of Intrigue," *New York Times* (August 20, 1989), X: 3; Richard D. Lyons, "Real Estate," *New York Times* (January 10, 1990), D: 10; David W. Dunlap, "Commercial Property: 40 Wall Street," *New York Times* (November 10, 1991), X: 13; Andree Brooks, "Commercial Property: Troubled Office Tenants," *New York Times* (September 6, 1992), X: 9; Christopher Gray, "Streetscapes: 40 Wall Street," *New York Times* (November 15, 1992), X: 7; Alan S. Oser, "Perspectives: 40 Wall Street," *New York Times* (June 20, 1993), X: 5; Peter Slatin, "Trump to Buy Leasehold at 40 Wall St.," *New York Times* (July 12, 1995), D: 20; Peter Grant, "New Trump Buy Is a Tall Order," *New York Daily News* (November 13, 1995): 40; "40 Wall Street Is Sold to Trump," *New York Times* (December 7, 1995), D: 6; Charles V. Bagli, "Cushman & Wakefield Starts a Feud to Tout Trump's Latest Ploy," *New York Observer* (March 18, 1996): 1, 19; Donald J. Trump with Kate Bohner, *Trump: The Art of the Comeback* (New York: Random House, 1997), 45–59, 205, 225–26; David M. Halbfinger, "Wall Street Space Leased," *New York Times* (April 9, 1997), B: 7; Peter Grant, "Trump's 5M Deal Now 125M," *New York Daily News* (May 30, 1998): 43; Charles Lockwood, "Trump's Other Tower," *Grid* 1 (Spring 1999): 116–18; Charles Lockwood, "A Lower Manhattan Success Story," *Urban Land* 58 (June 1999): 28–29; "Der Scutt Awarded Premier Award for 1999," *New York Construction News* 47 (July 1999): 5; White and Willensky, *AIA Guide* (2000), 19. For H. Craig Severance and Yasuo Matsui's building, see Stern, Gilmartin, and Mellins, *New York 1930*, 586, 602–3, 605.

20. Trump with Bohner, *Trump: The Art of the Comeback*, 57.

21. Andrew Rice and Matthew Creamer, "F. W. Woolworth Didn't Sleep Here: Landmark Tower Goes Residential," *New York Observer* (April 17, 2000): 1, 11; David W. Dunlap, "Commercial Real Estate: Change the Woolworth?" *New York Times* (October 18, 2000), B: 12; David W. Dunlap, "Condos to Top Vaunted Tower of Woolworth," *New York Times* (November 2, 2000), F: 1, 6; Matthew Creamer, "Can They Canopy?" *New York Observer* (November 20, 2000): 13. For Cass Gilbert's building, see Stern, Gilmartin, and Massengale, *New York 1900*, 175–77.

22. For the Ehrenkrantz Group's restoration, see Ada Louise Huxtable, "'All New' vs. Rehabilitation," *New York Times* (November 25, 1979), II: 23; Paul Goldberger, "A Life Renewed for 'Cathedral of Commerce,'" *New York Times* (November 5, 1981), B: 1–2; White and Willensky, *AIA Guide* (2000), 67.

23. John Holusha, "Commercial Real Estate: Regional Market–Downtown," *New York Times* (November 20, 2002), C: 8; Eric Herman, "Can't-Do Condos," *New York Daily News* (June 4, 2003): 32; John Holusha, "Commercial Property: Lower Manhattan," *New York Times* (September 21, 2003), XI: 6.

24. Dena Kleiman, "Negotiations Are Under Way to Construct Hotel at World Trade Center," *New York Times* (January 15, 1978): 31; "Investor Said to Be Interested in Building Trade Center Hotel," *New York Times* (March 20, 1978), B: 5; "New York's Old and New," *New York Times* (March 27, 1979), B: 5; "SOM Designs First Hotel for Lower Manhattan in 150 Years," *Architectural Record* 165 (June 1979): 39; Fred Ferretti, "At Trade Center, a Hotel Rises," *New York Times* (December 12, 1979), C: 20; Suzanne Slesin, "Four New Luxury Hotels in the City: Elaborate Decor and Matching Prices," *New York Times* (August 24, 1980), VIII: 1; Ari L. Goldman, "Fire Damages Hotel at World Trade Center," *New York Times* (March 30, 1981), B: 3; Dorothy J. Gaiter, "Hotel in the Trade Center Greets Its First 100 Guests," *New York Times* (April 2, 1981), B: 3; "Vista International Hotel to Officially Open Its Doors Tomorrow," *New York Times* (June 30, 1981), B: 3; Laurie Johnston, "Vista Hotel Bringing New Life to Downtown Area," *New York Times* (January 24, 1982): 38; *Skidmore, Owings & Merrill: Architecture and Urbanism, 1973–1983* (Stuggart: Verlag Gerd Hatje; New York: Van Nostrand Reinhold, 1983), 254–57; "SOM: Vista International Hotel," *Architecture + Urbanism* (March 1983): 53–55; White and Willensky, *AIA Guide* (2000), 54. For the Astor House, see Stern, Mellins, and Fishman, *New York 1880*, 24, 63, 137, 518.

25. For the World Trade Center towers, see Stern, Mellins, and Fishman, *New York 1960*, 198–206.

26. *Skidmore, Owings & Merrill: Architecture and Urbanism, 1973–1983*, 254.

27. White and Willensky, *AIA Guide* (2000), 54.

28. Johnston, "Vista Hotel Bringing New Life to Downtown Area": 38.

29. Robert D. McFadden, "Explosion at the Twin Towers," *New York Times* (February 27, 1993): 1, 22–23; Malcolm Gladwell, "At Least 5 Die, 500 Hurt as Explosion Rips Garage Under World Trade Center," *Washington Post* (February 27, 1993): 1; James Bennet, "Crisis in the Twin Towers," *New York Times* (March 1, 1993), B: 5; Brigitte Maxey, "Vista Costs Could Exceed Coverage Limits," *Journal of Commerce* (March 4, 1993): 9A; Nadine M. Post et al., "Anatomy of a Building

Disaster," *Engineering News-Record* 230 (March 8, 1993): 8; Nadine M. Post with Judy Schriener, "Trade Center Digs Out After Blast," *Engineering News-Record* 230 (March 15, 1993): 9; James C. McKinley Jr., "Vista Hotel Is Closed Until Summer, Officials Say," *New York Times* (March 15, 1993), B: 7; "Bomb-Damaged Vista Hotel Plans Summer Opening," *Nation's Restaurant News* (March 22, 1993): 2; "Repairs Continue at the Bomb-Damaged Vista Hotel," *New York Times* (August 21, 1993): 21; Michael Meyer, "The Vista Hotel Bombing," *Lodging Hospitality* (January 1994): 32–34; Alan S. Oser, "A Downtown Hotel in Search of a Niche All Its Own," *New York Times* (February 13, 1994), X: 7; "Closed Hotel Struggles Through Blast-Related Repairs and a Renovation," *Engineering News-Record* 232 (February 28, 1994): 34; "Vista Bounces Back," *Newsday* (September 14, 1994): 35; Claudia H. Deutsch, "20 Months After Bombing, Vista Hotel to Finally Reopen," *New York Times* (October 31, 1994), B: 3; "Open for Business Again," *New York Times* (November 2, 1994), B: 3; Ron Donoho, "Vista Back in Business," *Successful Meetings* 44 (January 1995): 12; Suzanne Kapner, "NY Vista: Back in the Action with Upgraded Facility," *Nation's Restaurant News* (January 9, 1995): 7; Glenn Withiam, "New York ReVista," *Cornell Hotel and Restaurant Administration Quarterly* 36 (February 1995): 10; Richard Perez-Pena, "2 Years After Blast, Hotel Awaits Security Devices," *New York Times* (March 17, 1995): 11; Thomas J. Lueck, "Vista Hotel for Sale, Port Authority Says," *New York Times* (May 10, 1995), B: 3; Mark Finnegan, "PA May see 150M from Vista Hotel," *New York Daily News* (November 9, 1995): 6; Clifford J. Levy, "Port Authority Is Selling Vista Hotel," *New York Times* (November 9, 1995), B: 2; Peter Grant, "PA Sheds Vista in 141.5M Deal," *New York Daily News* (November 10, 1995): 38; "Port Authority Sells Hotel," *New York Times* (November 10, 1995), B: 4; Terry Trucco, "Lodging in Lower Manhattan," *New York Times* (September 8, 1996), V: 13, 18.

30. White and Willensky, *AIA Guide* (1988), 23; Richard D. Lyons, "Success of Vista Hotel Draws Developers Downtown," *New York Times* (January 22, 1989), X: 15; David W. Dunlap, "Commercial Property: Downtown Hotels," *New York Times* (June 30, 1991), X: 19; Terry Trucco, "New York Hotels, New and Renewed," *New York Times* (September 15, 1991), V: 15; Claudia H. Deutsch, "Bombing Aftermath: 2 Nearby Hotels Fill the Vista Vacuum," *New York Times* (March 7, 1993), X: 1.

31. "Manhattan Moves Downtown," *Architectural Record* 173 (April 1985): 73; "City News Digest," *New York Observer* (June 12, 1989): 6; David W. Dunlap, "Kalikow Opts for a 58-Story Lower Manhattan Hotel," *New York Times* (January 21, 1990), X: 15; "Millenium Hotel," *Newsday* (June 26, 1991): 37; Dunlap, "Commercial Property: Downtown Hotels": 19; Peter D. Slatin, "Kalikow's Opening a Downtown Gamble," *New York Times* (June 28, 1992), X: 5; Robert Selwitz, "Amenities at Millenium Go Beyond Basics," *Hotel and Motel Management* 207 (July 27, 1992): 5; Terry Trucco, "Travel Advisory," *New York Times* (September 13, 1992), V: 3; "Bankruptcy Kalikow Style," *Newsday* (August 30, 1992): 76; Deutsch, "Bombing Aftermath: 2 Nearby Hotels Fill the Vista Vacuum": 1; "Bitter Suite: New Luxury Hotels Have Enriched the City, But Not Their Developers," *Newsday* (October 7, 1994), D: 1; Claudia H. Deutsch, "Commercial Properties: Hotels," *New York Times* (March 26, 1995), IX: 1.

32. For St. Paul's Chapel, see Landmarks Preservation Commission of the City of New York, LP-0075 (August 16, 1966); Diamonstein, *The Landmarks of New York III*, 43; Stern, Mellins, and Fishman, *New York 1880*, 63.

33. For Bosworth's building, see Stern, Gilmartin, and Massengale, *New York 1900*, 162–63.

34. Peter Kalikow, quoted in Dunlap, "Kalikow Opts for a 58-Story Lower Manhattan Hotel": 15.

35. Peter Kalikow, quoted in Dunlap, "Commercial Property: Downtown Hotels": 19.

36. John Holusha, "New Niche Hotels in Downtown Manhattan," *New York Times* (July 25, 1999), XI: 9; Jayne Merkel, "Welcome to New York: Do You Have a Reservation," *Oculus* 62 (March 2000): 12–26; Nadine M. Post, "Hotel Architect Follows Money Trail into Development," *Engineering News-Record* 246 (February 19, 2001): 16.

37. Holusha, "New Niche Hotels in Downtown Manhattan": 9. Also see Landmarks Preservation Commission of the City of New York, *Stone Street Historic District Designation Report* (New York, 1996), 2.

38. For the Merchants' Exchange, see Stern, Gilmartin, and Massenagle, *New York 1900*, 185; Diamonstein, *The Landmarks of New York III*, 85; Stern, Mellins, and Fishman, *New York 1880*, 458.

39. Carter B. Horsley, "How Banks Are Using Space Now," *New York Times* (June 13, 1979), D: 17; Ada Louise Huxtable, "An Imperfect Renovation," *New York Times* (January 27, 1980), II: 27, 37; "Citibank, 55 Wall Street," *Process Architecture* 77 (June 1988): 76–79; Suzanne Stephens, "Foiled Again," *Progressive Architecture* 61 (November 1990): 96–99.

40. Huxtable, "An Imperfect Renovation": 27, 37.

41. Raymond T. O'Keefe, quoted in Claudia H. Deutsch, "Commercial Property: 55 Wall Street," *New York Times* (October 23, 1994), IX: 13. Also see David W. Dunlap, "Commercial Property: 55 Wall Street," *New York Times* (April 8, 1990), X: 19; Michael T. Kaufman, "A Wall Street Engineer Tends His Money Temple," *New York Times* (January 14, 1995): 27.

42. Peter Grant, "Trump Takes Stock in Downtown, Buys Landmark," *New York Daily News* (September 28, 1996): 12; Peter Slatin, "Trump Buying 55 Wall," *New York Post* (September 28, 1996): 17; Robert D. McFadden, "Trump in Deal to Buy 55 Wall Street," *New York Times* (September 28, 1996): 27.

43. Peter Slatin, "Trump Dumps 55 Wall St. Deal," *New York Post* (May 6, 1997): 26; David M. Halbfinger, "Trump's Bank Making Deal He Declined," *New York Times* (May 28, 1997), B: 6; Charles V. Bagli, "Luxury Hotel Planned for 55 Wall Street," *New York Times* (September 30, 1997), B: 6; Charles V. Bagli, "Hotel Business Is Growing Bigger, Busier and Faster," *New York Times* (November 23, 1997): 39; Florence Fabricant, "An Empire Is Built, the Cipriani Way," *New York Times* (June 24, 1998), F: 8; John Holusha, "From Temple of Capitalism to an All-Suite Hotel," *New York Times* (November 29, 1998), XI: 9.

44. John Holusha, "Operator Replaced for Hotel at 55 Wall St.," *New York Times* (March 4, 1999), B: 8; Robert Selwitz, "Regent Readies Wall Street Property," *Hotel and Motel Management* 214 (April 5, 1999): 22; Charles Lockwood, "Sleeping Beauty Is Kissed," *Grid* 1 (Summer 1999): 102–6; Holusha, "New Niche Hotels in Downtown Manhattan": 9; White and Willensky, *AIA Guide* (2000), 17–18; Terry Trucco, "On Wall St., Rooms Fit for a Robber Baron," *New York Times* (January 30, 2000), V: 3; Abby Bussel, "Room Boom!" *Grid* 2 (March-April 2000): 94, 96, 98; Merkel, "Welcome to New York: Do You Have a Reservation": 16; John Holusha, "In Manhattan, a Scattering of New Hotels," *New York Times* (April 16, 2000), XI: 1, 6; Peter Benchley, "Plutocrats' Retreats," *New York Times* (May 14, 2000), VI, part 2: 30; Edwin McDowell, "When Hotels Add Hospitality to History," *New York Times* (June 24, 2001), XI: 1, 6.

45. Louise Kramer, "Hotel's Royal Pain: Regent Wall Street Misses Its Gilded Mark," *Crain's New York Business* (December 4–10, 2001): 1, 41; David W. Dunlap, "Surviving 9/11, but Not Afterward: A Wall Street Landmark to End Short Run as a Luxury Hotel," *New York Times* (December 19, 2001), B: 1.

46. Charles Kaiser, "Planning Unit Votes Pornographic Limits," *New York Times* (January 27, 1977): 1, 29; David Bird "Nassau Street Mall," *New York Times* (July 9, 1977): 30; "Traffic Pattern Changes," *New York Times* (April 22, 1978): 23; Susan Heller Anderson and David W. Dunlap, "Midpoint for a Mall," *New York Times* (July 19, 1985), B: 3; Sonia Reyes, "Nassau St. Mall Coming to Life Again," *New York Daily News* (May 5, 1995): 29.

47. Dulcie Leimbach, "The Lure of Bargains Way Downtown," *New York Times* (April 16, 1995): 32. Also see "Shopping," *Daily Telegraph* (London) (December 4, 1993): 41; White and Willensky, *AIA Guide* (2000), 42; Lynn Yaeger, "Century 21 in the Twenty-first Century," *New Yorker* 76 (January 29, 2001): 14. For Walker & Gillette's East River Savings Bank, see Stern, Gilmartin, and Mellins, *New York 1930*, 184–85.

48. Slatin, "Housing Pioneers Scout the Downtown Frontier": 7; *Stone Street Historic District*; David W. Dunlap, "Jump-Starting a Historic District," *New York Times* (May 5, 1996), IX: 1, 8; Erik Wood, "Revitalizing Stone Street," letter to the editor, *New York Times* (July 14, 1996), IX: 12; Diamonstein, *The Landmarks of New York III*, 526; David Sokol, "Stone Street Strikes Back," *Grid* 2 (May-June 2000): 92–94; David W. Dunlap, "Turning an Alley into a Jewel," *New York Times* (December 6, 2000), B: 1, 8; David W. Dunlap, "In Downtown Canyon, a Vibrant Social Scene Blooms," *New York Times* (September 4, 2003), B: 3.

49. John Belle, quoted in Dunlap, "Jump-Starting a Historic District": 1.

50. Tony Goldman, quoted in Sokol, "Stone Street Strikes Back": 94.

51. For the Wall Street Kitchen and Bar, see Ruth Reichl, "Diner's Journal," *New York Times* (January 10, 1997): 27; Daniel Young, "Wall Street," *New York Daily News* (January 24, 1997): 68; Florence Fabricant, "Off the Menu," *New York Times* (January 14, 1998), F: 9; Ruth Reichl, "Diner's Journal," *New York Times* (January 23, 1998), E: 2; White and Willensky, *AIA Guide* (2000), 21. For the American Bank Note Company Building, see Stern, Gilmartin, and Massengale, *New York 1900*, 184. For Bayard's, see Florence Fabricant, "Off the Menu," *New York Times* (December 16, 1998), F: 18; Ruth Reichl, "Where History Is Always on the Menu," *New York Times* (March 10, 1999), F: 10; Moira Hodgson, "Inside a Gentlemen-Only Club, Noshing Bull Market Foie Gras," *New York Observer* (May 10, 1999): 36; Owen Phillips, "Tables for Two," *New Yorker* 76 (December 11, 2000): 23; Moira Hodgson, "A Star's on Board: Eberhard Müller at Bayard's," *New York Observer* (December 18, 2000): 36. For India House, see Landmarks Preservation Commission of the City of New York, LP-0042 (December 23, 1965); Diamonstein, *The Landmarks of New York III*, 111.

52. For Warren Platner's Windows on the World, see Stern, Mellins, and Fishman, *New York 1960*, 204–6.

53. Bryan Miller, "Windows on the World: Where Hundreds Would Dine, Silence," *New York Times* (March 7, 1993): 40; Thomas J. Lueck, "Around Windows on World Clouds of Uncertainty Swirl," *New York Times* (April 7, 1993), B: 5; Florence Fabricant, "A New Era for Windows on the World," *New York Times* (September 22, 1993): 10; Milford Prewitt, "Windows on the World to Get Face-Lift Before Reopening," *Nation's Restaurant News* (October 11, 1993): 3; Jane Freiman, "Trade Center Pot at End of Rainbow," *Newsday* (May 13, 1994): 4; Bryan Miller, "Familiar Face Behind New 'Windows,'" *New York Times* (May 13, 1994), B: 3; Milford Prewitt, "Baum, Whiteman Will Resurrect Windows at WTC," *Nation's Restaurant News* (May 23, 1994): 1; "Windows on the World," *Oculus* 57 (September 1994): 3; Milford Prewitt, "Windows on the World Rebirth Heralds New Era," *Nation's Restaurant News* (September 25, 1995): 28; Florence Fabricant, "Can the Food Ever Match the View?" *New York Times* (June 19, 1996), C: 1, 6; Paul Goldberger, "New Windows on a New World," *New York Times* (June 19, 1996), C: 1, 6, reprinted in *Bauwelt* 87 (October 1996): 2192–95; "Windows on Port Authority World," editorial, *New York Daily News* (June 29, 1996): 14; Jerry Adler, "Yes, We Redo Windows," *Newsweek* 128 (July 8, 1996): 57; Corby Kummer, "Windows '96," *New York* 29 (July 15, 1996): 40–47; Daniel Young, "At Windows," *New York Daily News* (September 20, 1996): 58; Ruth Reichl, "A Room

with a View and a Big Desire to Please, Songs for Every Occasion Included," *New York Times* (November 8, 1996), C: 29; Stanley Abercrombie, "Windows '96," *Interior Design* 67 (December 1996): 94–100; Waters, *Hardy Holzman Pfeiffer Associates: Buildings and Projects, 1992–1998*, 110–15.

54. Kummer, "Windows '96": 45.

55. Reichl, "A Room with a View and a Big Desire to Please, Songs for Every Occasion Included": 29.

56. Goldberger, "New Windows on a New World": 1, 6.

57. Robert D. McFadden, "Bowling Green Park to Get Dutch Flavor Back," *New York Times* (March 6, 1972): 35; Carter B. Horsley, "Fiscal Crisis," *New York Times* (October 6, 1975): 33; Richard Haitch, "Rebuilding History," *New York Times* (December 19, 1976): 45; "Bowling Green Park Reopens," *New York Times* (September 24, 1977): 1; Susan Heller Anderson and David W. Dunlap, "The Spice of Strife," *New York Times* (March 21, 1985), B: 5; Curtis L. Taylor, "An Anniversary for Bowling Green Park," *Newsday* (March 22, 1989): 25; "M. Paul Friedberg: Landscape Design," *Process Architecture* 82 (May 1989): 137; White and Willensky, *AIA Guide* (2000), 11.

58. Jennifer Dunning, "Financial Area to Get a New Park," *New York Times* (August 5, 1977), B: 3; Paul Goldberger, "Design Notebook," *New York Times* (August 9, 1979), C: 10; Jean Lipman, *Nevelson's World* (New York: Hudson Hills Press, 1983), 41, 176; Laurie Lisle, *Louise Nevelson: A Passionate Life* (New York: Summit Books, 1990), 261–67; White and Willensky, *AIA Guide* (2000), 40.

59. Goldberger, "Design Notebook": 10.

60. "Koch Backs Monument to Veterans of Vietnam," *New York Times* (March 7, 1982): 35; "Downtown Site Chosen for a Vietnam Memorial," *New York Times* (September 17, 1982), B: 3; David W. Dunlap, "Wall to Honor City's Veterans of Vietnam," *New York Times* (May 30, 1984), B: 1; James Reston Jr., "A Wall Honoring Not Only Vietnam Veterans," *New York Times* (November 6, 1984): 25; Peter Wormser, William Fellow, and Joseph Ferrandino, "A New York Memorial for Whose Vietnam War?" letter to the editor, *New York Times* (November 17, 1984): 22; Susan Heller Anderson and David W. Dunlap, "Vietnam Memorial Pledge," *New York Times* (February 27, 1985), B: 3; "Vietnam Memorial Is Taking Shape," *New York Times* (April 5, 1985): 18; "Model of Shrine Gets Showing in New York," *New York Times* (April 30, 1985), B: 2; Douglas C. McGill, "Art People," *New York Times* (May 3, 1985), C: 29; Patricia C. Phillips, "Vietnam Veterans Memorial," *Artforum* 24 (December 1985): 90–91; Victoria Geibel, "Soldier Story," *Metropolis* 6 (November 1986): 29; White and Willensky, *AIA Guide* (2000), 27. For Maya Lin's Vietnam Veterans Memorial, see Maya Lin, *Boundaries* (New York: Simon & Schuster, 2000), 4: 4–23. For Jeannette Park and 55 Water Street, see Stern, Mellins, and Fishman, *New York 1960*, 183–85.

61. William Britt Fellows, quoted in Geibel, "Soldier Story": 29. For Kahn's design, see Stern, Mellins, and Fishman, *New York 1960*, 196–97.

62. Geibel, "Soldier Story": 29.

63. David W. Dunlap, "Putting a Shine on a Memorial Long Forlorn," *New York Times* (May 24, 2000), B: 1, 8.

64. Glenn Collins, "Fresh Pain at Plaza Downtown: Refurbished Vietnam Memorial Is Dedicated, 11/9/01," *New York Times* (November 10, 2001), D: 1–2; David W. Dunlap, "In Remembrance of Sorrow from Other Times," *New York Times* (January 25, 2002), E: 39, 48.

65. For the United States Custom House, see Stern, Gilmartin, and Massengale, *New York 1900*, 74–77.

66. Carter B. Horsley, "Outlook for Old Custom House, Vintage, 1907, Is Under Scrutiny," *New York Times* (November 30, 1977), D: 12; Donald G. McNeil, Jr., "Senate Unit Approves $29.2 Million Project at Old Custom House," *New York Times* (September 14, 1979), B: 8; Ada Louise Huxtable, "An Enlightened Plan for Converting the Custom House," *New York Times* (June 1, 1980), II: 25, 33; "Old Custom House Renovation," *Progressive Architecture* 63 (August 1982): 40; "Rehabilitation of the Old Custom House," *Process Architecture* 32 (September 1982): 150–51, 154–56, 163; *James Stewart Polshek: Context and Responsibility* (New York: Rizzoli International Publications, 1988), 41–42, 97, 251.

67. Stern, Mellins, and Fishman, *New York 1960*, 1133.

68. Huxtable, "An Enlightened Plan for Converting the Custom House": 33.

69. Huxtable, "An Enlightened Plan for Converting the Custom House": 33.

70. James Stewart Polshek, "Notes on My Life and Work," in *James Stewart Polshek: Context and Responsibility*, 41–42.

71. George Lewis, "Custom House," *Oculus* 44 (February 1983): 7.

72. David W. Dunlap, "After Decade of Abandonment, Custom House Invites Tenants," *New York Times* (November 11, 1983), B: 1, 5; "Work to Begin on Custom House," *New York Times* (July 25, 1984), B: 3; David W. Dunlap, "Plans for Custom House Are Presented to Board," *New York Times* (August 2, 1984), B: 6; "What to Do with the Custom House," editorial, *New York Times* (August 11, 1984): 22; Samuel G. Freedman, "2 Groups Vying for Custom House," *New York Times* (September 19, 1984), C: 19; D. A. Pumphrey, "What the Custom House Should House," letter to the editor, *New York Times* (September 27, 1984): 22; Clem Colucci, "Custom House of Fame," letter to the editor, *New York Times* (October 9, 1984): 22; Joseph Berger, "Custom House Will Be Museum on Holocaust," *New York Times* (October 18, 1984), B: 3; Peter Freiberg, "Custom Fit," *Metropolis* 4 (November 1984): 10; Michael Oreskes, "Battery Park City Offers Holocaust Museum a Site," *New York Times* (April 5, 1985): 1, B: 3; Ted Weiss, "Arts May Find a Home in Custom House," letter to the editor, *New York Times* (January 1, 1986): 22.

73. Brendan Gill, quoted in Freiberg, "Custom Fit": 10.

74. Douglas C. McGill, "Perot Seeks to Move Indian

Museum," *New York Times* (February 21, 1985), C: 24; Douglas C. McGill, "City Raises the Stakes with Bid to Save Indian Museum," *New York Times* (March 10, 1985), IV: 6; Philip S. Jessup, "Museum of American Indian Wants to Stay," letter to the editor, *New York Times* (March 16, 1985): 22; Michael A. Bush, "Curators, Give It Back to the Indians," *New York Times* (March 24, 1985), IV: 22; Roland W. Force, "Indians Should Rejoice at Museum's Dallas Offer," letter to the editor, *New York Times* (April 6, 1985): 18; "Museum Moves," editorial, *New York Times* (April 7, 1985), IV: 16; Grace Glueck, "Will New York Lose This Art Treasury?" *New York Times* (April 21, 1985), II: 1, 30; Douglas C. McGill, "Indian Museum Agrees to New Merger Talks," *New York Times* (April 27, 1985): 9; Douglas C. McGill, "Museum Temporarily Accepts Perot Offer to Move to Texas," *New York Times* (June 28, 1985), C: 21; "Museum Fire Sale," editorial, *New York Times* (June 30, 1985), IV: 22; "The Vanishing Museum," editorial, *New York Times* (April 9, 1986): 26; Alfonse D'Amato, "Indian Museum Should Combine with Natural History Museum," letter to the editor, *New York Times* (April 23, 1986): 22; "New York's Fading Indian Museum," editorial, *New York Times* (July 29, 1986): 22; David W. Dunlap, "A Museum Turns to Congress for Help," *New York Times* (January 5, 1987), B: 1; David Saltman, "N.Y. Indian Museum Hopes to Get a Bigger Home," *Washington Post* (January 12, 1987), D: 7; Douglas C. McGill, "Perot Backs Museum's Plan," *New York Times* (January 28, 1987), C: 23; Douglas Martin, "Indians Quarrel over Custom House," *New York Times* (February 5, 1987), B: 3; George Johnson and Laura Mansnerus, "Indians Want Part of Custom House," *New York Times* (February 8, 1987), IV: 7; "Indian Museum to Maintain a Presence in Harlem," *New York Times* (February 13, 1987), B: 3. For Audubon Terrace, see Stern, Gilmartin, and Mellins, *New York 1900*, 105, 107.

75. Irvin Molotsky, "Smithsonian Acts to Acquire Indian Museum in New York," *New York Times* (May 12, 1987), B: 3; "Romancing the Indian Museum," *New York Times* (May 13, 1987): 26; Irving Molotsky, "Plan to Move Indian Museum Is Under Attack," *New York Times* (May 13, 1987), B: 36; Carlyle C. Douglas and Mary Connelly, "Indian Museum Hitting the Trail?" *New York Times* (May 17, 1987), IV: 8; Douglas Martin, "Fight Builds over New Site for Museum," *New York Times* (May 21, 1987), B: 1; "Keep the Indian Museum in New York," editorial, *New York Times* (June 3, 1987): 26; Grace Glueck, "Indian Museum Remains a Heritage in Search of a Home," *New York Times* (June 7, 1987), IV: 7; Robert Abrams, "Indian Leaders Seem Determined to Leave New York," letter to the editor, *New York Times* (July 7, 1987): 26; Irvin Molotsky, "Smithsonian Pushes Its Plan to Move the Indian Museum," *New York Times* (July 16, 1987), B: 3; Jim Naughton, "Indian Museum Dispute Flares," *Washington Post* (July 17, 1987), D: 1, 3; Alan Finder, "Koch Shifts on New Site for Museum," *New York Times* (August 12, 1987), B: 1, 4; Irvin Molotsky, "New Senate Bill Seeks Move of Indian Museum," *New York Times* (September 30, 1987): 18; Robert D. McFadden, "Koch Offers Inducement to Keep Museum in City," *New York Times* (October 10, 1987): 34; "Homes, at Last, for the Indian Museum," *New York Times* (April 13, 1988): 26; Irvin Molotsky, "Compromise Is Reached to Keep Indian Museum in New York City," *New York Times* (April 13, 1988): 1, B: 4; Irvin Molotsky, "Smithsonian Accepts Indian Museum's Move to Custom House in New York," *New York Times* (May 10, 1988), B: 3; William Grimes, "The Indian Museum's Last Stand," *New York Times* (November 27, 1988), VI: 46–47, 66, 69, 76–77; Irvin Molotsky, "Indian Museum Plan Favors Smithsonian over New York Site," *New York Times* (January 25, 1989): 1, 15; Irvin Molotsky, "Agreement Made on Indian Museum Shift," *New York Times* (January 26, 1989): 14; "Fair Compromise on the Indian Museum," editorial, *New York Times* (January 28, 1989): 26; Irvin Molotsky, "Smithsonian Votes Plan for an American Indian Museum," *New York Times* (January 31, 1989), B: 3; Kara Swisher, "Smithsonian Approves Indian Museum Pact," *Washington Post* (May 9, 1989): B: 7; Barbara Gamarekian, "Senate Passes Indian Museum Bill," *New York Times* (November 15, 1989), B: 5.

76. "New York," *Engineering News-Record* 224 (May 17, 1990): 35; "Details," *Architecture* 79 (July 1990): 36; Nadine Brozan, "Chronicle," *New York Times* (September 27, 1991), B: 5; "In the City," *Oculus* 54 (January 1992): 3; Amy Gamerman, "Indian Museum Takes Shelter in Beaux-Arts Wickiup," *Wall Street Journal* (November 17, 1992): 16; Ashley Dunn, "A Heritage Reclaimed," *New York Times* (October 9, 1994): 45; "Museum of the American Indian to Open Next Sunday; Changing Roles for a Once-Empty Landmark," *New York Times* (October 23, 1994), IX: 1; "Renovated Museum Is a Work of Art Itself," *USA Today* (October 27, 1994), D: 5; Benjamin Forgey, "A New Duty Imposed at the Custom House," *Washington Post* (October 30, 1994), G: 4; Nadine M. Post, "Indian Spirit Rests in Town," *Engineering News-Record* 233 (October 31, 1994): 24; David Van Biema, "Of Spirit and Blood," *Time* 144 (October 31, 1994): 72–74; M. Lindsay Bierman, "National Museum of the American Indian Opens in New York," *Architecture* 83 (December 1994): 19; Hugo Lindgren, "Financial (District) Assistance," *Metropolis* 15 (December 1994): 28; "A Building Inside a Building," *Progressive Architecture* 75 (December 1994): 17; Randy Kraft, "A Mixed Review for Indian Museum," *Cleveland Plain Dealer* (December 30, 1994): 21; Philip Jodidio, "Grandeur et Misère," *Connaissance des Arts* 513 (January 1995): 106–13; White and Willensky, *AIA Guide* (2000), 12–13; Alan Balfour, *World Cities: New York* (New York: Wiley Academy, 2001), 149.

77. Gamerman, "Indian Museum Takes Shelter in Beaux-Arts Wickiup": 16.

78. Denis Kuhn, quoted in "Renovated Custom House Is a Work of Art Itself": 5.

79. Forgey, "A New Duty Imposed at the Custom House": 4.

80. Post, "Indian Spirit Rests in Town": 24.

81. Quoted in "Alexander Hamilton U.S. Custom House,"

www.eekarchitects.com/project/prjahu.htm.

82. Bierman, "National Museum of the American Indian Opens in New York": 19.

83. Kraft, "A Mixed Review for Indian Museum": 21.

WALL STREET GUGGENHEIM

1. Ralph Blumenthal and Carol Vogel, "Guggenheim Plans a Branch at the Hudson," *New York Times* (November 19, 1998), B: 1, 5. Also see Carol Vogel, "Guggenheim Shrinks in SoHo," *New York Times* (February 5, 1999), E: 34.

2. For the Guggenheim Museum in Bilbao, see Coosje van Bruggen, *Frank O. Gehry, Guggenheim Museum Bilbao* (New York: Harry N. Abrams, 1998). For the Deutsche Guggenheim, see *Space Framed: Richard Gluckman Architect* (New York: Monacelli Press, 2000),154–57, 221, 239.

3. Peter Grant, "Guggenheim Eyes Seaport," *New York Daily News* (March 25, 1999): 44; Carol Vogel, "Inside Art," *New York Times* (March 26, 1999), E: 38; Ralph Blumenthal and Carol Vogel, "The Guggenheim Proposes Gehry Museum for New York," *New York Times* (September 28, 1999), B: 5; Susanna Sirefman, "The Guggenheim Spreads Out," *Architecture* 89 (February 2000): 27; Robin Pogrebin, "Guggenheim May Face Fight over Site," *New York Times* (March 30, 2000), B: 4; Herbert Muschamp, "From the Guggenheim, a Bold Vision for a Lower Manhattan Museum," *New York Times* (April 17, 2000), B: 4; Martin Filler, "The Museum Game," *New Yorker* 76 (April 17, 2000): 94–105; Pearl Greenberg, "Tears of Joy in Bilbao, and Now New York," letter to the editor, *New York Times* (April 19, 2000): 22; David D'Arcy, "Not Bilbao," *Grid* 2 (May 2000): 24–26; "A Waterfront Guggenheim," editorial, *New York Observer* (May 1, 2000): 4; "The Floating Guggenheim," *Wall Street Journal* (May 3, 2000): 24; Carol Vogel, "Guggenheim Lines," *New York Times* (May 5, 2000), E: 36; Paul Goldberger, "Architect of Dreams," *Vanity Fair* 63 (June 2000): 184–91, 206–8; "On the Drawing Boards," *Oculus* 62 (Summer 2000): 4; "Project for a New Guggenheim Museum in New York City," *The Guide to the Guggenheim Museums* (Summer 2000): 8–9; "Edifice Complex," *House Beautiful* 142 (July 2000): 32; Kristi Cameron, "Foiled Again?" *Metropolis* 19 (July 2000): 48; Herbert Muschamp, "Living Up to the Memories of a Poetic Old Skyline," *New York Times* (August 13, 2000), II: 32; Ralph M. Vitello, "Gehry's Guggenheim," letter to the editor, *New York Times* (August 27, 2000), II: 4; Richard W. Snibbe, "Snibbe Snubs Gehry," letter to the editor, *Metropolis* 20 (October 2000): 24; Catherine Croft, "American Dream," *Building Design* (October 27, 2000): 13; "Gehry's Guggenheim," *Grid* 2 (November-December 2000): 91; *Patrons, Power, Public Space* (New York: Institute for Urban Design, November 9, 2000); Lisa L. Colangelo, "Guggenheim Will Expand Near South St. Seaport," *New York Daily News* (November 28, 2000): 27; Eric Lipton and Robin Pogrebin, "Guggenheim Gets Backing for New Museum," *New York Times* (November 28, 2000), B: 1, 6; Eric Lipton, "Guggenheim on East River Is Years Away," *New York Times* (November 29, 2000), B: 1, 10; Robin Pogrebin, "Architects Says His Design Is Just a Start," *New York Times* (November 29, 2000), B: 10; "An East River Guggenheim," editorial, *New York Times* (November 29, 2000): 34; Eric Gibson, "Museums: On the Waterfront," *Wall Street Journal* (November 30, 2000): 20; Patricia J. Scharlin, "A Stunning Guggenheim, but in the Wrong Place," letter to the editor, *New York Times* (December 2, 2000): 18; Steven Berkowitz, "Bilbao and the Bronx," letter to the editor, *New York Times* (December 9, 2000): 22; "Titanium vs. Tsunami," *New York* 33 (December 11, 2000): 24; Hilton Kramer, "Gehry's New Guggenheim Is Kitschy Theme Park," *New York Observer* (December 11, 2000): 1, 17; Robert Campbell, "Exciting Evolution of New Guggenheim," *Boston Globe* (December 14, 2000), B: 17; Belmont Freeman and Eric Fauerbach, "Ga-Ga for Gehry," letters to the editor, *New York Observer* (December 25, 2000-January 1, 2001): 4; Alan Balfour, *World Cities: New York* (New York: Wiley Academy, 2001), 244–47; Thomas Krens, "A Personal Reflection," in J. Fiona Ragheb, ed., *Frank Gehry, Architect* (New York: Solomon R. Guggenheim Museum, 2001), 11, 258–63, 377; Anthony Mariani, "New Guggenheim Approved for Big Apple," *Architecture* 90 (January 2001): 29; Reena Jana, "Clouds Part," *Artforum* 39 (January 2001): 25; Craig Kellogg, "Gallery Talk," *Oculus* 63 (January 2001): 4; "First He'll Take Manhattan . . . ," *World Architecture* 92 (January 2001): 70; Alan Riding, "Faces Turn Red Over Bilbao Blemishes," *New York Times* (January 9, 2001): 1–2; Celestine Bohlen, "Guggenheim Adds a Link, This Time with Vienna," *New York Times* (January 16, 2001), E: 3; Anthony Vidler, "Critique," *Architectural Record* 189 (May 2001): 71–72; Thomas G. Lunke, "As Long As We're Rearranging Gotham . . . ," letter to the editor, *New York Times* (May 27, 2001), IV: 8; John M. Ellis, "Governors Island Dream," letter to the editor, *New York Times* (June 3, 2001): 16; Karrie Jacobs, "Visiting the Portfolio," *Metropolis* 21 (October 2001): 146, 157; Herbert Muschamp, "Welcoming a Return to Risk," *New York Times* (November 18, 2001), II: 36; Celestine Bohlen, "The Guggenheim's Scaled-Back Ambition," *New York Times* (November 20, 2001), E: 1, 3; Jonathan Mahler, "Gotham Rising," *Talk* (December 2001-January 2002): 120–25, 148–52; Raymond W. Gastil, *Beyond the Edge: New York's New Waterfront* (New York: Princeton Architectural Press, 2002), 23–24; Deborah Solomon, "Is the Go-Go Guggenheim Going, Going . . . ," *New York Times* (June 30, 2002), VI: 36; Herbert Muschamp, "Here a Museum, There a New Museum," *New York Times* (September 8, 2002), II: 90; Michael Kimmelman, "An Era Ends for the Guggenheim," *New York Times* (December 6, 2002), E: 39; Eric Herman, "Guggenheim's E. River Plans Dries Up," *New York Daily News* (December 31, 2002): 4; David W. Dunlap, "Guggenheim Drops Plans for Elaborate New Museum on East River," *New York Times* (December 31, 2002), E: 1, 5; "Guggenheim Museum New York," *El Croquis* 117 (2003): 284–91; "Rescaling the Guggen-

heim," editorial, *New York Times* (January 5, 2003), IV: 10.

4. Frank O. Gehry, quoted in D'Arcy, "Not Bilbao": 24.

5. Frank O. Gehry, quoted in Cameron, "Foiled Again?": 48.

6. Thomas Krens, quoted in Campbell, "Exciting Evolution of New Guggenheim": 17.

7. Frank O. Gehry, quoted in Filler, "The Museum Game": 98.

8. Goldberger, "Architect of Dreams": 208.

9. Muschamp, "From the Guggenheim, a Bold Vision for a Lower Manhattan Museum": 4.

10. "The Floating Guggenheim": 24.

11. Una L. Perkins, quoted in Lipton, "Guggenheim on East River Is Years Away": 1.

12. Gibson, "Museums: On the Waterfront": 20.

13. Kramer, "Gehry's New Guggenheim Is Kitschy Theme Park": 17.

TRIBECA

1. For the Washington Market Urban Renewal Area, see Stern, Mellins, and Fishman, *New York 1960*, 193, 1149, 1151.

2. Robert E. Tomasson, "Big Downtown Project Starts," *New York Times* (October 29, 1972): 1, 12; "For Sale," *Architectural Forum* 138 (May 1973): 14, 16; Joseph P. Fried, "Planning Agency Meets on Housing," *New York Times* (June 14, 1973): 13; Michael Winkleman, "The Visible City," *Metropolis* 1 (August/September 1981): 26–29; White and Willensky, *AIA Guide* (2000), 58.

3. Winkleman, "The Visible City": 28. For the Harrison Street Houses, see Stern, Mellins, and Fishman, *New York 1960*, 1149, 1151.

4. See Stern, Mellins, and Fishman, *New York 1960*, 193, 195.

5. "Urban Oases," *Architectural Record* 171 (May 1983): 98–101; Joan Lee Faust, "Green Spots, on and off the Beaten Path," *New York Times* (May 25, 1984), C: 1; White and Willensky, *AIA Guide* (2000), 57–58.

6. White and Willensky, *AIA Guide* (1988), 51.

7. "Creeping Renewal," *New York Times* (January 9, 1983), VIII: 1; Dee Wedemeyer, "Agencies Differ in Ideas for Renewal Site," *New York Times* (August 21, 1983), VIII: 3.

8. Richard D. Lyons, "City Plan to Sell TriBeCa Tract Protested," *New York Times* (May 15, 1988), X: 9; "Drexel's New Digs: A Vacant City Lot?" *New York* 21 (May 16, 1988): 12; Peg Tyre and Jeannette Walls, "Drexel's Tower Plans May Topple," *New York* 22 (April 3, 1989): 11; Arnold H. Lubasch, "New Builder Is Sought After Drexel Cancels Project in Manhattan," *New York Times* (April 20, 1989), B: 4; Jeannette Walls, "Drexel, Merc: Trading Places," *New York* 22 (October 30, 1989): 11.

9. *Alexander Gorlin: Buildings and Projects* (New York: Rizzoli International Publications, 1997), 142–43.

10. Charles V. Bagli, "Tower Developer Chosen," *New York Times* (April 10, 2001), B: 7; Andrew Rice, "Minskoff Declares Battery Park Tower Even as Foes Moan," *New York Observer* (June 25, 2001): 1, 9; James R. Fitzgerald, "Don't Minskoff Words," letter to the editor, *New York Observer* (July 23, 2001): 4; Denny Lee, "600-Foot Office Tower Is Proposed in an Area Where Lofts Abound," *New York Times* (August 12, 2001), XIV: 4; Andrew Rice, "Back to the Drawing Board," *Architecture* 91 (January 2002): 44–45, 47, 49; Eric Herman, "Office Tower Opposition Builds," *New York Daily News* (June 14, 2002): 90; Lore Croghan, "Tribeca Apt. Tower Fight," *New York Daily News* (September 22, 2003): 28.

11. Peter Kaufman, "TriBeCa Offices," *New York Times* (August 1985): 50; "City Art Panel Names Nine Winners," *New York Times* (May 3, 1986): 9; Paul Goldberger, "Good Buildings That Make Respectful Neighbors," *New York Times* (July 10, 1988), II: 35; Carter B. Horsley, "PS 234 Playground Is Really Shipshape," *New York Post* (November 10, 1988): 81; Carter B. Horsley, "The Good, the Bad & the Ugly," *New York Post* (December 29, 1988): 53, 57; Ellen Posner, "Primary Consideration," *Architectural Record* 177 (March 1989): 108–11; Barbara Presley Noble, "If You're Thinking of Living In: TriBeCa," *New York Times* (May 14, 1989), X: 9; Patricia Leigh Brown, "A Winning Building," *New York Times* (June 29, 1989), C: 3; Robert Bateman and Robert MacLean, "Letters," letter to the editor, *Architectural Record* 177 (September 1989): 4, 8; Richard Dattner, "Letters," letter to the editor, *Architectural Record* 177 (September 1989): 8; Jennifer Dunning, "Afoot amid the Cultural Landmarks," *New York Times* (April 27, 1990), C: 23; Constance L. Hays, "After Winning a School, Some Find It's Off Limits," *New York Times* (June 14, 1990), B: 6; Hugo Lindgren, "Learning from Tribeca," *Metropolis* 12 (November 1992): 13, 17; Richard Dattner, *Civil Architecture: The New Public Infrastructure* (New York: McGraw-Hill, 1995), 97–114; Susanna Sirefman, *New York: A Guide to Recent Architecture* (London: Ellipsis, 1997), 48–51; White and Willensky, *AIA Guide* (2000), 57; *Richard Dattner: Selected and Current Works of Richard Dattner & Partners Architects* (Mulgrave, Australia: Images Publishing, 2000), 24–29.

12. Bateman and MacLean, "Letters": 4, 8.

13. Dattner, "Letters": 8.

14. Posner, "Primary Considerations": 108.

15. Horsley, "The Good, the Bad & the Ugly": 57.

16. Goldberger, "Good Buildings That Make Respectful Neighbors": 35.

17. Julian Pretto, quoted in Grace Glueck, "The Name's Only So-So, but Loft-Rich TriBeCa Is Getting the Action," *New York Times* (April 30, 1976), C: 15. Also see Christopher Gray, "Streetscapes/105 Hudson Street," *New York Times* (June 25, 2000), XI: 7. For the Pierce Building, see Stern, Gilmartin, and Massengale, *New York 1900*, 150.

18. Glueck, "The Name's Only So-So, but Loft-Rich TriBeCa Is Getting the Action": 15. Also see Landmarks Preservation Commission of the City of New York, *Tribeca East Historic District Designation Report* (New York, 1992), 151.

19. Glen Fowler, "Lofts in TriBeCa Win Zone Change," *New York Times* (June 12, 1976): 20.

20. Laurie Johnston, "TriBeCa Follows SoHo Footsteps,

Gingerly," *New York Times* (August 25, 1977), B: 1–2; Alan S. Oser, "Legalizing Older Buildings as Apartments," *New York Times* (September 16, 1977), B: 11. For the Franklin-Hudson Building, see Landmarks Preservation Commission of the City of New York, *Tribeca West Historic District Designation Report* (New York, 1991), 100–102.

21. Johnston, "TriBeCa Follows SoHo Footsteps, Gingerly": 8.

22. Johnston, "TriBeCa Follows in SoHo Footsteps, Gingerly": 2; *Tribeca West Historic District*, 102–4.

23. Christopher Gray, "Streetscapes/The Coconut King's Beheaded Factory," *New York Times* (November 24, 1991), X: 4; *Tribeca West Historic District*, 86–87.

24. "Micro-Chips on the Old Block," *Village Voice* (August 5-August 11, 1981): 61; Nancy McKeon, "Wired for the Future," *New York* 14 (August 31, 1981): 50; Andrea Gabor, "Old-World Luxury Is Combined with Computer-Age Living," *Architectural Record* 170 (April 1982): 34; *Developing Times: Jonathan Rose & Company Newsletter* 5 (Winter 2001): 1.

25. Michael Goodwin, "Albany Is Asked to Pass Koch Rent Plan for Lofts," *New York Times* (December 3, 1981), B: 5; Josh Barbanel, "Bill Signed to Legalize Status of Lofts' Tenants," *New York Times* (June 23, 1982), B: 5.

26. Edward I. Koch and John Scott, quoted in "Koch Goes to Trinity Place to Field Resident's Gripes": 1.

27. Susan Heller Anderson and David W. Dunlap, "How Local Groups Form," *New York Times* (December 26, 1984), B: 3; Andrew Scott Dolkart, *The Texture of Tribeca* (New York: Tribeca Community Association, 1989).

28. Carol DeSaram, quoted in Clare McHugh, "Arguing About Tribeca's Past, Trying to Shape Its Future," *New York Observer* (January 15, 1990): 8.

29. Lisa W. Foderado, "Circa 1885," *New York Times* (May 10, 1987), VIII: 1; *Tribeca West Historic District*, 180–81; White and Willensky, *AIA Guide* (2000), 64.

30. Dolkart, *The Texture of Tribeca*, 40. Also see Richard D. Lyons, "New Risk Takers in the Realty Game," *New York Times* (December 3, 1989), VI: 58; *Tribeca West Historic District*, 230–31; *R. M. Kliment & Frances Halsband Architects: Selected and Current Works* (Mulgrave, Australia: Images Publishing, 1998), 88–91; White and Willensky, *AIA Guide* (2000), 62. For the Mercantile Exchange see Stern, Mellins, and Fishman, *New York 1880*, 466–67.

31. Alan S. Oser, "Condominium Construction in TriBeCa," *New York Times* (March 14, 1986): 23.

32. Alan S. Oser, "Slowly, Vacant Manhattan Land Is Rezoned," *New York Times* (November 27, 1988), X: 3, 8.

33. Peter Samton, quoted in Victoria Geibel, "But Is It Really 'Friendly'?" *Metropolis* 7 (October 1987): 33. Also see Oser, "Condominium Construction in TriBeCa": 23; "New York's Tribeca," *Wall Street Journal* (March 18, 1987): 33; White and Willensky, *AIA Guide* (1988), 50–51; Paul Goldberger, "Good Buildings That Make Respectful Neighbors," *New York Times* (July 10, 1988), II: 35; Oser, "Slowly, Vacant Manhattan Land Is Rezoned": 3, 8.

34. "Cast-Iron-Like Apartments," *New York Times* (September 21, 1986), VIII: 1; *Beyer Blinder Belle Architects & Planners* (New York: Beyer Blinder Belle, 1997), unpaginated; Lisa W. Foderaro, "Concert Aid Part of TriBeCa Campaign," *New York Times* (August 28, 1987): 22; Oser, "Slowly, Vacant Manhattan Land Is Rezoned": 3, 8; "Dalton-on-Greenwich," *Architecture* 78 (May 1989): 226; Richard D. Lyons, "New Risk Takers in the Realty Game," *New York Times* (December 3, 1989), VI: 58.

35. Quoted in *Beyer Blinder Belle Architects & Planners*, unpaginated.

36. White and Willensky, *AIA Guide* (1988), 51.

37. Goldberger, "Good Buildings That Make Respectful Neighbors": 35.

38. "At Home in TriBeCa," *New York Times* (July 31, 1988), X: 1; White and Willensky, *AIA Guide* (2000), 57.

39. Christopher Gray, "Streetscapes/114 Hudson Street," *New York Times* (April 30, 1989), X: 12.

40. David W. Dunlap, "Planned Tower atop Old Building Upsets TriBeCa," *New York Times* (August 31, 1986): 51; Jeanie Kasindorf, "Artists Rally to Block a Tower," *New York* 19 (October 20, 1986): 14; David W. Dunlap, "Landmark Potential Confuses Plans for a Building," *New York Times* (December 28, 1987), B: 3; Landmarks Preservation Commission of the City of New York, LP-1651 (March 22, 1988); Peg Tyre and Jeannette Walls, "Tribeca Developer: A Bridge Too Far?" *New York* 21 (September 19, 1988): 18; Richard D. Lyons, "16 Condos in TriBeCa," *New York Times* (November 12, 1989), X: 1; Barbaralee Diamonstein, *The Landmarks of New York III* (New York: Harry N. Abrams, 1998), 518–19. For the Condict Building, see Stern, Mellins, and Fishman, *New York 1880*, 470.

41. For Shaare Zedek, see Stern, Mellins, and Fishman, *New York 1960*, 191–92.

42. David W. Dunlap, "52-Story Tower in TriBeCa Faces Opposition," *New York Times* (March 6, 1988): 43; "Work Underway on 53-Story Tower in Lower Manhattan's Tribeca Area," *New York Construction News* 37 (January 22, 1990): 1, 5; Alan S. Oser, "The 52-Story Tower in Lower Manhattan," *New York Times* (May 6, 1990), X: 9; Rachelle Garbarine, "Prices Cut at Condo Tower to Avoid an Auction," *New York Times* (June 14, 1991), B: 8; "TriBeCa Troubles in TriBeCa," *New York Times* (December 20, 1992), X: 1.

43. For AT&T Long Lines and U. S. Federal Building, see Stern, Mellins, and Fishman, *New York 1960*, 161–63.

44. "Tribeca Districts," *Municipal Art Society Annual Report* (1988/1989); Audrey Farolino, "Sparing Tribeca Trophies," *New York Post* (May 25, 1989): 39, 48; Michael Moss, "Shifts in Tribeca Spurring Changes in Land-Use Rules," *Newsday* (May 31, 1989): 17; "Tribeca Districts Proposed," *Municipal Arts Society Newsletter* (June 1989): 2; David W. Dunlap, "For TriBeCa, Delicate Diversity or Wall Street North?" *New York Times* (June 13, 1989), B: 1, 4; Richard D.

Lyons, "A TriBeCan History," *New York Times* (November 5, 1989), X: 1; McHugh, "Arguing About TriBeCa's Past, Trying to Shape Its Future": 8; "Tribeca. Or...the Triangle Below Canal," *Friends of the Upper East Side Historic Districts Newsletter* 5 (Fall/Winter 1991): 11; Shawn G. Kennedy, "TriBeCa West: The Issue of Boundaries," *New York Times* (August 11, 1991), X: 1; David W. Dunlap, "Landmarks Panel to Hear TriBeCa Plan," *New York Times* (December 7, 1992), B: 3; "Tribeca Closes in on History; Council to Vote on Historical Designation," *Newsday* (April 1, 1993): 29.

45. Dunlap, "For TriBeCa, Delicate Diversity or Wall Street North?": 1.

46. *Tribeca West Historic District*; David W. Dunlap, "District in TriBeCa Wins Historic Designation and Elbow Room to Flaunt and Flex," *New York Times* (May 12, 1991): 23; David W. Dunlap, "A New Historic District Under Landmarks Scrutiny," *New York Times* (May 26, 1991), X: 11; Shawn G. Kennedy, "TriBeCa West: The Issue of Boundaries," *New York Times* (August 11, 1991), X: 1; Diamonstein, *The Landmarks of New York III*, 518; White and Willensky, *AIA Guide* (2000), 59.

47. Landmarks Preservation Commission of the City of New York, *Tribeca West Historic District Manual* (New York, 1993).

48. Eric Wm. Allison, "Landmarks Preservation Works for New York," letter to the editor, *New York Times* (May 15, 1993): 18.

49. *Tribeca East Historic District*, Landmarks Preservation Commission of the City of New York, *Tribeca North Historic District Designation Report* (New York, 1992); Landmarks Preservation Commission of the City of New York, *Tribeca South Historic District Designation Report* (New York, 1992); "3 Historic Districts Are Created in TriBeCa," *New York Times* (December 9, 1992), B: 3; Diamonstein, *The Landmarks of New York III*, 518–19; White and Willensky, *AIA Guide* (2000), 59.

50. William H. Honan, "De Niro Is Trying Life Behind the Camera," *New York Times* (August 23, 1989), C: 13; "De Niro Is Converting a N.Y. Factory into a Film Center," *San Francisco Chronicle* (August 23, 1989), E: 5; "De Niro Downtown: Double Feature?" *New York* 23 (January 15, 1990): 9; Janice Berman, "Setting up Shop with De Niro," *New York Newsday* (February 20, 1990): 9; Constance L. Hays, "TriBeCa Yawns Hello to Film Studio," *New York Times* (May 6, 1990): 40; "Prentice & Chan Ohlhausen," *Oculus* 53 (September 1990): 3. For 375 Greenwich Street, see *Tribeca West Historic District*, 144–45.

51. Hays, "TriBeCa Yawns Hello to Film Studio": 40.

52. Lo-Yi Chan, quoted in Berman, "Setting up Shop with De Niro": 9.

53. *Tribeca West Historic District*, 182–83; Elaine Louie, "Paris's Glass House Comes to TriBeCa," *New York Times* (July 4, 1991), C: 1, 6; "The A.I.A. Awards: Conversion of a Warehouse in TriBeCa Wins a Top Prize," *New York Times* (December 25, 1994), IX: 1; White and Willensky, *AIA Guide* (2000), 64.

54. For Maison de Verre, see Marc Vellay and Kenneth Frampton, *Pierre Chareau: Architect and Craftsman, 1883–1950* (New York: Rizzoli International Publications, 1984).

55. Cynthia Elitzer, quoted in Louie, "Paris's Glass House Comes to TriBeCa": 6.

56. Richard Schaffer, quoted in David W. Dunlap, "A Balancing Act for TriBeCa," *New York Times* (February 14, 1993), X: 1, 6. Also see Monte Williams, "TriBeCa's 'Downzoning': So How Low Can You Go?" *New York Times* (January 29, 1995), XIII: 6; Rachelle Garbarine, "About Real Estate: Loft Conversions on Rise in Downtown Manhattan," *New York Times* (July 7, 1995): 16.

57. Herbert Muschamp, "The New Season/Architecture: The Annotated List," *New York Times* (September 9, 2001), II: 82; Herbert Muschamp, "The Commemorative Beauty of Tragic Wreckage," *New York Times* (November 11, 2001), II: 37; "Gordon Kipping-Frank O. Gehry," *Architecture and Urbanism* (December 2001): 56–61; Raul Barreneche, "G Force," *Interior Design* 73 (April 2002): 244–47; Elizabeth Hayt, "The Architect," *New York Times* (September 29, 2002), IX: 3; "Issey Miyake Tribeca," *Lotus International* 118 (2003): 98–101; Philip Nobel, *Sixteen Acres: Architecture and the Outrageous Struggle for the Future of Ground Zero* (New York: Metropolitan Books, 2005), 10–11, 40–41. For 119 Hudson Street, see *Tribeca West Historic District*, 111–12.

58. Barreneche, "G Force": 247.

59. Eric Asimov, "The Russian Tea Room Question: Power Diners Wonder When, or If, It Will Reopen," *New York Times* (November 30, 1996): 29; Elaine Louie, "Bouley and Kitchen: Joined at the Hip," *New York Times* (March 13, 1997), C: 3; David Blum, "The Heat Is Outside the Kitchen," *New York Times* (August 17, 1997), VI: 32–37, 46, 58–60. For 36–38 and 40 Hudson Street, see *Tribeca West Historic District*, 81–83.

60. William Grimes, "Farewell, Sauteed Foie Gras, It's Time for Steak and Spuds," *New York Times* (January 8, 2003), F: 1, 3.

61. "TriBeCa Lofts, Wine, Cigars," *New York Times* (May 5, 1996), IX: 1; Peter Grant, "Lofty Plans for a Building in Tribeca," *New York Daily News* (October 7, 1996): 44. For 429 Greenwich Street, see *Tribeca North Historic District*, 47–48.

62. Mark Blau, quoted in Rachelle Garbarine, "TriBeCa Lofts Are Growing, and Growing Larger," *New York Times* (June 27, 1997), B: 5. Also see Grant, "Lofty Plans for a Building in Tribeca": 44. For 166 Duane Street, see *Tribeca West Historic District*, 80–81.

63. "Blood Lines," *Oculus* 55 (December 1992): 12. For the John Ericsson Ice House, see *Tribeca West Historic District*, 308.

64. Tracie Rozhon and Paul Byard, quoted in "Blood Lines": 12.

65. "1905 Ice House Building to Be a Condominium: For TriBeCa, 49 More Lofts," *New York Times* (November 24, 1996), IX: 1; Garbarine, "TriBeCa Lofts Are Growing, and Growing Larger": 5; White and Willensky, *AIA Guide* (2000), 60.

66. Nadine Brozan, "State Sues Developers," *New York Times* (January 19, 2001), B: 4; "Settlement of Lawsuit Against

Sponsors of the Ice House Building to Fund Needed Repairs," press release (February 15, 2002); Eric Herman, "Settlement Worth Millions to Celebs, Condo Residents," *New York Daily News* (February 20, 2002): 28.

67. Peter Slatin, "Tribeca Chill!" *New York Post* (April 25, 1996): 34; Garbarine, "TriBeCa Lofts Are Growing, and Growing Larger": 5; Bernard Stamler, "First They Wanted Movies, But...," *New York Times* (July 20, 1997), XIII: 5; Craig Kellogg, "New York's Secret Power," *Metropolis* 17 (February/March 1998): 29–30; Bernard Stamler, "A Six-Screen Plan Goes Dark," *New York Times* (May 24, 1998), XIV: 5; "From Butter and Eggs to Lofts," *New York Times* (April 16, 2000), XI: 1; David S. Chartock, "Structural Solutions Key to Conversion of Cold Storage Warehouse into Condos," *New York Construction News* 49 (January 2001): 27–30. For 25 North Moore Street, see *Tribeca West Historic District*, 306–7.

68. For 120 Church Street, see Byron Porterfield, "News of Realty: Downtown Loan," *New York Times* (January 26, 1966): 76.

69. Rachelle Garbarine, "TriBeCa Warehouses to Become Condominiums," *New York Times* (June 26, 1998), B: 9; Andrew Rice and Deborah Schoeneman, "A Tribeca Break-Up: Goldman, Sachs and Hot-Shot Developer," *New York Observer* (October 9, 2000): 2; David W. Dunlap, "For Once-Gritty TriBeCa, a Golden Glow," *New York Times* (July 30, 2000), XI: 1, 6.

70. Harry Kendall, interview by author, April 24, 2001. For 385–397 Greenwich Street, see *Tribeca West Historic District*, 148–150.

71. Craig Harwood, quoted in Rachelle Garbarine, "In TriBeCa, a Condo Building on a Parking Lot Site," *New York Times* (July 17, 1998), B: 7. Also see "Luxury Apt. Building Planned for Tribeca," *New York Construction News* 46 (September 1998): 11.

72. "$35 Million, Nine-Story Building; 26 Condos on Hudson St. in TriBeCa," *New York Times* (April 23, 2000), XI: 1; Christopher Gray, "Streetscapes/The Former Beach Street, Now Ericsson Place in TriBeCa," *New York Times* (May 28, 2000), XI: 7; Dunlap, "For Once-Gritty TriBeCa, a Golden Glow": 6; "$35M Condo Building Planned for Tribeca," *New York Construction News* 49 (August 2000): 6; Michael Sorkin, "Fabricating Authenticity," *Metropolis* 20 (March 2001): 100, 102.

73. Harry Kendall, quoted in "$35 Million, Nine-Story Building; 26 Condos on Hudson St. in TriBeCa": 1.

74. Sorkin, "Fabricating Authenticity": 102.

75. "Downtown Chic," *AIA New York Chapter Annals* (1996–97): 47; "A Fraternal Twin for an Oldtimer," *New York Times* (July 21, 1996), IX: 1; Garbarine, "In TriBeCa, a Condo Building on a Parking Lot Site": 7; "New TriBeCa Building Designed to Look Old," *New York Times* (December 1998), XI: 1; Carole Ashley, "TriBeCa Dissent: A 'Postmodern Hulk,'" letter to the editor, *New York Times* (January 17, 1999), XI: 10; White and Willensky, *AIA Guide* (2000), 60; Albert Amateau, "Goldman Sachs Presents Hubert St. Plan," *Downtown Express* (February 28, 2001): 1. For 145 Hudson Street, see *Tribeca West Historic District*, 119–20.

76. Joseph Pell Lombardi, quoted in "$20 Million, 12-Story, 68-Unit Condominium; New TriBeCa Building Designed to Look Old": 1.

77. Ashley, "TriBeCa Dissent: A 'Postmodern Hulk'": 10.

78. Dunlap, "For Once-Gritty TriBeCa, a Golden Glow": 6; Rachelle Garbarine, "Condo Complex to Rise in TriBeCa by Late '03," *New York Times* (June 21, 2002), B: 4.

79. Harry Kendall, quoted in Garbarine, "Condo Complex to Rise in TriBeCa by Late '03": 4.

80. Stephen B. Jacobs, quoted in "123 Rental Apartments Going Up in TriBeCa," *New York Times* (August 10, 1997), IX: 1.

81. Dunlap, "For Once-Gritty TriBeCa, a Golden Glow": 6; Christopher Gray, "Streetscapes/Staple Street in TriBeCa: A Brief Walk Through Manhattan Old and New," *New York Times* (February 18, 2001), XI: 7.

82. "Three New Red-Brick Town Houses: A Genteel Touch for TriBeCa," *New York Times* (August 22, 1999), XI: 1; Abby Bussel, "Housing Starts," *Grid* 2 (January + February 2000): 80–83; "Tribeca Town Houses Under Construction," *New York Construction News* 48 (May 2000): 6; Dunlap, "For Once-Gritty TriBeCa, a Golden Glow": 6; Stephen P. Williams, "Tapping into TriBeCa's Geothermal Layers," *New York Times* (January 4, 2001), F: 7.

83. Bussel, "Housing Starts": 83.

84. Williams, "Tapping into TriBeCa's Geothermal Layers": 7; David W. Dunlap, "John L. Petrarca, 51, Architect Who Made Old Look Like New," *New York Times* (May 14, 2003): 23.

85. "First the SoHo Grand, Next the TriBeCa Grand," *New York Times* (July 26, 1998), XI: 1; "$50M Tribeca Hotel Starts Construction," *New York Construction News* 46 (October 1998): 14; Bernard Stamler, "Now That SoHo Has a Hotel, the Idea Is Moving South," *New York Times* (November 15, 1998), XIV: 8; David S. Chartock, "Steel More Cost-Effective for Tribeca Grand Hotel," *New York Construction News* 48 (September 1999): 15; Elaine Louie, "Forget the Architecture, the Fun's Inside," *New York Times* (May 11, 2000), F: 10; Abby Bussel, "Room Boom!" *Metropolis* 2 (March + April 2000): 94, 96; John Holusha, "In Manhattan, a Scattering of New Hotels," *New York Times* (April 16, 2000), XI: 6; Jayne Merkel, "Gotham Hospitality," *Oculus* 62 (March 7, 2000): 12–16; Craig Kellogg, "Grand Hotel," *House Beautiful* 142 (May 2000): 40; Dunlap, "For Once-Gritty TriBeCa, a Golden Glow": 1; William Weatherby Jr., "Varied Lamp Sources Create Layers of Light to Enhance the Public Spaces of a New Hotel," *Architectural Record* 189 (February 2001): 188–90, 192.

86. Bernard Stamler, "Discord Grows Where Plants Once Did," *New York Times* (March 1, 1998), XIV: 7; David Novros, "TriBeCa Atelier Rendering Distorts the Surroundings," letter to the editor, *New York Times* (April 5, 1998), XIV: 15.

87. Anita Murray, quoted in "First the SoHo Grand, Next the TriBeCa Grand": 1.

88. Emanuel Stern, quoted in "First the SoHo Grand, Next

the TriBeCa Grand": 1.

89. Charles D. Linn, "Franklin Street Station," *Architectural Record* 181 (June 1993): 136–37.

90. For Wagner's work, see Heinz Geretsegger and Max Peintner, *Otto Wagner 1841–1918: The Expanding City, The Beginning of Modern Architecture* (New York: Praeger, 1970), 47–78.

91. "Tribeca Park Getting a Face-Lift," *New York* 20 (October 19, 1987): 24. For Duane Park, see *Tribeca West Historic District*, 171.

92. White and Willensky, *AIA Guide* (2000), 63.

93. Signe Nielsen, interview by the author, April 25, 2001.

94. Toby Axelrod, "Vanished Greenery Millions Make Tribecans See Red," *New York Observer* (October 2, 1995): 12; Greg Sargent, "What Would Travis Bickle Do? De Niro Reacts to Traffic Plan," *New York Observer* (May 12, 1997): 7; Bernard Stamler, "Greenwich St. Has Moved into Fast Lane but Brakes Are On," *New York Times* (June 8, 1997), XIII: 22; Bernard Stamler, "Trees, Traffic and a Street Fight," *New York Times* (May 3, 1998), XIV: 6; William Berlind, "A Tribeca Tale: Robert De Niro Versus Some of His Neighbors," *New York Observer* (July 20, 1998): 9.

95. Signe Nielsen, interview by the author, April 25, 2001.

CIVIC CENTER

1. See Stern, Gilmartin, and Massengale, *New York 1900*, 61–68; Stern, Gilmartin, and Mellins, *New York 1930*, 93–96; Stern, Mellins, and Fishman, *New York 1960*, 154–61.

2. For City Hall, see Stern, Mellins, and Fishman, *New York 1880*, 125. For the Municipal Building, see Stern, Gilmartin, and Massengale, *New York 1900*, 60, 64–67. For the New York County Courthouse and United States Courthouse, see Stern, Gilmartin, and Mellins, *New York 1930*, 92–93, 97–99.

3. Stern, Mellins, and Fishman, *New York 1960*, 163–67.

4. Stern, Mellins, and Fishman, *New York 1960*, 161–63.

5. *Richard Serra: Interviews Etc., 1970–1980* (Yonkers, N.Y.: Hudson River Museum, 1980), 168; "Tilted Arc," *New York Times* (September 23, 1981): 1; Grace Glueck, "Serra Work Stirs Downtown Protest," *New York Times* (September 25, 1981), C: 24; Alicia Legg, Deborah Wye, Lincoln Rothschild, Donald W. Thalacker, Brent C. Brolin, and Richard Madison, "The Leaning Sculpture of Federal Plaza," letters to the editor, *New York Times* (October 3, 1981): 26; S. A. Morse, "Use the Michelangelo/Picasso Defense Sparingly," letter to the editor, *New York Times* (October 31, 1981): 26; Don Hawthorne, "Does the Public Want Public Sculpture?" *Art News* 81 (May 1982): 56–63; Mary Miss, "On a Redefinition of Public Sculpture," *Perspecta* 21 (1984): 52–69; Susan Heller and David W. Dunlap, "'Arc' Under Scrutiny," *New York Times* (December 29, 1984): 29; Grace Glueck, "What Part Should the Public Play in Choosing Public Art?" *New York Times* (February 3, 1985), II: 1; Douglas C. McGill, "Art People," *New York Times* (February 22, 1985), C: 24; Michael Sorkin, "Que Serra Sera," *Village Voice* (March 5, 1985): 85, reprinted in Michael Sorkin, *Exquisite Corpse* (London and New York: Verso, 1991), 97–100; Douglas C. McGill, "Office Workers and Artists Debate Fate of a Sculpture," *New York Times* (March 7, 1985), B: 1; Margot Hornblower, "New Yorkers, Artists Tilt Over 'Arc,'" *Washington Post* (March 7, 1985), D: 1; Douglas C. McGill, "Art People," *New York Times* (April 5, 1985): C: 24; Gary Indiana, "Debby with Monument: A Dissenting Opinion," *Village Voice* (April 16, 1985): 94; Esther B. Fein, "Panel Backs Removal of Foley Square Sculpture," *New York Times* (April 19, 1985), C: 4; Alan Finder and Albert Scardino, "Panel Favors Removal of Arc," *New York Times* (April 21, 1985), IV: 6; Peter Freiberg, "Insites," *Metropolis* 4 (May 1985): 14–15; Margaret Moorman, "Arc Enemies," *Art News* 84 (May 1985): 13, 156; Paul Goldberger, "Harmonizing Old and New Buildings," *New York Times* (May 2, 1985), C: 23; "Wailing at the Wall," *Washington Post* (May 13, 1985): 94; Eleanor Munro, "For an Art Truce in Foley Square," *New York Times* (May 18, 1985): 25; Michael Brenson, "The Case in Favor of a Controversial Sculpture," *New York Times* (May 19, 1985), II: 1; "Intrusive Arc," editorial, *New York Times* (May 31, 1985): 26; Gustave Harrow, "Public Sculpture Is Symbolic First and Pleasurable Only Second," letter to the editor, *New York Times* (May 31, 1985): 26; Joseph Berger, "'Tilted Arc' to Be Moved from Plaza at Foley Sq.," *New York Times* (June 1, 1985): 25; Douglas C. McGill, "'Tilted Arc' Removal Draws Mixed Reaction," *New York Times* (June 6, 1985), C: 21; Herbert George, "Not Publicity, Notoriety or Even Site Makes a Sculpture Great," letter to the editor, *New York Times* (June 20, 1985): 26; "'Tilted Arc' Hearing," *Artforum* 23 (Summer 1985): 98–99; Patricia C. Phillips, "Forum: Something There Is That Doesn't Love a Wall," *Artforum* 23 (Summer 1985): 100–101; William Wilson, "The Matter of Serra's 'Arc' de Trauma," *Los Angeles Times* (June 30, 1985): 80; "GSA Plans to Move Sculpture; Serra May Seek Injunction," *Architecture* 74 (July 1985): 11–12; Robert C. Buck, "Applying the Test of Time to Public Sculpture," letter to the editor, *New York Times* (July 6, 1985): 20; Alvin S. Lane, "Public Art vs. Public Sentiment," *New York Times* (July 13, 1985): 21; Michael Brenson, "What's New Around Town in Outdoor Sculpture," *New York Times* (July 19, 1985), C: 1; Robert Worthing, "The Emperor's Arc," letter to the editor, *New York Times* (July 20, 1985): 22; Douglas C. McGill, "St. Louis Bid to Remove Serra Work," *New York Times* (August 21, 1985), C: 13; Brendan Gill and Adele Chatfield-Taylor, "Richard Serra and the Crisis of Public Art," *Pratt Journal of Architecture* 1 (Fall 1985): 85–90; Andrea Oppenheimer, "Removal of Serra's Sculpture Under Consideration in St. Louis," *Architecture* 74 (October 1985): 16, 18; Henry Eng, "Tilted Arc's Urban Space," letter to the editor, *Architecture* 74 (October 1985): 6, 89; J. Roy Haase, "Serra's Sculpture," letter to the editor, *Architecture* 74 (November 1985): 6; Eleanor Blau, "'Tilted Arc' Dispute Brings New Procedures by U.S. for Buying Public Art," *New York Times*

(October 13, 1985): 62; George F. Will, "Giving Art a Bad Name," *Newsweek* 106 (September 16, 1985): 80; Will Ellsworth-Jones, "Disappearing Art Work," *The Times* (London) (September 29, 1985); Grace Glueck, "A New Face and Fresh Ideas in the Public-Art Debate," *New York Times* (January 12, 1986), II: 35; Michael Brenson, "Richard Serra's Radical Message Is Rooted in Tradition," *New York Times* (March 16, 1986), II: 31; Richard Haitch, "Plan to Relocate Wall Sculpture," *New York Times* (March 16, 1986): 53; "Unmovable Art," editorial, *Wall Street Journal* (July 24, 1986): 22; David Bird and David W. Dunlap, "A Monumental Sculpture May Be Getting a New Home," *New York Times* (July 28, 1986), B: 2; Robert Storr, "'Tilted Arc': Enemy of the People!" *Art in America* 73 (September 1986): 90–97; Janet Malcolm, "Profiles: A Girl of the Zeitgeist–I," *New Yorker* 62 (October 20, 1986): 49–52, 55–56, 58–60, 62–64, 66–68, 73–74, 76–89; David W. Dunlap, "Gimbels, the Snail and the Tilted Arc," *New York Times* (November 13, 1986), B: 1; "Can Artists Control the Work They've Sold?" *New York Times* (November 23, 1986), IV: 26; Douglas C. McGill, "Artist Sues U.S. Over 'Tilted Arc,'" *New York Times* (December 24, 1986), C: 8; Douglas Crimp, "Serra's Public Sculpture: Redefining Site Specificity," in Ernst-Gerhard Güse, ed., *Richard Serra* (New York: Rizzoli International Publications, 1987), 22–39, fig. 94, also published in Hal Foster and Gordon Hughes, eds., *Richard Serra* (Cambridge, Mass.: MIT Press, 2000), 147–74; Douglas C. McGill, "Judge Rules Against 'Tilted Arc' Sculptor in Suit," *New York Times* (July 16, 1987), C: 19; Tom Morganthau, "Get Rid of That Eyesore!" *Newsweek* 110 (August 17, 1987): 23; David W. Dunlap, "Judge Upholds Effort to Move Sculpture," *New York Times* (September 1, 1987), B: 1; Lynn Nesmith, "Richard Serra's 'Tilted Arc,'" *Architecture* 76 (October 1987): 14; Ginger Danto, "A Loss for Serra," *Art News* 86 (October 1987): 61; Douglas C. McGill, "'Tilted Arc' Gains Adherents," *New York Times* (December 16, 1987), C: 21; Douglas C. McGill, "Debating 'Tilted Arc,'" *New York Times* (December 18, 1987), C: 36; White and Willensky, *AIA Guide* (1988), 65–66; M. Froehlich, "Bore the 'Arc,'" letter to the editor, *New York Times* (January 2, 1988): 22; "Trying to Move a Wall of Art," *New York Times* (March 13, 1988): 48; Richard Lacayo, "The 'Moral Rights' of Artists," *Time* 131 (March 14, 1988): 59; Edward Frost and Diane Goldner, "Sculptor Fights Removal of Arc," *Manhattan Lawyer* (March 15–21, 1988): 7; Douglas C. McGill, "Federal Judge Rules on 'Arc,'" *New York Times* (June 2, 1988), C: 17; Paul Goldberger, "Sculptural Links in the Chain of Urban Events," *New York Times* (January 29, 1989), II: 33; David W. Dunlap, "Moving Day Arrives for Disputed Sculpture," *New York Times* (March 11, 1989), 29; Todd S. Purdum, "Sculpture's Move Delayed by Judge," *New York Times* (March 12, 1989): 43; David W. Dunlap, "Artist Abandons Fight to Bar Uprooting of Plaza Sculpture," *New York Times* (March 16, 1989), B: 2; "Against the Wall," *New York Times* (March 19, 1989), V: 9; "The Arc Comes Down," editorial, *Washington Post* (March 24, 1989): 22; Michael Brenson, "The Messy Saga of 'Tilted Arc' Is Far from Over," *New York Times* (April 2, 1989), II: 33; Jan R. Harrington, "Rent a Work and Then Decide," letter to the editor, *New York Times* (April 16, 1989), II: 5; Richard Serra, "A Precedent?" letter to the editor, *New York Times* (April 30, 1989), II: 5; Richard Serra, "'Tilted Arc' Destroyed," *Art in America* 77 (May 1989): 34–37, 39, 41, 43, 45, 47; "U.S. Dismantles Serra's Tilted Arc, New York," *Journal of Art* 1 (May 1989): 1–2; "'Tilted Arc' Dismantled," *Landscape Architecture* 79 (May 1989): 13; Daniel Salz and Vincent Doyle, "'Tilted Arc,'" letters to the editor, *New York Times* (May 14, 1989), II: 13; Michele Marder Kamhi and Mary Baez, "'Tilted Arc,'" letters to the editor, *New York Times* (May 21, 1989), II: 18; John Morvay, "Serra's 'Arc,'" letter to the editor, *New York Times* (June 4, 1989), II: 15; "Open Space Replaces 'Arc,'" *New York Times* (June 15, 1989), C: 15; Hilton Kramer, "Is Art Above the Laws of Decency?" *New York Times* (July 2, 1989), II: 1; Douglas W. Hitzig, "Tilted Arc,'" letter to the editor, *New York Times* (July 9, 1989), II: 3; Deborah Solomon, "Our Most Notorious Sculptor," *New York Times* (October 8, 1989), VI: 39, 74; Maggie Malone, "The Great Outdoors," *Newsweek* 114 (October 23, 1989): 76; "Foreign Exchange," editorial, *New York Times* (November 28, 1989): 24; Harriet Senie, "Richard Serra's 'Tilted Arc': Art and Non-Art Issues," *Art Journal* 48 (Winter 1989): 298–302; Robin Cembalest, "Going, Going, Gone," *Art News* 88 (Summer 1989): 50, 52; Clara Weyergraf-Serra and Martha Buskirk, eds., *The Destruction of Tilted Arc: Documents* (Cambridge, Mass. and London: MIT Press, 1991); John Rockwell, "An Artist a Lot More at Home Away From Home," *New York Times* (June 14, 1993), C: 11; Hilton Kramer, "Serra: Art Critics' Darling as Misunderstood Genius," *New York Observer* (September 5, 1994): 1, 24; Harriet F. Senie, "Public Art and the Legal System," *Public Art Review* 6 (Fall/Winter 1994): 13–15, 37; D. S. Friedman, "Public Things in the Modern City: Belated Notes on Tilted Arc and the Vietnam Veterans Memorial," *Journal of Architectural Education* 49 (November 1995): 62–78; Jeffrey Kastner, "Tilted Arc," *Art News* 95 (November 1996): 54; Greg M. Horowitz, "Public Art/Public Space: The Spectacle of the Tilted Arc Controversy," *Journal of Aesthetics and Art Criticism* 54 (Winter 1996): 8–14; Michael Kelly, "Public Art Controversy: The Serra and Lin Cases," *Journal of Aesthetics and Art Criticism* 54 (Winter 1996): 15–22; Peter Schjeldahl, "Twisted Fate," *Village Voice* (December 2, 1997): 93; White and Willensky, *AIA Guide* (2000), 72–73; Peter Schjeldahl, "Serra Smiles," *New Yorker* 75 (February 7, 2000): 88–89; Daniel B. Schneider, "F.Y.I.: The Homeless 'Arc,'" *New York Times* (April 9, 2000), XIV: 2.

6. Judith Cummings and Laurie Johnson, "3 Commuters, Waiting," *New York Times* (April 23, 1980), B: 5; "A Sculpture Makes Debut on Broadway," *New York Times* (April 25, 1980), B: 3; Vivien Raynor, "Art People," *New York Times* (May 2, 1980), C: 19; Douglas Crimp, "Richard Serra's Urban

Sculpture: An Interview," *Arts Magazine* 55 (November 1980): 118–23; Donald B. Kuspit, "Richard Serra, Utopian Constructivist," *Arts Magazine* 55 (November 1980): 124–29; Robert Pincus-Witten, "Entries: Oedipus Reconciled," *Arts Magazine* 55 (November 1980): 130–33; Hilton Kramer, "Today's Avant-Garde Artists Have Lost the Power to Shock," *New York Times* (November 16, 1980), II: 1, 27; Richard Serra, "Notes from Sight Point Road," *Perspecta* 19 (1982): 172–81; Güse, ed., *Richard Serra*, figs. 89–90; "Outdoor Exhibition Closes," *New York Times* (January 30, 1987), B: 2; Yve-Alain Bois, "A Picturesque Stroll Around *Clara-Clara*," in Foster and Hughes, eds., *Richard Serra*, 59–98.

7. Richard Serra, quoted in Crimp, "Richard Serra's Urban Sculpture: An Interview": 122.

8. Kramer, "Today's Avant-Garde Artists Have Lost the Power to Shock": 27.

9. Richard Serra, quoted in *Richard Serra: Interviews Etc., 1970–1980*, 168, also quoted in Storr, "'Tilted Arc': Enemy of the People?": 92.

10. Crimp, "Serra's Public Sculpture: Redefining Site Specificity," in Güse, ed., *Richard Serra*, 23.

11. Quoted in Glueck, "Serra Work Stirs Downtown Protest": 24.

12. William J. Diamond, quoted in Anderson and Dunlap, "'Arc' Under Scrutiny": 29.

13. Glueck, "What Part Should the Public Play in Choosing Public Art?": 1.

14. Sorkin, "Que Serra Sera": 85.

15. William Rubin's hearing testimony, quoted in Güse, ed., *Richard Serra*, 101–2.

16. William Toby's hearing testimony, quoted in McGill, "Office Workers and Artists Debate Fate of Sculpture": 1.

17. Goldberger, "Harmonizing Old and New Buildings": 23.

18. Brenson, "The Case in Favor of a Controversial Sculpture": 1.

19. McGill, "'Tilted Arc' Gains Adherents": 21.

20. William J. Diamond, quoted in "Open Space Replaces 'Arc'": 15.

21. Richard Serra, quoted in Dunlap, "Moving Day Arrives for Disputed Sculpture": 29.

22. Quoted in Schneider, "F.Y.I.: The Homeless 'Arc'": 2.

23. Moorman, "Arc Enemies": 13.

24. William J. Diamond, quoted in "Open Space Replaces 'Arc'": 15.

25. Carol Vogel, "Where an Arc Once Ruled," *New York Times* (May 28, 1993), C: 23; Vernon Mays, "Federal Buildings and Campuses," *Architecture* 85 (January 1996): 86–89, 95; John Beardsley, "The Haunting of Federal Plaza," *Landscape Architecture* 86 (May 1996): 159–60; David Colman, "A Playground for Adults," *New York Times* (October 10, 1996), C: 14; Kastner, "Tilted Arc": 54; Heidi Landecker, ed., *Martha Schwartz: Transfiguration of the Commonplace* (Washington, D.C.: Spacemaker Press, 1997), 84–86, 148–49; Dean Cardasis, "Three Projects for Public Spaces in America," *Domus* 802 (March 1998): 26–31; "Landscape Corner," *Architecture of Israel* 37 (Spring 1999): 58–61; Linette Widder, "Jacob Javits Plaza in New York," *Architect: Dossier* 10 (November 1999): 56–59; White and Willensky, *AIA Guide* (2000), 72–73; Clare Cooper Marcus, "Can There Be Too Much Seating?" *Landscape Architecture* 90 (February 2000): 129, 132; Fred Bernstein, "Design: Anything But Square," *The Independent* (London) (September 3, 2000): 32–34; Fred Bernstein, "At Home With/Martha Schwartz," *New York Times* (December 21, 2000), F: 1, 5; Susanna Sirefman, *New York: A Guide to Recent Architecture* (London: Ellipsis, 2001), cover, I: 30–31.

26. Martha Schwartz, quoted in Mays, "Federal Buildings and Campuses": 89.

27. White and Willensky, *AIA Guide* (2000), 72.

28. Lindsey Gruson, "City's Plan on New Jail Is Assailed," *New York Times* (September 3, 1982), B: 1; Suzanne Daley, "Chinatown Jail Might Put Space to Private Uses," *New York Times* (September 11, 1982): 25; "A Jail Plan That Can Work," editorial, *New York Times* (October 2, 1982): 26; David W. Dunlap, "City's Planning Agency Votes Plan for Jail Near Chinatown," *New York Times* (October 6, 1982), B: 1; Charles P. Wang, "Wrong Place for a New York City Jail," letter to the editor, *New York Times* (October 11, 1982): 18; Lloyd N. Merrill, Robert V. Lott, and Richard L. Ropiak, "Downtown Manhattan Needs No New Prison," letter to the editor, *New York Times* (October 23, 1982): 26; Robin Herman and Laurie Jonston, "Chinatown Jail Protest," *New York Times* (November 17, 1982), B: 3; Sheila Rule, "City Juvenile Justice Chief Resigns, Citing Proposed Detention Center," *New York Times* (November 18, 1982), B: 6; Maurice Carroll, "Action on Chinatown Jail Put Off After Protest," *New York Times* (November 19, 1982): 1, B: 2; Maurice Carroll, "Koch Is Seeking to Compromise on Jail Dispute," *New York Times* (November 20, 1982): 27; "If Not Here, Where?" editorial, *New York Times* (November 27, 1982): 22; "Foes of New Jail Near Chinatown Seek Alternative," *New York Times* (November 30, 1982), B: 7; "Build the White Street Jail," editorial, *New York Times* (December 2, 1982): 30; Maurice Carroll, "Jail Near Chinatown Is Approved by 7 to 4 by Board of Estimate," *New York Times* (December 3, 1982): 1, 28; Maurice Carroll, "Koch Discerns Outbreak of Community 'Selfishness,'" *New York Times* (December 18, 1982): 29; "Chinatown Prison," *Oculus* 44 (January 1983): 2; "New Chinatown Jail Is Approved by Judge," *New York Times* (August 31, 1983), B: 5; Philip Shenon, "City Is Planning to Open Tombs Before Schedule," *New York Times* (September 24, 1983): 27; David C. Anderson, "New York's 'New Generation' Jail," *New York Times* (October 25, 1983): 34; Helen Thorpe, "At New Jail, the 1 Percent Solution," *New York Observer* (December 4, 1989): 17; Jeffrey Hoff and Steven Saltzman, "Jail House for Lower Manhattan," *Metropolis* 5 (May 1991): 25–26; Yasmin Ramirez, "Protest Hits Jail Mural," *Art in America* 80 (July 1992): 29; White and Willensky, *AIA Guide*

(2000), 73–74.

29. For the Tombs, see Stern, Gilmartin, and Mellins, *New York 1930*, 98–99, 101.

30. Charles P. Wang, quoted in Gruson, "City's Plan on New Jail Is Assailed": 1.

31. "A Jail Plan That Can Work": 26.

32. Edward Koch, quoted in Carroll, "Koch Discerns Outbreak of Community 'Selfishness'": 29.

33. Hoff and Saltzman, "Jail House for Lower Manhattan": 25–26.

34. White and Willensky, *AIA Guide* (2000), 74.

35. Richard Haas, quoted in Ramirez, "Protest Hits Jail Mural": 29.

36. Deirdre Carmody, "Pact Announced on Housing Next to Planned Chinatown Jail," *New York Times* (May 10, 1984), B: 7; Marvine Howe, "Chinatown Plan Is Key to Dispute," *New York Times* (July 20, 1986): 22; "City Ousts 6 Voted to Board in Chinatown Housing Clash," *New York Times* (September 14, 1986): 45; "Koch Warns of Halt on Chinatown Plan," *New York Times* (January 22, 1987), B: 4; Diana Shaman, "New Rental in Chinatown for Low-Income Elderly," *New York Times* (March 29, 1991), B: 4; "Chinatown Tour de Force," *New York Construction News* (April 29, 1991): 1–2; White and Willensky, *AIA Guide* (2000), 74.

37. Clifford D. May, "U.S. Plans 2 Buildings at Foley Sq.," *New York Times* (December 24, 1987), B: 1–2; Thomas L. Waite, "Feds in Foley Square," *New York Times* (June 26, 1988), A: 1; Carter B. Horsley, "Builders Square Off," *New York Post* (October 20, 1988): 60–61; Clifford D. May, "Moynihan Criticizes Delay in Building Courts," *New York Times* (February 5, 1989): 35; "Architect on Planning Panel Quits as He Pursues Project," *New York Times* (August 25, 1989), B: 3; David W. Dunlap, "2 U.S. Towers at Foley Sq. Will Avoid Review Steps," *New York Times* (November 29, 1989), B: 1; "Developers Vie for U.S. Project in Manhattan," *Wall Street Journal* (March 5, 1990), B: 6.

38. Daniel Patrick Moynihan, quoted in May, "U.S. Plans 2 Buildings at Foley Sq.": 1.

39. Quoted in Horsley, "Builders Square Off": 60–61.

40. Daniel Patrick Moynihan, quoted in May, "Moynihan Criticizes Delay in Building Courts": 35.

41. Alan S. Oser, "Perspectives: The Federal Buildings: A Spur to Slow Construction," *New York Times* (April 28, 1991), X: 5. Also see Craig Wolff, "Building Plans for Foley Sq. Are Unveiled," *New York Times* (March 30, 1991): 21.

42. Wolff, "Building Plans for Foley Sq. Are Unveiled": 21; Oser, "Perspectives: The Federal Buildings: A Spur to Slow Construction": 5; "Courthouse Construction," *New York Observer* (May 13, 1991): 6; Ted Cohen, "Feds Take Shortcut to Foley Square," *Metropolis* 5 (December 1991): 13–14; Mervyn Rothstein, "Architects Sheltering in Government Projects," *New York Times* (December 20, 1992), X: 1; Warren A. James, ed., *Kohn Pedersen Fox: Architecture and Urbanism, 1986–1992* (New York: Rizzoli International Publications, 1993), 90–93; Bradford McKee, "Federal Design/Build," *Architecture* 83 (October 1994): 109–11; Herbert Muschamp, "A Pair of Towers Trapped in Gray Flannel Suits," *New York Times* (October 9, 1994), II: 40; Melinda Henneberger, "Report Assails Cost Overruns for New Court," *New York Times* (December 14, 1994), B: 1; Roderick R. McKelvie, "Open Office Windows Save on Energy," letter to the editor, *New York Times* (December 20, 1994): 22; David S. Floyd, "On Letting Dollars Fly out the Window," *New York Times* (December 28, 1994): 14; Maryann Haggerty, "Building Luxuries Traced to Flaws in GSA Practices," *Washington Post* (October 5, 1995): 21; Maryann Haggerty, "Judging Extravagance of Courthouse Projects," *Washington Post* (November 9, 1995): 21; Heidi Landecker, "Court Houses," *Architecture* 85 (January 1996): 64–67, 77; *Kohn Pedersen Fox: Selected and Current Works* (Mulgrave, Australia: Images Publishing, 1997), 120–21; Sirefman, *New York*, I: 32–35; White and Willensky, *AIA Guide* (2000), 73; Eric Schmitt, "A New York Courthouse Is Left Nameless in the Wake of Partisan Fighting in Congress," *New York Times* (November 2, 2000): 29; Frank Lombardi, "Sen. Pat Says So Long, Gives Courthouse His Good Name," *New York Daily News* (December 5, 2000): 30; Eric Lipton, "Moynihan Name Lives On at the Newest Courthouse," *New York Times* (December 5, 2000), B: 9.

43. Landecker, "Court Houses": 77.

44. Muschamp, "A Pair of Towers Trapped in Gray Flannel Suits": 40.

45. Quoted in Henneberger, "Report Assails Cost Overruns for New Court": 1.

46. "Maya Lin's Downtown Fountain," *Art in America* 84 (October 1996): 31; Maria Ann Conelli and Marilyn Symmes, "Fountains as Entertainment and Pleasure," in Marilyn Symmes, ed., *Fountains: Splash and Spectacle: Water and Design from the Renaissance to the Present* (New York: Rizzoli International Publications in association with Cooper-Hewitt, National Design Museum, Smithsonian Institution, 1998), 153; Julie V. Iovine, "Fountain Fantasies, From Cascades to Curbs," *New York Times* (June 11, 1998), F: 4; Marilyn Symmes, "Fountains: Designing for the Rise and Fall of Water," *Drawing* 20 (Fall 1998): 1–6; Maya Lin, *Boundaries* (New York: Simon & Schuster, 2000), 6: 24–25; 12: 5.

47. "Foley Square," *Architecture + Urbanism* (December 1990): 218–23; Wolff, "Building Plans for Foley Sq. Are Unveiled": 21; Oser, "Perspectives: The Federal Buildings: A Spur to Slow Construction": 5; "Federal Government to Erect $276M Office Building in Man.," *New York Construction News* (May 13, 1991): 1; Cohen, "Feds Take Shortcut to Foley Square": 13–14; Rothstein, "Architects Sheltering in Government Projects": 1; McKee, "Federal Design/Build": 109–11; Muschamp, "A Pair of Towers Trapped in Gray Flannel Suits": 40; Sirefman, *New York*, I: 36–37; *Hellmuth, Obata + Kassabaum* (Mulgrave, Australia: Images Publishing, 1998),

86–87; White and Willensky, *AIA Guide* (2000), 72.

48. For the Humana Building, see Karen Vogel Nichols, Patrick J. Burke, and Caroline Hancock, eds., *Michael Graves: Buildings and Projects, 1982–1989* (New York: Princeton Architectural Press, 1990), 34–43.

49. Sirefman, *New York*, I: 36.

50. Muschamp, "A Pair of Towers Trapped in Gray Flannel Suits": 40.

51. "Ancient NYC Black Cemetery Explored," *Atlanta Journal and Constitution* (October 9, 1991): 7; David W. Dunlap, "Dig Unearths Early Black Burial Ground," *New York Times* (October 9, 1991), B: 1, 5; Mark Tran, "Black Cemetery Hints at Colonial Past of New York," *The Guardian* (London) (October 11, 1991); William M. Frick and Christopher Moore, "Early Black Burial Ground Recalls Alleged Slave Conspiracy," letters to the editor, *New York Times* (October 26, 1991): 18; "Patterson to Monitor Dig at Burial Ground," *New York Times* (December 7, 1991): 27; "Retrieving Old New York," editorial, *Washington Post* (December 25, 1991): 18; David W. Dunlap, "Unfree, Unknown," *New York Times* (December 26, 1991), B: 3; Steven Wilf, "Don't Rush Excavation of Black Burial Ground," letter to the editor, *New York Times* (December 26, 1991): 24; Christopher Moore, "Rename Foley Square the African Square," letter to the editor, *New York Times* (July 4, 1992): 18; "Blacks in New York Urge Feds to Install 'Fitting Memorial' for Slaves," *Jet* (July 6, 1992): 32; "Research Yee, Desecration, No," *Newsday* (July 27, 1992): 36; Jill Dutt, "Burial Ground Research Plans Offered by Team," *Newsday* (November 18, 1992): 22; "Con Edison Crew Unearths Bones Near Early Black Graveyard," *New York Times* (February 14, 1993): 43; "The Real Scoop on Lower Manhattan," *Newsday* (March 18, 1993): 113; Karen Cook, "Bones of Contention," *Village Voice* (May 4, 1993): 23–27; Clifford J. Levy, "Study to Examine Bones from Blacks' Burial Site," *New York Times* (August 13, 1993), B: 1; Larry Kaggwa, "Early Slave Burial Site a Rare Prize for Scientists," *Chicago Sun-Times* (August 20, 1993): 24; David A Paterson, "It Took a Community to Save Burial Ground," letter to the editor, *New York Times* (August 21, 1993): 18; Sharon Fitzgerald, "Sacred Ground," *Essence* 24 (September 1993): 108, 110; Nathan Jackson, "The Discovery of 'Little Africa,'" *Newsday* (November 3, 1993), II: 56; Rosalind Bentley, "Our Long-Buried Past: New York's Slave Cemetery," *Minneapolis Star Tribune* (November 4, 1993): 1E; "A Procession of Candles Honors African-Americans of the Past," *New York Times* (November 5, 1993), B: 3; Bruce Lambert, "In Remembrance of a Burial Ground," *New York Times* (December 19, 1993), XIII: 6; "Howard Experts Study Remains for First Clues on Early U.S. Blacks," *Jet* (January 31, 1994): 24; Harriet Jackson Scarupa, "Learning from Ancestral Bones: New York's Exhumed African Past," *American Visions* 9 (February-March 1994): 18–21; Michael L. Blakey, "What Makes Burial Ground Project a Milestone," letter to the editor, *New York Times* (May 30, 1995): 16; Anthony M. Tung, *Preserving the World's Great Cities: The Destruction and Renewal of the Historic Metropolis* (New York: Clarkson Potter, 2001), 404–6.

52. David A. Paterson, quoted in Dunlap, "A Black Cemetery Takes Its Place in History": 5. Also see "Blacks in New York Urge Feds to Install 'Fitting Memorial' for Slaves": 32.

53. Landmarks Preservation Commission of the City of New York, *African Burial Ground and the Commons Historic District Designation Report* (New York, February 1993); David W. Dunlap, "African Burial Ground Made Historic Site," *New York Times* (February 26, 1993), B: 3; "African Burial Ground," *Washington Post* (February 26, 1993): 7; David W. Dunlap, "A Black Cemetery Takes Its Place in History," *New York Times* (February 28, 1993), IV: 5; "African Burial Ground," *Architectural Record* 181 (April 1993): 27; Barbaralee Diamonstein, *The Landmarks of New York III* (New York: Harry N. Abrams, 1998), 520.

54. Edward Kaufman, ed., *Reclaiming Our Past, Honoring Our Ancestors: New York's 18th Century African Burial Ground and the Memorial Competition* (New York: African Burial Ground Competition Coalition, 1994); Michael H. Cottman, "A Contest for a Tribute," *Newsday* (February 16, 1994): 28; Marvine Howe, "Four Visions to Honor Burial Ground," *New York Times* (February 27, 1994), XIII: 6; "Competition Winners' Designs Honor African Ancestors," *Architectural Record* 182 (March 1994): 12; "News: And the Winners Are . . . ," *Municipal Art Society Newsletter* (March 1994): 1–2; Herbert Muschamp, "Claiming a Potent Piece of Urban Turf," *New York Times* (March 13, 1994), II: 38; Kira Gould, "On Hallowed Ground: The African Burial Ground Competition," *Competitions* 4 (Fall 1994): 28–33; Steven R. King, "Exhibits," *Landscape Journal* 13 (Fall 1994): 181–84; Karen Bermann and Jeanine Centuori, "The Africa Burial Ground Memorial," *Assemblage* 26 (April 1995): 88–93; Edward Kaufman, "Re: African Burial Ground Memorial Competition," letter to the editor, *Assemblage* 28 (December 1995): 86–87.

55. Gould, "On Hallowed Ground: The African Burial Ground Competition": 32.

56. "Burial Ground Memorial Commissioned," *Art in America* 82 (May 1994): 29; Brent Staples, "Manhattan's African Dead," *New York Times* (May 22, 1995): 14.

57. "Design Competitions to Commemorate African Burial Site in Manhattan," *Architectural Record* 185 (May 1997): 56; Joyce Shelby, "Fed Memorial to Honor African Burial Ground," *New York Daily News* (January 21, 1998): 3; Mike Claffey, "Bones at Main Break," *New York Daily News* (October 25, 1998): 10; "African Burial Ground Memorial Project," *Oculus* 61 (January 1999): 40; Judith H. Dobrzynski, "Contest for Memorial at Black Burial Ground," *New York Times* (March 15, 1999), E: 3; Marc Ferris, "8 Years After the Bones, More Battles," *New York Times* (March 21, 1999), XIV: 6; "Memorial Service," *Architectural Record* 187 (April 1999): 62–63; Harry Brunius, "African Burial Ground Under New York Streets,"

Christian Science Monitor (June 17, 1999): 16; Michael Finnegan, "African Burial Ground Memorial Work Begins," *New York Daily News* (March 14, 2000): 63; Robin Finn, "Pressing the Cause of the Forgotten Slaves," *New York Times* (August 8, 2000), B: 2; "African Burial Ground on Hold," *Architectural Record* 188 (September 2000): 38; Kira L. Gould, "Designers Selected for African Burial Ground Center," *Oculus* 63 (September 2000): 7; Robin Finn, "With Memorial, a Monumental Predicament," *New York Times* (September 27, 2000), B: 2; "'Still I Rise,'" *New York Times* (October 20, 2000), B: 4.

58. Quoted in "Design Competitions to Commemorate African Burial Site in Manhattan": 56.

59. Robert Ingrassia, "$21M Plan Mired in Woe: Researchers, Feds Wrangle Over African Burial Ground," *New York Daily News* (February 5, 2001): 6; Michael Saul, "African Burial Ground Parley," *New York Daily News* (February 6, 2001): 17; Thomas Hackett, "Remains of African Slaves to Be Reburied," *New York Daily News* (March 11, 2001): 2; Derek Rose, "Feds Nix 350G for Burial Celebration," *New York Daily News* (August 3, 2001): 7; Michael O. Allen, "Reburial Plan Almost Set, Feds Say but Black Group Assails Delays," *New York Daily News* (August 23, 2001): 4; Marcia Slacum Greene, "No Rest for African Burial Ground," *Washington Post* (August 27, 2002): 1; Julia Cosgrove, "Jesse Says Burial Ground Sacred, Too," *New York Daily News* (August 28, 2002): 7; E. R. Shipp, "Burial Grounds Part of City's Foundation," *New York Daily News* (September 15, 2002): 45; "Burial Ground of Unkept Promises," editorial, *New York Times* (October 6, 2002): 12; Julie V. Iovine, "Memorials Proliferate in Crowded Downtown," *New York Times* (March 13, 2003): E: 1, 3; Daisy Hernandez, "Have Something to Say About African Burial Ground Memorial? Do It Now," *New York Daily News* (July 27, 2003): 27.

60. Johnny Dwyer, "Remains of Ex-Slaves to Be Buried with Honors," *New York Daily News* (September 23, 2003): 6; Corey Kilgannon, "Unearthing the Past, Then Burying It with Respect," *New York Times* (October 2, 2003), B: 2, 4; Michael Luo, "In Manhattan, Another Burial for 400 Colonial-Era Blacks," *New York Times* (October 2, 2003): 1; Austin Fenner, "Africans' Remains on Last Journey," *New York Daily News* (October 4, 2003): 12; "Honoring the Slaves of New York," editorial, *New York Times* (October 4, 2003): 12; Michael Luo, "City's Role in Slavery Is Recalled at Rites," *New York Times* (October 4, 2003), B: 3; Jose Martinez, "400 Slaves' Remains Are Returned to Burial Site," *New York Daily News* (October 5, 2003): 10; Randy Kennedy, "Gray Skies Match the Mood at Reburial," *New York Times* (October 5, 2003): 35.

61. Kyle Gann, "Raising Ghosts," *Village Voice* (May 21, 1996): 62; Mary Talbot, "Festival Stars African Sights and Sounds," *New York Daily News* (May 24, 1996): 61; Jared McCallister, "Educators Eye African Burial Ground," *New York Daily News* (August 11, 1996): 14; F. Romall Smalls, "African Burial Ground Is Documented in Film," *New York Times* (March 16, 1997), XIII: 21; Mark Mooney, "Slaves Worked to Death," *New York Daily News* (July 20, 1997): 22; Michael Daly, "Some Brass Tacks of Slavery Revealed," *New York Daily News* (December 7, 1997): 8.

62. David W. Dunlap, "Around City Hall, the Past Is New," *New York Times* (April 19, 1998), XI: 1; "Artforms," *Essence* 30 (April 2000): 86; Deborah Rouse, "Remember the Sacrifice," *American Visions* 15 (April-May 2000): 10–11; Eun Lee Koh, "Shrouded for Months, Memorial to Be Unveiled," *New York Times* (September 16, 2000), B: 4; Robin Finn, "With Memorial, a Monumental Predicament," *New York Times* (September 27, 2000), B: 2; Paula Young, "Foley Square Gets Facelift," *New York Daily News* (October 12, 2000): 4; Frank Lombardi, "Memorial-Day Discord," *New York Daily News* (October 13, 2000): 44; "A New Park, an Eternal Spirit," *New York Times* (October 13, 2000), B: 6.

63. Lorenzo Pace, quoted in Lombardi, "Memorial-Day Discord": 44.

64. Terry Golway and Robert Grossman, "Mr. Giuliani Builds His Dream House," *New York Observer* (February 5, 1996): 15; "Renovation," *New York Construction News* 45 (June 2, 1997): 7; Dunlap, "Around City Hall, the Past Is New": 1, 6; "Raise High the Cupola," *New York Times* (July 20, 1998), B: 3; White and Willensky, *AIA Guide* (2000), 69.

65. Dunlap, "Around City Hall, the Past Is New": 1, 6; Herbert Muschamp, Public Space, Private Space and Anti-Space," *New York Times* (December 27, 1998), II: 38; David M. Herszenhorn, "It's City Hall Park, Where Everything Old Has Been Made New," *New York Times* (October 8, 1999), B: 5; "The View from City Hall Park," editorial, *New York Times* (October 9, 1999): 16; Herbert Muschamp, "A Newly Renovated City Hall Park Offers a Mix of Bucolic and Bunker," *New York Times* (October 9, 1999), B: 3; Herbert Muschamp, "New York Starts to Look Beyond Its Past," *New York Times* (December 26, 1999), II: 49; "City Snapshot: Project Name: City Hall Park," *New York Construction News* 48 (April 2000): 5; Bernard Stamler, "Beyond Prometheus," *New York Times* (July 2, 2000), XIV: 3.

66. Dunlap, "Around City Hall, the Past Is New": 1, 6; Michael R. Blood, "Full-Pay Leave for Lategano," *New York Daily News* (June 13, 1999): 13; Herszenhorn, "It's City Hall Park, Where Everything Old Has Been Made New": 5; White and Willensky, *AIA Guide* (2000), 70; Douglas Feiden, "Boss Tweed's Legacy Deserves Place in Sun," *New York Daily News* (December 7, 2000): 29; Dan Barry, "Courthouse That Tweed Built Seeks to Shed Notorious Past," *New York Times* (December 12, 2000): 63; Dan Barry, "City Museum Plans to Move Downtown," *New York Times* (December 14, 2000), B: 1, 9; Dan Barry, "As Museum Move Evokes Tweed, City Hall Is Criticized," *New York Times* (December 15, 2000), B: 3; Christopher Moore, "A Museum to Remember Our Slave History," letter to the editor, *New York Times* (December 16,

2000): 18; Katharine Flanders Mukherji, "Preserve the Museum, and Its Memories," letter to the editor, *New York Times* (December 19, 2000): 34; Nis Petersen, "Boss Tweed's Legacy," letter to the editor, *New York Times* (December 20, 2000): 34; David W. Dunlap, "The Grandeur That Graft Built," *New York Times* (March 9, 2001), B: 1, 7; Sara Pepitone, "Fight for City Museum: Down and Dirty," *New York Observer* (April 9, 2001): 9; "History on Display," *Oculus* 64 (October 2001): 6; Barbara Stewart, "New York Yearns for an Institution of Historic Proportions," *New York Times* (August 25, 2001), B: 7, 9; Joanne Wasserman, "Boss Tweed Courthouse Restored to Opulence," *New York Daily News* (September 4, 2001): 4; Kelly Crow, "Refurbishing a Courthouse, If Not Its Reputation," *New York Times* (December 2, 2001), XIV: 4; Mel Gussow, "Here's a Big Surprise for Boss Tweed, Wherever He May Be," *New York Times* (December 22, 2001): 31; Diane Cardwell and David M. Herszenhorn, "City Reconsidering Moving Museum into Tweed Courthouse," *New York Times* (February 8, 2002), B: 1, 4; Diane Cardwell, "Doubts on Tweed Courthouse for Museum Are Part of a Penchant for Review," *New York Times* (February 9, 2002), B: 2; Brian C. Thompson, "A Cultural Move," letter to the editor, *New York Times* (February 9, 2002): 26; "Museum Directors Urge Move Downtown," *New York Times* (February 12, 2002), B: 4; "The New Tweed Courthouse," editorial, *New York Times* (February 28, 2002): 26; Megan Costello, "Looking for Key to the Tweed, Museum Turns to the People," *New York Observer* (March 11, 2002): 9; Jennifer Steinhauer, "Mayor Wants Tweed Building for School Use," *New York Times* (March 19, 2002): 1, B: 6; "A Better Use for the Tweed Courthouse," editorial, *New York Times* (March 19, 2002): 22; Abby Goodnough, "The Tweed Courthouse or 110 Livingston?" *New York Times* (March 20, 2002), B: 6; Todd J. Sanders, Thomas S. Goodkind, Roger Seguin, and Linda Cantor, "Do We Value History, or Cubicles?" letters to the editor, *New York Times* (March 20, 2002): 28; Barbara Stewart, "With Rug Pulled from Under Its Feet, Museum Is Reeling," *New York Times* (March 20, 2002), B: 1, 6; "Tweed Tenant," *Crain's New York Business* (March 25, 2002): 34; Anemona Hartocollis, "Filling In the Blanks on a Tweed School Plan," *New York Times* (March 25, 2002), B: 1, 6; Glenn Collins, "After Losing Its New Home, Museum Loses Its Director," *New York Times* (March 27, 2002), B: 3; Clyde Haberman, "A City Jewel in the Hands of Mr. Cubicle," *New York Times* (March 30, 2002), B: 1; Paul Goldberger, "The Prize," *New Yorker* 78 (April 1, 2002): 72–73; Denny Lee, "The Mayor's Courthouse Plan Strands Yet Another Museum," *New York Times* (April 7, 2002), XIV: 4; Stephanie Cash, "Bloomberg Scuttles Museum's Move to Tweed Courthouse," *Art in America* 90 (May 2002): 168; Elizabeth Kolbert, "Around City Hall: Fellowship of the Ring," *New Yorker* 78 (May 6, 2002): 86–91; Glenn Collins, "A Hall Monitor, in This Hall?" *New York Times* (May 13, 2002), B: 1, 4; John Tierney, "Boss Tweed Would Agree: Unload It," *New York Times* (May 21, 2002), B: 1; "More Thinking on Tweed," editorial, *New York Times* (June 15, 2002): 28; Clyde Haberman, "Spacious Skies and Rows of Cubicles," *New York Times* (August 6, 2002), B: 1; Betty Heller, "The Tweed Courthouse," letter to the editor, *New York Times* (August 7, 2002): 16; Shelley Preston, "Use of Tweed Courthouse Called 'Vandalism,'" *New York Sun* (September 24, 2002): 1, 10; Abby Goodnough, "Plan for School in Courthouse Is Up in Air, Educators Say," *New York Times* (October 15, 2002), B: 3; Abby Goodnough, "Learning to Work in an Heirloom After Life in a Warren," *New York Times* (October 16, 2002), B: 9; Anna Schneider-Mayerson, "Bloomberg Committed to Tweed Conversion," *New York Sun* (October 30, 2002): 3; Joyce Purnick, "Resolutions for New Year, and New York," *New York Times* (December 30, 2002), B: 1; "N.Y.'s Tweed Academy to Open on Monday," *New York Sun* (March 21, 2003): 2; David Sokol, "When Good Restorations Go Bad," *Oculus* (Spring 2003): 42–43; Carl Campanile, "Tweed Gets 'Classy,'" *New York Post* (March 25, 2003): 23; Abby Goodnough, "Mayor's 'School' Opens at Tweed Courthouse," *New York Times* (March 25, 2003), D: 5. For the New York County Courthouse, see Stern, Mellins, and Fishman, *New York 1880*, 127–31.

67. Landmarks Preservation Commission of the City of New York, LP-1437 (October 16, 1984); Jesus Rangel, "City Moves to Preserve a Symbol of Corruption," *New York Times* (December 7, 1984), B: 1; Alan Finder and Katherine Roberts, "Boss Tweed's Landmark," *New York Times* (December 9, 1984), IV: 6; Diamonstein, *The Landmarks of New York III*, 138–39.

68. For the Museum of the City of New York, see Stern, Gilmartin, and Mellins, *New York 1930*, 128, 133, 135.

69. "A Better Use for the Tweed Courthouse": 22.

70. Pete Hamill, quoted in Stewart, "With Rug Pulled from Under Its Feet, Museum Is Reeling": 6.

71. Goldberger, "The Prize": 72.

LOWER EAST SIDE
1. See Stern, Mellins, and Fishman, *New York 1960*, 134–47.
2. "Lower East Side Residents Are Divided," *New York Times* (January 31, 1980), B: 6; "3 Ethnic Groups Disputing Plans for Lower East Side," *New York Times* (March 12, 1980), B: 1, 7; Joyce Purnick, "Low-Rent Units on Delancey St. Are Voted Down," *New York Times* (April 25, 1980), B: 1, 5; Roger Starr, "Urban Renewal: Has There Been a Turnaround?" *New York Times* (June 8, 1980), VIII: 1, 10. For the Seward Park Extension urban renewal plan, see Stern, Mellins, and Fishman, *New York 1960*, 147–48.
3. Scott Ladd, "Manhattan Neighborhoods: From a Shell to Shelter," *Newsday* (September 15, 1987): 29; Charles V. Bagli, "LeFrak Plan Sparks Heated Controversy," *New York Observer* (December 5, 1988): 1, 8.
4. For the Norfolk Street Baptist Church, see Landmarks Preservation Commission of the City of New York, LP-0637 (February 28, 1967); Barbaralee Diamonstein, *The Landmarks*

of New York III (New York: Harry N. Abrams, 1998), 109. Also see Ladd, "Manhattan Neighborhoods: From a Shell to Shelter": 1.
5. Alan Finder, "Koch and LeFrak Agee on Plan for 1,200 Middle-Income Units," *New York Times* (February 29, 1988): 1; "Back in Town: Lefrak's Smart Proposal to Build Subsidized Housing," editorial, *Newsday* (March 3, 1988): 76; "Housing, the Koch-LeFrak Way," editorial, *New York Times* (March 17, 1988): 30; Alan Finder, "LeFrak's Offer Allows Chance for Conversions," *New York Times* (April 2, 1988): 27; Alan S. Oser, "The Lefrak Plan: Using Condo Sales to Assist New Rentals," *New York Times* (April 10, 1988), X: 9; Alan Finder, "Lower East Side Housing: Plans and Conflict," *New York Times* (May 14, 1988): 33; T. J. Collins, "Lefrak Wins Seward Park Project," *Newsday* (May 26, 1988): 17; "LeFrak Wins Development Right," *New York Times* (May 26, 1988), B: 5; Bonnie Brower, "LeFrak Plan," letter to the editor, *New York Times* (May 29, 1988), X: 16; Martin Rosen, "The Lefrak Plan," letter to the editor, *New York Times* (July 10, 1988), X: 20; Brian Zabcik and Jeffrey Weill, "Who's Suing Whom," *Manhattan Lawyer* (October 25–31, 1988): 20; "Manhattan Neighborhoods," *Newsday* (October 26, 1988): 27; Larry Bivins, "'Upscale' Urban Renewal Housing Hit," *Newsday* (November 28, 1988): 25; Bagli, "LeFrak Plan Sparks Heated Controversy": 1, 8; Douglas Balin and William E. Rapfogel, "LeFrak Plan," letters to the editor, *New York Observer* (December 19, 1988): 4. Samuel LeFrak changed the spelling of his name but kept the original spelling for the development company he took over, the Lefrak Organization, founded by his father.
6. Sam LeFrak, quoted in Bagli, "LeFrak Plan Sparks Heated Controversy": 8.
7. "Back in Town: Lefrak's Smart Proposal to Build Subsidized Housing": 76.
8. White and Willensky, *AIA Guide* (2000), 96.
9. Jonathan Mandell, "The Name Game," *Newsday* (October 17, 1994): 15; Janice Fioravante, "If You're Thinking of Living In: The Lower East Side," *New York Times* (May 31, 1998), XI: 3; White and Willensky, *AIA Guide* (2000), 88.
10. Susan Heller Anderson and Maurice Carroll, "A Boys Club Celebration," *New York Times* (June 23, 1984): 26; Marvine Howe, "Boys' Club," *New York Times* (September 1, 1985): 39; White and Willensky, *AIA Guide* (1988), 91.
11. White and Willensky, AIA Guide (1988), 89. Also see Anna Quindlen, "Peace and Anarchy in the Garden of Eden," *New York Times* (July 10, 1982): 26; Deirdre Carmody and Laurie Johnston, "Decisions, Decisions," *New York Times* (December 17, 1982), B: 2; Mervyn Rothstein, "Garden of Eden," *New York Times* (September 4, 1983): 49; Douglas C. McGill, "Art People," *New York Times* (October 5, 1984), C: 18; "Expelled from Eden?" *Progressive Architecture* 65 (November 1984): 38; Susan Heller Anderson and David W. Dunlap, "The Bloom May Be Over for 'Garden of Eden,'" *New York Times* (September 2, 1985): 25; Mary Cantwell, "Adam Purple's Garden," *New York Times* (September 9, 1985): 18; Susan Heller Anderson and David W. Dunlap, "Plowed Under," *New York Times* (September 25, 1985), B: 3; Eric Owen Moss, "The Indigent as King," *Oz* 9 (1987): 16–19; Guy Trebay, "Everyday Purple," *Village Voice* (October 11, 1994): 49.
12. Paul Goldberger, "Design Notebook," *New York Times* (September 15, 1977), C: 19; David Bird and Maurice Carroll, "A Piece of the Past in Search of a Future," *New York Times* (October 8, 1983): 26; David W. Dunlap, "On Lower East Side, a Synagogue Begins a New Life," *New York Times* (September 24, 1984), B: 1, 6; Peter Freiberg, "An Act of Faith," *Metropolis* 4 (March 1985): 10–11; David W. Dunlap, "Synagogue Cracks Safe to Find Riches," *New York Times* (April 5, 1985), B: 3; "The Eldridge Street Synagogue," *Architectural Record* 173 (August 1985): 67; Susan Heller Anderson and David W. Dunlap, "A Marriage," *New York Times* (January 6, 1986), B: 3; Paul Goldberger, "Two Gestures of Faith in Religious Landmarks of a Community," *New York Times* (September 28, 1986), II: 31, 35; "The Talk of the Town: Restoration," *New Yorker* 64 (September 26, 1988): 33–35; Daniel S. Levy, "Religious Relics," *Metropolis* 8 (April 1989): 84–87, 89, 91; "A Long-Lost Skeleton in a Synagogue Cellar," *New York Times* (April 14, 1989), B: 2; Bill Moyers, "Preservation Profile: The Eldridge Street Synagogue," *Common Bond* 5 (Fall 1989): cover, 2–4; Maria Stieglitz, "Awakening on Eldridge St.," *Preservation News* 29 (December 1989): 3–4; "Historic Pews Returned to Synagogue," *New York Times* (September 14, 1990), B: 2; Bill Kaufman, "A Landmark, a Labor of Love," *Newsday* (October 6, 1990), II: 5; Suzanne Slesin, "Currents: Just Bring Elbow Grease; The Rags Are Supplied," *New York Times* (April 4, 1991), C: 3; Erin A. Zeno, "Exploring the Lower East Side," *Oculus* 55 (December 1992): 13; Nina Reyes, "A Restoration Revived for Prayer and Posterity," *New York Times* (February 13, 1994), XIII: 6; "Divine Restoration," *Clem Labine's Traditional Building* 8 (January-February 1995): 51–52, 54, 56; Christopher Gray, "Streetscapes/Eldridge Street Synagogue," *New York Times* (May 19, 1996), IX: 7; "Synagogue Is Reborn," *Newsday* (December 12, 1996): 37; Nina Rappaport, "Resurrecting Religious Buildings," *Oculus* 59 (April 1997): 5–7; Vince Beiser, "Building On the Past," *Jerusalem Report* (August 21, 1997): 30; Jonathan Rosen, "On Eldridge Street, Yesteryear's Shul," *New York Times* (October 2, 1998), E: 42; David W. Dunlap, "A Firm Foundation, Starting at the Roof," *New York Times* (December 26, 1999), XI: 1, 3; White and Willensky, *AIA Guide* (2000), 88; David W. Dunlap, "City Awards $1 Million to Aid Synagogue," *New York Times* (October 22, 2000): 39; Richard F. Grein, "Houses of Worship," letter to the editor, *New York Times* (October 29, 2000), IV: 16. For Herter Brothers's building, see Stern, Mellins, and Fishman, *New York 1880*, 332–33.
13. Goldberger, "Design Notebook": 10.
14. David W. Dunlap, "New Life Is Envisioned for Historic Synagogue," *New York Times* (February 19, 1987), B: 1–2; Levy, "Religious Relics": 91; Carly Berwick, "A Synagogue's Artistic

Route to a Rebirth," *New York Times* (December 19, 1999), XIV: 6; White and Willensky, *AIA Guide* (2000), 96. For Saeltzer's building, see Landmarks Preservation Commission of the City of New York, LP-1440 (February 10, 1987); Diamonstein, *The Landmarks of New York III*, 106.
15. "Tenement Museum: The Immigrant Experience in New York," *Preservation League of New York State Newsletter* 14 (Winter 1988): 8; James Hirsch, "Museum Memorializes Life in Tenements," *New York Times* (December 15, 1988), C: 12; "Tenement Museum: The Immigrant Experience in New York," *Brownstoner* (Spring 1989): 4; Eve Kahn, "A Museum of Urban Living," *Metropolis* 8 (May 1989): 33; "Tenement Homecomings," *New York Times* (May 26, 1989): 30; "Tenement Tours," *New York Times* (June 4, 1989), X: 1; Arnold Berke, "Lower East Side Story," *Preservation News* 29 (September 1989): 3; Robert E. Tomasson, "Orchard Street Tenement Project: A Chronicle of Immigrant Life," *New York Times* (December 31, 1990): 26; Christopher Gray, "Streetscapes: The Lower East Side Tenement Museum," *New York Times* (May 5, 1991), X: 6; David Holmstrom, "Tenement Museum a Haunting Time Warp," *San Diego Union-Tribune* (August 16, 1992), G: 3; "The Tenement Museum," *New York Times* (September 20, 1992), X: 1; John Voelcker, "Lessons in Living," *Metropolis* 12 (December 1992): 27; Terry Golway, "A Frontier of Our Own," *New York Observer* (February 7, 1994): 13; Edward R. Silverman, "A Million-and-One Pushcarts," *Jerusalem Report* (May 19, 1994): 44; "Out with the Old, In with the Old," *ANY* 22 (1998): 26; White and Willensky, *AIA Guide* (2000), 95. For 97 Orchard Street, see Stern, Mellins, and Fishman, *New York 1880*, 500.
16. "Condos with Verandas: Riverside Rebirth," *New York Times* (October 19, 1986), VIII: 1.
17. "A New Life for Gouverneur," *New York Times* (October 25, 1992), X: 1; Richard M. Stapleton, "Rescuing a Worthy Building for a Worthy Purpose," *Historic Preservation News* 33 (February 1993): 8–9; Bethany Neubauer, "Saving a Building for Saving People," *Metropolis* 12 (April 1993): 15, 20–21; Shawn G. Kennedy, "New Look for S.R.O.'s: Decent Housing," *New York Times* (March 28, 1995), B: 1–2; "A Dignified Place to Live," *Progressive Architecture* 76 (June 1995): 54.
18. Shawn G. Kennedy, "A Beaux Arts Playland on Houston St.," *New York Times* (January 8, 1984), VIII: 1; Herbert Muschamp, "A New York Morality Tale with a Happy Ending," *New York Times* (September 6, 1992), II: 24; Charles K. Hoyt, "Back in the Swim," *Architectural Record* 181 (January 1993): 96–101; White and Willensky, *AIA Guide* (2000), 97. For Carrère & Hastings's building, see Landmarks Preservation Commission of the City of New York, LP-1264 (December 21, 1982); Diamonstein, *The Landmarks of New York III*, 240.
19. Muschamp, "A New York Morality Tale with a Happy Ending": 24.
20. For Attia's scheme, see "New Store Space: Upgrading Delancey," *New York Times* (April 16, 1989), X: 1; Audrey Farolino, "Upgrading Delancey," *New York Post* (May 11, 1989): 65. For the growth of the Lower East Side's retail trade, see Bill Van Parys, "Planet Ludlow," *New York Times* (January 10, 1993), IX: 8; Hugo Lindgren, "Can Orchard Street Compete with Megastores?" *Metropolis* 12 (June 1993): 19, 22–23; Lore Croghan, "Natives Greet Urban Settlers: Revival of Lower East Side," *Crain's New York Business* (May 18–24, 1998): 3, 33; Fioravante, "If You're Thinking of Living In: The Lower East Side": 3; Sheila Kim, "The Hot Zone," *Interior Design* 70 (April 1999): 166–73; Edie Cohen, "The Cult of Zao," *Interior Design* 71 (April 2000): 218–23; Sheila Kim, "A Life of Its Own," *Interior Design* 71 (April 2000): 236–37; Joseph P. Fried, "Renovations, with Reservations," *New York Times* (July 11, 2000), B: 1, 6.
21. "On the Lower East Side: Rehabilitating Tenements," *New York Times* (May 3, 1992), X: 1; Holly Kaye, "Tenements," letter to the editor, *New York Times* (June 28, 1992), X: 12; Fioravante, "If You're Thinking of Living In: The Lower East Side": 3; Allen Salkin, "Lower East Side: Gentrification Comes to Those Who Wait–Yes, Even Here," *New York* 32 (April 12, 1999), 59–60; William L. Hamilton, "Visions of Greener Pastures Reinvent the Lower East Side," *New York Times* (January 6, 2000), F: 1, 7; Tina Kelley, "Walls Talk, but Their Story Has Changed: A Home to Immigrants Now Draws Trendsetters," *New York Times* (November 13, 2000), B: 1, 5; Rachelle Garbarine, "Residential Real Estate," *New York Times* (April 19, 2002), B: 7. For Lansky's Lounge, see Mike McAlary, "Old Mobster's Lounge Act: Meyer Lansky Still Able to Make Money," *New York Daily News* (February 28, 1997): 8; Angela Tribelli, "So You Got Purple Hair: Try a Nice Latke," *New York Times* (May 25, 1997): 39; Jon Pareles, "The New Bohemia: It's East of SoHo and Still Unspoiled," *New York Times* (September 26, 1997), E: 1, 29.
22. Christopher Gray, "Streetscapes/The Jewish Daily Forward Building, 175 East Broadway," *New York Times* (July 19, 1998), XI: 5; Rosen, "On Eldridge Street, Yesteryear's Shul": 42; White and Willensky, *AIA Guide* (2000), 90–91; Hamilton, "Visions of Greener Pastures Reinvent the Lower East Side": 1, 7. For Boehm's building, see Landmarks Preservation Commission of the City of New York, LP-1419 (March 18, 1986); "Daily Forward Building Given Landmark Status," *New York Times* (March 19, 1986), B: 8; Diamonstein, *The Landmarks of New York III*, 312.
23. Fioravante, "If You're Thinking of Living In: The Lower East Side": 3; Alan S. Oser, "Perspectives," *New York Times* (October 24, 1999), XI: 7.
24. Hamilton, "Visions of Greener Pastures Reinvent the Lower East Side": 1, 7; Holly Kaye, "Lower East Side Story," letter to the editor, *New York Times* (January 13, 2000), F: 9; Shaila K. Dewan, "Lower East Side Is Added to U.S. Register of Historic Places," *New York Times* (April 18, 2001), B: 3; Max Page, "Historic District Skews Story of Lower E. Side," *New York Daily News* (April 26, 2001): 37; Samuel G. Freedman, "Recognize New Arrivals' Value," *USA Today* (May 16, 2001):

15A; Garbarine, "Residential Real Estate": 7.

25. Andrew Dolkart, quoted in Dewan, "Lower East Side Is Added to U.S. Register of Historic Places": 3.

26. Page, "Historic District Skews Story of Lower E. Side": 37.

LITTLE ITALY

1. For the Lower Manhattan Expressway and SoHo, see Stern, Mellins, and Fishman, *New York 1960*, 259–63.

2. "The Urban Design Group," *Progressive Architecture* 58 (January 1977): 80–81.

3. Frank J. Prial, "Little Italy Is Restive as Chinatown Expands," *New York Times* (April 26, 1974): 39.

4. John Wang, "Plans and Promises: Like Letters to Santa Claus," *New York Affairs* 6 (No. 3, 1980): 70–79.

5. "Pickets Block School Project Saying Housing Is Needed First," *New York Times* (June 18, 1974): 42; "Protestors in Little Italy Agree to Permit Excavation," *New York Times* (June 20, 1974): 18; "Court Stays Little Italy School," *New York Times* (August 8, 1974): 37; Wang, "Plans and Promises: Like Letters to Santa Claus": 70–79.

6. *Little Italy Risorgimento: Proposals for the Restoration of an Historic Community* (New York: Department of City Planning, 1974); Ada Louise Huxtable, "A Recession-Proof Plan to Rescue Little Italy," *New York Times* (May 4, 1975), II: 2; Glenn Fowler, "Preservation of Little Italy Urged," *New York Times* (September 3, 1976), B: 3; Glenn Fowler, "Italian and Chinese Clash on Zoning," *New York Times* (October 15, 1976), B: 2; "The Urban Design Group": 80–81; Carter B. Horsley, "New Doubts About Special Zones," *New York Times* (May 1, 1977), VIII: 1, 6; Beverly Solochek, "In Little Italy, the Word Is Risorgimento," *New York Times* (May 1, 1977), VIII: 1, 6; Wolf Von Eckardt, "Little Italy Lives! Preserving Little Italy," *Washington Post* (April 4, 1981), B: 1.

7. Huxtable, "A Recession-Proof Plan to Rescue Little Italy": 2.

8. Victor Marrero, quoted in Fowler, "Preservation of Little Italy Urged": 3. Also see *Little Italy Special District* (New York: New York City Planning Commission, 1976).

9. Horsley, "New Doubts About Special Zones": 1.

10. Solochek, "In Little Italy, the Word Is Risorgimento": 1, 6. Alessandra Latour, *Pasanella + Klein* (Rome: Edizioni Kappa, 1983), 100–12; White and Willensky, *AIA Guide* (1988), 80; *Pasanella + Klein Stolzman + Berg* (Gloucester, Mass.: Rockport Publishers, 1999), 6, 139; White and Willensky, *AIA Guide* (2000), 87.

11. For Pasanella's work in Twin Parks, see Stern, Mellins, and Fishman, *New York 1960*, 956–61.

12. Grace Glueck, "What's Doing on Centre St.," *New York Times* (October 21, 1977), C: 26; Grace Glueck, "What to Do with a Public Legacy," *New York Times* (November 4, 1977), III: 25; Fred Ferretti, "Arts and Politics Create a New Cultural Center," *New York Times* (November 5, 1977): 23, 34; Carter B. Horsley, "Use of Police Building Stirs Controversy in Little Italy," *New York Times* (November 9, 1980), VIII: 1; Lee A. Daniels, "Luxury Hotel Proposed for Old Police Building," *New York Times* (February 18, 1981), B: 1; "Hotel or Housing in Former Police Building," *Progressive Architecture* 62 (March 1981): 50, 52; Richard Landman, "Police Headquarters Reuse," *Progressive Architecture* 52 (May 1981): 10; Robert D. McFadden, "Old Police Headquarters Due for Rebirth as Hotel," *New York Times* (October 12, 1981), B: 1, 5; "Hotel de Ville," *New York Times* (March 7, 1982): 41; David W. Dunlap, "Some Municipal White Elephants Are Now Hot Properties," *New York Times* (September 11, 1983), IV: 7. For Hoppin & Koen's Police Headquarters, see Stern, Gilmartin, and Massengale, *New York 1900*, 73. For One Police Plaza, see Stern, Mellins, and Fishman, *New York 1960*, 163–65.

13. "A.S.P.C.A. Finds Dead Guard Dogs," *New York Times* (November 10, 1982), B: 2.

14. David W. Dunlap, "Old Police Headquarters Draw 5 Renovation Bids," *New York Times* (November 15, 1983), B: 3; David W. Dunlap, "City Sells Former Police Headquarters for Apartments," *New York Times* (April 6, 1984), B: 1; Alan Finder and Carlyle C. Douglas, "Pricey Future for Police Building," *New York Times* (April 8, 1984), IV: 6; "At Last, New Life for a Grand Dowager," *Architectural Record* 172 (June 1984): 77; "Names and News," *Oculus* 45 (June 1984): 13; David Bird and David W. Dunlap, "Cartographic Correction," *New York Times* (February 25, 1986), B: 4; Lisa W. Foderado, "Million-Dollar Residences in a Police Headquarters," *New York Times* (January 9, 1987): 25; Ruth Ryon, "Old Police Building Becoming Co-ops," *Los Angeles Times* (May 17, 1987), VIII: 8; "Old Building to Get Shiny New Top," *New York Times* (July 16, 1987), B: 3; "Crowning Touch for a Former Constabulary," *New York Times* (December 18, 1988): 56; Carter B. Horsley, "The Good, the Bad & the Ugly," *New York Post* (December 29, 1988): 53, 57; Michael Kaplan, "What's in a Name? A Loft Is a Loft Is a Loft," *Manhattan, inc.* 6 (February 1989): 30; Paul Goldberger, "Three New York City Success Stories," *New York Times* (July 22, 1990), II: 28, 30; "Police Headquarters Units: On the Block on Center Street," *New York Times* (March 29, 1992), VIII: 1; Andrew Jacobs, "Co-op's Basement Too Exclusive for Senior Center?" *New York Times* (November 26, 1995), XIII: 6; White and Willensky, *AIA Guide* (2000), 84.

15. Goldberger, "Three New York City Success Stories": 28.

16. Quoted in "Smith-Miller + Hawkinson, Model Apartment, Police Building," *GA Houses* 27 (November 1989): 127–29. Also see "Model Apartment, 1989," *Sites* 23 (1990): 70–73; "Apartment, New York, NY," *Quadern d'arquitectura i urbanisme* 184 (January–March 1990): 70–71; Mark Alden Branch, "Next Year's Model," *Progressive Architecture* 71 (September 1990): 128–29; "Modell-Apartment im Polizei-Hauptquartier," *Bauwelt* 83 (February 14, 1992): 282–83; *Smith-Miller + Hawkinson* (Barcelona: Editorial Gustavo Gili, 1994), 30–33; Frank F. Drewes, "Kontextgebunden, rationell und beweglich: die Architektur von Smith-Miller + Hawkinson, New York City," *Deutsche Bauzeitschrift* 43 (July

17. Quoted in "Smith-Miller + Hawkinson, Model Apartment, Police Building": 127.

18. Brad Collins, ed., *Gwathmey Siegel: Buildings and Projects, 1992–2002* (New York: Rizzoli International Publications, 2003), 64–71; Philip Nobel, "An Arresting Development," *Architectural Digest* 60 (February 2003): cover, 148–57.

19. Quoted in Collins, ed., *Gwathmey Siegel: Buildings and Projects, 1992–2002*, 64.

20. "Storefront for Art and Architecture," *Sites* 19 (1987): 49–65. Also see Lebbeus Woods, "Storefront: Iconoclasm, Invention and the Ideal," *Architecture + Urbanism* (February 1987): 71–98; "Kyong Park: Storefront for Art and Architecture, New York," *Progressive Architecture* 68 (June 1987): 94; Dennis L. Dollens, "The Storefront for Art and Architecture '87–88," *Sites* 20 (1988): 29–33; Linda Lee, "In a Tiny Storefront, Big Design Ideas Grow," *New York Times* (October 27, 1988), C: 9; Kyong Park, "Storefront for Art and Architecture," *World Architecture* 14 (1991): 74–79; Lois E. Nesbitt, "Storefront for Art and Architecture," *Skala* 26 (1992): 11; "Vito Acconci + Steven Holl: A Collaborative Building Project," *Storefront for Art and Architecture Newsletter* (1993); Herbert Muschamp, "The Unconventional as a Convention," *New York Times* (May 20, 1990), C: 10; "A Storefront Gallery Turns More Than Heads," *New York Times* (November 13, 1993): 13; Edward Ball, "Shelter/In and Out," *Village Voice* (November 23, 1993): 92; Peter Slatin, "Holl and Acconci Reface Storefront," *Architecture* 83 (January 1994): 23; "Swing Wide, Sweet Street Facade," *Architectural Record* 182 (January 1994): 13; Suzanne Stephens, "All in the Name of Art and Architecture," *Oculus* 56 (January 1994): 5; "Steven Holl: Un Américain à New York," *Architecture d'aujourd'hui* 291 (February 1994): 86–109; "Holl and Acconci Redesign Storefront Gallery," *Progressive Architecture* 75 (March 1994): 27; Geert Bekaert, "Storefront," *Archis* 6 (June 1994): 50–51; Matteo Vercelloni, "New York: Store Front: Steven Holl," *Abitare* 334 (November 1994): 190–93; Kyong Park, "Storefront Changing Faces," *World Architecture* 33 (1995): 104–9; Herbert Muschamp, "Mourning the Gorgeous Mosaic That Was Sarajevo," *New York Times* (February 10, 1995), C: 1, 24; "Steven Holl," *El Croquis* 78 (1996); Yukio Futagawa, "Steven Holl," *GA Document* 6 (1996): 34–43; Susanna Sirefman, *New York: A Guide to Recent Architecture* (London: Ellipses, 1997), 76–77; White and Willensky, *AIA Guide* (2000), 85; Steven Holl, *Parallax* (New York: Princeton Architecture Press, 2000), 234–43; Ian Luna, ed., *New New York: Architecture of a City* (New York: Rizzoli International Publications, 2003), 28–31; Francesco Garofalo, ed., *Steven Holl* (London: Thames & Hudson, 2003), 88–93.

21. Muschamp, "The Unconventional as a Convention": 18.

22. Park, "Storefront Changes Faces": 106.

23. Vito Acconci, quoted in "Vito Acconci + Steven Holl: A Collaborative Building Project": no pagination.

24. Steven Holl, quoted in "Vito Acconci + Steven Holl: A Collaborative Building Project": no pagination.

25. Stephens, "All in the Name of Art and Architecture": 5.

26. Sirefman, *New York*, 76.

27. Park, "Storefront Changing Faces": 109.

28. Sarah Herda, interview by the author, May 10, 2001.

29. Andrew Jacobs, "A 'Park' May One Day Become One," *New York Times* (December 24, 1995), XIII: 6; "Margaret Helfand: Lt. Petrosino Park, Lower Manhattan," *AIA New York Chapter Annals* (1996–97): 40; "Open Space/Public Life: Petrosino Park Redevelopment Design Competition," *Storefront for Art and Architecture Newsletter* (1996); Richard P. Rosenthal, "Nothing Elaborate Needed to Develop the Small Parks," letter to the editor, *New York Times* (January 14, 1996), XIII: 15; "Piece of Asphalt Pie," *New York Times* (October 17, 1996), C: 3; Patricia O'Haire, "The Hanging Gardens of Lafayette St.: That's One Plan on Display as Pocket Gets Set for Face Lift," *New York Daily News* (November 10, 1996): 22; Craig Kellogg, "Storefront for Neighborhood Activism: Redesigning Petrosino Park," *Oculus* 59 (December 1996): 5; Craig Kellogg, "From Public Eyesore to Public Use: Soho's Petrosino Park Competition," *Competitions* 7 (Spring 1997): 48–53; Andrew Mead, "Small Worlds of Self-Discovery," *Architects' Journal* 207 (June 4, 1998): 46–48; *Margaret Helfand Architects: Essential Architecture* (New York: Monacelli Press, 1999), 132–35.

30. Henry Stern, quoted in Jacobs, "A 'Park' May One Day Become One": 6.

31. "Open Space/Public Life: Petrosino Park Redevelopment Design Competition": no pagination.

32. Rosalyn Deutsch and Michael Sorkin, quoted in "Open Space/Public Life: Petrosino Park Redevelopment Design Competition": no pagination.

SOHO

1. For a comprehensive discussion of SoHo's transformation, as well as its impact on other parts of New York and other American cities, see Roberta Brandes Gratz's chapter, "The SoHo Syndrome," in Roberta Brandes Gratz, *Cities Back from the Edge: New Life for Downtown* (New York: John Wiley & Sons, 1998), 295–323. Also see James S. Rossant, "The Lively and Versatile Lofts of New York's SoHo," *Journal of the American Institute of Architects* 168 (April 1979): 64–69; Stern, Mellins, and Fishman, *New York 1960*, 489, 491; Richard Kostelanetz, *Soho: The Rise and Fall of an Artists' Colony* (New York: Routledge, 2003).

2. Constance L. Hays, "Cobblestones to Make a Comeback in SoHo," *New York Times* (July 6, 1990), B: 1; Trish Hall, "Walks as Sheer as Cliffs Jut Above the Ordinary," *New York Times* (June 24, 1991), B: 3; Kim C. Flodin, "SoHo Gets Stoned," *New York* 25 (August 24, 1992): 36.

3. Janet Allon, "Historically Inaccurate Trees," *New York Times* (March 31, 1996), XIII: 6.

4. Ingrid Wiegand, quoted in Bret Senft, "If You're Thinking of Living In: SoHo," *New York Times* (January 3, 1993), X: 5.

5. Greg Sargent, "SoHo," *Metropolis* 14 (December 1994): 37–41, 43. Also see Brent Ryan, "Soho," letter to the editor, *Metropolis* 14 (May 1995): 34; Greg Sargent, "Greg Sargent Responds," letter to the editor, *Metropolis* 14 (May 1995): 34; Marie Dormuth and Sean Sweeney, "New York's SoHo Is on the Verge of Losing Its Cultural Flavor," letter to the editor, *New York Times* (December 12, 1995): 26; Herbert Muschamp, "Behind Cast-Iron Facades, Dreams Are Wrought," *New York Times* (May 9, 1997), C: 1, 27; Peter Slatin, "The City as Stage: Entertainment Meets Manhattan," *Urban Land* 56 (October 1997): 88–91.

6. Sargent, "SoHo": 43. Also see Claudia H. Deutsch, "Grit to Glamour: The Evolution of SoHo," *New York Times* (May 8, 1994), X: 1, 14; Laurie Beckelman, "The Evolution of the SoHo District," letter to the editor, *New York Times* (June 24, 1994), IX: 12.

7. See Stern, Mellins, and Fishman, *New York 1960*, 266–70.

8. White and Willensky, *AIA Guide* (1988), 100; Suzanne Stephens, "Remodernization Restores an Old Building's Harmony," *New York Times* (September 22, 1988), C: 3; Lois E. Nesbitt, "Art Within Reason," *Progressive Architecture* 70 (September 1989): 116–19; "SoHo Gallery Wooster Street, N.Y.," *Lotus International* 66 (1990): 40–45; "Chalk-Vermilion Gallery, New York, N.Y.," *Quaderns d'arquitectura i urbanisme* 101 (January 1990): 68–69; *Smith Miller + Hawkinson* (Barcelona: Editorial Gustavo Gili, 1994), 16–19; Matteo Vercelloni, *New Showrooms & Art Galleries in USA* (Milan: Edizioni L'Archivolto, 1999), 132–35. For 141–145 Wooster Street, see Landmarks Preservation Commission of the City of New York, *SoHo–Cast-Iron Historic District Designation Report* (New York, 1973), 170.

9. For the Amy Lipton Gallery, see Stan Allen, *Between Drawing and Building* (New York: Columbia University Graduate School of Architecture, Planning and Preservation, 1991), 12–17; Patricia C. Phillips, "Stan Allen: Columbia University," *Artforum* 30 (October 1991): 130–31; "40 Under 40: Stan Allen," *Interiors* 154 (September 1995): 53; Stan Allen, *Points + Lines: Diagrams and Projects for the City* (New York: Princeton Architectural Press, 1999), 146. For the Fiction/Nonfiction Gallery, see Roberta Smith, "The East Village's Art Galleries Are Alive in SoHo," *New York Times* (January 27, 1989), C: 1, 19; Allen, *Between Drawing and Building*, 4–11; Allen, *Points + Lines: Diagrams and Projects for the City*, 146. For the White Columns Gallery, see Allen, *Between Drawing and Building*, 18–25; Allen, *Points + Lines: Diagrams and Projects for the City*, 146.

10. Brian Carter, "Urban Artefact," *Architectural Review* 202 (November 1997): 86–87; Vercelloni, *New Showrooms & Art Galleries in USA*, 132–35; White and Willensky, *AIA Guide* (2000), 109; "Art et Industrie Gallery and Sculpture Garden, New York City," *Architecture + Urbanism* (June 2000): 96–103.

11. Julie V. Iovine, "Size Is in the Eye of the Architect," *New York Times* (September 19, 1996), C: 4; "Koolhaas Works Small in the Big Apple," *Architectural Record* 184 (November 1996): 14; Ned Cramer, "Koolhaas Designs New York Gallery," *Architecture* 85 (December 1996): 36–37; Susanna Sirefman, *New York: A Guide to Recent Architecture* (London: Ellipsis, 1997), 60–61; Ernest Pascucci, "XS Gallery–Koolhaas in Manhattan," *Archis* (January 1997): 47–49; Bob Colacello, "Avant Guardians," *Vanity Fair* (December 1998): 182; Kathy Battista and Siân Tichar, *Art New York* (London: Ellipsis, 2000), 2: 44–47. For 39 Greene Street, see *SoHo–Cast-Iron Historic District*, 95.

12. Iovine, "Size Is in the Eye of the Architect": 4.

13. Rem Koolhaas, quoted in Iovine, "Size Is in the Eye of the Architect": 4.

14. Sirefman, *New York*, 60.

15. *Space Framed: Richard Gluckman Architect* (New York: Monacelli Press, 2000), 237. For 484 Broome Street, see Stern, Mellins, and Fishman, *New York 1960*, 489, 491.

16. "Richard Gluckman Architects," *Architectural Design* 64 (July-August 1994): 66–69; Sirefman, *New York*, 66–67; Battista and Tichar, *Art New York*, 2: 26–28; *Space Framed: Richard Gluckman Architect*, cover, 13: 1–4, 201; White and Willensky, *AIA Guide* (2000), 106.

17. Sirefman, *New York*, 66.

18. Jonathan Napack, "SoHo May Be Under Siege–But It Still Beats Chelsea," *New York Observer* (October 16, 1995): 39; *Space Framed: Richard Gluckman Architect*, 239.

19. *Space Framed: Richard Gluckman Architect*, 238. For 155 Wooster Street, see *SoHo–Cast-Iron Historic District*, 171.

20. Michael Brenson, "New Museum Given Home in SoHo," *New York Times* (January 8, 1983): 11; Grace Glueck, "2 Museums to Add Balance to SoHo," *New York Times* (July 21, 1983), C: 15; Michael Brenson, "New Museum Will Open in SoHo Home Saturday," *New York Times* (October 4, 1983), C: 16. For the Astor Building, see *SoHo–Cast-Iron Historic District*, 50.

21. Andrew Jacobs, "Transforming an Eyesore into a Jewel," *New York Times* (December 3, 1995), XIII: 10; Carol Vogel, "Inside Art: Expanding by Exchanging," *New York Times* (January 10, 1997), B: 39; "Lofts Above, Museum Below," *New York Times* (January 26, 1997), IX: 1; Beth Landman Keil and Deborah Mitchell, "Intelligencer: Museum Yes, But Is It Art?" *New York* 31 (January 5, 1998): 13; Roberta Smith, "The 'New' New Museum, with a Tableau of Wrenching Reality," *New York Times* (March 20, 1998), E: 35; "On the Drawing Boards," *Oculus* 60 (May 1998): 4–5; Kathy Battista and Siân Tichar, *Art New York* (London: Ellipsis, 2000), 2: 48–55; White and Willensky, *AIA Guide* (2000), 100.

22. Carol Vogel, "On and Off the Web," *New York Times* (November 10, 2000), E: 32; Aric Chen, "Silicon Gallery,"

Metropolis 20 (July 2001): 98–101, 133–34.

23. Rita Reif, "For African Art Treasures, a Place to Spread Out," *New York Times* (February 7, 1993), II: 33; Amei Wallach, "New Home for African Art," *Newsday* (February 9, 1993): 55; Herbert Muschamp, "Crossing Cultural Boundaries," *New York Times* (February 12, 1993), C: 1, 26; Christopher Knight, "Auspicious Bow for African Art Museum," *Los Angeles Times* (March 27, 1993), F: 1, 26; Donald Albrecht, "Cross-Cultural Journey," *Architecture* 82 (July 1993): 66–69; "Evening Hours: A Museum Celebrates 10 Years," *New York Times* (May 15, 1994), IX: 7; Mark Alden Branch, "Maya Lin: After the Wall," *Progressive Architecture* 75 (August 1994): 60–65; Sirefman, *New York*, 70–71; Justin Henderson, *Museum Architecture* (Gloucester, Mass.: Rockport Publishers, 1998), 110–15; Vercelloni, *New Showrooms & Art Galleries in USA*, 166–71; Maya Lin, *Boundaries* (New York: Simon & Schuster, 2000), 10: 8–11; White and Willensky, *AIA Guide* (2000), 99; Alan Balfour, *World Cities: New York* (New York: Wiley Academy, 2001), 130. For 593 Broadway, see *SoHo–Cast-Iron Historic District*, 49.

24. Albrecht, "Cross-Cultural Journey": 68.

25. Grace Glueck, "Guggenheim Plans SoHo Branch for Offices and Art Exhibitions," *New York Times* (April 18, 1991), C: 15, 22; "Details," *Architecture* 80 (June 1991): 28; "Museum Update," *Oculus* 54 (November 1991): 4; Robin Cembalest, "The Guggenheim's High-Stakes Gamble," *Art News* 91 (May 1992): 84–93; "Guggenheim Branch's Inaugural Exhibition Spurs Protest," *New York Times* (June 27, 1992): 13; "Evening Hours," *New York Times* (June 28, 1992), IX: 6; Philip Jodidio, "Une Collection D'espaces," *Connaissance des Arts* 485–486 (July-August 1992): 36; Daniela Reinsch, "Das neue Guggenheim Museum, New York," *Bauwelt* 83 (July 17, 1992): 1559–60; Karen Salmon, "Guggenheim Expands at Home and Abroad," *Architecture* 81 (August 1992): 25; Joseph Giovannini, "Breaking the Institutional Envelope," *Progressive Architecture* 73 (October 1992): 116–17; Carol Vogel, "The Art Market," *New York Times* (December 4, 1992), C: 6; Michael Kimmelman, "Guggenheim Hits (the Restaurant) and Misses (the Opening in SoHo)," *New York Times* (December 27, 1992), II: 35; Mayer Rus, "TAS Design," *Interior Design* 65 (June 1994): 120–23; David Gauld, "Guggenheim Museum SoHo," *Japan Architect* 12 (Winter 1993–94): 95–100; "Guggenheim Museum New York," *Lotus International* 85 (1995): 60–61; Lee Rosenbaum, "Wired for Art: The Reopened Guggenheim SoHo," *Wall Street Journal* (July 2, 1996): 12; Sirefman, *New York*, 68–69; Victoria Newhouse, *Towards a New Museum* (New York: Monacelli Press, 1998), 166; Carol Vogel, "Inside Art: Guggenheim Shrinks in SoHo," *New York Times* (February 5, 1999), E: 34; Carol Vogel, "Inside Art: Warhol 'Supper' for Openers," *New York Times* (March 26, 1999), B: 34; White and Willensky, *AIA Guide* (2000), 100; Deborah Solomon, "Is the Go-Go Guggenheim Going, Going . . . ?" *New York Times* (June 30, 2002), VI: 36; Michael Kimmelman, "An Era Ends for the Guggenheim," *New York Times* (December 6, 2002), E: 39. For 575 Broadway, see *SoHo–Cast-Iron Historic District*, 48–49.

26. Giovannini, "Breaking the Institutional Envelope": 117.

27. Sirefman, *New York*, 68.

28. Michael Boodro, "Collaboration on West Broadway," *Express* 2 (Spring 1983): 31; "Swank but No Swank" *Metropolis* 4 (March 1984): 6; *Richard Haas: Architectural Projects, 1974–1988* (New York: Brooke Alexander; Chicago: Rhona Hoffman Gallery, 1988), 18, 22; White and Willensky, *AIA Guide* (2000), 110.

29. Ed Mills, quoted in Boodro, "Collaboration on West Broadway": 31.

30. Thomas L. Waite, "SoHo Project: Blending New and Old," *New York Times* (March 27, 1988), X: 1; Sirefman, *New York*, 64–65; White and Willensky, *AIA Guide* (2000), 106–7.

31. Sirefman, *New York*, 65.

32. "Project X, New York," *Progressive Architecture* 69 (December 1988): 36; Heinrich Klotz, ed., *New York Architecture: 1970–1990* (Munich: Prestel-Verlag, 1989), 182–83.

33. www.christianhubert.com.

34. Richard D. Lyons, "On a 1705 Land Grant: Offices for SoHo," *New York Times* (March 18, 1990), X: 1; "Digging In," *New York Observer* (March 19, 1990): 16; "$100M Office Building Gets Underway in SoHo," *New York Construction News* 37 (March 26, 1990): 1, 2; Herbert Muschamp, "One Building That Knows What It's About," *New York Times* (January 12, 1992), II: 32.

35. Muschamp, "One Building That Knows What It's About": 32.

36. Christopher Gray, "Streetscapes/Charles Rouss and 555 Broadway," *New York Times* (August 11, 1996), IX: 7; "After Working with . . . ," *Oculus* 59 (September 1996): 3; Paul Goldberger, "Primers in Urbanism, Written in Cast Iron," *New York Times* (September 22, 1996): II, 34; Alberto Ferlenga, *Aldo Rossi: Tutte le Opere* (Milan: Electa, 1999), 370–71; Nina Rappaport, "Brief aus New York," *Deutsche Bauzeitung* 133 (May 1999): 26; White and Willensky, *AIA Guide* (2000), 101; David W. Dunlap, "A Building Fits in by Standing Out," *New York Times* (April 23, 2000), XI: 1, 6; "Books and Mortar," *Oculus* 63 (September 2000): 6; Bay Brown, "Cast-iron Wizard," *World Architecture* 90 (October 2000): 36–37; Alberto Ferlenga, ed., *Aldo Rossi: The Life and Works of an Architect* (Cologne: Könemann, 2001), 370–71; Balfour, *World Cities: New York*, 97; Herbert Muschamp, "A Message from a Poet of Public and Private Memory," *New York Times* (April 1, 2001), II: 40; "Steel Facade Makes a Statement in SoHo," *Metals in Construction* (Fall 2001): 6–9; "'Modern' Architecture in Historic Districts?" *District Lines* 15 (Autumn 2001): 1, 7; Alan G. Brake, "Brothers But Not Twins," *Architecture* 90 (November 2001): 127, 129; Diane Ghirardo, "New York City: Scholastic," *Architectural Record* 90 (November 2001): 59; Ian Luna, ed., *New New York: Architecture of a City* (New York: Rizzoli International Publications, 2003), 68–69.

37. For the Little Singer Building, see Christopher Gray, "Streetscapes/Singer Building at Broadway and Prince Street," *New York Times* (June 29, 1997), IX: 7; Stern, Gilmartin, and Massengale, *New York 1900*, 153–55.

38. Gray, "Streetscapes/Charles Rouss and 555 Broadway": 7. For the Rouss Building, see Stern, Mellins, and Fishman, *New York 1880*, 490–91.

39. Monica Geran, "Invisible Diversity," *Interior Design* 55 (May 1984): 304–13; Nicholas Polites, *Hardy Holzman Pfeiffer Associates: Buildings and Projects, 1967–1992* (New York: Rizzoli International Publications, 1992), 106–9, 258.

40. Marilyn Zelinsky, "Academic Achievements," *Interiors* 152 (August 1993): 38; Edie Cohen, "Hardy Holzman Pfeiffer," *Interior Design* 65 (April 1993): 122–29; Gray, "Streetscapes/Charles Rouss and 555 Broadway": 7; *Hardy Holzman Pfeiffer Associates: Buildings and Projects, 1993–1998* (New York: Rizzoli International Publications, 1999), 54–57.

41. Quoted in *Hardy Holzman Pfeiffer Associates: Buildings and Projects, 1993–1998*, 54.

42. Patrick O'Malley, quoted in Brown, "Cast-iron Wizard": 36.

43. Goldberger, "Primers in Urbanism, Written in Cast Iron": 34.

44. Winka Dubbeldam, "(In-)Crease: Integral Architectures," *Oz* 23 (2001): 32–39; Herbert Muschamp, "A Pair of Crystal Gems Right for Their Setting," *New York Times* (January 14, 2001), II: 39; Winka Dubbeldam, "Thing-shapes," *Architectural Design* 72 (March 2002): 26–31; Rachelle Garbarine, "Condos Behind a Cascading Wall of Colored Glass," *New York Times* (June 28, 2002), B: 7; Bradford McKee, "The Ultimate Shabby Chic: Bare-Naked Spaces," *New York Times* (September 26, 2002), F: 1, 8; Luna, ed., *New New York*, 42–46; Michael Speaks, "Winka Dubbeldam/Archi-Tectonics," *Architecture + Urbanism* (November 2003): 190–95; David B. Sokol, "Brit in the Big City," *Architectural Design* 74 (January/February 2004): 34–39.

45. Muschamp, "A Pair of Crystal Gems Right for Their Setting": 40.

46. Dubbeldam, "(In-)Crease: Integral Architectures": 38.

47. Muschamp, "A Pair of Crystal Gems Right for Their Setting": 39; Denny Lee, "Philip Johnson Joins Other Architects in the Cross Hairs," *New York Times* (January 28, 2001), XIV: 7; Peter Slatin, "The Old Man and the Streetscape," *Grid* 3 (May 2001): 20; Tom McGeveran, "Philip Johnson Is Mad: Of All Tall Towers, Why Pick on Mine?" *New York Observer* (June 25, 2001): 25, 29; Clifford A. Pearson, "Still the Bad Boy, Philip Johnson Looks Ahead at Age 95," *Architectural Record* 189 (July 2001): 59–61; Steve Cuozzo, "A New 'Season' for Johnson," *New York Post* (July 17, 2001): 34; Katy Bordonaro, "This Ain't Rome, Johnson!" letter to the editor, *New York Observer* (July 23, 2001): 4; Antonio Nino Vendome, "Vendome's Place," letter to the editor, *New York Observer* (July 30, 2001): 4; "But Would Philip Johnson Live There?" *New York 34* (September 17, 2001): 12; "A Poster Campaign for a New Building?" *Van Alen Report* (December 2001): 6; Christopher Gray, "Streetscapes/326 Spring Street," *New York Times* (December 30, 2001), XI: 7; *Philip Johnson/Alan Ritchie Architects* (New York: Monacelli Press, 2002), 174–79; David W. Dunlap, "A Cubist Tower's Reach Exceeds Its Grasp; Philip Johnson's Replacement Design Is Smaller, but Still Larger Than Zoning Allows," *New York Times* (July 7, 2002), XI: 1; Lois Weiss, "Between the Bricks," *New York Post* (July 16, 2003): 34, 36. For the Ear Inn, see Landmarks Preservation Commission of the City of New York, LP-0568 (November 19, 1969); Gray, "Streetscapes/326 Spring Street": 7.

48. Muschamp, "A Pair of Crystal Gems Right for Their Setting": 39.

49. Philip Johnson, quoted in McGeveran, "Philip Johnson Is Mad: Of All Tall Towers, Why Pick on Mine?": 1.

50. Peter Freiberg, "No Go in SoHo?" *Metropolis* 4 (September 1984): 4; David W. Dunlap, "Lodgings for Tourists and the Innovative Art World," *New York Times* (March 25, 1990), X: 19; Suzanne Beilenson, "SoHo Woes," *Oculus* 52 (June 1990): 6; David W. Dunlap, "Moving Beyond the Talking Stage," *New York Times* (April 14, 1991), X: 13.

51. Andrew Jacobs, "Light at End of Hotel Tunnel? No, a Fight at Its Beginning," *New York Times* (December 10, 1995), XIII: 8.

52. Bernard Stamler, "Non-Artists' Housing Seen as Blot on Local Canvas," *New York Times* (May 10, 1998), XIV: 5; Bernard Stamler, "Judge Blocks Artist-less Buildings," *New York Times* (January 24, 1999), XIV: 6; "SoHo Apartments," *Crain's New York Business* (March 6, 2000): 12; Denny Lee, "Artists Say a Court Ruling Means It Won't Be the Place They Knew," *New York Times* (December 24, 2000), XIV: 5; David Amsden, "SoHo Low Blow," *New York 34* (June 18, 2001): 16.

53. Beth Landman, "Seeing a Niche, Hartz Plans Hotel with 'Tude," *New York Times* (December 4, 1994), XIII: 6; Trip Gabriel, "Awash in Chic, Embattled Hotel Hopes to Fit In; In Soho, the Welcome's Muted," *New York Times* (August 1, 1996), C: 1, 6; Phoebe Hoban, "Design Breakup, Design Breakout," *New York Times* (August 1, 1996), C: 1, 6; Judith Nasatir, "Grand Hotel," *Interior Design* 67 (October 1996): 88–97; Ruth Reichl, "Restaurants," *New York Times* (August 8, 1997), C: 26; David Paul Helpern, "The SoHo Grand Hotel: A Brand-New Start in Old New York," *Urban Land* 56 (October 1997): 32–34; Herbert Ypma, *Hip Hotels: City* (New York: Thames & Hudson, 1999), 160–65; Dore Ashton, "Grand Illusion," *Interiors* 158 (March 1999): 97–98; White and Willensky, *AIA Guide* (2000), 109.

54. Thomas P. McConnell, quoted in Beilenson, "SoHo Woes": 6.

55. Emanuel Stern, quoted in Landman, "Seeing a Niche, Hartz Plans Hotel with 'Tude": 6.

56. Jean Nathan, "The Paralepsis," *New York Observer* (October 18, 1990): 3; Toby Axelrod, "Board 2/Vote Assists Development of a Hotel in SoHo," *New York Observer*

(November 26, 1990): 6; Dunlap, "Moving Beyond the Talking Stage": 13; Stuart Elliot, "Group Planning SoHo Hotel Brings in Ex-Spy Publisher," *New York Times* (July 19, 1991), D: 6; Carlos Rosas, "Inn Spot," *Vanity Fair* 55 (August 1992): 6; "Checking in at the Mercer Hotel," *New York 25* (August 31, 1992): 12; Phillip Lopate, "Helping an 'Honest' Building Stand Tall," *New York Times* (September 13, 1992), II: 50; Charles V. Bagli, "$26 Million Later, Plywood Shutters Hide Balazs' SoHo Hotel," *New York Observer* (December 20, 1993): 1, 26; Bruce Lambert, "The Mercer Hotel: Still Trying, Even Harder, to Open," *New York Times* (December 26, 1993), XIII: 6; Lucie Young, "He Makes Princely Hotels out of Frogs," *New York Times* (July 10, 1997), C: 1, 6; Terry Trucco, "Two Small Hotels with Big Senses of Style," *New York Times* (June 28, 1998), V: 8–9; Bruce Weber, "No Place Like Home, Not Even Home," *New York Times* (October 2, 1998), E: 33; Jane Withers, "Interiors: Mercer, Mercer Me . . . ," *The Observer* (London) (October 11, 1998): 26; Ypma, *Hip Hotels: City*, 172–77; White and Willensky, *AIA Guide* (2000), 106.

57. Trucco, "Two Small Hotels with Big Senses of Style": 9.

58. Withers, "Interiors: Mercer, Mercer Me . . . ": 26.

59. Weber, "No Place Like Home, Not Even Home": 40.

60. "For Thompson Street, a New Boutique Hotel," *New York Times* (July 18, 1999), XI: 1; White and Willensky, *AIA Guide* (2000), 110; Jayne Merkel, "Gotham Hospitality," *Oculus* 62 (March 2000): 12–17; John Holusha, "To Boutique Hoteliers, Small Is Beautiful," *New York Times* (March 1, 2000), XI: 1, 8; "New York Room Boom!" *Grid* 2 (March + April 2000): 96; "Spot On," *Interiors* 160 (March 2001): 76–79.

61. "Hotel Hot Shots," *Grid* 2 (March + April 2000): 34; Herbert Muschamp, "Architectural Trendsetter Seduces Historic SoHo," *New York Times* (April 11, 2001), E: 1, 5; Herbert Muschamp, "Fitting into History's True Fabric," *New York Times* (May 6, 2001), II: 44; Albert S. Bennett, "Jean Nouvel: Further Clarification," letter to the editor, *New York Times* (May 20, 2001): 4; Jonathan Mahler, "Gotham Rising," *Talk* (December 2001/January 2002): 120–25, 148–52; "Soho Hotel in Broadway," *El Croquis* 112/113 (2002): 306–11; Donald Albrecht with Elizabeth Johnson, *New Hotels for Global Nomads* (London: Merrell Publishers, 2002), 44–47; Peter Malbin, "Plodding Along," *Real Estate New York* 21 (April 2002): 46–48; Jim O'Grady, "Hotel or Trojan Horse?" *New York Times* (June 8, 2003), XIV: 7; Denny Lee, "The Shadow from One Modest Tower Grows to Cover a Whole Neighborhood," *New York Times* (October 12, 2003), XIV: 6.

62. Muschamp, "Architectural Trendsetter Seduces Historic SoHo": 1.

63. Muschamp, "Architectural Trendsetter Seduces Historic SoHo": 1, 5.

64. Mildred F. Schmertz, "Mix and Match: Two Small Shops in Pre-classical Free-style," *Architectural Record* 171 (March 1983): 122, 126–27. Also see Anne-Marie Schiro, "In SoHo, 2 New Boutiques," *New York Times* (September 22, 1986), B: 10; White and Willensky, *AIA Guide* (1988), 103.

65. Michael Gross, "Notes on Fashion," *New York Times* (June 17, 1986), C: 11; Schiro, "In SoHo, 2 New Boutiques": 10; Lisa S. Cohen, "Dressing Up: Voorsanger & Mills Creates a Museum Setting for Dianne B.'s Third New York City Boutique," *Interiors* 148 (January 1989): 172–73.

66. Daralice D. Boles, "With Ma in Mind," *Progressive Architecture* 55 (July 1984): 88–91; Susan S. Szenasy, "Comme des Garçons," *Metropolis* 6 (October 1986): 60; Anja Hübener and Bror Karlsson, "För Galleriet," *Arkitektur* 90 (May 1990): 42–47.

67. Karen D. Stein, "Tailor Made," *Architectural Record* 177 (January 1989): 92–93.

68. Toshiko Mori, quoted in Kira Gould, "Veiled Illusion," *Architecture* 87 (September 1998): 124–29. Also see Luna, ed., *New New York*, 54–55.

69. Susan Doubilet, "All the World's a Stage," *Progressive Architecture* 65 (September 1984): 86–93. Also see Hübener and Karlsson, "För Galleriet": 44–45.

70. Suzanne Slesin, "Two New Stores Set a Style," *New York Times* (April 21, 1988), C: 1, 6; Suzanne Slesin, "Schnabel Designed It, Alaïa Sells There, but Is It Really Art?" *Blueprint* 51 (October 1988): 10; Vera Graaf, "Julian Schnabel Meets Alaïa," *Architektur + Wohnen* 6 (November-December 1988): 154–57; Hübener and Karlsson, "För Galleriet": 46–47.

71. Slesin, "Two New Stores Set a Style": 1.

72. Corky Pollan, "An Exchange of Heart," *New York 25* (January 6, 1992): 48; Edie Lee Cohen, "A/X: Naomi Leff Draws on American P/X Imagery for Giorgio Armani's Latest Venture," *Interior Design* 63 (May 1992): 170–75; Woody Hochswender, "Armani. Air Kisses. Cash," *New York Times* (December 17, 1991), B: 10.

73. Monica Geran, "Relaunching a Legend," *Architectural Record* 71 (February 2000): 154–59. For Rubinstein's taste, see Suzanne Slesin, *Over the Top* (New York: Pointed Leaf Press, 2003).

74. Abby Bussel, "Inner Sanctum," *Interior Design* 69 (April 1998): 186–91; "Gluckman Mayner Architects: Helmut Lang, SoHo, New York City," *Architectural Design* 69 (May-June 1999): 48–51; *Space Framed: Richard Gluckman Architect*, 162–65, 223; Martin Filler, "Richard Gluckman Architecture," *House Beautiful* 143 (June 2001): 59–60, 62.

75. Bussel, "Inner Sanctum": 186–91.

76. Richard Gluckman, quoted in Filler, "Richard Gluckman Architecture": 62.

77. Mary Tannen, "The Sky's the Gimmick," *New York Times* (September 10, 2000), VI: 82; Craig Kellog, "Fun in Store," *Oculus* 63 (November 2000): 6–7; Filler, "Richard Gluckman Architecture": 66–67.

78. *Space Framed: Richard Gluckman Architect*, 239; Jayne Merkel, "Yves Saint Laurent Rive Gauche Homme, New York," *Architectural Design* 70 (December 2000): 72–73.

79. Elaine Louie, "Architectural Philosophy," *New York Times* (August 30, 1998), IX: 3; Abby Bussel, "Extreme

Theater," *Interior Design* 69 (October 1998): 142–49.

80. Ginia Bellafante, "Front Row," *New York Times* (April 18, 2000), B: 9; "Prada Hires Koolhaas," *World Architecture* (July-August 2000): 37; Arthur Lubow, "The Architect's Architect in the Architect's Time," *New York Times* (July 9, 2000), VI: 30–37, 42, 62–63; Herbert Muschamp, "The Annotated List: Architecture," *New York Times* (September 10, 2000), II: 100; Alice Rawsthorn, "Creative Business," *Financial Times* (October 10, 2000): 1; Chuihua Judy Chung, Jeffrey Inaba, Rem Koolhaas, and Sze Tsung Leong, eds., *Harvard Design School Guide to Shopping* (Cologne: Taschen; Cambridge, Mass.: Harvard Design School, 2001); Rem Koolhaas, *Projects for Prada. Part 1* (Milan: Fondazione Prada Edizioni, 2001); Bay Brown, "United States Art Movement," *World Architecture* (January 2001): 82–83; Philip Nobel, "Waiting for Prada," *Interior Design* 72 (April 2001): 82–84; Maria Giulia, "Fashion and Modernity," *Abitare* (May 2001): 163–71; Paul Makovsky, "Prada A to Z," *Metropolis* 21 (October 2001): 94–99; "OMA–Rem Koolhaas," *Architecture + Urbanism* (December 2001): 50–55; Herbert Muschamp, "Forget the Shoes, Prada's New Store Stocks Ideas," *New York Times* (December 16, 2001), IX: 1, 6; Ellen Tien, "A Harvard Shopping Guide? Charge It," *New York Times* (December 16, 2001), IX: 6; Maureen Dowd, "Styles Beside Sorrow," *New York Times* (December 23, 2001), IV: 9; Richard Johnson, "Page Six: Prada is up a Tree in SoHo," *New York Post* (January 18, 2002): 10; Michael Sorkin, "Critique: Riff on Rem," *Architectural Record* 190 (January 2002): 51–52; Cathleen Mcguigan, "How Kool Is Rem," *Newsweek* 139 (January 20, 2002): 56; Ingrid Sischy, "The Rebel in Prada," *Vanity Fair* (February 2002): 110–15, 133–35; Rhonda Lieberman, "Rem Koolhaas and the Harvard Design School Project on the City," *Artforum* 40 (February 2002): 98–99; Sara Hart, "A Seismic Meeting of Retail and Architecture in the New Prada Flagship Store by Rem Koolhaas in Manhattan's SoHo," *Architectural Record* 190 (February 2002): 85–87; Fulvio Irace and Paola Antonelli, "NY: Delirious Prada," *Abitare* (March 2002): 148–57, 182; Alan G. Brake, "Prada World's Price Tag," *Architecture* 91 (March 2002): 105, 107, 109, 111; Fred Bernstein, "Prada's New Bag: Prada, New York," *World Architecture* (March 2002): 56–60; Paul Goldberger, "The Sky Line: High-Tech Emporiums," *New Yorker* 78 (March 25, 2002): 100–101; Joseph Giovannini, "Finally, Prada," *Interior Design* 73 (April 2002): 222–25; Ada Louise Huxtable, "Merging Culture and Commerce in Architecture," *Wall Street Journal* (May 16, 2002), D: 7; Sarah Williams Goldhagen, "Kool Houses, Kold Cities," *The American Prospect* 13 (June 17, 2002): 29; "OMA–Rem Koolhaas: Prada New York Epicenter," *Architecture + Urbanism* (August 2002): 118–21; Richard Johnson, "Page Six: Glass Cage," *New York Post* (October 23, 2002): 10; "The Prada-Soho," *New York Construction News* 50 (December 2002): 71; Joseph Giovannini, "Introduction," in Luna, ed., *New New York*, 9, 60–65.

81. Rem Koolhaas, quoted in http://www.oma.nl.

82. Lubow, "The Architect's Architect in the Architect's Time": 42.

83. Muschamp, "Forget the Shoes, Prada's New Store Stocks Ideas": 1, 6.

84. Huxtable, "Merging Culture and Commerce in Architecture": 7.

85. Sischy, "The Rebel in Prada": 110, 113–14.

86. Goldberger, "The Sky Line: High-Tech Emporiums": 100–1.

87. Sorkin, "Critique: Riff on Rem": 51.

88. Dowd, "Style Beside Sorrow": 9.

EAST VILLAGE

1. For the Electric Circus, see Stern, Mellins, and Fishman, *New York 1960*, 257–58.

2. For a detailed analysis, see Christopher Mele, *Selling the Lower East Side* (Minneapolis, MN: University of Minnesota Press, 2000), 180–219.

3. Mele, *Selling the Lower East Side*, 181–82.

4. White and Willensky, *AIA Guide* (2000), 171.

5. Reverend Volodymyr Gavlich, quoted in Carter B. Horsley, "Reclamation Is Starting in the East Village," *New York Times* (September 28, 1977): 32.

6. Horsley, "Reclamation Is Starting in the East Village": 32. For St. George Ukrainian Catholic Church, see also "5,000 at Dedication of Ukrainian Church," *New York Times* (April 24, 1978), D: 9; Marvine Howe, "Ukrainian Resurgence in East Village," *New York Times* (June 9, 1985): 46; White and Willensky, *AIA Guide* (2000), 171. For 24 East Seventh Street, see Lisa W. Foderaro, "Church's Housing Plan Unsettles the East Village," *New York Times* (January 4, 1987), VIII: 7.

7. For the East Village, see Stern, Mellins, and Fishman, *New York 1960*, 254–58. For a detailed account of the East Village's evolution, see Mele, *Selling the Lower East Side*.

8. Ann Magnuson, "Ann Magnuson on Club 57," *Artforum* 38 (October 1999): 121.

9. Gary Indiana, "Crime and Misdemeanors," *Artforum* 38 (October 1999): 117, 159–60.

10. *Downtown 81* (director, Edo Bertoglio, 2000).

11. Walter Robinson and Carlo McCormick, "Slouching Toward Avenue D," *Art in America* 72 (Summer 1984): 134–61. Also see Craig Owen, "Commentary: The Problem with Puerilism," *Art in America* 72 (Summer 1984): 162–63.

12. Gracie Mansion, quoted in Maureen Dowd, "Youth–Art–Hype: A Different Bohemia," *New York Times* (November 17, 1985), VI: 26.

13. Seth Mydans, "1,362 Seized in 18 Days of Drug Drive Downtown," *New York Times* (February 7, 1984): 1, B: 20; "Drug Drive Hailed," *New York Times* (March 21, 1984), B: 6; William B. O'Brien, "A War New York Can't Win Alone," letter to the editor, *New York Times* (May 8, 1984): 30; William R. Greer, "The Fortunes of the Lower East Side Are Rising," *New York Times* (August 4, 1985), IV: 6.

14. Greer, "The Fortunes of the Lower East Side Are Rising": 6.

15. Lisa Belkin, "The Gentrification of the East Village," *New York Times* (September 2, 1984), VIII: 1, 13; Deborah Elkan and Mark Clifford, "'Gentrification of East Village," letters to the editor, *New York Times* (September 23, 1984), VIII: 12; Rosalyn Deutsche and Cara Gendel Ryan, "The Fine Art of Gentrification," *October* 31 (Winter 1984): 91–111.

16. Patrick J. Carroll, "Lower East Side Did Not Win in Order to Lose," *New York Times* (January 12, 1985): 21.

17. White and Willensky, *AIA Guide* (1988), 164.

18. White and Willensky, *AIA Guide* (1988), 164.

19. Shawn G. Kennedy, "Up to 4,800 Sq. Ft.: Conversion on East 13th," *New York Times* (October 7, 1984), VIII: 1; "Positively 12th Street," *Real Estate Shoppers Guide* (March 1987): 3A.

20. "40 on 14th; East East Village?" *New York Times* (March 12, 1985), VIII: 1.

21. Belkin, "The Gentrification of the East Village": 13; Carroll, "Lower East Side Did Not Win in Order to Lose": 21; "Hot House," *New York* 19 (August 4, 1986): 28; White and Willensky, *AIA Guide* (1988), 163–65; Mark A. Uhlig, "Condominiums Divide Angry Tompkins Square Residents," *New York Times* (August 26, 1988), B: 1, 4; Mele, *Selling the Lower East Side*, 66–67, 225, 243, 251, 264, 274; Neil Smith, "New City, New Frontier: The Lower East Side as Wild, Wild West," in Michael Sorkin, ed., *Variations on a Theme Park: The New American City and the End of Public Space* (New York: The Noonday Press, 1992), 61–93.

22. Liza Kirwin, "East Side Story," *Artforum* 38 (October 1999): 170, 161.

23. Patrick J. Pomposello, quoted in Michael Wines, "Behind the Park Melee, a New Generation Gap," *New York Times* (August 8, 1988), B: 2.

24. Robert D. McFadden, "Park Curfew Protest Erupts into a Battle and 38 Are Injured," *New York Times* (August 8, 1988): 1, B: 2; Wines, "Behind the Park Melee, a New Generation Gap: 2; "Blood and the Park," editorial, *New York Times* (August 9, 1988): 18; Michael Wines, "Class Struggle Erupts Along Avenue B," *New York Times* (August 10, 1988), B: 1–5; C. Carr, "Night Clubbing," *Village Voice* (August 16, 1988): 10, 17; Sarah Ferguson, "The Boombox Wars," *Village Voice* (August 16, 1988): 11, 17; "Officer Removed Badge at Melee, Police Assert," *New York Times* (January 6, 1989), B: 3; "Not the Last Word on Tompkins Square," editorial, *New York Times* (April 22, 1989): 26; Jonathan Foreman, "Tompkins Square: After the Uprising," *City Journal* 7 (Autumn 1997): 124.

25. John Kifner, "Neighbors' Attitudes Shift as Park Declines," *New York Times* (December 7, 1989), B: 1-2.

26. "Razing of Shanties Starts Confrontations in Tompkins Square," *New York Times* (July 6, 1989), B: 4; James C. McKinley Jr., "City Moves to Clean Up Tompkins Sq. After Raid," *New York Times* (July 7, 1989), B: 1, 3.

27. John T. McQuiston, "Dinkins Supports Removal of Tents in Tompkins Square," *New York Times* (December 14, 1989), B: 8; John Kifner, "Tent City in Tompkins Square Park Is Dismantled by Police," *New York Times* (December 15, 1989), B: 1, 6; Sarah Ferguson, "Fire and Ice," *Village Voice* (December 26, 1989): 34–35, 135.

28. Andrew Jacobs, "Showdown in the East Village," *Metropolis* 11 (November 1991): 15–16. For the fountains, see Margot Gayle and Michele Cohen, *The Art Commission and the Municipal Art Society Guide to Manhattan's Outdoor Sculpture* (New York: Prentice Hall Press, 1988), 85–87.

29. Elizabeth Acevedo, "Neighbors Reject New York's Sacrifice of Tompkins Sq. Park," letter to the editor, *New York Times* (October 13, 1990): 24.

30. John T. McQuiston, "7 Officers Hurt as Melee Erupts in Tompkins Sq.," *New York Times* (May 28, 1991), B: 3; Alessandra Stanley, "Tompkins Sq. Park, Where Politics Again Turns Violent," *New York Times* (May 30, 1991), B: 1, 6.

31. "Make Tompkins Square a Park Again," editorial, *New York Times* (May 31, 1991): 30.

32. John Kifner, "New York Closes Park to Homeless," *New York Times* (June 4, 1991): 1, B: 2; "Retaking Tompkins Square," editorial, *New York Times* (June 5, 1991): 28; Sarah Ferguson, "Should Tompkins Square Be like Gramercy?" *Village Voice* (June 11, 1991): 16; Sarah Ferguson, "The Park Is Gone," *Village Voice* (June 18, 1991): 25; Russell Miller, "The Other Side of Summer," *New York* 24 (July 22, 1991): 18; Sarah Ferguson, "Tompkins Follies," *Village Voice* (August 27, 1991): 11; Andrew Jacobs, "Showdown in the East Village," *Metropolis* 11 (November 1991): 15–16; Toby Axelrod, "Board 3/Bandshell on Lower East Side?" *New York Observer* (February 10, 1992): 8; Clifford J. Levy, "New York City Reopens Tompkins Square Park," *New York Times* (August 26, 1992), B: 3; George James, "Police Keeping Close Watch on Tompkins Square Park," *New York Times* (August 27, 1992), B: 5.

33. Wines, "Class Struggle Erupts Along Avenue B": 5; D. J. Saunders, "East Siders Fight for a Park," *New York Daily News* (September 30, 1988), Metro: 1; Michael Winerip, "H.U.D. Economist Says Bosses Pressed Him to Approve Grants," *New York Times* (October 26, 1989): 1, B: 6; "H.U.D. to Review Plan for a Housing Project," *New York Times* (December 22, 1989), B: 5; Jessie Mangaliman, "Tug-of-War with City over Park Space," *Newsday* (April 5, 1990): 21; Guy Trebay, "Where the Wild Things Are," *Village Voice* (April 16, 1991): 16; Cathryn J. Prince, "People's Park Spared; Eviction Threat Rescinded," *Newsday* (August 28, 1992): 29.

34. Richard D. Lyons, "Turn Left at the Village; Red Square," *New York Times* (April 9, 1989), X: 1; Victoria Geibel, "A Dangerous Name," *Metropolis* 9 (July-August 1989): 32; Elaine Louie, "A Plain Brick House Topped with Found Objects," *New York Times* (December 21, 1989), C: 3; Liz Farrelly, *Tibor Kalman: Design and Undesign (Cutting Edge)* (New York: Watson-Guptill Publications, 1998), 24–25; Peter Hall and Michael Bierut, eds., *Tibor Kalman: Perverse Optimist* (New York: Princeton Architectural Press, 2000), 48–51, 237, 397.

35. Tibor Kalman, quoted in Farrelly, *Tibor Kalman: Design and Undesign (Cutting Edge)*, 24.

36. Johnny Swing, quoted in Louie, "A Plain Brick House Topped with Found Objects": 3.

37. Randy Kennedy, "The New Money: Patient and Realistic," *New York Times* (September 25, 1994), XIII: 6. Also see Alan S. Oser, "Along East 2d Street, New Market-Rate Apartments," *New York Times* (June 8, 1997), IX: 5.

38. Oser, "Along East 2d Street, New Market-Rate Apartments": 5.

39. David W. Dunlap, "As Disco Faces Razing, Gay Alumni Share Memories," *New York Times* (August 21, 1995), B: 3; Rachelle Garbarine, "In East Village, a Spirited Pace for Rental Project Development," *New York Times* (August 29, 1997), B: 5. For Pilevsky, see "Six Screens on Second; Films for Fillmore East," *New York Times* ((May 14, 1989), X: 1; Jeanette Walls, "Sour Notes from Fillmore East," *New York* 25 (December 21–28, 1992): 23.

40. Andrew Jacobs, "Theatrical Ghosts Lose Haunt," *New York Times* (November 17, 1996), XIII: 10; Garbarine, "In East Village, a Spirited Pace for Rental Project Development": 5.

41. Alan S. Oser, "Settling into New Condominiums in the East Village," *New York Times* (October 24, 1999), XI: 7. Also see Kayte VanScoy, "East Village Eden," *Grid* 2 (January + February 2000): 29; John Leland, "On Avenue C, Renewal and Regret," *New York Times* (August 3, 2000), F: 1.

42. Eric V. Copage, "Apartment Project Is Pitting Gardener Against Gardener," *New York Times* (July 11, 1999), XIV: 7; C. J. Chivers, "After Arresting 31 Protestors, City Bulldozes Prized Garden," *New York Times* (February 16, 2000): 1, B: 3; "Death of a Garden," editorial, *New York Times* (February 17, 2000): 28.

43. "Crowd Storms Former Garden to Protest Bulldozing by City," *New York Times* (March 6, 2000), B: 3; Alice McQuillan and Bill Egbert, "E. Village Melee Injures 7 Cops," *New York Daily News* (March 6, 2000): 25.

44. Marc Borbély, "Lower East Side Church Shouts Hallelujah," *New York Observer* (April 12, 1999): 13; Copage, "Apartment Project Is Pitting Gardener Against Gardener": 7.

45. Charles V. Bagli, "The Bowery's Boozy Image Undergoes a Transformation," *New York Observer* (August 27, 1990): 10.

46. "Architecture Award: Andrew Bartle Architects/ABA Studio, The Gateway School," *Oculus* 64 (December 2001): 13; "The Gateway School of New York, New York City," *Architectural Record* 190 (February 2002): 116–18; Christopher Gray, "Streetscapes/Readers' Questions," *New York Times* (July 7, 2002), XI: 7.

47. Bodgen Pestka, interview by the author, August 15, 2001.

48. "Museums in Expansion," *New York Observer* (September 26, 1988): 2; *Cesar Pelli: Buildings and Projects, 1965–1990* (New York: Rizzoli International Publications, 1990), 270.

49. "Construction of $5 Million Building to Begin in November; For East Sixth St., a Ukrainian Museum," *New York Times* (September 24, 1997), IX: 1; Grace Glueck, "New Museum Opens on a Foundation of Modernism," *New York Times* (April 14, 2005), E: 1, 7.

50. Andrew L. Yarrow, "For New and Old Independent Films, an Archive and Exhibition Center," *New York Times* (October 13, 1988), C: 21; Brigitte Groihofer, ed., *Raimund Abraham: [UN]BUILT* (Vienna: Springer, 1996), 250–53, 307.

51. "Raimund Abraham," *Oculus* 60 (May 1998): 5; Edward Lewine, "An Alley May Become a High Road for Film Buffs," *New York Times* (March 1, 1998), XIV: 6.

52. Dave Kehr, "At the Movies," *New York Times* (December 7, 2001), E: 8; Josh Goldfein, "Heritage Cinema; The Secret History of the Sunshine Cinema," *Village Voice* (December 25, 2001): 48–49; Craig Kellogg, "Local Landmark," *Oculus* 64 (January/February 2002): 6; Kelly Crow, "A Glimpse of Vaudeville in a Renovated Movie House," *New York Times* (January 6, 2002), XIV: 4.

53. Samuel G. Freedman, "Theater Seeking New Home," *New York Times* (November 26, 1984), C: 13; Michael Wagner, "Theaters on First Avenue," *Interiors* 145 (May 1986): 26; Nan Robertson, "Theater Unit in Agreement on New Site," *New York Times* (May 20, 1986), C: 13; "Theater for the New City," *Architecture + Urbanism*, extra edition (December 1986): 186–89; SITE (New York: Rizzoli International Publications, 1989), 186–89; Jeremy Gerard, "Fresh Start for Troupe on 1st Ave.," *New York Times* (January 16, 1987), C: 3; Jennifer Dunning, "Curtain Raiser Now, a Grand Reopening Later," *New York Times* (November 29, 1990), C: 19; "Building SITE: Theater for the New City," *Architectural Record* 179 (February 1991): 17; "Apartments to Rise atop Theater in East Village," *New York Times* (May 28, 2000), XI: 1; Vanessa Weiman, "Air Rights Sale Keeps the Curtain from Dropping Forever," *New York Times* (November 26, 2000), XIII: 8.

54. Crystal Field, interview by the author, August 14, 2001.

GREENWICH VILLAGE

1. Landmarks Preservation Commission of the City of New York, *Greenwich Village Historic District Designation Report* (New York, 1969); Stern, Mellins, and Fishman, *New York 1960*, 1144–45; Barbaralee Diamonstein, *The Landmarks of New York III* (New York: Harry N. Abrams, 1998), 493; Luther S. Harris, *Around Washington Square: An Illustrated History of Greenwich Village* (Baltimore and London: Johns Hopkins University Press, 2003), 284–87.

2. Joyce Purnick, "The Saga of a Landmark Gas Station," *New York Times* (November 1, 1984): C: 1, 6. Also see *Greenwich Village Historic District*, 214, 258.

3. Akiko Busch, "Altarnative Plan," *Metropolis* 1 (June 1982): 5–6; White and Willensky, *AIA Guide* (2000), 133.

4. White and Willensky, *AIA Guide* (1988), 142.

5. "Coming Attraction in the 'Village,'" *New York Times* (August 5, 1984), VIII: 1; Richard Severo, "Battle Over Cornices and Lintels Rages in 'Village,'" *New York Times* (August 28,

1984), B: 1, 7; Gregory K. Dreicer, "In the 'Village,' a Needless Battle Over Cornices," *New York Times* (September 15, 1984): 22; Paul Goldberger, "Debating Design in Historic Districts," *New York Times* (September 20, 1984), C: 28; "Complex in Village Given Support," *New York Times* (November 29, 1984), B: 9; Peter Lemos, "Vienna Downtown," *Metropolis* 5 (March 1986): 10–11; Douglas Brenner, "City Limits," *Architectural Record* 174 (October 1986): 89, 90–95; "Washington Court Apartments," *Oculus* 48 (May 1987): 12, 15; James Stewart Polshek, "Notes on My Life and Work," in *James Stewart Polshek: Context and Responsibility* (New York: Rizzoli International Publications, 1988), 52, 178–81; Helen Searing, "James Stewart Polshek as Form-Giver," in *James Stewart Polshek: Context and Responsibility*, 11–12; Richard D. Lyons, "The Past Yields to Present 'Village' Needs," *New York Times* (August 21, 1988), X: 5; Ellen Shoshkes, *The Design Process* (New York: Whitney Library of Design, 1989), 72–95; Marisa Bartolucci, "Citizen Architect," *Metropolis* 14 (June 1995): 62–67, 74–79; Susanna Sirefman, *New York: A Guide to Recent Architecture* (London: Ellipsis, 2001), 4: 2–3; Paul Spencer Byard, *The Architecture of Additions: Design and Regulation* (New York: W. W. Norton, 1998), 145–46; White and Willensky, *AIA Guide* (2000), 117–18; Harris, *Around Washington Square*, 284–87.

6. For Andrew Jackson Thomas's work, see Stern, Gilmartin, and Mellins, *New York 1930*, 419–21, 478–86.

7. For Karl Ehn's Karl Marx Hof, see Eve Blau, *The Architecture of Red Vienna, 1919–1934* (Cambridge, Mass., and London: MIT Press, 1999), 144–45, 208–9, 320–30, 400–401, plates 12–18. For Michel de Klerk's Eigen Haard, see Maristella Casciato, *The Amsterdam School* (Rotterdam: 010 Publishers, 1996), 162–65.

8. For St. Joseph's Church, see *Greenwich Village Historic District*, 135.

9. Dreicer, "In the 'Village,' a Needless Battle Over Cornices": 22.

10. Goldberger, "Debating Design in Historic Districts": 28.

11. Lyons, "The Past Yields to Present 'Village' Needs": 5; White and Willensky, *AIA Guide* (2000), 151. For the Jefferson Market Courthouse, see Stern, Mellins, and Fishman, *New York 1880*, 124, 129, 132–34.

12. Joseph P. Fried, "Federal Government to Give Up Landmark in Greenwich Village," *New York Times* (May 19, 1976): 45. For the Archive Building, see Landmarks Preservation Commission of the City of New York, LP-0211 (March 15, 1966); Diamonstein, *The Landmarks of New York III*, 215.

13. Alan S. Oser, "Federal Archive Building Plan Proceeds Despite Legal Tangle," *New York Times* (July 15, 1977), B: 5. Also see Paul Goldberger, "Archives Unit of U.S. Sought for Apartments," *New York Times* (September 12, 1977): 35–36; Suzanne Stephens, "How the West Village Was Won," *New York 11* (April 17, 1978): 56–57.

14. "The U.S. Government Transfers a Landmark for Private Use," *Architectural Record* 167 (April 1980): 36; Carter B. Horsley, "Federal Archive Building in Greenwich Village," *New York Times* (July 2, 1980), B: 5; Leslie Bennetts, "Historic Status Eases 'Village' Growth," *New York Times* (February 14, 1981): 25–26; Alan S. Oser, "The Stop-and-Go Renewal of the Archives Building," *New York Times* (January 3, 1986), B: 7; Terence H. Benbow, "Restorations," letter to the editor, *New York Times* (February 23, 1986), VIII: 12; Michele Herman, "River Views," *Metropolis* 8 (November 1988): 98–101, 103; Michele Herman, "Opening Up the Archive," *Metropolis* 8 (December 1988): 22–23; "New York City Historic Properties Fund," *New York Landmarks Conservancy Newsletter* 7 (Winter 1990): no pagination.

15. Herman, "Opening Up the Archive": 23.

16. Bennetts, "Historic Status Eases 'Village' Growth": 25.

17. Stephens, "How the West Village Was Won": 56; Michael Goodwin, "New Life for Old Jail: Cellblock Is 'Luxury' Housing," *New York Times* (November 12, 1978), VIII: 1; Herman, "River Views": 103; White and Willensky, *AIA Guide* (2000), 146.

18. Carter B. Horsley, "Loft Conversion Exceeding New Apartment Construction," *New York Times* (October 12, 1980), VIII: 1, 12; Bennetts, "Historic Status Eases 'Village' Growth": 25–26; Ron Alexander, "On the Right Track Down in the Village," *New York Times* (November 19, 1981), C: 8; Laurie Johnston, "The Far West Village," *New York Times* (April 18, 1982), VIII: 9; Lee A. Daniels, "Residential Conversion in West Village," *New York Times* (November 19, 1982), B: 7; Peter Freiberg, "Housing Beefs," *Metropolis* 3 (December 1983): 8; Peter Freiberg, "Updates," *Metropolis* 3 (March 1984): 11; David W. Dunlap, "Permit Residential Use," *New York Times* (April 17, 1984), B: 3; Herman, "River Views": 101; White and Willensky, *AIA Guide* (2000), 148–49.

19. Richard D. Lyons, "Wave of Development Changing the Far West," *New York Times* (November 17, 1985), VIII: 7; White and Willensky, *AIA Guide* (2000), 149.

20. Toby Axelrod, "Board 2," *New York Observer* (January 7, 1991): 6; David W. Dunlap, "Elevated Freight Line Being Razed Amid Protests," *New York Times* (January 15, 1991), B: 3; "Apartments Replace Rail Right-of-Way," *New York Times* (April 3, 1994), X: 1.

21. William G. Blair, "Memphis on Charles St.," *New York Times* (June 23, 1985), VIII: 1; "Apartments for the Avant-Garde," *Architectural Record* 173 (December 1985): 26; Peter Lemos, "Down in the Village," *Metropolis* 6 (July-August 1986): 15; Alan S. Oser, "Residential Projects Spur West Village's Expansion," *New York Times* (October 10, 1986): 31; White and Willensky, *AIA Guide* (1988), 138; Herman, "River Views": 100, 103.

22. See Barbara Radice, *Memphis: Research, Experiences, Results, Failures and Successes of New Design* (New York: Rizzoli International Publications, 1984); Barbara Radice, *Ettore Sottsass: A Critical Biography* (New York: Rizzoli International

Publications, 1993).

23. White and Willensky, *AIA Guide* (1988), 138.

24. Oser, "Residential Projects Spur West Village's Expansion": 31; White and Willensky, *AIA Guide* (2000), 147.

25. Michele Herman, "A Mews Amazes Villagers," *Metropolis* 7 (March 1988): 22–23; Lyons, "The Past Yields to Present 'Village' Needs": 5; Diana Shaman, "Eight One-Family Homes Going Up in West Village," *New York Times* (March 17, 1989): 25.

26. For 100 Jane Street, see Ian Fisher, "Temporary Walls Make Good Roommates Better," *New York Times* (September 16, 1996), B: 1–2; Rachelle Garbarine, "Residential Real Estate," *New York Times* (April 3, 1998), B: 10. For 99 Jane Street, see Rachelle Garbarine, "Two Luxury Projects May Cast Shadows on the West Village," *New York Times* (August 8, 1997), B: 5; "Condominium Project at 99 Jane Street," *New York Times* (June 21, 1998), XI: 1; Rachelle Garbarine, "From Garage for 'Taxi' on TV to Condos," *New York Times* (November 6, 1998), B: 6; White and Willensky, *AIA Guide* (2000), 1999; Jayne Merkel, "Dream Housing," *Oculus* 63 (October 2000): 8–9.

27. For 495 West Street, see Rachelle Garbarine, "Condominium Developers Expand Boundaries of West Village," *New York Times* (March 12, 1999), B: 8; "11-Story, 9-Unit Condo Being Built on West St.," *New York Times* (May 30, 1999), XI: 1; David W. Dunlap, "In West Village, a Developers' Gold Rush," *New York Times* (August 29, 1999), XI: 1, 6; Soren Larson, "Keeping It Raw: A New NYC Building Capitalizes on Its Industrial Roots," *Architectural Record* 188 (January 2000): 16; "Architecture Awards," *Oculus* 64 (December 2001): 13–33; Aimee Molloy, "A Tower of Damnation," *Architectural Design* 74 (January/February 2004): 26–33. For 140 Perry Street, see "From Stable to Condo in the West Village," *New York Times* (October 31, 1996), IX: 1; Molloy, "A Tower of Damnation": 26–27, 30.

28. Florence Fabricant, "Off the Menu," *New York Times* (June 30, 1999), F: 8; Dunlap, "In West Village, a Developers' Gold Rush": 1, 6; Larson, "Keeping It Raw: A New NYC Building Capitalizes on Its Industrial Roots": 16; Tracie Rozhon, "Richard Meier Builds in Manhattan. At Last," *New York Times* (May 25, 2000), F: 1, 11; Susanna Sirefman, "Meier Takes Manhattan," *Architectural Record* 188 (June 2000): 42; Richard A. Plunz, "Richard Meier in the Boroughs," *New York Times* (June 8, 2000), F: 9; Robert Kolker, "Glass Houses," *New York 33* (June 19, 2000): 13–14; Paul Sullivan, "All Abuzz Over a Brace of Buildings," *Financial Times* (July 2, 2000): 21; Denny Lee, "As Village Towers Loom, Foes Seek New Boundaries," *New York Times* (July 9, 2000), XIV: 8; Christine Pittel, "Ice Palaces," *House Beautiful* 142 (September 2000): 114; Merkel, "Dream Housing": 8; "US: Meier Brings Loft Living to Manhattan," *World Architecture* 90 (October 2000): 32; Rima Suqi, "Wonder Twin Towers Activate," *Paper* (October 2000): 42; Deborah Schoeneman, "Richard Meier Builds Perry Street Palace for Calvin and Martha," *New York Observer* (December 4, 2000): 29, 32; Gregory Cerio, "Mr. Meier Builds His Dream House," *House & Garden* 170 (March 2001): 86, 89; "Richard Meier," *Global Architecture Document* 65 (May 2001): 37–38; Maura McEvoy, "15 Rooms, River View," *Town & Country* (July 2001): 102–7, 116, 125, 130; Jonathan Mahler, "Gotham Rising," *Talk* (December 2001-January 2002):121–25, 148–52; Jean Tang, "Is This the Next Park Avenue?" *Avenue* (December 2001): 2–6; David S. Chartock, "Accommodating Design Key to Perry Street Job," *New York Construction News* 50 (January 2002): 37–40; Julie Iovine, "Solving Modern's Midlife Crisis," *New York Times* (February 7, 2002), F: 1, 6; James Gardner, "A Welcome Enhancement," *New York Sun* (July 15, 2002): 10; Aric Chen, "Outside the Box," *New York 35* (September 9, 2002): 24; James Gardner, "From Perry Street To . . . ?" *New York Sun* (September 24, 2002): 1, 10; Alan S. Oser, "Along West Street, a Residential Makeover," *New York Times* (November 24, 2002), XI: 1, 6; Kenneth Frampton, *Richard Meier* (Milan: Electa Architecture, 2003), 412–17, 474, 479; Ian Luna, ed., *New New York: Architecture of a City* (New York: Rizzoli International Publications, 2003), 82–85; Philip Nobel, "Richard & Me," *Metropolis* 22 (April 2003): 66, 68; Herbert Muschamp, "Blond Ambition on Red Brick," *New York Times* (June 19, 2003), F: 1, 6; Herbert Muschamp, "The Buildings (and Plans) of the Year," *New York Times* (December 28, 2003), II: 39; Jayne Merkel, "Architecture in Developer Land," *Architectural Design* 74 (January/February 2004): 6–15; Deborah Schoeneman, "Down by the Riverside," *New York 37* (February 9, 2004): cover, 26–37, 44; Motoko Rich, "The Art of Selling Luxury Condos as Art," *New York Times* (March 11, 2004), F: 8; Charles Laurence, "Rich and Famous Fall Out of Love with the 'Faulty Towers' of New York," *Sunday Telegraph* (London) (May 9, 2004): 32; Sam Lubell, "A Third New York High-Rise for Meier," *Architectural Record* (June 2004): 66; Vicky Ward, "Faulty Towers," *Vanity Fair* (June 2004): 186–93, 232–34; "Richard Meier: 173–176 Perry Street, New York, USA 1999–2003," *Architecture + Urbanism* (August 2004): 12–21; "Richard Meier: Charles Street Apartments, New York, USA 2003–2005," *Architecture + Urbanism* (August 2004): 22–23; Robin Pogrebin, "For Act II, Architect Gets More Hands-On," *New York Times* (April 11, 2005), E: 1, 7.

29. Richard Meier, quoted in Rozan, "Richard Meier Builds in Manhattan. At Last": 11. For Westbeth, see Stern, Mellins, and Fishman, *New York 1960*, 251–54; Tracie Rozhon, "Westbeth, a Canvas Still Taking Shape," *New York Times* (May 25, 2000), F: 1, 11. For Twin Parks Northeast, see Stern, Mellins, and Fishman, *New York 1960*, 958, 960–61.

30. Richard Born, quoted in Cerio, "Mr. Meier Builds His Dream House": 89.

31. Muschamp, "Blond Ambition on Red Brick": 1.

32. Merkel, "Architecture in Developer Land": 11–13.

33. Florence Fabricant, "Expecting Less Fuss at Perry St.," *New York Times* (June 15, 2005), F: 12.

34. Richard Meier, quoted in www.richardmeier.com/

PROJECTS/Charles.html.

35. David W. Dunlap, "Greenwich Village Battles PATH Plan," *New York Times* (November 30, 1987), B: 3; "PATH Safety, Not Neighborhood Blight," editorial, *New York Times* (December 19, 1987): 26; Judy Siegel, "No Five-Story Bunkers for the Village, Please," letter to the editor, *New York Times* (January 5, 1988): 18; David W. Dunlap, "West Side Planning Panel Rules Out Landfill for Hudson Riverfront," *New York Times* (July 20, 1989), B: 3; Paul Goldberger, "The New Season: Architecture," *New York Times* (September 8, 1991), II: 48; Elizabeth Kraft, ed., *Robert A. M. Stern: Buildings and Projects, 1987–1992* (New York: Rizzoli International Publications, 1992), 164–65; Bill Hine, "Why You Can't Trust the Port Authority," letter to the editor, *New York Times* (October 21, 1992): 22; Richard R. Kelly, "PATH Put the Safety of Its Passengers First," letter to the editor, *New York Times* (November 6, 1992): 28; Herbert Muschamp, "The Tale of a Chimney That Turned into an Oasis," *New York Times* (January 31, 1993), II: 30; "Competitions," *Classicist* 2 (1995–96): 77–80.

36. Kraft, ed., *Robert A. M. Stern: Buildings and Projects, 1987–1992*, 164.

37. Muschamp, "The Tale of a Chimney That Turned into an Oasis": 30.

38. "N.Y.U. Revives Its $7 Million Plan for a Sports and Recreation Hall," *New York Times* (February 26, 1978): 47; Colin Campbell, "Some Neighbors of N.Y.U. Enjoy Its Elegant New Gym," *New York Times* (September 28, 1981), B: 3; White and Willensky, *AIA Guide* (2000), 126.

39. White and Willensky, *AIA Guide* (1988), 114–15. Also see Carter B. Horsley, "N.Y.U.'s Program of Rebuilding Drawing to a Close," *New York Times* (February 15, 1981), VIII: 1. For Henry Engelbert's Grand Central Hotel, see Stern, Mellins, and Fishman, *New York 1880*, 523–24.

40. "Law School at N.Y.U. Given a $4 Million Gift," *New York Times* (December 30, 1984): 19; White and Willensky, *AIA Guide* (1988), 115. For Eggers & Higgins's Vanderbilt Law School, see Stern, Mellins, and Fishman, *New York 1960*, 117.

41. George W. Goodman, "N.Y.U. Plans 2 East Village Dorms," *New York Times* (November 25, 1984), VIII: 6; James Brooke, "100 Protest Against N.Y.U. Plan to Build 2 Dorms in East Village," *New York Times* (January 13, 1985): 22; William R. Greer, "N.Y.U. Acts to Build Controversial Dormitory," *New York Times* (May 5, 1985): 43; William R. Greer, "They May Be Ivory Towers but They Still Raise Concern," *New York Times* (May 26, 1985), IV: 6; "New Construction Around Town," *Oculus* 48 (May 1987): 28; White and Willensky, *AIA Guide* (2000), 172.

42. Goodman, "N.Y.U. Plans 2 East Village Dorms": 6; Brooke, "100 Protest Against N.Y.U. Plan to Build 2 Dorms in East Village": 22; Greer, "N.Y.U. Acts to Build Controversial Dormitory": 43; Greer, "They May Be Ivory Towers but They Still Raise Concern": 6; White and Willensky, *AIA Guide* (2000), 174.

43. "N.Y.U. Gets Town House for Italian Studies," *New York Times* (May 10, 1988), B: 3; Clifford A. Pearson, "Town and Gown," *Architectural Record* 179 (March 1991): 100–105. For the Winfield Scott House, see *Greenwich Village Historic District*, 96.

44. David W. Dunlap, "N.Y.U. Plan Is Undeterred by a Fire," *New York Times* (January 15, 1989): 34; Pearson, "Town and Gown": 101–2, 104–5. For 58 West Tenth Street, see *Greenwich Village Historic District*, 83.

45. "For Vatican Diplomats and Jewish N.Y.U. Students," *New York Times* (August 14, 1994), X: 1; Andrew Jacobs, "An Indian-Style Gem Takes on a New Role," *New York Times* (December 1, 1996), XIII: 9; "Edgar M. Bronfman Center for Jewish Student Life at NYU," *Oculus* 60 (October 1997): 3. For the Lockwood de Forest house, see Stern, Mellins, and Fishman, *New York 1880*, 637–38.

46. Peter Marks, "New Life for a Historic Village Theater," *New York Times* (October 18, 1996), C: 2; Mervyn Rothstein, "Provincetown Playhouse Being Restored by N.Y.U.," *New York Times* (April 30, 1997), B: 7; "The Provincetown Playhouse," *Oculus* 60 (October 1997): 3; *Marvin H. Meltzer: City as Poetry* (Milan: l'Arca Edizioni, 2004), 96.

47. "Metal-and-Glass Look for an Old Art Theater," *New York Times* (September 7, 1997), IX: 1; "Iris and B. Gerald Cantor Film Center," *Oculus* 60 (October 1997): 3; White and Willensky, *AIA Guide* (2000), 120.

48. Maya Lin, quoted in Allan Punzalan Isaac, "Tea and Empathy," *Metropolis* 17 (October 1997): 98–99, 145. Also see Maya Lin, *Boundaries* (New York: Simon & Schuster, 2000), 10: 12–15; Alan Balfour, *World Cities: New York* (New York: Wiley Academy, 2001), 161; Luna, ed., *New New York*, 70–71.

49. "A Kiss from a King," *New York Times* (April 10, 1997), B: 3; "Polshek and Partners," *Oculus* 60 (October 1997): 3. For the Judson Memorial Church, see Stern, Gilmartin, and Massengale, *New York 1900*, 110–11, 124.

50. Michael Goldman, "Law School Looking to Buy a Beloved Church Building," *New York Times* (March 14, 1999), XIV: 7; Denny Lee, "Church Sells Building to N.Y.U. but Keeps a Say in Design," *New York Times* (February 6, 2000), XIV: 12; Annia Ciezadlo, "Po' Poe," *New York Observer* (February 7, 2000): 10; Bill Hutchinson, "Poe Fans to NYU: Have a (Telltale) Heart," *New York Daily News* (February 23, 2000): 8; Timothy Fitzsimmons, "Save Poe's House!" *New York Observer* (April 10, 2000): 11; Laura Lippman, "Quoth the Raven, Nevermore," *Baltimore Sun* (May 10, 2000): 1E; Timothy Fitzsimmons, "Poe Again," *New York Observer* (June 5, 2000): 9; Denny Lee "The Fall of the House of Poe (Unless Scholars Prevail)," *New York Times* (July 2, 2000), XIV: 6.

51. For the Elmer Holmes Bobst Library and Loeb Student Center, see Stern, Mellins, and Fishman, *New York 1960*, 232–34, 238–41.

52. Nina Siegal, "Rapping on Poe's Door, a Hint of

Nevermore," *New York Times* (July 19, 2000), B: 1, 8; Julie Lasky, "Unhappy Hunting Grounds," *Interiors* 159 (August 2000): 6; Joanne Wasserman, "Op-Poe-Sition Halts NYU Bldg. Plan," *New York Daily News* (August 1, 2000): 20; "Judge Halts Demolition of Poe Home," *Newsday* (August 2, 2000): 16; Nina Siegal, "Manhattan: Demolition Protest," *New York Times* (August 3, 2000), B: 6; Don Oldenburg, "Nevermore?" *Preservation* 52 (September-October 2000): 19; Jim Dwyer, "NYU Fifths Rev. Billy, 'Raven,'" *New York Daily News* (September 10, 2000): 8; Helen Peterson, "Judge Oks Razing Poe Home," *New York Daily News* (October 4, 2000): 28; "Judge Allows School to Raze Poe's House," *New York Times* (October 4, 2000), B: 3; Timothy Fitzsimmons, "Tragedy Ahead for Poe House? Stop that Bulldozer!" *New York Observer* (August 14, 2000): 8; Beth Landman Keil and Ian Spiegelman, "Nagtime: Doctorow Fights for Poe Home," *New York* 33 (November 6, 2000): 11; Jim O'Grady, "N.Y.U. Law School Agrees to Save Part of Poe House," *New York Times* (January 23, 2001), B: 3; Karen W. Arenson, "The Villain of the Village?" *New York Times* (April 19, 2001), B: 1, 8; Jim O'Grady, "Critics Praise N.Y.U. Plan," *New York Times* (May 15, 2001), B: 4; Nadine Brozan, "New Academic Building for N.Y.U. Law School," *New York Times* (October 7, 2001), XI: 1; Stephen Garmhausen, "Town Versus Gown at NYU," *Grid* 3 (November 2001): 30–31; Craig Kellogg, "Higher and Higher Learning," *Oculus* 64 (November 2001): 7; Harris, *Around Washington Square*, 299; Joan Dim, "School of Law Dedicates Furman Hall," *NYU Today* (January 30, 2004): 1, 11; James Gardner, "A Brick Beauty for New York University," *New York Sun* (February 9, 2004): 17.

53. Peg Breen, letter to John W. Sexton (July 10, 2000).

54. E. L. Doctorow, "A Plea to Save the House of Poe," letter to the editor, *New York Times* (July 25, 2000): 24.

55. Woody Allen, "A City, So Lovely, Through Woody Allen's Lens," letter to the editor, *New York Times* (July 27, 2000): 24; Lou Reed, "The End? The Fall of the House of Poe," letter to the editor, *New York Times* (October 6, 2000): 32.

56. John W. Sexton, quoted in Brozan, "New Academic Building for N.Y.U. Law School": 1.

57. Gardner, "A Brick Beauty for New York University": 17.

58. "New Student Center for N.Y.U.," *New York Times* (March 14, 1999), XI: 1; Michael Goldman, "An N.Y.U. Plan Casts a Shadow," *New York Times* (March 28, 1999), XIV: 6; Linda Sandler, "Schools Build Luxury Hangouts," *Wall Street Journal* (April 28, 1999), B: 14; Michael J. O'Connor, "This Center Cannot Hold," *Architecture* 88 (May 1999): 87; Corey Kilgannon, "Last-Ditch Protest Over N.Y.U.'s Plan for Student Center," *New York Times* (August 29, 1999), XI: 7; "Loebotomy: The Loss of NYU's Loeb Student Center," *Docomomo* (Fall 1999): 4; Karrie Jacobs, "Architecture 101," *New York* 32 (October 4, 1999): 20–21; White and Willensky, *AIA Guide* (2000), 123; Siegal, "Rapping on Poe's Door, a Hint of Nevermore": 1; Arenson, "The Villain of the Village?": 1, 8; Garmhausen, "Town Versus Gown at NYU": 30–31; Kellogg, "Higher and Higher Learning": 7; David W. Dunlap, "A Delicate Balance: Community Facilities and Communities," *New York Times* (October 27, 2002), XI: 1, 4; Harris, *Around Washington Square*, 296–97; Denny Lee, "Residents Aren't Happy with Arch's Healthy Glow," *New York Times* (February 9, 2003), XIV: 7; James Gardner, "Washington Square Park's Welcome New Resident," *New York Sun* (April 29, 2003): 15; David W. Dunlap, "865-Seat Skirball Center to Open on La Guardia Place," *New York Times* (September 14, 2003), XI: 1. For the Loeb Student Center, see Stern, Mellins, and Fishman, *New York 1960*, 232–34.

59. Jacobs, "Architecture 101": 20.

60. Gardner, "Washington Square Park's Welcome New Resident": 15.

61. White and Willensky, *AIA Guide* (1988), 113. Also see Laurie Johnston, "Hebrew Union College," *New York Times* (October 30, 1979), II: 2.

62. *1100 Architect* (New York: Monacelli Press, 1997), 182–83; Christopher Gray, "Streetscapes/The Little Red School House at 196 Bleecker Street," *New York Times* (March 29, 1998), XI: 5; "'Little' School Grows Bigger," *New York Times* (September 5, 1999), XI: 1; Philip Nobel, "A Back-to-School Special," *New York Times* (September 9, 1999), F: 13; Clifford A. Pearson, "Little Red School House," *Architectural Record* 189 (February 2001): 146–48.

63. "News Briefs: The Center," *Architectural Record* 176 (April 1988): 59; Christopher Gray, "Streetscapes: Old P.S. 16 on West 13th Street," *New York Times* (April 14, 1991), X: 6; Marvine Howe, "Gay Center Is Hub to Share and Care," *New York Times* (October 22, 1992), B: 5; "Preservationists," *Newsday* (December 8, 1992): 31; "Details," *Architecture* 83 (September 1994): 29; "Building for Communities in the City," *Oculus* 59 (December 1996): 3; Scott Baldinger, "Coming to Fruition," *Outfront* (September 2000): 56; White and Willensky, *AIA Guide* (2000), 133. Also see *Greenwich Village Historic District*, 197–98.

64. Judith Davidsen, "Staging a Comeback," *Architectural Record* 181 (May 1993): 34–37; "John Tishman Auditorium," *New York State AIA News* (November 1993): 9; Jayne Merkel and Craig Kellogg, "College Tour," *Oculus* 59 (September 1996): 10; White and Willensky, *AIA Guide* (2000), 134; Balfour, *World Cities: New York*, 162. For Joseph Urban's New School for Social Research, see Stern, Gilmartin, and Mellins, *New York 1930*, 115–19.

65. "For the New School, a New Courtyard," *New York Times* (November 23, 1997), XI: 1; White and Willensky, *AIA Guide* (2000), 134.

66. David W. Dunlap, "A.I.A. Gets New Home, and New Goals," *New York Times* (August 8, 1999), XI: 6; Jayne Merkel, "Tale of Two Competitions," *Oculus* 62 (April 2000): 6; Jane F. Kolleeny, "New AIA N.Y. Headquarters Moves Forward," *Architectural Record* 188 (June 2000): 40; Edwin McDowell, "Winner of Architectural Competition Is Chosen," *New York*

Times (June 4, 2000), XI: 1; Jayne Merkel, "Architects as Clients on LaGuardia Place," *Oculus* 62 (Summer 2000): 3; "Round Two: The LaGuardia Place Competition," *Oculus* 62 (Summer 2000): 10–15; "Building News," *New York Construction News* 50 (May 2003): 59; Herbert Muschamp, "The New Season/Architecture," *New York Times* (September 7, 2003), II: 103; Sam Lubell, "AIA to Open New York Center for Architecture," *Architectural Record* 191 (October 2003): 32; Lawrence Van Gelder, "Arts Briefing," *New York Times* (October 6, 2003), E: 2.

67. Merkel, "Architects as Clients on LaGuardia Place": 3.

68. H. Deglane, "Greetings from the École des Beaux-Arts," *American Architect and Building News* 89 (February 1906): 47–49; "National Institute for Architectural Education/NIAE," *Oculus* 44 (September 1982): 9; Stanley Salzman, "Architectural Education: What Is the National Institute for Architectural Education All About?" *Architectural Record* 174 (February 1986): 55, 57; Jayne Merkel, "The Van Alen Institute," *Oculus* 57 (May 1995): 5; Nina Rappaport, "Civic Consciousness Raising," *Oculus* 59 (January 1997): 14–15.

69. Sirefman, *New York*, 5: 2–5. Also see "Division of Labour," *Architectural Review* 206 (July 1999): 86–87; Bonnie Schwartz, "The Van Alen Effect," *Interior Design* 158 (October 1999): 64–65; Luna, ed., *New New York*, 120–23.

70. "News Notes," *Oculus* 52 (January 1990): 3; Herbert Muschamp, "What's on Third?" *Seven Days* (February 28, 1990): 33, 35; Peter Eisenman, "Project for the Cooper Union Student Housing, New York," *Zodiac* 4 (September 1990): 186–203; Diane Lewis, "Bones and Skin," *AA Files* 20 (Autumn 1990): 42–45; Brent C. Brolin, "Ugly Dorm for Cooper Union Won't Advance Art Much," *New York Observer* (September 24, 1990): 8; "Cooper Union to Construct $10.9M Dorm/Retail Unit," *New York Construction News* 38 (October 8, 1990): 1, 17; "For Cooper Union: 15-Story Dorm," *New York Times* (December 2, 1990), X: 1; Herbert Muschamp, "Ground Up," *Artforum* 30 (October 1991): 13–15; Murray Jacobson, "Cooper Union First," *Newsday* (September 25, 1992): 29; Suzanne Stephens, "Cooper Union," *Oculus* 55 (October 1992): 6–8; David W. Dunlap, "City's Colleges Add $2 Billion in Facilities," *New York Times* (September 12, 1993), X: 1, 12; "AIA Honor Awards for Architecture," *Architectural Record* 182 (February 1994): 57; *Eisenman Architects: Selected and Current Works* (Mulgrave, Australia: Images Publishing, 1995), 170–73; "Cooper Union Student Housing," *AV Monografias* 53 (May-June 1995): 34–37; White and Willensky, *AIA Guide* (2000), 172; Sirefman, *New York*, 4: 6–7.

71. Muschamp, "What's on Third?": 33.

72. Quoted in Muschamp, "What's on Third?": 33.

73. Muschamp, "What's on Third?": 33.

74. Eisenman, "Project for the Cooper Union Student Housing, New York": 186.

75. Muschamp, "Ground Up": 14.

76. Stephens, "Cooper Union": 7.

77. Jacob Alspector, quoted in Stephens, "Cooper Union": 8.

78. White and Willensky, *AIA Guide* (2000), 164. Also see Craig Kellogg, "Cash Cow Café," *Metropolis* 17 (October 1997): 60. For the Engineering Building, see Stern, Mellins, and Fishman, *New York 1960*, 254–55.

79. David W. Dunlap, "College Dreams of a Grand Public Plaza," *New York Times* (July 18, 1999): 27; David W. Dunlap, "A Clock of Note Runs Out of Time," *New York Times* (July 25, 1999), XIV: 6; Sam Charap, "Cooper Union Faculty in Fight with Board Over Its Hotel Plan," *New York Observer* (July 26, 1999): 1, 3.

80. David W. Dunlap, "Planners Hope New Hotel Jolts New York," *New York Times* (January 23, 2000): 27; "Koolhaas, Herzog & de Meron Team Up for a Hotel Design," *Architectural Record* 188 (March 2000): 32; "The Boutique Boom," *Oculus* 62 (March 2000): 12; Arthur Lubow, "The Architect's Architect in the Architect's Time," *New York Times* (July 9, 2000), VI: 30–37, 42, 62–63; Herbert Muschamp, "Design That Coaxes Buildings out of Themselves," *New York Times* (September 10, 2000), II: 100; Herbert Muschamp, "A Supermodel of a Hotel Sashays to Astor Place," *New York Times* (May 10, 2001), E: 1–2; Meryl Gordon, "The Cool War," *New York Times* (May 27, 2001), VI: 34–39; Francis Morrone, "'Second City' Syndrome," *New Criterion* (June 2001): 9–15; Luther S. Harris, "The Cool War," letter to the editor, *New York Times* (June 17, 2001), VI: 10; Charles V. Bagli, "A Hotel Alliance Splits Up, but Schrager Presses Ahead," *New York Times* (June 28, 2001), B: 1, 7; John E. Czarnecki, "Plans Nixed for NYC Hotel by Koolhaas and Herzog & de Meron," *Architectural Record* 189 (July 2001): 27; Holly Obernauer, "Cooper Union Builds," *Grid* 3 (July-August 2001): 24; Linda Mack, "A Herzog Demurral," *Minneapolis Star Tribune* (July 6, 2001): 2; Lois Weiss, "Prized Office Tower to Hit Market," *New York Post* (July 18, 2001): 40; Schrager Design Called Off," *Building Design* (July 20, 2001): 2; Mahler, "Gotham Rising": 123–25; Harris, *Around Washington Square*, 310–11; Christopher Hawthorne, "Goodbye 'Fountainhead,' Hello Kibbutz," *New York Times* (April 27, 2003), II: 32–33.

81. Rem Koolhaas, *Delirious New York: A Retroactive Manifesto for Manhattan* (New York: Oxford University Press, 1978), 297–99.

82. Muschamp, "A Supermodel of a Hotel Sashays to Astor Place": 1–2.

83. Frank Gehry, quoted in Weiss, "Prized Office Tower to Hit Market": 40.

84. Herbert Muschamp, "Welcoming a Return to Risk," *New York Times* (November 18, 2001), II: 1; Marc S. Malkin, "No Room for the Inn at Schrager Empire," *New York* 35 (February 4, 2002): 9; "Astor Place Hotel, New York, New York," *GA Document* (March 2002): 96–99; "Frank O. Gehry: Astor Place Hotel," *GA Document* (July 2002): 21–23; *Frank Owen Gehry: Flowing In All Directions* (Los Angeles: Circa, 2003), 92–95;

Harris, *Around Washington Square*, 311–12.

85. Paul Goldberger, "The Sky Line: Green Monster a Startling Addition to Astor Place," *New Yorker* 81 (May 2, 2005): 106. Also see Harris, *Around Washington Square*, 326; Erika Kinetz, "Neighborhood Report," *New York Times* (February 23, 2003), XIV: 5; "Building News," *New York Construction* 52 (November 1, 2004): 11.

MIDTOWN

UNION SQUARE

1. Daniel Garrison Brinton Thompson, "Ruggles of New York: A Life of Samuel B. Ruggles" (Ph.D. diss., Columbia University, 1946): 62–63; I. N. Phelps Stokes, *The Iconography of Manhattan Island*, 6 vols. (New York: Robert H. Dodd, 1915–1928; New York: Arno Press, 1967), vol. 5, 1705.

2. Stokes, *The Iconography of Manhattan Island*, vol. 5, 1942, 1948; David Schuyler and Jane Turner Censer, eds., *The Papers of Frederick Law Olmsted, vol. 6: The Years of Olmsted, Vaux & Company, 1865–1874* (Baltimore and London: Johns Hopkins University Press, 1992), 531–36.

3. Paul Goldberger, *The City Observed: New York* (New York: Vintage Books, 1979), 91–92.

4. *Union Square Street Revitalization* (New York: Department of City Planning, January 1976).

5. Deirdre Carmody, "Union Square Park to Undergo Overhaul," *New York Times* (November 2, 1982), B: 1, 12; "New York Park Renovation," *Progressive Architecture* 64 (January 1983): 60; Deirdre Carmody, "New Day Is Celebrated for Union Square Park," *New York Times* (April 20, 1984), B: 3; "Union Square Renovation Taking Shape," *New York Times* (April 19, 1985), B: 2; Deirdre Carmody, "Renewal of Union Sq. Park Is Hailed," *New York Times* (August 3, 1986): 28; "NYC Department of Parks and Recreation," *Oculus* 48 (December 1986): 12; White and Willensky, *AIA Guide* (1988), 185; G. Thompson Burke, "Don't Let Union Sq. Fall Back into Neglect," letter to the editor, *New York Times* (October 4, 1988): 30; Jayne Merkel, "The Next Incarnation of Union Square," *Oculus* 58 (March 1996): 4–5.

6. Deborah Dietsch, "Fast Relief for New York Depression," *Interiors* 144 (January 1985): 73.

7. White and Willensky, *AIA Guide* (1988), 185. Also see Peter Blauner, "Weird Welcome," *New York* 19 (July 21, 1986): 20.

8. Merkel, "The Next Incarnation of Union Square": 7; Edward Lewine, "Trees Will Squeeze, Farmers Say," *New York Times* (November 1, 1998), XIV: 6; Karrie Jacobs, "Down on the Farm," *New York* 31 (November 9, 1998): 18; Barbara Stewart, "For Customers, a Greenmarket Plan Still Stirs Suspicions," *New York Times* (November 12, 1998), B: 12; White and Willensky, *AIA Guide* (2000), 201.

9. Rosalyn Deutsche, *Evictions: Art and Spatial Politics* (Chicago: Graham Foundation for Advanced Studies in the Fine Arts; Cambridge, Mass.: MIT Press, 1996), 6.

10. "Mayor Giuliani Dedicates Union Square Park as a National Historic Landmark," press release, (September 12, 1998).

11. Janet Allon, "As Visions for Park Clash, Funds Hang in Balance," *New York Times* (January 26, 1997), XIII: 6; Janet Allon, "One Problem Lingers in Resurrected Park: Access," *New York Times* (August 31, 1997), XIII: 6; Douglas Martin, "A Growth Spurt for Union Square Park," *New York Times* (September 12, 1998), D: 7–8.

12. Andrew Friedman, "In Union Square, the End of a Long Wait," *New York Times* (December 3, 2000), XIV: 10.

13. Alan S. Oser, "Klein's Plan Given Union Square a Prophet," *New York Times* (March 3, 1976): 62; "Revitalizing the City," editorial, *New York Times* (March 17, 1976): 40; Junius Ellis, "Union Square a Hard Test for City's Recycling Efforts," *New York Times* (May 16, 1976), VII: 1, 8.

14. "Manhattan's Union Square Gets a Much-Needed Face Lifting," *New York Times* (May 1976): 35; Eleanor Blau, "Project Aimed at Sprucing Union Square," *New York Times* (May 19, 1977), B: 2.

15. Carter B. Horsley, "A Union Square Revival? Plan for Klein's Stirs Hope," *New York Times* (June 29, 1980), VIII: 1, 9.

16. Christopher Wellisz, "Union Square on Verge of Redevelopment," *New York Times* (August 14, 1983), VIII: 1, 11; Peter Freiberg, "Klein Site Focus of Union Square Zoning Debate," *Metropolis* 3 (November 1983): 10.

17. Lee A. Daniels, "The Efforts to Revitalize Neglected Union Square," *New York Times* (April 6, 1984), B: 4; "Zeckendorf Unveils Plan: A Preview of Union Sq. East," *New York Times* (July 29, 1984), VIII: 1; "Forming a More Perfect Union Square," *Architectural Record* 174 (May 1986): 61; Peter Lemos, "Davis Brody on Union Square," *Progressive Architecture* 67 (June 1986): 23, 26; Richard D. Lyons, "The Zeckendorf Flag Flying High Again," *New York Times* (July 13, 1986), VIII: 1, 16; Grace M. Anderson, "Zeckendorf Towers," *Architectural Record* 176 (February 1988): 131; Susan Braybrooke, "Two Old Hands Talk about Housing," *Architectural Record* 176 (February 1988): 122–27; Iver Peterson, "Union Square: Gritty Past, Bright Future," *New York Times* (November 26, 1989), X: 1, 7; Merkel, "The Next Incarnation of Union Square": 4–6; Susanna Sirefman, *New York: A Guide to Recent Architecture* (London: Ellipsis, 1997), 90–93; White and Willensky, *AIA Guide* (2000), 204.

18. Mrs. Francis G. Serr, "Old Union Square," letter to the editor, *New York Times* (August 28, 1983), VIII: 12; Selma Rattner, "Union Sq. Beauty," letter to the editor, *New York Times* (September 18, 1983), VIII: 12; Susan Heller Anderson and Maurice Carroll, "Pieces," *New York Times* (October 17, 1984), B: 4.

19. Lee A. Daniels, "A Plan to Revitalize Union Square," *New York Times* (July 1, 1984), VIII: 6, 14; "Speaking Up for Union Square," editorial, *New York Times* (August 16, 1984):

22; Henry Walter Weiss, "On Zoning: The 14th Street Solution," letter to the editor, *New York Times* (September 3, 1984): 24; Peter Freiberg, "Square Deal," *Metropolis* 4 (November 1984): 11–12; *Hardy Holzman Pfeiffer Associates: Buildings and Projects, 1967–1992* (New York: Rizzoli International Publications, 1992), 249, 252.

20. "Plan for Union Sq. Is Backed by Panel," *New York Times* (November 27, 1984): B: 4; "Tower Approved for Union Square," *New York Times* (November 29, 1984): B: 9; Jesus Rangel, "Estimate Board Approves Plan for Union Square," *New York Times* (January 11, 1985), B: 3.

21. Peter Freiberg, "News Briefs," *Metropolis* 5 (July/August 1985): 14–15. For the Lincoln Building, see Landmarks Preservation Commission of the City of New York, LP-1536 (July 12, 1988); Stern, Mellins, and Fishman, *New York 1880*, 442–43. For the Bank of the Metropolis, see Landmarks Preservation Commission of the City of New York, LP-1537 (July 12, 1988). For the Century Building, see Landmarks Preservation Commission of the City of New York, LP-1539 (October 7, 1986); Stern, Mellins, and Fishman, *New York 1880*, 442–43. For the Everett Building, see Landmarks Preservation Commission of the City of New York, LP-1540 (September 6, 1988). For the Germania Life Insurance Company Building, see Stern, Gilmartin, and Massengale, *New York 1900*, 158; Landmarks Preservation Commission of the City of New York, LP-1541 (September 6, 1988).

22. White and Willensky, *AIA Guide* (2000), 204. For the Consolidated Gas Company Building, see Stern, Gilmartin, and Mellins, *New York 1930*, 587, 590, 592.

23. Bruce Lambert, "Amid Dispute, Work to Start on Housing for Homeless," *New York Times* (November 21, 1993), XIII: 6; Alan S. Oser, "Housing and Stores for a Site off Union Square," *New York Times* (January 23, 1994), X: 7; Claudia H. Deutsch, "The Shifting Nature of 14th St.: The Hub of Change Is Union Square," *New York Times* (December 19, 1993), X: 11; "Union Square," *New York Times* (February 25, 1994): 28; Claudia H. Deutsch, "Midtown South: Funky Area Lures Not-so-Funky," *New York Times* (May 22, 1994), X: 17; Betty Liu Ebron, "Genesis Apartments," *New York Daily News* (March 2, 1995): 33; "Feared Projects Arrive: Residents Survive," *New York Times* (February 4, 1996), XIII: 6; "Excellence in Design," *American Institute of Architects/New York State News* 14 (December 1998): 5.

24. David W. Dunlap, "Merchants Ambivalent About Their Prospects," *New York Times* (May 20, 1990), X: 25; *Municipal Art Society Annual Report* (1995–96): 3; "A Model for Public/Private Collaboration," *Municipal Art Society Annual Report* (1996–97): 3; "Union Square South: Partnership and Precedent," *Municipal Art Society Annual Report* (1996–97): 8; Ellen Ryan, "Partnership and Precedent in Union Square Development," *Municipal Art Society Newsletter* (January/February 1996): 2–3; Andrew Jacobs, "Bold Lines for Tower on 14th St.," *New York Times* (February 11, 1996), XIII: 6; Jayne Merkel, "The Next Incarnation of Union Square," *Oculus* 58 (March 1996): 4–7; "Art in Union Square South," *Municipal Art Society Newsletter* (July/August 1996): 3; Andrew Jacobs, "Hopes Are Moving East on 14th Street," *New York Times* (December 29, 1996), XIII: 6; Alan S. Oser, "Renewal of Union Square Reaches Key Block," *New York Times* (January 19, 1997), IX: 1, 4; Carol Vogel, "Inside Art: An 'Artwall' at Union Square," *New York Times* (March 7, 1997), C: 34; Georgina Keenan, "Letting off Steam," *Artnews* 96 (May 1996): 35–36; Peter Morris Dixon, ed., *Robert A. M. Stern Architects: Buildings and Projects, 1993–1998* (New York: Monacelli Press, 1998), 288–89; Mervyn Rothstein, "Union Square's Resurgence Exceeds Landlords' Wildest Dreams," *New York Times* (June 3, 1998): B: 7; Karrie Jacobs, "Cineplex Odious," *New York* 31 (June 29–July 6, 1998): 38–39; Tami Solondz, "Imperfect Union," letter to the editor, *New York* 31 (August 17, 1998): 8; Alan S. Oser, "All Over Town, Movie Screens Are Popping Up," *New York Times* (December 30, 1998), B: 6; Bernard Stamler, "Full Circle at Union Square," *New York Times* (February 14, 1999), XIV: 4; Herbert Muschamp, "If the Cityscape Is Only a Dream," *New York Times* (May 2, 1999), II: 25, 27; Eric V. Copage, "Giant Artwork to Announce Time in Infinite Detail," *New York Times* (June 13, 1999), XIV: 6; Emily DeNitto, "Enough Already with Improvement," *Crain's New York Business* (June 21, 1999): 6; Amy E. Shaw and Jack Taylor, "Union Sq. Art Wall Is Large, but Ultimately, Just Flat," letters to the editor, *New York Times* (July 11, 1999), XI: 15; "Time Pieces," *Public Art Review* 11 (Fall/Winter 1999): 20–21; White and Willensky, *AIA Guide* (2000), 204–5; Ian LeBon, "Under Metronome," *Metropolis* 19 (January 2000): 36, 48; Herbert Muschamp, "The Ominous Message of a Box on Union Square," *New York Times* (January 2, 2000), II: 43, 45; Amelia G. Baker, "Union Square's Name," letter to the editor, *New York Times* (January 16, 2000), II: 6; Kent Barwick, "Art Society's Role," letter to the editor, *New York Times* (January 16, 2000), II: 4; Steven M. Davis, "Architect's Response," letter to the editor, *New York Times* (January 16, 2000), II: 4, 6; John Fawcett, "Instant Gratification," letter to the editor, *New York Times* (January 16, 2000). II: 4; Susan K. Freedman and Tom Eccles, "Public Art," letter to the editor, *New York Times* (January 16, 2000), II: 6; Laurence Frommer, "A Respect for Context," letter to the editor, *New York Times* (January 16, 2000), II: 4; Michael King, "Make It Beautiful," letter to the editor, *New York Times* (January 16, 2000), II: 4; Jeffery Rudell, "Ruminations on Time," letter to the editor, *New York Times* (January 16, 2000), II: 4; Robert C. Morgan, "Metronome," *Sculpture* 19 (May 2000): 10–11; "New York Voices/Public Opinion," *New York Times* (October 6, 2002), XIV: 14.

25. For the Union Square Theater, see Stern, Mellins, and Fishman, *New York 1880*, 665.

26. Muschamp, "If the Cityscape Is Only a Dream": 27.

27. Muschamp, "The Ominous Message of a Box on Union Square": 43.

28. Glenn Fowler, "Luchow's Moving to Theater District," *New York Times* (March 23, 1982), B: 3; Frank J. Prial, "Luchow's Symbol of the Good Old Days," *New York Times* (March 24, 1982), C: 3; Clyde Haberman, "Panel Considers Citing Luchow's as a Landmark," *New York Times* (March 30, 1982), B: 9; Clyde Haberman and Laurie Johnston, "Auf Wiedersehen on 14th Street," *New York Times* (July 12, 1982), B: 2; "Owners of Luchow's Building Fight Landmark Designation," *New York Times* (September 19, 1982): 56; Susan Heller Anderson and David W. Dunlap, "Worries About Luchow's," *New York Times* (August 26, 1985), B: 5. For Luchow's, see Stern, Gilmartin, and Massengale, *New York 1900*, 225.

29. Dunlap, "Merchants Ambivalent About Their Prospects": 25; Michael Cooper, "From Suppers of Legend to a Spot on Dormitory Row," *New York Times* (January 14, 1996), XIII: 6; Jacobs, "Hopes Are Moving East on 14th St.": 6; "N.Y.U. Plans a Revival of Luchow's," *New York Times* (January 23, 1997), B: 8; "NYU Dormitory Goes up on 14th Street," *New York Construction News* 44 (June 16, 1997): 1, 7; "5 Projects," *Oculus* 60 (October 1997): 3; David W. Dunlap, "Alma Mater Gets a Makeover," *New York Times* (November 16, 1997), XI: 1, 6; Mervyn Rothstein, "Union Square's Resurgence Exceeds Landlords' Wildest Dreams," *New York Times* (June 3, 1998), B: 7; White and Willensky, *AIA Guide* (2000), 205; "Best Educational Facility: Davis Brody Bond; New York University; New York City," *Interiors* 159 (January 2000): 68–71; Karen W. Arenson, "The Villain of the Village?" *New York Times* (April 19, 2001), B: 1, 8.

30. Peterson, "Union Square: Gritty Past, Bright Future": 1, 7; Dunlap, "Merchants Ambivalent About Their Prospects": 25; Andrew Jacobs, "Realtors See Gold in Site of Palladium," *New York Times* (October 6, 1996), XIII: 8; Jacobs, "Hopes Sre Moving East on 14th St.": 6; Thomas J. Lueck, "Palladium to Fall for N.Y.U. Housing," *New York Times* (September 19, 1997), B: 4; Rothstein, "Union Square's Resurgence Exceeds Landlords' Wildest Dreams": 7; "A 16-Story, $80 Million Building on East 14th Street: From a Disco Palace to an N.Y.U. Dormitory," *New York Times* (August 23, 1998), XI: 1; White and Willensky, *AIA Guide* (2000), 205; Arenson, "The Villain of the Village?": 1, 8; Craig Kellogg, "Higher and Higher Learning," *Oculus* 64 (November 2001): 7; "New York University Dormitory & Athletic Facility," *New York Construction News* 49 (June 2002): 33.

31. Nadine Brozan, "Grieving Workers Brace for Mays's Closing," *New York Times* (December 30, 1988), B: 1, 4; Peg Tyre and Jeannette Walls, "Developers Looking to Lease Mays Site," *New York* 22 (February 13, 1989): 13; Tami Hausman and Steven Saltzman, "Road Repair," *Metropolis* 10 (June 1991): 11–12.

32. Michael Gotkin, quoted in Dennis Hevesi, "Restoring a Remnant of 1950's Glitz," *New York Times* (July 19, 1998), XI: 1.

33. Robin Pogrebin, "Wrecking Ball Dashes Hopes for a Lapidus Work," *New York Times* (March 9, 2005), E: 1, 2; Lore Croghan, "Stones Thrown Over Glass Tower," *New York Daily News* (April 4, 2005): 2.

34. Peter Grant, "Union Sq. Hotel: Ross Goes After Guardian Life Building," *New York Times* (January 25, 1999): 22; "Rockwell Group: Projects on the Boards," *Interior Design* 70 (November 1999): 194–96; Corey Kilgannon, "Life of a Landmarked Sign Is Cut Short (by 2 Letters)," *New York Times* (January 23, 2000), XIV: 1; Jayne Merkel, "Welcome to New York: Do You Have a Reservation?" *Oculus* 62 (March 2000): 12–17; "On Union Square, a Sweeping Staircase and a Ballroom to Match," *New York Times* (December 7, 2000), F: 3; Abby Bussel, "Flower Power," *Interior Design* 72 (March 2001): S69–72; Peter Hall, "Spot On," *Interiors* 160 (March 2001): 76–79; Owen Phillips, "Olives," *New Yorker* 77 (March 26, 2001): 18; Donald Albrecht with Elizabeth Johnson, *New Hotels for Global Nomads* (London: Merrell Publishers, 2002), 90–93; *Pleasure: The Architecture and Design of Rockwell Group* (New York: Universe; London: Troika, 2002), 96–105.

35. Phillips, "Olives": 18.

36. Landmarks Preservation Commission of the City of New York, LP-1541 (September 6, 1988), 1, 6.

MADISON SQUARE

1. For Madison Square, see Stern, Gilmartin, and Massengale, *New York 1900*, 167, 173, 307; Stern, Gilmartin, and Mellins, *New York 1930*, 147, 150, 536–37; Stern, Mellins, and Fishman *New York 1960*, 23–25; Stern, Mellins, and Fishman, *New York 1880*, 39, 672–73, 695–705.

2. I. N. Phelps Stokes, *The Iconography of Manhattan Island*, 6 vols. (New York: Robert H. Dodd, 1915–1928; New York: Arno Press, 1967), vol. 5: 1803; Landmarks Preservation Commission of the City of New York, *Madison Square North Historic District Designation Report* (New York, 2001), 6–7.

3. For the Hippodrome and Madison Square Garden, see Stern, Mellins, and Fishman, *New York 1880*, 695–705.

4. For 1 Madison Avenue, see Stern, Gilmartin, and Massengale, *New York 1900*, 171–73, 176; Christopher Gray, "Streetscapes/Metropolitan Life at 1 Madison Avenue," *New York Times* (May 26, 1996), IX: 5. For the New York Life Insurance Building, see Stern, Gilmartin, and Mellins, *New York 1930*, 541–44. For 11 Madison Avenue, see Stern, Gilmartin, and Mellins, *New York 1930*, 535–37.

5. For the Leonard Jerome house and Merchandise Mart, see Stern, Mellins, and Fishman, *New York 1960*, 1125.

6. "Roger C. Ferri," *Architectural Design* 47 (June 1977): 401, 422; "Corporate Skyscraper at Madison Square," *Architecture + Urbanism* (June 1977): 94–95; Paul Goldberger, "Architectural Drawings Make Comeback to Respectability," *New York Times* (September 22, 1977), C: 16; Gerald Allen, "A Mountain for Madison Square," *New York* 11 (March 20, 1978): 57–60; Colin Amery, "Blooms in the Desert," *Financial Times* (London) (January 24, 1983): 13; Roger Ferri, "Garden Tower,"

Landscape Architecture 80 (December 1990): 37; James Wines, "The Presumption of Vision," *Landscape Architecture* 80 (December 1990): 51–52; Christopher Gray, "Streetscapes/-Appellate Division, 25th Street and Madison Avenue," *New York Times* (October 24, 1999), XI: 7. For the Appellate Court, see Stern, Gilmartin, and Massengale, *New York 1900*, 67–68, 71.

7. "Roger C. Ferri": 401.

8. Goldberger, "Architectural Drawings Make Comeback to Respectability": 16.

9. Shaman Stein and Richard Esposito, "A Little Boy's Final Agony: Mother Charged in Scalding Death of Son, 3," *Newsday* (March 24, 1988): 1.

10. Quoted in Carter B. Horsley, "SRO Hit List," *New York Post* (February 9, 1989): 55, 65.

11. Horsley, "SRO Hit List": 55, 65; "For the Prince George Hotel, a New Life," *New York Times* (August 3, 1997), IX: 1; Matthew Blanchard, "Rooms for Improvement," *City Limits* 24 (November 1999): 5; Jayne Merkel, "Dream Housing," *Oculus* 63 (October 2000): 8–9; David W. Dunlap, "A Future for Madison Square's Past," *New York Times* (July 15, 2001), XI: 1, 6.

12. Alan S. Oser, "Madison Square Park Enters Condominium Era," *New York Times* (October 1, 1982): 27.

13. Alan S. Oser, "New 42-Story Structure off Madison Square Park," *New York Times* (May 24, 1985), B: 5.

14. Nick Ravo, "New York City Lands New Cable Network," *New York Times* (February 12, 1994): 23; Eve M. Kahn, "A Chic TV Set with Tongue in Cheek," *New York Times* (June 2, 1994), C: 8; Edie Cohen, "fX Studios," *Interior Design* 65 (August 1994):70–75. For 212 Fifth Avenue, see *Madison Square North Historic District*, 71–72.

15. Marvine Howe, "A Cornfield in Manhattan?" *New York Times* (January 23, 1994), XIII: 8; "Harvesting Art, History and an Ear of Corn," *New York Times* (September 4, 1994), XIII: 9.

16. Herbert Muschamp, "Fleeting Homage to an Architect Who Only Dreams," *New York Times* (April 9, 1995), II: 40. Also see John Hejduk, *Mask of Medusa: Works, 1947–1983* (New York: Rizzoli International Universe, 1985), 148, 415; Sarah Amelar, "First Hejduk Structure Installed in New York City," *Architecture* 84 (June 1995): 26–27; Jayne Merkel, "John Hejduk's *Conciliator* on Madison Square," *Oculus* 57 (June 1995): 3.

17. Florence Fabricant, "Union Square Café Owner to Open Two Restaurants," *New York Times* (June 27, 1997), B: 5; Monica Geran, "Remembering Things Past," *Interior Design* 71 (November 2000): 110–13.

18. Danny Meyer, quoted in Monte Williams, "Madison Square Park to Regain Its 19th-Century Luster," *New York Times* (November 8, 1998): 44. Also see Monte Williams, "Giving Madison Square Park a Face (and a Facelift)," *New York Times* (June 25, 1995), XIII: 6; John Grobler, "Hope That Dingy Park Can Become Parklike," *New York Times* (July 21, 1996), XIII: 7; "Corrections," *New York Times* (July 28, 1996), XIII: 4; Rosalie R. Radomsky, "If You're Thinking of Living In/Madison Square," *New York Times* (September 28, 1997), IX: 3; Lisa Sanders, "Neighbors Reshape Madison Square Park," *Crain's New York Business* (November 9, 1998): 15; Robin Raisfeld, "The Green Marketer," *New York* 31 (November 23, 1998): 15–16; Joseph B. Treaster, "Restoring the Charm to Madison Square Park," *New York Times* (December 30, 1999), B: 6; White and Willensky, *AIA Guide* (2000), 198; Kelly Crow, "Idling Buses Leave a Stain of Pollution on a Jewel of a Park," *New York Times* (October 8, 2000): 7; "A Statue's Stature Renewed," *New York Times* (May 5, 2001), B: 7; "Taxi Shelter," *New York Times* (June 12, 2001): 1; Barbara Stewart, "Partnerships Restore City Parks, Within Limits," *New York Times* (June 12, 2001), B: 4; "A City Parks Revival," editorial, *New York Times* (June 13, 2001): 32; "Corrections," *New York Times* (June 18, 2001): 2.

19. Rachelle Garbarine, "A 48-Story Tower for a Low-Rise Neighborhood," *New York Times* (September 18, 1998), B: 8; Nina Rappaport, "Supportive Housing," *Oculus* 62 (April 2000): 4.

20. William L. Hamilton, "In a New Museum, a Blue Period," *New York Times* (March 11, 1999), F: 11; Susanna Sirefman, "New York City Set to Erect America's First Museum of Sexuality," *Architectural Record* 187 (May 1999): 107; Karrie Jacobs, "Champagne Design," *New York* 32 (May 17, 1999): 107; "SHoP-Sharples Holden Pasquarelli: Museum of Sex," *Architecture + Urbanism* (October 1999): 142–52; Michael Kimmelman, "What D'Ya Call a House of Sex? A Museum. Oh," *New York Times* (January 18, 2000), E: 1, 9; Anthony Lane, "Exhibitions for Exhibitionists," *New Yorker* 75 (January 31, 2000): 29–30; "The Smithsonian of Sex," *New Criterion* (February 2000): 180; Jayne Merkel, "Sex Show," *Details* (October 2000): 180; Jayne Merkel, "SHoP Talk," *Oculus* 63 (November 2000): 16; Clifford A. Pearson, "SHoP Pulls Disparate Pieces Together to Create a Practice-Driven Firm with Kick," *Architectural Record* 188 (December 2000): 124–27; Alan Balfour, *World Cities: New York* (New York: Wiley Academy, 2001), 236–39; Holly Obernauer, "A Model for Mosex," *Grid* 3 (September 2001): 86; Brian Carter and Annette Lecuyer, *All American: Innovation in American Architecture* (London: Thames & Hudson, 2002), 62–63; N. R. Kleinfeld, "Sex Sells, But Can It Sell a Museum?" *New York Times* (May 30, 2002), B: 4; Ralph Blumenthal, "Sex Museum Says It Is Here to Educate," *New York Times* (September 19, 2002), E: 1, 6; Julie Lasky, "Porno Graphics," *Metropolis* 22 (November 2002): 42; Ralph Blumenthal, "Sex Museum Reports Profitability," *New York Times* (November 19, 2002), E: 1; Ian Luna, ed., *New New York: Architecture of a City* (New York: Rizzoli International Publications, 2003), 129–30; Steve Kurutz, "The Museum of Sex Spends Its First Year with a Headache," *New York Times* (October 12, 2003), XIV: 5. For 233 Fifth Avenue, see "The Reform Club's Home: Planning Pleasant Quarters for Its Many Members," *New York Times* (April 18, 1890): 8; "Notes of the Campaign," *New York Times* (November 4, 1890): 5.

21. Daniel Gluck, quoted in Kimmelman, "What D'Ya Call a

House of Sex? A Museum. Oh'": 1, 9.

22. *Madison Square North Historic District*; Andrew Friedman, "10 Blocks of Commercial Hallmarks Transformed into Landmarks," *New York Times* (July 1, 2001), XIV: 5; Dunlap, "A Future for Madison Square's Past": 6.

23. Larry Rohter, "Baruch College Reveals a Plan for Expansion," *New York Times* (September 12, 1986), B: 3.

24. Charles K. Hoyt, "Cable-Car College," *Architectural Record* 183 (February 1995): 86–91; Nina Rappaport, "Academic Invasion," *Oculus* 60 (October 1997): 3; David W. Dunlap, "Baruch Builds an Urban Quadrangle," *New York Times* (November 29, 1998), XI: 1, 6; White and Willensky, *AIA Guide* (2000), 212.

25. Andrew White, "Board 6/Baruch Dormitories Planned for Sites of SRO's," *New York Observer* (October 21, 1991): 6; Anthony Ramirez, "Neighbors Feel Squeezed by Baruch's Tower Plan," *New York Times* (November 17, 1996), XIII: 9; *KPF: Selected and Current Works* (Mulgrave, Australia: Images Publishing, 1997), 90–94; "14-Story, $250 Million Academic Complex; An Urban Campus Begun for Baruch," *New York Times* (June 22, 1997), IX: 1; Graham Rayman, "Baruch Beginning Expansion Project," *New York Newsday* (June 25, 1997): 25; Rappaport, "Academic Invasion": 3; Michael Maynard, "III Programat Campus Buildings," *Architecture* 86 (November 1997): 131–32; Linda Sandler, "Architects Won; That News Is Too Good," *Wall Street Journal* (September 23, 1998), B: 12; Dunlap, "Baruch Builds an Urban Quadrangle": 1, 6; *KPF: The First 22 Years* (Milan: L'Arco Edizioni, 1999), 174–81; White and Willensky, *AIA Guide* (2000), 212; Nadine Brozan, "On CUNY's Campuses, the Subject Is Change," *New York Times* (September 17, 2000), XI: 1, 4; Balfour, *World Cities: New York*, 158–59; Karen W. Arenson, "Baruch College Opens a Huge 'Vertical Campus,'" *New York Times* (August 28, 2001), B: 4; "Baruch College Academic Center Illustrates Versatility of Steel," *Metals in Construction* (Fall 2001): 38–43; Jayne Merkel, "A New Kind of Vertical Campus," *Oculus* 64 (November 2001): 6; Ian Luna and Kenneth Powell, eds., *Kohn Pedersen Fox: Architecture and Urbanism, 1993–2002* (New York: Rizzoli International Publications, 2002), 218–33; Joseph Giovannini, "KPF New York: A Decade of Change," in Luna and Powell, eds., *Kohn Pedersen Fox: Architecture and Urbanism, 1993–2002*, 15–16; Carol Herselle Krinsky, "KPF: Solving Problems in Three Dimensions," in Luna and Powell, eds., *Kohn Pedersen Fox: Architecture and Urbanism, 1993–2002*, 21–22; Joseph Giovannini, "The Vertical Campus," *Architecture* 91 (October 2002): 62–67; Luna, ed., *New York*, 10, 124–29; "New Academic Complex, Baruch College, CUNY," *Architectural Record* 191 (May 2003): 133.

26. William Pedersen, quoted in "14-Story, $250 Million Academic Complex; An Urban Campus Begun for Baruch": 1.

27. Giovannini, "The Vertical Campus": 63.

MURRAY HILL

1. "Postings: Duplexes on Park," *New York Times* (July 22, 1984), VIII: 1; Kirk Johnson, "Transformation of Murray Hill 'Sliver,'" *New York Times* (February 22, 1985), B: 5; White and Willensky, *AIA Guide* (1988), 218; Ingrid Eisenstadter, "Murray Hill," *New York Times* (May 31, 1998), XIV: 6. For Lord's building, see "The Building Department," *New York Times* (August 19, 1898): 10.

2. White and Willensky, *AIA Guide* (1988), 218.

3. "Murray Hill Sliver: Under the Wire," *New York Times* (November 13, 1983), VIII: 1; Michael deCourcy Hinds, "Growing Pessimism Over the Mortgage-Rate Outlook Brings Rush to Build and Buy," *New York Times* (March 4, 1984), VIII: 1; Kirk Johnson, "Modern 'Sliver' Building Going Up in Murray Hill," *New York Times* (September 7, 1984), B: 5; Paula Rice Jackson, "Mixing Metaphors," *Interiors* 145 (June 1986): 150–61; White and Willensky, *AIA Guide* (2000), 242.

4. Harold Liebman, quoted in "Murray Hill Sliver: Under the Wire": 1. For Littel's Church of the Incarnation and parish house, see Stern, Mellins, and Fishman, *New York 1880*, 276–77, 279, 282.

5. Douglas C. McGill, "Morgan Library Names Scholar Its New Director," *New York Times* (May 27, 1987), C: 17; "Morgan Library Expanding," *New York Times* (April 20, 1988): 1; John Russell, "Morgan Library, in an Expansion, Is Buying a Neighboring Mansion," *New York Times* (April 20, 1988), C: 15; Michael Tomasky, "City News Digest," *New York Observer* (April 25, 1988): 6; "Museums in Expansion," *New York Observer* (October 10, 1988): 2; Suzanne Stephens, "A Tale of Two Landmarks," *Architectural Digest* 45 (November 1988): 108, 114, 118, 122, 124–25; Paul Goldberger, "Bridging Two Architectural Styles at the Morgan," *New York Times* (March 1, 1989), C: 17; "By the Book," *Architectural Record* 177 (May 1989): 55; "New Chapter for Morgan Library," *Art in America* 77 (June 1989): 37; Michael Wagner, "Works in Progress," *Interiors* 148 (July 1989): 138; "Work Starts on Morgan Library Addition," *New York Construction News* 37 (December 18–25, 1989): 1; Vanessa Giganò, "La Morgan Library si amplia," *Arca* 48 (April 1991): 48–53; Eleanor Blau, "As Reopening Nears, the Morgan Library Gets a Good Scrubbing," *New York Times* (August 8, 1991), C: 13; Paul Goldberger, "The New Season: Architecture: Critic's Choices," *New York Times* (September 8, 1991), II: 44; Michael Kimmelman, "The New Morgan Is More Museum, No Less Library," *New York Times* (September 29, 1991), II: 37; Verlyn Klinkenborg, "Belle of the Morgan Library," *House & Garden* 163 (October 1991): 73–74, 78; "A New Wing at the Pierpont Morgan Library," *Antiques* 140 (October 1991): 486, 488, 490; "Biblioteca Pierpont Morgan," *Spazio e Società* 56 (October-December 1991): 6–11; John Russell, "Expanded Facility Debuts Today a Bigger and Better Morgan Library," *Newsday* (October 1, 1991): 55; Benjamin Forgey, "At Home with J. P. Morgan," *Washington Post* (October 13, 1991), G: 1; Hilton Kramer, "The Vital Morgan of New York City Survives

Comprehensive Redesign," *New York Observer* (October 14, 1991): 1, 20; Roger Kimball, "Treasures from Mr. Morgan's Library," *Wall Street Journal* (October 18, 1991): 12; Kay Larson, "Master Mind," *New York* 24 (October 28, 1991): 83; Homan Potterton, "Letter from New York: The Morgan Library Expands," *Apollo* 134 (November 1991): 361; "Museum Update," *Oculus* 54 (November 1991): 4; Paul Goldberger, "J. P. Morgan's House Is Back," *New York Times* (November 3, 1991), II: 36; "The House of Morgan, Doubled," editorial, *New York Times* (November 8, 1991): 26; Kenneth Baker, "Reopening of Larger Morgan Library," *San Francisco Chronicle* (December 7, 1991), C: 3; Clifford A. Pearson, "Bound Volumes," *Architectural Record* 180 (January 1992): 98–105; Michael J. Crosbie, "Glass Artistry," *Architecture* 81 (January 1992): 93–96; Bartholomew Voorsanger, "Wall Eyed," letter to the editor, *Architectural Record* 180 (March 1992): 4; "Una Serra di Libri," *Abitare* 312 (November 1992): 153–56; "Pierpoint [sic] Morgan Library Atrium," *Process Architecture* 108 (February 1993): 106–9; *The Pierpont Morgan Library: Garden Court and Master Plan Extension* (New York: USA Books, 1996); Susanna Sirefman, *New York: A Guide to Recent Architecture* (London: Ellipsis, 1997), 106–7; Dan Kiley and Jane Amidon, *Dan Kiley: The Complete Works of America's Master of Landscape Architect* (Boston: Little, Brown and Co., 1999), 215; White and Willensky, *AIA Guide* (2000), 242.

6. For McKim, Mead & White's Morgan Library, see Stern, Gilmartin, and Massengale, *New York 1900*, 102–5. For Morris's Annex, see Stern, Gilmartin, and Mellins, *New York 1930*, 137.

7. Charles E. Pierce Jr., quoted in Russell, "Morgan Library, in an Expansion, Is Buying a Neighboring Mansion": 15.

8. See Stern, Mellins, and Fishman, *New York 1960*, 1107.

9. Bartholomew Voorsanger, quoted in *The Pierpont Morgan Library: Garden Court and Master Plan Extension*, 34, 37.

10. Bartholomew Voorsanger, quoted in *The Pierpont Morgan Library: Garden Court and Master Plan Extension*, 38.

11. Goldberger, "Bridging Two Architectural Styles at the Morgan": 17.

12. Alexander, "New Chapter for Morgan Library": 37.

13. Bartholomew Voorsanger, quoted in *The Pierpont Morgan Library: Garden Court and Master Plan Extension*, 38.

14. For Gilbert's building, see Landmarks Preservation Commission of the City of New York, LP-0884 (March 25, 1975); Barbaralee Diamonstein, *The Landmarks of New York III* (New York: Harry N. Abrams, 1998), 261.

15. Forgey, "At Home with J. P. Morgan": 1.

16. Pearson, "Bound Volumes": 99, 104.

17. Goldberger, "J. P. Morgan's House Is Back": 36.

18. Kramer, "The Vital Morgan of New York City Survives Comprehensive Redesign": 1, 20.

19. Kimball, "Treasures from Mr. Morgan's Library": 12.

20. David W. Dunlap, "A Plan Unfolds for a $75 Million Morgan Makeover," *New York Times* (January 30, 2002), B: 3; Herbert Muschamp, "A Courtyard at the Heart of the Story," *New York Times* (February 10, 2002), II: 36; David W. Dunlap, "City Clears Morgan Library Plan," *New York Times* (March 1, 2002), B: 2; David Sokol, "Piano's Morgan Addition Approved," *Architectural Record* 190 (April 2002): 26; Philip Jodidio, *Piano: Renzo Piano Building Workshop 1966–2005* (Cologne: Taschen, 2005), 484–87.

21. "From French Neo-Classicism to Zinc, Spruce and Glass on Park Ave.: A New Scandinavia House," *New York Times* (February 14, 1999), XI: 3; Soren Larsen, "New York Meets Norwegian Wood: The Scandinavia House Design," *Architectural Record* 186 (July 1999): 60; "Scandinavia House to Rise on Park Ave.," *New York Construction News* 48 (August 1999): 11; White and Willensky, *AIA Guide* (2000), 243; Andrea Codrington, "Norse Recourse," *Interiors* 159 (October 2000): 30–31; Edward Wong, "From Ingmar to Ikea, New Center Gives City a Nordic Touch," *New York Times* (October 18, 2000), B: 4; Roberta Smith, "A Smorgasbord of Nifty Ideas," *New York Times* (November 3, 2000), E: 31, 34; James Gardner, "At Scandinavia, Photo Museums, Geometry Is Destiny," *New York Observer* (November 13, 2000): 12; Amanda May, "New York on Display," *Grid* 3 (March 2001): 30–31; Ian Luna, ed., *New New York: Architecture of a City* (New York: Rizzoli International Publications, 2003), 132–35.

22. For 58 Park Avenue, see Michael C. Kathrens, *American Spendor: The Residential Architecture of Horace Trumbauer* (New York: Acanthus Press, 2002), 325. For 56 Park Avenue, see "Park Ave. Rectory Leased by Trinity," *New York Times* (December 22, 1937): 48; Michael Goodwin, "East Germans Finesse the Mess Next Door by Buying It," *New York Times* (January 22, 1978), VIII: 1.

23. James Stewart Polshek, quoted in "From French Neo-Classicism to Zinc, Spruce and Glass on Park Ave.: A New Scandinavia House": 1.

24. James Stewart Polshek, quoted in "Nordic Flair": 30.

25. For Larsen's building, see Penny McGuire, "Design Counsel," *Architectural Review* 208 (July 2000): 84–86.

26. Smith, "A Smorgasbord of Nifty Ideas": 31.

27. Gardner, "At Scandinavia, Photo Museums, Geometry Is Destiny": 12.

28. "Japanese Hotel Growing," *New York Times* (January 27, 1991), X: 1; "The Kitano Hotel Reopens with New Look and New Goal," *New York Times* (July 16, 1995), XIII: 4; Jean Gorman, "The Kitano New York Hotel," *Interiors* 155 (February 1996): 102–7. For the Murray, see "To Open the Murray Jan. 1," *New York Times* (December 19, 1926): 21; James Trager, *Park Avenue: Street of Dreams* (New York: Atheneum, 1990), 224.

29. William R. Greer, "Warhol Has Plans for Substation," *New York Times* (November 22, 1981), VIII: 10; Pilar Viladas, "Power House," *Progressive Architecture* 64 (September 1983): 88–93; Victor Bockris, *The Life and Death of Andy Warhol*

(New York: Bantam Books, 1989), 457–58, 462–63, 471; White and Willensky, *AIA Guide* (2000), 240; "Warhol at the Factory," *Via Arquitectura* 11 (May 2002): 9–13.

30. Viladas, "Power House": 92.

RIVER WALK

1. "East River Project," *New York Times* (November 28, 1979), B: 5; Joyce Purnick, "City Weighing Proposals for an East River Project," *New York Times* (April 16, 1980), B: 3; Joyce Purnick, "A Decision Nears on Complex Plan for Project on East River," *New York Times* (June 11, 1980), B: 1, 8; Joyce Purnick, "East River Plan Wins Limited Support," *New York Times* (June 20, 1980), B: 3; "How Not to Plan a City," editorial, *New York Times* (June 21, 1980): 22; "The Lengthy Road to Approval," *New York Times* (June 21, 1980): 27; Paul Goldberger, "Decision Nears for Gracing East River," *New York Times* (June 21, 1980): 27; "The City Planning Lesson, Cont'd," editorial, *New York Times* (June 27, 1980): 30; "Koch Delays River Project Decision," *New York Times* (June 28, 1980): 25; Paul Goldberger, "Mayor's Choice for Riverfront Appears to Offer Something for Everyone," *New York Times* (July 18, 1980), B: 3; Robert McG. Thomas Jr., "Multi-Use Plan Along East River Picked by Koch," *New York Times* (July 18, 1980): 1, B: 3; "Cadillac Fairview Group Wins Major New York Project," *Wall Street Journal* (July 18, 1980): 23; Dorothy Galter and Alvin Davis, "A Mixed Bag for Development along East River," *New York Times* (July 20, 1980), IV: 6; "Buildings in the News," *Architectural Record* 168 (August 1980): 45; Anthony Dearden, "Realty or Parks for East River Waterfront," letter to the editor, *New York Times* (August 8, 1980): 28; William G. Blair, "Should Architects Become Builders and Developers?" *New York Times* (August 10, 1980), VIII: 1, 10; Joyce Purnick, "City Sued on Waterfront Plan," *New York Times* (October 11, 1981): 54; Michael Oreskes, "Plan for East River Housing Loses Key Financial Backer," *New York Times* (July 31, 1982): 29; Richard Levine and William C. Rhoden, "East Side Project Loses Developer," *New York Times* (August 1, 1982), IV: 6; Diane Henry, "Developer Adjusts to Recession," *New York Times* (October 6, 1982), D: 26; William G. Blair, "City Reports Accord with Developer for East River Complex," *New York Times* (November 4, 1983), B: 3; Ruth Shereff, "River Walk Livens Pace," *Manhattan, inc.* 3 (August 1986): 11; Joseph Giovannini, "New York Harbor Being Redesigned," *New York Times* (November 11, 1986), B: 1–2; Andrew Rosenthal, "Tucked Away on East Side, 2 Communities Resist Project," *New York Times* (April 21, 1987), B: 1–2; "Piling It On in the East River," *Avenue* (May 1987): 120; Albert Scardino, "Cities in the Sky, Skyscrapers by the Acre," *New York Times* (May 17, 1987), IV: 28; Alan S. Oser, "Perspectives: Waterfront Development," *New York Times* (November 29, 1987), VIII: 3, 14; Susan Braybrooke, "Two Old Hands Talk About Housing," *Architectural Record* 176 (February 1988): 122–27; Daniel J. McConville, "Hurrahs and Hisses in Midtown," *New York Post* (January 5, 1989): 46; Karen Cook, "Waterfront Projects," *New York Post* (January 12, 1989): 50; Doug Turetsky, "Riverwalk Still Floats," *City Limits* 13 (August-September 1988): 8–10; Charles V. Bagli, "Moynihan vs. Koch: Mayor Is Thwarted on Tax Bill Favor," *New York Times* (November 14, 1988): 1, 8; Thomas J. Lueck, "Koch Ends Support for River Projects," *New York Times* (January 6, 1989), B: 3; Karen Cook, "High and Dry," *New York Post* (January 12, 1989): 51; Thomas J. Lueck, "Koch Looks to Rivers for Development," *New York Times* (January 12, 1989), X: 1, 19; Michael Tomasky, "Controversial Projects Await the Next Mayor," *New York Observer* (October 16, 1989): 11; Michael Wise, "Modest Endeavors," in Kevin Bone, ed., *The New York Waterfront: Evolution and Building Culture of the Port and Harbor* (New York: Monacelli Press, 1997), 238; Ann L. Buttenwieser, *Manhattan Water-Bound*, 2nd ed. (New York: Syracuse University Press, 1999), 6–7, 210–11, 229–35, 238–41, 250.

2. See Stern, Mellins, and Fishman, *New York 1960*, 278–85, 291–94.

3. Goldberger, "Decision Nears for Gracing East River": 27.

4. Goldberger, "Decision Nears for Gracing East River": 27.

5. "How Not to Plan a City": 22.

6. Goldberger, "Mayor's Choice for Riverfront Appears to Offer Something for Everyone": 3.

7. "Public Interest," *New York Times* (October 30, 1994), XIII: 7; *Stuyvesant Cove 197-a Plan* (New York: Department of City Planning, 1997), 1–2, fig. 8.

8. *Stuyvesant Cove 197-a Plan*; Bernard Stamler, "Park to Grow on the Ashes of the Riverwalk Plan," *New York Times* (October 26, 1997), XIV: 6; Buttenwieser, *Manhattan Water-Bound*, 259–61; Karina Lahni, "Board Faces Quandary: Don't Ask for Something . . . ," *New York Observer* (April 23, 2001): 22; Deborah Snoonian, "Architecture Rediscovers Being Green," *Architectural Record* 189 (June 2001): 86–96; Raymond W. Gastil, *Beyond the Edge: New York's New Waterfront* (New York: Princeton Architectural Press, 2002), 143–44; Erika Kinetz, "Neighborhood Report: East Side," *New York Times* (January 13, 2002), XIV: 6.

9. *Richard Dattner* (Mulgrave, Australia: Images Publishing, 2000), 172–73; Rosalie R. Radomsky, "Con Ed Station on East 16th Street," *New York Times* (April 14, 2002), XI: 1.

KIPS BAY

1. For Bellevue Hospital, see Stern, Mellins, and Fishman, *New York 1880*, 254–57.

2. For development of Kips Bay in the 1960s and 1970s, see Stern, Mellins, and Fishman, *New York 1960*, 285–90.

3. Alan S. Oser, "Zone Shift Spurs Housing on East Side," *New York Times* (September 12, 1986): 24.

4. Susan Heller Anderson, "Luxury Housing Is Being Erected on the East Side," *New York Times* (March 8, 1983), B: 3; Alan S. Oser, "Housing Construction near East River," *New York Times* (March 11, 1983), B: 7; Oser, "Zone Shift Spurs Housing

on East Side": 24; Jerold S. Kayden, *Privately Owned Public Space: The New York Experience* (New York: John Wiley, 2000), 197–98; White and Willensky, *AIA Guide* (2000), 219; *Thomas Balsley: The Urban Landscape* (San Francisco: Spacemaker Press, 2001), 12–13, 72.

5. Anderson, "Luxury Housing Is Being Erected on the East Side": 3; Oser, "Housing Construction near East River": 7; "Manhattan Tower Is Under Way," *Building Design and Construction* 24 (June 1983): 17; Dee Wedemeyer, "Lobbies with Stellas: The Developers' Choice," *New York Times* (May 12, 1985), XII: 7; Kayden, *Privately Owned Public Space*, 197; *Thomas Balsley: The Urban Landscape*, 12–13, 72.

6. Kayden, *Privately Owned Public Space*, 197.

7. Kayden, *Privately Owned Public Space*, 201; White and Willensky, *AIA Guide* (2000), 220.

8. "400 Condominiums; Midtown Tower," *New York Times* (April 8, 1984), VIII: 1; Michael J. Crosbie, *The Architecture of Frank Williams* (Rockport, Mass.: Rockport Publishers, 1997), 126–29; Kayden, *Privately Owned Public Space*, 207.

9. Joseph Berger, "Airlines Terminal on East Side Sold for $90.6 Million," *New York Times* (February 14, 1985): 1, B: 7; Oser, "Zone Shift Spurs Housing on East Side": 24; Robert Campbell, "'Suburban' Tower Is All Take and Very Little Give Standing Small in Manhattan," *Boston Globe* (July 21, 1987): 57; Diana Shaman, "2 Blocks of First Avenue Become a Neighborhood," *New York Times* (April 29, 1988), B: 14; Richard D. Lyons, "New Look in Lobbies: Glitzy Eclectic," *New York Times* (July 24, 1988), X: 1, 14; Robert P. Metzger, *Der Scutt Retrospective* (Reading, Penn.: Reading Public Museum, 1996), 54–55; Kayden, *Privately Owned Public Space*, 202; *Thomas Balsley: The Urban Landscape*, 12–13, 73. For the East Side Airlines Terminal, see Stern, Mellins, and Fishman, *New York 1960*, 301–3.

10. For the Rockefeller Apartments, see Stern, Gilmartin, and Mellins, *New York 1930*, 421–24.

11. Carter B. Horsley, "The Midtown Book: The List," in http://www.thecityreview.com.

12. White and Willensky, *AIA Guide* (1988), 220.

13. Campbell, "'Suburban' Tower Is All Take and Very Little Give Standing Small in Manhattan": 57.

14. Carter B. Horsley, "The Highpoint," in www.cityrealty.com.

15. Oser, "Zone Shift Spurs Housing on East Side": 24; Shaman, "2 Blocks of First Avenue Become a Neighborhood": 14; White and Willensky, *AIA Guide* (2000), 219.

16. "East Side's Top Growth," *Manhattan, inc.* 3 (October 1986): 16; "East River Esplanade," *Landscape Architecture* 79 (October 1989): 18; "East River Esplanade Park," *Clem Labine's Traditional Building* 9 (September/October 1996): 76; Paul Bennett, "An Island unto Itself," *Landscape Architecture* 89 (July 1999): 64–75, 94–95; *Thomas Balsley: The Urban Landscape*, 32–35, 73; Jayne Merkel, "At the Water's Edge," *Oculus* 64 (November 2001): 10–11.

17. Alan S. Oser, "Murray Hill Building at a Turning Point," *New York Times* (March 10, 1991), X: 7; Josh Barbanel, "Inside a Condo, a Not-So-Civil War," *New York Times* (March 27, 2005), XI: 1, 7.

18. For the Paramount Tower, see Rachelle Garbarine, "Smaller Building with Bigger Apartments," *New York Times* (June 20, 2000), B: 6. For the Montrose, see "20-Story Rental Between Second and First Avenues," *New York Times* (January 9, 2000), XI: 1; Garbarine, "Smaller Building with Bigger Apartments": 6; *Marvin H. Meltzer: City as Poetry* (Milan: L'Arca Edizioni, 2002), 74–77.

19. Marvin Meltzer, quoted in "20-Story Rental Between Second and First Avenues": 1.

20. For New York University Medical Center, see Stern, Mellins, and Fishman, *New York 1960*, 285–88. For Kips Bay Plaza, see Stern, Mellins, and Fishman, *New York 1960*, 287–88.

21. White and Willensky, *AIA Guide* (2000), 218.

22. "New York University Medical Center Biomedical Research/Mixed-Use Building," *Architecture + Urbanism* (November 1990): 122–26; "Skirball Institute and Residential Tower," *Architecture* 82 (March 1993): 126; Katherine Kai-sun Chia, "A Slim Tower Packages Multiple Functions," *Architectural Record* 182 (July 1994): 36–41; Susanna Sirefman, *New York: A Guide to Recent Architecture* (London: Ellipsis, 1997), 102–5; White and Willensky, *AIA Guide* (2000), 218.

23. Sirefman, *New York*, 102.

24. "Science Center Plan Calls for More Data," *New York Observer* (July 23, 2001): 9; "Biotech Plan," *Crain's New York Business* (October 22, 2001): 43; Nadine Brozan, "At N.Y.U. Medical School, by the F.D.R. Drive: A New 13-Story Tower for Biomedical Research," *New York Times* (December 2, 2001), XI: 1.

25. Peter Slatin and Suzanne Stephens, "Around New York: Renovations," *Oculus* 56 (May 1994): 3; Gale Scott, "Arched Brows at Bellevue: Timing of $1.5 M Entranceway 'Unfortunate' in Face of Squeeze," *Newsday* (November 3, 1994), B: 7; White and Willensky, *AIA Guide* (2000), 217–18. For the parking garage, see Stern, Mellins, and Fishman, *New York 1960*, 287.

26. Bernard Stamler, "Board vs. Children's Shelter," *New York Times* (February 15, 1998), XIV: 9; Bernard Stamler, "Battle on 2 Fronts over Planned Shelter for Children," *New York Times* (October 11, 1998), XIV: 6; Dan Barry and Nina Bernstein, "Questions Clouding Future of Men's Shelter at Bellevue," *New York Times* (January 21, 1999), B: 1, 6; Jayne Merkel, "Introduction," in *Richard Dattner: Selected and Current Works of Richard Dattner & Partners Architects* (Mulgrave, Australia: Images Publishing, 2000), 14, 114–15; "On the Drawing Boards," *Oculus* 62 (March 2000): 5; "New York Administration for Children's Services New Intake Center & Training Facility," *New York Construction News* 48 (June 2001): 41; Nina Bernstein, "New Center for Foster Children Echoes Changes in an Agency," *New York Times* (June 1, 2001), B: 3; Elaine Louie, "Designed to Be Almost as

Welcoming as a Mother's Arms," *New York Times* (September 6, 2001), F: 10.

27. Richard Dattner, quoted in Louie, "Designed to Be Almost as Welcoming as a Mother's Arms": 10.

28. Andrew Friedman, "Bellevue's Idea of Modern Is an Eyesore to Some Neighbors," *New York Times* (March 25, 2001), XIV: 6; Kelly Crow, "City Is to Build the Largest DNA Lab, for a Grim Task," *New York Times* (October 7, 2001), XIV: 7.

DIPLOMATIC COMMUNITY?

1. For the United Nations headquarters and the growth of its immediate vicinity, see Stern, Mellins, and Fishman, *New York 1960*, 600–39.

2. Kathleen Teltsch, "New 39-Story U.N. Tower Planned: To Be Topped by a 10-Story Hotel," *New York Times* (May 1, 1980), B: 1, 5; Paul Goldberger, "Frank Lloyd Wright Is Clearly the Man of the Year," *New York Times* (September 11, 1983), II: 39; Paul Goldberger, "Romanticism Is the New Motif in Architecture," *New York Times* (October 23, 1983), II: 1, 35; David Newell, "Waging Peace in the United Nations," *New York Times* (November 13, 1983), VIII: 7; "A Glassy Triumph," *New York Times* (November 18, 1983): 34; Andrea Oppenheimer Dean, "Angular Sculpture Completed," *Architecture* 73 (May 1984): 252–57; Francesco Dal Co, *Kevin Roche* (New York: Rizzoli International Publications, 1985), 13–15, 160–65; "United Nations Plaza," *Architecture + Urbanism*, extra edition (August 1987): 88–97; Paul Goldberger, "Kevin Roche Finishes a Trio and Changes His Tune," *New York Times* (November 29, 1987), II: 42, 44; "United Nations Plaza, New York, 1976–1983," *Architecture + Urbanism*, extra edition (April 1988): 206; Ashley Dunn, "New York City Seeks to Sell U.N. Plaza Hotel to Help Close Deficit," *New York Times* (June 7, 1994), B: 3; Eric P. Nash, *Manhattan Skyscrapers* (New York: Princeton Architectural Press, 1999), 139–40; White and Willensky, *AIA Guide* (2000), 304–5; Mario Campi and ETH Zurich Department of Architecture, *Skyscrapers: An Architectural Type of Modern Urbanism* (Basel: Birkhauser, 2000), 96–97; Heinrich Klotz, *The History of Postmodern Architecture* (Cambridge, Mass.: MIT Press, 2002), 66, 79–80. For One United Nations Plaza, see Stern, Mellins, and Fishman, *New York 1960*, 636–39.

3. Kevin Roche, quoted in Dean, "Angular Sculpture Completed": 252. For Roche's 1969 plan, see Stern, Mellins, and Fishman, *New York 1960*, 632.

4. Dean, "Angular Sculpture Completed": 252.

5. Goldberger, "Frank Lloyd Wright Is Clearly the Man of the Year": 39.

6. Goldberger, "Kevin Roche Finishes a Trio and Changes His Tune": 42.

7. "Phase III: U.N. Project," *New York Times* (April 7, 1985), VIII: 1; Michael deCourcy Hinds, "On E. 44th St., Construction Never Ceases," *New York Times* (June 11, 1985), B: 1, 4; Paul Goldberger, "Kevin Roche Finishes a Trio and Changes His Tune," *New York Times* (November 29, 1987), II: 42, 44; Paul Goldberger, "When the Tide Turned on Rampant Growth," *New York Times* (December 27, 1987), II: 34, 37; "UNICEF Headquarters," *Architecture + Urbanism* (April 1988): 68–69, 102–9; Jerold S. Kayden, *Privately Owned Public Space: The New York Experience* (New York: John Wiley, 2000), 212; White and Willensky, *AIA Guide* (2000), 304–5. For the Beaux Arts Apartments, see Stern, Gilmartin, and Mellins, *New York 1930*, 396–99.

8. Goldberger, "Kevin Roche Finishes a Trio and Changes His Tune": 42.

9. Kevin Roche, quoted in "Kevin Roche on Design and Building; Conversation with Francesco Dal Co," in Dal Co, *Kevin Roche*, 43.

10. Kathleen Teltsch, "Uganda Building at U.N. to Exceed That of the U.S.," *New York Times* (January 7, 1977): 1, 4; Ada Louise Huxtable, "When Things Get This Bad You Have to Laugh," *New York Times* (February 6, 1977): 31; Neal Travis, "Idi Diplomacy from New York Visit," *New York* 11 (September 18, 1978): 6; Kathleen Teltsch, "Uganda's New U.N. Mission Is a Monument to Idi Amin," *New York Times* (April 3, 1979): 2; "Amin's Photo Falls at U.N. Office," *New York Times* (April 13, 1979): 2; Kathleen Teltsch, "14-Story Monument Built for Amin Displays Its Structural Shortcomings," *New York Times* (October 18, 1980): 27.

11. For the United States Mission to the United Nations, see Stern, Mellins, and Fishman, *New York 1960*, 628–29.

12. Huxtable, "When Things Get This Bad You Have to Laugh": 31.

13. Teltsch, "14-Story Monument Built for Amin Displays Its Structural Shortcomings": 27, 30.

14. Kathleen Teltsch, "Libyan Government Plans to Build 23-Story Tower on East 48th Street," *New York Times* (October 29, 1979): 1, B: 6; William G. Blair, "Construction Update; Libya House Work Set," *New York Times* (September 14, 1980), VIII: 6; Kathleen Teltsch, "Government Building for U.N. Delegations," *New York Times* (February 15, 1981), VIII: 9.

15. For Stubbins's Federal Reserve Bank, see Mildred F. Schmertz, "Designing Everything Down to the Last Detail," *Architectural Record* 164 (September 1978): 109–18.

16. Teltsch, "Governments Building for U.N. Delegations": 9.

17. Audrey Farolino, "Nations Build Their Own Digs," *New York Post* (October 27, 1988): 57, 71; White and Willensky, *AIA Guide* (2000), 305.

18. "Excavation Starts in N.Y. for a New Indian Mission," *New York Construction News* 37 (September 18, 1989): 1, 19; Peter Slatin, "Muscling in on Midtown: Three New High-Rises," *Oculus* 55 (June 1993): cover, 6–7; Philip Arcidi, "Correa's Indian Mission Opens in Manhattan," *Progressive Architecture* 74 (June 1993): 23; *Charles Correa* (London: Thames & Hudson, 1996), 108–15, 258; Susanna Sirefman, *New York: A Guide to Recent Architecture* (London: Ellipsis,

1997), 160–61; White and Willensky, *AIA Guide* (2000), 302; Alan Balfour, *World Cities: New York* (New York: Wiley Academy, 2001), 145; Georges Binder, ed., *Sky High Living* (Mulgrave, Australia: Images Publishing, 2002), 56–57.

19. *Charles Correa*, 114.

20. Sirefman, *New York*, 160.

21. Claudia H. Deutsch, "Marketing Target: Foreign Missions," *New York Times* (October 17, 1993), X: 1; Peter Grant, "Germany to Build 30M Tower," *New York Daily News* (April 22, 1996): 39; "23-Story Building to Go Up near United Nations: $30 Million Office Tower for German Government," *New York Times* (April 28, 1996), IX: 1; White and Willensky, *AIA Guide* (2000), 306.

22. "Republic of Korea Permanent Mission to the United Nations," in www.pcfandp.com.

23. "Gwathmey Siegel to Do Building Near U.N.: Architect Set for U.S. Mission," *New York Times* (August 23, 1998), VIII: 1; "On a Mission," *Architectural Record* 186 (September 1998): 60; "Gwathmey Siegel Names U.S. Mission Architecture," *New York Construction News* 46 (November 1998): 15; Nina Rappaport, "Grab Bag of Commissions and Completions," *Oculus* 61 (November 1998): 4; Diana Estigarribia, "U.S. Mission in Turtle Bay: Building a New Building," *New York Observer* (May 24, 1999): 13; Karina Lahni, "Their Mission: To Grow U.S. Presence at U.N.," *New York Observer* (June 25, 2001): 10; Jonathan Mahler, "Gotham Rising," *Talk* (December 2001-January 2002): 120–25, 148–52; Herbert Muschamp, "The Bruisers Play Defense, the Seducers Trap the Eye," *New York Times* (February 3, 2002), II: 31; Barbara A. Nadel, "Building for a Secure Future," *Engineering News-Record* 248 (March 25, 2002): 13; Philip Nobel, "Diplomatic Immunity," *Metropolis* 22 (October 2002): 84, 86; Brad Collins, ed., *Gwathmey Siegel: Buildings and Projects, 1992–2002* (New York: Rizzoli International Publications, 2003), 334–39, 362. For the 1961 mission, see Stern, Mellins, and Fishman, *New York 1960*, 628–29.

24. Muschamp, "The Bruisers Play Defense, the Seducers Trap the Eye": 31.

25. Charles Gwathmey, quoted in Nobel, "Diplomatic Immunity": 85.

26. Muschamp, "The Bruisers Play Defense, the Seducers Trap the Eye": 31.

27. White and Willensky, *AIA Guide* (2000), 305–6. Also see George W. Goodman Jr., "Hammarskjold Tower Planned," *New York Times* (April 26, 1981), VIII: 10; Alan S. Oser, "New Manhattan Apartments Are Bigger," *New York Times* (September 25, 1981), B: 12; Kayden, *Privately Owned Public Space*, 214–15;

28. Paul Goldberger, "Defining Luxury in New York's New Apartments," *New York Times* (August 16, 1984), C: 1, 8. Also see "On 2d; Crowning Touch," *New York Times* (January 22, 1984), VIII: 1; White and Willensky, *AIA Guide* (2000), 311.

29. Lee A. Daniels, "A Condominium of Glass to Be Erected Near U.N.," *New York Times* (August 19, 1983), B: 5; "Making a Point," *Architectural Record* 171 (November 1983): 57; "100 United Nations Plaza Tower," *Architecture + Urbanism* (July 1984): 89; "100 United Nations Plaza Tower, Der Scutt Architect," *Process Architecture* 64 (January 1986): 120; Philip S. Gutis, "Amenity: East Side Park," *New York Times* (March 30, 1986), VIII: 1; Robert P. Metzger, *Der Scutt Retrospective* (Reading, Pa.: Reading Public Museum), 50; White and Willensky, *AIA Guide* (2000), 306.

30. Der Scutt, quoted in Daniels, "A Condominium of Glass to Be Erected Near U.N.": 5.

31. Donald J. Trump with Kate Bohner, *Trump: The Art of the Comeback* (New York: Random House, 1997), 215, 230; Peter Grant, "Donald Hoping to Cash in on Condo," *New York Daily News* (April 29, 1997): 33; Peter Grant, "Fewer Holes in Mogul's Net," *New York Daily News* (May 3, 1997): 5; Tracie Rozhon, "A New Trump Tower Could Overshadow Diplomacy," *New York Times* (September 12, 1997), B: 6; Charles V. Bagli, "Trump Starts a New Tower Near the U.N.," *New York Times* (October 3, 1998), B: 1, 6; Mark Tran, "Trump Plans to Tower over UN in New York," *The Guardian* (October 17, 1998): 3; David L. Hunter, "More Exciting Skyline," letter to the editor, *New York Times* (October 21, 1998): 24; Philip K. Howard and Michael B. Gerrard, "The Unstoppable Shadow," *New York Times* (October 21, 1998): 25; Randy Kennedy, "When Scraping the Sky Makes a City Bleed," *New York Times* (October 23, 1998), B: 2; "Trump to Build Residential Tower," *Newsday* (October 30, 1998), C: 3; Marc Hochstein, "German Bank Finances Huge Trump Project," *American Banker* (November 24, 1998): 5; Karrie Jacobs, "Ich Bein ein New Yorker," *New York* 31 (November 30, 1998): 36, 38, 40; Julie Lipper, "Trump vs. the World: U.N. Wants to Strike His 90-Story Building," *New York Observer* (November 30, 1998): 1, 6; "Towering Above the Rest," *Building Design & Construction* 39 (December 1998): 12; "In the Public Realm," *Oculus* 61 (December 1998): 5; Julie Lipper, "Walter Cronkite and Mrs. Newhouse May Sue Trump Over 'Gross' Tower," *New York Observer* (December 14, 1998): 1, 29; Charles V. Bagli, "Big Names Line up Against Trump Tower Near U.N.," *New York Times* (December 20, 1998): 49, 63; Caroline C. Pam, "Anti-Trump Groups Feel Snubbed as Politicians Meet Without Them," *New York Observer* (January 25, 1999): 9; Charles V. Bagli, "City Urged to Revoke Permit for Trump Tower Near U.N.," *New York Times* (February 5, 1999), B: 5; Donald B. Bady, "Too Tall a Tower," letter to the editor, *New York Times* (February 12, 1999): 26; Sidney Sisk, "Trump's New Tower May Enrich City Life," letter to the editor, *New York Times* (February 14, 1999): 12; "Trump's Towering Ego," editorial, *New York Observer* (February 15, 1999): 4; Paul Goldberger, "The Sky Line: Zone Defense," *New Yorker* 75 (February 22-March 1, 1999): 176–81; Terry Pristin, "Trump Tower Would Lie in Path of Pollution, Critics Assert," *New York Times* (February 26, 1999), B: 2; "City Upholds Permit for

Trump Building," *New York Times* (April 23, 1999), B: 11; Matthew L. Wald, "Trump's Giant Tower Near U.N. Attracts F.A.A.'s Attention," *New York Times* (June 17, 1999), B: 6; Mildred F. Schmertz, "Will a Reformed Zoning Resolution Reform Donald Trump?" *Oculus* 61 (Summer 1999): 10–11; Devin Leonard, "Dug in, Trump Battles Walter Cronkite Group over His Big, Big Tower," *New York Observer* (July 12, 1999): 1, 11; Rebecca Gardyn, "Walter Cronkite Battles South Korean Backers of Trump Supertower," *New York Observer* (August 16, 1999): 1, 18; Blaine Harden, "A Bankroll to Fight a Behemoth," *New York Times* (September 8, 1999): B: 1, 9; Seth W. Pinsky, "In New York, You Just Can't Stop Progress," letter to the editor, *New York Times* (September 10, 1999): 24; Diana Maxtone-Graham, "Modern-Day Pharaoh," letter to the editor, *New York Times* (September 10, 1999): 24; "A Victory for Trump and a Residential Tower," *New York Times* (September 29, 1999), B: 6; "Battle Over Trump Tower Continues . . . ," *Municipal Art Society Newsletter* (October 1999); "NY Comes up Trump's," *Building Design* (October 8, 1999): 5; Leslie Eaton, "Neighborhood Coalition Sues Over Trump Building Project," *New York Times* (October 26, 1999), B: 9; Devin Leonard, "Trump's Good Cop Eyes Deal with Tower Foes," *New York Observer* (November 15, 1999): 9; Terry Pristin, "Judge Dismisses Lawsuit by Foes of Trump Project," *New York Times* (December 2, 1999), B: 3; "All Donald, All the Time," *Grid* 1 (Winter 1999): 23; White and Willensky, *AIA Guide* (2000), 306; Lloyd Chrein and Linda Alexander, "Coddling for Condos," *Grid* 2 (January-February 2000): 94–96; Peter Slatin, "Block Buster," *Grid* 2 (January-February 2000): 70–72; Andrew Rice, "The Tummler of Turtle Bay," *New York Observer* (March 6, 2000): 25, 27; "New York City's New Dreams," editorial, *New York Times* (March 26, 2000), IV: 16; Peggy Edersheim Kalb, "The Next Best Things," *New York* (April 10, 2000): 60; Alex Ulam, "Trump This," *Metropolis* 20 (August-September 2000): 38; Deborah Schoeneman and Deborah Netburn, "Turtle Bay," *New York Observer* (August 28, 2000): 29; "Trump Considers Thinking Globally," *New York Times* (December 8, 2000), B: 2; Bay Brown, "United States Art Movement," *World Architecture* 92 (January 2001): 82–83; Randi Feigenbaum, "High-Rising Above the Controversy: Things Are Looking Up at Trump's Latest Tower," *Newsday* (March 8, 2001): 48; Eugene R. Dunn, "Trump Triumphant," letter to the editor, *Newsday* (March 20, 2001): 38; "Trump World Tower," *New York Construction News* (June 2001): 21; Binder, ed., *Sky High Living*, 192–93; Herbert Muschamp, "A Handsome Hunk of a Glass Tower," *New York Times* (June 2, 2002), II: 30; Michael Wetstone, "Glass Towers: A Question of Cost," letter to the editor, *New York Times* (June 16, 2002), II: 4; James Gardner, "The Midas Touch," *New York Sun* (June 24, 2002): 1, 10; Florence Fabricant, "Off the Menu," *New York Times* (July 24, 2002), F: 7; Julia Chaplin, "Boite," *New York Times* (October 27, 2002), IX: 8; C.C. Sullivan, "Modern Monolith," *Architecture* 92 (February 2003): 103. For Shreve, Lamb & Harmon's Engineering Societies Center, see Stern, Mellins, and Fishman, *New York 1960*, 628–29.

32. For the Japan Society, see Stern, Mellins, and Fishman, *New York 1960*, 632, 634–35. For the Holy Family Church, see George Dugan, "Church at U.N. Is Consecrated," *New York Times* (March 15, 1965): 27; Lawrence O'Kane, "First a Brewery, Then a Stable, Building Is Now Artistic Church," *New York Times* (May 30, 1965): 1, 9.

33. For the U.N. Secretariat, see Stern, Mellins, and Fishman, *New York 1960*, 617–21.

34. Goldberger, "The Sky Line: Zone Defense": 180.

35. Jacobs, "Ich Bein ein New Yorker": 40.

36. Muschamp, "A Handsome Hunk of a Glass Tower": 30. For the Empire State Building, see Stern, Gilmartin, and Mellins, *New York 1930*, 610–15.

37. Terence Riley, quoted in Muschamp, "A Handsome Hunk of a Glass Tower": 30.

38. Hunter, "More Exciting Skyline": 24.

39. Kathleen Teltsch, "U.N. Proposed Building Expansion to Provide Room for 170 Nations," *New York Times* (November 11, 1976): 2; Penny Rogg, "Growing U.N. Expands," *New York Times* (November 4, 1979), VIII: 1; Bernard D. Nossiter, "Unicef, Going Against Trend, Plans Big Expansion," *New York Times* (June 7, 1981): 13.

40. Christopher S. Wren, "International Symbol of Neglect," *New York Times* (October 24, 1999): 35, 41. Also see Philip Nobel, "A Diplomatic Solution for the U.N.," *Architecture* 89 (February 2000): 166; "U.N. Weighs Rebuilding Its Complex," *New York Times* (July 26, 2000), B: 3; "UN's Own Rescue Mission," *World Architecture* 90 (October 2000): 29.

41. Carter B. Horsley, "Apartments Strive to Break the Mold," *New York Times* (October 11, 1981), VIII: 1; White and Willensky, *AIA Guide* (1988), 258; Kayden, *Privately Owned Public Space*, 230–31.

42. Michael Stevens, quoted in Lee A. Daniels, "'Super-luxury' Apartments Go up near Sutton Place," *New York Times* (February 26, 1982): 21. Also see Carter B. Horsley, "Luxury-Tower Builders Turning to Condominiums," *New York Times* (March 29, 1981), VIII: 1, 10; Alan S. Oser, "New Manhattan Apartments Are Bigger," *New York Times* (September 25, 1981), B: 12; Horsley, "Apartments Strive to Break the Mold": 1; Edward Deitch, "A Long Huddle, and 'I've Got It!' Thus Do Buildings Get Their Names," *New York Times* (November 15, 1981), VIII: 1, 14; "Luxurious Tax Abatement," *Progressive Architecture* 63 (April 1982): 53; Paul Goldberger, "A New Meaning for Luxury," *New York Times* (April 17, 1983), VI: 4; White and Willensky, *AIA Guide* (1988), 259; White and Willensky, *AIA Guide* (2000), 307; Kayden, *Publicly Owned Private Space*, 232–33.

43. Goldberger, "A New Meaning for Luxury": 46.

44. White and Willensky, *AIA Guide* (2000), 288. Also see Lee A. Daniels, "Fitting a 'Sliver' Building into the Block,"

New York Times (May 18, 1984): 21; *Marvin H. Meltzer: City as Poetry* (Milan: L'Arca Edizioni, 2002), 28–31.

45. "In and Around the City," *Oculus* 53 (September 1990): 3; Alan S. Oser, "The Benenson Approach: A Sometime Builder at Work in 2 Cities," *New York Times* (November 17, 1991), X: ; Rachelle Garbarine, "5 Years Later, Sales Start at an East Side Condo," *New York Times* (May 31, 1996), A: 23; *Fox & Fowle: Function, Structure, Beauty* (Milan: L'Arca Edizioni, 1999), 68–71; White and Willensky, *AIA Guide* (2000), 307.

CHELSEA

1. For the General Theological Seminary and Chelsea, see Stern, Mellins, and Fishman, *New York 1880*, 156–59, 163, 549–50. For London Terrace, see Stern, Gilmartin, and Mellins, *New York 1930*, 417–18. For development after World War II, see Stern, Mellins, and Fishman, *New York 1960*, 309–13.

2. Jennifer Dunning, "Elgin Will Be Theater for Medium-Sized Troupes," *New York Times* (January 29, 1979), C: 12; Jennifer Dunning, "Plans to Convert Elgin to Dance Theater Falter," *New York Times* (June 4, 1980), C: 25; "U.S. Helping to Renovate Elgin Theater," *New York Times* (July 5, 1980): 9; "Dance Institutions Get Grants," *New York Times* (October 16, 1980), C: 13; "2 New York Dance Groups Get Major Federal Grants," *New York Times* (January 15, 1981), C: 21; "Facelift Begins at Renamed Elgin," *New York Times* (June 20, 1981), C: 26; Anna Kisselgoff, "Creating a Theater Just for Dance," *New York Times* (July 26, 1981), II: 18; Clifford Pearson, "Deco into Dance," *Metropolis* 1 (December 1981): 12; Jack Anderson, "The Feld Christens Its New Home," *New York Times* (May 30, 1982), II: 6; Anna Kisselgoff, "The Feld Presents New Works in Its New Theater," *New York Times* (July 4, 1982), II: 4; "Art Deco Awards Made," *New York Times* (January 12, 1984), C: 13; Grace Anderson, "For Live Action," *Architectural Record* 172 (November 1984): 101–5; Leslie Armstrong and Roger Morgan, *Space for Dance: An Architectural Design Guide* (New York: Publishing Center for Cultural Resources, 1984), 101–5, 151; Andrew L. Yarrow, "Chelsea: Where Avant-Garde Rubs Shoulders with Old New York," *New York Times* (October 16, 1987), C: 1, 36; *Hardy Holzman Pfeiffer Associates: Buildings and Projects 1967–1992* (New York: Rizzoli International Publications, 1992), 94–97, 255; Elliot Feld, "A View of the Vortex," in *Hardy Holzman Pfeiffer Associates: Theaters* (Mulgrave, Australia: Images Publishing, 2000), 67–73; White and Willensky, *AIA Guide* (2000), 182.

3. Nicholas Polites, "The Joyce Theater," in *Hardy Holzman Pfeiffer Associates: Buildings and Projects 1967–1992*, 94.

4. Grace Glueck, "Dia Foundation, Back from Brink, Opens New Center," *New York Times* (October 7, 1987), C: 23; Roberta Smith, "Art: Beuys, Palermo and Knoebel at the New Dia," *New York Times* (October 9, 1987), C: 36; David W. Dunlap, "The New Chelsea's Many Faces," *New York Times* (November 13, 1994), IX: 1, 8; Roberta Smith, "Chelsea's Works in Progress," *New York Times* (November 29, 1996), C: 1, 32; Hal Foster, "Illuminated Structure, Embodied Space," in *Space Framed: Richard Gluckman Architect* (New York: Monacelli Press, 2000), 30–43, 183–85, 195; White and Willensky, *AIA Guide* (2000), 186; Alan Balfour, *World Cities: New York* (New York: Wiley Academy, 2001), 117.

5. Smith, "Art: Beuys, Palermo and Knoebel at the New Dia": 36.

6. Dunlap, "The New Chelsea's Many Faces": 1, 8; Smith, "Chelsea's Works in Progress": 1, 32; *Space Framed: Richard Gluckman Architect*, 78–81, 150–53, 202–3, 220.

7. Carol Vogel, "Inside Art," *New York Times* (September 8, 2000), E: 32.

8. Carol Vogel, "Confident Climate Fosters New Art Galleries," *New York Times* (October 1, 1996), C: 11; Michael Kimmelman, "Art in Review," *New York Times* (November 15, 1996), C: 21; Smith, "Chelsea's Works in Progress": 1, 32; David Rimanelli, "Chelsea Passage," *Interior Design* 68 (September 1997): 172–75; Kathy Battista and Siân Tichar, *Art New York* (London: Ellipsis, 2000), 4:6–9; White and Willensky, *AIA Guide* (2000), 186; *Space Framed: Richard Gluckman Architect*, 116–23, 213, back cover.

9. Richard Gluckman, quoted in Rimanelli, "Chelsea Passage": 172.

10. Smith, "Chelsea's Works in Progress": 1, 32.

11. "From One Warehouse, Three Art Galleries," *New York Times* (February 16, 1997), IX: 1; John Holusha, "Ex-Garages Attracting Art Galleries from SoHo," *New York Times* (October 12, 1997), X: 7; Michael Kimmelman, "A New Chelsea and the Evanescence of Chic," *New York Times* (November 1, 1998), II: 47; Battista and Siân, *Art New York*, 4: 24–27, 46–49.

12. Kimmelman, "A New Chelsea and the Evanescence of Chic": 47; Battista and Siân, *Art New York*, 4:58–62; Shaila K. Dewan, "In Chelsea, West Side Meets West Coast," *New York Times* (March 17, 2001): B: 1, 4.

13. Carol Vogel, "Pace Artist Is Designing New Gallery," *New York Times* (September 15, 2000), E: 28; Dewan, "In Chelsea, West Side Meets West Coast": 1, 4; Jeff Hill, "The Sky's the Limit," *Interior Design* 782 (August 2001): 190–93; Ian Luna, ed., *New New York: Architecture of a City* (New York: Rizzoli International Publications, 2003), 110–11.

14. Smith, "Chelsea's Works in Progress": 1, 32.

15. Jeffrey Hogrefe, "Gagosian Pays $5.75 Million for Largest Gallery in Chelsea," *New York Observer* (August 23, 1999): 8; Holland Cotter, "Surging into Chelsea," *New York Times* (January 21, 2000), E: 37; Dewan, "In Chelsea, West Side Meets West Coast": 1, 4; Luna, ed., *New New York*, 112–13.

16. Julie Iovine, "Behind Glass Walls," *New York Times* (November 18, 1997), F: 3; Alastair Gordon, "Making Manhattan an Island of Calm," *New York Times* (November 18, 1999), F: 1, 9; White and Willensky, *AIA Guide* (2000), 186; Susana Sirefman, *New York: A Guide to Recent Architecture* (London: Ellipsis, 2001): 5–6/7; Luna, ed., *New New York*, 106–9.

17. Sirefman, *New York*, 5: 6.

18. Holland Cotter, "A Tour Through Chelsea, the New Center of Gravity," *New York Times* (May 15, 1998), E: 29.

19. For the Sean Kelly Gallery, see Roberta Smith, "As Chelsea Expands, a Host of Visions Rush In," *New York Times* (June 1, 2001), E: 29; Jeff Hill, "High Concept," *Interior Design* 72 (August 2001): 178–85. For Robert Irwin's PaceWildenstein Gallery, see Vogel, "Pace Artist Is Designing New Gallery": 28; "Conversation," *Talk* (May 2001): 31.

20. James Dao, "Bids Accepted to Develop 4 Chelsea Piers," *New York Times* (May 23, 1992): 27; "Waterfront Test: The Fate of the Chelsea Piers," *Newsday* (May 27, 1992): 40; James Dao, "Plan for Ice Rink and TV Studio on Chelsea Piers," *New York Times* (June 18, 1992), B: 3; Molly Gordy, "Terminal Neglect?" *Newsday* (July 2, 1992): 27; Carmen Livingston, "Hollywood on Hudson," *Newsday* (July 7, 1992): 31; "Back Lot on the Waterfront," *Architectural Record* 190 (September 1992): 35; David W. Dunlap, "Charting the Future of the Waterfront," *New York Times* (November 15, 1992), X: 1, 8; Yanick Rice Lamb, "Big Plans for the Hudson River Piers," *New York Times* (December 3, 1992), C: 3; Allee King Rosen & Fleming, *Chelsea Piers: Draft Environmental Impact Statement* (New York, July 1993); Tom Fox, "Times Have Changed," *Newsday* (April 10, 1993): 16; David W. Dunlap, "Jostling for Position on the Riverfront," *New York Times* (July 11, 1993), X: 1, 6; Marvine Howe, "Neighborhood Report: Chelsea," *New York Times* (September 12, 1993), XIII: 8; William Bunch, "New Golden Age for Chelsea Piers?" *Newsday* (July 13, 1994): 7; Vilma Barr, "The Chelsea Piers Complex," *Urban Land* 53 (August 1994): 38–41; Florence Fabricant, "Off the Menu," *New York Times* (September 28, 1994), C: 2; David W. Dunlap, "The New Chelsea's Many Faces," *New York Times* (November 13, 1994), IX: 1, 8; Bruce Lambert, "Wanted: Pier with a View," *New York Times* (December 4, 1994), XIII: 8; Monte Williams, "A Super Store? Or Just Too Big?" *New York Times* (January 8, 1995), XIII: 6; William Bunch, "Developer Has Big Plans for Chelsea Piers," *Newsday* (January 22, 1995): 6; Brett Pulley, "On the Waterfront," *New York Times* (February 4, 1995): 21; Stuart Waldman, "Give Lower West Side a Green Waterfront," letter to the editor, *New York Times* (February 10, 1995): 28; Brett Pulley, "Deal Collapses for Sports Store at Chelsea Piers Development," *New York Times* (February 11, 1995): 23; "New Yorkers & Co.," *New York Times* (April 2, 1995), XIII: 4; Roger Rubin, "Athletes Can Moor at New Chelsea Piers Sports Center," *Newsday* (April 16, 1995): 43; Judith Childs, "Chelsea Is Short-Changed by Community Board 4," letter to the editor, *New York Times* (May 14, 1995), XIII: 15; Naomi Freedman Serviss, "Sky Rink Lands on Pier," *Newsday* (May 22, 1995), B: 7; Bruce Weber, "For Huge Recreation Complex, It's Time to Start Playing Ball," *New York Times* (August 9, 1995), B: 3; Charles V. Bagli, "Wild Card Economics: As Yankees Drain City, Chelsea Piers Pays Off," *New York Observer* (October 9, 1995): 1, 20; Nick Paumgarten, "Chelsea Likes Skating Yalies, Boots Hell's Kitchen 'Thugs,'" *New York Observer* (October 9, 1995): 20; Nadine M. Post, "Golf on a Pier? What Next?" *Engineering News-Record* 235 (October 16, 1995): 22; "Goooooaaalll!" *New York Times* (October 26, 1995), B: 2; Robert Dominguez, "What's Up, Dock?" *New York Daily News* (October 27, 1995): 74; Paul Goldberger, "Chelsea Dawning: Giving New Life to Old Piers," *New York Times* (November 17, 1995), C: 1, 26; Herbert Muschamp, "Chelsea Dawning: Reawakened and Resplendent," *New York Times* (November 17, 1995), C: 1, 27; Stuart Waldman, "Chelsea Piers Offer High-Price Amenities," letter to the editor, *New York Times* (November 21, 1995): 20; Terry Pristin, "Bright Lights Fail to Dazzle," *New York Times* (March 5, 1996), B: 1; Joe Sharkey, "Quality of Life vs. Quality of Golf," *New York Times* (March 24, 1996), XIII: 1; Andrew Jacobs, "More Backwash on the Waterfront," *New York Times* (May 5, 1996), XIII: 6; "A Microbrewery Beside the Hudson," *New York Times* (May 26, 1996), XIII: 4; Peter Grant, "City Reeling in Producers," *New York Daily News* (June 10, 1996): 39; Joel Siegel, "Fed Pier Pressure," *New York Daily News* (June 26, 1996): 40; Andrew Jacobs, "$100 Mistake Gives Piers a Walkway," *New York Times* (June 30, 1996), XIII: 7; David W. Dunlap, "Chelsea Piers: The Fight to Stay Afloat," *New York Times* (August 11, 1996), IX: 1, 8; Peter Grant, "Bowling Is Right Up Chelsea Piers' Alley," *New York Daily News* (October 2, 1996): 45; Peter Grant, "In the Red?" *New York Daily News* (October 6, 1996): 4; Neal Thompson, "New York Revives Its Waterfront with Paean to the Stairmaster Age," *Christian Science Monitor* (December 27, 1996): 3; Gayle Berens, "Hudson River Park," in Alexander Garvin and Gayle Berens, *Urban Parks and Open Space* (Washington, D.C.: Urban Land Institute, 1997), 116–33; Michael Wise, "Modest Endeavors," in Kevin Bone, ed., *The New York Waterfront: Evolution and Building Culture of the Port and Harbor* (New York: Monacelli Press, 1997), 239, 241; Anthony Iannacci, *Butlers Rogers Baskett: Revitalizing the Waterfront* (Milan: L'Arca, 1997); Janet Allon, "Park Advocates Oppose Drop-Off Area," *New York Times* (February 2, 1997), XIII: 6; Anthony Iannacci, "Nuova vita sul fiume," *L'Arca* 115 (May 1997): 24–33; "Bowling Is Latest Addition to Chelsea Piers' Lineup," *New York Times* (May 11, 1997), XIII: 4; Frank Lombardi, "Popular Pier Complex Has Sailed Choppy Sea," *New York Daily News* (June 28, 1997): 2; Sheryl McCarthy, "Arrogance Surfaces Along the Hudson," *Newsday* (July 31, 1997): 48; Jesse McKinley, "Park vs. Putting," *New York Times* (October 19, 1997), XIV: 6; Constance C. R. White, "The Woes of Chelsea Piers," *New York Times* (November 4, 1997), B: 11; Constance C. R. White, "American Fashion Ends Fling at the Piers," *New York Times* (December 20, 1997), B: 3; "Chelsea Piers," *Urban Land* 57 (February 1998): 19–20; Lisa W. Foderaro, "Giant Rec Room, River View," *New York Times* (March 6, 1998), B: 1, 10; Alan Hyde, "Parks for the Rich," letter to the editor, *New York Times* (March 11, 1998): 22; Ann L. Buttenwieser, *Manhattan Water-Bound*, 2nd. ed. (Syracuse, N.Y.: Syracuse

University Press, 1999], 97–101, 260–69; Bernard Stamler, "Waves of Trouble Are Lapping at Chelsea's Piers," *New York Times* (January 31, 1999), XIV: 4; Roland W. Betts and Tom A. Bernstein, "Despite Article's Tone, Chelsea Piers Is Thriving," letter to the editor, *New York Times* (February 14, 1999), XIV: 15; Douglas Martin, "Chelsea Piers, Where Grown-Ups Play, Too," *New York Times* (August 4, 2000), E: 31, 38; Denny Lee, "Neighborhood Report: Chelsea," *New York Times* (August 12, 2001), XIV: 4; Raymond W. Gastil, *Beyond the Edge: New York's New Waterfront* (New York: Princeton Architectural Press, 2002), 51. For Warren & Wetmore's Chelsea Piers, see Stern, Gilmartin, and Massengale, *New York 1900*, 49–50.

21. For the Westyard Distribution Center, see Stern, Mellins, and Fishman, *New York 1960*, 314.

22. Goldberger, "Chelsea Dawning: Giving New Life to Old Piers": 1, 26.

23. Muschamp, "Chelsea Dawning: Reawakened and Resplendent": 27.

24. Waldman, "Chelsea Piers Offer High-Price Amenities": 20.

25. Philip K. Howard, quoted in Foderaro, "Giant Rec Room, River View": 10.

26. Andrew Jacobs, "Sibling Rivalry Divides Parks," *New York Times* (December 22, 1996), XIII: 7; Julie V. Iovine, "1 Dog Run, 3 Mounds, Many, Many Opinions," *New York Times* (August 26, 1999), F: 3; *Thomas Balsley: The Urban Landscape* (Berkeley, Calif.: Spacemaker Press, 2000), 58–61; Pete Donohue, "Green Park Sprouts on W. Side," *New York Daily News* (October 12, 2000), Metro: 1.

27. For the Starrett-Lehigh Building, see Stern, Gilmartin, and Mellins, *New York 1930*, 520–22; Landmarks Preservation Commission of the City of New York, LP-1295 (October 7, 1986); Barbaralee Diamonstein, *The Landmarks of New York III* (New York: Harry N. Abrams, 1998), 366; Christopher Gray, "Streetscapes/Starrett-Lehigh Building," *New York Times* (May 31, 1998), XI: 5.

28. Charles V. Bagli, "Manhattan's Real Estate Boom Spreads to the West Side," *New York Times* (June 14, 1998): 39; John Holusha, "In a Tight Market, New Areas Bloom," *New York Times* (September 19, 1999), XI: 1, 8; Alex Williams, "Welcome to the Lower West Side," *New York* 32 (October 4, 1999): 25–35; John Holusha, "Office Space Is Scarce, and Getting More Expensive," *New York Times* (November 7, 1999), XI: 9; Charles V. Bagli, "As an Industrial Building in Chelsea Goes 'Shabby Chic,' Charges Fly," *New York Times* (February 18, 2000), B: 8; David W. Dunlap, "For 1930's Behemoth, a New Upscale Life," *New York Times* (February 20, 2000), XI: 1, 6; John Holusha, "Providing a Helping Hand to Internet Start-Ups," *New York Times* (March 5, 2000), XI: 9; Adam Gopnik, "New York Journal: Food Fight," *New Yorker* 76 (October 2, 2000): 64, 67–68, 70–71. Also see Karen Cook, "Behemoths Battle the Blues," *New York Post* (February 2, 1989): 48; Jerry Cheslow, "Commercial Property," *New York Times* (March 15, 1992), X: 13.

29. Elaine Louie, "First Impressions: It's All Done with Mirrors," *New York Times* (November 2, 2000), F: 3.

30. Williams, "Welcome to the Lower West Side": 28; Holusha, "Office Space Is Scarce, and Getting More Expensive": 9; Julie V. Iovine, "Genial Mosh-Pit Offices Keep New-Media Workers Happy," *New York Times* (January 20, 2000), F: 8; Dunlap, "For 1930's Behemoth, a New Upscale Life": 1, 6; Edie Cohen, "Media Madness," *Interior Design* 71 (March 2000): 166–73.

31. For Gehry's Chiat/Day Building, see Francesco Dal Co and Kurt W. Forster, *Frank O. Gehry: The Complete Works* (New York: Monacelli Press, 1998), 318–23.

32. Jane Sachs, quoted in Cohen, "Media Madness": 173.

33. Jane Sachs and Thomas Hut, quoted in Cohen, "Media Madness": 168.

34. "On the Drawing Boards," *Oculus* 62 (February 2000): 4.

35. Jayson Blair, "Bugs in Silicon Alley, and Some Can Crawl," *New York Times* (February 16, 2001), B: 1, 6; Henry Urbach, "Outside.In," *Interior Design* 72 (March 2001): 132–35.

36. Urbach, "Outside.In": 134.

37. Scott Specht, quoted in John Holusha, "Industrial Center Is Reborn as Offices," *New York Times* (October 11, 2000), B: 8. Also see "On the Drawing Boards": 4; Henry Urbach, "Top Deck," *Interior Design* 72 (May 2001): 268–73; James S. Russell, "Concrete Media," *Architectural Record* 189 (June 2001): 154–57.

38. Blair, "Bugs in Silicon Alley, and Some Can Crawl": 1. Also see Williams, "Welcome to the Lower West Side": 28–31; Alexandra Lange, "The Great White Open," *New York* 32 (October 11, 1999): 58–59; Iovine, "Genial Mosh-Pit Offices Keep New-Media Workers Happy": 8; Bagli, "As an Industrial Building in Chelsea Goes 'Shabby Chic,' Charges Fly": 8; Dunlap, "For 1930's Behemoth, a New Upscale Life": 1, 6; Craig Kellogg, "Industrial Strength Martha," *Oculus* 63 (March 2001): 4; Jane F. Kolleeny, "This Warehouse Atelier Is Cast in Light and Airy Tones," *Architectural Record* 190 (November 2002): 112.

39. Martha Stewart, quoted in Williams, "Welcome to the Lower West Side": 31.

40. Daniel Rowen, quoted in Kellogg, "Industrial Strength Martha": 4.

41. Mayer Rus, "Stop the Madness," *Interior Design* 71 (November 2000): 151–52.

42. John Holusha, "Commercial Property," *New York Times* (March 8, 1998), XI: 7; Roberta Smith, "The Ghosts of SoHo," *New York Times* (August 27, 1998), E: 1–2; Anne-Laure Egg, "Espace du troisième type: boutique 'Comme des Garçons,'" *Architecture intérieure-Crée* 290 (1999): 122–23; Marcus Field, "Comme des Aliens," *Blueprint* 158 (February 1999): 26–27; Constance C. R. White, "Patterns," *New York Times* (February 2, 1999), B: 10; Peter Grant, "Bloomberg Fishing for New HQ," *New York Daily News* (February 11, 1999): 78; Pilar Viladas, "Up

from SoHo," *New York Times* (March 14, 1999), VI: 55–59; Abby Bussel, "The Mod Pod," *Interior Design* 70 (April 1999): 176–85; Herbert Muschamp, "The Premiere of a Koolhaas Fantasy," *New York Times* (April 8, 1999), E: 1; "Comme des Garçons," *A + U* (May 1999): 12–21; "Chelsea's New Palette," *New York Times* (May 30, 1999), IX: 5; William L. Hamilton, "Concrete Flooring: So Chic It Hurts," *New York Times* (August 12, 1999), F: 1, 12; Penny McGuire, "Garçons à la mode," *Architectural Review* 206 (October 1999): 73–77; "Shop Entrance in New York," *Detail* 39 (October-November 1999): 1202–04; "Boutique Posmoderna," *Summa+* 39 (October-November 1999): 120–25; "Relocation, Relocation, Relocation," *DNR* 29 (December 10, 1999): 2; Mary Tannen, "The Affair Between Fashion and Art? Definitely On Again," *New York Times* (April 19, 2000), H: 6; Ned Kramer, "Unfashionable Fashion," *Architecture* 89 (May 2000): 108–9; Justin Korhammer, "Bij Comme des Garçons gaan mode en architectuur een lat-relatiee aan," *Architect interieur* (May 2000): 32–35; Sirefman, *New York*, 5: 8–11; Luna, ed., *New York*, 104–5.

43. Field, "Comme des Aliens": 26.

44. Sirefman, *New York*, 5: 8.

45. Bussel, "The Mod Pod": 185.

46. Gregory S. Johnson, "New York City," *Journal of Commerce* (September 29, 1992): 2B. Also see David W. Dunlap, "Elevated Freight Line Being Razed Amid Protests," *New York Times* (January 15, 1991): B: 3; Gregory S. Johnson, "New York City," *Journal of Commerce* (November 5, 1992): 3B; Jesse McKinley, "High Line History," *New York Times* (September 24, 1995), XIII: 4.

47. For the West Side Improvement, see Stern, Gilmartin, and Mellins, *New York 1930*, 696, 698–700.

48. "Bridge of Houses," *Pamphlet Architecture* 7 (July 1981): no pagination; "Steven Holl," *GA Houses* 10 (1982): 130–33; "Projet pour Manhattan," *Architecture d'Aujourd'hui* 225 (February 1983): IX-X; "Bridge of Houses in Manhattan," *Lotus International* 44 (1984): 41–43; "Propuesta para Manhattan," *Croquis* 6 (July 1987): 138–40; Paul Goldberger, "Review/Architecture," *New York Times* (August 16, 1988), C: 15; Benjamin Forgey, "The Unbuilt and the Unanswered," *Washington Post* (December 3, 1988), C: 1; Heinrich Klotz, ed., *New York Architecture, 1970–1990* (Munich: Prestel-Verlag, 1989), 152–53; "Steven Holl," *Architectural Review* 185 (February 1989): 33; Steven Holl, *Anchoring*, 3rd ed. (New York: Princeton Architectural Press, 1991), 36–43; "Steven Holl," *GA Architect* 11 (1993): 96–99; "Bridge of Houses, New York, 1981," *Archithese* 24 (March-April 1994): 29; Nicolai Ouroussoff, "Architecture Review," *Los Angeles Times* (October 26, 1996), F: 1; Kenneth Frampton, *Steven Holl Architect* (Milan: Electa, 2002), 152–55.

49. Thomas J. Lueck, "Up, but Not Running, on the West Side," *New York Times* (July 25, 1999): 23. Also see David W. Dunlap, "A City Shaped by Movement," *New York Times* (January 25, 1998), XV: 30; "Conrail Faces Suit Over Old Rail Line," *New York Times* (April 21, 1999): B: 9; Corey Kilgannon, "Fight Over Unused Rail Line," *New York Times* (May 16, 1999), XIV: 8; *Friends of the High Line*, promotional brochure (New York, 2000); David Sokol, "High Line Hopefulness," *Oculus* 64 (March-April 2000): 9–10; "High Noon for High Line," editorial, *New York Daily News* (December 30, 2000): 12; David W. Dunlap, "Which Track for the High Line?" *New York Times* (December 31, 2000), XI: 1, 6; J. A. Lobbia, "One Track Mind," *Village Voice* (January 2, 2001): 25; William B. Garrison, "Use the High Line for Light Rail," letter to the editor, *New York Times* (January 14, 2001), XI: 10; David W. Dunlap, "Skyline Views from Midstream," *New York Times* (January 18, 2001), F: 1, 12; George Fletcher, "Restore Rail Service to the High Line," letter to the editor, *New York Times* (January 21, 2001), XI: 8; Jessica Dheere, "Friends Work to Save High Line Structure," *Architectural Record* 189 (February 2001): 34; Brendan B. Read, "Which Track for the High Line?" letter to the editor, *New York Times* (February 11, 2001), XI: 8; Douglas Feiden, "Sky's the Limit for West Side," *New York Daily News* (February 18, 2001): 50; "Silver Is Right to Let in the Light," editorial, *New York Daily News* (April 18, 2001): 34; Abby Tegnelia, "Railroad Ties," *New York* 34 (May 21, 2001): 20; Adam Gopnik, "A Walk on the High Line," *New Yorker* 77 (May 21, 2001): 44–49; David Sokol, "Meatpacker Chic," *Grid* 3 (July-August 2001): 78–81; "The High Line," *Places* 14 (Fall 2001): 56–63; Roberta Smith, "Joel Sternfeld–'Walking the High Line,'" *New York Times* (December 28, 2001), E, part 2: 44.

50. Dunlap, "Which Track for the High Line?": 1.

51. Joseph Rose, quoted in Lueck, "Up, but Not Running, on the West Side": 23.

52. Anne Guiney, "Chelsea Carwash, New York City," *Architecture* 89 (October 2000): 88–91. Also see Luna, ed., *New York*, 94–95; Antoinette Martin, "Prosaic Buildings Are Honored for Inventive Designs," *New York Times* (January 12, 2003), XI: 7.

53. Edwin McDowell, "Complex by Haute Architect," *New York Times* (October 14, 2001), XI: 1; Tracie Rozhon, "Turf," *New York Times* (March 14, 2002), F: 1, 4; Alan S. Oser, "Along West Street, a Residential Makeover," *New York Times* (November 24, 2002), XI: 1, 6; Erika Kinetz, "Neighborhood Report," *New York Times* (December 8, 2002), XIV: 7; Luna, ed., *New York*, 92–93.

54. Kelly Crow, "Fight Heats Up Again Over Grassy Bed of Rails," *New York Times* (January 27, 2002), XIV: 6; Philip Nobel, "High Life on the High Line," *Metropolis* 21 (May 2002): 68; "Rallying for the Rail," *New York Sun* (June 25, 2002): 12; Philip Connors, "A Magic-Carpet View of the City," *Wall Street Journal* (August 22, 2002), D: 10; David W. Dunlap, "Turning a View into a Point of View," *New York Times* (August 29, 2002), B: 3; Cathy Lang Ho, "Walking the High Line," *Architecture* 91 (September 2002): 120; Dave Platter, "An Elevated Park for Manhattan?" *Urban Land* 61 (November-December 2002): 54; David W. Dunlap, "On West Side, Rail Plan Is Up and Walking," *New York*

Times (December 22, 2002): 43; Nicolai Ouroussoff, "Gardens in the Air Where the Rail Once Ran," *New York Times* (August 12, 2004), E: 1, 7; "A Plan for the High Line," *New York Times* (August 15, 2004), XIV: 9; Paul Vitello, "Rusty Railroad On Its Way to Pristine Park," *New York Times* (June 15, 2005), B: 1, 7.

55. Ricardo Scofidio, quoted in Tracy Ostroff, "Friends of the High Line Unveils Preliminary Designs," in www.aia.org/aiarchitect.

56. Charles Kaiser, "Apartment Building for the Blind Is Planned for Site in Manhattan," *New York Times* (April 7, 1977): 1, D: 15; Clyde Haberman and Laurie Johnson, "Ground-Breaking on Housing for Visually Handicapped," *New York Times* (December 14, 1978), C: 16; "Apartments for Blind Under Way," *New York Times* (December 17, 1978): 58; April Koral, "A House for the Blind: To Some, It's Segregation," *New York Times* (February 25, 1979), VIII: 1–2; Timothy M. Phelps, "A Deluge of Applications Greets Opening of Apartments for Blind," *New York Times* (December 27, 1980): 25.

57. "An Old Hospital Moves to Meet the Needs of New Generation," *New York Times* (October 16, 1988): 32; White and Willensky, *AIA Guide* (2000), 192.

58. Philip S. Gutis, "45 Condos on 15 Floors," *New York Times* (May 18, 1986), VIII: 1.

59. Lisa W. Foderaro, "About Real Estate," *New York Times* (March 27, 1987): 25; White and Willensky, *AIA Guide* (2000), 184.

60. "'Statement' on 23d," *New York Times* (May 19, 1985), VIII: 1; White and Willensky, *AIA Guide* (2000), 190.

61. David W. Dunlap, "8th Ave. Scenes," *New York Times* (December 11, 1986), B: 1; Lisa W. Foderaro, "A Tower Plan in Chelsea Irks Low-Rise Neighbors," *New York Times* (April 24, 1987): 22; James Stewart Polshek, "Notes on My Life and Work," in *James Stewart Polshek: Context and Responsibility* (New York: Rizzoli International Publications, 1988), 54, 182; Jan Hoffman, "Chelsea's New Blockbuster," *Village Voice* (June 6, 1989): 13; Rachelle Garbarine, "Chelsea Condominium," *New York Times* (October 14, 1993), B: 8; White and Willensky, *AIA Guide* (2000), 182.

62. Rachelle Garbarine, "In Chelsea, from Parking to Tower," *New York Times* (September 24, 1999), B: 8; David W. Dunlap, "In the Flower District, a Crop of High-Rises," *New York Times* (October 10, 1999), XI: 1, 9; Sana Siwolop, "365 Units Under New City Bond Plan," *New York Times* (August 3, 2001), B: 6.

63. For the Fashion Institute of Technology's Seventh Avenue buildings, see Stern, Mellins, and Fishman, *New York 1960*, 312–13.

64. Lore Croghan, "Related Enters Chelsea After Zoning Change," *Crain's New York Business* (December 11–17, 2000): 38; Nancy Dillon and Eric Herman, "Chelsea Driven by Building Boom," *New York Daily News* (April 30, 2001): 26; Jonathan Mahler, "Gotham Rising," *Talk* (December 2001-January 2002): 120–25, 148–52; Rachelle Garbarine, "Residential Real Estate," *New York Times* (March 29, 2002), B: 6; Peter Morris Dixon, ed., *Robert A. M. Stern: Buildings and Projects, 1999–2003* (New York: Monacelli Press, 2003), 450–55.

65. Anthony Ramirez, "Apartments, or Just an Eyesore, Along the Ladies' Mile?" *New York Times* (January 12, 1997), XIII: 8; "For the Ladies' Mile, New Residences," *New York Times* (November 30, 1997), XI: 1; Dunlap, "In the Flower District, a Crop of High-Rises": 9; Jack Taylor, "Developing a Site on West 23rd Street," letter to the editor, *New York Times* (November 14, 1999), XI: 10; White and Willensky, *AIA Guide* (2000), 190; David S. Chartock, "Site, Logistics Challenge Caroline's Project Team," *New York Construction News* 48 (May 2001): 51–54; Garbarine, "Residential Real Estate": 6; "The Caroline," *New York Construction News* 49 (June 2002): 31.

66. Landmarks Preservation Commission of the City of New York, *Ladies' Mile Historic District Designation Report* (New York, 1989), 392–93. Also see Alan S. Oser, "23d St. Project Is Rising on McCreery Site," *New York Times* (June 13, 1975): 56; Stern, Mellins, and Fishman, *New York 1880*, 665–67.

67. David Kirby, "Forerunner of Skyscrapers Faces the Wrecker's Ball," *New York Times* (October 3, 1999), XIV: 6; Dunlap, "In the Flower District, a Crop of High-Rises": 9; David Kirby, "Chelsea," *New York Times* (December 12, 1999), XIV: 10; Peter Slatin, "Block Buster," *Grid* 2 (January-February 2000): 70–72; David S. Chartock, "Logistics Pose the Toughest Challenge for 776 Sixth Ave.," *New York Construction News* 49 (January 2001): 33–36; Rachelle Garbarine, "In Old Flower District, a New Luxury Building," *New York Times* (June 15, 2001), B: 1; Elizabeth Howard, "At the Podium," *Oculus* 64 (December 2001): 9–10; Garbarine, "Residential Real Estate": 6. For Thorp's building, see Stern, Mellins, and Fishman, *New York 1880*, 218–19.

68. Landmarks Preservation Commission of the City of New York, LP-1790 (1989); David W. Dunlap, "Board Drops 1876 Building as Landmark," *New York Times* (December 8, 1989), B: 1, 3; Richard D. Lyons, "Real Estate," *New York Times* (May 23, 1990), D: 20; Christopher Gray, "Streetscapes: Readers' Questions," *New York Times* (June 2, 1991), X: 6; David W. Dunlap, "In Flower District, Ground Is Sown for Housing," *New York Times* (December 10, 1995), IX: 1, 8.

69. Dunlap, "In the Flower District, a Crop of High-Rises": 9; Garbarine, "Residential Real Estate": 6.

THE FAR WEST

1. "Metropolitan Briefs: Yunich Would Shift Convention Site," *New York Times* (July 3, 1976): 25. Also see Stern, Mellins, and Fishman, *New York 1960*, 321.

2. For the Coliseum, see Stern, Mellins, and Fishman, *New York 1960*, 667–71.

3. Stern, Mellins, and Fishman, *New York 1960*, 321–23.

4. Donald J. Trump, "Convention Center: The Better Site," letter to the editor, *New York Times* (January 5, 1976): 28. Also see "Convention Center," editorial, *New York Times* (January

19, 1976]: 28; Deirdre Carmody, "Port Authority to Consider 34th St. Convention Center," *New York Times* (January 23, 1976): 35; "Port Authority Center Opposed," *New York Times* (January 24, 1976): 31; Carter B. Horsley, "Convention Centers: Another Kind of Show Business," *New York Times* (January 25, 1976), VIII: 1, 6; "New York City Studies Two Sites for a Convention Center in Manhattan," *Architectural Record* 159 (February 1976): 35; Richard Bascome, "Convention Off-Center," letter to the editor, *New York Times* (February 7, 1976): 20; William J. Ronan, "Port Authority: Actions for Mass Transit," letter to the editor, *New York Times* (March 3, 1976): 36; Donald J. Trump, "Convention Center: A Case for 34th St.," letter to the editor, *New York Times* (June 16, 1976): 38; Donald Trump with Tony Schwartz, *Trump: The Art of the Deal* (New York: Random House, 1987), 72–78; Stern, Mellins, and Fishman, *New York 1960*, 322–24.

5. "Convention Center," (January 19, 1976): 28.

6. John P. Keith, quoted in Edward Ranzal, "Planners Back Times Sq. as Convention Site," *New York Times* (April 26, 1976): 42. Also see "Convention Center," editorial, *New York Times* (May 6, 1976): 36; Ralph Pomerance and Simon Breines, "Convention Center: The Better Site," letter to the editor, *New York Times* (May 25, 1976): 34; "2 Sites Proposed for a City Center," *New York Times* (June 4, 1976), B: 2; Alan S. Oser, "Some Urge Convention Center in Midtown," *New York Times* (June 9, 1976): 66; Alex M. Parker, "Gold in Times Sq.," letter to the editor, *New York Times* (June 24, 1976): 32.

7. "Convention Center," (May 6, 1976): 36.

8. Francis X. Clines, "Savings May Revive Convention Center," *New York Times* (July 20, 1976): 1, 37; Francis X. Clines, "Beame Planners Thinking of Hotel Levy to Help Finance Convention Center," *New York Times* (July 24, 1976): 27; "Triborough Authority Is Sought as Convention Center Financier," *New York Times* (October 3, 1976): 49; "Study Says Battery Park Is Best Convention Site," *New York Times* (May 6, 1977): 13.

9. Steven R. Weisman, "Beame's Budget Will Revive Plans to Build Convention Center in City," *New York Times* (April 19, 1977): 74; Charles Kaiser, "Beame's Budget Includes Money for Design of Convention Center," *New York Times* (April 23, 1977): 24; Dan Dorfman, "Miracle on 34th Street," *New York* 10 (April 25, 1977): 13.

10. Steven R. Weisman, "44th Street Leading as Convention Site," *New York Times* (May 1, 1977): 42.

11. Ada Louise Huxtable, "Design: Unbuilt America," *New York Times* (January 30, 1977), VI: 44–45, 49. Also see Steven R. Weisman, "Beame Considers '52 Mies plan for New City Center," *New York Times* (May 18, 1977), B: 1, 20. Also see Alison Sky and Michele Stone, *Unbuilt America: Forgotten Architecture in the United States from Thomas Jefferson to the Space Age* (New York: McGraw-Hill 1976).

12. "Build the Convention Center," editorial, *New York Times* (May 27, 1977): 24. Also see Lee Dembart, "Beame Gets Set Back on Convention Plan," *New York Times* (May 26, 1977), B: 2.

13. "Build the Convention Center": 24. Also see "Topics: Mies to Kissinger to Torre," *New York Times* (June 7, 1977): 34.

14. Carter B. Horsley, "Backers of Site for a Convention Center Jockey for Attention as Debate Continues," *New York Times* (June 15, 1977), D: 16; Bella S. Abzug, "Convention Center Stand," letter to the editor, *New York Times* (July 14, 1977): 38; Emmanuel Perlmutter, "Convention Center Panel Rejects Site at 44th St. and Hudson River," *New York Times* (November 20, 1977): 45; Glenn Fowler, "Panel Recommends Convention Center Near 34th on River," *New York Times* (November 23, 1977), B: 3; Robert Kupferman, "Convention Center: At the Crossroads of the World," letter to the editor, *New York Times* (February 2, 1978): 18.

15. Robert D. McFadden, "Koch Declares Convention Center Top Priority and Calls for Action," *New York Times* (February 18, 1978): 27; Charles Kaiser, "Koch Said to Have Chosen 34th St. as Site of New Convention Center," *New York Times* (March 31, 1978): 1, B: 4; Pamela G. Hollie, "Clinton Residents Deplore Choice of 34th St. for Convention Center," *New York Times* (April 29, 1978): 12; Charles Kaiser, "Convention Site at West 34th St. Chosen by Koch," *New York Times* (April 29, 1978): 1, 12; Ada Louise Huxtable, "The N.Y. Convention Center--Too Big to Be Bad," *New York Times* (April 30, 1978), II: 1, 25; Dee Wedemeyer, "Conventions: A Vision of Gold in the Desert," *New York Times* (May 14, 1978), VIII: 1, 4.

16. Huxtable, "The N.Y. Convention Center--Too Big to Be Bad": 1, 25.

17. E. J. Dionne Jr., "Accord Is Reached on Convention Site for New York City," *New York Times* (March 14, 1979): 1, D: 15; Richard J. Meislin, "Regan a Skeptic on Plan to Build Convention Hall," *New York Times* (March 14, 1979), B: 1; "Now or Never on a Convention Center," editorial, *New York Times* (March 24, 1979): 18; "Good Start for a Convention Center," editorial, *New York Times* (March 28, 1979): 24; Ari L. Goldman, "Legislature Votes Convention Center for New York City," *New York Times* (March 30, 1979): 1, D: 14.

18. "Good Start for a Convention Center": 24. For the Dallas Municipal Administration Center, see Carter Wiseman, *I. M. Pei: A Profile in American Architecture*, rev. ed. (New York: Harry N. Abrams, 2001), 120–37.

19. Robert D. McFadden, "I. M. Pei Will Design Convention Center," *New York Times* (April 22, 1979): 1, 33; Paul Goldberger, "A Tough Architectural Job," *New York Times* (April 30, 1979), B: 4; "I. M. Pei Awarded Convention Center," *Progressive Architecture* 60 (May 1979): 23, 26; Paul Goldberger, "Winning Ways of I. M. Pei," *New York Times* (May 20, 1979), VI: 24–27, 116, 118, 120–22, 124; "New York's Next Crystal Palace," editorial, *New York Times* (December 12, 1979): 30; Paul Goldberger, "Plan for Center Reveals Effort to Adorn Mass," *New York Times* (December 12, 1979): 1, D: 23; "Convention Center Gets a Preview," *New York Times*

(December 16, 1979], IV: 5; Ada Louise Huxtable, "Redeveloping New York," *New York Times* (December 23, 1979]: 31–32; Ada Louise Huxtable, "The Retreat Continued," *New York Times* (December 30, 1979], II: 23, 31; Eleni Constantine, "Pei's Convention Center Crystal Behemoth," *Progressive Architecture* 61 (February 1980): 42, 46; Paul Goldberger, "Convention Center Model Displayed at the Modern," *New York Times* (March 13, 1980), C: 18; Edward Schumacher, "Convention Center Perils Squatter's Dream World," *New York Times* (March 25, 1980), B: 1; Philip Winslow, "A Convention Center's Crucial Plan," letter to the editor, *New York Times* (April 5, 1980): 16; Joyce Purnick, "Carey, Koch Join Forces to Celebrate New Center," *New York Times* (June 18, 1980), B: 1, 4; "A Vast Space Frame Wraps New York's Convention Center like a Taut Fabric," *Architectural Record* 168 (Mid-August 1980): 47–57; "New York City Exposition and Convention Center," *Techniques et architecture* (December 1980): 115–18; "New York Exposition & Convention Center," *Architecture + Urbanism* (January 1982): 50–53; Clifford Pearson, "Convention Center Cut-Up," *Metropolis* 1 (January-February 1982): 6–7; Maurice Carroll, "Convention Groups Busy Booking Hole in the Ground on West Side," *New York Times* (February 6, 1982): 1, 26; "Convention Center Rising Slowly on the West Side," *New York Times* (November 17, 1982), B: 3; Anna Quindlen, "A Texas-Style Extravaganza," *New York Times* (January 19, 1983), B: 1; Selwyn Raab, "Convention Site Faces Overruns of $16 Million," *New York Times* (March 7, 1983), B: 1; Michael Oreskes, "Convention Hall May Face Delays of Year or More," *New York Times* (March 30, 1983): 1, B: 2; Michael Oreskes, "Booker for City Convention Center Sees Delays as Economic Disaster," *New York Times* (March 31, 1983): 1, B: 16; Paul Goldberger, "Convention Center Problems Partly Solved," *New York Times* (April 1, 1983): 1, B: 2; Martin Gottlieb, "Officials Hoping for Faster Work on Meeting Hall," *New York Times* (April 5, 1983), B: 1; "The Unconventional Convention Center," editorial, *New York Times* (April 16, 1983): 22; "Pencil Points," *Progressive Architecture* 64 (May 1983): 25; Martin Gottlieb, "Convention Hall, Still Enmeshed in Uncertainty," *New York Times* (July 1, 1983), B: 1, 8; Martin Gottlieb, "Completion Date in mid-'86 Seen for Convention Center," *New York Times* (July 16, 1983): 25; Martin Gottlieb, "Convention Center Officials Agree to Pay $1.2 Million for New Parts," *New York Times* (July 20, 1983), B: 3; Ronald Smothers, "Sale-Leaseback Intrigue the Nation's Municipalities," *New York Times* (July 31, 1983), VIII: 7; Martin Gottlieb, "Convention Hall Idea," *New York Times* (August 22, 1983): 32; "Convention Center Draws 4 Bids," *New York Times* (September 24, 1983): 27; Robert D. McFadden, "Convention Site Feared to Have Further Delays," *New York Times* (October 3, 1983), B: 3; Josh Barbanel, "2 Buyers Picked in Plan to Lease Convention Hall," *New York Times* (October 21, 1983), B: 2; Joe Klein, "Beached Whale on the Hudson," *New York* 16 (November 7, 1983): 27, 30; "Convention Center: A Risky Rescue," editorial, *New York Times* (November 12, 1983): 22; Martin Gottlieb, "A Lease Plan for Convention Center," *New York Times* (November 16, 1983), B: 4; Martin Gottlieb, "U.D.C. to Seek a Lease for Convention Center," *New York Times* (November 18, 1983), B: 3; Dan Margulies, "Investors' Rich Reward," letter to the editor, *New York Times* (November 21, 1983): 22; William J. Stern, "Convention Rescue with Minimal Risk," letter to the editor, *New York Times* (November 21, 1983): 22; Martin Gottlieb, "Cuomo for Use of M.A.C. Aid at New Center," *New York Times* (December 2, 1983), B: 1; Michael Goodwin, "Koch Is Seeking Use of M.A.C.'s Surplus for Convention Hall," *New York Times* (December 6, 1983): 1, D: 31; Martin Gottlieb, "New Plan Seeks to Step Up Convention Time Table," *New York Times* (December 7, 1983), B: 1; Steven J. Marcus, "The Nodes: Why They Had Flaws," *New York Times* (December 7, 1983), B: 1–2; Martin Gottlieb, "Japanese Parts Planned for Convention Center," *New York Times* (January 18, 1984), B: 3; Susan Heller Anderson and Maurice Carroll, "The Calm After the Storm," *New York Times* (July 3, 1984), B: 3; Martin Gottlieb, "City Acts to Reshape Area near Convention Center," *New York Times* (August 9, 1984), B: 3; Martin Gottlieb, "Search for a Name for New York's New Convention Center Ends in 'Javits,'" *New York Times* (December 13, 1984), B: 1; Martin Gottlieb, "Javits Center: 2 Views," *New York Times* (December 20, 1984), B: 1, 7; Martin Gottlieb, "A 'Deeply Moved' Javits Attends Convention Center's Topping Out," *New York Times* (December 20, 1984), B: 7; "Fire Damages Roof of Javits Center," *New York Times* (March 8, 1985), B: 4; Selwyn Raab, "Suit Filed on Selling Concrete," *New York Times* (March 12, 1985), B: 1, 4; Martin Gottlieb, "Convention-Center Issues Unsettled," *New York Times* (April 15, 1985), B: 3; "Progress atop the Convention Center," *New York Times* (May 7, 1985), B: 3; C. Ray Smith, "The Convention Center," *Oculus* 47 (December 1985): 2–8, 13–15; "Lessons from the Convention Center: An Interview with Thomas F. Galvin," *Oculus* 47 (December 1985): 16–17; Martin Gottlieb, "Solved: Convention Center Cleaning Puzzle," *New York Times* (January 21, 1986), B: 1; James Brooke, "City Altering Traffic Flow Toward Javits Center," *New York Times* (February 28, 1986), B: 3; Deirdre Carmody, "Center Chiefs Ponder Space, Inside and Out," *New York Times* (March 3, 1986), B: 1, 4; David Bird and David W. Dunlap, "A Special Tour," *New York Times* (March 15, 1986): 32; Sara Rimer, "Javits Center, Poised to Open, Is Booked Far into the Future," *New York Times* (March 27, 1986), B: 1, 8; James Brooke, "Center Confronting Parking Problem," *New York Times* (March 28, 1986), B: 1; Suzanne Daley, "Javits Center Records Sought for Inquiry on Concrete Bids," *New York Times* (March 29, 1986): 24; Todd S. Purdum, "Police to Increase Patrols near Javits Center," *New York Times* (March 29, 1986): 25; Maureen Dowd, "City's New Glass Palace Gets Hectic Last-Minute Polishing," *New York Times* (March 31,

1986], B: 1–2; Paul Goldberger, "Javits Center: Noble Ambition Largely Realized," *New York Times* (March 31, 1986), B: 1–2; Martin Gottlieb, "Javits Hall Is Poised to Exhibit," *New York Times* (April 3, 1986), B: 2; "With Snip of a Ribbon, Convention Center Opens," *New York Times* (April 4, 1986): 1; Martin Gottlieb, "Javits Center Bustles on Opening Day," *New York Times* (April 4, 1986), B: 3; William E. Geist, "About New York," *New York Times* (April 12, 1986), B: 1–2; Lisa Belkin, "Javits Center: Early Cheers," *New York Times* (April 5, 1986): 33, 35; "Opening Day," *New York Times* (April 6, 1986), IV: 6; Richard D. Lyons, "Glittering Javits Center Kindles Dreams for West Side," *New York Times* (April 6, 1986), VIII: 7; Susan Heller Anderson and David Bird, "Ribbons at Javits Center," *New York Times* (April 10, 1986), B: 12; Ronald Smothers, "Javits Center Puts on Show for Its First Public Audience," *New York Times* (April 16, 1986): 34; Michael Sorkin, "Freed, at Last," *Village Voice* (April 22, 1986): 94, reprinted in Michael Sorkin, *Exquisite Corpse* (London: Verso, 1991), 160–65; Anthony DePalma, "Fuses Out, Javits Hall Overheats," *New York Times* (May 20, 1986), B: 1; Anthony DePalma, "Javits Center Sweltered After Paperwork Froze," *New York Times* (May 24, 1986): 1; Jim Murphy, "Javits Center Opens," *Progressive Architecture* 67 (June 1986): 23, 25; Julie V. Iovine, "Slick but Classy: New York's Convention Center, a New Romanticism," *Connoisseur* (July 1986): 38–39; Eleanor Blau, "New York's Center Reports Success," *New York Times* (July 20, 1986): 27; Deborah K. Dietsch, "Space Frame Odyssey," *Architectural Record* 174 (September 1986): 106–17; Philip Jodidio, "Art, espace, public," *Connaissance des arts* (September 1986): 98–109; James Ingo Freed, "Letters," *Architectural Record* 174 (November 1986): 4, 106; "Convention Center in New York," *Baumeister* 83 (November 1986): 56–60; "Jacob K. Javits Convention Center," *Architecture d'aujourd'hui* (December 1986): xlii-xliv; "Javits Convention Center," *Oculus* 48 (December 1986): 23; Jeanie Kasindorf, "New York's Node-iest Cases," *New York* 19 (December 8, 1986): 22; Mitchell B. Rouda, "Dazzling, Problem Plagued 'Crystal Palace,'" *Architecture* 76 (March 1987): 92–101, 152; Thomas E. Baker, "The Javits Convention Center," letter to the editor, *Architecture* 76 (May 1987): 16; "Awards," *Oculus* 48 (May 1987): 6, 14; Giorgio Fonio, "Mirror Metraphor," *Arca* (July-August 1987): 18–19; Maurizio Vogliazzo, "New York's Crystal Palace," *Arca* (July-August 1987): 8–17; "Design Awards," *Architectural Record* 175 (August 1987): 66–67; Ginger Danto, "Javits Center Draws Crowds; Neighborhood Impact Mixed," *New York Observer* (January 18, 1988): 1, 7; "The Jacob K Javits Convention Center," *Architecture + Urbanism* (February 1988): 55–74; Thomas J. Lueck, "Despite Defects, Javits Center Becomes Boon to New York," *New York Times* (April 4, 1988): 1, B: 4; "AIA Honor Awards 1988," *Architecture* 77 (May 1988): 156; "AIA Honors: Soup to Nuts," *Progressive Architecture* 69 (May 1988): 21, 23; "Design Awards," *Architectural Record* 176 (June 1988): 72–74; Galeazzo Ruspoli, "Interpretazioni del vetro nell'architettura contemporanea," *Abacus* 4 (August-September 1988): 21–25; Silvano Stucchi, "Two Recent Designs by I. M. Pei & Partners," *Industria delle Costruzioni* 22 (September 1988): 30–40; Daralice D. Boles and Jessica Elin, "P/A Inquiry: More than a Box with Docks," *Progressive Architecture* 70 (February 1989): 74–81; "Jacob K. Javits Convention Center in New York, USA," *Architektur + Wettbewerbe* (September 1989): 11–12; Charles Jencks, *The New Moderns* (New York: Rizzoli International Publications, 1990), 36–37; "New York's Convention Center Plays an International Role," *Process Architecture* 104 (June 1992): 120–21; Marilyn Symmes, "James Ingo Freed's Sketchbooks: A Language of Lines and Angles," *Print Collector's Newsletter* 26 (May-June 1995): 41–49; Susanna Sirefman, *New York: A Guide to Recent Architecture* (London: Ellipsis, 1997), 114–117; Terry Pristin, "Jacob Javits to Be Honored with Dedication of Statue," *New York Times* (May 17, 1999), B: 2; White and Willensky, *AIA Guide* (2000), 238; Alan Balfour, *World Cities: New York* (New York: Wiley Academy, 2001), 92; Wiseman, *I. M. Pei: A Profile in American Architecture*, 208–27. For a transcription of the selection process deliberations, see Robert A. M. Stern Archive, Manuscripts and Archives, Sterling Library, Yale University.

20. James Ingo Freed, quoted in Goldberger, "A Tough Architectural Job": 4.

21. For the Kennedy Library, see Wiseman, *I. M. Pei: A Profile in American Architecture*, 92–119.

22. Michael Flynn, quoted in "A Vast Space Frame Wraps New York's Convention Center like a Taut Fabric": 56.

23. James Ingo Freed, quoted in "A Vast Space Frame Wraps New York's Convention Center like a Taut Fabric": 49.

24. Goldberger, "Plan for Center Reveals Effort to Adorn Mass": 23.

25. Winslow, "A Convention Center's Crucial Plan": 16.

26. "The Unconventional Convention Center": 22.

27. For the John Hancock Tower, see Wiseman, *I. M. Pei: A Profile in American Architecture*, 138–53.

28. Smith, "The Convention Center": 4. For the Municipal Building, see Stern, Gilmartin, and Massengale, *New York 1900*, 60, 64–67.

29. James Ingo Freed, quoted in Smith, "The Convention Center": 7.

30. Dietsch, "Space Frame Odyssey": 108. For the Palm House, see Edward J. Diestelkamp, "The Design and Building of the Palm House, Royal Botanic Gardens, Kew," *Journal of Garden History* (No. 3, 1982): 233–72.

31. Goldberger, "Javits Center: Noble Ambition Largely Realized": 1.

32. Sorkin, "Freed, at Last": 94.

33. Sirefman, *New York*, 114, 116.

34. Martin Gottlieb, "Head of Javits Center Says Major Expansion Is Needed," *New York Times* (July 18, 1990), B: 1–2; Saul Poliak, "To Expand Javits Center, Reopen the Coliseum,"

letter to the editor, *New York Times* (August 2, 1990): 20; "Fresh Start at the Javits Center," editorial, *New York Times* (May 9, 1992): 22; "Javits Center Facing Tougher Outside Competition," *New York Times* (May 29, 1994), XIII: 5; Clifford J. Levy, "Javits Overhaul Praised in Audit," *New York Times* (October 4, 1996): 1, B: 4; "Progress at the Javits Center," editorial, *New York Times* (October 12, 1996): 22; David Larkin, "Expand Javits Center," letter to the editor, *New York Times* (October 19, 1996): 22; Dean Starkman, "Exhibitors Say It's New Day at Javits Center," *Wall Street Journal* (April 10, 1997), B: 1, 6; David W. Chen, "Expansion Advised for Javits Center," *New York Times* (April 23, 1997), B: 5; Thomas J. Lueck, "Renewed Calls for Expansion of Javits Center," *New York Times* (May 3, 1997): 29; Charles V. Bagli, "Bid to Expand Javits Center Loses Ground," *New York Times* (June 10, 1998), B: 4; "Expand the Javits Center," editorial, *New York Times* (June 20, 1998): 10; Terry Pristin, "300-Booth Pavilion to Be Built to Add Space to Javits Center," *New York Times* (August 6, 1998), B: 10.

35. Robert E. Boyle, quoted in Pristin, "300-Booth Pavilion to Be Built to Add Space to Javits Center": 10.

36. Martin Gottlieb, "Adjunct to Convention Center Sought," *New York Times* (December 3, 1983): 26; Mark Sherman, "Cities Move to Develop Unused Land," *New York Times* (May 13, 1984), XII: 53; Martin Gottlieb, "City Acts to Reshape Area Near Convention Site," *New York Times* (August 9, 1984), B: 3; Anthony DePalma, "Developers' Battle Halts Jersey Riverfront Project," *New York Times* (August 24, 1986), VIII: 1, 14; David W. Dunlap, "City to Select Developer of Center on the Hudson," *New York Times* (January 26, 1987), B: 3; Alan Finder, "Developers Named for Hudson Complex," *New York Times* (February 11, 1987), B: 1; "More Towers on the Hudson," *New York Times* (February 15, 1987), IV: 6; Sam Roberts, "The Waterfront Is Rediscovered with a Passion," *New York Times* (March 19, 1987), B: 1; Cliff Pearson, "On the Waterfront," *Metropolis* 6 (April 1987): 18–19; George Lewis, "The Hudson River Center," *Oculus* 48 (April 1987): 12–15; "Manhattan de Janeiro," *Avenue* (May 1987): 116; "Hudson River Center, New York," *Progressive Architecture* 68 (May 1987): 51; Alan S. Oser, "Huge Projects That Shape the Landscape of the City," *New York Times* (May 10, 1987), XII: 65; Albert Scardino, "Cities in the Sky, Skyscrapers by the Acre," *New York Times* (May 17, 1987), IV: 28; "Why Paralyze the Waterfront?" editorial, *New York Times* (June 1, 1987): 16; Mark McCain, "Commercial Property," *New York Times* (July 26, 1987), VIII: 27; Alan S. Oser, "Waterfront Development," *New York Times* (November 29, 1987), VIII: 3; Thomas L. Waite, "Pier Redevelopment Plans Stir Concerns," *New York Times* (May 1, 1988), X: 9; Thomas J. Lueck, "Koch Looks to Rivers for Development," *New York Times* (February 12, 1989), X: 1, 19; *Cesar Pelli: Buildings and Projects, 1965–1990* (New York: Rizzoli International Publications, 1990), 269; Constance L. Hays, "Hudson River Park Plan Draws Critics," *New York Times* (September 29, 1990): 25; David W. Dunlap, "Big Developments Stalled in New York's Real-Estate Slump," *New York Times* (March 4, 1991), B: 4; David W. Dunlap, "A Blueprint of the Future Along the Hudson River," *New York Times* (May 24, 1992): 37; David W. Dunlap, "Jostling for Position on the Riverfront," *New York Times* (July 11, 1993), X: 1, 6; David W. Dunlap, "The Hudson Waterfront: What's Next?" *New York Times* (June 26, 1994), IX: 1, 8; Ann L. Buttenwieser, *Manhattan Water-Bound*, 2nd ed. (New York: Syracuse University Press, 1999), 210, 232–33, 250.

37. Lewis, "The Hudson River Center": 12.

38. John Guare, quoted in Richard David Story, "The Buildings New Yorkers Love to Hate," *New York* 20 (June 15, 1987): cover, 30–35. Also see Sydney H. Schanberg, "Saving the Garden," *New York Times* (November 7, 1981), 23; Frank Lynn, "City Mulls Taking Over Madison Square Garden," *New York Times* (November 28, 1981): 27; Maurice Carroll, "State Urged to Aid Madison Sq. Garden Sports," *New York Times* (December 7, 1981): 1, B: 4; Damon Stetson, "Unions Vow Support on Keeping the Garden Open," *New York Times* (December 13, 1981): 47; "A Cold Stare at the Garden Ice," editorial, *New York Times* (December 14, 1981): 26; "City Tax Breaks for Rangers Expected," *New York Times* (February 25, 1982), B: 23; Thomas Rogers, "Fan Sentiment on Move a Matter of Geography," *New York Times* (February 25, 1982), B: 23. For the destruction of McKim, Mead & White's Pennsylvania Station and the construction of Charles Luckman Associates' replacement, see Stern, Mellins, and Fishman, *New York 1960*, 1113–20.

39. Gerald Eskenazi, "Garden in Profit Rift," *New York Times* (March 2, 1982): 19, 21.

40. Gerald Eskenazi, "Madison Sq. Garden Offered City Tax Cut as Part of Aid Plan," *New York Times* (March 6, 1982): 1, 15; Maurice Carroll, "Tax Deal to Keep the Garden Open," *New York Times* (April 23, 1982): 1, B: 4.

41. Leonard Sloane, "Site, Lease on Garden Being Sold," *New York Times* (September 18, 1984), D: 15.

42. "Owners of Garden Said to Weigh Building New Arena Farther West," *New York Times* (December 28, 1985): 27; Martin Gottlieb, "New Sports Arena Planned for Site West of 10th Ave.," *New York Times* (April 26, 1986): 1, 30; "Corrections," *New York Times* (April 27, 1986): 2; Martin Gottlieb, "Penn Station Revamp Is in Arena Plan," *New York Times* (April 27, 1986): 38; Laura Landro, "G&W to Raze Madison Square Garden, Build New Arena, Commercial Complex," *Wall Street Journal* (April 28, 1986): 1; Peter Samton, "Penn Station Redux," letter to the editor, *New York Times* (May 7, 1986): 30; Lorraine B. Diehl, "End of a Landmark," letter to the editor, *New York Times* (May 16, 1986): 34; Jeanie Kasindorf, "Mega-Project Set for West Thirties," *New York* 19 (March 30, 1987): 9.

43. Albert Scardino, "12-Block Office Entertainment Center Planned on West Side," *New York Times* (April 6, 1987), B: 1, 6; Frank J. Prial, "Companies Join in Plan for Madison Sq. Garden," *New York Times* (May 28, 1987), B: 3; Laura Landro, "G&W Agrees on Plan to Build New York Complex," *Wall*

Street Journal (May 28, 1987): 1.

44. *Cesar Pelli: Buildings and Projects, 1965–1990*, 234–35.

45. For Helmut Jahn's proposal, see "Madison Square Garden 'Penn Gate,'" *Architecture + Urbanism* (September 1992): 116–19. For Richard Meier's proposal, see Thomas Phifer, "Madison Square Garden Site Redevelopment," *Oz* 11 (1989): 40–41; Yukio Futagawa, ed., "Richard Meier," *GA Document* 23 (April 1989): 7–11; "Madison Square Garden Site Redevelopment, New York City, NY," in Livio Dimitriu, ed., *New York Architects 3* (New York: Urban Studies and Architecture Books, 1990), 178–81; *Richard Meier Architect: 1985/1991* (New York: Rizzoli International Publications, 1991), 220–29; 418–19, 421; Livio Dimitriu, "Richard Meier," in *Architetture Per Il Terzo Millennio: Ipotesi e Tendenze* (Perugia: Fondazione Adriano Olivetti, 1991), 73–76; Philip Jodidio, *Richard Meier* (Cologne: Taschen, 1995), 106–7; Lisa J. Green, ed., *Richard Meier: Architect* (New York: Monacelli Press, 1999), 224–31, 294; Balfour, *World Cities: New York*, 282–83; James Gardner, "Is Richard Meier Becoming the Architect of the Moment?" *New York Sun* (September 24, 2002): 1, 10; Kenneth Frampton, *Richard Meier* (Milan: Electa Architecture, 2003), 234–39, 466, 494. For Skidmore, Owings & Merrill and Frank Gehry's proposal, see Joseph Giovannini, "Frank Gehry Really Loves Fish," *New York Times* (January 21, 1988), C: 3; *Frank O. Gehry*, exhibition catalog (Stockholm: Arkitekturmuseet, 1990), 35; "Madison Square Garden Site Redevelopment," *Architecture + Urbanism* (September 1993): 72–81; "Penn Station/Madison Square Garden Redevelopment," in Yukio Futagawa, ed., *GA Architect: Frank O. Gehry* (Tokyo: A.D.A Edita, 1993), 147; Francesco Dal Co, *Frank O. Gehry: The Complete Works* (New York: Monacelli Press, 1998), 358.

46. *Murphy/Jahn: Selected and Current Works* (Mulgrave, Australia: Images Publishing, 1995), 108–11.

47. Helmut Jahn, quoted in "Madison Square Garden 'Penn Gate'": 116.

48. Phifer, "Madison Square Garden Site Redevelopment": 40–41.

49. Peg Tyre and Jeannette Walls, "Penn Station Project Derailed?" *New York* 21 (March 21, 1988): 13.

50. Robert D. McFadden, "New Project Will Renovate Garden," *New York Times* (January 24, 1989), B: 1, 6; William G. Blair, "Garden to Close the Felt Forum for Two Years," *New York Times* (January 27, 1989), B: 3; Johnnie L. Roberts, "Spotlight Is on Restored Garden," *Wall Street Journal* (July 13, 1992), B: 3.

51. Stephen Holden, "New Paramount Theater to Give Radio City a Run for Its Music," *New York Times* (September 11, 1991), C: 13.

52. "In the City Limits," *Oculus* 53 (February 1991): 3; "Pavilion Marks New Entry to Penn Station," *Architectural Record* 179 (March 1991): 43; "An Entrance of Pennsylvania Station," *Architecture + Urbanism* (May 1993): 116–20; Stewart Ain, "Pennsylvania Station Puts on a Smiling Face," *New York Times* (July 18, 1993), XIII: 1, 10; "New Penn Station Entrance," *Progressive Architecture* 74 (October 1993): 30; Bruce Lambert, "At Penn Station, the Future Pulls In, Recalling the Past," *New York Times* (May 1, 1994), XIII: 6; "Easing the Job of Getting to Work," *New York Times* (June 23, 1994), C: 3; "L.I.R.R. Has a New Front Door at Pennsylvania Station," *New York Times* (July 7, 1994), B: 4; Stewart Ain, "High Marks for New Penn Station," *New York Times* (October 9, 1994), XIII: 1, 14; "A Front Door for NYC's Penn Station," *Progressive Architecture* 75 (December 1994): 17; "For the Dashing Commuter: L.I.R.R. Finishing 34th St. Pavilion," *New York Times* (January 8, 1995), IX: 1; "LIRR Entrance Pavilion," *Progressive Architecture* 76 (February 1995): 108; Raul A. Barreneche, "Details: Entrance Pavilion," *Architecture* 84 (August 1995): 152; Mildred F. Schmertz, "Civic Transit," *Architecture* 84 (August 1995): 68–75; Frank F. Drewes, "Eingangspavillon der Penn Station in New York City, New York," *Deutsche Bauzeitschift* 43 (July 1995): 55–62; "R. M. Kliment & Frances Halsband," *Architecture + Urbanism* (January 1996): 94–101; Sirefman, *New York*, 118–21; *R. M. Kliment & Frances Halsband Architects: Selected and Current Works* (Mulgrave, Australia: Images Publishing, 1998), 130–39; White and Willensky, *AIA Guide* (2000), 236; Balfour, *World Cities: New York*, 187.

53. Sirefman, *New York*, 120. Also see *Maya Lin: Public/Private* (Columbus, Ohio: Wexner Center for the Arts, 1994), 32, 37; Bruce Lambert, "Station's Sculpture: Time, Always Running, Running," *New York Times* (July 24, 1994): 6; Peter Plagens with Yahlin Chang, "Maya Lin's Time for Light," *Newsweek* 124 (August 8, 1994): 52; "The Talk of the Town: Maya Lin's Moment," *New Yorker* 70 (July 11, 1994): 31; Mark Alden Branch, "Maya Lin: After the Wall," *Progressive Architecture* 75 (August 1994): 60–65; Judith E. Stein, "Space and Place," *Art in America* 82 (December 1994): 66; Michael Brenson, "Maya Lin's Time," in *Maya Lin* (Milan: Electa, 1998), 86–88; Maya Lin, *Boundaries* (New York: Simon & Schuster, 2000), 2: 5, 7, 6: 22–23; 12: 5.

54. James Dao, "Amtrak's Envious Look at Post Office," *New York Times* (May 13, 1992), B: 1–2; "Topics of The Times: The Glory That Was Rail," *New York Times* (May 14, 1992): 24; James Dao, "Penn Station II: A Post Office?" *New York Times* (May 17, 1992), IV: 3; Jeannette Walls, "All Aboard Amtrak at Eighth Ave. GPO?" *New York* 25 (May 18, 1992): 7; Paul Goldberger, "Some Welcome Fiddling with Landmarks," *New York Times* (May 24, 1992), II: 26; "Back to the Future," editorial, *New York Observer* (May 25, 1992): 4; John Tauranac, "Flights of Fancy Doom Post Office Conversion for Rail Travel," letter to the editor, *New York Times* (May 27, 1992): 20; "Penn Station's Revenge?" *Progressive Architecture* 73 (June 1992): 164; Eric Gibson, "Waiting for the Resurrection," *National Review* 44 (July 6, 1992): 48–49; Dan Cupper, "A New Penn Station?" *Trains* 53 (January 1993): 40; "Glimpse into a Possible Future Penn Station, If Amtrak Has Its Way," *New York Times* (May 2, 1993): 45; David W. Dunlap, "Amtrak

Unveils Its Design to Transform Post Office," *New York Times* (May 2, 1993): 47; Charles V. Bagli, "Amtrak's Grand Post Office Plan Fans Hopes for West 30's Revival," *New York Observer* (May 3, 1993): 1, 17; "A Noble Gateway for Gotham," editorial, *New York Times* (May 9, 1993), IV: 14; Mark Alden Branch, "Post Office for New Penn Station?" *Progressive Architecture* 74 (June 1993): 23; Judith Davidsen, "Can Penn Station Rise Again?" *Architectural Record* 181 (June 1993): 23; Herbert Muschamp, "In This Dream Station Future and Past Collide," *New York Times* (June 20, 1993), II: 1, 40; Suzanne Stephens, "Post Office to Penn Station: High Expectations," *Oculus* 56 (September 1993): 6–7; "Clinton for New Station," *New York Times* (October 28, 1993), B: 8; Mervyn Rothstein, "Post Office Will Restore a Crumbling Cornice," *New York Times* (January 23, 1994), X: 1; Sidney Blumenthal, "To the Pennsylvania Station," *New Yorker* 70 (March 14, 1994): 70–73; Marvine Howe, "Grand New Amtrak Terminal: Arriving, the First $10 Million," *New York Times* (May 1, 1994), XIII: 6; Todd S. Purdum, "A Rough Stretch of Track for a New Penn Station," *New York Times* (September 21, 1994), B: 1, 4; Todd S. Purdum, "Congress Keeps $40 Million for Pennsylvania Station in a Spending Bill," *New York Times* (September 23, 1994), B: 3; Ada Louise Huxtable, "On the Right Track," *New York Times* (November 28, 1994): 17; Melinda Henneberger, "$21 Million Restored for Penn Station Renovation," *New York Times* (April 6, 1995), B: 3; William D. Middleton, "New York Penn Station: New Look, New Nerve Center," *Railway Age* 196 (July 1995): 48; Thomas J. Lueck, "Senate Vote Furthers Plan to Overhaul Penn Station," *New York Times* (August 11, 1995), B: 3; Ian Fisher, "Renovation of Penn Station Moves Closer," *New York Times* (October 20, 1995), B: 6; Ian Fisher, "U.S. Panel Gives Penn Station Renovation Plans a Lift," *New York Times* (November 16, 1995), B: 9; Bruce Lambert, "Power Struggle Stalls Station Plan," *New York Times* (January 28, 1996), XIII: 6; Alice Lipowicz, "Penn Rail Rehab Downsized; Cost Estimates Soar," *Crain's New York Business* (June 30-July 6, 1997): 1, 39; David M. Halbfinger, "Scaled-Down Plan Approved for New Amtrak Station," *New York Times* (July 11, 1997), B: 5; *A Master Plan for a New Pennsylvania Station* (New York: Municipal Art Society, 1998); Anthony Tischhauser and Stanislaus von Moos, eds., *Calatrava: Public Buildings* (Basel: Birkhauser, 1998), 389; Martha T. Moore, "Next Door in Store for Penn Station?" *USA Today* (January 21, 1998): 3A; David W. Dunlap, "Lost Colossus Draws Closer to Resurrection," *New York Times* (February 9, 1998), B: 1, 6; David W. Dunlap, "Reclaiming 'Day' and 'Night,' Memories in Marble," *New York Times* (February 9, 1998), B: 1, 6; Philip K. Howard, letter to Robert A. M. Stern (February 19, 1998); "From Sleeping Giant to Vibrant Gateway," *Municipal Art Society Newsletter* (March-April 1998): 1, 3; Elisabeth Bumiller, "A Dream of Glory: Penn Station's, That Is," *New York Times* (March 4, 1998), B: 2; Thomas J. Lueck, "Deal Will Give a Grand Space to Penn Station," *New York Times* (March 5, 1998): 1, B: 8; "Manhattan Post Office Will Be Converted into New Penn Station," *Wall Street Journal* (March 5, 1998), C: 20; "A New Penn Station," editorial, *New York Times* (March 6, 1998): 22; Daniel Patrick Moynihan, "Putting Pizazz Back in Public Works," *New York Times* (March 6, 1998): 23; James Vescovi, "Post Office Murals, at 50, Get Face Lift," *New York Times* (March 8, 1998), XIV: 5; Ellen Kirschner Popper, "To Compensate for a Lost Landmark, Feds Make Way for Penn Station," *Architectural Record* 186 (April 1998): 35; Michael J. O'Connor, "Penn Station Goes Postal," *Architecture* 87 (April 1998): 27; Blaine Harden, "In N.Y., Recreating a Penn Station Past," *Washington Post* (April 25, 1998): 8; "Update on the New Penn Station!" *Municipal Art Society Newsletter* (May-June 1998): 3; "Penn Station Design Team," *New York Times* (June 14, 1998), XI: 1; "Good for New York," *Municipal Art Society Newsletter* (July-August 1998): 3; David W. Dunlap, "A Quest for Fragments of the Past," *New York Times* (August 16, 1998): 33, 38; Karrie Jacobs, "New Train of Thought," *New York* 31 (October 12, 1998): 28–30; David W. Dunlap, "Before Expanding, Sprucing Up Old Penn Station," *New York Times* (October 14, 1998), B: 7; Charles J. Margiotti 3d, Halton Adler Mann, Peter Sultan, and David Vandor, "At Penn Station: Rider Egression," letters to the editor, *New York Times* (October 17, 1998): 14; Darrin W. Arremony, Raymond Crane, and Gersil N. Kay, "Looking Forward," letters to the editor, *New York* 31 (November 2, 1998): 12; David W. Dunlap, "Work on the Future of Pennsylvania Station Unearths a Bit of Its Past," *New York Times* (November 8, 1998): 41; David W. Dunlap, "Clearing the Tracks for Penn Station III," *New York Times* (January 3, 1999), XI: 1, 4; "On the Drawing Boards," *Oculus* 61 (February 1999): 5; Anne Matthews, "End of an Error," *Preservation* 51 (March-April 1999): cover, 42–51; Thomas J. Lueck, "Station Has a Blueprint, but Still Needs Money," *New York Times* (May 16, 1999): 31; Herbert Muschamp, "In New Penn Station, a Vision of the Future," *New York Times* (May 16, 1999): 1, 31; Michael Tomasky, "The Next Big Things," *New York* 32 (May 17, 1999): 40–47; "Planning for Greatness to Come," editorial, *New York Times* (May 20, 1999): 26; "Seeking to Invoke Part of New York's Past," *New York Times* (May 20, 1999): 1; Adam Nagourney, "Giuliani Snubs Clinton's Visit for Rail Hub," *New York Times* (May 20, 1999), B: 1, 8; Douglas J. Boyle, "Who Needs a New Penn Station?" letter to the editor, *New York Times* (May 22, 1999): 12; Brendan B. Read, "New Station, No Benefit," letter to the editor, *New York Times* (May 27, 1999): 32; William J. Clinton, "Remarks at the Launching of the Pennsylvania Station Redevelopment Corporation in New York City," *Weekly Compilation of Presidential Documents* 35 (May 24, 1999): 936–38; George Plimpton, "Dept. of Hoopla," *New Yorker* 75 (May 31, 1999): 34–35; Dean Michael Mead, "Think Big," letter to the editor, *New York* 32 (June 7, 1999): 10; Paul Goldberger, "The Talk of the Town: A Second Chance for Penn Station," *New Yorker* 75 (June 7, 1999): 29–30; Allen Salkin, "Re-Penned," *Grid* 1 (Summer 1999): 80–82; Herbert Muschamp, "A Model for Penn

Station Is on View at the Modern," *New York Times* (June 25, 1999), E: 33; Soren Larson, "Penn Station's Ghost Lingers: Landmarks to Get New Looks," *Architectural Record* 187 (July 1999): 55; Raul A. Barreneche, "Penn, Again," *Architecture* 88 (July 1999): 37; Melanie Rehak, "Questions for David Childs: Spatial Relations," *New York Times* (August 15, 1999), VI: 20; Paula Deitz, "Pennsylvania Phoenix," *Architectural Review* 206 (September 1999): 27; Jayne Merkel, "The Newest Penn Station," *Oculus* 62 (September 1999): 6; Thomas J. Lueck, "A Sparkling New Penn Station Gets a Push with $160 Million in U.S. Loans," *New York Times* (September 27, 1999), B: 3; "New York Misses Out," *World Architecture* 81 (November 1999): 29; Thomas J. Lueck, "A $60 Million Step Forward in Rebuilding Penn Station," *New York Times* (November 19, 1999), B: 4; Herbert Muschamp, "New York Starts to Look Beyond Its Past," *New York Times* (December 26, 1999), II: 49; *Skidmore, Owings & Merrill: Architecture and Urbanism, 1995–2000* (Mulgrave, Australia: Images Publishing, 2000), 136–39; Abby Bussel, *SOM Evolutions: Recent Work of Skidmore, Owings & Merrill* (Basel: Birkhauser, 2000), 168–75; Kenneth Powell, *City Transformed* (New York: Te Neues, 2000), 12–13; Paul Spencer Byard, "A Penn for Today," *Architectural Record* 188 (January 2000): 24; "Project Award: Skidmore, Owings & Merrill," *Oculus* 62 (January 2000): 42; Julie V. Iovine, "Working on the Railroad: The Reincarnation of a Classic Station," *New York Times* (January 27, 2000), F: 3; Peter Reinharz, "Why Penn Station Should Stay Put, *City Journal* 10 (Autumn 2000): 9; Benjamin Forgey, "Senator of Design," *Metropolis* 20 (December 2000), 78–83, 104–5, 113; Dean F. Murphy, "As New Penn Station Proceeds, Officials Say Tunnel Problems Tempt Fate," *New York Times* (December 10, 2000): 57, 59; Dean E. Murphy, "Penn Station Needs Millions for Repairs," *New York Times* (December 19, 2000), B: 1, 8; Balfour, *World Cities: New York,* 64–68, 256–59; Wilfried Wang, ed., *SOM Journal 1* (Ostfildern-Ruit, Germany: Hatje Cantz Verlag, 2001), 32–51; David W. Dunlap, "Developers Chosen for New Pennsylvania Station," *New York Times* (March 16, 2001), B: 10; Todd W. Bressi, "James A. Farley Building–Pennsylvania Station," *Places* 14 (Fall 2001): 22–23; David W. Dunlap, "Penn Station Faces Delay of Expansion," *New York Times* (October 11, 2001), D: 1, 4; Joseph P. Fried, "Post Office to Proceed in Expanding Penn Station," *New York Times* (October 13, 2001), D: 3; Marilyn Jordan Taylor, "The New Pennsylvania Station," in Hilary Ballon, *New York's Pennsylvania Stations* (New York: W. W. Norton, 2002), 151- 96; Jerry W. Szatan, "Retain, Renew, Rebuild," *Urban Land* 61 (February 2002): 88–91; Tom McGeveran, "Is Penn Station Being Stalled? Moynihan Back," *New York Observer* (April 8, 2002): 1, 9; John E. Czarnecki, "Stalled Plans for New Penn Station at a Critical Juncture," *Architectural Record* 190 (May 2002): 44; Timothy Starks, "Moynihan Tapped to Help Rescue a 'Dreary Failure,'" *New York Sun* (August 28, 2002): 1, 4; Michael Cooper, "Plan to Build a New Penn Station Is Moving Ahead, Officials Say," *New York Times* (August 28, 2002), B: 3; Tom McGeveran, "Penn Station Deal Reaches Junction; Bush, Pataki Push," *New York Observer* (September 30, 2002): 1, 9; Charles V. Bagli, "Deal Revives Delayed Plan for Train Hub," *New York Times* (October 8, 2002), B: 1, 6; "Resurrecting Penn Station," editorial, *New York Post* (October 9, 2002): 26; Leah Haines, "New Penn Station Back on Track," *New York Post* (October 9, 2002): 6; Beagan Wilcox, "The Vision for Pennsylvania Station Is Unveiled," *New York Sun* (October 9, 2002): 7; "Old Post Office to Become New York City Transit Hub," *Engineering News-Record* 249 (October 14, 2002): 7; Ian Luna, ed., *New New York: Architecture of a City* (New York: Rizzoli International Publications, 2003), 148–53; David W. Dunlap, "Blocks," *New York Times* (January 23, 2003), B: 3; Nichole M. Christian, "Moynihan Monument," *New York Times* (March 28, 2003), D: 6; David W. Dunlap, "Blocks," *New York Times* (April 3, 2003), D: 3.

55. For the General Mail Facility, see "Work Is Underway on a $200M Addition, Renovation of Morgan Station Post Office," *New York Construction News* 34 (September 9, 1991): 1–2; "Midtown High Point; Post Office's Flag Day," *New York Times* (December 29, 1991), X: 1.

56. Muschamp, "In This Dream Station Future and Past Collide": 40.

57. Dan Dolan, quoted in Stephens, "Post Office to Penn Station: High Expectations": 7.

58. Daniel Patrick Moynihan, quoted in Harden, "In N.Y., Recreating a Penn Station Past": 8.

59. Muschamp, "In New Penn Station, a Vision of the Future": 1, 31.

60. Goldberger, "A Second Chance for Penn Station": 29–30.

61. William J. Clinton, quoted in Barreneche, "Penn, Again": 37.

62. Allen Salkin, "Re-Penned": 81.

63. Daniel Patrick Moynihan, quoted in Lueck, "A $60 Million Step Forward in Rebuilding Penn Station": 4.

64. Stern, Mellins, and Fishman, *New York 1960,* 313–14.

65. Herbert Muschamp, "Architects to Compete with Ideas for Cities," *New York Times* (November 14, 1998), B: 9, 16; "Buzz," *Architecture* 87 (December 1998): 30; Herbert Muschamp, "Public Space, Private Space and Anti-Space," *New York Times* (December 27, 1998), II: 38; *Move* (Amsterdam: UN Studio, Goose Press, 1999), 257; "Architects to Offer Proposals for Area West of Midtown," *New York Times* (February 13, 1999), B: 15; "Congratulations Due," *Oculus* 61 (March 1999): 6; "Canada," *World Architecture* 74 (March 1999): 30; Herbert Muschamp, "A 12-Block Glimmer of Hope for New York," *New York Times* (March 14, 1999), II: 1, 45; "Buzz," *Architecture* 88 (April 1999): 27; "Five Listed for IFCCA," *World Architecture* 76 (May 1999): 26; Thomas J. Lueck, "Big Visions for the West Side," *New York Times* (June 29, 1999), B: 1, 6; Howard H. Slatkin, "Architects' New West Side Story," *New York Times* (July 3, 1999): 10; John Tierney, "Grand Designs Warrant Wary Looks," *New York Times* (July 8, 1999), B: 1; Karrie Jacobs, "Robert Moses Lives," *New York*

32 (July 12, 1999): 16, 18, 77; Michael Cannell, "Eisenman Nabs CCA Prize," *Architecture* 88 (August 1999): 23; Soren Larsen, "CCA's Design Competition Yields Bold Plans for New York," *Architectural Record* 187 (August 1999): 53; "Peter Eisenman," *Arquitetura & Urbanismo* 85 (August/September 1999): 27; "Eisenman Shows the Way," *Blueprint* 164 (September 1999): 13; "The Eisenman Cometh," *World Architecture* 79 (September 1999): 19; James S. Russell, "Railyard Dog?" *Grid* 1 (Fall 1999): 72–77; "In the Works . . . Manhattan's West Side," *Planning* 65 (October 1999): 50; Karrie Jacobs, "To Hell's Kitchen and Back," *Architecture* 88 (October 1999): 63, 65–66, 69, 71; Valerie Gladstone, "Best Western?" *Metropolis* 19 (October 1999): 104–9; Nina Rappaport, "The IFCCA Ideas Competition," *Oculus* 62 (October 1999): 6; "Architects Envision West Side Stories," *New York Times* (October 3, 1999), XI: 1; Herbert Muschamp, "Design Fantasies for a Strip of the West Side," *New York Times* (October 18, 1999), E: 1, 7; "Rieser + Umemoto Win High-Powered Prize," *World Architecture* 81 (Nobember 1999): 30; Robert A. Ivy, "Who Speaks for Architecture?" editorial, *Architectural Record* 187 (November 1999): 15; Catherine Slessor, "West Side Story," *Architectural Review* 206 (November 1999): 31; Michael Sorkin, "Six Degrees of Phyllis Lambert," *Metropolis* 19 (November 1999): 82, 84; Jayne Merkel, "IFCCA Competition," *Oculus* 62 (December 1999): 10–11; "New York," *Metropolis* 19 (January 2000): 86–92; "Eisenman Vence Concursos na Espanha e nos EUA," *Projeto* 240 (February 2000): 18; Michael Sorkin, "The Devil's in the Details," *Metropolis* 19 (February/March 2000): 48, 50, 52, 54; "Deep Planning: West Side, New York," *Architectural Design* 70 (June 2000): 44–55; "West Side Convergence," *Architectural Design* 70 (June 2000): 78–89; "Project for the West Side, New York," *Industria delle Costruzioni* 347 (September 2000): 48–51; Balfour, *World Cities: New York,* 328–31; "Pennsylvania Station/West Side Manhattan," *Lotus International* 108 (2001): 102–5; "Peter Eisenman: Urban Icon," *Lotus International* 108 (2001): 106–7; "Reiser + Umemoto: View from the Roof," *Lotus International* 108 (2001): 110–11; "UN Studio: Five Clusters," *Lotus International* 108 (2001): 108–9; Ben van Berkel and Caroline Bos, *UN Studio UN Fold* (Rotterdam: NAI Publishers, 2002), 40–57; Luna, ed., *New New York,* 144–47.

66. Cedric Price, quoted in Lueck, "Big Visions for the West Side": 6.

67. Peter Eisenman, quoted in "Urban Icon of the Next Millenium," in http://cca.qc.ca.

68. Jacobs, "Robert Moses Lives": 16, 18.

69. Jacobs, "To Hell's Kitchen and Back": 63, 65–66, 69, 71; Jayne Merkel, "Reshaping Hell's Kitchen South," *Oculus* 62 (October 1999): 7; "Some Good Intentions for Hell's Kitchen," *New York Times* (November 14, 1999), XIV: 14; Todd Bressi, "Developing Strategies for Hell's Kitchen South," *Oculus* 62 (January 2000): 7–8; Sorkin, "The Devil's in the Details": 48, 50, 52, 54; "Reimagining Hell's Kitchen South," *Places* 13 (No. 3, 2000): 48–51; Jayne Merkel, "Building Consensus on Midtown West," *Oculus* 63 (February 2001): 13–16; Michele Bertomen, "Figure/Fabric: Process/Production," *Journal of Architectural Education* 54 (May 2001): 272–78; Michael Conard and David Smiley, *Hell's Kitchen South: Developing Strategies* (New York: Design Trust for Public Space, 2002).

70. Quoted in "Hell's Kitchen South: Developing Strategies," exhibition announcement.

71. Sorkin, "The Devil's in the Details": 50.

72. Bressi, "Developing Strategies for Hell's Kitchen South": 7.

73. Sorkin, "The Devil's in the Details": 52.

74. For Gwathmey Siegel's unbuilt project, see Albert Scardino, "Project Would Extend Office Towers to Ninth Avenue," *New York Times* (April 22, 1987), B: 1, David W. Dunlap, "Commercial Property: Clinton South," *New York Times* (April 1, 1990), X: 19; David W. Dunlap, "The Shattered Vision of the Booming 90's," *New York Times* (March 8, 1992), X: 1, 10; David W. Dunlap, "The Taming of the 'Wild West,'" *New York Times* (August 24, 1997), IX: 1, 6; Peter Grant, "Plots & Ploys," *Wall Street Journal* (August 16, 2000), B: 16. For the Penmark, see Alan S. Oser, "A Mixed-Use Tower for Theaters and Apartments," *New York Times* (June 16, 1999), B: 11; Edwin McDowell, "Residential Real Estate," *New York Times* (May 4, 2001), B: 9; Eric Herman, "Penmark Seeks Upscale Tenants in Down Market," *New York Daily News* (August 14, 2001): 50; Robert Dominguez, "Multiplex Miracle on 34th St.," *New York Daily News* (November 1, 2001): 56; Elizabeth Howard, "At the Podium," *Oculus* 64 (December 2001): 10; Tracie Rozhon, "For Renters, the Map Is Redrawn," *New York Times* (December 27, 2001), F: 1, 7.

75. McDowell, "Residential Real Estate": 9.

CLINTON

1. Stern, Mellins, and Fishman, *New York 1960,* 316–20.

2. See Stern, Mellins, and Fishman, *New York 1960,* 316–20.

3. Max H. Siegel, "50-Story Apartment Building Planned for West 57th Street," *New York Times* (October 7, 1972): 1, 66; Robert E. Tomasson, "Parc Vendome Utility Bill a Hint of Builders' Woes," *New York Times* (March 25, 1975): 36; Alan S. Oser, "After 3 Years, Work Is Resuming on Vendome Addition," *New York Times* (December 9, 1977), B: 11; Carter B. Horsley, "Eighth Ave. Heading for Better Times," *New York Times* (April 5, 1979), VIII: 1–2; James Barron, "Those New Manhattan High-Rises: Less Space, More Money," *New York Times* (November 11, 1979), VIII: 1, 4; Alan S. Oser, "West 57th St. Apartments: Upgrading Trend Continues," *New York Times* (December 7, 1979), B: 8; Richard D. Lyons, "Buildings with Room to Hold a Party," *New York Times* (December 28, 1986), VIII: 1, 8. For the Parc Vendôme, see "Noted Architect Dies," *New York Times* (February 20, 1954): 17; Stern, Gilmartin, and Mellins, *New York 1930,* 417–18.

4. Thomas J. Lueck, "Are Plazas Public Boons, or Nuisances?" *New York Times* (October 7, 1990), X: 1, 11.

5. David Kirby, "A Plaza, a Blight, Perhaps a Park," *New York Times* (April 26, 1998), XIV: 5; Jerold S. Kayden, *Privately Owned Public Space: The New York Experience* (New York: John Wiley, 2000), 113–14; Raul Barraneche, "Plaza into Park, with Coffee Kiosk and Greenmarket," *New York Times* (June 29, 2000): 3; Andrew Alpern, "A Dissent on a Park," letter to the editor, *New York Times* (July 13, 2000), D: 7; David W. Dunlap, "Breathing Life into City's Barren Plazas," *New York Times* (July 16, 2000), XI: 1, 6; *Thomas Balsley: The Urban Landscape* (Berkeley, Calif.: Spacemaker Press, 2001), 68–71; William Welsh, "Public Notice: In an Unusual Gesture, a Developer Names a Park After the Landscape Architect Who Redesigned It," *Landscape Architecture* 91 (February 2001): 18; Todd W. Bressi, "New Life for an Old Plaza," *Places* 14 (Fall 2001): 6–8.

6. Quoted in Dunlap, "Breathing Life into City's Barren Plazas": 6.

7. Samuel G. Freedman, "Arts Groups Oppose Plan for Clinton," *New York Times* (September 3, 1985), C: 13; Michael R. Benson, "Clinton Frets over That Gleam in Developers' Eyes," *New York Times* (December 22, 1985), VIII: 5; Paul Goldberger, "Clinton Renewal Proposal Raises Fears over Effects of 2 High-Rises," *New York Times* (January 16, 1986), B: 1, 6; Martin Gottlieb, "Clinton Renewal Proposal Raises Fears over Effects of 2 High-Rises," *New York Times* (January 16, 1986), B: 1.

8. Stern, Mellins, and Fishman, *New York 1960,* 319–20.

9. Goldberger, "Clinton Renewal Proposal Raises Fears over Effects of 2 High-Rises": 1.

10. Gottlieb, "Clinton Renewal Proposal Raises Fears over Effects of 2 High-Rises": 1. Also see Gottlieber, "Clinton Renewal Proposal Raises Fears over Effects of 2 High-Rises": 1, 6; "Clinton," *Progressive Architecture* 69 (March 1988): 83; "Housing Projects," *Progressive Architecture* 69 (October 1988): 94–95; "Mid-Manhattan Urban Renewal," *Progressive Architecture* 71 (January 1990): 110–12; Peter Katz, *The New Urbanism: Toward an Architecture of Community* (New York: McGraw- Hill, 1994), 206–11.

11. Steven Peterson, quoted in "Housing Projects": 94.

12. Goldberger, "Clinton Renewal Proposal Raises Fears over Effects of 2 High-Rises": 6.

13. David W. Dunlap, "Koch, Under Stiff Pressure, Kills Clinton Housing Plan," *New York Times* (April 18, 1986), B: 1, 3; Joyce Purnick, "A New Climate at City Hall," *New York Times* (April 19, 1986): 29, 31; Alan Finder, "Builder Sues to Continue Project Koch Withdrew," *New York Times* (September 3, 1986), B: 3.

14. Rachelle Garbarine, "In Far West 50's, Project Will Bring New Rentals," *New York Times* (May 26, 2000), B: 6; "The Foundry Aims for Younger Crowd," *Real Estate New York* 20 (June 2001): 28; William Weathersby Jr., "Interlocking Volumes Outlined in Light Enhance the Lobby of a High-Rise Apartment Tower in Manhattan," *Architectural Record* 190 (May 2002): 325–28.

15. David L. Picket, quoted in Garbarine, "In Far West 50's, Project Will Bring New Rentals": 6.

16. Peter Grant, "Moving into Manhattan; Costco to Try City Concept in Hell's Kitchen," *New York Daily News* (November 2, 1999): 63; Corey Kilgannon, "Stiffening Resistance to a Planned Megamarket," *New York Times* (February 13, 2000), XIV: 6; Terry Pristin, "Costco Drops Plan for West Side Store," *New York Times* (June 23, 2000), B: 8; Terry Pristin, "What Price Costco? Too High in Manhattan," *New York Times* (July 16, 2000): 23.

17. Costas Kondylis, quoted in David Chartock, "Site, Logistics, Design Challenge 500 W. 56th St. Development Team," *New York Construction News* 50 (January 2003): 29. Also see Rachelle Garbarine, "Rental Units Set at Ex-Costco Sites in Manhattan," *New York Times* (July 12, 2002), B: 7.

18. Iver Peterson, "Eighth Avenue Goes from Grit to Glitter," *New York Times* (January 29, 1989), X: 1, 18.

19. "Eighth Ave. Development: Westward Ho!" *New York Times* (January 15, 1984), VIII: 1; Christopher Gray, "Streetscapes/Eighth Avenue, From 43d to 55th Street," *New York Times* (September 26, 1999), XI: 9.

20. "Old Garden Site Sold to Developers," *New York Times* (December 13, 1984), B: 4; Susan Heller Anderson and David W. Dunlap, "Plans for Site of Old Garden," *New York Times* (January 29, 1985), B: 3; "G&W Out, Zeckendorf In," *Metropolis* 4 (April 1985): 12–13; Paul Goldberger, "Plan for Old Garden Site: Impressive Restraint and a Sense of the City," *New York Times* (November 26, 1985), B: 16; Martin Gottlieb, "Complex Planned for Old Madison Square Garden Site," *New York Times* (November 26, 1985): 1, B: 16; "In Progress," *Progressive Architecture* 66 (December 1985): 16; Courty Andrews, "Jahn and SOM in N.Y.: Contrasting Approaches to Urban Design," *Architecture* 75 (February 1986): 16, 18; Philip S. Gutis, "Community Boards Gaining in Power," *New York Times* (September 21, 1986), VIII: 1, 26; Peter Carlsen, "World-Wise," *Real Estate Shopper's Guide* (September 1987): 3a; "Worldwide Plaza," *Real Estate Shoppers Guide* (May 1988): 13a; Alan S. Oser, "Shaping Four Acres in Mid-Manhattan," *New York Times* (May 22, 1988), X: 9, 22; "Major Law Firm Moves to Worldwide Plaza," *New York Post* (August 11, 1988): 52; Karl Sabbagh, *Skyscraper* (London: Macmillan, 1989); Susan Browne, "Adding a Notch to a City Skyline," *Engineering News-Record* 222 (January 5, 1989): 22–23, 28–29; Audrey Farolino, "Popcorn Partners," *New York Post* (January 5, 1989): 43, 50; Michael Quint, "Talking Deals," *New York Times* (January 19, 1989), D: 2; Peterson, "Eighth Avenue Goes from Grit to Glitter": 1, 18; Adam R. Rose, "Eighth Avenue," letter to the editor, *New York Times* (January 5, 1989): 1; Felicia R. Lee, "Gentrification and Crime Lay Siege to Clinton," *New York Times* (July 8, 1989): 25-26; Martin Pawley, "Reach for the Skies," *Architects' Journal* 190 (November 22, 1989): 104–5; Paul Goldberger, "World Wide Plaza: So Near and Yet So Far,"

New York Times (January 21, 1990), II: 28, 34; Philip Lopate, "The Great Context Con," *7 Days* (March 21, 1990): 35–36; Andrea Oppenheimer Dean, "Urban Civility," *Architecture* 79 (April 1990): 84–89; Paul Goldberger, "How Do You Build a Skyscraper? With Frustration," *New York Times* (May 7, 1990), C: 14; David W. Dunlap, "Zeckendorf Is Ready for Another Burst of Building," *New York Times* (May 13, 1990), X: 21; "Spreading the Word," editorial, *Engineering News-Record* 224 (May 17, 1990): 66; Judy Schriener, "Finally, a TV Series for Builders," *Engineering News-Record* 224 (May 17, 1990): 13; James Kim, "Realty Baron Blues," *USA Today* (August 8, 1990), B: 1; Daniel Bluestone, "New York Forum About Architecture Worldwide Yet out of Place," *Newsday* (September 26, 1990): 54; Brendan Gill, "The Sky Line: Worldwide Plaza," *New Yorker* 66 (December 24, 1990): 86–90; Ron Alexander, "Movie Houses: The Oases of Summer," *New York Times* (August 9, 1991), C: 1, 6; Michael Sardina, "Worldwide Plaza," *Process Architecture* 103 (May 1992): 71; "Worldwide Plaza," *Architecture + Urbanism*, special issue (September 1993): 102–5; Claudia H. Deutsch, "In Hell's Kitchen, Retail Is on the Front Burner," *New York Times* (May 5, 1996), IX: 9; Peter Grant, "Zeck Jr. in Building Battle," *New York Daily News* (August 9, 1996): 34; "Changes Due at Worldwide Plaza," *New York Times* (October 20, 1996), IX: 1; Michael J. Crosbie, *The Architecture of Frank Williams* (Rockport, Mass.: Rockport Publishers, 1997), 26–35; Susanna Sirefman, *New York: A Guide to Recent Architecture* (London: Ellipsis, 1997), 139; David D. Kirkpatrick, "Equity Office Says It Will Purchase New York Complex," *Wall Street Journal* (October 2, 1998), B: 10; "Equity Office to Buy Worldwide Plaza in New York," *New York Times* (October 3, 1998), C: 3; Eric P. Nash, *Manhattan Skyscrapers* (New York: Princeton Architectural Press, 1999), 155–56; White and Willensky, *AIA Guide* (2000), 263; Barbara Martinez, "A Real-Estate King Sees a Legacy Unravel as Creditors Move In," *Wall Street Journal* (March 21, 2000): 1, 6; David W. Dunlap, "In City Canyons, Slivers of Public Space Erode," *New York Times* (September 28, 2000): B: 6.

21. Stern, Mellins, and Fishman, *New York 1960*, 1120.

22. Stern, Gilmartin, and Mellins, *New York 1930*, 579–80.

23. Goldberger, "Worldwide Plaza: So Near and Yet So Far": 28, 34.

24. Stern, Gilmartin, and Mellins, *New York 1930*, 541–44, 591–95.

25. Goldberger, "Worldwide Plaza: So Near and Yet So Far": 28, 34.

26. Gill, "The Sky Line: Worldwide Plaza": 88–89.

27. "52d St. Conversion: Off Broadway," *New York Times* (March 15, 1987), VIII: 1.

28. "Eighth Ave. Rentals: Lost Frontier," *New York Times* (December 28, 1986), VIII: 1; Peterson, "Eighth Avenue Goes from Grit to Glitter": 1, 18.

29. "Mixing Uses: 43 Stories in Midtown," *New York Times* (May 19, 1985), VIII: 1; David W. Dunlap, "8th Ave. Scenes; Present to the Future: Dowdy to Jaunty," *New York Times* (December 11, 1986), B: 1; Andree Brooks, "Early Buys; Pitfalls for the Unwary," *New York Times* (January 11, 1987), VIII: 1, 12; Shawn G. Kennedy, "Some Developers Are Shifting from Condos to Rental Units," *New York Times* (February 15, 1987), VIII: 1; Mark McCain, "Mixed-Use Buildings: The Rocky Marriages of Offices and Apartments," *New York Times* (April 19, 1987), VIII: 19; David W. Dunlap, *On Broadway: A Journey Uptown over Time* (New York: Rizzoli International Publications, 1990), 195.

30. Dunlap, *On Broadway*, 195.

31. "The Ritz Plaza: Off Broadway," *New York Times* (December 25, 1988), X: 1; Andree Brooks, "An Apartment Hotel Opens on West 48th Street," *New York Times* (January 19, 1990), B: 7; Alan S. Oser, "New Midtown Rentals: A Developer Rides the Market's Waves," *New York Times* (September 29, 1991), X: 5; Dunlap, "Breathing Life into City's Barren Plazas": 1; Kayden, *Privately Owned Public Space*, 147–48.

32. "Keeping Lost Heroes Near," *New York Times* (May 22, 2002), B: 4.

33. Barry Dimson, quoted in Dunlap, "Zeckendorf Is Ready for Another Burst of Building": 21.

34. Peter Grant, "Hell's Kitchen Is Hot; Developer Eyes Adonis Digs for Luxury Apts.," *New York Daily News* (January 24, 1997): 37; Rachelle Garbarine, "For 8th Avenue in the 50's, 80's-Like Growth Spurt," *New York Times* (April 18, 1997), B: 5; Alan S. Oser, "A New Wave of Rentals for Eighth Avenue in the 50's," *New York Times* (November 2, 1997), XI: 5; "Owners Buy Right to Call It the Gershwin; Building's Name Got Rhythm," *New York Times* (July 12, 1998), XI: 1; Rachelle Garbarine, "A New Tower for Young Professionals," *New York Times* (September 25, 1998): B: 9; Gray, "Streetscapes/Eighth Avenue, From 43d to 55th Street": 9.

35. Dunlap, "Zeckendorf Is Ready for Another Burst of Building": 21; Grant, "Hell's Kitchen Is Hot; Developer Eyes Adonis Digs for Luxury Apts.": 37; Peter Grant, "Macklowe Back in the Game," *New York Daily News* (April 17, 1997): 67; Garbarine, "For 8th Avenue in the 50's, 80's-Like Growth Spurt": 5; Oser, "A New Wave of Rentals for Eighth Avenue in the 50's": 5; Garbarine, "A New Tower for Young Professionals": 9; Gray, "Streetscapes/Eighth Avenue, From 43d to 55th Street": 9; Rachelle Garbarine, "For Clinton Corner, More Apartments," *New York Times* (April 14, 2000), B: 6.

36. Gray, "Streetscapes/Eighth Avenue, From 43d to 55th Street": 9.

37. David W. Dunlap, "Three Manhattan Theaters Are Given Landmark Status," *New York Times* (November 11, 1987), B: 3; Esther Iverem, "Fire Damages Interior of the Biltmore Theater," *New York Times* (December 11, 1987), B: 3; Thomas L. Waite, "Biltmore on the Block; Curtain Falling," *New York Times* (February 7, 1988), VIII: 1; Jeremy Gerard, "Biltmore Theater Is Sold," *New York Times* (February 17, 1988), C: 22; "Neglect and Vandalism Threaten a Broadway Theater," *New*

York Times (August 10, 1988), B: 1; David W. Dunlap, "Scavengers Steal Show at a Landmark Theater," *New York Times* (August 10, 1988), B: 3; "Biltmore Theater's Owner Rejects $5.25 Million Offer," *New York Times* (April 1, 1989): 16; Lisa W. Foderaro, "43-Story Hotel Planned over Shuttered Biltmore Theater," *New York Times* (April 18, 1997), B: 5; "42nd St. Beat Goes On," editorial, *New York Daily News* (April 19, 1997): 12; Jesse McKinley, "For Sale, Again," *New York Times* (June 11, 1999), E: 2; Alan S. Oser, "Developer Is Stepping Up Its Activity in West Midtown Area," *New York Times* (September 15, 1999), B: 7; Robin Pogrebin, "Little Theaters Are Suddenly in Demand, Yet in Peril," *New York Times* (September 16, 1999), E: 1, 3; Robin Pogrebin, "Theater Club Has Plans for Broadway House," *New York Times* (November 22, 2000), E: 1, 16; Patricia O'Haire, "A Second Act on B'Way for Shuttered Biltmore," *New York Daily News* (November 23, 2000): 63; Terry Pristin, "A Compromise on Biltmore Block," *New York Times* (June 12, 2001), B: 6; Lois Weiss, "Curtain Up on Theater Plan," *New York Post* (December 12, 2001): 42; David W. Dunlap, "Dawning of a New Age for the Biltmore," *New York Times* (December 12, 2001), D: 4; Patricia O'Haire, "MTC Stages the Biltmore's Revival," *New York Daily News* (December 13, 2001): 60; Rachelle Garbarine, "New Eighth Ave. Building Towers over Neighbors," *New York Times* (March 28, 2003), D: 6; Dan Friedman, "A New [Concrete] Star in Theater District," *New York Construction News* 50 (May 2003): 49–52.

38. Landmarks Preservation Commission of the City of New York, LP-1320 (November 10, 1987); Barbaralee Diamonstein, *The Landmarks of New York III* (New York: Harry N. Abrams, 1998), 345.

39. Lore Croghan, "Hearst's New Castle," *Crain's New York Business* (January 10–16, 2000): 1, 26; Denny Lee, "A Tower Hearst Dreamed of May Finally Arise," *New York Times* (April 23, 2000), X: 5; Andrew Rice, "Glass-Steel Whiz Chosen to Design New Hearst Tower," *New York Observer* (January 26, 2001): 1, 10; David W. Dunlap, "Hearst May Finish Tower Started in 1926," *New York Times* (February 21, 2001), B: 10; "Foster Hired by Hearst for New York Building," *Architectural Record* 189 (April 2001): 44; Herbert Muschamp, "A Crystal Beacon Atop a 20's Curiosity," *New York Times* (October 30, 2001), E: 1; David W. Dunlap, "Landmarks Group Approves Bold Plan for Hearst Tower," *New York Times* (November 28, 2001), D: 1–2; John E. Czarnecki, "Foster Proposes Daring Add-on Tower for Itself," *Architectural Record* 190 (January 2002): 32; "Hearst Castle," *Oculus* 64 (January/February 2002): 5; Maurizio Vitta, "L'area Flash," *L'Arca* 167 (February 2002): 75; "Praising the Proposed Hearst Building Tower," *New York Landmarks Conservancy Newsletter* (Spring 2002): 14–15; Keith J. Kelly, "New Hearst 'Castle,'" *New York Post* (May 28, 2002): 29; "Norman Foster: Hearst Headquarters," *GA Document* 70 (July 2002): 28–31; Denny Lee, "Hearst Woos, and Wins, a Wary Neighborhood," *New York Times* (July 14, 2002), X: 8; David W. Dunlap, "Trade-Offs and Reminders at 59th St.," *New York Times* (September 26, 2002), B: 3; Ian Luna, ed., *New New York: Architecture of a City* (New York: Rizzoli International Publications, 2003), 230–31; "Showing Steel," *New York Construction News* 51 (September 2003): 73; John Holusha, "Commercial Property/Midtown," *New York Times* (December 21, 2003), XI: 4. For the International Magazine Building, see Stern, Gilmartin, and Mellins, *New York 1930*, 619, 621; Landmarks Preservation Commission of the City of New York, LP-1625 (February 16, 1988).

40. Quoted in Lee, "A Tower Hearst Dreamed of May Finally Arise": 5. For the 1946 expansion plans, see Landmarks Preservation Commission of the City of New York, LP-1625 (February 16, 1988), 8.

41. Quoted in Rice, "Glass-Steel Whiz Chosen to Design New Hearst Tower": 1.

42. For the Reichstag, see Norman Foster, *Rebuilding the Reichstag* (Woodstock, N.Y.: Overlook Press, 2000). For the Great Court at the British Museum, see *Norman Foster: Selected and Current Works of Foster and Partners* (Mulgrave, Australia: Images Publishing, 1997), 190–93.

43. Quoted in Rice, "Glass-Steel Whiz Chosen to Design New Hearst Tower": 10.

44. Kent Barwick, quoted in Rice, "Glass-Steel Whiz Chosen to Design New Hearst Tower": 10.

45. Muschamp, "A Crystal Beacon Atop a 20's Curiosity": 3.

46. Simeon Bankoff, quoted in Dunlap, "Landmarks Group Approves Bold Plan for Hearst Tower": 2.

47. Dunlap, "Landmarks Group Approves Bold Plan for Hearst Tower": 2.

48. Garbarine, "For Clinton Corner, More Apartments": 6; "$25M Apt./Office Bldg. Starts at W. 50th St.," *New York Construction News* 48 (December 2000): 65.

49. Lou Chapman, "Clash in Clinton over Con Ed Plan," *New York Observer* (October 17, 1988): 6; Alan S. Oser, "Designer's Touch Felt on West 54th St.," *New York Times* (April 25, 1993), VIII: 5, 12; *Richard Dattner: Selected and Current Works of Richard Dattner & Partners Architects* (Mulgrave, Australia: Images Publishing, 2000), 124–25.

50. Richard Dattner, quoted in Oser, "Designer's Touch Felt on West 54th St.": 5.

51. "New Buildings for Dependent Singles on the Way," *New York Times* (February 19, 1995), IX: 7.

52. Rachelle Garbarine, "Assisted-Living Project with a Twist," *New York Times* (February 4, 2000), B: 9.

53. David W. Dunlap, "For Churches, Births and Rebirths," *New York Times* (December 22, 2002), XI: 1, 6; Chris Hedges, "Soldiers of the Lord, Spreading the Gospel on Stage," *New York Times* (January 21, 2003), B: 2.

54. For Park West High School, see Stern, Mellins, and Fishman, *New York 1960*, 316.

55. "Film Production Center Planned for Haaren High School Building," *New York Times* (August 1, 1979), B: 3; Damon

Stetson, "Studios Growing to Meet City Film Industry Surge," *New York Times* (May 31, 1981): 32; Gene Rondinaro, "New Uses for an Old High School," *New York Times* (May 19, 1985), VIII: 6.

56. Rondinaro, "New Uses for an Old High School": 6; "Resurrection on Tenth Avenue," *Architectural Record* 173 (September 1985): 55. For DeWitt Clinton High School, see Stern, Gilmartin, and Massengale, *New York 1900*, 80–83; Stern, Mellins, and Fishman, *New York 1960*, 316, 677.

57. Dympna Bowles, "The John Jay College Building Project: An Innovative Public/Private Partnership," *Urban Land* 48 (October 1989): 20–24; *Rafael Viñoly* (New York: Princeton Architectural Press, 2002), no pagination.

58. *Rafael Viñoly*, no pagination.

59. For Roosevelt Hospital, see Stern, Mellins, and Fishman, *New York 1880*, 784.

60. Ronald Sullivan, "Emergency Room Operation Merges St. Luke's, Roosevelt," *New York Times* (September 23, 1979), E: 6; Ronald Sullivan, "Roosevelt and St. Luke's Merge into One Hospital," *New York Times* (November 20, 1979), B: 1. For St. Luke's Hospital, see Stern, Gilmartin, and Massengale, *New York 1900*, 402–3; Stern, Mellins, and Fishman, *New York 1960*, 751.

61. Christopher Gray, "Streetscapes/The Syms Operating Theater," *New York Times* (October 25, 1987), VIII: 14; Alan S. Oser, "From a Hospital Project Comes Housing," *New York Times* (April 15, 1990), X: 3, 6; Alan S. Oser, "Building for the 'Young Professional' Class," *New York Times* (February 9, 1992), X: 5, 13; Tracie Rozhon, "What's Up–and What's Going Up," *New York Times* (January 15, 1995), IX: 1, 8; Alan S. Oser, "Mixed-Income Rentals as the Key to Housing Development," *New York Times* (November 19, 1995), IX: 7; "On the Boards," *Oculus* 58 (September 1996): 4; Kirk Johnson, "A Touch of College Life, but at $1,900 a Month," *New York Times* (November 6, 1997), B: 1, 12; Kayden, *Privately Owned Public Space*, 241; White and Willensky, *AIA Guide* (2000), 251.

62. For the Syms Operating Theater, see Landmarks Preservation Commission of the City of New York, LP-1578 (July 11, 1989); Stern, Mellins, and Fishman, *New York 1880*, 784.

63. "Design Unifies Two Buildings on W. 57th Street," *New York Construction News* 42 (April 25, 1994): 1, 10; Peter Slatin and Suzanne Stephens, "Around New York: Renovations," *Oculus* 56 (May 1994): 3; "'Automobile Row' No More; A New Fragrance Image for the Far West Side," *New York Times* (May 8, 1994), X: 1; Alan S. Oser, "A Fragrance Maker Sprays the Elegance on Itself," *New York Times* (December 25, 1994), IX: 6; Robert Metzger, *Der Scutt Retrospective* (Reading, Penn.: Reading Public Museum, 1996), 64–65.

64. Der Scutt, quoted in "Design Unifies Two Buildings on W. 57th Street": 1, 10.

TERMINAL CITY

1. "Estimate Board to Rule on Easing of Tax Allowing Commodore Transformation," *New York Times* (March 3, 1976): 41; "Revitalizing the City," editorial, *New York Times* (March 17, 1976): 40; "Manhattan Hyatt Regency Proposed for 42nd Street," *Architectural Record* 159 (April 1976): 35; Alan S. Oser, "Hotel Dispute Focuses on Tax Abatements," *New York Times* (April 27, 1976): 27; Carter B. Horsley, "Commodore Plan Is Key to the City's Tax-Aid Strategy," *New York Times* (March 28, 1976), VIII: 1, 8; Carter B. Horsley, "New Offer Is Made for the Commodore," *New York Times* (April 10, 1976): 20; Edward Ranzal, "Talks Slated on Commodore Hotel Deal," *New York Times* (April 23, 1976): 39; Glenn Fowler, "Tax Plan Voted to Permit Rebuilding of Commodore," *New York Times* (May 21, 1976): 1, B: 5; "Investing in the Future," editorial, *New York Times* (May 31, 1976): 14; Judy Klemesrud, "Donald Trump, Real Estate Promoter, Builds Image as He Buys Buildings," *New York Times* (November 1, 1976): 41, 77; Alan S. Oser, "Beame Seeking to Spur Commercial and Industrial Work," *New York Times* (November 10, 1976), D: 16; "Hotel Commodore Deal," *New York Times* (January 12, 1977), B: 2; Charles Kaiser, "Financing Is Set for Rebuilding of Commodore," *New York Times* (December 23, 1977): 1, 21; Paul Goldberger, "The Commodore Being Born Again," *New York Times* (January 11, 1978), C: 20; "Tax Abatement Applied," *Progressive Architecture* 59 (March 1978): 50; James P. Sterba, "Koch Breaks Vow and Cuts 'Big Ribbons,'" *New York Times* (June 29, 1978), B: 8; Alan S. Oser, "Law to Change on Conversion of Buildings," *New York Times* (June 30, 1978): 17; Joseph P. Fried, "Goodbye, Slum Razing; Hello, Grand Hyatt," *New York Times* (July 15, 1979), IV: 6; Alan S. Oser, "Grand Hyatt," *New York Times* (May 14, 1980), IV: 17; "$1.5 Million Restoring of Grand Central Near," *New York Times* (July 25, 1980): 13; Paul Goldberger, "Three Ways to Get a Sense of Extraordinary New York," *New York Times* (August 8, 1980), C: 9; Carter B. Horsley, "Lexington Ave. Builds New Image," *New York Times* (August 20, 1980), D: 18; Suzanne Slesin, "Four New York Luxury Hotels in the City: Elaborate Decor and Matching Prices," *New York Times* (August 24, 1980), VIII: 1, 10; Howard Blum, "Trump: Development of a Manhattan Developer," *New York Times* (August 26, 1980), B: 1; Paul Goldberger, "42d Street Is About to Add Something New and Pleasant: The Grand Hyatt," *New York Times* (September 22, 1980), B: 1, 9; Ada Louise Huxtable, "Two Triumphant New Hotels for New York," *New York Times* (October 19, 1980), II: 33, 36; David Morton, "Rating Reuse," *Progressive Architecture* 61 (November 1980): 87; Peter Samton, "Rating the Grand Hyatt," letter to the editor, *Progressive Architecture* 62 (February 1981): 12; Edie Lee Cohen, "The Grand Hyatt," *Interior Design* 52 (February 1981): 194–205; David Lowe, "A Look at the Two Hotels," *Interior Design* 52 (February 1981): 218–21; Richard F. Shepard, "Big Sound," *New York Times* (February 11, 1981), C: 22; "The Grand Hyatt Hotel," *Space Design* (October 1983): 81; William E. Geist, "The Expanding Empire of Donald Trump," *New York Times* (April 8, 1984), VI: 28; Ada Louise Huxtable, "Donald Trump's Tower," *New York Times* (May 6, 1984), VI: 134;

Lawrence J. Tell, "Holding All the Cards–How Donald Trump Cuts Such Wonderful Deals," *Barron's National Business and Financial Weekly* 64 (August 6, 1984): 6; Donald J. Trump with Tony Schwartz, *Trump: The Art of the Deal* (New York: Random House, 1987), 81–97; Robert P. Metzger, *Der Scutt Retrospective* (Reading, Penn.: Reading Public Museum, 1996), 44–45; Charles V. Bagli, "Trump Sells Hyatt Share to Pritzkers," *New York Times* (October 8, 1996), D: 4; White and Willensky, *AIA Guide* (2000), 276. For Grand Central Terminal, Terminal City, and the Commodore Hotel, see Stern, Gilmartin, and Massengale, *New York 1900*, 34–41, 272.

2. "Revitalizing the City": 40.

3. For Fred Trump's Trump Village in Brooklyn, see Stern, Mellins, and Fishman, *New York 1960*, 934–36.

4. Quoted in Klemesrud, "Donald Trump, Real Estate Promoter, Builds Image as He Buys Buildings": 41. For William Zeckendorf, see William Zeckendorf with Edward McCreary, *The Autobiography of William Zeckendorf* (New York: Holt, Rinehart and Winston, 1970).

5. Trump with Schwartz, *Trump: The Art of the Deal*, 86.

6. Goldberger, "The Commodore Being Born Again": 20. For the Chrysler, Chanin, and Bowery Savings Bank buildings, see Stern, Gilmartin, and Mellins, *New York 1930*, 175–81, 592–93, 597–99, 604–10. For the Socony-Mobil Building, see Stern, Mellins, and Fishman, *New York 1960*, 452–56.

7. Goldberger, "42d Street Is About to Add Something New and Pleasant: The Grand Hyatt": 1, 9. For the New York Hilton and Americana Hotel (Sheraton Centre), see Stern, Mellins, and Fishman, *New York 1960*, 403–5, 436–38. For the Waldorf-Astoria, see Stern, Gilmartin, and Mellins, *New York 1930*, 222–25. For Portman's Regency Hyatt, see Paolo Riani, *John Portman* (Washington, D.C.: American Institute of Architects Press, 1990), 62–77.

8. Huxtable, "Two Triumphant New Hotels for New York": 33, 36.

9. "Bank of America May Buy or Lease Hotel in New York," *Wall Street Journal* (July 29, 1981): 15; "Biltmore Is Expected to Be Reconstructed into Office Building," *New York Times* (July 29, 1981), B: 3; "Bank of America Gets Lease, Option to Buy Hotel in Manhattan," *Wall Street Journal* (July 30, 1981): 12; Carter B. Horsley, "Hotel Weighed as 'Landmark,'" *New York Times* (August 16, 1981): 42; David W. Dunlap, "Biltmore Closes, Surprising Guests," *New York Times* (August 16, 1981): 1, 42; "Demolition Crew Visits Biltmore Ahead of Time," *Wall Street Journal* (August 17, 1981): 6; David W. Dunlap, "Biltmore Dismantling Stopped Again," *New York Times* (August 17, 1981), B: 1, 7; David W. Dunlap, "Bid to Preserve What Is Left of Biltmore Is Set Back," *New York Times* (August 18, 1981): 1, B: 3; David W. Dunlap, "Restraining Orders to Block Biltmore Demolition Expire," *New York Times* (August 19, 1981), B: 1; "Another Undesignated Landmark Bites the Dust," *Architectural Record* 169 (September 1981): 33; William G. Blair, "Accord Is Reached on Restoring Palm Court of the Biltmore Hotel," *New York Times* (September 10, 1981), B: 1–2; "Board Refuses to List Biltmore as a Landmark," *New York Times* (September 20, 1981): 57; David A. Morton, "Time Ran Out at the Biltmore," *Progressive Architecture* 62 (October 1981): 28; "Work on Biltmore Awaits Safety Plan," *New York Times* (April 28, 1982), B: 3; Frank Emblen, "Clock Passes Time," *New York Times* (August 22, 1982): 41; David W. Dunlap, "Pact to Save Palm Court Violated, Group Asserts," *New York Times* (August 26, 1982), B: 6; James B. Gardner, "Structural and Design Ingenuity Aids Historic Hotel Transformation," *Architectural Record* 171 (January 1983): 128–33; Martin Gottlieb, "Developer Won't Re-create Part of Biltmore Palm Court," *New York Times* (September 30, 1983), B: 1, 9; Paul Goldberger, "Mediocre Skyscrapers Dominate the Skyline," *New York Times* (February 19, 1984), II: 31–32; "Heel Trap," *New York Times* (February 28, 1984): 22; Anthony DePalma, "Biltmore, Now Office Building, to Get Its Clock Back," *New York Times* (April 4, 1984), B: 10; David W. Dunlap, "It's Possible to Meet Again Under the Biltmore Clock," *New York Times* (May 16, 1984): 1; Gary Klott, "New Bank of America Center in City," *New York Times* (May 16, 1984), D: 4; Paul Goldberger, "The Sidewalks of New York–Indoors," *New York Times* (March 24, 1985), X: 21; Avery Corman, "Beneath the Biltmore Clock," *New York Times* (April 28, 1985), VI: 33. For the Biltmore Hotel, see Stern, Gilmartin, and Massengale, *New York 1900*, 270–72.

10. Dena Kleiman, "It's All Over for the Biltmore Bar," *New York Times* (July 1, 1977), D: 11.

11. Nancy Winter, "35 Great New York Hotels," *New York* 11 (July 3, 1978): 41; Frank J. Prial, "Biltmore Closes Café Fanny, Men's Bar Successor," *New York Times* (April 15, 1979): 38.

12. Quoted in Blair, "Accord Is Reached on Restoring Palm Court of the Biltmore Hotel": 2.

13. Norman Pfeiffer, quoted in Dunlap, "Pact to Save Palm Court Violated, Group Asserts": 6.

14. Goldberger, "Mediocre Skyscrapers Dominate the Skyline": 32.

15. Goldberger, "The Sidewalks of New York–Indoors": 21.

16. "Philip Morris Says Airlines Terminal Building on E. 42nd Will Be Replaced by Office Tower," *New York Times* (August 2, 1978), B: 9; Eleni Constantine, "Airlines Terminal Demolished," *Progressive Architecture* 59 (November 1978): 24; Paul Goldberger, "Philip Morris Plans Tower at 42d Street," *New York Times* (December 14, 1978), B: 1, 16; "Philip Morris Plan Wins New Approval," *New York Times* (December 16, 1978): 27; "3 Proposed Midtown Towers to Get Nearly $30 Million Abatements," *New York Times* (December 20, 1978), B: 2; "In Manhattan, Franzen Designs a Tower for Park and 42nd," *Architectural Record* 165 (February 1979): 41; Eleni Constantine, "Philip Morris Tower Design," *Progressive Architecture* 60 (February 1979): 24, 27; Suzanne Stephens, "Corporate Given-Givers," *Progressive Architecture* 60 (July 1979): 55–59; Robert E. Tomasson, "Quarries Cutting More Granite for Skyline," *New York Times* (September 15, 1979): 22; "NYC High Rise Adds a Festive Museum to Grand Central Station Area," *Architectural Record* 167 (April 1980): 130–32; Michael Sorkin, "Shaft," *Village Voice* (June 25, 1980): 73; "Philip Morris World Headquarters," *Architecture + Urbanism* (August 1981): 71–74; Paul Goldberger, "The Building Boom Gives Birth," *New York Times* (August 30, 1981): 29, 34; Paul Goldberger, *The Skyscraper* (New York: Alfred A. Knopf, 1982), 154–55; Paul Goldberger, "This Will Be the Year of the Skyscraper," *New York Times* (September 12, 1982): 33, 39; Michael Brenson, "A Whitney for Midtown," *New York Times* (December 3, 1982), C: 22; David L. Shirey, "There's Poetry in the Newest Office Portals," *New York Times* (December 5, 1982), VIII: 1, 14; Michael Brenson, "Whitney at Philip Morris Set to Open," *New York Times* (April 4, 1983), C: 11; Michael Brenson, "DiSuvero out of Whitney," *New York Times* (April 6, 1983), C: 14; Paul Goldberger, "Philip Morris Building Plus Whitney Branch Combine Office Space and Art," *New York Times* (April 7, 1983), C: 17; John Russell, "Art: A Sculpture Court of Midtown," *New York Times* (April 7, 1983): C: 17; Judy Klemesrud, "Celebrating a New Branch of the Whitney," *New York Times* (April 8, 1983), B: 4; Paul Goldberger, "New Skyscrapers and Unfulfilled Promises," *New York Times* (April 10, 1983), II: 31, 33; Henry Hope Reed, "A Medallion's Creators," letter to the editor, *New York Times* (April 30, 1983): 22; Paul Goldberger, "Those New Buildings: Promise vs. the Reality," *New York Times* (June 9, 1983), C: 18; "Philip Morris Incorporated New Headquarters Building," *Architecture + Urbanism* 169 (October 1984): 91–97; Martin Filler, "High Rise, part II," *Art in America* 72 (October 1984): 168–77; Hope Cooke, "Touring the City on Foot, In Depth," *New York Times* (March 24, 1985), X: 20; Grace Glueck, "Are the Whitney's Satellite Museums on the Right Course?" *New York Times* (June 9, 1985), II: 31, 34; Peter Blake, *The Architecture of Ulrich Franzen* (Basel, Berlin, and Boston: Birkhäuser, 1999), 151–52, 176–81; White and Willensky, *AIA Guide* (2000), 274. For the Airlines Terminal Building, see Stern, Gilmartin, and Mellins, *New York 1930*, 704–5.

17. Goldberger, "Philip Morris Building Plus Whitney Branch Combine Office Space and Art": 17.

18. Goldberger, "New Skyscrapers and Unfulfilled Promises": 31.

19. Carter B. Horsley, "From Brick to Glass in Grand Central Area," *New York Times* (March 11, 1979), VIII: 1, 6; Ada Louise Huxtable, "A Radical Change on the City's Skyline," *New York Times* (July 22, 1979), II: 27, 29; "101 Park Avenue, New York City," *Architectural Record* 167 (June 1980): 41; "Office Tower, New York, N.Y.," *Progressive Architecture* 61 (June 1980): 48, 52; Sorkin, "Shaft": 73; Alan S. Oser, "A Tower Is Born on Park Ave.," *New York Times* (September 17, 1980), D: 21; Janet Nairn, "Seven Architects Convene at the Museum of Modern Art to Discuss 'Super-Building,'" *Architectural Record* 169 (April 1981): 35; Paul Goldberger, "The New American Skyscraper," *New York Times* (November 8, 1981), VI: 68–73, 76, 78, 86, 88, 90, 92, 94, 96; Goldberger, *The Skyscraper*, 142–43; Daniel C. Brown, "Park Avenue's Multi-faceted Jewel," *Building Design & Construction* 24 (March 1983): 146–49; Ada Louise Huxtable, *The Tall Building Artistically Reconsidered* (New York: Pantheon Books, 1984), 59; Paul Goldberger, "New Skyscrapers: 101 Park Avenue," *Baumeister* 81 (February 1984): 34–35; "101 Park Avenue, New York, 1982," *Architecture + Urbanism*, extra edition (April 1988): 208; Jerold S. Kayden, *Privately Owned Public Space: The New York Experience* (New York: John Wiley, 2000), 129; White and Willensky, *AIA Guide* (2000), 243. For 101 Park Avenue, see Christopher Gray, "Streetscapes/Readers' Questions," *New York Times* (March 7, 1994): 7. For 109–111 East Fortieth Street, see Mardges Bacon, *Ernest Flagg: Beaux-Arts Architect and Urban Reformer* (New York: Architectural History Foundation; Cambridge, Mass.: MIT Press, 1986), 147–51.

20. Huxtable, "A Radical Change on the City's Skyline": 27, 29.

21. Goldberger, "The New American Skyscraper": 92, 94.

22. Goldberger, "New Skyscrapers and Unfulfilled Promises": 33.

23. Carter B. Horsley, "$90 Million Renovation at Lexington and 46th," *New York Times* (April 20, 1979), B: 1, 14; "New York Holds Up $90 Million Project," *New York Times* (May 31, 1979): 1, B: 8; "Agency Supports Tax Cuts to Aid Midtown Plans," *New York Times* (August 15, 1979), B: 1; Carter B. Horsley, "Tax Lures for Builders Facing Cuts This Month," *New York Times* (September 2, 1979), VIII: 1–2; Carter B. Horsley, "An Atrium for Public in Midtown," *New York Times* (August 19, 1981), D: 16; Shirey, "There's Poetry in the Newest Office Portals": 1, 14; Goldberger, "The Sidewalks of New York–Indoors": 21; Andrea Israel, "Sampling the Atriums," *New York Times* (March 24, 1985), X: 20, 39; Dan Graham and Robin Hurst, "Corporate Arcadias," *Artforum* 26 (December 1987): 68–74; Dan Graham and Robin Hurst, "Odysseys in Space," *Building Design* (October 21, 1988): 38–43; Anthony Bianco, *The Reichmanns: Family, Faith, Fortune and the Empire of Olympia & York* (New York: Random House, 1997), 390–94; White and Willensky, *AIA Guide* (2000), 246. Also see Carter B. Horsley, "Park Avenue Atrium," www.thecityreview.com.

24. Graham and Hurst, "Corporate Arcadias": 71.

25. George W. Goodman, "Replacing Grand Central Post Office," *New York Times* (September 16, 1984), VIII: 6. For the Grand Central Post Office, see Stern, Gilmartin, and Massengale, *New York 1900*, 40.

26. Hugh Hardy, quoted in Goodman, "Replacing Grand Central Post Office": 6. Also see *Hardy Holzman Pfeiffer: Buildings and Projects, 1967–1992* (New York: Rizzoli International Publications, 1992), 259.

27. "New Building Set for Postal Site," *New York Times* (April 9, 1986), B: 4; "Developers Selected for Post Office Plan," *New York Times* (March 31, 1987), B: 5; Christopher Gray, "Streetscapes: Grand Central Post Office," *New York Times* (May 31, 1987), VIII: 14; "Davis Polk's Next Legal Residence?" *New York* 21 (December 12, 1988): 14; David W. Dunlap, "Up from the Depths: A Neo-Neo-Classical Tower," *New York Times* (November 25, 1990), X: 14; Patric Dolan, "450 Lexington: Midtown Manhattan's Masterpiece," *Real Estate Forum* 46 (January 1991): 30–36; Rachelle Garbarine, "Not Bargain, but Building Is Renting," *New York Times* (December 2, 1992), D: 19; Paul Goldberger, "David Childs," *Architecture + Urbanism*, special edition (September 1993): 18–20, 94–97.

28. Quoted in Paul Goldberger, "Future of the Chrysler Building Is Looking Up," *New York Times* (March 12, 1978): 61. For the Chrysler Building, see Stern, Gilmartin, and Mellins, *New York 1930*, 603–10.

29. Edward I. Koch, quoted in Paul Goldberger, "Owners of the Chrysler Building to Spend $23 Million to Renovate It," *New York Times* (March 24, 1978), B: 3. Also see Goldberger, "Future of the Chrysler Building Is Looking Up": 61; "Total Restoration Planned for Chrysler Building," *Architectural Record* 163 (May 1978): 37; "Landmark Tag Fought by Chrysler Building," *New York Times* (July 12, 1978), B: 3; Martin Filler, "Learning to Love a Landmark," *Progressive Architecture* 59 (November 1978): 78–80; Paul Goldberger, "Chrysler Lobby Focus of Dispute," *New York Times* (November 14, 1978), C: 9; Kevin Lee Sarring, "Adding Deco to Deco," letter to the editor, *Progressive Architecture* 60 (February 1979): 8, 12; Alan S. Oser, "Chrysler Building's Rescue," *New York Times* (January 9, 1980), D: 19; Paul Goldberger, "The Chrysler Building at 50: A City's Enduring Symbol," *New York Times* (August 18, 1980), B: 1, 8; Shirey, "There's Poetry in the Newest Office Portals": 1, 14.

30. Edward J. Kulik, quoted in Goldberger, "Owners of the Chrysler Building to Spend $23 Million to Renovate It": 3.

31. Quoted in Filler, "Learning to Love a Landmark": 79.

32. Landmarks Preservation Commission of the City of New York, LP-0992 (September 12, 1978); Barbaralee Diamonstein, *The Landmarks of New York III* (New York: Harry N. Abrams, 1998), 360.

33. Goldberger, "Chrysler Lobby Focus of Dispute": 9.

34. Michael Kernan, "The Night Light: Lighting Up the N.Y. Night," *Washington Post* (September 17, 1981), C: 1; David Morton, "The Lives of Landmarks," *Progressive Architecture* 62 (November 1981): 81; Paul Goldberger, "Separating Concrete from Abstract," *New York Times* (November 5, 1981), C: 22; "Crowns of Light Grace the Skyline," *New York Times* (November 26, 1981), B: 1; "Decorative Lighting Restores Grandeur of Skyscraper Tower," *Electrical Construction and Maintenance* 81 (November 1982): 58–60; Karen Bouchard and Dietrich Neumann, "Chrysler Building, New York, New York: 1981," in Dietrich Neumann, *Architecture of the Night: The Illuminated Building* (Munich: Prestel, 2002), 202–3.

35. Goldberger, "Separating Concrete from Abstract": 22.

36. Christopher Gray, "Streetscapes/The Chrysler Building," *New York Times* (December 17, 1995), IX: 5; "Van Alen's Renown," *Architecture* 85 (February 1996): 30–31; Devin Leonard, "A Cursed Landmark? Tenants Are Leaving Chrysler Building," *New York Observer* (December 23-December 30, 1996): 1, 37; "A Shining Example of Preservation," *AIA Architect* 5 (July 1998): 7.

37. David M. Halbfinger, "Investor Seeks Bidding Edge for Landmark on 42nd St.," *New York Times* (June 17, 1996), B: 6; Kirk Johnson, "Once Again, a Landmark Faces a Suit to Foreclose," *New York Times* (May 10, 1997): 22; "Bids on Chrysler Building," *New York Times* (May 23, 1997), B: 6; Devin Leonard, "Who Will Purchase Jack Kent Cooke's Chrysler Building?" *New York Observer* (May 26, 1997): 1, 28; Tracie Rozhon, "A Scalloped Dream, a Hotelier's Fantasy," *New York Times* (July 24, 1997), C: 1, 6; Devin Leonard, "Chrysler Finalists Zuckerman and Roth Duel for Landmark," *New York Observer* (September 15, 1997): 1, 14; Charles V. Bagli, "Chrysler Building Lures 20 Bidders with Romance and Profit Potential," *New York Times* (September 18, 1997), B: 1, 10; Charles V. Bagli, "Finalists in Bidding for Chrysler Building," *New York Times* (October 1, 1997), B: 6; Charles V. Bagli, "A New Owner to Take Over an Old Classic," *New York Times* (November 25, 1997), B: 1.

38. For Chrysler Building East, see Stern, Mellins, and Fishman, *New York 1960*, 424, 452–53.

39. David W. Dunlap, "Chrome Spire by Chrysler to Meet Crystal by Johnson," *New York Times* (June 28, 1998): 21, 27; Ian Lebon, "A New Life," *Metropolis* 18 (August/September 1998): 34; David W. Dunlap, "110-by-76-Foot Work on Ceiling Was Installed in 1930; Chrysler Building Mural Awakens," *New York Times* (March 21, 1999), XI: 1; "Drilling Around the Dentist," *New York* 32 (March 22, 1999): 7; Peter Slatin, "There Goes the Neighborhood–With Luck!" *Grid* 1 (Spring 1999): 86–88, 90, 92; David S. Chartock, "Building Transformation Creates Chrysler Center," *New York Construction News* 47 (April 1999): 31–33; David S. Chartock, "Unusual 'Work Week' Facilitates Occupied Building's Expansion," *New York Construction News* 47 (April 1999): 37–40; Ada Louise Huxtable, "On Design: Manhattan's Landmark Buildings Today," *Wall Street Journal* (May 6, 1999): 24; John Holusha, "The Making of the Chrysler Center," *New York Times* (May 30, 1999), XI: 9; Cheryl C. Effron, "Trophy Towers," *Architecture* 88 (November 1999): 140–42; White and Willensky, *AIA Guide* (2000), 276; "'A Monument for 42nd Street,'" *New York Times* (May 9, 2001): 1; David W. Dunlap, "Philip Johnson's Latest Creation Is Now Stopping Traffic," *New York Times* (May 9, 2001), B: 7; Joseph Giovannini, "Working the Angles," *New York* 34 (August 6, 2001): 58–59; Stephen Fox, *The Architecture of Philip Johnson* (Boston: Bulfinch Press, 2002), 312–13; Ian Luna, ed., *New New York: Architecture of a City* (New York: Rizzoli International Publications, 2003), 194–95.

40. Lewis Mumford, "The Sky Line: Preview of the Past," *New Yorker* 28 (October 11, 1952): 66, 69.

41. Philip Johnson, quoted in Dunlap, "Chrome Spire by

Chrysler to Meet Crystal by Johnson": 27.

42. Carter Wiseman, *I. M. Pei: A Profile in American Architecture* (New York: Harry N. Abrams, 1990), 229–61.

43. "Tower with Flare," *New York Times* (June 24, 1984), X: 1; Paul M. Sachner, "Redefining the Manhattan Skyline: Three New Projects by Murphy/Jahn," *Architectural Record* 173 (January 1985): 57; Alan S. Oser, "City's Demolition Moratorium Chills Development," *New York Times* (February 24, 1985), VIII: 7; Paul Goldberger, "Harmonizing Old and New Buildings," *New York Times* (May 2, 1985), C: 23; Nory Miller, *Helmut Jahn* (New York: Rizzoli International Publications, 1986), 211–15; "Rising Tower on Lexington Avenue to Be a Standout," *Building Stone Magazine* (March-April 1986): 8–9; Cheryl Kent, "Rise to the Top," *Metropolis* 5 (March 1986): 22–25, 32–33; "425 Lexington Avenue," *Architecture + Urbanism*, special edition (June 1986): 232; Shawn G. Kennedy, "Grand Central Area Gains," *New York Times* (September 10, 1986), D: 28; Ante Glibota, *Helmut Jahn: Modern Romantic* (Paris: Paris Art Center, 1987), 442–47; Ellen Posner, "Helmut Jahn Takes on the Big Apple," *Wall Street Journal* (May 17, 1988): 36; Mark McCain, "Commercial Property: The Grand Central Area," *New York Times* (October 30, 1988), X: 37; Carter B. Horsley, "Heere's Jahn-Y!" *New York Post* (November 10, 1988): 84; Heinrich Klotz, ed., *New York Architecture, 1970–1990* (Munich: Prestel-Verlag, 1989), 162–63; "425 Lexington Avenue," *Architecture + Urbanism*, special edition (September 1992): 76; Ross Miller, "Architecture in Search of a New Urban Type," *Architecture + Urbanism*, special edition (September 1992): 4–6; *Murphy/Jahn: Selected and Current Works* (Mulgrave, Australia: Images Publishing, 1995), 90–91; Eric P. Nash, *Manhattan Skyscrapers* (New York: Princeton Architectural Press, 1999), 153–54; White and Willensky, *AIA Guide* (2000), 276.

44. Helmut Jahn, quoted in Sachner, "Redefining the Manhattan Skyline: Three New Projects by Murphy/Jahn": 57. For Loos's Chicago Tribune competition entry, see *The International Competition for a New Administration Building for the Chicago Tribune* (Chicago, 1923), plate 196; Robert Bruegmann, "When Worlds Collided: European and American Entries to the Chicago Tribune Competition of 1922," in John Zukowsky, ed., *Chicago Architecture, 1872–1922: Birth of a Metropolis* (Munich: Prestel-Verlag; Chicago: The Art Institute of Chicago, 1987), 302–17.

45. Posner, "Helmut Jahn Takes on the Big Apple": 36.

46. White and Willensky, *AIA Guide* (2000), 276.

47. Carter B. Horsley, "Air Rights Bought at Grand Central," *New York Times* (November 26, 1983): 1; Darl Rastorfer, "William J. LeMessurier's Super-Tall Structures: Architecture /Engineering," *Architectural Record* 173 (February 1985): 150–51, 156–57; "KPF Classical, Controversial," *Progressive Architecture* 66 (July 1985): 73; "Projects: 383 Madison Avenue," *Architecture + Urbanism* (December 1985): 14–15; Paul Goldberger, "Architecture That Pays Off Handsomely," *New York Times* (March 16, 1986), VI: 48–54, 74, 78; Martin Gottlieb, "Plan Filed for Tower and Depot's Air Rights," *New York Times* (September 17, 1986): 48; "383 Madison Is the Wrong Address," editorial, *New York Times* (September 22, 1986): 20; Richard Lanier, "New York Could Gain a Beautiful Skyscraper," letter to the editor, *New York Times* (October 2, 1986): 22; Martin Gottlieb, "Zoning Fight Again Imperils Grand Central," *New York Times* (October 14, 1986), B: 1, 8; Sonia R. Chao and Trevor D. Abramson, eds., *Kohn Pedersen Fox: Buildings and Projects, 1976–1986* (New York: Rizzoli International Publications, 1987), 196–201; Grace Anderson, "Five by KPF," *Architectural Record* 175 (February 1987): 126–27; "383 Madison Avenue," *Architecture + Urbanism* (April 1988): 30–33; "383 Madison Avenue Scheme III," *Architecture + Urbanism* (April 1988): 34–37; Alan S. Oser, "Air Rights in Search of a Place to Alight," *New York Times* (June 12, 1988), X: 9; Lou Chapman, "Why Developers Spend Millions for Thin Air," *New York Observer* (December 26, 1988–January 2, 1989): 1, 8; Lou Chapman, "City Loses a Round in Air Rights Case on East Side," *New York Observer* (January 30, 1989): 9; Joan Lebow, "Plan by First Boston to Develop Property in New York Undergoes Public Review," *Wall Street Journal* (April 17, 1989): 1; Carter B. Horsley, "Air War," *New York Post* (April 20, 1989): 39, 48; Carter B. Horsley, "Trump's Tennis Court Oath," *New York Post* (April 27, 1989): 43, 45; David W. Dunlap, "A Battle Looms Over Grand Central's Air Space," *New York Times* (July 6, 1989), B: 3; Alison Carper, "Request to Move Air Rights over Grand Central Rejected," *Newsday* (August 24, 1989): 18; "Hot Air Rights," editorial, *Newsday* (August 25, 1989): 76; Steven D. Kowaloff, "Grand Central Zoning Game," *New York Law Journal* (September 20, 1989): 33; David W. Dunlap, "Plan to Ease the Transfer of Air Rights," *New York Times* (November 15, 1989), D: 22; David W. Dunlap, "A New Look at a 1910 Proposal for Using Air Rights," *New York Times* (September 23, 1990), X: 15; David W. Dunlap, "Plan to Use Grand Central Air Rights for Tower Is Rejected," *New York Times* (August 8, 1991), B: 3; David W. Dunlap, "Adding to the Area Where Air Rights Can Be Used," *New York Times* (December 8, 1991), X: 11; Claudia H. Deutsch, "Commercial Realty in New York Shows Signs of a Strong Recovery," *New York Times* (March 7, 1994): 1, B: 2; "Corrections," *New York Times* (March 11, 1994): 2; Claudia H. Deutsch, "New Office Tower for Midtown?" *New York Times* (April 17, 1994), X: 15; George Rush and Joanna Molloy, "Whitney's Prerogative; Back with Brown at 'Exhale' Preem," *New York Daily News* (December 21, 1995): 14; Peter Grant, "Dueling Developers Dispute over Getting Control of 383 Madison," *Newsday* (January 24, 1996): 45; Charles V. Bagli, "Four Saudi Brothers Burn Bear Stearns on Madison Avenue," *New York Observer* (February 26, 1996): 1, 16; Charles V. Bagli, "The Haunted Skyscraper of Midtown: A Saudi Investor Sues First Boston," *New York Observer* (March 25, 1996): 1, 19; Peter Slatin, "The Chase Is on for New HQ

Site," *New York Post* (October 11, 1996): 28; Charles V. Bagli, "The Collapse of a Master Builder," *New York Times* (December 14, 1997), III: 1. For 383 Madison, see Stern, Gilmartin, and Mellins, *New York 1930*, 526–27; Stern, Mellins, and Fishman, *New York 1960*, 416–17, 563–65.

48. "Bear Stearns to Buy Site from CS First Boston Inc.," *Wall Street Journal* (January 24, 1996), C: 21; Brett Pulley, "Bear, Stearns Signs Deal for Valuable Midtown Site," *New York Times* (January 25, 1996), D: 2; Charles V. Bagli, "Bear Stearns Takes Whole City Block from Jittery Brit," *New York Observer* (January 29, 1996): 1, 17; Peter Grant, "Mets Big Strikes Out on Madison Avenue," *New York Daily News* (February 17, 1996): 8; Claudia H. Deutsch, "New Bid May Undo Deal for Manhattan Site," *New York Times* (February 17, 1996): 47; "Short Cuts," *Newsday* (August 27, 1997): 52; Charles V. Bagli, "Pledge to Stay in City Wins Bear Stearns a Tax Break," *New York Times* (August 28, 1997), B: 6; Robert Polner, "Leichter Slams Giuliani on Corporate Tax Breaks," *Newsday* (August 29, 1997): 33; David W. Dunlap, "A Mosaic Jazz Age Memory," *New York Times* (June 7, 1998), XI: 1; Leon Lazaroff, "Bad News, Bear: Locals Bash HQ Plan," *New York Observer* (October 26, 1998): 11; "Mechanical Space Is Culprit at 383 Madison Avenue," *Municipal Art Society Newsletter* (January/February 1999): 1, 3; Paul Goldberger, "Accidental Piazza," *New Yorker* 74 (February 15, 1999): 58–59; *Skidmore, Owings & Merrill: Architecture and Urbanism, 1995–2000* (Mulgrave, Australia: Images Publishing, 2000), 252; Edwin McDonnell, "Around Grand Central, New Office Tower and a 54-Story Residence," *New York Times* (February 13, 2000), XI: 1, 6; "Office Tower Planned," *New York Times* (July 25, 2000), B: 7; Marc Hochstein, "Bear's Bear Stands Tall," *Grid* 3 (January-February 2001): 68–72; James Verini, "Battleship B.S.," *New York Observer* (August 27, 2001): 25, 27; Rosalie R. Radomsky, "At Bear Stearn's New Headquarters," *New York Times* (September 2, 2001), XI: 1; "Steel Solutions for Bear Stearns Headquarters," *Metals in Construction* (Fall 2001): 5; Robert Sales, "Bear Stearns Marches On with Trading Floor Relocation," *Wall Street & Technology* 19 (November 2001): 20, 22; Jeffrey Smilow, "Metamorphosis," *Civil Engineering* 72 (March 2002): 70–75; Joseph Giovannini, "Bearish on Madison Ave.," *New York* 35 (March 25, 2002): 137–38; "Bear Stearns World Headquarters," *New York Construction News* 49 (June 2002): 15.

49. Giovannini, "Bearish on Madison Ave.": 137–38.

50. "Project Honor Award: Skidmore, Owings & Merrill, 350 Madison Avenue," *Oculus* 61 (January 1999): 38; "Skidmore, Owings & Merrill, 350 Madison Avenue," *Architecture* 88 (April 1999): 114–15; "There Goes the Neighborhood–With Luck!": 86–88, 90, 92; Herbert Muschamp, "One Way to Get Taller in a City of Giants," *New York Times* (May 16, 1999), II: 31; Scott Springer, "Yes, Appropriate," letter to the editor, *New York Times* (May 30, 1999), II: 4; *Skidmore, Owings & Merrill: Architecture and Urbanism, 1995–2000*, 76–77; Herbert Muschamp, "A Pair of Crystal Gems Right for Their Setting," *New York Times* (January 14, 2001), II: 39–40; Alan Balfour, *World Cities: New York* (New York: Wiley Academy, 2001), 229; John Zukowsky and Martha Thorne, *Skyscrapers: The New Millennium* (Munich: Prestel, 2001), 42–43; *SOM Journal 1* (Ostfildern-Ruit, Germany: Hatje Cantz, 2002), 72–87; Peter Slatin, "Macklowe's Madison Avenue Remake," *Grid* 4 (January + February 2002): 38–39.

51. Roger Duffy, quoted in Slatin, "There Goes the Neighborhood–With Luck": 88.

52. For the Brill Building, see Stern, Gilmartin, and Mellins, *New York 1930*, 305. Also see Christopher Gray, "Streetscapes/The Other Brill Building," *New York Times* (October 22, 1995), IX: 7. For 310 Madison Avenue, see "Great Building Operations on 42d Street Reveal Its Future Commercial Importance," *New York Times* (March 31, 1912): 21. For 300 Madison Avenue, see "New Home for Fred F. French Co.," *New York Times* (April 4, 1920): 2.

53. Peter Slatin, "Land Barons Fight Over Midtown Site," *New York Post* (January 16, 1998): 31; Charles V. Bagli, "Man with Past Speculates on Future; Without Renters in Place, Macklowe Plans a Manhattan Office Tower," *New York Times* (March 11, 1998), B: 1; Devin Leonard, "Harry Macklowe's Back and Ready to Remake a Piece of 42nd Street," *New York Observer* (March 16, 1998): 1, 8; Alan S. Oser, "Small Office Tenants Are on the Move in Manhattan," *New York Times* (February 17, 1999): 8; Devin Leonard, "A $300 Million Dispute: Bank Sues Macklowe Over Skyscraper Plan," *New York Observer* (March 1, 1999): 1, 20; Peter Grant, "Macklowe's Midtown Tower May Not Rise," *New York Daily News* (May 6, 1999): 72.

54. Charles V. Bagli, "Bank and Developer Seek to Buy Site for 42d Street Tower," *New York Times* (September 16, 1999), B: 5; Peter Grant, "Late Crunch on Midtown Site," *New York Daily News* (December 9, 1999): 92; Charles V. Bagli, "Canadian Developer Buys Coveted East Side Corner," *New York Times* (July 2, 2000): 24; Charles V. Bagli, "Canadian Bank Closes Deal to Construct a Tower in Midtown," *New York Times* (March 13, 2001), B: 8; Edwin McDowell, "Bank to Consolidate Staff in New Tower on 42nd Street," *New York Times* (July 4, 2001), B: 6; Linda K. Monroe, "Anatomy of a Building," *Buildings* 96 (April 2002): 24–27; Eric Lipton and James Glanz, "9/11 Prompts New Caution in Design of U.S. Skyscrapers," *New York Times* (September 9, 2002): 1, 10; Steve Cuozzo, "CIBC Downgrades to Small Slice of HQ Tower," *New York Post* (January 27, 2003): 33; John Holusha, "Lessons of 9/11 Shape an Office Tower," *New York Times* (February 1, 2004), XI: 1, 4.

55. Stern, Gilmartin, and Massengale, *New York 1900*, 34–41.

56. Stern, Mellins, and Fishman, *New York 1960*, 1143.

57. "A Grand Building Belongs to All," editorial, *New York Times* (April 27, 1977): 22; Ada Louise Huxtable, "Grand Central at a Crossroads," *New York Times* (January 29, 1978), II:

25, 28; Ellen Stern, "The Little Engine That Could," *New York* 11 (April 10, 1978): 63; Warren Weaver Jr., "Justice Dept. Files Brief Backing Grand Central's Landmark Status," *New York Times* (April 14, 1978), B: 4; Wylie F. Tuttle, "To Top Grand Central," letter to the editor, *New York Times* (April 28, 1978): 26; "Grand Central Case Reaches Supreme Court," *Preservation News* 18 (May 1978): 1, 6; Ada Louise Huxtable, "A 'Landmark' Decision on Landmarks," *New York Times* (July 9, 1978), II: 21, 24; "Saving a Station: Grand Central Terminal," *Time* 112 (July 10, 1978): 26; William Hickman, "Supreme Court Validates Landmarks Law as Community Tools for Building Preservation," *Architectural Record* 164 (August 1978): 34; "Preservationists Heartened by High Court Ruling on Grand Central Terminal," *Journal of the American Institute of Architects* 167 (August 1978): 9; Carleton Knight III, "We Won: Supreme Court Rules in Favor of Grand Central Terminal," *Preservation News* 18 (August 1978): 1, 8; "Supreme Court 'Saves' Grand Central," *Progressive Architecture* 59 (August 1978): 25; Norman Caplan, "Landmark Statutes," *Progressive Architecture* 59 (November 1978): 112; Norman Caplan, "Landmark Statutes–Part II," *Progressive Architecture* 60 (January 1979): 126; "Buildings Lost, Some Saved and Important Progress in the Courts," *Journal of the American Institute of Architects* 168 (May 1979): 88; Gregory F. Gilmartin, *Shaping the City: New York and the Municipal Art Society* (New York: Clarkson Potter, 1995), 407–11.

58. *Hardy Holzman Pfeiffer Associates: Buildings and Projects, 1967–1992*, 254.

59. *Hardy Holzman Pfeiffer Associates: Buildings and Projects, 1967–1992*, 253.

60. Glenn Fowler, "12 Buildings Are Named Landmarks," *New York Times* (September 12, 1979), B: 1, 5; Landmarks Preservation Commission of the City of New York, LP-1099 (September 23, 1980).

61. Deborah Nevins, ed., *Grand Central Terminal: City Within the City* (New York: Municipal Art Society, 1982). Also see Jacqueline Kennedy Onassis, "Foreword," in Nevins, ed., *Grand Central Terminal: City Within the City*, 8–9; Hugh Hardy, "Saving Grand Central–Again," in Nevins, ed., *Grand Central Terminal: City Within the City*, 135–40; "All Aboard," *New York Times* (May 23, 1982), IX: 1; Paul Goldberger, "Man-Made Miracle on 42d Street," *New York Times* (May 23, 1982), VI: 67–68, 72, 74; Susan Woldenberg, "Terminal City in Flux," *Metropolis* 1 (June 1982): 4; Lindsay Li, "Coming and Going: A Portrait of Grand Central Terminal," *Architectural Record* 170 (July 1982): 53; Deborah Dietsch, "Grand Central: An Imaginative Presentation," *Progressive Architecture* 63 (July 1982): 25–26; Andrea Oppenheimer Dean, "'Heart of the Country's Greatest City,'" *Journal of the American Institute of Architects* 171 (October 1982): 50–55; Paul M. Sachner, "In Print: Grand Central Terminal: City Within the City," *Metropolis* 3 (July-August 1983): 28; *Hardy Holzman Pfeiffer Associates: Buildings and Projects, 1967–1992*, 254.

62. "Dining at Grand Central: Landmark Decision," *New York Times* (December 11, 1983), VIII: 1.

63. *Hardy Holzman Pfeiffer Associates: Buildings and Projects, 1967–1992*, 260.

64. Deirdre Carmody, "Grand Central Spruces Up as It Approaches 75," *New York Times* (February 13, 1986), B: 1, 20; John Belle and Maxinne R. Leighton, *Grand Central Terminal: Gateway to a Million Lives* (New York: W. W. Norton & Company, 2000), 110.

65. "Names and News," *Oculus* 47 (June 1986): 7; "Central Grandeur," *House & Garden* 159 (December 1987): 68A; Belle and Leighton, *Grand Central Terminal: Gateway to a Million Lives*, 110.

66. Quoted in Calvin Sims, "Metro-North Plans $400 Million Grand Central Renewal," *New York Times* (April 28, 1990): 27–28. Also see "End of the Line for Grand Central's Pastoral Views," *New York Times* (March 6, 1990), B: 3; Steven Saltzman, "Scene + Heard: The Metropolis Revisited," *Metropolis* 9 (April 1990): 20–21; "Grandiose Central Terminal," editorial, *New York Times* (May 9, 1990): 30; "The Malling of Grand Central," editorial, *New York Observer* (May 14, 1990): 4; "Metro-North Plans Major Renovation of Grand Central," *Architectural Record* 178 (June 1990): 21; "On the Boards," *Architecture* 79 (June 1990): 38; David Colley, "Grand Central's Restoration," *Mechanical Engineering* 112 (June 1990): 48–53; Suzanne Stephens, "Grand Central's Attractions," *Oculus* 52 (June 1990): 1; Abby Bussel, "Preservation: Grand Central Restoration," *Progressive Architecture* 71 (June 1990): 26; Jessica Stern, "Grand Central, Grand Plan," *Railway Age* 191 (June 1990): 52, 54; Paul Goldberger, "Grand Central Basks in a Burst of Morning Light," *New York Times* (June 3, 1990): 27, 32; Mary Kelly, "Making It Tick," *New York Observer* (June 25, 1990): 15; "Grand Central Terminal," *Metropolis* 9 (July-August 1990): 21; "Update: Grand Central Terminal," *Municipal Art Society Newsletter* (November 1990): unpaginated; John Hughes, "CAD Meets the Beaux Arts: Renaissance of Grand Central Station," *Architectural Record* 191 (March 1991): 56–57, 197; "Follow-Up," *Oculus* 53 (March 1991): 5; Steven Saltzman with Bret Senft, "Grand Central Terminal," *Metropolis* 11 (September 1991): 17–24; Kevin Sack, "Cuomo Outlines Fiscal Blueprint for Recovery of New York City," *New York Times* (September 24, 1991): 1, B: 4; "From the Editors," *Metropolis* 11 (November 1991): 11; "More Commuter Exits," *New York Times* (October 26, 1991): 23; Joseph Berger, "All of New York's Tumult Jammed into a Terminal," *New York Times* (December 28, 1991): 21, 23; Lisa W. Foderaro, "Suddenly, Travelers at Grand Central Miss a Funky Old Friend," *New York Times* (January 16, 1992), B: 6; Mildred F. Schmertz, "Public Servant," *Architecture* 81 (May 1992): 48–49; David W. Dunlap, "Grand Central Owner Seeks Broader Use of Air Rights," *New York Times* (May 3, 1992), X: 1, 11; Eileen Clarke, "Mercury Rising,"

New York 25 (August 31, 1992): 18; Marilyn Alva, "Grand Central's Grand Plans," *Restaurant Business* 91 (September 1, 1992): 80; Trish Hall, "Grand Central's Cinderella Room Awaits Its Prince," *New York Times* (September 23, 1992), C: 6; John Tauranac, "Keeping the Best of a Beaux-Arts Beauty," *New York Times* (September 23, 1992), C: 1; "Statue Cleaning Is an Olympian Task," *New York Times* (September 29, 1992), B: 3; "Grand Central Terminal Invites Gazing, Not Waiting," *New York Times* (March 4, 1993), B: 1; "Red Grooms for Openers," *New York Times* (March 7, 1993), X: 1; Douglas Martin, "A Step Up in the Shoeshine Business," *New York Times* (November 4, 1993), B: 1, 12; Lisa W. Foderaro, "Plan for a TV Screen in Grand Central Draws Criticism," *New York Times* (November 5, 1993), B: 3; "Grand Central Television," editorial, *New York Times* (November 10, 1993): 26; David W. Dunlap, "Deal Reached on Restoration of Grand Central Terminal," *New York Times* (December 21, 1993): 1, B: 4; "A Grand Grand Central," editorial, *New York Times* (December 26, 1993), IV: 10; "The Talk of the Town: Catching the 5:48 Under the Stars," *New Yorker* 69 (January 24, 1994): 29; Christopher Gray, "Streetscapes/In a Forgotten Corner, a Curious Office of the 20's," *New York Times* (January 9, 1994), X: 7; Matthew L. Wald, "Grand Central to Get Exits to North End," *New York Times* (February 21, 1994), B: 1, 4; Bernard Ryan Jr. "Ahead of My Time," letter to the editor, *New York Times* (March 5, 1994): 22; Susan G. Weil, "Don't Forget the Disabled in Giving Grand Central New Exits," letter to the editor, *New York Times* (March 5, 1994): 22; "Grand Central Renovation," *New York Times* (March 27, 1994), X: 1; Randy Kennedy, "By Grand Central, Our Sidewalks of Discontent," *New York Times* (August 6, 1994), XIII: 6; "Making Grand Central Grander," *New York Times* (August 21, 1994), IX: 1; David W. Dunlap, "Explaining a Vision for a Grand Central," *New York Times* (September 17, 1994): 6; David W. Dunlap, "Grand Central May Be Getting East Staircase," *New York Times* (September 29, 1994), B: 1, 7; "An Even Grander Terminal," *Progressive Architecture* 75 (November 1994): 29; Ada Louise Huxtable, "On the Right Track," *New York Times* (November 28, 1994): 17; Graham Vickers, "The New Face of Grand Central," *World Architecture* 37 (1995): 72–75; David W. Dunlap, "Grand Central Makeover Is Readied," *New York Times* (January 29, 1995), IX: 1, 8; "Restoring Grand Central Terminal in the Beaux-Arts Tradition," *New York Times* (November 26, 1995): 41; "210M Grand Central Restoration Underway," *New York Construction News* 43 (November 27, 1995): 1, 4; Stuart D. Zaro, "Grand Central Renovation Will Require Zaro's Baker to Close," letter to the editor, *New York Times* (November 30, 1995): 28; "Corrections," *New York Times* (December 6, 1995): 2; James Barron, "Cleansing 'Triumphant Portal' Ceiling," *New York Times* (February 3, 1996): 25, 28; Herbert Muschamp, "Grand Central as a Hearth in the Heart of the City," *New York Times* (February 4, 1996), II: 27; Nadine Brozan, "High Above the Commuting Crowd, a Grandson's Constant Star," *New York Times* (February 15, 1996), B: 10; "Getting Ready for a Facelift at Grand Central," *New York Times* (February 16, 1996), B: 5; David S. Chartock, "Grand Central to Undergo $175M Revitalization," *New York Construction News* 43 (March 18, 1996): 5; "New Life for Grand Central," editorial, *New York Times* (March 25, 1996): 14; "Grand Plans for Grand Central," *Civil Engineering* 66 (April 1996): 24; Patricia G. Horan, "Grand Central's Departure Board, Gone!" letter to the editor, *New York Times* (July 23, 1996): 18; Karl E. Meyer, "Signs of Bad Times," *New York Times* (July 28, 1996): 12; "Out With the New," *New York* 29 (August 5, 1996): 17; Thomas J. Lueck, "To Clean Sky, Keep It Simple," *New York Times* (September 20, 1996), B: 1–2; Peter Dunleavy, "Transportation Projects," letter to the editor, *New York Times* (September 28, 1996): 22; Tony Hiss, "Heaven's Gate," *New Yorker* 72 (December 9, 1996): 54; "Grand Central Redux," *Architectural Record* 185 (March 1997): 30; "Where Trains and Stomachs Rumble Everyday," *New York Times* (March 1, 1997): 27; Karrie Jacobs, "Lost in the Stars," *New York* 30 (March 10, 1997): 17; Scott A. Hartley, "Reaching to the Stars," *Trains* 57 (June 1997): 24–25; Neil MacFarquhar, "Rara Avis; An Iron Eagle Returning to City Roost," *New York Times* (June 20, 1997), B: 3; Robert D. MacFadden, "Fire Wrecks the Oyster Bar, Tiled Oasis at Grand Central," *New York Times* (June 30, 1997), B: 1, 3; Warren St. John, "Oyster Bar Fire Claims 3,360 Oysters; Owner Jerome Brody Will Shuck Again," *New York Observer* (July 21, 1997): 1, 21; Frederick Gabriel, "Grand Central Fails to Attract Key Restaurants," *Crain's New York Business* (September 15–21, 1997): 1, 55; Thomas J. Lueck, "With More Space to Spare, Grand Central Draws Shops," *New York Times* (September 23, 1997), B: 10; Eric Rasmussen, "The Rebirth of a Station," *Civil Engineering* 67 (October 1997): 54–57; Michael J. Ewing, "Revitalizing Grand Central Terminal," *Urban Land* 56 (October 1997): 42; Ross Shaw, "The Best Big Room," *Preservation* 49 (November-December 1997): 60–63, 66; Mimi Sheraton, "History on the Half-Shell," *Preservation* 49 (November-December 1997): 64–65; Florence Fabricant, "Grand Central Palazzo," *New York Times* (November 26, 1997), F: 9; "Twinkle, Twinkle," *New York Times* (January 18, 1998), XIV: 2; David W. Dunlap, "Grand Central Gets Northern Exposure," *New York Times* (February 25, 1998), B: 1, 6; Bart Ziegler, "Where Pigeons Roosted, a Mall Rises," *Wall Street Journal* (April 8, 1998), B: 1, 18; Elisabeth Bumiller, "For a Grand New York Stage, 119 Fine Sets," *New York Times* (May 19, 1998), B: 2; "A Temporary Touch Causes a Stir," *New York Times* (June 23, 1998), B: 1; "A Grander Grand Central," *Interior Design* 69 (July 1998): 36; David W. Dunlap, "Oyster Bar's Sign Fails Grand Central's Taste Test," *New York Times* (July 25, 1998), B: 3; David W. Dunlap, "Grand Central, Reborn as a Mall," *New York Times* (August 2, 1998): 33, 36; "A Gala for Grand Central," *Municipal Art Society Newsletter* (September/October 1998): 3; Karrie Jacobs, "A Star, Reborn," *New York* 31 (September 14, 1998): 131–32, 134;

Paul Goldberger, "Now Arriving," *New Yorker* 74 (September 28, 1998): 92–93; "Grand Central Grand Again," *City Journal* 8 (Autumn 1998): 87–93; Andy Newman, "Revamped Terminal Puttin' on the Ritz," *New York Times* (October 1, 1998), B: 6; "A Grand Entrance," *New York Times* (October 2, 1998): 1; "Grand Central, Reborn," editorial, *New York Times* (October 2, 1998): 28; Herbert Muschamp, "Restoration Liberates Grand Vistas, and Ideas," *New York Times* (October 2, 1998), B: 6; Susan Sachs, "From Gritty Depot, a Glittery Destination," *New York Times* (October 2, 1998), B: 1, 6; Kathryn Shattuck, "At Grand Central, Music by a Timetable," *New York Times* (October 2, 1998), E: 4; "Gateway. Have. Universe. Grand Central," *New York Times* (October 3, 1998): 17; Christopher Gray, "Streetscapes/Grand Central Terminal," *New York Times* (October 11, 1998), X: 7; Bruce Guthrie and Bob Meadows, "Jackie's Gift," *People* 50 (October 6, 1998): 158; Nicholas Adams, "The Rebirth of the Grand Central Terminal, New York: The Electric Modern Restored," *Casabella* 62 (November 1998): 36–47; Ian LeBon, "Tunnel Vision," *Metropolis* 18 (November 1998): 42; "That Was Just Half the Story!" *Mileposts: A Publication for MTA Metro-North Railroad Customers* (November 1998): 1–2; Bernard Stamler, "With a New Grand Central, Memories of the Old," *New York Times* (November 8, 1998), XIV: 9; "Grand Central Back in Fashion," *Crain's New York Business* (November 9, 1998): 6; Jeffrey Hart, "Simply Grand," *National Review* 50 (November 9, 1998): 66–67; "Grand Old Terminal," letters to the editor, *New York Times* (November 15, 1998), XIV: 3, 21; "Celebrating the Renewal of Grand Central Terminal," *Oculus* 61 (December 1998): 22; Herbert Muschamp, "Public Space, Private Space and Anti-Space," *New York Times* (December 27, 1998), II: 38; Clifford A. Pearson, "Project Diary: Beyer Blinder Belle's Makeover of Grand Central Terminal Involved Careful Restoration and Critical Changes," *Architectural Record* 187 (February 1999): 84–95; "Cleaning a Massive Ceiling with Masses Underfoot," *Building Design and Construction* 40 (March 1999): 36; Deborah Silver, "Grand Plan," *Building Design and Construction* 40 (March 1999): 32–36; Benjamin H. Cheever, "A Star Is Reborn," *Town and Country* 153 (April 1999): 144–47; Paula Dietz, "Delight," *Architectural Review* 205 (May 1999): 98; Trish Hall, "New York, Renewed and Restored," *New York Times* (May 16, 1999), II: 13–14; "Once Again, an Eagle Watches Grand Central," *New York Times* (October 19, 1999), B: 6; "New Art for Grand Central," *New York Times* (October 20, 1999), E: 3; Nan Siegal, "How the Other Half Lived It Up," *New York Times* (October 24, 1999): 5; Belle and Leighton, *Grand Central Terminal: Gateway to a Million Lives*; Kurt C. Schlichting, *Grand Central Terminal: Railroads, Engineering, and Architecture in New York City* (Baltimore: Johns Hopkins University Press, 2000); White and Willensky, *AIA Guide* (2000), 274; "Restoration Citation: Beyer Blinder Belle Architects and Planners," *Oculus* 62 (January 2000): 2; Joseph Giovannini, "New York State of Mind," *World Architecture* (February 2000): 48–55; Susan Jacoby, "All Starry-Eyed in Grand Central," *New York Times* (March 10, 2000), E: 45; Balfour, *World Cities: New York*, 185; Marty Kapell and Lyle Rexer, "Time Will Tell," *Metropolis* 21 (March 2002): 80–83, 101; Arthur C. Danto, Timothy Hyman, and Marco Livingstone, *Red Grooms* (New York: Rizzoli International Publications, 2004), 18–47.

67. Goldberger, "Grand Central Basks in a Burst of Morning Light": 27.

68. Pamela Bayless, "First Step in Grand Central's Grand Plan," *Crain's New York Business* (May 29, 1989): 2; Christopher Gray, "Streetscapes: The Grand Central Viaduct," *New York Times* (October 29, 1989), IX: 10; Elaine Louie, "1919 Lights Return to a Viaduct," *New York Times* (October 8, 1992), C: 3; Peter Slatin, "Al Fresco Dining Facing Grand Central?" *New York Times* (August 22, 1993), X: 5, 11; Douglas Martin, "Plan for Pershing Square Would Yield New Park," *New York Times* (November 16, 1995), B: 10; Mervyn Rothstein, "Restaurant to Fill Niche Under Park Ave. Viaduct," *New York Times* (May 14, 1997), B: 6; Milford Prewitt, "Grand Central Cafe Gears Up for Opening," *Nation's Restaurant News* 31 (August 4, 1997): 11.

69. Richard D. Lyons, "Grand Central to Be Bathed in Bright Light," *New York Times* (November 10, 1989), B: 2; "The Talk of the Town: Light the Lights," *New Yorker* 67 (April 1, 1991): 25–26; Charles Linn, "Grand Designs," *Architectural Record Lighting* 179 (August 1991): cover, 30–33; "Urban Bright," *Urban Land* 50 (September 1991): 26–27.

70. Kevin Flynn, "Decision's Effect on Loitering Law Is Still Unclear," *Newsday* (February 29, 1988): 19; Carter Wiseman, "All Aboard for Grand Central," *New York* 23 (July 16, 1990): 74–75; Jacques Steinberg, "Coaxing Grand Central's Homeless into the Light," *New York Times* (March 17, 1992), B: 1, 3; William Bunch, "Advocates Fear Homeless Sweep," *Newsday* (May 11, 1992): 18.

71. Wiseman, "All Aboard for Grand Central": 74–75.

72. Belle and Leighton, *Grand Central Terminal: Gateway to a Million Lives*, 148.

73. John Belle, quoted in Pearson, "Project Diary": 87.

74. Ed Valeri, quoted in Clarke, "Mercury Rising": 18.

75. Faye Penn, "Raising the Bar on Sophisticated Sipping," *New York Post* (March 4, 1998): 43.

76. "Dribblers Welcome at the Restaurant," *New York Times* (July 21, 1998), B: 2; William Grimes, "A Table for Very Close Friends," *New York Times* (September 9, 1998), F: 1, 6; Hal Rubinstein, "Championship Bull," *New York* 31 (September 21, 1998): 72–73; Ruth Reichl, "Michael Jordan, Grand Central's New Player," *New York Times* (September 30, 1998), F: 1, 9; *Pleasure: The Architecture and Design of Rockwell Group* (New York: Universe, 2002), 54–59, 223.

77. Reichl, "Michael Jordan, Grand Central's New Player": 1.

78. Rubinstein, "Championship Bull": 72.

79. Peter Slatin, "Ciprianis on Track for New $1M Eatery,"

New York Post (January 15, 1998): 40; Geraldine Fabrikant, "Restaurant Leases Signed at Grand Central," *New York Times* (January 16, 1998), B: 9; Florence Fabricant, "Off the Menu," *New York Times* (November 1, 2000), F: 14; Florence Fabricant, "Off the Menu," *New York Times* (February 20, 2002), F: 7.

80. "Moving Ahead in Crucial Areas," *Oculus* 60 (May 1998): 5; Florence Fabricant, "New Owners for Restaurant at Terminal," *New York Times* (November 14, 1999): 46; William Grimes, "Diner's Journal," *New York Times* (January 28, 2000), E: 2; Craig Kellogg, "Métrazur, New York City," *Architectural Record* 188 (May 2000), 254–57; Raul Barraneche, "Starlight Express," *House Beautiful* 142 (May 2000): 100.

81. Grimes, "Diner's Journal": 2.

82. "Celebrating the Renewal of Grand Central Terminal," *Oculus* 61 (December 1998): 22.

83. "Grand Central's Little Secret: It's a Destination for Cooks," *New York Times* (December 22, 1999), F: 1, 6.

84. Geraldine Fabrikant, "Restaurant Leases Signed at Grand Central," *New York Times* (January 16, 1998), B: 9; Marion Burros, "Grand Central Food: No End to Delays," *New York Times* (May 28, 1999), F: 1, 8; Paul Frumkin, "Grand Central Is Back on Track as Food Service Rolls," *Restaurant News* 33 (October 25, 1999): 1, 51, 65; *Pleasure: The Architecture and Design of Rockwell Group*, 223.

85. Hart, "Simply Grand": 67.

86. Muschamp, "Restoration Liberates Grand Vistas, and Ideas": 6.

MADISON AVENUE

1. See Stern, Mellins, and Fishman, *New York 1960*, 416–22.

2. "Notes on People," *New York Times* (June 17, 1977): 23; "AT&T," *Wall Street Journal* (June 21, 1977): 3; Kenneth Frampton, "A.T.&T. Headquarters, New York," in *Philip Johnson: Processes*, exhibition catalog (New York: Institute for Architecture and Urban Studies, 1978), 60–71, "Two Towering Votes for New York City," editorial, *New York Times* (January 28, 1978): 20; "A.T.&T.," *New York Times* (March 31, 1978): 1; Maurice Carroll, "A.T.&T. to Build New Headquarters Tower at Madison and 55th St.," *New York Times* (March 31, 1978), B: 4; Paul Goldberger, "A Major Monument of Post-Modernism," *New York Times* (March 31, 1978), B: 4; Francis Brennan, "Architecture: The Pigeons' Gain," letter to the editor, *New York Times* (April 10, 1978): 22; Ada Louise Huxtable, "Johnson's Latest–Clever Tricks or True Art?" *New York Times* (April 16, 1978), II: 26, 31; Wolf Von Eckardt, "The Defiant Architect: Philip Johnson Upsets the Modernists," *Washington Post* (April 22, 1978), C: 1; "New Headquarters," *Washington Post* (April 30, 1978), B: 3; "Philip Johnson Designs a Post-Modernist Tower for AT&T," *Architectural Record* 163 (May 1978): 34; "Philip Johnson on Philip Johnson," *Skyline* (May 1, 1978): 7–8; Paul Goldberger, "Philip Johnson: A Controversial New Vision for Architecture," *New York Times* (May 14, 1978), VI: cover, 26–27, 65–73; Peter Blake, "Philip Johnson Knows Too Much," *New York* 11 (May 15, 1978): 58–61; Paul Goldberger, "Design Notebook," *New York Times* (May 18, 1978), C: 10; John Morris Dixon, "Take It from the Top," *Progressive Architecture* 59 (June 1978): 7–8; Raymond J. Wisniewski, "Ma Bell's Cupboard," letter to the editor, *Progressive Architecture* 59 (June 1978): 12; "In Progress: AT&T Headquarters," *Progressive Architecture* 59 (June 1978): 44; Eugene J. Johnson and James Stevenson, "World's Biggest Pay Phone," letters to the editor, *New York Times* (June 25, 1978), VI: 78; "Three Designs by Johnson/Burgee," *Architectural Record* 164 (July 1978): 79–88; Mitchell R. Friedman, Kem Hinto, David P-C Chang, Daniel Beekman, Charles Colbert, and K. Charles Romanowski, "AT&T Communications," letters to the editor, *Progressive Architecture* 59 (August 1978): 8; Michael Sorkin, "Philip Johnson: The Master Builder as a Self-Made Man," *Village Voice* (October 30, 1978): 61–62, reprinted in Michael Sorkin, *Exquisite Corpse* (London: Verso, 1991), 7–14; Irving Lepselter, "Calling Up the Past," letter to the editor, *Progressive Architecture* 59 (November 1978): 8; "3 Proposed Midtown Towers to Get Nearly $30 Million in Abatements," *New York Times* (December 20, 1978), B: 2; Philip Johnson, "Re-Building," *New York Times* (December 28, 1978): 17; Ada Louise Huxtable, "'Towering' Achievements of '78," *New York Times* (December 31, 1978): 21, 24; Nory Miller, *Johnson/Burgee Architecture* (New York: Random House, 1979), 111–12; Robert Hughes, "U.S. Architects: Doing Their Own Thing," *Time* 113 (January 8, 1979): cover, 52–59; "The Modern Post-Modernists," *The Economist* (March 10, 1979): 48; Wolf Von Eckardt, "Changing Gospel of the Skyscraper," *Washington Post* (June 16, 1979), B: 1; Donald Canty, "Architecture in the Public Eye," *Journal of the American Institute of Architects* 67 (July 1978): 33; Suzanne Stephens, "Corporate Form-Givers," *Progressive Architecture* 60 (July 1979): 55–59; Ada Louise Huxtable, "A Radical Change on the City's Skyline," *New York Times* (July 22, 1979), II: 27–28; Robert E. Tomasson, "Quarries Cutting More Granite for Skyline," *New York Times* (September 15, 1979): 22; Der Scutt, "Gracing the Skyline–Not Disgracing It," *New York Times* (September 22, 1979), II: 27; Michael Sorkin, "Shaft," *Village Voice* (June 25, 1980): 73; "Behind a 'Renaissance' Tower: A Contemporary Structure That Lets It Work," *Architectural Record* 168 (October 1980): 106–11; Richard Rush, "Structure and Circumstance," *Progressive Architecture* 61 (December 1980): 50–57; Paul Goldberger, "New Madison Avenue Buildings, a New New York," *New York Times* (December 18, 1980), C: 21; "On and Up with Johnson," *The Economist* (December 27, 1980): 31; Paul Goldberger, *The Skyscraper* (New York: Alfred A. Knopf, 1981), 152–53, 157–58; Paul Goldberger, "Where Are the 'Form-Givers' of Today?" *New York Times* (March 22, 1981), II: 1, 22; Janet Nairn, "Seven Architects Convene at the Museum of Modern Art to Discuss 'Super-Building,'" *Architectural Record* 169 (April 1981): 35;

Kathleen Teltsch, "Landmark Statue Being Restored," *New York Times* (August 31, 1981), B: 3; "Philip Johnson's Post-Modernist Venture," in Lisa Appignanesi, ed., *Brand New York* (London: Namara Press, 1982), 52–53; Robert Jensen and Patricia Conway, *Ornamentalism* (New York: Clarkson N. Potter, 1982), 2; David W. Dunlap, "A Graceful Move 'Upstairs,'" *New York Times* (May 23, 1982), VIII: 6; Charlotte Curtis, "Philip Johnson's Home," *New York Times* (August 24, 1982), C: 8; Paul Goldberger, "This Will Be the Year of the Skyscraper," *New York Times* (September 12, 1982), II: 33, 39; Diane Henry, "A.T.&T. in the Role of Landlord," *New York Times* (September 29, 1982), D: 24; "AT&T Corporate Headquarters Building," *Architecture + Urbanism* (January 1983): 56–57; Diane Henry, "A.T.&T. Ends Rent Plan at Its Tax-Aided Building," *New York Times* (February 16, 1983), B: 11; Colin Amery, "New York Indulges in a Mad Chase Upwards," *Financial Times* (March 29, 1983): 17; Paul Goldberger, "New Skyscrapers and Unfulfilled Promises," *New York Times* (April 10, 1983), II: 31, 33; Carleton Knight III, "Significant Clients: Ma Bell Builds Big," *Architecture* 72 (July 1983): 60–75; Paul Goldberger, "Frank Lloyd Wright Is Clearly the Man of the Year," *New York Times* (September 11, 1983), II: 1, 40; Paul Goldberger, "A.T.&T. Bldg.: A Harbinger of a New Era," *New York Times* (September 28, 1983), B: 1, 9; "'Golden Boy,'" *New York Times* (October 21, 1983), C: 1; Paul Goldberger, "Romanticism Is the New Motif in Architecture," *New York Times* (October 23, 1983), II: 1, 35; Ada Louise Huxtable, *The Tall Building Artistically Reconsidered* (New York: Pantheon Books, 1984), 65–48, 106, 108; "AT&T Building," *Architecture + Urbanism* (January 1984): 11; Joseph Giovannini, "Philip Johnson Designs for a Pluralistic Age," *New York Times* (January 8, 1984), II: 29, 36; Susan Doubilet, "AT&T Headquarters, New York, N.Y.," *Progressive Architecture* 65 (February 1984): 70–75; Paul Goldberger, "Manhattan's New Skyscrapers Pay Homage to the 20's," *New York Times* (June 17, 1984), II: 31; Paul Goldberger, "Romantic Modernism Is Now at the Cutting Edge of Design," *New York Times* (July 8, 1984), II: 23; Reyner Banham, "AT&T: The Post Post-Deco Skyscraper," *Architectural Review* 176 (August 1984): 22–29; Martin Gottlieb, "A.T.&T. Gets Its Tax Break for a Museum," *New York Times* (August 1, 1984), B: 1; "Tax Break for A.T.&T.," *New York Times* (August 5, 1984), IV: 6; Martin Filler, "High Ruse, part 1," *Art in America* 72 (September 1984): 150–65; Monica Geran, "ISD: American Telephone & Telegraph," *Interior Design* 55 (October 1984): 278–85; "Philip Johnson & John Burgee: AT&T Corporate Headquarters, NYC," *Architectural Design* 54 (No. 11–12, 1984): 30–31; Eric Marcus, "For Whom the Bell Tolls," *Metropolis* 4 (November 1984): 16–17, 28; Carleton Knight, "Introduction," in *Philip Johnson/John Burgee: Architecture 1979–1985* (New York: Rizzoli International Publications, 1985), 7, 10, 40–50; "AT&T Headquarters," *Architecture + Urbanism* (January 1985): 19–26; Robert A.M. Stern, "Four Towers," *Architecture + Urbanism* (January 1985): 49–58; "John Burgee Architects with Philip Johnson: AT&T Headquarters, New York," *GA Document* 12 (January 1985): 26–33; Patrick Davies, "New York Classic: AT&T Headquarters, New York," *Building* 248 (January 11, 1985): 28–31; Donald Canty, "AT&T: The Tower, the Skyline, and the Street," *Architecture* 74 (February 1985): cover, 46–55; Paul Goldberger, "The Sidewalks of New York–Indoors," *New York Times* (March 24, 1985), X: 21; William Zimmer, "Bold, Brash and Controversial Buildings," *New York Times* (May 26, 1985), XI: 28; Paul Goldberger, "A Look at the Impact of 12 Buildings," *New York Times* (May 31, 1985), C: 28; Vincent Scully, "Buildings Without Souls," *New York Times* (September 8, 1985), VI: 42, 65–68, 109–11, 116; Julie Iovine, "Back to the Future," *Architectural Record* 174 (June 1986): 75, 77; Robert A. M. Stern with Raymond W. Gastil, *Modern Classicism* (New York: Rizzoli International Publications, 1988), 84–87; "American Telephone and Telegraph Building," *Architecture + Urbanism* (April 1988): 212–13; Kay Lazar, "IBM, Trump, A.T.&T., How Do Your Gardens Grow?" *New York Observer* (November 28, 1988): 1, 8; Charles Jencks, *The New Moderns* (New York: Rizzoli International Publications, 1990), 56–57; Marisa Bartolucci, "550 Madison Avenue," *Metropolis* 13 (October 1993): 27–28, 30–33; Hilary Lewis and John O'Connor, *Philip Johnson: The Architect in His Own Words* (New York: Rizzoli International Publications, 1994), 104–11; Franz Schulze, *Philip Johnson: Life and Work* (Chicago: University of Chicago Press, 1994), 344–52; "No Longer a City 'Boy,'" *New York Times* (December 31, 1995), XIII: 3; Peter Blake, *Philip Johnson* (Basel and Boston: Birkhauser Verlag, 1996), 192–95; Susanna Sirefman, *New York: A Guide to Recent Architecture* (London: Ellipsis, 1997), 172–75; Eric Nash, *Manhattan Skyscrapers* (New York: Princeton Architectural Press, 1999), 147–48; Mario Campi, *Skyscrapers: An Architectural Type of Modern Urbanism* (Basel: Birkhauser, 2000), 126–27; White and Willensky, *AIA Guide* (2000), 297; Stephen Fox, *The Architecture of Philip Johnson* (Boston: Bulfinch Press, 2002), 238–43; Hilary Lewis, "No Rules, Just Art," in Fox, *The Architecture of Philip Johnson*, 11; Heinrich Klotz, *The History of Postmodern Architecture*, trans. by Radka Donnell (Cambridge, Mass., and London: MIT Press, 2002), 45, 48–49.

3. "Two Towering Votes for New York City": 10.

4. Architect's statement, quoted in "AT&T Headquarters," *Architecture + Urbanism*: 24.

5. For the Delman Building, see Christopher Gray, "Streetscapes/William Van Alen," *New York Times* (March 22, 1998), XI: 5.

6. For the Municipal Building, see Stern, Gilmartin, and Massengale, *New York 1900*, 60, 64–67, 164–65.

7. For Bosworth's 195 Broadway, see Stern, Gilmartin, and Massengale, *New York 1900*, 60.

8. Goldberger, "A Major Monument of Post-Modernism": 4.

9. Huxtable, "Johnson's Latest–Clever Tricks or True Art?":

26, 31.

10. Johnson, "World's Biggest Pay Phone": 78.

11. Beekman, "AT&T Communications": 7.

12. Sorkin, "Philip Johnson: The Master Builder as a Self-Made Man": 62.

13. Johnson, "Re-Building": 17.

14. Huxtable, "'Towering' Achievements of '78": 21.

15. Hughes, "U.S. Architects: Doing Their Own Thing": 59.

16. Goldberger, "A.T.&T. Bldg.: A Harbinger of a New Era": 1, 9.

17. Doubilet, "AT&T Headquarters, New York, N.Y.": 70.

18. Scully, "Buildings Without Souls": 66.

19. Banham, "AT&T: The Post Post-Deco Skyscraper": 27.

20. Andrew Pollack, "Bell System Breakup Opens Era of Great Expectations and Great Concern," *New York Times* (January 1, 1984): 12; Albert Scardino, "A.T.&T. Is Vacating Much of Its Tower," *New York Times* (March 27, 1987): 1, D: 17; Bruce Lambert, "A.T.&T. Suspends Rental of Headquarters Space," *New York Times* (April 2, 1987), B: 4; Alan Stone, *Wrong Number: The Breakup of AT&T* (New York: Basic Books, 1989).

21. Richard D. Hylton, "Sony Is Reportedly Near Deal to Lease A.T.&T. Skyscraper," *New York Times* (May 23, 1991): 1, D: 9; "A.T.&T. Confirms Headquarters Shift," *New York Times* (July 9, 1991), D: 4; David W. Dunlap, "Commercial Property: The Office Market," *New York Times* (July 28, 1991), X: 1, 13; "Details," *Architecture* 80 (November 1991): 22; David W. Dunlap, "A Leaner A.T.&T. Returns to Lower Manhattan," *New York Times* (January 19, 1992): 30; David W. Dunlap, "Plan Reduces Public Areas for a Tower," *New York Times* (May 1, 1992), B: 1, 4; Paul Goldberger, "Some Welcome Fiddling with Landmarks," *New York Times* (May 24, 1992), II: 26; "Pencil Points," *Progressive Architecture* 123 (June 1992): 26; "The Usual Suspects," *Spy* (June 1992): 18; Patricia McCobb, "New Yorkers Now Risk the Loss of a Popular Oasis in Midtown," letter to the editor, *New York Times* (August 12, 1992): 18; "Sony Chips Away," editorial, *New York Observer* (August 24, 1992): 4; David W. Dunlap, "Remaking Spaces for Public Use," *New York Times* (September 27, 1992), X: 1, 6; Michael Wise, "The Deconstruction of Philip Johnson, 86," *The Independent* (London) (November 11, 1992): 17; Claudia H. Deutsch, "Sony's New Headquarters: Carving Chippendale into the Sony Image," *New York Times* (February 21, 1993), X: 1, 11; Beverly Russell, "Gwathmey Siegel at 25," *Interiors* 152 (September 1993): 55–64; Regina S. Baraban, "Freshly Prepared Penne," *Metropolis* 13 (October 1993): 11; Bartolucci, "550 Madison Avenue," 27–28, 30–33; Marvine Howe, "Sony's Plaza Plan: Peace and Quiet, Banners and TV," *New York Times* (January 30, 1994), XIII: 6; Jean Gorman, "A Stage for Sony," *Interiors* 153 (May 1994): 118–23; "Assessing Sony Plaza," *New York Times* (May 1, 1994), X: 1; "Benefits," *New York Times* (May 22, 1994), IX: 14; David W. Dunlap, "So Inviting, So . . . Sony," *New York Times* (May 24, 1994), B: 1, 3; Mark Alden Branch, "From Highboy to Boom Box," *Progressive Architecture* 75 (July 1994): 100–105, 109; Peter Slatin, "Sony 'Public' Plaza," *Oculus* 57 (September 1994): 5; Christopher Gray, "Streetscapes/Readers' Questions: An 1896 Sliver in SoHo and a Golden AT&T Statue," *New York Times* (December 4, 1994), IX: 7; Bryan Miller, "After the Quilted Giraffe, There's Sony and Cyberspace," *New York Times* (May 24, 1995), C: 3; Mildred F. Schmertz, "Public Use vs. Private Abuse," *Architecture* 84 (June 1995): 51, 53, 55, 57; "Sony Wants Plaza Sweet," *Crain's New York Business* (October 9, 1995): 6; Anthony Ramirez, "Homeless Say Public Plaza Is Harassing," *New York Times* (May 21, 1996), XIII: 8; "Adaptive Re-Use of Buildings," *Southeast Asia Building* (November 1996): 22; Sirefman, *New York*, 172–75; *Gwathmey Siegel & Associates Architects: Selected and Current Works* (Mulgrave, Australia: Images Publishing, 1998), 233; White and Willensky, *AIA Guide* (2000), 297; Shaila Dewan, "AT&T Golden Boy Stays Suburban," *New York Times* (April 20, 2000), B: 4; Brad Collins, ed., *Gwathmey Siegel: Buildings and Projects, 1992–2002* (New York: Rizzoli International Publications, 2003), 134–39, 353. For the Long Lines Building, see Landmarks Preservation Commission of the City of New York, LP-1747–1748 (October 1, 1991); Barbaralee Diamonstein, *The Landmarks of New York III* (New York: Harry N. Abrams, 1998), 418.

22. Quoted in Dunlap, "Plan Reduces Public Areas for a Tower": 1, 4.

23. Goldberger, "Some Welcome Fiddling with Landmarks": 26.

24. McCobb, "New Yorkers Now Risk the Loss of a Popular Oasis in Midtown": 18.

25. Russell, "Gwathmey Siegel at 25": 57.

26. Carter B. Horsley, "The Corporation as Landlord and Tenant," *New York Times* (July 4, 1976), VIII: 1, 3; Alan S. Oser, "An I.B.M. Skyscraper Discussed with City," *New York Times* (December 9, 1976): 51; "Tale of Two Buildings" editorial, *New York Times* (December 21, 1976): 32; "Two Towering Votes for New York City": 20; Goldberger, "Design Notebook": 10; Paul Goldberger, "Glass Box Gives Way to Slab, Shaft and Block," *New York Times* (July 12, 1978), B: 1; Carter B. Horsley, "A $75 Million, 41-Story Prism for I.B.M.," *New York Times* (July 12, 1978), B: 1, 11; "IBM Building," *Progressive Architecture* 59 (August 1978): 42; "Barnes Designs a Manhattan Tower for IBM," *Architectural Record* 163 (September 1978): 39; Scutt, "Gracing the Skyline–Not Disgracing It": 21; Sorkin, "Shaft": 73; "More on IBM's Blockbuster," *Interiors* 140 (November 1980): 76–77, 100, 102, 104, 114; Goldberger, "New Madison Avenue Building, a New New York?": 21; Goldberger, *The Skyscraper*, 146; Paula Deitz, "15,000 Granite Slabs Journey to Midtown," *New York Times* (February 8, 1981), VIII: 1, 4; Robert F. Fischer, "Granite Panels," *Architectural Record* 169 (March 1981): 130–33; Jared T. Freeman, "New York's New Public Spaces," *Urban Design International* 2 (March-April 1981): 22–27; Walter H. Waggoner, "Logistical Challenge: Getting Materials to Building Site," *New York Times* (March 22, 1981),

VIII: 8; Nairn, "Seven Architects Convene at the Museum of Modern Art to Discuss 'Super-Building'": 35; Paul Goldberger, "The Building Boom Gives Birth," *New York Times* (August 30, 1981), II: 29, 34; Paul Goldberger, "The New American Skyscraper," *New York Times Magazine* (November 8, 1981), VI: 68–73, 76, 78, 86, 88, 90, 92, 94, 96; Ada Louise Huxtable, "Changes on the Drawing Board and the Skyline," *New York Times* (December 27, 1981), II: 27, 34; Frank J. Prial, "Interview: Brendan Gill on Urban Density," *New York Times* (March 28, 1982), VIII: 7; Goldberger, "This Will Be the Year of the Skyscraper": 33, 39; David L. Shirey, "There's Poetry in the Newest Office Portals," *New York Times* (December 5, 1982), VIII: 1, 14; Michael Brenson, "New I.B.M. Gallery for Major Exhibits Will Open Next Fall," *New York Times* (February 19, 1983): 1, 11; Paul Goldberger, "Architecture: I.B.M.'s Green Granite Giant," *New York Times* (March 28, 1983), C: 11; Goldberger, "New Skyscrapers and Unfulfilled Promises": 31, 33; "I.B.M. Gallery," *New York Times* (October 21, 1983), C: 24; Huxtable, *The Tall Building Artistically Reconsidered*, 106–9; Joan Lee Faust, "Buildings with a Heart of Green," *New York Times* (March 9, 1984), C: 1, 4; Paula Deitz, "The IBM Garden Plaza," *Architectural Record* 172 (May 1984): 154–55; Mildred F. Schmertz, "A Skyscraper in Context," *Architectural Record* 172 (May 1984): 146–53; "IBM 590 Madison Avenue," *Architecture + Urbanism* (May 1984): 27–35; Filler, "High Ruse, part 1": 150–65; "Edward Larrabee Barnes Associates," *GA Document* 12 (January 1985): 34–39; "IBM 590 Madison Avenue, New York, New York," *Architectural Record* 173 (March 1985): 66; Goldberger, "The Sidewalks of New York–Indoors": 21; Andrea Israel, "Sampling the Atriums," *New York Times* (March 24, 1985), X: 20; "Abstract Volume," *Space Design* (July 1985): 56–67; Carleton Knight III, "Clients: IBM Returns to Its Roots," *Architecture* 85 (June 1986): 60–64; "Gentle Humanism," *Process Architecture* 69 (July 1986): 33; Dan Graham and Robin Hurst, "Corporate Arcadias," *Artforum* 26 (December 1987): 68–74; Margot Gayle and Michele Cohen, *The Art Commission and the Municipal Art Society Guide to Manhattan's Outdoor Sculpture* (New York: Prentice Hall Press, 1988), 127; Lazar, "IBM, Trump, A.T.&T., How Do Your Gardens Grow?": 1, 8; Peter Hellman, "The IBM Bamboo Garden," *New York* 22 (May 22, 1989): 34; Sarah Rossbach, "Interior Dialogue," *Landscape Architecture* 79 (September 1989): 70–71; Tony Hiss, *The Experience of Place* (New York: Alfred A. Knopf, 1990), 25–26; Sarah Rossbach, "Corporate Commitment Enlivens an Indoor Garden Plaza," *Process Architecture* 94 (February 1991): 44–51; *Edward Larrabee Barnes: Architect* (New York: Rizzoli International Publications, 1994), 158–65; Nash, *Manhattan Skyscrapers*, 145–46; Campi, *Skyscrapers: An Architectural Type of Modern Urbanism*, 114–15; Jerold S. Kayden, *Privately Owned Public Space: The New York Experience* (New York: John Wiley & Sons, 2000), 173–74; White and Willensky, *AIA Guide* (2000), 298.

27. For Carrère & Hastings's buildings, see Stern, Gilmartin, and Mellins, *New York 1930*, 360; Christopher Gray, "Streetscapes/The Philippine Center at 556 Fifth Avenue," *New York Times* (April 30, 2000), XI: 9. For Barber's building, see W. Parker Chase, *New York: The Wonder City* (New York: Wonder City Publishing Co., 1932; New York: New York Bound, 1983), 254.

28. For Bonwit Teller and Tiffany & Company, see Stern, Gilmartin, and Mellins, *New York 1930*, 316–17, 319, 321.

29. Edward Larrabee Barnes, quoted in Goldberger, "Glass Box Gives Way to Slab, Shaft and Block": 1.

30. *Edward Larrabee Barnes: Architect*, 158. For Stubbins's Citicorp Center, see Stern, Mellins, and Fishman, *New York 1960*, 490–97.

31. Goldberger, "Glass Box Gives Way to Slab, Shaft and Block": 1.

32. Goldberger, "The Building Boom Gives Birth": 29, 34.

33. Goldberger, "Architecture: I.B.M.'s Green Granite Giant": 11.

34. Brendan Gill, quoted in Prial, "Interview: Brendan Gill on Urban Density": 7.

35. Filler, "High Ruse, part 1": 161.

36. Huxtable, *The Tall Building Artistically Reconsidered*, 108.

37. Schmertz, "A Skyscraper in Context": 148.

38. Carol Vogel, "I.B.M. to Close Its Midtown Gallery," *New York Times* (March 23, 1993), C: 13; Charles V. Bagli, "Symbol of Flashy Era for Sale," *New York Observer* (April 11, 1994): 1, 17; Claudia H. Deutsch, "I.B.M. Sells Its Building in New York," *New York Times* (May 7, 1994): 41.

39. Herbert Muschamp, "A Tempest over a Withering Oasis," *New York Times* (April 24, 1995), B: 1; Mildred F. Schmertz, "Public Use vs. Private Abuse," *Architecture* 84 (June 1995): 51, 53, 55, 57; Edward Larrabee Banres, "IBM's Public Mandate," letter to the editor, *Architecture* 84 (August 1995): 18; Charles Gwathmey, "Nonintervention at IBM," letter to the editor, *Architecture* 84 (August 1995): 18; "Alteration of IBM Building's Public Garden Approved," *Municipal Art Society Newsletter* (November-December 1995):1; Bruce Lambert, "Public Atria at the Heart of a Policy Debate," *New York Times* (November 19, 1995), XIII: 6; Carol Vogel, "Inside Art: Bamboo and Peace," *New York Times* (December 15, 1995), C: 36; Paul Goldberger, "Atrium Renewal, Adding Art, Chases Away Most of the Zen," *New York Times* (December 17, 1995): 49, 55; Hilton Kramer, "Robert Stern's 'Garden' Looks like a Showroom," *New York Observer* (January 15, 1996): 1, 17; Peter Schjeldahl, "Atrial Sclerosis," *Village Voice* (January 16, 1996): 67; David W. Dunlap, "How Best to Make Public Spaces Serve the Public?" *New York Times* (February 4, 1996), IX: 1, 8.

40. Goldberger, "Atrium Renewal, Adding Art, Chases Away Most of the Zen": 49, 55.

41. Carter B. Horsley, "A 36-Story Building Proposed in Busy Development Area," *New York Times* (December 9, 1979), VIII: 1, 4; Carter B. Horsley, "New Works in Midtown by an Old Hand," *New York Times* (December 9, 1979), VIII: 4; "Manhattan Offices Rise 36 Stories on Madison Avenue,"

Architectural Record 167 (March 1980): 41; Nory Miller, "Form and Circumstance," *Progressive Architecture* 61 (December 1980): 46–49; "Corner Core, Cutouts Complicate Concrete Job," *Engineering News-Record* 207 (September 10, 1981): 17; George W. Goodman, "Lease at 535 Madison," *New York Times* (December 13, 1981), VIII: 4; Dee Wedemeyer, "A Fervor of Creativity Grips Developers," *New York Times* (May 16, 1982), VIII: 7; Robert J. Cole, "Dillon, Read Plans to Move Uptown," *New York Times* (December 17, 1982), D: 4; Goldberger, "Architecture: I.B.M.'s Green Granite Giant": 11; Goldberger, "New Skyscrapers and Unfulfilled Promises": 31, 33; *Park Tower Group*, brochure (New York, 1992), no pagination; Kayden, *Privately Owned Public Space*, 171–72; White and Willensky, *AIA Guide* (2000), 295.

42. Kayden, *Privately Owned Public Space*, 171.

43. Goldberger, "Architecture: I.B.M.'s Green Granite Giant": 11.

44. Carter B. Horsley, "New Office Tower to Rise at 520 Madison," *New York Times* (October 21, 1979), VIII: 1, 4; Alan S. Oser, "An Office Building in Midtown Avoids New York City Land Use Review," *New York Times* (January 16, 1980), B: 7; Carter B. Horsley, "Lease Reflects City's Attraction to Banks," *New York Times* (November 16, 1980), VIII: 1, 6; Goldberger, "New Madison Avenue Buildings, a New New York?" 21; "Bidding Steel and Concrete Saves New York Job Money," *Engineering News-Record* 207 (September 7, 1981): 18; Goldberger, "New Skyscrapers and Unfulfilled Promises": 31; Andrew Alpern and Seymour Durst, *Holdouts!* (New York: McGraw-Hill, 1984), 70–75; Martin Filler, "High Ruse, part II," *Art in America* 72 (October 1984): 168.

45. See Stern, Gilmartin, and Mellins, *New York 1930*, 507–10.

46. Filler, "High-Ruse, part II": 175–76. For the W. R. Grace Building and 9 West Fifty-seventh Street, see Stern, Mellins, and Fishman, *New York 1960*, 464–65, 502–5.

47. "26 for 17: New on Madison," *New York Times* (February 17, 1985), VIII: 1; Shawn G. Kennedy, "New Office Towers on Madison," *New York Times* (July 9, 1986), D: 26; Paul Goldberger, "Crowding Can Vitiate Design–Good and Bad," *New York Times* (February 9, 1987), II: 35; White and Willensky, *AIA Guide* (2000), 295.

48. Goldberger, "Crowding Can Vitiate Design–Good and Bad": 35.

49. Diane Henry, "A Couple's Big Project in Midtown," *New York Times* (July 14, 1982), D: 20; Paul Goldberger, "Mediocre Skyscrapers Dominate the Skyline," *New York Times* (February 19, 1984), II: 31; Dee Wedemeyer, "Women as Developers: Four Who Made It," *New York Times* (March 10, 1985), VIII: 1; Kayden, *Privately Owned Public Space*, 142–43.

50. Alan S. Oser, "Catering to Midtown Office Needs," *New York Times* (November 2, 1986), VIII: 6, 22; Paul Goldberger, "On Madison Avenue, a Building That Blends In," *New York Times* (July 19, 1987), II: 30; White and Willensky, *AIA Guide* (2000), 384. For Horgan & Slattery's Building, see "In the Real Estate Field," *New York Times* (June 14, 1900): 12; "East Side Alteration," *New York Times* (June 15, 1924): 2; "Three Floors to Be Altered in 667 Madison Ave. Building," *New York Times* (March 27, 1938): 159.

51. Goldberger, "On Madison Avenue, a Building That Blends In": 30.

PARK AVENUE

1. See Stern, Mellins, and Fishman, *New York 1960*, 330–69.
2. Carter B. Horsley, "$100 Million Offered for Park Ave. Church," *New York Times* (September 19, 1980): 1, B: 7; Dudley Clendinen, "The Faithful Have Doubts About a Bid for St. Bartholomew's Church," *New York Times* (September 22, 1980), B: 3; "Testing St. Bartholomew's," editorial, *New York Times* (September 30, 1980): 26; Emilie B. Dague, J. J. Gross, and Esteban H. Swartz, "Whither St. Bartholomew's?" letters to the editor, *New York Times* (September 25, 1980): 26; Mildred F. Schmertz, "The People Who Own St. Bartholomew's Church," letter to the editor, *New York Times* (October 12, 1980): 26; Carter B. Horsley, "St. Bartholomew's Debates Church Sale," *New York Times* (October 10, 1980), B: 6; Frank C. Platt, "Raze St. Bart's," letter to the editor, *New York Times* (October 11, 1980): 22; Carter B. Horsley, "St. Bartholomew's Officials Refuse to Sell Their Church for Any Price," *New York Times* (October 15, 1980): 1, D: 23; "Devoutly Wrong on St. Bartholomew's," editorial, *New York Times* (October 20, 1980): 18; Ada Louise Huxtable, "The Sell-Off at St. Bartholomew's," *New York Times* (October 26, 1980), II: 33; Carter B. Horsley, "St. Bartholomew's Vote a Key to Church Land Sale," *New York Times* (December 14, 1980): 55; Carter B. Horsley, "Injunction Sought in Dispute at St. Bartholomew's," *New York Times* (December 21, 1980): 51; Kenneth A. Briggs, "St. Bartholomew's Split Goes Beyond Real Estate," *New York Times* (February 23, 1981), B: 1, 4; Carter B. Horsley, "26-Story Office Tower Proposed for St. Bartholomew's Property," *New York Times* (May 3, 1981): 45; Paul L. Montgomery, "St. Bartholomew's to Proceed on Lease," *New York Times* (June 4, 1981), B: 3; "Koch Hears Complaints on Midtown," *New York Times* (June 10, 1981), B: 4; "A Theology for the Ministry of St. Bartholomew's Parish," advertisement, *New York Times* (June 28, 1981), IV: 22; "Panel Seeks to Bar a Lease of St. Bart's Land," *New York Times* (October 4, 1981): 52; Michael Oreskes, "Vestry Backs Skyscraper at St. Bartholomew," *New York Times* (October 29, 1981): 1, D: 27; Paul Goldberger, "St. Bart's: Landmark Battle for the 80's," *New York Times* (October 30, 1981): 1, 26; Michael Oreskes, "Cost of Tower near St. Bart's Will Be Higher by $33 Million," *New York Times* (October 30, 1981): 26; Michael Oreskes, "Bishop Moore to Review St. Bart's Tower Plan," *New York Times* (November 1, 1981): 62; Eva Hoffman and Margot Slade, "Ideas & Trends: High Stakes at St. Bart's Church," *New York Times* (November 1, 1981), IV: 8; Paul Goldberger, "Separating Concrete from Abstract," *New York Times* (November 5, 1981), C: 22; Julian H. Salomon and Alicia R. Civitello, "Over- and Undershadowing St. Bart's," letters to the editor, *New York Times* (November 7, 1981): 22; Michael Oreskes, "Vision of St. Bart's Rector Pushes Tower Deal Ahead," *New York Times* (November 10, 1981), B: 1, 6; Kenneth A. Briggs, "A Collision of Interests on St. Bart's Building Plan," *New York Times* (November 14, 1981): 26; E. R. Shipp, "State Court Prohibits Meeting at St. Bart's on Its Lease Plan," *New York Times* (November 17, 1981), B: 6; Christopher Vasillopulos, "The Prime Opportunity of St. Bartholomew's," letter to the editor, *New York Times* (November 17, 1981): 30; Michael Oreskes, "St. Bart's Bows to the Court; Vote on Lease Plan Scrapped," *New York Times* (November 18, 1981), B: 2; "Tower at St. Bart's Opposed by Board," *New York Times* (November 20, 1981): 34; William Geib, "If the City Must Have More Office Buildings," letter to the editor, *New York Times* (November 28, 1981): 28; Susan Doubilet, "St. Bart's: Architects Propose, 'Savers' Oppose," *Progressive Architecture* 62 (December 1981): 30; C. Ray Smith, "St. Bart's Weighs Its Future," *Preservation News* 21 (December 1981): 1, 3; Marie Brenner, "Holy War on Park Avenue," *New York* 14 (December 14, 1981): 34–42; Glenn Fowler, "Parish Approves Skyscraper Plan in St. Bart's Vote," *New York Times* (December 19, 1981): 30; Richard Levine and Carlyle C. Douglas, "Tower Power at St. Bart's," *New York Times* (December 20, 1981), IV: 6; Paul L. Montgomery, "At St. Bartholomew's, a Time to Heal," *New York Times* (December 21, 1981), B: 3; "Appeal Is Filed on St. Bart's Vote," *New York Times* (December 23, 1981), B: 3; Ada Louise Huxtable, "Changes on the Drawing Board and the Skyline," *New York Times* (December 27, 1981), II: 27; Kenneth L. Woodward and Eloise Salholz, "The Battle of St. Bart's," *Newsweek* 98 (December 28, 1981): 60; "St. Bart's with an Office Spire?" editorial, *New York Times* (January 3, 1982), IV: 18; "Sale at St. Bart's Held Up by Court," *New York Times* (January 8, 1982), B: 3; Rector, Church Wardens and Vestrymen of St. Bartholomew's Church v. Committee to Preserve St. Bartholomew's Church, 84 A.D.2d 309 (January 14, 1982); "New York: St. Bart's Embattled," *The Economist* (February 6, 1982): 28; Deirdre Carmody, "Bishop Backs Plan to Lease St. Bart's Land to Developer," *New York Times* (February 14, 1982): 42; "Critics to Continue Fight on St. Bart's," *New York Times* (February 15, 1982), B: 3; "Judge Grants Stay on St. Bart's Plan," *New York Times* (March 22, 1982), B: 3; Richard F. Shepard, "Constructions," *New York Times* (March 22, 1982), C: 14; Diane Henry, "Developer Says Job Is Easier in U.S. Than in Europe," *New York Times* (April 7, 1982): 16; Art Harris, "The Pulpit vs. the Preservationists," *Washington Post* (April 25, 1982), H: 1, 9–11; "St. Bart's Vote on Lease Upheld," *New York Times* (May 19, 1982), B: 3; David W. Dunlap, "A Graceful Move 'Upstairs,'" *New York Times* (May 23, 1982), VIII: 6, 12; Paul Goldberger, "Theaters and Churches Are the City's New Battleground," *New York Times* (May 30, 1982), II: 1, 24; Edward A. Morrison, "Weighing Art and Religion at St. Bart's," letter to the editor, *New York Times* (June 13, 1982), II: 42; Clyde Haberman and Laurie Johnston, "St. Bart's Update," *New York Times* (July 26, 1982), B: 3; Edward C. Wallace, "St. Bart's and the Law," *New York Times* (August 21, 1982): 23; Anthony P. Marshall and Charles Scribner Jr., "Of St. Bart's, the Facts and the Landmarks Commission," letters to the editor, *New York Times* (August 28, 1982): 22; "St. Bartholomew's Church," *Oculus* 44 (September 1982): 4; "Group Says St. Bart's Misstated Lease Deal," *New York Times* (September 16, 1982), B: 6; David Lowe, *Three St. Bartholomew's: An Architectural History of a Church* (New York: The Victorian Society in America, 1983); "St. Bart's (Cont'd.)," *New York Times* (January 8, 1983): 26; Peter Lemos, "Bowers Bowing?" *Metropolis* 3 (September 1983): 6; Martin Gottlieb, "Landmark Park Ave. Church Asks Permission to Change a Building," *New York Times* (December 13, 1983): 1, B: 24; "The St. Bart's Battle Resumes," *New York Times* (December 18, 1983), IV: 6; Anthony P. Marshall, "No One Will 'Wreck' St. Bartholomew's," letter to the editor, *New York Times* (December 23, 1983): 22; David Lowe, "New York City's Landmarks Preservation Commission Rules Against St. Bartholomew's Tower," *The Victorian* 12 (1984): 5; Percival Goodman, "A Free-Will Offering to St. Bart's," *Oculus* 45 (January 1984): cover, 6; Brendan Gill, "Block St. Bart's Request," *New York Times* (January 28, 1984): 23; N. J. L'Heureux Jr., "Allowing Buildings at St. Bart's," *New York Times* (January 28, 1984): 23; David Margolick, "Church's Fight on Landmarks," *New York Times* (January 31, 1984), B: 1, 4; J. Sinclair Armstrong, "A Fund for St. Barts," *Oculus* 45 (February 1984): 6, 11; George Lewis, "Chapter Reports," *Oculus* 45 (February 1984): 2; David W. Dunlap, "Battle of St. Bart's Goes to Landmarks Panel," *New York Times* (February 1, 1984), B: 1, 7; Martin Gottlieb, "A Boom Borough," *New York Times* (February 1, 1984), B: 1, 7; Paul Windels Jr., "Church, State and St. Bart's," letter to the editor, *New York Times* (February 11, 1984): 26; George Lewis, "Chapter Reports," *Oculus* 45 (March 1984): 9; Paul Goldberger, "Who Owns Landmarks?" *Preservation News* 24 (March 1984): 5, 10; Daralice D. Boles, "Save the Law That Saved the Landmarks," *Progressive Architecture* 65 (March 1984): 19–20; Peter Freiberg, "Separating Church from State," *Metropolis* 3 (April 1984): 10; Peter Freiberg, "St. Bart's Goes for Broke," *Metropolis* 3 (April 1984): 12; David W. Dunlap, "Landmarks Panel Vetoes Tower Plans for St. Bart's and Historical Society," *New York Times* (June 13, 1984), B: 1, 7; Paul Goldberger, "Landmarks Cases: A Decisive Verdict," *New York Times* (June 14, 1984), B: 1, 6; Jonathan Walters, "No Starts for St. Bart's," *Preservation News* 24 (July 1984): 6; "Pencil Points," *Progressive Architecture* 65 (July 1984): 22; Peter Freiberg, "To the Vigilant Go the Rewards," *Metropolis* 4 (September 1984): 10; Peter Freiberg, "Decisions, Decisions," *Metropolis* 4 (September 1984): 11–12; "New Plan at St. Bart's," *New York Times* (December 21, 1984): 1; Matthew L. Wald, "A Smaller Office Tower Is Planned by St. Bart's," *New York Times* (December 21, 1984), B: 3; Paul Goldberger, "St. Bart's: New Plan That Faces Old Issues," *New York Times* (December 28, 1984), B: 1, 4; Milton Kirchman, "Traditional Yet Innovative Tower for St. Bart's," letter to the editor, *New York Times* (January 5, 1985): 20; Ari L. Goldman, "St. Bart's Sets Tower Dispute Aside to Celebrate Its 150th Anniversary," *New York Times* (January 21, 1985), B: 3; "Church and Foes Clash Again on St. Bart's Project," *New York Times* (January 30, 1985), B: 22; "Once More onto a Religious Battlefield: A New Proposal for St. Bart's Tower," *Architectural Record* 173 (February 1985): 65; "New Starts for St. Bart's?" *Preservation News* 25 (February 1985): 7; "Pencil Points," *Progressive Architecture* 66 (February 1985): 24; Michael Sorkin, "Mr. Wright," *Village Voice* (February 5, 1985): 87, reprinted in Michael Sorkin, *Exquisite Corpse: Writings on Buildings* (New York and London: Verso, 1991), 92–96; Paul Goldberger, "What Has Architecture to Do with the Quality of Life?" *New York Times* (February 10, 1985), II: 33; "New Design for St. Bart's Tower Raises Old Questions," *Architecture* 74 (March 1985): 42, 47; "A Balance for St. Bart's," editorial, *New York Times* (March 23, 1985): 22; Richard J. Zanard, "St. Bart's a Bright Jewel in City's Crown," letter to the editor, *New York Times* (April 1, 1985): 20; Michael Oreskes, "On 20th Anniversary, Landmarks Panel Is Strong but Controversial Force in City," *New York Times* (April 24, 1985), B: 1, 8; Isabel Wilkerson, "St. Bart's Loses 2d Bid to Build an Office Tower," *New York Times* (July 10, 1985), B: 1, 4; "Commission Rejects Latest Proposal for St. Bart's," *Architecture* 74 (August 1985): 37; Martin Gottlieb, "St. Bart's to Try Again to Build Tower," *New York Times* (September 5, 1985), B: 3; "St. Bart's Claims Economic Hardship in Third Application," *Architecture* 74 (October 1985): 16, 18; Jeffrey Schmalz, "St. Bart's and Group of Parishioners Clash at Landmark Hearing on Need for Tower," *New York Times* (October 30, 1985), B: 1, 3; Peter Lemos, "Blessed Are the Rich," *Metropolis* 5 (November 1985): 18; Jeffrey Schmalz, "Ex-Trustee Says Church Aides Lied in Tower Hearing," *New York Times* (December 4, 1985), B: 1; Jeffrey Schmalz, "St. Bartholomew Skyscraper Suit Dismissed," *New York Times* (December 14, 1985): 30; "Surprise Charges," *Engineering News-Record* 215 (December 19, 1985): 43; "Chapter Reports," *Oculus* 47 (January 1986): 15; Crystal Nix, "St. Bart's Again Denied on Office-Tower Plans," *New York Times* (February 25, 1986), B: 4; Crystal Nix, "St. Bart's Plans Lawsuit on Office Tower Denial," *New York Times* (February 26, 1986), B: 3; Peter Lemos, "St. Bart's Books," *Metropolis* 5 (March 1986): 11; Alan Finder and Mary Connelly, "At St. Bart's, Round Three," *New York Times* (March 2, 1986), IV: 6; Lynn Nesmith, "St. Bart's Plans Lawsuit After Third Denial of Tower," *Architecture* 75 (April 1986): 28, 32; "St. Bart's Disapproved," *Oculus* 47 (April 1986): 8; "St. Bart's Is Suing City on Office Tower Plan," *New York Times* (April 9, 1986), B: 3; "The Hole in Landmarks Law," editorial, *New York Times* (April 22, 1986): 30; "Pencil Points," *Progressive Architecture* 67 (May 1986): 26; "Notes on the Year," *Oculus* 47 (June 1986): 4; Peter Lemos, "More Assaults on the Landmarks Law," *Metropolis* 6 (July-August 1986): 15; "St. Bart's Project Suffers Setback," *New York Times* (July 18, 1986), B: 2; Jeanie Kasindorf, "St. Bart's to Churches: 'Help!'" *New York* 19 (July 28, 1986): 9; Arnold M. Berke, "St. Bart's Sues City," *Preservation News* 26 (August 1986): 8; Ari L. Goldman, "St. Bart's Members Approve 47-Story Tower," *New York Times* (September 24, 1986), B: 3; David W. Dunlap, "Preserving Churches: A Quandary," *New York Times* (September 22, 1986), B: 3; Mary Connelly and Carlyle C. Douglas, "St. Bart's Rector Wins a Mandate," *New York Times* (September 28, 1986), IV: 6; "Back in Court for St. Bart's," *New York Times* (October 6, 1986), B: 2; "Bowers Battles Landmarks Law," *New York* 19 (November 10, 1986): 22; Peter Lemos, "Deus Ex Machina," *Metropolis* 6 (January-February 1987): 19; David W. Dunlap, "Court Backs St. Bart's in Tower Legal Battle," *New York Times* (April 29, 1987), B: 3; "Judge Rules in Lawsuit on Building of Tower," *New York Times* (July 11, 1987): 34; Fletcher Hodges III, "Two Viewpoints on the Religious Properties Crisis," *Preservation Forum* 1 (Winter 1987–88): 2–5; Brent C. Brolin, *The Battle of St. Bart's: A Tale of the Material and the Spiritual* (New York: William Morrow, 1988); J. Sinclair Armstrong and Robert E. Morris Jr., "The St. Bart's Case," letter to the editor, *Preservation Forum* 2 (Spring 1988): 1; L. J. Davis, "God and Mammon on Park Avenue," book review, *New York Times* (May 1, 1988), VII: 14; Richard L. Bayles, "At St. Bart's, Good Works Sink Under the Burden of a Landmark," letter to the editor, *New York Times* (June 30, 1988): 22; J. Sinclair Armstrong, "Greed, Not Need, Lies Behind St. Bart's Real Estate Venture," *New York Times* (July 22, 1988): 30; "New York City Wins First Judicial Round in St. Bart's Case," *Preservation League of New York State Newsletter* 15 (Winter 1989): 1; The Rector, Wardens, and Members of the Vestry of St. Bartholomew's Church v. City of New York and Landmarks Preservation Commission of the City of New York, 728 F. Supp. 958 (December 13, 1989); William Glaberson, "Court Backs Landmarks Law," *New York Times* (December 14, 1989), B: 5; "St. Bart's Saved!" Municipal Art Society Newsletter (January 1990): 1; Jeannette Walls, "St. Bart's Heavenly Park Avenue Co-op," *New York* 23 (January 8, 1990): 11; Amy Worden, "Court Denies St. Bart's Plea," *Preservation News* 30 (February 1990): 1, 22; "Scene + Heard: Updates," *Metropolis* 9 (April 1990): 21; Roger K. Lewis, "Historic Preservation Poses Problems," *Washington Post* (April 7, 1990), E: 3–4; David W. Dunlap, "Change on the Horizon for Landmarks," *New York Times* (April 29, 1990): 32; The Rector, Wardens, and Members of the Vestry of St. Bartholomew's Church v. City of New York and Landmarks Preservation Commission of the City of New York, 914 F.2d 348 (September 12, 1990); David W. Dunlap, "Church's Landmark Status Is Upheld," *New York Times* (September 13, 1990), B: 4; "Victory in St. Bartholomew's Case," *Historic Preservation News* 30 (October 1990): 1; Steven Saltzman, "Updates," *Metropolis* 10 (December 1990): 25; "St. Bart's Revisited: Court

Upholds Landmark Designation," *Preservation League of New York State Newsletter* 16 (Winter 1990–91): 1; Linda Greenhouse, "Court Ends Tower Plan at St. Bart's," *New York Times* (March 5, 1991), B: 1, 4; Paul Goldberger, "Two Reasons for Dancing in the Streets of New York," *New York Times* (March 17, 1991), II: 36, 42; Laurie Goodstein, "St. Bart's Loses Bid to Build Skyscraper," *Washington Post* (March 23, 1991), G: 12, 14; Kim Kelster, "Supreme Court Rules for Preservation," *Historic Preservation News* 31 (April 1991): 1–2; Todd S. Purdum, "Church as Landmark: Battle Rejoined," *New York Times* (April 13, 1991): 27; "Pencil Points," *Progressive Architecture* 72 (May 1991): 28; David W. Dunlap, "St. Bart's to Open Its Doors to an Adversary," *New York Times* (May 4, 1991): 25–26; Jane Brown Gillette, "Judgment Day," *Historic Preservation News* 43 (September-October 1991): 56–57, 102–3; Gregory F. Gilmartin, *Shaping the City: New York and the Municipal Art Society* (New York: Clarkson Potter, 1995), 421–24.

3. For Goodhue's church, see Stern, Gilmartin, and Massengale, *New York 1900*, 113, 120–21; Stern, Gilmartin, and Mellins, *New York 1930*, 152, 158–59. For Renwick & Sands's church, see Stern, Mellins, and Fishman, *New York 1880*, 296–97.

4. Carter B. Horsley, "Midtown Architecture Honored," *New York Times* (June 18, 1972), B: 1, 8.

5. "Testing St. Bartholomew's": 26.

6. Thomas D. Bowers, quoted in Horsley, "St. Batholomew's Debates Church Sale": 6.

7. Brolin, *The Battle for St. Bart's*, 90.

8. "Devoutly Wrong on St. Bartholomew's": 18.

9. Huxtable, "The Sell-Off at St. Bartholomew's": 33.

10. J. Sinclair Armstrong, quoted in Horsley, "Injunction Sought in Dispute at St. Bartholomew's": 51.

11. Richard Dattner, quoted in Horsley, "26-Story Office Tower Proposed for St. Bartholomew's Property": 45. For the Waldorf-Astoria, see Stern, Gilmartin, and Mellins, *New York 1930*, 223.

12. Quoted in Montgomery, "St. Bartholomew's to Proceed on Lease": 3.

13. Cesar Pelli, quoted in Brenner, "Holy War on Park Avenue": 40.

14. Goldberger, "St. Bart's: Landmark Battle for the 80s": 1. For Cross & Cross's General Electric Building, originally the RCA Victor Building, see Stern, Gilmartin, and Mellins, *New York 1930*, 595, 599.

15. Brenner, "Holy War on Park Avenue": 41.

16. Goodman, "A Free-Will Offering to St. Bart's": 5.

17. Salomon, "Over- and Undershadowing St. Bart's": 22.

18. Thomas D. Bowers, quoted in Brenner, "Holy War on Park Avenue": 36.

19. Brenner, "Holy War on Park Avenue": 36.

20. Edward J. Greenfield, quoted in Woodward and Salholz, "The Battle for St. Bart's": 60.

21. Thomas D. Bowers, quoted in Herman and Johnston, "St. Bart's (cont'd)": 26.

22. Landmarks Preservation Commission of the City of New York, LP-0275 (March 16, 1967), quoted in Herman and Johnston, "St. Bart's (cont'd)": 26.

23. Margot Gayle, "St. Bartholomew's in the 1980s," in Lowe, *An Architectural History of a Church*, 19–20.

24. Thomas D. Bowers, quoted in Gill, "Block St. Bart's Request": 23.

25. Gill, "Block St. Bart's Request": 23.

26. Goldberger, "St. Bart's: New Plan That Faces Old Issues": 1, 4.

27. Goldberger, "What Has Architecture to Do with the Quality of Life?": 33, 35.

28. David Todd, quoted in Nix, "St. Bart's Again Denied on Office-Tower Plans": 4.

29. Thomas D. Bowers, quoted in, "Bowers Battles Landmarks Law": 22.

30. Carter B. Horsley, "Park Ave. Building Could Signal End of Construction Drought," *New York Times* (August 4, 1977), B: 1–2; Paul Goldberger, "Design Notebook," *New York Times* (September 15, 1977), C:10; Alan S. Oser, "Look What Coincidence and $6 Million Can Do," *New York Times* (November 22, 1978), D: 14; "New Office Tower to Rise on Park Avenue," *New York Times* (December 19, 1978): 1; "Buildings in the News," *Architectural Record* 166 (February 1979): 41; "Building Systems: Something Special in a Pei High-Rise," *Architectural Record* 166 (November 1979): 131–33; Suzanne Daley, "Rugged Art of Erecting a Building's Structure," *New York Times* (May 18, 1980), VIII: 1, 6; Paul Goldberger, "499 Park, the Intent Is Serious," *New York Times* (February 12, 1981), C: 24; Janet Nairn, "Seven Architects Convene at the Museum of Modern Art to Discuss 'Super-Building,'" *Architectural Record* 169 (April 1981): 35; Ada Louise Huxtable, "500 Park–A Skillful Solution," *New York Times* (May 3, 1981), II: 27–28; Jeanie Kasindorf, "Pei Building's Pane-ful Problem," *New York* 20 (March 16, 1987): 11; White and Willensky, *AIA Guide* (1988), 284; Jerold S. Kayden, *Privately Owned Public Space: The New York Experience* (New York: John Wiley & Sons, 2000), 187. For the Arion Society clubhouse, see Stern, Mellins, and Fishman, *New York 1880*, 233–34. For the Pepsi-Cola Building, see Stern, Mellins, and Fishman, *New York 1960*, 336–38, 1170.

31. Goldberger, "Design Notebook": 10.

32. James Ingo Freed, quoted in Goldberger, "499 Park, the Intent Is Serious": 24.

33. Goldberger, "499 Park, the Intent Is Serious": 24. For Olympic Tower and One United Nations Plaza, see Stern, Mellins, and Fishman, *New York 1960*, 391–93, 636–39.

34. Goldberger, "499 Park, The Intent Is Serious": 24.

35. Huxtable, "500 Park–A Skillful Solution": 28.

36. Ada Louise Huxtable, "Today the Cards Are All in the Builders' Hands," *New York Times* (March 26, 1978), II: 29;

Carter B. Horsley, "Hotel Is Planned over Racquet and Tennis Club," *New York Times* (March 31, 1978), B: 4; Charles Kaiser, "Midtown Developer Gets Variance Allowing Additional Office Space," *New York Times* (May 2, 1978): 28; Carter B. Horsley, "3 Prominent Midtown Hotels Sold; 2 May Be Turned into Apartments," *New York Times* (July 29, 1978): 21; "Realty News," *New York Times* (November 12, 1978), VIII: 1, 8; "3 Proposed Midtown Towers to Get Nearly $30 Million in Abatements," *New York Times* (December 20, 1978), B: 2; Carter B. Horsley, "Ground Broken for a Skyscraper on Park Avenue," *New York Times* (March 14, 1979), D: 15; Alan S. Oser, "4 Big Leases Already Signed for Office Building Going Up," *New York Times* (November 14, 1979), B: 7; Suzanne Daley, "Rugged Art of Erecting a Building's Structure," *New York Times* (May 18, 1980), VIII: 1, 6; Michael Sorkin, "Shaft," *Village Voice* 25 (June 25, 1980): 73; "Seven Architects Convene at the Museum of Modern Art to Discuss 'Super-Building'": 35; Jill Jonnes, "City's Zoning: A Tough Game That Few Can Play," *New York Times* (July 12, 1981), VIII: 1; Paul Goldberger, "At Park Ave. Plaza, Accent's on Interior," *New York Times* (February 20, 1982): 25, 39; Skidmore, Owings & Merrill: *Architecture and Urbanism, 1973–1983* (Stuttgart: Verlag Gerd Hatje; New York: Van Nostrand Reinhold, 1983), 236–39; "Design Awards/Competitions," *Architectural Record* 171 (January 1983): 75; "Park Avenue Plaza–New York, 1981," *Architecture + Urbanism* (March 1983): 49–52; Martin Filler, "High Ruse, Part II," *Art in America* 72 (October 1984): 168; Paul Goldberger, "The Sidewalks of New York–Indoors," *New York Times* (March 24, 1985), X: 21; Christopher Gray, "Streetscapes/The Racquet & Tennis Club," *New York Times* (November 23, 1997), XI: 6; Kayden, *Privately Owned Public Space*, 156. For the Racquet and Tennis Club, see Stern, Gilmartin, and Massengale, *New York 1900*, 237.

37. Huxtable, "Today the Cards Are All in the Builders' Hands": 29.

38. Horsley, "Hotel Is Planned over Racquet and Tennis Club": 4.

39. Landmarks Preservation Commission of the City of New York, LP-1000 (May 8, 1979); Barbaralee Diamonstein, *The Landmarks of New York III* (New York: Harry N. Abrams, 1998), 328.

40. Philip Johnson, quoted in Horsley, "Hotel Is Planned over Racquet and Tennis Club" 4.

41. "Realty News": 1, 8.

42. Jonathan Morse, quoted in Gray, "Streetscapes/The Racquet & Tennis Club": 6.

43. Filler, "High Ruse, Part II": 174.

44. "3 Proposed Midtown Towers to Get Nearly $30 Million in Abatements": 2.

45. Goldberger, "At Park Ave. Plaza, Accent's on Interior": 25, 39.

46. Goldberger, "At Park Ave. Plaza, Accent's on Interior": 25, 39.

47. Filler, "High Ruse, Part II": 175.

48. "Equitable Buys Building . . . ," *New York Times* (October 11, 1980), VIII: 1; Huxtable, "500 Park–A Skillful Solution": 27, 31; "Realty News," *New York Times* (January 31, 1982), VIII: 12; Paul Goldberger, "The Limits of Urban Growth," *New York Times* (November 14, 1982), VI: 46–49, 53, 56, 58, 60, 62, 64, 68; "A Vintage Building Shares Its Air Space," *Architectural Record* 171 (February 1983): 51; "Names and News," *Oculus* 44 (March 1983): 10; Lee A. Daniels, "Park Ave. Luxury Is Attracting Buyers," *New York Times* (March 4, 1983), B: 7; Paul Goldberger, "A New Meaning for Luxury," *New York Times* (April 17, 1983), VI: 46, 50–55; Carter Wiseman, "James Stewart Polshek: Setting New Standards for Sensitive Innovation on Park Avenue," *New York Times* 16 (September 19, 1983): 112–13; "500 Park Tower," *Baumeister* 81 (February 1984): 40; Carter Wiseman, "Good Neighbor Policy," *Architectural Record* 172 (July 1984): 86–95; Paul Goldberger, "Defining Luxury in New York's New Apartments," *New York Times* (August 16, 1984), C: 1, 8; Cervin Robinson, "Contextual Tower Rises Above a '50s Classic," *Architecture* 75 (May 1986): 206–9, 278; "Design Awards/Competitions: 1986 AIA Honor Awards," *Architectural Record* 174 (June 1986): 86–87; "1987 Tucker Award Winners: 500 Park Tower," *Building Stone Magazine* 2 (March/April 1987): 34; "Design Awards/Competitions: Building Stone Institute 1987 Tucker Architectural Awards," *Architectural Record* 175 (November 1987): 76–77; *James Stewart Polshek: Context and Responsibility* (New York: Rizzoli International Publications, 1988), cover, 13, 15, 48, 112–15; Marisa Bartolucci, "Citizen Architect," *Metropolis* 14 (June 1995), 62–67, 74–79; Paul Spencer Byard, *The Architecture of Additions: Design and Regulation* (New York: W.W. Norton, 1998), 54–57; Kayden, *Privately Owned Public Space*, 184; White and Willensky, *AIA Guide* (2000), 284.

49. Huxtable, "500 Park–A Skillful Solution": 27.

50. For the Pepsico headquarters in Purchase, New York, see Stern, Mellins, and Fishman, *New York 1960*, 1079–80.

51. *James Stewart Polshek: Context and Responsibility*, 46, 240–41.

52. Wiseman, "Good Neighbor Policy": 86.

53. Robinson, "Contextual Tower Rises Above a '50s Classic": 107–8.

54. Daniel C. Cuff, "A 'Pragmatic' Banker for Amro in New York," *New York Times* (June 30, 1982), D: 2; Michael Wagner, "Public Space Experience," *Interiors* 144 (November 1985): 111–21, 172, 177; *James Stewart Polshek: Context and Responsibility*, 46, 242–43.

55. James Stewart Polshek, "Notes on My Life and Work," in *James Stewart Polshek: Context and Responsibility*, 46.

56. For the PSFS Building, see Robert A. M. Stern, *George Howe: Toward a Modern American Architecture* (New Haven, Conn.: Yale University Press, 1975), 108–30, figs. 83–97.

57. Huxtable, "500 Park–A Skillful Solution": 27, 31.

58. Goldberger, "Defining Luxury in New York's New

Apartments": 8.

59. Wiseman, "James Stewart Polshek: Setting New Standards for Sensitive Innovation on Park Avenue": 112.

60. Wiseman, "Good Neighbor Policy": 86.

61. Shawn G. Kennedy, "Glass and Granite: 36-Story Obelisk off the Avenue," *New York Times* (November 25, 1984), VIII: 1; Paul M. Sachner, "Redefining the Manhattan Skyline: Three New Projects by Murphy/Jahn," *Architectural Record* 173 (January 1985): 57; Shawn G. Kennedy, "Midtown Venture for I.B.M.," *New York Times* (January 9, 1985), D: 20; Joachim Andreas Joedicke, *Helmut Jahn* (Stuttgart and Zurich: Karl Krämer Verlag, 1986), 94–97; Nory Miller, *Helmut Jahn* (New York: Rizzoli International Publications, 1986), 206–10; "Park Avenue Tower," *Architecture + Urbanism*, special edition (June 1986): 228; Ante Glibota, *Helmut Jahn: Modern Romantic* (Paris: Paris Art Center, 1987), 368–75; Carter Wiseman, "Tarted Up," *New York* 20 (April 20, 1987): 72, 74; Ellen Posner, "Helmut Jahn Takes on the Big Apple," *Wall Street Journal* (May 17, 1988): 36; Carter B. Horsley, "Heere's Jahn-Y!" *New York Post* (November 10, 1988): 84; "Park Avenue Tower, New York," *Architektur, Innenarchitektur, Technischer Ausbau* 97 (October 1989): 62; *Park Tower Group*, brochure (New York, 1992), no pagination; Ross Miller, "Architecture in Search of a New Urban Type," *Architecture + Urbanism*, special edition (September 1992): 4–6; "Park Avenue Tower," *Architecture + Urbanism*, special edition (September 1992): 104; *Murphy/Jahn: Selected and Current Works* (Mulgrave, Australia: Images Publishing, 1995), 114; Susanna Sirefman, *New York: A Guide to Recent Architecture* (London: Ellipsis, 1997), 164; White and Willensky, *AIA Guide* (2000), 283.

62. For Stern's entry, see Stanley Tigerman, *Chicago Tribune Tower Competition & Late Entries* (New York: Rizzoli International Publications, 1981), 140.

63. For the Friars Club, see "The Friars Club, New York: Harry Allan Jacobs," *Architectural Record* 40 (September 1916): 212–22. For Emery Roth & Sons' 430 Park Avenue, see Stern, Mellins, and Fishman, *New York 1960*, 334–35.

64. White and Willensky, *AIA Guide* (2000), 285.

65. "30 Stories on Fifth: A British Project," *New York Times* (January 13, 1985), VIII: 1; "70 East 55th Street," *Architecture + Urbanism* (December 1985): 18; "70 East 55th Street (Heron Tower)," *Architecture + Urbanism*, extra edition (April 1988): 106–9; Sonia R. Chao and Trevor D. Abramson, eds., *Kohn Pedersen Fox: Buildings and Projects, 1976–1986* (New York: Rizzoli International Publications, 1987), 206–11, 334; White and Willensky, *AIA Guide* (1988), 250; Heinrich Klotz, ed., *New York Architecture, 1970–1990* (Munich: Prestel Verlag, 1989), 168–69; Warren A. James, ed., *Kohn Pedersen Fox: Architecture and Urbanism, 1986–1992* (New York: Rizzoli International Publications, 1993), 401; "Heron Picks Up Award in New York," *Daily Telegraph* (February 16, 1993): 23.

66. For the American Radiator Building, see Stern, Gilmartin, and Mellins, *New York 1930*, 576–77, 581–83. For 410 Park Avenue, see Stern, Mellins, and Fishman, *New York 1960*, 335.

67. "New Headquarters: Banco Di Roma Buys on East 51st," *New York Times* (February 14, 1993), X: 1; Claudia H. Deutsch, "Town House Headquarters; Foreign Banks Pay a Premium for a Smart Address," *New York Times* (July 25, 1993), X: 13; *Piero Sartogo, Nathalie Grenon: Architecture in Perspective* (New York: Monacelli Press, 1998), 26–31. For Fred F. French Company's building, originally built as an apartment house, see "Latest Dealings in Realty Field," *New York Times* (August 25, 1922): 26.

68. Massimo di Forti, quoted in *Piero Sartogo, Nathalie Grenon: Architecture in Perspective*, 27.

LEXINGTON AVENUE

1. Alan S. Oser, "A New Office Building with Public Amenities," *New York Times* (November 10, 1978): 23; Carter B. Horsley, "560 Lexington Avenue," *New York Times* (September 23, 1979), VIII: 6; "Lexington Avenue," *New York Times* (June 8, 1980), VIII: 10; Carter B. Horsley, "560 Lexington Avenue," *New York Times* (September 23, 1979), VIII: 6; Paul Goldberger, "St. Bart's: Landmark Battle for the '80's," *New York Times* (October 31, 1981), 1, 26; "No Building Found to Merit City Club Award," *New York Times* (January 17, 1982): 44; David L. Shirey, "There's Poetry in the Newest Office Portals," *New York Times* (December 5, 1982), VIII: 1, 14; Sheila Mehlman, "Portal Artist," letter to the editor, *New York Times* (January 23, 1983), VIII: 12; White and Willensky, *AIA Guide* (1988), 247. For the RCA Victor Building, see Stern, Gilmartin, and Mellins, *New York 1930*, 595, 599.

2. For the Cathedral High School, see "New Conditions on Lexington Avenue," *New York Times* (August 1, 1926): 1–2.

3. Carter B. Horsley, "Howard Ronson Begins Work on One Tower, Sells Another," *New York Times* (September 20, 1981), VIII: 2; Paul Goldberger, "Mediocre Skyscrapers Dominate the Skyline," *New York Times* (February 19, 1984), II: 31.

4. Goldberger, "Mediocre Skyscrapers Dominate the Skyline": 31.

5. Goldberger, "Mediocre Skyscrapers Dominate the Skyline": 31; Diane Henry, "British Methods in Manhattan," *New York Times* (December 1, 1982), D: 23; Shawn G. Kennedy, "How to Make the Most of Midblock Site," *New York Times* (February 29, 1984), B: 6; "4th in 3 Blocks," *New York Times* (January 20, 1985), VIII: 1.

6. Brian Rainbow, quoted in Kennedy, "How to Make the Most of Midblock Site": 6.

7. Goldberger, "Mediocre Buildings Dominate the Skyline": 31.

8. Walter B. Wriston, quoted in Carter B. Horsley, "Citicorp Plans New Office Tower on Lexington, South of Its Center," *New York Times* (January 4, 1981): 1, 27. Also see Diane Henry, "Citicorp to Sell Key Site to Canadian Developer," *New York Times* (August 18, 1981), B: 1; "Citicorp Center," *Wall Street Journal* (August 18, 1981): 56; Diane Henry, "City Feels the

Toronto Touch," *New York Times* (September 6, 1981), VIII: 1, 6; Diane Henry, "Big Project in Midtown Hits Snags," *New York Times* (May 5, 1982), D: 24; Randall Smith, "Citicorp," *Wall Street Journal* (August 30, 1982): 15; Nicholas Hirst, "Cadillac Drops New York Deal," *Financial Times* (September 10, 1982), II: 21; "Aid to Fairview," *New York Times* (September 22, 1982), D: 4; Diane Henry, "Developer Adjusts to Recession," *New York Times* (October 6, 1982), D: 26; Diane Henry, "Loan Default Leads Citicorp to Reclaim Office Site," *New York Times* (October 28, 1982), B: 3; "Citicorp Signs Contract," *Wall Street Journal* (July 5, 1983): 14; Diane Henry, "Boston Firm May Breathe New Life into Citicorp Site," *New York Times* (July 6, 1983), B: 7; David W. Dunlap, "Builder Offers Subway Tunnel in City Zoning Deal," *New York Times* (January 19, 1984): 1, D: 23; Alan Finder and Richard Levine, "Trading a Tube for a Tunnel," *New York Times* (January 22, 1984), IV: 6; *Edward Larrabee Barnes Associates, GA Document* 12 (January 1985): 40; Shawn G. Kennedy, "Timing Right for New Midtown Tower," *New York Times* (February 20, 1985): 20; Dee Wedemeyer, "Lobbies with Stellas: The Developers' Choice," *New York Times* (May 12, 1985), XII. 71; Robert Ponte, "599 Lexington Avenue," *Institute for Urban Design Project Monograph* 1 (December 1985): 1–8; Douglas C. McGill, "A New Stella in Office Lobby," *New York Times* (April 25, 1986), C: 29; Anthony DePalma, "In a New Tower, a Waiting Rental Strategy Unfolds," *New York Times* (December 7, 1986), VIII: 7; Shawn G. Kennedy, "Law Firms Actively Leasing Office Space in Midtown," *New York Times* (February 18, 1987), B: 8; Herbert L. Smith Jr., "A Paradoxical Neighbor," *Architectural Record* 176 (February 1988): 100–107; "599 Lexington Avenue: New York, NY, 1986," *Architecture + Urbanism*, extra edition (April 1988): 9, 76–84; Edward Larrabee Barnes, *Edward Larrabee Barnes, Architect* (New York: Rizzoli International Publications, 1994), 166–73; Anthony DePalma, "Building Offices Without a Prime Tenant," *New York Times* (July 27, 1986), 1, 14; White and Willensky, *AIA Guide* (2000), 281. For Citicorp Center, see Stern, Mellins, and Fishman, *New York 1960*, 490–97.

9. Edward Larrabee Barnes, quoted in "Timing Right for New Midtown Tower": 20.

10. "750 Lexington Avenue," *Chicago Architectural Journal* 5 (1985): 70–71; "New York," *Engineering News-Record* 215 (December 12, 1985): 33; Andreas Joedicke, *Helmut Jahn* (Stuttgart and Zurich: Karl Krämer Verlag, 1986),100–101; Nory Miller, *Helmut Jahn* (New York: Rizzoli International Publications, 1986), 243; "750 Lexington Tower," *Chicago Architecture Annual* 6 (1986): 170; "750 Lexington Avenue," *Architecture + Urbanism*, special edition (June 1986): 240; Alan S. Oser, "Catering to Midtown Office Needs," *New York Times* (November 2, 1986), VIII: 6, 22; Ante Glibota, *Helmut Jahn: Modern Romantic* (Paris: Paris Art Center, 1987), 509–13; Shawn G. Kennedy, "East Side Getting 2 New Office Towers," *New York Times* (April 20, 1988), B: 14; Harry Berkowitz, "Going for Glitz in Office Space," *Newsday* (August 29, 1988): 1; Paul Goldberger, "Breaking the Rules to Make a Corner an Urban Event," *New York Times* (October 9, 1988), II: 32; Carter B. Horsley, "Here's Jahn-Y!" *New York Post* (November 10, 1988): 84; "750 Lexington Avenue," *Architecture + Urbanism*, special edition (September 1992): 104; *Murphy/Jahn: Selected and Current Works* (Mulgrave, Australia: Images Publishing, 1995), 92–93; Susanna Sirefman, *New York: A Guide to Recent Architecture* (London: Ellipsis, 1997), 164–65; White and Willensky, *AIA Guide* (2000), 285. Also see Carter B. Horsley, "1 International Plaza," in http://www.thecityreview.com. For Bloomingdale's, see Stern, Gilmartin, and Mellins, *New York 1930*, 317.

11. Carter B. Horsley, "1 International Plaza," in http://www.thecityreview.com.

12. Goldberger, "Breaking the Rules to Make a Corner an Urban Event": 32.

13. Esther B. Fein, "A Rent-Control Holdout Showing Her Gumption," *New York Times* (February 13, 1986), B: 1, 8; Christopher Gray, "Streetscapes: Holding Out in a Once-Gracious 1865 Brownstone," *New York Times* (April 12, 1987), VIII: 14; "$650,000 Holdout: 'No Regrets,'" *New York Times* (April 3, 1988), X: 1; Daniel Seligman, "A Big Deal," *Fortune* 117 (May 9, 1988): 135; "M. Jean Herman, 69, Brownstone Holdout," *New York Times* (March 26, 1992), B: 14; "'Ultimate Holdout Tenant Dies: She Forced Developers to Build Around Her," *Atlanta Journal and Constitution* (April 15, 1992): 2; Dennis Duggan, "Leave Here? Not for a Million!" *Newsday* (April 19, 1992): 43.

14. Seymour Durst, quoted in "'Ultimate Holdout Tenant Dies: She Forced Developers to Build Around Her': 2. Also see Andrew Alpern and Seymour Durst, *Holdouts!* (New York: McGraw-Hill, 1984).

15. "News Notes," *Oculus* 53 (October 1990): 2; "New Lighthouse," *New York Times* (March 3, 1991), X: 1; Peter D. Slatin, "Midtown Lighthouse," *Architectural Record* 179 (April 1991): 37; "Pulse," *Engineering News-Record* 226 (May 6, 1991): 170; Peter Slatin, "Beyond Wheelchairs," *Architectural Record* 182 (August 1993): 38–41; Peter Slatin, "The Lighthouse Gets Bright, Airy New Headquarters," *New York Times* (June 19, 1994), X: 7; Janet L. Rumble, "Lighting the Way," *Metropolis* 14 (April 1995): 70–73, 99, 105; Raul A. Barreneche, "Details: The Lighthouse," *Architecture* 84 (June 1995): 160; Mildred F. Schmertz, "Community Beacon," *Architecture* 84 (June 1995): 94–101; Monica Geran, "Mitchell/Giurgola," *Interior Design* 66 (August 1995): 80–87; Mildred F. Schmertz, "The Aesthetic Dimension," in *Mitchell/Giurgola Architects: Selected and Current Works* (Mulgrave, Australia: Images Publishing, 1996), 12, 196–207; "Mitchell/Giurgola Architects," *Oculus* 60 (Summer 1998): 11; "Lighthouse International in New York City," *Architectural Record* 187 (February 1999): 141; White and Willensky, *AIA Guide* (2000), 284. For Kahn & Jacobs's building, see Stern,

Mellins, and Fishman, *New York 1960*, 498.

16. Slatin, "The Lighthouse Gets Bright, Airy New Headquarters": 7.

17. Schmertz, "Community Beacon": 100.

18. For Alexander's, see Stern, Mellins, and Fishman, *New York 1960*, 430–31.

19. Alan S. Oser, "Split-Lot Lexington Project Melds Conflicting Themes," *New York Times* (October 14, 1984), VIII: 7; Isadore Barmash, "Alexander's Will Close 58th St. Flagship Store," *New York Times* (December 5, 1985), D: 8; Alan S. Oser, "Movement at the Alexander's Site," *New York Times* (December 15, 1985), VIII: 6, 18; Albert Scardino, "Alexander's Plans Shift to Partnership," *New York Times* (October 4, 1986): 33; Lisa Belkin, "Trump to Acquire 20% of Alexander's," *New York Times* (November 22, 1986): 42; "Alexander's Changes Tack," *New York Times* (November 27, 1986), D: 3; Daniel F. Cuff, "Trump and Interstate End Talks on Alexander's," *New York Times* (September 27, 1987), D: 2; Isadore Barmash, "Behind the Surge for Alexander's," *New York Times* (October 21, 1988), D: 4; Frederic Dicker and Leo Standora, "Donald Grump," *New York Post* (August 19, 1988): 14; Isadore Barmash, "Trump Says He May Seek Retail Chain," *New York Times* (December 21, 1989), D: 4; Isadore Barmash, "Alexander's New Focus: Retailing," *New York Times* (September 4, 1990), D: 1, 4; Stephanie Strom, "Alexander's Is Emerging as a Real Estate Group," *New York Times* (April 24, 1992), D: 1, 9; Stephanie Strom, "Alexander's Shuts All Its 11 Stores; Plans Liquidation," *New York Times* (May 10, 1992), 1, 27; "Alexander's Reorganization Plan Approved," *New York Times* (September 23, 1993), D: 4; Daniel Gross, "Cagey Mogul Keeps Alexander's Empty," *New York Observer* (May 2, 1994): 1, 24; Charles V. Bagli, "After Trumping Trump Roth Has Grand Plan for Silk Stocking Site," *New York Observer* (May 30, 1994): 1, 17; Bruce Lambert, "Boarded-Up, Alexander's Awaits New Life," *New York Times* (June 19, 1994), XIV: 8; Carol Vogel, "Inside Art: The Alexander's Site," *New York Times* (August 5, 1994), C: 24; "Alexander's to Get Loan for Old Store," *New York Times* (October 20, 1994), B: 8; Daniel Gross, "Fight Begins for Alexander's Building," *Newsday* (October 28, 1994), E: 11; Leo Frantzman, "Shelter the Homeless in Empty Alexander's," letter to the editor, *New York Times* (December 27, 1994): 20; Carol Vogel, "Inside Art: Need Rm; Never Mind Vu," *New York Times* (October 25, 1996), C: 36.

20. Peter Grant, "Vornado Races Time," *New York Daily News* (September 20, 1999): 26; Charles V. Bagli, "Silk Stocking's Mystery Hole," *New York Times* (December 16, 1999), B: 1, 8; Florence K. Diamond, "An Oasis in the City," letter to the editor, *New York Times* (December 20, 1999): 36; Danielle Reed, "Bloomberg HQ Deal Seen Near," *New York Daily News* (March 7, 2000): 63; Steve Cuozzo, "Realty Check," *New York Post* (May 16, 2000): 47; Charles V. Bagli, "Tentative Deal for Skyscraper at Former Site of Alexander's," *New York Times* (September 19, 2000), B: 1, 4; Charles V. Bagli, "Bloomberg Close to Deal to Move into Tower on Alexander's Site," *New York Times* (February 21, 2001), B: 11; Charles V. Bagli, "Behind Trade Center Deal, the Toughest of the Tough in Real Estate," *New York Times* (February 24, 2001), B: 3; Marc Hochstein, "Bloomberg Signs On at Alexander's Site," *Grid* 3 (June 2001): 20; Charles V. Bagli, "Bloomberg Is Expected to Close a Deal on Alexander's Site," *New York Times* (April 27, 2001), B: 8; "Glass Tower for East Side," *New York Times* (May 2, 2001), B: 7; Rachelle Garbarine, "Zoning Aid Helps Create Housing for the Poor," *New York Times* (March 22, 2002), B: 8; David W. Dunlap, "Reclusive Developer Conjures Accessible Space," *New York Times* (June 12, 2003), B: 3; Josh Barbanel, "The Alchemy of a Zoning Bonus," *New York Times* (December 14, 2003), XI: 1; Nicolai Ouroussoff, "The New New York Skyline," *New York Times* (September 5, 2004), II: 1, 22–23; Justin Davidson, "Where the Sky Is No Limit," *Newsday* (March 23, 2005), B: 4; "731 Lexington Avenue," *New York Construction* 52 (June 1, 2005): 23.

21. Davidson, "Where the Sky Is No Limit": 4.

22. Robert D. McFadden, "Fire Heavily Scars Landmark East Side Synagogue," *New York Times* (August 29, 1998), 1, B: 5; Susan Sachs, "A Living History of American Judaism," *New York Times* (August 29, 1998), B: 5; Jim Yardley, "Rabbi Promises to Rebuild Synagogue Damaged by Fire," *New York Times* (August 30, 1998): 29, 31; Robert D. McFadden, "Offers of Help Pour In for Damaged Synagogue," *New York Times* (August 31, 1998), B: 5. For the Central Synagogue, see Stern, Mellins, and Fishman, *New York 1880*, 329–30.

23. Hugh Hardy, quoted in Ken Shulman, "Restoring the Soul," *Metropolis* 20 (October 2000): 134–39, 164–65. Also see *Hardy Holzman Pfeiffer Associates: Buildings and Projects, 1992–1998* (New York: Rizzoli International Publications, 1999), 215; James Barron with Charles Strum, "Restoring the Soul of a Spiritual Place," *New York Times* (June 12, 1999), B: 2; "On the Drawing Boards," *Oculus* 62 (September 1999): 4; David W. Dunlap, "A Firm Foundation, Starting at the Roof," *New York Times* (December 26, 1999), XI: 1, 3; White and Willensky, *AIA Guide* (2000), 282; David S. Chartock, "Ravaged by Fire, Manhattan's Oldest Synagogue Being Restored," *New York Construction News* 48 (February 2000): 11–16; Alan Balfour, *World Cities: New York* (New York: Wiley Academy, 2001), 250; David W. Dunlap, "Restoring the Luster to Sacred Sites," *New York Times* (April 15, 2001), XI: 1, 3; Joyce Wadler, "At Historic Temple, a Joyous Revival," *New York Times* (September 10, 2001), B: 1, 7; "HHPA Brings Craftsmanship to New York's Central Synagogue," *Architectural Record* 189 (November 1, 2001): 99; Nancy Ramsey, "Central Synagogue, Grand Again," *Grid* 3 (November 2001): 26; Mayer Rus, "The Central Synagogue, New York," *House & Garden* 170 (December 2001): 140–43; Fred A. Bernstein, "Leap of Faith," *Interior Design* 73 (May 2002): 298–303.

24. Joy Kestenbaum, quoted in Dunlap, "A Firm Foundation, Staring at the Roof": 3.

25. Jonathan Schloss, quoted in Shulman, "Restoring the Soul": 164.

THIRD AVENUE

1. Susan Heller Andersen, "Long After the El, What's on Third? A Wall of Towers," *New York Times* (January 30, 1983), VIII: 1, 14.

2. For 711 Third Avenue, see Stern, Mellins, and Fishman, *New York 1960*, 424–25.

3. Carter B. Horsley, "Third Avenue Developing a Distinctive Signature," *New York Times* (August 9, 1981), VIII: 1, 12.

4. Suzanne Stephens, quoted in Andersen, "Long After the El, What's on Third? A Wall of Towers": 14.

5. Carter B. Horsley, "New Burst of Building in the Offing on 3d Ave.," *New York Times* (May 11, 1980), VIII: 1, 4; William G. Blair, "Kaufman Brothers Wave an Avant-Garde Banner," *New York Times* (September 21, 1980), VIII: 1, 6; "In Progress," *Progressive Architecture* 61 (October 1980): 42, 44; Laurie Johnston, "Tower Rising on East Side Apologizes for All the Mess," *New York Times* (March 12, 1981), B: 1; Walter H. Waggoner, "Logistical Challenge: Getting Materials to Building Site," *New York Times* (March 22, 1981), VIII: 8; Carter B. Horsley, "Designing Manhattan Retail Sites," *New York Times* (June 17, 1981), D: 21; Horsley, "Third Avenue Developing a Distinctive Signature": 1, 12; Paul Goldberger, "The Building Boom Gives Birth," *New York Times* (August 30, 1981), II: 29, 34; Paul Goldberger, "The New American Skyscraper," *New York Times* (November 8, 1981), VI: 68–73, 76, 78, 86, 88, 90, 92, 94, 96; Anderson, "Long After the El, What's on Third? A Wall of Towers": 1, 14; "767 Third Avenue," *Baumeister* 81 (February 1984): 41; "767 Third Avenue," *Design Solutions* 5 (Fall 1985): 50–51; White and Willensky, *AIA Guide* (1988), 260; *Fox & Fowle: Function Structure Beauty* (Milan: L'Arca Edizioni, 1999), 9; Jerold S. Kayden, *Privately Owned Public Space: The New York Experience* (New York: John Wiley, 2000), 219.

6. For 777 and 747 Third Avenue, see Stern, Mellins, and Fishman, *New York 1960*, 427–29.

7. White and Willensky, *AIA Guide* (1988), 262.

8. Goldberger, "The Building Boom Gives Birth": 29, 34.

9. Horsley, "New Burst Of Building In the Offing on 3d Ave.": 1, 4; Carter B. Horsley, "One Project Beclouded by Decision on Bonus," *New York Times* (May 11, 1980), VII: 1, 5; Carter B. Horsley, "Size Curb Perils Plan for 3d Ave. Tower," *New York Times* (June 19, 1980), B: 1; Jeanette G. Bamford, "An Office Tower Not for 3d Avenue," letter to the editor, *New York Times* (July 4, 1980): 16; Ada Louise Huxtable, "The Problems of Zoning," *New York Times* (July 13, 1980), II: 25, 34; Suzanne Charle, "New Laws Protect Rights to Unblocked Sunshine," *New York Times* (July 20, 1980), VIII: 1, 8; Alan S. Oser, "Retail Mall Is Feature of New Third Ave. Office Building," *New York Times* (December 31, 1980), B: 7; Horsley, "Designing Manhattan Retail Sites": 21; Horsley, "Third Avenue Developing a Distinctive Signature": 1, 12; Dee Wedemeyer, "A Fervor of Creativity Grips Developers," *New York Times* (May 16, 1982), VIII: 7; Anderson, "Long After the El, What's on Third? A Wall of Towers": 1, 14; "A Wrap-Around Solution," *New York Times* (March 20, 1983), VIII: 1; Paul Goldberger, "Mediocre Skyscrapers Dominate the Skyline," *New York Times* (February 19, 1984), II: 31; Andrea Israel, "Sampling the Atriums," *New York Times* (March 24, 1985), X: 20, 39; Kayden, *Privately Owned Public Space*, 222–23. For Amster Yard, see Landmarks Preservation Commission of the City of New York, LP-0277 (June 21, 1966); Stern, Mellins, and Fishman, *New York 1960*, 303–4.

10. For Greenacre Park, see Stern, Mellins, and Fishman, *New York 1960*, 490.

11. Goldberger, "Mediocre Skyscrapers Dominate the Skyline": 31.

12. Stern, Mellins, and Fishman, *New York 1960*, 303–4.

13. Tina Kelley, "A New York Landmark in Rubble: Preservationists Protest Demolition of Amster Yard," *New York Times* (May 21, 2002), B: 1; Hal Bromm, "What Landmarks Law?" letter to the editor, *New York Times* (May 27, 2002): 12; Michael J. Lewis, "It Depends on How You Define 'Real,'" *New York Times* (June 23, 2002), IV: 3; David W. Dunlap, "Illusion in a Midtown Courtyard: Landmark Keeps More of Its Spirit Than Its Structure," *New York Times* (September 22, 2003), B: 1, 4; "Landmark Demolition, By Intent or Neglect," *District Lines* 17 (Autumn 2003): 1–3, 11.

14. Horsley, "New Burst of Building in the Offing on 3d Ave.": 1, 4; "Atriums Highlight 30-Story Office Building," *Architectural Record* 168 (Mid-August 1980): 21; Alan S. Oser, "Chicago Influence in Third Ave. Building," *New York Times* (November 5, 1980), B: 5; Horsley, "Designing Manhattan Retail Sites": 21; Horsley, "Third Avenue Developing a Distinctive Signature": 1, 12; "City Gets Cash and Apology over 2 Floors," *New York Times* (December 13, 1983), B: 1; "Building Fudge Out of Fudging," editorial, *New York Times* (December 23, 1983): 24; Anderson, "Long After the El, What's on Third? A Wall of Towers": 1, 14; Andrew Alpern and Seymour Durst, *Holdouts!* (New York: McGraw-Hill, 1984), 92–93; Paul Goldberger, "New Madison Avenue Buildings, a New New York," *New York Times* (December 18, 1986), C: 21; Kayden, *Privately Owned Public Space*, 227–28; White and Willensky, *AIA Guide* (2000), 310.

15. Bruce Graham, quoted in Oser, "Chicago Influence in Third Ave. Building": 5.

16. Robert Gladstone, quoted in Oser, "Chicago Influence in Third Ave. Building": 5.

17. For 33 West Monroe Street, see *Skidmore, Owings & Merrill: Architecture and Urbanism, 1973–1983* (Stuttgart: Verlag Gerd Hatje; New York: Van Nostrand Reinhold, 1983), 107, 110–13.

18. Bruce Graham, quoted in Horsley, "New Burst of Building in the Offing on 3d Ave.": 4.

19. Mervyn Rothstein, "As Law Firms Relocate, New Image for '82 Tower," *New York Times* (May 3, 2000), B: 8.

20. White and Willensky, *AIA Guide* (2000), 310.

21. Goldberger, "New Madison Avenue Buildings, a New New York": 21.

22. Horsley, "New Burst of Building in the Offing on 3d Ave.": 1, 4; Janet Nairn, "Seven Architects Convene at the Museum of Modern Art to Discuss 'Super-Building,'" *Architectural Record* 169 (April 1981): 35; Carter B. Horsley, "Designers Planning Slender Tower," *New York Times* (May 3, 1981), VIII: 12; Diane Henry, "City Feels the Toronto Touch," *New York Times* (September 6, 1981), VIII: 1, 6; Diane Henry, "Developer Adjusts to Recession," *New York Times* (October 6, 1982), D: 26; *Skidmore, Owings & Merrill: Architecture and Urbanism, 1973–1983*, 244–45; Anderson, "Long After the El, What's on Third? A Wall of Towers": 1, 14; "780 Third Avenue–New York," *Architecture + Urbanism* (March 1983): 57; "Stepped Panels Stiffen Slim Tube: System Imitates Steel Braced Tube of Hancock Tower in Concrete," *Engineering News-Record* 215 (June 30, 1983): cover, 30; "780 Third Avenue," *Baumeister* 81 (February 1984): 32; Goldberger, "Mediocre Skyscrapers Dominate the Skyline": 31; Rose Thomas, "New York Office Uses First Braced Tube Frame in Concrete," *Building Design & Construction* 26 (July 1985): 152–55; White and Willensky, *AIA Guide* (2000), 312.

23. Raul de Armas, quoted in "Stepped Panels Stiffen Slim Tube: System Imitates Steel Braced Tube of Hancock Tower in Concrete": 30.

24. Horsley, "New Burst of Building in the Offing on 3d Ave.": 1, 4; Alan S. Oser, "Argentine Developer Is Planning to Put Up an Office Building on 3d Ave.," *New York Times* (June 4, 1980): 29; Horsley, "Third Avenue Developing a Distinctive Signature": 1, 12; Anderson, "Long After the El, What's on Third? A Wall of Towers": 1, 14; "Coming Attraction: A 2d Greenhouse on the 6th Floor," *New York Times* (October 9, 1983), VIII: 1; "Tenants Stick: No Greenhouse," *New York Times* (May 6, 1984), VIII: 1; White and Willensky, *AIA Guide* (1988), 259; *Cesar Pelli: Buildings and Projects, 1965–1990* (New York: Rizzoli International Publications, 1990), 269; White and Willensky, *AIA Guide* (2000), 309; *The Architecture of Rafael Viñoly* (New York: Princeton Architectural Press, 2002), no pagination.

25. "How Not to Build a City," editorial, *New York Times* (January 12, 1981): 18; "Houston Developer Looks to New York," *New York Times* (January 12, 1981), D: 2; Paul Goldberger, "Midtown Area and Its Zoning," *New York Times* (April 13, 1981), B: 1, 5; Horsley, "Third Avenue Developing a Distinctive Signature": 1, 12; Diane Henry, "Citicorp to Sell Key Site to Canadian Developer," *New York Times* (August 18, 1981), B: 1; Diane Henry, "Developer Adjusts to Recession," *New York Times* (October 6, 1982), D: 26; Diane Henry, "Loan Default Leads Citicorp to Reclaim Office Site," *New York Times* (October 28, 1982), B: 3; Anderson, "Long After the El, What's on Third? A Wall of Towers": 1, 14; "Third Avenue Tower: Ellipse Among Rectangles," *New York Times* (May 27, 1984), VIII: 1; Paul Goldberger, "Manhattan's New Skyscrapers Pay Homage to the '20's," *New York Times* (June 17, 1984), II: 31; "In the Offing," *Metals in Construction* (Fall 1984): 31; Michael Wagner, "Skyscrapers Chiseled into New Forms," *Interiors* 144 (November 1984): 45; "Work Underway on Two N.Y. Office Buildings," *Building Design & Construction* 25 (December 1984): 25; *Philip Johnson/John Burgee: Architecture, 1979–1985* (New York: Rizzoli International Publications, 1985), 134–35, 183; "John Burgee Architects with Philip Johnson; 53rd at Third," *GA Document* 12 (January 1985): 20–25; Robert A. M. Stern, "Four Towers," *Architecture + Urbanism* (January 1985): 19–58; David W. Dunlap and Sara Rimer, "'53rd at Third' Tower Separates the Unseparable," *New York Times* (March 28, 1985), B: 3; "Four Solid Steel Foundation Columns Provide Economical Solution," *Metals in Construction* 4 (1986): 21–25; Michael Sorkin, "The Real Thing," *Architectural Record* 174 (September 1986): 78–85; Carter Wiseman, "Tarted Up," *New York* 20 (April 20, 1987): 72, 74; White and Willensky, *AIA Guide* (1988), 259–60, "53rd at Third; New York, 1986," *Architecture + Urbanism*, extra edition (April 1988): 14–21; "An Evolving Cityscape Mixes New Shapes with Old," *New York Times* (July 21, 1990): 24; Ujjval Vyas, "Das Versteckte Ich," *Werk, Bauen + Wohnen* (September 1991): 46–57; Franz Schulze, *Philip Johnson: Life and Work* (Chicago: University of Chicago Press, 1994), 387–89, 404; Peter Blake, *Philip Johnson* (Basel: Birkhauser Verlag, 1996), 186–89; Susanna Sirefman, *New York: A Guide to Recent Architecture* (London: Ellipses, 1997), 190–91; Eric P. Nash, *Manhattan Skyscrapers* (New York: Princeton Architectural Press, 1999), 85; Mario Campi and ETH Zurich Department of Architecture, *Skyscrapers: An Architectural Type of Modern Urbanism* (Basel: Birkhauser Verlag, 2000), 140–41; Stephen Fox, *The Architecture of Philip Johnson* (Boston: Bulfinch Press, 2002), 254–55.

26. Kenneth Hubbard, quoted in Horsley, "Third Avenue Developing a Distinctive Signature": 1, 12.

27. Philip Johnson, quoted in "Four Solid Steel Foundation Columns Provide Economical Solution": 21.

28. For the Johnson/Burgee partnership, see Mitchell Pacelle, "Design Flaw: Noted Architects' Firm Falls Apart in Fight over Control, Client," *Wall Street Journal* (September 2, 1992): 1.

29. Goldberger, "Midtown Area and Its Zoning": 1, 5.

30. For Hood's "oil can" design, see Stern, Gilmartin, and Mellins, *New York 1930*, 638–39, 644–46.

31. Sorkin, "The Real Thing": 78.

FIFTH AVENUE

1. Ada Louise Huxtable, "The Trashing of Fifth Avenue," *New York Times* (December 5, 1976), II: 33–34. For the Empire State Building, see Stern, Gilmartin, and Mellins, *New York 1930*, 610–15. For the New York Public Library, see Stern, Gilmartin, and Massengale, *New York 1900*, 91, 94–97. For Tiffany & Company, see Stern, Gilmartin, and Massengale, *New York 1900*, 195–96.

2. Stern, Gilmartin, and Massengale, *New York 1900*, 193–201.

3. Stern, Gilmartin, and Mellins, *New York 1930*, 307–10.

4. Isadore Barmash, "S. H. Kress Store on Fifth Ave. Will Be Closed in 4 to 6 Weeks," *New York Times* (September 16, 1977), D: 1; Paul Goldberger, "New Buildings Squeezing into a Crowded Midtown," *New York Times* (December 11, 1978), B: 1, 19; Ada Louise Huxtable, "Remnants of an Era: Two Silent Stores," *New York Times* (November 8, 1979), C: 1, 10; William G. Blair, " . . . While Renewal Proceeds," *New York Times* (August 17, 1980), VIII: 1, 5; Carter B. Horsley, "New Tower for Republic National Bank," *New York Times* (August 16, 1981), VIII: 6; "New Building in New York Links Three Old Ones," *Architectural Record* 170 (January 1982): 39; William R. Greer, "A New Style Making Its Mark," *New York Times* (March 7, 1982), VIII: 1, 12; Robin Herman and Laurie Johnston, "Topping Out on 5th Ave.," *New York Times* (February 9, 1983), B: 1, 3; Laurie Johnston, "Storing the Glories of a 5-and-10," *New York Times* (April 16, 1983): 27; Paul Goldberger, "Mediocre Skyscrapers Dominate the Skyline," *New York Times* (February 19, 1984), II: 31–32; Joseph Giovannini, "For 5th Ave.: Offices or Stores?" *New York Times* (October 20, 1986), B: 1, 16; "Republic National Bank World Headquarters, Fifth Avenue, New York, N.Y.," *Architecture + Urbanism* (February 1988): 24–26; Eileen McMorrow, "Landmark-Status Building Is Focal Point for Republic Bank," *Facilities Design and Management* 7 (October 1988): 80–87; Pamela H. Roderick, "View Down Fifth," letter to the editor, *New York Times* (January 14, 1990): 12; Richard D. Lyons, "A New Face for Stretch of Fifth Ave.," *New York Times* (January 17, 1990), D: 22; White and Willensky, *AIA Guide* (2000), 228. For the Knox Building, see Landmarks Preservation Commission of the City of New York, LP-1091 (September 23, 1980), 251; Barbaralee Diamonstein, *The Landmarks of New York III* (New York: Harry N. Abrams, 1998), 251.

5. Goldberger, "Mediocre Skyscrapers Dominate the Skyline": 32.

6. Shawn G. Kennedy, "Something for All," *New York Times* (March 18, 1984), VIII: 1; Lyons, "A New Face for Stretch of Fifth Ave.": 22.

7. "New York," *Engineering News-Record* 216 (May 22, 1986): 32; "Etched in Stone," *Architectural Record* 174 (August 1986): 57; Carter B. Horsley, "Fifth Fights Back," *New York Post* (September 1, 1988): 61, 76; Carter B. Horsley, "Plots & Plans," *New York Post* (September 1, 1988): 77; Carter B. Horsley, "The Good, the Bad & the Ugly," *New York Post* (December 29, 1988): 53, 57; "Commercial Property," *Daily Telegraph* (London) (January 17, 1989): 24; Paul Goldberger, "Has Fifth Avenue Become Beside the Point?" *New York Times* (January 7, 1990), II: 31, 34; Lyons, "A New Face for Stretch of Fifth Ave.": 22; David W. Dunlap, "Commercial Property," *New York Times* (September 16, 1990), X: 17; White and Willensky, *AIA Guide* (2000), 228–29.

8. Horsley, "Plots & Plans": 77. Also see Horsley, "The Good, the Bad & the Ugly": 57.

9. Goldberger, "Has Fifth Avenue Become Beside the Point?": 34.

10. Jeannette Walls, "New York Intelligencer: L & T Getting a Big Neighbor," *New York* 21 (April 25, 1988): 21; "Fifth Avenue to Get First Full Block Building in 15 Years," *Better Buildings* 7 (August 1988): 12; Carter B. Horsley, "Board Rips a Plaza as 'Weird,'" *New York Post* (May 11, 1989): 65; Shawn G. Kennedy, "Fifth Avenue Abuzz from 34th to 42d St.," *New York Times* (May 18, 1988), D: 24; "Hammerson Property Corp. Tops Out 420 Fifth Avenue," *New York Real Estate Journal* (December 1989): 1; Goldberger, "Has Fifth Avenue Become Beside the Point?": 31, 34; Lyons, "A New Face for Stretch of Fifth Ave.": 22; Patric Dolan, "Manhattan's 420 Fifth Avenue," *Real Estate Forum* 45 (April 1990): 50–56; David W. Dunlap, "Girl Scouts Come to Aid of Developer," *New York Times* (January 22, 1992), D: 17; Thomas J. Lueck, "420 Fifth Avenue: A Conversion Transforms a Nightmare Office Rental," *New York Times* (April 18, 1993), X: 17; "New Kid on the Block," *Architectural Record Lighting* 181 (May 1993): 13; "New York," *National Real Estate Investor* (December 1993): 10; Mervyn Rothstein, "Superstore Anchor for Center of 5th Ave.," *New York Times* (March 20, 1994), X: 13; "Anatomy of a Flexible Building," *Buildings* 88 (July 1994): 64; "On the Move," *Newsday* (June 16, 1995), D: 3. For the Franklin Simon Building, see "Fifth Avenue Association Awards Prizes," *New York Times* (November 19, 1922): 11.

11. Lyons, "A New Face for Stretch of Fifth Ave.": 22.

12. Alan S. Oser, "A Rental Builder Shifts to High Gear," *New York Times* (June 21, 1998), XI: 1, 6; F. Peter Model, "They'll Take Manhattan," *New York Living* (December 1999): 22–27; Edwin McDowell, "Around Grand Central, New Office Towers and a 54-Floor Residence," *New York Times* (February 13, 2000), XI: 1; Peter Morris Dixon, ed., *Robert A. M Stern: Buildings and Projects, 1999–2003* (New York: Monacelli Press, 2003), 561.

13. "425 Fifth Avenue," *Architectural Record* 189 (May 2001): 177; "Change of Big-Name Architect," *New York Times* (August 12, 2001), XI: 1; Jonathan Mahler, "Gotham Rising," *Talk* (December 2001-January 2002): 120–25, 148–52; "Tishman Construction Tops Out 290,000 S/F 425 Fifth Ave.," *New York Real Estate Journal* (April 16–29, 2002): 2B; James Gardner, "The Ugly Building Ethically Considered," *New York Sun* (June 4, 2002): 1, 12; Robin Finn, "Developer Stalks His Prize in the Wilds Downtown," *New York Times* (November 21, 2002), B: 2; Ian Luna, ed., *New New York: Architecture of a City* (New York: Rizzoli International Publications, 2003), 140–41; Julie V. Iovine, "An Architect's World Turned Upside Down," *New York Times* (June 12, 2003), F: 1, 10; Motoko Rich, "The Art of Selling Luxury Condos as Art," *New York Times* (March 11, 2004), F: 8.

14. Gardner, "The Ugly Building Ethically Considered": 12.

15. Kathleen Teltsch, "Charity Law May Force Sale of Altman's Store," *New York Times* (May 13, 1984): 38; "Altman Sale Set," *New York Times* (November 26, 1984), D: 4; Paul Goldberger, "At B. Altman, an Architecture of Spaciousness," *New York Times* (December 20, 1984), C: 10; Jesus Rangel, "Upper West Side History in Proposed District," *New York Times* (March 3, 1985), B: 1; Robert W. Ryley, "End of a Miracle on 34th Street," letter to the editor, *Wall Street Journal* (December 22, 1989): 7; Goldberger, "Has Fifth Avenue Become Beside the Point?": 31, 34.

16. Landmarks Preservation Commission of the City of New York, LP-1274 (March 12, 1985); Diamonstein, *The Landmarks of New York III*, 279.

17. Isadore Barmash, "B. Altman Conversion Advancing," *New York Times* (May 21, 1985), D: 5.

18. Sarah Lyall, "Major Renovation Planned at Midtown Altman's," *New York Times* (November 24, 1987), B: 3; Hugh Hardy, "Altman's Midtown Center," *Oculus* 50 (January 1988): 14–15; Jim Murphy, "Addition Proposed for New York City Landmark," *Progressive Architecture* 69 (March 1988) 37, 40; "Whatever Happened To . . . ," *Oculus* 52 (October 1989): 5; Hugh Hardy, "What Time Is It?'" *Oz* 12 (1990): 30–35; Lyons, "A New Face for Stretch of Fifth Avenue": 22; Christopher Gray, "Streetscapes: B. Altman's," *New York Times* (January 28, 1990), X: 2; *Hardy Holzman Pfeiffer Associates: Buildings and Projects, 1967–1992* (New York: Rizzoli International Publications, 1992), 20, 273.

19. See Stern, Gilmartin, and Mellins, *New York 1930*, 308.

20. Hardy, "Altman's Midtown Center": 14–15.

21. "B. Altman's Flagship Store to Close, Bankruptcy Court Rules," *New York Times* (November 18, 1989): 1; Isadore Barmash, "No Bidder to Rescue B. Altman," *New York Times* (November 18, 1989): 35, 37; Suzanne Daley, "Altman's Last Sale: Every Memory Must Go," *New York Times* (November 25, 1989): 1, 27; Nick Ravo, "At B. Altman, Christmas but No Santa," *New York Times* (December 25, 1989): 35; Mark Roman, "B. Altman's," *7 Days* (December 27, 1989): 33; Alvin Tresselt, "B. Altman," letter to the editor, *New York Times* (March 11, 1990): 12.

22. "Details," *Architecture* 80 (September 1991): 22; David W. Dunlap, "A Metamorphosis for 880,000 Sq. Ft.," *New York Times* (November 17, 1991): 13.

23. "The Transom: Library Search," *New York Observer* (September 2, 1991): 3; Kevin Sack, "Cuomo Outlines Fiscal Blueprint for Recovery of New York City," *New York Times* (September 24, 1991): 1, B: 4; Alan Finder, "Cuomo Ideas for New York City: Some Are Old, Some Are New," *New York Times* (September 25, 1991): 1, B: 4; Charles V. Bagli, "Cuomo Bets Store on Madison Avenue," *New York Observer* (October 14, 1991): 1, 15; Dunlap, "A Metamorphosis for 880,000 Sq. Ft.": 13; Alan Finder, "Public Library Will Issue Bonds to Buy Part of Altman Building," *New York Times* (November 22, 1991), B: 2; "New York Public Library to Purchase Portion of B. Altman Site," *Wall Street Journal* (November 25, 1991): 7; "Corrections," *New York Times* (November 26, 1991): 3; "The New York Public Library," *Progressive Architecture* 73 (January 1992): 22; "Library Credits," *Progressive Architecture* 73 (March 1992): 10; Hugo Lindgren, "Mario's Planes, Trains and Apartment Buildings," *Metropolis* 12 (September 1992): 16; "New York Public Library," *Library Journal* 117 (September 1, 1992): 112; "$23 Million in Bonds Issued for NYPL," *Library Journal* 117 (September 15, 1992): 16; "Face Lift Continues for Former Department Store," *New York Times* (November 18, 1992), B: 4; John Voelcker, "Depths," *Metropolis* 12 (December 1992): 38–41, 53; *Gwathmey Siegel: Buildings and Projects, 1982–1992* (New York: Rizzoli International Publications, 1993), 328; David W. Dunlap, "Library Buys Piece of Altman's," *New York Times* (February 28, 1993), X: 1; John Holusha, "New York Library Nears Start on Science Center," *New York Times* (April 6, 1993), D: 2; "NYPL's Science Library Gets $9.5M," *Library Journal* 118 (May 15, 1993): 18; "Gwathmey Siegel at 25," *Interiors* 152 (September 1993): 55–83; David W. Dunlap, "The B. Altman Building Goes Bookish," *New York Times* (January 2, 1994), X: 1. 9; "Planning for Tomorrow's Sounds of Silence," *New York Times* (June 27, 1994), B: 3; Marie-Pierre Dillenseger, "Bibliothèque des Sciences, de l'Industrie et du Commerce," in *Nouvelles Alexandries: Les grands chantiers de bibliothèques dans le monde* (Paris: Electre-Éditions du Cercle de la Librarie, 1996), 232–59; Andrea Moed, "Dinner at the Homepage Restaurant," *Metropolis* 15 (March 1996): 42–44; Robert Neuwirth, "Goodbye Room 227, Hello SIBL," *Metropolis* 15 (March 1996): 49; Bruce Weber, "Moving Bits, Bytes and Books to the Library of the Future," *New York Times* (April 5, 1996), B: 1, 5; Paul Goldberger, "Grandeur and Modernity in New York City," *New York Times* (April 24, 1996): 1, B: 2; "Big Apple's Library Gets Wired," *Information Week* (April 29, 1996): no pagination; "Miracle on Madison Avenue," editorial, *New York Times* (May 11, 1996): 18; Easy Klein, "Check Out Business Help at Two Upgraded Libraries," *Crain's New York Business* (May 13, 1996): 14; Jeffrey R. Sipe, "New York Public Library Gets Down to Business," *Insight on the News* (May 27, 1996): 38; Joseph Giovannini, "Science Library Opens in New York City," *Architecture* 85 (June 1996): 54–55; Judith Nasatir, "Public Access," *Interior Design* 67 (June 1996): 33; Victoria Griffith, "NY Learns There's More to Books," *Financial Times* (June 10, 1996): 13; Karen D. Stein, "Next Century's Library–Today," *Architectural Record* 184 (September 1996): 84–91; Nina Rappaport, "Altman's Transformation," *Oculus* (September 1996): 5; Nicholas von Hoffman, "Checking Out Electronic Libraries," *Architectural Digest* 53 (October 1996): 130, 134, 138; "An Old Space Explores a New Future," *Buildings* 90 (October 1996): 58; "How Now, Dow Jones? PaineWebber Donates Business Information Wall to SIBL," *Public Library News* (November-December 1996 and January 1997): 3; "Adaptive Reuse of Buildings," *Southeast Asia Building* (November 1996):

16–26; "A Quiet Day at the Library Following the Market," *New York Times* (November 24, 1996), VIII: 4; Susanna Sirefman, *New York: A Guide to Recent Architecture* (London: Ellipsis, 1997), 108–9; Ingrid Eisenstadter, "A Tangled Info Web," *Newsweek* 129 (February 17, 1997): 16; William D. Walker, letter to the editor, *Newsweek* 129 (March 10, 1997): 17; "Technological Overdrive," *World Architecture* 56 (May 1997): 116–19; "Centuries Collide in Urban Structure," *Facilities Design & Management* 16 (June 1997): 48–49; Francis Morrone, "New York's Library in Cyberspace," *New Criterion* 16 (June 1997): 76–80; Juanita Dugdale, "Wayfinding Takes a Detour," *Print* 51 (July-August 1997): 58–67; Laura Shapiro, "What About Books," *Newsweek* 130 (July 7, 1997): 75, 78; Anne Field, "Biblio-Tech," *Inc.* (September 1997): 21; *Gwathmey Siegel & Associates Architects: Selected and Current Works* (Mulgrave, Australia: Images Publishing, 1998), 130–35; Brad Collins, ed., *Gwathmey Siegel: Buildings and Projects, 1992–2002* (New York: Rizzoli International Publications, 2003), 194–201, 353; Luna, ed., *New New York*, 142–43.

24. Charles Gwathmey, quoted in "The Transom: Library Search": 3.

25. Goldberger, "Grandeur and Modernity in New Library": 2.

26. Morrone, "New York's Library in Cyberspace": 78.

27. "Oxford Press to Join Library at Former Altman's," *New York Times* (December 19, 1993), XIII: 4; Dunlap, "The B. Altman Building Goes Bookish": 1, 9; "A Midtown Procession," *New York Times* (July 19, 1995), B: 3; Goldberger, "Grandeur and Modernity in New Library":1–2.

28. Bruce Lambert, "Domino Real-Estate Deal Cleared," *New York Times* (August 6, 1995), XIII: 6; John Holusha, "From Department Store to Storehouse of Knowledge," *New York Times* (May 25, 1997), IX: 7; "CUNY Graduate School and University Center," *ANY* 22 (1998): 29; Glenn Collins, "In Aisle 3, Medieval Studies," *New York Times* (May 25, 1999), B: 1, 8; Karen W. Arenson, "CUNY Graduate Center Puts Off Classes in Its Unfinished Building," *New York Times* (August 20, 1999), B: 2; "CUNY Graduate Center to Reopen," *New York Times* (August 29, 1999): 39; Andrea Delbanco, "CUNY's Festival of the Mind," *New York Times* (April 2, 2000), XIV: 16; Karen W. Arenson, "Graduate Center Adds Life to a CUNY Institution," *New York Times* (April 5, 2000), B: 8; Collins, ed., *Gwathmey Siegel: Buildings and Projects, 1992–2002*, 268–77, 357.

29. For the Arnold Constable store, see "Store," *Real Estate Record and Builders' Guide* 95 (January 2, 1915): 8; "Plans for Arnold Constable & Co.'s New Home," *New York Times* (January 22, 1915): 18.

30. "5th Ave. Building Sold," *New York Times* (October 20, 1961): 52; Homer Bigart, "Library Planned at 5th Ave. Store," *New York Times* (February 11, 1964): 41; Isadore Barmash, "Arnold Constable Closing on Fifth Avenue," *New York Times* (February 11, 1975): 1; Robert E. Tomasson, "Library to Move Central Office," *New York Times* (March 7, 1975): 39; Deirdre Carmody, "Library to Open Formally Thursday," *New York Times* (February 16, 1982), B: 1.

31. "The Short of It," *Architectural Record* 188 (March 2000): 42; Gwathmey Siegel & Associates Architects, *Competition: The New York Public Library, Mid-Manhattan Branch* (New York: March 2, 2000); "Gwathmey Siegel to Design the Latest New York Public Library Projects," *Architectural Record* 188 (April 2000): 31; Alan Balfour, *World Cities: New York* (New York: Wiley Academy, 2001), 312–13; Craig Kellogg, "The Mid-Manhattan Library Under Wraps," *Oculus* 63 (March 2001): 6–7; "Gwathmey Siegel Designs NY Public Library," *Architectural Record* 189 (April 2001): 30; Herbert Muschamp, "The Bruisers Play Defense, the Seducers Trap the Eye," *New York Times* (February 3, 2002), II: 31; Collins, ed., *Gwathmey Siegel: Buildings and Projects, 1992–2002*, 340–45, 362.

32. Kellogg, "The Mid-Manhattan Library Under Wraps": 7.

33. Muschamp, "The Bruisers Play Defense, the Seducers Trap the Eye": 31.

34. William Claiborne, "Moon Cult Buys Old Tiffany Building," *New York Times* (February 10, 1977), D: 3; David W. Dunlap, "3 Manhattan Buildings Are Named Landmarks," *New York Times* (February 11, 1987), B: 2; *Hardy Holzman Pfeiffer Associates: Buildings and Projects, 1967–1992*, 279.

35. Christopher Gray, "Streetscapes: The Old Tiffany Building," *New York Times* (March 25, 1990), X: 8. Also see David W. Dunlap, "Unusual Spaces: A Striking Medley for the Right Renter," *New York Times* (May 5, 1991), X: 13.

36. David W. Dunlap, "Former Tiffany Building Gets a Solid Restoration," *New York Times* (February 13, 2002), C: 10.

37. Stern, Mellins, and Fishman, *New York 1960*, 1107–8; Christopher Gray, "Streetscapes/Herbert Tannenbaum," *New York Times* (February 27, 2000), XI: 7; Christopher Gray, "Streetscapes/The 1905 Gorham Building," *New York Times* (October 22, 2000), XI: 7.

38. Landmarks Preservation Commission of the City of New York, LP-2027 (December 15, 1998).

39. Maurice Carroll, "Manhattan Glows Red, White and Blue for July Guests," *New York Times* (June 30, 1976): 20.

40. "Chameleon Tower," *Journal of the American Institute of Architects* 67 (March 1978): 14, 22; Paul Goldberger, "Design: 5 Ideas to Redo Empire State's Deck," *New York Times* (April 5, 1979), C: 22; Bayard Webster, "New Lights-Out Policies Save the Lives of Migrating Birds," *New York Times* (April 16, 1979), B: 6; Paul Goldberger, "Design Notebook," *New York Times* (June 7, 1979), C: 10; Judith Cummings, "Official Status Asked for Empire State," *New York Times* (November 10, 1979): 25; Landmarks Preservation Commission of the City of New York, LP-2000-2001 (May 19, 1981); "The Empire State Building Celebrates Its 50th Birthday," *Architectural Record* 169 (June 1981): 37; Diamonstein, *The Landmarks of New York III*, 364–65.

41. David Bird and Maurice Carroll, "Empire State Building Going Dark for 2 Months," *New York Times* (September 4,

1984), B: 3; Sam Roberts, "High Atop 5th Avenue, a City Symbol Shrinks," *New York Times* (September 20, 1984): 1, B: 7; "Antenna Removal Lacked Approval," *New York Times* (September 21, 1984), B: 4; "Empire State Building Given a Halo of Light," *New York Times* (November 29, 1984), B: 4; Sam Howe Verhovek, "Changing of Color Guard at Empire State Building," *New York Times* (December 16, 1986), B: 3; Douglas Martin, "On Top Where King Kong Once Romped," *New York Times* (September 7, 1988), B: 1; Richard D. Hylton, "Searching for a Really High-Profile Investment?" *New York Times* (May 20, 1991), D: 1, 4; Mitchell J. Shields, "The Ups and Downs of New York's 60-Year Wonder," *New York Times* (November 1, 1991), C: 1, 5; "Pencil Points," *Progressive Architecture* 73 (March 1992): 22; Christopher Gray, "Streetscapes: The Empire State Building," *New York Times* (June 14, 1992), X: 7; Marvine Howe, "Empire State, a Work in Progress," *New York Times* (January 16, 1994), XIII: 6; Lindsey Gruson, "Getting to the Top of Empire State: Opening the Way for Disabled," *New York Times* (March 4, 1994), B: 3.

42. Stern, Gilmartin, and Massengale, *New York 1900*, 91, 94–97. Also see Henry Hope Reed, *The New York Public Library: Its Architecture and Decoration* (New York: W. W. Norton, 1986).

43. C. Gerald Fraser, "The Library Starts Fund Drive with Ad Campaign on Buses," *New York Times* (February 4, 1979): 46; "The Library Branches Are Dying," editorial, *New York Times* (September 2, 1980): 22; C. Gerald Fraser, "Couper Resigns as Head of Library," *New York Times* (September 11, 1980), C: 20; Jill Smolowe, "Survey Projects $52 Million Deficit for New York Public Library by '85," *New York Times* (October 5, 1980): 42; Serge Schmemann, "Readers Mobilizing to Save the Libraries," *New York Times* (January 9, 1981), B: 1; Richard F. Shepard, "Library Elects New Leadership," *New York Times* (April 14, 1981), C: 9; Christopher Swan, "Help for US Libraries: Overdue?" *Christian Science Monitor* (April 21, 1981): 1; David Bird, "Public Library Seeks to Buy Apartment for Its President," *New York Times* (November 22, 1981): 46.

44. Paul Goldberger, "Restoring the Public Library to Its Original Splendor," *New York Times* (April 25, 1982), II: 1, 27.

45. Deirdre Carmody, "Main Library to Revive Unused Exhibition Area," *New York Times* (December 25, 1981): 25; "Public Library Planning New and Inviting Look," *New York Times* (March 14, 1982): 64; Goldberger, "Restoring the Public Library to Its Original Splendor": 1, 27; "Library/Lovelorn," *New York Times* (May 5, 1982): 26; Deirdre Carmody, "Public Library, Under Gregorian, Celebrating a Good Year," *New York Times* (July 8, 1982), B: 1, 6; "An Ornate Restoration," *New York Times* (August 11, 1982): 3; "A Fence Takes Shape Around the Public Library as Restoration Begins," *New York Times* (August 21, 1982): 26; Deirdre Carmody and Clyde Haberman, "Good Neighbors and Bad," *New York Times* (September 8, 1982), B: 3; Edwin McDowell, "Library Reviving as Cultural Center," *New York Times* (September 30, 1982), C: 17; "Public Library Renovation," *Progressive Architecture* 63 (November 1982): 68; Deirdre Carmody, "Library Restores Periodical Room's Splendor," *New York Times* (April 6, 1983), B: 1, 7; Paul Goldberger, "A New Life for the 42nd Street Library," *New York Times* (April 15, 1983), C: 3; Deirdre Carmody, "Mrs. Astor Turns Philanthropic Work to Library," *New York Times* (May 14, 1983): 25; Herbert L. Smith, Jr., "Libraries: The Dawn of the Information Age," *Architectural Record* 171 (August 1983): 73–83; Deirdre Carmody, "Public Library to Reopen Hall for Exhibitions," *New York Times* (December 21, 1983), B: 3; "Renaissance at the Library," *New York Times* (December 25, 1983), IV: 6; Deirdre Carmody, "Exhibition Hall Opens with a Flourish," *New York Times* (May 25, 1984), B: 1, 4; Paul Goldberger, "Inside and Out, Library Recaptures Its Splendor," *New York Times* (May 25, 1984), B: 1, 4; "Names and News," *Oculus* 45 (June 1984): 13; Douglas Davis, "The Palace on 42nd St.," *Newsweek* 103 (June 25, 1984): 3, 76–77; Giorgio Cavaglieri, "Restoration Responsibilities of Giorgio Cavaglieri Architect," *Oculus* 46 (October 1984): 4, 12–13; Lewis Davis, "Restoration Responsibilities of Davis Brody & Associates," *Oculus* 46 (October 1984): 5, 14–15; Theo Prudon, "Restoration Responsibilities of The Ehrenkrantz Group," *Oculus* 46 (October 1984): 6, 11; Arthur Rosenblatt, "New York Public Library Restoration," *Oculus* 46 (October 1984): 3; Isabel Wilkerson, "Library to Expand Its Stacks," *New York Times* (June 16, 1985): 27; Alexander Reid, "Library's Lunch Crowd Loses Seats," *New York Times* (June 25, 1985), B: 3; "Names and News," *Oculus* 47 (September 1985): 10; "Library Reforestation Proves to be a Struggle," *New York Times* (September 16, 1985), B: 3; Reed, *The New York Public Library: Its Architecture and Decoration*, 32–33; Jerry Cooper, "Gottesman Hall," *Interior Design* 57 (January 1986): 232–37; Nayana Currimbhoy, "Back to Order," *Interiors* 145 (January 1986): 194–95; Lynn Nesmith, "Exhibition Hall Returned to Its Original Grandeur," *Architecture* 75 (May 1986): 218–21; Ira Wolfman, "Library Lift," *Metropolis* 5 (May 1986): 18; William E. Geist, "About New York: Finding Every Nook and Cranny at the Library," *New York Times* (May 10, 1986): 31; Paul Goldberger, "Public Library: Classic Revisited," *New York Times* (May 19, 1986), B: 1, 4; Sara Rimer, "The 'People's Library' to Celebrate as a Cathedral of Knowledge for All," *New York Times* (May 19, 1986), B: 1, 4; "The Lions' House," editorial, *New York Times* (May 20, 1986): 26; Ron Alexander, "Lively at 75, the Library Throws a Party," *New York Times* (May 23, 1986): 20; "1986 AIA Honor Awards," *Architectural Record* 174 (June 1986): 86–87; John Morris Dixon, "Paradoxes of Restoration," editorial, *Progressive Architecture* 67 (August 1986): 11; John Morris Dixon and David Morton, "Beaux Arts Burnished," *Progressive Architecture* 67 (August 1986): 88–95; "Views," *Progressive Architecture* 67 (October 1986): 11; "Miracle on Fifth Avenue," editorial, *New York Times* (October 5, 1986): 20; "New York Public Library Phase II," *Architecture* 76 (May 1987): 229; Sharon Lee Ryder, "Triad of Spaces Restored to Their Original

Grandeur," *Architecture* 76 (May 1987): 156–59; "Awards," *Oculus* 48 (May 1987): 6, 14; Daralice D. Boles, "Ecumenical Honor Awards," *Progressive Architecture* 68 (May 1987): 29, 32, 34; "Design Awards/Competitions," *Architectural Record* 175 (June 1987): 72–73; "Book Stacks to Be Tunneled Beneath Bryant Park," *New York Public Library News* 17 (September-October 1987): 1; "Skylit Forum Opens at Fifth Avenue Library," *New York Public Library News* 17 (September-October 1987): 1, 4; Eleanor Blau, "Library's Forum Is Set for Opening," *New York Times* (September 6, 1987), VI: 66; Paul Goldberger, "An Abandoned Room 80 Is a Treasure Restored," *New York Times* (September 23, 1987), B: 1, 5; Barbara Costikyan, "The Library's New Jewel," *New York* 20 (September 28, 1987): 34; "Library Plans to Build 84 Miles of Book Shelves Under Bryant Park," *New York Times* (October 27, 1987), B: 1; Susan Heller Anderson, "Library Starts Road to 84-Mile Shelves Under Park," *New York Times* (October 27, 1987), B: 5; *Richard Haas: Architectural Projects, 1974–1988* (New York: Brooke Alexander; Chicago: Rhona Hoffman Gallery, 1988), 6, 23; Lewis Davis, "New York Public Library," *Interior Design* 59 (March 1988): 212–19; John Morris Dixon, "Beaux Arts Under Glass," *Progressive Architecture* 69 (April 1988): 110–13; "A Landmark Restoration," *Architectural Record* 176 (July 1988): 116–17; Joseph Berger, "Gregorian Is Chosen as President of Brown University," *New York Times* (September 1, 1988), B: 1, 5; "New York Public Library Fifth Avenue Terrace," *Landscape Architecture* 78 (November 1988): 48–49; Nadine M. Post, "Walking on Books in an Urban Park," *Engineering News-Record* 222 (February 23, 1989): 44; Jean Gorman, "Beaux Arts Revival," *Interiors* 150 (April 1991): 52–57; "A Landmark of Form and Function, the Library Quietly Celebrates Its 80th Birthday," *New York Times* (May 24, 1991), B: 4; Beverly Russell, "Literate Brilliance," *Interiors* 150 (September 1991): 86–87; "NYPL Goes Underground," *Library Journal* 116 (September 15, 1991): 19; John Masten, "Landmarks with Steps Can Welcome Wheelchairs," letter to the editor, *New York Times* (December 26, 1993), XIII: 13; William Grimes, "Bill Blass Gives $10 Million to Library," *New York Times* (January 13, 1994), C: 13; Charles Linn, "Ex Libris," *Architectural Record* 182 (February 1994): 98–101; "The New York Public Library," *Architecture + Urbanism*, extra edition (December 1994): 78–89; Kenneth Frampton, "New York Capital of the 20th Century: An Aide Memoir," *Architecture + Urbanism*, extra edition (December 1994): 6–32; Dinita Smith, "Mystery Donor Gives $15 Million to Public Library," *New York Times* (November 16, 1995), C: 15, 22; J. William Thompson, *The Rebirth of New York City's Bryant Park* (Washington, D.C.: Spacemaker Press, 1997), 24–30; David W. Dunlap, "For Libraries, a Time of Rebirth," *New York Times* (September 28, 1997), IX: 1, 6; Ellen Kirschner Popper, "Lions in Hard Hats," *Architectural Record* 185 (December 1997): 38; Dan Cruickshank, "New York Public Library," *RIBA Journal* 105 (April 1998): 58–65; "Refurbishing a Place to Read," *New York Times* (July 3, 1998), B: 6; David W. Dunlap, "Updating a Bookish Aristocrat," *New York Times* (August 22, 1998), B: 1, 4; "Libraries for the Next Century," *Oculus* 61 (October 1998): 4; Paul Goldberger, "Room to Think," *New Yorker* 74 (October 5, 1998): 68–69; Kristin Miller, "Reading Materials," *Metropolis* 18 (November 1998): 39; Julie V. Iovine, "Open for Travel in Realms of Gold," *New York Times* (November 5, 1998), F: 1, 7; "Tribute to Literacy and Literature," *New York Times* (November 13, 1998), B: 5; "The Reading Room Reopens," editorial, *New York Times* (November 16, 1998): 20; "The Reading Room Goes Digital," *New York Times* (November 17, 1998), B: 1; Frank Bruni, "Library's Reading Room Reopens in Blaze of Glory," *New York Times* (November 17, 1998), B: 5; Shiela Tunney, Natalee S. Fogel, Barbara Vanderkolk, and Marvin Scilken, "Renovated Library Is a Paradigm," letters to the editor, *New York Times* (November 21, 1998): 14; Karrie Jacobs, "The Public Library Bids Farewell to Its Poky Old Dumbwaiter," *New York* 31 (November 23, 1998): 17; Allison Eckardt Ledes, "A Research Citadel Restored," *Antiques* 154 (December 1998): 760, 762; Eric Adams, "Study Hall," *Architecture* 88 (January 1999): 127–31; Karen W. Arenson, "Three Packed Libraries Seek Storage Space in New Jersey," *New York Times* (March 22, 1999), B: 6; Rita Reif, "Seeing a Familiar Haunt Again, but in a New Light," *New York Times* (April 4, 1999), B: 39; Thomas Mallon, "Paradise Regained," *Preservation* 51 (May/June 1999): 54–59; "State Helping Library," *New York Times* (September 2, 1999), B: 7; White and Willensky, *AIA Guide* (2000), 229; "IALD Annual Lighting Design Awards," *Asian Architect and Contractor* 29 (2000): 28–32; "IALD Awards," *Architectural Lighting* 15 (June-July 2000): 28–43; Edwin McDowell, "For Public Library, New Building Within the Old One," *New York Times* (September 17, 2000), XI: 7; Balfour, *World Cities: New York*, 147–48; Tom Vanderbilt, "Davis Brody Bond: Rose Main Reading Room, the New York Public Library, New York, New York," *Interiors* 160 (January 2001): 72–75; David W. Dunlap, "When Expansion Leads to Inner Space," *New York Times* (May 5, 2002), XI: 1, 6; Howard Kissel, "Library Adds Wing," *New York Daily News* (May 15, 2002): 38; "Ex Libris," *Wall Street Journal* (May 30, 2002), B: 4; Raul A. Barreneche, "Davis Brody Bond Gives New Life to a Beaux-Arts Grande Dame, with the Modern New South Court of the New York Public Library," *Architectural Record* 190 (November 2002): 135–41; "South Court Building at the New York Public Library," *New York Construction News* 50 (December 2002): 35.

46. Goldberger, "Inside and Out, Library Recaptures Its Splendor": 4.

47. Goldberger, "Inside and Out, Library Recaptures Its Splendor": 4.

48. Goldberger, "An Abandoned Room 80 Is a Treasure Restored": 1. For Pennsylvania Station, see Stern, Gilmartin, and Massengale, *New York 1900*, 40–43.

49. Mallon, "Paradise Regained": 55, 58.

50. Barreneche, "Davis Brody Bond Gives New Life to a Beaux-Arts Grande Dame, with the Modern New South Court of the New York Public Library": 140.

51. "Civic Leader Wants Bryant Park Closed, Police Oppose Move," *New York Times* (June 24, 1976): 37; Joseph B. Treaster, "Bryant Park: An Oasis Plagued by Crime," *New York Times* (June 26, 1976): 27. For the 1934 rebuilding of the park, see Stern, Gilmartin, and Mellins, *New York 1930*, 712–13.

52. Mary Breasted, "Fair to Help Fix Up Bryant Park Dampened by Rain," *New York Times* (May 16, 1977): 37.

53. Leslie Maitland, "Bryant Park Is Showing Improvement but It Still Has Its Ups and Downs," *New York Times* (July 1, 1978): 19–20.

54. William H. Whyte, "Revitalization of Bryant Park," report for the Rockefeller Brothers Fund, November 26, 1979; William H. Whyte, *City: Rediscovering the Center* (New York: Doubleday, 1988), 160–63; Gayle Berens, "Bryant Park," in Alexander Garvin and Gayle Berens, *Urban Parks and Open Space* (Washington, D.C.: Urban Land Institute, 1997), 44–57; J. William Thompson, *The Rebirth of New York City's Bryant Park* (Washington, D.C.: Spacemaker Press, 1997), 21–23.

55. William H. Whyte, quoted in Berens, "Bryant Park," in Garvin and Berens, *Urban Parks and Open Space*, 46.

56. Anna Quindlen, "Bright Note in a Seedy Park," *New York Times* (July 31, 1980): B: 3; Glenn Fowler, "Some Success Seen in Effort to Reclaim Bryant Park," *New York Times* (September 15, 1980), B: 2; David Bird, "City Awaiting Bids for Outdoor Café in Bryant Park," *New York Times* (May 17, 1981): 46; "Counterattack in Bryant Park," editorial, *New York Times* (November 13, 1981): 34; Berens, "Bryant Park," in Garvin and Berens, *Urban Parks and Open Space*, 47; Thompson, *The Rebirth of New York City's Bryant Park*, 23.

57. Daniel A. Biederman, quoted in Fowler, "Some Success Seen in Effort to Reclaim Bryant Park": 2.

58. Jonathan Barnett, "Beyond Revivalsim and the Bauhaus: A New Partnership in the Arts," in *Collaboration, Artists and Architects: In Celebration of the Centennial of the Architectural League* (New York: Whitney Library of Design, 1981), 90–95; Hugh Hardy with Malcolm Holzman and Norman Pfeiffer, "Restaurant Pavilions for Bryant Park: Musings on Variety," in *Collaboration, Artists and Architects: In Celebration of the Centennial of the Architectural League*, 96–103; Paul Goldberger, "A Meeting of Artistic Minds," *New York Times* (March 1, 1981), VI: 70–73, 80; Carol Lawson, "How Art and Architecture Look at the 80's," *New York Times* (March 6, 1981): 22; Michael Sorkin, "The Odd Couples," *Village Voice* (March 18, 1981): 78; Robert Jensen and Patricia Conway, *Ornamentalism* (New York: Clarkson N. Potter, 1982), 152–53; *Hardy Holzman Pfeiffer Associates: Buildings and Projects 1967–1992*, 253; Berens, "Bryant Park," in Garvin and Berens, *Urban Parks and Open Space*, 48–49; Thompson, *The Rebirth of New York City's Bryant Park*, 25.

59. Sorkin, "The Odd Couples": 78.

60. Richard F. Shepard, "Parking," *New York Times* (July 19, 1982), C: 13; Glenn Fowler, "Crime in Bryant Park Down Sharply," *New York Times* (August 10, 1982), B: 1–2; "Topics of The Times: Armies of the Day," *New York Times* (August 16, 1982): 14; Clyde Haberman and Laurie Johnston, "Now TKTS II: For Opera and Concerts," *New York Times* (August 31, 1982), B: 3; Stan Pinkwas, "Breakfast at Bryant's," *Metropolis* 2 (September 1982): 7–8; C. Gerald Fraser, "Discount Tickets Booth Planned for Bryant Park," *New York Times* (September 8, 1982), C: 18; "Ticket Booth to Open in Bryant Park," *New York Times* (December 14, 1982), C: 13; Laurie Johnston and Susan Heller Anderson, "Bryant Park's New Booth," *New York Times* (March 30, 1983), B: 3; "More Help for Bryant Park," *New York Times* (August 23, 1983), B: 2.

61. Deirdre Carmody, "Vast Rebuilding of Bryant Park Planned," *New York Times* (December 1, 1983): 1, B: 2.

62. Peter Freiberg, "Privatizing Bryant Park," *Metropolis* 3 (October 1983): 8; Carmody, "Vast Rebuilding of Bryant Park Planned": 1–2; Paul Goldberger, "The 'New' Bryant Park: A Plan of Pros and Cons," *New York Times* (December 1, 1983), B: 2; Richard Levine and Alan Finder, "Regentrifying Bryant Park," *New York Times* (December 4, 1983), IV: 6; John H. Detmold, "One Crystal Palace Deserves Another," letter to the editor, *New York Times* (December 10, 1983): 22; Richard Edes Harrison, "'A Desecration,'" letter to the editor, *New York Times* (December 10, 1983): 22; Emily Menlo Marks, "Bryant Park Plan: Heed the Public Interest," letter to the editor, *New York Times* (December 10, 1983): 22; "Names and News," *Oculus* 47 (January 1984): 10; Deirdre Carmody, "City Offers Legislation for Privately Run Restaurant in Bryant Park," *New York Times* (May 27, 1984): 43; Peter Freiberg, "Another Merry Go-Round in Bryant Park," *Metropolis* 4 (June 1984): 9–10; Susan Heller Anderson and David Bird, "The See-Through Woman of Bryant Park," *New York Times* (August 14, 1984), B: 2; Joyce Purnick, "Panel Approves Restaurant Plan for Bryant Park," *New York Times* (April 23, 1985), B: 3; Michael Oreskes, "The City's Parks Have a Politics All Their Own," *New York Times* (April 28, 1985), IV: 6; Sara Rimer, "Restaurateur Withdraws Proposal for Bryant Park," *New York Times* (March 18, 1986), B: 1, 11; Roger Starr, "The Editorial Notebook: The Vulnerable Paper City," *New York Times* (April 10, 1986): 30; "Café Cluster Possible for Bryant Park," *New York Times* (April 25, 1986), B: 1–2; Jeanie Kasindorf, "New York Intelligencer: New Day for Bryant Park?" *New York* 19 (September 15, 1986): 19; Deirdre Carmody, "Questions About Restaurant Stall Bryant Park Redesign," *New York Times* (December 1, 1986), B: 2; David W. Dunlap, "Landmarks Panel Calls Plan for Bryant Park 'Untenable,'" *New York Times* (January 8, 1987), B: 1, 3; "A Landmark of Misfeasance," editorial, *New York Times* (January 11, 1987): 30; David W. Dunlap, "Landmarks Commission Member Losing Post," *New York Times* (January 23, 1987), B: 1; Gene A. Norman, "Proper Planning to Dine in Bryant Park," letter to the editor, *New York Times* (January 24, 1987): 14; John Low-Beer, "Bryant Park Restaurant Plan Was Landmarks Board Business," letter to the editor, *New York Times* (January 28, 1987): 26; Henry Urbach, "Reclaiming Public Parks," *Metropolis* 7 (January-February 1988): 20–21; Thompson, *The Rebirth of New York City's Bryant Park*, 25–27; Edwin McDowell, "Adolf K. Placzek, 87, Is Dead; Architecture Library Director," *New York Times* (March 21, 2000), C: 31.

63. For the Crystal Palace, see John A. Kouwenhoven, *The Columbia Historical Portrait of New York* (Garden City, N.Y.: Doubleday, 1953), 242–43. For the Tavern on the Green and Maxwell's Plum, see Stern, Mellins, and Fishman, *New York 1960*, 527, 529, 783–84.

64. Goldberger, "The 'New' Bryant Park: A Plan of Pros and Cons": 2.

65. Jeanette Bamford, quoted in Freiberg, "Another Merry Go-Round in Bryant Park": 10.

66. "Yet Another Bryant Park Plan," *New York* 20 (September 14, 1987): 14; Susan Heller Anderson, "New Restaurant Design Readied for Bryant Park," *New York Times* (September 22, 1987), B: 3; Paul Goldberger, "A Simpler Way to Improve Bryant Park," *New York Times* (October 4, 1987), II: 36, 38; Susan Heller Anderson, "Library Starts Road to 84-Mile Shelves Under Park," *New York Times* (October 27, 1987), B: 5; Whyte, *City: Rediscovering the Center*, 162–63; Estelle Lander, "Bryant Park to Undergo $5-Million Renovation," *Newsday* (July 12, 1988): 28; Mark McCain, "Commercial Property," *New York Times* (August 14, 1988), X: 19; Jean Elson Nathan, "A Lindsay Veteran Becoming Magnate of City Eateries," *New York Observer* (October 31, 1988): 1, 8; Clara Clayman, "Why Bryant Park?" letter to the editor, *New York Observer* (November 14, 1988): 4; "A Gotham Chef: Some Library Dish," *New York* 22 (September 25, 1989): 22; Michael Kaplan, "Will There Ever Be a Tavern on the Green in Bryant Park?" *Manhattan, inc.* 7 (May 1990): 45–49; "Poet's Park," *Landscape Architecture* 99 (March 1989): 13; Albert Amateau and Steven Saltzman, "Bryant Park Plans Proceed," *Metropolis* 9 (January-February 1990): 13–14; "Bryant Park," *Metropolis* 10 (July-August 1990): 20–21; Stephanie Strom, "One Landmark, As Is. We Don't Deliver," *New York Times* (May 6, 1990): 38; Suzanne Slesin, "An Elegant Old Facility Will Gain a New Felicity," *New York Times* (January 24, 1991), C: 3; "Elegant Outhouse," editorial, *New York Times* (January 25, 1991): 28; Nick Ravo, "Bryant Park Journal," *New York Times* (June 13, 1991), B: 3; "Bryant Park, Partly Renovated, Is Reopened to the Public," *New York Times* (July 2, 1991), B: 1; "A Living Room on 42d Street," editorial, *New York Times* (July 10, 1991): 18; *Hardy Holzman Pfeiffer Associates: Buildings and Projects 1967–1992*, 275; Marvine Howe, "Chronicle," *New York Times* (March 30, 1992), B: 8; Eleanor Dwight, "Bryant Park Comes Back," *New York* 25 (April 20, 1992): 44–46; Sergei John Rioux, "The Green, Green Grass of Home," letter to the editor, *New York* 25 (June 8, 1992): 8; Bruce Weber, "After Years Under Wraps, a Midtown Park Is Back," *New York Times* (April 22, 1992), B: 1, 4; A. M. Rosenthal, "Tale of One City," *New York Times* (April 24, 1992): 35; "A Park Reborn," editorial, *New York Times* (April 26, 1992): 18; Paul Goldberger, "Bryant Park, an Out-of-Town Experience," *New York Times* (May 3, 1992), II: 34; David Von Drehle, "Letter from Bryant Park," *Washington Post* (May 16, 1992): 3; Guy Trebay, "In the Green Room," *Village Voice* (May 26, 1992): 18; Bruce Weber, "About New York," *New York Times* (May 30, 1992): 22; "Memorial Caps Bryant Park Restoration," *Architectural Record* 180 (June 1992): 41; James Bennet, "One Emerald Shines, Others Go Unpolished," *New York Times* (August 30, 1992): 35; Jane Brown Gillette, "New Park Necessary," *Historic Preservation* 44 (September-October 1992): 46–47; Eve Kahn, "Panacea in Needle Park," *Landscape Architecture* 82 (December 1992): 60–61; "Two New Newsstands," *New York Times* (December 27, 1992), X: 1; "Upward Mobility in Bryant Park," *New York Times* (January 16, 1993): 23; Claudia H. Deutsch, "Bryant Park: Once Anathema, Now a Midtown Marketing Tool," *New York Times* (June 6, 1993), X: 17; Eleanor Blau, "Financing Finally Seals Deal for a Restaurant in Bryant Park," *New York Times* (December 4, 1993): 25; "AIA Honor Awards for Urban Design," *Architectural Record* 182 (February 1994): 71; "AIA Announces Urban Design Awards," *Progressive Architecture* 75 (February 1994): 15; Robert A. M. Stern and Thomas Mellins, *New York, the World's Premier Public Theater: Creating and Managing Public Space in the Post-Industrial Metropolis*, exhibition catalog (New York: Columbia University Graduate School of Architecture, Planning and Preservation, 1995), 30, 35–37; Ruth Reichl, "Diner's Journal," *New York Times* (May 26, 1995), C: 22; Guy Trebay, "Herd Instinct," *Village Voice* (July 25, 1995): 21; Matthew Barhydt, "Quiet Please, This Is Bryant Park," *Oculus* 58 (September 1995): 4; Herbert Muschamp, "Remodeling New York for the Bourgeoisie," *New York Times* (September 24, 1995), II: 1, 38; Monica Geran, "Lee Harris Pomeroy with Cary Tamarkin and Nancy Mah," *Interior Design* 66 (October 1995): 108–13; Mitchell Owens, "Urban Arcadia," *New York Times* (October 15, 1995), V: 22, 24, 42; Constance C. R. White, "The Bryant Park Question," *New York Times* (November 7, 1995), B: 7; Julie V. Iovine, "Tenacity in the Service of Public Culture," *New York Times* (December 12, 1995), B: 1, 4; Berens, "Bryant Park," in Garvin and Berens, *Urban Parks and Open Space*, 44–57; Sirefman, *New York*, 156–59; Thompson, *The Rebirth of New York City's Bryant Park*; Thomas J. Lueck, "Off to See the Wizard, for One, in Bryant Park," *New York Times* (June 23, 1997), B: 1, 4; "Bringing Back Bryant Park," *Urban Land* 56 (October 1997): 112–13; Roberta Brandes Gratz, *Cities Back from the Edge* (New York: John Wiley & Sons, 1998), 38–42; Debra Waters, *Hardy Holzman Pfeiffer Associates: Buildings and Projects, 1992–1998* (New York: Rizzoli International Publications, 1999), 20–25; White and Willensky, *AIA Guide* (2000), 230–31; Balfour, *World Cities: New York*, 199–200.

67. William H. Whyte, quoted in Berens, "Bryant Park," in Garvin and Berens, *Urban Parks and Open Space*, 51.

68. Lynden B. Miller, quoted in Amateau and Saltzman, "Bryant Park Plans Proceed": 13.

69. For the New York Telephone Building, see Stern, Mellins, and Fishman, *New York 1960*, 464–65.

70. Joan K. Davidson, quoted in "Elegant Outhouse": 28.

71. Goldberger, "A Simpler Way to Improve Bryant Park": 36, 38.

72. Owens, "Urban Arcadia": 22.

73. Reichl, "Diner's Journal": 22.

74. Barhydt, "Quiet Please, This Is Bryant Park": 4.

75. Amy M. Spindler, "Designers Turn New York into a Fashion Big Top," *New York Times* (October 31, 1993): 1, 39; "Present and Future Tents," *New York Times* (November 7, 1993): 4; Frank Scalpone, "Bryant Park Fashion Show: Right Idea but Wrong Site," letter to the editor, *New York Times* (November 14, 1993): 21; Bradford McKee, "Tents Showcase New York Fashion Shows," *Architecture* 83 (January 1994): 93; Jennifer Steinhauer, "Crowding the Runway," *New York Times* (March 27, 1998), B: 1, 6.

76. Huxtable, "The Trashing of Fifth Avenue": 33–34. Also see Ralph Blumenthal, "On Fifth Avenue, Shoppers' Jungle," *New York Times* (July 9, 1980), C: 1, 9. For Olympic Tower, see Stern, Mellins, and Fishman, *New York 1960*, 391–93.

77. For 650 Fifth Avenue, see Stern, Mellins, and Fishman, *New York 1960*, 393–94.

78. Paul Goldberger, "Fifth Avenue Losing Its Grandeur as Glass and Metal Replace Stone," *New York Times* (December 20, 1979): C: 10.

79. Dee Wedemeyer, "Bonwit Teller Building to Be Sold," *New York Times* (January 26, 1979): 1, D: 11; "A New Skyscraper for Manhattan," *New York Times* (January 28, 1979), ßC: 15; Isadore Barmash, "Bonwit Woes: Shifts in Managers Cited," *New York Times* (February 10, 1979): 25–26; Carter B. Horsley, "In the Air over Midtown: Builders' New Arena," *New York Times* (February 11, 1979), VIII: 1, 6; Dee Wedemeyer, "60-Story Tower Sought for Bonwit-Teller Site," *New York Times* (March 1, 1979), D: 1, 10; Paul Goldberger, "Plan for Bonwit Site: Gifts at What Price?" *New York Times* (March 15, 1979), C: 17; Judith Cummings, "49 Years of Elegance Ends at Bonwit's 5th Ave. Store," *New York Times* (May 20, 1979): 37; Michael Sorkin, "License to Pillage," *Village Voice* (June 11, 1979): 80; Eleni Constantine, "Retail Construction: Wholesale Destruction," *Progressive Architecture* 60 (July 1979): 25–26; Ada Louise Huxtable, "A New York Blockbuster of Superior Design," *New York Times* (July 1, 1979), II: 25; "Zoning Change Opposed for Tower at Bonwit Site," *New York Times* (September 6, 1979), B: 5; Glenn Fowler, "Tower Approved for Bonwit Site," *New York Times* (October 20, 1979): 26; Suzanne Daley, "Bonwit Building Set for the Ultimate Sale," *New York Times* (March 16, 1980), VIII: 1, 4; Robert D. McFadden, "Developer Scraps Bonwit Sculptures," *New York Times* (June 6, 1980): 1, B: 5; Josh Barbanel, "Grillwork Missing at Bonwit Building," *New York Times* (June 7, 1980): 23; Robert D. McFadden, "Designer Astonished by Loss of Bonwit Grillwork," *New York Times* (June 8, 1980): 47; Robert D. McFadden, "Builder Says Costs Forced Scrapping of Bonwit Art," *New York Times* (June 9, 1980), B: 3; "Mr. Trump's Jackhammer," editorial, *New York Times* (June 15, 1980): 20; William G. Blair, "After a Lull, Construction of Co-ops Picks Up in Manhattan," *New York Times* (June 22, 1980), VIII: 1, 18; Michael Sorkin, "Shaft," *Village Voice* (June 25, 1980): 73; "Trump Pursued a 'Vision' of Tower with Tenacity," *New York Times* (August 26, 1980), B: 4; Richard Rush, "Structure and Circumstance," *Progressive Architecture* 61 (December 1980): 50–57; Paul Goldberger, *The Skyscraper* (New York: Alfred A. Knopf, 1981), 144–46; Allen T. Freeman, "New York's New Public Spaces," *Urban Design International* 2 (March-April 1981): 22–27; Lee A. Daniels, "Trump Denied Tax Abatement for Fifth Avenue Tower," *New York Times* (March 29, 1981): 46; Janet Nairn, "Seven Architects Convene at the Museum of Modern Art to Discuss 'Super-Building,'" *Architectural Record* 169 (April 1981): 35; "In Progress," *Progressive Architecture* 63 (April 1982): 81; "Pencil Points," *Progressive Architecture* 63 (July 1982): 42; "A Tower Topping," *New York Times* (July 11, 1982), VIII: 1; Clyde Haberman, "Ruling Supports Tax Abatement Asked by Trump," *New York Times* (July 22, 1981), B: 1; "Trump Suing City and Housing Chief," *New York Times* (July 23, 1981), B: 3; Paul Goldberger, "The New American Skyscraper," *New York Times* (November 8, 1981), VI: 68–73, 76, 78, 86, 88, 90, 92, 94, 96; Frank J. Prial, "Interview: Brendan Gill on Urban Density," *New York Times* (March 28, 1982), VIII: 7; Paul Goldberger, "This Will be the Year of the Skyscraper," *New York Times* (September 12, 1982), II: 33, 39; "Pencil Points," *Progressive Architecture* 63 (October 1982): 50; Sydney H. Schanberg, "Strictly Beau Monde," *New York Times* (December 18, 1982): 27; John Peter Barie, "Trump Tower Design," letter to the editor, *New York Times* (February 10, 1983), C: 11; Robin Herman and Laurie Johnston, "Frenzied Finish for Trump Tower Atrium," *New York Times* (February 11, 1983), B: 4; Paul Goldberger, "Architecture: Atrium of Trump Tower Is a Pleasant Surprise," *New York Times* (April 4, 1983), C: 13; Paul Goldberger, "New Skyscrapers and Unfulfilled Promises," *New York Times* (April 10, 1983), II: 31, 33; Marylin Bender, "The Empire and Ego of Donald Trump," *New York Times* (August 7, 1983), III: 1, 8; Ada Louise Huxtable, *The Tall Building Artistically Reconsidered* (New York: Pantheon Books, 1984), 107–9; Jonathan Mandell, *Trump Tower* (Secaucus, N.J.: Lyle Stuart, 1984); "Trump Tower," *Baumeister* 81 (February 1984): 42; "Trump Tower," *Architecture + Urbanism* (July 1984): 78–83; David Margolick, "Top State Court Rules Trump Is Entitled to Tax Break for Midtown Tower," *New York Times* (July 6, 1984), B: 1; "Trump Tower Gets a Break," *New York Times* (July 8, 1984), IV: 6; Martin Filler, "High Ruse, part 1," *Art in America* 72 (September 1984): 150–65; "Trump Tower,"

Interior Design 55 (September 1984): 250–55; "Trump," *Progressive Architecture* 65 (September 1984): 26; Paul Goldberger, "The Sidewalks of New York–Indoors," *New York Times* (March 24, 1985), X: 21; Andrea Israel, "Sampling the Atriums," *New York Times* (March 24, 1985), X: 20, 39; Steven M. L. Aronson, "New York Apogee: Donald and Ivana Trump's Towering Residence," *Architectural Digest* 42 (July 1985): 100–9; Peter Lemos, "New Math," *Metropolis* 5 (November 1985): 16; Albert Scardino, "Trump Find Big 'Bonus' on 5th Ave.," *New York Times* (February 8, 1986): 33, 44; "Trump Tower," *Process Architecture* 64 (June 1986): 114–18; Daralice D. Boles, "Manhattan Malls," *Architectural Review* 180 (September 1986): 78, 80–82; Wendy Staebler, "Trump Tower Waterfall," *Interiors* 146 (November 1986): 78–79; Donald J. Trump with Tony Schwartz, *The Art of the Deal* (New York: Random House, 1987), 7–8, 30, 38, 41–42, 98–129, 241; White and Willensky, *AIA Guide* (1988), 282; "Trump Tower," *Architecture + Urbanism*, extra edition (April 1988): 209; "We Have Ways of Making You Stroll," *Spy* (June 1988): 95–99; Diane Ghirardo, "Towers of Trumped-Up Power," *Architectural Review* 184 (August 1988): 63–65; Andrew Reinbach, "Inside Trump Tower," *7 Days* (August 31, 1988): 13–17; Kay Lazar, "IBM, Trump, A.T.&T., How Do Your Gardens Grow," *New York Observer* (November 28, 1988): 1, 8; Alyne Model, "Can Vertical Malls Make It in New York?" *New York Real Estate Journal* (November 30, 1989): 20; John Sailer, *The Great Stone Architects* (Oradell, N.J.: Tradelink Publishing, 1991), 95–98, 102–6; Robert P. Metzger, *Der Scutt Retrospective* (Reading, Pa.: Reading Public Museum), 46–48; Sirefman, *New York*, 176–77; Donald J. Trump with Kate Bohner, *Trump: The Art of the Comeback* (New York: Random House, 1997), 5, 109–14; Beate Wedekind, *New York Interiors* (Cologne: Taschen, 1997), 216–25; Eric Nash, *Manhattan Skyscrapers* (New York: Princeton Architectural Press, 1999), 143–44; Mario Campi, *Skyscrapers: An Architectural Type of Modern Urbanism* (Basel: Birkhauser, 2000), 122–23; Jerold S. Kayden, *Privately Owned Public Space: The New York Experience* (New York: John Wiley & Sons, 2000), 174–76; White and Willensky, *AIA Guide* (2000), 298; Georges Binder, ed., *Sky High Living* (Mulgrave, Australia: Images Publishing, 2002), 26; James Gardner, "The Midas Touch," *New York Sun* (June 24, 2002): 1, 10.

80. Trump with Schwartz, *The Art of the Deal*, 104. For Tiffany & Company, see Stern, Gilmartin, and Mellins, *New York 1930*, 316–17, 321.

81. For Warren & Wetmore's building and Ely Jacques Kahn's renovation, see Stern, Gilmartin, and Mellins, *New York 1930*, 316, 319, 321. For Walker/Grad's renovation, see Paul Goldberger, "Design Notebook," *New York Times* (July 28, 1977): C: 12.

82. Trump with Schwartz, *The Art of the Deal*, 112.

83. Goldberger, "Plan for Bonwit Site: Gifts at What Price?": 17. For the Corning Glass Building, see Stern, Mellins, and Fishman, *New York 1960*, 378–81.

84. Sorkin, "License to Pillage": 80.

85. Huxtable, "A New York Blockbuster of Superior Design": 25.

86. Trump with Schwartz, *The Art of the Deal*, 115.

87. Der Scutt, quoted in Barbanel, "Grillwork Missing at Bonwit Building": 23.

88. "Mr. Trump's Jackhammer": 20.

89. Donald J. Trump, quoted in Mandell, *Trump Tower*, 48.

90. Glenn Fowler, "Bonwit Seeks to Return to a Fifth Avenue Site," *New York Times* (June 5, 1979): D: 1, 10; "Bonwit's Redux," *New York Times* (June 10, 1979): C: 15; Carter B. Horsley, "A Flagship Store Will Open Nearby," *New York Times* (March 16, 1980), VIII: 4; Isadore Barmash, "Bonwit's Return to Fifth Avenue," *New York Times* (April 18, 1981): 27–28; Paul Goldberger, "Bonwit Teller: Lively Interior on 57th Street," *New York Times* (April 23, 1981), C: 10; Edward A. Gargan, "Thousands Jam New Bonwit's for Preview," *New York Times* (April 27, 1981), B: 1.

91. Goldberger, "Bonwit Teller: Lively Interior on 57th Street": 10.

92. Huxtable, *The Tall Building Artistically Reconsidered*, 109; White and Willensky, *AIA Guide* (1988), 282.

93. Filler, "High Ruse, part 1": 164.

94. Kayden, *Privately Owned Public Space*, 174.

95. Goldberger, "Architecture: Atrium of Trump Tower Is a Pleasant Surprise": 13.

96. Huxtable, *The Tall Building Artistically Reconsidered*, 109.

97. Filler, "High Ruse, part 1": 164.

98. "Ludwig Beck at Trump Tower, New York," *Progressive Architecture* 63 (April 1982): 81; Suzanne Slesin, "Bavarian Wares Come to 5th Ave. in a New Store," *New York Times* (April 2, 1983): 16; Anne-Marie Schiro, "Notes on Fashion," *New York Times* (April 12, 1983), D: 23; Walter F. Wagner Jr., "Eine Kleine Castle: Shop for Ludwig Beck of Munich, New York City," *Architectural Record* 172 (March 1984): 146–51; "Ludwig Beck at Trump Tower, Fifth Avenue, New York," *Architecture + Urbanism*, extra edition (February 1985): 130–36; "Hollein in Manhattan," *Deutsche Bauzeitung* 119 (February 1985): 16–21; Paul Goldberger, "Viennese Architect Selected for Prize," *New York Times* (April 4, 1985), C: 16; "Ludwig Beck of Munich, New York," *Architektur, Innenarchitektur, Technischer Ausbau* 93 (September 1995): 18–19; Gianni Pettena, *Hans Hollein: Opere 1960–1988* (Milan: Idea Books Edizioni, 1988), 76–80.

99. Wagner, "Eine Kleine Castle: Shop for Ludwig Beck of Munich, New York City": 147.

100. Aronson, "New York Apogee": 106.

101. *Charles Gwathmey and Robert Siegel: Buildings and Projects 1964–1984*, ed. Peter Arnell and Ted Bickford (New York: Harper & Row, 1984), 21; Deborah Dietsch, "Spatial Effects," *Architectural Record* 173 (Mid-September 1985): 162–69; Monica Geran, "At Trump Tower," *Interior Design* 57 (April 1986): 250–57; Marco Romanelli, "Apartment in New York," *Domus* (May 1986): 56–63; *Gwathmey Siegel: Buildings and Projects, 1982–1992*, 224–27.

102. Geran, "At Trump Tower": 255.

103. Dietsch, "Spatial Effects": 162.

104. Isadore Barmash, "Trump Group Makes Bid for Bonwit," *New York Times* (April 3, 1990), D: 3; Isadore Barmash, "The Decline of Bonwit Teller: Did Time Pass Retailer By?" *New York Times* (April 14, 1990): 1, 32; Richard D. Hylton, "Retail Deal Expected for Trump," *New York Times* (July 9, 1990), D: 1, 5; Isadore Barmash, "French Seek Niche with Trump Site," *New York Times* (July 10, 1990), D: 1, 5; Richard D. Hylton, "Lease Improves Trump's Financial Picture," *New York Times* (July 10, 1990), D: 5; David W. Dunlap, "A New Glitter Added to a Premier Retail Boulevard," *New York Times* (September 30, 1990), X: 14; Isadore Barmash, "A Store on Fifth Avenue Will Be 'Totally French,'" *New York Times* (May 30, 1991), D: 4; Stephanie Strom, "French Retailer Seeks Piece of the Fifth Avenue Trade," *New York Times* (July 26, 1991), D: 1, 4; Stephanie Strom, "Making a Difference," *New York Times* (September 29, 1991), III: 12; Anne-Marie Schiro, "Filling a Niche and Making It French," *New York Times* (October 6, 1991): 50; Joseph P. Griffith, "Trump Tower Scales Back Expectations," *New York Times* (June 3, 1992), D: 19; "Loss Grows at French Store," *New York Times* (June 25, 1992), D: 1; Claudia H. Deutsch, "New Tenant Mix, New Image and New Revenues," *New York Times* (April 24, 1994), X: 13; Laurence Zuckerman, "Galeries Lafayette to Close Its Doors," *New York Times* (August 31, 1994), D: 1.

105. Trump with Bohner, *Trump: The Art of the Comeback*, 111.

106. Anthony DePalma, "Tower Rises on 5th Avenue," *New York Times* (September 7, 1983), D: 21; Shawn G. Kennedy, "New Signs of Old Glamour on Fifth Ave.," *New York Times* (August 26, 1984), VIII: 1, 14; White and Willensky, *AIA Guide* (1988), 264; Rachelle Garbarine, "Experts Differ on Malls for Downtowns," *New York Times* (August 29, 1990), D: 17.

107. For the Windsor Arcade, see Stern, Gilmartin, and Massengale, *New York 1900*, 194–95. For the W. & J. Sloane and S. W. Straus & Company buildings, see Stern, Gilmartin, and Mellins, *New York 1930*, 175.

108. White and Willensky, *AIA Guide* (1988), 272. Also see John Duka, "Notes on Fashion," *New York Times* (December 20, 1983), B: 14; Douglas Brenner, "The Elements of Style," *Architectural Record* 172 (Mid-September 1984): 112–17; Andrea Truppin, "Cementing a Style," *Interiors* 144 (January 1985): 162–65; "Design Awards/Competitions," *Architectural Record* 74 (October 1986): 66–67; Susan S. Szenasy, "Norma Kamali," *Metropolis* 6 (October 1986): 62.

109. Stern, Gilmartin, and Mellins, *New York 1930*, 324, 326–27.

110. Norma Kamali, quoted in Brenner, "The Elements of Style": 112.

111. Brenner, "The Elements of Style": 112.

112. Stern, Mellins, and Fishman, *New York 1960*, 598–99, 1086–87.

113. Isadore Barmash, "Bergdorf's Planning Renovation," *New York Times* (October 12, 1981), D: 1, 4; Shawn G. Kennedy, "Bergdorf's Facelift," *New York Times* (July 22, 1984), VIII: 1; Paul Goldberger, "5th Ave., at Its Brightest, Sees Shadows of Change," *New York Times* (December 15, 1984): 25, 29; *Allan Greenberg: Selected Works* (London: Academy Editions, 1995), 14–17; Christopher Gray, "Streetscapes/The Bergdorf Goodman Building on Fifth Avenue," *New York Times* (August 30, 1998), XI: 5.

114. For Kahn's buildings, see Stern, Gilmartin, and Mellins, *New York 1930*, 310–11, 318–19. For Post's Vanderbilt house, see Stern, Mellins, and Fishman, *New York 1880*, 596–601.

115. *Allan Greenberg: Selected Works*, 15.

116. Gray, "Streetscapes/The Bergdorf Goodman Building on Fifth Avenue": 5.

117. Goldberger, "5th Ave., at Its Brightest, Sees Shadows of Change": 25.

118. Pilar Viladas, "Cultural Exchange," *Progressive Architecture* 66 (March 1985): 91–94; Susan S. Szenasy, "Issey Miyake," *Metropolis* 6 (October 1986): 58.

119. Edie Lee Cohen, "Eva Jiricna: Renovation of the Venerable Bergdorf Goodman's Fifth Floor," *Interior Design* 64 (January 1993): 122–27; "Manhattan Transfer," *Architectural Review* 193 (December 1993): 39–41.

120. Shawn Kennedy, "New Signs of Glamour on Fifth Ave.," *New York Times* (August 26, 1984), VIII: 1, 4.

121. Goldberger, "5th Ave., at Its Brightest, Sees Shadows of Change": 25, 29.

122. Kennedy, "New Signs of Old Glamour on Fifth Ave.": 1; "A History of Fifth," *New York Times* (December 2, 1984), VIII: 1; Susan Heller Anderson and David W. Dunlap, "Glass Master's Windows," *New York Times* (December 3, 1984), B: 3; Goldberger, "5th Ave., at Its Brightest, Sees Shadows of Change": 25, 29; Jesus Rangel, "Proposal for 5th Ave. Sparks Dispute," *New York Times* (January 13, 1985): 27; Michael Blumstein, "Dollars vs. History on a Fifth Ave. Block," *New York Times* (February 15, 1985): 1, B: 6; Robert Guenther, "New York Land Price Breaks Record, Yet Hurdle Remains," *Wall Street Journal* (January 23, 1985): 35; Frank J. Prial, "5th Ave. Tower Blocked by Vote for Landmarks," *New York Times* (January 31, 1985), B: 6; Michael Blumstein, "Dollars vs. History on a Fifth Ave. Block," *New York Times* (February 15, 1985): 1, B: 6; "Coty Building's Owner Loses Permits to Alter," *New York Times* (February 22, 1985), B: 6; Jesus Rangel, "City Procedures on Landmarks to Be Reviewed," *New York Times* (February 26, 1985), B: 4; Peter Freiberg, "Rizzoli: To Raise or to Raze," *Metropolis* 4 (March 1985): 12–13; "Landmarking Needs a Review," editorial, *New York Times* (March 9, 1985): 22; Christabel Gough, "Making a Start on Fifth Ave. Historic District," letter to the editor, *New York Times* (March 27, 1985): 26; Joyce Purnick, "The Lay of the Landmark Commission," *New York Times* (April 7, 1985), IV: 6; Gene A. Norman, "Landmarking Adds to the Quality of Life in New York City," letter to the editor, *New York Times* (April 20, 1985): 22; Charles Lockwood, "To Keep Faith with the Landmark Spirit," letter to the editor, *New York Times* (May 27, 1985): 18; Jesus Rangel, "Panel Approves Tower Plan Using Facades of 2 Landmarks," *New York Times* (May 29, 1985), B: 4; "Saving Face," *New York Times* (June 2, 1985), IV: 7; "KPF Classical, Controversial," *Progressive Architecture* 66 (July 1985): 73; Jilian Mincer, "Study Urges Cities to Speed Decisions on Landmarks," *New York Times* (July 14, 1985), VIII: 7; Paul Goldberger, "'Facadism' on the Rise: Preservation or Illusion?" *New York Times* (July 15, 1985), B: 1; Joyce Purnick, "For Koch, 1985 Was a Year of Promises, with Some Unfulfilled," *New York Times* (December 31, 1985), B: 3; Susan Heller Anderson and David W. Dunlap, "Lalique Windows Are Going but Just for Restoration," *New York Times* (April 21, 1986), B: 2; Suzanne Daley, "New Landmarks Policy Urged by Mayoral Panel," *New York Times* (May 31, 1986): 31; Isadore Barmash, "Bendel Sets Move to 5th Ave.," *New York Times* (October 3, 1986), D: 1, 4; Joseph Giovannini, "For 5th Ave.: Offices or Stores?" *New York Times* (October 20, 1986), B: 1, 16; "Taubman Blocks Trump," *Manhattan, inc.* 3 (November 1986): 24; Sonia R. Chao and Trevor D. Abramson, eds., *Kohn Pedersen Fox: Buildings and Projects, 1976–1986* (New York: Rizzoli International Publications, 1987), 230–36; David W. Dunlap, "Design Change of Skyscraper Provokes Debate on Hearing," *New York Times* (February 20, 1987), B: 18; Dunlap, "3 Manhattan Buildings Are Named Landmarks," 2; "Revised Tower Plans Approved by Panel," *New York Times* (March 11, 1987), B: 3; David W. Dunlap, "Surmounting a Development Dilemma," *New York Times* (March 29, 1987), IV: 9; David W. Dunlap, "City Landmark Designations Slowed," *New York Times* (April 14, 1987), B: 3; Shawn G. Kennedy, "New Tower on 56th St. at 5th Ave.," *New York Times* (September 30, 1987): 36; "Preserving Balance on Landmarks," editorial, *New York Times* (December 26, 1987): 22; "On the Avenue," *Architectural Record* 176 (September 1988): 55; Mark McCain, "Developers Working Around Remnants of the Past in Towers," *New York Times* (January 22, 1989), X: 23; Christopher Gray, "Streetscapes: The View Down Fifth Avenue," *New York Times* (December 17, 1989), X: 7; Goldberger, "Has Fifth Avenue Become Beside the Point?": 31; Richard D. Lyons, "Preservation Battle Ends in Manhattan," *New York Times* (March 7, 1990), D: 18; James S. Russell, "Designing the Super-Thin New Buildings," *Architectural Record* 178 (October 1990): 105–6; Lynn Nesmith, "Unlimited Vision," *Architecture* 79 (December 1990): 66–73; "The Fifth Dimension," *Avenue* (January 1991): 21; Marc S. Harriman, "Set in Stone," *Architecture* 80 (February 1991): 79–83; David W. Dunlap, "High Hopes, and Vacancy, for a 4-Building Complex," *New York Times* (February 17, 1991), X: 9; "A Belle of Fifth Avenue Returns, Freshened Up," *New York Times* (February 28, 1991), B: 1, 3; Georgian Dullea, "A Glittery Opening for New Bendel Store," *New York Times* (February 28, 1991), C: 10; Frank DeCaro, "A New Showplace," *Newsday* (February 28, 1991): 72; "News Notes," *Oculus* 53 (March 1991): 4; Isadore Barmash, "New Bendel's Has It All, but Will It Be Enough?" *New York Times* (March 1, 1991), D: 1, 4; "Bouquet for 5th," *Newsday* (March 7, 1991): 60; Paul Goldberger, "A Shot of Adrenaline for Fifth Avenue," *New York Times* (March 10, 1991), II: 34–35; Paul Goldberger, "Two Reasons for Dancing in the Streets of New York," *New York Times* (March 17, 1991), II: 36, 42; "Restored Lalique Windows in New Bendel's," *Architectural Record* 179 (April 1991): 39; Wendy Goodman, "Living with Style," *House & Garden* 163 (June 1991): 72; Brendan Gill, "The Sky Line: 712 Fifth," *New Yorker* 67 (June 10, 1991): 97–102; Edie Lee Cohen, "Henri Bendel," *Interior Design* 62 (July 1991): 82–87; Abby Bussel, "The New Henri Bendel: Paris in New York," *Progressive Architecture* 72 (June 1991): 30; Judith Davidsen, "Lighting a Landmark While Moving the Merchandise," *Architectural Record Lighting* 179 (August 1991): 14; Paul Goldberger, "Architecture/1991," *New York Times* (December 29, 1991), II: 32; Margaret Gaskie, "Double Play," *Architectural Record* 180 (June 1992): 90–95; Warren A James, ed., *Kohn Pedersen Fox: Architecture and Urbanism, 1986–1992* (New York: Rizzoli International Publications, 1993), 66–71; Gregory F. Gilmartin, *Shaping the City: New York and the Municipal Art Society* (New York: Clarkson Potter, 1995), 418–20; *Beyer Blinder Belle, Architects & Planners* (New York: Beyer Blinder Belle, 1997), no pagination; Charles V. Bagli, "Record Price Echoes Buying Frenzy of 80's," *New York Times* (June 23, 1998), B: 1, 8; Nash, *Manhattan Skyscrapers*, 161–62; Kayden, *Privately Owned Public Space*, 168–69; White and Willensky, *AIA Guide* (2000), 297; David W. Dunlap, "Public Space, Private Sales, at a Price," *New York Times* (December 12, 2002), B: 3.

123. For the Fifth Avenue Presbyterian Church, see Stern, Mellins, and Fishman, *New York 1880*, 293–97. For the Rizzoli Building, see Stern, Gilmartin, and Massengale, *New York 1900*, 200; Landmarks Preservation Commission of the City of New York, LP-1533 (January 29, 1985); Stern, Mellins, and Fishman, *New York 1960*, 381; Diamonstein, *The Landmarks of New York III*, 290. For the Coty Building, see Landmarks Preservation Commission of the City of New York, LP-1534 (January 29, 1985); Diamonstein, *The Landmarks of New York III*, 290. For 716 Fifth Avenue, see "In the Real Estate Field," *New York Times* (February 1, 1910): 15; "Altered Building Cited on 5th Av.," *New York Times* (March 24, 1940): 12; "Building Is Sold on Fifth Avenue," *New York Times* (May 3, 1940): 39.

124. Goldberger, "5th Ave., at Its Brightest, Sees Shadows of Change": 25, 29.

125. For Regnault's renovation for Harry Winston, see Stern, Mellins, and Fishman, *New York 1960*, 381, 1109. For Platt &

Platt's Corning Building, see Stern, Gilmartin, and Mellins, *New York 1930*, 306–7.

126. "Landmarking Needs a Review": 22.

127. Lockwood, "To Keep Faith with the Landmark Spirit": 18.

128. Goldberger, "'Facadism' on the Rise: Preservation or Illusion?": 1.

129. Goldberger, "A Shot of Adrenaline for Fifth Avenue": 34–35.

130. Gray, "Streetscapes: The View Down Fifth Avenue": 7.

131. Jesus Rangel, "Saks, Named a Landmark, Plans a Corporate Tower," *New York Times* (December 22, 1984): 25, 27; "Saks Tower a Sure Controversy," *Progressive Architecture* 66 (July 1985): 75; David W. Dunlap, "Saks and Swiss Bank to Build Tower," *New York Times* (April 8, 1986): B: 3; Carter B. Horsley, "Partner Joins Saks in Plans for a Tower," *New York Times* (October 20, 1986): B: 3; David Dunlap, "Blending In," *New York Times* (November 6, 1986): B: 1; "Names and News," *Oculus* 48 (May 1987): 19; Isadore Barmash, "B.A.T. to Expand Saks 5th Ave. Chain," *New York Times* (October 14, 1987), D: 5; "Swiss Bank Tower," *Building Stone Magazine* (November-December 1989): 30–32; David W. Dunlap, "A Building Designed to Suit Needs and Neighbors," *New York Times* (April 15, 1990), X: 11; Paul Goldberger, "Mute in Manhattan: A Politically Correct Building," *New York Times* (June 9, 1991), II: 32; Rachelle Garbarine, "Swiss Bank Fills Tower in Manhattan," *New York Times* (November 4, 1992), D: 22; Sydney LeBlanc, "Design Helps a (Big) Office/Retail Deal Happen," *Urban Land* 52 (May 1993): 46–47; White and Willensky, *AIA Guide* (2000), 290; Balfour, *World Cities: New York*, 96. For Saks Fifth Avenue, see Landmarks Preservation Commission of the City of New York, LP-1523 (December 20, 1984); Stern, Gilmartin, and Mellins, *New York 1930*, 310–11, 317–18.

132. Isadore Barmash, "Saks Expansion Set; Cost $200 Million," *New York Times* (February 23, 1979), D: 1, 12; Charlotte Evans, "Saks Plans Tower Behind Main Store," *New York Times* (July 26, 1979): 1, B: 8; Paul Goldberger, "Midtown Construction: Problem of Prosperity," *New York Times* (July 30, 1979): B: 1, 4; Paul Goldberger, "Redesigning a Department Store's Space," *New York Times* (November 15, 1979), C: 10; Anne-Marie Schiro, "A Store Rearranges Itself for the 80's," *New York Times* (April 6, 1980): 40; Anne-Marie Schiro, "A Fashion Floor Designed in Opulence," *New York Times* (November 7, 1980): 18; "Saks Lets the Ceiling Shape Its Spaces," *Architectural Record* 169 (May 1981): 102.

133. Barmash, "Saks Expansion Set; Cost $200 Million": 1.

134. Goldberger, "Redesigning a Department Store's Space": 10.

135. Goldberger, "Mute in Manhattan: A Politically Correct Building": 32.

136. Anthony DePalma, "Catering to Small Offices," *New York Times* (December 11, 1985), D: 28; Mark McCain, "Foreign Developers; Learning Just How the Game Is Played in the States," *New York Times* (July 26, 1987), VIII: 27.

137. John M. Weir, quoted in Richard D. Lyons, "Redcoats? No, Greycoats; Britons on Fifth," *New York Times* (February 12, 1989), X: 1. Also see "New York Offices," *Financial Times* (London) (June 19, 1989): 10; Goldberger, "Has Fifth Avenue Become Beside the Point?": 31, 34; David W. Dunlap, "Doldrums? Not Along Fifth Ave.," *New York Times* (January 24, 1993), X: 1, 13.

138. Goldberger, "Has Fifth Avenue Become Beside the Point?": 31, 34.

139. Goldberger, "Has Fifth Avenue Become Beside the Point?": 31, 34; Alan S. Oser, "Retailers Place Heavy Chips on the 50's," *New York Times* (March 3, 1991), X: 5.

140. Paul Goldberger, "730 Fifth Avenue, New York," *Arca* 37 (April 1990): 72–79; Paul Goldberger and Richard Reid, "730 Fifth Avenue, New York," *Arca* 39 (June 1990): 1–61; Piero Sartogo and Nathalie Grenon: *Architecture in Perspective* (New York: Monacelli Press, 1998), 66–71. For I. Miller, see Stern, Mellins, and Fishman, *New York 1960*, 584, 586. For Carlo Scarpa, see *Carlo Scarpa, Architect: Intervening with History* (New York: Canadian Centre for Architecture, 1999).

141. Goldberger, "730 Fifth Avenue, New York," (June 1990): 5–6, 34, 41, 58.

142. Felicia R. Lee, "5th Avenue Merchants Want a Ban on Vendors," *New York Times* (December 20, 1990), B: 3; Terry Golway, "Off the Avenue, Fifth Avenue," *New York Observer* (January 14, 1991): 5.

143. Samuel G. Freedman, "Peninsula of Tranquility in the Fifth Avenue Sea," *New York Times* (May 3, 1991), C: 1, 17.

144. Stuart Elliott, "Coke Plans 5th Avenue Retail Store," *New York Times* (July 19, 1991), D: 16; Woody Hochswender, "Patterns," *New York Times* (November 19, 1991), B: 13; Ron Alexander, "A Pause to Refresh Memories," *New York Times* (November 24, 1991): 59. For 711 Fifth Avenue, see "Fifth Av. Association Awards Prizes for Architecture," *New York Times* (February 12, 1928), XI: 1.

145. David W. Dunlap, "What's Up on 5th Avenue? A Studio Store," *New York Times* (February 10, 1993), B: 3; Alex Williams, "Bugs Money," *New York* 26 (November 1, 1993): 23; Marcy Stanley, "Looney Tunes Takes Over Chic Corner," *Architectural Record* 181 (November 1993): 13.

146. Carter B. Horsley, quoted in www.thecityreview.com/plots1.html

147. For the Disney store, see Claudia H. Deutsch, "As Fifth Ave. Changes, Disney May Replace La Cote Basque," *New York Times* (December 7, 1991): 1; Peter Slatin, "Disney's Store," *New York Post* (August 7, 1996): 31–32; Anthony Ramirez, "Neighborhood Report," *New York Times* (October 6, 1996), XII: 6; "Walt Disney," *New York Post* (October 30, 1996): 35. For the remodeled Warner Bros. store, see Sonia Reyes, "Warner's Gros on Fifth Ave.," *New York Daily News* (March 6, 1996): 9; Mervyn Rothstein, "Real Estate," *New York Times* (March 6, 1996), D: 20; Elaine Louie, "Where the Shopping and Tunes Are Looney," *New York Times* (October 17, 1996), C: 3; Peter Grant, "Warner Premiere: Fifth Ave. Flagship Opens," *New York Daily News* (October 23, 1996): 53; John Holusha,

"Commercial Property," *New York Times* (November 3, 1996), IX: 5; Kristen Richards, "Warner Bros. Studio Store Flagship Expansion, New York City," *Interiors* (April 1997): 52–55.

148. Dunlap, "Doldrums? Not Along Fifth Ave.": 1, 13.

149. "Demolition on Fifth: 'Last Day' at Last," *New York Times* (September 18, 1988), X: 1; Alan S. Oser, "A Builder Takes the Plunge on Fifth Ave.," *New York Times* (September 15, 1991), X: 5, 16; Dunlap, "Doldrums? Not Along Fifth Ave.": 1; Suzanne Stephens, "Muscling in on Midtown: Three New High-Rises," *Oculus* 55 (June 1993): 6–7; Paul Goldberger, "On Fifth Avenue, Two New Buildings Come to the Rescue," *New York Times* (July 4, 1993), II: 25; "Norman Jaffe, 61, an Architect Famed for Home Designs, Is Dead," *New York Times* (September 23, 1993), D: 22; Paul Goldberger, "Norman Jaffe Made a Mark on the Landscape of the East End," *New York Times* (October 3, 1993), Long Island Section, XIII: 16; Alastair Gordon, *Romantic Modernist: The Life and Work of Norman Jaffe, Architect* (New York: Monacelli Press, 2005), 216–21.

150. Norman Jaffe, quoted in Stephens, "Muscling in on Midtown: Three New High-Rises": 6.

151. Stephens, "Muscling in on Midtown: Three New High-Rises": 7.

152. For the Manufacturers Trust Company building, see Stern, Mellins, and Fishman, *New York 1960*, 372–75.

153. Stephens, "Muscling in on Midtown: Three New High-Rises": 7.

154. Goldberger, "On Fifth Avenue, Two New Buildings Come to the Rescue": 25.

155. Audrey Farolino, "Shoe Fits for Japan Store," *New York Post* (January 12, 1989): 57; "Takashimaya Building: Return to Fifth," *New York Times* (November 25, 1990), X: 1; "People and Projects in the City," *Oculus* 53 (January 1991): 2–3; "Takashimaya Unveils Burgee Tower Plan," *Architectural Record* 179 (February 1991): 17; Dunlap, "Doldrums? Not Along Fifth Ave.": 1, 13; Ylonda Gault, "A Japanese Retailer Set to Rise on Fifth," *Crain's New York Business* (February 15, 1993): 3, 21; Stephanie Strom, "Bold Stroke in Japan's Retailing Art," *New York Times* (April 23, 1993), D: 1, 7; Elaine Louie, "Zen and the Art of Shopping," *New York Times* (May 2, 1993), IX: 10; Suzanne Stephens, "Takashimaya Turns It On," *Oculus* 55 (June 1993): 6; Goldberger, "On Fifth Avenue, Two New Buildings Come to the Rescue": 25; Jean Gorman, "Quiet Impact," *Interiors* 152 (September 1993): 84–89; Judith Nasatir, "MGR: The Formative Stages of a Design Firm Are Documented at Takashimaya, New York," *Interior Design* 66 (December 1995): 78–83.

156. Stern, Mellins, and Fishman, *New York 1960*, 380–81.

157. For the Aeolian Building, see Stern, Gilmartin, and Mellins, *New York 1930*, 312.

158. Mitchell Pacelle, "Design Flaw: Noted Architects' Firm Falls apart in Fight Over Control, Clients," *Wall Street Journal* (September 2, 1992): 1.

159. Stephens, "Takashimaya Turns It On": 6.

160. Goldberger, "On Fifth Avenue, Two New Buildings Come to the Rescue": 25.

161. www.thecityreview.com/takash.html.

162. Stephens, "Takashimaya Turns It On": 6.

163. "Club Scrub: In the Pinkish," *New York Times* (January 1, 1984), VIII: 1.

164. For the St. Regis Hotel, see Stern, Gilmartin, and Massengale, *New York 1900*, 260–62, 267. For the Gotham Hotel, see Stern, Gilmartin, and Massengale, *New York 1900*, 278–79.

165. Craig Wolff, "St. Regis to Be Closed for at Least a Year," *New York Times* (June 1, 1988), B: 3; "Slate $80M Renovation for St. Regis Sheraton," *New York Post* (October 27, 1988): 58; "St. Regis to Undergo $50M Renovation," *New York Construction News* 36 (November 14, 1988): 1, 14; "In New York, Two of the City's Landmark Hotels Undergo Renovation and Restoration," *Interior Design* 60 (April 1989): 46; Justin Henderson, "Restoration Drama," *Interiors* 150 (May 1991): 132–44; David W. Dunlap, "New St. Regis: '04 Pomp, '91 Prices," *New York Times* (May 14, 1991), B: 4; Alessandra Stanley, "New York on $450 a Night (Sodas and Fruit Free)," *New York Times* (September 15, 1991): 36; Suzanne Stephens, "The St. Regis Reborn: Manhattan's Legendary Hotel Is Back with a Splash," *Architectural Digest* 48 (November 1991): 118–19, 122, 124, 126, 128, 130; Edie Lee Cohen, "St. Regis: The New York Landmark Returns Renovated and Revitalized," *Interior Design* 63 (January 1991): 100–107.

166. www.bbg-bbgm.com/singleproj_bbg.cfm.

167. Carter B. Horsley, "Swiss Hotelman and Innovator Comes to Gotham," *New York Times* (January 11, 1981): 1, 4; Stan Pinkwas, "Womb for the Wealthy," *Metropolis* 2 (January/February 1983): 7; Lee A. Daniels, "Emphasis on Psychology at a Luxury Hotel in City," *New York Times* (May 18, 1983), B: 8; Lee A. Daniels, "Nova-Park's Embattled Hotel," *New York Times* (November 5, 1984): D: 1, 6; "Nova Park Ruling," *New York Times* (April 18, 1985), D: 4; Philip Messino, "Two Are Indicted for Flushing S&L Hotel Loan Scam," *New York Post* (October 29, 1988): 25.

168. René Hatt, quoted in Horsley, "Swiss Hotelman and Innovator Comes to Gotham": 1.

169. Deirdre Carmody, "New Effort to Revamp Gotham Hotel," *New York Times* (June 23, 1985): 26; Richard D. Lyons, "Gotham Restoration Is On Again," *New York Times* (August 24, 1986), VIII: 6; Richard D. Lyons, "At Last, a 5th Ave. Hotel Gets Ready for Reopening," *New York Times* (November 18, 1987), B: 10; Mark McCain, "Prestige Tenants Battling Tourist-Oriented Stores," *New York Times* (April 24, 1988), X: 35.

170. Carter B. Horsley, "Hotel Chain Buys Maxim's de Paris," *New York Post* (August 26, 1988): 45; Richard D. Lyons, "Prices of New York Hotel Deals Expected to Jump," *New York Times* (August 28, 1988): 38; Freedman, "Peninsula of Tranquility in the Fifth Avenue Sea": 1, 17; Lisa Sanders, "City's Hotels Prepare Their Toiletries," *Crain's New York

Business* (October 19, 1998): 3, 79; John Holusha, "Despite Strong Business, Luxury Hotel Renovates," *New York Times* (November 25, 1998), B: 9; Charles Lockwood, "Defying Conventional Wisdom: The Renovation of the Peninsula Hotel," *Grid* 1 (Spring 1999): 21–22; Charles Lockwood, "Good Times for NYC's Hotels," *Urban Land* 59 (February 2000): 80–83, 90–91.

171. Landmarks Preservation Commission of the City of New York, LP-1552 (November 1, 1988).

172. "A Versace Rehab That's Fit for a Vanderbilt," *New York Times* (July 18, 1996), C: 3. For the Marble Twins, see Stern, Gilmartin, and Massengale, *New York 1900*, 332–33; Stern, Mellins, and Fishman, *New York 1960*, 392.

173. Nina Rappaport, "Restoration Rebounds," *Oculus* 60 (March 1998): 4; "Streets of Dreams," *Architectural Record* 168 (April 1998): 44; David W. Dunlap, "Cartier Spruces Up to Show Off Its Jewels in Style," *New York Times* (April 26, 2000), B: 10; Christopher Gray, "Streetscapes/52nd Street and Fifth Avenue," *New York Times* (January 28, 2001), XI: 7; Caitlin Kelly, "Fifth Avenue Jewel Duel," *Grid* 4 (January + February 2002): 66–67.

174. Alain Viot, quoted in Dunlap, "Cartier Spruces Up to Show Off Its Jewels in Style": 10.

175. David W. Dunlap, "50's Tower to Be Fitted for 90's Retail," *New York Times* (October 15, 1997), B: 6; "Architecture vs. Commerce: 666 Transit Gloria Mundi," *New York Times* (April 5, 1998), XIV: 7; David W. Dunlap, "Now, Landlord to Repair 2 Noguchi Sculptures," *New York Times* (July 29, 1998), B: 7; John Holusha, "Fifth Ave. Tower to Shift to Multilevel Retailing," *New York Times* (November 28, 1998), B: 11; John Holusha, "A Refurbished Tower Keeps Its Feel," *New York Times* (July 14, 1999), B: 7; "666 Fifth Avenue," *New York Construction News* 48 (June 2000): 38. For the Tishman Building, see Stern, Mellins, and Fishman, *New York 1960*, 377–78.

176. For the Alitalia ticket office, see Stern, Mellins, and Fishman, *New York 1960*, 383–84.

177. Isamu Noguchi, quoted in Dunlap, "50's Tower to Be Fitted for 90's Retail": 6.

178. Dan Hsu, quoted in Holusha, "Fifth Ave. Tower to Shift to Multilevel Retailing": 11.

179. Ylona Gault, "Basketball Takes a Shot at Retail Store in City," *Crain's New York Business* (June 30-July 6, 1997): 4; "Retail Store to Open at 666 5th Ave.," *New York Times* (November 16, 1997), XI: 1; Richard Wilner, "NBA to Score with New Store," *New York Post* (November 17, 1997): 30; Karrie Jacobs, "Hoopless Dreams: The NBA Store Plays Ralph Lauren's Game," *New York* 31 (October 5, 1998): 13; Holusha, "Fifth Ave. Tower to Shift to Multilevel Retailing": 11.

180. Jacobs, "Hoopless Dreams: The NBA Store Plays Ralph Lauren's Game": 13.

181. Mervyn Rothstein, "Not Just Button-Down: Brooks Bros. on Fifth," *New York Times* (August 12, 1998), B: 9; Holusha, "Fifth Ave. Tower to Shift to Multilevel Retailing": 11; "Brooks Brothers, Unbuttoned," *New York Times* (April 29, 1999), F: 3; Elena Frankel, "New Navy," *Interior Design* 71 (April 2000): 84–86.

182. John Holusha, "A Fifth Avenue Home for a Line of Men's Clothing," *New York Times* (April 11, 2001), B: 4.

183. "Top Projects of 1999: 666 Fifth Avenue," *New York Construction News* 48 (June 2000): 38; Stan Gellers, "Hickey-Freeman to Open Store on Fifth Avenue," *DNR* (November 29, 2000): 1; Stan Gellers, "The Reinvention of Hickey-Freeman," *DNR* (March 23, 2001): 12, 14; Holusha, "A Fifth Avenue Home for a Line of Men's Clothing": 4; Dixon, ed., *Robert A. M Stern: Buildings and Projects, 1999–2003*, 518–23, 585.

184. David W. Dunlap, "Citigroup Sign Replacing Those 3 Sixes at the Top," *New York Times* (January 3, 2002), B: 3.

185. Lisa W. Foderaro, "A Literary Tradition Disappears," *New York Times* (June 17, 1997), B: 1, 6; "The Endangered Bookshop," editorial, *New York Times* (June 19, 1997): 22.

186. Bruce Lambert, "In Memoriam: Closing the Book on Brentano's," *New York Times* (January 21, 1996), XIII: 6. For the Scribner Building, see Stern, Gilmartin, and Massengale, *New York 1900*, 200–201.

187. "Landmark 5th Ave. Building to Be Sold by Scribner's," *New York Times* (August 1, 1984), B: 2; "Rizzoli Acquires Bookstores of Scribner," *New York Times* (December 10, 1984), C: 15; Anthony DePalma, "Office Space Offered in Landmark Scribner Building," *New York Times* (February 13, 1985), B: 10.

188. Herbert Mitgang, "Scribner Book Store, 75, Will Close Next Month," *New York Times* (December 7, 1988), B: 1, 3; "Topics of The Times: Lost Literary Refuge," *New York Times* (December 13, 1988): 30; Brendan Gill, "Landmarkers Find Ally at Scribner Bookstore," letter to the editor, *New York Times* (December 16, 1988): 38; Mardges Bacon, "Scribner: Down to the Last Syllable," *New York Times* (January 18, 1989): 25; Richard David Story, "Good-bye to All That," *New York* 22 (January 23, 1989): 27; David W. Dunlap, "For Scribners, Bookstore Closing Is Put Off but Not for Long," *New York Times* (January 23, 1989), B: 3; David W. Dunlap, "Landmarks Unit Studies Scribner Store's Interior," *New York Times* (February 12, 1989): 54; Peter Slatin, "Saving Scribner's," *Metropolis* 8 (May 1989): 24–25; Landmarks Preservation Commission of the City of New York, LP-1698 (July 11, 1989); "Farewell Scribner's, Hello K-Mart," editorial, *New York Observer* (September 25, 1989): 4; Gilmartin, *Shaping the City*, 418; Diamonstein, *The Landmarks of New York III*, 419.

189. "New Yorkers & Co.," *New York Times* (July 14, 1996), XIII: 4; Christopher Gray, "Streetscapes/597 Fifth Avenue," *New York Times* (October 6, 1996), IX: 7; Tony Marcano, "Benetton Adds Books," *New York Times* (March 20, 1997), B: 8; Monica Geran, "Design by Detection," *Interior Design* 68 (September 1997): 218–20; "Return to Splendor: United Colors of Benetton Retail Outlet," *World Architecture* 59 (September 1997): 135; White and Willensky, *AIA Guide* (2000), 289.

190. Geran, "Design by Detection": 220.

191. "A Bit of Fifth Avenue History," *New York Times* (July 22, 1990), X: 1; "The New York That's Here to Stay," editorial, *New York Times* (July 24, 1990): 20; "Media Watch," *Oculus* 53 (September 1990): 5; Gill, "The Sky Line: 712 Fifth": 97. Also see Christopher Gray, "Streetscapes: 503 Fifth Avenue," *New York Times* (February 21, 1988), VIII: 13; Scott Marshall, "503 Fifth Avenue," letter to the editor, *New York Times* (March 27, 1988): 34.

192. "The New York That's Here to Stay": 20.

193. "Media Watch": 5.

194. "Projects," *Oculus* 57 (October 1992): 4.

195. John Holusha, "Office-Building Plans Come Off the Shelf," *New York Times* (October 7, 2001), XI: 1, 10; Peter Slatin, "Spec 'Landmark' for 42nd and Fifth," *Grid* 3 (November 2001): 27; Peter Slatin, "Macklowe's Madison Avenue Remake," *Grid* 4 (January 2002): 38. Also see Kimberley A. Strassel, "Plots & Ploys," *Wall Street Journal* (November 3, 1999), B: 16.Charles V. Bagli, "Office Tower Planned at Historic Corner," *New York Times* (January 13, 2000), B: 7.

196. Lois Weiss, "Between the Bricks," *New York Post* (March 31, 2004): 38; Edwin McDowell, "Offices Rising Across from Library's Lions," *New York Times* (April 21, 2004), C: 7.

197. See Stern, Gilmartin, and Massengale, *New York 1900*, 129–30.

198. "A Vision of Change for a Fifth Avenue Plaza," *New York Times* (March 27, 1985), B: 1; Joyce Purnick, "For a Historic Plaza, Pears and Limes?" *New York Times* (March 27, 1985), B: 5; Michael Gross, "Bergdorf's Party Toasts Pulitzer Fountain," *New York Times* (September 19, 1986): 26; David W. Dunlap, "Group Plans Overhaul of the Pulitzer Fountain," *New York Times* (October 24, 1988), B: 3; "10 Years Later, Grand Army Plaza Is to Reopen," *New York Times* (June 7, 1990), B: 1; "Restored Plaza Hailed (but Turn Down That General!)," *New York Times* (June 7, 1990), B: 2; Paul Goldberger, "A Restored Grand Army Plaza, with a New Coat for the General," *New York Times* (June 28, 1990), C: 13; "Firm Footing for Goddess," *New York Times* (November 8, 1996), B: 3; Christopher Gray, "Streetscapes/Grand Army Plaza," *New York Times* (July 18, 1999), XI: 7; White and Willensky, *AIA Guide* (2000), 300–301.

199. For the Sherry-Netherland Hotel, see Stern, Gilmartin, and Mellins *New York 1930*, 217–19.

200. Bernadine Morris, "Diane Von Furstenberg: Couture in a New Shop," *New York Times* (December 7, 1984) B: 20; "Michael Graves: Diane Von Furstenberg Boutique, New York," *Art and Design* 1 (March 1985): 46–49; "Michael Graves: Un Magasin de la Cinquième Avenue," *Connaissance des Arts* 399 (May 1985): 72–75; "Michael Graves: diane von Furstenberg Boutique, New York, New York, USA, 1984," *Architecture + Urbanism* (June 1985): 72–33; Karen D. Stein, "A Fitting Shrine," *Architectural Record* 173 (Mid-September 1985): 122–25; Wendy Staebler, "Michael Graves Derails Detailing Cliche of Diane von Furstenberg," *Interiors* 145 (June 1986): 50–51; *Michael Graves: Buildings and Projects 1982–1989* (Princeton, N.J.: Princeton University Press, 1990), 142–45.

201. Bernadine Morris, "In New Retail Shop, Beene Envisions a Laboratory of Fashion," *New York Times* (December 19, 1989): B: 11.

202. Shawn G. Kennedy, "Renovation of 5th Ave. Tower," *New York Times* (June 10, 1987), D: 24; Christopher Gray, "Streetscapes: The Old Squibb Building," *New York Times* (October 2, 1988), X: 12; "On the Boards," *Oculus* 53 (October 1990): 3–4; James S. Russell, "745 Fifth Avenue: New York City," *Architectural Record* 179 (March 1991): 158–59; White and Willensky, *AIA Guide* (2000), 299. For the Squibb Building, see Stern, Gilmartin, and Mellins, *New York 1930*, 200, 557–58, 563.

203. Ruth La Ferla, "A Star Is Born," *New York Times* (May 26, 1990), VI: 67–68. Also see "Shopping," *New York* 23 (September 10, 1990): 125–26; Edie Lee Cohen, "Bergdorf Goodmen Men," *Interior Design* 62 (January 1991): 110–15.

204. La Ferla, "A Star Is Born": 67.

205. James Nakaoka, quoted in La Ferla, "A Star Is Born": 67.

206. For the Plaza Hotel, see Stern, Gilmartin, and Massengale, *New York 1900*, 252, 257, 261–62.

207. See Stern, Mellins, and Fishman, *New York 1960*, 1123–25.

208. Glenn Fowler, "Planners O.K. Film House at Plaza Hotel," *New York Times* (May 14, 1976), D: 23; Jennifer Dunning, "The Nicest Place to See a Movie?" *New York Times* (January 12, 1977): 59; Paul Goldberger, "Inglorious Urban Entries," *New York Times* (March 24, 1977), C: 14; Vincent Canby, "When Movie Theaters and Patrons Are Obnoxious," *New York Times* (February 7, 1982): D: 19, 24.

209. Goldberger, "Inglorious Urban Entries": 14.

210. Nancy Winters, "35 Great New York Hotels," *New York* 27 (July 3, 1979): 41–46; Daniel F. Cuff, "The Plaza Hotel: A Moneymaking Fairyland," *New York Times* (December 30, 1979), F: 1, 5; Paul Goldberger, "At 75, Plaza Hotel Seeks to Remain Forever Old," *New York Times* (September 21, 1982), B: 1–2; Fred Ferretti, "At Plaza and Met, Echoes of the Past," *New York Times* (October 2, 1982): 15.

211. Lee Harris Pomeroy, quoted in Ginger Danto, "Home Suite Home of Eloise, Gatsby, May Be Sold to Trump," *New York Observer* (March 28, 1988): 6.

212. Lisa W. Foderaro, "Plaza Hotel May Be Sold for Co-Ops," *New York Times* (February 27, 1988): 33.

213. Donald J. Trump, quoted in Robert J. Cole, "Plaza Hotel Is Sold to Donald Trump for $390 Million" (March 27, 1988): 1, 33. Also see Danto, "Home Suite Home of Eloise, Gatsby, May Be Sold to Trump": 6; "What's News–Business and Finance," *Wall Street Journal* (March 28, 1988): 1; Roger Lowenstein, "Trump to Pay $410 Million for Plaza: Developer Vows to Restore Hotel's Luster," *Wall Street Journal* (March 28, 1988): 4; "All the Dresses She Can Buy," edi-

torial, *New York Times* (March 29, 1988): 26; Betty Aldrich, "Plaza Won't Be the Plaza Without Eloise," letter to the editor, *New York Times* (April 14, 1988): 34; Florence Berkman, "Thought for Trump," letter to the editor, *New York Post* (August 30, 1988): 22; Donald J. Trump, "Why I Bought the Plaza," advertisement, *New York* 21 (September 12, 1988): 27; "This Could Be the Bid Crown Jewel," *New York Daily News* (September 13, 1988): 6; Jean Elson Nathan, "Evictions Begin Trumps' Reign at Plaza Hotel," *New York Observer* (September 19, 1988): 1, 7; William H. Meyers, "Stalking the Plaza," *New York Times* (September 25, 1988), VI: 20–23, 62, 64, 66; David W. Dunlap, "Trumps Plan to Revamp the Plaza in a Big Way," *New York Times* (December 20, 1988), B: 3; Carter B. Horsley, "Donald's Wish List for Rehab at Plaza," *New York Post* (December 22, 1988): 57, 60; Carol Vogel, "The Plaza Suite," *New York Times* (January 15, 1989), VI: 50–52, 66; Paul Goldberger, "A Spot of Paint Won't Hurt This Lily," *New York Times* (January 22, 1989), II: 28, 33; "Trump to Close a 'Tacky' Trader Vic's," *New York Times* (January 25, 1989), B: 1–2; Halina Rosenthal, "Not Amusing," letter to the editor, *New York Observer* (February 6, 1989): 4; Timothy K. Smith, "Plan for Returning the Plaza to Glory: Remove the Canoes," *Wall Street Journal* (February 7, 1989): 1, 16; "Up-to-Date Old-Fashioned Stylishness," *Architectural Record* 177 (March 1989): 45; "Alarms and Diversions: A Very Modern Restoration," *On the Avenue* (March 4, 1989): 3; "Grand Dames," *Interior Design* 60 (April 1989): 46; Carter B. Horsley, "Trump Gets Green Light on Plaza's Renovations," *New York Post* (May 11, 1989): 48; "Plaza Hotel, HHPA," *Oculus* 52 (October 1989): 5; Donald J. Trump with Charles Leerhsen, *Trump: Surviving at the Top* (New York: Random House, 1990), 74–75, 79–80, 110–31; Hugh Hardy, "'What Time Is It?'" *Oz* 12 (1990): 30–35; Richard D. Hylton, "Trump Aims to Turn Most of Plaza Hotel into Condominiums," *New York Times* (April 9, 1991): 1, D: 18; James Barron, "Imagining the Plaza as Condos," *New York Times* (April 10, 1991), B: 3; "Plaza Condos," editorial, *New York Observer* (April 22, 1991): 4; Jeannette Walls, "Le Club May Get a Plaza Suite," *New York* 24 (October 21, 1991): 17; Richard D. Hylton, "Trump's Bank Talks May Trim Plaza Stake," *New York Times* (November 15, 1991), D: 6; *Hardy Holzman Pfeiffer Associates: Buildings and Projects, 1967–1992*, 269; Richard D. Hylton, "Debt Deal for Trump on Plaza," *New York Times* (March 19, 1992), D: 1, 8; Charlotte Hays, "Trump Creditors: Sell the Plaza Hotel," *New York Observer* 7 (January 25, 1993): 1, 3; "Home Alone Too: Pampered at the Plaza," *New York Times* (December 26, 1993): 36; Saul Hansell, "Banks Consider Offer to Buy Trump's Plaza Hotel," *New York Times* (February 10, 1994): 33; Enid Nemy, "Where the Room Is the View," *New York Times* (September 22, 1994), C: 4; Trump with Bohner, *Trump: The Art of the Comeback*, 206, 232–33; Beth Landman Keil and Deborah Mitchell, "Donald's Suite; Debbie's Treat," *New York* 31 (January 5, 1998): 13; White and Willensky, *AIA Guide* (2000), 300; John Hyland, "Oak Bar's Murals Are All Spruced Up," *New York Times* (May 30, 2001), F: 5.

214. Donald J. Trump, quote in Cole, "Plaza Hotel Is Sold to Donald Trump for $390 Million": 1.

215. Donald J. Trump, quoted in Cole, "Plaza Hotel Is Sold to Donald Trump for $390 Million": 1.

216. Goldberger, "A Spot of Paint Won't Hurt This Lily": 33.

217. For the Frank Lloyd Wright suite, see Stern, Mellins, and Fishman, *New York 1960*, 1124.

218. David Stout with Kenneth N. Gilpin, "Trump Is Selling the Plaza Hotel to Saudi and Asian Investors," *New York Times* (April 12, 1995): 1, D: 6; Claudia H. Deutsch, "Buyer of Major Hotels Remains a Bit of a Mystery," *New York Times* (August 20, 1995), IX: 11.

219. Mervyn Rothstein, "Plaza May Brighten Up Stately Edwardian Room," *New York Times* (November 5, 1997), B: 13; William Grimes, "Tihany Dresses a Dowager," *New York Times* (November 8, 2000), F: 10; Steve Cuozzo, "Plaza Pastiche: Send an S.O.S. for C.P.S.," *New York Post* (November 29, 2000): 53.

220. Grimes, "Tihany Dresses a Dowager": 10.

221. Peter Slatin, "GM Building on the Block," *New York Post* (February 6, 1998): 31; Jim Yardley, "Trump Buying the Landmark G. M. Building," *New York Times* (May 31, 1998): 25, 27; Peter Slatin, "Vroom at the Top? Trump Eyes GM Condos," *New York Post* (June 1, 1998): 3; David W. Dunlap, "Courtyard Is Rising with New Look," *New York Times* (June 30, 1999), B: 6; Albert LaFarge, "G.M. Plaza Changes," letter to the editor, *New York Times* (July 3, 1999): 10; Christopher Gray, "Streetscapes/Grand Army Plaza," *New York Times* (July 18, 1999), XI: 7; Paul Goldberger, "Master Builders," *New Yorker* 75 (August 16, 1999): 25; John Tierney, "Towering Case of Trump Writ Large," *New York Times* (October 18, 1999), B: 1; "All Donald, All the Time," *Grid* 1 (Winter 1999): 23; David W. Dunlap, "Condo Offering at the G.M. Building," *New York Times* (December 1, 1999), B: 14; Kayden, *Privately Owned Public Space*, 183–84; White and Willensky, *AIA Guide* (2000), 300; David W. Dunlap, "Breathing Life into the City's Barren Plazas," *New York Times* (July 16, 2000), XI: 1, 6; "Trump/Conseco/GM Building," *Grid* 2 (November + December 2000): 2. Also see Michael Reis, "Expressing Trump Style in Marble and Brass," www.stoneworld.com. For the General Motors Building, see Stern, Mellins, and Fishman, *New York 1960*, 508–12, 1123.

222. Goldberger, "Master Builders": 25.

223. Clyde Haberman and Laurie Johnston, "A Shelter on the Park?" *New York Times* (August 7, 1982): 29; Richard Haitch, "Follow Up on the News: Shelter Game," *New York Times* (May 29, 1983): 37; Sydney H. Schanberg, "Trump for Mayor," *New York Times* (June 4, 1983): 23; Ron Suskind, "Trump Eviction Dispute Taken to State Hearing," *New York Times* (February 28, 1985), B: 4; Sydney H. Schanberg, "Doer and Slumlord Both," *New York Times* (March 9, 1985): 23; George

James, "Trump Drops 5-Year Effort to Evict Tenants," *New York Times* (March 5, 1986), B: 2; Lisa W. Foderaro, "New Trump Plan: Make 2 Buildings Look Like 1," *New York Times* (October 17, 1986): 30; Trump with Schwartz, *Trump: The Art of the Deal*, 27–29, 165–80; "Barbizon Hotel Sold to Developers," *New York Times* (August 31, 1988), B: 5; Metzger, *Der Scutt Retrospective*, 42; Michael J. Crosbie, *The Architecture of Frank Williams* (Rockport, Mass.: Rockport Publishers, 1997), 146–49. For the Barbizon Plaza Hotel, see Stern, Gilmartin, and Mellins, *New York 1930*, 222. For 100 Central Park South, see "No. 124, n. 100, Central Park South, New York City," *Architectural Record* 51 (March 1922): 267–68.

224. Trump with Schwartz, *Trump: The Art of the Deal*, 176.

225. Susan Heller Anderson and David W. Dunlap, "Trump Buys the St. Moritz," *New York Times* (January 9, 1985), B: 4. For the St. Moritz Hotel, see W. Parker Chase, *New York: The Wonder City* (New York: Wonder City Publishing; New York: New York Bound, 1983), 141; Stern, Gilmartin, and Mellins, *New York 1930*, 194, 221.

226. James Barron, "Trump to Sell the St. Moritz at Big Profit," *New York Times* (October 18, 1988), B: 1, 5; "City News Digest," *New York Observer* (October 24, 1988): 6; Peg Tyre and Jeannette Walls, "St. Moritz Owner Checking Out?" *New York* 22 (April 10, 1989): 21; Trump with Leerhsen, *Trump: Surviving at the Top*, 200–203.

227. Quoted in "St. Moritz Owner Checking Out?": 21.

228. Robert D. McFadden, "Plan Calls for Trump to Turn St. Moritz Hotel into Condos," *New York Times* (January 17, 1997): 1, B: 4.

229. McFadden, "Plan Calls for Trump to Turn St. Moritz Hotel into Condos": 1, B: 4; Helen Kennedy, "St. Moritz Could Be Trumped by Condos," *New York Daily News* (January 17, 1997): 28; Anthony Ramirez, "Board Would Trump Trump with a Historic District," *New York Times* (February 23, 1997), XIII: 6; Trump with Bohner, *Trump: The Art of the Comeback*, 232; Michael Gotkin, "Central Park South: The Evolution of a Historic District," *District Lines: News and Views of the Historic Districts Council* (Summer 1997): 1, 4–5; Peter Morris Dixon, ed., *Robert A. M. Stern: Buildings and Projects, 1993–1998* (New York: Monacelli Press, 1998), 358–59; "Stern Gets Trumped at the St. Moritz," *New York* 30 (February 23, 1998): 18; Herbert Muschamp, "Public Space, Private Space and Anti-Space," *New York Times* (December 29, 1998), II: 38; Deborah S. Gardner et al., "The St. Moritz," letter to the editor, *New York Times* (January 10, 1999), II: 4.

230. Jennifer Raab, quoted in Tracie Rozhon, "Out with the Old, In with the Old-Fashioned," *New York Times* (April 20, 1998), B: 1, 4.

231. Muschamp, "Public Space, Private Space, and Anti-Space": 38.

232. Jennifer Raab, quoted in "Stern Gets Trumped at the St. Moritz": 18.

233. Rozhon, "Out with the Old, In with the Old-Fashioned": 1, 4; Muschamp, "Public Space, Private Space and Anti-Space": 38; Gardner et al., "The St. Moritz": 4.

234. Tracie Rozhon, "Schrager Plucks St. Moritz Hotel from Trump's Grasp," *New York Times* (May 1, 1998), B: 3; Devin Leonard and Carl Swanson, "How the Hip Hotelier Beat the Trump Hype in the St. Moritz Deal," *New York Observer* (May 18, 1998): 1, 24; Charles V. Bagli, "A Hotelier for Jaded Boomers," *New York Times* (July 19, 1998), III: 1, 9; "St. Moritz Picks Up the Mantle," *New York* 30 (November 23, 1998): 11–12.

235. "Plans Are Completed to Redo St. Moritz," *New York Times* (June 10, 1999), B: 10; Charles V. Bagli, "Buyer Plans for St. Moritz to Be Ritz-Carlton Flagship," *New York Times* (November 8, 1999), B: 5; "Ritzy Digs," *Oculus* 64 (April 2002): 6–7.

ROCKEFELLER CENTER

1. Paul Goldberger, "Rockefeller Center Design: A Triumph for 30's and 70's," *New York Times* (July 14, 1976): 39, 47.

2. Paul Goldberger, "Rockefeller Center at 50: A Model of Urban Design," *New York Times* (June 17, 1982), B: 1, 8; Frank J. Prial, "22 Acres of Real Estate That Generate Millions," *New York Times* (June 17, 1982), B: 8; Deirdre Carmody and Clyde Haberman, "Rejuvenating Prometheus," *New York Times* (September 29, 1982), B: 2; Paula Dietz, "Design Notebook," *New York Times* (December 16, 1982), C: 10.

3. Kathleen Teltsch, "2 Works to Rejoin Prometheus After 50 Years," *New York Times* (April 8, 1984): 1, 41. For the gardens, see "Roof-Garden Restorations," *New York Times* (June 29, 1986), VIII: 1; Susan Doubilet, "Rock's Gardens Restored," *Progressive Architecture* 68 (November 1987): 27.

4. G. Bruce Knecht, "New Money for the New Rockefellers," *New York Times* (January 9, 1983): 1, 28.

5. David W. Dunlap, "Rockefeller Center: A 'Jewel' but Is All of It a Landmark?" *New York Times* (September 21, 1983), B: 1, 4; "Chapter Reports," *Oculus* 45 (October 1983): 11; Peter Freiberg, "Rockefeller Center Opposes Landmarking," *Metropolis* 3 (November 1983): 8.

6. Landmarks Preservation Commission of the City of New York, LP-1446 (April 23, 1985); Michael Oreskes, "On 20th Anniversary, Landmarks Panel Is Strong but Controversial Force in City," *New York Times* (April 24, 1985), B: 1, 8; Barbaralee Diamonstein, *The Landmarks of New York III* (New York: Harry N. Abrams, 1998), 368–70. For the Columbia sale, see Maureen Dowd, "Columbia Is to Get $400 Million in Rockefeller Center Land Sale," *New York Times* (February 6, 1985): 1, B: 2; "Rockefeller Center's Land Sold for $400 Million," *Corporate Design & Realty* 4 (April 1985): 9.

7. "New Landmark Status for Rockefeller Center," *New York Times* (September 27, 1988), B: 2; "Rockefeller Center Is Designated National Landmark," *Better Buildings* 8 (January 1989): 6, 8.

8. Susan Heller Anderson and David W. Dunlap, "A Shower of White Light for the RCA Building," *New York Times*

(November 23, 1984), B: 3; Paul Goldberger, "A Snowflake Weighs Heavily on Fifth Avenue," *New York Times* (December 13, 1984), C: 19; "Coming Attractions," *New York Times* (November 27, 1986), B: 1; Victoria Geibel, "Up in Lights," *Metropolis* 7 (July/August 1987): 25; Jerry Talmer, "Bringing the Fire to Prometheus," *New York Post* (October 20, 1988): 36; Wanda Jankowski, "Water Colors," *Architectural Lighting* 3 (November 1989): 26–31; "Rockefeller Center," *Architectural Record Lighting* (May 1992): 19.

9. Fred Ferretti, "Rockefeller Center Celebrates a New Look," *New York Times* (May 22, 1984), C: 10; Mildred F. Schmertz, "Prometheus Rebounded," *Architectural Record* 174 (September 1986): 126–31; *John Portman and Associates: Selected and Current Works* (Mulgrave, Australia: Images Publishing, 2002), 208–9.

10. Andrea Truppin, "Pure Theater: 25 Years After Its Likely Beginning, Hardy Holzman Pfeiffer Continues to Broaden the Designer's Role," *Interiors* 146 (July 1987): 161–79, 201; John A. Conway, "David Rockefeller Builds His Dream Club in the Sky," *Manhattan, inc.* 4 (December 1987): 57–65; Steven Ruttenbaum, "The Rainbow Room Reopens," *Metropolis* 7 (December 1987): 24; Paul Goldberger, "The New Rainbow Room: S'Wonderful!" *New York Times* (December 20, 1987), II: 40; Susan Strauss, "The Rainbow Room: Inventing Breathtaking Panoramas," *New York Observer* (December 28, 1987-January 4, 1988): 7; "A Starry Room with a View," *Newsweek* 111 (January 11, 1988): 55; Gael Greene, "Over the Rainbow: The Renaissance of a New York Classic," *New York* 21 (February 8, 1988): 38–45; Bryan Miller, "Restaurants/The Rainbow Room," *New York Times* (March 25, 1988), C: 26; Douglas Brenner, "Change Partners and Dance," *Architectural Record* 176 (June 1988): 110–21; Sandy Heck, "The Only Possible Word Is 'Swank,'" *Architecture* 77 (June 1988): 54–61, 140; Edie Lee Cohen, "Rainbow," *Interior Design* 59 (June 1988): 240–51; Ruth Reichl, "Heaven's Plate," *Metropolitan Home* 20 (June 1988): 91–99; Sandy Heck, "The Rainbow Room," *Architecture + Urbanism* (December 1988): 47–64; Carter B. Horsley, "The Good, the Bad & the Ugly," *New York Post* (December 29, 1988): 53, 57; *Hardy Holzman Pfeiffer Associates: Buildings and Projects, 1967–1992* (New York: Rizzoli International Publications, 1992), 15–16, 160–67; Beverly Russell, "Golden Oldie," *Interiors* 151 (September 1992): 62–65.

11. Hugh Hardy, quoted in Mildred F. Schmertz, "Interview," in *Hardy Holzman Pfeiffer Associates: Buildings and Projects, 1967–1992*, 15.

12. Goldberger, "The New Rainbow Room: S'Wonderful!": 40.

13. Steven E. Prokesch, "Realty Trusts in a Comeback," *New York Times* (August 7, 1985), D: 6; Richard W. Stevenson, "New Rockefeller Center Offer," *New York Times* (September 10, 1985), IV: 8; "Rockefeller's Family Heirloom Offered to the Masses," *Corporate Design & Realty* 4 (November 1985): 9; "NBC Peacock Secures Nest," *New York Post* (December 22, 1988): 56; Robert J. Cole, "Japanese Buy New York Cachet with Deal for Rockefeller Center," *New York Times* (October 31, 1989): 1, D: 6; James Sterngold, "Mitsubishi Estate a Force in Japanese Real Estate," *New York Times* (October 31, 1989), D: 7; Steven R. Weisman, "Japanese Are Concerned About Rockefeller Deal," *New York Times* (November 1, 1989), IV: 7; James Sterngold, "Many Japanese Wary on Mitsubishi U.S. Deal," *New York Times* (November 1, 1989), D: 1, 7; "Japan Buys the Center of New York," editorial, *New York Times* (November 3, 1989): 34; Russell Baker, "Scrap Iron and Rockettes," *New York Times* (November 4, 1989): 25; Robert J. Cole, "Behind Rockefeller Center's Allure," *New York Times* (November 10, 1989), D: 1, 3; Carolyn Friday and Joshua Hammer, "'Now They're Just Rich,'" *Newsweek* 114 (November 13, 1989): 62–63; John Greenwald, "Sure, We'll Take Manhattan," *Time* 134 (November 13, 1989): 83; "Pencil Points," *Progressive Architecture* 70 (December 1989): 20; Felicia Lamport, "Japanoply," *New York Times* (December 25, 1989): 31; Nancy Marx Better and Peter M. Stevenson, "How the Rockefellers Sold Their Name," *Manhattan, inc.* 7 (January 1990): 49–59; Jeanne B. Pinder, "Rockefeller Center with Clay Feet," *New York Times* (June 17, 1993), D: 1, 5; Claudia H. Deutsch, "Surmounting the Hump of Lease Expirations," *New York Times* (December 13, 1993), X: 13; "Mitsubishi Disputes Report on Rockefeller Group," *New York Times* (February 15, 1994), D: 3; Saul Hansell, "Rockefeller Center May Face Mortgage Default," *New York Times* (November 16, 1994), D: 1-2; Saul Hansell, "Loan Arranged at Rockefeller Center," *New York Times* (November 18, 1994), D: 7; Saul Hansell, "How the Japanese Could Lose Rockefeller Center," *New York Times* (November 27, 1994), III: 4; "Rockefeller-Goldman Deal," *New York Times* (December 20, 1994), D: 5; Saul Hansell, "For the Rockefellers, a Deal Falls Short Only by Inches," *New York Times* (May 12, 1995), D: 4; Stephanie Strom, "Rockefeller Center Forced to File for Bankruptcy by Tokyo Owner," *New York Times* (May 12, 1995): 1, D: 4; David Stout, "A Deal Brought Cachet, but Cash Is Another Matter," *New York Times* (May 12, 1995), D: 4; Stephanie Strom, "Shift Blocked in Rockefeller Center Stake," *New York Times* (June 9, 1995), D: 3; Stephanie Strom, "Bankruptcy Judge Blocks Move on Rockefeller Center," *New York Times* (June 10, 1995): 46; Stephanie Strom, "A Rockefeller Center Infusion of $250 Million," *New York Times* (August 17, 1995), D: 1; Stephanie Strom, "A Rival Offer for a Chunk of Rockefeller Center," *New York Times* (August 18, 1995), D: 1-2; Stephanie Strom, "Getting Around Goldman at Rockefeller Center," *New York Times* (August 24, 1995), D: 5; Stephanie Strom, "Japanese Scrap $2 Billion Stake in Rockefeller Center," *New York Times* (September 12, 1995): 1, D: 6; Stephanie Strom, "Lines Redrawn in Rockefeller Center Battle," *New York Times* (September 13, 1995), D: 1, 4; Steven R. Weisman, "Mr. Rockefeller Regrets," editorial, *New York Times* (September 14, 1995): 26; David Rockefeller, "Rockefellers Tried in Good Faith to Save

Rockefeller Center," letter to the editor, *New York Times* (September 21, 1995): 22; Charles V. Bagli, "In Rockefeller Mess, Shareholders Plan a Possible Revolt," *New York Observer* (September 25, 1995): 1, 22; Stephanie Strom, "Fight for Rockefeller Center Joined by David Rockefeller," *New York Times* (October 2, 1995), D: 2; Stephanie Strom, "David Rockefeller Leaving Center's Board After His Bid," *New York Times* (October 3, 1995), D: 10; Stephanie Strom, "How to Run a Safe Bet," *New York Times* (October 5, 1995), D: 1, 11; Stephanie Strom, "In Bidding for Center, Is Board Too Close to Rockefeller?" *New York Times* (November 3, 1995), D: 1; Stephanie Strom, "Goldman, Sachs Group Strikes Deal for Rockefeller Center," *New York Times* (November 8, 1995), D: 1, 3; Christopher Byron, "David Rockefeller Grabs After Mitsubishi Millions," *New York Observer* (November 6, 1995): 1, 20; "A Deal for Rockefeller Center," *New York Times* (November 13, 1995), III: 2; Peter Grant, "Rock's Buyers Eye New Profit Center," *New York Daily News* (March 25, 1996): 38; "G.E. Seen in Talks to Purchase Space in Rockefeller Center," *New York Times* (April 30, 1996), D: 4; Claudia H. Deutsch, "NBC Will Buy Rockefeller Center Space," *New York Times* (May 4, 1996): 33, 45; "Rockefeller Center Plan," *New York Times* (May 30, 1996): D: 8; David Rockefeller, *Memoirs* (New York: Random House, 2002), 463–80.

14. Dennis Hevesi, "30 Rock? RCA? NBC? No, G.E.!" *New York Times* (July 14, 1988), B: 1; Tama Janowitz, "Formerly the RCA Building," *New York Times* (July 15, 1988): 31; "Good Things to Life," editorial, *New York Observer* (August 8, 1988): 4; Robert S. Keefe, "RCA Building It Is, Was and Always Will Be," letter to the editor, *New York Times* (August 10, 1988): 26; Peg Tyre and Jeannette Walls, "NBC Workers to GE: 'Your Name Is Mud,'" *New York* 21 (August 22, 1988): 15; S. Wynn, "Save RCA Building," letter to the editor, *New York Post* (August 28, 1988): 20. For the RCA Victor Building, see Stern, Gilmartin, and Mellins, *New York 1930*, 595, 599.

15. "Award for Excellence in Design: Renovation of the 1270 Avenue of the Americas Lobby at Rockefeller Center," *New York State Association of Architects* (1991).

16. Peter D. Slatin, "Rockefeller Center, Heery International," *Architectural Record* 180 (May 1992): 48.

17. Peter Slatin, "The Gentle Touch," *World Architecture* 52 (December 1996-January 1997): 70–71; Mitchell Pacelle, "Lighting Up a Landmark," *Wall Street Journal* (December 20, 1996), B: 16; John Holusha, "Hard-Pressed a Year Ago, It's Bouncing Back," *New York Times* (July 27, 1997), IX: 7; Peter Slatin, "Rock Center Owners Get Design Mouse-cle," *New York Post* (August 11, 1997): 24; "A Manhattan Makeover: Can New Owners Make Rock Center Sexy Again?" *New York Observer* (December 1, 1997): 1, 29; Rockefeller, *Memoirs*, 479–81.

18. Charles V. Bagli, "Growing, Christie's Plans a Move to a Space in Rockefeller Center," *New York Times* (January 24, 1997): 1, B: 5; "Christie's Eying Rockefeller Center," *Art in America* 85 (March 1997): 29–30; Carol Vogel, "Rockefeller Center Lease Is Signed by Christie's," *New York Times* (March 25, 1997), C: 11, 15; Carol Vogel, "Companions for Prometheus," *Art* (April 17, 1998), E: 36; Jeffrey Hogrefe, "Christie's Double-Books Space Meant for LeWitt Mural," *New York Observer* (November 2, 1998): 30; Carol Vogel, "Sol LeWitt Throws Curves into a Bastion of the 30's," *New York Times* (April 22, 1999), E: 1, 3; Noreen O'Leary, "Deal for the Art," *Metropolis* 1 (Summer 1999): 94–96.

19. David W. Dunlap, "Rockefeller Center Seeks City Approval for Flashier Facades," *New York Times* (May 2, 1998), B: 1-2; David W. Dunlap, "Preservationists Criticize Rockefeller Center Renovation Plan," *New York Times* (May 6, 1998), B: 4; David S. Morton and Douglas Newton, "Rockefeller Center Is Class, Not Flash," letters to the editor, *New York Times* (May 9, 1998): 10; Nina Rappaport, "Front Page News," *Oculus* 60 (June 1998): 4; Glenn Collins, "Flashy Plans for a Famous Address," *New York Times* (June 7, 1998): 25, 31; Edward Bleier, "Updating a Landmark," letter to the editor, *New York Times* (June 12, 1998): 20; "At the Landmarks Commission on May 5," *New York Landmarks Conservancy Newsletter* (Summer 1998): 12; David W. Chen, "Concerns on Rockefeller Center Plans," *New York Times* (July 1, 1998), B: 3; Roberta Brandes Gratz, "Don't Deface This N.Y. Landmark," *New York Daily News* (July 2, 1998): 43; "The Rockefeller Center Wars," editorial, *New York Post* (July 2, 1998): 36; Ronald J. Kopnicki, "Building Wars," letter to the editor, *New York Post* (July 7, 1998): 26; Jennifer Raab and Kimberly Stahlman Kearns, "Rocky Landmark Conversions?" letters to the editor, *New York Post* (July 23, 1998): 32; "Rockefeller Center: The Proposed Alterations," *Village Views* 8 (August 1998): 1–48; Monte Williams, "Rockefeller Center Plans Approved," *New York Times* (September 16, 1998), B: 3; "Rockefeller Center: The Decision," *Village Views* 8 (April 1999): 1–48; Glenn Collins, "Bringing Up the Basement," *New York Times* (February 21, 1999), XIV: 1, 10; Christopher Gray, "Streetscapes/Rockefeller Center," *New York Times* (February 28, 1999), X: 7; Monica Geran, "Deco Echo," *Interior Design* 70 (September 1999): S58–59, 70.

20. "Foreword: Pioneers of Alteration," *Village Views* 8 (August 1998): 3. For the battles over Pennsylvania Station and Grand Central, see Stern, Mellins, and Fishman, *New York 1960*, 1113–20, 1138–43.

21. Charles Platt, quoted in Dunlap, "Preservationists Criticize Rockefeller Center Renovation Plan": 4.

22. Roger Lang, quoted in Dunlap, "Preservationists Criticize Rockefeller Center Renovation Plan": 4.

23. Jennifer Raab, quoted in Chen, "Concerns on Rockefeller Center Plans": 3.

24. Jerry Speyer, quoted in Collins, "Bringing Up the Basement": 1.

25. For the Walker Group's unrealized plan, see "Rockefeller Center Concourse Redesign," *Progressive Architecture* 59 (December 1978): 22- 23; "Rockefeller Center Shopping Concourse Will Undergo $2-Million Revitalization,"

Architectural Record 165 (January 1979): 35.

26. "Dimming the Lights," *New York Times* (October 19, 1999), B: 1; David W. Dunlap, "Rockefeller Center Quietly Closes Theater," *New York Times* (October 19, 1999), B: 5. For the Newsreel Theater, see Stern, Gilmartin, and Mellins, *New York 1930*, 666.

27. For the Time & Life Building and the XYZ towers, see Stern, Mellins, and Fishman, *New York 1960*, 397–403, 410–15.

28. Stern, Gilmartin, and Mellins, *New York 1930*, 652–57; Stern, Mellins, and Fishman, *New York 1960*, 328, 1127.

29. Paul Goldberger, "45 Years of Pageantry, Magic and Obsolescence," *New York Times* (January 6, 1978), B: 1; Gregory Jaynes, "'No Hope' Seen for Music Hall to Stay Open," *New York Times* (January 6, 1978): 1, B: 1; Lesley Oelsner, "Efforts to Save Music Hall Started," *New York Times* (January 7, 1978): 1, 34; Pranay Gupte, "Panel Suggests 'Rescue' Plans for Radio City," *New York Times* (January 9, 1978): 1, 28; "Hold That Sunset at Radio City," editorial, *New York Times* (January 10, 1978): 32; "Radio City Signals a Goodbye," *Progressive Architecture* 59 (February 1978): 24; Murray Schumach, "Ideas for Music Hall Weighed, Dismissed," *New York Times* (March 6, 1978), C: 18; Joan K. Davidson, "How to Save Radio City Music Hall," letter to the editor, *New York Times* (March 11, 1978): 22; "Radio City Debated by Landmarks Unit," *New York Times* (March 15, 1978), B: 3; Ada Louise Huxtable, "Is It Curtains for the Music Hall?" *New York Times* (March 19, 1978), II: 1, 31; "Now the Music Hall Drama Begins," editorial, *New York Times* (March 19, 1978), IV: 22; "Wreckers' Ball Threatens Hall," *New York* 11 (March 20, 1978): 11; Edwin McDowell, "Interior of Music Hall Designated as Landmark Despite Objections," *New York Times* (March 29, 1978), B: 3; "Radio City Show for Handicapped," *Progressive Architecture* 59 (April 1978): 40, 42; Fred Ferretti, "Agreement Reached on Radio City Tower," *New York Times* (April 7, 1978): 1, 12; Robert McG. Thomas Jr., "Agreement on Radio City Is Denied," *New York Times* (April 11, 1978): 32; Fred Ferretti, "State's Plan to Save Music Hall Reportedly Wins City's Backing," *New York Times* (April 12, 1978), B: 12; "Agreement with U.D.C. Keeps Music Hall Open Indefinitely," *New York Times* (April 13, 1978), B: 4; "Kick On, Rockettes," editorial, *New York Times* (April 14, 1978): 26; Robert D. McFadden, "Rescue Strategy for the Music Hall Involves Many 'Ifs' over 16 Years," *New York Times* (April 14, 1978), B: 4; "Atlanta's Efforts Save '29 Moorish Movie Palace," *Journal of the American Institute of Architects* 67 (May 1978): 10, 17; Pamela G. Hollie, "Center Seeks Permit to Demolish Radio City If Rescue Plans Fail," *New York Times* (May 5, 1978), B: 4; "Financial Outlook Better for Radio City Music Hall," *New York Times* (June 25, 1978): 34; "Music Hall a Landmark," *New York Times* (June 30, 1978), B: 3; Nory Miller, "Keep It Kicking," *Journal of the American Institute of Architects* 67 (September 1978): 70–75; "Music Hall's Prospects Not Certain Past April," *New York Times* (November 17, 1978), C: 10; Joseph P. Fried, "3 Plans Weighed by State to Keep Music Hall Open," *New York Times* (December 26, 1978), B: 10; Carter B. Horsley, "Radio City Tower Urged," *New York Times* (February 11, 1979), VIII: 1, 6; Joseph P. Fried, "Radio City Hall Is to Stay Open Under New Plan," *New York Times* (February 28, 1979), B: 1, 5; "Coming to the Music Hall's Rescue," editorial, *New York Times* (March 6, 1979): 16; Ada Louise Huxtable, "Update on the Music Hall," *New York Times* (April 19, 1979), II: 33, 36; Richard F. Shepard, "Music Hall to Be Restored, New Show Format Set," *New York Times* (April 19, 1979), C: 17; Eleni Constantine, "Development Over or Without Hall," *Progressive Architecture* 60 (May 1979): 19–20; Fred Ferretti, "Music Hall Rehearsing for Rebirth," *New York Times* (May 23, 1979), C: 21; Paul Goldberger, "Music Hall Arches: Theater Incarnate," *New York Times* (June 1, 1979), C: 6; Richard F. Shepard, "New Look but Old Style on Music Hall Stage," *New York Times* (June 1, 1979), C: 1, 6; "To Save a Landmark: A Bold Proposal with Even Bolder Implications," *Architectural Record* 167 (January 1980): 121–24; Ysrael A. Seinuk, letter to the editor, *Architectural Record* 167 (May 1980): 4; "Tower over the Hall," *Architectural Review* 168 (July 1980): 68–69.

30. Vincent D. McDonnell, quoted in Gupte, "Panel Suggests 'Rescue' Plans for Radio City": 28.

31. "Hold That Sunset at Radio City": 32.

32. Alton G. Marshall, quoted in "Radio City Debated by Landmarks Unit": 3.

33. Huxtable, "Is It Curtains for the Music Hall?": 31.

34. Stern, Mellins, and Fishman, *New York 1960*, 1127.

35. Huxtable, "Is It Curtains for the Music Hall?": 31.

36. Huxtable, "Is It Curtains for the Music Hall?": 31.

37. For the Associated Press and RKO Buildings, see Stern, Gilmartin, and Mellins, *New York 1930*, 639, 647, 666, 670–71.

38. Paul Goldberger, "A Landmark Showdown," *New York Times* (April 14, 1997), C: 11–12; Thomas J. Lueck, "Lease of Radio City Music Hall Keeps Rockettes Kicking," *New York Times* (December 4, 1997), B: 10; Glenn Collins, "Radio City's Luster to Be Renewed in $30 Million Project," *New York Times* (June 15, 1998), B: 5; "Polishing the Apple," *Architectural Record* 186 (August 1998): 41; Peter Grant, "Radio City to Get $30 Million Face-Lift," *New York Times* (December 24, 1998): 44; *Hardy Holzman Pfeiffer Associates: Buildings and Projects, 1992-1998* (New York: Rizzoli International Publications, 1999), 174–75; Terry Pristin, "For Radio City Restoration, a $2.5 Million Sales Tax Break," *New York Times* (January 30, 1999), B: 3; "Cheap Seats, Very Obstructed View," *New York Times* (February 20, 1999): 1; Julie V. Iovine, "Losing Our Seats," *New York Times* (February 25, 1999), F: 4; Peter Grant, "70M Radio City Redo: Cablevision Sees Future Payoff in Restoring Past," *New York Daily News* (April 9, 1999): 43; Douglas Feiden, "New Yorkers Star in Radio City Revival: Mammoth Remake Will Let the Show Go On in State-of-the-Art-Deco," *New York Daily News* (July 22, 1999): 46; Julie V. Iovine, "Piece by Piece, a Faded Icon Regains Its Art Deco

Glow," *New York Times* (September 6, 1999): 1, B: 6; "Spectaculars," *New York* 32 (September 13, 1999): 116; Bill Bell, "Deck the Hall: Radio City Ready to Make Music Again After $70M Restoration," *New York Daily News* (September 19, 1999): 4; Daniel Okrent, "Encore, Encore," *Time* 154 (September 27, 1999): 94–95; Martha T. Moore, "Praises Are Sung for Music Hall's Renovation," *USA Today* (October 1, 1999): 11A; Herbert Muschamp, "Art Deco Authenticity," *New York Times* (October 4, 1999), E: 1, 3; *The Grand Re-Opening Gala of Radio City Music Hall*, program (October 4, 1999); David Hinckley, "Oh, You Look Divine!" *New York Daily News* (October 5, 1999): 6; "Radio City Glistens Back to Life," *New York Times* (October 5, 1999): 1; Glenn Collins, "Radio City, with Face Lift, Reopens," *New York Times* (October 5, 1999), B: 6; "Restoring Radio City," editorial, *New York Times* (October 7, 1999): 30; Paul Goldberger, "The Talk of the Town: Dept. of Face-Lifts," *New Yorker* 75 (October 11, 1999): 43; "Radio City Returns to Art Deco Glory After Extensive Restoration," *Architectural Record* 187 (November 1999): 41; Reed Kroloff, "Architects Deserve Top Billing–But They're Going to Have to Grab It," editorial, *Architecture* 88 (November 1999): 11; Ellen Stern, "Razzle and Redazzle," *House Beautiful* 141 (November 1999): 164; Ward Morehouse III, "Deco Palace Delights Again: Radio City Music Hall Swings Wide Its Doors After Renovation," *Christian Science Monitor* (November 18, 1999): 20; Herbert Muschamp, "New York Starts to Look Beyond Its Past," *New York Times* (December 26, 1999), II: 49; *Hardy Holzman Pfeiffer Associates: Theaters* (Mulgrave, Australia: Images Publishing, 2000), 17; White and Willensky, *AIA Guide* (2000), 287; Lisa Annunziato, "Radio City Revival," *Facilities Design & Management* 19 (January 2000): 22–26; Melissa Shipley, "Landmark Renovations," *Urban Land* 59 (February 2000): 38; Sara Hart, "Up Against the Wall," *Architecture* 89 (March 2000): 65; Christopher Hawthorne, "Star Treatment," *Architecture* 89 (March 2000): 59–63, 65, 134; Julia Lewis, "A Star Is Reborn," *Interior Design* 71 (March 2000): 143–48; Wendy Smith, "Backstage at Radio City," *Preservation* 52 (March-April 2000): 52–59; David Barbour, "The Showplace of the Nation Reborn," *Entertainment Design* 34 (April 2000): 42–45; "Swank & Simple," *Grid* 2 (May-June 2000): 104–8; "Radio City Music Hall," *New York Construction News* 48 (June 2000): 26, 29.

39. Hugh Hardy, quoted in Goldberger, "The Talk of the Town: Dept. of Face-Lifts": 43.

40. Hugh Hardy, quoted in Iovine, "Piece by Piece, a Faded Icon Regains Its Art Deco Glow": 6.

41. Walter Lippmann, "Radio City," *American Architect* 143 (March 1933): 18, also quoted in Okrent, "Encore, Encore": 94.

MOMALAND: CROSSROADS OF CULTURE AND COMMERCE

1. See Stern, Mellins, and Fishman, *New York 1960*, 473–87.
2. Stern, Mellins, and Fishman, *New York 1960*, 480–85.
3. Grace Glueck, "Modern Museum May Add Condominium," *New York Times* (February 10, 1976): 1, 4; Paul Goldberger, "Beame Backs Plan for Modern's Tower," *New York Times* (February 13, 1976): 18; "A Rescue Device," editorial, *New York Times* (February 16, 1976): 18; Hilton Kramer, "Art: Modern's Tower May Add Pictures at an Exhibition," *New York Times* (February 17, 1976): 33; "The 'Vasari' Diary. 6 rms, MOMA vs . . . ," *Art News* 75 (April 1976): 20, 22; Suzanne Stephens, "MOMA's Castle in the Air," *Artforum* 14 (Summer 1976): 28–31; Ronald Smothers, "Measure to Let Museum Build Apartments Loses," *New York Times* (June 29, 1976): 27; Paul Goldberger, "Governor Approves Creation of Trust to Build Museum of Modern Art Unit," *New York Times* (July 30, 1976), B: 3; Paul Goldberger, "Modern Museum's Plan for Apartments," *New York Times* (August 17, 1976): 25; Glenn Fowler, "City Approves Trust for Building Museum of Modern Art Complex," *New York Times* (September 17, 1976), B: 3; Paul Goldberger, "Art People," *New York Times* (November 19, 1976), II: 19. For Olympic Tower, see Stern, Mellins, and Fishman, *New York 1960*, 388–93.
4. For Goodwin and Stone's building, see Stern, Gilmartin, and Mellins, *New York 1930*, 141–45.
5. Quoted in Kramer, "Art: Modern's Tower May Add Pictures at an Exhibition": 33.
6. Kramer, "Art: Modern's Tower May Add Pictures at an Exhibition": 33.
7. Stephens, "MOMA's Castle in the Air": 31.
8. Grace Glueck, "$1 Million Is Given to Modern Museum," *New York Times* (October 14, 1976): 43.
9. Franz Schulze, *Philip Johnson: Life and Work* (Chicago: University of Chicago Press, 1994), 353–55.
10. For Pei's work at the National Gallery and the John Hancock Tower, see Carter Wiseman, *I. M. Pei: A Profile in American Architecture*, rev. ed. (New York: Harry N. Abrams, 2001), 138–83.
11. Paul Goldberger, "Museum of Modern Art Picks Architect for Tower," *New York Times* (January 27, 1977): 29; Gerald Marzorati, "MOMA's Tower in the Sky," *Art News* 76 (April 1977): 54–56; Paul Goldberger, "A Tower and Gallery for the Museum of Modern Art," *New York Times* (June 30, 1977), C: 10; Carter B. Horsley, "Museum Tower Plan Runs Into Obstacles," *New York Times* (August 6, 1977): 21; Ada Louise Huxtable, "Survival Plan for the Modern," *New York Times* (August 7, 1977), II: 1, 20; Carter B. Horsley, "Museum of Modern Art Tower Endorsed by Community Board 5," *New York Times* (August 12, 1977), B: 14; "MOMA Plans Expansion–Including an Apartment Tower," *Architectural Record* 162 (September 1977): 37; John Morris Dixon, "The MoMA Paradox," *Progressive Architecture* 58 (September 1977): 7–8; Charles K. Hoyt, Jean Dwyer McCormick, Richard B. Oliver, and David N. Steinman,, "MoMA's Tower–

Architectural Feat or Disaster?" letters to the editor, *New York Times* (September 4, 1977), II: 17; Charles Kaiser, "Panel Approves Apartment Tower for Art Museum," *New York Times* (September 27, 1977): 43; Charles Kaiser, "Museum Tower and Bridge Market Win Approval of Estimate Board," *New York Times* (September 27, 1977), B: 3; Suzanne Stephens, "City Okays MOMA's Controversial Plan," *Progressive Architecture* 58 (November 1977): 21–22; Jasper D. Ward, "Museum Appendage," letter to the editor, *Progressive Architecture* 58 (December 1977): 8; Paul Goldberger, "Museums That Build Glass Houses," *New York Times* (January 26, 1978): C: 20; Grace Glueck, "Museum Tower Delayed by Rift," *New York Times* (May 31, 1978), C: 15; Charles Kaiser, "Court Invalidates Law for Apartment Tower Over Modern Museum," *New York Times* (July 14, 1978): 1, 13; Grace Glueck, "Modern Museum Head Hopeful Despite Setback from Court," *New York Times* (August 7, 1978), C: 13; "Court Says 'No' to MoMA's Tower," *Progressive Architecture* 59 (September 1978): 46; Grace Glueck, "State's Highest Court to Weigh Modern Museum Building Plan," *New York Times* (November 7, 1978): 57; Tom Goldstein, "High Court Backs Project of Museum of Modern Art," *New York Times* (December 28, 1978), C: 13; "MoMA Tower, Trust Approved by High Court," *Progressive Architecture* 60 (February 1979): 21–22; "Cesar's Palace," *Skyline* 1 (March 1979): 4; Grace Glueck, "Modern Museum's Plan for Building Advances," *New York Times* (May 17, 1979), C: 16; Grace Glueck, "Modern Museum Will Get $17 Million for Air Rights," *New York Times* (June 10, 1979): 60; Judith Cummings, "Tower Over Museum to Rise in Expensive Luxury," *New York Times* (June 10, 1979): 59; Arthur Holden, "The Modern Museum's Venture into the Art of Finance," letter to the editor, *New York Times* (July 4, 1979): 16; Grace Glueck, "Trust Holds 2nd Hearing on Modern Museum Plan," *New York Times* (July 11, 1979), C: 21; Ada Louise Huxtable, "Architecture: 'Bigger–And Maybe Better,'" *New York Times* (August 26, 1979), II: 25–26; Paul Goldberger, "The New MOMA: Mixing Art with Real Estate," *New York Times* (November 4, 1979), VI: 46, 52, 56; "The Museum of Modern Art Project: An Interview with Cesar Pelli," *Perspecta* 16 (1980): 96–107; "Museum of Modern Art Wins Approval of Expansion Boards," *New York Times* (January 2, 1980), C: 11; William G. Blair, "After a Lull, Construction of Co-ops Picks Up in Manhattan," *New York Times* (June 22, 1980), VIII: 1, 8; Ada Louise Huxtable, "The Modern Prepares for Expansion," *New York Times* (June 29, 1980), II: 1, 6; "Cesar Pelli," *Architecture + Urbanism* (October 1980): 110–14; *Annual Report, 1980–81* (New York: Museum of Modern Art, 1981), 6–8; Paul Goldberger, *The Skyscraper* (New York: Alfred A. Knopf, 1981), 147–48; Grace M. Anderson, "MOMA," *Architectural Record* 169 (March 1981): 94–99; Robert A. Peck, "Living Over the Museum," *Urban Land* 40 (December 1981): 17–20; *Annual Report, 1981–82* (New York: Museum of Modern Art, 1982), 4; Helen Searing, *New American Art Museums* (Berkeley, Calif.: University of California Press, 1982), 78–85; Paul Goldberger, "Public to See Revisions at Modern Art Museum," *New York Times* (March 7, 1982): 48; Leslie Bennetts, "Art Museum, Optimism Amid Chaos," *New York Times* (August 3, 1982), C: 9; "The Museum of Modern Art," *Space Design* (September 1982): 4–11; Carol Vogel, "3 Apartments at Museum Tower," *New York Times* (September 16, 1982), C: 3; Sharon Zane, "Museum Tower Apartments," *Bulletin of the Museum of Modern Art* (Fall 1982): 2; Dan Budnik, "The Way to Go," *Connoisseur* 212 (November 1982): 124–29; Herbert Mitgang, "2d Theater at the Modern," *New York Times* (November 18, 1982): C: 18; "Names and News," *Oculus* 44 (December 1982): 10; Howard Blum, "Museums Turning from Air Rights to Revenues," *New York Times* (January 7, 1983): 1, B: 2; William S. Paley and Blanchette H. Rockefeller, "The Modern Museum's No-Risk Project," letter to the editor, *New York Times* (January 18, 1983): 26; Mario Amaya, "The New MOMA," *Studio International* 197 (1984): 54–55; Sam Hunter, "Introduction," in *The Museum of Modern Art, New York: The History and the Collection* (New York: Harry N. Abrams, 1984), 40–41; Ada Louise Huxtable, *The Tall Building Artistically Reconsidered* (New York: Pantheon Books, 1984), 87; Cesar Pelli, "Architectural Form and the Tradition of Building," *Via* 7 (1984): 145–59, reprinted in *Architecture + Urbanism*, extra edition (July 1984): 26–32; Dee Wedemeyer, "For New Lobbies, the Motif Is Opulence," *New York Times* (February 12, 1984), VI: 1, 14; Nan Robertson, "The Fine Art of Modernizing the Modern," *New York Times* (March 6, 1984), C: 13; George Lewis, "Chapter Reports," *Oculus* 45 (April 1984): 7; "Johnson Gallery Dedicated at Museum of Modern Art," *New York Times* (April 4, 1984), C: 25; Paul Goldberger, "The New MOMA," *New York Times* (April 15, 1984), VI: 36–41, 43, 46, 49, 68, 70, 72, 74; Michael O'Connor, "The Block of the New," *Art and Antiques* (May 1984): 21; Milton Esterow and Sylvia Hochfield, "Richard Oldenburg," *Art News* 83 (May 1984): 51–56; "An Interview with Cesar Pelli," *Bulletin of the Museum of Modern Art* (May 1984): 3; Suzanne Stephens, "MoMA Loses Her Modernity," *Vanity Fair* 47 (May 1984): 92–93; Fred Ferretti, "Museum's Big Week: Frenzy of Planning," *New York Times* (May 7, 1984), B: 7; "Champagne and Compliments Flow as Museum Puts Itself on Display," *New York Times* (May 8, 1984): 1, 4; Kay Larson, "MoMA Unveils Its Treasures," *New York* 17 (May 14, 1984): 34–49; Robert Hughes, "Revelation on 53rd Street," *Time* 123 (May 14, 1984): 78–80; Michael Brenson, "A Critic's Walk Through the New Modern Museum," *New York Times* (May 18, 1984), C: 1, 22; John Russell, "Inaugural Show Is Survey of New York," *New York Times* (May 18, 1984), C: 23; Joseph Giovannini, "Museums Make Room for the Art of Architecture," *New York Times* (May 20, 1984), II: 33; "Mr. Peeper's Nights: 'Dreamgirl' at MOMA," *New York* 17 (May 21, 1984): 33; Douglas Davis, "MOMA Lets the Sunshine In,"

Newsweek 103 (May 21, 1984): 88–89; "Rededicating New York's Pantheon of Modernism," *Architectural Record* 172 (June 1984): 71; Eugene Victor Thaw, "MOMA Grows Up," *New Republic* 190 (June 4, 1984): 26–28; Nicolaus Mills, "The New MOMA," *Commonweal* 111 (July 13, 1984): 405–6; Jeffrey Simpson, "Two Cheers for MOMA," *Art News* 83 (September 1984): 56–61; Daralice D. Boles, "MoMA's Back in Town," *Progressive Architecture* 65 (September 1984): 27–28; Mildred F. Schmertz, "The New MOMA," *Architectural Record* 172 (October 1984): 164–77; Stanley Abercrombie, "MoMA Builds Again," *Architecture* 73 (October 1984): 87–95; Martin Filler, "High Ruse, part II," *Art in America* 72 (October 1984): 168–77; Calvin Tomkins, "The Art World," *New Yorker* 60 (October 15, 1984): 126, 128, 131–33; "The Museum of Modern Art: Cesar Pelli & Associates," *Architecture + Urbanism* (December 1984): 31–51; Lynne Breslin, "The Museum of Modern Art–1939," *Architecture + Urbanism* (December 1984): 61–66; Gavin Macrae-Gibson, "The Museum of Modern Art: Modernism for the Masses," *Architecture + Urbanism* (December 1984): 56–60; "Cesar Pelli," *Architectural Design* 55 (Nos. 1–2, 1985): 32–37; "Cesar Pelli & Associates," *GA Document* 12 (January 1985): 42–49; Paul Goldberger, "New Museums Harmonize with Art," *New York Times* (April 14, 1985), II: 1, 27; Grace Glueck, "The Art Boom Sets Off a Museum Building Spree," *New York Times* (June 23, 1985), II: 1, 14; "The Museum of Modern Art: Gallery Expansion and Residential Tower," *Architecture + Urbanism*, extra edition (July 1985): 200–16; Gavin Macrae-Gibson, "Cesar Pelli: Heir of Mies," *Architecture + Urbanism*, extra edition (July 1985): 224–27; John Pastier, "Cesar Pelli: The Architect as Servant," *Architecture + Urbanism*, extra edition (July 1985): 85–88; "The Museum of Modern Art Residential Tower," *Process Architecture* 64 (January 1986): 46–49; Peter Lemos "Hard Sell," *Metropolis* 5 (January February 1986): 14; Suzanne Stephens, "Rating the New Museums," *House & Garden* 159 (October 1987): 62, 64; Douglas Davis, *The Museum Transformed* (New York: Abbeville Press, 1990), 164–67; Paul Goldberger, "Introduction," in *Cesar Pelli: Buildings and Projects, 1965–1990* (New York: Rizzoli International Publications, 1990), 6–8, 56–67; Alan Wallach, "The Museum of Modern Art: The Past's Future," *Journal of Design History* 5 (No. 3, 1992): 207–15; *Cesar Pelli: Selected and Current Works* (Mulgrave, Australia: Images Publishing, 1993), 30–31; Schulze, *Philip Johnson: Life and Work*, 353–56, 379; Laurie D. Olin, "The Museum of Modern Art Garden: The Rise and Fall of a Modernist Landscape," *Journal of Garden History* 17 (Summer 1997): 140–62; Michael J. Crosbie, *Cesar Pelli: Recent Themes* (Basel: Birkhauser, 1998), 8–17; Victoria Newhouse, *Towards a New Museum* (New York: Monacelli Press, 1998), 148–59; White and Willensky, *AIA Guide* (2000), 293–94; David Rockefeller, *Memoirs* (New York: Random House, 2002), 456–58.
12. Donald Marron, quoted in Goldberger, "Museum of Modern Art Picks Architect for Tower": 29.
13. For Miller & Noel's Whitney Museum, see Stern, Mellins, and Fishman, *New York 1960*, 477–79.
14. Goldberger, "A Tower and Gallery for the Museum of Modern Art": 10. For Warren & Wetmore's 1020 Fifth Avenue, see Stern, Gilmartin, and Mellins, *New York 1930*, 388–89.
15. Richard E. Oldenburg, quoted in Horsley, "Museum Tower Plan Runs Into Obstacles": 21.
16. Huxtable, "Survival Plan for the Modern": 1, 20.
17. Huxtable, "Survival Plan for the Modern": 1, 20.
18. Huxtable, "Survival Plan for the Modern": 1, 20.
19. Hoyt, "MoMA's Tower–Architectural Feat or Disaster?": 17.
20. Goldberger, "Museums That Build Glass Houses": 20.
21. Richard H. Koch, quoted in Glueck, "Modern Museum Head Hopeful Despite Setback from Court": 13.
22. Quoted in Glueck, "State's Highest Court to Weigh Modern Museum Building Plan": 57.
23. Cesar Pelli, quoted in "The Museum of Modern Art Project: An Interview with Cesar Pelli": 101, 104, 107.
24. Huxtable, "The Modern Prepares for Expansion": 1, 6.
25. Goldberger, "Public to See Revisions at Modern Art Museum": 48.
26. Cesar Pelli, quoted in Abercrombie, "MoMA Builds Again": 91.
27. Stephens, "MoMA Loses Her Modernity": 92–93.
28. Jasper Johns, quoted in "Champagne and Compliments Flow as Museum Puts Itself on Display": 1.
29. Arthur Drexler, quoted in Abercrombie, "MoMA Builds Again": 91.
30. Abercrombie, "MoMA Builds Again": 92.
31. Boles, "MoMA's Back in Town": 27.
32. Amanda Burden, quoted in "Mr. Peeper's Nights: 'Dreamgirl' at MOMA": 33.
33. Olin, "The Museum of Modern Art Garden: The Rise and Fall of a Modernist Landscape": 155–57. Also see Schmertz, "The New MOMA": 166.
34. Abercrombie, "MoMA Builds Again": 91.
35. Suzanne Stephens, quoted in "Architecture: Philip Johnson-Suzanne Stephens," *Egoïste* 9 (Fall 1985): 88–90. Also see Stover Jenkins and David Mohney, *The Houses of Philip Johnson* (New York: Abbeville Press, 2001), 208, 214.
36. Abercrombie, "MoMA Builds Again": 88. For the 1946 plan, see Stern, Mellins, and Fishman, *New York 1960*, 473, 475.
37. Grace Glueck, "Museum of Modern Art Considers Building Gallery Under Garden," *New York Times* (January 17, 1991), C: 15; Suzanne Stephens, "MoMA's Expansion," *Oculus* 53 (March 1991): 3.
38. Philip Johnson, quoted in Glueck, "Museum of Modern Art Considers Building Gallery Under Garden": 15.
39. Philip Johnson, quoted in Stephens, "MoMA's Expansion": 3.
40. Stephens, "MoMA's Expansion": 3.
41. Hilton Kramer, "The Shape of the Future at MoMA Could Be a Grim Postmodern Era," *New York Observer* 3

(April 24, 1989): 1, 13.

42. Carol Vogel, "The Modern Plans a Paid President and Seeks a 2d Site," *New York Times* (January 28, 1993), C: 15; Andrew Goldman, "What's the Big Deal at MoMA?" *New York Observer* (June 5, 2000): 1, 3.

43. John Parkinson III and James A. Gara, "Report of the Treasurer: The Museum's Future Plans," *MoMA Annual Report, 1995–96* (New York: Museum of Modern Art, 1996), no pagination; Carol Vogel, "Its Art Squeezed, the Modern Buys Growing Room," *New York Times* (February 5, 1996): 1, C: 16; Carol Vogel, "The Girth of the Modern," *New York Times* (February 11, 1996), IV: 2; "Making Room at MoMA," *Artnews* 95 (April 1996): 51; For the Hotel Dorset, see Stern, Gilmartin, and Mellins, *New York 1930*, 207–8.

44. Glenn Lowry, quoted in Vogel, "Its Art Squeezed, the Modern Buys Growing Room": 1.

45. Jayne Merkel, "Glenn Lowry (Cautiously) on the MoMA Expansion," *Oculus* 59 (December 1996): 7; "The Museum of Modern Art Expansion," *AIA New York Chapter Annals* (1996–97): 50–51; Tony Vidler, "Momas and Magmas," *Lotus International* 95 (1997): 24–26; Joanna Merwood, "Ten Projects for MoMA," *Lotus International* 95 (1997): 27–45; Herbert Muschamp, "10 Architects to Compete for Project at the Modern," *New York Times* (January 16, 1997), C: 20; Herbert Muschamp, "Rethinking the Meaning of the Modern," *New York Times* (January 26, 1997), II: 35; Lee Rosenbaum, "MOMA's Makeover," *Art in America* 85 (February 1997): 25; "MoMA Finalists," *Oculus* 59 (March 1997): 4; Jayne Merkel, "Riley on MoMA's Soul-Searching," *Oculus* 59 (March 1997): 4–5; Alexandra Lange, "MoMA's Boys," *New York* 30 (March 31, 1997): 38–44; Martin Filler, "MOMA Meets Manhattan," *House Beautiful* 139 (April 1997): 58, 60–61; "Three Architects Named as Finalists for the Museum of Modern Art's Expansion and Renovation Project," press release (April 10, 1997); Joseph Giovannini, "Finalists Announced for MoMA Expansion," *Architecture* 86 (May 1997): 46–47; Nina Rappaport and Jayne Merkel, "Urban Design on the Agenda," *Oculus* 59 (May 1997): 3; Herbert Muschamp, "Architects' Visions of How the Modern May One Day Appear," *New York Times* (May 3, 1997): 15, 20; Ada Louise Huxtable, "Redefining the Modern," *Wall Street Journal* (May 8, 1997); Joseph Giovannini, "Back to the Box," *New Yorker* 73 (May 12, 1997): 38–39; Julie I. Iovine, "Show at the Modern Purges an Architect," *New York Times* (May 22, 1997), C: 13; Ruth Berktold, "Das Museum für das Nächste Jahrhundert: Erweiterung und Renovierung des MoMA in New York," *Arch Plus* 137 (June 1997): 14–15; Christopher Gray, "Streetscapes/Museum of Modern Art," *New York Times* (July 27, 1997), IX: 5; Karrie Jacobs, "Rough Drafts," *New York* 30 (June 16, 1997): 18–21; "Toward the New Museum of Modern Art," *Architecture + Urbanism* (June 1997): 10–11; Deborah K. Dietsch, "Museum Imports," editorial, *Architecture* 86 (June 1997): 13; Herbert Muschamp, "Make the Modern Modern? How Very Rash!" *New York Times* (June 15, 1997), II: 31; "Herzog and de Meuron in SoHo," *Metropolis* 17 (July-August 1997): 42; "Three Architects Chosen as Finalists for MoMA Design Competition," *MoMA Magazine* 2 (Summer 1997): 24–26; Glenn D. Lowry, "Letter from the Director," *MoMA Magazine* 2 (Summer 1997): 1; "Off the Cuff on the MoMA," *Oculus* 60 (September 1997): 10–14; Jed Perl, "The Incredible Shrinking Classics," *New Republic* 217 (September 22, 1997): 31–36; Witold Rybczynski, "Keeping the Modern Modern," *Atlantic Monthly* 280 (October 1997): 108–12; Douglas Davis, "MOMA Looks to the Future," *Art in America* 85 (October 1997): 33, 35; Nicholas Adams, "Un Moderno Neomoderno: Ampliamento del MoMA, architettura e aura al Museum of Modern Art," *Casabella* (October 1997): 80–85; Paul Goldberger, "The Modern Made New," *New Yorker* 73 (December 8, 1997): 118–19.

46. John Elderfield, ed., *Imagining the Future of the Museum of Modern Art* (New York: Museum of Modern Art, 1998).

47. Quoted in Elderfield, ed., *Imagining the Future of the Museum of Modern Art*, 21, 22, 26.

48. Glenn D. Lowry, "The New Museum of Modern Art: A Process of Discovery," in Elderfield, ed., *Imagining the Future of the Museum of Modern Art*, 16.

49. Muschamp, "10 Architects to Compete for Project at the Modern": 20.

50. Muschamp, "Rethinking the Meaning of the Modern": 35.

51. Ralph Lerner, Michael Rotondi, and Stanley Tigerman, quoted in Giovannini, "Back to the Box": 38–39.

52. Lange, "MoMA's Boys": 42–43.

53. Sid Bass, quoted in "Toward the New Museum of Modern Art": 10.

54. Muschamp, "Architects' Visions of How the Modern May One Day Appear": 15.

55. Cesar Pelli and Terence Riley, quoted in Iovine, "Show at the Modern Purges an Architect": 13.

56. Filler, "MOMA Meets Millennium": 58.

57. Rybczynski, "Keeping the Modern Modern": 112.

58. Huxtable, "Redefining the Modern": 20.

59. Quoted in Elderfield, ed., *Imagining the Future of the Museum of Modern Art*, 180.

60. *WITH: Dominique Perrault Architect* (Barcelona: Actar; Basel: Birkhauser, 1999), 265.

61. Quoted in Elderfield, ed., *Imagining the Future of the Museum of Modern Art*, 211.

62. Quoted in Elderfield, ed., *Imagining the Future of the Museum of Modern Art*, 220–21.

63. Edward I. Mills, quoted in "Off the Cuff on the MoMA": 13.

64. Quoted in Elderfield, ed., *Imagining the Future of the Museum of Modern Art*, 190–91. Also see Rem Koolhaas, *Charette* (Rotterdam: Office for Metropolitan Architecture, 1997).

65. Muschamp, "Make the Modern Modern? How Very Rash!": 31.

66. Goldberger, "The Modern Made New": 119.

67. Quoted in "Three Architects Named as Finalists for the Museum of Modern Art's Expansion and Renovation Project."

68. Quoted in Elderfield, ed., *Imagining the Future of the Museum of Modern Art*, 211, 230–31.

69. Huxtable, "Redefining the Modern": 20.

70. Quoted in Elderfield, ed., *Imagining the Future of the Museum of Modern Art*, 254–55.

71. Huxtable, "Redefining the Modern": 20.

72. Muschamp, "Architects' Visions of How the Modern May One Day Appear": 15, 20.

73. Michael Sorkin, "Lite Construction," *Metropolis* 17 (July 1998): 45, 47.

74. Quoted in "Three Architects Named as Finalists for the Museum of Modern Art's Expansion and Renovation Project."

75. Muschamp, "Architects' Visions of How the Modern May One Day Appear": 15.

76. Quoted in Elderfield, ed., *Imagining the Future of the Museum of Modern Art*, 242.

77. Huxtable, "Redefining the Modern": 20.

78. "Radical Redux: The Modern Picks a Design," *New York Times* (December 9, 1997): 1; Herbert Muschamp, "The Modern Picks Taniguchi's Expansion Plan," *New York Times* (December 9, 1997), E: 1–2; Mark Stevens, "Post-MoMA-ism," *New York* 30 (December 22–29, 1997): 40–42; Victoria Newhouse, *Towards a New Museum*, 148–61; Cynthia Davidson, "Mo' Modern," *ANY* 22 (1998): 20–23; "Yoshio Who? MoMA's New Architect," *Architectural Record* 186 (January 1998): 29; Ned Cramer, "MoMA Picks Taniguchi," *Architecture* 87 (January 1998): 28; "Privileging the Contemporary," *New Criterion* 16 (January 1998): 3; Julie V. Iovine, "A Modest Someone Redoes the Modern," *New York Times* (January 1, 1998), F: 1, 5; Armelle Lavalou, "MoMA, Projets de Collection," *L'Architecture d'Aujourd'hui* (February 1998): 30–36; Barbara A. MacAdam, "Modern Picks Taniguchi," *Artnews* 97 (February 1998): 47; "New York 1; London 1," *Blueprint* 147 (February 1998): 13; Martin Filler, "MOMA Now and Zen," *House Beautiful* 140 (March 1998): 50, 52; Edna Goldstaub-Dainotto, "A Modern Modern, After All," *Domus* (March 1998): 83–88; Hal Foster, et al., "The MoMA Expansion: A Conversation with Terence Riley," *October* 84 (Spring 1998): 3–30; Suzannah Lessard, "The Underdog," *New York Times* (April 12, 1998), VI: cover, 30–37, 54, 57–58, 60, 64–65; Judith H. Dobrzynski, "MOMA to Get $65 Million From the City," *New York Times* (April 24, 1998), B: 1, 7; Jayne Merkel, "Modern Redux," *Oculus* 60 (May 1998): 14; "MoMA Mia!" editorial, *New York Observer* (May 18, 1998): 4; Joseph Giovannini and Terence Riley, "Fisticuffs on Fifty-third Street," *Architecture* 87 (June 1998): 104–7; Allan Schwartzman, "Why Does MoMA Matter?" *Architecture* 87 (June 1998): 102–3; Herbert Muschamp, "Designing Museums: Often Not a Lively Art," *New York Times* (June 28, 1998), II: 32; Sorkin, "Lite Construction": 45, 47; Nicholas Adams, "Il Nuovo MoMA, Paul Rudolph; Tschumi e Stern alla Columbia," *Casabella* (October 1998)* 84–89; Fumihiko Maki, "Silenzio e Pienezza: l'Architettura di Yoshio Taniguchi," *Casabella* (November 1998): 66–73; *WITH: Dominique Perrault Architect*, 264–73; *The Architecture of Yoshio Taniguchi* (New York: Harry N. Abrams, 1999), 260–70; "Steven Holl, 1996–99," *El Croquis* 93 (1999), 160–71; Andreas Ruby, "Bernard Tschumi on His MoMA Competition Entry," *Daidalos* 71 (1999): 38–47; "Local Heroes," *Interior Design* 71 (February 2000): 38; "Cultural and Public Projects," *Oculus* 62 (February 2000): 6; Joseph Giovannini, "New York State of Mind," *World Architecture* (February 2000): 48–55; Hilton Kramer, "More on the New MoMA," *New York Observer* (March 6, 2000): 14; Antonella Mari, "Steven Holl: Recent Works," *Industria delle Costruzioni* 342 (April 2000): 46–47, 69–70; "MoMA Funds Risky Move," *Wall Street Journal* (April 28, 2000), W: 9; Daniel Costello, "Museum of Modern Art's Ambitious Expansion Plan Faces Trouble," *Wall Street Journal* (June 7, 2000), B: 1, 4; Andrew Goldman, What's the Big Deal at MoMA?" *New York Observer* (June 5, 2000): 1, 3; Danielle Posen, "Strikers, Neighbors Can't Stop MoMA's Edifice Complex," *New York Observer* (July 24, 2000): 9; Anne Raver, "A Magical Space to Disappear for Four Years," *New York Times* (August 20, 2000), XIV: 1; Jayson Blair, "Museum's Plan Jars Harmony with Neighbors," *New York Times* (September 3, 2000): 38; *Dominique Perrault: Selected and Current Works* (Mulgrave, Australia: Images Publishing, 2001), 96–103, 212; Craig Kellogg, "Gallery Talk," *Oculus* 63 (January 2001): 4; James Barron, "Memories in a Shovelful of Soil," *New York Times* (May 11, 2001), B: 2; Calvin Tomkins, "The Modernist," *New Yorker* 77 (November 5, 2001): 72–83; Alan Balfour, *World Cities: New York* (New York: Wiley Academy, 2001), 55–59, 240–42, 292–99, 303–5; Kenneth Frampton, "Taniguchi's MoMA: Preview," in Balfour, *World Cities: New York*, 211–13; *The Architecture of Rafael Viñoly* (New York: Princeton Architectural Press, 2002), no pagination; Rockefeller, *Memoirs*, 458–62; Jonathan Mahler, "Gotham Rising," *Talk* (December 2001/January 2002): 120–25, 148–52; "Last Chance at This Location," *New York Times* (May 21, 2002): 1; Rachel Donadio, "The Long View," *New York Sun* (July 1, 2002): 1, 9; Ian Luna, ed., *New York* (New York: Rizzoli International Publications, 2003), 204–7; David Sokol, "MoMA's Expansion Costs Increase as It Acquires More Land," *Architectural Record* 191 (June 2003): 34; "MoMA Renovation on Target for '05," *New York Post* (June 5, 2003): 21; Julie I. Iovine, "Who's Co-Designing for Co-Whom?" *New York Times* (November 16, 2003), II: 38; Nicolai Ouroussoff, "Art Fuses with Urbanity in an Aesthetically Pure Redesign of the Modern," *New York Times* (November 15, 2004): E: 1, 6–7; Paul Goldberger, "The Sky Line: Outside the Box," *New Yorker* 80 (November 15, 2004): 110–12; Robin Pogrebin, "At Modern, Architect Is

Content (Mostly)," *New York Times* (November 16, 2004), E: 1, 7; Holland Cotter, "Housewarming Times for Good Old Friends," *New York Times* (November 19, 2004), E: 35–36; Michael Kimmelman, "Racing to Keep Up with the Newest," *New York Times* (November 19, 2004), E: 35–36; Hilton Kramer, "Oedipus on 53rd St.," *New York Observer* (November 22, 2004): 1, 20; Martin Filler, "Big MoMA," *House & Garden* 173 (December 2004): 78–81, 143; Michael J. Lewis, "MOMA Reopened," *New Criterion* 23 (December 2004): 15–18; Peter Schjeldahl, "Easy to Look At," *New York* 37 (December 6, 2004): 17–18; Ada Louise Huxtable, " . . . In MoMA's Big, New, Elegantly Understated Home," *Wall Street Journal* (December 7, 2004), D: 11; Robert Campbell, "What's Wrong with MoMA: Disappearing Architecture and a Sense of the Unreal," *Architectural Record* 193 (January 2005): 67–69; Suzanne Stephens, "With Yoshio Taniguchi's Design, New York's Museum of Modern Art Finally Becomes What It Wanted to Be All Along," *Architectural Record* 193 (January 2005): 95–109.

79. Quoted in Elderfield, ed., *Imagining the Future of the Museum of Modern Art*, 272, 274.

80. Lessard, "The Underdog": 62.

81. Bernard Tschumi, quoted in Ruby, "Bernard Tschumi on His MoMA Competition Entry": 39.

82. Sorkin, "Lite Construction": 47.

83. Herbert Muschamp, "Urban Dreams, Urban Realities," *New York Times* (April 22, 1994), C: 26.

84. Philip Johnson, quoted in Iovine, "A Modest Someone Redoes the Modern": 5.

85. Muschamp, "The Modern Picks Taniguchi's Expansion Plan": 2.

86. Yoshio Taniguchi, quoted in Iovine, "A Modest Someone Redoes the Modern": 6.

87. Glen Lowry, quoted in Stevens, "Post-MoMA-ism": 41.

88. Frampton, "Taniguchi's MoMA: Preview," in Balfour, *World Cities: New York*, 212.

89. Newhouse, *Towards a New Museum*, 161.

90. Giovannini and Riley, "Fisticuffs on 53rd Street": 104.

91. Yoshio Taniguchi, quoted in Mahler, "Gotham Rising": 150.

92. Kirk Varnedoe, quoted in Lessard, "The Underdog": 65.

93. William Pedersen, quoted in Iovine, "Who's Co-Designing for Co-Whom?": 38.

94. Agnes Gund, quoted in "Museum of Modern Art's Ambitious Expansion Plan Faces Trouble": 3.

95. Yoshio Taniguchi, quoted in Mahler, "Gotham Rising": 150.

96. Yoshio Taniguchi, quoted in Pogrebin, "At Modern, Architect Is Content (Mostly)": 1.

97. Ouroussoff, "Art Fuses with Urbanity in an Aesthetically Pure Redesign of the Modern": 1, 6–7.

98. Goldberger, "The Sky Line: Outside the Box": 111.

99. Campbell, "What's Wrong with MoMA: Disappearing Architecture and a Sense of the Unreal": 67, 69.

100. Campbell, "What's Wrong with MoMA: Disappearing Architecture and a Sense of the Unreal": 67–69.

101. Kramer, "Oedipus on 53rd St.": 1, 20.

102. Filler, "Big MoMA": 80, 143.

103. Huxtable, " . . . In MoMA's Big, New, Elegantly Understated Home": 11.

104. Stephens, "With Yoshio Taniguchi's Design, New York's Museum of Modern Art Finally Becomes What It Wanted to Be All Along": 95, 97.

105. Ada Louise Huxtable, "Focus on the Museum Tower," *New York Times* (August 24, 1980), II: 27–28; "Museum as Work of Art," *Domus* (March 1981): 13–16; Rita Reif, "Folk Museum Protests Rezoning Proposal," *New York Times* (January 31, 1982): 51; Michael Goodwin, "Midtown Zoning Changes Are Approved," *New York Times* (May 14, 1982), B: 3; "New York's Museum of Folk Art Introduces a Well Mannered Tower," *Architectural Record* 170 (July 1982): 53; Peter Buchanan, "An Awe-Filled Arcadia: The Architectural Quest of Emilio Ambasz," *Architecture + Urbanism* (August 1983): 29–39; Renate Cornu, *Emilio Ambasz* (Geneve: Halle Sud, 1987), 59–61; *Emilio Ambasz: The Poetics of the Pragmatic* (New York: Rizzoli International Publications, 1988), 96–101; *Emilio Ambasz: Architettura e Design* (Milan: Electa, 1994), 40–41.

106. Ralph Esmerian, quoted in David W. Dunlap, "Of Britons, Bahrainis and a Block of Brownstones," *New York Times* (September 16, 1990), X: 15.

107. "London & New York Forms Joint Venture on Manhattan Site," *Daily Telegraph* (October 24, 1989): 32; Rita Reif, "Folk Museum Homeward Bound," *New York Times* (July 21, 1990): 11; Dunlap, "Of Britons, Bahrainis and a Block of Brownstones": 15; David W. Dunlap, "New Snag in Folk Art Museum's Hunt for a Home," *New York Times* (June 5, 1993): 16.

108. Herbert Muschamp, "Design for Folk Museum Points to the Future by Honoring the Past," *New York Times* (October 29, 1997), E: 1, 10; Ned Cramer, "On the Boards: Museum of American Folk Art," *Architecture* 86 (December 1997): 46; Alexandra Lange, "Exhibitionists," *New York* 30 (December 22–29, 1997): 50–51; Tod Williams and Billie Tsien, *Tod Williams Billie Tsien: The 1998 Charles & Ray Eames Lecture* (Ann Arbor, Mich.: College of Architecture and Urban Planning, University of Michigan, 1998), 44–47; Judith Nasatir, "Expansion Joint," *Interior Design* 69 (January 1998): 29; "Museum of American Folk Art, New York, USA," *Zodiac* 20 (January-June 1999): 112–17; "Tod Williams & Billie Tsien," *GA Document* 58 (April 1999): 100–103; "Museum of American Folk Art," *Abitare* (May 1999): 98, 148–51; Tod Williams and Billie Tsien, "A Weather Report from New York," *Abitare* (May 1999): 150; "Museum of American Folk Art," *Obras y Proyectos* (No. 9, 1999): 118–23; C. J. Chivers, "Folk Art Museum Plans a Six-Story Building in Midtown," *New York Times* (October 13, 1999), B: 6; Soren Larson, "Williams and Tsien Getting Folksy in New York," *Architectural Record* 187 (November 1999): 46; Hadley Arnold, ed., *Work Life: Tod Williams Billie Tsien* (New York: Monacelli Press, 2000),

250–51; White and Willensky, *AIA Guide* (2000), 293; "Groundbreaking for Folk Art Museum," *Oculus* 62 (January 2000): 5; "Tod Williams Billie Tsien and Associates," *World Architecture* 84 (March 2000): 26; Balfour, *World Cities: New York*, 172–73; "Monolito Mineral," *Arquitectura Viva* 76 (January-February 2001): 62–63; Jeffrey Hogrefe, "Interventions," *Interiors* 160 (April 2001): 59; Rita Reif, "Folk Art Finds a Home, and Humble It Isn't," *New York Times* (September 9, 2001), II: 86; Herbert Muschamp, "For Rebuilders, Inspiration All Around," *New York Times* (October 5, 2001), E: 27, 29; Allison Eckardt Ledes, "A New Home for Folk Art in New York City," *Antiques* 160 (December 2001): 750, 752; Edward M. Gomez, "Folk Art's New Monument," *Art & Antiques* (December 2001): 82, 84, 86; Martin Filler, "Folk Wisdom," *House & Garden* 170 (December 2001): 88, 90–92; Herbert Muschamp, "Fireside Intimacy for Folk Art Museum," *New York Times* (December 14, 2001), E: 35, 38; Raul Barreneche, "A New Museum Building Goes Up in New York," *Folk Art* 26 (Winter 2001): 40–47; Joseph Giovannini, "Architecture," *New York* 34 (December 24–31, 2001): 115; Jayne Merkel, "Worldly Folk (Art Museum)," *Oculus* 64 (January-February 2002): 10; Clare Henry, "No Place Like Home for Folk Art," *Financial Times* (January 9, 2002): 11; Linda Hales, "For Folk Art, a Welcome Home," *Washington Post* (January 12, 2002); G: 2; Martin Filler, "Art and Hand," *New Republic* 226 (January 14, 2002): 27–30; Peter Schjeldahl, "Folks: A New Home for Unsung Artisans," *New Yorker* 77 (January 14, 2002): 88–89; Cathleen McGuigan, "A Tree Grows in Midtown," *Newsweek* 139 (January 21, 2002): 56; Carol Strickland, "Folk Finds a New Home," *Christian Science Monitor* (January 24, 2002): 12; Penny McGuire, "City Folk," *Architectural Review* 211 (February 2002): 68–73; Ned Cramer, "A Design Problem," *Architecture* 91 (February 2002): 76–78, 80–84; Alan G. Brake, "Perfect Imperfection," *Architecture* 91 (February 2002): 91, 93; Fred Bernstein, "City Folk," *World Architecture* (February 2002): 26–33; Jed Perl, "Making Taste," *New Republic* 226 (February 4, 2002): 25–33; Herbert Muschamp, "A Lesson Abroad: Get Comfortable with Continuity," *New York Times* (February 24, 2002), II: 46; Rowan Moore, "The Rock in a Hard Place," *Domus* (March 2002): 30–43; Benjamin Forgey, "Discrete Charms," *Washington Post* (March 10, 2002), G: 1; "American Folk Art Museum, New York, New York," *American Craft* 62 (April-May 2002): 40–41; Ada Louise Huxtable, "A Home for Folk Art Is Art Itself," *Wall Street Journal* (April 8, 2002): 25; Clifford A. Pearson, "American Folk Art Museum," *Architectural Record* 190 (May 2002): 202–11; David Ebony, "High-Tech Home for Folk Art," *Art in America* 90 (May 2002): 37; Paul Goldberger, "Folk Art Masterpiece," *Metropolis* 21 (June 2002): 150, 166; Kieran Long, "The Best Building in the World," *World Architecture* (September 2002): 26–31; "Tod Williams Billie Tsien, Architects: Museum of American Folk Art," *Architecture + Urbanism* (October 2002): 40–45; Brook S. Mason, "American Folk Art Finds New Fans," *Wall Street Journal* (October 15, 2002), D: 6; "Tod Williams Billie Tsien Architects: American Folk Art Museum, New York, 2001," *Casabella* (December 2003-January 2003): 128–35; Luna, ed., *New New York*, 198–203; "American Folk Art Museum, New York City," *Architectural Record* 191 (May 2003): 147. For the Whitney Museum, see Stern, Mellins, and Fishman, *New York 1960*, 824–30.

109. Williams and Tsien, *Tod Williams Billie Tsien: The 1998 Charles & Ray Eames Lecture*, 44–47.

110. For Soane's house-museum, see Helen Dorey, "12–14 Lincoln's Inn Fields," in Margaret Richardson and Mary Anne Stevens, eds., *Sir John Soane, Architect: Master of Space and Light* (London: Royal Academy of Arts, 1999), 150–73.

111. Muschamp, "Design for Folk Museum Points to the Future by Honoring the Past": 1, 10.

112. Filler, "Art and Hand": 29. Also see Filler, "Folk Wisdom": 88, 91.

113. Carter B. Horsley, "58-Story Needle Planned on 52d St. Near '21' Club," *New York Times* (June 5, 1981), B: 2; Paul Goldberger, "The New American Skyscraper," *New York Times* (November 8, 1981), VI: 68–73, 76, 78, 86, 88, 90, 92, 94, 96; "Thirty-Three–New York," *Architecture + Urbanism* (March 1983): 57. For the CBS Building, see Stern, Mellins, and Fishman, *New York 1960*, 406–10.

114. Huxtable, *The Tall Building Artistically Reconsidered*, 70–72; Alan S. Oser, "'Black Rock' Getting a Neighbor," *New York Times* (March 4, 1984), VIII: 6; George Lewis, "Names and News," *Oculus* 45 (April 1984): 7; "Etched in Stone," *Architectural Record* 172 (June 1984): 71; "40 West 53rd Street, New York," *Progressive Architecture* 65 (July 1984): 37; Deborah Dietsch, "Plum Jobs," *Interiors* 144 (August 1984): 37; *Kevin Roche* (New York: Rizzoli International Publications, 1985), 236–37; "Kevin Roche John Dinkeloo and Associates," *GA Document* 12 (January 1985): 52–53; Carter Wiseman, "High Rise, Hard Sell," *New York* 18 (March 11, 1985): 42–46; "40 West 53rd Street," *Metals in Construction* (Winter 1985/86): 21–23; Paul Goldberger, "Out-of-Town Builders Bring Their Shows to New York," *New York Times* (June 1, 1986), II: 35, 40; Bruce S. Fowle, "The New American Craft Museum," *Oculus* 48 (November 1986): 12–13; Ada Louise Huxtable, "Creeping Gigantism in Manhattan," *New York Times* (March 22, 1987), II: 1, 36; "E. F. Hutton Building," *Architecture + Urbanism*, extra edition (August 1987): 176–77; Justin Henderson, "Institutional Winner: Fox & Fowle Architects," *Interiors* 147 (January 1988): 158–59; Carter B. Horsley, "How 'Folly' Fetched a Fortune," *New York Post* (September 1, 1988): 63; "AIA Component Awards," *Architecture* 77 (May 1988): 111; Susan Doubilet, "Introduction," in *Fox & Fowle: Function Structure Beauty* (Milan: L'Arca Edizioni, 1999), 9–12; "The American Craft Museum," *Architectural Record* 174 (October 1986): 59; Paul Goldberger, "A Museum with New Answers, and Old Questions," *New York Times* (October 19, 1986), II: 1,

34; Thomas Hine, "An Attention-Getting Design for the Brooklyn Museum," *Philadelphia Inquirer* (October 26, 1986), G: 14; J. D. Reed, "Handsome and Homemade," *Time* 128 (November 3, 1986): 94–95; Douglas Brenner, "A Fine American Hand," *Architectural Record* 175 (March 1987): 122–27; Margot Gayle and Michele Cohen, *The Art Commission and the Municipal Art Society's Guide to Manhattan's Outdoor Sculpture* (New York: Prentice Hall Press, 1988), 170; "E. F. Hutton Headquarters," *Architecture + Urbanism*, extra edition (April 1988): 32–44; Carter B. Horsley, "New Lease on Life," *New York Post* (August 3, 1988): 31; Dunlap, "Of Britons, Bahrainis and a Block of Brownstones": 15; Susanna Sirefman, *New York: A Guide to Recent Architecture* (London: Ellipses, 1997), 170–71; David W. Chen, "Bank Buys Interest in 52d St. Building," *New York Times* (July 16, 1997), B: 6; White and Willensky, *AIA Guide* (2000), 293. Also see http://www.thecityreview.com/deutsche.html. For America House and the Donnell Library, see Stern, Mellins, and Fishman, *New York 1960*, 485–87.

115. For Roche's Ford Foundation, One United Nations Plaza, and work for the Metropolitan Museum of Art, see Stern, Mellins, and Fishman, *New York 1960*, 457–61, 636–39, 792–97.

116. Huxtable, "Creeping Gigantism in Manhattan": 36.

117. White and Willensky, *AIA Guide* (2000), 293.

118. Goldberger, "Out-of-Town Builders Bring Their Shows to New York": 35, 40.

119. Wiseman, "High Rise, Hard Sell": 44, 44–45.

120. Fowle, "The New American Craft Museum": 13.

121. Hine, "An Attention-Getting Design for the Brooklyn Museum": 14.

122. Carter B. Horsley, quoted in http://www.thecityreview.com/deutsche.html.

123. William S. Paley, quoted in C. Gerald Fraser, "Museum of Broadcasting Opens with Paley Gift," *New York Times* (November 10, 1976): 80.

124. Fraser, "Museum of Broadcasting Opens with Paley Gift": 80; *Beyer Blinder Belle, Architects & Planners* (New York: Beyer Blinder Belle, 1997), no pagination.

125. "7.8 Million Deal: The Lure of '21,'" *New York Times* (February 10, 1985), VIII: 1; Albert Scardino, "Manhattan Lot Soars in Value," *New York Times* (June 4, 1986), D: 1, 5; Mary Anne Ostrom, ed., "Networks Bring Museum to Paley's Own Backyard," *Manhattan, inc.* (November 1986): 21; Thomas Morgan, "New Building for Broadcast Museum," *New York Times* (December 3, 1986), C: 30; Michael Kimmelman, "Erecting a Monument to the Television Industry," *New York Times* (July 3, 1988), II: 16; Carter B. Horsley, "Broadcast Museum Eyes a New Home in Midtown," *New York Post* (July 8, 1988): 18; Jeremy Gerard, "Paley Presents Model of New Broadcast Museum," *New York Times* (July 8, 1988), C: 26; "Broadcast Museum," *Progressive Architecture* 69 (September 1988): 26; "Museums in Expansion," *New York Observer* (October 10, 1988): 2; Glenn Collins, "Broadcasting Museum Moves Down a Block and Up 17 Stories," *New York Times* (July 22, 1991), C: 13–14; Randall Rothenberg, "Art of Schlock: Is TV Suitable for Framing?" *New York Times* (August 25, 1991), II: 1, 21; "New Museum of TV Opens," *New York Times* (September 13, 1991), C: 3; Paul Goldberger, "A Post-Modern Museum for Television, Sans Irony," *New York Times* (September 22, 1991), II: 36; Donald Albrecht, "Museum of Television and Radio Opens in New York," *Architecture* 80 (November 1991): 27; Paul Goldberger, "Philip Johnson John Burgee Architect/1991," *New York Times* (December 29, 1991), II: 32; "Philip Johnson John Burgee Architect," *Architecture + Urbanism* 268 (January 1993): 22–29; Philip Johnson, "The Architect's Apologia," *Architecture + Urbanism* (August 1993): 28; Hilary Lewis and John O'Connor, *Philip Johnson: The Architect in His Own Words* (New York: Rizzoli International Publications, 1994), 160–61, 167; Peter Blake, *Philip Johnson* (Basel: Birkhauser, 1996), 224–25; Sirefman, *New York*, 169; White and Willensky, *AIA Guide* (2000), 292–93; Stephen Fox, *The Architecture of Philip Johnson* (Boston: Bulfinch Press, 2002), 286.

126. William S. Paley, quoted in Kimmelman, "Erecting a Monument to the Television Industry": 16.

127. Johnson, "The Architect's Apologia": 28.

128. Philip Johnson, quoted in Kimmelman, "Erecting a Monument to the Television Industry": 16.

129. Johnson, "The Architect's Apologia": 28. For Goodhue's Nebraska State Capitol, see Richard Oliver, *Bertram Grosvenor Goodhue* (New York: Architectural History Foundation; Cambridge, Mass.: MIT Press, 1983), 184–212.

130. Johnson, "The Architect's Apologia": 28. For the Hanover Bank, see Stern, Gilmartin, and Mellins, *New York 1930*, 178, 182.

131. Goldberger, "Post-Modern Museum for Television, Sans Irony": 36.

132. Philip Johnson, quoted in Lewis and O'Connor, *Philip Johnson: The Architect in His Own Words*, 160.

133. *Austrian Cultural Institute, New York: An Architectural Competition* (Innsbruck: Haymon-Verlag, 1993); David N. Cohn, "New York," *Geometria* 15 (1993): 119–20; Herbert Muschamp, "For Manhattan Tower, a 4-Plane Glass Facade," *New York Times* (January 6, 1993), C: 15; Michael Z. Wise, "Giant 'Metronome' for 52nd Street," *New York Observer* (January 11, 1993): 1, 20; Stephen A. Kliment, "Flawed Signal," editorial, *Architectural Record* 181 (February 1993): 9; "Austrian Cultural Institute," *Progressive Architecture* 74 (March 1993): 25; Stefano Pavarini, "The Austrian Cultural Institute," *L'Arca* 72 (June 1993): 8–11; Herbert Muschamp, "A Nervous Prism of a Building for Manhattan," *New York Times* (September 26, 1993), II: 45; Brendan Gill, "The Sky Line: Knight in Glass Armor," *New Yorker* 69 (November 22, 1993): 108–11; "A Debate: Raimund Abraham's Design for the Austrian Cultural Institute," *Oculus* 56 (January 1994): 1; Lebbeus Woods, "Raimund Abraham: Austrian Cultural Institute," *Architecture + Urbanism* (April 1994): 18–27; Briggite Groihofer, ed., *Raimund Abraham:*

[un]built (Wien: Springer, 1996), 208–12, 292–303; Karrie Jacobs, "New Style: No Style," *New York* 29 (September 23, 1996): 30, 115; "New York Towers," *ANY* 22 (1998): 28; Dietmar M. Steiner, *Manhattan, Austria: The Architecture of the Austrian Cultural Institute by Raimund Abraham* (Vienna: Architektur Zentrum Wien; Salzburg: Verlag Anton Pustet, 1999); Nina Rappaport, "Brief aus New York," *Deutsche Bauzeitung* 133 (May 1, 1999): 26; "Ein Keil in der New Yorker Baulandschaft," *Werk, Bauen + Wohnen* (July/August 1999): 56–57; Michael Sorkin, "When to Fold," *Metropolis* 19 (December 1999): 56, 58; Joseph Giovannini, "New York State of Mind," *World Architecture* (February 2000): 48–55; Edwin McDowell, "Slim Building Casts a Modern Image," *New York Times* (November 22, 2000), B: 7; Balfour, *World Cities: New York*, 112–13; Amanda May, "New York on Display," *Grid* 3 (March 2001): 30–31; Jayne Merkel, "New New York 2," *Oculus* 63 (March 2001): 17; Craig Kellogg, "Austrian Encounter," *Oculus* 64 (March/April 2002): 6; Herbert Muschamp, "Measuring Buildings Without a Yardstick," *New York Times* (July 22, 2001), II: 30; Julie V. Iovine, "For Austria: A Tribute and Protest," *New York Times* (March 7, 2002), F: 1, 14; Philip Nobel, "Tough Facade," *Artforum* 40 (April 2002): 41; Brook S. Mason, "A Little Austria in the Big Apple," *Arts & Antiques* 26 (April 2002): 27; Jamie Reynolds, "Forum Fitting," *Grid* 4 (April 2002): 64; Kieran Long, "A Little Piece of Austria in New York," *World Architecture* (April 2002): 14; Michael Z. Wise, "Showing the Flag of Culture (or Not)," *New York Times* (April 14, 2002), II: 1, 31; Blair Kamin, "New York's Cutting Edge Tower: More 'Ow' Than 'Wow,'" *Chicago Tribune* (April 19, 2002), V: 1; Herbert Muschamp, "A Gift of Vienna That Skips the Schlag," *New York Times* (April 19, 2002), E: 33, 38; Paul Goldberger, "The Sky Line: Neo-Ziggurat," *New Yorker* (April 22–29, 2002): 168–69; James Gardner, "An End to Gemütlichkeit," *New York Sun* (April 23, 2002): 9; Joseph Giovannini, "Forum and Function," *New York* 35 (April 29, 2002): 55; Ada Louise Huxtable, "Merging Culture and Commerce in Architecture," *Wall Street Journal* (May 16, 2002), D: 7; Paul Goldberger, "Austria Today," *Architecture* 91 (June 2002): 75–83; Bay Brown, "Sliver," *World Architecture* (June 2002): 30–37; James S. Russell, "Abraham's Austrian Cultural Forum," *Architectural Record* 190 (August 2002): 122–29; "2002 Award of Merit: Institutional Project, Austrian Cultural Forum," *New York Construction News* 50 (December 2002): 39; Luna, ed., *New New York*, 208–13; Craig Kellogg, "Architectural Bias Crimes," *Architectural Design* 74 (January/February 2004): 102–5. For Trowbridge & Livingston's Proctor house, see Christopher Gray, "Streetscapes: 11 East 52d Street," *New York Times* (February 21, 1993), X: 7.

134. Raimund Abraham, quoted in Wise, "Giant 'Metronome' for 52nd Street": 1.

135. Raimund Abraham, quoted in Iovine, "For Austria: a Tribute and Protest": 1.

136. Kamin, "New York's 'Cutting Edge' Tower: More 'Ow' than 'Wow'": 1.

137. Muschamp, "A Gift of Vienna That Skips the Schlag": 38.

HERALD SQUARE

1. Christopher Gray, "Cityscape/Gimbels," *New York Times* (March 22, 1987), VIII: 14. For Macy's, see Stern, Gilmartin, and Massengale, *New York 1900*, 190, 192; Stern, Gilmartin, and Mellins, *New York 1930*, 312–17. For Saks & Company, see Christopher Gray, "Streetscapes/Saks," *New York Times* (April 16, 1995), IX: 5. For Gimbel's, see Stern, Gilmartin, and Massengale, *New York 1900*, 192.

2. Gray, "Streetscapes/Saks": 5.

3. Carter B. Horsley, "Spruced-Up Herald Square to Assert Itself," *New York Times* (February 4, 1979), VIII: 1, 4.

4. Isadore Barmash, "Macy's Profits to Going Its Own Way," *New York Times* (May 15, 1983), II: 1, 12–13; George Lewis, "Names and News," *Oculus* 45 (October 1983): 7; Paul Goldberger, "Macy's New Main Floor: Art Deco Elegance," *New York Times* (December 1, 1983), C: 8; Sandra Salmans, "Man in the News: Edward Sidney Finkelstein," *New York Times* (October 22, 1985), D: 1.

5. Goldberger, "Macy's New Main Floor: Art Deco Elegance": 8.

6. Herbert Muschamp, "Nature and Artifice in Bloom," *New York Times* (April 5, 1996), C: 1, 4.

7. Isadore Barmash, "Herald Sq. Korvettes Store to Be Mall," *New York Times* (July 15, 1982), D: 5; "Designers' Touch for Midtown Mall," *New York Times* (November 23, 1982), B: 1; Claus Reinisch, "Herald Square Needs an Underground Mall," *New York Times* (December 4, 1982): 26; "A Massive Mural for a Microcosm," *New York Times* (December 19, 1982), VIII: 1; Isadore Barmash, "Fancy Shops at Herald Center," *New York Times* (April 24, 1984), D: 1; Daralice D. Boles, "Manhattan Malls," *Architectural Review* 180 (September 1986): 78, 80–82; Isadore Barmash, "Herald Center: More Troubles," *New York Times* (March 24, 1987), D: 1, 10; Mark McCain, "Revitalizing the Store That Marcos's Millions Built," *New York Times* (December 25, 1988), VIII: 5; Richard D. Lyons, "Toys 'R' Us Called Lift for Herald Center," *New York Times* (March 28, 1990), D: 26; White and Willensky, *AIA Guide* (2000), 225. For Citicorp Center, see Stern, Mellins, and Fishman, *New York 1960*, 490–97.

8. Boles, "Manhattan Malls": 82.

9. Albert Scardino, "Accord Reached to Sell 2 Gimbels Stores in City," *New York Times* (September 11, 1986), D: 3–4; Elizabeth Kolbert, "Gimbels Makes Bittersweet Finale," *New York Times* (September 28, 1986): 44; Gray, "Cityscape/Gimbels": 14; Jeanie Kasindorf, "Gimbels Group Goes Underground," *New York* 20 (March 23, 1987): 14; Isadore Barmash, "New Department Store for Old Gimbels' Site," *New York Times* (April 23, 1987): 12; "A. & S. Chairman Challenges Macy's," *New York Times* (April 27, 1987), D: 2; Alan S. Oser, "Plugging in an Anchor at the Gimbels Site," *New York Times* (June 7, 1987), VIII: 9; "New Design Concept for Manhattan

Landmark," *Urban Land* 48 (January 1989): 26; Audrey Farolino, "Shufflin' for Shoppers," *New York Post* (January 12, 1989): 53, 55; Isadore Barmash, "A.&S. Moves to Fill Gimbels Void," *New York Times* (March 18, 1989): 33, 35; Christine Dugas, "A&S Gets All Dolled Up for Its Manhattan Debut," *New York Newsday* (April 17, 1989): 3; Woody Hochswender, "A. & S. Makes a Big Bet in Manhattan Retailing," *New York Times* (September 5, 1989); D: 1, 4; Thomas J. Lueck, "Fortune's Smile Glimmers on Herald Sq.," *New York Times* (September 10, 1989), X: 1, 15; Rachel Epstein, "A&S Plaza a Haven for Shoppers Who Wish to Escape the Cold," *New York Observer* (December 11, 1989): 21; Clifford A. Pearson, "A Mall with a Big-City View," *Architectural Record* 178 (April 1990): 108–11; David W. Dunlap, "Launching a 4-Deck Flagship for Children's Wear," *New York Times* (April 22, 1990), VIII: 23; *RTKL: Selected and Current Works* (Mulgrave, Australia: Images Publishing, 1996), 230; Lynn Yeager, "Manhattan Mall-O-Drama," *Village Voice* (June 18, 1996): 44; Mitchell Pacelle, "Brawl Brewing in Manhattan Mall," *Wall Street Journal* (May 7, 1997), B: 10; White and Willensky, *AIA Guide* (2000), 225; Terry Pristin, "Remaking the Manhattan Mall," *New York Times* (September 30, 2000), B: 1, 3.

10. Pearson, "A Mall with a Big-City View": 110.

11. Stephanie Strom, "Sears Is Said to Seek Site in Herald Sq.," *New York Times* (October 12, 1994), D: 3; Amy Feldman, "Manhattan Mall on Sale Now," *Crain's New York Business* (February 17–23, 1997): 1, 23; David M. Halbfinger, "Mortgage Is Bought on Gimbels Building," *New York Times* (April 3, 1997), B: 8.

12. "Kmart Mostly Has Eyes for Penn Station," *New York Times* (July 3, 1994): 4; Bruce Lambert, "New Merchants Make It a Resurrection on 34th Street," *New York Times* (September 18, 1994), XIII: 6; Richard Wilner, "Retail Turnaround Is a Miracle on 34th Street," *New York Post* (March 31, 1997): 24.

13. Sonia Reyes, "Arcade Set Up for National Retail Chains," *New York Daily News* (August 12, 1996): 43; David M. Halbfinger, "Plans for Old Navy Store Scuttled by Cost of Taxes," *New York Times* (August 12, 1997), B: 6; Lisa W. Foderaro, "Old Navy to Open Store on 34th Street," *New York Times* (March 27, 1998), B: 10.

14. For the Pennsylvania Arcade, see Bruce Lambert, "Casbah? Gem? Arcade Sees Dim Future," *New York Times* (August 27, 1995), XIII:13.

15. "Gardens of Herald and Greeley Squares Are Spruced Up," *New York Times* (July 9, 1992): B: 1.

16. Douglas Martin, "The Greening of Herald and Greeley Squares," *New York Times* (November 30, 1996): 31; "In Manhattan," *Oculus* 62 (November 1999): 5; Barbara Stewart, "Islands in the Stream of Traffic Provide an Escape," *New York Times* (June 4, 2000): 41; Barbara Stewart, "At Last 2 Public Pay Toilets in Midtown," *New York Times* (January 18, 2001), B: 4.

SIXTH AVENUE

1. For the development of Sixth Avenue in the 1950s and 1960s, see Stern, Mellins, and Fishman, *New York 1960*, 396–416.

2. Carter B. Horsley, "On Ave. of Americas, the Lull is Ending," *New York Times* (May 4, 1980), VIII: 1, 4; Alan S. Oser, "New Office Building for Ave. of Americas," *New York Times* (April 15, 1981), B: 5; "What a Trip!" *New York Times* (June 13, 1982), VIII: 1; Diane Henry, "Law Firm Relocating in Midtown," *New York Times* (March 16, 1983), D: 22; Paul Goldberger, "Mediocre Skyscrapers Dominate the Skyline," *New York Times* (February 19, 1984), II: 31.

3. For a discussion of the Durst holdings in the Times Square area, see Alan S. Oser, "Finding Productive Uses for Midtown Property," *New York Times* (January 3, 1979), D: 15.

4. Oser, "New Office Building for Ave. of Americas": 5.

5. Goldberger, "Mediocre Skyscrapers Dominate the Skyline": 31. For the Exxon and McGraw-Hill Buildings, see Stern, Mellins, and Fishman, *New York 1960*, 406.

6. Richard D. Lyons, "Postings: Progress on 45th St.," *New York Times* (December 29, 1985), VIII: 1; "Tower on New York," *Engineering News-Record* 232 (September 4, 1986): 30; Lisa Foderaro, "Doing a Deal: Atrium on 45th," *New York Times* (June 7, 1987), VIII: 1; Susan Browne, "Cable-Braced Columns Rise 180 ft," *Engineering News-Record* 234 (May 26, 1988): 17; Mark McCain, "The Pot's Bubbling Along Avenue of the Americas," *New York Times* (August 9, 1987), VIII: 25. For the Belasco Theater, see William Morrison, *Broadway Theaters: History and Architecture* (Mineola, N.Y.: Dover Publications, 1999), 51–53.

7. McCain, "The Pot's Bubbling Along Avenue of the Americas": 25.

8. David W. Dunlap, "New Manhattan Arts School Planned," *New York Times* (September 8, 1986), B: 2; McCain, "The Pot's Bubbling Along Avenue of the Americas": 25; Alan Finder, "Koch Supports Air Rights Sale to a Developer," *New York Times* (December 17, 1987), B: 9; Todd S. Purdum, "School-Tower Plan in Doubt," *New York Times* (January 28, 1988), B: 3; Shawn G. Kennedy, "2 Deals Aid Office Tower in Manhattan," *New York Times* (August 31, 1988), D: 19; Alan S. Oser, "No Man's Land Breached on 45th Street," *New York Times* (January 29, 1989), X: 9; "Americas Tower: In the Grand Tradition of New York Architecture," *Real Estate Forum* 44 (July 1989): 76–100; "Midtown North Office Market Rebounds," *New York Real Estate Journal* 1 (October 15, 1989): 9; "950,000 s/f Americas Tower Now Under Construction," *New York Real Estate Journal* 1 (October 15, 1989): 1; Thomas J. Lueck, "Office Construction in the Doldrums," *New York Times* (December 24, 1989), X: 1, 4; David W. Dunlap, "For Durst, It's Now a Tower Instead of Taxpayers," *New York Times* (February 18, 1990), X: 16; Shawn G. Kennedy, "Americas Tower Now Goes to Arbitration," *New York Times* (March 4, 1990), X: 5, 8; David W. Dunlap, "Developers End a Legal Tussle on Skyscraper," *New York Times* (December 29, 1990): 28; David W. Dunlap, "Incomplete, but Being Restored,"

New York Times (September 29, 1991), VIII: 13. For the High School of the Performing Arts, see Landmarks Preservation Commission of the City of New York, LP-1241 (May 19, 1981); Barbaralee Diamonstein, *The Landmarks of New York III* (New York: Harry N. Abrams, 1998), 218.

9. Dunlap, "New Manhattan Arts School Planned": 2; "Top Firms in Their Fields Make for a Winning Construction Team," *Real Estate Forum* 44 (July 1989): 86–88; Lynda Baril, "'Famed' School Is Reborn," *Newsday* (July 1, 1992): 23; "Landmarks Preservation Commission Awards: 13 Projects Win Citations for Enhancing the Urban Environment," *New York Times* (June 12, 1994), X: 1.

10. Dunlap, "Developers End a Legal Tussle on a Skyscraper": 28.

11. John Peter Barie, quoted in "Americas Tower: In the Grand Tradition of New York Architecture": 96.

12. McCain, "The Pot's Bubbling Along Avenue of the Americas": 25; Alan S. Oser, "Midtown Development: Land-Use Issues Converge in West 40's," *New York Times* (December 27, 1987), VIII: 2; "Fox & Fowle, Pelli Design New Towers," *Building Design & Construction* 29 (November 1988): 32; White and Willensky, *AIA Guide* (2000), 262. For the Atlantic Building, see Stern, Gilmartin, and Massengale, *New York 1900*, 156–57.

13. Robert Fox, quoted in McCain, "The Pot's Bubbling Along Avenue of the Americas": 25.

14. Joseph Giovannini, "Offices Move Boldly Backward or Playfully Forward," *New York Times* (January 19, 1986), III: 8; Paul Goldberger, "Architecture That Pays Off Handsomely," *New York Times* (March 16, 1986), VI: 48–52, 54, 74, 78; *Kohn Pedersen Fox: Buildings and Projects, 1976–1986* (New York: Rizzoli International Publications, 1987), 327; White and Willensky, *AIA Guide* (1988), 238; White and Willensky, *AIA Guide* (2000), 231.

15. White and Willensky, *AIA Guide* (1988), 238.

16. White and Willensky, *AIA Guide* (1988), 238; White and Willensky, *AIA Guide* (2000), 231.

17. White and Willensky, *AIA Guide* (1967), 136. Also see Anthony DePalma, "2 Midtown Facelifting Projects," *New York Times* (March 21, 1984), D: 26; Mark McCain, "Cladding Aging Buildings in Sprightly New Outfits," *New York Times* (April 3, 1988), X: 15. For 1180 Sixth Avenue, see "20-Story Building Set for 6th Ave.," *New York Times* (March 11, 1961): 33; "New Building Started on 6th Ave at 46th St.," *New York Times* (September 26, 1961): 63; "6th Ave. Construction Moves South of Rockefeller Center," *New York Times* (April 8, 1962): 1, 10.

18. "Former Penney Building Is Getting a New Facade," *New York Post* (November 10, 1988): 72; "Former Home of J.C. Penney Is Renovated," *New York Times* (April 12, 1989), D: 22; "3 Jim Dine Sculptures: Venue on the Avenue," *New York Times* (January 14, 1990): 1; David W. Dunlap, "New Name, New Owners, New Tenants, New Image," *New York Times* (August 19, 1990), II: 15; Diana Ketcham, "The Sirens of Sixth Avenue," *Metropolis* 10 (June 1991): 24; Beverly Russell, "Strong Economy: The French Bank Credit Lyonnais Invests in Moed de Armas," *Interior Design* 151 (November 1992): 56–57; "Venues Under Wraps: A Mystery on Sixth Solved," *New York Times* (January 31, 1993), X: 1; Jerold S. Kayden, *Privately Owned Public Space: The New York Experience* (New York: John Wiley, 2000), 161–62.

19. Ketcham, "The Sirens of Sixth Avenue": 24.

20. Carol Vogel, "Inside Art," *New York Times* (September 22, 1995), C: 26; "1997's Top 25 Projects," *New York Construction News* 45 (April 1998): 31.

21. "43d St. Photo Gallery: Home Again on 6th Ave.," *New York Times* (March 26, 1989), X: 1; Carol Vogel, "A Larger Format," *New York Times* (November 12, 1999), E: 36; David W. Dunlap, "Photography Center Presents Renovated Midtown Space," *New York Times* (October 25, 2000), E: 3; Alanna Stang, ed., "Photo Refinish," *Interiors* 159 (November 2000): 21; Stephanie Cash, "ICP to Reopen in Midtown," *Art in America* 88 (November 2000): 47; Mila Andre, "A Major Development at Photo Museum," *New York Daily News* (November 3, 2000): 69; Ariella Budick, "ICP: $22.5M Overhaul," *Newsday* (November 3, 2000): 14; Vicki Goldberg, "In New Galleries, a Collection of the Unexpected," *New York Times* (November 3, 2000), E: 31; James Gardner, "At Scandinavia, Photo Museums, Geometry Is Destiny," *New York Observer* (November 13, 2000): 12; Ariella Budick, "The New International Center of Photography Provides a World-Class Frame for Its Entire Collection," *Newsday* (November 19, 2000), D: 18; "Photo Finish," *Oculus* 63 (March 2001): 6; Abby Bussel, "Photo Op," *Interior Design* 72 (March 2001): 156–61; Amanda May, "New York on Display," *Grid* 3 (March 2001): 30–31. For 1133 Sixth Avenue, see, Robert F. R. Ballard, *Directory of Manhattan Office Buildings* (New York: McGraw-Hill, 1978), 186.

22. For the Willard Straight house, see Stern, Gilmartin, and Massengale, *New York 1900*, 344, 346.

23. Gardner, "At Scandinavia, Photo Museums, Geometry Is Destiny": 12.

24. David W. Dunlap, "Glass Box Will Mark Midtown Home of Photography Center," *New York Times* (January 10, 2001), B: 7; David W. Dunlap, "International Center of Photography's New Midtown Home: An Underground Minicampus," *New York Times* (January 10, 2001), XI: 1; "Gone Underground," *Oculus* 64 (December 2001): 6. For the Grace Building, see Stern, Mellins, and Fishman, *New York 1960*, 464–65.

25. Quoted in Ralph Blumenthal, "Building Shuts Troubled 43d St. Plaza," *New York Times* (August 27, 1981), B: 4. Also see Frank J. Prial, "Fence Is Taken Down at Grace Plaza," *New York Times* (June 30, 1982), B: 3.

26. David W. Dunlap, "Policies Reworked as Open Spaces Go Unused," *New York Times* (August 8, 1988), B: 1, 4.

6 1/2 AVENUE

1. For a detailed discussion of midblock passages, see Jerold

S. Kayden, *Privately Owned Public Space: The New York Experience* (New York: John Wiley, 2000), 33–36, 46.

2. Stephen Garmey, *Gramercy Park: An Illustrated History of a New York Neighborhood* (New York: Balsam Press, 1984), 7, 31–39.

3. Jane Jacobs, *The Death and Life of Great American Cities* (New York: Random House, 1961), 182.

4. For the XYZ midblock passages, see Stern, Mellins, and Fishman, *New York 1960*, 410, 414–16.

5. "Equitable Life Considers Building a Tower," *New York Times* (October 5, 1980), VIII: 10; "R.I.P. Abbey," *New York Times* (June 27, 1982), VIII: 1; David W. Dunlap, "Equitable Life to Build 7th Ave. Tower," *New York Times* (February 18, 1983), B: 5; "East Side, West Side," *Architectural Record* 171 (May 1983): 55; "Equitable Tower West, New York, N.Y.," *Progressive Architecture* 64 (May 1983): 50; Anthony DePalma, "About Real Estate," *New York Times* (November 30, 1983), B: 8; Martin Gottlieb, "Developers Looking West of Sixth Avenue," *New York Times* (December 4, 1983), VIII: 1, 14; Kirk Johnson, "Towers Sprouting near Carnegie Hall," *New York Times* (September 9, 1984), VIII: 1, 14; "Edward Larrabee Barnes Associates," *GA Document* 12 (January 1985): 41; "The Equitable's Race for Assets," *Chief Executive* 101 (March 1985): 42–46; Maureen Dowd, "Construction Hoist Topples and 2 Workers Are Killed," *New York Times* (July 19, 1985), B: 3; Paul Goldberger, "Equitable's New Tower: A Curious Ambivalence," *New York Times* (February 20, 1986), B: 1, 5; Suzanne Stephens, "An Equitable Relationship?" *Art in America* 74 (May 1986): 116–23; Pilar Viladas, "Equitable: Art for All," *Progressive Architecture* 67 (May 1986): 25–26; Roger Kimball, "Art & Architecture at the Equitable Center," *New Criterion* 5 (November 1986): 24–32; Paul Goldberger, "Developers Learned Some Lessons and Cut Back," *New York Times* (December 28, 1986), II: 27–28; Andrea Truppin, "Designers of the Year," *Interiors* 146 (January 1987): 135–53; White and Willensky, *AIA Guide* (1988), 235–36; "Equitable Tower," *Architecture + Urbanism*, extra edition (April 1988): 216; "We Have Ways of Making You Stroll," *Spy* (June 1988): 95–99; *Edward Larrabee Barnes, Architect* (New York: Rizzoli International Publications, 1994), 249; John Rousmaniere, *The Life and Times of the Equitable* (New York: Equitable Companies, 1995), 288–92; Susanna Sirefman, *New York: A Guide to Recent Architecture* (London: Ellipsis, 1997), 140–41; Kayden, *Privately Owned Public Space*, 150–51.

6. Stern, Mellins, and Fishman, *New York 1880*, 391–96.

7. Stern, Mellins, and Fishman, *New York 1880*, 426–29.

8. Stern, Gilmartin, and Massengale, *New York 1900*, 173–76.

9. For Starrett & Van Vleck's building, see Stern, Gilmartin, and Mellins, *New York 1930*, 532–33. For Skidmore, Owings & Merrill's building, see Stern, Mellins, and Fishman, *New York 1960*, 400–403.

10. For the Hotel Victoria, see Stern, Gilmartin, and Mellins, *New York 1930*, 206.

11. Goldberger, "Equitable's New Tower: A Curious Ambivalence": 1, 5.

12. Stephens, "An Equitable Relationship?": 119.

13. Kimball, "Art & Architecture at the Equitable Center": 26–28.

14. Martin Gottlieb, "Equitable Life Will Mix Art and Commerce," *New York Times* (September 21, 1984), B: 1, 4; Douglas C. McGill, "Art Complex Planned in New Tower," *New York Times* (May 14, 1985), C: 11; Grace Glueck, "What Big Business Sees in Fine Art," *New York Times* (May 26, 1985), II: 1, 20; Grace Glueck, "Are the Whitney's Satellite Museums on the Right Course?" *New York Times* (June 2, 1985), II: 31; Harold R. Snedcof, "New York's Equitable Center: Where Art Is More Than an Ornament," *Urban Land* 44 (July 1985): 16–21; "Names and News," *Oculus* 47 (September 1985): 10; Douglas C. McGill, "New Midtown Branch for Whitney," *New York Times* (January 27, 1986), C: 21; Susan Heller Anderson and David Bird, "Preview of a Tower," *New York Times* (February 1, 1986): 31; Michael deCourcy Hinds, "Equitable Seeking Park Avenue Rents on Seventh Avenue," *New York Times* (February 9, 1986), VIII: 1, 18; Michael Brenson, "Museum and Corporation–A Delicate Balance," *New York Times* (February 23, 1986), II: 1, 28; Stephens, "An Equitable Relationship?": 116–23; Viladas, "Equitable: Art for All": 25–26; Richard F. Shepard, "Gallery Hopping," *New York Times* (June 9, 1986), C: 22; Kimball, "Art & Architecture at the Equitable Center": 24–32; "Dressing Up New York's Seventh Ave.," *New York Times* (February 1, 1987), III: 23; Douglas C. McGill, "Galleries," *New York Times* (April 26, 1987), VI, part 2: 61–62; Carol Vogel, "The Art Market," *New York Times* (January 31, 1992), C: 28.

15. Douglas C. McGill, "Art People," *New York Times* (December, 6, 1985), C: 30; Margaret Donavan and Anne Yarowsky, eds., *Roy Lichtenstein: Mural with Blue Brushstroke* (New York: Harry N. Abrams, 1987).

16. Scott Burton, quoted in Douglas C. McGill, "Art People," *New York Times* (February 7, 1986), C: 30. Also see Brenda Richardson, *Scott Burton* (Baltimore: Baltimore Museum of Art, 1987), 14–15.

17. Michael Brenson, "Benton Mural May Be Split Up," *New York Times* (January 17, 1983), C: 11; David W. Dunlap, "Equitable Purchases Benton Mural 'America Today,' Keeping It in the City," *New York Times* (February 14, 1984), B: 1, 3; Margot Slade and Carlyle C. Douglas, "Benton Mural Finds a Home," *New York Times* (February 19, 1984), IV: 20. Also see Stern, Gilmartin, and Mellins, *New York 1930*, 115–19.

18. Stephens, "An Equitable Relationship?": 122.

19. Kimball, "Art & Architecture at the Equitable Center": 24.

20. "Midtown Condominium: 46-Story Tower," *New York Times* (February 12, 1984), VII: 1; Dee Wedemeyer, "Midtown Housing Woos Out-of-Town Executives," *New York Times* (January 18, 1985): 17; Anthony DePalma, "Thrift Units Lend

for Commercial Construction, Too," *New York Times* (January 30, 1985), B: 10; Philip S. Gutis, "Midtown Pied-a-Terre Condominiums," *New York Times* (December 27, 1985), B: 9; Peter Lemos, "Harder Sell," *Metropolis* 5 (January/February 1986): 15; Andree Brooks, "Early Buys: Pitfalls for the Unwary," *New York Times* (January 11, 1987), VIII: 1, 12; Mark McCain, "Mixed-Use Buildings: The Rocky Marriages of Offices and Apartments," *New York Times* (April 19, 1987), VIII: 19; Michael deCourcy Hinds, "Why Some Manhattan Condos Founder," *New York Times* (October 4, 1987), VIII: 1, 20; Karen Cook, "Sour Deals, Empty Condos," *New York Post* (October 20, 1988): 57; David W. Dunlap, "Trade-Offs: Delaying the Amenities-for-Building-Bonuses Pledge," *New York Times* (October 7, 1990), X: 17; David W. Dunlap, "Arcade Meant for Public Is Parking Lot for a Hotel," *New York Times* (August 13, 1997), B: 5; Kayden, *Privately Owned Public Space*, 162; White and Willensky, *AIA Guide* (2000), 265; *The Architecture of Rafael Viñoly* (New York: Princeton Architectural Press, 2002), no pagination; "Elias, Owner of Flatotel: Two New Restaurants," *New York Real Estate Journal* (July 16–29, 2002), B: 1; Jen Renzi, "No Reservations," *Interior Design* 73 (September 2002): 117–18.

21. White and Willensky, *AIA Guide* (2000), 265. For the Americana Hotel, see Stern, Mellins, and Fishman, *New York 1960*, 436–38.

22. Jacob Finkleinstein, quoted in Whittlesey, "Midtown Housing Woes Inflict Town Executives": 17.

23. James Charles Stewart, quoted in Hinds, "Why Some New Condos Founder": 20.

24. Shawn G. Kennedy, "Postings: 35-Story Office Tower," *New York Times* (November 29, 1987), VIII: 1; Carter B. Horsley, "Minskoff's Tower of Power," *New York Post* (April 6, 1989): 48; David W. Dunlap, "Addresses in Times Square Signal Prestige, If Not Logic," *New York Times* (July 15, 1990): 1, 21; "New Office for Warner," *New York Times* (August 24, 1990), D: 5; *Kohn Pedersen Fox: Architecture & Urbanism, 1986–1992* (New York: Rizzoli International Publications, 1993), 78–81; David Henry, "Skyline Mover: Edward Minskoff Is One of New York's Premier Landlords–And He Hates to Lose," *Newsday* (June 20, 1994), C: 1; Kayden, *Privately Owned Public Space*, 162–63.

25. "Planners Approve Hilton Expansion," *New York Times* (July 25, 1979), B: 3; Joyce Purnick, "City Hilton Cancels Plans for Extension," *New York Times* (June 3, 1981), B: 3. For the New York Hilton, see Stern, Mellins, and Fishman, *New York 1960*, 403–6.

26. White and Willensky, *AIA Guide* (1988), 279; Harry Berkowitz, "Manhattan's Poshest Hotels Are Competing in Extravagant Style," *Newsday* (July 4, 1988): 4; David W. Dunlap, "The Rihga Royal Hotel: A Tower Long in Conception Is Finally Realized," *New York Times* (May 27, 1990), X: 15; James S. Russell, "Designing the Super-Thin New Buildings," *Architectural Record* 178 (October 1990): 105–9; Michael J. Crosbie, *The Architecture of Frank Williams* (Rockport, Mass.: Rockport Publishers, 1997), 14–25; Kayden, *Privately Owned Public Space*, 165; White and Willensky, *AIA Guide* (2000), 267; Barbara Martinez, "Name Dropping: A Real-Estate King Sees a Legacy Unravel As Creditors Move In," *Wall Street Journal* (March 21, 2000): 1, 6.

27. For the Holbein Studio, see Christopher Gray, "Streetscapes/Holbein Studio," *New York Times* (December 20, 1987), VIII: 5; White and Willensky, *AIA Guide* (2000), 267.

28. White and Willensky, *AIA Guide* (2000), 267.

29. Crosbie, *The Architecture of Frank Williams*, 14.

30. Thomas L. Waite, "Choir School Site: Offices by Macklowe," *New York Times* (March 13, 1988), X: 1; Karen Cook, "Boom-Boom Town," *New York Post* (December 22, 1988): 50; "New Office Entry on Manhattan's Burgeoning West Side," *Real Estate Forum* 44 (November 1989): 100; David W. Dunlap, "The Anatomy of a Macklowe Tower Leasing Coup," *New York Times* (November 24, 1991), X: 12.

31. Joseph Giovannini, "Young Voices Soar at the New St. Thomas Choir School," *New York Times* (September 17, 1987), C: 1, 12; Paul M. Sachner, "Perfect Pitch," *Architectural Record* 175 (November 1987): 116–19; "Corrections," *Architectural Record* 176 (January 1988): 4; White and Willensky, *AIA Guide* (2000), 270.

32. Lee A. Daniels, "72-Story Tower Proposed Next to the City Center," *New York Times* (May 3, 1984), B: 3; David W. Dunlap, "City's Plan to Sell Air Rights at Landmarks Draws Critics," *New York Times* (August 26, 1984): 51; Kirk Johnson, "Towers Sprouting Near Carnegie Hall," *New York Times* (September 9, 1984), VIII: 1, 14; "City Center Expansion Plan Detailed," *New York Times* (October 30, 1984), C: 13; Paul M. Sachner, "Redefining the Manhattan Skyline: Three New Projects by Murphy/Jahn," *Architectural Record* 173 (January 1985): 57; Paul Goldberger, "The Tower Blight Has Struck West 57th Street," *New York Times* (January 27, 1985), II: 29–30; "Helmut Jahn," *Gentleman's Quarterly* 55 (May 1985): cover; Peter Freiberg, "City Center's Blockbusting Performance," *Metropolis* 4 (June 1985): 11; "Board Gives Approval for a 70-Story Tower," *New York Times* (August 16, 1985), B: 2; Richard D. Lyons, "The Long Battle for Approval of City Center Tower," *New York Times* (September 1, 1985), VIII: 7; Joachim Andreas Joedicke, *Helmut Jahn* (Zurich: Karl Krämer Verlag, 1986), 98–99; Nory Miller, *Helmut Jahn* (New York: Rizzoli International Publications, 1986), 231–33; "City Center Tower," *Process Architecture* 64 (January 1986): 28–29; "City Center Tower," *Architecture + Urbanism*, extra edition (June 1986): 233; Joseph Giovannini, "Architect Puts His Mark on Skyline," *New York Times* (September 8, 1986), C: 17; Ante Glibota, *Helmut Jahn* (Paris: Paris Art Center, 1987), 460–65; McCain, "The Rocky Marriages of Offices and Apartments": 19; David W. Dunlap, "City to Review Cityspire Tower for Second Time," *New York Times* (June 23, 1987), B: 3; Barry Donaldson, "Stone: New Technology and Design,"

Architectural Record 175 (July 1987): 136–45; David W. Dunlap, "Enforcing of Height Limit Is Urged for Tower," *New York Times* (November 4, 1987), B: 3; "Corrections," *New York Times* (November 5, 1987): 3; David W. Dunlap, "Planners Reject a Tower That Is 11 Feet Too Tall," *New York Times* (December 22, 1987), B: 1, 5; White and Willensky, *AIA Guide* (1988), 279; David W. Dunlap, "A Tough Stance by the Planning Chief," *New York Times* (January 27, 1988), B: 1–2; David W. Dunlap, "Pact Reached on Skyscraper Built Too Tall," *New York Times* (April 20, 1988), B: 1, 4; David W. Dunlap, "Civic Leaders Fault Pact on Outsized Skyscraper," *New York Times* (April 23, 1988): 35; "City News Digest," *New York Observer* (May 2, 1988): 6; Ellen Posner, "Helmut Jahn Takes on the Big Apple," *Wall Street Journal* (May 17, 1988): 50; Carter B. Horsley, "Eichner's Tall Tale," *New York Post* (June 23, 1988): 50; David W. Dunlap, "Proposal to Build a Dance Studio over an Arcade Draws Opposition," *New York Times* (June 27, 1988), B: 5; David W. Dunlap, "New Dome Atop Cityspire Seen As Violating an Accord," *New York Times* (August 24, 1988), B: 4; "City News Digest," *New York Observer* (August 29, 1988): 6; "Corrections," *New York Times* (August 31, 1988): 3; Peg Tyre and Jeannette Walls, "City Center Claim May Mire Cityspire," *New York 21* (October 24, 1988): 17; David W. Dunlap, "Cityspire to Dismantle Part of Tower," *New York Times* (November 9, 1988), B: 1, 3; "Cityspire Comes Down a Few Notches," *New York Times* (December 14, 1988), B: 1; "Corrections," *New York Times* (December 16, 1988): 2; Peg Tyre and Jeannette Walls, "Eichner Colonizing Castle in the Air," *New York 22* (February 6, 1989): 12; David W. Dunlap, "Planners Approve a Disputed Tower," *New York Times* (February 16, 1989), B: 3; Paul Goldberger, "When Developers Change the Rules of the Game," *New York Times* (March 19, 1989), II: 36, 38; "How to Compensate for 11 Feet," editorial, *New York Times* (March 25, 1989): 26; Arnold H. Lubasch, "Board of Estimate Approves New Staten Island Jail," *New York Times* (March 31, 1989), B: 5; Russell, "Designing the Super-Thin New Buildings": 105–9; Paul Goldberger, "Skyscrapers Battle It Out near Carnegie Hall," *New York Times* (October 21, 1990): 38, 43; Susan Heller Anderson, "Chronicle," *New York Times* (November 28, 1990), B: 7; Allan R. Gold, "A Manhattan Skyscraper Is Told to Stop Whistling," *New York Times* (December 7, 1990): 1, B: 4; Monroe Price, "Cityspire: Music at Its Peak," *New York Times* (December 12, 1990): 23; "Briefs," *Architectural Record* (January 1991): 21; "Furthermore . . . ," *Progressive Architecture* 72 (February 1991): 125; Allan R. Gold, "Must Whistling Skyscraper Change Tune? Hearing to Decide," *New York Times* (February 11, 1991), B: 3; Allan R. Gold, "Yes, Building Whistles, Judge Rules, but It May Be Legal," *New York Times* (February 12, 1991), B: 3; "More Problems for Whistling Tower," *New York Times* (March 2, 1991): 27; Carter Wiseman, "Two for the Seesaw," *New York 24* (March 11, 1991): 68, 85; Allan R. Gold, "Ear-Piercing Skyscraper Whistles Up a Gag Order," *New York Times* (April 13, 1991): 26; Jerry Adler, *High Rise: How 1,000 Men and Women Worked Around the Clock for Five Years and Lost $200 Million Building a Skyscraper* (New York: Harper Collins, 1993), 68–69, 119–20, 244–45; David W. Dunlap, "Whistle Silenced, Cityspire Sales Resume," *New York Times* (June 13, 1993), X: 7; Claudia H. Deutsch, "A Deal-Maker's Comeback," *New York Times* (May 15, 1994), X: 15; *Murphy/Jahn: Selected and Current Works* (Mulgrave, Australia: Images Publishing, 1995), 94; Bruce Lambert, "How Do You Solve a Problem like Cityspire," *New York Times* (December 17, 1995), XIII: 6; David W. Dunlap, "Arcade Meant for Public Is Parking Lot for a Hotel," *New York Times* (August 13, 1997), B: 5; David W. Dunlap, "Midtown, Midblock Walkway Nears Completion," *New York Times* (August 13, 1997), B: 5; Sirefman, *New York*, 148–49; Kayden, *Privately Owned Public Space*, 166.

33. For the Mecca Temple, see Stern, Gilmartin, and Mellins, *New York 1930*, 197.

34. Carol Lawson, "City Center Renovation Set for Summer," *New York Times* (March 16, 1982), C: 10; Heidi Waleson, "Turning the City Center Theater into a First-Rate Dance Space," *New York Times* (August 29, 1982), II: 20.

35. Giovannini, "Architect Puts His Mark on Skyline": 17.

36. Sachner, "Redefining the Manhattan Skyline: Three New Projects by Murphy/Jahn": 57.

37. Goldberger, "The Tower Blight Has Struck West 57th Street": 30. For the Williamsburgh Savings Bank Building, see Stern, Gilmartin, and Mellins, *New York 1930*, 544–45.

38. Adler, *High Rise*, 69.

39. Goldberger, "Skyscrapers Battle It Out near Carnegie Hall": 38.

40. Gold, "A Manhattan Skyscraper Is Told to Stop Whistling": 1.

41. Price, "Cityspire: Music at Its Peak": 23.

42. Dunlap, "Midtown, Midblock Walkway Nears Completion": 5.

TIMES SQUARE: THE WORM IN THE APPLE

1. Dick Netzer, "The Worm in the Apple," *New York Affairs* 4 (1978): 40–48. Also see Stern, Mellins, and Fishman, *New York 1960*, 432–52.

2. Glenn Fowler, "Ban on Massage Parlors in Times Sq. Is Passed," *New York Times* (January 9, 1976): 35.

3. Murray Schumach, "Luxor Baths Being Secretly Converted into a 9-Story Luxury Massage Parlor," *New York Times* (March 5, 1976): 35; Murray Schumach, "Luxor Baths Owner Rules Out Criminal Action on Prostitution," *New York Times* (March 9, 1976): 12.

4. "Owner Sells Luxor Baths, Dropping Eviction Move," *New York Times* (March 11, 1976): 41; Murray Schumach, "Durst Asked to Quit His Cleanup Post," *New York Times* (March 12, 1976): 37.

5. *Erzoznik v. City of Jacksonville*, 422 U.S. 205 (1975); Fred Ferretti, "On Prostitution Row, Business Hums as Mayor

Talks," *New York Times* (April 29, 1976): 43; Nathaniel Shephard Jr., "Beame and a Broadway Cast Call for Eradication of 'Porno Plague,'" *New York Times* (April 29, 1976): 43; Lee Dembart, "Along 8th Avenue, Where Leer is King . . . ," *New York Times* (November 12, 1976), B: 3.

6. Nicholas Gage, "Beame Defied on Sex-Film House," *New York Times* (May 17, 1976): 1, 56; "Reversal Blocks 3 Sex-Film Houses," *New York Times* (May 18, 1976): 41. For the Mayfair Theater, see W. Parker Chase, *New York: The Wonder City* (New York: Wonder City Publishing Co., 1932; New York: New York Bound, 1983), 71; "Reade Gets Title to Theatre Site," *New York Times* (January 28, 1944): 28.

7. Edith Evans Asbury, "Mayor and Mouse Open One Times Square," *New York Times* (March 3, 1976): 41. For the Times Tower, see Stern, Gilmartin, and Massengale, *New York 1900*, 269. For the Allied Chemical Building, see Stern, Mellins, and Fishman, *New York 1960*, 1103.

8. George N. Stonbely, quoted in Philip H. Dougherty, "An Addition to Times Square," *New York Times* (October 11, 1976): 44. Also see Philip H. Dougherty, "The Green Lights on Times Sq.," *New York Times* (March 18, 1980), D: 15.

9. *Young v. American Mini Theatres, Inc.*, 427 US 50 (1976). Also see "Zoning 'Adult' Movies," editorial, *New York Times* (July 8, 1976): 30.

10. Alan S. Oser, "About Real Estate: Times Square," *New York Times* (June 30, 1976): 63.

11. Judy Klemesrud, "A New Game in Town for Times Sq Marks," *New York Times* (August 28, 1976): 24; Edward Ranzal, "Midtown People Call Car Lots Outdoor Bordellos," *New York Times* (December 1, 1976), B: 3.

12. Junius Henri Browne, quoted in Maurice Carroll, "Times Square Cleanup: Breach of Civil Liberties?" *New York Times* (November 15, 1976): 35. Also see Junius Henri Browne, *The Great Metropolis; a Mirror of New York* (Hartford, Conn.: American Publishing Co., 1869).

13. Charles Kaiser, "New Zoning to Curb Pornography Places Submitted by Beame," *New York Times* (November 12, 1976): 1, B: 3; Ronald Smothers, "Zoning Threat Fails to Faze Proprietors of Sex Shops," *New York Times* (November 13, 1976): 27; "Plans to Curb Pornography," *New York Times* (November 14, 1976), VI: 6; "Neighbors Protest 8th Ave. Pornography," *New York Times* (November 15, 1976): 35; Glenn Fowler, "28 Sex Places Midtown Limit in Zoning Map," *New York Times* (November 16, 1976): 43; "Map Illustrates Zone Proposal on Sex Places," *New York Times* (November 17, 1976), B: 2; "Zoning Out the Porn," *New York Times* (November 18, 1976): 42.

14. "Zoning Out the Porn": 42.

15. Charles Kaiser, "Planning Unit Votes Pornography Limits," *New York Times* (January 27, 1977): 1, 29; "The Zone Defense Against Smut," editorial, *New York Times* (February 5, 1977): 18.

16. Charles Kaiser, "Pedestrian Mall on Times Square Will Be Tested with U.S. Funds," *New York Times* (January 28, 1977): 1, B: 2; "Times Square Pedestrian Mall," *Progressive Architecture* 58 (March 1977): 21, 27; Martin Bloom, "The Salvation of Times Square as a Challenge to Urban Design," *Journal of the American Institute of Architects* 66 (June 1977): 54–59; Kenneth Halpern, *Downtown USA: Urban Design in Nine American Cities* (New York: Whitney Library of Design, 1978), 39–47; Lesley Oelsner, "'New' Times Square Waiting in the Wings," *New York Times* (November 14, 1978), B: 1, 6; Lynne B. Sagalyn, *Times Square Roulette: Remaking the City Icon* (Cambridge, Mass.: MIT Press, 2001), 117.

17. "When Does a Mall Pale?" editorial, *New York Times* (February 5, 1977): 18.

18. Charles Kaiser, "Planning Agency Moves to Widen Limitations on Pornography Outlets," *New York Times* (March 8, 1977): 35.

19. Charles Kaiser, "A 4-Borough-Pornography Ban Unexpectedly Loses," *New York Times* (March 25, 1977): 1, D: 12; "Mayor Beame Leads Pornography Raids," *New York Times* (March 25, 1977), D: 12.

20. Judy Klemesrud, "Anti-Smut Rally Plays to 8,000 at Its Final Act," *New York Times* (April 14, 1977), B: 3.

21. "Lights Go Out in Times Square," *New York Times* (April 29, 1977), B: 2.

22. Susan Heller Anderson and David W. Dunlap, "Times Sq. News Sign," *New York Times* (April 3, 1986), B: 4.

23. Joseph M. Conforti, "Why Pornography Settled in Times Square," letter to the editor, *New York Times* (April 20, 1977): 24. Also see Harold H. Berkin, "Toward Floating 'Smut,'" letter to the editor, *New York Times* (April 20, 1977): 24; Mary C. Henderson, "Times Square Pornography: 'The Real Issue Is Survival of a Great City,'" letter to the editor, *New York Times* (May 19, 1977): 22.

24. Selwyn Raab, "Koch Plans Tougher Zoning Laws to Ban New Smut Shops Midtown," *New York Times* (February 24, 1978): 16; Joseph P. Fried, "Koch Details 60 Grant Projects Including a Mall on Times Square," *New York Times* (April 18, 1978): 43; Selwyn Raab, "Police Manpower Tripled in the Times Square Area," *New York Times* (June 13, 1978), B: 3; "Companies Aid Times Square Study," *New York Times* (June 16, 1978), B: 3.

25. Selwyn Raab, "Koch Gets Plan for Cleanup of Times Sq. by 1980," *New York Times* (July 3, 1978), C: 23. Also see *Times Square Action Plan* (New York: City of New York, August 1978).

26. "Massage Parlors Get Deadline for Closing from Planning Unit," *New York Times* (November 9, 1978), B: 3; Dena Kleiman, "Drive Against 'Massage Parlors' in New York Is Gaining Strength," *New York Times* (November 19, 1978): 60.

27. Carter B. Horsley, "Modular, Zig-Zag, Futurist, Democratic Space Frames," *New York Times* (April 8, 1979), VIII: 1, 4; "Two Architectural Approaches to Advertising–Anti-Sign on a Virginia Highway, Signs as Outdoor Room on Times

Square," *Architectural Record* 165 (June 1979): 34.

28. Douglas Leigh, quoted in Horsley, "Modular, Zig-Zag, Futurist, Democratic Space Frames'": 4.

29. Jonathan Barnett, "Foreword," in Barbaralee Diamonstein, ed., *Artists & Architects Collaboration* (New York: Architectural League, 1981), 94. Also see James Freed and Alice Aycock, "Two Fantasies of a Mythical Waterworks," in Diamonstein, ed., *Artists & Architects Collaboration*, 152–55; Michael Sorkin, "The Odd Couples," *Village Voice* (March 18, 1981): 78.

30. Sorkin, "The Odd Couples": 78.

31. "Development Study for Times Square," *New York Times* (May 24, 1979), B: 4.

32. Glenn Fowler, "Restoration of Times Sq. Moving Closer to Reality," *New York Times* (June 18, 1979), B: 3.

33. For Schwartz & Gross's building, originally built as the Hotel Lincoln, see Stern, Gilmartin, and Mellins, *New York 1930*, 203–6.

34. Carter B. Horsley, "Broadway Poised for New Growth; Mall Questioned," *New York Times* (May 10, 1981), VIII: 1, 10; Clyde Haberman, "$4.5 Million in U.S. Aid Clears Plan for Mall in Times Square," *New York Times* (September 29, 1981), B: 4; "Misguided Mall," editorial, *New York Times* (October 1, 1981): 34; Michael Goodwin, "Council Unit Votes Business Aid Plan," *New York Times* (December 9, 1981): 1; Paul Goldberger, "Portman Hotel's Plan Seems to Assure Mall on Broadway," *New York Times* (January 17, 1982): 1, 37; Paul Goldberger, "Portman Drama: A Crowded Stage," *New York Times* (March 6, 1982): 17; Paul Goldberger, "Projected Mall in Times Sq. Area Losing Support," *New York Times* (May 5, 1982): 1; Sagalyn, *Times Square Roulette*, 489, 505.

35. Richard Bassini, quoted in Horsley, "Broadway Poised for New Growth; Mall Questioned": 10.

36. For the TKTS booth, see Stern, Mellins, and Fishman, *New York 1960*, 451–52.

37. Quoted in Goldberger, "Projected Mall in Times Sq. Area Losing Support": 1.

38. See Stern, Mellins, and Fishman, *New York 1960*, 448–50, 452.

39. Maurice Carroll, "Times Square Block to Get Face Lift," *New York Times* (December 5, 1976): 75.

40. Charles Kaiser, "Plan Offered for Times Sq. Hotel," *New York Times* (March 1, 1978), B: 18; Oelsner, "'New' Times Square Waiting in the Wings": 1, 6; Alan S. Oser, "Alexander's Weighs Ex-Macy Jamaica Site," *New York Times* (November 15, 1978), B: 7; Glenn Fowler, "Plans for a Hotel at Times Square Nearer to Reality," *New York Times* (October 6, 1979): 25, 27; "Keystone to a Renewal Taken off the Market," *New York Times* (November 13, 1979): 3; James Barron, "Financing Casts Doubt on Proposal for Portman's Times Square Hotel," *New York Times* (November 14, 1979): 33; C. Gerald Fraser, "Equity Moves to Save 3 Theaters," *New York Times* (December 5, 1979), C: 31; C. Gerald Fraser, "Actors Rally Against Hotel Plan," *New York Times* (February 28, 1980), C: 15; Paul Goldberger, "Has Times Square Room for the Portman?" *New York Times* (March 6, 1980), C: 17; Vito J. Pitta, "A New Hotel That Must Be Built," letter to the editor, *New York Times* (March 6, 1980): 22; "The Portman Hotel, Act III," editorial, *New York Times* (March 8, 1980): 20; Antonio G. Olivieri, "A Portman Hotel on Any Other Block . . . ," letter to the editor, *New York Times* (March 17, 1980): 18; "The Portman Hotel, Without Reservations," editorial, *New York Times* (July 17, 1980): 18; "Board Vote Approves Portman Hotel," *New York Times* (July 18, 1980), C: 15; Paul Goldberger, "Portman Hotel Project Faces Financing Hurdle," *New York Times* (July 19, 1980): 10; Antonio G. Olivieri, "Right Hotel, Wrong Site," letter to the editor, *New York Times* (July 26, 1980): 16; Joan K. Davidson, "An Urban-Planning Blunder Called the Portman Hotel," letter to the editor, *New York Times* (November 6, 1980): 34; Ronald Smothers, "Proposal for Hotel Clears One Hurdle," *New York Times* (November 23, 1980): 41; Ronald Smothers, "Hotel for Times Sq. Clears Key Hurdle," *New York Times* (December 3, 1980): 1, B: 6; "A Broadway Revival: Urban Development," editorial, *New York Times* (December 14, 1980): 30; C. Gerald Fraser, "New Attempt to Block Portman," *New York Times* (December 11, 1980), C: 36; Clyde Haberman, "Key Grant to Aid Portman Project Is Cast in Doubt," *New York Times* (December 24, 1980), B: 1; Clyde Haberman, "U.S. Withholds Funds for the Portman Hotel Planned for Times Sq.," *New York Times* (January 9, 1981): 1, B: 2; Ronald Smothers, "Portman Hotel Hurdles, Step by Step," *New York Times* (January 11, 1981), IV: 7; Irwin Molotsky, "Times Sq. Plans Tied to Program Reagan Opposes," *New York Times* (February 4, 1981), B: 4; Clyde Haberman, "Federal Approval Expected for Grant to Portman Hotel," *New York Times* (March 27, 1981), B: 1; Joyce Purnick, "2 Theaters' Tenants Accept Portman Bid to Vacate Early," *New York Times* (June 6, 1981): 27; Joyce Purnick, "Hearing on Portman Hotel Project Turns into Emotional Debate," *New York Times* (July 11, 1981): 26; Joyce Purnick, "Revised Hotel Design Urged to Save Theaters," *New York Times* (September 13, 1981): 54; Joyce Purnick, "Portman, Thinking Big, Is Unfazed by New York," *New York Times* (October 7, 1981), B: 1, 6; "Morosco Gains as Landmark," *New York Times* (November 22, 1981): 45; "Times Square Hotel," *GA Document* 3 (Winter 1981): 94–97; Ben A. Franklin, "2 Reagan Aides Acted to Speed Portman Hotel," *New York Times* (December 28, 1981): 19; Arnold H. Lubasch, "Stay Is Granted on Plan to Raze 2 City Theaters," *New York Times* (January 7, 1982), B: 1; Ronald Sullivan, "State and U.S. Courts Conflict on Portman Project," *New York Times* (January 10, 1982): 36; "Razing to Begin for Portman Hotel," *New York Times* (January 13, 1982), B: 5; Glenn Fowler, "Demolition of Bijou Starts for Portman Hotel," *New York Times* (January 14, 1982), B: 5; Paul Goldberger, "Portman's Hotel Plan Seems to Assure Mall on Broadway," *New York Times* (January 17, 1982): 1, 37; "The

Paper Hotel in Times Square," editorial, *New York Times* (January 20, 1982): 26; Michael Sorkin, "Portman's Hotel: Assault on a Mythic Center?" *Wall Street Journal* (January 22, 1982): 9; Michiko Kakutani, "Portman Hotel: Broadway Is a House Divided," *New York Times* (January 24, 1982), II: 1, 30; Colleen Dewhurst, Jason Robards, and Alan Eisenberg, "Let the Portman and the Theaters Coexist," letter to the editor, *New York Times* (January 25, 1982): 30; Paul Goldberger, "The Portman Project: Is It an Asset or an Albatross?" *New York Times* (January 31, 1982), II: 1, 32; "Pencil Points: Portmangate," *Progressive Architecture* 63 (February 1982): 24; Arnold H. Lubasch, "Portman Plan Clears Another Hurdle," *New York Times* (February 12, 1982), B: 4; "Razing of Theaters Staged by Court," *New York Times* (February 17, 1982), B: 3; C. Gerald Fraser, "Two Broadway Theaters Given a Reprieve by Appeals Judge," *New York Times* (March 2, 1982), C: 7; C. Gerald Fraser, "Marathon Protest Set at Portman Site," *New York Times* (March 3, 1982), C: 20; "Debris from Unintended Theater Collapse Blocks Street at Portman Hotel Site," *New York Times* (March 4, 1982), B: 19; John Corry, "Broadway Stages a Drama to Save 2 Theaters," *New York Times* (March 5, 1982): 1, C: 7; "Judge Extends a Ban on Razing Theaters; Protest Is Called Off," *New York Times* (March 6, 1982): 1, 17; Goldberger, "Portman Drama: A Crowded Stage": 17; Ann Dorszynski, Helen Hayes, Patricia Davies, Frederick Fox, Edgar C. Kintzer, Lenore Blumenfeld, Anthony Newfield, Gilbert Vassilatos, "Debating the Portman Project," letters to the editor, *New York Times* (March 7, 1982), II: 1, 7; John Corry, "Hotel-Theater Struggle: Complicated Legal Issues," *New York Times* (March 9, 1982), C: 12; "Anti-Demolition Actors to Play Streets," *New York Times* (March 12, 1982), C: 16; Sydney H. Schanberg, "Portman's Progress," *New York Times* (March 13, 1982): 25; Frank J. Prial, "Top State Court Refuses to Block Theater Razing," *New York Times* (March 17, 1982), B: 1, 8; "A New Petition on Portman Hotel," *New York Times* (March 19, 1982), B: 3; Paul L. Montgomery, "Judge Dismisses Another Appeal in Portman Plan," *New York Times* (March 20, 1982): 31; "Looks Like Curtains," *New York Times* (March 21, 1982), IV: 6; Edward A. Gargano, "Package Signed for Financing Portman Hotel," *New York Times* (March 22, 1982), B: 3; Eleanor Blau, "At Morosco, Ghosts Haunt Memories," *New York Times* (March 23, 1982), B: 5; Frank J. Prial, "Court Stay Lifted and Demolition Begins at Two Broadway Theaters," *New York Times* (March 23, 1982): 1, B: 5; Carol Lawson, "Wrecking Halts at the Helen Hayes to Save Artworks," *New York Times* (March 27, 1982): 25, 28; "Portman's Progress," *New York Times* (March 28, 1982), IV: 6; "And Then There Was One," *New York Times* (April 9, 1982): 1; "New York Theaters Demolished," *Journal of the American Institute of Architects* 71 (May 1982): 22; Akiko Busch, "When the Lights Go Down," *Metropolis* 1 (May 1982): 6–7; "Morosco, Hayes Lose to Portman," *Progressive Architecture* 63 (May 1982): 23; Goldberger, "Projected Mall in Times Sq. Area Losing Support": 1, D: 23; "Times Square After the Mall," editorial, *New York Times* (May 17, 1982): 14; Carol Lawson, "Fallen Façade Revives Theater-Razing Dispute," *New York Times* (June 9, 1982): C: 16; "Some Portman Anomalies," *Progressive Architecture* 63 (July 1982): 40; Frank J. Prial, "Final Contracts to Be Signed Today for the Portman Hotel," *New York Times* (July 2, 1982), B: 4; Carol Lawson, "Helen Hayes Honored as Theater Is Renamed," *New York Times* (July 22, 1983), C: 10; "Newest Times Sq. Tower," *New York Times* (January 20, 1983), B: 3; Eric Pace, "For Broadway: A New Hotel with a Theater," *New York Times* (July 6, 1983), B: 1, 8; Merrill Brown, "Marriott Plants Blue-Chip Hotel on Seedy Times Square," *Washington Post* (January 8, 1984): 1; Damon Stetson, "Putting Together a 50-Story Extravaganza," *New York Times* (January 8, 1984), VIII: 1, 14; "Broadway Revolution," editorial, *Engineering News-Record* 215 (March 1, 1984): 66; David W. Dunlap, "Marriott Marquis Builds Inner Roadway for Taxis," *New York Times* (July 28, 1984): 27; Edward William Henry Jr., "Portman, Architect and Entrepreneur: The Opportunities, Advantages, and Disadvantages of His Design-Development Process" (Ph.D. diss., University of Pennsylvania, 1985): 200–14; Benjamin Forgey, "Times Square," *Washington Post* (October 6, 1984), B: 1; Samuel G. Freedman, "New Theater in Hotel Assailed and Defended," *New York Times* (January 15, 1985), C: 15; Paul Goldberger, "Travel Notes on New York," *New York Times* (March 24, 1985), X: 21; Paul Goldberger, "Marriott Marquis Hotel: An Edsel in Time Sq.?" *New York Times* (August 31, 1985): 25; Ethan Schwartz, "Marriott Marquis Opens Its Doors," *New York Times* (September 4, 1985), B: 3; Leslie Wayne, "Marriott Stakes Out New Territory," *New York Times* (September 22, 1985), III: 1; Paul Goldberger, "Will Times Square Become a Grand Canyon?" *New York Times* (October 6, 1985), II: 31; William E. Geist, "New Broadway Hotel Gets the Once Over," *New York Times* (October 12, 1985): 31; C. Ray Smith, "The Portman Hotel on Times Square," *Oculus* 47 (November 1985): 15; Paul Goldberger, "The Prospect of Bigger Towers Cast a Shadow," *New York Times* (December 29, 1985), II: 31; Peter Lemos, "The Worst of Times," *Metropolis* 5 (December 1985): 12; Peter Lemos, "Deficiencies on Times Square," *Progressive Architecture* 67 (June 1986): 26; "Rooftop Revolution: The View, Marriott Marquis Hotel, New York," *Restaurant and Hotel Design* 8 (September 1986): 40; Ellen Cohn, "The Portman Fund," *Village Voice* (January 12, 1988): 12; Paolo Riani, *John Portman* (Milan: L'Arcaedizioni, 1990), 144–47; Ada Louise Huxtable, "Reinventing Times Square: 1990," in William R. Taylor, *Inventing Times Square: Commerce and Culture at the Crossroads of the World* (New York: Russell Sage Foundation, 1991), 362; Gregory F. Gilmartin, *Shaping the City: New York and the Municipal Art Society* (New York: Clarkson N. Potter, 1995), 446–49; Eric P. Nash, *Manhattan Skyscrapers* (New York: Princeton Architectural Press, 1999), 149–50; White and Willensky, *AIA Guide* (2000), 260; Sagalyn, *Times Square*

Roulette, 119–20, 133, 176–78, 333; *John Portman and Associates: Selected and Current Works* (Mulgrave, Australia: Images Publishing, 2002), 142–45; James Traub, *The Devil's Playground: A Century of Pleasure and Profit in Times Square* (New York: Random House, 2004), 152–54.

41. For the Piccadilly Hotel, see W. Parker Chase, *New York: The Wonder City* (New York: Wonder City Publishing, 1932; New York: New York Bound, 1983), 126.

42. For the Uris and Minskoff Theaters, see Stern, Mellins, and Fishman, *New York 1960*, 442–46.

43. Quoted in Gilmartin, *Shaping the City*, 447. For the Helen Hayes Theater (Folies Bergère), see Stern, Gilmartin, and Massengale, *New York 1900*, 216–17. For the Morosco and the Bijou, see Stern, Gilmartin, and Mellins, *New York 1930*, 230.

44. David Mamet, quoted in Fraser, "Actors Rally Against Hotel Plan": 15.

45. Goldberger, "Has Times Square Room for the Portman?": 17.

46. "The Portman Hotel, Without Reservations": 18.

47. Joan K. Davidson, quoted in "Board Vote Approves Portman Hotel": 15.

48. Franklin, "2 Reagan Aides Acted to Speed Portman Hotel": 39.

49. "The Paper Hotel in Times Square": 26.

50. Goldberger, "Will Times Square Become a Grand Canyon?": 31.

51. Carter B. Horsley, "Novotel Plans Broadway Hotel on Offices," *New York Times* (October 18, 1981), VIII: 10; George W. Goodman, "City Adding 3,500 Hotel Rooms," *New York Times* (November 7, 1982), VIII: 1; David W. Dunlap, "From Dust of Demolition, a New Times Square Rises," *New York Times* (July 6, 1988), B: 1; David W. Dunlap, *On Broadway: A Journey Uptown Over Time* (New York: Rizzoli International Publications, 1990), 186, 198.

52. Goldberger, "Will Times Square Become a Grand Canyon?": 31; "Visual Simulations as Planning Aids," *Wall Street Journal* (July 2, 1986), II: 25; Gilmartin, *Shaping the City*, 457–59; Sagalyn, *Times Square Roulette*, 248–49.

53. Goldberger, "Will Times Square Become a Grand Canyon?": 31.

54. Brendan Gill, "The Sky Line: On the Brink," *New Yorker* 63 (November 9, 1987): 113–18, 120–26.

55. Herbert Sturz, quoted in Richard D. Lyons, "Making Great White Way Great Again," *New York Times* (January 5, 1986), VIII: 1, 14. Also see Michael Hirschfeld, "Times Square," letter to the editor, *New York Times* (February 2, 1986), VIII: 12; Walter Cooke, "Times Square," letter to the editor, *New York Times* (March 9, 1986), VIII: 12; James Brooke, "Conserving the Glitter Times Sq.," *New York Times* (May 11, 1986): 35; Robert T. Hall, "Why the Times Square We All Love and Hate Has Got to Go," letter to the editor, *New York Times* (July 4, 1986): 26; "Due Regard for Old Broadway," editorial, *New York Times* (July 28, 1986): 14; Martin Gottlieb, "Times Square to Stay Bright in City's Plan," *New York Times* (August 6, 1986), B: 1, 4; Virginia Dajani, "This Is Times Square?" *The Livable City* 10 (October 1986): 4; Philip K. Howard, "This Is Times Square!" *The Livable City* 10 (October 1986): 5; Alan S. Oser, "Planning for a Brighter Times Sq.," *New York Times* (December 14, 1986), VIII: 6, 16; "Signs of Life in Times Square," editorial, *New York Times* (January 25, 1987): 22; Paul Goldberger, "New Times Sq. Zoning: Skyscrapers with Signs," *New York Times* (January 30, 1987), B: 1, 3; Peter Samton, "Times Square," letter to the editor, *New York Times* (March 22, 1987), VIII: 12; Mark McCain, "Racing the Clock in West Midtown," *New York Times* (May 10, 1987), VIII: 1, 20; Albert Scardino, "Builder Wants Green in Great White Way," *New York Times* (June 13, 1987): 32; Albert Scardino, "New Offices Changing the Theater District," *New York Times* (June 13, 1987): 29, 32; Paul Goldberger, "For Times Square, Light at the Mouth of the Tunnel," *New York Times* (October 25, 1987), II: 42; "New Lights on Old Broadway," *Architectural Record* 175 (November 1987): 71; Gill, "The Sky Line: On the Brink": 113–18, 120–26; Kurt Andersen, "Renewal, but a Loss of Funk," *Time* 131 (February 29, 1988): 102–3; Herbert Sturz, "The Editorial Notebook: A Planner Faces Reality," *New York Times* (August 6, 1988): 24; Mark McCain, "A Mandated Comeback for the Great White Way," *New York Times* (April 9, 1989), X: 23; Paul Goldberger, "A Huge Architecture Show in Times Square," *New York Times* (September 9, 1990), II: 45; Huxtable, "Reinventing Times Square: 1990," in Taylor, *Inventing Times Square*, 365–70; Gilmartin, *Shaping the City*, 459–61; Sagalyn, *Times Square Roulette*, 252–65.

56. Sagalyn, *Times Square Roulette*, 253.

57. Alan Lapidus, quoted in Andersen, "Renewal, but a Loss of Funk": 103.

58. "Due Regard for Old Broadway": 14.

59. David Solomon, quoted in Scardino, "Builder Wants Green in Great White Way": 32.

60. Goldberger, "New Times Sq. Zoning: Skyscrapers with Signs'": 3.

61. Gilmartin, *Shaping the City*, 459.

62. Huxtable, "Reinventing Times Square: 1990," in Taylor, *Inventing Times Square*, 366, 370.

63. Mark McCain, "3 Hostelries to Join the Marquis, a Hit on Broadway," *New York Times* (May 21, 1989), X: 27.

64. Martin Gottlieb, "Surge of Times Sq. Projects Raises Questions on Effects," *New York Times* (November 1, 1986): 33, 36; Oser, "Planning for a Brighter Times Sq.": 6, 16; "New Lights on Old Broadway": 71; David W. Dunlap, "The City Casts Its Theaters in Stone," *New York Times* (November 22, 1987), IV: 6; Alan S. Oser, "Perspectives: Times Square," *New York Times* (February 21, 1988), VIII: 9, 18; McCain, "3 Hostelries to Join the Marquis, a Hit on Broadway": 27; Richard D. Lyons, "Ramada's Times Sq. Hotel Plans," *New York Times* (June 14, 1989), D: 21; Jerry Adler, "The Temples of Lapidus," *Newsweek* 113 (June 16, 1989): 64–65; Anne Kates, "Big Apple

Hotel to Mimic Lights of Broadway," *USA Today* (July 14, 1989): 6B; Anne Kates, "Architect Designs Fantasy," *USA Today* (October 20, 1989): 8B; Richard D. Lyons, "A 'Jukebox' Hotel for Times Square," *New York Times* (December 13, 1989); D: 18; Dunlap, *On Broadway*, 178–79; David W. Dunlap, "The Sun Is Setting on the Times Square Porn Palaces," *New York Times* (August 12, 1990), X: 14; Paul Goldberger, "Once a Hotel Desert, Times Square Blooms" in *New York Times* (August 15, 1990), B: 1, 3; Goldberger, "A Huge Architecture Show in Times Square": 45; Huxtable, "Reinventing Times Square: 1990," in Taylor, *Inventing Times Square*, 368; Eve M. Kahn, "Empty New High-Rises Preserve Anarchy of Broadway," *Wall Street Journal* (June 9, 1992): 14; Gilmartin, *Shaping the City*, 460; White and Willensky, *AIA Guide* (2000), 263; Sagalyn, *Times Square Roulette*, 255; Traub, *The Devil's Playground*, 258.

65. Alan Lapidus, quoted in Lyons, "A 'Jukebox' Hotel for Times Square": 18.

66. Huxtable, "Reinventing Times Square: 1990," in Taylor, *Inventing Times Square*, 368.

67. Adler, "The Temples of Lapidus": 64. Also see Morris Lapidus, *An Architecture of Joy* (Miami, Fla.: E.A. Seemann, 1979).

68. David W. Dunlap, "Demolition Plays the Palace (But the Theater Plays On)," *New York Times* (May 13, 1988), B: 1, 3; "New Hotel for Times Square," *New York Post* (February 9, 1989): 30; "Embassy Suites Unit Plans to Build New York Hotel," *Wall Street Journal* (February 9, 1989), C: 13; "New Times Square Embassy Suites Will Preserve 75 Year Old Theater," *Restaurant/Hotel Design International* 11 (April 1989): 14; Peg Tyre and Jeannette Walls, "Intelligencer: Lights Stay Bright on Broadway," *New York* 22 (May 1, 1989): 14; McCain, "3 Hostelries to Join the Marquis, a Hit on Broadway": 27; Lyons, "Ramada's Times Sq. Hotel Plans": 21; Dunlap, *On Broadway*, 174–75; "Embassy Suites Times Square," *Progressive Architecture* 71 (January 1990): 102–3; Goldberger, "Once a Hotel Desert, Times Square Blooms": 1, 3; James S. Russell, "When There's No Place to Go but Up," *Architectural Record* 178 (September 1990): 160–63; Goldberger, "A Huge Architecture Show in Times Square": 45; Huxtable, "Reinventing Times Square: 1990," in Taylor, *Inventing Times Square*, 368; Marc S. Harriman, "Spanning History," *Architecture* 80 (November 1991): 107–9; Kahn, "Empty New High-Rises Preserve Anarchy of Broadway": 14; Gilmartin, *Shaping the City*, 460; Fox & Fowle: Function Structure Beauty* (Milan: L'Arca Edizioni, 1999), 20–25; White and Willensky, *AIA Guide* (2000), 262; Alan Balfour, *World Cities: New York* (New York: Wiley Academy, 2001), 85.

69. For the Palace Theater, see Landmarks Preservation Commission of the City of New York, LP-1367 (July 14, 1987); Barbaralee Diamonstein, *The Landmarks of New York II* (New York: Harry N. Abrams, 1993), 315; William Morrison, *Broadway Theatres: History & Architecture* (New York: Dover, 1999), 91–93.

70. Goldberger, "Once a Hotel Desert, Times Square Blooms": 3. For the PSFS Building, see Robert A. M. Stern, *George Howe: Toward a Modern American Architecture* (New Haven, Conn.: Yale University Press, 1975), 108–30, figs. 83–97.

71. Huxtable, "Reinventing Times Square: 1990," in Taylor, *Inventing Times Square*, 368.

72. "Buildings Wrecked Without Permits," *New York Times* (January 9, 1985), B: 3; Martin Gottlieb, "Nighttime Demolition Leaves a 44th St. Mystery," *New York Times* (January 10, 1985), 1, B: 7; Matthew L. Wald, "City Is Planning to Reopen Lane on 44th St.," *New York Times* (January 11, 1985), B: 3; "White-Collar Vandalism on 44th St.," editorial, *New York Times* (January 12, 1985): 20; Martin Gottlieb, "City Is Planning Action to Block Razing of Hotels," *New York Times* (January 12, 1985): 25; Sydney H. Schanberg, "Gold on 44th Street," *New York Times* (January 12, 1985): 21; Josh Barbanel, "City Sues for $10 Million in Demolition on 44th St.," *New York Times* (January 15, 1985), B: 4; Marcia Chambers, "Defamation Is Laid to City Aides in West 44th St. Demolition Case," *New York Times* (April 3, 1985), B: 4; Marcia Chambers, "Guilty Pleas Entered in Demolition at Times Sq.," *New York Times* (May 8, 1985): 1, B: 5; "Bargain Justice for a Bulldozer," editorial, *New York Times* (May 9, 1985): 30; Frederick A. O. Schwarz Jr., "The Best Available Deal for New York," *New York Times* (May 16, 1985): 30; Joe Klein, "Mr. Big: Harry Macklowe Wants to Trump Donald Trump," *New York* 18 (December 9, 1985): cover, 52–60; Martin Gottlieb, "Developer Told Jury He Ordered Illegal Demolition," *New York Times* (December 19, 1985), B: 11; Martin Gottlieb, "Contractor Guilty in Demolition of 44th Street Buildings at Night," *New York Times* (December 21, 1985): 1, 52; Martin Gottlieb, "Macklowe Demolition Man Is Given a No-Jail Sentence," *New York Times* (February 12, 1986), B: 3; "Justice for Reckless Wreckers," editorial, *New York Times* (February 17, 1986): 16; "Developer Cleared of Perjury in Midtown Demolition Trial," *New York Times* (May 22, 1986), B: 3; David W. Dunlap, "Plan Blocked for Tower atop Landmark," *New York Times* (November 18, 1987), B: 3; Dunlap, "The City Casts Its Theaters in Stone": 6; Robert D. McFadden, "$1.5 Million Awarded in Illegal Razing," *New York Times* (January 8, 1988), B: 3; Tom Robbins, "The Cost of Doing Business," *Village Voice* (May 17, 1988): 12; "Luxury Hotel and Office Center for Times Square," *Better Buildings* 7 (June 1988): 14; "A Macklowe Hotel That *Who* Built?" *New York* 21 (July 25, 1988): 9–10; Shawn G. Kennedy, "A Mixed-use Tower Rising Off Times Sq.," *New York Times* (August 10, 1988), D: 21; Nancy Marx Better, "Marriott, Hilton . . . Macklowe?" *Manhattan, inc.* 5 (September 1988): 36; Alan Finder, "Ban Disappears, and a New Hotel Appears," *New York Times* (January 14, 1989): 1, 28; Alan Finder, "Koch Disputed on a Benefit to Developer," *New York Times* (January 16, 1989), B: 1, 3; "A Macklowe Cloud over New York," editorial, *New York Times* (January 18, 1989): 14; Alan Finder, "Koch Clarifies

Comment on S.R.O. Law," *New York Times* (January 20, 1989), B: 3; Alan Finder, "New York's Error Is Macklowe's Hotel," *New York Times* (January 22, 1989), IV: 6; "The Macklowe Mess: Still a Mess," editorial, *New York Times* (January 25, 1989): 22; "An Explanation, at Last, on Macklowe," editorial, *New York Times* (February 2, 1989): 24; Robert Esnard, "New York City Served the Public Interest in the Macklowe Case," letter to the editor, *New York Times* (February 2, 1989): 24; McCain, "3 Hostelries to Join the Marquis, a Hit on Broadway": 27; Lyons, "Ramada's Times Sq. Hotel Plans": 21; Shawn G. Kennedy, "2 Hotels Build for Business Travelers," *New York Times* (October 25, 1989), D: 24; "Pioneering Developers Moves in New Directions," *Real Estate Forum* 44 (November 1989): 72–75, 80–83, 90–91, 101, 106; Alan Finder, "Supreme Court Won't Review S.R.O. Ruling," *New York Times* (November 28, 1989), B: 1, 6; Bruce Serlen, "A New Role for the Hudson Theater," *Metropolis* 9 (December 1989): 18–20; Charles V. Bagli, "Macklowe, Zeckendorf: Return SRO Money," *New York Observer* (December 11, 1989): 16; Charles V. Bagli, "Now, Macklowe May Be *Building* SRO's," *New York Observer* (May 7, 1990): 12; Charles V. Bagli, "Macklowe Gets SRO Refund," *New York Observer* (May 28, 1990): 6; Sam Roberts, "Hotel Is Macklowe's Bid for a Shinier Image," *New York Times* (August 4, 1990): 25–26; Goldberger, "Once a Hotel Desert, Times Square Blooms": 1, 3; Goldberger, "A Huge Architecture Show in Times Square": 45; "Topics of The Times: Chess in Times Square," *New York Times* (September 26, 1990): 26; Clifford A. Pearson, "Putting Fleet to Work," *Architectural Record Lighting* 180 (May 1992): 42–48; White and Willensky, *AIA Guide* (2000), 259.

73. Klein, "Mr. Big: Harry Macklowe Wants to Trump Donald Trump": 54.

74. For the Hudson Theater, see Landmarks Preservation Commission of the City of New York, LP-1340–41 (November 17, 1987); Nicholas van Hoogstraten, *Lost Broadway Theaters* (New York: Princeton Architectural Press, 1991), 66–67; Diamonstein, *The Landmarks of New York II*, 266.

75. "Bargain Justice for a Bulldozer": 30.

76. "Topics of The Times: Chess in Times Square": 26.

77. Philip M. Jones, quoted in Serlen, "A New Role for the Hudson Theater": 20.

78. Goldberger, "Once a Hotel Desert, Times Square Blooms": 3.

79. David Henry, "Macklowe's Finances May Be Crumbling," *Newsday* (December 22, 1993): 39; "New Yorkers & Co.," *New York Times* (September 25, 1994), XIII: 4; David Henry, "Real Estate: Bitter Suite," *Newsday* (October 7, 1994), D: 1; "Hong Leong to Buy Another NY Hotel," *Business Times* (Singapore) (October 12, 1994): 1.

80. Paul Goldberger, "New Times Sq. Zoning: Skyscrapers with Signs," *New York Times* (January 30, 1987), B: 1, 3; "New Lights on Old Broadway": 71; Shawn G. Kennedy, "New Tower at North End of Times Sq.," *New York Times* (February 3, 1988), D: 30; Dunlap, "From Dust of Demolition, a New Times Square Rises": 1; David W. Dunlap, "Site of the Latin Quarter Giving Way to a Tower," *New York Times* (February 13, 1989), B: 2; Joan Lebow, "Ramada Plans to Build Hotel at Times Square," *Wall Street Journal* (June 6, 1989), C: 17; Lyons, "Ramada's Times Sq. Hotel Plans": 25; Estelle Lander, "Hotels Hope Times Square Hospitable," *Newsday* (June 26, 1989): 3; Dunlap, *On Broadway*, 175, 178; Jeannette Walls, "Intelligencer: Coca-Cola Sign Fizzling Out," *New York* 23 (April 16, 1990): 10; David W. Dunlap, "North of Duffy Sq., a Butler-on-Every-Floor Hotel," *New York Times* (June 10, 1990), V: 25; David W. Dunlap, "Commercial Property: Times Square Signs," *New York Times* (June 2, 1991), X: 15; Paul Goldberger, "The New Season: Architecture," *New York Times* (September 8, 1991), II: 48; Stuart Elliott, "New Giants in Times Square Light Brigade," *New York Times* (November 15, 1991), D: 1, 15; "Hoist a Tall, Cool One," *New York Times* (December 15, 1991): 46; "Times Square Ramada Is Due," *New York Times* (December 22, 1991), V: 3; Edwin McDowell, "Ramada's Gamble in Times Sq.," *New York Times* (March 3, 1992), D: 1, 4; Kahn, "Empty New High-Rises Preserve Anarchy of Broadway": 14; Herbert Muschamp, "For Times Square, a Reprieve and Hope of a Livelier Day," *New York Times* (August 6, 1992), C: 15; David W. Dunlap, "Signs Signal Both Profit and Controversy," *New York Times* (February 6, 1994), X: 1, 12; "Mayers & Schiff: Two Times Square," *Architecture + Urbanism* (November 1995): 60–63; John Holusha, "For the Great White Way, More Glitz," *New York Times* (September 1, 1996), IX: 9; White and Willensky, *AIA Guide* (2000), 263; Paul Goldberger, "The Sky Line: Busy Buildings," *New Yorker* 76 (September 4, 2000): 90–93; Sagalyn, *Times Square Roulette*, 328–29; Traub, *The Devil's Playground*, 258.

81. For the TKTS pavilion, see Stern, Mellins, and Fishman, *New York 1960*, 451–52.

82. Muschamp, "For Times Square, a Reprieve and Hope of a Livelier Day": 18.

83. Gretchen Dykstra, quoted in Holusha, "For the Great White Way, More Glitz": 9.

84. Charles V. Bagli, "French Luxury Hotel Planned for West Side of Manhattan," *New York Times* (February 28, 1997), B: 5; Charles V. Bagli, "Hotel Business Is Growing Bigger, Busier and Faster," *New York Times* (November 23, 1997): 39; "$90 Million New York Sofitel Hotel to Open in 2000; On W. 44th St., a Touch of France," *New York Times* (January 25, 1998), XI: 1; "Sofitel to Rise in N.Y.," *New York Construction News* 45 (April 1998): 1; David S. Chartock, "Design and Owner Requirements Top Challenges for Sofitel's Team," *New York Construction News* 46 (January 1999): 1–3; "New York Room Boom!! *Grid* 2 (March + April 2000): 96; "Hotel Sofitel," *New York Construction News* 47 (June 2000): 31; Herbert Muschamp, "An Architect Earns the Right to Build the Blues," *New York Times* (August 3, 2000): F: 1, 8; Karen Nichols, ed., *Michael Graves: Buildings and Projects, 1995–2003* (New York: Rizzoli International Publications, 2003), 154–55.

85. For the New York Yacht Club, see Stern, Gilmartin, and Massengale, *New York 1900*, 238–39. For the Seymour Hotel, see Stern, Gilmartin, and Massengale, *New York 1900*, 278.

86. Muschamp, "An Architect Earns the Right to Build the Blues": 8.

87. Denny Lee, "Debating the Sincerest Form of Architectural Flattery," *New York Times* (February 25, 2001), XIV: 6; Christopher Gray, "Streetscapes/44th Street Between Fifth and Sixth Avenues," *New York Times* (April 1, 2001), XI: 7; Peter Grant, "Plots & Ploys," *Wall Street Journal* (July 18, 2001), B: 10; Tracie Rozhon, "Design and Dissent Roil Ivy Clubhouse," *New York Times* (August 16, 2001), F: 1, 8; Steve Fisher, "The Harvard Club Debate," letter to the editor, *New York Times* (September 6, 2001), F: 5; Val K. Warke, "What Comes Next?" letter to the editor, *New York Times* (September 6, 2001), F: 5; Roger K. Lewis, "In Battles of Traditionalism vs. Modernism, Creativity Is Often the Biggest Casualty," *Washington Post* (September 8, 2001), H: 3; Thomas de Monchaux, "Group of Harvard Alums Protest Clubhouse Facade," *Architectural Record* 189 (November 2001): 42; Alex Ulam, "In Roiling Coup at Harvard Club, Board Blasted Over Glass House," *New York Observer* (January 7, 2002): 1, 10; Alex Ulam, "Harvard Club Completed, Still Controversial," *Architectural Record* 191 (September 2003): 50; Rosalie R. Radomsky, "Postings: New Addition to Harvard Club on West 44th Street," *New York Times* (November 2, 2003), XI: 1. For McKim, Mead & White's work, see Stern, Gilmartin, and Massengale, *New York 1900*, 237–38.

88. Christie De Kay, *From the App That Is Past: Harvard Club of New York City, a History (New York: Harvard Club of New York, 1994), 418–21.

89. Richard Economakis, ed., *Building Classical: A Vision of Europe and America* (London: Academy Editions, 1993), 232.

90. Richard Jenrette, quoted in Rozhon, "Design and Dissent Roil Ivy Clubhouse": 1.

91. Max Bond, quoted in Lee, "Debating the Sincerest Form of Architectural Flattery": 6, and Ulam, "Harvard Club Completed, Still Controversial": 50.

92. Lewis, "In Battles of Traditionalism vs. Modernism, Creativity Is Often the Biggest Casualty": 3.

93. Lloyd Zuckerberg, quoted in Ulam, "Harvard Club Completed, Still Controversial": 50.

94. Alan S. Oser, "A Coming Broadway Attraction," *New York Times* (October 5, 1986), VIII: 6; "Broadway Bound," *Architectural Record* 175 (February 1987): 59; "Names and News," *Oculus* 49 (February 1987): 7; Edwin Wilson, "Theater: Boffo Fall for Broadway," *Wall Street Journal* (October 2, 1989): 12; Russell, "When There's No Place to Go but Up": 160–63; "1675 Broadway, Contemporary Office Building Architects: Fox & Fowle," *Architecture + Urbanism* (July 1987): 11; Goldberger, "A Huge Architecture Show in Times Square": 45; Susanna Sirefman, *New York: A Guide to Recent Architecture* (London: Ellipsis, 1997), 144–47; *Fox & Fowle: Function Structure Beauty*, 16–19; White and Willensky, *AIA Guide* (2000), 265.

95. For the Broadway Theater, see Morrison, *Broadway Theaters: History and Architecture*, 132–33. For 30 Rockefeller Plaza, see Stern, Gilmartin, and Mellins, *New York 1930*, 639, 647.

96. Sirefman, *New York*, 144.

97. Bruce Fowle, quoted in Oser, "A Coming Broadway Attraction": 6.

98. Goldberger, "A Huge Architecture Show in Times Square": 45.

99. Sirefman, *New York*, 146.

100. Oser, "Planning for a Brighter Times Sq.": 6, 16; David W. Dunlap, "Two Times Square Stalwarts Make Way for New Buildings; Colorful Haberdashery, After 67-Year Stand on Broadway, Closes," *New York Times* (December 20, 1986): 29; Goldberger, "New Times Sq. Zoning: Skyscrapers with Signs": 1, 3; Scardino, "Builder Wants Green in Great White Way": 32; "New Lights on Old Broadway": 71; White and Willensky, *AIA Guide* (2000), 234; Claudia Carpenter, "Signing on a Times Sq.," *New York Post* (August 12, 1988): 47; "1585 Broadway–Solomon Equities, Inc.," *Architecture + Urbanism* (April 1989): 128–29; Dunlap, *On Broadway*, 175; Goldberger, "A Huge Architecture Show in Times Square": 45; Huxtable, "Re-Inventing Times Square: 1990," in Taylor, ed., *Inventing Times Square*, 369–70; Paul Goldberger, "In Times Square, Dignity by Day, Glitter by Night," *New York Times* (February 10, 1991), II: 32, 34; Paul Goldberger, "Architecture/1991," *New York Times* (December 29, 1991), II: 32; David W. Dunlap, "Tracing the Path from Leasing Coup to Bankruptcy," *New York Times* (January 19, 1992), X: 11; Kahn, "Empty New High-Rises Preserve Anarchy of Broadway": 14; Brad Collins and Diane Kasprowicz, eds., *Gwathmey Siegel: Buildings and Projects, 1982–1992* (New York: Rizzoli International Publications, 1993), 128–33; Claudia H. Deutsch, "Waiting for Act 2 Around Times Square," *New York Times* (May 2, 1993), X: 1, 8; Jeanne B. Pinder, "Midtown Building Is Sold for Lofty $176 Million," *New York Times* (August 12, 1993), B: 5; Alan S. Oser, "An Investment Firm Gives Its Regard to Broadway," *New York Times* (November 14, 1993), X: 8; Gilmartin, *Shaping the City*, 460; Stanley Abercrombie, "How to Succeed in Business," *Interior Design* 67 (September 1996): 126–33; Sirefman, *New York*, 136–37; *Gwathmey Siegel & Associates Architects: Selected and Current Works* (Mulgrave, Australia: Images Publishing, 1998), 56–59; Nina Rappaport, "About to Play in the Area," *Oculus* 61 (September 1998): 6; Nash, *Manhattan Skyscrapers*, 157–58; Brad Collins, ed., *Gwathmey Siegel: Buildings and Projects, 1965–2000* (New York: Rizzoli International Publications, 2000), 98–103; White and Willensky, *AIA Guide* (2000), 263; Balfour, *World Cities: New York*, 86; Sagalyn, *Times Square Roulette*, 314, 329–30; Brad Collins, ed., *Gwathmey Siegel: Buildings and Projects, 1992–2002* (New York: Rizzoli International Publications,

2003), 130–34, 354; Traub, *The Devil's Playground*, 255–60. For the Strand Theater, see Stern, Gilmartin, and Massengale, *New York 1900*, 220; Dunlap, *On Broadway*, 175.

101. Collins and Kasprowicz, eds., *Gwathmey Siegel: Buildings and Projects, 1982–1992*, 128–33.

102. Goldberger, "In Times Square, Dignity by Day, Glitter by Night": 32.

103. Goldberger, "In Times Square, Dignity by Day, Glitter by Night": 32, 34.

104. Huxtable, "Re-Inventing Times Square: 1990," in Taylor, ed., *Inventing Times Square*, 369.

105. Deutsch, "Waiting for Act 2 Around Times Square": 1.

106. Bob Jackowitz, quoted in Sagalyn, *Times Square Roulette*, 330.

107. Oser, "Planning for a Brighter Times Square": 6, 16; "New Lights on Old Broadway": 71; White and Willensky, *AIA Guide* (1988), 235; "750 Seventh Avenue," *Architecture + Urbanism* (April 1988): 140–42; Goldberger, "A Huge Architecture Show in Times Square": 45; Huxtable, "Re-Inventing Times Square: 1990," in Taylor, ed., *Inventing Times Square*, 369; Carter Wiseman, "Two for the Seesaw," *New York* 24 (March 11, 1991): 68, 85; Kahn, "Empty New High-Rises Preserve Anarchy of Broadway": 14; Deutsch, "Waiting for Act 2 Around Times Square": 1, 8; Judith Evans, "Times Square Skyscraper Sold; Morgan Stanley Buys Its 2nd Building in the Area for $90M," *Newsday* (April 29, 1994): 45; Sirefman, *New York*, 142–43; White and Willensky, *AIA Guide* (2000), 264.

108. Wiseman, "Two for the Seesaw": 85.

109. Goldberger, "A Huge Architecture Show in Times Square": 45.

110. Sirefman, *New York*, 142.

111. Huxtable, "Re-Inventing Times Square: 1990," in Taylor, ed., *Inventing Times Square*, 369.

112. Alan S. Oser, "A Major Mall in a Broadway Building," *New York Times* (February 21, 1988), VII: 9, 18; "An Indoor Times Square," *New York Times* (February 24, 1989): B: 1; David W. Dunlap, "Man to Evoke Memories of Times Sq.," *New York Times* (February 24, 1989): B: 3; Karrie Jacobs, "Metaphysical Developments: A Trip to Times Square," *Metropolis* 8 (June 1989): 98; Richard D. Lyons, "Mandating More Glitter on Times Sq.," *New York Times* (December 27, 1989): D: 15; Dunlap, *On Broadway*, 171; Goldberger, "A Huge Architecture Show in Times Square": 45; Huxtable, "Re-Inventing Times Square: 1990," in Taylor, ed., *Inventing Times Square*, 369–70; Sarah Bartlett, "Media Group Makes a Deal for Building," *New York Times* (March 4, 1992), B: 3; Charles V. Bagli, "City Continues to Blink in Real Estate Dealings," *New York Observer* (March 9, 1992): 21; Alan S. Oser, "A Buyer Takes a Stake in Times Square," *New York Times* (March 22, 1992), X: 5; Lewis Rudin, "Times Sq. Deal Shows Where the Bargains Are," letter to the editor, *New York Times* (March 23, 1992): 16; Kahn, "Empty New High-Rises Preserve Anarchy of Broadway": 14; Jerry Adler, *High Rise: How 1,000 Men and Women Worked Around the Clock for Five Years and Lost $200 Million Building a Skyscraper* (New York: Harper Collins, 1993); Deutsch, "Waiting for Act 2 Around Times Square": 1, 8; Paul Goldberger, "David Childs," *Architecture + Urbanism*, special issue (September 1993): 18–20; Marilyn Jordan Taylor, "Six Projects for New York City," *Architecture + Urbanism*, special issue (September 1993): 26–27; Frank F. Drewes, "One Broadway Place," *Deutsche Bauzeitschrift* 43 (July 1995): 34; Margaret Crawford, "The Architect and the Mall," in *You Are Here: The Jerde Partnership International* (London: Phaidon, 1999); Nash, *Manhattan Skyscrapers*, 159–60; White and Willensky, *AIA Guide* (2000), 260; Sagalyn, *Times Square Roulette*, 314–15.

113. For the Loew's State Theater, see Stern, Gilmartin, and Mellins *New York 1930*, 256.

114. "Times Square Project," *Architecture + Urbanism*, extra edition (June 1986): 255; "New Lights on Old Broadway": 71; White and Willensky, *AIA Guide* (1988), 231; Heinrich Klotz, ed., *New York Architecture: 1970–1990* (Munich: Prestel Verlag, 1989), 158–59.

115. Jon Jerde, quoted in Jacobs, "Metaphysical Developments: A Trip to Times Square": 98.

116. For the Virgin Megastore, see David W. Dunlap, "A Disk Store, Not Compact, and More for Times Square," *New York Times* (September 22, 1994), B: 10; "Work Starts on World's Largest Record Store," *New York Construction News* 48 (October 9, 1995): 1, 6; Stuart Elliott, "For the Debut of Virgin Megastore, Everything's on a Grand Scale," *New York Times* (April 17, 1996), D: 6; "Megastore in Times Square," *New York Times* (April 24, 1996): 1; Thomas J. Lueck, "Times Square Heralds Megastore," *New York Times* (April 24, 1996), B: 2; Julie Baumgold, "Born-Again Virgin," *Esquire* 126 (August 1996): 130–32; "Mega Projects," *Oculus* 47 (September 1996): 3; "Large Hard Lines: Virgin Megastore," *Chain Store Age* 73 (February 1997): 26.

117. David Childs, quoted in Adler, *High Rise*, 91.

118. David Childs, quoted in Oser, "A Major Mall in a Broadway Building": 9.

119. Jacobs, "Metaphysical Developments: A Trip to Times Square": 98.

120. Thomas J. Lueck, "Battling for Tenants in a Slow Market," *New York Times* (March 4, 1990), X: 1, 11; Kahn, "Empty New High-Rises Preserve Anarchy of Broadway": 14; Deutsch, "Waiting for Act 2 Around Times Square": 1, 8; Shawn G. Kennedy, "Times Square Means New Tenants Around Times Square," *New York Times* (April 25, 1994), B: 1, 6; Sagalyn, *Times Square Roulette*, 313–19.

121. Kahn, "Empty New High-Rises Preserve Anarchy of Broadway": 14.

122. "Rockefeller Plaza West," *Progressive Architecture* 70 (January 1989): 90–92; Paul Goldberger "A Gesture to the 'Good' Rockefeller Center," *New York Times* (May 21, 1989), II: 32, 36; Carter Wiseman, "Architecture," *New York* 32

(September 11, 1989): 146–47; Pam Spritzer, "Rockefeller Center West on 7th Avenue Endorsed," *New York Observer* (February 19, 1990): 6; "Rockefeller Center Plans 55-Story Building," *New York Times* (May 25, 1990), B: 2; Andrew White, "The Center Moves West," *Metropolis* 10 (October 1990): 26–29; Huxtable, "Reinventing Times Square: 1990," in Taylor, *Inventing Times Square*, 370; Paul Goldberger, "Mute in Manhattan: A Politically Correct Building," *New York Times* (June 9, 1991), II: 32; Warren A. James, ed., *Kohn Pedersen Fox: Architecture and Urbanism, 1986–1992* (New York: Rizzoli International Publications, 1993), 182–91; Joseph Giovannini, "Kohn Pedersen Fox: Transition and Development," in James, ed., *Kohn Pedersen Fox: Architecture and Urbanism, 1986–1992*, 16; *KPF: Selected and Current Works* (Mulgrave, Australia: Images Publishing, 1997), 32–35; Charles V. Bagli, "Bear Stearns Is Negotiating for Space in Proposed Tower," *New York Times* (February 12, 1997), B: 6; Peter Slatin, "Guardian to Anchor Midtown Project," *New York Post* (September 18, 1997): 38; Charles V. Bagli, "Morgan Stanley Plans Tower in Midtown," *New York Times* (November 20, 1998), B: 3; *KPF: The First 22 Years* (Milan: L'Arca Edizioni, 1999), 78–85; Joseph Giovannini, "New York State of Mind," *World Architecture* (February 2000): 48–55; Steve Cuozzo, "Rock Center Meets Times Sq.," *New York Post* (March 28, 2000): 38; Edwin McDowell, "Project Picks Up Where It Left Off a Decade Ago," *New York Times* (December 13, 2000), B: 9; David S. Chartock, "Fast-Tracking Facilitates Morgan Stanley Dean Witter Bldg.," *New York Construction News* 48 (March 2001): 19–25; "745 Seventh Avenue," *New York Construction News* 48 (June 2001): 16; Kelly Crow, "Lehman Bros. Grapples with Arts Zoning Rules," *New York Times* (January 6, 2002), XIV: 4; Paul Goldberger, "The Talk of the Town: A Morgan Stanley Sunrise, a Lehman Brothers Moon," *New Yorker* 77 (January 28, 2002): 33–34; John Holusha, "Flexible Design Helps Firm Take Over a Building," *New York Times* (February 27, 2002), C: 6; Ian Luna, ed., *New New York: Architecture of a City* (New York: Rizzoli International Publications, 2003), 180–83; Traub, *The Devil's Playground*, 260–68.

123. For the Time & Life Building and the XYZ towers, see Stern, Mellins, and Fishman, *New York 1960*, 397–403, 410–15.

124. James, ed., *Kohn Pedersen Fox: Architecture and Urbanism, 1986–1992*, 182.

125. Dee Wedemeyer, "Earl Carroll's Castle Question," *New York Times* (December 29, 1985), VIII: 5. For the Earl Carroll Theater, see Stern, Gilmartin, and Mellins, *New York 1930*, 240–44.

126. "Rockefeller Center: A Parking Lot, Pro Tem," *New York Times* (May 15, 1994), X: 1; Claudia H. Deutsch, "As an Investment, Parking's Attractive," *New York Times* (March 5, 1995), IX: 9.

127. Tommy Craig, quoted in McDowell, "Project Picks Up Where It Left Off a Decade Ago": 9.

128. Goldberger, "The Talk of the Town: A Morgan Stanley Sunrise, a Lehman Brothers Moon": 33–34.

129. David W. Dunlap, "Zeckendorf Is Ready for Another Burst of Building," *New York Times* (May 13, 1990), X: 21; Charles V. Bagli, "A Rental Tower Is Planned for West Side," *New York Times* (February 13, 1997), B: 8; Alan S. Oser, " A New Wave of Rentals for Eighth Avenue in the 50's," *New York Times* (November 2, 1997), XI: 5; Charles V. Bagli, "55th Street Is Said to Be Site for a Random House Tower," *New York Times* (February 4, 1999), B: 9; Charles V. Bagli, "Tax Breaks for Midtown Office Tower," *New York Times* (June 6, 1999): 43; Charles V. Bagli, "Corporation Walks Away from Tax Deal," *New York Times* (September 5, 1999): 27, 34; Joseph P. Fried, "A Demolition, Instead of a Study in Contrasts," *New York Times* (December 30, 1999), B: 7; Charles V. Bagli, "Con Ed Land Deal Erupts into Byzantine, High-Stakes Battle," *New York Times* (January 17, 2000), B: 1, 6; Rachelle Garbarine, "A Tower with Housing and a Publishing House," *New York Times* (September 8, 2000), B: 11; Ellen Lask, "Design Requires Structural Ingenuity for Random House/Park Imperial Job," *New York Construction News* 49 (October 2001): 63–73; David Handelman, "At High-Rise Towers, Views Without Terror," *New York Times* (October 18, 2001), F: 1, 13; "2002 Ward of Merit: Mixed-Use Project," *New York Construction News* 50 (December 2002): 75; "Random House Headquarters/Park Imperial," *New York Construction News* 50 (June 2003): 27.

130. Moshin Ahmed, quoted in "Lask, "Design Requires Structural Ingenuity for Random House/Park Imperial Job": 64.

131. Quoted in http://www.som.com.

132. Claudia H. Deutsch, "Those Retail Feet Are Dancing North of 42d Street," *New York Times* (March 10, 1996), IX: 11; Peter Grant, "Times Sq. Good Fit," *New York Daily News* (October 31, 1996): 63; "Coming to Times Square," *New York Times* (November 17, 1996), XIII: 3; Amy Feldman, "Viacom Will Butt Heads in Times Sq.," *Crain's New York Business* (December 9–15, 1996): 1, 49.

133. For Murray's Roman Gardens, see Stern, Gilmartin, and Massengale, *New York 1900*, 224–25.

134. Douglas Feiden, "Get Your Fill of Comedy at This Club," *New York Daily News* (June 26, 1996): 40; David Bianculli, "Serving Up Humor, Well Done," *New York Daily News* (March 31, 1997): 67; Elaine Louie, "Chronicle," *New York Times* (March 31, 1997): 3; Christine Sparta, "Making Comedy Easy to Digest at N.Y. Eatery," *USA Today* (April 3, 1997): 4D.

135. Peter Grant, "Times Square Eatery Will Stress Vine Dining," *New York Daily News* (June 30, 1997): 25.

136. Douglas Martin, "Step Right Up to Cyberland," *New York Times* (January 31, 1997), B: 1–2.

137. Rudolph Giuliani, quoted in Tom Topousis, "Times Sq. Joins Apples $weet Streets," *New York Post* (February 5, 1998): 20.

138. Herbert Muschamp, "Nostalgia Tripping in Times

Square," *New York Times* (August 25, 1996), II: 36. Also see Bruce Weber, "Bye, 1996. Bye, Scuzz. Thanks Again," *New York Times* (December 29, 1996), IV: 4.

139. "Assignment: Times Square," *New York Times* (May 18, 1997), VI.

140. James Barron, "Letterman's No. 1 Question: Where?" *New York Times* (January 21, 1993): B: 1, 6; "Late Night with Malibu Dave," editorial, *New York Observer* (February 1, 1993): 4; Bill Carter, "Letterman's Choice: New York. Maybe," *New York Times* (February 10, 1993): C: 15; Bill Carter, "CBS Buys a Theater to Keep Letterman in New York," *New York Times* (February 22, 1993): 1, C: 18; Jane Hall, "No. 1 Reason for Letterman Remaining in New York . . . ," *Los Angeles Times* (February 23, 1993): 2; David W. Dunlap, "Polishing a Quirky Setting for Letterman," *New York Times* (August 18, 1993), C: 13; Bill Carter, "Indoors and Out, a Big Show," *New York Times* (August 31, 1993): C: 11; "Corrections," *New York Times* (September 8, 1993): 2; William Grimes, "Adventures in Daveland (and Not Just at Night)," *New York Times* (October 22, 1993), C: 1, 30; Virginia Kent Dorris, "Adapted for Television," *Architecture* 82 (November 1993): 131–36; William Weathersby Jr., "Letterman's Late Show Lair," *Theatre Crafts International* 27 (November 1993): 22; "The Best Design of 1993," *Time* 143 (January 3, 1994): 72–73; Kim Keister, ed., "A Little Something for Dave," *Historic Preservation* 46 (March-April 1994): 10; Marisa Bartolucci, "Citizen Architect," *Metropolis* 14 (June 1995): 62–67, 74–79.

141. For Hammerstein's Theater, see Stern, Gilmartin, and Mellins, *New York 1930*, 234, 265, 267; Landmarks Preservation Commission of the City of New York, LP-1381 (January 5, 1988); Hoogstraten, *Lost Broadway Theatres*, 236–41; Morrison, *Broadway Theatres: History and Architecture*, 156–57.

142. For the CBS Radio Playhouse, see Stern, Gilmartin, and Mellins, *New York 1930*, 265, 267.

143. Richard Olcott, quoted in Dorris, "Adapted for Television": 131.

144. Grimes, "Adventures in Daveland (and Not Just at Night)": 1.

145. Bill Carter, "'Today' Show Moving to Storefront Studio," *New York Times* (November 9, 1993), C: 21; Verne Gay, "'Today' to Open Its Windows to the World," *Newsday* (November 9, 1993): 80; "New Studios in Rockefeller Center; NBC's 'Today' Finds a Future in Its Beginnings," *New York Times* (May 29, 1994), X: 1; Verne Gay, "Off Camera; 'Today' Under Glass," *Newsday* (June 13, 1994), B: 25; Bernard Stamler, "A Window of Opportunity," *New York Times* (December 14, 1997), XIV: 4.

146. Sandy Genelius, quoted in David W. Dunlap, "Courtyard Is Rising with New Look," *New York Times* (June 30, 1999), B: 6. Also see Charles V. Bagli, "NBC Rivals Look to Times Square in Quest for Studio Space on the Street," *New York Times* (November 19, 1997), B: 1, 8; John Holusha, "Companies Seek High-Profile Street-Level Presence," *New York Times* (March 29, 1998), XI: 7; "Calling Bryant Gumbel: Has CBS Got a Studio for You!" *New York Observer* (April 26, 1999): 11; Bill Carter, "CBS Will Make It Official: Gumbel Is on Morning Team," *New York Times* (May 4, 1999), C: 8; Donna Petrozzello, "CBS Plots Its A.M. Attack; Network Unveils Its Plans for Fifth Ave. Studio," *New York Daily News* (July 27, 1999): 69. For the General Motors Building and exhibition rooms, see Stern, Mellins, and Fishman, *New York 1960*, 508–12.

147. Judy McGrath, quoted in Bill Carter, "Times Square Awaits MTV Live," *New York Times* (July 13, 1997), 21. Also see "I Want My Times Square," *New York Times* (July 13, 1997): 1, 21; Traub, *The Devil's Playground*, 282–85.

148. Peter Slatin and Michael Starr, "'GMA' Makes a Square Deal," *New York Post* (November 20, 1997): 98; David M. Halbfinger, "ABC Confirms Lease for Times Sq. Studio," *New York Times* (November 21, 1997), B: 9; Holusha, "Companies Seek High-Profile Street-Level Presence": 7; Carter, "CBS Will Make It Official: Gumbel Is on Morning Team": 8; "ABC Raises Blinds, and Goes 'Oops!'" *New York Times* (September 10, 1999), B: 2; Bill Carter, "Part ABC Studio, Part Disney Billboard," *New York Times* (September 18, 1999), C: 1, 4; Verlyn Klinkenborg, "Crossing Times Square," *New York Times* (September 19, 1999), IV: 16; Beth Landman Keil and Deborah Mitchell, "The Tourists That Ate Times Square," *New York* 32 (October 11, 1999): 13; Annia Ciezadlo, "Key Board Figure Resigns in Protest over Mouse Trap," *New York Observer* (October 25, 1999): 11; Edward Wong, "Neighbors Are Not Fans of Morning-Show Studios," *New York Times* (November 14, 1999), XIV: 3; Soren Larsen, "Times Square Studios, New York City," *Architectural Record* 187 (December 1999): 138–39; David Barbour, "Good Morning, Times Square," *Entertainment Design* 34 (July 2000): 34, 48; Traub, *The Devil's Playground*, 282.

149. Amy Klein, "A New Face for NASDAQ," *Grid* 1 (Fall 1999): 33; Victoria Hall, "Virtual Trading Gets Real," *Grid* 2 (May/June 2000): 66–69; David Barbour, "Nasdaq Marketsite: Times Square Greets the Digital Age in a New Themed/Broadcast Venue," *Entertainment Design* 34 (July 2000): 32; Debra Goldman, "Nasdaq Marketsite; New York, NY," *Interiors* 160 (January 2001): 92–95; Wanda Jankowsky, "Trading Place," *Architectural Lighting* 16 (April 2001): 42–44.

150. Barbour, "Nasdaq Marketsite: Times Square Greets the Digital Age in a New Themed/Broadcast Venue": 32.

151. Michael Sorkin, "The Big Peep Show," *New York Times* (December 26, 1999), VI: 10.

152. Herbert Muschamp, "The Party's Never Over in the New Times Square," *New York Times* (January 3, 2000), E: 1, 8.

153. Traub, *The Devil's Playground*, xiii.

154. Thomas J. Lueck, "Traffic Jams the Sidewalk," *New York Times* (November 29, 1997), B: 1–2; John Tierney, "Piazza Broadway," *New York Times* (December 28, 1997), VI: 12; "Gridlock City," editorial, *New York Times* (July 17, 1999): 12; Clyde Haberman, "Matinee Days: The Madness Is Curable,"

New York Times (July 23, 1999): B: 1; John Tierney, "Attempt Is Made to Cross Times Sq. Bearing an Infant," *New York Times* (October 25, 1999): B: 1, 4.

155. Haberman, "Matinee Days: The Madness Is Curable": 1. For Karim Rashid's manhole covers, see Kit R. Roane, "For Stylish Millennium, Official Manhole Cover," *New York Times* (September 16, 1999): B: 4; Herbert Muschamp, "A Humble Manhole Cover Conveys the Global Grid," *New York Times* (September 26, 1999): XIV: 6; Barbara Stewart, "An Art Form of the Streets, and for the Streets," *New York Times* (December 5, 1999): 55; John Seabrook, "Plastic Man," *New Yorker* 76 (September 17, 2001): 120, 122, 124–26, 128.

156. David W. Dunlap, "Vintage Theater May Get New Role," *New York Times* (February 19, 1997): B: 5; Nina Rappaport, "Boom Boom on Broadway," *Oculus* 59 (May 1997): 6–7; Karrie Jacobs, "Greater White Way," *New York* 29 (December 22–29, 1997): 77; "Transforming Times Square," *New York Daily News* (December 21, 1997): 11; Thomas J. Lueck, "Opening Soon in Times Square: A Visitor Center, with Amenities," *New York Times* (February 3, 1998): B: 3; Nina Rappaport, "About to Play in the Neighborhood," *Oculus* 61 (September 1998): 6; Owen Moritz, "City Visitors Center Is Tour(ist) de Force," *New York Daily News* (September 2, 1998): 34; Ward Morehouse III, "Tourists Square-D-Away: Visitors Center Proves to Be a High-Tech Hit," *New York Post* (September 1, 1998): 6; "Visitors Center Opens in Times Square," *Newsday* (September 27, 1998): ___; Willensky, *AIA Guide* (2000), 262. For the Embassy 1 Theater, see Landmarks Preservation Commission of the City of New York, LP-1130 (November 17, 1987); Diamonstein, *The Landmarks of New York III*, 342.

157. For Mayers & Schiff's TKTS pavilion, see Stern, Mellins, and Fishman, *New York 1960*, 450–52.

158. "Competition Brief," *tkts2k Competition* (New York: Theatre Development Fund and Van Alen Institute, 1999); Jayne Merkel, "Now Playing in Times Square," *Oculus* 61 (June 1999): 4; Andrew Jacobs, "Times Square to Get New Tkts Booth," *New York Times* (June 16, 1999): B: 3; David W. Dunlap, "A Tough Act to Follow," *New York Times* (July 8, 1999): F: 1, 5; Dennis Duggan, "Battling for Fighting Father Duffy," *Newsday* (November 11, 1999): 4; Pete Bowles, "Duffy Statue Gains," *Newsday* (December 3, 1999): 37; Kira L. Gould, "The View's the Thing," *Competitions* 10 (Winter 1999/2000): 52–61; Philip Nobel, "Crtns for tkts," *Metropolis* 19 (December 1999): 43; White and Willensky, *AIA Guide* (2000), 262; Julie V. Iovine, "Imagining a Ticket Booth as a Stairway to the Stars," *New York Times* (February 16, 2000): E: 1, 3; "Australian Architects on Stairway to New York Fame," *Australian Financial Review* (February 17, 2000): 39; Ira Sohn and Stanley F. Wainapel, "A Ticket Booth for a New Century," letters to the editor, *New York Times* (February 17, 2000): 18; Joellen Brown, "Anger at TKTS Booth," letter to the editor, *New York Times* (February 21, 2000): 18; Jack Goldstein, "A Tkts Booth for All," letter to the editor, *New York Times* (February 26, 2000): 14; Ned Cramer, "On the Boards," *Architecture* 89 (February 2000): 32–35; Soren Larson, "Australian Duo Wins Competition to Design New Ticket Booth at Crossroads of the World," *Architectural Record* 188 (March 2000): 36; Sandi Hubbard, "Tkts2k Competition: Red Square?" *Grid* 2 (March-April 2000): 26; "Cheap Seats," *Interiors* 159 (April 2000): 25; Alexandra Lange, "Stair Masters," *Metropolis* 19 (April 2000): 46; Jayne Merkel, "Tale of Two Competitions," *Oculus* (April 2000): 6–7; "Tkts 2k Competition, NYC," *Arcade* 19 (Winter 2000): 14; Sagalyn, *Times Square Roulette*, 483–85.

159. Dunlap, "A Tough Act to Follow": 5.

160. Cramer, "On the Boards": 34.

161. For the 1950 recruiting station, see "Joint Center Set for Armed Forces," *New York Times* (August 16, 1950): 8; Dunlap, *On Broadway*, 168.

162. "Times Change, Times Square, Too," *New York Times* (December 31, 1995): IV: 8. Also see Andrew Shore, "The Military Deserves a Site on Times Square," letter to the editor, *New York Times* (January 5, 1996): 12; Clyde Haberman, "Army Outpost at Crossroads Has New Foes," *New York Times* (November 7, 1997): B: 1.

163. "U.S. Armed Forces Recruiting Station," *Oculus* 60 (May 1998): 5; Charles V. Bagli, "Recruiting Station to Get That Times Square Look," *New York Times* (June 13, 1998): B: 3; Julie V. Iovine, "Showing Its Patriotic Colors," *New York Times* (September 2, 1999): F: 3; "Project Award: Architecture Research Office," *Oculus* 61 (January 1999): 42; Paul Zielbauer, "Taps for Unglitzy Times Sq. Recruiting Station," *New York Times* (February 4, 1999): B: 3; Philip Nobel, "In the Belly of the Beast," *Metropolis* 18 (July 1999): 100–5, 107, 110–11; "Architectural [sic] Research Office: US Armed Forces Recruiting Station, New York," *Casabella* 63 (December 1999-January 2000): 32–34; White and Willensky, *AIA Guide* (2000), 258; "The Stage for the Turn of the Century," *Oculus* 62 (January 2000): 4; Nina Rappaport, "Architecture Research Office: Armed Forces Recruiting Station," *Architecture* 89 (January 2000): 96–101; "US Armed Forces Recruiting Station," *Architecture + Urbanism* (March 2000): 54–63; "U.S. Armed Forces Recruiting Station by ARO, Times Square, New York," *Interior Design* 71 (December 2000): 109; Balfour, *World Cities: New York*, 98; Sagalyn, *Times Square Roulette*, 483–84; "Barras sin estrellas: Centro de reclutamiento en Times Square, Manhattan," *Arquitectura viva* 76 (January-February 2001): cover, 50–51; "Architectural [sic] Research Office," *Casabella* 65 (July-August 2001): 74; Brian Carter and Annette Lecuyer, *All American: Innovation in American Architecture* (London: Thames & Hudson, 2002), 14–15; "Recruiting," *Topic Magazine* 1 (Summer 2002): 39–44; Stephen Cassell and Adam Yarinsky, *ARO: Architecture Research Office* (Chicago: Graham Foundation for Advanced Studies in the Fine Arts; New York: Princeton Architectural Press, 2003), 12–29; 160;

164. Rappaport, "Architecture Research Office: Armed Forces Recruiting Station": 97.

165. Charles V. Bagli, "Wrestlers and Accountants Now Take on Times Sq.," *New York Times* (July 15, 1999): B: 1.

166. Charles V. Bagli, "Novelty Gone, Theme Restaurants Are Tumbling," *New York Times* (December 27, 1998): 1, 38; Charles V. Bagli, "As Rents Soar, Boom Is Slowed in Times Square," *New York Times* (February 8, 1999): 1, B: 7.

167. "An ESPN Sports Bar Is Set for Times Sq.," *New York Times* (October 8, 1998): B: 7; John Holusha, "Disney Presses Ahead with Times Sq. Restaurant," *New York Times* (May 5, 1999), B: 12; Polly LaHue, "In the Zone," *Restaurant Hospitality* 83 (September 1999): 46, 48, 50; Richard Sandomir, "At ESPN, the Revolution Was Televised," *New York Times* (September 7, 1999), D: 1, 4; Bill Hutchinson, "ESPN Hoping Sports Fans Will Tune in to Its New Bar," *New York Daily News* (September 8, 1999): 24; Richard Sandomir, "When a TV Network Is Your Chef," *New York Times* (November 8, 1999), C: 21.

168. Charles V. Bagli, "Muscles on the Half Shell on the Menu?" *New York Times* (March 24, 1999): B: 3; Bagli, "Wrestlers and Accountants Now Take on Times Sq.": 1; Charles V. Bagli, "Taking a Chance on Times Square," *New York Times* (January 24, 2000): B: 3; David W. Dunlap, "Reviving Paramount's Marquee and Waldorf's Stars," *New York Post* (April 18, 2001): B: 7; "W.W.F. Profits Down," *New York Times* (August 24, 2001): B: 6; David W. Dunlap, "The Great Red Green and Blue," *New York Times* (December 20, 2001): F: 1, 6.

169. "Where Is Harold Lloyd When You Really Need Him?" *New York Times* (June 5, 1997): B: 3; "An Old Beacon Is a New Light for Broadway," *New York Times* (December 17, 1997): B: 1; David W. Dunlap, "Broadway Beacon Set to Glow Again," *New York Times* (December 17, 1997): B: 3. For the Paramount Building, see Stern, Gilmartin, and Mellins, *New York 1930*, 534; Landmarks Preservation Commission of the City of New York, LP-1566 (November 1, 1988); Diamonstein, *The Landmarks of New York III*, 426.

170. Timothy J. Burger, "NRA Takes a Shot at an Eatery; Times Sq. Site Sought," *New York Daily News* (May 19, 2000): 3; Anthony Ramirez, "N.R.A. Planning a Restaurant and Arcade in Times Square," *New York Times* (May 20, 2000), B: 4; "NRA Says Shooting Store to Open in Times Square," *Wall Street Journal* (May 22, 2000): 6; Julian E. Barnes, "Giuliani Doubts N.R.A. Arcade in Times Square Would Survive," *New York Times* (May 23, 2000), B: 9; "Topics of The Times: The N.R.A. in Times Square," *New York Times* (May 24, 2000): 24; Gary Fields, "NRA Café Drawing Heavy Fire; Gun-Rights Group Eyes Times Square for Restaurant/Arcade," *USA Today* (May 24, 2000): 3; David Hinckley, "No Shotgun, No Service," *New York Daily News* (June 4, 2000): 15; Paul Frumkin, "NRA Still Guns for NYC Site as Operators, Pols Shoot Down Concept," *Nation's Restaurant News* 34 (June 5, 2000): 4, 68; Lisa L. Colangelo, "NRA Eatery Draws Fire of Council," *New York Daily News* (June 6, 2000): 23; Hendrik Hertzberg, "Comment: Bullets over Broadway," *New Yorker* 75 (June 12, 2000): 29–30; Lynne Duke, "The NRA Triggers a Times Square Showdown; Mayor, Senator, City Officials Decry Plan for Gun-Themed Café," *Washington Post* (June 13, 2000): 3; Mickey O'Connor, "Guns of Fun in Times Square," *Architecture* 89 (July 2000): 49; Sagalyn, *Times Square Roulette*, 447.

171. Quoted in Ramirez, "N.R.A. Planning Restaurant and Arcade in Times Square": 4.

172. "Topics of The Times: The N.R.A. in Times Square": 24.

173. Quoted in Colangelo, "NRA Eatery Draws Fire of Council": 23.

174. Charles V. Bagli, "Toys 'R' Us to Build the Biggest Store in Times Sq.," *New York Times* (August 2, 2000), B: 6; "Toys 'R' Us to Build Store in Times Square," *Wall Street Journal* (August 2, 2000), B: 4; Sagalyn, *Times Square Roulette*, 483; Elizabeth Sanger, "Monster-Size Toys 'R' Us Lands in Times Square," *Newsday* (November 14, 2001): 70; Terry Pristin, "Toys 'R' Us Thinks Big in Less Playful Time," *New York Times* (November 15, 2001): D: 10; Judith Schoolman, "Toys 'R' Us Tries Lure of Times Square," *New York Daily News* (November 19, 2001): 43; John Tierney, "The Big City," *New York Times* (December 11, 2001): D: 1; Charles V. Bagli, "Toy Store Is Leading Retail Shuffle in Times Sq.," *New York Times* (December 15, 2001), D: 3; Dunlap, "The Great Red, Green and Blue Way": 6; Nayana Currimbhoy, "The Veiled Theatrical Landscape of a Flagship Toy Store in Times Square Beckons with a Sense of Anticipation," *Architectural Record* 190 (January 2002): 158–60; Penelope Green, "Never Grow Up: A Toys 'R' Us Designer," *New York Times* (February 17, 2002), IX: 9; Paul Goldberger, "High-Tech Emporiums," *New Yorker* 78 (March 25, 2002): 100–101; "Entertainment Retailing Is the New Buzz Word at Toys 'R' Us," *Architectural Record* 190 (November 2002): 98; "Toys 'R' Us in Times Square," *New York Construction News* 50 (December 2002): 49; Traub, *The Devil's Playground*, 217–26.

175. Don Nelson, "Two, Two, Two Theaters in One," *New York Daily News* (October 3, 1988): 41; Charles V. Bagli, "The Times Square Boom Costs a Theater Its Lease," *New York Times* (March 25, 1997): B: 1, 6. For Hammerstein's Olympia Theater, see Stern, Gilmartin, and Massengale, *New York 1900*, 207–8; Hoogstraten, *Lost Broadway Theatres*, 36–39; Morrison, *Broadway Theatres: History and Architecture*, 24–26.

176. Charles V. Bagli, "New Owner Wants to Build a Tower for Random House," *New York Times* (July 11, 1998): B: 3; David Leonard and Elizabeth Manus, "Bridge over Times Sq.: Bertelsmann Barons Seeking *Lebensraum*," *New York Observer* (November 9, 1998): 1, 11; Charles V. Bagli, "Deal for Largest Development Site in Times Sq. Falls Apart," *New York Times* (December 9, 1998): B: 1, 10; Charles V. Bagli, "Deal Collapses for a Home on Broadway for Random House," *New York Times* (December 17, 1998): B: 20; Charles V. Bagli, "Times Sq.

164. Luna, ed., *New New York*, 176–79.

Dreamer or Visionary, He Hopes for a Better Deal," *New York Times* (May 30, 1999): 23; Charles V. Bagli, "Tax Breaks for Midtown Office Tower," *New York Times* (June 6, 1999): 43.

177. Architects quoted in http://www.gensler.com/retail/toys.htm.

178. Thomas J. Lueck, "$31 Million for Prime Broadway Spot," *New York Times* (November 21, 1996): B: 4; Charles V. Bagli, "Planet Hollywood's First Hotel May Enter Times Square's Orbit," *New York Times* (September 11, 1997): B: 1, 6; Charles V. Bagli, "Planet Hollywood Signs for Times Sq. Hotel and Restaurant," *New York Times* (December 5, 1997): B: 14; Christopher Gray, "Streetscapes/The Lunt-Fontanne," *New York Times* (February 1, 1998): XI: 5; "Planet Hollywood Plans Hotel Complex," *New York Times* (March 10, 1998): B: 7; "Planet Hollywood Is in Pact to Develop 2nd New York Hotel," *Wall Street Journal* (March 10, 1998): 1; John Holusha, "For Unusual Tower, It's All About Signs," *New York Times* (December 8, 1999): B: 10; "1567 Broadway," *New York Construction News* 47 (June 2000): 24–25; "Starwood Hotels and Resorts: Future Projects," *Interior Design* 72 (March 2001): S99–100; David W. Dunlap, "From Planet Hollywood to a Hotel W in Gray," *New York Times* (August 29, 2001): B: 8; Pilar Guzman, "The Anti-Times Square, with Bar and Rooms," *New York Times* (December 20, 2001): F: 3; Bob Lape, "Steve Hanson Lands Winner in Times Sq. with Blue Fin," *Crain's New York Business* (March 4, 2002): 45; Steve Cuozzo, "Blue Fin No Fluke," *New York Post* (March 6, 2002): 38; William Grimes, "Appearances Can Be Pleasantly Deceiving," *New York Times* (March 6, 2002): F: 9; Julie Lasky, "Defiant Debut," *Metropolis* 21 (June 2002): 90–97, 134–35; William Weathersby Jr., "At the W Hotel," *Architectural Record* 190 (September 2002): 155–59; Sheila Kim, "On the Town: Blue Fin, New York City," *Interior Design* 73 (September 2002): 230–35; George Epaminondas, "A North Wind Heats Up Manhattan," *New York Times* (October 2002): F: 1, 6; Traub, *The Devil's Playground*, 278.

179. For the Globe Theater, see Stern, Gilmartin, and Massengale, *New York 1900*, 219; Gray, "Streetscapes/The Lunt-Fontanne": 5.

THE BRIGHT LIGHT ZONE: THE FALL AND RISE OF FORTY-SECOND STREET

1. For the New York Public Library, see Stern, Gilmartin, and Massengale, *New York 1900*, 94–98. For Grand Central Terminal, see Stern, Gilmartin, and Massengale, *New York 1900*, 34–40. For the United Nations, see Stern, Mellins, and Fishman, *New York 1960*, 601–38. For the Ford Foundation, see Stern, Mellins, and Fishman, *New York 1960*, 457–61.

2. Stern, Gilmartin, and Massengale, *New York 1900*, 167, 203. Also see "Times Square Is the Name of City's New Centre," *New York Times* (April 9, 1904): 2.

3. For Hammerstein's Victoria Theater, see Stern, Gilmartin, and Massengale, *New York 1900*, 221. For the Theatre Republic, see Nicholas Van Hoogstraten, *Lost Broadway Theaters* (New York: Princeton Architectural Press, 1991), 44–51. For the New Amsterdam Theater and Aerial Gardens, see Stern, Gilmartin, and Massengale, *New York 1900*, 210–11, 222; Mary C. Henderson, *The New Amsterdam: The Biography of a Broadway Theatre* (New York: Hyperion, 1997). For the Lyric Theater, see Van Hoogstraten, *Lost Broadway Theaters*, 60–65. For the Liberty Theater, see Van Hoogstraten, *Lost Broadway Theaters*, 82–85. For the Lew M. Fields Theater, see Van Hoogstraten, *Lost Broadway Theaters*, 86–89. For the Eltinge Theater, see Van Hoogstraten, *Lost Broadway Theaters*, 146–49. For the Selwyn Theater, see Van Hoogstraten, *Lost Broadway Theaters*, 186–89. For the Apollo Theater, see Stern, Gilmartin, and Mellins, *New York 1930*, 231. For the Times Square Theater, see Stern, Gilmartin, and Mellins, *New York 1930*, 231. For the Candler Theater, see Stern, Gilmartin, and Mellins, *New York 1930*, 547. For the Candler Building, see Stern, Gilmartin, and Mellins, *New York 1930*, 546–47; Christopher Gray, "Streetscapes/The Candler Building," *New York Times* (March 31, 1996): IX: 7.

4. For Murray's Roman Gardens, see Stern, Gilmartin, and Massengale, *New York 1900*, 224–25.

5. For *42nd Street*, see Stern, Gilmartin, and Mellins, *New York 1930*, 80, 83, 88; James Sanders, *Celluloid Skyline: New York and the Movies* (New York: Alfred A. Knopf, 2001), 305–11.

6. *Miller v. California*, 411 U.S. 949 (1973). For a detailed account of Forty-second Street's theaters and the movies shown there from the 1960s to 1980s, see Bill Landis and Michelle Clifford, *Sleazoid Express: A Mind-Twisting Tour Through the Grindhouse Cinema of Times Square!* (New York: Simon & Schuster, 2002).

7. For *Midnight Cowboy*, see Stern, Mellins, and Fishman, *New York 1960*, 1185; Sanders, *Celluloid Skyline*, 318–19. For *Taxi Driver*, see Stern, Mellins, and Fishman, *New York 1960*, 1181, 1185; Sanders, *Celluloid Skyline*, 395–98; James Traub, *The Devil's Playground: A Century of Pleasure and Profit in Times Square* (New York: Random House, 2004), 121–22.

8. For Manhattan Plaza, see Stern, Mellins, and Fishman, *New York 1960*, 470–72.

9. Mel Gussow, "Staging a 42d St. Transformation," *New York Times* (December 10, 1976): C: 3; Alan S. Oser, "The Possible Flowering of West 42d Street," *New York Times* (February 16, 1977): D: 12; William Claiborne, "'Theater Row' Is a Start at Reclaiming 42d Street," *Washington Post* (July 4, 1977): 1; Jennifer Dunning, "42d Street's Future Taking Shape As Building of Theater Row Starts," *New York Times* (September 1, 1977), C: 1; Ada Louise Huxtable, "Old Magic and New Dreams on 42d Street," *New York Times* (November 6, 1977), II: 31, 39; C. Gerald Fraser, "Theater Row, 9 New Leases on Life," *New York Times* (March 22, 1978), C: 23; Mel Grissow, "42d Street's New Theater Row Staging an Alfresco Celebration," *New York Times* (May 12, 1978): C: 1, 18; Judith Cummings, "42d St. Theater Row Dedicated As Rundown

West Side Looks Up," *New York Times* (May 14, 1978): 29; Eleni Constantine, "Forty-second Street Changes Its Spots," *Progressive Architecture* 60 (December 1979): 34, 38; John Corry, "Theater Row May Fold, a Victim of Hard Times," *New York Times* (February 18, 1981), C: 22; Carol Lawson, "Broadway/Warner Is Planning at Least Five Plays for the New Season," *New York Times* (July 3, 1981), C: 2; Eleanor Blau, "Theater Row at 3: Jubilation and Anxiety," *New York Times* (May 14, 1981), C: 21; Susan Woldenberg, "The Salvaging of Theater Row," *Metropolis* 1 (March 1982): 8–9; Lynne B. Sagalyn, *Times Square Roulette: Remaking the City Icon* (Cambridge, Mass.: MIT Press, 2001), 59. For the 42nd Street Redevelopment Corporation, see "Redevelop West 42nd Street," *New York* 9 (March 22, 1976): 45–46; Gregory F. Gilmartin, *Shaping the City: New York and the Municipal Art Society* (New York: Clarkson Potter, 1995), 449–51; Sagalyn, *Times Square Roulette*, 59; Traub, *The Devil's Playground*, 133–35.

10. Constantine, "Forty-second Street Changes Its Spots": 34.

11. Stern, Mellins, and Fishman, *New York 1960*, 467.

12. Albert Reyes, quoted in Dunning, "42d Street's Future Taking Shape As Building of Theater Row Starts": 1.

13. Steven R. Weisman, "U.S. to Provide $1.9 Million for Times Sq. Renovation," *New York Times* (April 3, 1979), B: 5; "Forty-second Street Changes Its Spots": 38; "New 42d St. Renewal," *New York Times* (March 13, 1980), B: 6; C. Gerald Fraser, "Theater Row," *New York Times* (October 9, 1980), C: 17; Carol Lawson, "News of the Theater," *New York Times* (January 28, 1981), C: 19; Damon Stetson, "Studios Growing to Meet City Film Industry Surge," *New York Times* (May 31, 1981): 1; Woldenberg, "The Salvaging of Theater Row": 9; *Hardy Holzman Pfeiffer Associates: Buildings and Projects, 1967–1992* (New York: Rizzoli International Publications, 1992), 251. For the West Side Airlines Terminal, see Stern, Mellins, and Fishman, *New York 1960*, 469, 471.

14. "Postings: Raising the Roof," *New York Times* (November 20, 1983), VIII: 1; *Hardy Holzman Pfeiffer Associates: Buildings and Projects, 1967–1992*, 256.

15. Jonathon Green, *The Cassell Dictionary of Slang* (London: Cassell, 1998), 324. Also see Ann Barry, "Arts and Leisure Guide: Forty-Deuce," *New York Times* (February 10, 1980): 37; Frank Rich, "Theater: 'Forty-Deuce,' Street Hustlers' Story," *New York Times* (March 25, 1981), C: 23.

16. John T. McQuiston, "Police Unit Urged on Times Square," *New York Times* (May 28, 1976), B: 3; "Pornography Store in Times Sq. Opens After Court Order," *New York Times* (July 16, 1976), B: 1; "City to Fight Reopening of Smut Shop," *New York Times* (July 17, 1976): 18; "Court Ruling Endorses Proposal to Make Sex Shop a Police Station," *New York Times* (December 15, 1976), B: 3; Nathaniel Shepard Jr., "24-Hour Police Substation Opens at Times Square," *New York Times* (May 27, 1977), D: 11; Alexander J. Reichl, *Reconstructing Times Square* (Lawrence: University Press of Kansas, 1999), 59; Traub, *The Devil's Playground*, 123.

17. Selwyn Raab and Nathaniel Sheppard Jr., "Ousted Times Sq. Smut Shop Reported Planning to Reopen," *New York Times* (July 11, 1977): 1, 26.

18. *The City at 42nd Street: A Proposal for the Restoration and Redevelopment of 42nd Street* (New York, January 1980), 1.

19. Robert Moss, quoted in Gussow, "Staging a 42d St. Transformation": 3.

20. Frederic S. Papert, quoted in Carter B. Horsley, "New Look for Old Crossroads in Brooklyn," *New York Times* (May 19, 1978): 15. Also see City University of New York, Graduate School and University Center, *West 42nd Street: "The Bright Light Zone"* (New York: Graduate School and University Center of the City University of New York, 1978); "City University of New York, Graduate School and University Center," *Progressive Architecture* 60 (January 1979): 96–97; Traub, *The Devil's Playground*, 125–27.

21. Quoted in Samuel Weiss, "Police Cannot Cure 42d St., Study Finds," *New York Times* (November 19, 1978): 55.

22. "Facelift for a Times Square Landmark," *New York Times* (November 23, 1978), B: 3; "A Grand Reopening Draws Closer on Broadway," *New York Times* (January 13, 1979): 25.

23. Paul Goldberger, "New York's Newest Theater Is Quite Old," *New York Times* (February 22, 1979), C: 14. For the New York Times Annex, see Stern, Gilmartin, and Mellins, *New York 1930*, 522–23.

24. Lesley Oelsner, "'New' Times Square Waiting in the Wings: Projects Include Mall and Big Discotheque," *New York Times* (November 14, 1978), B: 1, 6; Paul Goldberger, "A New Plan for West 42d St.," *New York Times* (January 31, 1979), B: 1, 3; Gilmartin, *Shaping the City*, 451; Traub, *The Devil's Playground*, 135–37.

25. Frederic S. Papert, quoted in Gilmartin, *Shaping the City*, 451.

26. Edward I. Koch, quoted in Goldberger, "A New Plan for West 42d St.": 3.

27. Maurice Carroll, "Is Clang of the Trolley 42d Street-Bound?" *New York Times* (January 23, 1979), B: 1, 4.

28. See Stern, Mellins, and Fishman, *New York 1960*, 15, 102–3.

29. "Trolley Folley," editorial, *New York Times* (November 22, 1983): 30. Also see Deirdre Carmody, "With Traffic Woes in 42d St.'s Future, Planners Look Back to the Trolley Era," *New York Times* (November 18, 1983), B: 1, 20; Kenneth S. Halpern, "42d Street Trolleys: Let's Do It—Let's Not," letter to the editor, *New York Times* (November 26, 1983): 1; Frederic Papert, "Ease Traffic with a Trolley," letter to the editor, *New York Times* (December 3, 1983): 22; Louis J. Gertsman, "The Missing Loop in New York's Subway," letter to the editor, *New York Times* (December 17, 1983): 22; George Zito, "Elevate the Times Square Pedestrian," letter to the editor, *New York Times* (January 7, 1984): 22; Frederic Papert, "Why Not a 42d St. Trolley?" *New York Times* (April 13, 1989): 27; Robert Diamond, "Don't Forget Brooklyn," letter to the editor, *New York Times* (May 6, 1989): 26; Henry E. Nystrom, "Wake Up, New York," letter to the editor, *New York Times* (May 6, 1989): 26; Victor Wouk, "Back on the Trolley or Aboard the Electric Bus?" letter to the editor, *New York Times* (May 6, 1989): 26; Robert Cobaugh, "Buses Got in the Way," letter to the editor, *New York Times* (May 27, 1989): 22; Frederic Papert, "A 42d Street Trolley Is Feasible for New York," letter to the editor, *New York Times* (May 27, 1989): 22; Joseph DePlasco, "42nd Street Trolley: Back on Track," *The Livable City* 16 (Spring 1992): 3; Robert J. Speyer, "Trolley Plan Stuck in 42nd Street Gridlock," *New York Observer* (November 3, 1992): 1, 21; "Planned 42d St. Trolley Stalls in Council," *New York Times* (November 30, 1992), B: 3; Marvine Howe, "Proposal Would Return 'Clang! Clang! Clang!' to 42d," *New York Times* (November 28, 1993), XIII: 6; Doug Feiden, Alan Mirabella, and Gerri Willis, "New York, New York; Derailing the Trolley," *Crain's New York Business* (December 13, 1993): 6; Roger J. Rudick, "Link Up the Airport Train and the 42d Street Trolley," letter to the editor, *New York Times* (December 26, 1993), XIII: 13; Toby Axelrod, "Board 5/Trolley Plan Approaches a Yellow Light," *New York Observer* (December 27, 1993-January 3, 1994): 8; "To Test a Trolley," editorial, *New York Times* (February 7, 1994): 16; Marvine Howe, "Trolley's Next Stop: Planning Commission," *New York Times* (February 13, 1994), XIII: 6; H. Claude Shostal, "Let's Have a Light-Rail Link for the Entire Midtown Core," letter to the editor, *New York Times* (February 16, 1994): 20; Beverly Dolinsky, "Put Trolley Elsewhere," letter to the editor, *New York Times* (February 26, 1994): 22; Wilma P. Gottlieb, "40th Street Overload," letter to the editor, *New York Times* (February 26, 1994): 22; Courtney Aison, "Board 5/Rail Plan Not on the Express Track," *New York Observer* (February 28, 1994): 10; "Midtown," *New York Times* (April 10, 1994), XIII: 6; "42nd Street Maglev Trolley," *New York Observer* (June 20, 1994): 4; Jonathan P. Hicks, "New York's Council Votes Plan to Build 42d St. Trolley Line," *New York Times* (June 30, 1994), B: 1–2; James McCown, "Urban Planner Fetish," letter to the editor, *New York Observer* (July 4, 1994): 4; Bruce Lambert, "Opposition Rises to 42d St. Trolley, Calling It a Streetcar Named Trouble," *New York Times* (August 14, 1994), XIII: 6; Bruce Lambert, "Trying to Gauge Feasibility or Folly of 42d St. Trolley," *New York Times* (July 16, 1995), XIII: 6; James McCown, "What's Wrong with Idea of a Trolley on 42d Street," letter to the editor, *New York Times* (July 23, 1995), XIII: 13; Wayne Fields, "Why Trolleys, not Buses Are Right for 42d Street," letter to the editor, *New York Times* (August 6, 1995), XIII: 3; Bruce Lambert, "Be It Vision of Folly, There is One Man Behind the Trolley," *New York Times* (September 3, 1995), XIII: 5; Michael O. Allen, "No Desire for Streetcars on 42d St.?" *New York Daily News* (February 19, 1996): 3; Philip Lentz, "Rudy Posts Roadblocks for 42nd Street Trolley," *Crain's New York Business* (July 27-August 2, 1998): 4, 28; "Once Hailed, Trolley Has Yet to Arrive," *New York Times* (May 13, 2001), XIV: 27.

30. Carter B. Horsley, "Times Square's Potential Inspires the Developers," *New York Times* (December 23, 1978), VIII: 1–2; Philip Lopate, "42d Street, You Ain't No Sodom," *New York Times* (March 8, 1979): 21; Carter B. Horsley, "Razing of One Skyscraper to Build 3 New Ones Proposed in Times Sq.," *New York Times* (November 15, 1979), B: 1, 15; Constantine, "Forty-second Street Changes Its Spots": 38; Ada Louise Huxtable, "Redeveloping New York," *New York Times* (December 23, 1979): 31–32; Hardy Holzman Pfeiffer Associates, *10 Theaters on Forty-second Street* (New York: City at 42nd Street, Inc., 1980); *The City at 42nd Street*, 1; "Times Square Stirs While Planning Sleeps," editorial, *New York Times* (January 15, 1980): 18; *Hardy Holzman Pfeiffer Associates: Buildings and Projects, 1967–1992*, 252; Gilmartin, *Shaping the City*, 451–52; Sagalyn, *Times Square Roulette*, 61–68, 80–89; Traub, *The Devil's Playground*, 137–39.

31. For the Rialto Theater Building, see Stern, Gilmartin, and Mellins, *New York 1930*, 262; Christopher Gray, "Streetscapes: The Rialto Theater," *New York Times* (July 19, 1987), VIII: 14; Andrew Alpern, *The New York Apartment Houses of Rosario Candela and James Carpenter* (New York: Acanthus Press, 2001), 26.

32. For an earlier proposed merchandise mart, see Stern, Mellins, and Fishman, *New York 1960*, 1114.

33. Constantine, "Forty-second Street Changes Its Spots": 38.

34. Lopate, "42d Street, You Ain't No Sodom": 21.

35. For the Times Tower, see Stern, Gilmartin, and Massengale, *New York 1900*, 167. For the Allied Chemical Corporation, Stern, Mellins, and Fishman, *New York 1960*, 1103.

36. Stern, Mellins, and Fishman, *New York 1960*, 1103.

37. Huxtable, "Redeveloping New York": 31–32.

38. Edward I. Koch, quoted in Michael Goodwin, "Roadblocks for a New Times Sq.," *New York Times* (June 8, 1980), IV: 6.

39. Goldberger, "A New Plan for West 42d St.": 3.

40. Carter B. Horsley, "Artist to Recreate Times Tower in 42d Street Mural," *New York Times* (September 6, 1979), B: 3; *Richard Haas: An Architecture of Illusion* (New York: Rizzoli International Publications, 1981), 94–99; Susan Heller Anderson and Frank J. Prial, "Progress vs. the Tower," *New York Times* (March 17, 1984): 27; *Richard Haas: Architectural Projects, 1974–1988* (New York: Brooke Alexander; Chicago: Rhona Hoffman, 1988), 20; Richard Haas, *The City Is My Canvas* (Munich: Prestel, 2001), 34–35, 94; Sagalyn, *Times Square Roulette*, 323–24.

41. *Richard Haas: An Architecture of Illusion*, 93–94; *Richard Haas: Architectural Projects, 1974–1988*, 20; Haas, *The City Is My Canvas*, 94; Sagalyn, *Times Square Roulette*, 323–24.

42. Richard Haas, quoted in Horsley, "Artist to Recreate Times Tower in 42d Street Mural": 3.

43. "The City Planning Lesson, Cont'd," editorial, *New York Times* (June 27, 1980): 30.

44. Edward I. Koch, quoted in Robert McG. Thomas Jr., "Plans for W. 42d St. Area Back on Drawing Boards," *New York Times* (June 28, 1980): 23–24.

45. McG. Thomas, "Plans for W. 42d St. Area Back on Drawing Boards": 23–24.

46. For the Hermitage Hotel, see Stern, Gilmartin, and Massengale, *New York 1900*, 273, 278; Christopher Gray, "Streetscapes: The Hermitage/National Hotel; Off Times Square, a 1933 'Remuddling,'" *New York Times* (March 24, 1991), X: 6.

47. New York State Urban Development Corporation, *42nd Street Development Project: Design Guidelines, May 1981* (New York: Urban Development Corporation, 1981). Also see New York State Urban Development Corporation, *42nd Street Development Project: A Discussion Document, February 10, 1981* (New York: Urban Development Corporation, 1981); Edward A. Gargan, "City and State Offer Plan to Rebuild Times Sq. Area," *New York Times* (February 11, 1981), B: 4.

48. New York State Urban Development Corporation, *42nd Street Development Project: A Discussion Document, February 10, 1981*, 50.

49. "Toward a Vital Times Square," editorial, *New York Times* (February 14, 1981): 22; Also see "Times Sq. Revival Aims for Song and Dance—and Moore," *New York Times* (February 15, 1981), IV: 5. A citizens' group, Save Our Broadway Committee, formed to oppose the Portman Hotel and including among its members leading actors, writers, and Joan K. Davidson, head of the J. M. Kaplan Fund, contemporaneously proposed that the block bounded by Broadway and Sixth Avenue, Forty-second and Forty-third Streets, be redeveloped with a sixty-story office building facing Sixth Avenue, a 500-room, thirty-one-story midblock economy hotel facing Forty-third Street, a 600-room, forty-one-story midblock luxury hotel facing Forty-second Street and, at the southwest corner of Forty-third Street and Broadway, a twenty-eight-story, 900-room hotel. Retail uses would form the base of all the new facilities and, according to a master plan drafted for the committee with funds provided by the Kaplan Fund, would sit atop a 600-car garage and be linked by a glazed atrium facing Forty-second Street. Intended to stand on its own merits whether or not the Portman Hotel was built, the plan, as Davidson boasted, "in every way, from esthetics to cost, to social utility" surpassed that project. Unfortunately, the drawing that accompanied the plan promised little in the way of artistic expression or urbanistic revitalization. Joan K. Davidson, quoted in Carter B. Horsley, "New Proposal for Times Square Block," *New York Times* (February 20, 1981), B: 3.

50. Paul Goldberger, "Latest Times Sq. Proposal: Why It May Succeed," *New York Times* (February 27, 1981), B: 4.

51. New York State Urban Development Corporation, *42nd Street Development Project Design Guidelines Supplement, June 1981* (New York: Urban Development Corporation, 1981); Joyce Purnick, "Builders Are Urged to Forge One Plan for Times Square," *New York Times* (June 5, 1981), B: 3; "Seize the Time for Times Square," editorial, *New York Times* (June 23, 1981): 26; Carter B. Horsley, "42d St. Plan Would Add Towers, Theaters and 'Bright Lights'," *New York Times* (July 1, 1981), B: 1, 8; Paul Goldberger, "A Renewal as Lively as Times Square Itself," *New York Times* (July 4, 1981): 1, 24.

52. For the Empire State Building, see Stern, Gilmartin, and Mellins, *New York 1930*, 610–15; John Tauranac, *The Empire State Building: The Making of a Landmark* (New York: St. Martin's Griffin, 1997); Carol Willis, ed., *Building the Empire State* (New York: W. W. Norton & Company, 1998).

53. "New Hearing Ordered on 42d Street Project," *New York Times* (September 2, 1981), B: 6.

54. Joyce Purnick, "5 Teams of Developers Expected to Offer Plans for Times Sq. Project," *New York Times* (September 4, 1981), B: 3; Joyce Purnick, "26 Rebuilding Proposals Submitted for Times Sq.," *New York Times* (September 9, 1981), B: 1; "The Times Square Gamble Pays Off," editorial, *New York Times* (September 11, 1981): 26; "Getting Serious in Times Square," *New York Times* (September 13, 1981), IV: 6.

55. Karen Gerard, quoted in Frank J. Prial, "City Names Main Builders in Times Sq. Redevelopment," *New York Times* (April 6, 1982), B: 3. Also see Frank J. Prial, "Redevelopment in Times Square Unlikely Till '84," *New York Times* (April 7, 1982), B: 3; "A Cool Billion on 42d Street," editorial, *New York Times* (April 8, 1982): 22; Frank J. Prial, "Can 42d Street Regain Its Showbiz Glamour?" *New York Times* (April 18, 1982), II: 1, 19; Max M. Tamir, "Times Square: Wrong Spot for a 'Cool Billion'," letter to the editor, *New York Times* (April 26, 1982): 16; Alan S. Oser, "A Billion-Dollar Plan for West Midtown," *New York Times* (May 30, 1982), VIII: 7, 12; Frank J. Prial, "Five Theaters Added to 42d St. Revival Plan," *New York Times* (June 13, 1982): 51; "Philip Johnson in Times Sq. Plan," *New York Times* (August 11, 1982), B: 2; "Times Square," *Progressive Architecture* 63 (September 1982): 29; "Times Square Plan Upheld by Court," *New York Times* (April 1, 1983), B: 3; Martin Gottlieb, "2 Groups of Developers Vie to Build Times Square Mart," *New York Times* (August 4, 1983), B: 3; Martin Gottlieb, "Koch Abolishes Times Sq. Pact with the State," *New York Times* (August 11, 1983), B: 1; "Divorce on 42d Street?" editorial, *New York Times* (August 13, 1983): 22; Martin Gottlieb, "Accord in Times Sq. Project Is Set by Cuomo and Koch," *New York Times* (August 16, 1983), B: 3; "Resolving the 42d Street Spat," editorial, *New York Times* (August 17, 1983): 22; Martin Gottlieb, "The Ghost of Robert Moses May Still Haunt City Hall," *New York Times* (August 21, 1983), IV: 47; Theodore Liebman and Kent Barwick, "A Crucial Choice for 42d Street," letter to editor, *New York Times* (August 27, 1983): 20; Martin Gottlieb, "Mart Operator Declines to Join in Times Square Plan," *New York Times* (August 31, 1983), B:

3; George Lewis, "Chapter Reports," *Oculus* 45 (October 1983): 7; Josh Barbanel, "Agreement Reached by Cuomo and Koch on Times Sq. Mart," *New York Times* (October 20, 1983): 1, B: 6; "City and State Reach a Deal on Times Square," *New York Times* (October 23, 1983), IV: 6; David Bird and Maurice Carroll, "Turmoil Over the Tower," *New York Times* (December 6, 1983), B: 3; Susan Heller Anderson and Maurice Carroll, "More on the Tower . . .," *New York Times* (December 20, 1983), B: 3; "Designs for 42d Street Disclosed," *New York Times* (December 21, 1983): 1; Paul Goldberger, "4 New Towers for Times Sq.," *New York Times* (December 21, 1983), B: 1, 11; "Times Square's New Look," *New York Times* (December 22, 1983), B: 5; Ada Louise Huxtable, *The Tall Building Artistically Reconsidered: The Search for a Skyscraper Style* (New York: Pantheon Books, 1984), 111; "Times Tower to Be Demolished?" *Oculus* 45 (January 1984): 12; "Excerpts from a Statement by John Burgee Architects with Philip Johnson," *Oculus* 45 (January 1984): 12–13; Excerpts From Study on Impact of Times Sq. Plan," *New York Times* (January 26, 1984): B: 4; "Project Report Labels 42d St. Tops in Crime," *New York Times* (January 26, 1984), B: 4; Martin Gottlieb, "Study on Project in Times Square Sees Rise in Jobs," *New York Times* (January 26, 1984): 1, B: 4; Martin Gottlieb, "New Times Square," *New York Times* (January 28, 1984): 26; Susan Doubilet, "I'd Rather Be Interesting," *Progressive Architecture* 65 (February 1984): 65–69; Martin Gottlieb, "Civic-Group Leaders Question Times Sq. Plan," *New York Times* (February 29, 1984), B: 3; Peter Freiberg, "Times Square Plan Raises Questions," *Metropolis* 3 (March 1984): 12; Thomas Bender, "Ruining Times Square," *New York Times* (March 3, 1984): 23; Martin Gottlieb, "Times Sq. Plan Getting Wary Public Approval," *New York Times* (March 19, 1984), B: 4; Martin Gottlieb, "Facing Issues of Times Sq.," *New York Times* (March 26, 1984), B: 1; Martin Gottlieb, "Times Square Hearing Draws an Array of Views," *New York Times* (March 27, 1984), B: 2; "Rekindling the Great White Way: A Redevelopment Proposal for Times Square," *Architectural Record* 172 (April 1984): 59; Carter Wiseman, "Brave New Times Square," *New York* 17 (April 2, 1984): 28–36; Martin Gottlieb, "Accord Reached on Times Sq. Mart," *New York Times* (April 8, 1984): 52; George Lewis, "Lively Times in Times Square," *Oculus* 45 (May 1984): 20–21; "Get Out of the Way in Times Square," editorial, *New York Times* (May 21, 1984): 16; Peter Freiberg, "Testaments to Times Square," *Metropolis* 3 (June 1984): 8; John Morris Dixon, "Architects/Clients/ Public," editorial, *Progressive Architecture* 65 (June 1984): 7; Paul Goldberger, "Design for Times Sq.: Problems Remain," *New York Times* (July 5, 1984), B: 1, 5; "Sometimes Square," editorial, *New York Times* (July 9, 1984): 18; Anthony DePalma, "One Times Square, Its Future Unsure, Is Sold Again," *New York Times* (July 11, 1984): 22; Brendan Gill, "The 'Heinous Misadventure' Facing Times Square," letter to the editor, *New York Times* (July 11, 1984): 24; Carter Wiseman, "Times Square Towers," *Progressive Architecture* 65 (August 1984): 10; James S. Russell, "Gold-diggers of '84?" *Architectural Record* 172 (October 1984): 125, 127, 129, 131; "Who'll Set the Beat for 42d Street?" editorial, *New York Times* (October 3, 1984): 26; Martin Gottlieb, "State Backing Won for Plan for Times Sq.," *New York Times* (October 5, 1984), B: 3; Benjamin Forgey, "Times Square: Putting a Shine on the Apple," *Washington Post* (October 6, 1984), B: 1; Martin Gottlieb, "Consultants' Times Sq. Role Brings Opposition at U.D.C.," *New York Times* (October 11, 1984), B: 3; Matthew L. Wald, "Garment Study Criticizing Plans for Times Sq.," *New York Times* (October 22, 1984), B: 3; "Reveille for Broadway," editorial, *New York Times* (October 24, 1984): 26; Maurice S. Paprin, "A Times Square Need," letter to the editor, *New York Times* (October 24, 1984): 24; "New Proposal for a Times Sq. Site," *New York Times* (October 25, 1984), B: 9; Susan Heller Anderson and Maurice Carroll, "Team for 8th Ave. Hotel," *New York Times* (October 25, 1984), B: 3; Martin Gottlieb, "Key Builder in Times Sq. Plan Tells Hearing of $1.1 Billion Loan Backing," *New York Times* (October 26, 1984): B: 1, 6; "The Rising Stake in Times Square," *New York Times* (October 28, 1984), IV: 6; John Burgee Architects with Philip Johnson, "The Times Square Development Project," *Oculus* 46 (November 1984): 2; George Lewis, "42nd Street/Times Square: A Project in Trouble," *Oculus* 46 (November 1984): 3–6; Martin Gottlieb, "Crossing Swords Over the Crossroads," *New York Times* (November 4, 1984), IV: 13; "City Acts to Keep Times Sq. Plan from Pushing Blight into Clinton," *New York Times* (November 4, 1984): 52; "The First Step on 42d Street," editorial, *New York Times* (November 7, 1984): 26; Martin Gottlieb, "Five Legislators in Bid to Delay Times Sq. Plan," *New York Times* (November 7, 1984), B: 3; Martin Gottlieb, "Development Plan for Times Sq. Wins Unanimous Backing of Estimate Board," *New York Times* (November 9, 1984), B: 1, 6; Martin Gottlieb, "Finding Project Director Next Step for Times Sq.," *New York Times* (November 10, 1984): 27; "Times Square Plan Approved," *New York Times* (November 11, 1984), IV: 6; Susan Heller Anderson and David W. Dunlap, "Likely New Head for Times Sq. Project," *New York Times* (November 28, 1984): B: 4; Sidney Z. Searles, "Fairness in Times Square Redevelopment," letter to the editor, *New York Times* (December 13, 1984): 30; Susan Heller Anderson and David W. Dunlap, "Objections on Times Square," *New York Times* (December 18, 1984), B: 3; "Times Square as Obstacle Course," editorial, *New York Times* (December 29, 1984): 20; "John Burgee Architects with Philip Johnson," *GA Document* 12 (January 1985): 22; Michael Sorkin, "Why Goldberger Is So Bad: The Case of Times Square," *Village Voice* (April 2, 1985): 90–91, reprinted in Michael Sorkin, *Exquisite Corpse: Writings on Buildings* (London: Verso, 1991), 101–7; Peter Freiberg, "City Goes Round in Circle Over Times Square," *Metropolis* 4

(January/February 1985): 10–11; Martin Gottlieb, "As Prices Soar, Cost of Land for Times Square Plan Is Harder to Estimate," *New York Times* (April 26, 1985), B: 1, 4; Martin Gottlieb, "Judge Bars Times Sq. Work, Pending a Study," *New York Times* (June 27, 1985), B: 3; Deborah Dietsch, "Times Square Saga Continues," *Progressive Architecture* 66 (July 1985): 75; Paul Goldberger, "Will Times Square Become a Grand Canyon?" *New York Times* (October 6, 1985), II: 31; Martin Gottlieb, "Mayor Opposes Lazar in Project in Times Square," *New York Times* (March 27, 1986), B: 3; Martin Gottlieb, "Delays Feared in Changes in Times Sq. Plan," *New York Times* (March 28, 1986), B: 3; Peter Lemos, "Brendan versus Philip (and John)," *Metropolis* 5 (April 1986): 13; Martin Gottlieb, "City and State Will Seek Removal of Lazar from Times Sq. Project," *New York Times* (April 1, 1986): 1, B: 3; Joyce Purnick, "After Indictment, City Seeks to Cancel Lazar Projects in Times Square and Brooklyn," *New York Times* (April 2, 1986), B: 3; Paul Goldberger, "A Times Sq. Bell Tower the Wrong Centerpiece," *New York Times* (August 15, 1986), B: 2; "Times Sq. Gets New Partner," *New York Times* (October 8, 1986), B: 5; Carter Wiseman, "Clouds over Times Square," *New York* 19 (October 10, 1986): 101–2; Stephen F. Wilder and Michael Hirschfeld, "Projection," letters to the editor, *New York* 19 (November 24, 1986): 8; Jeanie Kasindorf, "42nd Street Loses Project Leader," *New York* 20 (February 2, 1987): 9; Richard J. Meislin, "Long Delayed Times Square Plan Is Taking More New Twists," *New York Times* (April 3, 1987), B: 1, 4; Richard J. Meislin, "Planning Chief Seen as Choice for 42d St. Post," *New York Times* (April 9, 1987), B: 3; Thomas J. Lueck, "Suit to Bar Times Sq. Plan Is Prepared by 5 Officials," *New York Times* (October 1, 1987), B: 1, 5; Brendan Gill, "The Sky Line: On the Brink," *New Yorker* 63 (November 9, 1987): 113–18, 120–26; White and Willensky, *AIA Guide* (1988), 229; Kurt Andersen, "Renewal, but a Loss of Funk," *Time* 131 (February 29, 1988): 102–3; Karrie Jacobs, "Times Square: The Dreamers and the Dream," *Metropolis* 7 (May 1988): 20–22; Doug Feiden, "At Last: A Times Sq. Deal," *New York Post* (June 22, 1988): 14; Thomas J. Lueck, "Key Step Taken in Times Sq. Redevelopment," *New York Times* (June 22, 1988): 1, B: 4; "The Revitalization of Times Square," editorial, *New York Post* (June 28, 1988): 26; "A Needless Detour on 42d Street," editorial, *New York Times* (July 13, 1988): 24; "Pencil Points," *Progressive Architecture* 69 (August 1988): 26; Jane McCarthy, "Pol Rips Times Sq. Deal as Giveaway," *New York Post* (October 4, 1988): 24; "Must We Spend $1 Billion to Destroy Times Square?" advertisement, *New York Times* (October 21, 1988): 10; "New Suit Hits 42nd St.," *New York Post* (November 10, 1988): 89; Michael Tomasky, "The Observatory: . . . And Not Government Interference," *New York Observer* (December 12, 1988): 3; Paul Goldberger, "Times Square: Lurching Toward a Terrible Mistake?" *New York Times* (February 19, 1989), II: 37; Susan Chira, "Bank's Withdrawal Deals Major Blow to Times Sq. Plan," *New York Times* (April 21, 1989), B: 1, 4; Susan Chira, "$150 Million Pledged to Times Sq. Plan," *New York Times* (April 26, 1989), B: 3; "Condemnation Begins for Times Sq. Project," *New York Times* (May 3, 1989), B: 5; "Condemnation Is Started on Times Square Parcels," *Wall Street Journal* (May 3, 1989): 3; Carter B. Horsley, "Condemnation Begins on 42nd St. Project," *New York Post* (May 4, 1989): 38; "Architects Pan 42nd St. Project," *New York Post* (May 11, 1989): 7; David W. Dunlap, "New Dispute Tangles Plan on Times Sq.," *New York Times* (May 18, 1989), B: 4; Peg Tyre and Jeannette Walls, "Gill vs. Burgee: 'Squaring' Off," *New York* 22 (May 22, 1989): 13–14; "Author Brendan Gill," *Progressive Architecture* 70 (June 1989): 22; Paul Goldberger, "The New Times Square Design: Merely Token Changes," *New York Times* (September 1, 1989), B: 1; Max M. Tamir, "Why Give Times Sq. Precedence over Other Deteriorating Sites?" letter to the editor, *New York Times* (September 30, 1989): 22; "New Revivals for Times Square," *Oculus* 52 (October 1989): 9; "New Scheme for Times Square," *Progressive Architecture* 70 (October 1989): 25; Ada Louise Huxtable, "Times Square Renewal (Act II), a Farce," *New York Times* (October 14, 1989): 25; James S. Russell Jr., "Gridlock," *Architectural Record* 177 (November 1989): 55; Robert Luchetti, "Times Square Opposition," letter to editor, *Architecture* 79 (January 1990): 18; Douglas Durst, "Times Square's Endless Future," *Newsday* (February 14, 1990): 56; Philip Lopate, "Whose Times Square?" *7 Days* (March 7, 1990): 45, 47; Brian Kell, "Block Party," letter to the editor, *7 Days* (March 28, 1990): 4–5; "Philip Lopate Responds," *7 Days* (March 7, 1990): 5; "Miracle on 42d Street," editorial, *New York Times* (April 19, 1990): 24; Richard Levine, "State Acquires Most of Times Square Project Site," *New York Times* (April 19, 1990): 1, B: 2; George Sternlieb, "Times Square Could Save New York . . .," *New York Times* (May 19, 1990): 25; Herbert Muschamp, "Ground Up," *Artforum* 28 (Summer 1990): 19–20; "Razing Times Square: The First Casualties," *New York Times* (June 24, 1990), X: 1; Steven Saltzman, "Scene & Heard," *Metropolis* 11 (July-August 1990): 21; John Tierney, "Extra!! 'Liar for Hire' Evicted!!" *New York Times* (November 6, 1991), B: 1–2; David W. Dunlap, "Times Square Redevelopers Seek Delay in Project," *New York Times* (November 9, 1991): 25–26; Charles V. Bagli, "Times Square Skyscrapers Face an Uncertain Future," *New York Observer* (November 11, 1991): 1, 14; Park Tower Group (New York, 1992), no pagination; Herbert Muschamp, "For Times Square, a Reprieve and Hope of a Livelier Day," *New York Times* (August 6, 1992), C: 15, 18; Herbert Muschamp, "The Alchemy Needed to Rethink Times Square," *New York Times* (August 30, 1992), II: 24; Franz Schulze, *Philip Johnson: Life and Work* (New York: Alfred A. Knopf, 1994), 403–5; Hilary Lewis and John O'Connor, *Philip Johnson: The Architect in His Own Words* (New York: Rizzoli International Publications, 1994), 184–85, 189; Susanna Sirefman, *New*

York: A Guide to Recent Architecture (London: Ellipses, 1997), 122–25; Sagalyn, *Times Square Roulette*, especially chapters V-VIII; Traub, *The Devil's Playground*, 139–50.

56. George W. Goodman, "Mart Developers on Times Sq. Plan Dropped by City," *New York Times* (November 4, 1982), B: 1; George W. Goodman, "Builder for a 42d Street Site Sought," *New York Times* (January 2, 1983), VIII: 2.

57. Edward I. Koch, quoted in Prial, "Can 42d St. Regain Its Showbiz Glamour?": 19.

58. Paul Goldberger, "Will a Source of Creative Urban Design Be Lost?" *New York Times* (February 27, 1983), II: 29–30. Also see *Kohn Pedersen Fox* (New York: Kohn Pedersen Fox, 1985), 37; *Kohn Pedersen Fox: Buildings and Projects, 1976–1986* (New York: Rizzoli International Publications, 1987), 289, 333; Warren A. James, ed., *Kohn Pedersen Fox: Architecture & Urbanism, 1986–1992* (New York: Rizzoli International Publications, 1993), 401; Sagalyn, *Times Square Roulette*, 122.

59. Lawrence Josephs, "A New Owner Takes the Reins in Times Square," *New York Times* (January 3, 1982), VIII: 1–2.

60. New York State Urban Development Corporation, *42nd Street Development Project Design Guidelines*, May 1981, 23.

61. "Excerpts from a Statement by John Burgee Architects with Philip Johnson": 12.

62. Goldberger, "4 New Towers for Times Sq.": 11.

63. Sorkin, "Why Goldberger Is So Bad: The Case of Times Square": 90.

64. Ada Louise Huxtable, quoted in Gottlieb, "Facing Issues of Times Sq.": 1.

65. Huxtable, *The Tall Building Artistically Reconsidered*, 111.

66. Bender, "Ruining Times Square": 23.

67. Goldberger, "Design for Times Sq.: Problems Remain": 1, 5.

68. "Sometimes Square": 18.

69. Gill, "The Sky Line: On the Brink". 115.

70. Gill, "The 'Heinous Misadventure' Facing Times Square": 24.

71. Brendan Gill, quoted in Freiberg, "Testaments to Times Square": 8.

72. Theodore Liebman, quoted in Michael J. Crosbie, "Times Square Redevelopment Provokes Dispute in New York," *Architecture* 73 (May 1984): 54, 58, 62. Also see "Times Sq. Is Dimmed in Concern Over Plan," *New York Times* (March 25, 1984): 36; Lewis, "Lively Times in Times Square": 20–21; George Lewis, "Notes on the Year," *Oculus* 45 (June 1984): 17.

73. Dixon, "Architects/Clients/Public": 7.

74. Wiseman, "Times Square Towers": 10.

75. Russell, "Gold-diggers of '84?": 125, 127, 129, 131.

76. For a discussion of the Clinton and West Midtown areas, see Stern, Mellins, and Fishman, *New York 1960*, 316–20.

77. Robert Venturi and Denise Scott Brown, *Complexity and Contradiction in Architecture* (New York: The Museum of Modern Art, 1967), 104. Also see Sagalyn, *Times Square Roulette*, 202.

78. "Estudi per al Disseny de Times Square. Març, 1984," *Quaderns d'arquitectura i urbanisme* 162 (July-September 1984): 126–27; "Big Things for Big Cities," *Oz* 8 (1986): 42–43; Heinrich Klotz, ed., *New York Architecture: 1970–1990* (Munich: Prestel Verlag, 1989), 240–41; Frederic Schwartz and Carolina Vaccaro, *Venturi, Scott Brown & Associates: Works and Projects* (Barcelona: Editorial Gustavo Gili, 1991), 157–58; Robert Venturi, *Iconography and Electronics upon a Generic Architecture: A View from the Drafting Room* (Cambridge, Mass.: MIT Press, 1996), 32; Stanislaus von Moos, *Venturi, Scott Brown & Associates: Buildings & Projects, 1986–1998* (New York: Monacelli Press, 1999), 55; David B. Brownlee, David G. DeLong, and Kathryn B. Hiesinger, *Out of the Ordinary: Robert Venturi Denise Scott Brown and Associates, Architecture, Urbanism, Design* (Philadelphia: Philadelphia Museum of Art; New Haven: Yale University Press, 2001), 146–47, 263.

79. Prentice, "A New Times Square with 'Life After Work'": 26, also quoted in Sagalyn, *Times Square Roulette*, 202.

80. George Lewis, "Chapter Reports," *Oculus* 45 (February 1984): 2; Susan Heller Anderson and Frank J. Prial, "Times Tower Contest," *New York Times* (March 24, 1984): 27; Lewis, "Lively Times in Times Square": 21; "The Times Tower Site," *Progressive Architecture* 65 (May 1984): 20; DePalma, "One Times Square, Its Future Unsure, Is Sold Again": 22; Pascal Quintard-Hofstein, "N.Y. Times Square ano ou sans Times Tower?" *Section A* 2 (September 1984): 9–12; Paul Goldberger, "Picking a Centerpiece for a New Times Square," *New York Times* (September 17, 1984), B: 1, 5; "Too Late for Times Square?" *Progressive Architecture* 65 (October 1984): 23–24; "Vivid, Diverse Images of a New Times Square Tower," *Architecture* 73 (October 1984): 15–16; "MAS Times Tower Competition: Report of the Jury," *Oculus* 46 (November 1984): 11–15; Virginia Dajani, "Times Square Tower Competition," *The Livable City* 10 (October 1986): 2–3; Raimund Abraham, "Times Theater Tower," *Architecture + Urbanism* (April 1987): 113–15; *Ricardo Bofill, Taller de Arquitectura: Buildings and Projects, 1960–1985* (New York: Rizzoli International Publications, 1988), 152–53; Rodolfo Machado, "Public Places for American Cities: Three Projects," *Assemblage* 6 (June 1988): 98–113; Klotz, ed., *New York Architecture: 1970–1990*, 184–85; Brigitte Groihofer, ed., *Raimund Abraham: [un]built* (Vienna: Springer, 1996), 188–89; Traub, *The Devil's Playground*, 155–56.

81. Abraham, "Times Theater Tower": 113–15.

82. *Ricardo Bofill, Taller de Arquitectura: Buildings and Projects, 1960–1985*, 152.

83. Nick Ravo, "Times Square Landmark Files in Bankruptcy," *New York Times* (March 14, 1992): 29.

84. Quoted in Thomas J. Lueck, "Madame Tussaud's Loses Bidding War and Drops Times Sq. Plan," *New York Times* (March 23, 1995), B: 5. Also see Steven Prokesch, "Dinkins's Europe Trip Polishes City's Image," *New York Times* (June 15,

1992), B: 3; David W. Dunlap, "Tussauds Considers Wax Exhibition in Times Square," *New York Times* (November 11, 1993), B: 3; Louis S. Hansen and Karen Rothmyer, "Times Sq. Gets Waxed," *Newsday* (December 30, 1994): 2; Ian Katz, "Times Square to Get Wax Treatment from Mme Tussaud," *The Guardian* (London) (December 31, 1994): 1; Bruce Lambert, "The 'Zipper' Is Speaking a New Language," *New York Times* (January 8, 1995), XIII: 5; Sagalyn, *Times Square Roulette*, 360–62.

85. Peter Grant, "Warner Zips Up Deal; Huge Times Sq. Complex Set," *New York Daily News* (October 17, 1996): 45; Kirk Johnson, "Bugs Bunny Is New Tenant at 1 Times Sq.," *New York Times* (November 16, 1996): 25; Herbert Muschamp, "Heart of Whimsy in Times Square: A Chance for an Architect to Let His Imagination Run Free," *New York Times* (April 7, 1997), C: 11; Todd Gitlin, "Times Square Eternity," letter to the editor, *New York Times* (April 10, 1997): 28; John Holusha, "Upstairs, Downstairs a Hit in Midtown, Downtown," *New York Times* (April 13, 1997), IX: 7; Ned Cramer, "Times Square Striptease," *Architecture* 86 (May 1997): 49; Charles V. Bagli, "Tower in Times Sq., Billboards and All, Earns 400% Profit," *New York Times* (June 19, 1997): 1, B: 8; Paul Bennett, ed., "Riprap/The Gehry Archives," *Landscape Architecture* 87 (October 1997): 58, 60; Philipp Meuser, "Die Kostümierung der Stadt," *Bauwelt* (November 7, 1997): 2369; Francesco Dal Co and Kurt W. Forster, *Frank O. Gehry: The Complete Works* (New York: Monacelli Press, 1998), 579–81; Paul Lieberman, "Frank Gehry Is Making Waves Up and Down Hudson River," *Los Angeles Times* (December 9, 1998): 1; Sagalyn, *Times Square Roulette*, 203–4.

86. Muschamp, "Heart of Whimsy in Times Square: A Chance for an Architect to Let His Imagination Run Free": 11.

87. K.C. Baker and Bill Hutchinson, "Tragedy in Elevator; Repairman Crushed at 1 Times Square," *New York Daily News* (December 10, 1997): 6; Terry Pristin, "1 Times Square Store for Warner Brothers," *New York Times* (April 21, 1998), B: 8; David M. Herszenhorn, "With Bugs's Debut, It's Toons Square," *New York Times* (April 26, 1998): 34.

88. "Losing Times Sq. Bidder Charges Favoritism," *New York Times* (October 3, 1984), B: 3; Martin Gottlieb, "Financial Concern Sues to Block Times Sq. Plan," *New York Times* (October 10, 1984), B: 3; Martin Gottlieb, "Movie Houses Sue Over Times Sq.," *New York Times* (October 23, 1984), B: 1; "The Rising Stake in Times Square": 6; Gottlieb, "Crossing Swords Over the Crossroads": 13; "Another Suit Filed on Times Sq. Plan," *New York Times* (December 11, 1984), B: 9; Searles, "Fairness in Times Square Redevelopment": 30; Dunlap, "Objections on Times Square": 7; "Favoritism Cited in Suit on Times Square Plan," *New York Times* (December 21, 1984): 30; "2 Clinton Residents Sue to Halt Times Sq. Project," *New York Times* (December 26, 1984), B: 3; "Times Square as Obstacle Course": 20; "Neighbors Sue on Renewal Plan," *New York Times* (December 30, 1984), IV: 8; "U.D.C. Is Upheld on Theater Plan," *New York Times* (April 18, 1985), B: 7; Sidney Z. Searles, "Compensation for Times Sq. Condemnations Should Include Fees," letter to the editor, *New York Times* (May 1, 1986): 26; Martin Gottlieb, "Top State Court Upholds Times Sq. Renewal," *New York Times* (May 9, 1986), B: 3; William J. Stern, "Don't Punish Times Square," *New York Times* (May 22, 1986): 31; "The Times Square Redevelopment Project," *New York Observer* (March 6, 1989): 6; Lou Chapman, "New Lawsuit Seeks to Block Times Square Redevelopment," *New York Observer* (May 29, 1989): 8; Sagalyn, *Times Square Roulette*, especially chapter VII.

89. Goldberger, "A Times Sq. Bell Tower the Wrong Centerpiece": 2.

90. Wiseman, "Clouds over Times Square": 101–2. Also see Robert D. McFadden, "Law Firm Withdraws Plan to Move to Times Square," *New York Times* (August 8, 1986), B: 3.

91. Franz S. Leichter, quoted in Jacobs, "Times Square: The Dreamers and the Dream": 22.

92. Stern, Mellins, and Fishman, *New York 1960*, 443–46.

93. Paul Goldberger, "Theater Zone: Panacea or Problem?" *New York Times* (October 1, 1983): 31.

94. Leonard Clark, "Official New York Stands in the Way of Upgrading 42d Street," letter to the editor, *New York Times* (May 11, 1988): 26.

95. Michael Goodwin, "Midtown Theaters Surveyed for Landmark Designation," *New York Times* (April 16, 1982), B: 3.

96. Michael Goodwin, "Midtown Zoning Changes Are Approved," *New York Times* (May 14, 1982), B: 3.

97. Paul Goldberger, "Theaters and Churches Are the City's New Battleground," *New York Times* (May 30, 1982), II: 1, 24. Also see Eleanor Blau, "Move to Designate Theaters as Landmarks Is Discussed," *New York Times* (June 15, 1982), C: 10; "13 Are Appointed to Theater Council," *New York Times* (June 23, 1982), B: 3; Carol Lawson, "Hearings Stir Debate on Theater District's Future," *New York Times* (October 18, 1982), C: 13; John Morris Dixon, "One Person's Landmark . . . ," *Progressive Architecture* 63 (November 1982): 7; Alan S. Oser, "Act I of a Zoning Drama in the Theater District," *New York Times* (November 7, 1982), VIII: 1; "Theater Preservation," *Oculus* 44 (December 1982): 10; George Lewis, "Broadway Theaters," *Oculus* 44 (May 1983): 2; George Lewis, "Notes on the Year," *Oculus* 44 (June 1983): 8; Peter Freiberg, "Theater District Debate," *Metropolis* 3 (September 1983): 11–12; Martin Gottlieb, "Innovative Zoning Plan Could Aid Theaters," *New York Times* (September 19, 1983): 1, B: 6; Martin Gottlieb, "Saving the Theaters," *New York Times* (September 23, 1983), B: 1; Samuel G. Freedman, "Questions Raised on Proposals to Save Theaters," *New York Times* (September 24, 1983): 12; Goldberger, "Theater Zone: Panacea or Problem?": 31; Samuel G. Freedman, "Broadway Waits to See What Develops," *New York Times* (October 2, 1983), IV: 9; "Think Hard About Theaters," editorial, *New York Times* (October 3, 1983): 22; Ellen Burstyn, "Wide-Ranging Strategy to Save Theaters," *New York Times* (October 11, 1983): 30; "City Panel Splits on

Theater Plan," *New York Times* (October 14, 1983), B: 3; George Lewis, "Saving the Broadway Theaters: The Great Debate," *Oculus* 45 (November 1983): 3–6, 12–13; Eugenie C. Cowan, "Who'll Stop the Show?" *Metropolis* 3 (March 1984): 11; Martin Gottlieb, "City Panel Near Vote on Save-the-Theaters Proposals," *New York Times* (April 15, 1984), VIII: 7; Deirdre Carmody, "A City Panel Approves Plan to Help Broadway Theaters," *New York Times* (June 22, 1984), B: 1; Peter Freiberg, "Theater Trust or Theater Bust?" *Metropolis* 4 (September 1984): 10; Peter Freiberg, "Update," *Metropolis* 4 (November 1984): 10; "Save the Theatres," advertisement, *New York Times* (March 24, 1985), II: 3; Gerald Schoenfeld, "It's Not Curtains Yet for Broadway's Theaters," letter to the editor, *New York Times* (March 31, 1985), IV: 22; Joseph Papp, "Mayor Must Act," letter to the editor, *New York Times* (March 31, 1985), IV: 22; Joan K. Davidson, "Landmarking Might Have Saved Two Theaters," *New York Times* (April 7, 1985), IV: 16; "U.D.C. Is Upheld on Theater Plan," *New York Times* (April 18, 1985), B: 7; Jeffrey Schmalz, "Landmarks Panel Listing Broadway Theaters," *New York Times* (August 7, 1985): 1, B: 8; "Why the Rush to Landmark Theaters?" editorial, *New York Times* (August 10, 1985): 22; Isabel Wilkerson, "Sheltering Theaters from Growth," *New York Times* (August 25, 1985), VIII: 6; Gene Norman, "The Care That Goes into Making a Theater a Landmark," letter to the editor, *New York Times* (September 2, 1985): 20; Joanna Wissinger, "Preservation News," *Progressive Architecture* 66 (November 1985): 35; "Protect Plays, Not Just Theaters," editorial, *New York Times* (December 19, 1985): 30; Peter Lemos, "The Test of Times," *Metropolis* 5 (March 1986): 12–13; Paul Goldberger, "Broadway Need Not Become a Doormat for Skyscrapers," *New York Times* (April 13, 1986), II: 35; "Notes on the Year," *Oculus* 47 (June 1986): 4; Peter Lemos, "Times Square Air," *Metropolis* 6 (July-August 1986): 14; David W. Dunlap, "5 More Broadway Theaters Classified as Landmarks," *New York Times* (November 5, 1987), B: 1; David W. Dunlap, "Three Manhattan Theaters Are Given Landmark Status," *New York Times* (November 11, 1987), B: 3; David W. Dunlap, "Landmark Theaters Are Up for Vote," *New York Times* (March 10, 1988), B: 3; Todd S. Purdum, "28 Theaters Are Approved as Landmarks," *New York Times* (March 12, 1988): 33, 36; Jeremy Gerard, "Theaters as Landmarks: Who Likes the Ruling, Who Doesn't, and Why," *New York Times* (March 14, 1988), C: 13; "Protect Every Lunette, Every Curlicue?" editorial, *New York Times* (April 7, 1988): 26; John Glasel, "Save Theater Interiors," letter to the editor, *New York Times* (April 22, 1988): 38; "28 Broadway Theaters," *Architectural Record* 176 (May 1988): 81; Peter L. Donhauser, "Broadway Theaters Earn Designation," *Progressive Architecture* 69 (June 1988): 30; "Landmarks Yes, Fossils No," editorial, *New York Post* (July 28, 1988): 28; Ronald Sullivan, "Theaters' Landmark Status Upheld," *New York Times* (December 8, 1989), B: 3; David W. Dunlap, "High Court Upholds Naming of 22 Theaters as Landmarks," *New York Times* (May 27, 1992), B: 3.

98. Landmarks Preservation Commission of the City of New York, LP-1306–9 (August 6, 1985); Barbaralee Diamonstein, *The Landmarks of New York III* (New York: Harry N. Abrams, 1998), 333, 345, 349.

99. "Why the Rush to Landmark Theaters?": 22.

100. Thomas J. Lueck, "Six Times Square Theaters to Go 'Populist,'" *New York Times* (September 18, 1988): 1, 42; *42nd Street: Glorious Past-Fabulous Future*, exhibition catalog (New York, October 1988); Harold Smith, "Call Those Theaters Anything but Populist," *New York Times* (October 7, 1988): 34; Carter B. Horsley, "Curtain's Up on Plans for 42d St. Theaters," *New York Post* (October 20, 1988): 64, 76; Neil Barsky, "Curtain Rises on Plan for 42d St. Theaters," *New York Daily News* (October 21, 1988), Metro: 1; "Times Square Theaters in Search of Developers," *New York Times* (October 21, 1988), B: 3; Lou Chapman, "Swords Cross Again Over 'Crossroads of the World,'" *New York Observer* (October 24, 1988): 6; "Joe Kafka Changes the 42nd Street Marquee on the Cineplex Odeon Warner Cinema," *New York Observer* (October 31, 1988): 1; Peter L. Donhauser, "'Populist' Plans for 42nd Street," *Progressive Architecture* 69 (November 1988): 24, 28; Paul Goldberger, "Lack of Money Threatens a Plan to Restore Six Times Sq. Theaters," *New York Times* (November 14, 1988): 1, B: 2; "Tiny Town," *New York Post* (November 22, 1988): 2; "Late Hit on 42d Street," editorial, *New York Times* (November 26, 1988): 22; Vincent Tese and Carl Weisbrod, "There Needn't Be a Fund Shortage to Restore 42d St. Theaters," letter to the editor, *New York Times* (December 1, 1988): 34; Ivan Sygoda, "Renaissance of Theaters in Times Sq. Needs Help," letter to the editor, *New York Times* (December 19, 1988): 16; "42d Street Burlesque," editorial, *New York Observer* (December 26, 1988): 4; Paul Goldberger, "Times Square: Lurching Toward a Terrible Mistake?" *New York Times* (February 19, 1989): 37–38; "City News Digest," *New York Observer* (March 13, 1989): 6; Craig Wolff, "On 42d Street, a Tour Back to the Future," *New York Times* (April 14, 1989), B: 1, 3; Karen Cook, "The Deuce Does Not Go Gently," *New York Post* (April 20, 1989): 43; James S. Russell, "42nd Street: No Beat of Dancing Feet—Yet," *Architectural Record* 177 (June 1989): 85; "Times Square Update," *Oculus* 52 (April 1990): 6; Mel Gussow, "Where Legends Were Born, Ghosts of Glory Linger," *New York Times* (May 23, 1990), C: 13, 16; Rebecca Robertson, "For Theatrical Palaces of 42d St., a New Life," letter to the editor, *New York Times* (June 23, 1990): 22; Jeannette Walls, "Come and Meet . . . Those Fighting Feet," *New York Times* 23 (August 13, 1990): 11; "42nd Street Entertainment Corporation Announced," *Crossroads: 42nd Street Development Project* 1 (January 1991): 1, 6; John Tierney, "Era Ends as Times Square Drops Slashers for Shakespeare," *New York Times* (January 14, 1991), B: 1–2; *Hardy Holzman Pfeiffer Associates: Buildings and Projects, 1967–1992*, 267; Elizabeth Kraft, ed., *Robert A. M. Stern: Buildings and Projects, 1987–1992* (New York: Rizzoli International Publications, 1992), 86–87; Jack Goldstein,

"The Theater District," *Metropolis* 11 (June 1992): 17–21.

101. Goldberger, "Times Square: Lurching Toward a Terrible Mistake?": 38.

102. Goldberger, "Times Square: Lurching Toward a Terrible Mistake?": 37.

103. John Burgee, quoted in "Gill vs. Burgee: Squaring Off": 14.

104. For the Johnson/Burgee partnership, see Mitchell Pacelle, "Design Flaw: Noted Architects' Firm Falls Apart in Fight Over Control, Client," *Wall Street Journal* (September 2, 1992): 1.

105. Russell, "Gridlock": 55. For Johnson's exhibition at the Museum of Modern Art, see Philip Johnson, *Deconstructivist Architecture* (New York: Museum of Modern Art, 1988).

106. Goldberger, "The New Times Square Design: Merely Token Changes": 1. For the New Coke story, see Pamela G. Hollie, "Keeping New Coke Alive," *New York Times* (July 20, 1986), III: 6–7; Glenn Collins, "Ten Years Later, Coca-Cola Laughs at 'New Coke,'" *New York Times* (April 11, 1995), D: 4.

107. Goldberger, "The New Times Square Design: Merely Token Changes": 1.

108. Huxtable, "Times Square Renewal (Act II), a Farce": 25.

109. Muschamp, "For Times Square, a Reprieve and Hope of a Livelier Day": 16.

110. Sagalyn, *Times Square Roulette*, 173.

111. Leonard Buder, "Development Officials Named," *New York Times* (March 31, 1990): 29.

112. "Razing Times Square: The First Casualties": 1. For 1482–1490 Broadway, see Stern, Mellins, and Fishman, *New York 1960*, 432–33.

113. David W. Dunlap, "Times Square Redevelopers Seek Delay in Project," *New York Times* (November 9, 1991): 25–26; Charles V. Bagli, "Times Square Skyscrapers Face an Uncertain Future," *New York Observer* (November 11, 1991): 1, 14.

114. David W. Dunlap, "New Times Sq. Plan: Lights! Signs! Dancing! Hold the Offices," *New York Times* (August 20, 1992): 1.

115. Herbert Muschamp, "The Alchemy Needed to Rethink Times Square," *New York Times* (August 30, 1992), II: 24; "Pencil Points," *Progressive Architecture* 73 (September 1992): 22; Peter Slatin, "New Plans for New York," *Architecture* 81 (October 1992): 25; "Times Square Shuffle," *Oculus* 55 (October 1992): 10; "Theater Talk," *Oculus* 55 (October 1992):11; Joseph Giovannini, "The Great White Way," *Avenue* (December 1992): 46–51; Robert A. M. Stern Architects and M & Co., *42nd Street Now!: A Plan for the Interim Development of 42nd Street* (New York, 1993); Douglas Martin, "42nd Street Project Remains on Track," *New York Times* (January 28, 1993), B: 3; Herbert Muschamp, "A Highbrow Peep Show on 42d Street," *New York Times* (August 1, 1993), II: 34; David W. Dunlap, "Choreographing Times Sq. into 21st Century," *New York Times* (September 16, 1993), B: 1, 2; Herbert Muschamp, "42d Street Plan: Be Bold or Begone!" *New York Times* (September 19, 1993), II: 33; Kurt Andersen, "Can 42nd Street Be Born Again," *Time* 142 (September 27, 1993): 37; Hugo Lindgren, "Art Plays a Bit Part on 42nd Street," *Metropolis* 13 (October 1993): 19, 22; Douglas N. Cogen, "Blinded by the Lights," *Newsday* (October 5, 1993): 44, reprinted as "'42nd Street Now!' vs. 42nd Street Later," *Municipal Art Society Newsletter* (November 1993); David W. Dunlap, "Office Towers in 42d St. Project May Be Getting Taller," *New York Times* (October 6, 1993), B: 3; Kent Barwick, "No More Towers," *New York Times* (October 16, 1993): 23; Brian J. Strum, "No, More Towers," *New York Times* (October 16, 1993): 23; Jackie Mason, "Lies, All Lies," *New York Times* (October 16, 1993): 23; Penn Jillette, "The Real Deal," *New York Times* (October 16, 1993): 23; Robert Campbell, "Let It Be Itself," *New York Times* (October 16, 1993): 23; Luc Sante, "Sin and Spectacle," *New York Times* (October 16, 1993): 23; Susan Orlean, "Street Life," *New York Times* (October 16, 1993): 23; Steven Goraobarsingh, "Now, the Menace," *New York Times* (October 16, 1993): 23; "Extra Glitz Precedes Gray Flannel Deluge," *Architectural Record* 181 (November 1993): 47; Raul A. Barreneche, "42nd Street Redevelopment," *Architecture* 82 (November 1993): 37; "42nd Street Now!" *Newsline* 6 (November-December 1993); Peter Slatin, "Warming Up the Audience: The 42nd Street Now! Interim Plan," *Oculus* 56 (November 1993): 10; Suzanne Stephens, "Who's Who: Cast of Characters," *Oculus* 56 (November 1993): 11; Philip Arcidi, "42nd Street: Almost All Right," *Progressive Architecture* 74 (November 1993): 23; "Times Square at the Crossroads," *New York Times* (November 14, 1993): 6; Peter Slatin, "Architecture: Disney to the Rescue in Times Square," *The Independent* (April 6, 1994): 20; Peter Grant, "Interim Plan for Times Sq. Endangered," *Crain's New York Business* (April 18, 1994): 3, 45; Mitchell Pacelle, "Flashy vs. Flashier: Developers Debate Times Square's Future," *Wall Street Journal* (April 18, 1994), B: 1, 4; "Times Sq. Is Hot! Should Renewal Plan Be Revised?" editorial, *Crain's New York Business* (April 25, 1994): 10; Thomas J. Lueck, "Hold the Neon: One More Battle on 42d Street," *New York Times* (May 1, 1994), XIII: 16; "Times Square, Meet Madame Tussaud," editorial, *New York Observer* (May 2, 1994): 4; Ruth G. Davis, "42nd Street: Haven't We Heard This Song Before?" *New York* 27 (May 30, 1994): 21; "42nd Street Towers: Big Subsidy, No Need," *Municipal Art Society Newsletter* (September-October 1994): 1–2; Bradford McKee, "Times Square Revival," *Architecture* 84 (November 1995): 94–98; Rem Koolhaas, "Regrets?" *Grand Street* 57 (1996): 137–38; Michael Goodwin, "Times Square Dazzles Again," *New York Daily News* (August 5, 1996): 29; Herbert Muschamp, "Nostalgia Tripping in Times Square," *New York Times* (August 25, 1996), II: 36; Paul Goldberger, "The New Times Square: Magic That Surprised the Magicians," *New York Times* (October 15, 1996), C: 11–13; Eric Asimov, "Disney Gets Credit: A Word Is Coined," *New York Times* (December 29, 1996), XIII: 6; Andrew Jacobs, "After Years of Sleaze and Decay, the Great White Way 'Suddenly' Looked White Hot," *New York*

Times (December 29, 1996), XIII: 6; "Forty-second Street Now!" *42nd Street Development Project, Inc., Newsletter* (Summer 1997); Liz Farrelly, *Tibor Kalman: Design and Undesign* (New York: Watson-Guptill, 1998), 44–47; Peter Morris Dixon, ed., *Robert A. M. Stern Architects: Buildings and Projects, 1993–1998* (New York: Monacelli Press, 1998), 160–69; *Fox & Fowle: Function Structure Beauty* (Milan: L'Arca Edizioni, 1999), 26–28; Rebecca Robertson, "The Street That Belongs to Everybody," in *Tibor Kalman: Perverse Optimist*, eds. Peter Hall and Michael Bierut (New York: Princeton Architectural Press, 2000), 228–33; "Seat the Street," in *Tibor Kalman: Perverse Optimist*, 234–35; Sagalyn, *Times Square Roulette*, 291–307; Ian Luna, ed., *New New York: Architecture of a City* (New York: Rizzoli International Publications, 2003), 158–61; Traub, *The Devil's Playground*, 164–67.

116. Robert A. M. Stern, quoted Slatin, "New Plans for New York": 25.

117. Philip Johnson, quoted in "Times Square Shuffle": 10.

118. Robert A. M. Stern, quoted in Slatin, "New Plans for New York": 25.

119. Robert A. M. Stern, quoted in Dunlap, "New Times Sq. Plan: Lights! Signs! Dancing! Hold the Offices": 3.

120. Tibor Kalman, quoted in Sagalyn, *Times Square Roulette*, 300.

121. Robert A. M. Stern Architects and M & Co., *42nd Street Now!: A Plan for the Interim Development of 42nd Street*, 16–21.

122. Creative Time mission statement, quoted in http://www.creativetime.org. Also see Carol Vogel, "In Times Square, Art Conquers Kung Fu," *New York Times* (July 7, 1993), C: 13; Thomas Walsh, "NYC's 42nd St. Opens Its Doors and Windows to Ask, 'But Is It Art?' The 42nd Street Art Project," *Back Stage* (July 9, 1993): 3; Roberta Smith, "A 24-Hour-a-Day Show, on Gaudy, Bawdy 42d Street," *New York Times* (July 30, 1993), C: 26; Herbert Muschamp, "A Highbrow Peep Show on 42d Street," *New York Times* (August 1, 1993), II: 34; Hilton Kramer, "Taking It to the Street: Schlock Art Finds a Curbside Home in New York," *Art & Antiques* 15 (October 1993): 98–99; Hugo Lindgren, "Art Plays a Bit Part on 42nd Street," *Metropolis* 13 (October 1993): 19, 22; "The Cat Came Back," *New York Times* (July 3, 1994), XIII: 5; Carol Vogel, "42d Street Says Move Over SoHo," *New York Times* (July 7, 1994), C: 13; Roberta Smith, "42d Street Puts on Heavy Makeup and Smiles a Summer Smile," *New York Times* (July 29, 1994), C: 25; Diller + Scofidio, "Soft Sell," in Patricia C. Phillips, ed., *City Speculations* (Flushing Meadows, N.Y.: Queens Museum of Art; New York: Princeton Architectural Press, 1996), 26–29; *Tibor Kalman: Perverse Optimist*, 234–35; Sagalyn, *Times Square Roulette*, 304–5.

123. Muschamp, "A Highbrow Peep Show on 42d Street": 34.

124. Muschamp, "42d Street Plan: Be Bold or Begone!": 33.

125. Koolhaas, "Regrets?": 137–38.

126. Muschamp, "Nostalgia Tripping in Times Square": 36.

127. Cogen, "Blinded by the Lights": 44.

128. Vincent Tese, quoted in Pacelle, "Flashy vs. Flashier: Developers Debate Times Square's Future": 4.

129. George Klein, quoted in Pacelle, "Flashy vs. Flashier: Developers Debate Times Square's Future": 4.

130. Robert A. M. Stern, quoted in Pacelle, "Flashy vs. Flashier: Developers Debate Times Square's Future": 4.

131. Rebecca Robertson, quoted in Grant, "Interim Plan for Times Sq. Endangered": 3.

132. Unidentified source, quoted in Pacelle, "Flashy vs. Flashier: Developers Debate Times Square's Future": 4.

133. Rebecca Robertson, quoted in Grant, "Interim Plan for Times Sq. Endangered": 45.

134. Robertson, quoted in Lueck, "Hold the Neon: One More Battle on 42d Street": 6.

135. Glenn Collins, "42d Street to Get a Theater for Youth," *New York Times* (October 20, 1993), C: 15, 2; David W. Dunlap, "Work Starts on Theater in Times Sq.," *New York Times* (May 18, 1994), B: 1, 3; "More Renovations Along 42d Street," *New York Times* (July 10, 1994): 27; David Salvesen, "Planning News," *Planning* 60 (October 1994): 26; Quinn Halford, "Vic Fix," *Avenue* (December 1995): 81; "Victory on 42d Street," editorial, *New York Times* (December 9, 1995): 20; Paul Goldberger, "An Old Jewel of 42d Street Reopens, Seeking to Dazzle Families," *New York Times* (December 11, 1995): 1, C: 18; Julie V. Iovine, "Tenacity in the Service of Public Culture," *New York Times* (December 12, 1995), B: 1, 4; "Dressing-Up Season," *New York Times* (December 17, 1995): 67; Charles K. Hoyt, "Times Square Victory," *Architectural Record* 184 (February 1996): 66–71; Ned Cramer, "Theater Restoration Inaugurates Times Square Revival," *Architecture* 85 (February 1996): 29; Jean Gorman, "Theater," *Interiors* 155 (March 1996): 44–49; David Cohn, "Szenenwechsel in New York," *Bauwelt* (May 17, 1996): 1048–49; Muschamp, "Nostalgia Tripping in Times Square": 36; David E. Brown, "Keeping It Real," *Metropolis* 17 (December 1997-January 1998): 68–69, 91; Debra Waters, *Hardy Holzman Pfeiffer Associates: Buildings and Projects, 1992–1998* (New York: Rizzoli International Publications, 1999), 74–77; Andre Gregory, "Living Room," in *Hardy Holfman Pfeiffer Associates: Theaters* (Mulgrave, Australia: Images Publishing, 2000), 132–39, 208; Alan Balfour, *World Cities: New York* (New York: Wiley-Academy, 2001), 126–27; Sagalyn, *Times Square Roulette*, 286–91, plates 14–15; Luna, ed., *New New York*, 168–69.

136. Goldberger, "An Old Jewel of 42d Street Reopens, Seeking to Dazzle Families": 1.

137. Jeanne B. Pinder, "Disney Considers Move into Times Sq.," *New York Times* (September 15, 1993), C: 15, 18; David W. Dunlap, "Theater Owners Battle Planned Disney Leap into 42d Street," *New York Times* (November 17, 1993), B: 2; Karen Rothmeyer, "Disney to Try Its Magic on Broadway," *Los Angeles Times* (December 31, 1993), D: 4; David W. Dunlap, "Cuomo Backs Loan Program for Broadway," *New York Times*

(January 7, 1994), B: 1–2; Frank Rich, "Mickey Does 42d Street," *New York Times* (January 16, 1994): 17; Neil Graves, "Disney Puts $8M into Broadway," *New York Post* (February 3, 1994): 26; Denene Millner, "Beauty for a Beast," *New York Post* (February 3, 1994): 3; Douglas Martin, "Disney Seals Times Square Theater Deal," *New York Times* (February 3, 1994), B: 1, 3; David Henry, "Disney to Spend $30M on 42nd Street Theater," *Newsday* (February 3, 1994): 7; David Henry, "Landing Disney on 42nd," *Newsday* (February 4, 1994): 41; Patricia Z. Stephenson, "Renaissance on 42d St.," letter to the editor, *New York Times* (February 22, 1994): 20; Michael Goldstein, "Broadway's New Beast," *New York* 27 (March 14, 1994): 41–45; David W. Dunlap, "Reviving a True Classic on West 42d Street," *New York Times* (August 14, 1994), II: 1, 29; Rian Keating, "Glory Days," letter to the editor, *New York Times* (August 28, 1994), II: 4; "Feb. Start Set for Theater Renovation for Disney," *New York Construction News* (August 29, 1994): 1, 6; Tom Lowry, "Disney Co. in City, a Bit like Beauty in the Beast," *New York Daily News* (September 3, 1994): 12; Kirstin Downey Grimsley, "The 'Beast' That Ate Broadway," *Washington Post* (September 7, 1994), F: 1; Salvesen, "Planning News": 26; Alan Finder, "A Prince Charming? Disney and the City Find Each Other," *New York Times* (June 10, 1995): 21–22; Tom Lowry, "Curtain Up on 42d St. Rehab," *New York Daily News* (July 20, 1995): 2; Brett Pulley, "A Restoration Is Announced for 42d Street," *New York Times* (July 20, 1995), B: 1, 6; Paul Goldberger, "Architecture: The New Amsterdam Theater," *Architectural Digest* 52 (November 1995): 40, 41, 50, 54, 58; Deborah K. Dietsch, "Disney's New Urban Influence," *Architecture* 84 (December 1995): 15; Julie V. Iovine, "Tenacity in the Service of Public Culture," *New York Times* (December 12, 1995), B: 1, 4; Gersh Kuntzman, "Putting the New in New Amsterdam," *New York Post* (June 10, 1996): 33; Ralph Blumenthal, "Disney Takes on Broadway and Bible," *New York Times* (August 20, 1996), C: 13, 18; David W. Dunlap, "A Landmark Reveals Its Glories," *New York Times* (August 25, 1996), II: 4; David W. Dunlap, "41st Street Edges into Times Square," *New York Times* (August 25, 1996), II: 4; David Kaliner, "Renewing Broadway's Legendary Park," letter to the editor, *New York Times* (September 22, 1996), II: 24; Frank Rich, "The Mouse That Ate America," *New York Times* (October 2, 1996): 23; William Grimes, "Disney 'King' for 42d Street: No Lion Suits," *New York Times* (November 7, 1996), C: 17, 21; Henderson, *The New Amsterdam*; Bruce Weber, "Disney Unveils Restored New Amsterdam Theater," *New York Times* (April 3, 1997), B: 3; Ada Louise Huxtable, "Architecture: Miracle on 42nd Street," *Wall Street Journal* (April 3, 1997): 16; Frank Rich, "Times Square's Act Two," *New York Times* (April 20, 1997): 15; Nina Rappaport, "Boom Boom on Broadway," *Oculus* 59 (May 1997): 5; Herbert Muschamp, "A Palace for a New Magic Kingdom, 42d St.," *New York Times* (May 11, 1997), II: 1, 39; Barry Singer, "A Resplendent Palace for 'King David,'" *New York Times* (May 11, 1997), II: 38; Ward Morehouse III, "Disney Takes on B'way," *New York Post* (May 19, 1997): 37, 39; Ben Brantley, "With Strobe Lights (but No Philistine Trophies), It's Disney's 'King David,'" *New York Times* (May 20, 1997), C: 11–12; Joel Raphaelson, "Those 'Hard-Bitten' Ziegfeld Girls," letter to the editor, *New York Times* (May 25, 1997), II: 4; John Margolies, "The New Amsterdam Theater," *Architectural Record* 185 (June 1997): 112–19; "The Show Must Go On," *World Architecture* 57 (June 1997): 121; George Strum, "Poor Olive Thomas, Lost in the Wings," *New York Times* (June 1, 1997), II: 8; John Heilpern, "Grrrr! Grrrr! Who Will Slay the Goliath of Broadway," *New York Observer* (June 2, 1997): 35; Brown, "Keeping It Real": 68–69, 91; Charles V. Bagli and Randy Kennedy, "Disney Wished Upon Times Sq. and Rescued a Stalled Dream," *New York Times* (April 5, 1998): 1, 38; Marian S. Heiskell and Cora Cahan, "Footlights on 42d St.," letter to the editor, *New York Times* (April 11, 1998): 10; "New Amsterdam Theater," *Architectural Record* 186 (June 1998): 121; Waters, *Hardy Holzman Pfeiffer Associates: Buildings and Projects, 1992-1998*, 118–23; "The New Amsterdam Theatre," *Oculus* 61 (January 1998): 31; "Hugh Hardy: New Amsterdam Theatre," *Casabella* 63 (December 1999-January 2000): 38–41; Frank Rich, "A House Is a Home," in *Hardy Holzman Pfeiffer Associates: Theaters*, 154–65, 209; Balfour, *World Cities: New York*, 123–24; Sagalyn, *Times Square Roulette*, 11–13, 339–54, plates 16–21; Traub, *The Devil's Playground*, 167–69; Francis Morrone, "Abroad in New York," *New York Sun* (January 26, 2004): 16. For Herts & Tallant's New Amsterdam, see Stern, Gilmartin, and Massengale, *New York 1900*, 209–12.

138. The story has been told often but probably best by Eisner in his autobiography, written with Tony Schwartz, *Work in Progress* (New York: Random House, 1998), 253–57.

139. Michael Eisner, quoted in Henderson, *The New Amsterdam*, 120.

140. David W. Dunlap, "State Acquires Landmark Theater to Salvage While It Still Can," *New York Times* (September 10, 1992), C: 17–18. Also see Landmarks Preservation Commission of the City of New York, LP-1026–27 (October 23, 1979); Henderson, *The New Amsterdam*, 115–17; Diamonstein, *The Landmarks of New York III*, 266.

141. Eleanor Blau, "Revival on 42d Street: New Amsterdam Roof," *New York Times* (May 11, 1983), C: 20; Henderson, *The New Amsterdam*, 117- 19. Also see Maureen Dowd, "Rebirth of Showcase 42d St. Theater Sought," *New York Times* (August 2, 1984), B: 1, 6; William R. Greer, "New Stage for 42d St. in Jeopardy," *New York Times* (April 28, 1985): 43; Susan Heller Anderson and David W. Dunlap, "Theater Money Shifted," *New York Times* (June 18, 1985), B: 3.

142. Janet Maslin, "Film Review: Vanya on 42d Street," *New York Times* (October 19, 1994), C: 13.

143. Rich, "Mickey Does 42d Street": 17.

144. Mario Cuomo, quoted in Millner, "Beauty for a Beast": 3.

145. *Hardy Holzman Pfeiffer Associates: Buildings and*

Projects, 1967–1992, 259.

146. Hugh Hardy, "Foreword," in Henderson, *The New Amsterdam*, 7.

147. Goldberger, "Architecture: The New Amsterdam Theater": 54.

148. Rich, "The Mouse That Ate America": 23. Also see *New York Plaisance–An Illustrated Series of New York Places of Amusement* 1 (New York: New York Plaisance Co., 1908).

149. Huxtable, "Architecture: Miracle on 42nd Street": 16.

150. Muschamp, "A Palace for a New Magic Kingdom, 42d St.": 39.

151. Muschamp, "A Palace for a New Magic Kingdom, 42d St.": 1, 39.

152. Lowry, "Curtain Up on 42d St. Rehab": 2; Brett Pulley, "A Restoration Is Announced for 42d Street," *New York Times* (July 20, 1995), B: 1, 6; Peter Marks, "Turning Two Historic Theaters Into One Big One," *New York Times* (January 17, 1996), C: 11–12; Thomas J. Lueck, "Heavy Bet on Broadway's Future," *New York Times* (December 27, 1996), B: 1, 4; Ward Morehouse III and Andy Geller, "Times Square Rehab in High Gear," *New York Post* (January 29, 1997): 15; David W. Dunlap, "Ford to Sponsor New Theater on 42d Street," *New York Times* (January 29, 1997), B: 5; Christopher Byron, "A Broadway Angel? Garth Drabinsky Bankrolls *Ragtime*," *New York Observer* (February 10, 1997): 1, 25; Rappaport, "Boom Boom on Broadway": 5; David M. Halbfinger, "Private-Suite Concept Is Coming to Broadway," *New York Times* (September 16, 1997), E: 1, 3; "42nd Street Now!" *42nd Street Development Project, Inc., Newsletter* (Summer 1997); "Featuring the Ford," *42nd Street Development Project, Inc., Newsletter* (Fall 1997); David Rohde, "The Ford Center Opens on Broadway," *New York Times* (December 13, 1997), B: 2; David W. Dunlap, "With a Lavish Bow to the Past, a Broadway Palace Is Built," *New York Times* (December 14, 1997), II: 1, 8; Patrick Tolson, "The Ford Center," letter to the editor, *New York Times* (January 4, 1998), II: 5; Jeffrey J. Zogg, "The Ford Center," letter to the editor, *New York Times* (January 11, 1998), II: 8; Morehouse, "42nd St.'s New Pleasure Palaces": 43; Herbert Muschamp, "Raising the Curtain on a Golden Broadway," *New York Times* (January 20, 1998), E: 1, 3; Bruce Weber, "Gambling on a Trip from 'Ragtime' to Riches," *New York Times* (February 19, 1998): 1, B: 10; Sarah Amelar, "Reclamation on 42nd Street," *Architecture* 87 (March 1998): 146–50; M. J. Madigan, "Ford Center for the Performing Arts," *Interiors* 157 (March 1998): 88–93; Rick Lyman, "Power Broker Ousted by Disney Challenges Ex-Boss on Broadway," *New York Times* (April 14, 1998), 1, D: 6.

153. Richard Blinder, quoted in Lueck, "Heavy Bet on Broadway's Future": 4.

154. Muschamp, "Raising the Curtain on a Golden Broadway": 1, 3.

155. William Grimes, "On Stage, and Off," *New York Times* (January 10, 1997), B: 2; Peter Grant, "Rehearsal Space for Times Sq.," *New York Daily News* (March 28, 1997): 35; Rick Lyman, "Roundabout Finds a 2d Act in the Old Selwyn Theater," *New York Times* (September 18, 1997), E: 1, 4; Dixon, ed., *Robert A. M. Stern Architects: Buildings and Projects, 1993–1998*, 166–67.

156. Charles Platt, quoted in Rick Lyman, "A Theatrical Building with Its Own Drama," *New York Times* (November 19, 1997), E: 1, 6. Also see "The Buzz," *Architecture* 87 (January 1998): 31; Rick Lyman, "Back to Drawing Board," *New York Times* (January 9, 1998), E: 2; Nina Rappaport, "Around Town," *Oculus* 60 (March 1998): 19; Karrie Jacobs, "Forty-Deuce Coup," *New York* 31 (April 6, 1998): 62–64; "A Place to Create," *42nd Street Development Project, Inc., Newsletter* (Fall 1998); Lawrence Van Gelder, "Unfolding Drama," *New York Times* (October 21, 1998), E: 1; Jayne Merkel, "42nd Street Modern," *Oculus* 61 (April 1999): 7; Ralph Blumenthal, "New Theater: Your Name Here," *New York Times* (November 23, 1999), E: 1, 3; "Platt/Byard/Dovell," *Casabella* (December 1999-January 2000): 35–37; "The Name Game," *Wall Street Journal* (March 2, 2000): 24; Elaine Louie, "A Peek into the Theater District," *New York Times* (June 1, 2000), F: 3; Jesse McKinley, "Bookings Greet 42d Street Studios," *New York Times* (June 14, 2000), E: 3; Daniel S. Levy, "The New 42nd St. Studios," *Time* 155 (June 26, 2000): 74; Joseph Giovannini, "Time of the Signs," *New York* 33 (June 26-July 3, 2000): 148–49; Nancy Ramsey, "Sweating on 42nd Street," *Grid* 2 (July-August 2000): 24–25; Robin Pogrebin, "A Roundabout Journey to Glamour," *New York Times* (July 27, 2000), E: 1, 8; Paul Goldberger, "The Sky Line: Busy Buildings," *New Yorker* 76 (September 4, 2000): 90–93; Andrew Blum, "Real! Live! Artists!" *Metropolis* 20 (October 2000): 46; William Weathersby Jr., "Choreographed Illumination of a Rehearsal Center's Facade Creates Its Own Street Theater on Broadway," *Architectural Record* 188 (November 2000): 196–200; Balfour, *World Cities: New York*, 131; "New York on Display," *Grid* 3 (March 2001): 30; Luna, ed., *New New York*, 170–75.

157. Thomas J. Lueck, "Unreported Flaws Cited After Building Collapses," *New York Times* (December 31, 1997): 1; B: 4; Thomas J. Lueck, "Building That Collapsed Is Gone: The Questions It Raised Remain," *New York Times* (January 1, 1998), B: 3.

158. Douglas Martin, "A 42d Street Diner Seeks a Place at the Table," *New York Times* (January 14, 1996): 29; Owen Moritz, "It's the End of an Era," *New York Daily News* (October 8, 1997): 16; Paul Schwartzman, "Sad End to a Grand Luncheonette," *New York Daily News* (October 19, 1997): 5; Randy Kennedy, "Luncheonette's Grill Turns Off for Good," *New York Times* (October 20, 1997), B: 3; "Celebrate New Life on the Deuce," editorial, *New York Daily News* (October 21, 1997): 36; "The Grand Finale," *New York* 30 (October 27, 1997): 17.

159. Louie, "A Peek into the Theater District": 3.

160. Giovannini, "Time of the Signs": 148–49.

161. Goldberger, "The Sky Line: Busy Buildings": 90, 92.

162. "4 Teams Compete to Design a Hotel," *New York Times* (September 18, 1994), IX: 1; *Michael Graves: Buildings and Projects, 1990–1994*, eds. Karen Nichols, Lisa Burke, and Patrick Burke (New York: Rizzoli International Publications, 1995), 290–95; Salvesen, "Planning News": 26; Herbert Muschamp, "3 Hotels for the World's Crossroads," *New York Times* (February 17, 1995), B: 1, 3; Jayne Merkel, "Shrozoom! It's a New Hotel on 42nd Street," *Oculus* 57 (April 1995): 4–5; Tom Lowry, "Business," *New York Daily News* (May 10, 1995): 43; Tom Lowry, "Disney Complex Corners 42d St.," *New York Daily News* (May 12, 1995): 7; Shawn G. Kennedy, "Disney and Developer Are Chosen to Build 42d Street Hotel Complex," *New York Times* (May 12, 1995), B: 1–2; Judith Evans, "Times Square Contract Awarded," *Newsday* (May 12, 1995): 43; "Disney on 42d Street," editorial, *New York Times* (May 13, 1995): 18; "Going from Pot to Pixie Dust," editorial, *New York Daily News* (May 15, 1995): 22; "Not a Fantasy: Mouseketeers Are 42nd-St. Bound," *Newsday* (May 16, 1995): 30; Max M. Tamir, "Why Choose Times Sq. for a Hotel Complex?" *New York Times* (May 20, 1995): 22; Herbert Muschamp, "A Flare for Fantasy: Miami Vice Meets 42d Street," *New York Times* (May 21, 1995), II: 1, 27; Nicolai Ouroussoff, "42nd Street's Glitz and Grit Meet Arquitectonica's Punchy (and Punchout) Times Square Design," *Architectural Record* 183 (June 1995): 15; Richard H. Talbert, "Mural Maker," letter to the editor, *New York Times* (June 4, 1995), II: 4; Finder, "A Prince Charming?": 21–22; "Arquitectonica Crashes on 42nd Street," *Progressive Architecture* 76 (July 1995): 25; "Disney's Debut on Broadway," *Bauwelt* (August 11, 1995): 1646–49; Jayne Merkel, "Fireworks on 42nd Street: As Much About Economics, as About Architecture," *Competitions* 5 (Fall 1995): 44–49; Claudia H. Deutsch, "Outlook: Cloudy, with Silver Linings," *New York Times* (January 14, 1996), IX: 1, 9; Ward Morehouse and Paul Tharp, "Disney Drops Out of Midtown Hotel," *New York Post* (April 18, 1996): 34; Thomas J. Lueck, "Disney Rejects Time Shares in Times Square Hotel Rooms," *New York Times* (April 19, 1996), B: 5; Thomas J. Lueck, "An Anchor and an Archway for Times Square," *New York Times* (September 19, 1996), B: 6; Charles V. Bagli, "Tishman Wins Sony," *New York Observer* (September 23, 1996): 1, 26; John Holusha, "The Delicate Task of Demolition," *New York Times* (April 13, 1997), IX: 9; "From the Ground Up," *42nd Street Development Project, Inc., Newsletter* (Fall 1997); "E Walk," *ANY* 22 (1998): 13; "42nd Street Competition," *ANY* 22 (1998): 13; *Zaha Hadid: The Complete Buildings and Projects* (New York: Rizzoli International Publications, 1998), 106–9; Jacobs, "Forty-Deuce Coup": 62–64; Beth Piskora, "Westin to Run Luxury Times Sq. Hotel," *New York Post* (December 11, 1998): 44; "Westin Plans to Run Times Square Hotel," *New York Times* (December 11, 1998), B: 14; John Holusha, "New Hotels Are Finding a Home on 42d Street," *New York Times* (January 24, 1999), XI: 9; "A Multitude of Multiplexes," *New York Times* (May 9, 1999), XI: 1; "42nd Street Hotel," *Industria delle Costruzioni* (July-August 1999): 38–41; James Barron, "Hurry! Hurry! Try Whack-a-Mayor!" *New York Times* (August 12, 1999), B: 2; Charles V. Bagli, "Soon in Times Square, a Place That the Blues Can Call Home," *New York Times* (August 17, 1999), B: 1, 6; John Holusha, "Cineplex Bringing Back the Movies to 42d St ," *New York Times* (November 10, 1999), B: 14; John Zukowsky and Martha Thorne, eds., *Skyscrapers: The New Millennium* (Munich: Prestel Verlag, 2000), 32–33; "Hello, Times Square," *Crain's New York Business* (February 21, 2000): 14; Charles V. Bagli, "Work Begins on Westin Hotel to the West of Times Square," *New York Times* (June 9, 2000), B: 8; "Arquitectonica's Times Square Hotel Goes Up," *Architectural Record* 188 (August 2000): 38; Terry Pristin, "Movie Theaters Build Themselves into a Corner," *New York Times* (September 4, 2000): 1, B: 3; John Holusha, "The Bustle of 42d Street, Architecturally Speaking," *New York Times* (December 3, 2000), XI: 9; Balfour, *World Cities: New York*, 77–78, 280–81; Sagalyn, *Times Square Roulette*, 362–63, 481–82; "Times Square Pegged," *Oculus* 64 (January 2001): 9; "Westin Times Square, New York, NY," *Interior Design* 72 (March 2001), S: 100; John Holusha, "Designed to Stand Out in a Crowd," *New York Times* (February 6, 2002), C: 6; James Gardner, "Unethical?" *New York Sun* (June 4, 2002): 1, 12; Paul Goldberger, "The Sky Line/Miami Vice: Is This the Ugliest Building in New York?" *New Yorker* 78 (October 7, 2002): 100; Herbert Muschamp, "A Latin Jolt to the Skyline," *New York Times* (October 20, 2002), II: 1, 37; "2002 Top Projects: The Westin New York at Times Square," *New York Construction News* 50 (June 2003): 19.

163. Merkel, "Fireworks on 42nd Street: As Much About Economics, as About Architecture": 45.

164. Schwartz and Vaccaro, *Venturi, Scott Brown & Associates: Works and Projects*, 252–53; Venturi, *Iconography and Electronics Upon a Generic Architecture: A View from the Drafting Room*, 37.

165. Muschamp, "3 Hotels for the World's Crossroads": 1, 3.

166. For the exhibition, see Herbert Muschamp, "Pumping Energy Into Urban Spaces," *New York Times* (February 5, 1995), II: 35.

167. Muschamp, "3 Hotels for the World's Crossroads": 1, 3.

168. Muschamp, "3 Hotels for the World's Crossroads": 1, 3.

169. Gardner, "Unethical?": 12.

170. Goldberger, "The Sky Line/Miami Vice: Is This the Ugliest Building in New York?": 100.

171. Muschamp, "A Latin Jolt to the Skyline": 1, 37.

172. Brett Pulley, "Tussaud's and Movie Chain Are Negotiating on 42d St. Site," *New York Times* (July 13, 1995), B: 3; Brett Pulley, "Tussaud's and Movie Chain Join Disney in 42d Street Project," *New York Times* (July 16, 1995): 25, 27; Lowry, "Curtain Up on 42d St. Rehab": 2; Ward Morehouse III, "RKO Is A-Ok with Us! Joins 42d St. Rehab," *New York Post* (November 14, 1995): 3; Peter Grant, "HMV Joins Party," *New York Daily News* (April 19, 1996): 38; Thomas J. Lueck, "New 42d St., Old Theater: You'll Find It Up the Block," *New York Times* (June 5, 1996): 1, B: 2; Ann Hornaday, "At Many a Multiplex, Lots of Screens but Little Choice," *New York Times* (August 4, 1996), II: 18–19; William Grimes, "Liberty Theater Facing Virtual-Reality Future," *New York Times* (December 21, 1996): 15, 20; Amy Richards, "Theater Worth Saving," letter to the editor, *New York Times* (January 4, 1997): 22; "Curtain Time," *New York Times* (February 23, 1997), IX: 2; David M. Halbfinger, "Times Square Project Gets Bank Financing," *New York Times* (June 13, 1997), B: 7; "42nd Street Now!"*42nd Street Development Project, Inc., Newsletter* (Summer 1997); "From the Ground Up," *42nd Street Development Project, Inc., Newsletter* (Fall 1997); John Holusha, "3,700-Ton Theater to Move to New Role and Address," *New York Times* (November 30, 1997), XI: 9; John Holusha, "The Theater's on a Roll, Gliding Down 42d Street," *New York Times* (February 28, 1998), B: 1, 4; Bernard Ryan Jr., "Theater History, Moved," letter to the editor, *New York Times* (March 7, 1998): 12; "Announcing the Biggest Move in the History of New York Real Estate," advertisement, *New York Times* (March 1, 1998): 23; Bill Egbert, "Empire Theater on a Roll," *New York Daily News* (March 2, 1998): 13; "Late-Rising New Yorkers Discover That Broadway Has Moved," *New York Times* (March 2, 1998): 1; Charles V. Bagli, "Developer Seeks to Build Another Hotel in (Where Else) Times Square," *New York Times* (March 18, 1998), B: 7; "The Empire Has Landed," *42nd Street Development Project, Inc., Newsletter* (Spring 1998); "All New Yorkers Were Moved," *Landmarks West Newsletter* (Spring 1998): 9; Ellen Kirschner Popper, "42nd Street Project Advances with Move of Its Historic Theater," *Architectural Record* 186 (April 1998): 38; Jacobs, "Forty-Deuce Coup": 62–64; Terry Pristin, "New Hotel for Times Square Gets European Financing," *New York Times* (November 24, 1998), B: 8; Alan S. Oser, "All Over Town, Movie Screens Are Popping Up," *New York Times* (December 30, 1998), B: 9; Holusha, "New Hotels Are Finding a Home on 42d Street": 9; "A Multitude of Multiplexes": 1; Holusha, "Cineplex Bringing Back the Movies to 42d St.": 14; John Holusha, "A Theater's Muses, Rescued," *New York Times* (March 24, 2000), B: 1, 6; Glenn Collins, "Coming Soon: The Wax Menagerie," *New York Times* (April 20, 2000), B: 1, 6; Ward Morehouse III, "Liberty to the Imax," *New York Times* (May 15, 2000): 38; Andrew Ross Sorkin, "Internet Cafe Chain to Try a Times Sq. Connection," *New York Times* (May 27, 2000), B: 4; Bagli, "Work Begins on Westin Hotel to the West of Times Square": 8; Pristin, "Movie Theaters Build Themselves into a Corner": 1, 3; Glenn Collins, "Bodyless Heads in Unfinished Building," *New York Times* (September 12, 2000), E: 1, 3; Bill Egbert, "$50M Wax Museum Opens," *New York Daily News* (November 16, 2000): 38; Balfour, *World Cities: New York*, 79–80; Sagalyn, *Times Square Roulette*, 364–69, 426–27; John Calhoun, "New York House of Wax," *Entertainment Design* 35 (April 2001): 26–34; "42nd Street Redevelopment Project Presents Unique Structural Challenges," *Metals in Construction* (Fall 2001): 14–19; Traub, *The Devil's Playground*, 285–86.

173. For the Empire Theater, see Stern, Gilmartin, and Massengale, *New York 1900*, 206; Stern, Mellins, and Fishman, *New York 1960*, 442, 1100.

174. Christopher Gray, "Streetscapes: The Eltinge/Empire Theater," *New York Times* (March 28, 1993), X: 7. Also see Vincent Canby, "Last Action Hero," *New York Times* (June 18, 1993), C: 1, 10.

175. Stern, Gilmartin, and Mellins, *New York 1930*, 546–47.

176. The play opened in February 1996 at the New York Theater Workshop in the East Village, a few weeks after its playwright, Jonathan Larson, died at the age of thirty-five. See Mel Gussow, "Jonathan Larson, 35, Composer of Rock Opera and Musicals," *New York Times* (January 26, 1996), B: 9; Anthony Tommasini, "A Composer's Death Echoes in His Musical," *New York Times* (February 11, 1996), II: 5, 20; Ben Brantley, "Rock Opera à la 'Boheme' and 'Hair,'" *New York Times* (February 14, 1996), C: 11; Peter Marks, "Looking on Broadway for Ramshackle Home," *New York Times* (February 26, 1996), C: 9; Bernard Holland, "Flaws Aside, 'Rent' Lives and Breathes," *New York Times* (March 17, 1996), II: 31.

177. Linda Lee, "Times Square, with Ketchup," *New York Times* (September 25, 2002), B: 1, 7; Douglas Martin, "Charles Mount Dies at 60; Designed 300 Restaurants," obituary, *New York Times* (November 12, 2002), C: 21; James Gardner, "Dropping Anchor," *New York Sun* (November 19, 2002): 1, 11.

178. Charles Mount, quoted in Lee, "Times Square, with Ketchup": 1.

179. Gardner, "Dropping Anchor": 11.

180. Charles V. Bagli, "Durst May Put Up a New Skyscraper on Times Square," *New York Observer* (August 21, 1995): 1, 16; Brett Pulley, "Key Developer Seeks a Role in Times Sq.," *New York Times* (November 21, 1995), B: 1, 4; Peter Grant, "Durst Makes a Deal," *New York Daily News* (February 14, 1996): 25; Thomas J. Lueck, "Developer Buys the Rights to Build a Times Square Tower," *New York Times* (April 12, 1996), B: 1, 4; Ned Cramer, "Times Square Tower Breaks Ground," *Architecture* 85 (August 1996): 50; Peter Slatin, "A Groundbreaking Review," *New York Post* (September 2, 1996): 27–28; Peter Slatin, "Work Starts at 'Conde Towers,'" *New York Post* (September 2, 1996): 28; Karrie Jacobs, "New Style: No Style," *New York* 29 (September 23, 1996): 30–31, 115; Carlo Paganelli, "4, Times Square," *L'Arca* 109 (November 1996): 56–59; Nora Kerr, "Renewal in New York, Thinking Big Beyond," *New York Times* (December 29, 1996), II: 38; Judith Davidsen, "Strange Bedfellows in Times Square," *World Architecture* (February 1997): 23; Ann Carrns, "Seeing Dollar Signs in Times Square," *Wall Street Journal* (February 28, 1997), B: 8; John Holusha, "Technology in the Front Seat at 4 Times Square," *New York Times* (March 30, 1997), IX: 7; "Bright Lights, Big Building,"

42nd Street Development Project, Inc., Newsletter (Summer 1997); Ann Carrns, "In Times Square, It May Pay to Be Green," *Wall Street Journal* (July 16, 1997), B: 10; "From the Ground Up," *42nd Street Development Project, Inc., Newsletter* (Fall 1997); James S. Russell, "Where Does Architecture Fit in the Big Apple," *Urban Land* 56 (October 1997): 76–78, 120; "The Condé Nast Building," *ANY* 22 (1998): 29; David S. Chartock, "4 Times Square: Setting New Standards," *New York Construction News* (June 1998): 28–34; Sara Hart, "Guess Who's Going Green?" *Architecture* 87 (August 1998): 116–19; Fox & Fowle: *Function Structure Beauty* (Milan: L'Arca Edizioni, 1999), 11, 34–37; Eric P. Nash, *Manhattan Skyscrapers* (New York: Princeton Architectural Press, 1999), 169–70; Sarah Bernard, "The New Death Star," *New York* 32 (February 8, 1999): 18; David W. Dunlap, "To Get a Rig Down, Build a Second One," *New York Times* (February 28, 1999): 27; "The Condé Nast Building at Four Times Square," *World Architecture* (March 1999): 104–5; Merkel, "42nd Street Modern": 7; Andrew Jacobs, "Invisible Tenant in New Tower?" *New York Times* (April 10, 1999), B: 1, 4; John Holusha, "Commercial Real Estate," *New York Times* (May 5, 1999), B: 12; Herbert Muschamp, "One Way to Get Taller in a City of Giants," *New York Times* (May 16, 1999): 31; Charles V. Bagli, "Condé Nast's Stylish Clan Moves Into Times Sq.," *New York Times* (June 20, 1999): 33; André Chaszar and Buro Happold, "Sign of the Times," *Architects' Journal* 209 (June 24, 1999), supplement: 6–9; Karrie Jacobs, "Fat City," *New York* 32 (June 28-July 5, 1999): 38–39, 41; Andrew Goldman, "Shotgun Wedding at 4 Times Square: Condé Nast Girl, Skadden Arps Boy," *New York Observer* (July 12, 1999): 1, 21; Annia Ciezadlo with Charles Forelle, "Make Way for Condé Nast Cars: 43rd St. Ready for Radio Roulette," *New York Observer* (July 19, 1999): 1, 8; Douglas Durst, "Family Pride," letter to the editor, *New York* 32 (August 9, 1999): 8; Herbert Muschamp, "A Tower That Flaunts Its Contradictions," *New York Times* (September 26, 1999), II: 43; Laurie Joan Aron, "Storied Architects Standing Tall," *Crain's New York Business* (November 8–14, 1999): 48; Mildred F. Schmertz, "Saved by the Stock Market: Condé Nast on Times Square," *Oculus* 62 (December 1999): 8–9; Zukowsky and Thorne, eds., *Skyscrapers: The New Millennium*, 36–37; Neil Frankel, "Shades of Green," *Interiors* 159 (January 2000): 28; Dave Platter, "The Big Apple Turns Green," *Urban Land* 59 (February 2000): 41; Nicola Turner, "The Greening of Times Square," *World Architecture* (February 2000): cover, 56–63; Suzanne Stephens, "Four Times Square," *Architectural Record* 188 (March 2000): 90–97; John Holusha, "Tax Incentive Approved for 'Green' Buildings," *New York Times* (May 29, 2000), B: 2; Jayne Merkel, "The New Skyscrapers," *Oculus* 62 (Summer 2000): 8–9; Goldberger, "The Sky Line: Busy Buildings": 90–93; Balfour, *World Cities: New York*, 83–84; Sagalyn, *Times Square Roulette*, 430–38; "New York Firms Honored for 10 Design Projects," *New York Times* (January 7, 2001), XI: 1; Andrew Friedman, "Limousines Get a Curb They Can Call Their Own," *New York Times* (January 28, 2001), XIV: 6; "The Condé Nast Building," *Architectural Record* 189 (May 2001): 111; Rossana Capurso, "The Condé Nast Building at Times Square, New York," *Industria delle Costruzioni* (May 2001): 40–47; Joseph Giovannini, "Acing the Deuce," *New York* 35 (January 21, 2002): 77–78; Luna, ed., *New New York*, 162–65.

181. Russell, "Where Does Architecture Fit in the Big Apple": 78.

182. Stephens, "Four Times Square": 92.

183. Bruce Fowle, quoted in Jacobs, "Fat City": 38.

184. Daisy Hernandez, "TV Tower to Be Built as a Backup in Times Sq.," *New York Times* (November 1, 2002), B: 11; Eric Herman, "TV Tower Planned for Times Sq.," *New York Daily News* (March 27, 2003): 70; Charles V. Bagli, "Broadcasters Put Antennas in Midtown," *New York Times* (May 12, 2003), B: 1, 3.

185. Stephens, "Four Times Square": 95.

186. Jacobs, "Fat City": 38.

187. Jacobs, "New Style: No Style": 115.

188. Muschamp, "One Way to Get Taller in a City of Giants": 31.

189. See Stephens, "Four Times Square": 90–97.

190. Goldberger, "The Sky Line: Busy Buildings": 90.

191. Dal Co and Forster, *Frank O. Gehry: The Complete Works*, 578; "Frank O. Gehry: Conde Nast Cafeteria," *GA Document* 63 (2000): 24–29; Keith J. Kelly, "Gehry Eatery Is Latest Edition at Conde Nast," *New York Post* (April 6, 2000): 38; Alexandra Jacobs, "Remember the Royalton?" *New York Observer* (April 17, 2000): 13, 16; Suzanne Stephens, "Condé Nast Cafeteria," *Architectural Record* 188 (June 2000): cover, 116–23; "Gehry Does Lunch at Condé Nast," *Architecture* 89 (June 2000): 37; "Cafeteria für Condé Nast," *Bauwelt* (June 2000): 3; "Times Change," *Architectural Review* 208 (October 2000): 86–89; "Condé Nast Cafeteria, New York, by Frank Gehry," *Interior Design* 71 (December 2000): 127; J. Fiona Ragheb, ed., *Frank Gehry, Architect* (New York: Solomon R. Guggenheim Museum, 2001), 236–43, 375; William J. Mitchell, "Roll Over Euclid: How Frank Gehry Designs and Builds," in Ragheb, ed., *Frank Gehry, Architect*, 360–61; "Frank O. Gehry & Associates," *Architecture + Urbanism* (May 2001): 58–61.

192. Frank Gehry, quoted in Stephens, "Condé Nast Cafeteria": 117.

193. Charles V. Bagli, "Bullish on Times Square Neon," *New York Times* (August 20, 1998), B: 1, 6; Beth Landman Keil and Deborah Mitchell, "Intelligencer: Nasdaq's Fashionable Theme Park," *New York* 31 (October 19, 1998): 10; Charles V. Bagli, "Battle of the Unbuilt Billboard," *New York Times* (May 13, 1999), B: 1, 3; Charles V. Bagli, "Nasdaq Wins Battle to Build Huge Video Sign," *New York Times* (August 4, 1999), B: 1, 3; Charles V. Bagli, "The Newest Showoff in the Land Where Neon Is King, Times Sq.," *New York Times* (December 19, 1999), B: 3; "Inside the Techno-Turret," *New York Times* (February 10,

2000), F: 3; Jayson Blair, "Turning Pixels into Panache," *New York Times* (February 17, 2000), B: 1, 10; Floyd Norris, "Nasdaq's Sign Is Great, but Does Its Market Measure Up?" *New York Times* (March 17, 2000), C: 1; Anonymous, "Life Inside the Can," *Metropolis* 20 (August-September 2000): 54.

194. "The Virtual Roller Coaster Arrives in Times Square," *New York Times* (September 15, 1996), XIII: 4; Thomas J. Lueck, "3 Prime Sites in Times Square Renewal Plan Go Up for Sale," *New York Times* (March 18, 1997), B: 1, 5; Amy Feldman, "Durst Near Deal for 2nd Tower in Times Square," *Crain's New York Business* (March 17–23, 1997): 1, 41; "Durst, Pru to Meet," *Crain's New York Business* (April 7–13, 1997): 1; Charles V. Bagli, "Reuters Steps Up Its Talks on Times Square Building," *New York Times* (August 1, 1997), B: 5; Bernard Stamler, "News on the Rialto? It's Finished," *New York Times* (February 15, 1998), XIV: 6; Herbert Muschamp, "Architectural Order Graces a Chaotic Hub," *New York Times* (March 8, 1998): 37; Jacobs, "Forty-Deuce Coup": 62–64; Nina Rappaport, "About to Play in the Neighborhood," *Oculus* 61 (September 1998): 6; John Holusha, "A Corporate Headquarters Next to Bugs and Mice," *New York Times* (September 6, 1998), VIII: 9; David W. Dunlap, "Where Raunch Met Excess," *New York Times* (September 22, 1998), D: 1, 7; *Fox & Fowle: Function Structure Beauty*, 38–37; "Going Up," *New York Times* (January 12, 1999), B: 7; Merkel, "42nd Street Modern": 7; John Holusha, "Economics, Pro and Con, of Making Buildings Green," *New York Times* (June 6, 1999), XI: 9; Jacobs, "Fat City": 38; Virginia Kent Dorris, "Newsroom Circuitry: The Reuters Building," *Grid* 1 (Winter 1999): 66–68, 70, 72; Aron, "Storied Architects Standing Tall": 48; Zukowsky and Thorne, eds., *Skyscrapers: The New Millennium*, 38–39; Platter, "The Big Apple Turns Green": 41; Holusha, "Tax Incentive Approved for 'Green' Buildings": 2; Merkel, "The New Skyscrapers": 8; "Tech Life at Giga-Speed," *Oculus* 63 (September 2000): 5; Goldberger, "The Sky Line: Busy Buildings": 90–93; Ned Cramer, "Frankenstein Takes Manhattan," *Architecture* 89 (November 2000): 162; Balfour, *World Cities: New York*, 81–82; Sagalyn, *Times Square Roulette*, 369, 437–38, 451, 479; Bay Brown, "United States," *World Architecture* (January 2001): 83; Giovannini, "Acing the Deuce": 77–78.

195. Merkel, "The New Skyscrapers": 8.

196. Muschamp, "Architectural Order Graces a Chaotic Hub": 37.

197. Bruce Fowle, quoted in Goldberger, "The Sky Line: Busy Buildings": 93.

198. Giovannini, "Acing the Deuce": 77.

199. Cramer, "Frankenstein Takes Manhattan": 162.

200. Charles V. Bagli, "Two Times Square Sites Are Suddenly Much in Demand," *New York Times* (January 1, 1998), B: 6; Charles V. Bagli, "Fierce Bidding Expected on 2 Sites in Times Square," *New York Times* (March 8, 1998): 37; Charles V. Bagli, "2 Developers Bid Top Dollar for What's Left in Times Sq.," *New York Times* (March 31, 1998): 1, B: 9; Devin Leonard, "Zuckerman Ends Up with Surprise Space in Times Square Deal," *New York Observer* (April 20, 1998): 1, 20.

201. Herbert Muschamp, "Philip Johnson Geometry in an Advertising Wrapper," *New York Times* (March 5, 1998), E: 1, 8; Rappaport, "About to Play in the Neighborhood": 6.

202. Muschamp, "Philip Johnson Geometry in an Advertising Wrapper": 1, 8.

203. "Architects for Times Square," *Crain's New York Business* (May 18, 1998): 1; Jacobs, "Fat City": 41; "Tenants Are Sought for Times Sq. Site" (October 27, 1999), B: 7; "Deal on Tower Lease Is Said to Be Near," *New York Times* (January 27, 2000), B: 9; Theresa Braine, "Ernst & Young Does the Deuce," *Grid* 2 (March-April 2000): 58–62; Merkel, "The New Skyscrapers": 8–9; Goldberger, "The Sky Line: Busy Buildings": 90, 93; Sagalyn, *Times Square Roulette*, 479–80; David S. Chartock, "Site Logistics Spur Creative Solutions for 5 Times Square," *New York Construction News* 48 (March 2001): 29–32, 34–38; Ian Luna and Kenneth Powell, eds., *Kohn Pedersen Fox: Architecture and Urbanism, 1993–2002* (New York: Rizzoli International Publications, 2002), 366–71; Jerry W. Szatan, "Retain, Renew, Rebuild," *Urban Land* 61 (February 2002): 88–91; "2002 Top Projects: 5 Times Square," *New York Construction News* 50 (June 2003): 31.

204. "Architects for Times Square": 1; Jacobs, "Fat City": 41; "Tenants Are Sought for Times Sq. Site": 7; Lore Croghan, "Tower Developer Tries Law Firm Pitch," *Crain's New York Business* (January 24, 2000): 17; Merkel, "The New Skyscrapers": 8–9; Goldberger, "The Sky Line: Busy Buildings": 90; Charles V. Bagli, "Lease Deal Helps Pave Way for Fourth New Tower in Times Sq.," *New York Times* (October 16, 2000), B: 1, 5; John E. Czarnecki, "Arthur Andersen Tower for Times Square," *Architectural Record* 188 (November 2000): 33; "News," *Architecture* 89 (December 2000): 29; Charles V. Bagli, "Move to Times Square Is Planned," *New York Times* (December 5, 2000), B: 7; Balfour, *World Cities: New York*, 232–33; Sagalyn, *Times Square Roulette*, 479–80; Andrew Rice, "Back to the Drawing Board," *Architecture* 91 (January 2002): 44–49; Szatan, "Retain, Renew, Rebuild": 88–91; Steve Cuozzo, "A Sky-High Jinx at 10 Times Sq.," *New York Post* (January 21, 2003): 28.

205. T. J. Gottesdiener, quoted in Merkel, "The New Skyscrapers": 9.

206. Goldberger, "The Sky Line: Busy Buildings": 90, 93.

207. Charles V. Bagli, "Times Is Said to Consider a New Tower," *New York Times* (October 14, 1999), B: 3; Paul Goldberger, "Comment/Extra! Extra! Newshounds Exit!" *New Yorker* 75 (November 29, 1999): 41–42; Charles V. Bagli, "Times Co. Picks Developer for New Home in Times Sq.," *New York Times* (February 19, 2000), B: 3; Carl Swanson, "The Pinch and Rudy Show," *New York* 33 (March 20, 2000): 15; Charles V. Bagli, "Bargaining Begins on Site for Times," *New York Times* (March 23, 2000), B: 8; Charles V. Bagli, "The Times Is Expected to Sign an Accord on a New Building," *New York Times* (June

20, 2000), B: 3; Andrew Rice, "Scrappy Parking Man Battles Times Tower, Won't Sell His Lots," *New York Observer* (July 3–10, 2000): 1, 28; Mickey O'Connor, "New York Times Leaving Times Square," *Architecture* 89 (September 2000): 34; Bay Brown, "New York Times Tower," *World Architecture* (September 2000): 36; David W. Dunlap, "Architects Submit Four Proposals for New Headquarters for The Times," *New York Times* (September 14, 2000), B: 10; John E. Czarnecki, "Four Vie for Coveted NY Times Tower Project," *Architectural Record* 188 (October 2000): 44; Mickey O'Connor, "New York Times Shows Shortlisted Schemes," *Architecture* 89 (October 2000): 39; "Architect for The Times," *New York Times* (October 13, 2000): 1; David W. Dunlap, "Times Chooses Architect, and His Vision, for New Building," *New York Times* (October 13, 2000), B: 1, 8; Herbert Muschamp, "A Rare Opportunity for Real Architecture Where It's Needed," *New York Times* (October 22, 2000), II: 1, 38–39; Paul Goldberger, "The Sky Line: Dream House," *New Yorker* 76 (October 30, 2000): 107–11; John E. Czarnecki, "Renzo Piano Takes Manhattan, Wins NY Times," *Architectural Record* 188 (November 2000): 33; "Fashion of the Times," *Oculus* 63 (November 2000): 4–5; Catherine J. Mathis, "No Sudden Movements," letter to the editor, *Architecture* 89 (November 2000): 29–30; James A. Gresham, "Ignoring a Role," letter to the editor, *New York Times* (November 19, 2000), II: 4; Nicholas Guyatt, "Multiple Moves," letter to the editor, *New York Times* (November 19, 2000), II: 4; Manuel Oncina, "The Right Choice," letter to the editor, *New York Times* (November 19, 2000), II: 4; Elizabeth H. Shapiro, "A Triumph," letter to the editor, *New York Times* (November 19, 2000), II: 4; Joseph Giovannini, "Lost in Space," *New York* 33 (November 27, 2000): 146, 148; Amanda May, "Times, Up," *Grid* 2 (November-December 2000): 24–25; "Zeitung im Glashaus," *Baumeister* (December 2000): 8; Christopher Hawthorne, "Piano Forte," *Interiors* 159 (December 2000): 20; "A Frank Answer," *New York* 33 (December 4, 2000): 19; Ragheb, ed., *Frank Gehry, Architect*, 280–87, 326–27, 378; "Piano Towers Over London and New York," *World Architecture* (January 2001): 73; Steven Heller, "The Times They Are A-Moving," *Interiors* 160 (February 2001): 27; "Gensler to Design Interiors of New York Times Building," *Interiors* 160 (March 2001): 30; Nicholas Adams, "Primedonne Alla Conquista del (New York) Times," *Casabella* (May 2001): 72–75, 87; David W. Dunlap, "The Times Still Plans to Build an Office Tower in Midtown," *New York Times* (September 25, 2001): 23; "Renzo Piano Speaks with Record about Skyscrapers and the City," *Architectural Record* 189 (October 2001): 136–37; Karina Lahni, "Times Tower Moves Ahead in Age of New Realities," *New York Observer* (October 15, 2001): 9; David W. Dunlap, "Blight to Some Is Home to Others," *New York Times* (October 25, 2001), D: 1, 4; Matthew Richards, "Towers Will Go Ahead, Say Architects," *World Architecture* (November-December 2001): 7; "Agency Authorized to Acquire Properties: Plans Advance for Times Sq. Tower Site," *New York Times* (December 2, 2001), XI: 1; "First Look," *New York Post* (December 13, 2001): 42; David W. Dunlap, "Times Goes Forward on Plan for Tower on Eighth Avenue," *New York Times* (December 14, 2001), D: 3; John E. Czarnecki, "Piano's N.Y. Times Tower Moves Forward," *Architectural Record* 190 (January 2002): 24; Rice, "Back to the Drawing Board": 44; "Grid Talks: Michael Golden," *Grid* 4 (January-February 2002): 80; Peter Grant, "Plots & Ploys," *Wall Street Journal* (January 23, 2002), B: 8; Anne Guiney, "On the Boards," *Architecture* 91 (February 2002): 30–31; *Frank Owen Gehry: Flowing in All Directions* (Los Angeles: Circa, 2003), 96–103; *Tall Buildings* (New York: Museum of Modern Art, 2003), 80–85, 132–37, 179, 183; Lore Croghan, "Foreign Architects Offer Blueprint for Cachet," *Crain's New York Business* (May 5, 2003): 15, 19; Dan Barry, "Small Strivers Are Uprooted by Big Plans," *New York Times* (July 9, 2003), B: 1; Charles V. Bagli, "Times Tower Is Delayed as Partner Awaits Loan," *New York Times* (October 17, 2003), B: 3; Steve Cuozzo, "40th St. Fiasco," *New York Post* (November 3, 2003): 31; Philip Jodidio, *Piano: Renzo Piano Building Workshop 1966–2005* (Cologne: Taschen, 2005), 478–83. Also see "The Gray Lady Dresses Up," in http://www.designarchitecture.com.

208. For the *New York Times*'s 1967 expansion, see Stern, Mellins, and Fishman, *New York 1960*, 1122. For the Paramount Theater, see Stern, Gilmartin, and Mellins, *New York 1930*, 256.

209. Goldberger, "The Sky Line: Dream House": 110.

210. Michael Golden, quoted in Croghan, "Foreign Architects Offer Blueprint for Cachet": 19.

211. Michael Golden, quoted in Dunlap, "Architects Submit Four Proposals for New Headquarters for The Times": 10.

212. For Renzo Piano's Potsdamer Platz buildings, see Peter Buchanan, *Renzo Piano Building Workshop: Complete Works*, vol. 4 (London: Phaidon Press, 2000), 156–213.

213. Renzo Piano, quoted in Goldberger, "The Sky Line: Dream House": 111.

214. Dunlap, "Architects Submit Four Proposals for New Headquarters for The Times": 10.

215. Muschamp, "A Rare Opportunity for Real Architecture Where It's Needed": 38.

216. Goldberger, "The Sky Line: Dream House": 107–8.

217. Renzo Piano, quoted in "The Gray Lady Dresses Up," in http://www.designarchitecture.com.

218. Peter Grant, "Plots & Ploys," *Wall Street Journal* (February 2, 2000), B: 1; "Times Sq. Tower Planned," *New York Times* (February 3, 2000), B: 8; "Times Sq. Site Is on Block," *Crain's New York Business* (April 17, 2000): 1, 83; Andrew Rice, "Battle of Milsteins: Old Brothers Make 2 do Restless Sons," *New York Observer* (May 29, 2000): 1, 29; Marc Hochstein, "Prodigious Son," *Grid* 3 (March 2001): 48–49; Rice, "Back to the Drawing Board": 44; Steve Cuozzo, "Last Piece of 42nd St. Puzzle," *New York Post* (October 22, 2002): 32;

Charles V. Bagli, "35-Story Tower Is Planned for Last Open Times Sq. Lot," *New York Times* (October 22, 2002), B: 3.

219. Anthony Ramirez, "Second Stage to Get a New Stage," *New York Times* (February 23, 1997), XIII; "Times Square," *ANY* 22 (1998): 26–27; "NYSCA Grants for 1998," *Oculus* 60 (March 1998): 19; Lawrence Van Gelder, "Second Act," *New York Times* (July 1, 1998), E: 1; Howard Kissel, "Bank, for the Memories," *New York Daily News* (July 12, 1998): 25; Herbert Muschamp, "The Premiere of a Koolhaas Fantasy," *New York Times* (April 8, 1999): E: 1, 5; Alexandra Lange, "Room with a View," *New York* 32 (April 19, 1999): 14; Maria Giulia Zunino, "Second Stage Theatre," *Abitare* (May 1999): 264–67; Judith Newmark, "Carole Rothman Finds Dream Home in New York for Second Stage Theater," *St. Louis Post-Dispatch* (May 9, 1999), C: 4; Linda Sandler, "Dutch Architect Takes a Starring Role–Koolhaas Is Revered by Many, but Too Hip for Some," *Wall Street Journal* (May 12, 1999), B: 16; "Now Playing in Times Square," *Oculus* 61 (June 1999): 4; Sabine von Fischer, "Theater am Times Square," *Bauwelt* (July 23, 1999): 1535; Suzanne Stephens, "Rem Koolhaas' and Richard Gluckman's Bank Renovation for Second Stage Theater Grabs the Spotlight with Economy, Efficiency, and a Bit of Flash," *Architectural Record* 187 (August 1999): 93–95; Leanne Boepple, "Second Stage's Second Stage," *Entertainment Design* 33 (November 1999): 16–18; "OMA + Gluckman Mayner: Second Stage Theater, New York," *Casabella* (December 1999-January 2000): 42–45; White and Willensky, *AIA Guide* (2000), 254; *Space Framed: Richard Gluckman Architect* (New York: Monacelli Press, 2000), 166–71, 224; "Second Stage Theatre," *Architecture + Urbanism*, special issue (May 2000): 214–15. For the State Bank and Trust Company Building, see Stern, Gilmartin, and Mellins, *New York 1930*, 178–79, 183.

220. Rem Koolhaas, quoted in "Times Square": 26.

221. Muschamp, "The Premiere of a Koolhaas Fantasy": 5.

222. Rem Koolhaas, quoted in "OMA + Gluckman Mayner: Second Stage Theater, New York": 42.

223. Rem Koolhaas, quoted in "Times Square": 26.

224. Muschamp, "The Premiere of a Koolhaas Fantasy": 5.

225. Sandler, "Dutch Architect Takes a Starring Role–Koolhaas Is Revered by Many, but Too Hip for Some": 16.

226. Stephens, "Rem Koolhaas' and Richard Gluckman's Bank Renovation for Second Stage Theater Grabs the Spotlight with Economy, Efficiency, and a Bit of Flash": 94.

227. Thomas J. Lueck, "Right to Build over Terminal Is up for Sale," *New York Times* (September 4, 1997), B: 1, 6; Lore Croghan and Philip Lentz, "Bus Station Tower Next Big Thing in Development," *Crain's New York Business* (December 7, 1998): 3, 35; Charles V. Bagli, "Tower to Rise Above Port Authority Terminal," *New York Times* (October 1, 1999), B: 4; *Skidmore, Owings & Merrill LLP: Architecture and Urbanism, 1995–2000* (Mulgrave, Australia: Images Publishing, 2000], 252; Kayte VanScoy, "Is the Port Authority Terminal?" *Grid* 2 (January-February 2000): 24–25; Merkel, "The New Skyscrapers": 8–9; Peter Grant, "Plots & Ploys," *Wall Street Journal* (November 15, 2000), B: 12; Sagalyn, *Times Square Roulette*, 465–66; Charles V. Bagli, "Cisco Reported as Anchor for Unbuilt Tower," *New York Times* (January 20, 2001), B: 6; Eric Herman, "Cicso PA Deal Hits Skids," *New York Daily News* (June 7, 2001): 65; Rice, "Back to the Drawing Board": 44–45.

228. For both the 1950 building and the 1975–81 addition, see Stern, Mellins, and Fishman, *New York 1960*, 468–71. Also see Joseph Deitch, "Bus Terminal: Rebuilding in Last Phase," *New York Times* (January 23, 1983), XI: 1, 4; Susan Heller Anderson and David Bird, "A Dream in Midtown," *New York Times* (January 27, 1984), B: 3.

229. Claudia H. Deutsch, "A Former Haven of Sleaze Is Now a Refuge of Retail," *New York Times* (March 17, 1996), XI: 11; Joe Mysak, *Perpetual Motion: The Illustrated History of the Port Authority* (Santa Monica, Calif.: General Publishing, 1997), 208–9, 227–28.

230. Cherrie Nanninga, quoted in Anthony Ramirez, "Bus Terminal Will Show How Big a Sign Can Get," *New York Times* (February 9, 1997), XIII: 6. Also see Karrie Jacobs, "Dressed to Shill: The Bus Terminal Gets a Madison Avenue Makeover," *New York* 31 (July 27, 1998): 15; Valerie Block, "It's Showtime, Folks!" *Crain's New York Business* (September 14, 1998): 54–55.

231. For the McGraw-Hill Building, see Stern, Gilmartin, and Mellins, *New York 1930*, 574–75, 579–80, 584–85.

232. Jodi Yegelwel, quoted in Ramirez, "Bus Terminal Will Show How Big a Sign Can Get": 6.

233. Jacobs, "Dressed to Shill: The Bus Terminal Gets a Madison Avenue Makeover": 15.

234. For Manhattan Plaza, see Stern, Mellins, and Fishman, *New York 1960*, 470–72.

235. Lisa W. Foderaro, "A Rental Tower for West Side," *New York Times* (December 12, 1986), D: 15; "Westward Ho," *Real Estate Shoppers Guide* (March 1987): 4A; Lisa W. Foderaro, "If You're Thinking of Living In: Clinton," *New York Times* (June 21, 1987), VIII: 11; Lisa W. Foderaro, "Residential 'Wall' Rises Along West 42d Street," *New York Times* (September 13, 1987), VIII: 9; Andree Brooks, "Luxury Tower at 10th Ave. and 42d St.," *New York Times* (June 3, 1988): 20; Thomas J. Lueck, "The Condo Glut That Didn't Happen," *New York Times* (December 18, 1988), X: 1; Carter B. Horsley, "The Good, the Bad & the Ugly," *New York Post* (December 29, 1988): 53, 57; Felicia R. Lee, "Gentrification and Crime Lay Siege to Clinton," *New York Times* (July 8, 1989): 25; *Hardy Holzman Pfeiffer Associates: Buildings and Projects 1967–1992*, 156–59; William Grimes, "On Stage, and Off," *New York Times* (January 25, 1997), C: 2; White and Willensky, *AIA Guide* (2000), 246–47.

236. Hugh Hardy, quoted in Foderaro, "A Rental Tower for West Side": 15.

237. Horsley, "The Good, the Bad & the Ugly": 53.

238. Harry Macklowe, quoted in Foderaro, "A Rental Tower

for West Side": 15.

239. Foderaro, "Residential 'Wall' Rises Along West 42d": 9, 22; Anthony DePalma, "Construction of Apartments in Manhattan Falls Sharply," *New York Times* (April 3, 1988), X: 1, 11; Brooks, "Luxury Tower at 10th Ave. and 42d St.": 20; Horsley, "The Good, the Bad & the Ugly": 53, 57; Richard D. Lyons, "Two Views of a View Bring a Lawsuit," *New York Times* (June 4, 1989), VIII: 9.

240. Costas Kondylis, quoted in Foderaro, "Residential 'Wall' Rises Along West 42d": 22.

241. Carter B. Horsley, "The Strand," in www.cityrealty.com.

242. Horsley, "The Good, the Bad & the Ugly": 53.

243. For the Special Clinton Zoning District, see Stern, Mellins, and Fishman, *New York 1960*, 319.

244. Rachelle Garbarine, "Affordable Apartments Open Way for Financing," *New York Times* (June 20, 1997), B: 5; Alan S. Oser, "Perspectives," *New York Times* (March 1, 1998), XI: 5; Charles V. Bagli, "Far West 42d St., Once Scorned, Is Now Much in Demand," *New York Times* (April 26, 2000), B: 1, 4; Rachelle Garbarine, "Residential Real Estate," *New York Times* (May 12, 2000), B: 14.

245. "Complex Decision on 42nd Could Affect Javits Plans," *Crain's New York Business* (March 10, 1997): 12; David W. Dunlap, "The Taming of the 'Wild West,'" *New York Times* (August 24, 1997), IX: 1, 6; Tracie Rozhon, "They Are to Rise, at Last, on 42d St. Between 11th and 12th," *New York Times* (June 27, 1999), XI: 1; Jerold S. Kayden, *Privately Owned Public Space: The New York City Experience* (New York: John Wiley & Sons, 2000), 111; Bagli, "Far West 42d St., Once Scorned, Is Now Much in Demand": 1, 4; Garbarine, "Residential Real Estate": 14; Deborah Netburn, "Financial Observer," *New York Observer* (September 11, 2000): 25; David S. Chartock, "River Place I: The Nation's Biggest Rental Apt. Building," *New York Construction News* 47 (November 2000): 11–13; Lore Croghan, "Builders Revive Long-Dormant Far-West 42nd," *Crain's New York Business* (April 16, 2001): 4, 75; Dennis Hevesi, "In Hell's Kitchen, a Changing Skyline," *New York Times* (May 12, 2002), XI: 1, 4; Eric Herman, "Hell's Kitchen Cooks Up Building Boom of Apts.," *New York Daily News* (July 29, 2002): 30.

246. For the Starrett-Lehigh Building, see Stern, Gilmartin, and Mellins, *New York 1930*, 520–22.

247. Larry A. Silverstein, quoted in Chartock, "River Place I: The Nation's Biggest Rental Apt. Building": 13.

248. Bagli, "Far West 42d St., Once Scorned, Is Now Much in Demand": 1, 4; Charles V. Bagli, "25-Year Feud Ends with Deal for a Tower near Times Sq.," *New York Times* (December 25, 2000), B: 1–2; Hevesi, "In Hell's Kitchen, a Changing Skyline": 1, 4.

249. For Flagg's building, see Stern, Gilmartin, and Massengale, *New York 1900*, 287.

250. Bagli, "Far West 42d St., Once Scorned, Is Now Much in Demand": 1, 4; Ralph Blumenthal, "Transforming Theater Row," *New York Times* (May 11, 2000), E: 1, 5; Garbarine, "Residential Real Estate": 14; Croghan, "Builders Revive Long-Dormant Far-West 42nd": 4, 75; Tracie Rozhon, "Condos on the Rise, by Architectural Stars," *New York Times* (July 19, 2001), F: 1, 10; Tracie Rozhon, "Theater Below 42d Street Rental Tower: Stages Stars, and Stripes," *New York Times* (October 21, 2001), XI: 1; Jesse McKinley, "Upscale March of Theater Row," *New York Times* (November 21, 2002), E: 1, 5.

251. Hugh Hardy, quoted in Rozhon, "Theater Below 42d Street Rental Tower: Stages Stars, and Stripes": 1.

252. Hevesi, "In Hell's Kitchen, a Changing Skyline": 1, 4.

253. Hevesi, "In Hell's Kitchen, a Changing Skyline": 1, 4.

FIFTY-SEVENTH STREET

1. For the Rembrandt and the Osborne, see Stern, Mellins, and Fishman, *New York 1880*, 545–46, 559–61.

2. For Carnegie Hall, see Stern, Mellins, and Fishman, *New York 1880*, 690–93. For the American Fine Arts Society and the Rodin Studios, see Stern, Gilmartin, and Massengale, *New York 1900*, 103–4, 106, 298. For Louis H. Chalif's School of Dancing, see Stern, Gilmartin, and Mellins, *New York 1930*, 357, 359. For Eidlitz's clubhouse for the American Society of Civil Engineers, see Christopher Gray, "Streetscapes: Readers' Questions: 220 West 57th Street," *New York Times* (June 3, 1990), X: 12.

3. For such examples as Robert Mook's Marble Row (1867–69), east side of Fifth Avenue between Fifty-seventh and Fifty-eighth streets, George L. Harney's Frederick W. Stevens house (1875–76), southwest corner of Fifth Avenue, and George B. Post's Cornelius Vanderbilt II house (1879–82, 1892–94), west side of Fifth Avenue between Fifty-seventh and Fifty-eighth Streets, see Stern, Mellins, and Fishman, *New York 1880*, 577–79, 596–601, 635–37.

4. For Bergdorf Goodman and Tiffany's, see Stern, Gilmartin, and Mellins, *New York 1930*, 310–11, 318–19, 316, 321.

5. For the Ritz Tower and the Fuller Building, see Stern, Gilmartin, and Mellins, *New York 1930*, 212–13, 215, 366–67.

6. For development on Sutton Place and One Sutton Place South, see Stern, Gilmartin, and Mellins, *New York 1930*, 367, 429–31.

7. For the Squibb Building and 9 West Fifty-seventh Street, see Stern, Mellins, and Fishman, *New York 1960*, 502–5.

8. Carter B. Horsley, "Is It One Building or Two? New Project Halted by Dispute," *New York Times* (January 14, 1979), VIII: 1, 6; Carter B. Horsley, "Tower Approved for West 57th Despite Vote of Local Board," *New York Times* (June 3, 1979), VIII: 4; "Air France to Run Hotel in New York," *New York Times* (January 22, 1980), B: 3; Alan S. Oser, "Meridien Hotel Set in New York," *New York Times* (January 23, 1980), D: 19; Suzanne Slesin, "Four New Luxury Hotels in the City: Elaborate Decor and Matching Prices," *New York Times* (August 24, 1980), VIII: 1, 10; Monica Geran, "The Parker Meridien: Manhattan's Newest Mid-Town Hotel," *Interior Design* 52 (December 1981): 158–67; Jerold S. Kayden, *Privately Owned Public Space: The New York Experience* (New York:

John Wiley, 2000), 177–78; White and Willensky, *AIA Guide* (2000), 268.

9. Stern, Mellins, and Fishman, *New York 1960*, 1112–13.

10. Harold C. Schonberg, "Carnegie Hall, at 90, Is Thinking Young," *New York Times* (June 29, 1980), II: 1, 17. For Philharmonic Hall, see Stern, Mellins, and Fishman, *New York 1960*, 684–91.

11. E. R. Shipp, "Carnegie Hall and City Negotiating on Renovation and Air-Rights Use," *New York Times* (October 21, 1980), B: 3.

12. "U.S. Gives $1.8 Million for Carnegie Renovation," *New York Times* (January 21, 1981), C: 20.

13. John Rockwell, "Carnegie Hall Begins $20 Million Renovation," *New York Times* (February 21, 1982): 1, 52; Paul Goldberger, "A Superb Scheme for the Renovation of Carnegie Hall," *New York Times* (March 7, 1982), II: 27; "Landmark Hall Renovation," *Progressive Architecture* 63 (April 1982): 41; Paul Goldberger, "Architecture: Carnegie Hall Restoration, Phase 1," *New York Times* (September 8, 1983), C: 16; Harold C. Schonberg, "Carnegie Impresario of Talent," *New York Times* (July 31, 1984), C: 15; *James Stewart Polshek: Context and Responsibility* (New York: Rizzoli International Publications, 1988), 43.

14. Goldberger, "Architecture: Carnegie Hall Restoration, Phase 1": 16.

15. "Carnegie Hall," *Progressive Architecture* 66 (May 1985): 39; John Rockwell, "Carnegie Hall to Close for 7 Months Next Year," *New York Times* (May 17, 1985), C: 28; "Landmarks Panel Backs Carnegie Hall Project," *New York Times* (July 25, 1985), C: 21; "Names and News," *Oculus* 47 (September 1985): 10; Susan Heller Anderson and David W. Dunlap, "Mixing Old with New at Carnegie Hall," *New York Times* (September 9, 1985), B: 3; Andrea Truppin, "Public Space Experience," *Interiors* 144 (November 1985): 111–21, 172, 177; Todd S. Purdum, "Art Slows Carnegie's Rebuilding," *New York Times* (January 5, 1986): 31; "Carnegie Hall's New Lobby," *Oculus* 47 (March 1986): 2–6, 11; "Credits for Carnegie Hall Restoration," *Oculus* 47 (April 1986): 8; Susan Heller Anderson and David Bird, "Seats Aplenty," *New York Times* (May 20, 1986), B: 4; Bernard Holland, "At Carnegie, Old Papers and Debris," *New York Times* (May 26, 1986): 13; "The Talk of the Town: Restoration," *New Yorker* 62 (July 7, 1986): 20–22; Susan Heller Anderson and David Bird, "Carnegie Hall Renovation in Tune with Schedule," *New York Times* (July 25, 1986), B: 3; Bernard Holland, "Carnegie Recital Hall to Be Renamed," *New York Times* (November 16, 1986), C: 23; "A Gala for Carnegie Hall," *New York Times* (November 25, 1986), C: 13; "New Canopy at Carnegie," *New York Times* (November 28, 1986), B: 1; Victoria Geibel, "Breaking Ground," *Metropolis* 6 (December 1986): 20; Paul Goldberger, "Carnegie's Allegro Facelift: Past Lives," *New York Times* (December 2, 1986), B: 1–2; Paul Goldberger, "Sensitive Restoration Has Made a Great Building Better," *New York Times* (December 14, 1986), II: 1, 17; John Rockwell, "Carnegie Hall, at 95, Prepares for a New Debut," *New York Times* (December 14, 1986), II: 1, 25; Harold C. Schonberg, "Carnegie Acoustics Get a Public Test Tonight," *New York Times* (December 15, 1986), C: 17; Will Crutchfield, "Details Linger Till the Last Moment," *New York Times* (December 16, 1986), C: 19; Donal Henahan, "Carnegie, at 95, Reopens with Several Surprises," *New York Times* (December 16, 1986): 1, C: 19; John Rockwell, "Rejuvenated Carnegie Is Again Premier Hall," *New York Times* (December 16, 1986), C: 19; Harold C. Schonberg, "Music: Does Carnegie Hall Remain the Stradivarius of the Concert World?" *New York Times* (December 18, 1986), C: 22; Alan Rich, "Face-Lift for an Old Beauty," *Newsweek* 108 (December 22, 1986): 73; Thor Eckert Jr., "Sumptuous New-Old Look Now Has a Sound to Match," *Christian Science Monitor* (December 26, 1986): 15; Carleton Knight III, "Carnegie Hall," *Christian Science Monitor* (December 26, 1986): 15; "Sound Management," editorial, *New York Times* (December 26, 1986): 34; Andrew Porter, "Musical Events: House of Music," *New Yorker* 62 (December 29, 1986): 80–82; Richard Schickel and Michael Walsh, *Carnegie Hall: The First One Hundred Years* (New York: Harry N. Abrams, 1987), 240–47; John Rockwell, "Weill Recital Hall Opens at Carnegie," *New York Times* (January 6, 1987), C: 13; Leighton Kerner, "Carnegie Hall: Sound Barrier," *Village Voice* (January 6, 1987): 75; Bernard Holland, "Setting the Right Tone for 'New' Carnegie Hall," *New York Times* (January 29, 1987), C: 22; Sharon Lee Ryder, "Carnegie Hall: Better Than Ever," *Architecture* 76 (February 1987): 60–65; Susan Doubilet, "Carnegie Hall Reopens," *Progressive Architecture* 68 (February 1987): 23–24; Donal Henahan, "The New Carnegie Sound Packs Less of a Wallop," *New York Times* (February 22, 1987), II: 23; Andrew Porter, "Musical Events: Chamber," *New Yorker* 63 (February 23, 1987): 101–4; Andrew Porter, "Musical Events: But Where Is the Glow of Yesteryear?" *New Yorker* 63 (April 20, 1987): 76–79; Bernard Holland, "Fiddling with Sound of Weill," *New York Times* (April 25, 1987): 13; Scott Melnick, "Complex Reconstruction Saves Carnegie Hall," *Building Design & Construction* 28 (May 1987): 118–21; Wesley Haynes, "Carnegie Hall: New York City," *Architectural Record* 175 (June 1987): 164–65; Michael Kimmelman, "Weill Hall Adds Drapes in Hope of Better Sound," *New York Times* (August 5, 1987), C: 20; Will Crutchfield, "Carnegie Hall vs. Fisher Hall," *New York Times* (September 28, 1987), C: 15; Leighton Kerner, "Carnegie v. Avery Fisher: TKO," *Village Voice* (October 13, 1987): 90; "It Remains a Jewel," *Historic Preservation* 39 (November–December 1987): 26; *James Stewart Polshek: Context and Responsibility*, 43–44, 88–95; White and Willensky, *AIA Guide* (1988), 278; James R. Oestreich, "Carnegie Hall's Great Sound Can No Longer Be Taken for Granted," *Connoisseur* 218 (March 1988): 72, 74, 76; Allen Freeman, "AIA Honor Awards 1988," *Architecture* 77 (May 1988): 154, 274; Allan Kozinn, "Seeking a Consensus on Carnegie," *New York Times* (September 22, 1988), C: 17, 22; Donal Henahan, "Carnegie Still Seeks Old

Sound," *New York Times* (October 6, 1988), C: 32; Bruce Weber, "A Bath Every Century, Need It or Not," *New York Times* (August 20, 1989), VI: 94; Leighton Kerner, "Carnegie Hall: Saving Phases," *Village Voice* (January 23, 1990): 70; Leighton Kerner, "A Hundred Years of Harmony," *Village Voice* (September 4, 1990): 61; Susan Heller Anderson, "A Museum for Carnegie Hall," *New York Times* (February 18, 1991): 28; James R. Oestreich, "A Carnegie Museum," *New York Times* (April 21, 1991), II: 25; Paul Goldberger, "Signs of Hope for a Cultural City in Fiscal Distress," *New York Times* (January 19, 1992), II: 34; Claudia H. Deutsch, "Commercial Property: Carnegie Hall," *New York Times* (October 11, 1992), X: 13; Bernard Holland, "At Carnegie, a More Resonant Philharmonic," *New York Times* (July 22, 1994), C: 12; Marisa Bartolucci, "Citizen Architect," *Metropolis* 14 (June 1995): 62–67, 74–79; Allan Kozinn, "A Phantom Exposed: Concrete at Carnegie," *New York Times* (September 14, 1995): 1, C: 14; "Concrete Evidence," editorial, *New York Times* (September 15, 1995): 34; Allan Kozinn, "Case of the Carnegie Concrete, Chapter II," *New York Times* (September 20, 1995), C: 13, 15; Bernard Holland, "A New Stage Is Set, Happily Not in Cement," *New York Times* (September 24, 1995), II: 29; Bernard Holland, "The Philadelphia Orchestra at Carnegie, Minus Concrete," *New York Times* (September 27, 1995), C: 11, 14; Tim Page, "Carnegie's Concrete Difference," *Washington Post* (September 28, 1995), C: 1, 8; James R. Oestreich, "Assessing Carnegie Hall Without the Concrete," *New York Times* (March 5, 1996), C: 11, 14.

16. Lawrence Goldman, quoted in "The Talk of the Town: Restoration": 20.

17. See Carl E. Schorske, *Fin-de-siecle Vienna: Politics and Culture* (New York: Knopf, 1980). For the Museum of Modern Art's exhibition, see John Russell, "The Brilliant Sunset of Vienna in Its Final Glory," *New York Times* (June 29, 1986), II: 29; Paul Goldberger, "Architecture: The Modern Offers 'Vienna 1900,'" *New York Times* (July 7, 1986), C: 12.

18. Goldberger, "Sensitive Restoration Has Made a Great Building Better": 1.

19. Holland, "Setting the Right Tone for 'New' Carnegie Hall": 22.

20. Judith Arron, quoted in Kozinn, "Seeking a Consensus on Carnegie": 17.

21. Christopher Willard, former employee of the Carnegie Hall press department, quoted in Kozinn, "Case of the Carnegie Concrete, Chapter II": 15.

22. Holland, "Setting the Right Tone for 'New' Carnegie Hall": 22.

23. James Stewart Polshek, "Notes on My Life and Work," in *James Stewart Polshek: Context and Responsibility*, 44.

24. Ralph Blumenthal, "In the Offing, Another Hall in Carnegie's Basement," *New York Times* (January 3, 1998), B: 1, 8; Ralph Blumenthal, "Carnegie Hall Expanding, Using Underground Space," *New York Times* (December 14, 1998): 1, B: 6; Allan Kozinn, "A New Stage and Lineup for Concerts at Carnegie," *New York Times* (January 12, 1999), E: 1, 8; "A New Stage for a Hallowed Hall," *Interior Design* 70 (March 1999): 35; "And the Beat Goes On," *Interiors* 158 (March 1999): 20; David W. Dunlap, "Carnegie Hall Grows the Only Way It Can," *New York Times* (January 30, 2000): 27, 32; Nadine M. Post, "Carving a Concert 'Cave' Under Carnegie Hall," *Engineering News-Record* 247 (July 16, 2001): 30–33; "Carnegie Delays Opening of Additional Hall," *New York Times* (November 1, 2001), E: 2; David S. Chartock, "Worker Harmony 'Composes' Facility Under Carnegie Hall," *New York Construction News* 49 (May 2002): 46; David W. Dunlap, "When Expansion Leads to Inner Space," *New York Times* (May 5, 2002), XI: 1, 6; Robin Pogrebin, "A New Underground at Carnegie, in More Ways Than One," *New York Times* (April 3, 2003), E: 5; "Carnegie Hall's New Hall," *New York Sun* (April 7, 2003): 17; John Rockwell, "Carnegie's Zanel Hall Joins the Competition for Audiences," *New York Times* (April 10, 2003), E: 1, 5; Anthony Tommasini, "Where's the Party? Carnegie's Basement," *New York Times* (September 7, 2003), II: 77, 79; Allan Kozinn, "A Three-Ring House of Music, Willing and Able to Surprise," *New York Times* (September 12, 2003), E: 1, 4; Herbert Muschamp, "Zankel Hall, Carnegie's Buried Treasure," *New York Times* (September 12, 2003), E: 1, 4; Anthony Tommasini, "Trash Cans on the Stage, a Subway Underfoot," *New York Times* (September 15, 2003), II: 1, 5; Susan Strauss and Sean Sawyer, eds., *Polshek Partnership Architects* (New York: Princeton Architectural Press, 2005), 200–201.

25. Muschamp, "Zankel Hall, Carnegie's Buried Treasure": 1, 4.

26. Tommasini, "Trash Cans on the Stage, a Subway Underfoot": 5.

27. Daniel J. Wakin, "At Eclectic Zankel Hall, One Thing Rarely Varies," *New York Times* (November 25, 2005), E: 1, 14.

28. Paul Goldberger, "A Superb Scheme for the Renovation of Carnegie Hall," *New York Times* (March 7, 1982), II: 27, 31; Peter Kihss, "Carnegie Hall Planning a Commercial Complex," *New York Times* (March 26, 1982), B: 3; "Second Step in Carnegie Hall Renovation Is Announced," *Architectural Record* 170 (May 1982): 35; Kirk Johnson, "Towers Sprouting near Carnegie Hall," *New York Times* (September 9, 1984), VIII: 1, 14; Paul Goldberger, "The Tower Blight Has Struck West 57th Street," *New York Times* (January 27, 1985): II: 29–30.

29. Quoted in Kihss, "Carnegie Hall Planning a Commercial Complex": 3.

30. Joe Klein, "Mr. Big: Harry Macklowe Wants to Trump Donald Trump," *New York* 18 (December 9, 1985): cover, 52–60.

31. "Pencil Points," *Progressive Architecture* 66 (June 1985): 24; "News Briefs: Carnegie Hall," *Architectural Record* 173 (July 1985): 67; Peter Freiberg, "Pelli Sets the Stage for Carnegie Hall," *Metropolis* 5 (July-August 1985): 13; Shawn G. Kennedy, "Carnegie Hall Plans Office Site," *New York Times* (February 12, 1986), D: 20; Paul Goldberger, "Carnegie Hall Details Plans for Office Tower," *New York Times* (April 30, 1986), C: 19; "In

Concert with a Midtown Building Boom," *Architectural Record* 174 (June 1986): 71; "Pelli Designs 59-Story Finale for Carnegie Hall Master Plan," *Buildings Design Journal* (July 1986): 1, 9; Peter Lemos, "Scene & Heard: Russian Tea Sandwich," *Metropolis* 6 (July-August 1986): 14; "Carnegie Tower," *Progressive Architecture* 67 (July 1986): 30; Douglas Davis, "The New Master Builder," *Newsweek* 108 (August 4, 1986): 61; "Names and News," *Oculus* 48 (October 1986): 10; "Final Approval Granted for Carnegie Tower," *New York Times* (September 19, 1987): 15; "Tower Harmonizes with Hall," *Engineering News-Record* 219 (October 1, 1987): 12; "Carnegie Hall Tower on Its Way," *New York Times* (November 21, 1987): 9; White and Willensky, *AIA Guide* (1988), 278; Judith Pearlman, "Tower of Babble," *Manhattan, inc.* 5 (January 1988): 109–12; Richard F. Shepard, "Carnegie Hall Marks a Milestone for a Cornerstone," *New York Times* (May 12, 1988), C: 30; Christopher Gray, "Streetscapes: The Russian Tea Room," *New York Times* (September 11, 1988), X: 12; "Carnegie Hall Tower, New York," *Progressive Architecture* 70 (March 1989): 51; "Correctly Placing Pelli," *Progressive Architecture* 70 (May 1989): 13; "Rockrose Completing Carnegie Hall Tower," *New York Real Estate Journal* 1 (November 30, 1989): 20; *Cesar Pelli: Buildings and Projects, 1965–1990* (New York: Rizzoli International Publications, 1990), ll, lll; Gavin Macrae-Gibson, "Urban Iconography and the Medium of Architecture: Three Recent Buildings by Cesar Pelli," *Architecture + Urbanism* (February 1990): 134–37; Cesar Pelli, "Carnegie Hall Tower, New York," *Architecture + Urbanism* (February 1990): 140–41; Kurt Andersen, "Big Yet Still Beautiful," *Time* 136 (September 24, 1990): 98–99; James S. Russell, "Designing the Super-Thin New Buildings," *Architectural Record* 178 (October 1990): 105–6; Paul Goldberger, "Skyscrapers Battle It Out Near Carnegie Hall," *New York Times* (October 21, 1990), II: 38; Nadine M. Post, "Big Squeeze for Lean Landmark," *Engineering News-Record* 226 (January 14, 1991): 30; Carter Wiseman, "Two for the Seesaw," *New York* 24 (March 11, 1991): 68, 85; Michael J. Crosbie, "Harmonious Neighbor," *Architecture* 80 (June 1991): 66–71; "Brick in Architecture: Carnegie Hall Tower, New York City, New York," *Architecture* 80 (November 1991): supplement; Jane Everhart, "Rockrose Development Corporation," *Real Estate Forum* 46 (December 1991): 28–30, 32, 34, 36, 38–40; Jane Everhart, "Carnegie Hall Tower: Rockrose's Corporate Masterpiece Enhances a World-Renowned Institution," *Real Estate Forum* 46 (December 1991): 40, 42–44; Lee Edward Gray, "Iconic Forms and Cosmic Pillars," in Lee Edward Gray and David Walters, *Pattern and Context: Essays on Cesar Pelli* (Charlotte: University of North Carolina Press, 1992), 4, 9–13; Maurizio Vitta, "A Tower for History," *L'Arca* 57 (February 1992): 26–31; "Cesar Pelli," *Architecture + Urbanism* (April 1992): 110–17; "Quatro edifícios que respondem a seu entorno," *Projeto* 154 (July 1992): 26–29; *Cesar Pelli: Selected and Current Works* (Mulgrave, Australia: Images Publishing, 1993), 166–71; Cesar Pelli, "Four Buildings Responsive to Their Critical Surroundings," *Architecture + Urbanism* (January 1993): 104–5; "AIA Honor Awards for Architecture: Carnegie Hall Tower," *Architectural Record* 182 (February 1994): 59; "17 Win AIA Honor Awards," *Progressive Architecture* 75 (February 1994): 27–28; Karrie Jacobs, "New Style: No Style," *New York* 29 (September 23, 1996): 30–31, 115; Susanna Sirefman, *New York: A Guide to Recent Architecture* (London: Ellipsis, 1997), 150–53; Alan Balfour, *World Cities: New York* (New York: Wiley Academy, 2001), 87; Andrew Rice and Rebecca Traister, "Tower of Ambition," *New York Observer* February 5, 2001): 15.

32. Goldberger, "Carnegie Hall Details Plans for Office Tower": 19. For the Fred F. French Building, see Stern, Gilmartin, and Mellins, *New York 1930*, 594–95, 597.

33. Davis, "The New Master Builder": 61.

34. Cesar Pelli, quoted in Andersen, "Big Yet Still Beautiful": 98.

35. Andersen, "Big Yet Still Beautiful": 98.

36. Cesar Pelli, quoted in Crosbie, "Harmonious Neighbor": 69.

37. Wiseman, "Two for the Seesaw": 68.

38. "Little Carnegie's Last Picture Show," *New York Times* (April 11, 1982), VIII: 1; Enid Nemy, "Broadway," *New York Times* (July 13, 1984), C: 2; Johnson, "Towers Sprouting near Carnegie Hall": 1, 14; "Metropolitan Tower," advertisement, *New York Times* (January 20, 1985), VIII: 4; Martin Gottlieb, "A Midtown High-Rise Developer's New Math: 17 + 48 = 78," *New York Times* (January 27, 1985): 20; Goldberger, "The Tower Blight Has Struck West 57th Street": 29–30; Ruth Ryon, "Hot Property: 'Tallest Building' Rising in New York," *New York Times* (September 15, 1985), VIII: 21; Peter Lemos, "Scene & Heard: Sellout Architecture," *Metropolis* 5 (November 1985): 16; Klein, "Mr. Big: Harry Macklowe Wants to Trump Donald Trump": 52–60; "Metal Curtainwall System Achieves Monolithic Look," *Metals in Construction* (Winter 1985/86): 14–15; "Metropolitan Tower," *Process Architecture* 64 (January 1986): 109–13; Richard Korman and Paul Zach, "A Construction Sampler," *Engineering News-Record* 216 (January 2, 1986): 27; Albert Scardino, "Lush Tower Gets Star Billing," *New York Times* (March 20, 1986), D: 1, 9; White and Willensky, *AIA Guide* (1988), 278; Gray, "Streetscapes: The Russian Tea Room": 12; Monica Geran, "Carte Blanche," *Interior Design* 61 (February 1990): 202–5; Goldberger, "Skyscrapers Battle It Out Near Carnegie Hall": 38, 43.

39. Harry Macklowe, quoted in Klein, "Mr. Big: Harry Macklowe Wants to Trump Donald Trump": 57.

40. Goldberger, "The Tower Blight Has Struck West 57th Street": 29–30.

41. Klein, "Mr. Big: Harry Macklowe Wants to Trump Donald Trump": 53.

42. Edie Lee Cohen, "Model Statements," *Interior Design* 58 (February 1987): 250–57; Sharon Lee Ryder, "'Floating Island' Thirty-five Stories Above the Street," *Architecture* 76 (June 1987): 74–75; Sophie Tasma-Anargyros, *Andrée Putman*

(Woodstock, N.Y.: Overlook Press, 1997), 142–45.

43. Ryder, "'Floating Island' Thirty-five Stories Above the Street": 74.

44. James S. Russell, "Skin and Bones," *Architectural Record* 176 (mid-September 1988): 122–27; "Metropolitan Tower Apartment," *GA Houses* (March 1989): 204–13; Paola Iacucci, "Living Within the Heart of the Metropolis: Manhattan, at the Knife Edged Point of Metropolitan Tower," *Abitare* (May 1989): 194–201; Steven Holl, *Anchoring: Selected Projects, 1975–1991* (New York: Princeton Architectural Press, 1991), 116–19; "Apartment, Metropolitan Tower," in Yukio Futagawa, ed., *GA Architect* 11 (Tokyo: ADA Edita, 1993): 42–47.

45. "Metropolitan Tower Apartment," *GA Houses*: 204.

46. Goldberger, "Skyscrapers Battle It out Near Carnegie Hall": 43.

47. Florence Fabricant, "Two Food Moguls Concoct a Merger," *New York Times* (October 18, 1995), C: 1, 10; Alex Witchel, "At Lunch With: Faith Stewart-Gordon," *New York Times* (December 27, 1995), C: 1, 8; "Colors of the Czars," *New York Times* (December 31, 1995), IX: 1; Douglas Frantz, "Tea Room: Final Toast to a Year and an Era," *New York Times* (January 1, 1996): 36; Frank DiGiacomo, "Russian Tea Room Gloom on Lunchless 57th Street," *New York Observer* (January 29, 1996): 1, 3; Beth Landman Keil and Deborah Mitchell, "Warner's Got the Tea Room in a Tizzy," *New York* 29 (October 14, 1996): 17; Eric Asimov, "Angst Over Russian Tea Room," *New York Times* (October 30, 1996): 29.

48. For both restaurants, see Stern, Mellins, and Fishman, *New York 1960*, 527, 529, 783 84.

49. Warner LeRoy, quoted in "Colors of the Czars": 1.

50. David W. Dunlap, "Like Russia, Tea Room's in a Flux, but Era of Czars Is Coming Back," *New York Times* (September 10, 1998), B: 3; Pilar Guzman, "Warner Druthers," *Metropolis* 19 (October 1999): 90; William Grimes, "First the New Russia, Now the New Tea Room," *New York Times* (December 15, 1999), F: 20; Eric Asimov, "Warner LeRoy, Restaurant Impresario, Is Dead at 65," *New York Times* (February 24, 2001): 11; "Russian Tea Room Honored," *Architectural Record* 189 (June 2001): 42; Glenn Collins, "Russian Tea Room to Close After Tomorrow's Dinner," *New York Times* (July 27, 2002), B: 1–2; Judy Collins, "Goodbye to Buttery Blini," *New York Times* (July 30, 2002): 19; Eric Asimov, "When Makeovers Go Awry," *New York Times* (July 31, 2002), F: 1, 6.

51. Richard Lyons, "Growing Space: Tower for Nippon Club," *New York Times* (August 27, 1989), X: 1; "22-Story Tower to House Nippon Club, Private Offices," *New York Construction News* 37 (September 11, 1989): 1, 23; David W. Dunlap, "57th Street: A New Glitter Added to a Premier Retail Boulevard," *New York Times* (September 30, 1990), X: 14. For the original Nippon Club, see Christopher Gray, "Streetscapes/161 West 93rd Street," *New York Times* (September 30, 2001), XI: 9.

52. Quoted in www.takenaka.co.jp.

53. George W. Goodman, "E. 57th St. Lot Focus of Development Clash," *New York Times* (July 31, 1983), VIII: 7; Ada Louise Huxtable, *The Tall Building Artistically Reconsidered* (New York: Pantheon Books, 1984), 74; Alan S. Oser, "Split-Lot Lexington Project Melds Conflicting Themes," *New York Times* (October 14, 1984), VIII: 7; "125 East 57th Street," *Architecture + Urbanism* (December 1985): 11–13; Anthony DePalma, "Building Offices Without a Prime Tenant," *New York Times* (July 27, 1986), VIII: 1; David W. Dunlap, "A Midtown Marketplace for Antiques Planned," *New York Times* (September 2, 1986), B: 5; Sonia R. Chao and Trevor D. Abramson, eds., *Kohn Pedersen Fox: Buildings and Projects, 1976–1986* (New York: Rizzoli International Publications, 1987), 134–39, 347; Paul Goldberger, "Introduction," in Chao and Abramson, eds., *Kohn Pedersen Fox: Buildings and Projects, 1976–1986*, 11; "Prep Alert for East 57th Street," *New York* 20 (August 31, 1987): 8; Joseph Giovannini, "International Antiques Center Opens Its Doors with a Gala," *New York Times* (November 19, 1987), C: 3; "Magnificent Mall," *House & Garden* 159 (December 1987): 68B; Shawn G. Kennedy, "East Side Getting 2 New Office Towers," *New York Times* (April 20, 1988), B: 14; Allan R. Gold, "Can Back Bay Elegance Find Success at 57th and the Lex?" *New York Times* (September 1, 1988), C: 12; Paul Goldberger, "Breaking the Rules to Make a Corner an Urban Event," *New York Times* (October 9, 1988), II: 32; Rita Reif, "Antiques Center Still Expanding as New Dealers Move into Shops," *New York Times* (October 14, 1988), C: 1, 26; Paul Goldberger, "Fashions in Bricks and Mortar Make Room for Conscience," *New York Times* (December 25, 1988), II: 32; Alexandra Peers, "Art Mall Tries to Be More Than a Still Life," *Wall Street Journal* (March 28, 1990), B: 1; David W. Dunlap, "Commercial Property: Underground Spaces," *New York Times* (April 21, 1991), X: 15; David W. Dunlap, "Distinct, Well-Sited, 90% Leased–And in Bankruptcy," *New York Times* (September 22, 1991), X: 15; "Commercial Property: East 57th Street," *New York Times* (January 17, 1993), X: 11; "Postings: Chez Places des Antiquaires: Daffy's," *New York Times* (November 27, 1994), IX: 1; Sirefman, *New York*, 186–87; White and Willensky, *AIA Guide* (2000), 283. For Thompson & Churchill's building, see Stern, Gilmartin, and Mellins, *New York 1930*, 364–66.

54. Stern, Mellins, and Fishman, *New York 1960*, 500–503.

55. Goldberger, "Breaking the Rules to Make a Corner an Urban Event": 32.

56. Sirefman, *New York*, 186.

57. White and Willensky, *AIA Guide* (2000), 283.

58. "Zeckendorf Plans Hotel by Pei," *New York* 21 (August 29, 1988): 19; Jennifer Shaw, "Zeckendorf Group Plans Deluxe Hotel," *New York Post* (January 31, 1989): 31; Thomas J. Lueck, "57th St. Loc., 2 TVs/Rm., $400 a Night," *New York Times* (January 31, 1989), B: 1–2; Harry Berkowitz, "Regent Plans Hotel on 57th St.," *Newsday* (February 1, 1989): 41; "400-a-Night Rooms: Grandest N.Y. Hotel Planned," *San*

Francisco Chronicle (February 1, 1989): 3; Carter B. Horsley, "Plenty of Room at the Inn," *New York Post* (February 2, 1989): 50–51; "Superluxury Hotel," *Architectural Record* 177 (March 1989): 47; "Pencil Points," *Progressive Architecture* 70 (March 1989): 34; Justin Henderson, "High Style for 57th Street," *Interiors* 148 (May 1989): 32; Carter Wiseman, *I. M. Pei: A Profile in American Architecture* (New York: Harry N. Abrams, 1990), 311; David W. Dunlap, "Staying the Course, Despite the Gloom of Recession," *New York Times* (January 12, 1992), X: 9; Ylonda Gault, "Colossus Checks in at Luxury Inn Market," *Crain's New York Business* (October 5–11, 1992): 3, 35; "New Tallest Hotel in New York," *New York Times* (May 2, 1993), V: 3; Carlo Wolff, "The High and the Mighty," *Lodging Hospitality* (June 1993): 28–30, 32; "At This Price, Don't Ever Close the Curtains," *New York Times* (June 10, 1993), C: 3; Claudia H. Deutsch, "New York City Hotels Battling the Blues," *New York Times* (June 13, 1993), X: 1, 13; Marilyn Bethany, "Grand Hotel," *New York* 26 (June 14, 1993): 52–55; Suzanne Slesin, "Hot Hotels," *New York Times* (June 20, 1993), IX: 7; Paul Goldberger, "A Grand Hotel, but Not What You'd Call Homey," *New York Times* (June 27, 1993), II: 32; Monica Geran, "Chhada, Siembieda," *Interior Design* 64 (October 1993): 114–27; Regina S. Baraban, "Hotel Dining Revisited," *Metropolis* 13 (December 1993): 57; Bonnie Schwartz, "New York Luxe," *Interiors* 153 (January 1994): 100–101; Michael Cannell, *I. M. Pei: Mandarin of Modernism* (New York: Carol Southern Books, 1995), 378–79; "Hotel," *New York* 29 (April 15, 1996): 47; Paul Tharp, "It's a New Chance to Stay at a 5-Star Hotel," *New York Post* (August 2, 1996): 27; Charles V. Bagli, "Hong Kong Firm Commits $190 Million to Schmooze New York," *New York Observer* (August 12, 1996): 1, 19; Michael J. Crosbie, *The Architecture of Frank Williams* (Rockport, Mass.: Rockport Publishing, 1997), 9, 11–12, 76–87; Sirefman, *New York*, 182–85; Charles V. Bagli, "Hotel Company in Talks to Buy Four Seasons," *New York Times* (March 24, 1998), B: 8; Eric P. Nash, *Manhattan Skyscrapers* (New York: Princeton Architectural Press, 1999), 167–68; Gero von Boehm, *Conversations with I. M. Pei: Light Is the Key* (Munich: Prestel Verlag, 2000), 122; White and Willensky, *AIA Guide* (2000), 298; Paul Goldberger, "The Architect of Swanky Populism," *New Yorker* 76 (December 4, 2000): 36; "Off the Record," *Architectural Record* 189 (May 2001): 36. For the Waldorf-Astoria, see Stern, Gilmartin, and Mellins, *New York 1930*, 222–25.

59. For Pei's expansion of the Louvre, see Wiseman, *I. M. Pei: A Profile in American Architecture*, 228–61. For the Blackstone Hotel, see Mark McCain, "Commercial Property: Small Hotels," *New York Times* (July 19, 1987), VIII: 39.

60. Christopher Hussey, *The Life of Sir Edwin Lutyens* (London: Country Life, 1950), 290–325, 495–523.

61. Bethany, "Grand Hotel": 55.

62. Slesin, "Hot Hotels": 7.

63. Goldberger, "A Grand Hotel, but Not What You'd Call Homey": 32.

64. Morris Lapidus, quoted in Goldberger, "The Architect of Swanky Populism": 36.

65. Goldberger, "A Grand Hotel, but Not What You'd Call Homey": 32. Cedric Gibbons, head of Metro-Goldwyn-Mayer's art department from 1924 to 1956, was the designer of the Academy Awards' Oscar statuette. See Paul Goldberger, "A Hollywood House Worthy of an Oscar," *New York Times* (November 6, 1980), C: 10; Michael Webb, "Pioneering Art Director Who Brought Modernism to the Movies," *Architectural Digest* 47 (April 1990): 100, 104, 108, 112.

66. Penny McGuire, "Time Machine," *Architectural Review* 202 (August 1997): 78–80.

67. Richard Wilner, "Niketown Meet Midtown," *New York Post* (October 30, 1996): 35; Eve Jouannais, "Welcome to 'Niketown,' New York," *Architecture intérieure Créé* 276 (1997): 106–7; Virginia Kent Dorris, "Nike Town, New York City," *Architectural Record* 185 (March 1997): 100–103; Mario Antonio Arnaboldi, "La decorazione e il mutamento = Sports and Shopping," *L'Arca* 114 (April 1997): 68–71; Kate Hensler, "Niketown, New York City," *Interiors* 156 (April 1997): 60–65; Paul Goldberger, "The Store Strikes Back," *New York Times* (April 6, 1997), VI: 45–49; Penny McGuire, "NikeTown USA," *Architectural Review* 201 (May 1997): 95–97.

68. Goldberger, "The Store Strikes Back": 45.

69. "Chanel Taking Over 57th Street Building," *New York Times* (September 12, 1993), X: 1; Christopher Mason, "Designing Boutiques Like Palaces," *New York Times* (May 23, 1996), C: 1, 6; Barbara Schuler, "Suite in Chanel's New City Digs Is Very Coco," *Newsday* (June 6, 1996), B: 18; Herbert Muschamp, "An Elegant Blow Against Kitsch," *New York Times* (July 23, 1996), B: 1, 3; Barbara Schuler, "Toujours Provence: A Hairdresser Returns to His Beloved Roots," *Newsday* (August 22, 1996), B: 14; "Platt Byard Dovell Architects," *Batiment* (September-October 1996): 3; "Chanel Inc. Moves US Headquarters," *Jewelers' Circular-Keystone* 167 (September 1996): 194; Jacobs, "New Style: No Style": 30; Sirefman, *New York*, 194; Karrie Jacobs, "Champagne Design," *New York* 32 (May 17, 1999): 20–23; Herbert Muschamp, "The Spirit of Deco Rises from the Dead," *New York Times* (June 27, 1999), II: 30, 32; Michael Sorkin, "When to Fold," *Metropolis* 18 (December 1999): 56, 58; White and Willensky, *AIA Guide* (2000), 299; Paul Goldberger, "The Sky Line: Dior's New House," *New Yorker* 75 (January 31, 2000): 88–91. For Stewart & Company and L. P. Hollander & Company, see Stern, Gilmartin, and Mellins, *New York 1930*, 316, 319, 321, 362, 364, 367.

70. Muschamp, "An Elegant Blow Against Kitsch": 1.

71. Muschamp, "The Spirit of Deco Rises from the Dead": 30.

72. Goldberger, "The Sky Line: Dior's New House": 88.

73. "New York, tour LVMH, 1995," *Architecture d'aujourd'hui* 302 (December 1995): 98–101; Michel Jacques, ed., *Christian de Portzamparc* (Basel: Birkhauser Verlag, 1996), 151, 160–63; *Christian de Portzamparc: Scènes d'atelier* (Paris:

Centre Georges Pompidou, 1996), no pagination; Riccardo Finio, *Christian de Portzamparc* (Rome: Officina Edizioni, 1996), 184; Elaine Louie, "Escaping the Grid," *New York Times* (June 13, 1996), C: 5; "New Commissions," *Architecture* 85 (July 1996): 34; Muschamp, "An Elegant Blow Against Kitsch": 1, 3; " . . . And European Architects to Build in New York," *Oculus* 59 (September 1996): 3; Jacobs, "New Style: No Style": 30; Elena Cardani, "The LVMH Tower," *L'Arca* 109 (November 1996): 52–55; "Christian de Portzamparc," *Metropolis* 16 (March 1997): 64; "Louis Vuitton Tower," *GA Document* 51 (April 1997): 84–86; "Christian de Portzamparc," *Architecture + Urbanism* (June 1997): 18–23; Lisa W. Foderaro, "Costly Gap on 57th St. Is the Center of a Dispute," *New York Times* (July 18, 1997), B: 1, 3; "LVMH Tower," *ANY* (1998): 24; "Louis Vuitton Office Building," *Oculus* 60 (May 1998): 5; "Vuitton, Partner Settle Dispute," *Crain's New York Business* (October 5–11, 1998): 1, 55; "Project Citation," *Oculus* 61 (January 1999): 43; Fred Bernstein, "A Star Is Born," *Blueprint* 158 (February 1999): 20–21; Nina Rappaport, "Brief aus New York," *Deutsche Bauzeitung* 133 (May 1999): 26; Jacobs, "Champagne Design": 20–23; Muschamp, "The Spirit of Deco Rises from the Dead": 30, 32; Sorkin, "When to Fold": 56, 58; Diane Lewis, "Paris on 57th Street: From Ludwig Bemelmans to Christian de Portzamparc," *Oculus* 62 (December 1999): 9; Jayne Merkel, "The End of the Twentieth Century," *Oculus* 62 (December 1999): 3; "Luxury's Latest Highrise Is Arnault's Towering Achievement," *DNR* 29 (December 6, 1999): 143; "High Fashion at New Address," *New York Times* (December 8, 1999), B: 3; Cathy Horyn, "Overdressed for Overkill: Vive La France!" *New York Times* (December 12, 1999), IX: 1, 3; Julie V. Iovine, "Designing the Nouveau Building on the Block," *New York Times* (December 15, 1999), E: 1, 5; Herbert Muschamp, "New York Starts to Look Beyond Its Past," *New York Times* (December 26, 1999), II: 49; White and Willensky, *AIA Guide* (2000), 298–99; "Reflections on Glass: A Conversation with Robert A. Heintges," *Praxis* 1 (No. 1, 2000): 100–107; Soren Larson, "Portzamparc's Tower Adds Sparkle to NYC," *Architectural Record* 188 (January 2000): 35; James Russell, "Fashion Fortress," *Grid* 2 (January-February 2000): 61–65; "MAS Benefit Celebrates Dazzling New Tower," *Municipal Art Society Newsletter* (January-February 2000): 1; Ada Louise Huxtable, "French Elegance Hits Midtown Manhattan," *Wall Street Journal* (January 10, 2000): 24; Goldberger, "The Sky Line: Dior's New House": 88–91; Ruth Berktold, "LVMH Tower Building, New York," *Domus* (February 2000): 16–21; "New York State of Mind," *World Architecture* (February 2000): 48–55; Suzanne Stephens, "LVMH Tower, New York City," *Architectural Record* 188 (March 2000): 181; Raul A. Barreneche, "Ready-to-Wear," *Architecture* 89 (March 2000): 83–88, 90–91; Sara Hart, "LVMH: Making Things Perfectly Clear," *Architecture* 89 (March 2000): 89; "LVMH Tower, New York, USA," *Chien Chu: Dialogue: Architecture and Design and Culture* 34 (March 2000): 36–47; "Vitrages," *Techniques + Architecture* (April-May 2000): 131–33; Gabriele Szaniszlo, "LVMH Tower, Manhattan," *L'Arca* (148 (May 2000): 28–33; Paula Dietz, "Portzamparc Takes Manhattan," *Architectural Review* 207 (May 2000): 26–27; Manuel Oncina, "The Right Choice," letter to the editor, *New York Times* (November 19, 2000), II: 4; Balfour, *World Cities: New York*, 94–95; John Zukowsky and Martha Thorne, eds., *Skyscrapers: The New Millennium* (Munich: Prestel; Chicago: The Art Institute of Chicago, 2001), 34–35; Herbert Muschamp, "A Pair of Crystal Gems Right for Their Setting," *New York Times* (January 14, 2001), II: 38–40; Claude Solnik, "Famed Architects Exert Their Outside Influence," *Crain's New York Business* (January 15, 2001): 28; "LVMH Tower Offers a New Slant on New York City Zoning Rules," *Architectural Record* 189 (October 2001): 102; Herbert Muschamp, "A Lesson Abroad: Get Comfortable with Continuity," *New York Times* (February 24, 2002), II: 46; Monica Geran, "To Each His Own," *Interior Design* 73 (April 2002): 256–61; Catherine Curan, "Luxury Stores Find Growth Plans Passé," *Crain's New York Business* (September 16, 2002): 14; Joseph Giovannini, "Introduction," in Ian Luna, ed., *New New York: Architecture of a City* (New York: Rizzoli International Publications, 2003), 10, 224–229.

74. Christian de Portzamparc, quoted in "LVMH Tower, New York, USA," *Chien Chu: Dialogue: Architecture and Design and Culture*: 36, 40. For Charles E. Birge's 598 Madison Avenue, see Robert F. R. Ballard, *Directory of Manhattan Office Buildings* (New York: McGraw-Hill, 1978), 179–80.

75. Christian de Portzamparc, quoted in Muschamp, "An Elegant Blow Against Kitsch": 3.

76. Sorkin, "When to Fold": 56.

77. Muschamp, "The Spirit of Deco Rises from the Dead": 30.

78. See Stern, Gilmartin, and Mellins, *New York 1930*, 507–10.

79. Muschamp, "The Spirit of Deco Rises from the Dead": 32.

80. Christian de Portzamparc, quoted in "LVMH Tower, New York, USA," *Chien Chu: Dialogue: Architecture and Design and Culture*: 40.

81. Christian de Portzamparc, quoted in Iovine, "Designing the Nouveau Building on the Block": 5.

82. Lewis, "Paris on 57th Street: From Ludwig Bemelmans to Christian de Portzamparc": 9.

83. Huxtable, "French Elegance Hits Midtown Manhattan": 24.

84. Goldberger, "The Sky Line: Dior's New House": 90–91. For the Irving Trust Building, see Stern, Gilmartin, and Mellins, *New York 1930*, 564, 567–69.

85. Stephens, "LVMH Tower, New York City": 99–100.

COLUMBUS CIRCLE

1. Stern, Mellins, and Fishman, *New York 1960*, 667–71.

2. "Housing: A Mixed-Use High Rise Building," *Point* 1 (Spring 1983): 9.

3. Kenneth Lipper, quoted in James LeMoyne, "Coliseum Disposal Part of M.A.C. Surplus Accord," *New York Times* (March 31, 1984): 27.

4. Martin Gottlieb, "Tower Proposed with 130 Floors at 59th Street," *New York Times* (July 13, 1984), B: 3.

5. Gregory F. Gilmartin, *Shaping the City: New York and the Municipal Art Society* (New York: Clarkson Potter, 1995), 464.

6. "Helmut Jahn," *Chicago Architecture Journal* 5 (1985): 66–67; "Coliseum Complex Is Put Up for Sale," *New York Times* (February 5, 1985), B: 3; "Leading Developers Represented at Briefing on Sale of Coliseum," *New York Times* (March 9, 1985): 27; "New York's Coliseum Site," *Progressive Architecture* 66 (April 1985): 28; Steven Marcus, "World's Tallest Building May Rise on Coliseum Site," *New York Post* (May 2, 1985): 2; Steven Marcus, "Greatest Stories Ever Sold," *New York Post* (May 3, 1985): 18–19; William G. Blair, "14 Plans for Coliseum Site Sent to City and M.T.A.," *New York Times* (May 3, 1985), B: 3; Joan Siohan, "Are the Builders Reaching Too Far?" *New York Post* (May 13, 1985): 22; Michael Sorkin, "Tipping the Circle: Will the World's Tallest Building Replace the Coliseum?" *Village Voice* 30 (May 28, 1985): 104, reprinted in Michael Sorkin, *Exquisite Corpse: Writing on Buildings* (London and New York: Verso, 1991), 114–18; Audrey Farolino, "Coliseum Poll: No. 3 Trumps 'Em All," *New York Post* (May 29, 1985): 19; Paul Goldberger, "The Coliseum Site: Grand Potential Inspires Little but Visions of Height," *New York Times* (June 5, 1985), B: 1, 4; David W. Dunlap and Sara Rimer, "Not Tall Enough," *New York Times* (June 12, 1985), B: 3; "A Tall Price in Bid for the Coliseum Site," *New York Times* (June 24, 1985), B: 3; Susan Heller Anderson and David W. Dunlap, "Public Discontent," *New York Times* (June 27, 1985), B: 3; Daralice D. Boles, "World's Tallest Building to Rise?" *Progressive Architecture* 66 (July 1985): 71; Susan Heller Anderson and David W. Dunlap, "Coliseum-Site Race Nears Finish Line," *New York Times* (July 11, 1985), B: 3; Joyce Purnik, "Site of Coliseum to Be Purchased for $455 Million," *New York Times* (July 12, 1985): 1, B: 4; Ian Martin, "Coliseum Climbdown," *Architects' Journal* 182 (July 17, 1985): 34; Frances Halsband, "Columbus Circle Folly," *New York Times* (July 20, 1985): 23; Carter Wiseman, "Cashing in on the Coliseum," *New York* 18 (July 29, 1985): 40–44; "Grande Vente New-Yorkaise," *Architecture Intérieure Créé* 207 (August-September 1985): 16–17; Susan Doubilet, "The Price Is Right," *Progressive Architecture* 66 (August 1985): 23–24; Jane Perlez, "Mortimer Zuckerman: A Developer Who Thrives on High-Stakes Dealing," *New York Times* (August 5, 1985), B: 1, 3; "Editor's Note," *New York Times* (August 7, 1985), B: 1; "Corrections," *New York Times* (August 14, 1985): 25; Paul Goldberger, "Casting a Heavy Shadow on a Pivotal Site," *New York Times* (August 18, 1985), II: 25, 28; "Safdie Redevelopment Scheme Chosen for Coliseum Site," *Architecture* 74 (September 1985): 54; Peter Lemos, "Pinnacle Envy," *Metropolis* 5 (September 1985): 14; Richard D. Lyons, "Developers Zero in on Columbus Circle," *New York Times* (September 22, 1985), VIII: 1, 14; Walter McQuade, "Where's the Architecture?" *Connoisseur* 215 (November 1985): 80, 82; "Michael Graves: Project," *Architecture + Urbanism* (December 1985): 50; Nory Miller, *Helmut Jahn* (New York: Rizzoli International Publications, 1986), 249; "Competition," *Architecture + Urbanism* (January 1986): 11–18; Jonathan Greenberg, "Clash of the Titans," *Manhattan, inc.* 3 (January 1986): 77–86; "Topics: The New York Coliseum Site, Ten Columbus Circle, New York, New York," *Process Architecture* 64 (January 1986): 61–99; Shawn G. Kennedy, "Columbus Circle Area Getting New Life," *New York Times* (January 7, 1986), B: 8; Ann LeRoyer, "In the Studio/Columbus Circle Revisited," *GSD News* 14 (May/June 1986): 7; "The Columbus Circle Projects," *Architecture + Urbanism*, extra edition (June 1986): 250–51; "Notes on the Year," *Oculus* 47 (June 1986): 4; Paul Goldberger, "Plan for Coliseum Site: An Issue of Sheer Size," *New York Times* (July 15, 1986), B: 1–2; "So Big," *Architectural Record* 174 (September 1986): 56; Suzanne Stephens, "There Goes the Neighborhood," *Manhattan, inc.* 3 (September 1986): 200; Alan Finder, "Three Manhattan Boards Oppose Plans for Towers," *New York Times* (September 21, 1986): 49; Philip S. Gutis, "Community Boards Gaining in Power," *New York Times* (September 21, 1986), VIII: 1, 26; "Replacing the Coliseum," *New York Times* (October 29, 1986), B: 2; Alan Finder, "Balancing the Highest Offer Against the Greatest Good," *New York Times* (November 30, 1986), IV: 6; Peter Lemos, "Good-Bye Columbus Circle," *Metropolis* 6 (December 1986): 15; "Panel Approves Plan for Coliseum Site," *New York Times* (December 11, 1986), B: 4; Ante Glibota, *Helmut Jahn* (Paris: Paris Art Center, 1987), 556–59; Joyce Purnik, "Bleak Outlook for a Lost Block of 59th Street," *New York Times* (January 7, 1987), B: 1; "Paying for Subways with Sky," editorial, *New York Times* (January 21, 1987): 30; Alan Finder, "Huge Project on Columbus Circle Is Approved by Board of Estimate," *New York Times* (February 6, 1987), B: 3; Joyce Purnik, "The Great Board of Estimate Marathon: Sound and Fury but Little Suspense," *New York Times* (February 8, 1987): 38; Christopher Gray, "Streetscapes/The Coliseum," *New York Times* (April 26, 1987), VIII: 14; Nathalie Grenon, "New York: Columbus Center Versus Coliseum," *L'Arca* 6 (May 1987): 16–27; David W. Dunlap, "Suit Seeks to Block Coliseum Project," *New York Times* (June 7, 1987): 38; Jun Watanabe, "Project," *Architecture + Urbanism* (July 1987): 7–9; Michael deCourcy Hinds, "Habitat: A Lonely Leader in Housing," *New York Times* (July 26, 1987), VIII: 1, 20; "La Seconda Zampata di Moshe Safdie," *Architettura: Cronache e Storia* 33 (August-September 1987): 562–63; "Safdie Towers Hit by Law Suit," *Architects' Journal* 186 (August 12, 1987): 10; Kirk Johnson, "Visions of Gridlock Raised by Foes of 59th St. Project," *New York Times* (August 29, 1987): 31; John Taylor, "The Shadow," *New York* 20 (October 5, 1987): 40–48; Mark McCain, "All Is Far from Quiet on the Western Front," *New*

York Times (October 11, 1987), IV: 7; Robert J. Cole, "Salomon to Dismiss 12% of Staff and End Its Municipal Bond Role," *New York Times* (October 13, 1987): 1, D: 9; Steve Swartz, "Salomon Charge Is Estimated at $70 Million," *Wall Street Journal* (October 13, 1987), B: 3; Thomas J. Lueck, "Developer Says He Will Reduce 59th St. Project," *New York Times* (October 14, 1987), B: 3; Paul Goldberger, "Square Deal for Columbus Circle?" *New York Times* (October 18, 1987), II: 1, 41; Cynthia Crane, Dan Wallack, and Andrew B. Hurvitz, "Dark Shadows," letters to the editor, *New York* (October 19, 1987): 8; Jeanie Kasindorf, "Salomon Checking out of Coliseum?" *New York* 20 (October 19, 1987): 23; Thomas J. Lueck, "Hundreds Rally Against Towers at Coliseum Site," *New York Times* (October 19, 1987), B: 3; "Office-Towers Plan Is Supported by 7,000 Unionists," *New York Times* (October 23, 1987): 26; Brendan Gill, "The Sky Line: On the Brink," *New Yorker* 63 (November 9, 1987): 113–25; William Menking, "Dear Reader," *Building Design* 861 (November 13, 1987): 16; Jane Gross, "2 Big West Side Projects Fuel Anti-Development Sentiment," *New York Times* (November 29, 1987): 1, 58; "The Municipal Arts Society," *Progressive Architecture* 68 (December 1987): 24; Thomas J. Lueck, "Brokerage Said to Quit Coliseum Project," *New York Times* (December 4, 1987), B: 1, 3; Thomas J. Lueck, "Coliseum Developer to Revise Plans," *New York Times* (December 5, 1987): 31; Sam Roberts, "As Towers Rise, a Slow Fade-Out of Sun and Sky," *New York Times* (December 7, 1987), B: 1; Thomas J. Lueck, "Judge in New York Strikes Down Sale of Coliseum's Site," *New York Times* (December 8, 1987), 1: B: 2; Elizabeth Kolbert, "For New York, Coliseum Setback and a Costly Victory," *New York Times* (December 9, 1987), B: 1, 5; "Good Big Buildings Need Friends," editorial, *New York Times* (December 11, 1987): 38; Sam Howe Verhovek, "Columbus Circle Developer Wins Assistance from Koch," *New York Times* (December 14, 1987), B: 3; Alan Finder, "Koch Warns of Impact of Columbus Circle Defeat," *New York Times* (December 15, 1987), B: 3; "Thumbs Down for the Coliseum," *The Economist* 305 (December 19, 1987): 26–27; Paul Goldberger, "When the Tide Turned on Rampant Growth," *New York Times* (December 27, 1987), II: 34, 37; *James Stewart Polshek: Context and Responsibility* (New York: Rizzoli International Publications, 1988), 53–54, 142–43; Arnold Berke, "Skyscraper Squabble," *Preservation News* (March 1988): 1, 12; Paul Goldberger, "Fashions in Bricks and Mortar Make Room for Conscience," *New York Times* (December 25, 1988), II: 32; *Cesar Pelli: Buildings and Projects, 1965–1990* (New York: Rizzoli International Publications, 1990), 168–69; *Michael Graves: Buildings and Projects, 1982–1989* (Princeton, N.J.: Princeton University Press, 1990), 164–67; Theodore L. Brown and Maurizio DeVita, eds., *Michael Graves: Idee e Progetti, 1981–1991* (Milan: Electa, 1991), 71; Gilmartin, *Shaping the City*, 462–69; *Murphy/Jahn: Selected and Current Works* (Mulgrave, Australia: Images Publishing, 1995), 119, 236; Irena Zantovská Murray, ed., *Moshe Safdie: Buildings and Projects, 1967–1992* (Montreal: McGill-Queens University Press, 1996), 172–73.

7. Stern, Gilmartin, and Mellins, *New York 1930*, 535–37.

8. Cesar Pelli and Michael J. Crosbie, *Petronas Towers: Architecture of High Construction* (Chichester: Wiley-Academy; New York: Wiley, 2001).

9. Sorkin, "Tipping the Circle: Will the World's Tallest Building Replace the Coliseum?": 104.

10. Goldberger, "The Coliseum Site: Grand Potential Inspires Little but Visions of Height": 4.

11. Halsband, "Columbus Circle Folly": 23.

12. Goldberger, "Casting a Heavy Shadow on a Pivotal Site": 25.

13. McQuade, "Where's the Architecture?": 80.

14. Goldberger, "Plan for Coliseum Site: An Issue of Sheer Size": 2.

15. Stephens, "There Goes the Neighborhood": 200.

16. Joan Davidson, quoted in Gilmartin, *Shaping the City*, 464.

17. Gilmartin, *Shaping the City*, 465–66.

18. Philip Howard, quoted in Gilmartin, *Shaping the City*, 466.

19. Quoted in Dunlap, "Suit Seeks to Block Coliseum Project": 38.

20. Quoted in "Safdie Towers Hit by Law Suit": 10.

21. Quoted in Taylor, "The Shadow": 43.

22. Carter Wiseman, quoted in Taylor, "The Shadow": 43.

23. Gill, "The Sky Line: On the Brink": 118.

24. Moshe Safdie, quoted in Taylor, "The Shadow": 48.

25. Robert Caro, quoted in Gross, "2 Big West Side Projects Fuel Anti-Development Sentiment": 58.

26. William H. Whyte, quoted in Gross, "2 Big West Side Projects Fuel Anti-Development Sentiment": 1.

27. Edward H. Lehner, quoted in Lueck, "Judge in New York Strikes Down Sale of Coliseum's Site": 1.

28. Paul Goldberger, "New Architect to Redesign Coliseum Plan," *New York Times* (December 16, 1987), B: 1, 4; Joyce Purnick, "Why the Columbus Circle Plan Is Shaky," *New York Times* (December 17, 1987), B: 1, 8; Joyce Purnick, "Third Deadline Set for Plan at Coliseum Site," *New York Times* (December 23, 1987), B: 3; "Editor's Note," *New York Times* (December 24, 1987): 3; Joyce Purnick, "New York Reaches Pact on Coliseum," *New York Times* (January 2, 1988): 1, 26; Michael Marriot, "Coliseum Pact Criticized by Goldin as Bad Deal," *New York Times* (January 4, 1988), B: 3; Albert Scardino, "Developer vs. Himself over Coliseum Project," *New York Times* (January 4, 1988), D: 1, 8; "Safdie Quits as Coliseum Stalls," *Architects' Journal* 187 (January 6, 1988): 11; Jeffrey Blyth, "Architect Pulls out in New York Skyscraper Rethink," *Building Design* (January 8, 1988): 5; Peg Tyre and Jeannette Walls, "Coliseum Fracas: Childs's Play," *New York* 21 (January 11, 1988): 7; "Save the Coliseum!" editorial, *New York Observer* (January 25, 1988): 2; Sandy Heck, "SOM/NY Replaces Safdie for Coliseum Site Development," *Architecture* 77 (February 1988): 13, 17, 19, 21, 23; "Coliseum Switch: Safdie out, SOM in," *Progressive Architecture* 69 (February 1988): 23;

Abraham D. Beame, "Koch Reverts to Poor Finance," *New York Times* (Febraury 3, 1988): 31; Edward I. Koch, "Accounting on New York Coliseum Sale Passed Two Reviews," letter to the editor, *New York Times* (February 10, 1988): 30; Harrison J. Goldin, "The Problem with New York's Coliseum Deal," letter to the editor, *New York Times* (March 3, 1988): 30; Moshe Safdie, "Platform," *Interiors* 147 (May 1988): 23, 32, 34, 36; Moshe Safdie, "Skyscrapers Shouldn't Look Down on Humanity," *New York Times* (May 29, 1988), II: 30, 32.

29. Harrison J. Goldin, quoted in Marriott, "Coliseum Pace Criticized by Goldin as a Bad Deal": 3.

30. Paul Goldberger, "Trying to Calm a Storm with a New Skyscraper," *New York Times* (June 3, 1988), B: 4; Richard Levine, "A New Plan Is Presented for Coliseum," *New York Times* (June 3, 1988), B: 1, 4; "The Nay-Sayers Never Give Up," editorial, *New York Post* (June 7, 1988): 20; "Columbus Circle, in Balance," editorial, *New York Times* (June 9, 1988): 30; Paul Goldberger, "Why Columbus Circle Should Go Back to Square One," *New York Times* (June 19, 1988), II: 35; Sandy Heck, "New, Scaled-Down Scheme Unveiled for Coliseum Site," *Architecture* 77 (July 1988): 38–39; Daralice D. Boles, "The New (and Improved?) Columbus Center," *Progressive Architecture* 69 (July 1988): 25; "Second Time Around for Columbus Center," *Architectural Record* 176 (August 1988): 37; John Gregerson, "Boston Properties Unveils a Revised Columbus Center," *Building Design & Construction* 29 (September 1988): 24; Thomas Hoving, "The Critic Smiles," *Connoisseur* 218 (September 1988): 48, 52; Lou Chapman, "Zuckerman Revision for Coliseum Site About to Be Filed," *New York Observer* (September 26, 1988): 1, 8; "The Circle Again," editorial, *New York Observer* (October 3, 1988): 4; Todd S. Purdum, "Worries Persist on Towers Plan at Coliseum Site," *New York Times* (October 18, 1988), B: 4; Carter B. Horsely, "Boards Play Scrooge to Columbus Center," *New York Post* (December 22, 1988): 56; Lou Chapman, "Revised Plan, Too, Called 'a Wall at Columbus Circle,'" *New York Observer* (December 12, 1988): 8; Lou Chapman, "Votes Scheduled on Revised Plan for Columbus Circle," *New York Observer* (January 23, 1989): 9; David W. Dunlap, "Goldin Threatens to Sue Koch on Coliseum Plan," *New York Times* (February 2, 1989), B: 3; Joseph Wasserman, Terrance R. Williams, and Lenore M. Lucey, "Columbus Center Project," *Oculus* 51 (March 1989): 3; David W. Dunlap, "Coliseum Plan Moves Ahead with Agency," *New York Times* (March 23, 1989), B: 1–2; "Richard Sennett Interview with David Childs," *Architecture + Urbanism*, special issue (September 1993): 8–17, 42–51; Paul Goldberger, "David Childs," *Architecture + Urbanism*, special issue (September 1993): 18–20.

31. Goldberger, "Trying to Calm a Storm with a New Skyscraper": 4.

32. Hoving, "The Critic Smiles": 52.

33. Susan Chira, "3d and Smallest Coliseum Plan Greeted by Signs of Approval," *New York Times* (April 20, 1989): 1, B: 4; "Three Cheers for Columbus Circle Three," editorial, *New York Times* (April 25, 1989): 28; "Why the Rush?" editorial, *New York Observer* (May 1, 1989): 4; Lou Chapman, "How Both Sides Bit the Bullet to Cut Columbus Circle Deal," *New York Observer* (May 1, 1989): 1, 7; "Community Board Reaffirms Its Opposition to Tower Plan," *New York Times* (May 3, 1989), B: 3; Susan Chira, "Board of Estimate Approves Project for Columbus Circle," *New York Times* (May 5, 1989), B: 4; "Columbus Circle Plan Approved at 59 Stories," *New York Times* (May 6, 1989): 32; "Sale of Coliseum Site Is Approved by M.T.A.," *New York Times* (May 11, 1989), B: 10; Lou Chapman, "Holdouts Still Hope to Undo the Deal on Columbus Circle," *New York Observer* (May 15, 1989): 7; Carter Wiseman, "Beware the Design Police," *New York* 22 (May 22, 1989): 64–65; "The Metropolitan Transportation Authority," *New York Observer* (May 22, 1989): 6; James S. Russell, "Columbus Center: $57 Million Buys 500,000 Square Feet," *Architectural Record* 177 (June 1989): 81; Lynn Nesmith, "SOM's Latest Scheme for Coliseum Site Gains Approval," *Architecture* 78 (June 1989): 16, 18; Philip K. Howard, "On Columbus Circle," *Municipal Art Society Newsletter* (June 1989): 1–2; "Third Columbus Center Unveiled," *Progressive Architecture* 70 (June 1989): 25; Arnold H. Lubasch, "Koch Warns of Layoffs over Coliseum Suit," *New York Times* (September 22, 1989), B: 1, 3; "How Tall? No: How Long?" editorial, *New York Times* (September 25, 1989): 18; David W. Dunlap, "Koch Orders Hiring Freeze, Citing a $400 Million Gap," *New York Times* (September 28, 1989), B: 3; Richard Levine, "Vital New York Taxes Lag, and Economy Is Blamed," *New York Times* (October 11, 1989), B: 1, 5; Richard Levine, "Coliseum Sale Not Expected by Deadline," *New York Times* (October 24, 1989), B: 7; Richard Levine, "U.S. Judge Dismisses Lawsuit Against Plan for Coliseum Site," *New York Times* (February 8, 1990), B: 2; Todd S. Purdum, "Bigger Budget Gap Is Seen by Dinkins as Tax Money Lags," *New York Times* (March 20, 1990): 1, B: 2; Andrew L. Yarrow, "Subway Improvements Will Be Delayed," *New York Times* (August 21, 1990), B: 2; Richard D. Hylton, "Zuckerman Talks Reported with Sony on Coliseum Site," *New York Times* (September 22, 1990): 31; Charles V. Bagli, "Coliseum Project: Is Delay a Blessing for the Developer?" *New York Observer* (September 24, 1990): 1, 10; "Barrier to Sale of Coliseum Is Removed by Appeals Court," *New York Times* (November 28, 1990), B: 3; Sam Roberts, "Evicting the Homeless," *New York Times* (June 22, 1991): 1, 26; Nick Ravo, "Homeless Living Outside Coliseum Face Removal Tonight," *New York Times* (June 26, 1991), B: 4; Thomas Morgan, "Homeless Move from Coliseum Under Pressure," *New York Times* (June 27, 1991), B: 3; Constance L. Hays, "Raising Hurdle for Coliseum, Judge Orders Clean-Air Plan," *New York Times* (July 11, 1991), B: 1; David W. Dunlap, "Change, but Not at the Coliseum," *New York Times* (July 21, 1991), X: 11; "The Coliseum Project," *Oculus* 54 (September 1991): 6; Ronald Sullivan, "New York

Backs Columbus Circle Plan in Court," *New York Times* (December 15, 1991): 62; David W. Dunlap, "Coliseum, Pronounced Dead, Looks for Extra Cash," *New York Times* (January 5, 1992), X: 9; James Barron, "Court Lifts Barrier to Skyscraper Project," *New York Times* (June 23, 1992), B: 3; Ian Fisher, "The Coliseum's Nocturnal Homeless," *New York Times* (September 2, 1993): B: 1, 8.

34. Wiseman, "Beware the Design Police": 64.

35. David W. Dunlap, "Zuckerman Discussing Coliseum and Terms," *New York Times* (December 16, 1992), B: 4; Charles V. Bagli, "Zuckerman's Shrinking Tower: Columbus Center Delay Sought," *New York Observer* (February 15, 1993): 1, 12; Jeanne B. Pinder, "Potential Tenants Line Up for Coliseum," *New York Times* (May 1, 1993): 1, 26; Jeanne B. Pinder, "After 8 Years, Coliseum May Be More Than Issue," *New York Times* (July 25, 1993): 31; Jeanne B. Pinder, "New Quarrel Delaying Plans for Coliseum Development," *New York Times* (August 14, 1993): 23; Jeanne B. Pinder, "M.T.A. Agrees to Renew Talks on Plans for New York Coliseum," *New York Times* (August 21, 1993): 23; Shawn G. Kennedy, "Pressure for a Decision on Coliseum Site," *New York Times* (November 24, 1993), B: 3; Shawn G. Kennedy, "Zuckerman Offers Plan for Coliseum," *New York Times* (December 1, 1993), B: 3; Shawn G. Kennedy, "Zuckerman Is Given Deadline of 90 Days to Deal for Coliseum," *New York Times* (December 7, 1994): 1, B: 3; Shawn G. Kennedy, "Zuckerman Sees Politics in a Deadline," *New York Times* (December 9, 1993), B: 3; "Time to Move on the Coliseum," editorial, *New York Times* (December 21, 1993): 26; Steven Lee Myers, "Deadline for New Coliseum Deal Postponed," *New York Times* (March 13, 1994): 30; Herbert Muschamp, "Columbus Circle's Changing Face: More Than Geometry," *New York Times* (March 27, 1994): 29, 33; James C. McKinley Jr., "Offer of Aid on Coliseum Is Withdrawn," *New York Times* (April 14, 1994), B: 1, 4; "No Giveaway on the Coliseum," editorial, *New York Times* (April 15, 1994): 30; Shawn G. Kennedy, "3 Players, 3 Agendas, One 3-Way Tug of War," *New York Times* (April 15, 1994), B: 3; Alison Mitchell, "Giuliani Seeks Delay on Coliseum," *New York Times* (April 16, 1994): 25; Shawn G. Kennedy, "M.T.A. Offers Later Closing for Coliseum but Dismisses Call for Appraisal," *New York Times* (April 17, 1994): 31; Shawn G. Kennedy, "Zuckerman Postpones Closing Deal for Coliseum," *New York Times* (April 19, 1994), B: 1; Shawn G. Kennedy, "Zuckerman to Sue Transit Agency and the City," *New York Times* (April 20, 1994), B: 4; "Moving Ahead on the Coliseum," editorial, *New York Times* (April 21, 1994): 18; Shawn G. Kennedy, "City Wants Appraisal Made of Coliseum Site," *New York Times* (April 22, 1994), B: 4; Shawn G. Kennedy, "New Building on Coliseum Is Weighed," *New York Times* (April 24, 1994): 41; Mortimer B. Zuckerman, "New York City Isn't Playing Favorites on the Coliseum Project," letter to the editor, *New York Times* (April 27, 1994): 16; Shawn G. Kennedy, "Coliseum Site Appraised at Less Than Developer's Offered Figure," *New York Times* (May 21, 1994): 28; Shawn G. Kennedy, "Coliseum: Its Worth Depends on Whom You Ask," *New York Times* (May 22, 1994): 31; "M.T.A. Says Studies Back Coliseum Price," *New York Times* (May 28, 1994): 22; "City Asks $100 Million for Coliseum Parcel," *New York Times* (June 1, 1994), B: 3; Shawn G. Kennedy, "Developer and M.T.A. Reach Agreement on Coliseum Site," *New York Times* (June 2, 1994): 1, B: 7; Shawn G. Kennedy, "Coliseum: Something for Everyone (Maybe)," *New York Times* (June 3, 1994), B: 1–2; Shawn G. Kennedy, "Zuckerman Assail Limits on Coliseum Construction," *New York Times* (June 4, 1994): 23; John Dyson, "Tell Them New York's Back in Business," letter to the editor, *New York Times* (June 5, 1994), IV: 16; Jeanie Russell Kasindorf, "Zuckerman Unbound," *New York* 27 (June 6, 1994): 34–38; Shawn G. Kennedy, "At Deadline, Deal to Develop Site of New York Coliseum Collapses," *New York Times* (July 16, 1994): 1, 27; Shawn G. Kennedy, "Amid Uncertainty, Exploring Options for the Coliseum," *New York Times* (July 17, 1994): 23–24; "Goodbye to a Bad Deal," editorial, *New York Times* (July 19, 1994): 18; Alan Finder with Shawn G. Kennedy, "Lessons in the Rubble of the Coliseum Deal," *New York Times* (July 23, 1994): 1, 22.

36. Muschamp, "Columbus Circle's Changing Face: More Than Geometry": 33.

37. "Goodbye to a Bad Deal": 18

38. "Post Mort on Columbus Circle," *New Yorker* 70 (May 16, 1994): 40–41; Thomas J. Lueck, "Eight Tell What They'd Do If They Had Coliseum Site," *New York Times* (July 24, 1994): 35; Richard T. Anderson, "Coliseum Site Deserves a World-Class Facility," letter to the editor, *New York Times* (August 22, 1994): 12; Shawn G. Kennedy, "M.T.A. Committee Presses City for Coliseum Development Plan," *New York Times* (October 20, 1994), B: 9; Thomas J. Lueck, "M.T.A. in Compromise, Seeking Short-Term Tenants for Coliseum," *New York Times* (January 15, 1995): 42; Shawn G. Kennedy, "What to Do with the Coliseum? Giuliani and M.T.A. in Deadlock," *New York Times* (April 1, 1995): 1, B: 3; Shawn G. Kennedy, "New Proposal for Coliseum: Use It to Hold Conventions," *New York Times* (April 20, 1995): 3; James Barron, "Coliseum Reopens After Decade in Limbo," *New York Times* (September 14, 1995), B: 1, 10.

39. Peter Slatin, "MTA Tries Another Run at Selling the Coliseum," *Crain's New York Business* (October 30-November 5, 1995): 1, 45; Shawn G. Kennedy, "New Buyer Being Sought for Coliseum," *New York Times* (November 22, 1995), B: 1, 8; Thomas J. Lueck, "After 12 Years of Delay, New Snag Clouds Coliseum's Future," *New York Times* (April 1, 1996), B: 1, 4; Richard Pérez-Peña, "Terms Are Set for Sale of Coliseum," *New York Times* (May 30, 1996), B: 3; John Harrington, "MTA to Sell Coliseum," *Crain's New York Business* (June 3, 1996): 42; H. Claude Shostal, "Money Mustn't Dictate New York Coliseum Sale," letter to the editor, *New York Times* (June 4, 1996): 14; Thomas J. Lueck, "New Plan for Coliseum Site Is Praised by Some Past Foes," *New York Times* (June 18, 1996),

B: 2; "Coliseum 'Shrinks' to Gasps," *New York Times* (June 23, 1996), XIII: 7; Thomas J. Lueck, "Officials Offer Expanded Plans to Rebuild Columbus Circle," *New York Times* (July 24, 1996), B: 1; April DiComo, "RFP's for New York Coliseum Due Nov. 1," *New York Construction News* 46 (August 5, 1996): 1, 5; Paul Tharp, "Sotheby's Eyes a Coliseum Bid," *New York Post* (August 6, 1996): 32; Amy Feldman, "Coliseum Ready for Prime Time," *Crain's New York Business* (August 19, 1996): 4; Peter Grant, "Building Bigs Join List of Coliseum Hopefuls," *New York Daily News* (September 24, 1996): 53; Devin Leonard, "Columbus Circle Jerk? Trump Stakes a Claim on Prime City Acres," *New York Observer* (October 28, 1996): 1, 13; Peter Slatin, "Coliseum Bid-ness," *New York Post* (November 2, 1996): 18; Thomas J. Lueck, "9 New Plans Are Submitted for Coliseum," *New York Times* (November 2, 1996): 25–26; "Columbus Circle Draws 9 Bids," *Crain's New York Business* (November 4, 1996): 55; Thomas J. Lueck, "Trying to Construct a Mirror of Manhattan," *New York Times* (November 13, 1996), B: 1, 6; Maurice S. Paprin, "Columbus Circle Project Needs a Clear-Cut Plan," letter to the editor, *New York Times* (November 20, 1996): 24; Karrie Jacobs, "Fun City," *New York* 29 (December 2, 1996): 36, 38, 40, 42, 44; Devin Leonard, "The Gang Who Killed Old Coliseum Plan Starts to Rumble," *New York Observer* (December 2, 1996): 1, 28; Devin Leonard, "Steve Wynn Razzes Hated Rival Donald Trump with Coliseum Bid," *New York Observer* (December 16, 1996): 1, 43; "Last Chance for a Grand Public Space," *Municipal Art Society Annual Report* (1996–1997): 2; "Full Circle: Columbus Circle," *Municipal Art Society Annual Report* (1996–1997): 8–9; "MAS Gears up for Columbus Circle Campaign," *Municipal Art Society Newsletter* (January/February 1997): 1–2; Jayne Merkel, "Another Round for Columbus Circle," *Oculus* 59 (January 1997): 4–5; Devin Leonard, "Giuliani, Vallone Offer Big Tax Gift to Trump, Kalikow," *New York Observer* (January 6, 1997): 1, 19; Peter Slatin, "Coliseum Bids Put as High as $300 Million," *New York Post* (January 6, 1997): 26, 28; Douglas Feiden, "Plan 9 for Coliseum," *New York Daily News* (January 7, 1997): 41; Thomas J. Lueck, "9 Plans for Coliseum Are Displayed," *New York Times* (January 7, 1997): B: 3; David W. Dunlap, "At Coliseum, Real Estate Lions Become Gladiators," *New York Times* (January 12, 1997), IX: 7; Alec Ian Gershberg, "Coliseum Tax Breaks: Highest Prices, Political Gain," letter to the editor, *New York Observer* (January 13, 1997): 4; Ada Louise Huxtable, "Architecture: Feeding the Coliseum to the Lions," *Wall Street Journal* (January 14, 1997): 18; Herbert Muschamp, "Worthy of a World Capital," *New York Times* (January 19, 1997), II: 41; Ian Alterman, "For a Prewar Site, a Design in Context," letter to the editor, *New York Times* (February 9, 1997), II: 6; Larry Doyle and Joe Davis, "Trumpus Maximus," *New York Observer* (January 20, 1997): 21; April DiComo, "Nine NY Coliseum Proposals to be Short-Listed by June," *New York Construction News* (January 20, 1997): 3, 9; Peter Slatin, "Politics Plays a Part in Resurrected Plans for New York's Coliseum," *World Architecture* (February 1997): 22; Susan Addelston, "Lions Become Gladiators," letter to the editor, *New York Times* (February 2, 1997), IX: 9; Devin Leonard, "Coliseum Wannabes Cough Up Donations for Giuliani, D'Amato," *New York Observer* (February 24, 1997): 1, 23; "Off the Cuff," *Oculus* 59 (March 1997): 6–7; "Columbus Circle," *Municipal Art Society Newsletter* (March/April 1997): 2, 4; Clifford J. Levy, "Squaring Off over the Future of Coliseum," *New York Times* (March 17, 1997), B: 1; Clifford J. Levy, "Leery Planners Slow Coliseum Competition," *New York Times* (April 26, 1997): 29; Jayne Merkel, "Dissecting Columbus Circle," *Oculus* 59 (May 1997): 14–16; Peter Morris Dixon, ed., *Robert A. M. Stern Architects: Buildings and Projects, 1993–1998* (New York: Monacelli Press, 1998), 334–37; Alan Balfour, *World Cities: New York* (New York: Wiley Academy, 2001), 60–63, 224–28, 274–77.

40. Merkel, "Another Round for Columbus Circle": 4.

41. Merkel, "Another Round for Columbus Circle": 4.

42. Robert A. M. Stern, quoted in Merkel, "Another Round for Columbus Circle": 4.

43. Merkel, "Another Round for Columbus Circle": 4.

44. Quoted in Jacobs, "Fun City": 40.

45. Quoted in Merkel, "Another Round for Columbus Circle": 5.

46. Merkel, "Another Round for Columbus Circle": 6.

47. Huxtable, "Architecture: Feeding the Coliseum to the Lions": 18.

48. Muschamp, "Worthy of a World Capital": 41.

49. Diana Agrest, quoted in "Off the Cuff": 6.

50. Frederic Schwartz, quoted in "Off the Cuff": 6.

51. Clifford J. Levy, "5 Developers Are Said to Be Finalists for Coliseum Project," *New York Times* (April 30, 1997), B: 7; Richard Wilner, "Thumps-Up for Coliseum Proposals," *New York Post* (May 2, 1997): 32; "And Then There Were Five: Finalists' Plans for Coliseum Site," *New York Times* (May 2, 1997): B: 5; Clifford J. Levy, "Giuliani Withdraws Tax Break for Developer of Coliseum Site," *New York Times* (May 8, 1997), B: 2; Devin Leonard, "The Little Old Ladies Prepare to Kill Again over Columbus Circle," *New York Observer* (June 23, 1997): 1, 10; Clifford J. Levy, "Developer's Tower Plan Emerges as Leader for Coliseum Site," *New York Times* (July 25, 1997), B: 1, 4; Clifford J. Levy, "Coliseum Deal Is Governed by Financing," *New York Times* (July 26, 1997): 23, 27; Clifford J. Levy, "Mayor Vows to Veto Coliseum Sale, Citing Long-Term Issues," *New York Times* (July 27, 1997): 23, 28; David M. Halbfinger, "Mayor's Coliseum Plan Threatens Lincoln Center Expansion," *New York Times* (July 28, 1997), B: 1–2; David Firestone, "Lincoln Center Is 'Interested' in a Theater at Coliseum Site," *New York Times* (July 29, 1997), B: 3; Clifford J. Levy, "Building on a Shaky Foundation," *New York Times* (July 31, 1997), B: 3; Peter Blake and Giorgio Cavaglieri, "Coliseum Plans Reveal Architecture's Weakness," letters to

the editor, *New York Times* (August 2, 1997): 18; David M. Halbfinger, "Exhibit Hall Added to Plan for Coliseum," *New York Times* (August 11, 1997), B: 3; Devin Leonard, "M.T.A. Tried Evicting Its Coliseum Tenants, but They Won't Go!" *New York Observer* (September 8, 1997): 1, 25; Peter Grant, "Sound Studio in Plans," *New York Daily News* (September 10, 1997): 47; James S. Russell, "Where Does Architecture Fit in the Big Apple?" *Urban Land* 56 (October 1997): 76–78, 120; Charles V. Bagli, "Giuliani Administration Negotiating for a Jazz Concert Hall on Site of the Coliseum," *New York Times* (January 28, 1998), B: 6; Peter Watrous, "City Proposes a Gift for Jazz: A Swinging Hall of Its Own," *New York Times* (February 4, 1998), E: 1, 4; Devin Leonard, "As the Coliseum Churns: Will the Boom Outlast the M.T.A's Dithering!" *New York Observer* (February 13, 1998): 1, 30; Charles V. Bagli, "Time Warner Joins Bidding for Coliseum Development," *New York Times* (April 30, 1998), B: 9; Peter Slatin, "Now You Coliseum . . . Now You Don't," *New York Post* (June 27, 1998): 16; Devin Leonard, "Trump, Speyer Go High; Each Offers $365 Million for 3.4 Acres of Heaven," *New York Observer* (June 29–July 6, 1998): 1, 25; Charles V. Bagli, "Officials Are Drawing Closer in Effort to Sell Coliseum," *New York Times* (June 30, 1998), B: 7; Charles V. Bagli, "Hints of Trouble from Trump, If His High Bid for Coliseum Site Does Not Win," *New York Times* (July 15, 1998), B: 6; Peter Grant, "Trump Makes Bold Move in Coliseum Competition," *New York Daily News* (July 15, 1998): 30.

52. Charles V. Bagli, "A Deal Is Struck for Coliseum Site," *New York Times* (July 28, 1998): 1; B, 6; "New Hope for Columbus Circle," editorial, *New York Times* (July 29, 1998): 18; Charles V. Bagli, "Sale of Coliseum Site Receives Approval," *New York Times* (July 30, 1998), B: 3; Herbert Muschamp, "Architect's Landfall at Columbus Circle," *New York Times* (July 31, 1998), B: 1, 7; Elizabeth Kolbert, "Trump's Loss Is a Victory for Taste," *New York Times* (August 3, 1998), B: 1; Paul Goldberger, "Malling Manhattan," *New Yorker* 74 (August 10, 1998): 4–5; Steven R. Weisman, "The Circle Comes Around at Columbus Circle," editorial, *New York Times* (August 17, 1998): 14; "Coliseum Breakthrough," *Municipal Art Society Newsletter* (September/October, 1998): 1, 3; David W. Dunlap, "At Columbus Circle, a Circuitous Path to Columbus Centre," *New York Times* (September 6, 1998), XI: 1, 6; Max M. Tamir, "Saturation Point at Columbus Circle," letter to the editor, *New York Times* (September 27, 1998), VIII: 11; Peter Blake, "Goodbye Columbus," *Architecture* 87 (November 1998): 95; Michael Sorkin, "Round and Round," *Metropolis* 18 (November 1998): 45; Herbert Muschamp, "Public Space, Private Space and Anti-Space," *New York Times* (December 27, 1998), II: 38; Abby Bussel, *SOM Evolutions: Recent Work of Skidmore, Owings & Merrill* (Basel: Birkhäuser, 2000), 13, 160–65; *Skidmore, Owings & Merrill LLP: Architecture and Urbanism, 1995–2000* (Mulgrave, Australia: Images Publishing, 2000), 220–21; Elizabeth Harrison Kubany, "SOM Takes Manhattan," *Architectural Record* (March 2000): 68–72, 74, 204; Peggy Edersheim Kalb, "The Next Best Things," *New York* 33 (April 10, 2000): 59–63, 102; Steve Cuozzo, "Builders Eerily Related," *New York Post* (May 16, 2000): 47; "Mayor Guiliani Unveils Design for Columbus Centre," press release (June 28, 2000); David W. Dunlap, "Columbus Center: Introducing a New Version in Angled Glass," *New York Times* (June 28, 2000), B: 1, 6; Herbert Muschamp, "The Spirit of Jazz Infuses the Plans for a Vertical City," *New York Times* (June 28, 2000), B: 1, 6; "Corrections," *New York Times* (July 5, 2000): 2; Herbert Muschamp, "The Context Isn't Limited to the Visible," *New York Times* (July 9, 2000), II: 28; "Fourth Time's the Charm for Columbus Circle Project," *Engineering News-Record* 245 (July 10, 2000): 11; Joseph Giovannini, "Most of That Jazz," *New York* 33 (July 17, 2000): 86–87; John E. Czarnecki, "One More Try: SOM's Columbus Center Scheme Less Boxy, Less Deco, More Transparent,"*Architectural Record* 188 (August 2000): 27; Martin Filler, "Goodbye, Columbus," *New Republic* 223 (August 28 and September 4, 2000): 30–33; Nancy Ramsey, "The Coliseum Is Dead, Long Live . . . ," *Grid* 2 (November/December 2000): 88; "Hudson Hawk," *Oculus* 63 (January 2001): 90; David W. Dunlap, "A New Colossus Begins to Rise," *New York Times* (May 20, 2001), XI: 1, 8; "The Next Rockefeller Center," *Crain's New York Business* (October 15, 2001): 40; Shira J. Boss, "Center's Glitz Draws Big-Name Tenants," *Crain's New York Business* (October 15, 2001): 41–42; Matthew Flamm, "Neighbors Brace for Rush When Complex Opens," *Crain's New York Business* (October 15, 2001): 42; Andrew Marks, "3.4 Acres, 28,000 Tons of Steel, and Ulcers," *Crain's New York Business* (October 15, 2001): 43; Kelly Crow, "The Newest Tower: Working 24/7," *New York Times* (December 9, 2001): 14; Steve Cutler, "Future Top Condos," *New York Living* (December 2001/January 2002): 16; Georges Binder, ed., *Sky High Living: Contemporary High-Rise Apartment and Mixed-Use Buildings* (Mulgrave, Australia: Images Publishing, 2002), 222; David W. Dunlap, "Columbus Circle's Towers Start to Tower," *New York Times* (March 3, 2002), XI: 1, 8; Barbara Wagner, "AOL Time Warner: On Center?" *Grid* 4 (June 2002): 38–40; Barbara Wagner, "Nuts and Bolts," *Grid* 4 (June 2002): 40; Catherine Curan, "AOL Time Warner Center Shaping Up as Retail Central," *Crain's New York Business* (June 17, 2002): 14; Simon Dumenco, "AOL's Faulty Towers," *New York* 35 (August 12, 2002): 11; Steve Cuozzo, "AOL TW Center Filling Up," *New York Post* (January 14, 2003): 36; David W. Dunlap, "A Vertical Neighborhood Takes Shape," *New York Times* (January 19, 2003), XI: 1, 6; Tom McGeveran, "Glass Menagerie," *New York Observer* (February 3, 2003): 1, 8; Michael Brick, "Fire Is Latest Setback at AOL Time Warner Tower in Columbus Circle," *New York Times* (April 9, 2003), D: 1, 6; "Creating a Landmark," *New York Construction News* 50 (May 2003): 7, 9, 11, 13, 15; "Strong Support," *New York Construction News* 50 (May

2003): 35, 37, 39; Charles Linn and Alan Joch, "The Making of AOL Time Warner Center," *Architectural Record* 191 (June 2003): 86–92, 94; William Grimes, "Yes, It's a Mall, but a Far Cry from the Food Court," *New York Times* (November 16, 2003): 1, 38; Paul Goldberger, "The Sky Line/The Incredible Hulk," *New Yorker* 79 (November 17, 2003): 168, 170–71; Steve Cuozzo, "Time Warner Center Hopes for Magic Mix," *New York Post* (November 18, 2003): 34; Terry Trucco, "Zen on Central Park," *New York Times* (December 7, 2003), V: 3; Anita Jain, "Tech Treatment Pushes Buttons," *Crain's New York Business* (December 22–28, 2003): 1, 18; James Gardner, "Soaring Triumphs & Sore Winners," *New York Sun* (December 29, 2003): 16; Ada Louise Huxtable, "The Best Way to Preserve 2 Columbus Circle? A Makeover," *Wall Street Journal* (January 7, 2004), D: 10;William Sherman, "The $42M Condo," *New York Daily News* (January 18, 2004): cover, 4; Lore Croghan, "Transforming Columbus Circle," *New York Daily News* (February 2, 2004): 51; Braden Keil, "The Gym Dandie$t," *New York Post* (February 2, 2004): 23; "A Winner at Columbus Circle," editorial, *New York Post* (February 4, 2003): 32; Adam Miller, "Time Warner Bldg. Opens Amid Chaos," *New York Post* (February 4, 2004): 24; James Gardner, "The West Side, Finally Fulfilled," *New York Sun* (February 4, 2004): 17; Glenn Collins, "Upscale Shopping (Emphasis on Up)," *New York Times* (February 4, 2004), B: 1, 6; Herbert Muschamp, "Glamorous Glass Gives 10 Columbus Circle a Look of Crystallized Noir," *New York Times* (February 4, 2004), B: 6; Phyllis Furman, Lisa L. Colangelo, and Leo Standora, "Power Towers," *New York Daily News* (February 5, 2004): 16; Jennifer Fermino and Ed Robinson, "Towering Triumph," *New York Post* (February 5, 2004): 13; "Star-Studded Opening Under the Stars," *New York Sun* (February 5, 2004): 1; "Room for 5,000, with View," *New York Times* (February 5, 2004): 1; Stephen Treffinger, "A View Worthy of a Treehouse and a Lauren over the Bar," *New York Times* (February 5, 2004), F: 3; William L. Hamilton, "The Palace Maker," *New York Times* (February 5, 2004), F: 1, 8; Alex Kuczynski, "At Towers' Opulent Debut, Even Guards Are Dolled Up," *New York Times* (February 5, 2004), B: 3; Soni Sangha, "So Pretty & So Pricey," *New York Daily News* (February 6, 2004): 12; Farrah Weinstein, "Shoppers in Mall Heaven," *New York Post* (February 6, 2004): 20–21; Corey Kilgannon, "Like 'Stamford in Midtown': Shoppers Pack the New Mall," *New York Times* (February 9, 2004), B: 1, 5; William Grimes, "A Pleasure Palace Without the Guilt," *New York Times* (February 18, 2004), F: 1, 5; Andrea Elliot and Florence Fabricant, "Chef's Lofty Dream Is Set Back by Fire at Columbus Circle," *New York Times* (February 23, 2004). 1, B: 4; Joseph Giovannini, "Twin Piques," *New York* 37 (March 1, 2004): 53–54; Adam Gopnik, "Just Looking: A New Mall," *New Yorker* 80 (March 1, 2004): 35–36; Tommy Fernandez, "America Discovers Columbus," *Crain's New York Business* (March 15, 2004): 12; Monica Blum, "Circle Boosts the Square," letter to the editor, *Crain's New York Business* (March 22, 2004): 10; Deborah Grossberg, "Glass Goliath," *Architect's Newspaper* (March 23, 2004): 5.

53. Muschamp, "Architect's Landfall at Columbus Circle": 7.

54. Muschamp, "Public Space, Private Space and Anti-Space": 38.

55. David W. Dunlap, "The M.T.A. Removes 4 Huge Plaques from the Coliseum," *New York Times* (September 24, 1999), B: 5.

56. Shannon D. Harrington, "A Final Sale That Means Goodbye to the Vendors," *New York Times* (October 24, 1999), XIV: 8; Alan S. Oser, "M.T.A. Starts Big Move Downtown," *New York Times* (November 3, 1999), B: 6.

57. David W. Dunlap, "Built, but Not Destined, to Last," *New York Times* (February 20, 2000): 39, 42; Elizabeth Kolbert, "Did Moses Suppose That His Coliseum Would Last?" *New Yorker* 76 (April 3, 2000): 30; Bruce Lambert, "Two Injured in Demolition-Site Mishap," *New York Times* (June 3, 2000), B: 3.

58. Joyce Purnick, "As the Coliseum Comes Down, a Long-Missing City Vista Starts to Open Up," *New York Times* (June 12, 2000), B: 1.

59. "Coliseum Continuum," *Grid* 1 (Winter 1999): 22–23.

60. Joseph Rose, quoted in Dunlap, "Columbus Center: Introducing a New Version, in Angled Glass": 6.

61. David Childs, quoted in Dunlap, "Columbus Center: Introducing a New Version, in Angled Glass": 6.

62. Muschamp, "The Spirit of Jazz Infuses the Plans for a Vertical City": 1, 6.

63. Filler, "Goodbye, Columbus": 33–34.

64. Robert D. Feller, quoted in Dunlap, "A New Colossus Begins to Rise": 8.

65. James Carpenter, quoted in Dunlap, "Columbus Circle's Towers Start to Tower": 8.

66. Goldberger, "The Sky Line/The Incredible Hulk": 170.

67. David Hershkovits and Alex von Bidder, quoted in Kuczynski, "At Towers' Opulent Debut, Even Guards Are Dolled Up": 3.

68. Kenneth A. Himmel, quoted in Kilgannnon, "Like 'Stamford in Midtown': Shoppers Pack the New Mall": 5.

69. Goldberger, "The Sky Line/The Incredible Hulk": 170.

70. Giovannini, "Twin Piques": 54.

71. Jon Pareles, "Jazz Suite with a Park View," *New York Times* (May 23, 2000), E: 1, 3; Gene Santoro and Frank Lombardi, "Bold New Jazz Center Will Be Scat's Meow," *New York Daily News* (May 24, 2000): 8; Dunlap, "Columbus Center: Introducing a New Version, in Angled Glass": 1, 6; Frank Lombardi, "Rudy Raises Curtain on Arts Complex Plan," *New York Daily News* (June 29, 2000): 46; "World's First Performing Arts Facility Built for Jazz," *Architectural Record* 188 (July 2000): 44; "All That Jazz," *Interior Design* 71 (August 2000): 54; Peter Hall, "Jazz at Lincoln Center Trio," *Metropolis* 20 (November 2000): 106–11, 142–43; Miriam Kreinin Souccar, "Playing It by Ear," *Crain's New York Business* (January 8–14, 2001): 3, 19; Mark Jacobson, "Jazz at Wynton Center," *New York* 34 (December 24–31, 2001): 54–58, 60, 62, 64, 66, 68; The

Architecture of Rafael Viñoly (New York: Princeton Architectural Press, 2002), no pagination; Robin Pogrebin, "Corporate Donation Buoys Home for Jazz," *New York Times* (January 14, 2003), E: 1, 8; "The New Jazz Age," *New York Post* (January 28, 2003): 30; "Smooth Jazz," *New York Construction News* 50 (May 2003): 53, 55, 57, 59.

72. Huxtable, "The Best Way to Preserve 2 Columbus Circle? A Makeover": 10.

73. Muschamp, "Glamorous Glass Gives 10 Columbus Circle a Look of Crystallized Noir": 6.

74. Goldberger, "The Sky Line/The Incredible Hulk": 168.

75. Giovannini, "Twin Piques": 53.

76. Stern, Mellins, and Fishman, *New York 1960*, 669–70.

77. Aaron A. Betsky, "Columbus Circle-ular," *Metropolis* 1 (October 1981): 12. Also see Heinrich Klotz, ed., *New York Architecture: 1970–1990* (Munich: Prestel, 1989), 108, 260; Herbert Muschamp, "Into the Void at Columbus Circle," *New York Times* (August 30, 1998), II: 20; *Scanning: The Aberrant Architectures of Diller + Scofidio* (New York: Whitney Museum of American Art, 2003), 49; Arthur Lubow, "Architects, in Theory," *New York Times* (February 16, 2003), VI: 38.

78. Muschamp, "Into the Void at Columbus Circle": 20.

79. Betsky, "Columbus Circle-ular": 12.

80. "Inviting Ideas for Columbus Circle," *Municipal Art Society Newsletter* (November/December 1997): 1–2; "A Grand Public Space at Columbus Circle," *Municipal Art Society Annual Report* (1997–1998): 3; Paul Henninger, "NY Merry-Go-Round: Columbus Circle," *ANY* 22 (1998): 14–15; Charles V. Bagli, "Architects' Designs Envision Columbus Circle as a Great City Crossroads," *New York Times* (February 15, 1998): 37; "Columbus Circle Visions," *Municipal Art Society Newsletter* (March/April 1998): 2; Jayne Merkel, "Full Circle: Invited Designs for Columbus Circle," *Oculus* 60 (May 1998): 2, 6–7; David E. Brown, "Rediscovering Columbus Circle," *Metropolis* 17 (June 1998): 34, 41; Dan Kiley and Jane Amidon, *Dan Kiley: The Complete Works of America's Master Landscape Architect* (Boston: Little, Brown & Co., 1999), 186–89; Marion Weiss and Michael A. Manfredi, *Site Specific: The Work of Weiss/Manfredi Architects* (New York: Princeton Architectural Press, 2000), 45–46, 56–61; Mark Robbins, "Working in the Present," in Weiss and Manfredi, *Site Specific: The Work of Weiss/Manfredi Architects*, 14.

81. Joseph C. Ingraham, "Columbus Circle Traffic Flow Is Speeded by New Changes," *New York Times* (March 13, 1956): 37.

82. Henry Hope Reed, "Another Chance for Columbus Circle," *City Journal* 9 (Spring 1999). 98.

83. "Discover the New Columbus Circle," advertisement, *New York Times* (July 26, 1998): 32; Andy Newman, "Traffic on Columbus Circle Finally Comes, Well, Full Circle," *New York Times* (August 11, 1998), B: 1, 6; Ada Louise Huxtable, "Columbus Circle: A Project Without a Plan," *Wall Street Journal* (January 14, 1999): 18; David Kirby, "Will This Island Be Rediscovered?" *New York Times* (May 2, 1999), XIV: 6; "Change Afoot at Columbus Circle," *Municipal Art Society Newsletter* (May/June 1999): 1–2; "An Oasis of Calm in a Traffic Carousel," *New York Times* (April 7, 2000), B: 3.

84. Ellen Ryan, "Columbus Circle: A Legacy in Waiting," *Municipal Art Society Newsletter* (March/April 2000): 2; Denny Lee, "The Traffic Goes in Circles, but the Plan Marches On," *New York Times* (October 13, 2002), XIV: 8; James Gardner, "Look East! Look East!" *New York Sun* (February 3, 2003): 1, 13; Steve Cuozzo, "Work Zone Is Colum-bust for View from TW Center," *New York Post* (February 24, 2004): 34; David W. Dunlap, "An Island of Sanctuary in the Traffic Stream," *New York Times* (August 4, 2005), B: 1, 7.

85. Richard D. Lyons, "Developers Zero In on Columbus Circle," *New York Times* (September 22, 1985), VIII: 1, 14; Shawn G. Kennedy, "Columbus Circle Area Getting New Life," *New York Times* (January 7, 1986), B: 8; White and Willensky, *AIA Guide* (1988), 276; Andree Brooks, "Central Park Vista from New Tower," *New York Times* (January 1, 1988): 42; David W. Dunlap, "Zeckendorf Is Ready for Another Burst of Building," *New York Times* (May 13, 1990), X: 21; White and Willensky, *AIA Guide* (2000), 271.

86. White and Willensky, *AIA Guide* (2000), 271.

87. Shawn G. Kennedy, "Architectural Double Role in Manhattan," *New York Times* (March 23, 1988), D: 24; Richard D. Lyons, "At Columbus Circle, Smaller Is Better," *New York Times* (November 29, 1989), D: 22; Dunlap, "Zeckendorf Is Ready for Another Burst of Building": 21.

88. "Many Moving Days Ahead at 4 Columbus Circle," *New York Times* (January 16, 1994), XIII: 4; Claudia H. Deutsch, "Commercial Property," *New York Times* (January 30, 1994), X: 13; Elaine Louie, "Desks Go West," *New York Times* (August 22, 1996), C: 3.

89. Eric N. Berg, "Buildings with Asbestos Shunned," *New York Times* (April 28, 1988), D: 1, 7; Mervyn Rothstein, "Twisting in the Wind on Columbus Circle," *New York Times* (January 31, 1993), X: 1, 11; "After the Renovation, What?" *New York Times* (September 19, 1993), X: 1. For the Gulf & Western Building, see Stern, Mellins, and Fishman, *New York 1960*, 723.

90. David W. Dunlap, "Former Gulf and Western Building to Be a Luxury Apartment Tower," *New York Times* (March 23, 1994), 1, B: 6; Herbert Muschamp, "Columbus Circle's Changing Face: More Than Geometry," *New York Times* (March 27, 1994): 29, 33; Charles V. Bagli, "Gut the G+W Tower? Here Comes Trump," *New York Observer* (March 28, 1994): 1, 6; David W. Dunlap, "The Seagram, Redux, on the Park?" *New York Times* (May 8, 1994), XIV: 8; "Johnson and Trump at Columbus Circle," *Progressive Architecture* 75 (June 1994): 24; David W. Dunlap, "For a Troubled Building, a New Twist," *New York Times* (July 17, 1994), IX: 1, 6; "Pouring a Troubled Tower into a New Skin," *Architectural Record* 182 (September 1994): 17; Herbert Muschamp, "Trump Tries to Convert 50's Style into 90's Gold," *New York Times*

(June 21, 1995), B: 1–2; "New Face of 1995," *New York Times* (October 22, 1995), IX: 1; Herbert Muschamp, "Going for the Gold on Columbus Circle," *New York Times* (November 19, 1995): 48; Alan J. Broder, "Built-In Obstructed Views," letter to the editor, *New York Times* (December 10, 1995): 5; Donald J. Trump, "Well, Somebody Likes It," letter to the editor, *New York Times* (December 10, 1995): 5; Peter Blake, *Philip Johnson* (Basel: Birkhäuser, 1996), 252; Robin Pogrebin, "52-Story Comeback Is So Very Trump," *New York Times* (April 25, 1996), B: 1, 4; Ellen R. Fox, "Goose and Gander," letter to the editor, *New York Times* (April 29, 1996): 26; Andy Rooney and Donald J. Trump, "Trump's Waistline, from Trump's Perspective," letters to the editor, *New York Times* (May 2, 1996): 22; "Mystical Moments on Columbus Circle," *Fortune* 133 (May 27, 1996): 208, 210; Jonathon Webster, "Johnson's Trump Card," *Architects' Journal* 203 (June 6, 1996): 22–23; Ned Cramer, "Urbanism Trumped on Columbus Circle," *Architecture* 85 (July 1996): 51; Donald J. Trump with Kate Bohner, *Trump: The Art of the Comeback* (New York: Random House, 1997), 81–95; Peter Slatin, "Classy 'Chez Donald'," *New York Post* (January 10, 1997): 33; Gersh Kuntzman, "Trump's Latest: Dollars & Incense," *New York Post* (January 16, 1997): 18; "New Trump Hotel on Central Park," *New York Times* (January 19, 1997), V: 3; Karrie Jacobs, "Small World, After All," *New York* 30 (January 27, 1997): 15; Beth Landman and Deborah Mitchell, "Trump: One Is the Loneliest Number," *New York* 30 (January 27, 1997): 9; Beth Landman and Deborah Mitchell, "All That Glitters Is Not Gold," *New York* 30 (February 24, 1997): 19; Donald J. Trump, "A Little Hospitality," letter to the editor, *New York* 30 (February 24, 1997): 16; Terry Trucco, "From Swank to Simplicity Itself," *New York Times* (May 18, 1997), V: 13, 34; Phoebe Hoban, "Trump Shows off His Nest," *New York Times* (November 5, 1997): 41; Herbert Muschamp, "A Midas of the Gold (Yes, I Do Mean Gold) Cudgel," *New York Times* (November 5, 1997), E: 2; Beth Landman and Deborah Mitchell, "Ain't No Tenant High-Class Enough," *New York* 31 (April 27, 1998): 9; John Bowe, "Trump L'oeil," *Interior Design* 69 (May 1998): 135–36; White and Willensky, *AIA Guide* (2000), 316.

91. Ysrael A. Seinuk and Donald J. Trump, quoted in Dunlap, "For a Troubled Building, a New Twist": 6.

92. Philip Johnson, quoted in Dunlap, "For a Troubled Building, a New Twist": 6.

93. Muschamp, "Trump Tries to Convert 50's Style into 90's Gold": 1–2.

94. Donald J. Trump, quoted in Jacobs, "Small World, After All": 15.

95. Philip Johnson, quoted in Webster, "Johnson's Trump Card": 23.

96. Pun Yin, quoted in Jacobs "Small World, After All": 15.

97. Grace Glueck, "Gulf & Western Gives New York a Culture Center," *New York Times* (December 9, 1976): 1, 54; "Cultural Center," editorial, *New York Times* (December 11, 1976): 22; Carter B. Horsley, "A Choice Site, a Sale, a Gift, a Tax Issue," *New York Times* (January 16, 1977), VIII: 1, 6; Grace Glueck, "Art People," *New York Times* (February 3, 1978), C: 17; C. Gerald Fraser, "A Former Arts Center, Unoccupied Since '75, to Open for City's Use," *New York Times* (May 20, 1979): 39; "Cultural Affairs Unit Given Hartford Gallery," *New York Times* (February 27, 1980), C: 25; C. Gerald Fraser, "Columbus Circle Museum Gets a New Cultural Life," *New York Times* (November 7, 1980): 59; Fred Ferretti, "The Evening Hours," *New York Times* (November 28, 1980), B: 14; Grace Glueck, "Art: 'Working Process' at Columbus Circle," *New York Times* (April 17, 1981), C: 20. For Stone's building, see Stern, Mellins, and Fishman, *New York 1960*, 671–73.

98. Charles G. Bluhdorn, quoted in Glueck, "Gulf & Western Gives New York a Culture Center": 54.

99. "Cultural Center": 22.

100. "City Plans to Give Up Site at Columbus Circle," *New York Times* (October 8, 1995), IX: 1.

101. Paul Goldberger, "A Postmodern Museum for Television, Sans Irony," *New York Times* (September 22, 1991), II: 36.

102. Thomas J. Lueck, "Officials Offer Expanded Plans to Rebuild Columbus Circle," *New York Times* (July 24, 1996), B: 1, 3; Herbert Muschamp, "The Short, Scorned Life of an Esthetic Heresy," *New York Times* (July 31, 1996), B: 1–2; Halton Adler Mann, "Columbus Circle Folly," letter to the editor, *New York Times* (August 4, 1996): 14; Neal B. Hitzig, "Columbus Circle Dream," letter to the editor, *New York Times* (August 7, 1996): 16; Devin Leonard, "Columbus Circle Chic: Preservation Drive Puzzles City Official," *New York Observer* (October 21, 1996): 1, 28; "A Preservationist Lists 35 Modern Landmarks-in-Waiting," *New York Times* (November 17, 1996), IX: 1, 6; Peter Slade, "Former Gallery of Modern Art," letter to the editor, *New York Times* (December 1, 1996), IX: 9; Thomas J. Lueck, "For a Building a Bit Unusual, Ideas to Match," *New York Times* (February 26, 1997), B: 1, 7; Clifford J. Levy, "Council Seeks Delay in Sale of Building in Midtown," *New York Times* (April 17, 1997), B: 12; Clifford J. Levy, "5 Developers Are Said to Be Finalists for Coliseum Project," *New York Times* (April 30, 1997), B: 7; "Dahesh Museum Bids to Preserve 2 Columbus Circle," *Dahesh Muse* (Winter 1997): 5; Devin Leonard, "Supermarket Heiress and an Architect Try Saving a Monstrosity," *New York Observer* (December 22, 1997): 1, 43; James Barron, "Making a Pitch for the Dahesh," *New York Times* (January 20, 1998), B: 2; Steven R. Weisman, "The Circle Comes Round at Columbus Circle," *New York Times* (August 17, 1998): 14; Eric Brill, "Building Is No Landmark," letter to the editor, *New York Times* (August 20, 1998): 2; Elisabeth Bumiller, "From Architectural Showman to Yale Dean," *New York Times* (September 23, 1998), B: 2; Monica Rivituso, "The Art of the Deal," *Manhattan Spirit* (December 3, 1998): 20, 32; David W. Dunlap, "Acquiring a Taste for Marble Lollipops," *New York Times* (December 11, 1998), B: 1, 8; John Goldman, "Artbreak Hotel," *New York* 31 (December 21–28,

1998): 23–24; Caroline C. Pam, "We Could Scream in Protest, but That's Just More Noise," *New York Observer* (December 14, 1998): 14; Alexander S. C. Rower, "Site Specific," letter to the editor, *New York* 32 (January 18, 1999): 7; "On the Drawing Boards," *Oculus* 61 (February 1999): 5.

103. Muschamp, "The Short, Scorned Life of an Esthetic Heresy": 1.

104. Charles Millard, quoted in Leonard, "Columbus Circle Chic: Preservation Drive Puzzles City Official": 1, 28.

105. Tom Wolfe, quoted in Leonard, "Columbus Circle Chic: Preservation Drive Puzzles City Official": 28.

106. Robert Stern, quoted in Leonard, "Columbus Circle Chic: Preservation Drive Puzzles City Official": 28.

107. Donald Trump, quoted in Leonard, "Supermarket Heiress and an Architect Try Saving a Monstrosity": 1, 43.

108. David Childs, quoted in Dunlap, "Acquiring a Taste for Marble Lollipops": 8.

109. David W. Dunlap, "On Columbus Circle, Hints of an End to an Enigma," *New York Times* (March 7, 2000), B: 3; Kimberly Stevens, "A Lot of New Yorkers with Their Heads in the Clouds," *New York Times* (April 30, 2000), XIV: 8; "Beauty or Beast? Conservancy Calls for a Hearing?" *New York Landmarks Conservancy Newsletter* (Autumn 2000): 7; Robert A. M. Stern, "We Should Save Edward Durell Stone's Maligned Marble Masterpiece in New York," *Architectural Record* 188 (November 2000): 63; "2 Columbus Circle," *Grid* 2 (November-December 2000): 91; Anthony Vidler, "It's Still All About Form and Function," *New York Times* (August 12, 2001), IV: 5; "Will the Site Go to Trump?" *New York Times* (January 27, 2002), XI: 1; Lois Weiss, "Last Stand at 2 Columbus," *New York Post* (May 15, 2002): 32; David W. Dunlap, "Fate of 2 Columbus Circle Is Hidden Behind Marble Walls," *New York Times* (May 23, 2002), B: 3; Erika Kinetz, "A Campaign to Honor Buildings Some Love to Hate," *New York Times* (June 9, 2002), XIV: 4.

110. Eric Herman, "Museum to Columbus Circle," *New York Daily News* (June 11, 2002): 41; Lois Weiss, "2 Columbus Saved: But Landmark Building Will Look Different," *New York Post* (June 21, 2002): 35; David W. Dunlap, "2 Columbus Circle Will Be a Museum Again," *New York Times* (June 21, 2002), B: 4; Eric Gibson, "When Is Preservation Not Preservation," *Wall Street Journal* (June 27, 2002), D: 9; David W. Dunlap, "Craft Project at Columbus Circle," *New York Times* (July 12, 2002), B: 1–2; Simeon Bankoff, "A Modern Touchstone," letter to the editor, *New York Times* (July 20, 2002): 12.

111. David W. Dunlap, "Manhattan: Architect Finalists Chosen," *New York Times* (August 22, 2002), B: 4; "Off the Record," *Architectural Record* 190 (September 2002): 34; Sharon McHugh, "Four Vie for New York Craft Museum," *World Architecture* (October 2002): 11; Carol Vogel, "In New Name, Museum Goes Contemporary," *New York Times* (October 3, 2002), E: 5; Celestine Bohlen, "Oregon Firm to Design for Museum," *New York Times* (November 5, 2002), E: 3; James Gardner, "Big Is In Around the Town," *New York Sun* (November 19, 2002): 1, 11; John E. Czarnecki, "Cloepfil, Allied Works Selected for New York Museum," *Architectural Record* 190 (December 2002): 24; Herbert Muschamp, "At Ground Zero, the Freshest Architecture May Be the Answer," *New York Times* (December 18, 2002), E: 1, 7; Brian Libby, "A Neo-Modernist Is Having His Moment," *New York Times* (January 12, 2003), II: 40; Lisa Goff, "NY Museums Gambling on New Talent," *Crain's New York Business* (January 13, 2003): 36; David W. Dunlap, "A New Look for a 10-Story Oddity," *New York Times* (April 1, 2003), E: 1, 5; Paul Fonseca, Simeon Bankoff, and Kate Wood, "That Quirky Building, Lollipops and All," letters to the editor, *New York Times* (April 4, 2003): 20; Rachel Donadio, "Donors for Craft Museum," *New York Sun* (April 7, 2003): 17; Frances Morrone, "Abroad in New York," *New York Sun* (June 23, 2003): 14; Tom Wolfe, "The Building That Isn't There," *New York Times* (October 12, 2003), IV: 11; Tom Wolfe, "The Building That Isn't There, Cont'd," *New York Times* (October 13, 2003): 17; James Barron, "Groups Sue to Prevent Sale of Columbus Circle Building," *New York Times* (November 8, 2003), B: 4; "Corrections," *New York Times* (November 12, 2003): 23; Joyce Purnick, "A Building Still Looking for Respect," *New York Times* (December 15, 2003), B: 1; "2 Columbus Circle Goes on the List," *Crain's New York Business* (November 24–30, 2003): 2; James Panero, "What Is Strange About the Dahesh Museum?" *New Criterion* 22 (December 2003): 33–36; Justin Davidson, "2 Columbus Circle and a Battle over Keeping Its Architecture," *Newsday* (December 10, 2003), B: 2; Herbert Muschamp, "The Highs: The Buildings (and Plans) of the Year," *New York Times* (December 28, 2003), II: 39; Herbert Muschamp, "The Lows: Banner Year for Lost Opportunities," *New York Times* (December 28, 2003), II: 39; James Gardner, "Mad About Mod," *New York Sun* (January 5, 2004): 17; Michael Sorkin, "Of Landmarks and Memorials," *Architectural Record* 192 (January 2004): 59–60; Huxtable, "The Best Way to Preserve 2 Columbus Circle? A Makeover": 10; Julie V. Iovine, "On Columbus Circle, Fighting a Face-Lift," *New York Times* (January 22, 2004), F: 9; Justin Davidson, "Facing a Turning Point," *Newsday* (February 4, 2004), B: 3; David W. Dunlap, "Museum Wins a Court Battle on Columbus Circle Renovation," *New York Times* (February 25, 2005), B: 5; Robin Pogrebin, "Group Seeks Removal of Landmarks Chairman," *New York Times* (May 27, 2005), B: 6; "Corrections," *New York Times* (May 28, 2005): 2; Robin Pogrebin, "Permit Issued for Long-Disputed Work at 2 Columbus Circle," *New York Times* (June 30, 2005), B: 3; Sherida E. Paulsen, "The Black Hole of Columbus Circle," *New York Times* (July 30, 2005): 15.

112. Wood, "That Quirky Building, Lollipops and All": 20.

113. Wolfe, "The Building That Isn't There": 11.

114. Quoted in Barron, "Groups Sue to Prevent Sale of Columbus Circle Building": 4.

115. Muschamp, "The Highs: The Buildings (and Plans) of the Year": 39; Muschamp, "The Lows: Banner Year for Lost

Opportunities": 39.

116. Huxtable, "The Best Way to Preserve 2 Columbus Circle? A Makeover": 10. Also see Ada Louise Huxtable, "Architecture: Huntington Hartford's Palatial Midtown Museum," *New York Times* (February 25, 1964): 33.

CENTRAL PARK

1. Stern, Mellins, and Fishman, *New York 1960*, 763–98. Also see Elizabeth Barlow, "32 Ways Your Time or Money Can Rescue Central Park," *New York* 9 (June 14, 1976): 32–39; Elizabeth Barlow, "Readers Respond to Park's Plight," *New York* 9 (August 2, 1976): 6; Fred Ferretti, "New York Parks Cope with Growing Decay . . . New York Parks Face Bleak Future," *New York Times* (May 26, 1977), B: 1, 11. For the origins of Central Park, see Stern, Mellins, and Fishman, *New York 1880*, 82–109. Also see Stern, Gilmartin, and Massengale, *New York 1900*, 134–35; Stern, Gilmartin, and Mellins, *New York 1930*, 707–12.

2. "Castle Is Secure but Weathermen Still Moving," *New York Times* (December 31, 1977): 21.

3. Elizabeth Barlow with Vernon Gray, Roger Pasquier, and Lewis Sharp, *The Central Park Book* (New York: The Central Park Task Force, 1977).

4. Paul Goldberger, "Triumphs of Design," book review, *New York Times* (July 9, 1978), VII: 9.

5. Lee Dembart, "Use of City's Parks Curbed by New York," *New York Times* (April 18, 1978): 1, 26.

6. Lee Dembart, "New Central Park Overseer," *New York Times* (February 28, 1979), B: 3; Francis X. Clines, "About New York/From Forest to Garden: A Vision for Central Park," *New York Times* (April 28, 1979): 29.

7. Leslie Maitland, "Special Management Plan Urged to Combat Central Park's Decay," *New York Times* (November 12, 1978): 60.

8. "Uniform for New Urban Park Rangers," *New York Times* (March 6, 1979), B: 1; "Parkies to the Rescue," editorial, *New York Times* (August 18, 1979): 18; "New Urban Rangers: A Force for Order," *New York Times* (August 19, 1979): 31.

9. Grace Glueck, "A Conservancy Will Seek Private Central Park Aid," *New York Times* (August 16, 1980), B: 23–24. For Gordon J. Davis, see Orde Coombs, "The Prince of Central Park," *New York* 14 (November 9, 1981): 26–30.

10. Glueck, "A Conservancy Will Seek Private Central Park Aid": 23- 24; Grace Glueck, "Mayor Koch Sets Up Conservancy for Central Park," *New York Times* (December 14, 1980): 100; "Ten to be Honored by the AIA for 'Distinguished Achievements'," *Architecture* 74 (April 1985): 15, 24, 28; Rita D. Jacobs, "Heir to the Olmsted Vision: Elizabeth Barlow Rogers," *Vis à Vis* (United Airlines Flight Magazine) (October 1988): 92–93; Peter Hellman, "The Central Park Conservancy," *New York* 22 (May 22, 1989): 37; Andrew L. Yarrow, "Private Money Is Keeping Central Park Healthy," *New York Times* (October 29, 1990), B: 3; Daniel Lowenstein, "The Central Park Conservancy: Whose Park Is It Anyway?" *Manhattan Spirit* (June 2, 1992): 10; Douglas Martin, "From Botany to the Beatles at Park Conservancy," *New York Times* (November 4, 1995): 27.

11. Elizabeth Barlow, quoted in Glueck, "A Conservancy Will Seek Private Central Park Aid": 23. Also see Richard Levine and Carlyle C. Douglas, "Life Is Hard on Parks, Too," *New York Times* (October 18, 1981), IV: 5; Andrea Gabor, "Fans of the Olmstead[sic] Landscape Channel Money and Energy to Rejuvenate Central Park," *Architectural Record* 169 (December 1981): 38; William Hubbard, "Reassessing the Art of Landscape Design: Central Park as a Case Study," *Architectural Record* 172 (September 1984): 69, 71, 73, 75; Deirdre Carmody, "Central Park Renews Its Details and Vistas in a Burst of Repairs," *New York Times* (October 13, 1984): 29, 32.

12. "Campaign to Renew the Sheep Meadow Gets Under Way," *New York Times* (August 1, 1979): 33.

13. Paul Goldberger, "A Startling Soft, Green Lawn in Central Park," *New York Times* (June 5, 1980), C: 10.

14. Edith Evans Asbury, "Resodded Sheep Meadow Gets an Unwanted Look," *New York Times* (June 27, 1980), B: 2.

15. Robin Herman, "'Limitations' Set for Sheep Meadow," *New York Times* (September 15, 1980), B: 2.

16. Malcolm Holzman, quoted in Paul Goldberger, "New Victorian-Style Kiosk Fits the Spirit of Central Park," *New York Times* (August 9, 1979), C: 10. Also see *Hardy Holzman Pfeiffer Associates: Buildings and Projects, 1967–1992* (New York: Rizzoli International Publications, 1992), 248.

17. Goldberger, "New Victorian-Style Kiosk Fits the Spirit of Central Park": 10.

18. Paul Goldberger, "1870 Dairy in the Park Reopening," *New York Times* (November 16, 1979): 32; Central Park Conservancy, *The Dairy in Central Park: Restoration Notes* (New York: Avon Products for the Central Park Conservancy, 1980); Deirdre Carmody, "Victorian Dairy Opens Once More in the Park," *New York Times* (October 15, 1981), B: 3; Gabor, "Fans of the Olmstead[sic] Landscape Channel Money and Energy to Rejuvenate Central Park": 38; "Robert Moses Information Desk and Shop, the Dairy in Central Park," *Oculus* 45 (May 1984): 17; Hubbard, "Reassessing the Art of Landscape Design: Central Park as a Case Study": 69, 71, 73, 75; "AIA Component Awards," *Architecture* 74 (May 1985): 167. For the Dairy, see Stern, Mellins, and Fishman, *New York 1880*, 94–95.

19. Frederick Law Olmsted, quoted in Goldberger, "1870 Dairy in the Park Reopening": 32.

20. For Lamantia's restaurant at Bethesda Terrace, see Stern, Mellins, and Fishman, *New York 1960*, 774–75.

21. Anna Quindlen, "Recapturing the Castle from the Vandals," *New York Times* (July 17, 1980), B: 3; Deirdre Carmody, "Park Restoration Gives Belvedere Castle New Life," *New York Times* (July 10, 1982): 27; Eleanor Blau, "Castle Open House," *New York Times* (July 16, 1982), C: 10;

"Castle from the Air," editorial, *New York Times* (August 31, 1983): 26; "Names and News," *Oculus* 45 (October 1983): 11; Susan Heller Anderson and Maurice Carroll, "Crown for a Castle," *New York Times* (September 21, 1983), B: 2; White and Willensky, *AIA Guide* (1988), 338.

22. "A New Use for an Old Folly: A Learning Center for the Belvedere Castle," *New York Times* (July 9, 1995), IX: 1.

23. "Gerald Allen–Peter Gluck & Associates," *Architecture + Urbanism*, extra edition (March 1981): 60–61; Deirdre Carmody, "Central Park Will Get Fewer but Brighter Lights," *New York Times* (October 29, 1981), B: 1; Gerald Allen and William Hubbard, "New Lessons from an Old Park," *Oz* 5 (1983): 48–53; Joseph Giovannini, "How Design Was Decided for Central Park's Lamps," *New York Times* (August 28, 1983): 52; Arthur J. Morgan, "Old 'New' Park Lamps," letter to the editor, *New York Times* (September 8, 1983): 22; Hubbard, "Reassessing the Art of Landscape Design: Central Park as a Case Study": 69, 71, 73, 75; Gerald Allen, "Landscape Revealed in Time," *Places* 13 (2000): 18–19.

24. Hubbard, "Reassessing the Art of Landscape Design: Central Park as a Case Study": 69, 71, 73, 75; "Gerald Allen–Peter Gluck & Associates": 60–61; Allen and Hubbard, "New Lessons from an Old Park": 48–53; Carmody, "Central Park Renews Its Details and Vistas in a Burst of Repairs": 29, 32; Douglas Martin, "A Whimsical Fountain Flows Again," *New York Times* (August 4, 1998), B: 3; Allen, "Landscape Revealed in Time": 18–19.

25. Jean Parker Murphy and Kate Burns Ottavino, "The Rehabilitation of Bethesda Terrace," *Association for Preservation Technology Bulletin* 18 (1986): 24–39. Also see Deirdre Carmody, "10-Year Restoration Planned for Central Park," *New York Times* (October 14,1981): 1, B: 3; Deirdre Carmody, "Renewal of Central Park Stirring Broader Debate," *New York Times* (June 24, 1982), B: 3; Deirdre Carmody, "Panel Approves Partial Removal of a Park Grove," *New York Times* (October 8, 1982), B: 3; "Restoration Begun at Bethesda Terrace," *New York Times* (September 1, 1983): B: 1; Carmody, "Central Park Renews Its Details and Vistas in a Burst of Repair": 29, 32; Deborah K. Dietsch, "Saving Sandstone," *Architectural Record* 174 (May 1986): 130–37; Michael Kimmelman, "Spruced-Up Fountain," *New York Times* (September 11, 1987), C: 1; Paula Deitz, "Central Park's Bethesda Terrace and Its Restoration," *Antiques* 133 (April 1988): 888–99; "Bethesda Fountain Flows Again," *New York Times* (September 24, 1988): 32; Forrest Wilson, "Curators for Future Restorers," *Architecture* 77 (November 1988): 134–35; Susan Gilman, "City's Plan for Gates in Park Endorsed," *New York Observer* (December 17, 1990): 6; Mary Kelly, "Another Endorsement of Bethesda Arcade Gates," *New York Observer* (January 21, 1991): 6; James S. Russell, "A New Life for a Historic Tile Ceiling," *Architectural Record* 180 (January 1992): 38–39; Danielle Reed, "A Roofless Pen Holds Park's Ceramic Treasure," *New York Observer* (May 9, 1994): 1, 22; Nina Siegal, "Ceiling Tiles Looking Up at Last," *New York Times* (October 11, 1998), XIV: 6; Ed Boland Jr., "Park Arch Needs Money," *New York Times* (July 8, 2001), XIV: 2.

26. Eugene Kinkead, *Central Park 1857–1995: The Birth, Decline, and Renewal of a National Treasure* (New York: W.W. Norton & Company, 1990), 154–56. Also see Stern, Mellins, and Fishman, *New York 1960*, 783.

27. Suzanne Daley and Laurie Johnston, "19th Century Revisited," *New York Times* (December 16, 1982), B: 2; Laurie Johnson and Susan Heller Anderson, "Central Park Shelter," *New York Times* (August 13, 1983): 27; George Lewis, "Names and News," *Oculus* 45 (October 1983): 7; Susan Heller Anderson, "Shelter in the Park," *New York Times* (May 21, 1985), B: 3; Kinkead, *Central Park 1857–1995*, 154.

28. Deirdre Carmody, "40-Seat Restaurant to Open in Loeb Boathouse," *New York Times* (January 9, 1983): 30; "Park Restaurant," *New York Times* (January 1, 1984): 21; Jayne Merkel, "Vaux Redux: Buttrick White & Burtis's Central Park," *Oculus* 57 (May 1995): 12–13. For the Loeb Boathouse, see Stern, Mellins, and Fishman, *New York 1960*, 764, 766.

29. Jennifer Dunning, "New Tour Spans Cast-Iron Bridges of Central Park," *New York Times* (June 6, 1980), C: 1, 22; Paul Goldberger, "Restoration," *New York Times* (October 7, 1984), VI: 55–61, 102–3, 111, 124–25; Allen Freeman, "Rebuilding the Bridges of Central Park," *Architecture* 77 (November 1988): 132–33; Henry Hope Reed, Robert M. McGee, and Esther Mipaas, *Bridges of Central Park* (New York: Greensward Foundation, 1990), 24–25, 62–63, 66–68; "Central Park Guide," *New York Times* (September 16, 1990), X: 1; David W. Dunlap, "Small Scale, Great Beauty: The Bridges of Central Park," *New York Times* (July 5, 1991), C: 1, 18; Christopher Gray, "Streetscapes/Glen Span Arch in Central Park," *New York Times* (July 5, 1992), X: 7; "Preserving a Central Park Classic," *New York Times* (September 22, 1994), B: 3; *Beyer Blinder Belle, Architects & Planners* (New York: Beyer Blinder Belle, 1997), no pagination; "Rebuilding a Bridge," *New York Times* (August 5, 1998), B: 5; Corey Kilgannon, "To Save Rain Forests, a Call for Plastic in the Parks," *New York Times* (August 30, 1998), XIV: 5.

30. Elizabeth Barlow, *Rebuilding Central Park for the 1980s and Beyond: An Outline for a Restoration Plan* (New York: New York City Department of Parks and Recreation and Central Park Conservancy, 1981); Elizabeth Barlow Rogers, *Rebuilding Central Park: A Management and Restoration Plan* (Cambridge, Mass.: MIT Press, 1987). Also see Deirdre Carmody, "10-Year Restoration Planned for Central Park," *New York Times* (October 14, 1981): 1, B: 3; Elizabeth Hawes, "Whose Park Is It Anyway?" *New York Times* (September 5, 1982), VI: 18–19, 36–38; "Central Park: The Master Plan to Restore Central Park," *Oculus* 44 (April 1983), 2–6, 11–14.

31. Linda Yang, "Hidden Splendor Restored in Park," *New York Times* (July 28, 1983), C: 3; Jean Spiro Breskend, "The Flowering of Central Park," *Garden Design* 8 (Summer 1989): 26–35.

32. "John Lennon Area in Park Approved," *New York Times* (April 7, 1983), B: 3; "John Lennon Park Approved," *Progressive Architecture* 64 (May 1983): 54; Richard Haitch, "Honoring Lennon," *New York Times* (September 16, 1984): 49; Carmody, "Central Park Renews Its Details and Vistas in a Burst of Repairs": 29, 32; White and Willensky, *AIA Guide* (2000), 377.

33. Elizabeth Barlow, quoted in Susan Heller Anderson and Maurice Carroll, "Goodbye Graffiti," *New York Times* (November 2, 1984), B: 3.

34. John Russell, "Artist Planning to Transform Central Park for Two Weeks," *New York Times* (October 6, 1980), B: 1, 4; Margot Slade and Tom Ferrell, "An Artistic Ripple in Central Park?" *New York Times* (October 12, 1980), IV: 7; "A Philistine Shrug for a Droopy Idea," editorial, *New York Times* (October 16, 1980): 30; Leo Steinberg, "The Promise of Christo's Central Park Project," letter to the editor, *New York Times* (October 24, 1980): 32; Martin Greif, "A Stunt Exalted," letter to the editor, *New York Times* (November 1, 1980): 24; Andrew MacNair, "Christo's Gates," *Express* 1 (December 1980): 3; Grace Glueck, "Christo's Plan for Project in Park Starts Fireworks," *New York Times* (January 22, 1981), C: 14; "A 'Giant Pillow in the Middle of a Concrete Block,'" *Art News* 80 (February 1981): 9; Grace Glueck, "City Rejects Christo Plan for Central Park 'Gates,'" *New York Times* (February 26, 1981), C: 15; Grace Glueck, "2d Request Planned for Park 'Gates,'" *New York Times* (March 1, 1981): 54; "Closing Christo's Gates," editorial, *New York Times* (March 5, 1981): 22; Grace Glueck, "Dispute Over Christo Central Park 'Gates' Continues," *New York Times* (March 12, 1981), C: 24; "The Other Side of *The Gates*," *Art News* 80 (May 1981): 12, 14; Coombs, "The Prince of Central Park": 26–30; Herbert Mitgang, "Christo Says Public Backs 'Gates' Plan," *New York Times* (February 25, 1982), C: 15; John Tierney, "Manhattan Projects," *New York Times* (March 31, 1996), VI: 26–27; Richard Jesaitis and Owen Levy, "Manhattan Projects," letters to the editor, *New York Times* (April 28, 1996), VI: 16; Pierre Restany, "The Great Veil of Wonder," *Domus* (February 1997): 59–65; Carol Vogel, "Stubbornly Wrapped Notion," *New York Times* (January 7, 1999), E: 1, 6; David R. Poma, Peter Gravina, and Dino Tasovac, "A 'Wrapped' Central Park: No Way!" letters to the editor, *New York Times* (January 10, 1999), IV: 20; Jonathan Fineberg, *On the Way to the Gates: Central Park, New York City: Christo and Jeanne-Claude* (New Haven, Conn.: Yale University Press; New York: Metropolitan Museum of Art, 2004); *Christo and Jeanne-Claude: The Gates, Central Park, New York City, 1979–2005* (Cologne: Taschen, 2005).

35. "A Philistine Shrug for a Droopy Idea": 30.

36. Gordon J. Davis, quoted in Glueck, "City Rejects Christo Plan for Central Park 'Gates'": 15.

37. "Closing Christo's Gates": 22.

38. Christo, quoted in Glueck, "City Rejects Christo Plan for Central Park 'Gates'": 15.

39. Amei Wallach, "Imagine Central Park in Saffron," *New York Times* (March 17, 2002), II: 1, 37; Benjamin Smith, "Mayor on the Spot Over Christo's Latest," *New York Sun* (April 25, 2002): 1, 5; "Saffron Gates," *Art Monthly* 256 (May 2002): 17; Benjamin Smith, "Christo Facing City Hearing on Park Gates," *New York Sun* (May 3, 2002): 1, 4; Robin Pogrebin, "Conservancy Approves Artist's Plan to Drape Central Park in Fabric," *New York Times* (December 19, 2002), B: 1, 9; Carol Vogel, "Work Begins on Colossal Artwork-in-the-Park," *New York Times* (January 4, 2005), E: 1, 6; Adam Sternbergh, "The Passion of the Christos," *New York* 38 (January 24–31, 2005): 27–33, 113; Carol Vogel, "Central Park Makeover: Reality Show, in a Way," *New York Times* (February 10, 2005), E: 1, 7; "Following Christo's Thread in Central Park," *New York Times* (February 11, 2005), E: 40; James Barron, "Dressing the Park in Orange, and Pleats," *New York Times* (February 13, 2005): 37, 40; Michael Kimmelman, "In a Safron Ribbon, a Billowy Gift to the City," *New York Times* (February 13, 2005): 1, 40; Myron Magnet, "The Road to Serfdom," *New York Sun* (February 16, 2005): 8; Witold Rybczynski, "Olmsted Vs. Christo," *New York Sun* (February 16, 2005): 8; David W. Dunlap, "In a City of Ads, 'The Gates' Promote Nothing, Except Maybe the Artists," *New York Times* (February 17, 2005), B: 3; Avery Johnson, "'Gates' Fills Up New York Hotels," *Wall Street Journal* (February 17, 2005), D: 4; Mark Stevens, "Curtain Up," *New York* 38 (February 28, 2005): 64–65; Hilton Kramer, "Saffron Succotash! Those Absurd Gates a Blight on Art, City," *New York Observer* (February 28, 2005): 1, 16; Mike McIntire, "Enough About 'Gates' as Art; Let's Talk About That Price Tag," *New York Times* (March 5, 2005): 1, B: 4; Mike Donovan, "Sacred Gates?" letter to the editor, *New York Observer* (March 7, 2005): 4.

40. Kimmelman, "In a Safron Ribbon, a Billowy Gift to the City": 1, 40.

41. Kramer, "Saffron Succotash! Those Absurd Gates a Blight on Art, City": 1, 16.

42. Donovan, "Sacred Gates?": 4.

43. "Play Ball," *New York Observer* (June 18, 1990): 6; "Snack Stand for Central Park Ball Field," *New York Times* (July 12, 1990), C: 3; Peter M. Slatin, "Ballplayers Refreshment Stand," *Architectural Record* 178 (June 1991): 100–103; Mark Alden Branch, "Flirting with Folly in Central Park," *Progressive Architecture* 72 (August 1991): 25; Merkel, "Vaux Redux: Buttrick White & Burtis's Central Park": 12–13.

44. Merkel, "Vaux Redux: Buttrick, White & Burtis's Central Park": 12–13.

45. Nancy Stark, "Could We Have Less Progress in Central Park?" letter to the editor, *New York Times* (February 11, 1987): 26; Elizabeth Barlow Rogers, "New Tennis Pavilion Will Enhance Central Park," letter to the editor, *New York Times* (March 3, 1987): 26; Robert M. Makla, "Olmsted and Vaux, Central Park Has Need of You at This Hour," letter to the editor, *New York Times* (March 14, 1987): 26; "The New Tennis House: A Net Gain," editorial, *New York Times* (April 4, 1987): 26; E. M. Halliday, "Never Mind Central Park's Tennis House: Fix the Court Surfaces," letter to the editor, *New York Times* (April 21, 1987): 30; Barbara Knapp, "Gothic? Who Cares?" letter to the editor, *New York Times* (April 21, 1987): 30; "Landmarks Panel Backs Plan for Pavilion in Central Park," *New York Times* (June 3, 1987), B: 2; David W. Dunlap, "Parks Chief Says Foes Imperil Pavilion Plans," *New York Times* (June 15, 1987), B: 3; Scott Ladd, "Tennis Buffs Rise Racket Over Tennis Pavilion Plan," *Newsday* (June 17, 1987): 31; Susan Heller Andersen, "The Private Greening of Central Park," *New York Times* (August 2, 1987), E: 6; Christopher Gray, "Streetscapes/The Central Park Tennis House," *New York Times* (October 4, 1987), VIII: 14; Scott Ladd, "A Political Match Over a Tennis Pavilion," *Newsday* (June 7, 1988): 35; Roy Rosenzweig and Elizabeth Blackmar, *The Park and the People: A History of Central Park* (Ithaca, N.Y.: Cornell University Press, 1992), 520.

46. Susan Heller Andersen, "Restaurant at the Meer," *New York Times* (October 10, 1984), B: 3; "Old Boathouse Being Deep-Sixed?" *New York* 19 (November 14, 1986): 14; David Bird, "Quietly, Plans for an Eatery in Park Gain," *New York Times* (November 28, 1986), B: 3; Henry Urbach, "Reclaiming Public Parks," *Metropolis* 7 (January/February 1988): 20–21; "Manhattan Island to Get an Island," *New York Times* (February 6, 1989), B: 1; David W. Dunlap, "Central Park Could Get a Little Island Unto Itself," *New York Times* (February 6, 1989), B: 3; David W. Dunlap, "Restaurant Planned for Harlem Meer Area," *New York Times* (December 10, 1989): 55; "Harlem Lakeside Restaurant Planned," *New York Observer* (December 18, 1989): 9; "Towers and Turrets at Harlem Meer," *New York Times* (January 18, 1990), C: 3; "Up in Central Park on the Shore of Harlem Meer," *Architectural Record* 178 (March 1990): 19; "Harlem Meer," *Metropolis* 9 (April 1990): 21; Andrew L. Yarrow, "Private Money Is Keeping Central Park Healthy," *New York Times* (October 29, 1990), B: 3; Christopher W. London, "Central Park Restaurant Plans Betray Olmsted's Vision," letter to the editor, *New York Times* (November 14, 1990): 28; Linda Davidoff and Charlotte Fahn, "Plan for Northern End of Central Park Sins Only in Its Size," letter to the editor, *New York Times* (December 1, 1990): 24; Mark Alden Branch, "Flirting with Folly in Central Park," *Progressive Architecture* 72 (August 1991): 25; Tom McGhee, "New York Turf Wars," *Metropolis* 12 (March 1992): 21; Marvine Howe, "A Rebirth for Upper Park," *New York Times* (October 31, 1993), XIII: 6; "Dana Discover Center, New York," *Progressive Architecture* 74 (December 1993): 44; Merkel, "Vaux Redux: Buttrick White & Burtis's Central Park": 12–13; Michael M. Dwyer, "Buildings in Public Parks," *Traditional Building* 8 (March/April 1995): 26, 28, 30; Michael M. Dwyer, "The Arts and Crafts in Architecture Today," *Classicist* 3 (1996–97): 90–96; Susanna Sirefman, *New York: A Guide to Recent Architecture* (London: Ellipsis, 1997), 224–25; Paul Spencer Byard, *The Architecture of Additions: Design and Regulation* (New York: W. W. Norton, 1998), 104–5.

47. For Tavern on the Green, see Stern, Mellins, and Fishman, *New York 1960*, 783–84.

48. Robert M. Makla, quoted in Bird, "Quietly, Plans for an Eatery in Park Gain": 3. For the Huntington Hartford Café proposal, see Stern, Mellins, and Fishman, *New York 1960*, 770–72, 774.

49. Quoted in Dunlap, "Restaurant Planned for Harlem Meer Area": 55.

50. Samuel G. White, quoted in "Towers and Turrets at Harlem Meer": 3.

51. Michael M. Dwyer, quoted in "Dana Discovery Center, New York": 44.

52. Sam Roberts, "131-Year-Old Reservoir Is Deemed Obsolete," *New York Times* (May 6, 1993): 1, B: 13; Ian Fisher, "Central Park Reservoir to Stay As Is," *New York Times* (October 28, 1993), B: 1–2; Marie Winn, "Loons Have Last Laugh in Central Park Pond Spat," *Wall Street Journal* (November 2, 1993): 20; Daniel B. Schneider, "F.Y.I.: Fountain Is Reborn," *New York Times* (November 29, 1993), XIV: 2.

53. Quoted in Winn, "Loons Have Last Laugh in Central Park Pond Spat": 20.

54. See Stern, Gilmartin, and Mellins, *New York 1930*, 710.

55. David W. Dunlap, "Revamping Great Lawn Is Weighed," *New York Times* (January 28, 1987), B: 1, 6. Also see David W. Dunlap, "Great Lawn," *New York Times* (February 2, 1987), B: 1; Jeanie Kasindorf, "More Static on Park Plan," *New York* 20 (May 4, 1987): 21; Anderson, "The Private Greening of Central Park": 6.

56. Jon Pareles, "Paul Simon's Audience Is Eager to Participate," *New York Times* (August 17, 1991): 15; Allan Kozinn, "Pavarotti Sings, and the Great Lawn Is All Ears," *New York Times* (June 28, 1993), C: 1.

57. Jane H. Lii, "Seeing Green, $71 Million Worth," *New York Times* (September 18, 1994), XIII: 7; "The Heart of Manhattan," editorial, *New York Times* (September 21, 1994): 22.

58. Quoted in Alan Finder, "Disney Venture Animates Great Lawn in Central Park," *New York Times* (June 7, 1995), B: 1, 4. Also see Lawrence Van Gelder, "Koch Opposes 'Pocahontas' on Great Lawn," *New York Times* (June 8, 1995), B: 3; Jimmy Breslin, "Rudy Helps Slick Disney Turn Us All Into Suckers," *Newsday* (June 11, 1995): 2.

59. Breslin, "Rudy Helps Slick Disney Turn Us All Into Suckers": 2.

60. Robert D. McFadden, "125,000 Join Pope at Mass in Central Park 'Basilica,'" *New York Times* (October 8, 1995): 1, 43.

61. Douglas Martin, "Keep Off the Grass, Please (for 2 Years)," *New York Times* (October 17, 1995), B: 1, 4; Christopher Gray, "Streetscapes/Central Park," *New York Times* (March 10, 1996), IX: 7; Rachel Lehmann-Haupt and John Wagley, "Enough Turtles in Central Park," *New York Observer* (September 5, 1996): 10; Douglas Martin, "Moving Toward Greener Ground," *New York Times* (October 28, 1996), B: 1, 3; "Lawn for a Concrete City," *New York Times* (October 9, 1997): 1; Douglas Martin, "City Emerald," *New York Times*

(October 9, 1997), B: 1, 4; "The Great Lawn, Sown Again," editorial, *New York Times* (October 12, 1997), IV: 14; Norman Vanamee, "Turf Wars: Kicked Out," *New York* 17 (October 27, 1997): 17; Jill Weiner, "Great Lawn or Great Yawn?" *New York Times* (November 16, 1997), XIV: 19; Melanie Coronetz, Charles Salzberg, and Henry J. Stern, "It was Ball Players Who Ruined the Grass," letters to the editor, *New York Times* (December 7, 1997), XIV: 15; Douglas Martin, "Caring for a Reborn Great Lawn," *New York Times* (June 13, 1998), B: 1, 6; "The Greatest Lawn," editorial, *New York Observer* (June 29–July 6, 1998): 4; James Gardner, "With Excessive Fences and Zeal, Central Park Has Been Tamed," *New York Observer* (October 9, 2000): 12.

62. Richard Gilder, "Set the Parks Free," *City Journal* 7 (Winter 1997): 40–49. Also see Douglas Martin, "Benefactor Wants Private Group to Manage Central Park," *New York Times* (January 17, 1997); Ann Buttenwieser, "Look Before Leaping into Private City Parks," letter to the editor, *New York Times* (January 25, 1997): 22.

63. Douglas Martin, "City Offers Private Group Contract to Maintain Central Park," *New York Times* (September 6, 1997): 25, 29; "A Good Deal for Central Park," editorial, *New York Times* (September 9, 1997): 26; Melvyn Jay Oremland, "Privatizing City Parks Comes at a Price," letter to the editor, *New York Times* (September 13, 1997): 22; Douglas Martin, "Private Group Signs Central Park Deal to Be Its Manager," *New York Times* (February 12, 1998): 1, B: 5.

64. A. O. Sulzberger, "Board Approves Leases for South St. Seaport Plan," *New York Times* (October 23, 1981), B: 3; Alice Herrington, "Let's Do Away with Central Park Zoo," *New York Times* (November 21, 1981): 27; Gordon J. Davis, "The Fall and Rise of the Central Park Zoo," letter to the editor, *New York Times* (December 5, 1981): 24; "A 3-Zone Zoo without Bars Is Proposed for Central Park," *New York Times* (March 8, 1982): 1, B: 12; Carlyle C. Douglas and Richard Levine, "A New View of the Zoo," *New York Times* (March 14, 1982), IV: 7; "Zoo Renewed," *Progressive Architecture* 63 (April 1982): 53; Deirdre Carmody, "City Shows Its Design for Central Park Zoo," *New York Times* (April 6, 1982), B: 1, 7; "Remodeling the Central Park Zoo," *Oculus* 44 (November 1982): 3–5; Deirdre Carmody, "Tale of Noah's Ark, Updated, at Central Park Zoo," *New York Times* (November 19, 1982), B: 3; Anna Quindlen, "About New York: Central Park Zoo Holds Little but Memories," *New York Times* (January 5, 1983), B: 3; "Zoo Is Coming Down," *New York Times* (December 10, 1983): 27; "Revamping of Central Park Zoo Begins," *New York Times* (December 30, 1983), B: 3; Carmody, "Central Park Renews Its Details and Vistas in a Burst of Repairs": 29, 32; Francesco Dal Co, *Kevin Roche* (New York: Rizzoli International Publications, 1985), 234–35; "4 Zoo Units Begun in Central Park," *New York Times* (April 17, 1985), B: 3; "Sprucing Up the Central Park Zoo," *New York Times* (April 18, 1985), B: 3; Susan Heller Anderson, "Making Home Sweet for Central Park Zoo Animals," *New York Times* (April 5, 1987): 52; "New Construction Around Town," *Oculus* 48 (May 1987): 28; "Central Park Zoo," *Architecture + Urbanism*, extra edition (August 1987): 174–75; Robert A. M. Stern with Raymond Gastil, *Modern Classicism* (New York: Rizzoli International Publications, 1988), 204–5; Richard Scheinin, "Tooth and Claw," *Avenue* (May 1988): 62–66, 68–74, 76, 78; "See You Later, Alligator," *Avenue* (Anniversary Issue 1988): 12; Carter B. Horsley, "Zoo Story: Think Small," *New York Post* (June 20, 1988): 25; Carter Wiseman, "The New Zoo," *New York* 21 (July 18, 1988): cover, 26–33; "Opening Is Scheduled for Central Park Zoo," *New York Times* (July 20, 1988), B: 2; Susan Heller Anderson, "At Last, a Joy for All Ages: Central Park Zoo Is Back," *New York Times* (August 9, 1988), B: 1, 4; "Manhattan's Peaceable Kingdom," editorial, *New York Times* (August 10, 1988): 26; Linda Yang, "At New Zoo, a Menagerie of Plantings," *New York Times* (August 18, 1988), C: 1, 14; Kathleen A. Devine, Sue Gillet, and Julia Moreth, "Zoo Logic," letters to the editor, *New York* 21 (August 22, 1988): 10, 12; Jonathan Kuhn, "Central Park's New Zoo," *Metropolis* 8 (September 1988): 26–28; "The New Central Park Zoo," *Oculus* 51 (September 1988): 14–15; Paul Goldberger, "The New Zoo: At Home in Central Park," *New York Times* (September 25, 1988), II: 35; Sarah Rossbach, "Central Park Zoo," *Landscape Architecture* 79 (January 1989): 80–83; James S. Russell, "Zoo Story," *Architectural Record* (February 1989): 84–89; "Corrections," *Architectural Record* 177 (May 1989): 4; Peter Hellman, "Central Park's New Boutique Zoo," *New York* 22 (May 22, 1989): 36; Breskend, "The Flowering of Central Park": 26–35; Kevin Roche, "Central Park Zoo," *Architecture + Urbanism* (April 1990): 26–39; "Details," *Architecture* 79 (August 1990): 26; Sirefman, *New York*, 222–23.

65. Stern, Gilmartin, and Mellins, *New York 1930*, 710–12.
66. Gordon J. Davis, quoted in Wiseman, "The New Zoo": 28.
67. William G. Conway, quoted in Wiseman, "The New Zoo": 30.
68. Kevin Roche, quoted in Scheinin, "Tooth and Claw": 71.
69. For the Arsenal, see Stern, Mellins, and Fishman, *New York 1880*, 238, 240. For the Delacorte Clock, see Stern, Mellins, and Fishman, *New York 1960*, 772–73.
70. Kevin Roche, quoted in Wiseman, "The New Zoo": 30.
71. Wiseman, "The New Zoo": 31.
72. Goldberger, "The New Zoo: At Home in Central Park": 35.
73. Sirefman, *New York*, 222.
74. "The Talk of the Town: De-Acquisitioning," *New Yorker* 66 (February 18, 1991): 25. Also see Deborah Mitchell, "It's All Happening at the Central Park Petting Zoo," *New York Observer* (October 28, 1991): 1, 6; Jennifer Steinhauer, "F.Y.I.: Zoo Story," *New York Times* (March 6, 1994), XIII: 2; Douglas Martin, "Restoring the Children's Zoo, Seriously," *New York Times* (September 28, 1995), B: 1–2; Douglas Martin, "Rethinking Plans for Children's Zoo," *New York Times*

(November 2, 1995), B: 3; "New Zoo Too?" *Municipal Art Society Newsletter* (January-February 1996): 2; Douglas Martin, "War Over Zoo: A Fantasy Land Vs. Interaction," *New York Times* (March 19, 1996), B: 1, 6; Sanna Feirstein, "The Old Children's Zoo Did More than Educate," letter to the editor, *New York Times* (March 23, 1996): 20; Henry Stern, "Save the Central Park Children's Zoo? A Better One Is Coming," *New York Daily News* (March 28, 1996): 59; Robert A. M. Stern, "Save the Central Park Children's Zoo? Yes, It's a Great Treasure," *New York Daily News* (March 28, 1996): 59; Karrie Jacobs, "New Zoo Review," *New York* 29 (April 8, 1996): 20–21; Douglas Martin, "Plans Approved for New Central Park Children's Zoo," *New York Times* (April 18, 1996), B: 3; "Judge Allows Children's Zoo to Be Replaced," *New York Times* (May 4, 1996): 24; Douglas Martin, "At the 1961 Children's Zoo, a Last Goodbye to Jonah and Friends," *New York Times* (August 11, 1996): 33; David W. Dunlap, "$3 Million Zoo Gift Revoked Because Plaque Is Too Small," *New York Times* (May 15, 1997), B: 1, 12; Karen Demeter, "If the Plaque Doesn't Fit," letter to the editor, *New York Times* (May 17, 1997): 18; Lena Williams, "The Plaque's the Thing, but How Tall Are the Letters," *New York Times* (May 18, 1997): 29; Judith Miller, "Tisch to Match, and Raise, Revoked Gift to Children's Zoo," *New York Times* (May 20, 1997), B: 1, 6; Norimitsu Onishi, "Central Park Whale Faces Tattered Retirement," *New York Times* (May 26, 1997): 27; Karrie Jacobs, "There *Are* Children Here: Central Park's New Zoo," *New York* 30 (October 6, 1997): 24; Barbara Surk, "Castoff Whale Washes Up on a New Shore," *New York Observer* (November 30, 1997), XIV: 8. For the Children's Zoo, see Stern, Mellins, and Fishman, *New York 1960*, 772.

75. Margot Gayle, quoted in Martin, "War Over Zoo: A Fantasy Land Vs. Interaction": 6.
76. Stern, "Save the Central Park Children's Zoo? Yes, It's a Great Treasure": 59.
77. Jacobs, "New Zoo Review": 20.
78. Jacobs, "There *Are* Children Here: Central Park's New Zoo": 24.
79. "Central Park on Thin Ice," editorial, *New York Times* (January 23, 1975): 32; Judith Cummings, "'Friends of Central Park' Oppose Plan to Renovate Wollman Rink," *New York Times* (May 8, 1977): 21; David Bird, "Repairs at Wollman Rink Renew a 30-Year Dispute," *New York Times* (January 20, 1981): 38; David Bird, "Rink Plan Renews Old Debate," *New York Times* (March 26, 1981), B: 1, 5; "Thin Ice in Central Park," editorial, *New York Times* (June 24, 1981): 22; Deirdre Carmody, "Restaurant Expansion Backed by Parks Panel," *New York Times* (October 9, 1981): 1, B: 8; Coombs, "The Prince of Central Park": 29; Deirdre Carmody, "Restaurant at Wollman Ruled Out by Parks Unit," *New York Times* (March 10, 1982), B: 1; Mervyn Rothstein, "Wollman Rink," *New York Times* (July 11, 1982): 29; Carmody, "Central Park Renews Its Details and Vistas in a Burst of Repairs": 32; "Another Delay for Wollman Rink," *New York Times* (November 15, 1984), B: 3; Joseph Berger, "Stubborn Problems at Wollman Rink Give Skaters Scant Hope for Season," *New York Times* (December 31, 1984): 25; Josh Barbanel, "New Wollman Rink Delay Is Feared," *New York Times* (May 22, 1985), B: 3; Joyce Purnick, "City to Use Old Way to Rebuild Ice Rink After New Way Fails," *New York Times* (May 22, 1986): 1, B: 17; Joyce Purnick, "Trump Offers to Rebuild Skating Rink," *New York Times* (May 31, 1986): 29; Martin Gottlieb, "Who Can Fix the Wollman Rink Faster? City and Trump Agree It's Trump," *New York Times* (June 6, 1986), B: 1, 4; Suzanne Daley, "Trump to Rebuild Wollman Rink at the City's Expense by Dec. 15," *New York Times* (June 7, 1986): 1, 31; Joseph L. Coplan, "Icing on Rink Cake," letter to the editor, *New York Times* (June 14, 1986): 26; Alan Finder, "Wollman Rink: 6 Years of Errors and Delays," *New York Times* (June 17, 1986): 1, 24; Peter Blauner, "Ice Capades: Donald Trump Takes On the Wollman Rink," *New York* 19 (June 23, 1986): 25; "On the Wing," *Manhattan, inc.* 3 (August 1986): 11; "Rebuilding Wollman Memorial Rink," *New York Times* (August 6, 1986), B: 1; Susan Heller Anderson and David W. Dunlap, "Down at the Wollman," *New York Times* (August 7, 1986), B: 3; David W. Dunlap, "Icing," *New York Times* (October 9, 1986), B: 1; "After 6 Years, the Rink Is Ready, but the Weather Isn't," *New York Times* (October 24, 1986), B: 4; John S. Demott, "End of the Six-Year Ice Follies," *Time* 128 (November 10, 1986): 33; "Lessons of the Wollman Rink," editorial, *New York Times* (November 13, 1986): 30; Eleanor Blau, "A New Ice Age Starts at Wollman Rink," *New York Times* (November 14, 1986), B: 2; William E. Geist, "Pssst, Here's a Secret: Trump Rebuilds Ice Rink," *New York Times* (November 15, 1986): 35; Jeanie Kasindorf, "Trump Spurs Koch Rinksmanship," *New York* 19 (November 17, 1986): 15; Alan Finder, "New York Hopes to Learn from Rink Trump Fixed," *New York Times* (November 21, 1986), B: 1, 4; "The Talk of the Town: The Rink," *New Yorker* 62 (December 1, 1986): 30–31; Donald J. Trump with Tony Schwartz, *Trump: The Art of the Deal* (New York: Random House, 1987), 6, 11, 17–18, 24, 27, 43, 199–214, 237; Andrew Rosenthal, "Trump Reports Large Profit from Wollman Rink," *New York Times* (April 1, 1987), B: 3; "Trump Gets License for Skating Rinks," *New York Times* (July 25, 1987): 35; Susan Heller Anderson, "Trump to Run 2 Ice-Skating Rinks in Central Park," *New York Times* (October 15, 1987), B: 3; Richard Johnson, "Page Six: Trump Cracks Down Over Missing $$," *New York Post* (June 21, 1988): 6; "Up to Par: Plans for Wollman Rink," *New York* 22 (June 5, 1989): 10; Wayne Barrett, "Trump: The Beginning of the End," *Village Voice* (December 17, 1991): 35–44; Sirefman, *New York*, 220–21. For Wollman Rink, see Stern, Mellins, and Fishman, *New York 1960*, 763–65.

80. "Central Park on Thin Ice": 32.
81. Martin Lang, quoted in Cummings, "'Friends of Central Park' Oppose Plan to Renovate Wollman Rink": 21.
82. Carmody, "Central Park Renews Its Details and Vistas in a Burst of Repairs": 32.

83. Donald J. Trump, quoted in Purnick, "Trump Offers to Rebuild Skating Rink": 29.
84. Trump with Schwartz, *Trump: The Art of the Deal*, 208.
85. Anderson, "The Private Greening of Central Park": 6; Christopher Gray, "Streetscapes/The Naumburg Bandshell," *New York Times* (February 19, 1989), X: 12; Carter B. Horsley, "It May Be Taps on the Mall," *New York Post* (April 20, 1989): 41; Henry Hope Reed and Richard Roth Jr., "Park Bandshell," letters to the editor, *New York Times* (May 7, 1989): 20; David W. Dunlap, "Is Doomsday Near for Central Park Bandshell?" *New York Times* (December 20, 1991), B: 1, 4; Margot Gayle, "Central Park Bandshell Has Become Irrelevant," letter to the editor, *New York Times* (January 14, 1992): 22; "Let the Bandshell Play On," *New York Observer* (February 3, 1992): 3; David W. Dunlap, "Despite Protests, Panel Approves Razing of Central Park Band Shell," *New York Times* (January 19, 1992): 30; Douglass M. Mann, "Don't Tear Down the Naumburg Bandshell," letter to the editor, *New York Times* (January 27, 1992): 20; Marian Marchesani, "Strike Up the Band," letter to the editor, *New York Times* (January 27, 1992): 20; "The Naumburg Bandshell in Central Park," editorial, *New York Observer* (January 27, 1992): 4; Clare McHugh, "Central Park's Bandshell Falls Victim to New 'Vision,'" *New York Observer* (January 27, 1992): 1, 21; "Save the Naumburg Bandshell," editorial, *New York Observer* (February 3, 1992): 4; "The Band Shell Cannot Play On," editorial, *New York Times* (February 8, 1992): 20; "And the Bandshell Played On," editorial, *New York Observer* (February 10, 1992): 4; Clare McHugh, "The Endless Flimflam," *New York Observer* (February 10, 1992): 3; David W. Dunlap, "For Central Park Band Shell, a 10-Day Reprieve," *New York Times* (February 11, 1992), B: 4; David W. Dunlap, "Line Begins to Form for Unwanted Band Shell," *New York Times* (February 14, 1992), B: 3; Clare McHugh, "Moving Monument," *New York Observer* (February 24, 1992): 3; W. H. von Dreele, "Bandshell Negatives," *New York Observer* (March 2, 1992): 5; Terry Golway, "Conservancy Patrons Urged to Halt Funds in Bandshell Battle," *New York Observer* (March 16, 1992): 1, 5; Jeannette Walls, "News and Notes from All Over," *New York* 25 (March 30, 1992): 10; "Conservancy Yea, Bandshell No," editorial, *New York Observer* (March 30, 1992): 4; "*In the Mood*, but in the Way," *Architectural Record* 180 (April 1992): 32; "Bandshell Countdown," *New York Observer* (April 20, 1992): 1; Clare McHugh, "Campaigning for Preservation," *New York Observer* (April 27, 1992): 3; "Bandshelled," editorial, *New York Observer* (May 4, 1992): 3; Jack Taylor, "Wanton Improvement?" letter to the editor, *New York Observer* (May 4, 1992): 4; David Evan Bright, "Bandshell on the Map," letter to the editor, *New York Observer* (May 18, 1992): 4; Glenn Loney, "Homeless off the Map," letter to the editor, *New York Observer* (May 18, 1992): 4; Christopher Gray, "Streetscapes/Monumental Parallels," *New York Times* (May 10, 1992), X: 7; Margaret H. Moore and Michael Alcamo, "Dueling Bandshells," letters to the editor, *New York Observer* (June 1, 1992): 4; "Bid for Central Park Band Shell," *New York Times* (June 10, 1992), B: 7; Robin Pogrebin, "Naumberg Heir Sues to Save Bandshell," *New York Observer* (June 15, 1992): 1, 24; Harry L. Langer, "Save the Band Shell and Keep Central Park for All New Yorkers," letter to the editor, *New York Times* (June 25, 1992): 30; Colin Amery, "New York's Oasis of the Park," *Financial Times* (London) (July 13, 1992): 9; Ronald Sullivan, "Judge Tells New York to Save Its Band Shell in Central Park," *New York Times* (July 16, 1992), B: 3; "The City Scene,'" *Friends of the Upper East Side Historic Districts Newsletter* (Fall/Winter 1992): 6; Peter Slatin, "Scope/Bandshell," *Oculus* 55 (October 1992): 10; Clare McHugh, "Battle Over Central Park Bandshell Isn't Played Out Yet," *New York Observer* (October 5, 1992): 19; Hugo Lindgren, "Central Park's Bandshell Blues," *Metropolis* 12 (April 1993): 16; Richard Pérez-Peña, "Court Blocks Demolishing Band Shell," *New York Times* (February 11, 1993), B: 11; Ronald Sullivan, "Court Blocks Plan to Raze Band Shell," *New York Times* (July 9, 1993), B: 1, 3; Allen Freeman, "Shell Game," *Historic Preservation* 45 (September-October 1993): 38–43, 91–92, 96; Ben Sisario, "Waging a Mission to Save a Family Heirloom," *New York Times* (August 4, 2002), XIV: 5.

86. Quoted in Pogrebin, "Naumberg Heir Sues to Save Bandshell": 24.
87. Betsy Gotbaum and Christopher London, quoted in Dunlap, "Is Doomsday Near for Central Park Bandshell?": 1.
88. Eugene Nardelli, quoted in Sullivan, "Judge Tells New York to Save Its Band Shell in Central Park": 3.
89. Grace Glueck, "Hoving Will Leave Met Next Year; Says It's Time for New Leadership," *New York Times* (November 5, 1976): 41; Hilton Kramer, "Hoving Era at the Met, Decade of Change, Ends," *New York Times* (June 30, 1977): 57.
90. Stern, Mellins, and Fishman, *New York 1960*, 788–97.
91. Grace Glueck, "Annenberg Offers Metropolitan Museum $20 Million for Art Communications Center Headed by Hoving," *New York Times* (November 11, 1976): 1, 49; Grace Glueck, "Met's New Annenberg Center Stirs Controversy," *New York Times* (February 27, 1977): 77–78; Barbara Goldsmith, "The Annenberg Affair: Mystery at the Met," *New York* 10 (March 7, 1977): 31–37; Grace Glueck, "Annenberg Halts $40 Million Gift for Arts Center," *New York Times* (March 16, 1977): 1, 16; "Annenberg Asks U. of Pennsylvania to Develop Visual Education Plan," *New York Times* (May 17, 1977): 24; Walter Hoving, *Making the Mummies Dance: Inside the Metropolitan Museum of Art* (New York: Simon & Schuster, 1993), 419–29.
92. For Roche Dinkeloo's work, see Stern, Mellins, and Fishman, *New York 1960*, 788–97. For de Montebello's appointment, see Grace Glueck, "Acting Director at Met Museum," *New York Times* (June 23, 1977): 66; Leah Shanks Gordon, "Help Wanted at the Met," *New York Times* (June 26, 1977), VI: 13–15, 40, 42, 46, 51; Grace Glueck, "De Montebello in Line to

Direct Met," *New York Times* (May 17, 1978), C: 23; Calvin Tomkins, "The Importance of Being Elitist," *New Yorker* 73 (November 24, 1997): 58, 60, 62–65, 67–69.

93. David A. Morton, "Lower Nubia to Upper Fifth," *Progressive Architecture* 49 (November 1978): 22–23; Grace Glueck, "Treasures of Tut Glitter in Daylight," *New York Times* (December 12, 1978), B: 1, 16; Ada Louise Huxtable, "'Towering' Achievements of '78," *New York Times* (December 31, 1978), II: 21, 24; David Morton, "Tipping the Scales," *Progressive Architecture* 60 (May 1979): 98–101; Suzanne Stephens, "What Becomes a Monument Most?" *Progressive Architecture* 60 (May 1979): 87–89; Paul Goldberger, "Architecture: Under Limestone and Glass," *New York Times* (May 19, 1980), C: 15; William Marlin, "The Metropolitan Museum as Amended," *Journal of the American Institute of Architects* 70 (May 1981): 28–41; Dal Co, *Kevin Roche*, 146–48; "Temple of Dendur Pavilion," *Architecture + Urbanism* (August 1987): 80–81; Stephen J. Dubner, "Pennies (And Lire, Too) in the Fountain," *New York* 24 (November 11, 1991): 34; Philippe de Montebello, "The Met and the New Millennium," *Bulletin of the Metropolitan Museum of Art* 52 (Summer 1994): 33–36; Morrison H. Heckscher, "The Metropolitan Museum of Art: An Architectural History," *Bulletin of the Metropolitan Museum of Art* 53 (Summer 1995): 72; Sirefman, *New York*, 200, 202; Victoria Newhouse, *Towards a New Museum* (New York: Monacelli Press, 1998), 144; White and Willensky, *AIA Guide* (2000), 421; Alan Balfour, *World Cities: New York* (New York: Wiley Academy, 2001), 137–39. Also see Stern, Mellins, and Fishman, *New York 1960*, 795–97.

94. Huxtable, "'Towering' Achievements of '78": 21.

95. Grace Glueck, "The Met Reclaims More Than 500 19th Century Treasures," *New York Times* (March 23, 1980), II: 1, 29; Ada Louise Huxtable, "The New Galleries Are 'Near Perfect,'" *New York Times* (March 23, 1980), II: 1, 29; Manuela Hoelterhoff, "The Met's New Wing of 19th Century Art," *Wall Street Journal* (May 13, 1980): 24; "Metropolitan Museum of Art Opens Two Wings," *Progressive Architecture* 61 (July 1980): 42, 47; Marlin, "The Metropolitan Museum as Amended": 36–37; Dal Co, *Kevin Roche*, 146; "Andre Meyer Galleries," *Architecture + Urbanism* (August 1987): 86; Newhouse, *Towards a New Museum*, 144; White and Willensky, *AIA Guide* (2000), 421.

96. Huxtable, "The New Galleries Are 'Near Perfect'": 1, 29.

97. Hoelterhoff, "The Met's New Wing of 19th Century Art": 24.

98. Clare McHugh, "Meyer Galleries Lost in Met Shuffle," *New York Observer* (April 8, 1991): 1, 3; Glenn Collins, "A Major Renovation of Met Museum's Impressionist Halls," *New York Times* (September 16, 1991), C: 13–14; Gary Tinterow, Susan Alyson Stein, and Barbara Burn, *The New Nineteenth-Century European Paintings and Sculpture Galleries* (New York: Metropolitan Museum of Art, 1993); Glenn Collins, "The Metropolitan Museum Rebuilds the Past," *New York Times* (September 13, 1993), C: 13, 16; Michael Kimmelman, "The Met Moves Things Around," *New York Times* (September 19, 1993), II: 40–41; Jayne Merkel, "Neo-Neoclassicism at the Metropolitan," *Architecture* 83 (February 1994): 39; Gary Tinterow, Brian J. Billings, John Robbins, and Stephen Falatko, "Defending the Met," letters to the editor, *Architecture* 83 (May 1994): 18; de Montebello, "The Met and the New Millennium": 65–67; Thomas Hine, "Design," *Philadelphia Inquirer* (May 7, 1995): 20; Newhouse, *Towards a New Museum*, 146–47; White and Willensky, *AIA Guide* (2000), 421.

99. Philippe de Montebello, quoted in Collins, "The Metropolitan Museum Rebuilds the Past": 13.

100. Gary Tinterow, quoted in Collins, "The Metropolitan Museum Rebuilds the Past": 13.

101. Kimmelman, "The Met Moves Things Around": 40.

102. Paul Goldberger, "Museum and Park Mark Century of Land Rivalry," *New York Times* (April 26, 1980): 1; Hoelterhoff, "The Met's New Wing of 19th Century Art": 24; Grace Glueck, "The Ultimate Renovation Job: Moving at the Met," *New York Times* (May 15, 1980), C: 1, 6; Goldberger, "Architecture: Under Limestone and Glass": 15; Hilton Kramer, "Art: Met's New American Wing Is a Museum in It's Own Right," *New York Times* (May 19, 1980), C: 15; John Corry, "Americana Wing at Met Dedicated," *New York Times* (May 20, 1980), C: 9; Ada Louise Huxtable, "A 'Beautiful' Showplace for American Art," *New York Times* (May 25, 1980), II: 1, 32; "New American Wing Opens at Metropolitan Museum," *Architectural Record* 168 (July 1980): 39; "Metropolitan Museum of Art Opens Two Wings": 42, 47; Ada Louise Huxtable, "The Boom in Bigness Goes On," *New York Times* (December 28, 1980), D: 25; Marlin, "The Metropolitan Museum as Amended": 28–29, 38–41; Dal Co, *Kevin Roche*, 146, 151; "American Wing," *Architecture + Urbanism* (August 1987): 84–85; de Montebello, "The Met and the New Millennium": 37–40; Heckscher, "The Metropolitan Museum of Art: An Architectural History": 72, 75–76; Sirefman, *New York*, 202–3; White and Willensky, *AIA Guide* (2000), 421; Balfour, *World Cities: New York*, 137–38.

103. Goldberger, "Museum and Park Mark Century of Land Rivalry": 18.

104. Goldberger, "Architecture: Under Limestone and Glass": 15.

105. Huxtable, "A 'Beautiful' Showplace for American Art": 1, 32.

106. Richard F. Shepard, "Metropolitan to Get Chinese Garden Court and Ming Room," *New York Times* (January 17, 1979), B: 4; Jane Geniesse, "At the Met, 27 Chinese Build Ming Garden and Good Will," *New York Times* (January 27, 1980): 38; Marlin, "The Metropolitan Museum as Amended": 36–37, 39; Audrey Topping, "A Chinese Garden Grows at the Met," *New York Times* (June 7, 1981), VI: 38–41, 60, 64, 66, 68, 70; "Chinese Court," *Architecture + Urbanism* (August 1987): 86;

de Montebello, "The Met and the New Millennium": 45.

107. Marlin, "The Metropolitan Museum as Amended": 39.

108. Marlin, "The Metropolitan Museum as Amended": 36; Grace Glueck, "Met's Rockefeller Wing Set to Open," *New York Times* (December 3, 1981), C: 24; Grace Glueck, "A Spectacular New Wing," *New York Times* (January 24, 1982), VI: 20–21, 23, 25, 27, 29, 68; Paul Goldberger, "Architecture: Primitives in Space," *New York Times* (February 3, 1982), C: 1, 24; "Met's New Rockefeller Wing: Sleek Setting, Primitive Art," *Journal of the American Institute of Architects* 71 (April 1982): 62–63; Douglas Newton, "Rockefeller Wing," letter to the editor, *Journal of the American Institute of Architects* 71 (June 1982): 6; Dal Co, *Kevin Roche*, 146; "Michael C. Rockefeller Primitive Art Wing," *Architecture + Urbanism* (August 1987): 82; de Montebello, "The Met and the New Millennium": 41–42; Heckscher, "The Metropolitan Museum of Art: An Architectural History": 72; Newhouse, *Towards a New Museum*, 144; White and Willensky, *AIA Guide* (2000), 421.

109. Goldberger, "Architecture: Primitives in Space": 24.

110. Grace Glueck, "City Weighs $8 Million for Met Museum Wing," *New York Times* (April 14, 1982): 1, C: 17; Michael Brenson, "Newest Wing at Met Completes First Phase," *New York Times* (September 18, 1983), C: 13; David W. Dunlap, "Rooftop of Sculpture Planned for Met," *New York Times* (October 24, 1984), B: 4; Dal Co, *Kevin Roche*, 146; Grace Glueck, "The Art Boom Sets Off a Museum Building Spree," *New York Times* (June 23, 1985), II: 1, 14; Douglas C. McGill, "Metropolitan Museum Unveils $26 Million Wing," *New York Times* (March 28, 1986), C: 33; Joanna Wissinger, "Metropolitan's New 20th-Century Wing," *Progressive Architecture* 67 (June 1986): 25; Cynthia Nadelman, "Corporate Culture," *Manhattan, inc.* 3 (August 1986): 139–43; "A New Wing for the Metropolitan Museum of Art," *L'Architecture d'Aujourd'hui* 247 (October 1986): xix; Kay Larson, "The Met Goes Modern," *New York* 19 (December 15, 1986): 40–48; Grace Glueck, "Collections Connoisseur," *New York Times* (January 21, 1987), C: 17; Paul Goldberger, "Architecture: Bland Without, a Marvel Within," *New York Times* (January 21, 1987), C: 17; John Russell, "Art: Unexpected Juxtapositions in the Met's New Wing," *New York Times* (January 21, 1987), C: 17; Sylvia Hochfield, "Thoroughly Modern Met," *Art News* 86 (February 1987): 112–17; Robert Hughes, "Another Temple for Modernism," *Time* 129 (February 2, 1987): 78–79; Gary Indiana, "Ill Met," *Village Voice* (February 3, 1987): 84; "Met Opens Wallace Wing," *Art in America* 75 (March 1987): 168; Hilton Kramer, "The Met's 20th-Century Folly," *New Criterion* 6 (March 1987): 1–3; Michael Brenson, "Large Spaces, Large Questions at the Met," *New York Times* (March 15, 1987), II: 35; Manuela Hoelterhoff, "Vast New Wallace Wing Opens at Met Museum," *Wall Street Journal* (March 17, 1987): 30; Joseph Giovannini, "Museum Piece," *Artforum* 25 (April 1987): 8–9; Jane Addams Allen, "The Met Strikes Out," *New Art Examiner* 14 (April 1987): 18–20; "Metropolitan Museum of Art: Wallace Wing for Twentieth Century Art," *Architecture + Urbanism* (April 1988): 120–27; Margaret Moorman, "Up On the Roof," *Art News* 87 (Summer 1988): 42–43; Heckscher, "The Metropolitan Museum of Art: An Architectural History": 72; Sirefman, *New York*, 202; Newhouse, *Towards a New Museum*, 145–46; White and Willensky, *AIA Guide* (2000), 421; Balfour, *World Cities: New York*, 137–38.

111. Giovannini, "Museum Piece": 8–9.

112. "News Briefs," *Architectural Record* 173 (November 1985): 67; "The Metropolitan Museum," *Progressive Architecture* 66 (November 1985): 24; Grace Glueck, "Work Begins on the Met's New European Wing," *New York Times* (December 6, 1986): 10; Douglas C. McGill, "Tisches Give $10 Million to Met for New Galleries," *New York Times* (June 4, 1987), C: 21; Douglas C. McGill, "City Giving $13.5 Million for Met Wing," *New York Times* (June 30, 1987), C: 13; Grace Glueck, "$10 Million Is Pledged for Met Sculpture Court," *New York Times* (August 7, 1987), C: 20; Douglas C. McGill, "$10 Million Gift for New Met Wing," *New York Times* (December 9, 1987), C: 25; "Museums in Expansion," *New York Observer* (October 10, 1988): 2; Paul Goldberger, "A Garden Gives Itself Airs at the Met," *New York Times* (December 9, 1990), II: 32, 44; "Final Piece of Met's Expansion Puzzle," *Architectural Record* 179 (June 1991): 37; P. Cannon-Brookes, "Carroll and Milton Petrie European Sculpture Court at the Metropolitan Museum of Art," *Museum Management and Curatorship* 11 (September 1992): 306–8; de Montebello, "The Met and the New Millennium": 50–58; Heckscher, "The Metropolitan Museum of Art: An Architectural History": 72, 75–76; Sirefman, *New York*, 201–2; White and Willensky, *AIA Guide* (2000), 421; Balfour, *World Cities: New York*, 137, 140.

113. For Vaux and Mould's and Weston's work at the Metropolitan, see Stern, Mellins, and Fishman, *New York 1880*, 176–82.

114. Goldberger, "A Garden Gives Itself Airs at the Met": 32.

115. Carol Vogel, "Met Museum Seeks $300 Million for an Array of New Projects," *New York Times* (October 6, 1994), C: 17; "Details," *Architecture* 83 (November 1994): 29; "A $20 Million Bequest," *Oculus* 58 (December 1995): 3; Beth Landman Keil and Deborah Mitchell, "Raising the Roof," *New York* 30 (March 10, 1997): 12; Elaine Louie, "Met Museum Carves New Space from the Air," *New York Times* (June 5, 1997), C: 3; Calvin Tomkins, "Out of the Attic," *New Yorker* 75 (April 19, 1999): 100–104; Michael Kimmelman, "Glory Comes Home to the Classics," *New York Times* (April 20, 1999), E: 1, 3; Kathryn Shattuck, "Making the Marble Come Alive: Just Let the Daylight Stream In," *New York Times* (April 20, 1999), E: 3; Anne Midgette, "The Met's New Greek and Roman Galleries," *Wall Street Journal* (April 20, 1999): 20; "The Met's Greek Galleries," editorial, *New York Times* (April 21, 1999): 22; Garry Wills, "Athens on Fifth Avenue," *New York Review of Books* (June 10, 1999): 38–40.

116. Kimmelman, "Glory Comes Home to the Classics": 1.

117. "The Met's Greek Galleries": 22.

UPPER WEST SIDE

HISTORIC DISTRICTS

1. For the Riverside-West End Historic District, see David W. Dunlap, "West Side Sites to Be Weighed as Landmarks," *New York Times* (November 17, 1986), B: 3; David W. Dunlap, "A Large West Side Landmark District Proposed," *New York Times* (May 7, 1987), B: 6; Anthony DePalma, "Preserving Upper West Side History," *New York Times* (December 27, 1987), VIII: 1, 7; Landmarks Preservation Commission of the City of New York, *Riverside-West End Historic District Designation Report* (New York, 1989); "New Historic District: West Side Preservation," *New York Times* (December 31, 1989), X: 1; "Historic District Designation," *Municipal Art Society Newsletter* (February 1990); Leonard Buder, "Upper West Side Area Named Historic District," *New York Times* (March 9, 1990), B: 3; Steven Saltzman, "A New Historic District," *Metropolis* 8 (April 1990): 21; Barbaralee Diamonstein, *The Landmarks of New York III* (New York: Harry N. Abrams, 1998), 515. For the Upper West Side-Central Park West Historic District, see Dunlap, "West Side Sites to Be Weighed as Landmarks," *New York Times* (November 17, 1986): 3; "Hearing Set for Proposed Central Park West District," *New York Landmarks Conservancy Newsletter* 4 (Fall 1987); DePalma, "Preserving Upper West Side History": 1, 7; Ginger Danto, "West Side Historic District Proposed," *New York Observer* (December 28, 1987): 11; Anthony DePalma, "Lindsay, in Rare Move, Backs Historic District," *New York Times* (January 13, 1988), B: 3; Karen Winner, "Landmark Zone Protest Is Aired," *The Westsider* (January 14–20, 1988): 1, 6; Jean Behrend, "Wide Support for West Side Landmark District," *New York Observer* (January 25, 1988): 8; "Jackie Joins West Side Battle," *New York* 21 (January 18, 1988): 12; Landmarks Preservation Commission of the City of New York, *Upper West Side-Central Park West Historic District* (New York, 1990); "Upper West Side/Central Park West Historic District," *District Lines* 5 (Autumn 1990): 2; "West Side Story," *New York Times* (November 18, 1990), X: 1; Diamonstein, *The Landmarks of New York III*, 516.

2. The previously landmarked historic districts included the Central Park West-West 76th Street and Riverside Drive-West 105th Street districts, both landmarked on April 19, 1973; the Central Park West-West 73rd-74th Street Historic District (July 12, 1977); the West End-Collegiate Historic District (January 3, 1984); the Riverside Drive-West 80th-81st Street Historic District (March 26, 1985); and the West 71st Street Historic District (August 29, 1989). See Diamonstein, *The Landmarks of New York III*, 497–98, 503, 510–11, 515.

3. DePalma, "Preserving Upper West Side History": 1.

4. Andrew Dolkart, quoted in Danto, "West Side Historic District Proposed": 11.

5. John V. Lindsay, quoted in DePalma, "Lindsay, in Rare Move, Backs Historic District": 3.

6. Charles Austin, "Church Battling Landmark Status," *New York Times* (March 21, 1982): 39; Josh Barbanel, "Houses of Worship Take Landmark Fight to Albany," *New York Times* (June 15, 1983), B: 1, B: 6; G. Morris Gurley and Floyd E. George 3d, "Preservationists vs. Freedom of Religion," letter to the editor, *New York Times* (July 2, 1983): 20; George M. Raymond, "When a Landmark Label Causes Hardship," letter to the editor, *New York Times* (July 16, 1983): 22; David Margolick, "Church's Fight on Landmarks," *New York Times* (January 31, 1984), B: 1, 4; Paul Goldberger, "Who Owns Landmarks?" *Preservation News* 24 (March 1984): 4, 10; Joseph Berger, "Church Seeks End to Status as Landmark," *New York Times* (September 3, 1986), B: 1; "Verbatim: Costly Esthetics," *New York Times* (September 7, 1986), IV: 7; Jeanie Kasindorf, "Church Goes for More Than Money," *New York* 19 (September 22, 1986): 18; Ronald Gibson, "New York Should Save St. Paul and St. Andrew," letter to the editor, *New York Times* (September 22, 1986): 20; Lynn Nesmith, "Religious Groups Wage Legal Battles Over Preservation Law," *Architecture* 75 (November 1986): 16; "Top Court Denies Appeal of West Side Church on Landmark Status," *New York Times* (December 2, 1986), B: 4; Christopher Gray, "Streetscapes: The Church of St. Paul and St. Andrew," *New York Times* (April 19, 1987), VIII: 12; David W. Dunlap, "Developer Wins a Point in Fight On Landmarks," *New York Times* (December 19, 1988), B: 3; Audrey Farolino, "Saints Under Siege," *New York Post* (February 9, 1989): 28; David W. Dunlap, "Fate of Church Divides a Neighborhood," *New York Times* (March 19, 1989): 34; David W. Dunlap, "Landmark Panel Vetoes Request to Raze Church," *New York Times* (May 10, 1989), B: 3; Lou Chapman, "Demolition of Church Barred," *New York Observer* (May 22, 1989): 8; "Landmark Church Won't Be Razed," *Municipal Art Society Newsletter* (June 1989): 2; Thomas J. Lueck, "The Struggle to Preserve Old Churches," *New York Times* (March 18, 1990), X: 1, 11; Alan S. Oser, "Perspectives: Landmarks Appeals," *New York Times* (June 16, 1991), X: 5. Also see Landmarks Preservation Commission of the City of New York, LP-1126 (November 24, 1981); Maurice Carroll, "Landmark Status Voted for Warburg Mansion," *New York Times* (November 25, 1981), B: 1, 9; Diamonstein, *The Landmarks of New York III*, 226. For Robertson's building, see Stern, Gilmartin, and Massengale, *New York 1900*, 370.

7. Gurley and Floyd E. George 3d, "Preservationists vs. Freedom of Religion": 20.

8. Rev. Floyd George, quoted in Austin, "Church Battling Landmark Status": 39.

9. Quoted in Dunlap, "Landmark Panel Vetoes Request to Raze Church": 3.

10. David W. Dunlap, "Tower Proposed for Central Park West," *New York Times* (August 24, 1983), B: 1, 20; David W.

Dunlap, "Temple's Building Plans Criticized by Neighbors," *New York Times* (July 5, 1983), B: 3; David W. Dunlap, "Synagogue Looks Up, but Not as High," *New York Times* (November 1, 2002), B: 6. For Brunner & Tryon's building, see Stern, Gilmartin, and Massengale, *New York 1900*, 392.

11. Peter Kihss, "Former Synagogue on West Side Sold to Developers for $2.4 Million," *New York Times* (June 30, 1981), B: 12; Landmarks Preservation Commission of the City of New York, LP-1272 (February 9, 1982); Dorothy J. Gaiter, "Synagogue's Landmark Status Debated," *New York Times* (April 4, 1982): 34; Deirdre Carmody, "Landmark Hardship Plea Backed," *New York Times* (July 24, 1982): 27; David W. Dunlap, "Landmarks Panel Permits Owner to Raze Synagogue," *New York Times* (February 9, 1983): B: 3; "Judge Bars Razing of City Landmark," *New York Times* (February 11, 1983), B: 3; "Landmark Razing Delayed by Court," *New York Times* (March 23, 1983), B: 3; "Names and News," *Oculus* 44 (April 1983): 7; Richard Bernstein, "Builder Offers a Deal to Save 79th St. Temple," *New York Times* (June 13, 1983), B: 3; Sara Rimer, "A Block Group on West Side Revives Neighborhood Spirit," *New York Times* (May 11, 1986): 28. For Schneider's building, see Stern, Gilmartin, and Mellins, *New York 1930*, 155, 160.

LINCOLN CENTER

1. For Lincoln Center, see Stern, Mellins, and Fishman, *New York 1960*, 676–717.

2. Jane Jacobs, *The Death and Life of Great American Cities* (New York: Random House, 1961), 25, 168–69. Also see Martin Bloom, "Cultural Colossi: Lincoln Center at 19," *Journal of the American Institute of Architects* 70 (August 1981): 32–39; Roberta Brandes Gratz, "Lincoln Center at 20: Bringing Down the House," *Metropolis* 2 (October 1982): 13–14; Sharon Lee Ryder, "Lincoln Center at 20: Cultural Complexes," *Metropolis* 2 (October 1982): 9; Robert Zwirn, "Lincoln Center at 20: Six Architects in Search of a Style," *Metropolis* 2 (October 1982): 10–12.

3. Stern, Mellins, and Fishman, *New York 1960*, 688–91.

4. Nory Miller, "Brightening Dark Corners," *Journal of the American Institute of Architects* 168 (October 1979): 46–47; *Charles Gwathmey and Robert Siegel: Buildings and Projects, 1964–1984* (New York: Harper & Row, 1984), 174–75; Monica Geran, "Lincoln Center Offices," *Interior Design* 56 (September 1985): 308–11.

5. *Charles Gwathmey and Robert Siegel: Buildings and Projects, 1964–1984*, 232–33.

6. A. O. Sulzberger Jr., "Lincoln Center's Worn Plazas to Be Restored," *New York Times* (September 11, 1981), B: 1, 4.

7. Richard F. Shepard, "At Lincoln Center, It's Regilding Time," *New York Times* (April 23, 1990), B: 1, 5.

8. "Big Apple Circus Will Open Dec. 4," *New York Times* (October 16, 1981), C: 3.

9. Robert A. M. Stern, quoted in Anne Raver, "Cherishing Landscapes as Living Art," *New York Times* (November 30, 1995), C: 1, 6. Also see André R. Mirabelli, "Lincoln Center's Vision," letter to the editor, *New York Times* (December 28, 1995), C: 9; Dan Kiley and Jane Amidon, *Dan Kiley: The Complete Works of America's Master Landscape Architect* (Boston: Bulfinch Press, 1999), 57; Anne Raver, "When It Goes It's Gone: Manhattan's Vanishing Oases," *New York Times* (December 2, 1999), F: 1, 7.

10. Harold C. Schonberg, "A Physical and Acoustic Facelift Waits in the Beaumont's Wings," *New York Times* (March 20, 1981), C: 3; John Rockwell, "Redesign of Beaumont and State Theater Set with $8 Million Gift," *New York Times* (May 15, 1981): 1, C: 4; Eleanor Blau, "Pei Quitting Project in Acoustic Dispute Over the Beaumont," *New York Times* (February 24, 1982): 1, C: 19; "Former Commission," *Progressive Architecture* 63 (April 1982): 41; Carol Lawson, "Renovation of Beaumont Is in Doubt," *New York Times* (July 19, 1982), C: 14; Harold C. Schonberg, "Troubles Stalk the Beaumont," *New York Times* (January 17, 1983), C: 15; Harold C. Schonberg, "Tensions Over Beaumont Are Increasing," *New York Times* (August 18, 1983), C: 15; Harold C. Schonberg, "Lincoln Center Moves Against the Beaumont," *New York Times* (August 25, 1983): 1, C: 14; Harold C. Schonberg, "Beaumont: Dark, and Now Isolated," *New York Times* (August 26, 1983): 1, C: 14; "Lincoln Center Actions Win Cautious Support," *New York Times* (August 26, 1983), C: 23; Harold C. Schonberg, "Beaumont: Must It Be Remodeled?" *New York Times* (September 1, 1983), C: 15; "The Beaumont Darkness," editorial, *New York Times* (September 8, 1983): 22; Harold C. Schonberg, "Beaumont Seeks Truce with Lincoln Center," *New York Times* (September 14, 1983), C: 20; "Bad News at the Beaumont," *Progressive Architecture* 64 (December 1983): 42; Harold C. Schonberg, "Debate Stirring Anew Over Beaumont Theater," *New York Times* (April 11, 1984), C: 18.

11. Harold C. Schonberg, "New Acoustics for State Theater," *New York Times* (January 9, 1981): 1, C: 24; Rockwell, "Redesign of Beaumont and State Theater Set with $8 Million Gift": 1, 4; Eleanor Blau, "Lincoln Center Shows Off Rebuilt State Theater," *New York Times* (August 25, 1982), C: 17; Bernard Holland, "Opera Opening Renovated State Theater," *New York Times* (September 7, 1982), C: 9; "Acoustics Renewed," *Progressive Architecture* 63 (October 1982): 27.

12. Peter Marks, "Beaumont Theater Plans Its Biggest Makeover," *New York Times* (December 13, 1995), C: 15, 20; William Weathersby Jr., "Hugh Hardy," *Theatre Crafts International* 32 (January 1998): 22; *Hardy Holzman Pfeiffer Associates: Buildings and Projects, 1992–1998* (New York: Rizzoli International Publications, 1999), 214; Bernard Gersten, "Musings on Architecture and the Theater: Unlikely Bedfellows," in *Hardy Holzman Pfeiffer Associates: Theaters* (Mulgrave, Australia: Images Publishing, 2000), 166–69, 209, 215.

13. "Lincoln Center Facility Study," *New York Times* (January 30, 1984), C: 13; Peter Freiberg, "A Tower Grows by Lincoln Center," *Metropolis* 4 (July-August 1984): 8–9; Alan

Finder, "2 Major New York Projects Advance," *New York Times* (July 10, 1986): 44; John Rockwell, "Lincoln Center Planning Major New Building," *New York Times* (October 11, 1984): 1, C: 19; Alan Finder, "West Side Coalition Opposes Towers Set for Lincoln Center," *New York Times* (August 12, 1986), B: 3; "Let Lincoln Center Grow," editorial, *New York Times* (August 13, 1986): 22; Alan Finder, "Neighbors Vow to Fight Lincoln Center Expansion," *New York Times* (August 16, 1986), B: 26; Al Amateau, "Lincoln Center Battle Clears Appeals Court," *The Westsider* (January 14–20, 1988): 3; Ron Alexander, "Metropolitan Diary," *New York Times* (January 20, 1988), C: 2; Peg Tyre and Jeannette Walls, "Lincoln Center Changes Tune," *New York* 21 (March 28, 1988): 12; Diana Shaman, "Condos Top 6th Building to Rise at Lincoln Center," *New York Times* (June 9, 1989), B: 6; Lee Wilmot, "Three Lincoln Center," *Urban Land* 48 (October 1989): 2–5; Holly Sraeel, "Lincoln Center," *7 Days* (November 1, 1989): 33; David W. Dunlap, "At Lincoln Center, a New Building Big Enough for All," *New York Times* (November 25, 1989): 13; Richard D. Lyons, "Real Estate," *New York Times* (March 21, 1990), D: 23; Eleanor Blau, "Lincoln Center Presents Its New Wing," *New York Times* (November 20, 1990), C: 22; Jennifer Dunning, "New Ballet School Opens, but Kirstein Worries" (January 9, 1991), C: 11; Vincent Canby, "A New Movie House Revives Memories of the Good Old Days," *New York Times* (December 9, 1991), C: 11; Allan Kozinn, "Juilliard Naming Dormitory for a Composer," *New York Times* (December 10, 1991), C: 20; Joel Weinberg, "1 Rm w/Great Vw, Popcorn," *New York* 24 (December 16, 1991): 18; Jennifer Dunning, "At Lincoln Center, a 'Black Box' for New Ideas," *New York Times* (February 22, 1992): 13; Naomi R. Pollock, "Davis Brody," *Interior Design* 64 (May 1993): 212–41; Susanna Sirefman, *New York: A Guide to Recent Architecture* (London: Ellipsis, 1997), 230–31.

14. Canby, "A New Movie House Revives Memories of the Good Old Days": 11. For the Ziegfeld Theater, see Stern, Mellins, and Fishman, *New York 1960*, 415.

15. "A Challenge to Euclid and Late Concertgoers," *New York Times* (July 9, 1996): 1; Ralph Blumenthal, "Debating a Sculpture with a Name and 4 Faces," *New York Times* (July 9, 1996), C: 11–12; "Sculptural Clock Wins a Vote," *New York Times* (July 11, 1996), C:15; Gordon Hyatt and Jascha Kessler, "Classy Lincoln Center Deserves a Classic Clock," letters to the editor, *New York Times* (July 13, 1996): 13; Marina Isola, "Protests Over New Face in a Public Park," *New York Times* (April 19, 1998), XIV: 7; Nina Siegal, "Mixed Notices for Clock Sculpture," *New York Times* (May 30, 1999), XIV: 5; Francis Morrone, "Statues and Civic Memory," *City Journal* 9 (Summer 1999): 96–101; *Philip Johnson/Alan Ritchie Architects* (New York: Monacelli Press, 2002), 82–85, 187; Stephen Fox, *The Architecture of Philip Johnson* (Boston: Bulfinch Press, 2002), 307; Timothy H. Buchman, "Park Vu, Tree Optional," letter to the editor, *New York Times* (March 3, 2002), IV: 14. For a similar sculptural work by Johnson, *Turning Point* (1996), located on the campus of Case Western Reserve University, Cleveland, see Fox, *The Architecture of Philip Johnson*, 306.

16. Joseph Volpe, quoted in Blumenthal, "Debating a Sculpture with a Name and 4 Faces": 12.

17. Morrone, "Statues and Civic Memory": 101.

18. Herbert Muschamp, "Lincoln Center's Enduring Vision," *New York Times* (July 19, 1996): C: 1, 25.

19. Bernard Holland, "A Music Mecca Loved but Reluctantly," *New York Times* (July 20, 1997), II: 1, 34. Also see Thomas G. Lunke, "Reknit the Fabric," letter to the editor, *New York Times* (December 3, 2000), II: 4.

20. David W. Dunlap, "Lincoln Center Wants to Build a Theater East of Broadway," *New York Times* (February 5, 1997), B: 1, 7; David W. Dunlap, "1926 Broadway: Behind the Facade," *New York Times* (March 2, 1997), IX: 1, 6; David W. Dunlap, "Street of Automotive Dreams," *New York Times* (July 7, 2000), E: 27; Barbara Stewart, "Dismantling Starts on Garage of a Bygone Era," *New York Times* (December 2, 2000), B: 4; Kelly Crow, "Lincoln Center," *New York Times* (February 17, 2002), IX: 6; David W. Dunlap, "Lincoln Square," *New York Times* (May 12, 2002), XIV: 6; Rachelle Garbarine, "264 Apartments in 2 Projects near Lincoln Center," *New York Times* (September 19, 2003), B: 8; Michael R. Stoler, "Luxury Residential Tower Rises on the West Side," *New York Sun* (May 20, 2004): 14.

21. David W. Dunlap, "Never Mind the Tired and Poor. Give Her a Home," *New York Times* (December 9, 2001), D: 3; Garbarine, "264 Apartments in 2 Projects near Lincoln Center": 8; Stoler, "Luxury Residential Tower Rises on the West Side": 14.

22. Ralph Blumenthal, "Midlife Hits Lincoln Center with Calls for Rich Face Lift," *New York Times* (June 1, 1999), B: 1, B: 8.

23. John D. Rockefeller III, quoted in Blumenthal, "Midlife Hits Lincoln Center with Calls for Rich Face Lift": 8.

24. Ralph Blumenthal, "Lincoln Center Gets $1.5 Billion Renovation Plan," *New York Times* (December 4, 1999): 1, B: 16; "Change Ahead at Lincoln Center," *Docomomo Newsletter* (Spring 2000): 4–5; Nina Rappaport, "Urban Complexes," *Oculus* 63 (November 2000): 10.

25. Myron Magnet, "The Cosmic Cathedral," *City Journal* 10 (Spring 2000): 116. Also see Henry Hope Reed, "Competing Visions," letter to the editor, *City Journal* 10 (Summer 2000): 117.

26. Myron Magnet, "A New Lincoln Center," *City Journal* 10 (Autumn 2000): 14–35. Also see Andrew Blum, "Modern New York Performance Hall in Neoclassicists' Sites," *Architecture* 89 (December 2000): 31.

27. Robert Adam, quoted in Ralph Blumenthal, "Roll Over, Moses: It's Centrum Lincolnensis," *New York Times* (November 8, 2000), E: 1.

28. Quoted in Magnet, "A New Lincoln Center": 19.

29. Bernard Holland, "Let's Rebuild the Sound, Too, Please,"

New York Times (November 19, 2000), II: 32.

30. Ralph Blumenthal, "Chief Is Selected for the Rebuilding of Lincoln Center," *New York Times* (June 29, 2000), B: 9, 14.

31. Ralph Blumethal, "Insider Is Chosen to Lead Lincoln Center," *New York Times* (October 27, 2000), B: 1, 3.

32. Ralph Blumenthal, "New York City Pledges $240 Million Toward the Overhaul of Lincoln Center," *New York Times* (January 19, 2001), E: 3; Herbert Muschamp, "Lincoln Center's Next Big Production: Itself," *New York Times* (January 21, 2001), II: 1, 46; "Corrections," *New York Times* (January 28, 2001), II: 4; Stephen R. Smith, Norman Rosenfeld, Theodore Prudon, Nina Rappaport, and Jay H. Lefkowitch, "Lincoln Center," letters to the editor, *New York Times* (February 4, 2001), II: 3.

33. Ralph Blumenthal, "Met Opera Rejects Plan for Renovation of Lincoln Center,"*New York Times* (January 24, 2001): 1, B: 4; Ralph Blumenthal and Robin Pogrebin, "Lincoln Center Renovation Plan Has Opera Houses at Odds," *New York Times* (January 25, 2001), B: 1, 6; "Planning Lincoln Center Anew," editorial, *New York Times* (January 29, 2001): 22; Betsy McCaughey, "Buildings Should Last," letter to the editor, *New York Times* (February 5, 2001): 20; "With or Without Met, Lincoln Center Plans $1.5 Billion Renovation," *Architectural Record* 189 (March 2001): 27; Ralph Blumenthal, "Met Discusses Rejoining Project at Lincoln Center," *New York Times* (March 9, 2001), B: 2; Ralph Blumenthal, "Met Is Ready to Rejoin Lincoln Center Redevelopment Plans Under New Rules," *New York Times* (March 19, 2001), E: 1, 3; Robin Pogrebin, "Met Is Rejoining the Project to Renovate Lincoln Center," *New York Times* (May 4, 2001), E: 5.

34. Ralph Blumenthal, "Lincoln Center Considers a Dome and More to Enliven Its Central Plaza," *New York Times* (May 14, 2001), E: 1–2; "Gehry and the Met on Board with Lincoln Center Plans," *Architectural Record* 189 (June 2001): 43; "Off the Record," *Architectural Record* 189 (July 2001): 30; "Redevelopment of Lincoln Center, New York, New York," *GA Document* 68 (March 2002): 86–87.

35. Ralph Blumenthal, "Lincoln Center Sees Chief Quit in Abrupt Exit," *New York Times* (September 29, 2001): 1, 14; Robin Pogrebin, "Now, Plans Have to Be Revised Yet Again," *New York Times* (September 29, 2001): 14; Elisabeth Franck and Andrew Rice, "Why Gordon Davis Left After Months at Lincoln Center," *New York Observer* (October 8, 2001): 1, 8; Ralph Blumenthal and Robin Pogrebin, "Conflicts Split Lincoln Center, with Redevelopment Project at Core," *New York Times* (October 11, 2001), E: 1, 8; "Where Lincoln Center Stands," editorial, *New York Times* (October 16, 2001): 22; Joseph Volpe, "Lincoln Center Renewal," letter to the editor, *New York Times* (October 18, 2001): 26; Robin Pogrebin, "Chairman of Lincoln Center Redevelopment Resigns," *New York Times* (October 23, 2001), D: 1–2.

36. Ralph Blumenthal, "Seeking City Money, Lincoln Center Submits Its Renovation Plans," *New York Times* (November 7, 2001), E: 1, 6; Evan and Freda Eisenberg, "The Public's Stake in a Cultural Crossroads," *New York Times* (December 2, 2001), II: 1, 28; Anthony Tommasini, "Beyond Renovation, into the Stuff of Dreams," *New York Times* (December 4, 2001), E: 1, 4; "Shuffling the Deck," *Wall Street Journal* (December 20, 2001): 13; "New York City Reviews Lincoln Center Plan," *Architectural Record* 190 (January 2002): 34.

37. "Plan for Building Jewish Cultural Center in Lincoln Center Area Hailed by Beame," *New York Times* (December 1, 1976), D: 22; Eleanor Blau, "Prize-Winning Cellist Tests New Hall," *New York Times* (December 1, 1978), C: 12; Peter G. Davis, "Music: Rosen-Sanders Recital Is First in New Concert Hall," *New York Times* (December 4, 1978), C: 18; Paul Goldberger, "Architecture: 4 Honor Buildings," *New York Times* (June 18, 1979), C: 13; Mildred F. Schmertz, "A Friendly New Neighbor for Lincoln Center: The Abraham Goodman House by Johansen & Bhavnani," *Architectural Record* 165 (April 1979): 125–29; Ashok Bhavnani, "Abraham Goodman House," *Theatre Design & Technology* 16 (1980): 4–8; Peter George, "Technical Criteria and Design Methods," *Theatre Design & Technology* 16 (1980): 8–11; Francis Booth, "An Architectural Evaluation," *Theatre Design & Technology* 16 (1980): 11–12; "Abraham Goodman House," *Architecture + Urbanism* (February 1980): 129–54; White and Willensky, *AIA Guide* (2000), 322.

38. Goldberger, "Architecture: 4 Honor Buildings": 13.

39. Davis, "Music: Rosen-Sanders Recital Is First in New Concert Hall": 18.

40. Les Brown, *Television: The Business Behind the Box* (New York: Harcourt Brace Jovanovich, 1971), 8–9; Sterling Quinlan, *Inside ABC: American Broadcasting Company's Rise to Power* (New York: Hastings House, 1979), 3–28, 195–234; Leonard H. Goldenson with Marvin J. Wolf, *Beating the Odds: The Untold Story Behind the Rise of ABC* (New York: Charles Scribner's Sons, 1991), 95–101.

41. For the Hotel des Artistes, see Stern, Gilmartin, and Massengale, *New York 1900*, 295–98.

42. Mardges Bacon, *Ernest Flagg: Beaux Arts Architect and Urban Reformer* (New York: Architectural History Foundation; Cambridge, Mass.: MIT Press, 1986), 295.

43. For the CBS Building, see Stern, Mellins, and Fishman, *New York 1960*, 406–10.

44. "ABC Buys an Armory on 66th St.," *New York Times* (June 23, 1976): 41; Michael Sterne, "ABC Studio Project Wins Tax Abatement," *New York Times* (April 16, 1977): 30; Roger Yee, "Mixed Use for an Urban Neighborhood," *Architectural Record* 169 (January 1981): 65–71; "ABC," *Architecture + Urbanism* (July 1982): 85; Paul Goldberger, "Architecture That Pays Off Handsomely," *New York Times* (March 16, 1986), VI: 48–49, 51–52, 54, 74, 78; Sonia R. Chao and Trevor D. Abramson, eds., *Kohn Pedersen Fox: Buildings and Projects, 1976–1986* (New York: Rizzoli International Publications, 1987), 16–19, 323; White and Willensky, *AIA Guide* (1988), 293–94; Sirefman, *New York*, 236–37; Eugene Kohn, "Our

History," in *Kohn Pedersen Fox: The First 25 Years* (Milan: L'Arca Edizioni, 1999), 8–9; Sheldon Fox, "Reflections," in *Kohn Pedersen Fox: The First 25 Years*, 25–26.

45. Kohn, "Our History," in *Kohn Pedersen Fox: The First 25 Years*, 8–9. Also see Goldberger, "Architecture That Pays Off Handsomely": 52, 54; Fox, "Reflections," in *Kohn Pedersen Fox: The First 25 Years*, 25–26.

46. Robert T. Goldman, quoted in Goldberger, "Architecture That Pays Off Handsomely": 52.

47. For Candela's building, see Landmarks Preservation Commission of the City of New York, *Upper West Side/Central Park West Historic District Designation Report* (New York, 1990), vol. 2: 179. For Schellenger's building, see White and Willensky, *AIA Guide* (1967), 179.

48. Paul Goldberger, "West 67th Street and ABC's Plan," *New York Times* (April 28, 1977), C: 21.

49. Sterne, "ABC Studio Project Wins Tax Abatement": 30; Edith Evans Asbury, "ABC-TV Keeping 900 Jobs in New York as a Result of State Tax Deal," *New York Times* (December 10, 1978): 53.

50. Paul Goldberger, *The City Observed: New York* (New York: Random House, 1979), 204; Yee, "Mixed Use For an Urban Neighborhood,": 65–71; Chao and Abramson, eds., *Kohn Pedersen Fox: Buildings and Projects, 1976–1986,*16–19.

51. Paul Golberger, "ABC's New Buildings: A Lesson in Placating Fearful Neighbors," *New York Times* (July 16, 1979), C: 12.

52. "ABC Phase II: New York," *Progressive Architecture* 64 (October 1983): 89; Chao and Abramson, eds., *Kohn Pedersen Fox: Buildings and Projects, 1976–1986*, 162–67, 331; Joseph Giovannini, "Kohn Pedersen Fox: Transition and Development," in Warren A James, ed., *Kohn Pedersen Fox: Architecture and Urbanism, 1986–1992* (New York: Rizzoli International Publications, 1993), 11–19; White and Willensky, *AIA Guide* (1988), 294; Sirefman, *New York*, 236.

53. Giovannini, "Kohn Pedersen Fox: Transition and Development," in James, ed., *Kohn Pedersen Fox: Architecture and Urbanism, 1986–1992*, 16.

54. Quoted in "Brick Institute of America: Brick in Architecture Awards," *Architectural Record* 177 (August 1989): 55. Also see Shawn G. Kennedy, "ABC's Expansion in a Lincoln Center Neighborhood," *New York Times* (November 9, 1983), B: 9; "Chapter Awards Program," *Oculus* 46 (May 1985): 10; Chao and Abramson, eds., *Kohn Pedersen Fox: Buildings and Projects, 1976–1986*, 118–23; White and Willensky, *AIA Guide* (1988), 296; Victoria Geibel, "Television Romance," *Architecture* 79 (December 1990): 56–59; James, ed., *Kohn Pedersen Fox: Architecture and Urbanism, 1986–1992*, 401.

55. David W. Dunlap, "ABC Plans Move to 'Campus' on Upper West Side," *New York Times* (May 16, 1986), B: 3; David W. Dunlap, "ABC Discloses Plans to Build Headquarters," *New York Times* (December 17, 1986), B: 1, 4; Paul Goldberger, "ABC vs. Neighbors: Stand-Off on West 67th St.," *New York Times* (January 17, 1988), II: 28; John Morris Dixon, "P/A Portfolio: On the Sidewalks of New York," *Progressive Architecture* 69 (July 1988):76–79; James, ed., *Kohn Pedersen Fox: Architecture and Urbanism, 1986–1992*, 86–89, 393, 399; Sirefman, *New York*, 236–37.

56. Susan Heller Anderson and Frank J. Prial, "ABC and 67th Street," *New York Times* (May 25, 1985): 27; Jane Gross, "As Buildings Rise on the Upper West Side, So Do the Voices of Opposition," *New York Times* (October 19, 1985): 29.

57. Goldberger, "ABC vs. Neighbors: Stand-Off on West 67th St.": 28.

58. Geibel, "Television Romance": 56; James, ed., *Kohn Pedersen Fox: Architecture and Urbanism, 1986–1992*, 266–69, 396, 402; Paul Goldberger, "Making a Street: Forget About Logos on the Skyline," *New York Times* (January 24, 1993), II: 30; Sirefman, *New York*, 236–37.

59. Sirefman, *New York*, 236.

60. Goldberger, "ABC vs. Neighbors: Stand-Off": 28.

61. "Fordham Is Planning to Build 2 Dormitories in Next 2 Years," *New York Times* (October 23, 1983): 58; Richard D. Lyons, "Developers Zero In on Columbus Circle," *New York Times* (September 22, 1985), VIII: 1, 14; David W. Dunlap, "Column One: Changes," *New York Times* (October 30, 1986), B: 1; "Make Room for West Side Students," editorial, *New York Times* (December 20, 1989): 26; "At Lincoln Center: A Fordham Dorm," *New York Times* (April 28, 1991), X: 1; David W. Dunlap, "City's Colleges Add $2 Billion in Facilities," *New York Times* (September 12, 1993), X: 1, 12. For Fordham's Lincoln Center campus, see Stern, Mellins, and Fishman, *New York 1960*, 717–19.

62. Dunlap, "City's Colleges Add $2 Billion in Facilities": 1, 12; "A 2.2-Acre Plaza for Conversation and Daydreaming," *New York Times* (May 1, 1994), X: 1; "Fordham's New Tower of Light," *Architectural Record Lighting* 183 (May 1995): 12; "Fordham University, New York, New York, 1998," *Land Forum* (No. 8, 1999): 48–53.

63. "American Bible Society," *Engineering News-Record* 237 (October 21, 1996): 67; "Bible Society Reaches Out," *New York Times* (December 21, 1997), XI: 1; Karrie Jacobs, "Gimme Some of That New-Time Religion," *New York* 31 (June 1, 1998): 16; *Fox & Fowle: Function Structure Beauty* (Milan: L'Arca Edizioni, 1999), 86–91; White and Willensky, *AIA Guide* (2000), 316; Niccolò Baldassini, "La trasparenza come segno: American Bible Society, New York," *L'Arca* 148 (May 2000): 60–63; "Fox & Fowle Honored," *New York Construction News* 49 (December 2000): 67. For Skidmore, Owings & Merrill's building, see Stern, Mellins, and Fishman, *New York 1960*, 722–23.

64. Jacobs, "Gimme Some of That New-Time Religion": 16.

65. For the Lincoln Square Special Zoning District, see Stern, Mellins, and Fishman, *New York 1960*, 723–24. Also see George W. Goodman, "West Side Housing Boom Splits City and Community," *New York Times* (February 17, 1985), VIII: 7, 14; Con Howe, "West Side Zoning," letter to the editor, *New York*

Times (March 3, 1985), VIII : 8.

66. Paul Goldberger, "Upper West Side Story: Explosive Growth Near," *New York Times* (February 4, 1982), B: 1, 10; Paul Goldberger, "Signs of Better Buildings," *New York Times* (November 10, 1983), C: 22; Lee A. Daniels, "About Real Estate," *New York Times* (December 16, 1983): 29; Dee Wedemeyer, "For New Lobbies, the Motif Is Opulence," *New York Times* (February 12, 1984), VIII: 1, 14; Goodman, "West Side Housing Boom Splits City and Community": 7; "45 West 67th Street," *Building Stone Magazine* (July-August 1986): 40–42.

67. Goldberger, "Signs of Better Buildings": 22.

68. Alan S. Oser, "West Side Is Getting High-Rise," *New York Times* (January 11, 1985): 13; Goodman, "West Side Housing Boom Splits City and Community": 7, 14.

69. For the Church of St. Paul the Apostle, see Stern, Mellins, and Fishman, *New York 1880*, 770–71.

70. Lyons, "Developers Zero In on Columbus Circle": 1, 14; "Tower for Power," *New York Times* (March 2, 1986), VIII: 1.

71. Shawn G. Kennedy, "Sofia's Rebirth," *New York Times* (August 28, 1983), VIII: 1; Lee A. Daniels, "An Art Deco Warehouse Becomes a Condominium," *New York Times* (May 25, 1984): 21; "Deco Warehouse Goes Condo," *Architectural Record* 172 (July 1984) 55; White and Willensky, *AIA Guide* (2000), 317. Also see Landmarks Preservation Commission of the City of New York, LP-1239 (April 12, 1983); Barbaralee Diamonstein, *The Landmarks of New York III* (New York: Harry N. Abrams, 1998), 359. For the Kent Automatic Parking Garage, see Stern, Gilmartin, and Mellins, *New York 1930*, 701.

72. Goodman, "West Side Housing Boom Splits City and Community": 7, 14; Alan S. Oser, "About Real Estate," *New York Times* (March 15, 1985), B: 9; Paul Goldberger, "New Towers on Broadway Avoid East Side's Pitfalls," *New York Times* (August 8, 1987): 29–30; "The Copley," *Architectural Record* 176 (February 1988): 134; David W. Dunlap, *On Broadway: A Journey Uptown Over Time* (New York: Rizzoli International Publications, 1990), 223, 226; White and Willensky, *AIA Guide* (2000), 322.

73. White and Willensky, *AIA Guide* (2000), 322.

74. Goldberger, "New Towers on Broadway Avoid East Side's Pitfalls": 30.

75. For the Bel Canto, see Goodman, "West Side Housing Boom Splits City and Community": 7, 14; Dee Wedemeyer, "About Real Estate," *New York Times* (August 2, 1985): 13; Michael deCourcy Hinds, "A Surge in High-Priced New Apartments," *New York Times* (January 26, 1986), VIII: 1; Michael deCourcy Hinds, "Why Some New Condos Founder," *New York Times* (October 4, 1987), VIII: 1, 20; Dunlap, *On Broadway*, 223; "After Two Illegal Closings, Public Plaza Will Reopen," *New York Times* (April 17, 1994), XIII: 7; "Atrium War: When Is 'Public' Public Enough?" *New York Times* (June 26, 1994), XIII: 5; Janet Allon, "Chinese Restaurant May Help Public Plaza to Shine," *New York Times* (April 14, 1996), XIII: 8. For the Chequers, see Richard D. Lyons, "Postings," *New York Times* (August 6, 1989), X: 1; Dunlap, *On Broadway*, 208; David W. Dunlap, "Commercial Property," *New York Times* (April 21, 1991), X: 15; Daniel B. Schneider, "F.Y.I.," *New York Times* (December 17, 2000), XIV: 2.

76. Helen Thorpe, "Struggles Renewed on Brodsky, Trump Plans," *New York Observer* (November 13, 1989): 13; David W. Dunlap, "Proposed West Side Project Attacked," *New York Times* (November 30, 1989), B: 2; "Planning Isn't Just a Word," editorial, *New York Observer* (December 11, 1989): 4; Suzanne Beilenson, "Urban Stories," *Oculus* 52 (April 1990): 6; Tom McGhee, "Wild, Riled West," *Metropolis* 10 (September 1990): 22–25; Alan S. Oser, "Building for the 'Young Professional' Class," *New York Times* (February 9, 1992), X: 5; "West Side Housing," *New York Times* (March 27, 1994), X: 1; Tracie Rozhon, "What's Up–And What's Going Up," *New York Times* (January 15, 1995), IX: 1, 8; Alan S. Oser, "Manhattan Renters Find Tighter Market," *New York Times* (July 9, 1995), IX: 1, 8.

77. Rachelle Garbarine, "Twin Towers in Lincoln Center Area," *New York Times* (March 31, 2002), B: 8.

78. "47-Story Apartment Tower Planned Near Lincoln Center," *New York Times* (April 21, 1992): 13; David W. Dunlap, "A $234.6 Million Mixed-Use Tower for the West Side," *New York Times* (July 5, 1992), X: 1, 6; Brendan Gill, "The Sky Line: Hazards of Bigness," *New Yorker* 68 (August 31, 1992): 69–75; James Barron, "Wall of Post Office Being Razed Collapses," *New York Times* (September 4, 1992), B: 3; Olive Freud, "Huge Development Wrong for Upper West Side," letter to the editor, *New York Times* (September 5, 1992): 18; Hugo Lindgren, "Jane Jacobs' Elevator Ride?" *Metropolis* 12 (December 1992): 10; James, ed., *Kohn Pedersen Fox: Architecture and Urbanism, 1986–1992*, 403–4; "Tower on Tower Records Site?" *New York Times* (January 30, 1994), XIII: 8; Alan S. Oser, "Shaping a West Side 'Urban Entertainment Center,'" *New York Times* (March 6, 1994), X: 7; Peter Grant, "Builder Bets on West Side," *Crain's New York Business* (March 7–13, 1994): 1, 35; Katherine Kai-Sun Chia, "Lincoln Square Developments Multiply," *Oculus* 56 (April 1994): 10–11; Mervyn Rothstein, "Lincoln Square: Growth and Doubts," *New York Times* (April 17, 1994), X: 1, 8; Randy Kennedy, "Upper West Side," *New York Times* (May 1, 1994), XIII: 6; Grace Glueck, "Mural Doesn't Please Foes of Aarons' Tower," *New York Observer* (May 16, 1994): 1, 20; "Imax in the Evening, or Afternoon, as 3-D Comes to Lincoln Center," *New York Times* (October 23, 1994), X: 4; Herbert Muschamp, "Showtime! The Once and Future Dream Palace," *New York Times* (December 11, 1994), II: 42; Maurizio Vitta, "Cinema & Cinema," *L'Arca* 91 (March 1995): 78–79; Marisa Bartolucci, "Movie Palace Redux," *Metropolis* 15 (July-August 1995): 38, 62–63, 83, 85; Herbert Muschamp, "On to an Age Where Rational Doesn't Make Sense" *New York Times* (July 23, 1995), II: 33; Matthew Barhydt, "A Square Peg in a Round Hole," *Oculus* 58 (October 1995): 4–5; Monica Geran, "Gensler

and Associates," *Interior Design* 66 (November 1995): 108; Mervyn Rothstein, "West Side Story: Three Partners and an Idea," *New York Times* (December 3, 1995), IX: 1, 8; Robert Kehlmann, "Urbane Glass: Profile of a Commission," *American Craft* 56 (June-July 1996): 34–39; Sirefman, *New York*, 238–39; White and Willensky, *AIA Guide* (2000), 322; Anthony Iannacci, ed., *Gensler Entertainment: The Art of Placemaking* (New York: Edizioni Press, 2001), 26–27. For the Ansonia Postal Station, see Dunlap, *On Broadway*, 223.

79. Gill, "The Sky Line: Hazards of Bigness": 70.

80. Muschamp, "On to an Age Where Rational Doesn't Make Sense": 33. For the Pepsi-Cola Building, see Stern, Mellins, and Fishman, *New York 1960*, 336–38.

81. Muschamp, "Showtime! The Once and Future Dream Palace": 42.

82. Sirefman, *New York*, 238.

83. "Tower on Tower Records Site?": 8; "Excavation Starts for $53M Lincoln Triangle in NYC," *New York Construction News* 41 (February 28, 1994): 1, 3; Oser, "Shaping a West Side 'Urban Entertainment Center'": 7; Grant, "Builder Bets on West Side": 1, 35; Chia, "Lincoln Square Developments Multiply": 10–11; Rothstein, "Lincoln Square: Growth and Doubts": 1, 8; Glueck, "Mural Doesn't Please Foes of Aarons' Tower": 1, 20; Barhydt, "A Square Peg in a Round Hole": 4–5; Rothstein, "West Side Story: Three Partners and an Idea": 1, 8; White and Willensky, *AIA Guide* (2000), 321. For the Lincoln Square Building, see Dunlap, *On Broadway*, 216. For Oppenheimer, Brady & Lehrecke's building, see Stern, Mellins, and Fishman, *New York 1960*, 722.

84. "Tower on Tower Records Site?": 8; Oser, "Shaping a West Side 'Urban Entertainment Center'": 7; Grant, "Builder Bets on West Side": 1, 35; Chia, "Lincoln Square Developments Multiply": 10–11; Rothstein, "Lincoln Square: Growth and Doubts": 1, 8; Glueck, "Mural Doesn't Please Foes of Aarons' Tower": 1, 20; Barhydt, "A Square Peg in a Round Hole": 4–5; Rothstein, "West Side Story: Three Partners and an Idea": 1, 8. For the Empire Building, see Stern, Mellins, and Fishman, *New York 1960*, 722.

85. Alan S. Oser, "A Manhattan Variation on the Time-Share Theme," *New York Times* (May 23, 1999), XI: 7; Jayne Merkel, "Welcome to New York. Do You Have a Reservation?" *Oculus* 62 (March 2000): 12–17. For the Lincoln Square Motor Inn, see Stern, Mellins, and Fishman, *New York 1960*, 721.

86. Jeanie Kasindorf, "West Side Y to Top Itself?" *New York* 19 (October 6, 1986): 14; David W. Dunlap, "Neighbors Criticize Plan for Tower at 63d St. Y.M.C.A.," *New York Times* (April 27, 1987), B: 1; Sam Howe Verhovek, "Board Votes Plan to Add Housing for Low Incomes," *New York Times* (May 22, 1987), B: 1; Sam Howe Verhovek, "Board Approves Zoning Bonus for Luxury Towers," *New York Times* (May 23, 1987): 32; Alan S. Oser, "Perspectives: Nonprofit Institutions," *New York Times* (May 24, 1987), VIII: 5; Paul Goldberger, "The City's Birthright Sold for Air Rights," *New York Times* (May 31, 1987), II: 1; David W. Dunlap, "Board to Study Disputed Tower Plan," *New York Times* (March 9, 1989), B: 2; "March Start Set for Tower Over the West Side YMCA," *New York Construction News* 37 (November 13, 1989): 1, 10; *Beyer Blinder Belle, Architects & Planners* (New York: The Architects, 1997), no pagination; Thomas J. Lueck, "A 41-Story Tower Is to Rise Over the West Side Y.M.C.A.," *New York Times* (September 26, 1997), B: 1, 6; David W. Dunlap, "The Preservation Band That Sets the Tone," *New York Times* (June 7, 1998), XI: 1, 22; Amy Higgins, "It's YMCA vs. Madonna as West Side Girds for 41-Story Battle," *New York Observer* (June 15, 1998): 1, 10; Rowena Daly, "Separate Entrances," letter to the editor, *New York Times* (June 21, 1998), XI: 10; Corey Kilgannon, "The Y Wants Tall Neighbor," *New York Times* (February 21, 1999), XIII: 6; Rachelle Garbarine, "West Side Tower to Have Park Views," *New York Times* (May 21, 1999), B: 10; Rachelle Garbarine, "Condo Shows Demand for Luxury Is Steady," *New York Times* (June 18, 1999), B: 9; White and Willensky, *AIA Guide* (2000), 321; Nadine Brozan, "When Top-of-the-Line Is the Minimum," *New York Times* (November 12, 2000), XI: 1, 6; Christopher Gray, "Streetscapes/The West Side Y," *New York Times* (June 16, 2002), XI: 7; Joseph Giovannini, "Site Unseen," *New York* 35 (July 8, 2002): 48–49.

RIVERSIDE SOUTH

1. Stern, Mellins, and Fishman, *New York 1960*, 718–21.

2. Stern, Mellins, and Fishman, *New York 1960*, 116–17, 718.

3. William G. Blair, "Argentines Back New Effort to Build on Old Penn Rail Yards," *New York Times* (November 2, 1980), VIII: 1, 8; Lee A. Daniels, "$1 Billion West Side Plan and Its Critics," *New York Times* (January 28, 1981), B: 3; "Gruzen & Partners and Rafael Viñoly Join Forces for $1-Billion New York City Development," *Architectural Record* 169 (March 1981): 40; "Lincoln West Development, New York, N.Y.," *Progressive Architecture* 62 (March 1981): 42; Joyce Purnick, "City Asks Lincoln West to Defer Current Plans," *New York Times* (March 24, 1982), B: 1–2; Joyce Purnick, "West Side Waterfront Project Is Facing a Series of Obstacles," *New York Times* (March 28, 1982): 36; "Governments, Rugs," *Progressive Architecture* 63 (May 1982): 42; Susan Woldenberg, "Penn-Ultimate!??!" *Metropolis* 2 (July-August 1982): 7; "Fancy Housing or Fanciful Trailers?" editorial, *New York Times* (July 17, 1982): 18; Joyce Purnick, "West Side Luxury Housing Plan Gaining," *New York Times* (July 19, 1982), B: 3; Joyce Purnick, "Luxury Housing Given Approval by City Planners," *New York Times* (July 20, 1982), B: 1; William C. Rhoden and Richard Levine, "For Manhattan Development, It's Westward Ho!" *New York Times* (July 25, 1982), IV: 6; "Betting a Billion Dollars on the Upper West Side," *New York Times* (August 8, 1982), VIII: 7; Joyce Purnick, "Estimate Board Puts Off West Side Housing Vote," *New York Times* (August 20, 1982), B: 3; Paul Goldberger, "Is the Lincoln West Project Right for the City?" *New York Times* (August 29, 1982), II: 25, 28; Joyce Purnick, "Board Expected to

Back Lincoln West Proposal," *New York Times* (September 14, 1982), B: 3; "For Lincoln West–Now," editorial, *New York Times* (September 15, 1982): 16; Joyce Purnick, "Estimate Board Gives Approval to Lincoln West," *New York Times* (September 17, 1982): 1, B: 4; Joyce Purnick, "Starting of Work Is Likely by April at Lincoln West," *New York Times* (September 18, 1982): 1, 28; Joyce Purnick, "Lincoln West: A Classic Tale of City Politics and Power," *New York Times* (November 8, 1982), B: 1, 4; *Mitchell/Giurgola Architects* (New York: Rizzoli International Publications, 1983), 258; David W. Dunlap, "Lincoln West Opponents Seek Ruling to Halt Plan," *New York Times* (February 26, 1983): 27; Joyce Purnick, "New Impact Study Ordered for Lincoln West Complex," *New York Times* (March 22, 1983), B: 1; Glenn Fowler, "Lincoln West Sponsor Is Confident Despite Setback," *New York Times* (April 3, 1983), VIII: 7; Ethel Sheffer, "The Lessons of Lincoln West," *New York Affairs* 8 (No. 3, 1984): 127–41; Susan Heller Anderson and David Bird, "Changes at Lincoln West," *New York Times* (March 28, 1984), B: 5; "Mortgage Dispute at Lincoln West," *New York Times* (July 21, 1984): 31; David W. Dunlap, "Lincoln West Is Given More Time," *New York Times* (September 14, 1984), B: 2; David W. Dunlap, "Persistent Doubts Cloud the Future of the Lincoln West Proposal," *New York Times* (October 2, 1984), B: 1, 4; Jesus Rangel, "Estimate Board Gives Extension to Lincoln West," *New York Times* (October 5, 1984), B: 6; Sandro Marpillero, "Rinascenza e illusione: Battery Park City ed altre storie," *Casabella* 507 (November 1984): 16–29; *Kohn Pedersen Fox: Buildings and Projects, 1976–1986* (New York: Rizzoli International Publications, 1987), 327; James Trager, *West of Fifth* (New York: Atheneum, 1987), 193–94; Donald Trump with Tony Schwartz, *Trump: The Art of the Deal* (New York: Random House, 1987), 216–19; H. V. Savitch, *Post-Industrial Cities: Politics and Planning in New York, Paris, and London* (Princeton, N.J.: Princeton University Press, 1988), 51, 61–68; Allee King Rosen & Fleming, Inc., and Philip Habib & Associates, *Riverside South Final Environmental Impact Statement*, vol. 1 (New York, October 11, 1992), I: 5–7; D. Graham Shane, "West Side Stories," *Design Book Review* 23 (Winter 1992): 17–22; Ann L. Buttenwieser, *Manhattan Water-Bound*, 2nd ed. (Syracuse, N.Y.: Syracuse University Press, 1999), 210–11; *The Architecture of Rafael Viñoly* (New York: Princeton Architectural Press, 2002), no pagination.

4. For Lincoln Towers, see Stern, Mellins, and Fishman, *New York 1960*, 717.

5. Jane Levy, quoted in Daniels, "$1 Billion West Side Plan and Its Critics": 3.

6. Goldberger, "Is the Lincoln West Project Right for the City?": 25, 28.

7. "Talks on Lincoln West," *New York Times* (January 17, 1984), B: 3; Susan Heller Anderson and David W. Dunlap, "Lincoln West's Future," *New York Times* (November 21, 1984), B: 3; Martin Gottlieb, "Trump Set to Buy Lincoln West Site," *New York Times* (December 1, 1984): 1, 28; Susan Heller Anderson and David W. Dunlap, "A Hint of Trump's Vision of the West Side's Future," *New York Times* (December 19, 1984), B: 2; "The Manhattan Phenomenon," *Fortune* 110 (December 24, 1984): 10–11; Susan Heller Anderson and David W. Dunlap, "An Architect Is Named for Trump City," *New York Times* (January 23, 1985), B: 3; Martin Gottlieb, "Trump Strikes Oil, but More of a Leak Than a Gusher, on the West Side," *New York Times* (February 1, 1985), B: 1; Peter Freiberg, "Updates: Blood, Sweat, and Fears of Development," *Metropolis* 4 (April 1985): 14–15; Josh Barbanel, "Trump and City Dispute Part of $1 Billion Project," *New York Times* (May 19, 1985): 36; "The Next Trump Tower and Its Shadow," editorial, *New York Times* (November 21, 1985): 35; "Donald Trump's Lofty Ambition," *Newsweek* 106 (December 2, 1985): 103; Kurt Andersen, "And Now, the Tallest of the Tall," *Time* 126 (December 2, 1985): 81; Paul Goldberger, "Is Trump's Latest Proposal Just a Castle in the Air?" *New York Times* (December 22, 1985), II: 33; George F. Will, "You Ain't Seen Nothing Yet!" *Newsweek* 106 (December 23, 1985): 84; Michael Sorkin, "Dump the Trump," *Village Voice* 31 (December 24, 1985): 112–13, reprinted in Michael Sorkin, *Exquisite Corpse* (London: Verso, 1991), 141–47; Joachim Andreas Joedicke, *Helmut Jahn: Design of a New Architecture* (Zurich: Karl Kramer Verlag, 1986), 114–17; Nory Miller, *Helmut Jahn* (New York: Rizzoli International Publications, 1986), 250; Daralice D. Boles, "Donald Trump's Deadly Gambit," *Progressive Architecture* 67 (January 1986): 25; Catherine Ingraham, "A New Trump Card," *Inland Architect* 30 (January-February 1986): 14–16; Peter Lemos, "All Show and No Tele?" *Metropolis* 5 (January-February 1986): 14; Michael H. Stone, "A Tower to Make the Hearts of New Yorkers Soar Outrageously," letter to the editor, *New York Times* (January 12, 1986), IV: 26; Carter Wiseman, "Donald Trump's Fantasy Island," *New York* 19 (January 20, 1986): 51–53; "Jahn and SOM in N.Y.: Contrasting Approaches to Urban Design," *Architecture* 75 (February 1986): 16, 18; Leon Goldenberg, "TV City Symbolism," letter to the editor, *Progressive Architecture* 67 (March 1986): 9; "TV City Site: Credit Correction," *Progressive Architecture* 67 (March 1986): 9; Martin Gottlieb, "Trump Plan: Wide Impact on West Side," *New York Times* (April 30, 1986), B: 1, 8; "A Giant Shadow," *New York Times* (May 4, 1986), IV: 6; "Helmut Jahn," *Architecture + Urbanism*, extra edition (June 1986): 242–43; "Neighbors Mad over TV City," *New York* 19 (July 28, 1986): 9–10; Carter Wiseman, "Architecture: Alexander Cooper Takes on Trump's Gargantuan Plan for the West Side," *New York* 19 (September 15, 1986): 140–41; Karen Cook, "Trumping Trump," *Manhattan, inc.* (October 1986): 31–32, 36, 38, 40, 42, 45–46; Peter Lemos, "West Side Bye-Bye?" *Metropolis* 6 (October 1986): 34; "Pencil Points," *Progressive Architecture* 67 (October 1986): 34; Paul Goldberger, "Television City Project: Tempered, but Still Big," *New York Times* (October 24, 1986),

B: 5; Jeanie Kasindorf, "Rossner Rallies Trump-City Foes," *New York* 19 (November 24, 1986): 13; "Bloomingdale's Set for TV City," *New York* 19 (December 22–29, 1986): 21; Ante Glibota, *Helmut Jahn* (Paris: Paris Art Center, 1987), 500–507; Trager, *West of Fifth*, 194–95; Trump with Schwartz, *Trump: The Art of the Deal*, 38, 219–34; Albert Scardino, "NBC Narrows Choices in Search for New Home," *New York Times* (January 24, 1987): 11; Maurizio Vitta, "Television City a New York," *L'Arca* 4 (March 1987): 88–93; "Romancing the Networks with the World's Tallest Antenna Tower," *Avenue* (May 1987): 138; Judith King, "Charting the Waterfront Renaissance," *Avenue* (May 1987): 108–9; Albert Scardino, "Trump Offers to Sell Tract to Keep NBC in New York," *New York Times* (May 6, 1987), B: 1; "Nine Acres for NBC," editorial, *New York Times* (May 7, 1987): 34; Alan S. Oser, "Huge Projects That Shape the Landscape of the City," *New York Times* (May 10, 1987), XII: 65, 68, 70; Albert Scardino, "Cities in the Sky, Skyscrapers by the Acre," *New York Times* (May 17, 1987), IV: 28; Jonathan Kuhn, "A Tale of Two (or More) Cities," *Metropolis* 6 (June 1987): 18–19; Thomas J. Lueck, "Opponents Seek Draft of Reports on Trump Plan," *New York Times* (September 22, 1987), B: 3; Lisa W. Foderaro, "Cocktails with Caro: TV City Opposed," *New York Times* (September 27, 1987), VIII: 1; Jeanie Kasindorf, "Board Seeks Data for Trump's TV City," *New York* 20 (September 28, 1987): 14; Thomas J. Lueck, "Celebrities Open Wallets to Fight Trump's Project," *New York Times* (September 30, 1987), B: 3; Thomas J. Lueck, "Trump Study Sees TV City as Disruptive," *New York Times* (October 7, 1987), B: 1, 6; Olive Freud, "Progress Isn't the Word for Television City," letter to the editor, *New York Times* (October 7, 1987): 30; Mark McCain, "All Is Far from Quiet on the Western Front," *New York Times* (October 11, 1987), IV: 7; Jane Gross, "2 Big West Side Projects Fuel Anti-Development Sentiment," *New York Times* (November 29, 1987): 1, 58; Sam Roberts, "As Towers Rise, a Slow Fade-Out of Sun and Sky," *New York Times* (December 7, 1987), B: 1; Paul Goldberger, "When the Tide Turned on Rampant Growth," *New York Times* (December 27, 1987), II: 34, 37; David W. Dunlap, "Soil Removal at Trump Site Draws Concern Over Relics and Wastes," *New York Times* (December 30, 1987), B: 4; Savitch, *Post-Industrial Cities: Politics and Planning in New York, Paris and London*, 68–70; Peg Tyre and Jeannette Walls, "Trump Courting Gray Power," *New York* 21 (January 11, 1988): 7; Roger Lowenstein, "Barring Bulldozers: New Yorkers Fighting Trump Forge Some Potent Weapons," *Wall Street Journal* (March 23, 1988): 1, 15; Michele Herman, "Whither the West Side?" *Metropolis* 7 (April 1988): 19–20; "Senior Groups Oppose 'Trump City,'" *Westpride Update* (April 1988): 1; "'Trump City' Unveiled," *Westpride Update* (April 1988): 1, 6; "Seniors Blasting Trump City," *New York* 21 (April 11, 1988): 22; "Troubleshooting in Trump City," *New York* 21 (May 23, 1988): 13; Roger Lowenstein, "Trump May Sell 76-Acre Manhattan Site of 'Tallest Building' Plan, Sources Say," *Wall Street Journal* (October 12, 1988), B: 5; Thomas J. Lueck, "Trump City Site May Be Sold, Developer Says," *New York Times* (October 13, 1988), B: 1, 7; Lou Chapman, "Opponents of Trump City Project Schedule Cabaret to Raise Funds," *New York Observer* (November 7, 1988): 8; Carter B. Horsley, "Trump: I'll Keep 'City,'" *New York Post* (December 12, 1988): 57; Karen Cook, "Waterfront Projects," *New York Post* (January 12, 1989): 50–51; David Masello, "Shadowing the Upper West Side," *Metropolis* 8 (May 1989): 23–24; Peg Tyre and Jeannette Walls, "Trump Recruits New Legal Eagle," *New York* 22 (May 22, 1989): 13; Frank Rose, "Celebrity Zoning," *Manhattan, inc.* (October 1989): 79–85; David W. Dunlap, "Civic Groups Propose Park at West Side Highway," *New York Times* (December 3, 1989): 58; Donald J. Trump with Charles Leerhsen, *Trump: Surviving at the Top* (New York: Random House, 1990), 82; Helen Thorpe, "The Bell to Start Trump City Fight Is About to Ring," *New York Observer* (January 22, 1990): 1, 8; Jeannette Walls, "On the Bumpy Road to Trump City," *New York* 23 (March 12, 1990): 11; Kay Lazar, "Board 7/Warnings About 'the Leviathan of Trump,'" *New York Observer* (March 19, 1990): 6; Helen Thorpe, "Trump City and Air Quality: Back to the Drawing Board," *New York Observer* (May 7, 1990): 12; "NYC/AIA to Trump City: Forget It," *Oculus* 52 (June 1990): 10; New York Chapter of the American Institute of Architects, *Report of the Sixtieth Street Yards Task Force* (New York, June 1990), 22; *Riverside South Final Environmental Impact Statement*, I: 7; Shane, "West Side Stories": 17–20; Gregory F. Gilmartin, *Shaping the City: New York and the Municipal Art Society* (New York: Clarkson Potter, 1995), 470–72; Buttenwieser, *Manhattan Water-Bound*, 231–32, 235–42.

8. Andersen, "And Now, the Tallest of the Tall": 81.

9. Donald Trump, quoted in Anderson and Dunlap, "An Architect Is Named for Trump City": 3.

10. Quoted in Boles, "Donald Trump's Deadly Gambit": 25.

11. Goldberger, "Is Trump's Latest Proposal Just a Castle in the Air?": 33.

12. Sorkin, "Dump the Trump": 112.

13. Donald J. Trump, quoted in Wiseman, "Donald Trump's Fantasy Island": 52.

14. Donald J. Trump, quoted in Wiseman, "Architecture: Alexander Cooper Takes on Trump's Gargantuan Plan for the West Side": 140.

15. Alexander Cooper, quoted in Cook, "Trumping Trump": 36.

16. Cook, "Trumping Trump": 38.

17. Alexander Cooper, quoted in Cook, "Trumping Trump": 38.

18. Alexander Cooper, quoted in Cook, "Trumping Trump": 40.

19. Donald J. Trump, quoted in Cook, "Trumping Trump": 40.

20. Goldberger, "Television City Project: Tempered, but Still Big": 5.

21. For the Apple Savings Bank, originally known as the Central Savings Bank, see Stern, Gilmartin, and Mellins, *New York 1930*, 170–71, 174.

22. "NYC/AIA to Trump City: Forget It": 10.

23. New York Chapter of the American Institute of Architects, *Report of the Sixtieth Street Yards Task Force*, 22.

24. Suzanne Stephens, quoted in "NYC/AIA to Trump City: Forget It": 10.

25. Paul Goldberger, "Another Chance for a Prime Piece of Real Estate," *New York Times* (July 1, 1990), II: 25, 34; Leonard Buder, "New York City Is Urged to Buy Big Trump Site," *New York Times* (July 12, 1990), B: 2; "Formula for Stagnation," editorial, *New York Post* (July 13, 1990): 22; "A Better Trump City," editorial, *New York Observer* (July 16–23, 1990): 4; "A Rare View," editorial, *New York Observer* (July 23–30 1990): 4; "The Last Best Site in Manhattan," editorial, *New York Times* (July 29, 1990), IV: 18; Daniel Gutman, "A Little History," *Westpride Update* (August 1990): 1; Bill Ryan, "Planning for Penn Yards," *Municipal Art Society Newsletter* (September 1990): 4; "Trump City: It's Not Over Until It's Six Feet Under," *Oculus* 53 (September 1990): 12–13; "From the Ground Up," *Oculus* 53 (October 1990): 6; Paul Willen and Daniel Gutman, "Riverside South," *Oculus* 53 (October 1990): 6, 8; Gilmartin, *Shaping the City*, 473–77; Buttenwieser, *Manhattan Water-Bound*, 254–57.

26. Goldberger, "Another Chance for a Prime Piece of Real Estate": 25.

27. Goldberger, "Another Chance for a Prime Piece of Real Estate": 25, 34.

28. Christoph Riedner and Joseph Wasserman, "Riedner/Wasserman Proposal," *Oculus* 53 (October 1990): 9–10. For the East River Drive and Carl Schurz Park, see Stern, Gilmartin, and Mellins, *New York 1930*, 700, 716.

29. Craig Whitaker, "The Road Less Travelled," *Oculus* 53 (October 1990): 6–11. For Whitaker's work on the Wateredge Development Study and Westway, see Stern, Mellins, and Fishman, *New York 1960*, 112–19.

30. Charles V. Bagli, "Developers Aghast at Ruling in Suit by Trump City Foes," *New York Observer* (December 10, 1990): 1, 17. Also see "A Monumental Decision on the Hudson," editorial, *New York Times* (December 17, 1990): 16; Alexander Cooper, "Trump City Rationalized," *Oculus* 53 (January 1991): 10–11; John M. Ellis, "Trump City Assailed," *Oculus* 53 (January 1991): 12; Norman C. Levin, "60th St. Yard Task Force Attacked," *Oculus* 53 (January 1991): 12; Suzanne Stephens, "The Neverending Battle," *Oculus* 53 (January 1991): 10; Craig Whitaker, "'Civic Alternative' Assailed," *Oculus* 53 (January 1991): 13; Paul Willen and Daniel Gutman, "'Civic Alternative' Rationalized," *Oculus* 53 (January 1991): 13.

31. Alexander Finder, "Trump Is Involved in Talks About a Smaller Trump City," *New York Times* (February 9, 1991): 27; Jeannette Walls, "Trimmer Trump City May Triumph," *New York* 24 (February 18, 1991): 11; Paul Goldberger, "Two Reasons for Dancing in the Streets of New York," *New York Times* (March 17, 1991), II: 36, 42.

32. Shane, "West Side Stories": 21.

33. David W. Dunlap, "Trump and Civic Groups Join to Oversee Project," *New York Times* (April 14, 1991): 28. Also see Charles V. Bagli, "Old Foes Make Strange Bedfellows on Trump's Long-Fought Project," *New York Observer* (April 22, 1991): 1, 17; "A Sellout?" editorial, *New York Observer* (April 29, 1991): 4; Peter D. Slatin, "Hopes Rise for Downsized Trump City Design," *Architectural Record* 179 (May 1991): 2; "Pencil Points," *Progressive Architecture* 72 (May 1991): 28; Mitchell Bernard, "The Road to Riverside South," *Livable City* 15 (June 1991): 5; Karen Salmon, "R/UDAT Examines New York's Penn Yards," *Architecture* 80 (August 1991): 21; Karen Salmon, "New Urban Design Commissions," *Architecture* 80 (September 1991): 32; "November 1990," *Metropolis* 11 (September 1991): 10; Alan Finder, "Cuomo Ideas for New York City: Some Are Old, Some Are New," *New York Times* (September 25, 1991): 1, B: 4.

34. Paul Goldberger, "Lower Skyline, Higher Aspirations," *New York Times* (August 11, 1991), II: 1, 26; Suzanne Stephens, "Riverside South," *Oculus* 54 (September 1991): 10; Andrea E. Monfried, "Suggestions from a Workshop," *Oculus* 54 (September 1991): 11; Tony Hiss, "The Bomb Chuckers of Trump Hamlet," *New York Times* (September 8, 1991): 44; Charles V. Bagli, "TV, er, Trump City, er, Riverside South–Soon," *New York Observer* (September 16, 1991): 1, 15; Alan Finder, "Cuomo Ideas for New York City: Some Are Old, Some Are New," *New York Times* (September 25, 1991): 1, 14; Andrea Monfried, "New Proposal for New York's Penn Yards," *Progressive Architecture* 72 (October 1991): 17–18; Ruth Messinger, "Afterword," *Oculus* 54 (November 1991): 11; Suzanne Stephens, "Afterword," *Oculus* 54 (November 1991): 11; Paul Goldberger, "Architecture/1991," *New York Times* (December 29, 1991), IV: 32; "Civic and Community Groups Collaborate on Riverside South," *Riverside South Forum*, vols. 1 and 2 (1992): no pagination; David W. Dunlap, "Plan Readied for a Smaller Trump City," *New York Times* (February 16, 1992), X: 1, 10; Judith Warner, "Development Fears in Clinton," *New York Observer* (February 17, 1992): 8; Anastasia Wilkes, "West Side Park," *Art in America* 80 (May 1992): 39, 156; "Midtown and About," *Oculus* 54 (May 1992): 5; Jim Windolf, "Riverside South to Be Studied," *New York Observer* (May 18, 1992): 8; David W. Dunlap, "Trump's West Side Project Declared Ready for Review," *New York Times* (May 19, 1992), B: 3; Charles V. Bagli, "Upper West Side in Peril from City Within a City," *New York Observer* (May 25, 1992): 1, 16; Andrea Monfried, "Down by the Riverside," *Oculus* 54 (June 1992): 7; "$3B Riverside South Project Certified by City Planning," *New York Construction News* 39 (June 1, 1992): 1, 5; "Riverside South Enters Approval Process," *Municipal Art Society Newsletter* (July-August 1992): 1; Richard A. Kahan et al., *Riverside South Planning Corporation*, promotional mailer (July 7, 1992); David W. Dunlap, "Altered Riverside South Plan Wins Messinger Over," *New York Times* (August 27, 1992), B: 2; Thomas J. Lueck, "Messinger Is Criticized for Supporting Plan by Trump," *New*

York Times (August 28, 1992), B: 3; "Riverside South: Still Questions," editorial, New York Times (August 31, 1992): 14; Brendan Gill, "The Sky Line: Hazards of Bigness," New Yorker 68 (August 31, 1992): 69–75; John Voelcker, "Riverside South Meets the Neighbors," Metropolis 12 (September 1992): 15, 19; "Riverside South: The Right Project, the Right Choices," editorial, Crain's New York Business (October 5, 1992): 10; Riverside South Final Environmental Impact Statement, I: 7–8, S: 1–28; Bunny Gabel, "Where's the Logic?" letter to the editor, New York Observer (October 12, 1992): 4; Charles V. Bagli, "Trump, Stein Feud as Riverside South Jockeying Rages On," New York Observer (October 12, 1992): 1, 15; Sam Roberts, "New York Tests a Model: Public Works in Private Hands," New York Times (November 1, 1992), IV: 6; "Workers Support Riverside South Development," New York Times (November 14, 1992): 25; James C. McKinley Jr., "Trump's Riverside West Plan Appears to Be Gaining Favor," New York Times (November 17, 1992): B: 4; "Save Riverside South!" editorial, New York Observer (November 23, 1992): 4; James C. McKinley Jr., "Trump Development Plan to Drop Giant TV Studio," New York Times (November 24, 1992), B: 2; Jon Gertner, "Down by the Riverside," City Limits 17 (December 1992): 8–10; Daniel Gutman, "Riverside South's Goal Is to Keep Park in Touch with Water," letter to the editor, New York Times (December 7, 1992): 18; Christopher Gray, "Riverside South's Threat to a 1904 Apartment Tower," New York Times (December 13, 1992), VIII: 5; James C. McKinley Jr., "Council Set to Approve Trump Plan for Housing," New York Times (December 17, 1992), B: 3; Ronald Sullivan, "Council Approves Trump Plan for Apartments on West Side," New York Times (December 18, 1992), B: 3; Matson, "It's Comeback Time, We're on a Roll!" cartoon, New York Observer (December 21, 1992): 1; Shane, "West Side Stories": 18–22; Charles V. Bagli, "'Civics' Grow Testy as Trump Marches On," New York Observer (January 4, 1993): 1, 16; Eric A. Goldstein, "Trump Project Adds to Sewage Problem," letter to the editor, New York Times (January 8, 1993): 24; John Morris Dixon, "Civics Lesson," Progressive Architecture 74 (June 1993): 118–23; Paul Goldberger, "David Childs," Architecture + Urbanism, special issue (September 1993): 18–20; Marilyn Jordan Taylor, "Six Projects for New York City," Architecture + Urbanism, special issue (September 1993): 26–33; "Riverside South," Architecture + Urbanism, special issue (September 1993): 34–49; Kent Barwick, "Riverside South," letter to the editor, Progressive Architecture 74 (September 1993): 9; Todd W. Bressi, "New York Holds the Trump Card," Planning 61 (May 1995): 4–9; Matthias Lerm, "Riverside South, New York," Bauwelt 87 (February 1996): 244–45; Michael Z. Wise, Wilbur Woods, and Eugenia Bone, "Evolving Purposes," in Kevin Bone, ed., The New York Waterfront (New York: Monacelli Press, 1997), 225–26; Donald J. Trump with Kate Bohner, Trump: The Art of the Comeback (New York: Random House, 1997), 151–67; Buttenwieser, Manhattan Water-Bound, 274–75.

35. Goldberger, "Lower Skyline, Higher Aspirations": 1, 26.
36. Stephens, "Afterword," Oculus: 11.
37. Goldberger, "Lower Skyline, Higher Aspirations": 1, 26.
38. Gill, "The Sky Line: Hazards of Bigness": 72, 75.
39. Michael Sorkin, Michael Sorkin Studio: Wiggle (New York: Monacelli Press, 1998), 158–60.
40. "Parallax Skyscrapers Proposed for 60th Street Yards by Steven Holl Architects," Oculus 53 (January 1991): back cover; Yukio Futagawa, ed., GA Architect: Steven Holl (Tokyo: A.D.A. Edita, 1993), 158–59; Steven Holl (Zurich: Artemis, 1993), 110–11; Kenneth Frampton, Steven Holl Architect (Milan: Electa Architecture, 2003), 84–85.
41. David W. Dunlap, "Philip Johnson, the Renowned Architect, Joins the Team on the Huge Riverside South Project," New York Times (November 3, 1993), D: 23; "Challenge to Trump Plan Loses," New York Times (January 30, 1994), XIII: 8; Pat Wechsler with David Feld, "And Noisy Flows the Don," New York 27 (January 31, 1994): 7; Peter Grant, "Deal Unravels for Financing at Trump Site," Crain's New York Business 10 (February 14–20, 1994): 1, 25; Nick Ravo, "Trump to Seek Federal Help to Get Riverside South Under Way," New York Times (April 17, 1994), XIII: 40; David W. Dunlap, "Hong Kong Investors Finance a Trump Project," New York Times (July 1, 1994), B: 1–2; Edward A. Gargan, "How the Chengs Finessed Trump," New York Times (July 16, 1994), D: 1–2; "Editors' Note," New York Times (July 16, 1994): 2; Jennifer Kingson Bloom, "Toilets at the Ready, Flushed with Pride to Help a Cause," New York Times (December 25, 1994), XIII: 6; Joyce Purnick, "New Political Landscape May Alter Highway Plan," New York Times (December 26, 1994): 43; Shawn G. Kennedy, "Trump Development Clears Hurdle Despite Objections," New York Times (February 4, 1995): 23; Bill Moyers, "Harlem Sewage Plant Can't Handle Trump's Riverside South," letter to the editor, New York Times (February 16, 1995): 26; Jennifer Kingson Bloom, "Miller Highway Counts Its Days," New York Times (February 26, 1995), XIII: 6; Richard Pérez-Peña, "Highway Plan for West Side Appears Dead," New York Times (July 26, 1995), B: 1, 3; Joyce Purnick, "The Never-Failing Optimism of Donald Trump," New York Times (July 27, 1995), B: 3; "The Battle by the River Drags On," New York Times (July 31, 1995), B: 3; Ian Fisher, "Plan to Put Part of West Side Highway Underground Suffers Setback in Congress," New York Times (November 24, 1995), B: 4; Jane Holtz Kay, "'Blight' Fight," The Nation 261 (December 4, 1995): 693–94; Greg Sargent, "Jerry Nadler Hopes to Demolish Trump's Riverside Dreams," New York Observer (November 18, 1996): 1, 28; Jane H. Lii, "Trump Nears a Missing Link: A Sewage Hookup," New York Times (December 22, 1996), XIII: 6; Thomas J. Lueck, "Groundbreaking Near for Trump Project, Despite Upper West Side Objections," New York Times (January 31, 1997), B: 6; David W. Dunlap, "Green Fades from a Blueprint," New York Times (February 25, 1997): B: 1, 6; "On the Trump Waterfront," New York Times (March 2, 1997), III: 2; Devin Leonard, "Rudy, Moynihan Won't Adopt a Highway in Trump's Megalopolis," New York Observer (March 3, 1997): 1, 25; Hugo Lindgren, "Railroaded," New York 30 (March

17, 1997): 28–29; Jane H. Lii, "A Street of Promises and Protest," New York Times (May 25, 1997), XIII: 6; Jane H. Lii, "Opponents of Park Plan Speak Out," New York Times (August 3, 1997): 6; Brendan Sexton, "New Riverside South Park Will Be Open to Everyone," letter to the editor, New York Times (August 24, 1997), XIII: 15; Devin Leonard, "Is Trump Reneging on Massive Park Plan for Riverside South?" New York Observer (September 29, 1997): 1, 13; David S. Chartock, "Riverside South Starts with a Bang," New York Construction News 45 (October 1997): 17–23; David M. Halbfinger, "Critics of Trump's Riverside South Focus on Road Plan," New York Times (October 2, 1997), B: 6; Malka F. Margolies, "Sunset Rides into the Sunset," New York Times (October 12, 1997), XIV: 17; Charles V. Bagli, "West Side Trump Project Went On Despite Flaws in Concrete," New York Times (November 4, 1997), B: 1, 16; Herbert Muschamp, "A Midas of the Gold (Yes, I Do Mean Gold) Cudgel," New York Times (November 5, 1997), E: 2; Charles V. Bagli, "A Concrete Subcontractor for Trump Has Been Banned from City Contracts," New York Times (November 7, 1997): 1, B: 4; Jim Yardley, "A Lament by the Hudson, as Trump Eclipses the Moon," New York Times (November 7, 1997), B: 1, 4; Charles V. Bagli, "Order That Halted Work on Trump Project Is Lifted," New York Times (January 10, 1998), B: 9; Thomas J. Lueck, "CBS Considers Manhattan and Jersey City for New Studios," New York Times (March 31, 1998), B: 9; Charles V. Bagli, "Trump's Backers Trying to Sell First Two Riverside Apartment Buildings," New York Times (June 3, 1998): B: 7; Greg Sargent, "Tricky Donald Trump Beats Jerry Nadler in Game of Politics," New York Observer (June 8, 1998): 1, 12; Raymond Sokolov, "Shore Enough: Two Guys Walk Around Big Island," Wall Street Journal (July 23, 1998): 14; Thomas J. Lueck, "Trump Projects Loses Big for U.S. Mortgage Insurance," New York Times (July 24, 1998), B: 3; Mike Allen, "House Bars Use of Funds to Move Highway," New York Times (July 31, 1998), B: 7; John Morris Dixon, ed., Urban Spaces (New York: Visual Reference Publications, 1999), 228–29; David S. Chartock, "The Trump Organization: Setting New Standards for Development," New York Construction News 47 (June 1999): 25, 27–28, 30, 35; Robin Pogrebin, "Protests Supplanted by Praise: Trump Place Becomes Real, and Even Popular," New York Times (June 25, 1999), B: 1, 8; Peter Slatin, "Block Buster," Grid 2 (January-February 2000): 70–72; Paul M. Barrett, "West Side Story," Wall Street Journal (October 9, 2000): 1, 14; David S. Chartock, "Building E's Toughest Challenge: Building over an Active Railroad," New York Construction News 48 (November 2000): 27–28, 31, 33; Charles V. Bagli, "Columbia May Expand onto Trump Riverfront Site," New York Times (September 15, 2000), B: 1, 10; Denny Lee, "Up Riverside, Trump's Road Goes; Where It Stops, Nobody Knows," New York Times (March 18, 2001), XIV: 4; "Building E at Trump Place," New York Construction News 49 (June 2001): 29; Philip Johnson/Alan Ritchie Architects (New York: Monacelli Press, 2002), 52–57, 186; Georges Binder, ed., Sky High Living (Mulgrave, Australia: Images Publishing, 2002), 124–27; Stephen Fox, The Architecture of Philip Johnson (Boston: Bulfinch Press, 2002), 304; James Gardner, "The Midas Touch," New York Sun (June 24, 2002): 1, 10; Lois Weiss, "Trump Rounding Out W. Side Development," New York Post (October 16, 2002): 35; Charles V. Bagli, "Blotting Out the Light: A New Tower by Trump," New York Times (October 21, 2002), B: 1; Benjamin Ryan, "Trump's Riverside South May Displace Highway Ramp," New York Observer (February 3, 2003): 6; Helen Peterson, "Donald Trumps Neighbor in Court," New York Daily News (March 6, 2003): 32; "220 Riverside Boulevard at Trump Place," New York Construction News 50 (June 2003): 29; James Gardner, "Ever Upward on the East Side, Stuck Inside on the West," New York Sun (August 12, 2003): 16.

42. Philip Johnson, quoted in Dunlap, "Philip Johnson, the Renowned Architect, Joins the Team on the Huge Riverside South Project": 23.
43. Dunlap, "Philip Johnson, the Renowned Architect, Joins the Team on the Huge Riverside South Project": 23.
44. Philip Johnson, quoted in Dunlap, "Philip Johnson, the Renowned Architect, Joins the Team on the Huge Riverside South Project": 23.
45. Stan Herd, quoted in "A West Side 'Countryside,'" New York Times (June 26, 1994), IX: 1. Also see Harold Faber, "From a Palette of Plants, with Tractors as Brushes," New York Times (September 1, 1994), B: 6; N. R. Kleinfield, "Not Just in Kansas Anymore: A Crop Artist Debuts on Manhattan's Unlikely Terrain," New York Times (November 10, 1994), B: 21; Alicia Rodriguez, "The Landscape Is His Canvas: Crop Artist Stan Herd Digs His Art," Landscape Architecture 86 (February 1996): 26, 28.
46. Donald J. Trump, quoted in Purnick, "The Never-Failing Optimism of Donald Trump": 3.
47. Jerrold Nadler, quoted in Dunlap, "Green Fades from a Blueprint": 6.
48. Donald J. Trump, quoted in Halbfinger, "Critics of Trump's Riverside South Focus on Road Plan": 6.
49. Pogrebin, "Protests Supplanted by Praise: Trump Place Becomes Real, and Even Popular": 1.
50. Gardner, "The Midas Touch": 10.
51. Art Samuels, "Downscaling a Dream: No Café for New Trump Park," New York Observer (January 15, 2001): 8; Susan Saulny, "Neighbors Greet New Pier with Grudging Accolades," New York Times (January 15, 2001), B: 2; David W. Dunlap, "Skyline Views from Manhattan," New York Times (January 18, 2001), F: 1, 12; Jayne Merkel, "At the Water's Edge," Oculus 64 (November 2001): 10–11; Raymond W. Gastil, Beyond the Edge: New York's New Waterfront (New York: Princeton Architectural Press, 2002), 130–31; Soni Sangha, "Trump Hands City Green: 3 Acres of New Parkland," New York Daily News (June 12, 2003), Metro: 2.
52. Dunlap, "Skyline Views from Manhattan": 1, 12.

APARTMENT HOUSES

1. White and Willensky, AIA Guide (2000), 346; Marvin H. Meltzer: City as Poetry (Milan: L'Arca Edizioni, 2002), 18–23.
2. David Gura, quoted in Suzanne Slesin, "Reinterpreting Luxury in Model Apartments," New York Times (January 13, 1983), C: 1, 3. Also see Patricia Leigh Brown, "Mystery of the Pharaohs," Metropolis 2 (October 1982): 5; White and Willensky, AIA Guide (1988), 295, 297; Daniel B. Schneider, "F.Y.I.," New York Times (September 24, 2000), XIV: 2.
3. Paul Goldberger, "Upper West Side Story: Explosive Growth Near," New York Times (February 4, 1982), B: 1, 10.
4. "Westside Zoning: More or Less?" Metropolis 3 (November 1983): 8–9; "West Side Development Debate Shifts from Streets to Table," New York Times (October 20, 1983), B: 1, 5; David W. Dunlap, "City Presents Plans at Forum to Residents and Builders," New York Times (October 20, 1983), B: 1, 5; "West Side Forum," Metropolis 3 (December 1983): 11; David W. Dunlap, "Board on Upper West Side Qualifies a Vote on Zoning," New York Times (February 9, 1984), B: 8; "Chapter Reports," Oculus 45 (April 1984): 7; Mark Sherman, "West Side Zoning Plan Criticized," New York Times (April 1, 1984), VIII: 6, 16; David W. Dunlap, "Planners Approve Zoning Change to Preserve the Upper West Side," New York Times (April 10, 1984), B: 1; Alan S. Oser, "New Rules on West Side May Alter Mix of Units," New York Times (June 3, 1984), VIII: 7.
5. William Zeckendorf Jr., quoted in "West Side Development Debate Shifts from Streets to Table": 5.
6. "Blockfront on Broadway Is Another Casualty of Boomis's Collapse," New York Times (March 2, 1976): 22; Joseph P. Fried, "The Boomis Empire Has Tumbled Down," New York Times (December 2, 1976): 54; Alan S. Oser, "Fate of Boomis Site Is Uncertain as West Side Demolition Begins," New York Times (December 8, 1976), D: 16; Murray Schumach, "New Hope Rises from Rubble of 96th and Broadway," New York Times (December 27, 1977), B: 1, 43; Judith Cummings, "Another Plan for Broadway Site," New York Times (November 11, 1979), VIII: 1, 4; Jill Smolowe, "Plan for Housing Revives Dispute Over 96th St. Site," New York Times (October 16, 1980), B: 1, 15; Carter B. Horsley, "High-Rise Complex Planned on W. 96th," New York Times (May 24, 1981): 29; Anna Quindlen, "On West Side, No One Is a Fence Straddler," New York Times (October 14, 1981), B: 3; Goldberger, "Upper West Side Story: Explosive Growth Near": 1, 10; Alan S. Oser, "Zeckendorf Project on Upper Broadway," New York Times (July 2, 1982): B: 7; William Bryant Logan, "Community Garden on a City Rooftop," New York Times (November 8, 1984), C: 3; White and Willensky, AIA Guide (1988), 319; David W. Dunlap, On Broadway: A Journey Uptown Over Time (New York: Rizzoli International Publications, 1990), 255, 257; Michael J. Crosbie, The Architecture of Frank Williams (Rockport, Mass.: Rockport Publishers, 1997),154–57.
7. See Stern, Mellins, and Fishman, New York 1960, 757–58.
8. White and Willensky, AIA Guide (1988), 319.
9. Alan S. Oser, "A Modern Condominium amid West Side Solidity," New York Times (August 26, 1983), B: 7; Alan S. Oser, "Building Apartments Despite High Costs," New York Times (June 3, 1984), VIII: 1, 14; Oser, "New Rules on West Side May Alter Mix of Units": 7; Paul Goldberger, "Defining Luxury in New York's New Apartments," New York Times (August 16, 1984), C: 1, 8; "The Park Belvedere; Frank Williams & Associates," Process Architecture 64 (January 1986): 104–5; Richard D. Lyons, "The Zeckendorf Flag Flying High Again," New York Times (July 13, 1986), VIII: 1, 16; White and Willensky, AIA Guide (1988), 312; Crosbie, The Architecture of Frank Williams, 94–101.
10. Goldberger, "Defining Luxury in New York's New Apartments": 8.
11. Goldberger, "Upper West Side Story: Explosive Growth Near": 1, 10; "In Progress," Progressive Architecture 63 (April 1982): 81; Alan S. Oser, "A Luxury Apartment House Will Rise on Broadway," New York Times (January 14, 1983), B: 7; Paul Goldberger, "Glass Towers on Upper Broadway Avoid the East Side's Pitfalls," New York Times (August 8, 1987): 29–30; White and Willensky, AIA Guide (1988), 317; Dunlap, On Broadway, 250, 255.
12. Norman Segal, quoted in Oser, "A Luxury Apartment House Will Rise on Broadway": 7.
13. Goldberger, "Glass Towers on Upper Broadway Avoid the East Side's Pitfalls": 30.
14. Goldberger, "Glass Towers on Upper Broadway Avoid the East Side's Pitfalls": 30.
15. Dunlap, On Broadway, 250.
16. Dunlap, On Broadway, 256.
17. Dunlap, On Broadway, 250.
18. "The Bromley; Philip Birnbaum and Associates," Process Architecture 64 (January 1986): 128–29; Goldberger, "Glass Towers on Upper Broadway Avoid the East Side's Pitfalls": 29–30; Dunlap, On Broadway, 248; White and Willensky, AIA Guide (2000), 349. For the movie theater complex, see Shawn G. Kennedy, "Loews Pursuing Multiscreen Concept," New York Times (January 18, 1984), B: 6; Lawrence Van Gelder, "A Half-Dozen New Theaters at W. 84th St.," New York Times (March 15, 1985), C: 6.
19. Goldberger, "Glass Towers on Upper Broadway Avoid the East Side's Pitfalls": 30.
20. White and Willensky, AIA Guide (2000), 347. Also see "Names and News," Oculus 47 (September 1984): 10; Alan S. Oser, "Broadway Builder Saves Facade of a 1914 Theater," New York Times (May 10, 1985), B: 10; Philip S. Gutis, "Developers Squeeze New and Old Uses onto Difficult Sites," New York Times (May 11, 1986), VIII: 1, 24; Goldberger, "Glass Towers on Upper Broadway Avoid the East Side's Pitfalls": 29–30; Dunlap, On Broadway, 247.
21. David W. Dunlap, "West Side Champs-Élysées Mixes the Chic and Dowdy," New York Times (August 6, 1987), B: 1, 4; White and Willensky, AIA Guide (1988), 337; Diana Shaman, "21-Story 'Condop' Rises on Broadway at 86th St.," New York

Times (February 17, 1989): 26; Dunlap, *On Broadway*, 250.

22. Alexander Cooper, quoted in Shaman, "21-Story 'Condop' Rises on Broadway at 86th St.": 26.

23. David W. Dunlap, "Key Site on Upper West Side Is Purchased by Developers," *New York Times* (April 25, 1986), B: 3; Matthew Flamm, "It's Curtains for Theater," *New York Post* (July 28, 1988): 31; David W. Dunlap, "50-Year Cinematic Tradition Fades on the West Side," *New York Times* (August 22, 1988), B: 3; "Arts Digest," *New York Observer* (August 29, 1988): 11; Iver Peterson, "What Shapes a New Apartment House?" *New York Times* (January 21, 1990), X: 1, 12; Crosbie, *The Architecture of Frank Williams*, 158–63.

24. Ruth W. Messinger, quoted in Dunlap, "Key Site on Upper West Side Is Purchased by Developers": 3.

25. Dunlap, *On Broadway*, 234–35, 237, 256.

26. Carter B. Horsley, "The Alexandria," in www.cityrealty.com.

27. White and Willensky, *AIA Guide* (1988), 317.

28. "222 Riverside Drive," *Architectural Record* 176 (April 1988): 57; Michael Cannell, "Building on Riverside Drive," *Metropolis* 7 (September 1988): 30–31; "On Riverside Dr.; 49 Condos Taken Over," *New York Times* (September 27, 1992), X: 1; Donald Sutherland, "Just Like Old Times," *On the Avenue* (November 4, 1989): 19–21; "Brick in Architecture: 222 Riverside Drive, New York City, New York," *Architecture* 80 (November 1991): supplement.

29. David W. Dunlap, "Apartments to Replace Wing of Walden School," *New York Times* (December 16, 1987), B: 4; Carter B. Horsley, "Bid to Stop CPW Tower Fails," *New York Post* (March 16, 1989): 59; Andree Brooks, "Central Park West Gets Luxury Condominiums," *New York Times* (November 10, 1989): 33; Alex Cohen, "New Old Apartment Tower on Central Park West," *Oculus* 52 (June 1990): 6; Sutherland, "Just Like Old Times": 19–21; Rachelle Garbarine, "Super-Luxury Condo Market Broadens," *New York Times* (July 10, 1998): B: 8; Peter Slatin, "Block Buster," *Grid* 2 (January-February 2000): 70–72. For the Progress Club, see Stern, Gilmartin, and Massengale, *New York 1900*, 390.

30. For the Beresford, see Stern, Gilmartin, and Mellins, *New York 1930*, 406.

31. Cohen, "New Old Apartment Tower on Central Park West": 6.

32. Christopher Gray, "Streetscapes/95th Street Rowhouses," *New York Times* (November 29, 1987), VIII: 8; David W. Dunlap, "Developer Wins a Point in Fight on Landmarks," *New York Times* (December 19, 1988), B: 3; Diana Shaman, "A Neighborhood Assists Central Park West Project," *New York Times* (January 4, 1991), B: 4; "The Dream Apartment," *New York Times* (March 5, 1992), C: 3; Suzanne Stephens, "The Post-Post-War Apartment House Part II," *Oculus* 54 (April 1992): 8–10; Rachelle Garbarine, "Testing the Market on Central Park West," *New York Times* (April 17, 1992): 20; Susanna Sirefman, *New York: A Guide to Recent Architecture* (London: Ellipsis, 1997), 240–41; Alan Balfour, *World Cities: New York* (New York: Wiley Academy, 2001), 104.

33. Landmarks Preservation Commission of the City of New York, LP-1641–43 (November 10, 1987); Gray, "Streetscapes/95th Street Rowhouses": 8.

34. Stephens, The Post-Post-War Apartment House Part II": 10.

35. David Herszenhorn, "Thalia Tries to Avert Second Death," *New York Times* (August 28, 1994), XIII: 6; Corey Kilgannon, "Symphony Space Shows Its Virtuosity in Art of the Deal," *New York Times* (November 29, 1998), XIV: 3; Corey Kilgannon, "Thalia Is Gutted, Dismaying Lovers of Art Deco," *New York Times* (April 11, 1999), XIV: 5; David W. Dunlap, "Filling the Space atop Symphony Space," *New York Times* (July 18, 1999), XI: 1, 6; Slatin, "Block Buster": 70–72; David S. Chartock, "Structural Solutions Are Music for the Lyric," *New York Construction News* 47 (November 2000): 17–18, 21–23, 25; Robin Pogrebin, "Innovative Theater Space Is Planning an Expansion," *New York Times* (December 14, 2000), E: 1, 5; Julie Lasky, "Theater of the Obsessed," *Interiors* 161 (February 2001): 20; "The Lyric: New York, N.Y.," *New York Construction News* 48 (June 2001): 31; Miriam Kreinin Souccar, "Bigger Symphony Space Aims to Hit Higher Note," *Crain's New York Business* (March 18, 2002): 26; Dinitia Smith, "For Arts Space, Shabby Charm Turns Sleek," *New York Times* (March 20, 2002), E: 1, 3; Michelle O'Donnell, "A Revivalist Revived: The Thalia Returns, Kindling Memories in Black and White," *New York Times* (March 31, 2002), XIV: 4; Clyde Haberman, "The Rebirth of a Temple for Film Fans," *New York Times* (April 13, 2002), B: 1.

36. Landmarks Preservation Commission of the City of New York, LP-1279 (September 14, 1982); "2 Sites Are Designated as Landmarks by City," *New York Times* (September 15, 1982), B: 6; Barbaralee Diamonstein, *The Landmarks of New York III* (New York: Harry N. Abrams, 1998), 337. For Pomander Walk, see Stern, Gilmartin, and Mellins, *New York 1930*, 427, 429; Christopher Gray, "Streetscapes/Pomander Walk, on the Upper West Side," *New York Times* (January 16, 2000), IX: 9.

37. See Stern, Gilmartin, and Mellins, *New York 1930*, 260, 265.

38. James Stewart Polshek, quoted in Kilgannon, "Symphony Space Shows Its Virtuosity in Art of the Deal": 7.

39. James Stewart Polshek, quoted in www.symphony space.org/institutional/newfacility.

INSTITUTIONS

1. Stern, Gilmartin, and Massengale, *New York 1900*, 370–73; Stern, Gilmartin, and Mellins, *New York 1930*, 135–36; Stern, Mellins, and Fishman, *New York 1960*, 662–63; Stern, Mellins, and Fishman, *New York 1880*, 182–89.

2. Paul Goldberger, "Design Notebook," *New York Times* (April 14, 1977), C: 13. Also see Boyce Rensberger, "Museum Will Open Hall of Gems," *New York Times* (May 19, 1976): 35.

3. "$2.5 Million Is Pledged to Museum Renovation," *New York Times* (June 24, 1990): 47; Malcolm W. Browne, "Dinosaur Displays Closing for Renovation," *New York Times* (November 29, 1990), C: 17; Timothy Egan, "Goodbyes to T. Rex Are Tearful," *New York Times* (December 10, 1990), B: 1, 6; "A Face Lift for Natural History Museum's Dinosaur," *New York Times* (March 1, 1991), B: 2; Glenn Collins, "Clearing a New Path for T. Rex and Company," *New York Times* (December 1, 1991), II: 38; Jonathan Greenberg, "Rattling the Bones," *New York 25 (March 30, 1992): 34–42; "Museum Chief Quits," *New York Times* (December 8, 1992), C: 7; "Skeletons in the Museum Closet?" *New York 25 (December 21–28, 1992): 23; "New Life for Extinct Animals," *New York Times* (March 9, 1993), B: 2; William H. Honan, "Barnard's President to Head Museum of Natural History," *New York Times* (June 29, 1993), C: 13, 22; Glenn Collins, "Museum of Natural History Welcomes Its New President," *New York Times* (December 2, 1993), B: 9; "Fossils to Be Shown in New Museum Wing," *New York Times* (April 24, 1994), V: 3; Ashley Dunn, "Jurassic Jigsaw Puzzle," *New York Times* (May 12, 1994), B: 1, 4; John Noble Wilford, "A Brand-New Hall for Some Very Old Mammals," *New York Times* (May 13, 1994), C: 1, 24; Christopher Gray, "Streetscapes/The American Museum of Natural History," *New York Times* (June 19, 1994), X: 7; Leslie Camhi, "A Family Affair," *Village Voice* (July 26, 1994): 21–23; Clifford A. Pearson, "American Museum of Natural History, Mammals Exhibit, New York City," *Architectural Record* 182 (September 1994): 30–31; "American Museum of Natural History, New York," *Bauwelt* 85 (October 1994): 2066–69; Arthur Fisher, "Fossil Life Styles," *Popular Science* 245 (October 1994): 70–71; Robert E. Calem, "Interactive New York: Andrewsarchus to the Zoo," *New York Times* (January 13, 1995), C: 5; Paul Goldberger, "Natural History Museum Plans Big Overhaul," *New York Times* (January 27, 1995): 1, B: 2; "Gesichte und Gesichten," *Arch Plus* 126 (April 1995): 18–19; Joanna Smith Bers, "Dinosaurs Demand State-of-the-Art Housing," *Facilities Design & Management* 14 (April 1995): 52–53; Richard Milner, "Bringing Back the Dinosaurs," *Natural History* 104 (May 1995): 6–10; Stephen Perrella, "An Immersive Display," *Newsline* 7 (May 1995): 4; Douglas Martin, "Museum's Dinosaur Display Puts New Life in Old Bones," *New York Times* (May 17, 1995), B: 4; Malcolm W. Browne, "New Dinosaur Exhibit Underscores Disputes Within Paleontology," *New York Times* (May 23, 1995), C: 1, 5; Charles Laurence, "New York Life: In Raptures at the 'Raptors,'" *Daily Telegraph* (May 31, 1995): 15; Eugene S. Gaffney, Lowell Dingus, and Miranda K. Smith, "Why Cladistics?" *Natural History* 104 (June 1995): 33–35; Bill Bell, "Skeleton Crew," *New York Daily News* (June 2, 1995): 59; Anne E. Kornblut, "Mighty Big Things Are Happening," *New York Daily News* (June 2, 1995): 60; "Some Stars of the New Halls," *New York Times* (June 2, 1995), C: 22; William Grimes, "Pretty Ugly Guys to Be So Salable," *New York Times* (June 2, 1995), C: 1, 23; John Noble Wilford, "The Dinosaurs Reappear in Top Form," *New York Times* (June 2, 1995), C: 1, 23; "Return of the Dinosaurs," editorial, *New York Times* (June 4, 1995), IV: 14; John Schwartz, "Age-Old Perceptions Evolve in New York," *Washington Post* (June 5, 1995): 3; Steve Jones, "Dynamic Displays Bring Behemoths to Life," *USA Today* (June 6, 1995), D: 6; John Schwartz, "N.Y. Museum Gives T. Rex a New Look," *San Francisco Chronicle* (June 7, 1995): 16; Douglas Martin, "Behind Dinosaurs, It's the Mounting Team's Game," *New York Times* (June 26, 1995), B: 3; Arthur Fisher, "Dinosaur Tales," *Popular Science* 247 (August 1995): 60–61; Henry S. F. Cooper Jr., "Origins: The Backbone of Evolution," *Natural History* 105 (June 1996): 30–33, 36–42; Mark Norell, "'V' as in Vertebrate," *Natural History* 105 (June 1996): 40–41; John Noble Wilford, "The Backbone of Natural History," *New York Times* (June 7, 1996), C: 1, 21; Sandro Marpillero, "The American Museum of Natural History," *Lotus International* 93 (1997): 82–93.

4. William T. Golden, quoted in Honan, "Barnard's President to Head Museum of Natural History": 22.

5. George Langdon, quoted in Collins, "Clearing a New Path for T. Rex and Company": 38.

6. Edwin H. Colbert, quoted in Browne, "Dinosaur Displays Closing for Renovation": 17.

7. Samuel Taylor, quoted in Collins, "Clearing a New Path for T. Rex and Company": 38.

8. Ralph Appelbaum, quoted in Pearson, "American Museum of Natural History, Mammals Exhibit, New York City": 30.

9. Pearson, "American Museum of Natural History, Mammals Exhibit, New York City": 30.

10. Gray, "Streetscapes/The American Museum of Natural History": 7.

11. "Natural History Museum Revamped and Wired," *Progressive Architecture* 76 (March 1995): 22; Marisa Bartolucci, "Citizen Architect," *Metropolis* 14 (June 1995): 62–67, 74–79; Paul Goldberger, "Natural History Museum Plans Big Overhaul," *New York Times* (January 27, 1995): 1, B: 2; David Gelernter, "The End of Dignity," *New York Times* (March 5, 1995), IV: 15, reprinted in *Sky and Telescope* 93 (June 1997): 6–7; James Barron, "Its Stars Eclipsed, Hayden Is Cleared for Demolition," *New York Times* (November 22, 1995), B: 3; "A Splendid Museum Gets a New Star," editorial, *New York Times* (November 24, 1995): 34; "Landmarks Downtown; Planetarium Uptown; New Zoo Too?" *Municipal Art Society Newsletter* (January-February 1996): 2; Nadine Brozan, "Chronicle: Hayden Planetarium Names a Director," *New York Times* (April 26, 1996), B: 7; Janet Allon, "Planetarium Plan Worries a Block," *New York Times* (July 14, 1996), XIII: 1; Christopher Gray, "Streetscapes/Hayden Planetarium," *New York Times* (August 18, 1996), IX: 7; N. R. Kleinfield, "Down-to-Earth Fight Over Planetarium," *New York Times* (October 22, 1996), B: 1, 4; Michael Henry Adams, "Maintain a Landmark," letter to the editor, *New York Times* (October 26, 1996): 24; Stephanie Calmenson, "$39 Million for What?" letter to the editor, *New York Times* (October 26, 1996): 24; Hope Cohen, "A No-Brainer," letter to the editor, *New York Times* (October 26, 1996): 24; Peter M. Wright and Michael A. Broomfield, "Plans for the New Planetarium," letter to the editor, *New York Times* (October 26, 1996): 24; Joyce Purnick, "A Mystery Gift to a Museum Loses Its Mask," *New York Times* (November 7, 1996), B: 21; Claudio Veliz, "Renaissance or Regret?" *Astronomy* 25 (January 1997): 20–24; Candy Schulman, "Daddy's Dome," *New York Times* (January 12, 1997), XIII: 15; Beth Landman Keil and Deborah Mitchell, "Intelligencer: Star Wars Over Central Park West," *New York* 30 (February 10, 1997): 9; "Judge Dismisses Lawsuit Over New Planetarium," *New York Times* (February 27, 1997), B: 6; Herbert Muschamp, "Star Light, Star Bright," *New York Times* (March 1, 1997): 25–26; Michael W. Teslar and Seth Pinsky, "No Starry, Starry Night on New Park," letters to the editor, *New York Times* (March 8, 1997): 22; "Court Upholds Construction of Planetarium," *New York Times* (April 19, 1997): 24; David S. Chartock, "New Center for the Universe Built for the New Millennium," *New York Construction News* 45 (April 1998): 19–24; Matthys Levy, "A Museum for the Heavens," *Civil Engineering* 68 (May 1998): 58–61; Paula Deitz, "A Twinkling Terrace That Reaches for the Stars," *New York Times* (January 7, 1999), F: 8; Gavin Keeney, "Eclipse on 81st Street?" *Oculus* 61 (February 1999): 6–7; Samuel Leff, "Bad Neighbors?" letter to the editor, *New York* 32 (March 1, 1999): 6; "Milestone for New Planetarium," *New York Times* (March 3, 1999), B: 6; David W. Dunlap, "Castles, and Planetariums, in the Air," *New York Times* (March 11, 1999), G: 1, 7; David W. Dunlap, "Digital Plans Will Make Dome a Pleasant Place to Visit," *New York Times* (March 11, 1999), G: 7; David W. Dunlap, "Stringing Holes Together, 5,599,663 of Them," *New York Times* (March 11, 1999), G: 7; Soren Larson, "A Design Crossing Time and Space: New York City's New Planetarium," *Architectural Record* 187 (May 1999): 105; Glenn Collins, "Planetarium Introducing Updated City Star System," *New York Times* (August 11, 1999), B: 1, 4; "Planetarium for the Millennium," *New York Times* (September 1, 1999), B: 3; Nadine M. Post, "A Sphere of Influence," *Engineering News-Record* 243 (December 6, 1999): 36–40; Barbara Flanagan, "Currents: Planetariums," *New York Times* (December 23, 1999), F: 3; "Polshek Partnership: Rose Center for Earth and Space," *GA Document* 63 (2000): 48–57; "On the Boards: Rose Center for Earth and Space," *Interiors* 159 (January 2000): 108; Glenn Collins, "At Planetarium, the Fanciest Ball Is Inside the Cosmic One," *New York Times* (January 1, 2000): 9; Christopher M. Johnston, "The Gift to Be Simple," letter to the editor, *Engineering News-Record* 244 (January 24, 2000): 5; William Shuzman, "Right Awardee, Wrong Awarder," letter to the editor, *Engineering News-Record* 244 (January 24, 2000): 5; Glenn Collins, "Bracing for Planetarium Impact," *New York Times* (January 25, 2000), B: 1, 8; Paul Goldberger, "The Sky Line: Stairway to the Stars," *New Yorker* 75 (January 27, 2000): 72–78; Sarah Boxer, "What 'Astronomical' Means," *New York Times* (January 29, 2000), B: 9, 11; "Space Makers," *World Architecture* (February 2000): 72–73; Todd Schindler, "From Sphere to Eternity," *Metropolis* 19 (February-March 2000): 38; Henry S. F. Cooper Jr., "Sphere of Influence," *Natural History* 109 (February 2000): 50–59; Bay Brown, "Space Makers," *World Architecture* (February 2000): 72–73; Jonathan Lipnick, "Planetarium Neighbors," *New York Times* (February 1, 2000): 20; Rebekah Creshkoff, "Hazardous Planetarium," letter to the editor, *New York Times* (February 5, 2000): 14; Johanna Huden, "Reach for the Stars," *New York Post* (February 12, 2000): 22; Julie V. Iovine, "Telling a 13-Billion-Year Story with the Tools of the Moment," *New York Times* (February 13, 2000), II: 37, 39; Herbert Muschamp, "It's Something New Under the Stars (And Looking Up)," *New York Times* (February 13, 2000), II: 1, 37; Barbara Stewart, "What It Takes," *New York Times* (February 13, 2000), XIV: 1, 13; "A Traffic Odyssey," *New York Observer* (February 14, 2000): 8; Robert D. McFadden, "Meteorite Dispute Greets Opening of Planetarium," *New York Times* (February 19, 2000): 1, B: 2; Ken Kalfus, "Lost in the Stars," *New York Times* (February 21, 2000): 27; Natasha Singer, "Out of This World," *New York* 33 (February 21, 2000): 22–26, 28–29; Eric Gibson, "Manhattan Reaches for Stars with New Planetarium," *Wall Street Journal* (February 22, 2000): 38; Nicolai Ouroussoff, "The World Under Glass," *Los Angeles Times* (February 26, 2000): 1; Peg Breen, "Hayden Planetarium: A Preservationist Role," *New York Times* (February 27, 2000), II: 4; Benjamin Forgey, "Starry-Eyed in Manhattan," *Washington Post* (February 27, 2000), G: 1; Anders Hansson, "Virtual Space Tourism," *Architectural Design* 70 (March 2000): 26–29; Soren Larson, "A Star Is Born," *Architectural Record* 188 (March 2000): 29; Donna Paul, "Manhattan Rose," *Blueprint* 170 (March 2000): 26–27; Sheila Kim, "Masters of the Universe," *Interior Design* 71 (March 2000): 68; Jayne Merkel, "Welcome to the Universe," *Oculus* 62 (March 2000): cover, 3, 6–7; Lee Rosenbaum, "The Wrong Kind of Star Power," *Wall Street Journal* (March 3, 2000), W: 11; "For Some, the Universe Is Over Their Heads," *New York Times* (March 7, 2000): 1; Tina Kelley, "A Place Where the Big Bang Often Produces Puzzled Silence," *New York Times* (March 7, 2000), B: 1, 4; Randall Rothenberg, "Rose Center: Lost in Space," *Crain's New York Business* (March 20, 2000): 9; Peter Hall, "Moving Heaven and Earth," *Metropolis* 19 (June 2000): 160, 168, 170; "Polshek & Partners: A Firm and Its Universe," *Architectural Record* 188 (August 2000): 88–94; Jerry Laiserin, "Many Models Make the Rose Center," *Architectural Record* 188 (August 2000): 177–78; Clifford A. Pearson, "Cosmic Portal: The Rose Center for Earth and Space," *Architectural Record* 188 (August 2000): cover, 98–111; Michael Reis, "Re-Creating 'Planet Earth,'" *Stone World* 17 (September 2000): 98, 100, 102, 104, 106, 108, 110; Barbara Stewart, "A Museum Fountain You Can Touch," *New York Times* (September 7, 2000), B: 7; "Making Science a Smash Hit, While Giving an Old Museum a New Face," *Architectural Record* 188 (October 2000): 93; Glenn Collins, "Welcome Not Universal, but Neighbors Adjust," *New York Times* (October 29, 2000): 33; Helen Schary Motro, "Star-

Crossed," *New York Times* (October 29, 2000), XIV: 23; Betty Marshall and Susan L. Friedman, "Criticism of Planetarium Brings Out Pro and Con," letters to the editor, *New York Times* (November 26, 2000), XIV: 17; "Rose Center for Earth and Space," *Interior Design* 71 (December 2000): 148; Alan Balfour, *World Cities: New York* (New York: Wiley Academy, 2001), 132–35; "Un invernadero cósmico," *Arquitectura Viva* 76 (January-February 2001): 38–41; Celestine Bohlen, "Built for Substance, Not Flash," *New York Times* (January 22, 2001): B: 1, 5; "Point of Entry," *Interior Design* 72 (March 2001): 58; "Time Stands Still," *Architectural Record* 189 (June 2001): 43; Rossano Capurso, "New Planetarium in New York," *Industria delle costruzioni* (July-August 2001): 34–41; Marcello Delcampo, "Magic Box: Rose Center for Earth and Space," *L'Arca* 164 (November 2001): 38–45; "Architecture Award: Polshek Partnership," *Oculus* 64 (December 2001): 25; Bradford A. McKee, "What He Says It Is," *Architecture* 91 (February 2002): 62–64; Ian Luna, ed., *New New York: Architecture of a City* (New York: Rizzoli International Publications, 2003), 10, 246–51; Susan Strauss and Sean Sawyer, eds., *Polshek Partnership Architects* (New York: Princeton Architectural Press, 2005), 150–65.

12. For Rogers's Millennium Dome, see Barrie Evans, "The Dome Experience," *Architects' Journal* 206 (November 27, 1997): 29–36; Clive Aslet, "There's No Place Like the Dome," *Country Life* 192 (July 2, 1998): 70–71; Sara Hart, "Richard Rogers' Tensile-Roofed Millennium Dome Brings London Under the Big Top," *Architecture* 88 (January 1999): 108–13; Charles Jencks, "An Idea Big Enough for a Dome," *Architectural Design* 69 (November-December 1999): 8–9.

13. For the Hayden Planetarium, see Stern, Gilmartin, and Mellins, *New York 1930*, 129, 136–37.

14. Landmarks Preservation Commission of the City of New York, LP-0282 (August 24, 1967); Barbaralee Diamonstein, *The Landmarks of New York III* (New York: Harry N. Abrams, 1998), 164–65.

15. Stern, Gilmartin, and Mellins, *New York 1930*, 135.

16. See Peter Rice and Hugh Dutton, *Structural Glass*, 2nd ed. (London and New York: E. & F. N. Spon, 1995).

17. Peter F. Vallone, quoted in Goldberger, "Natural History Museum Plans Big Overhaul": 2.

18. James Stewart Polshek, quoted in Goldberger, "Natural History Museum Plans Big Overhaul": 2.

19. Gelernter, "The End of Dignity": 15.

20. Veliz, "Renaissance or Regret?": 20–24. Also see Ken Kalfus, "Science Fiction at the Planetarium," *New York Times* (February 26, 1994): 23. This essay was expanded and published under the title "Last Night at the Planetarium," in Katharine Washburn and John F. Thornton, eds., *Dumbing Down: Essays on the Strip Mining of American Culture* (New York: W. W. Norton, 1996), 139–48.

21. For the Perisphere, see Stern, Gilmartin, and Mellins, *New York 1930*, 276–78, 748–52. For Boullée's project, see Jean-Marie Pérouse de Montclos, *Étienne-Louis Boullée, 1728–1799: Theoretician of Revolutionary Architecture* (New York: George Braziller, 1974), plates 57–59. For Ledoux's scheme, see *L'Architecture de C. N. Ledoux* (Paris, 1804; Princeton, N.J.: Princeton University Press, 1983), plate 254; Anthony Vidler, *Claude-Nicolas Ledoux* (Cambridge, Mass., and London: MIT Press, 1990), 314–15.

22. Muschamp, "Star Light, Star Bright": 25–26.

23. Muschamp, "Star Light, Star Bright": 26.

24. Goldberger, "The Sky Line: Stairway to the Stars": 72, 74.

25. Muschamp, "It's Something New Under the Stars (And Looking Up)": 1, 37.

26. Kalfus, "Lost in the Stars": 27.

27. Ellen Futter, quoted in Singer, "Out of This World": 29.

28. Rosenbaum, "The Wrong Kind of Star Power": 11.

29. Ralph Appelbaum, quoted in Rosenbaum, "The Wrong Kind of Star Power": 11.

30. Rosenbaum, "The Wrong Kind of Star Power": 11.

31. Kelley, "A Place Where the Big Bang Often Produces Puzzled Silence": 1.

32. Pearson, "Cosmic Portal: The Rose Center for Earth and Space": 100.

33. David W. Dunlap, "Museum Seeks a New Building on W. 76th St.," *New York Times* (March 18, 1983), B: 3; Peter Freiberg, "Central Park West Landmarks Controversy," *Metropolis* 3 (September 1983): 10; Carter Wiseman, "Taking on the Towers," *New York* 17 (January 23, 1984): 62–63; David W. Dunlap, "Museum's Plan to Build Tower Stirs West Siders," *New York Times* (January 25, 1984), B: 3; "Landmark Works vs. Buildings," *New York Times* (February 2, 1984): 18; Lawrence J. Cohn, "A Historical Society Unlikely to 'Perish,'" letter to the editor, *New York Times* (February 11, 1984): 26; Peter Freiberg, "Furor Over Historical Society Tower," *Metropolis* 3 (March 1984): 10; George Lewis, "New York Historical Society: Chapter Opposition," *Oculus* 45 (March 1984): 15, 17; Hugh Hardy, "New York Historical Society: HHPA Proposal," *Oculus* 45 (March 1984): 14–17; Paul Goldberger, "Who Owns Landmarks?" *Preservation News* 24 (March 1984): 5, 10; David W. Dunlap, "Landmarks Panel Vetoes Tower Plans for St. Bart's and Historical Society," *New York Times* (March 8, 1984), B: 1, 7; Paul Goldberger, "Landmarks Cases: A Decisive Verdict," *New York Times* (June 14, 1984), B: 1, 6; Peter Freiberg, "Decisions, Decisions," *Metropolis* 4 (September 1984): 11–12; "The Hole in Landmarks Law," editorial, *New York Times* (April 22, 1986): 30; Nicholas Polites, *Hardy Holzman Pfeiffer Associates: Buildings and Projects, 1967–1992* (New York: Rizzoli International Publications, 1992), 194–97, 283, 260; Paul Spencer Byard, *The Architecture of Additions: Design and Regulation* (New York: W. W. Norton, 1998), 153–54; Carter B. Horsley, "Save the Museum, Improve Our Skyline," *New York Post* (September 22, 1988): 61. For the New-York Historical Society's headquarters, see Stern, Gilmartin, and Massengale, *New York 1900*, 18, 87, 104–5, 314, 393, 395; Stern, Gilmartin,

and Mellins, *New York 1930*, 135.

34. For the designation of the New-York Historical Society, see Landmarks Preservation Commission of the City of New York, LP-0281 (July 19, 1966); Diamonstein, *Landmarks of New York III*, 268. For the Central Park West–West 76th Street Historic District, see Landmarks Preservation Commission of the City of New York, *Central Park West–West 76th Street Historic District Designation Report* (New York, 1973); Diamonstein, *Landmarks of New York III*, 497.

35. Byard, *The Architecture of Additions*, 154.

36. Quoted in Freiberg, "Furor Over Historical Society Tower": 10.

37. Robert A. M. Stern, quoted in Freiberg, "Furor Over Historical Society Tower": 10.

38. Douglas C. McGill, "Historical Society Is Planning Cuts to Meet Crisis," *New York Times* (June 28, 1988), C: 15, 20; Douglas C. McGill, "Historical Society Cuts Staff in Budget Crisis," *New York Times* (June 30, 1988), C: 20; Douglas C. McGill, "Hundreds of Art Works Damaged by Mildew in Museum Warehouse," *New York Times* (July 10, 1988): 1, 23; Douglas C. McGill, "Museum's Downfall: Raiding Endowment to Pay for Growth," *New York Times* (July 19, 1988), C: 1, 18; Kay Larson, "Plundering the Past," *New York* 21 (July 25, 1988): 38–44; Douglas C. McGill, "Criticism Moves Historical Society, a Little," *New York Times* (July 25, 1988), C: 13, 15; "New York's Ill-Kept Treasure," editorial, *New York Times* (July 26, 1988): 20; Douglas C. McGill, "Historical Society Director Quits and Trustees Dismiss His Deputy," *New York Times* (July 25, 1988): 1, C: 24; Geoffrey Blodgett, "Cass Gilbert Papers," letter to the editor, *New York Times* (August 5, 1988): 24; Douglas C. McGill, "Panel Will Seek Rescue for Historical Society," *New York Times* (August 14, 1988): 36; Christopher Gray, Wendy Shadwell, and Kathryn A. Jolowicz, "Back to the Past," letters to the editor, *New York* 21 (August 15, 1988): 8; Douglas C. McGill, "Troubled Museums Try to Master the Fine Art of Survival," *New York Times* (August 28, 1988), IV: 24; Douglas C. McGill, "Historical Society Seeks to Save Neglected but Priceless Library," *New York Times* (September 15, 1988), C: 19, 24; Andrew L. Yarrow, "Historical Society Opens Two Conservation Labs," *New York Times* (January 28, 1989): 17; "Our Landmark Building Is Restored," *The New-York Historical Society Gazette* (Fall 1989): 4; Michael Kimmelman, "A New Spirit at the New-York Historical Society," *New York Times* (September 5, 1990), C: 13, 15; William H. Honan, "To Be Rescued, Historical Society May End Up Joining Its Savior," *New York Times* (November 19, 1992), C: 19, 22; William H. Honan, "Historical Society to Close Library," *New York Times* (February 4, 1993), C: 15, 19; William H. Honan, "Scholars Mourn and Fight a Landmark Library's Closing," *New York Times* (February 9, 1993), C: 11, 16; "Saving the City's 'Memory,'" *New York Times* (February 18, 1993): 22; Christopher Moore, "Historical Society Holds Black History Trove," letter to the editor, *New York Times* (February 18, 1993): 22; David W. Dunlap, "Historical Society Shuts Its Doors but Still Hopes," *New York Times* (February 20, 1993): 9; Michael Kimmelman, "Is This the End for New York's Attic?" *New York Times* (February 21, 1993), II: 1, 39; Ada Louise Huxtable, "New York Must Save Historical Society Before It's Too Late," letter to the editor, *New York Times* (March 3, 1993): 24; William H. Honan, "Historical Society Tries to Live by Subtraction," *New York Times* (March 12, 1993), C: 3; Michael Kimmelman, "Selling Art to Save Historical Society: A Painful Remedy," *New York Times* (March 18, 1993): C: 17, 22; "Cleaning Out New York's 'Attic,'" *New York Times* (March 21, 1993), IV: 16; Barbara L. Michaels, "Historical Society: Does It Have a Future?" *Landmark West* (Spring 1993): 2–3; William H. Honan, "Historical Society Budget Priority in Doubt," *New York Times* (April 27, 1993), C: 18; "Redford to Rescue Historical Society?" *New York Observer* (May 3, 1993): 1, 3; William Grimes, "Historical Society Gets N.Y.U.'s Help," *New York Times* (August 12, 1993), C: 13; William Grimes, "Betsy Gotbaum Heads Troubled Historical Society," *New York Times* (June 20, 1994), C: 15; Ralph Blumenthal, "Trying to Keep the Historical Society," *New York Times* (December 6, 1994), C: 15, 20; Carol Vogel, "Fire on Central Park West," *New York Times* (March 10, 1995), C: 13; Michael T. Kaufman, "Museum Dusts Off Itself, Its Fop and a Horse's Tail," *New York Times* (April 29, 1995): 27; Christopher Gray, "Streetscapes/The New-York Historical Society," *New York Times* (May 14, 1995), IX: 7; Mark Lasswell, "It's History," *New York* 28 (October 30, 1995): 46–47; Karen W. Arenson, "A Society Decides It Can't Go It Alone," *New York Times* (November 29, 1995), C: 13, 15; "Two Collections and a Courtship," editorial, *New York Times* (December 3, 1995), IV: 14; Paul Goldberger, "To the Rescue of a Grande Dame of Museums," *New York Times* (June 2, 1997), C: 9–10; Roberta Smith, "In Quiet Corners, a Rhapsody for the Eyes and Soul," *New York Times* (January 1, 1999), E: 35; Glenn Collins, "Digging for Forgotten Treasure; Museum Opens Its Vaults for New Exhibition Space," *New York Times* (July 31, 2000), B: 1, 3; Allison Eckardt Ledes, "Out of Storage and Now On View," *The Magazine Antiques* 158 (December 2000): 816.

39. Donald Garfield, "The Democratic Impulse Still Resonates from this 1830s Gallery," *Museum News* 70 (January-February 1991): 26–27; *Allan Greenberg: Selected Works* (London: Academy Editions, 1995), 18. The design of Reed's townhouse is attributed to Alexander Jackson Davis and Isaac Green Pearson, who designed the facade and the interiors, respectively. For 13 Greenwich Street and a discussion of the original galleries, see Ella M. Foshay, *Mr. Luman Reed's Picture Gallery: A Pioneer Collection of American Art* (New York: Harry N. Abrams in association with the New-York Historical Society, 1990).

40. *Allan Greenberg: Selected Works*, 18.

41. Collins, "Digging for Forgotten Treasure: Museum Opens Its Vaults for New Exhibition Space": 1, 3.

42. Suzanne Slesin, "Children's Museum Plans to Move and Grow," *New York Times* (October 26, 1988), B: 32; Daniel J. McConville, "Kids' Digs," *New York Post* (April 6, 1989): 47; Michael Dupree, "Broadcast News, 2001: The New Children's Museum of Manhattan Builds a Playground for the Video Generation," *Avenue* (October 1989): 100–102; Andrew L. Yarrow, "New Children's Museum Joins 2 Old Favorites," *New York Times* (October 13, 1989), C: 1, 31; David Masello, "New School of Thought," *Architectural Record* 178 (July 1990): 68–71. For the Clinton Youth and Family Center, see Stern, Mellins, and Fishman, *New York 1960*, 318. For Dunn's school, see "Cardinal Blesses New Trinity School," *New York Times* (September 30, 1929): 14.

43. Mervyn Rothstein, "From Swimming to Study," *New York Times* (May 2, 1999), XI: 1; "Future Work: New York, N.Y.," *New York Construction News* 47 (June 1999): 102; "Future Work: New York, N.Y.," *New York Construction News* 48 (July 1999): 95; "Jewish Community Ctr. Planned for West Side," *New York Construction News* 48 (August 1999): 11; "Awards of Excellence 2000: Playing It Safe," *Canadian Architect* 45 (December 2000): 12–35; "Pool, Theater, Gym, More . . . Steel Made It Possible," *Metalworks* (May 2001): 4; Alissa Macmillan, "Hidden Treasure," *New York Daily News* (March 24, 2002): 12; "Jewish Community Center of the Upper West Side," *New York Construction News* 49 (June 2002): 49; Kelly Crow, "A New 92nd Street Y? Almost," *New York Times* (October 6, 2002), XIV: 4.

44. A. J. Diamond, quoted in Rothstein, "From Swimming to Study": 1.

45. "Adaptive Re-Use/Historic Preservation Citation: Polshek Partnership," *Oculus* 64 (December 2001): 32; Strauss and Sawyer, eds., *Polshek Partnership Architects*, 213. For Buchman & Fox's townhouse, see Landmarks Preservation Commission of the City of New York, *Upper West Side–Central Park West Historic District* (New York, 1990), 591.

46. Lisa Wolfe, "West Side School Prepares $4.5 Million Expansion," *New York Times* (March 3, 1985): 44; Christopher Gray, "Streetscapes: The Columbia Grammar and Preparatory School," *New York Times* (August 12, 1990), VIII: 4; *Pasanella + Klein Stolzman + Berg* (Gloucester, Mass.: Rockport Publishers, 1999), 139; White and Willensky, *AIA Guide* (2000), 365–66.

47. White and Willensky, *AIA Guide* (2000), 366.

48. Michael Wurmfeld, quoted in "New Columbia Grammar Middle School," *New York Times* (February 27, 1994), X: 1. Also see "Private Middle School to Start in Late June," *New York Construction News* 41 (May 16, 1994): 1, 7.

49. "Trinity School: Gyms Upstairs and Down," *New York Times* (May 18, 1997), IX: 1; Stephen A. Kliment, "For Private Schools Ingenuity Is a Key to Expansion Plans," *New York Times* (April 18, 1999), XI: 1, 6. For Potter's building, see Landmarks Preservation Commission of the City of New York, LP-1659 (August 1, 1989); Diamonstein, *The Landmarks of New York III*, 397.

WEST SIDE URBAN RENEWAL AREA

1. Stern, Mellins, and Fishman, *New York 1960*, 728–33.

2. Alan S. Oser, "A Community Board Review in West Side Renewal Project," *New York Times* (June 17, 1977): 25; "9 Renewal Projects Slated for West Side," *New York Times* (December 12, 1977): 29; Robert McG. Thomas, Jr., "West Side Board Creates Blueprint for Redevelopment," *New York Times* (December 14, 1977), B: 3; "Rich and Poor on the West Side," editorial, *New York Times* (December 19, 1977): 30; Glenn Fowler, "Renewal Project on the West Side Affirmed by City," *New York Times* (October 8, 1979), B: 3; Glenn Fowler, "Revised West Side Housing Plan Passed," *New York Times* (November 16, 1979), B: 3; Alan S. Oser, "West Side's Renewal Plan Is Held Costly to New York," *New York Times* (November 30, 1979), B: 8; "The West Side Plan and the Squatters," editorial, *New York Times* (December 1, 1979): 20; Paul B. Hoeber, "Whose Upper West Side?" letter to the editor, *New York Times* (February 20, 1980): 24; Carol Lamberg, "West Side Renewal," *New York Times* (September 14, 1981): 25; "A Final West Side Compromise," editorial, *New York Times* (October 24, 1981): 22; Lee A. Daniels, "U.S. Ends Its Role in West Side Renewal," *New York Times* (December 11, 1981), B: 3; "The West Side Without Washington," editorial, *New York Times* (December 28, 1981): 18; Ralph Blumenthal, "Renewal of the West Side a Slow-Moving Story," *New York Times* (September 29, 1982), B: 1, 6; Lee A. Daniels, "Completion of West Side Plan Sought," *New York Times* (September 2, 1983), B: 7.

3. "Rich and Poor on the West Side": 30.

4. "Carriage Houses: New Home for Ballet," *New York Times* (November 12, 1989), X: 1.

5. Linda Amster, "West Side Success Story of a Restaurant and a Neighborhood," *New York Times* (October 27, 1979): 44.

6. Blumenthal, "Renewal of the West Side a Slow-Moving Story": 1, 6.

7. Alan S. Oser, "West Side Housing Program Resumes," *New York Times* (April 27, 1984), B: 7; Philip S. Gutis, "A Price Cut Spurs Sales at West 89th St. Project," *New York Times* (June 20, 1986): 23.

8. Fergus M. Bordewich, "West Side Story: From Gang Fights to Class War," *New York* 11 (June 5, 1977): 8–11; Arnold H. Lubasch, "Court Bars West Side Low-Income Project," *New York Times* (December 17, 1978): 57; Linda Greenhouse, "Top Court Backs Housing Project on the West Side," *New York Times* (January 8, 1980), B: 1–2; Michael Goodwin, "City Officials Remain Undecided on Housing Project for West Side," *New York Times* (January 9, 1980), B: 3; Laurie Johnston, "West Side's Renaissance Is Fanning Old Tensions," *New York Times* (January 18, 1980): 1, B: 4; "Pickets Protest Renewal Plan," *New York Times* (January 21, 1980), B: 3; "Another Chance on the West Side," editorial, *New York Times* (January 22, 1980): 20; Linda Greenhouse, "Supreme Court Roundup: Housing

Project," *New York Times* (April 22, 1980), B: 12.

9. For the Stephen Wise Towers, see Stern, Mellins, and Fishman, *New York 1960*, 731–32.

10. "Another Chance on the West Side": 20.

11. Lee A. Daniels, "City Proposes Housing for Disputed West Side Site," *New York Times* (September 6, 1983), B: 7; "Housing Proposed for West Side Site," *New York Times* (September 8, 1983), B: 3; "Urban Renewal Site's Last Argument," *New York Times* (November 20, 1983), VIII: 9; Peter Freiberg, "Westside Renewal Controversy," *Metropolis* 3 (April 1984): 12; "Two Housing Developments Approved for West Side Site," *New York Times* (May 24, 1985), B: 4; Lisa W. Foderaro, "2 Luxury Rentals Extend Columbus Ave. Renewal," *New York Times* (October 3, 1986): 19.

12. White and Willensky, *AIA Guide* (1988), 334; "In and Around the City," *Oculus* 3 (September 1990): 3.

13. Oser, "West Side Housing Program Resumes": 7; Alan S. Oser, "A New Way of Creating Mixed-Income Developments," *New York Times* (March 17, 1985), VIII: 7, 14; Foderaro, "2 Luxury Rentals Extend Columbus Ave. Renewal": 19.

14. Oser, "A New Way of Creating Mixed-Income Developments": 7.

15. Oser, "West Side Housing Program Resumes": 7; Oser, "A New Way of Creating Mixed-Income Developments": 14; Foderaro, "2 Luxury Rentals Extend Columbus Ave. Renewal": 19; White and Willensky, *AIA Guide* (2000), 367.

16. David W. Dunlap, "Tempest Over Tower Is Nearing End," *New York Times* (January 1, 1989), B: 3.

17. David W. Dunlap, "Landmarks Panel to Study Stable and Pepsi-Cola Sign," *New York Times* (April 18, 1988), B: 3; Christopher Gray, "Streetscapes/Claremont Stables," *New York Times* (April 24, 1988), X: 14; Landmarks Preservation Commission of the City of New York, LP-1658 (July 12, 1988); Charles V. Bagli, "Bond Issue to Save Manhattan Riding Stable," *New York Observer* (February 12, 1990): 6; Richard D. Lyons, "West Side Landmark: Rebuilding a Stable," *New York Times* (February 18, 1990), X: 1; Barbaralee Diamonstein, *The Landmarks of New York III* (New York: Harry N. Abrams, 1998), 394.

18. Joseph Berger, "Hispanic Life Dims in Manhattan Valley," *New York Times* (September 11, 1987), B: 1, 4.

19. For the Frederick Douglass Houses, see Stern, Mellins, and Fishman, *New York 1960*, 74–75, 726.

20. Alan S. Oser, "Project Evokes City's Brownstone Era," *New York Times* (January 13, 1984), B: 7; Evelyn Nieves, "Manhattan Valley's Boom Ends Up Just a Fizzle," *New York Times* (December 25, 1990): 33–34; Lee A. Daniels, "New Condominiums at Harlem's Edge," *New York Times* (February 19, 1984), VIII: 1, 14; Adam Liptak, "Manhattan Valley Townhouses," *New York Times* (March 31, 1985), VIII: 6, 14; "Just off Central Park: Rocky Road for Townhouses," *New York Times* (January 8, 1989), X: 1; "U-Shaped Condo Complex," *New York Post* (January 13, 1989): 59; Elaine Louie, "Good Design, Good Prices Uptown," *New York Times* (February 8, 1990), C: 11; White and Willensky, *AIA Guide* (2000), 371–72.

21. White and Willensky, *AIA Guide* (2000), 372.

22. For the Association Residence for Respectable and Indigent Females, see Stern, Mellins, and Fishman, *New York 1880*, 782.

23. Paul Goldberger, "A Visible Anchor to Past Would Be Lost in Razing," *New York Times* (June 19, 1974): 49; John L. Hess, "Victorian Home for Aged to Be Demolished," *New York Times* (June 19, 1974): 49.

24. Goldberger, "A Visible Anchor to Past Would Be Lost in Razing": 49.

25. "West Siders Seek to Save Building," *New York Times* (November 17, 1974): 31; Robert A. M. Stern, "Designating Landmarks," letter to the editor, *New York Times* (December 25, 1974): 26.

26. Stern, "Designating Landmarks": 26.

27. Richard D. Lyons, "West Side Landmark to Become a Hostel," *New York Times* (March 27, 1988), X: 9.

28. Jesus Rangel, "500-Bed Hostel Proposed for Amsterdam Ave. Landmark," *New York Times* (November 28, 1984), B: 1, 5; Al Amateau, "Youth Hostel Building Plans Move Ahead," *The Westsider* 17 (January 14–20, 1988): 1, 9; Lyons, "West Side Landmark to Become a Hostel": 9; Audrey Farolino, "Happy Hostel Takeover," *New York Post* (March 30, 1989): 53; "The Talk of the Town: Lodging," *New Yorker* 65 (November 27, 1989): 10; Michele Herman, "New York Gets Hostel," *Metropolis* 9 (May 1990): 27–28; "New York International Youth Hostel," *Oculus* 52 (June 1990): 1; Paul Goldberger, "Three New York City Success Stories," *New York Times* (July 22, 1990), II: 28, 30; Rachel Cox, "Windows on the World," *Historic Preservation* 44 (January/February 1992): 66, 68–69. Also see Landmarks Preservation Commission of the City of New York, LP-1280 (April 12, 1983); Diamonstein, *The Landmarks of New York III*, 181.

29. Goldberger, "Three New York City Success Stories": 30.

30. David W. Dunlap, "Developer Plans to Link 39-Story Tower to a West Side Landmark," *New York Times* (October 26, 1986): 47; Susan Heller Anderson, "Central Park West Tower Approved," *New York Times* (October 4, 1987): 49, 54; Helen Thorpe, "Board 7/Support for Project at West 106th St.," *New York Observer* (December 18, 1989): 8; Andrew White, "The Rise of Manhattan Valley," *Metropolis* 9 (January/February 1990): 16–18; "Towers Nursing Home," *Landmark West! Newsletter* (Fall 1993): 8; Jennifer Kingson Bloom, "After 6 Years, Landmark Eyesore Is Still an Eyesore," *New York Times* (December 4, 1994), XIII: 6; Rachelle Garbarine, "An Attempt to Redevelop a Manhattan Landmark," *New York Times* (June 13, 1997), B: 7; Beth Landman Keil and Deborah Mitchell, "Jacob's Ladder to Trump's Tower," *New York* 30 (July 21, 1997): 12; Nina Rappaport, "Restoration Rebounds," *Oculus* 60 (March 1998): 4; Anthony Connors, "Then & Now: Fallen Towers," *New York Daily News* (May 3, 1998): 49; Tara Bahrampour,

"After a Long Sleep, an Old Tower Is Poised for Role in New Century," *New York Times* (March 19, 2000), XIII: 6; David Sokol, "Cure for Cancer Hospital?" *Grid* 2 (March-April 2000): 28–29; Tara Bahrampour, "Luxury Condos Are Planned for a Turreted Landmark," *New York Times* (May 28, 2000), XIII: 8; Amanda May, "Park Place," *Grid* 3 (March 2001): 72; Peter Bafitis, "Building Credit," letter to the editor, *New York* 34 (April 9, 2001): 14; Nadine Brozan, "Old Hospital Is Centerpiece of a Luxurious Compound," *New York Times* (May 18, 2001), B: 7; Steve Cutler, "Future Top Condos," *New York Living* (December 2001/January 2002): 16; Denny Lee, "One More Rescue Attempt for a Battered Landmark," *New York Times* (December 1, 2002), XIII: 6; Braden Keil, "Luxe CPW Condos Make the Grade Once More," *New York Post* (September 18, 2003): 38; Nadine Brozan, "Central Park West, 105th to 106th St.: Columbia Help Puts Tower at Landmark Site," *New York Times* (December 21, 2003), XI: 1; Christopher Gray, "Streetscapes/Central Park West Between 105th and 106th Streets," *New York Times* (December 28, 2003), XI: 5. For the New York Cancer Hospital, see Stern, Mellins, and Fishman, *New York 1880*, 784–85.

31. Pranay Gupte, "Status of Towers Home as a Landmark Debated," *New York Times* (July 14, 1976): 41; Landmarks Preservation Commission of the City of New York, LP-0938 (August 17, 1976); Carter B. Horsley, "Landmark Rating Is Given to Towers Nursing Home," *New York Times* (August 18, 1976): 41.

COLUMBIA UNIVERSITY

1. For the addition to Avery Hall and the Fairchild Center, see Stern, Mellins, and Fishman, *New York 1960*, 749–51.

2. Gregg Bloche, "Construction Woes Endanger Future," *Columbia Spectator* (October 6, 1975): 1–2; "McGill Sees Hope for Funding Dorm," *Columbia Spectator* (December 4, 1975): 1, 3; Maxwell G. Bloche, "Hope Diminishes for College Dorm," *Columbia Spectator* (August 12, 1976): 1, 3; "Columbia Plans a $20 Million Dorm Project," *New York Times* (May 13, 1977), B: 2; Richard Hart, "East Campus Dorm, Renovations Mark Area 'Renaissance,'" *Columbia Spectator* (May 18, 1977): 1, 6; "New Plans Show Revised Thinking," *Columbia Spectator* (May 18, 1977): 1, 5; "Columbia University Housing," *Progressive Architecture* 58 (July 1977): 41; "Center for Humanities to Be Built by Columbia," *New York Times* (November 19, 1977): 46; *To Assure the Quality of Life: East Campus, Columbia University* (New York: Columbia University, 1978); Alan Suemori, "Committee Calls for East Campus Changes," *Columbia Spectator* (March 27, 1978): 1–2; Roger Wilkins, "'Children's Free School' Fights for Right to Keep Columbia Site," *New York Times* (April 7, 1978): 14; Carter B. Horsley, "Columbia to Construct Housing That Meets Student Demands," *New York Times* (June 2, 1978), B: 5; Robin Micheli, "CU Forced to Resubmit Dorm Plan," *Columbia Spectator* (June 29, 1978): 1; Helene Rubinstein, "HUD Loan Sought for New Dormitory," *Columbia Spectator* (September 11, 1978): 1–2; Ken Wills, "CB9 Asks Statement on Dorm's Impact," *Columbia Spectator* (September 20, 1978): 1, 3; "Film Promoting New Dorm Urges Alumni Gift-Giving," *Columbia Spectator* (September 25, 1978): 2; Ken Wills, "HUD Grants CU $5 Million Loan for East Campus Dorm Complex," *Columbia Spectator* (October 4, 1978): 1, 3; Peter Brown, "Study Claims Community Ignored on Dorm Plans," *Columbia Spectator* (October 6, 1978): 3, 6; Jeff Tamarin, "Wagner Defends Dorm Variance at CB9 Meeting," *Columbia Spectator* (November 17, 1978): 1, 5; Pete Brown, "New Dorm Delayed Till September '81," *Columbia Spectator* (February 2, 1979): 1, 3; Eileen Tabios, "Inflation Boosts East Campus Cost $5M Past Estimate," *Columbia Spectator* (March 28, 1979): 1, 3; Joey Trevisani, "E. Campus May Get Solar Heating," *Columbia Spectator* (April 26, 1979): 1, 5; Jim Schachter, "New Dormitory Cost Is Now $21 Million," *Columbia Spectator* (May 16, 1979): 5; Pete Brown and Stuart Karle, "East Campus Cost Up $6M; Jump Termed 'Horrendous,'" *Columbia Spectator* (September 17, 1979): 1, 3; Stuart Karle, "$6M Price Hike Seen as Last for New Dorm," *Columbia Spectator* (September 19, 1979): 1, 3; Eileen Tabios, "E. Campus Costs Limit Facilities," *Columbia Spectator* (September 26, 1979): 1, 3; Barbaralee Diamonstein, *American Architecture Now* (New York: Rizzoli International Publications, 1980), 71, 73–74; "Space, Place, Object: Gwathmey/Siegel Architects," *Skyline* 2 (February 1980): 6–7; Tom Willcox and David Rier, "December Opening for East Campus Seen," *Columbia Spectator* (September 19, 1980): 1; Cullen Stanley, "Architect Doubts January Finish for East Campus," *Columbia Spectator* (October 8, 1980): 1, 3; Pete Brown, "East Campus Breaks Dorm Mold," *Columbia Spectator* (November 10, 1980): 1; Pete Brown, "View Will Dictate East Campus Rates," *Columbia Spectator* (November 20, 1980): 1–2; Pete Brown and Todd Bressi, "Officials Give Final Okay for Transfer to East Campus," *Columbia Spectator* (November 21, 1980): 1, 3; Leila Johannesen and Tom Willcox, "New Dorm May Have Stores; Humanities Center Planned," *Columbia Spectator* (December 4, 1980): 2; Stanley Abercrombie, *Gwathmey Siegel* (New York: Whitney Library of Design, 1981), 108–14; "Gwathmey Siegel & Associates," *GA Document* 4 (1981): 68–79; "East Campus Housing, Columbia University, New York, New York," *Progressive Architecture* 62 (January 1981): 72; Pete Brown and Steve Waldman, "'Luxury Rooms Lack Heat, Water and Electricity," *Columbia Spectator* (January 20, 1981): 1, 6; Todd Bressi, "Workers Tackle Details in East Campus Dorm," *Columbia Spectator* (January 21, 1981): 1–2; Marcus Brauchli, "CU Shifts Blame for Uncompleted Dormitory Rooms," *Columbia Spectator* (January 26, 1981): 1, 3; Mark Segall, "New Dormitory Is Paradise Found," *Columbia Spectator* (January 26, 1981): 1; Pete Brown and Rich Rothman, "CU Officials Will Investigate East Campus Alarm System," *Columbia Spectator* (January 30, 1981): 1, 3; Steven Waldman, "New Dorm Had 18 Fire Violations," *Columbia Spectator*

(February 4, 1981): 1–2; Steven Waldman and Pete Brown, "New Dorm Choked by Fumes, Smoke," *Columbia Spectator* (February 10, 1981): 1; Richard Pollack, "East Campus Plagued by Rodents," *Columbia Spectator* (February 13, 1981): 1–2; Michael Sorkin, "On Building Blocks," *Village Voice* (April 8, 1981): 91; Marcus Brauchli, "Thefts, Damages Total Over $80G at East Campus," *Columbia Spectator* (April 9, 1981): 1–2; Patrick Clark, "Officials Say Students Toss Objects out of New High-Rise," *Columbia Spectator* (April 15, 1981): 1, 6; "Columbia Dedicates New Suites and Town Houses for Students," *New York Times* (June 4, 1981), B: 11; Jane Gamble, "CU Says 'Thanks Millions' in East Campus Dedication," *Columbia Spectator* (June 10–16, 1981): 1, 3; Pete Brown, "New Dorm to Get Fire Alarm Horns," *Columbia Spectator* (August 31, 1981): 1–2; William G. Blair, "Center for Humanities Dedicated at Columbia," *New York Times* (September 17, 1981), B: 1, 8; Ada Louise Huxtable, "An Ingenious Advance in Housing Design," *New York Times* (October 4, 1981), II: 33, 39; Dave Peterson, "Vandalism Down in East Campus So Far This Year," *Columbia Spectator* (November 5, 1981): 1, 4; Susan Doubilet, "Gwathmey Siegel: East Campus Complex," *Skyline* 4 (January 1982): 18–19; "Expanding Horizons: The East Campus Complex," *Architectural Record* 170 (February 1982): 65–71; "East Campus Complex, Columbia University, by Gwathmey Siegel & Associates," *Space Design* 214 (July 1982): 59–66; "Columbia University, Student Housing and Academic Center, *Architecture + Urbanism* (May 1983): 72–77; "Guest Speaker: Charles Gwathmey on a Personal Approach to Architecture," *Architectural Digest* 40 (November 1983): 48–49; Sharon Waxman, "East Campus: The Dream Dorm in Decay," *Columbia Spectator* (November 15, 1983), X: 1; Peter Arnell and Ted Bickford, eds., *Charles Gwathmey and Robert Siegel: Buildings and Projects, 1964–1984* (New York: Harper & Row, 1984), 130–37; "East Campus," *Columbia Spectator* (May 16, 1984): 5; "East Campus Housing Complex and Academic Center," *Process Architecture* 64 (January 1986): 145–49; White and Willensky, *AIA Guide* (1988), 423; Norman Coplan, "Law: Substantial Completion," *Progressive Architecture* 74 (January 1993): 33; "University's Lawsuit Is Rendered Untimely," *New York Law Journal* (January 25, 1995): 25; Barry Bergdoll, *Mastering McKim's Plan: Columbia's First Century on Morningside Heights* (New York: Columbia University, 1997), 136–37; Andrew S. Dolkart, *Morningside Heights: A History of Its Architecture & Development* (New York: Columbia University Press, 1998), 461.

3. Horsley, "Columbia to Construct Housing That Meets Student Demands": 5.

4. Huxtable, "An Ingenious Advance in Housing Design": 33.

5. Huxtable, "An Ingenious Advance in Housing Design": 39.

6. Doubilet, "Gwathmey Siegel: East Campus Complex": 18.

7. Huxtable, "An Ingenious Advance in Housing Design": 33, 39.

8. Doubilet, "Gwathmey Siegel: East Campus Complex": 18.

9. Sorkin, "On Building Blocks": 91.

10. David T. Gordon, "East Campus Languishes in Limbo," *Columbia Spectator* (June 21, 1989): 4; Kirsten Danis, "E. Campus, Hamilton to Get Facelifts," *Columbia Spectator* (February 1, 1990): 1, 16; "Columbia Dormitory: A New Facade," *New York Times* (June 23, 1991), X: 1; "News Notes: Within City Limits," *Oculus* 54 (September 1991): 3; "Renovations in Our Time," *Oculus* 55 (October 1992): 9; Norman Coplan, "Law: Substantial Completion," *Progressive Architecture* 74 (January 1993): 33; Bergdoll, *Mastering McKim's Plan*, 137–38; Dolkart, *Morningside Heights*, 461; White and Willensky, *AIA Guide* (2000), 468.

11. "James Stirling Gets Pritzker Architecture Award," *New York Times* (April 16, 1981), C: 17; Ada Louise Huxtable, "Changes on the Drawing Board and the Making," *New York Times* (December 27, 1981), II: 27; James Stirling and Michael Wilford, "Chandler North: The Extension of the Chemistry Department, Columbia University, New York," *Architectural Design* 53 (Nos. 3-4, 1983): 10–15; "Extension to the Chemistry Department, Columbia University, New York," *Architectural Review* 173 (March 1983): 26–30; Peter Arnell and Ted Bickford, eds., *James Stirling: Buildings and Projects* (New York: Rizzoli International Publications, 1984), 315–22; Michael Wilford, "Responding to Context," *UIA International Architect* 5 (1984): 29; Michael Sorkin, "The Big Man on Campus," *Architectural Review* 175 (April 1984): 24–28; "Autour des Projets Récents," *AMC* 5 (October 1984): 14–17; *James Stirling, Michael Wilford and Associates: Buildings and Projects, 1975–1992* (New York: Thames & Hudson, 1994), 96–99, 298; Bergdoll, *Mastering McKim's Plan*, 135–36, 240, plate 16; Mark Girouard, *Big Jim: The Life and Work of James Stirling* (London: Chatto & Windus, 1998), 212; Robert Maxwell, *James Stirling, Michael Wilford* (Basel: Birkhäuser, 1998), 12, 90–91.

12. For the Marcellus Hartley Dodge Physical Fitness Center, see Stern, Mellins, and Fishman, *New York 1960*, 747, 749.

13. James Stirling, quoted in "Extension to the Chemistry Department, Columbia University, New York": 26–27. For Pupin Hall, see Stern, Gilmartin, and Mellins, *New York 1930*, 109.

14. Bergdoll, *Mastering McKim's Plan*, 136.

15. Julius Genachowski, "CU Scales Down Chem Building Plan," *Columbia Spectator* (February 8, 1983): 1, 6; "Legislation Allows DOE Funds for National Chemistry Center," *Columbia Spectator* (August 10, 1983): 1, 3; Richard Froehlich, "Fed Money Makes Chem Center Certain," *Columbia Spectator* (September 21, 1983): 1–2; Richard Froelich, "New Chemistry Building Wins $3 M," *Columbia Spectator* (June 20, 1984): 1–2; John Oswald, "Chem Gets Profs, New Building, Renovations," *Columbia Spectator* (December 3, 1984): 1, 5; Demetri Gounaris, "Chemistry Building Renovations on Time," *Columbia Spectator* (February 19, 1986): 1, 3; Gerson Rothschild, "Renovations Underway on Havemeyer, Pupin Halls," *Columbia Spectator* (June 14, 1989): 1; Kirsten Fermaglich, "Chemistry Construction to End Soon," *Columbia Spectator* (March 27, 1990): 1, 5;

Crossed," *New York Times* (October 29, 2000), XIV: 23; Betty Marshall and Susan L. Friedman, "Criticism of Planetarium Brings Out Pro and Con," letters to the editor, *New York Times* (November 26, 2000), XIV: 17; "Rose Center for Earth and Space," *Interior Design* 71 (December 2000): 148; Alan Balfour, *World Cities: New York* (New York: Wiley Academy, 2001), 132–35; "Un invernadero cósmico," *Arquitectura Viva* 76 (January-February 2001): 38–41; Celestine Bohlen, "Built for Substance, Not Flash," *New York Times* (January 22, 2001), B: 1, 5; "Point of Entry," *Interior Design* 72 (March 2001): 58; "Time Stands Still," *Architectural Record* 189 (June 2001): 43; Rossano Capurso, "New Planetarium in New York," *Industria delle costruzioni* (July-August 2001): 34–41; Marcello Delcampo, "Magic Box: Rose Center for Earth and Space," *L'Arca* 164 (November 2001): 38–45; "Architecture Award: Polshek Partnership," *Oculus* 64 (December 2001): 25; Bradford A. McKee, "What He Says It Is," *Architecture* 91 (February 2002): 62–64; Ian Luna, ed., *New New York: Architecture of a City* (New York: Rizzoli International Publications, 2003), 10, 246–51; Susan Strauss and Sean Sawyer, eds., *Polshek Partnership Architects* (New York: Princeton Architectural Press, 2005), 150–65.

12. For Rogers's Millennium Dome, see Barrie Evans, "The Dome Experience," *Architects' Journal* 206 (November 27, 1997): 29–36; Clive Aslet, "There's No Place Like the Dome," *Country Life* 192 (July 2, 1998): 70–71; Sara Hart, "Richard Rogers' Tensile-Roofed Millennium Dome Brings London Under the Big Top," *Architecture* 88 (January 1999): 108–13; Charles Jencks, "An Idea Big Enough for a Dome," *Architectural Design* 69 (November-December 1999): 8–9.

13. For the Hayden Planetarium, see Stern, Gilmartin, and Mellins, *New York 1930*, 129, 136–37.

14. Landmarks Preservation Commission of the City of New York, LP-0282 (August 24, 1967); Barbaralee Diamonstein, *The Landmarks of New York III* (New York: Harry N. Abrams, 1998), 164–65.

15. Stern, Gilmartin, and Mellins, *New York 1930*, 135.

16. See Peter Rice and Hugh Dutton, *Structural Glass*, 2nd ed. (London and New York: E. & F. N. Spon, 1995).

17. Peter F. Vallone, quoted in Goldberger, "Natural History Museum Plans Big Overhaul": 2.

18. James Stewart Polshek, quoted in Goldberger, "Natural History Museum Plans Big Overhaul": 2.

19. Gelernter, "The End of Dignity": 15.

20. Veliz, "Renaissance or Regret?": 20–24. Also see Ken Kalfus, "Science Fiction at the Planetarium," *New York Times* (February 26, 1994): 23. This essay was expanded and published under the title "Last Night at the Planetarium," in Katharine Washburn and John F. Thornton, eds., *Dumbing Down: Essays on the Strip Mining of American Culture* (New York: W. W. Norton, 1996), 139–48.

21. For the Perisphere, see Stern, Gilmartin, and Mellins, *New York 1930*, 728–30, 748–52. For Boullée's project, see Jean-Marie Pérouse de Montclos, *Étienne-Louis Boullée, 1728–1799: Theoretician of Revolutionary Architecture* (New York: George Braziller, 1974), plates 57–59. For Ledoux's scheme, see *L'Architecture de C. N. Ledoux* (Paris, 1804; Princeton, N.J.: Princeton University Press, 1983), plate 254; Anthony Vidler, *Claude-Nicolas Ledoux* (Cambridge, Mass., and London: MIT Press, 1990), 314–15.

22. Muschamp, "Star Light, Star Bright": 25–26.

23. Muschamp, "Star Light, Star Bright": 26.

24. Goldberger, "The Sky Line: Stairway to the Stars": 72, 74.

25. Muschamp, "It's Something New Under the Stars (And Looking Up)": 1, 37.

26. Kalfus, "Lost in the Stars": 27.

27. Ellen Futter, quoted in Singer, "Out of This World": 29.

28. Rosenbaum, "The Wrong Kind of Star Power": 11.

29. Ralph Appelbaum, quoted in Rosenbaum, "The Wrong Kind of Star Power": 11.

30. Rosenbaum, "The Wrong Kind of Star Power": 11.

31. Kelley, "A Place Where the Big Bang Often Produces Puzzled Silence": 1.

32. Pearson, "Cosmic Portal: The Rose Center for Earth and Space": 100.

33. David W. Dunlap, "Museum Seeks a New Building on W. 76th St.," *New York Times* (March 18, 1983), B: 3; Peter Freiberg, "Central Park West Landmarks Controversy," *Metropolis* 3 (September 1983): 10; Carter Wiseman, "Taking on the Towers," *New York* 17 (January 23, 1984): 62–63; David W. Dunlap, "Museum's Plan to Build Tower Stirs West Siders," *New York Times* (January 25, 1984), B: 3; "Landmark Works vs. Buildings," *New York Times* (February 2, 1984): 18; Lawrence J. Cohn, "A Historical Society Unlikely to 'Perish,'" letter to the editor, *New York Times* (February 11, 1984); Peter Freiberg, "Furor Over Historical Society Tower," *Metropolis* 3 (March 1984): 10; George Lewis, "New York Historical Society: Chapter Opposition," *Oculus* 45 (March 1984): 15, 17; Hugh Hardy, "New York Historical Society: HHPA Proposal," *Oculus* 45 (March 1984): 14–17; Paul Goldberger, "Who Owns Landmarks?" *Preservation News* 24 (March 1984): 5, 10; David W. Dunlap, "Landmarks Panel Vetoes Tower Plans for St. Bart's and Historical Society," *New York Times* (June 13, 1984), B: 1, 7; Paul Goldberger, "Landmarks Cases: A Decisive Verdict," *New York Times* (June 14, 1984), B: 1, 6; Peter Freiberg, "Decisions, Decisions," *Metropolis* 4 (September 1984): 11–12; "The Hole in Landmarks Law," editorial, *New York Times* (April 22, 1986): 30; Nicholas Polites, *Hardy Holzman Pfeiffer Associates: Buildings and Projects, 1967–1992* (New York: Rizzoli International Publications, 1992), 194–97, 283, 260; Paul Spencer Byard, *The Architecture of Additions: Design and Regulation* (New York: W. W. Norton, 1998), 153–54; Carter B. Horsley, "Save the Museum, Improve Our Skyline," *New York Post* (September 22, 1988): 61. For the New-York Historical Society's headquarters, see Stern, Gilmartin, and Massengale, *New York 1900*, 18, 87, 104–5, 314, 393, 395; Stern, Gilmartin,

and Mellins, *New York 1930*, 135.

34. For the designation of the New-York Historical Society, see Landmarks Preservation Commission of the City of New York, LP-0281 (July 19, 1966); Diamonstein, *Landmarks of New York III*, 268. For the Central Park West–West 76th Street Historic District, see Landmarks Preservation Commission of the City of New York, *Central Park West–West 76th Street Historic District Designation Report* (New York, 1973); Diamonstein, *Landmarks of New York III*, 497.

35. Byard, *The Architecture of Additions*, 154.

36. Quoted in Freiberg, "Furor Over Historical Society Tower": 10.

37. Robert A. M. Stern, quoted in Freiberg, "Furor Over Historical Society Tower": 10.

38. Douglas C. McGill, "Historical Society Is Planning Cuts to Meet Crisis," *New York Times* (June 28, 1988), C: 15, 20; Douglas C. McGill, "Historical Society Cuts Staff in Budget Crisis," *New York Times* (June 30, 1988), C: 20; Douglas C. McGill, "Hundreds of Art Works Damaged by Mildew in Museum Warehouse," *New York Times* (July 10, 1988): 1, 23; Douglas C. McGill, "Museum's Downfall: Raiding Endowment to Pay for Growth," *New York Times* (July 19, 1988), C: 1, 18; Kay Larson, "Plundering the Past," *New York* 21 (July 25, 1988): 38–44; Douglas C. McGill, "Criticism Moves Historical Society, a Little," *New York Times* (July 25, 1988), C: 13, 15; "New York's Ill-Kept Treasure," editorial, *New York Times* (July 26, 1988): 20; Douglas C. McGill, "Historical Society Director Quits and Trustees Dismiss His Deputy," *New York Times* (July 25, 1988): 1, C: 24; Geoffrey Blodgett, "Cass Gilbert Papers," letter to the editor, *New York Times* (August 5, 1988): 24; Douglas C. McGill, "Panel Will Seek Rescue for Historical Society," *New York Times* (August 14, 1988): 36; Christopher Gray, Wendy Shadwell, and Kathryn A. Jolowicz, "Back to the Past," letters to the editor, *New York* 21 (August 15, 1988): 8; Douglas C. McGill, "Troubled Museums Try to Master the Fine Art of Survival," *New York Times* (August 28, 1988), IV: 24; Douglas C. McGill, "Historical Society Seeks to Save Neglected but Priceless Library," *New York Times* (September 15, 1988), C: 19, 24; Andrew L. Yarrow, "Historical Society Opens Two Conservation Labs," *New York Times* (January 28, 1989): 17; "Our Landmark Building Is Restored," *The New-York Historical Society Gazette* (Fall 1989): 4; Michael Kimmelman, "A New Spirit at the New-York Historical Society," *New York Times* (September 5, 1990), C: 13, 15; William H. Honan, "To Be Rescued, Historical Society May End Up Joining Its Savior," *New York Times* (November 19, 1992), C: 19, 22; William H. Honan, "Historical Society to Close Library," *New York Times* (February 4, 1993), C: 15, 19; William H. Honan, "Scholars Mourn and Fight a Landmark Library's Closing," *New York Times* (February 9, 1993), C: 11, 16; "Saving the City's 'Memory,'" *New York Times* (February 18, 1993): 22; Christopher Moore, "Historical Society Holds Black History Trove," letter to the editor, *New York Times* (February 18, 1993): 22; David W. Dunlap, "Historical Society Shuts Its Doors but Still Hopes," *New York Times* (February 20, 1993): 9; Michael Kimmelman, "Is This the End for New York's Attic?" *New York Times* (February 21, 1993), II: 1, 39; Ada Louise Huxtable, "New York Must Save Historical Society Before It's Too Late," letter to the editor, *New York Times* (March 3, 1993): 24; William H. Honan, "Historical Society Tries to Live by Subtraction," *New York Times* (March 12, 1993), C: 3; Michael Kimmelman, "Selling Art to Save Historical Society: A Painful Remedy," *New York Times* (March 18, 1993), C: 17, 22; "Cleaning Out New York's 'Attic,'" *New York Times* (March 21, 1993), IV: 16; Barbara L. Michaels, "Historical Society: Does It Have a Future?" *Landmark West* (Spring 1993): 2–3; William H. Honan, "Historical Society Budget Priority in Doubt," *New York Times* (April 27, 1993), C: 18; "Redford to Rescue Historical Society?" *New York Observer* (May 3, 1993): 1, 3; William Grimes, "Historical Society Gets N.Y.U.'s Help," *New York Times* (August 12, 1993), C: 13; William Grimes, "Betsy Gotbaum Heads Troubled Historical Society," *New York Times* (June 20, 1994), C: 15; Ralph Blumenthal, "Trying to Keep the Historical Society," *New York Times* (December 6, 1994), C: 15, 20; Carol Vogel, "Fire on Central Park West," *New York Times* (March 10, 1995), C: 26; William H. Kaufman, "Museum Dusts Off Itself, Its Fop and a Horse's Tail," *New York Times* (April 29, 1995): 27; Christopher Gray, "Streetscapes/The New-York Historical Society," *New York Times* (May 14, 1995), IX: 7; Mark Lasswell, "It's History," *New York* 28 (October 30, 1995): 46–47; Karen W. Arenson, "A Society Decides It Can't Go It Alone," *New York Times* (November 29, 1995), C: 13, 15; "Two Collections and a Courtship," editorial, *New York Times* (December 3, 1995), IV: 14; Paul Goldberger, "To the Rescue of a Grande Dame of Museums," *New York Times* (June 2, 1997), C: 9–10; Roberta Smith, "In Quiet Corners, a Rhapsody for the Eyes and Soul," *New York Times* (January 1, 1999), E: 35; Glenn Collins, "Digging for Forgotten Treasure; Museum Opens Its Vaults for New Exhibition Space," *New York Times* (July 31, 2000), B: 1, 3; Allison Eckardt Ledes, "Out of Storage and Now On View," *The Magazine Antiques* 158 (December 2000): 816.

39. Donald Garfield, "The Democratic Impulse Still Resonates from this 1830s Gallery," *Museum News* 70 (January-February 1991): 26–27; *Allan Greenberg: Selected Works* (London: Academy Editions, 1995), 18. The design of Reed's townhouse is attributed to Alexander Jackson Davis and Isaac Green Pearson, who designed the facade and the interiors, respectively. For 13 Greenwich Street and a discussion of the original galleries, see Ella M. Foshay, *Mr. Luman Reed's Picture Gallery: A Pioneer Collection of American Art* (New York: Harry N. Abrams in association with the New-York Historical Society, 1990).

40. *Allan Greenberg: Selected Works*, 18.

41. Collins, "Digging for Forgotten Treasure: Museum Opens Its Vaults for New Exhibition Space": 1, 3.

42. Suzanne Slesin, "Children's Museum Plans to Move and Grow," *New York Times* (October 26, 1988), B: 32; Daniel J. McConville, "Kids' Digs," *New York Post* (April 6, 1989): 47; Michael Dupree, "Broadcast News, 2001: The New Children's Museum of Manhattan Builds a Playground for the Video Generation," *Avenue* (October 1989): 100–102; Andrew L. Yarrow, "New Children's Museum Joins 2 Old Favorites," *New York Times* (October 13, 1989), C: 1, 31; David Masello, "New School of Thought," *Architectural Record* 178 (July 1990): 68–71. For the Clinton Youth and Family Center, see Stern, Mellins, and Fishman, *New York 1960*, 318. For Dunn's school, see "Cardinal Blesses New Trinity School," *New York Times* (September 30, 1929): 14.

43. Mervyn Rothstein, "From Swimming to Study," *New York Times* (May 2, 1999), XI: 1; "Future Work: New York, N.Y.," *New York Construction News* 47 (June 1999): 102; "Future Work: New York, N.Y.," *New York Construction News* 48 (July 1999): 95; "Jewish Community Ctr. Planned for West Side," *New York Construction News* 48 (August 1999): 11; "Awards of Excellence 2000: Playing It Safe," *Canadian Architect* 45 (December 2000): 12–35; "Pool, Theater, Gym, More . . . Steel Made It Possible," *Metalworks* (May 2001): 4; Alissa Macmillan, "Hidden Treasure," *New York Daily News* (March 24, 2002): 12; "Jewish Community Center of the Upper West Side," *New York Construction News* 49 (June 2002): 49; Kelly Crow, "A New 92nd Street Y? Almost," *New York Times* (October 6, 2002), XIV: 4.

44. A. J. Diamond, quoted in Rothstein, "From Swimming to Study": 1.

45. "Adaptive Re-Use/Historic Preservation Citation: Polshek Partnership," *Oculus* 64 (December 2001): 32; Strauss and Sawyer, eds., *Polshek Partnership Architects*, 213. For Buchman & Fox's townhouse, see Landmarks Preservation Commission of the City of New York, *Upper West Side–Central Park West Historic District* (New York, 1990), 591.

46. Lisa Wolfe, "West Side School Prepares $4.5 Million Expansion," *New York Times* (March 3, 1985): 44; Christopher Gray, "Streetscapes: The Columbia Grammar and Preparatory School," *New York Times* (August 12, 1990), VIII: 4; *Pasanella + Klein Stolzman + Berg* (Gloucester, Mass.: Rockport Publishers, 1999), 139; White and Willensky, *AIA Guide* (2000), 365–66.

47. White and Willensky, *AIA Guide* (2000), 366.

48. Michael Wurmfeld, quoted in "New Columbia Grammar Middle School," *New York Times* (February 27, 1994), X: 1. Also see "Private Middle School to Start in Late June," *New York Construction News* 41 (May 16, 1994): 1, 7.

49. "Trinity School: Gyms Upstairs and Down," *New York Times* (May 18, 1997), IX: 1; Stephen A. Kliment, "For Private Schools Ingenuity Is a Key to Expansion Plans," *New York Times* (April 18, 1999), XI: 1, 6. For Potter's building, see Landmarks Preservation Commission of the City of New York, LP-1659 (August 1, 1989); Diamonstein, *The Landmarks of New York III*, 397.

WEST SIDE URBAN RENEWAL AREA

1. Stern, Mellins, and Fishman, *New York 1960*, 728–33.

2. Alan S. Oser, "A Community Board Review in West Side Renewal Project," *New York Times* (June 17, 1977): 25; "9 Renewal Projects Slated for West Side," *New York Times* (December 12, 1977): 29; Robert McG. Thomas, Jr., "West Side Board Creates Blueprint for Redevelopment," *New York Times* (December 14, 1977), B: 3; "Rich and Poor on the West Side," editorial, *New York Times* (December 19, 1977): 30; Glenn Fowler, "Renewal Project on the West Side Affirmed by City," *New York Times* (October 8, 1979), B: 3; Glenn Fowler, "Revised West Side Housing Plan Passed," *New York Times* (November 16, 1979), B: 3; Alan S. Oser, "West Side's Renewal Plan Is Held Costly to New York," *New York Times* (November 30, 1979), B: 8; "The West Side Plan and the Squatters," editorial, *New York Times* (December 1, 1979): 20; Paul B. Hoeber, "Whose Upper West Side?" letter to the editor, *New York Times* (February 20, 1980): 24; Carol Lamberg, "West Side Renewal," *New York Times* (September 14, 1981): 25; "A Final West Side Compromise," editorial, *New York Times* (October 24, 1981): 22; Lee A. Daniels, "U.S. Ends Its Role in West Side Renewal," *New York Times* (December 11, 1981), B: 3; "The West Side Without Washington," editorial, *New York Times* (December 28, 1981): 18; Ralph Blumenthal, "Renewal of the West Side a Slow-Moving Story," *New York Times* (September 29, 1982), B: 1, 6; Lee A. Daniels, "Completion of West Side Plan Sought," *New York Times* (September 2, 1983), B: 7.

3. "Rich and Poor on the West Side": 30.

4. "Carriage Houses: New Home for Ballet," *New York Times* (November 12, 1989), X: 1.

5. Linda Amster, "West Side Success Story of a Restaurant and a Neighborhood," *New York Times* (October 27, 1979): 44.

6. Blumenthal, "Renewal of the West Side a Slow-Moving Story": 1, 6.

7. Alan S. Oser, "West Side Housing Program Resumes," *New York Times* (April 27, 1984), B: 7; Philip S. Gutis, "A Price Cut Spurs Sales at West 89th St. Project," *New York Times* (June 20, 1986): 23.

8. Fergus M. Bordewich, "West Side Story: From Gang Fights to Class War," *New York* 11 (June 5, 1978): 8–11; Arnold H. Lubasch, "Court Bars West Side Low-Income Project," *New York Times* (December 17, 1978): 57; Linda Greenhouse, "Top Court Backs Housing Project on the West Side," *New York Times* (January 8, 1980), B: 1–2; Michael Goodwin, "City Officials Remain Undecided on Housing Project for West Side," *New York Times* (January 9, 1980), B: 3; Laurie Johnston, "West Side's Renaissance Is Fanning Old Tensions," *New York Times* (January 18, 1980), I: B: 4; "Pickets Protest Renewal Plan," *New York Times* (January 21, 1980), B: 3; "Another Chance on the West Side," editorial, *New York Times* (January 22, 1980): 20; Linda Greenhouse, "Supreme Court Roundup: Housing

Project," *New York Times* (April 22, 1980), B: 12.

9. For the Stephen Wise Towers, see Stern, Mellins, and Fishman, *New York 1960*, 731–32.

10. "Another Chance on the West Side": 20.

11. Lee A. Daniels, "City Proposes Housing for Disputed West Side Site," *New York Times* (September 6, 1983), B: 7; "Housing Proposed for West Side Site," *New York Times* (September 8, 1983), B: 3; "Urban Renewal Site's Last Argument," *New York Times* (November 20, 1983), VIII: 9; Peter Freiberg, "Westside Renewal Controversy," *Metropolis* 3 (April 1984): 12; "Two Housing Developments Approved for West Side Site," *New York Times* (May 24, 1985), B: 4; Lisa W. Foderaro, "2 Luxury Rentals Extend Columbus Ave. Renewal," *New York Times* (October 3, 1986): 19.

12. White and Willensky, *AIA Guide* (1988), 334; "In and Around the City," *Oculus* 3 (September 1990): 3.

13. Oser, "West Side Housing Program Resumes": 7; Alan S. Oser, "A New Way of Creating Mixed-Income Developments," *New York Times* (March 17, 1985), VIII: 7, 14; Foderaro, "2 Luxury Rentals Extend Columbus Ave. Renewal": 19.

14. Oser, "A New Way of Creating Mixed-Income Developments": 7.

15. Oser, "West Side Housing Program Resumes": 7; Oser, "A New Way of Creating Mixed-Income Developments": 14; Foderaro, "2 Luxury Rentals Extend Columbus Ave. Renewal": 19; White and Willensky, *AIA Guide* (2000), 367.

16. David W. Dunlap, "Tempest Over Tower Is Nearing End," *New York Times* (January 1, 1989); B: 3.

17. David W. Dunlap, "Landmarks Panel to Study Stable and Pepsi-Cola Sign," *New York Times* (April 18, 1988), B: 3; Christopher Gray, "Streetscapes/Claremont Stables," *New York Times* (April 24, 1988), X: 14; Landmarks Preservation Commission of the City of New York, LP-1658 (July 12, 1988); Charles V. Bagli, "Bond Issue to Save Manhattan Riding Stable," *New York Observer* (February 12, 1990): 6; Richard D. Lyons, "West Side Landmark: Rebuilding a Stable," *New York Times* (February 18, 1990), X: 1; Barbaralee Diamonstein, *The Landmarks of New York III* (New York: Harry N. Abrams, 1998), 394.

18. Joseph Berger, "Hispanic Life Dims in Manhattan Valley," *New York Times* (September 11, 1987), B: 1, 4.

19. For the Frederick Douglass Houses, see Stern, Mellins, and Fishman, *New York 1960*, 74–75, 726.

20. Alan S. Oser, "Project Evokes City's Brownstone Era," *New York Times* (January 13, 1984), B: 7; Evelyn Nieves, "Manhattan Valley's Boom Ends Up Just a Fizzle," *New York Times* (December 25, 1990): 33–34; Lee A. Daniels, "New Condominiums at Harlem's Edge," *New York Times* (February 19, 1984), VIII: 1, 14; Adam Liptak, "Manhattan Valley Townhouses," *New York Times* (March 31, 1985), VIII: 6, 14; "Just off Central Park: Rocky Road for Townhouses," *New York Times* (January 8, 1989), X: 1; "U-Shaped Condo Complex," *New York Post* (January 13, 1989): 59; Elaine Louie, "Good Design, Good Prices Uptown," *New York Times* (February 8, 1990), C: 11; White and Willensky, *AIA Guide* (2000), 371–72.

21. White and Willensky, *AIA Guide* (2000), 372.

22. For the Association Residence for Respectable and Indigent Females, see Stern, Mellins, and Fishman, *New York 1880*, 782.

23. Paul Goldberger, "A Visible Anchor to Past Would Be Lost in Razing," *New York Times* (June 19, 1974): 49; John L. Hess, "Victorian Home for Aged to Be Demolished," *New York Times* (June 19, 1974): 49.

24. Goldberger, "A Visible Anchor to Past Would Be Lost in Razing": 49.

25. "West Siders Seek to Save Building," *New York Times* (November 17, 1974): 31; Robert A. M. Stern, "Designating Landmarks," letter to the editor, *New York Times* (December 25, 1974): 26.

26. Stern, "Designating Landmarks": 26.

27. Richard D. Lyons, "West Side Landmark to Become a Hostel," *New York Times* (March 27, 1988), X: 9.

28. Jesus Rangel, "500-Bed Hostel Proposed for Amsterdam Ave. Landmark," *New York Times* (November 28, 1984), B: 1, 5; Al Amateau, "Youth Hostel Building Plans Move Ahead," *The Westsider* 17 (January 14–20, 1988): 1, 9; Lyons, "West Side Landmark to Become a Hostel": 9; Audrey Farolino, "Happy Hostel Takeover," *New York Post* (March 30, 1989): 53; "The Talk of the Town: Lodging," *New Yorker* 65 (November 27, 1989): 10; Michele Herman, "New York Gets Hostel," *Metropolis* 9 (May 1990): 27–28; "New York International Youth Hostel," *Oculus* 52 (June 1990): 1; Paul Goldberger, "Three New York City Success Stories," *New York Times* (July 22, 1990), II: 28, 30; Rachel Cox, "Windows on the World," *Historic Preservation* 44 (January/February 1992): 66, 68–69. Also see Landmarks Preservation Commission of the City of New York, LP-1280 (April 12, 1983); Diamonstein, *The Landmarks of New York III*, 181.

29. Goldberger, "Three New York City Success Stories": 30.

30. David W. Dunlap, "Developer Plans to Link 39-Story Tower to a West Side Landmark," *New York Times* (October 26, 1986): 47; Susan Heller Anderson, "Central Park West Tower Approved," *New York Times* (October 4, 1987): 49, 54; Helen Thorpe, "Board 7/Support for Project at West 106th St.," *New York Observer* (December 18, 1989): 8; Andrew White, "The Rise of Manhattan Valley," *Metropolis* 9 (January/February 1990): 16–18; "Towers Nursing Home," *Landmark West! Newsletter* (Fall 1993): 8; Jennifer Kingson Bloom, "After 6 Years, Landmark Eyesore Is Still an Eyesore," *New York Times* (December 4, 1994), XIII: 6; Rachelle Garbarine, "An Attempt to Redevelop a Manhattan Landmark," *New York Times* (June 13, 1997), B: 7; Beth Landman Keil and Deborah Mitchell, "Jacob's Ladder to Trump's Tower," *New York* 30 (July 21, 1997): 12; Nina Rappaport, "Restoration Rebounds," *Oculus* 60 (March 1998): 4; Anthony Connors, "Then & Now: Fallen Towers," *New York Daily News* (May 3, 1998): 49; Tara Bahrampour,

"After a Long Sleep, an Old Tower Is Poised for Role in New Century," *New York Times* (March 19, 2000), XIII: 6; David Sokol, "Cure for Cancer Hospital?" *Grid* 2 (March-April 2000): 28–29; Tara Bahrampour, "Luxury Condos Are Planned for a Turreted Landmark," *New York Times* (May 28, 2000), XIII: 8; Amanda May, "Park Place," *Grid* 3 (March 2001): 72; Peter Bafitis, "Building Credit," letter to the editor, *New York* 34 (April 9, 2001): 14; Nadine Brozan, "Old Hospital Is Centerpiece of a Luxurious Compound," *New York Times* (May 18, 2001), B: 7; Steve Cutler, "Future Top Condos," *New York Living* (December 2001/January 2002): 16; Denny Lee, "One More Rescue Attempt for a Battered Landmark," *New York Times* (December 1, 2002), XIII: 6; Braden Keil, "Luxe CPW Condos Make the Grade Once More," *New York Post* (September 18, 2003): 38; Nadine Brozan, "Central Park West, 105th to 106th St.: Columbia Help Puts Tower at Landmark Site," *New York Times* (December 21, 2003), XI: 1; Christopher Gray, "Streetscapes/Central Park West Between 105th and 106th Streets," *New York Times* (December 28, 2003), XI: 5. For the New York Cancer Hospital, see Stern, Mellins, and Fishman, *New York 1880*, 784–85.

31. Pranay Gupte, "Status of Towers Home as a Landmark Debated," *New York Times* (July 14, 1976): 41; Landmarks Preservation Commission of the City of New York, LP-0938 (August 17, 1976); Carter B. Horsley, "Landmark Rating Is Given to Towers Nursing Home," *New York Times* (August 18, 1976): 41.

COLUMBIA UNIVERSITY

1. For the addition to Avery Hall and the Fairchild Center, see Stern, Mellins, and Fishman, *New York 1960*, 749–51.

2. Gregg Bloche, "Construction Woes Endanger Future," *Columbia Spectator* (October 6, 1975): 1–2; "McGill Sees Hope for Funding Dorm," *Columbia Spectator* (December 4, 1975): 1, 3; Maxwell G. Bloche, "Hope Diminishes for College Dorm," *Columbia Spectator* (August 12, 1976): 1, 3; "Columbia Plans a $20 Million Dorm Project," *New York Times* (May 13, 1977), B: 2; Richard Hart, "East Campus Dorm, Renovations Mark Area 'Renaissance,'" *Columbia Spectator* (May 18, 1977): 1, 6; "New Plans Show Revised Thinking," *Columbia Spectator* (May 18, 1977): 1, 5; "Columbia University Housing," *Progressive Architecture* 58 (July 1977): 41; "Center for Humanities to Be Built by Columbia," *New York Times* (November 19, 1977): 46; *To Assure the Quality of Life: East Campus, Columbia University* (New York: Columbia University, 1978); Alan Suemori, "Committee Calls for East Campus Changes," *Columbia Spectator* (March 27, 1978): 1–2; Roger Wilkins, "'Children's Free School' Fights for Right to Keep Columbia Site," *New York Times* (April 7, 1978): 14; Carter B. Horsley, "Columbia to Construct Housing That Meets Student Demands," *New York Times* (June 2, 1978), B: 5; Robin Micheli, "CU Forced to Resubmit Dorm Plan," *Columbia Spectator* (June 29, 1978): 1; Helene Rubinstein, "HUD Loan Sought for New Dormitory," *Columbia Spectator* (September 11, 1978): 1–2; Ken Wills, "CB9 Asks Statement on Dorm's Impact," *Columbia Spectator* (September 20, 1978): 1, 3; "Film Promoting New Dorm Urges Alumni Gift-Giving," *Columbia Spectator* (September 25, 1978): 2; Ken Wills, "HUD Grants CU $5 Million Loan for East Campus Dorm Complex," *Columbia Spectator* (October 4, 1978): 1, 3; Peter Brown, "Study Claims Community Ignored on Dorm Plans," *Columbia Spectator* (October 6, 1978): 3, 6; Jeff Tamarin, "Wagner Defends Dorm Variance at CB9 Meeting," *Columbia Spectator* (November 17, 1978): 1, 5; Pete Brown, "New Dorm Delayed Till September '81," *Columbia Spectator* (February 2, 1979): 1, 3; Eileen Tabios, "Inflation Boosts East Campus Cost $5M Past Estimate," *Columbia Spectator* (March 28, 1979): 1, 3; Joey Trevisani, "E. Campus May Get Solar Heating," *Columbia Spectator* (April 26, 1979): 1, 5; Jim Schachter, "New Dormitory Cost Is Now $21 Million," *Columbia Spectator* (May 16, 1979): 5; Pete Brown and Stuart Karle, "East Campus Cost Up $6M; Jump Termed 'Horrendous,'" *Columbia Spectator* (September 17, 1979): 1, 3; Stuart Karle, "$6M Price Hike Seen as Last for New Dorm," *Columbia Spectator* (September 19, 1979): 1, 3; Eileen Tabios, "E. Campus Costs Limit Facilities," *Columbia Spectator* (September 26, 1979): 1, 3; Barbaralee Diamonstein, *American Architecture Now* (New York: Rizzoli International Publications, 1980), 71, 73–74; "Space, Place, Object: Gwathmey/Siegel Architects," *Skyline* 2 (February 1980): 6–7; Tom Willcox and David Rier, "December Opening for East Campus Seen," *Columbia Spectator* (September 19, 1980): 1; Cullen Stanley, "Architect Doubts January Finish for East Campus," *Columbia Spectator* (October 8, 1980): 1, 3; Pete Brown, "East Campus Breaks Dorm Mold," *Columbia Spectator* (November 10, 1980): 2; Pete Brown, "View Will Dictate East Campus Rates," *Columbia Spectator* (November 20, 1980): 1–2; Pete Brown and Todd Bressi, "Officials Give Final Okay for Transfer to East Campus," *Columbia Spectator* (November 21, 1980): 1, 3; Leila Johannesen and Tom Willcox, "New Dorm May Have Stores; Humanities Center Planned," *Columbia Spectator* (December 4, 1980): 2; Stanley Abercrombie, *Gwathmey Siegel* (New York: Whitney Library of Design, 1981), 108–14; "Gwathmey Siegel & Associates," *GA Document* 4 (1981): 68–79; "East Campus Housing, Columbia University, New York," *Progressive Architecture* 62 (January 1981): 72; Pete Brown and Steve Waldman, "'Luxury Rooms Lack Heat, Water and Electricity," *Columbia Spectator* (January 20, 1981): 1, 6; Todd Bressi, "Workers Tackle Details in East Campus Dorm," *Columbia Spectator* (January 21, 1981): 1–2; Marcus Brauchli, "CU Shifts Blame for Uncompleted Dormitory Rooms," *Columbia Spectator* (January 26, 1981): 1, 3; Mark Segall, "New Dormitory Is Paradise Found," *Columbia Spectator* (January 26, 1981): 1; Pete Brown and Rich Rothman, "CU Officials Will Investigate East Campus Alarm System," *Columbia Spectator* (January 30, 1981): 1; Steven Waldman, "New Dorm Had 18 Fire Violations," *Columbia Spectator*

(February 4, 1981): 1–2; Steven Waldman and Pete Brown, "New Dorm Choked by Fumes, Smoke," *Columbia Spectator* (February 10, 1981): 1; Richard Pollack, "New Dorms Plagued by Rodents," *Columbia Spectator* (February 13, 1981): 1–2; Michael Sorkin, "On Building Blocks," *Village Voice* (April 8, 1981): 91; Marcus Brauchli, "Thefts, Damages Total Over $80G at East Campus," *Columbia Spectator* (April 9, 1981): 1–2; Patrick Clark, "Officials Say Students Toss Objects out of New High-Rise," *Columbia Spectator* (April 15, 1981): 1, 6; "Columbia Dedicates New Suites and Town Houses for Students," *New York Times* (June 4, 1981), B: 11; Jane Gamble, "CU Says 'Thanks Millions' in East Campus Dedication," *Columbia Spectator* (June 10–16, 1981): 1, 3; Pete Brown, "New Dorm to Get Fire Alarm Horns," *Columbia Spectator* (August 31, 1981): 1–2; William G. Blair, "Center for Humanities Dedicated at Columbia," *New York Times* (September 17, 1981), B: 1, 8; Ada Louise Huxtable, "An Ingenious Advance in Housing Design," *New York Times* (October 4, 1981), II: 33, 39; Dave Peterson, "Vandalism Down in East Campus So Far This Year," *Columbia Spectator* (November 5, 1981): 1, 4; Susan Doubilet, "Gwathmey Siegel: East Campus Complex," *Skyline* 4 (January 1982): 18–19; "Expanding Horizons: The East Campus Complex," *Architectural Record* 170 (February 1982): 65–71; "East Campus Complex, Columbia University, by Gwathmey Siegel & Associates," *Space Design* 214 (July 1982): 59–66; "Columbia University, Dorm in Housing and Academic Center," *Architecture + Urbanism* (May 1983): 72–77; "Guest Speaker: Charles Gwathmey on a Personal Approach to Architecture," *Architectural Digest* 40 (November 1983): 48–49; Sharon Waxman, "East Campus: The Dream Dorm in Decay," *Columbia Spectator* (November 15, 1983): 1, 3; Peter Arnell and Ted Bickford, eds., *Charles Gwathmey and Robert Siegel: Buildings and Projects, 1964–1984* (New York: Harper & Row, 1984), 130–37; "East Campus," *Columbia Spectator* (May 16, 1984): 5; "East Campus Housing Complex and Academic Center," *Process Architecture* 64 (January 1986): 145–49; White and Willensky, *AIA Guide* (1988), 423; Norman Coplan, "Law: Substantial Completion," *Progressive Architecture* 74 (January 1993): 33; "University's Lawsuit Is Rendered Untimely," *New York Law Journal* (January 25, 1995): 25; Barry Bergdoll, *Mastering McKim's Plan: Columbia's First Century on Morningside Heights* (New York: Columbia University, 1997), 136–37; Andrew S. Dolkart, *Morningside Heights: A History of Its Architecture & Development* (New York: Columbia University Press, 1998), 461.

3. Horsley, "Columbia to Construct Housing That Meets Student Demands": 5.

4. Huxtable, "An Ingenious Advance in Housing Design": 33.

5. Huxtable, "An Ingenious Advance in Housing Design": 39.

6. Doubilet, "Gwathmey Siegel: East Campus Complex": 18.

7. Huxtable, "An Ingenious Advance in Housing Design": 33, 39.

8. Doubilet, "Gwathmey Siegel: East Campus Complex": 18.

9. Sorkin, "On Building Blocks": 91.

10. David T. Gordon, "East Campus Languishes in Limbo," *Columbia Spectator* (June 21, 1989): 4; Kirsten Danis, "E. Campus, Hamilton to Get Facelifts," *Columbia Spectator* (February 1, 1990): 1, 16; "Columbia Dormitory: A New Facade," *New York Times* (June 23, 1991), X: 1; "News Notes: Within City Limits," *Oculus* 54 (September 1991): 3; "Renovations in Our Time," *Oculus* 55 (October 1992): 9; Norman Coplan, "Law: Substantial Completion," *Progressive Architecture* 74 (January 1993): 33; Bergdoll, *Mastering McKim's Plan*, 137–38; Dolkart, *Morningside Heights*, 461; White and Willensky, *AIA Guide* (2000), 468.

11. "James Stirling Gets Pritzker Architecture Award," *New York Times* (April 16, 1981), C: 17; Ada Louise Huxtable, "Changes on the Drawing Board and the Skyline," *New York Times* (December 27, 1981), II: 27; James Stirling and Michael Wilford, "Chandler North: The Extension of the Chemistry Department, Columbia University, New York," *Architectural Design* 53 (Nos. 3–4, 1983): 10–15; "Extension to the Chemistry Department, Columbia University," *Architectural Review* 173 (March 1983): 26–30; Peter Arnell and Ted Bickford, eds., *James Stirling: Buildings and Projects* (New York: Rizzoli International Publications, 1984), 315–22; Michael Wilford, "Responding to Context," *UIA International Architect* 5 (1984): 29; Michael Sorkin, "The Big Man on Campus," *Architectural Review* 175 (April 1984): 24–28; "Autour des Projets Récents," *AMC* 5 (October 1984): 14–17; *James Stirling, Michael Wilford and Associates: Buildings and Projects, 1975–1992* (New York: Thames & Hudson, 1994), 96–99, 298; Bergdoll, *Mastering McKim's Plan*, 135–36, 240, plate 16; Mark Girouard, *Big Jim: The Life and Work of James Stirling* (London: Chatto & Windus, 1998), 212; Robert Maxwell, *James Stirling, Michael Wilford* (Basel: Birkhäuser, 1998), 12, 90–91.

12. For the Marcellus Hartley Dodge Physical Fitness Center, see Stern, Mellins, and Fishman, *New York 1960*, 747, 749.

13. James Stirling, quoted in "Extension to the Chemistry Department, Columbia University, New York": 26–27. For Pupin Hall, see Stern, Gilmartin, and Mellins, *New York 1930*, 109.

14. Bergdoll, *Mastering McKim's Plan*, 136.

15. Julius Genachowski, "CU Scales Down Chem Building Plan," *Columbia Spectator* (February 8, 1983): 1, 6; "Legislation Allows DOE Funds for National Chemistry Center," *Columbia Spectator* (August 10, 1983): 1, 3; Richard Froehlich, "Fed Money Makes Chem Center Certain," *Columbia Spectator* (September 21, 1983): 1–2; Richard Froelich, "New Chemistry Building Wins $3 M," *Columbia Spectator* (June 20, 1984): 1–2; John Oswald, "Chem Gets Profs, New Building, Renovations," *Columbia Spectator* (December 3, 1984): 1, 5; Demetri Gounaris, "Chemistry Building Renovations on Time," *Columbia Spectator* (February 19, 1986): 1, 3; Gerson Rothschild, "Renovations Underway on Havemeyer, Pupin Halls," *Columbia Spectator* (June 14, 1989): 1; Kirsten Fermaglich, "Chemistry Construction to End Soon," *Columbia Spectator* (March 27, 1990): 1, 5;

Bergdoll, *Mastering McKim's Plan*, 136.

16. "Columbia to Build Computer Facility," *New York Times* (February 14, 1982): 52; "New Merging with Old in Projects at Columbia," *New York Times* (August 24, 1982): B: 1, 16; Julius Genachowski, "Com Sci Home Nearly Done; to Finish Under $5.6 Million," *Columbia Spectator* (February 11, 1983): 1; Maureen Dowd, "Columbia Enters New Era with Computer Center," *New York Times* (October 12, 1983): B: 3; Margaret Gaskie, "Classical Complexity," *Architectural Record* 172 (March 1984): 126–33; Stanley Abercrombie, "Waltzing to the CRT," *Interior Design* 55 (March 1984): 226–31; "Computer Science Building, Columbia University," *Architecture + Urbanism* (September 1984): 39–46; Carter Wiseman, "Fitting in at School," *New York* 17 (December 3, 1984): 150, 152, 154; Paul Goldberger, "When the Site Tests the Designer," *New York Times* (February 17, 1985), II: 31; Sarah Williams, "The Architecture of the Academy," *Change* 17 (March/April 1985): 14–30, 50–55; "Computer Science Building, Columbia University," *Oculus* 46 (May 1985): 5; Andrea Truppin, "Guiding Light," *Interiors* 145 (May 1986): 300–311; Sharon Lee Ryder, "Building Threaded Between Neighbors," *Architecture* 76 (May 1987): 144–46, 229; "Computer Science Building, Columbia University, New York City," *Architectural Record* 175 (June 1987): 75; Bergdoll, *Mastering McKim's Plan*, 138–39, 240–41; Susanna Sirefman, *New York: A Guide to Recent Architecture* (London: Ellipses, 1997), 244–47; James S. Russell, "R. M. Kliment & Frances Halsband Architects," *Architectural Record* 185 (May 1997): 90–91; Dolkart, *Morningside Heights*, 200; Carole Rifkind, *A Field Guide to Contemporary American Architecture* (New York: Penguin Books, 1998), 253, 260; *Educational Spaces: Volume 1* (Mulgrave, Australia: Images Publishing, 1998), 94–95; *R. M. Kliment & Frances Halsband Architects: Selected and Current Works* (Mulgrave, Australia: Images Publishing, 1998), 36–45; White and Willensky, *AIA Guide* (2000), 470–71. For Mudd Hall, see Stern, Mellins, and Fishman, *New York 1960*, 739, 741.

17. For Moore & Hutchins's Uris Hall, see Stern, Mellins, and Fishman, *New York 1960*, 739–41.

18. Julius Genachowski, "$2.5M Uris Gift Will Build Annex," *Columbia Spectator* (January 27, 1983): 1, 8; "Columbia Gifts of $3 Million," *New York Times* (January 27, 1983), D: 19; "Donations to Enable Columbia to Expand Program in Business," *New York Times* (January 30, 1983): 32; Josh Moreines, "Bigger Business," *Columbia Spectator* (March 8, 1984): 8; Jeremy Feldman and Richard Froehlich, "Asbestos Fibers Push Concern for Uris Project," *Columbia Spectator* (June 6, 1984): 1, 3; Jeremy Feldman, "Uris Asbestos Removal Resumes with No Upsets," *Columbia Spectator* (June 13, 1984): 1, 6; Jeremy Feldman, "Uris Renovations to Close Business School," *Columbia Spectator* (June 20, 1984): 1, 3; Consuello Rockliff, "Report Sites New Uris Asbestos Leak," *Columbia Spectator* (June 27, 1984): 1–2; Jeremy Feldman with Consuello Rockliff, "Uris Hall Remains Closed; New Contractor Takes Over," *Columbia Spectator* (July 11, 1984): 1–2; Jeremy Feldman, "Uris Is Reopened After an Extra Week Delay," *Columbia Spectator* (July 18, 1984): 1–2; "Reasserting a Beaux-Arts Tradition: An Expansion Plan for Columbia's Business School," *Architectural Record* 173 (February 1985): 61; "Columbia Removing Asbestos from Its Buildings," *New York Times* (February 3, 1985): 39; R. Douglas Hamilton, "A New Facade for Modernism," *Columbia Art Review* (Spring 1985): 10–12; "Uris Hall Addition at Columbia University," *Building Stone Magazine* (January-February 1986): 40–43; Roger Kimball, "Business as More Than Usual," *Architectural Record* 174 (April 1986): 120–25; Richard Bender, "Boom and Reverberation," *Architecture* 79 (January 1990): 58–59; Bergdoll, *Mastering McKim's Plan*, 138; Sirefman, *New York*, 248–49; Dolkart, *Morningside Heights*, 407; White and Willensky, *AIA Guide* (2000), 471.

19. For Nashdom, see A. S. G. Butler, *The Architecture of Sir Edwin Lutyens, Volume 1: Country-Houses* (London: Country Life, 1950), 36, figs. 72–76.

20. Kimball, "Business as More Than Usual": 120.

21. Bergdoll, *Mastering McKim's Plan*, 138.

22. Sirefman, *New York*, 248.

23. "University Announces Plans for New Library," *Columbia Spectator* (July 20, 1983): 1; William G. Blair, "Columbia Is Starting New Library to Hold Rare Book Treasures," *New York Times* (July 24, 1983): 36; "Names and News," *Oculus* 45 (September 1983): 9; Susan Heller Anderson and David W. Dunlap, "Renewal in the Library," *New York Times* (December 11, 1984), B: 3; Andrea Truppin, "Rare Example," *Interiors* 145 (August 1985): 148–55, 212; Douglas Farr, "The Light at the End of the Tunnel: Columbia's New Rare Book Library," *Columbia Art Review* (Winter 1985): 3–6.

24. "Columbia Is Given $3.5 Million for a Gallery and Arts Center," *New York Times* (September 29, 1983), B: 2; "Names and News," *Oculus* 45 (November 1983): 7; Julius Genachowski, "Wallach Gives $3.5 M for New Art Gallery," *Columbia Spectator* (September 29, 1983): 1, 11; Jennifer Tower, "Schermerhorn Rehab on Time," *Columbia Spectator* (September 28, 1984): 5; Leah Karliner, "Schermerhorn Hall Renovated," *Columbia Art Review* (Spring 1985): 19; Daralice D. Boles, "Teaching Architecture," *Progressive Architecture* 67 (September 1986): 128–31; "Columbia Corrections," *Progressive Architecture* 67 (November 1986): 11.

25. Larry Rohter, "Nearing 100, Barnard Plans 18-Story Dormitory Tower," *New York Times* (October 25, 1986): 29–30; Alison Craiglow, "BC Dorm to Be 18-Story Addition to BHR Quad," *Columbia Spectator* (October 27, 1986): 1, 12; Alison Craiglow, "BC Architectural Plans Would Emphasize Arts," *Columbia Spectator* (October 31, 1986): 1, 6; Christopher Browne, "New Barnard Dorm: Made in the Shade?" *Columbia Spectator* (November 21, 1986): 3; "Well, What Do You Think?" *Columbia Spectator* (March 19, 1987): 1; "Ground Broken for New Dorm," *Columbia University Record* (April 17, 1987): 3;

Peggy Edersheim, "Barnard Raising," *Manhattan, inc.* 4 (June 1987): 161–62; *James Stewart Polshek: Context and Responsibility* (New York: Rizzoli International Publications, 1988), 56–57, 188–89; Deirdre Carmody, "Birthday for Barnard: New Dorm's the Gift," *New York Times* (July 21, 1988), B: 1–2; "Centennial Hall Makes Its Debut," *Columbia University Record* (September 9, 1988): 8; Clifford A. Pearson, "Holding Court," *Architectural Record* 177 (October 1989): 112–15; "Centennial Hall, Barnard College," *Architecture + Urbanism* (November 1990): 89–95; Stephanie Strom, "Gift to Barnard Honors Iphigene Sulzberger," *New York Times* (January 15, 1991), B: 5; Kathleen Teltsch, "Barnard Dorm Is Dedicated to Iphigene Ochs Sulzberger," *New York Times* (October 18, 1991), B: 2; "Mut der Lücke," *Bauwelt* 83 (January 1992): 198; Sirefman, *New York*, 250–51; Dolkart, *Morningside Heights*, 223, 427; White and Willensky, *AIA Guide* (2000), 473; Susan Strauss and Sean Sawyer, eds., *Polshek Partnership Architects* (New York: Princeton Architectural Press, 2005), 2–11.

26. See Stern, Gilmartin, and Massengale, *New York 1900*, 410–11; Stern, Mellins, and Fishman, *New York 1960*, 740.

27. Richard Froehlich, "Columbia Contemplating Increase in Class Size, Dorm to Go on 115th," *Columbia Spectator* (August 11, 1982): 1, 3; Steven Waldman, "CU Tries to Find $30M to Fund New Dormitory," *Columbia Spectator* (September 20, 1982): 1, 6; William Teichner, "115th St. Dorm in Planning," *Columbia Spectator* (February 27, 1984): 1, 8; Irene Tucker, "CU Needs $5 Million to Begin New Dorm," *Columbia Spectator* (September 30, 1985): 1, 5; Jennifer Lynch with John A. Oswald, "Barnard and CU to Build New Dorms: Alum Provides CC with at Least $5M," *Columbia Spectator* (January 22, 1986): 1, 3; "Columbia and Barnard Will Add Dormitories," *New York Times* (January 26, 1986): 22; Asha Badrinath, "Morris A. Schapiro Hall to Be Built on 115th St.," *Columbia Spectator* (January 27, 1986): 1, 13; "Bouncing Baby Building," *Columbia Spectator* (October 23, 1986): 1; Sharon Stern, "Schapiro Hall to Feature Picture Windows, Beds," *Columbia Spectator* (October 23, 1986): 3; Jennifer Hirsh, "A Good Neighbor in the Columbia Tradition," *Columbia Art Review* (Winter 1986): 8–9; "Building of Arts Center Progresses at Columbia," *New York Times* (November 1, 1987): 66; Joseph Berger, "New Dorm at Columbia Means Diversity," *New York Times* (August 26, 1988): 1, B: 2; "Schapiro Hall to Open Next Week," *Columbia University Record* (August 26, 1988): 1, 8; David Kaufman, "Schapiro Theater Delays Postpone Two Productions," *Columbia Spectator* (November 3, 1989): 1, 4; Rosanna G. Liebman, "West Side Study," *Architecture* 79 (January 1990): 90–91; Amanda H. Kahn, "Schapiro Hall Exterior Will Be Tested," *Columbia Spectator* (November 22, 1991): 1–2; White and Willensky, *AIA Guide* (2000), 472.

28. Vukani Magubane, "Columbia Planning to Build $54 Million High-Technology Research Center," *New York Times* (December 29, 1985): 27; Alison Craiglow, "State Grants CU $5M for Technology Center," *Columbia Spectator* (April 2, 1986): 1, 3; "Design Plans for New Engineering Building Unveiled," *Columbia University Record* (November 4, 1988): 1; "Research Center and Boiler Plant Start at Columbia," *New York Construction News* 36 (December 12, 1988): 1, 23; "Goodbye Tennis Courts," *Columbia Spectator* (March 9, 1989): 1; "Columbia University Center for Engineering and Physical Science Research," *Architecture + Urbanism*, extra edition (December 1990): 178–81; Eric Roston, "Task Force Report, CEPSR Building Both in Final Stages," *Columbia Spectator* (August 29, 1991): 3, 23; Danny Franklin, "Schapiro Center Will Be Finished by Spring Term," *Columbia Spectator* (October 2, 1991): 1, 5; Elizabeth Berke, "CEPSR Well-Designed to Suit Professors' Research," *Columbia Spectator* (August 5, 1992): 1, 5; "High Technology Schapiro Center to Be Dedicated," *Columbia University Record* (September 11, 1992): 1, 3; Steven Prokesch, "Public and Private Mix at Columbia," *New York Times* (September 17, 1992), B: 3; "Columbia Science Praised at Schapiro Dedication," *Columbia University Record* (September 25, 1992): 1, 6; "The Schapiro Center: Leading the Way to the 21st Century," *Columbia University Record* (September 25, 1992): 7; Meg Dooley, "Engineering the Future at Columbia," *Columbia* (Fall 1992): 30–31, 34–36; Nancy Levinson, "Labs Come of Age," *Architectural Record* 190 (November 1992): 60–61, 120; White and Willensky, *AIA Guide* (2000), 471; *Hellmuth, Obata & Kassabaum: Selected and Current Works* (Mulgrave, Australia: Images Publishing, 2002), 120–21.

29. White and Willensky, *AIA Guide* (2000), 471.

30. Tim Carvell, "City Library Looks for New Home," *Columbia Spectator* (January 16, 1992): 1, 4; Elizabeth Berke, "Library Branch Still Looking for New Home," *Columbia Spectator* (October 2, 1992): 1, 5; Emily M. Bernstein, "On Broadway, Book Is Mightier Than Car," *New York Times* (February 27, 1994), XIII: 6; Mike Lifrak, "NY Library Branch May Move," *Columbia Spectator* (March 21, 1994): 1, 5; Harriet Ryan, "Two Sites Considered for New Undergrad Dorm," *Columbia Spectator* (June 28, 1995): 1, 4; Allison Margolin, "New Dorm Planned for Broadway Site," *Columbia Spectator* (September 20, 1996): 1, 7; Lauren Goodman, "Chemical Bank Site Potential Location for New Dorm," *Columbia Spectator* (October 23, 1995): 1, 9; Michael Gwertzman, "Public Library Branch to Move from Butler," *Columbia Spectator* (November 16, 1995): 1, 15; Eli Sanders, "Residents Wary of University Building Plans," *Columbia Spectator* (January 18, 1996): 1, 9; Charles Sisk, "Residents Submit Pro-Landmark Proposal," *Columbia Spectator* (February 14, 1996): 1, 5; "A Storm Over a Dorm Plan," *New York Times* (March 17, 1996), XIII: 8; Hans Chen, "New Dorm Architect Proposes Plans to Area Residents," *Columbia Spectator* (March 25, 1996): 1, 5; "A New Den for the Lions of Columbia," *New York Times* (April 20, 1997), X: 1; Eric Wm. Allison, "The President's Column," *District Lines* (Summer

1997): 2, 7; David Garrard Lowe, "Now They're Deconstructing the Columbia Campus," *City Journal* 7 (Autumn 1997): 84–97; David W. Dunlap, "Alma Mater Gets a Makeover," *New York Times* (November 16, 1997), XI: 1, 6; Jenna Klatell, "Chase Makes Way for Broadway Dorm," *Columbia Spectator* (November 18, 1997): 1, 5; Peter Morris Dixon, ed., *Robert A. M. Stern: Buildings and Projects, 1993–98* (New York: Monacelli Press, 1998), 248–53; "Conservation of Scaffolding," *Columbia Spectator* (February 3, 1998): 1; Benjamin Lowe, "$50 Million Dorm Stirs Talk," *Columbia Spectator* (February 11, 1998): 1, 5; Mia-Margaret Laabs, "Community Approves Plan for Dorm," *Columbia Spectator* (February 18, 1998): 1; "Dormitory Plan: One Minus, Many Pluses," *Columbia Spectator* (February 22, 1998), VI: 6; Mia-Margaret Laabs, "Board Approves Proposed Dormitory," *Columbia Spectator* (February 23, 1998): 1, 5; "The New Dormitory," editorial, *Columbia Spectator* (February 26, 1998): 5; Hannah Fairfield, "New Residence Hall and Jewish Life Center Are Underway," *Columbia University Record* (February 26, 1999): 1, 6; Anne Canty, "Residence Hall Passes Hurdle with Vote of Community Bd.," *Columbia University Record* (February 27, 1998): 3; Erik Seadale, "Town and Gown Marry on Columbia Dorm Plan," *New York Observer* (March 9, 1998): 8; Kaya Tretjak, "Construction Starts on $50 Million Dorm," *Columbia Spectator* (September 15, 1998): 1, 7; Nicholas Adams, "Il Nuovo McKim, Paul Rudolph, Tschumi e Stern alla Columbia," *Casabella* 62 (October 1998): 84–89; Daniel Feldman, "Architect Outlines Dorm Plan," *Columbia Spectator* (February 10, 1999): 1, 9; Bob Morris, "Style to Which They're Accustomed," *New York Times* (May 13, 1999), F: 1, 8; Jordan Fox, "Technology in Residence," *American Schools & Universities* (August 1999): 111–15; Karrie Jacobs, "Architecture 101," *New York* 32 (October 4, 1999): 20–21; Karen W. Arenson, "Reseeding Ivy: Columbia on Comeback Trail from Troubles," *New York Times* (November 1, 1999), B: 1, 7; Maggie Garb, "2 Parks Sandwich Town and Gown," *New York Times* (November 21, 1999): 5; White and Willensky, *AIA Guide* (2000), 471; Felicia Lee, "Dreams and Knowledge, Under One Roof," *New York Times* (March 26, 2000), XIV: 1; Hilary Ballon, "The Architecture of Columbia; Educational Visions in Conflict," *Columbia College Today* (January 2002): 14–21; Peter Morris Dixon, ed., *Robert A. M. Stern: Buildings and Projects, 1999–2003* (New York: Monacelli Press, 2003), 278–85.

31. For 565 West 113th Street, see Dolkart, *Morningside Heights*, 449.

32. For Hogan Hall, see Stern, Mellins, and Fishman, *New York 1960*, 751.

33. Nina Siegel, "Columbia High-Rise Might Rise Too High, Critics Worry," *New York Times* (January 23, 2000), XIV: 8; Lauren Marshall, "Design and Floor Plans of New Faculty Residence at 110th Street Are Unveiled," *CCAlumni@ Columbia.edu* (October 2000): 4; Candace Rondeaux, "Columbia Can Build New Faculty Housing," *New York Observer* (March 19, 2001): 12; Kelly Crow, "Columbia Roils Neighbors Again, Now Over an Elementary School," *New York Times* (March 25, 2001), XIV: 4; Lauren Marshall, "Outreach Continues as Construction Begins on 110th Street Apartment and School," *Columbia University Record* (October 12, 2001): 2; Denny Lee, "For a Columbia School, a Reluctant Peace Dissolves," *New York Times* (December 29, 2002), XIV: 5; "The School Opens," *Columbia* (Fall 2003): 12.

34. John Beyer, quoted in Marshall, "Outreach Continues as Construction Begins on 110th Street Apartment and School": 2.

35. Daniel J. Wakin, "Columbia Reconsiders a Building, and the Neighbors Are Pleased," *New York Times* (December 10, 2000), XIV: 6; Nadine Brozan, "Residence Hall and Academic Center for Columbia," *New York Times* (February 8, 2002), B: 3; Denny Lee, "On the Heights, a Chill Wind Begins to Blow," *New York Times* (September 14, 2003), XIV: 1, 11.

36. Brozan, "Residence Hall and Academic Center for Columbia": 3; Lee, "On the Heights, a Chill Wind Begins to Blow": 1, 11.

37. For Harrison & Abramovitz's Law School, see Stern, Mellins, and Fishman, *New York 1960*, 736–37.

38. For Jerome L. Greene Hall, see Stern, Mellins, and Fishman, *New York 1960*, 751.

39. "Addition Planned for Law School at Columbia U.," *New York Construction News* 36 (January 16, 1989): 1, 18; *The Architecture of Kallmann McKinnell & Wood* (New York: Rizzoli International Publications, 1988), 118.

40. Danny Franklin, "Law School Raises Funds for New Student Lounge," *Columbia Spectator* (October 18, 1991): 1–2; Suzanne Stephens, "Competitive Edge," *Oculus* 55 (November 1992): 3; Henry Tam Jr., "Law School to Unveil Plans for Student Lounge Soon," *Columbia Spectator* (February 26, 1993): 5.

41. "Planning Ahead," *Columbia Spectator* (September 23, 1994): 1; "Law School Announces Campaign," *Columbia University Record* (September 30, 1994): 1, 6; Kathy Wrightson, "Greene to Be Renovated in Spring 1995," *Columbia Spectator* (October 7, 1994): 1, 7; "Major Renovation at Columbia Law," *New York Times* (October 9, 1994), IX: 1; Heidi Nasr, "Construction Nears Completion," *Columbia Spectator* (May 29, 1995): 5; Catherine Slessor, "Grove of Academe," *Architectural Review* 202 (August 1997): 56–59; Paul Spencer Byard, *The Architecture of Additions: Design and Regulation* (New York: W. W. Norton, 1998), 169–71; Paul Spencer Byard, "Pickling the Past," *Architecture* 87 (February 1998): 58–63; White and Willensky, *AIA Guide* (2000), 468; Strauss and Sawyer, eds., *Polshek Partnership Architects* 100–111.

42. Byard, *The Architecture of Additions*, 169, 171. For the United Nations General Assembly Building, see Stern, Mellins, and Fishman, *New York 1960*, 622–25.

43. Michael Gwertzman, "Law to Construct 10-Story Building," *Columbia Spectator* (October 6, 1995): 1, 6; "On a Narrow Lot, Legal Maneuvers," *New York Times* (December 3,

1995), IX: 1; White and Willensky, *AIA Guide* (2000), 468.

44. Verad A. Frank, "Law, Business Schools Plan New, Joint Building," *Columbia Spectator* (March 1, 1995): 1, 7; Chas Sisk, "Building Plans Going 'Smoothly,'" *Columbia Spectator* (September 28, 1995): 1, 7; Meital Hershkovitz, "Law School Building Warren Hall," *Columbia Spectator* (February 6, 1996): 1, 7; "Spring '97 Start Set for $25M Columbia University Classroom & Office Building," *New York Construction News* 44 (August 12, 1996): 1, 12; "A Building Reflecting Those on Main Campus," *New York Times* (August 25, 1996), IX: 1; A. Leah Vickers, "Law, Business Site Construction Begins," *Columbia Spectator* (February 14, 1997): 1, 5; "A Ground-breaking Ceremony for Warren Hall," *Columbia* (Fall 1997): 8; "Gifts to Business and Law Support Warren Hall," *Developments: Campaign for Columbia* (Summer 1998); Hannah Fairfield, "Business-Law Opens," *Columbia University Record* (January 29, 1999): 1, 6; "The William and June Warren Hall," *Columbia University Record* (May 19, 1999): 4; White and Willensky, *AIA Guide* (2000), 469; William Weathersby Jr., "Deft Illumination Enhances the Profile and Function of Classrooms at Columbia's New Warren Hall," *Architectural Record* 188 (May 2000): 345–46; Ian Fletcher, "Unwitty Parody Party," letter to the editor, *Architectural Record* 188 (July 2000): 20.

45. *Commission on the Future of the University: Draft Report, Part III* (New York: Columbia University, May 1985), 10–11.

46. Bergdoll, *Mastering McKim's Plan*, 140. Also see Skidmore, Owings & Merrill, *Columbia University: East Campus Development* (March 1990); Kohn Pedersen Fox Associates, *Columbia University: East Campus Redevelopment Master Plan* (March 12, 1990).

47. Skidmore, Owings & Merrill, *Columbia University: East Campus Development* (March 1990).

48. Bergdoll, *Mastering McKim's Plan*, 142.

49. For Casa Italiana, see Stern, Gilmartin, and Mellins, *New York 1930*, 109. For the President's House, see Stern, Gilmartin, and Massengale, *New York 1900*, 417.

50. Kristina Nye, "Casa Italiana Architects Chosen for Renovations," *Columbia Spectator* (November 7, 1991): 1, 6; "Casa Famiglia," *Oculus* 54 (December 1991): 4; Peter D. Slatin, "Casa Italiana, New York," *Architectural Record* 180 (January 1992): 19; Christopher Gray, "Streetscapes/Casa Italiana," *New York Times* (April 12, 1992), X: 6; Stephanie J. Geositis, "Casa Italiana to Begin $7.5 Million Renovation," *Columbia Spectator* (July 22, 1992): 1, 7; Mike Lifrak, "Casa Italiana Plans Contested," *Columbia Spectator* (January 28, 1994): 1, 5; Emily M. Bernstein, "Casa Italiana Going Moderne?" *New York Times* (February 6, 1994), XIII: 9; "Upper West Side," *New York Times* (March 13, 1994), XIII: 6; Mike Lifrak, "Casa Italiana to Be Renovated," *Columbia Spectator* (March 31, 1994): 1, 11; Jayne Merkel, "In the Streetscape: The Casa and the Convent," *Oculus* 58 (April 1996): 6–7; Stephen A. Kliment, "Rescue Transforms Columbia Landmark," *Architectural Record* 184 (July 1996): 80–83; "La Casa Italiana," *Ottagono* 120 (September–November 1996): 65–69; Giampiero Bosoni, "La Casa Italiana a New York," *Domus* (December 1996): 46–52; Mario Lupano, *Italo Rota: Il Teatro dell'architettura* (Milan: Motta Architettura, 1997), 17–25; "Ein Studienhaus in New York," *Bauwelt* 88 (May 30, 1997): 1192–93; Raymond Quinn, "Il Progetto di Recupero della Casa Italiana a New York," *Lotus International* 103 (1999): 78–89; White and Willensky, *AIA Guide* (2000), 468.

51. Evan P. Schultz, "Butler Library Lobby Will Undergo Renovations Soon," *Columbia Spectator* (September 25, 1989): 1, 10; Evan P. Schultz, "Architects Chosen for Butler Lib. Renovation," *Columbia Spectator* (October 23, 1989): 1, 9; David A. Shimkin, "Butler Renovation Plans Will Be Completed Soon," *Columbia Spectator* (September 17, 1991): 1, 5; Mary E. Pflum, "Butler Library Shortens Hours," *Columbia Spectator* (October 8, 1992): 1, 15; Tova Mirvis, "Butler Library in Serious Need of Renovations," *Columbia Spectator* (January 28, 1993): 1, 5; Tova Mirvis, "Butler Repairs to Occur in Stages," *Columbia Spectator* (February 18, 1993): 1, 4; Maurice B. Toueg, "Hole Made in Third Floor Ceiling of Butler Library," *Columbia Spectator* (March 24, 1993): 1, 4; Tova Mirvis, "Butler Renovations May Get Underway This October," *Columbia Spectator* (August 4, 1993): 1; J. J. Lee, "Design for Butler Renovation Prepared," *Columbia Spectator* (November 3, 1993): 1, 7; Jeffrey Bellin, "It's Time to Renovate Butler," *Columbia Spectator* (March 25, 1994): 3; Aileen Soper, "Butler Library Renovations to Begin in 1995," *Columbia Spectator* (September 27, 1994): 1, 7; Hans Chen, "Butler Library Renovations Delayed Until Spring," *Columbia Spectator* (January 18, 1995): 1, 6; Lauren Goodman and Sally Magdi, "Libraries Plan Extensive Renovations," *Columbia Spectator* (April 26, 1995): 19–20; "Butler Library," *Columbia Spectator* (June 7, 1995): 5; Sumathi Reddy, "First Phase of Butler Renovations Underway," *Columbia Spectator* (November 9, 1995): 1, 15; David Karp, "Librarians Review Butler Renovation Plans," *Columbia Spectator* (October 31, 1996): 1, 7; Louise Choi, "Butler to Add Rooms, Coffee Bar," *Columbia Spectator* (February 19, 1997): 1, 7; Shira J. Boss, "Butler, Books and Beyond," *Columbia College Today* 25 (Fall 1997): 6–7; David W. Dunlap, "For Libraries, a Time of Rebirth," *New York Times* (September 28, 1997), IX: 1, 6; "$10 Million Gift Creates Milstein Family College Library," *Developments: The Campaign for Columbia* (Summer 1998): 1; Lauren Kofke, "Butler Opens New Coffee Shop and Reading Rooms," *Columbia Spectator* (September 8, 1998): 1, 7; Michelle Lee and Kathleen O'Shea, "Historic Mural Gets a Facelift," *Columbia Spectator* (September 11, 1998): 1, 6; Nan Ramnath, "Butler Renovation Does Some Good, Creates New Problems," *Columbia Spectator* (September 15, 1998): 5; Benjamin Ryan, "Some Taken Aback as Butler Enters Modernity," *Columbia Spectator* (October 19, 1998): 1, 9; Will Heinrich, "Butler Café Brings Library Closer to Real World,"

Columbia Spectator (November 6, 1998): 5; Eve M. Kahn, "Restoration by the Book," *Interiors* 159 (March 2000): 76–81; "Columbia University, Butler Library," *American School & University* 72 (August 2000): 36–38. For Butler Library, see Stern, Gilmartin, and Mellins, *New York 1930*, 109–10.

52. Marion Weiss and Michael A. Manfredi, *Site Specific: The Work of Weiss/Manfredi Architects* (New York: Princeton Architectural Press, 2000), 99–100, 102–9, 125.

53. Chiu-Huey Hsia, "Media Center Spurs Renovations," *Columbia Spectator* (April 6, 1995): 6; *Columbia University, President's Report, 1996–97* (New York: Columbia University, 1997), 20; Deme Kasimis, "Journalism Building Overhauls Nearly Done," *Columbia Spectator* (September 17, 1997): 5; Marylena Mantas, "Lobby Dedication Marks J-School Renovation End," *Columbia Spectator* (September 25, 1997): 1, 5; Dolkart, *Morningside Heights*, 337.

54. "Fare Thee Well, Ferris?" *New York Times* (October 23, 1994), XIII: 3; "Campaign Sets a New Goal: $2.2B in 2000," *Columbia University Record* 21 (December 8, 1995): 1, 6; Nicolai Ouroussoff, "Tschumi Abstracts McKim, Mead, & White's Plan for Columbia University," *Architectural Record* 184 (January 1996): 11; "Eagerly Awaited Student Center Project to Begin," *Columbia University Record* 21 (January 26, 1996): 1, 7; "For Columbia, a New $68 Million Student Center," *New York Times* (January 28, 1996), IX: 1; Nina Rappaport, "Columbia Under Construction," *Oculus* 59 (September 1996): 14; "Ground Breaking for a Grand Student Center: Lerner Hall," *Columbia University Record* 21 (October 4, 1996): 1; "At Columbia," *AIA New York Chapter Annals, 1996–1997* (1997): 53; Bergdoll, *Mastering McKim's Plan*, 143; Jos Bosman, "Between the Mirrors of Ideal Space and Real Space," in Bernard Tschumi, *Bernard Tschumi: Architecture In/Of Motion* (Rotterdam: NAi Publishers, 1997), 7–13; Tschumi, *Bernard Tschumi: Architecture In/Of Motion*, cover, 84–101; "Bernard Tschumi: Deviance, the Normative and the In-Between," *Newsline* 9 (Spring 1997): 5; "Columbia University: $650 Million Planned in Capital Construction," *New York Construction News* 44 (April 28, 1997): 1; "Lerner Hall: Looks Back, Sees Future," *New York Construction News* 44 (April 28, 1997): 4, 6; "Local, Minority, and Women-Owned Firms Sought for Lerner Hall," *New York Construction News* 44 (April 28, 1997): 5; Jacopo della Fontana, "A Dynamic Hub," *L'Arca* 115 (May 1997): 8–11; Nina Rappaport, "Tschumi at Columbia," *Oculus* 59 (May 1997): 17; "Bernard Tschumi with Gruzen Samton Associated Architects: Lerner Student Center, Columbia University," *Architecture + Urbanism* (September 1997): 10–23; Hugh Dutton, "Lerner Student Center Hub Glass Wall and Ramps," *Architecture + Urbanism* (September 1997): 24–29; Lowe, "Now They're Deconstructing the Columbia Campus": 84–97; John V. Bennett, "Lerner Hall Not Salvation for Campus," *Columbia Spectator* (November 12, 1997): 2–3; David W. Dunlap, "Alma Mater Gets a Makeover," *New York Times* (November 16, 1997), XI: 1, 6; Dolkart, *Morningside Heights*, 200–201, 337; "Something Borrowed, Something New," *ANY* 22 (1998): 29; Eeva Liisa Pelkonen, "Bernard Tschumi's Event Space," *Daidalos* 67 (March 1998): cover, 82–85; Patrick Queen and Nina Covalesky, "A New Lease on Undergraduate Life," *Columbia* (Spring 1998): 21–25; Jessica Barrow Dawson, "Project Portfolio: Bernard Tschumi Architects," *Architecture* 87 (April 1998): 45, 47; Adams, "Il Nuovo MoMA; Paul Rudolph; Tschumi e Stern alla Columbia": 84–89; "Lerner Student Center, Columbia University, New York, USA," *Zodiac* 20 (January–June 1999): 104–11; Nina Rappaport, "Brief aus New York," *Deutsche Bauzeitung* 133 (May 1999): 26; "Bernard Tschumi, Gruzen Samton: Lerner Center, Columbia University," *Domus* (June 1999): 35–38; Karen W. Arenson, "On Campus," *New York Times* (July 28, 1999), B: 8; Daniel Feldman, "Lerner Satisfies Press, but Not Some Students," *Columbia Spectator* (September 15, 1999): 1, 7; Julia Rose Kraut, "Following Space Allocations, Some Student Groups Are Displaced," *Columbia Spectator* (September 15, 1999): 1, 7; "Concepts Materialized: A Conversation with Bernard Tschumi," *Praxis* 1 (Fall 1999): 58–65; Megan Miller, "Bernard Tschumi: Alfred Lerner Hall, with Gruzen Samton Architects," *Praxis* 1 (Fall 1999): cover, 56–57, 66–81; Eeva Liisa Pelkonen, "In Context: Tschumi at Lerner Hall," *Praxis* 1 (Fall 1999): 82–87; Raymund Ryan, "Re-made in America," *Blueprint* 165 (October 1999): 44–47; Julia Einspruch Lewis, "New Building on Campus," *Interior Design* 70 (October 1999): 42; Jacobs, "Architecture 101": 20–21; James Barron, "An Architect with a Film Director's Eye," *New York Times* (October 5, 1999), B: 2; Herbert Muschamp, "Echoes of '68 on Columbia Campus," *New York Times* (October 24, 1999): 40–41; Sabine von Fischer, "Rampenspektakel hinter Glas: Lerner Student Center, Columbia University, New York," *Bauwelt* 90 (October 29, 1999): 2232–33; Robert Campbell, "Modernism and Contextualism Meet at Bernard Tschumi and Gruzen Samton's Lerner Hall with Provocative Results," *Architectural Record* 187 (November 1999): cover, 94–101; Ned Cramer, "Tschumi's Columbia Space Opens," *Architecture* 88 (November 1999): 40; "Alfred Lerner Hall Opens," *Columbia College Today* 26 (November 1999): cover, 4–7; "Cutting the Ribbon at Lerner," *Columbia College Today* 26 (November 1999): 9; David Ebony, "State-of-the-Art Student Center for Columbia," *Art in America* 87 (November 1999): 25; Todd Bressi, "Going Public: Lerner Hall," *Oculus* 62 (December 1999): 6–7; Bernard Tschumi, *Event-Cities 2* (Cambridge, Mass., and London: MIT Press, 2000), 288–377; White and Willensky, *AIA Guide* (2000), 471–72; Ian Fletcher, "Live and Lerner," letter to the editor, *Architectural Record* 188 (January 2000): 21; Paula Deitz, "Tschumi Builds Columbia," *Architectural Review* 207 (January 2000): 18–19; "Architecture Citation: Bernard Tschumi Gruzen Samton," *Oculus* 62 (January 2000): 23; Paula Deitz, "New Rhythm on Broadway," *Art News* 99 (February 2000): 108–10; Philip Nobel, "Textbook Example," *Metropolis* 19 (April 2000): 54, 58, 61; Alan Balfour, *World Cities: New York* (New York: Wiley Academy, 2001), 168–71; Ballon, "The Architecture of

Columbia; Educational Visions in Conflict": 14–21. For Ferris Booth Hall, see Stern, Mellins, and Fishman, *New York 1960*, 738–39.

55. For Tatlin and Rodchenko, see S. O. Khan-Mahomedov, "Creative Trends," in O. A. Shvidkovsky, ed., *Building in the USSR 1917–1932* (London: Studio Vista, 1971), 9–18. For Parc de la Villette, see Marianne Barzilay, *L'invention du parc: Parc de la Villette, Paris* (Paris: Graphite, 1984); Bernard Tschumi, *La case vide, La Villette* (London: Architectural Association, 1986); Andrew Benjamin, "Deconstruction and Art/The Art of Deconstruction," in *What Is Deconstruction?* (London: Academy Editions; New York: St. Martin's Press, 1988).

56. For Tschumi's philosophy, see Bernard Tschumi, *The Manhattan Transcripts* (London: Academy Editions; New York: St. Martin's Press, 1981; rev. ed., London: Academy Editions; New York: St. Martin's Press, 1994); Bernard Tschumi, *Questions of Space: Lectures on Architecture* (London: Architectural Association, 1990); Bernard Tschumi, *Architecture and Disjunction* (Cambridge, Mass.: MIT Press, 1994). For Tschumi's exhibition at the Museum of Modern Art, see Bernard Tschumi, *Bernard Tschumi, Architecture and Event: April 21–July 5, 1994* (New York: Museum of Modern Art, 1994); Herbert Muschamp, "Urban Dreams, Urban Realities," *New York Times* (April 24, 1994), C: 26.

57. Tschumi, *Bernard Tschumi: Architecture In/Of Motion*, 85.

58. Dutton, "Lerner Student Center Hub Glass Wall and Ramps": 24. Also see Peter Rice and Hugh Dutton, *Structural Glass*, 2nd ed. (London and New York: E. & F. N. Spon, 1995).

59. Bernard Tschumi, quoted in Feldman, "Lerner Satisfies Press, but Not Some Students": 7.

60. Pelkonen, "In Context: Tschumi at Lerner Hall": 82, 84–86.

61. Muschamp, "Echoes of '68 on Columbia's Campus": 40–41.

62. Muschamp, "Echoes of '68 on Columbia's Campus": 41.

63. Campbell, "Modernism and Contextualism Meet at Bernard Tschumi and Gruzen Samton's Lerner Hall with Provocative Results": 95–96.

64. Campbell, "Modernism and Contextualism Meet at Bernard Tschumi and Gruzen Samton's Lerner Hall with Provocative Results": 101.

65. Amanda H. Kahn, "Plans for JSU Building Proceeding," *Columbia Spectator* (January 23, 1992): 1, 15; Veronica Lei, "Construction of Kraft Center Set for Fall 1996," *Columbia Spectator* (April 9, 1996): 1, 7; Fairfield, "New Residence Hall and Jewish Life Center Are Underway": 1, 6; "New Jewish Center at Columbia," *New York Times* (June 20, 1999), XI: 1; Jacobs, "Architecture 101": 21; White and Willensky, *AIA Guide* (2000), 472; Randal C. Archibold, "New Home at Columbia for Center for Jews," *New York Times* (April 3, 2000), B: 3; "A Jewish Center for Columbia," *New York Observer* (April 10, 2000): 4.

66. "Off the Record," *Architectural Record* 188 (October 2000): 34; Ulrika Brand, "School of the Arts Considers Expanding in Prentis Hall on W. 125th," *Columbia University Record* (October 20, 2000): 1, 4; Jayne Merkel, "ShoP Talk," *Oculus* 63 (November 2000): 17; Brian Carter and Annette Lecuyer, *All American: Innovation in American Architecture* (London: Thames & Hudson, 2002), 62, 64.

67. Karen W. Arenson, "Columbia Hires Architects and Planners to Help Design Long-Term Expansion," *New York Times* (February 15, 2003), B: 3.

68. For early history of the cathedral, see Stern, Gilmartin, and Massengale, *New York 1900*, 396–402; Stern, Gilmartin, and Mellins, *New York 1930*, 155–57; Stern, Mellins, and Fishman, *New York 1880*, 334–66.

69. Stern, Mellins, and Fishman, *New York 1960*, 754–56.

70. Stern, Mellins, and Fishman, *New York 1960*, 756.

71. James Ward, ed., *The Artifacts of R. Buckminster Fuller: Volume Four* (New York: Garland Publishing, 1985), 346–47. Also see "86-Year History of Cathedral's Construction," *New York Times* (December 5, 1978), B: 9; Kenneth A. Briggs, "Construction of Cathedral of St. John Will Resume," *New York Times* (December 5, 1978): 1, B: 9; Tom Ferrell and Virginia Adams, "Cathedral to Get Homemade Towers," *New York Times* (December 10, 1978). IV: 7; John Evanish, "'A Symbol of Strength,'" letter to the editor, *New York Times* (December 17, 1978), IV: 20; "The Stone Carvers," editorial, *New York Times* (December 19, 1978): 20; Lee A. Daniels, "After 37 Years, Cathedral's Completion Is Resumed," *New York Times* (June 22, 1979), B: 3; Gavin Macrae-Gibson, "Reflections upon the New Beginnings at the Cathedral Church of Saint John the Divine," *Architectural Record* 166 (November 1979): 119–26; Richard Haitch, "Medieval Project," *New York Times* (December 9, 1979): 51; James Parks Morton and Ben Weese, letters to the editor, *Architectural Record* 167 (March 1980): 4; Richard Haitch, "A Love of Labor," *New York Times* (April 19, 1981): 29; Sharon Lee Ryder, "Wholly Holy," *Metropolis* 1 (December 1981): 6; James Parks Morton, "Resurrections," *Metropolis* 1 (January/February 1982): 12–15; "Aerialist Opens Dedication at Cathedral," *New York Times* (September 30, 1982): 1; Paul Goldberger, "St. John the Divine: The Slow Finishing Touch," *New York Times* (September 30, 1982), B: 1; Lindsay Li, "Born Again: Construction Resumes at the Cathedral Church of St. John the Divine," *Architectural Record* 170 (November 1982): 51; Thomas Fisher, "Stone and Terra Cotta," *Progressive Architecture* 64 (June 1983): 94–97; Nancy Jack Todd and John Todd, *Bioshelters, Ocean Arks, City Farming: Ecology as the Basis of Design* (San Francisco: Sierra Club Books, 1984), 88–92; "'Peace Fountain' Unveiled," *New York Times* (October 16, 1984), B: 3; Lee A. Daniels, "$80 Million Campaign to Start in Bid to Finish Building St. John the Divine," *New York Times* (October 28, 1984): 40; Susan Heller Anderson and David W. Dunlap, "An Ecumenical Appeal for St. John the Divine," *New York Times* (January 15, 1985), B: 3; Susan Heller Anderson and David W. Dunlap, "Confrontation and Peace," *New York Times*

Bergdoll, *Mastering McKim's Plan*, 136.

16. "Columbia to Build Computer Facility," *New York Times* (February 14, 1982): 52; "New Merging with Old in Projects at Columbia," *New York Times* (August 24, 1982), B: 1, 16; Julius Genachowski, "Com Sci Home Nearly Done; to Finish Under $5.6 Million," *Columbia Spectator* (February 11, 1983): 1; Maureen Dowd, "Columbia Enters New Era with Computer Center," *New York Times* (October 12, 1983), B: 3; Margaret Gaskie, "Classical Complexity," *Architectural Record* 172 (March 1984): 126–33; Stanley Abercrombie, "Waltzing to the CRT," *Interior Design* 55 (March 1984): 226–31; "Computer Science Building, Columbia University," *Architecture + Urbanism* (September 1984): 39–46; Carter Wiseman, "Fitting in at School," *New York* 17 (December 3, 1984): 150, 152, 154; Paul Goldberger, "When the Site Tests the Designer," *New York Times* (February 17, 1985), II: 31; Sarah Williams, "The Architecture of the Academy," *Change* 17 (March/April 1985): 14–30, 50–55; "Computer Science Building, Columbia University," *Oculus* 46 (May 1985): 5; Andrea Truppin, "Guiding Light," *Interiors* 145 (May 1986): 300–311; Sharon Lee Ryder, "Building Threaded Between Neighbors," *Architecture* 76 (May 1987): 144–46, 229; "Computer Science Building, Columbia University, New York City," *Architectural Record* 175 (June 1987): 75; Bergdoll, *Mastering McKim's Plan*, 138–39, 240–41; Susanna Sirefman, *New York: A Guide to Recent Architecture* (London: Ellipses, 1997), 244–47; James S. Russell, "R. M. Kliment & Frances Halsband Architects," *Architectural Record* 185 (May 1997): 90–91; Dolkart, *Morningside Heights*, 200; Carole Rifkind, *A Field Guide to Contemporary American Architecture* (New York: Penguin Books, 1998), 253, 260; *Educational Spaces: Volume 1* (Mulgrave, Australia: Images Publishing, 1998), 94–95; *R. M. Kliment & Frances Halsband Architects: Selected and Current Works* (Mulgrave, Australia: Images Publishing, 1998), 36–45; White and Willensky, *AIA Guide* (2000), 470–71. For Mudd Hall, see Stern, Mellins, and Fishman, *New York 1960*, 739, 741.

17. For Moore & Hutchins's Uris Hall, see Stern, Mellins, and Fishman, *New York 1960*, 739–41.

18. Julius Genachowski, "$2.5M Uris Gift Will Build Annex," *Columbia Spectator* (January 27, 1983): 1, 8; "Columbia Gifts of $3 Million," *New York Times* (January 27, 1983), D: 19; "Donations to Enable Columbia to Expand Program in Business," *New York Times* (January 30, 1983): 32; Josh Moreines, "Bigger Business," *Columbia Spectator* (March 8, 1984): 8; Jeremy Feldman and Richard Froehlich, "Asbestos Fibers Push Concern for Uris Project," *Columbia Spectator* (June 6, 1984): 1, 3; Jeremy Feldman, "Uris Asbestos Removal Resumes with No Upsets," *Columbia Spectator* (June 13, 1984): 1, 6; Jeremy Feldman, "Uris Renovations to Close Business School," *Columbia Spectator* (June 20, 1984): 1, 3; Consuello Rockliff, "Report Sites New Uris Asbestos Leak," *Columbia Spectator* (June 27, 1984): 1–2; Jeremy Feldman with Consuello Rockliff, "Uris Hall Remains Closed; New Contractor Takes Over," *Columbia Spectator* (July 11, 1984): 1–2; Jeremy Feldman, "Uris Is Reopened After an Extra Week Delay," *Columbia Spectator* (July 18, 1984): 1–2; "Reasserting a Beaux-Arts Tradition: An Expansion Plan for Columbia's Business School," *Architectural Record* 173 (February 1985): 61; "Columbia Removing Asbestos from Its Buildings," *New York Times* (February 3, 1985): 39; R. Douglas Hamilton, "A New Facade for Modernism," *Columbia Art Review* (Spring 1985): 10–12; "Uris Hall Addition at Columbia University," *Building Stone Magazine* (January-February 1986): 40–43; Roger Kimball, "Business as More Than Usual," *Architectural Record* 174 (April 1986): 120–25; Richard Bender, "Boom and Reverberation," *Architecture* 79 (January 1990): 58–59; Bergdoll, *Mastering McKim's Plan*, 138; Sirefman, *New York*, 248–49; Dolkart, *Morningside Heights*, 407; White and Willensky, *AIA Guide* (2000), 471.

19. For Nashdom, see A. S. G. Butler, *The Architecture of Sir Edwin Lutyens, Volume 1: Country-Houses* (London: Country Life, 1950), 36, figs. 72–76.

20. Kimball, "Business as More Than Usual": 120.

21. Bergdoll, *Mastering McKim's Plan*, 138.

22. Sirefman, *New York*, 248.

23. "University Announces Plans for New Library," *Columbia Spectator* (July 20, 1983): 1; William G. Blair, "Columbia Is Starting New Library to Hold Rare Book Treasures," *New York Times* (July 24, 1983): 36; "Names and News," *Oculus* 45 (September 1983): 9; Susan Heller Anderson and David W. Dunlap, "Renewal in the Library," *New York Times* (December 11, 1984), B: 3; Andrea Truppin, "Rare Example," *Interiors* 145 (August 1985): 148–55, 212; Douglas Farr, "The Light at the End of the Tunnel: Columbia's New Rare Book Library," *Columbia Art Review* (Winter 1985): 3–6.

24. "Columbia Is Given $3.5 Million for a Gallery and Arts Center," *New York Times* (September 29, 1983), B: 2; "Names and News," *Oculus* 45 (November 1983): 7; Julius Genachowski, "Wallach Gives $3.5 M for New Art Gallery," *Columbia Spectator* (September 29, 1983): 1, 11; Jennifer Tower, "Schermerhorn Rehab on Time," *Columbia Spectator* (September 28, 1984): 5; Leah Karliner, "Schermerhorn Hall Renovated," *Columbia Art Review* (Spring 1985): 19; Daralice D. Boles, "Teaching Architecture," *Progressive Architecture* 67 (September 1986): 128–31; "Columbia Corrections," *Progressive Architecture* 67 (November 1986): 11.

25. Larry Rohter, "Nearing 100, Barnard Plans 18-Story Dormitory Tower," *New York Times* (October 25, 1986): 29–30; Alison Craiglow, "BC Dorm to Be 18-Story Addition to BHR Quad," *Columbia Spectator* (October 27, 1986): 1, 12; Alison Craiglow, "BC Architectural Plans Would Emphasize Arts," *Columbia Spectator* (October 31, 1986): 1, 5; Christopher Browne, "New Barnard Dorm: Made in the Shade?" *Columbia Spectator* (November 25, 1987): 1, 5; "Well, What Do You Think?" *Columbia Spectator* (March 19, 1987): 1; "Ground Broken for New Dorm," *Columbia University Record* (April 17, 1987): 3;

Peggy Edersheim, "Barnard Raising," *Manhattan, inc.* 4 (June 1987): 161–62; James Stewart Polshek: *Context and Responsibility* (New York: Rizzoli International Publications, 1988), 56–57, 188–89; Deirdre Carmody, "Birthday for Barnard: New Dorm's the Gift," *New York Times* (July 21, 1988), B: 1–2; "Centennial Hall Makes Its Debut," *Columbia University Record* (September 9, 1988): 8; Clifford A. Pearson, "Holding Court," *Architectural Record* 177 (October 1989): 112–15; "Centennial Hall, Barnard College," *Architecture + Urbanism* (November 1990): 89–95; Stephanie Strom, "Gift to Barnard Honors Iphigene Sulzberger," *New York Times* (January 15, 1991), B: 5; Kathleen Teltsch, "Barnard Dorm Is Dedicated to Iphigene Ochs Sulzberger," *New York Times* (October 18, 1991), B: 2; "Mut der Lücke," *Bauwelt* 83 (January 1992): 198; Sirefman, *New York*, 250–51; Dolkart, *Morningside Heights*, 223, 427; White and Willensky, *AIA Guide* (2000), 473; Susan Strauss and Sean Sawyer, eds., *Polshek Partnership Architects* (New York: Princeton Architectural Press, 2005), 2–11.

26. See Stern, Gilmartin, and Massengale, *New York 1900*, 410–11; Stern, Mellins, and Fishman, *New York 1960*, 740.

27. Richard Froehlich, "Columbia Contemplating Increase in Class Size, Dorm to Go on 115th," *Columbia Spectator* (August 11, 1982): 1, 3; Steven Waldman, "CU Tries to Find $30M to Fund New Dormitory," *Columbia Spectator* (September 20, 1982): 1, 6; William Teichner, "115th St. Dorm in Planning," *Columbia Spectator* (February 27, 1984): 1, 8; Irene Tucker, "CU Needs $5 Million to Begin New Dorm," *Columbia Spectator* (September 30, 1985): 1, 5; Jennifer Lynch with John A. Oswald, "Barnard and CU to Build New Dorms: Alum Provides CC with at Least $5M," *Columbia Spectator* (January 22, 1986): 1, 3; "Columbia and Barnard Will Add Dormitories," *New York Times* (January 26, 1986): 22; Asha Badrinath, "Morris A. Schapiro Hall to Be Built on 115th St.," *Columbia Spectator* (January 27, 1986): 1, 13; "Bouncing Baby Building," *Columbia Spectator* (October 23, 1986): 1; Sharon Stern, "Schapiro Hall to Feature Picture Windows, Beds," *Columbia Spectator* (October 23, 1986): 3; Jennifer Hirsh, "A Good Neighbor in the Columbia Tradition," *Columbia Art Review* (Winter 1986): 8–9; "Building of Arts Center Progresses at Columbia," *New York Times* (November 1, 1987): 66; Joseph Berger, "New Dorm at Columbia Means Diversity," *New York Times* (August 26, 1988): 1, B: 2; "Schapiro Hall to Open Next Week," *Columbia University Record* (August 26, 1988): 1, 8; David Kaufman, "Schapiro Theater Delays Postpone Two Productions," *Columbia Spectator* (November 3, 1989): 1, 4; Rosanna G. Liebman, "West Side Study," *Architecture* 79 (January 1990): 90–91; Amanda H. Kahn, "Schapiro Hall Exterior Will Be Tested," *Columbia Spectator* (November 22, 1991): 1–2; White and Willensky, *AIA Guide* (2000), 472.

28. Vukani Magubane, "Columbia Planning to Build $54 Million High-Technology Research Center," *New York Times* (December 29, 1985): 27; Alison Craiglow, "State Grants CU $5M for Technology Center," *Columbia Spectator* (April 2, 1986): 1, 3; "Design Plans for New Engineering Building Unveiled," *Columbia University Record* (November 4, 1988): 1; "Research Center and Boiler Plant Start at Columbia," *New York Construction News* 36 (December 12, 1988): 1, 23; "Goodbye Tennis Courts," *Columbia Spectator* (March 9, 1989): 1; "Columbia University Center for Engineering and Physical Science Research," *Architecture + Urbanism*, extra edition (December 1990): 178–81; Eric Roston, "Task Force Report, CEPSR Building Both in Final Stages," *Columbia Spectator* (August 29, 1991): 3, 23; Danny Franklin, "Schapiro Center Will Be Finished by Spring Term," *Columbia Spectator* (October 2, 1991): 1, 5; Elizabeth Berke, "CEPSR Well-Designed to Suit Professors' Research," *Columbia Spectator* (August 5, 1992): 1, 5; "High Technology Schapiro Center to Be Dedicated," *Columbia University Record* (September 11, 1992): 1, 3; Steven Prokesch, "Public and Private Mix at Columbia," *New York Times* (September 17, 1992), B: 3; "Columbia Science Praised at Schapiro Dedication," *Columbia University Record* (September 25, 1992): 1, 6; "The Schapiro Center: Leading the Way to the 21st Century," *Columbia University Record* (September 25, 1992): 7; Meg Dooley, "Engineering the Future at Columbia," *Columbia* (Fall 1992): 30–31, 34–36; Nancy Levinson, "Labs Come of Age," *Architectural Record* 190 (November 1992): 60–61, 120; White and Willensky, *AIA Guide* (2000), 471; *Hellmuth, Obata & Kassabaum: Selected and Current Works* (Mulgrave, Australia: Images Publishing, 2002), 120–21.

29. White and Willensky, *AIA Guide* (2000), 471.

30. Tim Carvell, "City Library Looks for New Home," *Columbia Spectator* (January 16, 1992): 1, 4; Elizabeth Berke, "Library Branch Still Looking for New Home," *Columbia Spectator* (October 2, 1992): 1, 5; Emily M. Bernstein, "On Broadway, Book Is Mightier Than Car," *New York Times* (February 27, 1994), XIII: 6; Mike Lifrak, "NY Library Branch May Move," *Columbia Spectator* (March 21, 1994): 1, 5; Harriet Ryan, "Two Sites Considered for New Undergrad Dorm," *Columbia Spectator* (June 28, 1995): 1, 4; Allison Margolin, "New Dorm Planned for Broadway Site," *Columbia Spectator* (September 20, 1996): 1, 7; Lauren Goodman, "Chemical Bank Site Potential Location for New Dorm," *Columbia Spectator* (October 23, 1995): 1, 3; Michael Gwertzman, "Public Library Branch to Move from Butler," *Columbia Spectator* (November 16, 1995): 1, 15; Eli Sanders, "Residents Wary of University Building Plans," *Columbia Spectator* (January 18, 1996): 1, 9; Charles Sisk, "Residents Submit Pro-Landmark Proposal," *Columbia Spectator* (February 14, 1996): 1, 5; "A Storm Over a Dorm Plan," *New York Times* (March 17, 1996), XIII: 8; Hans Chen, "New Dorm Architect Proposes Plans to Area Residents," *Columbia Spectator* (March 25, 1997): 1, 5; "A New Den for the Lions of Columbia," *New York Times* (April 20, 1997), X: 1; Eric Wm. Allison, "The President's Column," *District Lines* (Summer

1997): 2, 7; David Garrard Lowe, "Now They're Deconstructing the Columbia Campus," *City Journal* 7 (Autumn 1997): 84–97; David W. Dunlap, "Alma Mater Gets a Makeover," *New York Times* (November 16, 1997), XI: 1, 6; Jenna Klatell, "Chase Makes Way for Broadway Dorm," *Columbia Spectator* (November 18, 1997): 1, 5; Peter Morris Dixon, ed., *Robert A. M. Stern: Buildings and Projects, 1993–98* (New York: Monacelli Press, 1998), 248–53; "Conservation of Scaffolding," *Columbia Spectator* (February 3, 1998): 1; Benjamin Lowe, "$50 Million Dorm Stirs Talk," *Columbia Spectator* (February 11, 1998): 1, 5; Mia-Margaret Laabs, "Community Approves Plan for Dorm," *Columbia Spectator* (February 18, 1998): 1; "Dormitory Plan: One Minus, Many Pluses," *Columbia Spectator* (February 22, 1998), XIV: 6; Mia-Margaret Laabs, "Board Approves Proposed Dormitory," *Columbia Spectator* (February 23, 1998): 1, 5; "The New Dormitory," editorial, *Columbia Spectator* (February 26, 1998): 1; Hannah Fairfield, "New Residence Hall and Jewish Life Center Are Underway," *Columbia University Record* (February 26, 1999): 1, 6; Anne Canty, "Residence Hall Passes Hurdle with Vote of Community Bd.," *Columbia University Record* (February 27, 1998): 3; Erik Seadale, "Town and Gown Marry on Columbia Dorm Plan," *New York Observer* (March 9, 1998): 8; Kaya Tretjak, "Construction Starts on $50 Million Dorm," *Columbia Spectator* (September 15, 1998): 1, 7; Nicholas Adams, "Il Nuovo McKim, Paul Rudolph, Tschumi e Stern alla Columbia," *Casabella* 62 (October 1998): 84–89; Daniel Feldman, "Architect Outlines Dorm Plan," *Columbia Spectator* (February 10, 1999): 1, 9; Bob Morris, "Style to Which They're Accustomed," *New York Times* (May 13, 1999), F: 1, 8; Jordan Fox, "Technology in Residence," *American Schools & Universities* (August 1999): 111–15; Karrie Jacobs, "Architecture 101," *New York* 32 (October 4, 1999): 20–21; Karen W. Arenson, "Reseeding Ivy: Columbia on Comeback Trail from Troubles," *New York Times* (November 1, 1999), B: 1, 7; Maggie Garb, "2 Parks Sandwich Town and Gown," *New York Times* (November 21, 1999): 5; White and Willensky, *AIA Guide* (2000), 471; Felicia Lee, "Dreams and Knowledge, Under One Roof," *New York Times* (March 26, 2000), XIV: 1; Hilary Ballon, "The Architecture of Columbia; Educational Visions in Conflict," *Columbia College Today* (January 2002): 14–21; Peter Morris Dixon, ed., *Robert A. M. Stern: Buildings and Projects, 1999–2003* (New York: Monacelli Press, 2003), 278–85.

31. For 565 West 113th Street, see Dolkart, *Morningside Heights*, 449.

32. For Hogan Hall, see Stern, Mellins, and Fishman, *New York 1960*, 751.

33. Nina Siegel, "Columbia High-Rise Might Rise Too High, Critics Worry," *New York Times* (January 23, 2000), XIV: 8; Lauren Marshall, "Design and Floor Plans of New Faculty Residence at 110th Street Are Unveiled," *CCAlumni@ Columbia.edu* (October 2000): 4; Candace Rondeaux, "Columbia Can Build New Faculty Housing," *New York Observer* (March 19, 2001): 12; Kelly Crow, "Columbia Roils Neighbors Again, Now Over an Elementary School," *New York Times* (March 25, 2001), XIV: 4; Lauren Marshall, "Outreach Continues as Construction Begins on 110th Street Apartment and School," *Columbia University Record* (October 12, 2001): 2; Denny Lee, "For a Columbia School, a Reluctant Peace Dissolves," *New York Times* (December 29, 2002), XIV: 5; "The School Opens," *Columbia* (Fall 2003): 12.

34. John Beyer, quoted in Marshall, "Outreach Continues as Construction Begins on 110th Street Apartment and School": 2.

35. Daniel J. Wakin, "Columbia Reconsiders a Building, and the Neighbors Are Pleased," *New York Times* (December 10, 2000), XIV: 6; Nadine Brozan, "Residence Hall and Academic Center for Columbia," *New York Times* (February 8, 2002), B: 3; Denny Lee, "On the Heights, a Chill Wind Begins to Blow," *New York Times* (September 14, 2003), XIV: 1, 11.

36. Brozan, "Residence Hall and Academic Center for Columbia": 3; Lee, "On the Heights, a Chill Wind Begins to Blow": 1, 11.

37. For Harrison & Abramovitz's Law School, see Stern, Mellins, and Fishman, *New York 1960*, 736–37.

38. For Jerome L. Greene Hall, see Stern, Mellins, and Fishman, *New York 1960*, 751.

39. "Addition Planned for Law School at Columbia U.," *New York Construction News* 36 (January 16, 1989): 1, 18; *The Architecture of Kallmann McKinnell & Wood* (New York: Rizzoli International Publications, 1988), 118.

40. Danny Franklin, "Law School Raises Funds for New Student Lounge," *Columbia Spectator* (October 18, 1991): 1–2; Suzanne Stephens, "Competitive Edge," *Oculus* 55 (November 1992): 3; Henry Tam Jr., "Law School to Unveil Plans for Student Lounge Soon," *Columbia Spectator* (February 26, 1993): 5.

41. "Planning Ahead," *Columbia Spectator* (September 23, 1994): 1; "Law School Announces Campaign," *Columbia University Record* (September 30, 1994): 1, 6; Kathy Wrightson, "Greene to Be Renovated in Spring 1995," *Columbia Spectator* (October 7, 1994): 1, 7; "Major Renovation at Columbia Law," *New York Times* (October 9, 1994), IX: 1; Heidi Nasr, "Construction Nears Completion," *Columbia Spectator* (May 29, 1996): 5; Catherine Slessor, "Grove of Academe," *Architectural Review* 202 (August 1997): 56–59; Paul Spencer Byard, *The Architecture of Additions: Design and Regulation* (New York: W. W. Norton, 1998), 169–71; Paul Spencer Byard, "Pickling the Past," *Architecture* 87 (February 1998): 58–63; White and Willensky, *AIA Guide* (2000), 468; Strauss and Sawyer, eds., *Polshek Partnership Architects* 100–111.

42. Byard, *The Architecture of Additions*, 169, 171. For the United Nations General Assembly Building, see Stern, Mellins, and Fishman, *New York 1960*, 622–25.

43. Michael Gwertzman, "Law to Construct 10-Story Building," *Columbia Spectator* (October 6, 1995): 1, 6; "On a Narrow Lot, Legal Maneuvers," *New York Times* (December 3,

1995], IX: 1; White and Willensky, *AIA Guide* (2000), 468.

44. Verad A. Frank, "Law, Business Schools Plan New, Joint Building," *Columbia Spectator* (March 1, 1995): 1, 7; Chas Sisk, "Building Plans Going 'Smoothly,'" *Columbia Spectator* (September 28, 1995): 1, 7; Meital Hershkovitz, "Law School Building Warren Hall," *Columbia Spectator* (February 6, 1996): 1, 7; "Spring '97 Start Set for $25M Columbia University Classroom & Office Building," *New York Construction News* 44 (August 12, 1996): 1, 12; "A Building Reflecting Those on Main Campus," *New York Times* (August 25, 1996), IX: 1; A. Leah Vickers, "Law, Business Site Construction Begins," *Columbia Spectator* (February 14, 1997): 1, 5; "A Ground-breaking Ceremony for Warren Hall," *Columbia* (Fall 1997): 8; "Gifts to Business and Law Support Warren Hall," *Developments: Campaign for Columbia* (Summer 1998); Hannah Fairfield, "Business-Law Opens," *Columbia University Record* (January 29, 1999): 1, 6; "The William and June Warren Hall," *Columbia University Record* (May 19, 1999): 4; White and Willensky, *AIA Guide* (2000), 469; William Weathersby Jr., "Deft Illumination Enhances the Profile and Function of Classrooms at Columbia's New Warren Hall," *Architectural Record* 188 (May 2000): 345–46; Ian Fletcher, "Unwitty Parody Party," letter to the editor, *Architectural Record* 188 (July 2000): 20.

45. *Commission on the Future of the University: Draft Report, Part III* (New York: Columbia University, May 1985), 10–11.

46. Bergdoll, *Mastering McKim's Plan*, 140. Also see Skidmore, Owings & Merrill, *Columbia University: East Campus Development* (March 1990); Kohn Pedersen Fox Associates, *Columbia University: East Campus Redevelopment Master Plan* (March 12, 1990).

47. Skidmore, Owings & Merrill, *Columbia University: East Campus Development* (March 1990).

48. Bergdoll, *Mastering McKim's Plan*, 142.

49. For Casa Italiana, see Stern, Gilmartin, and Mellins, *New York 1930*, 109. For the President's House, see Stern, Gilmartin, and Massengale, *New York 1900*, 417.

50. Kristina Nye, "Casa Italiana Architects Chosen for Renovations," *Columbia Spectator* (November 7, 1991): 1, 6; "Casa Famiglia," *Oculus* 54 (December 1991): 4; Peter D. Slatin, "Casa Italiana, New York," *Architectural Record* 180 (January 1992): 19; Christopher Gray, "Streetscapes/Casa Italiana," *New York Times* (April 12, 1992), X: 6; Stephanie J. Geositis, "Casa Italiana to Begin $7.5 Million Renovation," *Columbia Spectator* (July 22, 1992): 1, 7; Mike Lifrak, "Casa Italiana Plans Contested," *Columbia Spectator* (January 28, 1994): 1, 5; Emily M. Bernstein, "Casa Italiana Going Moderne?" *New York Times* (February 6, 1994), XIII: 9; "Upper West Side," *New York Times* (March 13, 1994), XIII: 6; Mike Lifrak, "Casa Italiana to Be Renovated," *Columbia Spectator* (March 31, 1994): 1, 11; Jayne Merkel, "In the Streetscape: The Casa and the Convent," *Oculus* 58 (April 1996): 6–7; Stephen A. Kliment, "Rescue Transforms Columbia Landmark," *Architectural Record* 184 (July 1996): 80–83; "La Casa Italiana," *Ottagono* 120 (September-November 1996): 65–69; Giampiero Bosoni, "La Casa Italiana a New York," *Domus* (December 1996): 46–52; Mario Lupano, *Italo Rota: Il Teatro dell'architettura* (Milan: Motta Architettura, 1997), 17–25; "Ein Studienhaus in New York," *Bauwelt* 88 (May 30, 1997): 1192–93; Raymond Quinn, "Il Progetto di Recupero della Casa Italiana a New York," *Lotus International* 103 (1999): 78–89; White and Willensky, *AIA Guide* (2000), 468.

51. Evan P. Schultz, "Butler Library Lobby Will Undergo Renovations Soon," *Columbia Spectator* (September 25, 1989): 1, 10; Evan P. Schultz, "Architects Chosen for Butler Lib. Renovation," *Columbia Spectator* (October 23, 1989): 1, 9; David A. Shimkin, "Butler Renovation Plans Will Be Completed Soon," *Columbia Spectator* (September 17, 1991): 1, 5; Mary E. Pflum, "Butler Library Shortens Hours," *Columbia Spectator* (October 8, 1992): 1, 15; Tova Mirvis, "Butler Library in Serious Need of Renovations," *Columbia Spectator* (January 28, 1993): 1, 5; Tova Mirvis, "Butler Repairs to Occur in Stages," *Columbia Spectator* (February 18, 1993): 1, 4; Maurice B. Toueg, "Hole Made in Third Floor Ceiling of Butler Library," *Columbia Spectator* (March 24, 1993): 1, 4; Tova Mirvis, "Butler Renovations May Get Underway This October," *Columbia Spectator* (August 4, 1993): 1; J. J. Lee, "Design for Butler Renovation Prepared," *Columbia Spectator* (November 3, 1993): 1, 7; Jeffrey Bellin, "It's Time to Renovate Butler," *Columbia Spectator* (March 25, 1994): 3; Aileen Soper, "Butler Library Renovations to Begin in 1995," *Columbia Spectator* (September 27, 1994): 1, 7; Hans Chen, "Butler Library Renovations Delayed Until Spring," *Columbia Spectator* (January 18, 1995): 1, 6; Lauren Goodman and Sally Magdi, "Libraries Plan Extensive Renovations," *Columbia Spectator* (April 26, 1995): 19–20; "Butler Library," *Columbia Spectator* (June 7, 1995): 5; Sumathi Reddy, "First Phase of Butler Renovations Underway," *Columbia Spectator* (November 9, 1995): 1, 15; David Karp, "Librarians Review Butler Renovation Plans," *Columbia Spectator* (October 31, 1996): 1, 7; Louise Choi, "Butler to Add Rooms, Coffee Bar," *Columbia Spectator* (February 19, 1997): 1, 7; Shira J. Boss, "Butler, Books and Beyond," *Columbia College Today* 23 (Fall 1997): 6–7; David W. Dunlap, "For Libraries, a Time of Rebirth," *New York Times* (September 28, 1997), IX: 1, 6; "$10 Million Gift Creates Milstein Family College Library," *Developments: The Campaign for Columbia* (Summer 1998): 1; Lauren Kofke, "Butler Opens New Coffee Shop and Reading Rooms," *Columbia Spectator* (September 8, 1998): 1, 7; Michelle Lee and Kathleen O'Shea, "Historic Mural Gets a Facelift," *Columbia Spectator* (September 11, 1998): 1, 6; Nan Ramnath, "Butler Renovation Does Some Good, Creates New Problems," *Columbia Spectator* (September 15, 1998): 5; Benjamin Ryan, "Some Taken Aback as Butler Enters Modernity," *Columbia Spectator* (October 19, 1998): 1, 9; Will Heinrich, "Butler Café Brings Library Closer to Real World,"

Columbia Spectator (November 6, 1998): 5; Eve M. Kahn, "Restoration by the Book," *Interiors* 159 (March 2000): 76–81; "Columbia University, Butler Library," *American School & University* 72 (August 2000): 36–38. For Butler Library, see Stern, Gilmartin, and Mellins, *New York 1930*, 109–10.

52. Marion Weiss and Michael A. Manfredi, *Site Specific: The Work of Weiss/Manfredi Architects* (New York: Princeton Architectural Press, 2000), 99–100, 102–9, 125.

53. Chiu-Huey Hsia, "Media Center Spurs Renovations," *Columbia Spectator* (April 6, 1995): 6; *Columbia University, President's Report, 1996–97* (New York: Columbia University, 1997), 20; Deme Kasimis, "Journalism Building Overhauls Nearly Done," *Columbia Spectator* (September 17, 1997): 5; Marylena Mantas, "Lobby Dedication Marks J-School Renovation End," *Columbia Spectator* (September 25, 1997): 1, 5; Dolkart, *Morningside Heights*, 337.

54. "Fare Thee Well, Ferris?" *New York Times* (October 23, 1994), XIII: 8; "Campaign Sets a New Goal: $2.2B in 2000," *Columbia University Record* 21 (December 8, 1995): 1, 6; Nicolai Ouroussoff, "Tschumi Abstracts McKim, Mead, & White's Plan for Columbia University," *Architectural Record* 184 (January 1996): 11; "Eagerly Awaited Student Center Project to Begin," *Columbia University Record* 21 (January 26, 1996): 1, 7; "For Columbia, a New $68 Million Student Center," *New York Times* (January 28, 1996), IX: 1; Nina Rappaport, "Columbia Under Construction," *Oculus* 59 (September 1996): 14; "Ground Breaking for a Grand Student Center: Lerner Hall," *Columbia University Record* 21 (October 4, 1996): 1; "At Columbia," *AIA New York Chapter Annals, 1996–1997* (1997): 53; Bergdoll, *Mastering McKim's Plan*, 143; Jos Bosman, "Between the Mirrors of Ideal Space and Real Space," in Bernard Tschumi, *Bernard Tschumi: Architecture In/Of Motion* (Rottderam: NAi Publishers, 1997), 7–13; Bernard Tschumi, *Bernard Tschumi: Architecture In/Of Motion*, cover, 84–101; "Bernard Tschumi: Deviance, the Normative and the In-Between," *Newsline* 9 (Spring 1997): 5; "Columbia University: $650 Million Planned in Capital Construction," *New York Construction News* 44 (April 28, 1997): 1; "Lerner Hall: Looks Back, Sees Future," *New York Construction News* 44 (April 28, 1997): 4, 6; "Local, Minority, and Women-Owned Firms Sought for Lerner Hall," *New York Construction News* 44 (April 28, 1997): 5; Jacopo della Fontana, "A Dynamic Hub," *L'Arca* 115 (May 1997): 8–11; Nina Rappaport, "Tschumi at Columbia," *Oculus* 59 (May 1997): 17; "Bernard Tschumi with Gruzen Samton Associated Architects: Lerner Student Center, Columbia University," *Architecture + Urbanism* (September 1997): 10–23; Hugh Dutton, "Lerner Student Center Hub Glass Wall and Ramps," *Architecture + Urbanism* (September 1997): 24–29; Lowe, "How They're Deconstructing the Columbia Campus": 84–97; John V. Bennett, "Lerner Hall Not Salvation for Campus," *Columbia Spectator* (November 12, 1997): 2–3; David W. Dunlap, "Alma Mater Gets a Makeover," *New York Times* (November 16, 1997), XI: 1, 6; Dolkart, *Morningside Heights*, 200–201, 337; "Something Borrowed, Something New," *ANY* 22 (1998): 29; Eeva Liisa Pelkonen, "Bernard Tschumi's Event Space," *Daidalos* 67 (March 1998): cover, 82–85; Patrick Queen and Nina Covalesky, "A New Lease on Undergraduate Life," *Columbia* (Spring 1998): 21–25; Jessica Barrow Dawson, "Project Portfolio: Bernard Tschumi Architects," *Architecture* 87 (April 1998): 45, 47; Adams, "Il Nuovo MoMA; Paul Rudolph; Tschumi e Stern alla Columbia": 84–89; "Lerner Student Center, Columbia University, New York, USA," *Zodiac* 20 (January-June 1999): 104–11; Nina Rappaport, "Brief aus New York," *Deutsche Bauzeitung* 133 (May 1999): 26; "Bernard Tschumi, Gruzen Samton: Lerner Center, Columbia University," *Domus* (June 1999): 35–38; Karen W. Arenson, "On Campus," *New York Times* (July 28, 1999), B: 8; Daniel Feldman, "Lerner Satisfies Press, but Not Some Students," *Columbia Spectator* (September 15, 1999): 1, 7; Julia Rose Kraut, "Following Space Allocations, Some Student Groups Are Displeased," *Columbia Spectator* (September 15, 1999): 1, 7; "Concepts Materialized: A Conversation with Bernard Tschumi," *Praxis* 1 (Fall 1999): 58–65; Megan Miller, "Bernard Tschumi: Alfred Lerner Hall, with Gruzen Samton Architects," *Praxis* 1 (Fall 1999): cover, 56–57, 66–81; Eeva Liisa Pelkonen, "In Context: Tschumi at Lerner Hall," *Praxis* 1 (Fall 1999): 82–87; Raymund Ryan, "Re-made in America," *Blueprint* 165 (October 1999): 44–47; Julia Einspruch Lewis, "New Building on Campus," *Interior Design* 70 (October 1999): 42; Jacobs, "Architecture 101": 20–21; James Barron, "An Architect with a Film Director's Eye," *New York Times* (October 5, 1999), B: 2; Herbert Muschamp, "Echoes of '68 on Columbia Campus," *New York Times* (October 24, 1999): 40–41; Sabine von Fischer, "Rampenspektakel hinter Glas: Lerner Student Center, Columbia University, New York," *Bauwelt* 90 (October 29, 1999): 2232–33; Robert Campbell, "Modernism and Contextualism Meet at Bernard Tschumi and Gruzen Samton's Lerner Hall with Provocative Results," *Architectural Record* 187 (November 1999): cover, 94–101; Ned Cramer, "Tschumi's Columbia Space Opens," *Architecture* 88 (November 1999): 40; "Alfred Lerner Hall Opens," *Columbia College Today* 26 (November 1999): cover, 4–7; "Cutting the Ribbon at Lerner," *Columbia College Today* 26 (November 1999): 9; David Ebony, "State-of-the-Art Student Center for Columbia," *Art in America* 87 (December 1999): 25; Todd Bressi, "Going Public: Lerner Hall," *Oculus* 62 (December 1999): 6–7; Bernard Tschumi, *Event-Cities 2* (Cambridge, Mass., and London: MIT Press, 2000), 288–377; White and Willensky, *AIA Guide* (2000), 471–72; Ian Fletcher, "Live and Lerner," letter to the editor, *Architectural Record* 188 (January 2000): 21; Paula Deitz, "Tschumi Builds Columbia," *Architectural Review* 207 (January 2000): 18–19; "Architecture Citation: Bernard Tschumi Gruzen Samton," *Oculus* 62 (January 2000): 23; Paula Deitz, "New Rhythm on Broadway," *Art News* 99 (February 2000): 108–10; Philip Nobel, "Textbook Example," *Metropolis* 19 (April 2000): 54, 58, 61; Alan Balfour, *World Cities: New York* (New York: Wiley Academy, 2001), 168–71; Ballon, "The Architecture of

Columbia; Educational Visions in Conflict": 14–21. For Ferris Booth Hall, see Stern, Mellins, and Fishman, *New York 1960*, 738–39.

55. For Tatlin and Rodchenko, see S. O. Khan-Mahomedov, "Creative Trends," in O. A. Shvidkovsky, ed., *Building in the USSR 1917–1932* (London: Studio Vista, 1971), 9–18. For Parc de la Villette, see Marianne Barzilay, *L'invention du parc: Parc de la Villette, Paris* (Paris: Graphite, 1984); Bernard Tschumi, *La case vide, La Villette* (London: Architectural Association, 1986); Andrew Benjamin, "Deconstruction and Art/The Art of Deconstruction," in *What Is Deconstruction?* (London: Academy Editions; New York: St. Martin's Press, 1988).

56. For Tschumi's philosophy, see Bernard Tschumi, *The Manhattan Transcripts* (London: Academy Editions; New York: St. Martin's Press, 1981; rev. ed., London: Academy Editions; New York: St. Martin's Press, 1994); Bernard Tschumi, *Questions of Space: Lectures on Architecture* (London: Architectural Association, 1990); Bernard Tschumi, *Architecture and Disjunction* (Cambridge, Mass.: MIT Press, 1994). For Tschumi's exhibition at the Museum of Modern Art, see Bernard Tschumi, *Bernard Tschumi, Architecture and Event: April 21-July 5, 1994* (New York: Museum of Modern Art, 1994); Herbert Muschamp, "Urban Dreams, Urban Realities," *New York Times* (April 24, 1994), C: 26.

57. Tschumi, *Bernard Tschumi: Architecture In/Of Motion*, 85.

58. Dutton, "Lerner Student Center Hub Glass Wall and Ramps": 24. Also see Peter Rice and Hugh Dutton, *Structural Glass*, 2nd ed. (London and New York: E. & F. N. Spon, 1995).

59. Bernard Tschumi, quoted in Feldman, "Lerner Satisfies Press, but Not Some Students": 7.

60. Pelkonen, "In Context: Tschumi at Lerner Hall": 82, 84–86.

61. Muschamp, "Echoes of '68 on Columbia's Campus": 40–41.

62. Muschamp, "Echoes of '68 on Columbia's Campus": 41.

63. Campbell, "Modernism and Contextualism Meet at Bernard Tschumi and Gruzen Samton's Lerner Hall with Provocative Results": 95–96.

64. Campbell, "Modernism and Contextualism Meet at Bernard Tschumi and Gruzen Samton's Lerner Hall with Provocative Results": 101.

65. Amanda H. Kahn, "Plans for JSU Building Proceeding," *Columbia Spectator* (January 23, 1992): 1, 15; Veronica Lei, "Construction of Kraft Center Set for Fall 1996," *Columbia Spectator* (April 9, 1996): 1, 7; Fairfield, "New Residence Hall and Jewish Life Center Are Underway": 1, 6; "New Jewish Center at Columbia," *New York Times* (June 20, 1999), XI: 1; Jacobs, "Architecture 101": 21; White and Willensky, *AIA Guide* (2000), 472; Randal C. Archibold, "New Home at Columbia for Center for Jews," *New York Times* (April 3, 2000), B: 3; "A Jewish Center for Columbia," *New York Observer* (April 10, 2000): 4.

66. "Off the Record," *Architectural Record* 188 (October 2000): 34; Ulrika Brand, "School of the Arts Considers Expanding in Prentis Hall on W. 125th," *Columbia University Record* (October 20, 2000): 1, 4; Jayne Merkel, "ShoP Talk," *Oculus* 63 (November 2000): 17; Brian Carter and Annette Lecuyer, *All American: Innovation in American Architecture* (London: Thames & Hudson, 2002), 62, 64.

67. Karen W. Arenson, "Columbia Hires Architects and Planners to Help Design Long-Term Expansion," *New York Times* (February 15, 2003), B: 3.

68. For early history of the cathedral, see Stern, Gilmartin, and Massengale, *New York 1900*, 396–402; Stern, Gilmartin, and Mellins, *New York 1930*, 155–57; Stern, Mellins, and Fishman, *New York 1880*, 334–46.

69. Stern, Mellins, and Fishman, *New York 1960*, 754–56.

70. Stern, Mellins, and Fishman, *New York 1960*, 756.

71. James Ward, ed., *The Artifacts of R. Buckminster Fuller: Volume Four* (New York: Garland Publishing, 1985), 346–47. Also see "86-Year History of Cathedral's Construction," *New York Times* (December 5, 1978), B: 9; Kenneth A. Briggs, "Construction of Cathedral of St. John Will Resume," *New York Times* (December 5, 1978): 1, B: 9; Tom Ferrell and Virginia Adams, "Cathedral to Get Homemade Towers," *New York Times* (December 10, 1978), IV: 7; John Evanish, "'A Symbol of Strength,'" letter to the editor, *New York Times* (December 17, 1978), IV: 20; "The Stone Carvers," editorial, *New York Times* (December 19, 1978): 20; Lee A. Daniels, "After 37 Years, Cathedral's Completion Is Resumed," *New York Times* (June 22, 1979), B: 3; Gavin Macrae-Gibson, "Reflections upon the New Beginnings at the Cathedral Church of Saint John the Divine," *Architectural Record* 166 (November 1979): 119–26; Richard Haitch, "Medieval Project," *New York Times* (December 9, 1979): 57; James Parks Morton and Ben Weese, letters to the editor, *Architectural Record* 167 (March 1980): 4; Richard Haitch, "A Love of Labor," *New York Times* (April 19, 1981): 29; Sharon Lee Ryder, "Wholly Holy," *Metropolis* 1 (December 1981): 6; James Parks Morton, "Resurrections," *Metropolis* 1 (January/February 1982): 12–15; "Aerialist Opens Dedication at Cathedral," *New York Times* (September 30, 1982): 1; Paul Goldberger, "St. John the Divine: The Slow Finishing Touch," *New York Times* (September 30, 1982), B: 1, 17; Lindsay Li, "Born Again: Construction Resumes at the Cathedral Church of St. John the Divine," *Architectural Record* 170 (November 1982): 51; Thomas Fisher, "Stone and Terra Cotta," *Progressive Architecture* 64 (June 1983): 94–97; Nancy Jack Todd and John Todd, *Bioshelters, Ocean Arks, City Farming: Ecology as the Basis of Design* (San Francisco: Sierra Club Books, 1984), 88–92; "'Peace Fountain' Unveiled," *New York Times* (October 16, 1984), B: 3; Lee A. Daniels, "$80 Million Campaign to Start in Bid to Finish Building St. John the Divine," *New York Times* (October 28, 1984): 40; Susan Heller Anderson and David W. Dunlap, "An Ecumenical Appeal for St. John the Divine," *New York Times* (January 15, 1985), B: 3; Susan Heller Anderson and David W. Dunlap, "Confrontation and Peace," *New York Times*

(May 10, 1985), B: 3; C. Ray Smith, "Finishing a Gothic Cathedral," *Oculus* 47 (October 1985): 2–6, 11–15; Peter Lemos, "Checks Cathedra," *Metropolis* 5 (December 1985): 11; William E. Geist, "About New York: Taking the Long View of Building a Cathedral," *New York Times* (March 19, 1986), B: 2; "Cathedral Church of St. John the Divine," *Architecture* 75 (April 1986): 22–23; George W. Wickersham II, "St. John the Divine," letter to the editor, *Architecture* 75 (July 1986): 6; Peter Lemos, "Deus Ex Machina," *Metropolis* 6 (January/February 1987): 19; Carter Wiseman, "Rev. James Parks Morton Lifts Spirits with the Cathedral of St. John the Divine," *New York* 20 (September 21, 1987): 121, 123; "Completing the Cathedral: A Call for Apprentices," *Architectural Record* 176 (May 1988): 35; Forrest Wilson, "Learning to Carve Stone the Old-Fashioned Way at St. John," *Architecture* 77 (October 1988): 37–38; Peter Slatin, "Carving in Stone," *Metropolis* 8 (November 1988): 36; Christopher Gray, "Streetscapes/The Leake & Watts Orphan Asylum," *New York Times* (June 24, 1990), X: 6; Douglas Martin, "Not Just Mortar: Holding Together Church's Stones," *New York Times* (July 14, 1990): 23; "Within the City," *Oculus* 53 (June 1991): 3; Stuart Brodsky, "Calatrava to Design Cathedral Biosphere," *Progressive Architecture* 72 (August 1991): 23; Peter D. Slatin, "Modern Gothic Bioshelter for Cathedral of St. John the Divine," *Architectural Record* 179 (August 1991): 21; Karen Salmon, "Ecological Sanctuary," *Architecture* 80 (September 1991): 35; "Within City Limits," *Oculus* 54 (September 1991): 3; "St. John the Divine," *El Croquis* 11 (1992): 100–104; William Bryant Logan, "The Gothic According to Calatrava: Completion of the New York Cathedral," *Lotus International* 72 (1992): 64–69; John Brodie, "A Garden of Eden for St. John's," *New York Times* (January 26, 1992): 34; "Tree of Life," *Architectural Review* 191 (April 1992): 34–37; Stanley Collyer, "Antoine Predock," *Competitions* (Winter 1992): 50–57; Jayne Merkel, "A Nature Sanctuary: St. John Bioshelter Competition," *Competitions* (Winter 1992): 15–21; "Ajout Organique," *Techniques et Architecture* 405 (December 1992): 79–81; Stanley Abercrombie, "Stepping Stones," *Historic Preservation* 44 (September-October 1992): 28–37, 88; Herbert Muschamp, "St. John the Divine: It Can't Go On. It Goes On," *New York Times* (December 20, 1992), II: 34; "Cathedral of St. John the Divine Celebrates 100th Birthday," *New York Times* (December 28, 1992): 1; Ian Fisher, "An Unfinished Act of Faith," *New York Times* (December 28, 1992), B: 3; Thomas Fedorek, "Yes, St. John the Divine Is the Largest Cathedral," letter to the editor, *New York Times* (January 11, 1993): 16; "Postgotik," *Architektur, Innenarchitektur, Technischer Ausbau* 101 (May 1993): 55; *Antoine Predock Architect* (New York: Rizzoli International Publications, 1994), 109–20; Dennis Sharp, ed., *Santiago Calatrava* (London: E. & F. N. Spon, 1994), 80–83; Alan Powers, "Divine Inspiration," *Perspectives on Architecture* 1 (November 1994): 44–47; "O Engenheiro e Seus Esqueletos," *Projeto* 187 (July 1995): 36–51; Sergio Polano, *Santiago Calatrava: The Complete Works* (Milan: Electa, 1996), 226–29; "Catedral de San Juan el Divino," *AV Monografias* 61 (September-October 1996): 94–95; Doug Stewart, "Transforming the Beauty of Skeletons into Architecture," *Smithsonian* 27 (November 1996): 76–85; Eric Darton, "Spirit," *Metropolis* 16 (November 1996): 54–57, 90–91, 93; Wes Jones, *Instrumental Form: (Boss Architecture): Words Buildings Machines, Jones Partners Architecture* (New York: Princeton Architectural Press, 1997), 39; Henry Petroski, "Santiago Calatrava," *American Scientist* 85 (March/April 1997): 114–18; "Chip, Chip, Chip . . . ," *New York Times* (March 9, 1997), XIII: 2; Nina Rappaport, "Resurrecting Religious Buildings," *Oculus* 59 (April 1997): 5–6; William Bryant Logan, "Stony Expressions," *House Beautiful* 139 (May 1997): 58–59; "Projects: David Sellers," *Perspecta* 29 (1998): 74–77; Byard, *The Architecture of Additions*, 128–31; Dolkart, *Morningside Heights*, 69–70; Alexander Tzonis, *Santiago Calatrava: The Poetics of Movement* (New York: Universe, 1999), 174–77; David Kirby, "St. John the Unfinished," *New York Times* (January 10, 1999), XIV: 1, 10; John Cornforth, "Patriarchs That Live in Stone," *Country Life* 193 (March 11, 1999): 80–83; James Parks Morton, "Bucky Fuller: Nine Epiphanies," in *Buckminster Fuller: Anthology for the New Millennium* (New York: St. Martin's Press, 2001); Balfour, *World Cities: New York*, 308–11; Daniel J. Wakin, "Memories Chiseled in a Cathedral's Stone," *New York Times* (February 23, 2001); 1, B: 4; Anne Raver, "A Place of Solace in a Time of Grief," *New York Times* (September 13, 2001), F: 1; Christopher Gray, "Streetscapes/The Cathedral of St. John the Divine," *New York Times* (July 28, 2002), XI: 7; www.predock.com/16t20.html.

72. David Sellers, phone interview, December 22, 2000.

73. Brodie, "A Garden of Eden for St. John's": 34.

74. www.predock.com/16t20.html.

75. Alan Feuer and Daniel J. Wakin, "Fire Damages St. John the Divine, Gutting Gift Shop and Scorching Art," *New York Times* (December 19, 2001), D: 1, 6; Robert F. Worth, "Wiring Is Suspected Cause of Cathedral Fire," *New York Times* (December 20, 2001), D: 3; Daniel J. Wakin, "Restoring a Cathedral to Unfinished Glory; Huge Cleanup for St. John the Divine," *New York Times* (February 6, 2002), B: 1, 3; Ula Ilnytzky, "After the Trials of Fire, Centuries-Old Tapestries Being Lovingly Restored; Workers Hope They Hang Again in Cathedral," *Washington Post* (November 30, 2002); B: 9.

76. See Stern, Gilmartin, and Massengale, *New York 1900*, 412–13.

77. *Mitchell/Giurgola Architects* (New York: Rizzoli International Publications, 1983), 168–69; "Chapter Awards Program," *Oculus* 45 (May 1984): 4; Susan Doubilet, "Let There Be Light," *Progressive Architecture* 65 (June 1984): 84–87; "The Burke Library Renovation," *Process Architecture* 81 (March 1989): 68–73; *Mitchell/Giurgola Architects: Selected and Current Works* (Mulgrave, Australia: Images Publishing, 1996), 242; Dolkart, *Morningside Heights*, 256; White and Willensky, *AIA Guide* (2000), 475.

78. Romaldo Giurgola, quoted in Doubilet, "Let There Be Light": 84.

79. Ari L. Goldman, "Seminary Considering Condo Project," *New York Times* (February 16, 1987): 31; Ari L. Goldman, "Union Seminary Rejects Proposal to Build Tower," *New York Times* (September 30, 1987), B: 3; Elizabeth Kraft, ed., *Robert A. M. Stern: Buildings and Projects, 1987–1992* (New York: Rizzoli International Publications, 1992), 28–29; James Stewart Polshek: Context and Responsibility, 57, 116, 253.

80. "Hastings Hall, Union Theological Seminary," *Architecture + Urbanism* (November 1990): 100–103; Jean Gorman, "Gothic Revisited," *Interiors* 150 (March 1991): 80–82; Dolkart, *Morningside Heights*, 256.

81. Kraft, ed., *Robert A. M. Stern: Buildings and Projects, 1987–1992*, 28–29.

82. *Philip Johnson/Alan Ritchie Architects* (New York: Monacelli Press, 2002), 40–41, 186.

83. Shaila Dewan, "New Building for School of Music Is Surprise to Neighbors," *New York Times* (April 7, 2000), B: 3; Ashley Hall, "Manhattan Music School Building Is out of Tune, Neighbors Say," *New York Observer* (June 5, 2000): 9; Chrisena Coleman, "School Addition Hits Sour Note in Manhattan," *New York Daily News* (September 27, 2000): 3; Peggy Thomson, "Riverside Drive and Grant's Tomb," letter to the editor, *New York Times* (October 8, 2000), XI: 8; Daniel J. Wakin, "A Vanishing World," *New York Times* (January 7, 2001), XIV: 1, 11; Joseph Finora, "Construction Is Music to the Ears for the Manhattan School of Music," *New York Construction News* 49 (October 2001): 49- 54.

84. Karin Tetlow, "Temple of Entertainment," *Interiors* 144 (January 1985): 174–75; "Student Pub, International House," *Architecture + Urbanism* (August 1985): 114; Luis F. Rueda, ed., *Robert A.M. Stern: Buildings and Projects, 1981–85* (New York: Rizzoli International Publications, 1986), 196–97, 286; Barry H. Slinker, "Robert A. M. Stern," *Lighting Dimensions* 11 (May/June 1987): 37–39, 50–51; Kraft, ed., *Robert A. M. Stern: Buildings and Projects, 1987–92*, 102–3. For International House, see Stern, Gilmartin, and Mellins, *New York 1930*, 110.

85. "Tenant Evicted After 10-Year Fight," *New York Times* (February 1, 1975): 31; Ari L. Goldman, "Jewish Seminary Plans an $18 Million Renovation," *New York Times* (October 24, 1980), B: 3; "Jewish Theological Seminary Library Complex," *Progressive Architecture* 62 (January 1981): 66; Herbert L. Smith Jr., "Urban Oasis," *Architectural Record* 174 (May 1986): 98; White and Willensky, *AIA Guide* (1988), 425. For the Jewish Theological Seminary, see Stern, Gilmartin, and Mellins, *New York 1930*, 110–12.

86. White and Willensky, *AIA Guide* (1988), 425.

87. "At the Jewish Theological Seminary: Renewal for a Burnt-Out Tower," *New York Times* (September 19, 1999), XI: 1; Andrew Scott Dolkart, "Works of Art at Jewish Seminary," letter to the editor, *New York Times* (October 3, 1999), XI: 11; Rabbi Michael B. Greenbaum, "Works of Art at Jewish Seminary," letter to the editor, *New York Times* (October 24, 1999), XI: 10; David S. Chartock, "Seminary Renovation Links a Tower and Two Wings," *New York Construction News* 49 (February 2001): 13–15; Kelly Crow, "A Seminary's Proud Tower Brings Unease to Some Neighbors," *New York Times* (May 20, 2001), XIV: 5; "Correction," *New York Times* (May 27, 2001), XIV: 2.

88. Dolkart, "Works of Art at Jewish Seminary": 11.

89. Christopher Gray, "Streetscapes/The Croton Gatehouse," *New York Times* (November 25, 1990), X: 7; Dennis Hevesi, "Cathedral Resists Nursing Home's Shadow," *New York Times* (August 23, 1992): 39; "Gatehouse Sale, with Conditions," *New York Times* (February 7, 1993), X: 1; Laura Starr and Michael Owen Gotkin, "Gatehouse," letter to the editor, *New York Times* (March 7, 1993), X: 15; Emily M. Bernstein, "Garden at Risk near Cathedral," *New York Times* (November 14, 1993), XIII: 6; Jennifer Kingson Bloom, "Nursing Home Loses a Round on Extension," *New York Times* (February 5, 1995), XIII: 8; Jennifer Kingson Bloom, "After Soul-Searching, Cathedral Files Suit," *New York Times* (August 20, 1995), XIII: 6; Soren Larson, "Manhattan Nursing Home Addition Adapts to Its Surroundings," *Architectural Record* 186 (September 1998): 54; Lowe, "Now They're Deconstructing the Columbia Campus": 84–97; "The West 119th Aqueduct Gatehouse; Landmark Designation Nearing," *New York Times* (December 19, 1999), XI: 1; White and Willensky, *AIA Guide* (2000), 466; Nina Siegal, "Plugging a Hole in the Reservoir of Memory," *New York Times* (May 7, 2000), XIV: 3. For New Croton Aqueduct, see Stern, Mellins, and Fishman, *New York 1880*, 49–50. For Amsterdam House, see Stern, Mellins, and Fishman, *New York 1960*, 752.

90. "Gatehouse Sale, with Conditions": 1.

91. "The West 119th Street Gatehouse; Landmark Designation Nearing," *New York Times* (December 19, 1999), XI: 1; Landmarks Preservation Commission of the City of New York, LP-2051 (March 28, 2000); Siegal, "Plugging a Hole in the Reservoir of Memory": 3.

UPPER EAST SIDE

PRESERVATION AS PLANNING

1. Carter B. Horsley, "Battle Lines Drawn Over Plan for East Side Historic District," *New York Times* (May 27, 1979), VIII: 1, 4; "Keeping Up the Upper East Side," editorial, *New York Times* (June 30, 1979): 18; Giorgio Cavaglieri, "Upper East Side Historic District Should Be Rejected," letter to the editor, *New York Times* (July 10, 1979): 14; Jane B. Trichter, Tammy Grimes, and Ralph C. Menapace Jr., "Protecting the Upper East Side," letter to the editor, *New York Times* (July 14, 1979): 18; Carter B. Horsley, "Community Panel Narrowly Backs Upper East Side Historic District," *New York Times* (September 16, 1979): 50; Alan S. Oser, "Debating Landmark Designation," *New York Times* (October 3, 1979), D: 16; Joan K. Davidson, "Landmarks

on the Upper East Side," letter to the editor, *New York Times* (October 13, 1979): 18; Jane B. Trichter and Daniel Rose, "Designation? Certainly, How Much? The Debate," *New York Times* (May 4, 1980), VIII: 1, 6; Paul Goldberger, "Historical District Status: An Upper East Side Issue," *New York Times* (April 21, 1980), B: 1, 4; Ronald Solomon, "On Upper East Side," letter to the editor, *New York Times* (July 6, 1980), VIII: 8; Carter B. Horsley, "City's Landmark Policies in Crossfire of Criticism," *New York Times* (July 27, 1980), VIII: 1; Paul Goldberger, "What's the Proper Role of Landmarks Commission?" *New York Times* (October 1, 1980), B: 1; Landmarks Preservation Commission of the City of New York, *Upper East Side Historic District Designation Report* (New York, 1981); Thomas Bender, "Preserving Our City's History," *New York Times* (February 20, 1981): 27; Clyde Haberman, "Panel Creates a Historic District in Manhattan's East 60's and 70's," *New York Times* (May 20, 1981): 1, B: 3; Paul Goldberger, "Preservation Victory," *New York Times* (May 21, 1981), B: 1, 6; Richard Levine and Carlyle C. Douglas, "A Plan to Preserve Without Freezing," *New York Times* (May 24, 1981), IV: 6; "Landmark Status Gains for East Side," *New York Times* (July 17, 1981), B: 3; Ada Louise Huxtable, "A Plan to Preserve the Upper East Side," *New York Times* (August 2, 1981), II: 25, 27; Paul Goldberger, "The Building Boom Gives Birth," *New York Times* (August 30, 1981), II: 29; A. O. Sulzberger Jr., "City Gives Final Approval to Upper East Side Historic District," *New York Times* (September 25, 1981), B: 3; Maurice Carroll, "Historic Status May Aid Landlords on East Side," *New York Times* (September 30, 1981), B: 3; Anthony C. Wood, "When the Process Works: A True Story," *New York Affairs* 7 (No. 2, 1982): 97–102; Clifford Pearson, "Historic Zoning," *Metropolis* 1 (March 1982): 5–6; "The Upper East Side Historic District," *Oculus* 44 (September 1982): 4; David W. Dunlap, "Bigger East Side Historic Area Pondered," *New York Times* (February 6, 1984), B: 3; Barbaralee Diamonstein, *The Landmarks of New York III* (New York: Harry N. Abrams, 1998), 508; Anthony M. Tung, *Preserving the World's Great Cities* (New York: Clarkson Potter, 2001), 352–53.

2. Stern, Mellins, and Fishman, *New York 1960*, 807, 1098, 1100.

3. Stern, Mellins, and Fishman, *New York 1960*, 1122–23.

4. Landmarks Preservation Commission of the City of New York, *Treadwell Farm Historic District Designation Report* (New York, 1967); Landmarks Preservation Commission of the City of New York, *Henderson Place Historic District Designation Report* (New York, 1969); Landmarks Preservation Commission of the City of New York, *Carnegie Hill Historic District Designation Report* (New York, 1974); Stern, Mellins, and Fishman, *New York 1960*, 1143; Diamonstein, *The Landmarks of New York III*, 491, 494, 500. In 1993 the Carnegie Hill Historic District was expanded to include a seventeen-block area roughly bounded by Eighty-sixth and Ninety-eighth Streets between Fifth and Madison Avenues and Ninetieth to Ninety-fifth Street between Madison and Lexington Avenues. See Landmarks Preservation Commission of the City of New York, *Expanded Carnegie Hill Historic District Designation Report* (New York, 1993); Diamonstein, *The Landmarks of New York III*, 522.

5. Landmarks Preservation Commission of the City of New York, *Metropolitan Museum Historic District Designation Report* (New York, 1977); Edward Ranzal, "NYC Landmarks Preservation Commission," *New York Times* (September 21, 1977), II: 3; Diamonstein, *The Landmarks of New York III*, 503.

6. "A Rash of New Building Projects," *New York Times* (November 12, 1978), VIII: 1, 8; Alan S. Oser, "Look What Coincidence and $6 Million Can Do," *New York Times* (November 22, 1978), D: 14; Ada Louise Huxtable, "As East 62d Street Goes, So Goes New York," *New York Times* (December 10, 1978), II: 39–40; Paul Goldberger, "New Buildings Squeezing into a Crowded Midtown," *New York Times* (December 11, 1978), B: 1, 19; Carter B. Horsley, "Planning Board Is Against a Tower on 62d St. as Dangerous Precedent," *New York Times* (January 24, 1979), B: 8; Carter B. Horsley, "In the Air over Midtown: Builders' New Arena," *New York Times* (February 11, 1979), VIII: 1, 6. For the Knickerbocker Club, see Stern, Gilmartin, and Massengale, *New York 1900*, 238.

7. For 4 and 6 East Sixty-second Street, see *Upper East Side Historic District*, 39–40. For 800 Fifth Avenue, see Stern, Mellins, and Fishman, *New York 1960*, 512–13.

8. Huxtable, "As East 62d Street Goes, So Goes New York": 39–40.

9. Horsley, "Planning Board Is Against a Tower on 62d St. as Dangerous Precedent": 8.

10. Peter Sharp, quoted in Horsley, "Battle Lines Drawn Over Plan for East Side Historic District": 4. For the Carlyle Hotel, see Stern, Gilmartin, and Mellins, *New York 1930*, 403–5.

11. Rose, "Designation? Certainly, How Much? The Debate": 6.

12. "Keeping Up the Upper East Side": 18.

13. Quoted in Horsley, "Battle Lines Drawn Over Plan for East Side Historic District": 1.

14. Goldberger, "Preservation Victory": 1, 6.

15. Kent L. Barwick, quoted in Goldberger, "Preservation Victory": 6.

16. Christopher Gray, "Streetscapes/42 West 72d Street, 118 West 72d Street and 126 West 73d Street," *New York Times* (March 15, 1998), XI: 5.

17. Stan Pinkwas, "A Pride of Slivers," *Metropolis* 2 (September 1982): 4–5; Alan S. Oser, "Preservation of Ambiance in Manhattan," *New York Times* (November 26, 1982), B: 17; "City to Stunt Sliver-Building Growth," *Engineering News-Record* 209 (December 9, 1982): 15; Stuart Pertz, "Sliver Buildings," *Oculus* 44 (February 1983): cover, 11–14; White and Willensky, *AIA Guide* (2000), 407–8. For Hill & Stout's town-house, see *Upper East Side Historic District*, 556.

18. Oser, "Preservation of Ambiance in Manhattan": 17.

19. Carter B. Horsley, "Slim Designs Make Slim Spaces Work," *New York Times* (August 23, 1981), VIII: 1, 10; Paul Goldberger, "'Sliver' Apartment Houses (and Tempers) Going Up in City," *New York Times* (February 8, 1982), B: 1, 4; Thomas E. Norton and Jerry E. Patterson, *Living It Up: A Guide to the Named Apartment Houses of New York* (New York: Atheneum, 1984), 164.

20. Pinkwas, "A Pride of Slivers": 4–5. Also see Horsley, "Slim Designs Make Slim Spaces Work": 10; Goldberger, "'Sliver' Apartment Houses (and Tempers) Going Up in City": 1; Pertz, "Sliver Buildings": cover.

21. Goldberger, "'Sliver' Apartment Houses (and Tempers) Going Up in City": 1, 4; "Sliver Buildings Invade the Big Apple," *Conserve Neighborhoods* 24 (May-June 1982): 229; White and Willensky, *AIA Guide* (2000), 450.

22. "'Sliver' Buildings," *New York Times* (October 27, 1982), B: 3; "City to Stunt Sliver-Building Growth": 15; Pertz, "Sliver Buildings": 11–14; Maurice Carroll, "Actions to Ban 'Sliver' Towers Voted by Panel," *New York Times* (February 3, 1983), B: 1; Maurice Carroll, "Ban on 'Sliver' Buildings Is Approved by the City," *New York Times* (March 4, 1983), B: 4; Maurice Carroll, "City Orders a Halt on Work at 5 East Side 'Sliver' Sites," *New York Times* (March 15, 1983), B: 1, 4; "Stuck by a Sliver," *New York Times* (March 20, 1983), IV: 6; William G. Blair, "'Sliver' Owners Cry Foul," *New York Times* (March 20, 1983), VIII: 14; George Lewis, "Notes on the Year: Sliver Buildings," *Oculus* 44 (June 1983): 8.

23. Horsley, "Slim Designs Make Slim Spaces Work": 1; Goldberger, "'Sliver' Apartment Houses (and Tempers) Going Up in City": 1, 4; Pinkwas, "A Pride of Slivers": 4–5; Pertz, "Sliver Buildings": 14; George W. Goodman, "A 'Sliver' Squabble That Won't Go Away," *New York Times* (December 25, 1983), VIII: 2; White and Willensky, *AIA Guide* (1988), 389; *Expanded Carnegie Hill Historic District*, 266.

24. Brendan Gill, "A 'Sliver' the East Side Can Do Without," letter to the editor, *New York Times* (October 24, 1981): 22; Clyde Haberman, "Tower for E. 71st St. Tentatively Rejected," *New York Times* (October 28, 1981): B: 1; Paul Goldberger, "Debate Over Proposed 71st St. Tower," *New York Times* (November 10, 1981), B: 8; A. O. Sulzberger Jr., "Commission Formally Rejects 71st St. Tower," *New York Times* (November 11, 1981), B: 24; "Right Building, Wrong Block," *Progressive Architecture* 63 (January 1982): 31–32; Pinkwas, "A Pride of Slivers": 4–5; "Architectural Drawing Awards," *Architectural Record* 172 (August 1984): 64; "Preserving a Low Profile," *New York Times* (May 3, 1985), VIII: 1; *Agrest and Gandelsonas: Works* (New York: Princeton Architectural Press, 1995), 122–27. For 22 East Seventy-first Street, see *Upper East Side Historic District*, 539.

25. Gill, "A 'Sliver' the East Side Can Do Without": 22.

26. *Agrest and Gandelsonas: Works*, 122.

27. For 740 Park Avenue, see Stern, Gilmartin, and Mellins, *New York 1930*, 394.

28. Goldberger, "Debate Over Proposed 71st St. Tower": 8.

29. "Pencil Points," *Progressive Architecture* 67 (March 1986): 22; Robert O. Boorstin, "Tower Proposed to Rise over Metropolitan Club," *New York Times* (May 23, 1986), B: 3; "Pierre Checks Out Club's Tower Plan," *New York* 20 (March 16, 1987): 12; David W. Dunlap, "Club's Plan for High-Rise Is Criticized," *New York Times* (March 26, 1987), B: 1, 4; Paul Goldberger, "Good Design, Bad Site–and Poor Timing," *New York Times* (March 29, 1987), II: 34; Christopher Gray, "Cityscape: The Metropolitan Club," *New York Times* (April 5, 1987), VIII: 14; David W. Dunlap, "Plan Blocked for Tower atop Landmark," *New York Times* (November 18, 1987), B: 3; *James Stewart Polshek: Context and Responsibility* (New York: Rizzoli International Publications, 1988), 57–58, 118–19; Paul Spencer Byard, *The Architecture of Additions: Design and Regulation* (New York: W. W. Norton, 1998), 155–56; White and Willensky, *AIA Guide* (2000), 382, 384. For the Metropolitan Club, see Stern, Gilmartin, and Massengale, *New York 1900*, 232–33. Also see Landmarks Preservation Commission of the City of New York, LP-1020 (September 11, 1979); *Upper East Side Historic District*, 29.

30. Goldberger, "Good Design, Bad Site–and Poor Timing": 34. For the Pierre, see Stern, Gilmartin, and Mellins, *New York 1930*, 217, 220–21.

31. Quoted in Dunlap, "Plan Blocked for Tower atop Landmark": X.

32. Jesus Rangel, "High-Rise Limit on the East Side Sought by Panel," *New York Times* (March 25, 1985): 1, B: 5; Michael deCourcy Hinds, "Upper East Side Institutions Fear Downzoning," *New York Times* (June 16, 1985), VIII: 1, 14; Josh Barbanel, "New High-Rises Are Barred in Much of Upper East Side," *New York Times* (September 20, 1985): 1; Alan Finder and Albert Scardino, "A Step Down in Zoning for the East Side," *New York Times* (September 22, 1985), IV: 6; Kirk Johnson, "Puzzling Out the Impact of East Side Downzoning," *New York Times* (November 3, 1985), VIII: 1.

33. Alexander B. Grannis, quoted in Barbanel, "New High-Rises Are Barred in Much of Upper East Side": 1.

34. Iver Peterson, "Downscaling the Avenues on the Upper East Side," *New York Times* (December 6, 1987), VIII: 1, 20; Alan S. Oser, "East Side Zoning," *New York Times* (December 17, 1989), X: 5; Brian Scott Lipton, "One Step Closer to Smaller Buildings!" *Upper East Side Resident* 2 (February 19, 1990): 1, 37; "Committee Takes on Zoning on the Upper East Side," *Oculus* 52 (June 1990): 7–10; "Committee Takes on Zoning on the Upper East Side: Part II," *Oculus* 53 (September 1990): 6–10; Alan S. Oser, "East Side Housing: Zoning's Potent Impact on Development," *New York Times* (September 30, 1990), X: 3; "Memo," *Oculus* 53 (February 1991): 7; "Update on Oculus Special Zoning Committee for the Upper East Side," *Oculus* 54 (November 1991): 11; "Follow-Up: Oculus Special Zoning Committee for the Upper East Side," *Oculus* 55 (February 1993): 10–12; "Making Towers Less Massive," *New York Times*

(December 5, 1993), XIII: 6; Alan Finder, "Planning Panel Approves New Zoning Rules for High-Rises," *New York Times* (December 21, 1993), B: 4; Marvine Howe, "Upper East Side Update," *New York Times* (December 26, 1993), XIII: 6; David W. Dunlap, "Rewriting Rules for East Side Avenues," *New York Times* (January 23, 1994), X: 1, 10; Suzanne Stephens, "The Oculus Special Zoning Committee for the Upper East Side Sees Results," *Oculus* 56 (February 1994): 10–12; "Sensible Rezoning for the East Side," editorial, *New York Times* (February 5, 1994): 20; James C. McKinley Jr., "Zoning Changes Reduce Size of East Side Projects," *New York Times* (February 10, 1994), B: 3; Bruce Fowle, "Upper East Side Zoning: Where Do We Go from Here?" *Oculus* 56 (April 1994): 12–13; Michael Matusz and Ashley Campbell, "Manhattan Towers Cut Down to Size," *Planning* 60 (April 1994): 30–31.

35. Stephens, "The Oculus Special Zoning Committee for the Upper East Side Sees Results": 10.

36. Sherida Paulsen, quoted in "Making Towers Less Massive": 6.

37. "Sensible Rezoning for the East Side": 20.

38. Fowle, "Upper East Side Zoning: Where Do We Go from Here?": 12.

39. Michael deCourcy Hinds, "A Building Boomlet Giving Manhattan 9,000 Apartments," *New York Times* (March 3, 1985), VIII: 1, 12.

40. Quoted in Michael deCourcy Hinds, "Marketing Third Ave. as a Chic Address," *New York Times* (March 24, 1985), VIII: 1, 14.

41. For the 1961 zoning ordinance, see Stern, Mellins, and Fishman, *New York 1960*, 130–31.

42. Lee A. Daniels, "A New Look for Third Avenue," *New York Times* (May 9, 1982), VIII: 1, 14; Lee A. Daniels, "Upper East Side Attracts Two Mixed-Use Projects," *New York Times* (January 7, 1983): 15; "Building Higher," *New York Times* (April 22, 1984), VIII: 1; "Accord Is Reached in Trump Dispute," *New York Times* (October 10, 1984), B: 3; Paul Goldberger, "Look-Alike Buildings: The Third Avenue Case," *New York Times* (October 25, 1984), C: 17; deCourcy Hinds, "A Building Boomlet Giving Manhattan 9,000 Apartments": 1, 12; deCourcy Hinds, "Marketing Third Ave. as a Chic Address": 1, 14; Donald J. Trump with Tony Schwartz, *Trump: The Art of the Deal* (New York: Random House, 1987), 38–39; White and Willensky, *AIA Guide* (1988), 392; Christopher Gray, "Stand By Your Plans," *Avenue* (November 1989): 132–41. For Manhattan House, see Stern, Mellins, and Fishman, *New York 1960*, 840–42. For Tower East, see Stern, Mellins, and Fishman, *New York 1960*, 842–43. For Ruppert Towers, see Stern, Mellins, and Fishman, *New York 1960*, 842–44.

43. Goldberger, "Look-Alike Buildings: The Third Avenue Case": 17. For a discussion of Philip Birnbaum's work, see Stern, Gilmartin, and Mellins, *New York 1930*, 493, 497; Stern, Mellins, and Fishman, *New York 1960*, 89, 500, 507, 724–25, 822, 831, 833, 851, 993–94.

44. "Building Higher": 1.

45. Morton L. Olshan, quoted in "Building Higher": 1.

46. Quoted in Goldberger, "Look-Alike Buildings: The Third Ave. Case": 17.

47. Lee A. Daniels, "Upper East Side Attracts Two Mixed-Use Projects," *New York Times* (January 7, 1983): 15; Christopher C. Angell, "Tower Protested," letter to the editor, *New York Times* (January 23, 1983): 12; Lee A. Daniels, "Side Street Density at Issue in Midtown," *New York Times* (January 27, 1984), B: 7; deCourcy Hinds, "Marketing Third Ave. as a Chic Address": 1, 14; Philip S. Gutis, "Rift over Tower Leaves Even Winners Unhappy," *New York Times* (May 16, 1986): 22; White and Willensky, *AIA Guide* (1988), 393; White and Willensky, *AIA Guide* (2000), 438.

48. White and Willensky, *AIA Guide* (2000), 438.

49. "On First Avenue: What Will Sell?" *New York Times* (December 26, 1982), VIII: 1; "The Kingsley, 400 E.70th Street," advertisement, *New York Times* (September 18, 1983), VIII: 5; Lee A. Daniels, "Developer in Manhattan Plans Sales, Then Builds," *New York Times* (September 23, 1983), B: 9; Norton and Patterson, *Living It Up*, 196; Paul Goldberger, "Defining Luxury in New York's New Apartment," *New York Times* (August 16, 1984), C: 1, 8; deCourcy Hinds, "Marketing Third Ave. as a Chic Address": 1, 14; White and Willensky, *AIA Guide* (2000), 441.

50. Stephen B. Jacobs, quoted in "On First Avenue: What Will Sell?": 1.

51. Goldberger, "Defining Luxury in New York's New Apartment": 8.

52. deCourcy Hinds, "Marketing Third Ave. as a Chic Address": 1, 14; William Grimes, "The Royale Treatment," *On the Avenue* (April 1987): 3; White and Willensky, *AIA Guide* (1988), 393; *Alfredo De Vido: Selected and Current Works* (Mulgrave, Australia: Images Publishing, 1998), 182–85.

53. Robert D. McFadden, "Developer Buys 3d Avenue Site from Hospital," *New York Times* (October 22, 1985), B: 3; Kirk Johnson, "Puzzling Out the Impact of East Side Downzoning," *New York Times* (November 3, 1985), VIII: 1, 18; "Trump Theaters Rile East Siders," *New York* 19 (December 8, 1986): 22; Peg Tyre and Jeannette Walls, "Foundling Hospital: A Trump Orphan?" *New York* 21 (August 15, 1988): 9; Richard D. Lyons, "Trump Palace Going Up: 55 Stories on Third," *New York Times* (April 23, 1989), X: 1; Donald J. Trump with Charles Leerhsen, *Trump: Surviving at the Top* (New York: Random House, 1990), 76–77, 85–86, 209–13; Diana Shaman, "Fast Sellout Expected at Trump Palace," *New York Times* (March 30, 1990): 20; Jeannette Walls, "Trump Has Trouble at 69th and Third," *New York* 23 (August 27, 1990): 1; Kenneth Koyen, "In Trump Palace, a Creature Was Stirring," *New York Observer* (September 17, 1990): 10; Thomas J. Lueck, "Abrams Bars Trump from Selling Condos on Upper East Side," *New York Times* (November 8, 1990), B: 21; Jeannette Walls, "Trump Giveth, and He Taketh Away," *New York* 24 (November 11, 1991): 11; Jeannette Walls,

"Trump Palace May Sign Conran's, D&D," *New York* 24 (December 16, 1991): 9; Herbert Muschamp, "For All the Star Power, a Mixed Performance," *New York Times* (July 12, 1992), II: 28; Michael J. Crosbie, *The Architecture of Frank Williams* (Rockport, Mass.: Rockport Publishers, 1997), 68–75. For the Galleria, see Stern, Mellins, and Fishman, *New York 1960*, 500, 501, 503.

54. Koyen, "In Trump Palace, a Creature Was Stirring": 10.

55. Muschamp, "For All the Star Power, a Mixed Performance": 28.

56. "Neighbors on Third: High Rises, Face to Face," *New York Times* (September 18, 1983), VIII: 1.

57. "Neighbors on Third: High Rises, Face to Face": 1; "Rising High: Where the El Once Clattered," *New York Times* (September 23, 1984), VIII: 1; deCourcy Hinds, "Marketing Third Ave. as a Chic Address": 1, 14.

58. Philip Birnbaum, quoted in "Rising High: Where the El Once Clattered": 1.

59. Alan S. Oser, "Building Apartments Despite High Costs," *New York Times* (June 3, 1984), VIII: 1, 14; Alan S. Oser, "Seizing an Opportunity: The Woolworth Parcel," *New York Times* (May 5, 1985), VIII: 7.

60. Oser, "Building Apartments Despite High Costs": 1, 14; "Yorkville Options: Bonus Gym?" *New York Times* (August 7, 1988), X: 1; Alan Finder, "Building a Dream, Floor by Rotting Floor," *New York Times* (January 8, 1989), B: 1, 3; "91st St. Town House: Dalton Expansion," *New York Times* (August 26, 1990), X: 1; Shawn G. Kennedy, "Private Schools Turn to Reconstruction," *New York Times* (October 13, 1991), X: 1, 13; Eric Pace, "Norman Segal, 50, a Developer Who Was a Patron of the Arts," *New York Times* (April 5, 1994), B: 8; Maggie Kinser Hohle, *John Ciardullo Associates: Architecture and Society* (New York: Edizioni Press, 2004), 140–47.

61. Shawn G. Kennedy, "A New Cachet for Old East 86th Street," *New York Times* (April 15, 1990), X: 1; Crosbie, *The Architecture of Frank Williams*, 58–63; Rachelle Garbarine, "After 7 Years, East Side Condominium Is Selling Quickly," *New York Times* (April 30, 1999), B: 10.

62. Michael deCourcy Hinds, "Battling to Control E. 96th Growth," *New York Times* (May 13, 1984), VIII: 1, 14.

63. August Heckscher, quoted in deCourcy Hinds, "Battling to Control E. 96th Growth": 14.

64. deCourcy Hinds, "Battling to Control E. 96th Growth": 1, 14; Kirk Johnson, "If You're Thinking of Living in Upper Yorkville," *New York Times* (December 1, 1985), VIII: 9; Kirk Johnson, "A Blurring of Boundaries Between Two City Areas," *New York Times* (November 30, 1984), B: 9; Beth Sherman, "Big-City Living 101; It's Post-Graduate Housing–with All the Trappings of a Dormitory–and the Roster Is Filling Up Fast," *Newsday* (September 17, 1987): 12.

65. For London Terrace, see Stern, Gilmartin, and Mellins, *New York 1930*, 417.

66. "December Start Planned for East Side Residences," *New York Construction News* 38 (October 1, 1990): 1, 11; "North Side of East 96th: A 421a Qualifier," *New York Times* (October 7, 1990), X: 1; Rachelle Garbarine, "New and Affordable East Side Rentals," *New York Times* (December 11, 1992), B: 6; White and Willensky, *AIA Guide* (2000), 433.

67. White and Willensky, *AIA Guide* (2000), 433. For 200 Central Park South, see Stern, Mellins, and Fishman, *New York 1960*, 505, 507.

68. Carter B. Horsley, "Builders Compete for Big Projects," *New York Times* (April 12, 1981), VIII: 1, 6; Carter B. Horsley, "Developer Picked for Ruppert Project," *New York Times* (August 6, 1981), B: 3; Alan S. Oser, "New Co-op Developer in City," *New York Times* (August 12, 1981), D: 17; Dorothy J. Gaiter, "City and Residents at Odds on Ruppert Renewal," *New York Times* (October 17, 1982), VIII: 7; Maurice Carroll, "What's Next for Ruppert Renewal," *New York Times* (December 12, 1982), VIII: 7; Sara Rimer, "Yorkville Turns Chic and Costly," *New York Times* (November 6, 1983): 1, 14; deCourcy Hinds, "Battling to Control E. 96th Growth": 1, 14; Alan S. Oser, "City's Rental-Subsidy Program to Get First Test Soon," *New York Times* (November 18, 1984), VIII: 7; Alan S. Oser, "Bonds Aid Housing in Manhattan," *New York Times* (November 23, 1984), D: 6; "Changing East Side: Yorkville Towers," *New York Times* (March 16, 1986), VIII: 1; White and Willensky, *AIA Guide* (1988), 411; Grace M. Anderson, "Carnegie Park and Brown Gardens," *Architectural Record* 176 (February 1988): 128–35; Susan Baybrooke, "Two Old Hands Talk about Housing," *Architectural Record* 176 (February 1988): 122–27; White and Willensky, *AIA Guide* (2000), 458.

69. For the Jacob Ruppert Brewery Urban Renewal Area, see Stern, Mellins, and Fishman, *New York 1960*, 842–43.

70. Kirk Johnson, "A Blurring of Boundaries Between Two City Areas," *New York Times* (November 30, 1984), B: 9; Michael deCourcy Hinds, "A Steady Sales Pace in Manhattan," *New York Times* (January 4, 1987), VIII: 1, 14; Shawn G. Kennedy, "How to Sell Retail Space in Manhattan," (May 4, 1988), D: 24; White and Willensky, *AIA Guide* (2000), 458.

71. "Changing East Side: Yorkville Towers": 1; "Monarch Investment: Italians Buy 53 Condos," *New York Times* (September 13, 1992), X: 1.

72. Alan Finder, "31-Floor Project Sparks a Dispute over Zoning," *New York Times* (August 14, 1986), B: 3; Alan Finder, "City Order to Demand 12-Story Cut from Tower," *New York Times* (October 15, 1986), B: 1; Jeanie Kasindorf, "Finishing Touches on Too-Tall Tower," *New York* 19 (October 27, 1986): 16; Richard D. Lyons, "Beheading a Tower to Make It Legal," *New York Times* (February 28, 1988), VIII: 9; Jeffrey L. Braun and Jay A. Segal, "Too Tall Tower," letter to the editor, *New York Times* (March 13, 1988), X: 22; Elena Marcheso Moreno, "N.Y. Courts Rule Building's Top 12 Floors Must Be Removed," *Architecture* 77 (April 1988): 32–33; "The Best Way to Punish Illegal Building," editorial, *New York Times* (May 14, 1988): 30; Christopher Gray, "Streetscapes/116 John Street," *New York*

Times (July 31, 1988), X: 8; "Tall Stories, Again," editorial, *New York Observer* (August 8, 1988): 4; Charles Bagli, "On East Side, the Battle Lines Form over Too Tall Building," *New York Observer* (August 8, 1988): 1, 9; "Sensible Solution to the Tower Problem," editorial, *New York Post* (August 9, 1988): 22; Chris Oliver, "E. Siders 'Behead' a Too-Tall Hi-Rise," *New York Post* (August 9, 1988): 10; Ormonde De Kay, "19 Yes, 31 No," letter to the editor, *New York Post* (September 16, 1988): 22; Jane McCarthy and Marsha Kranes, "Low Blow to Hi-Rise in High Court," *New York Post* (October 4, 1988): 25; Charles V. Bagli, "A Long Battle Is Still Likely on That Too Tall Building," *New York Observer* 2 (October 17, 1988): 6; Carter B. Horsley, "Too Tall Trauma: Hold the Hatchet," *New York Post* (December 1, 1988): 10; Charles V. Bagli, "Decision Due on 'Too-Tall Building,'" *New York Observer* 3 (January 30, 1989): 6; Charles V. Bagli, "Too Tall' Building, Glick's Project are Subjects of Pending Lawsuits," *New York Observer* (November 6, 1989): 6; Genie Rice, "12 Illegal Stories Back to the Courts," *Municipal Art Society Newsletter* (February 1990): 2; David W. Dunlap, "Developer Agrees to Plan to Cut 12 Floors from a Too-Tall Tower," *New York Times* (April 23, 1991), B: 1, 4; David W. Dunlap, "Cutting a Building Down to Size, Very Carefully," *New York Times* (October 1, 1992), B: 3; David W. Dunlap, "Fewer Stories and More Sky on Upper East Side," *New York Times* (March 2, 1993), B: 3; Alan S. Oser, "As Buildings Slows, So Does Demolition," *New York Times* (April 18, 1993), X: 1, 6; Jesse Mangaliman, "Too Tall Tale; Owner Antes up $1M to Tear Down 12 Floors," *Newsday* (May 26, 1993): 15; "Twelve off the Top," *Metropolis* 12 (June 1993): 16; White and Willensky, *AIA Guide* (2000), 433.

73. "The Best Way to Punish Illegal Building": 30.

74. "Tall Stories, Again": 4.

75. Edward I. Koch, quoted in De Kay, "19 Yes, 31 No": 22.

76. *Carnegie Hill Historic District; Expanded Carnegie Hill Historic District*.

77. Carter B. Horsley, "Luxury Tower Builders Turning to Condominiums," *New York Times* (March 29, 1981), VIII: 1, 10; Lee A. Daniels, "Condominium Is Rising at Madison Ave. and 94th St.," *New York Times* (January 21, 1981), B: 7; Dee Wedemeyer, "A Turn in the Market for New Apartments," *New York Times* (July 3, 1983), VIII: 1, 10; Anthony DePalma, "New in Condominium Sales: Storefronts on Madison," *New York Times* (May 16, 1984); Jerold S. Kayden, *Privately Owned Public Space: The New York Experience* (New York: John Wiley, 2000), 289–90; White and Willensky, *AIA Guide* (2000), 432.

78. Corey Kilgannon, "Sale of Air Rights Shows Citi's Asleep, Protestors Charge," *New York Times* (February 7, 1999), XIV: 6; Tom Loftus, "Woody Allen's Next Project: A Pitch to Save Carnegie Hill," *New York Observer* (January 31, 2000): 13; Robert Polner, "Woody: Leave My Neighborhood Alone," *Newsday* (February 9, 2000): 4; Paul Goldberger, "In the Neighborhood: A Sneak Peek at Woody Allen's Newest Project," *New Yorker* 75 (February 14, 2000): 25–26; Clifford Pugh, "Woody Allen Slams Houston Development," *Houston Chronicle* (February 18, 2000): 1; James Barron, "Sequel to 'Manhattan' Is a Horror Film of Sorts," *New York Times* (March 12, 2000): 43, 47; James Barron, "Landmarks Panel Blocks a Tower Opposed by Woody Allen," *New York Times* (June 14, 2000), B: 3; Andrew Rice and Deborah Schoeneman, "Woody Allen, Carnegie All-Stars Cut 17-Story Tower Down to Size," *New York Observer* (June 19, 2000): 1, 11; Jay Weiser, "To Some an Eyesore, to Others a Home," *New York Times* (June 24, 2000): 15; "Tower on 91st Nixed by LPC," *Friends of the Upper East Side Historic Districts Newsletter* (Fall 2000): 12–13; James Barron, "Developer Revises Plans for Upper East Side Site," *New York Times* (December 3, 2000): 55; Ralph Gardner Jr., "The Battle of Carnegie Hill," *New York* 34 (April 2, 2001): 48–51; Petra Bartosiewicz, "Oops, They Did It Again! And Carnegie Hill Still Says No," *New York Observer* (April 2, 2001): 11; James Barron, "Woody Sounds Off," *New York Times* (April 8, 2001), IV: 2; John Tierney, "Woody Allen and Some Curious Logic," *New York Times* (April 10, 2001), B: 1; Cecilia Martin Ford, "Woody Allen's Cause," letter to the editor, *New York Times* (April 12, 2001): 28; Maureen Mahoney, "Woody Allen's Logic," letter to the editor, *New York Times* (April 14, 2001): 12; Barbara C. Coffey, "Preserving Landmarks," letter to the editor, *New York Times* (April 16, 2001): 18; James Barron, "What's Up, Woody? Don't Ask," *New York Times* (December 13, 2001), D: 2; Edwin McDowell, "At 91st and Madison: Nine Stories of Condos Above a Bank," *New York Times* (March 2, 2003), XI: 1; James Gardner, "Regions of Sorrow Made Light," *New York Sun* (November 24, 2003): 10; Sherri Day, "Disappointment for Woody Allen, but Not at Box Office," *New York Times* (March 26, 2004), B: 3.

79. For 48 East Ninety-second Street, see *Expanded Carnegie Hill Historic District*, 180.

80. Charles A. Platt, quoted in Loftus, "Woody Allen's Next Project: A Pitch to Save Carnegie Hill": 13.

81. Robert S. Davis, quoted in Barron, "Sequel to 'Manhattan' Is a Horror Film of Sorts": 47.

82. Lisa Kersavage, testimony before the Landmarks Preservation Commission, April 3, 2001.

83. Sherida Paulsen, quoted in Barron, "What's Up, Woody? Don't Ask": 2.

84. Gardner, "Regions of Sorrow Made Light": 10.

85. For the development of East End Avenue, see Stern, Gilmartin, and Mellins, *New York 1930*, 431, 433–34, 437; Stern, Mellins, and Fishman, *New York 1960*, 853.

86. Michael deCourcy Hinds, "New York Developer Seeks to Evict 1,200 Under Rent Controls," *New York Times* (April 19, 1985): 1, B: 2; Peter Freiberg, "Yorkville's Model Tenements Are Flagging," *Metropolis* 4 (May 1985): 16–17; Michael deCourcy Hinds, "Developer, Under Fire, Alters Plan in East 70's," *New York Times* (October 29, 1985), B: 1; Brooke Astor, "Stop Demolition of Sound Housing in New York," letter to the edi-

tor, *New York Times* (January 16, 1986): 22; Peter Lemos, "Kalikow Capers," *Metropolis* 5 (April 1986): 14; Lisa W. Foderaro, "Landmark at Risk," *New York Times* (March 29, 1987), VIII: 1; Iver Peterson, "Kalikow Revives Plan to Build on Historic East Side Block," *New York Times* (February 24, 1988), B: 3; Donna Cornachio, "The Struggle at City and Suburban Homes," *New York Observer* (May 30, 1988): 17–18; Christopher Gray, "Streetscapes: City and Suburban Homes," *New York Times* (July 3, 1988), X: 4; Paul Goldberger, "What Does It Take to Make a Landmark?" *New York Times* (October 2, 1988), II: 36; Shawn G. Kennedy, "Kalikow Complex Up for Landmarking," *New York Times* (October 2, 1988), X: 9; "Landmark Status for a Lost Cause?" editorial, *New York Times* (October 6, 1988): 30; Brian Scott Lipton, "Can Skyscrapers Be Stopped?" *Upper East Side Resident* (December 2, 1988): 1, 25; Charles V. Bagli, "Kalikow Sues on City & Suburban Evictions," *New York Observer* (December 26, 1988): 9; Eleanor Clark French, "Landmark Housing Deserves Landmark Status," letter to the editor, *New York Times* (March 9, 1989): 30; Landmarks Preservation Commission of the City of New York, LP-1694 (April 24, 1990); Gina Luria Walker & Associates, ed., *City and Suburban Homes Company's York Avenue Estate: A Social and Architectural History* (New York: Kalikow 78/79 Company, 1990); Leonard Buder, "Landmarks Panel Decision Is Blow to Developer," *New York Times* (April 25, 1990), B: 2; Charles V. Bagli, "Kalikow Is Trying Again to Get the Tenants Out," *New York Times* (July 9, 1990): 1, 10; Todd S. Purdum, "East Side Developer Enlists a Close Advisor of Dinkins," *New York Times* (July 19, 1990), B: 1, 4; Betty Cooper Wallerstein, "A People's Landmark," *Newsday* (August 14, 1990): 42; "Self-Requiem for the Board of Estimate," editorial, *New York Times* (August 15, 1990): 26; Don Terry, "New York City Panel Clears Demolishing Part of a Landmark," *New York Times* (August 22, 1990): 1, B: 3; "Money, Power and Greed," editorial, *New York Observer* (August 27, 1990): 4; Virginia Davenport Stearns, "Shedding a Tear," letter to the editor, *New York Observer* (September 17, 1990): 4; Anthony C. Wood, "City & Suburban Homes," *District Lines* 5 (Autumn 1990): 1; William Murphy, "Suit Hits Landmark Ruling," *Newsday* (November 27, 1990): 18; Richard D. Hylton, "Developer Sued for $60 Million by Three Banks," *New York Times* (March 25, 1991): 1, D: 5; Greg Steinmetz, "Post Chief Can Ax Buildings," *Newsday* (August 23, 1991): 22; Clare McHugh, "Neighborhood Uproar," *New York Observer* (May 4, 1992): 3; Tom Collins, "Kalikow Loss on Bid to Raze Buildings," *Newsday* (May 20, 1992): 40; David W. Dunlap, "Court Blocks Giant Tower Proposed by Kalikow," *New York Times* (May 20, 1992), B: 3; Thomas J. Lueck, "Foreclosure Begins of Historic Buildings Owned by Kalikow," *New York Times* (July 2, 1992), B: 4; "Long-Running Fight Comes to an End," *New York Times* (May 22, 1994), X: 1; Diamonstein, *The Landmarks of New York III*, 404; White and Willensky, *AIA Guide* (2000), 445–46; "Following Up/After Landmark Battle, New Landlords Rebuild," *New York Times* (November 19, 2000): 47. For the Pavilion, see Stern, Mellins, and Fishman, *New York 1960*, 851–52. For City and Suburban Homes, see Stern, Gilmartin, and Massengale, *New York 1900*, 283, 290.

87. For the East River Houses, see Stern, Gilmartin, and Massengale, *New York 1900*, 286–90. Also see Landmarks Preservation Commission of the City of New York, LP-1230 (July 9, 1985); Diamonstein, *The Landmarks of New York III*, 305.

88. Quoted in Dunlap, "Court Blocks Tower Proposed by Kalikow": 3.

89. Shawn G. Kennedy, "By the Riverside," *New York Times* (March 17, 1985), VIII: 1; Peter Lemos, "Six Rms, Chimney Vu," *Metropolis* 5 (November 1985), 17; Alan S. Oser, "Rezoning for Residential: East Side Builder's Tactic," *New York Times* (December 6, 1985), B: 14; "The Promenade: Philip Birnbaum and Associates, PC," *Process Architecture* 64 (January 1986): 130–31; White and Willensky, *AIA Guide* (1988), 400; Frank Sommerfield, "The Man Who Would Be Trump," *Manhattan, inc.* 7 (February 1990): 96–101.

90. "New Condos: Neo-Classic on 72d St.," *New York Times* (September 14, 1986), VIII: 1; White and Willensky, *AIA Guide* (2000), 442.

91. Diana Shaman, "A Residential High-Rise Goes Up on Midblock Lot," *New York Times* (May 25, 1990): 24; Rachelle Garbarine, "In a Soft Market, a Simple Sales Pitch," *New York Times* (February 21, 1992): 17; Kayden, *Privately Owned Public Space*, 268–69.

92. Maurice Carroll, "Board of Estimate Approves 39-Story Tower on East Side," *New York Times* (April 15, 1983), B: 3; Alan S. Oser, "Shaping Up a Mixed-Use Parcel," *New York Times* (March 4, 1984), VIII: 1; "River Terrace," *Process Architecture* 64 (January 1986): 106–8; Alan S. Oser, "Building for the Wealthy on E. 72d Street," *New York Times* (February 5, 1989), X: 9, 16.

93. Dee Wedemeyer, "Atop 103 Rentals: Piggyback Condos," *New York Times* (February 16, 1986), VIII: 1; Crosbie, *The Architecture of Frank Williams*, 11, 164–69.

94. Diana Shaman, "New Luxury Tower Joins Manhattan Rental Market," *New York Times* (March 18, 1988): 27; Patricia Leigh Brown, "Fleeting Art on a Changing Landscape," *New York Times* (April 21, 1988), C: 3; Karen Cook, "Moving Tales of Relocation," *New York Post* (November 10, 1988): 73, 87; Oser, "Building for the Wealthy on E. 72d Street": 9, 16; Nancy Marx Better, "Revolt of the Rich," *Manhattan, inc.* 6 (March 1989), 78–87; Kayden, *Privately Owned Public Space*, 271; White and Willensky, *AIA Guide* (2000), 442.

95. For the "black and whites," see White and Willensky, *AIA Guide* (2000), 442.

96. For Paley Park, see Stern, Mellins, and Fishman, *New York 1960*, 489–90.

97. Alan S. Oser, "New Boom in Manhattan Luxury Construction," *New York Times* (September 9, 1977), B: 11; Dee Wedemeyer, "Up the Laundry Room!" *New York Times*

(May 21, 1978), VIII: 1, 6; Paul Goldberger, "Living in Style: Architecture," *New York* 11 (September 18, 1978): 54–55; "A Rash of New Building Projects," *New York Times* (November 12, 1978), VIII: 1, 8; Paul Goldberger, "Architecture: 4 Honor Buildings," *New York Times* (June 18, 1979), C: 13; Paul Goldberger, "Top Postwar Apartment Buildings," *New York Times* (September 20, 1979), C: 1, 6; Paul Goldberger, "The True Glory of Older Apartments Is Space That Is Not Part of Any Room," *New York Times* (September 18, 1980), C: 10; Charles K. Gandee, "A 46-Story Apartment Tower in Manhattan," *Architectural Record* 168 (December 1980): 82–87; "Solow Tower: The Gruzen Partnership," *Process Architecture* 64 (January 1986): 121; White and Willensky, *AIA Guide* (2000), 439.

98. Gandee, "A 46-Story Apartment Tower in Manhattan": 82.

99. Kirk Johnson, "A Condominium Uptown for Art-Oriented Buyers," *New York Times* (August 9, 1985): 16; White and Willensky, *AIA Guide* (1988), 392–93; White and Willensky, *AIA Guide* (2000), 436.

100. Aaron Green, quoted in Johnson, "A Condominium Uptown for Art-Oriented Buyers": 16.

101. http://www.cityrealty.com.

102. "40-Story Tower on 2d," *New York Times* (September 15, 1985), VIII: 1; Christopher Gray, "What Are Dakota and Montana Doing in New York," *New York Times* (September 28, 1986), VIII: 7; White and Willensky, *AIA Guide* (2000), 438.

103. "New $23 Million, 23-Story Glass and Limestone Building," *New York Times* (April 18, 1999), XI: 1; "$23.5M Luxury Building Planned for 66th Street," *New York Construction News* 48 (April 2000): 7.

104. Alan S. Oser, "Rezoning for Residential: East Side Builder's Tactic," *New York Times* (December 6, 1985), B: 14; Charles Bagli, "Developer Proposing Huge New Project on the East Side," *New York Observer* (July 18, 1988): 1, 9; Carter B. Horsley, "Twin Tower Behemoth," *New York Post* (July 21, 1988): 59, 62; Iver Peterson, "Big Glick Plan in East 60's Set for Review," *New York Times* (July 24, 1988), X: 9, 16; Carter B. Horsley, "Glick Revises Park Designs," *New York Post* (September 1, 1988): 73; Charles V. Bagli, "On East Side, Zuccotti Law Firm Battles a Developer," *New York Observer* (October 10, 1988): 9; David W. Dunlap, "Twin-Towers Complex Approved for East Side," *New York Times* (November 17, 1988), B: 8; Audrey Farolino, "Popcorn Partners," *New York Post* (January 5, 1989): 43, 50; Harry Berkowitz, "Board of Estimate Meeting Extended by Condo Debate," *Newsday* (January 13, 1989): 25; Todd S. Purdum, "Board of Estimate Approves Twin Towers for First Ave.," *New York Times* (January 14, 1989): 29; Charles V. Bagli, "Vote on East Side Project Scheduled," *New York Observer* (January 16, 1989): 9; Michael Tomasky, "City News Digest," *New York Observer* (January 23, 1989): 6; "Glick Project Yields Lawsuit," *Newsday* (May 12, 1989): 55; Carter B. Horsley, "City Slapped with Suit over Glick's Twin Towers," *New York Post* (May 18, 1989): 39, 48; Emily F. Mandelstam, "Four Civic Groups," *New York Observer* (May 22, 1989): 6; Charles V. Bagli, "'Too Tall' building, Glick's Project are Subjects of Pending Lawsuits," *New York Observer* (November 6, 1989): 6; Sommerfield, "The Man Who Would Be Trump": 96–101.

105. Jeffrey Glick, quoted in Petersen, "Big Glick Plan in East 60's Set for Review": 9.

106. Rachelle Garbarine, "Tower Rising near Queensboro Bridge," *New York Times* (December 17, 1999), B: 14; "Luxury Condominium Rises on East Side," *New York Construction News* 48 (April 2000): 9; "New Developments," special advertising section, *New York Observer* (April 17, 2000): 6; "Bridge Tower Place, 410 East 61st St.," *New York Construction News* 49 (June 2001): 33.

107. White and Willensky, *AIA Guide* (2000), 438.

108. For the Ritz Tower, see Stern, Gilmartin, and Mellins, *New York 1930*, 212–13, 215. For 2 East Seventieth Street, see Stern, Gilmartin, and Mellins, *New York 1930*, 388; Andrew Alpern, *The New York Apartment Houses of Rosario Candela and James Carpenter* (New York: Acanthus Press, 2001), 214–16. For 720 Park Avenue, see Stern, Gilmartin, and Mellins, *New York 1930*, 394; Alpern, *The New York Apartment Houses of Rosario Candela and James Carpenter*, 130–31. For 19 East Seventy-second Street, see Stern, Gilmartin, and Mellins, *New York 1930*, 392, 394; Alpern, *The New York Apartment Houses of Rosario Candela and James Carpenter*, 217–23.

109. For 800 Fifth Avenue, see Stern, Mellins, and Fishman, *New York 1960*, 512–13.

110. Alan S. Oser, "Three New East Side Apartment Houses," *New York Times* (January 23, 1977), VIII: 1; Anna Quindlen, "5th Ave. Group Loses Town House but May Win War," *New York Times* (March 2, 1977), B: 3; Tom Draper, "To Site a New School," letter to the editor, *New York Times* (March 14, 1977): 28; "Nibbling Away at the Upper East Side," editorial, *New York Times* (March 26, 1977): 18; Ada Louise Huxtable, "A Graceful Break with Tradition on Fifth Avenue," *New York Times* (July 31, 1977), II: 20; Paul Goldberger, "Philip Johnson: A Controversial New Vision for Architecture," *New York Times* (May 14, 1978), VI: cover, 26–27, 65–75; Goldberger, "Living in Style: Architecture": 54–55; Nory Miller, *Johnson/Burgee: Architecture* (New York: Random House, 1979), 106–7; Ada Louise Huxtable, "The 'Pathetic Fallacy,' or Wishful Thinking at Work," *New York Times* (February 11, 1979), II: 29; Christopher S. Gray, ". . . Zoning by Closing Rooms," *New York Times* (April 1, 1979), VIII: 1, 4; *Philip Johnson/John Burgee: Architecture, 1979–1985* (New York: Rizzoli International Publications, 1985), 174; White and Willensky, *AIA Guide* (1988), 378–79; White and Willensky, *AIA Guide* (2000), 421; Herbert Muschamp, "A Pair of Crystal Gems Right for Their Setting," *New York Times* (January 14, 2001), II: 39, 40; *The Architecture of Philip Johnson* (Boston: Bulfinch Press, 2002), 192.

111. For 2 East Eighty-second Street, see *Metropolitan Museum Historic District*, 93; "A Vast Pied à Terre: Mansion to Share," *New York Times* (January 20, 1991), X: 1.

112. Quoted in Oser, "Three New East Side Apartment Houses": 6.

113. *Metropolitan Museum Historic District*. Also see Deirdre Carmody, "Residents near Metropolitan Museum Sue to Obtain Historic District Status," *New York Times* (March 17, 1975): 31; Carter B. Horsley, "A Landmark District Is Proposed on 5th Ave. Opposite Art Museum," *New York Times* (January 31, 1977): 25; "New York City's Proposed Designation of Historic District Brings Fiery Debate–and Uncertainty," *Architectural Record* 161 (April 1977): 35; "Nibbling Away at the Upper East Side": 18; Edward Ranzal, "Museum Area a Historic District," *New York Times* (September 21, 1977), B: 3; "Metropolitan Museum Historic Area Is Approved," *New York Times* (November 4, 1977), B: 2.

114. Quindlen, "5th Ave. Group Loses Town House but May Win War": 3.

115. Huxtable, "A Graceful Break with Tradition on Fifth Avenue": 20.

116. Huxtable, "A Graceful Break with Tradition on Fifth Avenue": 20. For 998 Fifth Avenue, see Stern, Gilmartin, and Massengale, *New York 1900*, 290, 295.

117. Huxtable, "A Graceful Break with Tradition on Fifth Avenue": 20.

118. For the New York State Theater, see Stern, Mellins, and Fishman, *New York 1960*, 690–95.

119. Goldberger, "Philip Johnson: A Controversial New Vision for Architecture": 70.

120. Huxtable, "The 'Pathetic Fallacy,' or Wishful Thinking at Work": 29.

121. Muschamp, "A Pair of Crystal Gems Right for Their Setting": 39.

122. "21-Story Condominium: Japanese Build on E. 79th St.," *New York Times* (August 7, 1983), VIII: 1; Kirk Johnson, "A Japanese Touch in East Side Building," *New York Times* (May 3, 1985), B: 8; Joseph Giovannini, "Apartment Builders Return to Prewar Design," *New York Times* (October 13, 1986): 1, B: 4; White and Willensky, *AIA Guide* (2000), 418.

123. "High-Rise Plan Would Save Landmark Facades," *New York Times* (June 26, 1985), B: 1; Josh Barbanel, "High-Rise Is Proposed atop Brownstone Row," *New York Times* (June 26, 1985), B: 6; Kirk Johnson, "Behind the Facades, or 'Adventures' on E. 79th," *New York Times* (July 7, 1985), VIII: 7; Paul Goldberger, "'Facadism' on the Rise: Preservation or Illusion?" *New York Times* (July 15, 1985), B: 1, 3; Audrey Farolino, "Earful Over an Eyeful," *New York Post* (December 15, 1988): 73, 81; White and Willensky, *AIA Guide* (2000), 418. For 72–74 East Seventy-ninth Street, see *Upper East Side Historic District*, 899. For 76 East Seventy-ninth Street, see *Upper East Side Historic District*, 900.

124. Frederick Bland, quoted in "Living in Luxury on East 88th: $2 Million for 4,200 Square Feet," *New York Times* (September 9, 1984), VIII: 1. Also see Alan S. Oser, "East Side Condominium: Prewar Look," *New York Times* (April 12, 1985), B: 7; "A Home in the City," *Architectural Record* 173 (July 1985): 71; Philip S. Gutis, "Condominiums in Park Avenue Vicinity," *New York Times* (September 5, 1986): 19; "Sixty East Eighty-eighth Street," advertisement, *New York Times* (October 5, 1986), VI: 91; White and Willensky, *AIA Guide* (1988), 382–83; Sarah Wachter, "Preserving Carnegie Hill: Contextual Zoning to the Rescue," *Metropolis* 11 (December 1991): 19–23; *Beyer Blinder Belle, Architects & Planners* (New York: Beyer Blinder Belle, 1997), no pagination; White and Willensky, *AIA Guide* (2000), 427.

125. For the Carnegie Mansion, see Stern, Gilmartin, and Massengale, *New York 1900*, 342–44.

126. "Sixty East Eighty-eighth Street": 91.

127. "Condo for Rowhouses: Designed to Blend," *New York Times* (June 30, 1985), VIII: 1; White and Willensky, *AIA Guide* (1988), 371.

128. For 52 East Seventy-second Street, see *Upper East Side Historic District*, 621. For 54 East Seventy-second Street, see Stern, Mellins, and Fishman, *New York 1960*, 830–31. For 750 Park Avenue, see Stern, Mellins, and Fishman, *New York 1960*, 831.

129. See *Upper East Side Historic District*, 620.

130. See Stern, Gilmartin, and Mellins, *New York 1930*, 392. Also see Mark Alan Hewitt, *The Architecture of Mott B. Schmidt* (New York: Rizzoli International Publications, 1991), no pagination.

131. White and Willensky, *AIA Guide* (1988), 371.

132. Lisa W. Foderaro, "Gimbels East Conversion: Contextual Plan," *New York Times* (September 6, 1987), VIII: 1; Keith Kahan, "Gimbels to Become Luxury Residence," *Our Town* 18 (September 20, 1987): 1, 3; Stu Newman, "Developer's Silence Is Not Golden," *Our Town* 19 (October 2, 1988): 1, 5; Diana Shaman, "A Plan to Give a New Feel to an Old Gimbels Site," *New York Times* (October 14, 1988): 27; Adam Snyder, "East 86th Street," *7 Days* (November 22, 1989): 39; Shawn G. Kennedy, "A New Cachet for Old East 86th Street," *New York Times* (April 15, 1990), X: 1, 8; Joe Catalano, "Bigger Selling a Bit Better," *Newsday* (September 8, 1990): 11; Wachter, "Preserving Carnegie Hill: Contextual Zoning to the Rescue": 20–21; Rachelle Garbarine, "Park Ave. Condominium Developers Hope to Regain an Investment's Luster," *New York Times* (March 27, 1994): 31; White and Willensky, *AIA Guide* (2000), 453.

133. "Hello to 'Quality' on Third Avenue," *New York Times* (December 5, 1982), VIII: 1; "Later, but Better," *New York Times* (June 10, 1984), VIII: 1; "KPF Classical, Controversial," *Progressive Architecture* 66 (July 1985): 73; "180 East 70th Street," *Architecture + Urbanism* (December 1985): 16–17; "180 East 70th Street: Kohn Pedersen Fox Associates PC," *Process Architecture* 64 (January 1986): 22–25; Paul

Goldberger, "Architecture That Pays Off Handsomely," *New York Times* (March 16, 1986), VI: 48–52, 54, 74, 78; Giovannini, "Apartment Builders Return to Prewar Design": 1, B: 4; *Kohn Pedersen Fox: Buildings and Projects, 1976–1986* (New York: Rizzoli International Publications, 1987), 11, 174–79; "New Construction Around Town," *Oculus* 48 (May 1987): 28–29; White and Willensky, *AIA Guide* (1988), 396; Robert A. M. Stern, *Modern Classicism* (New York: Rizzoli International Publications, 1988), 194; White and Willensky, *AIA Giude* (2000), 441.

134. "The Real Estate Field," *New York Times* (July 1, 1916): 18.

135. For Holkham Hall, see Christopher Hussey, *English Country Houses: Early Georgian, 1715–1760* (London: Country Life, 1955), 131–45.

136. Goldberger, "Architecture That Pays Off Handsomely": 51.

137. "Landmark Church in Air-Rights Swap," *Architectural Record* 179 (February 1991): 17; *Hardy Holzman Pfeiffer Associates: Buildings and Projects, 1967–1992* (New York: Rizzoli International Publications, 1992), 228–29; "GC Bids to Be Advertised by March '93 for a $27M, 31-Story, Apt. Bldg. on Manhattan's Upper East Side," *New York Construction News* 39 (March 16, 1992): 1, 5; "31-Story Building Going Up Next to St. Jean Baptiste on E. 76th St.; Condo Rising Beside Church's Dome," *New York Times* (March 17, 1996), IX: 1; Rachelle Garbarine, "Condo, with Air Rights, Rising on the East Side," *New York Times* (September 6, 1996), B: 12; Karrie Jacobs, "New Style: No Style," *New York* 29 (September 23, 1996): 30–31; *Hardy Holzman Pfeiffer Associates: Buildings and Projects, 1992–1998* (New York: Rizzoli International Universe, 1999), 128–29; White and Willensky, *AIA Guide* (2000), 415. For St. Jean Baptiste Church, see Diamonstein, *The Landmarks of New York III*, 306.

138. For the church restoration, see Christopher Gray, "Streetscapes/St. Jean Baptiste Church," *New York Times* (December 30, 1990), VIII: 5.

139. Quoted in Jacobs, "New Style: No Style": 30.

140. "15-Story, 22-Apartment Condominium at 76th Street; It's on the Avenue: Lexington," *New York Times* (July 12, 1998), XI: 1; Tracie Rozhon, "Enter the Computer-Generated Condo and Walk Around," *New York Times* (December 24, 1998), F: 7; Rachelle Garbarine, "Condo Shows Demand for Luxury Is Steady," *New York Times* (June 18, 1999), B: 9; Paul Goldberger, "A Touch of Crass," *New Yorker* 75 (August 16, 1999): 86–90.

141. Goldberger, "A Touch of Crass": 88.

142. Peg Tyre and Jeannette Walls, "Zeckendorf, Klein: Designs on Park?" *New York* 22 (April 17, 1989): 10; Christopher Gray, "Streetscapes/55[sic] Park Avenue," *New York Times* (January 6, 1991), X: 5; "Corrections," *New York Times* (January 20, 1991), X: 7; Robert D. McFadden with Rachelle Garbarine, "A Haven for the Super-Rich with Room for the Servants," *New York Times* (April 25, 1998): 1, B: 2; David W. Dunlap, "Using Thin Air to Let Buildings Grow Taller," *New York Times* (May 17, 1998), XI: 1, 6; Devin Leonard and Carl Swanson, "The Brothers Zeckendorf Cede Control of Tower to Goldman Sachs Team," *New York Observer* (June 1, 1998): 1, 20; Tracie Rozhon, "Brass: It's No Longer the Top," *New York Times* (August 6, 1998), F: 1, 11; Rozhon, "Enter the Computer-Generated Condo and Walk Around": 7; Goldberger, "A Touch of Crass": 86–90; White and Willensky, *AIA Guide* (2000), 284; Charles Lockwood, "Big Rich Digs," *Grid* 2 (January-February 2000): 74–78; "515 Park Avenue," *New York Construction News* 48 (June 2000): 35; "Home Sweet Home," *Grid* 2 (November-December 2000): 92; Charles Lockwood, "Grand Scale," *Urban Land* 60 (May 2001): 64–67. For Denby & Nute's 515 Park Avenue, see Gray, "Streetscapes/55[sic] Park Avenue": 5.

143. Goldberger, "A Touch of Crass": 88.

144. "Union of American Hebrew Congregations to Move Offices; Building at 5th and 65th to Be Sold by Sealed Bid," *New York Times* (June 16, 1996), VIII: 1; "Safra to Buy Land for Temple," *Crain's New York Business* (May 12–18, 1997): 1; Lore Croghan, "5th Ave. Condos for the Superrich," *Crain's New York Business* (February 1–7, 1999): 1, 18; Peter Grant, "Billionaires Squabble over Luxury Condos," *New York Daily News* (April 29, 1999): 78; "From $9 Million to $18 Million: At 65th and Fifth, 10 New Condos," *New York Times* (October 17, 1999), XI: 1; Lockwood, "Big Rich Digs": 74–78; Rachelle Garbarine, "A Luxury Condo Project on Fifth Avenue Is Attracting Buyers," *New York Times* (March 3, 2000), B: 8; Lockwood, "Grand Scale": 64–67. For the Union of American Hebrew Congregations, see Stern, Mellins, and Fishman, *New York 1960*, 803–4.

145. For 2 East Sixty-fifth Street, see *Upper East Side Historic District*, 803.

146. Kimberly Stevens, "'Cottages,' Once Visionary, Now Imperiled," *New York Times* (March 2, 1997), XIII: 5; "Preservation Threat–The Cottages," *Friends of the Upper East Side Historic Districts Newsletter* (Spring/Summer 1997): 4; Anthony Ramirez, "Landmark Status Is Denied at the Cottages," *New York Times* (April 20, 1997), XIII: 5; Peter Duffy, "'I Don't Like Developers,'" *Eastside Resident* (May 7–13, 1997): 11; Rachelle Garbarine, "East Side Condo Plan Meets Resistance," *New York Times* (May 16, 1997): 26; Joseph Howard Katz, "Owner of 'Cottages' Viewed Garden as a Necessity," letter to the editor, *New York Times* (May 25, 1997): 13; Guy Trebay, "Lights Out," *Village Voice* (June 10, 1997): 28; Beth Landman Keil and Deborah Mitchell, "A Rose Grows in a Secret Garden," *New York* 30 (June 16, 1997): 11; Michael Finnegan, "Lobbying vs. Cottages May Oust Senior Citizens," *New York Daily News* (June 19, 1997): 4; "Tony: Cottage Hero," *New York Post* (July 7, 1997): 8; David W. Dunlap, "Enlarging the Preservation Band," *New York Times* (July 20, 1997), IX: 1, 8; Tracie Rozhon, "An Eden, Yes. But Whose?" *New York Times* (August 28, 1997), C: 1, 6; Robert E. Davidson, "Cottages No Eyesore," *New York Times* (September 18, 1997), F: 13; Carolyn B. Maloney, "Rethink the

Cottages," letter to the editor, *New York Times* (September 18, 1997), F: 13; James Barron and Phoebe Hoban, "A Noble Cause on Third Avenue," *New York Times* (April 4, 1998), B: 2; Rachelle Garbarine, "Developers Join in Project on East Side," *New York Times* (February 20, 1998), B: 11; Clyde Haberman, "Just a Hearing On Landmark, but City Balks," *New York Times* (March 10, 1998), B: 1, 6; Carolyn B. Maloney, "City Owes Community Hearing on the Cottages," letter to the editor, *New York Times* (March 14, 1998): 16; Tracie Rozhon, "Cottages Can Stay, but Neighbor Will Loom," *New York Times* (April 4, 1998), B: 1–2; Alan S. Oser, "A Rental Builder Shifts to High Gear," *New York Times* (June 21, 1998), XI: 1, 6; Tracie Rozhon, "Cottage Tenants Settle with Developers," *New York Times* (August 15, 1998), B: 3; "Cottages' End a Grim Reality," *Friends of the Upper East Side Historic Districts Newsletter* (Winter 1998): 4; Rachelle Garbarine, "Large Luxury Condominiums Sell Steadily at East Side Tower," *New York Times* (July 23, 1999), B: 7; Goldberger, "A Touch of Crass": 86–90; Christopher Gray, "Streetscapes/'There's Nothing Wrong with White-Glazed Brick Buildings,'" *New York Times* (December 31, 2000), XI: 7; Lois Weiss, "Mighty Empire Sued," *New York Post* (October 29, 2001): 33; Robin Finn, "Developer Stalks His Prize in the Wilds Downtown," *New York Times* (November 21, 2002), B: 2. For the Cottages, see Stern, Gilmartin, and Mellins, *New York 1930*, 399, 401.

147. Anthony Ramirez, "At the Sign of the Dove, a Sign of the Times," *New York Times* (February 8, 1998), XIV: 7; Bernard Stamler, "Hope Dims in Effort to Save Sign of the Dove Building," *New York Times* (March 22, 1998), XIV: 5; Tracie Rozhon, "$110 Million Condominium at Former Site of Sign of the Dove; Designed by Stern, but No Shingles," *New York Times* (November 22, 1998), XI: 1; Rozhon, "Enter the Computer-Generated Condo and Walk Around": 7; Alan S. Oser, "How to Build with a Firm Foundation," *New York Times* (January 31, 1999), XI: 1, 6; Kate Kelly, "Building Boom of 1999: Will Manhattan Change into Tacky Condo Town?" *New York Observer* (February 1, 1999): 1, 11; Rachelle Garbarine, "Luxury Condominiums Seeing Strong Demand," *New York Times* (April 16, 1999): B: 9; Rachelle Garbarine, "Upper East Side Story," *New York Times* (May 30, 1999): 2; Goldberger, "A Touch of Crass": 86–90; White and Willensky, *AIA Guide* (2000), 394, 439; Lloyd Chrein and Linda Alexander, "Coddling for Condos," *Grid* 2 (January-February 2000): 94–96; Tracie Rozhon, "Condos on the Rise, by Architectural Stars," *New York Times* (July 19, 2001), F: 1, 10; Georges Binder, ed., *Sky High Living* (Mulgrave, Australia: Images Publishing, 2002), 156–57, 241; Peter Morris Dixon, ed., *Robert A. M. Stern: Buildings and Projects, 1999–2003* (New York: Monacelli Press, 2003), 334–39, 578.

148. For Jones Wood Gardens, see Christopher Gray, "Streetscapes/The Jones Wood Gardens," *New York Times* (December 28, 1997), XI: 5. For Jones's Wood, see Stern, Mellins, and Fishman, *New York 1880*, 82–84. For Turtle Bay Gardens, see Stern, Gilmartin, and Mellins, *New York 1930*, 428–29.

149. For 770 and 778 Park Avenue, see Stern, Gilmartin, and Mellins, *New York 1930*, 394; Alpern, *The New York Apartment Houses of Rosario Candela and James Carpenter*, 138–43, 152–57. For River House, see Stern, Gilmartin, and Mellins, *New York 1930*, 416.

150. Steven M. L. Aronson, "Robert A. M. Stern: The Architect's Creation Stands Tall in Manhattan," *Architectural Digest* 59 (September 2002): cover, 196–203, 289; Dixon, ed., *Robert A. M. Stern: Buildings and Projects, 1999–2003*, 340–45, 564, 578.

151. "Celebrating Yorkville: Jahn's Yorkville Salute," *New York Times* (October 12, 1986), VIII: 1; White and Willensky, *AIA Guide* (2000), 453.

152. "46 Stories on East 88th: High There, New Neighbor!" *New York Times* (January 1, 1989), X: 1; "388 East 88th St.," *New York Times* (September 24, 1989), X: 1; Suzanne Stephens, "The Post-Post-War Apartment House, Part II," *Oculus* 54 (April 1992): 8–9; White and Willensky, *AIA Guide* (2000), 456.

153. Stephens, "The Post-Post-War Apartment House, Part II": 8–9.

154. Alan S. Oser, "A Rental Builder Shifts to High Gear," *New York Times* (June 21, 1998), XI: 1, 6; Kelly, "Building Boom of 1999: Will Manhattan Change into Tacky Condo Town?: 1, 11; Rachelle Garbarine, "A Partnership Is Thriving on Luxury Apartment Projects," *New York Times* (April 28, 2000), B: 8; David S. Chartock, "High-Strength Concrete Provides Layout Flexibility for the Seville," *New York Construction News* 49 (July 2001): 45–49; Jonathan Mahler, "Gotham Rising," *Talk* (December 2001/January 2002): 120–25, 148–52; James Gardner, "A Promising Combination," *New York Sun* (May 20, 2002): 10; "The Seville; New York, N.Y.," *New York Construction News* 49 (June 2002): 55; Dixon, ed., *Robert A. M. Stern: Buildings and Project, 1999–2003*, 346–47, 578.

155. Gardner, "A Promising Combination": 10.

156. "Rentals at 75th Street: 3-Building Complex Rising on First Ave.," *New York Times* (December 20, 1998), XI: 1; Alexandra Lange, "The Towers That Will Be," *New York* 32 (April 12, 1999), 42–44; White and Willensky, *AIA Guide* (2000), 224; Rachelle Garbarine, "Luxury-Rental Project on East Side Is Converted to Condos," *New York Times* (September 22, 2000), B: 8; James Gardner, "Frontally Viewed, the Impala Is a Graves Injustice to New York," *New York Observer* (October 30, 2000): 11; Martha Thorne and John Zukowsky, *Skyscrapers: The New Millennium* (Munich: Prestel, 2001), 40–41; "Top Projects: The Impala," *New York Construction News* 48 (June 2001), 42; Sana Siwolop, "Designs Change to Meet a Demand for Larger Apartments," *New York Times* (August 31, 2001), B: 9; James Gardner, "Unethical?" *New York Sun* (June 4, 2002): 1, 12; Karen Nichols, *Michael Graves: Buildings and Projects, 1995–2003* (New York: Rizzoli

International Publications, 2003], 170–73.

157. Michael Graves, quoted in Garbarine, "Luxury-Rental Project on East Side Is Converted to Condos": 8.

158. For the Lundquist & Stonehill renovation, see "New York Architects Lundquist and Stonehill Renovate Former Cigar Factory for Sotheby Parke Bernet," *Architectural Record* 168 (October 1980): 37; White and Willensky, *AIA Guide* (1988), 397.

159. Rita Reif, "Sotheby's to Shut 2 Galleries in U.S.," *New York Times* (June 10, 1982), C: 32; Rita Reif, "Art Dealers Dismayed at Sotheby's Closing," *New York Times* (June 11, 1982), C: 7; John Russell, "What Sotheby's Meant to a Neighborhood," *New York Times* (June 27, 1982), II: 25. For the Parke-Bernet Building, see Stern, Mellins, and Fishman, *New York 1960*, 823–24.

160. Rita Reif, "Sotheby's Plans $70 Million Addition," *New York Times* (February 6, 1986), C: 14; "A Quintessential Marriage of Art and Architecture: Michael Graves Designs for Sotheby's," *Architectural Record* 174 (March 1986): 57; "Graves Again," *Metropolis* 5 (April 1986): 14; "Graves Designs Sotheby's Tower," *Progressive Architecture* 67 (April 1986): 25–26; Charles V. Bagli, "Neighbors in Yorkville Bid to Block Sotheby's Tower," *New York Observer* (April 20, 1989): 6; Karen Vogel Nichols, Patrick J. Burke, and Caroline Hancock, eds., *Michael Graves: Buildings and Projects, 1982–1989* (Princeton, N.J.: Princeton University Press, 1990), 176–79; Todd S. Purdum, "It's Farewell for Planners on a Panel," *New York Times* (June 28, 1990), B: 1, 4.

161. Nichols, Burke, and Hancock, eds., *Michael Graves: Buildings and Projects, 1982–1989*, 176.

162. David M. Halbfinger, "Sotheby's Says It May Build at Its Present East Side Site," *New York Times* (June 4, 1997), B: 5; Devin Leonard, "Sotheby's Goes Nowhere While Christie's Primps for Rockefeller Center," *New York Observer* (July 21, 1997): 1, 12; Carol Vogel, "Sotheby's, Expanding, Plans a Showplace," *New York Times* (July 21, 1998): E: 1, 7; "Corrections," *New York Times* (August 6, 1998): 2; "Sotheby's World Headquarters Expansion, N.Y., N.Y.," *New York Construction News* 47 (March 1999): 50; Noreen O'Leary, "Sotheby's Stays Put," *Grid* 1 (Summer 1999): 98; "Sotheby's Expansion Unveiled," *Art in America* 87 (December 1999): 23; White and Willensky, *AIA Guide* (2000), 442; "Sotheby's World Headquarters, New York," *New York Construction News* 48 (June 2000): 24; Monica Geran, "Upping the Bid," *Interior Design* 71 (August 2000): 58–60; "Sotheby's Sparkling New Look," *Metalworks* (May 2001): 1, 5; Mindi Altman, "Sotheby's Rise with Renovation," *Building Design and Construction* 42 (July 1, 2001): 17; James B. Stewart, "Bidding War," *New Yorker* 77 (October 15, 2001): 158–62; Ian Luna and Kenneth Powell, eds., *Kohn Pedersen Fox: Architecture and Urbanism, 1993–2002* (New York: Rizzoli International Publications, 2002), 306–13; Sheila Kim, "A Winning Bid," *Interior Design* 73 (March 2002): 68–70; Carol Vogel, "Sotheby's Agrees to Sell Its Home, Then Lease It," *New York Times* (December 18, 2002), C: 9; Ian Luna, ed., *New New York: Architecture of a City* (New York: Rizzoli International Publications, 2003), 256–59.

163. Kevin Kennon, quoted in "Sotheby's Sparkling New Look": 5.

164. See Stern, Mellins, and Fishman, *New York 1960*, 732–33, 916.

165. Paul Goldberger, "Townhouse Rows," *New York Times* (June 16, 1980), C: 15; "Eleven on 67," *New York Times* (April 4, 1982), VIII: 1; *Richard Meier Architect 1964/1984* (New York: Rizzoli International Publications, 1984), 400–401; Peter Arnell and Ted Bickford, eds., *James Stirling: Buildings and Projects* (New York: Rizzoli International Publications, 1984), 269–73; Paul Goldberger, "Design Notebook," *New York Times* (March 22, 1984), C: 10; "New York Houses," *Architectural Review* 175 (April 1984): 43; Walter McQuade, "Only the Best," *Connoisseur* 215 (August 1985): 80–87; Victoria Geibel, "A Solow Performance," *Metropolis* 5 (September 1985): 11; Dee Wedemeyer, "Q and A," *New York Times* (December 15, 1985), VIII: 9; Shawn G. Kennedy, "Q and A," *New York Times* (December 20 1987), VIII: 5; "The Big Fix on 67th St.," *Avenue* (January 1988): 17; Better, "Revolt of the Rich": 78–87; Alan S. Oser, "East Side Project Back in Construction," *New York Times* (November 12, 1989), X: 9; *James Stirling Michael Wilford and Associates: Buildings & Projects, 1975–1992* (London: Thames and Hudson, 1994), 72–75; Lisa J. Green, ed., *Richard Meier: Architect* (New York: Monacelli Press, 1999), 290; White and Willensky, *AIA Guide* (2000), 440.

166. Katy Koontz, "A Public Showcase for Architectural Drawings in New York City," *Architectural Record* 168 (August 1980): 39; Carter B Horsley, "Lexington Ave. Builds New Image," *New York Times* (August 20, 1980), D: 18. For 369 Lexington Avenue, see W. Parker Chase, *New York: The Wonder City* (New York: Wonder City Publishing Co., 1932; New York: New York Bound, 1983), 218.

167. Goldberger, "Townhouse Rows": 15.

168. Goldberger, "Design Notebook": 10.

169. "Rare Development: Homes for One," *New York Times* (January 2, 1983), VIII: 1; White and Willensky, *AIA Guide* (1988), 397; White and Willensky, *AIA Guide* (2000), 441.

170. White and Willensky, *AIA Guide* (2000), 441. Also see White and Willensky, *AIA Guide* (1988), 397.

171. *Upper East Side Historic District*, 187; Paul Goldberger, "Landmarks Cases: A Decisive Verdict," *New York Times* (June 14, 1984), B: 1, 6; Deirdre Carmody, "East Siders Ask If Garage Is Worth Tree," *New York Times* (February 23, 1985): 1, 47; Thomas L. Waite, "Détente on 64th," *New York Times* (April 17, 1983), X: 1; *Agrest and Gandelsonas: Works*, 156–59; White and Willensky, *AIA Guide* (2000), 390.

172. For the Park Avenue Baptist Church, see Stern, Gilmartin, and Mellins, *New York 1930*, 149. For Asia House,

see Stern, Mellins, and Fishman, *New York 1960*, 837–38.

173. For the unbuilt apartment tower scheme at 110 East Sixty-fourth Street, see *Agrest and Gandelsonas: Works*, 128–31.

174. *Agrest and Gandelsonas: Works*, 156.

175. "In the City," *Oculus* 52 (June 1990): 1; Richard D. Lyons, "East 85th Town Houses: All in the Family," *New York Times* (June 17, 1990), X: 1; "Two Town Houses Recall Past Glamor," *Architectural Record* 178 (July 1990): 25; Alan S. Oser, "Perspectives: Town-House Rentals," *New York Times* (July 15, 1990), X: 5; *Gwathmey Siegel: Buildings and Projects, 1982–1992* (New York: Rizzoli International Publications, 1993), 323; Nick Ravo, "Town-House Sales Pick Up as Their Prices Fall Off," *New York Times* (June 20, 1993), X: 6; Marisa Bartolucci, "Town-House Tales," *Town and Country* (June 1997): 126–31, 168; White and Willensky, *AIA Guide* (2000), 423.

176. Charles Gwathmey, quoted in Bartolucci, "Town-House Tales": 126.

177. "Putting 1 House Where 2 Are," *New York Times* (March 27, 1994), X: 1; Marvine Howe, "Ivana Trump's Landmark Fight," *New York Times* (March 27, 1994), XIII: 6; Lauren Ramsby, "Message to Geffen: Heed Ivana's Lesson," *New York Observer* (April 4, 1994): 1, 14; "Street of Choice: More Cachet for East 64th," *New York Times* (June 19, 1994), X: 1; Lauren Ramsby, "What Do Geffen and Bronfman Jr. Have in Common? East 64th Street," *New York Observer* (June 20, 1994): 8; "Postings," *New York Times* (April 2, 1995), IX: 1; Christopher Mason, "Home Sweet Elsewhere," *New York Times* (January 11, 1996), C: 1, 7. Also see *Upper East Side Historic District*, 156–57.

178. "New Office-Residential Building Planned," *New York Times* (April 28, 1996), XI: 1; Steven Greenhouse, "At 82, Legendary Mediator Has a Vision for E. 64th St.," *New York Times* (October 13, 1996): 41; Nadine Brozan, "Chronicle," *New York Times* (January 22, 1997), B: 20; Andrew C. Revkin, "Digging as Deep as It Gets in Manhattan: New Building Will Use a Geothermal Energy System," *New York Times* (April 20, 1997): 33; Steven Greenhouse, "A Building Worth a Wait? Not Anymore," *New York Times* (November 28, 1997), B: 6.

179. For Automation House, see Stern, Mellins, and Fishman, *New York 1960*, 1111.

180. "Condos for E. 64th Street," *New York Times* (September 12, 1999), XI: 1; "Upper East Side," *New York Observer* (August 27-September 3, 2001): 29.

181. "Postings," (April 2, 1995), IX: 1; Christopher Mason, "Lorenzo De Versace," *New York Times* (October 31, 1996), C: 1, 6; Brozan, "Chronicle": 20. For 5 East Sixty-fourth Street, see *Upper East Side Historic District*, 155.

182. "Street of Choice: More Cachet for East 64th": 1; Ramsby, "What Do Geffen and Bronfman Jr. Have in Common? East 64th Street": 8; Brozan, "Chronicle": 20; Julie V. Iovine, "Bronfmans Tame a Town House," *New York Times* (September 23, 1999), F: 1, 7; William L. Hamilton, "Hard Work, Being a Man of Steel," *New York Times* (February 17, 2000), F: 1, 13. For 15 East Sixty-fourth Street, see *Upper East Side Historic District*, 159.

183. For the Canadian Centre for Architecture, see Suzanne Stephens, "L'architecture parlante," *Architectural Record* 177 (August 1989): 57–61.

184. Edgar Bronfman Jr. and Peter Rose, quoted in Iovine, "Bronfmans Tame a Town House": 7.

185. Iovine, "Bronfmans Tame a Town House": 7.

186. White and Willensky, *AIA Guide* (2000), 401. Also see *Upper East Side Historic District*, 409–10, 459; "For One Family: 6 Stories on Spec," *New York Times* (October 21, 1984), VIII: 1; Ted Kenney, "Marketing the Modern Town House," *New York Times* (May 20, 1990), X: 9.

187. *Metropolitan Museum Historic District*, 55–56; Richard Economakis, ed., *Building Classical: A Vision of Europe and America* (London: Academy Editions, 1993), 232; White and Willensky, *AIA Guide* (2000), 420.

188. *Peter Pennoyer Architects* (New York, 2001), 13, 17, 36.

189. Tracie Rozhon, "Echoes of the Gilded Age," *New York Times* (July 5, 1995), B: 1, 3; American Institute of Architects, New York Chapter, *Annals 1996–1997* (New York: American Institute of Architects, 1997): 20; Joan Ockman, "Tod Williams and Billie Tsien," *Casabella* 61 (February 1997): 14–23; Karen Stein, "Family Home of Modern Icon? Williams and Tsien Do Both at Once," *Architectural Record* 185 (April 1997): 76–83; "Tod Williams and Billie Tsien: New York City House," *Architecture + Urbanism* (June 1997): 30–43; Peter Davey, "America Rediscovered," *Architectural Review* 202 (November 1997): 4–5; Margaret Seal, "Town House Triumph," *Architectural Review* 202 (November 1997): 45–49; James Traub, "The Anti-Trump," *New York Times* (December 20, 1998), VI: 62–68; "New York City House," *International Architectural Review* 9 (1999): 32–41; Hadley Arnold, ed., *Work Life: Tod Williams Billie Tsien* (New York: Monacelli Press, 2000), 114–29; White and Willensky, *AIA Guide* (2000), 409; Alan Balfour, *World Cities: New York* (New York: Wiley Academy, 2001), 110; Luca Molinari, *Atlas: North American Architecture Trends, 1990–2000* (Milan: Marazzi Gruppo Ceramiche, 2001), 100–105; Cathleen McGuigan, "A Tree Grows in Midtown," *Newsweek* 139 (January 21, 2002): 56; Luna, ed., *New New York*, 240–45.

190. Stover Jenkins and David Mohney, *The Houses of Philip Johnson* (New York: Abbeville Press, 2001), 206–7, 218–19.

191. Stein, "Family Home of Modern Icon? Williams and Tsien Do Both at Once": 76.

192. Davey, "America Rediscovered": 5.

193. David W. Dunlap, "World Too Tiny for Foreign Relations," *New York Times* (March 19, 1997), F: 7; White and Willensky, *AIA Guide* (2000), 399. Also see *Upper East Side Historic District*, 384–87. For Delano & Aldrich's Pratt house, see Stern, Gilmartin, and Mellins, *New York 1930*, 372–73.

194. Russell Sturgis, "The Art Gallery of New York Streets," *Architectural Record* 10 (July 1900): 92–112. Sturgis's article documented new houses on Fifty-fourth Street. See Stern, Gilmartin, and Massengale, *New York 1900*, 350.

195. *Upper East Side Historic District*, 230; Karen Vogel Wheeler, Peter Arnell, and Ted Bickford, eds., *Michael Graves: Buildings and Projects, 1966–1981* (New York: Rizzoli International Publications, 1982), 157–59; Vincent Scully, "Michael Graves' Allusive Architecture," in Wheeler, Arnell, and Bickford, eds., *Michael Graves: Buildings and Projects, 1966–1981*, 295–96. For the Fairchild house, see Stern, Gilmartin, and Mellins, *New York 1930*, 379–80, 383.

196. Scully, "Michael Graves' Allusive Architecture," in Wheeler, Arnell, and Bickford, eds., *Michael Graves: Buildings and Projects, 1966–1981*, 295.

197. Quoted from *Hannah and Her Sisters* (Orion Pictures, 1986), written and directed by Woody Allen, produced by Robert Greenhut.

198. Stern, Mellins, and Fishman, *New York 1960*, 548, 550–51.

199. Tim Rohan, "Public and Private Spectacles," *Casabella* (December 1999-January 2000): 138–49. Also see Dee Wedemeyer, "To Rise Above Space Limitations You Can Always Add Floors," *New York Times* (February 5, 1978), VIII: 1, 4; Paul Goldberger, "Show of Rudolph's Work," *New York Times* (July 5, 1979), C: 14; Paul Goldberger, "Design Notebook," *New York Times* (November 3, 1983), C: 10; Michael Sorkin, "The Light House," *House & Garden* 160 (January 1988): 88–95, 168; Daniel J. McConville, "Beekman Place," *Newsday* (November 18, 1989): 11; Herbert Muschamp, "Paul Rudolph Is Dead at 78; Modernist Architect of the 60's," *New York Times* (August 9, 1997): 50; Joseph Giovannini, "If There's Heaven, It Should Expect Changes," *New York Times* (August 14, 1997), C: 1, 10; Christopher Gray, "Streetscapes/Beekman Place," *New York Times* (November 30, 1997), XI: 7; Thomas Mellins, "An Architect's Home Was His Modernist Castle," *New York Times* (June 21, 1999), XI: 7; Alexandra Lange, "Paul's Boutique," *New York* 31 (July 13, 1998): 12; James Barron with Alex Kuczynski, "Peekaboo Suite," *New York Times* (November 25, 1998), B: 2; Patricia Leigh Brown, "Toil and Trouble in Plexi-Land," *New York Times* (December 3, 1998), F: 1, 8; Jane Withers, "Life Interiors: Clear Storey," *The Observer* (April 4, 1999): 50; Maria Giulia Zunino, "23 Beekman Place," *Abitare* (May 1999): 230–33; Catherine Slessor, "Delight," *Architectural Review* 206 (August 1999): 98; White and Willensky, *AIA Guide* (2000), 307; Danielle Reed, "House That Rudolph Built," *New York Daily News* (May 4, 2000): 44; Bonnie Schwartz, "A Modern Masterpiece Becomes Child's Play," *New York Times* (May 4, 2000), F: 1, 13; Bonnie Schwartz, "A Constructivist Sculpture Fit for a Family?" *Architectural Record* 188 (June 2000): 38; Julie V. Iovine, "Not Just an Office Romance," *New York Times* (November 8, 2001), F: 6; Mildred F. Schmertz, "Paul Rudolph," *Architectural Digest* 58 (December 2001): 162–69, 199; Andrew Mead, "Rudolph's Manhattan High-Rise Gets Makeover," *Architects' Journal* 214 (December 20-27, 2001): 18; Wendy Moonan, "A New Breed of Aficionado Comes of Age," *New York Times* (May 17, 2002), E, part 2: 37; Craig Kellogg, "Four Units, Furnished," *Interior Design* 73 (September 2002): 246–47; Roberto De Alba, *Paul Rudolph: The Late Work* (New York: Princeton Architectural Press, 2003), 68–77.

200. Goldberger, "Show of Rudolph's Work": 14.

201. Giovannini, "If There's Heaven, It Should Expect Changes": 1.

202. Sorkin, "The Light House": 88–89.

203. Schmertz, "Paul Rudolph": 199.

204. Joseph Giovannini, "An Architect's Last Word," *New York Times* (July 8, 2004), D: 1, 7.

205. Peter Arnell and Ted Bickford, eds., *Frank Gehry: Buildings and Projects* (New York: Rizzoli International Publications, 1985), 146–51; Anne-Marie Schiro, "Transforming a Manhattan Carriage House," *New York Times* (May 30, 1985), C: 1, 6; *The Architecture of Frank Gehry* (Minneapolis, Minn.: Walker Art Center; New York: Rizzoli International Publications, 1986), 58–59. For the carriage house, see *Upper East Side Historic District*, 400, 446. Another renovation of note was the 1987–90 reworking of 10 East Ninety-third Street (A. B. Ogden & Son, 1889) by Robert A. M. Stern Architects. See Elizabeth Kraft, ed., *Robert A. M. Stern: Buildings and Projects, 1987–1992* (New York: Rizzoli International Publications, 1992), 349.

206. Frank Gehry, quoted in Arnell and Bickford, eds., *Frank Gehry: Buildings and Projects*, 146.

207. Carol Vogel, "Catering to the Carriage Trade," *New York Times* (April 17, 1988), VI: 86–89; Nichols, Burke, and Hancock, eds., *Michael Graves: Buildings and Projects, 1982–1989*, 110–11; Flora Miller Biddle, *The Whitney Women and the Museum They Made: A Family Memoir* (New York: Arcade Publishing, 1999), 326–27. For Harney's building, see *Upper East Historic District*, 305.

208. Michael Graves, quoted in Vogel, "Catering to the Carriage Trade": 86, 89.

209. Vogel, "Catering to the Carriage Trade": 86, 89.

210. Biddle, *The Whitney Women and the Museum They Made: A Family Memoir*, 326.

211. *Upper East Side Historic District*, 448; Paul Goldberger, "A Teahouse Within a City Carriage House," *New York Times* (May 7, 1981), C: 10; Sarah Bodine, "Tea Architecture and Sensibility," *Metropolis* 1 (August-September 1981): 16–19; White and Willensky, *AIA Guide* (2000), 402.

212. Quoted in Goldberger, "A Teahouse Within a City Carriage House": 10.

213. Goldberger, "A Teahouse Within a City Carriage House": 10.

A TALE OF TWO MUSEUMS:
THE GUGGENHEIM AND THE WHITNEY

1. Landmarks Preservation Commission of the City of New York, LP-1775 (August 14, 1990), 14–15; Stern, Mellins, and Fishman, *New York 1960*, 807–20.

2. Landmarks Preservation Commission of the City of New York, LP-1775 (August 14, 1990), 15.

3. Paul Goldberger, "New Room at the Guggenheim," *New York Times* (June 15, 1978), C: 17; "Splendid Spinoff," *Progressive Architecture* 59 (October 1978): 68–71; *Richard Meier Architect: 1964/1984* (New York: Rizzoli International Publications, 1984), 228–31, 398–99; Lisa J. Green, ed., *Richard Meier: Architect* (New York: Monacelli Press, 1999), 289.

4. See Neil Levine, *The Architecture of Frank Lloyd Wright* (Princeton, N.J.: Princeton University Press, 1996), 224–52, 272, 303–5.

5. Goldberger, "New Room at the Guggenheim": 17.

6. "Guggenheim Museum Expansion Program," *Progressive Architecture* 59 (June 1978): 26, 31.

7. Peter Arnell and Ted Bickford, eds., *Charles Gwathmey and Robert Siegel: Buildings and Projects, 1964–1984* (New York: Harper & Row, 1984), 264–67; Paul Goldberger, "Guggenheim Museum Plans to Erect an 11-Story, $12 Million Addition," *New York Times* (February 19, 1985), C: 17; "Guggenheim Museum Announces Expansion Plan," *Architectural Record* 173 (April 1985): 73; "The Guggenheim Museum," *Progressive Architecture* 66 (April 1985): 28; Sarah Williams, "Controlled Tower," *Art News* 84 (summer 1985): 14, 16; Grace Glueck, "The Art Boom Sets Off a Museum Building Spree," *New York Times* (June 23, 1985), II: 1, 14; Paul Goldberger, "The Case for Keeping Wright's Vision of the Guggenheim," *New York Times* (November 10, 1985), II: 35; Paul Goldberger, "Modernism Reaffirms Its Power," *New York Times* (November 24, 1985), II: 1, 35; Ziva Freiman, "Gwathmey Siegel's Guggenheim: Redoing Wright," *Progressive Architecture* 66 (December 1985): 25; Lynn Nesmith, "Gwathmey Siegel's Guggenheim Addition Draws Mixed Reactions," *Architecture* 74 (December 1985): 11; Carter Wiseman, "Doing Right by Wright," *New York* 18 (December 2, 1985): 132–34; Charles Gwathmey, "Solomon R. Guggenheim Museum," in Suzanne Stephens, ed., *Building the New Museum* (New York: Architectural League of New York; Princeton, N.J.: Princeton Architectural Press, 1986), 70–75; Alan Plattus, "Response," in Stephens, ed., *Building the New Museum*, 82–83; "Discussion," in Stephens, ed., *Building the New Museum*, 84–88; Peter Lemos, "Museum Wars II," *Metropolis* 5 (January–February 1986): 16; Martin Filler, "Wright Wronged," *House & Garden* 158 (February 1986): 42, 44, 46, 48; "The Guggenheim Addition," *Oculus* 47 (February 1986): 4; Gwathmey Siegel & Associates, "The Environmental Impact Statement," *Oculus* 47 (February 1986): 3–4, 6, 12, 14; C. Ray Smith, "The Opinions: A Debate," *Oculus* 47 (February 1986): 3, 5, 11, 13, 15; Charles Reed Jr., "Guggenheim Reaction," letter to the editor, *Progressive Architecture* 67 (February 1986): 3, 5; Calvin Tomkins, "The Art World: Modern vs. Postmodern," *New Yorker* 61 (February 17, 1986): 58, 60–66; Michael Sorkin, "Leaving Wright Enough Alone," *Architectural Record* 174 (March 1986): 79, 81, 83; Andrea Oppenheimer Dean, "Wright's Guggenheim Museum Receives AIA's 25-Year Award," *Architecture* 75 (March 1986): 12–13, 16; "The Quest," *Friends of Kebyar* 4 (March-April 1986): 4; "Additions to the Guggenheim and Whitney Museums," *International Journal of Museum Management and Curatorship* 5 (March 1986): 92–95; "An Editorial," *Oculus* 47 (March 1986): 12; Percival Goodman, "The Guggenheim Spiral," *Oculus* 47 (March 1986): cover, 12–13; Klaus Herdeg and Romaldo Giurgola, "The Debate Continued," *Oculus* 47 (March 1986): 12; Halina Rosenthal, "The Debate Continued," letter to the editor, *Oculus* (March 1986): 13; Manuela Hoelterhoff, "Death by Design: How to Murder a Monument," *Wall Street Journal* (March 18, 1986): 26; "News Briefs," *Architectural Record* 174 (April 1986): 49; "The Great Museum Debate," *Oculus* 47 (April 1986): 4–5, 14–16; Edgar Kaufmann Jr., "A Statement by Edgar Kaufmann Jr.," *Oculus* 47 (April 1986): 19; Wolf Von Eckardt, Raul de Armas, and William Pedersen, "Guggenheim Letters," letters to the editor, *Oculus* 47 (April 1986): 19; Susan S. Szenasy, "Defending Their Own," *Metropolis* 5 (May 1986): 17; Daralice D. Boles, "Update on the Guggenheim," *Progressive Architecture* 67 (May 1986): 25, 32, 34; Nan Robertson, "Guggenheim Dramatizes Space Woes," *New York Times* (May 21, 1986), C: 21; Joseph W. Ketas, Gerry Kelpin, Klaus Herdeg, Bruno Zevi, Michael Levy, Edward Frank, and Giorgio Cavaglieri, "Letters," *Oculus* 47 (June 1986): 14–15; George Lewis, "Notes on the Year," *Oculus* 47 (June 1986): 3; Manuela Hoelterhoff, "The Wrong Way to Expand Wright's Museum," *Wall Street Journal* (June 17, 1986): 26; Douglas C. McGill, "Guggenheim Plan Debated at Hearing," *New York Times* (June 26, 1986), C: 17; Lynn Nesmith, "Proposed Guggenheim Addition Debated at Municipal Hearing," *Architecture* 75 (August 1986): 10–12; John Taylor, "Avant Guardians," *Manhattan, inc.* 3 (August 1986): 72–80; "Architects Join Guggenheim Foes," *New York* 19 (August 4, 1986): 12; George Lewis, "The Guggenheim Design at the Board of Standards and Appeals," *Oculus* 47 (September 1986): 2; Eric Gibson, "Two Proposals for the 90s," *Studio International* 199 (September 1986): 4–11; Sandy Heck, "Guggenheim Dilemma," *Building Design* (September 12, 1986): 30–35; Douglas C. McGill, "Guggenheim Neighbors Offer Alternative Plan," *New York Times* (September 18, 1986), C: 25; George Ike Okoye, "Letters," *Architectural Record* 180 (October 1986): 4; Peter Lemos, "Guggenheim: Wright or Wrong?" *Metropolis* 6 (October 1986): 32–33; Douglas C. McGill, "Guggenheim Would Alter New Design," *New York Times* (October 25, 1986): 50; Joseph Giovannini, "Guggenheim Hearings to Reopen," *New York Times* (October 30, 1986), C: 28; Anand D. Godse, "Letters," *Architectural Record* 174 (December 1986): 4; Lynn Nesmith, "Whitney and Guggenheim: The Controversies Continue," *Architecture* 75 (December 1986): 30, 32; *The Chicago Tapes:*

Transcript of the Conference at the University of Illinois at Chicago, November 7 and 8, 1986 (New York: Rizzoli International Publications, 1987), 144–51.

8. Goldberger, "Guggenheim Museum Plans to Erect an 11-Story, $12 Million Addition": 17.

9. Arthur Rosenblatt, quoted in Williams, "Controlled Tower": 16.

10. Goldberger, "The Case for Keeping Wright's Vision of the Guggenheim": 35.

11. Martin Filler, quoted in Smith, "The Opinions: A Debate": 11, 13.

12. Victoria Newhouse, quoted in Smith, "The Opinions: A Debate": 13.

13. Henry N. Cobb and Kevin Roche, quoted in Nesmith, "Gwathmey Siegel's Guggenheim Addition Draws Mixed Reactions": 11.

14. Von Eckardt, "Guggenheim Letters": 19.

15. Wiseman, "Doing Right by Wright": 132, 134.

16. Quoted in Nesmith, "Gwathmey Siegel's Guggenheim Addition Draws Mixed Reactions": 11.

17. Richard Meier, quoted in "The Great Museum Debate": 14.

18. Peter Eisenman, quoted in "The Great Museum Debate": 14–15. For the Masieri memorial, see Levine, *The Architecture of Frank Lloyd Wright*, 374–83.

19. Hoelterhoff, "Death by Design: How to Murder a Monument": 26.

20. Boles, "Update on the Guggenheim": 32, 34.

21. Michael Sorkin, quoted in Nesmith, "Proposed Guggenheim Addition Debated at Municipal Hearing": 11.

22. Alistair Cooke, quoted in Nesmith, "Proposed Guggenheim Addition Debated at Municipal Hearing": 11.

23. "Guggenheim Opposition Goes Underground," *Architectural Record* 174 (November 1986): 61; Michael Kwartler & Associates, "Guggenheim Expansion Underground?" *Oculus* 48 (November 1986): 4–6, 14–15.

24. Gwathmey Siegel & Associates Architects, *The Guggenheim Museum Addition: Scheme II* (New York, 1987); Lynn Nesmith, "Guggenheim Unveils Modified Gwathmey Siegel Addition," *Architecture* 76 (March 1987): 40, 42; David Morton, "Guggenheim Revision," *Progressive Architecture* 68 (March 1987): 40, 43; "Board Approves Zoning in Guggenheim Plan," *New York Times* (March 13, 1987), C: 32; Ada Louise Huxtable, "Creeping Gigantism in Manhattan," *New York Times* (March 22, 1987), II: 1, 36; Manuela Hoelterhoff, "Guggenheim Plan Is Wrong for Wright," *Wall Street Journal* (March 23, 1987): 29; Kay Larson, "Heir Heads," *New York* 20 (March 30, 1987): 94–95; Paul Sachner, "A Far, Far Better Thing: The Guggenheim and Whitney Redesign Their Expansion Schemes," *Architectural Record* 175 (April 1987): 45, 157; Victoria Geibel, "What Wright Has Wrought," *Metropolis* 6 (April 1987): 20–21; "The Guggenheim Museum Announces Revised Expansion Plans," *Oculus* 48 (April 1987): cover, 2; Gwathmey Siegel & Associates Architects, "The Guggenheim Museum Addition: Scheme II," *Oculus* 48 (April 1987): 3–5; Joseph Giovannini, "Museum Piece," *Artforum* 25 (May 1987): 2–5; Peter Lawson-Johnston, "The Wright Site," letter to the editor, *New York Times* (May 10, 1987), II: 11; "Two Museums, Two Steps Forward," editorial, *New York Times* (June 4, 1987): 26; Martin Filler, "Square One, Round Two," *House & Garden* 159 (July 1987): 16; Charles Boxenbaum, "A Guggenheim Proposal," letter to the editor, *Architecture* 76 (August 1987): 6; Charles Boxenbaum, "Making the Guggenheim an Architecture Museum," *New York Times* (August 27, 1987): 26; Robin Chandler Duke, "The Guggenheim Needs Space, Not Pipe Dreams," *New York Times* (September 18, 1987): 38; Charles Boxenbaum, "Letters," *Architectural Record* 175 (October 1987): 4; "Gwathmey Siegel's Guggenheim Addition Wins Final Approval," *Architecture* 76 (December 1987): 35, 40; "Pencil Points," *Progressive Architecture* 68 (December 1987): 24; "The Guggenheim Museum, 1071 Fifth Avenue," *Friends of the Upper East Side Historic Districts* (January 1988): 1; Charles Bagli, "Board of Estimate Votes to Review Variances for Guggenheim Addition," *New York Observer* (January 4, 1988): 9; "The Guggenheim's Glut," editorial, *Wall Street Journal* (January 8, 1988): 18; Douglas C. McGill, "Guggenheim Expansion Plan Upheld," *New York Times* (January 15, 1988), C: 27; "Guggenheim Addition," *Oculus* 50 (March 1988): 2–3, 14–15; "Manhattan Museum Additions: A Discussion with Charles Gwathmey and Michael Graves," *Colonnade* 3 (Summer 1988): 15–17; Martin Filler, "Playing 'Beat the Clock' with the Guggenheim," *New York* 21 (July 30, 1988): 25; "Guggenheim Foes Won't Give Up," *New York* 21 (August 15, 1988): 10; Charles V. Bagli, "Guggenheim Museum's Age at Issue in Battle Over 10-Story Addition," *New York Observer* (September 19, 1988): 6; "Museums in Expansion," *New York Observer* (October 10, 1988): 2; "The Guggenheim Museum Addition," *Architecture + Urbanism* (April 1989): 124–27; Vernon Mays, "Revealing Wright," *Progressive Architecture* 70 (April 1989): 82–85; Carter Wiseman, "Beware the Design Police," *New York* 22 (May 22, 1989): 64–65; "Update," *Oculus* 52 (November 1989): 3; Peter Barna and Justin Henderson, "Lighting Wright," *Architecture* 79 (March 1990): 191–95; "The Guggenheim Museum," *Friends of the Upper East Side Historic Districts Newsletter* (Fall-Winter 1990): 8–9; Michael Sorkin, "Forms of Attachment," *Lotus International* 72 (1992): 91–95; Stephen A. Kliment, "Doing the Right Thing," *Architectural Record* 180 (January 1992): 86–88.

25. Gwathmey Siegel & Associates Architects, *The Guggenheim Museum Addition: Scheme II*, 1.

26. Huxtable, "Creeping Gigantism in Manhattan": 36.

27. Ada Louise Huxtable's reply to Lawson-Johnston, "The Wright Site": 11.

28. Hoelterhoff, "Guggenheim Plan Is Wrong for Wright": 29.

29. Jeanie Kasindorf, "Museum May Be Wooing Williams Man," *New York* 20 (May 11, 1987): 13; "The Guggenheim's

Man," *New York Times* (January 17, 1988), IV: 7.

30. Halina Rosenthal, "Letter," *Friends of the Upper East Side Historic Districts* (September 13, 1989); Landmarks Preservation Commission of the City of New York, LP-1774 (August 14, 1990); Landmarks Preservation Commission of the City of New York, LP-1775 (August 14, 1990); "Guggenheim Museum Is Designated a Landmark," *New York Times* (August 19, 1990): 24; Halina Rosenthal, "Letter," *Friends of the Upper East Side Historic Districts* (August 14, 1990); "The Guggenheim Museum," *Friends of the Upper East Side Historic Districts Newsletter* (Fall/Winter 1990): 8–9; "Details," *Architecture* 79 (October 1990): 22; Barbaralee Diamonstein, *The Landmarks of New York III* (New York: Harry N. Abrams, 1998), 435.

31. "The Guggenheim Museum," *New York Observer* (April 30, 1990): 26; Grace Glueck, "At Guggenheim, Changing the Changes," *New York Times* (October 15, 1990), C: 13, 15; Andrea Oppenheimer Dean, "Renewing Our Modern Legacy," *Architecture* 79 (November 1990): 66–69; Grace Glueck, "Guggenheim Withdraws Design Change," *New York Times* (November 28, 1990), C: 18; Clare McHugh, "Costly Building," *New York Observer* (May 20, 1991): 3; Grace Glueck, "In Guggenheim Restoration, Wright Laughs Last," *New York Times* (August 12, 1991), C: 11–12; Thomas M. Messer, "At Guggenheim Museum, Dialogue with Wright Never Ends," letter to the editor, *New York Times* (September 13, 1991): 24; Clare McHugh, "Recasting the Guggenheim," *New York Observer* (September 9, 1991): 3, 19; "The Guggenheim Museum," *Oculus* 54 (November 1991): 4; "Reopening of Guggenheim Museum Is Postponed Until May," *New York Times* (November 11, 1991), C: 11; Jeannette Walls, "News and Notes from All Over," *New York* 24 (December 2, 1991): 28; Christine Pittel, "Finally: The Guggenheim as Wright Conceived It," *House Beautiful* 134 (June 1992): 82–88, 134; Kay Larson, "The Wright Stuff," *New York* 25 (June 1, 1992): 34–35; John Taylor, "Born Again: The New Guggenheim," *New York* 25 (June 1, 1992): cover, 30–33, 36; Catherine Drillis, "Getting It Wright," *Our Town* 23 (June 13, 1992): cover, 13; Paul Goldberger, "The Liberation of the Guggenheim," *New York Times* (June 21, 1992), II: 1, 26; Michael Kimmelman, "At the Guggenheim, Bigger May Be Better," *New York Times* (June 21, 1992), II: 26; Martin Filler, "Back into the Box," *Design Quarterly* 156 (Summer 1992): 6–9; Christopher Knight, "The Guggenheim's Grand Reopening," *Los Angeles Times* (June 26, 1992), F: 1, 16; Michael Kimmelman, "Guggenheim: Virtue Rewarded and Flaws Fixed," *New York Times* (June 26, 1992), C: 3; "Evening Hours: Guggenheim in a New Light," *New York Times* (June 28, 1992), IX: 6; Bob Morris, "The Night: High Life," *New York Times* (June 28, 1992), IX: 6–7; Roberta Smith, "Guggenheim Reopens on a New Chapter," *New York Times* (June 29, 1992), C: 11, 14; Carol Vogel, "Lining Up to Inspect an Old Friend," *New York Times* (June 29, 1992), C: 11, 14; Cathleen McGuigan, "Do the Wright Thing," *Newsweek* 119 (June 29, 1992): 58–59, 62; "Pencil Points," *Progressive Architecture* 73 (July 1992): 18; Roger Kimball, "Rehabbed Guggenheim Museum's Coming-Out Party," *Wall Street Journal* (July 2, 1992): 5; Kurt Andersen, "Finally Doing Right by Wright," *Time* 140 (July 6, 1992): 64–65; Nancy Levinson, "Fifth Avenue Curves," *Christian Science Monitor* (July 13, 1992): 10; John Richardson, "Go Go Guggenheim," *New York Review of Books* (July 16, 1992): 18–22; Brendan Gill, "The Sky Line: Pure Wright," *New Yorker* 68 (July 27, 1992): 67–71; Mildred F. Schmertz, "Wright Revamped," *Architecture* 81 (August 1992): 34–41; Hilton Kramer, "Dispersing a Museum Collection," *New Criterion* 10 (September 1992): 4–7; Mildred F. Schmertz, "Disfiguring a Landmark," *New Criterion* 10 (September 1992): 8–11; John Morris Dixon, "Guggenheim Reopens, Expanded and Renovated," *Progressive Architecture* 73 (August 1992): 13–14; "Born Again," *Architectural Record* 190 (October 1992): 100–101; Carter Wiseman, "Guggenheim Go-Around," *Architectural Record* 190 (October 1992): 102–3; Charles Gwathmey, "On Wright's Foundations," *Architectural Record* 190 (October 1992): 104–3; Edward Frank and Robert McCarter, "Guggenheim Design Debate," letters to the editor, *Architectural Record* 190 (December 1992): 2; Gwathmey Siegel: *Buildings and Projects, 1982–1992*, eds. Brad Collins and Diane Kasprowicz (New York: Rizzoli International Publications, 1993), 16–37; "Gwathmey Siegel," *Architecture + Urbanism* (January 1993): 72–86; Kenneth Frampton, "Usonia Revisited: The Recasting of the Guggenheim," *Architecture + Urbanism* (January 1993): 87–89; Stanley Allen, "The Guggenheim Re-figured," *Architecture + Urbanism* (March 1993): 3–11; Jack Quinan, "Frank Lloyd Wright's Guggenheim Museum: A Historian's Report," *Journal of the Society of Architectural Historians* 52 (December 1993): 466–82; Victor A. Cusack, "Guggenheim Redux," *Journal of the Taliesin Fellows* 13 (Winter 1993–94): 12–18, 21; Carol Vogel, "Inside Art," *New York Times* (January 14, 1994), C: 24; Michael J. Crosbie, "Falling Water," *Progressive Architecture* 76 (March 1995): 64–67; Michael J. Crosbie, "Selected Detail: Guggenheim Skylight," *Progressive Architecture* 76 (March 1995): 95; Susanna Sirefman, *New York: A Guide to Recent Architecture* (London: Ellipsis, 1997), 204–7; Gwathmey Siegel & Associates Architects: Selected and Current Works (Mulgrave, Australia: Images Publishing, 1998), 16–21, 229, 234; Paul Spencer Byard, *The Architecture of Additions* (New York: W. W. Norton, 1998), 142–44; Victoria Newhouse, *Towards a New Museum* (New York: Monacelli Press, 1998), 162–68; White and Willensky, *AIA Guide* (2000), 425–26; Luca Molinari, *Atlas: North American Architecture Trends, 1990–2000* (Milan: Marazzi Gruppo Ceramiche, 2001), 18–23.

32. Goldberger, "The Liberation of the Guggenheim": 1, 26.

33. Filler, "Back into the Box": 7–9.

34. Schmertz, "Disfiguring a Landmark": 10–11.

35. Wiseman, "Guggenheim Go-Around": 102–3.

36. Gwathmey, "On Wright's Foundations": 104.

37. Carol Vogel, "Guggeheim Honors the LeFraks," *New York Times* (December 14, 1993), C: 19; Carol Vogel, "$10 Million Buys Immortality," *New York Times* (December 19, 1993), IV: 2; Edward Cortese, "Guggenheim Museum to Keep Its Name," letter to the editor, *New York Times* (February 11, 1994): 34; Suzanne Stephens, "The Guggenheim Way to Architectural Heaven," *Oculus* 56 (March 1994): 6; Carol Vogel, "A Landmark's Changing Face," *New York Times* (March 11, 1994), C: 26; "Wright Wronged," editorial, *Wall Street Journal* (April 8, 1994): 14; Suzanne Stephens, "The Gugg as a Signboard," *Oculus* 56 (May 1994): 4; Carol Vogel, "Clash Over Name Puts Museum Gift in Doubt," *New York Times* (December 17, 1994): 13; Carol Vogel, "Inside Art," *New York Times* (March 3, 1995), C: 24.

38. Stephens, "The Guggenheim Way to Architectural Heaven": 6. For Lefrak City, see Stern, Mellins, and Fishman, *New York 1960*, 994–96.

39. Byard, *The Architecture of Additions*, 145.

40. Newhouse, *Towards a New Museum*, 166–67.

41. For Breuer and Smith's Whitney, see Stern, Mellins, and Fishman, *New York 1960*, 824–30. For the Whitney at 22 West Fifty-fourth Street, see Stern, Mellins, and Fishman, *New York 1960*, 477–79.

42. Bernard P. Spring, "Evaluation: The Whitney Suffers from Success," *Journal of the American Institute of Architects* 67 (September 1978): 40–47.

43. John Morris Dixon, "Whitney Museum of American Art," *Architectural Forum* 125 (September 1966): 80–85, quoted in Spring, "Evaluation: The Whitney Suffers from Success": 42.

44. Spring, "Evaluation: The Whitney Suffers from Success": 43.

45. John Russell, "'200 Years of Sculpture' Honors Nation," *New York Times* (March 17, 1976): 36; Hilton Kramer, "A Monumental Muddle of American Sculpture," *New York Times* (March 28, 1976), II: 1, 34; "2 Sculptors Seek to Withdraw Work from Whitney Show," *New York Times* (March 31, 1976): 43; Stanislaus von Moos, *Venturi, Rauch & Scott Brown: Buildings and Projects* (New York: Rizzoli International Publications, 1987), 330.

46. Flora Miller Biddle, *The Whitney Women and the Museum They Made: A Family Memoir* (New York: Arcade Publishing, 1999), 220.

47. "Industrial Materials and Techniques Become Art at Foster Associates," *Architectural Record* 166 (mid-August 1979): 54–55; Ada Louise Huxtable, "Architecture: 'Bigger–And Maybe Better,'" *New York Times* (August 26, 1979): 25–26; Eleni Constantine, "Whitney Tower by Foster Stalled," *Progressive Architecture* 60 (October 1979): 26; "A New York Ampliamento Del Whitney Museum," *Domus* (November 1979): 20–23; "Museum Extension, New York," *Architectural Review* 167 (January 1980): 14–15; "Projet d'extension du Whitney Museum, New York," *Architecture d'Aujourd'hui* 207 (February 1980): 46–48; "Whithcy[sic] Museum Development," *Architecture + Urbanism* (October 1980): 121–23; White and Willensky, *AIA Guide* (1988), 373; Tim Ostler, "Whitney Development," in Norman Foster, *Foster Associates: Buildings and Projects*, vol. 3 (Hong Kong: Watermark, 1989), 68–73.

48. Huxtable, "Architecture: 'Bigger–And Maybe Better'": 26.

49. For Foster's Hong Kong skyscraper, see Foster, *Foster Associates: Buildings and Projects*, vol. 3, 112–255.

50. Norman Foster, quoted in Ostler, "Whitney Development," in Foster, *Foster Associates: Buildings and Projects*, vol. 3, 70. For the Carlyle, see Stern, Gilmartin, and Mellins, *New York 1930*, 403–5.

51. Grace Glueck, "How Will the Whitney Develop Its New Land?" *New York Times* (February 28, 1981): 11.

52. Grace Glueck, "Graves Named to Design Addition to the Whitney," *New York Times* (October 18, 1981): 69; Susan Doubilet, "Mixing Breuer and Graves," *Progressive Architecture* 63 (December 1981): 36; Sarah Williams, "Galleries for Tomorrow's Art," *Art News* 83 (November 1984): 9–10; "Whitney Museum Plans $37.5 Million Addition," *New York Times* (May 22, 1985): 1; Paul Goldberger, "A Daring and Sensitive Design," *New York Times* (May 22, 1985), C: 20; Douglas C. McGill, "Whitney Addition Is Planned," *New York Times* (May 22, 1985), C: 20; Enid Nemy, "Architect Castigates Whitney Plan," *New York Times* (June 21, 1985), C: 15; Michael Sorkin, "Save the Whitney," *Village Voice* (June 25, 1985): 104, reprinted in Michael Sorkin, *Exquisite Corpse: Writing on Buildings* (London and New York: Verso, 1991), 119–24; "Whitney Museum Expansion Proposal Seeks a Reconciliation of Opposites," *Architectural Record* 173 (July 1985): 65; Pilar Viladas, "Graves's Whitney Plans," *Progressive Architecture* 66 (July 1985): 23; Charlotte Curtis, "Drawing the Battle Lines," *New York Times* (July 2, 1985), C: 8; Hamilton Smith, "Architecture That Disserves New York: Don't Ruin the Whitney," *New York Times* (July 20, 1985): 23; Douglas C. McGill, "Architects Debate Plan for Whitney Museum," *New York Times* (July 26, 1985), C: 26; Lynn Nesmith, "Controversy Brews Over Graves' Whitney Addition," *Architecture* 74 (August 1985): 11–12; Thomas Hoving, "My Eye: An Open-and-Shut Letter," *Connoisseur* 215 (August 1985): 9; Martin Filler, "The Sum of Its Arts," *House & Garden* 157 (August 1985): 80–81, 169; Beverly Russell, "Remodeling the Future," *Interiors* 145 (August 1985): 147, 211; Gibson A. Danes, "A Whitney Designed for 21st-Century Use," letter to the editor, *New York Times* (August 1, 1985): 18; Paul Goldberger, "For the Whitney, Adding Less May Result in More," *New York Times* (August 11, 1985), II: 31; Carter Wiseman, "Graves Questions at the Whitney," *New York* 18 (August 19, 1985): 74–75; Lynn Nesmith, "The Whitney: A Chance for Presentation and Discussion," *Architecture* 74 (September 1985): 48–49; Peter Lemos, "Scene + Heard: The Once and Future Whitney," *Metropolis* 5 (September 1985): 16; Hilton Kramer, "The Whitney's New Graves," *New Criterion* 4 (September 1985): 1–3; Daralice D. Boles, "Commentary: The Whitney Design

Debate," *Progressive Architecture* 66 (September 1985): 25; George Lewis, "The Whitney: Keen Interest in Michael Graves's Design," *Oculus* 47 (September 1985): 12–13; Roger Kimball, "Michael Graves Tackles the Whitney," *Architectural Record* 173 (October 1985): 113, 115; Ronald E. Zocher, "Letters," *Architectural Record* 173 (October 1985): 4; "Whitney Stalls Approval Process," *Architecture* 74 (October 1985): 18; Stephen H. Gabrielson, "Letters," *Architecture* 74 (October 1985): 6; Cynthia Nadelman, "An Inappropriate Appropriation," *Art News* 84 (October 1985): 188; Peter Lemos, "Marcel and Michael (and Philip)," *Metropolis* 5 (October 1985): 10; "News Briefs," *Architectural Record* 173 (November 1985): 67; Lynn Nesmith, "Petition Protesting Proposal Submitted to Whitney," *Architecture* 74 (November 1985): 24, 28; Joseph Giovannini, "A Grave Situation for Marcel Breuer's Whitney," *Artforum* 24 (November 1985): 84–86; "The Whitney Museum," *Progressive Architecture* 66 (November 1985): 24; Bob Dial and Caldwell R. Dial Jr., "Whitney Addition: The Next Episode?" letter to the editor, *Progressive Architecture* 66 (November 1985): 11; "Neighbors Criticize Plan to Expand Whitney," *New York Times* (November 14, 1985), C: 33; Douglas C. McGill, "Expansion at Whitney: The Debate Broadens," *New York Times* (November 26, 1985), C: 17; "Whitney Museum of American Art, New York," *Architecture + Urbanism* (December 1985): 49; Wiseman, "Doing Right by Wright": 132–34; Michael Graves, "The Museum of Art and Archaeology at Emory University and the Whitney Museum of American Art," in Stephens, ed., *Building the New Museum*, 76–81; Alan Plattus, "Response," in Stephens, ed., *Building the New Museum*, 82–83; "Discussion," in Stephens, ed., *Building the New Museum*, 84–88; Suzanne Stephens, "Conclusion," in Stephens, ed., *Building the New Museum*, 92–93; Matthew Arnold, Michael Faber, and Caldwell R. Dial Jr., letters to the editor, *Architectural Record* 174 (January 1986): 12; Julie Collins, "Graves's Humana Center and Whitney Addition: Issues of Context and Public Scrutiny," *Harvard University, Graduate School of Design News* 14 (January-February 1986): 7–8; Suzanne Stephens, "A Confrontation in Context," *Manhattan, inc.* 3 (January 1986): 141–44; "Landmarks Under 30," *Oculus* 47 (January 1986): 15; Richard R. Mazer, "Whitney Words," letter to the editor, *Progressive Architecture* 67 (January 1986): 11; Pascal Quintard-Hofstein, "Michael Graves Frappe à New York," *Section A* 3 (January 1986): 39–41; "Cloaked in Controversy," *Architectural Record* 174 (February 1986): 65; Calvin Tomkins, "The Art World: Modern vs. Postmodern," *New Yorker* 61 (February 17, 1986): 58, 60–66; "The Quest Whitney?" *Friends of Kebyar* 4 (March-April 1986): 4; G. Gregory Dovey, "A Graves Mistake? Letter to Architecture Magazine," *Friends of Kebyar* 4 (March-April 1986): 5; "Additions to the Guggenheim and Whitney Museums," *International Journal of Museum Management and Curatorship*: 92–95; Hoelterhoff, "Death by Design: How to Murder a Monument": 26; Tician Papachristou and Ad Hoc Committee to Save the Whitney, "Whitney Letters," letters to the editor, *Oculus* 47 (April 1986): 18; "Pencil Points," *Progressive Architecture* 67 (April 1986): 26; Frances Halsband, Mildred F. Schmertz, and John M. Dixon, letters to the editor, *Oculus* 47 (May 1986): 10; George Lewis, "Notes on the Year," *Oculus* 47 (June 1986): 3; Richard Haitch, "Art Museum in Esthetic Clash," *New York Times* (June 15, 1986): 41; Jeanie Kasindorf, "Intelligencer: Whitney Museum Turns Neighborly," *New York* 19 (August 11, 1986): 9; Gibson, "Two Proposals for the 90s": 4–11; Nesmith, "Whitney and Guggenheim: The Controversies Continue": 30, 32; Lenore M. Lucey, "Names and News," *Oculus* 48 (December 1986): 13; "Court Rebuffs the Whitney on Tenants," *New York Times* (January 24, 1987): 13; Douglas C. McGill, "The Whitney Unveils Smaller Expansion Plan," *New York Times* (March 11, 1987), C: 19; Paul Goldberger, "Adding a Little Less to the Whitney," *New York Times* (March 15, 1987), II: 33; Huxtable, "Creeping Gigantism in Manhattan": 1, 36; Kay Larson, "Heir Heads," *New York* 20 (March 30, 1987): 94–95; Sachner, "A Far, Far Better Thing: The Guggenheim and Whitney Redesign Their Expansion Schemes": 45, 157; "The Whitney Museum in New York City," *Architecture* 76 (April 1987): 20; "The Whitney Museum Announces Revised Expansion Plans," *Oculus* 48 (April 1987): cover, 6–7; Daralice D. Boles, "Revised Whitney Unveiled," *Progressive Architecture* 68 (April 1987): 27, 29; Eric Wolf, "Maintaining the Whitney," letter to the editor, *New York Times* (April 12, 1987), II: 35; Joseph Giovannini, "Museum Piece," *Artforum* 25 (May 1987): 2–5; Victoria Geibel, "Growing Pains," *Metropolis* 6 (May 1987): 22–23; Constance Breuer, "Would Marcel Breuer Approve of the Whitney Addition?" letter to the editor, *New York Times* (May 24, 1987), II: 25; David W. Dunlap, "Whitney Expansion Raises Preservation Issue," *New York Times* (May 24, 1987): 25; "Two Museums, Two Steps Forward," editorial, *New York Times* (June 4, 1987): 26; "Whitney Proposal Wins Backing of Local Board," *New York Times* (June 19, 1987), C: 3; Lynn Nesmith, "Graves's Whitney Addition Debated at Landmarks Hearing," *Architecture* 76 (July 1987): 15–16, 18; Martin Filler, "Growing Pains," *Art in America* 75 (July 1987): 14–19; Martin Filler, "Square One, Round Two," *House & Garden* 159 (July 1987): 16; Robert F. Gatje, "Whitney Addition Design," letter to the editor, *Progressive Architecture* 68 (July 1987): 9; John Helmeke, letter to the editor, *Architectural Record* 175 (August 1987): 4; "Novo Progetto per L'espansione del Whitney Museum," *Domus* (September 1987): 3; Tom Armstrong, "Introduction," in *Bulletin of the Whitney Museum of American Art, 1986–1987* 9 (Fall 1987): 11–12; "Graves Unhinges the Whitney," *New York* 21 (March 21, 1988): 14; "Manhattan Museum Additions: A Discussion with Charles Gwathmey and Michael Graves": 15–19; Carter B. Horsley, "Gehry at the Whitney," *New York Post* (July 14, 1988): 54; Thomas Hoving, "The Critic Smiles," *Connoisseur* 218 (September 1988): 48, 52; Frank Gehry, "Gehry Stands by Graves Design for the Whitney," letter to the editor,

New York Post (September 1, 1988): 78; "Museums in Expansion": 2; Paul Goldberger, "3d Try on an Expansion Design for the Whitney," *New York Times* (December 20, 1988), C: 19; Carter B. Horsley, "Modern Masterpiece Deserves TLC," *New York Post* (December 22, 1988): 59, 61; Paul Goldberger, "The Whitney Paradox: To Add Is to Subtract," *New York Times* (January 8, 1989), II: 31, 34; Lynn Nesmith, "Whitney Museum Unveils Graves's Third Scheme," *Architecture* 78 (February 1989): 22; "The Proposed Whitney Expansion No. 3," *Oculus* 51 (February 1989): 9; Mark Alden Branch, "Another Try for Graves and Whitney," *Progressive Architecture* 70 (February 1989): 21–22; Carter Wiseman, "Beware the Design Police," *New York* 22 (May 22, 1989): 64–65; Sylvia Lavin, "Interiors Viewpoint," *Interiors* 148 (June 1989): 17, 19, 21, 23, 25; Grace Glueck, "Troubles at the Whitney, Both at the Top and in the Future," *New York Times* (December 26, 1989), C: 15, 26; Karen Vogel Nichols, Patrick J. Burke, and Caroline Hancock, eds., *Michael Graves: Buildings and Projects, 1982–1989* (New York: Princeton Architectural Press, 1990), 234–39, 316–17; "The Whitney Museum: Oh No Not Again! Well Maybe . . . ," *Friends of the Upper East Side Historic Districts* 5 (Fall/Winter 1990): 9–10; "The Whitney Museum," *Oculus* 54 (November 1991): 4; Michael Sorkin, "Forms of Attachment: Additions to Modern American Monuments," *Lotus International* 72 (1992): 91–95; Stephen A. Kliment, "Doing the Right Thing," *Architectural Record* 180 (January 1992): 86–88; "Whitney Scraps Graves Plan," *Architectural Record* 180 (April 1992): 30; Herbert Muschamp, "Considering the Once and Future Whitney Museum," *New York Times* (November 17, 1996), II: 42; Byard, *The Architecture of Additions*, 151–53; Newhouse, *Towards a New Museum*, 138–39, 169–70; Biddle, *The Whitney Women and the Museum They Made: A Family Memoir*, 267–81, 314, 318–27, 332–39, 358–61, 367.

53. For Kahn's building, see Vincent J. Scully, "The Yale Center for British Art," *Architectural Record* 161 (June 1977): 95–104; Patricia Cummings Loud, *The Art Museums of Louis I. Kahn* (Durham, N.C., and London: Duke University Press, 1989), 172–243.

54. Doubilet, "Mixing Breuer and Graves": 36.

55. "Museum Projects: Master of Science, Building Design, Second Year Studio, Master of Architecture," *Precis* 4 (1983): 70–77.

56. William MacDonald, quoted in "Museum Projects: Master of Science, Building Design, Second Year Studio, Master of Architecture": 73.

57. Richard Levitz, quoted in "Museum Projects: Master of Science, Building Design, Second Year Studio, Master of Architecture": 77.

58. Transcript of Arthur Drexler's review, May 17, 1982, Columbia University.

59. Michael Graves, quoted in McGill, "Whitney Addition Is Planned": 20.

60. Goldberger, "A Daring and Sensitive Design": 20.

61. Goldberger, "A Daring and Sensitive Design": 20.

62. Lemos, "Scene + Heard: The Once and Future Whitney": 16.

63. Abraham W. Geller, quoted in Nemy, "Architect Castigates Whitney Plan": 15.

64. Kramer, "The Whitney's New Graves": 2.

65. Sorkin, "Save the Whitney": 104.

66. Smith, "Architecture That Disserves New York: Don't Ruin the Whitney": 23.

67. Vincent Scully, quoted in Nesmith, "The Whitney: A Chance for Presentation and Discussion": 49.

68. Kimball, "Michael Graves Tackles the Whitney": 113, 115.

69. Goldberger, "For the Whitney, Adding Less May Result in More": 31.

70. Nadelman, "An Inappropriate Appropriation": 188.

71. Stephens, "A Confrontation in Context": 143.

72. Filler, "Growing Pains": 16. For Citicorp Center, see Stern, Mellins, and Fishman, *New York 1960*, 490–99.

73. Michael Graves, quoted in "Discussion," in Stephens, ed., *Building the New Museum*, 85–86.

74. Stephens, "A Confrontation in Context": 143.

75. Stephens, "A Confrontation in Context": 144.

76. Tomkins, "The Art World: Modern vs. Postmodern": 65.

77. Goldberger, "Adding a Little Less to the Whitney": 33.

78. Geibel, "Growing Pains": 22.

79. Filler, "Growing Pains": 16.

80. Landmarks Preservation Commission of the City of New York, *Upper East Side Historic District Designation Report* (New York, 1981), 1044–47.

81. Brendan Gill, quoted in Dunlap, "Whitney Expansion Raises Preservation Issue": 25.

82. Goldberger, "The Whitney Paradox: To Add Is to Subtract": 31.

83. "Whitney Planning $13.5 Million Expansion," *New York Times* (August 20, 1995), IX: 1; Carol Vogel, "$14 Million Expansion Planned by the Whitney," *New York Times* (September 20, 1995), C: 14; "Gluckman to Redo Whitney Museum," *Architectural Record* 183 (November 1995): 19; Bradford A. McKee, "Whitney Museum Announces Expansion," *Architecture* 84 (November 1995): 23; "Whitney Museum Expansion," *Oculus* 58 (November 1995): 3; "Once Burned, Twice Shy at the Whitney," *Progressive Architecture* 76 (November 1995): 19; Ned Cramer, "The Whitney Turns 30," *Architecture* 85 (October 1996): 41; Jeffrey Kastner, "Whitney Expansion," *Art News* 95 (October 1996): 60; Karrie Jacobs, "Modern Rocks," *New York* 30 (November 24, 1997): 24; Newhouse, *Towards a New Museum*, 169–70; "Covert Expansion at the Whitney," *ANY* 22 (1998): 27; Carol Vogel, "Inside Art: Names for Dollars," *New York Times* (February 20, 1998), E: 34; Philip Nobel, "Revamping the Whitney," *Metropolis* 17 (February-March 1998): 50; Karrie Jacobs, "Faulty Towers," *New York* 31 (March 16, 1998): 57; Louis Begley, "At the Whitney, Some New Rooms with a View," *Wall Street Journal* (April 9, 1998): 21; Edward R. Roehm, "Breuer's

Box," letter to the editor, *Metropolis* 17 (May 1998): 15; Allan Schwartzman, "Expanding an Icon," *Architecture* 87 (June 1998): 108–13; *Space Framed: Richard Gluckman Architect* (New York: Monacelli Press, 2000), 102–7, 209, 239. For the Warhol museum, see Karen D. Stein, "Home Again: The Andy Warhol Museum," *Architectural Record* 182 (September 1994): 74–79. For 31 and 33 East Seventy-fourth Street, see *Upper East Side Historic District*, 721–22.

84. Roehm, "Breuer's Box": 15.

85. Robin Pogrebin, "Revised Whitney Plan Wins Panel's Approval," *New York Times* (May 25, 2005), E: 1, 7.

86. Paul Goldberger, "Asia Society Plans to Build on Church Site," *New York Times* (January 8, 1975): 39; George Dugan, "Presbyterians Expected to Vote for Sale of Park Avenue Church," *New York Times* (January 11, 1975): 33; George Dugan, "Congregation Votes Sale of Central Presbyterian," *New York Times* (January 13, 1975): 33; "Presbytery Votes to Sell Church," *New York Times* (June 12, 1975): 41; Eleanor Blau, "Planned Sale of Church Now in Doubt," *New York Times* (February 3, 1976): 35; "'Doomed' Church," *New York Times* (November 21, 1976): 45. For Asia House, see Stern, Mellins, and Fishman, *New York 1960*, 837–38. For the Park Avenue Baptist Church, see Stern, Gilmartin, and Mellins, *New York 1930*, 149.

87. For 591 Park Avenue, see *Upper East Side Historic District*, 1077.

88. "Asia Society Acquires 70th St. Building Site," *New York Times* (December 23, 1977): 21; Peter Kihss, "Japan to Give Asia Society $1 Million for New Building" (April 27, 1979), B: 3; Paul Goldberger, "Asia Society Building Rising on Park Ave.," *New York Times* (June 6, 1979), C: 21; *Upper East Side Historic District*, 1113; Grace Glueck, "Asia Society to Open a New Home in April," *New York Times* (February 26, 1981): B: 1, 10; Paul Goldberger, "Asia Society Building, a Design Full of Civilized Intentions," *New York Times* (April 11, 1981): 15; Enid Nemy, "For Asia Society, Reasons to Celebrate," *New York Times* (April 15, 1981): C: 1, 22; John Russell, "A Splendid New Home for Rockefeller's Treasures," *New York Times* (October 11, 1981), II: 33; John Russell, "Asia Society Opens New Gallery," *New York Times* (October 13, 1981), C: 7; Jane Holtz Kay, "Buildings as Storytellers," *Christian Science Monitor* (December 24, 1981): 17; Margaret Gaskie, "Bowing to the East," *Architectural Record* 172 (February 1984): 122–27; Suzanne Slesin, "Home Beat," *New York Times* (August 9, 1984), C: 3; "Asia Society Gallery and Office Building," *Space Design* (July 1985): 66–67; Edward Larrabee Barnes, *Edward Larrabee Barnes Museum Designs* (Katonah, N.Y.: The Gallery, 1987), 14–15; White and Willensky, *AIA Guide* (1988), 367; James Trager, *Park Avenue: Street of Dreams* (New York: Atheneum, 1990), 70–71; *Edward Larrabee Barnes: Architect* (New York: Rizzoli International Publications, 1994), 247; Michael Cannell, *I. M. Pei: Mandarin of Modernism* (New York: Carol Southern Books, 1995), 229; Suzanne Stephens, "Geometry Is Destiny," *New York Times* (November 12, 1995), VII: 59; White and Willensky, *AIA Guide* (2000), 405.

89. See Stern, Gilmartin, and Massengale, *New York 1900*, 351.

90. Goldberger, "Asia Society Building Rising on Park Ave.": 21. For 733 Park Avenue, see Stern, Mellins, and Fishman, *New York 1960*, 832–33. For the Lamont house, see Stern, Gilmartin, and Mellins, *New York 1930*, 375–77.

91. Goldberger, "Asia Society Building Rising on Park Ave.": 21.

92. Goldberger, "Asia Society Building, a Design Full of Civilized Intentions": 15.

93. Goldberger, "Asia Society Building, a Design Full of Civilized Intentions": 15.

94. Slesin, "Home Beat": 3.

95. Anthony Ramirez, "Some Exhibit Concern Over Museum Expansion," *New York Times* (October 25, 1998), XIV: 6; Caroline E. Pam, "Asia Society Expansion Irks East Side Mandarins," *New York Observer* (November 2, 1998): 15; "Asia Society Angst," *Architectural Record* 187 (February 1999): 60; Caroline C. Pam, "Preservationists Applaud Blow to Asia Society's Glass House," *New York Observer* (February 1, 1999): 8; Peter Grant, "Trying for Roof over Met Heads," *New York Daily News* (May 20, 1999), Metro: 1; Carol Vogel, "Inside Art," *New York Times* (December 10, 1999), E: 46; "East Meets Best," *Interiors* 159 (February 2000): 17; Susanna Sirefman, "Asia Society Add-Ons Pass Local Muster," *Architectural Record* 188 (March 2000): 36; Jayne Merkel, "Asia House Addition to Encompass a Continent," *Oculus* 62 (March 2000): 7; Carol Vogel, "Asian Focus," *New York Times* (March 31, 2000), E: 32; Alan Riding, "Coming Attractions," *New York Times* (May 2, 2001), H: 26; Sheila Kim, "The Next Wave," *Interior Design* 72 (August 2001): 66; Celia McGee, "A Park Ave. Museum Shows Off Its New Look," *New York Daily News* (November 17, 2001): 29; "Asia Society," *Van Alen Report* 10 (December 2001): 8; Paul Goldberger, "The Talk of the Town: Dept. of Second Chances," *New Yorker* 77 (December 10, 2001): 48; Craig Kellogg, "(Far) East Side Makeover," *Oculus* 64 (January-February 2002): 10; Craig Kellogg, "Cultural Ministry," *Architectural Design* 72 (March 2002): 109–13; Laura Fisher Kaiser, "On the Rise," *Interior Design* 73 (May 2002): 222–29.

96. Bartholomew Voorsanger, quoted in Merkel, "Asia House Addition to Encompass a Continent": 7.

97. Goldberger, "The Talk of the Town: Dept. of Second Chances": 48.

98. Paul Goldberger, "Frick Addition Echoes Original, a Holdover from Innocent Times," *New York Times* (March 1, 1977): 33; Russell Page, "The Shaping of a Garden," *House & Garden* 149 (July 1977): 34, 36; Paul Goldberger, "How the Cityscape Fared in 1977," *New York Times* (January 5, 1978), C: 1, 11; *Upper East Side Historic District*, 461–62; David Morton, "Grand Trianon, New York: Frick Collection Addition," *Progressive Architecture* 62 (October 1981): 78–79; Wolfgang

Saxon, "John B. Bayley, 67; Architect Defended New York City Past," *New York Times* (December 24, 1981), B: 6; Carol Vogel, "Oases of Tranquility in Bustling City," *New York Times* (June 7, 1985), C: 1; Paula Deitz, "Art," *New York Times* (April 10, 1988), II: 43; Marina Schinz, *The Gardens of Russell Page* (New York: Stewart, Tabori & Chang, 1991), 224–29; White and Willensky, *AIA Guide* (2000), 403; Christopher Gray, "Streetscapes/The Frick Mansion," *New York Times* (April 2, 2000), XI: 7. For Carrère & Hastings's building, see Stern, Gilmartin, and Massengale, *New York 1900*, 339–41. For the transformation of the Frick mansion into a museum by John Russell Pope, see Stern, Gilmartin, and Mellins, *New York 1930*, 130–31, 137.

99. Page, "The Shaping of a Garden": 34.

100. Morton, "Grand Trianon, New York: Frick Collection Addition": 78.

101. "Jewish Museum," *New York Times* (April 12, 1981), VIII: 8; Deirdre Carmody, "Jewish Museum Proposal Revives Landmark Issue," *New York Times* (June 15, 1981), B: 1. For Gilbert's Warburg mansion, see Stern, Gilmartin, and Massengale, *New York 1900*, 321.

102. White and Willensky, *AIA Guide* (1988), 386. Also see Carol Lawson, "A Birthday Party for the Jewish Museum," *New York Times* (June 3, 1977), C: 24; Joan Rosenbaum, "Introduction," in Vivian B. Mann, *The Jewish Museum, New York* (London and New York: Scala Books in association with the Jewish Museum, 1993), 7.

103. Deirdre Carmody, "Landmarks Commission to Vote on Status of the Jewish Museum," *New York Times* (November 23, 1981), B: 3; Landmarks Preservation Commission of the City of New York, LP-1116 (November 24, 1981); Maurice Carroll, "Landmark Status Voted for Warburg Mansion," *New York Times* (November 25, 1981), B: 1, 9; Diamonstein, *The Landmarks of New York III*, 284.

104. Clyde Haberman, "Board of Estimate Agrees to Allow a Tower Next to Warburg Mansion," *New York Times* (April 2, 1982), B: 3.

105. Herbert Mitgang, "Jewish Museum to Expand," *New York Times* (June 20, 1985), C: 19.

106. "Fordham Would Sell Parcel to a Developer," *New York Times* (February 23, 1986): 32.

107. Peg Tyre and Jeannette Walls, "Jewish Museum Taking Wing," *New York* 21 (May 9, 1988): 16; "Jewish Museum Opts for Tradition," *New York Times* (May 12, 1988): 1; Grace Glueck, "A Redesign for Jewish Museum Expansion," *New York Times* (May 12, 1988), C: 25, 29; "City News Digest," *New York Observer* (May 23, 1988): 6; Paul Goldberger, "An Addition That Leaves Well Enough Alone," *New York Times* (June 5, 1988), II: 35; "Museums in Expansion": 2; Suzanne Stephens, "A Tale of Two Landmarks," *Architectural Digest* 45 (November 1988): 108, 114, 118, 122, 124–25; Peter Donhauser, "Lookalike Wing for New York Museum," *Progressive Architecture* 70 (January 1989): 24, 26; Grace Glueck, "The Jewish Museum Reaches Out," *New York Times* (April 4, 1989), C: 15; Richard F. Shepard, "The Jewish Museum Preparing for a Move," *New York Times* (August 21, 1989), C: 18; "Museumserweiterungen–Imitation als Architektursprache," *Baumeister* 87 (November 1990): 44–47; Andrew L. Yarrow, "A 'Tit for Tat' Cathedral Gift to Jewish Museum," *New York Times* (November 12, 1990), B: 2; Suzanne Slesin, "Fancies Frozen in Stone," *New York Times* (July 18, 1991), C: 3; Christopher Gray, "Streetscapes: The Felix Warburg Mansion," *New York Times* (August 11, 1991), X: 6; "Museum Update," *Oculus* 54 (November 1991): 4; Eve M. Kahn, "Ancient Art & Robotic Technology," *Clem Labine's Traditional Building* 5 (January-February 1992): 56–57; "Stone Wall Brings Back a Lost Art," *Engineering News-Record* 228 (February 17, 1992): 17; Nancy Wartik, "Board 8/Jewish Museum Banner Not Waving Yet," *New York Observer* (January 11, 1993): 8.

108. Kevin Roche, quoted in Glueck, "A Redesign for Jewish Museum Expansion": 25.

109. Goldberger, "An Addition That Leaves Well Enough Alone": 35.

110. Stephens, "A Tale of Two Landmarks": 118, 122, 124.

111. "Evening Hours: Bigger and Better," *New York Times* (May 9, 1993), IX: 8; Peter Slatin, "Jewish Museum Expands on Fifth Avenue," *Architecture* 82 (June 1993): 31; "Renewed Resource," *Metropolis* 12 (June 1993): 75; Herbert Muschamp, "Jewish Museum Renovation: A Celebration of Gothic Style," *New York Times* (June 11, 1993): C: 1, 20; Roberta Smith, "Jewish Museum as Sum of Its Past," *New York Times* (June 11, 1993), C: 21; Michael Kimmelman, "A Museum Finds Its Time," *New York Times* (June 13, 1993), II: 1; Edward Ball, "Historicism Once Again," *Village Voice* (June 15, 1993): 94; Clifford A. Pearson, "Jewish Museum Addition: Roche Achieves Seamless Link," *Architectural Record* 181 (July 1993): 21; John Morris Dixon, "Roche Inflates a Mansion for the Jewish Museum," *Progressive Architecture* 74 (August 1993): 19–20; Benjamin Forgey, "More of a Good Thing," *Washington Post* (August 28, 1993), F: 1; Raul A. Barreneche, "Computer-Aided Gothic," *Architecture* 82 (November 1993): 123–27; "Changing (but not too much) the Face of New York," *Oculus* 56 (November 1993): 8; Sirefman, *New York*, 208–9; Byard, *The Architecture of Additions*, 162; White and Willensky, *AIA Guide* (2000), 430.

112. Slatin, "Jewish Museum Expands on Fifth Avenue": 31.

113. Sirefman, *New York*, 208.

114. Dixon, "Roche Inflates a Mansion for the Jewish Museum": 19–20.

115. Muschamp, "Jewish Museum Renovation: A Celebration of Gothic Style": 20.

116. "Midtown and About," *Oculus* 54 (April 1992): 4–5; Jeannette Walls, "Another Mêlée on Museum Mile," *New York* 25 (August 31, 1992): 11–12; "Landmark Museum Incorporates Townhouses in Accessible Design," *Architectural Record* 182 (August 1994): 13; Carol Vogel, "Inside Art," *New York Times*

(May 19, 1995), C: 26; Herbert Muschamp, "In an Age of Synthetics, Style Is in the Substance," *New York Times* (June 4, 1995), II: 32; "A Bigger, Better Cooper-Hewitt Museum," *Progressive Architecture* 76 (August 1995): 34; Andrew Jacobs, "Carnegie Mansion Exposed, but Only Briefly," *New York Times* (October 15, 1995), XIII: 8; Susan Yelavich, "Cooper-Hewitt National Design Museum," *Annals 1995–1996* (New York: American Institute of Architects, 1996): 40; Dinitia Smith, "Renovation of Museum Opens Door for Director," *New York Times* (August 22, 1996), C: 11; Michael Henry Adams, "Looking Askance at Cooper-Hewitt Renovation," letter to the editor, *New York Times* (August 28, 1996): 18; Herbert Muschamp, "A Reopening and a Carnival of Graphics," *New York Times* (September 20, 1996), C: 1, 27; Raul A. Barreneche, "Renovated Cooper-Hewitt Reopens," *Architecture* 85 (October 1996): 43; Martin Filler, "Appropriately Polished," *House Beautiful* 138 (October 1996): 70, 72; Frank Rich, "20th Century Unlimited," *New York Times* (March 20, 1997): 25; Benjamin Forgey, "Design Museum's Pattern for Success," *Washington Post* (June 13, 1998), E: 1; Akiko Busch, "Design Future," *Metropolis* 18 (December 1998): 64–65, 83, 85; White and Willensky, *AIA Guide* (2000), 429. For Babb, Cook & Willard's building, see Stern, Gilmartin, and Massengale, *New York 1900*, 342–43. For Hardy Holzman Pfeiffer's renovation, see Stern, Mellins, and Fishman, *New York 1960*, 1110–11.

117. Muschamp, "A Reopening and a Carnival of Graphics": 1.

118. Forgey, "Design Museum's Pattern for Success": 1.

119. David W. Dunlap, "Mansion Sale to Make Way for New Art Museum," *New York Times* (November 8, 1993), B: 3; "Art for Deutsch-Land's Sake," *New York* 26 (November 15, 1993): 15–16; "Serge Sabarsky, 83, Art Dealer and Expert on Expressionism," *New York Times* (February 26, 1996), B: 10; Greg Sargent, "East Side Building Mystery: It'll Be an Art Museum, Right?" *New York Observer* (April 27, 1998): 14; Carol Vogel, "Inside Art," *New York Times* (November 12, 1999), E: 36; White and Willensky, *AIA Guide* (2000), 424; "On the Drawing Boards," *Oculus* 62 (February 2000): 5; "The Art of the New," *World Architecture* 84 (March 2000): 27; Carol Vogel, "Inside Art," *New York Times* (May 18, 2001), E: 26; Carol Vogel, "Lauder's Pet Project Nears Completion," *New York Times* (October 31, 2001), E: 1, 3; Roberta Smith, "A Museum Finds Small Is Beautiful," *New York Times* (November 16, 2001), E: 27, 30; Clare Henry, "The Arts," *Financial Times* (November 19, 2001): 13; Marianne Rohrlich, "An Exclusive Collection of Museum Shop Gifts in a Converted Mansion," *New York Times* (November 22, 2001), F: 3; Hilton Kramer, "A Flawless New Museum and Viennese Coffee," *New York Observer* (November 26, 2001): 1; Jo Ann Lewis, "A Haus United: Austrian, German Art Gets a N.Y. Home," *Washington Post* (December 9, 2001), G: 4; Paul Goldberger, "A Face-Lift on Fifth," *New Yorker* 77 (December 31, 2001): 39–40; Michael Kimmelman, "The Year in Review: Offering Beauty, and Then Proof That Life Goes On," *New York Times* (December 31, 2001), II: 35; Herbert Muschamp, "The Year in Review: The Deadly Importance of Making Distinctions," *New York Times* (December 30, 2001), II: 36; Karen Wilkin, "New York's Newest Gem: The Neue Galerie," *New Criterion* 20 (January 2002): 45–49; David Sokol, "What Is Old Is Neue Again," *Oculus* 64 (January/February 2002): 11; Nadine Brozan, "Postings: Landmarks Conservancy's Awards," *New York Times* (March 10, 2002), XI: 1; Ada Louise Huxtable, "Two New Museums Reveal the Virtues of Intimacy," *Wall Street Journal* (March 13, 2002): 16; Suzanne Stephens, "Annabelle Selldorf Brings the Sensibility of Mies and Loos to the Conversion of a Beaux Arts Town House into the Neue Galerie in New York City," *Architectural Record* 190 (May 2002): 222–29; Carol Strickland, "Hub for Austrian Modernism," *Christian Science Monitor* (May 3, 2002): 20; Alan G. Burke, "Radical, Refined," *Architecture* 91 (June 2002): 84–87. For Carrère & Hastings's Miller house, see Stern, Gilmartin, and Massengale, *New York 1900*, 475 (n.151).

120. "On 16th and 17th Streets, between Fifth Avenue and Avenue of the Americas; New Center for Jewish History," *New York Times* (February 15, 1998), XI: 1; White and Willensky, *AIA Guide* (2000), 192.

121. Annabelle Selldorf, quoted in Stephens, "Annabelle Selldorf Brings the Sensibility of Mies and Loos to the Conversion of a Beaux Arts Town House into the Neue Galerie in New York City": 223–24.

122. Stephens, "Annabelle Selldorf Brings the Sensibility of Mies and Loos to the Conversion of a Beaux Arts Town House into the Neue Galerie in New York City": 224.

123. Annabelle Selldorf, quoted in Goldberger, "A Face-Lift on Fifth": 40, and Stephens, "Annabelle Selldorf Brings the Sensibility of Mies and Loos to the Conversion of a Beaux Arts Town House into the Neue Galerie in New York City": 228.

124. Kramer, "A Flawless New Museum and Viennese Coffee": 1.

125. Stephens, "Annabelle Selldorf Brings the Sensibility of Mies and Loos to the Conversion of a Beaux Arts Town House into the Neue Galerie in New York City": 228.

SCHOOLS

1. For Hunter College, see Stern, Gilmartin, and Mellins, *New York 1930*, 114. For Normal College, see Stern, Gilmartin, and Massengale, *New York 1900*, 314, 447 (n.108).

2. "Hunter College Gets a Campus and an Identity on Crowded Streets," *Architectural Record* 158 (September 1975): 82–83; Samuel Weiss, "Bond Sale Moves Hunter and York College Projects Forward," *New York Times* (November 16, 1979), B:1; "Project On at Hunter," *New York Times* (June 29, 1980), VIII: 6; Laurie Johnston, "2 'Skywalks' Change Lexington Ave. Vista," *New York Times* (March 9, 1981): 1, B:2; Craig Wolff, "Hunter Gets 'Campus' with 2 New Buildings," *New York Times* (January 20, 1984), B: 3; Carter Wiseman,

"Fitting In at School," *New York* 17 (December 3, 1984): 150, 152, 154; Bruce Rosen, "Letters," letter to the editor, *Architectural Record* 173 (December 1985): 4; White and Willensky, *AIA Guide* (1988), 363–64; Peter Blake, *The Architecture of Ulrich Franzen* (Basel: Birkhauser, 1999), 149–50, 158–67; White and Willensky, *AIA Guide* (2000), 383.

3. "67th St. Buildings Declared Landmarks," *New York Times* (February 4, 1980), B: 3; "To Preserve and Protect an Architectural Legacy," *Architectural Record* 173 (September 1985): 53; "Long-Deserved Landmark Status Conferred on East 67th Street Buildings," *Friends of the Upper East Side Historic Districts Newsletter* 10 (Fall 1988): 4–5; Alan S. Oser, "6-Year Construction Nears the End," *New York Times* (October 20, 1991), X: 5, 13.

4. Margot Wellington, quoted in Johnston, "2 'Skywalks' Change Lexington Ave. Vista": 2.

5. Ulrich Franzen, quoted in Blake, *The Architecture of Ulrich Franzen*, 158.

6. Wiseman, "Fitting In at School": 150.

7. "Morris and Ida Newman Educational Center, New York, NY," *Architectural Record* 61 (June 1980): 48, 52; Grace Anderson, "A New-Fashioned Schoolhouse," *Architectural Record* 169 (October 1981): 90–95; Michael deCourcy Hinds, "Upper East Side Institutions Fear Downzoning," *New York Times* (June 16, 1985), VIII: 1, 14; White and Willensky, *AIA Guide* (1988), 375–77; White and Willensky, *AIA Guide* (2000), 417.

8. William Conklin, quoted in Anderson, "A New-Fashioned Schoolhouse": 90.

9. White and Willensky, *AIA Guide* (1988), 375–76.

10. White and Willensky, *AIA Guide* (2000), 417.

11. Mervyn Rothstein, "School Plans to Build at Another's Site," *New York Times* (May 21, 1997), B: 6; "Corrections," *New York Times* (June 4, 1997): 2.

12. Charles V. Bagli, "Lycée Français Will Build a School on a Site in the 70's East of York Avenue," *New York Times* (December 12, 2000), B: 10; Tom McGeveran, "*Merde!* Lycée Buys Toxic Dump," *New York Observer* (August 19, 2002): 1, 9; Elsa Berry, "Lycée Responds," letter to the editor, *New York Observer* (September 16, 2002): 4; Nadine Brozan, "New Home for Lycée Français on Upper East Side: A Design Inspired by Descartes," *New York Times* (December 15, 2002), XI: 1; Jason Feldman, "Lycée Français Unifies Under One Roof," *New York Construction News* 50 (June 2003): 97, 99, 101, 103, 105, 107; James Gardner, "A Pair of Polsheks," *New York Sun* (September 30, 2003): 12; "Why Settle for Concrete When You Can Have a Jardin?" *New York Times* (December 11, 2003), F: 3; Sam Lubell, "Lycée Français, New York City," *Architectural Record* 192 (March 2004): 132–35; Susan Strauss and Sean Sawyer, eds., *Polshek Partnership Architects* (New York: Princeton Architectural Press, 2005), 202–3, 219.

13. Charles V. Bagli, "Cashing In on a New Era of Opulence," *New York Times* (August 29, 2000), B: 1, 4; Christopher Gray, "Streetscapes/9 East 72nd Street," *New York Times* (January 7, 2001), XI: 7; Deborah Schoeneman, "Lycée Français Lists Beaux-Arts Mansions at Over $100 Million," *New York Observer* (February 12, 2001): 29, 32 "Upper East Side Lycée Sells," *New York Observer* (August 5, 2002): 29. For 9 East Seventy-second Street, see Landmarks Preservation Commission of the City of New York, *Upper East Side Historic District Designation Report* (New York, 1981), 611. For 7 East Seventy-second Street, see *Upper East Side Historic District*, 610. For 3 East Ninety-fifth Street, see Landmarks Preservation Commission of the City of New York, *Carnegie Hill Historic District Designation Report* (New York, 1974), 256–57. For 5 East Ninety-fifth Street, see Landmarks Preservation Commission of the City of New York, *Expanded Carnegie Hill Historic District Designation Report* (New York, 1993), 257. For 60 East Ninety-third Street, see *Expanded Carnegie Hill Historic District*, 212. For 12 East Seventy-third Street, see *Upper East Side Historic District*, 635.

14. Anthony Ramirez, "East 76th Street Worries: One Tall Building Too Many?" *New York Times* (March 8, 1998), XIV: 6; Tracie Rozhon, "Residential Developer vs. Community Groups on Upper East Side: A 31-Story Building, or Two 8-Story Buildings," *New York Times* (June 6, 1999), XI: 1; Rebecca Gardyn, "A Small of Tall World," *New York Observer* (June 28–July 5, 1999): 8; Corey Kilgannon, "Aiding a Hoped-for Neighbor," *New York Times* (August 8, 1999), XIV: 7; Edward Wong, "City Blocks East River High-Rise, Pleasing Nobody," *New York Times* (October 17, 1999), XIV: 6.

15. Strauss and Sawyer, eds., *Polshek Partnership Architects*, 202.

16. Gardner, "A Pair of Polsheks": 12.

17. Peter Slatin and Suzanne Stephens, "Around New York: Renovations," *Oculus* 56 (May 1994): 3; Christopher Gray, "Streetscapes/The Brearley School," *New York Times* (August 21, 1994), IX: 7; Charles K. Hoyt, "Over the Top," *Architectural Record* 184 (February 1996): 76–77. For the Brearley School, see Stern, Gilmartin, and Mellins, *New York 1930*, 122, 437; Gray, "Streetscapes/The Brearley School": 7.

18. Anthony Ramirez, "Author! Author! Choosing Sides in a Debate at Chapin," *New York Times* (March 3, 1996), XIII: 6; Susan Cheever, "My Neighbor, My Nuisance," *New York Times* (March 10, 1996), XIII: 15; Stephen A. Kliment, "For Private Schools Ingenuity Is a Key to Expansion Plans," *New York Times* (April 18, 1999), XI: 1, 6. For the Chapin School, see Stern, Gilmartin, and Mellins, *New York 1930*, 122, 437.

19. Lisa S. Foderaro, "School's Needs Collide with New Zoning," *New York Times* (March 15, 1987), VIII: 9; Mark McCain, "If You're Thinking of Living in: Carnegie Hill," *New York Times* (May 31, 1987), VII: 11; "Fox & Fowle Architects," *Oculus* 58 (October 1995): 3; White and Willensky, *AIA Guide* (2000), 430. For the Spence School, see Stern, Gilmartin, and Mellins, *New York 1930*, 122.

20. Foderaro, "School's Needs Collide with New Zoning": 9;

Dana Wechsler, "Tension on East 92nd Street," *Metropolis* 7 (March 1988): 21–22; "Nightingale-Bamford; Growth Awaits Grading," *New York Times* (October 30, 1988), X: 1; Andree Brooks, "For Private Schools, Popularity Brings Catch-22," *New York Times* (November 30, 1988), B: 14; Clare McHugh, "For the Girls of Nightingale, 3 R's are Reading, 'Riting and Roving," *New York Observer* (September 17, 1990): 1, 10; Shawn G. Kennedy, "Private Schools Turn to Reconstruction," *New York Times* (October 13, 1991), X: 1, 13. For the Nightingale School, see Stern, Gilmartin, and Mellins, *New York 1930*, 122.

21. For the Adams & Woodbridge addition, see *Expanded Carnegie Hill Historic District*, 177–78.

HOSPITAL ROW

1. Bruce Lambert, "Giants of Health Cast Larger Nets Across East Side," *New York Times* (May 8, 1994), XIV: 6.

2. Gene Rondinaro, "Institutions Taking On Developer's Role," *New York Times* (October 14, 1984), VIII: 1, 14; Philip S. Gutis, "2 Institutions Hail New Staff Housing," *New York Times* (June 22, 1985): 31; Peter Lemos, "FDR Tunnel," *Metropolis* 5 (May 1986): 11; White and Willensky, *AIA Guide* (1988), 403; Charles Bagli, "Overpass Being Built," *New York Observer* (January 18, 1988): 7; White and Willensky, *AIA Guide* (2000), 448. For Rockefeller University, see Stern, Mellins, and Fishman, *New York 1960*, 847–51; Christopher Gray, "Streetscapes/Rockefeller University, 62nd to 68th Streets Along the East River," *New York Times* (February 25, 2001), XI: 7.

3. For Faculty House, see Stern, Mellins, and Fishman, *New York 1960*, 850–51.

4. David W. Dunlap, "Planners Approve a Lab atop F.D.R. Drive," *New York Times* (October 19, 1989), B: 7; "Structural Arches Erected over FDR Drive for Rockefeller University," *Focus: The Office of Irwing G. Cantor, PC* 7 (Winter 1991): 1; Daniel Lowenstein, "Hospitals Go for Drive," *Our Town* 23 (April 2, 1992): 1, 10; Kathleen Teltsch, "A Rockefeller Center with a Scientific Bent," *New York Times* (October 7, 1992), B: 3.

5. Paul Goldberger, "Right Time, Right Place," *New Yorker* 74 (May 24, 1999): 30–31; Aileen Cho, "Cantilevered Cable-Stayed Span Erected in Manhattan," *Engineering News-Record* 243 (November 1, 1999): 19; David W. Dunlap, "Rockefeller University's Campus Bridge over East 63rd Street: An Engineering and Legal Feat," *New York Times* (December 12, 1999), XI: 1; Wendy Talarico, "Crossing Safely to the Other Side," *Architectural Record* 188 (March 2000): 149; "Rockefeller University Bridge," *Architectural Record* 188 (March 2000): 152; "Rockefeller University Bridge & Plaza," *New York Construction News* 49 (December 2000): 50; "Welcoming Bridge Boosts Safety," *Architectural Record* 189 (October 2001): 108.

6. White and Willensky, *AIA Guide* (2000), 447.

7. For New York Hospital-Cornell Medical Center, see Stern, Gilmartin, and Mellins, *New York 1930*, 113–14; Stern, Mellins, and Fishman, *New York 1960*, 851.

8. Samuel Weiss, "Hospital Wing to Use 70th Street Air Rights," *New York Times* (October 4, 1981), VIII: 14; Paul Goldberger, "When Architects' Labels Don't Mean What They Say," *New York Times* (October 21, 1982), C: 19; "New Addition Treats Venerable Hospital with Tender Loving Care," *Architectural Record* 171 (January 1983): 65; "Spanning 70th: A Pavilion," *New York Times* (January 30, 1983), VIII: 1.

9. James J. Sficos, quoted in "Spanning 70th: A Pavilion": 1.

10. Goldberger, "When Architects' Labels Don't Mean What They Say": 19.

11. Rondinaro, "Institutions Taking On Developer's Role": 1, 14; White and Willensky, *AIA Guide* (2000), 449.

12. Joseph Berger, "New York Hospital Planning Research Center," *New York Times* (April 14, 1985): 46; White and Willensky, *AIA Guide* (2000), 449.

13. Peg Tyre and Jeannette Walls, "N.Y. Hospital in Over Drive," *New York* 21 (January 25, 1988): 11.

14. Charles V. Bagli, "2 Hospitals in City Planning to Expand over F.D.R. Drive," *New York Observer* (April 23, 1990): 1, 13; Kay Lazar, "Board 8/New York Hospital Tower Opposed," *New York Observer* (May 28, 1990): 6; "New York," *Engineering News-Record* 226 (January 21, 1991): 66; Daniel Lowenstein, "Hospitals Go for Drive," *Our Town* 23 (April 2, 1992): 1, 10; David W. Dunlap, "Panel Approves New York Hospital Proposal for New Building over F.D.R. Drive," *New York Times* (January 26, 1993), B: 3; "Another Hospital over a Highway," *Engineering News-Record* 230 (February 1, 1993): 5; David W. Dunlap, "$6 Billion for Ailing New York Hospitals," *New York Times* (May 23, 1993), X: 1, 8; "This Saturday-Night Show was a Bit Different," *New York Times* (February 7, 1994), B: 1; "New York Hospital Expands over FDR Drive," *Progressive Architecture* 75 (May 1994): 39; Alan S. Oser, "Leaping Hurdles, Hospital Reaches Halfway Mark," *New York Times* (November 20, 1994), IX: 7; Nadine M. Post, "And a Highway Runs Through It," *Engineering News-Record* 235 (August 7, 1995): 24; *Hellmuth, Obata + Kassabaum: Selected and Current Works* (Mulgrave, Australia: Images Publishing, 1998), 180–81; "Syska & Hennessy Honored by ACEC," *New York Construction News* 49 (December 2000): 67.

15. "Attia Claims Hospital Used His Design Illegally," *Engineering News-Record* 234 (May 8, 1995): 5; "Hospital, Architect Pledge to Fight Attia," *Engineering News-Record* 234 (May 15, 1995): 14; "Artists' Credit Crunch," *Wall Street Journal* (April 19, 2001): 20; David W. Dunlap, "Architects Rush to the Ramparts in a Battle over Creative Credit," *New York Times* (May 31, 2001), E: 1, 5.

16. Eli Attia, quoted in "Hospital, Architect Pledge to Fight Attia": 14.

17. Bagli, "2 Hospitals in City Planning to Expand over F.D.R. Drive": 1, 13; Lowenstein, "Hospitals Go for Drive": 1, 10; Dunlap, "$6 Billion for Ailing New York Hospitals": 1, 8;

Oser, "Leaping Hurdles, Hospital Reaches Halfway Mark": 7; Post, "And a Highway Runs Through It": 24; White and Willensky, *AIA Guide* (2000), 449.

18. "Once the 60th Street Sanitation Transfer Station: An Open-Air Pavilion at the East River," *New York Times* (November 7, 1993), X: 1; Carole Rifkind, "A 'Cinderella' Plan on the East River," *New York Times* (November 21, 1993), X: 12; Hugo Lindgren, "Park, Art, & Industry," *Metropolis* 13 (March 1994): 7; D. T. Max, "Heliport Din Spoils Big-Budget City Park," *New York Observer* (April 25, 1994): 1, 22; "60th Street Pavilion," *New York Times* (June 10, 1994), C: 28; "Look, Up in the Sky," *New York Times* (September 10, 1995), XIII: 17; Carol Vogel, "Beyond Museum Precincts, the City as Gallery," *New York Times* (January 22, 1996), C: 11.

19. Quoted in Max, "Heliport Din Spoils Big-Budget City Park": 22.

20. "60th Street Pavilion": 28.

21. Paul Goldberger, "Design Can't Heal, but It Shouldn't Make You Worse," *New York Times* (August 27, 1989), II: 30. For the Memorial Sloan-Kettering Cancer Center, see Stern, Mellins, and Fishman, *New York 1960*, 851.

22. Goldberger, "Design Can't Heal, but It Shouldn't Make You Worse": 30. For the New York Cancer Hospital, see Stern, Mellins, and Fishman, *New York 1880*, 784–85.

23. Goldberger, "Design Can't Heal, but It Shouldn't Make You Worse": 30; White and Willensky, *AIA Guide* (2000), 448.

24. Goldberger, "Design Can't Heal, but It Shouldn't Make You Worse": 30.

25. Kristen Richards, "Special Suites: Memorial Sloan Kettering Cancer Center, Perkins Eastman Architects," *Interiors* 157 (August 1998): 56–59; "Perkins Eastman Architects," *Oculus* 61 (November 1998): 6.

26. Edwin McDowell, "On East 68th St., a Center for Prostate and Urological Cancers: New Sloan-Kettering Building," *New York Times* (November 25, 2001), XI: 1; "For Recovery," *Oculus* 64 (December 2001): 6; "New Center Ready to Open," *Community Matters: News from Memorial Sloan-Kettering Cancer Center* 2 (February 2002): 1–2.

27. For the Museum of Modern Art, see Stern, Gilmartin, and Mellins, *New York 1930*, 141–45.

28. Petra Bartosiewicz, "East Side Neighbors Fear Memorial's Unchecked Growth," *New York Observer* (May 28, 2001): 10; *The Architecture of Rafael Viñoly* (New York: Princeton Architectural Press, 2002), no pagination.

29. Jennifer Steinhauer, "Sloan-Kettering Seeks to Build Research Unit," *New York Times* (May 18, 2001), B: 7; Andrew Friedman, "Hospital Building Assailed as Hazardous to Health," *New York Times* (May 27, 2001), XIV: 6; Bartosiewicz, "East Side Neighbors Fear Memorial's Unchecked Growth": 10; Michael Saul, "Sloan-Kettering Tower OK with Bloomy," *New York Daily News* (August 2, 2001): 17; Erika Kinetz, "Sloan-Kettering's Tower Proposal Pits Medicine Against Development Fears," *New York Times* (October 14, 2001), XIV: 8; Marc Hochstein, "Urban Cancer at Sloan-Kettering?" *Grid* 3 (November 2001): 28; Petra Bartosiewicz, "Shelly the Fixer," *New York Observer* (November 12, 2001): 13, 15; Erika Kinetz, "Council Ends by Approving Sloan-Kettering Tower and N.Y.U. Science Park," *New York Times* (December 23, 2001), XIV: 6; "Double Vision?" *New York Post* (May 28, 2002): 33.

HOUSES OF WORSHIP

1. "A Project Is Delayed by a War," *New York Times* (October 5, 1980), VIII: 8; Michael deCourcy Hinds, "Battling to Control E. 96th Growth," *New York Times* (May 13, 1984), VIII: 1; George W. Goodman, "Ground Broken for Islamic Center," *New York Times* (October 28, 1984), VIII: 6; Winston Williams, "Amid Rejoicing, Work Begins on Mosque," *New York Times* (May 29, 1987), B: 1; Manuel Perez-Rivas, "Islamic Center Is Building New Mosque," *Newsday* (July 6, 1988): 29; Paul Lewis, "Mosque Rising Is a First in New York," *New York Times* (September 26, 1988), B: 2; Charles V. Bagli, "Delays on Mosque on East 96th St.," *New York Observer* (May 29, 1989): 6; Joseph P. Griffith, "Mecca, Medina, Jerusalem . . . and New York," *Metropolis* 9 (December 1989): 17; "East Is East," *New York* 23 (March 12, 1990): 24; Charles V. Bagli, "Islamic Mosque Rises on Upper East Side," *New York Observer* (September 24, 1990): 6; Mark Alden Branch, "Inquiry: Religious Buildings," *Progressive Architecture* 71 (December 1990): 78–85; Ari L. Goldman, "Persian Gulf Crisis Slows New York Mosque Project," *New York Times* (December 9, 1990): 50; "Manhattan Mosque Opens After Years of Delay," *New York Times* (April 16, 1991): 1; Peter Steinfels, "For New York Moslems, a Soaring Dome Is Ready," *New York Times* (April 16, 1991), B: 1, 5; Eve M. Kahn, "Mosque for Gotham Muslims," *Wall Street Journal* (January 29, 1992): 10; David W. Dunlap, "A New Mosque for Manhattan, for the 21st Century," *New York Times* (April 26, 1992), II: 38; Hugo Lindgren, "A Dislocated Mosque," *Metropolis* 11 (June 1992): 11–12; Stephen A. Kliment, "Manhattan Mosque," *Architectural Record* 190 (August 1992): 90–97; Karin Tetlow, "Cultural Collaboration," *Interiors* 152 (January 1993): 98–99; Marc Ferris, "The Crescent in the Apple," *Newsday* (April 8, 1993): 54; Hasan-Uddin Khan, "An Overview of Contemporary Mosques," in Martin Frishman and Hasan-Uddin Khan, eds., *The Mosque* (London: Thames & Hudson, 1994), 246–47; Brad Gooch, "Floating Saucer," *New Republic* 212 (April 17, 1995): 12; Martin Filler, "Facets of Islam Refracted in a New York Lens," *New York Times* (December 8, 1996), II: 42; *Skidmore, Owings & Merrill: Selected and Current Works*, 2nd ed. (Mulgrave, Australia: Images Publishing, 1997), 180–83; Susanna Sirefman, *New York: A Guide to Recent Architecture* (London: Ellipsis, 1997), 212–13; Daniel B. Schneider, "F.Y.I.: The Islamic Angle," *New York Times* (October 5, 1997), XIII: 2; Gwendolyn Wright, "Spaces for Worship, Places for Community," *New York Times* (January 17, 1999), II: 37; White and Willensky, *AIA Guide*

(2000), 433; Jerrilynn D. Dodds, *New York Masjid: The Mosques of New York City* (New York: PowerHouse Books, 2002), 23, 38–39, 56–59; David W. Dunlap, "Michael A. McCarthy, 68, Architect of Mosque on Upper East Side," *New York Times* (July 18, 2002): 19.

2. Dunlap, "A New Mosque for Manhattan, for the 21st Century": 38.

3. Kahn, "Mosque for Gotham Muslims": 10.

4. Dunlap, "Michael A. McCarthy, 68, Architect of Mosque on Upper East Side": 19.

5. Dunlap, "A New Mosque for Manhattan, for the 21st Century": 38.

6. Paul Goldberger, "Abandoning Orthodox Modernism," *New York Times* (July 11, 1981): 13. Also see White and Willensky, *AIA Guide* (2000), 425. For Schneider's building, see Stern, Gilmartin, and Mellins, *New York 1930*, 160. For the Civic Center Synagogue, see Stern, Mellins, and Fishman, *New York 1960*, 191–93.

7. For Richardson's Marshall Field Warehouse, see Jeffrey Karl Ochsner, *H. H. Richardson: Complete Architectural Works* (Cambridge, Mass., and London: MIT Press, 1982), 380–84.

8. David W. Dunlap, "A Firm Foundation, Starting at the Roof," *New York Times* (December 26, 1999), XI: 1, 3.

9. Christopher Gray, "Streetscapes/82nd Street and Lexington Avenue," *New York Times* (December 16, 2001), XI: 7; James Gardner, "A Promising Combination," *New York Sun* (May 20, 2002): 10; David W. Dunlap, "In Synagogue Design, Many Paths," *New York Times* (December 8, 2002), XI: 1, 6.

10. Gardner, "A Promising Combination": 10.

11. Brook S. Mason, "An Architect Who Reaches Up to Paint the Stars," *New York Times* (September 15, 2002), II: 31; Dunlap, "In Synagogue Design, Many Paths": 1, 6. Also see Landmarks Preservation Commission of the City of New York, *Upper East Side Historic District Designation Report* (New York, 1981), 104–5.

12. Dunlap, "In Synagogue Design, Many Paths": 1.

RECYCLING THE PAST:
ASPHALT GREEN AND BRIDGEMARKET

1. Janet Vrchota, "Humanizing New York," *Design & Environment* 3 (Fall 1972): 48–55; "Fund-Raising Drive Starts for Yorkville Sports Center," *New York Times* (September 21, 1975): 44; Paul Goldberger, "Yorkville Group Plans to Convert Asphalt Plant into Gymnasium," *New York Times* (January 27, 1976): 35; Charles Kaiser, "Yorkville Group Plans to Convert Asphalt Plant into Gymnasium," *New York Times* (January 27, 1976): 35; Lee Dembart, "Old Asphalt Plant Off F.D.R. Drive to Become a Recreation Center," *New York Times* (April 7, 1979): 25; Glenn Fowler, "Center on East River to Study Energy," *New York Times* (January 22, 1980), B: 3; Laurie Johnston, "Renewal Thrives at Asphalt Green," *New York Times* (June 5, 1981), B: 1, 4; "A Waterfront Sports and Cultural Complex Generates Its Own Energy," *Architectural Record* 169 (November 1981): 106–7; "Recycling: The Municipal Asphalt Plant," *Architecture + Urbanism* (August 1982): 108; James Brooke, "Arts and Sports Center Opening in Landmark," *New York Times* (October 24, 1984), B: 3; George E. Murphy, ed., *Opening of the Murphy Center at Asphalt Green* (New York: Neighborhood Committee for the Asphalt Green, October 24, 1984); Paul Goldberger, "When the Site Tests the Designer," *New York Times* (February 17, 1985), II: 31; "Dall'asfalto al Tartan," *Casabella* 49 (June 1985): 36–37; Susan Doubilet, "Arch Support," *Progressive Architecture* 66 (November 1985): 100–103; "George and Annette Murphy Center," *Architecture + Urbanism* (September 1986): 61–64; "Sport- und Kunstzentrum Asphaltfabrik (George and Annette Murphy Zentrum), New York/USA," *Architektur + Wettbewerbe* 127 (September 1986): 16–17; "Dr. George E. Murphy, Professor of Pathology," *New York Times* (July 18, 1987): 32; White and Willensky, *AIA Guide* (1988), 414–15; Lee Solon, "If You're Thinking of Living In/East End Avenue," *New York Times* (September 2, 1990), X: 5; "The George and Annette Murphy Center 'Asphalt Green,'" *Bauwelt* 83 (February 14, 1992): 290–91; "Municipal Asphalt Plant," *Architecture + Urbanism*, extra edition (December 1994): 226–31; Janet Allon, "Asphalt Green Gym Is Nearly All Roof, and It's Leaky," *New York Times* (March 2, 1997), XIII: 5; *Pasanella + Klein Stolzman + Berg* (Gloucester, Mass.: Rockport Publishers, 1999), 139; White and Willensky, *AIA Guide* (2000), 461; Laurie Kerr, "Back to the Future," *Oculus* 64 (March/April 2000): 7–8.

2. Robert Moses, quoted in Brooke, "Arts and Sports Center Opening in Landmark": 3. For the Municipal Asphalt Plant, see Stern, Mellins, and Fishman, *New York 1960*, 853–55.

3. Dr. George E. Murphy, quoted in "Fund-Raising Drive Starts for Yorkville Sports Center": 44.

4. White and Willensky, *AIA Guide* (1988), 415.

5. "A Waterfront Sports and Arts Complex Generates Its Own Energy": 107.

6. Daniel Scully, quoted in "A Waterfront Sports and Arts Complex Generates Its Own Energy": 107.

7. Goldberger, "When the Site Tests the Designer": 31.

8. "Park on Ex-Asphalt Plant Dedicates Playing Field," *New York Times* (July 6, 1986): 29; "New York," *Engineering News-Record* 217 (August 28, 1986): 90; White and Willensky, *AIA Guide* (1988), 414–15; "Taking the Plunge," *New York Observer* (October 23, 1989): 13; "Making Waves for Landmark Parabolic Asphalt Plant," *Architectural Record* 179 (June 1991): 37; "5-Story Sports Center: A Pool House by the Drive," *New York Times* (October 27, 1991), X: 1; "Biggest Pool in New York," *New York Times* (April 25, 1993), X: 1; Ted Glick, "'Biggest Pool,'" letter to the editor, *New York Times* (May 16, 1993), X: 15; Elizabeth Royte, "Last One In Is a Rotten Egg," *New York* 26 (May 31, 1993): 23; Jon Gertner, "A New Era of 'Public Works,'" *Metropolis* 13 (July/August 1993): 17; Effie C. MacDonald, "Manhattan Oasis," *Architectural Review* 196 (August 1994): 45–47; Richard Dattner, *Civil Architecture: The*

New Public Infrastructure (New York: McGraw-Hill, 1995), 18–25; Susanna Sirefman, *New York: A Guide to Recent Architecture* (London: Ellipsis, 1997), 210–11; *Richard Dattner: Selected and Current Works of Richard Dattner & Partners Architects* (Mulgrave, Australia: Images Publishing, 2000), 70–75; White and Willensky, *AIA Guide* (2000), 461.

9. MacDonald, "Manhattan Oasis": 47.

10. Sirefman, *New York*, 210.

11. White and Willensky, *AIA Guide* (2000), 461.

12. For the Queensboro Bridge, see Stern, Gilmartin, and Massengale, *New York 1900*, 50–55.

13. Karin Moss Link, "Guastavino Tile Construction: History and Restoration" (Master's thesis, University of Oregon, 1995), 149–74; Janet Parks, *The Old World Builds the New: The Guastavino Company and the Technology of the Catalan Vault, 1885–1962* (New York: Avery Architectural and Fine Arts Library and the Miriam and Ira D. Wallach Art Gallery, Columbia University, 1996), 128.

14. Stern, Mellins, and Fishman, *New York 1960*, 1134–35.

15. Edward Ranzal, "Council Stays Queensboro Project," *New York Times* (June 29, 1977), D: 17; Charles Kaiser, "Plans for $2 Million Open-Air Market Under Queensboro Bridge Are Approved," *New York Times* (July 8, 1977), B: 3; Charles Kaiser, "Safety Dispute Delays a Market," *New York Times* (July 21, 1977), B: 2; "Topics: The Greengrocer Explosion," *New York Times* (July 28, 1977): 18; Paul Goldberger, "Design Notebook," *New York Times* (August 4, 1977), C: 10; "Planning Unit Approves Proposal to Build Market Under Queensboro Span," *New York Times* (August 9, 1977): 37; Solomon P. Friedman, "Queensboro Bridge Market," letter to the editor, *New York Times* (August 11, 1977), C: 5; Suzanne LaCroix, "'A Bridgemarket Is Quite Unnecessary,'" letter to the editor, *New York Times* (August 13, 1977): 18; George Hyland and Zelina Brunschwig, "More on Bridge Market," letters to the editor, *New York Times* (August 18, 1977), C: 11; Barry Benepe, "What a Greenmarket Is," letter to the editor, *New York Times* (September 5, 1977): 16; "Topics: Manhattan Salad," *New York Times* (September 14, 1977): 20; "Buildings in the News," *Architectural Record* 162 (October 1977): 39; Charles Kaiser, "Museum Tower and Bridge Market Win Approval of Estimate Board," *New York Times* (October 7, 1977), B: 3; "Board of Estimate Votes a New Lease for Bridgemarket," *New York Times* (December 23, 1977): 17; M. A. Farber, "Radio City Music Hall to Close After Easter Show, Koch Is Told," *New York Times* (January 5, 1978): 1, C: 16; Edward Ranzal, "New York Council Panel Puts Off Action on Market Beneath Bridge," *New York Times* (March 11, 1978): 27; Edward Ranzal, "Queensboro Bridge Market Plan Blocked by Assembly Committee," *New York Times* (July 30, 1978): 36; Joyce Purnick, "Plan for Market Beneath Bridge Revived by City," *New York Times* (November 9, 1981), B: 1, 6; "The Space Below the Bridge," editorial, *New York Times* (January 27, 1982): 27; Charmaine Kaplan, "Bridgemarket's Invitation to Unfair Competition," letter to the editor, *New York Times* (February 15, 1982): 16; Clyde Haberman, "Bridgemarket Plan Gets Local Officials' Backing," *New York Times* (March 17, 1982), B: 2; Howard Blum, "Bridgemarket Work About to Start," *New York Times* (October 9, 1983), VIII: 6; Marilyn Hoffman, "Bridgemarket," *Christian Science Monitor* (May 24, 1985): 25; Gene Rondinaro, "Bridgemarket Is Back on the Track," *New York Times* (April 21, 1985), VIII: 6; Susan Heller Anderson and David W. Dunlap, "After 9 Years, Bridgemarket Plans Change," *New York Times* (May 28, 1986), B: 4; "Bridgemarket Approved by Panel," *New York Times* (July 10, 1986), B: 5; Frank J. Prial, "Construction Date Is Set at Stalled Bridgemarket," *New York Times* (May 16, 1987): 35; David W. Dunlap, "Sutton Place Group Fights Bridgemarket Growth," *New York Times* (April 29, 1988), B: 3; Donna Cornachio, "To Market, to Market, to Bridgemarket," *Metropolis* 8 (October 1988): 42, 44; Elizabeth Ungar, "Sutton Place's Endangered Spaces," *Manhattan, inc.* 5 (December 1988): 30; David W. Dunlap, "59th St. Bridge Market to Shrink a Bit," *New York Times* (June 7, 1989), B: 4; Audrey Farolino, "More Troubled Waters for Bridgemarket Plan," *New York Post* (June 15, 1989): 53; Richard D. Lyons, "Bridge-Vault Development Is Stalled," *New York Times* (February 28, 1990), D: 22; Natalie Berkowitz, "59th St. Bridge Market Developers Have Duty to Clean Up Site," letter to the editor, *New York Times* (August 23, 1990): 22; David W. Dunlap, "59th St. Bridgemarket Proposal Is Close to Fading Away," *New York Times* (July 27, 1990), B: 1–2; *Hardy Holzman Pfeiffer Associates: Buildings and Projects, 1967–1992* (New York: Rizzoli International Publications, 1992), 270; Marvine Howe, "A Market? A Museum? Watch This Space," *New York Times* (November 14, 1993): 8; Marvine Howe, "Court Backs Bridgemarket," *New York Times* (April 3, 1994), XIII: 1.

16. "Topics: The Greengrocer Explosion": 18.

17. Peter Slatin, "Can Conran Bridge 59th St. Attacks?" *New York Post* (July 31, 1996): 25; Andrew Jacobs, "Bridgemarket Finally Gets Its Yes," *New York Times* (October 13, 1996), XIII: 6; Lucie Young, "Snatching Grandeur from the Grit Under the Queensboro Bridge," *New York Times* (February 5, 1998), F: 3; Lesley Downer, "The Return of Terence Conran," *Fortune* 137 (February 16, 1998): 38, 42; David W. Dunlap, "Bridgemarket Emerging, After 22 Years," *New York Times* (March 7, 1998), XI: 1, 8; Florence Fabricant, "Suit Is Latest Snag for Bridgemarket," *New York Times* (April 24, 1998), B: 9; Alan S. Oser, "Market and Store to Rise near Bridge," *New York Times* (December 8, 1998), B: 7; *Hardy Holzman Pfeiffer Associates: Buildings and Projects, 1992–1998* (New York: Rizzoli International Publications, 1999), 176–77; Peggy Caylor, "Retail News," *National Real Estate Investor* 41 (February 1, 1999): 22; David W. Dunlap, "Bridgemarket Emerging, After 22 Years," *New York Times* (March 7, 1999), XI: 1, 8; Victoria C. Rowan, "Under the Bridge," *Architectural Record* 187 (August 1999): 57; Maurice S. Paprin, "Bridgemarket and Its

Neighborhood," letter to the editor, *New York Times* (April 11, 1999), XI: 11; "Spectaculars," *New York* 32 (September 13, 1999): 116; Michelle Ogundehin, "Unfinished Business," *Interiors* 158 (November 1999): 46–53; Damian Chadwick, "From Sir, with Love," *Metropolis* 18 (December 1999): 50; Anthony Barzilay Freund, "Market Report," *Town and Country* 153 (December 1999): 65; White and Willensky, *AIA Guide* (2000), 308; Raul A. Barreneche, "He'll Take Manhattan–Again," *Architecture* 89 (January 2000): 25; Lore Croghan, "Conran Is Bridge to 1st Ave.'s Future," *Crain's New York Business* (January 24, 2000): 1, 47; "Destinations and Diversions," *USA Today* (February 4, 2000): 8D; Jerry Shriver, "Food & Wine," *USA Today* (February 4, 2000): 8D; Florence Fabricant, "Bridgemarket Brasserie," *New York Times* (February 9, 2000), F: 10; Holly Finn, "How to Spend It," *Financial Times* (London) (February 19, 2000): 11; Paul Frumkin, "Kissin, Conran Launch Guastavino's in Bridgemarket Complex," *Nation's Restaurant News* (February 21, 2000): 8, 89; Donna Paul, "Under the Bridge," *Blueprint* 170 (March 2000): 18–19; David W. Dunlap, "Sensuous Curves Ascend Above the Hard-Edged City," *New York Times* (March 3, 2000): 47, 61; Florence Fabricant, "To Market, Under the Bridge," *New York Times* (March 22, 2000), F: 2; Judith Nasatir, "Underneath the Arches," *House Beautiful* 142 (April 2000): 90, 92; "Bridge Spans Several Dining Concepts," *Restaurants and Institutions* (April 1, 2000): 24; Hal Rubenstein, "Arch Support," *New York* 33 (April 3, 2000): 82; Karina Lahni, "A Little Rain Falls on Guastavino's Plans," *New York Observer* (April 24, 2000): 11; "Technical Challenges," *Architectural Record* 188 (May 2000): 248; Thomas Mellins, "Project Diary: Bridgemarket," *Architectural Record* 188 (May 2000): 242- 49; Suzanne Stephens, "Guastavino's Restaurant," *Architectural Record* 188 (May 2000): 246; Richard Turcsik, "Feelin' Groovy," *Progressive Grocer* 79 (May 2000): 70–78; William Grimes, "London? Paris? A Global Vision Under the Bridge," *New York Times* (May 10, 2000), F: 1, 12; Paul Goldberger, "Monumental Space," *Metropolis* 19 (July 2000): 138, 141, 143; Lucy Bullivant and Duncan McCorquodale, *From Milton Keynes to Manhattan: Conran & Partners* (London: Black Dog Publishing, 2002), 60–65, 186.

18. Goldberger, "Monumental Space": 143.

19. Goldberger, "Monumental Space": 138, 141, 143.

20. Stephens, "Guastavino's Restaurant": 246.

21. For Stoughton's fountain, see Gregory F. Gilmartin, *Shaping the City: New York and the Municipal Art Society* (New York: Clarkson Potter, 1995), 232–33.

ROOSEVELT ISLAND

1. See Stern, Mellins, and Fishman, *New York 1960*, 640–59.

2. Paul Goldberger, "A Broader Horizon Is in the Offing for Roosevelt Island," *New York Times* (September 26, 1977): 33, 36; Carter B. Horsley, "New Direction for the U.D.C.," *New York Times* (February 25, 1979), VIII: 1, 4; Steven R. Krog, "Evaluation: The Fabric of Roosevelt Island," *Journal of the American Institute of Architects* 168 (May 1979): 38–47; "Roosevelt I. Developer to Enlarge Project by 1,000 Housing Units," *New York Times* (June 5, 1979), B: 6; *Charles Gwathmey and Robert Siegel: Buildings and Projects, 1964–1984* (New York: Harper & Row, 1984), 170–73, 291.

3. For the competition, see Stern, Mellins, and Fishman, *New York 1960*, 655–59.

4. "Roosevelt Island to Add New Units," *New York Times* (November 22, 1981), VIII: 10; Dorothy J. Gaiter, "State Renews Push for Growth on Roosevelt Island," *New York Times* (November 8, 1982): 1, B: 5.

5. G. E. Kidder Smith, "Roosevelt Island Needs a New Bridge," letter to the editor, *New York Times* (November 20, 1982): 22.

6. Edward J. Logue, "One Bridge Too Many for Roosevelt Island," letter to the editor, *New York Times* (December 28, 1982): 22. Also see Murray Hausknecht, "On the Need for a Manhattan Connection," letter to the editor, *New York Times* (November 27, 1982): 22.

7. Robin Lynn, "Island in the Stream," *Metropolis* 2 (January-February 1983): 10–11, 34. Also see Peter Applebome, "Trying to Preserve a Village in the Middle of the East River," *New York Times* (January 2, 1986), B: 1–2.

8. "Summary of Major Actions by New York's Legislature in '84," *New York Times* (July 6, 1984), B: 4; "$180 Million in Bonds for Roosevelt Island," *New York Times* (February 5, 1985), D: 23. For the tram's financial problems, see Deirdre Carmody, "Insurance Gap to Close Tram to Roosevelt I.," *New York Times* (February 14, 1986), B: 1, 4; "For Roosevelt Island, Detours on First Day Without Tram," *New York Times* (February 16, 1986): 45; "Topics: On the Shoals," *New York Times* (February18, 1986): 22; "Roosevelt Islanders Protest Tram's Closing," *New York Times* (February 23, 1986): 32; Michael A. Lewis, "Rent Strike Set on Roosevelt I. as Tram Protest," *New York Times* (February 24, 1986), B: 3; "Roosevelt Island Tram Goes Back into Service," *New York Times* (March 4, 1986), B: 1; David Bird and David W. Dunlap, "A 10-Speed Solution to Tram Troubles," *New York Times* (March 6, 1986), B: 8.

9. Lydia Chavez, "1,108 More Apartments for Roosevelt I. Voted," *New York Times* (May 23, 1986), B: 3; "Roosevelt I. Housing Approved by Judge," *New York Times* (December 30, 1986), B: 4; Andree Brooks, "A Rental Complex for Roosevelt Island," *New York Times* (December 18, 1987), B: 8; "Roosevelt Island Tour," *New York Times* (January 10, 1988), VIII: 1; Iver Peterson, "A New Complex for Roosevelt Island," *New York Times* (October 16, 1988), X: 9, 18; Beth Landman, "New Complex on Roosevelt Island Offers Reasonably Priced Housing Units," *New York Post* (October 20, 1988): 59; Charles V. Bagli, "Model Apartments Open for New Roosevelt I. Project," *New York Observer* (October 24, 1988): 6; June Skinner, "Roosevelt Island," letter to the editor, *New York Times* (November 6, 1988), X: 21; Paul Goldberger, "An Island

of Idealism in a Sea of Disdain," *New York Times* (April 8, 1990), II: 35, 40; White and Willensky, *AIA Guide* (2000), 537. Also see Martin Gottlieb, "U.D.C. Backs $162 Million Housing Development Plan for Roosevelt Island," *New York Times* (July 20, 1984), B: 1.

10. Bagli, "Model Apartments Open for New Roosevelt I. Project": 6.

11. Goldberger, "An Island of Idealism in a Sea of Disdain": 40.

12. Andrew L. Yarrow, "Getting to Know a Quirky Little Island Off Manhattan," *New York Times* (October 27, 1989), C: 1, 16; Donatella Lorch, "The 'Subway to Nowhere' Now Goes Somewhere," *New York Times* (October 29, 1989): 37; Michael Freitag, "Hard Times Overtake the Roosevelt Tram," *New York Times* (November 17, 1989), B: 1, 3; "Topics of The Times: Glorious Transit," *New York Times* (November 19, 1989): 22; Sandy Neis and Abraham Weinstein, "Aerial Tram, the Symbol of Roosevelt Island, Must Be Preserved," letter to the editor, *New York Times* (December 14, 1989): 38; Dennis Hevesi, "Roosevelt I. Tram Faces Money Woes," *New York Times* (April 8, 1990): 30; "An Endangered Species," editorial, *New York Observer* (April 23, 1990): 4.

13. "New Projects in Town," *Oculus* 52 (October 1989): 5; Iver Peterson, "A Mix of Roosevelt Island Housing Planned," *New York Times* (October 12, 1989), B: 1, 8; "Rockefeller Labs, Roosevelt Homes," editorial, *New York Times* (December 7, 1989): 34; Jeffrey Hoff, "Roosevelt Island's Urban Planning Lab," *Metropolis* 9 (February 1990): 14–16; Goldberger, "An Island of Idealism in a Sea of Disdain": 35, 40; Alan Finder, "Roosevelt Island: A 'Wonderful' Experiment Still Building," *New York Times* (April 26, 1990), B: 1, 4.

14. Goldberger, "An Island of Idealism in a Sea of Disdain": 40.

15. J. P. Olsen, "The Effects of Urban Isolation," *Metropolis* 13 (September 1993): 19, 22–23.

16. David S. Chartock, "Roosevelt Island's Southtown Moves Forward," *New York Construction News* 45 (August 1997): 1, 5; "MDI to Build Housing on Roosevelt Island," *New York Construction News* 47 (June 1999): 13; Dennis Hevesi, "An Island with a History of Change Awaits Its Latest Transformation," *New York Times* (January 14, 2001): 33; Brian Eckhouse, "Homes Grow on Roosevelt Isle.," *New York Daily News* (June 26, 2002), Metro: 4; Rachelle Garbarine, "2 Residences Planned for Southtown," *New York Times* (June 30, 2002), XI: 1.

17. Peter Slatin, "Roosevelt Island Update," *Oculus* 55 (December 1992): 11; Margaret Gaskie, "Island Rigor," *Architecture* 82 (April 1993): 64–67; "Primary/Intermediate School 217," *Architectural Record* 182 (February 1994): 62; Susanna Sirefman, *New York: A Guide to Recent Architecture* (London: Ellipsis, 1997), 216–17; White and Willensky, *AIA Guide* (2000), 537–38; Alan Balfour, *World Cities: New York* (New York: Wiley Academy, 2001), 152.

18. White and Willensky, *AIA Guide* (2000), 538.

19. Sirefman, *New York*, 216.

20. Slatin, "Roosevelt Island Update": 11; Eve Kahn, "New Parks for Mean Streets," *Landscape Architecture* 83 (January 1993): 66–69; White and Willensky, *AIA Guide* (2000), 538–39; Balfour, *World Cities: New York*, 196.

21. "Roosevelt Island Gets an Eight-Sided Facelift," *Architectural Record* 182 (November 1994): 12; Balfour, *World Cities: New York*, 320–21. For the Octagon Tower, see Landmarks Preservation Commission of the City of New York, LP-0910 (March 23, 1976); David W. Dunlap, "A Historic Asylum Needs Urgent Care," *New York Times* (November 21, 1988), B: 1, 8; Barbaralee Diamonstein, *The Landmarks of New York III* (New York: Harry N. Abrams, 1999), 52–53.

22. White and Willensky, *AIA Guide* (2000), 538; Nadine Brozan, "Honoring Preservation Projects: The Strecker Laboratory," *New York Times* (March 10, 2002), XI: 1. For the Strecker Laboratory, see Landmarks Preservation Commission of the City of New York, LP-0909 (March 23, 1976); Diamonstein, *The Landmarks of New York III*, 52–53.

23. "The F.D.R. Memorial, Redux," editorial, *New York Times* (August 23, 1992), IV: 14; Douglas Feiden, "Backers Hope for New Deal for Stalled Memorial to FDR," *Crain's New York Business* (October 5, 1992): 23; Slatin, "Roosevelt Island Update": 11; Daniel B. Schneider, "F.Y.I.: Missing Memorial," *New York Times* (October 19, 1997), XIV: 2. For Kahn's design, see Stern, Mellins, and Fishman, *New York 1960*, 648–49.

24. "The F.D.R. Memorial, Redux": 14.

25. "Calatrava Stakes a Claim in the U.S.," *Architectural Record* 183 (October 1995): 25; Ann C. Sullivan, "Calatrava's American Works in Progress," *Architecture* 84 (December 1995): 22; Nicolai Ouroussoff, "A Bird-Like Structure Rises from the Ruins," *Architectural Record* 184 (January 1996): 12; "Southpoint Pavilion, Roosevelt Island, N.Y.," *Architecture + Urbanism* (February 1996): 65, 114–15; Ally Ireson, "Moving Monument (2)," *Blueprint* 129 (June 1996): 14.

HARLEM AND UPPER MANHATTAN

125TH STREET

1. Rev. Robert Chapman, quoted in Michael Sterne, "In Last Decade, Leaders Say, Harlem's Dreams Have Died," *New York Times* (March 1, 1978): 1, 13.

2. Sterne, "In Last Decade, Leaders Say, Harlem's Dreams Have Died": 1, 13.

3. Stern, Mellins, and Fishman, *New York 1960*, 887–88; Stern, Mellins, and Fishman, *New York 1880*, 812–20.

4. Quoted in James Barron, "Harlem Pins Revival Hopes on New Plans for 125th Street," *New York Times* (May 20, 1979), VIII: 1, 4.

5. See Stern, Mellins, and Fishman, *New York 1960*, 888–91.

6. Sheila Rule, "Mondale, in Harlem, Gets Report on Trade Center," *New York Times* (April 27, 1979): 1, B: 3; Barron, "Harlem Pins Revival Hopes on New Plans for 125th Street":

1, 4; "Carter Aides to Discuss Harlem Trade Center," *New York Times* (May 30, 1979), B: 3; "Working Panel to Spur Harlem Trade Complex," *New York Times* (May 31, 1979), B: 15; Lee A. Daniels, "Amid Uncertainty, Revival of 125th St. Proceeds," *New York Times* (December 3, 1981), B: 1, 6; "Taking 'No' for 'Maybe,'" *New York Times* (June 15, 1982), B: 4; Susan Woldenberg, "Mammon to Harlem?" *Metropolis* 2 (July-August 1982): 4–5; James Stewart Polshek, "Notes on My Life and Work," in *James Stewart Polshek: Context and Responsibility* (New York: Rizzoli International Publications, 1988), 42, 68–69.

7. For the Harlem State Office Building, see Stern, Mellins, and Fishman, *New York 1960*, 888–89.

8. Barron, "Harlem Pins Revival Hopes on New Plans for 125th Street": 1, 4; "Harlem Shopping Mall, New York, N.Y.," *Progressive Architecture* 61 (July 1980): 52; Daniels, "Amid Uncertainty, Revival of 125th St. Proceeds": 1, 6; Woldenberg, "Mammon to Harlem?": 4–5; Polshek, "Notes on My Life and Work," in *James Stewart Polshek: Context and Responsibility*, 42, 214.

9. "May Reopening Set for Apollo Theater," *New York Times* (April 28, 1978), B: 5; Robert Palmer, "Lights Go On Again at the Apollo," *New York Times* (May 5, 1978), C: 10; "Show Time at the Apollo," editorial, *New York Times* (May 5, 1978): 28; Ellen Stern, "The Big Apollo," *New York* 11 (May 8, 1978): 64.

10. "Show Time at the Apollo": 28.

11. David W. Dunlap, "Harlem's Apollo Theater to Be a Cable TV Studio," *New York Times* (May 18, 1982): 1, B: 3; "U.S. Aid Awarded to Apollo Theater," *New York Times* (September 30, 1982), B: 11; "New Act at Apollo," *New York Times* (December 12, 1982): 57; Sheila Rule, "Revival Plans for Apollo Theater Are Dropped," *New York Times* (December 26, 1982): 45; Sheila Rule, "The Apollo Reopens Heartening Harlem," *New York Times* (February 23, 1984), B: 1, 4; "Apollo's Financing Plan Complete," *New York Times* (January 6, 1987), VIII: 1; Stephen Holden, "Apollo Theater Celebrates Its Return," *New York Times* (May 5, 1985): 42; "Apollo Theater Video Center," *Oculus* 48 (December 1986): 23.

12. Barron, "Harlem Pins Revival Hopes on New Plans for 125th Street": 1, 4; Daniels, "Amid Uncertainty, Revival of 125th St. Proceeds": 1, 6; Woldenberg, "Mammon to Harlem?": 4–5; "Harlem Theater Awarded Grant," *New York Times* (March 31, 1983), B: 8; Mark McCain, "$15 Million to Spruce Up Harlem's Shopping Strip," *New York Times* (July 5, 1987), VIII: 11.

13. Glenn Fowler, "Koch Breaks Ground for a Peddlers Mart on 125th St.," *New York Times* (November 24, 1979): 27; Daniels, "Amid Uncertainty, Revival of 125th St. Proceeds": 1, 6; Ronald Smothers, "On 125th St., New Hope for Harlem's Renewal," *New York Times* (June 11, 1986), B: 1; McCain, "$15 Million to Spruce Up Harlem's Shopping Strip": 11; "Harlem Market Offers Cultures of Third World," *New York Times* (July 31, 1988): 40; Hardy Holzman Pfeiffer Associates: Buildings and Projects, 1967–1992 (New York: Rizzoli International Publications, 1992), 263; Shawn G. Kennedy, "New Momentum Builds on 125th Street," *New York Times* (November 8, 1992), VIII: 1, 6.

14. McCain, "$15 Million to Spruce Up Harlem's Shopping Strip": 11; Shawn G. Kennedy, "125th Street Experiences New Vitality," *New York Times* (February 1, 1989), D: 20.

15. Anthony DePalma, "Third World Center in Harlem Stirs Again," *New York Times* (January 1, 1989), X: 1, 7; Douglas Feiden, "A Trade Center Grows in Harlem," *Crain's New York Business* (August 31, 1992): 5.

16. Michael Avramides, quoted in "In the City," *Oculus* 54 (December 1991): 3. Also see "Coming to Harlem: A Ben & Jerry's for the Homeless," *New York Times* (October 20, 1991), X: 11; "Details," *Architecture* 81 (February 1992): 24; Kennedy, "New Momentum Builds on 125th Street": 1, 6; Adam Fisher, "Harlem Renaissance?" *Metropolis* 12 (June 1993): 19, 23.

17. Kennedy, "New Momentum Builds on 125th Street": 1, 6; Fisher, "Harlem Renaissance?": 19, 23.

18. Ronald Smothers, "Loan Approved for Harlem Theater," *New York Times* (May 18, 1986): 40; Smothers, "On 125th St., New Hope for Harlem's Renewal": 1; Kennedy, "125th Street Experiences New Vitality": 20; C. Gerald Fraser, "Harlem Ground Is Broken for National Black Theater," *New York Times* (May 21, 1989): 67; Peter D. Slatin, "National Black Theater Awaits Debut on 125th Street," *Architectural Record* 179 (October 1991): 25; Kennedy, "New Momentum Builds on 125th Street": 1, 6.

19. Walter Stafford, quoted in Guy Halverson, "Harlem: Rich Cultural Mix Gets More Vibrant," *Christian Science Monitor* (March 3, 1993): 10.

20. Ron Scherer, "The Ways and Means of Rangel," *Christian Science Monitor* (June 3, 1994): 2; Steven A. Holmes, "New York Is Picked to Get Federal Development Zone," *New York Times* (December 21, 1994), B: 3; Thomas J. Lueck, "3 Empowerment Areas Must Create a Wish List," *New York Times* (December 27, 1994), B: 3; Jennifer Kingson Bloom, "$300 Million Is Coming: Who Will Spend It," *New York Times* (January 8, 1995), XIII: 6; Alice Lipowicz, "NY Empowerment Zone Loser," *Crain's New York Business* (January 23, 1995): 1; Brett Pulley, "End of Urban Agency Draws Fears of Neglect," *New York Times* (March 30, 1995), B: 3; Dan Barry and Jonathan P. Hicks, "With Harlem at a Crossroad, Visions for Economic Future Diverge," *New York Times* (December 24, 1995): 19, 21.

21. John Kifner, "Death on 125th Street," *New York Times* (December 9, 1995): 1, 30; N. R. Kleinfeld, "Death on 125th Street: The Shopper," *New York Times* (December 10, 1995): 49; Clyde Haberman, "When a Store Changes Color on 125th St.," *New York Times* (December 12, 1995), B: 1; Matthew Purdy, "For Owner of Harlem Clothing Store, a Collision of Two Different Worlds," *New York Times* (December 16, 1995): 27; Barry and Hicks, "With Harlem at a Crossroad, Visions for

Economic Future Diverge": 19, 21; Gene Mustain, "Six Months After Massacre at Freddy's, Life Goes On," *New York Daily News* (June 2, 1996): 21; Lizette Alvarez, "Year After Freddy's Fire, Nothing's Quite the Same," *New York Times* (December 7, 1996): 25.

22. Rachelle Garbarine, "A New Effort to Redevelop Harlem Site," *New York Times* (February 27, 1991), D: 16; Shawn G. Kennedy, "Supermarket Invests in Harlem, Long Shunned by Chains," *New York Times* (September 22, 1994), B: 3; Sarah Jay, "Pathmark Plans Cheer Shoppers, but Shake Shopkeepers," *New York Times* (October 2, 1994), XIII: 6; Jennifer Kingson Bloom, "A Rose or a Thorn for East Harlem?" *New York Times* (February 2, 1995), B: 1, 5; Steven Lee Myers, "Giuliani Proposes Changes in Zoning to Aid Superstores," *New York Times* (February 19, 1995): 1, 43; Jennifer Kingson Bloom, "Supermarket Lobbying Intense," *New York Times* (April 23, 1995), XIII: 8; Joyce Purnick, "Plans for Supermarket Caught Up in Politics," *New York Times* (April 24, 1995), B: 3; "A Pathmark for East Harlem," editorial, *New York Times* (April 25, 1995): 22; Brett Pulley, "East Harlem Pathmark Plan Appears Headed for Defeat," *New York Times* (April 27, 1995), B: 3; Brett Pulley, "East Harlem Supermarket Is Approved," *New York Times* (April 28, 1995), B: 1, 3; Adam Nossiter, "Saving Money and Offering Pride," *New York Times* (April 30, 1995): 37, 39; "Supermarket Success," editorial, *New York Times* (May 1, 1995): 16; James Traub, "The Political Supermarket," *New Yorker* 71 (May 29, 1995): 41–44; Philip Lentz, "Rudy Crafting Deal to Okay Pathmark Site," *New York Times* (June 19, 1995): 1; Jonathan P. Hicks, "Harlem Pathmark Is Stalled, Awaiting Word from Mayor," *New York Times* (June 23, 1995), B: 3; "What Gives with the Pathmark?" editorial, *New York Times* (June 24, 1995): 18; Antonio Pagan, "Why Should New York Put Pathmark on the Dole?" *New York Times* (July 21, 1995): 25; Jonathan P. Hicks, "Mayor Gives Final Approval for East Harlem Supermarket," *New York Times* (August 2, 1995), B: 1, 3; "Pathmark: The Right Move," editorial, *New York Times* (August 3, 1995): 24; Jonathan P. Hicks, "Giuliani Bows to Reality of Ethnicity on Pathmark," *New York Times* (August 3, 1995), B: 3; "In Harlem, Diverse Views on Pathmark Deal," *New York Times* (August 6, 1995): 35; Brett Pulley, "In Store Fight, Mayor Got Tough," *New York Times* (August 12, 1995): 25; Davidson Goldin, "Pathmark Ruckus Puts Muralists on the Move," *New York Times* (August 27, 1995), XIII: 6; Janet Allon, "Pathmark Is Delayed as New $1 Million Loan Is Sought," *New York Times* (June 23, 1996), XIII: 6; David W. Dunlap, "Retailers Have Harlem on Their Mind," *New York Times* (November 10, 1996), VIII: 1, 6; Janet Allon, "On 125th Street, Upbeat Era Is No Sure Thing," *New York Times* (December 29, 1996), XIII: 6; Victoria Pope, "Harlem's Next Renaissance," *U.S. News & World Report* (February 10, 1997): 56; Thomas J. Lueck, "Work to Begin on Pathmark in Harlem After 5 Years," *New York Times* (August 23, 1997): 27; Jane H. Lii, "Ground Broken for Pathmark but Concerns Remain," *New York Times* (August 24, 1997), XIII: 6; Craig Horowitz, "The Shining Pathmark," *New York* 30 (September 1, 1997): 16–17; "Supermarket Construction Is Underway in East Harlem," *National Mortgage News* (October 6, 1997): 2; Terry Pristin, "A Supermarket as a Spur for Change," *New York Times* (May 28, 1999), B: 1, 5; "The 125th Street Corridor," *Oculus* 61 (Summer 1999): 7; Richard Turcsik, "Taking Root," *Progressive Grocer* 78 (July 1999): 64–66, 68, 70; Nina Siegal, "Harlem on the Brink," *New York Times* (September 26, 1999), XIV: 1, 12; Terry Pristin, "Harlem's Pathmark Anchors a Commercial Revival on 125th Street," *New York Times* (November 13, 1999), B: 1–2; Jayson Blair, "Financial Woes Cloud Pathmark's Future in Poor Areas," *New York Times* (January 18, 2000), B: 6.

23. Pristin, "Harlem's Pathmark Anchors a Commercial Revival on 125th Street": 1.

24. "Metro-North to Renovate Its 125th St. Station," *New York Times* (February 12, 1995), VIII: 1; Chastity Pratt, "Metro-North Will Build It. Who Will Come?" *New York Times* (June 25, 1995), XIII: 6; Tina Kelley, "Six Years in the Making, a Reconstructed Metro-North Station Opens in Harlem," *New York Times* (December 19, 1999): 55; "MTA/Metro-North Harlem 125th Street Station," *New York Construction News* 48 (December 2000): 40–41.

25. Thomas J. Lueck, "Retail Complex in Harlem Takes a Big Step Forward," *New York Times* (March 19, 1996), B: 6; "Harlem U.S.A.," editorial, *New York Observer* (March 25, 1996): 4; Abby Bussel, "Entertainment Investors Rediscover Harlem's Drawing Power," *Architectural Record* 184 (June 1996): 13; Peter Slatin, "Disney May Open Store in Harlem," *New York Post* (June 3, 1996): 22; Laurie Bird and Mitchell Pacelle, "Disney Makes Bet on Harlem Renaissance," *Wall Street Journal* (June 6, 1996): 2; Tom Vanderbilt, "A Mall Grows in Harlem," *Metropolis* 16 (July-August 1996): 21, 25; Laura Bird, "Shunned No More, New York's Harlem Entices Big Chains Seeking Fresh Turf," *Wall Street Journal* (July 25, 1996), B: 1, 10; Janet Allon, "De Niro Up for 'Empowerment,'" *New York Times* (October 20, 1996), XIII: 8; Douglas Feiden, "The Magic Touch," *New York Post* (October 3, 1996): 31; Dunlap, "Retailers Have Harlem on Their Mind": 1, 6; Allon "On 125th Street, Upbeat Era Is No Sure Thing": 6; Eric L. Smith, "Harlem Renaissance–Take Two," *Black Enterprise* 27 (February 1997): 23, 26; Pope, "Harlem's Next Renaissance": 56; John Holusha, "Harlem U.S.A. Project Is Progressing, but Tempo Lags," *New York Times* (March 26, 1997), B: 8; "The End of Mom and Pop?" *Metropolis* 17 (June 1997): 27; David M. Halbfinger, "Magic Johnson Project Shifts to Another Harlem Site," *New York Times* (July 31, 1997), B: 5; Peter Slatin, "Music Giant HMV to Open Harlem Digs," *New York Post* (September 23, 1997): 28; Peter Slatin, "Harlem Shuffle," *Urban Land* 56 (October 1997): 91; Kirk Johnson, "Uneasy Renaissance on Harlem's Street of Dreams," *New York Times* (March 1, 1998): 1, 30; Keith H. Hammonds, "Hooray for Harlem," *Business Week* (May 11, 1998): 40; "From the Ground Up, in Harlem," *New York Times*

(July 28, 1998), B: 5; "The 125th Street Corridor": 7; Tamar Jacoby and Fred Siegal, "Growing the Inner City?" *New Republic* 221 (August 23, 1999): 22–27; Siegal, "Harlem on the Brink": 1, 12; Amy Waldman, "Where Green Trumps Black and White," *New York Times* (December 11, 1999), B: 1, 8; *Skidmore, Owings & Merrill: Architecture and Urbanism, 1995–2000* (Mulgrave, Australia: Images Publishing, 2000), 166–67; "Great Expectations," *Oculus* 62 (January 2000): 5; Terry Pristin, "New Cinema and New Hope in Harlem," *New York Times* (July 1, 2000), B: 1–2; Terry Pristin, "Harlem U.S.A. Tries to Lure Stores Owned by Minorities," *New York Times* (September 11, 2000), B: 3; William P. Macht, "Inside Out in Harlem," *Urban Land* 59 (October 2000): 32–33; Charles David, "Development Sparks a Revival in Harlem," *Urban Land* 60 (April 2001): 33; Sharyn Clark, "Harlem USA, New York City," *Grid* 3 (May 2001): 78–79.

26. Anthony Ramirez, "A Caffe Latte Spot on West 125th Street," *New York Times* (April 28, 1999), B: 5.

27. David, "Development Sparks a Revival in Harlem": 33.

28. Jane H. Lii, "Act 2 for Prime Site, and Butts Is Supporting Player," *New York Times* (June 8, 1997), XIII: 22; Slatin, "Harlem Shuffle": 91; Philip Lentz, "Giuliani Blocks Harlem Project in Butts Feud," *Crain's New York Business* (February 1–7, 1999): 1, 23; Amy Waldman, "Feud with Mayor Cited in Project Cutback," *New York Times* (February 2, 1999), B: 3; Siegal, "Harlem on the Brink": 1, 12; Charles V. Bagli, "Plan Set for Retail Complex on State Land in Harlem," *New York Times* (November 4, 1999), B: 9; Waldman, "Where Green Trumps Black and White": 1, 8; "Great Expectations": 5; "New Contracts," *World Architecture* 84 (March 2000): 26; "Harlem Center," *Grid* 2 (November-December 2000): 93; David W. Dunlap, "The Changing Look of the New Harlem," *New York Times* (February 10, 2002), XI: 1, 6. For Washington and Mitchell/Giurgola's trade center scheme, see Peter Slatin and Suzanne Stephens, "Harlem on Architects' Minds," *Oculus* 55 (January 1993): 3–4; Shawn G. Kennedy, "Harlem Dreams Are Revived for Trade Center and Hotel," *New York Times* (November 14, 1994), B: 3; *Mitchell/Giurgola Architects: Selected and Current Works* (Mulgrave, Australia: Images Publishing, 1996), 72–75.

29. "Harlem Renaissance," *ANY* 22 (1998): 24; "The Studio Museum in Harlem," *L'Arca* 127 (1998): 82–83; "Studio Museum in Harlem," *Oculus* 60 (January 1999): 37; "Postings," *New York Times* (January 21, 2001), XI: 1; Amanda May, "New York on Display," *Grid* 3 (March 2001): 30–31; "New New York 2," *Oculus* 63 (March 2001): 17; Aric Chen, "Glimpsing the Secret Garden," *Metropolis* 20 (July 2001): 58; "Rogers Marvel Architects: The Studio Museum in Harlem," *Architecture + Urbanism* (September 2001): 126–29; "Rogers Marvel Architects: The Studio Museum in Harlem," *Quaderns d'arquitectura i urbanisme* 232 (2002): 134–37; Tracie Rozhon, "To Be New and True to Harlem," *New York Times* (January 31, 2002), F: 1, 4; Ian Luna, ed., *New New York: Architecture of a City* (New York: Rizzoli International Publications, 2003), 268–69.

30. Charlayne Hunter-Gault, "Planned Move of Museum of Black Art from Harlem Stirs Dissension Among Institution's Staff Members," *New York Times* (June 21, 1977): 37; C. Gerald Fraser, "Harlem Studio Museum Searching for a Home," *New York Times* (June 5, 1979), C: 9; C. Gerald Fraser, "Studio Museum Finds a Harlem Home," *New York Times* (November 10, 1979): 14; "New Home for Studio Museum," *New York Times* (May 21, 1981), C: 16; Michael Brenson, "New Home and Life for Studio Museum in Harlem," *New York Times* (June 17, 1982), C: 16; Woldenberg, "Mammon to Harlem?": 4.

31. "Movies Come to Harlem, After an Intermission," *Wall Street Journal* (December 15, 1992), B: 1; Laura Seigle, "Manhattan Community Boards," *New York Observer* (November 15, 1999): 14.

32. Dan Barry, "Giuliani and Pataki Demand Apollo Theater Financial Data," *New York Times* (May 5, 1998), B: 1, 9; "Audit Time at the Apollo," editorial, *New York Times* (May 8, 1998): 20; Alan Finder and Anthony Ramirez, "For the Apollo, Audits and Anger," *New York Times* (May 11, 1998), B: 1, 9; Terry Pristin, "Audit of Apollo Management Is Expected by End of Week," *New York Times* (March 23, 1999), B: 3; Andrea Bernstein, "Time Warner Steps In to Save Apollo Theater, Calming Spitzer Storm," *New York Observer* (May 3, 1999): 1, 13; Josh Getlin, "Corporate Show Time at the Apollo," *Los Angeles Times* (July 9, 1999): 1–2; Terry Pristin and Ralph Blumenthal, "Rescue Time at the Apollo: Time Warner to Control Board," *New York Times* (August 5, 1999), B: 1, 4; "A Rescue Plan for the Apollo," editorial, *New York Times* (August 6, 1999): 18; Terry Pristin, "Big Ideas for Apollo Theater Are Held Up by Internal Squabbles," *New York Times* (September 17, 2000): 41, 48; Craig Kellog, "Culture All Around Town," *Oculus* 63 (November 2000): 4.

33. Terry Pristin, "Executive Named to Head Apollo Theater," *New York Times* (March 30, 2001), B: 6; Valerie Block, "It's Showtime at the Apollo," *Crain's New York Business* (June 4, 2001): 3, 45; Valerie Block, "Tough Act at the Apollo," *Crain's New York Business* (June 11, 2001): 15; Dunlap, "The Changing Look of the New Harlem": 1, 6.

34. Charles V. Bagli with Marc Lacey, "Criticized on Office Rent, Clinton Looks to Harlem," *New York Times* (February 13, 2001): 1, B: 4; Susan Saulny, "Harlem's Executive Perks? Park View, Golden Arches," *New York Times* (February 13, 2001), B: 4; Elizabeth Bumiller and Dexter Filkins, "Snag in Clinton's Office Plan: Giuliani Stakes Claim to Space," *New York Times* (February 14, 2001): 1, B: 5; Eric Lipton, "City Rejects the First Two Offers for Clinton's Harlem Office Site," *New York Times* (February 15, 2001), B: 8; Dean E. Murphy, "For an Ex-President in New York, No Hair Shirt Required," *New York Times* (February 17, 2001), B: 1, 6; Andrew Rice, "Clinton in Harlem," *New York Observer* (February 19, 2001): 1, 8; Nancy Ramsey, "As Bill Heads Uptown, Will Others

Follow," *Grid* 3 (June 2001): 22; Amy Waldman, "In Harlem, a Hero's Welcome for New Neighbor Clinton," *New York Times* (July 31, 2001): 1, B: 4; "Harlem on the Cusp," editorial, *New York Times* (August 26, 2001): 12; Peter Slatin, "Uptown Man," *Grid* 3 (September 2001): 21. For 55 West 125th Street, also known as the CAV Building, see Stern, Mellins, and Fishman, *New York 1960*, 891.

35. Waldman, "In Harlem, a Hero's Welcome for New Neighbor Clinton": 1.

BROWNSTONE REVIVAL

1. See Stern, Mellins, and Fishman, *New York 1880*, 791–801.

2. Lee A. Daniels, "City to Sell Harlem Brownstones by Lottery," *New York Times* (July 24, 1981): 1, 14; Lee A. Daniels, "Koch Offers Housing and Economic Plan to Revivify Harlem," *New York Times* (August 26, 1982), B: 1, 8; Lee A. Daniels, "A Surge in Housing in Harlem Prompts Hopes for a Renewal," *New York Times* (September 12, 1981): 1, 8; Lee A. Daniels, "Hope and Suspicion Mark Plan to Redevelop Harlem," *New York Times* (February 6, 1983), IV: 6; Lee A. Daniels, "Houses in Harlem Attracting Buyers," *New York Times* (August 21, 1983), VIII: 1, 14; Lee A. Daniels, "Signs of Private Investing in Harlem Housing Seen," *New York Times* (September 9, 1983): 17.

3. "For Sale by City," *New York Times* (March 28, 1985), B: 3; "Brownstones in Harlem: Buying Redevelop," *New York Times* (April 28, 1985), VIII: 1; Carlyle C. Douglas, "City Taking Bids for 149 Vacant Harlem Buildings," *New York Times* (May 11, 1985): 29; Carlyle C. Douglas, "For Some, City Auction of Houses Is Chance to Come Home to Harlem," *New York Times* (June 20, 1985) B: 1, 9; Carlyle C. Douglas, "149 Win in Auction of Harlem Houses," *New York Times* (August 17, 1985): 46; Carlyle C. Douglas, "The Brownstone Project in Harlem Raises Hopes and Fears," *New York Times* (September 13, 1985), IV: 22; Michael deCourcy Hinds, "Mixed Record Emerges from Auction Sales of City Houses," *New York Times* (September 13, 1987), VIII: 1, 20; David W. Dunlap, "Revisiting Promises Koch Made in '85," *New York Times* (September 9, 1989): 26.

4. Howard W. French, "Harlem," *New York Times* (April 25, 1988), B: 1, 4.

5. Suzanne Slesin, "New Residents, New Life in Hamilton Hts.," *New York Times* (May 19, 1988), C: 1, 6; Suzanne Slesin, "Energy of Rebirth in Hamilton Heights," *New York Times* (May 31, 1990), C: 1, 6.

6. Diana Shaman, "8 Brownstones Rehabilitated in Harlem," *New York Times* (July 12, 1991): 14; Suzanne Slesin, "To Recapture an Uptown Elegance," *New York Times* (June 4, 1992), C: 1, 6.

7. Landmarks Preservation Commission of the City of New York, *Hamilton Heights Historic District Designation Report* (New York, 1974), 12, 15.

8. Stern, Mellins, and Fishman, *New York 1880*, 796–800.

9. Clare McHugh, "Neighborhood Work," *New York Observer* (August 19–26, 1991): 3; "First Phase of a Harlem Project Is Completed," *New York Times* (October 7, 1992), B: 3; Brendan Gill, "The Sky Line: On Astor Row," *New Yorker* 68 (November 2, 1992): 51–54; Andrea Oppenheimer Dean, "Part of the Solution," *Historic Preservation* 45 (March-April 1993): 12, 90, 92; Andrea Oppenheimer Dean, "A Values-Added Practice," *Progressive Architecture* 74 (October 1993): 54–57; Randy Kennedy, "Dispute Snarls the Restoration of Astor Row," *New York Times* (August 21, 1994), XIII: 8; Christopher Gray, "Streetscapes/Astor Row on West 130th," *New York Times* (October 9, 1994), IX: 7; "Harlem," *Annals of the New York Chapter of the American Institute of Architects, 1996–97* (1997): 53–54; Nina Rappaport, "A Harlem Renaissance Revival," *Oculus* 59 (March 1997): 8–12; Theresa Braine, "High Wire Act," *Grid* 2 (January-February 2000): 90–92. For Astor Row, see Landmarks Preservation Commission of the City of New York, LP-1137-64 (August 11, 1981); Barbaralee Diamonstein, *The Landmarks of New York III* (New York: Harry N. Abrams, 1998), 176; Stern, Mellins, and Fishman, *New York 1880*, 795–96.

10. Christopher Gray, "Streetscapes/28 West 126th Street," *New York Times* (February 8, 1998), XI: 5. Also see Stern, Mellins, and Fishman, *New York 1880*, 794.

11. Lisa W. Foderaro, "For Affluent Blacks, Harlem's Pull Is Strong," *New York Times* (September 18, 1998): 1, B: 5.

12. Jayson Blair, "Residential Beachhead for Landing Gentry," *New York Times* (January 23, 2000), XIV: 8. Also see Danielle Reed, "Leading Realtor to Open Harlem Branch," *New York Daily News* (January 8, 2000): 15; Terry Pristin, "Inquiries on Mortgage Deals Crimp Harlem's Realty Boom," *New York Times* (November 26, 2000): 1, 51.

13. Shawn G. Kennedy, "Landmarks: Now, It's Harlem's Turn," *New York Times* (May 12, 1991), X: 1, 10; C. Gerald Fraser, "Many in Harlem Want Longer Landmarks List," *New York Times* (July 15, 1991), B: 3; David Gonzalez, "Architecture Doesn't Stop at 96th Street," *New York Times* (January 21, 1998), B: 1; Nina Siegal, "Can Harlem's Heritage Be Saved," *New York Times* (February 7, 1999), XIV: 1, 10; Stephen Lynch, Maritta Dunn, Rachelle L'Ecuyer Schneider, Albert Davis, and Stuart Waldman, "Making Landmarks in Harlem," letters to the editor, *New York Times* (February 28, 1999), XIV: 13; Stanley Crouch, "New Challenge Up in Harlem: Saving History," *New York Daily News* (May 10, 1999): 33; Ellen Barry, "The Metropolis Observed," *Metropolis* 19 (July 1999): 64.

14. Landmarks Preservation Commission of the City of New York, *St. Nicholas Historic District Designation Report* (New York, 1967); Landmarks Preservation Commission of the City of New York, *Mount Morris Park Historic District Designation Report* (New York, 1971); *Hamilton Heights Historic District*; Diamonstein, *The Landmarks of New York III*, 490, 497, 501.

15. Michael Henry Adams, quoted in Siegal, "Can Harlem's Heritage Be Saved": 10. Also see Michael Henry Adams, *Harlem: Lost and Found* (New York: Monacelli Press, 2002).

16. Karen A. Phillips, quoted in Siegal, "Can Harlem's

Heritage Be Saved": 10.

17. Nina Siegal, "Harlem," *New York Times* (March 5, 2000), XIV: 6; Landmarks Preservation Commission of the City of New York, LP-2044 (March 28, 2000); Nina Siegal, "Landmark Status for Harlem Buildings," *New York Times* (June 15, 2000), B: 1, 6; Landmarks Preservation Commission of the City of New York, LP-2064 (June 27, 2000); Anthony Ramirez, "Black Historic District Approved," *New York Times* (October 17, 2000), B: 6; Landmarks Preservation Commission of the City of New York, LP-2103-4 (October 23, 2001); Judith Matloff, "Neighborhood Report: Harlem," *New York Times* (April 14, 2002), XIV: 4; Landmarks Preservation Commission of the City of New York, LP-2105 (June 18, 2002).

CENTRAL HARLEM

1. Sheila Rule, "A Plan to Aid South Harlem Is Announced," *New York Times* (August 14, 1979), B: 1.

2. Lee A. Daniels, "Action to Harlem Gateway Tenants: A Success Story," *New York Times* (May 14, 1982), B: 7.

3. Carlyle C. Douglas, "Harlem Warily Greets Plans for Development," *New York Times* (January 19, 1986): 35.

4. Lee A. Daniels, "Minority Concern to Buy 2 City Buildings on Park," *New York Times* (August 19, 1983), B: 3; Lee A. Daniels, "New Condominiums at Harlem's Edge," *New York Times* (February 19, 1984), VIII: 1, 14; Douglas, "Harlem Warily Greets Plans for Development": 35.

5. Daniels, "New Condominiums at Harlem's Edge": 1, 14; Alan S. Oser, "Mixed-Income High Rise Takes Condominium Form," *New York Times* (June 30, 1985), VIII: 7; Douglas, "Harlem Warily Greets Plans for Development": 35; Richard D. Lyons, "If You're Thinking of Living In: Manhattan Valley," *New York Times* (February 8, 1987), VIII: 9; Alan S. Oser, "City Assisted Housing: Mixed-Income Condo Nears Completion," *New York Times* (February 7, 1988), VIII: 9; "Topics of The Times: Vital Partnership," *New York Times* (February 9, 1988): 30; White and Willensky, *AIA Guide* (2000), 490.

6. Stern, Mellins, and Fishman, *New York 1960*, 880–81.

7. White and Willensky, *AIA Guide* (2000), 490.

8. "Mayor Koch Gets Preview of Duke Ellington Statue," *New York Times* (October 15, 1986), C: 21; Eleanor Blau, "Bobby Short Backs Central Park Statue to Honor Ellington," *New York Times* (February 23, 1983), B: 3; Dennis Hevesi, "Ellington Sculpture Puts Some Critics in Mood Indigo," *New York Times* (May 4, 1990), B: 1, 3; Emily M. Bernstein, "Rounding Off a Central Park Edge," *New York Times* (January 9, 1994), XIII: 5; Nina Rappaport, "A Harlem Renaissance Revival," *Oculus* 59 (March 1997): 8–12; Rick Lyman, "After an 18-Year Campaign, an Ellington Memorial Rises," *New York Times* (July 1, 1997), C: 9; Rick Lyman, "Returning Duke's Love for a City," *New York Times* (July 2, 1997), C: 18.

9. Edward Wyatt, "School-Managing Company and Museum Plan Harlem Headquarters," *New York Times* (July 20, 2000), B: 1, 7; Edward Wyatt, "Defeat Aside, Edison Plans to Expand," *New York Times* (April 1, 2001), 29; Marjorie Coeyman, "New Edison Schools Proposal Lights Up Discontent in Harlem," *Christian Science Monitor* (September 4, 2001): 12; Jonathan Mahler, "Gotham Rising," *Talk* 1 (December 2001/January 2002): 120–25, 148–52; *Next: 8th International Architecture Exhibition 2002* (New York: Rizzoli International/Universe, 2002), 80–81; "Edison Schools Suspends Effort to Build Headquarters Project in East Harlem," press release (September 5, 2002); Joseph Berger, "Edison Schools Cancels Harlem Building Plan," *New York Times* (September 6, 2002), B: 3; Colin Miner, "Edison Pulls Plug on Harlem HQ," *New York Sun* (September 6–8, 2002): 1, 4; Ian Luna, ed., *New New York: Architecture of a City* (New York: Rizzoli International Publications, 2003), 266–67; Lois Weiss, "Deal to Rescue Harlem Museum," *New York Post* (June 26, 2003): 36.

10. *The Architecture of Rafael Viñoly* (New York: Princeton Architectural Press, 2002), no pagination.

11. Stern, Gilmartin, and Mellins, *New York 1930*, 735, 740.

12. Rappaport, "A Harlem Renaissance Revival": 8–12; "Cityscape's Demonstration Projects," *Cityscape News* (Summer 1998): 2–4; Nina Siegal, "On 110th St., Heritage and a New Plan for Grandeur," *New York Times* (November 1, 1998), XIV: 6; Nina Siegal, "Forget 'Heritage Corridor,' Some Say," *New York Times* (May 9, 1999), XIV: 6; Nina Siegal, "A 'Heritage Corridor' Bends to Preservationists' Wishes," *New York Times* (August 20, 2000), XIV: 6; Douglas Martin, "Street Fighter," *New York Times* (August 12, 2001), XIV: 1, 8; "Groundbreaking for the Harlem Gateway Corridor," *Cityscape News* (Fall 2001): 1–4.

13. Anne Raver, "A Sliver of Paradise Blooms in Harlem," *New York Times* (August 3, 2000), F: 10; "A Paradisical New Plaza," *Oculus* 63 (September 2000): 9; "The New York Plaza," *Van Alen Report* 8 (December 2000): 18–21.

14. *Boulevard/Manhattan: An Exhibition of the Frederick Douglass Boulevard Project by the Hudson Studio," Newsline* 4 (December 1991): 3.

15. William R. Greer, "U.S. to Give State $70 Million to Foster Nonprofit Housing," *New York Times* (September 24, 1985), B: 5; "Building in Harlem: Housing the Aged," *New York Times* (May 28, 1989), X: 1.

16. *Boulevard/Manhattan: The Hudson Studio: Roy Strickland, Linda Gatter* (New York: Columbia Architecture, Planning, Preservation, 1991); "Redesigning Harlem," *Columbia University Record* (December 6–19, 1991): 4.

17. *Frederick Douglass Boulevard Study* (New York: Office of the Manhattan Borough President; New York: Urban Technical Assistance Project, Columbia University), i.

18. *Frederick Douglass Boulevard First Action Plan–Harriet Tubman Square* (New York: Office of the Manhattan Borough President; New York: Urban Technical Assistance Program, Summer 2000).

19. "Honoring Harriet Tubman–Square and Avenue in

Harlem to Be Named for Female 'Moses,'" press release (March 9, 2001); Frank Lombardi, "Harriet Tubman Sq. Plan Goes to Council," *New York Daily News* (March 14, 2001): 11.

20. Amy Waldman, "Homes and Shops to Rise on Abandoned Harlem Properties," *New York Times* (December 27, 2000), B: 1, 6; Nadine Brozan, "Co-ops and Town Houses in Harlem," *New York Times* (May 3, 2002), B: 8.

21. "Financed by CPC and New York City HDC; Gaetano DiPlacidi and Assoc. Develops Gateway I," *New York Real Estate Journal* (July 16-July 29, 2002): 10B. Also see "Gateway to Harlem Opens," press release (June 26, 2002).

22. www.gda-inc.com/Gateway%20II.html.

23. Nina Siegal, "Ambulance Station Is Not a Good Fit, Some Say," *New York Times* (August 15, 1999), XIV: 6. Also see Nina Siegal, "Land in Manhattan for $1 a Lot?" *New York Times* (October 17, 1999), XIV: 4; Nina Siegal, "Spreading Harlem's Boom to a Neglected Boulevard," *New York Times* (December 15, 1999), B: 22.

24. "NYC HPD Announces Designation of Developers for Affordable Apartments in Harlem," press release (April 20, 2000).

25. "Harlem," *New York Daily News* (July 15, 1999), Metro: 2; Rachelle Garbarine, "Residential Real Estate," *New York Times* (July 30, 1999), B: 8; Alan S. Oser, "At Lenox and 116th, Co-ops and Stores Are Rising," *New York Times* (August 8, 1999), XI: 7; Nina Siegal, "Harlem on the Brink," *New York Times* (September 26, 1999), IX: 1, 12; Rachelle Garbarine, "Buyers Waiting for Harlem Apartments," *New York Times* (February 18, 2000), B: 8; Tracie Rozhon, "Grit and Glory in South Harlem," *New York Times* (March 16, 2000), F: 1, 9; Atim Annette Oton and Nina Rappaport, "Harlem on the Move," *Oculus* 62 (May 2000): 5–7; Jose Martinez, "Kids Try on Hardhats," *New York Daily News* (June 13, 2000), Metro: 3; Rachelle Garbarine, "Residential Real Estate," *New York Times* (October 20, 2000), B: 8; Jose Martinez, "N.Y. Takes Harlem Growth to the Bank," *New York Daily News* (April 26, 2001), Metro: 1; Rachelle Garbarine, "Harlem Co-op Has a Financing Twist," *New York Times* (June 29, 2001), B: 6; David W. Dunlap, "The Changing Look of Harlem," *New York Times* (February 10, 2002), XI; 1, 6; Marc Hochstein, "Renaissance Complex," *Grid* 4 (April 2002): 20; Alan J. Wax and Tania Padgett, "Things Are Looking Uptown," *Newsday* (August 5, 2002), D: 1. Also see Shawn G. Kennedy, "A Housing Renaissance Sweeps Central Harlem," *New York Times* (August 27, 1989), X: 1, 9; Randy Kennedy, "Harlem," *New York Times* (August 7, 1994), XIII: 5.

26. See Jerrilynn D. Dodds, *New York Masjid: The Mosques of New York City* (New York: PowerHouse Books, 2002), 89–90.

27. "Harlem," *New York Daily News* (July 15, 1999): 2; Oser, "At Lenox and 116th, Co-ops and Stores Are Rising": 7; Siegal, "Harlem on the Brink": 1, 12; Rozhon, "Grit and Glory in South Harlem": 1, 9; Oton and Rappaport, "Harlem on the Move": 6–7.

28. Navid Maqami, quoted in Oser, "At Lenox and 116th, Co-ops and Stores Are Rising": 7.

29. Janet Allon, "Building Will Plug into the Future," *New York Times* (February 23, 1997), XIII: 8; Rachelle Garbarine, "A Housing Plan Where Stores Have Been Included," *New York Times* (November 28, 1997), B: 12; Nina Rappaport, "Another Harlem Renaissance," *Oculus* 10 (Summer 1999): 6; "New York," *Engineering News-Record* 242 (June 28, 1999): 145; Theresa Braine, "High Wire Act," *Grid* 2 (January-February 2000): 90–92; Garbarine, "Buyers Waiting for Harlem Apartments": 8; Tracie Rozhon, "To Be New and True to Harlem," *New York Times* (January 31, 2002), F: 1, 4; Nadine Brozan, "On Fifth Avenue Between 115th and 116th Streets," *New York Times* (June 23, 2002), XI: 1; "Manhattan," *New York Construction News* 50 (August 2002): 115; Wax and Padgett, "Things Are Looking Uptown": 1.

30. Constance L. Hays, "Loan Given to Rebuild a Harlem Hospital," *New York Times* (May 11, 1988), B: 1, 4; Howard W. French, "Rebuilding Buoys Hopes for Hospital in Harlem," *New York Times* (November 9, 1989), B: 2; Lisa Belkin, "At North General, Moving a Whole Hospital, One Patient at a Time," *New York Times* (December 12, 1991), B: 9; "A Hospital on the Move," *New York Times* (December 13, 1991), B: 3; Sam Roberts, "Breathing New Life into a Hospital," *New York Times* (December 28, 1992), B: 3; White and Willensky, *AIA Guide* (2000), 496. For the Hospital for Joint Diseases, see "Hotel for the Sick," *New York Times* (October 14, 1923), X: 1.

31. White and Willensky, *AIA Guide* (2000), 496.

32. Andrew White, "Board 11 'Aye' to East Harlem Housing," *New York Observer* (June 8, 1992): 8; Alan S. Oser, "For East Harlem, a 135-Unit Midrise Co-op on a Park," *New York Times* (January 9, 1994), X: 7; Rappaport, "A Harlem Renaissance Revival": 8–12.

33. "Limited-Equity Co-op to Rise in East Harlem: Three Bedrooms for $4,000," *New York Times* (December 31, 1995), IX: 1; Rachelle Garbarine, "New East Harlem Co-op Is Priced for Wide Range," *New York Times* (March 27, 1998), B: 10.

34. Alan S. Oser, "Crafting Financing to Assist Housing Construction," *New York Times* (December 13, 1998), XI: 7.

35. Alan S. Oser, "New Roles for Nonprofit Housing Groups," *New York Times* (June 3, 2001), XI: 1, 4. Also see "East Harlem Welcomes Affordable Townhouses," press release (September 25, 2001).

36. "First of Three Middle-Income Buildings: A New Co-op Going Up in East Harlem," *New York Times* (July 8, 2001), XI: 1.

37. Lee A. Daniels, "Church in Harlem Plans a Town-House Project," *New York Times* (September 4, 1981), B: 3; Lee A. Daniels, "A Surge in Housing in Harlem Prompts Hopes for a Renewal," *New York Times* (September 12, 1981): 1, 8; Kennedy, "A Housing Renaissance Sweeps Central Harlem": 1, 9; Rachelle Garbarine, "Affordable Housing," *New York Times* (April 30, 1993): 21; Emily M. Bernstein, "A New Look for Striver's Row Area," *New York Times* (January 9, 1994), XIII: 5; Diana Shaman, "2 Subsidized Projects, and Attractive to Boot," *New York Times* (February 11, 1994): 29; Tracie Rozhon, "New

Harlem Rowhouses," *New York Times* (March 13, 1994), X: 8; "Ribbon-Cutting for New Affordable Housing in Harlem," *New York Times* (July 12, 1994): 25; Chastity Pratt, "A Cresting Wave of Change, Powered by Condominiums," *New York Times* (July 9, 1995), XIII: 7; Janet Allon, "Tempest in the Town Houses," *New York Times* (January 28, 1996), XIII: 8; "A Program to Revive Harlem," editorial, *New York Times* (March 21, 1996): 24; Craig Horowitz, "The Battle for the Soul of Harlem," *New York* 30 (January 27, 1997): 22–31; White and Willensky, *AIA Guide* (2000), 508.

38. Quoted in http://www.sbjgroup.com/stcharles.html.

39. E. R. Shipp, "Harlem Battles Over Development Project," *New York Times* (July 31, 1991), B: 1–2.

40. Shipp, "Harlem Battles Over Development Project": 1–2; Erika Mallin, "The Bradhurst Battles," *City Limits* 17 (April 1992): 18–21; "Rebirth for Bradhurst," *New York Times* (April 12, 1992), X: 1; Emily M. Bernstein, "Neighborhood Report: Harlem," *New York Times* (September 12, 1993), XIII: 6; Emily M. Bernstein, "A New Bradhurst," *New York Times* (January 6, 1994), B: 1, 4; Douglas Martin, "Three Decades in Free Fall: The Sad Saga of 140th Street," *New York Times* (March 6, 1994), XIII: 6; Denene Millner, "Activists Fear for Harlem Project," *New York Daily News* (May 14, 1995): 20.

41. Jane H. Lii, "Church Group Battles Pathmark Proposal," *New York Times* (February 9, 1997), XIII: 8; April Tyler, "Showdown on Aisle Five," *City Limits* 22 (April 1997): 10–11; Chrisena Coleman, "Decision Eyed Soon on Harlem Build Plan," *New York Daily News* (June 15, 1999), Metro: 2; Terry Pristin, "Big vs. Local in Harlem Supermarket Proposals," *New York Times* (June 15, 1999), B: 12; Terry Pristin, "Team Chosen to Build Harlem Market," *New York Times* (June 19, 1999), B: 3; Chrisena Coleman, "Developer Picked for Harlem Complex," *New York Daily News* (June 23, 1999), Metro: 2; Jayson Blair, "Pathmark Pulls Out of Supermarket Project in Northwest Harlem," *New York Times* (June 14, 2000), B: 11; Terry Pristin, "2 Years Later, Harlem Still Waits for a Supermarket It Needs," *New York Times* (May 20, 2001): 43.

42. "Harlem," *Annals of the New York Chapter of the American Institute of Architects, 1996–97* (1997): 53–54; Rappaport, "A Harlem Renaissance Revival": 8–12.

43. Rappaport, "A Harlem Renaissance Revival": 9.

44. Alan S. Oser, "New Roles for Nonprofit Housing Groups," *New York Times* (June 3, 2001), XI: 1, 4. Also see http://www.lsgsarchitects.com.

45. Edwin McDowell, "Residential Real Estate," *New York Times* (November 29, 2002), B: 10.

46. *Marvin H. Meltzer: City as Poetry* (Milan: L'Arca Edizioni, 2002), 68–71; Philip Lentz, "Harlem Megastore Project Rolls Ahead Despite Protests," *Crain's New York Business* (February 25, 2002): 4; Terry Pristin, "Construction Is to Start in Fall on Central Harlem Supermarket," *New York Times* (July 3, 2002), B: 6; Graham Rayman, "City-Backed Harlem Project at Standstill," *Newsday* (June 25, 2003): 7.

47. Stern, Gilmartin, and Massengale, *New York 1900*, 101.

48. Stern, Mellins, and Fishman, *New York 1960*, 881–82.

49. John Darnton, "Schomburg Files Get Harlem Site," *New York Times* (February 4, 1973): 53; Judith Cummings, "Schomburg Beset by Aging Process," *New York Times* (February 16, 1975): 30; Ada Louise Huxtable, "Can New York Save the Schomburg Center?" *New York Times* (April 25, 1976), II: 31.

50. Huxtable, "Can New York Save the Schomburg Center?": 31.

51. Glenn Fowler, "New York Asking U.S. Building Aid of $232.9 Million," *New York Times* (October 27, 1976): 81; Judith Cummings, "Library Will Get $3 Million Grant from U.S. Fund," *New York Times* (December 15, 1976): 29; Charlayne Hunter-Gault, "Center for Black Culture Is Given New Hope as Federal Aid Near," *New York Times* (January 11, 1977): 30; David Bird, "Evicted Merchants Find Aid for Building Mixed Blessing," *New York Times* (April 4, 1977): 33; Lena Williams, "Some Refuse to Abandon Hope They Find in Harlem," *New York Times* (March 6, 1978), B: 2; Laurie Johnston, "Panel Tells Koch How to Restore Quality to New York's Libraries," *New York Times* (April 2, 1978): 49; C. Gerald Fraser, "Schomburg Unit Listed as Landmark," *New York Times* (May 1, 1979): 53; Barbara Gamarekian, "403 Museums, 56 in New York, Granted $7.4 Million by H.E.W.," *New York Times* (September 6, 1979), C: 16; "Libraries Get $1.6 Million," *New York Times* (October 2, 1979), C: 11; W. J. Simpkins, "New Home for Schomburg," *Encore American & Worldwide News* 9 (January 1980): 44–45; "A Black Studies Center Is Dedicated in Harlem," *New York Times* (September 29, 1980): 23; "Research Libraries Get $1.6 Million Grant," *New York Times* (October 7, 1980), C: 6; "Auction for Schomburg Library," *New York Times* (October 26, 1980): 65; "The Talk of the Town: Ceremonies," *New Yorker* 56 (November 17, 1980): 45–46; C. Gerald Fraser, "Harlem's Schomburg Research Center Enjoys Popular Boom in New Building," *New York Times* (January 25, 1981): 45; C. Gerald Fraser, "Schomburg Black Culture Center Names Wendell Wray as Chief," *New York Times* (April 4, 1981): 13; Ernest Kaiser, "The Schomburg Center," *Ebony* 37 (September 1982): 62–63, 66; White and Willensky, *AIA Guide* (2000), 507; Rozhon, "To Be New and True to Harlem": 1, 4; Alex Ulam, "Whose Harlem?" *Metropolis* 22 (December 2002): 120–28.

52. Isabel Wilkerson, "Library to Expand Stacks," *New York Times* (June 16, 1985): 27; Amy Wallace, "Plan for Schomburg Center Displayed," *New York Times* (February 24, 1986), B: 3; Ronald Smothers, "Schomburg Center Marks 60 Years of Black Culture Research," *New York Times* (October 26, 1986): 40; "Recalling the Early Days at the Schomburg Center, a Harlem Cultural Hub," *New York Times* (August 29, 1987): 10; Andrew L. Yarrow, "Repository of Black Past Is Reopened," *New York Times* (June 3, 1990): 32; David W. Dunlap, "Minority Firm Joins Davis, Brody Architects," *New York Times* (October 21, 1990), X: 13; Paula Span, "Famed Black

Studies Center Set to Open New Facilities," *New York Times* (April 6, 1991), D: 1; White and Willensky, *AIA Guide* (2000), 507. Also see Landmarks Preservation Commission of the City of New York, LP-1133 (February 3, 1981); Barbaralee Diamonstein, *The Landmarks of New York III* (New York: Harry N. Abrams, 1998), 275.

53. Michael Mostoller with Victoria Geibel, "A Refuge from the Street," *Metropolis* 8 (March 1989): 54–59, 79 81, 83–84; Andrea Oppenheimer Dean, "Part of the Solution," *Historic Preservation* 45 (March-April 1993): 12, 90, 92; Andrea Oppenheimer Dean, "A Values-Added Practice," *Progressive Architecture* 74 (October 1993): 54–57.

54. Sara Pepitone, "New High School to Rise Out of Abandoned Harlem Club," *New York Observer* (June 4, 2001): 11; "Nightclub Site to Riff into a School," *New York Times* (August 26, 2001), XI: 1; "Gruzen Samton," *Oculus* 64 (October 2001): 6; Adam Gopnik, "New York Journal," *New Yorker* 79 (April 22–29, 2002): 76, 78–80, 82, 84, 86; Andrew G. Rowe, "Complex Site Challenges Team Building Thurgood Marshall Academy," *New York Construction News* 50 (October 2002): 63, 65–66; Carl Campanile, "Historic Harlem School Opening," *New York Post* (February 1, 2004): 19; Celeste Katz, "Harlem School Spirit," *New York Daily News* (February 3, 2004), Metro: 1; Carl Campanile, "School's a Jewel," *New York Post* (February 3, 2004): 22; Elissa Gootman, "400 Harlem Students Move to New Home," *New York Times* (February 3, 2004), B: 8; Stanley Crouch, "Harlem School Teaches Us How to Reclaim Kids," *New York Daily News* (February 5, 2004): 37.

EAST HARLEM

1. See Stern, Mellins, and Fishman, *New York 1960*, 863–74.

2. Stern, Mellins, and Fishman, *New York 1960*, 871–72.

3. "Mt. Sinai Medical Center of the City University of New York Residential Facility," *Architecture + Urbanism* (December 1985): 101–6; John Morris Dixon, "P/A Portfolio: Residence Hall, Mt. Sinai Medical Center, New York," *Progressive Architecture* 67 (May 1986): 104–5; "7 Projects Win Awards for Design," *New York Times* (October 17, 1986), C: 40; White and Willensky, *AIA Guide* (2000), 434.

4. Quoted in "Mt. Sinai Medical Center of the City University of New York Residential Facility": 103.

5. Dixon, "P/A Portfolio: Residence Hall, Mt. Sinai Medical Center, New York": 105.

6. Deirdre Carmody, "Mt. Sinai Trustees Plan a Renovation," *New York Times* (November 2, 1981): 1, D: 14; "Big Medical Problems," *Progressive Architecture* 63 (January 1982): 58; Robin Herman, "Modernizing of 4 Hospitals in City Is Delayed by a State Cost Squeeze," *New York Times* (July 24, 1982): 1, 26; Clifford D. May, "Many Architects Are Losing Jobs in the Recession," *New York Times* (January 19, 1983), B: 1, 5; Ronald Sullivan, "Hospital Pressured to Aid Another in Harlem," *New York Times* (October 9, 1983): 1, 41; Ronald Sullivan, "Health Agency Urges Rejection of Mt. Sinai's Rebuilding Plan," *New York Times* (October 31, 1984), B: 2; Ronald Sullivan, "Building Plan for Mt. Sinai Is Approved," *New York Times* (March 1, 1985), B: 1; Carter Wiseman, *I. M. Pei: A Profile in American Architecture* (New York Harry N. Abrams, 1990), 360; Georgia Dullea, "Mount Sinai Shows Off New Pavilion with Gala," *New York Times* (May 5, 1990): 30; Janice Hopkins Tanne, "Recovery Room with a View," *New York* 25 (September 21, 1992): 27; "Mount Sinai Opens a Medical Pavilion," *New York Times* (September 24, 1992), B: 2; Herbert Muschamp, "Architecture as an Antidote," *New York Times* (September 24, 1992), B: 1–2; "The Guggenheim Pavilion at Mount Sinai," *Oculus* 55 (February 1993): 6–9; Andrea E. Monfried, "Metropolitan Health," *Architecture* 82 (March 1993): 68–73; Susanna Sirefman, *New York: A Guide to Recent Architecture* (London: Ellipsis, 1997), 214–15; White and Willensky, *AIA Guide* (2000), 434; Alan Balfour, *World Cities: New York* (New York: Wiley Academy, 2001), 163.

7. Muschamp, "Architecture as an Antidote": 1–2.

8. "The Guggenheim Pavilion at Mount Sinai": 7.

9. White and Willensky, *AIA Guide* (2000), 434.

10. Mary B.W. Tabor, "A Library, a Refuge," *New York Times* (February 6, 1994), XIII: 1, 15; "Renovations Begin for an East Harlem Library," *New York Times* (June 17, 1994), B: 3; Chrisena Coleman, "Library Primed & Online," *New York Daily News* (May 9, 1996): 2; Christopher Gray, "Streetscapes/Aguilar Library," *New York Times* (June 9, 1996), IX: 7; "Adopting Branch Libraries," editorial, *New York Times* (July 15, 1996): 12; White and Willensky, *AIA Guide* (2000), 517.

11. "Public School 72," *Oculus* 58 (September 1996): 4; "Harlem," *Annals of the New York Chapter of the American Institute of Architects, 1996–97* (1997): 53–54; White and Willensky, *AIA Guide* (2000), 516. For Stagg's building, see Stern, Mellins, and Fishman, *New York 1880*, 800–802.

12. White and Willensky, *AIA Guide* (2000), 518; Atim Annette Oton, "Harlem on the Move," *Oculus* 62 (May 2000): 5–7.

13. Chrisena Coleman, "Cheers, Fears Over Cop Site," *New York Daily News* (April 30, 1998): 6; White and Willensky, *AIA Guide* (2000), 511.

14. White and Willensky, *AIA Guide* (2000), 511.

15. "Assisted Living on Fifth Ave.," *New York Times* (October 18, 1998), XI: 1; Rachelle Garbarine, "Special Help for Elderly Extends to Less Affluent," *New York Times* (January 22, 1999), B: 10.

WEST HARLEM

1. Charles Kaiser, "New North River Plant May Be 'Downgraded,'" *New York Times* (July 20, 1976): 22; Gladwyn Hill, "Pollution: Cost Becomes a Factor," *New York Times* (January 9, 1977), III: 39; Arnold H. Lubasch, "U.S. Gives New York $50 Million to Speed Big Sewage Projects," *New York Times* (January 15, 1977): 1, 26; Edward Ranzal, "Beame Signs a Bill Allowing City to Finance Three Sewage Plants," *New York Times* (June 9, 1977), B: 12; Emanuel Perlmutter, "Goldin Sees

Bad Sewer Planning Costing New York $23 Million," *New York Times* (October 24, 1977): 35; "U.S. Aid in Jeopardy for 2 Sewage Projects Being Planned in City," *New York Times* (August 26, 1979): 38; "New York State Gets Pure-Water Grants," *New York Times* (October 8, 1979), B: 2; "N.Y.C. Sewerage Job Revived," *Engineering News-Record* 210 (August 19, 1982): 21; Suzanne Daley, "New York City Seeking to Cut Size of Sewage Plant on Hudson River," *New York Times* (September 4, 1982): 1, 25; "Cleaning Up Henry Hudson's River," editorial, *New York Times* (September 27, 1982): 14; Suzanne Daley, "New York Acts to End Threat of Sewage Spill," *New York Times* (October 4, 1982): 1, D: 13; Joseph T. McGough Jr., "On Water Standards: How Clean Is a Clean Hudson?" letter to the editor, *New York Times* (October 9, 1982): 24; Steven S. Ross, "North River Cleanup: Where the Funds Are," letter to the editor, *New York Times* (October 16, 1982): 26; "City to Keep Funds for Pollution Plant," *New York Times* (March 3, 1983), B: 3; "Sewage Plant Nears Approval," *Engineering News-Record* 212 (June 21, 1984): 56; Robert Hanley, "City Accelerates Its Effort to End Waste Dumping," *New York Times* (July 28, 1984): 26; Philip Shabecoff, "Accord Is Reached on Sewage Limits," *New York Times* (September 20, 1984): 1; Peter Salwen, "Textured Arches," *Metropolis* 6 (November 1986): 19; Mark McIntyre, "Palace of Sludge Rises on Hudson," *Newsday* (May 17, 1987): 6; Julie Iovine, "Good Architecture in New York at Last," *Connoisseur* 218 (March 1988): 188–21; Jonathon Rosenblum, "Coney Island on the Hudson," *Time* 132 (November 21, 1988): 18, 20, 22; Allan R. Gold, "Despite Decades of Spending, Sewage Plants Are Full Up," *New York Times* (August 18, 1991), IV: 16; "Deep Tanks Still Cause Headaches," *Engineering News-Record* 228 (May 4, 1992): 13; Brian Woolfenden, "Was the Sewage Plant a Blunder from Start?" letter to the editor, *New York Times* (July 30, 1992): 24; Robert Hennelly, "The Uptown Flush: Cleaning Up the Hudson, Fouling Up Harlem," *Village Voice* (November 9, 1993): 31–37; *Richard Duttner: Selected and Current Works* (Mulgrave, Australia: Images Publishing, 2000), 76–81; White and Willensky, *AIA Guide* (2000), 479.

2. See Stern, Mellins, and Fishman, *New York 1960*, 884–86.

3. "Cleaning Up Henry Hudson's River": 14.

4. Salwen, "Textured Arches": 19.

5. Iovine, "Good Architecture in New York at Last": 121.

6. Salwen, "Textured Arches": 19.

7. Iovine, "Good Architecture in New York at Last": 119. For the Riverside Drive Viaduct, see White and Willensky, *AIA Guide* (2000), 477–78.

8. Quoted in Dunlap, "Atop a Harlem Waste Plant, a Park Grows": 4.

9. Scott Aiges, "An $80-Million Park Planned Atop Treatment Plant," *New York Times* (August 4, 1985), VIII: 7; Ron Davis, "Cuomo Budget Marks Funds for Park in City," *Newsday* (January 27, 1987): 29; "State Set to Build Park on City Treatment Plant," *Engineering News-Record* 218 (May 14, 1987): 17; "Park No Picnic to Build," *Engineering News-Record* 219 (April 7, 1988): 16; Rosenblum, "Coney Island on the Hudson": 18, 20, 22; Lou Chapman, "Bridge over Parkway," *New York Observer* (March 13, 1989): 8; David W. Dunlap, "Atop a Harlem Waste Plant, a Park Grows," *New York Times* (May 17, 1989), B: 1, 4; Samme Chittum, "From Sludge to Roses: Park on Sewage Plant Set for '93," *Newsday* (August 14, 1992): 23; Lynette Holloway, "28 Acres of Roof and a Place to Play in West Harlem," *New York Times* (September 1, 1992), B: 1, 4; "New York City Park Is up on the Roof," *American City & County* 107 (October 1992): 10–11; Mervyn Rothstein, "Creating Parks in a Crowded Metropolis," *New York Times* (April 4, 1993), X: 1, 6; Michael Winerip, "Up on the Roof, Harlem Gains Acres of Beauty," *New York Times* (May 23, 1993): 29; Lynette Holloway, "Park, However Bad It Smells, Blossoms on the River," *New York Times* (May 28, 1993), B: 3; Jesse Mangaliman, "Park Opens on Sewage Plant Roof," *Newsday* (May 28, 1993): 23; Malcolm Gladwell, "Letter from the Park: Play Area Hailed at First Flush Now Appears Ripe for Criticism," *Washington Post* (May 28, 1993): 3; Nadine M. Post, "River Site Is Breathtaking," *Engineering News-Record* 230 (May 31, 1993): 21; Peter Slatin, "Manhattan Mix," *Oculus* 55 (June 1993): 8; Clare Beckhardt, "Large, Happy Crowds Greeted Opening of West Harlem Park," *New York Times* (June 9, 1993): 20; Peter Marks, "Visitors Instantly Embrace Rooftop Park," *New York Times* (June 28, 1993), B: 1; "Largest Rooftop Park Built on Foam," *Civil Engineering* 63 (July 1993): 86; "Harlem's Flushing Meadows," *Metropolis* 13 (July/August 1993): 18; Kirsten A. Conover, "Relax on a Rooftop," *Christian Science Monitor* (July 9, 1993): 10; Michael T. Kaufman, "Stepping Out to Harlem and Its New Park Place," *New York Times* (August 25, 1993), B: 3; David Taylor, "Harlem Gets a Sewage Plant . . . and a Park," *Progressive Architecture* 74 (October 1993): 24; Charles D. Linn, "Riverbank State Park," *Architectural Record* 181 (November 1993): 108–13; Jane Holtz Kay, "Riverbank: Something's Missing in the 'Bionic' Park," *Landscape Architecture* 84 (March 1994): 50–51; Herbert Muschamp, "When Is a Roof Not a Roof," *New York Times* (April 10, 1994), II: 42; Matthias Kroitzch, "Riverbank State Park New York," *Garten + Landschaft* 104 (November 1994): 10–13; Richard Dattner, *Civil Architecture: The New Public Infrastructure* (New York: McGraw-Hill, 1995), 41–60; Alexander Garvin and Gayle Berens, *Urban Parks and Open Space* (Washington, D.C.: Urban Land Institute, 1997), 180–85; Susanna Sirefman, *New York: A Guide to Recent Architecture* (London: Ellipsis, 1997), 254–57; Christopher Leinberger and Gayle Berens, "Designing for Urban Parks," *Urban Land* 56 (December 1997): 54–58, 67–68; White and Willensky, *AIA Guide* (2000), 479.

10. Richard Dattner, quoted in Sirefman, *New York*, 254.

11. Dattner, *Civil Architecture: The New Public Infrastructure*, 46.

12. Dattner, *Civil Architecture: The New Public Infrastructure*, 52.

13. Joyce Purnick, "The Foul Mystery of North River," *New York Times* (December 6, 1989): 30; Harvey W. Schultz, "North River Plant in Bad Odor Because of Sewer," letter to the editor, *New York Times* (December 29, 1989): 34; "The North River Plant Still Stinks," editorial, *New York Times* (July 23, 1990): 14; "New York Plant Is a Stinker," *Engineering News-Record* 227 (August 26, 1991): 10; Michael Specter, "Stench at Sewage Plant Is Traced; Millions Pledged for Repair Work," *New York Times* (April 17, 1992): 1, B: 2; Jonathon Mandell, "A State Park in Harlem: Nature in a Surreal Setting, a Sewage Plant by Any Name Still Stinks," *Newsday* (May 27, 1993): 15; Susan Jaffe, "Odor Fix Starts in New York," *Engineering News-Record* 231 (August 9, 1993): 25; Richard Perez-Pena, "Settlement in Harlem Suit Over Odors," *New York Times* (January 5, 1994), B: 1; William Bunch, "It's Compared to Rotten Eggs: $1B Sewage Facility Raises Harlem's Ire," *Newsday* (June 7, 1994), B: 7; William Bunch, "$52M Won't Flush Stink," *Newsday* (June 30, 1994): 27; "Pungent Park; Sewage Plant Odors Cover Harlem Fields," *Phoenix Gazette* (September 27, 1994): 2. Also see http://www.cucrej.rutgers.edu/html/body_weact_nrstp.html.

14. Hennelly, "The Uptown Flush: Cleaning Up the Hudson, Fouling Up Harlem": 35.

15. http://www.cucrej.rutgers.edu/html/body_weact_nrstp.html.

16. Purnick, "The Foul Mystery of North River": 30.

17. Albert F. Appleton, quoted in Specter, "Stench at Sewage Plant Is Traced; Millions Pledged for Repair Work": 2.

18. Linn, "Riverbank State Park": 113.

19. Muschamp, "When Is a Roof Not a Roof?": 42.

20. Slatin, "Manhattan Mix": 8.

21. Kay, "Riverbank: Something's Missing in the 'Bionic' Park": 50.

22. Muschamp, "When Is a Roof Not a Roof?": 42.

23. Muschamp, "When Is a Roof Not a Roof?": 42.

24. For Harlem Valley, see Stern, Mellins, Fishman, *New York 1880*, 785, 820, 823; Stern, Mellins, Fishman, *New York 1960*, 883–87.

25. See Stern, Mellins, and Fishman, *New York 1960*, 859–60.

26. "A Festival at 125th St.," *New York Times* (September 5, 1986], C: 20.

27. Luix Overbea, "Harlem Faces Hopes–and Concerns–with 'New Renaissance,'" *Christian Science Monitor* (March 9, 1987): 1; Mark McCain, "$15 Million to Spruce Up Harlem's Shopping Strip," *New York Times* (July 5, 1987), VIII: 12; Howard W. French, "Japanese Prince Visits Harlem Site," *New York Times* (October 10, 1987): 35; "Harlem-on-the-Hudson," *Architectural Record* 176 (January 1988): 35; Mary Jo Neuberger, "Harlem into the Hudson," *Village Voice* (March 8, 1988): 10; Thomas J. Lueck, "Japanese Interest; In Harlem, Megaprojects Create Hope–and Fear," *New York Times* (April 17, 1988], IV: 6; Lucia Mouat, "Restoring Harlem to Former Glory," *Christian Science Monitor* (January 14, 1992): 6.

28. White and Willensky, *AIA Guide* (1988), 428; Emily M. Bernstein, "Looming on the Hudson, a Skeleton of Steel," *New York Times* (September 12, 1993), XIII: 6; Daniel B. Schneider, "F.Y.I.: Snapped Together," *New York Times* (August 24, 1997), XIII: 2; "Skyline Swingers Make a Playground," *New York Times* (August 24, 1998): 1; Barbara Stewart, "Development Claims a Harlem Sculpture," *New York Times* (September 4, 1998), B: 8.

29. Emily M. Bernstein, "Fresh Food, Fresh Ideas at a Market," *New York Times* (December 5, 1993), XIII: 6; Norimitsu Onishi, "Fancy Food at Warehouse Prices," *New York Times* (December 19, 1995), B: 1, 5; Randy Kennedy, "New Fairway Market in Permit Dispute," *New York Times* (February 12, 1996), B: 3; "Save the Harlem Fairway," editorial, *New York Times* (February 15, 1996): 26; Janet Allon, "Fairway Wants Riverside Parking with a 10-Year Meter," *New York Times* (January 4, 1998), XIV: 5.

30. Lisa Rein, "City Seeking Ideas for Waterfront Site," *New York Daily News* (July 12, 1998), Metro: 1; William Berlind, "Full Spectrum of Opinion on a West Harlem Hotel," *New York Observer* (October 5, 1998): 12; Nina Siegel, "Pier Developers Look Toward Harlem," *New York Times* (October 25, 1998), XIV: 4, 29.

31. Matt Pacenza, "River Plan Floated on Choppy Waters," *New York Observer* (February 5, 2001): 12; Jayne Merkel, "At the Water's Edge," *Oculus* 64 (November 2001): 10–11; Raymond W. Gastil, *Beyond the Edge: New York's New Waterfront* (New York: Princeton Architectural Press, 2002), 132–34; Terry Pristin, "Harlem Neighborhood Competes for Stretch of Riverfront Turf," *New York Times* (June 10, 2002), B: 3.

32. For City College, see Stern, Gilmartin, and Massengale, *New York 1900*, 108–9.

33. For Warnecke's master plan, see Stern, Mellins, and Fishman, *New York 1960*, 885–87.

34. Robert D. McFadden, "Dormitory Unit Halts Work at Colleges," *New York Times* (November 11, 1975): 21.

35. Eleanor Blau, "C.C.N.Y. Opening Performing Arts Complex Today," *New York Times* (October 24, 1979), C: 20; Paul Goldberger, "Aaron Davis Hall: Architectural Paradox," *New York Times* (November 5, 1979), C: 13; Leonard Buder, "City College to Resume Its Building," *New York Times* (October 13, 1976): 47; "Aaron Davis Hall: Three Theaters for CCNY," *Architectural Record* 167 (June 1980): 96–103; White and Willensky, *AIA Guide* (2000), 482. For the destruction of Lewisohn Stadium, see Stern, Mellins, and Fishman, *New York 1960*, 887.

36. Goldberger, "Aaron Davis Hall: Architectural Paradox": 13.

37. "Plan Is Revised by City College," *New York Times* (November 7, 1971): 84; Robert D. McFadden, "Dormitory Unit Halts Work at Colleges," *New York Times* (November 11, 1975): 21; Jill Smolowe, "Fire Causes $1 Million in Damages to Building Project at City College," *New York Times* (November 12, 1980), B: 4; Robin Herman and Laurie Johnston, "The Old

Days," *New York Times* (February 1, 1983), B: 3; Samuel Weiss, "New Buildings Are Benefiting City U. Schools," *New York Times* (March 26, 1984), B: 2; White and Willensky, *AIA Guide* (2000), 481. Also see Stern, Mellins, and Fishman, *New York 1960*, 887.

38. White and Willensky, *AIA Guide* (2000), 481.

39. "$185 Million in Improvements: New Laboratories for City College," *New York Times* (January 5, 1992), X: 1; "$42M Project Begins on CCNY's Steinman Hall," *New York Construction News* 39 (January 13, 1992): 1, 4; White and Willensky, *AIA Guide* (2000), 481.

40. Barbaralee Diamonstein, *The Landmarks of New York III* (New York: Harry N. Abrams, 1998), 225.

41. *Richard Dattner: Selected and Current Works*, 50–51; Matthew Phair, "CCNY Terra Cotta Restoration May Be 'Largest' in North America," *New York Construction News* 50 (October 2002): 49–50, 52–53; Henrika Taylor, "Terra Cotta Reaches New Heights," *Clem Labine's Traditional Building* 15 (September/October 2002): 54, 56.

42. "Names and News," *Oculus* 48 (February 1987): 7. Also see http://www.lhparch.com/compgoet.htm.

43. Christopher Gray, "Streetscapes/City College," *New York Times* (February 2, 1992), X: 7; Michael Z. Wise, "City College Facelift to Cost $170 Million," *New York Observer* (February 1, 1993): 1, 21; Carl Stein, "Technics: Restoring with CAD and Camera," *Progressive Architecture* 74 (August 1993): 64–69; Gareth Fenley, "A Little Light Music," *Architectural Record Lighting* 182 (November 1994): 20–23; Kristen Richards, "Shepard Hall Restoration," *Interiors* 154 (April 1995): 52–55; White and Willensky, *AIA Guide* (2000), 481.

44. Gray, "Streetscapes/City College": 7.

45. Dorothy Maynor, quoted in "The Harlem School of the Arts: A Gleam of Home from a Cultural Oasis," *Architectural Record* 165 (May 1979): 97–104.

46. "Harlem Gets a School of the Arts," *Architectural Record* 158 (September 1975): 85; "Harlem School of the Arts Helps the Poor to Broaden Experiences," *New York Times* (November 13, 1977): 63; Paul Goldberger, "Diversity Marks Architecture Awards," *New York Times* (June 6, 1978), B: 1, 17; "The Harlem School of the Arts: A Gleam of Home from a Cultural Oasis": 97–104; C. Gerald Fraser, "Harlem School of Arts in New Home," *New York Times* (May 20, 1979): 55; "Harlem School of the Arts, New York, USA," *Architecture + Urbanism* (March 1981): 49–60; Eleanor Blau, "Arts School Gets A in Looks, F in Leaks," *New York Times* (August 17, 1991): 11, 14; White and Willensky, *AIA Guide* (2000), 510.

47. Goldberger, "Diversity Marks Architecture Awards": 17.

48. *Hardy Holzman Pfeiffer Associates: Buildings and Projects, 1967–1992* (New York: Rizzoli International Publications, 1992), 240; White and Willensky, *AIA Guide* (2000), 486.

49. "Expansion in Harlem: Dance Theater Back from the Brink," *New York Times* (March 15, 1992), X: 1; "Harlem Dance Troupe Expanding Quarters," *New York Times* (June 10, 1992), C: 18; "Harlem Dancers Open New Home," *New York Times* (October 18, 1994), C: 19; Clifford A. Pearson, "Pas de Deux," *Architectural Record* 183 (February 1995): 82–85; Wendy Moonan, "What a Difference a Building Can Make: Dance Theater of Harlem," *Oculus* 57 (June 1995): 3; Sirefman, *New York*, 252–53; *Hardy Holzman Pfeiffer Associates: Buildings and Projects, 1992–1998* (New York: Rizzoli International Publications, 1999), 62–65; White and Willensky, *AIA Guide* (2000), 486; Alan Balfour, *World Cities: New York* (New York: Wiley Academy, 2001), 125.

50. Sirefman, *New York*, 252.

51. Nina Rappaport, "Another Harlem Renaissance," *Oculus* 61 (Summer 1999): 6; Maitefa Angaza, "Caples Jefferson Architects Blends Design with Community Needs," *Network Journal* (September 1999): 8–9; Susanna Sirefman, *New York: A Guide to Recent Architecture*, 2nd ed. (London: Ellipsis, 2001), 13: 20–21; Tracie Rozhon, "To Be New and True to Harlem," *New York Times* (January 31, 2002), F: 1, 4; Jayne Merkel, "Heightened Experience: Caples Jefferson," *Architectural Design* 72 (June 2002): 117–24; "Honor Awards: Heritage Health & Housing," *Architectural Record* 191 (May 2003): 139.

52. "Postings: At Riverside Drive and 140th Street," *New York Times* (November 5, 2000), XI: 1; Alan Feuer, "For Ex-Convicts, a Bed, a View, a New Outlook," *New York Times* (June 27, 2002), B: 1, 7.

UPPER MANHATTAN

1. See Stern, Gilmartin, and Mellins, *New York 1930*, 112–13; Stern, Mellins, and Fishman, *New York 1960*, 891.

2. "Columbia Is Buying Audubon Ballroom; Demolition Planned," *New York Times* (February 24, 1983), B: 9; Philippe Adler and Anne Kornhauser, "CU Wants Industry Money for Biomed Park," *Columbia Spectator* (September 14, 1984): 1–2; Philippe Adler, "CU May Destroy Historic Ballroom," *Columbia Spectator* (December 6, 1984): 1, 6; Alison Craiglow, "CU Likely to Build Lab on Audubon Ballroom Site," *Columbia Spectator* (January 21, 1985): 8; Alison Craiglow, "Audubon Park Smaller Than Peers," *Columbia Spectator* (March 26, 1985): 1, 4; "Site of Malcolm X Assassination Has an Uncertain Future," *New York Times* (September 11, 1985), B: 1; Susan Heller Anderson and David W. Dunlap, "Ballroom in Jeopardy," *New York Times* (September 11, 1985), B: 3; Alison Craiglow, "Audubon Construction to Start in 1988," *Columbia Spectator* (October 3, 1985): 5; Susan Heller Anderson and David W. Dunlap, "Endangered Ballroom," *New York Times* (October 11, 1985), B: 4; Samuel Weiss, "Biotechnology Park for Washington Hts. Is Close to Approval," *New York Times* (June 11, 1987): 1, B: 10; White and Willensky, *AIA Guide* (1988), 462; Howard W. French, "New York City Slips as Center of Research," *New York Times* (October 17, 1988), B: 1, 4; Jeffrey Kantrowitz, "Say Goodbye to the Audubon Ballroom," *Columbia Spectator* (October 16, 1989): 9, 6; Peggy Dye, "High Tech Ballroom,"

Village Voice (December 5, 1989): 10–12; Elizabeth Reza, "Hirsch Says CU Should Renovate the Audubon," *Columbia Spectator* (March 8, 1990): 1, 5; David W. Dunlap, "A 'Spec' Building Planned for Audubon Theater Site," *New York Times* (March 11, 1990), X: 15; Darrell M. McNeill, "Demand Malcolm X Memorial," *Village Voice* (March 13, 1990): 13; "Biotech Facility Moves Closer to Realization," *Columbia Record* 15 (March 16, 1990): 1, 6; Leonard Buder, "A Proposal to Raze Audubon Ballroom Causes Controversy," *New York Times* (May 3, 1990), B: 4; Sam Roberts, "Malcolm X Plan: Picking a Shrine or Self-Reliance," *New York Times* (May 10, 1990), B: 1; "Growth Plus Grace on the Audubon Site," editorial, *New York Times* (June 15, 1990): 28; Todd S. Purdum, "It's Farewell for Planners on a Panel," *New York Times* (June 28, 1990), B: 1, 4; Todd S. Purdum, "Ballroom Is Sensitive Issue for Dinkins," *New York Times* (July 26, 1990), B: 1–2; "How Not to Honor Malcolm X," editorial, *New York Times* (July 30, 1990): 14; Todd S. Purdum, "Audubon Site Is Dropped for Building," *New York Times* (August 4, 1990): 25; "Rangel and Others Pressing to Salvage Ballroom Project," *New York Times* (August 9, 1990), B: 3; "Ms. Messinger's Obstructionism," editorial, *New York Times* (August 10, 1990): 24; "Self-Requiem for the Board of Estimate," editorial, *New York Times* (August 15, 1990): 26; Todd S. Purdum, "To Borough Chief, Ballroom Issue Is No Waltz," *New York Times* (August 16, 1990), B: 1; Don Terry, "Estimate Unit Approves Plan for Ballroom," *New York Times* (August 22, 1990), B: 1, 3; Felicia R. Lee, "Board of Estimate, Headed for Demise, Approves Flurry of Projects," *New York Times* (August 23, 1990), B: 5; "The Board of Estimate's Upbeat End," editorial, *New York Times* (August 27, 1990): 16; "Board 12/Compromise on Columbia's Audubon Project," *New York Observer* (October 7, 1991); Christopher Gray, "Streetscapes/St. Mary's Episcopal Church," *New York Times* (December 8, 1991), X: 5; David W. Dunlap, "Columbia's Big Medical Center Plans Expansion," *New York Times* (March 29, 1992), X: 1, 9; Ronald Sullivan, "Court Upholds Plan to Build Audubon Medical Research Center," *New York Times* (June 10, 1992), B: 2; Herbert Muschamp, "Once and Future Audubon," *New York Times* (August 23, 1992), II: 1, 24; Steven Greenfield, "Maximum Use, Minimal Site," letter to the editor, *New York Times* (September 13, 1992), II: 10; Elizabeth Berke, "University to Continue Plans for Audubon," *Columbia Spectator* (November 18, 1992): 1, 4; "Plans for Site of Malcolm X's Death Stir Protest," *Chronicle of Higher Education* (January 6, 1993): 4; Kevin Sack, "Science Center Backed at Site of Malcolm X Death," *New York Times* (January 8, 1993), B: 3; Ruth Halikman and Mike Stanton, "Hamilton Blockaded in Protest of Audubon Plans," *Columbia Spectator* (January 19, 1993): 1, 8; J. J. Lee, "Students Face Possible Expulsion for Blockade," *Columbia Spectator* (January 19, 1993): 1, 9; Tova Mirvis, "Sovern Defends Plans for Audubon Ballroom," *Columbia Spectator* (February 1, 1993): 1, 7; Maria Newman, "Columbia Torn by Disciplinary Hearing," *New York Times* (February 22, 1993), B: 3; Bill Torrey, "Construction on Audubon Continues," *Columbia Spectator* (February 24, 1993): 1, 5; "4 Columbia Students Ordered Suspended," *New York Times* (March 26, 1993), B: 3; Ruth Halikman, "Audubon Fades into Harlem History," *Columbia Spectator* (June 23, 1993): 1, 4; Mike Stanton, "One Year Later, Audubon Work Well Underway," *Columbia Spectator* (November 23, 1993): 1, 5; "Restoring Terra-Cotta," *Architecture* 83 (November 1994): 127–31; Tracie Rozhon, "Research Park Rising on Site of Audubon Ballroom," *New York Times* (June 11, 1995), IX: 7; Nicolai Ouroussoff, "Malcolm X Memorial Planned," *Architectural Record* 183 (July 1995): 11; Chiu-Huey Hsia, "New Research Center Built," *Columbia Spectator* (July 12, 1995): 1, 4; Michael Gwertzman, "Audubon Faces Changes," *Columbia Spectator* (October 11, 1995): 1, 9; "Columbia Opens First Audubon Biotech Building," *Columbia University Record* 21 (October 20, 1995): 1, 6; "Daughters of Malcolm X and Dr. Betty Shabazz Dedicate Center to Their Late Parents," *Jet* (November 24, 1997): 22–23; David W. Dunlap, "A Medical Center Works on Its Health," *New York Times* (October 4, 1998), XI: 1, 24; Monica Geran, "A Room of Their Own," *Interior Design* 70 (March 1999): 172–74; White and Willensky, *AIA Guide* (2000), 525; Corey Kilgannon, "Remembering Malcolm X In the Place Where He Fell," *New York Times* (February 21, 2005), B: 1, 3.

3. "Malcolm X Shot to Death at Rally Here," *New York Times* (February 22, 1965): 1, 10.

4. For the controversy over Columbia's gymnasium, see Stern, Mellins, and Fishman, *New York 1960*, 740, 742–45.

5. Charles A. Platt, quoted in Purdum, "Ballroom Is Sensitive Issue for Dinkins": 2.

6. "Ms. Messinger's Obstructionism": 24.

7. Muschamp, "Once and Future Audubon": 24.

8. Yafa Zweiter, "Sherman Grant Funds Audubon," *Columbia Spectator* (April 6, 1994): 1, 6; David W. Dunlap, "Columbia's Audubon Center Is Picking Up Momentum," *New York Times* (April 10, 1994), X: 1; Rozhon, "Research Park Rising on Site of Audubon Ballroom": 7; "Corrections," *New York Times* (June 18, 1995), IX: 5; "A Biomedical Research Park Continues to Grow in Washington Heights," press release (New York: College of Physicians and Surgeons at Columbia-Presbyterian Medical Center, Office of Public Relations, June 26, 1995); "Groundbreaking for Audubon," *New York Times* (June 27, 1995), B: 3; Hsia, "New Research Center Built": 1, 4; "Columbia Dedicates New Research Center," *New York Times* (May 30, 1997), B: 5; "Medical Research at Columbia Gets a $66 Million Shot in the Arm: New Buildings Named for Russ Berrie," press release (New York: College of Physicians and Surgeons at Columbia-Presbyterian Medical Center, Office of Public Relations, May 30, 1997); White and Willensky, *AIA Guide* (2000), 525.

9. White and Willensky, *AIA Guide* (2000), 525.

10. Matthew Phair, "Teamwork Key to Columbia University's Irving Cancer Research Center," *New York Construction*

50 (October 2002): 55.

11. White and Willensky, *AIA Guide* (1988), 462; Kathleen Teltsch, "Milsteins Give $25 Million to a Hospital," *New York Times* (December 14, 1988), B: 1, 6; Suzanne Katz, "Milstein Building Dedicated at Columbia-Presbyterian Hospital," *Columbia Spectator* (November 21, 1989): 3; Margaret Gaskie, "Strong Medicine," *Architectural Record* 179 (October 1991): 120–27; "L-Shaped Nursing Unit," *Progressive Architecture* 73 (March 1992): 95; Renato Morganti, "Edilizia Ospedaliera a New York," *L'Industria Delle Costruzioni* 26 (September 1992): 38–49; "Complesso Ospedaliero a New York," *L'Industria Delle Costruzioni* 27 (February 1993): 77; White and Willensky, *AIA Guide* (2000), 525.

12. Anne Kornhauser, "State Approves $500 Million Hospital Plan," *Columbia Spectator* (May 23, 1984): 1, 3; Anne Kornhauser, "CU, Hospital Launch $500 Million Project," *Columbia Spectator* (October 18, 1984): 1, 10; Morganti, "Edilizia Ospedaliera a New York": 38–49.

13. David W. Dunlap, "Columbia's Big Medical Center Plans Expansion," *New York Times* (March 29, 1992), X: 1, 9; "New York Psychiatric Institute: New York City," *Architecture* 82 (March 1993): 34; "A Battle Lost, a Bridge Won," *New York Times* (May 1, 1994), XIV: 9; "A Bridge to Better Mental-Health Care," *Architectural Record* 182 (October 1994): 19; "A Psychiatric Institute for New York State," *Progressive Architecture* 75 (November 1994): 32; *Peter Pran: Jonathan Ward, Timothy Johnson, Paul Davis: An Architecture of Poetic Movement: Altered Perceptions* (Windsor, Berks, England: Andreas Papadakis Publisher, 1998), 2, 8, 11–15, 40–57; Dunlap, "A Medical Center Works on Its Health": 1, 24; Clifford A. Pearson, "New York Psychiatric Institute," *Architectural Record* 187 (July 1999): 138–41; Deborah Silver, "East Side, West Side," *Building Design and Construction* 40 (September 1999): 44–46; White and Willensky, *AIA Guide* (2000), 525; Alan Balfour, *World Cities: New York* (New York: Wiley Academy, 2001), 150–51.

14. Joseph Fernandez, quoted in Mervyn Rothstein, "For New York, User-Friendly Schools," *New York Times* (May 29, 1994), X: 1, 6. Also see Clifford A. Pearson, "Community Service," *Architectural Record* 181 (August 1993): 104–7; Richard Dattner, *Civil Architecture: The New Public Infrastructure* (New York: McGraw-Hill, 1994), 208–11; *Richard Dattner: Selected and Current Works* (Mulgrave, Australia: Images Publishing, 2000), 30–31; White and Willensky, *AIA Guide* (2000), 531.

15. Richard Dattner, quoted in Pearson, "Community Service": 105. For Baker House, see Göran Schildt, *Alvar Aalto: Masterworks* (New York: Universe, 1998), 66–71.

16. Jayne Merkel, "Introduction: Richard Dattner Architect," in *Richard Dattner: Selected and Current Works*, 13.

17. Randy Kennedy, "Police Hit Streets in a New Precinct," *New York Times* (October 9, 1994), XIII: 6; David M. Halbfinger, "A Warm and Fuzzy Precinct House," *New York Times* (July 19, 1998), XIV: 5; "In the Nabes; 33rd Pct. Project Is Begun," *New York Daily News* (October 29, 1998), Metro: 2; *Richard Dattner: Selected and Current Works*, 184–85; "Mayor Michael R. Bloomberg and Police Commissioner Raymond W. Kelly Dedicated New Police Station House in Washington Heights," press release (October 4, 2002); Austin Fenner, "Wash Hts. Embraces New Stationhouse," *New York Daily News* (October 7, 2002), Metro: 1.

18. Peter Kihss, "$3 Million Gift for Baker Field," *New York Times* (April 27, 1982), B: 1, 5; Deirdre Carmody, "A Philanthropist Leaves His Mark," *New York Times* (August 9, 1982), B: 1–2; "More Columbia Building," *Progressive Architecture* 63 (June 1982): 44; "New Merging with Old in Projects at Columbia," *New York Times* (August 24, 1982), B: 1, 10; James Tuite, "A Columbia Football Era Ends at Baker Field," *New York Times* (November 20, 1982): 19; "A Stadium Rises," *New York Times* (October 3, 1983), C: 2; "Columbia Will Get a Soccer Stadium," *New York Times* (December 12, 1983), C: 7; "Columbia Comes Home Again," *New York Times* (August 26, 1984), V: 1; Esther B. Fein, "New Columbia Stadium: End of a Nostalgic Era," *New York Times* (September 22, 1984): 29; Dattner, *Civil Architecture*, 208–11; *Richard Dattner: Selected and Current Works*, 98–99. Also see "Cornerstone Set in Columbia Wing," *New York Times* (May 1, 1955): 84.

19. "A New Garden Spot," *New York Daily News* (October 21, 1998): 8; "Reclaiming the Waterfront," *Good Dirt*, newsletter of the New York Restoration Project (Fall 1999): 5; Jonathan Mandell, "Always Divine, Now Garbage Has Made Her a Saint," *New York Times* (November 17, 1999), H: 10; White and Willensky, *AIA Guide* (2000), 531; "Art Commission Awards: 8 Are Honored for Excellence in Design," *New York Times* (February 27, 2000), XI: 1; "Design That Makes a Difference: Bette Midler," *Metropolitan Home* 33 (March-April 2001): 86; Kira L. Gould, "Art Commission Honors Outstanding City Projects," *Oculus* 62 (April 2000): 17; "Swindler Cove Expanded," *Good Dirt* (Winter 2001): 1, 6; "The Peter Jay Sharp Foundation Endows NYRP Boathouse at Swindler Cove," *Good Dirt* (Fall 2002): 1, 7; "Evening Hours: Whimsy," *New York Times* (October 27, 2002), IX: 9; Nancy Beth Jackson, "If You're Thinking of Living In/Inwood," *New York Times* (December 15, 2002), XI: 5; Peter Morris Dixon, ed., *Robert A. M. Stern: Buildings and Projects, 1999–2003* (New York: Monacelli Press, 2003), 386–87; André Leon Talley, "New Year's Resolutions: Give Back," *Vogue* 193 (January 2003): 37; Mary Voboril, "Force of Nature," *Newsday* (April 23, 2003), B: 6; "Boathouse Update," *Good Dirt* (Summer 2003): 3; Peter Hellman, "On Harlem River, Hope Floats," *New York Times* (October 30, 2003), F: 1, 9.

20. Joyce Purnick, "Alvarado Says Schools Need Repairs," *New York Times* (February 23, 1984), B: 3; "Prototype School Program: New York City Board of Education Background," *Oculus* 51 (February 1989): 4; Ben E. Graves, "Prototype Schools: A Design Trend?" *Oculus* 51 (February 1989): 5–7;

Ellen Posner, "Building Blocks," *Architectural Record* 177 (March 1989): 112–15; Paul Goldberger, "In Pursuit of Intimate Monumentality," *New York Times* (March 12, 1989), II: 37; Cynthia Chapin Davidson, "Protoparts for Pupils," *Inland Architect* 35 (March/April 1991): cover, 36–37; Anthony DePalma, "In Building Schools, Going Beyond a Square," *New York Times* (August 21, 1991), B: 7; David C. Walters, "'Big Apple' School Designs Shine," *Christian Science Monitor* (May 26, 1992): 12; Mildred F. Schmertz, "Educating New York," *Architecture* 82 (April 1993): 54–59.

21. For Snyder's work, see Stern, Gilmartin, and Massengale, *New York 1900*, 78–86.

22. Dattner, *Civil Architecture*, 68–75. Also see "Excavation Underway on $45M Manhattan Intermediate School," *New York Construction News* 39 (January 27, 1992): 1, 6; *Richard Dattner: Selected and Current Works*, 36–41.

23. Dattner, *Civil Architecture*, 72.

24. "Work Starts on $35M School in Inwood," *New York Construction News* 37 (July 30, 1990): 1, 6; Mildred F. Schmertz, "Urban Modules: Primary Schools 5 and 6, New York City, Gruzen Samton Steinglass," *Architecture* 82 (April 1993): 60–61; Rothstein, "For New York, User-Friendly Schools": 1, 6; White and Willensky, *AIA Guide* (2000), 531.

25. George Luaces, quoted in Rothstein, "For New York, User-Friendly Schools": 6.

INTERIORS

RESTAURANTS

1. Suzanne Slesin, "New Great-Looking Restaurants," *New York* 9 (December 20, 1976): 51.

2. Regina S. Baraban, "You Are Where You Eat," *Metropolis* 5 (September 1985): 26–29, 42–43.

3. "Mayor Koch for a Third Term," editorial, *New York Times* (September 4, 1985): 26.

4. "Eat and Fun," *Interiors* 145 (December 1985): 166–69, 182.

5. Edward Meyer, quoted in John Mariani, "Restaurants: The Hot and Spicy New Investment," *Avenue* (September 1986): 150–56.

6. Roger C. Ferri, "Lutece Garden Restaurant, New York, New York/1976," *Architecture + Urbanism*, special edition (March 1981): 68–69. Also see "Garden Room, New York," *Architectural Review* 165 (May 1979): 305.

7. Ferri, "Lutece Garden Restaurant, New York, New York/1976": 69. Also see Hugh Ferriss, *The Metropolis of Tomorrow* (New York: I. Washburn, 1929).

8. Paul Goldberger, "The New Le Cygne Is Also a Design Event," *New York Times* (May 17, 1982), C: 18; Pilar Viladas, "An Upwardly Mobile Feast," *Progressive Architecture* 63 (December 1982): 47–51; White and Willensky, *AIA Guide* (1988), 250–51.

9. Goldberger, "The New Le Cygne Is Also a Design Event": 18.

10. "Chapter Awards Program," *Oculus* 44 (May 1983): 6; Joseph Giovannini, "Dramatic Effects in Restaurant Design," *New York Times* (June 14, 1984): C: 1, 6.

11. Michael Chow, quoted in Suzanne Slesin, "Decorating a New Chinese Restaurant with the Rich Flavor of Elegance," *New York Times* (October 22, 1979), B: 6. For the apartment building, see Stern, Gilmartin, and Mellins, *New York 1930*, 367.

12. Michael Chow, quoted in Slesin, "Decorating a New Chinese Restaurant with the Rich Flavor of Elegance": 6.

13. "The Grand Café," *Interior Design* 47 (October 1976): 124–27.

14. Monica Geran, "Shun Lee Palace," *Interior Design* 55 (January 1984): 262–63.

15. Regina S. Baraban, "Best Dressed," *Metropolis* 5 (March 1986): 21; Bryan Miller, "Restaurants: Shun Lee," *New York Times* (January 16, 1987), C: 20; Justin Henderson, "Black on Black Forms an Understated Backdrop for an Elegant Dragon in a Chinese Restaurant," *Interiors* 146 (April 1987): 43–46.

16. Grace Anderson, "Monochrome Made Vivid," *Architectural Record* 172 (Mid-September 1984): 140–43.

17. Bryan Miller, "Restaurants: Aurora," *New York Times* (January 31, 1986), C: 22; Kenneth Brozen, "Bubbles of Light in an Effervescent Manhattan Restaurant," *Interiors* 145 (April 1986): 85–90; Regina S. Baraban, "Best Dressed," *Metropolis* 5 (April 1986): 23.

18. See Stern, Mellins, and Fishman, *New York 1960*, 204–6, 401–2.

19. Baraban, "Best Dressed," (April 1986): 23.

20. Miller, "Restaurants: Aurora": 22.

21. Regina S. Baraban, "Toscana Ristorante," *Metropolis* 7 (September 1987): 37; Bryan Miller, "Restaurants: Toscana Ristorante," *New York Times* (September 4, 1987), C: 18; "Fine Italian Hand," *New York* 20 (September 28, 1987): 54–57; Richard L. Wentworth, ed., *Piero Sartogo and Nathalie Grenon: Architecture in Perspective* (New York: Monacelli Press, 1998), 96–99. For the Four Seasons, see Stern, Mellins, and Fishman, *New York 1960*, 348–51.

22. Baraban, "Toscana Ristorante": 37.

23. Bryan Miller, "Restaurants: The Casual Quilted Giraffe," *New York Times* (August 15, 1986), C: 20; Bryan Miller, "Spaces and Places," *New York Times* (April 26, 1987), VI: 21, 61–62; Regina Baraban, "The Casual Quilted Giraffe," *Metropolis* 6 (October 1986): 40–41; Mary Jean Madigan, "Cosmic Fun," *Restaurant and Hotel Design* 9 (January 1987): 80–83; Pilar Viladas, "Cool and Crisp," *Progressive Architecture* 68 (March 1987): 104–7.

24. Barry Wine, quoted in Madigan, "Cosmic Fun": 81.

25. J. Woodson Rainey, quoted in Madigan, "Cosmic Fun": 81–82.

26. Barry Wine, quoted in Viladas, "Cool and Crisp": 106.

27. Viladas, "Cool and Crisp": 106.

28. Lee A. Daniels, "A Rental Lure: Elegant Dining," *New*

York Times (October 31, 1985), D: 1, 9; Suzanne Stephens, "An Equitable Relationship?" Art in America 74 (May 1986): 116–23; Pilar Viladas, "Equitable: Art for All," Progressive Architecture 67 (May 1986): 25–26; Bryan Miller, "Restaurants: Palio," New York Times (May 2, 1986), C: 22; Jerry Cooper, "At Equitable Center," Interior Design 57 (September 1986): 254–67; Beverly Russell, "The Palio Restaurant," Interiors 147 (January 1988): 164–65.

29. Jerry Cooper, "Le Bernardin," Interiors 58 (October 1987): 308–9.

30. Edie Lee Cohen, "Eldorado Petit," Interior Design 62 (June 1991): 144–47; Bryan Miller, "Restaurants: Eldorado Petit," New York Times (September 6, 1991), C: 14; "Restaurante en Manhattan, Nueva York," On Diseño 140 (August 1993): 160–67.

31. David Morton, "The Past Unmasked," Progressive Architecture 62 (September 1981): 62–64; Mimi Sheraton, "Restaurants: The Odeon," New York Times (September 30, 1983), C: 18; White and Willensky, AIA Guide (1988), 58; Landmarks Preservation Commission of the City of New York, Tribeca South Historic District Designation Report (New York, 1992), 49–52.

32. Marion Burros, "Restaurants: Gotham Bar and Grill," New York Times (June 1, 1984), C: 18; Giovannini, "Dramatic Effects in Restaurant Design": 1, 6; Baraban, "You Are Where You Eat": 26–29, 42–43; Paul Goldberger, "New York Dining by Design," New York Times (December 15, 1985), X: 20; Martin E. Dorf, Restaurants That Work (New York: Whitney Library of Design, 1992), 136–43; "Paul Segal: Comments on Custom Designed Furniture and Light Fixtures," Architecture + Urbanism (December 1992): 3–4.

33. Paul Segal, quoted in Dorf, Restaurants That Work, 140–41.

34. Regina Baraban, "The Best Dressed: America," Metropolis 5 (July August 1985): 17; Goldberger, "New York Dining by Design": 20; White and Willensky, AIA Guide (1988), 187.

35. Baraban, "The Best Dressed: America": 17.

36. Deborah Dietsch, "On the Importance of Being Ernie's," Interiors 143 (October 1983): 104–7.

37. White and Willensky, AIA Guide (1988), 199. Also see Edie Lee Cohen, "Positano," Interior Design 56 (October 1985): 218–21; Goldberger, "New York Dining by Design": 20.

38. White and Willensky, AIA Guide (1988), 234. Also see Bryan Miller, "Restaurants: B. Smith's," New York Times (March 20, 1987), C: 18; Regina S. Baraban, "Best Dressed: B. Smith's," Metropolis 6 (April 1987): 37; Justin Henderson, "New York Design," Interiors 147 (September 1987): 170–75.

39. See Stern, Mellins, and Fishman, New York 1960, 409–10.

40. Paul Goldberger, "In Two Restaurants Excellent Design Did What Once Seemed to Be Impossible," New York Times (January 17, 1980), C: 10. Also see Frank Stanton, "Design Footnotes," letter to the editor, New York Times (January 24, 1980), C: 13; Mimi Sheraton, "Restaurants: The American Charcuterie," New York Times (February 1, 1980), C: 16.

41. Fred Ferretti, "Restaurant Finds Its 6th Midtown Home," New York Times (October 26, 1983), C: 3.

42. Jane Freiman, "Grill Power at Black Rock," New York 20 (October 19, 1987): 41; Andrea Loukin, "China Grill," Interior Design 59 (September 1988): 256–59; Bryan Miller, "Restaurants: China Grill," New York Times (April 20, 1990), C: 20.

43. Justin Henderson, "Manhattan Mesa," Interiors 150 (July 1991): 56–57; Dorf, Restaurants That Work, 144–51. For the Schuyler Building, see Landmarks Preservation Commission of the City of New York, Ladies' Mile Historic District Designation Report (New York, 1989), 183–85.

44. Stern, Gilmartin, and Massengale, New York 1900, 224–25.

45. Stern, Gilmartin, and Mellins, New York 1930, 271–73.

46. Stern, Mellins, and Fishman, New York 1960, 401–2, 524–25.

47. John Hench, quoted in Molly O'Neill, "Fantasy for the Price of a Burger," New York Times (October 23, 1991), C: 1, 6.

48. Suzanne Slesin, "Stadium Motif for Sports-Loving Diners," New York Times (February 19, 1987), C: 8; Regina S. Baraban, "Best Dressed," Metropolis 7 (May 1987): 46–47; Justin Henderson, "Sports Restaurant, New York City," Interiors 147 (January 1988): 162–63; "'Sports' Restaurant," Bauwelt (February 1992): 288–29.

49. Slesin, "Stadium Motif for Sports-Loving Diners": 8.

50. Patricia Sapinsley, quoted in Slesin, "Stadium Motif for Sports-Loving Diners": 8.

51. John G. Specale, "Dinner Theater," Interior Design 55 (January 1984): 276–77.

52. Bryan Miller, "A Décor Theme of Oversize Body Parts with Echoes of DiMaggio and Mussolini," New York Times (January 20, 1989), C: 20. Also see Patricia Leigh Brown, "Currents: A Bistro with Humor, from Glaser," New York Times (November 17, 1988), C: 3; Bryan Miller, "Trattoria's Visual Puns," New York Times (December 2, 1988), C: 16; Regina S. Baraban, "Trattoria dell'Arte," Metropolis 8 (March 1989): 37; Edie Lee Cohen, "Trattoria dell'Arte," Interior Design 60 (June 1989): 214–18.

53. M. Lindsay Bierman, "America's Street of Themes," editorial, Interior Design 66 (December 1995): 103.

54. Herbert Muschamp, "On West 57th, a Confederacy of Kitsch," New York Times (June 5, 1994), XIV: 4.

55. Bryan Miller, "Diner's Journal," New York Times (March 30, 1984), C: 22; White and Willensky, AIA Guide (1988), 277.

56. David Bird and Maurice Carroll, "The Great Cadillac Debate," New York Times (September 25, 1984), B: 2.

57. Molly O'Neill, "Fantasy for the Price of a Burger," New York Times (October 23, 1991), C: 1, 6; Paul Goldberger, "Architecture/1991," New York Times (December 29, 1991): 32; Lucie Young, "Stars, Sky and Lunch," Designers' Journal 73 (February 1992): 13; Judith Davidsen, "Lighting Another Planet," Architectural Record 190 (August 1992): 44–47; Justin

Henderson, "Fantasies of Filmdom," Interiors 153 (September 1994): 106–7.

58. Young, "Stars, Sky and Lunch": 13.

59. David Rockwell, quoted in Michael Kaplan, Theme Restaurants (Glen Cove, N.Y.: PBC International, 1997), 8.

60. Marvine Howe, "Horrors!? It's Another Restaurant," New York Times (January 16, 1994), XIII: 8; Kaplan, Theme Restaurants, 164–67; Martin M. Pegler, Theme Restaurant Design: Entertainment & Fun Dining (New York: McGraw-Hill, 1997), 48–49.

61. Ruth Reichl, "Diner's Journal: A Younger View," New York Times (September 15, 1995), C: 27; Kate Hensler, "Restaurant," Interiors 155 (May 1996): 226–31; Kaplan, Theme Restaurants, 12–17. Also see White and Willensky, AIA Guide (1988), 279.

62. Jay Haverson, quoted in Hensler, "Restaurant": 226–31.

63. Ruth Reichl, "The Diner Is the Theme," New York Times (July 7, 1995), C: 23; Michael T. Kaufman, "About New York," New York Times (July 8, 1995): 23; Douglas Martin, "An Error Most Foul in Brooklyn Mural," New York Times (September 16, 1995): 21.

64. "At This Restaurant, You'll Just Have to Try the Hogs," New York Times (July 15, 1993), C: 3; Florence Fabricant, "The Milieu of Hogs," New York Times (July 23, 1993), C: 20.

65. Ruth Reichl, "A Chef and a Dining Room Are Matched in a 1950s Style with a Decided Swagger," New York Times (June 7, 1996), C: 22; Kaplan, Theme Restaurants, 168–71; Pegler, Theme Restaurant Design, 20–23; Donna St. George, "Restaurant Wasn't Toast of Town," New York Times (February 18, 1998), B: 1, 7.

66. Reichl, "A Chef and a Dining Room Are Matched in a 1950s Style with a Decided Swagger": 22.

67. Ron Paul, quoted in Charles V. Bagli, "Novelty Gone, Theme Restaurants Are Tumbling," New York Times (December 27, 1998): 1, 38.

68. Bryan Miller, "Restaurants: El Internacional," New York Times (October 26, 1984), C: 22; Ronald Christ, "El Internacional: An Archaeological Sandwich," Sites 14 (1985): 30–39; John Duka, "The New Restaurants," New York Times (January 4, 1985), B: 6; Sharon Lee Ryder, "El Internacional," Metropolis 5 (September 1985): 28; Charles K. Gandee, "El Internacional Style," Architectural Record 173 (Mid-September 1985): 94–99; Goldberger, "New York Dining by Design": 20; White and Willensky, AIA Guide (1988), 55; Elaine Louie, "At El Teddy's," New York Times (April 20, 1989), C: 12; Regina S. Baraban, "Best Dressed Restaurants," Metropolis 8 (May 1989): 45.

69. Gandee, "El Internacional Style": 94.

70. Bob Lape, "Iridium's Place to See and Be Seen in '94," Crain's New York Business (January 3, 1984): 14; Ruth Reichl, "Diner's Journal: Young and Zany," New York Times (January 14, 1994), C: 22; "Moser Mix," Bauwelt (March 1994): 518–21; Carol Lawson, "Music to See and Eat By," New York Times (March 20, 1994), IX: 1, 8.

71. Jordon Mozer, quoted in Lawson, "Music to See and Eat By": 8.

72. Reichl, "Diner's Journal: Young and Zany": 22.

73. Jordan Mozer, quoted in Lawson, "Music to See and Eat By": 8.

74. White and Willensky, AIA Guide (1988), 175.

75. Frederic Schwartz, ed., Alan Buchsbaum, Architect and Designer: The Mechanics of Taste (New York: Monacelli Press, 1996), 138–41.

76. Judy Sutton, "Let's Boogie," Inland Architect 35 (November-December 1991): 40–41; "Let the Good Light Roll," Architectural Record 64 (May 1992): 64–67.

77. "A Shrine to Saint Java," New York Times (August 20, 1992), C: 3; Pentagram: The Compendium (London: Phaidon, 1993), 88–89; Marilyn Bethany, "Diner, Blow Your Horn," New York 26 (March 8, 1993): 52–55; Justin Henderson, "The Real Thing," Interiors 152 (April 1993): 56–57; Ylonda Gault, "Diners Garish Blue Plate," Crain's New York Business (May 10–16, 1993): 3, 38; "Pentagram: Recent Work," Graphis 49 (November-December 1993): 80–83.

78. Herbert L. Smith Jr., "Two Interiors by Torre: An Office . . . and a Restaurant," Architectural Record 170 (August 1982): 128–31.

79. Susan Colgan, "A Clean Interpretation of the Indian Aesthetic without the Use of Saris," Restaurant and Hotel Design 8 (September 1986): 54–57; Hugh Aldersey-Williams, "Today's Specials," I.D. 35 (January-February 1988): 52–55.

80. Charles Gwathmey, quoted in Mary Jean Madigan, "Calm Chaos," Restaurant/Hotel Design International 10 (July 1988): 40–43. Also see Regina S. Baraban, "Due," Metropolis 7 (May 1988): 53; Jane Freiman, "That's Italian," New York 21 (May 9, 1988): 36; Edie Lee Cohen, "Due," Interior Design 59 (October 1988): 222–26; Gwathmey Siegel: Buildings and Projects, 1982–1992, ed. Brad Collins and Diane Kasprowicz (New York: Rizzoli International Publications, 1993), 323.

81. Charles Gwathmey, quoted in Cohen, "Due": 224.

82. Suzanne Stephens, "Murals to Munch By," New York Times (May 18, 1989), C: 3; Agrest and Gandelsonas: Works (New York: Princeton Architectural Press, 1995), 204–5.

83. Agrest and Gandelsonas: Works, 204.

84. Florence Fabricant, "In Chelsea, Lot 61," New York Times (March 4, 1998), F: 11; "Supersize It," New York 31 (March 9, 1998): 16.

85. Thomas Leeser, quoted in Nina Rappaport, "Art World Eats," Interior Design 69 (October 1998): 170–73.

86. Rick Marin, "After the Menu, a Quiz," New York Times (May 20, 1999), F: 1, 10.

87. Roy Liebenthal, quoted in Marin, "After the Menu, a Quiz": 10.

88. Ali Tayar, quoted in Marin, "After the Menu, a Quiz": 1.

89. Marin, "After the Menu, a Quiz": 10. Also see

"Waterloo," New York Times (August 10, 1997), XIII: 4.

90. Meryl Gordon, "Table Stakes," New York 33 (January 10, 2000): 34–39; Addison DeWitt, "Art Gets in the Way," Interiors 71 (February 2000): 203; Herbert Muschamp, "Exploring Space and Time, Here and Now," New York Times (February 6, 2000), II: 37; Soren Larson, "Record News," Architectural Record 189 (March 2000): 29; "Johnson Waxed," Interiors 159 (March 2000): 20; William Grimes, "Out of the Ashes: New Look, Old Spirit," New York Times (March 15, 2000), F: 10; Paul Goldberger, "Comfort Zone," Metropolis 19 (May 2000): 130, 140; Aaron Betsky, "Diller + Scofidio: Under Surveillance," Architecture 89 (June 2000): 128–47; Craig Kellogg, "Underworld Dining," House Beautiful 142 (June 2000): 128, 130; Nicola Turner, "Gin Palace," World Architecture (July-August 2000): 86–91; "Brasserie in New York," Detail 41 (March 2001): 236–41; "Diller + Scofidio: The Brasserie," Architecture + Urbanism (May 2001): 70–77. For Johnson and Pahlmann's Brasserie, see Stern, Mellins, and Fishman, New York 1960, 348, 350.

91. Muschamp, "Exploring Space and Time, Here and Now": 37.

92. Donato Savoie, quoted in Paul Goldberger, "Architects Help Italian Design Come Home–To Little Italy," New York Times (November 10, 1977), C: 10. Also see Ann Carter, "Italia Comes to Little Italy," Progressive Architecture 58 (September 1977): 40.

93. Goldberger, "Architects Help Italian Design Come Home–To Little Italy": 10. Also see Carter, "Italia Comes to Little Italy": 40.

94. Carter, "Italia Comes to Little Italy": 40.

95. Bryan Miller, "Restaurants: Arqua," New York Times (April 24, 1987), C: 16; Daralice D. Boles, "A Comfortable Fit," Progressive Architecture 68 (September 1987): 100–109; Justin Henderson, "A North Italian Jewel in Manhattan," Interiors 147 (October 1987): 170–71. For 281 Church Street, see Landmarks Preservation Commission of the City of New York, Tribeca East Historic District Designation Report (New York, 1992), 93–94.

96. Bryan Miller, "Restaurants: Felidia," New York Times (March 29, 1985), C: 24; Boles, "A Comfortable Fit": 107.

97. Regina S. Baraban, "Ristorante Barolo," Metropolis 10 (July-August 1990): 27; Justin Henderson, "SoHo Italian Style," Interiors 150 (August 1991): 88–89.

98. Baraban, "Ristorante Barolo": 27.

99. Goldberger, "Architects Help Italian Design Come Home–To Little Italy": 10.

100. Antonio Morello, quoted in Boles, "A Comfortable Fit": 100.

101. Mimi Sheraton, quoted in Regina Nadelson, "Table Settings," Avenue (April 1987): 101–5. Also see Carol Schatz, "Tasteful Designs," Manhattan, inc. 12; Patricia Leigh Brown, "Putting a High Gloss on New York Style," New York Times (March 12, 1987), C: 1, 8.

102. Moira Hodgson, "Restaurants: Joanna," New York Times (November 7, 1980), C: 16; Patricia Leigh Brown, "For Sam Lopata, Restaurant as Theater," New York Times (March 12, 1987), C: 1, 8.

103. Sam Lopata, quoted in Nadelson, "Table Settings": 101–5.

104. Sam Lopata, quoted in Brown, "For Sam Lopata, Restaurant as Theater": 8.

105. Brown, "For Sam Lopata, Restaurant as Theater": 1.

106. Daralice D. Boles, "East/West Exotica," Progressive Architecture 64 (September 1983): 136–37; Giovannini, "Dramatic Effects in Restaurant Design": 1, 6.

107. Marian Burros, "Restaurants: Prunelle," New York Times (January 13, 1984), C: 16; Giovannini, "Dramatic Effects in Restaurant Design": 1, 6; Kenneth Brozen, "A Plum of a Place," Interiors 144 (September 1984): 152–53.

108. Kenneth Brozen, "High-Vu," Interiors 144 (October 1984): 92–95; White and Willensky, AIA Guide (1988), 179.

109. Andrea Truppin, "Illusionary Magic," Interiors 144 (April 1985): 120–21; Anthony Brandt, "Wild Restaurants," Connoisseur 218 (April 1988): 100–107. For Manhattan House, see Stern, Mellins, and Fishman, New York 1960, 840–42.

110. Regina S. Baraban, "Lox Around the Clock," Metropolis 5 (May 1986): 21; Justin Henderson, "A 'Found' Interior Is Transformed into a Rock 'n Roll All-Night Deli," Interiors 146 (November 1986): 67–68; White and Willensky, AIA Guide (1988), 178–79; Brandt, "Wild Restaurants": 100–107; "Wie Vorgefunden," Architektur, Innenarchitektur, Technischer Ausbau 99 (June 1991): 36–38.

111. Regina S. Baraban, "Extra! Extra!," Metropolis 6 (December 1986): 33; Mary Jean Madigan, "Stop the Presses," Restaurant and Hotel Design 9 (February 1987): 58–61; White and Willensky, AIA Guide (1988), 254.

112. Bryan Miller, "Diner's Journal: Chop Suey Looey's Litchi Lounge," New York Times (September 4, 1992), C: 16; Bonnie S. Schwartz, "Animating with Light," Interiors 151 (October 1992): 22; Bonnie S. Schwartz, "Midtown Camp," Interiors 151 (October 1992): 74–75.

113. Bryan Miller, "Restaurants: Batons," New York Times (November 29, 1985), C: 18; Regina S. Baraban, "Batons," Metropolis 5 (January-February 1986): 23; Justin Henderson, "A Cool West Coast Scene Comes Back East," Interiors 145 (March 1986): 75–78; Brown, "For Sam Lopata, Restaurant as Theater": 1, 8; Brandt, "Wild Restaurants": 100–107.

114. Baraban, "Batons": 23.

115. Brandt, "Wild Restaurants": 100.

116. Sam Lopata, quoted in Maureen Picard, "Happy Trails," Restaurant and Hotel Design 10 (February 1988): 46–49. Also see Regina S. Baraban, "Home On the Range," Metropolis 7 (November 1987): 43.

117. Baraban, "Home On the Range": 43.

118. William Weathersby Jr., "Industrial Strength," Restaurant/Hotel Design International 11 (November 1989): 56–59.

119. Barbara Pensoy, quoted in Weathersby, "Industrial

Strength": 59.

120. Marilyn Bethany, "Adam's Edens," *New York* 21 (August 1, 1988): 34–40.

121. Suzanne Slesin, "Attempting to Copy a Famous Original," *New York Times* (February 18, 1982), C: 10; White and Willensky, *AIA Guide* (1988), 216. For Two Park Avenue, see Stern, Gilmartin, and Mellins, *New York 1930*, 555–56, 560.

122. Adam Tihany, quoted in Slesin, "Attempting to Copy a Famous Original": 10.

123. Edie Lee Cohen, "Club A," *Interior Design* 54 (March 1983): 214–19.

124. Bryan Miller, "Restaurants: Alo Alo," *New York Times* (June 21, 1985), C: 20; Edie Lee Cohen, "Alo Alo," *Interior Design* 56 (September 1985): 278–81; Goldberger, "New York Dining by Design": 20.

125. Bryan Miller, "Restaurants: Bice," *New York Times* (October 23, 1987), C: 28; Edie Lee Cohen, "Bice," *Interior Design* 59 (September 1988): 248–49; Dorf, *Restaurants That Work*, 152–59.

126. Regina S. Baraban, "Huberts," *Metropolis* 8 (September 1988): 47. Also see Bethany, "Adam's Edens": 34–40; Edie Lee Cohen, "Huberts, New York," *Interior Design* 60 (February 1989): 212–17. For the Brooklyn Huberts, see Mimi Sheraton, "Restaurants: Huberts," *New York Times* (December 28, 1979), C: 20.

127. Seymour Britchky, quoted in Bethany, "Adam's Edens": 40.

128. Moira Hodgson, "Dining Out Around Manhattan: Metro," *New York Observer* (January 8, 1990): 19; Bryan Miller, "Restaurant Slump Claims a Victim," *New York Times* (May 9, 1990), C: 12.

129. Regina S. Baraban, "Remi," *Metropolis* 6 (June 1987): 33; Edie Lee Cohen, "Remi, New York," *Interior Design* 58 (October 1987): 290–91; Bryan Miller, "Restaurants: Remi," *New York Times* (November 13, 1987), C: 24.

130. Edie Lee Cohen, "Remi Redux," *Interior Design* 61 (September 1990): 182–85; Regina S. Baraban, "Remi," *Metropolis* 10 (December 1990): 31; Dorf, *Restaurants That Work*, 160–67; Kaplan, *Theme Restaurants*, 126–29.

131. Adam Tihany, quoted in Dorf, *Restaurants That Work*, 164.

132. Adam Tihany, quoted in Cohen, "Remi Redux": 184.

133. "March of the Toy Restaurants," *New York Times* (December 27, 1995), C: 2; Kaplan, *Theme Restaurants*, 154–55.

134. Laura Shapiro, "Haute Cuisine Heats Up," *Newsweek* 129 (June 23, 1997): 68; Matt Tyrnauer, "The Big Top," *Vanity Fair* (July 1997): 64; Hendrik Hertzberg, "Dept. of Hoopla," *New Yorker* 73 (December 8, 1997): 39; Holly Brubach, "Style," *New York Times* (March 22, 1998), VI: 49. For the Villard Houses, see Stern, Mellins, and Fishman, *New York 1880*, 601–8. For the restoration of the Villard Houses, see Stern, Mellins, and Fishman, *New York 1960*, 1127–29.

135. Adam Tihany, quoted in Christy Casamassima, *Restaurant 2000: Dining Design III* (Glen Cove, N.Y.: PBC International, 1998), 106–13.

136. Adam Tihany, quoted in Marin, "After the Menu, a Quiz": 1, 10.

137. Brubach, "Style": 49.

138. Ruth Reichl, "A Subtle Revolution in Four Star Dining," *New York Times* (June 6, 1997), C: 1, 28; Shapiro, "Haute Cuisine Heats Up": 68; Casamassima, *Restaurant 2000: Dining Design III*, 62–65.

139. Reichl, "A Subtle Revolution in Four Star Dining": 28.

140. Patricia Leigh Brown, "Step Right Up: Let an Architect Thrill You," *New York Times* (February 19, 1998), F: 1, 8.

141. David Rockwell, quoted in N. R. Kleinfield, "Why Is That Sushi Bar Glowing," *New York Times* (December 18, 1994), XIII: 4.

142. David Rockwell, quoted in Kaplan, *Theme Restaurants*, 8.

143. John G. Tucker, "Stage-Set Sushi," *Interior Design* 55 (November 1984): 272–73.

144. Regina S. Baraban, "Caffe Roma," *Metropolis* 5 (June 1986): 21; Jerry Cooper, "Caffe Roma," *Interior Design* 57 (October 1986): 278–79.

145. Regina S. Baraban, "Twenty:Twenty," *Metropolis* 6 (September 1986): 19. Also see Sharon Lee Ryder, "Interiors," *Architecture* 75 (December 1986): 125.

146. Jerry Cooper, "Ocean Reef Grille," *Interior Design* 59 (February 1988): 304–7.

147. Regina S. Baraban, "Il Bianco," *Metropolis* 8 (July-August 1988): 33; Linda Lee Moore, "A Garden of Light," *Restaurant/Hotel Design International* 11 (February 1989): 50–53.

148. Julia Franks, "California Dreaming," *Restaurant/Hotel Design International* 11 (November 1989): 68–71.

149. Regina S. Baraban, "A Little Night Music," *Metropolis* 11 (October 1991): 107. Also see Gareth Fenley, "That Extra Edge," *Architectural Record Lighting* 180 (May 1992): 52–55.

150. Molly O'Neill, "Fantasy for the Price of a Burger," *New York Times* (October 23, 1991), C: 1, 6.

151. Regina S. Baraban, "Tatou," *Metropolis* 10 (May 1991): 107. Also see Bryan Miller, "Restaurants: Tatou," *New York Times* (October 4, 1991), C: 22; Fenley, "That Extra Edge": 52 55. For the Versailles, see Stern, Mellins, and Fishman, *New York 1960*, 532, 534.

152. Bryan Miller, "Diner's Journal: French and Asian at Vong," *New York Times* (January 15, 1993), C: 21. Also see Trish Hall, "Forsaking More, a Restaurant Design Team Adapts to Era of Less," *New York Times* (February 17, 1993), C: 1, 6; Herbert Muschamp, "Masterful Lighting Sets the Stage for Discovery at Vong," *New York Times* (February 17, 1993), C: 6; Bryan Miller, "Restaurants: Vong," *New York Times* (February 26, 1993), C: 22.

153. Kaplan, *Theme Restaurants*, 38–39.

154. Ruth Reichl, "Diner's Journal: Monkey Bar Is Back," *New York Times* (September 24, 1994), C: 24; Ruth Reichl, "Restaurants: Monkey Bar," *New York Times* (November 4, 1994), C: 20; Frank J. Prial, "Monkey Bar: Sound of Success," *New York Times* (November 27, 1994): 68; Kaplan, *Theme Restaurants*, 9; Ruth Reichl, "Glamour, and a Luxurious New Menu," *New York Times* (March 4, 1998), F: 11.

155. Reichl, "Glamour, and a Luxurious New Menu": 11.

156. David Rockwell, quoted in Mayer Rus, "Rockwell Group," *Interior Design* 65 (December 1994): 56–59. Also see Ruth Reichl, "Diner's Journal: Novel Sushi," *New York Times* (September 2, 1994), C: 22; Ruth Reichl, "Restaurants: Nobu," *New York Times* (October 7, 1994), C: 24; Kleinfield, "Why Is That Sushi Bar Glowing": 4; M. J. Madigan, "Best in Restaurant Design," *Interiors* 154 (January 1995): 118–19.

157. Reichl, "Restaurants: Nobu": 24.

158. Kristen Richards, "Close Quarters," *Interiors* 157 (December 1998): cover, 44–47; Hal Rubenstein, "The Soy Next Door," *New York* 32 (January 18, 1999): 67.

159. Kate Hensler, "Official All Star Café," *Interiors* 155 (June 1996): 64–69; Pegler, *Theme Restaurant Design*, 38–39.

160. David Rockwell, quoted in Hensler, "Official All Star Café": 66.

161. Brown, "Step Right Up: Let an Architect Thrill You": 1, 8. Also see "$28 Million Project at Broadway and 49th Street; Presto! A David Copperfield Magic Restaurant," *New York Times* (July 13, 1997), IX: 1; Charles V. Bagli, "Poof! $34 Million Vanishes on Broadway," *New York Times* (September 26, 1999), III: 1, 14.

162. Suzanne Slesin, "This Surreal Way to Your Table," *New York Times* (October 26, 1995), C: 27; John P. Radulski, "Torre Di Pisa," *Hospitality Design* (May-June 1996): cover, 40–45; Kaplan, *Theme Restaurants*, 135–39; Holly Brubach, "Bread and Circuses," *New York Times* (March 22, 1998), VI: 49.

163. Slesin, "This Surreal Way to Your Table": 27.

164. Brubach, "Bread and Circuses": 49.

165. David Rockwell, quoted in "Hot New Mixed Use: Merchandising and Dining," *Urban Land* 54 (August 1995): 68.

166. "More Fish to Fry," *New York* 31 (June 29-July 6, 1998): 20; "Turning the Bento Box on Its Head," *New York Times* (February 18, 1999), F: 9; Ruth Reichl, "Glitzing Up the West Side," *New York Times* (March 24, 1999), B: 13; Meryl Gordon, "Steve Hanson Wants You to Be Happy," *New York* 32 (March 29, 1999): 36–40.

167. Reichl, "Glitzing Up the West Side": 13.

168. Suzanne Slesin, "Designed for Dancing," *New York* 10 (June 13, 1977): 80–84; Norma Skunka, "Storehouse of Ideas," *New York Times* (July 17, 1977), VI: 34–35; "Where Many a Rigoletto Once Poured Forth His Anguish, Studio 54, a New Mecca for Disco Designed by Experience Space, Now Takes Wondrous, Varicolored Shape," *Architectural Record* 163 (January 1978): 84–87; Anthony Haden-Guest, *The Last Party: Studio 54, Disco, and the Culture of the Night* (New York: William Morrow, 1997), esp. prologue, chapters 3–4.

169. For the Gallo Theater, see Stern, Gilmartin, and Mellins, *New York 1930*, 231.

170. Judy Klemesrud, "Discothèque Fanatics Mob Latest Addition to Scene," *New York Times* (June 9, 1978): 16.

171. Martin Filler, "Where the Elite Meet," *Progressive Architecture* 59 (June 1978): 60–63. For the Delmonico, see Stern, Gilmartin and Mellins, *New York 1930*, 215.

172. John Addison and Maurice Brahms, quoted in Suzanne Slesin, "Spiral Staircase Dominates a New Nightclub," *New York Times* (April 3, 1980), C: 10. For Deskey's International Casino, see Stern, Gilmartin, and Mellins, *New York 1930*, 289–91.

173. Lee Mindel, quoted in Slesin, "Spiral Staircase Dominates a New Nightclub": 10.

174. Paul Goldberger, "The Palladium: An Architecturally Dramatic New Discotheque," *New York Times* (May 20, 1985), B: 3; Ann Kaufman, "Pandora's Box," *Architecture + Urbanism* (September 1985): 10–11; Charles K. Gandee, "Heaven's Gate," *Architectural Record* 173 (Mid-September 1985): 126–36; "The Palladium," *Kenchiku Bunka* 40 (October 1985): 48–59; Edie Lee Cohen, "The Palladium," *Interior Design* 46 (October 1985): 230–33; Enslie Fedden, "Electronic Cathedral," *Interiors* 145 (October 1985): 128–37; Martin Filler, "Evening Star," *House & Garden* 157 (October 1985): 216–17, 262, 264; Gini Alhadeff, "The Palladium: Immaterial Building," *Domus* (November 1985): 36–41; "The Palladium," *Japan Architect* (November-December 1985): 17–26; Philip Jodidio, "Rigueur et Declin," *Connaissance des Arts* (December 1985): 112–19; Claudia Donà, "Timebusters," *Modo* 88 (April 1986): 30–35; White and Willensky, *AIA Guide* (1988), 194–95.

175. Goldberger, "The Palladium": 3.

176. Alhadeff, "The Palladium": 38.

177. Filler, "Evening Star": 262.

178. Alhadeff, "The Palladium": 38.

BOUTIQUE HOTELS

1. "The Ex-Executive," *New York Times* (August 19, 1984), VIII: 1; Suzanne Slesin, "Design Ideas in 2 New Small Hotels," *New York Times* (September 20, 1984): C: 1, 8; John Duka, "Notes on Fashion," *New York Times* (December 11, 1984), C: 18; Charles K. Gandee, "The French Connection," *Architectural Record* 173 (March 1985): 144–51; Regina S. Baraban, "Far-Out Inns," *Metropolis* 10 (November 1990): 48–53.

2. Gandee, "The French Connection": 146.

3. Douglas Martin, "New Yorkers & Co.," *New York Times* (July 11, 1988), D: 1; Suzanne Slesin, "The Royalton, at 90 a Dowager of a Hotel, Turns Into a Sylph," *New York Times* (September 29, 1988): C: 1, 6; Judith Weinraub, "Superstar Starck's High-Style Hotel," *Washington Post* (October 13, 1988), T: 11; Jillian Burt, "The Hippest Hotel in Manhattan," *Blueprint* (December 1988-January 1989): 22–26; Donn Dunn, "Three Gotham Dowagers Put on the Ritz," *Business Week* (December 5, 1988): 184; John Skow, "An Ocean Cruise in Manhattan," *Time* 132 (December 19, 1988): 89; Charles

Gandee, "The Royalton Treatment," *House & Garden* 161 (January 1989): 170–77; Lisa S. Cohen, "Where Streamline Becomes Dreamline," *Interiors* 148 (January 1989): 26; "Le Royalton à New York," *Architecture d'Aujourd'hui* 261 (February 1989): 70–75; Karen D. Stein, "Rags to Riches: The Royalton Hotel, New York City," *Architectural Record* 177 (March 1989): 94–99; "Corrections," *Architectural Record* 177 (May 1989): 4; Lucie Young, "Undercover Report," *Design* 487 (July 1989): 40–45; Peter B. Flint, "Steve Rubell, Studio 54's Creator and a 'Pasha of Disco,' Dies at 45," *New York Times* (July 27, 1989): 19; James Barron, "Rubell Created Homes Away from Home for the Trendsetters," *New York Times* (July 28, 1989): 10; Anja Hübener, "Hotell i särklass," *Arkitektur: The Swedish Review of Architecture* 89 (October 1989): 64; Birgit Dietsch, "Royalton Hotel, New York," *Bauwelt* (March 30, 1990): 530–31; Baraban, "Far-Out Inns": 48–53; Justin Henderson, "Royal Flash," *Interiors* 150 (January 1991): 115–16; "19 Projects Win AIA Honor Awards," *Architectural Record* 179 (February 1991): 21; Fulvio Irace, *Dimore Metropolitane* (Milan: Electa, 1992), 26–33; "The Royalton, New York," *Architektur, Innenarchitektur, Technischer Ausbau* 100 (January-February 1992): 58–59; Philip Arcidi, "Hotel Hauteur, Two Models from Manhattan," *Progressive Architecture* 74 (February 1993): 80–83; Franco Bertoni, *The Architecture of Philippe Starck* (London: Academy Editions, 1994), 98–105; Conway Lloyd Martin, *Starck* (New York: Universe Publishing, 1999), 56–61; Christopher Gray, "Streetscapes/44th Street Between Fifth and Sixth Avenues," *New York Times* (April 1, 2001), XI: 7; Meryl Gordon, "The Cool War," *New York Times* (May 27, 2001), VI: 34–39; "Hotelbars für Ian Schrager," *Bauwelt* (July 20, 2001): 24–27.

4. Ian Schrager, quoted in Weinraub, "Superstar Starck's High-Style Hotel": 11.

5. Henderson, "Royal Flash": 115.

6. Philippe Starck, quoted in Weinraub, "Superstar Starck's High-Style Hotel": 11.

7. Skow, "An Ocean Cruise in Manhattan": 89.

8. Suzanne Slesin, "Currents," *New York Times* (December 24, 1987), C: 3; Flint, "Steve Rubell, Studio 54's Creator and a 'Pasha of Disco,' Dies at 45": 19; Suzanne Slesin, "A Hotel Where Magic and Humor Reside," *New York Times* (December 14, 1989), C: 1, 8; Suzanne Slesin, "Lobby as Urban Living Room," *New York Times* (August 9, 1990): C: 1, 6; Patricia Leigh Brown, "Night at the Paramount," *New York Times* (September 21, 1990), C: 1, 27; "Paramount Hotel," *Architecture intérieure crée* 239 (October-November 1990): 146–51; Baraban, "Far-Out Inns": 48–53; Fred A. Bernstein, "For Ian Schrager, Design Is Paramount," *Metropolitan Home* 22 (November 1990): 63–70, 164; Jeannine Stein, "The Place to Be Seen," *Los Angeles Times* (November 21, 1990), E: 1; Edie Lee Cohen, "Paramount," *Interior Design* 61 (December 1990): 142–47; Karen D. Stein, "Repeat Performance: Paramount Hotel, New York City," *Architectural Record* 179 (January 1991): 72–75; Brigitte Fitoussi, "Paramount Hotel, New York," *Architecture d'Aujourd'hui* 273 (February 1991): 150; José Manser, "Picture Palace," *Designers' Journal* (February 1991): 68; "Starck-Strom in Manhattan," *Architektur, Innenarchitektur, Technischer Ausbau* 99 (June 1991): 14–17; Annamaria Scevola, "The Grand Hotel," *Ottagono* 99 (June 1991): 142–45; Irace, *Dimore Metropolitane*, 38–41; David Dillon, "Context and Craft," *Architecture* 81 (March 1992): 48–55; Arcidi, "Hotel Hauteur, Two Models from Manhattan": 80–83; Bertoni, *The Architecture of Philippe Starck*, 166–75; Judy Smith, "Hotel as Theatre," *Asian Architect and Contractor* 27 (October 1998): 16–18; Martin, *Starck*, 57–61. For Lamb's Hotel Paramount, see Stern, Gilmartin, and Mellins, *New York 1930*, 204.

9. Stein, "Repeat Performance: Paramount Hotel, New York City": 72.

10. Philippe Starck, quoted in Stein, "Repeat Performance: Paramount Hotel, New York City": 72.

11. Slesin, "Lobby as Urban Living Room": 1, 6.

12. Cohen, "Paramount": 144.

13. Lisa W. Foderaro, "Economy Hotel Is Planned on West Side by Schrager," *New York Times* (November 13, 1997), B: 6; Charles V. Bagli, "Hotel Business Is Growing Bigger, Busier and Faster," *New York Times* (November 23, 1997): 39; Christopher Gray, "Streetscapes/The Henry Hudson Hotel," *New York Times* (January 4, 1998), XI: 5; White and Willensky, *AIA Guide* (2000), 251; "New York Room Boom!" *Grid* 2 (March-April 2000): 96; Herbert Muschamp, "Design That Coaxes Buildings Out of Themselves," *New York Times* (September 10, 2000), II: 100; Herbert Muschamp, "Interior City: Hotel as the New Cosmopolis," *New York Times* (October 5, 2000), F: 1, 6; James Gardner, "The Hudson's Inner Beauty Embraces the Beautiful People," *New York Observer* (October 16, 2000): 21; Moira Hodgson, "Is Starck Raving Mad? Introducing 'Lifestyle Dining'," *New York Observer* (November 6, 2000): 24; Abby Bussel, "Checking In," *Grid* 2 (November-December 2000): 99–103; Mickey O'Connor, "Philippe Starck Is Funkier than Thou," *Architecture* 89 (December 2000): 24; Denny Lee, "A New Icon of Supercool Is Way Too Hot for Some Tastes," *New York Times* (December 10, 2000), XIV: 6; Edie Cohen, "High on Hudson," *Interior Design* 62 (January 2001): 190; "Hudson Hawk," *Oculus* 63 (January 2001): 9; Peter Hall, "Spot On," *Interiors* 160 (March 2001): 76–79; Jonathan Ringen, "Sweet Dreams," *Metropolis* 20 (April 2001): 76; Martin C. Pedersen, "Hudson," *Metropolis* 20 (April 2001): 80–81; Cynthia Davidson, "Hudson: New York City," *Architectural Record* 189 (May 2001): 250–52; Meryl Gordon, "The Cool War," *New York Times* (May 27, 2001): 34–39; "Hudson Hotel: New York, N.Y.," *New York Construction News* 48 (June 2001): 48.

14. Ian Schrager, quoted in Foderaro, "Economy Hotel Is Planned on West Side by Schrager": 6.

15. Philippe Starck, quoted in Rowan Moore, "Urban Idyll,"

Vogue 190 (November 2000): 496–503.

16. Gardner, "The Hudson's Inner Beauty Embraces the Beautiful People": 21.

17. Muschamp, "Interior City: Hotel as the New Cosmopolis": 1.

18. Muschamp, "Interior City: Hotel as the New Cosmopolis": 1.

19. Gardner, "The Hudson's Inner Beauty Embraces the Beautiful People": 21.

20. Herbert Muschamp, "For Rebuilders, Inspiration All Around," *New York Times* (October 5, 2001), E: 2.

21. "New Hotel on West 56th Street: A Downtown Look in Manhattan," *New York Times* (July 23, 2000), XI: 1; George Epaminondas, "Chambers Made," *Wallpaper* (November 2000): 55; Bussel, "Checking In": 99–103; Craig Kellogg, "Housing Travelers," *Oculus* 63 (January 2001): 8; András Szántó, "The Artful Lodger," *Interiors* 160 (March 2001): 70–75, 116; Elaine Louie, "Downtown Style Uptown, and Art All Around," *New York Times* (May 10, 2001), F: 3; Jen Renzi, "Site Specific," *Interior Design* 72 (August 2001): 230–35; Paul Goldberger, "Celebrating with a Whiff of Irony," *Metropolis* 21 (December 2001): 110, 117.

22. Ira Drukier, quoted in "New Hotel on West 56th Street: A Downtown Look in Midtown": 1.

23. David Rockwell, quoted in "New Hotel on West 56th Street: A Downtown Look in Midtown": 1.

24. Epaminondas, "Chambers Made": 55.

25. Quoted in www.rockwellgroup.com.

26. Goldberger, "Celebrating with a Whiff of Irony": 110.

27. Suzan Wines, "The Two Souls of Design," *Domus* (December 1998): 56–63; Jayne Merkel, "Welcome to New York. Do You Have a Reservation?" *Oculus* 62 (March 2000): 12–15; Toni Schlesinger, "Money," *Village Voice* (April 11, 2000): 18; David W. Dunlap, "A Future for Madison Square's Past," *New York Times* (July 15, 2001), XI: 1, 6.

28. Stefan Lindfurst, quoted in Dunlap, "A Future for Madison Square's Past": 6.

29. Jayne Merkel, "Gotham Hospitality," *Oculus* 62 (March 2000): 12–16; Rosalie R. Radomsky, "A 12-Story Giraffe at 26th St.," *New York Times* (November 7, 1999), XI: 1; Barbara Shea, "Grand Openings in NYC," *New York Newsday* (November 19, 2000), E: 10; John Holusha, "In Manhattan, a Scattering of New Hotels," *New York Times* (April 16, 2000), XI: 1, 6; John Holusha, "Giraffe, a Hotel Raising Its Independent Profile," *New York Times* (March 15, 2000), B: 8.

30. Henry Kallan, quoted in Radomsky, "A 12-Story Giraffe at 26th St.": 1.

31. John Holusha, "Commercial Property/Lodging in New York City," *New York Times* (November 2, 1997), XI: 7; Herbert Muschamp, "Atop a Hill in Midtown, Where Life Is a Stroll," *New York Times* (December 5, 1997), E, part 2: 29, 38; Henry Urbach, "Gotham Style," *Interior Design* 69 (February 1998): 126–31.

32. "Postings: Converting Madison Ave. Offices to a Boutique Hotel," *New York Times* (April 25, 1999), XI: 1; White and Willensky, *AIA Guide* (2000), 243; Lauren David Peden, "Literary Inn in Midtown," *New York Times* (November 5, 2000), IX: 3; "Modern Classic," *Interiors* 72 (June 2001): 230–33.

33. "Postings: $400 a Night on East 41st Street," *New York Times* (January 3, 1999), XI: 1; "Postings: Converting Madison Ave. Offices to a Boutique Hotel": 1; "Chemist Club Being Converted to a Hotel," *New York Construction News* 47 (July 1999): 8; Edwin McDowell, "Around Grand Central, New Office Towers and a 54-Floor Residence," *New York Times* (February 13, 2000), XI: 1, 6; Kellogg, "Housing Travelers": 8; John Holusha, "Commercial Property/Dylan Hotel," *New York Times* (June 3, 2001), XI: 10. For the Chemists' Club, see Christopher Gray, "Streetscapes: The Chemists' Club and the Godmothers League," *New York Times* (November 28, 1993), X: 5.

34. Carter B. Horsley, "Japanese Scoop Up 'Trophy,'" *New York Post* (September 1, 1988): 66; Christopher Gray, "Streetscapes/The American Radiator Building," *New York Times* (February 20, 1994), X: 7; "More Rooms with Views," *New York Times* (November 23, 1997): 39; Bagli, "Hotel Business Is Growing Bigger, Busier and Faster": 39; David W. Dunlap, "Turning Radiator Building into a Boutique Hotel," *New York Times* (August 11, 1999), B: 6; Florence Fabricant, "Off the Menu," *New York Times* (February 23, 2000), F: 9; Merkel, "Gotham Hospitality": 12–16; David W. Dunlap, "From Front Office to Front Desk," *New York Times* (September 10, 2000), XI: 1, 6; Bussel, "Checking In": 98–103; Kellogg, "Housing Travelers": 8; John Holusha, "To Boutique Hoteliers, Small Is Beautiful," *New York Times* (March 11, 2001), XI: 1, 8; Edwin McDowell, "When Hotels Add Hospitality to History," *New York Times* (June 24, 2001), XI: 1, 6; Elaine Louie, "Currents: Interiors," *New York Times* (June 28, 2001), F: 3; Christopher Gray, "Streetscapes/40th Street Between Fifth Avenue and Avenue of the Americas," *New York Times* (August 4, 2002), XI: 7. For the American Radiator Building, see Stern, Gilmartin, and Mellins, *New York 1930*, 576–77, 581–83.

APARTMENTS

1. Paul Goldberger, "Le Winners," *New York Times* (March 13, 1977), VI: 66–67, 69–70. Also see "Apartments by Paul Segal Associates," *Architecture + Urbanism* (October 1981): 92–105. For the Prasada, see Stern, Gilmartin, and Massengale, *New York 1900*, 387–88.

2. For D'Urso's Calvin Klein apartment, see Stern, Mellins, and Fishman, *New York 1960*, 540.

3. Charles K. Gandee, "A Room with a View," *Architectural Record* 168 (December 1980): 86–87.

4. Edie Cohen, "Exploiting the Views," *Interior Design* 52 (January 1981): 260–67.

5. See Stern, Mellins, and Fishman, *New York 1960*, 556–57.

For the Swid apartment, see Susan Grant Lewin, "The Art of Space Sculpture," *House Beautiful* 120 (September 1978): 106–11; "An Apartment of Ideas," *Interior Design* 50 (January 1979): 170–79; "A New York in un grattacielo del 1912," *Abitare* (November 1979): 20–29; "Swid Apartment," *Process Architecture* 13 (March 1980): 58–61; Stanley Abercrombie, *Gwathmey Siegel* (New York: Whitney Library of Design, 1981), 60–65; Charles K. Gandee, "A Sign of the Times," *Architectural Record* 169 (Mid-February 1981): 80–82; Pamela Heyne, *Today's Architectural Mirror, Interiors Buildings and Solar Designs* (New York: Van Nostrand Reinhold, 1982), 40; *Charles Gwathmey and Robert Siegel: Buildings and Projects, 1964–1984*, ed. Peter Arnell and Ted Bickford (New York: Harper & Row, 1984), 156–57, 290; Colin Rowe, *As I Was Saying*, vol. 2 (Cambridge, Mass.: MIT Press, 1996), 336, 339–40, 342.

6. Gandee, "A Sign of the Times": 80–82.

7. Abercrombie, *Gwathmey Siegel*, 60.

8. Rowe, *As I Was Saying*, 336, 339.

9. John Elderfield, Peter Reed, Mary Chan, Maria del Carmen González, eds., *Modernstarts: People, Places, Things* (New York: Museum of Modern Art, 1999), 174–75, 183–85.

10. "Geffen Apartment," *Process Architecture* 13 (March 1980): 62–64; Abercrombie, *Gwathmey Siegel*, 84–89; Gandee, "A Sign of the Times": 80–82; Paul Goldberger, "Architectural Approach, Inventive Spatial Solution for an Apartment in Manhattan," *Architectural Digest* 40 (June 1983): 148–53, 172; *Charles Gwathmey and Robert Siegel: Buildings and Projects, 1964–1984*, 160–61, 291.

11. Stern, Mellins, and Fishman, *New York 1960*, 508–9, 512.

12. Goldberger, "Architectural Approach, Inventive Spatial Solution for an Apartment in Manhattan": 152.

13. Charles Gwathmey, quoted in Charles K. Gandee, "Art and Architecture," *Architectural Record* 172 (Mid-September 1984): 106–11. Also see *Charles Gwathmey and Robert Siegel: Buildings and Projects, 1964–1984*, 246–49, 294; Martin Filler, "Material Matters," *House & Garden* 157 (February 1985): 90–97.

14. Charles Gwathmey, quoted in Pilar Viladas, "Revisionist Modern," *Progressive Architecture* 66 (June 1985): 92–97. Also see "State of the Art Style," *House & Garden* 57 (June 1985): 114–23; Edie Lee Cohen, "Then and Now," *Interior Design* 60 (August 1989): 166–75; *Gwathmey Siegel & Associates: Selected and Current Works* (Mulgrave, Australia: Images Publishing, 1998), 230.

15. Carol Vogel, "A Change of Space," *New York Times* (December 27, 1987), VI: 30–33.

16. Paul Goldberger, "A Manhattan Cabinet," *Architectural Digest* 52 (July 1995): 52–61, 139.

17. Stern, Mellins, and Fishman, *New York 1960*, 550, 553, 555–57.

18. "Park Avenue Apartment," *GA Houses* (1979): 92–93; "Park Avenue Apartment," *Architecture + Urbanism* (July 1982): 164–67; Peter Arnell and Ted Bickford, eds., *Robert A.M. Stern: Buildings and Projects, 1965–1980* (New York: Rizzoli International Publications, 1981), 126–27, 254.

19. Suzanne Slesin, "The Postmodern Interior: A Collage of Times Gone By," *New York Times* (September 18, 1980), C: 1, 6; Arnell and Bickford, eds., *Robert A.M. Stern: Buildings and Projects, 1965–1980*, 150–53, 255; Barclay Gordon, "Reminted in the Coin of Post-Modernism," *Architectural Record* 74 (Mid-February 1981): 74–75; Charles Jencks, "Hitzig Apartment Renovation," *Architectural Design* 52 (1982): 72–75; "Hitzig Apartment Renovation," *Architecture + Urbanism* (July 1982): 158–63. For the Gramercy, see Stern, Mellins, and Fishman, *New York 1880*, 557–59.

20. Slesin, "The Postmodern Interior: A Collage of Times Gone By": 1, 6.

21. Robert Stern, quoted in Slesin, "The Postmodern Interior: A Collage of Times Gone By": 1, 6.

22. Arnell and Bickford, eds., *Robert A.M. Stern: Buildings and Projects, 1965–1980*, 200–203, 254; Ross Miller, "Architecture: Robert A.M. Stern," *Architectural Digest* 40 (April 1983): cover, 112–21; "Special Feature: Recent Works of Robert A.M. Stern," *Architecture + Urbanism* (August 1985): 81, 106–7; Luis F. Rueda, ed., *Robert A.M. Stern: Buildings and Projects, 1981–1985* (New York: Rizzoli International Publications, 1986), 106, 290. For the Danziger apartment, see Stern, Mellins, and Fishman, *New York 1960*, 556.

23. Rueda, ed., *Robert A.M. Stern: Buildings and Projects, 1981–1985*, 48–49, 290.

24. Rueda, ed., *Robert A.M. Stern: Buildings and Projects, 1981–1985*, 219, 293; Elizabeth Kraft, ed., *Robert A.M. Stern: Buildings and Projects, 1987–1992* (New York: Rizzoli International Publications, 1992), 340, 352.

25. For Stern and Hagmann's apartment, see Stern, Mellins, and Fishman, *New York 1960*, 556. For Graves's work, see Berkeley Reinhold, "MY Apartment," *Express* 1 (Fall 1981): 15; Karen Vogel Wheeler, Peter Arnell, and Ted Bickford, eds., *Michael Graves: Buildings and Projects, 1966–1981* (New York: Rizzoli International Publications, 1982), 250–56; Marilyn Bethany, "The Architect as Artist," *New York Times* (April 25, 1982), VI: 95–96, 98; Martin Filler, "New Vistas: Reopening an Old Perspective," *House & Garden* 154 (June 1982): 102–5. For Agrest and Gandelsonas's renovation, see Mildred F. Schmertz, "Homage to Loos," *Architectural Record* 177 (Mid-September 1989): cover, 162–69; Pilar Viladas, "Revisionist History: Architects Diana Agrest and Mario Gandelsonas Add Another Dimension to a Spacious Manhattan Apartment," *House & Garden* 161 (November 1989): 162–69; *Agrest and Gandelsonas: Works* (New York: Princeton Architectural Press, 1995), 192–201, 299.

26. Filler, "New Vistas: Reopening an Old Perspective": 104–5.

27. Reinhold, "MY Apartment": 15.

28. Viladas, "Revisionist History": 163.

29. Diana Agrest and Mario Gandelsonas, quoted in Viladas,

"Revisionist History": 163.

30. Diana Agrest and Mario Gandelsonas, quoted in Schmertz, "Homage to Loos": 52.

31. Paul Goldberger, "Spatial Imagery," *Architectural Digest* 36 (April 1979): 64–71; Martin Filler, "Park Avenue Palazzo," *Progressive Architecture* 60 (May 1979): 114–16; "Private Apartment," *Process Architecture* 13 (March 1980): 97–101; C. Ray Smith, "Spatial Imagery," in *Piero Sartogo and Nathalie Grenon: Architecture in Perspective* (New York: Monacelli Press, 1998), 138.

32. Goldberger, "Spatial Imagery": 71.

33. Rodolfo Machado and Jorge Silvetti, quoted in Pilar Viladas, "Cool, Calm, and Corrected," *Progressive Architecture* 63 (December 1982): 52–56. Also see Carol Vogel, "Neo-Classical Touches Transform a Town House," *New York Times* (January 6, 1983), C: 1, 6; Alfredo di Legge, "Un interno neo-classico," *Domus* (February 1984): 60–63; Heather Smith MacIsaac, "Living Theater," *House & Garden* 156 (October 1984): 198–203.

34. Margaret Helfand, quoted in John G. Tucker, "Clear Expression," *Interior Design* 55 (June 1984): 240–43.

35. Tucker, "Clear Expression": 240–43.

36. Donna Sapolin, "Poetry in a Box," *Metropolitan Home* 22 (October 1990): 156–60; Margaret Helfand, *Margaret Helfand Architects* (New York: Monacelli Press, 1999), 44–58.

37. Jay Adlersberg, quoted in Sapolin, "Poetry in a Box": 158.

38. Helfand, *Margaret Helfand Architects*, 106–17.

39. Helfand, *Margaret Helfand Architects*, 106.

40. For Shelton-Mindel's apartment work, see "Strength in Structure," *Interior Design* 53 (March 1982): 194–99; Heather Smith MacIsaac, "Transformed for Art," *House & Garden* 158 (September 1986): 204–7, 231; Stephen Drucker, "Romantic Minimalism," *House & Garden* 158 (December 1986): 174–79, 210; Beauregard Houston-Montgomery and Ronnie Cooke, "Manhattan Transfer," *World of Interiors* (May 1988): 116–25; Monica Geran, "3 by Shelton," *Interior Design* 60 (July 1989): 150–65; Joseph Giovannini, "Making Room for Art," *House & Garden* 161 (December 1989): 132–39; Monica Geran, "The Big Picture," *Interior Design* 61 (January 1990): 156–65; Joan Kron, "Central Park East," *House & Garden* 162 (October 1990): 230–35; Monica Geran, "Planting an Idea," *Interior Design* 62 (April 1991): 140–45; Jane Margolies, "The Apartment That Broke the Mold," *House Beautiful* 133 (September 1991): 92–99; Michael Cunningham, "Six (Chic) Rooms, River View," *Metropolitan Home* 30 (March-April 1998): 110–17; Kate Hensler Fogarty, "Fifth Avenue Apartment, New York City," *Interiors* 158 (January 1999): 68–71; Carol Lufty, "Manhattan Sugar Cube," *Architectural Digest* 56 (May 1999): 150–57. For 1100 Architect's work in this area, see *1100 Architect* (New York: Monacelli Press), 32–49, 64–73, 82–99.

41. For the Robertson penthouse, see Oscar Riera Ojeda, ed., *Hariri & Hariri* (New York: Monacelli Press, 1995), 112–13. For the Buziak penthouse, see Victoria Geibel, "Material Witness," *Architecture* 79 (June 1990): 64–67; "Buziak Penthouse," *Architecture + Urbanism* (July 1993): 100–105. For the Silbermann apartment, see Abby Bussel, "Territorial Hybrids," *Progressive Architecture* 72 (September 1991): 112–13; Martin Filler, "User Friendly," *House Beautiful* 136 (November 1994): 114–17; Ojeda, ed., *Hariri & Hariri*, 80–85.

42. Ojeda, ed., *Hariri & Hariri*, 122–25.

43. Ojeda, ed., *Hariri & Hariri*, 108–11.

44. Ruth Lande Shuman, quoted in "Pesce's Play House," *New York* 30 (March 24, 1997): 50–53. Also see Marco Romanelli, "A House as a Portrait," *Domus* (April 1994): 70–77.

45. Romanelli, "A House as a Portrait": 70.

46. Martin Filler, "Eye of His Times," *Architectural Record* 175 (Mid-September 1987): 108.

47. For Buchsbaum's early work in New York, see Stern, Mellins, and Fishman, *New York 1960*, 596–97; Frederic Schwartz, ed., *Alan Buchsbaum, Architect and Designer: The Mechanics of Taste* (New York: Monacelli Press, 1996), 32–39, 50–51, 56–57, 164–67.

48. For his Miller (1978), Hirsch (1979), and Patricoff (1984) kitchens, see Schwartz, ed., *Alan Buchsbaum, Architect and Designer: The Mechanics of Taste*, 93, 118–19, 150–51.

49. For both apartments, see Schwartz, ed., *Alan Buchsbaum, Architect and Designer: The Mechanics of Taste*, 106–7, 116–17.

50. Schwartz, ed., *Alan Buchsbaum, Architect and Designer: The Mechanics of Taste*, 172–77, 224.

51. Schwartz, ed., *Alan Buchsbaum, Architect and Designer: The Mechanics of Taste*, 126. For Jakobson's collection of furniture, see Lisa Sanders, "In the Footsteps of Bauhaus," *Forbes* 156 (July 31, 1995): 138–39.

52. Schwartz, ed., *Alan Buchsbaum, Architect and Designer: The Mechanics of Taste*, 152–53, 223.

53. David Morton, "Celebrity Homes," *Progressive Architecture* 65 (September 1984): 132–35; Schwartz, ed., *Alan Buchsbaum, Architect and Designer: The Mechanics of Taste*, 154–57, 223.

54. Morton, "Celebrity Homes": 132–35; Schwartz, ed., *Alan Buchsbaum, Architect and Designer: The Mechanics of Taste*, 158–59.

55. Filler, "Eye of His Times": 111–13; Schwartz, ed., *Alan Buchsbaum, Architect and Designer: The Mechanics of Taste*, 178–82.

56. Heather Smith MacIsaac, "Definitive Details," *House & Garden* 162 (October 1990): 204–7, 248; Elaine Louie, "Completing the Dreams of Artists with AIDS," *New York Times* (March 7, 1991), C: 1, 6; Schwartz, ed., *Alan Buchsbaum, Architect and Designer: The Mechanics of Taste*, 183–91.

57. Filler, "Eye of His Times": 118–19; Schwartz, ed., *Alan Buchsbaum, Architect and Designer: The Mechanics of Taste*,

196–97.

58. Charles K. Gandee, "Homework," *Architectural Record* 172 (Mid-September 1984): 156–63; "Cohen Apartment," *Architecture + Urbanism* (August 1986): 64–65; "Meet the Architect: Steven Holl," *GA Houses* (March 1989): 164–65, 167, 184–90; Kenneth Frampton, "On the Architecture of Steven Holl," *GA Houses* (March 1989): 166–68; Steven Holl, *Anchoring: Selected Projects, 1975–1991* (New York: Princeton Architectural Press, 1991), 62–65; "Cohen Apartment," in Yukio Futagawa, ed., *GA Architect* 11 (Tokyo: ADA Edita, 1993): 20–27. For 875 Fifth Avenue, see Stern, Gilmartin, and Mellins, *New York 1930*, 390.

59. Andrew Cohen, quoted in Gandee, "Homework": 156.

60. Steven Holl, quoted in Gandee, "Homework": 156.

61. Frampton, "On the Architecture of Steven Holl": 166–67.

62. Karen D. Stein, "Magnificent Obsession," *Architectural Record* 175 (Mid-September 1987): 90–97; "Museum Tower Apartment," *GA Houses* (March 1989): 214–15; "Renovation of an Apartment on the 42nd Floor of the MoMA Tower," *Architecture + Urbanism* (January 1988): 55–58; Holl, *Anchoring: Selected Projects, 1975–1991*, 108–11; "Apartment, Museum of Modern Art Tower," in Futagawa, ed., *GA Architect* 11 (1993): 32–35.

63. Quoted in Stein, "Magnificent Obsession": 92.

64. Charles K. Gandee, "At Home with Ghosts," *Architectural Record* 174 (Mid-April 1986): cover, 146–51; "Laurie Mallet House," *Architecture + Urbanism* (December 1986): 147–54; *SITE* (New York: Rizzoli International Publications, 1989), 196–203.

65. *SITE*, 196.

66. Toshio Nakamura, "Gramercy Park Apartment," *Architecture + Urbanism* (August 1994): 28–37. Also see Martin Filler, "New Angles on Modernism," *House & Garden* 165 (May 1993): 122–27; Vera Graaf, "Auf der Kippe," *Architektur & Wohnen* (August-September 1993): 20–26.

67. Paul Henninger, "Architect Breaks Up the Home," *Architecture New York* 22 (1998): 38. Also see "Joseph Giovannini: Manhattan Intersection," *GA Houses* (March 1995): 56–57.

68. Henninger, "Architect Breaks Up the Home": 38.

69. Richard Meier, "New York Apartment Renovation," *GA Houses* (December 1978): 110–15.

70. Meier, "New York Apartment Renovation": 111.

71. "Open Spaces from Enclosed Rooms: An Architect's New York Penthouse," *Architectural Record* 161 (January 1977): 126–28; "Franzen Apartment, 1976, New York City, USA," *Toshi Jutaku* 189 (July 1983): 74–75; Peter Blake, *The Architecture of Ulrich Franzen* (Basel, Berlin, and Boston: Birkhäuser, 1999), 112–13.

72. Nory Miller, "Architecture: Steven K. Peterson and Barbara Littenberg," *Architectural Digest* 41 (August 1984): 104–111.

73. Suzanne Slesin, "Fooling the Eye in SoHo," *New York* 9 (October 11, 1976): 69–71; Martin Filler, "Adam in the Big Apple," *Progressive Architecture* 68 (September 1977): 94–96; "Peter Nelson Loft," *GA Houses* (March 1983): 142–45.

74. Filler, "Adam in the Big Apple": 96.

75. I. M. Pei, quoted in Charles K. Gandee, "Self-Portrait: Tsao Apartment, New York City," *Architectural Record* 171 (September 1983): 152–159. Also see Martin Filler, "New York Surreal: Architect Calvin Tsao's New York Apartment Offers Views Both Inward and Outward," *House & Garden* 155 (December 1983): 116–21, 215.

76. Martin Filler, "Family Gallery," *House Beautiful* 137 (September 1995): 110–13.

77. "François de Menil," *Architecture + Urbanism* (March 1992): 44–51; Mildred F. Schmertz, "Domesticating Art," *House & Garden* 164 (March 1992): 90–99; Edie Lee Cohen, "De Menil's Debut," *Interior Design* 63 (April 1992): 132–39.

78. Suzanne Slesin, "Rooftop Living: The New Frontier," *New York Times* (February 9, 1984), C: 1, 6.

79. Carol Vogel, "Top-Notch," *New York Times* (May 14, 1989), VI: 74–75.

80. Chessy Rayner, *New York: Trends and Traditions* (New York: Monacelli Press, 1997), 222–24; Mayer Rus, *Loft* (New York: Monacelli Press, 1998), 78–91; "Manhattan Rooftop Residence," *Architectural Record* 186 (June 1998): 118; Macauley Connor, "Aerie Tale," *Home Observer* (April 1999): 32–35.

81. Mildred F. Schmertz, "Urban Realism," *Architecture* 79 (June 1990): 86–90; Edie Cohen, "Malcolm Holzman: The Manhattan Loft of the Hardy Holzman Pfeiffer Partner," *Interior Design* 65 (June 1994): 96–101; Beate Wedekind and Angelika Taschen, *New York Interiors* (Köln: Taschen, 1997), 100–105.

82. Malcolm Holzman, quoted in Schmertz, "Urban Realism": 86.

83. Julie V. Iovine, "For a Master Builder, It's Hands Off at Home," *New York Times* (May 5, 1997), C: 1, 6.

84. Paul Goldberger, "Housing in Loft Buildings Key to New Urban Vitality," *New York Times* (June 15, 1977), B: 1, 4.

85. Goldberger, "Housing in Loft Buildings Key to New Urban Vitality": 1, 4.

86. Alan S. Oser, "Higher Income Manhattanites Filling Converted Buildings," *New York Times* (March 15, 1978), D: 12.

87. Isadore Barmash, "Conversions of Lofts Snag Clothes Maker," *New York Times* (July 19, 1978), D: 1, 5.

88. Alan S. Oser, "Legalizing Older Buildings as Apartments," *New York Times* (September 16, 1977), B: 11; Joseph P. Fried, "New York City Announces Moves to Halt Illegal Conversion of Lofts," *New York Times* (July 27, 1978): 1, D: 16; "Living the Loft Life," editorial, *New York Times* (October 6, 1980): 22.

89. Carter B. Horsley, "Loft Conversion Exceeding New Apartment Construction," *New York Times* (October 12, 1980), VIII: 1, 12.

90. Carter B. Horsley, "The New 'Loft Policy': A Sweeping Change Nears Final Test," *New York Times* (March 8, 1981), VIII: 6; Edward A. Gargan, "Loft-Conversion Law Gets Mixed Review," *New York Times* (March 28, 1982), VIII: 10; Edward A. Gargan, "City Approves Plan on Loft Conversion for Residential Use," *New York Times* (April 10, 1981): 1, B: 3.

91. Carter B. Horsley, "Architecture Firm's Fortune Rises on Conversion Tide," *New York Times* (December 27, 1979), VIII: 1, 4.

92. Rus, *Loft*, 12. Also see Sharon Zukin, "Loft Living as 'Historic Compromise' in the Urban Core: The New York Experience," *International Journal of Urban and Regional Research* 6 (June 1982): 256–67; Bernhard Leitner, "Lofts in New York," *Bauwelt* (May 17, 1985): 722–25.

93. Suzanne Slesin, "Evolution of the Loft: Open Space Rescaled," *New York Times* (September 17, 1987), C: 1, 8.

94. For earlier loft designs, see Stern, Mellins, and Fishman, *New York 1960*, 270–77.

95. Norma Skurka, "Fixturing Up a Loft," *New York Times* (February 6, 1977), VI: 82–83; "Loft Living: Big Spaces, Fresh Images," *Architectural Record* 161 (July 1977): 97–100; Carter Horsley, "The Boom in Glass Bricks," *New York Times* (November 17, 1977), C: 1, 8; "Ol Rempero Dell'arredamento Industriale," *Casa Amica* (October 1978): 30–31; "The Recycling of America," *Time* (June 11, 1979): 84; Marilyn Bethany, "Fleeting Fads of 70's Decor," *New York Times* (December 30, 1979), VI: 36–37; Schwartz, ed., *Alan Buchsbaum, Architect and Designer: The Mechanics of Taste*, 76–83, 223.

96. Robert Hughes, quoted in Schwartz, ed., *Alan Buchsbaum, Architect and Designer: The Mechanics of Taste*, 72–75. Also see "Art Critic's Apartment: A Factory Loft in Manhattan," *Remodeling: A House and Garden Guide* (Fall/Winter 1977): 170–74; Lord McMillan, "Making Room for Space," *Residential Interiors* (March/April 1978): 68–71; "Loft Aloft," *Ambience* (Spring 1978): 36; Roberto Schezen, "Cinque Lofts di Artisti Nel Cuore di Soho," *Gran Bazaar* (April 1982): 100–105; Martin Filler, "Industrialist Interiors," *House & Garden* 159 (March 1987): 64–70.

97. Janet Malcolm, "Profiles: A Girl of the Zeitgeist–I," *New Yorker* 62 (October 20, 1986): 49–52, 55–56, 58–60, 62–64, 66–68, 73–74, 76–89. Also see Janet Malcolm, "Profiles: A Girl of the Zeitgeist–II," *New Yorker* 62 (October 27, 1986): 47–48, 51–52, 56–66.

98. "Dwelling & Studio of an Architect," *Japan Interior Design* (June 1981): 22, 26; Schezen, "Cinque Lofts di Artisti Nel Cuore di Soho": 100–105; Ben Lloyd, "The Revisionist Loft," *Metropolitan Home* 14 (September 1982): 530–60, 562; Joanna Krotz, *Metropolitan Home Renovation Style* (New York: Villard Books, 1986), 91–97; Schwartz, ed., *Alan Buchsbaum, Architect and Designer: The Mechanics of Taste*, 83–92, 222–23.

99. Alan Buchsbaum, quoted in Schwartz, ed., *Alan Buchsbaum, Architect and Designer: The Mechanics of Taste*, 160–63, 223. Also see "Casa Sipario per Un'Attrice," *Casa Vogue* (June 1985): 186–89.

100. Filler, "Industrialist Interiors": 68. Also see Nory Miller, "Moveables," *Progressive Architecture* 62 (September 1981): 197; Marilyn Bethany, "When Enough Is Enough," *New York Times* (December 19, 1982), VI: 98–100; Elaine Greene, "The Architect and Miss X," *House & Garden* 157 (November 1985): 210–15; Rixa Von Treuenfels, "Vogue Design," *Deutsch Vogue* (April 1980): 146; Schwartz, ed., *Alan Buchsbaum, Architect and Designer: The Mechanics of Taste*, 164–71, 223–24.

101. "Mercer Street Loft, New York City," *GA Houses* (1981): 140–45.

102. Barclay Gordon, "Fresh Images in Old Chelsea," *Architectural Record* 169 (Mid-February 1981): 78–79; "Peix and Partner," *Perspecta* 18 (1982): 180–85.

103. Pe'era Goldman, "Passage and Entry; An Artist's Loft," *Princeton Journal* 1 (1983): 148–150.

104. "New York Loft," *Princeton Journal* 1 (1983): 135–38.

105. "Giuseppe Zambonini," *Progressive Architecture* 71 (November 1990): 26.

106. Giuseppe Zambonini, "Three Lofts in Manhattan," *GA Houses* (March 1983): 162–67.

107. Zambonini, "Three Lofts in Manhattan": 164–65.

108. John Morris Dixon, "Handcrafted Habitats," *Progressive Architecture* 62 (September 1981): 176–81; Zambonini, "Three Lofts in Manhattan": 166–67.

109. Zambonini, "Three Lofts in Manhattan": 167.

110. John G. Tucker, "Ranalli Studio," *Interior Design* 54 (November 1983): 224–27; Oscar Riera Ojeda, ed., *Casas Internacional: George Ranalli* (Madrid: Kliczkowski, 1998), 38–41.

111. Anthony Vidler, "New York Loft: George Ranalli Devises an Ingenious House Within a House," *Interior Design* 57 (March 1986): 228–33. Also see Philip Arcidi, "Projects," *Progressive Architecture* 71 (June 1990): 128–30; "Loft de la Calle 22," *Casas* (September 1998): 30–37. Vidler's article was republished as "Loft, Furniture Design, New York," *Domus* (May 1986): 50–55.

112. George Ranalli, "K-Loft in New York," *Architecture + Urbanism* (March 1997): 40–49; Rus, *Loft*, 144–53; "K-Loft," *Casas* (September 1998): 16–29.

113. Colin Rowe and Fred Koetter, *Collage City* (Cambridge, Mass.: MIT Press, 1978).

114. Ron Bentley, quoted in Pilar Viladas, "Old, New, Borrowed, and Blue," *Progressive Architecture* 64 (September 1983): 146–49.

115. For the apartments, see Douglas Brenner, "Collage," *Architectural Record Interiors* 173 (Mid-September 1985): 108–113.

116. Sal LaRosa, quoted in Viladas, "Old, New, Borrowed, and Blue": 149.

117. Herbert Muschamp, "New York Dig," *House & Garden* 156 (September 1984): 176–81, 241, 244.

118. Norma Skurka, "Bringing Home Art Deco," *New York Times* (April 3, 1977), VI: 74; "In the Nature of Fake Materials," *Progressive Architecture* 58 (September 1977): 92–93; Suzanne Slesin, "City Windows: Who Needs a View?" *New York Times* (August 16, 1979), C: 1, 6. Also see Richard Gillette's apartment for a private art dealer in Suzanne Stephens, "Faux Bois Sans Faux Pas," *Progressive Architecture* 60 (September 1979): 168–69.

119. David Salle, quoted in Pilar Viladas, "Free Association," *Progressive Architecture* 65 (September 1984): 120–23. Also see Martin Filler, "Tribeca Textures," *House & Garden* 157 (February 1985): 128–35; "New York: Un Loft Patchwork," *Maison Française* (April 1988): 74–81.

120. Christian Hubert, quoted in Viladas, "Free Association": 120.

121. "La scala ibrida," *Abitare* (November 1990): 116–21; "Schneider Penthouse," *Architecture + Urbanism* (July 1993): 87–91; Ojeda, ed., *Hariri & Hariri*, 100–107.

122. For the Wexner Center, see *Wexner Center for the Visual Arts, the Ohio State University: A Building* (New York: Rizzoli International Publications, 1989).

123. Peter Eisenman, quoted in Deborah K. Dietsch, "Prime Dislocation," *Architectural Record* 176 (Mid-September 1988): 78–87. Also see Peter Eisenman, "Eisenman + Yorgancioglu: Tom's[sic] Loft, New York," *Architectural Design* 58 (No. 7–8, 1988): 38–43; Donna Dorian, "The Dangers of Living in a Poem," *Connoisseur* 218 (November 1988): 54, 58; Manolo de Giorgio, "Eisenman e Yorgancioglu: Tom's[sic] Loft, New York," *Domus* (December 1988): 64–69; Jean-Pierre Cousin, "Les sens désorientés," *Architecture intérieure créé* 228 (February-March 1989): 118–23; "Tom's[sic] Loft in New York," *Detail* 29 (March-April 1989): 141–46; *Eisenman Architects: Selected and Current Works* (Mulgrave, Australia: Images Publishing, 1995), 78–81.

124. Peter Eisenman, quoted in "Tom's[sic] Loft in New York," *Detail*: 141.

125. Thomas Leeser, quoted in Thomas Fisher, "Against Beauty," *Progressive Architecture* 69 (September 1988): 114–15. Also see "Zwischen zwei Bildern: Ludwig/Fineman Loft, New York, 1987," *Werk, Bauen + Wohnen* 7–8 (July-August 1991): 8–9.

126. Michael McDonough, quoted in Joseph Giovannini, "New Angles for a Classic Loft: '87 Apartment Living," *New York Times* (January 22, 1987), C: 1, 8.

127. Clifford A. Pearson, "Balancing Act," *Architectural Record* 179 (September 1991): cover, 108–15. Also see Charles Gandee, "Exploring Space," *House & Garden* 163 (October 1991): 150–57. For a much more modest early loft project by Tsien, see "Pareti luminose: A New York, strada interna con finestre," *Abitare* (March 1984): 30–37.

128. "Stanza del collezionista, loft 'M,' N.Y.," *Lotus International* 66 (1990): 52–57; Philip Arcidi, "Transfigured by Art and Glass," *Progressive Architecture* 71 (September 1990): 126–27; "A Loft in New York, New York," *Architecture + Urbanism* (March 1992): 28–35.

129. "Per un collezionista," *Abitare* (May 1992): 163–69.

130. Carey Goldberg, "Sudden Death for 2 Who Had Everything to Live For," *New York Times* (June 23, 1995), B: 2; "Obituaries: David Roth," *Progressive Architecture* 76 (September 1995): 22.

131. Henry Smith-Miller and Laurie Hawkinson, quoted in Pilar Viladas, "Living with Modernism," *New York Times* (April 5, 1998), V: cover, 35, 37–41. Also see Cynthia Davidson, "Plan-Free Living," *ANY* 22 (1998): 40–41; Rus, *Loft*, 42–53.

132. Deborah Berke, quoted in Jayne Merkel, "Apartments and Lofts: The New Humility," *Oculus* 59 (June 1997): 10–16.

133. Deborah Berke, quoted in Merkel, "Apartments and Lofts: The New Humility": 10–16.

134. Deborah Berke, quoted in Rus, *Loft*, 20–31. Also see Paul Henninger, "Minimal Paranoia," *ANY* 22 (1998): 39; Henry Urbach, "Everyday Sublime," *Interior Design* 69 (September 1998): 186–95.

135. Judith Nasatir, "Scott Marble, Karen Fairbanks," *Interior Design* 66 (May 1995): 158–65; Rus, *Loft*, 170–77; "Choreographer's Loft," *Oculus* 60 (Summer 1998): 19.

136. Karen D. Stein, "Off the Wall," *Architectural Record* 183 (September 1995): 74–79; "Loft Residence," *Architecture + Urbanism* (January 1996): 122–29; "Adaptation of a Loft in New York," *Domus* (January 1996): 44–47; "Durchblick: Manhattan Wohnloft, New York," *Deutsche Bauzeitschrift* 44 (August 1996): 34–35; "Interior Award: Hanrahan + Meyers," *American Institute of Architects, New York Chapter, Annals, 1996–1997* (1997): 31; Merkel, "Apartments and Lofts: The New Humility": 10–16; Rus, *Loft*, 134–43; "Loft Residence," *Architectural Design* 69 (May-June 1999): 52–55.

137. Raul A. Barreneche, "Dean/Wolf Architects," *Architecture* 85 (June 1996): 100–105.

138. Barreneche, "Dean/Wolf Architects": 100–105; "Interior Architecture Honor Award: Dean/Wolf Architects," *Oculus* 60 (Summer 1998): 13; "Dean/Wolf Architects," *1998 AIA New York State Design Awards* 14 (December 1998): 6; Alexander Gorlin, *The New American Townhouse* (New York: Rizzoli International Publications, 1999), 32–40.

139. Gorlin, *The New American Townhouse*, 32.

140. Quoted in "Interior Architecture Honor Award: Dean/Wolf Architects": 13.

141. Joanna Wissinger, "A Dialectic of Details," *Progressive Architecture* 69 (September 1988): 92–99; Pilar Viladas, "Architecture, 1100 Architect," *Architectural Digest* 51 (July 1994): 44, 48, 50–51.

142. Pilar Viladas, "Introduction," in *1100 Architect* (New York: Monacelli Press, 1997), 9, 164–69; Pilar Viladas, "Uptown Downtown," *New York Times* (June 29, 1997), VI: 46–51.

143. Heather Smith MacIsaac, "Light Motifs," *House & Garden* 163 (October 1991): 174–81, 212; *1100 Architect*, 64–73; Rus, *Loft*, 204–11. For the Greenwich Village town-

house, see *1100 Architect*, 92–99.

144. Judith Green, "Tuscan Focus in Soho," *Architectural Digest* 54 (May 1997): 168–73, 201.

145. Suzanne Stephens, "Making It New in SoHo," *Architectural Digest* 54 (February 1997): 108–15, 190.

OFFICE INTERIORS

1. See Stern, Mellins, and Fishman, *New York 1960*, 561–63, 566–68.

2. Ada Louise Huxtable, "The Editorial Notebook: Office Landscapes and Inner Space," *New York Times* (January 31, 1979): 22.

3. For the firm's office work in the early 1970s, see Stern, Mellins, and Fishman, *New York 1960*, 568–69.

4. Eleni Constantine, "A Corner on the World," *Progressive Architecture* 60 (September 1979): 140–43; *Charles Gwathmey and Robert Siegel: Buildings and Projects, 1964–1984*, ed. Peter Arnell and Ted Bickford (New York: Harper & Row, 1984), 183, 292.

5. Constantine, "A Corner on the World": 140–43; *Charles Gwathmey and Robert Siegel: Buildings and Projects, 1964–1984*, 176–77, 291.

6. Charles Gwathmey, quoted in Deborah Dietsch, "Mutual Support," *Interiors* 144 (June 1985): 126–35, 182.

7. Robert Siegel, quoted in Gerald Allen, "Gwathmey Siegel & Associates: Offices for Morton L. Janklow & Associates," *Architectural Record* 170 (Mid-February 1982): 104–7. Also see *Charles Gwathmey and Robert Siegel: Buildings and Projects, 1964–1984*, 230–31, 293.

8. Dietsch, "Mutual Support": 130, 132–34; *Charles Gwathmey and Robert Siegel: Buildings and Projects, 1964–1984*, 236–37.

9. Charles Gwathmey and Robert Siegel, quoted in Edie Lee Cohen, "Reliance Group Holdings Inc.," *Interior Design* 54 (January 1983): 208–15. Also see *Charles Gwathmey and Robert Siegel: Buildings and Projects, 1964–1984*, 226–29, 293; "Oak Is a Sound Investment for a Financial Firm," *Design Solutions* 4 (Winter 1984): 22–23.

10. Jerry Cooper, "SBK: Recent Work by Gwathmey Siegel," *Interior Design* 60 (February 1989): 198–207; *Gwathmey Siegel: Buildings and Projects, 1982–1992*, ed. Brad Collins and Diane Kasprowicz (New York: Rizzoli International Publications, 1993), 200–205; *Gwathmey Siegel & Associates Architects: Selected and Current Works* (Mulgrave, Australia: Images Publishing, 1998), 82–85.

11. Robert Siegel, quoted in Edie Lee Cohen, "Gwathmey Siegel," *Interior Design* 64 (January 1993): 89–99. Also see *Gwathmey Siegel: Buildings and Projects, 1982–1992*, 206–11. For the Colony Theater, see Mary C. Henderson, *The City and the Theatre* (Clifton, N.J.: James T. White & Co., 1973), 217.

12. Cohen, "Gwathmey Siegel": 96–99. For 750 Third Avenue, see Stern, Mellins, and Fishman, *New York 1960*, 424–25.

13. *Gwathmey Siegel: Buildings and Projects, 1982–1992*, 196–97.

14. Charles Gwathmey, quoted in Edie Lee Cohen, "Gwathmey Siegel: The Surprisingly Human-Scaled Offices of Ronald S. Lauder," *Interior Design* 63 (September 1992): 182–87. Also see *Gwathmey Siegel: Buildings and Projects, 1982–1992*, 212–15; Beverly Russell, "Gwathmey Siegel at 25," *Interiors* 152 (September 1993): 55–83; Beverly Russell, "Viennese Vigor," *Interiors* 153 (January 1994): 76–77; *Gwathmey Siegel & Associates Architects: Selected and Current Works*, 116–19. For the General Motors Building, see Stern, Mellins, and Fishman, *New York 1960*, 508–12.

15. Paul M. Sachner, "Capital Gains," *Architectural Record* 177 (September 1989): 98–103; Joseph Wilkinson, "When and How to Hire a Lighting Designer," *Architectural Record Lighting* (August 1990): 8–11; "Local IES Lumen Awards to Four," *Architectural Record Lighting* (August 1991): 12; Elizabeth Kraft, ed., *Robert A.M. Stern: Buildings and Projects, 1987–1992* (New York: Rizzoli International Publications, 1992), 156–59, 360; *Robert A.M. Stern: Buildings* (New York: Monacelli Press, 1996), 120–27. For the International Building, see Stern, Gilmartin, and Mellins, *New York 1930*, 665–67.

16. "An Executive Reception Area in New York City, By Kohn Pedersen Fox Associates," *Architectural Record* 167 (January 1980): 94–95. For 195 Broadway, see Stern, Gilmartin, and Massengale, *New York 1900*, 162–63.

17. Stern, Mellins, and Fishman, *New York 1960*, 434.

18. Paul Sachner, "Corporate Details," *Architectural Record* 176 (Mid-September 1988): 92–99. Also see Paula Rice Jackson, "Deco Echo," *Interiors* 148 (May 1989): 288–91.

19. Sachner, "Corporate Details": 98–99; Gregory Littleton, "Heavy Metal," *Interiors* 148 (January 1989): 162–65; "Polishing the Apple," *Interiors* 150 (September 1991): 84–85.

20. J. Woodson Rainey, quoted in Stanley Abercrombie, "KPFIA," *Interior Design* 66 (September 1995): 136–41. Also see Akiko Busch, "Rosecliff, Inc.," *Metropolis* 15 (October 1995): 87, 123.

21. Andrea Loukin, "Viacom International," *Interior Design* 62 (September 1991): 190–95.

22. Edie Lee Cohen, "KPFIA," *Interior Design* 63 (November 1992): 112–17.

23. Gerald Allen, "Mapping and Remapping," *Architectural Record* 161 (February 1977): 103–10; "Law Offices," *Process Architecture* 13 (March 1980): 46–49; *R. M. Kliment & Frances Halsband Architects: Selected and Current Works* (Mulgrave, Australia: Images Publishing, 1998), 20–21.

24. "Offices of William M. Mercer, Inc., New York City," *Architectural Record* 167 (June 1980): 112–13; "Actuarial Offices," *Process Architecture* 13 (March 1980): 43–45; *R. M. Kliment & Frances Halsband Architects: Selected and Current Works*, 26–27. For 1166 Sixth Avenue, see Stern, Mellins, and Fishman, *New York 1960*, 416.

25. Allen, "Mapping and Remapping": 103.

26. Charles K. Gandee, "On the Temperate Edge," *Architectural Record* 169 (December 1981): 74–77. For 55 Water Street, see Stern, Mellins, and Fishman, *New York 1960*, 183–85.

27. Gandee, "On the Temperate Edge": 74.

28. Mayer Rus, "LHS&B," *Interior Design* 61 (June 1990): 214–19; *R.M. Kliment & Frances Halsband Architects: Selected and Current Works*, 114–19.

29. Paul Goldberger, "Good Lessons in Creating Working Quarters That Work," *New York Times* (October 20, 1977), C: 10. Also see Martin Filler, "One for the Books," *Progressive Architecture* 58 (September 1977): 76–79; *James Stewart Polshek: Context and Responsibility* (New York: Rizzoli International Publications, 1988), 38, 230–31. For the U.S. Rubber Company Building, see Stern, Gilmartin, and Mellins, *New York 1930*, 671. For Simon & Schuster's 1940 offices by Edward Durell Stone, see Stern, Mellins, and Fishman, *New York 1960*, 558–59.

30. *Allan Greenberg: Selected Works* (London: Academy Editions, 1995), 19–21.

31. *Allan Greenberg: Selected Works*, 22–23. For the Parke-Bernet Building, see Stern, Mellins, and Fishman, *New York 1960*, 823–24.

32. Charles K. Gandee, "James Stewart Polshek and Partners: Offices for Backer & Spielvogel, Inc.," *Architectural Record* 170 (Mid-February 1982): 116–19; *James Stewart Polshek: Context and Responsibility*, 44, 236–39.

33. Goldberger, "Good Lessons in Creating Working Quarters That Work": 10. Also see "Rolling Stone Offices, New York, New York," *Architectural Record* 163 (January 1978): 89–90. For the Squibb Building, see Stern, Gilmartin, and Mellins, *New York 1930*, 557–58, 563.

34. Henry Smith-Miller, quoted in Jerry Cooper, "Solomon Equities," *Interior Design* 57 (May 1986): 228–33.

35. Henry Smith-Miller, quoted in Victoria Geibel, "Implied Movement," *Architecture* 79 (June 1990): 80–85.

36. Michael Lynne, quoted in Aaron Betsky, "Points of View," *Architectural Record* 190 (September 1992): 122–29. For 888 Seventh Avenue, see Stern, Mellins, and Fishman, *New York 1960*, 446.

37. Henry Smith-Miller, quoted in Betsky, "Points of View": 126.

38. Mayer Rus, "Smith-Miller & Hawkinson," *Interior Design* 64 (September 1993): 178–81.

39. Jerry Andreozzi, quoted in Nory Miller, "There's No Business Like . . . ," *Progressive Architecture* 63 (September 1982): 218–21. Also see Suzanne Slesin, "Architects Bridge the Gap between Home and Office," *New York Times* (May 27, 1982), C: 1, 12; Frederic Schwartz, ed., *Alan Buchsbaum, Architect and Designer: The Mechanics of Taste* (New York: Monacelli Press, 1996), 142–43.

40. Alan Buchsbaum, quoted in Slesin, "Architects Bridge the Gap between Home and Office": 12.

41. Karen D. Stein, "Finnish Spirits," *Architectural Record* 138 (May 1989): 138–41. For the RCA Building, see Stern, Gilmartin, and Mellins, *New York 1930*, 650–53.

42. "Anderson/Schwartz," *Architecture + Urbanism* (March 1992): 60–63; "Anderson/Schwartz a Soho," *Abitare* (October 1992): 203–6; Emanuela Frattini Magnusson, "Ross Anderson: Uffici in un loft, New York," *Domus* (November 1993): 12–13.

43. Monica Geran, "Anderson/Schwartz," *Interior Design* 65 (July 1994): 124–27. For the Bendheim Building, see Landmarks Preservation Commission of the City of New York, *Tribeca West Historic District Designation Report* (New York, 1991), 112–13.

44. Ross Anderson, quoted in Stephen A. Kliment, "Soho Video," *Architectural Record* 183 (September 1995): 100–103.

45. Ross Anderson, quoted in Abby Bussel, "Let's Get Lost," *Interior Design* 69 (September 1998): 210–17. For the Port Authority building, see Stern, Gilmartin, and Mellins, *New York 1930*, 522.

46. Bussel, "Let's Get Lost": 214.

47. Judith Nasatir, "3 by Bausman Gill," *Interior Design* 60 (May 1989): 240–49; "Advertising and Design Agency," *Architecture + Urbanism* (March 1993): 40–43.

48. Bob Krasnow, quoted in Judith Nasatir, "Elektra Entertainment," *Interior Design* 62 (May 1991): 140–49. Also see Jan Burney, "Elektra Chic Treatement," *Designers' Journal* 70 (September 1991): 54–56; Michael J. Crosbie, "Mark of the Hand: Bausman-Gill Associates," *Architecture* 80 (October 1991): 50–53; "Bausman + Gill nel Rockefeller Center: Elektra Entertainment," *Abitare* (October 1992): 196–202; "Elektra Entertainment," *Architecture + Urbanism* (March 1993): 52–59; Thomas Fisher, "Music and Matter," *Progressive Architecture* 74 (October 1993): 58–65. For 75 Rockefeller Plaza (Esso Building), see Stern, Mellins, and Fishman, *New York 1960*, 324–26.

49. Judith Nasatir, "Elektra Revisited," *Interior Design* 67 (September 1996): 120–25.

50. Judith Nasatir, "Bausman-Gill: Warner Brothers Records' New York Offices in Rockefeller Center," *Interior Design* 63 (September 1992): 168–75; "Warner Bros. Records," *Architecture + Urbanism* (March 1993): 44–51; Fisher, "Music and Matter": 58–65.

51. Margaret F. Gaskie, "High-Tech, High Touch," *Architectural Record* 172 (Mid-September 1984): 146–51.

52. Abby Bussel, "Street Beat," *Progressive Architecture* 73 (September 1992): 94–97; "JSM Music Studios," *Architecture + Urbanism* (July 1993): 122–30; Kenneth Frampton, "Introduction," in Oscar Riera Ojeda, ed., *Hariri & Hariri* (New York: Monacelli Press, 1995), 8–9, 58–67.

53. Scott Specht, quoted in Henry Urbach, "Sense and Sensibility," *Interior Design* 69 (March 1998): 146–49.

54. Louise Harpman, quoted in Urbach, "Sense and Sensibility": 149.

55. Steven Harris, quoted in Henry Urbach, "Light Construction," *Interior Design* 69 (March 1998): 162–65.

56. David Ling, quoted in Abby Bussel, "Midtown Gets

Down," *Interior Design* 69 (May 1998): 278–83.

57. Elaine Louie, "An Oval Office to Make Workers Feel Right at Home," *New York Times* (December 31, 1998), F: 3; Henry Urbach, "Circus Maximus," *Interior Design* 72 (May 1999): 260–67.

58. Angi Bates, "High Design, Low Budget," *Interiors* 149 (May 1990): 32.

59. Edie Lee Cohen, "Elders," *Interior Design* 62 (September 1991): 214–17.

60. Laura E. Mayer, "Down-under, Downtown," *Metropolis* 11 (January/February 1992): 31; Monica Geran, "OMON N.Y.," *Interior Design* 62 (December 1991): 104–7; "Zivkovic Associates," *Architecture + Urbanism* (March 1992): 98–101.

61. Susana Torre, quoted in David Morton, "For More Complexity," *Progressive Architecture* 58 (May 1977): 76–79. Also see "Law Offices/Studio Legale," *Domus* (July 1977): 34–35; Suzanne Slesin, "Office, Sweet Office," *New York* 10 (October 31, 1977): 55–61; "Law Offices," *Process Architecture* 13 (March 1980): 107–11. For the Fred F. French Building, see Stern, Gilmartin, and Mellins, *New York 1930*, 594–95, 597.

62. Susana Torre, quoted in "Law Offices," *Process Architecture*: 107.

63. Herbert L. Smith, "Two Interiors By Torre: An Office . . . and a Restaurant," *Architectural Record* 170 (August 1982): 128–31.

64. Steven Holl, quoted in Karen D. Stein, "Virtual Reality," *Architectural Record* 180 (June 1992): 114–19. Also see Philippe Barrière, "Lumières Couleurs et Réflexions," *Architecture intérieure créé* 247 (March-April 1992): 156–57; "Steven Holl a Manhattan: società finanziaria D.E. Shaw," *Abitare* 311 (October 1992): 207–12; *Steven Holl* (Zurich: Artemis; Bordeaux: Arc en rêve centre d'architecture, 1993), 36–37; Yukio Futagawa, ed., "Steven Holl," *GA Architect* 11 (Tokyo: A.D.A. Edita, 1993): 48–51; Jean Gorman, "Enlightened Reflection," *Interiors* 152 (January 1993): 82–83; "Büro- und Geschäftsräume der Firma D.E. Shaw & Co. in New York, U.S.A.," *Architektur + Wettbewerbe* 158 (June 1994): 44–45; Steven Holl, "Phenomenal Zone: Of Color," *Architecture + Urbanism*, special edition (July 1994): 57–61; Martin Tschanz, "Farbige Räume = Espaces en couleur," *Archithese* 24 (November-December 1994): 44–45, 50–51; "Oficinas D.E. Shaw & Co.," *Croquis* 78 (1996): 128–31.

65. For Banque Bruxelles Lambert, see Grace M. Anderson, "Silk Fringe: Banque Bruxelles Lambert, New York City," *Architectural Record* 172 (Mid-September 1984): 92–97; *Emilio Ambasz: The Poetics of the Pramatic* (New York: Rizzoli International Publications, 1988), 144–48. For the Financial Guaranty Insurance Company, see Deborah K. Dietsch, "Fringe Benefits," *Architectural Record* 173 (November 1985): 126–31; Emilio Ambasz, "Carrelli Elevatori a Wall Street," *L'Arca* 3 (January February 1987): 84–87; Andrea Truppin, "Inventive Genius," *Interiors* 146 (April 1987): 171–87, 212; Peter Buchanan, "Curtains for Ambasz," *Architectural Review* 181 (May 1987): 73–77; "Wirkliches und Imaginäres: Beispiele zeitgenössischer Rauminszenierungen," *Werk Bauen + Wohnen* 11 (November 1989): 52–53; *Emilio Ambasz: Architettura e Design* (Milan: Electa, 1994), 108–11.

66. Emilio Ambasz, quoted in Anderson, "Silk Fringe": 95.

67. Gerald L. Friedman, quoted in Dietsch, "Fringe Benefits": 127.

68. Ambasz, "Carrelli Elevatori a Wall Street": 85.

69. Buchanan, "Curtains for Ambasz": 77.

70. Karin Tetlow, "Pro Bono Value," *Interiors* 153 (January 1994): 114–15.

71. Gaetano Pesce, quoted in Ziva Freiman, "Going Turfless," *Progressive Architecture* 75 (October 1994): 88–95. Also see James S. Russell, "Chiat/Day Advertising," *Architectural Record* 93 (September 1994): 92; Karrie Jacobs, "Dinosauring the Future: Waiting for the Millennium, part III," *Metropolis* 14 (October 1994): 86–95, 97.

72. Stern, Mellins, and Fishman, *New York 1960*, 573–74.

73. Suzanne Slesin, "Architects Bridge the Gap between Home and Office," *New York Times* (May 27, 1982), C: 1, 12; Edie Lee Cohen, "Moving West," *Interior Design* 54 (January 1983): 196–207; *Charles Gwathmey and Robert Siegel: Buildings and Projects, 1964–1984*, 260–63.

74. See Stern, Mellins, and Fishman, *New York 1960*, 1152.

75. Robert Siegel and Charles Gwathmey, quoted in Slesin, "Architects Bridge the Gap between Home and Office": 12.

76. "Richard Meier, New York Office," *Architecture + Urbanism* (March 1988): 112–15; Edie Lee Cohen, "Richard Meier & Partners: Two Offices By and For the Architectural Firm," *Interior Design* 59 (May 1988): 278–85. For Meier's offices of 1963 and 1969, see Stern, Mellins, and Fishman, *New York 1960*, 571, 573.

77. Massimo Vignelli, quoted in Beth Sherman, "Castle Vignelli," *ID* 33 (May-June 1986): 28–33, 81. Also see Edie Lee Cohen, "Vignelli Associates: The New Manhattan Headquarters of and By the Design Firm," *Interior Design* 57 (September 1986): 234–41; Paul M. Sachner, "The Lords of Discipline," *Architectural Record* 174 (Mid-September 1986): 122–27; Marilyn Bethany, "Now It's Neo-Modern," *New York* 19 (October 13, 1986): 82–84; "New York: Spazi per progettare: Vignelli Associates," *Domus* (November 1986): 68–73; Paula Rice Jackson, "Executive Office Design Winner: Vignelli Associates' Spectacular New Office in New York City," *Interiors* 146 (January 1987): 174–75; Andrea Oppenheimer Dean, "Office, Palazzo, and Monastery," *Architecture* 76 (June 1987): 76–81; "West Side Glory," *Interiors* 150 (September 1991): 96–97.

78. Massimo Vignelli, quoted in Dean, "Office, Palazzo, and Monastery": 79.

79. For Barnes's offices, see "Studio D'Architettura a Misura D'America," *Abitare* (November 1986): 176–79; Herbert L. Smith, "Contemporary Cool," *Architectural Record* 175 (June 1987): 108–9. For Polshek's office, see *James Stewart Polshek:*

80. For Polshek's 1964 Madison Avenue offices, see Stern, Mellins, and Fishman, *New York 1960*, 571.

81. For the offices at 200 West Seventy-second Street, see Stern, Mellins, and Fishman, *New York 1960*, 573. For the Colonial Club, see Stern, Gilmartin, and Massengale, *New York 1900*, 390–91.

82. Herbert L. Smith, "Postmodern Paradox," *Architectural Record* 175 (June 1987): 102–5. Also see Kraft, ed., *Robert A.M. Stern: Buildings and Projects, 1987–1992*, 18–19; *Robert A.M. Stern: Buildings*, 138–45. For Amsterdam Houses, see Stern, Mellins, and Fishman, *New York 1960*, 675–77.

83. Peter Morris Dixon, ed., *Robert A.M. Stern: Buildings and Projects, 1993–1998* (New York: Monacelli Press, 1998), 12–15.

84. Herbert L. Smith, "A New Site for SITE," *Architectural Record* 172 (Mid-September 1984): 152–55; "Groupe Site, New-York," *L'Architecture d'aujourd'hui* 237 (February 1985): 72–74; "SITE Studio and Offices," *Architecture + Urbanism*, extra edition (December 1986): 131–37; *SITE* (New York: Rizzoli International Publications, 1989), 164–67. SITE's, as well as other architectural offices in the Bayard Building, including that of Rafael Viñoly, are discussed in Andrea Truppin, "Lofty Landmark," *Interiors* 144 (September 1984): 162–74, 182, 184. For the Bayard Building, see Stern, Gilmartin, and Massengale, *New York 1900*, 153.

85. *SITE* (1989), 164.

86. Andrea Truppin, "Pure Theatre," *Interiors* 146 (July 1987): 161–69; *Hardy Holzman Pfeiffer Associates: Buildings and Projects, 1967–1992* (New York: Rizzoli International Publications, 1992), 262. For the firm's offices of 1967, see Stern, Mellins, and Fishman, *New York 1960*, 572–73.

87. Tibor Kalman, quoted in Steven Heller, "The Man Behind the M," in *Tibor Kalman: Perverse Optimist* (New York: Princeton Architectural Press, 1998), 56.

88. Tibor Kalman, quoted in Victoria Geibel, "Hanging Out the Shingle," *Metropolis* 6 (May 1987): 76–83. Also see Heller, "The Man Behind the M," in *Tibor Kalman: Perverse Optimist*, 57–58.

89. Geibel, "Hanging Out the Shingle": 78–79. For the Park Row Building, see Stern, Gilmartin, and Massengale, *New York 1900*, 147.

90. In 1908 the Park Row Building lost its status as tallest to Ernest Flagg's Singer Tower. See Stern, Gilmartin, and Massengale, *New York 1900*, 170–71.

91. Gregory Kiss, quoted in Geibel, "Hanging Out the Shingle": 83.

92. Suzanne Stephens, "Architect Amid the Angles," *New York Times* (May 18, 1989), C: 3. Also see Ziva Freiman, "Method to the Madness," *Progressive Architecture* 70 (September 1989): 96–99; Margaret Helfand, *Margaret Helfand Architects* (New York: Monacelli Press, 1999), 28–39. For *The Cabinet of Dr. Caligari*, see Siegfried Kracauer, "Caligari," in *Classic Film Scripts: The Cabinet of Dr. Caligari*, trans. R. V. Adkinson (London: Lorimer Publishing, 1972), 5–26.

93. Margaret Helfand, quoted in Stephens, "Architect Amid the Angles": 3.

94. Edie Lee Cohen, "Swanke Hayden Connell: The Firm Builds a Building for Its New York Headquarters," *Interior Design* 61 (July 1990): 148–53.

SHOPS

1. Anne-Marie Schiro, "On City's Fashionable Streets, European Shops Proliferate," *New York Times* (December 23, 1978): 42.

2. "An Ingenious New Design Shop," *New York Times* (December 18, 1980), C: 3; Charles Gandee, "Mixing Memory and Design," *Architectural Record* 169 (September 1981): 102–5.

3. Stanley Tigerman, *Chicago Tribune Tower Competition* (New York: Rizzoli International Publications, 1981).

4. Suzanne Slesin, "A Designer's First Solo, First Store and First Restaurant," *New York Times* (April 6, 1989), C: 12; Edie Lee Cohen, "L.S.: The Madison Avenue Shop by Patino-Wolf Associates," *Interior Design* 60 (September 1989): 268–73.

5. Charles K. Gandee, "Pace Maker," *Architectural Record* 174 (April 1986): 97–103; "Showroom for the Pace Collection," *Architecture + Urbanism* (May 1987): 84–94; Manolo De Giorgi, "Steven Holl: Una Picola Galleria a Manhattan," *Domus* (June 1987): 5–6; *Steven Holl* (Zurich: Artemis; Bordeaux, France: Arc en rêve centre d'architecture, 1993), 32–33; "Steven Holl," in Yukio Futagawa, ed., *GA Architect 11* (1993): 27–31; "Pace Collection Showroom," in "Steven Holl 1986–1996," *El Croquis* 78 (1996): 50–53.

6. Steven Holl, quoted in Gandee, "Pace Maker": 98.

7. Karen D. Stein, "Window Dressing," *Architectural Record* 175 (Mid-September 1987): 90–101; Marilyn Bethany, "Interiors: What's Modern Now," *New York* 20 (September 28, 1987): 65–67; White and Willensky, *AIA Guide*, 370–71; "Women's Clothing Shop 'Giada,'" *Architecture + Urbanism* (January 1988): 51–53; Peter Buchanan, "Holl Pressures," *Architectural Review* 185 (January 1989): 58–59; *Steven Holl* (1993), 34–35; "Steven Holl," in Futagawa, ed., *GA Architect*: 38–41; "Giada Showroom, New York," *Archithese* 24 (March-April 1994): 38.

8. Buchanan, "Holl Pressures": 58.

9. Steven Holl, quoted in *Steven Holl* (1993), 34.

10. Buchanan, "Holl Pressures": 58.

11. Quoted in "Portantina," *Architecture + Urbanism* (April 1990): 80–85. Also see Douglas Brenner, "What's News on the Rialto: Portantina, New York City," *Architectural Record* 174 (Mid-September 1986): 80–83.

12. "Ebel, Here," *Interior Design* 61 (March 1990): 154–57.

13. Edie Lee Cohen, "Niessing," *Interior Design* 61 (September 1990): 186–89.

14. "For this Jewelry, a Jewel-Box Shop," *New York Times* (November 3, 1994), C: 3; Andrea Loukin, "Stover Jenkins Architects," *Interior Design* 66 (September 1995): 172–73.

15. "Architecture d'interreur: Shiro Kuramata," *Architecture intérieure créé* 226 (October-November 1988): 114–17; Edie Lee Cohen, "Issey Miyake: The New York Shop By Shiro Kuramata and Toshiko Mori," *Interior Design* 60 (February 1989): 256–59.

16. Woody Hochswender, "Gigli Opens a New Playground for His Imagination," *New York Times* (November 11, 1990): 60. For the townhouse, see Landmarks Preservation Commission of the City of New York, *Upper East Side Historic District Designation Report* (New York, 1981), 423.

17. "An Elegant Store for Cashmere," *Progressive Architecture* 76 (March 1995): 27; Stanley Abercrombie, "1100 Architect: The Manhattan Retail Shop for Tse Cashmere Is as Sensuous as the Clothing It Displays," *Interior Design* 66 (September 1995): 164–67; *1100 Architect* (New York: Monacelli Press, 1997), 130–39.

18. Frederic Schwartz, ed., *Alan Buchsbaum, Architect and Designer: The Mechanics of Taste* (New York: Monacelli Press, 1996), 134–35.

19. Jon Weiser, quoted in Claudia H. Deutsch, "New Stores Make Shopping a Many-Tiered Experience," *New York Times* (August 28, 1994), B: 1, 9.

20. Edie Cohen, "Charivari Workshop," *Interior Design* 54 (May 1983): 280–81.

21. Edie Cohen, "Charivari 57," *Interior Design* 55 (September 1984): 244–29; Kenneth Brozen, "Many Levels of Business," *Interiors* 145 (January 1986): 172–73.

22. Anne-Marie Schiro, "Patterns: Choose Your Boutique," *New York Times* (September 29, 1992), B: 7.

23. Jon Weiser, quoted in Lisa W. Foderaro, "Charivari: Boutique Blues on West 57th Street," *New York Times* (November 6, 1997), B: 12.

24. Amy M. Spindler, "Lauren Moves Polo Into Its Own Quarters," *New York Times* (September 17, 1993), C: 3. For the Gertrude Rhinelander Waldo mansion, see Stern, Gilmartin, and Massengale, *New York 1900*, 321.

25. Paul Goldberger, "The Store Strikes Back," *New York Times* (April 6, 1997), VI: 45–49.

26. Shawn G. Kennedy, "How Deal on Barneys Came About," *New York Times* (November 21, 1990), D: 19; David W. Dunlap, "Refashioning Madison Avenue," *New York Times* (April 11, 1993), X: 1, 4; Stephanie Strom, "Barneys Takes on Uptown Set," *New York Times* (June 28, 1993), D: 1, 3; Nadine M. Post, "Barneys New York Store Squeezed into Former Office Space," *Engineering News-Record* 231 (July 26, 1993): 28; Steve Lohr, "Barneys Bets the Store," *New York Times* (August 29, 1993), VI: 42–46, 59–61; Deyan Sudjic, "New York Storeys," *The Guardian* (September 7, 1993): 4; Cathy Horyn, "The Store That Went Uptown," *Washington Post* (September 8, 1993), D: 1; Nadine Brozan, "Chronicle," *New York Times* (October 25, 1993): 16; "Peter Marino Architects," *Oculus* 56 (November 1993): 6–7; Susan Scherreik, "Tenants for 660 Madison Avenue," *New York Times* (June 29, 1994), D: 18; Emily Prager, "A Legend Confronts Its Ultimate Challenge: Taking Manhattan," *New York Times* (November 3, 1996): 53, 56; Jennifer Steinhauer, "After Dressing Men for 74 Years, Original Barneys Is Closing," *New York Times* (June 18, 1997), B: 1, 7; Henry Urbach, "Losing Barneys," *ANY* 22 (1998): 47; Joshua Levine, "Let Them Wear Black," *New York* 22 (March 1, 1999): 22–29, 121.

27. Peter Marino, quoted in "Peter Marino Architects": 7.

28. Sudjic, "New York Storeys": 4.

29. Stern, Mellins, and Fishman, *New York 1960*, 540.

30. Caroline Roux, "Madison Modern," *Blueprint* (October 1995): cover, 28–30; Martin Filler, "Keeping Cool with Calvin," *House Beautiful* 137 (December 1995): 50, 52; Jayne Merkel, "High Style on Upper Madison," *Oculus* 58 (January 1996): 6–7; Susanna Sirefman, *New York: A Guide to Recent Architecture* (London: Ellipsis, 1997), 194–97; Anne Laure Goulet, "Boutiques de luxe et de mode," *Architecture intérieure créé* (1997): 120–23; Jayne Merkel, "The New Minimalsim," *Oculus* 59 (January 1997): 7–9; "John Pawson: Gallery for Clothing: Calvin Klein, N.Y., Madison Avenue, N.Y., USA," *Architecture + Urbanism* (August 1997): 128–35.

31. Calvin Klein, quoted in Roux, "Madison Modern": 28.

32. Roux, "Madison Modern": 28.

33. For Georg Jensen, see Stern, Mellins, and Fishman, *New York 1960*, 589–90.

34. For Emporio Armani and Giorgio Armani (couture), see Lucie Young, "Armani Opens Museum Shops Selling Clothes," *New York Times* (September 12, 1996), C: 3. Also see Sirefman, *New York*, 178; Ned Cramer, "Fashion Victim," *Architecture* 86 (February 1997): 45; Charles Linn, "The Very Fine Art of Lighting Basic Black," *Architectural Record* 185 (November 1997): 158–59.

35. Peter Marino, quoted in Young, "Armani Opens Museum Shops Selling Clothes": 3.

36. Young, "Armani Opens Museum Shops Selling Clothes": 3.

37. Cramer, "Fashion Victim": 45.

38. Elaine Louie, "The Difference Is in the Flash," *New York Times* (September 19, 1996), C: 3. Also see Tracie Rozhon, "An Awkward Storefront Seeks Style in an Upward Expansion," *New York Times* (January 19, 1996), B: 5.

39. Peter Marino, quoted in Louie, "The Difference Is in the Flash": 3.

40. Martin Filler, "Two for the Show," *Progressive Architecture* 59 (March 1978): 76–79; "Swirl Showroom, New York, New York," *Process Architecture* 13 (March 1990): 50–51; *Charles Gwathmey and Robert Siegel: Buildings and Projects, 1964–1984*, ed. Peter Arnell and Ted Bickford (New York: Harper & Row, 1984), 152–53, 290.

41. Filler, "Two for the Show": 76–79; *Charles Gwathmey and Robert Siegel: Buildings and Projects, 1964–1984*, 159, 291.

42. Suzanne Stephens, "Monochromed and Minimal," *Progressive Architecture* 58 (September 1977): 60–65.

43. "Calvin Klein Menswear," *Interior Design* 50 (January 1979): 184–95; "Calvin Klein Menswear," *Process Architecture* 13 (March 1980): 78–81.

44. Joseph D'Urso, quoted in "Calvin Klein Menswear," *Process Architecture*: 80.

45. Edie Lee Cohen, "Calvin Klein Jeans," *Interior Design* 52 (March 1981): 216–21.

46. Marilyn Bethany, "Design," *New York Times* (July 18, 1982), VI: 41–43. Also see Pilar Viladas, "Sidewalk Sales," *Progressive Architecture* 63 (September 1982): 230–33; Carleton Knight, "SITE Moves Indoors," *Design Action* 1 (November-December 1982): 6; "Willi Wear Showroom," *Architecture + Urbanism*, extra edition (December 1986): 103–6; *SITE* (New York: Rizzoli International Publications, 1989), 132–34.

47. Quoted in "Willi Wear Men's Showroom," *Architecture + Urbanism*, extra edition (December 1986): 107–13. Also see Andrea Truppin, "On the Waterfront," *Interiors* 144 (January 1985): 166–69; Marc Emery, "Groupe SITE, New York: Projets Récents," *Architecture d'Aujourd'hui* (February 1985): 62–63; *SITE*, 132, 135–37.

48. Susan Doubilet, "Landscape Architecture," *Progressive Architecture* 64 (September 1983): 130–31.

49. "Wayne Berg," *Interiors* 145 (September 1985): 170–75, 270.

50. Wayne Berg, quoted in Sharon Lee Ryder, "Rich in Space, Simple in Surface," *Architecture* 76 (June 1987): 72–73. Also see "Wayne Berg," *Interiors*: 174–75.

51. Quoted in "Citation," *Oculus* 48 (May 1987): 9, 15. Also see Michael Wagner, "Showroom Design Winner: Margaret Helfand Architects," *Interiors* 147 (January 1988): 156–57; *Margaret Helfand Architects* (New York: Monacelli Press, 1999), 16–27.

52. Edie Lee Cohen, "Karl Lagerfeld, N.Y.," *Interior Design* 58 (February 1987): 262–65.

53. Michael McDonough, quoted in "Fashion Statement," *ID* 35 (No. 4, 1988): 58. Also see Justin Henderson, "In a Showroom for Mexx, the Office of Robert A.M. Stern Creates an Interior Steeped in Modern Classicism," *Interiors* 147 (June 1988): 154–57; Elizabeth Kraft, ed., *Robert A. M. Stern: Buildings and Projects, 1987–1992* (New York: Rizzoli International Publications, 1992), 74–75.

54. Graham Wyatt, quoted in Henderson, "In a Showroom for Mexx, the Office of Robert A.M. Stern Creates an Interior Steeped in Modern Classicism": 157.

55. Roger Kimball, "Talk Is Chic," *Architectural Record* 174 (Mid-September 1986): 134–41; *Agrest and Gandelsonas: Works* (New York: Princeton Architectural Press, 1995), 168–73.

56. Bill Robinson, quoted in Kimball, "Talk Is Chic": 134.

57. Kimball, "Talk Is Chic": 134.

58. Diana Agrest, quoted in Kimball, "Talk Is Chic": 134.

59. Kimball, "Talk Is Chic": 134.

60. *Agrest and Gandelsonas: Works*, 168.

61. Kimball, "Talk Is Chic": 134.

62. Isaac Mizrahi, quoted in Karen D. Stein, "Fashion Statement," *Architectural Record* 75 (September 1991): 74–79. Also see "Showroom and Büros für Isaac Mizrahi," *Bauwelt* (February 14, 1992): 296–98, 303; "Isaac Mizrahi, Office," *Architecture + Urbanism* (March 1992): 44–67; Brigitte Fitoussi, "Bureaux et showroom," *Architecture d'Aujourd'hui* (October 1992): 156–59; "Büros und Showroom der Isaac Mizrahi, Ltd., in New York," *Architektur + Wettbewerbe* (June 1994): 46–47.

63. Todd Dalland, quoted in Clifford Pearson, "Fashion Plate," *Architectural Record* 190 (September 1992): 98–105.

64. Carmelo Pomodoro, quoted in Pearson, "Fashion Plate": 100.

65. Justin Henderson, "Stretching the Limits," *Interiors* 146 (November 1986): 142–49.

66. Sirefman, *New York*, 134–35. Also see Thomas Fisher, "Up on the Roof," *Progressive Architecture* 73 (December 1992): 54–57; Forrest Wilson, "Designing for Today: Six Buildings," *Blueprint* 11 (Spring 1993): 2–7.

67. Wilson, "Designing for Today: Six Buildings": 7.

68. Thomas Fisher, "The Free Plan Idea," *Progressive Architecture* 73 (September 1992): 66–71; Justin Henderson, "Espirit's New Spirit," *Interiors* 153 (January 1994): 90–91; Pat Morton, "The 'Death' of the Architect," in *1100 Architect*, 3, 100–11.

69. Judith Nasatir, "Michael McDonough: The Sam & Libby Showroom in New York," *Interior Design* 64 (September 1993): 204–5.

70. Billie Tsien, quoted in Clifford A. Pearson, "Understated," *Architectural Record* 181 (September 1993): 78–83. Also see Kristen Richards, "Pivotal Portals," *Interiors* 152 (November 1993): 28; Michael Wagner, "Rarefied Retreat," *Interiors* 152 (November 1993): 80.

71. Jerry Hirsch, quoted in Pearson, "Understated": 79.

72. See Stern, Gilmartin, and Mellins, *New York 1930*, 301.

73. Edie Lee Cohen, "Ecco Shoes," *Interior Design* 58 (February 1987): 260–61; Schwartz, ed., *Alan Buchsbaum, Architect and Designer: The Mechanics of Taste*, 202–3, 224.

74. Edie Lee Cohen, "Famolare for Franchise," *Interior Design* 56 (September 1985): 260–63; Allen Freeman, "Interiors," *Architecture* 75 (February 1986): 86.

75. Edie Lee Cohen, "Joan & David," *Interior Design* 62 (September 1991): 186–89; "Le Grand Axe," *Architecture intérieure créé* (November-December 1992): 144–45. For Jiricna's work, see Martin Pawley, *Eva Jiricna: Design in Exile* (London: Fourth Estate, 1990).

76. Kenneth Cole, quoted in Beverly Russell, "Neat Footwork," *Interiors* 150 (January 1990): 106–7. Also see "Feet First," *Interiors* 150 (September 1991): 106–7.

77. Norma Skurka, "Storehouse of Ideas," *New York Times* (July 17, 1977), VI: 34–35. Also see Suzanne Stephens, "Impeccably Park Ave.," *Progressive Architecture* 58

(September 1977): 84–85.

78. Martin Filler, "Black Beauty," *Progressive Architecture* 58 (September 1977): 86–87.

79. Henry Urbach, "Shear Energy," *Interior Design* 67 (September 1996): 134–41; Patrizia Malfatti, "Bumble and Bumble," *Abitare* 357 (December 1996): 56–61; Sirefman, *New York*, 192–93; "Phönix aus der Asche: Friseursalon in New York," *Deutsche Bauzeitschrift* 44 (October 1997): 67–72.

80. Ross Anderson, quoted in Sirefman, *New York*, 192.

81. Carter B. Horsley, "Strictly 'By the Book' Is Boom in Midtown," *New York Times* (June 12, 1977), VIII: 1, 6. For 666 Fifth Avenue, see Stern, Mellins, and Fishman, *New York 1960*, 377–78.

82. Paul Goldberger, "The Best Bookstores Make You Want to Read Books," *New York Times* (November 9, 1978), C: 10. For the 1936 Doubleday shop, see Stern, Gilmartin, and Mellins, *New York 1930*, 310. For the 1967 Doubleday shop, see Stern, Mellins, and Fishman, *New York 1960*, 381.

83. For profiles of Riggio, see I. Jeanne Dugan, "The Baron of Books," *Business Week* (June 29, 1998): cover, 109–15; David D. Kirkpatrick, "Barnes & Noble's Jekyll and Hyde," *New York 32* (July 19, 1999): 24–31.

84. "Barnes & Noble to Open New Store," *New York Times* (May 13, 1977), B: 2; Horsley, "Strictly 'By the Book' Is Boom in Midtown": 1, 6.

85. For Rizzoli, see Stern, Mellins, and Fishman, *New York 1960*, 381.

86. Fred Ferretti, "The Conversion of Bookmasters," *New York Times* (July 25, 1979), C: 17; "Marboro Is Sold to Barnes & Noble," *New York Times* (October 23, 1979), B: 1, 4.

87. Lisa Belkin, "Discounter Purchases B. Dalton," *New York Times* (November 27, 1986), D: 1, 4; Allene Symons, "Barnes & Noble to Buy B. Dalton," *Publisher's Weekly* 230 (December 12, 1986): 17–20; Edwin McDowell, "Doubleday Book Shops Sale Is Seen," *New York Times* (February 14, 1990), D: 1.

88. David Berreby, "The Growing Battle of the Big Bookstores," *New York Times* (November 8, 1992), III: 5.

89. Douglas Martin, "Barnes & Noble Superstore Prompts Volumes of Worry," *New York Times* (April 26, 1993), B: 1, 4; "B & N in NYC: Big Broadway Store Opens, 6th Ave. Site Next," *Publisher's Weekly* 240 (May 17, 1993): 11, 17; Charles Michener, "Broadway's Newest Hit," *New York 26* (August 9, 1993): 46–50; Sarah Lyall, "Sipping and Nibbling One's Way Through Manhattan's Bookstores," *New York Times* (December 23, 1994), C: 1, 34.

90. "B & N in NYC: Big Broadway Store Opens, 6th Ave. Site Next": 11, 17; Christopher Gray, "Streetscapes/Make-Overs on Lower Sixth Avenue," *New York Times* (December 12, 1993), X: 5.

91. "Barnes & Noble Strikes Again," *New York Times* (September 4, 1994), XIII: 6. For Citicorp Center, see Stern, Mellins, and Fishman, *New York 1960*, 490–97.

92. John Mutter, "Barnes & Noble Pushes the Envelope," *Publisher's Weekly* 242 (December 11, 1995): 24–25; Jayne Merkel, "The Next Incarnation of Union Square," *Oculus* 58 (October 1996): 47. For the Century Building, see Stern, Mellins, and Fishman, *New York 1880*, 440–43.

93. Randy Kennedy, "Could a Beloved Bookstore Turn Into Shakespeare & Café?" *New York Times* (July 3, 1994), XIII: 5; Bruce Lambert, "More Bookstore Casualties," *New York Times* (July 16, 1995), XIII: 8; "New York's Book Bind," *New Yorker* 71 (August 7, 1995): 27–28.

94. Victor Navasky, "Buying Books: Theory vs. Practice," *New York Times* (June 20, 1996): 21.

95. John Mutter, "Chain Store Openings: A Roundup," *Publisher's Weekly* 242 (September 18, 1995): 29–30; Claudia H. Deutsch, "Barnes & Noble vs. Everyone Else: Next Chapter," *New York Times* (October 15, 1995), IX: 11; Kirk Johnson, "Giant Book Emporium Enters New York Fray," *New York Times* (September 4, 1996), B: 3.

96. Hugh Hardy, quoted in Maeve Slavin, "Literate Renaissance," *Interiors* 145 (August 1985): 176–81. Also see White and Willensky, *AIA Guide* (1988), 281; *Hardy Holzman Pfeiffer Associates: Buildings and Projects, 1967–1992* (New York: Rizzoli International Publications, 1992), 120–23, 261.

97. Goldberger, "The Best Bookstores Make You Want to Read Books": 10.

98. Burt Britton, quoted in Goldberger, "The Best Bookstores Make You Want to Read Books": 10.

99. Diane Patrick Wexler, "Books & Co. Looks to Stay Open," *Publishers Weekly* 244 (March 10, 1997): 12; David M. Halbfinger, "Bookstore's Friends Try to Keep It Open," *New York Times* (March 25, 1997), B: 6; David W. Chen, "Books and Company on East Side to Close Down," *New York Times* (April 26, 1997): 25, 27; Paul A. D'Alessandro, "Bookstore: The Life and Times of Jeannette Watson and Books & Co.," *Library Journal* 124 (October 1, 1999): 94.

100. Michael Rubin, quoted in Nayana Currimbhoy, "The Best Little Bookstore," *Interiors* 152 (January 1993): 112–13.

101. Penny McGuire, "Book Worms," *Architectural Review* 194 (April 1994): 79–81. Also see "St. Mark's Bookshop," *Architecture + Urbanism* (August 1994): 48–51; Monica Geran, "Zivkovic Associates," *Interior Design* 66 (September 1995): 168–71. For the Panopticon, see Nikolaus Pevsner, *A History of Building Types* (Princeton, N.J.: Princeton University Press, 1976), 163–69.

102. Quoted in "St. Mark's Bookshop": 48.

OUTER BOROUGHS

BROOKLYN

1. Randall Rothenberg, "Hey, This Way To Brooklyn!" *New York Times* (February 4, 1980): 19.

2. Robin Herman and Laurie Johnston, "Buying the Memorabilia Instead of the Bridge," *New York Times* (November 19, 1982), B: 3; "Re-enacting a Memorable Walk Across the Brooklyn Bridge," *New York Times* (December 10, 1982): 1; Robin Herman and Laurie Johnston, "A Big Time Coming at Brooklyn Bridge," *New York Times* (February 24, 1983), B: 4; Paul Goldberger, "Brooklyn Salutes Its Great Bridge at 100 with Paintings, Photos and Words," *New York Times* (March 18, 1983), C: 1, 11; David McCullough, "The Great Bridge and the American Imagination," *New York Times* (March 27, 1983), VI: 29–38, 68–69, 80; Richard Perry, "A Summer's Brooklyn Bridge Celebration," letter to the editor, *New York Times* (March 28, 1983): 14; Laurie Johnston and Susan Heller Anderson, "Warhol and the Bridge," *New York Times* (April 6, 1983), B: 6; Daralice Donkervoet Boles, "The Brooklyn Bridge: An American Icon," *Progressive Architecture* 64 (May 1983): 25–26; Stan Pinkwas, "Geometry of Light," *Metropolis* 2 (May 1983): 9; "Biggest Fireworks Show Planned at Bridge," *New York Times* (May 23, 1983), B: 7; "The Roeblings' Bridge, and Era," *New York Times* (May 24, 1983): 24; Paul Goldberger, "Brooklyn Bridge, at 100, Embodies the Spirit of an Age," *New York Times* (May 24, 1983): 1, B: 2; Michael J. Crosbie, "Happy Birthday to a Very Architectural Bridge," *Architectural Record* 72 (July 1983): 52–59; Horst Berger, "Brooklyn Bridge at 100," *Architectural Record* 171 (August 1983): 118–24. For the Brooklyn Bridge, see Stern, Mellins, and Fishman, *New York 1880*, 110–21.

3. "Condition of Victim in a Bridge Accident Is Still 'Very Critical,'" *New York Times* (July 3, 1981), B: 5; "Brooklyn Bridge Cables to Be Secured," *New York Times* (July 7, 1981): 1; William G. Blair, "New Cable Work to Go On Bridge Because of a Sag," *New York Times* (July 7, 1981), B: 3; David McCullough, "The Brooklyn Bridge," *New York Times* (July 17, 1981): 23; David Margolick, "A Bridge Cable's Fatal Snap Leads to Years of Litigation," *New York Times* (October 8, 1984), B: 1–2.

4. Steven Ross, "The Next Hundred Years," in Deborah Nevins et al., *The Great East River Bridge, 1883–1983* (Brooklyn: Brooklyn Museum, 1983), 172–77; Stephen Kinzer, "U.S. Grants Aid to Help Repair Brooklyn Bridge," *New York Times* (February 17, 1983), B: 1; "A Time for Repairs," *New York Times* (September 18, 1983): 1; "Bridge Stairway Closing for Repairs," *New York Times* (July 12, 1983), B: 4; James Brooke, "Spinning New Cables for Bridge's 2d Century," *New York Times* (March 8, 1986): 29, 31; Dennis Hevesi, "Driving in Brooklyn? Expect the Worst," *New York Times* (October 24, 1991), B: 1–2; "Restoring a New York Legend," *New York Times* (October 26, 1991): 23; Thomas J. Lueck, "As Concrete Falls, City Moves to Fix Brooklyn Bridge," *New York Times* (February 5, 1999), B: 3.

5. Gerald F. Lieberman, "Roebling Sketches Are Going to Museum," *New York Times* (October 5, 1975), BQLI: 3; Paul Goldberger, "Archives Get Brooklyn Bridge Plans," *New York Times* (April 14, 1976): 78.

6. Bob Davis, quoted in Pinkwas, "A Geometry of Light": 9.

7. Maryann Ondovcsik, "Bridge to the Past," *Clem Labine's Traditional Building ?* (January/February 1989): 10.

8. Rita Reif, "Below Bridge, Room to Grow," *New York Times* (January 18, 1976), VIII: 1, 4. Also see Marcia Chambers, "The 'Other' Brooklyn Bridge: Spacious Offices and Labyrinthine Caves," *New York Times* (September 22, 1976): 43; "City Begins Leasing Space Under Bridges," *New York Times* (December 19, 1979), B: 24; David W. Dunlap, "Some Municipal White Elephants Are Now Hot Properties," *New York Times* (September 11, 1983), IV: 7; Mervyn Rothstein, "Arches for Rent," *New York Times* (August 26, 1984): 49.

9. "Under the Brooklyn Bridge: Rms w/Rv Vu?" *Architectural Record* 175 (August 1987): 61; Barbara Mensch, "The Hidden Bridge: Secret Histories of a Beloved New York Landmark," *Metropolis* 19 (May 2000): 80–83.

10. Walter F. Wagner Jr., "The Anchorages: A Second Spectacular," *Architectural Record* 171 (August 1983): 125–27; Jennifer Dunning, "New Theater Realm Inside a Bridge," *New York Times* (June 6, 1986), C: 1, 17; C. Carr, "Life During Wartime," *Village Voice* (June 25, 2002): 51; Andrew Yang, "Marking Time," *Print* 58 (March-April 2004): 62–67.

11. Dunning, "New Theater Realm Inside a Bridge": 1.

12. Warren Hoge, "In the Air at the Bridge," *New York Times* (May 30, 1983): 11.

13. Landmarks Preservation Commission of the City of New York, *Fulton Ferry Historic District Designation Report* (New York, 1977); Barbaralee Diamonstein, *The Landmarks of New York III* (New York: Harry N. Abrams, 1998), 502. Also see David Gordon, "Fulton Ferry Shaping Up as a Landmark," *New York Times* (July 29, 1973): 90; "Landmark Panel Is Considering 3 Brooklyn Sites," *New York Times* (July 20, 1975): 89; "Landmark Status Voted for 5 Places in City," *New York Times* (November 26, 1975): 64; Carter B. Horsley, "Tax Law Gives Landmarks a Lift as City Gets Set to Create More," *New York Times* (January 2, 1977), VIII: 1, 3.

14. For the Empire Stores, see Stern, Mellins, and Fishman, *New York 1880*, 852–53.

15. For the River Café, see Stern, Mellins, and Fishman, *New York 1960*, 913. Also see Regina Schrambling, "The Restaurant That Launched a Thousand Chefs," *New York Times* (August 29, 2001), F: 1, 6.

16. Ira Rosenblum, "Bargemusic: Reflection of a Dream," *New York Times* (August 18, 1985), H: 17.

17. Judith Cummings, "Sea Museum, Park Opened at Ferry Site," *New York Times* (May 22, 1977): 36.

18. Carter B. Horsley, "Developers Map Rebirth for Brooklyn Waterfront," *New York Times* (August 15, 1979), B: 3; Alan S. Oser, "Warehouse at Fulton Ferry Is Converted," *New York Times* (August 8, 1980): 19; "Homes for Better Living Awards: The Eagle, Brooklyn, New York," *Architectural Record* 169 (June 1981): 46; White and Willensky, *AIA Guide* (2000), 670; Francis Morrone, *An Architectural Guidebook to Brooklyn* (Salt Lake City, Utah: Gibbs Smith, 2001), 108–10. For Freeman's building, see Stern, Mellins, and Fishman, *New York 1880*, 853.

19. For Morton's renovation, see Stern, Mellins, and Fishman, *New York 1880*, 912–13.

20. Paul Goldberger, "A Guide to Brooklyn's Revitalized Fulton Ferry," *New York Times* (July 30, 1982), C: 1, 20.

21. "For Fulton Ferry Area, a New Sense of Purpose," *New York Times* (July 26, 1981): 40.

22. Peter Freiberg, "Fulton Ferry," *Metropolis* 3 (September 1983): 12; David W. Dunlap, "Lehman Bros. Plans Brooklyn Office," *New York Times* (January 3, 1984), B: 3; Martin Gottlieb, "A Boom Borough," *New York Times* (February 1, 1984), B: 1, 7; Martin Gottlieb, "Developer Is Dismissed by the City," *New York Times* (March 1, 1984), B: 10; Martin Gottlieb, "Golden Says City 'Sabotaged' Proposed Project in Brooklyn," *New York Times* (March 2, 1984), B: 5; David W. Dunlap, "Brooklyn Developer Withdraws Request for Tax Exemption," *New York Times* (March 13, 1984), B: 3; Peter Freiberg, "Fulton Ferry District Going Back and Forth," *Metropolis* 3 (May 1984): 12; David W. Dunlap, "Brooklyn Developer Tries Approach on 2 Fronts," *New York Times* (May 7, 1984), B: 5; "Reviving the Brooklyn Waterfront," *Architectural Record* 172 (September 1984): 61; Martin Gottlieb, "Agreement Reached on Plan to Develop Brooklyn Waterfront," *New York Times* (December 19, 1984): 1, D: 22; Peter Freiberg, "Fulton Ferry's Future Flounders," *Metropolis* 4 (April 1985): 12–13.

23. For the Gair Building, see Stern, Mellins, and Fishman, *New York 1880*, 853.

24. Shawn G. Kennedy, "Waterfront Offices in Brooklyn," *New York Times* (July 16, 1986), D: 22; David W. Dunlap, "Fulton Ferry" (January 15, 1987), B: 1; Andrew L. Yarrow, "Changing Warehouses into a Cultural Center," *New York Times* (March 23, 1991): 25.

25. Lynette Holloway, "Fulton Ferry," *New York Times* (October 17, 1993), XIII: 10; Gary Pierre-Pierre, "Fulton Ferry," *New York Times* (August 21, 1994), XIII: 9; Alexandra Lange, "Will Dumbo Grow Up to Be SoHo–Minus the J. Crew," *New York 30* (July 7, 1997): 13.

26. Peter Grant, "New Contender on Waterfront," *New York Daily News* (July 10, 1996): 42; David Rohde, "Agency's Exit Derails Dream," *New York Times* (November 17, 1996), XIII: 12; David Rohde, "Developer's Big Plans Have Seen Ups and Downs," *New York Times* (June 15, 1997), XIII: 8; David Rohde, "Fulton Landing Plan Rises from the Ashes for Another Try," *New York Times* (June 15, 1997), XIII: 8; Amy Waldman, "Fulton Ferry," *New York Times* (September 7, 1997), XIII: 9; Joan K. Davidson, "Nine Riverfront Acres May Disappear into a Developer's Pocket," *New York Times* (March 15, 1998), XIV: 17; Howard Golden and Jayne DeSesa, "Essay on River Park Ignores Effort to Improve the Site," letters to the editor, *New York Times* (April 5, 1998), XIV: 15; Joan K. Davidson, "Development Was Sought Only for Park Site's Edge," letter to the editor, *New York Times* (April 19, 1998), XIV: 17; David W. Dunlap, "SoHo, TriBeCa and Now Dumbo?" *New York Times* (October 25, 1998), XI: 1, 20; Julian E. Barnes, "Dueling Over Dumbo: Commerce vs. Parks," *New York Times* (April 11, 1999), XIV: 8.

27. Herbert Muschamp, "Developer Pursues Plans for Complex Along Brooklyn's Waterfront," *New York Times* (May 8, 1999), B: 1, 3; Thomas J. Lueck, "Unveiling a New Vision for Brooklyn's Waterfront," *New York Times* (May 24, 1999), B: 1, 6; Herbert Muschamp, "A Stunning New Hotel Design Stands Out Amid a Flawed Plan," *New York Times* (May 24, 1999), B: 1, 6; Joan L. Millman, Steve Seltzer, and Tensie Whelan, "In Brooklyn, a Stunning Design That's All Wrong," letters to the editor, *New York Times* (May 31, 1999): 12; "The Battle of Brooklyn," *Architectural Record* 187 (June 1999): 68; Somini Sengupta, "A Neighborhood Identity Crisis," *New York Times* (June 9, 1999), B: 1, 7; Herbert Muschamp, "A Bridge Between a City and Its Self-Image," *New York Times* (June 13, 1999), II: 37; Susanna Sirefman, "Amid a Development Squabble, Nouvel Creates First Design for U.S.," *Architectural Record* 187 (July 1999): 64; Chap Taylor, "A Public Menace," letter to the editor, *New York Times* (July 4, 1999), II: 2; Andrea Malloy, "Artists Must Act to Save Brooklyn Waterfront," letter to the editor, *New York Times* (June 14, 1999): 22; Jeffrey Hogrefe, "Who Will Inherit Dumbo?" *New York Observer* (August 16, 1999): 22; Julian E. Barnes, "Plug Pulled on Dumbo Proposal," *New York Times* (December 12, 1999): 58; Herbert Muschamp, "New York Starts to Look Beyond Its Past," *New York Times* (December 26, 1999), II: 49; White and Willensky, *AIA Guide* (2000), 672; "245 Rooms: Architectures Jean Nouvel," *Quaderns d'arquitectura i urbanisme* 227 (2000): 72–77; "Jean Nouvel," *Architecture + Urbanism* (November 2000): 54–63; Alan Balfour, *World Cities: New York* (New York: Wiley Academy, 2001), 284–85; Morrone, *An Architectural Guidebook to Brooklyn*, 115; Raymond Gastil, *Beyond the Edge: New York's New Waterfront* (New York: Princeton Architectural Press, 2002), 153; "River Hotel in Brooklyn," *El Croquis* 112/113 (2002): 176–83; Herbert Muschamp, "A Lesson Abroad: Get Comfortable with Continuity," *New York Times* (February 24, 2002), II: 46; Ian Luna, ed., *New New York: Architecture of a City* (New York: Rizzoli International Publications, 2003), 322–25.

28. Quoted in Luna, ed., *New New York*, 323.

29. Muschamp, "A Stunning New Hotel Design Stands Out Amid a Flawed Plan": 1.

30. Joseph B. Rose, quoted in Barnes, "Plug Pulled on Dumbo Proposal": 58.

31. Waldman, "Fulton Ferry": 9; Dunlap, "SoHo, TriBeCa and Now Dumbo?": 1, 20; White and Willensky, *AIA Guide* (2000), 672; Morrone, *An Architectural Guidebook to Brooklyn*, 113–14; Christopher Gray, "Streetscapes/Robert Gair, Dumbo and Brooklyn," *New York Times* (March 14, 2004), XI: 7.

32. Nadine Brozan, "For Dumbo, Two New Buildings," *New York Times* (March 4, 2001), XI: 1.

33. Brozan, "For Dumbo, Two New Buildings": 1; "New York," *Engineering News-Record* 246 (April 16, 2001): 94;

"Light Bridges Project Planned," *New York Construction News* 48 (June 2001): 9; Craig Kellogg, "On the Drawing Boards," *Oculus* 63 (Summer 2001): 5; Brian Carter and Annette Lecuyer, *All American: Innovations in American Architecture* (London: Thames & Hudson, 2002), 62; John Holusha, "In Brooklyn, Projects, Plans and Hopes," *New York Times* (January 27, 2002), XI: 1, 6; "Dumbo to Get Major Face Lift," *New York Post* (February 26, 2002): 28; "SHoP's Dumbo Building Moves Forward," *Architectural Record* 190 (March 2002): 35; Rachelle Garbarine, "More Builders Are Joining in Development of Dumbo," *New York Times* (October 24, 2003), B: 10.

34. Richard D. Lyons, "In Brooklyn Heights, a Spotlight on 87 Neglected Acres," *New York Times* (October 27, 1985), VIII: 7; Martin Gottlieb, "Brooklyn Promenade Complex Urged," *New York Times* (February 25, 1986), B: 4; Henrik Krogius, "Will Brooklyn Heights Lose Sight of Manhattan's Skyline?" *New York Times* (August 30, 1986): 25; "Group to Study Brooklyn Piers," *New York Times* (October 24, 1986), B: 5; Thomas L. Waite, "Pier Redevelopment Plans Stir Concerns," *New York Times* (May 1, 1988), VIII: 9, 18; David W. Dunlap, "Brooklyn's Waterfront: Two Visions of a Compelling Vista," *New York Times* (August 19, 1988), B: 1–2; Karen Cook, "Waterfront Projects," *New York Post* (January 12, 1989): 50–51; Thomas J. Lueck, "Citizens Gain in Anti-Developer Wars," *New York Times* (May 1, 1989), VIII: 1, 14; Joseph P. Griffith, "The Changing Character of the Brooklyn Heights Esplanade," *Metropolis* 8 (June 1989): 21–22; David W. Dunlap, "Port Authority Endorses Plan for Pier," *New York Times* (December 4, 1989), B: 4; Anthony DePalma, "The Fate of a Waterfront Minus Ships," *New York Times* (December 17, 1989), E: 6; Steven Saltzman, "Updates," *Metropolis* 8 (April 1990): 20; Andrew L. Yarrow, "Development Not Even a Contender on Brooklyn's Waterfront," *New York Times* (August 21, 1991), B: 3; Mary B. W. Tabor, "Despite Opposition, Agency Plans to Sell Brooklyn Piers to Private Developer," *New York Times* (April 3, 1992), B: 3; Mary B. W. Tabor, "Port Authority Pulls Back from Sale of the Waterfront," *New York Times* (April 8, 1992), B: 3; "Brooklyn Piers Update," *Municipal Art Society Newsletter* (May/June 1992): 2; James C. McKinley Jr., "Proposal to Double Park Area on the Shore," *New York Times* (August 12, 1992), B: 3; Lynette Holloway, "Keeping a Vista in the View," *New York Times* (January 30, 1994), XIII: 10.

35. Michael Sorkin, *Michael Sorkin Studio: Wiggle* (New York: Monacelli Press, 1998), 32–33.

36. Julian E. Barnes, "Disparate Visions for a New Park," *New York Times* (December 12, 1999): 55, 58; "Port Authority Agrees to Let Piers Be Used for Brooklyn Bridge Park," *New York Times* (February 1, 2000), B: 1, 8; Tara Bahrampour, "80-Acre Park: Urban Oasis or Concrete Nightmare," *New York Times* (March 5, 2000), XIV: 10; Peggy Edersheim Kalb, "Real Estate 2000: The Next Big Things," *New York* 33 (April 10, 2000): 61, 63, 102; Julian E. Barnes, "Brooklyn Waterfront Park Plan Has Commercial Uses," *New York Times* (April 25, 2000), B: 1, 3; Susanna Sirefman, "Collaborative Process Creates the Highly Praised Brooklyn Bridge Park," *Architectural Record* 188 (June 2000): 32; Julian E. Barnes, "Park Plan Gets a $64 Million Pledge," *New York Times* (June 8, 2000), B: 3; Marianna Koval, "An Opportunity to Seize . . . ," *New York Times* (July 2, 2000), XIV: 11; Gary Maranga, "A Park for Brooklyn," letter to the editor, *New York Times* (August 5, 2000): 14; Julian E. Barnes, "As Some Fight a Park Plan, Its Supporters See Elitism," *New York Times* (August 16, 2000), B: 1, 6; Susannah B. Heelan, Jeff Prant, and Neil Calet, "A Waterfront Park for Brooklyn?" letters to the editor, *New York Times* (August 21, 2000): 24; "A Park Grows in Brooklyn," *Cityscape News* (Winter 2000–2001): 1–3; Nichole M. Christian, "Long a Dream, Brooklyn Park Nears Reality," *New York Times* (January 6, 2001), B: 1, 4; Gastil, *Beyond the Edge*, 152–56; Jacob Gershman, "Brooklyn to Get New Waterfront Park," *New York Sun* (May 3, 2002): 3; Barbara Stewart, "Riverfront Park Edges Closer in Brooklyn," *New York Times* (May 3, 2002), B: 8.

37. Diane Cardwell, "Brooklyn Waterfront Park Inches Closer," *New York Times* (December 24, 2004), B: 3; Patrick Gallahue, "Park-Ing Space," *New York Post* (January 3, 2005): 23; Nicolai Ouroussoff, "Proposed Brooklyn Park Draws Class Lines," *New York Times* (September 19, 2005), E: 1, 5.

38. For Brooklyn Heights and Brooklyn Heights Historic District, see Stern, Mellins, and Fishman, *New York 1960*, 912–14, 1144; Stern, Mellins, and Fishman, *New York 1880*, 851–77.

39. Stern, Mellins, and Fishman, *New York 1960*, 1144–45.

40. Joseph P. Fried, "New Building vs. the Old in Brooklyn Heights," *New York Times* (May 6, 1978): 25; "Modern Design Gets Approval for 'Historic' Site in Brooklyn," *New York Times* (May 10, 1978), D: 16; Marilyn Bethany, "A House Grows in Brooklyn," *New York Times* (December 27, 1981), VI: 26; Jill Jonnes, "Builder Grasps 'Lucky' Chance," *New York Times* (February 7, 1982), VIII: 1, 6; Charles K. Gandee, "Learning to Live with Landmarks," *Architectural Record* 170 (July 1982): 82–85; "Design Awards/Competitions: Homes for Better Living Awards," *Architectural Record* 170 (August 1982): 79; Alfredo De Vido, "222 Columbia Heights–New York, USA," *Architecture + Urbanism* 143 (August 1982): 84–87; *Alfredo De Vido: Selected and Current Works* (Mulgrave, Australia: Images Publishing, 1998), 186–91; White and Willensky, *AIA Guide* (2000), 659.

41. Alfredo De Vido, quoted in Fried, "New Building vs. the Old in Brooklyn Heights": 25.

42. Alan S. Oser, "Building Conversions in Brooklyn Heights," *New York Times* (October 12, 1979): 19; "An Ice-Encrusted Block: A Chilly Aftermath of Fire at Brooklyn Landmark," *New York Times* (February 2, 1980): 23; Robert D. McFadden, "A Fire Destroys Landmark Hotel at Brooklyn Site," *New York Times* (February 2, 1980): 24; Ari L.

Goldman, "Burned Hotel Poses Peril," *New York Times* (February 4, 1980), B: 3; David Bird, "Section of Expressway Reopens as Burned Hotel Is Demolished," *New York Times* (February 5, 1980), B: 1; "Demolition of Landmark Hotel in Brooklyn to Begin Today," *New York Times* (February 11, 1980), B: 1; James Barron, "Owner May Resist Hotel Razing," *New York Times* (February 12, 1980), B: 15; Jill Jonnes, "Builder Grasps 'Lucky' Chance," *New York Times* (February 7, 1982), VIII: 1, 6; David Bird, "If You're Thinking of Living In: Brooklyn Heights," *New York Times* (November 21, 1982), VIII: 9; David W. Dunlap, "Brooklyn Area Is Trying to Stop 11-Story Project," *New York Times* (January 12, 1984), B: 5; Richard D. Lyons, "Work Starting on Embattled Site," *New York Times* (May 4, 1986), VIII: 1; Susan Doubilet, "P/A Profile: Cooper, Eckstut Associates," *Progressive Architecture* 67 (July 1986): 98–105; White and Willensky, *AIA Guide* (1988), 592; Morrone, *An Architectural Guidebook to Brooklyn*, 97. For the Hotel Margaret, see Stern, Mellins, and Fishman, *New York 1880*, 870–71.

43. Shawn G. Kennedy, "On Willow St.: New Echoes Old," *New York Times* (May 13, 1984), VIII: 1; *Alfredo De Vido: Selected and Current Works*, 190–91; White and Willensky, *AIA Guide* (2000), 666.

44. "Completing Cadman Plaza: Condos for Bridge Watchers," *New York Times* (November 2, 1986), VIII: 1; David W. Dunlap, "Conversion of Orphanage," *New York Times* (January 15, 1987), B: 1; Charles K. Hoyt, "Focus On: A Rich Range of Recycled Buildings; Bridge Harbor Heights Condominium Apartments," *Architectural Record* 182 (February 1994): 122–23; White and Willensky, *AIA Guide* (2000), 667; "A Critical Look at New Construction in Historic Districts," *District Lines* 18 (Autumn 2004): 4–6. For the Cadman Plaza Urban Renewal Area, see Stern, Mellins, and Fishman, *New York 1960*, 903–6.

45. White and Willensky, *AIA Guide* (2000), 653.

46. Christopher Gray, "Streetscapes: 125 Joralemon Street," *New York Times* (August 1, 1993), X: 7. For the Daniel Chauncey house, see Stern, Mellins, and Fishman, *New York 1880*, 874.

47. "Architectural Sleight of Hand: Stable Becomes Carriage House," *New York Times* (January 3, 1993), X: 1; White and Willensky, *AIA Guide* (2000), 650; "A Critical Look at New Construction in Historic Districts": 4–6.

48. Rachelle Garbarine, "At State and Hicks Street: In Brooklyn, a New Condo with 11 Units," *New York Times* (March 24, 2002), XI: 1; "A Critical Look at New Construction in Historic Districts": 4–5.

49. William G. Blair, "Brooklyn Hts. Tower Plan Is Disputed," *New York Times* (July 9, 1984), B: 3; Peter Freiberg, "Barring Witnesses," *Metropolis* 4 (November 1984): 11; "Brooklyn Hts. Tower Advances," *New York Post* (August 11, 1988): 52; Sarah Lyall, "Hundreds Protest Jehovah's Witness Tower Plan," *New York Times* (September 26, 1988), B: 1, 4; Todd S. Purdum, "Board Blocks Tower for Religious Group," *New York Times* (September 30, 1988), B: 3; Pat Smith, "Jehovah's Building Nixed in B'klyn," *New York Post* (September 30, 1988): 2.

50. "City-Owned Site Sought for Offices," *New York Times* (June 15, 1985): 27; Kirk Johnson, "Development Activity Advances in Brooklyn," *New York Times* (August 11, 1985), VIII: 1, 14; Paul Goldberger, "Plan for Skyscraper in Brooklyn Hts. Pits Livability Against Development," *New York Times* (October 11, 1985), B: 1, 4; Jeffrey Schmalz, "Planning Commission Approves Proposal for Brooklyn Hts. Office Tower," *New York Times* (October 16, 1985), B: 1; Alan S. Oser, "Downtown Brooklyn; Coming Attractions for Office Tenants," *New York Times* (June 28, 1987), VIII: 9; Shawn G. Kennedy, "Envisioning Brooklyn as Office Center," *New York Times* (January 20, 1988), B: 22; Alan S. Oser, "Zoning: Controlling Scale Near Historic Districts," *New York Times* (October 28, 1990), X: 7; White and Willensky, *AIA Guide* (2000), 663.

51. Henry Smith-Miller, quoted in Andrea A. Monfried, "Further Afield," *Oculus* 54 (April 1992): 5. Also see "Award for Excellence in Design: Rotunda Gallery," *AIA New York State News* (November 1993): 6; Donald Albrecht, "In the Swing: Rotunda Gallery, New York City, Smith-Miller + Hawkinson, Architect," *Architecture* 82 (November 1993): 82–87; Frank F. Drewes, "Kommunale Galerie in Brooklyn," *Deutsche Bauzeitschrift* 42 (January 1994): 14–15; Bart Lootsma, "Context en Engagement: Werk van Smith-Miller + Hawkinson," *Architect* 25 (June 1994): cover, 28–45; Vanessa Viganó, "New York: Rotunda Gallery: H. Smith-Miller e L. Hawkinson," *Abitare* 334 (November 1994): 178–81; *New Architecture in Brooklyn 1985–1995: The Rotunda Gallery, November 9-December 21, 1995* (Brooklyn: The Gallery, 1995), 3–4, 10; "Moving in Space," *L'Arca* 102 (March 1996): 90; Susanna Sirefman, *New York: A Guide to Recent Architecture* (London: Ellipsis, 1997), 282–83.

52. Sirefman, *New York*, 282.

53. *New Architecture in Brooklyn 1985–1995: The Rotunda Gallery, November 9-December 21, 1995*, 5, 15.

54. Rachelle Garbarine, "Luxury High-Rise Planned for Brooklyn Heights," *New York Times* (January 24, 1997), B: 5; Corey Kilgannon, "2 Projects, 2 Methods, 2 Reactions," *New York Times* (October 11, 1998), XIV: 11; "Apartment Complex Starts in Brooklyn," *New York Construction News* 47 (April 1999): 14; Rachelle Garbarine, "For Brooklyn, a New Rental Tower," *New York Times* (March 17, 2000), B: 6.

55. Ian Bruce Eichner, quoted in Garbarine, "For Brooklyn, a New Rental Tower": 6.

56. Kilgannon, "2 Projects, 2 Methods, 2 Reactions": 11; Jean Ende, "Retail Promenades in Brooklyn Heights," *Crain's New York Business* (October 19, 1998): 41; Jim Yardley, "Lights, Camera, Lots of Action," *New York Times* (December 28, 1998), B: 1, 4; Alan S. Oser, "All over Town, Movie Screens Are Popping Up," *New York Times* (December

30, 1998), B: 6; Julian E. Barnes, "A Sock? A Fish? A Snake? It's Worse, Tower's Foes Say," *New York Times* (December 5, 1999), XIV: 14; White and Willensky, *AIA Guide* (2000), 655; David W. Dunlap, "A Complex Plan's Aim: Simpler Zoning Rules," *New York Times* (January 30, 2000), XI: 1, 6; John Holusha, "National Chains Vie for Piece of the Local Retail Pie," *New York Times* (March 26, 2000), XI: 9.

57. Hugh Hardy, quoted in Oser, "All over Town, Movie Screens Are Popping Up": 6.

58. White and Willensky, *AIA Guide* (2000), 674. For the E. M. Fuller Pavilion, see Stern, Mellins, and Fishman, *New York 1960*, 914–15.

59. David W. Dunlap, "On the Brooklyn Waterfront: A Park, a Hospital and a Controversy," *New York Times* (August 8, 1993), X: 1; Lynette Holloway, "Residents Fight to Save Their Small Park," *New York Times* (September 26, 1993), XIII: 10; "Neighborhood Report; Brooklyn Update," *New York Times* (January 9, 1994), XIII: 8; Garry Pierre-Pierre, "O.K., Draw! Architects Join Fight for Park," *New York Times* (April 10, 1994), XIII: 10; "'Visions for an Endangered Park' Exhibition Opens at Urban Center," *Municipal Art Society Newsletter* (May/June 1994): 1–2; Anne Raver, "Garden Notebook: Trying to Measure a Park's Worth," *New York Times* (May 19, 1994), C: 6; Garry Pierre-Pierre, "Mayor Approves Sale of Park," *New York Times* (May 22, 1994), XIV: 10; Tony Marcano, "Van Voorhees Hearing Tomorrow," *New York Times* (March 12, 1995), XIII: 8; Charlotte Fahn, "A Park Dies in Brooklyn," *New York Times* (July 22, 1995): 19; Elane Feldman, "A Brooklyn Hospital Needs the Parking More Than the Park," letter to the editor, *New York Times* (July 29, 1995): 18; Heidi Rain, "Place for Solace," letter to the editor, *New York Times* (July 29, 1995): 18; Erin St. John Kelly, "Children Find Locks, Not Slides," *New York Times* (November 23, 1997), XIV: 8.

60. Ronald Shiffman, quoted in Dunlap, "On the Brooklyn Waterfront: A Park, a Hospital and a Controversy": 1.

61. Joseph G. Merz, quoted in "Cobble Hill: Turning a Garage into a House-Garage That Blends into a Historic District," *New York Times* (November 14, 1993), X: 1. Also see White and Willensky, *AIA Guide* (2000), 676.

62. Shawn G. Kennedy, "Cobble Hill Conversion: The Fourth R, for Residing," *New York Times* (April 14, 1985), VIII: 1. For Sacred Heart and St. Stephen's School, see "Brooklyn School Contract Awarded," *New York Times* (April 29, 1922): 28; Landmarks Preservation Commission of the City of New York, *Cobble Hill Historic District Designation Report* (New York, 1969), 53.

63. "Carroll Gardens Units: Convent to Condos," *New York Times* (May 26, 1991), X: 1.

64. Alan S. Oser, "Loft Conversion Extends Boundary of Cobble Hill," *New York Times* (April 11, 1986): 25; Alan S. Oser, "Columbia Street Tips Hat to Commerce," *New York Times* (April 14, 1991), X: 5, 14.

65. "Cobble Hill Condos: A New Mews," *New York Times* (November 25, 1990), X: 1; Oser, "Columbia Street Tips Hat to Commerce": 5, 14; Rachelle Garbarine, "70 Condos in a Former Furniture Plant," *New York Times* (May 10, 1991), B: 8.

66. Joseph Giovannini, "Living in a Former Church: Space, Drama and Tranquillity," *New York Times* (March 7, 1985), C: 1, 6; White and Willensky, *AIA Guide* (2000), 680. For South Congregational Church and Ladies Parlor, see Landmarks Preservation Commission of the City of New York, LP-1245 (March 23, 1982); Diamonstein, *The Landmarks of New York III*, 112.

67. Giovannini, "Living in a Former Church: Space, Drama and Tranquillity": 1, 6; "Circa 1855: Seamen's Haven to Co-op," *New York Times* (April 13, 1986), VIII: 1.

68. "11 Middle-Income Condos: Old Church, New Life," *New York Times* (June 10, 1990), X: 1; White and Willensky, *AIA Guide* (2000), 682.

69. For the historic district, see Landmarks Preservation Commission of the City of New York, *Carroll Gardens Historic District Designation Report* (New York, 1973).

70. For the church, see *Carroll Gardens Historic District*, 5.

71. Alan S. Oser, "Brooklyn's Columbia St. in the Condominium Era," *New York Times* (September 14, 1984): 27; "80 Camp Out, Waiting for Condominium Offer," *New York Times* (June 10, 1985), B: 2; Oser, "Loft Conversion Extends Boundary of Cobble Hill": 25; Oser, "Columbia Street Tips Hat to Commerce": 5, 14; White and Willensky, *AIA Guide* (2000), 681.

72. "Growing in the Boerum Hill Historic District; Brooklyn Gets a House and Garden," *New York Times* (December 17, 1995), IX: 1; White and Willensky, *AIA Guide* (2000), 689; "Brick in Architecture: The 2000 Residential Issue: New York City Townhouse, Boerum Hill Landmark District," *Architecture* 89 (November 2000): 18–19. For Boerum Hill Historic District, see Landmarks Preservation Commission of the City of New York, *Boerum Hill Historic District Designation Report* (New York, 1973).

73. For Red Hook Houses, see Stern, Gilmartin, and Mellins, *New York 1930*, 445, 496, 498–99.

74. "A Container Terminal Dedicated in Brooklyn," *New York Times* (September 24, 1981), B: 8; Bruce Rosen, "Vitality of New York Port: A Water's-Edge View," letter to the editor, *New York Times* (June 27, 1986): 34; Anthony DePalma, "Measuring an Ominous Cloud Over the Port of New York," *New York Times* (January 11, 1987), E: 32; Anthony DePalma, "A Terminal Bustles and Bristles," *New York Times* (April 12, 1988), B: 1, 5; Anthony DePalma, "The Fate of a Waterfront Minus Ships," *New York Times* (December 17, 1989), E: 6; Lynette Holloway, "A New Crane to Help Lift Up a Sagging Port," *New York Times* (March 13, 1994), XIII: 8; "Refurbishing of Port Gets a Big Helping Hand," *New York Times* (April 20, 1994), B: 3; Michael Cooper, "Deep Water and 2 Cranes Revive Port," *New York Times* (July 30, 1995) XIII: 8.

75. "Port Agency Approves Two Brooklyn Projects," *New*

York Times (December 9, 1983), B: 3; David Bird and Maurice Carroll, "New York Day by Day," *New York Times* (September 21, 1984), B: 4; Samuel Weiss, "College in Brooklyn to Train Workers for Expected Seafood Industry Boom," *New York Times* (March 30, 1986): 33, 35; Michael Quint, "Only the Fish Are Missing at Fishport in Brooklyn," *New York Times* (July 27, 1988), B: 1, 8; Michael Quint, "Brooklyn Fish Market Closed," *New York Times* (April 4, 1989), B: 4; Andrew L. Yarrow, "Development Not Even a Contender on Brooklyn's Waterfront," *New York Times* (August 21, 1991), B: 3.

76. John Marchese, "Call It RedHo? An Artists' Colony Grows in (Red Hook) Brooklyn," *New York Times* (May 8, 1994), IX: 1, 8.

77. *Alfredo De Vido: Selected and Current Works*, 57–59.

78. David Gonzalez, "About New York," *New York Times* (July 5, 1997): 25; "Construction Begins on Red Hook Recreation Area," *New York Times* (July 31, 1997), B: 3; Paul H.B. Shin, "Red Hook Fixup," *New York Daily News* (August 28, 1998), Metro: 1; White and Willensky, *AIA Guide* (2000), 685.

79. "Red Hook Community Center, Brooklyn, New York," *Architecture* 85 (June 1996): 63; "A Small Project with Major Impact," *Architectural Record* 184 (September 1996): 16; "Project Citation: Red Hook Community Center," *Oculus* 60 (Summer 1998): 27; White and Willensky, *AIA Guide* (2000), 686; Balfour, *World Cities: New York*, 155; James S. Russell, "Red Hook Center for the Arts," *Architectural Record* 189 (March 2001): 136–39; *Hanrahan + Meyers Architects: The Four States of Architecture* (West Sussex, England: Wiley-Academy, 2002), 36–45.

80. For the 1944 master plan, see Stern, Mellins, and Fishman, *New York 1960*, 904–6.

81. For Cadman Plaza, the New York State Supreme Court Building, and the Federal Building and Courthouse, see Stern, Mellins, and Fishman, *New York 1960*, 904, 907–8.

82. For Borough Hall, see Stern, Mellins, and Fishman, *New York 1880*, 854. For the General Post Office, see Stern, Mellins, and Fishman, *New York 1880*, 854, 859. For the Municipal Building, see Stern, Gilmartin, and Mellins, *New York 1930*, 100–101, 104.

83. "Pulse," *Engineering News-Record* 206 (April 16, 1981): 153; Robin Herman and Laurie Johnston, "Sprucing Up in Brooklyn," *New York Times* (December 29, 1982), B: 1; William J. Conklin and Jeffrey Simpson, *Brooklyn's City Hall* (New York: Department of General Services, 1983); David Bird and Maurice Carroll, "Taking Leave of Borough Hall," *New York Times* (October 3, 1983), B: 4; Susan Heller Anderson and Maurice Carroll, "What a Restoration Can Do," *New York Times* (January 6, 1984), B: 3; "News Briefs," *Metropolis* 5 (July-August 1985): 14–15; Jesus Rangel, "Brooklyn Renews a Symbol of Pride," *New York Times* (March 26, 1986), B: 1, 24; Joyce Purnick, "Delays and Overruns Plague Borough Hall Restoration," *New York Times* (August 14, 1986), B: 1, 7; Christopher Gray, "Streetscapes: Brooklyn Borough Hall," *New York Times* (June 7, 1987), VIII: 14; David W. Dunlap, "In Brooklyn, Restoration Nears an End," *New York Times* (September 2, 1988), B: 1, 4; Larry Nathanson, "Revamp: It's a Wrap," *New York Post* (June 1, 1989): 44; Thomas Morgan, "Borough Hall Is Reopened in Brooklyn," *New York Times* (June 9, 1989), B: 3; Paul Goldberger, "4 Projects Honored for Design," *New York Times* (June 29, 1990), C: 11; Paul Goldberger, "Three New York City Success Stories," *New York Times* (July 22, 1990), II: 28, 30; White and Willensky, *AIA Guide* (2000), 638–39; Morrone, *An Architectural Guidebook to Brooklyn*, 39–42.

84. Goldberger, "Three New York City Success Stories": 28, 30.

85. Quoted in Jonathan Rabinovitz, "Moving of Courts Planned in Brooklyn," *New York Times* (August 18, 1992), B: 3.

86. Joseph P. Fried, "Courthouse Proposal Leaves Brooklyn Post Office Unscathed," *New York Times* (May 17, 1994), B: 3; Bill Farrell, "Feds to Deliver on Redesign Plan for Post Office," *New York Daily News* (September 18, 1995), Metro: 1; Michael Cooper, "Brooklyn Civic Center," *New York Times* (October 1, 1995), XIII: 12.

87. Lynda Richardson, "Revised Plan for Criticized Courthouse," *New York Times* (July 19, 1996), B: 3; Benjamin Forgey, "The Halls of Government," *Washington Post* (January 11, 1997), B: 1; "Pulse," *Engineering News-Record* 238 (February 24, 1997): 52; David Rohde, "As Courthouse Gets Go-Ahead, Lawsuit May Be One Step Behind," *New York Times* (March 16, 1997), XIII: 11; David Rohe, "Suit Seeks to Put Chains on Courthouse," *New York Times* (May 18, 1997), XIII: 8; Soren Larson, "No Shortage of Building Action in New York's Biggest Borough," *Architectural Record* 186 (June 1998): 40; David W. Dunlap, "Putting a New Face on Justice," *New York Times* (July 19, 1998), XI: 1, 14; David W. Dunlap, "Soaring Costs Delay Building of Federal Courthouse," *New York Times* (September 11, 1998), B: 3; Joseph P. Fried, "U.S. Courthouse Plan in Brooklyn Is Cut Back," *New York Times* (December 29, 1998), B: 3; Warren Chiara, "Kings County Construction to Increase 15%," *New York Construction News* 47 (April 1999): 20; White and Willensky, *AIA Guide* (2000), 640; Bill Farrell, "New Courthouse Arising," *New York Daily News* (February 8, 2000), Metro: 1; David S. Chartock, "Sequencing Aids Construction of Brooklyn Court Addition," *New York Construction News* 49 (March 2001): 39–40, 42, 45, 47–48; Bill Farrell, "Courthouse Survives Cuts," *New York Daily News* (July 2, 2001), Metro: 1; "U.S. Federal Courthouse," *New York Construction News* 49 (June 2002): 21; "Limestone Defines Brooklyn Courthouse," *Stone World* 20 (October 2003): 108; Tom Stabile, "A Monumental Job," *New York Construction News* 51 (November 2003): 31; John Marzulli, "Courthouse Delays Fed Project Close Pushed to 2006 by Bankruptcy," *New York Daily News* (January 28, 2004), Metro: 1.

88. Quoted in *R. M. Kliment & Frances Halsband Architects* (Mulgrave, Australia: Images Publishing, 1998), 204–13. Also see "Construction Week," *Engineering News-Record* 238

(March 17, 1997): 5; "R. M. Kliment & Frances Halsband Architects," *Architectural Record* 185 (May 1997): 90; Larson, "No Shortage of Building Action in New York's Biggest Borough": 40; Dunlap, "Putting a New Face on Justice": 1, 14; Carter Wiseman, "Critique," *Architectural Record* 187 (May 1999): 49; Roberto Santiago, "Bright Idea Downtown," *New York Daily News* (September 9, 1999), Metro: 2; "From Main Post Office to Federal Courtrooms," *New York Times* (September 12, 1999), XI: 1; White and Willensky, *AIA Guide* (2000), 640; David S. Chartock, "Brooklyn's History Meets Its Future at $129.7M Adaptive Reuse Project," *New York Construction News* 48 (February 2000): 22–25; Balfour, *World Cities: New York*, 157; "U.S. Courthouse and Post Office Renovation and Addition," *New York Construction News* 49 (June 2002): 25; Marzulli, "Courthouse Delays Fed Project Close Pushed to 2006 by Bankruptcy": 1.

89. Joseph P. Fried, "High-Rise Answer to Brooklyn's Courtroom Problem," *New York Times* (August 15, 1999): 29; Eric Lipton, "Halls of Justice Going Up All Over," *New York Times* (December 5, 2000), B: 1, 9; Edwin McDowell, "For Brooklyn, a High Courthouse," *New York Times* (August 1, 2001), B: 6; "Brooklyn Courthouse Project Begins on Jay St.," *New York Construction News* 49 (March 2002): 9; David S. Chartock, "Brooklyn Courthouse," *New York Construction News* 49 (July 2002): 51.

90. Pat Smith, "AIG Will Move 2000 to B'klyn," *New York Post* (June 28, 1988): 37–38; Thomas J. Lueck, "Transforming Downtown Brooklyn," *New York Times* (January 22, 1989), X: 1, 13; Shawn G. Kennedy, "Metrotech's Start Signals a Neighborhood Comeback," *New York Times* (October 1, 1989), X: 25; David W. Dunlap, "Two Tall Office Towers Planned on a Single Block," *New York Times* (March 18, 1990), X: 21; David W. Dunlap, "Big Developments Stalled in New York's Real-Estate Slump," *New York Times* (March 4, 1991), B: 4; Michael Cooper, "Developer Given More Time to Finance Renaissance Plaza," *New York Times* (June 25, 1995), IX: 9; Claudia H. Deutsch, "Looking Back, and Ahead; Outlook: Cloudy, with Silver Linings," *New York Times* (January 14, 1996), IX: 1, 9; Bill Farrell, "Renaissance Plaza's On Again," *New York Daily News* (February 22, 1996): 2; Bill Farrell, "Hotel's Traffic Jam Threat Called Minimal," *New York Daily News* (May 10, 1996), Metro: 1; Lynda Richardson, "Land Clearing Starts for Brooklyn Hotel," *New York Times* (July 24, 1996), B: 3; John Holusha, "Things Are Looking Up–And Going Up," *New York Times* (September 15, 1996), IX: 1, 8; Bill Farrell, "How Suite It Is to Build New Hotel," *New York Daily News* (October 14, 1996), Metro: 1; "Long-Awaited Construction Underway at Brooklyn's Renaissance Plaza," *New York Construction News* 45 (May 19, 1997): 1, 7; Bill Farrell, "Newest High-Rise Hits the Heights," *New York Daily News* (August 21, 1997), Metro: 1; "With a Flourish of Flags, the Finishing Touch," *New York Times* (September 5, 1997), B: 6; Bill Farrell, "Marriott Beaming With Joy," *New York Daily News* (September 5, 1997), Metro: 2; Charles V. Bagli, "Hotel Business Is Growing Bigger, Busier and Faster," *New York Times* (November 23, 1997): 39; Alan S. Oser, "In Brooklyn, New Allure for Old Office Buildings," *New York Times* (November 26, 1997), B: 6; Bill Farrell, "Majestic Hotel Checks In," *New York Daily News* (June 28, 1998), Metro: 1; John Holusha, "Assembling the Puzzle That Is Renaissance Plaza," *New York Times* (September 2, 1998), B: 7; Marcia Biederman, "A Year Later, Marriott Isn't Big Enough," *New York Times* (July 11, 1999), XIV: 9; White and Willensky, *AIA Guide* (2000), 641; John Holusha, "Open Only Two Years, a Hotel Is Ready to Expand," *New York Times* (April 2, 2000), XI: 9; Morrone, *An Architectural Guidebook to Brooklyn*, 68–69; "280 More Rooms for the Marriott; Hotel to Grow in Brooklyn," *New York Times* (March 24, 2002), XI: 1.

91. "Brooklyn Law School to Erect a $25M, 10-Story Addition," *New York Construction News* 38 (February 25, 1991): 1, 5; "Pulse," *Engineering News-Record* 226 (April 8, 1991): 72; Clare Melhuish, "Present Tense," *Building Design* (May 17, 1991): 20–21; Henrik Krogius, "Brooklyn Law Is Set to Add New Building," *Brooklyn Heights Press and Cobble Hill News* (February 27, 1992): 1, 13; David W. Dunlap, "City Colleges Add $2 Billion in Facilities," *New York Times* (September 12, 1993), X: 1, 12; "Brooklyn Law School Tower, Brooklyn, New York," *Classicist* 1 (1994–1995): 38; Herbert Muschamp, "If You Squint, This is Not a Faulty Tower," *New York Times* (August 21, 1994), II: 32; "Brooklyn Law School Tower, Brooklyn, by Robert A. M. Stern Architects," *Oculus* 57 (September 1994): 8–9; H. Robert Lloyd and Carolyn Konheim, "Brooklyn Law School," letters to the editor, *New York Times* (September 11, 1994), II: 16; David Brussat, "Squinting at Prof. Muschamp," *Providence Journal-Bulletin* (September 15, 1994): 17; *New Architecture in Brooklyn 1985–1995: The Rotunda Gallery, November 9-December 21, 1995*, 4, 17; Wendy Moonan, "Classical Comeback," *Oculus* 57 (April 1995): 12–13; "New Architecture in Brooklyn," *Newsline* (November/December 1995): 7; "Cityscape as Art," *New York Times* (November 5, 1995), XIII: 14; Gabriele Tagliaventi, ed., *Urban Renaissance* (Bologna: Grafis Edizioni, 1996), 212–13; Sirefman, *New York*, 284–85; Peter Morris Dixon, ed., *Robert A. M. Stern: Buildings and Projects, 1993–1998* (New York: Monacelli Press, 1998), 84–89; White and Willensky, *AIA Guide* (2000), 639; Roger Scruton, "After Modernism," *City Journal* 10 (Spring 2000): 91, 95; Morrone, *An Architectural Guidebook to Brooklyn*, cover, 46–48. Also see "Law School Buys Bank Building," *New York Times* (April 11, 1984), B: 4. For Praeger-Kavanagh-Waterbury's building, see Stern, Mellins, and Fishman, *New York 1960*, 908.

92. Muschamp, "If You Squint, This is Not a Faulty Tower": 32.

93. Konheim, "Brooklyn Law School": 16.

94. Morrone, *An Architectural Guidebook to Brooklyn*, 46.

95. Tara Bahrampour, "A Native Son to Design for the Law School," *New York Times* (May 27, 2001), XIV: 7; Lore Croghan,

"Downtown B'klyn Dead Zone Shows Signs of New Life," *Crain's New York Business* (June 4, 2001): 19–20; A. J. Harris, "Brooklyn Residents Will Fight Law School Dorm," *New York Sun* (April 19, 2002): 3; Tara Bahrampour, "Brooklyn Heights," *New York Times* (May 5, 2002), XIV: 8; Errol Louis, "Downtown Brooklyn Prefers a Jail to a Law Dorm," *New York Sun* (May 29, 2002): 6; Errol Louis, "Plan for Law School Dorm Draws Heavy Fire," *New York Sun* (May 30, 2002): 3; David W. Dunlap, "In Downtown Brooklyn, Too Tall Suddenly Fits," *New York Times* (July 4, 2002), B: 3; Frances Yauch, "120 Feet in Brooklyn," letter to the editor, *New York Times* (July 9, 2002): 20; Frank Lombardi, "Foes Raise Roof About Dorm," *New York Daily News* (July 22, 2002), Metro: 1; Patrick Gallahue, "Law Tower Ok," *Brooklyn Heights Paper* (July 29, 2002): 1, 9; Rachelle Garbarine, "First, the Zoning Change; Next, the Apartments," *New York Times* (September 6, 2002), B: 8; Micki Berman, "Law School Dorm Faces New Hurdle," *New York Daily News* (November 19, 2002), Metro: 3; Anita Jain, "Construction Accident at Brooklyn Law School Spurs Opposition to New Dorm," *New York Sun* (November 22, 2002): 11; Michael Brick, "Plugging a Hole in Brooklyn's Heart," *New York Times* (January 7, 2004), B: 1–2.

96. Joan L. Millman, quoted in Dunlap, "In Downtown Brooklyn, Too Tall Suddenly Fits": 3.

97. Diane Henry, "Research Venture at Polytechnic," *New York Times* (June 30, 1982), D: 18; "A Technical Center Grows in Brooklyn," *Architectural Record* 171 (April 1983): 85; "MetroTech Pyrotechnics," *Metropolis* 3 (November 1983): 10–11; Edward A. Gargan, "Six Growth Plans Proposed by City," *New York Times* (December 7, 1983): 1, B: 4; Jesus Rangel, "A $340 Million Complex Announced for Brooklyn," *New York Times* (December 8, 1984): 27; "Opening the Brooklyn Option," editorial, *New York Times* (December 26, 1984): 30; Alan S. Oser, "Metrotech: A Test for a New Form of Urban Renewal," *New York Times* (January 6, 1985), VIII: 7; Alan S. Oser, "Brooklyn Launches Its Biggest Office-Building Effort," *New York Times* (January 27, 1985), VIII: 7; Samuel Weiss, "Revived Polytech Is Focusing on Plan for Industrial Park," *New York Times* (April 12, 1985), B: 1, 4; Kirk Johnson, "Development Activity Advances in Brooklyn," *New York Times* (August 11, 1985), VIII: 1, 14; Crystal Nix, "Brooklyn Gets Wall St. Data Group," *New York Times* (April 8, 1986), B: 1; "The Common Pursuit," *Architectural Record* 175 (March 1987): 55; Michael Sorkin, "Silicon Implants in Brooklyn," *Village Voice* (March 31, 1987): 92, reprinted in Michael Sorkin, *Exquisite Corpse* (London: Verso, 1991), 215–18; "Names and News," *Oculus* 48 (May 1987): 19, 30; James C. McKinley, "Metrotech Waits Approval Amid Protests," *New York Times* (June 28, 1987), VIII: 9; George James, "High-Tech Brooklyn Complex Approved," *New York Times* (July 7, 1987), B: 3; Susan Bellow, "Turning Brooklyn High-Tech," *Metropolis* 7 (July/August 1987): 15–16; "Plan to Alter Firehouse Is Debated in Brooklyn," *New York Times* (September 6, 1987): 54; "Computer Concern to Sign Metrotech Lease," *New York Times* (March 10, 1988), D: 23; Alan S. Oser, "Lease Gives Impetus to Brooklyn Project," *New York Times* (April 3, 1988), X: 5; Thomas J. Lueck, "Koch Assures Chase on Security If It Moves Unit to Brooklyn Site," *New York Times* (September 21, 1988), B: 3; "Brooklyn Needs a Friend at Chase," editorial, *New York Times* (October 14, 1988): 34; Pat Smith, "How College Nightmare Bore MetroTech Dream," *New York Post* (October 20, 1988): 68; Thomas J. Lueck, "Chase Is Said to Have Picked Brooklyn Site," *New York Times* (November 8, 1988), B: 1–2; Thomas J. Lueck, "Chase Deal Reflects Era of Subsidies," *New York Times* (November 11, 1988), B: 1, 4; "Topics of The Times: Brooklyn's Chase Advantage," *New York Times* (November 16, 1988): 30; Thomas J. Lueck, "Lawsuit Settled for MetroTech; Work Is to Start," *New York Times* (December 15, 1988), B: 4; Thomas J. Lueck, "Transforming Downtown Brooklyn," *New York Times* (January 22, 1989), X: 1, 13; Peg Tyre and Jeannette Walls, "Artists Say They Won't Be Moved," *New York* 22 (June 5, 1989): 10; Thomas Morgan, "Ceremony Heralds a $1 Billion Project in Brooklyn," *New York Times* (June 9, 1989), B: 3; Thomas J. Lueck, "Metrotech Agrees to Pay $2 Million to Aid Tenants," *New York Times* (September 30, 1989): 27; Jennifer Stern, "When Community Groups Cut a Deal, Who Wins?" *City Limits* 14 (November 1989): 17–20; Ted Glick, "Metrotech," letter to the editor, *New York Times* (November 5, 1989), X: 16; "Making Way for Metrotech: Historic Homes on the Move," *New York Times* (February 4, 1990), X: 1; "Landmark Buildings on the Move," *New York Times* (February 17, 1990): 31; Alan S. Oser, "Perspectives: Developing in Brooklyn," *New York Times* (January 12, 1992), X: 3; Mervyn Rothstein, "Industrial Revolution," *New York Times* (April 5, 1992), 4A: 20; Steven Lee Myers, "The Prime of 'Wall Street East,'" *New York Times* (May 15, 1992), B: 1–2; Somini Sengupta, "Downtown Brooklyn: The Promise and the Peril," *New York Times* (October 27, 1996), XIII: 10; Joyce Shelby, "Metrotech Dream Grows," *New York Daily News* (May 27, 1997), Metro: 1; John Holusha, "A Dream Grows in Brooklyn," *New York Times* (June 22, 1997), IX: 1, 6; Todd Bressi, "Downtown Brooklyn: Turning the Corner?" *Urban Land* 56 (October 1997): 28–29; Bill Farrell, "MetroTech Eyed as Object Lesson," *New York Daily News* (October 16, 1997), Metro: 1; Morrone, *An Architectural Guidebook to Brooklyn*, 30–35; John Holusha, "In Brooklyn, Projects, Plans and Hopes," *New York Times* (January 27, 2002), XI: 1, 8.

98. Landmarks Preservation Commission of the City of New York, LP-2089 (2001).

99. For Freeman's Fire Headquarters, see Stern, Mellins, and Fishman, *New York 1880*, 854, 858–59.

100. Morgan, "Ceremony Heralds a $1 Billion Project in Brooklyn": 3; Shawn G. Kennedy, "Metrotech's Start Signals a Neighborhood Comeback," *New York Times* (October 1, 1989), X: 25; Alan S. Oser, "Creating a Critical Mass at Metrotech," *New York Times* (January 14, 1990), X: 5.

101. Kennedy, "Metrotech's Start Signals a Neighborhood Comeback": 25; Oser, "Creating a Critical Mass at Metrotech": 5; David W. Dunlap, "Commercial Property: Metrotech," *New York Times* (June 16, 1991), X: 15.

102. Rob Speyer, "Fire Dept. Has Eye on New \$55M HQ," *New York Daily News* (March 2, 1995), Metro: 4; Austin Evans Fenner, "FDNY Move May Be in the Cards," *New York Daily News* (March 16, 1995), Metro: 9; Shelby, "Metrotech Dream Grows": 1; Bill Farrell, "Bravest Get Hot New Digs," *New York Daily News* (October 10, 1997), Metro: 1; White and Willensky, *AIA Guide* (2000), 642; Morrone, *An Architectural Guidebook to Brooklyn*, 32.

103. "Proposals Due Dec. 6 for Chase Building," *New York Construction News* 36 (November 28, 1988): 1; "'90 Start Set for Chase MetroTech Center," *New York Construction News* 37 (September 11, 1989): 1, 10; Kennedy, "Metrotech's Start Signals a Neighborhood Comeback": 25; Oser, "Creating a Critical Mass at Metrotech": 5; *New Architecture in Brooklyn 1985–1995: The Rotunda Gallery, November 9-December 21, 1995*, 14; White and Willensky, *AIA Guide* (2000), 642; Morrone, *An Architectural Guidebook to Brooklyn*, 31–32. For Walker's building, see Stern, Gilmartin, and Mellins, *New York 1930*, 567, 571.

104. Eric Herman, "Empire Blue Headed to Brooklyn," *New York Daily News* (November 15, 2001): 69; Andrew Rice, "Back to the Drawing Board," *Architecture* 91 (January 2002): 44–45, 47–49; Holusha, "In Brooklyn, Projects, Plans and Hopes": 1, 8.

105. Oser, "Creating a Critical Mass at Metrotech": 5; Dunlap, "Commercial Property: Metrotech": 15; Anthony DePalma, "Maxwell to Donate \$10 Million to Polytechnic U.," *New York Times* (September 18, 1991): 17; Nadine M. Post, "Taking the Path of Most Resistance," *Engineering News-Record* 228 (February 10, 1992): 26; Rothstein, "Industrial Revolution": 20; White and Willensky, *AIA Guide* (2000), 642; Morrone, *An Architectural Guidebook to Brooklyn*, 32.

106. White and Willensky, *AIA Guide* (2000).

107. Dunlap, "City Colleges Add \$2 Billion in Facilities": 1, 12; "New Student Center in Brooklyn," *New York Times* (October 27, 1996), IX: 1; White and Willensky, *AIA Guide* (2000), 642; Morrone, *An Architectural Guidebook to Brooklyn*, 35–36.

108. Karen W. Arenson, "Polytechnic U. Plans a Makeover Using Gift, but Not Everyone Is Happy," *New York Times* (October 25, 1999), B: 5; "A \$175 Million Gift, a \$100 Million Upgrading: 2 New Buildings for Polytechnic U. in Brooklyn," *New York Times* (November 14, 1999), XI: 1; Bob Liff, "Polytechnic Thinking Big," *New York Daily News* (May 15, 2000), Metro: 1; Roberto Santiago, "Poly Grad, Patron a Groundbreaker," *New York Daily News* (May 19, 2000), Metro: 1; Bill Farrell, "Metrotech's Plans: Sky Is the Limit," *New York Daily News* (November 26, 2000), Metro: 4; Michael O. Allen, "Polytechnic Ceremony Raises the Roof," *New York Daily News* (May 21, 2001), Metro: 2; Elizabeth Hays, "\$275M & More for Poly," *New York Daily News* (June 26, 2001), Metro: 1; Carolina Gonzalez, "Polytech Looking Up," *New York Daily News* (July 27, 2001), Metro: 3; Ellen Lask, "Polytechnic Dormitory Team Beats Schedule Odds, Overcomes Delays," *New York Construction News* 49 (March 2002): 25–26, 29–31; "Polytechnic University's Donald F. and Mildred Topp Othmer Residence Hall," *New York Construction News* 50 (December 2002): 43.

109. Nory Miller, *Helmut Jahn* (New York: Rizzoli International Publications, 1986), 255; "Cylinders by Jahn," *New York Times* (June 29, 1986), VIII: 1; "New York," *Engineering News-Record* 218 (January 8, 1987): 28; Alan S. Oser, "Coming Attractions for Office Tenants," *New York Times* (June 28, 1987), VIII: 9; David W. Dunlap, "Designed for a Dozen, but One Tenant's Enough," *New York Times* (November 3, 1991), X: 13; *Murphy/Jahn: Selected and Current Works* (Mulgrave, Australia: Images Publishing, 1995), 242; Morrone, *An Architectural Guidebook to Brooklyn*, 49–51.

110. Deirdre Carmody, "Gateway to Brooklyn," *New York Times* (June 5, 1985), B: 4; White and Willensky, *AIA Guide* (2000), 646.

111. For Brooklyn Paramount Theater and office building, see Stern, Gilmartin, and Mellins, *New York 1930*, 254, 263; Christopher Gray, "Streetscapes/The Brooklyn Paramount," *New York Times* (July 31, 1994), IX: 7; Stern, Mellins, and Fishman, *New York 1960*, 903, 910, 1105.

112. *Mitchell/Giurgola: Selected and Current Works* (Mulgrave, Australia: Images Publishing, 1996), 128.

113. Dunlap, "City's Colleges Add \$2 Billion in Facilities": 1, 12; "April Start Set for \$20M LIU Health Sciences Center," *New York Construction News* 41 (March 14, 1994): 1, 3; "Zeckendorf Center Features Clock Tower; A New Building for L.I.U.," *New York Times* (October 1, 1995), IX: 1; *Mitchell/Giurgola: Selected and Current Works*, 130–35; White and Willensky, *AIA Guide* (2000), 646.

114. "Addition for School of Education on Brooklyn Campus: A New Building for L.I.U.," *New York Times* (August 29, 1999), XI: 1; Joyce Shelby, "L.I.U. Building Its Future; New 6-Story Hi-Tech Center," *New York Daily News* (March 18, 2001), Metro: 1.

115. "People-Oriented Mall in Brooklyn," *Domus* 563 (October 1976): 30–31; Marcia Chambers, "Federal Government Grants \$2.9 Million to Build Fulton Street Mall," *New York Times* (January 20, 1977): 41; "'Improvements' Debated on Brooklyn's Fulton St.," *New York Times* (January 11, 1981): 46; Frank J. Prial, "Mall Stands Alone in Brooklyn 'Renaissance,'" *New York Times* (April 9, 1982), B: 1–2; Jesus Rangel, "Two Years After Renovation, Brooklyn's Fulton Mall Still Seeks an Anchor," *New York Times* (June 14, 1986): 29; Mary McAleer Vizard, "Planning Strategies for a New Retail Environment," *New York Times* (June 14, 1992), X: 11.

116. For the RKO Albee, see Stern, Mellins, and Fishman, *New York 1960*, 910.

117. Lynette Holloway, "Toys 'R' Us Creates Burst of Optimism," *New York Times* (November 28, 1993), XIII: 10; Claudia H. Deutsch, "Learning a Lesson in Urban Retailing," *New York Times* (June 19, 1994), X: 13; Andy Newman, "Grand Plans for a Mall That's Heard It All Before," *New York Times* (April 1, 2002), B: 6; Andy Newman, "Unfinished Mall Renovation Angers Merchants," *New York Times* (December 4, 2002), B: 3.

118. For Atlantic Terminal Urban Renewal Area, see Stern, Mellins, and Fishman, *New York 1960*, 912, 919.

119. Jesus Rangel, "Office-Housing Plan for Downtown Brooklyn," *New York Times* (January 17, 1985), B: 3; Alan S. Oser, "Brooklyn Launches Its Biggest Office-Building Effort," *New York Times* (January 27, 1985), VIII: 7, 14; Susan Heller Anderson and David W. Dunlap, "Complexities in Brooklyn," *New York Times* (February 19, 1985): 27; Martin Gottlieb, "Brooklyn Plan: Retail Center and 2 Towers," *New York Times* (July 31, 1985), B: 1; "In Progress," *Progressive Architecture* 66 (August 1985): 41; Kirk Johnson, "Development Activity Advances in Brooklyn," *New York Times* (August 11, 1985), VIII: 1, 14; "Give Central Brooklyn a Boost," editorial, *New York Times* (September 24, 1986): 30; Jesus Rangel, "A Plan for Brooklyn Rises at Atlantic Terminal," *New York Times* (September 28, 1986): 51; "Brooklyn Plan Is Approved," *New York Times* (October 10, 1986), B: 3; Alan S. Oser, "Creating an Urban Neighborhood," *New York Times* (November 16, 1986), VIII: 6, 20; James C. McKinley, "Brooklyn Projects Get E.P.A. Go-Ahead," *New York Times* (May 31, 1987), VIII: 9; Thomas J. Lueck, "Transforming Downtown Brooklyn," *New York Times* (January 22, 1989), X: 1, 13; Shawn G. Kennedy, "Metrotech's Start Signals a Neighborhood Comeback," *New York Times* (October 1, 1989), X: 25; Tom McGhee, "Terminal Gets a New Start," *Metropolis* 9 (June 1990): 17–18; David W. Dunlap, "Big Developments Stalled in New York's Real-Estate Slump," *New York Times* (March 4, 1991), B: 4; Thomas J. Lueck, "'Other Boroughs' Strategy Bucks Difficult Times," *New York Times* (March 10, 1991), X: 1, 13; "Dialogue/June 1990," *Metropolis* 10 (May 1991): 18; "\$10.7 Million Grant Nullified: Atlantic Terminal Blow," *New York Times* (May 26, 1991), X: 1; Peter Calthorpe, *The Next American Metropolis: Ecology, Community, and the American Dream* (New York: Princeton Architectural Press, 1993), 136–37, 171; Alan S. Oser, "Bradlees at Atlantic Center: Retailing Opens a New Front in Brooklyn," *New York Times* (June 27, 1993), X: 5; Peter Katz, *The New Urbanism: Toward an Architecture of Community* (New York: McGraw-Hill, 1994), 164–67, 236; Rachelle Garbarine, "New Project Takes Shape in Brooklyn," *New York Times* (June 10, 1994) B: 6; Jennifer Steinhauer, "Downtown Brooklyn: Atlantic Center Loses Bradlees, Officials Say," *New York Times* (November 13, 1994), XIII: 11; Thomas J. Lueck, "Downtown Development Is Looking Up in Brooklyn, Planners Find," *New York Times* (October 30, 1996), B: 1, 3; "Booming Brooklyn," editorial, *New York Times* (November 7, 1996): 32; David W. Dunlap, "Developers' Hazard: Legal Hardball," *New York Times* (December 8, 1996), IX: 1, 6; Alan S. Oser, "Housing at Atlantic Center Nears a New Phase," *New York Times* (August 31, 1997), IX: 5; Amy Waldman, "Scenes from the Malls: Megastores and Mini-Bazaars," *New York Times* (December 14, 1997), XIV: 9; Jotham Sederstrom, "Ratner Tower Won't Play by City Rules," *Brooklyn Paper* (March 27, 2004): 1, 14; Diane Cardwell, "Rethinking Atlantic Center with the Customer in Mind," *New York Times* (May 26, 2004), B: 1.

120. "Give Central Brooklyn a Boost": 30.

121. Frederick Rose, quoted in Oser, "Brooklyn Launches Its Biggest Office-Building Effort": 7.

122. For the Williamsburgh Savings Bank, see Stern, Gilmartin, and Mellins, *New York 1930*, 544–45.

123. Calthorpe, *The Next American Metropolis*, 136.

124. Peter Calthorpe, quoted in Oser, "Creating an Urban Neighborhood": 6.

125. "Give Central Brooklyn a Boost": 30.

126. Paul A. Travis, quoted in Oser, "Bradlees at Atlantic Center: Retailing Opens a New Front in Brooklyn": 5.

127. Quoted in Sederstrom, "Ratner Tower Won't Play by City Rules": 14.

128. Francis Morrone, "Abroad in New York," *New York Sun* (February 23, 2004): 15.

129. David W. Chen, "M.T.A. Backs Plan to Build Mall Over Brooklyn Terminal," *New York Times* (January 28, 1998), B: 3; Andy Newman, "Mayor, Ordering City Hall Review, Delays Plan to Build Mall Over Brooklyn Terminal," *New York Times* (January 29, 1998), B: 5; Thomas J. Lueck, "Plan Ratified for Mall at L.I.R.R. Terminal," *New York Times* (March 27, 1998), B: 10; Kit R Roane, "Mall Builder Sees New Brooklyn, but Neighbors See Trouble," *New York Times* (June 21, 1999), B: 3; *Hardy Holzman Pfeiffer Associates: Buildings and Projects, 1992–1998* (New York: Rizzoli International Publications, 1999), 196–97; Balfour, *World Cities: New York*, 254–55; Sana Siwolop, "Work to Start Soon on Mall at Atlantic Terminal," *New York Times* (April 4, 2001), B: 4; John Holusha, "In Brooklyn, Projects, Plans and Hopes," *New York Times* (January 27, 2002), XI: 1, 8; Amy S. Choi, "Retail in Brooklyn: Atlantic Terminal Retail Complex Built Over Transportation Hub," *New York Construction* 51 (October 2003): 69, 71–72; Morrone, "Abroad in New York": 15; Denis Hamill, "Atlantic Terminal Is Just a Start," *New York Daily News* (July 25, 2004), Metro: 2; Steve Viuker, "At Site Dodgers Rejected, Target Store Is a Hit," *New York Times* (August 8, 2004), XI: 11; Hope Reeves, "Sampling Suburbia Inside a Brooklyn Mall," *New York Times* (August 16, 2004), B: 3.

130. Quoted in *Hardy Holzman Pfeiffer Associates: Buildings and Projects, 1992–1998*, 196-97.

131. Luis Perez, "High Hopes in Move by Bank," *New York Daily News* (August 27, 2002): 4.

132. Stern, Mellins, and Fishman, *New York 1880*, 861–64.

133. Stern, Gilmartin, and Massengale, *New York 1900*, 212, 214–15.

134. John Rockwell, "Brook's Hindu Epic to Tour in U.S.," *New York Times* (November 4, 1986), C: 13; Nan Robertson, "Making Way for 'Mahabharata,'" *New York Times* (September 30, 1987), C: 19; Susan Heller Anderson, "Restoring a Theater to Its Decrepit State," *New York Times* (October 13, 1987), B: 1, 4; Frank Rich, "Stage: From Brook, 'The Mahabharata,'" *New York Times* (October 19, 1987), C: 15; Michael Kimmelman, "Putting Old Wrinkles into a Theater's New Face," *New York Times* (October 25, 1987), II: 20, 41; Enid Nemy, "New Yorkers, Etc.," *New York Times* (October 25, 1987): 55; Kurt Andersen, "Echoes of the Past, Visions for the Present," *Time* 131 (January 4, 1988): 74–75; Andrew L. Yarrow, "Transforming a Brooklyn Theater," *New York Times* (January 5, 1988), C: 13; Jim Murphy, "A Celebrated Dissolution," *Progressive Architecture* 69 (April 1988): 100–103; Nora Fitzgerald, "Renovating Brooklyn's Majestic," *Metropolis* 8 (July/August 1988): 22–23; Hugh Hardy, "'What Time Is It?'" *Oz* 12 (1990): 30–35; "Stage Experience," *Interiors* 150 (September 1991): 100–101; *Hardy Holzman Pfeiffer Associates: Buildings and Projects, 1967–1992* (New York: Rizzoli International Publications, 1992), 28, 152–55, 264; Glenn M. Andres, *Hardy Holzman Pfeiffer Associates: Concepts and Buildings* (Middlebury, Vt.: Middlebury College Museum of Art, 1993), 32; Andrew Todd, "Rinascite Quotidiane," *Spazio e Società* 18 (October-December 1996): 8–21; Somini Sengupta, "The Big BAM Theory," *New York Times* (November 3, 1996), XIII: 3; Sirefman, *New York*, 286–87; David E. Brown, "Keeping it Real," *Metropolis* 17 (December 1997-January 1998): 68–69, 91; White and Willensky, *AIA Guide* (2000), 694; *Hardy Holzman Pfeiffer Associates: Theaters* (Mulgrave, Australia: Images Publishing, 2000), 84–87; Peter Brook, *Threads of Time: A Memoir* (London: Methuen Drama, 1998), 192; Balfour, *World Cities: New York*, 121–22.

135. Kimmelmann, "Putting Old Wrinkles Into a Theater's New Face": 41.

136. *Hardy Holzman Pfeiffer Associates: Buildings and Projects, 1992–1998*, 134–39; *Hardy Holzman Pfeiffer Associates: Theaters*, 88–97. Also see Douglas Martin, "Brooklyn Academy Bets on the Borough," *New York Times* (January 14, 1998), E: 1, 3; Andy Newman, "More Than Just a Movie House," *New York Times* (November 12, 1998), E: 1, 7.

137. "Exterior Restoration Job Commence on BAM," *New York Construction News* 49 (June 2002): 64; "BAM Makeover Is a Piece of Cake," *Crain's New York Business* (September 2, 2002): 6; Carol Vogel, "Academy of Music in the Land of the Sweets," *New York Times* (September 30, 2002), E: 1, 5; Glenn Collins, "A Brooklyn Landmark Gets Its Crown Back," *New York Times* (May 17, 2004), B: 1, 4.

138. Mark McCain, "An Agency with Large Successes in Small Projects," *New York Times* (October 4, 1987), VIII: 29.

139. Nicolai Ouroussoff, "A Born-Again Building in Brooklyn," *New York Times* (April 5, 1992), II: 40; *Steven Holl* (Zurich: Artemis; Bordeaux: Arc en rêve centre d'architecture, 1993), 40–41; Dennis Hevesi, "Art of Glass Blowing Finds a Home in Brooklyn," *New York Times* (November 25, 1993), B: 4; *Steven Holl: Idea and Phenomena* (Baden: Lars Müller, 2002), 115; Kenneth Frampton, *Steven Holl Architect* (Milan: Electa Architecture, 2003), 391.

140. Jennifer Dunning, "Mark Morris Will Build Brooklyn Dance Center," *New York Times* (July 1, 1999), E: 5; Celestine Bohlen, "Dancers' Brooklyn Fixer-Upper," *New York Times* (March 8, 2001), E: 3; Jeff Hill, "Phoenix Rising," *Interior Design* 72 (September 2001): 234–39; Celestine Bohlen, "Mark Morris Dance Center Adds Luster to Brooklyn," *New York Times* (September 12, 2001), E: 1, 4; Laura Leivick, "Possessed by the Idea of Presenting Mark Morris to the World," *New York Times* (February 3, 2002), II: 7, 32; "Correction," *New York Times* (February 24, 2002), II: 6; Christopher Reardon, "In His New Space, Mark Morris Has Room to Move," *Boston Globe* (March 10, 2002), L: 5.

141. Fred Bland, quoted in Hill, "Phoenix Rising": 239.

142. For Fort Greene, see Stern, Mellins, and Fishman, *New York 1960*, 900–901; Stern, Mellins, and Fishman, *New York 1880*, 884–88.

143. Landmarks Preservation Commission of the City of New York, *Fort Greene Historic District Designation Report* (New York, 1978).

144. Stephen B. Jacobs, quoted in Shawn G. Kennedy, "Fort Greene Integrates as It Gentrifies," *New York Times* (June 23, 1985), VIII: 1, 14. Also see Alan S. Oser, "Brooklyn's Brownstones Thrive Amid Restoration," *New York Times* (September 26, 1986): 29; "Fort Greene Condominium: A Brooklyn Phoenix," *New York Times* (March 13, 1988), X: 1; Tracie Rozhon, "Second Empire Phoenix," *New York Times* (January 2, 1994): 4.

145. Alan S. Oser, "City Housing Challenges: A Developer's Expertise," *New York Times* (November 20, 1981): 33; White and Willensky, *AIA Guide* (2000), 701.

146. Andrew S. Dolkart, "Historical Introduction," in Landmarks Preservation Commission of the City of New York, *Clinton Hill Historic District Designation Report* (New York, 1981), 7. For Clinton Hill, see Stern, Mellins, and Fishman, *New York 1960*, 901–3; Stern, Mellins, and Fishman, *New York 1880*, 888–99.

147. David W. Dunlap, "New York City Seeks to Raze a Landmark," *New York Times* (December 23,1987), B: 1–2; David W. Dunlap, "Tenement Demolition Plan Ended," *New York Times* (January 28, 1988), B: 5; David W. Dunlap, "After Surviving Razing Plan, Brooklyn Building Gets Grant," *New York Times* (August 24, 1988), B: 2; Richard D. Lyons, "48 Duplex Condos: Subsidized Town Houses Near Clinton Hill," *New York Times* (February 5, 1989), X: 1; Diana Shaman, "Converting a Building, Reviving an Area," *New York Times* (October 12, 1990): 23; Mervyn Rothstein, "Clinton Hill: The Past Serving the Present," *New York Times* (December 5, 1993), X: 1, 11. For the Vendome, see *Clinton Hill Historic District*, 101.

148. "Building in a Historic District: 11 Condo Rowhouses for Clinton Hill," *New York Times* (May 20, 1990), X: 1.

149. For Pratt, see Landmarks Preservation Commission of the City of New York, LP-2010-12 (December 22, 1981); Stern, Mellins, and Fishman, *New York 1930*, 114; Diamonstein, *The Landmarks of New York III*, 190; Stern, Mellins, and Fishman, *New York 1880*, 894–95.

150. White and Willensky, *AIA Guide* (2000), 706–7; Morrone, *An Architectural Guidebook to Brooklyn*, 213.

151. Ann Carter, "Pratt's Athletic Facility Opens," *Progressive Architecture* 62 (January 1976): 33; "An Aquifer in Brooklyn," *Industrial Design* 23 (March 1976): 13; White and Willensky, *AIA Guide* (2000), 707.

152. "$9 Million Building Is Being Financed by a 1940 Graduate," *New York Times* (March 30, 1997), IX: 1; "Stabile Hall, Pratt Institute, Pasanella + Klein Stolzman + Berg Architects," *Architecture* 86 (April 1997): 45; Nina Rappaport, "On the Drawing Boards," *Oculus* 59 (April 1997): 3; "Stabile and Steuben Halls Construction and Renovation," *Prattfolio* (Summer 1997): 14; Noel Millea, "The Expansion of an Urban Campus: Four Firms Vie in Pratt Dormitory Competition," *Competitions* 7 (Autumn 1997): 46–53; Jayne Merkel, "Wayne Berg at Pratt," *Oculus* 60 (June 1998): 7; "Project Award," *Oculus* 60 (Summer 1998): 24; *Pasanella + Klein Stolzman + Berg* (Gloucester, Mass.: Rockport Publishers, 1999), 34–41, 142; Jayne Merkel, "Preface," in *Pasanella + Klein Stolzman + Berg*, 6; Richard Weinstein, "Introduction," in *Pasanella + Klein Stolzman + Berg*, 11; "Pasanella + Klein Stolzman + Berg: Stabile Hall," *Architecture* 88 (April 1999): 106–7; White and Willensky, *AIA Guide* (2000), 707.

153. For Pratt Row, see Landmarks Preservation Commission of the City of New York, LP-2012 (December 22, 1981).

154. Thomas Hanrahan, quoted in Millea, "The Expansion of an Urban Campus: Four Firms Vie in Pratt Dormitory Competition": 48.

155. For Adelphi Academy, see Stern, Mellins, and Fishman, *New York 1880*, 893–94.

156. "News Briefs," *Architectural Record* 177 (May 1989): 55; "Gwathmey Siegel & Associates," *Progressive Architecture* 70 (July 1989): 20; Brad Collins and Diane Kaprowicz, ed., *Gwathmey Siegel: Buildings and Projects, 1982–1992* (New York: Rizzoli International Publications, 1993), 324.

157. Blanca M. Quintanilla and K. C. Baker, "Historic School Burns," *New York Daily News* (July 22, 1996): 8; Laura Williams, "Pratt Regroups After Blaze," *New York Daily News* (July 23, 1996), Metro: 1; Somini Sengupta, "Pratt's Dream Is Thwarted by a Fire," *New York Times* (July 28, 1996), XIII: 8; "Fire at Pratt," *Oculus* 59 (September 1996): 4; Noel Millea, "Out of the Ashes at Pratt," *Oculus* 59 (December 1996): 5–6.

158. Quoted in http://rogersmarvel.com/projects/higgins/index.html.

159. Robert Rogers, quoted in Victoria Milne, "Rogers Marvel Architects: Higgins Hall, Pratt Institute, Brooklyn, New York," *Interiors* 160 (January 2001): 68–71. Also see "American Institute of Architects Announce Awards: New York Firms Honored for 10 Design Projects," *New York Times* (January 7, 2001), XI: 1; "Higgins Hall, Pratt Institute School of Architecture," *Architectural Record* 189 (May 2001): 127; "Rogers Marvel Architects, Higgins Hall North Wing, Pratt Institute School of Architecture," *Oculus* 64 (December 2001): 33.

160. Ralph Lerner, quoted in "Rogers Marvel Architects, Higgins Hall North Wing, Pratt Institute School of Architecture": 33.

161. "For Pratt, a Bold Addition to a Landmark Building," *Architectural Record* 185 (December 1997): 31; Ned Cramer, "Holl Resuscitates Pratt," *Architecture* 87 (January 1998): 29; "Steven Holl," *El Croquis* 93 (1999): 144–48, 190; *Steven Holl: Idea and Phenomena* (Baden: Lars Müller Publishers, 2002), 118; Kenneth Frampton, *Steven Holl Architect* (Milan: Electa, 2002), 250–57; Francesco Garofalo, ed., *Steven Holl* (London: Thames & Hudson, 2003), 144–47, 238; Luna, ed., *New New York*, 312–13.

162. Steven Holl, quoted in Frampton, *Steven Holl Architect*, 250.

163. Quoted in "For Pratt, a Bold Addition to a Landmark Building": 31.

164. Stern, Mellins, and Fishman, *New York 1960*, 916–17, 1143; Stern, Mellins, and Fishman, *New York 1880*, 922–39.

165. Landmarks Preservation Commission of the City of New York, *Park Slope Historic District Designation Report* (New York, 1973).

166. Denis Hamill, "Park Slope: The Myth of Neighborhood," *New York* 11 (February 13, 1978): 36–40.

167. Michael Winkleman, "The Visible City: Park Slope," *Metropolis* 1 (November 1981): 23, 26.

168. David Bird, "Park Slope," *New York Times* (April 4, 1982), VIII: 9; Jane Peterson, "Anguish and Joy in a Changing Neighborhood: Brooklyn's Park Slope," *Historic Preservation* 35 (July-August 1983): 20–27; Alan S. Oser, "Curbs on Incentives Affect Rehabilitation," *New York Times* (December 4, 1983), VIII: 7; Maureen Dowd, "Park Slope: New Faces, New Shops and New Worries over Its Growth," *New York Times* (May 7, 1984), B: 1, 4; Diana Shaman, "Brooklyn Conversion: Factory to Co-Ops," *New York Times* (May 6, 1994), B: 7; White and Willensky, *AIA Guide* (2000), 722; Denis Hamill, "Factory Holds Memories, 800G Condos," *New York Daily News* (July 20, 2004), Metro: 3. For the Ansonia Clock Factory, see "Fire in South Brooklyn," *New York Times* (October 28, 1880): 8.

169. Quoted in Peterson, "Anguish and Joy in a Changing Neighborhood: Brooklyn's Park Slope": 27.

170. "Lowering Buyers' Risks: A New Co-op for Park Slope," *New York Times* (August 12, 1990), X: 1.

171. "Building Into a Low-Rise Neighborhood," *New York Times* (September 11, 1988), X: 1; Alan S. Oser, "Zoning for Compatibility: Market Test for a Windsor Terrace Condo,"

New York Times (March 25, 1990), X: 7; "Changing Times: Park Slope Auction," *New York Times* (September 15, 1991), X: 1.

172. "Faux Limestone Co-op: 20 Units in Park Slope," *New York Times* (December 29, 1991), IX: 1; Jacqueline Charles, "Park Slope: Housing for Ex-Drug Abusers? Not Here, Say the Neighbors," *New York Times* (July 24, 1994), XIII: 7; Somini Sengupta, "Park Slope: A Pledge of Homes, Half Kept," *New York Times* (January 14, 1996), XIII: 9.

173. Michael Dobbs, quoted in "Faux Limestone Co-op: 20 Units in Park Slope": 1. Also see Jacqueline Charles, "Park Slope: Housing for Ex-Drug Abusers? Not Here, Say the Neighbors," *New York Times* (July 24, 1994), XIII: 7; Somini Sengupta, "Park Slope: A Pledge of Homes, Half Kept," *New York Times* (January 14, 1996), XIII: 9.

174. Shawn G. Kennedy, "Private Schools Turn to Reconstruction," *New York Times* (October 13, 1991), X: 1, 13; "Further Afield," *Oculus* 54 (March 1992): 4; *New Architecture in Brooklyn 1985–1995: The Rotunda Gallery, November 9-December 21, 1995*, 9; White and Willensky, *AIA Guide* (2000), 720; Morrone, *An Architectural Guidebook to Brooklyn*, 344. For the Berkeley Carroll School, see *Park Slope Historic District*, 70.

175. Morrone, *An Architectural Guidebook to Brooklyn*, 344.

176. Andrew S. Dolkart and Judith Saltzman, quoted in *New Architecture in Brooklyn 1985–1995: The Rotunda Gallery, November 9-December 21, 1995*, 9.

177. Somini Sengupta, "School's Critics Fix on Tree," *New York Times* (November 17, 1996), XIII: 11; Richard Weir, "Divisive Gym Now on Track," *New York Times* (November 15, 1998), XIV: 10; Marcia Biederman, "An Elegant Brownstone You Can't Live In," *New York Times* (May 23, 1999), XIII: 10; *Richard Dattner: Selected and Current Works of Richard Dattner & Partners Architects* (Mulgrave, Australia: Images Publishing, 2000), 90–91.

178. For Olmsted and Vaux's Prospect Park, see Stern, Mellins, and Fishman, *New York 1880*, 910–19.

179. Anna Quindlen, "For Prospect Park, $10 Million to Recapture What It Was," *New York Times* (January 4, 1980), B: 1; Deirdre Carmody, "$10 Million Gives Park a New Life," *New York Times* (November 12, 1981), B: 3; Paul C. Berizzi, "Prospect Park," *Oculus* 45 (March 1984): 2–8, 13; Deirdre Carmody, "A Born-Again Prospect Park Is Greener, Safer and Busier," *New York Times* (August 4, 1984): 25, 48.

180. David Bird and Maurice Carroll, "Refurbished Picnic House for Prospect Park," *New York Times* (September 21, 1984), B: 4.

181. White and Willensky, *AIA Guide* (1988), 653; Scott Gutterman, "Return to Splendor," *Architectural Record* 177 (July 1989): 110–13. Also see Alfred E. Clark, "Teahouse in Park Destroyed by Fire," *New York Times* (March 10, 1974): 27.

182. James Lamantia, quoted in Gutterman, "Return to Splendor": 111. For Calvert Vaux and George K. Radford's Tilden house, see Stern, Mellins, and Fishman, *New York 1880*, 638–39.

183. Susan Heller Anderson, "Nonprofit Group to Nourish Once-Shabby Prospect Park," *New York Times* (April 6, 1987), B: 7.

184. Andrew L. Yarrow, "Carousel, 78, to Run Like a Child Again," *New York Times* (October 14, 1990): 29; Lynette Holloway, "Prospect Park," *New York Times* (September 12, 1993), XIII: 10.

185. Douglas Martin, "A Zoo Story: 2 Hefty Tenants, Facing Eviction," *New York Times* (April 1, 1989): 29; Calvin Sims, "Surplus in Budget Expected for Year by New York City," *New York Times* (April 22, 1992): 1, B: 7; Francis X. Clines, "What's 3 Letters and Zoologically Incorrect," *New York Times* (February 4, 1993): 1, B: 4; Alan Finder, "Rebuilding a Brooklyn Zoo, Step by Agonizing Step," *New York Times* (April 8, 1993), B: 1, 4; David W. Dunlap, "Smaller Architects Find Their Niche," *New York Times* (December 12, 1993), X: 1, 8; White and Willensky, *AIA Guide* (2000), 726. For Embury's zoo, see Stern, Gilmartin, and Mellins, *New York 1930*, 712.

186. Edward Lewine, "Park Warily Tends a Wound," *New York Times* (October 5, 1997), XIII: 9; Douglas Martin, "A Lush Park Woodland, the Way It Used to Be," *New York Times* (November 30, 1997): 47; Douglas Martin, "Prospect Park's Ravine Inching Closer to Past," *New York Times* (September 14, 1998), B: 3.

187. Tara Bahrampour, "Bird Lovers Will Find a Home in a Beaux-Arts Boathouse," *New York Times* (April 30, 2000), XIV: 10. For Brown, Lawford & Forbes's restoration, see Stern, Mellins, and Fishman, *New York 1960*, 917.

188. "Names and News," *Oculus* 47 (December 1985): 12; Julie Collins, "An Addition to the Brooklyn Museum," *GSD News* 14 (March-April 1986): 10; Douglas C. McGill, "The Brooklyn Museum Plans to Double Its Size," *New York Times* (March 18, 1986), C: 20; "Pencil Points," *Progressive Architecture* 67 (May 1986): 26; "Brooklyn Museum Names Semi-Finalists," *New York Times* (May 27, 1986), C: 14; "Brooklyn Museum Selects 5 Architectural Finalists," *New York Times* (June 20, 1986), C: 24; "Pencil Points," *Progressive Architecture* 67 (July 1986): 24; Michael Sorkin, "Dim Prospect at Brooklyn Museum," *Village Voice* (July 8, 1986): 90; Grace Glueck, "Why the Brooklyn Museum Must Bet on a Daring Master Plan," *New York Times* (July 20, 1986), II: 1, 30; "Five Finalists Named in Brooklyn Museum Master-Plan Competition," *Architectural Record* 174 (August 1986): 32; Joseph Giovannini, "Brooklyn Museum Design Selected," *New York Times* (October 17, 1986), C: 40; "Corrections," *New York Times* (October 25, 1986): 3; Paul Goldberger, "A Japanese Master Debuts on Two Coasts," *New York Times* (October 26, 1986), II: 1, 32; Thomas Hine, "An Attention-Getting Design for the Brooklyn Museum," *Philadelphia Inquirer* (October 26, 1986), VII: 14; "Pencil Points," *Progressive Architecture* 67 (November 1986): 26; Frank Sommerfield, "Museum Links

Lofty Aspirations to Architects' Quest for Prestige," *Crain's New York Business* (November 3, 1986): 17, 19, 21; L. S. Heck, "Isozaki/Polshek Team Selected for Brooklyn Museum Addition," *Architecture* 75 (December 1986): 12–13, 16; Richard B. Woodward, "Thinking Big Again in Brooklyn," *Art News* 85 (December 1986): 14, 178; Daralice D. Boles, "A Bold Plan for Brooklyn Museum," *Progressive Architecture* 67 (December 1986): 27; "The Master Plan Competition," in *The Brooklyn Museum Report: 1982–1986* (New York: Brooklyn Museum, 1987), 18–21; "Brooklyn Museum Master Plan Design Competition," *Architectural Record* 175 (January 1987): 45; "The Brooklyn Museum Master Plan," *Oculus* 48 (January 1987): 2–7, 16–23; Sandy Heck, "Competition," *Architecture + Urbanism* (February 1987): 3–15; Jun Aoki, "The Brooklyn Museum," *Japan Architect* 358 (February 1987): 24–25; Douglas Davis, "Winging It: Does Adding On Add Up?" *Newsweek* 109 (February 23, 1987): 70–73; Julie Iovine, "Will an Isozaki Grow in Brooklyn?" *Connoisseur* 217 (March 1987): 26; "The Brooklyn Museum," *Kenchiku Bunka* 42 (March 1987): 47–49; Christopher Gray, "Streetscapes/A Touch of Imperial Rome Gracing Imperial Parkway," *New York Times* (October 11, 1987), VIII: 14; Deirdre E. Lawrence, "From Library to Art Museum: The Evolution of the Brooklyn Museum," *International Journal of Museum Management and Curatorship* 6 (December 1987): 381–86; Joan Darragh, ed., *A New Brooklyn Museum: The Master Plan Competition* (New York: Brooklyn Museum; New York: Rizzoli International Publications, 1988); James Stewart Polshek, "Notes on My Life and Work," in *James Stewart Polshek: Context and Responsibility* (New York: Rizzoli International Publications, 1988), 58, 190–91; Gwendolyn Wright, "The Challenge of Constraints," in *James Stewart Polshek: Context and Responsibility*, 15; Paul Goldberger, "The Brooklyn Museum Competition," *New York Times* (March 13, 1988): 57; Joel Warren Barna, "Museum Design Discussed in Houston," *Progressive Architecture* 69 (May 1988): 26, 28; Thomas Vonier, "A Design Competition Chronicled: A New Brooklyn Museum: The Master Plan Competition," book review, *Museum News* 66 (July/August 1988): 70–71; Patricia C. Phillips, "A New Brooklyn Museum: The Master Plan Competition,'" book review, *Artforum* 27 (September 1988): 141–42; "Dossier," *Manhattan, inc.* 5 (September 1988): 30; Mihail Moldoveanu, "Projet Isozaki-Polshek: Le Brooklyn Museum à New York," *Techniques et Architecture* 381 (December 1988-January 1989): 92–94; Scott Gutterman, "A New Brooklyn Museum: The Master Plan Competition," book review, *Architectural Record* 177 (February 1989): 69; Patrick L. Pinnell, "A New Brooklyn Museum: The Master Plan Competition," book review, *Winterthur Portfolio* 24 (Spring 1989): 105–10; "Brooklyn Museum Gets $3.5 Million Gift," *New York Times* (May 4, 1989), C: 26; *The Brooklyn Museum Report: 1987–1989* (New York: Brooklyn Museum, 1990), 9, 12–16; Douglas Davis, *The Museum Transformed* (New York: Abbeville Press, 1990), 209–16; Andrew L. Yarrow, "Big Expansion Starts at Brooklyn Museum," *New York Times* (April 28, 1990): 13, 15; Susan R. Bleznick, "Brooklyn Museum Expansion Proceeds," *Architectural Record* 178 (July 1990): 23; David B. Stewart and Hagime Yatsuka, *Arata Isozaki: Architecture, 1960–1990* (New York: Rizzoli International Publications, 1991), 200–203; Grace Glueck, "New Assembly Hall Opening at the Brooklyn Museum," *New York Times* (April 8, 1991), C: 11, 13; Joan Darragh, "Arata Isozaki & Associates, James Stewart Polshek & Partners," *GA Document* 30 (August 1991): 28–33; Peter D. Slatin, "International Affairs," *Architectural Record* 179 (September 1991): 88–93; "Philanthropists Aid Brooklyn Museum," *New York Times* (September 12, 1991), C: 15; "The Brooklyn Museum Competition," *Spazio e Società* 14 (October-December 1991): 12–13; Arata Isozaki, *Arata Isozaki: Works 30, Architectural Models, Prints, Drawings* (Tokyo: Rikuyo-sha, 1992), 250–57; Paul Goldberger, "Sign of Hope for a Cultural City in Fiscal Distress," *New York Times* (January 19, 1992), II: 34; Carol Vogel, "The Art Market," *New York Times* (May 8, 1992), C: 18; "Waiting for the New Wing," *Art News* 91 (November 1992): 48; Nicholas Fox Weber, "A Museum Grows in Brooklyn (Painfully)," *New York Times* (November 15, 1992), II: 1, 38; "Brooklyn Museum," *Apollo* 136 (December 1992): 364; Warren A. James, ed., *Kohn Pedersen Fox: Architecture and Urbanism, 1986–1992* (New York: Rizzoli International Publications, 1993), 400; "Assuming the Pose of the Worker," *New York Times* (June 23, 1993), B: 4; "Brooklyn Museum Opens West Wing," *New York Times* (November 28, 1993), V: 3; "West Wing Renovated at Brooklyn Museum," *New York Times* (November 28, 1993), X: 1; Glenn Collins, "New Wing, New Hope at Brooklyn Museum," *New York Times* (November 30, 1993), C: 15, 24; Amei Wallach, "The Brooklyn Museum Expansion: Old Egypt's New Home," *Newsday* (November 30, 1993), II: 51; Roberta Smith, "A New Temple for Egyptian Art," *New York Times* (December 3, 1993), C: 1, 30; Amei Wallach, "Museum's West Wing Meshes Past, Innovation," *Newsday* (December 3, 1993), II: 117; Benjamin Forgey, "A Magnificent Twist on Two Cultures," *Washington Post* (December 4, 1993), F: 1, 5; Eve M. Kahn, "A Museum Keeps Growing in Brooklyn," *Wall Street Journal* (December 8, 1993): 12; "In Brooklyn, Wonderful Things," editorial, *New York Times* (December 9, 1993): 30; Herbert Muschamp, "Isozaki's Designs for an Insecure Postwar World," *New York Times* (December 17, 1993), C: 34; John O'Reilly, "The Brooklyn Museum: Master Plan and Renovation," *Japan Architect* 12 (Winter 1993–1994): 37–44; Donald Albrecht, "Brooklyn Museum Renovation Unveiled," *Architecture* 83 (January 1994): 25; Edward Ball, "A Room Is the View," *Village Voice* (January 18, 1994): 82; William Grimes, "$5 Million for Museum in a Long Love Affair," *New York Times* (January 27, 1994), C: 16; Joseph Giovannini, "Exhibition Review: Arata Isozaki: Works in Architecture," *Architecture + Urbanism* (April 1994): 2–3;

"Chronicle," *New York Times* (April 5, 1994), B: 6; *New Architecture in Brooklyn 1985–1995: The Rotunda Gallery, November 9-December 21, 1995*, 22; "A Landmark Repair in Brooklyn," *New York Times* (April 19, 1995), B: 3; Marisa Bartolucci, "Citizen Architect," *Metropolis* 14 (June 1995): 62–67, 74–79; Joan Darragh, "Mastering the Plan," *Metropolis* 15 (September 1995): 84–85, 105, 107, 109, 123; Carol Vogel, "Brooklyn Museum Chief Resigns After 13 Years," *New York Times* (May 27, 1996): 13, 16; Itziar Sen, "Lecture Hall and West Wing of the Brooklyn Museum," in Francisco Asensio Cerva, ed., *The Architecture of Museums* (New York: Arco, 1997), 50–59; Sirefman, *New York*, 288–91; Carol Vogel, "Inside Art," *New York Times* (January 31, 1997), C: 23; Carol Vogel, "For Brooklyn Museum, New Director and New Image," *New York Times* (March 17, 1997), C: 14; Paul Spencer Byard, *The Architecture of Additions: Design and Regulation* (New York: W. W. Norton, 1998), 121–24; Carol Vogel, "Inside Art," *New York Times* (May 1, 1998), E: 38; "The New Cubism: Making Art Out of Necessity," *New York Times* (June 11, 1998), F: 3; White and Willensky, *AIA Guide* (2000), 729; Balfour, *World Cities New York*, 136; Morrone, *An Architectural Guidebook to Brooklyn*, 463; Susan Strauss and Sean Sawyer, eds., *Polshek Partnership Architects: 1988–2004* (New York: Princeton Architectural Press, 2005), 180, 182–85.

189. Stern, Gilmartin and Massengale, *New York 1900*, 88–91; Stern, Gilmartin and Mellins, *New York 1930*, 123, 132, 138–39; Leland M. Roth, "McKim, Mead & White and The Brooklyn Museum, 1893–1934," in Darragh, ed., *A New Brooklyn Museum: The Master Plan Competition*, 26–51.

190. Stern, Gilmartin and Mellins, *New York 1930*, 138–39; Joan Darragh, "The Brooklyn Museum: Institution as Architecture, 1934–1986," in Darragh, ed., *A New Brooklyn Museum: The Master Plan Competition*, 52–72; Roth, "McKim, Mead & White and The Brooklyn Museum, 1893–1934," in Darragh, ed., *A New Brooklyn Museum: The Master Plan Competition*, 26–51.

191. Darragh, "The Brooklyn Museum: Institution as Architecture, 1934–1986," in Darragh, ed., *A New Brooklyn Museum: The Master Plan Competition*, 68.

192. Darragh, "The Brooklyn Museum: Institution as Architecture, 1934–1986," in Darragh, ed., *A New Brooklyn Museum: The Master Plan Competition*, 70.

193. Pinnell, "A New Brooklyn Museum: The Master Plan Competition": 107–8. For the Rayburn House Office Building, see Pamela Scott and Antoinette J. Lee, *Buildings of the District of Columbia* (New York: Oxford University Press, 1993), 136–37.

194. Polshek, "Notes on My Life and Work," in *James Stewart Polshek: Context and Responsibility*, 50.

195. James Stewart Polshek, quoted in Glueck, "New Assembly Hall Opening at the Brooklyn Museum": 13.

196. Slatin, "International Affairs": 90.

197. Arata Isozaki, quoted in Slatin, "International Affairs": 90.

198. Smith, "A New Temple for Egyptian Art": 1, 30.

199. Wallach, "The Brooklyn Museum Expansion: Old Egypt's New Home": 51.

200. Carol Vogel, "A New Staircase as Arts Stage," *New York Times* (September 10, 1999), E: 34; David Barstow, "$55 Million Face Lift for Museum," *New York Times* (September 20, 2000), B: 3; Herbert Muschamp, "A Modern Embellishment Seeks Harmony with a Beaux-Arts Jewel," *New York Times* (September 20, 2000), E: 1–2; "Brooklyn's Front Stoop at Museum Entrance," *Architectural Record* 188 (November 2000): 40; Craig Kellogg, "Culture All Around Town," *Oculus* 63 (November 2000): 4; Elizabeth Hays, "Landmarks Panel Likes Museum Pavilion," *New York Daily News* (December 13, 2000), Metro: 4; Elizabeth Hayes, "New Museum Sensation Eyed," *New York Daily News* (December 17, 2000), Metro: 1; Celestine Bohlen, "Built for Substance, Not Flash," *New York Times* (January 22, 2001), B: 1, 5; Joseph Giovannini, "Breaking Out of the Box," *New York* 34 (February 12, 2001): 55–56; "Brooklyn Museum Addition Approved," *Interiors* 160 (March 2001): 32; Joyce Shelby, "Rebuild It, and They'll Come," *New York Daily News* (April 14, 2002), Metro: 3; Joyce Shelby, "Art Pavilion Is 30% Done," *New York Daily News* (October 7, 2002), Metro: 1; Luna, ed., *New New York:*, 314–15; "Arnold Lehman: No Regrets," *New York Sun* (March 17, 2003): 14; Carol Vogel, "Inside Art," *New York Times* (December 5, 2003), E: 42; Randy Kennedy and Carol Vogel, "Brooklyn Museum, Newly Refurbished, Seeks an Audience," *New York Times* (April 12, 2004): 1, B: 6; Herbert Muschamp, "Brooklyn's Radiant New Art Palace," *New York Times* (April 16, 2004), E: 31, 37; Francis Morrone, "What Happened to Moral Uplift?" *New York Sun* (April 22, 2004): 1, 18; Carolyn Curiel, "Brooklyn's Museum Under Glass," *New York Times* (May 10, 2004): 20; Hilton Kramer, "The Brooklyn Museum Gives Open House on Dumbing Down," *New York Observer* (May 17, 2004): 1; Strauss and Sawyer, eds., *Polshek Partnership Architects: 1988–2004*, 178–89.

201. Arnold Lehman, quoted in Barstow, "$55 Million Face Lift for Museum": 3, and Hayes, "New Museum Sensation Eyed": 1.

202. Quoted in Strauss and Sawyer, eds., *Polshek Partnership Architects: 1988–2004*, 184–85.

203. Giovannini, "Breaking Out of the Box": 56.

204. James Stewart Polshek, quoted in Barstow, "$55 Million Face Lift for Museum": 3.

205. James Stewart Polshek, Christabel Gough, and Roger Lang, quoted in Barstow, "$55 Million Face Lift for Museum": 3.

206. Muschamp, "Brooklyn's Radiant New Art Palace": 31, 37.

207. Kramer, "The Brooklyn Museum Gives Open House on Dumbing Down": 1.

208. Morrone, "What Happened to Moral Uplift?": 18.

209. Stern, Gilmartin, and Mellins, *New York 1930*, 138.

210. Deirdre Carmody, "Renovation Planned for Brooklyn Botanic Garden," *New York Times* (January 7, 1984): 27; "Names and News," *Oculus* 45 (February 1984): 7; Thomas Morgan, "Brooklyn's Big Garden Is Growing Bigger," *New York Times* (March 10, 1988), B: 1, 4; Paul Goldberger, "Glass Houses for Trees That Grow in Brooklyn," *New York Times* (July 3, 1988), II: 26; Maggie Malone, "True Splendor in the Glass," *Newsweek* 112 (September 12, 1988): 68–69, 71; Donald Canty, "Reconstructing a Victorian Legacy," *Architectural Record* 177 (November 1989): 110–15; Sirefman, *New York*, 292–93; White and Willensky, *AIA Guide* (2000), 729; Morrone, *An Architectural Guidebook to Brooklyn*, 450–51.

211. Goldberger, "Glass Houses for Trees That Grow in Brooklyn": 26.

212. "Libraries for the Next Century," *Oculus* 61 (October 1998): 4; Laurel Graeber, "Family Fare," *New York Times* (May 5, 2000), E: 45; Abigail A. Van Slyck, "A New Chapter," *Architectural Record* 188 (October 2000): 151; Bonnie Schwartz, "Shhhh! Not at This Library," *Fast Company* (December 2000): 88; Morrone, *An Architectural Guidebook to Brooklyn*, 441. For Githens & Keally's building, see Stern, Gilmartin, and Mellins, *New York 1930*, 132–33, 139–40.

213. See Stern, Mellins, and Fishman, *New York 1880*, 954–61.

214. For the Williamsburg Bridge, see Stern, Gilmartin, and Mellins, *New York 1900*, 50–51.

215. For the Williamsburgh Savings Bank, see Stern, Mellins, and Fishman, *New York 1880*, 954–57.

216. For Williamsburg Houses, see Stern, Gilmartin, and Mellins, *New York 1930*, 495, 497–98. For Woodhull Hospital, see Stern, Mellins, and Fishman, *New York 1960*, 928–30.

217. Frank Lynn, "Democrats in Brooklyn Face Hispanic Demand," *New York Times* (August 16, 1984), B: 3; Margot Hornblower, "Cultures Clash as Hasidic Jews Compete for Turf," *Washington Post* (November 8, 1986): 1; Richard F. Shepard, "Assembling Brooklyn's Hispanic History," *New York Times* (February 26, 1989): 59; John T. McQuiston, "Hispanic Rally Assails Hasidim in Williamsburg," *New York Times* (October 26, 1990), B: 3; David Gonzalez, "A Storm in Williamsburg as Two Ethnic Groups Clash," *New York Times* (November 17, 1990): 25; Jerry Gray, "Where Minorities Rub, It's 'Us' Against 'Them,'" *New York Times* (July 21, 1991): 22; Sara Rimer, "Between 2 Worlds: Dominicans in New York," *New York Times* (September 16, 1991): 1, B: 8.

218. Andree Brooks, "Loft Rent Up, Artists Move to Houses," *New York Times* (January 6, 1980), VIII: 1, 4; Laurie Johnston and Michael Oreskes, "Unveiling New Artists," *New York Times* (August 21, 1982): 26; Marcus W. Brauchli, "Brooklyn Rents Lure Artists," *New York Times* (October 30, 1983), VIII: 7, 14; William E. Geist, "About New York," *New York Times* (March 20, 1985), B: 4; Josh Barbanel, "Board Acts to Evict Artists Occupying Brooklyn Lofts," *New York Times* (December 21, 1985): 31; David Dorian, "If You're Thinking of Living In: Williamsburg," *New York Times* (June 15, 1986), VIII: 9; Grace Glueck, "Art Shows in Familiar and Unexpected Places," *New York Times* (November 14, 1986), C: 24; Lisa W. Foderaro, "A Metamorphosis for Old Williamsburg," *New York Times* (July 19, 1987), VIII: 9; Shawn G. Kennedy, "Co-op Space for Artists in Brooklyn," *New York Times* (October 12, 1988), D: 24; Roberta Smith, "A Sprinkling of Exhibitions Near Factories and the Water," *New York Times* (March 23, 1990), C: 27; Brad Gooch, "The New Bohemia: Portrait of an Artists' Colony in Brooklyn," *New York* 25 (June 22, 1992): cover, 25–31; Joyce Cohen, "If You're Thinking of Living In: Williamsburg," *New York Times* (October 6, 1996), XI: 5; Whitney Walker, "Brooklyn Bohemia," *New York Daily News* (April 20, 1997), Metro: 2; Jay Walljapser and David Kraker, "The 15 Hippest Places to Live," *Utne Reader* (November/December 1997); Anthony Ramirez, "Neighborhood Report," *New York Times* (February 1, 1998), XIV: 8; Roberta Smith, "Brooklyn Haven for Art Heats Up," *New York Times* (November 6, 1998), E: 33, 37; Bob Liff, "North Side's Hip–But Wary," *New York Daily News* (July 27, 1999), Metro: 2; Sam Lubell, "New Yorkers & Co.," *New York Times* (February 27, 2000), XIV: 4; Anna Holmes, "My Old Burg, So Hip It Hurts," *New York Times* (April 2, 2000), XIV: 1; Tara Bahrampour, "In Williamsburg, a Club Tests Tolerance for the Hip," *New York Times* (July 23, 2000), XIV: 8; Bob Morris, "Brooklyn Is Home to Hipsters, Ja?" *New Yorker* 76 (June 19, 2000): 72; Leslie Downer, "Getting a Taste for the Funky: Williamsburg Is Suddenly Fashionable," *Financial Times* (March 10, 2001): 20; Ted Weesner, "Bohemian Scene Moves to NYC's Hip Williamsburg," *Boston Globe* (April 7, 2002), M: 11; Denny Lee, "Has Billburg Lost Its Cool?" *New York Times* (July 27, 2002), XIV: 1, 7.

219. Foderaro, "A Metamorphosis for Old Williamsburg": 9.

220. Gooch, "The New Bohemia: Portrait of an Artists' Colony in Brooklyn": 27–28.

221. Downer, "Getting a Taste for the Funky: Williamsburg Is Suddenly Fashionable": 20.

222. Morrone, *An Architectural Guidebook to Brooklyn*, 230.

223. "SITE's Current Sites," *Progressive Architecture* 64 (September 1983): 27; "A Dual Message in Williamsburg," *New York Times* (October 16, 1983), VIII: 1; "Paz Building, Brooklyn," *Architectural Design* 54 (No. 1–2, 1984): 38–39; Douglas Brenner, "Between Utopia and Apocalypse: Five Projects by SITE," *Architectural Record* 172 (March 1984): 134–39; "Les marques du temps: aménagement d'un inneuble, Brooklyn, New York," *L'Architecture d'aujourd'hui* (June 1984): 34–37; "SITE Comes to Brooklyn," *Metropolis* 5 (September 1985): 15; Anthony DePalma, "An Illusion Is Built Into Conversion," *New York Times* (October 2, 1985), D: 26; "Brooklyn's First Major Office Tower in 25 Years," *Interiors* 145 (January 1986): 30; Elaine Edelman, "SITE for Sore Eyes," *Connoisseur* (June 1986): 14; "The Paz Building, Brooklyn, New York City," *Architecture + Urbanism* (December 1986): 166–67;

Foderaro, "A Metamorphosis for Old Williamsburg": 9; *SITE* (New York: Rizzoli International Publications, 1989), 168–71.

224. Quoted in *SITE*, 168.

225. Brenner, "Between Utopia and Apocalypse: Five Projects by SITE": 139.

226. Rachelle Garbarine, "Reclaiming Vacant Land: Low-Cost Row Houses for Brooklyn," *New York Times* (October 9, 1991): 19; "In the City," *Oculus* 54 (January 1992): 3; White and Willensky, *AIA Guide* (2000), 756.

227. Charles K. Hoyt, "Moore Street Market," *Architectural Record* 183 (February 1995): 102–3; Clay B. Lifflander, "First Source," letter to the editor, *Architectural Record* 183 (May 1995): 4, 75.

228. Joyce S. Lee, "Creating Neighborhood Stability by Design," *Competitions* 8 (Summer 1998): 24–33; Elaine Louie, "A Community Center That Is Inviting To Its Young Guests," *New York Times* (December 17, 1998), F: 3; John Morris Dixon, ed., *Urban Spaces* (New York: Visual Reference Publications, 1999), 150; *Margaret Helfand Architects* (New York: Monacelli Press, 1999), 168–71; *Pasanella + Klein Stolzman + Berg*, 48–53, 142; Cathy Lang Ho, "Multiples: Small Civic Works," *Newsletter of the Architectural League of New York* (Winter 2002/2003): 5; Jim O'Grady, "Urban Tactics," *New York Times* (May 18, 2003), XIV: 4; Sheila Kim, "The Top of the Heap," *Interior Design* 74 (August 1, 2003): 79; Jean Nayar, "Come One, Come All," *Contract Magazine* (November 1, 2004): 56.

229. Lawrence Zeroth, quoted in Nayar, "Come One, Come All": 56.

230. O'Grady, "Urban Tactics": 4.

231. Joe Dziemianowicz, "Greenpoint Renaissance," *New York Daily News* (April 22, 2001): 16. Also see John Rather, "Ethnic and Artistic in North Brooklyn," *New York Times* (August 13, 1995), IX: 5.

232. For the McCarren Park Pool and Bathhouse, see Stern, Gilmartin, and Mellins, *New York 1930*, 717–19.

233. Robert A. M. Stern, quoted in David W. Dunlap, "Old Bathhouse Defended as Brooklyn Landmark," *New York Times* (March 6, 1989), B: 1, 4.

234. Henry J. Stern, quoted in Dunlap, "Old Bathhouse Defended as Brooklyn Landmark": 4.

235. Hannah Wallace, "A Long-Dry Pool, with a Famous Past, Faces the Future," *New York Times* (December 17, 2000), XIV: 10.

236. Elizabeth Hays, "Plan to Fix Up Pool Makes a Big Splash," *New York Daily News* (April 24, 2001), Metro: 5; Luis Perez, "City Rapped on Pool," *New York Daily News* (September 3, 2002), Metro: 1.

237. "$4.88 Million Renovation of the Metropolitan Pool and Bathhouse," *New York Times* (December 7, 1997), XI: 1; Sarah Amelar, "In the Swim," *Architecture* 87 (June 1998): 162–66.

238. Medhat Salam, quoted in "$4.88 Million Renovation of the Metropolitan Pool and Bathhouse": 1.

239. See Stern, Mellins, and Fishman, *New York 1960*, 917; Stern, Mellins, and Fishman, *New York 1880*, 899–909.

240. See Stern, Mellins, and Fishman, *New York 1960*, 918–20.

241. Maurice Carroll, "Eight Buildings to Be Converted to House Poor and Elderly," *New York Times* (August 18, 1983), B: 3; Susan Heller Anderson and Sara Rimer, "Face Lift for Three Facades," *New York Times* (August 11, 1984): 26; Carlyle C. Douglas, "In Brooklyn's Bedford-Stuyvesant, Glimmers of Resurgence Are Visible," *New York Times* (April 19, 1985), B: 1, 8; Fay S. Joyce, "Union and Churches Join in Brooklyn Condo Project," *New York Times* (October 6, 1985), VIII: 7; Philip S. Gutis, "In Bedford-Stuyvesant, a Key Restoration Is On," *New York Times* (February 21, 1986): 21; Thomas Morgan, "Eyesores Becoming New Homes in Brooklyn," *New York Times* (April 5, 1987): 31; Diana Shaman, "Blighted Buildings Renovated in Bedford-Stuyvesant," *New York Times* (November 3, 1989): 26; Shawn Kennedy, "Seeing Bedford-Stuyvesant Brownstones," *New York Times* (October 18, 1990), C: 10; "Renovation Funds: Bed-Stuy Loans," *New York Times* (September 1, 1991), X: 1; "In Old Rowhouses, 60 New Condos," *New York Times* (March 29, 1992), X: 1; Nick Ravo, "Nonprofits Did Many of the Rehabilitations," *New York Times* (August 30, 1992), X: 6; Christopher Gray, "Streetscapes: 950–952 Bergen Street," *New York Times* (May 2, 1993), X: 9; Rachelle Garbarine, "Real Estate," *New York Times* (May 17, 1996), D: 9; Tracie Rozhon, "A New Program to Fix Up the Eyesore on the Block," *New York Times* (September 13, 1996): 29.

242. Landmarks Preservation Commission of the City of New York, LP-1431 (March 18, 1986); Christopher Gray, "Streetscapes/The Alhambra in Bedford-Stuyvesant," *New York Times* (January 5, 1997), IX: 5; Diamonstein, *The Landmarks of New York III*, 201; "Not That Alhambra," *Architectural Record* 186 (June 1998): 49; "Anderson Associates," *Oculus* 60 (June 1998): 5; White and Willensky, *AIA Guide* (2000), 736. For Morris's Alhambra, see Stern, Mellins, and Fishman, *New York 1880*, 901–2.

243. Landmarks Preservation Commission of the City of New York, LP-1433 (March 18, 1986); Gray, "Streetscapes/The Alhambra in Bedford-Stuyvesant": 5; Diamonstein, *The Landmarks of New York III*, 212; "'Landscapes of Hope': Before and After," *New York Times* (January 24, 1999), XI: 1; Chrisena Coleman, "Making Turn for the Better," *New York Daily News* (March 30, 1999), Metro: 6; White and Willensky, *AIA Guide* (2000), 735. For Morris's Renaissance Apartments, see Stern, Mellins, and Fishman, *New York 1880*, 902.

244. Bill Farrell, "Eyesore Becomes a Haven for Needy," *New York Daily News* (September 24, 2002), Metro: 1; Marieke Cassia Gartner, "A Mansion Retooled," *Period Homes* (Spring 2004): 26–27.

245. Beth Cooper Lawrence, quoted in Gartner, "A Mansion Retooled": 26.

246. Richard Higgins, "2,000-House Plan Will Test Market in Renewal Areas," *New York Times* (February 22, 1981), VIII: 1, 6; Ronald Smothers, "Koch Plan for 2,200 New Houses in Jeopardy, Builders Say," *New York Times* (December 13, 1981),

VIII: 4; Alan S. Oser, "Brooklyn Renewal: Two-Story Homes," *New York Times* (April 13, 1984), B: 9.

247. Oser, "Brooklyn Renewal: Two-Story Homes": 9.

248. "Two-Family Houses," *New York Times* (December 15, 1991), X: 1; Alan S. Oser, "Perspectives: City Housing Cutbacks," *New York Times* (April 5, 1992), X: 4, 15.

249. Rachelle Garbarine, "Adding Affordable 3-Family Homes to Bedford-Stuyvesant Mix," *New York Times* (July 2, 1999), B: 7; Nancie L. Katz, "New Homes Open Doors in Bed-Stuy," *New York Daily News* (October 2, 2000), Metro: 1.

250. "Eisenman Robertson Architects," *Architectural Design* 54 (No. 11–12, 1984): 14–15; "Firehouse for Engine Company 233, Ladder Company 176, Brooklyn, New York, USA, 1984–87," *Architecture + Urbanism* (July 1987): 33–48; "Peter Eisenman: Tre opere recenti," *Domus* (September 1987): 29–39; White and Willensky, *AIA Guide* (1988), 668; Herbert L. Smith Jr., "Square Dance," *Architectural Record* 176 (March 1988): 112–15; Heinrich Klotz, ed., *New York Architecture: 1970–1990* (Munich: Prestel Verlag, 1989), 110–11; *New Architecture in Brooklyn 1985–1995: The Rotunda Gallery, November 9-December 21, 1995*, 7; Sirefman, *New York*, 296–97; Herbert Muschamp, "Making a Rush-Hour Battleground High Art," *New York Times* (April 6, 1997), II: 42.

251. Quoted in "Peter Eisenman: Tre opere recenti": 30.

252. Smith, "Square Dance": 112.

253. Sirefman, *New York*, 296.

254. Muschamp, "Making a Rush-Hour Battleground High Art": 42.

255. Jayne Merkel, "Against All Odds," *Oculus* 63 (October 2000): 12–14; David W. Dunlap, "Bedford-Stuyvesant Community Center," *New York Times* (February 24, 2002), XI: 1; John E. Czarnecki, "Ranalli Inspired by Wright for Center," *Architectural Record* 190 (April 2002): 36; C. C. Sullivan, "George Ranalli, Architect, Saratoga Community Center, Brooklyn, New York," *Architecture* 93 (February 2004): 41.

256. For Hardy Holzman Pfeiffer's museum, see Stern, Mellins, and Fishman, *New York 1960*, 921–22.

257. Daniel J. McConville, "Kids' Digs," *New York Post* (April 6, 1989): 47.

258. "On the Drawing Boards," *Oculus* 61 (October 1998): 5; Joyce Shelby, "100 Yrs. Old, No Kidding," *New York Daily News* (October 25, 1998), Metro: 1; Elizabeth Hayes, "Children's Museum Expansion Forging Ahead," *New York Daily News* (March 13, 2002), Metro: 3; Robin Pogrebin, "More Museums for New York, Despite Poor Economy," *New York Times* (December 11, 2002), E: 1, 8; Glenn Collins, "Neither Children Nor Hammers Faze Museum Chief," *New York Times* (December 24, 2002), B: 2; Elizabeth Hays, "$750G Gift to Highlight Kids Museum Benefit," *New York Daily News* (May 17, 2004), Metro: 3.

259. Julian E. Barnes, "Crown Heights," *New York Times* (September 5, 1999), XIV: 8; Pogrebin, "More Museums for New York, Despite Poor Economy": 1, 8; Joyce Shelby, "New Kids Museum Stresses Laughing, Learning," *New York Daily News* (December 5, 2004), Metro: 4.

260. Stern, Mellins, and Fishman, *New York 1960*, 922–28.

261. Elizabeth Hayes, "Brownsville Bounces Back Better Than Ever: New Life for Victim of Urban Decay," *New York Daily News* (October 20, 2002), Metro: 6; Josh Barbanel, "Steady Focus, Evolving Vision," *New York Times* (May 16, 2004), XI: 1, 6.

262. Johnny Ray Youngblood, quoted in Dennis Hevesi, "East New York: A Neighborhood Reborn," *New York Times* (June 10, 2001), XI: 1, 6. Also see Linnaea Tillet, "Nighttime Lighting and Community Character," *Places* 11 (Summer 1997): 84–87.

263. Camilo José Vergara, "Tracking New York's Ghettos," in Patricia C. Phillips, ed., *City Speculations* (New York: Princeton Architectural Press, 1996), 94–99.

264. Lynette Holloway, "Officer Is Shot by a Suspect in Brooklyn," *New York Times* (June 11, 1996), B: 3; Hevesi, "East New York: A Neighborhood Reborn": 1, 6.

265. Margot Hornblower, "Bang! Pow! It's the Sultan of Scowl," *Washington Post* (November 23, 1985), G: 1.

266. Mary B. W. Tabor, "4th New York City Police Officer in 4 Days Is Shot," *New York Times* (November 17, 1991): 37.

267. Mary B. W. Tabor, "Mourners of Slain Student Ask, 'When Does It Stop?'" *New York Times* (November 30, 1991): 23.

268. Alison Mitchell, "2 Teen-Agers Shot to Death in a Brooklyn School," *New York Times* (February 27, 1992): 1, B: 2; Bethany Kandel, "Shootings Occur Just Before Mayor's Visit," *USA Today* (February 27, 1992): 3; Mark Tran, "Youth Kills Two Fellow Pupils at New York School 15FT From Police," *Guardian* (London) (February 28, 1992): 10; Glenn Thrush, "Anti-Arms Build-Up at School," *Metropolis* 12 (July/August 1992): 11–12; Steven Lee Myers, "A New Term, and Cautious Hope at Jefferson High," *New York Times* (September 12, 1992): 23.

269. E. Perry Winston, quoted in Hevesi, "East New York: A Neighborhood Reborn": 1.

270. Project description provided by the architects. Also see White and Willensky, *AIA Guide* (2000), 794.

271. Jane Perlez, "Plan for Market on Queens Site Backed by U.S.," *New York Times* (March 30, 1984), B: 4; Glenn Fowler, "Supply Scarce as Demand for Industrial Space Rises," *New York Times* (May 27, 1984), VIII: 1; "Brooklyn Industrial Complex," *New York Times* (March 26, 1986), D: 22; Sam Roberts, "Manufacturing Reclaims Pasture in East New York," *New York Times* (July 30, 1987), B: 1; Alan S. Oser, "More Sites Spoken for in Industrial Park," *New York Times* (December 13, 1987), VIII: 5; Ellen Marie Snyder-Grenier, "East New York," in Kenneth T. Jackson, ed., *The Encyclopedia of New York* (New Haven: Yale University Press; New York: New-York Historical Society, 1995), 357.

272. Alan S. Oser, "Perspectives: Low-Income Housing," *New York Times* (April 17, 1988), X: 9; Alan Finder, "Swapping Tax Credits for Housing," *New York Times* (June 21, 1988), B: 1, 5; Raymond W. Gastil, "Designing Public Housing," *Metropolis* 8 (December 1988): 23–25; Alan S. Oser, "Perspectives: Providing for Parking," *New York Times* (December 4, 1988), X: 9; Paul Goldberger, "On a Desolate Beach in Queens, a Point of Departure," *New York Times* (July 23, 1989), II: 29; Iver Peterson, "Linking 421a to Low-Income Housing," *New York Times* (December 17, 1989), X: 1, 7; "Spring Creek, Brooklyn, New York," *Architecture* 79 (July 1990): 51–55; Philip Arcidi, "Affordable Housing: Essays," *Progressive Architecture* 72 (June 1991): 110–11; Shawn G. Kennedy, "A Secure Rental Oasis for East New York," *New York Times* (January 9, 1994), X: 1, 10; Alan Melting, "'Secure Rental Oasis for East New York,'" letter to the editor, *New York Times* (January 30, 1994), X: 12; Theresa Braine, "High Wire Act: Affordable Housing Design," *Grid* 2 (January-February 2000): 90–92.

273. For Marcus Garvey Village, see Stern, Mellins, and Fishman, *New York 1960*, 924–25.

274. Theodore Liebman, quoted in "Spring Creek, Brooklyn, New York": 52.

275. Goldberger, "On a Desolate Beach in Queens, a Point of Departure": 29.

276. Hevesi, "East New York: A Neighborhood Reborn": 1, 6; Linda G. Miller, "Raising the Bar in Affordable Housing," *Oculus* 65 (Winter 2003/2004): 38–39.

277. Sorkin, *Michael Sorkin Studio: Wiggle*, 34–35.

278. Joan Copjec and Michael Sorkin, "Shrooms: East New York," *Assemblage* 24 (August 1994): 96–103. Also see Sorkin, *Michael Sorkin Studio: Wiggle*, 120–29. For the souks of Beirut, see Sorkin, *Michael Sorkin Studio: Wiggle*, 114.

279. Sorkin, *Michael Sorkin Studio: Wiggle*, 120.

280. Sorkin, *Michael Sorkin Studio: Wiggle*, 34–35.

281. "Garden Walk, Architecture and Art," *New York Times* (August 17, 1995), C: 9; Todd W. Bressi, "(Some) Architects Tackle East New York," *Oculus* 58 (September 1995): 14.

282. Denise Bekaert, quoted in Bressi, "(Some) Architects Tackle East New York": 14.

283. "Projects Within the City," *Oculus* 52 (February 1990): 3; Peter D. Slatin, "Turned-On Congregation Rebuilds Church," *Architectural Record* 179 (April 1991): 38; "Bethelite Institutional Baptist Church," *AIA New York State News* (November 1993): 9; Jayne Merkel and Philip Nobel, "Building for Belief," *Oculus* 59 (February 1997): 8–12; White and Willensky, *AIA Guide* (2000), 795.

284. Merkel and Nobel, "Building for Belief": 10–11; White and Willensky, *AIA Guide* (2000), 795.

285. Merkel and Nobel, "Building for Belief": 10–11.

286. *Richard Dattner: Selected and Current Works of Richard Dattner & Partners Architects*, 58–59, 248.

287. "Davis Brody Bond LLP/Larsen Shein Ginsberg + Magnusson, Joint Venture Architects," *AIA New York State News* (December 1998): 11.

288. "Rental Housing for the Elderly: $7.6 Million Residence in East New York," *New York Times* (September 28, 1997), IX: 1.

289. "Construction Under Way on PS/IS 156 in Brooklyn," *New York Construction News* 48 (December 2000): 65–66; Jane F. Kolleeny, "As Good As It Gets," *Architectural Record* 191 (March 2003): 131, 140–43; "2002 Top Projects: P.S./I.S. 156," *New York Construction News* 50 (June 2003): 58.

290. Paul Broches, quoted in Kolleeny, "As Good As It Gets": 142.

291. Mark DuBois, quoted in David W. Dunlap, "Projects' Community Centers Open Up, with Glass and Air," *New York Times* (November 14, 2002), B: 3. For Van Dyke Houses, see Stern, Mellins, and Fishman, *New York 1960*, 922–23.

292. Cathy Lang Ho, "Multiples: Small Civic Works," *Newsletter of the Architectural League of New York* (Winter 2002/2003): 3–7. For Marcus Garvey Houses, see Edward Ranzal, "Ground Is Broken in Brownsville for U.S.-Aided Housing Project," *New York Times* (November 22, 1972): 39.

293. Quoted in www.capjeff.com/site.html.

294. For Starrett City, see Stern, Mellins, and Fishman, *New York 1960*, 942.

295. Alan S. Oser, "Giving Housing a Push in Spring Creek," *New York Times* (November 5, 1989), X: 9, 14; Diana Shaman, "2 Projects Planned Near Brooklyn Starrett Complex," *New York Times* (September 25, 1992), B: 7; White and Willensky, *AIA Guide* (2000), 796.

296. Alan S. Oser, "Perspectives: The Starrett Proposal," *New York Times* (November 5, 1989), X: 9, 14; Diana Shaman, "2 Projects Planned Near Brooklyn Starrett Complex," *New York Times* (September 25, 1992), B: 7; Alan S. Oser, "Perspectives: Changeover in the Housing Agency," *New York Times* (July 8, 1990), X: 5; Alison Mitchell, "Group Makes Bid for Land in Brooklyn," *New York Times* (March 9, 1992), B: 1, 6; "Make the Most of Spring Creek," editorial, *New York Times* (April 18, 1992): 18; Steven Prokesch, "Housing Pact Is Reached for Brooklyn," *New York Times* (October 6, 1992), B: 1, 4; Alan S. Oser, "Revising the Script for a Starrett Plan in Brooklyn," *New York Times* (September 25, 1994), IX: 7; Claire Serant, "Gateway to a Mess: Plan's Impact Feared," *New York Daily News* (April 2, 1996), Metro: 1; Bill Farrell, "Panel Says Yes to New Community," *New York Daily News* (June 25, 1996), Metro: 1; Somini Sengupta, "East New York–Update: $500 Million Housing Plan Gets Council Approval," *New York Times* (June 30, 1996), XIII: 9; Samuel G. Freedman, "From the Ground Up in East New York," *New York Times* (April 4, 1998): 13; Amy Waldman, "East New York: Weed-Choked Acres Bring Forth Frustration, Not Housing," *New York Times* (May 10, 1998), XIV: 8; "Cost Control," *Oculus* 64 (December 2001): 10–11; Josh Barbanel, "Steady Focus, Evolving Vision," *New York Times* (May 16, 2004), XI: 1, 6. For the Brooklyn Developmental Center, see Stern, Mellins, and Fishman, *New York 1960*, 928.

297. Nichole M. Christian, "East New York Senses Promise in a New Mall," *New York Times* (November 15, 2000), B: 1, 6; "Industry Events," *New York Construction* 50 (January 2003): 47.

298. Stern, Gilmartin, and Massengale, *New York 1900*, 423–25; Stern, Mellins, and Fishman, *New York 1960*, 931–33; Stern, Mellins, and Fishman, *New York 1880*, 940–41.

299. Landmarks Preservation Commission of the City of New York, LP-0871 (January 28, 1975); Shawn G. Kennedy, "Ocean Parkway Gets Landmark Designation," *New York Times* (January 29, 1975): 36; Glenn Fowler, "Status of Ocean Parkway as Landmark in Dispute," *New York Times* (March 23, 1975): 89, 106; Glenn Fowler, "Ocean Parkway Ratified as a Landmark," *New York Times* (April 11, 1975): 51; Diamonstein, *The Landmarks of New York III*, 162. Also see Stern, Mellins, and Fishman, *New York 1880*, 920–22.

300. Ari L. Goldman, "City Cites Progress on Ocean Parkway," *New York Times* (April 20, 1975): 97; "Hearing Set on Ocean Parkway Plan," *New York Times* (May 11, 1975): 46; Edward C. Burks, "Highway Projects Planned for Year in New York City," *New York Times* (August 24, 1976): 33; "Other Highway Projects in Metropolitan Area," *New York Times* (December 13, 1976): 39.

301. William G. Blair, "Housing Values Grow Stronger on Brooklyn's Ocean Parkway," *New York Times* (December 7, 1980), VIII: 1, 4; Kenneth A. Briggs, "Orthodox Judaism Is Buoyed By a Resurgence in New York," *New York Times* (March 29, 1983): 1, B: 2.

302. Luis F. Rueda, ed., *Robert A. M. Stern: Buildings and Projects, 1981–1985* (New York: Rizzoli International Publications, 1986), 192–93, 292; C. Ray Smith, "1985 Architectural Awards for Unbuilt Projects," *Oculus* 47 (January 1986): 26; Daralice D. Boles, "P/A Profiles: Suburban Stern," *Progressive Architecture* 67 (August 1986): 68–79; Ghisi Grütter, *Il Desegno degli Architetti Americani Contemporanei* (Rome: Gangemi Editore, 1987), 134–38; Michael Collins and Andreas Papadakis, *Post-Modern Design* (New York: Rizzoli International Publications, 1989), 130; Heinrich Klotz, ed., *New York Architecture: 1970–1990* (Munich: Prestel Verlag, 1989), 220–21; *The American Houses of Robert A. M. Stern*, intro. by Clive Aslet (New York: Rizzoli International Publications, 1991), 202–7; Elizabeth Kraft, ed., *Robert A. M. Stern: Buildings and Projects, 1987–1992* (New York: Rizzoli International Publications, 1992), 26–27, 352; White and Willensky, *AIA Guide* (2000), 780.

303. Merkel and Nobel, "Building for Belief": 8–12; Elizabeth Pochoda, "Light Catcher," *House & Garden* 169 (January 2000): 108–15, 144.

304. Quoted in www.gluckpartners.com/projects/blurbs.

305. Pochoda, "Light Catcher": 111, 114.

306. White and Willensky, *AIA Guide* (2000), 786.

307. Rueda, ed., *Robert A. M. Stern: Buildings and Projects, 1981–1985*, 266–67, 293; Chanie Friedman, "Robert Stern: Creating Instant Landmarks," *Good Fortune* (February 1987): 91–97; "A Synagogue Grows in Brooklyn," *Architectural Record* 175 (June 1987): 55; "Robert A. M. Stern Architects," *AT Architecture* (November 1988): 27; Klotz, ed., *New York Architecture: 1970–1990*, 222–23; Kraft, ed., *Robert A. M. Stern: Buildings and Projects, 1987–1992*, 118–19, 358; Lucia Funari, ed., *Robert A. M. Stern: Modernità e Tradizione* (Rome: Edizioni Kappa, 1990), 142–45; *Robert A. M. Stern: Selected Works*, intro. by Charles Jencks (London: Academy Editions, 1991), 76–77; Laura Felleman Fattal, "American Sephardic Synagogue Architecture," *Jewish Art* 19/20 (1993/1994): 42–43; *New Architecture in Brooklyn 1985–1995: The Rotunda Gallery, November 9-December 21, 1995*, 8; Wendy Moonan, "Currents: Brooklyn Architecture," *New York Times* (November 9, 1995), C: 3; Nina Rappaport, "In the Galleries," *Oculus* 58 (December 1995): 7; Sirefman, *New York*, 294–95; White and Willensky, *AIA Guide* (2000), 786; Balfour, *World Cities: New York*, 181.

308. Fattal, "American Sephardic Synagogue Architecture": 42.

309. Stern, Gilmartin, and Mellins, *New York 1930*, 114.

310. "Museum of the Borough of Brooklyn," *Architecture + Urbanism*, extra edition (December 1986): 158; Margaret Gaskie, "Out of the Commonplace," *Architectural Record* 175 (Mid-September 1987): 162–65; *SITE*, 180–83.

311. *R. M. Kliment & Frances Halsband Architects: Selected and Current Works*, 182–85.

312. David W. Dunlap, "For Libraries, a Time of Rebirth," *New York Times* (September 28, 1997), IX: 1, 6; "For Brooklyn College, a Bigger, Modern Library," *New York Times* (June 13, 1999), XI: 1; "B'klyn College Books $62M Library Project," *New York Construction News* 48 (August 1999): 10; "Higher Education," *Oculus* 62 (February 2000): 7; Nadine Brozan, "On CUNY's Campuses, the Subject Is Change," *New York Times* (September 17, 2000), XI: 1, 4; "Larger Library Is Dedicated," *New York Times* (October 20, 2002), XI: 1.

313. "House Votes for a Takeover by City of Old Army Terminal in Brooklyn," *New York Times* (November 15, 1979), B: 13.

314. Carter B. Horsley, "Brooklyn Project Reviewed by City," *New York Times* (June 22, 1980), VIII: 1, 6; Ronald Smothers, "City Decides on a Developer for Brooklyn Army Terminal," *New York Times* (September 20, 1980): 20; Ronald Smothers, "City Bid to Buy Army Terminal Stalled on Price," *New York Times* (December 4, 1980), B: 3; "Army Terminal Aid Wins U.S. Approval," *New York Times* (April 24, 1981), B: 3; Joyce Purnick, "City Halts Talks with Helmsley on Army Depot," *New York Times* (August 7, 1981), B: 1; Stanley Turkel, "A New Opportunity on the Waterfront," letter to the editor, *New York Times* (August 15, 1981): 22; "Helmsley Drops Talks to Lease Army Terminal," *New York Times* (September 26, 1981): 26; Carter B. Horsley, "Brooklyn Army Terminal Study Asked," *New York Times* (October 4, 1981), VIII: 8; Joyce Purnick, "Plan to Develop Old Army Terminal Set Back," *New York Times* (October 25, 1981): 54.

N/A

315. Harry B. Helmsley, quoted in Purnick, "Plan to Develop Old Army Terminal Set Back": 54.

316. Herbert Muschamp, "Marginal Role for Architecture at Ground Zero," *New York Times* (May 23, 2002), B: 1, 4.

317. "Plan Fall Start for B'klyn Army Terminal Day Care Ctr.," *New York Construction News* 39 (June 8, 1992): 1; Michael J. Crosbie, "Daycare on a Shoestring," *Progressive Architecture* 74 (December 1993): 60–63.

318. "Fall Start Planned for $5.5 Brooklyn Amy Terminal Renovation Project," *New York Construction News* 39 (June 8, 1992): 1, 15; Alan S. Oser, "A Leasing Pickup on the Brooklyn Waterfront," *New York Times* (October 12, 1997), X: 5; Bob Liff, "Terminal To Get 30M Renovation," *New York Daily News* (March 30, 2000), Metro: 2; "NYCEDC Announces Completion of Phase IV Renovations at Brooklyn Army Terminal," press release (May 21, 2003); Fiona McDonough, "Army Terminal Tapped for a 30M Rehab Tour," *New York Daily News* (May 28, 2003), Metro: 3.

319. Anthony DePalma, "Brooklyn's Industry City vs. the Garment District," *New York Times* (March 13, 1985), B: 6; Shawn G. Kennedy, "Industrial Condominiums at the Old Bush Terminal," *New York Times* (April 30, 1986): 24.

320. Frank J. Prial, "Jail Is Planned for Brooklyn, and Foes Rise," *New York Times* (February 6, 1991), B: 3; Stephanie P. Cunningham, "Meeting the Challenge: Turning a Warehouse Into a B'klyn FDC," *New York Construction News* 42 (November 20, 1995): 1, 9.

321. Roberto Santiago, "Plan Buries Road, Brightens Sunset Pk.," *New York Daily News* (July 25, 2000), Metro: 5; Jayne Merkel, "Bringing Expertise to Sunset Park," *Oculus* 63 (February 2001): 10; Kira L. Gould, "Anticipating Big Dig II," *Competitions* 11 (Spring 2001): 42–49, 60.

322. Quoted in Gould, "Anticipating Big Dig II": 44.

323. Frank J. Prial, "City Offers Waterfront Sites to Commercial Developers," *New York Times* (February 9, 1984), B: 3; "City Selects Developer for Brooklyn Pier Site," *New York Times* (June 9, 1985): 45; Kirk Johnson, "City Revitalizing Sheepshead Bay," *New York Times* (June 16, 1985), VIII: 6; "At Sheepshead Bay: Fair Winds," *New York Times* (September 14, 1986), VIII: 1.

324. Bruce Lambert, "Sheepshead Bay Project Revived After Setback," *New York Times* (August 28, 1987), B: 3; Elizabeth Kolbert, "Project Irks Fishermen of Sheepshead Bay," *New York Times* (August 31, 1987), B: 1–2.

325. "At Sheepshead Bay: Fair Winds": 1; Alan S. Oser, "Residential Focus for Sheepshead Bay," *New York Times* (December 5, 1986), B: 6; Thomas L. Waite, "A New Era for Brooklyn's South Shore," *New York Times* (August 2, 1987), VIII: 9; Andrew L. Yarrow, "Sheepshead Bay Losing Its Old-Salt Air," *New York Times* (July 8, 1991), B: 1, 4.

326. Douglas Martin, "Sheepshead Bay at Odds on a Waterfront Proposal," *New York Times* (July 19, 1993), B: 3; Bruce Lambert, "With Regret, City Rejects Loehmann's," *New York Times* (January 23, 1994), XIII: 10; "Sheepshead Bay," *New York Times* (May 1, 1994), XIV: 10; Claudia H. Deutsch, "Should There Be a Fishing Village or a Loehmann's?" *New York Times* (July 9, 1995), IX: 11; Joyce Shelby, "Sore Over Shore Store," *New York Daily News* (April 15, 1996), Metro: 1; Tom Vanderbilt, "Shopping in Sheepshead Bay," *Metropolis* 17 (March 1997): 19, 25, 97; Edward Lewine, "Fishing Parties First Have to Fish for Parking Near Docks," *New York Times* (May 18, 1997), XIII: 10.

327. Douglas Martin, "Restaurant's Rebirth: A Breeze Blows in Brooklyn," *New York Times* (April 22, 1992), B: 3; "Late Summer CM, G/C Bids Planned for a $6M Lundy's in Brooklyn, N.Y.," *New York Construction News* 39 (June 8, 1992): 1, 14; Garry Pierre-Pierre, "Renovations at Lundy's. Yes, Really," *New York Times* (June 5, 1994), XIV: 10; Laura Williams, "Doin' the Lundy After 16 Years," *New York Daily News* (December 11, 1995), Metro: 1.

328. For Lundy's, see Landmarks Preservation Commission of the City of New York, LP-1706 (March 3, 1992); Diamonstein, *The Landmarks of New York III*, 432.

329. Anthony Weiner, quoted in Williams, "Doin' the Lundy After 16 Years": 1.

330. Rachelle Garbarine, "Brooklyn Project Aims at People 75 and Older," *New York Times* (January 8, 1999), B: 10; "Assisted Living Facility Under Way in Brooklyn," *New York Construction News* 47 (July 1999): 7; Alan S. Oser, "More Elderly Living Options, at a Price," *New York Times* (October 8, 2000), XI: 1, 6.

331. Project description provided by the architect.

332. Dennis Hevesi, "In a Garden by the Water, a Tower of Memories," *New York Times* (October 31, 1993), XIII: 10; "Brooklyn on Its Mind: 4 Projects Await Art Panel's Approval," *New York Times* (February 13, 1994), X: 1; Tara George, "Holocaust Memorial," *New York Daily News* (March 21, 1996), Metro: 6; Bob Liff, "Exclusions Cited in Holocaust Park," *New York Daily News* (August 12, 1996), Metro: 1; Somini Sengupta, "A Rift Opens Over 'Other Victims' at Holocaust Memorial," *New York Times* (August 18, 1996), XIII: 10; "Correction," *New York Times* (September 1, 1996), XIII: 4; Lucille Nieporent, "Don't Judge Holocaust Park By Its Unfinished State," letter to the editor, *New York Times* (March 16, 1997), XIII: 17; Tara George, "Outcry Over Holocaust Park," *New York Daily News* (March 13, 1997), Metro: 1; Howard Golden, "Holocaust Remembered," letter to the editor, *New York Times* (October 10, 1997): 22; "Brooklyn Remembers," *New York Daily News* (June 23, 1997): 6; "Holocaust Memorial Park," *Municipal Art Society Annual Report* (1997–98): 11.

333. "G/C Bids for $2.2M Brooklyn Library Branch Expected to Be Advertised by September '93," *New York Construction News* 40 (September 28, 1992): 1, 15; Dunlap, "For Libraries, a Time of Rebirth": 1, 6; White and Willensky, *AIA Guide* (2000), 780; Joyce Cohen, "Secluded Peninsula in South Brooklyn," *New York Times* (March 3, 2002), XI: 5; Maggie Kinser Hohle, *John*

334. Dunlap, "For Libraries, a Time of Rebirth": 6.

335. "The Earth Moves in Brooklyn," *Architectural Record* 181 (September 1993): 3.

336. Project description provided by the architect.

337. Stern, Gilmartin, and Massengale, *New York 1900*, 246–51; Stern, Mellins, and Fishman, *New York 1960*, 934–42; Stern, Mellins, and Fishman, *New York 1880*, 942–49.

338. Marcia Chambers, "New York, After 10 Years, Finds Plan to Create a Coney Island Park Is Unsuccessful," *New York Times* (April 3, 1977): 42; Marcia Chambers, "City, in a Shift, Says Coney I. Park Should Become Amusement Area," *New York Times* (June 16, 1977): 47; Carter B. Horsley, "Amusement Parks: Demand Strong, Space Scarce," *New York Times* (July 17, 1977), VIII: 1, 4. For Steeplechase Park, see Stern, Gilmartin, and Massengale, *New York 1900*, 229.

339. For the Parachute Jump, see Stern, Gilmartin, and Mellins, *New York 1930*, 752.

340. Beverly Moss Spatt, quoted in "Parachute Jump at Coney Island Loses Chance of Landmark Status," *New York Times* (October 21, 1977): 30. Also see Landmarks Preservation Commission of the City of New York, LP-0922 (July 12, 1977); "Tower Named Landmark," *New York Times* (July 13, 1977), B: 3.

341. Quoted in "Parachute Jump at Coney Island Loses Chance of Landmark Status": 30. Also see Susan Chira, "At Coney I., Symbols of Heyday Fading Away," *New York Times* (August 20, 1983): 23; "Parachute Jump," *New York Times* (January 1, 1984): 21.

342. For the designation of the Parachute Jump, see Landmarks Preservation Commission of the City of New York, LP-1638 (May 23, 1989); "Heartstoppers Are Declared Landmarks," *New York Times* (May 24, 1989), B: 2; Audrey Farolino, "Two Coney Island Thrillers Earn Landmark Status," *New York Post* (May 25, 1989): 47; Diamonstein, *The Landmarks of New York III*, 433. Also see Christopher Gray, "Streetscapes: The Coney Island Parachute Jump," *New York Times* (November 17, 1987), VIII: 14.

343. Deirdre Carmody, "Reborn Steeplechase Park Planned at Coney I.," *New York Times* (August 5, 1985), B: 1, 6; "Steeplechase Park in Brooklyn," *Architectural Record* 173 (September 1985): 55; Jesus Rangel, "Broad Redevelopment Is Urged for Coney Island," *New York Times* (June 5, 1987), B: 3; Thomas Morgan, "Coney I. Opens Today Amid Hope of Revival," *New York Times* (March 27, 1988): 34; "Steeplechase at the Starting Gate," editorial, *New York Times* (August 15, 1988): 16; Daniel J. McConville, "Coney Weighs Ups & Downs," *New York Post* (February 2, 1989): 54; David W. Dunlap, "Planners Approve a Disputed Tower," *New York Times* (February 16, 1989), B: 3; Shawn G. Kennedy, "Real Estate," *New York Times* (August 9, 1989), D: 20; Garry Pierre-Pierre, "Despite a Rebuff, Hope Springs Eternal," *New York Times* (April 24, 1994), XIV: 10.

344. "Activity and Hope Rising at Coney I.," *New York Times* (April 7, 1985): 20; Carmody, "Reborn Steeplechase Park Planned at Coney I.": 1, 6; Jesus Rangel, "Coney I. Opening Season with Hope," *New York Times* (March 29, 1986): 25.

345. "Walks of Life: The Boardwalk," *New York Times* (April 9, 1987): 26.

346. For the Cyclone, see Landmarks Preservation Commission of the City of New York, LP-1636 (July 12, 1988); David W. Dunlap, "Coney I. Thriller Becomes Landmark," *New York Times* (July 13, 1988), B: 3; "The Coney Island Cyclone," *Architectural Record* 176 (October 1988): 55; Diamonstein, *The Landmarks of New York III*, 427. For the Wonder Wheel, see Landmarks Preservation Commission of the City of New York, LP-1708 (May 23, 1989); "Heartstoppers Are Declared Landmarks": 2; Farolino, "Two Coney Island Thrillers Earn Landmark Status": 47; Diamonstein, *The Landmarks of New York III*, 422.

347. William G. Blair, "Aquarium Constructing a New Complex," *New York Times* (March 22, 1986): 31; Dunlap, "Smaller Architectural Firms Find Their Niche": 1, 8; Douglas Martin, "Aquarium Turns 100 with Renewed Popularity," *New York Times* (December 12, 1996), B: 4. For Harrison & Abramovitz's and Goldstone & Dearborn's work at the New York Aquarium, see Stern, Mellins, and Fishman, *New York 1960*, 939.

348. Dan Barry, "Feverish Dream of Baseball as Mets Look at Brooklyn," *New York Times* (January 17, 1998), B: 3; Andy Newman, "Mets Accord Could Return Pro Baseball to Brooklyn," *New York Times* (September 16, 1998), B: 5; Douglas Martin, "Plans for Minor League Park Shouldered Aside Sports Complex," *New York Times* (November 23, 1998), B: 5; Martin J. Licari, "Plans Being Fast-Tracked for Regional Stadium Market," *New York Construction News* 47 (July 1999): 23–28; Charles V. Bagli, "Despite Criticism, Giuliani Pursues Ballparks as Economic Catalysts," *New York Times* (March 2, 2000), B: 1, 6; Julian E. Barnes, "Deal Secures a Ballpark, and Extras, for Coney Island," *New York Times* (April 12, 2000), B: 6; "City Council Approves Coney Island Stadium," *New York Times* (April 13, 2000), B: 7; David Barstow, "Facing the Ghost of Summers Past," *New York Times* (June 9, 2000), B: 1, 6; Thomas J. Lueck, "Opposition Rears Its Head at Coney I. Stadium Before Teams Arrive," *New York Times* (August 23, 2000), B: 1, 6; Steve Viuker, "Cyclones Ready to Rumble," *Real Estate New York* 20 (June 2001): 10; Andy Newman, "Not Dodgers II, but It's Baseball: The Game Is Back in Brooklyn, on a Smaller Scale," *New York Times* (June 23, 2001), B: 1, 3; Alex Marshall, "Play Ball," *Metropolis* 21 (August/September 2001): 70–74, 105, 107; Nicholas Dawidoff, "The House that Rudy Built," *New York Times* (August 12, 2001), VI: 40–43; Gastil, *Beyond the Edge*, 113–16; Jane H. Kolleeny, "This Stadium Breathes New Life Into Historic Coney Island," *Architectural Record* 190 (November 2002): 116; Shira J. Ross, "Stadium's a Hit Out of the Park," *Crain's New York Business* (January 13, 2003): 37.

349. Edward A. Gargan, "Russian Immigrants Establish New Enclaves in City," *New York Times* (December 21, 1980): 56; Alex Kucherov, "For Russian Jews, a Bit of Odessa Grows in Brooklyn," *U.S. News & World Report* (November 16, 1981): 85; Colette Rossant, "Moscow Nights," *New York 17* (November 5, 1984): 87–88; Keith Henderson, "The Melting Pot, Circa 1986," *Christian Science Monitor* (July 3, 1986): 37; Annelise Orleck, "The Soviet Jews: Life in Brighton Beach, Brooklyn," in Nancy Foner, ed., *New Immigrants in New York* (New York: Columbia University Press, 1987), 273–304; "Brooklyn-on-Volga," *The Economist* (June 9, 1990): 25; Chris Hedges, "Where Soviet Emigrés Finally Let Loose," *New York Times* (August 11, 1990): 27, 29; Roger Rosenblatt, "From Russia, with Hope and Fear," *New York Times* (November 20, 1994), VI: 70–78; Ian Katz, "Brooklyn Becomes Another Country for the Russian Jews Fleeing Persecution Once More," *The Guardian* (March 21, 1995): 11; Jim Yardley, "For Russian New York, a 'Suburb' Next Door: Many View Brighton Beach as the 'City,' and Manhattan Beach Is Now Home," *New York Times* (September 23, 1998), B: 1, 8; Annelise Orleck, *The Soviet Jewish Americans* (Westport, Conn.: Greenwood Press, 1999), 85–121; Edward Lewine, "From Brighton Beach to America," *New York Times* (March 14, 1999), XIV: 1, 10.

350. Jesus Rangel, "For Brighton Beach, a Time of Change," *New York Times* (July 23, 1986): 26; "The Shifting Fortunes of Brooklyn's Brighton Beach," *Architectural Record* 174 (August 1986): 55; Peter Lemos, "Brighton Beach Boudoirs," *Metropolis* 6 (September 1986): 12–13.

351. Alan S. Oser, "A Revised Proposal for the Baths Site," *New York Times* (November 19, 1989), X: 9; Mireya Navarro, "Aging Baths in Brighton Face Demise," *New York Times* (November 29, 1989), B: 1, 4; David W. Dunlap, "Proposed West Side Project Attacked," *New York Times* (November 30, 1989), B: 2; James Barron, "Luxury Brooklyn High-Rise Fails to Win Planning Votes," *New York Times* (January 23, 1990), B: 3; Andrew L. Yarrow, "For Family of Builders, Brick Walls," *New York Times* (September 9, 1991), B: 1, 3; Mary B. W. Tabor, "2 Sides Clash Over Project for Brighton Beach," *New York Times* (May 7, 1992), B: 3; Alan S. Oser, "Perspectives: Brighton Beach," *New York Times* (May 17, 1992), X: 5; Mary B. W. Tabor, "Brighton-by-the Sea Housing Proposal Endures a Stormy Hearing," *New York Times* (June 11, 1992), B: 3; "Brighton Beach," *New York Times* (April 10, 1994), XIII: 10.

352. Linda Davidoff, quoted in Barron, "Luxury Brooklyn High-Rise Fails to Win Planning Votes": 3.

353. Mark Francis Cohen, "The Baths Are Getter Closer to a Trip to the Showers," *New York Times* (February 23, 1997), XIII: 10; Lena Williams, "Brighton Beach Memories, Sold!" *New York Times* (November 9, 1997), XIV: 10; "Brooklyn, N.Y.," *New York Construction News* 45 (July 1999): 95; "On Former Site of Brighton Beach Baths," *New York Times* (July 25, 1999), XI: 1; Alan S. Oser, "A Developer Reshapes a Brighton Beach Project," *New York Times* (September 5, 1999), XI: 9; Rachelle Garbarine, "Luxury Housing by the Boardwalk," *New York Times* (March 10, 2000), B: 8; Joy Armstrong, "Sand Dollars," *New York 34* (August 13, 2001): 18; Alan S. Oser, "On Brighton Beach, a Tide of Immigrants," *New York Times* (December 23, 2001), XI: 1, 6; Bill Farrell, "New Luxury Tower Rises: Work Begins on 7th Oceana Building," *New York Daily News* (May 16, 2002), Metro: 3; Tara Bahrampour, "Neighborhood Report: Brighton Beach," *New York Times* (May 25, 2003), XIV: 7.

THE BRONX

1. See Stern, Mellins, and Fishman, *New York 1960*, 954–56.

2. Charles Kaiser, "Rules Restrict U.S.-Aided Housing in South Bronx to Over-Track Site," *New York Times* (February 10, 1977), 1, 34; "New York 'Assured' on a Housing Switch," *New York Times* (February 11, 1977), B: 3; "City View on Bronx Housing Plan Explained," *New York Times* (February 12, 1977): 23; "New York Planning Agency Clears Housing Project," *New York Times* (March 3, 1977): 37; Charles Kaiser, "Estimate Unit Votes Plan to Put Housing Over Bronx Tracks," *New York Times* (March 25, 1977): 11; White and Willensky, *AIA Guide* (1988), 491.

3. Steven R. Weisman, "City Is Planning Housing Over Bronx Rail Tracks," *New York Times* (May 26, 1971): 85; "Plan Board Backs New High School," *New York Times* (June 16, 1971): 32.

4. Kaiser, "Rules Restrict U.S.-Aided Housing in South Bronx to Over-Track Site": 1.

5. For Chelsea Walk, see Stern, Mellins, and Fishman, *New York 1960*, 313–14.

6. Kira L. Gould, "The Annual Design Awards Symposium," *Oculus* 62 (November 1999): 17–18.

7. Quoted in http://www.cplusga.com/marh-urban.htm.

8. "Morrisania Air Rights," *New York Daily News* (October 29, 1999), Metro: 2; "Big-Money Makeovers at Projects," *New York Daily News* (July 7, 2002), Metro: 1; Jim O'Grady, "Urban Tactics," *New York Times* (May 18, 2003), XIV: 4.

9. Charles Mohr, "Udall, Campaigning in South Bronx, Keeps a Watchful Eye on Wisconsin," *New York Times* (March 20, 1976): 12.

10. Lee Dembart, "Carter Takes 'Sobering' Trip to South Bronx," *New York Times* (October 6, 1977): 1, B: 18. Also see "The Trip to the Bronx," editorial, *New York Times* (October 6, 1977): 26; Richard Severo, "Bronx a Symbol of America's Woes," *New York Times* (October 6, 1977): 1; Lee Dembart, "City Reminds Carter There Is a Plan for South Bronx," *New York Times* (October 7, 1977): 54; Joseph P. Fried, "The South Bronx, U.S.A.," *New York Times* (October 7, 1977): 27; Michael Sterne, "A Loan and Some 'Sweat Equity' Create an Oasis Amid Desolation," *New York Times* (October 7, 1977): 54; "Tenants Still Cling to Last Building on the Block," *New York Times* (October 21, 1977): 29; Fred Ferretti, "After 70 Years, South Bronx Street Is at a Dead End," *New York Times* (October

21, 1977), B: 1, 3; Robert A. M. Stern, "The Suburban Alternative for the 'Middle City,'" *Architectural Record* 164 (August 1978): 93–100; Jill Jonnes, *South Bronx Rising: The Rise, Fall, and Resurrection of an American City* (New York: Fordham University Press, 2002), 311–23; Evelyn Gonzalez, *The Bronx* (New York: Columbia University Press, 2004), 127–29.

11. Jimmy Carter, quoted in Dembart, "Carter Takes 'Sobering' Trip to South Bronx": 1, 18.

12. "The Trip to the Bronx": 26.

13. Alan S. Oser, "Regeneration of Street in the South Bronx," *New York Times* (January 28, 1977), B: 3.

14. *The South Bronx: A Plan for Revitalization* (New York, December 1977); Charles Kaiser, "$870 Million Revitalization Plan for South Bronx Unveiled by City," *New York Times* (December 21, 1977): 1, D: 15; Michael Sterne, "Koch Orders 3 Agencies to Work Closely on a South Bronx Effort," *New York Times* (February 12, 1978): 49; Maurice Carroll, "Koch Seeks Control over Proposed Bronx Renewal," *New York Times* (March 30, 1978): B: 3; Maurice Carroll, "Badillo in Command of Project in Bronx," *New York Times* (April 5, 1978): B: 3; Glenn Fowler, "$55.6 Million by Fall to Help South Bronx Is Pledged by U.S.," *New York Times* (April 13, 1978): 1, B: 6; "Braving the Bronx," editorial, *New York Times* (April 17, 1978): 22; Joseph \P. Fried, "Is South Bronx Revival Plan Simply Folly?" *New York Times* (June 18, 1978), D: 9; Joseph P. Fried, "A Glimmer of Hope in the South Bronx," *New York Times* (November 15, 1978), B: 2; Joseph P. Fried, "Estimate Board Votes South Bronx Housing Project," *New York Times* (November 17, 1978), B: 4; Roger Wilkins, "City Planner Brings Hope for a New South Bronx," *New York Times* (November 17, 1978), B: 4; "The Symbol of Charlotte Street," editorial, *New York Times* (December 21, 1978): 22; Joseph P. Fried, "In Rebuilding the South Bronx, Politics Is Also a Priority," *New York Times* (December 24, 1978), IV: 6; Myron Kayton, "Farms for the Bronx," letter to the editor, *New York Times* (December 30, 1978): 18; Steven R. Weisman, "U.S. Delays Its Approval of Project in South Bronx," *New York Times* (January 20, 1979): 25; Stephen R. Weisman, "White House Backs a Housing Program in the South Bronx," *New York Times* (February 7, 1979): 1, B: 4; "Fudging over the South Bronx," editorial, *New York Times* (February 8, 1979): 18; Glenn Fowler, "South Bronx Plan Voted Down 7 to 4 by Estimate Board," *New York Times* (February 9, 1979): 1, B: 4; Francis X. Clines, "About New York," *New York Times* (February 10, 1979): 22; Glenn Fowler, "Congressmen Try to Revive Plans for Redeveloping the South Bronx," *New York Times* (February 10, 1979): 1, 22; Steven R. Weisman, "City Hall Split: Gloves Are Off," *New York Times* (February 10, 1979): 1, 22; Paul Goldberger, "For Urban Planners, a Case Study in Frustration," *New York Times* (February 11, 1979), IV: 5; Lee Dembart, "Koch, in a Reversal, Orders New Plan for South Bronx," *New York Times* (February 13, 1979): 1, B: 6; William G. Tucker, "New York's 'Radical Chic' vs. Charlotte Street," letter to the editor, *New York Times* (February 22, 1979): 26; "South Bronx Debate; Dig It Now or Plan It Later," *New York Times* (February 25, 1979), IV: 7; Carter B. Horsley, "About Real Estate," *New York Times* (June 22, 1979): 17; Anna Quindlen, "Revival Plan Alive in the South Bronx," *New York Times* (June 24, 1979): 29; Ari L. Goldman, "New Plan Submitted for Housing and Jobs in South Bronx Area," *New York Times* (August 14, 1979), B: 6; "Badillo Deplores New Koch Plan on South Bronx," *New York Times* (August 15, 1979): B: 4; "Smaller Is Sounder in the Bronx," editorial, *New York Times* (August 20, 1979): 20; Anna Quindlen, "The Politics of Charlotte Street," *New York Times* (October 7, 1979), VI: 107; Ira Rosen, "The Glory That Was Charlotte Street," *New York Times* (October 7, 1979), VI: 43–44, 74, 76, 106–9; Michael Goodwin, "'Mr. Urban Renewal' Acts to Rebuild His Image," *New York Times* (May 10, 1980): 25, 27; Michael Goodwin, "New Plan, Dependent on U.S. Aid, Is Offered to Rebuild South Bronx," *New York Times* (July 20, 1980): 1, 35; "Reagan, in South Bronx, Says Carter Broke Vow," *New York Times* (August 6, 1980): 16; Paul Moore Jr., "Same Carter-Reagan Urban Policy," letter to the editor, *New York Times* (August 12, 1980): 18; Robert McG. Thomas Jr., "Mayor Outlines Aid on Housing in South Bronx," *New York Times* (October 10, 1980): B: 3; Wolf Von Eckardt, "The Rubble and the Resolve," *Washington Post* (April 18, 1981), D: 1; "The South Bronx Looks to Itself," editorial, *New York Times* (May 8, 1981): 30; Joyce Purnick, "U.S. Won't Back a Key City Plan for South Bronx," *New York Times* (October 6, 1981), B: 1, 4; Sydney H. Schanberg, "Retreating in the Bronx," *New York Times* (October 6, 1981): 31; Richard Levine and Carlyle C. Douglas, "South Bronx Plan Fails Credit Test, May Go Under," *New York Times* (October 11, 1981), IV: 6; Jonnes, *South Bronx Rising*, 324–44.

15. Joseph P. Fried, "A Bronx Rehabilitation Is Now a Ruined Dream," *New York Times* (February 6, 1978), B: 1, 7. Also see Daniel Lewis and Milton Leebaw, "For the Bronx, a Revealing Failure," *New York Times* (February 12, 1978), IV: 5; Joseph P. Fried, "Vandalized South Bronx Project Gets New Chance," *New York Times* (July 6, 1978): B: 1, 4; Michael Goodwin, "H.U.D. Drops 2d Renovation of a South Bronx Project," *New York Times* (November 30, 1979): B: 3.

16. Stern, Mellins, and Fishman, *New York 1960*, 45, 80, 642, 645–46, 888, 918–19, 924–25, 936. Also see Jim Yardley, "A Master Builder's Mixed Legacy," *New York Times* (December 29, 1997), B: 1, 6; Rebecca Barnes, "Master Pieces," *Architecture Boston* 1 (No. 2, 1998): 30–34; William H. Honan, "Edward Logue, 78, Dies: Fought Urban Decay," *New York Times* (January 29, 2000), B: 7; Herbert Muschamp, "From an Era When Equality Mattered," *New York Times* (February 20, 2000), II: 41; "In Memoriam," *Planning* 66 (March 2000): 42; Jayne Merkel, "Ken Frampton and Friends on Ed Logue," *Oculus* 63 (October 2000): 14–15; "Good Old Days of Housing: Exhibition Review," *Oculus* 63 (April 2001): 14, 16.

17. See Stern, Mellins, and Fishman, *New York 1960*, 34–35.

18. Edward J. Logue, quoted in Wilkins, "City Planner Brings Hope for a New South Bronx": 4.

19. Howard Golden, quoted in Quindlen, "The Politics of Charlotte Street": 107, also quoted in Jonnes, *South Bronx Rising*, 325.

20. Quoted in Goldman, "New Plan Submitted for Housing and Jobs in South Bronx Area": 6.

21. Herman Badillo, quoted in "Badillo Deplores New Koch Plan on South Bronx": 4.

22. "Smaller Is Sounder in the Bronx": 20.

23. Vincent Canby, "'Fort Apache, the Bronx,' with Paul Newman," *New York Times* (February 6, 1981), C: 6; Selwyn Raab, "Film Image Provokes Outcry in South Bronx," *New York Times* (February 6, 1981), C: 6; "'Apache' Film's Debut Protested," *New York Times* (February 7, 1981): 9; Lee A. Daniels, "The Talk of the South Bronx," *New York Times* (April 11, 1981), II: 25.

24. David W. Dunlap, "Suburban Housing Grows in the Bronx," *New York Times* (May 2, 1982), IV: 6; Kathleen Teltsch, "94 Factory-Built Houses Planned for South Bronx," *New York Times* (June 27, 1982): 39; Philip Shenon, "Taste of Suburbia Arrives in South Bronx," *New York Times* (March 19, 1983): 1, 27; "Ranch Houses? Where?" editorial, *New York Times* (March 24, 1983): 30; Michael J. Crosbie, "Suburbia Comes to the South Bronx," *Architecture* 72 (October 1983): 65; Alan S. Oser, "The Factory-Built House Gets a Foothold in City," *New York Times* (November 13, 1983), VIII: 1, 14; "Cuomo, in Bronx, Helps Build Home," *New York Times* (December 10, 1983): 27; Philip Shenon, "'Pioneer' Settlers Bring Glow to South Bronx," *New York Times* (January 14, 1984): 1, 19; Sydney H. Schanberg, "Vital Signs in the Bronx," *New York Times* (January 17, 1984): 25; "Urban Homesteaders: Charlotte Gardens," *Time* 123 (January 30, 1984): 16; Mark Starr with David L. Gonzalez, "Ranch Houses at Fort Apache," *Newsweek* 103 (February 13, 1984): 30; Ellen Hopkins, "Charlotte Gardens Housing Project," *New York Times* 17 (March 12, 1984): 18; Eric Marcus, "Charlotte Street," *Metropolis* 4 (April 1985): 27, 29, 34–35; Alan S. Oser, "Lessons from One-Family Housing in the South Bronx," *New York Times* (April 21, 1985), VIII: 7; Robert A. M. Stern, *Pride of Place: Building the American Dream* (Boston: Houghton Mifflin; New York: American Heritage, 1986), 158; Sam Roberts, "Charlotte Street: Tortured Rebirth of a Wasteland," *New York Times* (March 9, 1987), B: 1; Genevieve S. Brooks, "South Bronx: Phoenix Ascending," *The Livable City* 13 (October 1989): 8–12; Bradford McKee, "South Bronx," *Architecture* 84 (April 1995): 86–95; Barbara Stewart, "Market's Nod to a Rebirth," *New York Times* (November 2, 1997): 37, 43; Richard Plunz, "South Bronx Suburbia," letter to the editor, *New York Times* (November 5, 1997): 26; Lloyd Ultan and Barbara Unger, *Bronx Accent* (New Brunswick, N.J.: Rutgers University Press, 2000), 276–77; White and Willensky, *AIA Guide* (2000), 562; Jonnes, *South Bronx Rising*, 376–88; Gonzalez, *The Bronx*, 135.

25. Edward J. Logue, quoted in Shenon, "Taste of Suburbia Arrives in South Bronx": 1, 27. For Freedomland and Co-op City, see Stern, Mellins, and Fishman, *New York 1960*, 968–71.

26. See Stern, Mellins, and Fishman, *New York 1960*, 954.

27. Marcus, "Charlotte Street": 27, 34–35.

28. Gwendolyn Wright, quoted in "Episode 4: Suburbs: Arcadia for Everyone," in *Pride of Place: Building the American Dream* (hosted by Robert A. M. Stern; W. A. Murray Grigor, director, 1986).

29. Robert D. McFadden, "Derelict Tenements in the Bronx to Get Fake Lived-In Look," *New York Times* (November 7, 1983): 1, B: 5; William E. Geist, "Residents Give a Bronx Cheer to Decal Plan," *New York Times* (November 12, 1983): 1, 26; "Putting a Happy Face on the Bronx," *New York Times* (November 13, 1983), IV: 6; "Fake Blinds Can't Hide Blight," editorial, *New York Times* (November 14, 1983): 18; Eugene Shapiro, "Decals to the Rescue," letter to the editor, *New York Times* (November 14, 1983): 18; Edward I. Koch and Dean Brackley, "Of Decals and Priorities for the South Bronx," letters to the editor, *New York Times* (November 19, 1983): 24; "Brightening Up the Bronx," *Progressive Architecture* 64 (December 1983): 42; Ismael Betancourt Jr., "Bronx Should Top M.A.C. Fund List," letter to the editor, *New York Times* (December 3, 1983): 22; "New York's Potemkin Borough," *The Economist* (December 3, 1983): 52; George F. Will, "Fixing Broken Windows," *Washington Post* (December 4, 1983), C: 7; August Heckscher, "The Imagemakers," *Christian Science Monitor* (December 16, 1983): 34; John T. Patterson Jr., "A South Bronx Task Made a Little Pleasanter," letter to the editor, *New York Times* (December 22, 1983): 20; Lydia Chavez with Richard J. Meislin, "From the Ashes, Bronx Faces Uncertain Future," *New York Times* (June 14, 1987): 1, 42; Margot Hornblower, "South Bronx," *Washington Post* (August 25, 1987): 1; Jack Rosenthal, "The Pyramids of New York," *New York Times* (January 29, 1989), IV: 22; Sam Roberts, "Metro Matters," *New York Times* (December 28, 1989), B: 1; Jonnes, *South Bronx Rising*, 385, 387.

30. Anthony B. Gliedman, quoted in McFadden, "Derelict Tenements in the Bronx to Get Fake Lived-In Look": 1, 5.

31. Geist, "Residents Give a Bronx Cheer to Decal Plan": 1.

32. Wilmer Cintron and Jose Ceballos, quoted in Geist, "Residents Give a Bronx Cheer to Decal Plan": 26.

33. "Fake Blinds Can't Hide Blight": 18.

34. Koch, "Of Decals and Priorities for the South Bronx": 24.

35. Will, "Fixing Broken Windows": 7.

36. Heckscher, "The Imagemakers": 34.

37. Edward J. Logue, quoted in Jonnes, *South Bronx Rising*, 385.

38. "South Bronx Transformation: From Fake Windows to Real Rehabilitation," *New York Times* (May 22, 1994), X: 1.

39. Lee Dembart, "City Planning Sites for Small Industry," *New York Times* (April 6, 1979), D: 13; Ari L. Goldman, "New Plan Submitted for Housing and Jobs in South Bronx Area,"

New York Times (August 14, 1979), B: 6; Ari L. Goldman, "Port Agency Plans 3 Industrial Parks," *New York Times* (March 13, 1981): 1, B: 3; Alan S. Oser, "Industrial Park Set for Bronx," *New York Times* (March 18, 1981), D: 21; Ronald Smothers, "South Bronx Industrial Park Begins to Take Shape," *New York Times* (December 18, 1981), B: 2; "Chuckles, Zones and Bones," editorial, *New York Times* (December 31, 1981): 22; "The Port Authority of New York and New Jersey," *Oculus* 48 (December 1986): 21; White and Willensky, *AIA Guide* (1988), 494; Norimitsu Onishi, "Industry Fills Tremont Park but Avoids Going Further," *New York Times* (October 30, 1994), II: 9; Joe Mysak with Judith Schiffer, *Perpetual Motion: The Illustrated History of the Port Authority of New York and New Jersey* (Los Angeles: General Publishing Group, 1997), 199; White and Willensky, *AIA Guide* (2000), 563; Jonnes, *South Bronx Rising*, 384–85.

40. Edward I. Koch, quoted in Smothers, "South Bronx Industrial Park Begins to Take Shape": 2.

41. White and Willensky, *AIA Guide* (1988), 494; White and Willensky, *AIA Guide* (2000), 563.

42. "Tiffany Plaza Construction Started in the South Bronx," *New York Times* (September 19, 1980), B: 3; Michael Goodwin, "Controversial Father Gigante Wins Applause," *New York Times* (July 15, 1981), B: 1; Anna Quindlen, "About New York," *New York Times* (May 15, 1982), II: 31; "Municipal Art Society Giving Awards," *New York Times* (June 3, 1982), C: 16; Robert Jensen, "South Bronx Turn-Around," *Progressive Architecture* 64 (January 1983): 49; Charles K. Gandee, "Urban Oases," *Architectural Record* 171 (May 1983): 98–101; "Architect Leaves Legacy in 20 Parks," *New York Times* (December 8, 1995): 73; White and Willensky, *AIA Guide* (1988), 495. For the Rev. Gigante, a controversial figure whose brother Vincent "the Chin" Gigante was the reputed head of the Gambino crime family, see William Bastone, "The Priest and the Mob," *Village Voice* (March 7, 1989): 1, 25–26; Stern, Mellins, and Fishman, *New York 1960*, 956; Amy Waldman, "Mortality on the Mind, a Legacy on the Agenda," *New York Times* (April 30, 2001), B: 1, 6.

43. Jensen, "South Bronx Turn-Around": 49.

44. Gandee, "Urban Oases": 98.

45. Gandee, "Urban Oases": 98–101; White and Willensky, *AIA Guide* (1988), 491–92.

46. Lee Weintraub, quoted in Gandee, "Urban Oases": 101.

47. "Longfellow Garden," *Landscape Architecture* 75 (September-October 1985): 68–71; "7 Projects Win Awards for Design," *New York Times* (October 17, 1986): C: 40; White and Willensky, *AIA Guide* (1988), 496.

48. Jensen, "South Bronx Turn-Around": 49; "A New Home for a Museum in the Bronx," *New York Times* (February 2, 1983), B: 3; Michael Brenson, "Art People," *New York Times* (May 6, 1983), C: 25; Grace Glueck, "Three Shows Open New Bronx Museum," *New York Times* (May 13, 1983), C: 24; Grace Glueck, "From Synagogue to Museum," *New York Times* (September 25, 1988), II: 38; Hugo Lindgren, "Pretty Pictures and Urban Renewal," *Metropolis* 14 (December 1994): 28, 34; White and Willensky, *AIA Guide* (2000), 582. For the Bronx County Building, see Stern, Gilmartin, and Mellins, *New York 1930*, 101, 104. For Zelnik's synagogue, see "Synagogue in Bronx Is Hailed by Mayor," *New York Times* (November 16, 1959): 24; George Dugan, "Synagogue Dedication," *New York Times* (April 7, 1962): 14.

49. Lindgren, "Pretty Pictures and Urban Renewal": 34.

50. Alan S. Oser, "The Housing Shift Near Charlotte Street," *New York Times* (March 19, 1989), X: 9, 16. Also see Philip S. Gutis, "Town Houses to Emerge From South Bronx Rubble," *New York Times* (July 25, 1986): 13; Pearl Bosco, "And the South Bronx Shall Rise Again," *U.S. Real Estate Week 1* (March 2, 1987): no pagination; Kathleen Teltsch, "Once Desperate, a Bronx Housing Group Wins Praise," *New York Times* (October 30, 1987): B: 1, 4; Sam Howe Verhovek, "After Exodus, Hope Comes to a South Bronx Block," *New York Times* (November 10, 1987), B: 1, 4; Brooks, "South Bronx: Phoenix Ascending": 9; Lynette Holloway, "Little Slices of Suburbia, a la South Bronx," *New York Times* (May 8, 1994), XIV: 9; Rafael A. Olmeda, "Affordable New Homes, & Old Woes," *New York Daily News* (March 9, 1998), Metro: 1; Bernard Stamler, "For a Family of Builders, the Bronx Is Up," *New York Times* (January 30, 2000), XIV: 4.

51. Genevieve S. Brooks, quoted in Oser, "The Housing Shift Near Charlotte Street": 9.

52. Oser, "The Housing Shift Near Charlotte Street": 16; "50 Affordable Bronx Town Houses," *New York Times* (July 15, 1990), X: 1; McKee, "South Bronx": 90; Stamler, "For a Family of Builders, the Bronx Is Up": 4.

53. "Start Set on Bronx Affordable Housing," *New York Construction News* 38 (September 17, 1990): 1, 15.

54. Alan S. Oser, "Perspectives: Bronx Town Houses," *New York Times* (May 19, 1991), X: 5; McKee, "South Bronx": 88–89.

55. Jonnes, *South Bronx Rising*, 399–401.

56. "76 Units in the Bronx: Low-Income Housing," *New York Times* (October 27, 1991), X: 1.

57. White and Willensky, *AIA Guide* (2000), 563. Also see McKee, "South Bronx": 90–91.

58. "Touch of Art Deco in the Bronx," *New York Times* (November 28, 1999), X: 1; "Casella Plaza," *New York Daily News* (November 17, 1999), Metro: 3; Nancy Ramsey, "Senior Housing in the Bronx," *Grid* 2 (January-February 2000): 27–28.

59. Alan S. Oser, "Perspectives: South Bronx Houses," *New York Times* (November 10, 1991), X: 5; "The South Bronx," *The Livable City* 18 (Spring 1994): 1; Lynette Holloway, "At Melrose Court, Progress in Shades of Teal," *New York Times* (May 8, 1994), XIV: 9; Mervyn Rothstein, "A Renewal Plan in the Bronx Advances," *New York Times* (July 10, 1994), IX: 1, 8; McKee, "South Bronx": 88–90; Robert D. McFadden, "A Tour of the Bronx, No Longer Burning," *New York Times* (October 19, 1996): 26; White and Willensky, *AIA Guide* (2000), 557; Stamler,

"For a Family of Builders, the Bronx Is Up": 4; *Marvin H. Meltzer: City as Poetry* (Milan: l'Arca Edizioni, 2002), 34–39.

60. Marvin H. Meltzer, quoted in McKee, "South Bronx": 88.

61. McKee, "South Bronx": 88.

62. Marvin H. Meltzer, quoted in *Marvin H. Meltzer: City as Poetry*, 35.

63. Rachelle Garbarine, "Low-Income Bronx Apartments Near Completion," *New York Times* (November 26, 1999), B: 8; Amy Waldman, "Housing Radical Meets Bottom Line," *New York Times* (January 18, 2000), B: 1, 6; *Marvin H. Meltzer: City as Poetry*, 48–51.

64. "South Bronx Low-Income Lottery," *New York Times* (January 23, 2000), XI: 1; *Marvin H. Meltzer: City as Poetry*, 58–63.

65. Marvin H. Meltzer, quoted in "A 7-Story Building, in Blue, Yellow and Orange," *New York Times* (August 27, 2000), XI: 1. Also see Theresa Braine, "High Wire Act: Affordable Housing Design," *Grid* 2 (January-February 2000): 90–92; Dave Platter, "From Blight to Bright in the Bronx," *Urban Land* 60 (May 2001): 32; *Marvin H. Meltzer: City as Poetry*, 64–67.

66. Todd S. Purdum, "Koch Proposes Police Academy for South Bronx," *New York Times* (January 26, 1989), B: 4; Alan S. Oser, "A Struggle over Sites in the South Bronx," *New York Times* (October 22, 1989), X: 9; Tim Golden, "In the Ravaged South Bronx, a Camelot Is Envisioned," *New York Times* (December 17, 1990), B: 1, 6; Steve Rosenbush, "Commons Concerns," *City Limits* 16 (January 1991): 18–19; Mary Lou Gallagher, "The Bronx Is Up," *Planning* 57 (September 1991): 14–15; Alan S. Oser, "Higher Density Goal Spurs New Designs," *New York Times* (November 10, 1991), X: 5.

67. Edward I. Koch, quoted in Purdum, "Koch Proposes Police Academy for South Bronx": 4.

68. Golden, "In the Ravaged South Bronx, a Camelot Is Envisioned": 6.

69. Blanca Ramirez, quoted in Rosenbush, "Commons Concerns": 19.

70. Bernd Zimmermann, quoted in Rosenbush, "Commons Concerns": 19.

71. David Gonzalez, "Revolution of People Power Wells Up in the Bronx," *New York Times* (July 8, 1993), B: 1, 4; Raymond Hernandez, "Melrose Commons Nearer Start," *New York Times* (December, 5, 1993), XIII: 11; Herbert Muschamp, "Slouching Toward Utopia in the South Bronx," *New York Times* (December 5, 1993), II: 44; Randy Kennedy, "Neighborhood Report: Melrose," *New York Times* (February 20, 1994), XIII: 11; Catharine Cary, Petr Stand, and Lee Weintraub, "We Stay: How Melrose Hopes to Build Its Future," *The Livable City* 18 (Spring 1994): 4; "There Is a Tomorrow That Will Favor Us," *The Livable City* 18 (Spring 1994): 5; David W. Dunlap, "Taking City Planning in a New Direction," *New York Times* (April 24, 1994), X: 1, 8; Holloway, "At Melrose Court, Progress in Shades of Teal": 9; Lynette Holloway, "Police Academy for South Bronx Moves Ahead, on Paper," *New York Times* (June 26, 1994), XIII: 8; Mervyn Rothstein, "A Renewal Plan in the Bronx Advances," *New York Times* (July 10, 1994), IX: 1, 8; Andrea Kannapell, "Banish Bulldozers, Save the Community," *New York Times* (September 4, 1994), XIII: 8; Bob Kappstatter, "Melrose Commons Plan Wins Ok," *New York Daily News* (March 17, 1995): 35; Mitchell L. Moss, "Where's the Power in the Empowerment Zone?" *City Journal* 5 (Spring 1995): 76–81; McKee, "South Bronx": 86–95; Zachary Margulis, "Pols to Fight Rudy Budget," *New York Daily News* (May 1, 1995), Metro: 1; Zachary Margulis, "Rudy Shown Ways to Save Academy," *New York Daily News* (May 12, 1995): 33; Bob Kappstatter, "Rudy Wows Officials," *New York Daily News* (November 20, 1996), Metro: 1; Carl Vogel, "Melrose's Thorny Predicament," *City Limits* 24 (September-October 1999): 13–15, 33; David Critchell, "Neighborhood Report: South Bronx," *New York Times* (December 19, 1999), XIV: 14; Jose Martinez and Ralph R. Ortega, "Housing Funds on Hold," *New York Daily News* (February 16, 2000), Metro: 1; Seth Kugel, "Neighborhood Report: Melrose," *New York Times* (February 10, 2002), XIV: 7.

72. Henry G. Cisneros, quoted in Rothstein, "A Renewal Plan in the Bronx Advances": 8.

73. Kent Barwick, quoted in Rothstein, "A Renewal Plan in the Bronx Advances": 8.

74. David M. Halbfinger, "State Grant Money to Spur Bronx Housing Development," *New York Times* (March 12, 1998), B: 10; Rafael A. Olmeda, "State Comes Clean: Clears Way for Housing," *New York Daily News* (March 13, 1998): 75; Rachelle Garbarine, "Neighborhood Rises in the South Bronx," *New York Times* (December 24, 1998), B: 7; "Melrose Commons Begins First Phase," *New York Construction News* 47 (March 1999): 10; Ralph R. Ortega, "Melrose's Uncommon Aim," *New York Daily News* (April 4, 1999), Metro: 1; White and Willensky, *AIA Guide* (2000), 556; Stamler, "For a Family of Builders, the Bronx Is Up": 4; Jose Martinez and Ralph R. Ortega, "Housing Funds on Hold," *New York Daily News* (February 16, 2000), Metro: 1; Greg Wilson, "Homeowners Buying into Resurgence of S. Bronx," *New York Daily News* (September 19, 2000), Metro: 1; Jayne Merkel, "Dream Housing," *Oculus* 63 (October 2000): 8–9; Dennis Hevesi, "New Homes for South Bronx," *New York Times* (October 8, 2000), XI: 1; Alan Balfour, *World Cities: New York* (New York: Wiley Academy, 2001), 111; Gonzalez, *The Bronx*, 140–41.

75. White and Willensky, *AIA Guide* (2000), 556.

76. Merkel, "Dream Housing": 9; Hevesi, "New Homes for South Bronx": 1; Bill Egbert, "Melrose Opens Door to Vitality," *New York Daily News* (October 9, 2002), Metro: 3; "At Melrose Commons Project," *New York Times* (October 13, 2002), XI: 1.

77. Don Marsh, "Systems Shelter," *Concrete Products* (April 2002): 9; "Housing Complex Nears Completion in Bronx," *New York Construction News* 50 (August 2002): 7; Juliette Fairley, "Real Estate," *Newsday* (May 9, 2003), C: 6.

78. Sam Howe Verhovek, "Cuomo Son Plans Units for Homeless," *New York Times* (October 31, 1988), B: 3; Sam Roberts, "Beyond Theories to What Works for the Homeless," *New York Times* (February 4, 1991), B: 1; "Metropolitan Desk," *New York Times* (December 18, 1993): 27; McKee, "South Bronx": 86–95; Rafael A. Olmeda, "Helping Homeless Kids Scout Out Their Future," *New York Daily News* (May 9, 1995), Metro: 3.

79. Rafael A. Olmeda, "PAL Gets 250G Gift," *New York Daily News* (October 19, 1995), Metro: 2; Rafael A. Olmeda, "$8M PAL to South Bronx," *New York Daily News* (July 3, 1996), Metro: 1; "A PAL in the Bronx," editorial, *New York Daily News* (July 6, 1996): 14; Rafael A. Olmeda, "PAL Is Friend to Kids," *New York Daily News* (July 8, 1998): 33; Trish Hall, "A South Bronx Very Different from the Cliche," *New York Times* (February 14, 1999), XI: 1, 6; White and Willensky, *AIA Guide* (2000), 565.

80. Frank Lombardi, "Youth Center in Works," *New York Daily News* (January 20, 1999), Metro: 1; Bruce Lambert, "City Plans to Spend $4 Million to Build Youth Center in Bronx," *New York Times* (January 20, 1999), B: 3; "Postings: Art Commission Awards," *New York Times* (February 27, 2000), XI: 1; Kira L. Gould, "Art Commission Honors Outstanding City Projects," *Oculus* 62 (April 2000): 17; *Hanrahan + Meyers Architects: The Four States of Architecture* (West Sussex, England: Wiley-Academy, 2002), 101–11; Clifford A. Pearson, "Hunts Point Community Center," *Architectural Record* 190 (March 2002): 120–23.

81. Victoria Meyers, quoted in Pearson, "Hunts Point Community Center": 120. For Ronchamp, see W. Boesiger, ed., *Le Corbusier: Oeuvre Complète 1946–1952* (Basel: Birkhäuser, 1995), 72–84.

82. Tom Hanrahan, quoted in Pearson, "Hunts Point Community Center": 120.

83. Michael J. O'Connor, "Community Commitment," *Architecture* 88 (February 1999): 38–39; White and Willensky, *AIA Guide* (2000), 558; Balfour, *World Cities: New York*, 248; Susanna Sirefman, *New York: A Guide to Recent Architecture* (London: Ellipsis, 2001), 14: 8–9; Jose Martinez, "Spectacular Community Center Opens," *New York Daily News* (February 15, 2001), Metro: 1; Suzanne Stephens, "Melrose Community Center," *Architectural Record* 189 (March 2001): 130–35; Justin Korhammer, "Melrose Community Center," *Architect* 32 (December 2001): 50–51, 97; "Architecture Award: Agrest and Gandelsonas," *Oculus* 64 (December 2001): 14; Herbert Muschamp, "The Year in Review: The Deadly Importance of Making Distinctions," *New York Times* (December 30, 2001), II: 36; "Diana Agrest-Mario Gandelsonas: Melrose Community Center," *Quaderns d'arquitectura i urbanisme* 232 (2002): 130–33; David W. Dunlap, "Postings: Bedford-Stuyvesant Community Center," *New York Times* (February 24, 2002), XI: 1; David W. Dunlap, "Blocks: Projects' Community Centers Open Up, with Glass and Air," *New York Times* (November 14, 2002), B: 3; Ian Luna, ed., *New New York: Architecture of a City* (New York: Rizzoli International Publications, 2003), 278–81. For Melrose Houses, see Stern, Mellins, and Fishman, *New York 1960*, 954.

84. Diana Agrest, quoted in Dunlap, "Blocks: Projects' Community Centers Open Up, with Glass and Air": 3.

85. David Burney, quoted in Dunlap, "Blocks: Projects' Community Centers Open Up, with Glass and Air": 3.

86. Stephens, "Melrose Community Center": 130, 134.

87. "The Right Place for the Police Academy," editorial, *New York Times* (March 10, 1987): 26. Also see Crystal Nix, "Plan to Move Police School Sparks Battle," *New York Times* (May 12, 1987), B: 1, 8.

88. "A Kinder, Smarter Mayor Koch," editorial, *New York Times* (January 26, 1989): 22; Purdum, "Koch Proposes Police Academy for South Bronx": 4; "Correction," *New York Times* (January 28, 1989): 31; Todd S. Purdum, "No-Growth Capital Plan by Dinkins," *New York Times* (May 18, 1990), B: 4; Golden, "In the Ravaged South Bronx, a Camelot Is Envisioned": 1, 6; "Competitions," *Oculus* 54 (October 1992): 5; Mervyn Rothstein, "Architects Sheltering in Government Projects," *New York Times* (December 20, 1992), X: 1, 4; David N. Cohn, "Un Surtido Newyorquino," *Geometria* 15 (1993): 85–99, 119–20; Lynn Nesmith, "Police Academy Competition Winner," *Architecture* 82 (January 1993): 23; Suzanne Stephens, "Police Academy," *Oculus* 55 (January 1993): 6–8; "GC Bids Expected to Be Advertised for $230M Police Training Facility by 1996's First Quarter," *New York Construction News* 40 (January 18, 1993): 1, 4; "Ellerbe Becket Design Wins South Bronx Police Academy Competition," *Architectural Record* 181 (February 1993): 27; Thomas Fisher, "NYC Police Academy," *Progressive Architecture* 74 (February 1993): 22–24; Herbert Muschamp, "Modernism and Morality in the South Bronx," *New York Times* (March 28, 1993), II: 1, 34; Ann Holloway, "Reading Between the Lines?" letter to the editor, *New York Times* (April 25, 1993), II: 6; Mark A. Hewitt, "Rebuilding the Armature of Civic Art: The Bronx Police Academy," *Competitions* 3 (Spring 1993): 38–43; "Peter Pran of Ellerbe Becket and Michael Fieldman: New York Police Academy," *Architectural Design* 63 (July-August 1993): 84–87; Philip Jodidio, *Sir Norman Foster* (Cologne: Taschen, 1994), 165; Randy Kennedy, "Police Academy Fades Away," *New York Times* (February 6, 1994), XIII: 12; Todd S. Purdum, "New Yorkers Fighting One Another over Federal Aid," *New York Times* (February 6, 1994): 39; "Budget Axes Police Academy," *Architectural Record* 182 (March 1994): 13; "The Police Academy," *Oculus* 56 (May 1994): 4; Matthew Purdy, "Resentment Zone: Officials' Courtship of Yankees Stirs Anger in the Bronx," *New York Times* (May 2, 1994), B: 1, 7; David W. Dunlap, "Reading the Giuliani Spending Blueprint," *New York Times* (June 12, 1994), X: 1, 8; Holloway, "Police Academy for South Bronx Moves Ahead, on Paper": 8; Frederic Schwartz and Carolina Vaccaro, eds., *Venturi Scott Brown and Associates*

(Barcelona: Gustavo Gili, 1995), 236–67; Fernando Ferrer, "Police Academy in the Bronx," *New York Daily News* (May 7, 1995): 37; Zachary Margulis, "Rudy Shown Ways to Save Academy," *New York Daily News* (May 12, 1995): 33; Jacopo della Fontana, "Complessità e chiarezza: New York City Police Academy," *Arca* 96 (September 1995): 34–39; Peter Pran, *Peter Pran: Jonathan Ward, Timothy Johnson, Paul Davis: An Architecture of Poetic Movement: Altered Perceptions* (Windsor, England: Andrea Papadakis Publisher, 1998), 66–73; Kenneth Frampton, "A Continuing Experiment: Peter Pran in NBBJ," in Pran, *Peter Pran: Jonathan Ward, Timothy Johnson, Paul Davis: An Architecture of Poetic Movement: Altered Perceptions*, 12; *Norman Foster: Selected and Current Works* (Mulgrave, Australia: Images Publishing, 1997), 239; *Richard Dattner: Selected and Current Works* (Mulgrave, Australia: Images Publishing, 2000), 186–87; Balfour, *World Cities: New York*, 153; *The Architecture of Rafael Viñoly* (New York: Princeton Architectural Press, 2002), no pagination.

89. *The Architecture of Rafael Viñoly*, no pagination.

90. *Richard Dattner: Selected and Public Works*, 186.

91. Muschamp, "Modernism and Morality in the Bronx": 1, 34.

92. Bartholomew Voorsanger, quoted in Dunlap, "Reading the Giuliani Spending Blueprint": 8.

93. Morris Adjmi, *Aldo Rossi: Architecture, 1981–1991* (New York: Princeton Architectural Press, 1991), 262–65, 287; Herbert Muschamp, "Creativity in Design as an Urban Survival Skill," *New York Times* (December 15, 1991), II: 36; Peter D. Slatin, "Rossi Art School for the South Bronx," *Architectural Record* 180 (February 1992): 17; "NYC/AIA 1992 Design Awards," *Oculus* 54 (May 1992): 27; Alberto Ferlenga, ed., *Aldo Rossi: The Life and Works of an Architect* (Cologne: Könemann, 2001), 295.

94. Adjmi, ed., *Aldo Rossi: Architecture, 1981–1991*, 263.

95. Michael Sterne, "A Plan Would Give South Bronx Stores, a Campus and 3,000 Jobs," *New York Times* (March 4, 1977), B: 4; Alan S. Oser, "Shot in the Arm for South Bronx: Enclosed 3-Level Shopping Mall," *New York Times* (March 16, 1977), D: 12.

96. C. Gerald Fraser, "College Building on a Base of Hope," *New York Times* (March 1, 1971): 18; Michael Sterne, "Space Need Upsets a College in Bronx," *New York Times* (January 29, 1978): 27.

97. Michael Sterne, "500 Marchers Protest the Delay on Annex at Hostos," *New York Times* (March 10, 1978), B: 3; Samuel Weiss, "City U. Proposes Large Cutbacks in Building Plans," *New York Times* (May 9, 1978): 1, 77; Sam Weiss, "Koch Is to Approve Hostos Renovation," *New York Times* (July 15, 1978): 21.

98. Samuel Weiss, "Hostos College Is to Get New Campus in Bronx," *New York Times* (August 30, 1985), B: 3; "Onward and Upward in the South Bronx," *Architectural Record* 175 (October 1987): 71; Heinrich Klotz, ed., *New York Architecture: 1970–1990* (Munich: Prestel-Verlag, 1989), 256–57; "East Academic Complex–Hostos Community College," *Architecture + Urbanism* (April 1989): 118–19; Forrest Wilson, "Designing for Today: Six Buildings," *Blueprint* 11 (Spring 1993): 2–7; David W. Dunlap, "City's Colleges Add $2 Billion in Facilities," *New York Times* (September 13, 1993), X: 1; Peter Slatin, "In the Bronx, Hostos College Bridges the Concourse," *New York Times* (July 31, 1994): 8; Emily M. Bernstein, "For Hostos, a Campus to Match Its Reputation," *New York Times* (October 9, 1994): 47; Kenneth T. Jackson, ed., *The Encyclopedia of New York City* (New Haven, Conn.: Yale University Press; New York: New-York Historical Society, 1995), 384; McKee, "South Bronx": 86–95.

99. Margaret Gaskie, "Street Life," *Architectural Record* 180 (February 1992): 88–93; Judith Davidsen, "A Touch of Class," *Architectural Record Lighting* 180 (May 1992): 48–51; Walter Bianchi, "New Bronx: Hostos Community College Extension," *Arca* 88 (December 1994): 74–79; Lindgren, "Pretty Pictures and Urban Renewal": 28, 34.

100. Quoted in Klotz, ed., *New York Architecture: 1970–1990*, 256.

101. Brad Collins and Diane Kasprowicz, eds., *Gwathmey Siegel: Buildings and Projects, 1982–1992* (New York: Rizzoli International Publications, 1993), 78–81; Jon Pareles, "At Hostos, a New World of Culture," *New York Times* (October 14, 1994), C: 1, 32; Susanna Sirefman, *New York: A Guide to Recent Architecture* (London: Ellipses, 1997), 260–61; *Gwathmey Siegel & Associates Architects: Selected and Current Works* (Mulgrave, Australia: Images Publishing, 1998), 52–55; Herbert Muschamp, "Echoes of '68 on Columbia's Campus," *New York Times* (October 24, 1999), II: 40–41; White and Willensky, *AIA Guide* (2000), 578.

102. Quoted in Collins and Kasprowicz, eds., *Gwathmey Siegel: Buildings and Projects, 1982–1992*, 78.

103. Sirefman, *New York* (1997), 260.

104. White and Willensky, *AIA Guide* (2000), 581. Also see Rudy Johnson, "Ground Is Broken for a Courthouse," *New York Times* (November 11, 1971): 54; Victoria Newhouse, *Wallace K. Harrison, Architect* (New York: Rizzoli International Publications, 1989), 324. For the Bronx Borough Courthouse, see Stern, Gilmartin, and Massengale, *New York 1900*, 68.

105. Alan S. Oser, "The Courts Pipeline Is Starting to Flow," *New York Times* (November 29, 1992), X: 5; Jorge Fitz-Gibbon, "Bronx Housing Court," *New York Daily News* (March 12, 1995), Metro: 1; Nina Rappaport, "New Courthouses Around New York," *Oculus* 58 (April 1996): 6–7; Alexandra Jacobs, "Bilbao-ing in the Boroughs," *New York* 30 (October 13, 1997): 97; White and Willensky, *AIA Guide* (2000), 582; Balfour, *World Cities: New York*, 174; *The Architecture of Rafael Viñoly*, no pagination.

106. *The Architecture of Rafael Viñoly*, no pagination.

107. Oser, "The Courts Pipeline Is Starting to Flow": 5;

David W. Dunlap, "Putting a New Face on Justice," *New York Times* (July 19, 1998), XI: 1, 18; "Corrections," *New York Times* (July 26, 1998): 2; Nina Siegal, "Courthouse Upsets Neighbors, but Where Can They Turn?" *New York Times* (June 13, 1999), XIV: 10; Amy Waldman, "Neighbors Say Bronx Courthouse Will Only Mean More Congestion," *New York Times* (December 2, 1999), B: 1, 8; White and Willensky, *AIA Guide* (2000), 581; Eric Lipton, "Halls of Justice Going Up All Over; New York City Nears a Peak in Its Courthouse Building Boom," *New York Times* (December 5, 2000), B: 1, 9; *The Architecture of Rafael Viñoly*, no pagination.

108. Murray Chass, "Beam May Be the Leverage," *New York Times* (April 14, 1998), C: 1, 3; Randy Kennedy, "Yankee Stadium Closed as Beam Falls," *New York Times* (April 14, 1998): 1, B: 3; Buster Olney, "Yanks' Schedule Is Disrupted by Stadium Accident," *New York Times* (April 14, 1998), C: 1, 3; Charles V. Bagli and Randy Kennedy, "Yankee Stadium's Structure Rarely Checked, Officials Say," *New York Times* (April 15, 1998): 1, B: 3; N. R. Kleinfield, "Yankees Are on First at Shea and the World Doesn't End," *New York Times* (April 16, 1998): 1, B: 6; Charlie LeDuff, "Stadium Gets the All-Clear to Bring Back the Yankees," *New York Times* (April 17, 1998), B: 3; Bill Pennington, "For 75 Years, a Raucous Stage in the Bronx," *New York Times* (April 19, 1998): 1, 39; Buster Olney, "All Seems Normal, for Now, in Bronx," *New York Times* (April 24, 1998): C: 1, 4; George Vecsey, "Questions Regarding the Stadium," *New York Times* (April 24, 1998), C: 1; Charlie LeDuff, "Crash of Steel Yields in Bronx to Crack of Bat," *New York Times* (April 25, 1998): 1, C: 2. For the 1976 renovation of Yankee Stadium, see Stern, Mellins, and Fishman, *New York 1960*, 949–50.

109. Dennis Hevesi, "A New Yankee Stadium Is Proposed in the Bronx," *New York Times* (January 25, 1990), B: 4; Max Bolstad, "Bad Idea for the Bronx," letter to the editor, *New York Times* (February 11, 1990): 24; Marc R. Perman and Jane A. Daniels, "You Don't Move American Landmarks Like Yankee Stadium," letter to the editor, *New York Times* (February 11, 1990): 24.

110. Richard Sandomir, "State Unveils Its Plan for Yanks in Manhattan," *New York Times* (October 1, 1993), B: 11; Richard Sandomir, "New Proposal from Cuomo for Yankees," *New York Times* (October 21, 1993), B: 1, 3; Richard Sandomir, "Yankees Show Little Interest in Old-Style Stadium Renovation," *New York Times* (March 19, 1994): 26; Howard Wolfson, "Yankee Stadium," *Metropolis* 13 (April 1994): 33–38; John Kifner, "Spring Rite for the Yankees: Complaining About the Stadium," *New York Times* (June 9, 1994), B: 1, 6; Charles V. Bagli, "Flight of the Yankees," *New York Observer* (September 18, 1995): 1, 25; Vivian S. Toy, "New York Officials Agree to Study 3 New Stadium Sites for the Yankees," *New York Times* (October 19, 1995), B: 3; Steven Lee Myers, "If the Yankees Leave, Mayor Faults Ferrer," *New York Times* (December 14, 1995), B: 1, 10; Charles V. Bagli, "Giuliani and Ferrer Snipe at Each Other; the Boss Is on Deck," *New York Observer* (December 25, 1995): 1, 41; Ian Fisher, "D'Amato Doubts Stadium Will Move to West Side," *New York Times* (October 31, 1996), B: 4; Dan Barry, "City Study Sees Big Revenues if Yankees Play in Manhattan," *New York Times* (April 22, 1998), B: 1, 4; Roger Angel, "Rudy Awakening: The Mayor's Dream Stadium Should Go Away," *New Yorker* 74 (April 23, 1998): 8–9; Dan Barry and Charles V. Bagli, "Steinbrenner Delays Move on Stadium," *New York Times* (May 1, 1998), B: 1, 11.

111. "The Battle of the Ballparks," *New York Daily News* (April 29, 1998): 22; Charles V. Bagli, "Bronx Offers Stadium Plan for Keeping Team," *New York Times* (September 28, 1998), B: 1, 3; Abby Goodnough, "Mayor Calls Bronx Stadium Plan a Rerun," *New York Times* (September 28, 1998), B: 6; Bob Herbert, "A Stadium for Everyone," *New York Times* (October 1, 1998): 31; David Gonzalez, "About New York," *New York Times* (October 21, 1998), B: 1.

112. Matthew Purdy, "Bronx Welcomes a Haven for Books," *New York Times* (July 7, 1994), B: 1, 5; Karen D. Stein, "Sedgwick Branch Library, Bronx, New York," *Architectural Record* 183 (June 1995): cover, 95, 97–99; Sirefman, *New York* (1997), 262–63. Also see "Sedgwick Branch Library to Nearly Double in Size with a $1.4 Million Addition of a Second Floor," press release (April 11, 2001).

113. David Prendergast, quoted in Sirefman, *New York* (1997), 262.

114. William Houseman, *The Harlem River Yards: Bridging a South Bronx Community Need* (Bronx, N.Y.: Wave Hill Inc., 1978); "Steven Holl," *Progressive Architecture* 59 (January 1978): 81; Yukio Futagawa, ed., *GA Architect 11: Steven Holl* (Tokyo: A.D.A. Edita, 1993), 92–95; "Gymnasium-Bridge, Bronx, New York," *Progressive Architecture* 74 (January 1993): 101; *Pamphlet Architecture 1–10* (New York: Princeton Architectural Press, 1998).

115. *The Harlem River Yards: Bridging a South Bronx Community Need*, 3.

116. *The Harlem River Yards: Bridging a South Bronx Community Need*, 13.

117. *The Harlem River Yards: Bridging a South Bronx Community Need*, 6–7.

118. Diana Shaman, "Rail Yards Inspire Plans for Housing and Industry," *New York Times* (February 22, 1981), VIII: 1, 4; Alan S. Oser, "Port Morris Industrial Area Coming Alive," *New York Times* (April 12, 1987), VIII: 9; "For Want of a Trestle," editorial, *New York Times* (October 27, 1989): 34; Jerrold Nadler, "Enough Foot Dragging on a Rail Link Vital to New York City," letter to the editor, *New York Times* (November 14, 1989): 30; David M. Halbfinger, "20 Years in the Making, Rail Freight Link Opens in Bronx," *New York Times* (October 12, 1998), B: 1, 6.

119. Jerrold Nadler, quoted in Halbfinger, "20 Years in the Making, Rail Freight Link Opens in Bronx": 6.

120. Charles V. Bagli, "Post Plans a Printing Plant for the Bronx or Jersey City," *New York Times* (November 11, 1997), B: 6; Amy Waldman, "Trash Giant Skirts Conditions Set for Bronx Station, Critics Say," *New York Times* (August 24, 1999), B: 1, 7.

121. John Holusha, "Pioneering Bronx Plant to Recycle City's Paper," *New York Times* (May 6, 1994), D: 1, 5; Lynette Holloway, "Bronx Group Signs Recycling Company for Mill Project," *New York Times* (December 4, 1995), B: 3; Matthew Reiss, "New York's Last Chance for Rail Relief," *Metropolis* 15 (January/February 1996): 18, 23; James Bradley, "Who's Not Working on Rail Yards? Galesi, Owner of 99-Year Lease," *New York Observer* (April 14, 1997): 1, 11; Lange, "Bilbao-ing in the Boroughs": 97; Barbara Stewart, "Factory Plan Blends Form and Function," *New York Times* (December 4, 1997), B: 15; Rosalie R. Radomsky, "$390 Million Project at Old Harlem River Rail Yard," *New York Times* (December 14, 1997), XI: 1; Karrie Jacobs, "A Factory That Makes Nice," *New York* 30 (December 22–29, 1997): 32; "Maya Lin's Eco-minimal Bronx Community Paper Mill: Art and Urban Renewal," *ANY* 22 (1998): 55; Ned Cramer, "Maya Lin's Green Machine," *Architecture* 87 (February 1998): 28; Nina Rappaport, "A Recycling Factory for the South Bronx," *Oculus* 60 (February 1998): 5; Maya Lin, interview by Jon Kalish, National Public Radio (February 6, 1998); Nina Rappaport, "Industrious Design," *Metropolis* 17 (April 1998): 36; Herbert Muschamp, "Public Space, Private Space and Anti-Space," *New York Times* (December 27, 1998), II: 38; Juan Forero, "Plans to Build Paper Recycler in South Bronx Are Called Off," *New York Times* (July 21, 2000), B: 7; Raymond W. Gastil, *Beyond the Edge: New York's New Waterfront* (New York: Princeton Architectural Press, 2002), 134; Lis Harris, *Tilting at Mills: Green Dreams, Dirty Dealings, and the Corporate Squeeze* (Boston: Houghton Mifflin, 2003); Tom McGeveran, "A Sad South Bronx Saga: Eco-Friendly Mill Pulped," *New York Observer* (February 17, 2003): 11.

122. Gastil, *Beyond the Edge*, 135.

123. Maya Lin, quoted in Stewart, "Factory Plan Blends Form and Function": 18.

124. Stern, Gilmartin, and Massengale, *New York 1900*, 141–43; Stern, Gilmartin, and Massengale, *New York 1930*, 712–13; Stern, Mellins, Fishman, *New York 1960*, 961–63.

125. James G. Doherty, quoted in Ari Goldman, "In Bronx, Giraffes Stand Tall Again," *New York Times* (June 11, 1982): 32.

126. John Iaderosa, quoted in Goldman, "In Bronx, Giraffes Stand Tall Again": 32.

127. Goldman, "In Bronx, Giraffes Stand Tall Again": 32.

128. Boyce Rensberger, "Elephant and Tiger and Rhinoceros Roaming the Bronx? Preposterous!" *New York Times* (August 17, 1977): 23.

129. Gerald Gold, "A Jungle in the Bronx," *New York Times* (May 26, 1985), VI: 33, 35, 44; Deirdre Carmody, "Zoo Brings Jungle to Bronx–Gibbons, Tapirs and All," *New York Times* (June 22, 1985): 29; "Day Trips; Tropical Bronx," *New York Times* (June 28, 1985): 26; White and Willensky, *AIA Guide* (2000), 575.

130. Daniel B. Schneider, "F.Y.I.; Unfriendly Skies," *New York Times* (December 29, 1996), XIII: 2; "New Bronx Home for Birds," *New York Times* (January 18, 1997): 27; "Architecture Citation: FTL/Happold, The Russell B. Aitken Seabird Aviary," *Oculus* 60 (Summer 1998): 10; White and Willensky, *AIA Guide* (2000), 575; Balfour, *World Cities: New York*, 198.

131. "More Elbow Room for Bronx Zoo Primates; Where Gorillas Can Act Like Gorillas," *New York Times* (February 25, 1996), IX: 1; "Congo, the Bronx," *New York Times* (May 30, 1999): 1; Douglas Martin, "A Big Backyard in the Bronx," *New York Times* (May 30, 1999): 21, 26; Nina Rappaport, "In the Bronx," *Oculus* 62 (November 1999): 4; Elaine Louie, "Face to Face with a Relative, Through a Glass Clearly," *New York Times* (July 8, 1999), F: 3.

132. Stern, Gilmartin, and Massengale, *New York 1900*, 141; Stern, Mellins, Fishman, *New York 1960*, 962–63.

133. Paul Goldberger, "New Panes Give Pleasure in Bronx Garden," *New York Times* (March 28, 1977): 33; Lesley Oelsner, "$5 Million Gift Restores Conservatory," *New York Times* (February 27, 1978): 1, D: 6; Ellen Stern, "Eden in the Bronx," *New York* 11 (March 13, 1978): 55–57; Eleni M. Constantine, "Restoring a Victorian Botanical Conservatory," *Architectural Record* 168 (October 1980): 72–77; Kevin Wolfe, "Visible City," *Metropolis* 3 (May1984): 24–28; White and Willensky, *AIA Guide* (1988), 506.

134. Edward Larrabee Barnes, quoted in Constantine, "Restoring a Victorian Botanical Conservatory": 5.

135. Ellen Posner, "Botany or Business?" *Landscape Architecture* 79 (January 1989): 52–59.

136. Posner, "Botany or Business?": 56.

137. Hugh Hardy, quoted in Mildred F. Schmertz, "Interview," in *Hardy Holzman Pfeiffer Associates: Buildings and Projects, 1967–1992* (New York: Rizzoli International Publications, 1992), 18–19, 272.

138. Judith Nasatir, "Hardy Holzman Pfeiffer: The New York Botanical Garden's Arthur and Janet Ross Lecture Hall," *Interior Design* 65 (October 1994): 136–39; *Hardy Holzman Pfeiffer Associates: Buildings and Projects, 1993–1998* (New York: Rizzoli International Publications, 1999), 214.

139. Gregory Long, quoted in Anne Raver, "Wooing Visitors into the Garden," *New York Times* (September 8, 1993): B: 1, 7. Also see Posner, "Botany or Business?": 52–59; Douglas Martin, "Garden Grows in New Direction," *New York Times* (December 13, 1995), B: 1, 3.

140. Christopher Gray, "Streetscapes/Bronx Botanical Conservatory," *New York Times* (January 16, 1994), X: 7; Arthur H. Ode, Jr., "Conservatory 'Restoration,'" letter to the editor, *New York Times* (February 27, 1994), X: 13; Paula Dietz, "A Victorian Gem Restored," *New York Times* (April 27, 1997), V: 8–9; "Plants Can't Believe Their Good Luck," *New York Times* (May 1, 1997): 1; Herbert Muschamp, "A Flower

Reopens in the Bronx," *New York Times* (May 1, 1997), C: 1, 6; Anne Raver, "Green, and Mostly Real," *New York Times* (May 1, 1997), C: 1, 6; Nina Rappaport, "Creative Restorations," *Oculus* 59 (June 1997): 5; "Enid A. Haupt Conservatory Reopens," *Metropolitan Historic Structures Association Newsletter* 18 (Summer 1997): 3; "New York Botanical Garden; Enid A. Haupt Conservatory," *Oculus* 60 (Summer 1998): 12; Arthur Lubow, "A Money Tree Grows in the Bronx," *New York Times* (September 27, 1998), VI: 26, 29, 31; White and Willensky, *AIA Guide* (2000), 576; Balfour, *World Cities: New York*, 193.

141. "At Botanical Garden, Letting the Sun Shine In," *New York Times* (January 4, 1996), C: 3; Dietz, "A Victorian Gem Restored": 8; Rappaport, "Creative Restorations": 5; Lubow, "A Money Tree Grows in the Bronx": 29; White and Willensky, *AIA Guide* (2000), 577.

142. "On the Boards; A Landscape for Learning," *Landscape Architecture* 86 (May 1996): 28; Rappaport, "Creative Restorations": 5; Paul Bennett, "Landscape for Learning," *Landscape Architecture* 88 (July 1998): cover, 70–77, 98–99, 101; Lubow, "A Money Tree Grows in the Bronx": 29; *Richard Dattner: Selected and Current Works*, 20–21; White and Willensky, *AIA Guide* (2000), 577.

143. "New for New York Botanical Garden; Ivy-Walled Herbarium," *New York Times* (November 2, 1997), XI: 1; White and Willensky, *AIA Guide* (2000), 577; Glenn Collins, "Beyond Flowers, a Grove of Academe," *New York Times* (April 15, 2002), B: 1, 3; "Botanical Garden's New Plant," *Interior Design* 73 (May 2002): 58; Bradford McKee, "Container Garden," *Architecture* 91 (September 2002): 72–77; Susan Strauss and Sean Sawyer, eds., *Polshek Partnership Architects* (New York: Princeton Architectural Press, 2005), 166–77, 218.

144. www.polshek.com.

145. Quoted in Strauss and Sawyer, eds., *Polshek Partnership Architects*, 173.

146. McKee, "Container Garden": 73.

147. James Stewart Polshek, quoted in Collins, "Beyond Flowers, a Grove of Academe": 3.

148. "$9 Million Project at New York Botanical Garden Designed by Hardy Holzman Pfeiffer Associates; Amid the Flowers, a Visitor Center," *New York Times* (February 4, 2001), XI: 1; "New Visitor Center Designed to Meld Horticulture, Landscape, and Function," press release (June 16, 2003); Glenn Collins, "For Its New Visitor Center, Botanical Landmark Preserves the Landscaping," *New York Times* (April 24, 2004), B: 1, 4; Joseph Giovannini, "Flower Power," *New York* 37 (May 17, 2004): 61; "New York Botanical Garden Visitor Center; Award of Merit–Cultural," *New York Construction* 52 (December 1, 2004): 53.

149. Giovannini, "Flower Power": 61.

150. David W. Dunlap, "A Tower Pits Fordham vs. Botanical Garden," *New York Times* (July 6, 1994): 1, B: 3; David W. Dunlap, "Buildings Dept. Says Fordham's Radio Tower Is Too Tall," *New York Times* (September 30, 1994), B: 3; Lizette Alvarez, "Fordham and Garden Renew Tower Dispute," *New York Times* (November 3, 1996): 43; Stephen Z. Wolner, "Fordham's Tower," letter to the editor, *New York Times* (November 6, 1996): 26; Lizette Alvarez, "Radio Battle Is in Eye of Beholder," *New York Times* (November 26, 1996), B: 1, 4; "Negotiation by Design," *Oculus* 59 (January 1997): 3; John Tierney, "The Height of Absurdity," *New York Times* (March 2, 1997), VI: 24; David Critchell, "The Botanical Garden Tires of Its Radio Tower Fight," *New York Times* (April 9, 2000), XIV: 11; Andrew Friedman, "Fans of Station and Garden Try to Compromise on a Tower," *New York Times* (December 10, 2000), XIV: 12; Joseph P. Fried, "Following Up; Green Thumbs Up for a Radio Tower," *New York Daily News* (February 10, 2002): 33; Bob Kappstatter, "Fordham Rethinks Its Radio Tower Site," *New York Daily News* (June 13, 2002), Metro: 1; "In the Ivory Tower, a Soaring Debate," *New York Times* (June 28, 2002), B: 1; Bob Kappstatter, "Static over Tower at Hearing; Fordham and Garden Battle," *New York Daily News* (June 28, 2002), Metro: 3; Alan Feuer, "Tower Pits the Garden Crowd Against Joni Mitchell Fans," *New York Times* (June 28, 2002), B: 3; Gregory Long, "Battle in the Bronx over a Radio Tower," letter to the editor, *New York Times* (July 2, 2002): 20; Ralph M. Jennings, "WFUV's Radio Tower," letter to the editor, *New York Times* (July 4, 2002): 12; "Fordham's Misplaced Tower," editorial, *New York Times* (July 22, 2002): 16; Joseph A. O'Hare, "Fordham Radio Tower," letter to the editor, *New York Times* (July 26, 2002): 20; Bob Kappstatter, "Put Tower in Center of Campus, Aide Says," *New York Daily News* (August 5, 2002), Metro: 1; Bob Kappstatter, "Feds: Move Radio Tower," *New York Daily News* (August 7, 2002), Metro: 3; Bob Kappstatter, "Fordham Hits FCC on Tower," *New York Daily News* (August 13, 2002), Metro: 1; Bob Kappstatter, "Tower Site Switch Scrubbed; Botanical Garden's Hopes Wilt," *New York Daily News* (June 26, 2003), Metro: 1; Andrea Elliott, "Deal Would End 10-Year Feud on Fordham's Radio Tower," *New York Times* (May 14, 2004), B: 1; Bob Kappstatter, "End in Sight for Tower Fight; City Expected to OK New Spot for Fordham Antenna," *New York Daily News* (March 1, 2005), Metro: 1.

151. Quoted in Feuer, "Tower Pits the Garden Crowd Against Joni Mitchell Fans": 3.

152. For Montefiore II, see White and Willensky, *AIA Guide* (2000), 603.

153. David W. Dunlap, "Smaller Architects Find Their Niche," *New York Times* (December 12, 1993), X: 1, 8; Joseph Finora, "Work Starts on New Fordham Library," *New York Construction News* 43 (July 15, 1996): 1, 5; Jayne Merkel and Craig Kellogg, "College Tour," *Oculus* 59 (September 1996): 10–11; David W. Dunlap, "For Libraries, a Time of Rebirth," *New York Times* (September 28, 1997), IX: 1, 6.

154. "At Last, a Step; Fordham Anchor," *New York Times* (March 28, 1982), VIII: 1; "Fordham Plaza; Bronx Offices," *New York Times* (October 7, 1984), VIII: 1; "Ground Broken in Bronx

for Office Complex," *New York Times* (October 10, 1984), B: 3; Alan S. Oser, "For a Hartford Developer, a Challenge in the Bronx," *New York Times* (December 16, 1984), VIII: 7; Deborah Dietsch, "Fast Relief for New York Depression," *Interiors* 144 (January 1985): 73; Alan S. Oser, "The Transition on Fordham Road," *New York Times* (October 19, 1986), VIII: 6, 26; "NYS Urban Development Corporation," *Oculus* 48 (December 1986): 23; Sam Howe Verhovek, "Fordham Plaza Vitalizes Its Area, but Not Itself," *New York Times* (November 28, 1988), B: 3.

155. "R. M. Kliment & Frances Halsband Architects," *Oculus* 58 (October 1995): 3; *R. M. Kliment & Frances Halsband Architects: Selected and Current Works* (Mulgrave, Australia: Images Publishing, 1998), 186–93, 241.

156. Ellen Posner, "Building Blocks," *Architectural Record* 177 (March 1989): 112–15; Ben E. Graves, "Prototype Schools: A Design Trend?" *Oculus* 51 (February 1989): 5–7; Paul Goldberger, "In Pursuit of Intimate Monumentality," *New York Times* (March 12, 1989), II: 37; Cynthia Chapin Davidson, "Protoparts for Pupils," *Inland Architect* 35 (March/April 1991): cover, 36–37; Anthony DePalma, "In Building Schools, Going Beyond a Square," *New York Times* (August 21, 1991), B: 7; Mildred F. Schmertz, "Bronx Benchmarks: Primary Schools 23 and 279, New York City, Perkins & Will," *Architecture* 82 (April 1993): 62–63; Lynette Holloway, "Long Quest for a New School Gets Longer," *New York Times* (October 3, 1993), XIII: 10; Maria Newman, "After 3 Years, New Delays for School in the Bronx," *New York Times* (August 1, 1996), B: 1, 3; White and Willensky, *AIA Guide* (2000), 601.

157. Aaron Schwarz, quoted in Posner, "Building Blocks": 112.

158. Goldberger, "In Pursuit of Intimate Monumentality": 37.

159. Vito Acconci, quoted in http://www.nyc.gov/html/dcla/html/panyc/acconci.html.

160. Katherine E. Finkelstein, "In 2001, an Odyssey to One Hospital Will Also Be a Trip to a Space Station," *New York Times* (July 24, 1999), B: 1–2; Cinda Becker, "For Children in Need; Four New N.Y. Specialty Hospitals Will Increase Visibility of Pediatric Services," *Modern Healthcare* (October 22, 2001): 46; *Pleasure: The Architecture and Design of Rockwell Group* (New York: Universe, 2002), 106–13; Joanne Kaufman, "Bronx Cheery," *New York* 35 (April 29, 2002): 20–21; Edwin McDowell, "At Children's Hospitals, Friendly Designs," *New York Times* (November 17, 2002), XI: 1, 6.

161. Irwin Redlener, quoted in Finkelstein, "In 2001, an Odyssey to One Hospital Will Also Be a Trip to a Space Station": 2.

162. David Rockwell, quoted in Finkelstein, "In 2001, an Odyssey to One Hospital Will Also be a Trip to a Space Station": 2.

163. See Stern, Gilmartin, and Mellins, *New York 1930*, 114; Stern, Mellins, Fishman, *New York 1960*, 948–50.

164. Todd/Pokorny, Architects, *Lehman: Master Plan* (New York: 1969); C. Gerald Fraser, "Arts Center In Bronx Completed," *New York Times* (April 3, 1980), C: 22; Eleanor Blau, "Lehman College Opens New Cultural Complex," *New York Times* (September 26, 1980), C: 4; Charles K. Hoyt, "New Priorities in College Building," *Architectural Record* 169 (September 1981): 112; Dena Kleiman, "New Lehman College Arts Center Underscores Change in an 'Oasis,'; The Talk of Lehman College," *New York Times* (September 26, 1981), II: 25.

165. "Lehman College Physical Education Facility, Bronx, New York," *Progressive Architecture* 70 (September 1989): 39; John Morris Dixon, "Projects: Rafael Viñoly Architects," *Progressive Architecture* 72 (May 1991): 120–22; "For the Public, Too; Athletic Center for Lehman," *New York Times* (March 28, 1993), X: 1; Herbert Muschamp, "Transforming the Merely Naked into the Nobly Nude," *New York Times* (May 1, 1994), II: 44; Maurizio Vitta, "Educazione Fisica; A Sports Complex in New York," *Arca* 84 (July-August 1994): 62–65; Karen D. Stein, "Stretched to the Limit," *Architectural Record* 182 (August 1994): cover, 74–81; Wendy Moonan, "The Siren Song of the Sports Center," *New York Times* (November 3, 1994), C: 3; Sirefman, *New York* (1997), 264–65; Benjamin Forgey, "Public Good Works; Exhibit Shows Government Funding's Design Successes," *Washington Post* (December 6, 1997), C: 1; Herbert Muschamp, "With the Spare, Sinewy Grace of an Athlete," *New York Times* (June 21, 1998), II: 32; "Lehman College Physical Education Facility, City University of New York," *Chien Chu* 22 (January 1999): 44–49; White and Willensky, *AIA Guide* (2000), 599; Herbert Muschamp, "For Rebuilders, Inspiration All Around," *New York Times* (October 5, 2001), E: 27; *The Architecture of Rafael Viñoly*, no pagination; Luna, ed., *New York Work*, 282–85.

166. Jay Bargmann, quoted in Stein, "Stretched to the Limit": 79.

167. Rafael Viñoly, quoted in Stein, "Stretched to the Limit": 76.

168. Muschamp, "Transforming the Merely Naked into the Nobly Nude": 44.

169. Rafael Viñoly, quoted in Stein, "Stretched to the Limit": 76.

170. Muschamp, "With the Spare, Sinewy Grace of an Athlete": 32.

171. Muschamp, "Transforming the Merely Naked into the Nobly Nude": 44.

172. Stern, Gilmartin, and Massengale, *New York 1900*, 430, 432–33; Stern, Gilmartin, and Mellins, *New York 1930*, 114, 122, 287, 500–503; Stern, Mellins, and Fishman, *New York 1960*, 950–54; Stern, Mellins, and Fishman, *New York 1880*, 968–69.

173. Judy Klemesrud, "Columbia U. Is Planning to Sell the Delafield Estate in the Bronx," *New York Times* (May 7, 1977): 29; Judith Cummings, "Riverdale Battle: Condominiums or Trees," *New York Times* (October 19, 1977), B: 1, 4; Charles

Kaiser, "Housing Proposal on Estate Fought," *New York Times* (December 22, 1977), B: 5; Charles Kaiser, "Planning Board Bars Delafield Project in Bronx," *New York Times* (December 28, 1977), B: 3.

174. Tuck Stadler, "Proposals Gain for Development of Bronx Estates," *New York Times* (April 27, 1980), VIII: 1, 4; Susan Doubilet, "The Classical Transformed," *Progressive Architecture* 62 (October 1981): 105–7; Kirk Johnson, "Riverdale Estate Project: Obstacles Are Overcome," *New York Times* (September 21, 1984), B: 7; "Delafield Estate," *Progressive Architecture* 66 (January 1985): 122–23; Shawn G. Kennedy, "Top Dollar with a View," *New York Times* (August 4, 1985), VIII: 1; *James Stewart Polshek: Context and Responsibility* (New York: Rizzoli International Publications, 1988), 44–45, 160–61, 251; White and Willensky, *AIA Guide* (1988), 530.

175. Gluck quoted in Stadler, "Proposals Gain for Development of Bronx Estates": 4.

176. Quoted in Johnson, "Riverdale Estate Project: Obstacles Are Overcome": 7.

177. Polshek, "Notes on My Life and Work," in *James Stewart Polshek: Context and Responsibility*, 45.

178. Federal Writers' Project, *The WPA Guide to New York City* (New York: Random House, 1939; New York: Pantheon Books, 1982), 527. Also see Sam Howe Verhovek, "In Riverdale, a Tempest over a Mansion's Future," *New York Times* (May 10, 1988), B: 1, 6; David Gonzalez, "What Is a 24,000-Square-Foot White Elephant?" *New York Times* (November 29, 1992): 45; Vivian Cristol, "Memories of Living Grandly on the Hudson," letter to the editor, *New York Times* (December 25, 1992): 30. For the Campagna house, see Stern, Gilmartin, and Mellins, *New York 1930*, 500–501, 503.

179. Landmarks Preservation Commission of the City of New York, *Riverdale Historic District Designation Report* (New York, 1990); Diamonstein, *The Landmarks of New York III*, 517. For the designation of the Campagna estate, see Landmarks Preservation Commission of the City of New York, LP-1887 (November 16, 1993); Diamonstein, *The Landmarks of New York III*, 479.

180. Mervyn Rothstein, "Debating Limits on Landmark No. 1,003," *New York Times* (January 16, 1994), X: 1, 8; Mervyn Rothstein, "Unanimous Vote on Yeshiva Property: A Riverdale Landmarking Approved," *New York Times* (March 20, 1994), X: 1; Dennis Hevesi, "The Guardians of the Vista: Riverdale Nature Preservancy," *New York Times* (May 1, 1994), X: 12; Mervyn Rothstein, "Gentle Faceoff over Plans for the Campagna Estate," *New York Times* (May 1, 1994), X: 12; Mervyn Rothstein, "Landmarks Agency Clearance; Yeshiva Proposal for Estate in Riverdale Wins Approval," *New York Times* (July 3, 1994), XI: 1.

181. David Beim, quoted in Rothstein, "Gentle Faceoff over Plans for the Campagna Estate": 12.

182. Quoted in Rothstein, "Landmarks Agency Clearance; Yeshiva Proposal for Estate in Riverdale Wins Approval": 1.

183. Quoted in Rothstein, "Landmarks Agency Clearance; Yeshiva Proposal for Estate in Riverdale Wins Approval": 1.

184. "A Decade of Change," editorial, *Riverdale Press* (June 15, 2000): 14; "Groundbreaking Set for the Fall; For Wave Hill, a $4 Million Visitor Center," *New York Times* (June 3, 2001), XI: 1.

185. Stern, Mellins, Fishman, *New York 1960*, 953.

186. "59 Unfurnished 1-Bedroom Units: In Riverdale, Apartments for the Elderly," *New York Times* (November 19, 1995), IX: 1; Alan S. Oser, "More Elderly Living Options, at a Price," *New York Times* (October 8, 2000), XI: 1, 6.

187. "2 New Buildings at Horace Mann; Middle School and a Focus on the Arts," *New York Times* (December 13, 1998), XI: 1; Tina Kelley, "Being Exclusive Draws Big Crowds," *New York Times* (October 15, 1999), B: 1, 6; White and Willensky, *AIA Guide* (2000), 606; "Horace Mann School," *New York Construction News* 47 (June 2000): 39; Hope Reeves, "Riverdale; Littering and Loitering Fuel Hostility to a School's Plans," *New York Times* (April 1, 2001), XIV: 4; Hope Reeves, "Approval for Mann Plan," *New York Times* (May 6, 2001), XIV: 10. For Horace Mann, see Stern, Mellins, Fishman, *New York 1960*, 950, 952.

188. For Meier's Bronx Developmental Center, see Stern, Mellins, and Fishman, *New York 1960*, 966–67.

189. Ada Louise Huxtable, "A Landmark Before Its Doors Open," *New York Times* (May 8, 1977), II: 25, quoted in Stern, Mellins, and Fishman, *New York 1960*, 966.

190. White and Willensky, *AIA Guide* (1978), 351.

191. "Developmental Center: Finding a New Use," *New York Times* (June 3, 1990), X: 1; Tim Golden, "Common Good in the Bronx," *New York Times* (June 6, 1990): B: 1–2.

192. Bob Kappstatter, "Ferrer Maps Future at His Final Inaugural," *New York Daily News* (January 19, 1998), Metro: 1; Bob Kappstatter, "Ferrer Begins Quest to Cultivate New Jobs," *New York Daily News* (March 6, 1998): 39; Fernando Ferrer, "Biotech in the Bronx," letter to the editor, *New York Times* (October 13, 1999): 24.

193. Douglas Martin, "An Architectural Milestone Loses Its Pedigree," *New York Times* (February 1, 2002), B: 1, 4; John Holusha, "Prime Office Space Is Planned in Unlikely Sites," *New York Times* (February 24, 2002), XI: 4; James S. Russell, "Drastic Alteration Underway for Meier's Bronx Developmental Center," *Architectural Record* 190 (March 2002): 23; Kieran Long, "Meier Mourns Loss of Bronx Centre," *World Architecture* 105 (April 2002): 9; Paul Makovsky, "Richard Meier's Late-Modern Merits Another Look," *DOCOMOMO Newsletter* (Spring 2002): 3; Robert Ivy, "Richard Meier After the Getty," *Architectural Record* 190 (September 2002): 100; Edwin McDowell, "Bronx Complex on Site of Former Health Center," *New York Times* (July 2, 2003), C: 4; Elsa Brenner, "An Office Park Focuses on Smaller Tenants," *New York Times* (July 13, 2003), XI: 7.

194. Joseph Simone, quoted in Holusha, "Prime Office Space Is Planned in Unlikely Sites": 4.

195. Theo Prudon, quoted in Russell, "Drastic Alteration Underway for Meier's Bronx Developmental Center": 23.

196. Robert A. M. Stern, quoted in Martin, "An Architectural Milestone Loses Its Pedigree": 4.

197. Richard Meier, quoted in Martin, "An Architectural Milestone Loses Its Pedigree": 1.

198. Quoted in Long, "Meier Mourns Loss of Bronx Centre": 9.

199. McDowell, "Bronx Complex on Site of Former Health Center": 4.

STATEN ISLAND

1. See Stern, Mellins, and Fishman, *New York 1960*, 973–85. For a discussion of Staten Island's development in the mid to late nineteenth century, see Stern, Mellins, and Fishman, *New York 1880*, 990–1007.

2. Robert Wieboldt, quoted in James Barron, "Staten Island Is Leading State in New-Home Building," *New York Times* (April 22, 1979), VIII: 1, 6. Also see Alan S. Oser, "About Real Estate," *New York Times* (February 29, 1980): 18; Alan S. Oser, "Vast Town-House Projects Are Rising on Staten Island," *New York Times* (June 11, 1980): 17.

3. Dorothy J. Gaiter, "'Mother-Daughter' Home Thrives on Staten Island," *New York Times* (August 29, 1982), VIII: 7; Lee A. Daniels, "About Real Estate," *New York Times* (January 28, 1983), B: 7; Alan S. Oser, "Where Young Buyers Find Affordability," *New York Times* (January 20, 1985), VIII: 1, 14.

4. Alan S. Oser, "Staten Island's Surge in Building," *New York Times* (September 28, 1986), VIII: 6, 28. Also see "Park-Like Setting," *New York Post* (June 17, 1988): 66; "Parkside Apts. with Balconies," *New York Post* (June 17, 1988): 67; "2-Bedroom Townhomes," *New York Post* (July 8, 1988): 60; "Staten Is. Colony Features 4 Models," *New York Post* (July 12, 1988): 35; "Indoor & Outdoor Swimming Pools," *New York Post* (September 30, 1988): 52; "20 Minutes from Manhattan," *New York Post* (October 21, 1988): 71; "Homes Come with Backyards," *New York Post* (October 21, 1988): 59; Andree Brooks, "A Surge of Housing on Staten Island," *New York Times* (October 21, 1988): 33; "Single-Story Models on S.I.," *New York Post* (November 4, 1988): 62; Diana Shaman, "Four Staten Island Developers Build Midrise Condos," *New York Times* (December 23, 1988), B: 7; Diana Shaman, "Developing Staten Island," *New York Times* (November 23, 1990), B: 22; Rachelle Garbarine, "Projects on Staten Island: Town Houses Feature a Patch of Green," *New York Times* (April 5, 1991): 17.

5. Elizabeth Kolbert, "Court Backs Staten Island's First Step to Secession from City," *New York Times* (September 19, 1990), B: 1–2; Alexandra Stanley, "Secession: Staten Island Votes a Resounding Yes on Taking Step Toward Separation," *New York Times* (November 7, 1990), B: 7; Jim Callaghan, "Staten Island's Pipe Dream," *Village Voice* (November 13, 1990): 11–12, 14; Calvin Sims, "Secession Study: Finds Cost High for Staten I.," *New York Times* (July 10, 1992), B: 3; Thomas J. Lueck, "S.I. Secession Could Avoid Big Tax Rise," *New York Times* (October 13, 1993), B: 1, 3; Kevin Sack, "After Staten Island Votes to Secede, What Will Albany Do?" *New York Times* (October 24, 1993): 29, 33; "S.I.: Let Those People Go!" editorial, *New York Observer* (October 25, 1993): 4; David Goldfarb, "Don't Secede," *New York Times* (October 25, 1993): 19; Guy V. Molinari, "Alone, We're Better Off," *New York Times* (October 25, 1993): 19; James Dao, "Secession Is Approved; Next Move Is Albany's," *New York Times* (November 3, 1993), B: 4; Michael T. Kaufman, "A Borough Gives Notice (Or Hadn't You Noticed)," *New York Times* (November 3, 1993), B: 3; James Dao, "Secession in Jeopardy?" *New York Times* (November 4, 1993), B: 2; Jonathan P. Hicks, "Giuliani Offers an Olive Branch to Cool Views on Staten Island," *New York Times* (November 11, 1993), B: 1, 4; "Court Slows S.I. Secession," *New York Times* (January 19, 1995), B: 6.

6. "Port Regalle," *New York Times* (December 9, 1984), VIII: 1; Andree Brooks, "Mediterranean Village on Staten Island," *New York Times* (April 17, 1987): 13; Alan S. Oser, "Waterfront Development," *New York Times* (November 29, 1987), VIII: 3; Shawn G. Kennedy, "Architects Now Doubling as Developers," *New York Times* (February 7, 1988), VIII: 1, 20; Andree Brooks, "Looking Behind the Deals," *New York Times* (September 3, 1989), X: 3; Eve M. Kahn, "City and Sea at Front Door All Year Long," *New York Times* (May 24, 1990), C: 1, 12; Jerry Cheslow, "If You're Thinking of Living In: Great Kills," *New York Times* (June 21, 1992), X: 7; White and Willensky, *AIA Guide* (2000), 926; Maggie Kinser Hohle, *John Ciardullo Associates: Architecture and Society* (New York: Edizioni Press, 2004), 148–57, 229.

7. Alan S. Oser, "Staten Island Project Is Back on Track," *New York Times* (April 20, 1987), VIII: 7; "Clusters of Homes on Staten Island," *New York Post* (October 28, 1988): 59; Diana Shaman, "Subsidized Housing: Staten Island Condos at Reduced Prices," *New York Times* (August 28, 1992), B: 7. Also see Rachelle Garbarine, "Homes for First-Time Buyers," *New York Times* (December 28, 1990): 22.

8. Alan S. Oser, "The Market for Custom-Built Homes on Staten Island," *New York Times* (November 12, 1982), B: 13; Shawn G. Kennedy, "Rural Exclusivity on Staten Island," *New York Times* (October 23, 1983), VIII: 1; Shawn G. Kennedy, "Custom-Built Luxury on Staten Island," *New York Times* (May 27, 1984), VIII: 1; Kirk Johnson, "Luxury Homes Sprout on Staten Island," *New York Times* (July 27, 1984), B: 7; Lisa W. Foderaro, "Grymes Hill Splendor," *New York Times* (January 4, 1987), VIII: 1.

9. *Alfredo De Vido: Selected and Current Works* (Mulgrave, Australia: Images Publishing, 1998), 200–201. Also see A. J. Benza, "Paulie's Place," *New York Daily News* (June 18, 1995): 29; David Kocieniewski, "Brazen Thieves Hit Mobsters' Homes, and Dons Don't See the Humor In It," *New York Times* (October

16, 1996), B: 1–2; Jerry Cheslow, "If You're Thinking of Living In: Todt Hill," *New York Times* (October 14, 1990), X: 7.

10. Stan Pinkwas, "Rally Round the Flagg," *Metropolis* 2 (April 1983): 7; Shawn G. Kennedy, "S.I. Estate Homes: Colonial Touch," *New York Times* (August 7, 1983), VIII: 1; "Portfolio Projects: Robert A. M. Stern Architects," *Progressive Architecture* 64 (December 1983): 29; Paul Goldberger, "Utopia in the Outer Boroughs," *New York Times* (November 4, 1984), VI: 42–44, 148–49, 154, 158–59; Carol Vogel, "The Trend Setting Traditionalism of Architect Robert A. M. Stern," *New York Times* (January 13, 1985), VI: 40–43, 46–49; "Recent Works of Robert A. M. Stern," *Architecture + Urbanism* (August 1985): 88–89; Susan Zevon, "Building the American Dream," *House Beautiful* 127 (November 1985): 70–75; Linda Mandeville, "Robert A. M. Stern: Custom of the Country," *Columbia* 11 (December 1985): 16–23; Luis F. Rueda, ed., *Robert A. M. Stern: Buildings and Projects, 1981–1985* (New York: Rizzoli International Publications, 1986), 174–83, 292; Daralice D. Boles, "Suburban Stern," *Progressive Architecture* 67 (August 1986): 68–79; Lisa W. Foderaro, "S.I. Builder Emphasizes Distinctive Architecture," *New York Times* (May 22, 1987): 22; Elizabeth Kraft, ed., *Robert A. M. Stern: Buildings and Projects, 1987–1992* (New York: Rizzoli International Publications, 1992), 30–33; White and Willensky, *AIA Guide* (2000), 916–17. For Flagg's buildings, see Stern, Gilmartin, and Massengale, *New York 1900*, 433–35; Landmarks Preservation Commission of the City of New York, LP-1400 (June 23, 1983); Barbaralee Diamonstein, *The Landmarks of New York III* (New York: Harry N. Abrams, 1998), 237, 330.

11. Ernest Flagg, *Small Houses: Their Economical Design and Construction* (New York: Charles Scribner's Sons, 1922).

12. Robert A. M. Stern, quoted in Mandeville, "Robert A. M. Stern: Custom of the Country": 22–23.

13. "Metz House," *Architecture + Urbanism* (April 1981): 82–84; "Steven Holl: Metz House," *GA Houses* (1982): 128–29; "Steven Holl," *Progressive Architecture* 63 (January 1982): 152–55; Kenneth Frampton, "On the Architecture of Steven Holl," *GA Houses* (March 1989): 170–72; Kenneth Frampton, *Steven Holl, Architect* (Milan: Electa Architecture, 2002), 385.

14. David Childs, Thomas Beeby, and Michael Graves, quoted in "Steven Holl": 154.

15. "Individual Characterizations: Houses for Craftsmen on Staten Island, 1980–84," *Lotus International* (1984): 44–45; "Autonomous Artisans' Housing, Staten Island, New York," *Architectural Record* 174 (March 1986): 60–61; "Autonomous Artisans' Houses," *Architecture + Urbanism* (August 1986): 68–69; "Casas Para Artesanos," *Croquis* (July 1987): 142–43; Frampton, "On the Architecture of Steven Holl": 171–72; "Autonomous Artisans' Housing, Staten Island, New York, 1980–84," *GA Houses* (1993): 100–101; Frampton, *Steven Holl, Architect*, 156–57, 385.

16. Alan S. Oser, "Conversions Changing Face of Staten Island Waterfront," *New York Times* (January 30, 1980): 25; George W. Goodman, "Waterfront in St. George Getting Loft Apartments," *New York Times* (May 24, 1981), VIII: 1, 6; "Co-op Special," *New York Times* (May 23, 1982), VIII: 1; Alan S. Oser, "A Nautical Look, from Michigan, for S.I.'s Bay Street," *New York Times* (February 4, 1983), B: 7; Michael Winkleman, "Enclaves of Luxury," *Metropolis* 3 (March 1984): 20–23, 32–33; Kirk Johnson, "Staten Island's Shore Primed for Growth," *New York Times* (July 14, 1985), VIII: 1, 14; "A 2d Project for Former Warehouses," *New York Times* (July 6, 1986), VIII: 1; Lisa W. Foderaro, "On the Pier at St. George," *New York Times* (November 30, 1986), VIII: 1; White and Willensky, *AIA Guide* (2000), 902.

17. Dinitia Smith, "Building a Beacon for a Kingdom by the Sea," *New York Times* (July 28, 1996), II: 34; Holland Cotter, "Sculpture That Basks in Summer," *New York Times* (August 9, 1996), C: 1, 24; Roberta Smith, "Sculpture Adorns the Urban Terrain," *New York Times* (August 8, 1997), C: 1, 23; Pierre Restany, "Siah Armajani: Poetry in the City," *Domus* (April 1998): 100–104; White and Willensky, *AIA Guide* (2000), 886.

18. Clifford J. Levy, "Not Just a New Ferry Terminal, but a Fanciful One," *New York Times* (February 25, 1997), B: 3; Herbert Muschamp, "Making a Rush-Hour Battleground High Art," *New York Times* (April 6, 1997), II: 42; Alexandra Lange, "Bilbao-ing in the Boroughs," *New York* 30 (October 13, 1997): 97; "Staten Island Plans New Museum," *ANY* 22 (1998): 26; Rémi Rouyer, "Peter Eisenman: l'histoire en perspective," *Architecture Intérieure-Créé* 292 (1999): 28–37; Susanna Sirefman, "Staten Island, New York City's Fifth Borough, Hosts a Series of Revitalizing Projects," *Architectural Record* 187 (September 1999): 71; Manuela Salas, "The Year of Eisenman," *Arquine* 10 (Winter 1999–2000): 6–8; White and Willensky, *AIA Guide* (2000), 884; Herbert Muschamp, "On Staten Island, the New Media Are the Message," *New York Times* (February 27, 2000), II: 52; Franco Purino, "Classicism Lost: Recent Projects by Peter Eisenman," *Industria delle costruzioni* 347 (September 2000): 32–37; Mary Engels, "Waterfront Museum's On Course Once Again," *New York Daily News* (December 6, 2000), Metro: 3; Alan Balfour, *World Cities: New York* (New York: Wiley Academy, 2001), 234–35; "Peter Eisenman: Staten Island Institute of Arts and Sciences and Staten Island Ferry Terminal," *Lotus International* 108 (2001): 96–99; Benjamin Forgey, "Pitch Out the T Square: Computer Design Tools Have Taken Architecture from Plane to Fancy," *Washington Post* (March 3, 2001), C: 1; Paul Goldberger, "Digital Dreams," *New Yorker* 76 (March 12, 2001): 96; Raymond W. Gastil, *Beyond the Edge: New York's New Waterfront* (New York: Princeton Architectural Press, 2002), 118–20; Ian Luna, ed., *New New York: Architecture of a City* (New York: Rizzoli International Publications, 2003), 327–29. For Madigan-Hyland's St. George Ferry Terminal, see Stern, Mellins, and Fishman, *New York 1960*, 974–75.

19. Forgey, "Pitch Out the T Square: Computer Design Tools Have Taken Architecture from Plane to Fancy": 1.

20. Guy Molinari, quoted in Levy, "Not Just a New Ferry Terminal, but a Fanciful One": 3.

21. Muschamp, "Making a Rush-Hour Battleground High Art": 42.

22. Thomas J. Lueck, "Ambitious Plans to Rebuild Staten Island Ferry Hub," *New York Times* (June 9, 1999), B: 1, 3; "N.Y.C. Reclaiming Its Waterfront," *Engineering News-Record* 242 (June 21, 1999): 16; "$81 M St. George Ferry Terminal Project Planned," *New York Construction News* 48 (August 1999): 12; Mary Engels, "Ferry Good News Says Guy," *New York Daily News* (May 1, 2000), Metro: 1; Mary Engels, "Ferry Terminal Rehab About to Get Underway," *New York Daily News* (March 20, 2001), Metro: 5; Mary Engels, "By George! Face-Lift for Ferry Terminal," *New York Daily News* (September 7, 2001), Metro: 3; *HOK: Selected and Current Works* (Mulgrave, Australia: Images Publishing, 2002), 22–23; David W. Dunlap, "Launching a Flotilla of Ferry Terminals," *New York Times* (April 7, 2002), XI: 1, 6; "Ferry Construction Steams Ahead," *New York Construction News* 51 (August 2003): 35.

23. Dan Barry, "What Staten Island Needs, Mayor Says, Is Baseball," *New York Times* (January 14, 1998), B: 3; Mike Allen, "Ballpark and Shops Among Options for a Gateway to Staten Island," *New York Times* (August 16, 1998): 34; Bob Liff, "George Rains on S.I. Ballpark Plans," *New York Daily News* (September 21, 1998), Metro: 4; Marita J. Licari, "Plans Being Fast-Tracked for Regional Stadium Market," *New York Construction News* 47 (July 1999): 23–28; Michael Finnegan, "Ballpark on S.I. May Cost 40M," *New York Daily News* (September 29, 1999): 14; Michael Finnegan, "S.I. Ballpark's Cost Triples," *New York Daily News* (December 2, 1999): 32; Jim O'Grady, "Minor Yankees' Stadium Facing Major Political Hurdles," *New York Times* (December 5, 1999), XIV: 12; Anthony Ramirez, "S.I. Stadium Plan Takes Step to Approval," *New York Times* (December 7, 1999), B: 3; Charles V. Bagli, "At Least One Yankee Team Gets Its Wish," *New York Times* (February 9, 2000): 1, B: 9; Charles V. Bagli, "Despite Criticism, Giuliani Pursues Ballparks as Economic Catalysts," *New York Times* (March 2, 2000), B: 1, 6; Mary Engels, "Rudy, Beep Name New $29M S.I. Ballpark," *New York Daily News* (June 9, 2000), Metro: 1; Thomas J. Lueck, "Bank Puts Its Money, and Its Name, on Staten Island Ballpark," *New York Times* (June 9, 2000), B: 6; "S.I. Yankees to Open 2001 in New Stadium," *New York Construction News* 49 (January 2001): 11; Mary Engels, "Stadium of Dreams," *New York Daily News* (May 15, 2001), Metro: 5; Harvey Araton, "A Ballpark a Skeptic Can Love," *New York Times* (June 25, 2001), D: 5; "Richmond County Bank Ballpark," *New York Construction News* 49 (June 2002): 45.

24. For Sailors' Snug Harbor, see Landmarks Preservation Commission of the City of New York, LP-0022–27 (October 14, 1965); Barnett Shepherd, *Sailors' Snug Harbor, 1801–1976* (New York: Snug Harbor Cultural Center, 1979); "Arts Replace Sailors at Snug Harbor," *New York Times* (August 12, 1983), C: 12; Stern, Mellins, and Fishman, *New York 1960*, 222; Diamonstein, *The Landmarks of New York III*, 72–73; Stern, Mellins, and Fishman, *New York 1880*, 990.

25. Betsy Wade, "Staten Island: Children's Museum," *New York Times* (June 8, 1984), C: 1; Paul Goldberger, "Building Blocks That Ask the Right Questions," *New York Times* (April 5, 1987), II: 34; White and Willensky, *AIA Guide* (2000), 894.

26. Goldberger, "Building Blocks That Ask the Right Questions": 34.

27. David W. Dunlap, "When City Hall Smiles on Public Art," *New York Times* (April 26, 2001), F: 1, 8; Rosalie R. Radomsky, "At Staten Island Site for Children: Connecting the Buildings of a Museum," *New York Times* (July 14, 2002), XI: 1.

28. David W. Dunlap, "Dispute Grows on Ex-Sailors' Home," *New York Times* (March 23, 1987), B: 1, 7; "Names and News," *Oculus* 48 (April 1987): 10; "Names and News," *Oculus* 48 (May 1987): 30; Paul Goldberger, "The Slow, Stylish Redesign of Snug Harbor," *New York Times* (July 5, 1987), II: 24; Mark A. Hewitt, "The Snug Harbor Music Hall Competition," *Oculus* 49 (September 1987): 6–7, 14–19; Kraft, ed., *Robert A. M. Stern: Buildings and Projects, 1987–1992*, 343; Christopher Gray, "Streetscapes/The Music Hall at Snug Harbor Cultural Center," *New York Times* (April 7, 1996), IX: 5; White and Willensky, *AIA Guide* (2000), 894.

29. Goldberger, "The Slow, Stylish Redesign of Snug Harbor": 24.

30. Hewitt, "The Snug Harbor Music Hall Competition": 16.

31. Goldberger, "The Slow, Stylish Redesign of Snug Harbor": 24.

32. "Petitions Oppose S.I. Navy Base," *New York Times* (September 25, 1984), B: 5; Larry Rohter, "Foes of S.I. Navy Base Proposal Air Concerns," *New York Times* (December 9, 1984): 55; Jane Perlez, "Staten Island Gets Ready to Go Navy," *New York Times* (April 14, 1985), IV: 6; Michael R. Gordon, "Navy's Plan for S.I. Port Is Set Back in Congress," *New York Times* (May 21, 1986), B: 3; "Names and News," *Oculus* 48 (October 1986): 10; "Estimate Board Postpones Vote on Homeport Plan," *New York Times* (October 1, 1988): 11; Sally Siddiqi, "The Navy's Staten Island Port," *Metropolis* 8 (March 1989): 21–22; Daniel J. McConville, "Homeport Makes Waves," *New York Post* (May 18, 1989): 42; Stephanie Strom, "Dinkins Asks U.S. to Halt Development of S.I. Naval Port," *New York Times* (April 11, 1990), B: 1–2; Anthony DePalma, "S.I. Port's Fate Is Muddled by the Mideast Crisis," *New York Times* (August 25, 1990): 27; Kimberly J. McLarin, "Opening a Wound on Staten Island," *New York Times* (June 26, 1993): 7; Eric Schmitt, "Panel Votes to Close Staten Island Base; Spares New London," *New York Times* (June 26, 1993): 1, 7; Douglas Martin, "A Final Staten Island Homecoming," *New York Times* (February 6, 1994): 43.

33. Mary Engels, "City Is Sued over Denial of Homeport Plan for S.I.," *New York Daily News* (May 3, 2000), Metro: 1; Jim

O'Grady, "In Home Port Plan, a Park and Housing with Harbor Vu," *New York Times* (April 8, 2001), XIV: 7; Andrew Friedman, "The City's Fastest-Growing Neighborhood: Small but Sailors Galore," *New York Times* (April 29, 2001), XIV: 4; Jonathan Lemire, "Early Yule Gift to City: Homeport," *New York Daily News* (December 10, 2001), Metro: 3; Mary Engels, "Movie Studio Going Up in S.I.," *New York Daily News* (January 17, 2002), Metro: 1; Jim O'Grady, "A Borough's Old Naval Base Gives It Silver Screen Dreams," *New York Times* (March 31, 2002), XIV: 8.

34. Jennifer Steinhauer, "City Sets Aside $66 Million for S.I. Development," *New York Times* (November 2, 2004), B: 4; "Mayor Michael R. Bloomberg Announces Consultant Team to Begin Implementation of Stapleton Waterfront Redevelopment Plan," press release (March 4, 2005).

35. "200 Acres, $400 Million; Planning for a New Campus on S. I.," *New York Times* (December 24, 1989), X: 1; "Briefs," *Architectural Record* 178 (January 1990): 23; "$299M S.I. College Seeks G.C., Sub Bids," *New York Construction News* 37 (February 19, 1990): 1, 16–17; David W. Dunlap, "City's Colleges Add $2 Billion in Facilities," *New York Times* (September 12, 1993), X: 1, 12; Hugo Lindgren, "College Brings Peace of Mind to Willowbrook," *Metropolis* 13 (December 1993): 11, 14; *Mitchell/Giurgola Architects: Selected and Current Works* (Mulgrave, Australia: Images Publishing, 1997), 124–27, 245; Raymond Gomez, "Creating a New Look," *American School & University* 71 (December 1998): 34b-34c. For Willowbrook State School, see Stern, Mellins, and Fishman, *New York 1960*, 985.

36. Lindgren, "College Brings Peace of Mind to Willowbrook": 14.

37. *Mitchell/Giurgola Architects: Selected and Current Works*, 140–43; Nancie L. Katz, "S.I. School Model for Millennium," *New York Daily News* (May 3, 1998): 36; "Mayor Giuliani Visits Public School 56 in Staten Island," press release (November 23, 1998).

38. www.mitchellgiurgola.com/giuh_pages/pss_7.html.

39. Alan S. Oser, "Costs Cut in Building S.I. Hospital," *New York Times* (April 11, 1979), D: 16. Also see "Hospital Buys S.I. Land for Building," *New York Times* (February 27, 1976): 34.

40. Nina Rappaport, "Hospitals to Lift the Spirit," *Oculus* 61 (November 1998): 6; "On the Drawing Boards," *Oculus* 64 (December 2001): 6.

41. "AIA Component Awards," *AIA Journal* 68 (Mid-May 1979): 256.

42. Quoted in *Richard Dattner: Selected and Current Works of Richard Dattner & Partners Architects* (Mulgrave, Australia: Images Publishing, 2000), 200–201.

43. Vivian S. Toy, "Despite Years of Broken Promises, Accord Vows to Close S.I. Landfill," *New York Times* (May 30, 1996), B: 1, 3; "Assembly Votes to Force S.I. Dump to Close," *New York Times* (May 31, 1996), B: 7; Vivian S. Toy, "After Fresh Kills, New York Will Need a Partner in Garbage," *New York Times* (June 2, 1996): 35; "Shutting the Fresh Kills Dump," editorial, *New York Times* (June 9, 1996), IV: 14; "The End of a Landfill," *New York Times* (June 10, 1996), B: 8; "Backward Steps on Garbage Disposal," *New York Times* (June 20, 1996): 20; Blake Eskin, "The End of the Line for Fresh Kills," *Metropolis* 16 (September 1996): 20, 25; Vivian S. Toy, "Planning to Close Its Landfill, New York Will Export Trash," *New York Times* (November 26, 1996): 1, 32; Clifford J. Levy, "Mayor Rebuts Export Fears on Landfill," *New York Times* (December 1, 1996): 47, 54; Vivian S. Toy, "Sealing Mount Garbage," *New York Times* (December 21, 1997): 41, 46; Sydney Fisher, "The End Nears: The Fears Don't Fade," *New York Times* (April 19, 1998), XIV: 1, 12; Amy Waldman, "Where to Put 10,000 Tons a Day: The Solid Answers Are Few," *New York Times* (April 19, 1998), XIV: 12; Douglas Martin, "Boroughs Battle Over Trash as Last Landfill Nears Close," *New York Times* (November 16, 1998), B: 1, 5; Guy V. Molinari, "Whose Garbage Is It?" letter to the editor, *New York Times* (November 20, 1998): 32; Howard Golden and Leslie H. Lowe, "Brooklyn Replies," letters to the editor, *New York Times* (November 26, 1998): 38; Douglas Martin and Dan Barry, "Giuliani Ignites Border Tension on Trash Plan," *New York Times* (December 3, 1998): 1, B: 10; David M. Herszenhorn, "Reaction in New Jersey Runs from Skepticism to Fury," *New York Times* (December 3, 1998): B: 10; Abby Goodnough, "Giuliani Calls Garbage Plan Regional Plus," *New York Times* (December 4, 1998), B: 5; Guy Billout, "Op-Art: Other Ways to Get Rid of New York City's Garbage," *New York Times* (December 5, 1998): 25; Douglas Martin, "Trash Plan Is Praised, but Faces Opposition," *New York Times* (December 13, 1998): 54; Douglas Martin, "New York Moves on Plan to Ship Trash Out of City," *New York Times* (January 21, 1999), B: 5; Andy Newman, "Five States Team Up to Fight Giuliani's Trash Proposal," *New York Times* (February 8, 1999), B: 3; Douglas Martin and Andrew C. Revkin, "New York City Forced to Rethink Plans to Send Trash Out of State," *New York Times* (February 21, 1999): 1, 42; David W. Chen, "Luster of New York's Trash Dims in Virginia," *New York Times* (March 11, 1999), 1: B, 8; Douglas Martin, "Sanitation Department Hints at Flexibility on Plans to Export Trash," *New York Times* (May 25, 1999), B: 5; Douglas Martin and Andrew C. Revkin, "As Deadline Looms for Dump, Alternate Plan Proves Elusive," *New York Times* (August 30, 1999): 1, B: 4; Eric Lipton, "Efforts to Close Fresh Kills Are Taking Unforeseen Tolls," *New York Times* (February 21, 2000): 1, B: 3; "Manhattan: The New Garbage Barge," editorial, *New York Observer* (February 28, 2000): 4; Tina Kelley, "Using Trash as Text," *New York Times* (March 23, 2000), B: 1, 8; Jennifer Steinhauer, "Fresh Kills, Chapter 2," *New York Times* (August 13, 2000): 27, 34; Eric Lipton, "City Begins Its Last Phase in Closing Out Fresh Kills Site," *New York Times* (February 5, 2001), B: 1, 3; Kirk Johnson, "Dumping Ends at Fresh Kills, Symbol of Throw-Away Era," *New York Times* (March 18, 2001): 1, 34; Kirk Johnson, "After

53 Years, Fresh Kills Gets Its Final Load of Trash," *New York Times* (March 23, 2001), B: 3; Eric Lipton, "City Trash Follows Long and Winding Road," *New York Times* (March 24, 2001), B: 1, 5; Jim O'Grady, "Requiem For a Garbage Dump," *New York Times* (March 25, 2001), XIV: 3; Jennifer Steinhauer, "Mayor Weighs Path to Solve Trash Woes," *New York Times* (June 25, 2002), B: 3; Steven Cohen, "Putting Garbage to Good Use," *New York Times* (August 15, 2002): 23; Jim Carlton, "Where Trash Reigned, Trees Sprout," *Wall Street Journal* (January 23, 2002), B: 1, 8; "Collecting the Rubbish on Staten Island," *World Architecture* 109 (September 2002): 20; Tom Vanderbilt, "The Last Man Standing," *New York Times* (October 6, 2002), XIV: 3; "Mayor Michael R. Bloomberg Kicks Off the Transformation of Fresh Kills in Staten Island," press release (September 29, 2003); Jeff Vandam, "Recycling a Reputation," *New York Times* (August 28, 2005), XIV: 4.

44. Richard Severo, "A Wonder of Waste Rises on S.I.," *New York Times* (April 13, 1989), B: 1, 8.

45. "Don't Fiddle: Burn New York's Trash," editorial, *New York Times* (December 20, 1984): 30; Josh Barbanel, "Board of Estimate Approves Plan for 5 Incinerators in City," *New York Times* (December 21, 1984): 1, B: 5; Alan Finder, "Plan to Build Incinerators Wins by a Vote," *New York Times* (December 23, 1984), IV: 7; Allan R. Gold, "Garbage Can't Just Go Anywhere, Anymore," *New York Times* (December 16, 1990): 16; Stanley Turkel, "Why New York City Must Build Incinerators," letter to the editor, *New York Times* (October 5, 1991): 20; "New York City: Garbage Ostrich," editorial, *New York Times* (April 26, 1992): 18; Michael Specter, "Pact on Garbage in New York City," *New York Times* (August 18, 1992): 1, B: 2; Ian Fisher, "Compromise on Garbage Faces a Test," *New York Times* (August 24, 1992), B: 3; James C. McKinley Jr., "Plan on Garbage Backed by Council in New York City," *New York Times* (August 28, 1992): 1, B: 3; Michael Specter, "Hope, Off the Ash Heap," *New York Times* (August 29, 1992): 1, 24; Joe Sexton, "Brooklyn Incinerator Opponents See Victory in High Court Ruling," *New York Times* (May 4, 1994), B: 2; Douglas Martin, "City's Last Waste Incinerator Is Torn Down," *New York Times* (May 6, 1999), B: 8.

46. Ian Urbina, "City Trash Plan Forgoes Trucks, Favoring Barges," *New York Times* (October 7, 2004): 1, B: 9.

47. "The Campaign for Useful and Enjoyable Open Space," *Municipal Art Society Annual Report* (2000–2001): 5–6; "Will New York Have Its Downsview Park?" *Van Alen Report* 8 (December 2000): 18–21; Alysha Sideman, "Forum on Landfill Is Scheduled," *Staten Island Advance* (May 24, 2001): 17; Holly Leicht, "A Fresh Start at Fresh Kills: Landfill to Landscape," *Municipal Art Society Newsletter* (May/June 2001): 1, 3; Fred Bernstein, "Talking Trash," *Architecture* 90 (June 2001): 62–63; Laurie Kerr, "Fresh Kills Forums," *Oculus* 64 (October 2001): 10; David W. Dunlap, "Planning Ahead, Looking Back: Design Competition for Transforming Fresh Kills Landfill," *New York Times* (October 28, 2001), XI: 1; "Fresh Kills Finalists," *Grid* 3 (November 2001): 29; Andrew Friedman, "Reprieve for Fresh Kills," *Planning* 67 (November 2001): 4–9; Diana Yates, "'From Landfill to Landscape," *Staten Island Advance* (December 7, 2001), F: 1–2; Denny Lee, "At Fresh Kills Landfill, Garbage Out, Grand Plans In," *New York Times* (December 9, 2001), XIV: 6; Gastil, *Beyond the Edge: New York's New Waterfront*, 178–81; Kate Orff, "Freshly Killed?" *Land Forum* 14 (2002): 25; "Fresh Kills: Landfill to Landscape," *Praxis* 4 (2002): 18–57; Linda Pollak, "Sublime Matters," *Praxis* 4 (2002): 58–63; Thomas Hayden, "Fields of Dreams," *U.S. News & World Report* (January 21, 2002): 62, 64; Philip Nobel, "The Other Environmental Crisis," *Metropolis* 21 (March 2002): 52; Gavin Keeney, "A Benign Vision for Capitalism's Golgotha," *Competitions* 12 (Summer 2002): 28–41, 58; Rosten Woo, "Fresher Kills?" *Metropolis* 21 (March 2002): 36; Laurie Kerr, "Tying Down Gulliver: The Fresh Kills Design Competition," *Oculus* 64 (March/April 2002): 8–9; Jeffrey Kastner, "The Department of Sanitation's Artist in Residence," *New York Times* (May 19, 2002), II: 37, 39; Rebecca Krinke, "Fresh Ideas?" *Landscape Architecture* 92 (June 2002): 76–85; James Corner, John Crandell, Frank Groznik, Gavin Keeney, Ellen Ryan, and John Spedding, "Anger and Praise for Fresh Kills Coverage," letters to the editor, *Landscape Architecture* 92 (August 2002): 9–10; Barbara Stewart, "Landfill to Park? Give It Time," *New York Times* (November 28, 2002), B: 1, 8; Alex Davidson, "Fresh Scheme for Fresh Kills," *Architects' Newspaper* 2 (February 17, 2004): 1, 4.

48. Quoted in "Fresh Kills: Landfill to Landscape": 35.

49. Quoted in "Fresh Kills: Landfill to Landscape": 20, 24.

50. Krinke, "Fresh Ideas?": 82.

QUEENS

1. Joseph Salvo, quoted in Suketu Mehta, "The Meltingest Pot," *New York Times* (October 5, 2003), VI: 88–92, 127. Also see Joel Kotkin, *The New Geography: How the Digital Revolution Is Reshaping the American Landscape* (New York: Random House, 2000), 103–4; Warren Lehrer and Judith Sloan, *Crossing the BLVD: Strangers, Neighbors, Aliens in a New America* (New York: W. W. Norton, 2003).

2. Edward A. Gargan, "Riverfront Business and Housing for Queens Offered by Port Body," *New York Times* (March 21, 1983): 1, B: 5; Edward A. Gargan, "Koch and Cuomo Agree on Waterfront Proposals," *New York Times* (November 19, 1983): 1, 29; "A Step Forward in Queens," editorial, *New York Times* (November 26, 1983): 22; Peter Freiberg, "Long Island City: Rezoned or Revised?" *Metropolis* 3 (December 1983): 9–10; *Hunters Point: A Recommendation for a Land Use Policy* (New York: Department of City Planning, 1984); Martin Gottlieb, "Marchi Studies Hunters Point for a Stadium," *New York Times* (January 21, 1984): 23, 25; Alan S. Oser, "Shaping the Future of the Hunters Point Waterfront," *New York Times* (September 23, 1984), VIII: 7; Jordan L. Gruzen, "Hunters Point," *Oculus* 46 (January 1985): 2–3; The Gruzen Partnership

and Beyer Blinder Belle, *Hunters Point: Waterfront Development* (New York: Port Authority of NY & NJ and the City of New York, October 1986); Norman I. Fainstein and Susan S. Fainstein, "Economic Restructuring and the Politics of Land Use Planning in New York City," *Journal of the American Planning Association* 53 (Spring 1987): 237–48; Judith King, "Charting the Waterfront Renaissance," *Avenue* (May 1987): 109; Albert Scardino, "Cities in the Sky, Skyscrapers by the Acre," *New York Times* (May 17, 1987), IV: 28; "Public Space," *Progressive Architecture* 69 (March 1988): 82; "Urban Design Credits," *Progressive Architecture* 69 (May 1988): 11; "PA Plan for Hunters Point," *New York Post* (June 23, 1988): 50; Michael Z. Wise, "Modest Endeavors," in Kevin Bone, ed., *The New York Waterfront: Evolution and Building Culture of the Port and Harbor* (New York: Monacelli Press, 1997), 248; Raymond W. Gastil, *Beyond the Edge: New York's New Waterfront* (New York: Princeton Architectural Press, 2002), 55.

3. For the Pepsi-Cola bottling plant, see Stern, Mellins, and Fishman, *New York 1960*, 987–89.

4. Jerrold Nadler, quoted in Gargan, "Riverfront Business and Housing for Queens Offered by Port Body": 5.

5. Peter C. Goldmark Jr., quoted in Oser, "Shaping the Future of the Hunters Point Waterfront": 7.

6. The Gruzen Partnership and Beyer Blinder Belle, *Hunters Point: Waterfront Development*, 2, 4.

7. Thomas J. Lueck, "New York Agencies Push Huge Queens Development," *New York Times* (June 9, 1990): 25, 28; Rachelle Garbarine, "Amenities for Urban Living," *New York Times* (September 7, 1990): 21; Michele Herman, "Getting to the Point," *Metropolis* 10 (October 1990): 106–19; Alison France, "If You're Thinking of Living In: Long Island City," *New York Times* (November 18, 1990), X: 7; Thomas Paino and Debra Whitelaw, "Long Island City," letter to the editor, *New York Times* (January 13, 1991), X: 10; "UDC Approves Modified Plan for Hunters Pt.," *New York Construction News* 38 (February 11, 1991): 1, 12; "Hunters Point: The Debate," *Oculus* 53 (March 1991): 8–11; Kevin Sack, "Cuomo Outlines Fiscal Blueprint for Recovery of New York City," *New York Times* (September 24, 1991): 1, B: 4; Alan Finder, "Cuomo Ideas for New York City: Some Are Old, Some Are New," *New York Times* (September 25, 1991): 1, B: 4; "Queens West Subsidiary Formed to Develop Hunters Point Project," *New York Construction News* 38 (October 20, 1991): 1, 5; Clare McHugh, "Hunting for a Point," *New York Observer* (January 27, 1992): 3; "Queens West," *Oculus* 54 (February 1992): 12; David W. Dunlap, "$2.3 Billion Plan on the Horizon for Hunters Point," *New York Times* (June 28, 1992), X: 1, 11; Hugo Lindgren, "Mario's Planes, Trains, and Apartment Buildings," *Metropolis* 12 (September 1992): 16; "Queens West President," *New York Times* (December 27, 1992), X: 1; Suzanne Stephens, "Hunters Point Alternate Plan," *Oculus* 55 (April 1993): 11–13; Jordan Gruzen and Jack Beyer, "Rebuttal to Alternate Plan for Hunters Point," *Oculus* 55 (June 1993): 3; Corrine Stoewsand and the Steering Committee of the Hunters Point Community Coalition, "Rebutting the Rebuttal: The Hunters Point Coalition Responds," *Oculus* 56 (September 1993): 8–9; Barbara Fedders, "Juggernaut," *City Limits* 19 (February 1994): 13–14; David S. Chartock, "Queens West," *New York Construction News* 41 (February 14, 1994): 1, 13; Douglas Feiden, "Queens Project Set to Start–Finally," *Crain's New York Business* (March 14–20, 1994): 7; Herbert Muschamp, "Queens West: Why Not Something Great?" *New York Times* (May 22, 1994), II: 36; Greg Sargent, "Queens West: New Vision for New York or Big-Deal Dinosaur?" *Metropolis* 14 (June 1995): 18, 23–24; Beyer Blinder Belle, *Architects & Planners* (New York: Beyer Blinder Belle, 1997), no pagination; Wise, "Modest Endeavors," in Bone, ed., *The New York Waterfront*, 248; Gastil, *Beyond the Edge*, 55.

8. John Beyer, quoted in "Hunters Point: The Debate": 8–9.

9. Gruzen and Beyer, "Rebuttal to Alternate Plan for Hunters Point": 3.

10. "Ground Broken for Huge Queens Development," *New York Times* (September 2, 1994), B: 4; David W. Dunlap, "Queens West Begins with a Park," *New York Times* (September 18, 1994), IX: 1, 10; Douglas Martin, "Welcome to Donnybrook Park," *New York Times* (March 26, 1996), B: 1, 5; Wise, "Modest Endeavors," in Bone, ed., *The New York Waterfront*, 248–49.

11. Martin, "Welcome to Donnybrook Park": 1.

12. Lee Weintraub and Henry J. Stern, quoted in Martin, "Welcome to Donnybrook Park": 5.

13. Chartock, "Queens West": 13; Feiden, "Queens Project Set to Start–Finally": 7; Muschamp, "Queens West: Why Not Something Great?": 36; Dunlap, "Queens West Begins with a Park": 1, 10; "January Start Set for First Queens West Co-op," *New York Construction News* 42 (October 10, 1994): 1, 6; "Financial Innovations in a Pelli Housing Project," *Progressive Architecture* 76 (February 1995): 36; Sargent, "Queens West: New Vision for New York or Big-Deal Dinosaur?": 18; Peter Passell, "Pioneers Wanted; East River Views," *New York Times* (October 6, 1996), IX: 1, 6; Wise, "Modest Endeavors," in Bone, ed., *The New York Waterfront*, 249; Amy Feldman, "Queens Waterfront Sizzles," *Crain's New York Business* (September 8–14, 1997): 1, 46; Todd Bressi, "Queens West Breaks New Ground," *Urban Land* 56 (October 1997): 100–103; Alexandra Lange, "Bilbao-ing in the Boroughs," *New York* 30 (October 13, 1997): 97; Dennis Hevesi, "Co-op in Unusual Site Pushes Plan Toward Goal," *New York Times* (November 14, 1997), B: 6; Alan S. Oser, "Queens West Pioneers Are Getting Company," *New York Times* (March 22, 1998), XI: 1, 6; White and Willensky, *AIA Guide* (2000), 819; Tina Kelley, "Tower in Hunters Point Wins Over Neighbors," *New York Times* (May 21, 2000): 35.

14. Muschamp, "Queens West: Why Not Something Great?": 36.

15. Oser, "Queens West Pioneers Are Getting Company": 1, 6; "Queens West's New Developer," *New York Times* (August 2, 1998), XI: 1; White and Willensky, *AIA Guide* (2000), 819; "Residential Towers," *Oculus* 62 (April 2000): 4; Peggy Edersheim Kalb, "The Next Best Things," *New York* (April 10, 2000): 59–63, 102; Nancy Ramsey, "Tower in Hunters Point Wins Over Neighbors": 35; "Queens West Plans 2nd Luxury Apt. Bldg.," *New York Construction News* 49 (October 2000); Charles V. Bagli, "A Waterfront with Potential, Still Unrealized," *New York Times* (November 28, 2000), B: 1, 4; "Leasing Begins at Avalon Site," *New York Times* (March 17, 2002), XI: 1; "Avalon Riverview," *New York Construction News* 50 (June 2003): 52.

16. Dunlap, "Queens West Begins with a Park": 1, 10; Wise, "Modest Endeavors," in Bone, ed., *The New York Waterfront*, 249; J. William Thompson, "Pier Review," *Landscape Architecture* 88 (January 1998): 38, 40–43; Herbert Muschamp, "Where Iron Gives Way to Beauty and Games," *New York Times* (December 13, 1998), II: 35; Deborah Marton, "History Moved Forward," *Landscape Architecture* 89 (January 1999): 50–57, 84–85; Kira L. Gould, "Action on the Waterfront: A New Park for Queens," *Oculus* 61 (January 1999): 7; White and Willensky, *AIA Guide* (2000), 818–19; Charles Linn, "Thomas Balsley and Collaborators Reclaim Priceless Waterfront Formerly Lost to Industrial Use for Gantry Plaza State Park," *Architectural Record* 188 (March 2000): 106–9; Alan Balfour, *World Cities: New York* (New York: Wiley Academy, 2001), 195; Jayne Merkel, "At the Water's Edge," *Oculus* 64 (November 2001): 10–11; Gastil, *Beyond the Edge*, 55–56; "Gantry Plaza State Park," *Land Forum* 13 (2002): 51–52.

17. Wise, "Modest Endeavors," in Bone, ed., *The New York Waterfront*, 249.

18. Gastil, *Beyond the Edge*, 56.

19. Bagli, "A Waterfront with Potential, Still Unrealized": 1, 4; "Waterfront Money," *New York Times* (December 1, 2000), B: 10; Rosina K. Abramson, "Development in Queens," letter to the editor, *New York Times* (December 3, 2000): 18; "Queens West," *New York Construction News* 49 (February 2001): 11; Lois Weiss, "Rockrose Gets Nod for Pepsi Site," *New York Post* (March 1, 2001): 36; David W. Dunlap, "Developer Is Picked for Queens Residential Project Across from U.N.," *New York Times* (March 1, 2001), B: 1, 7; Herbert Muschamp, "Fireworks of Fallbacks for a New River City?" *New York Times* (March 5, 2001), E: 1, 3; Gastil, *Beyond the Edge*, 145–46; Jayne Merkel, "Arts in Queens," *Oculus* 64 (January-February 2002): 14; David W. Dunlap, "Blocks," *New York Times* (June 6, 2002), B: 3; Joseph P. Fried, "Following Up," *New York Times* (August 4, 2002): 27; David W. Dunlap, "3,200 Apartments to Be Built in Glow of Giant Pepsi Sign," *New York Times* (September 24, 2003), B: 1; Beth Dunlop, *Arquitectonica* (New York: Rizzoli International Publications, 2004), 174–81.

20. Quoted in Dunlop, *Arquitectonica*, 174.

21. Bagli, "A Waterfront with Potential, Still Unrealized": 1, 4; "Developer Is Picked for Queens Residential Project Across from U.N.": 1; David W. Dunlap, "New Focus on Queens West Office Sites," *New York Times* (September 23, 2001), XI: 1; Marc Hochstein, "News," *Grid* 3 (November 2001): 28; Gastil, *Beyond the Edge*, 145–46.

22. Jim O'Grady, "Queens Up Close," *New York Times* (October 29, 2000), XIV: 6; Bagli, "A Waterfront with Potential, Still Unrealized": 4; Charles V. Bagli, "After the Promises Come the Realities," *New York Times* (November 3, 2002): 22.

23. Herbert Muschamp, "Let the Design Sprint Begin," *New York Times* (March 11, 2004), F: 1, 5; Corey Kilgannon, "Santa Monica Design Firm Chosen for Olympic Site in Queens," *New York Times* (May 27, 2004), B: 2; Joseph Giovannini, "New York Chooses for Potential Olympic Village," *Architectural Record* 192 (July 2004): 30.

24. Stern, Gilmartin, and Mellins, *New York 1930*, 78–79; Stern, Mellins, Fishman, *New York 1960*, 1175.

25. "Dream Factory in Queens," *New York Times* (January 11, 1976), VIII: 5; Fred Ferretti, "Students Play a Role in Revival on Astoria Film Stage," *New York Times* (April 7, 1976): 38.

26. Paul Gardner, "Astoria Is Reborn," *New York* 10 (August 15, 1977): 28–31; Dee Wedemeyer, "The Emerald City Comes to New York City," *New York Times* (September 23, 1977), B: 3; Phyllis Bernstein, "Nassau Paints Attractive Picture of Itself for Film Makers," *New York Times* (December 25, 1977): 48.

27. "Astoria Studio Pushed," *New York Times* (April 14, 1978), C: 22. Also see Landmarks Preservation Commission of the City of New York, LP-0977 (March 14, 1978); Barbaralee Diamonstein, *The Landmarks of New York III* (New York: Harry N. Abrams, 1998), 337.

28. C. Gerald Fraser, "Koch Predicts Astoria Studio's Rebirth," *New York Times* (September 6, 1980): 12; Damon Stetson, "Studios Growing to Meet City Film Industry Surge," *New York Times* (May 31, 1981): 32; "Year's Extension for 3 City Taxes Is Voted by Council Finance Panel," *New York Times* (July 21, 1981), B: 6; Eleanor Blau, "4 in Show Business Plan Enlarged Astoria Studio," *New York Times* (November 24, 1981), C: 10; Deirdre Carmody and Laurie Johnston, "Frigid Ground-Breaking," *New York Times* (December 14, 1982), B: 2; Leslie Bennetts, "Astoria Studio Revives Film Era in New York," *New York Times* (August 3, 1983), C: 17; Margot Hornblower, "The Astoria Studio and Its Rebirth," *Washington Post* (December 18, 1983), G: 1; Andrew L. Yarrow, "Astoria Expands on Its Movie Heritage," *New York Times* (September 28, 1986), II: 17; Mark McCain, "A Casting Call Goes Out for Back-Office Tenants," *New York Times* (May 1, 1988), X: 39; Robin Kamen, "Astoria Film Studio Gaining on California," *Crain's New York Business* (March 7, 1994): 7; Charles V. Bagli, "A New Idea of 'Get Me the Coast,'" *New York Times* (September 5, 1999), B: 1, 8; Charles V. Bagli, "A Star Is Born, in Queens," *New York Times* (August 8, 1999), IV: 1; "40,000 Sq. Ft., $8.425

Million Building; Sound Stage, Its Seventh, for Astoria," *New York Times* (January 2, 2000), XI: 1.

29. Yarrow, "Astoria Expands on Its Movie Heritage": 17.

30. Woody Allen, quoted in Yarrow, "Astoria Expands on Its Movie Heritage": 17.

31. George S. Kaufman, quoted in McCain, "A Casting Call Goes Out for Back-Office Tenants": 39.

32. Hornblower, "The Astoria Studio and Its Rebirth": 1; *Charles Gwathmey and Robert Siegel: Buildings and Projects, 1964–1984* (New York: Harper: Harper & Row, 1984), 280–81, 294; Victoria Irwin, "New York's Astoria Movie Studio Gets Second Premiere as a Museum," *Christian Science Monitor* (March 13, 1984): 7; Lisa Belkin, "At Revived Astoria Studios, the Birth of a Museum," *New York Times* (July 16, 1984), B: 2; "Schlosser Will Head Film-Making Museum," *New York Times* (May 8, 1986), C: 15; "Re-creating a TV Lounge of Three Decades Past," *New York Times* (August 11, 1988), C: 3; Stephen Holden, "From Tut to Taylor, Moving-Image Museum Captures Film History," *New York Times* (August 30, 1988), C: 15; Helen Dudar, "How a Museum Grew in Astoria," *New York Times* (September 4, 1988), II: 25; Susan Isaacs, "Through the Looking Glass of Movies and Television," *New York Times* (September 4, 1988), II: 1, 25; Matthew Flamm, "Screen Souvenirs," *New York Post* (September 7, 1988): 23, 26; Megan Rosenfeld, "The Mecca for Moviegoers; New Museum Opening in N.Y.," *Washington Post* (September 10, 1988): C: 1; Valerie Block, "New Museum: Gable, Fonz, Monkees and More," *New York Observer* (September 12, 1988): 12; "Moving Images," *New Yorker* 64 (October 24, 1988): 32–33; Richard Gehr, "Lights, Cameras, and More Cameras," *Metropolis* 8 (December 1988): 27; Julie Salamon, "A Cultural Outpost in the Land of Archie Bunker," *Wall Street Journal* (January 10, 1989): 16; "American Museum of the Moving Image," *Architecture + Urbanism* (April 1989): 98–103; Deborah K. Dietsch, "Art and Industry," *Architectural Record* 177 (May 1989): 116–21; Deborah K. Dietsch, "Double Feature," *Architectural Record* 177 (May 1989): 177–78; Elena Marcheso Moreno, "A Museum That Invites Participation," *Architecture* 78 (June 1989): 74–79; Paul Goldberger, "From Sound Stage to Strong, Silent Museum," *New York Times* (July 2, 1989), II: 24; Brad Collins and Diane Kasprowicz, eds., *Gwathmey Siegel: Buildings and Projects, 1982–1992* (New York: Rizzoli International Publications, 1993), 38–45; Beverly Russell, "New York Renovations," *American Museum of the Moving Image," Interiors* 152 (September 1993): 55–83; "Adaptive Re-use of Buildings," *Southeast Asia Building* 23 (November 1996): 16, 18, 20, 22, 24, 26; Susanna Sirefman, *New York: A Guide to Recent Architecture* (London: Ellipses, 1997), 270- 71; *Gwathmey Siegel & Associates Architects: Selected and Current Works* (Mulgrave, Australia: Images Publishing, 1998), 22–27; White and Willensky, *AIA Guide* (2000), 810; A. O. Scott, "To Unearth the Secrets of Moviemaking, Take the BMT," *New York Times* (May 2, 2001), H: 18; Arthur C. Danto, Timothy Hyman, and Marco Livingstone, *Red Grooms* (New York: Rizzoli International Publications, 2004), 200–205.

33. Collins and Kasprowicz, eds., *Gwathmey Siegel: Buildings and Projects, 1982–1992*, 38.

34. Sirefman, *New York*, 270.

35. Moreno, "A Museum That Invites Participation": 76.

36. Goldberger, "From Sound Stage to Strong, Silent Museum": 24.

37. Holden, "From Tut to Taylor, Moving-Image Museum Captures Film History": 15.

38. "New Bank Building," *New York Post* (March 9, 1989): 50.

39. Alan S. Oser, "All Over Town, Movie Screens Are Popping Up," *New York Times* (December 30, 1998), B: 6.

40. Suzanne Slesin, "Queens Site to Be Converted into International Design Center," *New York Times* (March 10, 1983), C: 6; Fred Ferretti, "The Evening Hours," *New York Times* (April 22, 1983): 18; "Names and News," *Oculus* 44 (May 1983): 7; "Design Center Developments," *Progressive Architecture* 64 (May 1983): 54; Diane Henry, "Interior Design Industry Studying a Move to Queens," *New York Times* (May 11, 1983): 20; "New York Furnishings Market Has Designs on Queens," *Architectural Record* 171 (October 1983): 69; *Charles Gwathmey and Robert Siegel: Buildings and Projects, 1964–1984*, 21, 294; Jane Perlez, "Plan for Market on Queens Site Backed by U.S.," *New York Times* (March 30, 1984), B: 4; David W. Dunlap, "Koch Leads 2-Stop Economic Development Tour," *New York Times* (May 11, 1984), B: 3; Martin Gottlieb, "Wooing the Design Tenant," *New York Times* (May 13, 1984), XII: 70, 71, 73; Suzanne Slesin, "Queens Design Center: To Join, or Not?" *New York Times* (June 6, 1985), C: 12; "Autumn in New York: Designer's Saturday Will Coincide with Design Center Opening," *Architectural Record* 173 (September 1985): 59; Victoria Geibel, "Over the River but Not Out of the Woods," *Metropolis* 5 (September 1985): 12; Suzanne Slesin, "Design Center Celebrates," *New York Times* (October 11, 1985): 26; Joanna Wissinger, "New York's IDC Opening," *Progressive Architecture* 66 (November 1985): 36; "International Design Center, New York," *Oculus* 47 (November 1985): 14; Charles K. Gandee, "A Bridge Too Far?" *Architectural Record* 174 (June 1986): 144–53; "Design Center to Open," *New York Times* (October 8, 1986), B: 5; Shawn G. Kennedy, "Showroom Area Rises in Queens," *New York Times* (October 8, 1986), D: 28; Joseph Giovannini, "Design Notebook/Designers' Showrooms That Reflect Architectural Trends," *New York Times* (January 29, 1987), C: 12; Joanna Krotz, "Moving the Furniture," *Avenue* (April 1987): 86–93; Gail Ernsberger, "How Near, Yet How Far," *Metropolis* 7 (October 1987): 28–29; Joseph Giovannini, "From Far and Near, Designers Flock to a New York 'Saturday,'" *New York Times* (October 15, 1987), C: 10; Paul Goldberger, "In Queens, a Design Center That Lives Up to Its Name," *New York Times* (January 10, 1988), II: 35; Pilar Viladas, "IDCNY/Center One," *Progressive Architecture* 69 (March 1988): 100–101;

Shawn G. Kennedy, "Showrooms in Queens Get Office Tenant," *New York Times* (September 7, 1988), D: 25; Carter Wiseman, *I. M. Pei: A Profile in American Architecture* (New York: Harry N. Abrams, 1990), 311; Suzanne Slesin, "For Design Mart, East River May Yet Prove Unbridgeable," *New York Times* (March 21, 1991): C: 1, 12; Collins and Kasprowicz, eds., *Gwathmey Siegel: Buildings and Projects, 1982–1992*, 122–27; *Gwathmey Siegel & Associates Architects: Selected and Current Works*, 68–73; White and Willensky, *AIA Guide* (2000), 814–15.

41. Frank J. Prial, "Office Complex Planned on American Chicle Site," *New York Times* (March 9, 1982), B: 2; Diane Henry, "A Midtown Developer in Queens," *New York Times* (April 21, 1982), D: 23. For American Chicle Company Building, see Stern, Gilmartin, and Mellins, *New York 1930*, 79, 524.

42. Robin Roberts, quoted in Geibel, "Over the River But Not Out of the Woods": 12.

43. Gandee, "A Bridge Too Far?": 149.

44. Charles Gwathmey, quoted in Gandee, "A Bridge Too Far?": 152.

45. Goldberger, "In Queens, a Design Center That Lives Up to Its Name": 38.

46. Goldberger, "In Queens, a Design Center That Lives Up to Its Name": 38.

47. For Domore showroom by New York Architects, see Paul Rice Jackson, "Strong Architectural Statements by New York Architects Complement Domore's Bi-Coastal Expansion," *Interiors* 146 (February 1987): 98, 100. For Kinetics showroom by Paolo Favaretto and Jim Hayward, with Skyline Architects, see Robert Janjigian, "A Clean, Well-Lighted Place for Kinetics at the IDCNY," *Interiors* 146 (July 1987): 64. For Innovative Products for Interiors showroom by Roberto Pamio, see "IPI: Roberto Pamio Designs a Showroom for the Firm's Three Divisions in the IDCNY," *Interior Design* 58 (September 1987): 240–43. For JG Furniture showroom by Cambridge Seven, see "JG Furniture at IDCNY," *Interior Design* 58 (October 1987): 80. For Poltronova showroom by Vignelli Associates, see Kenneth Brozen, "Spectacular Milan," *Interiors* 147 (January 1988): 184–85. For USG Interiors showroom by Daroff Design, see Paula Rice Jackson, "A New Showroom at IDCNY for USG Interiors Presents an Evolution of Design Purpose," *Interiors* 147 (March 1988): 81, 84, 86. For Lee's Commercial Carpets showroom by HOK, see "HOK's Inverted Design for Lee's Commercial Carpets Puts the Central Focus Along the Perimeters," *Interiors* 147 (June 1988): 80. For Architex showroom by Skyline Architects, see Gregory Littleton, "A New Background for Architex Fabrics at the IDCNY," *Interiors* 147 (May 1988): 130; "Architex at IDCNY," *Interior Design* 59 (June 1988): 56. For Fuller showroom by James Vaughan, see Monica Geran, "James Vaughan's Fuller Showroom at IDCNY," *Interior Design* 59 (June 1988): 58. For Bellinger showroom by DePolo/Dunbar, see Andrea Loukin, "Showrooms: Bellinger, IDCNY," *Interior Design* 59 (September 1988): 68. For Staff Lighting showroom by Jurgen Schulten and Philip Zurfleide, see Justin Henderson, "The Staff Lighting Showroom at IDCNY Brings New Form to a Company Noted for Function," *Interiors* 148 (September 1988): 64, 66. For Artemide showroom by Vignelli Associates, see "Displaying Lamps," *Abitare* 268 (October 1988): 256–63. For Rudd International showroom by Alfred Homann, see Monica Geran, "Rudd International: The Furniture Producer's IDCNY Showroom Designed by Alfred Homann," *Interior Design* 59 (October 1988): 296–99. For B&B Italia showroom by Gregotti Associati and Frank Spadaro, see Edie Lee Cohen, "B & B Italia," *Interior Design* 60 (January 1989): 208–11. For Brueton showroom by Stanley Jay Friedman, see Barry H. Slinker, "Brueton," *Interior Design* 60 (January 1989): 198–203. For LSI showroom by Thomas Gass, see Justin Henderson, "LSI's New Showroom at IDCNY Showcases Lighting and Accessories in a Museum-Quality Space," *Interiors* 148 (March 1989): 42–44.

48. Giovannini, "Design Notebook": 12; Pilar Viladas, "Soft Sell," *Progressive Architecture* 69 (March 1988): 94–99; Joanna Wissinger, "Design Trends," *Interiors* 147 (June 1988): 162–67; Collins and Kasprowicz, eds., *Gwathmey Siegel: Buildings and Projects, 1982–1992*, 188–95; *Gwathmey Siegel & Associates Architects: Selected and Current Works*, 74–77.

49. Thad Hayes, quoted in Jerry Cooper, "Edward Pashayan," *Interior Design* 59 (April 1988): 272–77.

50. Giovannini, "Design Notebook": 12. Also see Michael Wagner, "Showroom Winner: The Richard Penney Group," *Interiors* 147 (January 1988): 154–55; Richard Penney, "A Display Setting," *Ottagono* 88 (March 1988): 102–7.

51. Mario Botta, quoted in Edie Lee Cohen, "ICF, New York: a Grand Gesture by Mario Botta in the IDCNY," *Interior Design* 58 (October 1987): 270–79. Also see Paul Goldberger, "Mario Botta Exemplifies 'Less Is More,'" *New York Times* (November 21, 1986), C: 1, 32; Giovannini, "Design Notebook": 12; Paul M Sachner, "A Little Bit Timeless," *Architectural Record* 175 (Mid-September 1987): 124–29; Goldberger, "In Queens, a Design Center That Lives Up to Its Name": 38.

52. Goldberger, "In Queens, a Design Center That Lives Up to Its Name": 38.

53. Giovannini, "Design Notebook": 12.

54. Michael Wagner, "Shower of Angels," *Interiors* 149 (July 1990): 76–77.

55. Paul M. Sachner, "Anything But Standard," *Architectural Record* 178 (September 1990): 94–97. Also see Patricia Leigh Brown, "Currents: It's Bathtub Heaven," *New York Times* (May 17, 1990), C: 3.

56. *SITE* (New York: Rizzoli International Publications, 1989), 226–31.

57. Quoted in *SITE*, 226.

58. Slesin, "For Design Mart, East River May Yet Prove Unbridgeable": 1.

59. Claudia H. Deutsch, "An Empty Feeling? Try Mixing Uses," *New York Times* (March 13, 1994), X: 15; Mervyn Rothstein, "A New Agency of New York City Is Moving into the International Design Center in Long Island City," *New York Times* (March 20, 1996), D: 6; Marcia Biederman, "Design Buildings Are Back from Dead, Though Less Tony," *New York Times* (March 15, 1998): 6; Edwin McDowell, "Changing Designs, a Project Revives," *New York Times* (June 28, 2000), B: 8.

60. Kirk Johnson, "New Downtown Space Prompts Fears of Surplus," *New York Times* (May 12, 1985), XII: 26. For Citicorp Center and 399 Park Avenue, see Stern, Mellins, and Fishman, *New York 1960*, 354–55, 490–97.

61. "Big Citicorp Plan," *New York Times* (July 28, 1985), VIII: 1; Shawn G. Kennedy, "Real Estate," *New York Times* (August 28, 1985), D: 19; "Names and News," *Oculus* 47 (September 1985): 10.

62. Martin Gottlieb, "Citicorp, to Decentralize, Plans Queens Complex," *New York Times* (December 16, 1985): 1, B: 2; "Setting Out for the Far East," *New York Times* (December 22, 1985), IV: 6; "Citicorp's New York Leap," editorial, *New York Times* (December 31, 1985): 14; Martin Gottlieb, "A Promised Land Where Others Feared to Build," *New York Times* (January 5, 1986), IV: 20; Stanley S. Litow and David Gallagher, "Office Expansion to Outer Boroughs Squeezes Manufacturers," letter to the editor, *New York Times* (January 24, 1986): 26; Alan Finder, "2 Major New York Projects Advance," *New York Times* (July 10, 1986): 44; David W. Dunlap, "Column One: Changes," *New York Times* (November 6, 1986), B: 1; Alan S. Oser, "Perspectives: Offices in Queens," *New York Times* (May 17, 1987), VIII: 9; Paula Deitz, "Letter from New York," *Financial Times* (London) (October 1, 1987): 25; Anthony DePalma, "A Giant to Dominate Low-Rise Queens," *New York Times* (August 7, 1988), X: 7, 10; James S. Rossant, "A Giant Glass Weed Has Sprung Up in Queens," letter to the editor, *New York Times* (October 4, 1988): 30; H. Alan Hoglund, "Give Manhattan Chauvinism a Bronx Cheer," letter to the editor, *New York Times* (October 18, 1988): 30; Paul Goldberger, "Alone in Queens, an Unlikely Tower Scrapes the Sky," *New York Times* (October 23, 1988), II: 29, 40; Carter B. Horsley, "The Good, the Bad & the Ugly," *New York Post* (December 29, 1988): 53, 57; Shawn G. Kennedy, "Commercial Property: Long Island City," *New York Times* (November 26, 1989), X: 9; David W. Dunlap, "Citicorp Tower as a Harbinger for Jackson Avenue," *New York Times* (June 3, 1990), X: 27; Richard F. Shepard, "Skyscrapers Scrape Only a Shine Here," *New York Times* (June 12, 1990), B: 1; "Citibank," *Process Architecture* 94 (February 1991): 92–93; Monica Geran, "Citibank," *Interior Design* 62 (October 1991): 158–61; *Skidmore, Owings & Merrill: Selected and Current Works*, 2nd. ed. (Mulgrave, Australia: Images Publishing, 1995), 52–53; Pam Belluck, "Group Tells Citibank: Nice Tower, Ugly Sign," *New York Times* (February 11, 1996), XIII: 9; Victoria Newhouse and Bernard X. Wolff, "Bank's Sign Mars a Garden and Fails in an Obligation," letters to the editor, *New York Times* (February 25, 1996), XIII: 13; Sirefman, *New York*, 272–73; White and Willensky, *AIA Guide* (2000), 816.

63. Landmarks Preservation Commission of the City of New York, LP-0925 (May 11, 1976); Landmarks Preservation Commission of the City of New York, *Hunters Point Historic District Designation Report* (New York, 1968); Diamonstein, *The Landmarks of New York III*, 277, 492; Stern, Mellins, and Fishman, *New York 1880*, 984.

64. "Citicorp's New York Leap": 14.

65. Litow and Gallagher, "Office Expansion to Outer Boroughs Squeezes Manufacturers": 26.

66. DePalma, "A Giant to Dominate Low-Rise Queens": 7.

67. Goldberger, "Alone in Queens, an Unlikely Tower Scrapes the Sky": 29.

68. Goldberger, "Alone in Queens, an Unlikely Tower Scrapes the Sky": 29, 40. For the Williamsburgh Savings Bank, see Stern, Gilmartin, and Mellins, *New York 1930*, 544–45.

69. Rossant, "A Giant Glass Weed Has Sprung Up in Queens": 30.

70. John M. Morris and George Armstrong, quoted in Belluck, "Group Tells Citibank: Nice Tower, Ugly Sign": 9.

71. "AIA Component Awards," *Architecture* 76 (May 1987): 56; *Alfredo De Vido: Selected and Current Works* (Mulgrave, Australia: Images Publishing, 1998), 90–93; White and Willensky, *AIA Guide* (2000), 805.

72. For the Knickerbocker Laundry, see Lewis Mumford, "The Sky Line: The Laundry Takes to Architecture," *New Yorker* 8 (November 26, 1932): 36–37, reprinted in *Sidewalk Critic: Lewis Mumford's Writings on New York*, ed. Robert Wojtowicz (New York: Princeton Architectural Press, 1998), 88–89; Stern, Gilmartin, and Mellins, *New York 1930*, 525. For the preservation of the Knickerbocker Laundry, see Christopher Gray, "Streetscapes: The Knickerbocker Laundry," *New York Times* (July 2, 1989), X: 5; Katherine Petrin, "The Knickerbocker Company Laundry Plant: A Preservation Perspective" (Historic Preservation Thesis, Columbia University, 1996); "A Preservationist Lists 35 Modern Landmarks-in-Waiting," *New York Times* (November 17, 1996), IX: 1. For the New York Presbyterian Church, see Alan S. Oser, "From a Laundry to a Perfume Factory to a Church," *New York Times* (July 28, 1996), IX: 1; "Corrections," *New York Times* (August 4, 1996), IX: 5; "Korean Presbyterian Church of New York," *Architecture* 86 (January 1997): 80–81; Jayne Merkel and Philip Nobel, "Building for Belief," *Oculus* 59 (February 1997): 8–12; Jayne Merkel, "Considering Sacred Space," *Oculus* 59 (April 1997): 7; Carlo Paganelli, "The Church in the Factory," *Arca* 115 (May 1997): 20–23; "Korean Presbyterian Church of New York," *Architecture + Urbanism* (June 1997): 82–95; Lange, "Bilbao-ing in the Boroughs": 97; "Korean Presbyterian Church," *ANY* 22 (1998): 54; Karrie Jacobs, "Computing a

Cathedral," *New York* 31 (August 31, 1998): 44, 46, 48; Min Yang and Adam Kushner, "Queens Style," letters to the editor, *New York* 31 (September 21, 1998): 6–7; Stephen A. Kliment, "When Places of the Spirit Face Concrete Realties," *New York Times* (November 27, 1998), XI: 1, 6; Susanna Sirefman, "Without a Trace," *Metropolis* 18 (December 1998): 74–77, 79, 81; "Korean Presbyterian Church of New York," *Assemblage* 38 (April 1999): 6–21; Mark Rakatansky, "Re: View," *Assemblage* 38 (April 1999): 22–27; Nicolai Ouroussoff, "The Sacred and the Mundane," *Los Angeles Times* (August 1, 1999): 59–60; Herbert Muschamp, "A Queens Factory Is Born Again, as a Church," *New York Times* (September 5, 1999), II: 30; Nancy A. Ruhling, "A Grand Design for a New Church," *Newsday* (September 20, 1999): 23; Joseph Giovannini, "Computer Worship," *Architecture* 88 (October 1999): 88–99; Olv Klijn and Joks Janssen, "Centrum voor Koreaanse gemeenschap in New York door FORM," *de Architect* 30 (November 1999): 76–83; Herbert Muschamp, "At Last, Buildings Are the Stuff of Dreams," *New York Times* (November 14, 1999), II: 22; "Korean Presbyterian Church," *Casabella* (December 1999-January 2000): 62–67; Alexander Gorlin, "Outside and Inside: The New York Presbyterian Church," *Oculus* 62 (December 1999): 6–7; Alice Rawsthorn, "Buildings to Celebrate," *Financial Times* (London) (December 23, 1999): 14; Herbert Muschamp, "New York Starts to Look Beyond Its Past," *New York Times* (December 26, 1999), II: 49; Donald Albrecht, "Greg Lynn," in Donald Albrecht, Ellen Lupton, and Steven Skov Holt, eds., *Design Culture Now* (New York: Princeton Architectural Press, 2000), 48–49, 211; Joseph Giovannini, "New York State of Mind," *World Architecture* 83 (February 2000): 48–55; "Clean Souls: The Korean Presbyterian Church of New York," *World Architecture* 83 (February 2000): 70–71; Jayne Merkel, "The New Age of the Engineer," *Oculus* 62 (March 2000): 8–11; Joseph Giovannini, "Best Bytes," *New York* 33 (March 27, 2000): 32; Eric Taub, "Architects Grow Reliant on the 40-Pound Pencil: The Computer," *New York Times* (August 10, 2000), G: 9; Ann Bergren, "The Easier Beauty of Animate Form," *Architectural Record* 188 (November 2000): 79–82; Balfour, *World Cities: New York*, 176–79; Brian Carter and Annette Lecuyer, *All American: Innovation in American Architecture* (New York: Thames & Hudson, 2002), 227–31; Helen Castle, "Korean Presbyterian Church of New York," *Architectural Design* 72 (September/October 2002): 73.

73. Mumford, "The Sky Line: The Laundry Takes to Architecture": 36.

74. "Queens Renovation: Art Deco Factory," *New York Times* (July 27, 1986), VIII: 1; Caryn Eve Wiener, "Sunnyside Mall Proposed for $35M," *Newsday* (August 15, 1989): 45; Shawn G. Kennedy, "A New Life for Factory in Queens," *New York Times* (August 16, 1989), D: 16; Sarah Amelar, "Fading Treasures," *Newsday* (November 25, 1993), II: 82.

75. Giovannini, "Computer Worship": 94.

76. Ouroussoff, "The Sacred and the Mundane": 59–60.

77. Muschamp, "A Queens Factory Is Born Again, as a Church": 30.

78. Giovannini, "Computer Worship": 94.

79. Antoine Predock, quoted in "Korean Presbyterian Church of New York," *Architecture*: 81.

80. Gorlin, "Outside and Inside: The New York Presbyterian Church": 6–7. For Aalto's Church of the Three Crosses, see Göran Schildt, *Alvar Aalto: Masterworks*, trans. Timothy Binham (New York: Universe Publishing, 1998), 116–27.

81. Grace Glueck, "Abandoned School in Queens Lives Again as Arts Complex," *New York Times* (June 10, 1976): 39; John Russell, "An Unwanted School in Queens Becomes an Ideal Art Center," *New York Times* (June 20, 1976), II: 41; Grace Glueck, "Art People," *New York Times* (October 22, 1976): 64; Thomas B. Hess, "Across the River and Into P.S. 1," *New York* 10 (April 25, 1977): 63–65; Grace Glueck, "Scenery Takes Bow in Queens," *New York Times* (December 30, 1977), C: 3; White and Willensky, *AIA Guide* (1988), 735.

82. Shael Shapiro, quoted in Glueck, "Abandoned School in Queens Lives Again as Arts Complex": 39.

83. Alanna Heiss, quoted in Glueck, "Abandoned School in Queens Lives Again as Arts Complex": 39.

84. Stephanie Brody Lederman, quoted in Dee Wedemeyer, "Artists Put Down Roots in L.I. City," *New York Times* (January 21, 1979), VIII: 1, 4.

85. Philip Shenon, "Long Island City, New Artists' Haven," *New York Times* (August 24, 1984), C: 1, 21. Also see Amy Singer, "If You're Thinking of Living In: Long Island City," *New York Times* (January 6, 1985), VIII: 9.

86. Douglas C. McGill, "Isamu Noguchi's Art Finds a Home in Queens," *New York Times* (April 3, 1985), C: 19; Grace Glueck, "Noguchi and His Dream Museum," *New York Times* (May 10, 1985), C: 1, 26; "Noguchi's New Museum," *Progressive Architecture* 66 (August 1985): 28; Anne-Marie Schiro, "A Dinner in Queens Honors Noguchi," *New York Times* (October 31, 1985), C: 12; Grace Glueck, "When Collecting Whets the Appetite for a Museum of One's Own," *New York Times* (April 6, 1986), II: 33; Isamu Noguchi, *The Isamu Noguchi Garden Museum* (New York: Harry N. Abrams, 1987); White and Willensky, *AIA Guide* (1988), 735; Michael Brenson, "Isamu Noguchi, the Sculptor, Dies at 84," *New York Times* (December 31, 1988): 1, 9; Victoria Geibel, "Noguchi's Vision," *Metropolis* 8 (April 1989): 32; Roxana Liebman, "The Setting That Noguchi Created for His Sculpture," *Architecture* 78 (June 1989): 84–87; "Isamu Noguchi Garden Museum," *Abitare* 334 (November 1994): 170–73; Sirefman, "The Setting That Noguchi Created for His Sculpture," *Architecture* 78 (June 1989): 84–87; "Isamu Noguchi Garden Museum," *Abitare* 334 (November 1994): 170–73; Ana Maria Torres, *Isamu Noguchi: A Study of Space* (New York: Monacelli Press, 2000), 224–29; Bennett Schiff, "An Oasis of Art," *Smithsonian* 31 (January 2001): 74–81.

87. Carol Vogel, "Inside Art: Facelift for the Noguchi," *New York Times* (January 25, 2002), E: 40; "Noguchi," *Oculus* 64
(April 2002): 6; Carol Vogel, "The Renovated Noguchi Museum Is Friendlier but Still Discreet," *New York Times* (June 8, 2004), E: 1, 5; Ken Johnson, "A Refuge for Repose Refreshed," *New York Times* (June 11, 2004), E: 33.

88. "City Art Panel Names Nine Design Winners," *New York Times* (May 3, 1986): 9; Douglas C. McGill, "A Sculpture Park Grows in Queens" (August 27, 1986), C: 17; Michael Brenson, "Di Suvero's Dream of a Sculpture Park Grows in Queens," *New York Times* (October 12, 1986), II: 31; "City Dump to Urban Park," *Architecture* 76 (March 1987): 45; White and Willensky, *AIA Guide* (1988), 735; Michael Brenson, "Bold Sculpture for Wide-Open Spaces," *New York Times* (July 21, 1989), C: 1, 24; Dennis Hevesi, "Sculpture Garden Rises in a New Patch of Green," *New York Times* (May 26, 1994), B: 1, 9; Michael T. Kaufman, "Where Once Stood a Dump, Sculptors Cavort," *New York Times* (June 14, 1995), B: 3; Jonathan Goodman, "A Blend of Art and Community: Socrates Sculpture Park," *Sculpture* 20 (April 2001): 38–43.

89. Mark di Suvero, quoted in McGill, "A Sculpture Park Grows in Queens": 17.

90. Douglas Martin, "Philosophies Differ on Future of Socrates Sculpture Park," *New York Times* (August 11, 1997), B: 1–2; Paul H. B. Shin, "Developer, Artists in Tug of War," *New York Daily News* (October 14, 1997), Metro: 1; "Hemlock for Socrates?" *Art News* 97 (January 1998): 42; Douglas Martin, "Queens Sculpture Garden Is Made a Permanent Park," *New York Times* (December 6, 1998): 51.

91. Michael Brenson, "City as Sculpture Garden," *New York Times* (July 17, 1987), C: 1, 30; Jennifer Dunning, "Art on the Beach Returns, in a New Setting," *New York Times* (July 24, 1987), C: 3; Andrew L. Yarrow, "Art and History with River View of Manhattan," *New York Times* (July 15, 1988), C: 1, 29; Victoria Geibel, "Passages," *Metropolis* 8 (September 1988): 37.

92. Linda Bradford, "Artists Settle Long Island City," *Metropolis* 10 (October 1990): 111.

93. Vicki Cheng, "What? A Famous Museum Here?" *New York Times* (August 13, 1995), XIII: 10; Herbert Muschamp, "In Los Angeles, the Esthetic of Urban Grit," *New York Times* (March 24, 1996), II: 40; Carol Vogel, "Big and Contemporary," *New York Times* (August 1, 1997), C: 28; Herbert Muschamp, "Heroic Spaces and the Perfect Spoon," *New York Times* (September 7, 1997), II: 84; Herbert Muschamp, "The Annotated Calendar: Architecture," *New York Times* (September 7, 1997), II: 101; Elaine Louie, "The New P.S. 1: Contemporary Art, but the Building's the Star," *New York Times* (October 2, 1997), F: 3; Carol Vogel, "The High Priestess of P.S. 1," *New York Times* (October 26, 1997), II: 40, 43; Sarah Boxer, "The Anatomy of a Photographer," *New York Times* (October 31, 1997), E: 33; Holland Cotter, "A Grandchild Remembers Her Roots," *New York Times* (October 31, 1997), E: 33; Holland Cotter, "All Over the Lot (The Back Lot, Too)," *New York Times* (October 31, 1997), E: 33; Roberta Smith, "Across 30 Years, Sculptural Solidity," *New York Times* (October 31, 1997), E: 33; Roberta Smith, "More Spacious and Gracious, Yet Still Funky at Heart," *New York Times* (October 31, 1997), E: 31, 34; Jayne Merkel, "Frederick Fisher at P.S. 1," *Oculus* 60 (November 1997): 5; Mark Stevens, "Queens for a Day," *New York* 30 (November 10, 1997): 64; Doris Lockhart Saatchi, "London O, New York P.S. 1," *Blueprint* 145 (December 1997): 28–30; "P.S. 1 Contemporary Art Center," *ANY* 22 (1998): 25; Eleanor Heartney, "The Return of the Red brick Alternative," *Art in America* 86 (January 1998): 56–58, 60–64, 66–67; Doris Lockhart Saatchi, "New York P.S. 1," *Bauwelt* 89 (January 1998): 210–13; Wolfgang Bachmann, "P.S. 1 Contemporary Art Center in New York," *Baumeister* 95 (February 1998): 41, 46; Andrea Truppin, "P.S. 1 Contemporary Art Center, Long Island City, New York," *Architectural Record* 186 (August 1998): 116–21; "Frederick Fisher: PS1 Contemporary Art Center, New York," *Casabella* 63 (December 1999-January 2000): 126–29; White and Willensky, *AIA Guide* (2000), 816; "P.S. 1," *Quaderns d'arquitectura i urbanisme* 230 (2001): 82–85; "Frederick Fisher: P.S. 1 Contemporary Art Center, Long Island City, New York," *Lotus International* 113 (2002): 41–45.

94. Frederick Fisher, quoted in Truppin, "P.S. 1 Contemporary Art Center, Long Island City, New York": 116.

95. Smith, "More Spacious and Gracious, Yet Still Funky at Heart": 31, 34.

96. Carol Vogel, "A Museum Merger: The Modern Meets the Ultramodern," *New York Times* (February 2, 1999): 1, B: 6; "Merging MoMA and P.S. 1," editorial, *New York Times* (February 6, 1999): 14; Calvin Tomkins, "The Talk of the Town: At the Museums," *New Yorker* 74 (February 15, 1999): 31; Anne Midgette, "At P.S. 1, MoMA Finds New Space Across the River," *Wall Street Journal* (March 4, 1999): 12.

97. Carol Vogel, "Old Hand, Young Plan," *New York Times* (May 21, 1999), E: 28; "On the Drawing Board," *Oculus* 10 (Summer 1999): 4–5; Somini Sengupta, "Queens Is Where the World's Music Comes Together," *New York Times* (June 25, 1999), E: 1, 22; Cathy Lang Ho, "P.J., D.J. at P.S. 1," *Architecture* 88 (August 1999): 25; Philip Nobel, "DJ PJ," *Metropolis* 19 (October 1999): 83.

98. Philip Johnson, quoted in Vogel, "Old Hand, Young Plan": 28.

99. Nobel, "DJ PJ": 83.

100. "On the Drawing Boards," *Oculus* 62 (Summer 2000): 4; William L. Hamilton, "In This Artwork, Tan's the New Favorite Color," *New York Times* (July 6, 2000), F: 1, 4; Paul Goldberger, "Surf's Up at P.S. 1," *New Yorker* 76 (July 10, 2000): 23; Clifford A. Pearson, "Never Swim Alone: MoMA and P.S. 1 Throw an Urban Beach Party with Designer Dunes," *Architectural Record* 188 (August 2000): 59–61; Jayne Merkel, "SHoP Talk," *Oculus* 63 (November 2000): 17.

101. Goldberger, "Surf's Up at P.S. 1": 23.

102. Herbert Muschamp, "The Modern Is Considering a Temporary Site in Queens," *New York Times* (January 26,
2000), B: 3; Herbert Muschamp, "Modern Chooses Architect," *New York Times* (February 10, 2000), E: 5; "Maltzan for the MOMA," *Architectural Record* 188 (March 2000): 42–43; "On the Drawing Boards," *Oculus* 62 (Summer 2000): 4; "Modern Will Take Refuge in Queens, Starting in 2002," *New York Times* (June 30, 2000), E: 39; Herbert Muschamp, "When Getting to It Is Part of a Museum's Aesthetic," *New York Times* (November 26, 2000), II: 34; Carol Vogel, "The Modern in Queens," *New York Times* (December 8, 2000), E: 38; "Base Line," *Wallpaper* (April 2001): 101–2; Donald Bertrand, "Free Shuttle Covers Art Scene," *New York Daily News* (August 24, 2001), Metro: 3; "MoMA QNS," *Architecture + Urbanism* (September 2001): 16–18; Andy Young, "At the Museums: MoMA on the Move," *New Yorker* 78 (March 25, 2002): 42–43; Mark Irving, "A Bridge Too Far," *Blueprint* 194 (April 2002): 40–44; Celestine Bohlen, "The Modern On the Move, Out to Queens," *New York Times* (April 1, 2002), E: 1, 8; R. C. Baker, "Take the 7 Train," *New York Times* (April 8, 2002): 19; Alexandra Lange, "Queens Modern," *New York* 35 (June 17, 2002): 35–39, 66; Celestine Bohlen, "The Modern Moves with a Bang (Several)," *New York Times* (June 26, 2002), E: 1, 8; Nicolai Ouroussoff, "A Jolt of the Modernist Spirit," *Los Angeles Times* (June 28, 2002), F: 1; Michael Kimmelman, "Queens, the New Modern Mecca," *New York Times* (June 28, 2002), E: 31; Herbert Muschamp, "Adjusting to a Shift in the Axis of Modern Art," *New York Times* (June 28, 2002), E: 31, 33; Paul Goldberger, "At the Museums: The View from the Seven," *New Yorker* 78 (July 1, 2002): 35–36; Hilton Kramer, "Mega-MoMA Mania: How Is Van Gogh Hanging in QNS?" *New York Observer* (July 15, 2002): 1, 16; Joseph Giovannini, "Ramping It Up," *New York* 35 (July 22, 2002): 45; Clifford Pearson, "Michael Maltzan and Cooper, Robertson Turn an Old Staple Factory into MoMA QNS by Bringing the Industrial Landscape Inside," *Architectural Record* 190 (August 2002): 107–15; Eric Fredericksen, "Sign of the Times," *Architecture* 91 (September 2002): 66–71; Lance Esplund, "Last Chance! Prices Slashed! Everything at MoMA QNS Must Go!" *New York Sun* (September 23, 2004): 17. Also see Vivian S. Toy, "The End of the Line: As the Swingline Factory in Queens Closes, Veteran Workers Wonder What's Next for Them," *New York Times* (January 17, 1999), XIV: 1, 12.

103. Ouroussoff, "A Jolt of the Modernist Spirit": 1.

104. For Aalto's Finnish exhibit, see Stern, Gilmartin, and Mellins, *New York 1930*, 735, 740.

105. Giovannini, "Ramping It Up": 45.

106. Goldberger, "At the Museums: The View from the Seven": 36.

107. For Jackson Heights, see Stern, Gilmartin, and Mellins, *New York 1930*, 481–85; Stern, Mellins, and Fishman, *New York 1960*, 992–93. Also see Michael Winkleman, "The Visible City: Jackson Heights," *Metropolis* 1 (March 1982): 23–25; Anne Fullam, "If You're Thinking of Living In: Jackson Heights," *New York Times* (December 27, 1987), VIII: 3; Janice Fioravante, "If You're Thinking of Living In: Jackson Heights," *New York Times* (December 1, 1996), IX: 3; Alex Marshall, *How Cities Work: Suburbs, Sprawl, and the Roads Not Taken* (Austin, TX: University of Texas Press, 2000), 124–31.

108. "Big Day for Queens: Jackson Heights: It Could be the Borough's Second Historic District," *District Lines* 5 (Autumn 1990): 1; Joseph P. Fried, "Historic Status Planned for 500 Sites Queens," *New York Times* (November 12, 1990), B: 3; Christopher Gray, "Streetscapes: Garden Apartments," *New York Times* (June 28, 1992), X: 7; Landmarks Preservation Commission of the City of New York, *Jackson Heights Historic District Designation Report* (New York, 1993); Steven Lee Myers, "Council Votes Historic District in 38-Block Section of Queens," *New York Times* (January 27, 1994), B: 2; Hugo Lindgren, "Landmark Heights & Depths," *Metropolis* 13 (March 1994): 71; Diamonstein, *The Landmarks of New York III*, 520.

109. Alan S. Oser, "In Jackson Heights, a New Building Evokes the Past," *New York Times* (February 6, 1994), X: 7.

110. Karen Hsu, "No 'Forever' for Synagogue," *New York Times* (July 6, 1997), XIII: 6; Richard Weir, "House (of Prayer) or Home?" *New York Times* (June 14, 1998), XIV: 6; Richard Weir, "Shifting Its Plan, Synagogue Chooses Steakhouse Site," *New York Times* (October 18, 1998), XIV: 8; Warren Woodbury Jr., "Jewish Center Downsizes; Bulldozes Smaller Jackson Heights Neighborhood Home," *New York Daily News* (June 28, 2000), Metro: 1.

111. Anthony DePalma, "A High-Coverage Project in Queens," *New York Times* (July 13, 1986), VIII: 6; Alan S. Oser, "Perspectives: Zoning for Apartments; An Erratic March to Mid-Rise Production," *New York Times* (June 14, 1987), VIII: 9; Lisa W. Foderaro, "The Upzoning Solution; Queens Condos," *New York Times* (October 11, 1987), VIII: 1.

112. Shawn G. Kennedy, "British Air's Move to the Bulova Building in Queens," *New York Times* (April 23, 1986): 20; Alan S. Oser, "Offices in Queens; British Airways Lands in Jackson Heights," *New York Times* (May 17, 1987), VIII: 9; Vivian S. Toy, "British Airways Will Close Base in Queens," *New York Times* (April 9, 1999), B: 3. For the Bulova Watch Company building, see Stern, Mellins, and Fishman *New York 1960*, 993.

113. "Former Bulova Facility in Queens 'Flies' with Designer/Tenant Cooperation," *Better Buildings* 7 (January 1988): 51–52.

114. Suzanne Slesin, "Hickory Dickory Dine," *New York Times* (January 12, 1989), C: 3.

115. Vincent Seyfried, "Corona," in Kenneth T. Jackson, ed., *The Encyclopedia of New York* (New York: New-York Historical Society; New Haven: Yale University Press, 1995), 284–85; Vincent Seyfried, "Elmhurst," in Jackson, ed., *The Encyclopedia of New York*, 373.

116. "The City; Precinct in Queens Gets New Building," *New York Times* (August 18, 1981), B: 3; "The New 115th; Station

House Rises, but Not High," *New York Times* (August 7, 1983), VIII: 1; David W. Dunlap, "New Police Station in Queens, a New Approach for the City," *New York Times* (January 4, 1984), B: 1, 20; White and Willensky, *AIA Guide* (2000), 825.

117. *Richard Dattner: Selected and Current Works of Richard Dattner & Partners Architects* (Mulgrave, Australia: Images Publishing, 2000), 252.

118. *Richard Dattner: Selected and Current Works of Richard Dattner & Partners Architects*, 68–69.

119. White and Willensky, *AIA Guide* (2000), 826; Kira L. Gould, "DDC Updates Emphasize Quality Design, Fair Play," *Oculus* 63 (December 2000): 46.

120. Lynette Holloway, "House of Satch Gets New Gig," *New York Times* (February 10, 1996): 25, 31; David W. Dunlap, "For a King of Jazz, a Castle in Queens," *New York Times* (October 9, 2003), F: 4. Also see Landmarks Preservation Commission of the City of New York, LP-1555 (December 13, 1988); Diamonstein, *The Landmarks of New York III*, 417.

121. Ashok M. Bhavnani, "Central Queens YM & YWHA Lemberg Center," *Architecture + Urbanism* (November 1983): 71–78; Diana Shaman, "If You're Thinking of Living In: Forest Hills," *New York Times* (March 15, 1987), VIII: 11.

122. Elaine Louie, "Currents: Windows of Opportunity," *New York Times* (July 11, 1996), C: 3; "Architecture Award; Gran Sultan Associates, P.S. 114," *Oculus* 60 (Summer 1998): 5.

123. "Forest Hills High-Rise: Risk Taker," *New York Times* (August 7, 1988), X: 1; Diana Shaman, "27-Story Condominium Going Up in Forest Hills," *New York Times* (January 26, 1990), B: 9; Diana Shaman, "Projects Being Priced to Sell in Queens," *New York Times* (November 9, 1990): 24.

124. "Office Rentals; Queens Rx," *New York Times* (January 5, 1986), VIII: 1; Dennis Hevesi, "An Eyesore in Queens Replaced by Apartments," *New York Times* (February 22, 2002), B: 9.

125. For Queens Borough Hall, see Stern, Gilmartin, and Mellins, *New York 1930*, 104. For Forest Hills Tower, see Stern, Mellins, and Fishman, *New York 1960*, 997–98.

126. Anthony DePalma, "Foundation Dug for Long-Delayed Queens Project," *New York Times* (January 18, 1987), VIII: 7; Shawn G. Kennedy, "Office Building in Queens Rises After Long Delays," *New York Times* (January 4, 1989): 13.

127. Alan S. Oser, "Perspectives: Public Construction," *New York Times* (November 29, 1992), X: 5; Lester Paul Korzilius, "Queens County (New York City) Criminal Courthouse Addition," *Oculus* 58 (April 1996): 6; Sirefman, *New York*, 274–75; White and Willensky, *AIA Guide* (2000), 837.

128. For the original building, see "New Courthouse to Rise in Queens," *New York Times* (February 22, 1956): 29; Walter H. Stern, "City Designing Courts and Jails to Reflect Idea of Rehabilitation," *New York Times* (June 19, 1960): 1, 8.

129. Quoted in www.eekarchitects.com.

130. Sirefman, *New York*, 274.

131. "Shaare Tova Synagogue, Kew Gardens, NY," *Progressive Architecture* 61 (June 1980): 52; White and Willensky, *AIA Guide* (1988), 761; White and Willensky, *AIA Guide* (2000), 838.

132. White and Willensky, *AIA Guide* (2000), 838.

133. Stern, Gilmartin, and Mellins, *New York 1930*, 704; Stern, Mellins, and Fishman, *New York 1960*, 989, 991–92.

134. See Stern, Mellins, and Fishman, *New York 1960*, 991–92.

135. Ralph Blumenthal, "La Guardia Airport Nears End of Last Project," *New York Times* (June 30, 1976): 63; White and Willensky, *AIA Guide* (1988), 745; White and Willensky, *AIA Guide* (2000), 823.

136. Landmarks Preservation Commission of the City of New York, LP-1110 (November 25, 1980); Diamonstein, *The Landmarks of New York III*, 376–77.

137. George James, "La Guardia's Growth Plans Irk Queens Residents," *New York Times* (December 21, 1986): 51; Christopher Gray, "Streetscapes/Marine Air Terminal," *New York Times* (October 1, 1995), IX: 7; Edwin McDowell, "The Delta Shuttle Sets the Formal Opening of Its Renovated Marine Air Terminal Tomorrow," *New York Times* (November 17, 1999), C: 12.

138. Morris Kaplan, "LaGuardia Getting 25 Million Terminal for Eastern Shuttle," *New York Times* (November 24, 1977): 1; Glenn Fowler, "Eastern Is Spreading Out in New Shuttle Terminal," *New York Times* (April 3, 1981), B: 3.

139. "Port Authority Votes 2 New Air Terminals," *New York Times* (October 14, 1979): 38; A. O. Sulzberger Jr., "Board Clears Way for Airport Improvements," *New York Times* (December 20, 1981): 52; White and Willensky, *AIA Guide* (1988), 745–46.

140. Eric Schmitt, "New York Airports: $3 Billion Program," *New York Times* (February 2, 1987): 1, B: 2; Robert D. McFadden, "'88 Arrival: $73 Million La Guardia Expansion," *New York Times* (October 19, 1987), B: 3.

141. Andrew H. Malcolm, "The Region: Airport Gridlock; 'Plane City' Grows, with No End in Sight and No Room to Move," *New York Times* (July 10, 1988), IV: 6; Calvin Sims, "The Port Authority Thinks It's Time to Build Again," *New York Times* (December 9, 1990), IV: 6; Peter Grant, "Staging Averts Chaos," *Engineering News-Record* 226 (May 6, 1991): cover, 29; "6-Lane Approach to La Guardia Due by July 4," *New York Times* (June 2, 1991), V: 3; Neil MacFarquhar, "La Guardia Sees Its Future in Smart, Small Shops," *New York Times* (July 13, 1997): 19, 24.

142. "On the Drawing Boards," *Oculus* 62 (December 1999): 2.

143. Schmitt, "New York Airports: $3 Billion Program": 1, B: 2; "Flight Time: A 'New Image' Project for Continental Airlines," *Sites* 24 (1992): 56–59; Helen Thorpe, "City's Three Airports to Get Major Spruce-Up," *New York Observer* (February 3, 1992): 1, 20; "Amplification," *Oculus* 55 (April 1992): 4; Guy Nordenson, "Notes on Light and Structure," *Architectural Design* 67 (March 1997): 8–15; Guy Nordenson,

"Four Experimental Projects," *Chien Chu* 32 (December 1999): 58–65.

144. For detailed discussions of the 1939–40 and 1964–65 World's Fairs, see Stern, Gilmartin, and Mellins, *New York 1930*, 726–55; Stern, Mellins, and Fishman, *New York 1960*, 1026–57.

145. F. Scott Fitzgerald, *The Great Gatsby* (New York: Charles Scribner's Sons, 1925), 27–28.

146. For the Unisphere, see Stern, Mellins, and Fishman, *New York 1960*, 1032–33.

147. For Shea Stadium, see Stern, Mellins, and Fishman, *New York 1960*, 993–94. For Singer Bowl, see Stern, Mellins, and Fishman, *New York 1960*, 1056.

148. Neil Amdur, "Flushing Meadow Park Is Sought as New Site For U.S. Open Tennis," *New York Times* (March 16, 1977): 19–20; "U.S. Open Site Goes Public for '78," *New York Times* (May 28, 1977): 15; Louise Bernikow, "Forest Hills: Another Daydream Bites the Dust," *New York* 10 (September 12, 1977): 70–71, 73; "For Big-Time Tennis: Wimbledon and–Flushing Meadow?" *Architectural Record* 164 (April 1978): 34; Neil Amdur, "U.S. Open Site Faces Race Against Time," *New York Times* (August 6, 1978), V: 1, 8; John Duka, "The U.S. Open: A Whole New Ball Game," *New York* 4 (September 4, 1978): 70–72, 74; William Ellis, "Double Fault," *Skyline* (October 1978): 9; Rex Bellamy, "Tennis Crowds Reflect the Differences Among Nations," *New York Times* (September 9, 1979), V: 2; "National Tennis Center, Flushing Meadow, New York, N.Y., 1979," *Architectural Record* 167 (February 1980): 110–13; Jane Gross, "An Event That Reflects the City's Brash Spirit," *New York Times* (August 27, 1984), C: 1, 6; White and Willensky, *AIA Guide* (2000), 829.

149. Duka, "The U.S. Open: A Whole New Ball Game": 71.

150. Joseph P. Fried, "New York Weighs More Tennis Space," *New York Times* (December 2, 1990): 45; Thomas Rogers, "An Expansion of the National Tennis Center Is Announced," *New York Times* (February 20, 1991), D: 25; "Open Up the Open," editorial, *New York Times* (March 3, 1991), IV: 16; Robin Finn, "Group Aims to Expand Park, Not U.S. Open," *New York Times* (August 18, 1991), VIII: 8; Leonard L. Fleisig, "Safety of Queens Residents Finishes a Poor Second to Tennis," letter to the editor, *New York Times* (September 4, 1991): 22; Claire Shulman, "No Danger in Airport Route During U.S. Open," letter to the editor, *New York Times* (October 1, 1991): 22; "Around the Chapter: United States Tennis Association Plans for a New Stadium in Queens," *Oculus* 54 (February 1992): 12; Tom McGhee, "New York Turf Wars," *Metropolis* 11 (March 1992): 21–22; Joseph P. Fried, "Plans Set for Expanded U.S. Open Tennis Center," *New York Times* (April 22, 1992), B: 7; Joseph P. Fried, "Queens Tennis Center Plan Is Announced and Denounced," *New York Times* (April 23, 1992), B: 2; Joseph P. Fried, "Proposal for U.S. Open Is Sweetened," *New York Times* (April 26, 1992): 33; Bernard Haber, "Tennis Center Plan Benefits Environment," letter to the editor, *New York Times* (May 21, 1992): 28; Benjamin M. Haber, "New York Faults on Tennis Center Deal," letter to the editor *New York Times* (May 30, 1992): 18; Robert E. Dieterich, "Tennis Center Would Destroy Flushing Meadows Environment," letter to the editor, *New York Times* (June 11, 1992): 22; Robin Finn, "Now a Money Pit Endangers U.S. Open Construction Plans," *New York Times* (July 10, 1992), B: 15; Joseph P. Fried, "Tennis Center Expansion Is Scaled Back," *New York Times* (October 22, 1992), B: 9; "Design/Briefs," *Architectural Record* 180 (November 22, 1992): 24; Robin Finn, "The Grand Plan of Flushing Meadows Slowed Down by Dollar Signs," *New York Times* (December 23, 1992), B: 13; Jacques Steinberg, "Tennis Center Expansion Receives Backing of Senate," *New York Times* (July 6, 1993), B: 4; "Tennis Center Plan Challenged in Council," *New York Times* (August 24, 1993), B: 2; Larry Olmstead, "Expansion Plan for Tennis Center in Queens Wins Approval from Council Committee," *New York Times* (September 9, 1993), B: 3; Alan Finder, "Game, Set, Match to Dinkins on Tennis Center," *New York Times* (December 14, 1993), B: 1, 3; "Lease in Tennis Deal Is Signed by Dinkins," *New York Times* (December 23, 1993), B: 2; Janny Scott, "Cut Down in Its Prime, a Tree Returns to Its Roots," *New York Times* (March 26, 1994): 23; Steven Lee Myers, "Reluctantly, Mayor Lets Tennis Deal Go Through," *New York Times* (June 18, 1994): 25; Frederick C. Klein, "Tennis Venue at U.S. Open Stinks, Literally," *Wall Street Journal* (August 30, 1996), B: 5; Clifford J. Levy, "Giuliani, Playing to the Bleacher Seats, Boycotts Tennis Open," *New York Times* (August 30, 1996), B: 1, 3; Clifford Krauss, "Arthur Ashe Stadium's Opening Serve Is in Giuliani's Court," *New York Times* (August 22, 1997), B: 1, 4; Clifford Krauss, "New Court Scores With Some Top Players," *New York Times* (August 22, 1997), B: 4; Clifford Krauss, "Upset by a Contract, Giuliani Won't Speak at Ashe Stadium," *New York Times* (August 23, 1997): 25–26; Jane H. Lii, "From New Ashe Stadium," *New York Times* (August 24, 1997): 29; Monique P. Yazigi, "At the Open, Most Fans Are Given a Back Seat," *New York Times* (August 24, 1997): 29; Robin Finn, "Smooth New Digs, but Still a Rugged Climb to the Title," *New York Times* (August 25, 1997), C: 1, 7; Robin Finn, "The New Face of Open Tennis," *New York Times* (August 25, 1997), C: 7; "Handshakes All Around as Tennis Stadium Opens," *New York Times* (August 26, 1997): 1; Christopher Clarey, "High Expectations Meet Higher Seats," *New York Times* (August 26, 1997), B: 12; Frederick C. Klein, "Plenty of Lunch Seating, but U.S. Open Stadium Isn't for the Masses," *Wall Street Journal* (August 29, 1997), B: 4; Frank Bruni, "At Arthur Ashe Stadium, Most Find Something to Love," *New York Times* (August 31, 1997): 25, 29; Herbert Muschamp, "A Sense of Place and Purpose," *New York Times* (September 4, 1997), B: 1, 4; Jeffrey Kroessler, "For Queens, Tennis Center Is an Intrusion," letter to the editor, *New York Times* (September 9, 1997): 26; White and Willensky, *AIA Guide* (2000), 829.

151. Quoted in Fried, "Queens Tennis Center Plan Is Announced and Denounced": 2.

152. Wolfgang Saxon, "Last Round for U.S. World's Fair Pavilion?" *New York Times* (July 29, 1976): 33. For United States Pavilion, see Stern, Mellins, and Fishman, *New York 1960*, 1033–34.

153. Muschamp, "A Sense of Place and Purpose": 1, 4.

154. Carter B. Horsley, "King-Sized Plans for Queens Park," *New York Post* (October 27, 1988): 62; Heinrich Klotz, ed., *New York Architecture: 1970–1990* (Munich: Prestel-Verlag, 1989), 233–34; Ellen Posner, "Harmony, Not Uniqueness," *Landscape Architecture* 79 (May 1989): 42–49; "In Progress: Bernard Tschumi Associates," *Progressive Architecture* 70 (November 1989): 37–38; "Future Park," *Progressive Architecture* 72 (January 1991): 124–25; "FMCP, Future Park, 1988," *Architecture + Urbanism*, special issue (March 1994): 30–34.

155. For Parc de la Villette, see Marianne Barzilay, *L'invention du parc: Parc de la Villette, Paris* (Paris: Graphite, 1984); Bernard Tschumi, *La case vide, La Villette* (London: Architectural Association, 1986).

156. For the Hall of Science, see Stern, Mellins, and Fishman, *New York 1960*, 1052–54.

157. Howard Blum, "Political Clash Clouds Future of Science Hall," *New York Times* (November 12, 1983): 25; Howard Blum, "Funds to Let Hall of Science Reopen," *New York Times* (November 18, 1983), B: 6; Susan Heller Anderson and David W. Dunlap, "A Museum for Touching," *New York Times* (March 21, 1985), B: 5; Richard Haitch, "Seeking Perfection at Science Hall," *New York Times* (April 20, 1986): 55.

158. "Briefs," *Architectural Record* 178 (April 1990): 25; "In and Around the City," *Oculus* 52 (April 1990): 3; Beyer Blinder Bolle, Architects & Planners, no pagination.

159. Paul Bennett, "Science Says," *Landscape Architecture* 89 (March 1999): 24, 26, 28, 30; "Science Disguised as Fun," *New York Times* (March 31, 2000): 1.

160. Quoted in www.polshek.com/nyhosdesc.htm. Also see Craig Kellogg, "Culture All Around Town," *Oculus* 63 (November 2000): 4; David W. Dunlap, "When City Hall Smiles on Public Art," *New York Times* (April 26, 2001), F: 1, 8; White and Willensky, *AIA Giude* (2000), 829; David W. Dunlap, "A Queens Park's Past Shapes Its Future," *New York Times* (August 26, 2001), XI: 1, 6.

161. For the New York City Building, see Stern, Gilmartin, and Mellins, *New York 1930*, 734, 736; Stern, Mellins, and Fishman, *New York 1960*, 1039.

162. "The Talk of the Town: Small Town," *New Yorker* 65 (May 8, 1989): 33–34; "Scale Model of New York," *New York Times* (May 20, 1990), X: 1; "Model Donations," *Oculus* 52 (June 1990): 2.

163. Joseph P. Fried, "Queens Museum: From 2 World Fairs to a New Look and Name," *New York Times* (June 14, 1991), B: 3; Raymond Hernandez, "Queens Museum of Art Drives Into Cultural Crossroads," *New York Times* (January 23, 1994), XIII: 9; Herbert Muschamp, "Evoking Moses' Vision of New York," *New York Times* (November 25, 1994), C: 1, 7; "New/Old Entry for the Queens Museum; Once Again, Face to Face with the Unisphere," *New York Times* (December 11, 1994), IX: 1; "800,000 Buildings in One Room," *Progressive Architecture* 76 (March 1995): 19; Sirefman, *New York*, 276–79; White and Willensky, *AIA Guide* (2000), 829; *The Architecture of Rafael Viñoly* (New York: Princeton Architectural Press, 2002), no pagination.

164. Muschamp, "Evoking Moses' Vision of New York": 7.

165. David W. Dunlap, "A Queens Park's Past Shapes Its Future," *New York Times* (August 26, 2001), XI: 1, 6; Benjamin Hemric, "The City Building in Queens Park," letter to the editor, *New York Times* (September 23, 2001): 11; "Stage II Competition," *Oculus* 64 (October 2001): 6; "Project Citation; Konyk Architecture, Queens Museum of Art," *Oculus* 64 (December 2001): 54; Fred Bernstein, "On the Old World's Fair Grounds, a Skating Rink Makes Way for an Amphitheater," *New York Times* (December 27, 2001), F: 3; *Eric Owen Moss: Building and Projects 3* (New York: Rizzoli International Publications, 2002), 272–81; Robin Pogrebin, "Institutions Brace for Cuts by the City," *New York Times* (January 16, 2002), E: 1, 3; David Sokol, "Jewel in Queens Crown," *Oculus* 64 (January/February 2002): 7; Thomas de Monchaux, "Eric Owen Moss Wins Queens Museum of Art Project, His First in N.Y.C.," *Architectural Record* 190 (February 2002): 23; Rachel Donadio, "Changes Seen for Queens Museum," *New York Sun* (June 3, 2002): 1, 10; Barbara Stewart, "Critics Say Design of Queens Museum Is Out of Context," *New York Times* (July 27, 2002), B: 3.

166. "Theaterama Restored in Philip Johnson's 1964 World's Fair Pavilion," *Architectural Record* 179 (November 1991): 26; *Alfredo De Vido: Selected and Current Works*, 78–81.

167. "Shift of Chemicals in Queens Sought," *New York Times* (July 10, 1979), B: 3; Christopher Gray, "Streetscapes: The New York State Pavilion," *New York Times* (April 22, 1990), X: 12; Denny Lee, "Hoping That Yesterday's Tent of Tomorrow Has a Future," *New York Times* (November 18, 2001), XIV: 9. For the New York State Pavilion, see Stern, Mellins, and Fishman, *New York 1960*, 1034–39.

168. Henry Stern, quoted in Dunlap, "A Queens Park's Past Shapes Its Future": 6.

169. Stern, Mellins, and Fishman, *New York 1960*, 1001.

170. Fred Ferretti, "Flushing: A New Center for Asian Markets and Food," *New York Times* (October 19, 1983), C: 1, 8; Kirk Johnson, "Asians Galvanize Sales Activity in Flushing," *New York Times* (July 29, 1984), VIII: 1, 14; Alan S. Oser, "New Vigor for Area in Queens," *New York Times* (November 7, 1986): 30; Tamar Lewin, "No. 7 Line–The Orient Express," *New York Times* (November 20, 1988), VI: 26–28, 32, 34, 38, 40, 42; Bernard Wysocki Jr., "Influx of Asians Brings Prosperity to Flushing, a Place for Newcomers," *Wall Street Journal* (January 15, 1991): 1, 8; Donatella Lorch, "In Flushing Council Contest,

a Slice of Asian Politics," *New York Times* (August 28, 1991), B: 1, 4.

171. C. Srinivasacharya, quoted in Pranay Gupte, "Hindu Temple, 'Just like India,' Opens in Queens," *New York Times* (June 4, 1977): 18. Also see Pranay Gupte, "Stamp of India Heavier in City," *New York Times* (June 4, 1978), VIII: 1, 8; David Gonzalez, "Indians Balance Changes and Tradition," *New York Times* (June 11, 1991), B: 1–2; Mary McGee, "Hindu Temples in New York State," *Common Bond* 13 (December 1997): 1–3, 20; White and Willensky, *AIA Guide* (2000), 853.

172. Gupte, "Hindu Temple, 'Just like India,' Opens in Queens": 18.

173. White and Willensky, *AIA Guide* (1988), 771; White and Willensky, *AIA Guide* (2000), 852.

174. Paul E. Kerson, "After 300 Years, Flushing Remains a Model of Peaceful Diversity," letter to the editor, *New York Times* (August 15, 1986): 26; David Firestone, "Pitfalls in Assimilation," *New York Times* (December 26, 1993): 1, 36; White and Willensky, *AIA Guide* (2000), 853.

175. See Stern, Mellins, and Fishman, *New York 1960*, 1083–85.

176. Martin Gottlieb, "Asian-Americans Compete to Build Queens Complex," *New York Times* (August 10, 1985): 25; Martin Gottlieb, "City Starts Talks with Developer on Queens Plan," *New York Times* (October 14, 1985), B: 3; Martin Gottlieb, "The Sky Is No Limit for New York's Master Builders," *New York Times* (November 24, 1985), IV: 24; "City Selects Developers for Complex in Queens," *New York Times* (March 30, 1986): 29; Philip S. Gutis, "About Real Estate," *New York Times* (April 18, 1986): 21; "Zeckendorf, Woodner File Plans for Flushing Center," *New York Construction News* 37 (December 18–25, 1989): 3; Joseph P. Fried, "Development Brings Discord to Flushing," *New York Times* (April 12, 1990), B: 1, 8; Joseph P. Fried, "Economy Kills Contested Plan for Flushing Project," *New York Times* (August 18, 1991): 26.

177. Alan S. Oser, "Asian-American Projects Aid Downtown Flushing," *New York Times* (November 7, 1986): 33; White and Willensky, *AIA Guide* (1988), 770; Shawn G. Kennedy, "Flushing's Main Street Is Thriving," *New York Times* (January 6, 1988), D: 22; Lewin, "No. 7 Line–The Orient Express": 40.

178. For the Westyard Distribution Center, see Stern, Mellins, and Fishman, *New York 1960*, 314.

179. Alan S. Oser, "Growing Asian Presence Inspires a Hotel," *New York Times* (December 23, 1990), X: 3.

180. Fried, "Development Brings Discord to Flushing": 8; Oser, "Growing Asian Presence Inspires a Hotel": 3; "A New Hotel for Flushing," *New York Times* (October 13, 1991), X: 1; Donatella Lorch, "New Flushing Hotel Typifies the Area's Development," *New York Times* (December 3, 1991), B: 8.

181. "$1.5 Million 'Y' in Queens," *New York Times* (October 24, 1993), X: 1; White and Willensky, *AIA Guide* (2000), 852.

182. Joseph P. Fried, "A Clash Over Revival of a Queens Landmark," *New York Times* (February 19, 1989): 41; "A Role in the Arts for Flushing's Old Town Hall," *New York Times* (October 16, 1994), IX: 1; Pam Belluck, "Queens Landmark Wins a Coveted Cultural Title," *New York Times* (May 21, 1996), B: 1, 7; Donald Bertrand, "Town Hall Joins Cultural Elite," *New York Daily News* (June 30, 1996), Metro: 1; Lisa Colangelo, "New Life for Town Hall," *New York Daily News* (June 25, 1999), Metro: 2; "Revitalizing Downtown," *Clem Labine's Traditional Building* 12 (July-August 1999): 18–22; Lisa Colangelo, "Landmark Puts on Ritz," *New York Daily News* (October 19, 1999), Metro: 6; White and Willensky, *AIA Guide* (2000), 850. For Flushing Town Hall, see Landmarks Preservation Commission of the City of New York, LP-0139 (July 30, 1968); Diamonstein, *The Landmarks of New York III*, 143.

183. "Flushing Regional Branch Library," *Engineering News-Record* 234 (March 27, 1995): 97; Blanca M. Quintanilla, "A New Chapter for Flushing Library," *New York Daily News* (August 9, 1995), Metro: 3; David W. Dunlap, "For Libraries, a Time of Rebirth," *New York Times* (September 28, 1997), IX: 1, 6; "Flushing Regional Library," *New York Construction News* 45 (April 1998): 31; Vivian S. Toy, "Bustling Queens Library Speaks in Many Tongues," *New York Times* (May 31, 1998): 1, 30; Claire Serant, "New Flushing Library Has Books–And More," *New York Daily News* (June 22, 1998), Metro: 1; Dennis Duggan, "Flushing Library, a Treasure Trove," *Newsday* (January 21, 1999): 6; White and Willensky, *AIA Guide* (2000), 851; William Weathersby Jr., "Queens Borough Library, Flushing, N.Y.," *Architectural Record* 188 (October 2000): 154–57; Balfour, *World Cities: New York*, 164–67; "New York Firms Honored for 10 Design Projects," *New York Times* (January 7, 2001), XI: 1; "Honor Awards: Queens Borough Public Library, Flushing Branch," *Architectural Record* 189 (May 2001): 115.

184. Dunlap, "For Libraries, a Time of Rebirth": 6.

185. Quoted in www.polshek.com/lib_queensdesc.htm.

186. For Fresh Meadows, see Stern, Mellins, and Fishman, *New York 1960*, 1002–5.

187. "Airport Building Receives Award," *New York Times* (November 30, 1958): 1, 5. Also see Dunlap, "For Libraries, a Time of Rebirth": 1, 6; Nina Rappaport, "In Queens," *Oculus* 61 (November 1999): 6; Kira L. Gould, "Art Commission Honors Outstanding City Project," *Oculus* 62 (April 2000): 17.

188. Quoted in www.audreymatlockarchitect.com/projects/institutional.

189. Raymond Hernandez, "A New Home for the 107th," *New York Times* (November 14, 1993), XIII: 8; Charles K. Hoyt, "Break-Out," *Architectural Record* 182 (March 1994): 80–83; White and Willensky, *AIA Guide* (2000), 855.

190. Lucian Andrei, quoted in Hoyt, "Break-Out": 82.

191. Alice Aycock, quoted in www.nyc.gov/html/dcla/html/panyc/aycock.shtml.

192. For Queens College, see Stern, Mellins, and Fishman, *New York 1960*, 1005.

193. "Long Island Journal," *New York Times* (October 10, 1982), XI: 3; Susan Chira, "College Projects Put Off as Agency Faces Fiscal Woes," *New York Times* (October 18, 1982): 1, B: 11; White and Willensky, *AIA Guide* (2000), 855.

194. "In Search of an Academic Ambiance: A New Library for Queens College," *Architectural Record* 173 (October 1985): 97; Deirdre Carmody, "Queens College, 50 Years Old, Seeks to Rebound," *New York Times* (October 11, 1987): 80.

195. Allan Kozinn, "Queens College Builds Sanctum in Pandemonium," *New York Times* (March 4, 1992), C: 15, 22; Edward Rothstein, "Trying Out the New Hall at Queens College," *New York Times* (March 10, 1992), C: 11.

196. Stern, Mellins, and Fishman, *New York 1960*, 1001–3.

197. "EDO Corp Begins $7.5 Million Expansion," *Wall Street Journal* (March 8, 1982): 32; Glenn Fowler, "Business Through the Generations," *New York Times* (December 23, 1984), XI: 12; White and Willensky, *AIA Guide* (2000), 842.

198. Fowler, "Business Through the Generations": 12; Shawn G. Kennedy, "College Point Projects Add Office Space," *New York Times* (July 27, 1988), D: 1; White and Willensky, *AIA Guide* (2000), 844.

199. Tom Redburn, "Times and New York City Reach Final Accord on New Plant," *New York Times* (December 23, 1993), B: 4; "Report Card: Industrial Park," *New York Times* (January 23, 1994), XIII: 9; "All the Presses That Fit Will Roll," *Oculus* 57 (October 1994): 4; Catherine Slessor, "City Edition," *Architectural Review* (November 1997): 69–71; Mildred Schmertz, "New York Times Printing Plant," *Architectural Record* 186 (May 1998): 202; Jayne Merkel, "Architecture Award," *Oculus* 60 (Summer 1998): 8; James S. Russell, "Good Design Is Good Business," *Architectural Record* 186 (October 1998): 89; Clifford Pearson, "The NY Times Breaks Out of the Industrial Box with a New Printing Plant," *Architectural Record* 186 (October 1998): 100; "The Times Building: It's Fit for Print," *Business Week* (November 2, 1998): 74; White and Willensky, *AIA Guide* (2000), 844; Balfour, *World Cities: New York*, 192; "New York Firms Honored for 10 Design Projects," *New York Times* (January 7, 2001), XI: 1; "The New York Times Printing Plant," *Architectural Record* 189 (May 2001): 119.

200. David A. Thurm, quoted in Schmertz, "New York Times Printing Plant": 202.

201. Richard M. Olcott, quoted in Schmertz, "New York Times Printing Plant": 202.

202. Slessor, "City Edition": 69–70.

203. For Levitt House, see Stern, Mellins, and Fishman, *New York 1960*, 1001–3.

204. Alan S. Oser, "When Development and Landmarking Conflict," *New York Times* (July 25, 1982), VIII: 7; Landmarks Preservation Commission of the City of New York, LP-1282 (July 27, 1982); "Three New Landmarks for the City," *New York Times* (August 1, 1982), VIII: 13; Diamonstein, *The Landmarks of New York III*, 344.

205. "Curtain-Raiser for the Hammerstein House," *New York Times* (July 17, 1988), X: 1; Christopher Gray, "Streetscapes: Hammerstein's Wildflower," *New York Times* (December 4, 1988), X: 12.

206. Rob Speyer, "Hammerstein House," *New York Daily News* (March 13, 1995): 10; Richard Perez-Pena, "Suspicion of Arson at Manse," *New York Times* (March 13, 1995), B: 3; Vivian Huang, "Meeting on Burned Manse," *New York Daily News* (March 24, 1995), Metro: 1; Thomas H. Matthews, "Fire Dept. Confirms: Arson," *New York Daily News* (April 2, 1995), XI: 9.

207. "Wildflower to Blossom Again in Beechhurst," *New York Times* (March 15, 1998), XI: 1; Claire Serant, "It's Landmark Neglect, Local Activists Charging," *New York Daily News* (September 25, 1998), Metro: 2; White and Willensky, *AIA Guide* (2000), 847; Trish Hall, "Finally Fulfilling a Dream of Living on the Water," *New York Times* (July 1, 2001), XI: 2; Nicole Bode, "Spotlight on Beechhurst," *New York Daily News* (January 19, 2003), Metro: 8.

208. Faruk Yorgancioglu, quoted in "Wildflower to Blossom Again in Beechhurst": 1.

209. Alan S. Oser, "Low-Rise Georgian Apartments Planned for Bayside," *New York Times* (August 7, 1981), B: 5; Michael Specter, "Waterfront Is a Magnet in Queens," *New York Times* (February 28, 1982), VIII: 1, 12; Alan S. Oser, "Housing Construction Near East River," *New York Times* (March 11, 1983), B: 7; Michael Winkleman, "Enclaves of Luxury," *Metropolis* 3 (March 1984): 20–23, 32–33; Michael deCourcy Hinds, "Rate Fears Spur Building and Buying," *New York Times* (March 4, 1984), VIII: 1, 12.

210. "Bayside Shopping Mall," *New York Times* (January 12, 1986), VIII: 1.

211. Suzanne Slesin, "For Elderly, the Triumph of Having a Place to Call Their Own," *New York Times* (August 13, 1981), C: 1, 8.

212. White and Willensky, *AIA Guide* (2000), 857. Also see Michael C. Jensen, "City U. Rising Again," *New York Times* (November 13, 1977), XII: 27. For the master plan and first buildings, see Stern, Mellins, and Fishman, *New York 1960*, 1002.

213. Phyllis Bernstein, "Children's Hospital Being Dedicated but Doubts Remain," *New York Times* (September 25, 1983), XXI: 1, 15; Susan Heller Anderson and Maurice Carroll, "A Change in Scenery," *New York Times* (November 2, 1983), B: 3; Lawrence Van Gelder, "Surgery for the Young," *New York Times* (December 11, 1983), XI: 2; White and Willensky, *AIA Guide* (2000), 870. For earlier buildings at the medical center, see Stern, Mellins, and Fishman, *New York 1960*, 1002.

214. Susan Carroll, "Help for Sick Children's Families," *New York Times* (August 30, 1987), XXI: 14; White and Willensky, *AIA Guide* (2000), 870.

215. Stern, Mellins, and Fishman, *New York 1960*, 1005–6.

216. Fred McMorrow, "About Long Island Journal," *New York Times* (April 11, 1982), XI: 2.

217. Quoted in www.gjdc.org/mission.html. Also see Joseph

P. Fried, "Revival Effort in Jamaica (Note: Not South Jamaica)," *New York Times* (December 12, 1988), B: 1, 8; Daniel J. McConville, "A High Wind in Jamaica," *New York Post* (February 9, 1989): 59; Alan S. Oser, "Carrying the Torch for Downtown Growth," *New York Times* (October 27, 1991), X: 5, 14; Sarah Kershaw, "Preaching Gospel of Rebirth in Jamaica," *New York Times* (November 27, 2000), B: 1, 8; Jim O'Grady, "So Many Stores, So Little Time," *New York Times* (January 11, 2004), XI: 4.

218. "Plaza in Jamaica Planned," *New York Times* (October 26, 1975), BQLI: 1, 15; Murray Schumach, "Jamaica Shopping Area Seeks Survival," *New York Times* (October 3, 1977): 33, 54; Robin Herman, "For Jamaica, Redevelopment Is a Promise Unfulfilled," *New York Times* (July 4, 1979), B: 3; Alan S. Oser, "Development Group Gets Financial Aid for Jamaica," *New York Times* (November 4, 1981): 29; Peter Kihss, "Arson Suspected After Fire Erupts in Jamaica Mall," *New York Times* (February 17, 1982), B: 3; Rosemary Breslin, "After a Long Slide, Hope for Jamaica," *New York Times* (May 22, 1983), VIII: 1, 14.

219. "Pedestrian Mall Urged in Jamaica," *New York Times* (December 17, 1961): 1, 6.

220. "Work Going on Around the Clock on Queens Subway Link," *New York Times* (November 14, 1981), II: 27; Kirk Johnson, "Big Changes for Subways Are to Begin," *New York Times* (December 9, 1988), B: 1, 6.

221. Shawn G. Kennedy, "Progress for Mall in Queens," *New York Times* (April 8, 1987), D: 28; "Jamaica Mall: Gertz Redux," *New York Times* (March 6, 1988), X: 1; Thomas J. Lueck, "$10 Million Shopping Mall Opens in Queens," *New York Times* (March 13, 1988): 32.

222. Robin Herman, "For Jamaica, Redevelopment Is a Promise Unfulfilled," *New York Times* (July 4, 1979), B: 3 Irvin Molotsky, "Federal Building in Queens Urged to Aid Economy," *New York Times* (November 16, 1979), B: 3; Glenn Fowler, "Design Chosen for 15-Story U.S. Tower in Jamaica," *New York Times* (May 10, 1981): 38; Alan S. Oser, "U.S. Role in Building Up in City," *New York Times* (June 3, 1981), D: 4; "GSA Competition Selects NY Team," *Progressive Architecture* 62 (August 1981): 36; Breslin, "After a Long Slide, Hope for Jamaica": 1, 14; "Names and News," *Oculus* 44 (June 1983): 9; George James, "York College in Queens Gets a Permanent Home," *New York Times* (November 2, 1986): 51; Alan S. Oser, "Perspectives: Jamaica Offices; Once Again, the Search for a Developer," *New York Times* (April 26, 1987), VIII: 9; "Addabbo Federal Building," *New York Post* (October 27, 1988): 58; Patricia Leigh Brown, "2 Sundials Mark Time in Queens," *New York Times* (December 22, 1988), C: 3; Michael Brenson, "Public Art at New Federal Building in Queens," *New York Times* (March 24, 1989), C: 32; "20 Housing and Civil Courtrooms: New Courts in Queens Halfway Complete," *New York Times* (February 11, 1996), IX: 1; White and Willensky, *AIA Guide* (2000), 864.

223. White and Willensky, *AIA Guide* (2000), 864.

224. Brenson, "Public Art at New Federal Building in Queens": 32.

225. Edward B. Fiske, "Chancellor Backs Modified Plan for Construction at York College," *New York Times* (May 23, 1978), B: 2; George Goodman Jr., "Construction Update: Delay Ends in Jamaica," *New York Times* (November 30, 1980), VIII: 4; "Gruzen & Partners' Core Campus for New York College," *Architectural Record* 169 (June 1981): 41; George James, "York College in Queens Gets a Permanent Home," *New York Times* (November 2, 1986): 51.

226. Jordan L. Gruzen, quoted in "Gruzen & Partners' Core Campus for New York College": 41.

227. "Farmers Market Jamaica: A Home at Last," *New York Times* (April 10, 1988): X: 1; "Jamaica Farmers Market: Brick Sale to Pave a Lane," *New York Times* (April 14, 1991): X: 1; "15 Years in Queens: Outdoor Market Getting Indoor Home," *New York Times* (August 25, 1991), X: 1; "From the Editors," *Metropolis* 11 (October 1991): 14; Mark Alden Branch, "A Farmer's Market for Jamaica, Queens," *Progressive Architecture* 73 (October 1992): 23; "Jamaica Market," *Architectural Record* 186 (June 1998): 125; "A Festival Market with a Spirit of Its Own," *Oculus* 61 (October 1998): 6.

228. Branch, "A Farmer's Market for Jamaica, Queens": 23.

229. Todd S. Purdum, "Boroughs Squabble Over Building Project," *New York Times* (February 27, 1994): 22; John Holusha, "F.D.A. Project Taps Unusual Public-Private Alliance," *New York Times* (October 26, 1997), XI: 7.

230. Alan S. Oser, "Public Construction: The Courts Pipeline Is Starting to Flow," *New York Times* (November 29, 1992), X: 5; Nina Reyes, "At Last, Work to Begin on a Civil Courthouse," *New York Times* (October 10, 1993), XIII: 9; Raymond Hernandez, "Plans for New Courthouse Stalled, Again, as Contractors Challenge Bid Process," *New York Times* (January 2, 1994), XIII: 6; "20 Housing and Civil Courtrooms: New Courts in Queens Halfway Complete": 1; "$56 Million Building Is 'User Friendly,'" *New York Times* (September 21, 1997), IX: 1; "Queens Civil Court," *New York Construction News* 45 (April 1998): 69; Pete Donohue, "Court Security Fears Spur Garage Shutdown," *New York Daily News* (May 4, 1998): 7; "Perkins Eastman Architects PC," *AIA/NYS News* 14 (December 1998): 15; Virginia Kent Dorris, "Queens Civil Courthouse," *Architectural Record* 187 (March 1999): 114–17; White and Willensky, *AIA Guide* (2000), 864.

231. White and Willensky, *AIA Guide* (2000), 864.

232. Claire Serant, "New Courthouse's Caveat: Luxurious Complex Will Snarl Parking," *New York Daily News* (March 28, 1999), Metro: 1; Warren Chiara, "Queens Construction Activity Rebounds," *New York Construction News* 47 (May 1999): 28, 30, 32; Austin Fenner, "Ceremonies at Site of New Family Court," *New York Daily News* (June 17, 1999), Metro: 1; White and Willensky, *AIA Guide* (2000), 864; "DASNY Court Program Kicks Into High Gear in 2000," *New York Construction News* 48 (April 2000): 13–21; Eric Lipton, "Halls

of Justice Going Up All Over," *New York Times* (December 5, 2000), B: 1, 9; "City Constructs New Home for Queens Family Court," press release (February 4, 2003); "New Queens Courthouse Opens in Jamaica," *New York Construction News* 50 (April 2003): 63; Kristen Richards, "Judicial Views," *Oculus* 65 (Summer 2003): 26–27; David W. Dunlap, "Changes at Jamaica," *New York Times* (July 6, 2003), XI: 1, 6.

233. Ian Bader, quoted in Dunlap, "Changes at Jamaica": 6.

234. Anthony DePalma, "Rebuilding Downtown Jamaica," *New York Times* (December 24, 1985), D: 16; "Theater for Queens from Magic Johnson," *New York Times* (August 30, 1996), B: 6; Jane H. Lii, "Multiplex, by Magic Johnson," *New York Times* (September 8, 1996), XIII: 9; John Holusha, "Plans Advance for Office Complex in Jamaica," *New York Times* (September 29, 1996), IX: 9; "Jamaica, N.Y.," *New York Construction News* 48 (March 2000): 74; Donald Bertrand, "Megaplex Milestone," *New York Daily News* (June 14, 2000), Metro: 1; Rachelle Garbarine, "$82 Million Retail-Movie Center to Open in Jamaica," *New York Times* (April 28, 2002), XI: 6; Jonathan Lemire, "Jamaica's Remaking Itself Again: Builds Today for Tomorrow," *New York Daily News* (May 12, 2002): 6.

235. Somini Sengupta, "Meshing the Sacred and the Secular," *New York Times* (November 23, 1995), B: 1, 12; "$23 Million Structure Accommodates 2,500 Worshipers: A Cathedral for a Queens Congregation," *New York Times* (July 20, 1997), IX: 1; Paul H. B. Shin, "Building Beauty for God: Flake May Focus Full Time on New Cathedral," *New York Daily News* (July 27, 1997): 12; White and Willensky, *AIA Guide* (2000), 867.

236. Kandace Simmons, interview by the author, November 12, 2004.

237. Michael J. Crosbie, *Architecture for the Books* (Mulgrave, Australia: Images Publishing, 2003), 64–67. Also see "South Jamaica Innovator: A Library Mindful of Light's Uses," *New York Times* (March 23, 1997), IX: 1; "Queens, N.Y. Library to Show 'Green' Buildings Belong in Public Sector," *Architectural Record* 185 (June 1997): 36; Dunlap, "For Libraries, a Time of Rebirth": 1, 6; "Stein Partnership Designs 'Green' Library," *New York Construction News* 45 (January 1998): 6; "Building Solutions That Enhance the Environment," *Architectural Record* 188 (August 2000): 174.

238. For St. John's University, see Stern, Mellins, and Fishman, *New York 1960*, 1005.

239. David W. Dunlap, "Major Projects at New York Colleges and Universities," *New York Times* (September 12, 1993), X: 12.

240. "Echoes by Design: St. John's Law Addition," *New York Times* (October 25, 1992), X: 1; Dunlap, "Major Projects at New York Colleges and Universities": 12. For Fromkes Hall, see Stern, Mellins, and Fishman, *New York 1960*, 1005.

241. Thomas J. Lueck, "St. John's University to Build First Dorms," *New York Times* (April 9, 1998): 9; Richard Weir, "Neighbors Troubled by St. John's Dorm Plan," *New York Times* (April 12, 1998), XIV: 6; "St. John's Building Its First Dormitories; Residential Halls for 700 By Fall '99," *New York Times* (June 28, 1998), XI: 1; Rachael Butler, "St. John's Aims Beyond Commuters with First On-Campus Residences," *Architectural Record* 186 (December 1998): 37; Winnie Hu, "After 129 Years, St. John's Adds Dormitories," *New York Times* (September 5, 1999): 29; Ellen Lask, "Private Universities Implementing Ambitious Expansion Programs," *New York Construction News* 49 (January 2001): 49–55.

242. "Phase II of St. John's Master Plan Begins," *New York Construction News* 48 (March 2000): 8; "St. John's University Residence Halls D & E," *New York Construction News* 49 (June 2001): 43.

243. "QCC Presents Annual Awards," *New York Construction News* 49 (February 2001): 7.

244. David W. Dunlap, "Part of $300 Million Master Plan: For St. John's Campus, a Cesar Pelli Church," *New York Times* (October 31, 1999), XI: 1; "Pelli's Progress," *Architectural Record* 188 (January 2000): 46; "St. John's University Plans $9.6M Church," *New York Construction News* 48 (March 2000): 10.

245. Corey Kilgannon, "New Church at St. John's Awaits Dedication," *New York Times* (November 20, 2004), B: 3.

246. *The Architecture of Rafael Viñoly*, no pagination; Dunlap, *Arquitectonica*, 208.

247. For an extensive discussion of Kennedy Airport between the 1940s and the mid-1970s, see Stern, Mellins, and Fishman, *New York 1960*, 1006–22.

248. Edward A. Gargan, "Port Authority Agrees with City to Expand Two Major Airports," *New York Times* (June 22, 1981), 1; D: 8; Edward A. Gargan, "City to Delay Airport Pact Over $5 Million Payment," *New York Times* (June 23, 1981), B: 3; Ari L. Goldman, "Kennedy Airport Shares Cities' Traffic Problems," *New York Times* (June 25, 1981), B: 1, 8; Shawn G. Kennedy, "Kennedy Residential Areas Troubled by Encroaching Air Cargo Concerns," *New York Times* (July 18, 1981), II: 27; Edward A Gargan, "More Than a Bookkeeper, Less Than a Mayor," *New York Times* (August 16, 1981), IV: 20; "Dispute over Finances Is Snarling Plan to Expand Queens Airport," *New York Times* (November 12, 1981), B: 10; Michael Goodwin, "Port Authority and City Revise Airport Leases," *New York Times* (December 10, 1981), B: 1; A. O. Sulzberger, "Board Clears Way for Airport Improvements," *New York Times* (December 20, 1981): 52; Frank J. Prial, "Expansion at Airports Approved," *New York Times* (May 14, 1982): 1, 19.

249. William G. Blair, "First in 15 Years: Hotel at Kennedy," *New York Times* (February 2, 1986), VIII: 1; Shawn G. Kennedy, "A New Hotel Rises at Kennedy Airport," *New York Times* (December 17, 1986), B: 15; White and Willensky, *AIA Guide* (1988), 788.

250. Schmitt, "New York Airports: $3 Billion Program": 1, B: 2; Sharon Monahan, "Airport Study Raises Fear," *New York Times* (November 15, 1987): 8; James Peters, "Kennedy Expansion Plan Rapped for Lacking a Link with Subways," *New York Daily News* (September 26, 1988), Metro: 6; Carter B. Horsley, "Flight of Fancy at JFK," *New York Post* (October 13, 1988): 63; Wiseman, *I. M. Pei: A Profile in American Architecture*, 310; Philip S. Gutis, "On Land and in Air, Kennedy Delays Persist," *New York Times* (January 19, 1990), B: 1–2; Jeannette Walls, "Will Airlines Pay to 'I. M. Pei' JFK," *New York* 23 (April 4, 1990): 13; Dean Baquet, "Airport Overhaul at Kennedy Is Cut," *New York Times* (May 11, 1990): 1, B: 3; Paul Goldberger, "Blueprint for an Airport That Might Have Been," *New York Times* (June 17, 1990), II: 29, 40; "Pencil Points," *Progressive Architecture* 71 (July 1990): 22; Henry N. Cobb, "J.F.K. Airport," letter to the editor, *New York Times* (August 12, 1990), II: 14; Paul Goldberger, "Architecture/1990: The Important Things Were What Didn't Happen," *New York Times* (December 30, 1990), II: 36; Iver Peterson, "Report to Cuomo Says Airport Plan Lost $100 Million," *New York Times* (May 23, 1992): 1, 28. For Pei's National Airlines Terminal, see Stern, Mellins, and Fishman, *New York 1960*, 1018–19.

251. Paul Karas, quoted in Horsley, "Flight of Fancy at JFK": 63.

252. For the Tri-Faith Chapels Plaza, see Stern, Mellins, and Fishman, *New York 1960*, 1018–19.

253. Quoted in Walls, "Will Airlines Pay to 'I. M. Pei' JFK": 13.

254. Jacques Steinberg, "Port Authority Plans Changes at Kennedy," *New York Times* (December 28, 1991): 21, 24; Helen Thorpe, "City's Three Airports to Get Major Spruce-Up," *New York Observer* (February 3, 1992): 1, 20.

255. Dennis Hevesi, "A New Air Control Tower for Kennedy Is Approved," *New York Times* (August 26, 1988), B: 3; Thorpe, "City's Three Airports to Get Major Spruce-Up": 1, 20; Ralph Blumenthal, "Building Lags on Kennedy Control Tower," *New York Times* (April 30, 1992), B: 4; John Zukowsky, ed., *Building for Air Travel* (New York: Prestel, 1996), 164.

256. Andrea E. Monfried, "Further Afield," *Oculus* 54 (April 1992): 4–5; "Work Underway on $250M J.F.K. Cogeneration Plant," *New York Construction News* 41 (March 28, 1994): 1, 5; Virginia Kent Dorris, "Cogeneration Plant; Jamaica, New York," *Architectural Record* 185 (August 1997): 82–85; "Merit Awards/The Hillier Group, Architects, PC," *AIA/NYS News* 14 (December 1998): 20.

257. Robert Davidson, quoted in Dorris, "Cogeneration Plant; Jamaica, New York": 82.

258. Quoted in www.hillier.com/portfolio.

259. Carter B. Horsley, "The Good, the Bad & the Ugly," *New York Post* (November 29, 1988): 53, 57; Klotz, ed., *New York Architecture: 1970–1990*, 160–61, 202–3; "NY Terminal," *Skala* (1989): 38–39; Karen D. Stein, "Against All Odds: Three Projects by Ellerbe Becket, New York, Architects," *Architectural Record* 177 (April 1989): 90–95; "Corrections," *Architectural Record* 177 (June 1989): 4; Claudio Fazzini, "Metropolitan Infrastructures," *L'Arca* 62 (July-August 1992): 32–41; Werner Blaser, "Perfeccionar el modelo: terminal de American Airlines en Nueva York," *Arquitectura viva* 29 (March 1993): 34–37; *Murphy/Jahn: Selected and Current Works* (Mulgrave, Australia: Images Publishing, 1995), 210–13; *Peter Pran: Jonathon Ward, Timothy Johnson, Paul Davis: An Architecture of Poetic Movement: Altered Perceptions* (Windsor, Berks, England: Andreas Papadakis Publisher, 1998), 24–27. For Kahn & Jacobs's American Airlines Terminal and Skidmore, Owings & Merrill's United Airlines Terminal, see Stern, Mellins, and Fishman, *New York 1960*, 1012–13.

260. Peter Pran, quoted in Stein, "Against All Odds: Three Projects by Ellerbe Becket, New York, Architects": 93.

261. For Murphy/Jahn's United Airlines Terminal One Complex at O'Hare, see *Murphy/Jahn: Selected and Current Works*, 214–19.

262. Paul Proctor, "American Gateway Upgrades," *Aviation Week & Space Technology* 138 (May 31, 1993): 15; David W. Dunlap, "J.F.K. Enters the Era of the Megaterminal," *New York Times* (March 19, 2000), XI: 1, 6.

263. Agis Salpukas, "3 International Airlines Plan a New Terminal at Kennedy," *New York Times* (November 9, 1991): 1, 28; *Kohn Pedersen Fox: Architecture and Urbanism, 1986–1992* (New York: Rizzoli International Publications, 1993), 340–45; "MDI CM On $300M Terminal at J.F.K. Airport," *New York Construction News* 41 (January 31, 1994): 1, 4; Greg Sargent, "JFK Crawls From the Wreckage," *Metropolis* 13 (May 1994), 25, 32, 42; "First New JFK Terminal Since 1971 Slated for Eastern's Old Site," *Architectural Record* 182 (September 1994): 17; "New Home for Air France, Japan Air Lines, Korean Air and Lufthansa; $450 Million Terminal Rising at JFK," *New York Times* (June 16, 1996), IX: 1; "William Nicholas Bodouva + Associates," *Oculus* 59 (September 1996): 3; David S. Chartock, "Fast-Tracking, Unique Design Fuel $400M Terminal One Job," *New York Construction News* 44 (April 14, 1997): 1, 3, 9–10; David W. Dunlap, "A 'New' Kennedy Airport Takes Wing," *New York Times* (October 26, 1997), XI: 1, 6; Nadine M. Post, "From Idle to Wild at JFK," *Engineering News-Record* 239 (November 17, 1997): cover, 30; Jane L. Levere, "Kennedy's New Terminal One Will Open Next Month with Plenty of Services for Frequent Fliers," *New York Times* (April 15, 1998), D: 8; Herbert Muschamp, "A Return to the Glamour of Flying," *New York Times* (May 15, 1998), B: 1, 9; Karrie Jacobs, "Sitelines: Air Apparent; Terminal 1 Launches a New Era at JFK," *New York* 31 (May 18, 1998): 15; Joyce Wadler, "Letting There Be Light at Kennedy Airport," *New York Times* (May 20, 1998), B: 2; Betsy Wade, "Bright Arrival at Kennedy," *New York Times* (July 12, 1998), V: 4; "Architecture Citation: William Nicholas Bodouva + Associates," *Oculus* 61 (January 1999): 23; White and Willensky, *AIA Guide* (2000), 872; David W. Dunlap, "J.F.K. Enters the Era of the Megaterminal," *New York Times* (March 19, 2000), XI: 1, 6; Balfour, *World Cities: New York*, 189, 318–19; Herbert

Muschamp, "Architecture Hands Off the Baton to Preservation," *New York Times* (April 4, 2001), B: 3; "Terminal One Canopy at JFK Soars With the Help of Steel," *Metals In Construction* (Fall 2001): 44–47.

264. Quoted in *Kohn Pedersen Fox: Architecture and Urbanism, 1986–1992*, 340.

265. For the British Overseas Airways Corporation Terminal, see Stern, Mellins, and Fishman, *New York 1960*, 1013–14.

266. William Bodouva, quoted in Post, "From Idle to Wild at JFK": 30.

267. William Bodouva, quoted in Chartock, "Fast-Tracking, Unique Design Fuel $400M Terminal One Job": 9.

268. Muschamp, "A Return to the Glamour of Flying": 9.

269. Muschamp, "Architecture Hands Off the Baton to Preservation": 3.

270. "Details," *Architecture* 82 (July 1993): 25; Sargent, "JFK Crawls From the Wreckage": 25, 32, 42; Clifford J. Levy, "Aging Terminal at Kennedy to Be Rebuilt," *New York Times* (October 14, 1994), B: 1–2; "Ground to Be Broken May 1 for $1.2B IAB," *New York Construction News* 44 (April 14, 1997): 1, 7; Barry Newman, "Dutch Are Invading JFK Arrivals Building and None Too Soon," *Wall Street Journal* (May 13, 1997): 1, 8; Karrie Jacobs, "Plane and Simple," *New York* 30 (August 25, 1997): 38–39; Kurt M. Eichler, "Redeveloping Terminal 4 at JFK International Airport," *Urban Land* 56 (October 1997): 35–37; Dunlap, "A 'New' Kennedy Airport Takes Wing": 1, 6; David Cay Johnston, "Terminal 4 to Ease Crush at Kennedy," *New York Times* (November 16, 1997), V: 3; Post, "From Idle to Wild at JFK": 30; Carol Vogel, "Inside Art: A Passport to the Arts," *New York Times* (February 12, 1999), E: 36; *Skidmore, Owings & Merrill LLP: Architecture and Urbanism, 1995–2000* (Mulgrave, Australia: Images Publishing, 2000), 144–45; White and Willensky, *AIA Guide* (2000), 873; David S. Chartock, "$1.2B International Arrivals Terminal Has a Flight Plan with Many 'Firsts,'" *New York Construction* 49 (August 2000): 10; Nadine M. Post, "'Greenfield' Site No Piece of Cake for JFK's New $1.4-Billion Terminal," *Engineering News-Record* 245 (August 21, 2000): 78–80, 83; Balfour, *World Cities: New York*, 260–61; Nina Siegal, "Runway Modern," *Interiors* 161 (February 2001): 54–57; Ronald Smothers, "Making 'Dwell Time' Fly Just a Little Faster," *New York Times* (May 21, 2001), B: 1, 3; Muriel Turk, "Passing Time at the Airport? Read This," letter to the editor, *New York Times* (May 22, 2001): 28; Celestine Bohlen, "Stepping Off a Plane to Meet New Art," *New York Times* (May 24, 2001), B: 1, 5; "Off the Record," *Architectural Record* 189 (June 2001): 28; Patricia Leigh Brown, "A Ray of Hope for Travelers Following Signs," *New York Times* (June 7, 2001), F: 1, 6; Betsy Wade, "J.F.K. Becoming a Bit Friendlier," *New York Times* (June 17, 2001), V: 4; "Terminal 4, The International Arrivals Terminal at JFK," *New York Construction News* 49 (December 2001): 75; Edie Cohen, "First Class," *Interior Design* 72 (September 2001): 268–73; James S. Russell, "A Tale of Two Airports," *Grid* 3 (December 2001): 66–71; Sarah Amelar, "JFK Terminal 4," *Architectural Record* 190 (January 2002): 114–19; Cary Brazeman, "Taking Off at JFK," *Urban Land* 61 (February 2002): 43; "Terminal 4," *New York Construction News* 49 (June 2002): 9; Joseph A. MacDonald, "Redevelopment Program Ensures JFK Airport's International Prominence," *New York Construction News* 50 (April 2003): 71–74. For the International Arrivals Building, see Stern, Mellins, and Fishman, *New York 1960*, 1009–11.

271. Dunlap, "J.F.K. Enters the Era of the Megaterminal": 6.

272. Nancy Hamilton, quoted in Chartock, "$1.2B International Arrivals Terminal Has a Flight Plan with Many 'Firsts'": 10.

273. Jacobs, "Plane and Simple": 39.

274. Jacobs, "Plane and Simple": 39.

275. Deborah Masters, quoted in Bohlen, "Stepping Off a Plane to Meet New Art": 5.

276. Philip Lentz, "Port Authority Puts the Brakes on JFK Terminal," *Crain's New York Business* (December 21–27, 1998): 1, 18; Vivian S. Toy, "New Terminal Is Announced in Expansion at Kennedy," *New York Times* (January 26, 1999), B: 1, 7; Thomas J. Lueck, "Delta and United Considering Major Expansion at Kennedy," *New York Times* (August 5, 1999), B: 4; Dunlap, "J.F.K. Enters the Era of the Megaterminal": 1, 6; MacDonald, "Redevelopment Program Ensures JFK Airport's International Prominence": 71–74.

277. Lueck, "Delta and United Considering Major Expansion at Kennedy": 4; Dunlap, "J.F.K. Enterx the Era of the Megaterminal": 1, 6; David W. Dunlap, "Delta Announces $1.6 Billion Expansion Plan for Kennedy Airport," *New York Times* (October 19, 2000), B: 1, 12; "Huge Building Program at JFK Gets Even Bigger," *Engineering News-Record* 245 (November 6, 2000): 9; MacDonald, "Redevelopment Program Ensures JFK Airport's International Prominence": 71–74. For the Braniff, Northeast and Northwest Orient Terminal, see Stern, Mellins, and Fishman, *New York 1960*, 1019.

278. For the Pan American Terminal, see Stern, Mellins, Fishman, *New York 1960*, 1012–13.

279. Stern, Mellins, and Fishman, *New York 1960*, 1014–17.

280. Eero Saarinen, quoted in "Saarinen's TWA Flight Center," *Architectural Record* 132 (July 1962): 129–34.

281. Stern, Mellins, and Fishman, *New York 1960*, 1021.

282. Paul Goldberger, "Architecture: 4 Honor Buildings," *New York Times* (June 18, 1979), C: 13. Also see "Addition to TWA Flight Center," *Progressive Architecture* 59 (October 1978): 22; White and Willensky, *AIA Guide* (1988), 790.

283. "Perkins & Will," *Progressive Architecture* 71(March 1990): 24; "TWA Plans June Start on $350M Job to Double Its JFK Airport Complex," *New York Construction News* 37 (March 5, 1990): 1, 19; "On the Drawing Boards," *Oculus* 52 (April 1990): 3.

284. Stanley Brezenoff, quoted in David W. Dunlap, "Landmarking Enters the Jet Age," *New York Times* (June 20, 1993), X: 1. Also see Thomas Fisher, "Landmarks: TWA

Terminal," *Progressive Architecture* 73 (May 1992): 96–101; "TWA's Influence," *Progressive Architecture* 73 (May 1992): 102–5; Christopher Hart Leubkeman, "Form Swallows Function," *Progressive Architecture* 73 (May 1992): 106–9.

285. Landmarks Preservation Commission of the City of New York, LP-1915–16 (July 19, 1994); David W. Dunlap, "T.W.A.'s Hub Is Declared a Landmark," *New York Times* (July 20, 1994), B: 1–2; Peter Slatin, "Preserving Landmarks Preservation," *Oculus* 57 (September 1994): 5; "TWA Terminal Gains Landmark Status," *Progressive Architecture* 75 (September 1994): 17; Herbert Muschamp, "Stay of Execution for a Dazzling Airline Terminal," *New York Times* (November 6, 1994), II: 31; Diamonstein, *The Landmarks of New York III*, 483.

286. Marvin B. Mitzner, quoted in Dunlap, "T.W.A.'s Hub Is Declared a Landmark": 1.

287. Stanley Brezenoff, quoted in Dunlap, "T.W.A.'s Hub Is Declared a Landmark": 2.

288. Randy Kennedy, "Airport Growth Squeezes the Landmark T.W.A. Terminal," *New York Times* (April 4, 2001), B: 1, 3; Muschamp, "Architecture Hands off the Baton to Preservation": 3; Adam Bartos, "Airport Architecture," letter to the editor, *New York Times* (April 10, 2001): 20; Anthony Vidler, "It's Still All About Form and Function," *New York Times* (August 12, 2001), IV: 5; "Rally for TWA," *Crain's New York Business* (August 13–19, 2001): 31; David W. Dunlap, "Planning a Nest of Concrete for a Landmark of Flight," *New York Times* (August 14, 2001), B: 1, 6; Andrea Peyser, "Queens Is Not a Wasteland," *New York Post* (August 15, 2001): 22; Witold Rybczynski, "A Cure for Terminal Decline," *Wall Street Journal* (August 22, 2001): 16; Herbert Muschamp, "Correcting the Nearsightedness of Airport Designers," *New York Times* (August 26, 2001), II: 25; Robert A. M. Stern, "Save the Great TWA Bird," letter to the editor, *Wall Street Journal* (August 27, 2001): 15; Abby Bussel, "Help Wanted," *Interior Design* 72 (September 2001): 304–7; Theo Prudon, "TWA Terminal Decommissioned: What Next?" *Docomomo Newsletter* (Fall/Winter 2001): 2; Joseph Giovannini, "Clipped Wings," *New York* 34 (October 1, 2001): 170–72; Sidney L. Delson, "Change of Plans," letter to the editor, *New York* 34 (October 8, 2001): 8; Suzanne Stephens, "TWA's Fight for Flight: What Preserves a Landmark Most?" *Architectural Record* 190 (November 2001): 63–66; Mark Lamster, "Will This Bird Fly? Pro," *Architecture* 90 (December 2001): 100, 104; Joseph Giovannini, "Will This Bird Fly? Con," *Architecture* 90 (December 2001): 100, 104; David Sokol, "Fight Over Flight: The Fate of JFK's TWA Terminal," *Grid* 3 (December 2001): 72; David W. Dunlap, "Unusual Planning Duel Over Kennedy Terminal," *New York Times* (November 28, 2002), B: 3; Vicki Weiner, "Update on TWA Terminal: MAS Offers Alternative Plan," *Municipal Art Society Newsletter* (January-February 2003): 2; Erika Kinetz, "An Airport Landmark, When It Was Young," *New York Times* (January 19, 2003), XIV: 5; Kevin Lerner, "TWA Terminal Placed on National Trust's Endangered List," *Architectural Record* 191 (July 2003): 36; Katherine Shana Lack, "TWA Terminal Makes Endangered List," *Architecture* 92 (August 2003): 13; Greg Sargent, "Airport Grab: JetBlue Cramps T.W.A. Jewel," *New York Observer* (August 4, 2003): 1, 7; J. Andrew Baute and Janet Ellis, "Flying Too High?" letters to the editor, *New York Observer* (August 11, 2003): 4; Tommy Fernandez, "JFK Rebounds with JetBlue, Renovation," *Crain's New York Business* (September 1–7, 2003): 1, 33; "Talks Aim to Green-Light JetBlue Terminal," *Crain's New York Business* (September 29-October 5, 2003): 10; Sam Lubell, "Municipal Art Society Talking with JetBlue About JFK's TWA Terminal," *Architectural Record* 191 (October 2003): 44; Stephanie Cash, "Saarinen's TWA Terminal Saved?" *Art in America* 91 (December 2003): 29.

289. Ted D. Kleiner, quoted in Kennedy, "Airport Growth Squeezes the Landmark T.W.A. Terminal": 3.

290. Philip Johnson, quoted in "Comments on Saarinen's TWA Terminal Delivered at the Municipal Art Society," August 14, 2001.

291. Quoted in Steven Lott, "JetBlue Names Architect, Designers for JFK Terminal," *Aviation Daily* (August 9, 2004): 1. Also see Steven Lott, "New York Port Authority Approves 26-Gate Terminal for JetBlue," *Aviation Daily* (August 5, 2004): 1; James Bernstein, "JetBlue Plans New Terminal with 26 Gates at Kennedy," *Newsday* (August 6, 2004): 53; "JetBlue Announces Plan to Build Terminal at JFK," *Engineering News-Record* 253 (August 23, 2004): 15.

292. See Stern, Mellins, and Fishman, *New York 1960*, 1023.

293. Joseph P. Fried, "Reviving the Rockaways: A Bitter Trail," *New York Times* (July 18, 1987): 29, 31. For Ocean Village, see Stern, Mellins, and Fishman, *New York 1960*, 1023–24.

294. Karl Butigian, quoted in George James, "A Faded Summer Place with Hopes of Revival," *New York Times* (May 26, 1986): 21–22. Also see William Rapfogel, "Bring Back the Glories of Rockaway Summers," letter to the editor, *New York Times* (June 10, 1986): 26.

295. Joseph P. Fried, "Starrett Proposes Housing Project at Urban-Renewal Site in Queens," *New York Times* (March 5, 1986), B: 2.

296. Fried, "Reviving the Rockaways: A Bitter Trail": 31; Anthony DePalma, "The Nehemiah Plan: A Success, but...," *New York Times* (September 27, 1987), VIII: 1, 20; Anthony DePalma, "Queens Coalition Challenges City with Low-Cost Rockaway Plan," *New York Times* (October 27, 1987), B: 2; Daniel H. Schneider, "Rockaways Need Revitalization and Environmental Protection," letter to the editor, *New York Times* (October 27, 1987): 34.

297. Carter B. Horsley, "City Sets Master Plan for Arverne Site," *New York Post* (October 27, 1988): 59, 65; "Queens Housing Plan Combines Market-Rate and Cheaper Units,"

New York Times (October 27, 1988), B: 3; Alan S. Oser, "Perspectives: The Arverne Plan," *New York Times* (November 20, 1988), X: 9; Doug Turetsky, "Battle for the Beach," *City Limits* 13 (December 1988): 7–8; Alan Finder, "In the Rockaways," *New York Times* (December 25, 1988), IV: 6; Karen Cook, "Waterfront Projects," *New York Post* (January 12, 1989): 50–51; "Three Arverne Finalist Teams Submit Proposals," *New York Post* (May 4, 1989): 38; Arnold H. Lubasch, "Joint Venture for Housing in Rockaways," *New York Times* (May 16, 1989), B: 1, 5; Joseph P. Fried, "Oasis or Mirage Likely for Tract in Rockaways," *New York Times* (June 6, 1989), B: 1, 6; Paul Goldberger, "On a Desolate Beach in Queens, a Point of Departure," *New York Times* (July 23, 1989), II: 29; "Arverne," *Oculus* 52 (November 1989): 8–9; Alex Cohen, "Planning Critique," *Oculus* 52 (November 1989): 10; Alex Cohen, "Rockaways Redux," *Oculus* 52 (December 1989): 7; Julie Meidinger, "Abandoned Arverne Plan to Be Revived," *Progressive Architecture* 71 (February 1990): 23; Andrea Oppenheimer Dean, "Taming the City Edge: Urban Design Portfolio," *Architecture* 79 (April 1990): 74–79, 147; Jacqueline Rivkin, "Setting the Table in Arverne," *Metropolis* 9 (June 1990): 19, 21; "Project for Rockaways Is Approved by Panel," *New York Times* (June 21, 1990), B: 3; Alan Finder, "Board of Estimate Approves Rockaways Housing Complex," *New York Times* (August 21, 1990), B: 3; *Park Tower Group*, brochure (New York, 1992), no pagination.

298. Abraham Biderman, quoted in Horsley, "City Sets Master Plan for Arverne Site": 65.

299. Henry J. Stern, quoted in "Queens Housing Plan Combines Market-Rate and Cheaper Units": 3.

300. Cohen, "Planning Critique": 10.

301. Goldberger, "On a Desolate Beach in Queens, a Point of Departure": 29.

302. Joseph P. Fried, "After 20 Lost Years, Arverne Skeptically Awaits Renewal," *New York Times* (March 7, 1991), B: 1, 6; Joseph P. Fried, "Long Delayed, New Town in Queens Appears Dead," *New York Times* (December 14, 1991): 29.

303. Joseph P. Fried, "City Planners Take New Tack on Giant Project: Think Small," *New York Times* (October 17, 1993), XIII: 9.

304. Alan S. Oser, "The New Approach in Arverne: Incrementalism," *New York Times* (February 9, 1997), IX: 9; "2-Family Houses in Arverne," *New York Times* (August 1, 1999), XI: 1; Dennis Hevesi, "Builders Prodding Rebirth of Dormant Beachfront," *New York Times* (August 27, 1999), B: 1, 8; Maxine Simpson, "Lottery's Key to 60 Homes in Rockaway," *New York Daily News* (August 14, 2001), Metro: 1; Dennis Hevesi, "In Rockaways, a Tide Is Coming In," *New York Times* (December 7, 2003), XI: 1, 6.

305. Donald Bertrand, "Sports Complex Dunked by City," *New York Daily News* (December 22, 2000), Metro: 1.

306. *Arverne: Housing on the Edge* (New York: Architectural League of New York, 2001); Jayne Merkel, "How to Do Housing," *Oculus* 63 (April 2001): 12–14; Herbert Muschamp, "The New Season: Exhibitions," *New York Times* (September 9, 2001), II: 82; "In the Streetscape: Housing on the Edge," *Oculus* 64 (November 2001): 12; Jayne Merkel, "Taking the A Train to Queens: Housing Alternatives for a New Seaside Community," *Architectural Record* 190 (May 2002): 107–8.

307. Rosalie Genevro, quoted in *Arverne: Housing on the Edge*, 2.

308. Merkel, "Taking the A Train to Queens: Housing Alternatives for a New Seaside Community": 107.

309. Quoted in *Arverne: Housing on the Edge*, 4–5.

310. Quoted in *Arverne: Housing on the Edge*, 9.

311. Michael Sorkin, quoted in *Arverne: Housing on the Edge*, 6–7.

312. Donald Bertrand, "Arverne-by-the-Sea on Tap for Development," *New York Daily News* (December 3, 2001), Metro: 1; Sarah Kershaw, "New Plan Announced for Area of Rockaways," *New York Times* (December 4, 2001), D: 6; Sarah Kershaw, "Out Here, Doubt Springs Eternal," *New York Times* (February 4, 2002), B: 1, 4; Warren Woodberry Jr., "Arverne Buildup Begins," *New York Daily News* (July 14, 2002), Metro: 3; Hevesi, "In Rockaways, a Tide Is Coming In": 1, 6; Lore Croghan, "Reviving the Rockaways," *New York Daily News* (May 3, 2004): 49; Tamar Anolic, "A Rockaway Renaissance?" *Newsday* (July 2, 2004), D: 7.

INDEX

Page numbers in *italics* refer to illustrations.

Trump International Hotel & Tower, 573, 759, 777, 777, 1082
Trump Organization, 549, 759
Trump Palace, 431, 899, 901, *901*
Trump Pinnacle, 575
Trump Place, *see* Riverside South
Trump Plaza, *892*, 897, 898, 1080
Trump Regent, 575
Trump Tower, *494*, 501, 507, 508, 548–49, *549, 550*, 551, 552, 556, 592, *736*, 739
Trump World Tower, 411–14, *411, 412*
Trust for Cultural Resources, 586, 590
Trust for Public Land, 60, 61
Trust House Forte, 642
Trylons (Chrysler Building), *479*, 480
Tsao, Calvin, 1103
Tsao & McKown Architects, 295, 490
Tschumi, Bernard, 16, 136, 596, 597, 600–601, *601*, 602, *603*, 848, 879, 880–81, *880, 881*, 1018, *1020, 1020*, 1309
Tsien, Billie, 203, 324, 329, 596, 599, 608, 768, *770*, 933, 1109, 1128, 1134, *1135*, 1137
see also Tod Williams Billie Tsien & Associates
TSNY Realty Corporation, 684
Tsu, Kuo Ming, 375
Tubby, William B., 281, 1174
Tucano, 1080
Tucker, Marcia, 327
Tung, Anthony M., 896
Tunnel Diner, 1075
Tupu, Steven, *95, 96*
Turett, Wayne, 77, *77*
Turkel, Spencer, 308
Turnbull, Jay, 1045
Turner, Richard, 442
Tuthill, William B., 730
TWA Terminal, 1258, 1335, 1337, 1340–42, *1342*
Twelfth Street, West:
 No. 24, 362
 No. 66, 366
22nd Street Loft, *1106*, 1107
Twenty-first Street, West:
 No. 534, 418–19, *418*
Twenty-second Street, East:
 No. 5, 383
Twenty-second Street, West:
 No. 30, 367
 No. 520, *426, 427*
 No. 535, 418
 No. 545, 418
 No. 548, 417, *417*
Twenty-third Street, West:
 No. 120, 431, *431*
 No. 149, 431
 No. 222, 416
 No. 501, 420, *421*
Twenty-fourth Street, East:
 No. 155, 385
Twenty-fourth Street, West:
 No. 77, 433
 Nos. 419, 419–20, *419*, 537–541
 Nos. 515–523, 419, *419*
 Nos. 525–531, 419
Twenty-fifth Street, East:
 No. 45, 383
 No. 151, *385*
Twenty-fifth Street, West:
 No. 534, 421
Twenty-sixth Street, West:
 No. 55, 433
 No. 100, 433
 No. 601, *424, 425*
Twenty-seventh Street, East:
 No. 7, 383
Twenty-ninth Street, East:
 No. 10, 383, *384*
Twenty-ninth Street, West:
 No. 528, 421
Twenty-Twenty, 1082
Twin Parks Northeast, 358
2x4 Studios, 342
Two Columbus Circle, 196, 748, 777–79, *779*
Two Lincoln Square, 608
Two MetroTech Center, 1164, *1164*
Two Park Avenue, 1080
Two Penn Plaza, 446
Two Trees Management, 1146, 1147
Two United Nations Plaza, 403, *403*, 405, *406*

Two World Financial Center, 169, *169*, 1080
249th Street, West, No. 640, 1250
Tyson, Neil deGrasse, 850

U

Uchida, Shigera, 1131
Udall, Morris K., 1213
Uenishi, Noboru, 739
Uganda House, *403*, 405
Uhlfelder, Eric, 174
Ukrainian Museum, *350*, 351
Ulrich Franzen & Associates, 174, 177, *177, 178, 181*, 211, 475–76, *476*, 892, 898, 899, 910, *1051*, 1052, *1052*, 1150
see also Franzen, Ulrich
Umemoto, Nanako, 453
Unification Church, 536
Uniform Land Use Review Procedure (ULURP), 304, 1061
Union of American Hebrew Congregations, 922
Union Square, 375–80
Union Square Community Coalition, 377
Union Square East:
 No. 50, 377, 380
Union Square Greenmarket, *375*
Union Square Hotel, 376
Union Square Park, 375–76, *375*
Union Square South, 377–78, *378*
Union Square Theater, 377
Union Square West:
 Nos. 1–3, 377
 No. 31, 377
 No. 33, 393
Union Theological Seminary, 886–88, *886, 887*
Unisphere, 1307, 1309, 1312
United Airlines, 1334–35, 1340, 1341, *1341*, 1342
United Jewish Council, 312, 314
United Nations, 675, 697
 General Assembly Building, 876
United Nations Development Corporation (UNDC), 403
United Nations Headquarters, *412*, 414–15
United Nations International School, 393
United Nations Plaza, *403*, 405
 No. 100, *405, 408, 409*, 411
 No. 845, 411–14, *411, 412*
 No. 871, 407–8, *408*
 Nos. 860–870, 414
United States Courthouse, 296, 302, *304*
United States Courthouse Annex, 304–6, *304, 305*
United States Custom House, 196–97, 271, *271, 272*
United States Eastern District Courthouse, *1159*, 1160
United States General Post Office Building (Farley Building), 446, 448
United States Holocaust Memorial Museum, 198, *199*
United States Mission to the United Nations, *403*, 405, 408–9, *409*
United States Trust Company Headquarters, *621*, 622, *649*
Unité d'Habitation, 179
University Club, 547, 564
University Hall, *378, 379*
UN Studio, 453, 455
Upper East Side, 890–1003
Upper East Side Historic District, 505, 806, 892, 893, 894, 895, 896, 916, 918, 920, 930, 933, 937, 976, 982, 987
Upper Room (Smyth), 210–11, *210*, 213
Upper West Side, 804–35
Upper Yorkville, 902–5
Urasenke Tea Ceremony Society, 941, *941*
Urbach, Henry, 426
Urbahn, Max, 1264
Urbahn Associates, 301, *302, 303*, *1204*, 1205
Urban, Joseph, 366, 466
Urban Archaeology, 285
Urban Center, 1156
Urban Design Associates, *1149*
Urban Design Group, 319, 320, 586, 625
Urban Development Corporation (UDC), 163, 167, 355, 435, 471, 582, 682, 683, 684, 686, 690, 693, 699, 700, 704, 719, 753,

827, 996, 998, 1007, 1146, 1147, 1209, 1214, 1252, 1272
see also Empire State Development Corporation
Urban Glass, 1173
Urban Interface Loft, *1110*, 1111
Urban Strategies, 1148, *1149*
Urban Technical Assistance Project, 1022–23
Urbitran Associates, 1331
Uris Brothers, 247
Uris Theater, 642, 678, 691
US Airways, 1306–7
USA Network, 446

V

Vacant Lots proposals, 43–49, *42–49*
Vail, Brian, 345
Valentino boutique, 1133, *1133*
Valeri, Ed, 486
Valey, Azin, 325
Valle, Gino, 251–52, *252*
Vallone, Peter F., 849
Van Alen, William, 367, 478, 479, *479*, 494
Van Alen Institute, 93, 104, 367, 670
Van Berkel, Ben, 453
Van Campen Taylor, 363
Vanderbilt, Mrs. Cornelius, 507, 967
Vanderbilt apartment tower, 397, *398*
Vanderbilt Hall (Grand Central Terminal), 491
Vanderbilt Law School, 361
Van der Ryn, Calthorpe & Partners, 884
Van Dyke, Harry, 964
Van Dyke Community Center, 1198
Van Dyke Houses, 1198
Van Elslander, Terrence, 322, *322*
Vanguard, The, 433
Van Sickle & Rolleri, 1242
Van Tieghem, David, 203
Van Valkenburgh, Michael, *194*, 195, 196, 831, 1148–49, *1149*
Van Wagner Advertising, 686
Varnedoe, Kirk, 603
Varnell, David, 220
Vasquez, Fernando, 719
Vaux, Calvert, 355, 375, 569, 782–85, 787–88, 795, 802, 846, 848, 1016, 1173, 1178, 1179, 1201
Vector Studley Associates, 569
Veliz, Claudio, 850
Vellonakis, George, 1206, *1206*
Vendome, Antonio "Nino," 334
Vendome apartment house, 1173–74, *1174*
Venezia, Francesco, 216
Venturi, Rauch & Scott Brown, *82, 83*, 213, 214, 687, *687*, 688, 966
Venturi, Robert, 134, 686, 787, 951, 957, 1118
Venturi, Scott Brown & Associates, 185, *185*, 196, 224, 227, 696, 709, *710*, 1018, 1020, *1020*, 1228, *1229*, 1258
Vergara, Camilo José, 52, 133, 1191, 1222
Veronese, Palladio and Paolo, 1102
Verrazano-Narrows Bridge, 1254
Versace, Gianni, 932
Versailles nightclub, 1083
Vesey Terrace, 214
Viacom, 667
 Nickelodeon division, 1114, 1115
Victorian Society of America, 510
Victoria, The, 1177
Victoria Theater, 675, 678, 706, 718, 1009, 1014, *1014*, 1045
Victory building, 728
Victory Theater, 679, 683, 691, 692, 693, 700, *700*
Vidler, Anthony, 1107
Vietnam Veterans Plaza, 270–71, *270*
Vignelli, Lella, 1069, 1124, 1125
Vignelli, Massimo, 69, 738, 1069, 1124–25
Vignelli Associates, 76, *76*, 484, 531, 1068, 1283, *1283*
 offices of, 1124–25
Viladas, Pilar, 393, 1069, 1095
Vilkas, Elliott, 277, 914
Vilkas, Peles Architects, 1047
Vilkas Group, 177, *178*, 843, *902, 903*
Village at Atlantic Center, 1169–70, *1170*
Village Coalition, 355
Village Square Transit Plaza, 1348

Villano, Josef, 1067
Villard Houses, 915, 1082
Vincent A. Stabile Hall, 1174, *1175*
Vincent Astor Foundation, 988
Viñoly, Diana, 1076, *1077*
Viñoly, Rafael, 224, 226, *226*, 236, 242, 392, 469, *469*, 529, *529, 530*, 559, *560*, 596, 598, *598*, 630, *631*, 762, 765, 768, *770*, 824, *825*, 1018, 1076, *1077*, 1091, *1091*, 1127, 1177, 1228, 1233–34, *1234, 1235*, 1248, *1248, 1249*, 1262, *1263*, 1312, 1330
Viola, Bill, 596
Viot, Alain, 565
Virginia Graham Fair Vanderbilt house, 973
Virginia Theater, 691
Virgin Megastore, 661, *661*, 665
Viscaya, *893, 894*, 1303
"Visions for an Endangered Park," 1156
Visiting Neighbors offices, 1123
Vista International Hotel, 264–65, *264*
Vitetta Group/Studio Four, 1179
Vitto & Oaklander, 344
Vivian Beaumont Theater, *see* Lincoln Center for the Performing Arts
VMS Realty Partners, 660
Vogel, Carol, 941
Vogel, Susan, 327
Voisin restaurant, 1133
Vollmer Associates, 80, *80*, 163, 174, *174*, 619, 1148, *1149*, 1188
Volpe, Joseph, 811
Volunteer Hospital, 236
von Bidder, Alex, 764
Von Eckardt, Wolf, 943
Vong, 531, 1084, *1084*
Vongerichten, Jean-Georges, 358, 764, 1068
von Klemperer, James, 760
von Rydingsvard, Ursula, 1328, *1329*
Voorhees, Gmelin & Walker, 499
Voorhees, Walker, Smith, Smith & Haines, 258, 263, *263*, 368, 819, 869, 1317
Voorsanger Architects, 68, 69
Voorsanger, Bartholomew, 388, 962, 1230
Voorsanger & Mills Associates, 329, 361, *362*, 388–89, *388–89*, 391, 392, 892, 898, 899, 962, *962, 963*, 964,1066, *1067*, 1179, *1180*, 1231–32, *1231*
Vornado Realty Trust, 452, 524, 726, 928

W

Wagenknecht, Lynn, 1069, *1069*
Wagner, Ernst, 938–40, *940*
Wagner, Otto, 295
Wagner, Robert F., 325, 858, 895
Wagner, Robert F., Jr., 435, 892
Wagner, Walter, Jr., 552
Waid, D. Everett, 380, 750
Wakin, Daniel, J., 733
Waldman, Stuart, 424
Waldorf-Astoria, 507, 740
Walentas, David, 1146, 1147, 1148
Walker, Derek, 951–53, *953*
Walker, Hobart A., 1174
Walker, Ralph, 169, 250, 254, 745, 1164
Walker & Gillette, 267, 695, 730, 854, 914, 961, 1127
Walker & Morris, 222, 1177
Walker & Poor, 926, 1115
Walker/Grad, 548
Walker Group, 266, *267*, 580
Walk of Honor, 271
Walking Among African Graves, Speaking Through the Ground (African Burial Ground Competition entry), *307*, 308
Wallace, DeWitt, 538
Wallace, Hamlett, 1016
Wallace, Lila Acheson, 790
Wallace Roberts & Todd, 1264
Wallach, Mark, 289
Wallach, Miriam and Ira D., 871
Wall Street:
 Guggenheim branch (proposed), 273–76, *274, 275*
 No. 1, 254
 No. 11, 257
 No. 23, 245, 258, 259
 No. 28, 247